AMERICAN ART DIRECTORY

2007-2008

61st EDITION

American Art Directory, 61st Edition

Chief Executive Officer	Gene M. McGovern	**President**	James A. Finkelstein
Chief Technology Officer	Ari Spivakovsky		
Senior Managing Director	Fred Marks		
Senior Managing Director, Special Projects	Jon Gelberg		
Director, Editorial & Product Development	Robert Docherty		

Editorial

Managing Editor	Eileen Fanning
Senior Editors	Kuntal S. Patel
	Sumitra R. Nicholson
Editors	Daniel P. Del Coro
	Linda Hummer
	Mary Whitehouse
Editorial Assistants	Aileen Krauskopf
	Betty Melillo

Research

Senior Managing Editor	Kerry Nugent Morrison
Senior Research Editors	Patricia Delli Santi
	Todd Kineavey
Research Editors	Laura Franklin
	Vanessa Karis
	Rachel Moloshok
	Todd Neale
	Geoffrey Schmidt
	Bill Schoener
	Kate Spirito

Editorial Services

Production Manager	Paul Zema
Production Editor	Dave Lubanski
Freelance Manager	Mary SanGiovanni
Systems Engineer	Ben McCullough
Mail Processing Manager	Kara A. Seitz

Information Systems

Manager, Software Engineering	Ben Loh
Composition Engineer	Tom Haggerty
Database Engineer	Latha Shankar

Creative Services

Director, Marketing & Reference Sales	Michael Noerr
Creative Services Manager	Rose Butkiewicz
Production Manager	Jeanne Danzig
Associate Marketing Manager	Anna McMahon

AMERICAN ART DIRECTORY

2007-2008

61st EDITION

National Register Publishing

New Providence, New Jersey

Published by National Register Publishing

American Art Directory is a trademark of Marquis Who's Who, LLC, used under license.
Printed and bound in the United States of America.
International Standard Book Number: 0-87217-843-9
International Standard Serial Number: 0065-6968
Library of Congress Catalog Number: 99-1016

Contents

Preface

The American Art Directory, first published in 1898 as the American Art Annual, continues in its tradition of excellence with the 60th edition. The directory is a standard in the field of art, and an indispensable reference to art museums, libraries, organizations, schools and corporate art holdings.

COMPILATION

The information for the directory is collected by means of direct communication whenever possible. Forms are sent to all entrants for corroboration and updating, and information submitted by entrants is included as completely as possible within the boundaries of editorial and space restrictions. Information is provided by new entrants in response to questionnaires. Alphabetizing in the directory is strictly letter-by-letter. Those museums, libraries, associations and organizations which bear an individual's name are alphabetized by the last name of that individual. Colleges and universities are alphabetized by the first word of their name, whether or not it is named for an individual.

CONTENT AND COVERAGE

Section 1 lists The National and Regional Organizations, which are arranged alphabetically and contain over 110 organizations which administer and coordinate the arts within the United States and Canada. Included here are libraries affiliated with these organizations. The Museums, Libraries and Associations listings are arranged geographically, and contain listings for over 2,200 main museums, 250 main libraries, 600 area associations, and 65 corporations with art holdings within the United States and Canada. There are over 1,600 additional listings for galleries, museums and libraries affiliated with main entries.

A classification key is printed to the left of each entry to designate the type:
 A—Association
 C—Corporate Art
 L—Library
 M—Museum
 O—Organization

The key "M" is assigned to organizations whose primary function is gathering and preserving the visual arts. The "O" designation is given to national and regional organizations supporting the arts through sponsorship of art activities. The "A" code is given to those supporting the arts on more local levels.

Section II lists detailed information on more than 1,550 art schools, and college and university departments of art, art history, and architecture in the United States and Canada.

Section III provides reference to more than 500 art museums and 100 schools abroad, state arts councils, directors and supervisors of art education, art magazines, newspapers and their art critics, art scholarships and fellowships, open exhibitions, and traveling exhibitions booking agencies.

Section IV is composed of three alphabetical indexes; organizational, personnel, and subject. The subject index includes general art subjects and specific collections, along with the name and location of the holding organization.

Every effort has been made to assure accurate reproduction of the material submitted. The publishers do not assume and hereby disclaim any liability to any party for any loss or damage caused by errors or omissions in the *American Art Directory*, whether such errors or omissions resulted from negligence, accident or any other cause. In the event of a publication error, the sole responsibility of the publisher will be the entry of corrected information in succeeding editions.

Please address any suggestions, comments or questions to The Editors, *American Art Directory*, National Register Publishing, 890 Mountain Ave., Suite 4, New Providence, New Jersey 07974.

I ART ORGANIZATIONS

Arrangement and Abbreviations

National and Regional Organizations in the U.S.

Museums, Libraries and Associations in the U.S.

National and Regional Organizations in Canada

Museums, Libraries and Associations in Canada

Arrangement and Abbreviations
Key to Art Organizations

ARRANGEMENT OF DATA

Name and Address of institution; telephone number, including area code.
Names and titles of key personnel.
Hours open; admission fees; date established and purpose; average annual attendance; membership.
Annual figures on income and purchases.
Collections with enlarging collections indicated.
Exhibitions.
Activities sponsored, including classes for adults and children, dramatic programs and docent training; lectures, concerts, gallery talks and tours; competitions, awards, scholarships and fellowships; lending programs; museum or sales shops.
Libraries also list number of book volumes, periodical subscriptions, and audiovisual and micro holdings; subject covered by name of special collections.

ABBREVIATIONS AND SYMBOLS

Acad—Academic
Admin—Administration, Administrative
Adminr—Administrator
Admis—Admission
A-tapes—Audio-tapes
Adv—Advisory
AM—Morning
Ann—Annual
Approx—Approximate, Approximately
Asn—Association
Assoc—Associate
Asst—Assistant
AV—Audiovisual
Ave—Avenue
Bldg—Building
Blvd—Boulevard
Bro—Brother
C—circa
Cert—Certificate
Chap—Chapter
Chmn—Chairman
Circ—Circulation
Cl—Closed
Col— College
Coll—Collection
Comt—Committee
Coordr—Coordinator
Corresp—Corresponding
Cr—Credit
Cur—Curator
D—Day
Den—Denominational
Dept—Department
Develop—Development
Dipl—Diploma
Dir—Director
Dist—District
Div—Division
Dorm—Dormitory
Dr—Doctor, Drive
E—East, Evening
Ed—Editor

Educ—Education
Elec Mail—Electronic Mail
Enrol—Enrollment
Ent—Entrance
Ent Req—Entrance Requirements
Est, Estab—Established
Exec—Executive
Exhib—Exhibition
Exten—Extension
Fel(s)—Fellowships
Fri—Friday
Fs—Filmstrips
Ft—Feet
FT—Full Time Instructor
GC—Graduate Course
Gen—General
Grad—Graduate
Hon—Honorary
Hr—Hour
HS—High School
Hwy—Highway
Inc—Incorporated
Incl—Including
Jr—Junior
Lect—Lecture(s)
Lectr—Lecturer
Librn—Librarian
M—Men
Maj—Major in Art
Mem—Membership
Mgr—Manager
Mon—Monday
Mss—Manuscripts
Mus—Museums
N—North
Nat—National
Nonres—Nonresident
Per subs—Periodical subscriptions
PM—Afternoon
Pres—President
Prin—Principal
Prof—Professor

Prog—Program
PT—Part Time Instructor
Pts—Points
Pub—Public
Publ—Publication
Pvt—Private
Qtr—Quarter
Rd—Road
Rec—Records
Reg—Registration
Req—Requirements
Res—Residence, Resident
S—South
Sat—Saturday
Schol—Scholarship
Secy—Secretary
Sem—Semeseter
Soc—Society
Sq—Square
Sr—Senior, Sister
St—Street
Ste—Suite
Sun—Sunday
Supt—Superintendent
Supv—Supervisor
Thurs—Thursday
Treas—Treasurer
Tues—Tuesday
Tui—Tuition
TV—Television
Undergrad—Undergraduate
Univ—University
Vis—Visiting
Vol—Volunteer
Vols—Volumes
VPres—Vice President
V-tapes—Videotapes
Vols—Volumes
W—West, Women
Wed—Wednesday
Wk—Week
Yr—Year(s)

A Association
C Corporate Art Holding
L Library
M Museum
O Organization

O **AFRICAN AMERICAN MUSEUMS ASSOCIATION,** PO Box 427, Wilberforce, OH 45384. Tel 937-376-4611; Fax 937-376-2007; Internet Home Page Address: www.artnoir.com; *Co-Founder* Dr Margaret Burroughs
Open Mon - Fri 9 AM - 5 PM; Estab 1978 to represent black museums around the country. Offers consulting & networking services. Sponsors annual conferences; Mem: 496; dues institutional $100-$250
Publications: Profile of Black Museums - A Survey; biannual directory; quarterly newsletter for mem only

O **THE ALLIED ARTISTS OF AMERICA, INC,** National Arts Club, 15 Gramercy Park S New York, NY 10003. Tel 212-582-6411; *VPres* Fay Moore; *Pres* Gary Erbe
Open Nov - Dec daily Noon - 5 PM; Estab 1914, incorporated 1922, as a self-supporting exhibition cooperative, with juries elected each yr by the mem, to promote work by American artists; Mem: 3601; dues $40 & up; 3 annual meetings in Apr
Income: Financed by members' fees
Exhibitions: Members' Regional AAA exhibitions; annual exhibition in the winter; Annual held at National Arts Club; numerous awards & medals; prizes total $16,000 each year
Publications: Catalogs; newsletter
Activities: Lect open to public, 1-3 vis lectr per year; gallery talks; competitions with awards

O **AMERICAN ABSTRACT ARTISTS,** 470 W End Ave, Apt 9D, New York, NY 10024. Tel 212-874-0747; *Treas* James Juszczyk; *Pres* Marthe Keller
Estab 1936, active 1937, to promote American abstract art; develop & educate through exhibitions & publications; to provide forums for the exchange of ideas among artists; Mem: 94; dues $35; 5 meetings per yr
Income: Financed by mem
Publications: Portfolio of prints, journal
Activities: Lect open to the public; individual and original objects of art lent to responsible galleries, museums and universities; originate traveling exhibitions

O **AMERICAN ACADEMY OF ARTS & LETTERS,** 633 W 155th St, New York, NY 10032-7599. Tel 212-368-5900; *Exec Dir* Virginia Dajani
Open Thurs - Sun 1 - 4 PM during exhibitions Mar - May; No admis fee; Estab 1898 as an honorary mem organization of artists, writers & composers whose function it is to foster, assist & sustain an interest in literature, music & the fine arts; Maintains reference library of books & papers of members; Average Annual Attendance: 6,000; Mem: 250; mem is by election; no dues; annual meeting in May
Income: $1,400,000 (financed by endowment)
Purchases: $80,000-$90,000 Hassam Speicher Purchase Program
Collections: Works by members
Exhibitions: Exhibition of Candidates for Art Awards; Exhibition of Paintings Eligible for Hassam Fund Purchase; Newly Elected Members & Recipients of Honors & Awards Exhibitions, art, scores & manuscripts; Richard Rodgers Awards in Musical Theater (competition); Special Exhibitions
Publications: Proceedings, annual; exhibition catalogs
Activities: Awards given (nominations come from members)

O **AMERICAN ANTIQUARIAN SOCIETY,** 185 Salisbury St, Worcester, MA 01609. Tel 508-755-5221; Fax 508-753-3311; Internet Home Page Address: www.americanantiquarian.org; *Pres* Ellen S Dunlap; *Andrew W. Mellon Cur* Georgia B Barnhill; *Librn* Thomas Knoles; *VPres Coll & Prog* John B. Hench; *Special Asst in Graphic Arts* Lauren Hawes
Open Mon - Tues & Thurs - Fri 9 AM - 5 PM, Wed 10 AM - 8 PM, cl Sat, Sun, holidays & Fri after Thanksgiving; No admis fee; Incorporated 1812 to collect, preserve & encourage serious study of the materials of American history & life through 1876; Maintains reference library; Mem: 775 honorary; meetings third Fri in Apr & Oct
Income: Financed by endowment, gifts & grants
Purchases: $273,900
Library Holdings: Auction Catalogs; CD-ROMs; Exhibition Catalogs; Manuscripts; Maps; Original Art Works; Pamphlets; Periodical Subscriptions; Photographs; Prints; Reproductions
Special Subjects: Cartoons, Etchings & Engravings, Graphics, Prints, Painting-American, Woodcuts, Maps, Bookplates & Bindings
Collections: Early American portraits; Staffordshire pottery; bookplates, prints, lithographs, cartoons, engravings; Colonial furniture; photographs
Publications: Monographs; newsletters; Proceedings, semi-annually
Activities: Undergraduate seminar in American Studies; docent training; lects open to public 4-6 per yr; scholarships & fels offered; sales shop sells books & postcards
L **Library,** 185 Salisbury St, Worcester, MA 01609-1634. Tel 508-755-5221; Fax 508-754-9069; Elec Mail library@mwa.org; Internet Home Page Address: www.americanantiquarian.org/library.htm; *Pres* Ellen S Dunlap; *VPres Coll &*

Prog John B Hench; *Librn* Nancy Burkett; *Andrew W Mellon Cur Graphic Arts* Georgia B Barnhill
Open Mon - Fri 10 AM - 8 PM; no admis fee, donations accepted; Estab 1812 Reference Libr; For reference only; Average Annual Attendance: 7,000; Mem: 800 honorary elected mem, meetings in apr, oct annually
Library Holdings: Auction Catalogs; Audio Tapes; Book Volumes 650,000; Cards; Exhibition Catalogs; Fiche; Manuscripts; Original Art Works; Pamphlets; Periodical Subscriptions 650; Photographs; Prints; Records; Reels; Sculpture
Special Subjects: Decorative Arts, Illustration, Photography, Etchings & Engravings, Graphic Design, Manuscripts, Maps, Painting-American, Prints, Portraits, Printmaking, Cartoons, Art Education, Miniatures, Woodcuts
Collections: 750,000 titles dating before 1877, including early American books on art & 20th century books & periodicals relating to the history & culture of the United States
Publications: Portraits in the Collection of the America Antiquarian Society
Activities: Docent training, k-12 prog; lect; seminar; fels offered; sales shop sells books & postcards

O **AMERICAN ARTISTS PROFESSIONAL LEAGUE, INC,** 47 Fifth Ave, New York, NY 10003. Tel 212-645-1345; Fax 212-645-1345; *Pres* Sonja Weir; *Recording Secy* Susanne Hurt
Estab 1928 to advance the cause of fine arts in America, through the promotion of high standards of beauty, integrity & craftsmanship in painting, sculpture & the graphic arts; to emphasize the importance of order & coherent communication as prime requisites of works of art through exhibitions & publications; Mem: 1000; election by jury of professional artists National Board of Directors; dues $40; annual meeting in Nov; traditional realism
Income: Financed by mem
Exhibitions: Annual Grand National Exhibition
Publications: AAPL News Bulletin, semi-annually
Activities: Competitions with awards; scholarships & fels offered

O **AMERICAN ASSOCIATION OF MUSEUMS,** US National Committee of the International Council of Museums (AAM-ICOM), 1575 Eye St NW, Ste 400, Washington, DC 20005. Tel 202-289-9115; Fax 202-289-6578; Elec Mail aam-icom@aam-us.org; Internet Home Page Address: www.aam-us.org/aamicom/; *Vice Chair, AAM/ICOM* W Richard West Jr; *Secy AAM/ICOM & Pres AAM* Edward H Able; *Dir, AAM/ICOM* Helen Wechsler; *VPres Finance & Admin, AAM* Mary Bowie; *VPres Policy & Progs, AAM* Kim Igoe; *Program Assoc, AAM/ICOM* Heather L Berry
Open 9 AM - 5 PM; No admis fee; AAM estab 1906, affiliated with US-ICOM in 1973, represents international museum interests within the United States & US museum interests abroad through the AAM/ICOM office which disseminates information on international conferences, publications, travel & study grants & training programs in AAM's newsletter, AVISO; Mem: 1000; members must be museum professionals or institutions; dues vary according to member category; members meet annually at the AAM annual meeting every spring and once every 3 yrs at the ICOM triennial conference
Income: Financed by mem dues
Publications: International Column in Aviso, monthly; ICOM News, quarterly (from ICOM Secretariat in Paris); occasional articles in Museum News, AAM's bi-monthly magazine
Activities: Specialty committees; annual meeting; international meetings; professional exchanges; publications catalogue available; Distinguished Serv Citation

O **AMERICAN ASSOCIATION OF UNIVERSITY WOMEN,** 1111 16th St NW, Washington, DC 20036. Tel 202-785-7700; Fax 202-872-1425; Internet Home Page Address: www.aauw.org; *Pres* Sandy Bernard
Open Mon - Fri 8 AM - 4 PM; No admis fee; Estab 1881 to unite alumnae of different institutions for practical educational work; to further the advancement of women, lifelong learning, & responsibility to soc expressed through action, advocacy, research & enlightened leadership; Mem: 150,000; holds biennial conventions
Publications: Action Alert, biweekly; AAUW Outlook, quarterly; Leader in Action, quarterly; brochures; booklets; research studies; study guides
Activities: Associations local branches develop & maintain programs in the arts. AAUW Foundation funds first professional degree in architecture, doctoral/post doctoral candidates in the arts

O **AMERICAN CERAMIC SOCIETY,** 735 Ceramic Pl, Westerville, OH 43081-8720. Tel 614-890-4700; Fax 614-899-6109; *Exec Dir* W Paul Holbrook
Open Mon - Fri 8:30 AM - 5 PM; No admis fee; Estab 1899 to promote the arts, science & technology of ceramics; Mem: 10,050; dues $50; annual meeting in May
Income: $2,000,000 (financed by mem)
Publications: American Ceramic Society Journal, monthly; Ceramic Engineering & Science Proceedings, bi-monthly; Journal and Abstracts, bi-monthly

O AMERICAN COLOR PRINT SOCIETY, 61 Coppermine Rd, Princeton, NJ 08540. Elec Mail idwill@superlink.net; Internet Home Page Address: www.americancolorprintsociety.org; *Pres* Idaherma Williams; *VPres & Color Proof Editor* Carole J Meyers; *Treas* Elizabeth H MacDonald; *Pub Chmn* Sy Hakim; *Chmn Mem* Raymond Hamilton; *Recording Secy* Thelma Grobes
Estab 1939 to exhibit color prints; Mem: 75; dues $20
Income: Financed by mem
Special Subjects: Prints, Watercolors, Woodcuts, Woodcarvings
Collections: The Phila Museum of Art, Phila, PA
Activities: Lect & symposium; sponsors annual national members exhibition of all media color prints; 6 annual prizes, Stella Draken Memorial Awards

O AMERICAN CRAFT COUNCIL, 72 Spring St, New York, NY 10012-4019. Tel 212-274-0630; Fax 212-274-0650; Elec Mail council@craftcouncil.org; Internet Home Page Address: www.craftcouncil.org; *Vice Chmn* Leatrice Eagle; *Exec Dir Council* Carmine Branagan; *Ed-in-Chief American Craft Magazine* Lois Moran; *Vice Chmn* Tina Oldknow
Open Mon - Fri 1 - 5 PM, Tues 1 - 7 PM; Estab 1943 to promote understanding and appreciation of American craft; Mem: 32,000; dues $40
Income: Financed by mem, private donations & government grants
Exhibitions: Ten shows & markets per yr
Publications: American Craft Magazine (formerly Craft Horizons), bimonthly
Activities: Competition with awards
L Library, 72 Spring St, New York, NY 10012-4019. Tel 212-274-0630; Fax 212-274-0650; Elec Mail library@craftcouncil.org; Internet Home Page Address: www.craftcouncil.org; *Librn* Mary B Davis
By appointment only; For reference only
Library Holdings: Audio Tapes; Book Volumes 6000; Cassettes; Clipping Files; Exhibition Catalogs 8000; Filmstrips; Motion Pictures; Other Holdings Journals 110; Pamphlets; Periodical Subscriptions 200; Photographs; Slides 40,000; Video Tapes 100
Special Subjects: Decorative Arts, Ceramics, Crafts, Porcelain, Furniture, Glass, Stained Glass, Metalwork, Embroidery, Enamels, Goldsmithing, Handicrafts, Jewelry, Pottery, Silversmithing, Tapestries, Textiles
Collections: ACC Fellows; American Craft Museum Slide Kits; Archives of the American Council & American Craft Museum (until 1990); Award Winners & Artists featured in American Craft Magazine, newsletters & catalogs of craft organizations & educational programs; 20th-century Fine Craft, with emphasis on post WW II Period (1945)

O THE AMERICAN FEDERATION OF ARTS, 41 E 65th St, New York, NY 10021. Tel 212-988-7700; Fax 212-861-2487; Elec Mail pubinfo@afaweb.org; Internet Home Page Address: www.afaweb.org; *Chmn* Jan Mayer; *Pres* Gilbert H Kinney; *VPres* Margot Linton; *VPres* Donald M Cox; *VPres* Stephanie French; *VPres* Hannelore Schulhof; *Treas-Secy* Richard Lane; *Dir Exhib* Thomas Padon; *Chief Develop Officer, Individual Giving* Amy Busam; *Chief Develop Officer, Corporate Foundation & Government Giving* Liz Flanagan; *Dir Pub Relations* Lisbeth Mark; *Dir* Julia Brown; *Dir Mus Svcs* John W Nichols
Estab 1909 by an act of Congress, it is the nation's oldest and most comprehensive nonprofit art museum service organization. The AFA provides its more than 550 member institutions with traveling art exhibitions and educational, professional and technical support programs developed in collaboration with the museum community. Through these programs, the AFA seeks to strengthen the ability of museums to enrich the public's experience and understanding of art; Mem: 550 museum members dues $250 - $675, 285 individual members $250 - $3,000
Income: Financed by government agencies, corporations, foundations & mem
Publications: Memo to Members The Newsletter of the AFA, 4 per year; exhibition catalogues
Activities: Educational components are developed to accompany exhibitions; originate and tour exhibitions of fine arts; organize Curators Forum and Directors Forum (annual events)

O THE AMERICAN FOUNDATION FOR THE ARTS, 3814 NE Miami Ct, Miami, FL 33137. Tel 305-576-0254; Fax 305-576-0259; *Pres* Richard Levine; *Dir* May Levine
Open Mon - Fri 10 AM - 4 PM; No admis fee; Estab 1974; Mem: Dues founder $25,000, trustee $10,000, life $5000, benefactor $1000, business $250, friend $100, sustaining $50, family $25, individual $15, student annual $5
Collections: Architecture; contemporary paintings; photography

O AMERICAN INSTITUTE OF ARCHITECTS, 1735 New York Ave NW, Washington, DC 20006. Tel 202-626-7300; Fax 202-626-7547; Internet Home Page Address: www.aia.org; *Exec VPres* Norman L Koonce FAIA
Open Mon - Fri 8:30 AM - 5 PM; Estab 1857 to organize & unite the architects of the United States & to promote the aesthetic, scientific & practical efficiency of the profession
Income: Financed by members
Library Holdings: Book Volumes 40,000; CD-ROMs 50; Motion Pictures; Periodical Subscriptions 200; Slides 100,000; Video Tapes 200
Publications: AIArchitect (online newsletter) monthly
Activities: Continuing educ program; awards given, Gold Medal, Kemper Award, Architectural Firm Award, R S Reynolds Memorial Award & Reynolds Aluminum Prize Citation of Honor, AIA Honor Awards, Institute Honors
L AIA Library & Archives, 1735 New York Ave NW, Washington, DC 20006. Tel 202-626-7492; Fax 202-626-7587; Elec Mail library@aiamail.aia.org; Internet Home Page Address: www.aia.org/; *Dir* Sarah Turner
Open by appointment; Open to the pub, lending provided for members only
Income: Financed by members
Library Holdings: Audio Tapes; Book Volumes 32,000; Cassettes; Clipping Files; Fiche; Filmstrips; Framed Reproductions; Kodachrome Transparencies; Lantern Slides; Manuscripts; Memorabilia; Original Art Works; Periodical Subscriptions 450; Photographs; Reels; Sculpture; Slides; Video Tapes
Special Subjects: Architecture

O AMERICAN INSTITUTE OF GRAPHIC ARTS, 164 Fifth Ave, New York, NY 10010. Tel 212-807-1990; Fax 212-414-0296; Elec Mail robyn_jordan@aiga.org; Internet Home Page Address: www.aiga.org/; *Exec Dir* Richard Grefe; *COO* Denise Wood; *Dir Exhib* Gabriela Mirensky; *Office & Facilities Mgr* Robyn Jordan
Open Mon - Fri 11 AM - 6 PM; No admis fee; Estab 1914 as a national nonprofit educational organization devoted to raising standards in all branches of the graphic arts; Art gallery showcases AIGA design competition, exhib, and exhib organized by visiting designers and cur; maintains library & slide archives; Mem: 17,000; dues professional mem $275, assoc mem $190, student $65, group $685
Income: Financed by mem
Exhibitions: Rotating exhibits
Publications: A1GA Graphic Design USA, hardbound annual; AlGA journal of Graphic Design, quarterly
Activities: Awards AIGA Medal for distinguished contributions to the graphic arts; originate traveling exhibitions
L Library, 164 Fifth Ave, New York, NY 10010. Tel 212-807-1990; Elec Mail grefe@aiga.org; Internet Home Page Address: www.aiga.org/; *Exec Dir* Richard Grefe
Open Mon - Fri 9:00 AM - 5:00 PM; For reference only; Art gallery maintained for AIGA exhibitions resulting from design competitions
Income: Financed by mem
Library Holdings: Book Volumes 1098; Periodical Subscriptions 25
Special Subjects: Art History, Illustration, Commerical Art, Graphic Arts, Graphic Design, Posters, Industrial Design, Art Education, Aesthetics

O AMERICAN NUMISMATIC ASSOCIATION, Money Museum, 818 N Cascade Ave, Colorado Springs, CO 80903. Tel 719-632-2646; Fax 719-634-4085; Elec Mail ana@money.org; Internet Home Page Address: www.money.org; *Pres* Gary E Lewis; *Museum Cur* Douglas Mudd; *Exec Dir* Christopher Cipoletti; *Mus Dir* Tiffanie Bueschel
Open Tues - Fri 9 AM - 5 PM, Sat 10 AM - 5 PM, Sun Noon - 5 PM, cl Mon; No admis fee; Estab 1891 as an international organization to promote numismatics as a means of recording history; Maintains a mus & library; galleries display numismatic material from paper money through coins & art medals; Average Annual Attendance: 28,000; Mem: 34,000; to qualify for mem, a person must be at least 18 years of age & interested in coin collecting; dues $33 plus one-time initiation fee of $6; annual meeting held at National Conventions in Mar & Aug
Income: Financed by mem, endowment, donations & miscellaneous sources
Library Holdings: Auction Catalogs; Audio Tapes; Book Volumes; CD-ROMs; Cards; Cassettes; Compact Disks; Exhibition Catalogs; Fiche; Filmstrips; Kodachrome Transparencies; Manuscripts; Memorabilia; Original Documents; Pamphlets; Periodical Subscriptions; Photographs; Slides; Video Tapes
Collections: Aubrey & Adeline Bebee Collection of US Paper Money; Robert T Herdegen Memorial Collection of Coins of the World; Norman H Liebman Collection of Abraham Lincoln on Paper Money; Elliott Markoff Collection of Presidential Memorabilia; general and specialized collections from all other fields of numismatics
Exhibitions: Changing galleries exhibiting coins of the American Colonial period, the United States 1792 to date and Modern Medallic Art from contemporary medals.
Publications: Numismatist, monthly
Activities: Classes for adults & children; annual seminar on campus of Colorado College, Colorado Springs; lect open to public, 50+ vis lectrs per yr; tours; sponsorship of National Coin Week third week in Apr (when members throughout the United States promote their avocations through exhibits in local areas); presentation of awards; scholarships offered; book traveling exhibitions; organize traveling exhibitions mostly to mem coin clubs; sales shop selling books, magazines, slides, medals & souvenir jewelry
L Library, 818 N Cascade Ave, Colorado Springs, CO 80903. Tel 719-632-2646; Fax 719-632-5208; Elec Mail library@money.org; Internet Home Page Address: www.money.org/resourcecenter.html; *Interim Librn* Nancy W Green; *Asst Librn* Jane Colvard
Open Mon - Fri 9 AM - 4 PM, Sat 10 AM - 4 PM; No admis fee; Estab 1891 to provide research materials to the members of the Assoc & the general pub; Circ 4500; Open to the pub for reference; lending restricted to members; Mem: 30,000; dues $33 first year, $26 to renew mem; meetings twice a year
Income: Financed by association & mem, endowments, donations
Library Holdings: Auction Catalogs; Audio Tapes; Book Volumes 35,000; CD-ROMs; Cards; Cassettes; Compact Disks; Exhibition Catalogs; Fiche; Filmstrips; Kodachrome Transparencies; Manuscripts; Memorabilia; Original Documents; Other Holdings Auction catalogs 20,000; Microfilm; Pamphlets; Periodical Subscriptions 110; Photographs; Slides; Video Tapes
Special Subjects: Coins & Medals
Collections: Arthur Braddan Coole Library on Oriental Numismatics; books, auction catalogs & periodicals, all on numismatics
Exhibitions: Annual Summer Conference
Activities: Classes for adults & children

O AMERICAN NUMISMATIC SOCIETY, Broadway at 155th St, New York, NY 10032. Tel 212-234-3130; Fax 212-234-3381; Elec Mail info@amnumsoc.org; Internet Home Page Address: www.amnumsoc.org/; *Cur* Michael L Bates; *Cur* Elena Stolyarik; *Librn* Francis D Campbell; *Dir* Ute Wartenberg
Open Tues - Fri 9 AM - 4:30 PM, cl Mon; No admis fee; Estab 1858 as an international organization for the advancement of numismatic knowledge; Maintains mus & library; one exhibition hall, devoted to the World of Coins; Average Annual Attendance: 18,000; Mem: 2279; dues assoc $30; annual meeting second Sat in Oct
Income: Financed by endowment
Collections: Universal numismatics
Publications: American Journal of Numismatics, annual; Numismatic Literature, semi-annual
Activities: Lect open to public, 2 vis lectrs per year; scholarships offered
L Library, Broadway at 155th St, New York, NY 10032. Tel 212-234-3130, ext 220; Fax 212-234-3381; Elec Mail campbell@amnumsoc.org; Internet Home Page Address: www.amnumsoc.org/library/; *Librn* Francis D Campbell
Open Tues - Fri 9 AM - 4:30 PM; For reference only

Library Holdings: Book Volumes 100,000; Exhibition Catalogs; Filmstrips; Manuscripts; Other Holdings Auction catalogs; Pamphlets; Periodical Subscriptions 246; Reels 200; Slides
Special Subjects: Coins & Medals
Collections: Auction catalogs

O **AMERICAN SOCIETY FOR AESTHETICS,** Armstrong Atlantic State University, 11935 Abercorn St Savannah, GA 31419. Tel 912-961-3189; Fax 919-961-1395; Elec Mail asa@mail.armstrong.edu; Internet Home Page Address: www.arts.org/asaesth; Internet Home Page Address: www.aesthetics-online.org; *Secy-Treas* Dabney Townsend; *Pres* Stephen Davies
Estab 1942 for the advancement of philosophical & scientific study of the arts & related fields; Mem: 800; dues $60
Income: Financed by mem, dues, subscriptions
Publications: Journal of Aesthetics & Art Criticism, quarterly; ASA Newsletter, 3 times per year
Activities: Ann conferences

O **AMERICAN SOCIETY OF ARTISTS, INC,** PO Box 1326, Palatine, IL 60078. Tel 312-751-2500, 847-991-4748; Elec Mail asoa@webtv.net; Internet Home Page Address: www.americansocietyofartists.com; *VPres* Helen DelValle; *Dir Promotional Svcs* Arnold Jackson; *American Artisans Dir* Judy A Edborg; *Dir Lecture & Demonstration Serv* Charles J Gruner; *Special Arts Servs Dir* Patricia E Nolan; *Dir Special Events* Marge Coughin; *Midwest Representative* Alajos Acs; *Chicago Representative* Donald Metcoff; *Southern Illinois Representative* Ann Childers; *Pres* Nancy J Fregin
Estab 1972, mem organization of professional artists; Mem: Over 10,000; qualifications for mem, must have work juried & pass jury to be accepted; dues $50, plus one initiation fee of $20; patronship, associateship & international mem also available
Income: Financed by mem
Library Holdings: Audio Tapes; Book Volumes; Clipping Files; Lantern Slides; Periodical Subscriptions; Photographs; Slides
Collections: Photographs & slides of members works
Exhibitions: Approximately 25 indoor & outdoor juried shows per year
Publications: Art Lovers' Art and Craft Fair Bulletin, quarterly; ASA Artisan, quarterly
Activities: Lect & demonstration service; assists members with various problems
L **Library Organization,** PO Box 1326, Palatine, IL 60078. Tel 312-751-2500, 847-991-4748; Elec Mail ASOA@webtv.net; Internet Home Page Address: community.americansocietyofarts.org; *Librn* Donald Metcoff
Open for mem use only; Estab 1978 to provide reference material for member artists only
Income: Financed by dues & fees
Library Holdings: Audio Tapes; Book Volumes; Clipping Files; Lantern Slides; Periodical Subscriptions 8; Photographs; Slides
Publications: Publication for Members
Activities: Lect & demonstration service

O **AMERICAN SOCIETY OF BOOKPLATE COLLECTORS & DESIGNERS,** PO Box 380340, Cambridge, MA 02238-0340. Tel 626-570-9404; Elec Mail exlibrisusa@hotmail.com; Internet Home Page Address: www.bookplate.org; *Dir & Ed* Audrey Spencer Arellanes
Estab 1922 as an international organization to foster an interest in the art of the bookplate through the publication of a YearBook & to encourage friendship & a greater knowledge of bookplates among members by an exchange membership list; Mem: 200 who are interested in bookplates as either a collector or artist, or just who want an interest in bookplates & graphic arts; dues $85 which includes yearbook & quarterly newsletter
Income: Financed by members
Exhibitions: Bookplates, Prints in Miniature
Publications: Bookplates in the News, quarterly newsletter; YearBook, annually
Activities: Lect given upon request; contributes bookplates to the Prints & Photographs Division of the Library of Congress & furnishes them with copies of quarterly & Year Book; originate traveling exhibitions

O **AMERICAN SOCIETY OF CONTEMPORARY ARTISTS (ASCA),** c/o Joseph V Lubrano, 130 Gale Pl No 9H Bronx, NY 10463. Tel 718-548-6790; *Pres* Joseph V Lubrano
Estab 1917 as the Brooklyn Society of Artists. Adopted its current name in 1963; Mem: 100 elected on basis of high level of professional distinction; professional artists juried by mems in May & Oct; dues $50; annual meeting May
Income: Financed by members
Exhibitions: Broome Street Gallery (in Nov)
Publications: Quarterly Newsletter
Activities: Educ dept; demonstrations in graphics, painting & sculpture; lect open to the public; 10 two hundred dollar annual cash awards with certs.

O **AMERICAN SOCIETY OF PORTRAIT ARTISTS (ASOPA),** Tel 800-622-7672; Fax 334-270-0150; Elec Mail asopa@mindspring.com; Internet Home Page Address: www.asopa.com; WATS 800-622-7672; *Pres* Leon Loard; *VPres* Jennifer F Williams; *Sec* Helen Sansom; *Chmn* Richard Whitney
Estab 1989 to provide artists with portrait information; Mem: 2000; mem open to portrait artists; dues $75; regional seminars, Portrait Arts Festival; active in portraiture
Activities: Lect open to public; competitions with awards

O **AMERICAN WATERCOLOR SOCIETY,** 47 Fifth Ave, New York, NY 10003. Tel 212-206-8986; Internet Home Page Address: www.watercolor-online.com/aws/; *Treas* Lynda A Doll; *Pres* Janet Walsh
Open daily 1 - 5 PM, cl Mon; No admis fee; Estab 1866 as a national organization to foster the advancement of the art of watercolor painting & to further the interests of painters in watercolor throughout the United States; occupies the galleries of the Salmagundi Club, 47 Fifth Ave, New York City for four weeks each yr for annual international exhibition usually in April; Average Annual Attendance: 4,000-5,000; Mem: 550 signature; to qualify for mem, an

artist must exhibit in two annuals then submit applicaton to mem chairman; dues $40; annual meeting in Apr
Income: Financed by mem & donations
Publications: AWS Newsletter, semi-annually; full color annual exhibition catalog; CD of complete exhibitions
Activities: Lect open to the public; demonstrations during annual exhibitions; awards given at annual exhibitions; scholarships offered; originate traveling exhibitions

O **AMERICANS FOR THE ARTS,** 1000 Vermont Ave NW, 6th Flr, Washington, DC 20005. Tel 202-371-2830; Fax 202-371-0424; Elec Mail info@artsusa.org; Internet Home Page Address: www.americansforthearts.org; *Pres & CEO* Robert L Lynch
Open Mon - Fri 9 AM - 5:30 PM; Estab to support the arts & culture through pub & private resource development, leadership development, pub policy development, information services, pub awareness & educ; Mem: 5,000; annual meeting June; membership not limited
Income: Financed by mem, foundations, corporations & government
Publications: Periodic journals; quarterly newsletter
Activities: Annual convention; regional workshops; technical assistance; annual conventions

O **AMERICANS FOR THE ARTS,** One E 53rd St, New York, NY 10022-4210. Tel 212-223-2787, 800-321-4510 (Book orders only); Fax 212-223-4857; Elec Mail rlynch@aartusa.org; Internet Home Page Address: www.artusa.org/; *Pres & CEO* Robert Lynch
Open by appointment; No admis fee; Estab 1960; Mem: 2500; dues organizations $150-$250, individual $30-$100
Income: Financed by mem
Publications: ACA Update, monthly newsletter of legislative & advocacy information available to members; books on arts policy, management, education & information for artists
L **Library,** One E 53rd St, New York, NY 10022-4210. Tel 212-223-2787, Ext 224; Fax 212-223-4857; Elec Mail bdavidson@artsusa.org; Internet Home Page Address: www.artsusa.org; WATS 800-232-2789 (Visual Artists Information Hotline, 2 - 5 PM); *Dir* Ben Davidson
Research collections available on an appointment only basis for a fee; information/referral service by phone, FAX & mail; No admis fee; Estab 1994; For reference only
Library Holdings: Book Volumes 7000; Other Holdings Vertical files; Periodical Subscriptions 300
Special Subjects: Art Education

O **ARCHAEOLOGICAL INSTITUTE OF AMERICA,** 656 Beacon St, 4th Flr Boston, MA 02215-2006. Tel 617-353-9361; Fax 617-353-6550; Elec Mail aia@aia.bu.edu; Internet Home Page Address: www.archaeological.org; *Exec Dir* Bonnie Clendeming
9am - 5pm; Estab 1879 as an international organization concerned with two major areas of responsibility: facilitating archaeological research & disseminating the results to the pub; Mem: 11,000 consisting of professionals & laypersons interested in archaeology; $95 for annual meeting in Dec
Income: Financed by endowment, mem & earned income from publications
Publications: Archaeology Magazine, bimonthly; Archaeological Fieldwork Opportunities Bulletin, annual; American Journal of Archaeology, quarterly; AIA Monograph Series; Colloquia Conference Paper Series
Activities: Lect open to public, 200 visiting lectures per year; tours & awards given; one or more fellowships awarded for an academic year

O **ART DEALERS ASSOCIATION OF AMERICA, INC,** 575 Madison Ave, New York, NY 10022. Tel 212-940-8590; Fax 212-940-6484; Elec Mail adaa@artdealers.org; Internet Home Page Address: www.artdealers.org; *Pres* Roland Augustine; *VPres* Carolyn Alexander; *VPres* Marian Goodman; *Admin VPres & Counsel* Gilbert S Edelson; *Dir Admin* Donna Carlson; *VPres* Ronald Feldman; *Exec Dir* Linda Blumberg
Estab 1962 as a national organization to improve the stature & status of the art-dealing profession; Mem: 165; mem by invitation
Income: Financed by mem & services
Exhibitions: The Art Show, annual fair ADAA members
Publications: Activities & Membership Roster
Activities: Appraisal service for donors contributing works of art to nonprofit institutions; estate tax appraisals; collectors forums

O **ART DIRECTORS CLUB,** 106 W 29th St, New York, NY 10001. Tel 212-643-1440; Fax 212-643-4266; Elec Mail info@adcglobal.org; Internet Home Page Address: www.adcny.org; *Exec Dir* Myrna Davis; *Assoc Dir* Olga Grisaitis; *Awards Prog Assoc* Kim Hanzich; *Asst Exec Dir* Danielle Epstein; *Mem Coordr* Ann Shirripa; *Ann Awards Mgr* Chris Reitz; *Educ Coordr* Kate Farina; *Facilities Assoc* Jennifer Griffiths; *Admin Asst* Ruthie Chung; *Interactive Mgr* Jenny Synan; *Awards Prog Assoc* Glenn Kubota
Open Mon - Fri 10 AM - 6 PM; No admis fee; Estab 1920 mission is to recognize excellence in visual communications, encourage young people coming into field. Mandate is to provide forum for creative leaders in advertising, design & interactive media in which to explore and anticipate the direction of those evolving & rapidly intersecting industries & to present innovative, inspiring work; Owns gallery; Average Annual Attendance: 20,000; Mem: 1100 mem; criteria for mem: qualifies art dir, at least 21 yrs age, of good character, at least two yrs practical experience in creating & directing in the visual communication of graphic arts industry, dues indiv $225, nonres $175, young professional $100, student $75; ann meeting in Sept
Income: Financed by mem
Library Holdings: Book Volumes; Exhibition Catalogs
Exhibitions: Art Directors' Annual Exhibition of National & International Advertising, Editorial & Television Art & Design & New Media. Bimonthly shows conceived to provide a showcase for works & ideas not readily viewed otherwise. They cover advertising & editiorial design & art education
Publications: The Art Directors Annual; bimonthly newsletter, Young Guns

Activities: Job fair; portfolio Review Programs; speaker events; seminars; lect open to public, 10-20 vis lectrs per year; competitions with awards; hall of fame, young guns (bi-ann); scholarships offered; originate traveling exhibitions; gallery sells books

O **ART SERVICES INTERNATIONAL,** 700 N Fairfax St, Ste 220, Alexandria, VA 22314; 1319 Powhaten St, Alexandria, VA 22314. Tel 703-548-4554; Fax 703-548-3305; Elec Mail asi@artservicesintl.org; Internet Home Page Address: www.artservicesintl.org; *Chief Exec Officer* Joseph Saunders; *Dir* Lynn K Rogerson
Nonprofit, educational institution which organizes & circulates fine arts exhibitions to museums & galleries in the US & abroad
Publications: Catalogs

O **ARTISTS' FELLOWSHIP, INC,** 47 Fifth Ave, New York, NY 10003. Tel 212-255-7740; Fax 212-229-0172; *Treas* Pamela Singleton; *Correspondence Secy* Robert J Riedinger; *Historian* Carl Thomson; *Pres* Marc Richard Mellon
Estab 1859, reorganized 1889 as Artists' Aid Society, then incorporated 1925 as Artists' Fellowship; to aid professional fine artists & their families in emergency situations including illness, disability & bereavement; Mem: 400; annual meeting in Dec
Income: From mems
Publications: Quarterly newsletter
Activities: Awards the Gari Melchers Gold Medal for distinguished service to the arts, and Benjamin West Clinedinst Memorial Medal for outstanding achievement in the arts

O **ARTS EXTENSION SERVICE,** c/o Div Continuing Educ, Univ of Mass, 358 N Pleasant St Amherst, MA 01003. Tel 413-545-2360; Fax 413-577-3838; Elec Mail aes@contined.umass.edu; Internet Home Page Address: www.umass.edu/aes; *Program Asst.* Alyson Ekblom
Open Mon - Fri 8:30 AM - 4 PM; No admis fee; Estab 1973 as a National arts service organization facilitating the continuing education of artists, arts organizations & community leaders. AES works for better access to the arts & integration of the arts in communities. AES is a nonprofit program of the Division of Continuing Education, University of Massachusetts at Amherst
Publications: Artist in Business, 1996; Arts Management Bibliography & Publishers; Community Cultural Planning Work Kit; Education Collaborations; Fundamentals of Arts Management; Intersections, Community Arts & Education Collaborations
Activities: Professional level arts management workshops; consulting; retreats & conferences,; exten dept serves civic sectors, community arts organizations, classes for adults

O **ASSOCIATION OF AMERICAN EDITORIAL CARTOONISTS,** 1221 Stoneferry Ln, Raleigh, NC 27606. Tel 919-859-5516; Fax 919-859-3172; Elec Mail wnicholson@nc.rr.com; Internet Home Page Address: http://pc99.detnews.com/99ec; *Gen Mgr* Shannon Parham
Estab 1957 as an international organization of professional editorial cartoonists for newspapers & newspaper syndicates; Mem: 300; to qualify for mem, editorial cartoonists must be primarily employed as a cartoonist & a resident of US, Canada or Mexico; dues $100
Income: Financed by mem
Publications: Best Editorial Cartoons of the Year; Notebook

O **ASSOCIATION OF ART MUSEUM DIRECTORS,** 41 E 65th St, New York, NY 10021. Tel 212-249-4423; Fax 212-535-5034; Elec Mail aamd@amn.org; Internet Home Page Address: www.aamd.net; *Exec Dir* Millicent Hall Gaudieri
Estab 1916; Mem: 170; chief staff officers of major art museums
Income: Financed by mem dues
Publications: Annual Salary Survey; Model Museum Directors Employment Contract; Professional Practices in Art Museums

O **ASSOCIATION OF COLLEGIATE SCHOOLS OF ARCHITECTURE,** 1735 New York Ave NW, Washington, DC 20006. Tel 202-785-2324; Fax 202-628-0448; Internet Home Page Address: www.acsa-arch.org; *Interim Exec Dir* Stephanie Vierra
Open Mon - Fri 8:30 AM - 5:30 PM; No admis fee; Estab 1912 as a non-profit, mem organization furthering the advancement of architectural educ; Mem: 3500 architecture faculty members; mem open to schools & their faculty as well as individuals; mem rates vary; annual meeting in Mar
Income: $1.4 million (financed by endowment, mem, state appropriation & grants)
Publications: ACSA News, 9 times per year; Journal of Architectural Education, quarterly; Annual Meeting Proceedings; Guide to Architecture Schools in North America, biannually
Activities: Educational seminars; institutes; publications; services to membership; sponsor student design competitions with awards

O **ASSOCIATION OF INDEPENDENT COLLEGES OF ART & DESIGN,** 3957 22nd St, San Francisco, CA 94114-3205. Tel 415-642-8595; Fax 415-642-8590; Elec Mail bbaicad@best.com; Internet Home Page Address: www.aicad.org; *Exec Dir* William O Barrett
Open by appointment only; Estab 1991 to improve quality of member colleges & provide information on art educ; Mem: 35; must be independent art college, fully accredited & grant BFA; dues $5500-$8000 depending on size; annual meeting in Oct
Income: $500,000 (financed by mem & occasional grants)
Publications: Internal newsletter

O **ASSOCIATION OF MEDICAL ILLUSTRATORS,** 810 E 10th St, PO Box 1897 Lawrence, KS 66044. Tel 617-395-8186; Elec Mail assnhq@mindspring.com; Internet Home Page Address: www.medical-illustrators.org; *Exec Dir* Janet McCandless; *Pres* Marcia Hartsock; *Dir Meetings & Prog* Carole Teja; *Dir Publs* Linda Johnson; *Dir Financial Servs* Diana Xander
Estab 1945 as an international organization to encourage the advancement of medical illustration & allied fields of visual educ; to promote understanding &

cooperation with the medical & related professions; Mem: 804; dues active $230; student $85; annual meeting in Jul or Aug
Income: Financed by mem
Exhibitions: Annual exhibition at national meeting
Publications: Journal of Biocommunications, 4 times per year; Medical Illustration, brochure; Newsletter, 6 times per year
Activities: Individual members throughout the world give lect on the profession; awards given for artistic achievements submitted to salon each year; originate traveling exhibitions

O **ATLATL,** 49 E Thomas Rd, St 105, Phoenix, AZ 85012. Tel 602-277-3711; Fax 602-277-3690; Elec Mail atlatl@atlatl.org; Internet Home Page Address: www.atlatl.org; *Exec Dir* M Hanley; *Creative Serv Dir* Michael Tsosie
Open Mon - Fri 9 AM - 5 PM; No admis fee; Estab 1981 as a national service organization for Native American Art. Atlatl creates an informational network between Native American artists & art organizations as well as between mainstream institutions & emerging organizations. Maintains a National Registry of Native American Artists which currently includes more than 2500 artists; Mem: 300; dues vary; mem open open to all
Income: financed by federal grants
Collections: Native American Artists files
Exhibitions: Annual Beyond Beads & Performing Arts Series; Hiapsi Wami Seewam: Flowers of Life; Native Women of Hope
Publications: Quarterly newsletter
Activities: Lect open to public, 5 or more vis lectr per year; concerts; competitions; artmobile; circulates audiovisual materials such as slides sets & videotapes by Native American artists; book traveling exhibitions 2-5 per year; originate exhibitions of Native American art to a variety of institutions including tribal museums, community & university galleries & fine art museums

C **AUTOZONE,** Autozone Corporation Collection, 123 S Front St, PO Box 2198 Memphis, TN 38103. Tel 901-495-6763; Fax 901-495-8300; *Cur* Lynda Ireland
Estab 1978 to support local artists & artists of the United States; 20th century collection of American art in a variety of media highlighting the work of artists in the South

O **COLLEGE ART ASSOCIATION,** 275 Seventh Ave, New York, NY 10001. Tel 212-691-1051; Fax 212-627-2381; Elec Mail nyoffice@collegeart.org; Internet Home Page Address: www.collegeart.org; *Pres* Ellen Baird; *Exec Dir* Susan L Ball; *MFO* Denise Mitchell
Open Mon - Fri 9 AM - 5 PM; Estab 1911 as a national organization to further scholarship & excellence in the teaching & practice of art & art history; Mem: 16,000, open to all individuals & institutions interested in the purposes of the Assoc; dues life $5000, institution $150, individual $45-$90 (scaled to salary), student $25; annual meeting in Feb
Income: Financed by mem
Publications: The Art Bulletin, quarterly; Art Journal, quarterly; CAA Newsletter, bimonthly; Careers, bimonthly
Activities: Awards: Distinguished Teaching of Art History Award; Distinguished Teaching of Art Award; Charles Rufus Morey Book Award; Frank Jewett Mather Award for Distinction in Art & Architectural Criticism; Arthur Kingsley Porter Prize for Best Article by Younger Scholar in The Art Bulletin; Alfred H Barr, Jr Award for Museum Scholarship; Distinguished Artist Award for Lifetime Achievement; Award for a Distinguished Body of Work, Exhibition, Presentation or Performance; scholarships offered

O **COLOR ASSOCIATION OF THE US,** 315 W 39th St, Studio 509 New York, NY 10018. Tel 212-947-7774; Fax 212-594-6987; Elec Mail caus@colorassociation.com; Internet Home Page Address: www.colorassociation.com; *Pres* Bill Bonnell; *Exec Dir* Marielle Bancou; *Dir Membership* Karyn Valino; *Dir* Margaret Walch
Open Mon - Fri 9 AM - 5 PM; Estab 1915 for the purpose of forecasting fashion colors & standards in the United States; Mem: 1000; dues $900
Income: Financed by mem
Collections: Colored Swatch Archives date back to 1915
Publications: CAUS Newsletter, 8 times per year; The Color Compendium; Living Colors; The Standard Color Reference of America
Activities: Workshops; lect, 12 vis lectrs per year

O **THE DRAWING SOCIETY,** Tel 212-479-6230; *Chmn of Board* Henry Welt
Estab 1959 to encourage interest in, & understanding of, drawing of all periods & cultures; Mem: 1000; dues $150 & up for patrons, institutional $75, Associate $60
Exhibitions: Theodore Roszak: The Drawings
Publications: Drawing, bi-monthly; Books & catalogues
Activities: Lect open to public, 1-2 vis lectr per year; gallery talks; tours; originate traveling exhibitions to museums in United States

M **EMIL MEMON GALLERY,** 121 Chanlon Road, New Providence, NJ 07974. Tel 908-790-0632; *Cur* Beverley Manley
Open Sept - May, Mon - Fri 10 AM - 8 PM, Sat 10 AM - 4 PM; Gallery used only for art students; Average Annual Attendance: 9,000 - 10,000; Mem: Annual meeting May
Collections: Mixed media collections by Emil Memon

O **FEDERATION OF MODERN PAINTERS & SCULPTORS,** 234 W 21st St, New York, NY 10011. Tel 212-568-2981, 255-4858; *Pres* Ahmet Gursoy; *Treas* John Servetas; *Pres* Haim Mendelson; *Secy* Florence C Martin
Estab 1940 as a national organization to promote the cultural interests of free progressive artists working in the United States; Mem: 60; selected by mem comt; dues $30; meeting every 2 months
Income: Financed by mem
Exhibitions: Exhibition at Art Students League; A Decade for Renewal, at Lever House, New York.
Publications: Exhibit catalog
Activities: Lect open to public, 1-2 vis lectr per year; symposium; originate traveling exhibitions

O **GENERAL SERVICES ADMINISTRATION,** Art-in-Architecture (PMB), 1800 F St NW Rm 3341 Washington, DC 20405; Art-in-Architecture Program Office Chief Architect, 1800 F St NW Rm 3341 PNH Washington, DC 20405. Tel 202-501-1812; Fax 202-501-2742; *Program Mgr* Susan Harrison; Jennifer Gibson; William Caine
Open to public by appointment: 9AM to 5 PM; No Admission Fees; GSA's Art in Architecture Program commissions artists, working in close consultation with project design teams, to create artwork that is appropriate to the diverse uses and architectural vocabularies of new federal buildings. These permanent installations of contemporary art within the nation's civic buildings afford unique opportunities for exploring the integration of art and architecture, and facilitate a meaningful cultural dialogue between the American people and their government. A panel that includes the project architect, art professionals, the federal client, and representatives of the community advises GSA in selecting the most suitable artist for each Art in Architecture commission, Artwork is funded by 0.5% of each building's construction budget.
Library Holdings: Book Volumes; CD-ROMs; Clipping Files; Slides
Collections: National Collection of Public Art

O **GUILD OF BOOK WORKERS,** 521 Fifth Ave, New York, NY 10175. Tel 212-873-4315; 845-657-3348; Elec Mail bcallery@flounder.com; *Pres* Betsy Palmer Eldridge
Open Mon - Fri 8:30 AM - 5:30 PM; No admis fee; Estab 1906 as a national organization to establish & maintain a feeling of kinship & mutual interest among workers in the several hand book crafts; Mem: 620; mem open to all interested persons; dues national; $40, chapter (New York City Area Guild, New England Guild, Midwest Guild, Lone Star, Delaware Valley, Potomac, Rocky Mountain & California) $10 additional; annual meeting in Oct
Income: Financed by mem
Exhibitions: 80th Anniversary Exhibition consisting of fine bindings, artists' books, restorations, calligraphy & decorated papers
Publications: Guild of Book Workers Journal, 2 times per year; membership list, annually; newsletter, 6 times per yr; supply list, biennially; Opportunities for Study in Hand Bookbinding & Calligraphy, directory & supplement
Activities: Lect open to members only; tours; workshops; annual seminar on Standards of Excellence in Hand Bookbinding open to public; book traveling exhibitions; originate traveling exhibitions
L **Library,** Univ of Iowa, Conservation Dept Iowa City, IA 52242. Tel 319-335-5908; Fax 319-335-5900; Elec Mail anna-embree@uiowa.edu; Internet Home Page Address: palimpsest.stanford.edu/byorg/gbw/library.shtml; *Guild Librn* Anna Embree
Open by appointment; Open to Guild members for lending & reference
Income: Financed by mem
Library Holdings: Book Volumes 700

O **HERITAGE PRESERVATION,** 1730 K St NW, Ste 566, Washington, DC 20006. Tel 202-634-1422; Fax 202-634-1435; Elec Mail lreger@heritagepreservation.org; Internet Home Page Address: www.heritagepreservation.org; *CEO & Pres* Lawrence L Reger; *Dir National Task Force* Jane Long; *Treas* Victoria Steele; *Dir Coll Care* Clare Hansen; *VChmn* Dennis Fiori; *Dir SOS!* Susan Nichols; *VPres External* Moira Egan
Estab 1974 as a national forum for conservation & preservation activities in the United States
Income: Financed by private grants, member dues
Publications: Update newsletter

O **INDUSTRIAL DESIGNERS SOCIETY OF AMERICA,** 45195 Business Ct, Ste 250 Sterling, VA 20166. Tel 703-707-6000; Fax 703-787-8501; Elec Mail idsa@idsa.org; Internet Home Page Address: www.idsa.org; *Exec Dir, COO* Kristina Goodrich; *Dir Educ & Progs* Celia Weinstein; *Senior Dir Finance & Office* Larry Allen; *Dir Marketing & Communications* Gigi Thompson
Open daily 9 AM - 5 PM; No admis fee; Estab & inc 1965 as a nonprofit national organization representing the profession of industrial design; Mem: 3300; dues full, affiliate & international $285, assoc $140
Publications: Innovation, quarterly; IDSA Newsletter, monthly; Membership Directory; other surveys & studies
Activities: IDSA Student Chapters; IDSA Student Merit Awards; lect; competitions; scholarships offered

O **INTER-SOCIETY COLOR COUNCIL,** Data Color Intl, 5 Princess Rd Lawrenceville, NJ 08648. Tel 703-318-0263; Fax 703-318-0514; Elec Mail iscc@compuserve.com; Internet Home Page Address: www.iscc.org; *Secy* Rich Riffel; *Pres* Jack Ladson; *Treas* Hugh Fairman
Estab 1931 as a national organization to stimulate & coordinate the study of color in science, art & industry; federation of 29 national societies & individuals interested in colors; Mem: 900; members must show an interest in color & in the aims & purposes of the Council; dues individual $25; annual meeting usually Apr
Income: Financed by mem
Publications: Inter-Society Color Council Newsletter, bimonthly
Activities: Lect open to public; lect at meetings; gives Macbeth Award and Godlove Award

O **INTERMUSEUM CONSERVATION ASSOCIATION,** Allen Art Bldg, Oberlin, OH 44074. Tel 440-775-7331; Fax 440-774-3431; Internet Home Page Address: www.oberlin.edu/~ica; *VPres* Ted Alfred; *Treas & Dir* Bill Busta; *Pres* Bill Lipscomb; *Admin Asst* Sandra Williamson
Estab 1952 as a nonprofit conservation laboratory to aid in the maintenance of the collections of its member museums; Maintains a technical conservation library; Mem: 28; must be non profit cultural institution; dues $100-$1000; meetings biannually
Income: Financed by membership, private & public grants
Activities: Lect open to public; 3-6 vis lectrs per year; seminars twice a year; scholarships for advanced training of conservators

O **INTERNATIONAL FOUNDATION FOR ART RESEARCH, INC,** 500 Fifth Ave, Ste 935, New York, NY 10110. Tel 212-391-6234; Fax 212-391-8794; Internet Home Page Address: www.ifar.org; *Exec Dir, Editor in Chief* Dr Sharon Flescher; *Asst to Dir* Kathleen Ferguson; *Spec Research Assoc* Dr Gertrude Wilmers
Open Mon - Fri 9:30 AM - 5:30 PM; Estab 1968 as a nonprofit educational and research organization dedicated to issues relating to art authenticity & ownership, art ethics, law, & connoisseurship. IFAR operates at the intersection of the scholarly, legal & commercial art worlds. Created to adjudicate questions concerning attribution & authenticity of major works of art; expanded in 1975 to include issues of art theft and art law. IFAR organizes pub prog & pub a quarterly journal.; Mem: Mem/supporter $250 and above, journal subscription $65
Income: Financed by donations, mem & fees
Publications: IFAR Journal, quarterly; Reference Material
Activities: Lect open to pub & symposia are conducted throughout the year on subjects relating to connoisseurship, authenticity, provenance research, art law & art theft & fraud; tours
—**Authentication Service,** 500 Fifth Ave, Ste 1234, New York, NY 10110. Tel 212-391-6234; Fax 212-391-8794; *Dir* Dr Sharon Flescher
Through this service, the resources of leading institutional experts, both scholarly & scientific, are made available to the pub in order to answer questions relating to authenticity & proper attribution of works of art

O **INTERNATIONAL SOCIETY OF COPIER ARTISTS (ISCA),** 759 President St, No 2H, Brooklyn, NY 11215. Tel 718-638-3264; Elec Mail isca4art2b@aol.com; Internet Home Page Address: www.members.aol.com/isea4artab/ISCA./homepage/html; *Dir* Louise Neaderland
Open by appt; No admis fee; Estab 1981 to promote use of copier as a creative tool; Circ 125 (ltd edition); Mem: 150; dues international subscriber $110, domestic $90 and $30, $40 annual dues; mem open to artists using the copier for printmaking & bookmaking; contributing artist membership outside US $40, domestic $30 (slides or samples of work)
Income: $10,000 (financed by mem & subscriptions to Quarterly)
Collections: Slide Archive of Xerographic Prints & Books
Exhibitions: ISCA GRAPHICS; Using the Copier as a Creative Tool; The Artists Book
Publications: Quarterly of Xerographic Prints & Artists Books
Activities: Gallery talks; tours; 1 book traveling exhibition per yr; originate traveling exhibitions to universities, art schools & libraries

O **KAPPA PI INTERNATIONAL HONORARY ART FRATERNITY,** 400 S Bolivar Ave, Cleveland, MS 38732-3745. Tel 662-846-6271; Elec Mail koehler@tecinfo.com; *Pres* Ron Koehler; *VPres* Dr Sam Bishop; *Treas* Tom Nawrocki; *Secy* Catherin Koehler
Estab 1911 as an international art fraternity for men & women in colleges, universities & art schools; Mem: 185 chapters; GPA minimum standards completion of 12 semester hours of art
Income: Financed by mem
Publications: Sketch Pad Newsletter, annually in the fall; Sketch Book, annual spring magazine
Activities: Sponsors competition in art; annual scholarships available to active members

O **LANNAN FOUNDATION,** 313 Read St, Santa Fe, NM 81501-2628. Tel 505-986-8160; Fax 505-986-8195; Internet Home Page Address: www.lannan.org; *Art Projects Mgr* Christie Davis; *Admin & Program Asst* Barbara Ventrello
Open by appointment; Estab 1960 for the support of work by contemporary artists; Installations of new & old work from Lannan Collection
Library Holdings: Book Volumes; Exhibition Catalogs; Video Tapes
Special Subjects: Photography, Sculpture, Painting-American, Painting-European
Collections: Small collection of modern & contemporary art
Activities: Lect open to public; 15 vis lectrs per yr; grants offered; individual paintings & original objects of art lent

O **MID AMERICA ARTS ALLIANCE & EXHIBITS USA,** 912 Baltimore Ave, Ste 700, Kansas City, MO 64105. Tel 816-421-1388 exten 212; Fax 816-421-3918; *Chmn* Wallace Richardson; *Dir* Mary Kennedy McCabe
A national division of Mid America Arts Alliance created to organize & tour exhibits throughout the Unites Sates & beyond
Income: $1,000,000 (financed by federal & state grants, private contributions & exhibition fees)
Exhibitions: American Indian Realism (photographs); Artists of the American West (handcolored prints); Buildings & Landscapes (prints, watercolors, photographs); Built, Thrown, & Touched: Contemporary Clay Works (ceramics); By a Clearer Light: Commemorating the 75th Anniversary of the National Park Service (photographs); Crossing Borders: Contemporary Australian Textile Art (mixed media); Enlightening the Classics: 18th-Century Etchings of Ancient Roman Architecture (etchings); First Quilt/Last Quilt: Ten Contemporary Quiltmakers (textiles); From Plastic Form to Printer's Plate: 16 Contemporary Sculptor/Printmakers (mixed media & installations); From the Hip: A Celebration of Youth Activism & Service (photographs); Gathering Medicine: Works by Coast to Coast, National Women Artists of Color (mixed media); Generations of Kentucky: An Exhibition of Folk Art with Photographs by Guy Mendes (mixed media); The Good Earth: Folk Art & Artifacts from the Chinese Countryside (paintings & artifacts); Hand, Mind, & Spirit: An Art Experience of the Senses (mixed media); Hmong Artistry: Preserving a Culture on Cloth (textiles); In Praise of Pattern: The Art of Alfredo Arreguin (paintings); In the Realm of the Senses: The Works of Mel Chin (mixed media & installations); Luis Jimenez (sculpture, maquettes, working drawings); Elizabeth Layton: Drawing on Life (drawings); Alfred Leslie: The Complete Prints (prints); Living Traditions: Mexican Popular Arts (mixed media & installations); Masks from Guerrero (masks & costumes); Mennonite Furniture: A Migrant Tradition (1766-1910) (furniture & decorative arts); Mojo: Photographs by Keith Carter (photographs); Moving the Fire: The Removal of Indian Nations to Oklahoma (photographs); The National Council on Education for the Ceramic Arts: 1995 Clay National (ceramics); Nature Watercolors USA: Works by Mario Reis (paintings & photographs); Navajo Weaving from the Harmsen Collection (textiles); Objects of Personal Significance (mixed media); On the Land: Three Centuries of American Farmlife (photographs); Picasso Posters: A Study in Design (linocuts, offset reproductions); Rags to Riches: Recycled Rugs (rugs); Betye Saar: Personal Icons (mixed media & installations); Sacred Ground/Sacred Sky: An Eco-Experience by Daniel Dancer (photographs & eco-sculpture); Saddlemaking in Wyoming: History, Utility, & Art (historic & contemporary saddles); Shared Stories: Exploring Cultural Diversity

(illustrations); Street Engagements: Social Landscape Photography of the 1960's (photographs); Tales from the Nuclear Age (photographs); Telling Tales: Children's Book Illustrations from the 1950s (illustrations); Through the Looking Glass: Drawings by Elizabeth Layton (drawings); A True Likeness: The Black South of Richard Samuel Roberts, 1920-1936 (photographs); Vision Quest: Men, Women, & Sacred Sites of the Sioux Nation (photographs); The Works of Louis Monza (paintings, drawings, prints); Benedicte Wrensted: An Idaho Photographer in Focus (photographs); Please Touch (mixed media); Howardena Pindell: A Retrospective (mixed media); Ribs, Rods and Splits: Appalachian Oak Basketry (basketry); Sacred Ground/Sacred Sky (mixed media); Textile Diaries: Quilts as Cultural Markers (quilts); Through the looking Glass; Tutavoh: Learning the Hopi Way (photography); Waterways West (photography); Welty (photography); Woven Vessels (mixed media)
Publications: Exhibition catalogs
Activities: Book traveling exhibitions; originate traveling exhibitions

O **MIDWEST ART HISTORY SOCIETY,** School of Art, Kent State Univ, Kent, OH 44242. Elec Mail jmann@slam.org; Internet Home Page Address: www.mahsonline.org; *Pres* Fred T Smith; *Treas* Randy Coleman; *Secy* Jane Campbell Hutchison
Estab 1973 to further art history in the Midwest as a discipline & a profession; Average Annual Attendance: 150 at meetings; Mem: 600; mem is open to institutions, students & academic & mus art historians in the Midwest; dues institution $75, professional $30, student $20; annual meeting in Mar or early Apr
Income: $3,500 (financed by mem)
Publications: Midwest Art History Society Newsletter, Oct & Apr
Activities: Lect provided; small travel grants for grad student travel to ann conference; award for best conference paper by a grad student

O **THE NAMES PROJECT FOUNDATION AIDS MEMORIAL QUILT,** (Names Project Foundation) 101 Krog St, Atlanta, GA 30307. Tel 415-882-5500; 404-688-5500; Fax 404-688-5552; Elec Mail info@aidsquilt.org; Internet Home Page Address: www.aidsquilt.org; *Exec Dir* Julie Rhoad; *Dir Quilt Operations* Brian Holman; *Dep Dir Prog* Jada Harris; *Dir Develop* Mark Hughes; Ricki Fairley-Brown
Estab June 1987; Average Annual Attendance: 13,800,000
Collections: AIDS Memorial Quilt, over 40,000 individual memorial panels commemorating people lost to AIDS
Publications: On Display, newsletter
Activities: Sales shop sells prints, buttons, magnets, clothing, cards

O **NATIONAL ACADEMY MUSEUM & SCHOOL OF FINE ARTS,** 1083 Fifth Ave, New York, NY 10128. Tel 212-369-4880; Fax 212-360-6795; Internet Home Page Address: www.nationalacademy.org; *Dir* Annette Blaugrund PhD; *Assoc Cur Nineteenth Century Art* Mark D Mitchell; *Asst Cur Contemporary Art* Marshall Price; *Dir Develop* Jean Telljohann; *Dir Finance* Nancy Cafferty; *Dir Operations* Charles Biada; *Dir Communications* Christine Williams; *Cur Education* Kristine Widmer; *Dir Schol Artist Mem* Nancy Little; *Dir Artist Mem* Anna Martin; *Chief Conservator* Lucie Kinsolving; *Dir Special Events* Eric Blomquist
Open Wed & Thurs Noon - 5 PM, Fri-Sun 11AM - 6PM, cl Mon, New Year's, Thanksgiving & Christmas; Admis adult $10, seniors & students $5; Estab 1825, honorary arts organization for American artists & architects; Mem: 500
Income: Financed by mem, endowment & grants
Collections: Permanent collection consists of 5000 watercolors, drawings & graphics, 2000 paintings, 250 sculptures, mostly the gifts of the artist & architectural members of the Academy from 1825 to present; American art from mid-nineteenth century to the present
Exhibitions: Annual juried exhibition of contemporary art; exhibitions of permanent collection & loan exhibitions
Publications: Annual exhibition catalogue; catalogues of exhibitions of permanent collection; catalogues of special loan exhibitions
Activities: Classes for adults & children; docent training; lect open to public vis lect per year 12-15; gallery talks; tours by appointment; Awards-Henry Legrand Cannon Prize, Andrew Carnegie Prize, Alex Ettl Award for Sculpture, Malvina Hoffman Artists Fund Prize, Leo Meissner Prize, Edwin Palmer Memorial Prize, William A Paton Prize, Henry Ward Ranger purchase Award; individual paintings & original objects of art lent to other museums; mus shop sells books, posters, catalogues & postcards

L **Archives,** 1083 Fifth Ave & 89th St, New York, NY 10128. Tel 212-369-4880; Fax 212-360-6795; Internet Home Page Address: www.nationalacademy.org; *Dir* Annette Blaugrund, PhD; *Assoc Cur Nineteenth Century Art* Mark D Mitchell; *Asst Cur Contemporary Art* Marshall Price; *Dir Develop* Jean Telljohann; *Dir Finance & Human Resources* Nancy Cafferty; *Dir Operations* Charles Biada; *Dir Communications* Christine Williams; *Cur Educ* Kristine Widmer; *School Dir* Nancy Little; *Dir Artist Mem* Nancy Malloy; *Registrar* Anna Martin; *Chief Conservator* Lucie Kinsolving; *Dir Special Events* Eric Blomquist
Wed & Thurs Noon - 5 PM, Fri - Sun 11 AM - 6 PM; Gen admis fee $10, student & sr $5; Estab 1825 to promote American art through exhib and educ; For reference; Average Annual Attendance: 35,000; Mem: mem artists are invited and elected by current artist mem
Library Holdings: Clipping Files; Exhibition Catalogs; Manuscripts; Memorabilia; Original Art Works; Other Holdings Biographical Member Files; National Academy of Design Records; Pamphlets; Photographs; Prints; Sculpture
Collections: Diploma works of artists elected to membership
Exhibitions: (7/5/2006-12/31/2006) Italia! Muse to American Artists, 1830-2005; (9/14/2006-12/31/2006) Luminist Horizons: The Art & Collection of James A Suydam; (2/15/2007-4/23/2007) High Times Hard Times; (5/16/2007-6/24/2007) 182nd Annual Exhibition; (7/5/2007-12/30/2007) Asher B Durand, PNA
Activities: Classes for adults & children; docent training; lectr open to public, 10 per yr; gallery talks; tours; awards, Henry Legrand Cannon Prize, Andrew Carnegie Prize, Alex Ettl Award for Sculpture, Malvina Hoffman Artists Fund Prize, Leo Meissner Prize, Edwin Palmer Memorial Prize, William A Paton Prize Henry Ward Ranger Purchase Award; schol & fels offered; organizes traveling exhib to various US mus; museum shop sells books and original art

O **NATIONAL ALLIANCE FOR MEDIA ARTS & CULTURE,** 145 Ninth St, Ste 250 San Francisco, CA 94103. Tel 415-431-1391; Fax 415-431-1392; Elec Mail namac@namac.org; Internet Home Page Address: www.namac.org; *National Coordr* Helen DeMichiel; *Program Assoc* Daniel Schott; *Co-Dir* Jack Walsh
Estab for the purpose of furthering diversity & participation in all forms of the media arts, including film, video, audio & multimedia production; Mem: 350; dues $60 - $450; support media arts field
Income: $200,000 (financed by grants & mem dues)
Publications: Field Guide; Main newsletter, bimonthly; NAMAC Member Directory, online; The National Media Educaton Directory; Digital Directions: Convergence Planning for the Media Arts; A Closer Look: Media Arts 2000; BULLETin, biweekly electronic newsletter
Activities: Online salons; 2 vis lectrs per yr; lectr for mems only; William Kirby Award in Media Arts

O **NATIONAL ANTIQUE & ART DEALERS ASSOCIATION OF AMERICA, INC,** 220 E 57th St, New York, NY 10022. Tel 212-826-9707; Fax 212-832-9493; Elec Mail inquiries@naadaa.org; Internet Home Page Address: www.naadaa.org; *VPres* Titi Halle; *Secy* Arlie Sulka; *Pres* Andrew Chait; *Treas* Mark Schaffer; *VPres* Leon Dalva
Estab 1954 to promote the best interests of the antique & art trade; to collect & circulate reports, statistics & other information pertaining to art; to sponsor & organize antique & art exhibitions; to promote just, honorable & ethical trade practices
Income: financed by member dues
Exhibitions: International Fine Art & Antique Dealers Show
Publications: NAADA Directory, biannual
Activities: Lect

O **NATIONAL ARCHITECTURAL ACCREDITING BOARD, INC,** 1735 New York Ave NW, Washington, DC 20006. Tel 202-783-2007; Fax 202-783-2822; Elec Mail info@naab.org; Internet Home Page Address: www.naab.org; *Exec Dir* Sharon C. Matthews, AIA
8 AM - 5 PM; Estab 1940 to produce & maintain a current list of accredited programs in architecture in the United States & its jurisdictions, with the general objective that a well-integrated program of architectural educ be developed which will be national in scope; Mem: 115
Income: financed by contributions
Publications: Criteria and Procedures, pamphlet; List of Accredited Programs in Architecture, annually

O **NATIONAL ART EDUCATION ASSOCIATION,** 1916 Association Dr, Reston, VA 20191. Tel 703-860-8000; Fax 703-860-2960; Elec Mail thatfield@naea-reston.org; Internet Home Page Address: www.naea-reston.org; *Pres* Susan J Gabbard; *Exec Dir* Dr Thomas A Hatfield
8:15 AM - 4:30 PM ; Estab 1947 through the affiliation of four regional groups, Eastern, Western, Pacific & Southeastern Arts Associations. The NAEA is a national organization devoted to the advancement of the professional interests & competence of teachers of art at all educational levels. Promotes the study of the problems of teaching art; encourages research & experimentation; facilitates the professional & personal cooperation of its members; holds public discussions & programs; publishes desirable articles, reports & surveys; integrates efforts of others with similar purposes; Mem: 29,000 art teachers, administrators, supervisors & students; fee institutional comprehensive $150, active $50
Income: Programs financed through mem, sales of publications & occasional grants for specific purposes
Publications: Art Education, 6 issues per year; NAEA Advisory, 4 issues per year; NAEA News, 6 issues per year; Studies in Art Education, 4 times per year; special publications

O **NATIONAL ASSEMBLY OF STATE ARTS AGENCIES,** 1029 Vermont Ave NW, 2nd Floor, Washington, DC 20005. Tel 202-347-6352, Ext 102; Fax 202-737-0526; Elec Mail nasaa@nasaa-arts.org; Internet Home Page Address: www.nasaa-arts.org; *Exec Dir* Jonathan Katz; *Exec Asst* Pat Hanley; *Managing Dir* Dennis Dewey
Open by appointment only; Estab 1975 to enhance the growth & development of the arts through an informed & skilled mem; to provide forums for the review & development of national arts policy; Mem: 56; members are the fifty-six state & jurisdictional arts agencies, affiliate memberships are open to public; annual meeting in the fall
Income: Financed by mem & federal grants
Publications: Annual survey of state appropriations to arts councils; NASAA Notes, monthly

O **NATIONAL ASSOCIATION OF ARTISTS' ORGANIZATIONS (NAAO),** c/o Space One Eleven, 2409 Second Ave N Birmingham, AL 35203-3009. Elec Mail info@naao.net; Internet Home Page Address: www.naao.net; *Exec Dir* F John Herbert; *Office Coordr* Anne Howard; Diane Barber; *Board Dirs* Rolando Arroyo-Sucre; *Treas Bd Dir* Julia Kirt; *Secy Board Dirs.* Ed Taylor
Estab 1982

O **NATIONAL ASSOCIATION OF SCHOOLS OF ART & DESIGN,** 11250 Roger Bacon Dr, Ste 21, Reston, VA 20190. Tel 703-437-0700; Fax 703-437-6312; Elec Mail info@arts-accredit.org; Internet Home Page Address: www.arts-accredit.org; *Assoc Dir* Karen P Moyhahan
Formerly the National Conference of Schools of Design, holding its first conference in 1944. Changed name in 1948, at which time its constitution & by-laws were adopted. Changed its name again in 1960 from National Association of Schools of Design to National Association of Schools of Art. Name changed again in 1981 to National Association of Schools of Art & Design.; Mem: 260 institutions; to qualify for mem, institutions must meet accreditation standards (peer evaluation process), open to any individual; annual meeting in Oct
Publications: Directory of Member Institutions, annually; Handbook of Accreditation Standards, biennial
Activities: Awards given

O **NATIONAL ASSOCIATION OF WOMEN ARTISTS, INC,** Tel 212-675-1616; Fax 212-675-1616; Elec Mail info@nawanet.org; Internet Home Page Address: www.nawanet.org; *Pres* Marcelle Harwell Pachinowski; *VPres* Jennifer Mahlman; *Treas* Connie Legakis Robinson; *Office Mgr* Anne Chennault
Open 10 AM - 5 PM; No admis fee; Estab 1889 as a national organization to encourage & promote the creative output of women artists; fosters awareness of the contributions of women artists to the ongoing history of American art; Maintains reference library; Mem: 800; member work is juried prior to selection; dues $100; meetings in Nov & May
Income: Financed by mem
Collections: Permanent collection at Jane Vorhees Zimmerli Museum, Rutgers Univ
Exhibitions: Annual members' exhibition in spring with awards; annual traveling exhibitions of oils, acrylics, works on paper, printmaking; annual New York City shows of oils, acrylics, works on paper, printmaking & sculpture
Publications: The Annual Members' Exhibition Catalog; NAWA News; One Hundred Years-A Centennial Celebration of the National Association of Women Artists; A View of One's Own, brochure
Activities: Lect & panels coordinated with exhibition; lect open to public, 1 vis lectr per year; gallery talks; sponsoring of competitions; awards given to members during annual exhibition; organizes book traveling exhib to mus & univ; originate traveling exhibitions to museums, university galleries, art ctrs

O **NATIONAL CARTOONISTS SOCIETY,** 1133 W Morse Blvd Ste 201, Winter Park, FL 32789. Tel 407-647-8839; Fax 407-629-2502; Elec Mail crowsegal@crowsegal.com; *Pres* Steve McGarry
Estab 1946 to advance the ideals & standards of the profession of cartooning; to stimulate interest in the art of cartooning by cooperating with estab schools; to encourage talented students; to assist governmental & charitable institutes; Mem: 480; annual Reuben Awards Dinner in Apr
Collections: Milt Gross Fund; National Cartoonists Society Collection
Publications: The Cartoonist, bimonthly
Activities: Educ dept to supply material & information to students; individual cartoonists to lect, chalktalks can be arranged; cartoon auctions; proceeds from traveling exhibitions & auctions support Milt Gross Fund assisting needy cartoonists, widows & children; gives Reuben Award to Outstanding Cartoonist of the Year, Silver Plaque Awards to best cartoonists in individual categories of cartooning; original cartoons lent to schools, libraries & galleries; originate traveling exhibitions

O **NATIONAL COUNCIL ON EDUCATION FOR THE CERAMIC ARTS (NCECA),** 77 Erie Village Sq, Erie, CO 80516. Tel 866-266-2322; *Exec Secy* Regina Brown; *Admin Asst* Sandy Early
Open Mon - Fri 8 AM - 5 PM; Estab 1967 as a nonprofit organization to promote & improve ceramic art, design, craft & educ through the exchange of information among artists, teachers & individuals in the ceramic art community; Average Annual Attendance: 4,500
Income: Financed by annual conferences & mem
Exhibitions: Annual Conference Exhibitions
Publications: Journal, annual; Information Annual Conference, spring; Newsletter, 4 times a year

O **NATIONAL ENDOWMENT FOR THE ARTS,** 1100 Pennsylvania Ave NW, Washington, DC 20506. Tel 202-682-5400, 682-5414; Fax 202-682-5639; Elec Mail webmgr@arts.endow.gov; Internet Home Page Address: www.arts.endow.gov; *Chmn* William J Ivey; *Deputy Chmn-Grants & Awards* Karen Christensen; *Sr Deputy Chmn* Scott Shanklin-Peterson; *Acting Dir Communications* Katherine Wood
Open 9 AM - 5:30 PM; No admis fee; Estab 1965 to encourage & support American arts & artists. Information is to foster the excellence, diversity & vitality of the arts in the United States & to help broaden their ability & appreciation
Income: Financed by federal appropriation
Publications: Annual Report; Guide to the National Endowment for the Arts
Activities: Educ dept; scholarships & fels offered
L **Library,** 1100 Pennsylvania Ave NW, Washington, DC 20506. Tel 202-682-5485; Fax 202-682-5651; Elec Mail kiserj@arts.endow.gov; *Librn* Joy M Kiser
Open Mon - Thurs 8:30 AM - 5 PM; Estab 1971 to provide an effective information service to staff which will support division activities & contribute to the accomplishment of agency goals
Income: Financed by federal appropriation
Library Holdings: Book Volumes 9000; Clipping Files; Periodical Subscriptions 160

O **NATIONAL FOUNDATION FOR ADVANCEMENT IN THE ARTS,** 444 Brickell Ave, Ste P-14 Miami, FL 33131. Tel 305-377-1140; Fax 305-377-1149; Elec Mail vivian@nfaa.org; Internet Home Page Address: www.artsawards.org; *Pres* William Banchs; *VPres, Prog* Chris Schram; *Prog Mgr* Vivian Orndorff
Estab 1981 to identify & reward young artists at critical stages in their development
Income: Financed by private funding

O **NATIONAL LEAGUE OF AMERICAN PEN WOMEN,** 1300 17th St NW, Washington, DC 20036-1973. Tel 202-785-1997; Fax 202-452-6868; Elec Mail nlapwi1@juno.com; Internet Home Page Address: nlapw.org; *National Pres* Elaine Waidelich; *Art Consultant* Patricia A Stippell; *First VPres* N Taylor Collins; *Second VPres* Jill Chambers; *Third VPres* Jean E Holmes
Estab 1897 to support women in the arts; Maintains member reference library; Mem: 5000; 200 local branches; dues $40
Income: Financed by mem dues & legacies
Collections: Purchase award
Exhibitions: NLAPW Biennial Arts Show at national Biennial Convention
Publications: The Pen Women, bi-monthly magazine (6 times per year)
Activities: Lect open to public; concerts; competitions with awards; scholarships offered

O **NATIONAL OIL & ACRYLIC PAINTERS SOCIETY,** PO Box 676, Osage Beach, MO 65065. Tel 417-533-7550, (573) 348-1189 (Secy-Treas); Fax 573-348-1189; Elec Mail martybill@aol.com; *Pres* Mark Nichols; *Exhibit Chmn* Betty Fitzgerald
Open 10 AM - 5 PM; No admis fee; Estab 1990 to promote the work of

exceptional living artists working in oil & acrylic paint & to expand the pub awareness, knowledge & appreciation of fine art, particularly in these two mediums; Main Hall, Columbia College; Average Annual Attendance: 5,000; Mem: Dues $40
Income: Not-for-profit 401C3
Exhibitions: Annual exhibit
Publications: Annual catalog; semiannual newsletter
Activities: Gallery talks; tours; Best of Show $1500, 4 @ $500, 2 @ $100; originates traveling exhibitions to Missouri galleries

O **NATIONAL SCULPTURE SOCIETY,** 237 Park Ave, Ground Flr New York, NY 10036. Tel 212-764-5645; Fax 212-764-5651; Elec Mail info@nationalsculpture.org; Internet Home Page Address: www.nationalsculpture.org/; *Pres* Elliot Offner; *VPres* Neil Estern; *Exec Dir* Gwen M Pier; *Ed, News Bullitin* Patricia Delahanty; *Ed-in-Chief, Sculpture Review* Giancarlo Biagi
Open Mon - Fri 9 AM - 6 PM; No admis fee; Estab 1893 as a national organization to spread the knowledge of good sculpture; Average Annual Attendance: 40,000; Mem: 35,000; work juried for sculptor mem; vote of Board of Directors for allied professional & patron mem; dues $50-$200; annual meeting in Jan
Income: Financed by endowment, mem & donations
Library Holdings: Book Volumes; Clipping Files; Exhibition Catalogs; Photographs; Slides; Video Tapes
Exhibitions: 3-4 exhibitions annually on a rotating basis; open to all United States citizens and residents
Publications: Sculpture Review Magazine, quarterly
Activities: Educ programs; internships for students of arts admin; lect open to public, 2 vis lectrs per year; gallery talks; tours; competitions with prizes; scholarships & fels offered; sculptures & educational videos lent to tenants in Americas Tower; originate traveling exhibitions 1 per year; sales shop sells books, magazines, original art
L **Archival Library,** 237 Park Ave, ground fl New York, NY 10036. Tel 212-764-5645; Fax 212-764-5651; Elec Mail nssl893@aol.com; Internet Home Page Address: www.nationalsculpture.org/library.asp; *Exec Dir* Gwen P Pier
Open by appointment; No admis fee; Open to the pub for reference; 2500 volumes & periodicals, photographic & original archival materials. For reference only
Income: Financed by endowment, mem & donations
Library Holdings: Clipping Files; Exhibition Catalogs; Fiche; Manuscripts; Memorabilia; Motion Pictures; Original Art Works; Pamphlets; Periodical Subscriptions 50; Photographs; Reproductions; Sculpture; Slides; Video Tapes
Special Subjects: Sculpture

O **NATIONAL SOCIETY OF MURAL PAINTERS, INC,** c/o American Fine Arts Society, 215 W 57th St New York, NY 10019. Tel 212-941-0130; Elec Mail reginas@anny.org; Internet Home Page Address: www.anny.org; *Acting Pres* Robert Harding; *1st VPres* George DeCarlo
Estab and incorporated 1895 to encourage and advance the standards of mural painting in America; to formulate a code for decorative competitions and by-laws to regulate professional practice; Mem: 200; dues $25, non-res $20
Income: Financed by dues & tax deductible contributions
Exhibitions: The Freedom Murals
Publications: Biographies and articles pertinent to the mural painting profession; Press Sheets of photographs and articles of the executed work of the members of society
Activities: Lect available to members only & their guests, 4 vis lectrs per year; individual paintings & original objects of art lent to galleries, museums & special charitable events; lending collection contains original art works & slides; book traveling exhibitions; originate traveling exhibitions; sales shop sells original art, reproductions, prints & slides

O **NATIONAL SOCIETY OF PAINTERS IN CASEIN & ACRYLIC, INC,** 969 Catasauqua Rd, Whitehall, PA 18052. Tel 610-264-7472; Elec Mail doug602ku@aol.com; *VPres* Robert Dunn; *Pres* Douglas Wiltrout
Open in June during exhibition; Estab 1952 as a national organization for a showcase for artists in casein & acrylic; Galleries rented from Salmagundi Club; Average Annual Attendance: 800 during exhibition; Mem: 120; mem by invitation, work must pass three juries; dues $40; annual meeting in May
Income: $3000 (financed by mem)
Exhibitions: Annual Exhibition
Publications: Exhibition Catalog, annually
Activities: Demonstrations; medals & $3500 in prizes given at annual exhibition; originate traveling exhibitions

O **NATIONAL WATERCOLOR SOCIETY,** 915 S Pacific Ave, San Pedro, CA 97031. Tel 310-831-1099; Internet Home Page Address: www.nws-online.org; *Treas* Phyllis Solcyk; *Dir Communications* Loa Sprung; *Pres* Donna Watson; *Webmistress* Lowri Sprung
Open by appointment in Nov; No admis fee; Estab 1921 to sponsor art exhibits for the cultural & educational benefit of the pub; Mem: 2000; dues $35 beginning each yr in Mar (must be juried into mem); annual meeting in Jan; Assoc mem open to all; signature mem juried
Income: financed by members
Purchases: one purchase award painting for permanent coll
Library Holdings: Exhibition Catalogs; Original Art Works; Slides
Collections: Award-winning paintings from 1954 to present
Exhibitions: Spring Membership Exhibition; National Annual Exhibition (Fall)
Publications: Society's newsletter; color annual catalog
Activities: Lect open to pub; sponsor yearly grant to children's art program of LA Southwest Museum; NWS award - $4000 - plus awards totalling $20,000; originate traveling exhibitions to art centers, college galleries, libr

O **NEW ENGLAND WATERCOLOR SOCIETY,** 162 Newbury St, Boston, MA 02116. Tel 617-536-7660; *Treas* Joan Griswold
Open Mon - Fri 9 AM - 5 PM; Estab 1886 to advance the fine art of aqua media; Mem: 200, assoc mem 80; annual meeting in Mar
Income: Financed by mem

Exhibitions: Annual winter membership exhibit; Biennial-North America National Show-Juried Exhibit; 2-3 exhibits per year
Activities: Demonstrations, lect & gallery works open to the public during exhibitions

O **PASTEL SOCIETY OF AMERICA,** National Arts Club Gallery, 15 Gramercy Park S, New York, NY 10003. Tel 212-533-6931; Elec Mail pastelny@juno.com; Internet Home Page Address: www.pastelsocietyofamerica.org; *Pres* Flora B Giffuni, MFA
Estab 1972 to promote & encourage pastel painting/artists; Mem: 600; initiation fee $100, dues full $40, assoc $35; jury fee $10; mem open to professional artists; monthly meetings
Library Holdings: Audio Tapes; Clipping Files; Exhibition Catalogs; Original Art Works; Slides; Video Tapes
Collections: Raymond Kintsler, Robert Phillip, Constance F Pratt & other master pastellists
Publications: Pastelagram, bi-annual
Activities: Classes for adults; lect open to public, 10 vis lectrs per year; gallery talks; competitions with awards; scholarships offered; exten dept serves lending collection of paintings; book traveling exhibitions 3-4 per year; originate traveling exhibitions to galleries & museums

O **PASTEL SOCIETY OF OREGON,** PO Box 105, Roseburg, OR 97470. Tel 541-440-0567; Internet Home Page Address: www.mcsi.net; *Pres* Lora Block
Estab 1987 to promote pastel as an art medium & to educate the pub on pastel; Mem: 80; dues $20 per yr; mem open to artists working in pastels; monthly working meetings
Income: $2000 (financed by mem & shows)
Publications: Pastel Newsletter, bi-monthly
Activities: Classes for adults; hands on exhibitions for schools

O **PASTEL SOCIETY OF THE WEST COAST,** Sacramento Fine Arts Center, Tel 916-783-4117; Fax 530-885-3253; Internet Home Page Address: www.jps.net/pswc/pages; *Pres* Joan Sexton; *VPres* Kat Higley
Call for hours; Estab 1985 to promote soft pastel medium & exhibitions, workshops; Mem: 427; dues $25; quarterly meetings in Jan, Apr, July & Oct 3rd Wed
Income: Financed by mem & donations
Library Holdings: Video Tapes
Exhibitions: Three exhibitions per yr
Publications: PSWC newsletter, quarterly; exhibit catalogs
Activities: Classes for adults; lect open to public, 3-4 vis lectrs per year; competitions with awards; scholarships offered

O **THE PRINT CENTER,** 1614 Latimer St, Philadelphia, PA 19103. Tel 215-735-6090; Fax 215-735-5511; Elec Mail info@printcenter.org; Internet Home Page Address: www.printcenter.org; *Pres* Ennes Littrell; *Interim Dir* Elizabeth F Spungen; *Cur Prints & Photographs* Jacqueline van Rhyn; *Gallery Store Mgr* Eli Vanden Berg; *Asst Dir* Ashley Peel Pinkham
Open Tues - Sat 11 AM - 5:30 PM; No admis fee; Estab 1915 as a nonprofit, educational organization dedicated to the promotion of fine prints & the support & encouragement of printmakers, photographers & collectors; Contemporary prints and photographs; Average Annual Attendance: 8,000; Mem: 1,000; dues household $75, artist $40, student $30
Income: $300,000 (financed by mem, private & government grants)
Collections: The Print Center Permanent Collection (prints & photograph collection held at the Philadelphia Museum of Art); The Print Center Archives (documents, books & catalogues held at the Historical Society of Pennsylvania)
Exhibitions: Changing bimonthly exhibitions of prints & photographs; Annual International Competition (since 1924)
Publications: Annual International Competition Catalogue
Activities: Workshops for adults & children; lect open to public; 5 vis lectrs per yr; gallery talks; tours; sponsoring of competitions; artist residencies; The Print Center Gallery Store sells original art, prints

O **PRINT COUNCIL OF AMERICA,** c/o Spencer Museum of Art, 1301 Mississippi Lawrence, KS 66045. Tel 785-864-0128; Fax 785-864-3112; Internet Home Page Address: www.printcouncil.org; *Pres* Stephen Goddard
Estab 1956 as a nonprofit organization fostering the study & appreciation of fine prints, new & old; Mem: 100 museum & university professionals interested in prints; annual meeting in Apr or May
Income: Financed by dues & publication royalties
Publications: Occasional publications on old & modern prints; The Print Council Index to Oeuvre-Catalogues of Prints by European & American Artists

O **SALMAGUNDI CLUB,** 47 Fifth Ave, New York, NY 10003. Tel 212-255-7740; Internet Home Page Address: www.salmagundi.org; *Chmn Board* Arthur Rosenblatt; *Pres* Richard Pionk; *Chmn Scholarship Members* Gaye Elise Beda; *Chmn Jr Members* Louis DeDonato; *Cur* Kenneth W Fitch; *Mgr* Barbara Grant
Open daily 1 - 5 PM, cl holidays; No admis fee; Estab 1871, incorporated 1880, to enhance the advancement of art appreciation, building purchased 1917; Clubhouse restaurant & bar, 2 galleries, Billiard room, library & board room. Maintains reference library; Average Annual Attendance: 10,000; Mem: 600; dues resident layman & resident artist $500, scholarship graduated to scale, Honorary & Emeritus
Income: Financed by dues, donations, bequests
Collections: Club collection of past & present members
Exhibitions: Seven per year by artist members with cash awards; two per year by non-members (artists, photographers, sculptors) with cash awards; Annual Junior/Scholarship exhibition in February
Publications: Centennial Roster published in 1972; Salmagundi Membership Roster, every three years; Salmagundian, three per yr
Activities: Classes for adults; demonstrations; lect, 10-12 vis lectrs per year; gallery talks; tours; competitions with awards; scholarships & fels offered; individual paintings & original objects of art lent to various museums & special

exhibitions; lending collection contains over 50 original art works, over 50 paintings, 10 sculptures; sales shop sells earrings, necklaces, patches, ties & tie tacks
L **Library,** 47 Fifth Ave, New York, NY 10003. Tel 212-255-7740; Internet Home Page Address: www.salmagundi.org; *Librn* Keneth Fitch
Open Tues 10:30 AM - 5 PM; For reference only
Library Holdings: Book Volumes 10,000; Exhibition Catalogs; Original Art Works; Other Holdings Steinway Player piano with 100 rolls; Periodical Subscriptions 10; Photographs; Sculpture
Special Subjects: Art History, Folk Art, Illustration, Photography, Drawings, Graphic Arts, Painting-American, Posters, Sculpture, Historical Material, History of Art & Archaeology, Watercolors, Woodcuts, Landscapes, Architecture

O **SCULPTORS GUILD, INC,** Soho Bldg, Ste 601, 110 Greene St New York, NY 10012. Tel 212-431-5669; Fax 212-431-5669; Elec Mail sculptorsguild@earthlink.net; Internet Home Page Address: www.sculptorsguild.org
Open Tues & Thurs 10 AM - 5 PM & by appointment; No admis fee; Estab 1937 to promote sculpture & show members' work in an annual show & throughout the country; Mem: 120; qualifications for mem, quality of work & professionalism; dues $125; annual meeting in May
Income: Financed by mem dues, donations, & commissions on sales
Exhibitions: Various exhibitions of small works are held in the Sculptors Guild office every two months; Annual Exhibition at Lever House, Park Ave, NY & Washington Square, Washington, DC
Publications: Brochure 1985; exhibit catalogs, every other year for annual exhibitions; 50th Anniversary Catalog 1937-1938; The Guild Reporter, Vol. 1, No. 1, 1986, annually
Activities: Speakers bureau; lect open to public; original objects of art lent to patrons & for movie & TV productions; lending collection contains cassettes & 50 sculptures; book traveling exhibitions; originate traveling exhibitions; sales shop sells original art

O **SOCIETY FOR FOLK ARTS PRESERVATION, INC (SFAP),** Tel 914-436-7314; 845-436-7314; Fax 914-436-7314; Elec Mail info@societyforfolkarts.com; Internet Home Page Address: www.societyforfolkarts.com; *Exec Dir* Kalika Stern
Estab 1977 to document on film and video, living folk art and craft traditions, worldwide; Mem: 350; dues $40
Income: Financed by donations
Collections: Folk toys & objects; Indian Textiles
Exhibitions: Warli Womens Wall Paintings from Maharashtra, India; A Sense of Beauty; Multi Image Slide Presentations - Crafts and People of Asia
Publications: Newsletter, twice a year
Activities: Educ dept; lect open to public, 3 vis lectrs per year; tours; originate traveling exhibitions
L **Library,** PO Box 808, South Fallsburg, NY 12779-0808. Tel 914-436-4053; Fax 914-436-7314; Elec Mail folkarts@in4web.com; *Exec Dir* Evelyn Stern
Estab 1979; Reference only
Library Holdings: Audio Tapes; Book Volumes 500; Clipping Files; Exhibition Catalogs; Memorabilia; Original Art Works; Pamphlets; Photographs; Slides 14,000; Video Tapes
Collections: Indian textiles; folk art

O **SOCIETY OF AMERICAN GRAPHIC ARTISTS,** 32 Union Sq, Rm 1214, New York, NY 10003. Tel 212-260-5706; Internet Home Page Address: www.clt-astate.edu; *VPres* Richard Sloat; *Treas* Linda Adato; *Pres* William Behnken
Estab 1915 as a society of printmakers, now a society of graphic artists; Mem: 250 voted in by merit; dues $20; annual meeting May
Income: Financed by mem & associate mem
Exhibitions: Semi-annual Open Competition National Print Exhibition; Semi-annual Closed Members Exhibit; National Traveling Exhibitions every two years
Publications: Exhibition Catalog, annually; Presentation Prints for Associate Membership
Activities: Lect open to public, 1 vis lectr per year; sponsors competitive & members' exhibits with awards; original objects of art lent, lending collection contains original prints; originate traveling exhibitions

O **SOCIETY OF AMERICAN HISTORICAL ARTISTS,** 146 Dartmouth Dr, Oyster Bay, NY 11801. Tel 516-681-8820; Fax 516-822-2253; *VPres* William Muller; *Pres* John Duillo
Estab 1980 for furthering American Historical Art, especially authenticity; Mem: 16; dues $150; meetings 3-4 per yr
Activities: Awards for excellence

O **SOCIETY OF ARCHITECTURAL HISTORIANS,** 1365 N Astor St, Chicago, IL 60610-2144. Tel 312-573-1365; Fax 312-573-1141; Elec Mail info@sah.org; Internet Home Page Address: www.sah.org; *Exec Dir* Pauline Saliga; *Pres* Christopher Mead; *First VPres* Diane Favro; *Second VPres* Therese O'Malley
Open Wed for tours Noon, Sat 10 AM & 1 PM; Admis $5 on Sat, free on Wed; Estab to provide an international forum for those interested in architecture & its related arts, to encourage scholarly research in the field & to promote the preservation of significant architectural monuments throughout the world; House Mus; Mem: 3500; show an interest in architecture, past, present & future; dues $95; annual meeting Apr
Income: Financed by mem
Publications: Journal, quarterly; Newsletter, bimonthly; Preservation Forum, biannual
Activities: Docent training; sponsors competitions; Antoinette Forrester Downing Award; Founder's Award; Alice Davis Hitchcock Book Award; Philip Johnson Award; fellowships offered; sales shop sells architectural guides & booklets & also back issues of the Journal

O **SOCIETY OF ILLUSTRATORS,** 128 E 63rd St, New York, NY 10021. Tel 212-838-2560; Fax 212-838-2561; Elec Mail si1901@aol.com; Internet Home Page Address: www.societyillustrators.org; *Pres* Vincent DiFate; *Dir* Terrence Brown
Open Tues 10 AM - 8 PM, Wed - Fri 10 AM - 5 PM, Sat Noon - 4 PM; No admis fee; Estab 1901 as a national organization of professional illustrators and art

directors; Gallery has group, theme, one-man & juried shows, approximately every four weeks; Average Annual Attendance: 40,000; Mem: 850
Publications: Illustrators Annual
Activities: Lect open to public; 7 vis lectrs per yr; sponsoring of competitions; holds annual national juried exhibition of best illustrations of the year; awards scholarships to college level art students; originate traveling exhibitions to college galleries; sales shop sells books

O **SOCIETY OF NORTH AMERICAN GOLDSMITHS,** 540 Oak St, Ste A, Eugene, OR 97401. Tel 630-579-3272; Tel 406-728-5248; Fax 630-369-2488; Elec Mail rmitchel@cftnet.com; Internet Home Page Address: www.snagmetalsmith.org; *Pres* Micki Lippe; *Treas* Allora Doolittle; *Exec Dir* Dana Singer; *Admin Dir* Liz Lenard
By appointment only; No admis fee; Maintains rental library; Mem: 2,800; dues $55; annual meeting in Apr
Income: $600,000 (financed by mem)
Exhibitions: Distinguished Members of SNAG; Jewelry USA
Publications: Metalsmith magazine, 5 per year; bi-monthly newsletter
Activities: Lect open to members only; competitions; scholarships; lending collection contains motion pictures, videotapes & 10,000 slides; originate traveling exhibitions

O **SOCIETY OF PHOTOGRAPHERS & ARTISTS REPRESENTATIVES,** 60 E 42nd St, Ste 1166, New York, NY 10165. Elec Mail infor@spar.org.; Internet Home Page Address: www.spar.org; *Coordr* Kat Hunt; *Asst Coordr* Adrienne Wheeler; *Pres* George Watson
Estab 1965 as an association of professional representatives of illustrators, photographers & related talent; Mem: must be representative in industry for at least 1 year & provide references; mem fees vary by region
Publications: Membership directory; newsletter
Activities: Some open to public; some for members only

O **SPECIAL LIBRARIES ASSOCIATION,** Tel 202-234-4700; Fax 202-265-9817; Elec Mail sla@sla.org; Internet Home Page Address: www.sla.org; *Pres* Donna Scheeder; *Exec Dir* David R Bender; *Bulletin Educ* Susan Brighton; *Dir Public Relations* Stoe
Estab 1964 to provide an information forum & exchange for librarians in the specialized fields of museums, arts & humanities; Mem: 14,000; dues $129; annual meeting in early June
Publications: Museums, Arts & Humanities Division Bulletin, semi-annual

O **THE STAINED GLASS ASSOCIATION OF AMERICA,** 4450 Fenton Rd, Hartland, MI 48353; 1009 E 62d St Kansas City, MO 64133-4003. Tel 800-888-7422; Elec Mail sgaa@stainedglass.org; Internet Home Page Address: www.stainedglass.org; *Exec Admin* Katie Gross
Estab 1903 as an international organization to promote the development & advancement of the stained glass craft; Mem: 600; dues accredited $350, active $150, affiliate $75, student $50 (various criteria apply to each mem)
Income: Financed by mem dues
Library Holdings: Slides; Video Tapes
Special Subjects: Stained Glass
Publications: Stained Glass magazine, quarterly
Activities: Educ dept with two & three week courses

O **UNITED STATES DEPARTMENT OF THE INTERIOR,** Indian Arts & Crafts Board, 1849 C St NW, Rm 2058-MIB, Washington, DC 20240. Tel 202-208-3773; 888-ART-FAKE; Fax 202-208-5196; Elec Mail iacb@os.doi.gov; Internet Home Page Address: www.iacb.doi.gov; *Dir* Meridith Z Stanton; *Prog Specialist* Jill Moran; *Program Asst* Ken Van Wey; *Admin Support Asst* Michele Hill; *Chmn* Jana McKeag; *Commisioner* Henry Townsend; *Commissioner* Shanan Campbell; *Commisioner* Cloyce V Choney; *Secy* Ferdousi Khanam
Open Mon - Fri 8 AM - 5 PM; No admis fee; Estab 1935 to promote contemporary arts by Indians & Alaska Natives of the United States; Board administers the Southern Plains Indian Museum, Anadarko, OK; Museum of the Plains Indian, Browning, MT; Sioux Indian Museum, Rapid City, SD; Average Annual Attendance: 150,000
Income: Financed by federal appropriation
Special Subjects: American Indian Art, Eskimo Art, Painting-Dutch
Collections: Contemporary American Indian & Alaska Native Arts
Exhibitions: Twelve special exhibitions among the three museums
Publications: Source Directory of American Indian & Alaska Native owned & operated arts & crafts businesses
Activities: Information & advice on matters pertaining to contemporary Indian, Eskimo & Aleut arts & crafts

O **VAN ALLEN INSTITUTE,** 30 W 22nd St, New York, NY 10010. Tel 212-924-7000; Fax 212-366-5836; Elec Mail vanallen@vanallen.org; Internet Home Page Address: www.vanallen.org; *Exec Dir* Ray Gastio
Open Mon - Fri Noon - 6 PM; No admis fee; Inc 1894 as Society of Beaux-Arts Architects, which was dissolved Dec 1941; Beaux-Arts Institute of Design estab 1916, name changed 1956 to present name; Average Annual Attendance: 2,500; Mem: 600; dues $50; annual meeting end of Oct
Income: mems, grants, corporate, found, gov grants
Exhibitions: Prize-winning drawings of competitions held during year; Rotating exhibits
Publications: Yearbook, annually in October
Activities: Lect open to public; 4-5 vis lectrs per year; competitions with awards; trustee for the Lloyd Warren Fellowship (Paris Prize in Architecture) for study & travel abroad; William Van Allen Architect Memorial Award (international competition) annual scholarship for further study or research project of some architectural nature; & other trust funds for prize awards for study & travel abroad & educational activities in the United States; individual paintings & original objects of art lent; lending collection contains 200 original prints; book traveling exhibitions 3-4 per year; originate traveling exhibitions

O **VISUAL ARTISTS & GALLERIES ASSOCIATION (VAGA),** 350 5th Ave, Ste 2820 New York, NY 10118. Tel 212-736-6666; Fax 212-736-6767; Elec Mail rpanzer.vaga@erols.com; *Exec Dir* Robert Panzer
Open daily 9 AM - 5 PM, by appointment; Estab 1976 to help artists control the reproduction of their works, from sculptures to photographs in textbooks; to act as a clearinghouse for licensing reproduction rights & set up a directory of artists & other owners of reproduction rights for international use; Mem: European 3000, American 500; dues gallery & associate $300, estates $75, artist $50
Income: Financed by mem & royalties
Publications: Newsletter

O **WASHINGTON SCULPTORS GROUP,** PO Box 42534, Washington, DC 20015. Tel 202-362-7707; Elec Mail mail@washingtonsculptors.org; Internet Home Page Address: www.washingtonsculptors.org; *Pres* Lynden Cline; *VPres* Joan Weber; *Treas* Joyce Zipperer; *Sec* Pattie Porter Finestone
Estab 1983 to promote sculpture; Use pub & corporate space for exhibitions; members' juried exhibitions available for exchange shows; Average Annual Attendance: 1,500; Mem: 380 mem; dues $35
Income: $6,500 (financed by mem & occasional grants)
Exhibitions: 2-3 juried exhibitions per year
Publications: Exhibition brochures & catalogs; newsletters, 3 per year
Activities: Lect open to public, 6-8 vis lectrs per year; image bank; originate traveling exhibitions

O **WOMEN'S CAUCUS FOR ART,** Canal Street Sta, PO Box 1498 New York, NY 10013. Tel 212-634-0007; Elec Mail info@nationalwca.org; Internet Home Page Address: www.nationalwca.org; *Pres* Jennifer Colby; *Treas* Margaret Lutze; *Admin* Karin Luner
Estab 1972 as a nonprofit women's professional & service organization for visual arts; Average Annual Attendance: 200; Mem: 1,600; annual meeting in Feb
Income: $55,000 (financed by mem)
Publications: Membership Directory, Honors Catalogue (all annual); Artines (triannually)
Activities: Life time achievement awards

U.S. Museums, Libraries & Associations

ALABAMA

ANNISTON

M ANNISTON MUSEUM OF NATURAL HISTORY, 800 Museum Dr, Anniston, AL 36202; PO Box 1587 Anniston, AL 36202-1587. Tel 256-237-6766; Fax 256-237-6776; Elec Mail cbragg@annistonmuseum.org; Internet Home Page Address: www.annistonmuseum.org; *Dir* Cheryl Bragg; *Dir Develop* Lindie K Brown; *Dir Mktg* Margie Conner; *Tour Coord* Jennifer Smith; *Mus Store Mgr* Gina Cooper; *Chm (V)* Georgia V Calhoun; *Facilities Mgr* Scott Williamon; *Cur Collections* Daniel Spaulding; *Dir Prog & Educ* Gina Morey
Open Tues - Sat 10 AM - 5 PM, Sun 1 - 5 PM, summer open Mon; Admis adults $4.50, children 4-17 $3.50, 3 & under free; Estab 1930, nationally accredited mus with the purpose of enhancing pub knowledge, understanding & appreciation of living things & their environments; Permanent exhibit halls interpret the theme Adaptation the Environment; changing exhibit gallery features exhibitions focusing on interrelationships between nature & art; Average Annual Attendance: 70,000; Mem: 1600; dues family $35, individual $25; annual meeting in Sept
Income: Financed by mem, earned income, donations & city appropriations
Collections: Archaeology; Ethnology; Natural Science; Wildlife Art
Exhibitions: 4-6 rotating per yr
Activities: Classes for adults & children; docent programs; lect open to public, 8 vis lectr per year; book traveling exhibitions 5 per year; retail store sells books, original art & reproductions

M BERMAN MUSEUM, 840 Museum Dr, Anniston, AL 36201; PO Box 2245, Anniston, AL 36202-2245. Tel 256-237-6261; Fax 256-238-9055; Elec Mail info@bermanmuseum.org; Internet Home Page Address: www.bermanmuseum.org
Open Sept - May Tues - Sat. 10 AM - 5 PM, Sun. 1 - 5 PM; June - Aug Mon - Sat 10 AM - 5 PM, Sun 1 - 5 PM. Cl New Year's Day, Thanksgiving, Christmas Eve & Day; Admis adults $3.50, seniors $3, children 4 - 17 $2.50, discount to AAA mems & active military, children 3 & under no admis fee; Mus houses 3,000 objects related to world history in five galleries. The coll was that of Farley L & Germaine K Berman, both who served in counterintelligence during WWII. They met in North Africa & traveled the world collecting rare & unusual artifacts for more than seventy years; Mem: Dues Benefactor $500 & up; Patron $250; Sustainer $100; Contributor $50; Family $25; Indiv $20; Student (FT) $10
Special Subjects: American Indian Art, Archaeology, American Western Art, Flasks & Bottles, Gold, Bronzes, Painting-European, Sculpture, Painting-American, Religious Art, Ceramics, Antiquities-Oriental
Collections: Spy coll including a silver flute, various ink pens, walking canes, box of antacids, & WWII German cigarette lighter, all of which were designed to conceal a firing mechanism; coll of bronzes including figural & animal subject matter, created & cast by European, Asian, and American artists and foundries; religious & ordinary objects created by Asian artisans over a span of nine centuries; traveling pistols of Jefferson Davis, Pres of the Confederacy; dressing set of Napoleon Bonaparte; royal Persian scimitar encrusted with 1,295 rose-cut diamonds and rubies, single 40-carat emerald, all set in three pounds of gold; coll of weapons & bronze sculptures from the American West
Activities: Art Camp and Etiquette For Children; History Festival; rotating exhibs

AUBURN

M JULE COLLINS SMITH MUSEUM OF ART, 901 S College St, Auburn, AL 36830. Tel 334-844-3081 (Main); Tel 334-844-1484 (Facilities rental & special events); Fax 334-844-1463; Elec Mail jcsm@auburn.edu; *Co-Dir* Bob Ekelund; *Dir Develop* Jack Stephens; *Office Adminr* Terrell Bean; *Develop Coordr* Haley Loilhite; *Exec Asst* Robbin Birmingham; *Mus Shop Mgr* Carol Robicheaux; *Communications Adminr* Scott Bishop Wagoner; *Mus Services & Special Events Adminr* Andy Tennant; *Cur* Catherine Walsh; *Exhib & Bldg Mgr* Daniel S Neil; *Co-Dir* Marilyn Laufer; *Registrar* Danielle Funderburg
Open Tues - Sat 10 AM - 5 PM, Sun 1 PM - 5 PM. Cl New Year's Day, Thanksgiving & Christmas; Admis adults $5, seniors $4, children 17 & under and Auburn Univ students & faculty (with ID) no admis fee; Mus is home to Auburn Univ's coll of American & European art; Mem: Dues Patron $500; Benefactor $250; Sustaining $125; Family or Dual $80; Indiv $45; Student $25
Special Subjects: Painting-American, Prints, Painting-European, Sculpture, Bronzes
Collections: Advancing American Art Coll; The Louise Hauss & David Brent Miller Audubon Coll; American & European 19th & 20th century art including paintings, sculpture & prints; The Bill L Harbert Coll of European Art; monumental mural Alma Mater by William Baggett; The Nelson and Joan Cousins Hartman Coll of Tibetan Bronzes
Activities: Gallery talks; walking paths with botanical gardens; lects; traveling & rotating exhibs; museum-related items for sale

BIRMINGHAM

M BIRMINGHAM MUSEUM OF ART, 2000 Eighth Ave N, Birmingham, AL 35203. Tel 205-254-2565; Fax 205-254-2714; Elec Mail museum@artsbma.org; Internet Home Page Address: www.artsbma.org; *Dir* Gail Trechsel; *Cur Educ* Miriam Fawler; *Chief Cur & Cur of Asian Art* Donald A Wood; *Bldg Supt* Wayne Blount; *Accountant* Ernest Hudson; *Museum Store Mgr* Michelle Crim; *Registrar* Melissa Falkner; *Graphic Designer* Joan Kennedy; *Cur Decorative Arts* Anne Forschler; *Chm* Thomas N Carruthers; *Kimberly King, Membership Coord; Vol Coordr* Rhonda Hethcox; *Dir Devel* Amy Templeton; *Pub Information Officer* Frances Caldwell; *Chief Security* G B Quinney; *Cur Painting & Sculpture* David Moos; *Designer* Terry Bechham; *Librarian* Grace Reid; *Admin Secy* Portia Stallworth; *Business Mgr* D Mike Mclane; *Facilities Mktg Coord* Charlotte Turnipseed
Open Tues - Sat 10 AM - 5 PM, Sun Noon - 5 PM; No admis fee; Estab 1951 as a general art mus with collections from earliest manifestation of man's creativity to contemporary work. Its goal is to illustrate the highest level of man's artistic work in an art historical context; The 36 galleries are climate controlled; lighting system is modern & controlled to latest safety standards; Average Annual Attendance: 100,000; Mem: 6,000; dues $35 - $500
Income: $3,500,000 (financed by mem, city appropriation & annual donations)
Purchases: $650,000
Special Subjects: Painting-American, Sculpture, American Western Art, Pre-Columbian Art, Decorative Arts, Asian Art, Silver
Collections: English ceramics & silver; American painting & sculpture; American decorative arts 19th-20th centuries; Ethnographic Collection; African, American Indian, Pre-Columbian works; Oriental Collection; Indian, Korean, Chinese & Southeast Asian works; Oriental Rug Collection; European paintings; Renaissance to 20th century art; Wedgewood Collection; photography; prints and drawings, 18th-19th centuries
Publications: Annual bulletin; bi-monthly calendar; Zorn Catalogue
Activities: Classes for adults & children; docent training; lect open to public, 12-15 vis lectrs per year; concerts; gallery talks; tours; competitions; individual paintings lent to other museums; organize & circulate traveling exhibitions; museum shop sells reproductions, prints and gifts

L Clarence B Hanson Jr Library, 2000 Eighth Ave N, Birmingham, AL 35203-2278. Tel 205-254-2566; Fax 205-254-2714; Elec Mail library@artsBMA.org; Internet Home Page Address: www.ArtsBMA.org; *Library Adminr* Tatum Preston; *R Hugh Daniel Dir* Gail A Trechsel; *Business Mgr* D Mike McLane; *Dir of Develop* Amy W Templeton; *Chief Cur & Cur of Asian Art* Dr Donald A Wood; *Cur Decorative Arts* Dr Anne M Forschler; *Registrar* Melissa B Falkner; *Exhibs Designer* Terry A Beckham; *Security Dir* G B Quinney; *Bldg Supt* Wayne Blount; *Cur Americas & Africa* Emily Hanna, Dr; *Cur European Art* Dr Jeannine A O'Grody
Open Tues - Fri 10 AM - 4 PM; No admis fee; Estab 1951; Reference only; Average Annual Attendance: 200,000; Mem: 6,500; dues range from $20 - $5,000
Income: Financed by city & private funding
Library Holdings: Auction Catalogs; Book Volumes 25,000; CD-ROMs; Clipping Files; Compact Disks; DVDs; Exhibition Catalogs; Manuscripts; Memorabilia; Original Documents; Other Holdings; Pamphlets; Periodical Subscriptions 110
Special Subjects: Art History, Decorative Arts, Film, Drawings, Painting-American, Pre-Columbian Art, Painting-European, Ceramics, American Western Art, Asian Art, Porcelain, Primitive art, Jade, Glass, Afro-American Art, Landscapes, Folk Art
Collections: Kress Collection of Italian Renaissance Art; Beeson Wedgwood Collection; Lamprecht Collection of Cast Iron Art; Hitt Collection of 19th Century French Furniture; Ireland Sculpture Garden; Oliver Collection of English Porcelain; Collins Collection of English Ceramics; Cooper Collection of Rugs; Simon Collection of Art of the American West; Cargo Collection of American Quilts
Activities: Classes for adults & children; dramatic programs; docent training; lect open to the public, 30 vis lectrs per yr; concerts; gallery talks; tours; sponsoring of competitions; Vol of Yr award; Youth Art Month Juried Competition; scholarships; extension program to Jefferson and Shelby counties; approx 6 traveling exhibs per yr; organize traveling exhibs to pub museums and galleries; museum shop sells publications, books, jewelry, toys, fine art, decorative arts, handicrafts & stationery

L BIRMINGHAM PUBLIC LIBRARY, Arts, Literature & Sports Department, 2100 Park Pl, Birmingham, AL 35203. Tel 205-226-3670; Fax 205-226-3731; Elec Mail hm@bham.lib.al.us; Internet Home Page Address: www.bham-lib.al.us; *Head Librn* Haruyo Miyagawa
Open Mon - Tues 9 AM - 8 PM, Thurs - Sat 9 AM - 6 PM, Sun 2 - 6 PM; Estab 1909 to serve the Jefferson County area
Income: Financed by city & state appropriations, pub & pvt grants
Library Holdings: Audio Tapes; Book Volumes 40,000; Cassettes; Compact Disks; DVDs; Fiche; Framed Reproductions 200; Periodical Subscriptions 155; Prints; Records; Video Tapes

Special Subjects: Art History, Folk Art, Decorative Arts, Mixed Media, Graphic Design, Islamic Art, Pre-Columbian Art, Sculpture, History of Art & Archaeology, Portraits, Asian Art, Porcelain, Pottery, Pewter, Architecture

M **BIRMINGHAM SOUTHERN COLLEGE,** Doris Wainwright Kennedy Art Center, 900 Arkadelphia Rd, PO Box 549021 Birmingham, AL 35254-0001. Tel 205-226-4928; Fax 205-226-3044; Internet Home Page Address: www.bsc.edu; *Prof* Neel Jim
Open Mon - Fri 8:30 AM - 5 PM; No admis fee
Income: Financed by the college
Exhibitions: Steve Cole faculty exhib

M **SLOSS FURNACES NATIONAL HISTORIC LANDMARK,** 20 32nd St N, Birmingham, AL 35222. Tel 205-324-1911; Fax 205-324-6758; Elec Mail info@slossfurnaces.com; Internet Home Page Address: www.slossfurnaces.com; *Metal Arts Cur* Paige Wainwright; *Asst Cur* Lenny Bates; *Dir* Bob Rathburn; *Coll Cur* Karen Utz; *Mktg & Develop Officer* Mary Brandau; *Educ Coordr* Kimbellee Watson; *Asst Cur* John Springer; *Admin Asst* Sherrie Jones; *Mus Asst* Ron Bates; *Sr Maintenance Repair Worker* Matt Landers
Open Tues - Sat 10 AM - 4 PM, Sun Noon - 4 PM; No admis fee; Estab 1983 as mus of industrial history, former blast furnace plant; temporary exhibitions, especially in metal arts; Average Annual Attendance: 125,000
Library Holdings: Audio Tapes; Book Volumes; CD-ROMs; Cassettes; Clipping Files; DVDs; Manuscripts; Maps; Memorabilia; Original Art Works; Original Documents; Pamphlets; Photographs; Prints; Records; Reels; Sculpture; Slides; Video Tapes
Activities: Classes for adults & children; concerts; tours; museum shop sells books, magazines, original art, prints

M **SPACE ONE ELEVEN, INC,** 2409 Second Ave N, Birmingham, AL 35203-3809. Tel 205-328-0553; Fax 205-328-0533; Elec Mail soe@artswire.org; Internet Home Page Address: www.spaceoneeleven.org; *Co-Founder & Co-Dir* Anne Arrasmith; *Co-Founder & Co-Dir* Peter Prinz; *Art Educ Coord* Chis Ross-Davis
Open Tues - Fri 1 - 5PM; No admis fee; Estab 1988 to explore, communicate & develop experimental ideas, issues & new work; 10,000 sq ft; twin 100-year old warehouses, 1200 sq ft of galleries, windows exhibition space, artist projects & education studios, rental facilities
Activities: Classes for children; lect open to public; gallery talks; financial assistance to children in city center arts program; book traveling exhibitions; originate traveling exhibitions; sales shop sells ceramics & art goods

M **UNIVERSITY OF ALABAMA AT BIRMINGHAM,** Visual Arts Gallery, 900 13th St S, Birmingham, AL 35294-1260. Tel 205-934-0815; Fax 205-975-2836; Internet Home Page Address: uab; Telex 88-8826; *Cur & Dir* Brett M Levin
Open Mon-Thurs 11AM-6PM, Fri 11AM-5PM, Sat 1-5PM except between exhibitions, holidays & vacation; No admis fee; Estab 1973 to exhibit works of students, faculty & nationally & internationally known artists & to form & exhibit a permanent collection of art since 1750; Two galleries, each 1,200 sq ft & adjacent storage all on first floor of Humanities building with adjacent sculpture courtyard. All are temperature, humidity controlled & secured by alarms; Average Annual Attendance: 4,100
Income: Financed by university & private donations
Special Subjects: Architecture, Drawings, Graphics, Painting-American, Photography, Prints, American Indian Art, African Art, Ceramics, Woodcuts, Etchings & Engravings, Landscapes, Afro-American Art, Decorative Arts, Collages, Portraits, Eskimo Art, Furniture, Jade, Oriental Art, Asian Art, Silver, Historical Material
Collections: Contemporary art; Student & faculty works since 1950; Works on paper since 1750
Exhibitions: Excavating the Seventies Parts 1 & 2
Publications: Exhibit catalogs
Activities: Lect open to pub, 2 vis lectrs per year; gallery talks; tours; competitions; awards; scholarships offered; individual and original objects of art lent to qualified mus & galleries; book traveling exhibitions; mus shop sells gallery publications & posters

M **WATERCOLOR SOCIETY OF ALABAMA,** 404 Poinciana Dr, Birmingham, AL 35209. Tel 205-822-3721; Fax 205-822-3721; Elec Mail makarty@aol.com; *Pres* Ed Starnes
Estab 1940 to promote watercolor painting; Mem: 408; dues $25; annual meeting in Sept
Income: financed by mem & award donations
Publications: Newsletters & prospectus
Activities: Classes for adults; lect open to public, 2 vis lectrs per year; competitions with prizes

DECATUR

M **JOHN C CALHOUN STATE COMMUNITY COLLEGE,** Art Gallery, Hwy 31 N, PO Box 2216 Decatur, AL 35609-2216. Tel 256-306-2500, 306-2699; Fax 256-306-2925; *Pres* Dr Richard Carpenter; *Dept Chair* John Colagross
Open Mon - Fri 8 AM - 3 PM, special weekend openings; No admis fee; Estab 1965 to provide temporary exhibits of fine art during the school year for the benefit of the surrounding three county area & for the students & faculty of the college; Located in a fine arts building completed June 1979, the gallery has 105 linear ft of carpeted wall space with adjustable incandescent track lighting & fluorescent general lights in a controlled & well-secured environment; Average Annual Attendance: 20,000
Special Subjects: Graphics
Collections: Permanent collection consists of graphics collection as well as selected student & faculty works
Exhibitions: (1999) John Dan's Photography Faculty Exhibit.; Student Art Exhibit; Student Photographs; Faculty Exhibit
Publications: Announcements; exhibition catalogs

Activities: Classes for adults; lect open to public, 3 vis lectrs per yr; gallery talks; tours; competitions with awards; scholarships and fels offered; individual paintings & original objects of art lent to museums, galleries & college art departments; lending collection contains 40 original art works & 85 original prints; book traveling exhibitions, biannually

DOTHAN

M **WIREGRASS MUSEUM OF ART,** 126 Museum Ave, PO Box 1624 Dothan, AL 36302-1624. Tel 334-794-3871; Fax 334-792-9035; Internet Home Page Address: wiregrassmuseumoart.org; *Exec Dir* Susan Robertson; *Dir Art & Educ* Alexandra Miller; *Special Events Mgr* Billie Smith; *Pub Relations Rep* Sarah Spencer; *Office Mgr* Rita Slicer; *Maintenance & Security* David Slicer; *Admin Asst* Robin Yelverton
Open Tues - Sat 10 AM - 5 PM, cl Mon & Sun; No Admis fee; Estab 1988 to provide exhibits & educational programs; Seven galleries & children's hands-on gallery; Average Annual Attendance: 30,000; Mem: 850; dues $25 - $3000
Income: $250,000 (financed by mem, city appropriation, special events & fees)
Special Subjects: Painting-American, Photography, Prints, Sculpture, African Art, Ceramics, Crafts, Afro-American Art, Decorative Arts, Glass, Juvenile Art
Collections: 19th & 20th century works on paper, decorative arts, paintings & sculpture
Exhibitions: (2001) A G Edwards & Sons Corporate Collection: Poster Graphics; (2001) Nature Revealed: The Monumental Landscapes of Susan Downing; (2001) The Romantic Symbolism of Robert Cox; (2001) Sunlight & Shadows: American Impressionism 1885-1945
Publications: Sketches, quarterly newsletter
Activities: Classes for adults & children; docent training; lect open to public, gallery talks, tours; mus shop sells books, original art, reproductions & prints

FAIRHOPE

A **EASTERN SHORE ART ASSOCIATION, INC,** Eastern Shore Art Center, 401 Oak St, Fairhope, AL 36532. Tel 334-928-2228; Fax 334-928-5188; *Mgr* Robin Fitzhugh; *Pres* Pat Bowman
Open Mon - Fri 10 AM - 4 PM, Sat 10 AM - 1 PM, cl Sun, New Years Day, Thanksgiving & Christmas; No admis fee; Estab Assoc 1952, Center 1963 features local, regional & nationally known artist; sponsor cultural, educational & social activities; Four galleries change monthly, a fifth gallery is for members only. Maintains library; Average Annual Attendance: 65,000; Mem: 1000; dues $1500, $500, $200, $100, $34, $20; annual meeting in May
Income: $200,000 (financed by gifts, dues, tuition fees & purchases)
Collections: Herman Bischoff, drawings, oils & watercolors; Maria Martinez, pottery; Emily Woodward Collection; contemporary American paintings from Gulf coast area; primarily southern artist
Exhibitions: Rotating exhibits monthly
Publications: Monthly newsletter; Yearbook
Activities: Classes for adults & children; concerts quarterly; gallery talks; tours; competitions with awards; outreach educational program arranges gallery tours, slide programs & portable exhibits; original art lent to local businesses; sales shop sells original art, reproductions, prints, photographs, pottery

L **Library,** 401 Oak St, Fairhope, AL 36532. Tel 251-928-2228; Fax 251-928-5188; Elec Mail esac@mindspring.com; Internet Home Page Address: easternshoreartcenter.com; *Registrar* Sheri Vanche; *Librn* Elouise Chapman; *Pub Relations Coordr* Karen Reynolds; *Special Events* Tina Frego; *ASC Project Dir* Nancy Raia
Open Mon - Fri 10 AM - 4 PM, Sat 10 AM - 1 PM, cl Sun, New Years Day, Thanksgiving & Christmas; No admis fee; For lending & reference
Library Holdings: Book Volumes 700; Clipping Files; Exhibition Catalogs; Memorabilia; Original Art Works; Pamphlets

FAYETTE

M **CITY OF FAYETTE, ALABAMA,** Fayette Art Museum, 530 N Temple Ave, Fayette, AL 35555. Tel 205-932-8727; Fax 205-932-8788; Elec Mail jackblack@froglevel.net; *Bd Chmn & Cur* Jack Black; *Asst Cur* Kathy Stoner
Open Mon - Fri; No admis fee; Estab 1969 to offer on continuous basis exhibits of visual arts free to the pub; All facilities are at Fayette Civic Center: six multi-purpose galleries, seven folk art galleries plus lobby & corridors; 1200 running ft of exhibition space; Average Annual Attendance: 38,000
Income: Financed by city appropriation & Annual Art Festival
Purchases: Very limited purchases of paintings & sculpture
Library Holdings: Auction Catalogs; Audio Tapes; Book Volumes; Cassettes; Memorabilia
Special Subjects: Drawings, Graphics, Painting-American, Sculpture, Watercolors, African Art, Textiles, Folk Art, Primitive art, Woodcarvings, Woodcuts, Landscapes, Afro-American Art, Portraits, Painting-Canadian, Metalwork, Miniatures, Painting-Australian
Collections: 3700 paintings, 2600 by Lois Wilson, a former resident; Margarette Guinther; others by local folk artists Jimmy Lee Sudduth, Benjamin Perkins, Fred Webster, Sybil Gibson & Braxton Ponder
Exhibitions: Pernanent gallery for Jimmy Lee Sudduth (folk art); Rev Benjamin Perkins (folk art); Fred Webster & Sybil Gibson
Publications: Souls Grown Deep
Activities: Educ prog varies; lect open to public; gallery talks; tours; individual paintings & original objects of art lent to museums & galleries; originate traveling exhibitions to qualified museums

GADSDEN

M **GADSDEN MUSEUM OF FINE ARTS, INC,** Gadsden Museum of Art and History, 515 Broad St, Gadsden, AL 35901. Tel 256-546-7365; Elec Mail Museum@gadsden.com; Internet Home Page Address: www.gadsdenmuseum.com; *Dir* Steve Temple; *Graphics Dir* Dan Hampton; *Exec Asst* Heather Kurayanagi; *Educ Dir* Elaine Campbell
Open Mon - Sat 10 AM - 4 PM; No admis fee; Estab 1965 to promote, foster, & preserve the collection of paintings, sculpture, artifacts & antiques; 8,000 sq ft; Average Annual Attendance: 10,000; Mem: 75; dues individual $25, family $50

Income: Financed by mem, city & local government & grants
Library Holdings: Book Volumes; Clipping Files; Framed Reproductions; Maps; Memorabilia; Original Art Works; Original Documents; Photographs; Prints; Records; Reproductions; Sculpture
Special Subjects: Folk Art, Historical Material, Landscapes, Glass, Furniture, Porcelain, Portraits, Silver, Woodcuts, Maps, Sculpture, Graphics, Photography, Prints, Watercolors, Pottery, Woodcarvings
Collections: Fowler Collection (paintings, sculpture & porcelain); Snelgrove Historical Collection
Exhibitions: Quilt exhibit; antique radios; annual juried art show; (1/2007-3/2007) Diversity; Alabama's Finest
Activities: Classes for adults & children; workshops; lect open to public, 500 vis lectrs per year; competitions with awards; mus shop sells books, original art, reproductions & prints

HUNTSVILLE

A HUNTSVILLE ART LEAGUE, 3005 L&N Dr, Ste 2, Huntsville, AL 35801. Tel 256-534-3860; Fax 256-534-3860; Internet Home Page Address: www.hsvartleague.org; *Educ Chmn* Sharon Albright; *Office Mgr* Karen Dewhitt; *Gallery Dir* Annette Teaza
Open Mon - Sat 10 AM - 6 PM, Sun 2 - 5 PM; No admis fee; Estab 1957. The League is a nonprofit organization dedicated to promoting & stimulating the appreciation of the visual arts; 81 artists exhibiting, all mediums, special exhibitions; Average Annual Attendance: 4,600; Mem: 295; dues vary; meetings held every 2d Tues of each month
Income: Financed by mem, commissions, grants
Exhibitions: Annual juried show; rotate art exhibits; workshops
Publications: Newsletter on activities & exhibition opportunities in the Southeast, monthly; mem books
Activities: Classes for adults & children; docent training; workshops; lect open to public, 200 vis lectrs per year; competitions; tours; individual paintings & original objects of art leased to banks, restaurants, theaters; lending collection contains original art works, original prints, paintings, photographs, sculpture; sales shop sells original art, reproductions, prints, small hand made art objects as special seasonal gifts

M HUNTSVILLE MUSEUM OF ART, 300 Church St S, Huntsville, AL 35801. Tel 256-535-4350; Fax 256-532-1743; Elec Mail info@hsvmuseum.org; Internet Home Page Address: www.hsvmuseum.org; *Chief Cur* Peter J Baldaia; *Educ Dir* Deborah S Taylor; *Registrar* David Reyes; *Devel Dir* Sheila McFerran; *Accounting & Personnel* Debbie Higdon; *Interim Pres* William T Kissam; *Communication Dir* Stephanie Kelley; *VChmn* George Thacker; *Educ Assoc* Carolyn Faraci; *Retail Sales Dir* Deborah Moore
Open Tues - Sat 10 AM - 5 PM, Sun 1 - 5 PM, cl Mon; No admis fee; Estab 1970; Mus is part of the Von Braun Civic Center; 23,000 sq ft total including 9000 sq ft exhibition galleries. Atmospherically controlled galleries & storage; 10-12 special exhibitions per year; Average Annual Attendance: 57,000; Mem: 1200; dues Champion $5000, Sustaining $2500, Participating $1000, Benefactor $500, Sponsor $200, Patron $100, Contributing $25
Income: $1,000,000 (financed by mem, city appropriation, grants & support groups)
Purchases: $25,000
Special Subjects: Painting-American, Photography, Prints, Sculpture, Watercolors
Collections: American art, 1700-present, including paintings & works on paper; local & regional art; African art; Oriental art
Exhibitions: Annual Youth Art Month & Holiday Celebrations Exhibitions
Publications: Brochures; catalogs, occasionally; Museum Calendar, quarterly
Activities: Classes for adults & children; docent training; Partnership in Art Education program; lect open to public, 3-4 vis lectrs per year; concerts; gallery talks; tours; competitions with awards; scholarships offered; collection loan program; book traveling exhibitions 8-10 per year; originate traveling exhibitions

L Reference Library, 300 Church St S, Huntsville, AL 35801. Tel 256-535-4350; Fax 256-532-1743; Elec Mail info@hsvmuseum.org; Internet Home Page Address: www.hsvmuseum.org; *Curatorial Affairs Dir* Peter J Baldaia; *Dir Educ* Carolyn Faraci; *Pres* Clayton Bass; *Dir Institutional Advancement* Suzanne Matthews; *Communications Mgr* Georgina Chapman; *Cur* Deborah S Taylor; *Adminr* Debbie Higdon
Open Mon - Sat 10 AM - 5 PM, Thurs 10 AM - 8 PM, Sun 1 - 5 PM; Admis adults $7, free to members & children under 6, discount to seniors over 60, military, students with proper ID & people in groups of 100 or more; children ages 6-11 $3; Estab 1970 to bring art & people together; 15,000 sq ft of gallery space in 6 galleries; Average Annual Attendance: 85,000; Mem: 3200; dues family $60
Income: Memberships, corporate underwriting, city funding, grants
Library Holdings: Book Volumes 3800; CD-ROMs 5-10; Clipping Files; Exhibition Catalogs 2000; Pamphlets; Periodical Subscriptions 20; Slides; Video Tapes 25
Special Subjects: Decorative Arts, Photography, Etchings & Engravings, Graphic Arts, Sculpture, Ceramics, Crafts, Bronzes, Glass, Metalwork, Miniatures, Oriental Art, Pottery, Antiquities-Greek, Architecture
Collections: 19th & 20th century American art with an emphasis on the region of the South; Asian art; African art; postwar graphics
Exhibitions: Triennial Red Clay Survey Exhibition, southern contemporary art; Encounters solo exhibitions of contemporary southern art; Permanent collection exhibitions; travelling exhibitions
Publications: Family Gallery Guides
Activities: Classes for adults & children; docent training; travel program for members; outreach into classroom; lect open to public, lect for members only; 2 vis lectrs per year; gallery talks; tours; competitions with awards; scholarships offered; 3-6 book traveling exhibitions per year; originate traveling exhibitions regionally & nationally; museum shop sells books, original art, reproductions, prints

M UNIVERSITY OF ALABAMA AT HUNTSVILLE, Union Grove Gallery & University Center Gallery, Roberts Hall, Room 313, Huntsville, AL 35899. Tel 256-890-6114; Elec Mail fromk@email.uah.edu; *Gallery Adminr* Kristy From; *Staff Asst* Marylyn Coffey
Open Mon - Fri 12:30 - 4:30 PM; No admis fee; Estab 1975; An intimate & small renovated chapel with a reserved section for exhibits located in the University Center; Average Annual Attendance: 1,800
Income: Financed by administration
Special Subjects: Drawings, Painting-American, Photography, Prints, Sculpture
Exhibitions: Contemporary artwork (US & international); Annual Juried Exhibition
Activities: Lect open to public, 7-10 vis lectrs per year; gallery talks; competitions with awards; individual paintings & original objects of art lent; book traveling exhibitions 3 per year; originate traveling exhibitions

MOBILE

M MOBILE MUSEUM OF ART, 4850 Museum Dr, Mobile, AL 36608-1917. Tel 251-208-5200; Fax 251-208-5201; Elec Mail prichelson@mobilemuseumofart.com; Internet Home Page Address: www.mobilemuseumofart.com; Cable FAMOS; *Asst Dir, Chief Cur* Paul W Richelson; *Cur Educ* Melissa Morgan; *Cur Exhib* Donan Klooz; *Registrar* Kurtis Thomas
Open Mon - Sat 10 AM - 5 PM, Sun 1 - 5 PM; Admis adults $6, students $4, additional fees for spec exhibs; Estab 1964 to foster the appreciation of art & provide art educ programs for the community; Primarily American 19th & 20th Century; Average Annual Attendance: 100,000; Mem: 1,800; dues business mem $1,500, benefactor $1,000, supporting $500, associate $245, patron $150, sustaining $75, family $35, individual $25, student $15
Income: Financed by mem, city appropriation & state grants
Purchases: $35,000
Library Holdings: Auction Catalogs; Book Volumes; Exhibition Catalogs; Periodical Subscriptions; Slides
Special Subjects: American Western Art, Bronzes, African Art, Ceramics, Crafts, Folk Art, Etchings & Engravings, Landscapes, Afro-American Art, Decorative Arts, Painting-European, Furniture, Glass, Oriental Art, Antiquities-Byzantine, Marine Painting, Metalwork, Painting-British, Painting-Dutch, Painting-French
Collections: American Crafts; African Art; 19th & 20th century American & European paintings, sculpture, prints, & decorative arts; Oriental art; Chinese ceramics, European paintings & sculpture; 17th to 20th century; Southern furniture; Wellington Collection of Wood Engravings; 1930s - 1940s paintings & graphics; International Contemporary Glass Collection
Publications: Fine Lines Newsletter, 6 per year
Activities: Classes for adults & children; docent training; lect open to public, 3 lectrs per year; gallery talks, tours, competitions with awards; scholarships offered; individual paintings & objects of art lent; lending collection includes art works, original prints, paintings, photographs, sculpture; organize 8 traveling exhibitions, circulating Southeastern Art Museums; museum shop sells books, original art, jewelry

L Library, 4850 Museum Dr, Mobile, AL 36608-1917. Tel 334-208-5200; Fax 334-208-5201; Elec Mail jschenk@mobilemuseumofart.com; Internet Home Page Address: www.mobilemuseumofart.com; *Dir* Joseph B Schenk; *Asst Dir, Chief Cur* Paul W Richelson; *Cur Educ* Meredith Madnick
Open Mon - Sat 10 AM - 5 PM, Sun 12 - 5 PM; Admis $6 general plus additional for special exhibitions; Estab 1963; For reference only; Average Annual Attendance: 90,000
Income: City of Mobile
Library Holdings: Book Volumes 1800; Clipping Files; Exhibition Catalogs; Framed Reproductions; Pamphlets; Periodical Subscriptions 20; Photographs; Prints; Reproductions; Slides
Collections: American & European paintings & decorative arts; contemporary crafts; Southern decorative arts; wood engraving
Publications: Picturing French Style: 300 Years of Art and Fashion
Activities: Classes for adults and children; lect open to public 6 vis lectrs per year; 5 book traveling exhibitions per year; originate exhibitions to Southeastern museums; museum shop sells books

M MUSEUM OF MOBILE, 111 S Royal St, Mobile, AL 36602. Tel 251-208-7569; Fax 251-208-7686; Elec Mail museum@cityofmobile.org; Internet Home Page Address: www.museumofmobile.com; *Dir* George Ewert; *Cur Exhibits* Terri Price; *Asst Dir* Sheila Flanagan; *Researcher* Charles Torrey; *Cur Coll* Dave Morgan; *Registrar* Joan Layne; *Event Coordr* Jessica Berry; *Cur History* Todd Kreamer; *Educ Coordr* Jennifer Theeck; *Group Tour & Volunteer Coordr* Mitzi Wolfarth
Open Mon - Sat 9 AM - 5 PM, Sun 1 - 5 PM, cl some city holidays; Admis adult $5, seniors $4, students $3; Estab 1964 to interpret Mobile's history; A 21st Century state of the history museum; five exhibit experiences offer people of all ages the chance to learn about more than 300 yrs of Mobile history; permanent exhibit presents survey of history of Mobile area; The Discovery Room is a hands-on gallery for children and adults; also Spec Collections Gallery highlights the museum's many artifacts; Average Annual Attendance: 66,000
Income: Financed by city appropriation
Library Holdings: Book Volumes; Clipping Files; Framed Reproductions; Manuscripts; Maps; Memorabilia; Original Art Works; Original Documents; Other Holdings; Pamphlets; Periodical Subscriptions; Photographs; Prints; Records; Sculpture; Slides; Video Tapes
Special Subjects: Archaeology, Ceramics, Decorative Arts, Manuscripts, Silver, Historical Material, Maps, Coins & Medals
Collections: CSS Hunley; Queens of Mobile Mardi Gras; Admiral Raphael Semmes collection includes probably the finest Confederate presentation sword in existence, along with a presentation cased revolver & accessories, books, paintings, documents, personal papers & ship models; Mardi Gras Gallery; 80,000 items reflecting the entire span of the history of Mobile
Exhibitions: (2003) Fun & Finery: Costumes of Mobile's Mardi Gras; (2003) France in the Americas: Cities of the King's Engineers in the New World in the 17th & 18th Centuries
Publications: Exhibition & collection catalogs
Activities: Pub programs for adults & children; docent training; lect open to pub; tours; concerts; sponsored competitions; Volunteer Mobile Inc Heart of Gold 2001 award; Main St Mobile's Leadership Achievement award; original objects of art lent to other mus; mus shop sells books, gifts, jewelry, toys, clothings, magnets, original art, prints, Mobile mementoes & unique gifts; evening spec event rentals, birthday parties, daytime event space

L **Reference Library,** 111 S Royal St, Mobile, AL 36602. Tel 334-208-7569; Fax 334-208-7686; Internet Home Page Address: www.museumofmobile.com; *Dir* George Ewert
Estab 1964; For reference only
Library Holdings: Book Volumes 3000; Clipping Files; Memorabilia; Original Art Works; Periodical Subscriptions 12; Photographs; Prints; Sculpture; Slides

M **Carlen House,** 54 Carlen St, Mobile, AL 36606; 111 S Royal St, Mobile, AL 36602. Tel 251-208-7569; Internet Home Page Address: www.museumofmobile.com; *Dir* George Ewert
Open Mon - Sat 10 AM - 5 PM, Sun 1 - 5 PM; Admis adults $5, seniors $4, students $2; Estab 1970 to preserve an authentic representation of Southern architecture; The Carlen House is an important representation of Mobile's unique contribution to American regional architecture. It is a fine example of the Creole Cottage as it evolved from the French Colonial form & was adapted for early American use. The house was erected in 1842; furnishings are from the collections of the Museum of the City of Mobile & are typical of a house of that period; Average Annual Attendance: 30,000
Income: Financed by city appropriation
Activities: Lect open to pub; group tours are conducted by guides in period costumes who emphasize aspects of everyday life in Mobile in the mid-nineteenth century. The making of material is demonstrated by the guide who cards wool, spins fibers & weaves cloth; individual paintings & original objects of art lent to other mus; sales shop sells books, slides & souvenirs

L **UNIVERSITY OF SOUTH ALABAMA,** Ethnic American Slide Library, Dept Arts & Art History, 172 VAB Mobile, AL 36688. Tel 334-460-6335; Fax 334-414-8294; *Chmn* Larry L Simpson
Open daily 8 AM - 5 PM; No admis fee; Estab for the acquisition of slides of works produced by Afro-American, Mexican-American & Native American artists & the distribution of duplicate slides of these works to educational institutions & individuals engaged in research
Library Holdings: Slides
Collections: 19th & 20th centuries ethnic American art works in ceramics, drawing, painting, photography, printmaking, sculpture
Publications: Slide Catalog

MONTEVALLO

M **UNIVERSITY OF MONTEVALLO,** The Gallery, Sta 6400, Montevallo, AL 35115. Tel 205-665-6400; Fax 205-665-6383; Elec Mail wackerka@montevallo.edu; Internet Home Page Address: www.montevallo.edu/art; *Gallery Dir* Dr Kelly Wacker
Open Mon - Fri 10 AM - 4 PM; No admis fee; Estab Sept 1977 to supply students & pub with high quality contemporary art; The gallery is 27 x 54 ft with track lighting; no windows; Average Annual Attendance: 3,000
Income: Financed by state appropriation & regular dept budget
Collections: WPA Prints
Exhibitions: Rotating exhibits
Publications: High quality catalogs & posters
Activities: Management classes; lect open to pub, 4-5 vis lectrs per year; gallery talks; originate traveling exhibitions

MONTGOMERY

M **ALABAMA DEPARTMENT OF ARCHIVES & HISTORY,** Museum Galleries, 624 Washington Ave, Montgomery, AL 36130; P.O. Box 300100, Montgomery, AL 36130-0100. Tel 334-242-4363; Fax 334-240-3433; Elec Mail lstemple@archives.state.al.us; Internet Home Page Address: www.archives.state.al.us; *Asst Dir Government Records* Tracey Berezansky; *Asst Dir Pub Svcs* Debbie Pendleton; *Dir* Edwin C Bridges; *Chm (V)* Genene Nelson; *Mus Shop Mgr* Alan Nichols; *Cur Education* Leona Stemple
Open Mon - Fri 8 AM - 5 PM, Sat 9 AM - 5 PM; No admis fee; Estab 1901; Reference only; Average Annual Attendance: 78,000
Income: Financed by state appropriation
Special Subjects: Painting-American, American Indian Art, Decorative Arts, Historical Material, Maps
Collections: Early Alabama Indians; Hands On Gallery & Grandma's Attic (for children of all ages); Military Room; the 19th Century Room; Selma to Montgomery March Photographic exhibit; Archives Sampler Room
Exhibitions: History of Alabama
Activities: Classes for adults; docent training; lect open to public, 15 vis lectrs per year; tours; exten dept serves Records Retention facility for state government records; individual paintings & original objects of art lent to museums with in state, state capitol, government offices & Governor's Mansion; lending collection contains paintings; sales shop sells books, Civil War & Civil Rights related materials, reproduced arrowheads, jewelry & posters

L **Library,** 624 Washington Ave, Montgomery, AL 36130. Tel 334-353-4712; Fax 334-240-3433; Elec Mail sherrie.hamil@archives.alabama.gov; Internet Home Page Address: www.archives.alabama.gov; *Archival Librn* Dr Norwood Kerr; *Cur Educ* Sherrie Hamil
Open Mon - Sat 8:30 AM - 4:30 PM, reference room cl Mon; No admis fee; Estab 1901; American Indian gallery, Military & Flag galleries, 19th century galleries & Hands On gallery with Grandma's Attic & Discovery Boxes; portraits and sculpture; photographic collections; Average Annual Attendance: 50,000; Mem: Friends of the Alabama Archives
Library Holdings: Audio Tapes; Book Volumes 32,000; Cassettes; Clipping Files; Fiche; Filmstrips; Lantern Slides; Manuscripts; Maps; Memorabilia; Motion Pictures; Original Art Works; Original Documents; Pamphlets; Photographs; Prints; Records; Reels; Sculpture; Video Tapes
Special Subjects: Manuscripts, Maps, Historical Material
Collections: Alabama Subjects 1700-1989; Political & Social Events; State Government Records
Activities: Classes for adults & children; docent training; lect open to the public, 12 vis lectrs per year; tours; sponsoring of competitions; museum shop sells books, reproductions, jewelry

AMERICAN SOCIETY OF PORTRAIT ARTISTS (ASOPA)
For further information, see National and Regional Organizations

M **MONTGOMERY MUSEUM OF FINE ARTS,** PO Box 230819, Montgomery, AL 36123-0819. Tel 334-244-5700; Fax 334-244-5774; Elec Mail info@mmfa.org; Internet Home Page Address: www.fineartsmuseum.com; Internet Home Page Address: www.mmfa.org; *Pres* Gordon Martin; *Deputy Dir* Andrea Carman; *Asst Dir Operations* Shirley A Woods; *Registrar* Pamela Bransford; *Cur Coll* Margaret Lynne Ausfeld; *Cur Educ* Tara Sartorius; *Spec Events Coordr* Tisha Rhodes; *Dir* Mark M Johnson; *Librn* Alice Carter; *Mus Shop Mgr* Pat Tomberlin; *Vol Coordr* Martha White; *Coordr Mem* Jennifer Pope; *Asst Cur Educ* Samantha Kelly; *Asst Cur Educ* Donna Pickens; *Preparator & Designor* Jeff Dutton
Open Tues - Sat 10 AM - 5 PM, Thurs evening until 9 PM, Sun Noon - 5 PM; No admis fee; Estab 1930 to generally promote the cultural artistic & higher educ life of the city of Montgomery by all methods that may be properly pursued by a mus or art gallery; Mus housed in 50,000+ sq ft facility located on 35 acres on landscaped park, adjacent to the Alabama Shakespeare festival. Galleries occupy lower & upper levels of two story neopalladian Structure. An educ wing. Artworks occupies 3000 sq ft & includes a hands-on, interactive gallery & studio. Forty-one American paintings from Blount Inc form the cornerstone of the American Art Collection which is permanently installed in spacious Blount Gallery in the museum. The Weil Graphics Arts Study Center provides an ideal enviroment for small specialized exhibitions & educational programs emphasizing works of art on paper. It is designed as a conference space with audiovisual & computer resources to serve advanced school groups & seminar participants. 240 seat auditorium; Average Annual Attendance: 160,000; Mem: 1800; dues Director's Circle $1000-$5000, patron $100-$500, general $25-$75; annual meeting in Oct
Income: Financed by mem, city & county appropriations & grants
Special Subjects: Drawings, Graphics, Painting-American, Photography, Prints, Sculpture, Watercolors, Folk Art, Woodcuts, Etchings & Engravings, Landscapes, Decorative Arts, Portraits, Glass, Porcelain, Juvenile Art
Collections: American & European Works on Paper; Contemporary graphics & other works on paper by artists living in the South; decorative arts; master prints of the 15th & 19th Centuries; paintings by American artists from early 19th Century through the present; 41 paintings from the Blount Collection of American Art; Contemporary American self-taught art
Publications: Annual Report; OnExhibit quarterly magazine; exhibitions catalogs for selected shows
Activities: Classes for adults & children; docent training; lect open to public, 20 vis lectrs per year; films; concerts; gallery talks; tours; scholarships & fels offered; individual paintings & original objects of art lent to galleries which meet AAM standards for security & preservation; lending collection contains 330 original prints, 250 paintings, photographs, sculpture & 3500 slides; book traveling exhibitions 12 per year; originate traveling exhibitions, national & international; museum shop sells books, original art, reproductions, prints & gift items

L **Library,** One Museum Dr, Montgomery, AL 36117; PO Box 230819, Montgomery, AL 36123-0819. Tel 334-240-4333; Fax 334-240-3484; Internet Home Page Address: www.fineartsmuseum.com; *Librn* Alice T Carter; *Mus Dir* Mark M Johnson
Open Tues - Fri 10 AM - 5 PM; No admis fee; Estab 1975 to assist the staff & community with reliable art research material; Circ Non-circ; For reference
Income: Financed by City of Montgomery & Mus Assoc & Montgomery Cty Commission
Library Holdings: Book Volumes 5000; Clipping Files; Exhibition Catalogs; Pamphlets; Periodical Subscriptions 25; Photographs; Prints; Slides; Video Tapes
Activities: Classes for adults & children; docent training; lec open to public; gallery talks; tours; museum shop sells books & original art

NORTHPORT

M **KENTUCK MUSEUM & ART CENTER,** 503 Main Ave, Northport, AL 35476-4483. Tel 205-758-1257; Fax 205-758-1258; Elec Mail kentuck@dbtech.net; Internet Home Page Address: www.dbtech.net/kentuck; *Exec Dir* Miah Michaelsen; *Asst Dir* Anne Huffaker
Open Mon - Fri 9 AM - 5 PM, Sat 10 AM - 4:30 PM, cl Sun; No admis fee; Estab 1971 to present art in a fun & casual manner; Average Annual Attendance: 5,000; Mem: 150; dues $30-$500
Income: $280,000 (financed by mem, city & state appropriations)
Exhibitions: Exhibits change monthly
Activities: Classes for adults & children; lect open to public, 6 vis lectrs per year; competitions & awards; sales shop sells books, original art, crafts

SELMA

M **STURDIVANT HALL,** 713 Mabry St, PO Box 1205 Selma, AL 36702. Tel 334-872-5626; Elec Mail smuseum@zebra.net; *Cur* Marie Barker; *Cur* Pat Tate; *Pres* Archie T Reeves; *Mus Shop Mgr* Patty DeBardeleben; *VPres* Claude Anderson
Open Tues - Sat 9 AM - 4 PM; Admis adults $5, student $2, children under 6 free; Estab 1957 as a mus with emphasis on the historical South. Period furniture of the 1850s in a magnificent architectural edifice built 1852-53; Average Annual Attendance: 10,000; Mem: 480; dues $15 - $1000; annual meeting in Apr
Income: Financed by mem, city & county appropriations
Special Subjects: Period Rooms
Collections: Objects of art; period furniture; textiles
Publications: Brochure
Activities: Lect open to public; tours; museum shop sells books, reproductions, lamps, silver, linens & gift items

THEODORE

M **BELLINGRATH GARDENS & HOME,** 12401 Bellingrath Gardens Rd, Theodore, AL 36582. Tel 251-973-2217; Fax 251-973-0540; Elec Mail bellingrath@juno.com; Internet Home Page Address: www.bellingrath.org; *Dir Mus* Thomas C McGehee; *Exec Dir* Dr William E. Barrick; *Vol Coordr* William Darr
Open daily 8 AM - 5 PM; Admis home & garden $15.75, children 5-12 $10, garden only $8.50, children $5; Estab 1932 to perpetuate an appreciation of nature

& display man-made objects d'art; The gallery houses the world's largest public display of Boehm porcelain & the Bellingrath Home contains priceless antiques; Average Annual Attendance: 200,000

Income: Financed by Foundation & admissions

Special Subjects: Porcelain

Collections: Early-mid 19th Century American antique furnishings from South, silver & crystal; separate Boehm Gallery from Bellingrath Home: porcelains by Meissen, Dresden, Copeland, Capo di Monte, Sevres

Activities: Classes for children; tours; lending collection contains kodachromes, motion pictures, slides; sales shop sells books, magazines, prints, reproductions & slides

TUSCALOOSA

A ARTS & HUMANITIES COUNCIL OF TUSCALOOSA, (Arts Council of Tuscaloosa County, Inc) Junior League Gallery, 600 Greensboro Ave, Tuscaloosa, AL 35401; PO Box 1117, Tuscaloosa, AL 35403. Tel 205-758-8083; Fax 205-345-2787; Elec Mail tuscarts@tuscarts.org; Internet Home Page Address: www.tuscarts.org; *Exec Dir* Pamela Penick; *Educ Dir* Sandy Wolf
Open Mon - Fri 8 AM - 5 PM; No admis fee; Estab 1970 for the develop, promotion & coordination of educational, cultural & artistic activities of the city & county of Tuscaloosa; Offices adjoin historic Bama Theatre; Average Annual Attendance: 3,000; Mem: 410 individual, 30 organization; dues organization $75, individual $15; annual meeting in Oct, meetings quarterly

Income: Financed by endowment, mem, city, state & county appropriation

Exhibitions: Jan & Feb: Double Exposure Photography Competition; Feb & March: Visual Art Achievement Award; Nov & Dec: West AL Juried Show

Publications: Arts calendar, monthly newsletter; semi-annual arts magazine, Jubilation

Activities: Dramatic programs; concert series, Bama Fanfare (professional performances for students K - 12); sponsor of educ program called SPECTRA (Special Teaching Resources in the Arts); Bluegrass, Big Bands & More, Cinema Nouveau movie series; gallery talks; tours; competition sponsorship

M UNIVERSITY OF ALABAMA, Sarah Moody Gallery of Art, the University of Alabama, 103 Garland Hall Box 870270 Tuscaloosa, AL 35487-0270. Tel 205-348-5967 (Art Dept); Fax 205-348-0287; Elec Mail wtdooley@art.as.ua.edu; Internet Home Page Address: www.as.ua.edu/art/pages/gallery; *Dir* William Dooley; *Asst to Dir* Vicki Rial
Open Mon - Fri 9 AM - 4:30 PM, Sun 2 - 5 PM; No admis fee; Estab 1946; Exhibitions of national, regional contemporary art; Average Annual Attendance: 1,000

Income: Financed by the college

Collections: Small collection of paintings, prints, photography, drawings, primarily contemporary

Exhibitions: Exhibits rotate once a month

Publications: Exhibit catalogs

Activities: Lect open to public; 3-4 vis lectrs per year; gallery talks; originate traveling exhibitions

TUSCUMBIA

A TENNESSEE VALLEY ART ASSOCIATION, 511 N Water St, PO Box 474 Tuscumbia, AL 35674. Tel 256-383-0533; Fax 256-383-0535; Elec Mail tvac@hiwaay.net; Internet Home Page Address: www.tvac.riverartists.com; *Exhibit Coordr* Lucie Ayers; *Exec Dir* Mary Settle-Cooney; *Pub Relations & Mem* Mary Jo Parker; *Tech Dir Ritz Theater* Jake Barrow
Open Mon - Fri 9 AM - 5 PM, Sun 2 - 4 PM; Admis varies, call for details; Incorp 1964 to promote the arts in the Tennessee Valley. Building completed 1972; Main Gallery 60 x 40 ft; West Gallery for small exhibits, meetings and arts and crafts classes. Located one block from the birthplace of Helen Keller in Tuscumbia. During the Helen Keller Festival, TVAC sponsors the Arts and Crafts Festival; Average Annual Attendance: 10,000; Mem: Dues benefactor $100, family $50, sustaining $30, student $10, patron $500, individual $20

Income: $300,000 (financed by appropriations, donations, grants & mem)

Collections: Reynolds Collection (paintings); TVAA Crafts Collection

Exhibitions: Exhibition South (paintings, sculpture, prints), annual fall juried art show for mid-south states; Spring Photo Show, annual juried; exhibits feature work by national artists, members & students; handcraft exhibits

Activities: Classes for adults and children; dramatic programs; docent training; class instruction in a variety of arts and crafts; workshops & performances in drama; lect open to public; concerts; competitions with awards; individual paintings lent; book traveling exhibits; museum shop sells books, reproductions, prints, puppets, jewelry, & stationary

TUSKEGEE INSTITUTE

M TUSKEGEE INSTITUTE NATIONAL HISTORIC SITE, George Washington Carver & The Oaks, PO Drawer 10, Tuskegee Institute, AL 36087. Tel 334-727-6390; Fax 334-727-4597; Internet Home Page Address: www.nps.gov/puin/index.htm; *Acting Park Supt* Brenda Caldwell; *Mus Technician* Mike Jolly
Open 9 AM - 5 PM, cl Thanksgiving, Christmas & New Year's; No admis fee; Original mus estab 1941 & National Park in 1976 to interpret life & work of George Washington Carver & the history of Tuskegee Institute; Maintains small reference library; Average Annual Attendance: 50,000

Income: Financed by federal funds

Collections: Artifacts interpreting life & work of George Washington Carver & history of Tuskegee Institute; life & contributions of Booker T Washington

Exhibitions: Exhibitions of local artwork 6-8 time per yr

Activities: Lect open to public; gallery talks; guided tours; sponsor competitions with awards; individual & original objects of art lent to other parks & museums;

lending limited to photos, films, slides & reproductions; book traveling exhibitions; originate traveling exhibitions; sales shop sells books, reproductions, prints & slides

ALASKA

ANCHORAGE

M ALASKA MUSEUM OF NATURAL HISTORY, 201 N Mountain View Dr, Anchorage, AK 99503; 206 E Fireweed Ln, Ste 209, Anchorage, AK 99503. Tel 907-274-2400; Elec Mail webcontact@alaskamuseum.org; Internet Home Page Address: www.alaskamuseum.org
Open Tues - Sat 10 AM - 6 PM, Sun 12 PM - 5 PM; Admis adults $5, children $3; Mission is to study & exhibit natural history materials relating to Alaska's natural history & to promote and develop educational progs which benefit students & enrich the curricula of schools & univs in Alaska; Mem: dues Life $1,000; Gift or Reg Mem $30

Special Subjects: Archaeology, Historical Material

Collections: History on the Alaskan Gold Rush; Alaskan rocks, minerals & fossils; Alaska's oldest known dinosaur; Native American cultural artifacts; 11,100 year-old Northern Paleoindian Hunting Camp

Exhibitions: The Dinosaurs of Darkness

Publications: Nunatak, quarterly newsletter

Activities: Group tours; summer camps for children; volunteer activities; lects; museum-related items for sale

A ALASKA WATERCOLOR SOCIETY, PO Box 90714, Anchorage, AK 99501. Tel 907-345-5857; *VPres* Michele Suchland
Open hours vary with exhibitions; No admis fee; Estab 1977; Maintains library

Income: Financed by mem

Exhibitions: Bi-annual juried watercolor exhibit at the Anchorage Museum of History & Art; additional traveling exhibitions

Activities: Workshops; scholarships offered; originate traveling exhibitions

M ANCHORAGE MUSEUM AT RASMUSON CENTER, 121 W Seventh Ave, Anchorage, AK 99501. Tel 907-343-4326; Fax 907-343-6149; Elec Mail museum@ci.anchorage.ak.us; Internet Home Page Address: www.anchoragemuseum.org; *Dir* Patricia B Wolf; *Deputy Dir* Suzi Jones; *Cur Exhibits* Dave Nicholls; *Cur Coll* Walter Van Horn; *Cur Pub Art* Jocelyn Young; *Registrar* Sharla Blanche; *Archivist* Kathleen Hertel-Baker; *Cur History* Marilyn Knapp
Open winter Tues - Sat 10 AM - 6 PM, Sun Noon - 5 PM, summer daily Thurs 9 AM - 9 PM, Fri - Wed 9 AM - 6 PM; Admis adults $6.50, seniors $6, under 18 $2; Estab 1968 to collect & display Alaskan art & artifacts of all periods; to present changing exhibs of the art of the world; Average Annual Attendance: 300,000; Mem: 4000

Income: $3,000,000

Purchases: $50,000

Library Holdings: Auction Catalogs; Book Volumes; CD-ROMs; Clipping Files; Exhibition Catalogs; Fiche; Manuscripts; Maps; Memorabilia; Original Documents; Other Holdings; Pamphlets; Periodical Subscriptions; Photographs; Prints; Slides; Video Tapes

Special Subjects: Drawings, Painting-American, Photography, Prints, Sculpture, Watercolors, American Indian Art, African Art, Anthropology, Archaeology, Ethnology, Pre-Columbian Art, Textiles, Costumes, Religious Art, Crafts, Etchings & Engravings, Landscapes, Eskimo Art, Dolls, Carpets & Rugs, Historical Material, Ivory, Maps

Collections: Alaskan art; Alaskan Eskimo & Indian art; Alaskan history; American art; Primitive Art (non-American)

Exhibitions: Exploration in the North Pacific 1750-1850 Travels; Arctic Transformations: The Jewelry of Denise and Samule Wallace

Publications: Agayuliyararput: Our Way of Making Prayer: The living tradition of Yupik masks (with University of Washington Press); Painting in the North: Alaskan art in the Anchorage Museum of History & Art; exhibition catalogs; monthly newsletters; occasional papers; A Northern Adventure: The Art of Fred Machetanz; Eskimo Drawings; John Hoovere: Art and Life; Sydney Laurence, Painter of the North; Spirit of the North: The Art of Eustace Paul Ziegler

Activities: Classes for adults & children; docent training; lect open to pub; gallery talks; tours; competitions; awards; individual paintings & original objects of art lent to AAM accredited museums; lending coll contains original art works, original prints, paintings, photographs, sculpture & slides; book traveling exhibs 10 per yr; originate traveling exhibs 2 per yr; mus shop sells books, magazines, original art, prints, slides & Alaskan Native art

L Archives, 121 W Seventh Ave, Anchorage, AK 99501. Tel 907-343-6189; Fax 907-343-6149; Elec Mail museum@ci.anchorage.ak.us; Internet Home Page Address: www.anchoragemuseum.org; *Museum Archivist* M Diane Brenner; *Asst Archivist* Mina Jacobs
Open winter Tues - Fri 10 AM - Noon, summer Mon - Fri 9 AM - Noon, afternoons by appointment; No admis fee; Estab 1968 to maintain archives of Alaska materials, particularly the Cook Inlet area; Reference only

Purchases: $4000

Library Holdings: Book Volumes 10,000; Clipping Files; Exhibition Catalogs; Fiche; Kodachrome Transparencies; Memorabilia; Other Holdings Original documents; Pamphlets; Periodical Subscriptions 10; Photographs 350,000; Reels; Slides; Video Tapes

Special Subjects: Historical Material, American Western Art, American Indian Art, Anthropology, Eskimo Art

Collections: Hinchey Alagco Photograph Collection of approximately 4000 pictures of the Copper River area; Alaska Railroad Collection, 19,000 historical photos; Reeve Collection, historical maps; Ward Wells Anchorage Photo Collection 1950-80, 125,000 items; FAA 1973-1975, 10,000 photos; Lu Liston Photo Collection 1920-1950, 6,000 photos; Steve McCutcheon Photo Collection, 70,000; J N Wyman (Upper Koyukon) 1989, 500 glass plates; Vern Brickley Photograph Collection (WWII to 1970) 30,000

BETHEL

M **YUGTARVIK REGIONAL MUSEUM & BETHEL VISITORS CENTER,** Third Ave, PO Box 329 Bethel, AK 99559. Tel 907-543-2911; Fax 907-543-2255; Open Tues - Sat 10 AM - 6 PM; No admis fee; Estab 1967 to help preserve the native culture & lifestyle of the Central Yupik Eskimos of the Yukon-Kuskokwin delta; Average Annual Attendance: 10,500; Mem: 50; dues $25
Income: $165,000 (financed by city appropriation & occasional grants)
Purchases: $5000
Special Subjects: Eskimo Art, Ivory
Collections: Traditional handmade objects of the Yupik Eskimo, both artifacts & contemporary art objects (included are full-size kayak, ivory carvings & wooden masks, wooden bowls, stone & ivory implements, grass baskets, Yupik toys, fishskin, sealgut, birdskin & fur clothing); black & white photographs
Exhibitions: Rotating exhibitions
Activities: Classes for adults & children; lect open to the public; book traveling exhibitions, 3-4 times per year; museum shop sells baskets, ivory jewelry, beaded work, skin & fur garments, wooden & ivory masks, books & posters relating to Yupik Eskimos

FAIRBANKS

A **FAIRBANKS ARTS ASSOCIATION,** Alaskan Land Civic Ctr, PO Box 72786 Fairbanks, AK 99707. Tel 907-456-6485; Fax 907-456-4112; *VPres* Carol Hilgemann; *Exec Dir* June Rojers; *Treas* Ken Beyer; *Pres* Bob Dempsey; *Visual Arts* Sandy Gillispie
Open Mon - Sat Noon - 8 PM, gallery Sat & Sun Noon - 5 PM; No admis fee; Estab 1965 to provide assistance & to help coordinate & promote the programs of arts organizations; to encourage & develop educational progams designed to strengthen & improve the climate for the arts; to inform the community of performing & creative arts awareness & develop in the Fairbanks area; 4000 sq ft contemporary art gallery; Average Annual Attendance: 28,000; Mem: 620; dues $25 & up; annual meeting in Sept
Income: Financed by city & state appropriations, national grants, contributions
Activities: Classes for adults & children; performing arts programs; docent training; professional workshops; lect open to public, 10 vis lectrs per year; gallery talks; tours; competitions with awards; scholarships & fels offered; book traveling exhibitions semi-annually; originate traveling exhibitions; museum shop sells books, magazines, original art, reproductions & prints

UNIVERSITY OF ALASKA

M **Museum of the North,** Tel 907-474-7505; Fax 907-474-5469; Elec Mail museum@uaf.edu; Internet Home Page Address: www.uaf.edu/museum; *Coordr Exhib & Exhib Designer* Wanda W Chin; *Pub Educ Prog* Terry P Dickey; *Cur Ethnology* Molly Lee; *Coordr Fine Arts* Barry J McWayne; *Cur Alaska Ctr for Documentary Film* Leonard J Kamerling; *Dir* Dr Aldona Jonaitis; *Mem & Develop* Emily Drygas; *Comm Coordr* Kerynn Fisher; *Visitor Services* Amy Reed-Geiger
Open summer (May 15-Sept 15) daily 9AM-7PM, winter (Sept 16-May 14) Mon-Fri 9AM-5PM, Sat & Sun Noon-5PM; Admis adult $5, seniors $4.50, ages 8-18 $3.50; Estab 1929 to collect, preserve & interpret the natural & cultural history of Alaska; Gallery contains 10,000 sq ft of exhibition space divided into 5 ecological & cultural regions; Average Annual Attendance: 120,000; Mem: 480
Income: Financed by state appropriation, pub & private donations, grants & contracts
Special Subjects: Photography, Ethnology
Collections: Contemporary Alaska photography; ethnographic collection; paintings & lithographs of Alaska subjects; native artifacts & art
Exhibitions: Temporary exhibits rotate every two to three months; summer free explainer program with talks on bears, wolves, Alaskan art & culture; Northern Inua live performances by World Eskimo Indian Olympiads; presentation & explanation on Northern Lights
Activities: Classes for adults & children; lect open to public, 3 vis lectrs per year; docent tours for grades 1-12; museum shop sells books, original art, reproductions, prints, slides

L **Elmer E Rasmuson Library,** Tel 907-474-7224; Fax 907-474-6841; Internet Home Page Address: www.uaf.edu/library; *Head Bibliographic Access Management* Natalie Forshaw; *Head Alaska & Polar Regions Colls* Susan Grigg; *Coll Develop Officer* Dennis Stephens; *Dir* Paul H McCarthy; *Information Services* Rheba Dupra
Open Mon - Thurs 7:30 AM - 11 PM, Fri 7:30 AM - 10 PM, Sat 10 AM - 6 PM, Sun 10 AM - 10 PM, when school is not in session 8 AM - 5 PM; Estab 1922 to support research & curriculum of the university; Circ 147,000
Income: Financed by state appropriation
Library Holdings: Book Volumes 2,260,000; Compact Disks; Manuscripts; Other Holdings Audio tapes; Film; Government documents; Photographs; Slides; Video Tapes
Collections: Lithographs of Fred Machetanz; paintings by Alaskan artists; C Rusty Heurlin; photographs of Early Alaskan bush pilots; print reference photograph collection on Alaska & the Polar Regions

HAINES

M **SHELDON MUSEUM & CULTURAL CENTER, INC,** Sheldon Museum & Cultural Center, 11 Main St, PO Box 269 Haines, AK 99827. Tel 907-766-2366; Fax 907-766-2368; Elec Mail museumdirector@aptalasha.net; Internet Home Page Address: www.sheldonmuseum.org; *Dir & Cur Sheldon Mus* Addison E Field; *Pres Chilkat Valley Historical Society* Cynthia L Jones; *Pres Mus Bd Trustees* Jim Heaton; *Store Mgr* Blythe Carter; *Educator* Kathy Friedle; *Registrar* Andrea Nelson
Open Winter Mon - Fri 1 - 4 PM, Summer daily 10 AM - 5 PM; Admis adults $3, children under 12 free; Estab 1924, under operation of Chilkat Valley Historical Society 1975 - 1991, incorporated Haines Borough facility, 1991; Maintains reference library; Average Annual Attendance: 23,000; Mem: 124; dues $12
Income: Financed by mem, user fees, Haines Borough appropriations, federal & state grants

Library Holdings: Audio Tapes; Book Volumes; Cassettes; Clipping Files; Fiche; Framed Reproductions; Kodachrome Transparencies; Lantern Slides; Manuscripts; Maps; Memorabilia; Motion Pictures; Original Art Works; Original Documents; Pamphlets; Periodical Subscriptions; Photographs; Prints; Records; Slides; Video Tapes
Special Subjects: Photography, American Indian Art, Ethnology, Woodcarvings, Eskimo Art, Metalwork, Ivory, Scrimshaw
Collections: Chilkat blankets; Tlingit Indian artifacts; ivory, silver, wood carvings; native baskets, pioneer artifacts, photos, maps, oral histories, archival; Eldred Rock Lighthouse Lens
Publications: Haines - The First Century; A Personal Look at the Sheldon Museum & Cultural Center; Journey to the Tlingits; More Than Gold-Nuggets of Haines History
Activities: Classes for adults & children; Tlingit language class; docent training; lect open to public; number of vis lectrs per y variees; competitions; Winter Film Festival; Friday brown bag lunches with historical programs; original objects of art lent to other museums; book traveling exhibitions 1-3 per year; museum store sells books, original art, prints, slides, jewelry, wood crafts

HOMER

M **BUNNELL STREET GALLERY,** 106 W Bunnel, Ste A, Homer, AK 99603. Tel 907-235-2662; Fax 907-235-9427; Elec Mail bunnell@xyz.net; Internet Home Page Address: www.bunnellstreet gallery.org; *Gallery Asst* Dana Roberts
Open Mon - Sat 10 AM - 6 PM; May - Aug open Sun Noon - 4 PM; No admis fee; Estab 1994 for art exhibitions & educ; Historic landmark building displaying innovative contemporary art; Average Annual Attendance: 11,000; Mem: 250; dues $30 individual, $50 family, $75 patron; annual meeting in Nov
Income: $150,000 (financed by mem, city & state appropriation, fund raising, Alaska State Council on the Arts, City of Homer Grant Prog through the Homer Foundation)
Publications: Newsletter, quarterly
Activities: Classes for adults & children; docent training; music; piano concerts; gallery talks; tours; lect open to public, 20 vis lectrs per year; poetry readings, slide lect by artist; art workshops various media; scholarship offered; sales shop sells original art

JUNEAU

L **ALASKA STATE LIBRARY,** Alaska Historical Collections, Alaska Historical Collections, PO Box 110571 Juneau, AK 99811-0571. Tel 907-465-2925; Fax 907-465-2990; Elec Mail aslhistorical@eed.state.ak.us; Internet Home Page Address: www.library.state.ak.us; *Cur Coll* Gladi Kulp; *Chief Librn* Kay Shelton
Open Mon - Fri 1 - 5 PM; No admis fee; Estab 1900; Part of library; Average Annual Attendance: 6,000
Income: State appropriation
Library Holdings: Book Volumes 34,000; Periodical Subscriptions 75; Photographs 110,000
Special Subjects: Photography, Manuscripts, Maps, Historical Material, Ethnology, American Indian Art, Anthropology, Eskimo Art
Collections: Winter & Pond; Wickersham Historical Site Collection; Skinner Collection; Grainger Post Card Collection
Publications: Books about Alaska, annual; Inventories for Individual Collections

M **ALASKA STATE MUSEUM,** 395 Whittier St, Juneau, AK 99801-1718. Tel 907-465-2901; Fax 907-465-2976; Elec Mail bruce_kato@eed.state.ak.us; Internet Home Page Address: www.museums.state.ak.us; *Chief Cur* Bruce Kato; *Cur Coll* Steve Henrikson; *Cur Museum Svcs* Ken DeRoux; *Cur Exhib* Mark Daughhetee; *Registrar* Donna Baron; *Exhibits Technician* Paul Gardinier; *Admin Asst* Debbie McBride; *Visitor Svcs* Lisa Golisek; *Visitor Serv* E Kai Augustine; *Asst to Visitor Svcs* Mary Irvine; *Security Off* Eugene Coffin; *Security Officer* Renate Howard; *Conservator* Scott Carrlee
Open Tues - Sat 10 AM - 4 PM (Sept 16 - May 15), daily 8:30 AM - 5:30 PM (May 16 - Sept 15), open until 8PM 1st Fri of winter months; Admis $5 summer, $3 winter, age 18 & younger free; Estab 1900 to collect, preserve, exhibit & interpret objects of special significance or value in order to promote pub appreciation of Alaska's cultural heritage, history, art & natural environment; Gallery occupies two floors housing permanent & temporary exhibits on 12,000 sq ft; Average Annual Attendance: 80,000 with more than 200,000 including outreach program
Income: Financed by state appropriation & grants
Collections: Alaskan ethnographic material including Eskimo, Aleut, Athabaskan, Tlingit, Haida & Tsimshian artifacts; Gold Rush & early Alaskan industrial & historical material; historical & contemporary Alaskan art; Natural History
Exhibitions: (2003) Photographs of Case and Draper; (2000) Eight Stars of Gold: The Story of Alaska's Flag; Dale DeArmand: The Nandalton Legends; Kayaks of Alaska and Sibera; Lockwood DeForest: Alaska Oil Sketches; Case & Draper Photographs 1898 - 1920
Publications: Eight Stars of Gold: The Story of Alaska's Flag (with CD)
Activities: Classes for adults & children; docent training; lect open to public, 2 vis lectr per year; gallery talks, tours & demonstrations; paintings & objects lent to other museums; 2-3 book traveling exhibitions per year; originate traveling exhibits to AK mus; sales shop sells books, magazines, reproductions, prints, Alaskan Native arts & crafts, outreach services to other museums

KETCHIKAN

M **CITY OF KETCHIKAN MUSEUM,** Tongass Historical Museum, 629 Dock St, Ketchikan, AK 99901. Tel 907-225-5600; Fax 907-225-5602; Elec Mail museumdir@city.ketchikan.ak.us; *Cur Coll* Christopher Hanson; *Cur Prog* Victoria Lord; *Dir* Michael Naab
Open summer Mon - Sun 8 AM - 5 PM, winter Wed - Sun 1 - 5 PM; Admis adults $2; Estab 1967 to collect, preserve & exhibit area articles & collect area photographs; Maintains reference library; Average Annual Attendance: 20,000

Income: $500,000 (financed by municipal funds)
Purchases: $9950
Collections: North West Indian Collection; ethnographic & development history, local artists contemporary artwork; local area history artifacts; works from local & Alaskan artists, photographs, manuscripts & newspaper archives
Publications: Art class listings; Calendar; Newsletter
Activities: Classes for adults; docent training; lect open to public, 5 vis lect per year; book traveling exhibitions

M **CITY OF KETCHIKAN MUSEUM DEPT,** Totem Heritage Ctr, 629 Dock St Ketchikan, AK 99901. Tel 907-225-5900; Fax 907-225-5901; Elec Mail museumdir@city.ketchikan.ak.us; *Dir* Michael Naab; *Sr Cur Prog* Victoria A Lord
Open summer daily 8 AM - 5 PM, winter Wed - Fri 1 PM - 5 PM; Admis $5, children under 12 free; Estab 1976 to preserve & teach traditional Northwest Coast Indian Arts; Average Annual Attendance: 80,000
Income: $200,000
Special Subjects: Sculpture, Historical Material
Collections: Indian arts; original totem poles; monumental sculpture
Activities: Classes for adults & children; docent training; workshops; lect open to public, 20 vis lectr per year; gallery talks; tours; arts & crafts festival; scholarships & work-study awards offered; museum shop sells books, magazines, original art, reproductions, prints, slides & native art
L **Library,** 629 Dock St, Ketchikan, AK 99901. Tel 907-225-5900; Fax 907-225-5901; *Dir* Michael Naab
Summer: Mon - Sun 8 AM - 5 PM; Winter: Wed - Fri 1 PM - 5 PM; No admis fee; For reference only
Library Holdings: Audio Tapes; Book Volumes 250; Cassettes; Clipping Files; Exhibition Catalogs; Fiche; Kodachrome Transparencies; Manuscripts; Original Art Works; Periodical Subscriptions 5; Slides; Video Tapes
Collections: 200 vols relating to northwest coast native art

NOME

M **CARRIE M MCLAIN MEMORIAL MUSEUM,** 200 E Front St, PO Box 53 Nome, AK 99762. Tel 907-443-6630; Fax 907-443-7955; Elec Mail museum@ci.nome.ak.us; *Dir* Laura Samuelson; *Asst Dir* Bev Gelzer
Open daily Noon-8PM summer, Tues-Sat Noon-6PM; No admis fee; Estab 1967 to show the history of Nome, Nome Gold Rush, Bering Strait Eskimo, Aviation, Dog mushing; Average Annual Attendance: 5,000
Income: Financed by City of Nome & supplemental grant projects & donations
Special Subjects: Ethnology, Dolls
Collections: Coons Collection; McLain Collection; Mielke Collection; permanent collection includes examples of art from 1890-1998, including basketry, carved ivory, ink, oil, skin drawings, stone carving, woodworking; extensive photography collection on database; gold rush & dog sledding memorabilia
Activities: Gallery talks; tours; individual paintings & original objects of art lent

SITKA

M **ALASKA DEPARTMENT OF EDUCATION, DIVISION OF LIBRARIES, ARCHIVES & MUSEUMS,** Sheldon Jackson Museum, 104 College Dr, Sitka, AK 99835. Tel 907-747-8981; Fax 907-747-3004; Elec Mail scott_mcadams@eed.state.ak.us; Internet Home Page Address: www.museums.state.ak.us; *Cur of Coll* Rosemary Carlton; *Security & Visitor Svcs* Scott McAdams; *Mus Security Clerk II* Lisa Bykonen
Open summer May 15 - Sept 15, 9 AM - 5 PM daily, winter Sept 16 - May 14 Tues - Sat 10 AM - 4 PM, cl Mon, Sun & holidays; Admis $4 over 18; Estab 1888, the first permanent mus in Alaska, for the purpose of collecting & preserving the cultural heritage of Alaskan Natives in the form of artifacts; The mus, a division of Alaska State Museums, occupies a concrete, octagonal structure from 1895 with permanent displays concerning Tlingit, Tsimshian, Haida, Aleut, Athabaskan & Eskimo cultures; Average Annual Attendance: 50,000
Income: $30,000 (financed by admis fee, sales, donation, State of Alaska)
Special Subjects: American Indian Art, American Western Art, Anthropology, Ethnology, Woodcarvings, Jade, Ivory, Scrimshaw
Collections: Ethnographic material from Tlingit, Haida, Tsimshian, Aleut, Athabaskan & Eskimo people; Alaskan ethnology produced through 1930
Publications: Brochures; catalogs of Ethnological Collection
Activities: Classes for adults & children; gallery interpreters & demonstrations; lect open to public, 4-6 vis lectr per year; gallery talks; exten dept serves entire state through Division; original works of art lent to qualified museums; museum shop sells books, original art, reproductions, prints, Alaskan Native arts & crafts
L **Stratton Library,** 801 Lincoln St, Sitka, AK 99835. Tel 907-747-5259; Fax 907-747-5237; Internet Home Page Address: www.sheldonjackson.edu; *Dir* Joseph MacDonald; *Archivist* June I. Degnan
Open Mon-Fri 8AM-5PM & 7-9PM, Sat & Sun 9AM-Noon & 1-5PM; Estab 1944 with Collection Library for curriculum support & meeting the needs of patrons interested in the arts; Serves students, academia & gen pub
Library Holdings: Audio Tapes; Book Volumes 82,000; Cassettes; Clipping Files; Exhibition Catalogs; Filmstrips; Framed Reproductions; Kodachrome Transparencies; Lantern Slides; Memorabilia; Motion Pictures; Original Art Works; Pamphlets; Periodical Subscriptions 352; Photographs; Records; Reels; Reproductions; Sculpture; Slides; Video Tapes
Collections: Alaska Reference Collection (containing works on Native Arts & Crafts); E W Merrill Glass Plate Photo Collection (representative of Sitka at the turn of the century)
Activities: Annual programs held in April; lect; demonstrations

M **SITKA HISTORICAL SOCIETY,** Isabel Miller Museum, 330 Harbor Dr, Sitka, AK 99835. Tel 907-747-6455; Fax 907-747-6588; Elec Mail sitkahis@pitalaska.net; Internet Home Page Address: www.sitkahistory.org; *Adminr* Karen Meizner
Open daily 8 AM - 5 PM (May - Sept), Tues - Sat 11 AM - 5 PM (Oct - Apr); No admis fee; Estab 1971 to preserve the history of Sitka, its people & industries; Average Annual Attendance: 70,000; Mem: 225; dues $15-$100; annual meeting in Oct

Income: Financed by grants, mem, donations & gift shop sales
Collections: Copy of warrant that purchased Alaska; 2000 documents & mss; Russian artifacts; library paintings of Alaska scenes; 10000 photographs; carved ivory, items for post-Russia Sitka through 1950
Exhibitions: Alaska Purchase; Diorama of Sitka in 1867 (Year of the Transfer); Forest Products Exhibit (past & present); Russian-American era Tlingit Culture; Last Qtr 19th Century Victorian Parlor & US Military Presence; First Flight Around the World; Fox Farming; WWII in Sotka
Activities: Lect open to pub, 4 vis lectr per year; awards given; sales shop sells books & reproductions of artifacts

SKAGWAY

M **SKAGWAY CITY MUSEUM & ARCHIVES,** PO Box 521, 700 Spring St Skagway, AK 99840. Tel 907-983-2420; Fax 907-983-3420; *Cur* Judith Munns
Open 9 AM - 5 PM, May - Sept; Oct - Apr on request; Admis adults $2, students $1; Estab 1961 to preserve & display items relating to the Klondike Gold Rush & Skagway history; Average Annual Attendance: 42,000
Income: Financed by admis
Collections: Gold Rush Era artifacts; Tlingit; traveling war canoe, duck neck quilt
Publications: Brochures
Activities: Sales shop sells, books, reproductions of old newspapers & postcards

ARIZONA

BISBEE

L **BISBEE ARTS & HUMANITIES COUNCIL,** Lemuel Shattuck Memorial Library, 5 Copper Queen Plaza, PO Box 14 Bisbee, AZ 85603. Tel 520-432-7071; Fax 520-432-7800; *Cur Archival Coll* Carrie Gustavson
Open Mon - Fri 10 AM - 4 PM, Sat & Sun by appointment; Estab 1971 to provide research facilities on copper mining & social history of Bisbee, Arizona, Cochise County & Northern Sonora, Mexico; For reference only
Income: $300 (financed by mem)
Purchases: $600
Library Holdings: Book Volumes 1,600; Cassettes 300; Clipping Files; Manuscripts; Periodical Subscriptions 3; Photographs 23,000; Reels 200
Special Subjects: Photography, Manuscripts, Maps, Historical Material
Activities: Classes for adults & children; docent training; lect open to public, 5 vis lectr per year; originate traveling exhibitions

CHANDLER

A **SCOTTSDALE ARTISTS' LEAGUE,** 5702 W Mercury Way, Chandler, AZ 85226. Tel 480-812-1076; Fax 480-857-0707; Elec Mail g.hoeck@home.com; Internet Home Page Address: www.gallery-online.org; *Pres* Gail Hoeck
During hospital vis hrs; No admis fee; Estab 1961 to encourage the practice of art & to support & encourage the study & application of art as an avocation, to promote ethical principals & practice, to advance the interest & appreciation of art in all its forms & to increase the usefulness of art to the public at large; Gallery in Scottsdale Memorial Hospital; Average Annual Attendance: 4,800; Mem: dues $35-50; monthly meetings first Tues Sept - June
Exhibitions: Yearly juried exhibition for members only; yearly juried exhibition for all Arizona artists (open shows)
Publications: Art Beat, monthly
Activities: Classes for adults; lect open to public, 6 vis lectr per year; gallery talks; tours; scholarships offered to art students

DOUGLAS

L **COCHISE COLLEGE,** Charles Di Peso Library, Art Dept, 4190 W Hwy 80 Douglas, AZ 85607-9724. Tel 520-417-4080, 515-5420; Internet Home Page Address: padme.cochise.cc.az.us/library/; *Libr Dir* Patricia Hotchkiss
Open Mon - Thurs 7:30AM-9PM, Fri 8AM-4:30 PM, Sat 10AM-2PM, Sun 1-5PM; No admis fee; Estab 1965
Income: Financed by state & local funds & the college
Library Holdings: Book Volumes 61,000; Exhibition Catalogs; Framed Reproductions; Memorabilia; Original Art Works; Periodical Subscriptions 300; Photographs; Prints; Reproductions; Sculpture
Special Subjects: Oriental Art
Collections: Oriental originals (ceramics & paintings); 19th century American & European Impressionists

M **DOUGLAS ART ASSOCIATION,** The Gallery and Gift Shop, 625 Tenth St, Douglas, AZ 85607. Tel 520-364-6410; *Pres* Maryann Nelson; *Dir* Terry J Mason
Open Mon - Sat 10:00 AM - 4 PM; No admis fee; Estab 1960 as a non profit tax exempt organization dedicated to promoting the visual arts & general cultural awareness in the Douglas, Arizona & Agua Prieta, Sonora area; The Gallery is operated in a city owned building with city cooperation; Average Annual Attendance: 2,000; Mem: 100; dues $15, $25 & $50
Income: Financed by mem & fundraising events, some lottery funds
Special Subjects: Southwestern Art
Exhibitions: Shows change about every six weeks
Publications: Monthly newsletter
Activities: Classes for adults & children; workshops in painting & various art activities; lect open to pub; gallery talks; competitions with cash awards; sales shop sells books, original art, prints, hand-made arts and crafts

DRAGOON

A AMERIND FOUNDATION, INC, Amerind Museum, Fulton-Hayden Memorial Art Gallery, 2100 N Amerind Rd, PO Box 400 Dragoon, AZ 85609. Tel 520-586-3666; Fax 520-586-4679; Elec Mail amerind@amerind.org; Internet Home Page Address: www.amerind.org; *Pres* Michael W Hard; *VPres* George J Gumerman; *Treas* Lawrence Schiever; *Exec Dir* John A Ware
Open Oct - May daily 10 AM - 4 PM, June - Sept Wed - Sun 10 AM - 4 PM; Admis adults $5, sr citizens, children (12-18) $3, under 12 free; Estab 1937 as a private, nonprofit archeological research facility & mus focusing on the native people of the Americas; Works on western themes, paintings & sculptures by 19th & 20th century Anglo & Native American artists; Average Annual Attendance: 13,000; Mem: 400; dues individual $30, family $40, Cochise Club $100-499, San Pedro Club $500-999, Casas Grandes Club $1,000 and above
Income: Financed by endowment income, grants, gifts
Special Subjects: Sculpture, Textiles, Watercolors, Painting-American, Pottery, American Western Art, American Indian Art, Archaeology, Ethnology, Scrimshaw, Southwestern Art
Collections: Archaeological & ethnological materials from the Americas; antique furniture; archives on film; ivory & scrimshaw; oil paintings; research & technical reports; santos; sculpture
Exhibitions: Images in Time; Traditions in Clay; The Prehistoric Southwest; recent acquisitions
Publications: Amerind Foundation Publication Series; Amerind New World Studies Series
Activities: Docent training; seminars; lect open to public, 3 visiting lect per year; gallery talks; tours for school groups; museum shop sells books, original art, Native American Arts & Crafts

L Fulton-Hayden Memorial Library, 2100 N Amerind Rd, PO Box 400 Dragoon, AZ 85609. Tel 520-586-3666; Fax 520-586-4679; Elec Mail libros@amerind.org; Internet Home Page Address: www.amerind.org; *Librn* Celia Skeeles
Library open by appointment only; Estab 1962 as archaeological research library for scholars
Income: Financed by endowment income, grants, gifts
Purchases: Miscellaneous ethnographic material from the American Southwest & Northern Mexico
Library Holdings: Audio Tapes; Book Volumes 27,500; Cards; Cassettes; Clipping Files; Exhibition Catalogs; Fiche; Filmstrips; Kodachrome Transparencies; Lantern Slides; Manuscripts; Memorabilia; Micro Print; Motion Pictures; Pamphlets; Periodical Subscriptions 60; Photographs; Reels; Reproductions; Slides; Video Tapes
Special Subjects: Archaeology, Ethnology, Anthropology
Collections: Collections of research & technical reports

FLAGSTAFF

M MUSEUM OF NORTHERN ARIZONA, 3101 N Fort Valley Rd, Flagstaff, AZ 86001. Tel 520-774-5213; Fax 520-779-1527; Elec Mail info@mna.mus.az.us; Internet Home Page Address: www.musnaz.org; *Deputy Dir* Dr Edwin L Wade; *Sr Cur Anthropology* Dr David R Wilcox; *Comptroller* Lynn Yeager; *Mktg Mgr* Michele Mountain; *Chair Bd Trustees* Thomas M Knoles; *Dir* Robert J Baughman; *Colbert Cur Paleontology* Dr David D Gillette; *Coll Mgr* Elaine R Hughes
Open Mon - Sun 9 AM - 5 PM, cl Thanksgiving, Christmas & New Year's Day; Admis adults $5, senior citizens $4, children $2; Estab 1928 to study, preserve & interpret the art & cultural & natural history of the Colorado Plateau; Maintains reference library; Average Annual Attendance: 80,000; Mem: 5500; dues $35-$500; annual meeting in Sept
Income: $2,500,000 (financed by endowment, mem & earned income)
Special Subjects: Painting-American, Photography, American Indian Art, American Western Art, Anthropology, Archaeology, Ethnology, Southwestern Art, Textiles, Ceramics, Crafts, Folk Art, Pottery, Silver, Historical Material, Juvenile Art
Collections: Works of Southwestern Native American artists; non-Indian art depicting Colorado Plateau subjects; archaeological & ethnographic artifacts & natural history specimens of the Colorado Plateau
Publications: Plateau Journal Magazine; Journal, semiannual; MNA, 3 per yr
Activities: Classes for adults & children; adult back-country expeditions; trips; docent training; lect open to public, 5-10 vis lectr per year; gallery talks; tours; competitions with prizes; scholarships offered; individual paintings & original objects of art lent to various institutions; lending coll contains 2200 original art works; book traveling exhibitions one per year; originate traveling exhibitions to other museums; museum shop sells books, original art, reproductions & fine Native American arts by master and emerging artists

M NORTHERN ARIZONA UNIVERSITY, Art Museum & Galleries, PO Box 6021, Flagstaff, AZ 86011-6021; Bldg 10 Rm M205 Flagstaff, AZ 86011. Tel 928-523-3471; Fax 928-523-1424; Elec Mail heidi.robinson@nau.edu, linda.stromberg@nau.edu; Internet Home Page Address: www.nau.edu/art_museum; *Opers Mgr* Linda Stromberg; *Curatorial Specialist* Heidi J Robinson
Open Mon - Fri 8 AM - 5 PM, summer hrs 7:30 AM - 4: 30 PM, cl nat and university holidays; No admis fee; Estab 1968 for the continuing education & service to the students & the Flagstaff community in all aspects of fine arts & to national & international fine arts communities; Gallery is a nonprofit educational institution; Average Annual Attendance: 10,000
Special Subjects: Southwestern Art, Coins & Medals
Collections: Contemporary ceramics; Master prints of the 20th century & American painting of the Southwest; Weiss collection of early 20th Century antiques, sculpture and paintings
Activities: Education program includes outreach to local schools; lect open to public, 3 vis lectr per year; national & international workshops & conferences; concerts; tours; competitions with awards; gallery talks; tours; scholarships; originate traveling exhibitions; museum shop sells books, original art works, prints & posters, reproductions, Hopi jewelry & other gift items; Beasley Student & Faculty Gallery Bldg 37 Flagstaff

GANADO

M NATIONAL PARK SERVICE, Hubbell Trading Post National Historic Site, PO Box 150, Ganado, AZ 86505. Tel 928-755-3475; Fax 928-755-3405; Elec Mail e_chamberlin@nps.gov; Internet Home Page Address: www.nps.gov/hutr; *Cur* Ed Chamberlin; *Supt* Anne Worthington; *Mus Tech* Kathy Tabaha; *Educ Dir* Naomi Shibata
Open May - Sept 8 AM - 6 PM, Oct - Apr 8 AM - 5 PM; No admis fee, tour buses $2; Estab 1967 to set aside Hubbell Trading Post as a historic site as the best example in Southwest of a Trader, an Indian Trading Post & people he served; Average Annual Attendance: 200,000
Income: Financed by federal appropriation
Special Subjects: American Indian Art, Anthropology, Archaeology, Photography, Painting-American, American Western Art, Southwestern Art, Period Rooms
Collections: Contemporary Western artists; ethnohistoric arts & crafts; furnishings; photographs
Exhibitions: Fully furnished 19th & 20th Century Trading Post & family home
Activities: Educ dept; lect open to public; tours; presentations; competitions; individual paintings & art objects are lent to certified museums; sales shop sells books, Indian arts & crafts, magazines, original art, prints & slides; semi annual Native American art auctions (May & Aug)

GLENDALE

M DEER VALLEY ROCK ART CENTER, 3711 W Deer Valley Rd Glendale, AZ 85308; PO Box 41998 Phoenix, AZ 85080-1998. Tel 623-582-8007; Fax 623-582-8831; Elec Mail dvrac@asu.edu; Internet Home Page Address: www.asu.edu/clas/anthropology /dvrac; *Educ* Lorelei Sells; *CEO* Peter Welsh; *Mus Shop Mgr* Theresa Cleary
Open Oct - Apr Tues - Sat 9 AM - 5 PM, Sun Noon - 5 PM, May - Sept Tues - Fri 8 AM - 2 PM, Sat 9 AM - 5 PM, Sun Noon - 5 PM; Admis adults $4, seniors & students $2, children 6-12 $1, children 5 & under free; Estab to preserve & provide pub access to the Hedgpeth Hills petroglyph site, to interpret the cultural expressions & be a center for rock art studies
Special Subjects: Anthropology, Archaeology
Activities: Clases for adults & children; lectrs open to the public, 4 visiting lectrs per year; museum shop sells books, magazines & original art

KINGMAN

M MOHAVE MUSEUM OF HISTORY & ARTS, 400 W Beale, Kingman, AZ 86401. Tel 520-753-3195; Fax 520-753-3195; Elec Mail mocohist@ctaz.com; Internet Home Page Address: www.ctaz.com/~mocohist/museum/index.htm; *Dir* Chambers Jaynell
Open Mon - Fri 9 AM - 5 PM, Sat & Sun 1 - 5 PM; Admis adults $3, children free; Estab 1960 to preserve & present to the pub the art & history of Northwest Arizona; Average Annual Attendance: 30,000; Mem: 600; dues $20-$125; annual meeting in Apr
Income: Financed by endowment, mem, sales & donations
Special Subjects: American Indian Art, Anthropology, Archaeology, Ethnology, Manuscripts, Historical Material, Restorations
Collections: American Indian Art; art & history of Northwest Arizona
Exhibitions: Quilt Show (Oct)
Activities: Classes for children; docent programs; lect open to public; museum shop sells books, prints, original art, craft items, reproductions

MESA

M ARIZONA MUSEUM FOR YOUTH, 35 N Robson St, Mesa, AZ 85201. Tel 480-644-2468; Fax 480-644-2466; Elec Mail azmus4youth@ci.mesa.az.us; Internet Home Page Address: www.ci.mesa.az.us; *Exhibits Cur* Rebecca Akins; *Exhibitions Designer* Larry Warner; *Exhibits Fabricator* Mark Fromeyer; *Exec Dir* Barbara Meyerson; *Educ Supv* Susan Sherrad; *Chmn* William H Mallender; *Adminstrative Svcs* Beth Bartholow
Open Tues - Fri & Sun 1 - 5 PM, Sat 10 AM - 5 PM; please call for current exhib & hours; Admis $3.50; Estab 1980 as fine art museum for children. Specially curated exhibits installed with original hands-on activities to involve children & families in the appreciation & making of art; Average Annual Attendance: 60,000; Mem: 300; dues $35 base
Income: $1,000,000 (financed by city appropriation)
Exhibitions: Exhibitions change every 4 months
Publications: Member newsletter, 3 times per year
Activities: Classes for children; tours; sales shop sells books & items for children as related to specific exhibit themes

M MESA ARTS CENTER, Mesa Contemporary Arts , 155 N Center, PO Box 1466 Mesa, AZ 85211-1466. Tel 480-644-2056; Fax 480-644-2901; Elec Mail patty.haberman@cityofmesa.org; Internet Home Page Address: www.mesaarts.com; *Cur* Patty Haberman; *Supv* Robert Schultz; *Asst Cur* Frank DeCurtis; *Registrar* Carolyn Zarr
Open Tues - Fri Noon - 8 PM, Sat Noon - 5 PM; No admis fee; Estab 1981 to provide an exhibition space for emerging & mid-career artists; Average Annual Attendance: 7,500; Mem: 200; dues vary; annual meeting in Spring
Income: Financed by city appropriation
Special Subjects: Painting-American, Photography, Sculpture, Watercolors, Southwestern Art, Textiles, Pottery
Collections: Permanent collection of contemporary arts & crafts, prints, crafts & traditional media
Activities: Classes & workshops for adults & children; awards $2,00 per exhibition; lect open to public, 2 vis lectr per year; gallery talks; tours; competitions with awards; book traveling exhibitions annually; originate traveling exhibitions through Ariz Commission on Arts

A **XICANINDIO, INC,** PO Box 1242, Mesa, AZ 85211-1242. Tel 480-833-5875; Fax 480-890-2327; *Secy* Bryon Barabe; *Exec Dir* Dina Lopez; *Pres* Gema Duarte
Open daily 9 AM - 5 PM; Estab 1977 as a nonprofit organization of Native American & Xicanindio artist to promote cross cultural understanding, preserve tradition & develop grass roots educational programs; Average Annual Attendance: 28,000; Mem: 20; annual meeting in Sept
Income: $64,000 (financed by endowment, city & state appropriation)
Publications: Papel Picado (paper cut-out techniques)
Activities: Lect open to public, 1 vis lectr per year

NOGALES

A **PIMERIA ALTA HISTORICAL SOCIETY,** 136 N Grand Ave, PO Box 2281 Nogales, AZ 85621. Tel 520-287-4621; Fax 520-287-5201; Elec Mail lealteresa@hotmail.com; *Acting Dir* Teresa Leal
Open Thurs-Sun 10 AM - 4 PM; No admis fee; Estab 1948 to preserve the unique heritage of northern Sonora Mexico & southern Arizona from 1000 AD to present; art is incorporated into interpretive exhibits; Also maintains a photo gallery; Average Annual Attendance: 15,000; Mem: 500; dues $20; annual meeting in Jan
Income: $55,000 (financed by mem, fundraising events, educ programs & grants)
Collections: Art & artifacts of Hohokam & Piman Indians, Spanish mission era & Mexican ranchers, Anglo pioneer settlement, early territorial maps, women costumes
Exhibitions: Railroad mining; firefighter
Publications: Centennial Book of Nogales; newsletter, 10 per year; annual calendar on historic subjects
Activities: Classes for adults & children; lect open to public, 3 vis lectr per year; tours; competitions; originate traveling exhibitions; sales shop sells books, maps & pins

L **Library,** 136 N Grand Ave, PO Box 2281 Nogales, AZ 85628-2281. Tel 520-287-4621; Fax 520-287-5201; *Acting Dir* Patricia Berrones-Molina
Collects books & archival material on Pimeria Alta, Northern Sonora & Southern Arizona
Income: $1,000
Purchases: $500
Library Holdings: Book Volumes 1,000; Cassettes; Clipping Files; Manuscripts; Memorabilia; Other Holdings Historical Photos & Maps 5,000; Pamphlets; Periodical Subscriptions 3
Collections: The Jack Kemmer Memorial Collection, books on the cattle industry of Texas, New Mexico, Arizona and California

PHOENIX

A **ARIZONA ARTISTS GUILD,** 8912 N Fourth St, Phoenix, AZ 85027. Tel 602-944-9713; Elec Mail info@arizonaartistsguild.org; Internet Home Page Address: http://arizonaartistsguild.net; *Pres* Vicki Lev; *First VPres* Judy Lawson
Estab 1928 to foster guild spirit, to assist in raising standards of art in the community & to assume civic responsibility in matters relating to art; Average Annual Attendance: 450; Mem: 360 juried, 90 assoc; dues $30; mem by jury; monthly meetings
Income: Financed by endowment & mem
Exhibitions: Horizons (annually in spring, members only); fall exhibition for members only; juried exhibition
Publications: AAG news, monthly
Activities: Classes for adults; lect sometimes open to public, 12 or more vis lectr per year; gallery talks; competitions with awards; workshops by vis professionals offered; paint-outs; sketch groups; demonstrations; scholarship offered

A **ARIZONA COMMISSION ON THE ARTS,** 417 W Roosevelt St, Phoenix, AZ 85003. Tel 602-255-5882; Fax 602-256-0282; Elec Mail artscomm@primenet.com; Internet Home Page Address: www.ArizonaArts.org; *Chmn* Jane Jozoff; *Exec Dir* Shelley Cohn; *Dir Educ* Alison Marshall; *Visual Arts Dir* Gregory Sale; *Performing Art Dir* Claire West; *Dir Pub Information & Literature* Paul Morris; *Expansion Arts Dir* Rudy Guglielmo; *Dir School-Work & Organization Develop* Cyndy Coon; *Dir After School & Educ Projects* Janie Leck-Grela; *Prog Adminr* Mollie Lankin-Hayes
Open 8 AM - 5 PM; No admis fee; Estab 1966 to promote & encourage the arts in the State of Arizona; Maintains reference library; Mem: Meetings, quarterly
Income: $1,152,800 (financed by state & federal appropriation)
Publications: Artists' Guide to Programs; monthly bulletin guide to programs
Activities: Workshops; conferences; artists-in-education grants program; scholarships & fels offered; originate traveling exhibitions 20-30 per year
L **Reference Library,** 417 W Roosevelt, Phoenix, AZ 85003. Tel 602-255-5882; Fax 602-256-0282; Elec Mail info@azarts.gov; Internet Home Page Address: www.azarts.gov; *Exec Dir* Robert C Booker
Open 8 AM to 5 PM; Topics related to the business of the arts. For reference only
Library Holdings: Book Volumes 900; Pamphlets; Periodical Subscriptions 25; Slides
Special Subjects: Art Education

A **ARIZONA WATERCOLOR ASSOCIATION,** 12809 N Second St, Phoenix, AZ 85022. Tel 623-584-2710; Tel 602-942-3157; Fax 623-584-2710; Elec Mail awa@watercolor.org; Internet Home Page Address: www.watercolor.org; *Treas* Pat Bears; *First VPres* Coleen Dixon; *Second VPres* Teri McDarby; *Third VPres* Gayla Bonnell; *Western Representative* Deloris Griffith; *Pres* Marsha Wright
Estab 1960 to further activity & interest in the watermedia, promote growth of individuals & group & maintain high quality of professional exhibits; Average Annual Attendance: 600; Mem: 500; qualifications for juried mem must be accepted in three different approved juried shows; all members who pay dues are considered members; dues $35
Income: Financed by dues & donations
Exhibitions: Two exhibitions yearly: Membership Show
Publications: AWA Newsletter, monthly; Directory, annual
Activities: Workshops; lect for members only; paint outs; competitions with awards

ATLATL
For Further Information see National and Regional Organizations

C **BANK ONE ARIZONA,** PO Box 71, Phoenix, AZ 85001. Tel 602-221-2236; *VPres & Mgr* Lydia Lee
Open to pub; Estab 1933 to support emerging artists throughout the state; encourage & promote talented high school students with Scholastic Art Awards; provide the pub with beautiful, integrated art in branch banks; Several thousand pieces of art collection displayed in over 200 branches, business offices & support facilities throughout the state of Arizona
Collections: Primarily Western, Southwestern art featuring many of the now classic Western artists; earliest lithograph dates back to the 1820s & coll continues through the present
Activities: Lect; gallery talks; tours by appointment; competitions, since 1942 state sponsor for Scholastic Art Awards throughout Arizona; purchase awards throughout the state, sponsor Employees' Art Show annually, with juried & popular choice awards, underwrite local art exhibitions on the Concourse of the Home Office Building; individual objects of art lent contingent upon bank policy

M **HEARD MUSEUM,** 2301 N Central Ave, Phoenix, AZ 85004-1323. Tel 602-252-8840; Fax 602-252-9757; Internet Home Page Address: www.heard.org; *Dir* Frank H Goodyear Jr; *Cur Colls* Diana Pardue; *Dir Research* Ann Marshall; *Dir Communications* Juliet Martin; *Cur of Fine Art* Margaret Archuleta; *Registrar* Sharon Moore; *Communications Mgr* Rebecca Murray; *Asst to Dir* Gloria Lomahaftewa; *Creative Dir* Lisa MacCollum; *Educ Servs Mgr* Gina Laczko; *Dir Develop* Marcia Halstead; *Dir Finance* Doug Thomey; *Librn & Archivist* Mario Nick Klimiades; *Mus Shop Mgr* Bruce McGee; *Guild Pres* Dave Dolgy; *Pres Board Trustees* Jim Meenaghan; *Assoc Registrar* Marcus Monenerkit; *Communications Mgr* Rebecca Stenhoim; *Dir Develop* Frank Bourget
Open Dailey 9:30 AM - 5 PM; Admis general $7, senior citizens 65 & up $6, children 4-12 $3, children under 4 free; Estab 1929 to collect, preserve & exhibit Native American art & artifacts, offering an expansive view of the Southwest as it was thousands of years ago & is today & to increase general awareness about Native American cultures, traditions & art; Art Galleries: Gallery of Indian Art, Native Peoples Gallery, North Gallery, COMPAS Gallery, World Cultures Gallery, South Gallery & Sandra Day O'Connor Gallery; Average Annual Attendance: 250,000; Mem: 5000; dues varies
Library Holdings: Auction Catalogs; Audio Tapes; Book Volumes 29,400; CD-ROMs; Cassettes; Clipping Files; Compact Disks; Exhibition Catalogs; Fiche; Manuscripts; Maps; Original Documents; Pamphlets 88; Periodical Subscriptions 240; Photographs; Prints; Records; Slides; Video Tapes 450
Special Subjects: Drawings, Hispanic Art, Mexican Art, Painting-American, Photography, Prints, Sculpture, Watercolors, American Indian Art, American Western Art, Bronzes, African Art, Archaeology, Southwestern Art, Textiles, Religious Art, Ceramics, Pottery, Primitive art, Woodcarvings, Dolls, Glass, Jewelry, Silver, Historical Material, Restorations, Tapestries
Collections: Barry M Goldwater Photograph Collection; Fred Harvey Fine Arts Collection; C G Wallace Collection; Archaeology; Native American fine arts; sculpture, primitive arts from the cultures of Africa, Asia & Oceania; American Indian
Exhibitions: (1999-00) Powerful Images: Portrayals of Native America
Publications: Earth Song Calendar (bi-monthly); The Heard Museum Journal (semi-annual); exhibition catalogs
Activities: Classes for adults & children; dramatic programs; docent training; outreach programs; music & dance performances; lect open to public, 6-8 vis lectr per year; concerts; gallery talks; tours; competitions with awards; scholarships & fels offered; exten dept serves Southwest; individual paintings & original objects of art lent to other art institutions & museums for exhibits; book traveling exhibitions; originate traveling exhibitions to other art institutions & museums; museum shop sells books, magazines, original art work & Native American art
L **Billie Jane Baguley Library and Archives,** 2301 N Central Ave, Phoenix, AZ 85004-1323. Tel 602-252-8840; Fax 602-252-9757; Elec Mail mario@heard.org; Internet Home Page Address: www.heard.org; *Library Archives Dir* Mario Nick Klimiades; *Asst Libr* Betty Murphy; *Archivist* LaRee Bates
Open Mon - Fri 10 AM - 4:45 PM; Estab 1929 as a research library for mus staff, members & the pub (in-house only); For reference only
Income: $11,000 (financed by mem & mus budget)
Library Holdings: Auction Catalogs; Audio Tapes; Book Volumes 26,500; Cassettes; Clipping Files; Exhibition Catalogs; Fiche; Filmstrips; Kodachrome Transparencies; Lantern Slides; Manuscripts; Maps; Memorabilia; Micro Print; Motion Pictures; Pamphlets; Periodical Subscriptions 250; Photographs 28,000; Prints; Records; Reels; Reproductions; Slides; Video Tapes
Special Subjects: Folk Art, Painting-American, Pre-Columbian Art, Crafts, Archaeology, Ethnology, American Indian Art, Primitive art, Anthropology, Eskimo Art, Mexican Art, Southwestern Art
Collections: Fred Harvey Company Research Collection; Native American Artists Resource Collection

M **PHOENIX ART MUSEUM,** 1625 N Central Ave, Phoenix, AZ 85004. Tel 602-257-1880; Fax 602-253-8662; Elec Mail info@phxart.org; Internet Home Page Address: www.phxart.org; *Cur American & Western Art* James K Ballinger; *Pres* Michael Greenbaum; *Deputy Dir Admin* Sherwood Spivey; *Dir Educ* Jan Krulick; *Deputy Dir External Affairs* Robert Chamberlain; *Mus Shop Mgr* Lee Werhan; *Pres Bd Trustees* Stephen Rineberg; *Cur Asian Art* Janet Baker; *Asst to Dir* Helen Bobince; *Registrar* Heather Northway; *Librn* Genni Houlihan; *Cur Fashion Design* Dennita Sewell; *Research Cur Asian Art* Claudia Brown; *Pub Information Officer* Cathy Arnold; *Cur Modern & Contemporary Art* Brady Roberts
Open Tues - Wed & Fri - Sun 10 AM - 5 PM, Thurs 10 AM - 9 PM, cl Mon; Admis to exhibition adults $7, senior citizens $5, students $3, children 6-17 free; Estab 1925, mus constructed 1959; Average Annual Attendance: 250,000; Mem: 7000; dues $50 & up; annual meeting in June
Income: $4,000,000 (financed by pub & private funds)
Special Subjects: Hispanic Art, Latin American Art, Mexican Art, Painting-American, Photography, Prints, Sculpture, Watercolors, Textiles, Costumes, Woodcuts, Decorative Arts, Painting-European, Portraits, Asian Art, Silver, Painting-British, Painting-Dutch, Baroque Art, Calligraphy, Miniatures, Painting-Flemish, Painting-Polish, Renaissance Art

Collections: Asian art; decorative arts; fashion design; 14th-20th century European & American art; Latin American art; Spanish Colonial art; Thorne Miniature Rooms; Western American art; Renaissance; Thorne Miniature Rooms; Western American art; Medieval art
Publications: Annual report; exhibition catalogs; quarterly newsletter
Activities: Classes for adults & children; docent training; lect open to public, 12 vis lectr per year; concerts; gallery talks; tours; competitions; originate traveling exhibitions; museum shop sells books, magazines, reproductions, prints, jewelry, slides & gifts from around the world

L **Art Research Library,** 1625 N Central Ave, Phoenix, AZ 85004-1685. Tel 602-257-1880; Fax 602-253-8662; Internet Home Page Address: www.phxart.org; *Librn* Genni Houlihan
Open Wed - Fri 11 AM - 3 PM; Estab 1959 to serve reference needs of the mus staff, docents, mem, students & pub; For reference only
Income: Financed by Museum operating funds
Library Holdings: Auction Catalogs; Book Volumes 40,000; Clipping Files; Exhibition Catalogs; Memorabilia; Other Holdings Auction Records; Ephemera; Pamphlets; Periodical Subscriptions 97; Reproductions; Slides
Special Subjects: Art History, Folk Art, Decorative Arts, Drawings, Etchings & Engravings, Graphic Arts, Islamic Art, Manuscripts, Ceramics, Conceptual Art, Latin American Art, Fashion Arts, Asian Art, Ivory, Jade
Collections: Arizona Artist Files; auction catalogs; museum archives; Rembrandt print catalogs; Whistler Print catalogs

C **WELLS FARGO,** Wells Fargo History Museum Phx, 145 W Adams, Phoenix, AZ 85003; 100 W Washington St, S4101-010 Phoenix, AZ 85003. Tel 602-378-1578; Fax 602-378-5174; Elec Mail whalenc@wellsfargo.com; Internet Home Page Address: www.wellsfargohistory.com; *Cur* Connie Whalen
Open Mon - Fri 10 AM - 3 PM by appt only; No admis fee; Estab Oct 3 2003 History Museum with art gallery; collection of 12 NC Wyeth Oil paintings of Western themes; Remington bronzes; M Dixon & F Schnoover oils; Average Annual Attendance: 9,000
Collections: Western scenes; Remington Bronzes; NC Wyeth; F Schnoover; M Dixon
Activities: Tours

PRESCOTT

M **GEORGE PHIPPEN MEMORIAL FOUNDATION,** Phippen Art Museum, 4701 Hwy 89 N, Prescott, AZ 86301. Tel 928-778-1385; Fax 928-778-4524; Elec Mail phippen@phippenartmuseum.org; Internet Home Page Address: www.phippenartmuseum.org; *Dir* Dr Gary Cassidy
Open daily (Memorial Day - Labor Day call for days and hrs; Admis adults $5, seniors & students $4, children under 12 free; Estab 1974 to exhibit art of the Americans West, collect & educ; Circ Reference only; Gallery has 6,000 sq ft; maintains reference library; Average Annual Attendance: 10,000; Mem: 500; dues $35 & up; annual meeting in Aug
Income: $400,000 financed by grants, sponsorships, mem, admis fees, special events
Library Holdings: Auction Catalogs; Book Volumes; Clipping Files; Exhibition Catalogs; Memorabilia; Original Documents; Periodical Subscriptions; Photographs; Prints; Reproductions; Sculpture; Slides; Video Tapes
Special Subjects: Drawings, Painting-American, Sculpture, Watercolors, American Indian Art, American Western Art, Bronzes, Southwestern Art, Ceramics, Crafts, Pottery, Etchings & Engravings, Landscapes, Historical Material, Cartoons
Collections: Permanent collection contains fine art depicting art of the American West
Exhibitions: Phippen Memorial Day Art Show; Annual Art Show, juried with 144 artists
Publications: Canvas, Phippen Museum members newsletter
Activities: Classes for adults & children; docent training; lect open to public, 10 vis lectr per year; concerts; gallery talks; tours; competitions & awards; individual paintings & original objects of art lent to various museums in the country; lending collection contains original art works, paintings & sculpture; book traveling exhibitions; originate traveling exhibitions; museum shop sells books, original art, reproductions, prints & gifts

A **PRESCOTT FINE ARTS ASSOCIATION,** Gallery, 208 N Marina St, Prescott, AZ 86301. Tel 928-445-3286; Fax 928-778-7888; Elec Mail pfaaoperations@qwest.net; Internet Home Page Address: www.pfaa.net; *Pres* Karen Baxter; *Managing Dir* LeDona Withaar; *Operations Mgr* Suzy Campbell; *Office Mgr* Sue Lord
Open Tues - & Sat 10 AM - 3 PM, Sun Noon - 4 PM; No admis fee, donations accepted; Estab 1968 as a nonprofit gallery & theatre to promote arts within the county & local community; Art Gallery is one large room below theater section in what was previously a Catholic Church; Average Annual Attendance: 20,000; Mem: 400; dues family $50, individual $25
Income: $30,000 (financed by mem & grants from Arizona Commission on Arts & Humanities Council)
Collections: 10 each yr-constantly changing
Publications: Newsletter
Activities: Classes for adults & children; docent training; lect open to pub, 2-3 vis lectrs per yr; concerts; scholarship; competitions with awards; gallery talks; scholarships offered; sales shop sells original art, prints, pottery, jewelry, glass & woven items

SCOTTSDALE

A **COSANTI FOUNDATION,** 6433 Doubletree Ranch Rd, Scottsdale, AZ 85253. Tel 480-948-6145; Internet Home Page Address: www.cosanti.com; *Asst to Pres* Scott M Davis; *Dir of Design* Tomiaki Tamura; *Admin* Mary Hoadley; *Pres* Paolo Soleri
Open Mon - Sat 11 AM - 5 PM; Suggested donation $1; Estab 1956 as a nonprofit educational organization by Paolo Soleri pursuing the research & develop of an

alternative urban environment; A permanent exhibit of original sketches, sculptures & graphics by Paolo Soleri; Average Annual Attendance: 50,000
Income: Financed by tuition, private donations & sales of art objects
Collections: Permanent coll of architectural designs & drawings by Paolo Soleri
Activities: Classes for adults & college students; academic conferences, experimental workshops; lect open to public; concerts; gallery talks; tours; scholarships offered; traveling exhibits organized & circulated; sales shop sells books, original art, prints, reproductions, slides

A **Arcosanti,** HC74 Box 4136, Mayer, AZ 86333. Tel 520-632-7135; Fax 520-632-6229; Internet Home Page Address: www.arcosanti.org; *Gen Mgr* Chris Ohlinger; *Pub Relations* Linda Roby
Open Mon - Sun 9 AM - 5 PM, tours on the hour 10 AM - 4 PM; Suggested donation for tour $6; Estab 1970 for architecture & urban design research & practical hands on experience, cultural events; A prototype arcology for 7000 people, combining compact urban structure with large scale, solar greenhouses on 25 acres of a 4000 acre preserve; Average Annual Attendance: 75,000
Income: Financed by art & crafts sales, tuition, volunteer labor & donations
Special Subjects: Architecture
Activities: Classes for adults & children; lect open to public, vis lectr vary; concerts; tours; scholarships & fels offered; original objects of art lent to other museums; originate traveling exhibitions circulated to museums, corporate space, exhibit halls attached to conventions; sales shop sells books, original art, reproduction, prints, slides, t-shirts, postcards & videos

A **FRANCHISE FINANCE CORPORATION OF AMERICA,** The Fleischer Museum, 17207 N Perimeter Dr, Scottsdale, AZ 85255-5402. Tel 480-585-3108; Fax 480-585-2225; WATS 800-528-1179; *Asst to Dir* Joan Hoeffel; *Exec Dir* Donna H Fleischer
Open 10 AM - 4 PM, cl holidays; No admis fee; Estab 1989 to provide a permanent home for the coll & develop a scholarly forum for educ on the art period; Average Annual Attendance: 25,000
Income: Financed by private funds
Collections: American Impressionism, California School from 1880 to 1940s; Russian & Soviet Impressionism 1930-1970s
Publications: Masterworks of California Impressionism, book; exhibition catalogs
Activities: Lect provided; tours by reservation only; museum shop sells books & prints

L **Fleischer Museum Library,** 17207 N Perimeter Dr, Scottsdale, AZ 85255-5402. Tel 480-585-3108; Fax 480-585-2225; *Asst to Dir* Joan Hoeffel; *Exec Dir* Donna H Fleischer
Open daily 10 AM - 4 PM, cl holidays; No admis fee; Estab 1990; Average Annual Attendance: 30,000
Income: $18,000 (financed by private collection)
Library Holdings: Book Volumes 800; Clipping Files; Exhibition Catalogs; Framed Transparencies; Kodachrome Transparencies; Memorabilia; Original Art Works; Pamphlets; Periodical Subscriptions 12; Photographs; Prints; Reproductions; Sculpture; Slides; Video Tapes
Collections: American Impressionism, California School; Russian & Soviet Impressionism from 1930-1980's
Publications: exhibit catalogs
Activities: Concerts; gallery talks; scholarships offered; museum shop sells books & prints

L **FRANK LLOYD WRIGHT SCHOOL,** William Wesley Peters Library, 12621 N Frank Lloyd Wright Blvd, PO Box 4430 Scottsdale, AZ 85261. Tel 480-860-2700; Fax 480-860-8472; Elec Mail wwplib@taliesin.edu; *Dir of Library* Elizabeth Dawsari
Open weekdays, 7:30 AM - 5:30 PM; Estab 1983
Library Holdings: Audio Tapes 19,000; Book Volumes 16,000; Cassettes; Clipping Files; Exhibition Catalogs; Pamphlets; Photographs; Reproductions; Slides; Video Tapes
Collections: 25,000 Collateral files & material; 100,000 drawings

L **SCOTTSDALE ARTISTS' SCHOOL LIBRARY,** 3720 N Marshall Way, Scottsdale, AZ 85251. Tel 480-990-1422; Fax 480-990-0652; Internet Home Page Address: www.scottsdaleartschool.org; WATS 800-333-5707; *Dir* Stephanie Lynch
Library Holdings: Book Volumes 2500; Exhibition Catalogs; Framed Reproductions; Original Art Works; Pamphlets; Periodical Subscriptions 20; Prints; Reproductions; Sculpture; Video Tapes
Special Subjects: Art History, Decorative Arts, Illustration, Photography, Commerical Art, Drawings, Etchings & Engravings, Graphic Design, Prints, Sculpture, Portraits, Watercolors, American Western Art, Bronzes, American Indian Art, Oriental Art

M **SCOTTSDALE CULTURAL COUNCIL,** (Scottsdale Center for the Arts) 7374 E Second St, Scottsdale, AZ 85251; 7380 E Second St, Scottsdale, AZ 85251. Tel 480-994-2787; Fax 480-874-4655; Elec Mail smoca@sccarts.org; Internet Home Page Address: www.smoca.org; *Dir* Susan Krane; *Sr Cur* Marilu Knode; *Asst Cur* Erin Kane
Open Tues - Sat 10 AM - 8 PM, Sun 12 PM - 5 PM, cl Mon; Admis $7 adults; $5 students; free for members & children under 15; Opened in 1999; prsents exhibitions of modern & contemporary art, architecture & design; Designed by Will Bruder, SMOCA features five galleries and an outdoor sculpture garden with one of James Turrell's "Skyspaces"; Average Annual Attendance: 37,000; Mem: 2,900; dues $30 - $5,000+
Income: Financed by mem, city appropriation & corporate sponsorship
Library Holdings: Book Volumes; Exhibition Catalogs
Special Subjects: Drawings, Architecture, Glass, Furniture, Photography, Prints, Sculpture
Collections: Paintings, prints, sculptures, photographs, drawings; James Turrell "Skyspace"
Exhibitions: Rotating exhibits
Publications: Exhibition catalogs
Activities: Classes for adults & children; docent training; gallery talks; tours; lect open to public, 10 vis lectr per year; exten dept serves local schools; book traveling exhibitions 5-6 per yr; originates traveling exhibition to other museums;

sales shop sells books, magazines, reproductions, prints, craft items & jewelry; Young @ Art Gallery, 7380 E Second St, Scottsdale, AZ 85251

M **SYLVIA PLOTKIN MUSEUM OF TEMPLE BETH ISRAEL,** 10460 N 56th St, Scottsdale, AZ 85253. Tel 480-951-0323; Fax 480-951-7150; Elec Mail museum@templebethisrael.org; Internet Home Page Address: www.sylviaplotkinjudaicamuseum.org; *Registrar* Thelma Bilsky; *Dir* Pamela Levin
Open Tues - Thurs 10 AM - 4 PM; Admis donations; Estab 1970 to promote education of Judaism; Tunisian Synagogue Gallery. Maintains library; Average Annual Attendance: 10,000; Mem: 500; dues $20 - $250; annual meeting Mar
Income: $40,000 (financed by endowment, mem & gifts)
Special Subjects: Photography, Sculpture, Textiles, Religious Art, Judaica, Silver, Tapestries, Period Rooms
Collections: Contemporary art reflecting the Jewish experience; Holiday Judaica; Jewish Life Cycles; Synagogue Period Room; Tunisian; AZ Jewish Experience
Publications: HA-OR, three times a year
Activities: Classes for adults & children; docent programs; lect open to public, 3 vis lectr per yr; concerts; tours; films; individual paintings & original objects of art are lent to other museums; lending collection contains 15,000 books & 200 videos; book traveling exhibitions 3 per yr; originate traveling exhibitions 1 per yr; mus shop sells original art

SECOND MESA

M **HOPI CULTURAL CENTER MUSEUM,** Rte 264, Box 7 Second Mesa, AZ 86043. Tel 520-734-6650; Fax 520-734-6650; *Dir* Anna Silas
Open Mon-Fri 8AM-5PM, Sat & Sun 8AM-3PM
Collections: Hopi arts & crafts; pre-historic & historic pottery; weavings; wood carvings; silver

TEMPE

ARIZONA STATE UNIVERSITY
M **ASU Art Museum,** Tel 480-965-2787; Fax 480-965-5254; Elec Mail artmuse@asuvm.inre.asu.edu; Internet Home Page Address: www.asuartmuseum.asu.edu; *Sr Cur* Heather Lineberry; *Registrar* Anne Sullivan; *Installationist* Stephen Johnson; *Dir* Marilyn A Zeitlin
Open academic yr Tues 10AM-9PM, Wed-Sat 10AM-5PM, Sun 1-5PM; No admis fee; Estab 1950 to provide esthetic & educational service for students & the citizens of the state; Permanent installations, changing galleries & various changing area; 48 shows annually; Average Annual Attendance: 55,000; Mem: 1,650
Income: $250,000 (financed by state appropriations, donations & earnings)
Special Subjects: Latin American Art, Painting-American, Prints, Sculpture, Ceramics, Crafts, Glass
Collections: American crafts, especially ceramics & glass; American painting & sculpture, 18th Century to present; Contemporary art; print collection, 15th Century to present; Latin American Art; Folk Art; 20th century ceramics
Publications: Too Late for Goya: Works by Francesc Torres; Art Under Duress: El Salvador 1980-Present; Bill Biola: Buried Secrets; Art of the Edge of Fashion
Activities: Educ dept; docent training; student docent program; special events; lect open to public, 12 vis lectr per year; gallery talks; tours; competitions; originate traveling exhibitions; museum shop sells books, original art & crafts, jewelry, cards
L **Hayden Library,** Tel 480-965-6164; Internet Home Page Address: www.asu.edu/lib; *Art Specialist* Thomas Grives; *Architecture Librn* Deborah Koshinsky; *Dean University Libraries* Sherrie Schmidt
Open Mon-Thurs 7AM-Midnight, Fri 7AM-7PM, Sat 9AM-5PM, Sun 10AM-Midnight
Income: Financed by state & other investors
Library Holdings: Book Volumes 2,826,679; Cards; Cassettes; Fiche; Maps; Periodical Subscriptions 31,694; Reels; Video Tapes
Special Subjects: Art History, History of Art & Archaeology, Archaeology, American Western Art, Interior Design, Art Education, American Indian Art, Anthropology, Coins & Medals, Architecture
M **Memorial Union Gallery,** Tel 480-965-6649; Fax 480-727-6212; Internet Home Page Address: www.asu.edu/mu; *Prog Coordr* Joy Klein
Open Mon - Fri 9 AM - 5 PM; No admis fee; Estab to exhibit work that has strong individual qualities from the United States, also some Arizona work that has not been shown on campus; Gallery is contained in two rooms with 1,400 sq ft space; fireplace; one wall is glass; 20 ft ceiling; 26 4 x 8 partitions; track lighting; one entrance and exit; located in area with maximum traffic; Average Annual Attendance: 30,000
Income: Financed by administrative appropriation
Purchases: $3,000
Collections: Painting, print & sculpture, primarily Altma, Gorman, Mahaffey, Schoulder & Slater
Exhibitions: Rotating exhibits
Activities: Internships; lect open to public, 4 vis lectr per year; gallery talks; competitions; originate traveling exhibitions
L **Architecture & Environmental Design Library,** Tel 480-965-6400; Fax 480-727-6965; Internet Home Page Address: www.asu.edu/caed/aedlibrary; *Dept Head* Deborah Koshinsky; *Archivist* James Allen; *Supv* Jodie Milam
Open academic yr Mon - Thurs 8 AM - 10 PM, Fri 8 AM - 5 PM, Sat Noon - 4 PM, Sun 2 - 10 PM; Estab 1959 to serve the College of Architecture & Environmental Design & the university community with reference & research material in the subjects of architecture, planning, landscape architecture, industrial design & interior design; Circ 35,000
Income: Financed by state appropriation
Library Holdings: Audio Tapes; Book Volumes 30,000; Cassettes; Fiche; Manuscripts; Memorabilia; Micro Print; Other Holdings Architectural models; Periodical Subscriptions 130; Photographs; Prints; Reels; Slides; Video Tapes
Special Subjects: Landscape Architecture, Industrial Design, Interior Design, Furniture, Architecture

Collections: Paolo Soleri & Frank Lloyd Wright Special Research Collections; Victor Olgyzy, Paul Schweiker, Litchfield Park, Will Bruder, Albert Chase MacArthur, other drawings & documents
L **Architectural Image Library,** Tel 480-965-5469; Fax 480-965-1594; Internet Home Page Address: www.asu.edu/mu; *Coordr* Diane Upchurch
Open daily 8AM-5PM; For reference & research staff & students; Circ 75,000
Library Holdings: Book Volumes 30,000; Prints; Slides 110,000
Special Subjects: Art History, Landscape Architecture, Photography, Etchings & Engravings, Graphic Design, Islamic Art, Painting-American, Painting-Dutch, Painting-Flemish, Painting-French, Painting-German, Painting-Italian, Sculpture, Painting-European, Printmaking, Interior Design, Asian Art, Primitive art, Furniture, Period Rooms, Pottery, Tapestries, Textiles, Woodcuts, Architecture

TUBAC

M **TUBAC CENTER OF THE ARTS,** 9 Plaza Rd, Tubac, AZ 85646; PO Box 1911, Tubac, AZ 85646. Tel 520-398-2371; Fax 520-398-9511; Elec Mail contactus@tubacarts.org; Internet Home Page Address: www.tubacarts.org; *Exec Dir* Josie E. DeFalla; *Pres* Larry Spooner
Open Mon - Sat 10 AM - 4:30 PM, Sun 1 - 4:30 PM; No admis fee; Estab 1963 to promote interest in arts and art education; Three galleries, one a Spanish Colonial Building, 300 running ft of exhibit space; Average Annual Attendance: 40,000; Mem: 800; dues $35-$500; annual meeting in Apr
Income: State arts council, grants, membership & contributions
Special Subjects: Painting-American, Sculpture, Watercolors, American Indian Art, American Western Art, Textiles, Ceramics, Crafts, Landscapes, Decorative Arts, Portraits, Historical Material
Exhibitions: Invitationals; members & non-members shows
Activities: Classes for adults & children; dramatic prog; docent training; lect open to public 10 per yr; competitions with awards; concerts; gallery talks; tours; 1 book traveling exhib per yr; sales shop sells books, magazines, original art, reproductions, jewelry & pottery
L **Library,** 9 Plaza Rd, Tubac, AZ 85646; PO Box 1911, Tubac, AZ 85646. Tel 520-398-2371; Fax 520-398-9511; Elec Mail jdefalla@tabacarts.org; Internet Home Page Address: www.tubacarts.org; *Dir* Josie DeFalla
Open Tues - Sat 10 AM - 4:30 PM; none; Estab 1964, 501(c)3 arts center; Brick territorial style bldg, 5,000 sq ft with paptio; Average Annual Attendance: 50,000; Mem: 850, $45 annual dues
Income: Financed by grants, gifts & contributions
Library Holdings: Book Volumes 850; Cards; Exhibition Catalogs; Slides
Special Subjects: Art History
Activities: Classes for adults & children; dramatic programs, docent training; lect open to public; concerts; gallery talks; tours; cash & non-cash exhib awards; mus shop sells books, original art, reproductions, prints, jewelry, pottery & weable art

TUCSON

A **NATIONAL NATIVE AMERICAN CO-OPERATIVE,** North America Indian Information & Trade Center, PO Box 27626, Tucson, AZ 85726-7626. Tel 520-622-4900; Elec Mail info@usaindianinfo.org; Internet Home Page Address: www.usaindianinfo.org; *Dir & Consultant* Fred Synder; *International Representative* Carole J Garcia
Open Mon - Sat 10 AM - 7 PM; No admis fee; Estab 1969 to provide incentive to 2700 American Indian artists representing over 410 tribes for the preservation of their contemporary & traditional crafts, culture & education through involvement in Indian cultural programs, including dances, traditional food, fashion shows & performances. Also sponsors various Indian events; Average Annual Attendance: 50,000-100,000; Mem: 2,700; meetings in Nov & Jan; American Indian Artists
Income: Financed through sales
Library Holdings: Book Volumes; Cassettes; Maps; Pamphlets; Periodical Subscriptions; Photographs
Special Subjects: American Indian Art
Collections: Native American arts & crafts, including jewelry, basketry, wood & stone carving, weaving, pottery, beadwork, quill-work, rug-making, tanning & leatherwork, dance & cookery
Exhibitions: Dance/Craft Competition
Publications: Native American Directory: Alaska, Canada, United States; Native American Reference Book (1996); Pow-Wow on the Red Road
Activities: Classes for adults; lect open to public, 5-10 vis lectr per year; concerts; competitions with prizes; scholarships offered; artmobile; book traveling exhibitions 40-50 per year; originate traveling exhibitions; museum shop sells books, magazines, original art & authentic American Indian crafts, books & tapes

M **TOHONO CHUL PARK,** 7366 N Paseo del Norte, Tucson, AZ 85704-4415. Tel 520-742-6455; Fax 520-797-1213; Internet Home Page Address: www.tohonochulpark.org; *Cur Exhibits* Vicki Donkersley; *Asst Exhibits Cur* Peggy Hazard; *Dir* Jo Falls; *Exec Dir* Joan Donnelly
Open Mon - Sat 9 AM - 5 PM, Sun 11 AM - 5 PM; Admis $5; Estab 1985 for people to experience the wonders of the Sonoran Desert & gain knowledge of natural & cultural heritage of the region; Changing exhibits featuring regional arts & artists; Average Annual Attendance: 130,000; Mem: 600; dues $20-$5000
Income: $2,400,000 (financed by mem, grants, donations & earned income)
Special Subjects: American Indian Art, Southwestern Art
Collections: Modern & contemporary Native American crafts of the Southwest
Exhibitions: 12 - 14 changing exhibits per year
Publications: Desert Corner Journal newsletter, bi-monthly
Activities: Classes for children & adults; docent training; concerts; tours; field trips; lect open to public, 12 - 15 vis lectr per year; museum store sells books, original art

M TUCSON MUSEUM OF ARTAND HISTORIC BLOCK, (Tucson Museum of Art) 140 N Main Ave, Tucson, AZ 85701. Tel 520-624-2333; Fax 520-624-7202; Elec Mail info@tucsonmuseumofart.org; Internet Home Page Address: www.tucsonmuseumofart.org; *Head Security* Delmar Bambrough; *CFO & Deputy Dir* Carol Bleck; *Mgr Support Svcs* Charlie Bodden; *Dir Educ* Stephanie J Coakley; *Coll Mgr & Registrar* Susan Dolan; *Dir Public Rel & Mktg* Meredith Hayes; *Interior Maintenance* Ed Jones; *Exec Dir* Robert E Knight; *Preparator* David Longwell; *Mus Shop Mgr* John McNulty; *Graphic Designer* Enjay Michaels; *Research Librn* Jill Provan; *Chief Cur & Cur Mod & Contemp Art* Julie Sasse; *Asst Registrar* Kristen Schmidt; *Dir Develop* Michele Schulze; *Chief Accountant* Ruth Sons; *Admin Asst* Alison Sylvester; *Mem & Vis Svcs Mgr* Katherine Wesolowski; *Bldgs & Grounds Supv* Allan Uno
Open Tues - Sat 10 AM - 4 PM, Sun Noon - 4 PM, cl Mon & major holidays; Admis adults $8, senior citizens $6, students $3, under 12 free, 1st Sun of month free; Estab 1924 to operate a private nonprofit civic art gallery to promote art educ, to hold art exhibitions & to further art appreciation for the pub; Galleries display permanent collections & changing exhibitions; Average Annual Attendance: 141,068; Mem: 2,500; dues Director's Circle $1000, President's Circle $500, patron $250, sustaining $100, sponsor $75, family $50, individual $40; student $20; annual meeting in June
Income: $2,635,645 (financed by grants, endowment, mem, city & state appropriations, contributions & generated income)
Library Holdings: Auction Catalogs; Book Volumes; CD-ROMs; Compact Disks; DVDs; Exhibition Catalogs; Maps; Original Documents; Pamphlets; Periodical Subscriptions; Photographs; Slides; Video Tapes
Special Subjects: Landscapes, Mexican Art, Pottery, Painting-American, Textiles, Sculpture, Latin American Art, Painting-American, Photography, Prints, Sculpture, Watercolors, Pre-Columbian Art, Southwestern Art, Painting-European, Portraits, Oriental Art, Period Rooms
Collections: Contemporary & decorative arts; contemporary Southwest, folk, Mexican, Pre-Columbian, Spanish Colonial, Western American & 20th century art
Publications: Quarterly Preview; exhibition catalogs
Activities: Classes for adults & children; docent training; lect open to public; gallery talks; tours; sponsored competitions; scholarships offered; mus shop sells books, magazines, original art, reproductions & prints

L Library, 140 N Main Ave, Tucson, AZ 85701-8290. Tel 520-624-2333, Ext 122; Fax 520-624-7202; Elec Mail jprovan@tucsonarts.com; Internet Home Page Address: www.tucsonarts.com; *Librn* Jill E Provan; *Grant Proj Dir* Jan Willkom
Open Mon - Fri 10 AM - 3 PM; No admis fee; Estab 1974 for bibliographic & research needs of Mus staff, faculty, students & docents; Circ 1,200; Open to public for research & study; Average Annual Attendance: 1,800; Mem: 2,000 - open for circulation to all museum members
Income: Financed by gifts & fund allocations
Purchases: 360 titles per yr
Library Holdings: Book Volumes 11,000; Cards; Clipping Files; Exhibition Catalogs 500; Fiche; Kodachrome Transparencies; Manuscripts; Other Holdings Indexes; Museum archives; Pamphlets 5,000; Periodical Subscriptions 35; Photographs; Prints; Slides 24,000; Video Tapes 100
Special Subjects: Folk Art, Decorative Arts, Mixed Media, Photography, Drawings, Etchings & Engravings, Painting-American, Painting-British, Painting-Dutch, Painting-Flemish, Painting-French, Painting-German, Painting-Italian, Painting-Japanese, Painting-Spanish, Pre-Columbian Art, Prints, Sculpture, Painting-European, Historical Material, History of Art & Archaeology, Watercolors, Ceramics, Crafts, Latin American Art, American Western Art, Printmaking, Art Education, Asian Art, American Indian Art, Porcelain, Eskimo Art, Furniture, Mexican Art, Southwestern Art, Jade, Costume Design & Constr, Glass, Mosaics, Stained Glass, Afro-American Art, Metalwork, Carpets & Rugs, Enamels, Handicrafts, Jewelry, Oriental Art, Religious Art, Silversmithing, Tapestries, Textiles, Woodcarvings, Woodcuts, Marine Painting, Landscapes, Scrimshaw
Collections: Biographic material documenting Arizona artists; Pre-Columbian; Spanish colonial; Latin American art TMA museum; Catalogs, historic block archives
Activities: Classes for adults & children; docent training; annual book sale fundraiser; book discussion groups; lec open to public; 10 vis lec per yr; annual book talk at local book store; gallery talks; tours; spons competitions; sells books & original art

UNIVERSITY OF ARIZONA

M Museum of Art, Tel 520-621-7567; Fax 520-621-8770; Elec Mail azs@email.arizona.edu/; Internet Home Page Address: artmuseum.arizona.edu/; *Exec Dir* Dr Charles A. Guerin; *Cur Educ* Lynn Berkowitz; *Assoc Cur Educ* Lisa Hastreiter-Lamb; *Chief Cur* Dr Peter Briggs; *Registrar* Richard Schaffer; *Exhib Specialist* Kevin Gillian; *Librn* Maurya Smith; *Information Specialist* Alisa Shorr; *Asst Cur Coll* Betsy Hughes; *Secy* Laura Ten Elshof; *Financial Admin* Tonia Blackwell
Open Sept 1 - May 15 Mon - Fri 9 AM - 5 PM, Sun Noon - 4 PM, cl Sat; May 15 - Sept 1 Mon - Fri 10 AM - 3:30 PM, Sun Noon - 4 PM, cl Sat; No admis fee; Estab 1955 to share with the Tucson community, visitors & the university students the treasures of three remarkable permanent collections: the C Leonard Pfeiffer Collection, the Samuel H Kress Collection & the Edward J Gallagher Jr Collection. One of the museums' most important functions is to reach out to schools around Tucson through the educ dept; Special exhibitions are maintained on the first floor of the mus; the permanent collections are housed on the second floor; Average Annual Attendance: 45,000
Income: Financed by state appropriation
Special Subjects: Drawings, Graphics, Hispanic Art, Latin American Art, Mexican Art, Painting-American, Prints, Etchings & Engravings, Landscapes, Afro-American Art, Collages, Painting-European, Painting-Japanese, Portraits, Marine Painting, Painting-British, Painting-Dutch, Painting-French, Baroque Art, Painting-Flemish, Painting-Polish, Painting-Spanish, Painting-Italian, Painting-German, Painting-Russian
Collections: Edward J Gallagher Collection of over a hundred paintings of national & international artists; Samuel H Kress Collection of 26 Renaissance works & 26 paintings of the 15th century Spanish Retablo by Fernando Gallego; C Leonard Pfeiffer Collection of American Artists of the 30s, 40s & 50s; Jacques Lipchitz Collection of 70 plaster models
Publications: Fully illustrated catalogs on all special exhibitions

Activities: Classes for adults & children; docent training; lect open to public, 10 vis lectr per year; concerts; gallery talks; tours; outreach tours; book traveling exhibitions 2-3 per year; originate traveling exhibitions to museums & schools; sales shop sells books, cards & poster reproductions

L Museum of Art Library, Tel 520-621-7567; Fax 520-621-8770; Elec Mail mauryas@u.arizona.edu; *Librn* Maurya Smith
Estab to assist staff & students working at mus with reference information; Not open to pub; telephone requests for information answered
Library Holdings: Book Volumes 5,000; Cassettes; Clipping Files; Exhibition Catalogs; Pamphlets; Periodical Subscriptions 16; Slides
Special Subjects: Art History
Activities: Docent training

M Center for Creative Photography, Tel 520-621-7968; Fax 520-621-9444; Internet Home Page Address: www.creativephotography.org; *Cur* Trudy Wilner Stack; *Registrar* Claudine Scoville; *Archivist* Leslie Calmes; *Librn* MIguel Juarez; *Acting Dir* Amy Rule
Open Mon - Fri 9 AM - 5 PM, Sat & Sun Noon - 5 PM; No admis fee; Estab 1975 to house & organize the archives of numerous major photographers & to act as a research center in 20th century photography; Gallery exhibitions changing approximately every six weeks; Average Annual Attendance: 30,000+
Income: Financed by state, federal, private & corporate sources
Special Subjects: Photography
Collections: Archives of Ansel Adams, Wynn Bullock, Harry Callahan, Aaron Siskind, W Eugene Smith, Frederick Sommer, Paul Strand, Edward Weston, Richard Aredon & others
Exhibitions: Various rotating exhibits, call for details
Publications: The Archive, approx 3 times per year; bibliography series; exhibitions catalogs; guide series
Activities: Lect open to pubic; gallery talks; tours; original objects of art lent to qualified museums; originate traveling exhibitions

L Library, Tel 520-621-1331; Fax 520-621-9444; Internet Home Page Address: www.creativephotography.org; *Librn* Miguel Juarez
Open Mon - Fri 10 AM - 5 PM, Sun Noon - 5 PM; Circ Non-circulating; Open to the pub for print viewing & research
Library Holdings: Audio Tapes; Book Volumes 15,000; Cassettes; Clipping Files; Exhibition Catalogs; Fiche; Manuscripts; Memorabilia; Original Art Works; Pamphlets; Periodical Subscriptions 95; Photographs; Reels; Slides; Video Tapes
Collections: Limited edition books; hand-made books; books illustrated with original photographs; artists' books

L College of Architecture Library, Tel 520-621-2498; Fax 520-621-8700; *Archives* Jeffrey Brooks; *Librn* Miguel Juarez
Open Mon - Thurs 9 AM - 9 PM, Fri 9 AM - 5 PM, Sat Noon - 4 PM, Sun 1 - 9 PM; Estab 1965
Income: $34,700 (financed by state appropriation)
Library Holdings: Book Volumes 14,000; Periodical Subscriptions 110; Video Tapes
Special Subjects: Landscape Architecture, Drafting, Architecture

M WOMANKRAFT, 388 S Stone Ave, Tucson, AZ 85701. Tel 520-629-9976; *Contact* Linn Lane
Open Tues, Wed & Sat 1 - 5 PM; No admis fee; Estab 1974 to claim & validate women artists; Craft area, topic gallery, featured artists each month; Average Annual Attendance: 5,000; Mem: 100; dues $30 & up
Collections: Members art collection
Activities: Classes for adults & children; dramatic programs; workshops & workshop series-poetry readings & performance; lect open to public

WICKENBURG

M MARICOPA COUNTY HISTORICAL SOCIETY, Desert Caballeros Western Museum, 21 N Frontier St, Wickenburg, AZ 85390. Tel 520-684-2272; Fax 520-684-5794; Elec Mail westernmuseum.org; Internet Home Page Address: www.westernmuseum.org; *Mktg & Pub Relations* Mary Ehlert; *Educs Progs Mgr* Peter Booth, PhD; *Business Mgr* Conni Davis; *Registrar* Nathan Augustine; *Mem* Linda Hughes
Open Mon - Sat 10 AM - 5 PM, Sun 12 - 4 PM; Admis general $5, sr citizens $4, children 6-16 $1, under 6 free; Estab 1960 to show the development of Wickenburg from prehistoric to present day; The museum houses western art gallery, mineral room, Indian room, period rooms & gold mining equipment; Average Annual Attendance: 35,000; Mem: 600; dues $25-$30; annual meeting in Jan
Income: $200,000 (financed by mem, private donations, endowments)
Special Subjects: Drawings, Painting-American, Photography, Sculpture, Watercolors, American Western Art, Bronzes, Southwestern Art, Textiles, Costumes, Folk Art, Landscapes, Decorative Arts, Manuscripts, Dolls, Furniture, Glass, Jewelry, Historical Material, Dioramas, Period Rooms
Collections: George Phippen Memorial Western Bronze Collection; 19th Century Decorative arts, textiles, Navajo rugs; Cowboy Art, bronze & paintings; Native American Art, minerals & gems; Western American Art
Exhibitions: Sole of the West: The Art & History of Cowboy Boots; Hays Spirit of the West
Publications: A History of Wickenburg to 1875 by Helen B Hawkins; The Right Side Up Town on the Upside Down River; Museum Highlights, newsletter bimonthly
Activities: Classes for adults & children; docent training; lect open to public, 15 vis lectr per year; gallery talks; tours; individual paintings & original objects of art lent to museum; book traveling exhibitions two per year; museum shop sells books, original art, reproductions, prints & slides

L Eleanor Blossom Memorial Library, 21 N Frontier St, PO Box 1446 Wickenburg, AZ 85358. Tel 520-684-2272; Fax 520-684-5794; Elec Mail dcwm@aol.com; Internet Home Page Address: www.westernmuseum.org; *Dir* Michael Ettema
Open Mon - Sat 10 AM - 5 PM by appointment; Open to members for reference only
Library Holdings: Book Volumes 2000; Periodical Subscriptions 25
Special Subjects: Manuscripts, History of Art & Archaeology, American Western Art

WINDOW ROCK

M **NAVAJO NATION,** Navajo Nation Museum, PO Box 1840, Window Rock, AZ 86515-1840. Tel 928-871-6675; Fax 928-871-6675; Internet Home Page Address: www.navajonationmuseum.org; *Dir* Geoffrey I Brown; *Cur* Clarenda Begay; *Archivist* Eunice Kahn; *Educ Cur* Norman Bahe
Open Mon 8 AM - 5 PM, Tues - Fri 8 AM - 8 PM, Sat 9 AM - 5 PM, , cl Sun, Federal and tribal holidays; No admis fee; Estab 1961 to collect & preserve items depicting Navajo history & culture art & natural history of region; Exhibit area approx 13,000 sq ft; Average Annual Attendance: 35,000
Income: Financed by tribal appropriation & donations
Special Subjects: Drawings, Sculpture, Watercolors, American Indian Art, Anthropology, Textiles, Pottery, Jewelry, Silver, Historical Material, Miniatures
Collections: Works in all media by Navajo Indian artists, & non-Navajo artists who depict Navajo subject matter; Navajo textiles, jewelry & historical objects
Exhibitions: (1999) Redwing T Nez; Navajo History Exhibit; Navajo Railroad Worker; Two Grayhill Rugs Exhibit; (2001) Andrew Van Tsihnahjinnie; (2002) Portraits of the People, E A Burbank at Hubbell Trading Post; (2002) Invitational Art Exhibit
Publications: Artist's directory & biographical file, exhibition publs
Activities: Educ program; classes for adults & children; school presentations; tours; conference/meeting/performance facilities for events; lect open to public; 4-6 vis lectrs per yr; concerts; gallery talks; tours; individual paintings & original works of art; lending collection contains 300 original works of art & 50,000 photographs; museum shop sells books, magazines, original art, reproductions, prints, video tapes, DVDs, t-shirts, arts & crafts

L **NAVAJO NATION LIBRARY SYSTEM,** PO Box 9040, Window Rock, AZ 86515. Tel 520-871-6376; Fax 520-871-7304; *Librn* Irving Nelson
Open Mon 8 AM-5 PM, Tues - Fri 8 AM-8PM, Sat 9 AM-5 PM, cl Sun; No admis fee; Estab 1949
Income: through the Navajo Nation
Library Holdings: Book Volumes 21,000; Periodical Subscriptions 50

YUMA

M **ARIZONA HISTORICAL SOCIETY-YUMA,** Sanguinetti House Museum & Garden, 240 Madison Ave, Yuma, AZ 85364. Tel 928-782-1841; Fax 928-783-0680; Elec Mail azhistyuma@cybertrials.com; Internet Home Page Address: www.yumalibrary.org (Click on Arizona Historical Society); *Cur* Carol Brooks; *Div Dir* Megan Reid
Open Tues - Sat 10 AM - 4 PM; Admis adults $3, Seniors & students $2, members & children under 12 free; Estab 1963 to collect, preserve & interpret the history of the lower Colorado River Regions; Average Annual Attendance: 2,500; Mem: 200; dues $40; annual meeting in Apr
Income: Financed by mem, state appropriation & donations
Library Holdings: Book Volumes; Clipping Files; Manuscripts; Maps; Original Documents; Other Holdings Oral History Tapes; Photographs
Special Subjects: Folk Art, Manuscripts, Portraits, Furniture, Glass, Porcelain, Historical Material, Maps, Period Rooms
Collections: Archives; Clothing; Furniture & Household Items; Photos & Maps; Trade & Business Items
Exhibitions: Lower Colorado River Region from 1540-1940; History Exhibits; Period Rooms
Publications: Newsletter
Activities: Lect; tours; living history; slide shows; walking tours; non-circulating library; museum collection contains books, artifacts, album-scrapbooks, archives & 12,400 photographs; museum shop sells books, reproductions, prints & turn of the century style gifts

M **YUMA FINE ARTS ASSOCIATION,** Art Center, PO Box 10295, Yuma, AZ 85366. Tel 520-329-6607; Fax 520-329-6616; Elec Mail contact@yumafinearts.com; Internet Home Page Address: www.yumafinearts.com; *Pres* Ual Drysdale; *Exec Dir* Louis LeRoy
Open Tues - Sun 10 AM - 5 PM; Admis adult $3, children $.50, free Tues; Estab 1962 to foster the arts in the Yuma area & to provide a showing space for contemporary art & art of the Southwest; Gallery is housed in new Yuma Art Center; Average Annual Attendance: 30,000; Mem: 350; dues $35 - $5000
Income: Financed by endowment, mem & city appropriation, grants & fundraising events
Special Subjects: Southwestern Art
Collections: Contemporary Art; Art of the Southwest
Publications: Art Notes Southwest, quarterly
Activities: Classes for adults & children; lect open to public, 10 vis lectr per year; concerts; gallery talks; tours; competitions; $3000 awards annually; individual paintings & original objects of art lent to other museums for specific exhibitions; book traveling exhibitions 6-10 times per year; originate traveling exhibitions; museum shop sells original art & art of the Southwest

ARKANSAS

CLARKSVILLE

UNIVERSITY OF THE OZARKS

L **Robson Library,** Tel 501-979-1382; Fax 501-979-1355; Internet Home Page Address: www.eidos.ozarks.edu; *Library Dir* Stuart Stelzer
Open Mon-Thurs 8AM-Midnight, Fri 8AM-4:30PM, Sat 11AM-5PM, Sun 2PM-Midnight; Estab 1891
Library Holdings: Book Volumes 89,000; CD-ROMs; Cassettes; Compact Disks; DVDs; Fiche; Periodical Subscriptions 12; Records; Reels; Slides 7,000; Video Tapes 76
M **Stephens Gallery,** Tel 501-979-1000, 979-1349 (Gallery); Fax 501-979-1349; *Gallery Dir* Blaine Caldwell

Open Mon - Fri 10 AM - 3 PM & by special arrangement; No admis fee; Estab 1986
Collections: Gould Ivory Collection; Pfeffer Moser Glass Collection
Exhibitions: Monthly exhibitions
Activities: Educ dept; lect open to public; concerts; gallery talks; tours

EL DORADO

A **SOUTH ARKANSAS ARTS CENTER,** 110 E Fifth St, El Dorado, AR 71730. Tel 870-862-5474; Fax 870-862-4921; Elec Mail saac@arkansas.net; Internet Home Page Address: www.saac-arts.org; *Pres* George Maguire; *Exec Dir* Beth James; *VPres* Robert Allen
Open Mon - Fri 9 AM - 5 PM; No admis fee; Estab 1965 for the promotion, enrichment & improvement of the visual & performing arts by means of exhibits, lectures & instruction & through scholarships to be offered whenever possible; Gallery maintained. New 2,000 sq ft gallery; Mem: 450; dues individual $25, seniors minimum $15; board of directors meeting second Tues every month
Income: Financed by mem, city & state appropriation
Collections: Japanese block prints (including Hokusai, Utamarro, Hiroshig); regional watercolorists; Indian Jewelry (Hopi, Zuni, Navaho)
Exhibitions: Various art shows in this & surrounding states; gallery shows, ten guest artists annually. One show monthly, featuring regional or national artists
Publications: Newsletter, quarterly
Activities: Classes for adults & children; theater & dance workshops; guitar lessons; visual arts classes; lect open to public; gallery talks; competitions; scholarships offered

FAYETTEVILLE

UNIVERSITY OF ARKANSAS

M **Fine Arts Center Gallery,** Tel 501-575-5202; Fax 501-575-2062; Internet Home Page Address: art.uark.edu/fineartsgallery/; *Gallery Dir* Shannon Dillard Mitchell
Open Aug - May Mon - Fri 9 AM - 5:30 PM; subject to change, call for details; No admis fee; Estab 1950 as a teaching and community art gallery in fields of painting, drawing, sculpture and architecture; One gallery with moveable display panels covers 80 x 40 ft, gallery is part of center for art and music; Average Annual Attendance: 7,500
Income: Financed by state appropriation
Collections: Permanent collection of paintings, photographs, prints and sculpture; Seven original Alexander Calder mobiles
Exhibitions: 10-12 exhibitions per year, featuring a variety of media MFA thesis exhibs; faculty artists exhib on rotating basis; vis artists progr
Activities: Classes for adults; lect open to the public, 6-8 vis lectr per year; concerts; gallery talks; competitions with awards; traveling exhibitions 1-2 per yr
L **Fine Arts Library,** Tel 479-575-4708; Internet Home Page Address: http://libinfo.uark.edu/fal/default.asp; *Librn* Norma Johnson
Open Mon - Thurs 8 AM - 11 PM, Fri 8 AM - 6 PM, Sat 10 AM - 6 PM, Sun 1 - 11 PM; Estab 1951 to support the curriculum in art & architecture; Circ 36,000
Library Holdings: Book Volumes 33,000; Exhibition Catalogs; Periodical Subscriptions 100
Special Subjects: Art History, Landscape Architecture, Art Education, Architecture

FORT SMITH

M **FORT SMITH ART CENTER,** 423 N Sixth St, Fort Smith, AR 72901. Tel 501-784-2787, 782-1156; Fax 501-784-9071; Elec Mail ftsartcenter@sbeglobal.net; Internet Home Page Address: www.ftsartscenter.com; *Pres Bd* Sharen Reeder; *Dir* Kathy Williams
Open daily 9:30AM-4:30PM, cl Mon, July 4, Labor Day, Thanksgiving & day after, Christmas Eve, Christmas Day, New Years Day & Memorial Day; No admis fee; Estab 1948 to provide art museum, art association and art education; Art Library maintained; Average Annual Attendance: 20,000; Mem: 400; dues indv $35, family $45, etc (tiered)
Income: $189,000 (financed by grants, mem, contributions & sales)
Library Holdings: Auction Catalogs; Book Volumes; Cards; Clipping Files; Exhibition Catalogs; Framed Reproductions; Memorabilia; Original Art Works
Special Subjects: Drawings, Painting-American, Photography, Prints, Sculpture, Watercolors, Porcelain
Collections: American painting, graphics and drawings; Boehm porcelain; local & regional art
Exhibitions: Two-three exhib per month; competitions
Publications: Bulletin, bi-monthly
Activities: Classes for adults, children & summer art camp; tours; competitions with awards; scholarships offered; original objects of art lent to CITT Government and corporate sponsors; Outreach programs for at risk youth & local nursing homes; off-site exhibits; sales shop sells books, original art, reproductions, prints, jewelry, clothing, ceramics, bronzes & wood carvings

HOT SPRINGS

M **THE FINE ARTS CENTER OF HOT SPRINGS,** (Hot Springs Art Center) 405 Park Ave, Hot Springs, AR 71901. Tel 501-624-0489; Elec Mail hanwayne@sbcglobal.net; Internet Home Page Address: www.hotspringsarts.org; *Exec Dir* Nan Wayne
Open Mon - Fri 10 AM - 2 PM; No admis fee; Estab 1947 as a multi-disciplinary Arts Center, for education, creative activities & encouragement of community participation; Exhib Center, gallery, gift shop; Average Annual Attendance: 5,000; Mem: patron $500, sponsor $250, subscriber & donor $100, family $50, partner $35, individual $20, student $10; annual meeting in Jan
Income: Financed by individual & corporate mem, grants from the Arkansas Arts Council & National Endowment for the Arts
Collections: Photos - Hot Springs Bath Houses; Marilyn Monroe collection
Exhibitions: regional, state & local artist exhibition

Publications: Class schedule brochures; monthly exhibit announcements; newsletters, 4 times per year
Activities: Classes for adults & children in art, dance, music; concerts; competitions with awards; scholarships offered; museum shop sells original art, pottery & woodcarvings

L **NATIONAL PARK COMMUNITY COLLEGE LIBRARY,** (Garland County Community College Library) 101 College Dr, Hot Springs, AR 71913. Tel 501-760-4110; Fax 501-760-4106; *Dir* Mary Farris
Open Mon - Thurs 7 AM - 9 PM, Fri 7 AM - 4:30 PM; Estab 1970
Income: Financed by state appropriation
Purchases: $50,000
Library Holdings: Book Volumes 750; Periodical Subscriptions 200; Video Tapes 150
Collections: Art history; pottery
Exhibitions: Rotating exhibitions

JONESBORO

M **ARKANSAS STATE UNIVERSITY-ART DEPARTMENT, JONESBORO,** Fine Arts Center Gallery, Caraway Rd, Jonesboro, AR; PO Box 1920, State University, AR 72467. Tel 870-972-3050; Fax 870-972-3932; Elec Mail cspeele@aztec.astate.edu; *Chair Art Dept* Curtis Steele; *Dir* Steven Mayes
Open weekdays 10 AM - 4 PM; No admis fee; Estab 1967 for educ objectives; recognition of contemporary artists & encouragement to students; Located in the Fine Arts Center, the well-lighted gallery measures 40 x 45 ft plus corridor display areas; Average Annual Attendance: 10,500
Income: $3956 (financed by state appropriation)
Collections: Contemporary paintings; contemporary sculpture; historical & contemporary prints; photographs
Publications: Exhibition catalogs
Activities: Lect open to public, 4-6 vis lectr per year; gallery talks; competitions; originate traveling exhibitions

L **Library,** 108 Cooley Dr, Jonesboro, AR; PO Box 2040, State University, AR 72467. Tel 870-972-3077; Fax 870-972-5706; *Dean* Dr Mary Moore; *Users Svcs Mgr* Anthony Phillips; *Reference Librn* Jeff Bailey
Library Holdings: Book Volumes 10,000; Cassettes; Fiche; Filmstrips; Kodachrome Transparencies; Motion Pictures; Periodical Subscriptions 79; Reels; Slides
Collections: Microfilm collection for 19th century photography

LITTLE ROCK

M **ARKANSAS ARTS CENTER,** Mac Arthur Park, PO Box 2137 Little Rock, AR 72203-2137. Tel 501-372-4000; Fax 501-375-8053; Internet Home Page Address: www.arkarts.com; *Dir & Chief Cur* Townsend D Wolfe III; *Cur Decorative Arts* Alan DuBois; *Registrar* Thom Hall; *Bus Mgr* Denise Woods
Open Mon - Sat 10 AM - 5 PM, Sun & holidays Noon - 5 PM; No admis fee to galleries & Decorative Arts Mus, admis charged for theatre activities; Estab 1937 to further the development, the understanding & the appreciation of the visual & performing arts; Six galleries, two for permanent collections, four for temporary exhibits, & eight at the Decorative Arts Mus; Average Annual Attendance: 350,000; Mem: 5000; dues from benefactor $20,000 to basic $40; annual meeting in Aug
Income: Financed by endowment, mem, city & state appropriation & earned income & private corporate, state, local & federal grants
Purchases: Peter Paul Rubens, Hygieia Goddess of Health Feeding the Serpent; Giacomo Manzu, Bust of Woman; Alison Saar, Invisible Man; Joseph Stella, Head of a Woman in Profile; William T Wiley, Gift of Ms Givings; John Himmelfarb, Broad Daylight Meeting; Morris Graves, Chalices; Mark Tobey, Untitled, ca1940; Hans Hofmann, Study for Fruit Bowl; Benny Andrews, Portrait of a Model & Cools
Special Subjects: Drawings, Painting-American, Prints, Decorative Arts
Collections: Drawings from the Renaissance to present, with major collection of American & European drawings since 1900; 19th & 20th century paintings & prints; 20th century sculpture & photographs; Oriental & American decorative arts; contemporary crafts & toys designed by artists
Publications: Members Bulletin, monthly; annual membership catalog; annual report; catalogue selections from the permanent collection; exhibit catalogues & brochures
Activities: Classes for adults & children; dramatic programs; children's theatre; docent training; lect open to public, 6-10 vis lectr per year; gallery talks; tours; competitions with awards; exten dept serving the state of Arkansas; artmobile; individual paintings & original objects of art lent to schools, civic groups & churches; lending collection contains motion pictures, original prints, paintings, 4300 phonorecords & 16,000 slides; book traveling exhibitions; originates traveling exhibitions; museum shop sells books, original art, reproductions, jewelry, crafts, cards & calendars

L **Elizabeth Prewitt Taylor Memorial Library,** 501 E 9th St, Little Rock, AR 72202; MacArthur Park, PO Box 2137 Little Rock, AR 72203; PO Box 2137, Little Rock, AR 72203. Tel 501-396-0341; Fax 501-375-8053; Elec Mail library@arkarts.com; Internet Home Page Address: www.arkarts.com; *Librn* Heather Higrite
Open Tues - Thurs 10 AM - 2 PM; Estab 1963 to provide resources in the arts for students, educators & interested pub; For reference only
Library Holdings: Auction Catalogs; Audio Tapes; Book Volumes 5,500; Cassettes; Clipping Files; Exhibition Catalogs; Kodachrome Transparencies; Motion Pictures; Pamphlets; Periodical Subscriptions 50; Photographs; Records; Slides; Video Tapes
Special Subjects: Folk Art, Decorative Arts, Historical Material, History of Art & Archaeology, Latin American Art, American Western Art, Asian Art, American Indian Art, Eskimo Art, Afro-American Art

M **HISTORIC ARKANSAS MUSEUM,** (Historic Museum of Arkansas) 200 E Third St, Little Rock, AR 72201. Tel 501-324-9351; Fax 501-324-9345; *Cur* Swannee Bennett; *Educ Coordr* Starr Mitchell; *Dir* William B Worthen Jr; *Dir Communications* Ellen Korenblat; *Develop Dir* Louise Terzia
Open daily 9 AM - 5 PM, Sun 1 - 5 PM, cl New Year's, Easter, Thanksgiving, Christmas Eve & Christmas Day; Admis to mus houses adults $2, senior citizens

(65 & over) $1.50, children $1, Museum Center & galleries free; Restoration completed 1941; Historic Arkansas Museum includes pre- Civil War homes, education space & galleries to interpret early Arkansas history; Average Annual Attendance: 50,000; museum shop sells books, original art, reproductions, prints & handmade crafts
Income: Financed by state & private funding
Special Subjects: Architecture, Drawings, Painting-American, American Indian Art, Archaeology, Ethnology, Costumes, Ceramics, Crafts, Folk Art, Etchings & Engravings, Afro-American Art, Decorative Arts, Manuscripts, Portraits, Furniture, Glass, Porcelain, Metalwork, Carpets & Rugs, Historical Material, Maps, Period Rooms, Embroidery, Laces
Collections: Arkansas made guns & furniture; Audubon prints; furnishing of the period; porcelain hands, prints & maps from the 19th century; silver collection; watercolors
Publications: Arkansas Made: The Decorative Mechanical & Fine Arts Produced in Arkansas 1819-1870, Vol I & Vol II
Activities: Classes for children; docent training; Log House activities include educational program for students & adults in candle dipping, cooking & needlework; reception center has award-winning video, exhibits & art gallery; tours; individual paintings & original objects of art lent to other museums & cultural institutions; originate traveling exhibitions to area museums & schools; museum store sells Arkansas made art & crafts

L **Library,** 200 E Third St, Little Rock, AR 72201. Tel 501-324-9351; Fax 501-324-9345; *Dir* W B Worthen Jr; *Cur* Swannee Bennett; *Educ Coordr* Starr Mitchell; *Pub Relations* Christie Eson
Open by appointment only; Estab 1941 to preserve & promote Arkansas history; Arkansas Artist Gallery contains 35 artists with new display monthly; Cromwell Hall contains historical exhibits 3 times a year; Average Annual Attendance: 50,000
Income: Financed by the state & private funds
Library Holdings: Audio Tapes; Book Volumes 1,000; Cassettes; Clipping Files; Framed Reproductions; Manuscripts; Original Art Works; Pamphlets; Periodical Subscriptions 8; Photographs; Prints; Reels; Reproductions; Slides
Collections: Arkansas-made decorative, mechanical & fine art
Exhibitions: Contemporary art; historical exhibits
Publications: Arkansas Made: The Decorative, Mechanical and Fine Art Produced in Arkansas 1819-1870
Activities: Classes for adults & children; dramatic programs; docent training; lect open to public, 3 vis lectr per year; tours; individual paintings & original objects of art lent to other museums; museum shop sells books, original art, reproductions, prints

M **QUAPAW QUARTER ASSOCIATION, INC,** Villa Marre, 1321 Scott, Little Rock, AR 72202; PO Box 165023, Little Rock, AR 72216. Tel 501-371-0075; Fax 501-374-8142; Elec Mail qqa@aristotle.net; Internet Home Page Address: www.quapaw.com; *Exec Dir* Roger D Williams; *Operations Asst* Michelle Bilello
Open Mon - Fri 9 AM - 1 PM, Sun 1 - 5 PM, & by appointment; Admis adults $3, senior citizens & students $2; Estab 1966; The Villa Marre is a historic house mus which, by virtue of its extraordinary collection of late 19th century decorative arts, is a center for the study of Victorian styles; Average Annual Attendance: 5,000; Mem: 350; dues $25 & up; annual meeting in Nov
Income: $95,000 (financed by mem, corporate support, grants & fundraising events)
Special Subjects: Textiles, Decorative Arts, Furniture
Collections: Artwork by Benjamin Brantley; curoies appropriate to an 1881 Second Empire Victorian home, late 19th & early 20th century furniture, textiles
Publications: Quapaw Quarter Chronicle, bimonthly
Activities: Classes for adults & children; docent training; lect open to public, vis lectr; tours; book traveling exhibitions; originate traveling exhibitions; sales shop sells books & magazines

L **Preservation Resource Center,** 1315 S Scott St, Little Rock, AR 72202; PO Box 165023, Little Rock, AR 72216. Tel 501-371-0075; Fax 501-374-8142; Internet Home Page Address: www.quapaw.com; *Exec Dir* Roger D Williams; *Operations Asst* Michelle Bilello
Open Mon - Fri 9 AM - 5 PM; No admis fee, donations; Estab 1976 for the assembly of materials relevant to historic buildings & neighborhoods in the greater Little Rock area
Income: Financed by private donations
Library Holdings: Book Volumes 250; Clipping Files; Kodachrome Transparencies; Lantern Slides; Manuscripts; Maps; Pamphlets; Periodical Subscriptions 12; Photographs
Special Subjects: Photography, Manuscripts, Maps, Architecture
Collections: Architectural drawings

M **UNIVERSITY OF ARKANSAS AT LITTLE ROCK,** Art Galleries, Dept of Art, 2801 S University Little Rock, AR 72204. Tel 501-569-8977; Fax 501-569-8775; Elec Mail becushman@uair.edu; *Cur Asst* Nathan Larson; *Cur* Brad Cushman
Open Mon - Fri 9 AM - 5 PM, Sun 2 - 5 PM; No admis fee; Estab 1976 as an academic resource for the university; Three gallery spaces in Fine Art Building on university campus. 2,500 sq ft, 650 sq ft, 900 sq ft, respectively. Maintains reference library; Average Annual Attendance: 2,000
Income: Financed by university
Special Subjects: Painting-American, Photography, Prints, Sculpture, Woodcuts, Etchings & Engravings
Collections: Graphic Arts, prints; Photography; Works on Paper, drawings
Activities: Lect open to public, 6-8 vis lectr per year; competitions; book traveling exhibitions 3-5 per year

L **UNIVERSITY OF ARKANSAS AT LITTLE ROCK,** Art Slide Library and Galleries, Fine Arts Bldg, Rm 202, 2801 S University Little Rock, AR 72204-1099. Tel 501-569-8976; Fax 501-569-8775; *Chmn* Win Bruhl; *Slide Cur* Laura Grace; *Gallery Cur* Brad Cushman
Open Mon - Fri 9 AM - 5 PM, Sun 1 - 4 PM; No admis fee; Estab 1978 for educational purposes; Gallery I, 2,500 sq ft, is a two story space; Gallery II, 500 sq ft, is glassed on three sides; Gallery III is a hallway for student works
Income: Financed by state funds & private donations

Library Holdings: Book Volumes 360; Clipping Files; Exhibition Catalogs; Filmstrips; Kodachrome Transparencies 160; Pamphlets; Periodical Subscriptions 15; Slides 80,000; Video Tapes 130
Collections: Photographs & other works on paper
Activities: Docent training; lect open to public, 3 vis lectr per year; gallery talks; student competitions with awards; scholarships offered; originate traveling exhibitions

MAGNOLIA

M **SOUTHERN ARKANSAS UNIVERSITY,** Art Dept Gallery & Magale Art Gallery, 100 E University, SAU Box 1309 Magnolia, AR 71753-5000. Tel 870-235-4000; Elec Mail rsstout@saumag.edu; Internet Home Page Address: www.saumag.edu/art; *Chmn Art Dept* Scotland Stout; *Prof* Steven Ochs; *Asst Prof* Doug Waterfield; *Pres* Steven G Gamble
Open Mon - Thurs 8 AM - 10 PM, Fri 8 AM - 5 PM, Sat 10 AM - 4 PM, Sun 2 - 10:30 PM (McGale Gallery), Mon, Wed & Fri 8 AM - 5 PM (Brinson Gallery); No admis fee; Estab 1970; Magale Library Art Gallery, foyer type with 120 running ft exhibition space, floor to ceiling fabric covered; Average Annual Attendance: 2,000; Scholarships
Income: Financed partially by state funds
Special Subjects: Prints
Collections: American printmakers
Exhibitions: Various professional exhibits
Activities: Classes for adults & children; lect open to public; gallery talks; tours; scholarships & fels offered; individual paintings & original objects of art lent to schools, nonprofit organizations

MONTICELLO

M **DREW COUNTY HISTORICAL SOCIETY,** Museum, 404 S Main, Monticello, AR 71655. Tel 870-367-7446, 367-5746; *Dir* Henri Mason; *Pres Commission Bd* Connie Mullis; *Treas* Kittie S Hoofman
No admis fee; Estab 1971; Average Annual Attendance: 3,000; Mem: dues benefactor $1,000, patron $500, corporate $200, friends of mus $100, individual with journal $25, individual $15; 160 members
Income: Financed by endowment, mem, city & county appropriation, fundraisers
Special Subjects: Historical Material
Collections: Antique Toys & Dolls; Civil War Artifacts; Indian Artifacts; Handwork & Clothing from early 1800s; Woodworking Tools; farm implements, log cabins, china
Exhibitions: Antique Quilts, Trunks, Paintings by Local Artists; Leather Parlor Furniture from late 1800s
Publications: Drew County Historical Journal, annually
Activities: Tours

MOUNTAIN VIEW

L **OZARK FOLK CENTER, ARKANSAS STATE PARK,** (Ozark Folk Center) Ozark Cultural Resource Center, 1032 Park Ave, PO Box 500 Mountain View, AR 72560. Tel 870-269-3280; Fax 870-269-2909; *Archival Asst* Tricia Hearn
Resource Center: Open Wed - Sat 1 PM - 5 PM; Resource Center: No admis fee; The Park was estab in 1973 to demonstrate various aspects of traditional culture of the Ozark Mountain region, the Resource Center was estab in 1975 to preserve the artifacts aspects & documentary history of the Ozark Region culture, crafts & music; The Resource Center is maintained for pub reference only; Average Annual Attendance: 200
Income: $70,000 (financed by state appropriation & auxiliary committee)
Library Holdings: Audio Tapes; Book Volumes 10,000; CD-ROMs; Cassettes; Clipping Files; Compact Disks; DVDs; Exhibition Catalogs; Filmstrips; Kodachrome Transparencies; Manuscripts; Maps; Memorabilia; Motion Pictures; Original Art Works; Pamphlets; Periodical Subscriptions 50; Photographs; Prints; Records; Reels; Slides; Video Tapes
Special Subjects: Art History, Constructions, Folk Art, Landscape Architecture, Decorative Arts, Photography, Drawings, Graphic Arts, Manuscripts, Historical Material, Portraits, Crafts, Art Education, Video, Furniture, Costume Design & Constr, Glass, Embroidery, Handicrafts, Textiles, Woodcarvings, Landscapes, Laces, Architecture
Collections: Traditional Ozark crafts; music folios & sheet music; 30 yrs of Live Folk Center performances
Activities: Lect open to public; concerts; tours; awards; workshops; sales shop sells books, magazines, slides

PINE BLUFF

A **ARTS & SCIENCE CENTER FOR SOUTHEAST ARKANSAS,** 701 Main, Pine Bluff, AR 71601. Tel 870-536-3375; Fax 870-536-3380; Elec Mail asc@seark.net; *Dir Educ* Amy Peck; *Dir Performing Arts* Phil Conte; *Dir Operations* Nell Brown; *Cur Coll & Exhib* Malinda Chadsey; *Dir* Mary Brock
Open Mon - Fri 10 AM - 5 PM, Sat - Sun 1 PM - 4 PM; No admis fee; Opened in 1968 in Civic Center Complex; mission is to provide for the practice, teaching, performance & understanding of the Arts & Sciences, opened new facility 1994; 22,000 sq ft facility containing four galleries & a 232 seat theatre, instructional studio; Average Annual Attendance: 55,000; Mem: 1,000; dues family $50
Income: $727,000
Library Holdings: Book Volumes; CD-ROMs; Cassettes; Clipping Files; Exhibition Catalogs; Original Art Works; Photographs; Sculpture; Video Tapes
Special Subjects: Photography, Prints, Sculpture, Watercolors, Painting-American, Afro-American Art
Collections: Photographs by: Matt Bradley; J C Coovert of the Southern Cotton Culture, early 1900s; Howard S Stern; John M Howard Memorial Collection of Works by African American Artists; art deco/noveau bronze sculptures; small works on paper (Arkansas artists); works on paper by local, national & international artists

Exhibitions: Art Gallery Exhibitions; Biennial Regional Competition; science exhibitions; annual cultural project
Activities: Classes for adults & children; dramatic programs; docent training; lect open to public, 3-5 vis lectr per year; concerts; gallery talks; tours; sponsoring of competition; extension program for 10 counties of Southeast Arkansas; book traveling exhibitions; originate traveling exhibitions to museums meeting facility requirements

M **PINE BLUFF/JEFFERSON COUNTY HISTORICAL MUSEUM,** 201 E Fourth, Pine Bluff, AR 71601. Tel 501-541-5402; Fax 501-541-5405; Elec Mail jcmuseum@ipa.net; *Dir* Sue Trulock; *VPres* Connie Carty; *Publicity & Promotions* Virginia Cloar
Open Mon - Fri 9 AM - 5 PM, Sat 10 AM - 2 PM; No admis fee; Estab 1980 to collect, preserve & interpret artifacts showing the history of Jefferson County; Restored Union train station; Average Annual Attendance: 20,000; Mem: 300; Dues $10 - $1,000 ann.
Income: $27,000 (financed by county Quortum Court appropriation)
Special Subjects: Historical Material
Collections: Clothing dating from 1870; personal artifacts; photographs; tools & equipment; Quapau Indian artifacts
Exhibitions: Bottle Collection; Made in Pine Bluff AR; exhibit of dolls; Quapaw Indian Artifacts; Settlers Exhibit; Civil War Exhibit; World War I; World War II; Local Black History exhibit
Publications: The Museum Record, quarterly newsletter
Activities: Lect open to public, 2 vis lectr per year; gallery talks; tours

SPRINGDALE

M **ARTS CENTER OF THE OZARKS,** 214 S Main, Springdale, AR 72765; PO Box 725, Springdale, AR 72765. Tel 501-751-5441; Fax 501-927-0308; Elec Mail acozarks@swbell.net; Internet Home Page Address: www.artscenteroftheozarks.org; *Dir Visual Arts* Lindsay Moover; *Dir Theatre* Harry Blundell; *Dir* Kathi Blundell
Open Mon - Fri 9 AM - 5 PM, Sat 9AM-3PM; No admis fee; Estab 1968, merged with the Springdale Arts Center to become Arts Center of the Ozarks in 1973 to preserve the traditional handcrafts, to promote all qualified contemporary arts & crafts, to help find markets for artists & craftsmen; Local & regional artists; Mem: 900; dues $20 & up
Income: Financed by mem & state appropriations
Exhibitions: Exhibitions change monthly
Publications: Arts Center Events, monthly; newsletter, bimonthly
Activities: Adult & children's workshops; instruction in the arts, music, dance & drama run concurrently with other activities; eight theater productions per year; concerts, arts & crafts

M **CITY OF SPRINGDALE,** Shiloh Museum of Ozark History, 118 W Johnson Ave, Springdale, AR 72764. Tel 479-750-8165; Fax 479-750-8171; Elec Mail shiloh@springdaleark.org; Internet Home Page Address: www.springdaleark.org/shiloh; *Educ Coordr* Pody Gay; *Exhib Designer* Curtis Morris; *Outreach Coordr* Susan Young; *Dir* Allyn Lord; *Coll Mgr* Carolyn Reno; *Librn* Marie Demeroukas; *Secy* Betty Bowling; *Collections Asst* Heather Marie Wells
Open Mon - Sat 10 AM - 5 PM; No admis fee; Estab 1968 to exhibit history & culture of Northwest Arkansas; Displays in main exhibit hall of 4500 sq ft, halls, meeting room & a restored 19th century home; Average Annual Attendance: 25,000; Mem: 1000; dues begin at $10
Income: $520,000 (financed by endowment, mem, city appropriation, private & pub grants)
Library Holdings: Book Volumes; Clipping Files; Manuscripts; Maps; Periodical Subscriptions; Photographs; Prints
Special Subjects: Architecture, Photography, Crafts, Folk Art, Primitive art, Manuscripts, Dolls, Historical Material, Maps, Period Rooms
Collections: Folk Arts; Ozarks Photographers; Charles Summey Oils; Essie Ward Primitive Paintings
Exhibitions: Essie Ward; Charles Summey; Peggy McCormack
Publications: Newsletter, quarterly
Activities: Programs & workshops for adults & children; docent training; lect open to public, 10 vis lectr per year; lending collection contains 500 items; retail store sells books, magazines & original art

STUTTGART

A **GRAND PRAIRIE ARTS COUNCIL, INC,** Arts Center of the Grand Prairie, 108 W 12th St, PO Box 65 Stuttgart, AR 72160. Tel 870-673-1781; Elec Mail artscenter@cpomail.net; *Pres* Becky Goetz; *Ex Dir* Wanda Loudermilk; *Prog Dir* Meredith Steward
Open Mon - Fri 10 AM - 12:30 PM & 1:30 - 4:30 PM, cl Sat & Sun; No admis fee; Estab 1956 & incorporated 1964 to encourage cultural development in the Grand Prairie area, to sponsor the Grand Prairie Festival of Arts held annually in Sept at Stuttgart. Estab as an arts center for jr & sr citizens; Average Annual Attendance: 2,500; Mem: 250; dues $25 & up; monthly meetings
Income: Financed by mem & donations
Collections: Permanent collection started by donations
Exhibitions: Monthly exhibitions of Arkansas artists
Publications: Festival invitations; newsletter, monthly; programs
Activities: Classes for adults & children; dramatic programs; lect open to public, 4-6 vis lectr per year; gallery talks; competitions with awards; monthly gourmet coffee house featuring various types of music & comedy; originate traveling exhibitions

CALIFORNIA

ALHAMBRA

AMERICAN SOCIETY OF BOOKPLATE COLLECTORS & DESIGNERS

For further information, see National and Regional Organizations

BAKERSFIELD

M BAKERSFIELD ART FOUNDATION, Bakersfield Museum of Art, 1930 R St, Bakersfield, CA 93301. Tel 661-323-7219; Fax 661-323-7266; Internet Home Page Address: www.csub.edu/bma; *Exec Dir* Charles Meyer; *Admin Asst* Nicole Carrol
Open Tues - Sat 10 AM - 4 PM, Sun Noon - 4 PM, cl Mon; Admis adult $4, seniors $3, students & children under 12 $2, children 6 & under free; Estab to provide the facilities & services of a municipal art museum which will nurture & develop the visual arts in Kern County; Gallery is a one story building located in Camellia Garden of Central Park; maintains reference library; Average Annual Attendance: 50,000; Mem: 800; dues $20-40; Board meeting second Mon each month
Income: Financed by corporate, state & local public, & private nonprofit sources
Special Subjects: Painting-American
Collections: California oils & watercolors, emphasis on impressionistic art
Publications: Catalogues with each exhibit (6 yrly); Perspective, monthly
Activities: Classes for adults & children; docent training; lect open to public; gallery talks; tours; juried competitions with prizes; scholarships offered; book traveling exhibitions; originate traveling exhibitions; museum shop sells books, magazines, gifts, crafts & art-related items

M BUENA VISTA MUSEUM OF NATURAL HISTORY, 2018 Chester Ave, Bakersfield, CA 93301. Tel 661-324-6350; Fax 661-324-7522; Elec Mail bvmnh@sharktoothhill.com; Internet Home Page Address: www.sharktoothhill.com;Bob Smith; Tina White; Lisa Brown
Open Thurs - Sat 10 AM - 5 PM, also by appt; Admis adults $3, children, seniors & students with ID $2; group rates available; Mus promotes scientific & educ aspects of art history with emphasis on paleontology & anthropology in Kern County; Mem: memberships available
Special Subjects: Historical Material, Anthropology
Collections: The Bob & Mary Ernst Coll, the largest pvt coll of Sharktooth Hill Miocene fossils in the world
Exhibitions: Sharktooth Hill, Kern County, CA; San Joaquin Valley Through Time; McKittrick Tar Seeps; Mount St Helens: 20 Years Later; San Andreas Fault; Yosemite Valley
Publications: Sharkbites, newsletter
Activities: Geology field trips; workshops; events; museum-related items for sale

M KERN COUNTY MUSEUM, 3801 Chester Ave, Bakersfield, CA 93301. Tel 661-852-5000; Fax 661-322-6415; Internet Home Page Address: kcmuseum.org; *Asst Dir* Jeff Nickell; *Dir* Carola R Enriquez; *Cur* Lori Wear
Open Mon - Fri 10 AM - 5 PM, Sat & holidays 10 AM - 5 PM, Sun noon - 5 PM; Admis adults $8, senior citizens $7, children 3-12 $6, under 3 free; Estab 1945 to collect & interpret local history & culture, mainly through a 14 acre outdoor mus. Also has Lori Brock Children's Discovery Center; One main building, 1929 Chamber of Commerce Building, houses changing exhibitions on assorted topics; modern track lighting, temporary walls; Average Annual Attendance: 103,000; Mem: 650; dues family $60
Income: $1.7 million (financed by county appropriation, earned income & non-profit foundation)
Purchases: Archival, occasionally decorative arts
Library Holdings: Manuscripts; Maps; Memorabilia; Motion Pictures; Original Documents; Other Holdings; Pamphlets; Periodical Subscriptions; Photographs; Prints; Records; Video Tapes
Special Subjects: Architecture, Photography, Archaeology, Ethnology, Costumes, Decorative Arts, Historical Material, Maps, Period Rooms, Laces
Collections: 60-structure outdoor museum covering 14 acres; Photographic Image Collection; Material Culture; Paleontology; Natural History
Publications: Brochure on the Museum; The Forgotten Photographs of Carleton E Watkins
Activities: Classes for adults & children; docent training; lect open to public; concerts; tours; Candlelight Christmas & Heritage celebrations; competitions with awards; book traveling exhibitions 2 per year; gift shop sells books, reproductions, slides, prints & handicrafts; junior museum located at Children's Discovery Center
L Library, 3801 Chester Ave, Bakersfield, CA 93301. Tel 661-852-5000; Fax 661-322-6415; Elec Mail kcmuseum@kern.org; Internet Home Page Address: www.kcmuseum.org; *Cur* Jeff Nickell; *Dir* Carola Rupert Enriquez; *Educ Prog* Jackie Brouillette; *VChmn* Bob Shore; *Mus Shop Mgr* Erica Hinojos
Open Mon - Fri 8 AM - 5 PM by appointment only; Estab 1950 to support the work of the mus; Open for reference only by appointment
Library Holdings: Book Volumes 2,200; Clipping Files; Filmstrips; Manuscripts; Memorabilia; Pamphlets; Photographs; Video Tapes
Special Subjects: Decorative Arts, Maps, Historical Material, History of Art & Archaeology, Crafts, Ethnology, Furniture, Period Rooms, Costume Design & Constr, Restoration & Conservation, Textiles
Collections: More than 200,000 photos relating to Kern County
Publications: Courier, quarterly newsletter
Activities: Classes for adults & children; docent training; lect open to public; concerts; tours; gallery talks; gift shop sells books, reproductions; Lori Brock Children's Discovery Ctr

BELMONT

A ARTS COUNCIL OF SAN MATEO COUNTY, 1219 Ralston Ave, Belmont, CA 94002. Tel 650-593-1816; Fax 650-593-4716; Elec Mail smcoarts@aol.com; Internet Home Page Address: www.smcoarts.org; *Pres* Peter Weiglin
Open Mon - Fri 9 AM - 4:30 PM, Sat & Sun 1 - 4 PM; No admis fee; Estab 1972 to promote the cultural life of San Mateo County through programs in schools, advocacy with business & government, to provide services for artists & arts organizations; Galleries maintained on premises & at the Hall of Justice in Redwood City, Calif. Exhibitors include elementary school students, high school students, amateur & professional & senior citizens; Average Annual Attendance: 3,600; Mem: 300; dues $25; annual meeting in July

Income: $200,000 (financed by mem, state & county appropriation, corporate & foundation support & programs)
Exhibitions: Monthly exhibits in three galleries by local & invited artists both regional & international
Activities: Classes for children; artist-in-residence program; school music program; volunteer & docent training; lect open to public, 3-5 vis lectr per year; concerts; gallery talks; tours; competitions with awards; originate traveling exhibitions; sales shop sells crafts, fine arts & posters

BERKELEY

A BERKELEY ART CENTER, 1275 Walnut St, Berkeley, CA 94709. Tel 510-644-6893; Fax 510-540-0343; Elec Mail berkeleyartc@earthlink.net; Internet Home Page Address: www.berkleyartcenter.org; *Exec Dir* Robbin Henderson
Open Wed - Sun Noon - 5 PM, cl Mon - Tues & holidays; No admis fee; Estab 1967 to display art works of Northern Calif artists; Average Annual Attendance: 14,000; Mem: 400; dues $30 - $2500; annual meeting Jan 1
Income: Financed by city appropriation and other grants
Collections: prints
Exhibitions: Rotating loan exhibitions & shows by Northern Calif artists; Annual Exhibitions: Members Exhibition, Youth Arts Festival & The National Juried Exhibition
Activities: Lect open to public, 8 vis lectr per year; concerts; gallery talks; competition with prizes; original objects of art lent to nonprofit & educational institutions; originate traveling exhibitions; sales shop sells prints

A BERKELEY CIVIC ARTS PROGRAM, 2118 Milvia St, Ste 200, Berkeley, CA 94704. Tel 510-705-8183; Fax 510-883-6554; Elec Mail mamfor@ci.berkeley.ca.us; Internet Home Page Address: www.cityberkeley.ca.us; *Others TDD* 510-644-6915; *Civic Arts Coordr* Mary Ann Merker
Estab 1980. Provides grants to art organizations, cultural service contracts, community outreach, business & technical assistance to artists & organizations, information referrals to the arts community; conducts on-going efforts to promote the importance of the arts & actively participates in regional & national local art agency development
Income: $264,500
Exhibitions: Exhibits 14 different showings annually by artists & art organizations in the Addison Street storefront windows
Publications: Arts Education Resource Directory; arts events list; quarterly newsletter

L BERKELEY PUBLIC LIBRARY, Art & Music Dept, 2090 Kittredge St Berkeley, CA 94704. Tel 510-649-3928; Fax 510-644-1145; *Librn* Lynn Murdock Wold; *Librn* Marti Morec; *Librn* Andrea Segall; *Head Reference* Patricia Mullan
Open Mon - Thurs 10 AM - 9 PM, Fri & Sat 10 AM - 6 PM, Sun 1 - 5 PM; No admis fee
Library Holdings: Book Volumes 22,560; Cassettes 4200; Other Holdings Compact discs 4500; Periodical Subscriptions 146; Records 15,000; Slides 22,000
Activities: Lectr on art four times a year

M JUDAH L MAGNES MUSEUM, 2911 Russell St, Berkeley, CA 94705. Tel 510-549-6950; Fax 510-849-3673; Elec Mail info@magnes.org; Internet Home Page Address: www.magnes.org; *Exec Dir* Terry Pink Alexander; *Chief Cur* Alla Efimova; *Head Preparator* Edward Foley; *Exhibs Registrar* Julie Franklin; *Judaica Cur* Elayne Grossbard; *Dir Finance & Operations* Rhonda Grossman; *Develop & Membership Asst* Camille Guimaraes; *Project Coordr* Marcie Gutierrez; *Educ Cur* Carin Jacobs; *Archivist, Western Jewish History Center* Aaron T Kornblum; *Dir Develop* James Leventhal; *School, Teacher & Family Prog Coordr* Heide Miller; *Curatorial Asst* Faith Powell; *Office Mgr* Amanda Sevak; *Exec Asst* Casondra Sobieralski; *Press Rels & Mktg* Robin Wander; *Colls Mgr & Registrar* Linda Waterfield
Open Sun - Wed 11 AM - 4 PM, Thurs 11 AM - 8 PM, cl Jewish & legal holidays; admis adults $ 6, sr $4, students, mem, children under 12 no admis fee; Estab 1962 to preserve, collect & exhibit Jewish artifacts & art from around the world; the mus also contains the Blumenthal Rare Books & Manuscripts Library & the Western Jewish History Center Archives on the Jewish community in the Western United States since 1849; Museum has 4 changing exhibitions galleries (including the Jacques & Esther Reutlinger Gallery estab 1981; Average Annual Attendance: 18,000; Mem: Mem 2,500; dues $65 & up
Income: Financed by mem, donations, & foundation grants
Purchases: Ethnic Costumes & Folk Art Pieces; Ceremonial & Fine Art; Rare Judaic books & manuscripts; Western US Jewish history rarities & oral histories
Library Holdings: Auction Catalogs; Audio Tapes; Book Volumes; Clipping Files; Exhibition Catalogs; Motion Pictures; Periodical Subscriptions; Photographs; Records; Video Tapes
Special Subjects: Art History, American Western Art, Prints, Drawings, Graphics, Painting-American, Photography, Sculpture, Watercolors, Textiles, Costumes, Religious Art, Ceramics, Crafts, Folk Art, Etchings & Engravings, Decorative Arts, Judaica, Manuscripts, Collages, Posters, Furniture, Metalwork, Carpets & Rugs, Historical Material, Coins & Medals, Calligraphy, Painting-Polish, Embroidery, Laces, Gold, Painting-German, Painting-Russian, Painting-Israeli
Collections: Hannukah lamps; Synagogue art & objects; spice boxes; graphics; manuscripts; prints; rare books; textiles; genre paintings; art & ceremonial objects from Sephardic & Indian Jewish communities
Exhibitions: Remembering Ben Shahn; Stalin's Forgotten Zion (Birobidzhan); Souvenirs of Israel; A Vanished World: Roman Vishniac; The Jewish Illustrated Book; Nupcias Sefardies (Sephardic Wedding); Winners of the Interfaith Forum on Religion, Art & Architecture Awards; Jewish Themes/Northern California Artists; Witnesses to History: The Jewish Poster, 1770-1985; Contemporary Jewish Themes Triennial; 30th Anniversary Exhibition; Faith & Survival: Jews of Ethiopia; Shtetl Life; Breaking the Mold: Harold Paris; First-Third Jewish Video Competitions-Winning Entries; Works by Louis Lozowick; Jerusalem; People's Art Movement of the '30s & '40s; Sephardic Horizons; Ann Chamberlain; Surviving Suprematism: Lazar Khidekel; "A Voice Silenced," by Diane Neumaier; Alfred Henry Jacons: Architect

Publications: Bibliographies; books of Western Jewish historical themes; exhibition catalogs; memoirs; poetry; triannual newsletter; trade books on recent European Jewish history

Activities: Classes for adults; docent training; lect open to public; gallery talks; tours; Rosenberg international poetry award; annual video award; numismatics series; individual paintings & original objects of art lent internationally & nationally to museums, synagogues, exhibition halls & Jewish organizations; originate traveling exhibitions organized & circulated; museum shop sells books original art, jewelry, note cards, posters, & gifts for home religious ceremonies

L **Blumenthal Rare Book & Manuscript Library,** 2911 Russell St, Berkeley, CA 94705. Tel 510-549-6956; Fax 510-849-3673; Elec Mail akornblum@magnesmuseum.org; Internet Home Page Address: www.magnesmuseum.org; *Acting Librn* Aaron T Kornblum
Open Mon - Thurs 10 AM - 4 PM; By appt only; Estab 1966 as a center for the study & preservation of Judaica; Circ Non-circ; For reference only. Changing & permanent exhibitions of painting, sculpture, photography, ceremonial objects
Income: Financed by mem & private gifts
Library Holdings: Book Volumes 12,000; Clipping Files; Exhibition Catalogs; Filmstrips; Manuscripts; Memorabilia; Motion Pictures; Other Holdings Original documents; Pamphlets; Periodical Subscriptions 15; Reproductions; Slides
Special Subjects: Art History, Illustration, Calligraphy, Manuscripts, Maps, Judaica, Cartoons, Bookplates & Bindings
Collections: Community collections from Cochin, Czechoslovakia, Egypt, India & Morocco; Holocaust Material (Institute for Righteous Acts); Karaite Community (Egypt); Passover Haggadahs (Zismer); 16th to 19th century rare printed editions, books & manuscripts; Ukrainian programs (Belkin documents)
Exhibitions: Jewish Illustrated Books
Publications: Exhibition catalogues; Jewish Illustrated Book; The Jewish Printed Book in India: Imprints of the Blumenthal Library
Activities: Docent training; lect open to public, 15 vis lectr per year; concerts; gallery talks; tours; awards; book traveling exhibitions; originate traveling exhibitions nationwide

A **KALA INSTITUTE,** Kala Art Institute, 1060 Heinz Ave, Berkeley, CA 94710. Tel 510-549-2977; Fax 510-540-6914; Elec Mail kala@kala.org; Internet Home Page Address: www.kala.org; *Artistic Dir* Yuzo Nakano; *Exec Dir* Archana Horsting; *Prog Mgr* Lauren Davies; *Dir Develop* Elaine Cohen; *Bookeeper & Photographer* Jan Wilson Kaufman; *Prog Assoc* Elisheva Marcus
Open Tues - Fri 10 AM - 5 PM; No admis fee; Estab 1974 to provide equipment, space, exhibition opportunities to artists; Maintains Ray Abel Memorial Library of Fine Arts Books; Average Annual Attendance: 5,000; Mem: 80; mem open to artists with proficiency in printmaking; studio rental $125-$340 per month
Income: $300,000 (financed by mem, city & state appropriation, art sales, classes & private foundations)
Collections: Kala Institute Archive; Works on Paper
Exhibitions: On going: Works on Paper
Activities: Classes for adults & children; lect open to public, 1 vis lectr per year; scholarships & fels offered; book traveling exhibitions 1 per year; originate traveling exhibitions 1 per year; retail store sells prints & original art

UNIVERSITY OF CALIFORNIA, BERKELEY

M **Berkeley Art Museum & Pacific Film Archive,** Tel 510-642-0808; Fax 510-642-4889; *Assoc Dir* Stephen Gong; *Cur Film* Edith Kramer; *Installation & Design Mgr* Nina Zurier; *Cur Heidi* Zuckerman Jacobson; *Cur Educ* Sherry Goodman; *Coll & Exhib Admin* Lisa Calden; *Cur* Connie Lewallen; *Asst Cur Video* Steve Seid; *Film Coll Mgr* Mona Nagai; *Develop Dir* Janine Sheldon; *Cur Film* Kathy Geritz; *Dir* Jacquelynn Baas
Open Wed - Sun 11 AM - 5 PM, Thurs 11 AM - 9 PM; Admis $4-$6; Estab 1963, new mus building opened in 1970; Mus designed by Mario Ciampi, Richard Jorasch & Ronald E Wagner of San Francisco; eleven exhibition galleries, a sculpture garden & a 234 seat theater; Average Annual Attendance: Gallery 100,000, Pacific Film Archive 100,000; Mem: 2800; dues vary
Income: $4,200,000 (financed by university sources, federal & foundation grants, earned income & private donations)
Special Subjects: Architecture, Drawings, Latin American Art, Painting-American, Photography, Prints, Sculpture, African Art, Folk Art, Afro-American Art, Painting-European, Posters, Asian Art, Painting-British
Collections: Gift of 45 Hans Hoffman paintings housed in the Hans Hoffman Gallery; pre-20th century paintings & sculpture; Chinese & Japanese paintings; 20th century European & American paintings & sculpture; over 7000 films & video tapes; 16th-20th century works on paper; conceptual art study center
Exhibitions: Twenty exhibitions annually; Matrix Program (a changing exhibition of contemporary art). 600 film programs
Publications: The Calendar, bi-monthly; catalogs; handbills; exhibition brochures; Matrix artists sheets
Activities: Educ dept; lect open to public, 50 vis lectr per year; concerts; gallery talks; on-site performances; film programs for classes & research screening; film study center & library; book traveling exhibitions 3-4 per year; originate traveling exhibitions to other art museums; museum shop sells books, magazines, posters, jewelry, rental facilities available, cafe

M **Phoebe Apperson Hearst Museum of Anthropology,** Tel 510-642-3681, 642-3682; Fax 510-642-6271; Elec Mail pahma@montu.berkeley.edu; *Dir* Rosemary Joyce
Exhibition Hall Open Sun - Wed 10 AM - 4:30 PM, Thurs 10 AM - 9 PM, cl major national holidays; access to research collections by appointment Sat & Sun; Admis adults $2, seniors $1, children $.50, no admis fee Thurs; Estab 1901 as a research mus for the training & educating of undergraduate & graduate students, a resource for scholarly research & to collect, preserve, educate & conduct research; Average Annual Attendance: 20,000
Income: Financed principally by state appropriations
Special Subjects: Afro-American Art, American Indian Art, Anthropology, Folk Art, Glass, American Western Art, Antiquities-Assyrian, Flasks & Bottles, Furniture, Gold, Photography, Porcelain, Portraits, Pottery, Pre-Columbian Art
Collections: Over four million objects of anthropological interest, both archaeological & ethnological. Ethnological collections from Africa, Oceania, North America (California, Plains, Arctic & Sub-Arctic); Archaeological Collections from Egypt, Peru, California, Africa & Oceania
Publications: Classics in California Anthropology; Museum News, annual

Activities: Family days; lect open to public, 12 vis lectr per year; gallery talks; originate traveling exhibitions varies; museum shop sells books, magazines, reproductions & slides

L **Pacific Film Archive,** Tel 510-642-1412, 642-1437; Fax 510-642-4889; *Library Head* Nancy Goldman; *Film Coll Mgr* Mona Nagai; *Assoc Film Cur* Kathy Geritz; *Cur Film* Edith Kramer
Open Mon - Fri 1 - 5 PM; nightly film screenings 6 - 11 PM; Estab 1971, the Archive is a cinematheque showing a constantly changing repertory of films; a research screening facility; a media information service & an archive for the storage & preservation of films
Income: Financed by earned box office income, grants, students fees & benefits
Library Holdings: Book Volumes 5,500; Clipping Files 60,000; Motion Pictures 6,000; Other Holdings Posters 7,000; Stills 25,000; Periodical Subscriptions 75; Photographs
Special Subjects: Film
Collections: Japanese film collection; Soviet Silents; experimental & animated films
Publications: Bi-monthly calendar
Activities: Nightly film exhibition; special daytime screening of films; lect, 50-57 vis filmmakers per year

L **Architecture Visual Resources Library,** Tel 510-642-3439; Fax 510-642-8655; Elec Mail maryly@berkeley.edu; Internet Home Page Address: www.mip.berkeley.edu/spiro (image database); Internet Home Page Address: www.arch.ced.berkeley.edu/resources/avre; Internet Home Page Address: www.lib.berkeley.edu/arch; *Library Asst* Tracy Farbstein; *Photographer* Steven Brooks; *Librn* Maryly Snow
Open Mon - Fri 9AM-5PM, after completion of new user orientation; Admis for outside borrowers $150 per semester; Estab 1905 for instructional support for the Department of Architecture. Library permits circulation on a 24 hour basis for educational presentations. No duplication of slides permitted; Circ 46,000; Average Annual Attendance: 300
Income: Financed by state & donor funds
Library Holdings: Kodachrome Transparencies; Lantern Slides; Other Holdings; Photographs; Slides
Special Subjects: Landscape Architecture, Architecture
Collections: Denise Scott Brown & William C Wheaton Collections: City Planning; Herwin Schaefer Collection: visual design; architecture & topography instructional circulating collection; Harold Stump world architecture slide collection; Ray Lifchez slide collection; Joseph Esherick travel slides collection

L **Environmental Design Library,** Tel 510-642-4818; Fax 510-642-8266; Elec Mail envi@library.berkeley.edu; Internet Home Page Address: www.lib.berkeley.edu/ENVI; *Head* Elizabeth Byrne; *Planning & Landscape Librn* Deborah Sommer; *Reference Librn* Susan Koskinen
Open Aug- May Mon - Thurs 9 AM - 9 PM, Fri 9 AM - 5 PM, Sat 1 - 5 PM, Sun 1 - 7 PM; Estab 1903; Circ 110,000
Library Holdings: Book Volumes 201,000; CD-ROMs; Fiche; Periodical Subscriptions 900; Reels; Video Tapes
Special Subjects: Landscape Architecture, Architecture
Collections: Beatrix Jones Farrand Collection: Architecture, city & regional planning, landscape architecture

BEVERLY HILLS

M **ACADEMY OF MOTION PICTURE ARTS & SCIENCES,** The Academy Gallery, 8949 Wilshire Blvd, Beverly Hills, CA 90211-1972. Tel 310-247-3000; Fax 310-247-3610; Elec Mail gallery@oscars.org; Internet Home Page Address: www.oscars.org; *Gallery Mgr* Robert Smolkin; *Exhib Cur* Ellen Harrington; *Gallery Staff* Jeni Giancoli
Open Mon - Fri 10 AM - 5 PM, Sat & Sun Noon - 6 PM; No admis fee; Estab 1970; Rotating exhibitions on motion picture history & contemporary filmmaking; Average Annual Attendance: 40,000
Library Holdings: Audio Tapes; Book Volumes; Clipping Files; Exhibition Catalogs; Kodachrome Transparencies; Lantern Slides; Manuscripts; Motion Pictures; Original Art Works; Photographs; Reproductions
Collections: Gallery borrows regularly from the Academy library's collections of archival posters, photos, & documents
Exhibitions: Rotating exhibits
Publications: exhibition catalogs
Activities: Seminars on producing & screen writing; lect open to pub; gallery talks; tours; Academy Awards; Nicholl Fel in screenwriting offered; approx 2 book traveling exhibitions per year; organize approx 4 traveling exhibitions per year to accredited fellow institutions, similar mus, galleries in nonprofit arena

L **BEVERLY HILLS PUBLIC LIBRARY,** Fine Arts Library, 444 N Rexford, Beverly Hills, CA 90201. Tel 310-288-2231; Fax 310-278-3387; Internet Home Page Address: www.bhpl.org; *Supv Fine Arts Svcs* Dr Stefan Klima; *Fine Art Librn* Jeri Byrne; *Fine Arts Librn* Suzy Chen; *Fine Arts Librn* Diane Ring
Open Mon - Thurs 10 AM - 9 PM, Fri & Sat 10 AM - 6 PM, Sun Noon - 5 PM; No admis fee; Estab 1973 to make art materials available to the general public; The library concentrates on 19th & 20th century American & West European art
Income: Financed by city appropriation and Friends of Library
Library Holdings: Book Volumes 20,000; Cassettes; Clipping Files; Exhibition Catalogs; Fiche; Kodachrome Transparencies; Motion Pictures; Pamphlets; Periodical Subscriptions 200; Photographs; Reels; Slides; Video Tapes
Special Subjects: Art History, Decorative Arts, Photography, Etchings & Engravings, Painting-American, Painting-French, Painting-German, Painting-Italian, Painting-European, History of Art & Archaeology, Printmaking, Fashion Arts, Drafting, Period Rooms, Architecture
Collections: Dorothi Bock Pierre Dance Collection; Artists Books
Exhibitions: Various exhib

BREA

M **CITY OF BREA,** Art Gallery, One Civic Center Circle, Brea, CA 92821. Tel 714-990-7730; Fax 714-990-7736; Elec Mail breagallery@cityofbrea.net; Internet Home Page Address: www.breagallery.com; *Dir Gallery* Thomas Ciganko; *Educ Dir* Tina Hasenberg
Open Wed, Thurs & Sun Noon - 5 PM, Fri & Sat Noon - 8 PM, cl Mon, Tues,

holidays; Admis adult $2, children 12 & under free; Estab 1980; 6300 sq ft exhib space; Average Annual Attendance: 7,000
Income: nonprofit
Exhibitions: Made in California (annual juried show); National Watercolor Society Juried Exhibition; The Media, 6 Degrees of Separation
Activities: Classes for children; docent training; lect open to public; tours; gallery talks; workshops; made in California Art Awards $500, $350, $200, $100; sales shop sells books, original art, prints, gifts & crafts

BURBANK

L **WARNER BROS STUDIO RESEARCH LIBRARY,** (Warner Bros Research Library) 277 N Ontario St, Burbank, CA 91504. Tel 818-977-5050; Fax 818-567-4366; *Library Admin* Phill Williams; *Research Librn* Barbara Poland
Open Mon - Fri 9 AM - 5 PM; Estab 1928 for picture & story research
Income: Financed by endowment
Library Holdings: Book Volumes 35,000; Clipping Files; Pamphlets; Periodical Subscriptions 85; Photographs
Special Subjects: Film, Fashion Arts, Interior Design, Costume Design & Constr
Collections: Art & Architecture History; Costumes; Interior Design; Military & Police; Travel & Description

CARMEL

M **CARMEL MISSION & GIFT SHOP,** 3080 Rio Rd, Carmel, CA 93923. Tel 831-624-3600; Fax 831-624-0658; Internet Home Page Address: www.carmelmission.org; *Shop Mgr* Kristine Silveria; *Cur* Richard J Menn
Open Mon - Sat 9:30 AM - 4:30 PM, Sun 10:30 AM - 4:30 PM, cl Thanksgiving & Christmas; No admis fee; donations accepted; Estab 1770
Collections: California's first library, founded by Fray Junipero Serra, 1770; library of California's first college, founded by William Hartnell, 1834; Munras Memorial Collection of objects, papers, furnishings of early California; large collection of ecclesiastical art of Spanish colonial period; large collection of ecclesiastical silver & gold church vessels, 1670-1820; paintings, sculpture, art objects of California Mission period
Activities: Sales shop sells religious articles, souvenir books & postcards

CARMICHAEL

PASTEL SOCIETY OF THE WEST COAST
For further information, see National and Regional Organizations

CARSON

M **UNIVERSITY ART GALLERY AT CALIFORNIA STATE UNIVERSITY, DOMINGUEZ HILLS,** 1000 E Victoria St, Carson, CA 90747. Tel 310-243-3334; Fax 310-217-6967; Elec Mail kzimmerer@csudh.edu; Internet Home Page Address: www.clw.csudh.edu/artgallery; *Gallery Dir* Kathy Zimmerer
Open Mon - Thurs 10:00 AM - 4 PM; No admis fee; Estab 1973 to exhibit faculty, student, contemporary & historical California art & multi-cultural exhibits; New 2,000 sq ft gallery in 1978; Average Annual Attendance: 10,000
Income: Financed by yearly grants from CSUDH Student Assoc; support from Friends of the Gallery, City of Carson; external grants
Library Holdings: Slides
Special Subjects: Art History
Exhibitions: Painted Light: California Impressionist Paintings; Walls of Heritage, Walls of Pride: African American Murals; Art by Design, Southern California Design Studios; An Obstinate Art Changing Images in Clay; An Architectural Stylist: W. Horace Austin and Eclecticism in California; (2006) Leslie Sutcliffe: The Galaxy Paintings; (2006) Urban Isolation: Figurative Paintings by York Chang and Yu Ji; (2007) Terra Incognita: Contemporary Landscape Painting
Publications: Exhibition catalogue published one time per yr; yearly newsletter
Activities: Lect open to public, 5 vis lectr per year; gallery talks; gallery tours; book traveling exhibitions 1 per year; organize traveling exhibs to California mus

CHERRY VALLEY

M **RIVERSIDE COUNTY MUSEUM,** Edward-Dean Museum & Gardens, 9401 Oak Glen Rd, Cherry Valley, CA 92223-3799. Tel 951-845-2626; Fax 951-845-2628; Internet Home Page Address: www.edward-deanmuseum.org; *Mus Mgr* Teresa Gallavan; Terri Neuenswander, Asst Mus Mgr
Open Fri - Sun 10 AM - 5 PM; Admis adults $3, seniors & students $2, children under 12 free; Built in 1957 & given to the county of Riverside in 1964; The South Wing of the gallery displays antiques & decorative arts as permanent collections; the North Wing has changing exhibits including contemporary artists; Average Annual Attendance: 20,000; Mem: 250; monthly meetings
Income: Financed by county funding
Library Holdings: Memorabilia; Original Documents; Sculpture
Special Subjects: Decorative Arts
Collections: 17th & 18th Century European & Oriental decorative arts; Fine Arts including series of original watercolors by David Roberts
Publications: Museum catalog
Activities: Classes for children; docent training; lect open to public; tours; outdoor art shows; cultural festivals; concerts; gallery talks; original objects of art lent to local universities & colleges; museum shop sells books, magazines, original art, reproductions & prints
L **Library,** 9401 Oak Glen Rd, Cherry Valley, CA 92223-3799. Tel 909-845-2626; Fax 909-845-2628; *Librn* Margaret Mueller
Open by appointment for reference only
Library Holdings: Book Volumes 2,300; Cards; Manuscripts; Original Art Works; Periodical Subscriptions 6; Prints

Special Subjects: Art History, Decorative Arts, Painting-British, Painting-European, History of Art & Archaeology, Watercolors, Ceramics, Asian Art, Porcelain, Furniture, Jade, Costume Design & Constr, Glass

CHICO

M **1078 GALLERY,** 738 W Fifth St, Chico, CA 95928. Tel 916-343-1973; Internet Home Page Address: www.1078gallery.org; *Dir* Jason Adkins
Open Tues - Sat 12:30 - 5:30 PM; No admis fee; Estab as a Nonprofit artist run arts organization showing contemporary art exhibitions & installations by artists of cultural & geographic diversity

M **CALIFORNIA STATE UNIVERSITY, CHICO,** University Art Gallery, Art Dept, Chico, CA 95929-0820. Tel 530-898-5864; Elec Mail jtannen@csuchico.edu; *Chmn* Jason Tannen
Open Mon - Fri 10 AM - 4 PM, Sun Noon - 4 PM; No admis fee; Estab to afford broad cultural influences to the massive North California region
Income: Financed by state appropriations & private funds
Collections: University Art Collection includes Masters of Graduate Artwork; Study collection of fine art print
Exhibitions: Varies every 4 mos: local artist
Activities: Lect open to public, 6-12 vis lectr per year; competitions with awards; individual & original objects of art lent to offices on campus
L **Meriam Library,** First & Hazel, Chico, CA 95929-0295. Tel 530-898-5862; Fax 530-898-4443; Internet Home Page Address: www.csuchico.edu/library; *Dir* Carolyn Dusenbury
Open to students & the pub
Library Holdings: Audio Tapes; Book Volumes 900; Cards; Cassettes; Fiche; Filmstrips; Micro Print; Motion Pictures; Original Art Works; Periodical Subscriptions 72; Photographs; Prints; Reels; Reproductions; Sculpture; Video Tapes
M **BMU Art Gallery,** Bell Memorial Union, Chico, CA 95929-0763. Tel 530-898-5489; Fax 530-898-4717; Elec Mail yzunig@csuchico.edu; Internet Home Page Address: www.csuchico.edu/as/bmu-art-gallery; *Coordr* Yvette Zuniga
Mon - Thur 7 AM - 11 PM, Fri 7 AM - 10 PM, Sat 11 AM - 10 PM, Sun noon - 11 PM; No admis fee; Estab 1945; 100 linear ft of enclosed area & two gallery halls; Average Annual Attendance: 1,000
Income: Financed by associated students & university
Exhibitions: Student work year round
M **Janet Turner Print Museum,** Laxson Auditorium, 400 W First St Chico, CA 95929-0820. Tel 530-898-4476; Fax 530-898-5581; Elec Mail csullivan@exchange.csuchico.edu; Internet Home Page Address: www.csuchico.edu/hfa; *Asst Collection Mgr* Celiz Melton; *Cur* Catherine Sullivan Sturgeon; *Curatorial Asst* Samantha Johnson; *Resource Mgr* Selda Arnoff; *Curatorial Asst* Pam Britting; *Resource Mgr* Reed Applegate
Open Mon - Fri 11 AM - 4 PM; No admis fee; Estab 1981; Located in Laxson Auditorium; displays seven thematic exhibitions per academic year from the Print Gallery's Collection of over 2,000 original prints; Average Annual Attendance: 6,000; Mem: 40; dues $2-$100
Income: $33,000 (financed by endowment, mem & state appropriation)
Purchases: Contemporary prints, mixed media, historic
Library Holdings: Auction Catalogs; Book Volumes; Clipping Files; Exhibition Catalogs; Memorabilia; Original Art Works; Periodical Subscriptions; Photographs; Reproductions; Slides; Video Tapes
Special Subjects: Afro-American Art, American Indian Art, American Western Art, Hispanic Art, Prints, Etchings & Engravings, Asian Art, Medieval Art
Collections: General collection of prints historical to contemporary, international in scope, includes all techniques
Activities: Educ dept classes for children; lect to CSU Chico classes; competitions with prizes; 4 purchase awards for Nat'l Print Compt Exhib; scholarships offered; original objects of art lent in traveling exhibitions; lending collection contains 2000 original prints; originate traveling exhibitions to other CSU system colleges; sales shop sells cards, catalogs & cards

CHULA VISTA

M **SOUTHWESTERN COLLEGE,** Art Gallery, 900 Otay Lakes Rd, Chula Vista, CA 91910. Tel 935-421-6700; Fax 935-421-6372; Elec Mail pturley@swc.cc.ca.us; *Gallery Dir* G. Pasha Turley
Open Mon - Tues & Fri 10 AM - 2 PM, Wed - Thurs 6 - 9 PM; No admis fee; Estab 1961 to show contemporary artists' work who are of merit to the community & the school, & as an educational service; Gallery is approx 3,000 sq ft; Average Annual Attendance: 10,000
Income: Financed by city and state appropriations
Collections: Permanent collection of mostly contemporary work
Exhibitions: (1999) Gang of Five, recent works; Painting (David Beck Brown) Allied Craftsman; De La Torre Brothers, The Printers Craft Photos, Linda McCartney; Ceicel Beattes
Activities: Classes for adults; lect open to public, 3-5 vis lectr per year; gallery talks; competitions, State Art Festival; individual paintings & original objects of art lent; lending collection contains color reproductions, photographs & original art works; junior museum

CITY OF INDUSTRY

M **WORKMAN & TEMPLE FAMILY HOMESTEAD MUSEUM,** 15415 E Don Julian Rd, City of Industry, CA 91745-1029. Tel 626-968-8492; Fax 626-968-2048; Elec Mail info@homesteadmuseum.org; Internet Home Page Address: www.homesteadmuseum.org; *Dir* Karen Graham Wade; *Coll Mgr* Paul Spitzzeri; *Asst Dir* Max A van Balgooy; *Asst Coll Mgr* Sylvia Hohenshelt; *Pub Prog Mgr* Alexandra Rasic; *Asst Pub Prog Mgr* Carol Henderson; *Operations Coordr* Robert Barron; *Vol Coordr* Tracy Smith
Open Wed-Sun 1-4 PM; group tours of 10+ by appointment; No admis fee; Estab 1981 to collect & interpret Southern California history from 1830 to 1930;

Contemporary exhibition gallery; mid-19th century Workman Family House; late 19th century watertower; 1922-27 Spanish Colonial Revival Temple Family Residence; Average Annual Attendance: 15,000
Income: $600,000 (financed by city appropriation)
Special Subjects: Architecture, Decorative Arts, Furniture, Metalwork, Historical Material, Stained Glass
Collections: California ceramic tile; La Casa Nueva stained glass; Southern California architecture
Exhibitions: La Casa Nueva: A 1920s Spanish-Style Mansion
Publications: The Homestead, quarterly; San Gabriel Valley Historian, annual
Activities: Classes for children; dramatic programs; docent training; architectural crafts fair; films; workshops; lect open to public; concerts; museum shop sells books & reproductions

L **Research Library,** 15415 E Don Julian Rd, City of Industry, CA 91745-1029. Tel 626-968-8492; Fax 626-968-2048; Elec Mail info@homesteadmuseum.org; Internet Home Page Address: www.homesteadmuseum.org; *Coll Mgr & Library Head* Paul Spitzzeri
Open by appt only; Estab 1981; Circ 2000; For reference only
Income: $60,000 (financed by city appropriation)
Library Holdings: Audio Tapes 50; Book Volumes 2,000; Cassettes; Clipping Files; Maps; Pamphlets; Periodical Subscriptions 20; Photographs 500; Prints; Reproductions; Slides 2,500; Video Tapes
Special Subjects: Decorative Arts, Historical Material, Crafts, Interior Design, Stained Glass, Restoration & Conservation, Architecture

CLAREMONT

M **THE POMONA COLLEGE MUSEUM OF ART,** Montgomery Gallery, 33 N College Way, Claremont, CA 91711-6344. Tel 909-621-8283; Fax 909-621-8989; Elec Mail mharth@pomona.edu; Internet Home Page Address: www.pomona-edu/montgomery; *Cur* Rebecca McGrew; *Gallery Mgr* Kathryn Horak; *Asst Dir & Registrar* Steve Comba; *Admin Asst* Barbara Senn; *Dir* Marjorie L Harth
Open academic yr Tues - Fri Noon - 5 PM, Sat & Sun 1 - 5 PM, cl Mon; No admis fee; Estab 1974 to present balanced exhibitions useful not only to students of art history & studio arts, but also to the general public
Income: Financed by Pomona College, support group & endowment grants
Special Subjects: Drawings, Graphics, Painting-American, Photography, Prints, Sculpture, Watercolors, American Indian Art, Woodcuts, Etchings & Engravings, Decorative Arts, Asian Art, Renaissance Art, Painting-Italian
Collections: Samuel H Kress Collection of Renaissance paintings; Old Master & contemporary graphics; photographs; Oriental art; African art; Native American art
Exhibitions: 8-10 rotating student shows & exhibits
Publications: Art Publications List, annual
Activities: Lect open to public, 2-3 vis lectr per year; gallery talks; tours; individual paintings & original objects of art lent to qualified museums & galleries; originates traveling exhibitions to other museums

M **SCRIPPS COLLEGE,** Ruth Chandler Williamson Gallery, 1030 Columbia Ave, Claremont, CA 91711. Tel 909-607-3397; Fax 909-607-4691; Elec Mail kdelman@scrippscol.edu; Internet Home Page Address: www.scrippscol.edu/~dept/gallery/index.html; *Dir* Mary Davis McNaughton; *Coll Mgr, Registar* Kirk Delman; *Admin Asst* Wendy Duckering; *Electronic Catalog Project Mgr* Krista Parsley-Welch
Open Wed - Sun 1 -5 PM, cl national & college holidays; No admis fee; Estab 1993 to present balanced exhibitions useful not only to students of art history & studio arts, but also the general public; Average Annual Attendance: 5,000; Mem: 10,000
Income: Financed by Scripps College, support group & endowment grants
Special Subjects: Painting-American, Photography, African Art, Textiles, Asian Art, Tapestries
Collections: Dr & Mrs William E Ballard Collection of Japanese Prints; Mrs James Johnson Collection of Contemporary American, British, Korean, Mexican & Japanese Ceramics; Dorothy Adler Routh Collection of Cloisonne; Wagner Collection of African Sculpture; General Edward Young Collection of American Paintings; drawings; photographs; prints
Exhibitions: Rotating exhibitions
Publications: Art Publictions List
Activities: Lect open to public, 2-3 vis lectr per year; gallery talks; films; tours; intermuseum loans; book traveling exhibitions biennially; originate traveling exhibitions

M **SCRIPPS COLLEGE,** Clark Humanities Museum, 1030 Columbia Ave, Claremont, CA 91711. Tel 909-607-3606; Fax 909-607-7143; *Admin Asst* Nancy Burson; *Dir* Eric Haskell
Open Mon - Fri 9 AM - Noon & 1 - 5 PM, cl holidays & summer; No admis fee; Estab 1970 to present multi-disciplinary exhibits in conjunction with Scripps College's humanities curriculum & to maintain a study collection; Mus has large room with storage & study area; reception desk
Income: Pvt income
Special Subjects: Sculpture, Textiles, Afro-American Art, Oriental Art
Collections: Nagel Collection of Chinese, Tibetan Sculpture & Textiles; Wagner Collection of African Sculpture
Exhibitions: Four to seven exhibits
Activities: Lect open to public; gallery talks

CONCORD

A **CALIFORNIA WATERCOLOR ASSOCIATION,** Gallery Concord, 1765 Galindo, Concord, CA 94520; PO Box 4631, Walnut Creek, CA 94596. Tel 925-691-6140; Elec Mail info@californiawatercolor.org; Internet Home Page Address: www.californiawatercolor.org; *Pres* Sue Johnston; *VPres* David Sarallano; *Dir Budget* Joanne Corbaley; *Dir of Communications* Pablo Villicana-Lara; *Dir Workshops* Rita Sklar; *Dir of Outreach* Karen Mason; *Dir Memberships* Bondi Abraham; *Dir Programs* Pamela Miller
Open Wed - Sun 11 AM - 4 PM; No admis fee; Estab 1968; Maintains art gallery at Gallery Concord in Concord, also in Danville, CA; Average Annual Attendance: 2,700; Mem: 900; dues $40; monthly meetings every third Wed

Income: Financed by mem dues
Library Holdings: DVDs; Exhibition Catalogs; Slides; Video Tapes
Exhibitions: Annual National Watercolor Exhibition plus 6-7 mem exhibits per yr
Publications: Annual catalog; monthly newsletter
Activities: Classes for adults & children; docent training; Workshops; 6-7 watercolor workshops per yr; lect open to public; vstg lect 4 workshops per yr; gallery talks; tours; competitions & cash awards; scholarships offered; lending collection contains cassettes & 1500 slides; originate traveling exhibitions; gallery shop sells original art, reproductions & prints

CORTE MADERA

A **MARIN COUNTY WATERCOLOR SOCIETY,** 138 Willow Ave, Corte Madera, CA 94925-1433. Tel 415-924-8191; Elec Mail jkehensel@comcast.net; *Bulletin Ed* Jacqueline Hensel
Estab 1970 to provide a way for members to share painting experiences in outdoor landscape; Mem: 180; open to painters, ranging from beginner to professional, in Marin County & San Francisco Bay area; dues $20
Exhibitions: Marin County Civic Center Show; exhibit throughout the area in various locals
Publications: Monthly bulletin

CUPERTINO

M **DE ANZA COLLEGE,** Euphrat Museum of Art, 21250 Stevens Creek Blvd, Cupertino, CA 95014. Tel 408-864-8836; *Dir Arts & Schools Prog* Diana Argabrite; *Dir* Jan Rindfleisch
Open Tues & Thurs 11 AM - 4 PM, Wed 7 - 9 PM; No admis fee; Estab 1971; 1700 sq ft contemporary gallery located on De Anza College Campus; Average Annual Attendance: 10,000
Income: $175,000 (financed by mem, grants, endowment, college)
Publications: Art Collectors in & Around Silicon Valley; Art of the Refugee Experience; Art, Religion & Spirituality; Content Contemporary Issues; The Power of Cloth (Political Quilts 1845-1986); Staying Visible: The Importance of Archives
Activities: Classes for children; docent programs; lect open to public; competition with awards; sales shop sells books

CYPRESS

M **CYPRESS COLLEGE,** Fine Arts Gallery, 9200 Valley View St, Cypress, CA 90630. Tel 714-826-2220; Fax 714-527-8238; *Secy* Maureen King; *Dir* Betty Disney
Open Mon & Thurs 10 AM - 2 PM, Tues & Wed 6 - 8 PM, clo Fri, except by appointment; No admis fee; Estab 1969 to bring visually enriching experiences to the school & community; Average Annual Attendance: 5,000
Income: Financed by school budget, donations & sales
Collections: Donor gifts; purchase awards; student works
Publications: Exhibition catalogs
Activities: Lect open to public, 2 vis lectr per year; competitions; scholarships

DAVIS

M **PENCE GALLERY,** 212 D St, Davis, CA 95616. Tel 530-758-3370; Fax 530-758-4670; Elec Mail penceassistant@sbcglobal.net; Internet Home Page Address: www.pencegallery.org; *Board Pres* Steve Boutin; *Gallery Asst* Eileen Hendren
Open Tues - Sat Noon - 4 PM & by appointment, except holidays & between shows; No admis fee; Estab 1975 to foster & stimulate awareness of the arts & cultural heritage of California through changing exhibitions of art & objects of artistic, aesthetic & historical significance; State of the art museum with 2 galleries & 4800 sq ft conference rooms available for rent and functions; Average Annual Attendance: 7,500; Mem: Dues: gallery circle $2500, curator's circle $1000, benefactor $500, patron $250, sponsor $100, family $60, individual $40, docent & student $25
Income: $50,000 (financed by mem, city appropriation & fund raisings)
Exhibitions: Seven rotating exhibitions per yr, exploring contemporary California art & history in Gallery A & 12 rotating exhibitions in Gallery B focusing on regional developing artists
Publications: Pence Events, quarterly newsletter
Activities: Classes for adults & children; docent training; artist lect series; lect open to public, 2 vis lectr per year; concerts; gallery talks; tours; Community Art awards; scholarships offered; museum shop sells books & original art

UNIVERSITY OF CALIFORNIA
M **Memorial Union Art Gallery,** Tel 530-752-2885; *Dir* Roger Hankins
Open Mon - Fri 9 AM - 5 PM, also by appointment; No admis fee; Estab 1965 to provide exhibitions of contemporary & historical concerns for the students, staff & community; Gallery consists of North Gallery & South Gallery
Collections: Northern California contemporary art
Exhibitions: Sacramento Valley Landscapes
Publications: Exhibition catalogs
Activities: Classes for adults; lect; concerts; poetry readings; films; competitions; internships offered

M **Richard L Nelson Gallery & Fine Arts Collection,** Tel 530-752-8500; Fax 530-752-0795; *Dir* L Price Amerson Jr; *Coll Mgr & Registrar* Carol Rosset
Open Mon - Fri Noon - 5 PM, Sun 2 - 5 PM; No admis fee; Estab 1976 to provide exhibitions of contemporary art as well as historical importance as a service to teaching program of the department of art, the university & pub; Contains main gallery & small gallery; Average Annual Attendance: 15,000; Mem: 175; dues $25 & up; annual meeting in May
Income: Financed by university appropriation, grants & Nelson ARTfriends
Special Subjects: Drawings, Graphics, Painting-American, Photography, Prints, Sculpture, Watercolors, Ceramics, Primitive art, Woodcarvings, Woodcuts, Etchings & Engravings, Posters, Asian Art, Historical Material

Collections: Fine Arts Collection; general collection representing various periods of historical & contemporary art, with emphasis on Northern California art; also special collection includes; The Nagel Collection of Oriental Ceramics & Sculpture
Publications: Exhibition catalogues
Activities: Lect open to public, 3-5 vis lectr per year; gallery talks; originate traveling exhibitions; sales shop sells books & reproductions

L **Art Dept Library,** Tel 530-752-0152; *Slide Librn* Leah Theis; *Book Librn* Bonnie Holt
Slide Library Open Mon - Fri 8 AM - Noon & 1 - 5 PM, Book Library Open Mon - Thurs 9 AM - 4 PM, Fri 9 AM - Noon; Estab 1966 to make readily accessible reference & research material to Art Department faculty, students & the general pub
Income: Financed by state appropriation & college funds
Purchases: $3,500
Library Holdings: Audio Tapes; Book Volumes 20,000; Clipping Files; Exhibition Catalogs; Fiche; Filmstrips; Kodachrome Transparencies; Lantern Slides; Micro Print; Motion Pictures; Other Holdings DIAL (Decimal Index of Art of the Low Countries) photographs; Periodical Subscriptions 15; Photographs; Reproductions; Slides; Video Tapes
Special Subjects: Art History, Folk Art, Film, Painting-American, Painting-British, Conceptual Art, American Western Art, Asian Art, American Indian Art, Mexican Art, Aesthetics, Afro-American Art, Oriental Art, Architecture

DESERT HOT SPRINGS

M **CABOT'S OLD INDIAN PUEBLO MUSEUM,** Cabot's Old Indian Pueblo Museum, 67-616 E Desert View Ave, Desert Hot Springs, CA 92240. Tel 760-329-7610; Internet Home Page Address: www.cabotsmuseum.org; Internet Home Page Address: www.cabotsmuseum.org; *Museum Mgr* Edna Wells; *Commission Chairperson* Jason Bruecks
Open Sat & Sun Noon - 4 PM; cl summer; Admis adults $6, sr citizens $5, under 16 $4, under 6 free; Estab 1968 as a source of reference; 1100 sq ft art gallery representing contemporary artists through a variety of media. Artifacts of past cultures & Americana along with native American work; Average Annual Attendance: 10,000; Mem: 50; dues lifetime $1,000, patron $500, donor $300, organization $100, supporting $75, family $35, individual $20, student $10
Income: Financed by donations, grants
Purchases: Cahuilla baskets, Navajo blankets & rugs acquired
Library Holdings: Book Volumes; Cassettes; Clipping Files; Kodachrome Transparencies; Memorabilia; Original Art Works; Original Documents; Pamphlets; Photographs; Prints; Records; Reproductions; Sculpture
Special Subjects: American Indian Art, Drawings, Etchings & Engravings, Historical Material, Architecture, American Western Art, Furniture, Photography, Portraits, Pottery, Painting-American, Period Rooms, Textiles, Sculpture, Southwestern Art, Costumes, Primitive art, Woodcarvings, Eskimo Art
Collections: The Theosophical Society Collection
Exhibitions: Select weekend exhibits of Art Faires with Blacksmith Exhib, artists working on their crafts; Indian Monument carved by Peter Toth (1978); Hopi-Style Pueblo Home & Museum of Cabot Yerxa (1941-45)
Activities: Classes for adults & children; docent training; lect open to public; tours; museum shop sells books, original art, reproductions, prints

DOWNEY

M **DOWNEY MUSEUM OF ART,** 10419 Rives Ave, Downey, CA 90241. Tel 562-861-0419; *Consulting Dir* Kate Davies
Open Wed - Sat Noon - 5 PM; No admis fee; Estab 1957 as an aesthetic & educational facility. Located in Furman Park, it is the only art mus with a permanent collection in Southeast Los Angeles, which includes in its area 27 neighboring communities of significant ethnic range & a total population close to one million. The Mus is continuing a prog for new emerging multi-ethnic artists; changing contemporary art exhibits; The facility has five gallery areas. Gallery I covers 15 x 39 ft, Gallery II covers approx 12 x 24 ft, Gallery III covers 15 x 20 ft, Gallery IV covers 23 x 39 ft, and Gallery V covers 24 x 24 ft; Average Annual Attendance: 18,000; Mem: 475; dues $40 - $1,000
Income: $45,000 (financed by mem, grants, donations & fundraising)
Library Holdings: Exhibition Catalogs
Special Subjects: American Indian Art, American Western Art, Crafts, Folk Art, Etchings & Engravings, Collages, Eskimo Art, Furniture, Glass
Collections: Many pieces produced by Southern California artists over the past 20 years, including Billy Al Bengston, Corita Kent, Sabato Fiorello, Hans Burkhardt, Anna Mahler, Shirley Pettibone, Betye Saar, Boris Duetsch & Frederick Wight
Publications: Exhibition catalogs
Activities: Educ program; classes for adults & children; young visitors/young artists programs & summer academy; arts homework support; lect open to public, 4 vis lectr per year; gallery talks; tours; traveling exhibitions organized & circulated to museums; museum shop selling reproductions & prints

EL CAJON

M **GROSSMONT COMMUNITY COLLEGE,** Hyde Art Gallery, 8800 Grossmont College Dr, El Cajon, CA 92020-1799. Tel 619-644-7299; Elec Mail benaubert@gcccd.net; Internet Home Page Address: www.grossmont.gcccd.cc.ca.us/home/; *Cur* James Wilsterman; *Cur* Ben Aubert
Open Mon & Thurs 10 AM - 6:30 PM, Tues - Wed 10 AM - 8 PM & by appointment, cl Fri - Sun & legal holidays; No admis fee; Estab 1970 as a co-curricular institution which cooperates with & supports the Art Department of Grossmont College & which provides a major cultural resource for the general pub in the eastern part of the greater San Diego area; Two galleries, one 30 x 40 ft; one 30 x 20 ft; Average Annual Attendance: 20,000
Income: Financed through College
Special Subjects: Photography, Prints, Pottery
Collections: Prints; photographs; clay objects; large Tom Holland painting
Publications: Exhibition catalogs; posters

Activities: Lect open to public, 6 vis lectr per year; concerts; student awards from ann art council auction; original objects of art lent to institutions; lending collection photographs; originate traveling exhibitions

ESCONDIDO

M **CALIFORNIA CENTER FOR THE ARTS,** Escondido Museum, 340 N Escondido Blvd, Escondido, CA 92025. Tel 760-839-4120 (museum), 839-4138 (office); Fax 760-743-6472 (office); Elec Mail mferguson@ci.escondido.ca.us; Internet Home Page Address: www.artcenter.org; *Mus Dir* Mary Catherine Ferguson; *Exhib Coordr* Olivia Luther
Open Tues - Sat 10 AM - 4 PM, Sun Noon - 4 PM, cl Mon & major holidays; Admis adults $5, seniors & active military $4, youth 12 - 18 & students $3, children under 12 & mem free; free admis first Wed of every month during an exhibition; Estab 1994 committed to presenting contemporary art; Average Annual Attendance: 6,500; Mem: Dues $50-$10,000
Income: Financed by grants, funds & mem
Library Holdings: Book Volumes; Exhibition Catalogs; Periodical Subscriptions; Video Tapes
Special Subjects: Painting-American, Sculpture, Landscapes
Collections: Collection of decorative arts, Paintings, photography & sculpture from 1900 to present
Exhibitions: Exhibits draw on a distinct theme or idea in contemporary art
Publications: Exhibition specific catalogues
Activities: Classes for children; docent training; lect open to public; gallery talks; tours; individual paintings & original objects of art lent; book traveling exhibitions; museum shop sells books, ceramics, glass, decorative items & jewelry

EUREKA

A **HUMBOLDT ARTS COUNCIL,** Morris Graves Museum of Art, 636 F St, Eureka, CA 95501. Tel 707-442-0278; Fax 707-442-2040; Internet Home Page Address: www.humboldtarts.org; *Mus Dir & Cur* Jemima Harr; *Mus Mgr* Sarah Connelly
Open Wed - Sun Noon - 5 PM; Estab 1966 to encourage, promote & correlate all forms of activity in the visual & performing arts & to make such activity a vital influence in the life of the community; Gallery has 7 spaces rotating 41 exhib; Mem: 700; dues $30; annual meeting in Apr
Income: $10,000 (financed by mem)
Collections: Art Bank, other purchase & donated works of art; photograph collection; Premier Collection of North Coast Art (traveling display); traveling import museum exhibits; Morris Graves Collection
Exhibitions: Annual Youth Art Exhibit
Activities: Childrens classes, music & dance performances; concerts; competitions; scholarships offered; individual paintings & original objects of art lent; originate traveling exhibitions

FORT BRAGG

A **ARTS COUNCIL OF MENDOCINO COUNTY,** (Mendocino County Arts Council) PO Box 1393, Fort Bragg, CA 95437. Tel 707-961-5449; Elec Mail director@artsmendocino.org; Internet Home Page Address: www.artsmendocino.org; *Exec Dir* Anna Kvinsland; *Pres* Trudy McCreanor
Open by appointment; No admis fee; Estab 2000 to promote, introduce & benefit the arts in Mendocino County; Mem: 400; dues $25 regular mem; $15 artist mem
Income: $45,000 annual budget
Special Subjects: Folk Art
Activities: Artists-in-the-schools grant prog; Mendocino Cty Art Champion annual awards

FREMONT

M **CITY OF FREMONT,** Olive Hyde Art Gallery, 123 Washington Blvd, PO Box 5006 Fremont, CA 94537. Tel 510-791-4357, 494-4240 (Dir); Fax 510-494-4753; Elec Mail ijordahl@ci.fremont.ca.us; Internet Home Page Address: www.fremont.gov; *Gallery Cur* Sandra Hemsworth; *Recreation Supvr II* Irene Jordahl
Open Thurs - Sun 12 - 5 PM; No admis fee; Estab 1964 for community exposure to artistic awareness; Historical former home of Miss Olive Hyde, a well-known San Franciscan art patron. This is the only fine arts gallery open to the public between Hayward & San Jose, located across from the Historical Mission San Jose in Fremont. Exhibits are displayed in 1000 sq ft of space; Average Annual Attendance: 10,000
Income: $20,000 (financed by city appropriation)
Special Subjects: Drawings, Painting-American, Photography, Prints, Sculpture, Watercolors, Textiles
Exhibitions: 7 exhibits per year in fine arts, crafts, photography, textiles, sculpture; local, regional, national & international artists
Publications: Full color exhibit postcards
Activities: Classes for adults & children; docent programs; gallery talks; tours; lect open to both the public & members only, 10 vis lectrs per year; competitions with cash prizes & awards; scholarships offered; book traveling exhibitions 1 per year; originate traveling exhibitions

FRESNO

M **FRESNO ARTS CENTER & MUSEUM,** 2233 N First St, Fresno, CA 93703. Tel 559-441-4220; Fax 559-441-4227; Elec Mail fam@qnis.net; Internet Home Page Address: www.fresnoartmuseum.com; *Dir & Chief Cur* Dyana Curreri-Ermatinger
Open Tues - Fri 10 AM - 5 PM, Sat & Sun Noon - 5 PM; Admis adults $4, students & seniors $2, children 16 & under, school tours & mus mem free, Sat free to pub; Estab 1949 as a visual arts gallery to provide Fresno & its environs

with a community oriented visual arts center; The Center exhibits works of internationally known artists & arranges shows of local artists. Three galleries plus entry for exhibits; Average Annual Attendance: 98,000; Mem: 2500; dues $25; annual meeting in May

Income: Financed by mem & fundraising efforts

Special Subjects: Mexican Art, Oriental Art

Collections: Works of prominent California artists; contemporary American artists; Mexican folk art; Mexican graphic arts; permanent collection, National & International artists; extensive Pre-Columbian folk art

Exhibitions: Rotating exhibits every 3 months

Activities: Classes for adults & children; docent training; lect open to public, 12 vis lectrs per year; gallery talks; concerts; tours; competitions; scholarships offered; individual paintings & objects of art lent to city & county offices & other institutions; lending collection contains framed reproductions, original art works, original prints & slides; book traveling exhibitions; traveling exhibitions organized & circulated; museum shop sells books, magazines, original art, reproductions, prints, cards & local crafts

M **FRESNO METROPOLITAN MUSEUM,** 1515 Van Ness Ave, Fresno, CA 93721. Tel 559-441-1444; Fax 559-441-8607; Elec Mail marketing@fresnomet.org; Internet Home Page Address: www.fresnonet.org; *Dir Exhib* Kim Cline; *Pres & Board Trustees* Hal Bolen; *Exec Dir* Kathleen Monaghan; *Dir Financial* Loretta Kullberg; *Develop Dir* Garry Griesser; *Dir Operations* John Brewer; *Educ Coordr* Ann Wanger; *Educ Coordr* Yolanda Barbosa; *Board Chmn* Betsy Reeves; *Mem Mgr* Cherie Benefield; *Marketing & Events Mgr* Darlene Kim; *Mem & Develop* Esther George; *Graphic Artist* Beth Greene; *Receptionist* Janet Wrazel; *Exec Asst* Kevin Rosenstein; *Marketing Asst* John English; *Dir Marketing* Jon Carroll; *Dir Vols* Karen Eten; *Coll Mgr* Kristina Homback; *Dir Educ Program* Karen McEwen; *Board Pres* Paul Gibson; *Chief Preparator* Mike Weatherson

Open daily 11 AM - 5 PM; Admis adults $6, seniors, students & children 3-12 $3, members & children under 3 free; Estab 1984 to increase the availability of fine & educational arts to the Fresno area; Mus is housed in a refurbished 1922 newspaper plant, two stories, with other floors marked for development; equipped with elevators & facilities for the handicapped; Average Annual Attendance: 180,000; Mem: 5000; dues $20-$1000

Income: $1,300,000 (financed by mem, donations, service fees & grants)

Collections: Frank & Mary Alice Diener Collection of ancient snuff bottles; Oscar & Maria Salzer Collection of still life & trompe L'oeil paintings; Oscar & Maria Collection of 16th & 17th century Dutch & Flemish paintings; Charles Small Puzzle Collection

Exhibitions: T-Rex Named Sue

Publications: MetReport, monthly

Activities: Children's classes & summer day camps; dramatic programs; docent training; lect open to public; tours; individual paintings & original objects of art lent; book traveling exhibitions; originate traveling exhibitions; museum shop sells books & prints

FULLERTON

M **CALIFORNIA STATE UNIVERSITY, FULLERTON,** Art Gallery, Visual Arts Center, 800 N State College Blvd, Fullerton, CA 92634-9480. Tel 714-278-2011; Internet Home Page Address: www.fullerton.edu; *Asst to Dir* Marilyn Moore; *Dir* Mike McGee

Open during exhibits, Mon, Tues & Thurs Noon - 4 PM, Wed 3 - 7 PM, Sun 3 - 5 PM, cl Fri & Sat; No admis fee; Estab 1963 to bring to the campus carefully developed art exhibits that instruct, inspire & challenge the student to the visual arts; to present to the student body, faculty & community exhibits of historical & aesthetic significance; to act as an educational tool, creating interaction between various departmental disciplines & promoting pub relations between campus & community; Four to five exhibits each year stemming from the Museum Studies & Exhibition Design Program. Undergraduate & graduate students have the opportunity to focus within a professionally oriented program directed toward the mus profession. Activity incorporates classes, art gallery & local mus. The Department of Art & the Art Gallery are the holders of the permanent collection; Average Annual Attendance: 15,000-20,000

Income: Financed by state appropriation, grants & donations

Collections: Contemporary Lithographs (Gemini); works by artists in the New York Collection for Stockholm executed by Styria Studio; lithographs by Lita Albuquerque, Coy Howard, Ed Rusha & Alexis Smith; Pre-Columbian artifacts; environmental & site-specific sculpture by Lloyd Hamrol, Ray Hein, Bernard Rosenthal, Michael Todd, Jay Willis

Exhibitions: Call for details

Publications: Exhibition catalogs

Activities: Lect open to public, 8-10 vis lectrs per year; workshops; production of slide/sound interpretation programs in conjunction with specific exhibitions; gallery talks; tours; scholarships offered; exten dept 4-6 major exhibitions per year; originate traveling exhibitions

A **MUCKENTHALER CULTURAL CENTER,** 1201 W Malvern, Fullerton, CA 92633. Tel 714-738-6595; Fax 714-738-6366; Internet Home Page Address: www.muckenthaler.org; *Center Adminr* Patricia House; *Exhib & Educ Adminr* Matt Leslie

Open Wed - Fri 10 AM - 4 PM, Sat - Sun Noon - 4 PM, By appt Tues; Admis adults $5, seniors & students $2; children under 12 free; Estab 1966 for the promotion & development of a public cultural center for the preservation, display & edification in the arts; Gallery is a National Historic Building, contains 2500 sq ft & is on 8 1/2 acres of land; outdoor theatre facilities; Average Annual Attendance: 65,000; Mem: 600; dues $10 & up; annual meeting in Apr

Income: $230,000 (financed by endowment, mem & city appropriation)

Publications: Exhibition catalogs

Activities: Classes for adults & children; dramatic programs; docent training; lect open to public, 12 vis lectrs per year; concerts; gallery talks; tours; book traveling exhibitions; museum shop sells original art, reproductions, prints & gifts

GILROY

M **GAVILAN COMMUNITY COLLEGE,** Art Gallery, 5055 Santa Teresa Blvd, Gilroy, CA 95020. Tel 408-846-4946; Fax 408-846-4927, 846-4801; Internet Home Page Address: www.Gavilan.cc.ca.us; *Gallery Advisor & Humanities Div Dir* Kent Child; *Prof Art & New Technology* Jane Edberg

Open Mon - Fri 8 AM - 5 PM; No admis fee; Estab 1967 to serve as a focal point in art exhibitions for community college district & as a teaching resource for the art department; Gallery is in large lobby of college library with 25 ft ceiling, redwood panelled walls & carpeted floor

Income: Financed through college

Collections: Over 25 paintings purchased as award purchase prizes in college art competitions

Exhibitions: Monthly exhibits of student & local artists; ann Gavilan Student Show, HS Student Exhib

Activities: Lending collection contains books, cassettes, color reproductions, film strips, Kodachromes, paintings, sculpture

GLEN ELLEN

M **JACK LONDON STATE HISTORIC PARK,** House of Happy Walls, 2400 London Ranch Rd, Glen Ellen, CA 95442. Tel 707-938-5216; Fax 707-938-4827; *Supv Ranger* Greg Hayes; *Ranger* Cheryl Lawton; *Ranger* Angie Nowicki

Open daily 10 AM - 5 PM, summers 10 AM - 7 PM, cl Thanksgiving, Christmas, New Year's Day; Admis $10-$20 per bus, $3 per car, seniors $2; Estab 1959 for the interpretation of the life of Jack London; the fieldstone home was constructed in 1919 by London's widow; The collection is housed on two floors in the House of Happy Walls, and is operated by Calif Dept of Parks & Recreation; Average Annual Attendance: 100,000

Income: Financed by state appropriation

Collections: Artifacts from South Sea Islands; original illustrations; Portrait of activity during Jack London's residence

Activities: Tours; sales shop sells some of London's books

GLENDALE

M **FOREST LAWN MUSEUM,** 1712 S Glendale Ave, Glendale, CA 91205. Tel 800-204-3131; Fax 323-551-5329; Elec Mail museum@forestlawn.com; Internet Home Page Address: www.forestlawn.com; *Dir* Margaret Burton; *Mus Exec Dir* Alison Brueshoff; *Exhib Designer* Joan Adan; *Educ Prog Coordr* Trina Duke; *Educ Prog Coordr* Sheila Fernandez; *Special Event & Tour Coordr* Andrea Fordham

Open daily 10 AM - 5 PM; No admis fee; Estab 1951 as a community museum offering education and culture through association with the architecture and the art of world masters; Two galleries of permanent collection, museum store & rotating exhibit gallery; Average Annual Attendance: 50,000

Special Subjects: Decorative Arts, Drawings, Landscapes, Architecture, Ceramics, American Western Art, Furniture, Gold, Photography, Bronzes, Manuscripts, Latin American Art, Sculpture, Religious Art, Glass, Jade, Jewelry, Silver, Ivory, Coins & Medals, Painting-Polish, Renaissance Art, Medieval Art, Islamic Art, Antiquities-Greek, Antiquities-Roman, Mosaics, Stained Glass, Reproductions, Enamels

Collections: American Western Bronzes; Ancient Biblical and Historical Coins; Crucifixion by Jan Styka (195 x 45 ft painting); Resurrection (Robert Clark), painting; reproductions of Michelangelo's greatest sculptures; stained glass window of the Last Supper by Leonardo da Vinci; originals and reproductions of famous sculptures, paintings, and documents

Exhibitions: Four changing exhibits every year, see website

Activities: Classes for adults & children; lectrs open to the public, 6-8 vis lectrs per year; docent training; community events, History Comes Alive Program; gallery talks; tours; scholarships offered; lending collection contains reproductions of the crown jewels of England; originate traveling exhibitions; museum shop sells books, original art reproductions, prints, objects that reflect the collection; Hall of Liberty, 6300 Forest Lawn Dr, Los Angeles, CA 90068

M **GLENDALE PUBLIC LIBRARY,** (Brand Library & Art Galleries) Brand Library & Art Center, 1601 W Mountain St, Glendale, CA 91201-1209. Tel 818-548-2051; Fax 818-548-5079; *Sr Library Supvr* Alyssa Resnick; *Librn* Blair Whittington; *Librn* Cathy Billings

Open Tues & Thurs 1 - 9 PM, Wed 1 - 6 PM, Fri & Sat 1 - 5 PM; No admis fee; Estab 1956 to exhibit Southern California artists; Circ 170,000; Large gallery, foyer gallery, glass & concrete sculpture court; Average Annual Attendance: 100,000; Mem: 375; dues $15 - $500

Income: Financed by city & state appropriations

Library Holdings: Book Volumes 106,000; Compact Disks; Exhibition Catalogs; Framed Reproductions; Records 16,000; Reproductions; Slides

Collections: Indexes & other guides to art & music literature; books, catalogue raisonne, scores, CDs DVDs, slides

Exhibitions: 4-6 exhibits per year

Activities: Los Angeles Opera Talks; lectrs open to the public; 4-6 vis lectrs; concerts; gallery talks; tours; competitions

HAYWARD

M **CALIFORNIA STATE UNIVERSITY, EAST BAY,** University Art Gallery, 25800 Carlos B Blvd Hayward, CA 94542. Tel 510-885-3299; Fax 510-885-2281; Internet Home Page Address: www.csueastbay.edu/artgallery; *Pres* Dr Norma Rees; *Dir* Lanier Graham

Open Mon - Fri 11 AM - 5 PM; No admis fee; Estab 1970 to provide a changing exhibition program for the university & general public; Gallery contains 2,200 sq ft; Average Annual Attendance: 11,000

Publications: Usually one catalog a yr; flyers for each show

Activities: Lect open to public, 6 vis lectrs per year; exten dept; artmobile; book traveling exhibitions

M **C E Smith Museum of Anthropology,** 25800 Carlos B Blvd Hayward, CA
94542. Tel 510-885-3104; Fax 510-885-3353; Elec Mail gmiller@csuhayward.edu;
Dir George Miller PhD
Open Mon - Fri 11 AM - 5 PM; No admis fee; Estab 1974 as a teaching museum;
Three converted classrooms; one main entrance from center room; alarm system;
smoke detectors; Average Annual Attendance: 2,500; Mem: 200
Income: $22,000 (financed by state appropriation)
Special Subjects: African Art, Anthropology, Archaeology, Ethnology,
Pre-Columbian Art, Southwestern Art, Textiles
Collections: Krone Collection: Philippine artifacts; Lee Collection: Hopi
Kachinas, baskets, Navajo Mat
Activities: Lect open to public, 12 vis lectrs per year

M **SUN GALLERY,** (Hayward Area Forum of the Arts) 1015 E St, Hayward, CA
94541. Tel 510-581-4050; Fax 510-581-3384; Internet Home Page Address:
www.sungallery.org; *Dir* Dr Maria Ochoa
Open Wed - Sat 11 AM - 5 PM, cl major holidays; No admis fee; Estab 1975;
Mem: dues sustaining $65, family $40, single $30, student & senior citizen $20
Income: Financed by city, county & mem funds, corporate & foundation grants
Library Holdings: Audio Tapes; Book Volumes; CD-ROMs; Cards; Cassettes;
Clipping Files; Kodachrome Transparencies; Original Art Works; Prints; Sculpture
Collections: Contemporary art by Northern California artists
Exhibitions: San Francisco Alumni Association exhibition (photography); recent
works in Monotype; contemporary Mexican painters (from Santiago Garza
collection); Jack & Marilyn da Silva (metalware); art programs for the physically
limited; Roger Hankins (painting, assemblage); Dicksen Schneider; Southern
Alameda County Art Educators; Corita Kent; Artistas del Grupo Hermes
(paintings, drawings); Recent Work in Metal; Artists With Creative Growth; The
Picture: As Object, As Image (painting, assemblage, photography); Shrine & Koan
(painting, sculpture); Corita & Southern Alameda County Art Educators
(multi-media); HAFA members exhibition (multi-media); Art in the News
(photojournalists, editorial cartoonists); Forms In Space (2-D, 3-D); Felted Fibers
Activities: Classes for adults & children; lect open to public, 6-8 vis lectrs per
year; gallery talks; tours; scholarships offered; individual paintings & original
objects of art lent to city offices; museum shop sells original art, prints, books &
crafts

HOLLYWOOD

A **LOS ANGELES CENTER FOR PHOTOGRAPHIC STUDIES,** 6518
Hollywood Blvd, Hollywood, CA 90028. Tel 323-466-6232; Fax 323-466-3203;
Elec Mail jbache@calarts.edu; Internet Home Page Address:
www.oversight.com//acps; *Co-Pres* Glen Kaino; *Co-Pres* Shelby Stone; *Dir* Tania
Martiniz-Lemke
Open Mon - Fri 10 AM - 5 PM; Estab 1974 to promote photography within the
visual arts; Mem: 600; dues patron $250 - $1000, friend $100, regular $30,
student & seniors $15
Income: $110,000 (financed by mem, city & state appropriation, federal funds,
corporations & foundations)
Exhibitions: Members exhibition; group exhibitions
Publications: Frame/Work, 3 times per yr, Photo Calendar, bi-monthly
Activities: Workshops for adults; symposia; lect open to public, 8-12 vis lectrs per
year; competitions with awards; originates traveling exhibitions; sales shop sells
magazines & original art

HUNTINGTON BEACH

M **HUNTINGTON BEACH ART CENTER,** 538 Main St, Huntington Beach, CA
92648. Tel 714-374-1650; Fax 714-374-5304; Elec Mail deangel@surfcity-hb.org;
Dir Michael Mudd; *Dir Programming* Darlene DeAngelo
Open Wed, Fri & Sat Noon - 6 PM, Thurs Noon - 8 PM, Sun Noon - 4 PM, cl
Mon & Tues; No admis fee; Estab 1995 to provide community art center; Three
large galleries, store gallery, studio & one educational gallery; Average Annual
Attendance: 3,000; Mem: 300
Activities: Classes for adults & children; performance art venue; lect open to
public; Sun jazz concerts; sales shop sells books & magazines

IRVINE

M **CITY OF IRVINE,** Irvine Fine Arts Center, 14321 Yale Ave, Irvine, CA
92604-1901. Tel 949-724-6880; Fax 949-552-2137; *Dir* Toni Pang; *Exhib Coordr*
Carl F Berg; *Youth Prog Coordr* Lisa Wren; *Adult Educ Coordr* Wendy Shields
Open Mon - Thurs 9 AM - 9 PM, Fri 9 AM - 5 PM, Sat 9 AM - 3 PM, Sun 1 - 5
PM; Estab 1980 to promote awareness of the value & function of the arts in the
community; Gallery contains 5000 sq ft; Average Annual Attendance: 65,000;
Mem: 250; dues $25 - $100
Income: $800,000 (financed by city appropriation, grants & donations)
Exhibitions: Solo & group themed exhibitions of local, national & international
contemporary artists
Publications: Art Beat, quarterly
Activities: Classes for adults & children; docent programs; open studios; lect open
to public, 4 vis lectrs per year; competitions; originate annual traveling exhibition;
retail store sells books & original art

M **IRVINE MUSEUM,** 18881 Von Karman Ave Ste 100, Irvine, CA 92612. Tel
949-476-0294; Fax 949-476-2437; Internet Home Page Address:
www.irvinemuseum.org; *Exec Dir* Jean Stern; *Exec Dir* Merika Adamas Gopaul;
Cur Educ Christine DeWitt; *Receptionist* Judy Thompson; *Bookstore Mgr* Don
Bridges
Open Tues - Sat 11 AM - 5 PM; No admis fee; Estab 1992 to promote the
California Impressionist Period; Average Annual Attendance: 19,000
Special Subjects: Painting-American
Collections: Paintings of the California Impressionist Period, 1890-1930
Exhibitions: Exhibits change every 4 months; traveling exhibs

Publications: Exhibit catalogs
Activities: Classes for children; docent programs; museum shop sells books

M **UNIVERSITY OF CALIFORNIA, IRVINE,** Beall Center for Art and
Technology, and University Art Gallery, Room 101 HTC, Univ of Calif Irvine
Irvine, CA 92697-2775. Tel 949-824-6206; Fax 949-824-4197; Elec Mail
gallery@uci.edu; Internet Home Page Address: www.beallcenter.uci.edu; *Dir*
Jeanie Weiffenbach; *Asst Dir* Indi McCarthy
Open Oct - June, Tues - Sun Noon - 5 PM, Thurs Noon - 8 PM; No admis fee;
Estab 1965 to house changing exhibitions devoted to contemporary art; 2 galleries
totalling 5,000 sq ft; Average Annual Attendance: 5,000
Income: Financed by state appropriations & by pvt and corporate donors
Exhibitions: (2000) SHIFT-CTRL: Computers, Eames and Art; (2000) 1990s Art
from Cuba (organized by Art in General, NY)
Publications: Exhibition catalogs; mailers
Activities: Monthly lect on each exhibit; performances; tours; field trips

KENTFIELD

M **COLLEGE OF MARIN,** Art Gallery, College Ave, Kentfield, CA 94904. Tel
415-485-9494; Internet Home Page Address: www.marin.edu; *Dir* Julie Gustafson
Open Mon - Fri 9 AM - 5 PM, also during all performances for drama, music &
concert; No admis fee; Estab 1970 for the purpose of educ in the college district
& community; Gallery is housed in the entrance to Fine Arts Complex, measures
3600 sq ft of unlimited hanging space; has portable hanging units & locked cases;
Average Annual Attendance: 100-450 daily
Income: Financed by state appropriation & community taxes
Collections: Art student work; miscellaneous collection
Exhibitions: Faculty & Art Student; Fine Arts & Decorative Arts
Publications: Catalogs, 1-2 per year
Activities: Gallery Design-Management course; gallery talks; tours

LA JOLLA

L **LIBRARY ASSOCIATION OF LA JOLLA,** Athenaeum Music & Arts Library,
1008 Wall St, La Jolla, CA 92037. Tel 858-454-5872; Fax 858-454-5835; Elec
Mail athdir@pacbell.net; Internet Home Page Address: www.ljathenaeum.org; *Exec
Dir* Erika Torri; *Prog Dir* Judith Oishei; *Mem Asst* Kathy White; *Librn* Kathi
Bower-Peterson; *Pub Relations* Kristina Meek; *School Dir* Emily Vermillion
Open Tues, Thurs, Fri & Sat 10 AM - 5:30 PM, Wed 10 AM - 8:30 PM; No
admis fee; Estab 1899 to provide the La Jolla & San Diego communities with
library resources in music & arts & an on going schedule of cultural programs,
classes, concerts & exhibitions; Circ 34,000; changing exhibitions every six
weeks; Average Annual Attendance: 100,000; Mem: 2300; dues $40-$5000; annual
meeting third Tues in July
Income: $1,500,000 (financed by endowment fund, rents, dues, gifts, admis &
tuitions)
Purchases: $50,000
Library Holdings: Audio Tapes 4,000; Book Volumes 16,000; CD-ROMs 200;
Cassettes 4000; Clipping Files 2500; Compact Disks 10,000; DVDs 400;
Exhibition Catalogs; Other Holdings Sheet Music, Artists' Books 1000; Pamphlets;
Periodical Subscriptions 85; Photographs; Records 8000; Video Tapes 3000
Special Subjects: Art History, Photography, Bronzes, Advertising Design, Asian
Art, Aesthetics, Afro-American Art, Bookplates & Bindings, Architecture
Collections: Collection of artists books
Exhibitions: Changing exhibitions every six weeks
Publications: Bimonthly newsletter, qtr school brochure, occasional exhib
catalogues
Activities: Classes for adults & children; lect open to public, 15 vis lectrs per
year; concerts; library tours; panel discussions; vis artists workshops; outreach
programs for children; qtr book sales; competitions with prizes; original artists
books lent to qualified mus & institutions

M **MUSEUM OF CONTEMPORARY ART, SAN DIEGO,** 700 Prospect St, La
Jolla, CA 92037. Tel 858-454-3541; Fax 858-454-6985; Elec Mail
info@mcasandiego.org; Internet Home Page Address: www.mcasandiego.rog;
VPres Dr Charles G Cochrane; *Dir* Hugh M Davies; *Deputy Dir* Charles E Castle;
Cur Educ Kelly McKinley; *Develop Dir* Anne Farrell; *Pres Board Trustees*
Pauline Foster; *Marketing Mgr* Jana Purdy; *Pub Relations Officer* Jennifer
Morrissey; *Mus Shop Mgr* Jon Weatherman; *Registrar* Mary Johnson; *Cur* Toby
Kamps
Open Sun - Tues & Fri - Sat 11 AM - 5 PM, Thurs 11 AM - 8 PM; Admis $4
adults, $2 seniors & students, children under 12 free; Estab 1941 to collect,
preserve & present post-1950 art; Maintains two locations, a 500 seat auditorium,
16,000 sq ft total exhibition space. See also listing for San Diego facility; Average
Annual Attendance: 170,000; Mem: 3,000; dues $50-$2,500
Income: $3,700,000 (financed by endowment, mem, city & state appropriations,
grants from the National Endowment for the Arts, Institute of Museum Services,
private foundations & contributions)
Special Subjects: Painting-American, Sculpture
Collections: Contemporary Art, International, 1950 to the present
Exhibitions: Vernon Fisher; Ann Hamilton; Alfredo Jaar; La Frontera/The Border;
David Reed; Francis Bacon: The Papal Portraits of 1953
Publications: Exhibition catalogs; newsletter, quarterly
Activities: Classes for adults & children; docent training; lect open to public,
10-15 vis lectrs per year; gallery talks, tours; films; individual paintings & original
objects of art lent to museums & qualified art organizations; lending collection
contains original art works, original prints, paintings, photographs, sculpture; book
traveling exhibitions 3-4 per year; originate traveling exhibitions; museum
bookstore sells books, magazines, posters, design objects

L **Geisel Library,** 700 Prospect St, La Jolla, CA 92037. Tel 858-454-3541; Fax
858-454-6985; Elec Mail aschofield@mcasandiego.org; Internet Home Page
Address: www.mcasandiego.org; *Librn* Andrea Hales; *Dir* Dr Hugh M Davies;
Deputy Dir Charles Castle; *Dir External Affairs* Anne Farrell; *Cur* Stephanie
Hanor; *Cur* Rachel Teagle; *Dir Institutional Advanc* Jane Rice

Open Sun - Tues, Thurs - Sat 11 AM 5 - 5 PM, Thurs 11 AM - 7 PM; Admis $6 adults, $2 seniors (65 and over), military & students, children under 12 free; Estab 1941; Average Annual Attendance: 160,000
Income: Financed by mem, gifts & grants
Library Holdings: Auction Catalogs; Audio Tapes; Book Volumes 4500; Cards; Cassettes; Clipping Files 2000; Exhibition Catalogs 6000; Pamphlets; Periodical Subscriptions 56; Slides 10,000; Video Tapes
Special Subjects: Art History, Photography, Drawings, Painting-American, Painting-British, Sculpture, Conceptual Art, Latin American Art, Video
Activities: Classes for children; docent training; concerts; gallery talks; tours; ext prog; lending of original objects of art to national & international museums; book traveling exhib; organize traveling exhibitions to national & international museums; museum shop sells books, magazines, reproductions, utensils, toys, decorative objects; second location at MCA Downtown, 1001 Kettner Blvd, San Diego 92101

M MUSEUM OF CONTEMPORARY ART, SAN DIEGO-DOWNTOWN, 700 Prospect St, La Jolla, CA 92037. Tel 619-234-1001; Fax 619-234-1070; Elec Mail info@mcasandiego.org; Internet Home Page Address: www.mcasandiego.org; *Pres Bd Trustees* Dr Charles Cochrane; *Cur* Toby Kamps; *Dir* Hugh M Davies; *Assoc Dir* Charles Castle; *Educ Cur* Kelly McKinley; *Dir Develop* Anne Farrell; *Mktg Mgr* Jana Purdy; *Publ Relations Officer* Jennifer Morrissey
Open Thurs - Tues 11 AM - 5 PM, cl Weds; No admis fee; Estab 1941 to collect, preserve & present post-1950 art; See also listing for La Jolla facility; Average Annual Attendance: 160,000; Mem: 3500; dues $50
Income: $5,400,000 (financed by endowment, mem, city & state appropriation, grants from the National Endowment for the Arts, Institute of Mus Services & private foundations)
Library Holdings: Audio Tapes; Clipping Files; Exhibition Catalogs; Pamphlets; Periodical Subscriptions; Slides
Special Subjects: Architecture, Drawings, Photography, Prints, Sculpture, Watercolors
Collections: Contemporary art, all media; post-1950 art, all media
Publications: VIEW, quarterly newsletter; exhibition catalogues
Activities: Classes for adults & children; docent programs; films; lect open to public; gallery talks; tours; internships offered; book traveling exhibitions 1 per year; originate traveling exhibitions 2 per year; museum shop sells books, magazines, reproductions, prints posters, original art & design objects

L UNIVERSITY OF CALIFORNIA, SAN DIEGO, Arts Libraries, Geisel Library, 0175F, 9500 Gilman Dr La Jolla, CA 92093-0175. Tel 858-534-4811; Fax 858-534-0189; Internet Home Page Address: artslib.ucsd.edu; *Visual Arts Librn* Susan Jurist; *Cur Visual Resources* Vickie O'Riordan; *Head* Leslie Abrams; *Music Librn* Ken Calkins; *Instruction & Outreach Librn* Lia Friedman
Open Mon - Thurs 8 AM - 9 PM, Fri 8 AM - 5 PM, Sat 12 - 5:45 PM, Sun 12 - 7 PM; No admis fee; Estab 1992; Circ 110,000
Income: Financed by state appropriation
Purchases: $100,000
Library Holdings: Audio Tapes 5,000; Book Volumes 118,000; Clipping Files 30,000; DVDs 4,000; Exhibition Catalogs; Motion Pictures 727; Other Holdings scores 51,000; LP 50,000; Periodical Subscriptions 180; Slides 300,000; Video Tapes 8,338
Special Subjects: Art History, Landscape Architecture, Film, Mixed Media, Photography, Manuscripts, Pre-Columbian Art, History of Art & Archaeology, Conceptual Art, Ethnology, Video, American Indian Art, Afro-American Art, Religious Art, Architecture
Publications: Art & Architecture Library, general guide; Contemporary Artists, Education & Careers; Guide to Architectural Information; Notes from the Underground; irregular newsletter
Activities: Classes for adults; lectrs open to the public, 1 vis lectr per yr, concerts, tours

M UNIVERSITY OF CALIFORNIA, SAN DIEGO, Stuart Collection, 9500 Gilman Dr, La Jolla, CA 92093-0010. Tel 858-534-2117; Fax 858-534-9713; Elec Mail mbeebe@ucsd.edu; Internet Home Page Address: www.stuartcollection.ucsd.edu; *Project Mgr* Mathieu Gregoire; *Dir* Mary Livingstone Beebe; *Prog Asst* Jane Peterson
Open 24 hours, 7 days a week; No admis fee; Estab 1981 to commission outdoor sculptures for UCSD campus; Maintains small library; Average Annual Attendance: 38,000 per day
Purchases: 156 commissioned sculptures
Special Subjects: Architecture, Drawings, Sculpture, Archaeology
Collections: Outdoor sculptures, 16 works
Publications: Landmarks
Activities: Lect open to public; tours; support groups

M UNIVERSITY OF CALIFORNIA-SAN DIEGO, University Art Gallery, 9500 Gilman Dr, Mail Code 0327 La Jolla, CA 92093-0327. Tel 858-534-2107; Fax 858-822-3548; Elec Mail uag@ucsd.edu; Internet Home Page Address: www.universityartgallery.ucsd.edu; *Dir* Kathleen Stoughton
Open Tues - Sun 11 AM - 4 PM, cl Mon, July, Aug & Christmas break; No admis fee; Estab 1967 to provide changing exhibitions of interest to the visual arts majors, university personnel & the community at large, including an emphasis on contemporary art; Located on the west end of Mandeville Center, flexible open space approximately 40 x 70 ft; Average Annual Attendance: 15,000; Mem: 200; dues $35 & up; bi-monthly meetings
Income: Financed by state appropriations, member contributions & student registration fees
Collections: Small Impressionist Collection owned by UC Foundation, presently on loan to San Diego Fine Arts Gallery, Balboa Park
Publications: Dear Vocio: Photographs by Tina Modotti
Activities: Classes for children & docent training; lect open to public, 3-4 vis lectrs per year; gallery talks; tours; originate traveling exhibitions

LAGUNA BEACH

L ART INSTITUTE OF SOUTHERN CALIFORNIA, Ruth Salyer Library, 2222 Laguna Canyon Rd, Laguna Beach, CA 92651. Tel 949-376-6000; Fax 949-376-6009; Elec Mail abarkley@aisc.edu; *Head Librn* Wendy Baldi
Open Mon - Thurs 9 AM - 6 PM, Fri 9 AM - 5 PM; No admis fee; Estab 1962; Circ 10,000; For lending only to students
Income: Financed through Institute
Purchases: $9000
Library Holdings: Book Volumes 14,471; CD-ROMs; Clipping Files; Exhibition Catalogs 400; Periodical Subscriptions 69; Slides 23,787; Video Tapes 97
Special Subjects: Film, Mixed Media, Photography, Commerical Art, Etchings & Engravings, Graphic Arts, Painting-American, History of Art & Archaeology, Portraits, Ceramics, Bronzes, Advertising Design, Art Education, Anthropology, Architecture
Publications: Catalog, annual; newsletters, semi-annual

M LAGUNA ART MUSEUM, 307 Cliff Dr, Laguna Beach, CA 92651. Tel 949-494-8971; Fax 949-494-1530; Elec Mail info@lagunaartmuseum.org; Internet Home Page Address: www.lagunaartmuseum.org; *Finance Officer* Robert Bitter; *Bookstore Mgr* Susan Tucker; *Dir* Bolton Colburn; *Pub Rels Mktg & Comm* Stuart Byer; *Develop* Ann Camp; *Mem* Lydia Roberts; *Cur of Exhib* Tyler Stallings; *Cur Coll* Janet Blake
Open Thurs - Tues 11 AM - 5 PM, cl Wed; Admis adults $9, seniors & students $7, children under 12 free; Estab 1918 as an art assoc; Two large galleries, six small galleries, mus store & offices; Average Annual Attendance: 40,000; Mem: 1800; dues $40 - $1000; annual meeting in Sept
Income: Financed by endowment & mem
Collections: American Art with focus on contemporary & early 20th century California painting
Exhibitions: Rotating exhibits
Activities: Classes for adults & children; docent training; lect open to public, 15 vis lectrs per year; concerts; gallery talks; tours; book traveling exhibitions; originate traveling exhibitions; sales shop sells books,

LONG BEACH

M ALPERT JEWISH COMMUNITY CENTER, Gatov Gallery, 3801 E Willow St, Long Beach, CA 90815. Tel 562-426-7601; Fax 562-424-3915; *Pres* Karen Strelitz; *Exec Dir* Michael Witenstein
Open Mon - Thurs 6 AM - 10 PM, Fri 6 AM - 6 PM, Sat 1 - 6 PM, Sun 8:30 AM - 6 PM; No admis fee; Estab 1960 to provide a community service for local artists & the broader community as well as offering exhibits of particular interest to the Jewish community; The gallery is located in the main promenade of the building; panels & shelves are for exhibit displays
Income: Financed by mem, United Jewish Welfare Fund, United Way & fundraising events
Special Subjects: Judaica
Exhibitions: Annual Holiday Craft & Gift Show; Annual Youth Art Show; Biannual Art for Social Justice Exhibit; monthly exhibits throughout the year; paintings, photography, portraits, sculpture
Publications: Center News, monthly; Jewish Federation News, bimonthly
Activities: Classes for adults & children; dramatic programs; lect open to public; concerts; gallery talks; tours; competitions with awards; sales shop sells books, Israeli & Jewish Holiday art objects & gift items

A CALIFORNIA STATE UNIVERSITY, Long Beach Foundation, 6300 State Univ Dr Ste 332, Long Beach, CA 90815. Tel 562-985-5537; Fax 562-985-7951; Elec Mail svanderh@csulb.edu; *Exec Dir* Sandra Vanderhaden
Estab 1955 existing solely to advance the mission of the University. Serves to complement & strengthen the University's teaching, research, scholarly, creative & public service goals
Activities: Lect open to public, 8 vis lectrs per year; grants offered

M CALIFORNIA STATE UNIVERSITY, LONG BEACH, University Art Museum, 1250 Bellflower Blvd, Long Beach, CA 90840-1901. Tel 562-985-5761; Fax 562-985-7602; Elec Mail uam@csulb.edu; Internet Home Page Address: www.csulb.edu/uam; *Dir & Chief Cur* Constance W Glenn; *Assoc Dir* Ilee Kaplan; *Educ Consultant* Liz Harvey; *Registrar & Cur Colls* Anna Marie Sanchez; *Cur Exhibs* Mary Kay Lombino; *Develop Dir* Michelle Sprokkereef
Open Tues - Thurs Noon - 8 PM, Fri - Sun Noon - 5 PM, cl Mon; Admis general pub $3, students $1, donation suggested; Estab 1949 to be an academic & community visual arts resource; Contemporary art; Average Annual Attendance: 50,000; Mem: 300
Income: Financed by university appropriation & private funding
Purchases: Site specific sculpture, works of art on paper
Collections: 1965 Sculpture Symposium; contemporary prints, drawings & photographs; site-specific sculpture
Exhibitions: Jim Dine Figure Drawings: 1975-1979; Kathe Kollwitz at the Zeitlin Bookshop 1937: CSULB 1979; Roy Lichtenstein: Ceramic Sculpture; Nathan Oliveira Print Retrospective; Lucas Samaras: Photo Transformations; George Segal: Pastels 1957 - 1965; Frederick Sommer at Seventy-five; The Photograph as Artifice; Renate Ponsold-Robert Motherwell: Apropos Robinson Jeffers; Francesco Clemente Recent Works; Paul Wonner: Recent Works; Jacques Hurtubise: Oeuvres Recentes-Recent Works; Bryan Hunt: A Decade of Drawings; Anders Zorn Rediscovered; Robert Longo: Sequences-Men in the Cities; A Collective Vision: Clarence White & His Students; Hirosada: Osaka Printmaker; Eric Fischl; Scenes Before the Eye; Lorna Simpson; Imagenes Liricas: New Spanish Visions; James Rosenquist: Time Dust, The Complete Graphics 1962 - 1992; The Great American Pop Art Store: Multiples of the Sixties
Publications: Exhibition catalogs & brochures, 3-4 per year
Activities: Classes for adults & children; docent training; lect open to public, 3-5 vis lectrs per year; concerts; gallery talks; tours; book traveling exhibitions 1-2 per year; originate traveling exhibitions to qualified museums; museum shop sells books, magazines, original art reproductions, jewelry & objects

L University Library, 1250 Bellflower Blvd, Long Beach, CA 90840-1901. Tel 562-985-4047; Fax 562-985-1703
Open Tues - Thurs Noon - 8 PM, Fri - Sun Noon - 5 PM, cl Mon; Estab 1949 for delivery of information & related services to the campus & surrounding communities; Circ 340,248; For lending & reference
Income: Financed by state appropriation
Purchases: $17,722
Library Holdings: Book Volumes 1,022,263; Cards; Cassettes; Exhibition Catalogs; Fiche; Filmstrips; Motion Pictures; Other Holdings Art vols 37,000; Pamphlets; Periodical Subscriptions 116; Prints; Records; Reels; Reproductions; Slides; Video Tapes
Special Subjects: Art History, Photography, Prints, Art Education, Asian Art, Video
Collections: Modern Photography Collection (Edward Weston, Ansel Adams), original photographic prints; Kathe Kollwitz Collection, original prints

M LONG BEACH MUSEUM OF ART FOUNDATION, 2300 E Ocean Blvd, Long Beach, CA 90803. Tel 562-439-2119; Fax 562-439-3587; Elec Mail haln@lbma.com; Internet Home Page Address: www.lbma.org; *Develop Dir* Susan Reeder; *Dir* Harold B Nelson; *Dir of Exhibitions* Martin Betz; *Dir Educ* Sue Ann Robinson; *Business Mgr* Knute Thune; *Registrar* Dianna Santillano; *Mus Shop Mgr* Chris Giaco; *VPres* Tamara Achauer
Open Tues - Sun 11 AM - 5 PM; cl New Year's, July 4, Thanksgiving & Christmas; Admis $5; Opened in 1951 as a Municipal Art Center under the city library department; in 1957 the Long Beach City Council changed the center to the Long Beach Museum of Art; managed by Foundation since 1985; Eight galleries & a screening room with changing exhibitions & selections from Permanent Collection; Average Annual Attendance: 50,000; Mem: 1600; dues individual $40, student $30
Income: Financed by annual contribution of City of Long Beach & through grants from private foundations & through individual & corporate contributions
Special Subjects: Drawings, Painting-American, Prints, Sculpture, Ceramics, Crafts, Decorative Arts
Collections: Paintings, sculpture, prints, drawings, crafts & photography; 1000 items with emphasis on West Coast & California modern & contemporary art; sculpture garden; Milton Wichner Collection includes Kandinsky, Jawlensky, Feininger, Moholy-Nagy; Major collection of video art
Exhibitions: 5 rotating exhibitions per yr
Publications: Announcements; exhibit catalogs; quarterly bulletin
Activities: Workshops for adults & children; docent training; screening & lect series open to public, 12 - 20 vis lectrs per year; concerts; gallery talks; tours; video art Open Channels competition; awards; book traveling exhibitions, 4 per year; originate traveling exhibitions that circulate to museums; museum shop sells books & small boutique sells jewelry & cards

L Long Beach Museum of Art, 2300 E Ocean Blvd, Long Beach, CA 90803. Tel 562-439-2119; Fax 562-439-3587; Elec Mail haln@lbma.com; Internet Home Page Address: www.lbma.org; *Dir* Harold Nelson; *Dir of Develop* Susan Reeder; *Dir of Gov Rel* Brenda Sheridan; *Dir of Finance* Knut Thune; *Dir of Coll* Sue Ann Robinson; *Mgr of Pub Rel & Marketing* Cari Marshall; *Dir of Educ* Victoria Damrel
Open 11 AM - 5 PM Tues - Sun; Admis $5; Estab 1950 to enrich lives and promote understanding by bringing people together to celebrate the arts; Open for staff reference with restricted lending of books, publications & slides; Average Annual Attendance: 65,000; Mem: 200; dues $40
Library Holdings: Book Volumes 3200; Clipping Files; Exhibition Catalogs; Periodical Subscriptions 8; Video Tapes
Special Subjects: Art History
Collections: Paintings, drawings, works on paper, ceramics, design/decorative arts
Exhibitions: Annual Children's Cultural Festival, fall each yr
Publications: Quar newsletter
Activities: Classes for adults & children; docent training; artmaking workshops; lect open to public; 1-3 vis lectrs per yr; concerts; gallery talks; tours; artmobile to other museums; 1-4 book traveling exhibitions per yr; originate traveling exhibitions to US & foreign museums; museum shop sells books, original art, reproductions, prints

L LONG BEACH PUBLIC LIBRARY, 101 Pacific Ave, Long Beach, CA 90822. Tel 562-570-7500; Fax 562-590-6956; Internet Home Page Address: www.lbpl.org; *Fine Arts Librn* Ruth Stewart; *Dir Libr Servs* Eleanore Schmidt
Open Mon & Thurs 10 AM - 8 PM, Tues, Wed, Fri & Sat 10 AM - 5:30 PM, Sun Noon - 5 PM; Estab 1897
Income: Financed by municipality
Library Holdings: Audio Tapes 20,000; Book Volumes 1,093,155; CD-ROMs; Clipping Files; Compact Disks; DVDs; Pamphlets; Periodical Subscriptions 2000; Records; Video Tapes 9000
Collections: Miller Special Collections Room housing fine arts books with an emphasis on Asian Art & Marilyn Horne Archives

A PUBLIC CORPORATION FOR THE ARTS, 110 W Ocean Blvd, Ste 20, Long Beach, CA 90802-4625. Tel 562-432-5100; Fax 562-432-5175; Elec Mail info@artspca.org; Internet Home Page Address: www.artspca.org; *Exec Dir* Joan Van Hooten
Open Mon - Thurs 9 AM - 5 PM, cl Fri, Sat & Sun; No admis fee; Estab 1977, nonprofit, official arts advisory council for city of Long Beach
Income: $750,000 (financed by endowment, mem, city appropriation, private corporations & foundations)
Publications: Quarterly events calendar
Activities: Enrichment & alternative arts programs; technical assistance; individual & community art grants, Smithsonian Week

M ROBERT GUMBINER FOUNDATION, Museum of Latin American Art, 628 Alamitos Ave, Long Beach, CA 90802. Tel 562-437-1689; Fax 562-437-7043; Internet Home Page Address: www.molaa.com; *Dir Pub Relations* Susan Golden; *Dir Colls & Exhibs* Eliud Alvarado; *Exec Dir* Gregorio Luke; *Deputy Dir* Alex Slato; *COO* Nancy Fox
Open Tues - Fri 11:30 AM - 7 PM, Sat 11 AM - 7 PM, Sun 11 AM - 6 PM; Admis $5, students & seniors $3, children under 12 free; Estab 1996 to research, collect & exhibit contemporary Latin American art (since WWII); Maintains reference library; Average Annual Attendance: 22,000; Mem: 8000; dues $40 individual, $60 family
Income: Financed by endowment, mem & grants
Library Holdings: Auction Catalogs; Audio Tapes; Clipping Files; Exhibition Catalogs; Kodachrome Transparencies; Pamphlets; Periodical Subscriptions; Slides; Video Tapes
Special Subjects: Drawings, Etchings & Engravings, Ceramics, Collages, Glass, Portraits, Prints, Bronzes, Graphics, Hispanic Art, Latin American Art, Mexican Art, Sculpture, Watercolors, Woodcarvings, Woodcuts
Collections: Robert Gumbiner Foundation Collection; contemporary Latin American art-paintings & sculpture produced since 1945; Molla's Collection - Donations & Acquisitions
Exhibitions: (12/01/2004-03/20/2005) Rufino Tamayo
Publications: History of Contemporary Latin American Art
Activities: Classes for adults & children; docent training; lect open to public; concerts; family day of events, including lect, workshops, music, film; book traveling exhibitions 4 per year; organize traveling exhib to museums in the USA; sales shop sells books, original art, prints, lithographs, contemporary fine art, folk art & jewelry

LOS ALTOS

M GALLERY 9, 143 Main St, Los Altos, CA 94022. Tel 415-941-7969; *Treas* Charles W Halleck; *Exhibits Chmn* Carol Hake; *Staff* Jean Pell Morton; *Publicity* Louise Freund
Open Tues - Sat 11:30 AM - 5:30 PM; No admis fee; Estab 1970 to exhibit local fine art; Average Annual Attendance: 1,200; Mem: 30; dues $520; meetings first Mon each month
Exhibitions: Exhibit changes each month. Member artists featured once every two years
Activities: Sales shop sells original art

LOS ANGELES

M CALIFORNIA AFRICAN-AMERICAN MUSEUM, 600 State Dr Exposition Park, Los Angeles, CA 90037. Tel 213-744-7432; Fax 213-744-2050; Internet Home Page Address: www.caam.ca.gov; *Dir* Jamesina Henderson; *History Program Mgr* Rick Moss; *Deputy Dir & Assoc Ed Publs* Nancy McKinney; *Educ Program* Evelyn Carter; *Exec Dir* Jai Henderson; *Registrar* Andrew Talley; *Librn* Ann Shea; *Chmn Bd* L Charmayne Mills; *Cur Educ* Mar Hollingworth; *Cur History* Redell Hearn; *Exhib Designer* Eduardo Carrasquillo; *Develop Officer* Sheila McTyer; *Visual Arts Program* John Riddle; *Mus Shop Mgr* Dimitri Monroe
Open daily 10 AM - 5 PM, cl Mon; No admis fee; Estab to examine, collect, preserve & display art, history & culture of Blacks in The Americas with concentration on Blacks in California
Publications: Calendar of Events, every 2 months; exhibition catalogs

M CALIFORNIA SCIENCE CENTER, (California Museum of Science and Industry) 700 State Dr, Los Angeles, CA 90037. Tel 213-744-7400, 744-7420; Fax 213-744-2034; Internet Home Page Address: www.casciencectr.org; *Pres & CEO* Jeffrey N Rudolph; *Cur World Ecology* Chuck Kopczak; *Deputy Dir Educ* Ron Rohouit; *Technology Cur* David Bibas; *Deputy Dir Exhib* Diane Perlov; *Sr VPres Develop & Marketing* William Harris; *Aerospace Cur* Kenneth E Phillips; *CFO* Cynthia Pygin; *Deputy Dir Operations* Tony Budrovich; *VPres Retail Operations* Kent Jones; *Deputy Dir Admin* Cheryl Tateischi
Open daily 10 AM - 5 PM; No admis fees to permanent galleries; A dynamic destination where families, school groups, adults & children can explore the wonders of science though interactive exhibits, live demonstrations & innovative programs; Three permanent exhibit galleries - Creative World (showcases the wonders & consequences of human innovation); World of Life (probes the commonalities of the living world); Air & Space (features hands-on exhibits coupled with real air & space craft). Also, a Special Exhibits Gallery hosts 3-4 exhibits a yr; Average Annual Attendance: 1,300,000; Mem: 5,000, $50-$500 per yr
Income: Financed by state appropriation and California Museum Foundation
Exhibitions: Various exhib
Publications: Notices of temporary exhibits, maps, pamphlets
Activities: Formal science-art educ programs for school groups & public, teacher training; lect open to the pub, 3 vis lectrs per yr, competitions; scholarships offered; organize traveling exhib; mus shop sells books, science toys & videos

M CALIFORNIA STATE UNIVERSITY, LOS ANGELES, Fine Arts Gallery, 5151 State University Dr, Los Angeles, CA 90032. Tel 323-343-4023; Fax 323-343-4045; *Dir* Lamont Westmorland
Open Mon - Thurs Noon - 5 PM; No admis fee; Estab 1954 as a forum for advanced works of art & their makers, so that educ through exposure to works of art can take place; Gallery has 3500 sq ft, clean white walls, 11 ft high ceilings with an entry & catalog desk; Average Annual Attendance: 30,000
Income: Financed by endowment & state appropriation
Exhibitions: Various exhib
Publications: Exhibition catalogs, three per year
Activities: Educ dept; lect open to public, 10-20 vis lectrs per year; gallery talks; exten dept

M CRAFT AND FOLK ART MUSEUM (CAFAM), 5814 Wilshire Blvd, Los Angeles, CA 90036. Tel 323-937-4230; Fax 323-937-5576; Elec Mail info@cafam.org; Internet Home Page Address: www.cafam.org; *Exec Dir* Maryna Hrushetska; *Exhib & PR Coordr* Sonja Cendak; *Mktg & Develop Assoc* Grace Nguyen; *Admis Asst* Lauren Watley; *Preparator & Facilities* Conor Thompson; *Mus Shop Dir* Yuko Makuughi; *Educ Dir* Holly Jerger
Mus open Tues - Fri 11 AM - 5 PM; Sat & Sun 12 PM - 6 PM; Admis adults $5, seniors & students $3, children under 13 & 1st Wed of month no admis fee; Founded in 1965 by the late Edith Wyle; mus was originally known as "The Egg and The Eye"; Mus exhibs traditional folk art & crafts as well as participates in

progs & has involvement in national traditional folk art conferences & publs;
Mem: Donor $2500; Director's Circle $1000; Patron $500; Contributor $250;
Associate $100; Family $60; Individual $45; Senior/Student $35
Special Subjects: Afro-American Art, Decorative Arts, Etchings & Engravings,
Art Education, Metalwork, Mexican Art, Furniture, Porcelain, Pottery, Textiles,
Woodcuts, Sculpture, Tapestries, Latin American Art, African Art, Costumes,
Ceramics, Crafts, Folk Art, Primitive art, Woodcarvings, Judaica, Posters, Jewelry,
Oriental Art, Asian Art, Coins & Medals, Dioramas, Embroidery, Islamic Art,
Mosaics
Collections: traditional folk arts & contemporary crafts
Activities: School tours; internships; family art workshops; theatrical
performances; craft workshops, progs & special events, classes for adults &
children; concerts, gallery talks & tours; books, original art, crafts, clothing,
housewares & museum-related items for sale

M CULTURAL AFFAIRS DEPARTMENT, Los Angeles Municipal Art Gallery,
4804 Hollywood Blvd, Los Angeles, CA 90027. Tel 323-644-6269; Fax
323-644-6271; Elec Mail cadmag@sbcglobal.net; *Dir* Mark Steven Greenfield;
Cur Scott Canty; *Dir Mus Educ & Tours* Sara L Cannon
Open Fri - Sun Noon - 5 PM, first Fri Noon - 9 PM; Admis $5, Seniors &
Students $3; children under 12 & first Fri free; Estab to show Southern California
Activities: Currently engaged in outreach through exhibitions and events at other
sites

**A CULTURAL AFFAIRS DEPARTMENT CITY OF LOS
ANGELES/BARNSDALL ART CENTERS,** Junior Arts Center, 4814 Hollywood
Blvd, Los Angeles, CA 90027. Tel 213-485-4474; *Teacher Outreach Coordr* Laura
Stickney; *Coordr Handicapped Svcs* Dr Mary J Martz; *Sunday Coordr* Nicolette
Kominos; *International Child Art Coordr* Patty Sue Jones; *Dir* Isti Haroh Glasgow
Open Tues - Sun 10 AM - 5 PM; No admis fee; Estab 1967 to stimulate & assist
in the development of art skills & creativity; The gallery offers exhibitions of
interest to children & young people & those who work with the young; Average
Annual Attendance: 80,000; Mem: 400; dues vary ; annual meeting June 1
Income: Financed by city appropriation & Friends of the Junior Arts Center
Collections: Two-dimensional works on paper; 8mm film by former students
Exhibitions: 12 exhibitions a year;
Publications: Schedules of art classes, quarterly; exhibition notices
Activities: Art classes for young people in painting, dramatic programs drawing,
etching, general printmaking, photography, filmmaking, photo silkscreen, ceramics,
film animation; workshops for teachers; lectrs, 2-4 vis lectrs per year; films;
musical instrument making, design, video festivals for students & the general
public; gallery talks; tours; scholarships offered
L Library, 4814 Hollywood Blvd, Los Angeles, CA 90027. Tel 323-644-6275;
644-6295; Fax 323-644-6277; Elec Mail jacbac@schglobal.net; Internet Home
Page Address: www.juniorartscenter.org; Internet Home Page Address:
www.barnsdallartcenter.org; *Dir* Istiharoh Glasgow; *Dir JAC Educ* Laura Stickney;
Dir BAC Educ Livija Lapaite; *Office Mgr* Nancy Jung
Open Mon - Sat 10 AM - 5 PM; No admis fee; Estab as reference library; Circ
Non-circulating; Open to public
Library Holdings: Book Volumes 700; Slides 15,000
Special Subjects: Art History, Crafts, Art Education
Activities: Classes for adults & children; dramatic progs

A EL PUEBLO DE LOS ANGELES HISTORICAL MONUMENT, 622 N Main
St, Los Angeles, CA 90012; 125 Paseo de la Plaza Ste 400 Los Angeles, CA
90012. Tel 213-628-1274, 628-1268; Fax 213-485-8238; Elec Mail
scheng@mailbox.lacity.org; Internet Home Page Address: cityofla.org/elp/; *Acting
Gen Mgr* Samuel Luna; *Park Dir* Kory Smith; *Mus Shop Mgr* Gloria Giangiuli
Open Mon - Sat 10 AM - 3 PM; No admis fee; Estab 1781 as a living memorial
to the history & traditions of Los Angeles life, preserving for the public forever
the architecture & characteristics of the history & the diverse peoples associated
with the City's founding & evolution.

A FELLOWS OF CONTEMPORARY ART, 777 S Figueroa St, 44th Flr, Los
Angeles, CA 90017-2513; 970 N Broadway, Ste 208, Los Angeles, CA 90012. Tel
213-8081008; Fax 213-808-1018, 243-4199; Elec Mail info@focala.org; Internet
Home Page Address: www.focala.org; *Exec Dir* Stacen Berg
Supports contemporary California art by initiating & sponsoring exhibitions &
videos at selected institutions; Mem: 150; nomination process for membership
Income: Mem dues
Exhibitions: At least one major exhibition per year
Activities: One day educ programs; guest speakers; domestic & international tours

A FREDERICK R WEISMAN ART FOUNDATION, 275 N Carolwood Dr, Los
Angeles, CA 90077. Tel 310-277-5321; Fax 310-277-5075; Elec Mail
julianne-nelson@att.net; Internet Home Page Address:
www.weismanfoundation.org; *Dir* Billie Milam Weisman; *Registrar* Mary Ellen
Powell; *Cur Asst* Julianne Nelson
Open Mon - Fri 9:30 AM - 4:30 PM by appointment only; No admis fee; Estab
1982 as a nonprofit foundation focusing on exhibition, workshop & award
programs; Circ Catalogue Available; House setting; 2 floors, 1 gallery
Income: Financed by endowment
Library Holdings: Auction Catalogs; Exhibition Catalogs; Kodachrome
Transparencies; Original Art Works; Original Documents; Periodical Subscriptions;
Photographs; Sculpture; Slides
Special Subjects: Architecture, Etchings & Engravings, Painting-German,
Photography, Prints, Sculpture, Painting-American, Ceramics, Painting-European,
Painting-Dutch, Painting-Japanese, Painting-Russian
Collections: Contemporary Art: Installation Work; Mixed Media; Painting;
Sculpture; Works on Paper
Exhibitions: Frederick R. Weisman permanent collection
Publications: Workshop publication, semi-annual
Activities: Docent training; art purchase & curatorial achievement awards
distributed annually to museum collections & professionals involved in
contemporary art; tours; lend original art objects to Major US & European
Museums

A GALLERY 825/LOS ANGELES ART ASSOCIATION, Gallery 825, 825 N
LaCienega Blvd, Los Angeles, CA 90069. Tel 310-652-8272; Fax 310-652-9251;
Elec Mail gallery825@laaa.org; Internet Home Page Address: www.laaa.org; *Exec
Dir* Peter Mays; *Artistic Dir, Contact* Sinead Finnerty
Open Tues - Sat 10 AM - 5 PM; No admis fee; Estab 1925; Gallery 825/LAAA is
a 501(c)(3) nonprofit arts organization supporting southern California artists with
an emphasis on emerging talent; Average Annual Attendance: 5,000; Mem: 230;
dues $150; annual meeting in Apr; must reside in southern California to exhibit
Exhibitions: Graphics, Painting & Sculpture by Southern California Artists,
monthly
Publications: Announcements of exhibitions & lectures, monthly; newsletter,
quarterly
Activities: Classes for adults; lects open to the pub; gallery talks

L GETTY CENTER, Trust Museum, 1200 Getty Center Dr, Los Angeles, CA
90049-1687. Tel 310-458-9811; Fax 310-440-7751; Internet Home Page Address:
www.getty.edu; Telex 82-0268; TWX 310-343-6873; *Cur of European Sculpture &
Works of Art* Peter Fusco; *Cur Paintings & Drawings* Scott Schaefer; *Cur
Antiquities* Marion True; *Cur Photographs* Weston Naef; *Cur Decorative Arts*
Gillian Wilson; *Cur Manuscripts* Thom Kren; *Assoc Dir* Deborah Gribbon
Open by appointment only; No admis fee, parking reservations required, call
310-440-7300; Estab 1983 for the purpose of advancing research in art history &
related disciplines; The mus building is a re-creation of an ancient Roman villa &
consists of 47 galleries; Average Annual Attendance: 400,000
Income: Financed by Foundation
Library Holdings: Book Volumes 800,000; Exhibition Catalogs; Fiche;
Pamphlets; Periodical Subscriptions 1500; Reels
Collections: Art historical archives; photo archives
Publications: Calendar, monthly; Museum Journal, annually
Activities: Docent training; slide show for children; classroom materials; research
scholar program by invitation only, 20 vis scholars per year; original objects of art
lent to other museums for special exhibitions; museum shop sells books,
reproductions, slides & museum publications
M The J Paul Getty Museum, 1200 Getty Center Dr, Los Angeles, CA 90049-1687.
Tel 310-440-7330; Fax 310-440-7751; Internet Home Page Address:
www.getty.edu; *Cur Antiquities* Marion True; *Cur Manuscripts* Thomas Kren; *Dir,
VPres* Deborah Gribbon; *Cur Decorative Arts* Gillian Wilson; *Cur Photographs*
Weston Naef; *Cur European Sculpture & Works of Art* Peter Fusco; *Cur Paintings
& Drawings* Scott Schaefer
Open Tues & Wed 10 AM - 7 PM, Thurs & Fri 10 AM - 9 PM, Sat & Sun 10
AM - 6 PM, cl Mon & major holidays; No admis fee; parking $5 per car, no
parking reservations required on Sat & Sun or after 4 PM on weekdays, call
310-440-7300; Estab 1974; international cultural & philanthropic organization
serving both general audiences & specialized professionals.; The museum is
designed around an open central courtyard surrounded by 5 2-story pavilions;
Average Annual Attendance: 4,966,569
Income: Financed by J Paul Getty Trust
Library Holdings: Auction Catalogs; Book Volumes 500,000; Exhibition
Catalogs; Fiche; Original Art Works; Pamphlets; Periodical Subscriptions 1500;
Photographs; Reels; Slides
Collections: Greek & Roman antiquities; French decorative arts; Western
European paintings, drawings, sculpture; illuminated manuscripts; deorative arts;
19th & 20th century photographs
Publications: Calendar, quarterly; Museum Journal, annually
Activities: Classes for adults & children; docent/volunteer training; school
programs; professional development program; community collaboration
workshops; lects open to public; seminars; concerts; performances; architecture &
garden tours; orientation film; storytelling; artist demonstrations; gallery games;
scholarships & fels offered; museum shop sells books, prints, slides, postcards, gift
cards, calendars, mugs, clothing, educational toys, stationery

C GOLDEN STATE MUTUAL LIFE INSURANCE COMPANY, Afro-American
Art Collection, 1999 W Adams Blvd, Los Angeles, CA 90018. Tel 323-731-1131
exten 237; Fax 323-732-6619; Elec Mail bganther@gsmlife.com; Internet Home
Page Address: www.gsmlife.com; *Mktg & Pub Relations Mgr* Becky Ganther
Open to pub by appointment through pub relations staff asst; Estab 1965 to
provide a show place for Afro-American Art; to assist in the development of
ethnic pride among the youth of our community; Collection displayed throughout
building; Average Annual Attendance: 400
Income: Financed by the Company
Collections: Drawings, lithographs, paintings and sculpture
Publications: Afro-American Art Collection Brochure; Historical Murals Brochure
Activities: Tours by appointment

M HEBREW UNION COLLEGE, Skirball Cultural Center, 2701 N Sepulveda
Blvd, Los Angeles, CA 90049. Tel 310-440-4500; Fax 310-440-4728; Internet
Home Page Address: www.skirball.org; *Sr Cur* Grace Cohen Grossman; *Assoc Cur*
Tal Gozani; *Media Resources Coordr* Susanne Kester; *Dir Emerita* Nancy
Berman; *Dir Music & Educ* Sheri Bernstein; *Prog Dir* Jordan Peimer; *Learning
for Life* Adele Lauder Burke; *Chief of Staff* Kathryn Girard; *Assoc Cur* Evin
Clancey
Open Mon - Wed & Fri - Sat Noon - 5 PM, Thurs Noon - 9 PM, Sun 11 AM - 5
PM, cl Mon; Admis general $8, students & seniors $6, children under 12 free;
Estab 1972 to interpret American Jewish experience & nurture American Jewish
identity & encourage cultural pluralism; 4000 years of Jewish historical experience
and American democratic values; Average Annual Attendance: 250,000; Mem:
6500; dues $45-$1200
Income: Financed by mem admis, private & pub grants, progams & fees
Library Holdings: Book Volumes
Special Subjects: Architecture, Drawings, Graphics, Archaeology, Ethnology,
Costumes, Crafts, Folk Art, Etchings & Engravings, Landscapes, Decorative Arts,
Judaica, Manuscripts, Collages, Dolls, Furniture, Glass, Jewelry, Metalwork,
Historical Material, Juvenile Art, Coins & Medals, Embroidery, Laces, Medieval
Art
Collections: American Jewish Ethnographic Collection (paintings, prints,
drawings, coins, sculpture); 2000 archaeological objects from the Near East,
primarily Israeli; Biblical Archaeology; 6000 ceremonial objects, primarily

Western European, but some exotic Oriental & Indian pieces as well; Chinese Torah & India Torah cases; 5000 ethnographic objects of American Jewish Life; Judaica Collection; 4000 prints & drawings from Western Europe, spanning 4-5 centuries

Exhibitions: Vision & Values; Jewish Life from Antiquity to America; Changing exhibitions: Noah's Ark Galleries

Publications: Exhibition brochures & catalogs

Activities: Classes for adults & children; dramatic programs; docent training; film series; lect open to public, 5 vis lectrs per year; concerts; gallery talks; tours; book traveling exhibitions 5-8 per year; originate traveling exhibitions; museum shop sells books, original art, reproductions, prints, jewelry & children's items

M **JAPANESE AMERICAN CULTURAL & COMMUNITY CENTER,** George J Doizaki Gallery, 244 S San Pedro St, Ste 505, Los Angeles, CA 90012-3895. Tel 213-628-2725; Fax 213-617-8576; *Dir Gallery* Robert Hori
Open Mon - Fri Noon - 5 PM, Sat & Sun 11 AM - 4 PM; Admis $3; Estab 1980; 6,000 sq ft; Average Annual Attendance: 30,000; Mem: 1500; dues $35 and up
Income: Financed through mem, grants & donations
Exhibitions: Exhibitions rotate every six weeks

M **JAPANESE AMERICAN NATIONAL MUSEUM,** 369 E First St, Los Angeles, CA 90012. Tel 213-625-0414; Fax 213-625-1770; Internet Home Page Address: www.janm.org/; *Dir Admin* John Katagi; *VPres External* Carol Komatsuka; *Dir Develop* Cheryl Ikemiya; *Community Affairs* Nancy Araki; *VPres* Nahan Gluck; *Dir Retail & Vistors* Maria Kwong; *Treas* Thomas Decker; *VChmn* George Takei; *Dir Support Svcs* Clement Hanami; *VPres NationalCtr* Eileen Kurahashi; *Dir Cur & Exhib* Karin Higa; *Dir National Program* Cayleen Nakamura; *Program Advisor* James Hirabayashi; *Mgr Human Resources* Myrna Mariona
Open Tues - Sun 10 AM - 5 PM, Thurs 10 AM - 8 PM, cl Mon, Thanksgiving Day, Christmas Day & New Year's Day; Admis adults $6, seniors $5, students (with ID) & children (6-17) $3, children under 5, mems, every Thurs 5 - 8 PM & every third Thurs each month free; Estab 1992 to share the Japanese American experience; Contains several galleries in new pavilion & 2 spaces in historic building; Average Annual Attendance: 160,000; Mem: dues $15 - $100
Collections: Collection of art work made in America's concentration camps during WWII by Japanese Americans; Henry Sugimoto
Publications: Japanese American National Museum Magazine
Activities: Classes for adults & children; dramatic programs; docent training; performances; lect open to public; concerts; gallery talks; tours; individual paintings & original objects of art lent to other museums; book traveling exhibitions 1-5 per year; originate traveling exhibitions to Smithsonian Museum, Bishop Museum, Ellis Island Museum; museum shop sells books, magazines, reproductions, clothing, videos & prints

M **L A COUNTY MUSEUM OF ART,** 5814 Wilshire Blvd, Los Angeles, CA 90036. Tel 323-937-4230; Fax 323-937-5576; *Librn* Joan Beneditti; *Exhibition Designer* Carol Fulton; *Controller* Lorraine Trippett; *Dir Project* Marcia Page; *Dir* Joan Bruin
Open Tues - Sun 11 AM - 5 PM; Admis general $4, students & seniors $2.50, children under 12 free; Estab 1973 as The Egg & The Eye Gallery
Special Subjects: Hispanic Art, Latin American Art, Mexican Art, Ethnology, Southwestern Art, Textiles, Costumes, Crafts, Folk Art, Pottery, Dolls, Furniture, Glass, Asian Art, Embroidery
Collections: Contemporary American Crafts; Contemporary Design; International Folk Art including Japanese, East Indian & Mexican works; masks of the worlds
Exhibitions: Annual International Festival of Masks; Intimate Appeal: The Figurative Art of Beatrice Wood; Ed Rossbach: 40 Years of Exploration & Innovation in Fiber Art
Publications: Quarterly calendar
Activities: Classes for adults & children; docent training; lect open to public, 5 vis lectrs per year; gallery talks; tours; community outreach programs; book traveling exhibitions 1-2 per year; originate traveling exhibitions; museum shop sells books, magazines, original art, reproductions, prints, jewelry, folk art, ceramics, glass

L **Edith R Wyle Research Library of The Craft & Folk Art Museum,** 5905 Wilshire Blvd, Los Angeles, CA 90036. Tel 323-857-6118; Fax 323-937-5576; Elec Mail benedetti@lacma.org; Internet Home Page Address: www.lacma.org; *Librn* Joan M Benedetti
Open by appointment only; Estab 1975 to support & supplement the documentation & information activities of the Craft & Folk Art Museum in regard to contemporary crafts, international folk art, design. Visual material collected equally with print; For reference only
Income: Financed by the museum
Library Holdings: Book Volumes 5000; Clipping Files; Exhibition Catalogs; Kodachrome Transparencies; Memorabilia; Other Holdings Posters; Pamphlets; Periodical Subscriptions 18; Photographs; Slides
Special Subjects: Folk Art, Decorative Arts, Mixed Media, Historical Material, Ceramics, Ethnology, Industrial Design, Costume Design & Constr, Glass, Aesthetics, Metalwork
Collections: Artists' files - self taught and contemporary crafts artists; 12 V F Drawers of Ephemera

LANNAN FOUNDATION
For further information, see National and Regional Organizations

M **LOS ANGELES CONTEMPORARY EXHIBITIONS,** 6522 Hollywood Blvd, Los Angeles, CA 90028. Tel 323-957-1777; Fax 323-957-9025; Elec Mail info@artleak.org; Internet Home Page Address: www.artleak.org; *Dir & Cur* Irene Tsatsos; *Mng Dir* Bridget Dulong; *Develop & Communications Coordr* Matt Lipps; *Prog Coordr* Karl Erickson
Open (gallery) Wed - Sun 12 - 6 PM, Fri 12 - 9 PM, (office) Mon - Fri 10 AM - 6 PM; Admis $3 suggested donation; Estab 1978, interdisciplinary contemporary visual arts ctr; 1400 sq ft main gallery; 1400 sq ft new gallery; Average Annual Attendance: 30,000; Mem: 1000; dues $40-$2500
Income: Financed by private & public contributions; earned income initiatives
Library Holdings: Auction Catalogs; Clipping Files; Pamphlets; Slides; Video Tapes

Publications: Exhibit catalogs
Activities: Panel discussions; film screenings; performances; lect open to public, 3 vis lectrs per year; gallery talks; educational programs; workshops for various target audiences; sales shop sells books & limited edition artworks

M **LOS ANGELES COUNTY MUSEUM OF ART,** 5905 Wilshire Blvd, Los Angeles, CA 90036. Tel 323-857-6000; Fax 323-857-6214; Elec Mail publicinfo@lacma.org; Internet Home Page Address: www.lacma.org; *Pres & Dir* Andrea L Rich; *Asst VPres Operations* Arthur Owens; *Chief Conservation* Victoria Blyth-Hill; *Cur Costumes & Textiles* Sharon Takeda; *Asst Dir Facilities* Romalis Taylor; *Cur Prints & Drawings* Kevin Salatino; *VPres Educ* Stephanie Barron; *Cur Modern & Contemporary Art* Howard Fox; *Cur Far Eastern Art* J Keith Wilson; *Cur European Paintings & Sculpture* Patrice Marandel; *Cur CoChair* Robert A Sobieszek; *Head Film Progs* Ian Birnie; *Head Music Progs* Dorrance Stalvey; *Asst VPres* Keith McKeowin; *Registrar* Ted Greenberg; *Head Librn* Deborah L Barlow; *Cur American Art* Bruce Robertson; *Assoc Cur Indian & Southeast Asian Art* Stephen Markel; *Cur Decorative Arts* Wendy Kaplan; *Asst Dir Exhib* Irene Martin; *Cur & CoChmn* Nancy Thomas; *Cur Modern & Contemporary Art* Lynn Zelevansky; Thaddeus Stauber; *Asst VPres* Erroll Southers; *Mus Shop Mgr* Jim B Castellon; *Chief Art Mus* Jane E Burrell; *Board Chmn* Walter L Weisman; *Asst VPres* Ann Rowland; *CIO* Peter Bodell; *Asst VPres* Stefanie Salata; *Asst Dir Coll* Renee Montgomery; *Sr VPres* Melody Kanschat; *Assoc VPres* Jim Rawitsch; *Cur Japanese Art* Robert Singer
Open Mon, Tues, Thurs & Fri Noon - 8 PM, Sat & Sun 11 AM - 8 PM, cl Thanksgiving, Christmas & New Year's Day; Admis adults $7, students & seniors with ID $5, young people 5-12 $1, free day second Tues of each month; mus members & children under 5 free; Estab 1910 as Division of History, Science & Art; estab separately in 1961, for the purpose of acquiring, researching, publishing, exhibiting & providing for the educational use of works of art from all parts of the world in all media, dating from prehistoric times to the present; Maintains reference library; Average Annual Attendance: 1,000,000+; Mem: 80,000; dues $45-$5000
Income: $30,000,000 (financed by endowment, mem & county appropriation)
Special Subjects: Drawings, Painting-American, Prints, Sculpture, Textiles, Costumes, Religious Art, Decorative Arts, Painting-European, Asian Art, Islamic Art
Collections: American art; ancient & Islamic art; contemporary art; decorative arts; European painting & sculpture; Far Eastern art; Indian & South Asian art; textiles & costumes; modern art; prints & drawings; photography
Publications: Members Calendar, monthly, exhibition catalogs, 6-8 yearly; exhibition education brochures, 6 yearly, permanent collection catalogs, 3 yearly
Activities: Classes for adults & children; dramatic programs; docent training; lect open to public, 50 vis lectrs per year; concerts; gallery talks; tours; films; individual paintings & original objects of art lent to other AAM-accredited museums for special exhibitions; lending collection contains original art work, original prints, paintings & 130,000 slides; originate traveling exhibitions organized & circulated; museum shop sells books, magazines, reproductions, prints, gifts, posters, postcards, calendars & jewelry

L **Allan C Balch Art Research Library,** 5905 Wilshire Blvd, Los Angeles, CA 90036. Tel 323-857-6118; Fax 323-857-4790; Elec Mail library@lacma.org; Internet Home Page Address: www.lacma.org; *Librn* Deborah Barlow Smedstad; *Assoc Librn* Susan Trauger; *Librn* Alexis Curry; *CJK Librn* Ming Hsia
Open Mon, Tues, Thurs & Fri 11 AM - 6 PM; No admis fee; Estab 1965 to support research needs of mus staff & outside scholars, pub by appointment; Circ Non-circulating; For reference only
Income: Financed through the museum
Library Holdings: Auction Catalogs; Audio Tapes; Book Volumes 150,000; CD-ROMs; Cassettes; Clipping Files; Exhibition Catalogs; Fiche; Manuscripts; Other Holdings Artists' Files; Auction catalogs 35,000; Pamphlets; Periodical Subscriptions 450; Slides; Video Tapes
Special Subjects: Photography, Drawings, Etchings & Engravings, Graphic Arts, Prints, Sculpture, Crafts, Archaeology, Interior Design, Asian Art, Furniture, Mosaics, Aesthetics, Afro-American Art, Antiquities-Assyrian

L **Robert Gore Rifkind Center for German Expressionist Studies,** 5905 Wilshire Blvd, Los Angeles, CA 90036. Tel 323-857-6165; Fax 323-857-4752; Elec Mail trauger@lacma.org; Internet Home Page Address: www.lacma.org; *Cur* Timothy Benson; *Asst Registrar* Christine Vigiletti; *Librn* Susan Trauger
Open by appointment; Circ Non-circulating; Reference library
Library Holdings: Book Volumes 6000; Exhibition Catalogs; Original Art Works; Prints
Special Subjects: Art History, Decorative Arts, Photography, Drawings, Etchings & Engravings, Graphic Arts, Painting-German, Posters, Prints, Sculpture, Portraits, Watercolors, Printmaking, Woodcuts
Collections: German expressionist prints, drawings, books & periodicals
Publications: Publications relating to German Expressionist studies
Activities: schols offered; individual graphics & illustrated books; periodicals lent to qualified institutions; book traveling exhibitions

L **LOS ANGELES PUBLIC LIBRARY,** Art, Music, Recreation & Rare Books, 630 W Fifth St, Los Angeles, CA 90071-2002. Tel 213-228-7225; Fax 213-228-7239; Elec Mail art@lapl.org; Internet Home Page Address: www.lapl.org; *Dept Mgr* D Norman Dupill; *Sr Librn* Shelia Nash
Open Mon - Thurs, 10 AM - 8 PM, Fri & Sat 10 AM - 6 PM, Sun 1 - 5 PM; No admis fee; Estab 1872
Income: Financed by municipality
Library Holdings: Book Volumes 200,000; Clipping Files; DVDs; Exhibition Catalogs; Original Art Works; Other Holdings Prints including original etchings, woodcuts, lithographs & drawings; Periodical Subscriptions 800; Photographs; Prints; Video Tapes
Collections: Twin Prints; Japanese prints, including a complete set of Hiroshige's Tokaido Series
Exhibitions: Museum's Artists Scrapbooks, NY Public Artist's File

M **LOYOLA MARYMOUNT UNIVERSITY,** Laband Art Gallery, One LMU Dr MS8346, Los Angeles, CA 90045. Tel 310-338-2880; Fax 310-338-6024; Elec Mail cpeter@lmu.edu; Internet Home Page Address: www.lmu.edu/colleges/cfa/art/laband; *Dir* Carolyn Peter
Open Wed - Sun Noon - 4 PM; No admis fee; Estab 1971 to hold exhibitions; The

new gallery which opened in 1984, is 40 ft by 50 ft with 20 ft ceilings, track lighting & closeable skylights; Average Annual Attendance: 10,000
Special Subjects: Hispanic Art, Latin American Art, Photography, Ethnology, Religious Art, Ceramics, Folk Art
Exhibitions: Biennial national exhibitions of the Los Angeles Printmaking Society; Annual exhibitions vary
Publications: Catalogs, 2-3 per year
Activities: Lect open to public, 4-5 vis lectrs per year; concerts; gallery talks; films; competitions with awards; originate traveling exhibitions

M **MOUNT SAINT MARY'S COLLEGE,** Jose Drudis-Biada Art Gallery, Art Dept, 12001 Chalon Rd Los Angeles, CA 90049. Tel 310-476-2237, 954-4361 (Gallery); Fax 310-476-9296; Elec Mail JBaral@msmc.edu; *Gallery Dir* Jody Baral
Open Mon - Fri Noon - 5 PM; No admis fee; Estab to present works of art of various disciplines for the enrichment of students & community
Income: Financed by College
Collections: Collection of works by Jose Drudis-Blada
Exhibitions: Gene Mako Collection; Sedivy & Zokosky: Recent Paintings; Works on Paper; Drucker: Constructions; Geer Installation
Publications: Exhibitions catalogs, 1 per year
Activities: Lect open to public, 2-3 vis lectrs per year; scholarships

M **MUSEUM OF AFRICAN AMERICAN ART,** 3rd Fl, 4005 S Crenshaw Blvd Los Angeles, CA 90008. Tel 323-294-7071; Fax 323-294-7084; *Founder* Dr Samella Lewis; *Pres* Belinda Fontenote-Jamerson
Open Thurs - Sat 11 AM - 6 PM, Sun Noon - 5 PM; No admis fee; Estab as a national resource dedicated to the presentation of the rich cultural heritage of people of African descent; educates the broadest possible audience; serves as a vehicle through which it promotes & fosters scholarship in art history with a particular interest in the contemporary & historical contributions of African American artists
Special Subjects: African Art, Afro-American Art
Collections: Arts of the African & African-descendant people; Soapstone Sculpture of Shona; People of Southeast Africa; Makonde Sculpture of East Africa; Traditional Sculpture of West Africa; Sculpture, Paintings, Ceramics of the Caribbean & the South American Peoples; Contemporary North American Artists
Activities: Lect for mem only; gallery talks; sales shop sells reproductions

M **THE MUSEUM OF CONTEMPORARY ART (MOCA),** 250 S Grand Ave at California Plaza, Los Angeles, CA 90012. Tel 213-621-2766; Fax 213-620-8674; Internet Home Page Address: www.moca.org; *Chmn* Audrey Irmas; *Dir Develop* Paul Johnson; *Chief Cur* Paul Schimmel; *Dir* Jeremy Strick
Open Tues, Wed & Fri - Sun 11 AM - 5 PM, Thurs 11 AM - 8 PM, cl Mon; Admis general $6, seniors & students $4, children under 12, members & Thurs 5 - 8 PM free; Estab 1979, emphasizing the arts since mid century, encompassing traditional & non-traditional media; Permanent building designed by Arata Isozaki opened in 1986; Average Annual Attendance: 300,000; Mem: 13,000; dues $20-$2500
Income: $10,500,000 (financed by donations, admis fees, grants (private, corporate, NEA), mem & sales)
Special Subjects: Architecture, Drawings, Graphics, Hispanic Art, Latin American Art, Mexican Art, Painting-American, Photography, Prints, Sculpture, Watercolors
Collections: El Paso Collection; Barry Lowen Collection; Panza Collection; Ralph M Parsons Foundation Photography Collection; Rita & Taft Schreiber Collection; Scott D F Spiegel Collection
Exhibitions: Various exhib
Publications: The Contemporary, quarterly
Activities: Classes for children; docent training; family workshops; lect open to public; gallery talks; tours; competitions with awards; individual paintings lent to other institutions; originate traveling exhibitions; museum shop sells books, magazines, original art, posters & gifts

M **MUSEUM OF NEON ART,** 501 W Olympic Blvd, Los Angeles, CA 90015. Tel 213-489-9918; Fax 213-489-9932; Elec Mail info@neonmona.org; Internet Home Page Address: www.neonmona.org; *Dir* Mary Carter; *Exec Dir* Kim Koga
Open Wed - Sat 11 AM - 5 PM, Sun Noon - 5 PM, 2nd Thurs of month 11 AM - 8 PM, cl Fri; Admis adults $5, seniors & students $3.50; Estab 1981 to exhibit, document & preserve works of neon, electric & kinetic art; Consists of large main gallery for group or theme exhibitions & a small gallery for solo shows; Average Annual Attendance: 15,000; Mem: 300; dues $35 & up; annual meetings in Dec
Income: Financed by mem, donations, admis fees, gifts & grants
Collections: Antique electrical signs; contemporary neon art
Exhibitions: Ladies of the Night; Victoria Rivers: Neon/Fabric Construction; Electro-Kinetic Box Art.
Publications: Transformer, quarterly
Activities: Classes for adults; lect open to public; concerts; gallery talks; tours; book traveling exhibition; originates traveling exhibitions; museum shop sells books, magazines, original art, reproductions, prints, slides, electronic jewelry & posters

M **NATURAL HISTORY MUSEUM OF LOS ANGELES COUNTY,** 900 Exposition Blvd, Los Angeles, CA 90007. Tel 213-763-3412, 763-3434; Fax 213-763-2999; Elec Mail glorez@nhm.org; Internet Home Page Address: www.nhm.org; *Dir* Dr James Powell; *VPres Exhibs* Michael Nauyok; *Chief Deputy Dir* Jural J Garrett; *Exec VPres* Ann Muscat; *Pres & Dir* Jane Pisano; *VPres Finance* Jane Piasecki; *VPres Marketing* Leslie Baer; *Sr VPres Advancement* Dyan Sublett; *Deputy Dir Research* John Heyning; *Deputy Dir Admin* Leonard Navarro
Open Mon - Sun 10 AM - 5 PM, cl Mon, Thanksgiving, Christmas & New Year's Day; Admis adults $8, seniors & students 12-17 $5.50, children 4-12 $2, members, children under 5 & first Tues of each month free; Estab 1913 to collect, exhibit & research collection in history, art & science; now focuses on American history, science & earth science; Average Annual Attendance: 1,500,000; Mem: 11,000; dues $40-$100; annual meeting in Sept
Income: Financed by county appropriation & private donations
Special Subjects: American Western Art, Anthropology, Archaeology, Bookplates & Bindings

Collections: American historical works & decorative arts; California & western paintings & prints; pre-Columbian artifacts
Exhibitions: Permanent exhibits: American History Halls; Chaparral: A Story of Life from Fire; Dinosaur Fossils; Egyptian Mummy; Gem & Mineral Hall; Habitat Halls; Lando Hall of California & Southwest History; Marine Biology Hall; Megamouth; Pre-Columbian Hall; Ralph M Parsons Children's Discovery Center; Ralph M Parsons Insect Zoo; The Ralph W Schreiber Hall of Birds
Publications: Science Bulletin; Contributions in Science; Terra, bimonthly magazine
Activities: Classes for adults & children; docent training; lect open to public; gallery talks; tours; artmobile; individual & original objects of art lent to recognized museums, educational galleries & similar institutions; lending collection contains 30,000 color reproductions, 8653 native artifacts, 35,670 slides, 5500 small mammals, historical & scientific models; originate traveling exhibitions; museum & sales shops sell books, magazines, original art, reproductions, prints, slides & ethnic art objects

L **Research Library,** 900 Exposition Blvd, Los Angeles, CA 90007. Tel 213-744-3388; Elec Mail dmcnamee@nhm.org; Internet Home Page Address: www.nhm.org; *Chief Librn* Donald W McNamee
Open Mon-Fri 10AM-4:30PM; None; Open to staff & pub by appointment for reference only
Library Holdings: Book Volumes 102,000; Clipping Files; Exhibition Catalogs; Memorabilia; Pamphlets; Periodical Subscriptions 350; Photographs; Prints; Reels 472; Slides
Special Subjects: Folk Art, Decorative Arts, Film, Maps, Pre-Columbian Art, Archaeology, Ethnology, Anthropology, Southwestern Art, Bookplates & Bindings, Dolls, Textiles, Dioramas, Coins & Medals

M **NEW IMAGE ART,** 7906 Santa Monica Blvd, # 208 Los Angeles, CA 90046. Tel 323-654-2192; Fax 323-654-2192; Elec Mail newimgart@aol.com; Internet Home Page Address: www.newimagartgallery.com; *Dir* Marsea Goldberg; *Dir* Chris Johansen; *Dir* Joe Jackson; *Dir* Clayton Brothers; *Dir* Rich Jacobs; *Dir* Ed Templeton; *Dir* Scooter Rudolf; *Intern* Iya Muto
Open Thurs - Sat 1 - 5 PM, or by appointment; No admis fee; Estab 1995 to define the concept of New Image within the present avant garde; Small alternative space in West Hollywood that shows a full season of primarily cutting edge American artists & street artists; Average Annual Attendance: 5,000
Income: pvt
Exhibitions: Cheryl Dunn, Barry McGee, Ed Templeton, Chris Johanson

M **OCCIDENTAL COLLEGE,** Weingart Galleries, 1600 Campus Rd, Los Angeles, CA 90041. Tel 323-259-2749 (art dept), 259-2714 (galleries); Elec Mail minta@edu; Internet Home Page Address: www.oxy.edu; *Pres* Linda Lyke
Open Mon - Fri 9 AM - 4:30 PM during shows; No admis fee; Estab 1938 to acquaint students & visitors with contemporary concerns in the visual arts; Average Annual Attendance: 80,000
Activities: Lect open to public; gallery talks

A **PLAZA DE LA RAZA CULTURAL CENTER,** 3540 N Mission Rd, Los Angeles, CA 90031-3195. Tel 323-223-2475; Fax 323-223-1804; Elec Mail admin@plazaraza.org; *School Coordr* Maria Jimenez-Torres; *Exec Dir* Rose Cano
Open 9 AM - 6 PM, Boathouse Gallery open by appointment; No admis fee; Estab 1969 to preserve, promote & present Chicano/Mexican/Latino art & culture & promote new works; Boathouse Gallery houses Plaza's permanent collection of Latino art & also hosts temporary exhibits of the work of Chicano artists; Average Annual Attendance: 10,000; Mem: 100; dues $35 - $500
Income: $500,000 (financed by endowment, mem, city & state appropriation, grants from pvt & pub foundations)
Collections: Permanent collection of works by nationally known Latino visual artists
Exhibitions: Rotating exhibitions
Activities: Adult classes in folk arts, dance & music; children classes in music, dance, visual arts, theatre & film; dramatic programs; competitions; retail store sells prints, original art, reproductions & crafts

A **SAVING & PRESERVING ARTS & CULTURAL ENVIRONMENTS,** 1804 N Van Ness, Los Angeles, CA 90028. Tel 323-463-1629; *Dir* Seymour Rosen
Open by appointment only; Estab 1978 for documentation & preservation of folk art environments; Mem: Dues $15-$250
Income: Financed by membership, state, grants
Collections: Archival material about America's contemporary folk art environments
Exhibitions: Several exhibitions per year
Publications: Occasional newsletter
Activities: Lect open to public, 6 vis lectrs per year; gallery talks; tours; lending collection contains 20,000 photographs; originates traveling exhibitions; sales shop sells books, magazines, prints

L **Spaces Library & Archive,** 1804 N Van Ness, Los Angeles, CA 90028. Tel 323-463-1629; *Dir* Seymour Rosen
Open by appointment only; Estab 1978 to provide reference for scholars, artists, preservations concerned with folk art environments; For lending & reference
Income: Financed by mem, state appropriation, government & pvt grants, volunteers
Library Holdings: Audio Tapes; Book Volumes 1500; CD-ROMs; Cassettes; Clipping Files; Exhibition Catalogs; Kodachrome Transparencies; Manuscripts; Maps; Memorabilia; Original Documents; Pamphlets; Periodical Subscriptions; Photographs; Prints; Records; Sculpture; Slides; Video Tapes
Special Subjects: Art History, Collages, Constructions, Folk Art, Intermedia, Landscape Architecture, Architecture
Collections: Watts Tower Collection - photographs, documentation, archive, letters, clippings, history
Exhibitions: Divine Disorder: Folk Art Environments in California
Publications: Spaces: Notes on America's Folk Art Environments, three times per year
Activities: Lect open to public, 5 vis lectrs per year; originate traveling exhibitions

A **SELF HELP GRAPHICS**, 3802 Cesar E Chavez Ave, Los Angeles, CA 90063.
 Tel 323-264-1259; Fax 323-881-6447; Internet Home Page Address:
 www.selfhelpgraphics.com; *Cur* Cristina Ochoa
 Open Tues - Sat 10 AM - 4 PM, Sun Noon - 4 PM; No admis fee; Estab 1972 to
 provide art opportunities for Chicano & all artists; One gallery on first floor, 1,700
 sq ft; Average Annual Attendance: 15,000
 Income: Financed through donations & grants
 Exhibitions: Rotating exhibitions, 10 -12 per yr

M **SIMON WIESENTHAL CENTER INC**, 1399 S Roxbury Dr, Los Angeles, CA
 90035. Tel 310-553-9036; Fax 310-553-4521; Elec Mail
 infomation@wiesenthal.net; Internet Home Page Address: www.wiesenthal.com;
 Assoc Dean Abraham Cooper; *Dean* Marvin Hier
 Estab 1977 as International Center for Holocaust remembrance, defense of human
 rights & Jewish people; Mem: 400,000; dues $25-$1000
 Income: Financed by mem & fees
 Publications: Response Magazine
 Activities: Sales shop sells books, videos & gifts

M **Museum of Tolerance**, 9786 W Pico Blvd, Los Angeles, CA 90035. Tel
 310-553-8403 (reservations); Fax 310-553-4512; Elec Mail
 information@wiesenthal.net; Internet Home Page Address:
 www.museumoftolerance.com; *Dir* Liebe Geft; *Dean & Founder* Rabbi Hier
 Marvin; *Assoc Dean* Rabbi Abraham Cooper; *Exec Dir* Rabbi Meyer H May; *Dir
 Admin & Finance Treas* Susan Burden; *Dir Mem Develop* Marlene F Hier; *Dir
 Public Relations* Avra Shapiro; *Dir Media Projects* Richard Trank; *Dir Develop
 Western Region* Janice Prager; *Dir Communication* Michele E Alkin
 Open Mon - Thurs 10 AM, last tour 4 PM, Fri 10 AM, last tour 1 PM (Nov -
 Mar), 3 PM (Apr - Oct), Sun 10:30 AM, last tour 5 PM, cl Sat & Jewish holidays;
 Admis adults $8.50, seniors (62 & over) $6.50, students $5.50 (with ID), children
 (3-10) $3.50; Estab 1993 to preserve the memory of the Holocaust by fostering
 tolerance and understanding through community involvement, educational outreach
 and social action; Museum level: theater, Tolerancenter with 16-screen video wall
 & interactive exhibits & Holocaust Section; Second level: artifacts & documents
 of the Holocaust; multimedia learning center & research room; Third level:
 auditorium & special exhibition gallery; Fourth level: gift shop; Mem: 400,000
 Collections: Artifacts from Auschwitz; artwork from Theresienstadt; bunk bed
 from Majdanek death camp; flag sewn by Mauthausen inmates for their American
 liberators; original letters of Anne Frank; Simon Wiesenthal Collection
 Activities: Docent training; interactive workshops; tours

L **Library & Archives**, 1399 S Roxbury Dr, Los Angeles, CA 90035-4709. Tel
 310-772-7605; Fax 310-277-6568; Elec Mail library@wiesenthal.net; Internet
 Home Page Address: www.wiesenthal.com/library; *Dir* Adaire J Klein
 Open Mon - Thurs 9 AM - 6 PM, Fri 9 AM - 3:30 PM; No admis fee;
 Information resource center on the Holocaust, 20th century genocides,
 antisemitism, racism & related issues. Primarily research depository for materials
 dealing with the Holocaust & the pre-World War II Jewish experience. Available
 to researchers, the media, students & the public
 Income: Financed by Simon Wiesenthal Center Inc
 Library Holdings: Other Holdings Bks & Per 30,000
 Collections: Artifacts; diaries; documents; ghetto & concentration camp postage &
 money; letters; liberation & occupation memorabilia; magazines; manuscripts;
 maps; newspapers; original artwork; pamphlets; personal narratives; photographs;
 posters; rare books

M **SOUTHWEST MUSEUM**, 234 Museum Dr, Los Angeles, CA 90065-0558. Tel
 323-221-2164; Fax 323-224-8223; Elec Mail info@southwestmuseum.org; Internet
 Home Page Address: www.southwestmuseum.org; *Exec Dir* Dr Duane King;
 Controller Cheryl Ramsay; *Asst to Dir* Joanne Smith; *Mus Shop Mgr* Jo Valiulis;
 Asst Cur Bryn Potter; *Exhibition Specialist* Rose Figueroa; *Sr Cur* Steven L Grate;
 VPres Michael Heumann; *Asst Cur* George Kritzman; *Asst Cur* Amy Simmons;
 Library Asst Michael Wagner; *Dir Educ* Barbara Arvi; *Library Dir* Kim Walters
 Open Tues - Sun 10 AM - 5 PM, cl Mon; Admis adults $6, children 7-17 yrs $3,
 students & seniors $4, children under 7 yrs free; Estab 1907; Four permanent halls
 focus on Native American culture; Average Annual Attendance: 70,000; Mem:
 5300; dues $50 & up
 Income: $1,360,000 (financed by endowment & mem)
 Special Subjects: American Indian Art, American Western Art, Pre-Columbian
 Art, Crafts, Primitive art
 Collections: Anthropology & the science of man in the New World; prehistoric,
 historical, Spanish Colonial & Mexican provincial arts
 Exhibitions: Permanent exhibits of Plains, Northwest Coast, California &
 Southwest Indian art & culture, plus three changing special exhibitions
 Activities: Classes for children & adults; docent training; lect open to public, 10
 vis lectrs per year; tours; exten dept serves Los Angeles School District, individual
 paintings & original objects of art lent to other museums; book traveling
 exhibitions; museum shop sells books, magazines, original art & prints

L **Braun Research Library**, 234 Museum Dr, Los Angeles, CA 90065; PO Box
 41558 Los Angeles, CA 90041-0558. Tel 323-221-2164; Fax 323-224-8223; Elec
 Mail library@southwestmuseum.org; Internet Home Page Address:
 www.southwestmuseum.org; *Librn & Dir* Kim Walters; *Library Asst* Michael
 Wagner
 Open Wed - Sat 1 - 4:45 PM, cl Sun, Mon & Tues by appointment preferred;
 Estab 1907; For reference only; Mem: Dues dual $50, individual $40
 Library Holdings: Auction Catalogs; Audio Tapes; Book Volumes 50,000;
 CD-ROMs; Cards; Cassettes; Clipping Files; Compact Disks; Exhibition Catalogs;
 Fiche; Filmstrips; Framed Reproductions; Kodachrome Transparencies; Lantern
 Slides; Manuscripts; Maps; Memorabilia; Motion Pictures; Original Art Works;
 Original Documents; Pamphlets; Periodical Subscriptions 300; Photographs; Prints;
 Records; Reels; Reproductions; Slides; Video Tapes
 Collections: George Wharton James's Collection; Joseph Amasa Munk's
 Collection; Charles F Lummis's Collection; Frederick Webb Hodge Collection
 Activities: Lect open to pub; 4 vis lectrs per yr; tours

C **SUNAMERICA, INC**, The SunAmerica Collection, One SunAmerica Center, Los
 Angeles, CA 90067-6022. Tel 310-772-6000; Fax 310-772-6567; *Acting Cur*
 Joanne Heyler
 Corporate collection estab in 1981 to bring contemporary art into the corporate
 workplace & support the local art community

Income: Financed by corporate budget
Collections: Selection of works primarily by Southern California artists; emphasis
on early to mid-career artists

UNIVERSITY OF CALIFORNIA, LOS ANGELES

M **Fowler Museum at UCLA**, Tel 310-825-4361; Fax 310-206-7007; Internet Home
 Page Address: www.fowler.ucla.edu; *Dir* Marla C Berns; *Admin Asst* Betsy
 Escandor; *Consulting Cur Costumes & Textiles* Patricia Anawalt; *Registrar* Sarah J
 Kennington; *Conservator* Jo Hill; *Photographer* Don Cole; *Educ Dir* Betsy Quick;
 Exhib Designer David Mayo; *Publications Dir* Daniel R Brauer; *Chief Cur & Cur
 Africa* Mary Nooter Roberts; *Develop Dir* Lynne Brodhead; *Photographer* Don
 Cole; *Hr & Admin Mgr* Roberto Salazar; *Cur Asian & Pacific Art* Roy Hamilton;
 Collections Mgr Rachel Raynor; *Managing Editor* Lynne Kostman; *Dir Mem* Lori
 LaVelle; *Cur Archaeology* Wendy Teeter; *Traveling Exhibs Dir* Karyn Zarubica;
 Dir Mktg & Communications Stacey Ravel Abarbanel; *Asst Dir* David Blair; *Mus
 Store Mgr* Jennifer Garbee; *Assoc Dir Develop* Sarah Gilfillan; *Mgr Pub Prog*
 Bonnie Poor
 Open Wed, Fri - Sun Noon - 5 PM, Thurs Noon - 8 PM; No admis fee; Estab in
 1963 to collect, preserve & make available for research & exhibition objects &
 artifacts from cultures considered to be outside the Western tradition; Circ
 Non-circulating; Changing exhibitions on view Wed - Sun Noon - 5 PM; Average
 Annual Attendance: 60,000; Mem: 607; dues Individual $50, family $75,
 contributing $150, supporting $275, patron $500, manus $1500, cur's circle $2500,
 dir's circle $5000
 Income: Financed by endowment, state appropriation & private donations
 Special Subjects: Metalwork, Mexican Art, Photography, Hispanic Art, Latin
 American Art, American Indian Art, African Art, Anthropology, Archaeology,
 Ethnology, Pre-Columbian Art, Religious Art, Folk Art, Primitive art, Eskimo Art,
 Asian Art, Islamic Art
 Collections: Archaeological & ethnographic collections; 150,000 objects primarily
 from non-Western cultures - Africa, Asia, the Americas, Oceania, The Near East &
 parts of Europe
 Publications: Exhibition catalogues; filmstrips; monographs; pamphlets; papers;
 posters; slide sets
 Activities: Classes for adults & children; publications program; lect open to
 public, 1-3 vis lectrs per year; concerts; gallery talks; tours; art workshops;
 symposiums; awards; book traveling exhibitions; originate traveling exhibitions;
 museum shop sells books, jewelry, magazines, textiles

M **Grunwald Center for the Graphic Arts**, Tel 310-443-7076; Fax 310-443-7099;
 Elec Mail cdixon@arts.ucla.edu; Internet Home Page Address:
 www.hammer.ucla.edu; *Dir* David S Rodes; *Dir Educ & Community Develop*
 Linda Duke; *Assoc Dir & Cur* Cynthia Burlingham; *Registrar* Grace Murakami;
 Cur Assoc Claudine Dixon; *Asst Cur* Carolyn Peter; *Collections Mgr* Layna White
 Open by appointment only; No admis fee; Estab 1956; Gallery serves the
 university & pub, program is integrated with the University curricula; Mem: 120
 Special Subjects: Graphics
 Collections: Grunwald Center for the Graphic Arts: 35,000 prints, drawings,
 photographs & illustrated books from the 13th through 20th Centuries, including
 old master prints & drawings, Frank Lloyd Wright Collection of Japanese Prints,
 Tamarind Lithography Archive; The Rudolf L Baumfeld Collection of Landscape
 Drawings & Prints; Hammer Honore' Daumier Collection
 Exhibitions: Three exhibitions annually
 Publications: Exhibition catalogues; French Caricature; French Renaissance in
 Prints from the Bibliotheque nationale de France; The Rudolf L Baumfeld
 Collection of Landscape Drawings & Prints; Visionary States: Surrealist Prints
 from the Gilbert Kaplan Collection; The World From Here: Treasures of the Great
 Libraries of Los Angeles
 Activities: Gallery talks; tours daily; book traveling exhibitions; originate
 traveling exhibitions; museum shop sells books, magazines, original art,
 reproductions & various gift items

M **UCLA at the Armand Hammer Museum of Art & Cultural Center**, Tel
 310-443-7000; Fax 310-443-7099; Internet Home Page Address:
 www.hammer.ucla.edu; *Dir Educ & Community Develop* Linda Duke; *Registrar*
 Susan Melton Lockhart; *Dir* Ann Philbin; *Dir Pub Relations* Terry Morello
 Open Tues, Wed, Fri & Sat 11 AM - 7 PM, Thurs 11 AM - 9 PM, Sun 11 AM - 5
 PM, cl Mon, Thanksgiving, Christmas & July 4; Admis adults $4.50, seniors (65
 & over), non-UCLA students, UCLA faculty & staff $3, UCLA students $1, mus
 members, children 17 & under free; admis is free Thurs 11 AM - 9 PM; Estab
 1990; Gallery serves the university & pub; program is integrated with the
 University curricula; Average Annual Attendance: 180,000; Mem: 3000; dues
 fellow $1000, patron $500, sustaining $250, participating $100, active $45, UCLA
 faculty & staff & senior citizen $25, students $20
 Special Subjects: Painting-American, Sculpture, Painting-European,
 Painting-British, Painting-French
 Collections: 300 paintings, including the Willitts J Hole Collection of the Italian,
 Spanish, Dutch, Flemish & English schools from the 15th-19th century; Franklin
 D Murphy Sculpture Garden: 70 sculptures from the 19th-20th centuries, including
 Arp, Calder, Lachaise, Lipchitz, Moore, Noguchi, Rodin & Smith; The Armand
 Hammer Collection includes approximately 100 paintings, primarily 19th century
 French artists; the Armand Hammer Daumier & Contemporaries Collection
 includes over 7000 works by 19th century French artist Honore Daumier & his
 contemporaries
 Exhibitions: 12 exhibitions annually; operates in close conjunction with the
 UCLA Grunwald Center for the Graphic Arts
 Publications: Exhibition catalogues; The Macchiaioli, California Assemblage; Silk
 Route & the Diamond Path; Chicano Art
 Activities: Gallery talks; tours daily; book traveling exhibitions; originate
 traveling exhibitions; museum shop sells books & prints

L **Visual Resource Collection**, Tel 310-825-3725; Fax 310-206-1903; Elec Mail
 ziegler@humnet.ucla.edu; *Dir* David Ziegler; *Asst Cur* Susan Rosenfeld
 Library Holdings: Filmstrips; Lantern Slides 30,000; Slides 300,000
 Special Subjects: Folk Art, Decorative Arts, Film, Etchings & Engravings,
 Graphic Arts, Archaeology, Ethnology, American Western Art, Asian Art, American
 Indian Art, Furniture, Costume Design & Constr, Afro-American Art,
 Antiquities-Assyrian, Architecture

L **Arts Library**, Tel 310-825-3817; Fax 310-825-1303; Internet Home Page Address:
 www.library.ucla.edu//arts; *Special Coll Librn* Julie Graham; *Head* Gordon Theil;
 Librn for Art Judith Herschman; *Librn for Film, TV & Theater* Lisa Kernan

Open Mon - Thurs 8 AM - 9 PM, Fri 8 AM - 5 PM, Sat 9 AM - 5 PM, Sun 1 - 5 PM, c. Sat & Sun, hrs vary during intersession, summer & holidays; spec collections 10 AM - 5 PM by appointment only; No admis fee; Founded 1952
Library Holdings: Book Volumes 180,000; CD-ROMs; DVDs; Exhibition Catalogs; Fiche; Manuscripts; Other Holdings Ephemera files; Periodical Subscriptions 7000; Photographs; Reels
Special Subjects: Art History, Film, Theatre Arts, Architecture

UNIVERSITY OF SOUTHERN CALIFORNIA

M **Fisher Gallery,** Tel 213-740-4561; Fax 213-740-7676; Internet Home Page Address: www.usc.edu/fishergallery; *Assoc Dir* Kay Allen; *Educator* Jeanette LeVere; *Exhib Coordr* Jennifer Jaskowiak; *Admin Asst* Kevin Parker; *Dir* Dr Selma Holo
Open Tues - Sat Noon - 5 PM, cl summer, except for special exhibitions; No admis fee; Estab 1939 as the art mus of the University; Fisher Gallery consists of three rooms, for changing exhibitions & 1 room for permanent collection exhibition; Average Annual Attendance: 12,000
Income: Financed by endowment & University subsidy
Special Subjects: Painting-American, Portraits, Painting-British, Painting-Dutch, Painting-French, Painting-Flemish, Painting-Italian
Collections: Elizabeth Holmes Fisher Collection; Armand Hammer Collection; galleries house the permanent collections of paintings of 17th century Dutch, Flemish & Italian, 18th century British, 19th century French & American landscape & portraiture schools
Publications: Exhibition catalogs, three annually
Activities: Classes for adults & children; dramatic probrams; docent training; lect open to public; concerts; gallery talks; tours; individual paintings & original objects of art lent; lending collection contains original prints, paintings, sculpture; originate traveling exhibitions

L **Helen Topping Architecture & Fine Arts Library,** Tel 213-740-1956; Fax 213-749-1221, 740-8884; Internet Home Page Address: www.lib.usc.edu/info/afa; *Reference Center* Ruth Wallach
Open Mon - Thurs 10 AM - 10 PM, Fri 10 AM - 7 PM, Sun 1 - 8 PM, Sat 10 AM - 5 PM, summer hours Mon - Thurs 10 AM - 4 PM; Estab 1925 to provide undergraduate & graduate level students & the teaching & research faculty materials in the areas of architecture & fine arts needed to achieve their objectives; Circ 65,000; Branch library in the central library system is supported by the University, lending library
Income: Financed by University funds
Purchases: $95,000
Library Holdings: Book Volumes 85,000; Clipping Files; Compact Disks; Exhibition Catalogs; Other Holdings Architectural drawings 1000; Artist's books 400; Pamphlets; Periodical Subscriptions 285; Reels; Slides 260,000; Video Tapes 150
Special Subjects: Art History, Landscape Architecture, Decorative Arts, Photography, Latin American Art, Antiquities-Roman, Architecture
Publications: Exhibit catalogs

L **Cinema-Television Library & Archives of Performing Arts,** Tel 213-740-8906; Fax 213-749-1221; Internet Home Page Address: www.usc.edu/cinemaarts; *Dir* Robert Rosen
Open academic semester 8:30 AM - 10 PM; No admis fee; Estab 1960
Library Holdings: Audio Tapes; Book Volumes 18,000; Cards; Cassettes; Clipping Files; Manuscripts; Memorabilia; Pamphlets; Periodical Subscriptions 225; Records; Reels; Video Tapes
Special Subjects: Film, Video
Collections: Film & television: scripts, stills, posters, production records, correspondence

C **WELLS FARGO & CO,** History Museum, 333 S Grand Ave, Los Angeles, CA 90071. Tel 213-253-7166; Fax 213-680-2269; *Asst Cur* Juan Coloto; *Cur* Sheila Hernandez
Open Mon - Fri 9 AM - 5 PM; No admis fee; Museum estab to demonstrate impact of Wells Fargo on California & American West; 6500 sq ft; approx 1000 objects on display; Average Annual Attendance: 40,000
Income: Financed by private funds
Collections: Authentic 19th century Concord Stagecoach; display of firearms; Dorsey Gold Collection of gold quartz ore; $50 gold piece; original Spanish language documents giving Los Angeles its city status in 1835; Perils of Road; Pony Express exhibit; two-pound gold nugget; Wells Fargo office
Exhibitions: Staging; mining; express; banking; South California
Publications: Various publications concerning Wells Fargo in US history
Activities: Dramatic programs; tours & off-site presentations; lect open to public; museum shop sells books, reproductions of memorabilia & prints

MENDOCINO

A **MENDOCINO ART CENTER,** Gallery & School, 45200 Little Lake St, PO Box 765 Mendocino, CA 95460. Tel 707-937-5818; Fax 707-937-1764; Elec Mail macdirec@mcn.org; Internet Home Page Address: www.mendocinoartcenter.org; *Exec Dir* Peggy Templer
Open daily 10 AM - 5 PM, winter 10 AM - 4 PM; No admis fee; Estab 1959 as a rental-sales gallery for exhibition & sales of member work; also to provide workshops on all media; Three major gallery rooms, one gallery room available for rental of one-man shows; Average Annual Attendance: 25,000; Mem: 1000; dues $50
Income: Membership, donations, tui
Library Holdings: Book Volumes
Collections: Graphics, paintings & sculpture; Dorr Bothwell
Exhibitions: Rotate 6-8 per yr
Publications: Arts & Entertainment, monthly
Activities: Classes for adults & children; docent training; lect open to public, 4-10 vis lectrs per year; concerts; competitions; scholarships offered; individual paintings & original objects of art lent to business & public places; sales shop sells books, original art, reproductions, prints & crafts

L **Library,** 45200 Little Lake St, PO Box 765 Mendocino, CA 95460. Tel 707-937-5818; Fax 707-937-1764; Internet Home Page Address: www.mendocinoartcenter.org; *Exec Dir* Peggy Templer

Open Tues - Sat 11 AM - 2 PM; No admis fee; Estab 1975 to provide members with access to art books & magazines; Circ 1350 books & 18 magazines; Lending library for members of Art Center only
Income: Financed by donations & mem
Library Holdings: Book Volumes 2500; Other Holdings Picture File; Periodical Subscriptions 4; Prints; Reproductions

MISSION HILLS

A **SAN FERNANDO VALLEY HISTORICAL SOCIETY,** 10940 Sepulveda Blvd, Mission Hills, CA 92346; PO Box 7039, Mission Hills, CA 91345. Tel 818-365-7810; *VPres & Cur* Dr Richard Doyle; *Pres* Carol Phelps
Tours by appointment Mon 10 AM - 3 PM; No admis fee; Estab 1943; The Soc manages the Andres Pico Adobe (1834) for the Los Angeles City Department of Recreation & Parks, where they house their collection; Average Annual Attendance: 500; Mem: dues life $100, active, sustaining & organization $15
Income: Financed by mem & donations
Collections: Historical material; Indian artifacts; paintings; costumes; decorative arts; manuscripts
Exhibitions: Permanent & temporary exhibitions
Publications: monthly newsletter, The Valley; guide
Activities: Lect; films; guided tours

L **Mark Harrington Library,** 10940 Sepulveda Blvd, Mission Hills, CA 91346; P O Box 7039, Mission Hills, CA 92346-7039. Tel 818-365-7810; *Pres & Cur* Dr Richard Doyle; *VPres* Jim Guleranson
Open by appointment; Estab 1970
Income: Financed by mem & gifts
Library Holdings: Book Volumes 1000; Cassettes; Clipping Files; Manuscripts; Memorabilia; Original Art Works; Pamphlets; Photographs; Prints
Collections: Citrus; Communities; Historical landmarks; Olive; Pioneers; San Fernando Mission; San Fernando Valley
Exhibitions: Regular exhibitions of valley history
Publications: The Valley, monthly newsletter

MONTEREY

M **CASA AMESTI,** 516 Polk St, Monterey, CA 93940. Tel 831-372-8173, 372-2808; *Pres* Pam McCollough
Open Sat & Sun 2 - 4 PM, cl 2 wks July; Admis $3, children & members free; Bequeathed to the National Trust in 1953 by Mrs Frances Adler Elkins; It is an 1833 adobe structure reflecting phases of the history & culture of the part of California owned by Mexico, after the period of Spanish missions & before development of American influences from the Eastern seaboard. It is a prototype of what is now known as Monterey style architecture. The Italian-style gardens within the high adobe walls were designed by Mrs. Elkins, an interior designer, & her brother, Chicago architect David Adler. The furnishings, largely European, collected by Mrs. Elkins are displayed in a typical 1930s interior. The property is a National Trust historic house. The Old Capital Club, a private organization, leases, occupies & maintains the property for social & educational purposes
Special Subjects: Historical Material
Collections: Elkins Collection of largely European furnishings
Activities: Monterey History & Art Association volunteers provide interpretive services for visitors on weekends

A **MONTEREY HISTORY & ART ASSOCIATION,** 5 Custom House Plaza, Monterey, CA 93940. Tel 831-372-2608; Fax 831-655-3054; *Pres* Kathi Wojtkowski
No admis fee; Estab 1931; The Assoc owns the 1845 Casa Serrano Adobe, the 1865 Doud House, the 1845 Fremont Adobe, the Mayo Hayes o'Donnell Library & the newly constructed Stanton Center - Monterey's Maritime Mus & History Center. The Assoc celebrates the birthday of Monterey (June 3, 1770) with the Merienda each year on the Sat nearest that date. The Assoc commemorates the landing at Monterey by Commodore John Drake Sloat in 1846; Mem: 1800; dues individual life mem $500, sustaining couple $75, sustaining single $50, couple $25, single $15, junior $1
Income: Financed by mem, donations & fundraising activities
Collections: Costumes, manuscripts & paintings, sculpture, antique furniture, books, photographs
Exhibitions: Permanent & temporary exhibitions; Fourth Grade History & Art Contest
Publications: Noticias Del Puerto De Monterey, quarterly bulletin
Activities: Guided tours; competitions

M **Maritime Museum of Monterey,** 5 Custom House Plaza, Monterey, CA 93942. Tel 831-375-2553; Internet Home Page Address: www.mntmh.org; *Exec Dir* Linda Jaffe
Open Tues - Sun 11 - 5 PM; Admis adults $5, seniors, military & children 13-17 $2.50, children under 12 free; Estab 1971, moved 1992 into new facility along waterfront; Maritime related artifacts & artwork; features operating light from Point Sur Lighthouse; Average Annual Attendance: 12,000; Mem: 1800; dues $30 - $50; annual meeting in Sept
Special Subjects: Marine Painting
Collections: Marine Artifacts, ship models, paintings, photographs, Fresnel First Order Lens from Point Sur, California (on loan from US Coast Guard)
Exhibitions: Permanent & temporary exhibitions
Activities: Lect open to public, 12 vis lectrs per year; gallery talks; tours; competitions with awards; museum shop sells books, prints, original art, reproductions & gift items

L **Library,** 5 Custom House Plaza, Monterey, CA 93940-2430. Tel 831-372-2608; Fax 831-655-3054; *Librn* Faye Messinger
Open Wed, Fri, Sat & Sun 1:30 - 3:30 PM; No admis fee; Estab 1971; Open for research on the premises
Library Holdings: Book Volumes 2500; Manuscripts; Memorabilia; Original Art Works; Other Holdings Local History archive; Periodical Subscriptions 2; Photographs; Prints
Publications: Brochure of Museum with map

A MONTEREY MUSEUM OF ART ASSOCIATION, Monterey Museum of Art, 559 Pacific St, Monterey, CA 93940. Tel 831-372-5477; Fax 831-372-5680; Elec Mail mtry_art@mbay.net; Internet Home Page Address: www.montereyart.org; *Exec Dir* Richard W Gadd; *VPres* Jay Sinclair; *VPres* Betty H Dwyer; *VPres* Lila Staples; *Pres* H William Keland; *Treas* Michael J Mazur; *Dir Develop* Donna Kneeland; Sandra Still; *Cur* Mary Murray
Open Wed - Sat 11 AM - 5 PM, Sun 1 - 4 PM, cl Mon, Tues, New Year's, Christmas & Thanksgiving; Admis non-member $5, full-time student with ID $2.50; Estab 1959, the mission of the Monterey Mus of Art is to educate and enrich the diverse Calif community. Provoking awareness and thought through the arts, the Mus serves as a forum and catalyst for the discussion and debate of ideas. The Mus creates progs that inspire and uplift the human spirit.; The museum's permanent collection includes Calif art, photography, Asian art, international folk art & features significant bodies of work by Armin Hansen, William Ritschel, Ansel Adams & Edward Weston.; Average Annual Attendance: 30,000; Mem: 2400; dues $15-$1000; annual meeting in July
Income: Financed by endowment, mem & fundraising functions
Library Holdings: Book Volumes; Exhibition Catalogs; Original Documents; Periodical Subscriptions
Special Subjects: Architecture, Drawings, Etchings & Engravings, Graphics, Landscapes, Photography, Prints, Sculpture, Textiles, Watercolors, Painting-American, American Western Art, Antiquities-Oriental, Asian Art, Bronzes, Decorative Arts, Folk Art, Pewter, Woodcuts
Collections: Armin Hansen Collection; William Ritschel Collection; American art; Asian & Pacific; international folk ethnic & tribal arts; photography & graphics; regional art, past & present
Exhibitions: Juried exhibitions; theme shows
Publications: Quarterly newsletter
Activities: Classes for adults & children; docent training; lect open to public; concerts; dramatic programs; gallery talks; tours; in service training for teachers; outreach program; scholarships; artmobile; Museum on Wheels teaches folk craft classes in schools; book traveling exhibitions 1 per year; originate traveling exhibitions; museum shops sell books, reproductions, prints, museum replicas & folk art objects

L MONTEREY PUBLIC LIBRARY, Art & Architecture Dept, 625 Pacific St, Monterey, CA 93940. Tel 831-646-3932; Fax 831-646-5618; Internet Home Page Address: www.monterey.org/library; *Dir* Paula Simpson
Open Mon - Thurs 9 AM - 9 PM; Fri 9 AM - 6 PM; Sat 9 AM - 5 PM; Sun 1 - 5 PM; Estab 1849
Income: Financed by mem & city appropriation
Purchases: $750,000
Library Holdings: Book Volumes 100,000; Cassettes 3000; Clipping Files; Manuscripts; Original Art Works; Periodical Subscriptions 379; Photographs; Reels 4000; Reproductions

M SAN CARLOS CATHEDRAL, 500 Church St, Monterey, CA 93940. Tel 831-373-2628; Fax 831-373-0518; *Rector* Joseph Occhiuto
Open daily 7:30 AM - 5 PM; No admis fee; Built in 1770, now a branch of the Monterey Diocese; The art museum is housed in the 1794 Royal Presidio Chapel
Special Subjects: Sculpture, Religious Art
Collections: Spanish religious paintings and sculpture of the 18th and 19th century
Activities: Classes for adults & children; lect open to pub, 1 vis lectr per year; self-guided tours

MONTEREY PARK

M EAST LOS ANGELES COLLEGE, Vincent Price Gallery, 1301 Avenide Nida Csar Chevez Ave, Monterey Park, CA 91754. Tel 323-265-8841; Fax 323-265-8763; Elec Mail east@laccd.cc.ca.us; Internet Home Page Address: www.lafn.org/education/elac/gallery; *Dir* Thomas Silliman
Open Mon - Fri Noon - 3 PM, Tues 6 - 9 PM; No admis fee; Estab 1958 as an institutional art gallery serving the East Los Angeles area
Income: Financed by the college, grants & donations
Special Subjects: American Indian Art, African Art, Renaissance Art
Collections: Includes art from Africa, Peruvian & Mexican artifacts dating from 300 B C, North American Indian Art; important works from the Renaissance to the present day; Leonard Baskin; Daumier; Delacroix; Durer; Garvarni; Hiroshige I; Rico Lebrun; Maillol; Picasso; Piranesi; Redon; Utrillo; Howard Warshaw; Anuskiewicz; Bufano; Rouault; Tamayo
Exhibitions: Annual Student Art Show; Selections from the private collection of the Vincent Price Art Collection

MORAGA

M SAINT MARY'S COLLEGE OF CALIFORNIA, Hearst Art Gallery, 1928 Saint Mary's Rd, Moraga, CA 94575; PO Box 5110, Moraga, CA 94575-5110. Tel 925-631-4379; Fax 925-376-5128; Elec Mail cbrewste@stmarys-ca.edu; Internet Home Page Address: http://gallery.stmarys-ca.edu; *Dir* Carrie Brewster; *Registrar* Julie Armistead; *Community Relations & Educ Programs* Heidi Donner
Open Wed - Sun 11 AM - 4:30 PM, cl Mon & Tues & between exhibitions; Suggested admis donation $2; Estab 1977 to exhibit a variety of the visual arts for the benefit of college community & gen pub audience; Maintains two rooms with connecting rampway (1640 sq ft) for temporary exhibitions, William Keith Room for permanent collection of 19th c landscape painting; Average Annual Attendance: 14,000; Mem: 350; dues supporting $100 & up, family $75, individual $40; accredited by Am Assn Mus
Income: $275,000 (financed by college, donations, grants & earned income)
Purchases: 19th & 20th Century California art
Special Subjects: Drawings, Graphics, Hispanic Art, Latin American Art, Mexican Art, Painting-American, Photography, Prints, Sculpture, African Art, Ethnology, Pre-Columbian Art, Religious Art, Etchings & Engravings, Landscapes, Historical Material, Coins & Medals, Medieval Art

Collections: 150 paintings by William Keith (1838-1911) & other 19th, 20th & 21st Century California art; African Oceanic & Latin American ethnographic objects; icons; medieval sculpture; thematic print collection; religious; Religious art, wine related art, ancient ceramics and coins
Publications: Exhibition catalogues, 2 - 3 per yr
Activities: Educ dept; lect open to public, 4 vis lectrs per year; gallery talks; tours; individual paintings & original objects of art lent to museums; book traveling exhibitions 2 per year; originate traveling exhibitions of William Keith Collection to museums; museum shop sells books, prints & jewelry

NEVADA CITY

A ARTNETWORK, PO Box 1360, Nevada City, CA 95959. Tel 530-470-0862; 800-383-0677; Fax 530-470-0256; Elec Mail info@artmarketing.com; Internet Home Page Address: www.artmarketing.com; *Dir* Constance Smith
Estab 1986 to publish marketing information for fine artists & art world professionals

NEWHALL

M LOS ANGELES COUNTY MUSEUM OF NATURAL HISTORY, William S Hart Museum, William S Hart Park, 24151 San Fernando Rd Newhall, CA 91321. Tel 661-254-4584; Fax 661-254-6499; Internet Home Page Address: www.hartmuseum.org; *Adminr* Janis Ashley; *Coordr Educ* Kyle Harris
Open winter Wed - Fri 10 AM - 1 PM, Sat - Sun 11 AM - 4 PM; summer mid-June to mid-Sept Wed - Sun 11 AM - 4 PM; No admis fee; Estab through the bequest of William S Hart (1946) & opened 1958 for use as a public park & museum; The retirement home of William S Hart is maintained as it was during his lifetime, his extensive collection of Western art is on display throughout the house; Average Annual Attendance: 250,000; Mem: 250; dues $35; meetings second Wed of every month
Income: Financed by county appropriation & private donations
Special Subjects: Painting-American, Watercolors, Bronzes, Textiles, Woodcarvings, Decorative Arts, Furniture, Glass, Silver, Carpets & Rugs, Historical Material, Period Rooms
Collections: Charles Cristadoro Sculpture Collection; Joe DeYong Collection of paintings; Clarence Ellsworth Collection of watercolor & oil paintings; James M Flagg Collection of oil & watercolor paintings, drawings; Gene Hoback Collection of woodcarvings; Robert L Lambdin Collection of oil paintings; Frederic Remington Collection of watercolor & oil paintings; Charles M Russell Collection of oil & watercolor paintings, gouache, pen & ink; Charles Schreyvogel Collection of oil paintings; decorative arts; Navajo rugs
Activities: Classes for Adults; docent training; school outreach program; classes for adults; docent training; school outreach program; museum shop sells books, videotapes, souvenirs

NEWPORT BEACH

M ORANGE COUNTY MUSEUM OF ART, Orange County Museum of Art, 850 San Clemente Dr, Newport Beach, CA 92660. Tel 949-759-1122; Fax 949-759-5623; Elec Mail ocma@pacbell.net; Internet Home Page Address: www.ocma.net; *Dir* Dr Naomi Vine; *Chief Cur* Sarah Unre; *Dir Educ* Elena Arojo; *Registrar* Tom Callus; *Dir, CEO* Elizabeth Armstrong; *VChmn* Darrel Anderson; *Mus Shop Mgr* Jeanine McWhorter
Open Tues - Sun 10 AM - 5 PM, cl Mon; Admis adults $4, students, seniors, military, groups of 10 $2, children 6-17 $1, children under 6 & Tues free; Estab 1962 as a mus of the Art of our Time serving Orange County & Southern California; Building completed in 1977 contains four galleries of various sizes; 5000; 1600; 1200; 500 sq ft plus lobby & sculpture garden area; Average Annual Attendance: 100,000; Mem: 5500; dues supporting member $500, Donor $100, general mem $45, student $25
Income: $2,500,000 (financed by special events, mem, government grants, private sector, sales from restaurant & bookstore)
Purchases: $100,000 year for works of art
Special Subjects: Drawings, Painting-American, Photography, Ceramics, Glass
Collections: Collections of Historical & contemporary American art; California artists from 1850 to present
Publications: Bimonthly calendar; exhibition catalogs; posters
Activities: Docent training; in-service training sessions for teachers, docent tours for school & adult groups; lect series, special guest lectr & meet-the-artist programs; gallery talks; creative art workshops; concerts & performances; film & video programs; individual paintings & original objects of art lent to qualified art museums; lending collection contains original prints; paintings & sculptures; traveling exhibitions organized & circulated; museum shop sells books, magazines, original art
L Library, 850 San Clemente Dr, Newport Beach, CA 92660. Tel 949-759-1122; Fax 949-759-5623; *Librn* Ruth Roe
Open Tues - Sun 10 AM - 5 PM; Open for reference by appointment
Income: Financed by Museum
Library Holdings: Audio Tapes; Book Volumes 5000; Cassettes; Clipping Files; Exhibition Catalogs; Periodical Subscriptions 11; Slides; Video Tapes

NORTHRIDGE

M CALIFORNIA STATE UNIVERSITY, NORTHRIDGE, Art Galleries, 18111 Nordhoff St, Northridge, CA 91330-8299. Tel 818-677-2156, 677-2226; Fax 818-677-5910; Internet Home Page Address: www.csun.edu/artgalleries; *Exhib Coordr* Michelle Giacopuzzi; *Preparator* Jim Sweeters; *Dir* Louise Lewis
Open Mon-Sat Noon - 4 PM, Thurs Noon-8 PM; No admis fee, donations accepted; Estab 1971 to serve the art department & to provide a source of international & contemporary art for the university & the community at large; Exhibitions in Main Gallery have average duration of five weeks. West Gallery for weekly MA candidate solo exhibitions; Average Annual Attendance: 35,000; Mem: 300; Arts Council for CSUN; dues $35 annually, meet weekly

Income: $40,000 (financed by city & state appropriation, community support organizations)

Special Subjects: Afro-American Art, Illustration, Ceramics, Drawings, Graphics, Hispanic Art, Latin American Art, Mexican Art, Painting-American, Photography, Prints, Sculpture, American Indian Art, American Western Art, African Art, Pre-Columbian Art, Southwestern Art, Textiles, Folk Art, Woodcuts, Etchings & Engravings, Collages, Painting-Japanese, Oriental Art, Asian Art, Maps, Painting-Spanish, Cartoons, Painting-Australian, Painting-Scandinavian

Exhibitions: (2006) Land Sakes Alive - 4 exhibition takes on Southern California; (2007) Contemporary Art of Oceania

Publications: Exhibition catalogs, 1 per yr

Activities: Docent training; 2-3 art performances per year; workshops for adults; lect open to public, 10-20 vis lectrs per year; concerts; gallery talks; tours; competitions; student exhibition cash awards $2,000 total; museum shop sells books, magazines, original art, prints, reproductions, slides, folk art objects, gifts, ceramics & jewelry

OAKLAND

M CALIFORNIA COLLEGE OF ARTS & CRAFTS, CCAC Wattis Institute for Contemporary Arts, 5212 Broadway, Oakland, CA 94618. Tel 415-551-9210; Fax 510-594-3761; Elec Mail institute@ccac-art.edu; Internet Home Page Address: www.wattis.org; *Dir* Ralph Rugoff; *Deputy Dir* Leigh Markopoulos; *Cur* Matthew Higgs; *Curatorial Assoc* Valerie Imus
Open Tues - Sat 11 AM - 6 PM; No admis fee; Estab 1989 to exhibit work of contemporary artists, craftspersons, architects & designers; 3600 sq ft exhibition area with 20 ft ceilings; Average Annual Attendance: 20,000; Mem: 2500
Income: Financed by grants & tuition
Exhibitions: Rotating exhibits every 6-8 weeks
Publications: catalogs
Activities: Classes for adults & children; lect open to public, 10-15 vis lectrs per year

CALIFORNIA COLLEGE OF THE ARTS, Libraries, 5212 Broadway & College Aves, Oakland, CA 94618. Tel 510-594-3658; Elec Mail refdesk@cca.edu; Internet Home Page Address: library.cca.edu; *Dir Libraries* Janice Woo; *Librn* Cody Hennesy; *Librn* Michael Lordi; *Librn* Jon Worona
Estab 1907; educates students to shape culture through the practice and critical study of the arts
Library Holdings: Audio Tapes 20; Book Volumes 55,000; DVDs 600; Original Art Works 650; Original Documents; Periodical Subscriptions 300; Photographs; Slides 120,000; Video Tapes 1,500
Special Subjects: Aesthetics, Architecture, Art History, Ceramics, Drawings, Film, Furniture, Glass, Graphic Design, Illustration, Industrial Design, Interior Design, Jewelry, Metalwork, Photography
Collections: Joseph P Sinel Collection of pioneering work in industrial design; Capp Street Project Archives; Hamaguchi Study Print Collection

M CREATIVE GROWTH ART CENTER, 355 24th St, Oakland, CA 94612. Tel 510-836-2340; Fax 510-836-0769; Elec Mail creativg@dnai.com; Internet Home Page Address: www.creativegrowth.org; *Exec Dir* Tom DiMaria; *Studio Mgr* Ron Kilgore; *Gallery Mgr* Bonnie Haight; *Accountant* Haideh Vincent
Open Mon - Fri 11 AM - 5:30 PM & by appointment; No admis fee; Estab 1974 to professionally exhibit the art of Creative Growth & art work by outsider & well-known artists; Average Annual Attendance: 5,000; Mem: $25 for 1 yr
Income: $900,000
Collections: Permanent collection includes art works in all media on traditional & contemporary subjects
Exhibitions: Individual & group shows; 9 exhibitions held per year in house gallery; 10 exhibitions in variety of locations
Publications: Creative Growth Art Center newsletter, 3-4 issues per year
Activities: Docent programs; lect open to public, 6-8 vis lectrs per year; competitions with awards; scholarships & fels offered; retail store sells prints, original art, reproductions

M EAST BAY ASIAN LOCAL DEVELOPMENT CORP, Asian Resource Gallery, 310 Eighth St, Ste 309, Oakland, CA 94607. Tel 510-287-5353; Fax 510-763-4143; Elec Mail info@ebaldc.com; Internet Home Page Address: www.EBALDC.com; *Office Mgr* Marquita Williams; *Exec Dir* Lynette Junglee; *Asst Dir* Margaret Gee
Open Mon - Fri 9 AM - 5 PM; No admis fee; Estab 1983 to promote Asian art & Asian artists; One gallery
Income: $3000 (financed by donations)
Special Subjects: Photography, Historical Material
Collections: Collection of photographs, paintings, mixed media; history exhibits on Asian groups from China, Japan & Korea
Exhibitions: (1999) Collection of Art by Carol Angel: Philippine American War; Every month rotating exhibits include different artists in the Bay Area

L LANEY COLLEGE LIBRARY, Art Section, 900 Fallon St, Oakland, CA 94607. Tel 510-464-3497; Fax 510-464-3264; Internet Home Page Address: www.laney-peralta.cc.ca.us; *Head Librn* Shirley Coaston; *Head of Ref* Margaret Traylor; *Catalog & Systems Librn* Evelyn Lord; *Acquisition Librn* Mae Frances Moore
Open Mon - Thurs 8 AM - 9 PM, Fri 8 AM - 2 PM, Sat 8:30 AM - 1:30 PM, cl Sun; No admis fee; Estab 1954; Circ 78,000; Average Annual Attendance: 350,000
Library Holdings: Audio Tapes; Book Volumes 81,000; CD-ROMs; Cassettes; DVDs; Filmstrips; Kodachrome Transparencies; Lantern Slides; Motion Pictures; Other Holdings Compact discs; Laser discs; Periodical Subscriptions 300; Prints; Records; Reproductions; Slides; Video Tapes
Exhibitions: Exhibitions vary; call for details
Publications: Monthly newsletter

M MILLS COLLEGE, Art Museum, 5000 MacArthur Blvd, Oakland, CA 94613. Tel 510-430-2164; Fax 510-430-3168; Elec Mail mills-gallery@mills.edu; Internet Home Page Address: www.mills.edu; *Asst Dir* Keith Lachowicz; *Dir* Dr Katherine B Crum
Open Tues - Sat 11 AM - 4 PM, Sun Noon - 4 PM; No admis fee; Estab 1925 to show contemporary & traditional painting, sculpture & ceramics, exhibitions from

permanent & loan collections; Gallery is Spanish colonial architecture & has 5500 sq ft main exhibition space, with skylight full length of gallery; Average Annual Attendance: 24,000
Income: Financed by college funds; grants & gifts
Purchases: Nagle, DeFeo, Bellows, Kales
Special Subjects: Drawings, Painting-American, Photography, Prints, Southwestern Art, Textiles, Pottery, Woodcarvings, Woodcuts
Collections: Asian & Guatemalan Collection (textiles); European & American Collection (prints, drawings & ceramics); Regional California Collection (paintings, drawings & prints); photographs
Exhibitions: Five internat. women artists
Publications: Annual bulletin; exhibition catalogs
Activities: Lect open to public, 3 vis lectrs per year; gallery talks; individual paintings & original objects of art lent; book traveling exhibition; originate traveling exhibition

M OAKLAND MUSEUM OF CALIFORNIA, Art Dept, 1000 Oak St, Oakland, CA 94607. Tel 510-238-2200, 238-2234; Fax 510-238-2258; Elec Mail dmpower@museumca.org; Internet Home Page Address: www.museumca.org; *Chief Cur Art* Philip Linhares; *Sr Cur Art* Harvey L Jones; *Sr Cur Art* Karen Tsujimoto; *Chief Cur Natural Sci* Tom Steller; *Dir Develop* Jan Berckefeldt; *VChmn* Ted Lagried; *Dir Mktg & Communications* Richard Griffoul; *Assoc Cur History* Inez Brooks-Myers; *Deputy Dir* Mark Medeiros; *Coll Coordr* Deborah Cooper; *Mus Shop Mgr* Katherine Ralph; *Chief Exec Dir* Dennis M Power; *Cur Library Natural Science* Paul Matzner; *Cur Special Project* Carey Caldwell; *Registrar Art* Joy Walker; *Registrar Art* Arthur Monroe; *Chief Cur Educ* Barbara Henry; *Assoc Cur Natural Science* Christopher Richard; *Assoc Cur Art Photography* Drew Johnson
Open Wed - Sat 10 AM - 5 PM, Sun Noon - 5 PM, 1st Fri of Month to 9 PM, cl Mon, Tues, New Year's, Thanksgiving & Christmas; Admis general $6, seniors & students $4, 5 yrs & under free; The Oakland Mus of California comprises three departments: Natural Sciences (formerly the Snow Mus of Natural History, founded 1922); History (formerly the Oakland Pub Mus, founded 1910); & the Art Department (formerly the Oakland Art Mus, founded 1916). Internationally recognized as a brilliant contribution to urban mus design; The Oakland Mus occupies a 4 sq block, three-storied site on the south shore of Lake Merritt. Designed by Kevin Roche, John Dinkeloo & Associates, the mus is a three-tiered complex of exhibition galleries, with surrounding gardens, pools, courts & lawns, constructed so that the roof of each level becomes a garden & a terrace for the one above. The Art Department has a large hall with 20 small exhibition bays for the permanent collection & 3 galleries for one-person or group shows as well as the Oakes Gallery; Average Annual Attendance: 500,000
Income: Financed by city funds, pvt donations & Oakland Mus of California Foundation
Special Subjects: Drawings, Painting-American, Photography, Prints, Sculpture, Crafts
Collections: Paintings, sculpture, prints, illustrations, photographs, by California artists & artists dealing with California subjects, in a range that includes sketches & paintings by early artist-explores; gold Rush genre pictures; massive Victorian landscapes; examples of the California Decorative Style, Impressionist, Post-Impressionist, Abstract Expressionist, & other contemporary works
Exhibitions: (1997) This Is Our Land! Teens Speak Out on Nature & Community in the City; In Front of the Lens: Portraits of California Photographers; Expressions in Woods: Masterworks from the Warnick Collection; Hello Again: A New Wave of Recycled Art & Design; Memory & Imagination: The Legacy of Maidu Indian Artist Frank Day; California Species: Biological Art & Illustrations; California Wildflower Show; The Art of John Cederquist: Reality of Illusion; William T Wiley (working title).
Publications: The Museum of California, quarterly; Oakland Museum of California, bimonthly calendar of exhibs & events
Activities: Docent training; lect open to public; gallery talks; tours; individual paintings & original objects of art lent to other museums & galleries for specific exhibitions; originate traveling exhibitions; museum shop sells books, magazines, reproductions, prints, slides & jewelry

L Library, 1000 Oak St, Oakland, CA 94607-4892. Tel 510-238-3005; Fax 510-238-2258
Library maintains extensive files on California art & artists. For in-house use only, cl to the pub at this time
Income: Financed by city & state appropriation
Library Holdings: Auction Catalogs; Audio Tapes; Book Volumes; Cassettes; Clipping Files; Exhibition Catalogs; Lantern Slides; Memorabilia; Periodical Subscriptions 23; Photographs
Special Subjects: Decorative Arts, Photography, Crafts, American Western Art, Printmaking

L OAKLAND PUBLIC LIBRARY, Art, Music & Recreation Section, Main Library, 125 14th St Oakland, CA 94612. Tel 510-238-3134, 238-3178 (art dept); Internet Home Page Address: www.oaklandlibrary.org; *Dir Library Svcs* Carmen Martinez; *Sr Librn in Charge* Jean Blinn
Open Mon - Thurs 10 AM - 8:30 PM, Fri Noon - 8 PM, Sat 10 AM - 5:30 PM, Sun 1 - 5 PM, cl holidays; Library cooperates with the Oakland Mus & local groups
Purchases: $30,000
Library Holdings: Audio Tapes; Book Volumes 1,010,000; Cassettes; Framed Reproductions; Other Holdings Posters; Periodical Subscriptions 2745; Records; Reproductions
Collections: Picture Collections
Publications: Museum catalogs

M PRO ARTS, 550 Second St, Oakland, CA 94607. Tel 510-763-4361; Fax 510-763-9470; Elec Mail info@proartsgallery.org; Internet Home Page Address: www.proartsgallery.org; *Exec Dir* Margo Dunlap
Open Wed-Sat 12 PM - 6 PM, Sun 12 PM - 5 PM; No admis fee; Estab 1974 as a contemporary art exhibition space for static & non-static works, nonprofit; Store-front gallery located in Jack London Sq, 2500 sq ft, 14 ft ceilings; Average Annual Attendance: 50,000; Mem: 1,000; dues $45 & up
Income: Mem & grants

Exhibitions: Rotating exhibits every 2 months; Insite
Activities: Gallery talks; museum shop sells books, magazines, original art, reproductions & prints

OCEANSIDE

M MISSION SAN LUIS REY DE FRANCIA, Mission San Luis Rey Museum, 4050 Mission Ave, Oceanside, CA 92057. Tel 760-757-3651; Fax 760-757-4613; Internet Home Page Address: www.sanluisrey.org; *Exec Dir* Br James Lockman; *Admin* Ed Gabarra; *Mus Cur* Bradford Claybourn
Open daily 10 AM - 4:00 PM; Admis adults $5, Youth $3, Children 5 & younger free; Estab 1798 to protect, conserve & display artifacts which reflect the history of the Mission; Art & history; Average Annual Attendance: 45,000
Income: Financed by property of Franciscan Friars Inc of California
Special Subjects: Architecture, Painting-American, American Indian Art, Southwestern Art, Textiles, Religious Art, Decorative Arts, Historical Material, Restorations, Painting-Spanish
Collections: Artifacts, furniture, paintings, statuary, religious vestments & vessels & other historical objects from early mission days in California
Activities: Educ dept; docent training; 3 lect open to public; concerts; gallery talks; tours; individual paintings & original objects of art lent to qualified museums & historical societies; lending collection contains original art works, paintings, sculpture & decorative arts; sales of books, original art, prints & jewelry

OJAI

A OJAI ART CENTER, 113 S Montgomery, Ojai, CA 93023; PO Box 331, Ojai, CA 93024. Tel 805-646-0117; Fax 805-646-0252; Elec Mail ojaiartcenter@aol.com; *Pres* Len Klaff; *Dir* Teri Mettala
Open Tues - Sun Noon - 4 PM; No admis fee; Estab 1936 to foster all art disciplines in community; Gallery is 40 x 50 ft, high ceilings, with a large hanging area; Average Annual Attendance: 60,000; Mem: 400; dues family $40, adult $30; annual meeting 1st Mon of Feb
Income: Financed by mem, class & special event fees
Exhibitions: Twelve monthly exhibitions; Annual Watercolor Competition
Publications: Newsletter, monthly; Rivertalk, ann poetry anthology
Activities: Classes for adults & children; dramatic programs; lect open to public; concerts; gallery talks; competitions with awards; scholarships offered

OROVILLE

M BUTTE COLLEGE, Coyote Gallery, 3536 Butte Campus Dr, Oroville, CA 95965. Tel 530-895-2987; Fax 530-895-2346; *Dir* Alan Carrier
Estab 1981, a contemporary college art gallery; Average Annual Attendance: 2,000
Exhibitions: Annual Juried Student Art Exhibit; contemporary art of a local, regional & national orientation
Activities: Classes for adults; lect open to public

OXNARD

M CARNEGIE ART MUSEUM, 424 S C St, Oxnard, CA 93030. Tel 805-385-8157; Fax 805-483-3654; *Dir* Mary S Bellah; *Cur* Suzzane Bellah
Open Thurs - Sat 10 AM - 5 PM, Sun 1 - 5 PM; Admis $3 donation suggested; Estab 1980 to serve as a city mus and to house permanent collection; 5000 sq ft of gallery space; Average Annual Attendance: 16,000; Mem: 500, dues $25 & up
Income: $190,000 (financed by endowment, city appropriation, city & nonprofit support)
Purchases: $8500
Collections: California Painters: 1920 to present; Art in Public Places Program
Exhibitions: Rotating exhibitions, six to eight per yr
Publications: Master of the Miniature: The Art of Robert Olszewski; Municipal Art Collection Catalogue; Quechuan Rug Catalogue; Theodor Lukits Catalogue
Activities: Classes for adults & children; docent programs; lect open to public, 6 vis lectrs per year; book traveling exhibitions, 4 per year; originate traveling exhibitions that circulate to other US & foreign museums

M VENTURA COUNTY MARITIME MUSEUM, INC, 2731 S Victoria Ave, Oxnard, CA 93035. Tel 805-984-6260; Fax 805-984-5970; Elec Mail vcmm@aol.com; *Exec Dir* Mark S Bacin; *Cur Arts* Jacquelyn Cavish
Open daily 11 AM - 5 PM; No admis fee; Estab 1991; Collection of maritime paintings (17th century - 20th century) and historic ship models; Average Annual Attendance: 25,000; Mem: 1000; dues $50; annual meeting in July
Income: $190,000 (financed by mem, contributions & grants)
Library Holdings: Book Volumes
Special Subjects: Etchings & Engravings, Marine Painting, Painting-European, Graphics, Painting-American, Photography, Prints, Watercolors, Manuscripts, Marine Painting, Painting-British, Painting-Dutch, Historical Material, Maps, Scrimshaw, Painting-Flemish
Collections: Nelson Family Trust Collection of Maritime Paintings, Prints & Ship Models (Dutch 17th C - Modern 20th C); Antique POW Bone models; Ship Models of the Age of Sail; Ed Marple Model Collection
Exhibitions: Nautica: Annual Juried Maritime Show; international & local artists exhibit 4 times per year; Biennal Exhibit of the American Society of Marine Artists; Plein Air Festival Exhibit
Activities: Classes for adults & children; dramatic programs; docent training; lect open to pub, 6 vis lectrs per year; gallery talks; tours; sponsoring of competitions; original objects of art lent to museums; organize traveling exhibitions; museum shop sells books, original art & prints

PACIFIC GROVE

A PACIFIC GROVE ART CENTER, 568 Lighthouse Ave, PO Box 633 Pacific Grove, CA 93950. Tel 831-375-2208; Fax 831-375-2208; Elec Mail pgart@mbay.net; Internet Home Page Address: www.pgartcenter.org; *Preparator* Mark Davy; *Pres Bd* Randy McKendry; *Vice Pres* Jane Flury; *Office Mgr* Joan Jeffers McCleary
Open Wed - Sat Noon - 5 PM, Sun 1 - 4 PM; No admis fee; Estab 1969 to promote the arts & encourage the artists of the Monterey Peninsula & California;

Four galleries consist of 6000 sq ft of exhibition space, showing traditional & contemporary fine art & photography; galleries are available for classes & lects; Average Annual Attendance: 25,000; Mem: 550; dues business & club $100, family $30, single $25; annual meeting in Nov
Income: Financed by grants, donations, mem. Dues & income from lease of studio space
Collections: Photography; painting
Exhibitions: Multiple exhibits every 7 weeks throughout the year
Publications: Newsletter every 7 weeks
Activities: Educ dept; classes for adults & children; dramatic programs; concerts; lect open to public & for mems only; concerts; gallery talks; competitions

PALM SPRINGS

M PALM SPRINGS ART MUSEUM, (Palm Springs Desert Museum) 101 Museum Dr, Palm Springs, CA 92262; P.O. Box 2310, Palm Springs , CA 92263. Tel 760-325-7186; Fax 760-327-5069; Elec Mail info@psmuseum.org; Internet Home Page Address: www.psmuseum.org; *Exec Dir* Janice Lyle, PhD; *Dir Communications* Kimberly Nichols; *Dir Operations* Steve Hubbard; *Chief Cur* Katherine Hough; *Dir Educ* Robert Brasier; *Dir Finance* Fred Clewell
Open Tues, Wed, Fri, Sat, Sun 10 AM - 5 PM, Thurs Noon - 8 PM, cl Mon; Admis $12.50, seniors 62 & over $10.50, children 6-17, students & active-duty $5; mem & children under 6 free; free admis every Thurs 4-8 PM; Estab 1938 to offer culture & educational opportunities to all interested persons. Includes Annenberg Theater; Average Annual Attendance: 150,000; Mem: 4100 dues, President's Circle $1,500, patron $750, bus sponsor $500, contributing $350, supporting $125, bus affiliate $100, family/dual $85, individual $50
Income: Financed by pvt funds
Library Holdings: Auction Catalogs; Audio Tapes; Book Volumes; CD-ROMs; Clipping Files; DVDs; Exhibition Catalogs; Periodical Subscriptions; Slides; Video Tapes
Special Subjects: Drawings, Ceramics, Collages, Pottery, Painting-American, Prints, Textiles, Bronzes, Woodcuts, Architecture, Graphics, Hispanic Art, Latin American Art, Painting-American, Photography, Prints, Sculpture, Watercolors, American Indian Art, American Western Art, African Art, Anthropology, Pre-Columbian Art, Southwestern Art, Etchings & Engravings, Landscapes, Afro-American Art, Furniture, Glass
Exhibitions: (4/21/2006-9/23/2007) Portraits of Marion Pike; (6/3/2006-1/21/2007) A Point of Convergence: Architectural Drawings & Photographs from the L J Cella Coll; (6/15/2006-1/14/2007) Desert Painters; (10/5/2006-1/21/2007) Contemporary Desert Photography: The Other Side of Paradise; (11/11/2006-4/15/2007) Multicultural Modernism: The Work of Steven Ehrlich Architects; (10/9/2006-3/11/2007) Roy Lichtenstein Prints 1956-97; (1/23/2007-3/4/2007) Artists Council 38th Annual Nat Juried Exhib; Contemporary Glass, 2/13/07 ongoing; (3/8/2007-5/6/2007) 2007 Fine Arts Creativity Awards Exhib; (4/11/2007-9/23/2007) Treasures of the Wes: Art from Desert Colls; (5/5/2007-9/2/2007) Russel Wright: Living with Good Design; (5/10/2007-6/3/2007) Myths, Images & Language; ongoing: Best of the West; 20th Century Art from the Museum's Coll; 20th Century Sculpture, Mesoamerica: Art from Ancient Lands; Leo S Singer Miniature Room Coll
Publications: Calendar of Events, quarterly; special exhibiton catalogs each season
Activities: Classes for adults & children; docent training; dramatic progs; student visits to mus; out-reach art classes; on-site child/adult classes; lect open to public, 25 vis lectrs per year; concerts; gallery talks; tours; competitions with awards; scholarships; exten dept serves pub schools; book traveling exhibitions 4 per year; originate traveling exhibitions; museum shop sells books, reproductions, jewelry, educational childrens toys, cards & artist-designed items
L Library, 101 Museum Dr, PO Box 2310 Palm Springs, CA 92263. Tel 760-325-7186; Fax 760-327-5069; Elec Mail psmuseum@psmuseum.org; Internet Home Page Address: www.psmuseum.org; *Cur* Katherine Hough; *Dir Performing Arts* John Finkler; *Dir* Janice Lyle PhD; *Librn* Kenneth Plate
Open for reference only; art & natural science books available for use on premises by members
Income: Financed by private funds
Library Holdings: Auction Catalogs; Audio Tapes; Book Volumes 9500; CD-ROMs; Cassettes; Clipping Files; Exhibition Catalogs; Manuscripts; Original Documents; Pamphlets; Periodical Subscriptions 28; Photographs; Slides; Video Tapes
Special Subjects: Art History, Folk Art, Mixed Media, Photography, Graphic Arts, Islamic Art, Pre-Columbian Art, History of Art & Archaeology, Portraits, Archaeology, American Western Art, Bronzes, Printmaking, Art Education, American Indian Art, Porcelain, Anthropology, Mexican Art, Oriental Art, Pottery, Religious Art
Publications: Exhibition Catalogs
Activities: Classes for adults & children, docent programs & training; lect open to public, 15 per yr; concerts; gallery talks; tours; sponsored competitions; museum shop sells books, magazines, original art, reproductions

PALO ALTO

A PALO ALTO ART CENTER, (Palo Alto Cultural Center) 1313 Newell Rd, Palo Alto, CA 94303. Tel 650-329-2366; Fax 650-326-6165; Internet Home Page Address: www.city.palo-alto.ca.us/palo/city/artsculture/; *Vol Coordr* Shiela Pastore; *Cur* Signe Mayfield; *Studio Supv* Gary Clarien; *Operations & Sales Mgr* Rebecca Barbee; *Dir Children's Class* Larnie Fox; *Dir* Linda Craighead; *Dir Project Look!* Daisy Colchie; *Publications* Sharon Fox; *VChmn* Tucher Carolyn; *Mus Shop Mgr* Diane Master
Open Tues - Sat 10 AM - 5 PM, Tues - Thurs evenings 7 - 10 PM, Sun 1 - 5 PM, cl Mon; No admis fee; Estab 1971 to stimulate aesthetic expertise & awareness in the Palo Alto & surrounding communities; Average Annual Attendance: 86,000; Mem: 625; dues $1000, $500, $250, $100, $50, $25, $15
Income: $850,000 (finance by municipal funds, private donations & earned income)
Exhibitions: Exhibits rotate every 3 months

Publications: Palo Alto Art Center Newsletter/Calendar, quarterly; exhibit catalogues

Activities: Classes for adults & children; dramatic programs; docent training; lect open to public, 6-8 vis lectrs per year; concerts; gallery talks; tours; competitions; sales shop sells books, original art, reproductions, prints & objects for sale related to exhibitions

M **PALO ALTO JUNIOR MUSEUM & ZOO,** 1451 Middlefield Rd, Palo Alto, CA 94301. Tel 650-329-2111; Fax 650-473-1965; *Dir* Rachel Meyer
Open Tues - Sat 10 AM - 5 PM, Sun 1 - 4 PM, cl Mon, cl New Years, Easter, July 4, Thanksgiving & Christmas; No admis fee; Estab 1932, completely renovated in 1969; Average Annual Attendance: 150,000
Income: Financed by city appropriation
Collections: Interactive children's exhibits
Publications: Notes, monthly
Activities: Classes; self-guided tours; exten dept

PASADENA

A **ARMORY CENTER FOR THE ARTS,** 145 N Raymond Avenue, Pasadena, CA 91103. Tel 626-792-5101; Fax 626-449-0139; Internet Home Page Address: www.armoryarts.org; *Dir Arts & Educ* Doris Hausmann
Estab 1974 for contemporary visual arts, exhibitions, performances & education; Average Annual Attendance: 35,000; Mem: 300; dues $35; annual meeting in Sept
Income: $1.3 million (financed by endowment, mem, city & state appropriation, foundations & corporations)
Special Subjects: Architecture, Graphics, Photography, Prints, Sculpture, Watercolors, Painting-American, Pottery, Woodcuts, Ceramics, Collages, Juvenile Art, Portraits, Bookplates & Bindings
Activities: Classes for adults & children; musical performances; lect open to public; book traveling exhibitions 1 per year; originate traveling exhibitions 1 per year

L **ART CENTER COLLEGE OF DESIGN,** James Lemont Fogg Memorial Library, 1700 Lida St, Pasadena, CA 91103-1999. Tel 626-396-2233; Fax 626-568-0428; Elec Mail cbetty@artcenter.edu; Internet Home Page Address: www.artcenter.edu; *VPres & Dir* Elizabeth Galloway; *Catalog Librn* Alison Holt; *Acquisitions Librn* George Porcari; *Circulation Supv* Mark Von Schlegell; *Circulations Supv* Nolina Burge; *Reference & Pub Servs Librn* Claudia Michelle Betty; *Photo Research Cur* Jennifer Faist
Open Mon - Thurs 8:30 AM - 10 PM, Fri 8 AM - 5 PM, Sat 9 AM - 5 PM, cl Sun; Estab to provide reference & visual resources for the designers who study & teach at Art Center College of Design; Circ 90,000
Income: Financed by institution & private grants
Purchases: $85,000 (books); $45,000 (periodicals); $30,000 (videos & slides)
Library Holdings: Book Volumes 65,000; Cassettes; Clipping Files 28,000; Exhibition Catalogs 1850; Motion Pictures 100; Periodical Subscriptions 450; Reproductions; Slides 90,000; Video Tapes 2200
Special Subjects: Illustration, Photography, Commerical Art, Graphic Design, Advertising Design, Industrial Design

M **NORTON SIMON MUSEUM,** 411 W Colorado Blvd, Pasadena, CA 91105. Tel 626-449-6840; Fax 626-796-4978; Elec Mail art@nortonsimon.org; Internet Home Page Address: www.nortonsimon.org; *Pres* Walter W Timoshuk; *Cur* Gloria Williams; *Sr Cur* Sara Campbell; *Registrar* Andrea Clark; *Rights & Reproductions* Giselle Anteaga-Johnson; *Assoc Cur* Christine Knoke; *Chief Cur* Carol Togneri; *Asst Cur* Michelle Deziel; *Mkg & Communications Mgr* Leslie Denk; *Collections Mgr* Jeffrey Taylor; *Mus Store Mgr* Andrew Uchin
Open Mon - Sun Noon - 6 PM, Fri until 9 PM - closed Tues; Admis adults $8, seniors $4; members & children 18 & under & students with ID free; Estab 1974; this museum brings to the western part of the United States one of the worlds great collections of paintings, prints & sculptures for the cultural benefit of the community at large; the museum is oriented toward the serious & meticulous presentation of masterpiece art; Average Annual Attendance: 150,000; Mem: Dues $65-$1000
Income: Financed by endowment, mem, city appropriation, tours, admis, contributions, bookshop & grounds maintenance
Special Subjects: Graphics, Sculpture, Tapestries
Collections: Art spanning 20 centuries: including paintings, sculptures & graphics from the early Renaissance through the 20th century; Indian & Southeast Asian sculpture
Publications: Masterpieces from the Norton Simon Museum; Handbook of the Norton Simon Museum & Coll Cats
Activities: Classes for adults; tours for children; private guided tours; lectrs open to pub; 10 viss lectrs; concerts; gallery talks; internships; museum shop sells books, reproductions, prints & slides

M **PACIFIC - ASIA MUSEUM,** 46 N Los Robles Ave, Pasadena, CA 91101. Tel 626-449-2742; Fax 626-449-2754; Internet Home Page Address: www.pacificasiamuseum.org; *Exec Dir* David Kamansky; *Educ Mgr* Rebecca Edwards; *Vol Coordr* Rosa Zee; *Asst Dir* William Hanbury-Tenison; *Mktg & Pub Relations* Agnes Gomes; *Cur East Asian Art* Meher McArthur
Open Wed - Sun 10 AM - 5 PM, Thurs 10 AM - 8 PM, cl holidays; Admis adults & non-members $5, seniors & students $3, under 12 free; Estab 1971 to promote understanding of the cultures of the Pacific & Far East through exhibitions, lectures, dance, music & concerts. Through these activities, the mus helps to increase mutual respect & appreciation of both the diversities & similarities of Asian/Pacific & Western cultures; The building was designed by Marston, Van Pelt & Mayberry, architects for Grace Nicholson. The building is listed in the national register of historic places as the Grace Nicholson Building. There is 11,000 sq ft of exhibition space; Average Annual Attendance: 50,000; Mem: 1000; dues benefactor $1000, donor $600, sponsor $350, patron $150, contributor $75, active $37
Special Subjects: Prints, Sculpture, Bronzes, Textiles, Ceramics, Folk Art, Pottery, Woodcarvings, Decorative Arts, Painting-Japanese, Furniture, Jade, Porcelain, Asian Art, Ivory, Coins & Medals, Tapestries, Calligraphy, Miniatures

Collections: Bronzes; Buddhist sculptures; Chinese & Japanese paintings & ceramics; Chinese textiles; Southeast Asian ceramics; Asian Art; Himalayan Art
Publications: Exhibit catalogs
Activities: Classes for adults & children; docent training; lect open to public; gallery talks; tours; original objects of art lent to other museums & limited number of libraries; originate traveling exhibitions to schools, libraries & other museums; museum shop sells books, magazines, original art, reproductions & prints

M **PASADENA CITY COLLEGE,** Art Gallery, Visual Arts & Media Studies Division, 1570 E Colorado Blvd Pasadena, CA 91106. Tel 626-585-7238; Fax 626-585-7914; Elec Mail lxmalm@paccd.cc.ca.us; Internet Home Page Address: www.pccd.cc.ca.us; *Dean Div* Alex Kritselis
Open Mon - Thurs Noon - 4 PM, Fri Noon - 4 PM; No admis fee; Estab to show work that relates to class given at Pasadena City College; Gallery is housed in separate building; 1000 sq ft; Average Annual Attendance: 20,000; Mem: 2800
Income: Financed by the college
Collections: Small permanent collection of contemporary art
Exhibitions: Rotating exhibits & juried student show
Publications: Mailers for each show
Activities: Educ dept; lect open to public, 5-10 vis lectrs per year; gallery talks; competitions; book traveling exhibitions occasionally

M **PASADENA HISTORICAL MUSEUM,** 470 W Walnut St, Pasadena, CA 91103. Tel 626-577-1660; Fax 626-577-1662; Elec Mail info@pasadenahistory.org; Internet Home Page Address: www.pasadenahistory.org; *Archivist* Tania Rizzo; *Dir Exhib* Ardis Willwerth; *Exec Dir* Jeannette O'Malley; *Admin Dir* Pamela Jungelaus
Open Wed - Sun 1 - 5 PM; Admis adults $5, students & seniors $3, children under 12 free; Estab 1924 for the preservation & collection of historical data relating to Pasadena; Historical house with American Impressionist Art; 2 exhibit galleries, Finnish Farm House; Average Annual Attendance: 10,000; Mem: 750; dues $35, annual meeting fourth Sun in Jan
Income: $159,000 (financed through mem, endowment & contributions)
Library Holdings: Book Volumes 1500; Clipping Files; Manuscripts; Memorabilia; Original Art Works; Photographs 750,000
Special Subjects: Costumes, Ceramics, Crafts, Folk Art, Decorative Arts, Dolls, Furniture, Glass, Carpets & Rugs, Embroidery
Collections: Collection of documents & artifacts relating to Pasadena; Collection of paintings by California artists; European & American furniture (antiques & reproductions); 750,000 photographs; rare books & manuscripts; Turn of the Century Life Style on Millionaire's Row; Costumes
Exhibitions: Calif Art Club Juries Exhib
Publications: Quarterly newsletter
Activities: Classes for adults; docent & junior docent training; lect open to public, 4-8 vis lectrs per year; gallery talks; tours; sales shop sells books, magazines, prints & gift items

M **PASADENA MUSEUM OF CALIFORNIA ART,** 490 E Union St, Pasadena, CA 91101; 495 E Colorado Blvd, Pasadena, CA 91101. Tel 626-568-3665; Fax 626-568-3674; Internet Home Page Address: www.pmcaonline.org; *Dir & Cur* Wesley Jessup; *Develop Mem* Jenkins Shannon; *Chmn* Bob Oltman; *Pub Rels* Emma Jacobson-Sire; *Treas* Mark Hilbert; *Registrar* Shirlae Cheng; *Mus Shop Mgr* Emmett Clements
Open Wed - Sun 12 - 5 PM; cl New Years, Fourth of July, Thanksgiving & Christmas; Admis adults $6, seniors & students $4, children under 12 & mems no admis fee; Estab 2002 with the mission to educate & enrich the pub through the coll, study & presentation of works of Calif art, design & architecture from 1850 - present; Average Annual Attendance: 55,000; Mem: dues Guild Level $275, Gallery Level $100, Studio Level $45
Collections: Mus houses no perm coll; exhibs focus on Calif art, design & architecture from 1850 - present; paintings; prints; drawings; graphic arts; photographs
Publications: Newsletter publishes 4 times per yr
Activities: Docent prog; guided tours; concerts; research in contemporary & historic Calif art; lects; exhibs: loan exhibs; traveling exhibs; Calif Design Biennial, Calif Air Club Gold Medal Exhib; books, clothing, jewelry, design objects & other museum-related items for sale

L **PASADENA PUBLIC LIBRARY,** Fine Arts Dept, 285 E Walnut St, Pasadena, CA 91101. Tel 626-744-4066; Internet Home Page Address: www.pasadenapubliclibrary.net; *Dir* Jan Sanders; *Prin Librn & Information Access Servs* Beth Walker
Open Mon - Thurs 9 AM - 9 PM, Fri & Sat 9 AM - 6 PM, Sun 1 - 5 PM; No admis fee; Art dept estab 1927
Income: Financed by endowments & gifts, for materials only
Library Holdings: Audio Tapes 4,737; Book Volumes 22,000; Cassettes 3,111; Compact Disks 9,522; DVDs 2,561; Fiche; Other Holdings Audiobooks on CD 381; Periodical Subscriptions 60; Photographs; Video Tapes 5,185

QUINCY

M **PLUMAS COUNTY MUSEUM,** 500 Jackson St, Quincy, CA 95971. Tel 530-283-6320; Fax 530-283-6081; Internet Home Page Address: www.pluma.s.ca.us; *Asst Cur* Evelyn Whisman; *Dir* Scott Lawson
Open winter Mon - Fri 8 AM - 5 PM, summer Mon - Fri 8 AM - 5 PM, Sat - Sun 10 AM - 4 PM; Admis fee adults $1, students $0.50; Estab 1964 to preserve the past for the enjoyment & edification of the present & future generations; 1878 historical home next door has been restored & opened to the pub with period rooms; Average Annual Attendance: 18,000; Mem: 584; dues life $100, general per yr $5; meetings held biannually
Income: Financed by members & county budget
Purchases: $300
Special Subjects: Architecture, Graphics, Painting-American, Photography, American Indian Art, Anthropology, Costumes, Ceramics, Crafts, Decorative Arts,

Furniture, Glass, Silver, Metalwork, Carpets & Rugs, Historical Material, Coins & Medals, Dioramas, Embroidery, Gold
Collections: Antique period furnishings, Indian (Maidu) artifacts, dolls, clothing, mining & logging artifacts, domestic, jewelry, guns, period furniture, Historic Home Museum adjacent; railroad collection, memorabilia; Variel Home
Exhibitions: Various Local Artists
Publications: Plumas County Museum Newsletter, two times a year
Activities: Lect open to public; gallery talks; tours

L **Museum Archives,** 500 Jackson St, Quincy, CA 95971. Tel 530-283-6320; Fax 530-283-6081; Elec Mail pcmuseum@psln.com; Internet Home Page Address: www.countyofplumas.com; *Asst Cur* Evelyn Whisman; *CEO* Scott Lawson; *Registrar* Jo Ann Filippi; *Bd Dir, VChmn* Roswitha Schulz; *VChmn* Noel Carlson
Open Mon - Fri 8 AM - 5 PM, May-Sept 10 AM - 4 PM; Admis adults $1, 17 & under $.50, children & members free; Estab 1964 to preserve Plumas County's rich heritage & history; Library for reference use only; Average Annual Attendance: 25,000; Mem: 300; dues $10 & up; annual meeting in June
Income: $80,000 (financed by county, memorial donations, mem, book store sales & personal donations)
Library Holdings: Audio Tapes; Book Volumes 2000; Cassettes; Clipping Files; Exhibition Catalogs; Kodachrome Transparencies; Memorabilia; Micro Print; Motion Pictures; Original Art Works; Other Holdings Negatives; Pamphlets; Periodical Subscriptions 1000; Photographs; Prints; Reels; Reproductions; Slides
Collections: Indian jewelry; Maidu Indian Basket Collection; agriculture; bottles; china; crystal; dolls; furniture; logging; mining; musical instruments; railroad items; toys; Coburn Variel Home
Activities: Docent training; demonstrations; lect open to public; gallery talks; tours; sales shop sells books, original art, reproductions, photographs

RANCHO PALOS VERDES

A **PALOS VERDES ART CENTER,** 5504 W Crestridge Rd, Rancho Palos Verdes, CA 90275. Tel 310-541-2479; Fax 310-541-9520; Elec Mail info@pvartcenter.org; Internet Home Page Address: www.pvartcenter.org; *Pub Relations Dir* Kathy Shinkle; *Exhib Dir* Scott Canty; *Admin Dir* Ann Willens; *Exec Dir* Robert A Yassin; *Registrar* Angela Hoffman
Open Mon - Fri 9 AM - 4 PM, Sat 10 AM - 4 PM, Sun 1 - 4 PM, cl major holidays; No admis fee; Estab 1931 to provide cultural enrichment thru art educ, exhibitions & outreach; Changing exhibits in 4 galleries; Average Annual Attendance: 25,000; Mem: dues $25-$5000; annual meeting in June
Income: Financed by mem & pvt donations
Special Subjects: Drawings, Photography, Prints, Sculpture, Ceramics, Jewelry, Calligraphy
Exhibitions: Annual Juried All-media Show (June-August); Biennial International Wearable Arts Exhibition (varies); twenty-four temporary exhibits per year
Publications: Exhibit catalogs; ARTifacts
Activities: Classes for children & adults; docent training; lect open to public; gallery talks; library tours; competitions with awards; scholarships offered; sales shop sells original art

RED BLUFF

M **KELLY-GRIGGS HOUSE MUSEUM,** 311 Washington St, Red Bluff, CA; PO Box 9082, Red Bluff, CA 96080. Tel 530-527-1129; *Pres* Linda Elsner; *Treas* Erick Frey; *Cur* Vivian Ogden
Open Thurs - Sun 1 - 4 PM, cl holidays, for groups any time by reservation; Admis donations accepted; Estab 1965, a Victorian history museum in a home built in 1880s; To preserve the past for present and future generations; Average Annual Attendance: 3,000; Mem: dues associate $10, sustaining $50, supporting $100 annually, memoriam $100, life $200, patron $500, benefactor $1000
Income: mems, donations, fundraising events
Library Holdings: Book Volumes; DVDs; Memorabilia; Original Art Works; Original Documents; Pamphlets; Photographs
Special Subjects: Archaeology, Historical Material, Ceramics, Glass, Furniture, Painting-American, Period Rooms, Textiles, Hispanic Art, American Indian Art, Costumes, Dolls, Jewelry, Porcelain, Embroidery, Laces, Antiquities-Oriental, Cartoons, Leather
Collections: Collection of paintings spanning a century of art; Indian artifacts; antique furniture; Victorian costumes
Exhibitions: Permanent and temporary exhibitions
Publications: Brochure; Kellygram (guides' newsletter and schedule)
Activities: Docent training; guided tours, lectures 4-6 per yr

REDDING

M **TURTLE BAY EXPLORATION PARK,** PO Box 992360 Redding, CA 96099-2360. Tel 530-243-8850; Fax 530-243-8929; Elec Mail info@turtlebay.org; Internet Home Page Address: www.turtlebay.org; *Pres* John C Peterson; *Art Cur* Robyn Peterson; *Coll Mgr* Julia Pennington; *Dir Educ Progs* Traci Weirman
Open Sun - Sat 9 AM - 5 PM; Admis adult $11, children $6; Estab 1963 to interpret the complex relationships between people and their environments; Two temporary exhibition galleries, totalling 7,000 sq ft present changing contemporary art, history & natural science exhibits; outdoor art; Average Annual Attendance: 100,000; Mem: 2000; dues $20-$5000; family $65; ann meeting in Jan
Income: Financed by admis, mem, city appropriation, fundraising activities
Special Subjects: Etchings & Engravings, Landscapes, Painting-American, Prints, Textiles, Photography, Sculpture, Watercolors, American Indian Art, American Western Art, Archaeology, Ethnology, Costumes, Manuscripts, Historical Material, Maps, Reproductions
Collections: Native American baskets; Shasta County historical artifacts & documents; Contemporary Regional art; photography; Forest History
Exhibitions: Annual Art Competition; Bug-Eyed: Art, Culture, Insects; Realism Today: Audubon's Animals
Publications: Temporary exhib catalogs
Activities: Classes for adults & children; docent training; lect open to public, vis lectr; gallery talks; tours; Art Fair; lending collection; book traveling exhibitions

3-5 per yr; originate traveling exhibitions to other museums; museum shop sells books & original art, consignment from local craftspeople & artists, reproductions, gifts

L **Shasta Historical Society Research Library,** 1335 Arboretum Dr, Ste A, Redding, CA 96003. Tel 530-243-3720; *Librn* Linda Sharpe
Open Mon - Fri 10 AM - 4 PM; Open for reference only by appointment
Library Holdings: Periodical Subscriptions 64

REDLANDS

L **LINCOLN MEMORIAL SHRINE,** 125 W Vine St, Redlands, CA 92373. Tel 909-798-7636, 798-7632; Fax 909-798-6566; Elec Mail archives@aksmiley.org; Internet Home Page Address: www.aksmiley.org; *Cur* Donald McCue; *Assoc Archivist* Richard Hanks; *Assoc Archivist* Nathan Gonzalez; *VPres* Jack D Tompkins
Open Tues - Sun 1 - 5 PM, other hours by appointment; cl Sun, Mon & holidays, except Lincoln's birthday; No admis fee; Estab 1932, operated as a section of the Smiley Public Library; Reference use only; Average Annual Attendance: 6,000; Mem: 325; dues $15-$30
Library Holdings: Book Volumes 4500; Clipping Files; Filmstrips; Memorabilia; Original Art Works; Pamphlets; Photographs; Sculpture
Special Subjects: Manuscripts, Maps, American Indian Art
Collections: Sculptures, paintings, murals
Publications: Lincoln Memorial Association Newsletter, quarterly
Activities: Docent training; lect open to public, 1 vis lectr per year; guided tours by appointment; Barondess Award, 1987; sales shop sells pamphlets & postcards; books

A **REDLANDS ART ASSOCIATION,** Redlands Art Association Gallery, 215 E State St, Redlands, CA 92373-5273. Tel 909-792-8435; Internet Home Page Address: www.redlands-art.org; *Pres* Evelyn Ifft; *Gallery Mgr* Jerry Meeker; *Publicity* Sandy Davies
Open Mon - Fri 10 AM - 5 PM, Sat 10 AM - 2 PM; No admis fee; Estab 1964 to promote interest in the visual arts & to provide a gallery for artists; Circ 200; 2 room business site on main shopping st; Average Annual Attendance: 3,000; Mem: 325; dues $35; annual meeting in May; Artist, Art Appreciator
Income: Financed by dues, gifts, grants
Purchases: Gallery takes 30% of items sold
Library Holdings: Book Volumes 400
Exhibitions: Multimedia mini juried show; Recycling Show; Plein Air Show
Publications: Bulletin, monthly
Activities: Classes for children & adults; lect open to public, 8 vis lectrs per year; tours; competitions with prizes; gallery talks; workshops; scholarships offered; lending collection contains books & original prints; gallery shop sells original art, reproductions, glass, ceramics, jewelry & cards

M **SAN BERNARDINO COUNTY MUSEUM,** Fine Arts Institute, 2024 Orange Tree Lane, Redlands, CA 92374. Tel 909-307-2669; Fax 909-307-0539; Elec Mail sramos@sbc.sbcounty.org; Internet Home Page Address: www.sbcountymuseum.org; *Dir* Robert L McKernan; *Registrar* Elizabeth Slimmer; *Cur Exhibitions* Holly Signi; *Cur Educ* Jolene Redvale; *Sr Cur Paleontology* Kathleen Springer; *Cur History* Ann Deegan; *Deputy Dir* Laurie Rozko; *Cur Anthropology* Adella Schroth; *Mus Shop Mgr* Blue Anderson
Open Tues - Sat 9 AM - 5 PM, Sun 9 AM - 5 PM; Admis adults $3, seniors, students & children 2-12 $2, mus mem free; Estab 1952 for education; Maintains upper & lower dome galleries & foyer; Average Annual Attendance: 300,000; Mem: 2100; dues Fine Arts Institute $40, Mus Assoc $15 & up; annual Fine Arts Institute meeting Mar; annual Mus Assoc meeting in May
Income: $280,000 (financed by mem)
Purchases: $2000
Special Subjects: Painting-American, American Indian Art, American Western Art, Archaeology, Collages, Historical Material
Collections: Collection consists primarily of representational art pertaining to Wildlife or the history of Southern California & annual purchase awards from Fine Arts Institute's Annual International Exhibit & Southern California Open Exhibit & County Heritage Exhibit
Exhibitions: Three juried art members exhibits; one annual international open exhibit; one regional Southern California open exhibit; one featured artists group exhibit
Publications: Newsletter, bimonthly
Activities: Classes for adults & children; docent training; lect open to public, 3 vis lectrs per year; gallery talks; tours; art competitions with cash & purchase awards totaling $45,000 annually; book traveling exhibition; originate traveling exhibitions; museum shop sells books, magazines, original art reproductions, prints & slides, jewelry, items pertaining to natural history

M **UNIVERSITY OF REDLANDS,** Peppers Art Gallery, 1200 E Colton Ave, PO Box 3080 Redlands, CA 92373. Tel 909-793-2121; Fax 909-748-6293; *Chair Art Dept* Penny McElroy; *Admin Asst* Terri Hodgson
Open Tues - Fri 1 - 5 PM, Sat & Sun 2 - 5 PM, cl summer; No admis fee; Estab 1963 to widen students interest in art; Gallery is one large room with celestial windows & movable panels for display; Average Annual Attendance: 1,500
Income: Financed by endowment
Collections: Ethnic Art; graphics; a few famous artists works
Exhibitions: (1999) John Brownfield; Dead Bowman; Senior Art Show.; Exhibitions during fall, winter, spring
Publications: Exhibition catalogs & posters
Activities: Lect open to public, 4-5 vis lectrs per yr; gallery talks; tours; talent awards

RICHMOND

A **NATIONAL INSTITUTE OF ART & DISABILITIES (NIAD),** Florence Ludins-Katz Gallery, 551 23rd St, Richmond, CA 94804. Tel 510-620-0290; Fax 510-620-0326; Elec Mail admin@niadart.org; Internet Home Page Address: www.niadart.org; *Exec Dir* Patricia Coleman; *Cur* Rose Kelly
NIAD open daily 9 AM - 4:30 PM; Florence Ludins-Katz Gallery open Mon - Fri 10 AM - 3 PM; No admis fee; Estab 1984 to provide an art environment for

people with developmental disabilities which promotes creative expression, independence, dignity and community integration; Maintains professional exhibition galleries which display the work of NIAD artists, often alongside the work of established artists from outside the NIAD setting in order to bring the art of NIAD artists to the attention of the general public; Average Annual Attendance: 1,000; Mem: 250; dues $15-$100

Collections: Gallery, books, pamphlets, posters, videotapes, CD-ROM
Exhibitions: NIAD artist work; 5 exhib a year at on-site gallery; numerous exhib nationally and internationally
Publications: Art & Disabilities, Freedom to Create, the Creative Spirit; Freedom to Create (videotape series)
Activities: Classes for adults with developmental disabilities; interdisciplinary visual art studio program; professional training in art & disabilities field; research, training & technical assistance; gallery talks; tours; originate traveling exhibitions of NIAD artist work to regional galleries, museums, colleges, community centers & businesses; sales shop sells books, original art & prints

A THE RICHMOND ART CENTER, Civic Center Plaza, 2540 Barrett Ave Richmond, CA 94804. Tel 510-620-6772; Fax 510-620-6771; Elec Mail admin@therac.org; Internet Home Page Address: www.therichmondartcenter.org; *Exec Dir* Don Adams
Open Tues - Sun 12 noon - 5 PM, cl Mon & holidays; No admis fee; Estab preliminary steps 1936-44; formed in 1944 to establish artists studios & community center for arts; to offer to the community an opportunity to experience & to improve knowledge & skill in the arts & crafts at the most comprehensive & highest level possible; A large gallery, small gallery & entrance gallery total 5000 sq ft & a rental gallery covers 1628 sq ft; an outdoor sculpture court totals 8840 sq ft; Average Annual Attendance: 8,000; Mem: 1,000; dues $35 & up
Collections: Primarily contemporary art & crafts of Bay area
Exhibitions: Rotating: group theme, solo, invitational & juried annuals
Publications: Catalog for annual shows; newsletter, quarterly; show announcements for exhibitions
Activities: Classes for adults & children; lect open to public, 5 vis lectrs per year; gallery talks; tours; scholarships offered; outreach program serving community; rental gallery, paintings & original objects of art lent to offices, businesses & homes, members of Art Center

RIVERSIDE

M RIVERSIDE ART MUSEUM, 3425 Mission Inn Ave, Riverside, CA 92501. Tel 951-684-7111; Fax 951-684-7332; Elec Mail ram@riversideartmuseum.org; Internet Home Page Address: www.riversideartmuseum.org; *Exec Dir* Daniel Foster; *Assoc Dir* Andi Campognone; *Sr Cur* Peter Frank; *Educ Cur* Steve Thomas; *Sr Preparator* Christaan Von Martin
Open Mon - Sat 10 AM - 4 PM; Adults non-mems $5; Estab 1935 to display art, collect & preserve art created in the West; Three spaces - Main Gallery 72 ft x 35 ft; Upstairs Gallery 18 ft x 30 ft; Art Alliance Gallery 72 ft x 35 ft; Average Annual Attendance: 70,000; Mem: 1,200; dues life mem $10,000 & up, patron $2500, supporting $300, family $50, individual $35, senior citizens $10
Income: Financed by mem, grants & donations
Library Holdings: Book Volumes; Exhibition Catalogs
Collections: Mixture of media dating from the late 1800s to the present; 300 pieces; art by Southern California artists (past & present) living in the west (Andrew Molles Collection); Works on paper
Exhibitions: Rotating exhibits
Publications: Artifacts, monthly
Activities: Classes for adults & children; docent training; internships; lect open to public, 6 vis lectrs per year; gallery talks; demonstrations; special events; sponsoring of competitions with prizes; tours; concerts; scholarships & fels offered; individual paintings & original objects of art lent; museum shop sells original art & books
L Library, 3425 Mission Inn Ave, Riverside, CA 92501. Tel 909-684-7111; Fax 909-684-7332; *Dir* Bobbie Powell; *Adminn Dir* Kathy Smith
Open Mon - Fri 10 AM - 4 PM; Open for reference upon request
Income: Financed by grants & donations
Library Holdings: Book Volumes 600; Exhibition Catalogs; Framed Reproductions; Pamphlets; Periodical Subscriptions 15; Photographs; Reproductions

M RIVERSIDE MUNICIPAL MUSEUM, 3580 Mission Inn Ave, Riverside, CA 92501. Tel 951-826-5273; Fax 951-369-4970; Elec Mail dbrennan@riversideca.gov; Internet Home Page Address: www.riversideca.gov/museum; *Restoration Specialist* Gary Ecker; *Dir Mus* H. Vincent Moses; *Cur Natural History* James Bryant; *Educ Cur* Wendy Sparks; *Cur Coll and Historic Structures* Lynn Voorheis; *Exhibitions Designer* Dasia Bytnerowicz; *Cur Coll & Exhib* Brenda Focht; *Sr Management Analyst* Denise Brennan; *Assoc Cur Educ* Maggie Wetherbee; *Assoc Cur Coll* Teresa Woodard
Open Tues - Fri 9 AM - 5 PM, Sat 10 AM - 5 PM, Sun 11 AM - 5 PM; No admis fee, donation requested; Estab 1924 to collect, preserve & display local & California prehistory, natural history & local history; Permanent galleries on local geology, paleontology, Indians, history & animals; Mem: 750; dues individual $20, family $30
Special Subjects: Architecture, Photography, American Indian Art, Anthropology, Archaeology, Ethnology, Pre-Columbian Art, Southwestern Art, Textiles, Folk Art, Primitive art, Eskimo Art, Dolls, Furniture, Carpets & Rugs
Collections: History photo archive; Indian art; Native American Basketry; historic house, 1891 Heritage House; photo & document archives; Citrus Label Art; Citrus Paraphernalia
Activities: Classes for children; docent training; lect open to members only, 6-10 vis lectrs per year; tours; original objects of art lent to other public museums & art galleries; nature lab; multicultural festival; museum shop sells books, original art, reproductions & prints

UNIVERSITY OF CALIFORNIA

M Sweeney Art Gallery, Tel 951-827-3755; Elec Mail karen.rapp@ucr.edu; Internet Home Page Address: sweeney.ucr.edu; *Dir* Karen Rapp; *Gallery Mgr* Jennifer Frias

Tues-Sat 11 AM-4 PM; No admis fee; Estab 1963, gallery presents major temporary exhibitions; Gallery contains 2,000 sq ft; Average Annual Attendance: 5,000; Mem: dues patron $1,000 & up, supporting $500, contributor $100, family $45, individual $30, student $15
Income: $100,000 (financed by mem & state appropriation)
Purchases: $30,000 (print collection)
Collections: Works on paper-portfolios of prints, sculpture
Exhibitions: Main Gallery: (1999) Western Archeological Center Collection; Bas Jan Ader Retrospective
Publications: Exhibition catalogs
Activities: Lect open to public, 2-3 vis lectrs per year; book traveling exhibitions 1-2 per year; sales shop sells catalogs & posters

M California Museum of Photography, Tel 909-787-4787; Fax 909-787-4797; *Dir* Jonathan Green; *Cur Exhibs* Ciara Ennis; *Cur Digital Media* Georg Burwick; *Store Mgr* Jeremy Denis
Open Tues 12 - 5 PM, first Sun of month 1 - 5 PM, first Thurs of month 6 - 9 PM; Admis $3, students & seniors free; Estab 1973 to preserve, protect & exhibit photography; Mus has five exhibition galleries which display changing exhibitions related to historical & contemporary photography & emerging technologies; Average Annual Attendance: 20,000; 3.5 million to website; Mem: 1,200; dues $35
Income: $800,000 (financed by university funds, grants, private donations & mem)
Special Subjects: Architecture, Drawings, Photography
Collections: Bingham camera & apparatus; Keystone-Mast stereo negatives & prints; photographs of the 19th & 20th centuries; Ansel Adams/Fiat Lux; Will Connnell Collection
Exhibitions: (10/28/2006-1/6/2007) Ruby Satellite - Curated by Ciara Ennis; (10/28/2006-1/6/2007) Mark Stockton & Edgar Endress: Samurai; (1/28/2007-4/14/2007) Liset Castillo: Lakewood, California; (1/28/2007-4/14/2007) Malerie Marder: Inland Empire; (1/28/2007-4/14/2007) Alex Slade: Wandering Through The Inland Empire; (4/28/2007-7/7/2007) Li Zhensheng; (4/28/2007-7/7/2007) Christy Johnson and 33 Confessors; Summer 2007: The Gravity In Art Curated by Theo Tegelaers in assoc w/Rene Daalder
Publications: American Photography by Jonathan Green; Che Guevarra: Revolutional & Icon by Trisha Ziff
Activities: Classes for adults & children; lect open to public, 2 vis lectrs per year; gallery talks; tours; competitions with awards; film series; symposia; original objects of art lent to other art institutions; lending collection contains 400,000 photographs; book traveling exhibitions 3 per year; originate traveling exhibitions; mus shop sells books, prints & misc items
L Tomas Rivera Library, Tel 951-827-3703; Fax 951-827-3285; Internet Home Page Address: http://library.ucr.edu; *Art Selector* Vicki Bloom; *Univ Librn* Ruth Jackson, PhD
Open Mon - Thurs 8 AM - Midnight, Fri 8 AM - 6 PM, Sat 10 AM - 6 PM, Sun 1 PM - 12 AM; Open to faculty, students & staff
Library Holdings: Audio Tapes; Book Volumes 38,000; Cards; Cassettes; Exhibition Catalogs; Fiche; Filmstrips; Manuscripts; Motion Pictures; Original Art Works; Periodical Subscriptions 172; Photographs; Records; Reels; Slides; Video Tapes
Special Subjects: Photography

ROHNERT PARK

M SONOMA STATE UNIVERSITY, University Art Gallery, 1801 E Cotati Ave, Rohnert Park, CA 94928. Tel 707-664-2295; Fax 707-664-2054; Elec Mail art.gallery@sonoma.edu; Internet Home Page Address: www.sonoma.edu/artgallery/; *Exhib Coordr* Carla Stone
Open Tues - Fri 11 AM - 4 PM, Sat & Sun Noon - 4 PM, cl summer; No admis fee; Estab 1978 to provide exhibitions of contemporary art to the university & Northern California community; 2500 sq ft of exhibition space designed to house monumental sculpture & painting
Income: financed through University & private funds
Special Subjects: Drawings, Etchings & Engravings, Ceramics, Collages, American Western Art, Photography, Prints, Sculpture, Painting-American, Portraits, Oriental Art, Cartoons
Collections: Asian Collection of Prints; Garfield Collection of Oriental Art
Publications: Bulletins and announcements of exhibitions; exhibition catalog
Activities: Docent training; educ-outreach program; 5-10 vis lectr per year; gallery talks; tours; annual benefit auction; book traveling exhibitions 1-2 per year; originate traveling exhibitions to national art museums; sales shop sells books, T-shirts & posters

ROSS

A MARIN SOCIETY OF ARTISTS INC, 30 Sir Francis Drake Blvd, PO Box 203 Ross, CA 94957. Tel 415-454-9561; Fax 415-457-5414; *Office Mgr, Dir* Jo Smith; *Pres* Marcia Kent
Open Mon - Thurs 11 AM - 4 PM; Sat & Sun Noon - 4 PM, cl Fri; No admis fee; Estab 1929 to foster cooperation among artists & to continually develop pub interest in art; Circ Small library for mem only; Gallery is located in a garden setting. It is approximately 3500 sq ft of well lighted exhibit space; Average Annual Attendance: 75,000; Mem: 450; dues $40; qualifications for signature mem: Previous exhibition in a juried show & must reside in Bay Area if active; meetings in May & Sept
Income: Financed by mem, sale & rental of art
Exhibitions: One show per month; annual art auction in June
Publications: Monthly newsletter
Activities: Classes for mem only; lect open to public, 2-3 vis lectrs per year; competitions with cash awards; sales shop sells original art, original prints, handcrafted jewelry ceramics & fiberworks

SACRAMENTO

M **CALIFORNIA DEPARTMENT OF PARKS & RECREATION,** California State Indian Museum, 2618 K St, Sacramento, CA 95816. Tel 916-324-0971; Fax 916-322-5231; Internet Home Page Address: www.cal-parks.ca.gov; *Lead Ranger* Joann Helmich; *Museum Technician* Bruce Stiny; *Museum Cur* Michael Tucker
Open daily 10 AM - 5 PM, cl New Years, Thanksgiving & Christmas; Admis adults $1, children 16 & under free; Estab 1940
Special Subjects: American Indian Art, Anthropology
Collections: Artifacts Collection from California Native Americans (basketry, hunting & fishing implements, regalia, musical instruments & photographs); Contemporary Native American Art
Exhibitions: Contemporary Art Show; Indian Arts & Crafts Christmas Fair
Activities: Docent training; tours; competitions with awards

CALIFORNIA STATE UNIVERSITY AT SACRAMENTO

L **Library - Central Reference Dept,** Tel 916-278-6218; Fax 916-278-7089; Internet Home Page Address: www.lib.csus.edu; *Slide Librn, Arts Librn* Alicia Snee; *Library Asst* Lynn O'Farrell
Open Mon - Thurs 7:45 AM - 11 PM, Fri 7:45 AM - 5 PM, Sat 10 AM - 6 PM, Sun 1 - 9 PM (during school year), summer sessions vary during week; Estab 1947
Income: Financed through the University
Library Holdings: Audio Tapes; Cards; Cassettes; Clipping Files; Exhibition Catalogs; Fiche; Filmstrips; Pamphlets; Periodical Subscriptions 250; Reels; Reproductions; Slides; Video Tapes
Publications: Women Artists: A Selected Bibliography; bibliographic handouts
M **University Union Exhibit Lounge,** Tel 916-278-6595; Fax 916-278-6278; *Assoc Dir* Richard Schiffers
Open Mon - Fri 10:30 AM - 3:30 PM, Wed & Thurs 5 - 8 PM, during school year, summer hours vary; No admis fee; Estab 1975 to expose students to a variety of visual arts & techniques; The Exhibit Lounge is located on the second floor of the University Union. It has 67 running ft of display space. Gallery run by students; Average Annual Attendance: 8,250
Income: Student fees & commissions
Purchases: Works purchased for permanent collection annually from artists with a relationship, past or present, with the University
Collections: Various prints, photographs, paintings by students; sculpture by Yoshio Taylor: Tsuki, painting by Jack Ogden: American Grove, Bronze original by John Battenberg J G Sheds His Wolf's Clothing
Exhibitions: Annual student competition, other various exhibits encompassing a variety of media & subjects
Activities: Lect open to public, 9 vis lectrs per year; gallery talks; competitions

M **CROCKER ART MUSEUM,** 216 O St, Sacramento, CA 95814. Tel 916-264-5423; Fax 916-264-7372; Elec Mail cam@cityofsacramento.org; Internet Home Page Address: www.crockerartmuseum.org; *Mus Dir* Lial A Janes; *Cur of Art* Scott Shields; *Fin Dir* David Navarereo; *Educ Dir* Stacey Shelnut; *Dir Mus Operations* Nancy Ray; *Development Dir* Kimberly Parker; *Marketing Dir* Rob Rough; *Mus Store Mgr* John Reilly
Open Tues - Sun 10 AM - 5 PM, Thurs 10 AM - 9 PM, cl Mon; Admis adults $6, students $3, seniors $4, 6 & under free; Estab 1873; municipal art mus since 1885; original gallery building designed by Seth Babson completed in 1873; R A Herold Wing opened in 1969; Crocker Mansion Wing opened in 1989; Average Annual Attendance: 120,000; Mem: 7,000; annual meeting in June
Income: $750,000 (financed by Crocker Art Mus Assoc & city appropriation)
Library Holdings: Auction Catalogs; Book Volumes; Exhibition Catalogs; Manuscripts; Maps; Slides
Special Subjects: Painting-American, Photography, Prints, Sculpture, Decorative Arts, Painting-European
Collections: 19th century California painting; American decorative arts; contemporary California painting, sculpture & crafts; prints & photographs; European decorative arts; European painting 1500 - 1900; Old Master drawings; Oriental art
Exhibitions: The Art of the Gold Rush Exhibition catalog
Publications: Calendar, 6 times per year
Activities: Seminars for adults; children's programs; docent training, dramatic programs; lect open to the public, 35 vis lectrs per year; concerts; tours; annual juried competitions; individual paintings & original objects of art lent to other museums; Art travels to K-8 schools in seven surrounding counties; book traveling exhibitions; originate traveling exhibitions; museum shop sells books, mags, original art, cards, reproductions, prints & miscellaneous gifts
L **Research Library,** 216 O St, Sacramento, CA 95814. Tel 916-264-8856; Fax 916-264-7372; Internet Home Page Address: www.crockerartmuseum.org; *Cur Educ* Stacey Shelnut-Hendrick
Open Wed, Thurs & Sat 1:30 - 4 PM; Open for reference only to public, staff, docent, interns and others upon application
Library Holdings: Book Volumes 2000; Exhibition Catalogs; Fiche; Other Holdings Dissertations; Periodical Subscriptions 30
Activities: Classes for adults & children; dramatic programs; docent training; lect open to public, some open to members only, vis lectr; concerts; artmobile; individual paintings lent

M **LA RAZA-GALERIA POSADA,** 1421 R St, Sacramento, CA 95814; 1022 22nd St, Sacramento, CA 95816. Tel 916-446-5133; Fax 916-446-1324; Internet Home Page Address: www.larazagaleriaposada.org; *Exec Dir* Francisca E Godinez, Ph.D
Open Tues - Sat Noon - 6 PM; Estab 1972 as a Chicano art & culture center; 2,000 sq ft gallery; Average Annual Attendance: 30,000; Mem: 1,000; dues $15-$150
Special Subjects: Mexican Art, Hispanic Art, Jewelry
Collections: Permanent Coll
Activities: Classes for adults & children; lect open to public; gallery talks; tours

SAINT HELENA

M **R L S SILVERADO MUSEUM,** 1490 Library Lane, PO Box 409 Saint Helena, CA 94574-0409. Tel 707-963-3757; Fax 707-963-0917; Elec Mail rlsnhs@calicom.net; Internet Home Page Address: www.silveradomuseum.org; *Dir* Edmond Reynolds; *Assoc Dir* Ann Kindred
Open Tues - Sun Noon - 4 PM, cl Mon & holidays; No admis fee; Estab 1968; the mus is devoted to the life & works of Robert Louis Stevenson, who spent a brief but important time in the area; the object is to acquaint people with his life & works & familiarize them with his stay; The mus has five wall cases & three large standing cases, as well as numerous bookcases; Average Annual Attendance: 5,500
Income: Financed by the Vailima Foundation, set up by Mr & Mrs Norman H Strouse
Special Subjects: Drawings, Photography, Watercolors, Etchings & Engravings, Manuscripts, Portraits, Furniture, Historical Material
Collections: All material relating to Stevenson & his immediate circle
Exhibitions: A different exhibition devoted to some phase of Stevenson's work is mounted every three months
Activities: Dramatic programs; docent training; lect open to public 4 per yr; tours; sales desk sells books
L **Reference Library,** 1490 Library Lane, PO Box 409 Saint Helena, CA 94574. Tel 707-963-3757; Fax 707-963-8131; *Dir* Edmond Reynolds
Open Tues - Sun Noon - 4 PM; Estab 1970; For reference only
Income: Financed by Vailima Foundation
Library Holdings: Book Volumes 3000; Kodachrome Transparencies 300; Motion Pictures
Special Subjects: Photography, Painting-American, Painting-British
Collections: First editions, variant editions, fine press editions of Robert Louis Stevenson, letters, manuscripts, photographs, sculptures, paintings and memorabilia
Exhibitions: Exhibits of two months duration 6 times a year; Christmas Exhibit
Publications: The Silverado Squatters; Prayers Written at Vailima

SALINAS

M **HARTNELL COLLEGE GALLERY,** 156 Homestead Ave, Salinas, CA 93901. Tel 831-755-6700, 755-6791; Fax 831-759-6052; Elec Mail gsmith@hartnell.cc.ca.us; *Dir* Gary T Smith
Open Mon 10 AM - 1 PM & 7 - 9 PM, Tues - Thurs 10 AM - 1 PM, cl Fri - Sun; No admis fee; Estab 1959 to bring to students & the community the highest quality in contemporary & historical works of all media; Main gallery is 40 x 60 ft, south gallery is 15 x 30 ft, brick flooring; Average Annual Attendance: 7,500
Collections: Approx 45 works on paper from the San Francisco Bay Area WPA; FSA photographs; Mrs Virginia Bacher Haichol Artifact Collection; Mrs Leslie Fenton Netsuke Collection
Exhibitions: Edward Weston; Claes Oldenburg; Edward Curtis; Oriental Porcelain from the Albert & Pat Scheopf Collection; Charles Russell & Frederick Remington; Russian Lacquer Boxes; Selections from the Hartnell Farm Security Admin Photography Collection; Christo: Wrapped Coast
Activities: Classes for adults; gallery management training; individual paintings & original objects of art lent to qualified institutions, professional galleries or museums; lending collection contains original art works; book traveling exhibitions; traveling exhibitions organized & circulated

SAN BERNARDINO

M **CALIFORNIA STATE UNIVERSITY, SAN BERNARDINO,** 5500 University Pky, San Bernardino, CA 92407-2397. Tel 909-880-5823, 880-7373 (Fullerton Mus); Fax 909-880-7068; *Dir Gallery* Eva Kirsch; *Chmn Art Dept* Joe Moran
Open Tues - Sat 11 AM - 5 PM; No admis fee; Estab 1990s for the purpose of providing high quality exhibitions on varied subjects suitable for both campus & community; Gallery expanded into museum; Average Annual Attendance: 13,000
Income: Financed by mem, city & state appropriations
Collections: Egyptian Antiquities; African Collection; Asian Ceramics
Publications: Catalogs; pamphlets
Activities: Classes for adults; summer workshop for children; lect open to public, 1-3 vis lectr per year; gallery talks; tours; competitions

A **SAN BERNARDINO ART ASSOCIATION, INC,** Sturges Fine Arts Center, Sturges Fine Arts Ctr, 780 North E St San Bernardino, CA 92413; PO Box 3574, San Bernardino, CA 92413. Tel 909-885-2816; *Treas* Harvey Tobias; *VPres, Acting Pres* Yolanda Voce; *Second VPres* Ferne Schmidt; *Recording Secy* Doro Johnson
Open Tues & Thurs 11 AM - 3 PM; No admis fee; Estab 1932 as a nonprofit organization to generate interest in art for all ages; Open to the public; maintains gallery of paintings & ceramics by local artists; Mem: 75; dues $20; meetings on first of each month
Exhibitions: Bimonthly exhibits
Publications: Newsletter
Activities: Classes for adults; artist presentations; lect open to public, 8 vis lectrs per year; gallery talks; competitions with awards; scholarships; individual paintings & original objects of art lent; sales shop sells original art, ceramics & photographs

SAN DIEGO

A **BALBOA ART CONSERVATION CENTER,** BACC, 1649 El Prado San Diego, CA 92101; BACC, PO Box 3755 San Diego, CA 92163. Tel 619-236-9702; Fax 619-236-0141; Elec Mail info@bacc.org; Internet Home Page Address: www.bacc.org; *Dir & Chief Paper Conservator* Janet Ruggles; *Chief Paintings Conservator* Elizabeth Court; *Field Serv Officer* Beverly N Perkins; *Field Serv Project Mgr* Josephine Ihrke
Open Mon - Fri 9 AM - 4:30 PM; No admis fee; Estab 1975 for research & educ in art conservation; services in exams, treatment & consulation in art conservation;

Mem: 18; nonprofit institutions are members, their members may contract for services; annual meeting in May

Income: $300,000 (financed by services performed)

Collections: Illustrative photographs, memorabilia, tools, equipment of profession; paintings for experimental & didactic purposes

Activities: Educ prog; regional workshop series on care of collections; lect open to public & some for members only; gallery talks; tours

L **Richard D Buck Memorial Library,** Balboa Park, PO Box 3755 San Diego, CA 92163-1755. Tel 619-236-9702; Fax 619-236-0141; *General Mgr* Janet Ruggles
Library not open to pub

Income: Financed by Mellon Grant

Library Holdings: Book Volumes 700; Cassettes; Clipping Files; Exhibition Catalogs; Memorabilia; Pamphlets; Periodical Subscriptions 35; Photographs; Reels; Slides

M **CENTRO CULTURAL DE LA RAZA,** 2125 Park Blvd, San Diego, CA 92101. Tel 619-235-6135; Fax 619-595-0034; *Elec Mail* centrocultural@earthlink.com; *Internet Home Page Address:* www.centroraza.com; *Bd Pres* Howard Hollman; *Board VPres* Marco Anguilo
Open Wed - Sun Noon - 5 PM; No admis fee, donations requested; Estab 1970 to create, promote & preserve Mexican, Indian & Chicano art & culture; 2500 sq ft of gallery space with five sections & 8 X 15 ft walls; Average Annual Attendance: 65,000; Mem: 500; dues $10-$1000

Income: $150,000 (financed by mem, city & state appropriation, sales & services, private grants, National Endowment for the Arts)

Purchases: $1500

Collections: Historical artifacts of Mexican & Indian culture; contemporary artwork by Chicano artists

Exhibitions: Native American Contemporary Photography; solo exhibitions of local & regional artists; group shows; invitational group exhibitions

Publications: Exhibit catalogues, 3 per year; literary publications, 2 per year

Activities: Classes for adults & children; lect open to public, 5-7 vis lectrs per year; exten dept; lending collection includes 15 pieces of original art & prints; book traveling exhibitions 1-2 per year; originate traveling exhibits that circulate to other galleries & cultural centers; sales shop sells books, magazines, original art, reproductions, prints

A **INSTALLATION GALLERY,** PO Box 2552, San Diego, CA 92112. Tel 619-544-1482; Fax 619-544-1486; *Elec Mail* gen@insite97.org, mkjaer@insite2000.org; *Internet Home Page Address:* www.insite2000.org; *Exec Dir* Michael Krichman; *Assoc Dir* Danielle Reo
No admis fee; Estab 1980 as a vital alternative space for San Diego, a forum for provocative ideas outside the boundaries of the mus & traditional gallery; an umbrella for community & educational outreach, for interaction with other community organizations & for art in pub context. Installation is important as a dynamic intertwining of art & life & in focusing new perspectives on pub issues; dedicated to promoting challenging & diverse art making without restrictions as to individuals, medium or content

Publications: Exhibit guides & catalogs

Activities: Classes for adults & children; docent training; lect open to public, 3 vis lectrs per year; tours

M **MARITIME MUSEUM OF SAN DIEGO,** (San Diego Maritime Museum) 1492 N Harbor Dr, San Diego, CA 92101. Tel 619-234-9153; Fax 619-234-8345; *Internet Home Page Address:* www.sdmaritime.com; *Develop Dir* Katie Boskoff; *Pres* William Dysart; *Cur* Mark Montijo; *Librn* Charles Dencik
Open daily 9 AM - 8 PM; Admis adults $6, service personnel, children 13-17 & seniors $4, children under 12 $3, discount to adult groups; Estab 1948 for preservation & educ of San Diego related maritime history; A maritime mus in a fleet of three ships: Star of India (1863 bark); Berkeley (1898 ferryboat) & Medea (1904 steam Yacht); Average Annual Attendance: 180,000; Mem: 2400; dues life $2000, benefactor/corporate $1000, patron $500, associate $250, friend $100, active $50, family $35, individual $25; annual meeting in Nov

Special Subjects: Marine Painting

Collections: Antiques; maritime art; maritime artifacts; clothing; navigation instruments

Exhibitions: Festival of Sail; Tall Ships

Publications: Mains'l Haul, quarterly historical journal; Books: Euterpe, MEDEA The Classic Stream Yacht, Star of India, They Came by Sea, Transpac 1900-1979

Activities: Educ dept; docent training; lect for members & guests, 5 vis lectrs per year; tours; special programs; competitions for children with awards; museum store sells books, magazines, reproductions, prints, slides & related maritime items, including video tapes.

M **MINGEI INTERNATIONAL, INC,** Mingei International Museum, 1439 El Prado, San Diego, CA 92101; PO Box 553, La Jolla, CA 92038. Tel 619-239-0003; Fax 619-239-0605; *Elec Mail* mingei@mingei.org; *Internet Home Page Address:* www.mingei.org; *Pres & Dir* Martha W Longenecker, MD; *Asst Dir* Rob Sidner; *Registrar* Adrianne Bratis; *Coll Gallery Mgr* Susan Fast; *Exec Secy & Operations Mgr* Carol Klich, MD; *Dir Develop* Maureen King, MD; *Dir Public Relations* Martha Ehringer; *Chmn* James F. Mulvaney; *Vice Chmn* Mary Rand Taylor; *Treas* Armand Labbe; *Librat Servs* Ann Bethel, PhD
Open Tues - Sun 10 AM - 4 PM, cl Mon & major holidays; Admis adults $5, students with ID and children 6-17 $2; Estab 1978 to further the understanding of arts of the people from all parts of the world; 41,000 sq ft mus, architecturally designed space, white interior, hardwood floors, track lighting. Maintains reference library; Average Annual Attendance: 110,000; Mem: 2300; dues $35-$5000; annual meeting in May

Income: Financed by mem, endowment, city appropriation, grants & contributions

Library Holdings: Auction Catalogs; Audio Tapes; Book Volumes; Clipping Files; Exhibition Catalogs; Original Art Works; Pamphlets; Periodical Subscriptions; Sculpture; Slides; Video Tapes

Special Subjects: Drawings, Hispanic Art, American Indian Art, Bronzes, African Art, Costumes, Ceramics, Crafts, Folk Art, Afro-American Art, Decorative Arts, Eskimo Art, Dolls, Furniture, Glass, Jade, Jewelry, Asian Art, Carpets & Rugs, Ivory, Calligraphy, Embroidery, Islamic Art, Enamels

Collections: Traditional & Contemporary Folk Art, Craft & Design (in all media including textiles, ceramics, metals, woods, stone, paper, bamboo & straw); African, American, Ethiopian, East Indian, Indonesian, Japanese, Pakistani, Himalayan & Mexican Folk Art

Publications: Exhibition related publications

Activities: Docent training; lect open to public, 10 vis lectrs per year; films; gallery talks; tours; concerts; book traveling exhibitions 1 per year; originate traveling exhibitions 1 per year; mus shop sells books, magazines, original art

L **Reference Library,** 1439 El Prado, San Diego, CA 92101. Tel 619-239-0003; Fax 619-239-0605; *Elec Mail* mingei@mingei.org; Martha W Langenecker
Open Tues - Sun 10 AM - 4 PM, cl Mon & major holidays

Income: Financed by endowments, city appropriation, contributions, grants

Library Holdings: Audio Tapes; Cassettes; Clipping Files; Exhibition Catalogs; Filmstrips; Framed Reproductions; Kodachrome Transparencies; Lantern Slides; Manuscripts; Memorabilia; Motion Pictures; Photographs; Slides; Video Tapes

M **MUSEUM OF PHOTOGRAPHIC ARTS,** 1649 El Prado, San Diego, CA 92101. Tel 619-238-7559; Fax 619-238-8777; *Dir* Arthur Ollman; *Admin Dir* Gaidi Finnie; *Dir Develop* Sarah Herr; *Registrar* Barbara Pope
Open daily 10 AM - 5 PM; Admis adults $6, students $4, seniors, military, children under 12, & mems free; Estab 1983 to collect & exhibit photographic works of art; 3,500 sq ft; Average Annual Attendance: 75,000; Mem: 2200; dues $25-$2,500

Income: $850,000 (financed by city, state, & federal appropriation, endowments, mem, grants & corporations)

Purchases: $20,000

Library Holdings: Book Volumes photography related; Exhibition Catalogs; Periodical Subscriptions

Collections: Photographic collection includes examples from earliest to most recent photographs

Publications: Points of Entry

Activities: Classes for adults & children; docent training; educator workshop; summer workshops with guest artists; lect open to public, 10-12 vis lectrs per year; gallery talks; tours; concerts; Lou Stouman prize for photography; Century Award for Lifetime Achievement; book traveling exhibitions 5-6 per year; originate traveling exhibitions; museum shop sells books, magazines, prints & photography related gifts

M **SAN DIEGO MUSEUM OF ART,** 1450 El Prado, Balboa Park PO Box 122107 San Diego, CA 92112-2107. Tel 619-232-7931; Fax 619-232-9367; *Internet Home Page Address:* www.sdmart.com; *Exec Dir* Derrick R. Cartwright; *Dir Admin* Heath Fox; *CFO* John Paterniti Jr; *Cur Asian Art* Sonya Quintanilla; *Cur American Art* D Scott Atkinson; *Cur Contemporary Art* Betti-Sue Hertz; *Dir Educ* Maxine Gaiber; *Museum Educator* Leslie Powell; *Pub Relations Coordr* Chris Zook; *Mgr Library* James Grebl; *Cur European Art* Steven Kern; *Mus Shop Mgr* Warren Herman; Lynda Stansbury, Dir of Dev; *Pres* Charles Hellerich; *Dir of Mktg* Susannah Stringam
Open Tues - Sun 10 AM - 6 PM, Thurs 10 AM - 9 PM, cl Mon; Admis adults $8, seniors (65 & up), young adults (18-24) $6, children (6-17) $3, active military $6, children 5 & under free; Estab 1925. Gallery built in 1926 by a generous patron in a Spanish Plateresque design; the West wing was added in 1966 & the East wing in 1974; Average Annual Attendance: 500,000; Mem: 33,200; dues Benefactor $10,000 Director's Circle $5000, President's Circle $1250, sponsor $600, associate $300, friend of museum $125, general $55, senior $45, student $25

Income: Financed by investment income, contributions, admis, city & county appropriations & sales

Purchases: $300,000

Special Subjects: Painting-American, Prints, Sculpture, Decorative Arts, Painting-European, Furniture, Oriental Art, Silver, Painting-British, Painting-Dutch, Baroque Art, Painting-Flemish, Renaissance Art, Painting-Spanish, Painting-Italian

Collections: Renaissance & Baroque paintings; with strong holdings in Spanish; 19th & 20th century American & European sculpture & paintings; Asian arts - sculpture, paintings, ceramics, decorative arts; American furniture & glass, English silver; Spanish Baroque, Flemish, Dutch & English schools

Exhibitions: Exhibits of pieces from the permanent collections rotating during the yr

Publications: Biennial Reports port; catalogs of collections; exhibition catalogs; membership calendar, monthly; gallery guide

Activities: Classes for adults & children; docent training; lect open to public; concerts; gallery talks; tours; competitions; originate traveling exhibitions; sales shops sell books, reproductions, prints, cards, jewelry & ceramics

L **Art Reference Library,** Balboa Park, PO Box 122107 San Diego, CA 92112-2107. Tel 619-232-7931; Fax 619-232-9367; *Internet Home Page Address:* www.sdmart.org; *Library Mgr* Dr James Grebl
Open to public by appointment only; open to museum members Tues - Fri 10 - 12, 1 PM - 4 PM; Estab 1926 for curatorial research. Noncirculating. Available to public on limited basis; For Reference Only; Mem: $55 & up per year

Income: financed by membership

Library Holdings: Audio Tapes; Book Volumes 25,000; Cassettes; Clipping Files; Exhibition Catalogs; Manuscripts; Memorabilia; Original Art Works; Pamphlets; Periodical Subscriptions 90; Photographs; Slides 15,000; Video Tapes

Special Subjects: Art History, Islamic Art, Painting-American, Painting-Italian, Painting-Japanese, Painting-Spanish, Prints, Sculpture, Painting-European, Watercolors, Latin American Art, Asian Art, Oriental Art, Religious Art

Collections: Bibliography of artists in exhibition catalogues

L **SAN DIEGO PUBLIC LIBRARY,** Art & Music Section, 820 E St, San Diego, CA 92101. Tel 619-236-5810; Fax 619-236-5878; *Elec Mail* Artmusic@sandiego.gov; *Internet Home Page Address:* www.ci.san-diego.ca.uspubliclibrary; *Picture Specialist* Victor Cardell; *Fine Art* Brenda Wegener; *Sr Librn* Bruce Johnson
Open Mon - Thurs 10 AM - 9 PM, Fri & Sat 9:30 AM - 5:30 PM, Sun 1 - 5 PM; No admis fee; Estab 1966 to make art available to students & the community; Two gallery spaces: smaller gallery is basically for student & classroom work; larger gallery is for invited guests; Average Annual Attendance: 8,000

Income: Financed by city and state appropriation

Purchases: $32,000

Library Holdings: Book Volumes 100,000; Clipping Files; Compact Disks; DVDs; Exhibition Catalogs; Other Holdings Postcards 10,000; Periodical Subscriptions 200; Records 11,000
Collections: Former libraries of William Templeton Johnson, architect & Donal Hord, sculptor; emphasis is on Spanish, Mediterranean, Italian & French Renaissance architecture & Oriental art, sculpture & ceramics; books on the theatre including biographies of famous actors and actresses as well as histories of the American, London and European stages, gift of Elwyn B Gould, local theatre devotee

M **SAN DIEGO STATE UNIVERSITY,** University Art Gallery, 5500 Campanile Dr, San Diego, CA 92182-4805. Tel 619-594-5171; Fax 619-594-1217; Elec Mail artgallery@sdsu.edu; Internet Home Page Address: www.sdsu.edu; *Gallery Dir* Tina Yapelli; *Dir* Ida K Rigby
Open Mon - Thurs & Sat Noon - 4 PM, cl Fri & Sun, cl summer May 16 - mid-Sept; No admis fee; Estab 1977 to provide exhibitions of importance for the students, faculty & pub of the San Diego environment; for study & appreciation of art & enrichment of the University; 1 large gallery; Average Annual Attendance: 35,000; Mem: 270; dues $35
Income: Supported by student fees, SDSU Art Council & grants
Special Subjects: Painting-American, Prints, Sculpture, Crafts
Collections: Crafts collection; contemporary print collection; graduate student sculpture & painting
Exhibitions: Contemporary national & international artists; 4 rotating exhibitions per year
Publications: Exhibit catalogs
Activities: Lect open to public, 4 vis lectrs per year; gallery talks; book traveling exhibitions 1 per year; originate traveling exhibitions; sales shop sells books & exhibition catalogs

L **Art Department Slide Library,** San Diego State University, 5500 Campani Dr San Diego, CA 92182-1606. Tel 619-594-6120; Fax 619-594-1217; Internet Home Page Address: www.sdsu.edu; *Slide Cur* Lilla Sweatt
Open Mon - Fri 8 AM - 4:30 PM, cl Sat & Sun; No admis fee for public, admis by appointment only; admis fee for faculty & students; Estab 1957 to aid & facilitate the faculty in teaching art & art history as well as aiding students in class reports; Circ 20,000; Gallery lending for faculty & students
Income: financed by university
Library Holdings: Cards; Cassettes; Clipping Files; Exhibition Catalogs; Fiche; Framed Reproductions; Kodachrome Transparencies; Manuscripts; Memorabilia; Micro Print; Pamphlets; Reels; Reproductions; Slides 122,000
Exhibitions: Special Art collections, student & women's art shows

M **TIMKEN MUSEUM OF ART,** 1500 El Prado, San Diego, CA 92101. Tel 619-239-5548; Fax 619-233-6629; Internet Home Page Address: www.timkenmuseum.org; *Dir* John Peterson; *VPres* John Thiele; *Pres* F P Crowell; *CEO* Jane Kirkeby
Open Tues - Sat 10 AM - 4:30 PM, Sun 1:30 - 4:30 PM, cl Mon & month of Sept; No admis fee; Estab to display & preserve European Old Masters, 18th & 19th centuries American paintings & Russian icons; Six galleries; Average Annual Attendance: 90,000
Income: financed by endowment
Special Subjects: Painting-American, Painting-Dutch, Painting-French, Painting-Spanish, Painting-Italian
Collections: Dutch & Flemish, French, Spanish & American Italian paintings; Russian icons; all paintings owned by Putnam Collection are on permanent display; Pissarro, Bords de l'Oise a Pontoise; Il Guercino - Return of the Prodigal Son; Copley, Mrs Thomas Gage
Publications: Gallery Guides; exhibit catalogs; Gabriel Metsu's The Letter monograph; Eastman Johnson's The Cranberry Harvest; Island of Nantucket; Corot: View of Volterra
Activities: Lect; tours available by request

M **UNIVERSITY OF SAN DIEGO,** Founders' Gallery, 5998 Alcala Park, San Diego, CA 92110. Tel 619-260-4600, 260-2280; Fax 619-260-6875; Internet Home Page Address: www.acusd.edu; *Dir* Dr Sally Yard
Open Mon - Fri Noon - 4 PM; No admis fee; Estab 1971 to enrich the goals of the Fine Arts department & university by providing excellent in-house exhibitions of all eras, forms & media & to share them with the community; Gallery is an architecturally outstanding facility with foyer, display area and patio, parking in central campus; Average Annual Attendance: 1,500
Income: Financed by Fine Arts department & private endowment
Special Subjects: Sculpture, Textiles, Furniture, Asian Art, Tapestries
Collections: 17th, 18th & 19th century French tapestries & furniture; South Asian textiles & costumes of 19th & 20th centuries; Tibetan & Indian looms, Ghandi spinning wheels; 19th Century French bronze sculpture; 20th Century Paintings
Exhibitions: Seven shows each year
Publications: The Impressionist as Printmaker; Child Hassam 1859-1935; Arbol de la Vida, The Ceramic Art of Metepec
Activities: Educ dept; seminars in art history; lect open to public, 4 vis lectrs per year; concerts; gallery talks; tours; awards; originate traveling exhibitions

SAN FRANCISCO

L **ACADEMY OF ART,** College Library, 180 New Montgomery St, 6th Flr, San Francisco, CA 94105. Tel 415-274-2270; Fax 415-263-8803; Elec Mail jwinsor@academyart.edu; Internet Home Page Address: www.academyart.edu; *Dir* John Winsor; *Asst Dir* Gretchen Good
Open Mon-Thurs 8:30 AM - 10 PM, Fri 8:30 AM - 6 PM, Sat & Sun 10 AM - 6 PM; No admis fee; Estab 1929
Library Holdings: Book Volumes 22,000; Clipping Files; Exhibition Catalogs; Other Holdings Indexed image files; Periodical Subscriptions 300; Slides 100,000
Special Subjects: Illustration, Photography, Graphic Design, Sculpture, Advertising Design, Fashion Arts, Industrial Design, Interior Design

A **ARCHIVES OF MOCA (MUSEUM OF CONCEPTUAL ART),** 657 Howard St, San Francisco, CA 94105. Tel 415-495-3193; Fax 415-495-3193; *Dir* Tom Marioni; *Mgr Soc Independent Artists* John Moore
Open by appointment; No admis fee; Estab 1970 for research, study & organization of exhibitions & events; Average Annual Attendance: 2,000

Income: Financed by endowment
Library Holdings: Audio Tapes; Exhibition Catalogs; Kodachrome Transparencies; Manuscripts; Original Art Works; Original Documents; Photographs; Prints; Slides; Video Tapes
Exhibitions: Vito Acconci; Robert Barry; Bar Room Video; Chris Burden; Lowell Darling; Howard Fried; Paul Kos; Masashi Matsumoto; Restoration of Back Wall; Miniatures from San Francisco & Kyoto; Social Art, Cafe Society; Graduate Bartenders 2000-
Publications: Vision, 1975-1982
Activities: Docent training; lect for mems only, 42 vis lectrs per year; concerts; awards; original traveling exhibitions

L **Library,** 657 Howard St, San Francisco, CA 94105. Tel 415-495-3193; Fax 415-495-3193; *Dir* Tom Marioni
For reference only
Library Holdings: Audio Tapes; Book Volumes 1200; Cassettes; Exhibition Catalogs; Filmstrips; Kodachrome Transparencies; Motion Pictures; Original Art Works; Other Holdings Original documents; Pamphlets; Photographs; Prints; Records; Reels; Sculpture; Slides; Video Tapes
Special Subjects: Calligraphy, Drawings, Etchings & Engravings, Sculpture, Period Rooms, Religious Art, Woodcuts
Exhibitions: Inspired by Leonardo

M **ASIAN ART MUSEUM OF SAN FRANCISCO,** Chong-Moon Lee Ctr for Asian Art and Culture, 200 Larkin St, San Francisco, CA 94102. Tel 415-581-3500; Fax 415-581-4700; Elec Mail pr@asianart.org; Internet Home Page Address: www.asianart.org; Cable SANCEMOR; *Cur Himalayan/Chinese Decorative Art* Terese Tse Bartholomew; *Cur Japanese Art* Yoko Woodson; *Cur Educ* Brian Hogarth; *Cur Chinese Art* Michael Knight; *Conservator* Donna Strahan; *Cur Korean Art* Kumja Kim; *Librn* John Stucky; *Dir* Emily Sano; *Chief Cur* Forrest McGill; *Pub Rels Mgr* Tim Hallman
Open Tues - Sun 10 AM - 5 PM, Thurs 10 AM -9 PM, cl Mon, maj holidays & during certain civic center events; Admis adults (18-64) $10, seniors $7, youth (13-17) $6, children under 12, mus mems, recognized educational groups & first Wed of each month free; Founded in 1969 by the City & County of San Francisco to collect, care for, exhibit & interpret the fine arts of Asia; 40,000 sq ft of exhibition space; Average Annual Attendance: 425,000; Mem: 40,000; dues $50
Income: Financed by city & county appropriation & the Asian Art Mus Foundation
Library Holdings: Auction Catalogs; Audio Tapes; Book Volumes; CD-ROMs; Cassettes; Clipping Files; Compact Disks; Exhibition Catalogs; Fiche; Filmstrips; Manuscripts; Maps; Original Documents; Other Holdings Pamphlets; Periodical Subscriptions; Photographs; Video Tapes
Special Subjects: Sculpture, Bronzes, Textiles, Religious Art, Ceramics, Pottery, Woodcarvings, Decorative Arts, Painting-Japanese, Portraits, Jade, Jewelry, Porcelain, Oriental Art, Asian Art, Metalwork, Carpets & Rugs, Ivory, Calligraphy, Embroidery, Antiquities-Oriental, Antiquities-Persian, Islamic Art
Collections: Nearly 12,000 objects from China, Japan, Korea, India, Southeast Asia, The Himalayas & Middle East; architectural elements, ceramics, decorative arts, paintings, sculpture; textiles, works on paper
Publications: Exhibition catalogs; handbooks & catalogs on museum collections
Activities: Classes for adults & children; docent training; storytelling; school tours; lect open to public, 6 vis lectrs per year; concerts; gallery talks; tours; original objects of art lent to other museums for exhibitions; organize traveling exhibitions; originate traveling exhibitions to other museums; museum shop sells books, magazines, original art, reproductions & slides

L **Library,** 200 Larkin St, San Francisco, CA 94102. Tel 415-581-3500; Fax 415-861-2388, 864-6705; Elec Mail jstucky@asianart.org; Internet Home Page Address: www.asianart.org; *Library Asst* Nancy Rondestvedt; *Librn* John Carl Stucky
Open Mon - Fri 9:30 AM - 4:30 PM by appointment only; No fee for library patrons; Estab 1967; For reference only
Income: Financed by city appropriation & private gifts
Library Holdings: Auction Catalogs; Audio Tapes; Book Volumes 30,000; CD-ROMs; Cassettes; Clipping Files; Exhibition Catalogs; Fiche; Filmstrips; Kodachrome Transparencies; Lantern Slides; Manuscripts; Memorabilia; Motion Pictures; Pamphlets; Periodical Subscriptions 230; Photographs; Prints; Reels; Reproductions; Slides; Video Tapes
Special Subjects: Art History, Folk Art, Landscape Architecture, Decorative Arts, Calligraphy, Drawings, Islamic Art, Painting-Japanese, Prints, Sculpture, Historical Material, History of Art & Archaeology, Watercolors, Ceramics, Archaeology, Bronzes, Printmaking, Asian Art, Porcelain, Furniture, Ivory, Jade, Glass, Metalwork, Antiquities-Oriental, Antiquities-Persian, Carpets & Rugs, Dolls, Embroidery, Enamels, Gold, Goldsmithing, Handicrafts, Jewelry, Leather, Miniatures, Oriental Art, Pottery, Religious Art, Restoration & Conservation, Silver, Silversmithing, Tapestries, Textiles, Woodcarvings, Woodcuts, Architecture
Collections: Chinese painting collection; Khmer Art Collection; exhibition catalogs, auction catalogs, extensive subject index; Special collection - older & antique books

ASSOCIATION OF INDEPENDENT COLLEGES OF ART & DESIGN
For further information, see National and Regional Organizations

A **BAY AREA VIDEO COALITION, INC,** 2727 Mariposa St, San Francisco, CA 94110. Tel 415-861-3282; Fax 415-861-4316; Elec Mail bavc@bavc.org; *Exec Dir* Sally Jo Fifer
Open Mon - Fri 9 PM - 5 PM; Estab 1976; Circ 2000; dues $45; Gallery features video & new media technology, education & exhibitions
Publications: Mediamaker Handbook, annually
Activities: Classes for adults; lect open to public, 450 vis lectrs per yr; competitions with awards

C **BOSTON PROPERTIES LLC,** (Embarcadero Center Ltd) 4 Embarcadero Ctr, Lobby Level, San Francisco, CA 94111. Tel 415-772-0700; Fax 415-772-0554; *Retail PM & Dir Mktg* Norman E Dito; *Mktg Coordr* Helen Han
Open to public at all hours; No admis fee; Estab 1971, modern art has been a key element in the planning & development of the Embarcadero Center complex; evidence of a desire to provide beauty on a smaller scale amid the harmony of its massive structures;

to enhance the total environment & provide a variety of dramatic views for pedestrians as they circulate through the complex; Collection displayed throughout the Center complex; Center supports San Francisco DeYoung Museum, Fine Arts Museum Downtown Center, American Conservatory Theatre, San Francisco Symphony, San Francisco Center for the Performing Arts, and others
Collections: Willi Gutmann, Two Columns with Wedge; Nicholas Schoffer, Chronos XIV; Olga de Amaral, Columbia; Anne Van Kleeck, Blocks, Stacks; Louise Nevelson, Sky Tree; Jean Dubuffet, La Chiffonniere; John Portman Jr, The Tulip; Elbert Weinberg, Mistral; Charles O Perry, Eclipse; Armand Vaillancourt, 101 precast aggregate concrete boxes that allow visitors to walk over, under & through its waterfalls; Arnaldo Pomodoro, Colonna; Fritz Koenig, Untitled Bronze; Dimitri Hadzi, Creazione; Jules Guerin, Traders of the Adriatic; Arman, Hermes and Dyonisis; Arman, The University of Wisdom; Stephen DeStaebler, Torso with Arm Raised I; Bill Barrett, Baile Merengue; Zhengfu Lu, Rhythm of the Metropolis

M **CAPP STREET PROJECT,** 1111 Eighth St, San Francisco, CA 94107-2247. Tel 415-551-9210; Elec Mail wattis@ccac-art.edu; Internet Home Page Address: www.wattis.org/cappstreet; *Dir* Ralph Rugoff; *Deputy Dir* Leigh Markopoulos; *Cur Art & Design* Mathew Higgs
Open Tues - Sat Noon - 6 PM; Estab 1983 as a nonprofit arts organization providing three month residencies in San Francisco for installation art; Average Annual Attendance: 20,000
Publications: Capp Street Project Catalog, biennially
Activities: Lectr open to public, 8-10 vis lectrs per year; tours; originate traveling exhibitions

M **CARTOON ART MUSEUM,** 655 Mission St, San Francisco, CA 94103. Tel 415-227-8666; Fax 415-243-8666; Elec Mail toonart@wenet.net, funnies@sirius.com; Internet Home Page Address: http://www.cartoonart.org; *Exec Dir* Rod Gilchrist; *Cur* Jenny Dietzen; *Print & Web Consultant* Christina Wikner; *Admin & Asst Dir* Summerlea Koshar; *Gallery Mgr* Andrew Farago
Open Tues - Fri 11 AM - 5 PM, Sat 10 AM - 5 PM, Sun 1 - 5 PM; Admis adult $6, student & seniors $4, children 6-12 $2; Estab 1984 to preserve exhibit & study original cartoon art; 3000 sq ft exhibition space; Average Annual Attendance: 20,000; Mem: 500; dues individual $35
Library Holdings: Audio Tapes; Book Volumes; Clipping Files; Exhibition Catalogs; Video Tapes
Special Subjects: Drawings, Hispanic Art, Latin American Art, Painting-American, Photography, Prints, Watercolors, American Western Art, Folk Art, Etchings & Engravings, Afro-American Art, Manuscripts, Painting-European, Portraits, Posters, Painting-Canadian, Painting-French, Historical Material, Juvenile Art, Cartoons, Reproductions
Collections: 11,000 pieces of original cartoon art
Exhibitions: Rotating exhibits
Publications: Cartoon Times
Activities: Classes for adults & children; lect open to public, 4 vis lectrs per year; gallery talks; tours; cartoon contests for children kindergarten through 12th grade with gift certificates; individual paintings & original objects of art lent to other museums, galleries & corporations; lending collection contains color reproductions, original art works, original prints & paintings; retail store sells books, prints, magazines, gift items

A **CENTER FOR CRITICAL ARCHITECTURE,** AAES (Art & Architecture Exhibition Space), 450 Irwin St, San Francisco, CA 94107. Tel 415-703-9568; Fax 415-551-9260; Internet Home Page Address: www.ccac-art.edu; *Dir* Ralph Rugoff
Open Mon - Sat 11 AM - 5 PM; No admis fee; Estab 1988 to establish awareness of design excellence & provide vehicle for exchange of critical ideas in architecture; Two floors; Average Annual Attendance: 3,500; Mem: 100; 1,600 mailing list; dues firms $100, individual $25
Income: Financed by endowment & mem
Exhibitions: Rotating exhibitions
Publications: Cafe Talks, annual
Activities: Lect open to public, 6 vis lectrs per year; competitions, conferences; book traveling exhibitions

M **CHINESE CULTURE FOUNDATION,** Center Gallery, 750 Kearny St, 3rd Flr, San Francisco, CA 94108. Tel 415-986-1822; Fax 415-986-2825; Elec Mail info@c-c-c.org; Internet Home Page Address: www.c-c-c.org; *Pres* Jonas Miller; *Interim Exec Dir* Gloria Tai
Open Tues - Sat 10 AM - 4 PM, cl holidays; No admis fee; Estab 1965 to promote the understanding & appreciation of Chinese & Chinese-American culture in the United States; Traditional & contemporary paintings, sculpture by Chinese & Chinese American artists, photographs & artifacts illustrating Chinese-American history & major international & cultural exchanges from China, Taiwan & Southeast Asia make the center a local & national focus of Chinese artistic activities; Average Annual Attendance: 60,000; Mem: 1,000; dues family $50, regular $35
Income: Financed by mem, city appropriation, grants & rental fees from auditorium
Special Subjects: Photography, Prints, Sculpture, Watercolors, Textiles, Folk Art, Woodcarvings, Decorative Arts, Jewelry, Oriental Art, Asian Art, Calligraphy
Exhibitions: In Search of Roots; Through Dust & Ruins: Photography by Tsung Woo Han; Urban Yearnings: Portraits of Contemporary China by Liu Qinghe, Su Xinping & Zhang Yajie
Publications: Chinese Culture Center Newsletter, quarterly; Exhibition catalogs
Activities: Classes for adults & children; dramatic programs; docent training; daily walking tour of Chinatown for school children & tourists; lect open to public, 10 vis lectrs per year; concerts; tours; film programs; museum shop sells books, original art, reproductions, prints, jewelry, pottery, jade, material & papercuts

A **EXPLORATORIUM,** 3601 Lyon St, San Francisco, CA 94123. Tel 415-563-7337; Fax 415-561-0307; Elec Mail pubinfo@exploratorium.edu; *Dir* Goery Delacote; *Pub Information Officer* Linda Dackman
Open winter Tues - Sun 10 AM - 5 PM, Wed 10 AM - 9 PM, summer Daily 10 AM - 6 PM, Wed 10 AM - 9 PM; Admis adult $9, seniors $7, 6-18 $5; Estab

1969 to provide exhibits & art works centering around the theme of perception, which are designed to be manipulated & appreciated at a variety of levels by both children & adults; Average Annual Attendance: 600,000; Mem: 1500; dues $45
Income: Financed by national, city & state appropriation, private foundations, corporation contributions & earned income
Collections: Over 650 exhibits
Publications: The Exploratorium Magazine, monthly; exhibition catalogs
Activities: Artists in residence program, performing artists in residence program & teachers training using artists & scientists in collaboration; lect open to the public; concerts; originate traveling exhibitions; museum shop sells books, magazines, reproductions, prints, slides & science related material

A **EYES & EARS FOUNDATION,** 642 Natoma, San Francisco, CA 94103. Tel 415-621-2300; Fax 415-981-3334; *Pres* Freddie Hahne; *Exec Dir* Mark Rennie
Open by appointment & available funds; No admis fee; Estab 1976 to sponsor pub visual performance art projects, mostly outdoor large-scale billboard art shows & the theatre projects; Average Annual Attendance: 175,000 per day; Mem: 100; dues $15
Income: $57,000 (financed by endowment, mem, fundraising, individual & corporate contributions)

A **FILM ARTS FOUNDATION,** 145 Ninth St, Ste 101 San Francisco, CA 94103. Tel 415-552-8760; Fax 415-552-0882; Elec Mail info@filmarts.org; Internet Home Page Address: www.filmarts.org; *Ops Mgr* Alicia Schmidt; *Release Print Ed* Tom Powers; *Membership Coordr* Eric Henry; *Seminars Dir* Danny Platnick; *Exec Dir* Fidelma McGinn; *Facility Mgr* K C Smith; *Pres* Gail Silva; *Develop Dir* Lisa Foster
Open Mon, Wed & Fri 10 AM - 5 PM; Tues & Thurs 2 - 6 PM; Estab 1976; Mem: 3,400 mem; dues $45/yr
Income: Grants, individual donors, mem dues & earned income
Exhibitions: Annual Film Arts Festival of Independent Cinema; monthly true stories
Publications: Release Print Magazine
Activities: Classes for adults; scholarships offered

M **FINE ARTS MUSEUMS OF SAN FRANCISCO,** M H de Young Museum, Golden Gate Park, 50 Hagiwara Tea Garden Dr San Francisco, CA 94118; 50 Tea Garden Dr, San Francisco, CA 94118-4501. Tel 415-750-3636, 750-3641 (March); Fax 415-750-7686; Internet Home Page Address: www.thinker.org; *Dir Membership* Gina Tan
Open Tues - Thurs & Sat - Sun 9:30 AM - 5 PM, Fri 9:30 AM - 8:45 PM, cl New Year's Day, Thanksgiving Day & Christmas Day; Admis adults $10, seniors $7, youths 13-17 & college students with ID $6, children 12 & under and first Tues of each month free; Estab 1971 as a mem organization for Fine Arts Museum of San Francisco & the Asian Art Mus of San Francisco & the Asian Art Mus of San Francisco; Mem: 45,000; dues $50
Income: $2,770,000 (financed by mem & bookshop revenues)
Publications: Triptych, bimonthly magazine
Activities: Mus shop sells books, reproductions, prints & slides

M **Legion of Honor,** Golden Gate Park, 50 Hagiwara Tea Garden Dr San Francisco, CA 94118-4501. Tel 415-750-3600, 863-3330 (public information); Elec Mail guestbook@famsf.org; Internet Home Page Address: www.thinker.org; *Dir* Harry S Parker III; *Dir Educ* Sheila Pressley; *Assoc Dir* Robert Futernick; *Cur African, Oceania & the Americas* Kathleen Berrin; *Mgr Exhib* Krista Davis; *Cur Interpretation* Renee Dreyfus; *Registrar* Terese Chen; *Ednah Root Cur American Art* Timothy Anglin Burgard; *Assoc Cur American Painting* Daniell Cornell; *Publications Mgr* Ann Heath Karlstrom; *Gen Mgr Mus Stores* J Couric Payne; *Ed Dir Media Relations* Barbara Traisman; *Dir Membership* Gina Tan
Open Tues - Thurs 9:30 AM - 5 PM, Fri 9:30 AM - 8:45 PM, Sat - Sun 9:30 AM - 5 PM; Admis tickets to the de Young museum maybe used on the same day for free entrance to Legion of Honor; Estab 1895 to provide museums of historic art from ancient Egypt to the 20th century; Two separate buildings are maintained one in the Golden Gate Part (de Young Mus) with 35 galleries & the other in Lincoln Park (California Palace of the Legion of Honor) with 22 galleries; Average Annual Attendance: 800,000; Mem: 50,000; dues patron $1000 sponsor $500, donor $250, contributing $125, family $70, participating $60
Income: Financed by pub-private partnership, city owned buildings
Special Subjects: Drawings, Graphics, American Indian Art, Bronzes, African Art, Costumes, Ceramics, Crafts, Etchings & Engravings, Afro-American Art, Decorative Arts, Eskimo Art, Furniture, Glass, Antiquities-Byzantine, Carpets & Rugs, Ivory, Embroidery, Laces, Antiquities-Egyptian, Antiquities-Greek, Antiquities-Roman, Antiquities-Etruscan, Enamels, Antiquities-Assyrian
Collections: Rodin sculpture collection; African art; American art; Ancient art; Art from Central & South America & Mesoamerica; textiles; graphic arts of all schools & eras; primitive arts of Africa, Oceania & the Americas
Activities: Classes for adults & children; docent training; lect open to public; concerts; gallery talks; tours; Mus shop sells books, magazines, reproductions, prints & jewelry

L **Library,** Golden Gate Park, San Francisco, CA 94118; 233 Post St 6th Flr, San Francisco, CA 94108. Tel 415-750-7603; *Librn* Allison Pennell
Estab 1955 to serve mus staff in research on collections, conservation, acquisition, interpretations; Graphic arts are housed in the Achenbach Foundation Library in the California Palace of the Legion of Honor
Income: Financed by mem & city appropriation
Library Holdings: Book Volumes 45,000; Exhibition Catalogs; Fiche 613; Periodical Subscriptions 125; Reels; Slides 30,000
Special Subjects: American Indian Art
Collections: Achenbach Foundation for Graphic Arts (prints & drawings)

M **GALERIA DE LA RAZA,** Studio 24, 2851 & 2857 24th St, San Francisco, CA 94110. Tel 415-826-8009; Fax 415-826-6235; *Dir* Carolina Ponce de Leon; *Dir Prog* Jaime Cortez
Open Tues - Sat Noon - 6 PM; Donations accepted; Estab 1969 as a community gallery & mus to exhibit works by Chicano-Latino artists, contemporary as well as cultural folk art; Two rooms in the Mission District of San Francisco, the heart of the Latino Community; maintains archives of posters, videos, publications, slides, prints & pamphlets; Average Annual Attendance: 42,000; Mem: 300; dues $35

Income: Financed by NEA, California Arts Council, private foundations & earned income from sales in studio
Special Subjects: Folk Art
Collections: Chicano & Latino murals; Mexican & Latin American Folk art & contemporary art
Exhibitions: Changing monthly
Publications: Exhibition catalogs, small publications, yearly calendar, children's coloring book & postcards; bimonthly newsletter
Activities: Docent training; lect open to public, 8-15 vis lectrs per year; gallery talks; tours; originate traveling exhibitions 1 per year; museum shop sells folk art

A **INTERSECTION FOR THE ARTS,** 446 Valencia, San Francisco, CA 94103. Tel 415-626-2787; Fax 415-626-1636; *Dir* Deborah Cullinan
Open Wed - Sat Noon - 5 PM, Tues by appointment; No admis fee; Estab 1965 to represent visual & performing arts; One gallery; Average Annual Attendance: 10,000
Income: Financed through foundation
Exhibitions: Rotating exhibitions, six per yr

A **JAPANTOWN ART & MEDIA WORKSHOP,** 1840 Sutter St, Ste 102, San Francisco, CA 94115. Tel 415-922-8700; Fax 415-922-8700; Elec Mail jtown@sirius.com; Internet Home Page Address: www.janworkshop.com; *Exec Dir* Dennis Taniguchi
Open daily 10 AM - 5 PM; No admis fee; Estab 1977 as an Asian-American art center; Mem: 120; dues $20
Income: $100,000 (financed by endowment, mem, foundations, city & state appropriations)
Special Subjects: Graphics, Posters, Asian Art, Painting-Japanese
Collections: Silkscreen posters & other art works
Exhibitions: Layer Exhibition; Asia-American Film & Video Exhibit
Publications: Enemy Alien; Yoisho
Activities: Classes for adults & children; graphic design intern programs; concerts; competitions with awards; lending collection contains posters

M **THE LAB,** 2948 16th St, San Francisco, CA 94103. Tel 415-864-8855; Fax 415-864-8855; Elec Mail programs@thelab.org; Internet Home Page Address: www.thelab.org; *Exec Dir* Elisabeth Beaird; *Assoc Dir* Kristen Chappa; *Facilities Technician* Tim Benjamin
Open Wed - Sat Noon - 5 PM; No admis fee; Estab 1983 to support the development & presentation of experimental & interdisciplinary art of emerging or mid-career artists
Income: $130,000 (financed by mem, city & state appropriations, federal funding & private foundations)
Exhibitions: Installations; Interdisciplinary & Experimental Art
Activities: Lect open to public; concerts; dance; performance art events; visual art exhibitions

L **MECHANICS' INSTITUTE LIBRARY,** 57 Post St, San Francisco, CA 94104. Tel 415-421-1750; Fax 415-421-1770; Internet Home Page Address: www.milibrary.org; *Dir* Inez Shur-Cohen; *Reference Librn* Craig Jackson
Open for members only Mon - Thurs 9 AM - 9 PM, Fri 9 AM - 6 PM, Sat 10 AM - 5 PM, Sun 1 - 5 PM; No admis fee; Estab 1854 to serve the needs of 7000 members with a general collection emphasizing the humanities; Circ 285,000
Income: Financed by city appropriation, building rents, endowment
Library Holdings: Book Volumes 200,000; Cassettes 1200; Clipping Files; Fiche 35; Other Holdings Newspapers 60; Periodical Subscriptions 475; Video Tapes 1300
Special Subjects: Art History, Decorative Arts, Etchings & Engravings, Painting-American, Painting-British, Painting-French, Painting-German, Crafts, American Western Art, Fashion Arts, Furniture, Embroidery, Handicrafts, Painting-Australian, Architecture

M **MEXICAN MUSEUM,** Fort Mason Ctr, Bldg D, Laguna & Marina Blvd San Francisco, CA 94123. Tel 415-202-9700; Fax 415-441-7683; Elec Mail info@mexicanmuseum.org; Internet Home Page Address: www.mexicanmuseum.org; *Interim Exec Dir* Patrick O'Donahue; *Cur Coll* Susana Macarron; *Dir Pub & International Affairs* Salvador Acevedo; *Educ Coordr* Laura Henry
Open Wed - Sat 11 AM - 5 PM; No admis fee, suggested donation $2; Estab 1975 to foster the exhibition, conservation & dissemination of Mexican & Mexican-American & Chicano culture for all people; Average Annual Attendance: 60,000; Mem: 720, dues $25
Income: Financed by state grants, corporate & individual support, earned income through gift shop, mem, educational tours & work shops
Library Holdings: Book Volumes; Exhibition Catalogs; Manuscripts; Maps; Original Art Works; Original Documents; Photographs; Prints
Special Subjects: Drawings, Hispanic Art, Latin American Art, Mexican Art, Photography, Prints, Sculpture, American Western Art, Pre-Columbian Art, Southwestern Art, Religious Art, Ceramics, Crafts, Folk Art, Pottery, Etchings & Engravings, Manuscripts, Portraits, Dolls, Jewelry, Embroidery, Pewter, Leather, Reproductions
Collections: Chicano, Colonial, Folk, Mexican, Mexican-American & Pre-Hispanic Fine Arts; Rare Books
Exhibitions: Highlights from the Permanent Coll
Publications: Exhibit catalogs
Activities: Classes for adults & children; docent training; dramatic programs; demonstrations & lectures; lect open to public; gallery talks; tours; Website award by Web Marketing Assn 2002

M **MISSION CULTURAL CENTER FOR LATINO ARTS,** 2868 Mission St, San Francisco, CA 94110. Tel 415-821-1155; Fax 415-648-0933; Internet Home Page Address: www.missionculturalcenter.org; *Exec Dir* Jennie Rodriquez
Open Tues - Sat 10 AM - 5 PM; No admis fee; Estab 1977 to promote, preserve & develop the Latino cultural arts that reflect the living tradition & experiences of Chicano, Central & South American & Caribbean people; Houses a 142-seat theater; 2650 sq ft gallery exhibition space; spacious performing & visual art studios; state of the arts screen print facility; Average Annual Attendance: 5,000

Income: Financed by National Endowment for the Arts, California Arts Council, contributions & foundations
Exhibitions: Rotating every month
Activities: Classes for adults & children; internship programs

M **MUSEO ITALO AMERICANO,** Fort Mason Ctr, Bldg C, San Francisco, CA 94123. Tel 415-673-2200; Fax 415-673-2292; Elec Mail museo@firstworld.net; Internet Home Page Address: www.museoitaloamericano.org; *VPres* Claudio Tarchi; *VPres* Paola Bagnatori; *Cur* Valentina Fogher; *Pres* Annette De Nunzio; *Secy* Argene Giorgi; *Exec Dir* Julie Benbow
Open Wed - Sun Noon - 5 PM; Admis $3, seniors & full-time students $2; Estab 1978 to research, preserve & display works of Italian & Italian-American artists & to foster educational programs for the appreciation of Italian & Italian-American art, history & culture; 3700 sq ft of exhibit space; The Fontana Gallery & The Lanzone Gallery; Average Annual Attendance: 25,000; Mem: 1034; dues $35-$1000
Income: Financed by mem, city appropriation, foundations & corporate contributions
Collections: 20th Century paintings, sculptures, prints & photographs
Exhibitions: Rotating exhibits
Publications: Calendar of Events, monthly
Activities: Classes for adults & children; school outreach art program; lect open to public; concerts; awards; individual paintings & original objects of art lent to museums; museum shop sells books, magazines, Italian pottery, blown glass & gift items

L **Library,** Fort Mason Ctr, Bldg C, San Francisco, CA 94123-1380. Tel 415-673-2200; Fax 415-673-2292; Elec Mail museo@firstworld.net; Internet Home Page Address: www.museoitaloamericano.org; *Cur* Valentina Fogher
Open Wed - Sun Noon - 5 PM; Estab 1978 to serve as a resource center of Italian & Italian-American culture & art
Library Holdings: Book Volumes 300

NAMES PROJECT FOUNDATION
For further information, see National and Regional Organizations

NATIONAL ALLIANCE FOR MEDIA ARTS & CULTURE
For further information, see National and Regional Organizations

M **NEW LANGTON ARTS,** 1246 Folsom St, San Francisco, CA 94103. Tel 415-626-5416; Fax 415-255-1453; Elec Mail nla@newlangtonarts.org; Internet Home Page Address: www.newlangtonarts.org; *Exec Dir* Susan Miller; *Managing Dir* Deborah Schwartz; *Communications Dir* Rachel Churner; *Prog Dir* James Bewley
Open Tues - Sat Noon - 5 PM; No admis fee; Estab 1975 to support artists in experimental art, nonprofit organization; Nonprofit alternative arts space with progs in literature, music, performance, video, net art, & visual arts
Activities: Lects open to pub; concerts; gallery talks; tours; Bay Area Award; Potrero Nuevo Fund

M **RANDALL JUNIOR MUSEUM,** 199 Museum Way, San Francisco, CA 94114. Tel 415-554-9600; Fax 415-554-9609; Elec Mail info@randall.org; Internet Home Page Address: www.randallmuseum.org; *Cur Natural Sciences* John Dillon; *Cur Arts* Chris Boetcher; *Art Instr* Dennis Treanor; *Dir* Amy Dawson; *Cur Natural Sciences* Carol Preston; *Spec Events & Art Instr* Julie Dodd Tetzlaff; *Science Instr* Margaret Goodale; *Animal Exhibit Coordr* Nancy Ellis; *Animal Exhibit Asst* Quinn McFredrick; *Operations Mgr* Ann Marie Donnelly; *Dir Develop* Ben Harwood; *Develop Asst* Kari Hopperstead
Open Tues - Sat 10 AM - 5 PM, cl holidays; No admis fee; Estab 1937 as part of the San Francisco Recreation & Park Dept; Gallery is located in 16-acre park overlooking city; Average Annual Attendance: 80,000; Mem: 300; dues $30-$500; annual meeting in June
Special Subjects: Drawings, Photography, Ceramics, Crafts, Jewelry
Collections: Animals; Children's Art; Indian Artifacts; Insects, Minerals; Fossils; Live animal exhibit
Exhibitions: Festival on the Hill; Bug Day; Water Day; crafts fair
Publications: Class flyer 5 times per year; Hands-On newsletter, quarterly
Activities: Classes for adults & children; dramatic programs; docent training; lect open to public; concerts; tours; competitions with awards; scholarships offered

M **SAN FRANCISCO ART INSTITUTE,** Galleries, 800 Chestnut St, San Francisco, CA 94133. Tel 415-749-4564; Fax 415-749-1036; Internet Home Page Address: www.sfai.com; *Dir Gallery* Karen Moss
Open Mon - Sat 11 AM - 6 PM ; No admis fee; Estab 1871, incorporated 1889 to foster the appreciation & creation of the fine arts & maintain a school & mus for that purpose; Walter McBean Gallery; two-level, used for exhibitions of contemporary artists of international repute; Diego Rivera Gallery, one room with Rivera miral, used for exhibitions of work by SFAI students; SFAI Photo Gallery, for photo students; Average Annual Attendance: 60,000
Income: Donations, tuition, grants
Exhibitions: Walter McBean (six exhibitions per year)
Publications: Exhibition catalogs
Activities: Lect open to public, 20 vis lectrs per year; gallery talks; tours; scholarships & fels offered; exten dept; sales shop sells art supplies

L **Anne Bremer Memorial Library,** 800 Chestnut St, San Francisco, CA 94133. Tel 415-749-4559; Internet Home Page Address: www.stai.edu; *Media Dir* Charles Stephanian; *Catalog Librn* Linda Perez; *Catalog Asst* Claudia Marlowe; *Library Asst* Alexis Knowlton; *Media Asst* Rebecca Alexander; *Librn* Jeff Gunderson
Open Mon - Thurs 8:30 AM - 8:30 PM, Fri 8:30 AM - 6 PM, Sat 11 AM - 5:30 PM, Sun Noon - 4 PM & during school sessions; Open to students only; researchers by appt; Estab 1871 to develop a collection & services which will anticipate, reflect & support the objectives & direction of the San Francisco Art Institute; Circ 12,795
Income: Tuition, donations
Library Holdings: Audio Tapes; Book Volumes 31,000; Cassettes 800; Compact Disks; DVDs; Exhibition Catalogs; Filmstrips; Kodachrome Transparencies; Manuscripts; Memorabilia; Motion Pictures; Original Documents; Pamphlets; Periodical Subscriptions 220; Photographs; Slides 125,000; Video Tapes 4,100

Special Subjects: Photography
Collections: Archives documenting the history of the Art Institute; artists' books
Exhibitions: Artists' Book Contest; 60 years of photography at S.F.A.I.; 1960's Rock Posters; Larry Sultan & Mike Mandel; Western Roundtable on Modern Art; music & San Francisco Art; John Collier, Jr, photographer; Gems from David & Peggy Ross collection; Peter Selz - Diego Rivera
Activities: Poetry-Book Readings; current events roundtable

M **SAN FRANCISCO ARTS COMMISSION**, Gallery & Slide Registry, 401 Van Ness Ave, San Francisco, CA 94102. Tel 415-554-6080; Fax 415-252-2595; Elec Mail gallery@thecity.sfsu.edu; Internet Home Page Address: www.sfacgallery.org; *Dir* Rupert Jenkins; *Asst Dir* Natasha Garcia-Lomas; *Slide Registry Mgr* Sharon Spain
Open Wed - Sat 11 AM - 5:30 PM, Tues by appointment; No admis fee; Estab 1970; Exhib the work of bay area emerging artist; Average Annual Attendance: 20,000; Mem: dues $20
Income: Financed by mem & city appropriations
Exhibitions: Construct: Annual Installation Award Exhib
Activities: Educ prog; lect open to public; gallery talks; lending collection contains slides

A **SAN FRANCISCO ARTS EDUCATION PROJECT**, C/O Norse Auditorium, 135 Van Ness Ave, Rm 110 San Francisco, CA 94102. Tel 415-551-7990; Fax 415-551-7994; *Artistic Dir* Emily Keeler; *Dir Prog* Camille Olivier-Salmon; *Exec Dir* Natalie A Hala
Estab to provide participatory experience in the arts to children of San Francisco so they are better equipped to make use of their creative abilities in all aspects of their lives

A **SAN FRANCISCO CAMERAWORK**, 1246 Folsom St San Francisco, CA 94103. Tel 415-863-1001; Fax 415-863-1015; Elec Mail sfcamera@sfcamerawork.org; Internet Home Page Address: www.sfcamerawork.org; *Assoc Dir* Marisa Olson; *Prog & Educ Coordr* Whitney Grace; *Gallery Bookstore Mgr* Amy LeDuc; *Dir* Marnie Gillett
Open Tues - Sat Noon - 5 PM; Estab 1973 to encourage & display contemporary photography & related visual arts through exhibitions, lectures, publications & communication services; One gallery as well as bookstore display area; Average Annual Attendance: 35,000; Mem: 1400; dues $40 & up
Income: Financed by government agencies & private contributions, mem
Library Holdings: Book Volumes; Cards; Exhibition Catalogs
Special Subjects: Photography
Publications: San Francisco Camerawork Quarterly
Activities: Lect open to public, 6 per yr; workshops; gallery talks; Phelan Award; mentoring program; book traveling exhibitions; museum shop sells books & magazines, postcards, original art, prints

A **SAN FRANCISCO CITY & COUNTY ART COMMISSION**, 25 Van Ness Ave, Ste 240, San Francisco, CA 94102. Tel 415-252-2590; Fax 415-252-2595; Internet Home Page Address: sfac.sfau.edu/; *Dir Cultural Affairs* Richard Newirth; *Asst Dir* Nancy Gonchar; *Dir Street Artist Prog* Howard Lazar; *Dir Pub Art Prog* Jill Manton; *Art Commission Gallery* Rupert Jenkins; *Mgr Civic Art Coll* Debra Lehane; *Dir Cultural Equity Grants* Jewelle Gomez; *Pres* Stanlee Gatti; *Dir Community Arts & Educ* Liz Lerma
Open daily 8 AM - 5 PM; No admis fee; Estab 1932; Average Annual Attendance: 100,000; Mem: Consists of nine professional & three lay-members appointed by the Mayor with advice of art societies & five ex-officio members; monthly meetings
Activities: Classes for adults & children; dramatic programs; docent training; neighborhood arts program; lect open to public; concerts; competitions; individual paintings & original objects of art lent to city agencies; lending collection contains 28,000 original artworks

M **SAN FRANCISCO CRAFT & FOLK ART MUSEUM**, Fort Mason Ctr, Landmark Bldg A, San Francisco, CA 94123-1382. Tel 415-775-0990; Fax 415-775-1861; Internet Home Page Address: www.mocfa.org; *Exec Dir* Kate Eilerstein; *Cur* Rachel Osajima; *Dir Educ* Linda Janklow; *Dir Develop* Tom Hyland; *Office Mgr* Staci Rosenthal
Open Tues - Sun 11 AM - 5 PM, Sat 10 AM - 5 PM, first Wed of month 11 AM - 7 PM; Admis $4, seniors $3, children under 12 free; Estab 1983 to provide a permanent showplace for contemporary craft, folk art & traditional ethnic art; Maintains reference library; Average Annual Attendance: 95,000; Mem: 900; dues $30-$2500
Income: $250,000 (financed by endowment, mem fees, city & state appropriations & private foundations)
Library Holdings: Book Volumes; Exhibition Catalogs; Other Holdings; Periodical Subscriptions
Exhibitions: Rotating exhibitions, five per yer
Publications: A Report, scholarly quarterly; exhibition catalogues
Activities: Classes for adults & children; slide programs; docent training; lect open to public, 5 vis lectrs per year; gallery talks; special events; originate traveling exhibitions; museum shop sells books, magazines, original art, handmade jewelry & art objects

M **SAN FRANCISCO MARITIME NATIONAL HISTORICAL PARK**, Maritime Museum, Hyde St Pier, Bldg E, Lower Fort Mason, Rm 265 San Francisco, CA 94123. Tel 415-561-7000; Fax 415-556-1624; Elec Mail lynn_cullivan@nps.gov; Internet Home Page Address: www.nps.gov/safr; *Publ* Lynn Cullivan; *Supt* William G Thomas; *Cur Maritime History* Steve Canright; *Coll Mgr* Mary Jo Pugh; *Chief Interpretation* Marc Hayman; *Supervisory Archivist* Lisbit Bailey
Open winter daily 10 AM - 5 PM, summer daily 10 AM - 6 PM; No admis fee for museum; Hyde St. Pier adults $6, children 12 -17 & seniors $2, children under 12 free; Estab 1951; mus built in 1939; a terazzo & stainless steel structure with a nautical theme; Maintains reference library; Average Annual Attendance: 500,000
Income: Financed by federal funding, private support from National Maritime Mus Assoc

Purchases: A S Palmer Film Collection; Barbara Johnson Whaling Collection, books
Library Holdings: Audio Tapes; Book Volumes; Clipping Files; Fiche; Filmstrips; Manuscripts; Maps; Motion Pictures; Original Documents; Pamphlets; Periodical Subscriptions; Photographs; Prints; Reels; Video Tapes
Special Subjects: Drawings, Graphics, Painting-American, Photography, Costumes, Crafts, Folk Art, Etchings & Engravings, Manuscripts, Eskimo Art, Marine Painting, Historical Material, Ivory, Maps, Scrimshaw
Collections: Barbara Johnson Whaling Collection, books; A S Palmer Film Collection; Historic photographs; paddlewheel ferry; paddlewheel tug; paintings; scow schooner; small craft; ship models; square-rigged sailing ship; steam schooner; steam tug; 3-mast schooner
Exhibitions: Tugboats; San Francisco Bay Ferryboats; Sparks, Waves and Wizards: Communications at Sea
Publications: Sealetter; booklets, irregular
Activities: Classes for adults & children; dramatic programs; docent training; lect open to public, 4 vis lectrs per year; concerts; tours; competitions; originate traveling exhibitions to maritime museums; museum shop sells books, magazines, models & children's educational materials

L **Maritime Library**, Lower Fort Mason, Bldg E, San Francisco, CA 94123. Tel 415-556-9870; Fax 415-556-3540; Elec Mail golibgo@well.sf.ca.usa; *Reference* Irene Stachura; *Technical Svcs* Sarah Brooks; *Library Technician* Bill Koolman; *Library Technician* Debbie Grace; *Library Technician* Loreen Powell; *Principal Librn* David Hull; *Library Technician* Mark Goldstein
Open Tues 5 - 8 PM, Wed - Fri 1 - 5 PM, Sat 10 AM - 5 PM, cl Sun & Mon; No admis fee; Estab 1951; Open to the public for research on premises
Income: $275,000 (financed by federal & friends group)
Purchases: $7500 (collection development)
Library Holdings: Audio Tapes; Book Volumes 23,000; Cassettes; Clipping Files; Fiche; Manuscripts; Memorabilia; Motion Pictures; Other Holdings Archives; Oral History; Vessel Plans; Pamphlets; Periodical Subscriptions 100; Photographs 250,000; Reels
Special Subjects: Historical Material, Marine Painting

M **SAN FRANCISCO MUSEUM OF MODERN ART**, 151 Third St, San Francisco, CA 94103-3159. Tel 415-357-4000; Fax 415-357-4037; Elec Mail director@sfmoma.org; Internet Home Page Address: www.sfmoma.org; *Dir* Neal Benezra; *Dir Curatorial Affairs* Lori Fogarty; *Chief Cur* Gary Garrels; *Controller* Ikuko Satoda; *Sr Cur Photography* Sandra S Phillips; *Chief Conservator* Jill Sterrett; *Sr Cur Painting* Madeleine Grynsztejn; *Dir Human Resources* Sanchie Fernandez; *Dir ISS* Leo Ballate; *Head Registrar* Tina Garfinkel; *CFO* Katie Koch; *Dir Exhibitions* Ruth Berson; *Cur Architecture* Joseph Rosa; *Dir Facilities* Joe Brennan; *Cur Photography* Douglas R Nickel; *Chmn* Elaine McKeon; *Cur Media Arts* Benjamin Weil; *Dir Retail & Wholesale* Irma Zigas; *Cur Painting & Sculpture* Janet C Bishop
Open Mon - Tues & Fri - Sun 11 AM - 6 PM, & Thurs 11 AM - 9 PM, cl Wed; Admis $9, seniors & students $6, members & children under 12 free, students with ID $5; Estab 1935 to collect & exhibit art of the 20th century; Mus occupies its own 225,000 sq ft building; Average Annual Attendance: 750,000; Mem: 42,000; dues $65-$1000
Income: Financed by endowment, mem, city hotel tax, earnings & grants
Special Subjects: Architecture, Painting-American, Photography, Sculpture
Collections: Clyfford Still; painting, photography, sculpture architecture & design, media & video works
Exhibitions: Exhibits rotate
Publications: Monthly Calendar
Activities: Classes for adults & children; docent training; lect open to public; 40 vis lectrs per year; gallery talks; tours; competitions; originate traveling exhibitions organized & circulated; Mus shop sells books, magazines, original art, reproductions, prints & slides

L **Library**, 151 Third St, San Francisco, CA 94103-3159. Tel 415-357-4120; Fax 415-357-4038; Internet Home Page Address: www.sfmoma.org
Open to the pub Tues & Thurs 11 AM - 4 PM, by appointment only; Estab 1935
Income: Endowment, mem., earnings, grants
Library Holdings: Book Volumes 900; Exhibition Catalogs; Other Holdings Artists files; Exhibition archives; Periodical Subscriptions 400
Collections: Margery Mann Collection of books in the history of photography

M **Artist Gallery**, Fort Mason Bldg A, San Francisco, CA 94123. Tel 415-441-4777; Fax 415-441-0614; Elec Mail artistsgallery@sfmoma.org; Internet Home Page Address: www.sfmoma.org; *Corporate Consultant* Michelle Vassell; *Gallery Coordr* Andrea Voinot; *Dir* Marian Parmenter
Open Tues - Sat 11:30 AM - 5:30 PM; No admis fee; Estab 1978 for the support & exposure of Northern California artists. Over 1200 artists represented; Rentals & sales
Income: Grants, contributions, endowment
Exhibitions: Eleven exhibitions per year, all media; one person & group exhibitions
Activities: Mus shop sells original art

L **SAN FRANCISCO PUBLIC LIBRARY**, Art & Music Center, 100 Larkin St, San Francisco, CA 94102. Tel 415-557-4525; Fax 415-557-4524; Elec Mail webmail@sfpl.org; Internet Home Page Address: www.sfpl.org; *City Librn* Susan Hildreth; *Mgr Art, Music, Bus & Technical Science* Thomas Fowler
Open Mon 10 AM - 6 PM, Tues - Thurs 9 AM - 8 PM, Fri Noon - 6 PM, Sat 10 AM - 6 PM, Sun Noon - 5 PM; Estab 1878
Income: Financed by city & state appropriations
Library Holdings: Audio Tapes; Book Volumes 45,000; Cards; Clipping Files; Exhibition Catalogs; Fiche; Motion Pictures; Periodical Subscriptions 250; Records; Reels; Video Tapes

L **SAN FRANCISCO STATE UNIVERSITY**, J Paul Leonard Library, 1630 Holloway, San Francisco, CA 94132. Tel 415-338-2188; Fax 415-338-6199; Elec Mail dtong@sfsu.edu; Internet Home Page Address: www.library.sfsu.edu; *Art Librn* Darlene Tong
Open Mon - Thurs 8 AM - 10 PM, Fri 8 AM - 5 PM, Sat 11 AM - 6 PM, Sun Noon - 9 PM; Estab 1899
Library Holdings: Book Volumes 1,000,000; Cards 2,000,000; Cassettes; Compact Disks; DVDs; Exhibition Catalogs; Fiche; Framed Reproductions;

Manuscripts; Memorabilia; Original Art Works; Other Holdings Bound per vol 132,000; Film & video 14,500; Graphic materials 98,000; Sound rec 57,000; Periodical Subscriptions 4500; Photographs; Video Tapes
Special Subjects: Art History, Intermedia, Graphic Design, Industrial Design, Jewelry, Antiquities-Etruscan, Antiquities-Roman, Architecture
Collections: H Wilder Bentley Brush Painting Collection; Frank deBellis Collection on Italian Culture; John Magnani Collection of Arts & Crafts; Simeon Pelenc Collection of Paintings & Drawings
Exhibitions: Exhibitions vary, call for details
Activities: Book traveling exhibitions; originate traveling exhibitions; sales shop sells books & reproductions

M **SOUTHERN EXPOSURE,** 401 Alabama St, San Francisco, CA 94110. Tel 415-863-2141; Fax 415-863-1841; Elec Mail soex@soex.org; Internet Home Page Address: www.soex.org; *Dir* Courtney Fink
Open Tues - Sat 11 AM - 5 PM; Estab 1974 to give exposure to contemporary California art by emerging and established artists; 28 ft ceilings; 2500 sq ft in three galleries; Average Annual Attendance: 25,000; Mem: 1800; dues $25-$2000 & up
Income: Financed by endowment, mem, contributions, grants
Collections: Juried Exhib (nationally recognized curator) Nov, Dec; Postcard Show
Activities: Artists in education program (ages 11-19), performances, symposiums, internship program; lect

M **TATTOO ART MUSEUM,** 841 Columbus Ave, San Francisco, CA 94133; 210 Clara Ave, Ukiah, CA 95482. Tel 415-775-4991; Elec Mail lyletutt@pacific.net; Internet Home Page Address: www.lyletuttle.com; *Consultant* Judith Tuttle; *Dir* Lyle Tuttle; *Mgr* Tanja Nixx
Open daily Noon - 9 PM; Estab 1974; Average Annual Attendance: 5,000
Special Subjects: Primitive art
Collections: Lyle Tuttle Collection, tattoo art, Memorabilia & Equipment, especially tattoo machines & primitive tools; George Burchett Collection
Publications: Magazine of the Tattoo Art Museum; Tattoo Historian, biannual
Activities: Lect open to public, 12 vis lectrs per year; awards; Tattoo Hall of Fame; individual paintings & objects of art lent

C **WELLS FARGO BANK,** Wells Fargo History Museum, 420 Montgomery St, San Francisco, CA 94163. Tel 415-396-2619; Fax 415-391-8644; *Cur* Anne Hall
Open Mon - Fri 9 AM - 5 PM, cl Bank holidays; Estab 1960 to provide information on Wells Fargo, California & San Francisco; For reference only; Average Annual Attendance: 65,000
Special Subjects: Sculpture, Painting-American, Prints, American Western Art, Coins & Medals, Gold, Historical Material, Jewelry, Landscapes, Manuscripts, Maps, Photography, Porcelain, Posters, Reproductions
Collections: Wiltsee Collection of Postal Franks; Califonia History; 19th & 20th Century Banking; San Francisco History
Activities: Concerts; tours; museum shop sells books

M **YERBA BUENA CENTER FOR THE ARTS,** (Center for the Arts at Yerba Buena Gardens) 701 Mission St, San Francisco, CA 94103-3138. Tel 415-978-2700; Fax 415-978-9635; Internet Home Page Address: www.ybca.org; *Visual Arts Cur* Rene de Guzman; *Assoc Cur* Berin Golonu
Open Tues - Sun 12PM - 5 PM, Thurs 12 PM - 8 PM; Admis $6; Estab 1993; contemporary art; Average Annual Attendance: 50,000; Mem: 2500
Special Subjects: Drawings, Painting-American, Sculpture, Hispanic Art, Latin American Art, Afro-American Art, Oriental Art, Juvenile Art
Exhibitions: Beautiful Losers; Cosmic Wonder; Erwin Wurm
Activities: Docent training; workshops for children; teen employment & art training; concerts; tours; gallery talks; organize traveling exhibitions circulating to any art museum

SAN JOSE

M **ROSICRUCIAN EGYPTIAN MUSEUM & PLANETARIUM,** (Rosicrucian Egyptian Museum & Art Gallery) Rosicrucian Order, A.M.O.R.C., 1342 Naglee Ave, San Jose, CA 95191-0001. Tel 408-947-3600; Fax 408-947-3638; Elec Mail info@egyptianmuseum.org; Internet Home Page Address: www.egyptianmuseum.org; *Dir* Julie Scott; *Cur* Lisa Schwappach-Shirriff; *Mgr* Julia Bly DeVere
Open Tues - Fri 10 AM - 5 PM, Sat & Sun 11 AM - 6 PM; Admis adults $9, seniors & students with ID $7, children 5-10 $5, under 5 free; Estab 1929, in present location 1966, to publicly show a collection of the works of ancient Egyptians, reflecting their lives & culture; Collections include Bronzes of Egyptian Gods & Goddesses; Funerary Models; full size walk-in tomb replica; human & animal mummies; Tel-El-Armana room with amulets, cosmetics & writing implements; jewelry, pottery & King Zoser's tomb complex; Mesopotamian collection - cuneiform tablets & seals from Babylon, Sumer & Assyria; Average Annual Attendance: 100,000
Income: Financed by Rosicrucian Order, AMORC
Purchases: Regular acquisitions of Egyptian antiquities
Special Subjects: Antiquities-Oriental, Antiquities-Egyptian, Antiquities-Assyrian
Collections: Collections include Bronzes of Egyptian Gods & Goddesses; Funerary Models; full size walk-in tomb replica; human & animal mummies; Tel-El-Armana room; amulets, cosmetics, writing implements, jewelry, pottery, scale model of King Zoser's tomb complex; Mesopotanian collection - cuneiform tablets & seals from Babylon
Exhibitions: Quarterly exhibitions in the Rotating Exhibits gallery featuring both Ancient and Modern Art
Publications: The Hieroglgphic Coloring Book Magazine; quarterly magazine
Activities: Tours; workshops; 4 annual lect for members; gallery talks; gift shop sells books, magazines, reproductions, prints, slides, jewelry, posters & educ materials

M **SAN JOSE INSTITUTE OF CONTEMPORARY ART,** 560 S First St, San Jose, CA 95113. Tel 408-283-8155; Fax 408-283-8157; Elec Mail info@sjica.org; Internet Home Page Address: www.sjica.org; *Dir* Cathy Kimball; *Asst Dir* Elizabeth Waldo
Open Tues, Wed, Fri 10 AM - 5 PM, Thurs 10 AM - 8 PM, Sat Noon - 5 PM; No admis fee; Estab 1980, SJICA is a non-profit visual arts organization highlighting

emerging & estab artists from the Greater Bay Area & beyond; 7500 sq ft facility; Average Annual Attendance: 70,000; Mem: 700; dues $25 & up
Income: Financed by mem & cultural grants
Exhibitions: Monthly exhibition.; Annual fall auction
Activities: Lect open to public; gallery talks; tours by appointment

M **SAN JOSE MUSEUM OF ART,** 110 S Market St, San Jose, CA 95113-2383. Tel 408-294-2787; Fax 408-294-2977; Elec Mail info@sjmusart.org; Internet Home Page Address: www.sanjosemuseumofart.org; *Deputy Dir* Deborah Norberg; *Dir Develop* Gary Landis; *Dir Communications* Diane Maxwell; *Museum Store Mgr* Cindy Sylvester; *Exec Dir* Daniel Keegan; *Chief Cur* Susan Landauee; *Sr Cur* JoAnne Northrup; *Dir Educ* Val DeLang
Open Tues - Thurs, Sat & Sun 11 AM - 5 PM; No admis fee; Estab 1969 to foster awareness, appreciation & understanding of 20th century art; An 1892 Richardson - Romanesque building with a striking contemporary new wing, totaling more than 18,000 sq ft of exhibition space; Average Annual Attendance: 200,000; Mem: 5000; dues $35 - $600; annual meeting in June
Income: Financed by City of San Jose, private sector contributions, state & federal government
Special Subjects: Drawings, Photography, Prints, Sculpture
Collections: Permanent Collection features work by nationally recognized artists, artists of the California region, American prints & sculptures
Publications: Exhibition catalogs; Framework Newsletter, quarterly
Activities: Classes for adults & children; docent training; family programs; school outreach; lect open to public, 13 vis lectrs per year; concerts; gallery talks; tours; individual paintings lent to nonprofit institutions for educational & scholarly purposes; summer art studios; book traveling exhibitions; originate traveling exhibitions to other museums in the US; museum store sells books, magazines, reproductions, prints, jewelry, gifts, toys & cards

L **Library,** 110 S Market St, San Jose, CA 95113. Tel 408-271-6840; Fax 408-294-2977; Elec Mail info@sjmusart.org; *Librn* Gloria Turk; *Chief Cur* Susan Landauer; *Dir Visitor Experience & Interpreter* Margaret Maynard; *Sr Cur* JoAnne Northrup; *Deputy Dir* Deborah Norbert; *Dir Educ* Val DeLang; *Financial Officer* Lynn Schuyler-King; *Chief Design & Installations* Richard Karson; *Assoc Marketing & Communication* Stephanie Vidergar; *Exec Dir* Daniel T Keegan; *Asst Cur* Ann Wolfe; *Deputy Dir of Extended Affairs* Gary Gallagher Landis; *Pres* Deborah Rappaport; *Dir* Cindy Sylvester; *Cur Asst* Lyndsey Wylie; *Marilyn Cahill*
Tues - Sun 11 AM - 5 PM; no admis fee; Estab 1969; Open to the mus staff & volunteers for reference only; Average Annual Attendance: 200,000; Mem: 2600
Income: Financed by donations
Library Holdings: Book Volumes 3400; Clipping Files; Exhibition Catalogs 5950; Pamphlets; Periodical Subscriptions; Photographs; Video Tapes
Special Subjects: Art History, Painting-American
Collections: California and West Coast contemporary art
Publications: SJMA Frameworks, 6 times a year
Activities: Classes for adults; docent training; lect open to pub; lect for mem only; gallery talks, tours; museum shop sells books, reproductions, prints

SAN JOSE STATE UNIVERSITY

M **Natalie & James Thompson Art Gallery,** Tel 408-924-4328; Fax 408-924-4326; Internet Home Page Address: www.sjsu.edu; *Dir* Jo Farb Hernandez
Open Tues 11 AM - 4 PM & 6 - 7:30 PM, Wed - Fri 11 AM - 4 PM during term; No admis fee; Estab 1960 as part of the university school of art & design; Gallery is 34 x 28 ft with 12 ft ceiling; Average Annual Attendance: 9,000
Income: Financed by city & state appropriations & private endowment
Exhibitions: Design, Contemporary Issues, Art & Art History
Publications: Exhibition catalogs; brochures
Activities: Lect open to public; over 30 per yr vis lects weekly during fall & spring semesters; concerts; gallery talks; tours; competition; scholarships offered; 0 - 1 book traveling exhibitions; originate traveling exhibitions to mus & galleries nationwide

L **Dr. Martin Luther King Jr. Library,** Tel 408-808-2037; Fax 408-808-2009; Elec Mail edith.crowe@sjsu.edu; Internet Home Page Address: sjlibrary.org; vrc-collections.sjsu.edu/vr_library/; *Visual Resources Cur* Stacy Barclay; *Art Reference Librn* Edith Crowe
Income: Financed by state funds, student library fees & private donations
Purchases: $52,800
Library Holdings: Audio Tapes; Book Volumes 53,500; CD-ROMs; Cards; Cassettes; Compact Disks; Exhibition Catalogs; Fiche; Filmstrips; Framed Reproductions; Lantern Slides; Micro Print; Motion Pictures; Original Art Works; Periodical Subscriptions 87; Photographs; Prints; Records; Reels; Reproductions; Slides; Video Tapes

SAN LUIS OBISPO

L **CALIFORNIA POLYTECHNIC STATE UNIVERSITY,** College of Architecture & Environmental Design-Architecture Collection, Media Resource Ctr, San Luis Obispo, CA 93407. Tel 805-756-2165; Fax 805-756-5986; *Asst Dir* Vickie Aubourg
Open Mon - Fri 8 AM - 5 PM, cl Sat & Sun; No admis fee; Estab 1969; 190,000 slides for reference; Circ 20,000 (slides)
Income: Financed by state appropriation
Library Holdings: Book Volumes 1000; Periodical Subscriptions 30
Special Subjects: Constructions, Landscapes, Architecture
Collections: Architecture & Landscape Architecture slide collection

L **CUESTA COLLEGE,** Cuesta College Art Gallery, PO Box 8106, San Luis Obispo, CA 93403-8106. Tel 805-546-3202; Fax 805-546-3904; Elec Mail pmckenna@cuesta.edu; Internet Home Page Address: www.academic.cuesta.cc.ca.us/finearts/gallery.htm; *Gallery Asst* Pamela McKenna; *Gallery Dir* Tim Anderson
Open Mon - Fri 11 AM - 4 PM, Sat 11 AM - 2 PM, cl Sun; vacation hrs vary; No admis fee; Estab 1966 to support the educational program of the college; Contemporary fine art gallery featuring rotating exhibitions of national, regional & local artists; Average Annual Attendance: 10,000

Library Holdings: Audio Tapes; Book Volumes 3130; Cassettes; Fiche; Filmstrips; Motion Pictures; Pamphlets; Periodical Subscriptions 18; Records; Reels; Slides; Video Tapes
Collections: 20 works of art primarily of California artists; 2 Japanese artists
Activities: Educ dept; lect open to public, 6 vis lectrs per year; gallery talks; tours; originate traveling exhibitions

A **SAN LUIS OBISPO ART CENTER,** 1010 Broad St, San Luis Obispo, CA; PO Box 813, San Luis Obispo, CA 93406-0813. Tel 805-543-8562; Fax 805-543-4518; *Cur* Arne Nybak; *Exec Dir* Carol Dunn
Gallery open Tues - Sun 11 AM - 5 PM; Estab 1952 to promote the visual arts through educ, expression & interaction; Average Annual Attendance: 40,000; Mem: 700; dues $15-$100
Income: $100,000 (financed by mem, earnings & donations)
Collections: Small collection of regional artists
Publications: Calendar of Events Newsletter, monthly
Activities: Classes for adults & children; docent programs; lect open to public, 50 vis lectrs per year; scholarships offered; sales shop sells original art, reproductions, cards & jewelry

SAN MARCOS

M **PALOMAR COMMUNITY COLLEGE,** Boehm Gallery, 1140 W Mission Rd, San Marcos, CA 92069. Tel 760-744-1150, Ext 2304; Fax 760-744-8723; Internet Home Page Address: www.palomar.edu; *Gallery Dir* Vicki Cole
Open Tues & Thurs 10 AM - 4 PM, Wed 10 AM - 7 PM, Fri 10 AM - 2 PM, Sat 10 AM - 2 PM, cl Mon; No admis fee; Estab 1964 to provide the community with fine art regardless of style, period or approach; The gallery is 35 x 35 ft, no windows, 18 in brick exterior, acoustic ceiling & asphalt tile floor; Average Annual Attendance: 50,000
Income: $8000 (exhibition budget). Financed by city & state appropriations
Collections: Contemporary art by nationally acclaimed artists; 16th - 20th century art; California artists
Activities: Lect open to public, 12 vis lectrs per year; competitions; individual paintings & original objects of art lent to reputable museums & galleries; lending collection contains original paintings, prints & sculpture

SAN MARINO

M **THE HUNTINGTON LIBRARY, ART COLLECTIONS & BOTANICAL GARDENS,** 1151 Oxford Rd, San Marino, CA 91108. Tel 626-405-2100; Fax 626-405-0225; Elec Mail lblackburn@huntington.org; Internet Home Page Address: www.huntington.org; *VPres Advancement* George Abdo; *VPres Financial Affairs* Alison Sowden; *Dir Art Div* John Murdoch; *Dir Library* David Zeidberg; *Dir Botanical Gardens* James Folsom; *Assoc VPres Communications* Susan Turner-Lowe; *Cur American Art* Jessica Smith; *Cur British & Continental Art* Shelley Bennett; *Pres* Steven S Koblik; *Dir Research* Robert C Ritchie; *Dir Educ* Susan Lafferty; *Dir Oper* Laurie Sowd
Open Tues - Fri Noon - 4:30 PM, Sat & Sun 10:30 AM - 4:30 PM, cl Mon & major holidays; Admis adults $15, seniors 65 & older $12, students 12 & older $10, groups of 15 or more $11, members free; Estab 1919 by the late Henry E Huntington as a free research library, art gallery, mus & botanical garden; exhibitions open to the pub in 1928 for educational & cultural purposes. Virginia Steele Scott Gallery for American art opened in 1984; Average Annual Attendance: 500,000; Mem: 15,000; supporters of the institution who give $60-$1000 annually are known as the Friends of the Huntington Library, Fellows give $2000 or more per year
Income: Financed by endowment & gifts
Special Subjects: Architecture, Drawings, Bronzes, Ceramics, Etchings & Engravings, Decorative Arts, Furniture, Carpets & Rugs, Baroque Art
Collections: Ellesmere manuscript of Chaucer's Canterbury Tales; Gutenberg Bible on vellum; Birds of America by Audobon; British, European & American art collections; Rich Collection of rare books & manuscripts
Exhibitions: Rotating exhibits
Publications: The Calendar, bimonthly; Huntington Library Quarterly; various monographs & exhibition catalogs
Activities: Classes for children; docent training; lect open to public, 25 vis lectrs per year; concerts; gallery talks; tours; scholarships & fels offered; individual paintings lent; museum shop sells books, calendars, gift items, note cards, postcards, prints, puzzles, reproductions, slides

L **Library,** 1151 Oxford Rd, San Marino, CA 91108. Tel 626-405-2100; Fax 626-405-0398; Elec Mail publicinformation@huntington.org; Internet Home Page Address: www.huntington.org; *Pres* Steven Koblik; *Exec Asst to Pres* Kathy Hacker; *VPres Advancement* George Abdo; *Dir Botanical Gardens* James Folsom; *Dir Educ* Susan Lafferty; *Asst VPres Advancement* Suzy Moser; *Dir Colls* John Murdock; *Dir Research & Educ* Robert C Richie; *Assoc VPres Operations* Laurie Sowd; *VPres Communications* Susan Turner-Lowe; *Dir Library* David Zeidberg
Open Tues - Fri noon - 4:30 PM -Sat & Sun 10:30 AM - 4:30 PM; cl New Year's Day, Memorial Day, Independence Day, Labor Day, Thanksgiving, Christmas Eve & Christmas Day; Admis adults $15, seniors 65+ $12, students ages 12-18 (or with full time student ID) $10, children ages 5-11 $6; Groups of 15 or more $11 per person; mems & children under 5 free; Admis is free to all vis on the first Thurs of every month; Estab 1919, research & educational institution; 18th century British & French art & early 18th to early 20th century American art; Average Annual Attendance: 521,000; Mem: 25,000; dues Benefactor $1,250, Patron $600, Supporting $300, Sponsoring $200, Sustaining $100, Senior $80
Income: Financed by contributions, admis, endowment & earned income
Library Holdings: Book Volumes 682,094; Cards; Exhibition Catalogs; Fiche; Manuscripts; Memorabilia; Micro Print; Other Holdings Photographic archive 100,000; Pamphlets; Periodical Subscriptions 1200; Photographs; Prints; Reels
Special Subjects: Art History, Landscape Architecture, Decorative Arts, Illustration, Drawings, Etchings & Engravings, Manuscripts, History of Art & Archaeology, Ceramics, American Western Art, Bronzes, Interior Design, Furniture, Carpets & Rugs, Landscapes

Exhibitions: (8/5/2006-1/7/2007) Chrysanthemums on the Eastern Hedge: Gardens & Plants in Chinese Art; (10/14/2006-1/3/2007) Treasures from Olana: Landscapes by Frederic Edwin Church; (2/2007-5/2007) Constable's Great Landscapes: The Six-Foot Paintings
Publications: Calender; Frontiers Magazine; Annual Report; In Fact
Activities: Classes for adults & children; docent training; lects open to the pub; 10-20 vis lects per yr; concerts; gallery talks; tours; scholarships; fel; lending of original objects of art to various orgs; organize traveling exhibs to various orgs; mus shop sells books, magazines, reproductions, prints, slides & gifts

M **OLD MILL FOUNDATION,** (The California Historical Society) California Art Club Gallery, 1120 Old Mill Rd, San Marino, CA 91108-1840. Tel 626-449-5458; Fax 626-449-1057; Elec Mail oldmill@sbcglobal.net; Internet Home Page Address: www.oldmill.org; *Exec Dir* Jack McQueen; *Asst Dir* Cathy Brown
Open Tues - Sun 1 - 4 PM, cl holidays; Historic adobe grist mill with changing art exhibit rooms; Mem: $15-$250
Income: Financed by mem dues & contributions
Special Subjects: Drawings, Watercolors, Furniture
Collections: Fine arts include California lithography & other graphics; oils; watercolors; drawings; furniture & artifacts to 1915; research materials both original & published on California & Western artists
Publications: California History, quarterly magazine
Activities: Classes for adults; docent training; programs; lect; tours & films throughout the state; lect open to the public; concerts; gallery talks; tours; awards given for participation in the field of California history; traveling exhibitions organized & circulated

L **North Baker Library,** 678 Mission St, San Francisco, CA 94105-4014. Tel 415-357-1848; Fax 415-357-1850; Elec Mail info@calhist.org; Internet Home Page Address: www.californiahistoricalsociety.org; *Dir* David Crosson; *Dir Develop* Darlene Plumtree; *Library Dir* Mary Margauti
Open Wed - Sat noon - 5 PM; Admis Adults $3, Srs & students $1; Estab 1871 to collect books, manuscripts, photographs, ephemera, maps and posters pertaining to California and Western history; Mem: 5,000 mem; dues starting at $52
Library Holdings: Audio Tapes; Book Volumes 60,000; Cassettes; Clipping Files; Exhibition Catalogs; Fiche; Framed Reproductions; Kodachrome Transparencies; Lantern Slides; Manuscripts; Maps; Memorabilia; Original Art Works; Original Documents; Other Holdings 3-D artifacts; Pamphlets; Periodical Subscriptions 100; Photographs 500,000; Prints; Reels; Reproductions; Slides
Collections: C Templeton Crocker Collections; Florence Keen Collection of Western Literature; Kemble Collection of Western Printing & Publishing
Publications: California History, quarterly; CHS Press Titles
Activities: Symposiums; website; lects open to pub, 12-15 lects per year; tours; Macfarlane Film Award; lending of original objects of art; circulate exhibs to all of Calif; mus shop sells books, reproductions, prints, jewelry

L **UNIVERSITY OF SOUTHERN CALIFORNIA/THE GAMBLE HOUSE,** Greene & Greene Archives, Huntington Library 1151 Oxford Rd, San Marino, CA 91108. Tel 626-405-2232; Fax 626-796-6498; Elec Mail scheid@usc.edu; Internet Home Page Address: www.usc.edu/dept/architecture/greeneandgreene; *Archivist* Ann Scheid
Hours by appointment; No admis fee; Estab 1968 as a concentrated collection of archival material on the work of architects Charles & Henry Greene; For research only; Average Annual Attendance: 100
Library Holdings: Audio Tapes 5; Book Volumes 800; CD-ROMs 60; Clipping Files; Exhibition Catalogs; Lantern Slides 50; Manuscripts 5,000; Memorabilia; Motion Pictures 5; Original Art Works 50; Original Documents 500; Other Holdings Drawings; Client files; Blueprints; Pamphlets; Photographs 200; Records; Slides 800; Video Tapes 10
Special Subjects: Decorative Arts, Historical Material, Architecture
Collections: Art, architecture, and decorative arts of architects Charles Sumner Greene and Henry Mather Greene

SAN MIGUEL

M **MISSION SAN MIGUEL MUSEUM,** 775 Mission St, PO Box 69 San Miguel, CA 93451. Tel 805-467-3256; Fax 805-467-2448; Internet Home Page Address: www.missionsanmiguel.org; *Dir* Bro William Short
Open daily 9:30 AM - 4:30 PM, half day Good Friday, cl New Year's, Easter, Thanksgiving & Christmas; Admis by donation; Estab 1797; The Mission fresco secco decorations date back to 1821, also original, not restored; Average Annual Attendance: 25,000
Income: Financed by Franciscan Friars & donations
Special Subjects: American Indian Art, Architecture, Mexican Art, Archaeology, Religious Art, Manuscripts, Historical Material, Restorations, Dioramas, Period Rooms, Painting-Spanish, Reproductions
Collections: Spanish era art & artifacts
Activities: Tours; gift shop sells books, reproductions, prints gifts & religious articles

SAN PEDRO

M **ANGELS GATE CULTURAL CENTER,** Gallery A & Gallery G, 3601 S Gaffey St, San Pedro, CA 90731. Tel 310-519-0936; Fax 310-519-8698; Elec Mail artatgate@aol.com; Internet Home Page Address: www.angelsgateart.org; *Dir* Robin Hinchliffe; *Prog Mgr* Victoria Bryan; *Mng Dir* Andrea Lien; *Admin* Esther Stephens
Open Tues - Sun 11 AM - 4 PM; No admis fee; Estab 1981 dedicated to innovation & cultural diversity; 3000 sq ft in Gallery A, 600 sq ft in Gallery G; Mem: 400; dues $25-1,000; annual meeting in Sept
Income: $250,000 (financed by mem, studio rentals, workshop tuition, donations & grants)
Activities: Classes for adults & children; internships; outreach workshops; docent training; artists in classrooms in local schools; lect open to public; director's tours; dialogue with artists; concerts; dance recitals; theatre productions; sales shop sells books, magazines, original art, prints, jewelry, handbags, cards & calendars

SAN RAFAEL

M CITY OF SAN RAFAEL, Falkirk Cultural Center, 1408 Mission Ave, San Rafael, CA 94901; PO Box 151560, San Rafael, CA 94915. Tel 415-485-3328, 485-3326; Fax 415-485-3404; Elec Mail jane.lange@ci.san-rafael.ca.us; Internet Home Page Address: www.falkirkculturalcenter.org; *Cur* Beth Goldberg; *Dir* Jane Lange; *Public Rels* Corey Bytof; *Pub Relations* Leslie Gavin
Gallery Open Mon - Fri 10 AM - 5 PM, Thurs until 9 PM, Sat 10 AM - 1 PM; No admis fee; Estab 1974 to provide classes, lectures, concerts for the city of San Rafael & surrounding region; Contemporary art gallery; Average Annual Attendance: 45,000; Mem: 50; dues business/corporate $1000, fellow $500, advocate $250, steward $100, family $50, friend $30, sr citizen & student $20, artist $20
Income: Financed by City of San Rafael appropriation, rentals, classes & grants
Special Subjects: Restorations
Exhibitions: Annual juried exhibition, Dia de Los Muertos exhibition
Publications: Exhibition catalogues
Activities: Classes for adults & children; docent training; lect open to public, 6 vis lectrs per year; concerts; tours; juried annual competitions; bookstore sells books, prints, & poetry readings

SANTA ANA

M BOWERS MUSEUM OF CULTURAL ART, Bowers Museum, 2002 N Main St, Santa Ana, CA 92706. Tel 714-567-3600; Fax 714-567-3603; Elec Mail info@bowers.org; Internet Home Page Address: www.bowers.org; *Dir Exhibit Design & Fabrication* Paul Johnson; *Pres* Dr Peter Keller; *CFO* Thuy Nguyen
Open Tues - Sun 10 AM - 4 PM, cl Mon; Admis week days: adults $17, students & seniors $12, under 5 years-old free, weekends: adults $19, students & seniors $14, under 5 years-old free; Estab 1936 to provide an active cultural arts museum for the community; Originally housed in an authentic California mission-style structure surrounding a courtyard fountain, devoted to the display of antique furniture, Indian relics & historical items of early California families, The museum has grown to encompass 90,000 sq ft. The new additions include major galleries, new collection storage rooms, administrative offices, library & restaurant exhibiting the cultural arts of the world; Average Annual Attendance: 133,000; Mem: 4,700
Income: Financed by city appropriation, earned revenue & contributions
Special Subjects: Painting-American, Photography, American Indian Art, African Art, Pre-Columbian Art, Decorative Arts, Asian Art
Collections: Pre-Columbian Mesoamerica; Native N & S American art & artifacts; African & Oceanic art; California plein air paintings
Exhibitions: First Californians Gallery - permanent exhib; Vision of the Shaman, Song of the Priest - permanent exhib; California Legacies - permanent exhib; California, the Golden Years: Selection from the Bowers Permanent Coll; Art of Adornment: Tribal Beauty - permanent exhib; (4/17/2005-12/31/2007) Mummies: Death & the Afterlife in Ancient Egypt; (2/18/2007-5/12/2007) Ansel Adams: Classic Images; (2/18/2007-8/19/2007) Treasures of Shanghai: 5000 Years of Chinese History; (6/16/2007-6/17/2008) Gems: Part II
Publications: Brochures; Quarterly Calendar; exhibition catalogs
Activities: Classes for adults & children; docent guild; lect open to public; films; gallery talks; tours; study clubs; paintings & original art objects lent to other museums; originate traveling exhibitions organized & circulated; sales shop sells books, magazines, original art, reproductions, prints, jewelry, imported clothing, gift items; Bowers Kidseum 1800 N Main St Santa Ana, Calif

M SANTA ANA COLLEGE, Art Gallery, 1530 W 17th St, Santa Ana, CA 92706-3398. Tel 714-564-5615; Fax 714-564-5629; Internet Home Page Address: www.sac.edu/art; *Dir* Mayde Herberg; *Asst Dir* Loren Sandvik; *Gallery Coordr* Caroline McCabe
Open Mon - Thurs 10 AM - 2 PM, also Tues & Wed 6:30 - 8:30 PM; No admis fee; Estab 1972 to educate students, staff, faculty & the community; Average Annual Attendance: 12,000
Income: Financed by Rancho Santiago Community College District budget
Exhibitions: Annual Juried Student Art Show; High School Art Show; Group exhibs, solo artists (professional)
Publications: Art Forum Newsletter, 6 per year
Activities: Classes for adults; dramatic programs; lect open to public, 36-40 vis lectrs per year; competitions with awards; concerts; gallery talks; tours; scholarships offered

SANTA BARBARA

L BROOKS INSTITUTE OF PHOTOGRAPHY, 801 Alston Rd, Santa Barbara, CA 93108. Tel 805-966-3888; Fax 805-564-1475; Elec Mail library@brooks.edu; *Librn* Susan Shiras
Open Mon - Fri 8 AM - 5 PM; Lend to students only, reference to non-students
Income: Financed by school tuition
Library Holdings: Book Volumes 7367; CD-ROMs 28; Filmstrips; Periodical Subscriptions 91; Video Tapes 234
Special Subjects: Film, Illustration, Mixed Media, Photography, Architecture
Exhibitions: Various student exhib
Activities: Online instruction for cyber libraries, research instruction

A SANTA BARBARA CONTEMPORARY ARTS FORUM, 653 Paseo Nuevo, Santa Barbara, CA 93101. Tel 805-966-5373; Fax 805-962-1421; Internet Home Page Address: www.sbcaf.org; *Others* TDD 805-965-9727; *Asst Dir* Rita Ferri; *VPres* Jeffrey Wyatt; *VPres* Keith Puccinelli; *Pres Bd Dir* Jill Kitnick; *Exec Dir* Meg Linton; *Office Mgr* Yvonne Heine
Open Tues - Sat 11 AM - 5 PM, Sun Noon - 5 PM; Estab 1976; committed to the presentation of contemporary art; Klausner Gallery 2345 sq ft & Norton Gallery 378 sq ft; Mem: 921; dues start at $25
Income: $265,000 (financed by federal, state, county & city grants, corporate & private contributions, fund raising events)

Publications: Addictions; Carl Cheng: exhibit catalogues; Carroll Dunham: paintings; Focus/Santa Barbara; Jene Highstein: Gallery/Landscape; Teraoka Erotica
Activities: Classes for adults & children; docent training; lect open to public, 15 vis lectrs per year; gallery talks; tours; book traveling exhibitions; originate traveling exhibitions to other nonprofit galleries

M SANTA BARBARA MUSEUM OF ART, 1130 State St, Santa Barbara, CA 93101-2746. Tel 805-963-4364; Fax 805-966-6840; Elec Mail info@sbmuseart.org; Internet Home Page Address: www.sbmuseart.org; *Dir Devel & External Affairs* Erik Pihl; *Acting Dir* Robert Henning Jr; *Cur Educ* Jill Finsten; *Registrar* Cherie Summers; *Cur 20th Century Art* Diana duPont; *Cur Asian Art* Susan Shin-Tsu Tai; *Cur Photo* Karen Sinsheimer
Open Tues - Thurs & Sat 11 AM - 5 PM, Fri 11 AM - 9 PM, Sun Noon - 5 PM; Admis adults $7, seniors $5, students & children 6-17 $4, children under 6 free; Estab 1941 as an art mus with exhibitions & educ programs; 14 galleries totaling 16,500 sq ft of exhibition space. Maintains reference library; Average Annual Attendance: 167,000; Mem: 4000; dues director's circle $1250 & up, patron $650, master member $350, gallery guild $175, assoc $75, general $45, student $20
Income: $2,600,000 (financed by earnings, including endowment, mem, grants, government & foundations & contributions)
Special Subjects: Drawings, Latin American Art, Painting-American, Photography, Prints, Sculpture, Watercolors, African Art, Woodcuts, Etchings & Engravings, Painting-European, Painting-Japanese, Jade, Oriental Art, Asian Art, Painting-French, Tapestries, Painting-Spanish, Antiquities-Greek, Antiquities-Roman
Collections: Preston Morton Collection of American Art; Asian Art; Classical Art; International Modern Art; 19th Century French Art; prints & drawings; photography; 20th Century Art
Exhibitions: Prized Possessions: Selections from the Permanent Collection; Venice: The City of All Seasons; Santa Barbara's Own: The Architecture of Lutah Maria Riggs; Cambios: The Spirit of Transformation in Spanish Colonial Art; Mexican Colonial Paintings: From the Old World to the New; Photographs of China by Loris Conner; In Dialogue: The Art of Elsa Rady & Robert Mapplethorpe; Brushstrokes: Styles & Techniques of Chinese Painting; Auguste Rodin: Selections from the Fine Arts Museums of San Francisco; In Rodin's Studio: Photographs; Seeing Straight: The F/64 Revolution in Photography; Egypt Through the Lens; Werner Bischof; The Splendid Centuries: 18th & 19th Century French Paintings From the Fine Arts Museums of San Francisco; 19th Century French Prints from the Permanent Collection; The Santa Barbara Connection: Contemporary Photography
Publications: Bulletin, bi-monthly newsletter; exhibit & collection catalogs; Update, semi-annual periodical
Activities: Classes for adults & children; docent training; outreach classes & programs; lect open to public, 4-6 vis lectrs per year; concerts; gallery talks; tours; scholarships offered to children's art classes only; artmobile; individual paintings original objects of art lent to other museums only for exhibition; book traveling exhibitions 3-5 per year; originate traveling exhibitions; museum shop sells books, original art, reproductions

L Library, 1130 State St, Santa Barbara, CA 93101. Tel 805-963-4364; Fax 805-966-6840; Internet Home Page Address: www.sbma.net; *Dir* Phillip Johnston; *Dir Develop* Kristi Wallace; *Chair Bd Trustees* Patrick Stone; *Dir Educ* Jill Finsten; *Dir Special Progs* Shelley S Ruston; *Cur Photography* Karen Sinsheimer; *Mus Store Mgr* Jennifer Escoto; *Cur Contemporary Art* Diana DuPont; *Registrar* Cherie Summers; *CFO* Diane Wondolowski; *Cur Asian Art* Susan Shin-tsu Tai; *Librn* Heather Brodhead
Open to pub on an appointment basis; Admis adult $9, seniors (65+) $6, students (with ID) $6, children 6-17 $6, under 6 free; 1941; For reference only
Income: Endowment, mem, grants, gov & foundation contributions
Library Holdings: Auction Catalogs; Book Volumes 40,000; Clipping Files; Exhibition Catalogs; Fiche; Kodachrome Transparencies; Manuscripts; Pamphlets; Periodical Subscriptions 20; Slides
Special Subjects: Art History, Photography, Etchings & Engravings, Sculpture, Watercolors, Latin American Art, Printmaking, Art Education, Mexican Art, Jade, Oriental Art, Textiles, Woodcuts
Activities: Classes for adults & children; docent training; applied art classes for children & adults; museum shop sells books, jewelry, accessories, ceramics & art glass

L SANTA BARBARA PUBLIC CENTRAL LIBRARY, Faulkner Memorial Art Wing, 40 E Anapamu St, PO Box 1019 Santa Barbara, CA 93102. Tel 805-962-7653, 564-5608 (library admin); Fax 805-962-6304; Internet Home Page Address: www.santa-barbara.ca.us; *Dir* Carol Keator
Open Mon - Thurs 10 AM - 9 PM, Fri & Sat 10 AM - 5:30 PM, Sun 1 - 5 PM; No admis fee; Estab 1930 & administered by the library trustees
Income: City funded
Library Holdings: Book Volumes 200,000; Cassettes 7800; Clipping Files; Fiche; Framed Reproductions; Micro Print; Pamphlets; Periodical Subscriptions 500; Records; Reels; Reproductions
Exhibitions: Local contemporary paintings & sculpture; Rotating exhibits
Activities: Lect, programs & meetings

UNIVERSITY OF CALIFORNIA, SANTA BARBARA

M University Art Museum, Tel 805-893-2951; Fax 805-893-3013; Elec Mail uam@uam.ucsb.edu; Internet Home Page Address: www.uam.ucsb.edu; *Designer* Rollin Fortier; *Registrar* Susan Lucke; *Cur Architectural Drawings* Kurt Helfrich; *Dir* Kathryn Kanjo; *Bus Manager* Vicki Stuber; *Asst to Dir* Marie Vierra; *Chief Cur* Natalie Sanderson; *Security* Bill Durham
Wed - Sun Noon - 5 PM, cl Mon, Tues & maj holidays; No admis fee; Estab 1959 & direct at both the needs of the university & the community; with a wide range of contemporary & historical exhibitions; Located on the UCSB campus, Arts Building complex; four galleries for changing exhibits; two which exhibit part of the permanent collection; Average Annual Attendance: 30,000; Mem: 100; dues vary; meeting dates vary
Income: Financed by university funds, grants, private donations
Special Subjects: Architecture, Drawings, Graphics, Painting-American, Photography, Sculpture, Watercolors, Ethnology, Religious Art, Etchings & Engravings, Painting-European, Posters, Painting-Dutch, Coins & Medals, Renaissance Art

Collections: Collection of Architectural Drawings by Southern California Architects, including Irving Gill, R M Schindler, George Washington Smith & Kem Weber; Morgenroth Collection of Renaissance Medals & Plaquettes; Sedgwick Collection of 16th-18th Century Italian, Flemish & Dutch Artists; Ala Story Print Collection; Grace H Dreyfus Collection of Ancient Peruvian & Middle Eastern Art; Fernand Lungren Bequest
Exhibitions: (1/2007-4/2007) Crafting a Modern World: The Architecture and Design of Antonin and Noemi Raymond; (1/2007-4/2007) Silk Road
Publications: Exhibition catalogs, 1-2 per year
Activities: Classes for adults & children; docent training; lect upon request; regular schedule of docent tours; gallery talks; 2-3 vis lectrs per year; sponsoring of competitions; 1 - 2 per year; originate traveling exhibitions to art museums; sales shop sells exhibition catalogs, books, prints, slides, reproductions, t-shirts, gifts

L **Arts Library,** Tel 805-893-2850; Internet Home Page Address: www.library.ucsb.edu; *Head Arts Library* Susan Moon
Open Mon - Thurs 9 AM - 10 PM, Fri & Sat 9 AM - 6 PM, Sun 2 - 10 PM; Estab 1966 to support academic programs; Circ 60,000
Income: Financed by state appropriation
Library Holdings: Book Volumes 90,000; Compact Disks; DVDs; Exhibition Catalogs 87,000; Fiche 75,000; Other Holdings Auction Catalogs 42,000; Pamphlets 11; Periodical Subscriptions 520; Photographs 5000; Reels 1400; Video Tapes 225
Special Subjects: Art History, Photography, Drawings, Etchings & Engravings, Painting-American, Painting-Dutch, Pre-Columbian Art, Prints, History of Art & Archaeology, American Western Art, Furniture, Aesthetics, Antiquities-Byzantine, Antiquities-Greek, Architecture
Publications: Catalogs of the Art Exhibition, Catalogs of the Arts Library, University of California, Santa Barbara; Cambridge, England, Chadwyck-Healey, 1978
Activities: Tours

SANTA CLARA

A **ARTS COUNCIL SILICON VALLEY,** (Arts Council of Santa Clara County) 4 N Second St, Ste 500, Santa Clara, CA 95113-1305. Tel 408-998-2787; Fax 408-971-9458; Elec Mail admin@artscouncil.org; Internet Home Page Address: www.artscouncil.org; *Exec Dir* Bruce Davis; *Dir Devel* Lisa Cole
Estab 1982 as the regional art support/planning agency for Santa Clara County, The Arts Council is the principal funding agency within the county for small, mid-size & multi-cultural arts groups & individual independent artists
Income: $1,000,000 (financed by county, California Arts Council, San Jose & other county municipalities, local, private & community foundations, Silicon Valley corporations, individual gifts & interest from two endowments)
Activities: Annual Music & Arts Campaign

M **SANTA CLARA UNIVERSITY,** de Saisset Museum, 500 El Camino Real, Santa Clara, CA 95053-0550. Tel 408-554-4528; Fax 408-554-7840; Internet Home Page Address: www.scu.edu/deSaisset/; *Academic Pres* Rev Paul Locatelli, SJ; *Vice Provost for Academic Affairs* Don Dodson; *Dir* Rebecca M Schapp; *Asst to Dir* Ramona Nadel; *Preparator* Brian Wanstein; *Coll Mgr* Jean MacDougall; *Cur Exhibits & Coll* Karen Kienzle
Open Tues - Sun 11 AM - 4 PM, cl Mon; No admis fee; Estab 1955 as a major cultural resource in Northern California; In recent years the museum has dramatically broadened its scope, exhibiting some of the world's leading avant-garde artists while not losing sight of the traditional. The gallery has 20,000 sq ft of floor space in a concrete structure adjacent to the Mission Santa Clara, two stories of galleries with a mezzanine for small exhibitions, plus offices & workrooms; Average Annual Attendance: 25,000; Mem: dues president's circle $1000, benefactor $500, friend $250, sponsor $100, family $70, senior & dual individual $50, educators $35, Santa Clara Community $25
Income: Financed by endowment, mem, University operating budget & grants
Purchases: All media
Special Subjects: Graphics, Painting-American, Photography, Sculpture, African Art, Ceramics, Furniture, Silver, Ivory, Tapestries
Collections: Kolb Collection of 17th & 18th century graphics; Arnold Mountfort Collection; D'Berger Collection of French furniture & ivories; African Collection; New Deal art repository; photography, paintings, antiques, sculpture, prints, china, silver & ivory collections; 17th & 18th century tapestries; Henrietta Shore Collection (paintings & prints); Focus Gallery Collection: Helen Johnston Bequest (photographs)
Exhibitions: (1/13/2007-3/4/2007) Faith Placed: The Intersection of Spirituality and Location Contemporary; (4/10/2007-5/25/2007) Minature Worlds: Art from India; (6/23/2007-8/19/2007) Kim Jung Hwa; (9/2007-12/2007) SAC Art Department Faculty exhib
Publications: Newsletter, quarterly; exhibition catalogs
Activities: Docent training; lect open to public; 8-12 vis lectr per yr; gallery talks; tours; paintings lent to campus offices; originate traveling exhibitions

M **TRITON MUSEUM OF ART,** 1505 Warburton Ave, Santa Clara, CA 95050. Tel 408-247-3754; Fax 408-247-3796; Elec Mail triton246@aol.com; Internet Home Page Address: www.tritonmuseum.org; *Exec Dir & Sr Cur* George Rivera; *Deputy Dir* Jill Meyers; *VPres* Rosalie Wilson; *Registrar* Stephanie Learmonth; *Mgr External Affairs & Assoc Cur* Preston Metcalf
Open Fri - Wed 11 AM - 5 PM, Thurs 11 AM - 9 PM ; No admis fee; Estab 1965 to offer a rich & varied cultural experience to members of the community through the display of 19th & 20th century American art, particularly artists of California & through related special events & programs; The mus consists of a state of the art facility designed by San Francisco architect Barcelon Jang. The building opened in Oct, 1987 & sits on a 7-acre park site with four Oriental/Spanish style pavilions & sculpture garden; Average Annual Attendance: 117,000; Mem: 1100; dues $15-$1000
Income: $1,250,000 (financed by endowment, mem, fundraisers, corporate sponsorships & city appropriation)
Library Holdings: Book Volumes; Exhibition Catalogs
Special Subjects: Painting-American, Sculpture, Ceramics, Glass

Collections: Paintings by Frank Duveneck; The Austen D Warburton Native American Art & Artifacts Collection; American paintings, prints & sculpture; oil paintings by Theodore Wores; international folk art
Exhibitions: Art Reach Exhibition
Publications: Exhibition catalogs; newsletter, bimonthly
Activities: Classes for children; docent training; lect open to public; concerts; gallery talks; tours; competition with prizes; schols offered; individual paintings & original objects of art lent to museums, nonprofit galleries & educational institutions; lending collection contains original art works; original prints; paintings & sculpture; museum shop sells original art

L **Library,** 1505 Warburton Ave, Santa Clara, CA 95050. Tel 408-247-3754; Fax 408-247-3796; Elec Mail triton246@aol.com; Internet Home Page Address: www.tritonmuseum.org; *Chief Cur* Susan Hillhouse; *Exec Dir* George Rivera; *Deputy Dir* Jill Meyers
Daily 11 AM - 5 PM, Thur 11 AM - 9 PM; none; Estab 1967 to enhance the resource of the art mus; Open to members for reference; Average Annual Attendance: 23,000; Mem: 550; dues $15-$1000
Income: 1,250,000
Library Holdings: Book Volumes 1200; Clipping Files; Exhibition Catalogs; Original Art Works; Periodical Subscriptions 15; Photographs; Prints; Sculpture; Slides; Video Tapes
Special Subjects: Folk Art
Collections: Special collection of artists books
Publications: Exhibition catalogs; quarterly newsletter
Activities: Classes for children; docent training; lect, gallery talks; tours; mus shop; books; magazines; original art

SANTA CLARITA

L **CALIFORNIA INSTITUTE OF THE ARTS LIBRARY,** 24700 McBean Pky, Santa Clarita, CA 91355. Tel 661-253-7885; Fax 661-254-4561; Elec Mail jgatten@calarts.edu; Internet Home Page Address: www.calarts.edu; *Dean* Jeff Gatten; *Performing Arts Librn* Kathy Carbone; *Info Resources Librn* Susan Lowenberg; *Reference & Instruction Librn* Aniko Halverson; *Visual Arts Librn* Karen Baxter
Open Mon - Thurs 9 AM - 12 AM, Fri 9 AM - 9 PM, Sat Noon - 5 PM, Sun 1 PM - 12 AM; Estab 1965, first classes 1970, designed to be a community of practicing artists working in schools of art, design film, music, theater & dance
Income: Financed by endowment
Library Holdings: Audio Tapes 6992; Book Volumes 98,215; Cards 3900; Cassettes; Exhibition Catalogs 14,410; Motion Pictures 1212; Pamphlets; Periodical Subscriptions 344; Records 10,418; Reels 5700; Slides 130,747; Video Tapes 4110
Special Subjects: Film, Theatre Arts, Video
Exhibitions: Student work, approximately 20 per year
Publications: California Institute of the Art Library Handbook
Activities: schols & fels offered

SANTA CRUZ

A **CHILDREN'S ART FOUNDATION,** Museum of International Children's Art, 765 Cedar St, Ste 201, Santa Cruz, CA 95060; PO Box 83, Santa Cruz, CA 95063. Tel 831-426-5557; Fax 831-426-1161; Elec Mail editor@stonesoup.com; Internet Home Page Address: www.stonesoup.com; *Pres* William Rubel; *Admin Asst* Barbara Harker; *VPres* Gerry Mandel
By appointment only; No admis fee; Estab 1973 to improve the quality of American art education; Gallery has 800 sq ft with rotating displays of art by children from around the world; Average Annual Attendance: 100; Mem: 20,000; dues $34; annual meetings
Collections: American children's art; drawings, paintings & prints from 40 countries
Exhibitions: Exhibit of 55 works from international children's art collection at Portland Art Museum; Exhibit of 50 paintings by Nelly Toll, made when she was a 10-year-old in hiding from the Nazis in Poland in 1943-44, at the University of California, Santa Cruz
Publications: Stone Soup, magazine 6 times per yr

M **MUSEUM OF ART & HISTORY, SANTA CRUZ,** 705 Front St, Santa Cruz, CA 95060. Tel 831-429-1964; Fax 831-429-1954; Elec Mail admin@santacruzmah.org; Internet Home Page Address: www.santacruzmah.org; *Exec Dir* Paul Figueroa; *Dir Exhib* Kathleen Moodie; *Cur Educ* Anna Castillo
Open Tues - Wed & Fri -Sun 11 AM - 5 PM, Thurs 11 AM - 7 PM; Admis adults $5, students & seniors $3, children 12-17 $2; Estab 1996 to promote understanding of contemporary art history & of Santa Cruz County; 2200 sq ft, 4 galleries, one permanent, 3 changing exhibition galleries; Average Annual Attendance: 21,000; Mem: 1400; dues $25-$10,000
Income: $100,000 (financed by endowment, mem, contributions, store income & county income)
Library Holdings: Book Volumes; Clipping Files; Exhibition Catalogs; Manuscripts; Maps; Memorabilia; Original Documents; Photographs; Prints; Slides; Video Tapes
Special Subjects: Architecture, Drawings, Painting-American, Photography, Prints, Sculpture, Watercolors, Textiles, Costumes, Ceramics, Folk Art, Pottery, Etchings & Engravings, Landscapes, Decorative Arts, Manuscripts, Dolls, Furniture, Historical Material, Maps, Embroidery, Gold
Collections: Contemporary art collection on paper; archival material; decorative costumes; textiles & 3-D objects; fine art of Santa Cruz County history; Santa Cruz County Photographs
Exhibitions: Where the Redwoods Meet the Sea: A History of Santa Cruz County & its people; Time & Place: 50 Years of Santa Cruz Studio Ceramics Art
Publications: Santa Cruz County History Journal, annually; catalogues; quarterly newsletter
Activities: Docent training; sch art & history progs; lect open to public, 12 vis lectrs per year; gallery talks; tours; originate traveling exhibitions; museum shop sells books, original art, gifts & film series

A **SANTA CRUZ ART LEAGUE, INC,** Center for the Arts, 526 Broadway, Santa Cruz, CA 95060. Tel 831-426-5787; Fax 831-426-5789; Internet Home Page Address: www.scal.org; *Office Mgr* Kim Scheibraur; *Pres* Stephanie Schriber; *Publ Mgr* Margo Kuhre
Open Wed - Sat 11 AM - 5 PM, Sun Noon - 4 PM, cl Mon & Tues; No admis fee; Estab 1919, Incorporated 1949, to further interest in visual & arts performing in community; 2000 sq ft of gallery space, off-site exhibits, 65-seat performance hall; Average Annual Attendance: 10,000; Mem: 750; dues seniors & students $35-55, individual $55, family $70-85, 2-year membership $95, business partners $250-500
Income: Financed by donations, dues & grants
Collections: Local historical & contemporary works
Exhibitions: Annual Statewide Juried Show; Open Studios Preview; Annual High School Show; Summer Art Fair; Luck-of-the-Draw Auction-Fundraiser; Dec 8 Auction
Publications: Quarterly newsletter, exhibit catalogs
Activities: Classes for adults & children; classes in painting, drawing & sculpture; dramatic programs; docent training; demonstration by professional artist at monthly meetings; 12 vis lectrs per year; gallery talks; competitions with awards; scholarships offered to senior high schools in Santa Cruz County; sales shop sells original art, reproductions & prints

UNIVERSITY OF CALIFORNIA AT SANTA CRUZ
M **Eloise Pickard Smith Gallery,** Tel 831-459-2953; *Dir* Linda Pope
Open Tues - Sun 11 AM - 5 PM; No admis fee; Estab 1967; art of the Monterey Bay Region; Average Annual Attendance: 4,000
Income: University Gallery
Activities: Docent training; gallery talks
M **Mary Porter Sesnon Art Gallery,** Tel 831-459-2314; Fax 831-459-3535; Elec Mail sesnon@ucsc.edu; Internet Home Page Address: http://arts.ucsc.edu/sesnon; *Dir* Shelby Graham
Open Tues - Sat Noon - 5 PM; No admis fee; Estab 1974 for curricular support through exhibitions & programs; Average Annual Attendance: 6,000
Income: $51,000 (financed by endowment, state appropriation, donor support & catalog sales)
Publications: Exhibition catalogs, periodically
Activities: Lect open to public, 3 vis lectrs per year; gallery talks; originate traveling exhibitions to other Univ Calif campuses

SANTA MONICA

A **18TH STREET ARTS COMPLEX,** 1639 18th Street, Santa Monica, CA 90404. Tel 310-453-3711; Fax 310-453-4347; Elec Mail arts18thst@aol.com; Internet Home Page Address: www.artswire.org/arts18st; *Co-Dir* Clayton Campbell; *Co-Dir* Jan Williamson; *Operations Mgr* Leo Garcia; *Prog Coordr* Michael Sakamoto; *Develop Assoc* Andrea Stang
Open 10 AM - 6 PM; Provides art services to the pub & services to artists & art organizations engaged with contemporary issues of community & diversity
Collections: High Performance Magazine Archives
Publications: Traffic Report, annual
Activities: Educ progrm; lects open to the public

M **AMERICAN MUSEUM OF CARTOON ART, INC,** 2930 Colorado Ave, A-14, Santa Monica, CA 90404. Tel 310-828-2919; Fax 310-453-3003; Elec Mail jeremykay@msn.com; Internet Home Page Address: cartoonmuseum.com; *Dir & Cur* Jeremy Kay; *Assoc Dir* Jaeson Kay; *Treas* Liz Kay
Internet 24/7; Estab 1976 to preserve & display historic cartoon art; Circ 200 +; Maintains reference library; Average Annual Attendance: 150; Mem: 1,500; dues $50
Income: Financed by endowment, mem, city & state appropriation
Special Subjects: Cartoons
Collections: Animation Cartoons Art Comic Books Cartoon Art Historic Cartoons Art Newspaper Cartoon Art Original Cartoon Art
Publications: Annual Report
Activities: Classes for adults & children; docent training; community cartoon classes; lect open to public, 150 vis lectrs per year; originate traveling exhibitions; sales shop sells books, magazines, original art, reproductions, prints & slides

M **SANTA MONICA COLLEGE,** Pete & Susan Barrett Art Gallery, 1900 Pico Blvd, Santa Monica, CA 90405. Tel 310-434-4000; Fax 310-434-3646; Internet Home Page Address: www.smc.edu; *Gallery Chmn* Maurizio Barattuci
Open Mon - Fri 10 AM - 5 PM, Sat 11 AM - 4 PM, cl academic holidays; No admis fee; Estab 1973 to provide a study gallery for direct contact with contemporary & historic works of art; Average Annual Attendance: 25,000
Income: Financed by mem, city & state appropriations
Collections: Southern California prints & drawings
Exhibitions: Rotating exhibitions every 3-4 weeks
Activities: Lect open to public; gallery talks; tours; original art objects lent

M **SANTA MONICA MUSEUM OF ART,** Bergamot Station Art Ctr, 2525 Michigan Ave G1 Santa Monica, CA 90404. Tel 310-586-6488; Fax 310-586-6487; Elec Mail info@smmoa.org; Internet Home Page Address: www.smmoa.org; *Exec Dir* Elsa Longhauser; *Exec Asst* Denise Feathers; *Registrar* Margaret Brady; *Deputy Dir Exhibitions* Lisa Melandri; *Dir External Affairs* Suzanne Tan; *Dir Finance & Admin* Patricia Scharf; *Visitor Svcs* Elizabeth Pezza; *Dir Educ* Asuka Hisa; *Pub Rels & Mktg* Alexandra Pollyea; *Membership Coordr* Diana Joe
Open Tues - Sat 11 AM - 6 PM,; Suggested donation adults $5, students and seniors $3; Estab 1985 to present exhibitions of contemporary art; Average Annual Attendance: 35,000; Mem: 600
Special Subjects: Anthropology, Drawings, Architecture, Ceramics, Photography, Painting-American, Prints, Textiles, Painting-European, Sculpture, Hispanic Art, Latin American Art
Collections: Contemporary art
Activities: Educ program; classes for adults & children; outreach programs; lect open to public; 8-10 vis lectrs per year; gallery talks; tours; concerts; book traveling exhibitions; mus shop sells books, original art, gifts

SANTA ROSA

SANTA ROSA JUNIOR COLLEGE
M **Art Gallery,** Tel 707-527-4298, 527-4011, Ext 4575; Fax 707-527-4532; Internet Home Page Address: www.santarosa.edu; *Dir* Renata Breth
Open Tues - Fri & Sun Noon - 4 PM; No admis fee; Estab 1973; 1700 sq ft exhibit space with movable walls; Average Annual Attendance: 10,000
Exhibitions: Four exhibits during the school year generally of contemporary artists of national & local prominence & of emerging new artists
Activities: 1-2 vis lectrs per year; gallery talks

SARATOGA

A **MONTALVO CENTER FOR THE ARTS,** 15400 Montalvo Rd, PO Box 158 Saratoga, CA 95071. Tel 408-961-5800; Internet Home Page Address: www.villamontalvo.org; *Exec Dir* Elizbeth Challener
Open daily; call ahead for hrs; No admis fee; Estab 1930; administered by Montalvo Association; Villa Montalvo is part of a cultural center for the development of art, literature, music & architecture by artists & promising students; There are facilities for five artists-in-residence. The home of the late US Senator & Mayor of San Francisco, James Duval Phelan, was bequeathed as a cultural center & is conducted as a nonprofit enterprise by the Board of Trustees of the Montalvo Association; Average Annual Attendance: 7,000; Mem: 1,250; dues $25 & up; annual meeting in Nov
Income: $350,000 (financed by donation, grants & investments)
Exhibitions: 20 solo exhibitions per year of emerging artists in all media; occasional special or group exhibitions
Publications: Calendar, monthly
Activities: Lect open to public, 8 vis lectrs per year; concerts; gallery talks; tours; competitions with awards; plays; winter workshops; scholarships offered; museum shop sells books, original art, reproductions, prints & gift items

SAUSALITO

A **HEADLANDS CENTER FOR THE ARTS,** 944 Fort Barry, Sausalito, CA 94965. Tel 415-331-2787; Fax 415-331-3857; Elec Mail staff@headlands.org; Internet Home Page Address: www.headlands.org; *Prog Dir* Linda Samuels; *Residency Mgr* Holly Blake; *Exec Dir* Kathryn Reasoner; *Develop Dir* Blair Winn
Open daily Tues - Fri & Sun Noon - 5 PM; No admis fee; Estab 1982 to provide studios for artists in the scenic natural setting of the Marin Headlands, a National Park; 1,800 square ft project space - rotates monthly; Average Annual Attendance: 10,000; Mem: 500; dues $35 & up
Income: $900,000 (financed by endowment, city appropriation, donations from foundations & corporations)
Publications: Newsletter, three times a year
Activities: Lect open to pub; lect for members only; artist talks, lect & performances; 8 vis lectrs per year; concerts; gallery talks; artist residencies

SEBASTOPOL

A **SURFACE DESIGN ASSOCIATION, INC,** PO Box 360, Sebastopol, CA 95473. Tel 707-829-3110; Fax 707-829-3285; Elec Mail surfacedesign@mail.com; Internet Home Page Address: www.surfacedesign.org; *Pres* Jason Pollen; *Treas* Suzanne Williams; *Ed Surface Design Journal* Patricia Malarcher; *Exec Dir* Joy Stocksdale
No admis fee; Estab 1976; Mem: 3600; dues students $25, regular $50, outside USA $65
Income: Financed by mem
Publications: SDA Newsletter, quarterly; Surface Design Journal, quarterly
Activities: Classes for adults; national conferences; workshops; seminars; lect open to members only; competitions with cash prizes; scholarships & fels offered; originate traveling exhibitions

SOLVANG

M **ELVERHOJ MUSEUM OF HISTORY AND ART,** 1624 Elverhoy Way, Solvang, CA 93464; PO Box 769, Solvang, CA 93464. Tel 805-686-1211
Wed & Thurs 10 - 4 PM, Fri - Sun 12 PM - 4 PM & by appt; Suggested donation $3 per person; Former residence of one of Solvang's most artistic families, mus is devoted to local history & the Danish-American pioneer spirit of the town's founder; Mem: Dues Patron $500; Benefactor $250; Business $100; Couple or Family $50; Indiv $35
Special Subjects: Decorative Arts, Art Education, Art History, Painting-European, Architecture, Porcelain, Silver
Collections: Exhibs featuring local history & Danish culture; art gallery with changing exhibs; porcelain; silver
Publications: newsletter
Activities: Garden; ann events; Living History Days, juried shows; Danish language classes; children's workshops

SONOMA

M **SONOMA VALLEY HISTORICAL SOCIETY'S DEPOT PARK MUSEUM,** 270 First St W, Depot Park Sonoma, CA; PO Box 861, Sonoma, CA 95476. Tel 707-938-1762; Fax 707-938-1762; Elec Mail depot@vom.com; Internet Home Page Address: www.vom.com/depot; *Dir* Diane Smith
Open Wed - Sun, 1 - 4 PM; No admis fee, donations welcome; Estab 1979; Old rail depot with three railroad cars, local history rooms, gift sop & book store; Average Annual Attendance: 5,000-7,000; Mem: 380; dues $20 & up; ann & monthly meetings
Income: Financed by mem, donations & grants
Collections: Raising of the Bear Flag

Exhibitions: Rotating exhibitions
Publications: Sonoma Valley Notes, bimonthly; Sonoma Mission, Robert Smiley; Pioneer Sonoma, Robert Parmelee; Schools & Scows of Early Sonoma, Roger & George Emanuels; Saga of Sonoma; The Men of the Bear Flag Revolt & their Heritage, Barbara Warner
Activities: Docent training; school tours; lect open to public; 6-8 vis lects per year; scholarships; museum shop; books; reproductions; photos & antiques

STANFORD

M **STANFORD UNIVERSITY,** Iris & B Gerald Cantor Center for Visual Arts, Lomita Dr at Museum Way, Stanford, CA 94305-5060. Tel 650-723-4177; Fax 650-725-0464; Internet Home Page Address: http://museum.stanford.edu/; *Dir* Thomas K Seligman; *Chief Cur* Bernard Barryte; *Cur Prints & Drawings* Betsy G Fryberger; *Head Registration-Conservation* Susan Roberts-Manganelli; *Cur Modern & Contemporary* Dr Hilarie Faberman; *Cur African & Oceanic Art* Dr Manuel Jordan; *Assoc Dir External Affairs* Mona Duggan; *Cur American Art* Claire Perry; *Cur Educ* Patience Young; *Finance Officer* Janet Tang; *Assoc Cur Educ* Lauren Silver
Open Wed - Sun 11 AM - 5 PM, Thurs 11 AM - 8 PM; No admis fee; Estab 1894 as a teaching mus & laboratory for University's Department of Art; Average Annual Attendance: 150,000; Mem: 3500; dues $50 - $10,000; annual meeting in May
Income: Financed by endowment, mem & university funds
Special Subjects: Painting-American, Photography, Watercolors, American Indian Art, Bronzes, African Art, Pre-Columbian Art, Religious Art, Pottery, Primitive art, Woodcuts, Etchings & Engravings, Decorative Arts, Painting-European, Portraits, Furniture, Painting-British, Baroque Art, Renaissance Art, Medieval Art, Painting-Spanish, Antiquities-Egyptian, Antiquities-Greek, Antiquities-Roman, Mosaics
Collections: B G Cantor Gallery of Rodin Sculpture; Cesnola Collection of Cypriote antiquities; prints & drawings since the Renaissance; Stanford Family Colection; African art; American art of 19th & 20th centuries; ancient art; contemporary art; European art 16th-20th century; Native American art; Asian art; Oceanic art; photography including major holdings by Robert Frank & Eadwaerd Muybridge; Pre-Columbian art
Exhibitions: (11/15/2006-3/4/2007) Visions of Dharma: Thai Contemporary Art; (2/14/2007-5/6/2007) In the American West: Photographs by Richard Avedon; (3/21/2007-7/1/2007) Bare Witness: Photographs by Gordon Parks; (5/30/2007-9/2/2007) Art of Being Tuareg: Sahara Nomads in a Modern World; (7/25/2007-10/28/2007) Yosemite's Structure & Textures: Photographs by Eadweard Muybridge, Carleton Watkins, Ansel Adams & Others; (8/8/2007-12/2/2007) Mutual Admiration: Eugène Carrière & His Circle; (10/3/2007-1/6/2008) Anxious Objects: Willie Cole's Favorite Brands; (11/21/2007-3/2/2008) Dreaming of a Speech Without Words: The Paintings and Early Objects of H.C. Westermann
Publications: The Stanford Museum, biennial journal; catalog of drawing collection; exhibition catalogs; handbook of the collection
Activities: Classes for children; docent training; lect open to the public, 15 vis lectrs per year; gallery talks; tours; 2-3 book traveling exhibitions per year; originate traveling exhibitions to international museums; museum shop sells books, jewelry & crafts
L **Art & Architecture Library,** 102 Cummings Art Bldg, Stanford, CA 94305-2018. Tel 415-723-3408; Fax 415-725-0140; Elec Mail artlibrary@stanford.edu; Internet Home Page Address: www.sul.stanford.edu/depts/art/index.html; *Head Librn* Alex Ross; *Deputy Librn* Peter Blank; *Ref Librn* Katie Keller; *Acting Head, VRC* Amber Ruiz
Open Mon - Thurs 9 AM - 10 PM, Fri & Sat 9 AM - 5 PM, Sun 1 - 10 PM; Circ 40,000; Library limited service to non-Stanford patrons
Library Holdings: Book Volumes 160,000; CD-ROMs; Exhibition Catalogs; Fiche; Periodical Subscriptions 560

STOCKTON

M **THE HAGGIN MUSEUM,** (San Joaquin Pioneer & Historical Society) 1201 N Pershing Ave, Stockton, CA 95203-1699. Tel 209-940-6311; Fax 209-462-1404; Elec Mail info@hagginmuseum.org; Internet Home Page Address: www.hagginmuseum.org; *Dir & Cur of History* Tod Ruhstaller; *Cur Educ* Marilyn Guida; *Cur Coll* Karen Jahnke-Banla; *Librn & Archivist* Susan Benedetti; *Develop Officer* Susan Obert; *Accountant* Karen Richards; *Mus Store Mgr* Patty Huntley; *Webmaster, Publicity* Carol Pejovich; *VPres* Arthur Sanguinetti; *Facilities Supt* Jun Pangilinan; *VPres* Jeffrey M. Greeenberg; *Dir Asst* Barbara Bahler
Open Tues - Sun 1:30 - 5 PM; Admis adults $5, youth 10 - 17, seniors, students with ID $250, children under 10 with an adult and members free; Estab 1928 to protect, preserve & interpret for present & future generations historical & fine arts collections that pertain to the museum's disciplines; The mus covers 34,000 sq ft of exhibit space housing art & history collections; Average Annual Attendance: 69,000; Mem: 1500; dues $25 & up; annual meeting third Tues in Jan
Income: $900,000 (financed by endowment, mem & foundation grant)
Library Holdings: Book Volumes; Cassettes; Clipping Files; Exhibition Catalogs; Kodachrome Transparencies; Lantern Slides; Manuscripts; Memorabilia; Motion Pictures; Other Holdings; Pamphlets; Photographs; Prints; Slides
Special Subjects: Painting-American, Decorative Arts, Painting-European, Painting-French
Collections: 19th-Century French, American & European paintings; Oriental & European decorative arts; graphics; Japanese woodblock prints; American Illustrators; ancient arts; Stockton/San Joaquin County History Collections
Exhibitions: 6 - 8 temporary exhibits per year; Stockton Art League Juried Exhibition; Robert T McKee Student Art Exhibition; Art and history related exhibitions
Publications: Museum Calendar, quarterly
Activities: Summer art classes for children; docent training; lect open to public; concerts; gallery talks; tours; competitions with awards; individual paintings & original objects of art lent; book traveling exhibitions 6-8 per year; sales shop sells books, postcards, posters, notecards, gift items
L **Petzinger Memorial Library & Earl Rowland Art Library,** Victory Park, 1201

N Pershing Ave Stockton, CA 95203-1699. Tel 209-940-6300; Fax 209-462-1404; Elec Mail info@hagginmuseum.org; Internet Home Page Address: www.hagginmuseum.org; *Dir* Tod Ruhstaller; *Librn, Archivist* Kimberly D. Bowden
appointment only; $15 appointment fee; Estab 1941 to supply material to those interested in the research of California & San Joaquin County history as well as the history of Stockton; art reference library; For reference only
Income: $15,000 (financed by endowment for Historical Libraries)
Purchases: $400
Library Holdings: Book Volumes 7500; Cassettes; Clipping Files; Exhibition Catalogs; Kodachrome Transparencies; Lantern Slides; Manuscripts; Memorabilia; Motion Pictures; Other Holdings Original documents; Pamphlets; Photographs; Prints; Slides
Special Subjects: Painting-American, Painting-French, Historical Material, American Western Art
Collections: Earl Rowland Art Reference Library

M **UNIVERSITY OF THE PACIFIC,** Jeannette Powell Art Center, 3601 Pacific Ave, Stockton, CA 95211. Tel 209-946-2011; Fax 209-946-2652; Internet Home Page Address: www.uop.edu; *Pres* Donald DeRosa; *Chair* Barbara Flaherty
Open Mon - Fri 8:30 AM - 4:30 PM, Sat & Sun 1 - 6PM; No admis fee; Estab 1975 to expose the University community to various art forms; Gallery is 1200 sq ft with 80 ft wall space, well equiped ceiling spots and flat panels; Average Annual Attendance: 10,000
Income: Financed by student fees & sales
Exhibitions: Rotating schedule of contemporary California artists
Activities: Lect open to public, 3-4 vis lectrs per year; gallery talks; juried contests; awards; tours

SYLMAR

M **COUNTY OF LOS ANGELES,** Century Gallery, 13000 Sayre St, Sylmar, CA 91342. Tel 818-362-3220; Fax 818-364-7755; *Dir* John Cantley
Open Mon - Fri 9 AM - 5 PM, Sat Noon - 4 PM; No admis fee; Estab 1977 for contemporary art exhibits & to bring educational value to the community; Average Annual Attendance: 7,500
Income: Financed by city, county & state appropriation
Exhibitions: Seven curated theme exhibits of contemporary art
Activities: Gallery talks; competitions

THOUSAND OAKS

M **CONEJO VALLEY ART MUSEUM,** PO Box 1616, Thousand Oaks, CA 91358. Tel 805-373-0054, 373-0049; Fax 805-492-7677; Internet Home Page Address: conejovalleyartmuseum.org; *CEO & VPres* Maria Dessornes
Open Wed & Fri - Sun Noon - 5 PM; No admis fee, donation suggested; Estab 1975 to exhibit works of nationally & internationally known artists; Average Annual Attendance: 10,000; Mem: 350; dues family $35, single $25
Income: Financed by mem, donations & grants
Collections: Large Serigraph by Ron Davis
Exhibitions: Artwalk; Juried Fine Art & Designer Crafts Outdoor Exhibition
Activities: Lect open to public, 6 vis lectrs per year; concerts; gallery talks; competitions with awards; scholarships offered; museum shop sells books, magazines, prints, jewelry & folk art

TORRANCE

M **EL CAMINO COLLEGE ART GALLERY,** 16007 Crenshaw Blvd, Torrance, CA 90506. Tel 310-660-3010, 3011; Fax 310-660-3792; *Dir* Susana Meiers
Open Mon & Tues 10 AM - 3 PM, Wed & Thurs 10 AM - 8 PM, Fri 10 AM - 2 PM; No admis fee; Estab 1970 to exhibit professional, historical & student art; Gallery has 2,300 sq ft of exhibit space located on the ground floor of the Art Building on campus; Average Annual Attendance: 5,000
Special Subjects: Prints, Sculpture
Collections: Small print collection; small sculpture collection
Exhibitions: Juried student exhibit; organizational & guild competitions.; Shadow Pieces; Student Show; Taleteller
Publications: Exhibit catalogs
Activities: Classes for adults; docent training; lect open to public, 25 vis lectrs per year; concerts; gallery talks; tours; competitions with awards; scholarships offered through the Library; exten dept serves the South Bay Community; collections or parts of collections are exchanged; lending collection contains books & sculpture; sales shop sells original art & posters

TURLOCK

CALIFORNIA STATE UNIVERSITY STANISLAUS
M **University Art Gallery,** Tel 209-667-3186; Fax 209-667-3871; Elec Mail art_gallery@csustan.edu; Internet Home Page Address: www.csustan.edu/art/gallery; *Gallery Dir* Dean De Cocker
Open Mon - Thurs Noon - 4 PM or by appointment; No admis fee; Estab 1967, for the purpose of community & cultural instruction; display, educate & foster contemporary art; Gallery is small, covering 200 running ft; Average Annual Attendance: 2,500
Income: Financed by state appropriation
Special Subjects: Drawings, Latin American Art, Painting-American, Photography, Sculpture, African Art, Pre-Columbian Art, Oriental Art, Asian Art, Historical Material
Collections: Permanent collection of graphics & small contemporary works; Ancient Egyptian & Greek artifacts; California Paintings 19th & 20th Century; contemporary paintings; Italian Renaissance Jewelry; Japanese artifacts; Pre-Conquest artifacts; Tamarind prints, William Wendt paintings (California landscapes)
Exhibitions: Exhibs annually including sr art sho

Activities: Classes for adults; lect open to public, 6 vis lectrs per year; concerts; gallery talks; tours; exten dept serving summer school; individual paintings & original objects of art lent to qualified museums & galleries & campus community; lending collection contains film strips, 35mm lantern slides, motion pictures, original art works, original prints; book traveling exhibitions 1-2 per year; originate traveling exhibitions to University Art Galleries

L **Vasche Library,** Tel 209-667-3232; Fax 209-667-3164; Internet Home Page Address: www.library.csustan.edu; *Dean Library Serv* Carl Bengston; *Library Admin Support Coordr* Loretta Blakeley
Open Mon - Thurs 7:30 AM - 11 PM, Fri 7:30 AM - 5 PM, Sat 9 AM - 5 PM, Sun 1 - 9 PM; Estab 1960, a regional state university
Purchases: $8,800
Library Holdings: Audio Tapes; Book Volumes 11,000; Cassettes; Fiche; Micro Print; Periodical Subscriptions 37; Reels; Video Tapes

UKIAH

M **CITY OF UKIAH,** Grace Hudson Museum & The Sun House, 431 S Main St, Ukiah, CA 95482. Tel 707-467-2836; Fax 707-467-2835; Elec Mail gracehudson@pacific.net; Internet Home Page Address: www.gracehudsonmuseum.org; *Dir* Sherrie Smith-Ferri; *Registrar* Karen Holmes; *Cur* Marvin Schenck
Open Wed - Sat 10 AM - 4:30 PM, Sun Noon - 4:30 PM; Admis individual $2, family $5; Estab 1975; 3 permanent collection collections galleries, 1 changing exhibit gallery; Average Annual Attendance: 11,500
Income: $220,000 (financed by endowment, mem, city appropriation & grants)
Special Subjects: Painting-American, American Indian Art, American Western Art, Anthropology, Ethnology, Manuscripts
Collections: Hudson & Carpenter Family Collection; Grace Hudson Art Collection; Collection of Pomo Indian arts & material cult; Photographic & manuscript archives
Exhibitions: Grace Hudson (art); History & Anthropology of Native Americans; regional artists
Publications: exhibit catalogs
Activities: Classes for adults & children in docent programs; lect open to public, 2-3 vis lectr per year; book traveling exhibitions 1 per year; originates traveling exhibitions 1 per year; museum shop sells books, magazines, slides, original art, reproductions & jewelry

VALLEY GLEN

M **LOS ANGELES VALLEY COLLEGE,** Art Gallery, 5800 Fulton Ave, Valley Glen, CA 91401. Tel 818-781-1200; Internet Home Page Address: www.lavalleycollege.com; *Dir* James Marren
Open Mon-Thurs Noon-3 PM & 7-9 PM; No admis fee, donation requested; Estab 1960 to show changing exhibitions of ethnic, historical, & contemporary art; Single gallery
Income: $25,000 (financed by state appropriation & fundraising)
Exhibitions: Various exhib
Activities: Lect open to public, 2 vis lectr per year

VENICE

A **BEYOND BAROQUE FOUNDATION,** Beyond Baroque Literary Arts Center, 681 Venice Blvd, Venice, CA 90291. Tel 310-822-3006; Fax 310-827-7432; Internet Home Page Address: www.beyondbaroque.org; *Exec & Artistic Dir* Fred Dewey
Open Fri 11AM-6PM & during events; Admis non-members $7, students $5, members free; Estab 1968 to promote & support literary arts projects, writers & artists in Southern Calif & nationally; Bookstore, theatre & gallery; Mem: 500; dues $30 annually
Income: $175,000 (financed by grants from National Endowment for the Arts, California Art Council, City of Los Angeles, other government & private grants as well as donations from the public)
Activities: All types of writing workshops; art lect open to public; weekly reading & performance series; art gallery; film program; music program

A **SOCIAL & PUBLIC ART RESOURCE CENTER,** (SPARC), 685 Venice Blvd, Venice, CA 90291. Tel 310-822-9560; Fax 310-827-8717; Elec Mail sparc@sparcmurals.org; Internet Home Page Address: www.sparcmurals.org; *Artistic Dir* Judith F Baca; *Exec Dir* Debra Padilla
Open Mon - Fri 10 AM - 4 PM, Sat - Sun 1 PM - 4 PM during some exhibitions only; Admis donations requested; Estab 1976 as a nonprofit multicultural art center that produces, exhibits, distributes & preserves public artworks; 1st fl in the Old Venice Police Sta; Average Annual Attendance: 10,000; Mem: 200; dues $25 & up; mem open to public
Income: Financed by government funding, mem & donations
Collections: Archive coll of over 60,000 mural images
Exhibitions: 4-6 exhibits per yr
Publications: California Chicano Muralists; Signs from the Heart
Activities: Classes for adults & children; lect open to public, 6-10 vis lectr per year; gallery talks; mural tours; competitions; scholarships & fels offered; individual paintings & original objects of art lent to museums; lending collection contains books, framed reproductions, original art works, original paintings, paintings, photographs & slides; originate traveling exhibitions; sales shop sells books, original art, reproductions, prints, slides, cards & postcards

VENTURA

M **VENTURA COLLEGE,** Art Galleries, 4667 Telegraph Rd, Ventura, CA 93003. Tel 805-648-8974; Fax 805-654-6466; *Dir Gallery* Sheldon Hocking
Call ahead for hours; No admis fee; Estab 1970s to showcase faculty & student artworks, as well as prestigious artists from throughout the country; Gallery 2 & New Media Gallery

Activities: Originate traveling exhibitions

M **VENTURA COUNTY HISTORICAL SOCIETY,** Museum of History & Art, 100 E Main St, Ventura, CA 93001. Tel 805-653-0323; Fax 805-653-5267; Internet Home Page Address: www.vcmha.org; *Res Librn* Charles Johnson; *Exec Dir* Tim Schiffer; *Dir Community Relations* Pattie Dix
Open Tues - Sun 10 AM - 5 PM, cl Mon; Admis $4 adults, $3 seniors, $1 children 6 - 17, members & children under 5 free; Estab 1913 to collect, study, & interpret the history & art of Ventura County; Hoffman Gallery houses changing exhibits every 6-8 weeks; Average Annual Attendance: 45,000; Mem: 2300; dues $45 - $5,000; annual meeting in Oct
Income: $500,000 (financed by endowment, mem, county appropriation)
Special Subjects: Historical Material
Collections: Farm implements & machines; fine arts; historical artifacts; historical figures; prehistorical artifacts
Publications: Heritage & History, monthly; Ventura County Historical Quarterly
Activities: Docent training & networking; school outreach; classes for adults & children; lect open to public, 9 vis lectr per year; gallery talks; tours; lect series & special events with each exhibit; museum shop sells books, original art, jewelry, and clothing

WALNUT CREEK

M **DEAN LESHER REGIONAL CENTER FOR THE ARTS,** Bedford Gallery, 1601 Civic Dr, Walnut Creek, CA 94596. Tel 925-295-1417; Fax 925-295-1486; *Cur* Carrie Lederer
Open Tues, Wed & Sun Noon - 5 PM, Thurs - Sat 6 - 8 PM, cl Mon & national holidays; No admis fee; Estab 1963 to offer varied & education changing exhibitions to the community & surrounding area; Gallery contains 396 running ft, 3500 sq ft; Mem: 1200; dues Diablo Regional Arts Assoc mem $35
Income: Funded by city, pub & pvt grants
Exhibitions: 5-6 exhibits on view at the gallery each year
Publications: City Scene Newsletter; three catalogs per year; The Diablo Magazine, quarterly
Activities: Classes for adults & children; dramatic programs; docent training; lect open to public, 6-10 vis lectr per year; concerts; gallery talks; tours; competitions

WEST HOLLYWOOD

M **MAK-CENER FOR ART & ARCHITECTURE,** MAK - Austrian Museum of Applied Art, 835 North Kings Rd, West Hollywood, CA 90069. Tel (0222) 71136-0; Elec Mail office@mak.at; Internet Home Page Address: www.mak.at; *Dir* Peter Noever; *Dir* Lou Anne Greenwald
Tues 10 a.m. - 12 p.m. (MAK-NITE), Wed - Sun 10 a.m. - 6 p.m.; Estab 1864, Museum for applied art/library/graphic collection; Circ 7,200; Library with 100,000 vols & 250,000 prints; Average Annual Attendance: 120,000
Library Holdings: Auction Catalogs; Book Volumes; Compact Disks; Exhibition Catalogs; Kodachrome Transparencies; Manuscripts; Original Art Works; Original Documents; Periodical Subscriptions; Photographs; Prints; Slides; Video Tapes
Collections: Applied arts from Roman to modern age; Vienna Workshop, Art Library, Far Eastern; Dept of Furniture, Glass & Ceramics
Activities: Cl for children; docent training; lectrs open to the publ; gallery talks; tours; lending of org objects of art all around the world; mus shop sells books, org art, reproductions, prints & items from contemporary designer

WESTCHESTER

M **OTIS COLLEGE OF ART & DESIGN,** Ben Maltz Gallery, 9045 Lincoln Blvd, Westchester, CA 90045. Tel 310-665-6905; Fax 310-665-6908; Elec Mail galleryinfo@otis.edu; Internet Home Page Address: www.otis.edu/benmaltzgallery; *Gallery Coordr* Jinger Heffner; *Dir* Meg Linton; *Gallery Mgr* Kathy Macpherson; *Public Prog Coordr* Emily de Araujo
Open Tues, Wed, Fri & Sat 10 AM - 5 PM, Thurs 10 AM - 7 PM; No admis fee; Estab 1954 as a forum for contemporary art; Gallery is white drywall; 2700 sq ft; Average Annual Attendance: 20,000
Income: Financed by endowment
Special Subjects: Drawings, Photography, Sculpture
Collections: Contemporary art
Publications: Catalogues for Tom Knechtel, Shahzier Sikander, Joan Tanner
Activities: Lect open to public, 2-3 vis lectrs per year; gallery talks; book traveling exhibitions; originate traveling exhibitions to other university museums & galleries

L **Millard Sheets Library,** 9045 Lincoln Blvd, Los Angeles, CA 90045. Tel 310-665-6930; Elec Mail otislib@otisart.edu; *Dir* Sue Maberry
Open Mon - Fri 9 AM - 9 PM (during school session), Sat 9 AM - 5 PM; open to pub by appointment only; cl Sun; Estab 1918 as a visual arts library
Library Holdings: Audio Tapes; Book Volumes 30,000; Cassettes; Clipping Files; Exhibition Catalogs; Original Art Works; Pamphlets; Periodical Subscriptions 150; Records 150; Slides 100,000; Video Tapes 1000
Special Subjects: Decorative Arts, Mixed Media, Photography, Graphic Arts, Costume Design & Constr

WHITTIER

M **RIO HONDO COLLEGE ART GALLERY,** 3600 Workman Mill Rd, Whittier, CA 90601-1699. Tel 310-908-3428; Fax 310-908-3446; *Div Dean* Dr. Mitjl Carvalho; *Gallery Dir* William Lane
Open Mon - Fri 11 AM - 4 PM; No admis fee; Estab 1967 to bring to the college students a wide variety of art experiences that will enhance & develop their sensitivity & appreciation of art; Small gallery about 1,000 sq ft located within the art facility; Average Annual Attendance: 8,000
Income: Financed through college
Collections: Contemporary paintings and graphics by Southern California artists

Exhibitions: Landscapes by Paul Donaldson, Carl Aldana, James Urstrom; Sculptures by Joyce Kohl; Self Portraits by Selected California Artists; student shows and area high school honor show
Activities: Classes for adults; lect open to public; 2-4 vis lectr per yr

YOSEMITE NATIONAL PARK

M **YOSEMITE MUSEUM,** National Park Service, PO Box 577 Yosemite National Park, CA 95389. Tel 209-372-0281, 372-0297; *Cur Ethnography* Craig D Bates; *Coll Mgr* Barbara Beroza; *Chief Cur* David M Forgang
Open daily summer 9 AM - 5 PM, winter Fri - Tues 9 AM - 5 PM; No admis fee; Estab 1926 to interpret the natural sciences & human history of the Yosemite area; Mem: 1700; dues $10 & up
Income: Financed by federal appropriation
Special Subjects: Photography, American Indian Art
Collections: Indian cultural artifacts; original paintings & photos of Yosemite; photographs (special collection on early Yosemite); pioneer artifacts; Yosemite related emphemera
Exhibitions: Rotating exhibits
Activities: Classes for adults & children; lect open to public; paintings & original art objects lent on special exhibits only; lending collection contains prints, photographs; sales shop sells books, magazines, reproductions, prints, slides; junior museum
L **Research Library,** PO Box 577, Yosemite National Park, CA 95389. Tel 209-372-0280;
For reference only
Income: Federal appropriation
Library Holdings: Book Volumes 10,000; Clipping Files; Exhibition Catalogs; Fiche; Lantern Slides; Manuscripts; Memorabilia; Pamphlets; Periodical Subscriptions 100; Photographs; Reels; Reproductions; Slides

YOUNTVILLE

M **NAPA VALLEY MUSEUM,** PO Box 3567, 55 Presidents Circle Yountville, CA 94599-3567. Tel 707-944-0500; Fax 707-945-0500; Internet Home Page Address: www.napavalley.museum.org; *Cur* Randolph Murphy; *Facilities Mgr* Victor Paddock; *Exec Dir* Eric Nelson; *Educ* Evangeline Tai; *Office Mgr* Tricia Westbrook
Open Wed - Mon 10 AM - 5 PM, cl Tues; Admis adult $4.50, seniors & students $3.50, children $2.50; Estab 1971 for regional history, art & natural history; Average Annual Attendance: 12,000; Mem: 900; dues $35-$1000 & up; annual meeting 2nd Tues in June
Income: $450,000 (financed by endowment, mem, museum store, admis & grants)
Special Subjects: Painting-American, Photography, Watercolors
Collections: Henry Evans - linocut prints; Andrew Grayson Jackson - lithos; Sophie Alstrom Mitchell - watercolors; Charles O'Rear - photography
Publications: Quarterly newsletter
Activities: Progs for adults & children; dramatic programs; docent training; lect open to public; exten dept serves local schools; book traveling exhibitions 6 per year; retail shop sells books, prints, magazines & gifts

COLORADO

ASPEN

M **THE ASPEN ART MUSEUM,** 590 N Mill St, Aspen, CO 81611. Tel 970-925-8050; Fax 970-925-8054; Elec Mail info@aspenartmuseum.org; Internet Home Page Address: www.aspenartmuseum.org; *Dir & Chief Cur* Heidi Zuckerman Jacobson
Open Tues - Sat 10 AM - 6 PM, free reception & gallery tours Thurs 5 - 7 PM, cl Mon; Admis $5, seniors & students $3, members & children under 12 free; Estab 1979 to provide the community with a variety of cultural & educational experiences through exhibits, lectures & classes; Average Annual Attendance: 15,000; Mem: 800; dues $35-$25,000; annual meeting in Aug
Income: $2,000,000 (financed by benefits, memberships, donations, grants)
Library Holdings: Audio Tapes; Book Volumes; Exhibition Catalogs; Periodical Subscriptions; Photographs; Slides; Video Tapes
Special Subjects: Sculpture
Activities: Classes for adults & children; docent training; lect open to public, 8 vis lectr per year; gallery talks; tours; Aspen Award for Art; scholarships offered; museum shop sells books, cards, toys, hats, catalogs, t-shirts

BOULDER

A **BOULDER HISTORY MUSEUM,** Museum of History, 1206 Euclid Ave, Boulder, CO 80302. Tel 303-449-3464; Fax 303-938-8322; Elec Mail ngeyer@boulderhistory.org; Internet Home Page Address: www.boulderhistorymuseum.org; *Cur Costumes* Terri Schindel; *Assoc Dir* Wendy Gordon; *Exec Dir* Nancy Geyer; *Prog Mgr* Julie Schumaker; *Coll Mgr* Laura Lee
Open Tues - Fri 10 AM - 4 PM, Sat & Sun noon - 4 PM, cl Mon; Admis $5 adults, $3 seniors, $2 children; Estab 1944 to promote history of Boulder Valley; history of the Boulder area 1840s to present; Average Annual Attendance: 5,000; Mem: 400; dues $20 - $100; annual meeting in Spring
Income: $450,000 (financed by endowment & mem)
Purchases: Quilts, photographs, costumes, agricultural tools, glass, historical artifacts
Special Subjects: Historical Material
Collections: Local Historical Material; Manuscripts & Photographs
Exhibitions: Period Kitchen & Sitting Room; 19th Century Businesses; Bicycles; Agriculture; Mining; Education
Publications: Biannual newsletter

Activities: Classes for adults & children, docent training; lect open to public, 400 vis lectr per year; lending collection contains 5000 paintings; book traveling exhibitions 2 per year; retail store sells books & local history artifacts

A **BOULDER MUSEUM OF CONTEMPORARY ART,** 1750 13th St, Boulder, CO 80306. Tel 303-443-2122; Fax 303-447-1633; Elec Mail info@bmoca.org; Internet Home Page Address: www.bmoca.org; *Pres Bd Dir* Andrew McArthur; *Devel Co-Exec Dir* Penny Barnow; *Sr Cur* Joan Markowitz; *Operations Mgr* Travis Allison; *Assoc Cur* Kirsten Gerdes
Open Tues - Sat 10 AM - 6 PM, cl Sun, Mon & holidays; Admis exhibs $5, students & seniors $4, mem & children under 12 free, Saturdays, free.; Estab 1972 to explore the forefront of contemporary art & ideas, bringing together innovative exhibits, performances & educ to inspire & challenge; Three galleries totaling 5000 sq ft; lecture space; black box theater; exhibitions focus on contemporary, regional, national & international art; Average Annual Attendance: 20,000; Mem: 700; dues from $12-$1000; annual meeting in Oct
Income: Financed by endowment, mem, city support & grants
Exhibitions: (2/9/2007) Halim Al Karim, Kris Cox; (6/1/2007) Alan Feltus, Lani Irwin, David Zimmer; (9/16/2007) Eco-Arts Exhibition curated by Lucy Lippard
Activities: Classes for adults & children; dramatic programs; docent training; poetry & performance art; pub theatre; lect open to public, 3-5 vis lectr per year, also lextrs for members; concerts; gallery talks; tours; competitions with awards; museum shop sells magazines & museum materials

L **BOULDER PUBLIC LIBRARY & GALLERY,** Dept of Fine Arts Gallery, 1000 Canyon Blvd, Boulder, CO 80302; PO Drawer H, Boulder, CO 80306. Tel 303-441-3100; Fax 303-442-1808, 441-4119; Internet Home Page Address: www.boulder.lib.co.us; *Exhib Coordr* Gregory Ravenwood; *City of Boulder Arts Commission & Dir Cultural Programs* Donna Gartenmann; *Dir Library* Liz Abbott
Open Mon - Thurs 9 AM - 9 PM, Fri & Sat 9 AM - 6 PM, Sun Noon - 6 PM; Estab to enhance the personal development of Boulder citizens by meeting their informational needs; Bridge Gallery, three shows change monthly; Average Annual Attendance: 300,000
Income: Financed by city appropriations, grants & gifts
Library Holdings: Audio Tapes; Cards; Cassettes; Clipping Files; DVDs; Exhibition Catalogs; Fiche; Filmstrips; Framed Reproductions; Manuscripts; Micro Print; Original Art Works; Pamphlets; Photographs; Prints; Reproductions; Sculpture; Slides; Video Tapes
Activities: Classes for adults & children; lect open to public; concerts; tours; competitions; awards

M **LEANIN' TREE MUSEUM OF WESTERN ART,** 6055 Longbow Dr Boulder, CO 80301; PO Box 9500, Boulder, CO 80301. Tel 303-530-1442 ext 4299; Fax 303-581-2152; Elec Mail artmuseum@leanintree.com; Internet Home Page Address: www.leanintreemuseum.com; WATS 800-777-8716; *Assoc Museum Dir* Sara Sheldon; *Founder & Dir* Edward P Trumble
Open Mon - Fri 8 AM - 5 PM, Sat & Sun 10 AM - 5 PM; No admis fee; Estab 1974; Two floors of paintings & bronzes; Average Annual Attendance: 40,000
Purchases: Hollywood Indian #5, 1970 by Fritz Scholder (1937-); Board of Directors 2002 by James E Reynolds (1926-); Stealth Hunter by Robert Kuhn (1920-); On the Beach by Burt Proctor (1901-1980); Respect, bronze 1985 by Allan Houser (1914-1994); Apache Cradle Board, bronze 1994 by Allan Houser (1914-1994); Kachina Dream State,(acrylic 2003 by Dan Namingha (1950-); Seal Hunter, acrylic 2002 by Bob Kuhn (1920-)
Special Subjects: Painting-American, Sculpture, Watercolors, American Indian Art, American Western Art, Bronzes, Southwestern Art
Collections: Contemporary western cowboy & Indian art; western bronze sculptures; paintings by major contemporary western artists, 1950 to present day
Activities: Self guided tours; guided tours by reservation; activities for children; sales shop sells reproductions, prints & museum-related items

M **UNIVERSITY OF COLORADO,** CU Art Galleries, Sibell-Wolle Fine Arts Bldg, 318 UCB Boulder, CO 80309-0318. Tel 303-492-8300; Fax 303-735-4197; Elec Mail krane@colorado.edu; Internet Home Page Address: www.colorado.edu/cuartgalleries; *Dir* Susan Krane; *Exhib Mgr* Bill Rumley
Open Mon - Fri 10 AM - 5 PM; Tues till 7:30 PM, Sat Noon - 4 PM; No admis fee; Estab 1939 to maintain & exhibit art collections & to show temporary exhibits; The galleries have 450 linear ft of wall space & a total of 5000 sq ft
Income: Financed through University, gifts & grants
Purchases: Colorado Collection
Special Subjects: Drawings, Painting-American, Photography, Prints, Sculpture, Watercolors, Ceramics
Collections: 19th & 20th century paintings & prints; photographs, prints, drawings, watercolors, sculptures & ceramics; The Colorado Collection
Exhibitions: Ongoing exhibitions of 20th century & contemporary art
Library Holdings: Audio Tapes; Book Volumes; Exhibition Catalogs; Periodical Subscriptions; Slides; Video Tapes
Publications: Brochures; exhibition catalogs
Activities: Lect open to public; gallery talks; tours; paintings & original art objects lent to museums; lending collection contains original art works & prints, paintings, photographs, sculpture, original drawings; organize traveling exhibitions
L **Art & Architecture Library,** Norlin Library, 184 UCB, 1720 Pleasant St Boulder, CO 80309. Tel 303-492-3966; Fax 303-492-0935; Elec Mail artlib@colorado.edu; Internet Home Page Address: ucblibraries.colorado.edu/art/index.htm; *Art & Architecture Librn* Jennifer Parker
Open Mon - Thurs 9 AM-9 PM, Fri 9 AM-5 PM, Sat 1-5 PM, Sun 1-9 PM; Estab 1966 to support the university curriculum in the areas of fine arts, art history, environmental design, architecture, planning, landscape & interior design; For lending only
Income: Financed by state appropriation
Library Holdings: Auction Catalogs; Book Volumes 120,000; Compact Disks; DVDs; Exhibition Catalogs; Fiche 5950; Other Holdings MFA thesis statements; Museum & gallery publications; Periodical Subscriptions 500; Reels
Special Subjects: Folk Art, Painting-American, History of Art & Archaeology, Latin American Art, American Western Art, American Indian Art, Eskimo Art,

Mexican Art, Southwestern Art, Afro-American Art, Oriental Art, Religious Art, Dioramas, Architecture

BRECKENRIDGE

M COLORADO MOUNTAIN COLLEGE, Fine Arts Gallery, 103 S Harris St, PO Box 2208 Breckenridge, CO 80424. Tel 970-453-6757; Fax 970-453-2209; No admis fee; Estab 1980
Exhibitions: monthly changing local artist

BRIGHTON

M ADAMS COUNTY HISTORICAL SOCIETY, 9601 Henderson Rd, Brighton, CO 80601. Tel 303-659-7103; Fax 303-659-7988;
Open Tues - Sat 10 AM - 3:30 PM, cl Sun & Mon; For reference. Different artists & groups exhibited throughout the yr
Income: $50,000 (financed by mem, dues, craft shows, gifts & grants)
Library Holdings: Book Volumes 200; Clipping Files; Latern Slides; Pamphlets; Records
Special Subjects: Art Education, Art History, Historical Material, Southwestern Art, Watercolors

CANON CITY

A FREMONT CENTER FOR THE ARTS, 505 Macon Ave, PO Box 1006 Canon City, CO 81215-1006. Tel 719-275-2790; Fax 719-275-4244; Elec Mail fcarta@ris.net; *Operations Mgr* Ann Kelly; *Admin Asst* Carrie Kuhn
Open Tues - Thurs 10 AM - 4 PM, Fri 10 AM - 7 PM, Sat 10 AM - 1 PM; Admis $1; Estab 1947; Average Annual Attendance: 10,000; Mem: 450
Income: Financed by mem, individual donations, local small businesses, grants, fundraising
Collections: permanent collections
Activities: Classes for adults & children; lects open to public; concerts; gallery talks; competitions; mus shop sells original art & prints

CENTRAL CITY

A GILPIN COUNTY ARTS ASSOCIATION, Eureka St, PO Box 98 Central City, CO 80427. Tel 303-642-0991; *Pres* Susan Snodgrass; *Gallery Mgr* Diane Sill
Open Tues - Sat 11 AM - 5:30 PM, June 22 - Aug 10 Sun Noon - 5:30 PM, cl Mon; No admis fee; Estab 1947 to offer a juried exhibition of Colorado artists & to support the local school arts program; Six wings on two floors; outdoor sculpture garden; memorial fountain in Newbury Wing sculpted by Angelo di Benedetto; gallery is open June - Sept 15; oldest juried art exhibition in Colorado; nonprofit organization; Average Annual Attendance: 25,000; Mem: 200; dues $1000; annual meeting, third Sun in Aug
Income: Financed by mem, sales & entry fee
Purchases: Over $60,000 annually
Publications: Annual exhibit catalog
Activities: Juried competitions with awards; sponsor elementary & secondary school art program

COLORADO SPRINGS

AMERICAN NUMISMATIC ASSOCIATION
For further information, see National and Regional Organizations

L ARJUNA LIBRARY, Digital Visual Dream Laboratory & Acoustic Studio, 1025 Garner St, D, Space 18 Colorado Springs, CO 80905. Tel 719-473-0360; Internet Home Page Address: http://home.earthlink.net/~pfuphoff/; *Dir & Edit in Chief, Journal of Regional Criticism* Ct. Pf. Joseph A Uphoff Jr
Estab 1963; For reference only
Library Holdings: Book Volumes 2100; CD-ROMs 100; Compact Disks 400; DVDs 200; Manuscripts; Original Art Works; Periodical Subscriptions; Records 150; Sculpture; Slides 1400
Special Subjects: Decorative Arts, Illustration, Calligraphy, Manuscripts, Painting-American, Painting-British, Painting-French, Painting-German, Sculpture, Painting-European, Historical Material, Ceramics, Conceptual Art, Archaeology, Aesthetics, Oriental Art, Coins & Medals
Collections: Eshkol-Wachman Movement Notation Studies; Manuscripts & Proceedings, Differential Logic, Mathematical Surrealistic Theory; Mathematical Proceedings in Criticism for Drama: Poetics, Dance, Martial Arts & Yoga; Metamathematics, Calculus, Abstract Algebra
Exhibitions: Type Programming Mail Art Exhib
Publications: Journal of Regional Criticism, irregular

M COLORADO SPRINGS FINE ARTS CENTER, 30 W Dale St, Colorado Springs, CO 80903. Tel 719-634-5581; Fax 719-634-0570; Internet Home Page Address: www.csfineartscenter.org; *Dir* Dr Michael DeMarsche; *Dir Exhib* Cathy Wright; *Dir Sales Shop* Ben Taylor; *Dir Performing Arts* Sandra Womochil Bray; *Librn* Roderick Dew; *Bemis Art School Dir* Tara Thomas; *Dir Finance* Kirk Skabo; *Dir Develop* Jerry Stafford; *Dir Pub Relations and Marketing* Daniel Vasey
Open Mon - Sat 9 AM - 5 PM, Sun 1 - 5 PM; Admis adults $5, senior citizens 63 & over, students between 6 & 16 $3, 6 & under free; Estab 1936 as a forum, advocate & programmer of visual & performing arts activities & art school for the community; Eleven galleries range in size from quite small to large. Exhibits range from international to national to regional; Average Annual Attendance: 190,000; Mem: 4,000; dues $20-$1000; annual meeting in Nov
Income: $2,174,000 (financed by endowment, mem, business & industry contributions, revenue producing enterprises, city, state & federal appropriations)
Library Holdings: Auction Catalogs; Audio Tapes; Book Volumes 27,000; Clipping Files; Exhibition Catalogs; Memorabilia; Pamphlets; Periodical Subscriptions 50; Video Tapes

Special Subjects: Anthropology, Folk Art, Landscapes, Ceramics, Glass, Mexican Art, American Western Art, Photography, Portraits, Pottery, Pre-Columbian Art, Prints, Silver, Textiles, Bronzes, Drawings, Graphics, Hispanic Art, Latin American Art, Painting-American, Sculpture, Watercolors, American Indian Art, Southwestern Art, Religious Art, Woodcarvings
Collections: Taylor Museum Collection of Southwestern Spanish Colonial & Native American Art; American paintings, sculptures, graphics & drawings with emphasis on art west of the Mississippi; ethnographic collections; fine arts collections; 19th & 20th century art
Exhibitions: Sacred Land: Indian & Hispanic Cultures of the Southwest; more than 20 exhibitions, changing annually
Publications: Artsfocus, bimonthly calendar; educational programs and tours; exhibition catalogs; gallery sheets; scholarly publications; catalogue of the collections
Activities: Art classes for pre-school arts program; classes for adults; gifted & talented classes (grades 3-6) in visual arts & drama; docent lect/presentations to children & adults; creative dramatics; docent training; lect open to public, 20 vis lects per year; concerts; films; gallery talks; competitions; Governors Award for Excellence in the Arts; art lent to AAM accredited museums; 1 book traveling exhibition per year; sales shop sells books, original art, reproductions

L Library, 30 W Dale St, Colorado Springs, CO 80903. Tel 719-634-5581; Fax 719-634-0570; Elec Mail rdew@csfineartscenter.org; Internet Home Page Address: www.csfineartscenter.org; *Librn* Roderick Dew
Open Tues - Sat 9 AM - Noon & 1 - 5 PM, cl Mon & Sun; $5 for non-members; Estab 1936 as a fine arts reference library in support of the museum's collection & activities; Open for pub reference, lending is restricted to members of the center & local university students & faculty
Income: Financed by endowment & mem
Library Holdings: Auction Catalogs; Book Volumes 30,000; Clipping Files; Compact Disks; Exhibition Catalogs; Memorabilia; Pamphlets; Periodical Subscriptions 50
Special Subjects: Art History, Folk Art, Painting-American, History of Art & Archaeology, Latin American Art, American Western Art, Art Education, American Indian Art, Eskimo Art, Southwestern Art, Textiles
Collections: Taylor Museum Collection on the art & anthropology of the Southwest
Activities: Tours by appointment

M UNITED STATES FIGURE SKATING ASSOCIATION, World Figure Skating Museum & Hall of Fame, 20 First St, Colorado Springs, CO 80906. Tel 719-635-5200; Fax 719-635-9548; *Cur* Beth Davis
Open winter Mon - Fri 10 AM - 4 PM & first Sat of month, summer Mon - Sat 10 AM - 4 PM; Admis adults $3, senior citizens $2, children $2; Estab 1979 to preserve the art & history of figure skating; Maintains 10,000 sq ft exhibition area; Average Annual Attendance: 20,000
Income: Financed by Association's general fund & mem
Special Subjects: Drawings, Prints, Sculpture, Watercolors, Bronzes, Costumes, Ceramics, Woodcuts, Etchings & Engravings, Decorative Arts, Manuscripts, Posters, Jewelry, Porcelain, Coins & Medals, Gold
Collections: Skating in Art, the Gillis Grafstrom Collection; costumes of the champions; On Edge (exhibit of technical aspects of skating); Pierre Brunet Collection, Gladys McFerron Collection, Kloss Photo Collection, Dorothy Stevens Collection
Exhibitions: Scott Hamilton: Portraiture of a Champion; Sonja Henie Remembered
Publications: Skating Magazine
Activities: Gallery talks; tours; competitions with awards; video tape showings; originate traveling exhibitions to skating organizations, clubs & members; gift shop sells books, reproductions, jewelry, decals, cards, decorations

L Museum & Hall of Fame Library, 20 First St, Colorado Springs, CO 80906. Tel 719-635-5200, Ext 424; Fax 719-635-9548; Elec Mail frontdesk@usfsa.org; Internet Home Page Address: www.usfsa.org; *Cur* Beth Davis
Open Sept-May Mon - Fri 10 AM - 4 PM & 1st Sat of month, summer Mon - Sat 10 AM - 4 PM; Admis adults $3, children 6-12 & seniors $2, mems & children under 6 free
Income: Financed by mems & fees
Library Holdings: Audio Tapes; Cassettes; Clipping Files; Exhibition Catalogs; Filmstrips; Framed Reproductions; Lantern Slides; Memorabilia; Motion Pictures; Original Art Works; Pamphlets; Photographs; Prints; Records; Reels; Slides; Video Tapes
Collections: First books published in English, French & German on skating

M UNIVERSITY OF COLORADO AT COLORADO SPRINGS, Gallery of Contemporary Art, 1420 Austin Bluffs Pkwy, Colorado Springs, CO 80933-7150; Austin Bluffs Pkwy, PO Box 7150 Colorado Springs, CO 80933-7150. Tel 719-262-3567; Fax 719-262-3183; Elec Mail clynn@uccs.edu; Internet Home Page Address: www.galleryuccs.org; *Dir* Christopher Lynn
Open Mon - Fri 10 AM - 4 PM, Sat 1 - 4 PM; Admis fee adults $1, sr citizens & students $.50, children under 12 free; Estab 1981 to organize & host group exhibitions primarily of contemporary art by artists of international, national & regional significance; 411 linear ft & 3,000 sq ft of exhibition space; adjoining classroom, auditorium & workshop/storage room; Average Annual Attendance: 28,000; Mem: Renewals: Jul 1 yearly
Income: $150,000 (financed by state appropriation, private donations & grants)
Special Subjects: Drawings, Latin American Art, Mexican Art, Photography, Prints, Sculpture, Watercolors, American Indian Art, American Western Art, Southwestern Art, Textiles, Crafts, Folk Art, Woodcuts, Etchings & Engravings, Landscapes, Afro-American Art, Glass, Asian Art
Exhibitions: 6 to 7 group exhibitions annually based on themes or surveys of particular mediums
Activities: Classes for adults & children; docent training; museum training program; lect open to public, 7 vis lectr per year; concerts; book traveling exhibitions

CRIPPLE CREEK

M **CRIPPLE CREEK DISTRICT MUSEUM,** 500 E Bennett Ave, PO Box 1210
Cripple Creek, CO 80813. Tel 719-689-2634; Internet Home Page Address:
www.cripplecreek.com; *Dir* Erik Swanson
Open Fall & Summer daily 10 AM - 5:30 PM, Spring & Winter weekends only;
Admis adults $2.50, children 7 - 12 $.50, children under 7 free; Estab 1953 as a
showplace for local artists; One room, 50 ft x 20 ft, second room 25 ft x 25 ft;
Average Annual Attendance: 35,000
Income: Financed by donations
Special Subjects: Painting-American
Collections: Archival Collection; small collection of locally produced paintings
Exhibitions: Permanent Gold Ore exhibit
Activities: Mus shop sells books

DENVER

M **BLACK AMERICAN WEST MUSEUM & HERITAGE CENTER,** 3091
California St, Denver, CO 80205. Tel 303-292-2566; Fax 303-382-1981; *Exec Dir*
Wallace Yvonne Tollette; *Chmn* Sidney Wilson; *Coordr* Daphne Rice-Allen; *Gen
Asst* Denver Norman
Call for information; Estab 1971; Blacks in the Western United States; Average
Annual Attendance: 10,000; Mem: 300; dues vary; annual meeting in Feb
Income: $200,000 (financed by mem, donations, gift shop sales, rentals & grants)
Activities: Docent training; classes for adults & children; lect open to public;
tours; originates traveling exhibitions; museum shop sells books, magazines, prints
& reproductions

M **COLORADO HISTORICAL SOCIETY,** Colorado History Museum, 1300
Broadway, Denver, CO 80203. Tel 303-866-3682; Fax 303-866-5739; Elec Mail
webmaster@chs.state.co; Internet Home Page Address: www.coloradohistory.org;
CEO Georgianna Contiguglia; *State Archaeologist* Susan Collins; *Cur Decorative
& Fine Arts* Moya Hansen; *Cur Photog* Eric Paddock; *Dir Research &
Publications* David Wetzel; *Dir Interpretive Servs* Martha Dyckes; *Dir Coll &
Exhibits* Anne Wainestein Bond; *Cur Books & Manuscripts* Bridget Burke; *Dir
General Serv* Joseph Bell; *Dir Colo Hist Found* Lane Ittelson; *Marketing* Janet
DeRuvo; *Historic Preservation* Mark Wolfe; *Vice Chmn* W Nicholas V Mathers;
Dir Mus Stores Vivian Coates; *Controller* Tom Zimmer; *VPres* Mae McGregor;
Dir Develop Carol Whitley; *Historian* Modupe Labode
Open Mon - Sat 10 AM - 4:30 PM, Sun Noon - 4:30, cl New Years Day,
Thanksgiving, Christmas; Admis adults $5, senior citizens $4.50, children 6-12 yrs
$3.50, children 5 & under free, students with ID $4.50, mems free; Estab 1879 to
collect, preserve & interpret the history of Colorado; 8600 sq ft for temporary
exhibits; 33,000 sq ft for permanent exhibits; Average Annual Attendance:
145,000; Mem: 8000; dues $50; annual meeting in Sept
Income: $4,000,000 (financed by endowment, mem, state & federal
appropriations)
Special Subjects: Hispanic Art, Painting-American, Prints, Sculpture, American
Indian Art, American Western Art, Anthropology, Archaeology, Ethnology,
Southwestern Art, Textiles, Costumes, Ceramics, Decorative Arts, Manuscripts,
Dolls, Furniture, Silver, Carpets & Rugs, Historical Material, Maps, Coins &
Medals, Dioramas
Collections: William H Jackson Photo Collection; painting, sculpture, fine &
decorative arts relating to Colorado & West America
Exhibitions: 20th Century Colorado; Artist of America
Publications: Colorado History, quarterly; Colorado History Now, monthly
Activities: Classes for children; docent training; lect open to public; 12 vis lectr
per year; gallery talks; tours; individual paintings & original objects of art lent to
qualified museums; lending collection contains film strips & motion pictures;
museum shop sells books, magazines, original art, reproductions, prints, slides &
souvenirs

L **Stephen H Hart Library,** 1300 Broadway, Denver, CO 80203. Tel 303-866-2305;
Fax 303-866-4204; Elec Mail research@chs.state.co.us; Internet Home Page
Address: www.coloradohistory.org; *Dir* Rebecca Lintz; *Ref Librn* Barbara Dey
Open Tues - Sat 10 AM - 4:30 PM; No admis fee; Estab 1879 to preserve the
history of Colorado; Open to public for reference; Average Annual Attendance:
5,000 visit reading rm; Mem: 7000; dues $30; annual meeting in Dec
Income: Financed by state agency, endowments & mus admis
Library Holdings: Audio Tapes 600; Book Volumes 45,000; Clipping Files 250;
Lantern Slides; Manuscripts 9,000,000; Maps 5,000; Memorabilia; Motion
Pictures; Original Art Works; Original Documents; Other Holdings Colorado
Newspapers on Microfilm 2500; Maps 5000; Pamphlets; Periodical Subscriptions
600; Photographs 600,000; Prints; Reels; Video Tapes
Special Subjects: Art History, Decorative Arts, Photography, Drawings, Etchings
& Engravings, Manuscripts, Maps, Painting-American, Posters, Historical
Material, Watercolors, Ceramics, Crafts, Archaeology, Ethnology, American
Western Art, Fashion Arts, American Indian Art, Anthropology, Furniture, Mexican
Art, Southwestern Art, Costume Design & Constr, Carpets & Rugs, Dolls,
Handicrafts, Pottery, Silver, Landscapes, Dioramas, Coins & Medals, Architecture,
Portraits, Textiles
Collections: William Henry Jackson Glass Plate Negatives of Views West of the
Mississippi; 600,000 photographs Colorado Western History; Aultman Photo
Studio; Denver Rio Grande Photo and Manuscripts
Exhibitions: La Gente; Mining in Colorado; Pulitzer photos; Ancient Voices 2005
Publications: Colorado Heritage, Colorado History, History Now newsletter
Activities: Classes for children; docent training; speakers bureau; historical treks;
workshops; lect open to public, 12 vis lectr per year; tours; Bancroft award;
individual paintings & original objects of art lent to other museums; museum shop
sells books, magazines, reproductions, prints, cards & gifts

M **COLORADO PHOTOGRAPHIC ARTS CENTER,** 1513 Boulder St, Denver,
CO 80211. Tel 303-455-8999; Fax 303-278-3693; *Pres* R Skip Kohloff; *Gallery
Coordr* Lisbeth Neergaard Kohloff
Open Wed - Sat Noon - 4 PM; No admis fee; Estab 1963 to foster the art of
photography; Average Annual Attendance: 5,000; Mem: 195; dues family $35,
individual $25, meetings in Jan, Apr, Sept & Nov

Income: $15,000 (financed by mem & grants)
Purchases: $1,000 (Carole Gallaoher print from American Ground Zero project);
Jerry N. Uelsmann print
Library Holdings: Book Volumes; CD-ROMs; Cards; Memorabilia; Original Art
Works; Periodical Subscriptions; Video Tapes
Special Subjects: Photography
Collections: Permanent collection, 500-600 photographs
Exhibitions: Local & regional exhibits; occasional national & international
exhibits
Activities: Classes for adults; student gallery talks; lect open to pub & members,
2-4 vis lectrs per year; gallery talks; competitions with awards; exhibits;
workshops & tours; CPAC Member grant; CPAC Personal Visions award(s);
original objects of art lent to educational institutions & related exhibitions; sales
shop sells books & original art

A **COLORADO WATERCOLOR SOCIETY,** PO Box 100003, Denver, CO 80250.
Elec Mail gyoungmann@comcast.net; Internet Home Page Address:
www.coloradowatercolor.org; *Pres* Gene Youngmann
Estab 1954
Exhibitions: Colorado State Watermedia Exhibit; Botanical Garden Show
Publications: Monthly newsletter

M **DENVER ART MUSEUM,** 100 W 14th Ave Pky, Denver, CO 80204. Tel
720-865-5000; Fax 720-913-0001; Elec Mail web-mail@denverartmuseum.org;
Internet Home Page Address: www.denverartmuseum.org; *Pubc Relations Dir*
Deanna Person; *Dir* Lewis Sharp; *Dir Marketing* Janet Meredith; *Cur New World*
Margaret Young-Sanchez; *Dir Coll Svcs* Carl Patterson; *Deputy Dir External*
Cynthia Ford; *Mus Shop Mgr* Mary Jane Butler; *Cur Contemporary* Dianne
Vanderlip; *Chief Cur Institute* Timothy J Standring; *Dir Finance & Operations*
Sharon Kermiet; *Architecture Design* R Craig Miller; *Cur Textile Art* Alice
Zrebiec; *Cur Asian* Ronald Otsuka; *CEO* Frederic C Hamilton; *Registrar* Lori Iliff;
Cur Institute of Western Joan C Roccoli; *VPres* Lorie Freeman; *Cur New World*
Donna Pierce; *Cur Native Arts* Nancy Blomberg; *Dean Educ* Patterson B Williams
Open Tues 10 AM - 5 PM, Sun Noon - 5 PM; Admis adults $6, senior
citizens & students $4.50, children under 12 & members free, Colorado res free
on Sat; Estab 1893, new building opened 1971, to provide a number of permanent
& rotating art collections for pub viewing, as well as a variety of art educ
programs & services; The mus, a seven story building contains 210,000 sq ft of
space, 117,000 of which is exhibit space; Average Annual Attendance: 400,000;
Mem: 35,500; dues family $50, individual $35; annual meeting in Apr
Income: Financed by mem, city & state appropriations & private funding
Special Subjects: Architecture, Latin American Art, American Indian Art,
American Western Art, African Art, Pre-Columbian Art, Religious Art, Folk Art,
Landscapes, Judaica, Painting-European, Painting-Japanese, Eskimo Art, Furniture,
Glass, Jade, Jewelry, Painting-British, Painting-French, Scrimshaw, Restorations,
Renaissance Art, Antiquities-Oriental, Painting-Italian, Gold
Collections: American art; contemporary art; design & architecture; European art;
Native American art; Native arts; New World art; Oriental art; Western art
Publications: Calendar, monthly; catalogues for exhibitions
Activities: Classes for adults & children; dramatic programs; docent training; lect
open to public, 10 vis lectr per year; concerts; gallery talks; tours; book traveling
exhibitions 2-3 per year; originate traveling exhibitions to national & international
museums & galleries; museum shop sells books, magazines, original art,
reproductions, prints, jewelry, rugs & children's art projects

L **Library,** 100 W 14th Ave Pky, Denver, CO 80204. Tel 720-913-0100; Fax
720-913-0001; *Dir* Nancy Simon
Open Mon - Thurs 10 AM - 3 PM, by appointment for research; Reference only
Library Holdings: Auction Catalogs; Book Volumes 25,000; Clipping Files;
Exhibition Catalogs; Manuscripts; Memorabilia; Pamphlets; Periodical
Subscriptions 50; Photographs
Special Subjects: Folk Art, Islamic Art, Pre-Columbian Art, History of Art &
Archaeology, Latin American Art, Archaeology, American Western Art, Asian Art,
American Indian Art, Anthropology, Southwestern Art, Afro-American Art
Collections: Native American

L **DENVER PUBLIC LIBRARY,** Reference, 10 W 14th Ave Pky, Denver, CO
80203. Tel 720-865-1363; Fax 720-865-1481; Internet Home Page Address:
www.denverlibrary.org; *City Librn* Shirley Amore; *Mgr Reference* Karen Kelley;
Mgr - Western History & Genealogy Jim Kroll
Open Mon - Tues 12 PM - 8 PM, Wed - Fri 10 AM - 6 PM, Sat 9 AM - 5 PM,
Sun 1 - 5 PM; No admis fee; Estab 1889
Income: Financed by city & county taxes
Library Holdings: Audio Tapes; Book Volumes 80,000; Cassettes; Clipping Files;
Compact Disks; DVDs; Exhibition Catalogs; Fiche; Manuscripts; Maps;
Memorabilia; Original Art Works; Other Holdings Original documents; Periodical
Subscriptions 100; Photographs 14,752; Prints 1384; Reels; Reproductions;
Sculpture; Video Tapes
Special Subjects: Photography, Painting-American, American Western Art
Collections: Western art
Exhibitions: Frequent exhibitions from the book & picture collections
Activities: Lect open to public; tours

M **EMMANUEL GALLERY,** Auraria Campus, 1205 Tenth St Mall Denver, CO
80217-3364; Auraria Campus, Campus Box 177, Box 173364 Denver, CO
80217-3362. Tel 303-556-8337; Fax 303-556-2335; Elec Mail
shannon.corrigan@cudenver.edu; Internet Home Page Address:
www.emmanuelgallery.org; *Dir* Shannon Corrigan
Open Tues - Fri 10 AM - 6 PM, Sat 11 AM - 5 PM; No admis fee; Estab 1976;
Gallery is in the oldest standing church structure in Denver which has been
renovated for exhibit space. This historic gallery supports the Community College
of Denver, Metropolitan State College, the University of Colorado at Denver as
well as local, national & international artists; Average Annual Attendance: 30,000
Income: Financed by above colleges & Auraria Higher Education Center
Library Holdings: Sculpture
Exhibitions: Various exhib by students, faculty & artists
Activities: 2 vis lect per year, gallery talks, tours, outreach programs; book
traveling exhibitions

M **KIRKLAND MUSEUM OF FINE & DECORATIVE ART,** 1311 Pearl St, Denver, CO 80203. Tel 303-832-8576; Fax 303-832-8404; Elec Mail info@kirklandmuseum.org; Internet Home Page Address: www.kirklandmuseum.org; *Conservator* Dean Sartori; *Dir* Hugh Grant; *Marketing Dir* Holly Victor; *Facilities & Collections Mgr* Jason Musgrave; *Vol Coordr* Maureen Corey; *Registrar* Chris Herron; *Admin Mgr* Gerald Horner; *Marketing & Mem Asst* Maya Wright
Tues - Sat 11 AM - 5 PM, Sun 1 - 5PM, other times by appt; Admis adults $6, seniors, students, teachers $5; Estab 1996 to promote the life & works of Vance Kirkland (1904-1981); Retrospective & individual works Mid-20th Century, decorative arts; Average Annual Attendance: 6,000; Mem: 170; student, senior, teacher $25, individual $30, dual $40, sustaining $100
Income: Privately funded
Library Holdings: Auction Catalogs; Book Volumes
Special Subjects: Architecture, Drawings, Painting-American, Prints, Sculpture, Watercolors, Bronzes, Ceramics, Woodcarvings, Landscapes, Decorative Arts, Posters, Furniture, Metalwork, Carpets & Rugs
Collections: Twentieth Century Decorative Arts; Twentieth Century Painting; Mid-Twentieth Century Colorado Artists (Kirkland Contemporaries)
Publications: Exhibition catalogs
Activities: Docent training; lectures for mem only; gallery talks; tours; book traveling exhibitions 4 per year; museum shop sells books, magazines & original art

M **METROPOLITAN STATE COLLEGE OF DENVER,** Center for Visual Art, 1734 Wazee St, Denver, CO 80202. Tel 303-294-5207; Fax 303-294-5210; Elec Mail andrewka@mscd.edu; Internet Home Page Address: www.mscd.edu/news/cva; *Asst Dir* Amy Banker; *Dir* Jennifer Garner
Open to public Tues - Thurs 10 AM - 5 PM, Fri 10 AM - 8 PM, Sat 12 - 4 PM, cl all major holidays; No admis fee, donations accepted; Estab 1990 for temporary exhibitions of contemporary art; 5000 sq ft in historic building; Average Annual Attendance: 32,000; Mem: 300; annual meeting in July; D & E; Scholarships
Income: $350,000 (financed by mem, state appropriation, grants & revenues)
Special Subjects: Hispanic Art, American Indian Art, Southwestern Art, Afro-American Art
Publications: Quarterly newsletter
Activities: Classes for adults, teens & children; lect open to public, 8 vis lectr per year; gallery talks; tours; book traveling exhibitions 1-2 per year; originate traveling exhibitions 5 per year
Ent Req: GED

M **MUSEO DE LAS AMERICAS,** 861 Santa Fe Dr, Denver, CO 80211. Tel 303-571-4401; Fax 303-607-9761; Elec Mail gloria@museo.org; Internet Home Page Address: www.museo.com; *Dir Educ* Julie Moreno; *Pub Rels Dir* Gloria Schoch; *Admin Asst* Michelle Montour
Open Tue - Sat 10 AM - 5 PM; Admis adults $4, students & seniors $3, members & children under 13 free; Estab 1991 to collect, preserve & interpret Latin American art, history & culture; Average Annual Attendance: 20,000; Mem: 800; dues $15 - $1,000
Income: $350,000 (financed by mem, foundation, corporation, pub funding & store revenue)
Special Subjects: Architecture, Drawings, Graphics, Hispanic Art, Painting-American, Photography, Sculpture, Watercolors, Bronzes, Anthropology, Archaeology, Ethnology, Southwestern Art, Textiles, Folk Art, Etchings & Engravings, Portraits, Furniture, Jade, Porcelain, Silver, Historical Material, Baroque Art, Painting-Spanish, Gold
Collections: Folk Art Collection; Historical Objects Collection; paintings; photography; sculpture
Exhibitions: Eppie Archuleta: Master Weaver of the San Luis Valley; Cuba Siempre Vive; Alberto Gironela: Madonna Series; Luis Jimenez: Man On Fire
Publications: Notitas Newsletter, quarterly
Activities: Classes for children; docent training; lect open to public, 5 vis lectr per year; book traveling exhibitions 5 per year; museum shop sells books, prints, original art & historical objects

M **MUSEUM OF CONTEMPORARY ART DENVER,** 1275 19th St, Denver, CO 80202. Tel 303-298-7554; Fax 303-298-7553; Elec Mail moca@mocadenver.com; Internet Home Page Address: www.mocadenver.com; *Preparator & Registrar* Jason Musgrave; *Dir* Sidney Payton
Open Tues - Sat 11 AM - 5:30 PM, Sun Noon - 5 PM, cl Mon; Admis $3, students suggested donation, members & children under 12 free; Estab 1997 to educate & inspire artists, students & the general public about important new developments in visual arts - regional, national or international; Mem: Dues $20 & over
Activities: Workshops; lect open to public; tours, symposiums

M **PIRATE-A CONTEMPORARY ART OASIS,** 1370 Verbena, Denver, CO 80220. Tel 303-458-6058; *Dir* Phil Bender
Open Sat & Sun Noon - 5 PM; No admis fee; Estab 1980; gallery displays contemporary art; Average Annual Attendance: 2,000; Mem: 15
Income: Financed by mem
Exhibitions: Member Artists Exhibit Yearly
Publications: Blackspot, quarterly newsletter
Activities: Community outreach prog; sales shop sells original art, hats, t-shirts, buttons & bumper stickers

C **SLA ARCH-COUTURE INC,** Art Collection, 2088 S Pennsylvania St, Denver, CO 80210. Tel 303-733-5157; *Exec Asst* Sara Church; *Asst* Cecil Burns; *Pres* Leslie Alcott Temple
Open by appointment only; Estab 1990 for educ & enjoyment; Sculpture, paintings, artifacts, African art, New Guinea, bone, skull & skeleton collections, BC & AD coins, art library, Native American, extensive photo & slide collection of Tarahumara Indians of Old Mexico. Maintains reference library; Average Annual Attendance: 500; Mem: contribution $20
Purchases: Rhinoceros Skin Shield, African & Bird Wing Collection
Collections: SLA Corporate Collection: African & New Guinea; Animal; Artifacts; Figurative; Landscape; Portraits; drawing, etching, litho, oil & watercolor; clay, sculpture/bronze, stone & wood

Exhibitions: Deceased Artists 1890 - 1930; Evolving Young Artists
Activities: Classes for adults & children; lect open to public, 4-6 vis lectr per year; concerts; gallery talks; tours by appointment; art appraisals; art brokering & locating; art collection consulting; environmental enrichment design; individual paintings & original objects of art lent to government offices & institutions; book traveling exhibitions 3 per year; originate traveling exhibitions; sales shop sells original art, reproductions & prints

A **YOUNG AUDIENCES INC,** Colo Chapter, Loretto Sta, 3001 S Federal Blvd, Box 205 Denver, CO 80236. Tel 303-922-5880; Fax 303-922-5884; Elec Mail execdir@youngaudiences.org; Internet Home Page Address: www.youngaudiences.org; *Exec Dir* Angela Norlander; *Educational Performanced Coordr* Christina Kittelstad; *Residency Coordr* Megan Weber; *AEIC Coordr* Barbara Barnhart
Open Mon - Fri 9 AM - 4 PM; admis fee per event; see program catalog; Estab to strive to make the arts an essential part of the education of every Colorado child enabling students & their teachers to experience the arts, to learn from professional artists & to understand the role of the arts in the creative process & in educational excellence; Average Annual Attendance: 7,000
Income: Grant funded
Activities: Classes for children; family programs

EVERGREEN

M **JEFFERSON COUNTY OPEN SPACE,** Hiwan Homestead Museum, 4208 S Timbervale Dr, Evergreen, CO 80439. Tel 303-674-6262; Fax 303-670-7746; Internet Home Page Address: www.jeffersoncounty.com; *Educ Coordr* Sue Ashbaugh; *Cur* Angela Rayne; *Adminr* John Steinle
Open Tues - Sun Noon - 5 PM, cl Mon; summer Tues - Sun 11 AM - 5 PM; No admis fee; Estab 1975 to collect, preserve & exhibit Jefferson County history; History House furnished to 1900; 17 room log mansion with original furnishings & displays on local history; maintains reference library; Average Annual Attendance: 18,000
Income: Financed by county taxes
Special Subjects: Architecture, Mexican Art, Painting-American, American Indian Art, American Western Art, Southwestern Art, Textiles, Costumes, Religious Art, Folk Art, Decorative Arts, Dolls, Furniture, Historical Material
Collections: Decorative & fine arts; manuscripts; Native American Arts & Crafts; Photographs; Textiles
Exhibitions: Seasonally rotating exhibitions
Publications: The Record, quarterly
Activities: Classes for children; docent training; historic lect series open to public, 4 vis lectr per year

FORT COLLINS

M **COLORADO STATE UNIVERSITY,** Curfman Gallery, 8033 Campus Delivery, Lory Student Ctr Fort Collins, CO 80523. Tel 970-491-2810; Fax 970-491-3746; Elec Mail curfman@lamar.colostate.edu; Internet Home Page Address: www.curfman.colostate.edu; *Dir* Matthew S Helmer; *Dir* Stanley Scott
Open Mon - T hurs 9 AM - 9 PM, Fri 9 AM - 9:30 PM, Sat 12 - 4 PM; No admis fee; Estab 1969 to exhibit multi-cultural works from all over the world plus student works; Average Annual Attendance: 50,000
Collections: African Collection
Exhibitions: Rotating Exhibits
Activities: Lect open to public; vis lect per year varies; gallery talks; awards Best of CSU & Best of Fort Collins

M **FORT COLLINS MUSEUM OF CONTEMPORARY ART,** 201 S College Ave, Fort Collins, CO 80524. Tel 970-482-2787; Elec Mail fcmoca@frii.com; Internet Home Page Address: www.fcmoca.org; *Exec Dir* Jeanne Shoaff; *Cur* Erica France
Open Tues - Sat 10 AM - 6 PM; Suggested donation $2; Estab 1990 a non-profit art mus dedicated to educ & exhibition of visual art; 2 galleries, 5000 sq ft housed in former 1911 post office on historic register; Average Annual Attendance: 10,000; Mem: 300
Income: $150,000 (financed by mem, fundraisers, tenant rent, grants & sponsorships)
Special Subjects: Drawings, Painting-American, Photography, Prints, Sculpture, Watercolors, Ceramics, Crafts, Pottery, Landscapes, Posters, Glass, Metalwork
Collections: Lithographs, prints, paintings, sculpture, photography
Exhibitions: Colorado-Wyoming Biennial Competition; Colorado Invitational International Poster Exhibition; Exhibits rotate every six months
Activities: Classes for adults & children; docent training; lect open to public, 5 vis lectr per year; gallery talks; tours; competitions; book traveling exhibition 1 per year

FORT MORGAN

M **FORT MORGAN HERITAGE FOUNDATION,** 414 Main St, PO Box 184 Fort Morgan, CO 80701. Tel 970-542-4010; Fax 970-542-4012; Elec Mail ftmormus@ftmorgan-mus.org; Internet Home Page Address: www.ftmorganws.org; *Pres Heritage Foundation* Sue Spencer; *VPres* Gerald Danford; *Publication Cur* Nickki Cooper; *Educ* Sarah Woodman; *Dir* Marne Jurgemeyer; *Museum Tech* Mary Preston
Open Mon - Fri 10 AM - 5 PM, Tues - Thurs evenings 6 - 8 PM, Sat 1:30 - 4:30 PM; No admis fee; Estab 1975 to interpret the history & culture of the area; Mus exhibits on a temporary basis fine art exhibits, both local artists & traveling exhibits; Average Annual Attendance: 10,000; Mem: 275; dues $10-$500; annual meeting fourth Thurs in Jan
Income: $110,000 (financed by endowment, mem, city appropriation & local, state & federal grants)

Library Holdings: Clipping Files; Filmstrips; Kodachrome Transparencies; Lantern Slides; Maps; Memorabilia; Original Documents; Photographs; Records; Video Tapes

Special Subjects: Painting-American, Anthropology, Archaeology, Costumes, Manuscripts, Historical Material

Collections: Hogsett Collection; primarily cultural & historical material; Native Arts; Howard Rollin Bird Paintings

Exhibitions: (2004) 16th Annual High Plains Artshow & Auctions

Activities: Classes for adults & children; dramatic programs; docent programs; 14 lectrs for mems only; AAM accredited awards; books, prints & original art

GOLDEN

M CLEAR CREEK HISTORY PARK, 1020 11th St, Golden, CO 80401; 822 12th St, Golden, CO 80401. Tel 303-278-3557; Fax 303-278-8916; Elec Mail info@clearcreekhistorypark.org; Internet Home Page Address: www.clearcreekhistorypark.org

Open May & Sept: Sat 10 AM - 4:30 PM, June, July & Aug: Tues - Sat 10 AM - 4:30 PM; Founded 1999; History mus & living history park; Average Annual Attendance: 9610

Special Subjects: Furniture

Collections: Six relocated homestead structures including 2 cabins, barn, chicken coop, and a one-room schoolhouse; historic & reproduction items with emphasis on furnishings, personal artifacts, recreational artifacts, tools & equip for materials

Publications: Dear Friends, quarterly newsletter; The Friendly Reminder, monthly newsletter

Activities: Organized educ progs for adults & children; docent prog; training prog; guided tours; concerts

A FOOTHILLS ART CENTER, INC, 809 15th St, Golden, CO 80401-1813. Tel 303-279-3922; Fax 303-279-9470; Elec Mail fac@foothillsartcenter.org; Internet Home Page Address: www.foothillsartcenter.org; *Exec Dir* Jennifer Cook; *Cur* Michael Chavez

Open Mon - Sat 10- AM - 5 PM, Sun 1 - 4 PM, cl holidays; Admis adults $3, seniors $2, mem & students free; Estab 1968 to provide a cultural center which embraces all the arts, to educate & stimulate the community in the appreciation & understanding of the arts, to provide equal opportunities for all people to participate in the further study & enjoyment of the arts & to provide artists & artisans with the opportunity to present their work; Housed in the former First Presbyterian Church of Golden, the original structure was built in 1872, the manse (a part of the whole layout) was built in 1892; there are five galleries, an outdoor sculpture garden and classrooms; Average Annual Attendance: 40,000; Mem: 1,200; dues $35; annual meeting in Dec

Income: $670,000 (financed by donated & earned income)

Special Subjects: Architecture, Drawings, Etchings & Engravings, Historical Material, Landscapes, Photography, Posters, Painting-American, Pottery, American Western Art, Bronzes, Decorative Arts, Folk Art, American Indian Art, Ceramics, Collages, Crafts, Hispanic Art, Juvenile Art, Latin American Art, Miniatures, Portraits, Pre-Columbian Art

Exhibitions: North American Sculpture Exhibitions; Rocky Mountain National Watermedia Exhibition; numerous open juried competitions

Publications: Bimonthly newsletter; catalogs of major national shows

Activities: Classes for adults & children; lect open to public, 8 vis lectr per year; concerts; gallery talks; tours; competitions with awards; individual paintings & original objects of art lent to businesses; museum shop sells original art

GRAND JUNCTION

M MUSEUM OF WESTERN COLORADO, 462 Ute Ave, Grand Junction, CO 81502; PO Box 20000, Grand Junction, CO 81502-5020. Tel 970-242-0971; Fax 970-242-3960; Elec Mail info@wcmuseum.org; Internet Home Page Address: www.wcmuseum.org; www.colosys.net/uranium; www.gjhistor; *Cur Archives & Librn* Michael J Menard; *Dir* Mike Perry; *Cur Educ* Kimberly Bailey; *Maintenance* Gaylon Reynolds; *Bus Mgr* Joan Crum; *Cur Cross Orchard* Zebulin Maricle; *Gift Shop Mgr* Karen Clark; *Cur Paleontology* John R Foster; *Maintenance* Fred Espinosa; *Facilities Mgr* Don Kerven; *Maintenance* Alfredo Yslas

Open Mon - Fri 10 AM - 4:45 PM, cl Sun, Christmas wk & major holidays; Admis adult $5, seniors $4, children $3, free for group mem; Estab 1965 to collect preserve, interpret social & natural history of Western Colorado; Mem: dues benefactor $1000, patron $500, sponsor $150, contributor & business $50, family $25, retired adult $15

Income: Financed by Mesa County, admis, gift shop revenues, grants, mem, donations, programs & special events

Library Holdings: Book Volumes 3500; Cassettes 2500; Lantern Slides 15; Manuscripts 300; Memorabilia; Micro Print; Motion Pictures; Original Art Works; Pamphlets 200; Periodical Subscriptions 15; Photographs 18,000; Reels 47; Slides 14,000

Collections: Frank Dean Collection; Al Look Collection; Warren Kiefer Railroad Collection; Wilson Rockwell Collection; artwork, books, manuscripts & photographs on the history & natural history of Western Colorado; Mesa County Oral History Collection

Exhibitions: Rotating exhibits & pieces from permanent collection

Publications: A Bibliography of the Dinosauria; Cross Orchards Coloring Book; Dinosaur Valley Coloring Book; Familiar Insects of Mesa County, Colorado; Footprints in the Trail; Mesa County, Colorado: A 100 Year History; Mesa County Cooking with History; More Footprints in the Trail; Museum Times, monthly newsletter; Paleontology & Geology of the Dinosaur Triangle

Activities: Classes for adults & children; docent training; lect open to public, 10 vis lectr per year; concerts; tours; Cross Ranch Apple Jubilee; Cross Ranch Artisan's Festival; slides/tape & video tape presentations; mus shop sells books, magazines, original art, reproductions

A WESTERN COLORADO CENTER FOR THE ARTS, INC, 1803 N Seventh, Grand Junction, CO 81501. Tel 970-243-7337; Fax 970-243-2482; Elec Mail arts@gjartcenter.org; Internet Home Page Address: www.gjartcenter.org; *Dir* Steven Bradley; *Art Dir* Trina Lindsay; *Educ Coordr* Kelley Raymond; *Head of Ceramics* Shepherd Terry; *Head Painting* Sara Oakley

Open Tues - Sat 9 AM - 4 PM; Admis $2 for non-members; Art Center - Mus incorporated in 1952 to provide an appropriate setting for appreciation of & active participation in the arts; Two changing exhibition galleries of 2000 sq ft each; permanent collection gallery; seven studio classrooms; auditorium; Average Annual Attendance: 24,000; Mem: 800; dues family $40, individual $30; annual meeting in Feb

Income: Financed by endowment, mem, tuition, gifts & grants

Collections: Ceramics, needlework, paintings; Navajo weavings & pottery

Exhibitions: Changing exhibits only in gallery; exhibits change monthly

Publications: Newsletter for members, monthly; catalog of permanent collections

Activities: Classes for adults & children; docent training; lect open to public; concerts; gallery talks; tours; competitions; sales shop sells books, magazines, original art, reproductions, Southwest Indian & contemporary craft items & notecards

L Library, 1803 N Seventh, Grand Junction, CO 81501. Tel 970-243-7337; *Dir* Richard Helm

Open to members & pub for reference

Library Holdings: Book Volumes 1000; Exhibition Catalogs

GREELEY

M MADISON & MAIN GALLERY, 927 16th St, Greeley, CO 80631. Tel 970-351-6201; Internet Home Page Address: www.madisonandmaingallery.com; *Treas* Susan B Anderson

Open Mon - Sat 10 AM - 6 PM; No admis fee; Estab 1987 as an artists' cooperative

Income: $30,000 (financed by art sales)

Exhibitions: Six shows per year plus work of members & consignees

M UNIVERSITY OF NORTHERN COLORADO, SCHOOL OF ART AND DESIGN, (University of Northern Colorado) John Mariani Gallery, Department of Visual Arts, Eighth Ave & 18th St Greeley, CO 80639; School of Arts & Design Galleries, Campus Box 30, Guggenheim Hall Greeley, CO 80639. Tel 970-351-2184; Fax 970-351-2299; Elec Mail charlotte.nichols@unco.edu; Internet Home Page Address: www.arts.unco.edu/visarts/visarts_galleries.html; *Dir* Charlotte Nichols

Open Mon, Tues & Thurs, Fri 10 AM - 3 PM, Wed 1 - 6 PM ; No admis fee; Estab 1973, to provide art exhibitions for the benefit of the University & the surrounding community; Remodeled space 2001; Average Annual Attendance: 20,000

Income: Financed by endowment & city & state appropriations

Exhibitions: UNC Faculty Exhibition; UNC Student Exhibition

Publications: Schedule of Exhibitions, quarterly

Activities: Competitions with awards

GUNNISON

M WESTERN STATE COLLEGE OF COLORADO, Quigley Hall Art Gallery, 101 Quigley Hall, Gunnison, CO 81231. Tel 970-943-2045, 943-0120 (main); Fax 970-943-2329; Elec Mail acaniff@western.edu; Internet Home Page Address: www.western.edu; *Art Area Coordr* Lee Johnson; *Dir Gallery* Harry Heil; *Chmn* Al Caniff

Open Mon - Fri 1 - 5 PM; No admis fee; Estab 1967 for the purpose of exhibiting student, staff & traveling art; Nearly 300 running ft composition walls, security lock-up iron grill gate is contained in the gallery; Average Annual Attendance: 7,500

Income: Financed by state appropriation

Special Subjects: Painting-American, Prints

Collections: Original paintings and prints

Exhibitions: Rotating exhibits

Activities: Competitions; originates traveling exhibitions

HOLYOKE

M PHILLIPS COUNTY MUSEUM, 109 S Campbell Ave, Holyoke, CO 80734. Tel 970-854-2129; Fax 970-854-3811; Internet Home Page Address: www.rootsweb.com/cophilli; *Pres* Carol Haynes; *Treas* Hilda Hassler; *Secy* Leona Oltjenbruns; *VPres* Diane Rahe

Open Tues - Sat 10 AM - 4 PM; No admis fee; Estab 1929 as an educational & cultural museum to impart an appreciation of local history & to display objects of art from all over the world; Average Annual Attendance: 5,000; Mem: 250; dues $3-$5; annual meeting first Fri in May

Income: Financed by endowment, mem & city appropriation

Special Subjects: Painting-American, Ceramics, Glass

Collections: China; glassware; paintings; Indian artifacts; Civil War memorabilia; Thomas Alva Edison Historical Display

LA JUNTA

M KOSHARE INDIAN MUSEUM, INC, 115 W 18th, PO BOX 580 La Junta, CO 81050. Tel 719-384-4411; Fax 719-384-8836; Elec Mail koshare@ria.net; Internet Home Page Address: www.koshare.org; *Office Mgr* Linda Root; *Gift Shop Mgr* Jo Ann Jones; *Develop Dir* Linda Powers; *Coll Mgr* Jo Anne Kent

Open all yr 9 AM - 5 PM, Mon and Wed open until 9 PM; $2 adults, $1 students under 17, $1 seniors 55 & older; Estab 1949 for the exhibition of Indian artifacts & paintings; 15,000 sq ft display space; For reference only to members only or by special arrangement; Average Annual Attendance: 100,000; Mem: 250; annual meeting second Tues in Dec; dues start at $25 & up

Income: Financed by donations & shows

Special Subjects: Hispanic Art, Mexican Art, Painting-American, Prints, Watercolors, American Indian Art, American Western Art, Bronzes, Archaeology, Textiles, Crafts, Folk Art, Pottery, Woodcarvings, Decorative Arts, Portraits, Eskimo Art, Jewelry, Carpets & Rugs, Ivory, Scrimshaw, Leather

Collections: Indian arts & crafts, of & by Indians; Taos Ten; prominent southwestern artists
Exhibitions: Exhibits change monthly
Activities: Classes for children; tours; paintings & original art works lent to qualified museums; book traveling exhibitions; museum shop sells books, original art, reproductions, souvenirs

L **Library,** 115 W 18th, La Junta, CO 81050. Tel 719-384-4411; Fax 719-384-8836; Elec Mail koshare@ria.net; Internet Home Page Address: www.ruralnet.net/~koshare; Internet Home Page Address: www.koshare.org; *Dir Progs* Joe Clay
Open by appt only; No admis fee; Estab 1949 for education through art & youth program; Open for reference only ; Average Annual Attendance: 18,000
Income: Donations, grants
Library Holdings: Book Volumes 1700; Clipping Files
Special Subjects: History of Art & Archaeology, Archaeology, American Western Art, American Indian Art, Primitive art, Anthropology, Eskimo Art, Southwestern Art, Pottery
Collections: Baskets; Clothing; Kachinas; Paintings; Pots; Textiles
Activities: Classes for children; dramatic programs; Boy Scouts of America-Koshare Indian Dancers; concerts; gallery talks; tours; individual paintings & original objects of art lent to other museums; book traveling exhibitions; museum shop sells books, original art, reproductions, prints, slides, jewelry, kachinas, pots & videos

LEADVILLE

A **LAKE COUNTY CIVIC CENTER ASSOCIATION, INC,** Heritage Museum & Gallery, 100-102 E Ninth St, PO Box 962 Leadville, CO 80461. Tel 719-486-1878, 486-1421; *Pres Board Dirs* Ray Stamps; *VPres* Ted Mullings
Open Memorial Day-Labor Day 10 AM-6 PM. Also open May, Sept & Oct on limited hours daily; Admis adults $4, sr citizens $3.50, children 6 - 16 $3, under 6 free, members free; Estab 1971 to promote the preservation, restoration & study of the rich history of the Lake County area & to provide display area for local & non-local art work & also to provide an educational assistance both to public schools & interested individuals; The Museum & Gallery own no art work, but display a variety of art on a changing basis; Average Annual Attendance: 9,000; Mem: 160; dues $20-$250; annual meeting Feb
Collections: Diorama of Leadville history; mining & Victorian era artifacts; Victorian furniture
Exhibitions: Changing displays of paintings, photography and craft work
Publications: The Tallyboard, newsletter, quarterly
Activities: Lect open to pub; competitions; sales shop sells books, slides, papers, postcards, rock samples

M **TABOR OPERA HOUSE MUSEUM,** 306-310 Harrison Ave, Leadville, CO; 815 Harrison Ave., Leadville, CO 80461. Tel 719-486-8409; Elec Mail sharon@taboroperahouse.net; Internet Home Page Address: taboroperahouse.net; *Owner* Sharon Bland
Open June - Oct Mon - Sat 10 AM - 5:00 PM, Nov - May by appointment only; Admis adults $5, children 6-11 $2.50, under 6 free; Tours adults $8, combined tour adults $5; Estab 1955 as a historic theatre museum
Collections: Costumes; paintings
Exhibitions: Original scenery live shows
Activities: Lect; living history tours for students; films; concerts; arts festivals; sales shop sells books, cards, pictures, prints & souvenirs

LITTLETON

M **ARAPAHOE COMMUNITY COLLEGE,** Colorado Gallery of the Arts, 2500 W College Dr, PO Box 9002 Littleton, CO 80160. Tel 303-797-5649; Fax 303-797-5935; Internet Home Page Address: www.arapahoe.com; *Chmn* Scott Engel; *Gallery Coordr* Trish Sangelo
Open Mon - Fri Noon - 5 PM, Tues 5 - 7 PM; No admis fee; Gallery contributes significantly to the cultural growth of the Denver-metro area
Income: funded by school appropriations
Special Subjects: Costumes

LOVELAND

M **LOVELAND MUSEUM GALLERY,** Fifth & Lincoln, Loveland, CO 80537; 503 N Lincoln, Loveland, CO 80537. Tel 970-962-2410; Fax 970-962-2910; Internet Home Page Address: www.ci.loveland.co.us; *Cur Interpretation* Tom Katsimpalis; *Cur Coll* Jennifer Slichter; *Exhib Preparator* David Phelps; *Cultural Events Coordr* Kim Akeley-Charron; *Dir Cultural Svcs* Susan Ison; *Cur Exhibits* Janice Currier; *Business Svcs* Suzanne Janssen; *Admin Spec* Claudette Phelps; *Youth Activities Coordr* Jenni Dobson
Open Tues, Wed & Fri 10 AM - 5 PM, Thurs 10 AM - 9 PM, Sat 10 AM - 4 PM, Sun Noon - 4 PM; No admis fee; Estab 1946 to preserve & interpret history of Loveland area; 4000 sq ft; features local, state, national & international art exhibitions; Average Annual Attendance: 50,000; Mem: 120; dues individual $15
Income: Financed by city appropriation
Library Holdings: Book Volumes; CD-ROMs; Exhibition Catalogs; Memorabilia; Original Documents; Pamphlets; Sculpture; Slides
Special Subjects: Architecture, Drawings, Painting-American, Photography, Sculpture, American Indian Art, American Western Art, Bronzes, Anthropology, Archaeology, Textiles, Costumes, Folk Art, Decorative Arts, Manuscripts, Dolls, Furniture, Glass, Jewelry, Historical Material, Dioramas, Period Rooms, Embroidery, Laces
Collections: Archaeology; art; dioramas, historical material; period rooms; sugar beet industry; textiles; tools; valentines; western; photography
Exhibitions: Bureau of Reclamation Relief Map of Big Thompson Project; Great Western Sugar Company Exhibit; pioneer cabin; Fireside History Gallery
Publications: Exhibition catalogues; history books; newsletter

Activities: Classes for adults & children; dramatic programs; art workshops; poetry readings; lect open to public, 20 vis lectr per year; concerts; gallery talks; tours & sponsoring of competitions; scholarships; inter-museum loan programs containing cassettes, filmstrips, motion pictures, nature artifacts, original works of art & slides; book traveling exhibitions 1 per year; originate traveling exhibitions; museum shop sells books, magazines, original art, reproductions & prints

MESA VERDE NATIONAL PARK

L **MESA VERDE NATIONAL PARK,** Research Library, PO Box 8, Mesa Verde National Park, CO 81330-0027. Tel 970-529-4465; Fax 970-529-4637; Internet Home Page Address: www.nps.gov/meve
Call for appointment; Admis $10; Estab 1906; Average Annual Attendance: 250
Income: $35,800 (financed by endowment)
Library Holdings: Audio Tapes; Book Volumes 10,000; Fiche; Manuscripts; Pamphlets; Periodical Subscriptions 43; Photographs; Slides
Special Subjects: Folk Art, Manuscripts, Maps, Historical Material, History of Art & Archaeology, Ceramics, Archaeology, Ethnology, American Indian Art, Anthropology, Furniture, Dioramas, Display, Architecture
Collections: American Indians; Anthropology; Archaeology; Ethnology

PUEBLO

M **ROSEMOUNT MUSEUM, INC,** 419 W 14th St, Pueblo, CO 81003. Tel 719-545-5290; Fax 719-545-5291; Elec Mail vol@rosemount.org; Internet Home Page Address: www.rosemount.org; *Exec Dir* Deb Darrow
Open Tues - Sat 10 AM - 4 PM, cl Sun, Mon and Jan; Admis adults $6, senior citizens $5, children 6-16 $4, under 6 free; Estab 1968 as a historic house museum to narrate late Victorian life in the west; 37-room Victorian mansion contains 80 percent of original furnishings including many decorative objects & art from late 19th century; Average Annual Attendance: 26,000; Mem: 650; dues $15-$500; annual meeting in Apr
Income: $503,000 (financed by endowment, mem, rental, gift shop, auxiliary organization, fundraisers, admis, donations & grants)
Purchases: $503,000
Library Holdings: Auction Catalogs; Book Volumes; Cards; Clipping Files; Kodachrome Transparencies; Lantern Slides; Manuscripts; Memorabilia; Original Art Works; Prints; Reproductions; Sculpture; Video Tapes
Collections: Permanent collections are displayed in a 37-room Victorian mansion & are one of the finest intact collections of the American Aesthetic Movement; Collections include furnishings, decorative objects, paintings, sculpture, drawings, photographs, all pertaining to the life of the Thatcher Family
Publications: Rosemount News, quarterly
Activities: Classes for adults & children; dramatic programs; docent training; lect open to public, vis lect varies per year; special theme & holiday events; concerts; gallery talks; tours; Best Museum in Pueblo-2000; El Pomar Award of Excellence; museum shop sells books, prints, & decorative art objects

A **SANGRE DE CRISTO ARTS & CONFERENCE CENTER,** 210 N Santa Fe, Pueblo, CO 81003. Tel 719-295-7200; Fax 719-295-7230; Elec Mail mail@sdc-arts.org; Internet Home Page Address: www.sdc-arts.org; *Dir* Maggie Divelbiss; *Asst Dir* Jennifer Cook; *Visual Art Cur* Jina Pierce; *Rentals Coordr, Facilities & Beverage Mgr* Lorrie Marquez; *Mktg Mgr* Erin Hergert; *Dir Educ* Gary Holder; *Admin Asst* Jennifer Owens; *Cur Children's Mus* Donna Stinchcomb; *Asst Cur & Coll Mgr* Joan Mertz
Open Mon - Sat 11 AM - 4 PM, galleries open Tues - Sat 11 AM - 4 PM; $4; Estab 1972 to promote the educational & cultural activities related to the fine arts in Southern Colorado including four gallery spaces & a hands on children's museum, a conference center with over 7000 sq ft of rentable space for conventions, receptions, meetings, including a 500 seat theater; The Helen T White Gallery provides four gallery spaces with changing exhibitions by local, regional & international artists, including the Francis King Collection of Western Art on permanent display. Buell Children's Mus displays over 2 dozen hands-on exhibits; Average Annual Attendance: 150,000; Mem: 3800; dues $15-$1500
Income: $993,000 (financed by mem, city & County appropriation, grants, grants, private underwriting, donations & in-kind services)
Collections: Francis King Collection of Western Art, on permanent display; Gene Kloss Collection; Santo Collection
Exhibitions: Converted art inspired by car culture
Publications: Town & Center Mosaic, four times a yr; Catalogue of Francis King Collection; West By Southwest book, collections of the Francis King Collection of Western Art, Collection of Intaglio Prints by Gene Kloss, Ruth Gast Collection of Santos; annual report exhibition catalogues; brochures for workshop & dance classes, quarterly; performance arts series, children's series, children's museum
Activities: Year-round workshop program, wide selection of disciplines for children & adults; special facilities for ceramics, painting & photography; school of dance; artists-in-residence; lect & seminars coinciding with exhibits; Theatre Arts - Town & Gown Performing Arts Series; Children's Playhouse Series; outdoor summer concerts, Repertory Theatre Company presenting 2 performances a year, resident modern dance company; scholarships offered; individual paintings & objects of art lent to museums, galleries & art centers; lending collection contains 575 original art works, 130 original prints, 445 paintings, photographs, nature artifacts & sculptures; book traveling exhibitions 1-3 per year; sales shop sells hand-crafted & imported gifts & southwestern artifacts, posters, books, jewelry

M **UNIVERSITY OF SOUTHERN COLORADO,** College of Liberal & Fine Arts, 2200 Bonforte Blvd, Pueblo, CO 81001-4901. Tel 719-549-2100; Fax 719-549-2120; Internet Home Page Address: www.uscolo.edu; *Art Dept Chmn* Roy Sonnema; *Dir Gallery* Dennis Dolton
Open daily 10 AM - 4 PM; No admis fee; Estab 1972 to provide educational exhibitions for students attending the University; Gallery has a 40 x 50 ft area with 16 ft ceiling; vinyl covered wooden walls; carpeted & adjustable track lighting; Average Annual Attendance: 6,000
Income: Financed through University & student government

Special Subjects: Drawings, Prints, American Indian Art
Collections: Basketry of the Plains Indian, clothing of the Plains Indian; Orman Collection of Indian Art of the Southwest including Indian blankets of the Rio Grande & Navajo people; pottery of the Pueblo Indians (both recent & ancient)
Exhibitions: (1999) Arte De San Carlos; Common Ground.; Art Director's Club of Denver Exhibition; Art Resources of South Colorado; Colorado Invites
Publications: Catalogs
Activities: Lect open to public; individual paintings & original objects of art lent; book traveling exhibitions 2-6 per year; originate traveling exhibitions organized & circulated

SNOWMASS VILLAGE

A ANDERSON RANCH ARTS CENTER, 5263 Owl Creek Rd, PO Box 5598 Snowmass Village, CO 81615. Tel 970-923-3181; Fax 970-923-3871; Elec Mail artranch@rof.net; Internet Home Page Address: www.andersonranch.org; *Registrar* Dawn Ogren; *Exec Dir* James Baker
Open Mon - Fri 9 AM - 5 PM; No admis fee; Estab 1966 to feature Ranch artists; Two floor exhibition space; 1st floor is dedicated to 2-Dimensional work, 2nd floor to 3-Dimensional work; Average Annual Attendance: 4,000
Income: $2,000,000 (financed by private donations, grants & tuition)
Special Subjects: Drawings, Etchings & Engravings, Photography, Prints, Sculpture, Pottery, Ceramics
Collections: Print collection of contemporary pieces by acclaimed artists
Publications: Workshops catalog, annual
Activities: Classes for adults & children; lect open to public; scholarships offered; sales shop sells books, original art, refreshments, clothing & art supplies

TRINIDAD

M ARTHUR ROY MITCHELL MEMORIAL INC, Museum of Western Art, 150 E Main St, Trinidad, CO 81082-0095. Tel 719-846-4224; Elec Mail themitch@smi.net; *Pres* Eugene Aiello; *VPres* Richard Louder; *Treas* Roy Boyd; *Exec Dir* Pat Patrick
Open Mon - Sat 10 AM - 4 PM, cl Sun Apr - Sept; Admis $2; Estab 1981 to preserve & display art of the American West; 15,000 sq ft gallery space; Average Annual Attendance: 18,000; Mem: 950; dues $25 - $1000
Income: $50,000 (financed by endowment, mem, donations, gifts, grants & gift shop)
Special Subjects: Architecture, Hispanic Art, Painting-American, Photography, Sculpture, Watercolors, American Indian Art, American Western Art, Southwestern Art, Religious Art, Ceramics, Folk Art, Pottery, Landscapes, Decorative Arts, Portraits, Jewelry, Carpets & Rugs, Historical Material
Collections: A R Mitchell Collection; Almeron Newman Collection of photography; The Aultman Collection of photography; Harvey Dienn Collection
Exhibitions: Santa Fe Trail Regional, 15 exhibits a year
Activities: Classes in docent programs; lect open to public, 1 vis lectr per year; concerts; gallery talks; tours; competitions with prizes; individual paintings & original objects of art lent to University of Colorado at Boulder, Colorado Community College & other museums; lending collection contains original art works & paintings; book traveling exhibitions; originate traveling exhibitions 4 per year; museum shop sells books, original art, Indian jewelry & Indian rugs

CONNECTICUT

AVON

A FARMINGTON VALLEY ARTS CENTER, Avon Park N, 25 Arts Center Lane Avon, CT 06001. Tel 860-678-1867; Fax 860-674-1877; *Educ Asst* Pat Parker; *Prog Coordr* Dana Herbert; *Dir Educ* Laura Davis; *Dir Programs* Sue Schamberger; *Exec Dir* John Cusano
Open Mon - Fri 9 AM - 5 PM; No admis fee; Estab 1972 to provide a facility with appropriate environment & programs that serves as a focal point for public awareness of & participation in the visual arts through quality arts education, exposure to dedicated artists & exposure to high quality crafts; The Fisher Gallery (1300 sq ft) displays and sells fine craft and art and offers educational programming; Average Annual Attendance: 20,000; Mem: 600; dues family $50, individual $35, teens & srs $20; children $20
Income: $780,000 (financed by class tuition, gallery, mem, grants, tuitions, donations from corporations & individuals special event earning)
Library Holdings: Book Volumes; Original Art Works; Pamphlets; Periodical Subscriptions; Photographs; Prints; Sculpture; Slides
Special Subjects: Drawings, Etchings & Engravings, Photography, Sculpture, Silver, Painting-American, Pottery, Decorative Arts, Ceramics, Portraits, Glass, Jewelry
Exhibitions: American craftspeople featured in Fisher Gallery; on-site studio artists featured in Visitor's Gallery
Activities: Classes for adults & children, educational outreach programs; 20 studios for rent; career advancement program for artists; teacher training; docent training; summer arts camp; lect open to public; 4 vis lectr per yr; gallery talks; tours; visits to artist's studios; annual holiday exhib of fine crafts

BRIDGEPORT

M THE BARNUM MUSEUM, 820 Main St, Bridgeport, CT 06604. Tel 203-331-1104; Fax 203-339-4341; Elec Mail awestmoreland@basnum.museum.org; Internet Home Page Address: www.barnum-museum.org; *Cur* Kathleen Maher; *Exec Dir* Lawrence A Fisher; *Dir Develop* Susan J Agamy; *Educ Dir* Jeffrey L Nichols; *Pub Rels Dir* Avril M Westmoreland; *Chm (V)* Craig Frew; *Educ Progs* Ken Blinn; *Mus Shop Mgr.* Debbie Saviello
Open Tues - Sat 10 AM - 4:30 PM, Sun Noon - 4:30 PM; Admis adults $5, college students & senior citizens $4 & children $3; Estab 1893 to exhibit the life

& times of P T Barnum; Average Annual Attendance: 20,000; Mem: 400; dues family $45, individual $25
Income: Financed by City of Bridgeport, corporate individual, mem & endowments
Collections: Tom Thumb Coll; Jenny Lind Coll, photos
Publications: The Barnum Herald newsletter, twice per year
Activities: Tours; films; school & public programs; workshops; lect open to public; book traveling exhibitions 1 per year; originate traveling exhibitions; sales shop sells books, souvenirs

M DISCOVERY MUSEUM, 4450 Park Ave, Bridgeport, CT 06604. Tel 203-372-3521; Fax 203-374-1929; Elec Mail audley@discoverymuseum.org; Internet Home Page Address: www.discovery.museum.org; *Pres* Paul Audley; *Dir Admin* Lynn Hamilton; *Develop* Cynthia Manning; *Acting Cur* Wendy Kelly; *Sr VPres* Linda Markin
Open Tues - Sat 10 AM - 5 PM, Sun Noon - 5 PM, cl major holidays; Admis adults $7, children, senior citizens & col students $5.50, children under 3 & members free; Estab 1958 to provide exhibitions & educational programs in the arts & sciences for a regional audience; Average Annual Attendance: 100,000; Mem: 1500; dues $20-$1000; annual meeting in June
Income: Financed by mem dues
Special Subjects: Painting-American, Furniture
Collections: Paintings, prints & works on paper; Historic house
Exhibitions: Temporary & permanent exhibitions; hands-on physical science exhibits; Hands-on Art Gallery; Challenger Space Station; Fine Art Gallery; Planetarium
Activities: Classes for children; docent training; lect open to public, 4 vis lectr per year; concerts; tours; competitions with awards; scholarships; planetarium shows; individual paintings & original objects of art lent to other local and regional mus; book traveling exhibitions 1 per year; museum shop sells books, reproductions, cards, calendars, gifts, jewelry, dishware & toys for children & adults

M HOUSATONIC COMMUNITY COLLEGE, (Housatonic Community-Technical College) Housatonic Museum of Art, 900 Lafayette Blvd, Bridgeport, CT 06604-4704. Tel 203-332-5052; Fax 203-332-5123; Elec Mail rzella@hcc.commnet.edu; Internet Home Page Address: www.housatonicmuseum.org; *Dir* Robbin Zella
Open Mon - Fri 8:30 AM - 5:30 PM, Sat 9 AM - 3 PM, Sun noon to 4 PM, Thurs until 7 PM; No admis fee; Mus estab 1967; Range of contemporary & historic shows; Average Annual Attendance: 12,000
Income: Financed by state & local funding, public & private foundation grants & donations
Library Holdings: Audio Tapes; Book Volumes; CD-ROMs; Clipping Files; Exhibition Catalogs; Original Art Works; Photographs; Prints; Sculpture
Special Subjects: Drawings, Painting-American, Sculpture
Collections: Extensive 19th & 20th Century drawings, paintings & sculpture: Avery, Baskin, Calder, Cassat, Chagall, Daumier, DeChirico, Derain, Dubuffet, Gottlieb, Lichtenstein, Lindner, Marisol, Matisse, Miro-Moore, Pavia,; Picasso, Rauchenberg, Rivers, Shahn, Vasarely, Warhol, Wesselmann & others; extensive ethnographic collections, including Africa, South Seas & others; smaller holdings from various historical periods
Exhibitions: Several exhibitions per year
Publications: Exhibition catalogs
Activities: Classes for adults; college art courses; lect open to public, 6-8 vis lectr per year; concerts; gallery talks; tours; scholarships offered; individual paintings & original objects of art lent to institutions; limited lending collection contains 2000 paintings, 25,000 slides, sculpture, original art works, original prints; book traveling exhibitions; originate traveling exhibitions to other universities; exhibits include Beyond Recognition, Ecce Homo, Monuments & Memory; museum shop sells books, t-shirts, posters

L Library, 900 Lafayette Blvd, Bridgeport, CT 06604. Tel 203-332-5070; Fax 203-332-5132; *Dir* Bruce Harvey
Libr Open Mon - Wed & Fri 8:30 AM - 5:30 PM, Thur 8:30 AM - 7 PM; No admis fee; Libr Estab 1967; Extensive art section open to students & community; Average Annual Attendance: 5,000
Income: state, fed & pvt
Library Holdings: Book Volumes 30,000; Fiche

M UNIVERSITY OF BRIDGEPORT GALLERY, Bernhard Ctr, Bridgeport, CT 06601. Tel 203-576-4239; Fax 203-576-4512; *Art Dept Chmn* Thomas Juliusburger; *Assoc VPres of Univ Rels* James Garland
No admis fee; Estab 1972
Collections: Contemporary art; prints
Activities: Lect open to public; gallery talks; concerts; individual paintings & original objects of art lent; originates traveling exhibitions

BROOKFIELD

M BROOKFIELD CRAFT CENTER, INC, Gallery, 286 Whiscenier Rd, PO Box 122 Brookfield, CT 06804. Tel 203-775-4526; Fax 203-740-7815; Elec Mail brkfldcrft@aol.com; Internet Home Page Address: www.brookfieldcraftcenter.org; *Exec Dir* John I Russell
Open daily 10 AM - 5 PM; No admis fee; Estab 1954 to provide a wide spectrum of craft education & exhibition to the local & national audiences; Average Annual Attendance: 15,000; Mem: 1200; dues $35-$50
Exhibitions: Contemporary craft exhibitions changing every 8 weeks
Publications: Catalogs
Activities: Classes for adults; lect open to public, 300 vis lectr per year; concerts; scholarships; scholarships offered; book traveling exhibitions to other craft organizations; sales shop sells books, original art & handmade craft items

BROOKLYN

M NEW ENGLAND CENTER FOR CONTEMPORARY ART, Rte 169, PO Box 302 Brooklyn, CT 06234. Tel 860-774-8899; Fax 860-774-4840; Internet Home Page Address: www.museum-necca.org; *Dir* Henry Riseman; *Assoc Dir* Paul Sorel; *Cur Chinese Art* Xue JianXin
Open Wed - Fri 10 AM - 4 PM, Sat & Sun 1 PM - 5 PM, cl Christmas; No admis

fee; Estab 1975; Mem: dues corporate $100, supporting $50, family $15, individual $10, senior citizen $6
Income: Financed by state appropriations, mem, contributions & gifts
Collections: Contemporary paintings & sculpture; print collection by Russian artists; woodblock print collection from the People's Republic of China
Exhibitions: Rotating and traveling exhibits
Activities: Classes for adults & children; lect; tours; films; gallery talks; originate traveling exhibitions; sales shop sells paintings, prints & books

CHESHIRE

M **BARKER CHARACTER, COMIC AND CARTOON MUSEUM,** 1188 Highland Ave, Rte 10, Cheshire, CT 06410. Tel 203-699-3822; Elec Mail fun@barkeranimation.com; Internet Home Page Address: www.barkermuseum.com; *Co-Founder* Herbert Barker, D.H.L.; *Co-Founder* Gloria Barker
Open Wed - Sat 11 AM - 5 PM. Cl holidays; tours available by appt for those 8 years of age & up; No admis fee; Comic strip & cartoon memories from childhood are captured here; advertising memorabilia amassed by Herb & Gloria Barker. Though none of the museum's coll is for sale, exhibs contain the current market value
Special Subjects: Miniatures, Cartoons
Collections: Official California Raisins Museum; Official Celebriducks Museum, featuring extensive coll of rubber ducks; Disney, Hanna-Barbera, Warner Bros, Charles Fazzino & many other colls of memorabilia; Roy Rogers lunch box; Ronald McDonald phone; Charlie McCarthy puppet; Flintstones Band Toy; Lone Ranger Gun; Mickey & Minnie hand car; advertising memorabilia; rare recent acquisitions
Activities: Field trips by advance reservation

COS COB

M **HISTORICAL SOCIETY OF THE TOWN OF GREENWICH, INC,** Bush-Holley House Museum, 39 Strickland Rd, Cos Cob, CT 06807. Tel 203-869-6899; Fax 203-861-9720; Elec Mail asmin@hstg.org; Internet Home Page Address: www.hstg.org; *Chmn* William C Crooks; *Exec Dir* Debra L Mecky; *Pres* Christopher Holbrook
Open Wed - Sun noon - 4 PM, Jan - Mar weekends only, cl Mon & Tues; Archives: Mon & Wed 9 AM - 4 PM, Tues, Thurs & Fri by appt only; Admis adults $6, senior citizens & students $4; 18th century Bush family home. Maintains reference library; Average Annual Attendance: 10,000; Mem: 2400; dues preservations $10,000, collector $5000, historian $2500, benefactor $1000, patron $500, donor $250, sponsor $100, family $50, individual $35
Income: Financed by contributions, mem, special events, fees
Special Subjects: Painting-American, Pottery, Etchings & Engravings, Decorative Arts, Furniture, Period Rooms
Collections: Outbuilding houses collection of John Rogers groups; 18th & 19th century decorative arts; paintings of American impressionists; antiques
Publications: Greenwich History Journal, annual; The Post newsletter bimonthly; annual report; pamphlets
Activities: Classes for adults & children; docent training; lect open to the public; gallery talks; tours; individual paintings & original objects of art lent; museum shop sells miscellaneous gift items

COVENTRY

M **NATHAN HALE HOMESTEAD MUSEUM,** 229 South St, Coventry, CT 06238. Tel 860-742-6917; Elec Mail sandrarux@comcast.net; Internet Home Page Address: http://ursamajor.hartnet.org/als/nathanhale/
Open mid-May to mid-Oct Wed - Sun 1 - 4 PM; Admis adults $4, children 6 - 18 $2, children under 6 no admis fee; Mus is on the grounds in which Revolutionary War hero Nathan Hale uttered his final words "I only regret that I have but one life to lose for my country." Georgian-style house was built by the Hale family in 1776, situated on over 500 acres of forest land; Average Annual Attendance: 3,500 ann
Special Subjects: Historical Material
Collections: Georgian house built in 1776 on site
Activities: Educ progs; birthday parties; summer camp; trails; horseback riding; 18th century demonstration garden; hands-on activities; museum-related items for sale

DANBURY

M **DANBURY SCOTT-FANTON MUSEUM & HISTORICAL SOCIETY, INC,** 43 Main St, Danbury, CT 06810. Tel 203-743-5200; Fax 203-743-1131; Elec Mail dmhs@danburyhistorical.org; Internet Home Page Address: www.danburyhistorical.org; *Dir* Levi Newsome; *Cur Specialist* Brigid Durkin; *Research Specialist* Kathleen Zuris
Call for information; No admis fee; donations welcome; Estab June 24, 1941 as historic house. Merged with Mus & Arts Center by Legislative Act 1947; Operates the 1785 John & Mary Rider House as a mus of early Americana & the 1790 Dodd Hat Shop with exhibits relating to hatting. Huntington Hall houses frequently changing exhibits. Ives Homestead, located at Rogers Park in Danbury is to be restored & opened to the pub as a memorial to American composer Charles Edward Ives. Marian Anderson Studio - a memorial to famous Afro-American singer; Average Annual Attendance: 5,000; Mem: 500; dues student $2 up to life $1000; annual meeting in May
Income: Financed by endowment & mem
Collections: Quilt Collection; Batting Collection; Early 1800s mens & womens clothing; Early American Furniture
Publications: Newsletter, quarterly; reprints
Activities: Classes for adults & children; dramatic programs; lect open to public; concerts; open house; special exhibits; gallery talks; tours; slide shows
L **Library,** 43 Main St, Danbury, CT 06810. Tel 203-743-5200; Internet Home Page

Address: www.danburyhistorical.org; *Dir* Levi Newsome; *Cur Specialist* Brigid Durkin; *Research Specialist* Kathleen Zuris
Call for information; Historic information & photographs for reference only
Library Holdings: Clipping Files; Manuscripts; Memorabilia; Other Holdings City Directories; Photographs
Collections: Charles Ives Photograph Collection

A **WOOSTER COMMUNITY ART CENTER,** 73 Miry Brook Rd, Danbury, CT 06810. Tel 203-744-4825; *Asst Dir* Judy Kagan; *Exec Dir* Nancy M Rogers
Open Mon - Fri 9:30 AM - 6 PM, cl Sat & Sun; Estab 1965 as a Community Art Center; Reception center gallery 500 sq ft; Average Annual Attendance: 1,500; Mem: 100; dues family $50, individual $35
Exhibitions: Faculty Exhibits; Art exhibits change monthly in Lobby Gallery, Area artists exhibit artwork in varied media, indoor & outdoor photography, painting & sculpture
Publications: Arts News (newsletter), 3 times per yr
Activities: Classes for adults & children; lect open to public, 5 vis lectr per year; scholarships & fels offered; originate traveling exhibitions; sales shop sells art supplies
L **Library,** 73 Miry Brook Rd, Danbury, CT 06810. Tel 203-744-4825; *Exec Dir* Nancy M Rogers
For reference only
Library Holdings: Book Volumes 2000; Periodical Subscriptions 3; Slides 2200

DERBY

M **OSBORNE HOMESTEAD MUSEUM,** 500 Hawthorne Ave, Derby, CT 06418; PO Box 435, Derby, CT 06418. Tel 203-734-2513; Fax 203-922-7833; Elec Mail diane.joy@po.state.ct.us; Internet Home Page Address: http://dep.state.ct.us/educ/kellogg; *Dir* Diane Chisnall Joy; *Environmental Educ* Roger Lawson; *Environmental Educ* Susan Quincy; *Mus Educ* Christiana Soares Jones; *Office Mgr* Donna Kingston; *Maintainer* Marguerite Heneghan
Mus open May 15 - Nov 21 Thurs & Fri 10 AM - 3 PM, Sat 10 AM - 4 PM, Sun 12 PM - 4 PM. Holiday tours: Nov 26 - Dec 19 Thurs - Sun 10 AM - 4 PM. Kellogg Estate Gardens open Spring - Autumn Mon - Sat 9 AM - 4:30 PM; Mus celebrates life & times of Frances Osborne Kellogg, noted industrialist, agriculturalist & conservationist who was dedicated to preserving land for future generations
Special Subjects: Historical Material, Furniture
Collections: period furniture; fine art; history of the Osborne family
Publications: Trillium, newsletter
Activities: School, teacher & scout progs; hands-on activities; bird walks; adjacent state park; formal gardens; holiday tours

ESSEX

A **ESSEX ART ASSOCIATION, INC,** 10 N Main St, PO Box 193 Essex, CT 06426. Tel 860-767-8996; *Treas* Cynthia Offredi; *Pres* Bob Gantner; *Admin Dir* Rick Silberberg; *Admin Dir* Iris Silberberg
Open daily 1 - 5 PM June - Labor Day; No admis fee; Estab 1946 as a nonprofit organization for the encouragement of the arts & to provide & maintain suitable headquarters for the showing of art; Maintains a small, well-equipped one-floor gallery; Average Annual Attendance: 2,500; Mem: 360; elected artists $40; assoc artists $30; supporting members $25
Income: Financed by mem & donations
Exhibitions: Three annual exhibits each year plus one or two special exhibits; 4 exhibits for EAA; Valley Regional High School Scholarship Award Show; Society of Connecticut Sculptors

FAIRFIELD

A **FAIRFIELD HISTORICAL SOCIETY,** Fairfield Museum & History Center, 636 Old Post Rd, Fairfield, CT 06824; 370 Beach Rd, Fairfield , CT 06824. Tel 203-259-1598; Fax 203-255-2716; Elec Mail info@fairfieldhs.org; Internet Home Page Address: www.fairfieldhs.org; *CEO* Michael Jehle; *Cur* Adrienne Saint-Pierre; *Dir Educ* Erik Larson; *Prog & Vol Coordr* Walter Matis; *Exec Asst* Mildred Glotzer; *Mus Shop Mgr* Barbara Bryan
Open Tues - Sat 10 AM - 4:30 PM, Sun 1 - 4:30 PM; Suggested donation adults $3, children $1; Estab 1902 to collect, preserve & interpret artifacts & information relating to the history of Fairfield; Changing exhibitions and permanent collections display; Average Annual Attendance: 3,000; Mem: 800; dues $25-$1,000; annual meeting in Oct
Library Holdings: Book Volumes; Clipping Files; Lantern Slides; Manuscripts; Maps
Special Subjects: Architecture, Costumes, Embroidery, Etchings & Engravings, Landscapes, Prints, Silver, Textiles, Painting-American, Decorative Arts, Ceramics, Portraits, Archaeology, Dolls, Furniture, Glass, Laces, Marine Painting
Collections: Ceramics, furniture, jewelry, paintings, photgraphs, prints, silver; local history; textiles & costumes; Archaeology; Kansas postcard series
Publications: Newsletter, quarterly
Activities: Classes for adults & children; docent training; dramatic programs; lect open to public; 3 vis lect per yr; gallery talks; tours; volunteer training; individual paintings & original objects of art lent to other museums; museum shop sells books & prints
L **Library,** 636 Old Post Rd, Fairfield, CT 06430. Tel 203-259-1598; *Librn* Dennis Barrow
Open Tues - Sat 10 AM - 4:30 PM, Sun 1 - 4:30 PM; Open to the pub for reference only; Mem: User fee $3
Library Holdings: Audio Tapes; Book Volumes 10,000; Cassettes; Clipping Files; Fiche; Lantern Slides; Manuscripts; Memorabilia; Motion Pictures; Other Holdings Diaries; Documents; Maps; Pamphlets; Periodical Subscriptions 12; Photographs; Records; Reels; Slides; Video Tapes
Special Subjects: Landscape Architecture, Photography, Manuscripts, Maps, Historical Material, Video, Architecture

Activities: Classes for adults

M **FAIRFIELD UNIVERSITY,** Thomas J Walsh Art Gallery, Quick Ctr for the Arts, N Benson Rd Fairfield, CT 06430. Tel 203-254-4242; Fax 203-254-4113; *Dir* Dr Diana Mille
Open Tues - Sat 11 AM - 5 PM, Sun Noon - 4 PM; No admis fee; Estab 1990; Multi-purpose space with state of the art security & environmental controls requirement; 2200 sq ft
Income: Financed by endowment & university funds
Special Subjects: Painting-American, Prints, Archaeology, Afro-American Art, Posters, Baroque Art, Renaissance Art
Exhibitions: Thematic & social context art exhibitions; Renaissance Baroque, 19th & 20th centuries.
Publications: Educational materials; exhibition catalogues
Activities: Adult classes; docent training; lect open to public; gallery talks; tours; book traveling exhibitions 2 per year; originate traveling exhibitions 1 per year

M **SACRED HEART UNIVERSITY,** Gallery of Contemporary Art, 5151 Park Ave, Fairfield, CT 06825-1000. Tel 203-365-7650; Fax 203-396-8361; Elec Mail gevass@sacredheart.edu; Internet Home Page Address: http://artgallery.sacredheart.edu; *Dir* Sophia Gevas
Open Mon - Thurs noon - 5:00 PM, Sun Noon - 4 PM; No admis fee; Estab 1989 for the purpose of exhibiting contemporary artists in a wide range of media; Average Annual Attendance: 3,000
Income: university support & annual fundraisers
Collections: The Collection; contemporary works; all media; Art Walk, sculpture on loan & commissioned permanent works
Publications: exhibition catalog, annually
Activities: Art talks for high school students & community groups; lect open to public, 2-3 vis lectr per year; gallery talks; book traveling exhibitions 1 per 3-5 years; organize traveling exhibitions to other university galleries

FARMINGTON

M **FARMINGTON VILLAGE GREEN & LIBRARY ASSOCIATION,**
Stanley-Whitman House, 37 High St Farmington, CT 06032. Tel 860-677-9222; Fax 860-677-7758; Internet Home Page Address: www.stanleywhitman.org; *Dir* Lisa Johnson; *Educ Coordr* Debbie Andrews; *Tour Interpreter* Peter Devlin; *Admin Asst* Jo-Ann B. Silverio
Open May - Oct Wed - Sun Noon - 4 PM; Nov - Apr, Sat & Sun Noon - 4 PM & by appointment; Admis adults $5, senior citizens $4, children $2, mems free; Estab 1935 to collect, preserve, educate about 18th century Farmington; A separate building, has space for art exhibits. Maintains reference library; Average Annual Attendance: 5,000; Mem: 200; dues $18-$500
Income: Financed by endowment interest, special events, mem & admis
Purchases: $186,000
Library Holdings: Original Documents; Photographs
Special Subjects: Architecture, Drawings, Archaeology, Costumes, Ceramics, Crafts, Folk Art, Etchings & Engravings, Decorative Arts, Dolls, Furniture, Glass, Coins & Medals, Embroidery, Bookplates & Bindings
Collections: American decorative arts; ceramics; costumes & textiles; 18th century decorative arts; dooryard & herb garden; furniture; glass; household utensils; photographs; weaving equipment
Exhibitions: Permanent & changing exhibitions
Publications: A Guide to Historic Farmington, Connecticut; A Short History of Farmington, Connecticut
Activities: Classes for adults & children; dramatic programs; docent training; family & school programs; children's hands-on tour; lect open to public, 3 vis lectr per year; gallery talks; tours; lending collection contains cassettes, over 1000 photographs & 300 slides; museum shop sells books, toys, games & cards

M **HILL-STEAD MUSEUM,** 35 Mountain Rd, Farmington, CT 06032. Tel 860-677-4787; Fax 860-677-0174; Elec Mail hillstead@hillstead.org; Internet Home Page Address: www.hillstead.org; *Dir & CEO* Linda Stagleder; *Asst Dir* Jennifer Polerd; *Dir Institutional Advertisingi* Claudia Thesing; *Mus Shop Mgr* Denise Bowen; *Dir Educ & Cur* Cynthia Cormier; *Dir Marketing & Communication* Alison Meyers
Open Tues - Sun 10 AM - 5 PM (May - Oct), 11 AM - 4 PM (Nov - Apr); Admis adults $7, senior citizens & students over 12 $6, under 12 $4, under age 6 & mem free; Estab 1947 to house French & American impressionist pottery; Colonial Revival style house designed by Theodate Pope in collaboration with McKim, Mead & White & built in 1901 for industrialist Alfred Atmore Pope. Set on 150 acres including a sunken garden designed by Beatrix Farrand, the house contains Mr. Pope's early collection of French Impressionist paintings & decorative arts; Average Annual Attendance: 35,000; Mem: 1028; dues family $50, individual $30; annual meeting in fall
Income: Financed by endowment, mem, contributions, individual, corporate & foundations, admis & sales
Special Subjects: Prints, Porcelain, Silver, Painting-French
Collections: Paintings by Cassatt, Degas, Manet, Monet & Whistler; prints by Durer, Piranesi, Whistler & other 19th century artists; American, English & other European furniture; Oriental & European porcelain; Japanese prints
Exhibitions: Rotating exhibits
Publications: Catalog of Hill-Stead Paintings; Theodate Pope Riddle, Her Life & Work; Hill-Stead Museum House Guide
Activities: Classes for adults & children; docent training; dramatic programs; poetry seminars; lect open to public, 5-10 vis lectr per year; concerts; gallery talks; tours; competition with awards; museum shop sells books, magazines, reproductions, slides, CDs, poetry, tapes & videos

GOSHEN

M **GOSHEN HISTORICAL SOCIETY,** 21 Old Middle Rd, PO Box 457 Goshen, CT 06756-2001; 27 Kimberly Rd Goshen, CT 06756-1528. Tel 860-491-9610, 491-9626; Elec Mail (curator) jvnkuq@juno.com; Internet Home Page Address: www.goshenhistoricalsociety.org; *Cur* Henrietta Horvay; *Pres* Margaret K Wood
Open April - Oct Tues 10 AM - Noon, by appointment; Estab 1955 to interpret the past & present of our area; Average Annual Attendance: 400; Mem: 200; meetings in May & Oct

Income: Financed by mem & donations
Special Subjects: Photography, American Indian Art, Historical Material
Collections: Collection of Indian art, farm tools, household items used through town's history & photographs
Exhibitions: Exhibits focused on 265 years of town's history; Goshen in Civil War
Activities: Classes for children; gallery talks; tours; lects open to the public, 2 vis lectr per month Dec - May; lending of objects of art to other historical societies & libraries; museum shop sells books & other museum-related items

GREENWICH

M **BRUCE MUSEUM, INC,** Bruce Museum, One Museum Dr, Greenwich, CT 06830-7100. Tel 203-869-0376; Fax 203-869-0963; Internet Home Page Address: www.brucemuseum.org; *Exec Dir* Peter C Sutton; *Sr Cur Art* Nancy Hall-Duncan; *Dir Educ* Robin Garr; *Dir Pub Rels* Mike Horyczun; *Dir Develop* York Baker
Open Tues - Sat 10 AM - 5 PM, Sun 1 - 5 PM, cl Mon & major holidays; Admis adult $7, sr citizen & student $6, Tues free, mem & children under 5 free; Estab 1908 by Robert M Bruce. Recently expanded & completely renovated. Museum features changing exhibits in fine & decorative arts & natural sciences; Changing exhibits in fine & decorative arts & interdisciplinary shows in four galleries; small reference library for staff use only; Average Annual Attendance: 100,000; Mem: 3000; dues individual $50, student $30, sr couple $55, family & dual $70, young friend $100, patron $200, benefactor $500; annual meeting in June
Income: $3,600,000 ($600,000 financed by town of Greenwich)
Special Subjects: Drawings, Etchings & Engravings, Folk Art, Photography, Portraits, Painting-American, Textiles, Painting-European, Sculpture, Graphics, Painting-American, Prints, American Indian Art, Ethnology, Costumes, Posters, Porcelain, Painting-Dutch, Renaissance Art, Dioramas
Collections: 19th & 20th century American paintings; costumes; North American Indian ethnology; Orientalia; American natural history; Major mineral collection
Publications: Exhibition Catalogs, 3 per yr; calender of events, newsletter, 6 per yr
Activities: Classes for adults & children; docent training; public programs; family days, films, performance art, museum outreach & afterschool progrs; lect open to public, 30-40 vis lectr per year; 2 concerts; gallery talks; tours; individual paintings & original objects of art lent to other museums; 30 mile radius - Brucemobile; originate traveling exhibitions; museum shop sells books, reproductions, & gifts

A **GREENWICH ART SOCIETY INC,** 299 Greenwich Ave, Greenwich, CT 06830. Tel 203-629-1533; Fax 203-629-3414; Elec Mail greenwichartsociety@verizon.net; Internet Home Page Address: www.greenwichartsociety.org; *Secy* Dorothy Petell; *Office Mgr* Virginia Burgess; *VP Dir of Classes* Carol N. Dixon; *Co-Pres* Peter Robinson; *Co-Pres* Liana Moonie; *Treas* Arnold Braff
Office: 9:00 - 12:30 PM weekdays, Greenwich Art Society Gallery weekdays 10 AM - 5 PM, Sat 12 - 5 PM, Sun 1 - 4 PM, except July & August; no admis fee; Estab 1912 as a nonprofit organization to further art educ & to awaken & stimulate broader interest in the visual arts in the town of Greenwich; Art Center studio is used for classes & Greenwich Art Society Gallery meetings & exhibitions; Mem: 350; dues regular $35, student 21 & under $20
Income: Financed by mem, fees & contributions, classes tuitions
Library Holdings: Book Volumes
Exhibitions: (2/2/2007-3/3/2007) 90th Annual Members' Juried Exhibition: Greenwich Art Center Galleries, 299 Greenwich Ave, 2nd Fl; Spring Show: Gertrude White Gallery, YWCA, 259 E Putnam Ave; Summer Exhibition: Flinn Gallery, Greenwich Library, 101 W Putnam Ave; Art & Nature Exhibition, Garden Education Center of Greenwich
Publications: The History of the Greenwich Art Society, booklet; bulletin of program for the year & class schedule
Activities: Day & evening classes for adults, special classes for children; critiques & demonstrations; lect open to public, art scholarship awards to Greenwich high school seniors (both public & private schools)

L **GREENWICH LIBRARY,** 101 W Putnam Ave, Greenwich, CT 06830-5387. Tel 203-622-7900; Fax 203-622-7939; Internet Home Page Address: www.greenwich.lib.cp.us; *Acting Dir* Inga Boydreau
Open Mon - Fri 9 AM - 9 PM, Sat 9 AM - 5 PM, Sun 1 - 5 PM Oct - May; Estab 1878 to provide free & convenient access to the broadest possible range of information & ideas; Circ 1,063,950; Hurlbutt Gallery features exhibits of paintings, prints, sculpture, photos, antiques & objects d'art, sponsored by Friends of the Greenwich Library
Income: $3,378,992 (financed by city appropriation)
Purchases: Art & Music $19,925, video $39,913, records & audio cassettes $46,285
Library Holdings: Book Volumes 313,824; Cassettes 6550; Framed Reproductions 326; Other Holdings Art related books 16,990; Compact discs 10,000; Periodical Subscriptions 600; Video Tapes 10,000
Collections: Book arts collection (fine press books)
Exhibitions: Six different exhibits per year
Publications: Monthly book lists
Activities: Lect open to public, 3-5 vis lectr per year; individual paintings lent to Greenwich residents; lending collection contains approx 438 items

HAMDEN

L **PAIER COLLEGE OF ART, INC,** Library, 20 Gorham Ave, Hamden, CT 06514. Tel 203-287-3023; Fax 203-287-3021; Elec Mail paierartlibrary@snet.net; Internet Home Page Address: www.paiercollegeofart.edu; *Pres* Jonathan E Paier; *VPres* Daniel Paier; *Dir Library* Beth R Harris
Open Mon & Tues 11 AM-7 PM, Wed & Thurs 9 AM-5 PM, Fri 9 AM-Noon; No admis fee; Estab 1946, library estab 1978

Library Holdings: Book Volumes 11,600; Clipping Files; Exhibition Catalogs; Pamphlets; Periodical Subscriptions 68; Prints; Reproductions; Slides 16,000; Video Tapes 120
Special Subjects: Art History, Folk Art, Decorative Arts, Illustration, Calligraphy, Commerical Art, Drawings, Graphic Arts, Graphic Design, History of Art & Archaeology, Conceptual Art, Advertising Design, Interior Design, Lettering, Architecture
Collections: Children's books (400); Reference pictures (30,000)

HARTFORD

A ARTISTS COLLECTIVE INC, 1200 Albany Ave, Hartford, CT 06120. Tel 860-527-3205; Fax 860-527-2979; *Exec Dir* Dollie McLean
Estab 1970
Income: $690,000
Activities: Classes for children; dramatic programs

A CONNECTICUT HISTORICAL SOCIETY MUSEUM, (Connecticut Historical Society) One Elizabeth St, Hartford, CT 06105. Tel 860-236-5621; Fax 860-236-2664; Elec Mail ask_us@chs.org; Internet Home Page Address: www.chs.org; *Exec Dir & Dir Admin* Kevin Hughes; *Deputy Dir Interpretation* Kate Steinway; *Dir Libr* Nancy Milnor; *Mgr Communications* Aaron Wartner; *Cur Graphics* Nancy Finlay; *Dir Mus Collections* Susan P Schoelwer; *Dir External Affairs* Peter Lisi; *VPres* Hugh Macgil; *Genealogist* Judith Ellen Johnson; *Mus Shop Mgr* Kathryn Mazzo; *VChmn* Wilson Wilde
Galleries open Tues - Sun 12 - 5 PM; cl holidays, Library open Tues - Sat 10 AM - 5 PM; Admis fee adults $6, senior citizens & students $3, children 5 & under & mems free, group discounts available; Estab 1825 to collect & preserve materials of Connecticut interest & to encourage interest in Connecticut history; Exhibition space totals 6500 sq ft, half of which is devoted to permanent exhibitions, the other half to changing exhibits; Average Annual Attendance: 33,000; Mem: 1900; dues $30 individual, $45 family; annual meeting in Dec
Income: Financed by endowment & mem
Library Holdings: Audio Tapes; Book Volumes; Cards; Cassettes; Clipping Files; Exhibition Catalogs; Original Documents; Other Holdings; Pamphlets; Periodical Subscriptions; Photographs; Prints; Records; Video Tapes
Collections: Historical Collections (decorative arts); Frederick K & Margaret R Barbour Furniture Collection; George Dudley Seymour Collection of Furniture; Morgan P. Brainard Tavern Signs
Exhibitions: Amistad; Tours & Detours Through Colonial Connecticut; Hands on History; Changing Gallery
Publications: Newsletter: CHS Newsletter, 3 times per year
Activities: Classes for adults & children, dramatic programs, docent training; lect open to pub, 12 vis lectr per year; gallery talks; tours; competitions including Conn History Day competition with awards; lending collection contains books, lent to qualified institutions; originate traveling exhibs; mus shop sells books, reproductions, prints

L Library, One Elizabeth St, Hartford, CT 06105. Tel 860-236-5621 ext 230; Fax 860-236-2664; Elec Mail libchs@chs.org; Internet Home Page Address: www.chs.org; *Genealogist* Judith E. Johnson; *Manuscript Cataloger* Barbara Austen; *Dir Libr* Nancy Milnor; *Monograph Cataloger* Jennifer Pike; *Ref Librn* Sharon Steinberg; *Ref Librn* Cynthia Harbeson
Open Tues - Sat 10 AM - 5 PM; Adults $6, students & seniors $3, members free; 1825; Reference only
Collections: 3,000,000 manuscripts, genealogical research collection; 100,000 vols monographs & serials
Activities: Docent training; lect open to public, 10 vis lectr per year; gallery talks; tours

L CONNECTICUT STATE LIBRARY, Museum of Connecticut History, 231 Capitol Ave, Hartford, CT 06106. Tel 860-757-6535; Fax 860-757-6533; Elec Mail dnelson@cslib.org; Internet Home Page Address: www.cslib.org; *Cur* David J Corrigan; *Cur* Patrick Smith; *Mus Adminr* Dean Nelson
Open Mon - Fri 9 AM - 4 PM, Sat 9 AM - 3 PM, cl holidays; No admis fee; Estab 1910 to collect, preserve & display artifacts & memorabilia reflecting the history & heritage of Connecticut; For reference only; Average Annual Attendance: 21,000
Income: State funding
Library Holdings: Book Volumes 500,000; Cassettes; Clipping Files; Fiche 50,000; Manuscripts; Memorabilia; Motion Pictures; Original Art Works; Other Holdings Original documents 100,000,000; Pamphlets; Photographs; Prints; Reels; Video Tapes
Special Subjects: Coins & Medals
Collections: Collection of Firearms; Portraits of Connecticut's Governors; Connecticut Collection - Industrial & Military History
Exhibitions: Changing exhibits
Activities: Classes for children

L HARRIET BEECHER STOWE CENTER, 77 Forest St, Hartford, CT 06105. Tel 860-522-9258; Fax 860-522-9259; Internet Home Page Address: www.harrietbeecherstowe.org; *Dir* Katherine Kane; *Cur* Dawn Adiletta; *Office Mgr* Carol Ann Stephenson; *Collections Mgr* Elizabeth Gard; *Dir Marketing* Mary Ellen White; *Dir Educ* Shannon Burke
Open Tues - Sat 9:30 AM - 4:30 PM, Sun Noon - 4:30 PM, cl Mon, June 1 - Columbus Day & Dec; Admis adult $8, sr citizen $7, children $4, children under 5 free; Estab 1941 to maintain & open to the pub the restored Harriet Beecher Stowe House; The Foundation operates the Stowe Library, oversees a publishing program of reprints of H B Stowe's works & new books & provides workshops & lect; Average Annual Attendance: 22,000; Mem: 150; dues sustaining $150, supporting $50, family $30, individual $20; fall & spring meetings
Library Holdings: Book Volumes; Clipping Files; Exhibition Catalogs; Manuscripts; Pamphlets; Periodical Subscriptions; Photographs
Collections: 19th Century Decorative Arts, Domestic Furnishing, Fine Arts; Wallpaper & Floor Treatment Sample Collections
Publications: The Journal newsletter, quarterly

Activities: Workshops for adults & teachers; docent training; Teachers Institute; lect open to public; concerts; 1-2 vis lectr per year; gallery talks; tours; paintings & original decorative, domestic or fine art objects lent to institutions; sales shop sells books, reproductions, prints, slides, fabrics, Victorian gift items

L Harriet Beecher Stowe House & Library, 77 Forest St, Hartford, CT 06105. Tel 860-522-9258; Fax 860-522-9259; Elec Mail info@stowecenter.org; Internet Home Page Address: www.harrietbeecherstowe.org; *Librn* John Reazer III; *Exec Dir* Katherine Kane; *Asst Librn* Sabra Ionno; *Cur* Dawn C Adiletta; *Educ & Visitor Servs* Mike Radice
House tours Mon - Sat 9:30 AM - 4:30 PM, Sun 12 - 4:30 PM; Admis adults $8, seniors $7, children 5-12 $4; library free; Estab 1941 to concentrate on the architecture, decorative arts, history & literature of the United States in the 19th century emphasizing a Hartford neighborhood known as Nook Farm; Circ Non-circulating; Reference only for gen pub, students, staff & academia; Average Annual Attendance: 30,000
Library Holdings: Book Volumes 15,000; Clipping Files; Exhibition Catalogs; Fiche; Lantern Slides 60; Manuscripts; Memorabilia; Original Documents; Other Holdings Original documents 160,000; Pamphlets 5000; Periodical Subscriptions 18; Photographs 5000; Reels 100; Slides 3500
Special Subjects: Landscape Architecture, Decorative Arts, Photography, Historical Material, Furniture, Restoration & Conservation, Textiles, Architecture
Collections: Architecture & Decorative Arts of 19th Century: books, plans, drawings, trade catalogs; Hartford 19th Century Literary Community, Nook Farm & Residents; Mark Twain; Harriet Beecher Stowe; Chas Dudley Warner; William Gillette; letters & documents of the Stowe family; Stowe family artifacts; 19th-Century artwork; Uncle Tom's Cabin memorabilia
Activities: Classes for adults & children; docent training; annual teacher institute; lect open to public & for members only; concerts; gallery talks; tours; sponsoring of competitions; Stowe Center Good Citizen Award; museum shop sells books, magazines & reproductions

M MARK TWAIN HOUSE MEMORIAL, 351 Farmington Ave, Hartford, CT 06105. Tel 860-247-0998 (admin office), 247-0998 ext 26 (visitor center); Fax 860-278-8148; Elec Mail info@marktwainhouse.org; Internet Home Page Address: www.marktwainhouse.org; *Exec Dir* John Boyer; *Deputy Dir* Debra Petke; *Dir Educ* Jeff Nichols; *Dir Pub Relations & Mktg* Joseph Fazzino; *Chief Dev Officer* Dina Plapler
Open Mon - Sun 9:30 AM - 5:30 PM, first Thurs of the month 9:30 AM - 8 PM, cl Tues Jan - Apr; Admis $12, senior citizens $11, children 6-12 $8, children 13-18 $10, children under 6 free; Estab 1929 to foster an appreciation of the legacy of Mark Twain as one of our nation's culturally defining figures; to demonstrate the continuing relevance of his work, life & times; Maintains Historic House Mus with period interiors, mus room of memorabilia; National Historic Landmark status, US Dept of Interior; Average Annual Attendance: 65,000; Mem: 900; dues $35-$5000; annual meeting in Nov
Income: financed by members, donations, admis fees
Special Subjects: Painting-American, Photography, Sculpture, Textiles, Ceramics, Woodcarvings, Decorative Arts, Furniture, Glass, Silver, Period Rooms, Stained Glass
Collections: Lockwood deForest Collection; Mark Twain memorabilia (photographs, manuscripts); period & original furnishings; Tiffany Collection; Candace Wheeler Collection
Exhibitions: National Symposia; Rotating exhibits; Orientation exhibitions
Publications: Exhibition catalogues
Activities: Classes for adults & children; symposia; internship programs; docent training; lect open to public, 6 vis lectr per year; concerts; gallery talks; tours; college internships offered; individual paintings & original objects of art lent to approved museums & organizations; lending collection contains books, color reproductions, prints, paintings, photographs, sculpture & slides; museum shop sells books, reproductions, prints, slides, gifts & Mark Twain memorabilia

L Research Library, 351 Farmington Ave, Hartford, CT 06105. Tel 860-247-0998 (admin office); Fax 860-278-8148; Internet Home Page Address: www.marktwainhouse.org; *Cur* Diane Forsberg; *Exec Dir* John Boyer
Open Mon - Sat 9:30 AM - 5 PM, Sun noon - 5 PM; For reference only
Library Holdings: Auction Catalogs; Audio Tapes; Book Volumes 6000; CD-ROMs; Cassettes; Clipping Files; Exhibition Catalogs; Fiche; Filmstrips; Framed Reproductions; Lantern Slides; Manuscripts; Memorabilia; Motion Pictures; Original Art Works; Original Documents; Other Holdings; Pamphlets; Periodical Subscriptions 22; Photographs; Records; Reels; Reproductions; Sculpture; Slides; Video Tapes

M OLD STATE HOUSE, 800 Main St, Hartford, CT 06103. Tel 860-522-6766; Fax 860-522-2812; Elec Mail info@shareCT.org; Internet Home Page Address: www.ctosh.org; *Chmn* Robert DeCrescenzo; *Pres* David Coffin; *Exec Dir* Wilson H Faude; *Pres, Chmn* James Williams; *Educ Coordr* Kathleen Hunter; *Mus Shop Mgr* Patty Furdas
Open Mon - Fri 10 AM - 4 PM, Sat 11 AM - 4 PM, cl Sun ; No admis fee; Estab 1975 to preserve oldest state house in the nation & present variety of exhibitions on historic & contemporary subjects; Former exec wing is used for exhibitions of contemporary artists & craftsmen, paintings, decorative arts on a rotating basis; Average Annual Attendance: 200,000; Mem: 1500; dues life $1000, family $15, individual $10; annual meeting in the fall
Income: Financed by endowment, mem & appeals
Collections: Connecticut portraits; documents; Restored Senate Chamber
Activities: Educ dept; classes for adults & children; dramatic programs; lect open to the public, 25 vis lectr per year; concerts; gallery talks; tours; individual paintings & original objects of art lent to museums for special exhibitions; museum shop sells books, magazines, original art, reproductions, prints, slides, Connecticut arts & crafts

M REAL ART WAYS (RAW), 56 Arbor St, Hartford, CT 06106. Tel 860-232-1006; Fax 860-233-6691; Elec Mail info@realartways.org; Internet Home Page Address: www.Realartways.org; *Dir Visual Arts* Barry A Rosenberg; *Exec Dir* Will K Wilkins
Open daily, hours vary; No admis fee; Estab 1975 to present artists of many disciplines working at the forefront of creative activity in their respective fields; 1 fl; Mem: Annual dues vary

Income: Financed by mem and donations
Special Subjects: Photography, Prints, Sculpture
Exhibitions: Rotating exhibitions
Activities: Classes for children, summer art workshop; lect open to public, 5 vis lectr per year; concerts; gallery talks; tours; book traveling exhibitions 2 per year; originate traveling exhibitions to qualified institutions

M **TRINITY COLLEGE,** Austin Arts Center, Widener Gallery, 300 Summit St, Hartford, CT 06106-3100. Tel 860-297-2498; Fax 860-297-5380; Elec Mail jeffry.walker@mail.trincoll.edu; *Cur* Felice Caivano; *Dir* Jeffry Walker
Open Sept - May Sun - Thurs 1 -9 PM, Fri & Sat 1 - 6 PM; No admis fee; Estab 1965; A building housing the teaching & performing aspects of music, theater dance & studio arts at a liberal arts college. Widener Gallery provides exhibition space mainly for student & faculty works, plus outside exhibitions; Average Annual Attendance: 12,000
Income: Financed by college appropriation
Collections: Edwin M Blake Memorial & Archive; College Collection; Samuel H Kress Study Collection; George Chaplin Collection
Exhibitions: Rotating exhibitions
Activities: Classes for adults; dramatic programs; lect open to public, 6-8 vis lectr per year; concerts; lending collection contains 500 original art works & 100,000 slides

M **WADSWORTH ATHENEUM MUSEUM OF ART,** 600 Main St, Hartford, CT 06103-2990. Tel 860-278-2670; Fax 860-527-0803; Elec Mail info@wadsworthatheneum.org; Internet Home Page Address: www.wadsworthatheneum.org; *Conservator* Stephen Kornhauser; *Registrar* Mary Schroeder; *Cur European Decorate Arts* Linda Roth; *Cur European Art* Eric Zafran; *Dir Properties* Alan Barton; *Media Relations* Susan Hood; *Mktg Mgr* Daniel McKinley; *Dir Curatorial & Prog* Nick Ruoeco; *Exec Dir* Willard Holmes; *Dept Dir Admin & Develop* David Baxter
Open Wed - Fri 11 AM - 5 PM, Sat - Sun 10 AM - 5 PM, cl Mon & Tues; Admis $10 adults, $8 seniors 62 & up, $5 students ages 13 - college; free children 12 & under; Estab 1842 by Daniel Wadsworth; Collections comprise nearly 45,000 works of European and American fine and decorative arts. Highlights include Hudson River School landscapes, 17th century American furniture, European baroque paintings, French & German porcelain, French & American impressionists, modern & contemporary masters & African American art & history; Average Annual Attendance: 140,000; Mem: 8,000; dues $45 & up; annual meeting in Nov
Income: Financed by private funds
Library Holdings: Auction Catalogs; Audio Tapes; Book Volumes; CD-ROMs; Cassettes; Clipping Files; Compact Disks; DVDs; Exhibition Catalogs; Manuscripts; Other Holdings; Pamphlets; Periodical Subscriptions; Slides; Video Tapes
Special Subjects: Afro-American Art, American Indian Art, Archaeology, Architecture, Ceramics, Silver, Textiles, Maps, Painting-British, Painting-French, Sculpture, Latin American Art, Painting-American, African Art, Costumes, Crafts, Woodcarvings, Woodcuts, Decorative Arts, Painting-European, Painting-Canadian, Jewelry, Painting-Dutch, Baroque Art, Painting-Flemish, Embroidery, Laces, Painting-Italian, Mosaics, Stained Glass, Painting-Australian, Painting-German, Painting-Israeli
Collections: European and American paintings, drawings, prints, porcelain, silver, furniture, textiles and other fine and decorative arts; Hudson River school landscapes, Old Master paintings, modernist masterpieces, 19th Century French and Impressionist paintings, Meissen & Sevres porcelains, costumes, textiles, American furniture & decorative arts of Pilgrim Century through the Gilded Age; African-American art
Publications: Newsletter, quarterly to members; collections and exhibitions catalogs
Activities: Docent training; workshops for families & adults; lect & gallery talks by staff; 4 vis lect per yr; docent talks; seasonal concerts; gallery tours; outside lect; members' exhibition previews & various special events; seminars; lending original objects of art to other museums; 3-5 book traveling exhibs per yr; 3-5 per yr organize traveling exhibs; museum shop sells books, reproductions, photographs, cards, toys, accessories & gifts; cafe

L **Auerbach Art Library,** 600 Main St, Hartford, CT 06103. Tel 860-278-2670, Ext 3115; Fax 203-527-0803; Elec Mail john.teahan@wadsworthatheneum.org; *Asst Librn* William Staples; *Librn* John W Teahan
Open Wed - Thurs & Sat 11 AM - 5 PM, cl Sun - Tues & Fri; Estab 1934 as a reference service to the mus staff, members & pub; to provide materials supporting work with mus collection; For reference only
Library Holdings: Auction Catalogs; Book Volumes 42,000; Clipping Files; Exhibition Catalogs; Fiche; Lantern Slides; Pamphlets; Periodical Subscriptions 150; Records; Reels
Special Subjects: Art History, Decorative Arts, Film, Illustration, Etchings & Engravings, Graphic Arts, Painting-American, Painting-British, Painting-Dutch, Painting-Flemish, Painting-French, Painting-German, Painting-Italian, Painting-Russian, Painting-Spanish, Painting-European, Historical Material, History of Art & Archaeology, Ceramics, Conceptual Art, Crafts, Archaeology, Fashion Arts, Industrial Design, Art Education, Asian Art, American Indian Art, Furniture, Costume Design & Constr, Afro-American Art, Embroidery, Enamels, Handicrafts, Jewelry, Painting-Australian, Painting-Canadian, Architecture
Collections: Sol Lewitt (contemporary art); Elizabeth Miles (English silver); Watkinson Collection (pre-1917 art reference)

KENT

M **CT COMMISSION ON CULTURE & TOURISM,** (Connecticut Historical Commission) Sloane-Stanley Museum, Route 7, Kent, CT 06757; CT Commision on Culture & Tourism, PO Box 917 Kent, CT 06757. Tel 860-927-3849; Fax 860-927-2152; Elec Mail sloanestanley.museum@snet.net; *Dir* Jennifer Aniskovich; *Dir Mus* Karin Peterson; *Museum Asst* Barbara Russ
Open mid-May - Oct, Wed - Sun 10 AM - 4 PM; Admis adults $4, senior citizens $3, children $2.50; Estab 1969 to collect, preserve, exhibit historic American tools,

implements & artwork of Eric Sloane (1905-1985); Artists re-created studio; Average Annual Attendance: 5,000
Income: Financed by state appropriation
Special Subjects: Painting-American, Landscapes, Historical Material
Collections: Eric Sloane Collection (artwork); American tools & implements
Activities: Lects open to the pub; 1-2 vis lectrs per yr; mus shop sells books, prints & other items

A **KENT ART ASSOCIATION, INC,** Gallery, 21 S Main St, PO Box 202 Kent, CT 06757. Tel 860-927-3989; *VPres* Gloria Malcolm-Arnold; *Second VPres* Charles Dransfield; *Treas* Lee Bardenheuer; *Pres* Constance Horton
Open during exhibitions only Tues - Sun , cl Mon; Estab 1923, incorporated 1935; Maintains gallery for changing exhibitions; Average Annual Attendance: 2,000; Mem: 400; dues life $200, patron $40, sustaining $25, assoc $15; annual meeting in Oct
Income: Financed by mem, donations
Exhibitions: Spring Show; Member's Show; President's Show; Fall Show
Publications: Exhibition catalogues, 4 per year
Activities: Lect; demonstrations

LITCHFIELD

A **LITCHFIELD HISTORY MUSEUM,** (Litchfield Historical Society) On-the-Green, PO Box 385 Litchfield, CT 06759. Tel 860-567-4501; Fax 860-567-3565; Internet Home Page Address: www.litchfieldhistory.org; *Cur* Judith Loto; *Educ Coordr* Rebecca Martin; *Dir* Catherine Keene Fields
Open mid Apr - Nov Tues - Sat 11 AM - 5 PM, Sun 1 - 5 PM; Admis $5, children under 14 free; seniors & children 6 & over $3; Estab 1896, incorporated 1897 for the preservation & interpretation of local historical collections; A gallery of portraits by Ralph Earl is maintained; Average Annual Attendance: 12,000; Mem: 450; dues benefactor $500, donor $250, contributing $100, family $40, individual $25; annual meeting second Fri in Sept
Income: $220,000 (financed by endowment, mem & fundraising)
Special Subjects: Costumes, Embroidery, Decorative Arts, Folk Art, Furniture
Collections: American & Connecticut fine & decorative arts, pewter, costumes, textiles, paintings, silver, pottery & graphics; furniture; textiles; household goods
Exhibitions: Changing exhibitions on area art & history
Activities: Classes for adults & children; docent training; curriculum units; workshops; lect open to public, 4 vis lectr per year; gallery talks; tours; individual & original objects of art lent to accredited museums with board approval; sales shop sells books, reproductions & prints

L **Ingraham Memorial Research Library,** On-the-Green, PO Box 385 Litchfield, CT 06759. Tel 860-567-4501; Fax 860-567-3565; Internet Home Page Address: w.litchfieldhistory.org; *Dir* Catherine Keene Fields
Open Tues - Fri 10 AM - Noon & 1 - 4 PM, 1 Sat a month; No admis fee; Estab 1896 as a center of local history & genealogy study; Reference only; Mem: Same as society
Income: $10,000 (financed by endowment & mem)
Library Holdings: Book Volumes 10,000; Clipping Files; Exhibition Catalogs; Manuscripts; Memorabilia; Other Holdings Original documents 50,000; Pamphlets; Periodical Subscriptions 10; Photographs; Prints; Reels
Collections: 40,000 manuscripts in local history
Exhibitions: Several rotating exhibitions per year

MERIDEN

A **ARTS & CRAFTS ASSOCIATION OF MERIDEN INC,** Gallery 53 of Meridan, 53 Colony St, PO Box 348 Meriden, CT 06450. Tel 203-235-5347; *Pres* Dick Kupspis
Open Tues - Fri Noon - 4 PM, Sat 10 AM - 2 PM; No admis fee; Estab 1907 to encourage appreciation of the arts in the community; One floor gallery to hold exhibits & art work studios above with meeting room; Average Annual Attendance: 1,800; Mem: 400; dues $12 & up; annual meeting in June
Income: Financed by mem & fund raising, class fees
Collections: Permanent collection of paintings & sculptures includes works by Eric Sloan, Emile Gruppe, Stow Wengenroth as well as works by Meriden artists
Exhibitions: Annual Members Show; Photography Show; Student Show; One man & group shows; theme shows & alternating exhibits of works from permanent collection
Activities: Classes for adults & children; dramatic programs; lect open to public, 8 vis lectr per year; workshops; gallery talks; tours; competitions with awards; scholarships offered; individual paintings & original objects of art lent to banks & public buildings; originate traveling exhibitions; sales shop sells original art & crafts

L **Gallery 53,** 53 Colony St, Meriden, CT 06451. Tel 203-235-5347; Fax 203-866-0015; *Pres* Rose Cignatta; *VPres* Joanne Nassar; *Gallery Dir* Rita Sarris
Open Tues - Fri Noon - 4 PM, Sat 10 AM - 2 PM; No admis fee; Estab 1907 to promote the arts; Gallery changes exhibits every 4 weeks approximately; shows work of art groups, individual painters, photographers, school students; permanent collection of paintings
Income: Non-profit
Library Holdings: Book Volumes 650
Collections: Indiana Thomas Book Collection
Activities: Educ program; classes for adults & children; gallery talks; scholarships offered; sales shop sells original art, prints, pottery, jewelry, accessories

MIDDLETOWN

M **WESLEYAN UNIVERSITY,** Davison Art Center, 301 High St, Middletown, CT 06459-0487. Tel 860-685-2500; Fax 860-685-2501; Internet Home Page Address: www.wesleyan.edu/dac; *Cur* Clare Rogan
Open Tues - Sun 12 - 4 PM; No admis fee; Part of the collection was presented to Wesleyan University by George W & Harriet B Davison. Since 1952 the

collection with its reference library has been housed in an addition to the historic Alsop House; collection of works on paper; rotating exhibitions
Special Subjects: Drawings, Photography, Prints, Woodcuts, Etchings & Engravings
Collections: The print collection, extending from the 15th century to present day, includes Master E S, Nielli, Mantegna, Pollaiuolo, Durer, Cranach, Rembrandt, Canaletto, Piranesi, Goya, Millet, Meryon, Jim Dine, & others; Japanese & contemporary American prints; 1840s to present, photographs
Exhibitions: Regularly changing exhibitions of prints, drawings, photographs & other works on paper
Publications: Exhibition catalogues
Activities: Lect open to public, 5-10 vis lectr per year; gallery talks; tours; original objects of art lent; lending collection contains 25,000 original prints, drawings & photographs; traveling exhibitions organized & circulated
—Art Library, Middletown, CT 06459-0487. Tel 860-685-3327; *Art Librn* Susanne Javorski
Open Mon - Thurs 9 AM - 11 PM, Fri 9 AM - 5 PM, Sat 1 - 5 PM, Sun 1 - 11 PM; Estab 1950 as research/reference library primarily supporting university courses in art history & studio arts
Library Holdings: Book Volumes 24,000; Periodical Subscriptions 125
Collections: Print Reference Collection (books pertaining to the history of the graphic arts)
A Friends of the Davison Art Center, 301 High St, Middletown, CT 06459-0487. Tel 860-685-2500; Fax 203-685-2501; *Pres* Peter M Frenzel
Estab 1961 for the support & augmentation of the activities & acquisition fund of the Davison Art Center by its members
Income: Financed by mem dues & contributions
Purchases: Photographs, Prints
Activities: Gallery talks
M Ezra & Cecile Zilkha Gallery, Ctr for the Arts, Middletown, CT 06459-0442. Tel 860-685-2695; Fax 860-685-2061; Internet Home Page Address: www.wesleyan.edu/cfalzilkha/home.html; *Cur Exhib* Nina Felshin
Open Tues - Sun Noon - 4 PM, cl Mon & academic vacations; No admis fee; Average Annual Attendance: 15,000
Income: Financed by contributions
Exhibitions: Changing exhibitions of contemporary art
Publications: Exhibition catalogs & brochures
Activities: Educ Dept; lect open to public, 6 vis lectr per year; gallery talks; tours; sales shop sells catalogs

MYSTIC

A MYSTIC ART ASSOCIATION, INC, Mystic Arts Center, 9 Water St, Mystic, CT 06355. Tel 860-536-7601; Fax 860-536-0610; Elec Mail maa@mystic-art.org; Internet Home Page Address: www.mystic-art.org; *Pres* Peter Stuart; *VPres* Sara Lathrop; *Treas* Blunt White; *Exec Dir* Claire Matthews; *Secy* Sarah Lusas
Open daily year round 11 AM - 5 PM; Admis adults $2, children & members free; Estab 1914 to maintain an art mus to promote cultural educ, local philanthropic & charitable interests; The assoc owns a historic building on the bank of Mystic River with spacious grounds; five galleries, handicap access, air conditioned, new educational wing opened Spring of 1999; Average Annual Attendance: 20,000; Mem: 1000, artist mem must have high standards of proficiency & be jurored in four shows; dues active $30, assoc $25; meeting held in June
Income: Financed by mem, grants & leases
Collections: Mystic Art Colony Paintings; original artwork by notable artists
Exhibitions: Juried Members' Show (all media); Annual Regional (all media)
Publications: News Views, monthly
Activities: Classes for adults & children; international workshop; photography lab; lect open to public, 2 vis lectr per year; concerts; gallery talks; tours; competitions with awards; scholarships offered; exten dept serves New London County; individual paintings & original objects of art lent to historical societies & museums; sales shop sells original art

NEW BRITAIN

M CENTRAL CONNECTICUT STATE UNIVERSITY, Art Dept Museum, 1615 Stanley St, New Britain, CT 06050. Tel 860-832-2633; Fax 860-832-2634; Open Mon-Wed 1-4PM, Thus 1-7PM; No admis fee; Estab to collect, display & interpret works of art & ethnic materials relating to the art educ program; Center will be constructed within two years & collection will be on display in center, whole collection will not be on permanent display
Income: Financed by the univ
Exhibitions: Changing exhibitions every month
Activities: Lect open to public; gallery talks

M NEW BRITAIN MUSEUM OF AMERICAN ART, 56 Lexington St, New Britain, CT 06052. Tel 860-229-0257; Fax 860-229-3445; *Dir* Laurene Buckley; *Dir Admin* Mel Ellis; *Coll Mgr* Michele Urtom; *Dir Develop Coordr* Claudia I Thesing
Open Tues 1 - 5 PM, Sat 10 AM - 5 PM, Sun Noon - 5 PM; Admis adults $3, senior citizens & students $2, children under 12, Sat 10 AM - Noon & members free; Estab 1903 to exhibit, collect & preserve American art; 19 galleries; Average Annual Attendance: 24,000; Mem: 1400; dues patron $100, contributing $50, family $25, individual $15
Income: Financed by endowment
Special Subjects: Painting-American
Collections: Sanford D D Low Illustration Collection (paintings, graphics & sculpture); Collections from Fredrick Church, Thomas Cole, Child Hassam, Thomas Hart; American painting, sculpture, graphic from 1740
Exhibitions: Ellsworth Kelly.
Publications: Newsletter, quarterly
Activities: Educ dept; docent training; lect open to public, 6 vis lectr per year; concerts; gallery talks; tours; competitions with prizes; original objects of art lent

to other museums; originate traveling exhibitions; museum shop selling books, reproductions, prints, slides & postcards & gifts

NEW CANAAN

M NEW CANAAN HISTORICAL SOCIETY, 13 Oenoke Ridge, New Canaan, CT 06840. Tel 203-966-1776; Tel 203-966-1776; Fax 203-972-5917; Fax 203-972-5917; Elec Mail newcanaan.historica@snet.net; Internet Home Page Address: www.nchistory.org; *Exec Dir* Janet Lindstrom; *Librn* Sharon Turo; *Dir Educ* Joyce Macauda
Open Wed, Thurs, Sun 2 - 4 PM, Town House open Tues - Sat 9:30 AM - 4:30 PM; Contribution $3; Estab 1889 to bring together & arrange historical events & genealogies, collect relics, form a museum & library; Society consists of seven museums & library. Rogers' studio contains sculpture groups by John Rogers. Exhibit room houses changing displays of costumes, photos & paintings; Average Annual Attendance: 5,000; Mem: 800; dues family $50, individual $35; meetings second Mon in Mar, June, Sept, Dec
Income: Financed by mem & contributions
Library Holdings: Audio Tapes; Book Volumes; Clipping Files; Fiche; Manuscripts; Maps; Original Documents; Photographs; Slides; Video Tapes
Special Subjects: Sculpture, Costumes, Pewter
Collections: Costume collection, including fans, purses & shoes; document collections; pewter; period furniture; photo collection; Rogers' sculpture groups; quilts
Exhibitions: Costume & History; permanent exhibition of Rogers' sculptures;
Publications: New Canaan Historical Society Annual; Philip Johnson in New Canaan; John Rogers (1829-1904) & the Rogers Groups by John Rogers (1945-present)
Activities: Seminars; children's classes; docent training; lect open to public, 4 vis lectr per year; concerts, tours; Bayles Award (Presidential Classroom), biannual & Award to New Canaan High School Junior for outstanding achievement in history; museum shop sells New Canaan Historical Society Annual, Christmas cards, maps, postcards & stationery

L NEW CANAAN LIBRARY, H. Pelham Curtis Gallery, 151 Main St, New Canaan, CT 06840. Tel 203-594-5000; Fax 203-594-5026; Elec Mail reference@newcanaanlibrary.org; Internet Home Page Address: www.newcanaanlibrary.org; *Dir* David Bryant; *Chair Art Committee* Suzanne Salomon
Open Mon - Thurs 9 AM - 8 PM, Fri & Sat 9 AM - 5 PM, Sun Noon - 5 PM except summer; Estab 1877; H. Pelham Curtis Gallery organizes 8 shows per year; Average Annual Attendance: 2,000; Mem: Art Committee - 20 members, no dues, 1st Thursday each month
Income: $1,293,000 (financed by mem, city & state appropriation)
Library Holdings: Audio Tapes; Book Volumes 146,000; CD-ROMs; DVDs; Other Holdings Audio & Video tapes 7338; Periodical Subscriptions 407
Special Subjects: Landscape Architecture, Photography, Painting-American, Painting-Japanese, Sculpture, Painting-European, Crafts, Video, Oriental Art
Collections: Alfandari Collection-European from fall of Rome to Impressionism; Chinese-Japanese art; general collection of art books & videos
Activities: Lectrs open to the public, 2 visiting lectrs per year, concerts, exhibit-related classes for children

M SILVERMINE GUILD ARTS CENTER, Silvermine Galleries, 1037 Silvermine Rd, New Canaan, CT 06840. Tel 203-966-5617, ext 21; Fax 203-972-7236; Internet Home Page Address: gallerysilvermineart.org; *Exec Dir* Cynthia B Clair; *Dir School* Anne Connell
Open Tues - Sat 11 AM - 5 PM, Sun 1 - 5 PM, Mon by appointment; No admis fee, suggested donation $2; Estab 1922 as an independent art center to foster, promote & encourage activities in the arts & art educ; to provide a place for member artists & invited artists to show & sell their work; to offer the community a wide variety of artistic, cultural & educational activities; Five exhibition galleries featuring one-person shows, regional & national juried artists; Average Annual Attendance: 20,000; Mem: 30; dues $45 & up
Income: Financed by mem, sale of art, contributions & tuitions
Collections: Permanent print collection containing purchase prizes from International Print Exhibition
Exhibitions: Rotating exhibits every 5-6 weeks
Publications: Exhibition catalogs; member newsletter, quarterly
Activities: Classes for adults & children; workshops; lect open to public, 10 vis lectr per year; concerts; gallery talks; tours; competitions with awards; scholarships offered; individual paintings & original objects of art lent to corporations & banks; lending collection contains books & original prints; originate traveling exhibitions; museum shop sells books, ceramics, jewelry
L School of Art, 1037 Silvermine Rd, New Canaan, CT 06840. Tel 203-966-6668; Fax 203-966-8570; Elec Mail sgac@silvermineart.org; Internet Home Page Address: www.silvermineart.org; *Dir Silvermine School* Anne Connell; *Gallery Dir* Helen Klisser During; *Mus Shop Mgr* Lauren Minor; *Exec Dir* Cynthia Clair
Open to members & out buyers by appt; Estab 1920; Average Annual Attendance: 1,000
Library Holdings: Book Volumes 2500; Periodical Subscriptions 11; Slides
Special Subjects: Scrimshaw
Exhibitions: 10 exhibs per yr
Activities: Classes for adults & children; lect open to public, 10 vis lectr per year; concerts; gallery talks; tours; competitions with awards; scholarships offered; original objects of art lent; sales shop sells books, orginal art & prints

NEW HAVEN

M KNIGHTS OF COLUMBUS SUPREME COUNCIL, Knights of Columbus Museum, Knights of Columbus Museum, One State St New Haven, CT 06511-6902; 1 State St, New Haven, CT 06511-6702. Tel 203-865-0400; Fax 203-865-0351; Internet Home Page Address: www.kofc.org; *Cur & Registrar* Mary Lou Cummings; *Dir* Larry Sowinski; *Archivist* Susan Brosnan; *Asst Dir* Kathryn Cogan
Winter hours: Wed - Sat 10 AM - 5 PM, Sun 11 AM - 5 PM; summer hours: Mon - Sun 10 AM - 5 PM; closed Goof Friday, Thanksgiving & Christmas Day ; No

admis fee; Estab 1982 as a corporate history museum revealing the history & activities of the Knights of Columbus; 77,000 sq ft bldg; 170 ft wall of history; Average Annual Attendance: 3,000
Special Subjects: Historical Material, Glass, Mexican Art, Painting-American, Textiles, Manuscripts, Painting-European, Sculpture, Latin American Art, Prints, Bronzes, Costumes, Religious Art, Ceramics, Woodcarvings, Etchings & Engravings, Decorative Arts, Portraits, Posters, Porcelain, Silver, Painting-Dutch, Ivory, Coins & Medals, Baroque Art, Mosaics
Collections: Fine & decorative arts
Exhibitions: Christopher Columbus; Founder Father Michael J McGivney; gifts & items from Knights of Columbus state & local councils; Knights of Columbus War Activities; Tributes (interactions with the Catholic Church & the Vatican)
Publications: Postcards; museum tour brochures; posters; exhib catalog
Activities: Lect open to the public; Christmas tree festival for children; gallery talks; tours; corporate archives research history of Knights of Columbus; individual paintings & original objects of art lent under special arrangements & careful consideration; originate 3-4 book traveling exhib per yr; museum shop sells books, reproductions, prints, religious items, tapes, videos & jewelry

A **NEW HAVEN COLONY HISTORICAL SOCIETY,** 114 Whitney Ave, New Haven, CT 06510. Tel 203-562-4183; Fax 203-562-2002; Elec Mail dcarter@nhchs.org; Internet Home Page Address: www.nhchs.org; *Board Dirs* David G Carter; *Cur* Amy Trout; *Dir* Peter Lamont; *Pres* Bruce Perlroth; *Librn* James W Campbell; *Dir Educ* Jennifer C White
Open Tues - Fri 10 AM - 5 PM, Sat, Sun 2 - 5 PM, cl Mon & major holidays; Admis adults $2, senior citizens $1.50, children 6-16 $1, members & Tues free; Estab 1862 for the preservation, exhibition & research of local history; Average Annual Attendance: 11,300; Mem: 1100; annual meeting in Nov
Income: $250,000 (financed by private contributions)
Collections: Morris House (c 1685 - 1780); decorative arts; ceramics; 18th & 19th Century Collection of portraits of the New Haven area personages; maritime collection of shops paintings; paintings by local artists Corne, Durrie, Jocelyn, Moulthrop
Exhibitions: Permanent exhibition includes paintings by local artists such as Jocelyn, Moulthrop & George H Durrie; landscape portraits; maritime historicl paintings; New Haven Illustrated: From Colony, Town to City; Maritime New Haven; Table Wares 1640 - 1840; Ingersoll Collection of Furniture & Decorative Arts; Two changing exhibitions per year minimum
Publications: Newsletter; Quarterly Journal
Activities: Classes for adults & children; hands-on programs; docent training; lect open to public, 4 vis lectr per year; slideshows; concerts; gallery talks & tours; individual paintings & objects of art lent to other approved museums; museum shop sells reproductions, prints, antiques & collectibles

L **Whitney Library,** 114 Whitney Ave, New Haven, CT 06510-1025. Tel 203-562-4183; Fax 230-562-2002; *Librn* James Campbell
Open Tues - Fri 1 - 5 PM, first Sat of every month 1 - 5 PM; Admis $2 for nonmembers for library use; Estab 1862 to collect, preserve, make available & publish historical & genealogical material relating to the early settlement & subsequent history of New Haven, its vicinity & incidentally, other parts of the USA; Four departments: mus, library-archives, photograph & educational, with the mus staff taking care of the galleries, the library is primarily for reference
Income: Financed by endowment, mem & grants
Library Holdings: Audio Tapes; Book Volumes 30,000; Cassettes; Clipping Files; Exhibition Catalogs; Fiche; Filmstrips; Manuscripts; Memorabilia; Motion Pictures; Other Holdings Glass plate negatives 30,000; Original documents; Pamphlets; Periodical Subscriptions 75; Photographs; Prints; Records; Reels; Video Tapes
Special Subjects: Art History, Landscape Architecture, Decorative Arts, Painting-American, Historical Material, Portraits, Period Rooms, Pottery, Marine Painting, Architecture
Collections: Afro-American Collection; Architectural Drawings; John W Barber Collection; Dana: New Haven Old & New; Durrie Papers; Ingersoll Papers; National & Local Historical Figures, A-Z; Ezra Stiles Papers; Noah Webster Collection
Publications: Journal, irregular; News and Notes, irregular; monographs; exhibition catalogs
Activities: Arrangement with local colleges for internship programs & work-study programs; lect open to public & members; tours; individual paintings & objects of art lent to other institutions; museum shop sells books, reproductions, prints & antiques

A **NEW HAVEN PAINT & CLAY CLUB, INC,** The John Slade Ely House, 51 Trumbull St New Haven, CT 06510. Tel 203-624-8055; Elec Mail dmgall@aol.com; Internet Home Page Address: www.elyhouse.org; *Pres* Dolores Gall
Open Wed- Fri 11 AM - 4 PM; Sat & Sun 2 - 5 PM; cl Mon & Tues; No admis fee; Estab 1900 to provide opportunities for artists in New England to exhibit their work, inc in 1928; Two floors of an historic house; Average Annual Attendance: 350; Mem: 270; open to artists working in any media whose work has been accepted two times in the Annual Juried Show; dues life $100, active $16, assoc $10; annual meeting in May
Income: $4000 (financed by dues)
Purchases: $3000
Collections: 280 2-D pictures & 14 sculptures
Exhibitions: Annual March-April Exhibition (New England & New York artists); Annual Fall Exhibition (active members only); Permanent Collection
Publications: Exhibition catalogs; newsletter
Activities: Lect at annual meeting; awards $500 members show, $4500 juried exhibition; scholarships; individual paintings & original objects of art lent to local organizations

PRINT COUNCIL OF AMERICA
For further information, see National and Regional Organizations

M **SOUTHERN CONNECTICUT STATE UNIVERSITY,** Art Dept, 501 Crescent St, PO Box 3144 New Haven, CT 06515. Tel 203-392-6652, Ext 5974; Internet Home Page Address: www.southernct.edu; *Dir* Cort Sierpinski
Open Mon - Fri 8 AM - 10 PM; Estab 1976 to build a collection of works of art for educational purposes, gallery developing now; Mem: 750

Income: $10,000 (financed by mem, state appropriation & fundraising)
Special Subjects: African Art, Pre-Columbian Art
Collections: African & Pre-Columbian art
Activities: Travelogues; lect open to public, 6 vis lectr per year; gallery talks; national & international tours; original objects of art lent to administrative offices

YALE UNIVERSITY
M **Yale University Art Gallery,** Tel 203-432-0600; Fax 203-432-9523; Elec Mail artgalleryinfo@yale.edu; Internet Home Page Address: www.yale.edu/artgallery.com; Internet Home Page Address: www.artgallery.yale.edu; *Dir* Jock Reynolds; *Cur Prints, Drawings & Photographs* Suzanne Boorsch; *Cur Ancient Art* Susan Matheson; *Cur American Painting* Helen Cooper; *Cur American Decorative Arts* Patricia Kane; *Registrar* Lynne Addison; *Mem* Linda Jerolmon; *Cur Educ* Jessica Sack; *Cur Modern & Contemporary Art* Jennifer Gross; *Asian* David Sensabaugh; *Public Relations* Amy Jean Porter; *Cur European Art* Lawrence Kanter; *Cur African Art* Frederick Lamp; *Cur Acad Initiatives* Pamela Franks
Open Tues - Sat 10 AM - 5 PM, Sun 1 PM - 6 PM, cl Mon; No admis fee; Estab 1832 to exhibit works of art from ancient times to present; Building designed by Louis Kahn & completed in 1953; Average Annual Attendance: 140,000; Mem: 1500; dues $50 & up
Income: Financed by endowment, mem & annual fundraising
Special Subjects: Painting-American, Sculpture, Painting-European, Oriental Art, Silver, Antiquities-Greek, Antiquities-Roman
Collections: American & European painting & sculpture; Chinese painting & ceramics; Dura-Europos Archaeological Collection; Garvan Collection of American Decorative Arts; History paintings & miniatures by John Trumbull; Japanese painting & ceramics; Jarves Collection of Italian Renaissance Painting; Societe Anonyme Collection of Twentieth century art; Stoddard Collection of Greek Vases; 20th Century Art; 25,000 prints, drawings & photographs
Publications: Exhibition catalogues; Yale University Art Gallery Bulletin, catalogue raisonnes
Activities: Classes for adults & children; family progs; evening lects; gallery tours three times per week; gallery talks; organize traveling exhibs; books

M **Yale Center for British Art,** Tel 203-432-2800; Fax 203-432-9628; Elec Mail bacinfo@yale.edu; Internet Home Page Address: www.yale.edu/ycba; *Dir* Amy Meyers; *Cur Paintings* Angus Trumble; *Cur Prints Drawings & Rare Books* Scott Wilcox; *Registrar* Timothy Goodhue; *Deputy Dir* Constance Clement; *Acting Librn* Karen Deravit; *Cur Rare Books & Archives* Elisabeth Fairman
Open Tues - Sat 10 AM - 5 PM, Sun Noon - 5 PM, cl Mon; No admis fee; Estab 1977 to foster appreciation & knowledge of British art; to encourage interdisciplinary use of the collections; Reference library & photograph archive for reference;; Average Annual Attendance: 100,000; Mem: 1400
Income: Financed by endowment, annual gifts, mem & mus shop
Special Subjects: Architecture, Drawings, Prints, Sculpture, Watercolors, Etchings & Engravings, Landscapes, Manuscripts, Portraits, Marine Painting, Painting-British, Maps, Miniatures, Bookplates & Bindings
Collections: Paintings & sculpture; drawings; prints; rare books
Publications: Calendar of Events-Preview of Exhibitions, biannually; exhibition catalogues, five per year
Activities: Classes for adults & children; dramatic programs; docent training; student guides; lect & symposia, 10 vis lectr per year; concerts, gallery talks; tours; films; fels offered; individual paintings & objects of art lent to other museums; lending collection contains rare books, original art works, original prints & paintings; book traveling exhibitions; originate traveling exhibitions; museum shop sells books, reproductions, slides, postcards, exhibitions catalogs, glass, ceramics, jewelry
—**Yale Center for British Art Reference Library,** Tel 203-432-2818; Fax 203-432-9613; Elec Mail bacref@pantheon.yale.edu; Internet Home Page Address: www.yale.edu/ycba; *Librn* Susan Brady
Open Tues - Fri 10 AM - 4:30 PM, Sat 1 - 4:30 PM when Yale is in session; No admis fee; Estab 1977 to support collection of British Art and related fields of architecture, history, literature and the performing arts; Reference library & photo archive
Library Holdings: Auction Catalogs; Book Volumes 20,000; CD-ROMs; Cards; Exhibition Catalogs; Fiche 75,000; Pamphlets; Periodical Subscriptions 70; Photographs 200,000; Reels 860; Video Tapes
Collections: British Art from age of Holbein to present
Activities: Classes for adults & children; docent training

L **Art & Architecture Library,** Tel 203-432-2640; Fax 203-432-0549; Elec Mail katherinehaskins@yale.edu; christine.devallet@yale.edu; susan.j.williams@yale.edu; barbara.rockenbach@yale.edu; jae.rossman@yale.edu; laurel.bliss@yale.edu; Internet Home Page Address: www.library.yale.edu/arr/aa.html; *Asst Dir* Christine deVallet; *Visual Resources* Susan J Williams; *Dir* Katherine Haskins; *Instructional Servs Librn* Barbara Rockenbach; *Spec Collections Librn* Jae Rossman; *Pub Services Librn* Laurel Bliss
Open academic yr Mon - Fri 8:30 AM - 6 PM, extended hrs by arrangement; sem breaks & summer Mon - Fri 8:30 AM - 5 PM; Estab 1868. Serves Schools of Art & Architecture, History of Art Department & the Yale University Art Gallery
Library Holdings: Book Volumes 115,000; Exhibition Catalogs; Other Holdings Digital Images, Photographs & Color Prints 183,000; Slides 825,000
Collections: Faber Birren Collection of Books on Color; Arts of the Book Collection
Publications: Faber Birren Collection of Books on Color: A Bibliography

L **Beinecke Rare Book & Manuscript Library,** Tel 203-432-2977; Fax 203-432-4047; Elec Mail beinecke.library@yale.edu; Internet Home Page Address: www.library.yale.edu/beinecke; *Prof* Frank M Turner
Open Mon - Fri 8:30 AM - 5 PM, Sat 10 AM - 5 PM; No admis fee; Estab 1963; Non-circulating
Library Holdings: Book Volumes 600,000; Clipping Files; Manuscripts; Maps; Memorabilia; Original Art Works; Original Documents; Pamphlets; Photographs; Prints; Sculpture
Special Subjects: Art History, Illustration, Calligraphy, Drawings, Etchings & Engravings, Graphic Arts, Graphic Design, Islamic Art, Historical Material, History of Art & Archaeology, Judaica, American Western Art, American Indian Art, Afro-American Art, Bookplates & Bindings
Collections: Osborn Collection of English literary & historical manuscripts from

the Anglo-Saxon period to 20th century; Collection of America Literature of 19th & early 20th century writings; German Literature Collection of rare books & first editions of 17th-20th century; Western Americana Collection of books, manuscripts, maps, art, prints & photographs of Trans-Mississippi West through world War I; General collection of Early Books & Manuscripts includes Greek & Roman papyri, medieval & Renaissance manuscripts; modern books & manuscripts in English literature & history from 17th-20th century
Publications: Exhibition catalogs
Activities: Lect open to the public, 10-15 vis lectrs per yr; concerts; fellowships; scholarships & fels offered; sales shop sells books

NEW LONDON

M LYMAN ALLYN ART MUSEUM, 625 Williams St, New London, CT 06320. Tel 860-443-2545; Fax 860-442-1280; Internet Home Page Address: www.lymanallyn.org; *Dir & CEO* Ronald L Crusan; *Asst Dir* Ann Wicks; *Cur & Deputy Dir* Nancy Stula; *Dir Develop* Alicia Kuranda; *Mem Coordr* Ellen Bremner
Open Tues - Sat 10 AM - 5 PM, Sun 1 - 5 PM, cl Mon & major holidays; Admis adults $5, students & seniors $4, children under 8 free; Estab 1932 for the educ & enrichment of the community & others; The museum is housed in a handsome Neo-Classical building designed by Charles A Platt; Average Annual Attendance: 25,000; Mem: 800; dues range from individual $40 to Harriet Allyn Society $1,000
Income: $220,000 (financed by endowment, trusts, mem & gifts)
Purchases: $10,000
Special Subjects: Painting-American, Decorative Arts, Dolls, Furniture, Oriental Art, Silver
Collections: American Impressionist Paintings; Connecticut Decorative Arts; Contemporary, Modern & Early American Fine Arts; collection of 30,000 works
Exhibitions: Temporary exhibitions of American Art from public & private collections; The Devotion Family of 18th Century Connecticut; Connecticut Women Artists; Impressionnist Paintings from the Lyman Allyn Collection
Publications: New London County Furniture from 1640-1840; New London Silver
Activities: Classes for adults & children; docent training; school tours & programs; lect open to public; concerts; gallery talks; tours; scholarships; individual paintings & original objects of art lent; museum shop sells books, reproductions, cards & gifts

L Hendel Library, 625 Williams St, New London, CT 06320. Tel 860-443-2545; Fax 860-442-1280; Internet Home Page Address: www.lymanallyn.conncoll.edu; *Librn* Lissa Van Dyke
Open Tues - Sat 10 AM - 5 PM, Sun 1 - 5 PM; Admis for mems & by appointment only; Estab 1932 to provide an art reference library as an adjunct to the material in the Lyman Allyn Art Museum; Reference only; Average Annual Attendance: 1,500
Income: financed by Harriet Allen trust
Library Holdings: Book Volumes 4500; Clipping Files; Exhibition Catalogs; Fiche; Pamphlets; Periodical Subscriptions 32; Photographs; Reproductions; Slides
Special Subjects: Decorative Arts
Collections: Decorative arts, furniture, drawings
Activities: Docent training; lect open to public, 2 vis lectrs per year; gallery talks; tours

A NEW LONDON COUNTY HISTORICAL SOCIETY, Shaw - Perkins Mansion, 11 Blinman St, New London, CT 06320. Tel 860-443-1209; Fax 860-443-1209; Elec Mail nlchsinc@aol.com; Internet Home Page Address: www.newlondonhistory.org; *Pres* Patricia M Schaefer; *Educator* Megan P Davis
Open Wed - Fri 1 - 4 PM, Sat 10 AM - 4 PM; by appointment; Admis $5 for tours; Estab 1870 for preservation of New London County history; Maintains reference library; paintings throughout historic house; Average Annual Attendance: 2,000; Mem: 350; dues family $25, individual $20, sr citizen & student $10; progs 2nd Sun of most months
Income: $75,000 (financed by endowment, mem, admis & research fees)
Purchases: Manuscripts; artifacts
Special Subjects: Historical Material, Manuscripts, Textiles, Painting-American, Maps, Scrimshaw
Collections: Six Portraits by Ralph Earle; furniture & decorative arts owned by Shaw & Perkins families; furniture made in New London County; miscellaneous portraits, miniatures, photographs, rare maps; Textile Collection
Exhibitions: Ongoing; New London in the Revolution; Maps & Charts of New London Harbor
Publications: NLCHS Newsletter, bimonthly
Activities: Lect open to public, 10 vis lectrs per year; sales shop sells books & gifts

M US COAST GUARD MUSEUM, US Coast Guard Academy, 15 Mohegan Ave New London, CT 06320-4195. Tel 860-444-8511; Fax 860-701-6700
Open Mon - Fri 9 AM - 4:30 PM, Sat 10 AM - 5 PM, Sun Noon - 5 PM; No Admis fee; Estab 1967 to preserve historical heritage of the US Coast Guard, US Life Saving Service, US Lighthouse Service & Revenue Cutter Service; Average Annual Attendance: 20,000
Income: Financed by federal appropriations and private donations
Special Subjects: Drawings, American Indian Art, Costumes, Ceramics, Etchings & Engravings, Decorative Arts, Eskimo Art, Coins & Medals
Collections: Ship & aircraft models; paintings; photographs & manuscripts representing the Coast Guard; military artifacts from WWI, WWII & Vietnam
Activities: Paintings & original objects of art lent to federal museums & qualified organizations for educational purposes only

NORFOLK

M NORFOLK HISTORICAL SOCIETY INC, Museum, 13 Village Green, PO Box 288 Norfolk, CT 06058-0288. Tel 860-542-5761; *Pres & Dir* Richard Byrne; *Archivist* Ann Havemeyer; *Cur Photog* Michaela A Murphy; *Cur Rare Books* Laura Byers; *Exhib Designer* Kathleen Bordelon
May - Oct Sat & Sun Noon - 4 PM; No admis fee; Estab 1960

Special Subjects: Architecture, Photography, Costumes, Portraits, Furniture, Historical Material, Maps
Collections: Marie Kendall Photography Collection (1884 - 1935), era during which she worked in Norfolk; Collection of works by Alfred S G Taylor, noted architect - his blueprints, drawings, photographs plus documents for 40 of his buildings in Norfork listed as a Thematic Group in the National Register of Historic Places; Small collection of Connecticut clocks; Fine 1879 dollhouse with elegant original furnishings; photographs & memorabilia of the Norfolk Downs, one of the very first New England golf courses (1897)
Exhibitions: Norfolk General Stores, Post Offices & Early Norfolk Merchants
Publications: Exhibition catalogs; books, pamphlets & maps, publishes at irregularly intervals

NORWALK

M LOCKWOOD-MATHEWS MANSION MUSEUM, 295 West Ave, Norwalk, CT 06850. Tel 203-838-9799; Fax 203-838-1434; Elec Mail lockmathew@aol.com; Internet Home Page Address: www.lockwoodmathews.org; *Dir* Zachary Studenroth; *Prog Dir* Susan Gold
Open Wed - Sun Noon - 5 PM by appointment; gift shop open Mon - Fri 9 - 5 PM, Sat & Sun Noon - 5 PM; Admis adults $8, students $5, children under 12 free; Estab 1968 to completely restore this 19th century 64 room mansion as a historic house mus. Now a registered National Historic Landmark. Can be rented for private parties & corporate events; Historic landmark; Average Annual Attendance: 20,000; Mem: 1200; annual meeting in June
Income: State and federal budgets
Special Subjects: Architecture, Painting-American, Costumes, Etchings & Engravings, Decorative Arts, Furniture, Glass, Painting-French, Restorations, Period Rooms
Collections: Furniture original to the mansion; 19th century decorative arts, painting & textiles
Publications: Newsletter, quarterly
Activities: Classes for adults & children; docent training; gallery talks; tours; performing arts; story & play reading; wine tasting; book traveling exhibitions 1-2 per year; museum shop sells books & magazines

NORWICH

M THE SLATER MEMORIAL MUSEUM, Slater Memorial Museum, 108 Crescent St, Norwich, CT 06360. Tel 860-887-2506; Fax 860-885-0379; Internet Home Page Address: www.norwichfreeacademy.com; *Cur Educ* Mary-Anne Hall; *Registrar* Susan Frankenbach
Open Tues - Fri 9 AM - 4 PM, Sat & Sun 1 - 4 PM, cl Mon & holidays; Admis adults $3, seniors & students $2, Friends of Museum & children under 12 free; Estab 1888; The Slater collection is housed in a 1886 Neo-Romanesque building on the campus of the Norwich Free Academy. The adjacent Converse Gallery was built in 1906; Average Annual Attendance: 10,000; Mem: 600; lifetime individual $500, patron $100, contributing $50, family $35, individual $25, senior citizen $15
Income: Financed by endowment
Special Subjects: Drawings, Graphics, American Indian Art, African Art, Costumes, Ceramics, Crafts, Landscapes, Decorative Arts, Eskimo Art, Dolls, Furniture, Glass, Jewelry, Marine Painting, Metalwork, Carpets & Rugs, Ivory, Embroidery, Laces, Antiquities-Oriental, Antiquities-Persian, Antiquities-Egyptian, Antiquities-Greek, Antiquities-Roman
Collections: Vanderpoel Collection of Asian Art; African Art; American Art & Furniture from the 17th - 20th Centuries; Native American Artifacts; Egyptian Art Objects & Textiles; Greek, Roman & Renaissance Plaster Cast Collection
Exhibitions: Special exhibitions on view in Converse Gallery - six per year; Annual Connecticut artists juried exhibition
Publications: Catalogue of the Plaster Cast Collection; Charlotte Fuller Eastman, Artist & Teacher; Greek Myths for Young People; Gualtieri, a Retrospect; NORWICH, a Photographic Essay; Renaissance Art for Young People
Activities: Educ dept; lect open to public; gallery talks; tours; competitions with awards

OLD LYME

L LYME ACADEMY OF FINE ARTS, 84 Lyme St, Old Lyme, CT 06371. Tel 860-434-5232; Fax 860-434-8725; Internet Home Page Address: www.lymeacademy.edu; *Pres* Henry E Putsch; *Acad Dean* Sharon Hunter
Lending to students & faculty only
Library Holdings: Book Volumes 6000; Exhibition Catalogs; Pamphlets; Periodical Subscriptions 40; Slides 10,000; Video Tapes 60
Publications: Brochure; catalog

A LYME ART ASSOCIATION, INC, 90 Lyme St, PO Box 222 Old Lyme, CT 06371. Tel 860-434-7461; Elec Mail lymeart@sbcglobal.net; Internet Home Page Address: www.lymeartassociation.org; *Pres* Jerry Litner; *Exec Dir* Robert Potter; *Gallery Mgr* Anna Swain
Open Tues - Sat 10 AM - 5 PM, Sun 1 - 5 PM; No admis fee, donations accepted; Estab 1914 to promote art & advance educ; Four large sky-lighted galleries are maintained. Present building designed by Charles Platt & built in 1922 by early Lyme artists; Average Annual Attendance: 12,000; Mem: 700; dues invitational juried members $50, associate mem, $30; meetings in May & Sept
Income: Financed by mem & associate members dues, donations & sales commissions
Library Holdings: Book Volumes; Cards; Exhibition Catalogs; Memorabilia; Original Art Works; Original Documents; Sculpture; Video Tapes
Special Subjects: Architecture, Painting-American
Exhibitions: Eight annual exhibs: 7 open, 1 mem only
Publications: LAA times, quarterly newsletter; Early Years: 1902-1930 of LAA, catalog

Activities: Classes for adults & children; art workshops; lect for members only, 5 - 6 vis lectrs per year; concerts; gallery talks; tours; competitions with awards; organized bus trips; sales shop sells books, original art, prints

M **LYME HISTORICAL SOCIETY,** Florence Griswold Museum, 96 Lyme St, Old Lyme, CT 06371. Tel 860-434-5542; Fax 860-434-9778; Internet Home Page Address: www.flogris.org; *Dir* Jeffrey W Andersen; *Pres* Mary Ann Begier
Open year round, Tues - Sat 10 AM - 5 PM, Sun 1 - 5 PM; Admis $8; Estab 1936 for the purpose of collecting, preserving & exhibiting the art & history of the Lyme region; Florence Griswold House 1817; Robert & Nancy Krieble Gallery 2002; Average Annual Attendance: 49,000; Mem: 2,100; dues family $75, individual $50; ann meeting in June
Income: $1,600,000 (financed by endowment, earned income, mem, grants & town appropriation)
Special Subjects: Painting-American, Decorative Arts, Historical Material
Collections: Clara Champlain Griswold Toy Collection; Evelyn McCurdy Salisbury Ceramic Collection; Old Lyme Art Colony Paintings; decorative arts & furnishings; local historical collections
Exhibitions: The Ancient Town of Lyme; The Art Colony at Old Lyme; 19th Century Period Rooms; Walker Evans Photographs; Clark Voorhees 1971 - 1933; Old Lyme: The American Barbizon; Dressed for Any Occasion: Patterns of Fashion in the 19th Century; Thomas W Nason, 1889 - 1971, The Notable Women of Lyme; The Whites of Waterford: An American Landscape Tradition; Childe Hassam in Connecticut; En Plein Air: The Art Colonies of East Hampton & Old Lyme; The Harmony of Nature; Frank Vincent DuMond; Wilson Irvine & The Poetry of Light
Publications: The Connecticut Impressionists at Old Lyme; The Lieutenant River; The Lymes Heritage Cookbook; Hamburg Cove: Past & Present; The Lyme Ledger, quarterly; Report of the Lyme Historical Society, annually; Miss Florence & The Artists of Old Lyme; A New Look at History
Activities: Classes for adults & children; dramatic programs; docent training; lect open to public; 4-5 vis lectrs per yr; gallery talks; tours; schools offered; exten program serves Connecticut; organize traveling exhibitions to American mus; museum shop sells books, reproductions & prints

L **Library,** 96 Lyme St, Old Lyme, CT 06371. Tel 860-434-5542; Fax 860-434-9778; Internet Home Page Address: www.flogris.org; *Registrar* Laurie Bradt; *Dir* Jeffrey Andersen
Open Mon - Sat 10 AM - 5 PM, Sun 1 - 5 PM; No admis fee; Estab 1953 as a research facility for mus programs & for the pub; Open to the public for reference by appointment
Purchases: $1500
Library Holdings: Book Volumes 1600; Cassettes; Clipping Files; Exhibition Catalogs; Kodachrome Transparencies; Manuscripts; Memorabilia; Motion Pictures; Pamphlets; Periodical Subscriptions 25; Photographs; Prints; Reproductions; Slides
Activities: Classes for adults and children; docent training; lect open to public; gallery talks; tours; museum shop sells books, reproductions, prints

RIDGEFIELD

M **ALDRICH MUSEUM OF CONTEMPORARY ART,** 258 Main St, Ridgefield, CT 06877. Tel 203-438-4519; Fax 203-438-0198; Elec Mail general@aldrichart.org; Internet Home Page Address: www.aldrichart.org/; *Asst Dir* Richard Klein; *Dir* Harry Philbrick
Open Tues - Sun Noon - 5 PM, Fri Noon - 8 PM, group visits by appointment; Admis adults $5, students & seniors $2, children under 12 free, Tues free all day; Estab 1964 for the presentation of contemporary painting & sculpture & allied arts; to stimulate public awareness of contemporary art through exhibitions & educ programs; Nine galleries on three floors, auditorium, gift shop. Renovated colonial building with modern addition, sculpture garden; Average Annual Attendance: 20,000; Mem: 1100; dues $35 & up
Income: Financed by mem, federal & state grants, corporate & private foundations
Special Subjects: Prints
Exhibitions: Rotating exhibits 4-6 per yr
Publications: Exhibition catalogs; quarterly newsletter
Activities: Classes for adults & children; docent training; lect open to public, 10 vis lectrs per year; concerts; gallery talks; tours; film; competitions with prizes; book traveling exhibitions; originate traveling exhibitions; museum shop sells books, jewelry, gift items & decorative objects

STAMFORD

L **FERGUSON LIBRARY,** One Public Library Plaza, Stamford, CT 06904. Tel 203-964-1000; Fax 203-357-9098; Elec Mail admin@ferg.lib.ct.us; Internet Home Page Address: www.fergusonlibrary.org; *Pres* Ernest A DiMattia Jr; *Dir Admin Servs* Nicholas Bochicchio Jr; *Dir Human Resources* Thomas Blair; *Business Office Supv* Marie Giuliano; *Dir Computer Svcs* Gary Giannelli; *Information Serv Supv* Michell Hackwelder
Open Mon - Thurs 10 AM - 9 PM, Fri 10 AM - 6 PM, Sat 10 AM - 5 PM, mid Sept - mid May Sun 1 - 5 PM; Estab 1880 as a public library dedicated to serving the information needs of the community
Income: Financed by city appropriation
Purchases: $8000 (art & music books), $50,000 (video cassettes), $22,000 (tapes & compact discs)
Library Holdings: Book Volumes 366,200; Cassettes; Framed Reproductions; Motion Pictures; Other Holdings Audio-Visual Materials 34,537; Records; Slides; Video Tapes
Collections: Photography of Old Stamford
Exhibitions: Painting, sculpture, photography & posters under sponsorship of Friends of Ferguson Library
Publications: Focus on Ferguson quarterly newsletter, Art Currents for the Whitney Museum, Musical Notes for the Stamford Symphony and the Connecticut Grand Opera

M **STAMFORD MUSEUM & NATURE CENTER,** 39 Scofieldtown Rd, Stamford, CT 06903. Tel 203-322-1646; Fax 203-322-0408; *Dir* Sharon Blume; *Asst Dir* Philip Novak; *Dir Art* Kenneth Marchione; *Pres* Keith Williamson
Open Mon - Sat 9 AM - 5 PM, Sun & holidays 1 - 5 PM, cl Thanksgiving, Christmas & New Year's Day; Admis adults $5, Stamford residents $3, Children accompanied by adult $3, mem free; Estab 1936, Art Department 1955; Museum has an art wing for changing exhibitions of 19th & 20th century art; Average Annual Attendance: 250,000; Mem: 3000; dues $35 & up; annual meeting in June
Income: Financed by mem, private & corporate donations & city appropriation
Special Subjects: Drawings, Painting-American, Photography, Prints, Sculpture, American Indian Art, Crafts
Collections: American crafts; American Indian drawings, photography, prints; 19th & 20th century painting, sculpture
Exhibitions: Annual Connecticut Artists; Four Winners Exhibition; Ellen Lanyon: Strange Games; Private Expressions: Personal Experiences; Color: Pure & Simple; American Art at the Turn of the Century; American Printmaking; The Natural Image; New American Paperworks; Connecticut Craftsmen; Bernstein; Button; Johnson; Margolies; Krushenick; Fiberforms; Contemporary Iroquois Art
Publications: American Art: American Women; Animals; brochures; exhibit catalogs; Folk Art: Then & Now; monthly newsletter
Activities: Educ dept, classes for adults & children in art, dance, nature & science; docent training; lects open to public, 12 vis lectrs per year; concerts; gallery talks; tours; competitions with awards; individual paintings & original objects of art lent to other museums; originate traveling exhibitions; museum shop sells books, magazines, slides, & 19th century collectibles & gifts

C **XEROX CORPORATION,** Art Collection, 800 Long Ridge Rd, Stamford, CT 06904. Tel 203-968-3000; Fax 203-968-3330; *VPres Xerox Foundation* Joseph M Cahalan; *Prog Mgr* Evelyn Shockley
Open by appointment, Mon - Fri 9 AM - 5 PM; No admis fee; Collection on display at Xerox Headquarters
Collections: The art collection represents a broad spectrum of American fine art as well as art forms from other countries. The works range from abstraction to realism & consist of sculpture by David Lee Brown located in the lobby, fiberwork by Gerhardt Knodel located in the dining facility, collages, etchings, lithographs, graphics, mezzotints, mono-prints, montages, pastels, photography, pochoir, silkscreens, watercolors & xerography

STORRS

UNIVERSITY OF CONNECTICUT

M **William Benton Museum of Art,** Tel 860-486-4520; Fax 860-486-0234; *Cur* Thomas P Bruhn; *Museum Shop Mgr* Linda Smith; *Registrar* Toni Hulse; *Dir* Salvatore Scalora; *Museum Shop Mgr* Laurie Whitehead; *Pub Relations* Diane Lewis; *Educ* Tracy Lawlor; *Mem Coordr* Lynn Ericksson; *Mus Technician* Philip Hollister; *Business Mgr* Karen Sommer
Open during exhibitions Tues - Fri 10 AM - 4:30 PM, Sat & Sun 1 - 4:30 PM, cl Mon; No admis fee; Estab 1966, a mus of art, operating as an autonomous department within the University, serving the students, faculty & general pub; contributing to the field at large through research, exhibitions & publications & by maintaining a permanent collection of over 3500 objects; The main gallery measures 36 x 116 ft, galley II 33 x 36 ft; Average Annual Attendance: 36,000; Mem: 600; dues double $25
Income: $700,000 (financed by mem, state appropriation, grants & gifts & donations)
Special Subjects: Graphics, Painting-American, Sculpture, Painting-European
Collections: American painting & graphics 19-20th Century; German & French graphics late 19th & 20th Century; selected 17th & 18th Century European paintings, sculptures & graphics; Western European & American c 1600 to present; paintings, graphics; contemporary photography
Publications: Exhibition catalogs,annually
Activities: Lect open to public, 5-8 vis lectrs per year; gallery talks; tours; individual paintings & original objects of art lent to accredited institutions for exhibition purposes; lending collection contains original prints, paintings & sculpture; book traveling exhibitions; originate traveling exhibitions; sales shop sells books, original art, prints, reproductions & museum related art objects & jewelry

M **Jorgensen Auditorium,** Tel 860-486-4228; Fax 860-486-6781; Elec Mail rock@jorg.anj.uconn.edu; Internet Home Page Address: www.jorgensen.ct-arts.com; *Dir* Rodney Rock; *Operations Dir* Gary Yakstis
Open Mon - Fri 8 AM - 5 PM, cl Sat & Sun; No admis fee; Estab 1967 to present work by leading contemporary North American artists. Serves the pub as well as the university community; The gallery is 2872 square ft; Average Annual Attendance: 25,000; Mem: 500 Friends of Jorgensen
Exhibitions: Various exhibitions, call for details
Activities: Gallery talks

L **Art & Design Library,** Tel 860-486-2787; Fax 860-486-3593; Elec Mail tom.jacoby@uconn.edu; *Art & Design Librn* Thomas J Jacoby
Open Mon - Thurs 10 AM - 10 PM, Fri 10 AM - 5 PM, Sat Noon - 5 PM, Sun 2 - 10 PM; No admis fee; Estab 1979 to support the Department of Art, Art History, Landscape Architecture & William Benton Mus of Art; Circ 16,000
Income: Financed by state appropriation & private funds
Library Holdings: Auction Catalogs; Book Volumes 70,000; Exhibition Catalogs; Fiche; Periodical Subscriptions 180
Special Subjects: Folk Art, Etchings & Engravings, Painting-American, Painting-European, Latin American Art, Theatre Arts, Asian Art, American Indian Art, Anthropology, Afro-American Art, Restoration & Conservation, Antiquities-Byzantine, Antiquities-Etruscan, Antiquities-Greek, Antiquities-Roman

STRATFORD

M **STRATFORD HISTORICAL SOCIETY,** Catharine B Mitchell Museum, 967 Academy Hill, Stratford, CT 06615; Box 382, Stratford, CT 06615. Tel 203-378-0630; Fax 203-378-2562; Elec Mail judsonhousestfd@aol.com; *Cur* Carol Lovell
Open Wed, Sat & Sun 11 AM - 4 PM, June - Oct; Admis adults $3, seniors & children $1; Estab 1925 to preserve Stratford's past; Mus contains local history;

Judson House, 1750 house with period furnishings; Average Annual Attendance: 1,500; Mem: 400; dues $12; meetings in Sept, Nov, Jan, Mar & May, last Fri of month

Income: Financed by endowment, fundraising & mem

Library Holdings: Book Volumes 4,000; Cards; Clipping Files; Kodachrome Transparencies; Manuscripts; Maps; Memorabilia; Original Art Works; Original Documents; Pamphlets; Photographs; Slides

Special Subjects: Architecture, Drawings, Painting-American, Photography, Prints, Watercolors, American Indian Art, Textiles, Ceramics, Folk Art, Primitive art, Manuscripts, Portraits, Posters, Dolls, Furniture, Glass, Porcelain, Oriental Art, Silver, Marine Painting, Maps, Period Rooms, Embroidery, Pewter

Collections: Local Indians; 18th century house with period furnishings; collection of baskets, ceramics, cooking items, paintings, quilts, military items & weapons, clothing, textiles & furniture

Exhibitions: Permanent and changing exhibitions

Publications: Newsletter

Activities: Classes for children; dramatic programs; docent training; lect open to public, 5 vis lectrs per year; tours; individual paintings & original objects of art lent to accredited museums & galleries; lending collection contains books, original art, paintings, photographs & slides; museum shop sells books, reproductions, cards, prints & souvenirs

L Geneological Library, 967 Academy Hill, Stratford, CT 06615; Box 382, Stratford, CT 06615. Tel 203-378-0630; Fax 203-378-2562; Elec Mail judsonhousetfd@aol.com; *Cur* Carol W Lovell
Office open Tues & Thurs 11 AM - 4 PM; No admis fee; Estab 1925 for preservation & dissemination of items of history of Stratford, Conn; For reference & geneological research

Income: Financed by mem & city appropriation

Library Holdings: Audio Tapes; Book Volumes 1000; Cassettes; Clipping Files; Exhibition Catalogs; Filmstrips; Kodachrome Transparencies; Manuscripts; Memorabilia; Original Art Works; Pamphlets; Photographs; Prints; Reproductions; Slides; Video Tapes

Special Subjects: Art History, Folk Art, Drawings, Manuscripts, Painting-American, Ceramics, American Indian Art, Furniture, Period Rooms, Glass, Miniatures, Oriental Art, Marine Painting, Pewter, Flasks & Bottles

Collections: Ceramics, Clothing, Textiles, Furniture

WASHINGTON DEPOT

A WASHINGTON ART ASSOCIATION, 4 Bryan Plaza, PO Box 173 Washington Depot, CT 06794-0173. Tel 860-868-2878; Fax 860-868-3447; Elec Mail washington.art.assoc@snet.net; Internet Home Page Address: www.washingtonart.org; *Pres* Deborah Dressler; *VPres* Nancy Mygatt; *Admin* Delancey Materne; *2d VPres* Joan Talbot
Open Mon - Sat 10 AM - 5 PM, Sun 2 - 5 PM, cl Wed; No admis fee; Estab 1952 to make available to the community a variety of art experiences through exhibitions & activities; Three connected galleries downstairs for individual & group shows; small members sales gallery upstairs; Average Annual Attendance: 10,000; Mem: 850; dues family $30, individual $20; annual meeting third Sun in Aug

Income: $32,000 (financed by endowment, mem & fund-raising events)

Exhibitions: Rotating exhibit every 3 weeks

Publications: Events Bulletin, quarterly

Activities: Classes for adults & children; lect open to public, vis lectr; gallery talks; sales shop sells original art & crafts by members

L Library, 4 Bryan Plaza, PO Box 173 Washington Depot, CT 06794-0173. Tel 860-868-2878; Internet Home Page Address: www.washingtonart.org; *Admin* Delancey Materne
Open Mon - Sat 10 AM - 5 PM, Sun 2 - 5 PM; Open to members, teachers & pub for reference only

Library Holdings: Book Volumes 800; Clipping Files; Exhibition Catalogs; Periodical Subscriptions 2

Special Subjects: Decorative Arts, Illustration, Photography, Graphic Arts, Painting-American, Portraits, Crafts, Printmaking, Porcelain, Aesthetics, Landscapes

WATERBURY

M MATTATUCK HISTORICAL SOCIETY, Mattatuck Museum, 144 W Main St, Waterbury, CT 06702. Tel 203-753-0381; Fax 203-756-6283; Elec Mail info@mattatuckmuseum.org; Internet Home Page Address: www.mattatuckmuseum.org; *Pres* Catherine Smith; *First VPres* Dana D Moreira; *Cur* Ann Smith; *Second VPres* Sharon Drubner
Open Tues - Sat 10 AM - 5 PM, Sun Noon - 5 PM, cl Mon, cl Sun in July & Aug; Admis $4 16 & older; Estab 1877 to collect & preserve the arts, history of the state of Connecticut, especially of Waterbury & adjacent towns; An art gallery is maintained; Average Annual Attendance: 100,000; Mem: 1300; dues $40-$5000; annual meeting in Nov

Income: Financed by endowment, mem & grants

Special Subjects: Architecture, Painting-American, Photography, Prints, Sculpture, Watercolors, Costumes, Ceramics, Woodcuts, Landscapes, Decorative Arts, Manuscripts, Portraits, Posters, Furniture, Glass, Silver, Metalwork, Historical Material, Maps, Coins & Medals, Period Rooms, Pewter

Collections: Connecticut artists collection; decorative arts collection; local history & industrial artifacts; period rooms

Exhibitions: Rotating exhibits

Publications: Annual Report

Activities: Classes for adults & children; dramatic programs; docent training; lect; gallery talks; group tours by appointment; competitions; individual paintings & original objects of art lent to other museums; lending collection contains paintings, photographs & slides; museum shop sells books, original art, reproductions, prints, decorative arts

L Library, 144 W Main St, Waterbury, CT 06702. Tel 203-753-0381; Fax 203-756-6283; Internet Home Page Address: www.mattatuckmuseum.org; *Cur* Ann Smith
Open for reference by appointment only

Income: Financed by grants & research fees

Library Holdings: Audio Tapes; Book Volumes 3000; Cassettes; Clipping Files; Exhibition Catalogs; Filmstrips; Lantern Slides; Manuscripts; Memorabilia; Original Art Works; Other Holdings CT artist files; Pamphlets; Periodical Subscriptions 10; Photographs; Prints; Sculpture; Slides; Video Tapes

Special Subjects: Art History, Decorative Arts, Drawings, Etchings & Engravings, Painting-American, Sculpture, Historical Material, Ceramics, Crafts, Industrial Design, Furniture, Period Rooms, Restoration & Conservation, Coins & Medals, Architecture

L SILAS BRONSON LIBRARY, Art, Theatre & Music Services, 267 Grand St, Waterbury, CT 06702. Tel 203-574-8236; Fax 203-574-8055; Internet Home Page Address: www.biblio.org/bronson/silas.htm; *Dir* Emmett McSweeney
Open Mon & Wed 9 AM - 9 PM, Tues, Thurs - Fri 9 AM - 5:30 PM, Sat 10 AM - 2 PM; Estab 1869 to provide a free public library for the community; A spotlighted gallery wall & locked glass exhibition case used for art exhibits; Average Annual Attendance: 300,000

Income: Financed by endowment & city appropriation

Library Holdings: Audio Tapes 1964; Book Volumes 207,463; Cassettes 5028; Periodical Subscriptions 2464; Video Tapes 4996

Exhibitions: Local artists in various media; High school art students

Publications: Books & Happenings, monthly newsletter

Activities: Lect open to the public; concerts; individual framed art prints lent

WEST HARTFORD

M NOAH WEBSTER HOUSE, INC, Noah Webster House, 227 S Main St, West Hartford, CT 06107-3430. Tel 860-521-5362; Internet Home Page Address: www.ctstateu.edu/noahweb/noahwebster.html; *Educ Coordr* Susan Dorko; *Office Mgr* Abigail Perkins; *Dir* Vivian Lae
Open daily 1 - 4 PM, extended hours July & Aug; Admis adult $5, senior citizens & AAA members $4, children 13-18 $3, 6-12 $1; Estab 1965 to preserve & promote 18th-century daily life, Noah Webster & West Hartford history; Average Annual Attendance: 15,000; Mem: 550; dues $20 & up, annual meeting in Sept

Exhibitions: Permanent Noah Webster exhibit & temporary exhibits on West Hartford history

Publications: The Spectator, quarterly member newsletter

Activities: Classes for adults & children; docent training; family programs; school & scout programs; lect open to public; tours; competitions with prizes; lending collection contains film strips; sales shop sells books, reproductions, prints & educational items

M SAINT JOSEPH COLLEGE, Saint Joseph College Art Gallery, 1678 Asylum Ave, West Hartford, CT 06117-2791. Tel 860-231-5399; Fax 860-231-5754; Elec Mail artgallery@sjc.edu; Internet Home Page Address: www.sjc.edu/artgallery; *Dir, Cur* Ann H Sievers; *Coll Mgr, Registrar* Rochelle L Reitinger Oakley
Open Tues, Wed, Fri 11 AM - 4 PM, Thurs 11 AM - 6 PM, Sat 11 AM - 2 PM, cl Sun & Mon; No admis fee; Estab 1984 to make the College's art available to students & the public for study & enjoyment; Average Annual Attendance: 5,000

Special Subjects: Painting-American, Prints, Watercolors, Woodcuts, Etchings & Engravings

Collections: Rev Andrew J Kelly Collection of American Paintings, 1920s & 1930s; Rev John J Kelley Collection of 15th Century to Early 20th Century Prints; Sister Mary Theodore Kelleher Collection of Contemporary Prints

Exhibitions: Objects of Our Affection

Publications: Exhibition brochures

Activities: Docent training; lect open to public; 1 vis lect per year; gallery talks

L UNIVERSITY OF HARTFORD, Mortensen Library, 200 Bloomfield Ave, West Hartford, CT 06117. Tel 860-768-4397; Fax 860-768-5165; Elec Mail bigazzi@hartford.edu; *Art Reference Librn* Anna Bigazzi
Open Mon - Thurs 8 AM - 12 AM, Fri 8 AM - 6 PM, Sat 10 AM - 6 PM, Sun Noon - 12 AM; Estab 1964

Purchases: $5000

Library Holdings: Exhibition Catalogs; Pamphlets; Periodical Subscriptions 80; Reproductions; Video Tapes

Special Subjects: Art History, Decorative Arts, Drawings, Graphic Arts, Pre-Columbian Art, Sculpture, History of Art & Archaeology, Portraits, Watercolors, Conceptual Art, American Indian Art, Primitive art, Mexican Art, Afro-American Art, Oriental Art

M UNIVERSITY OF HARTFORD, Joseloff Gallery, Harry Jack Gray Ctr, 200 Bloomfield Ave West Hartford, CT 06117. Tel 860-768-5135; Fax 860-768-5159; Internet Home Page Address: www.joseloffgallery.org; *Dir* Zina Davis; *Gallery Mgr* Lisa Gaumond
Open Tues - Fri 11 AM - 4 PM, Sat & Sun Noon - 4 PM; No admis fee; Comprehensive exhibition program focusing on established & emerging artists

Income: financed by the college

Collections: 20th-century & contemporary art in all media; Rotating exhibitions

Activities: Classes for adults

L Anne Bunce Cheney Art Collection, Mortensen Library, University of Hartford, 200 Bloomfield Ave West Hartford, CT 06117. Tel 860-768-4397; Fax 860-768-5298; Elec Mail bigazzi@hartford.edu; Internet Home Page Address: www.library.hartford.edu; *Art Reference Librn* Anna Bigazzi
Open Mon - Thurs 8:30 AM - midnight, Fri 8:30 - 6 PM, Sat 10 AM - 6 PM, Sun Noon - midnight; Estab 1964

Income: Financed through university library

Library Holdings: Book Volumes 20,500; Exhibition Catalogs; Pamphlets; Periodical Subscriptions 80; Reproductions 17,600

Special Subjects: Art History, Photography, Drawings, Etchings & Engravings, Graphic Arts, Sculpture, History of Art & Archaeology, Judaica, Ceramics, Archaeology, Advertising Design, American Indian Art, Furniture, Aesthetics, Oriental Art

WESTPORT

A NEW YORK SOCIETY OF WOMEN ARTISTS, INC, 19A Darbrook Rd, Westport, CT 06880. Tel 203-329-9179; Elec Mail eblack@eliseblack.com; Internet Home Page Address: www.anny.org; Internet Home Page Address: www.nyswa.com; *Pres* Elise Black; *VPres* Elisa Pritzker; *Exec VPres* Benice Catchi; *Treas* Joyce Pommer; *Recording Sec* Marlene Wiedenbaum; *Recording Sec* Olga Poloukhine
Cl to pub; Admis $45; Estab 1920 for the advancement of women's art; Affiliated with Pleiades Gallery in Chelsea, NY; Mem: 60; mem open to superior artists; dues $100; meetings in Nov & May
Income: Financed by jury selection
Special Subjects: Drawings, Prints, Sculpture

L WESTPORT PUBLIC LIBRARY, Arnold Bernhard Plaza, Westport, CT 06880. Tel 203-291-4840; Fax 203-291-4820; Elec Mail dcelia@westportlibrary.org; Internet Home Page Address: www.westportlibrary.org; *Dir* Maxine Bleiweis
Open Mon - Thurs 9 AM - 9 PM, Fri 9 AM - 6 PM, Sat 9 AM - 5 PM, Sun (Sept-May) 1 - 5 PM; No admis fee; Estab 1907; Circ 780,000; Art display kiosks in library with quarterly exhibits
Income: $3,566,998, 85% town appropriation, 15% contributions, endowments and other
Purchases: $358,313
Library Holdings: Book Volumes 189,756; Compact Disks; Periodical Subscriptions 476; Video Tapes 16,515
Collections: Picture collection (for pictorial research by artists, illustrators, & designers); Famous Artists School Publications
Publications: 5 per year newsletter
Activities: Lect open to public

WETHERSFIELD

M WETHERSFIELD HISTORICAL SOCIETY INC, Museum, 150 Main St, Wethersfield, CT 06109. Tel 860-529-7656; Fax 860-563-2609; *Dir* Brenda Milkofsky
Open Tues - Sat 10 AM - 4 PM, Sun 1 - 4 PM; Estab 1932 to preserve local history; Two changing exhibit rooms; Average Annual Attendance: 18,000; Mem: 800; dues family $35, individual $23; annual meeting in mid-May
Income: $190,000 (financed by endowment, mem, programs & fundraising)
Special Subjects: Painting-American, Photography, Archaeology, Textiles, Costumes, Folk Art, Furniture, Historical Material, Maps, Period Rooms
Collections: Local history/culture
Exhibitions: Changing monthly exhibits
Publications: Newsletter, quarterly
Activities: Children's programs; docent programs; lect open to public, 4 vis lectrs per year; book traveling exhibitions 8 per year; retail store sells books & prints

L Old Academy Library, 150 Main St, Wethersfield, CT 06109. Tel 860-529-7656; Fax 860-563-2609; Elec Mail weth.hist.society@snet.net; Internet Home Page Address: www.wethhist.org; *Interim Dir* Melissa Siriclo
Open Tues - Fri 9 AM - 4 PM & by appointment; Estab 1932
Income: $250,000 (financed by endowment, mem, programs, donations & rentals)
Library Holdings: Book Volumes 2000
Collections: Wethersfield history & genealogy
Exhibitions: Wethersfield History; Legendary People, Ordinary Lives (permanent)
Publications: Newsletter, quarterly
Activities: Classes for adults & children; docent programs; lect open to public, 3 - 4 vis lectrs per year; concerts; gallery talks; tours; book traveling exhibitions 4 per year; retail store sells books, prints & more

WILTON

M NATIONAL PARK SERVICE, Weir Farm National Historic Site, 735 Nod Hill Rd, Wilton, CT 06897. Tel 203-834-1896; Fax 203-834-2421; Elec Mail wefa_interpretation@nps.gov; Internet Home Page Address: www.nps.gov/wefa; *Exec Dir, Weir Farm Heritage Trust* Constance Evans; *Supt* Randy Turner
Open 8:30 AM - 5 PM; No admis fee; Estab 1990; Visitor center has changing exhibits in two small rooms; Average Annual Attendance: 10,000; Mem: 200; annual meeting in May
Special Subjects: Architecture, Painting-American, Watercolors, Etchings & Engravings, Landscapes, Decorative Arts, Furniture, Historical Material
Collections: J Alden Weir Archive & Manuscripts Collection; American Impressionist paintings; Decorative Arts Collection; Finding Aid for the Dorothy Weir Young Research Papers (1813-1947); Finding Aid for the Weir Family Papers (1746-1962); Finding Aid for the Burlingham/Weir Archive of the Metropolitan Museum of Art
Activities: Classes for children; visiting & resident artist program for professional artists; lect open to public, 5 vis lectrs per year; tours; museum shop sells books & prints

DELAWARE

DOVER

M BIGGS MUSEUM OF AMERICAN ART, 406 Federal St, Dover, DE 19901; PO Box 711, Dover, DE 19903-0711. Tel 302-674-2111; Fax 302-674-5133; Elec Mail biggs@delaware.net; Internet Home Page Address: www.biggsmuseum.org; *Cur* Ryan Grover; *Dir* Karol A Schmiegel; *Educ* Carrie Happoldt; *Asst Dir* Sandra Conner; *Office Mgr* Linda Danko
Open Wed - Fri 10 AM - 4 PM, Sun 1:30 - 4:30 PM, Sat & minor holidays 9 AM - 5 PM; No admis fee; Estab 1989; Includes 14 galleries; Average Annual Attendance: 8,000; Mem: 250; dues $30

Income: financed by endowment, mem, state appropriation, foundations & contributions
Purchases: $50,000
Library Holdings: Auction Catalogs; Book Volumes; Clipping Files; Exhibition Catalogs; Kodachrome Transparencies; Memorabilia; Periodical Subscriptions; Photographs; Slides
Special Subjects: Painting-American, Sculpture, Watercolors, Textiles, Ceramics, Portraits, Furniture, Silver
Collections: Biggs Collection of American Representational Paintings & Decorative Arts from the Delaware Valley
Exhibitions: (2003) For the Joy of It: Animal Sculptures
Publications: Quarterly newsletter; bi-monthly calendar
Activities: Docent training; school tours; lect for mem only, 10 vis lectrs per yr; gallery talks; classes for children; competitions; mus shop sells book & postcards

M DELAWARE ARCHAEOLOGY MUSEUM, 316 S Governors Ave, Dover, DE. Tel 302-739-3260; Tel 302-739-4266 (Tour info); Elec Mail bev.laing@state.de.us; Internet Home Page Address: www.destatemuseums.org/Information/Museums/arch/arch_museum.shtml
Open Tues - Sat 10 AM - 3:30 PM. Cl Sun, Mon & State Holidays; No admis fee, donations accepted; Mus focus is on archaeology, the study of previous peoples, civilizations, & their lifeways through scientific analysis of remaining artifacts
Special Subjects: Anthropology, Archaeology, Historical Material, Ceramics, Glass, Pottery, Primitive art, Woodcarvings
Collections: 12,000 years worth of archaeological history found in the state of DE, ranging from the last ice age to the 20th century; arrowheads; ceramics; stone & bone tools; glass objects; personal artifacts used in DE in the 17th - 20th centuries; miscellaneous findings of anthropologists, osteologists, geologists, physical anthropologists, botanists & many other scientific disciplines used in the identification & analysis of the archaeological record
Activities: Group tours available with reservation; ann events: Old Dover Days, first weekend in May, Archaeology Month

M DELAWARE DIVISION OF HISTORICAL & CULTURAL AFFAIRS, 102 S State St, Dover, DE 19901; 21 The Green, Dover, DE 19901. Tel 302-739-5316; Fax 302-739-6712; Internet Home Page Address: www.destatemuseum.org; *Cur Coll* Ann Baker Horsey; *Cur Educ* Madeline Dunn; *Coll Mgr* Claudia Leister; *Cur Archaeology* Charles Fithian; *Mgr* Lynn Riley; *Site Adminstr* Beverly Laing
John Dickinson Plantation: Tues - Sat 10 AM - 3:30 PM, Apr - Dec 1:30 - 4:30 PM; Johnson Victrola Museum, Meeting House Galleries I & II: Tues - Sat 10 AM - 3:30 PM; Old State House, Zwaanendael, New Castle Courthouse: Tues - Sat 8:30 AM - 4:30 PM, Sun 1:30 - 4:30 PM; State Visitor Center (Dover): Mon - Sat 8:30 AM - 4:30 PM, Sun 1:30 - 4:30 PM; No admis fee; Historic house museums were opened in the 1950s, Zwaanendael Museum 1931, to reflect the pre-historic & historic development of Delaware by exhibiting artifacts & interpreting the same through various facilities-those of early times; Average Annual Attendance: 100,000
Income: $2,4000,000 (state appropriations)
Library Holdings: Book Volumes; Cassettes; Compact Disks; Exhibition Catalogs; Manuscripts; Maps; Memorabilia; Original Art Works; Original Documents; Periodical Subscriptions; Photographs; Records
Special Subjects: Ceramics, Textiles, Architecture, Painting-American, Archaeology, Portraits, Posters, Glass, Silver, Historical Material, Period Rooms
Collections: Meeting House Galleries I & II: Prehistoric & Historic Archaeology; Museum of Small Town Life: Main Street Delaware; John Dickinson Plantation: Decorative arts, furniture & Dickinson family objects; New Castle Court House: Portraits of famous Delawareans, archaeological artifacts, furniture & maps; Old State House: legislative judicial & governmental furniture & decorative arts; Zwaanendael Museum: HMB Debraak Artifacts; Commemorative gifts to the State of Delaware from Holland, china, glass, & silver; Johnson Victrola Museum: Talking machines, Victrolas, early recordings & Johnson memorabilia associated with the Victor Talking Machine Company (RCA)
Publications: Delaware State Museum Bulletins; Delaware History Notebook; miscellaneous booklets & brochures
Activities: Classes for adults & children; docent training; special educational programs for school groups & adults which reflect the architecture, government, educ & aspects of social history relevant to Delaware; lectrs open to the public; gallery talks; tours; Nat Tourism award; individual paintings are lent to governmental facilities; in-service programs relating to Delaware history are offered to Delaware teachers; internship; lending of original objects of art to other museums; traveling trunk program circulated to elementary schools; museum shop sells books, magazines, prints, original art & Delaware souvenirs

MILLSBORO

M NANTICOKE INDIAN MUSEUM, Rte 24, Millsboro, DE 19966; 27073 John J Williams Hwy, Millsboro, DE 19966. Tel 302-945-7022 (Museum); Tel 302-945-3400 (Tribal Office); Elec Mail nanticok@bellatlantic.net; Internet Home Page Address: www.thelongneckpage.com/nia
Open Summer: Tues - Sat 10 AM - 4 PM; adults $2, Children $1; 1984; Mus mission is to tell the story of the Nanticoke Native Americans, people who have faced many obstacles throughout history; mus is living proof of their strength & success.
Special Subjects: Historical Material, Photography, Pottery, Costumes, Woodcarvings
Collections: Stone artifacts; carvings; pottery; traditional clothing; mus library houses large coll of Native American books, photos & video presentations
Activities: Ann Nanticoke Indian Powwow celebration

NEWARK

UNIVERSITY OF DELAWARE
M University Gallery, Tel 302-831-8039; Fax 302-831-8057; Elec Mail bchapp@udel.edu; Internet Home Page Address: www.museums.udel.edu; *Cur* Jan Broske; *Head Exhib Designer* Timothy Goecke; *Dir* Janis A Tomlinson; *Office Supvr* Joan Faull

Open Tues, Thurs, Fri 11 AM - 4 PM, Wed 11 AM - 8 PM, Sat & Sun 1 - 4 PM, cl university holidays; No admis fee; Estab 1978 to promote excellence in arts & humanities at the University of Delaware through exhibitions, acquisitions, preservation, interpretation of art collection & through providing support system to Mus studies curriculum; 2 art galleries in Old College & Mechanical Hall, Mineralogical Collection; Average Annual Attendance: 15,000
Special Subjects: Drawings, Graphics, Painting-American, Prints, Sculpture, African Art, Textiles, Pottery, Etchings & Engravings, Landscapes, Eskimo Art, Antiquities-Byzantine, Antiquities-Egyptian, Antiquities-Greek, Antiquities-Roman
Collections: 19th & 20th century American works on paper; Pre-Columbian textiles & ceramics; African Artifacts; early 20th century photographs; Contemporary Canadian Prints and Inuit Drawings; African-American Art; Paul R Jones Collection of African American 20th Century Art
Publications: Exhibit catalog
Activities: Classes for children; lect open to public, 2-3 vis lectrs per year; gallery talks; tours; individual & original objects of art lent to other mus & universities; Mus In Motion program brings art objects to local classrooms (K-4); book traveling exhibitions 1 per year; originate traveling exhibitions which circulate nationally to mus & universities; mus shop sells books & exhibs catalogs

L **Morris Library,** Tel 302-831-2965, 831-2231; Fax 302-831-1046; Internet Home Page Address: www.lib.udel.edu; *Dir Libraries* Susan Brynteson; *Subject Librn (Art & Art History)* Susan A Davi; *Head Reference Dept* Shirley Branden; *Asst Dir Library Collections* Craig Wilson; *Asst Dir Library Public Serv* Sandra Millard
Open Fall and Spring Mon - Thur 8 AM - 12 AM, Fri 8 AM - 8 PM, Sat 9 AM - 8 PM, Sun 11 AM - 12 AM
Income: Financed through the University
Purchases: $113,150
Library Holdings: Audio Tapes; Book Volumes 2,704,986; Cards; Cassettes 7735; Compact Disks; DVDs 2,199; Exhibition Catalogs; Fiche; Filmstrips 1646; Manuscripts 2952; Micro Print; Motion Pictures; Pamphlets; Periodical Subscriptions 12,532; Photographs; Prints; Records; Reels; Slides; Video Tapes 14,204
Collections: American art & architecture; early 20th century European art; material on ornamental horticulture; ARTstor

ODESSA

L **CORBIT-CALLOWAY MEMORIAL LIBRARY,** 115 High St, PO Box 128 Odessa, DE 19730-0128. Tel 302-378-8838; Fax 302-378-7803; Elec Mail corbit@infinet.com; *Dir* Steven J Welch
Open Mon & Sat 1 - 9 PM, Wed & Fri 10 AM - 5 PM, Wed 10 AM - 9 PM, Sat 9 AM - 1 PM; No admis fee; Estab 1847
Library Holdings: Audio Tapes; Book Volumes 21,000; Periodical Subscriptions 58; Slides; Video Tapes
Collections: Delawareana

REHOBOTH BEACH

A **REHOBOTH ART LEAGUE, INC,** 12 Dodds Lane, Henlopen Acres Rehoboth Beach, DE 19971. Tel 302-227-8408; Fax 302-227-4121; Internet Home Page Address: www.rehobothartleague.org; *Pres Board* Jessrey Seemans; *Dir* Nancy Alexander
Open Mon - Sat 10 AM - 4 PM, Sun Noon - 4 PM; No admis fee; Estab 1938 to provide art education & creative arts in Rehoboth Beach community & Sussex County, Delaware; Two galleries, the Corkran & the Tubbs built for exhibitions; plus Homestead, circa 1743, gallery & studio; Average Annual Attendance: 10,000; Mem: 1200; dues $30 & up
Income: Financed by mem, donation & fund raising & sales of paintings
Collections: Small permanent collection from gifts, includes many Ethel P B Leach, Orville Peats & Howard Pyle
Exhibitions: Annual Members Fine Arts Crafts Exhibition; Annual Members Fine Arts Exhibition; Outdoor Fine Art
Publications: Brochure of yearly events
Activities: Classes for adults & children; lect open to public, 3 vis lectrs per year; concerts; gallery talks; competitions with awards; sales shop sells original art & prints

WILMINGTON

A **CHRISTINA CULTURAL ARTS CENTER, INC,** 705 N Market Street, Wilmington, DE 19801. Tel 302-652-0101; Fax 302-652-7480; Elec Mail ccacdel@aol.com; Internet Home Page Address: www.ccac-de.org; *Dir* H Raye Jones-Avery; *Pub Relations* Karen Ellis Wilkens
Open Mon - Fri 9 AM - 9 PM, Sat 9 AM - 3 PM; No admis fee; Estab to bring professional arts training & education to a broad spectrum of the community with an emphasis on serving low income families

M **DELAWARE ART MUSEUM,** 800 S Madison St Ste B, Wilmington, DE 19801; 2301 Kentmere Pkwy, Wilmington, DE 19806. Tel 302-571-9590; Fax 302-571-0220; Internet Home Page Address: www.delart.org; *Dir Educ* Roberta Adams; *Registrar* Mary Holahan; *Dir* Stephen T Bruni; *Assoc Dir External Affairs* Janet Davis; *Cur Contemporary Art* Judith Cizek; *Assoc Cur 19th & 20th Century* Joyce Schiller; *Head Librn* Kraig Binkowski; *Assoc Dir Admin & Finance* Marcia Cumiskey
Open Tues, Thurs, Fri 10 AM - 6 PM; Wed 10 AM - 9 PM, Sat 10 AM - 5 PM, Sun 1 - 5 PM, cl Mon; Admis adults $7, seniors & students $5, children 8 & under free, Sat 10 AM - 7 PM free; Incorporated 1912 as the Wilmington Soc of Fine Arts; present building expanded 1987; a privately funded, non-profit cultural & educational institution dedicated to the increase of knowledge & pleasure through the display & interpretation of works of art & through classes designed to encourage an understanding of & a participation in the fine arts; Nine galleries are used for exhibitions; six usually hold permanent or semi-permanent exhibitions

which change at six week intervals; Average Annual Attendance: 20,000; Mem: 3200; dues family $50, individual $30; annual meeting in Mar
Income: $1,800,000 (financed by endowment, mem & grants)
Purchases: $20,000
Special Subjects: Afro-American Art, Landscapes, Graphics, Painting-American, Photography, Prints, Sculpture, Etchings & Engravings, Decorative Arts, Portraits, Posters, Painting-British
Collections: Bancroft Collection of English Pre-Raphaelite Paintings; Copeland Collection of Work by Local Artists; Phelps Collection of Andrew Wyeth Works; American paintings & sculpture, including many Howard Pyle works & complete etchings & lithographs of John Sloan; American illustrations; Contemporary American Art & photography; Works by Edward Hopper, George Segal & Robert Motherwell
Exhibitions: 6 or more every yr
Publications: DAM Magazine, quarterly
Activities: Classes for adults & children; docent training; workshops; lectrs open to the public; concerts; gallery talks; tours; exten dept serving schools & community groups offering two-week programs in visual educ; originate traveling exhibitions; museum shop sells books, original art, reproductions

L **Helen Farr Sloan Library,** 2301 Kentmere Pky, Wilmington, DE 19806. Tel 302-571-9590; Fax 302-571-0220; Internet Home Page Address: www.delart.org; *Head Librn* Sarena Fletcher, CA
Open Wed - Fri 10 AM - 4 PM; Estab 1923; Open to public for reference only
Library Holdings: Auction Catalogs; Book Volumes 40,000; Clipping Files; DVDs; Exhibition Catalogs; Lantern Slides; Manuscripts; Memorabilia; Original Art Works; Original Documents; Pamphlets; Periodical Subscriptions 70; Photographs; Prints; Reproductions; Video Tapes 30
Special Subjects: Art History, Decorative Arts, Illustration, Photography, Manuscripts, Painting-American, Painting-British, Posters, Prints, Crafts
Collections: John Sloan Archives and Library; Howard Pyle Archives and Library; Samuel Bancroft Pre Raphaelite Library; Everett Shinn Archives; Frank Schoonover Archives

M **DELAWARE CENTER FOR THE CONTEMPORARY ARTS,** 200 S Madison St, Wilmington, DE 19801. Tel 302-656-6466; Fax 302-656-6944; Elec Mail info@thedcca.org; Internet Home Page Address: www.thedcca.org; *Exec Dir* Maxine Gaiber
Open Tues, Thurs & Fri 10 AM - 5 PM, Wed 12 noon - 5 PM, Sat 10 AM - 5 PM, Sun 12 noon - 5 PM; adult $5, seniors, students & artists $3, Sat 10AM -1PM free; Estab 1979 to promote growth & development of contemporary arts in Delaware; Main Gallery presents major, curated group & solo shows of national & regional work in all media
Exhibitions: Art Auction; Rotating exhibitions every 6-8 weeks
Activities: Classes for children; outreach programs; lect open to public; symposia

HISTORICAL SOCIETY OF DELAWARE

M **Delaware History Museum,** Tel 302-655-7161; Fax 302-655-7844; Internet Home Page Address: www.hsd.org; *Dir Museum Div* Timothy Mullin; *Registrar* Thomas Beckman; *Exec Dir* Dr Barbara E Benson; *Pub Relations* Jan Morrill
Open Tues - Fri Noon - 4 PM, Sat 10 AM - 4 PM; Admis fee adults $4, seniors $3 children $2; Estab 1864 to preserve, collect & display material related to Delaware History; Delaware History Mus & Old Town Hall Mus are the main mus galleries for the Historical Soc of Delaware; Mem: 1700; dues $35; annual meeting in Apr
Collections: Regional decorative arts; children's toys; costumes; distinctively Delaware; photos; art
Publications: Delaware Collections by Deborah D Waters; Delaware History, twice a year
Activities: Lect open to public, 3-7 vis lectrs per year; concerts; gallery talks; tours; originate traveling exhibitions in conjunction with other history museums; museum shop sells books, reproductions, prints

M **George Read II House and Gardens,** Tel 302-322-8411; Internet Home Page Address: www.hsd.org; *Cur Museums* Timothy J Mullin; *Gift Shop Mgr* Dorothy Foley
Open Tues - Sat 10 AM - 4 PM, Sun Noon - 4 PM, cl New Year's, Thanksgiving & Christmas; Admis adults $4, students $3.50, children $2, under 6 free; Average Annual Attendance: 20,000; Mem: 1200; dues $10 & up
Collections: Federal Period decorative arts & architecture
Activities: Walking tours; sales shop sells books & crafts

L **Library,** Tel 302-655-7161; Fax 302-655-7844; Elec Mail hsd@hsd.org; Internet Home Page Address: www.hsd.org; *Exec Dir* Dr Barbara E Benson; *Dir Mus Divsn* Timothy J Mullin; *Registrar* Thomas Beckman; *Read House Site Admin* Michele Anstine; *Dir Develop* J Christopher Casio; *Mus Shop Mgr* Linda Degnan; *Cur Read House* Kara Briggs; *Educ & Programs* Joy Baldwin; *Dir Pub Relations* Jan Morrill; *VPres* Ellen Semple; *Asst Cur* Erik Jodlbauer
Open Mon 1 - 9 PM, Tues - Fri 9 AM - 5 PM, by appointment; Circ non-circulation; reference only
Income: $1,100,000 (financed by endowment, annual support & grants)
Purchases: $15,000
Library Holdings: Book Volumes 75,000; Cassettes; Clipping Files; Exhibition Catalogs; Fiche; Filmstrips; Kodachrome Transparencies; Lantern Slides; Manuscripts; Memorabilia; Motion Pictures; Pamphlets; Periodical Subscriptions 73; Photographs; Prints; Records; Reels; Slides

M **NEMOURS MANSION & GARDENS,** Rockland Rd, 1600 Rockland Rd Wilmington, DE 19803. Tel 302-651-6912; Fax 302-651-6933; Elec Mail tours@nemours.org; Internet Home Page Address: www.nemoursmansion.org; *Exec Dir* Grace Gary; *Registrar* Francesca B Bonny; *Mktg* Susan E Matsen; *Supt* James Solge
Closed for restoration until May, 2008; Admis $12, not handicap accessible, no children 12 & under are admitted; Estab 1977; 300 acre estate of Alfred I du Pont; 102 room modified Louis XVI chateau built 1909 - 10; formal French-style gardens and natural woods; Average Annual Attendance: 10,000
Income: Financed by pvt funding
Special Subjects: Decorative Arts, Drawings, Landscapes, Marine Painting, Ceramics, Glass, American Western Art, Painting-American, Painting-European, Painting-French, Sculpture, Tapestries, Prints, Watercolors, Bronzes, Religious Art,

Pottery, Portraits, Furniture, Porcelain, Silver, Painting-British, Painting-Dutch, Carpets & Rugs, Tapestries, Painting-Flemish, Renaissance Art, Painting-Spanish, Painting-Italian, Painting-German, Enamels
Collections: Collection of European furniture, tapestries, & paintings dating back to the 15th century

C WILMINGTON TRUST COMPANY, Rodney Square N, Wilmington, DE 19890. Tel 302-651-1741; Fax 302-651-8717; Elec Mail cconway@wilmingtontrust.com; *VPres Mktg* Joan Sullivan; *VPres* Cindy Conway
Open to public; Collection displayed nationwide in offices
Collections: Primarily Mid-Atlantic scenes & still life by Mid-Atlantic artists, includes mostly paintings, works on paper, textiles (antique to contemporary) & other mediums

WINTERTHUR

C HENRY FRANCIS DUPONT WINTERTHUR MUSEUM WINTERTHUR, AN AMERICAN COUNTRY ESTATE, 5105 Kennett Pike, Winterthur, DE 19735. Tel 302-888-4600; Fax 302-888-4820; Elec Mail webmaster@winterthur.org; Internet Home Page Address: www.winterthur.org; *Dir* Leslie Greene Bowman
Open Tues - Sun 10 AM - 5 PM, cl mondays (except holidays), Thanksgiving, Christmas; Admis $15, sr, student & group discounts, guided tours of mansion additional fee; Opened 1951, a nonprofit, educ corporation; Collection of 85,000 objects made and used in America between 1640-1860 including furniture, textiles, paintings, prints, ceramics, brass, pewter, needlework & much more; Average Annual Attendance: 200,000; Mem: 23,000 individuals & families, 50 businesses, dues vary
Income: nonprofit corporation
Library Holdings: Auction Catalogs; Audio Tapes; Book Volumes; Cards; Exhibition Catalogs; Fiche; Manuscripts; Maps; Original Documents; Other Holdings; Pamphlets; Periodical Subscriptions; Photographs; Prints
Special Subjects: Ceramics, Textiles, Painting-American, Prints
Collections: Antique furniture, silver, needlework, textiles, painting, prints, ceramics and glass; interior architecture
Publications: Catalogue; Winterthur portfolio; Winterthur magazine (for mem)
Activities: Classes for adults; 2 grad prog; lect; gallery talks; tours; seminars; film; competitions with awards; extension prog for regional area , original art lent to other museums & institutions; book traveling exhibitions; originate traveling exhibitions to museums only; Winter and Fall Institutes; museum shop sells books, reproductions, plants

M WINTERTHUR GARDENS & LIBRARY, (Winterthur Museum) Rte 52, Winterthur, DE 19735. Tel 302-888-4600, 888-4907; Fax 302-888-4880; WATS 800-448-3883; *Dir* Dwight P Lanmon; *Deputy Dir Coll* Brock Jobe; *Deputy Dir Finance & Adminr* Richard F Crozier; *Head of Gardens* Thomas Buchter; *Registrar* Fran Cottler; *Dir Public Relations* Janice Roosevelt; *Chmn* Samuel Schwartz
Open Mon - Sat 9 AM - 5 PM, Sun Noon - 5 PM, cl New Year's, Thanksgiving & Christmas; Admis adults $8, seniors & youth 12-16 $6, children 5-11 $4; Corporation estab in 1930, mus opened in 1951; Mus collection housed in two buildings, the Period Rooms (guided tours) & the Galleries (self guided) featuring decorative arts made or used in America from 1640-1860; vast naturalistic garden; Average Annual Attendance: 165,000; Mem: 20,000
Income: Financed by endowment, mem, grants for special projects, admis, commercial activities
Special Subjects: Painting-American, Textiles, Etchings & Engravings, Decorative Arts, Manuscripts, Portraits, Furniture, Porcelain, Period Rooms, Pewter
Collections: Over 89,000 American decorative arts made or used from 1640-1860; ceramics, furniture, glassware, interior architecture, metals, needlework, paintings, prints & textiles
Exhibitions: Point to Point Steeplechase Race
Publications: Publications & articles by staff, including Winterthur Portfolio, quarterly; Annual Report
Activities: School programs for K-12; classes for adults & children; Winterthur Program in Early American Culture; Winterthur Program in the Conservation of Artistic & Historic objects & PhD programs in the History of American Civilization, all graduate programs co-sponsored with the University of Delaware; lect open to public & to members; Yuletide tours; competitions; fels offered; individual paintings & original objects of art lent to museum & historical societies; museum shop sells books, gifts, postcards, plants & slides; Winterthur reproduction gallery sells over 200 reproductions of museum objects
L Library, Rte 52, Winterthur, DE 19735. Tel 302-888-4681; Fax 302-888-4870; Elec Mail reference@winterthur.org; Internet Home Page Address: www.winterthur.org; *Assoc Conservator Librn Coll* Lois Price; *Sr Librn Visual Resources Coll* Bert Denker; *Sr Librn Joseph Downs Coll of Manuscripts & Printed Ephemera* Richard McKinstry; *Sr Librn Printed Books & Periodical Coll* Catherine Cooney; *Dir* Gary Kulik
Open Mon - Fri 8:30 AM - 4:30 PM; Estab in 1951 to support advanced study in American artistic, cultural, social & intellectual history up to the early twentieth century. For reference only
Library Holdings: Book Volumes 87,000; Cards; Exhibition Catalogs; Fiche 9200; Lantern Slides; Manuscripts 73,000; Memorabilia; Other Holdings Auction Catalogs; Architectural Drawings; Pamphlets; Periodical Subscriptions 300; Photographs 165,000; Prints; Reels 3450; Slides 170,000; Video Tapes
Special Subjects: Decorative Arts, Painting-American, Architecture
Collections: Waldron Phoenix Belknap, Jr Research Library of American Painting; Edward Deming Andrews Memorial Shaker Collection; Decorative Arts Photographic Collection; Henry A duPont & Henry F duPont Papers; Thelma S Mendsen Card Collection; Maxine Waldron Collection of Children's Books & Paper Toys
Publications: Catalogs of collections of printed books: General (9 volumes); Trade Catalogs; Andrews Shaker Collection; America Cornucopia (thematic guide to library collections)
M Historic Houses of Odessa, Main St, PO Box 507 Odessa, DE 19730. Tel

302-378-4069; Fax 302-378-4050; *Exhib & Prog Coordr* Deborah Buckson; *Site Adminr* Steven M Pulinka
Open Tues - Sat 10 AM - 4 PM, Sun 1 - 4 PM, cl Mon & holidays, Mar - Dec; Admis adults (combined) $6, (house) $3, students & seniors (combined) $5, (house) $2.25; Estab 1958 for interpretation of regional lifestyle, architecture & material culture; Historic Houses of Odessa is a cluster of 18th & 19th century domestic structures composing a historic village within the community of Odessa. Gallery is humidity-controlled & contains seven gallery spaces; Average Annual Attendance: 20,000
Income: Financed by endowment
Collections: Corbit-Sharp House containing Chippendale, Federal & Queen Anne furniture; Wilson-Warner House; 19th century Brick Hotel Gallery; Federal Decorative Arts; Brick Hotel contains largest collection of early Victorian Belter Furniture in Nation
Activities: Tours

DISTRICT OF COLUMBIA

WASHINGTON

M AMERICAN ARCHITECTURAL FOUNDATION, The Octagon Museum, The Octagon, 1799 New York Ave NW Washington, DC 20006-5292. Tel 202-638-3105 (information), 638-3221 (museum); Fax 202-879-7764; Internet Home Page Address: www.archfoundation.org; *Dir* Eryl J Wentworth; *Cur Exhibits* Linnea Hamer; *Cur Coll* Sherry Birk
Open Tues - Sun 10 AM - 4 PM, cl Mon; Admis adults $5, seniors & students $3; groups over 10 charges $3 per person except student & seniors groups $1 per person; Opened as house mus in 1970; formerly a federal townhouse designed by the first architect of the United States Capitol, Dr William Thornton for Col John Taylor III to serve as a winter home; used by President & Mrs Madison as temporary White House during war of 1812; Furnished with late 18th & early 19th centuries decorative arts; changing exhibition program in second floor galleries; Average Annual Attendance: 35,000
Collections: Permanent collection of furniture, paintings, ceramics, kitchen utensils
Publications: Competition 1792-Designing a Nation's Capitol, 1976 book; exhibition catalogs; Octagon being an Account of a Famous Residence: Its Great Years, Decline & Restortaion, 1976 book; William Thornton: A Renaissance Man in the Federal City, book; The Architect & the British Country House, book; Architectural Records Management, 1985 booklet; the Architecture of Richard Morris Hunt, 1986 book; Building the Octagon, 1989 book; Ambitious Appetites: Dining, Behavior & Patterns of Consumption in Federal Washington, 1990 book; In the Most Fashionable Style: Making a Home in the Federal City, 1991 book; Creating the Federal City, 1774-1800: Potomac Fever, 1988 book; The Frame in American, 1700-1900: A survey of Fabrication, Techniques & Styles, 1983 catalog; Robert Mills, Architect, 1989 book; Sir Christopher Wren: The Design of St Paul's Cathedral, 1987 book; & exhibit catalogs
Activities: Educ dept; docent training; lect open to public, 6 vis lectrs per year; tours; museum shop sells books & gift items
M Museum, 1735 New York NW Washington, DC 20006-5292. Tel 202-626-7500; Fax 202-879-7764; Internet Home Page Address: www.aaspages.org; *VPres* Melissa Houghton
Open to the pub for reference but primarily used by staff; Mem: 350; dues $30-$50
Income: mem & contributions
Special Subjects: Archaeology, Decorative Arts

AMERICAN ASSOCIATION OF MUSEUMS
For further information, see National and Regional Organizations

AMERICAN ASSOCIATION OF UNIVERSITY WOMEN
For further information, see National and Regional Organizations

AMERICAN INSTITUTE FOR CONSERVATION OF HISTORIC & ARTISTIC WORKS (AIC)
For further information, see National and Regional Organizations

AMERICAN INSTITUTE OF ARCHITECTS
For further information, see National and Regional Organizations

L AMERICAN UNIVERSITY, Jack & Dorothy G Bender Library & Learning Resources Center, 4400 Massachusetts Ave NW, Washington, DC 20016-8046. Tel 202-885-3237; Fax 202-885-3226; Elec Mail librarymail@american.edu; Internet Home Page Address: www.library.american.edu; *Acting University Librn* Diana Vogelsong; *Asst University Librn* Janice Flug; *Acting Asst University Librn* Chris Lewis; *Coll Develop Librn* Martin Shapiro; *Reference Team Leader* Melissa Becher
113 hrs per week during semesters; Estab 1893; Circ 268,488 for all disciplines; Mem: Friends of American University Libr, 800 members qualified by donation
Library Holdings: Audio Tapes; Book Volumes 1,000,000; CD-ROMs; Cassettes; Compact Disks; DVDs; Fiche; Filmstrips; Manuscripts; Maps; Memorabilia; Motion Pictures; Original Documents; Other Holdings playbills; Periodical Subscriptions 21,055 electonic, 2,900 print; Photographs; Records; Reels; Video Tapes
Special Subjects: Art History, Film, Mixed Media, Photography, Commerical Art, Graphic Arts, Graphic Design, Painting-American, Painting-British, Painting-French, Painting-German, Painting-Italian, Painting-Russian, Painting-Spanish, Pre-Columbian Art, Prints, Sculpture, Painting-European, Historical Material, History of Art & Archaeology, Judaica, Stage Design, Watercolors, Conceptual Art, Latin American Art, Theatre Arts, Archaeology, Ethnology, Printmaking, Advertising Design, Video, Anthropology, Costume Design & Constr, Aesthetics
Collections: General Academic Collection supporting all Art Fields
Activities: Lect open to pub

M AMERICAN UNIVERSITY, Katzen Art Center Gallery, 4400 Massachusetts Ave NW, Washington, DC 20016. Tel 202-885-1670, 885-1064; Fax 202-885-1132; Elec Mail museum@american.edu; Internet Home Page Address: http://www.american.edu/academic.depts/cas/katzen/index.cfm; *Dir & Cur* Jack Rasmussen, PhD
Open Tues - Thurs 11 AM - 4 PM, Fri - Sat 11 AM - 7 PM, Sun Noon - 4 PM; Programming will focus on Contemporary Art; 3-floor, 30,000 sq/ft gallery space
Special Subjects: Drawings, Painting-American, Prints, Sculpture, Watercolors, Woodcuts, Etchings & Engravings, Painting-European, Posters
Collections: Katzen Collection of 19th & 20th century American & European paintings; drawings & prints
Activities: Lect open to the public; individual paintings & original objects of art lent to museums & university galleries; traveling exhibitions organized & circulated on occassion

AMERICANS FOR THE ARTS
For further information, see National and Regional Organizations

M ANACOSTIA MUSEUM, 1901 Fort Pl SE, Washington, DC 20020. Tel 202-287-3369; Fax 202-287-3183; *Deputy Dir* Sharon Reinckens; *Acting Dir Educ & Outreach* Robert Hall; *Historian* Portia P James; *Dir* Steven Newsome
Open daily 10 AM - 5 PM, cl Christmas; No admis fee; Estab 1967, as a nonprofit federally chartered corporation to record & research African, Black American & Anacostia history & urban problems; the first federally funded, community-based museum
Income: Financed by federally funded bureau of Smithsonian Institute
Special Subjects: Afro-American Art
Collections: Afro-American & African art; Afro-American history; exhibits & artifacts of the Black Diaspora in the Western Hemisphere
Publications: Educational booklets; exhibit programs; museum brochures accompany each major exhibit
Activities: Programs for children & adults; lect; tours; gallery talks; art festivals; competitions; extension department serves groups unable to visit the museum; traveling exhibitions organized and circulated
L Branch Library, 1901 Fort Pl SE, Washington, DC 20020. Tel 202-287-3380; Fax 202-287-3183; *Contact* Gail Lowe
Open to public for research on the premises; call for appointment
Library Holdings: Book Volumes 2000; Periodical Subscriptions 16

M ARCHIVES OF AMERICAN ART, Smithsonian Institution, 750 9th St, NW, Ste 2200, Washington, DC 20013-7012. Tel 202-275-1961; Fax 202-275-1955; Elec Mail aaaemref@aaa.si.edu; Internet Home Page Address: www.archivesofamericanart.si.edu; *Dir* Richard J Wattenmaker; *Asst Dir Operations* Judy L Pettibone; *Asst Dir Mem & Devel* Jeanne Baker Priscoll
Open Mon - Fri 9 AM - 5 PM; No admis fee; Since 1954, the Archives of American Art has provided researchers worldwide with access to the largest collection of primary source materials documenting the history of the visual arts in America from the Colonial period to the present. Among the collection's 14.6 million items are letters and diaries of artists and collectors; manuscripts of critics and scholars; records of museums, galleries and schools; photographs of art world figures and events; works of art on paper, and oral and video history interviews. A research institute of the Smithsonian since 1970, the Archives fulfills its ongoing mission to collect, preserve and make accessible for study the documentation of this country's rich artistic legacy. As a result, the Archives had played a pivotal role in expanding scholarship and illuminating the history of art in American for the benefit of future generations; Average Annual Attendance: 2,500; Mem: 2,000; dues benefactor $2,500, fellow $1000, patron $500, sponsor $250, associate $125, sustaining $65
Income: Financed by a combination of federal appropriation, private contributions & foundation grants
Special Subjects: Manuscripts
Collections: More than 14.6 million documents, diaries, letters, manuscripts, records of museums, galleries, and schools, works of art on paper; and oral and video history interviews
Publications: Finding aids & guides, video: From Reliable Sources - The Archives of American Art
Activities: Various members' events, including trips, tours, gallery talks and special fundraising events; lectrs open to the public; lending of original material to museum and other arts organizations; museum shop by mail sells books & journals
—New York Regional Center, 1285 Avenue of the Americas, Lobby Level, New York, NY 10019. Tel 212-399-5015; Fax 212-399-6890; *Supv & Archivist* Valerie Komor
Open daily 9 AM - 5 PM; Estab 1956 to collect papers of artists, critics, dealers & collectors; 3,000 sq ft; Average Annual Attendance: 5,000; Mem: 1,200; dues $65; annual meeting varies
Collections: Letters, diaries, artwork, writings, photographs & oral histories of the American art world
Exhibitions: American Art of the 19th & 20th centuries; four yearly from our collections: Dorothy Miller, Frank Stella, Louise Bourgeois, Jacob Kainen, Katherine Kuh
Activities: Lect open to members only, 1,500 vis lectrs per year; gallery talks
—Midwest Regional Center, 5200 Woodward Ave, Detroit, MI 48202. Tel 313-226-7544; Fax 313-226-7620; Elec Mail aaaemill@sivm.si.edu; *Librn* Cynthia Williams
Open Mon - Fri 9 AM - 5 PM; No admis fee; Estab 1954 to locate, preserve & make accessible primary sources for study of American Art; maintains lending library
Income: Financed trust funds
Activities: Lect open to public, 3-4 vis lectr per year
—New England Regional Center, 87 Mount Vernon St, Boston, MA 02108. Tel 617-565-8444; Fax 617-565-8466; Elec Mail aaabos02@sivm.si.edu; *Dir & Journal Ed* Robert F Brown
This office is now limited to collecting, editorial & telephone/written inquiries; un-restricted AAA microfilm is now available for research use in the Fine Arts Dept of the Boston Public Library, main branch
Publications: Archives of American Art Journal, quarterly

—Archives of American Art, 1151 Oxford Rd, San Marino, CA 91108. Tel 626-583-7847; Fax 626-583-7207; Elec Mail aaawcrc@aaa.si.edu; *Regional Dir* Paul J Karlstrom
Open by appointment only Mon - Fri 9 AM - Noon & 1 - 5 PM; Estab 1954 as a manuscript repository of American artists; Reference only
Library Holdings: Filmstrips; Reels
Special Subjects: Art History
Collections: Manuscripts, correspondence, journals, diaries of American painters, sculptors, craftsmen, designers & architects
Publications: The Archives of American Art Journal, quarterly

M ART MUSEUM OF THE AMERICAS, 201 18th St, NW, Washington, DC; 1889 F St, NW, Washington, DC 20006. Tel 202-458-6016; Fax 202-458-6021; *Cur Reference Center* Maria Leyva; *Dir* Ana Maria Escallon
Open Tues - Sun 10 AM - 5 PM, cl holidays; No admis fee; Estab 1976 by organization of American States to bring about an awareness & appreciation of contemporary Latin American art; The mus maintains an art gallery with the focus on contemporary Latin American art; Average Annual Attendance: 100,000
Special Subjects: Drawings, Prints, Sculpture
Collections: Contemporary Latin American & Caribbean art including paintings, prints, drawings & sculpture
Activities: Lect open to public, 10 vis lectrs per year; gallery talks; tours; paintings & original art objects lent to museums & educational institutions; originate traveling exhibitions; sales shop sells films on Latin American art & artists
L Archive of Contemporary Latin American Art, 201 18th St NW Washington, DC 20006; 1889 F St NW Washington, DC 20006. Tel 202-458-6016; Fax 202-458-6021; *Cur* Maria Leyva
Open by appt only; No admis fee; Maintain archives of Latin Am artists and gen pub; Open to scholars for research only
Library Holdings: Audio Tapes; Book Volumes 200; Clipping Files; Exhibition Catalogs; Fiche; Memorabilia; Pamphlets; Photographs; Reels; Reproductions; Slides; Video Tapes
Special Subjects: Art History, Film, Painting-Spanish, Latin American Art, Mexican Art, Aesthetics

A ART PAC, 408 Third St SE, Washington, DC 20003. Tel 202-546-1804; Fax 202-543-2405; *Treas* Robert J Bedard
Estab 1981 to lobby for art's legislation & assist federal candidates supporting the arts; Mem: dues $40
Income: Financed by mem
Publications: Newsletter/ART PAC News, quarterly
Activities: Legislator of the Year Award

A ART RESOURCES INTERNATIONAL, 5813 Nevada Ave NW, Washington, DC 20015. Tel 202-363-6806; Fax 202-244-6844; *Exec Dir* Donald H Russell; *Dir Spec Projects* Helen M Brunner
Estab 1987 to provide consulting to foundations and organizations in strategic planning and institutional change; management of exhib, public prog, publ & coll
Special Subjects: Photography, Prints, Sculpture, Painting-American

M ARTS CLUB OF WASHINGTON, James Monroe House, Monroe & MacFeely Galleries, 2017 I St NW Washington, DC 20006. Tel 202-331-7282; Fax 202-857-3678; Elec Mail artsclub.membership@verizon.net; *Dir* Maureane O'Sahaugnessy; *Gen Mgr* Brennan Hurley
Open Tues & Fri 10 AM - 5 PM, Sat 10 AM - 2 PM, cl Mon; No admis fee; Founded 1916. The James Monroe House (1803-1805) was built by Timothy Caldwell of Philadelphia. It is registered with the National Register of Historic Places, the Historical Survey 1937 & 1968 & the National Trust for Historic Preservation; James Monroe, fifth President of the United States, resided in the house while he was Secretary of War & State. During the first six months of his Presidency (1817-1825) the house served as the Exec Mansion, since the White House had been burned in the War of 1812 & had not yet been restored. Garden, banquet rooms & formal galleries, parlors, stairhalls serve as galleries; Average Annual Attendance: 10,000; Mem: 350; annual meeting in Apr
Income: Financed by mem, catering functions, fundraising, gallery sales, pub programs
Purchases: Obtained through gifts & bequests
Library Holdings: Original Art Works; Original Documents; Pamphlets; Sculpture
Collections: Washington, DC art
Exhibitions: Solo shows in two galleries, Oct - July, third gallery coming soon
Publications: Monthly news bulletin to members, promotional material, brochures
Activities: Classes for adults; pub progs vary; literary; musical & dramatic; lect open to public & for members, 12-24 vis lectrs per year; concerts; gallery talks; scholarships offered

ASSOCIATION OF COLLEGIATE SCHOOLS OF ARCHITECTURE
For further information, see National and Regional Organizations

M B'NAI B'RITH INTERNATIONAL, B'nai B'rith Klutznick National Jewish Museum, 2020 K St NW, Washington, DC 20006. Tel 202-857-6583; Fax 202-857-2700; Elec Mail museum@bnaibrith.org; Internet Home Page Address: www.bbinet.org; *Museum Educator* Diana Altman; *Cur* Kessin Berman
Open Mon - Thurs 12 - 3 PM; Suggested donation adults $5, children under 12 free; Estab 1957 to exhibit & preserve Jewish art & culture; Permanent collection gallery including life & holiday cycles; Average Annual Attendance: 40,000; Mem: 1000; dues $45-$5000
Income: General operations financed by parent organization; private & corporate donations; programs & exhibitions financed by mus members
Special Subjects: Judaica
Collections: Permanent collection of Jewish ceremonial & folk art; archives of B'nai B'rith; contemporary paintings; lithographs; photographs; sculptures
Exhibitions: Jews in Sports
Publications: Exhibitions brochures & catalogues; members newsletter, semi-annual; permanent collection catalogue

Activities: Classes for adults & children; docent training; lect open to public; 1 vis lectr per yr; concerts; gallery talks; tours; individual paintings lent to museums; originate traveling exhibitions

M **CANADIAN EMBASSY,** Art Gallery, 501 Pennsylvania Ave NW, Washington, DC 20001. Tel 202-682-1740; Fax 202-682-7791; Internet Home Page Address: www.canadianembassy.org; *Cultural Counsellor* Louise Blais
Open Mon - Fri 10 AM - 5 PM; No admis fee
Publications: Cultural Calendar, every month

L **CATHOLIC UNIVERSITY OF AMERICA,** Humanities Library, Mullen Library, 3rd Fl, 620 Michigan Ave NE Washington, DC 20064. Tel 202-319-5075; Internet Home Page Address: www.libraries.cua.edu; *Head Humanities Div* Kevin Gunn
Open fall & spring terms Mon - Thurs 8 AM - 10 PM, Fri & Sat 9 AM - 5 PM, Sun 11 AM - 10 PM; No admis fee; Estab 1958 to offer academic resources & services that are integral to the work of the institution
Library Holdings: Book Volumes 14,000
Collections: Various collections

CONGRESSIONAL ARTS CAUCUS
For further information, see National and Regional Organizations

M **CORCORAN GALLERY OF ART,** 17th St & New York Ave NW, Washington, DC 20006. Tel 202-639-1700; Fax 202-639-1768; *Pres & Dir* David C Levy; *Deputy Dir & Chief Cur* Jack Cowart; *Cur Contemporary Art* Terrie Sultan; *Registrar* Kirsten Verdi; *Cur Photo & Media Arts* Philip Brookman; *Bechhoefer Cur American Art* Sarah Cash; *Cur Educ* Susan Badder
Open Mon, Wed & Thurs 10 AM - 9 PM; Suggested Donation $3; Founded 1869 primarily for the encouragement of American art; The nucleus of the collection of American Paintings was formed by its founder, William Wilson Corcoran, early in the second half of the 19th century. In 1925 a large wing designed by Charles A Platt was added to house the European collection bequested by Senator William Andrews Clark of Montana. The Walker Collection, formed by Edward C and Mary Walker, added important French Impressionists to the collection upon its donation in 1937; Average Annual Attendance: 400,000; Mem: 4500; dues contributing $500 & up, sponsor $250, Friends of the Corcoran $125, family $50, single $35, student & senior citizens $15
Special Subjects: Drawings, Painting-American, Photography, Watercolors, Bronzes, Painting-European, Furniture, Painting-British, Painting-Dutch, Painting-French, Tapestries, Painting-Flemish, Antiquities-Greek, Stained Glass
Collections: The American collection of paintings, watercolors, drawings, sculpture & photography from the 18th through 20th centuries; European collection includes paintings & drawings by Dutch, Flemish, English & French artists; 18th century French salon, furniture, laces, rugs, majolica; Gothic & Beauvais tapestries; Greek antiquities; 13th century stained glass window & bronzes by Antoine Louise Barye; tryptich by Andrea Vanni; Walker Collection of French Impressionists
Exhibitions: Changing exhibitions of Contemporary Art; Fine Art Photography; works by regional artists; works drawn from the permanent collection
Publications: Calendar of Events (for members); Corcoran Shop Catalogue
Activities: Classes for adults & children; docent training; lect open to public; concerts; gallery talks; tours; originates traveling exhibitions; sales shop sells books, magazines, reproductions, prints & slides
L **Corcoran Library,** 500 17th St, NW, Washington, DC 20006. Tel 202-478-1544; Fax 202-628-7908; Elec Mail library@corcoran.org; Internet Home Page Address: www.corcoran.edu/library/index.asp; *Technical Servs Assoc* Pat Reid; *Dir Library* Douglas Litts; *Circ Desk Mgr* Bridget Dwyer; *Visual Resource Coordr* Michael Parker
Research & lending resource for mus & school, staff, faculty & student. Provides interlibrary loan to other institutions & open for pub use by appointment only
Library Holdings: Book Volumes 32,000; DVDs 200; Exhibition Catalogs; Periodical Subscriptions 200; Slides 80,000; Video Tapes 250
Special Subjects: Art History, Photography, Commerical Art, Drawings, Etchings & Engravings, Graphic Arts, Graphic Design, Painting-American, Prints, Printmaking, Advertising Design, Lettering, Furniture, Afro-American Art, Pottery, Religious Art
Collections: Artists books

A **CULTURAL ALLIANCE OF GREATER WASHINGTON,** 1436 U St NW, Ste 103, Washington, DC 20009-3997. Tel 202-638-2406; Fax 202-638-3388; Internet Home Page Address: www.cultural-alliance.org; *Exec Dir* Jennifer Cover Payne
Open 9 AM - 5 PM; Estab 1978 to increase appreciation & support for the arts in Washington DC region; Mem: 647; mem open to artists, arts administrator or patron; dues individual $60, organization-scaled to annual income; annual meeting in the fall
Income: $82,663 (financed by mem & donations)
Exhibitions: Tony Taylor Award
Publications: Arts Washington, newsletter 10 times per year; Cultural Alliance Directory, biennial
Activities: Lect open to public for fee, free to members

M **DAR MUSEUM,** National Society Daughters of the American Revolution, 1776 D St NW, Washington, DC 20006. Tel 202-879-3241; Fax 202-628-0820; Elec Mail museum@dar.org; *Dir & Chief Cur* Diane Dunkley
Open Mon - Fri 8:30 AM - 4 PM, Sun 1 - 5 PM; No admis fee; Estab 1890 for collection & exhibition of decorative arts used in America from 1700-1840; for the study of objects & the preservation of Revolutionary artifacts & documentation of American life; There are 33 period rooms which reflect the decorative arts of particular states, also a mus which houses large collections grouped by ceramics, textiles, silver, glass, furniture & paintings; Average Annual Attendance: 12,000; Mem: 215,000; dues $15 - $17; annual meeting in Apr
Income: $200,000 (financed by mem)
Special Subjects: Painting-American, Textiles, Costumes, Ceramics, Pottery, Decorative Arts, Portraits, Dolls, Furniture, Glass, Jewelry, Porcelain, Silver, Carpets & Rugs, Coins & Medals, Miniatures, Period Rooms, Embroidery, Pewter
Collections: Ceramics, furniture, glass, paintings, prints, silver, textiles

Exhibitions: Special exhibitions arranged & changed periodically, usually every 6 months
Activities: Classes for adults & children; docent training; lect open to public; tours; paintings & original art works lent to museums & cultural institutions for special exhibitions; museum shop sells books, stationery, dolls & handcrafted gift items
L **Library,** 1776 D St NW, Washington, DC 20006-5392. Tel 202-879-3241; Fax 202-628-0820; Elec Mail museum@dar.org; Internet Home Page Address: www.dar.org/museum; *Dir & Chief Cur* Diane Dunkley; *Cur Coll* Olive Graffam; *Cur Historic Furnishings* Patrick Sheary; *Cur Textiles* Nancy Gibson
Open Mon - Fri 8:30 AM - 4:00 PM, Sat 9:00 AM - 5:00 PM; No admis fee; Estab 1890; collects objects made or used in America prior to 1840; Open to pub
Income: Pvt donations
Library Holdings: Book Volumes 3000; Periodical Subscriptions 10
Collections: American Decorative Arts and Fine Arts
Activities: Classes for adults & children; school programs; Christmas open house; docent training; lect open to pub; 4 vis lect per yr; gallery talks; tours of 32 period rooms; exten program serves mus nationwide; museum shop sells books, reproductions, prints & slides

M **DISTRICT OF COLUMBIA ARTS CENTER (DCAC),** 2438 18th St NW, Washington, DC 20009. Tel 202-462-7833; Fax 202-328-7099; Elec Mail dcac@dcartscenter.org; Internet Home Page Address: www.dcartscenter.org; *Exec Dir* B Stanley; *Gallery Mgr* Karey E Kessler
Open Wed - Sun 2 - 7 PM; No admis fee; Estab 1989 to support new & emerging artists; 800 sq ft converted apartments; Average Annual Attendance: 5,000; Mem: 500; dues $30
Income: $120,000 (financed by mem, city appropriation & foundations)
Activities: Classes for adults; dramatic programs; lect open to public, 5 vis lectr per year; gallery talks

M **FEDERAL RESERVE BOARD,** Art Gallery, 20th & C Sts, Washington, DC 20551. Tel 202-452-3778; Fax 202-736-5680; Internet Home Page Address: www.federalreserve.gov; *Dir* Mary Anne Goley
Open Mon - Fri advance reservation required; No admis fee; Estab 1975 to promote art in the work place; Two story atrium space with travertine, marble walls. Works are hung on four landings & one very long hall
Income: Operating expenses by the Federal Reserve Board
Special Subjects: Architecture, Drawings, Hispanic Art, Latin American Art, Painting-American, Photography, Prints, Sculpture, Etchings & Engravings, Landscapes, Collages, Marine Painting, Painting-Australian
Collections: American & European paintings; 19th century sculpture; Works on paper
Exhibitions: Money Making, The Fine Art of Currency; The Influence of Velasquez on Modern Painting; The American Experience; The Emergence of Modern Greek Painting 1830-1930 from the Bank of Greece Coll
Publications: Exhibition catalogs
Activities: Docent programs; originate public exhibitions 3 per year

L **FOLGER SHAKESPEARE LIBRARY,** 201 E Capitol St SE, Washington, DC 20003. Tel 202-544-4600; Fax 202-544-4623; Internet Home Page Address: www.folger.edu; *Dir* Gail Kern Paster; *Librn* Richard J Kuhta; *Head of Ref* Georgianna Ziegler; *Cur Art* Erin Blake
Open (exhibition gallery) Mon - Sat 10 AM - 4 PM; Estab 1932 as a private, independent research library & international center for the study of all aspects of the European Renaissance & civilization in the 16th & 17th centuries; Maintains an exhibition gallery & a permanent display of Shakespearean items, with changing topical exhibits of books, manuscripts, paintings & porcelain
Income: Financed by endowment, grants, gifts & earned income
Library Holdings: Audio Tapes; Book Volumes 260,000; Exhibition Catalogs; Filmstrips; Manuscripts 55,000; Memorabilia; Motion Pictures; Original Art Works 3700; Other Holdings Rare books 120,000; Pamphlets; Periodical Subscriptions 180; Photographs 3000; Prints 20,000; Records; Reels 10,000; Reproductions; Sculpture; Slides
Collections: Shakespeare, playbills & promptbooks; Continental & English Renaissance, 1450-1700; manuscripts; paintings; works of art on paper; prints & engravings
Exhibitions: (9/2006-2/2007) Technologies of Writing in an Age of Print; (3/2007-8/2007) Shakespeare in American Life; (9/2007-1/2008) Marketing Shakespeare: Boydell & Beyond; (2/2008-5/2008) Making History: Commemoration & the Reconstruction of the Early Modern Past; (6/2008-10/2008) Now Thrive the Armorers: Arms & Armor in Shakespeare; (11/2008-3/2009) Renaissance Journalism: The Development of the Newspaper in Early Modern England
Publications: The Folger Edition of the Complete Plays of William Shakespeare; Shakespeare Quarterly; Folger News 3 times per year
Activities: Educ prog; classes for children; dramatic progs; docent training; seminars for advanced graduate students; lect open to public; lect open to mems; 20 vis lect per year; concerts; gallery talks; tours; fels offered; sales shop sells books, reproductions, music

M **FONDO DEL SOL,** Visual Art & Media Center, 2112 R St NW, Washington, DC 20008. Tel 202-483-2777; Fax 202-658-1078; *Exec Dir* W Marc Zuver; *Co-Chmn* Osvaldo Mesa; *Co-Chmn* Michael Auld
Open Wed - Sat 12:30 - 5 PM, Tues by appt; Admis adults $3; Estab 1973 to promote Latin American and Caribbean culture, nonprofit museum
Special Subjects: Sculpture, Ceramics
Collections: Permanent collection, Pre-Columbian, Latin America, Chicano & Puerto Rican Art
Exhibitions: Pre-Columbian art by Santos

GENERAL SERVICES ADMINISTRATION
For further information, see National and Regional Organizations

M **GEORGE WASHINGTON UNIVERSITY,** The Dimock Gallery, Lower Lisner Auditorium, 730 21st St NW Washington, DC 20052. Tel 202-994-1525; Fax 202-994-1632; Internet Home Page Address: www.gwu.edu/dimock; *Dir* Lenore D Miller
Open Tues - Fri 10 AM - 5 PM; No admis fee; Estab 1967 to enhance graduate & undergraduate programs in fine art & research in art history; documentation of

permanent collections; feature historical & contemporary exhibitions related to university art dept programs; Average Annual Attendance: 10,000
Special Subjects: Graphics, Painting-American, Photography, Prints, Sculpture
Collections: U S Grant Collection; Joseph Pennell Collection of Prints; W Lloyd Wright Collection of Washingtoniana; graphic arts from the 18th, 19th & 20th centuries, with special empasis on American art; historical material; paintings; prints; sculpture; works pertaining to George Washington
Publications: Exhibition catalogs
Activities: Lect open to public; gallery talks; tours; individual paintings & original objects of art lent

M **GEORGETOWN UNIVERSITY,** Art Collection, 3700 O St NW, Washington, DC 20057-1174. Tel 202-687-1469; Fax 202-687-7501; Elec Mail llw@georgetown.edu; Internet Home Page Address: www.library.georgetown.edu/dept/speccoll/guac; *Asst Cur* David C Alan; *Cur* Lulen Walker
Call for hrs; No admis fee; University estab 1789; The collection is on the Georgetown University campus in Healy Hall (1879)
Income: Financed by University budget
Special Subjects: Graphics, Painting-American, Sculpture, Religious Art
Collections: American portraits; Works by Van Dyck, Giordano & Gilbert Stuart; graphics, historical objects, paintings, religious art, early Maryland church silver, antiques, micro mosaics
Exhibitions: 4 exhibitions per yr of graphic art held in Lauinger Library
Activities: Educational programs for undergraduate students; gallery talks, guided tours; art festivals, temporary exhibitions
L **Lauinger Library-Special Collections Division,** 3700 O St NW, Washington, DC 20057-1104. Tel 202-687-7475; Fax 202-687-7501; Elec Mail barringg@georgetown.edu; Internet Home Page Address: www.library.georgetown.edu/dept/speccoll/; *Special Collections Librn* George M Barringer; *Art Coll Coordr* Lulen Walker; *Art Tech* David Alan
Open Mon - Fri 9 AM - 5:30 PM; none; Estab 1975 to support Georgetown's academic programs; 4 exhibitions per yr of fine prints in Library; permanent collection of paintings, sculpture & dec arts in Carroll Porter of Healy Bldg
Library Holdings: Original Art Works; Photographs; Prints
Special Subjects: Illustration, Drawings, Cartoons, Bookplates & Bindings, Woodcuts
Collections: Editorial Cartoon Collection - Originals (American) c 1910 to present; Elder Collection - Artist Self - Portraits, prints, drawings, watercolors, paintings, c 1925-1975; Jesuit Collection - American fine prints, c 1900-1950; Eric F Menke Collection - prints, drawings, watercolors, paintings; Murphy Collection - American Fine Prints, c 1900-1950; Eric Smith Collection - original editorial cartoon; Lynd Ward Collection - prints, drawings, watercolors, paintings, c 1925-1980; Printmakers' Collections: John DePol, Werner Drewes, Isac Friedlander, Norman Kent, Clare Leighton, William E C Morgan, Barry Moser, Philip Riesman, Prentiss Taylor, Ralph Fabri Collection; Paintings, sculpture, antiques, dec arts (see web site)
Publications: Issued with many special exhibitions

M **HARVARD UNIVERSITY,** Dumbarton Oaks Research Library & Collections, 1703 32nd St NW, Washington, DC 20007. Tel 202-339-6400; Internet Home Page Address: www.doaks.org; *Dir* Edward Keenan
Open daily (Gardens) Apr - Oct 2 - 6 PM, Nov - Mar 2 - 5 PM, (Collections) Tues - Sun 2 - 5 PM, cl holidays; Conveyed in 1940 to Harvard University by Mr & Mrs Robert Woods Bliss as a research center in the Byzantine & Medieval humanities & subsequently enlarged to include Pre-Columbian studies & studies in landscape architecture; Average Annual Attendance: 100,000
Special Subjects: Sculpture, Pre-Columbian Art, Textiles, Religious Art, Pottery, Decorative Arts, Jewelry, Antiquities-Byzantine, Metalwork, Ivory, Mosaics
Collections: Byzantine devoted to early Christian & Byzantine mosaics, textiles, bronzes, sculpture, ivories, metalwork, jewelry, glyptics & other decorative arts of the period; pre-Columbian devoted to sculpture, textiles, pottery, gold ornaments & other objects from Mexico, Central & South America, dating from 800 BC to early 16th century; European & American paintings, sculpture & decorative arts
Publications: Handbooks & catalogs of the Byzantine & pre-Columbian collection; scholarly publications in Byzantine, pre-Columbian & landscape architecture studies
Activities: Lect; conferences
L **Dumbarton Oaks Research Library,** 1703 32nd St NW, Washington, DC 20007. Tel 202-339-6490; Internet Home Page Address: www.doaks.org; *Head Librn* Sheila Klos; *Head Cataloger* Kimball Clark; *Pre-Columbian Studies Librn* Bridget Gazzo; *Systems Librn* Ingrid Gibson; *Rare Book Librn* Linda Lott; *Byzantine Studies Librn* Deborah Brown; *Photo Archives Cur* Natalia Teteriatnikov
Library Holdings: Book Volumes 185,000; CD-ROMs; Exhibition Catalogs; Fiche; Manuscripts; Memorabilia; Motion Pictures; Original Art Works; Original Documents; Pamphlets; Periodical Subscriptions; Photographs; Prints; Reels; Reproductions; Slides; Video Tapes
Special Subjects: Pre-Columbian Art
Collections: Dumbarton Oaks Census of Early Christian and Byzantine Objects in American Collection; Photographic copy of the Princeton Index of Christian Art; collection of photographs

HERITAGE PRESERVATION
For further information, see National and Regional Organizations

M **HILLWOOD MUSEUM & GARDENS FOUNDATION,** (Marjorie Merriweather Post) Hillwood Museum & Gardens, 4155 Linnean Ave NW, Washington, DC 20008. Tel 202-686-8500, 686-5807; Fax 202-966-7846; Elec Mail info@hillwoodmuseum.org; Internet Home Page Address: www.hillwoodmuseum.org; *Pres* Ellen MacNeille Charles; *Deputy Dir Colls & Chief Cur* David T Johnson; *Exec Dir* Frederick J Fisher; *Deputy Dir Finance & Admin* Madge Minor; *Dep Dir for Interpretation* Angie Dodson; *Asst Dir Colls & Colls Mgr* Ruthann Uithol; *Dir Human Resources* Joyce Adams; *Dep Dir Horticulture* Brian Barr; *Dep Dir Facil & Dir Security* Wickie Lyons; *Dir Spec Initiatives* Ellen Willenbecher; *Librarian* Regina Kristen; *Archivist & Vis Resources Mgr* Heather Corey; *Preservation & Exhib Mgr* Scott Brouard; *Assoc Cur Am Mat Cul & Historian* Stephanie Brown, PhD; *Cur Russian & Eastern Euro Art* Karen L Kettering, PhD; *Cur Western European Art* Liana Paredes; *Asst Cur Russian & Eastern Euro Art* Scott Ruby; *Asst Cur Costumes & Textiles* Howard Kurtz; *Cur Emerita* Anne Odom; *Dir Merchandising* Lauren Chapin
Open Tues - Sat 10 AM - 5 PM, cl Jan & nat holidays; Admis adults $12, students $7, children $5, children under 6 not admitted in mansion; Estab 1977 to enlighten & engage visitors with an exper inspired by found Marjorie Merriweather Post's passion for excel, gracious hospitality & intent to preserve & share beauty & Hist of her coll, gardens & estate; Mansion in the Georgian style, home of the late Marjorie Merriweather Post, situated on 25 acres of landscaped grounds; Average Annual Attendance: 45,000; Mem: 2,000; dues $50-$1,000
Income: Financed by endowment, operating income & grants
Purchases: Active acquisitions program in Russian & Western European decorative arts
Library Holdings: Auction Catalogs; Book Volumes; Clipping Files; Exhibition Catalogs; Kodachrome Transparencies; Pamphlets; Periodical Subscriptions; Photographs; Slides
Special Subjects: Etchings & Engravings, Folk Art, Historical Material, Landscapes, Marine Painting, Metalwork, Photography, Pottery, Painting-American, Prints, Period Rooms, Manuscripts, Maps, Painting-British, Painting-European, Sculpture, Watercolors, Bronzes, Textiles, Costumes, Religious Art, Ceramics, Crafts, Woodcarvings, Decorative Arts, Judaica, Portraits, Posters, Furniture, Glass, Jade, Jewelry, Porcelain, Oriental Art, Asian Art, Silver, Painting-French, Carpets & Rugs, Ivory, Coins & Medals, Tapestries, Baroque Art, Miniatures, Painting-Flemish, Painting-Polish, Embroidery, Laces, Gold, Military Art, Painting-Russian, Enamels
Collections: Western European & French fine & decorative arts, furnishings & American memorabilia; Russian fine & decorative arts; Asian decorative arts; Art Research Library; Archives & visual resources relating to collection & Marjorie Merriweather Post, mus found
Exhibitions: 2007 - Thirty Years of Collecting; 2008 - Fragil Persuasion: Late Russian and Soviet Porcelain from the Traisman Collectiion; 2009 - Sevres Then and Now: Tradition and Innovation in Porcelain 1750-2000
Publications: The Hillwood Post newsletter, triennial, 1998 catalogue A Taste for Splendor: Russian Imperial and European Treasures from the Hillwood Mus; Hillwood Collection Series of 5 books: Faberge at Hillwood, Russian Icons at Hillwood, Sevres Porcelain at Hillwood, Russian Imperial Porcelain at Hillwood & Russian Glass at Hillwood; Art of the Russian North; French Furniture in the Collection of Hillwood Museum & Gardens; What Became of Peter's Dream? Court Culture in the Reign of Nicholass II co-published with Midlebury College Museum of Art in Middlebury, VT; Tradition in Transition: Russian Icons in the Age of the Romanovs
Activities: Lect open to public; concerts; gallery talks; tours; museum shop sells books, gifts, reproductions, prints & slides

M **HIRSHHORN MUSEUM & SCULPTURE GARDEN,** Smithsonian Institution, Seventh & Independence Ave SW, Washington, DC 20560. Tel 202-357-3091; Fax 202-786-2682; Elec Mail colburnm@hmsg.si.edu; *Dir* James Demetrion; *Asst Dir Finance & Administration* Beverly Pierce; *Educ Prog Dir* Linda Powell; *Sr Educator* Teresia Bush; *Registrar* Brian Kavanagh; *Chief Exhib* Edward Schelsser; *Chief Conservator* Lawrence Hoffman; *Chief Photography* Lee Stalsworth; *Librn* Anna Brooke; *Head Pub Affairs* Sidney Lawrence; *Chief Cur* Kerry Brougher; *Specialist Pub Affairs* Michele Colburn
Open Mon - Sun 10 AM - 5:30 PM, cl Christmas Day; No Admis fee; Estab 1966 under the aegis of the Smithsonian Institution; building designed by Gordon Bunshaft of the architectural firm of Skidmore, Owings & Merrill. Opened in 1974; Average Annual Attendance: 800,000
Income: Financed by federal funds
Library Holdings: Auction Catalogs; Audio Tapes; Book Volumes; Cassettes; Clipping Files; Exhibition Catalogs; Pamphlets; Periodical Subscriptions; Video Tapes
Special Subjects: Drawings, Latin American Art, Painting-American, Sculpture, Afro-American Art, Collages, Painting-European
Collections: American art beginning with a strong group of Thomas Eakins & going on to De Kooning, Gorky, Hartley, Hopper, Johns, Elizabeth Murray, Rothko, Frank Stella, Warhol; European paintings & mixed media work of the last 5 decades represented by Bacon, Balthus, Kiefer & Korenellis, Leger, Miro, Polke & Richter; extensive sculpture collection includes works by Bourgeois, Brancusi, Calder, Cragg, Giacometti, Hessi, Merz, Moore, Oldenburg & Shea; David Smith; 12,000 paintings, sculptures, mixed media works, drawings & prints, the nucleus donated to the nation by Joseph H Hi emphasizing contemporary art & the development of modern art from the latter half of the 19th century to present
Exhibitions: Permanent collection & special loan exhibitions
Publications: Exhibit catalogs; Family Guide; collection catalogs; seasonal events calendar, three times per yr
Activities: Classes for children; workshops for adults; docent training; workshops for teachers; outreach; free summer concerts; lect open to public, 4 vis lectrs per year; gallery talks; tours; individual paintings & original objects of art lent to accredited museums that meet security & conservation standards, loans, subject to approval by curators; lending contains original art works, original prints &

sculpture; book traveling exhibitions 1-2 per year; originate traveling exhibitions 1-2 per year; museum shop sells books, reproductions, slides, jewelry by artists, CD's sculptural toys

L Library, Seventh & Independence Ave SW, Washington, DC 20560. Tel 202-633-2773; Fax 202-786-2682; Elec Mail brookea@si.edu; Internet Home Page Address: www.hirshhorn.si.edu; *Librn* Anna Brooke; *Library Technician* Amy Watson; *Library Technician* Jennifer Maslin
No admis fee; Estab 1974; For reference only by appointment
Income: Financed by federal funds
Library Holdings: Audio Tapes; Book Volumes 50,400; Cassettes; Clipping Files; Exhibition Catalogs; Fiche; Memorabilia; Other Holdings Auction catalogs; Periodical Subscriptions 53; Photographs; Reels; Slides; Video Tapes
Collections: Armory Show Memorabilia; Eakins Memorabilia; 5 Samuel Murray Scrapbooks

M HISTORICAL SOCIETY OF WASHINGTON DC, The City Museum of Washington DC, 1307 New Hampshire Ave NW, Washington, DC 20036; 801 K St NW, Washington, DC 20001. Tel 202-785-2068; Fax 202-887-5785; Internet Home Page Address: www.hswdc.org; *Chair* Sluveen Dodson; *VPres Programs* Susan Schreiber; *VPres Library* Gail Redmann; *Pres & CEO* Barbara Franco; *Cur* Jill Connors; *Dir Educ* Mychalene Giampaoli; *Cur* Laura Schiaro
Open Tues - Sun 10 AM - 5 PM; Admis adults $3, children, students & seniors $2, multimedia show $5 or $6; Estab 1894 to preserve & interpret local history of Washington, DC; Permanent and changing exhibitions on the history of Washington, DC; Maintains reference library; Average Annual Attendance: 350,000; Mem: 1,800; dues $50-$5000
Income: $2.5 million (financed by endowment, mem, grants & earned income)
Library Holdings: Audio Tapes; Book Volumes; Clipping Files; Fiche; Lantern Slides; Manuscripts; Maps; Memorabilia; Original Art Works; Original Documents; Pamphlets; Photographs; Prints; Sculpture
Special Subjects: Architecture, Decorative Arts, Historical Material
Collections: Photographs, Prints, Paintings, Maps, Decorative Arts, Ephemera, Archives
Exhibitions: Washington Perspectives; Digging History and Washington Stories; City of Sports; Taking a Closer Look; Chinatown; Mount Vernon Square
Publications: Washington History, semi-annual magazine
Activities: Classes for adults & children; dramatic programs; docent training; lect open to public, 12 vis lect per yr; tours; sponsoring competitions; awards; originate traveling exhibitions to local organizations, libraries & schools; museum shop sells books, reproductions, prints, crafts & souvenirs

L Kiplinger Research Library, 1307 New Hampshire Ave, Washington, DC 20036; 801 K St NW, Washington, DC 20001. Tel 202-785-2068, Ext 111; Fax 202-785-6605; Elec Mail hswlibrary@hswdc.org; Internet Home Page Address: www.hswdc.org; *Pres & CEO* Barbara Franco; *Libr VPres* Gail Redmann; *Collections Librn* Ryan Shepherd; *Coll Mgr* Lucinda Janke
Open Tues - Sat 10 AM - 5 PM; No admis fee; Estab 1894 for collection of materials related to Washington, DC history; For reference only; Average Annual Attendance: 3,000; Mem: 1,800; dues $50 - $5000
Income: $2.5 million (financed by endowment, mem, grants & earned income)
Library Holdings: Book Volumes 14,000; Cards; Clipping Files; Exhibition Catalogs; Fiche; Lantern Slides; Manuscripts; Memorabilia; Original Art Works; Pamphlets; Photographs; Prints; Reels; Slides
Collections: Photographs, Prints, Paintings, Maps, Decorative Arts, Archives, Books, Ephemera
Publications: Washington History, semi-annual magazine
Activities: Classes for adults & children; lect open to public; individual paintings & original objects of art lent; museum shop sells books, magazines, original art, reproductions & prints

M HOWARD UNIVERSITY, Gallery of Art, College of Fine Arts, 2455 Sixth St NW Washington, DC 20059. Tel 202-806-7047; Fax 202-806-9258; Internet Home Page Address: www.howarduniversity.edu; *Asst Dir* Scott Baker; *Registrar* Eileen Johnston; *Dir* Dr. Benjamin Tritobia
Open Mon - Fri 9 AM - 5 PM, Sun 1 - 4 PM during exhibits, cl Sat; No admis fee; Estab 1928 to stimulate the study & appreciation of the fine arts in the University & community; Three air-conditioned art galleries are in Childers Hall, James V Herring Heritage Gallery, James A Porter Gallery & the Student Gallery along with Gumbel Print Room, Lois Jones Gallery; Average Annual Attendance: 26,000
Income: School funding
Special Subjects: Graphics, Prints, Sculpture, Watercolors, African Art, Afro-American Art, Renaissance Art, Painting-Italian
Collections: Agnes Delano Collection of contemporary American watercolors & prints; Irving R Gumbel Collection of prints; Kress Study Collection of Renaissance paintings & sculpture; Alain Locke Collection of African art; University collection of painting, sculpture & graphic arts by Afro-Americans; Era Katz Collection of Theatrical Marquis 1970's-1980's
Exhibitions: Changing tri-monthly exhibits; acad exhibits; ann student show
Publications: Catalogue of the African & Afro-American collections; exhibition catalogues; informational brochures; Native American Arts (serial)
Activities: Bimonthly gallery lect & community programs

L Architecture & Planning Library, 2366 Sixth St NW, Washington, DC 20059. Tel 202-806-7773; Internet Home Page Address: www.howarduniversity.edu; *Cur* Sarah Humber
Open Mon - Fri 8:30 AM - 5 PM; No admis fee; Estab for students & staff covering aspects of architecture & Afro American design
Library Holdings: Book Volumes 27,000; CD-ROMs; Filmstrips; Lantern Slides; Other Holdings Documents 600; Periodical Subscriptions 400; Photographs; Reels 1,300; Slides 29,000
Collections: Dominick Collection of pre-1900 books & periodicals on architecture; K Keith Collection of books & photographs on indigenous African architecture

A THE JOHN F KENNEDY CENTER FOR THE PERFORMING ARTS, 2700 F St. NW, Washington, DC 20566. Tel 202-416-8000; Fax 202-416-8421; Internet Home Page Address: www.kennedy-center.org; *Chmn* James A Johnson; *Pres* Michael M. Kaiser
Open Mon - Sun 10 AM - 12 AM; No admis fee for building, ticket prices vary; The Center opened in Sept 1971. Facilities include the 2200-seat Opera House,

2750-seat Concert Hall, 1130-seat Eisenhower Theater, 500-seat Terrace Theater, 224-seat film theater & 350-seat Theater Lab operated by the American Film Institute. Estab in 1958 by Act of Congress as the National Cultural Center. A bureau of the Smithsonian Institution, but administered by a separate independent Board of Trustees; the Center is the sole official memorial in Washington to President Kennedy. Although the Center does not have an official collection, gifts in the form of art objects from foreign countries are on display throughout the Center; Average Annual Attendance: 2,000,000 ticketed, 2,500,000-3,000,000 visitors; Mem: Friends of the Kennedy Center 40,000; dues from $30-$2000
Income: $30,000,000 (financed by ticket revenue & private contributions)
Exhibitions: Changing exhibits on the performing arts are displayed in the Center's Performing Arts Library, a cooperative effort between Kennedy Center & the Library of Congress. Exhibits frequently include portraits, prints, engravings, sketches, etc, of relevence to the performing arts
Publications: Kennedy Center News, bimonthly
Activities: Classes for adults & children; dramatic programs; performing arts series for young audiences; lect open to public, 50 vis lectrs per year; concerts; tours; originate traveling exhibitions to Library of Congress; sales shop sells books, original art, reproductions, slides, souvenirs, needle point & posters

L Education Resources Center, Roof Terrace Level, Washington, DC 20566. Tel 202-416-8780; *VPres Educ* Derek Gordon
Open Tues - Fri 11 AM - 8:30 PM, Sat 10 AM - 6 PM, cl Mon & Sun; Estab 1979 to provide a national information & reference facility for all areas of the performing arts, including film & broadcasting; For reference only. Access to all Library of Congress collections
Income: grants, gifts & private contributions
Library Holdings: Audio Tapes; Book Volumes 7800; Cassettes; Clipping Files; Exhibition Catalogs; Fiche; Framed Reproductions; Manuscripts; Memorabilia; Pamphlets; Periodical Subscriptions 450; Records; Reels; Reproductions; Slides; Video Tapes

L LIBRARY OF CONGRESS, Prints & Photographs Division, Madison Bldg, Rm 339, 101 Independence Ave SE Washington, DC 20540-4730. Tel 202-707-6394 (reference), 707-5836 (offices), 707-5000(general); Fax 202-707-6647; Elec Mail lcweb@loc.gov; Internet Home Page Address: lcweb.loc.gov/rr/print; *Head Reference Section* Mary M Ison; *Head Technical Serv Section* Helena Zinkham; *Cur Architecture* C Ford Peatross; *Photographs* Beverly W Brannan; *Photographs* Verna Curtis; *Posters* Elena G Millie; *Librn* James H Billington; *Chief Prints & Photograph* Jeremy Adamson; *Chief Interpretive* Irene Chambers; *Dir Am Folklife* Peggy Bulge; *Dir Publ Office* W Ralph Eubanks; *Assoc Librn* Winston Tabb; *Dir Congressional* Daniel P Mulhollan; *Law Librn* Rubens Medina; *Register Copyright* Marybeth Peters; *Asst Chief Motion Pictures* Gregory Lukow; *Assoc Librn* Laura Campbell; *Dir Preservation* Mark Roosa; *Deputy Librn* Donals Scott; *Head Retail Mktg* Anna S Lee
Reading Room open Mon - Fri 8:30 AM - 5 PM; No admis fee; Estab 1897; For reference only; Average Annual Attendance: 1,152,902
Income: Financed by congressional appropriation, gifts & endowments
Purchases: Fine prints, master photographs, posters, architectural drawings & historical prints & drawings
Library Holdings: Auction Catalogs; Audio Tapes; Book Volumes 18,306,178; CD-ROMs; Cards; Cassettes; Clipping Files; Compact Disks; DVDs; Exhibition Catalogs; Fiche; Filmstrips; Framed Reproductions; Kodachrome Transparencies; Lantern Slides; Manuscripts; Maps 4,562,267; Memorabilia; Micro Print; Motion Pictures; Original Art Works; Original Documents; Other Holdings Architectural items 2,000,000; Fine prints 75,000; Master photographs; Photographic images 10,500,000; Popular & applied graphic art item 20,000; Posters 100,000; Pamphlets; Periodical Subscriptions; Photographs; Prints; Records; Reels; Reproductions; Sculpture; Slides; Video Tapes
Collections: Archive of Hispanic Culture; Japanese Prints; Pennell Collection of Whistleriana; Civil War drawings, prints, photographs & negatives; early American lithographs; pictorial archives of early American architecture; Historic American Buildings Survey; Historic American Engineering Record; Cabinet of American Illustration; original fine prints of all schools & periods; Yanker Collection of Propaganda posters; originally designed posters for all periods, dating 1840s - present; Seagram County Court House Collection; Swann Collection of Caricature & Cartoon; American Political Cartoons; Outstanding among the collection of photographs & photographic negatives are the Brady-Handy Collection, Farm Security Administration Collection, Alexander Graham Bell Collection, Arnold Genthe, J C H Grabill, F B Johnston, Tony Frissell, Detroit Photographic Co, W H Jackson Collection, George Grantham Bain Collection, H E French Washington Photographs, Matson Near Eastern Collection; NY Work-Telegram & Sun, US News & World Report; Presidential, geographical, biographical & master photograph groupings, captured German photographs of the WW II period & panorama photographs & the Look magazine archive; early 20th Century architecture photograph coll Gottscho-Schleisner
Exhibitions: Permanent collection
Publications: A Century of Photographs, 1846-1946; American Prints in the Library of Congress; American Revolution in Drawings & Prints; Eyes of the Nation: A Visual History of the United States; Graphic Sampler; Historic America: Buildings, Structures & Sites; Historic American Buildings Survey; Middle East in Pictures, Prints & Photographs: An Illustrated Guide; Viewpoints; Special Collections in the Library of Congress; Fine Prints in the Library of Congress; The Poster Collection in the Library of Congress; Popular & Applied Graphic Art in the Library of Congress
Activities: Docent training; lect open to the pub; concerts; gallery talks; tours; fels offered; 2 sales shops sell books, magazines, reproductions & slides

M MERIDIAN INTERNATIONAL CENTER, Cafritz Galleries, 1630 Crescent Pl NW, Washington, DC 20009; 1624 Crescent Pl NW, Washington, DC 20009. Tel 202-667-6800; Fax 202-319-1306; Elec Mail nmatthew@meridian.org; Internet Home Page Address: www.meridian.org.; *Pres & CEO* Walter L Cutler; *VPres Develop* Thomas O'Coin; *VPres for Mgt* M. Jean Thomas; *Dir* Nancy Matthews; *VPres Educ & Visitors* Richard Rodgers; *VChmn* James R Jones; *Dir Exhib* Curtis Sandberg; *Dir Prog* Claudine Hughes
Open Wed - Sun 2 - 5 PM; No admis fee; Estab 1960 to promote international understanding through exchange of people, ideas & the arts; 3000 sq ft, 5 rooms in renovated historic mansion; Average Annual Attendance: 50,000; Mem: donations

Income: Financed by endowment, contributions, arts: private support, grants & corporate support
Publications: Exhibit catalogues; Meridian newsletter, 3 per year
Activities: Docent training; lect open to public, 2-3 vis lectrs per year, concerts, tours; organize traveling exhibitions

M **NATIONAL ACADEMY OF SCIENCES,** Arts in the Academy, 2101 Constitution Ave, NW, Washington, DC 20418; 500 5th St NW, Washington, DC 20001. Tel 202-334-2436; Fax 202-334-1690; Elec Mail jtalasek@nas.edu; Internet Home Page Address: www.nationalacademies.org/nas/arts; *Dir* Janis A Tomlinson Dr; *Exhibition Coordr* J D Talasek; *Outreach Coordr* Jeffrey Zimmer
Open Mon - Fri 9 AM - 5 PM; No admis fee; Exhib of Science Related Art; Two small galleries within operating office building; Average Annual Attendance: 5,000
Income: Organizational endowment
Activities: Lect open to public; concerts

M **NATIONAL AIR AND SPACE MUSEUM,** Sixth & Independence Ave SW, Washington, DC 20560-0310; Office of Public Affairs MRC 321, PO Box 37012 Washington, DC 20013-7012. Tel 202-357-2700, 357-1745; Fax 202-633-8174; Elec Mail nasm@nasm.si.edu; *Dir* John R Dailey; *Pub Relations* Walt Ferrell; *Pub Rels* Claire Brown; *Ctr for Earth* Bruce Campbell; *Deputy Dir* Donald Lopez; *Space History Dept* Allan Needell; *Aeronautics Dept* Dominick Pisano
Open daily 10 AM - 5:30 PM, cl Dec 25; No admis fee; Estab 1946 to memorialize the national development of aviation & space flight; One gallery comprised of 5,000 sq ft devoted to the theme, Flight & the Arts; Average Annual Attendance: 8,000,000
Income: Financed through the Smithsonian Institute
Special Subjects: Drawings, Painting-American, Prints, Sculpture
Collections: Paintings, prints & drawings include: Alexander Calder, Lamar Dodd, Richard Estes, Audrey Flack, Francisco Goya, Lowell Nesbitt, Robert Rauschenberg, James Wyeth; major sculptures by Richard Lippold, Alejandro Otero, Charles Perry; Stuart Speiser Collection of Photo Realist Art
Exhibitions: Exhibitions change annually
Publications: Various publications relating to aviation & space science
Activities: Educ dept; handicapped services; regional resource program; lect open to public, 15-20 vis lectrs per year; concerts; gallery talks; tours; scholarships offered; individual paintings & original objects of art lent to nonprofit educational institutions; book traveling exhibitions; originate traveling exhibitions; museum shop sells books, magazines, reproductions, prints, slides, posters, stamp covers, kites, models & jewelry

L **Library,** Sixth & Independence Ave SW, Washington, DC 20560-0310. Tel 202-357-3133; *Reference Librn* Elaine Cline
Open Mon - Fri 10 AM - 4 PM; Estab 1972 to support research in aerospace field; Library is part of the Smithsonian Institution Libraries system; Libr used for reference; Average Annual Attendance: 4,000
Income: Financed by federal funds
Library Holdings: Book Volumes 40,000; Fiche 200,000; Periodical Subscriptions 300; Reels 2000
Collections: Aerospace Event Files; Aviation & Space Art; Illustrated Sheet Music; Archives of Personalities
Publications: NASM Library Guide; NASM Library Periodical Index
Activities: Educ dept; classes for children; docent training; lect open to public; tours; awards; scholarships

NATIONAL ARCHITECTURAL ACCREDITING BOARD, INC
For further information, see National and Regional Organizations

NATIONAL ARTISTS EQUITY ASSOCIATION INC
For further information, see National and Regional Organizations

NATIONAL ASSEMBLY OF STATE ARTS AGENCIES
For further information, see National and Regional Organizations

NATIONAL ASSOCIATION OF ARTISTS' ORGANIZATIONS (NAAO)
For further information, see National and Regional Organizations

NATIONAL ENDOWMENT FOR THE ARTS
For further information, see National and Regional Organizations

M **NATIONAL GALLERY OF ART,** Constitution Ave at Fourth St NW, Washington, DC 20565; 2000B S Club Dr, Landover, MD 20785. Tel 202-737-4215; Fax 202-789-4976; Elec Mail rstevenson@nga.gov; Internet Home Page Address: www.nga.gov; *Others* 202-842-6176 (TDD); *Dir* Earl A Powell III; *Deputy Dir* Alan Shestack; *Dean, Center for Advanced Study in Visual Arts* Elizabeth Cropper; *Chief Librn* Neal Turtell; *Special Events Officer* Genevra Higginson; *Cur Photo Archives* Ruth Philbrick; *Cur American Art* Nicholai Cikovsky; *Cur Northern Baroque Painting* Arthur Wheelock; *Cur Renaissance Painting* David Brown; *Cur Sculpture* C Douglas Lewis; *Cur Educ* Linda Downs; *Chief Design & Installation* Mark Leithauser; *Chief Photographic Svcs* Sara Greenaugh; *Head Educ Resources Progs* Ruth Perlin; *Horticulture* Donald Hand; *Chief Conservation* Ross Merrill; *Gallery Archivist* Maygene Daniels; *Secy & Gen Counsel* Elizabeth Croog; *Treas* Ann Leven; *Registrar* Sally Freitag; *Coordr of Photography* Ira Bartfield; *Asst to Dir Music* George Manos; *Public Information Officer* Debra Cisco; *Corporate Relations Officer* Christine Meyers; *Develop Officer* Ruth Anderson-Coggeshall; *Visitor Svcs* Sandra Creighton; *Pub Sales Mgr* Sabel Leightner; *Chmn Board Trustees* Ruth Carter Stevenson
Open Mon - Sat 10 AM - 5 PM; Sun 11 AM - 6 PM; cl Christmas & New Years Day; No admis fee; Administered by a board of trustees which consists of Chairman, US Chief Justice, US Secretary of State, Treasury, Smithsonian Institution, Robert Smith Alexander M Laughin & Ruth Carter Stevenson. Estab 1941; East Building opened 1978. West Building was a gift from Andrew W Mellon; the East Building was a gift of Paul Mellon, Ailsa Mellon Bruce & Andrew Mellon Foundation; Average Annual Attendance: 6,500,000
Income: Financed by private endowment & federal appropriation
Collections: The Andrew W Mellon Collection of 126 paintings & 26 pieces of sculpture includes Raphael's Alba Madonna, Niccolini-Cowper's Madonna & St George & the Dragon; van Eyck Annunciation; Botticelli's Adoration of the Magi; nine Rembrants. Twenty-one of these paintings came from the Hermitage. Also in

the original gift were the Vaughan Portrait of George Washington by Gilbert Stuart & The Washington Family by Edward Savage.; The Samuel H Kress Collection, given to the nation over a period of years, includes the great tondo The Adoration of the Magi by Fra Angelico & Fra Filippo Lippi, the Laocoon by El Greco & fine examples by Giorgione, Titian, Grunewald, Durer, Memling, Bosch, Francois Clouet, Poussin, Watteau, Chardin, Boucher, Fragonard, David & Ingres. Also included are a number of masterpieces of Italian & French sculpture; In the Widener Collection are paintings by Rembrandt, van Dyck & Vermeer, as well as major works of Italian, Spanish, English & French painting & Italian & French sculpture & decorative arts. The Chester Dale Collection includes masterpieces by Braque, Cezanne, Degas, Gauguin, Manet, Matisse, Modigliani, Monet, Picasso, Pissarro, Renoir, Toulouse-Lautrec, van Gogh & such American painters as George Bellows, Childe Hassam & Gilbert Stuart. Several major works of art by Cezanne, Gauguin, Picasso & the American painter Walt Kuhn were given to the Gallery in 1972 by the W Averell Harriman Foundation in memory of Marie N Harriman.; Paintings to round out the collection have been bought with funds provided by the late Ailsa Mellon Bruce. Most important among them are: portrait of Ginevra de' Benci (the only generally acknowledged painting by Leonardo da Vinci outside Europe), Georges de la Tour's Repentant Magdalen, Picasso's Nude Woman-1910, Ruben's Daniel in the Lions' Den, Claude Lorrain's Judgment of Paris, St George & the Dragon attributed to Rogier van der Weyden & a number of American paintings, including Thomas Cole's second set of the Voyage of life.; The National Gallery's rapidly expanding graphic arts holdings, in great part given by Lessing J Rosenwald, numbers about 50,000 items & dates from the 12th century to the present. The Index of American Design contains over 17,000 watercolor renderings & 500 photographs of American crafts & folk arts. The National Gallery's Collection continues to be built by private donation, rather than through government funds, which serve solely to operate & maintain the Gallery
Exhibitions: Temporary exhibitions from collections both in the United States & abroad
Publications: A W Mellon Lectures in the Fine Arts; Studies in the History of Art; exhibition catalogs; annual report; monthly calendar of events
Activities: Sunday lect by distinguished quest speakers & members of the staff are given throughout the year; the A W Mellon Lect in the Fine Arts are delivered as a series each spring by an outstanding scholar; concerts are held in the West Garden Court, West Building each Sunday evening between October & June at 7 PM without charge; general tours & lect are given in the Gallery by members of the Educ Dept throughout the week; special tours are arranged for groups; films on art are presented on a varying schedule; color slide programs, films & video cassettes on gallery exhibitions & collections, free of charge, free catalog; sponsors Metropolitan Opera auditions; programs to 4900 communities; exten dept provides art loans to galleries around the world; lending collection contains books, cassettes, color reproductions, film strips, framed reproductions, Kodachromes, sculpture & slides; museum shop sells books, magazines, reproductions, prints, slides & video-cassettes

L **Library,** Constitution Ave at Fourth St NW, Washington, DC 20565; 2000B S Club Dr, Landover, MD 20785. Tel 202-842-6511; Elec Mail F-Lederer@nga.gov; Internet Home Page Address: www.nga.gov; *Exec Librn* Neal Turtell; *Head Reader Svcs* Lamia Doumato; *Reference Librn* Frances Lederer
Open Mon Noon - 4:30 PM, Tues - Fri 10 AM - 4:30 PM; Estab 1941 to support the national curatorial, educational & research activities & serve as a research center for graduate & undergraduate students, vis scholars & researchers in the visual arts. Supports the research programs of the Center for Advanced Study in the Visual Arts; For reference only
Income: Financed by federal appropriations & trust funds
Library Holdings: Auction Catalogs; Book Volumes 261,000; Clipping Files; Exhibition Catalogs; Fiche; Manuscripts; Other Holdings Vertical Files 125,000; Pamphlets; Periodical Subscriptions 990; Photographs; Reels; Slides
Collections: Art exhibition, art auction & private art collection catalogs; artist monographs; Leonardo da Vinci, catalogues raisonne
Publications: NGA Library Guide, 1994 & 1996
Activities: Library tours on request

L **Department of Image Collections,** Constitution Ave at Fourth St NW, Washington, DC 20565; 2000B S Club Dr, Landover, MD 20785. Tel 202-842-6026; Fax 202-789-3068; Elec Mail g-most@nga.gov; Internet Home Page Address: www.nga.gov/resources/dlidesc.htm; *N European Specialist* Elizabeth Oliver; *Architecture Specialist* Andrea Gibbs; *Italian Specialist* Melissa Beck Lemke; *Mod & Contemp Specialist* Meg Melvin; *Staff Asst* Debra Massey; *Circ Asst* Carrie Scharf; *American Specialist* Lisa M. Coldiron; *French Specialist* Nicholas A. Martin; *Spanish Specialist* Thomas A. O'Callaghan Jr
Open Mon Noon - 4:30 PM, Tues - Fri 10 AM - 4:30 PM, cl federal holidays; Slide Library (estab 1941) & Photographic Archives (estab 1943) merged in 2004 to Dept of Image Collections; The Department of Image Collections is a study and research collection of images documenting European and American art and architecture; Average Annual Attendance: 30,000
Library Holdings: Book Volumes; CD-ROMs 150; Fiche 7,000,000; Photographs 5,000,000; Prints; Slides 225,000
Special Subjects: Art History, Decorative Arts, Drawings, Manuscripts, Painting-American, Painting-British, Painting-Dutch, Painting-Flemish, Painting-French, Painting-German, Painting-Italian, Painting-Russian, Pre-Columbian Art, Prints, Sculpture, Painting-European, Portraits, Watercolors, Ceramics, Bronzes, Furniture, Oriental Art, Religious Art, Silver, Architecture
Publications: Manual for Classifying and Cataloging Images; Guide to the National Gallery of Art Photo Archives

L **Index of American Design,** Constitution Ave at Sixth NW, Washington, DC 20565. Tel 202-842-6605; Fax 202-842-6859; Elec Mail c-ritchie@nga.gov; *Asst Cur* Ruth Fein; *Asst Cur* Carlotta Owens
Open daily 10 AM - Noon & 2 - 4 PM; No admis fee; Acquired by National Gallery in 1943 to serve as a visual archive of American decorative arts, late 17th through 19th centuries; Study room with National Gallery print galleries available for exhibitions; offices; storeroom
Library Holdings: Fiche; Other Holdings Watercolors 18,000; Photographs
Special Subjects: Folk Art, Decorative Arts, Ceramics, Furniture, Costume Design & Constr, Glass, Jewelry, Religious Art, Silver, Textiles, Woodcarvings, Architecture
Activities: Original objects of art lent to institutions complying with National Gallery lending rules; lending collection contains 11 slide programs available through National Gallery dept of exten programs

NATIONAL LEAGUE OF AMERICAN PEN WOMEN
For further information, see National and Regional Organizations

M NATIONAL MUSEUM OF WOMEN IN THE ARTS, 1250 New York Ave NW, Washington, DC 20005. Tel 202-783-5000; Fax 202-393-3235; Elec Mail media@nmwa.org; Internet Home Page Address: www.nmwa.org; *Admin Dir* Judy L Larson; *Dir of Library & Research Center* Sharon Wasserman; *Deputy Dir* Dr Susan Fisher Sterling
Open Mon - Sat 10 AM - 5 PM, Sun Noon - 5 PM, cl Thanksgiving, Christmas & New Year's Day, group tours by appointment; Admis adults $8, seniors & students $6, youth 18 & under and NMWA members free; Estab 1981 to promote knowledge & appreciation of women artists through exhibits, publications, educ programs & library services; Maintains library; Average Annual Attendance: 120,000; Mem: 40,000
Income: Private non-profit
Library Holdings: Audio Tapes; Clipping Files; Exhibition Catalogs; Slides; Video Tapes
Special Subjects: Latin American Art, Painting-American, Photography, American Indian Art, American Western Art, Costumes, Ceramics, Crafts, Etchings & Engravings, Landscapes, Afro-American Art, Decorative Arts, Jewelry, Asian Art, Calligraphy
Collections: Works by 800 women artists from the Renaissance to the present. Includes paintings, sculpture & pottery; 600 unique & limited edition artists' books; Women silversmiths; Botanical prints
Exhibitions: Selections from the permanent collection (indefinitely)
Publications: Exhibit catalogs, women artists (Oct 2000), Women in the Arts quar magazine
Activities: Classes for adults & children; dramatic programs; docent training; films; lect open to public, concerts; tours; library fellows award; individual paintings & original objects of art lent; book exhibitions 1 per year; originate traveling exhibitions; museum shop sells books, prints & reproductions, jewelry, crafts

L Library & Research Center, 1250 New York Ave NW, Washington, DC 20005. Tel 202-783-5000; Fax 202-393-3234; Internet Home Page Address: www.nmwa.org; *Dir of Libr & Res Ctr* sharon M Wasserman; *Archivist* Stacey Flatt; *Libr Asst* Rebecca Brown
Open Mon - Fri 10 AM - 5 PM, by appointment only; Fee only for museum entrance
Library Holdings: Audio Tapes 32; Book Volumes 11,000; Cassettes; Exhibition Catalogs; Manuscripts; Memorabilia; Original Art Works; Original Documents; Other Holdings Artists files; Pamphlets; Periodical Subscriptions 60; Photographs; Prints; Reproductions; Slides; Video Tapes
Special Subjects: Decorative Arts, Calligraphy, Drawings, Etchings & Engravings, Ceramics, Crafts, Bronzes, Asian Art, Bookplates & Bindings, Embroidery, Jewelry, Laces
Collections: Irene Rice Pereira Library; Collection of Artists' Books; Collection of Bookplates; Archives of the International Festival of Women Artists in Copenhagen, Denmark, 1980
Activities: Lect; concerts; gallery talks; tours; original objects of art & individual paintings lent to museums; book traveling exhibitions 2-3 per year; originate traveling exhibition to museums; museum shop sells books, magazines, reproductions, prints, slides

M NATIONAL PORTRAIT GALLERY, F St at Eighth NW, Washington, DC 20560. Tel 202-357-2700; *Dir* Alan Fern; *Deputy Dir* Carolyn Carr; *Assoc Dir Admin* Barbara A Hart; *Cur Paintings & Sculpture* Ellen G Miles; *Chief Design & Production* Nello Marconi; *Cur Exhib* Beverly Cox; *Cur Photographs* Mary Panzer; *Cur Prints & Drawings* Wendy W Reaves; *Registrar* Suzanne Jenkins; *Keeper Catalog of American Portraits* Linda Thrift; *Ed Charles Willson Peale Papers* Sidney Hart; *Conservator* Cindylou Ockershausen; *Chief Photographer* Rolland White; *Public Affairs Officer* Brennan Rash; *Publications Officer* Frances Stevenson
Open daily 10 AM - 5:30 PM; cl Dec 25; No admis fee; The National Portrait Gallery was estab by Act of Congress in 1962 as a mus of the Smithsonian Institution for the exhibition & study of portraiture depicting men & women who have made significant contributions to the history, development & culture of the people of the United States; One of the oldest government structures in Washington, the former US Patent Office Building constructed between 1836 & 1867, on the very site which Pierre L'Enfant, in his original plan for the city, had designated for a pantheon to honor the nation's immortals. The first floor is devoted to changing exhibitions & images of performing artists & sports figures from the permanent collection. Second floor features the permanent collection of portraits of eminent Americans & the Hall of Presidents, containing portraits & associative items of our Chief Executives. Also houses a collection of photographs by Mathew Brady, silhouettes by Auguste Edouart & portrait sculptures by Jo Davidson. The two-story Victorian Renaissance Revival Great Hall on the third floor is used for special events & pub programs. The third floor mezzanine houses a permanent collection civil gallery with portraits, engravings & photographs; Average Annual Attendance: 414,000
Income: Financed by federal appropriation & private contributions
Special Subjects: Drawings, Painting-American, Photography, Prints, Sculpture, Watercolors, Bronzes, Woodcarvings, Woodcuts, Portraits, Posters, Historical Material, Miniatures, Cartoons
Collections: The collections, which are constantly being expanded, include portraits of significant Americans, preferably executed from life, in all traditional media: oils, watercolors, charcoal, pen & ink, daguerreotypes, photographs; portraits of American Presidents from George Washington to Bill Clinton; 1800 original works of art from the Time Magazine Cover collection; more than 5000 glass plate negatives by Mathew Brady & studio in the Meserve Collection
Publications: Large-scale, richly illustrated publications accompany major shows & provide comprehensive analysis of exhibition themes; descriptive brochures about the gallery; documentary, audio & visual materials designed to be used as teaching guides; illustrated checklist; American portraiture; biographies
Activities: Outreach programs for elementary & secondary schools, senior citizens groups, hospitals & nursing homes; docent training; scheduled walk-in tours for special groups, adults, families & schools; programs for handicapped & other special audiences; films; lect; Cultures In Motion, (special musical & dramatic

events); museum shop sells books, magazines, reproductions, recordings, CDs, cassettes, jewelry & gifts, prints, & slides

L Library, Victor Bldg Ste 8300 MRC, PO Box 37012 Washington, DC 20013-7012. Tel 202-275-1738; Fax 202-275-1887; Elec Mail npgweb@npg.si.edu; Internet Home Page Address: www.npg.si.edu; *Asst Librn* Pat Lynagh; *Cataloger* Kent Boese; *Chief Librn* Cecilia H Chin; *Exhibitions & Coll* Beverly Cox; *Deputy Dir* Carolyn Carr; *Cur Paintings* Ellen Miles; *VChmn* Barbara Novak; *Cur Prints* Wendy Wick Reaves; *Acting Cur Photography* Ann Shumard; *Dir* Marc Pachter; *Develop Officer* Patrick M Madden
Open Mon - Fri 10 AM - 5 PM; Shared with the National Mus of American Art; see library entry under National Mus of American Art
Library Holdings: Book Volumes 100,000; Clipping Files; Exhibition Catalogs; Fiche; Manuscripts; Periodical Subscriptions 800; Reels; Reproductions

M NATIONAL TRUST FOR HISTORIC PRESERVATION, 1785 Massachusetts Ave NW, Washington, DC 20036. Tel 202-588-6000; Fax 202-588-6038; Elec Mail feedback@nthp.org; Internet Home Page Address: www.nationaltrust.org; *Pres* Richard Moe; *Dir Interpretation* Max VanBalgooy; *Sr Architect* George Siekkinen; *Dir Mus Coll* Sandra Smith; *VPres* James Vaughn; *Admin Dir* Lawrence Goldschmidt
Open to the pub, hrs & fees vary with the property, cl Christmas, New Year's, call for information; Founded 1949, the National Trust for Historic Preservation is the only national, nonprofit, private organization chartered by Congress to encourage pub participation in the preservation of sites, buildings & objects significant in American history & culture; Its services, counsel & educ on preservation & historic property interpretation & administration, are carried out at national & regional headquarters in consultation with advisors in each state & U S Territory; Mem: 265,000; dues sustaining $100, active $20, student $15
Income: Financed by mem dues, contributions & matching grants from the US Department of the Interior, National Park Service, under provision of the National Historic Preservation Act of 1966
Special Subjects: Decorative Arts, Furniture
Collections: Fine & decorative arts furnishing nine historic house museums: Chesterwood, Stockbridge, MA; Cliveden, Philadelphia, PA; Decatur House & Woodrow Wilson House, Washington, DC; Drayton Hall, Charleston, SC; Lyndhurst, Tarrytown, NY; Oatlands, Leesburg, VA; The Shadows-on-the-Teche, New Iberia, LA; Woodlawn/Pope-Leighey Plantation House, Mt Vernon, VA. (For additional information, see separate listings)
Publications: Preservation Magazine, bi-monthly

M Decatur House, 748 Jackson Pl NW, Washington, DC 20006. Tel 202-842-0920; Fax 202-842-0030; *Exec Dir* Paul Reber
Open Tues - Fri 10 AM - 3 PM, Sat & Sun Noon - 4 PM, cl Mon; No admis fee; Estab 1958, bequeathed to National Trust for Historic Preservation by Mrs Truxton Beale to foster appreciation & interest in the history & culture of the city of Washington, DC; The House is a Federal period townhouse designed by Benjamin Henry Latrobe & completed in 1819; Average Annual Attendance: 19,000; Mem: National Trust members
Income: Financed by endowment & mem
Special Subjects: Furniture, Period Rooms
Collections: Furniture & memorabilia of the Federal period; Victorian house furnishings
Exhibitions: Special exhibits
Activities: Lect open to public, 2-3 vis lectrs per year; concerts; individual paintings & original objects of art lent; sales shop sells books, magazines, reproductions, prints & Christmas decorations

M NAVAL HISTORICAL CENTER, The Navy Museum, Washington Navy Yard, 901 M St SE Washington, DC 20374-5060; 805 Kidder Breese SE, Washington Navy Yard Washington, DC 20374-5060. Tel 202-433-4882; Fax 202-433-8200; Internet Home Page Address: www.history.navy.mil; *Cur* Dr Edward Furgol; *Pub Prog* Shelia Brennan; *Dir* Kim Nielsen; *Art Coll Cur* Gale Munro
Open Sept - Mar Mon - Fri 9 AM - 4 PM, Apr - Aug daily 9 AM - 5 PM, Weekends & Holidays 10 AM - 5 PM; No admis fee & parking; Estab 1961 to present history & preserve heritage of US Navy; 48,000 sq ft exhibit area; Average Annual Attendance: 150,000
Income: Financed by federal appropriations
Special Subjects: Architecture, Drawings, Graphics, Painting-American, Photography, Prints, Sculpture, Watercolors, Bronzes, Archaeology, Costumes, Ceramics, Folk Art, Woodcuts, Etchings & Engravings, Decorative Arts, Manuscripts, Portraits, Posters, Furniture, Glass, Porcelain, Asian Art, Silver, Marine Painting, Metalwork, Ivory, Maps, Scrimshaw, Coins & Medals, Calligraphy, Miniatures, Dioramas, Embroidery, Cartoons, Leather, Military Art
Collections: History of US Navy from 1775 to Space Age; Naval Art; Paintings; Prints; Watercolors; Naval Artifacts; Fighting Top of Constitution; WW II Corsair (744 plane)
Exhibitions: Changing art exhibitions; Polar Exploration; Perry & Japan
Activities: Docent training; tours; concerts; internships; 10 visiting lect per year; individual paintings & original objects of art lent to public institutions; museum shop sells books, reproductions, prints, postcards, jewelry, t-shirts, models & nautical accessories

M THE PHILLIPS COLLECTION, 1600 21st St NW, Washington, DC 20009. Tel 202-387-2151, Ext 238/239, 387-3036 (membership); Fax 202-387-2436; Internet Home Page Address: www.phillipscollection.org; *Dir* Jay Gates; *Chief Cur* Eliza Rathbone; *Sr Cur* Elizabeth Hutton Turner; *Cur* Stephen Phillips; *Dir Music* Mark Carrington; *Chief Registrar* Joseph Holbach; *Librn* Karen Schneider; *Dir Corporate Relations* Katherine Hansen; *Dir Finance* Troy Bickford; *Dir of Human Resources* Barbara M Benny; *Dir of Educ* Suzane Wright; *Dir Operations Security* Daniel Datlow; *Dir Communications* Ann Greer; *Chmn of Brd* George Vradenburg; *Assoc Registrar* Christopher Ketcham; *Museum Shop Mgr* Cathy Wetmiller; *Asst Cur* Sue Behrends Frank; *Installations Mgr* William Koberg; *Asst Cur* Elsa Mezvinsky-Smith; *Dir Devel* Barbara Hall; *Dir Membership* Melanie Smith
Open Tues - Sat 10 AM - 5 PM, Sun Noon - 7 PM (non - 5 PM June-Sept), Thurs 10 AM - 8:30 PM; Weekday admis is suggested contribution, weekend admis varies by special exhibition; Open to the pub 1921 to show & interpret the best of contemporary painting in the context of outstanding works of the past; to

underscore this intent throught the presentation of concerts & lectures; The original building, a Georgian Revival residence designed in 1897 by Hornblower & Marshall, was added to in 1907 & renovated in 1983-84. A modern annex connected by a double bridge to the old gallery was opened to the public in 1960 & renovated in 1987-89. In April 2006 the Phillips celebrated the opening of its new Sant Bldg which adds 30,000 sf of expanded gallery spaces, a 180 seat auditorium, new educational spaces & more; Average Annual Attendance: 150,000; Mem: 4000; dues corporate mem $10,000, $5000 & $500, individual $45-$5000 & up
Income: $4,000,000 (financed by endowment, mem, contributions, grants, sales, rental fees & exhibition fees)
Special Subjects: Painting-American, Painting-European
Collections: 19th & 20th century American & European painting with special emphasis on units of particular artists such as Bonnard, Braque, Cezanne, Daumier, de Stael, Dufy, Rouault & Americans such as Avery, Dove, Gatch, Knaths, Marin, O'Keeffe, Prendergast, Rothko & Tack. The best known painting is Renoir's Luncheon of the Boating Party
Exhibitions: (10/14/2006-1/21/2007) The Societe Anonyme: Modernism America; (10/14/2006-1/21/2007) El Lissitzky: Futurist Portfolios; (2/17/2007-5/20/2007) Moving Pictures: American Art and Early Film; (4/12/2007-7/29/2007) Color Field.remix; (6/16/2007-9/9/2007) American Impressionism: Paintings from The Phillips Collectiion; (6/16/2007-9/9/2007) Recent Acquisitions and Promised Gifts; (10/20/2007-1/13/2008) Impressionists by the Sea
Publications: The Phillips Collection: A Summary Catalogue; News & Events, bi-monthly; childrens guides; exhibition catalogs & brochures; membership brochures & communications
Activities: Classes for adults & children; docent training; lect open to public; vis lectr per year; weekly concerts Oct-May; gallery talks; tours; Duncan Phillips award; individual paintings & original objects of art lent to national & international museums; book traveling exhibitions 3-5 per year; originate traveling exhibitions to national & international museums; museum sales shop sells books, magazines, reproductions, prints, slides, jewelry & original crafts
L **Library,** 1600 21st St NW, Washington, DC 20009. Tel 202-387-2151, Ext 212; Fax 202-387-2436; Elec Mail phillipsco@aol.com; *Chief Cur* Eliza Rathbone; *Librn* Karen Schneider
Available to serious students, researchers & mus professionals, by appointment. Reference only
Library Holdings: Book Volumes 6500; Clipping Files; Exhibition Catalogs; Filmstrips; Other Holdings Vertical files; Pamphlets; Periodical Subscriptions 20; Reels 60
Special Subjects: Art History, Collages, Folk Art, Decorative Arts, Drawings, Etchings & Engravings, Graphic Arts, History of Art & Archaeology, Latin American Art, Art Education, Asian Art, Furniture, Mexican Art, Aesthetics, Afro-American Art

L **PROVISIONS LIBRARY & GAEA FOUNDATION,** 1611 Connecticut Ave NW, 2nd fl, Washington, DC 20009. Tel 202-299-0460; Fax 202-232-1651; Internet Home Page Address: www.provisionslibrary.org; *Pres* Gaylord Neely; *Dir & Cur* Donald Russell; *Develop Mem* Adam Griffiths; *Educ* Delritta Hornbuckle
Open Tues - Fri 11 AM - 9 PM, Sat & Sun 11 AM - 4 PM; No charge, donations accepted; Estab 1993; Library, exhibs & educ progs linking contemporary global arts with social change issues; 2500 sq ft exhib space; auditorium capacity 100; Average Annual Attendance: 10,000 - 49,999 by estimate; Mem: dues Sponsor $250, Family $75, Basic $50
Library Holdings: Audio Tapes 300; Book Volumes 3500; Other Holdings 400 DVDs; Periodical Subscriptions 350
Collections: Books, periodicals, audiovisuals & films on global social issues
Activities: Research on global social change; formal educ progs for adults & col students; training progs for professional mus workers; guided tours; hobby workshops; participatory exhibs; study clubs; lects; films; arts festivals

PUBLIC LIBRARY OF THE DISTRICT OF COLUMBIA
L **Art Division,** Tel 202-727-1291; Fax 202-727-1129; Elec Mail george-mckinley.martin@dc.gov; Internet Home Page Address: www.dclibrary.org; *Chief Art Division* George-McKinley Martin; *Librn* Patricia Wood; *Librn S* Michele Casto
Open winter & summer Mon - Thurs 9:30 AM - 9 PM, Fri 9:30 AM - 5:30 PM, Sat 9:30 AM - 5:30 PM, Sun 1 - 5 PM; No admis fee
Income: Financed by city government appropriation
Library Holdings: Auction Catalogs; Book Volumes 48,961; Clipping Files; Exhibition Catalogs; Original Art Works; Original Documents; Pamphlets; Periodical Subscriptions 95; Reels
Special Subjects: Art History, Calligraphy, American Western Art, Bronzes, Asian Art, American Indian Art, Aesthetics, Afro-American Art, Antiquities-Oriental, Antiquities-Assyrian, Antiquities-Byzantine, Antiquities-Egyptian, Antiquities-Etruscan, Antiquities-Greek, Architecture
Collections: Reference & circulating books & periodicals on architecture, painting, sculpture, photography, graphic & applied arts; extensive pamphlet file including all art subjects, with special emphasis on individual American artists & on more than 1400 artists active in the area; circulating picture collection numbering over 81,519 mounted reproductions
Exhibitions: Special exhibitions held occasionally
L **Audiovisual Division,** Tel 202-727-1265; Fax 202-727-1129; Elec Mail www.avdcpl@yahoo.com; *Chief Film & Video Librn* Turner Freeman
Open Mon - Thurs 10 AM - 9 PM, Fri 10 AM - 5:30 PM, Sun 10 AM - 5:30 PM
Purchases: 16 mm, VHS
Library Holdings: Cassettes; Motion Pictures; Other Holdings Books-on-tape; Periodical Subscriptions 15; Records; Video Tapes

M **SMITHSONIAN AMERICAN ART MUSEUM,** Eighth & G Sts NW, Washington, DC 20560. Tel 202-357-1959; Fax 202-357-2528; Internet Home Page Address: www.americanart.si.edu; *Dir* Elizabeth Broun; *Deputy Dir* Charles Robertson; *Chief Cur* Lynda Hartigan; *Renwick Gallery Cur-in-Charge* Ken Trapp; *Research & Scholars Center Chief* Rachel Allen; *Acting Educ Prog Chief* Sherwood Dowling; *Registrar* Melissa Kroning; *Design & Production Chief* John Zelenik; *Admin Officer* Maureen Damaska; *Acting Develop Officer* JoAnn Sims
The main building is currently undergoing renovation, but the Renwick Gallery is continuing a full program of exhibitions & is open daily 10 AM - 5:30 PM, cl

Christmas; No admis fee; Estab 1829 & later absorbed by the Smithsonian Institution, it was designated the National Gallery of Art in 1906. The museum's name was changed to the National Collection of Fine Art in 1937 & in 1980, to the National Museum of American Art. With the largest collection of American art in the world, it is the leading center for study of the nation's heritage. On Oct 27, 2000 its name was officially changed to the Smithsonian American Art Museum; Circ 100,000; Average Annual Attendance: 500,000
Income: $7,000,000 annually (financed by federal appropriation, gifts, grants & trust income)
Library Holdings: Book Volumes; CD-ROMs; Exhibition Catalogs; Pamphlets; Periodical Subscriptions
Special Subjects: Drawings, Graphics, Hispanic Art, Painting-American, Photography, Watercolors, American Indian Art, American Western Art, Textiles, Folk Art, Primitive art, Woodcarvings, Woodcuts, Etchings & Engravings, Landscapes, Afro-American Art, Decorative Arts, Portraits, Furniture, Glass, Jewelry, Marine Painting, Gold, Stained Glass
Collections: All regions, cultures & traditions in the United States are represented in the museum's holdings, research resources, exhibitions & public programs. Colonial portraiture, 19th century landscapes, American impressionism, 20th century realism & abstraction, New Deal projects, sculpture, photography, graphic arts, works by African Americans, contemporary art & the creativity of self-taught artists are featured in the galleries.; Major collections include those of Harriet Lane Johnston (1906), William T Evans (1907), John Gellatly (1929), the SC Johnson & Son Collection (1967), Container Corporation of America Collection (1984), Sara Roby Foundation Collection (1984), Herbert Waide Hemphill Jr Collection (1986) & the Patricia & Phillip Frost Collection.; Research resources include 300,000 listings on the Inventory of American Painting & Sculpture
Exhibitions: A representative selection of works from the collection are on permanent display in the galleries, providing a comprehensive view of the varied aspects of American art. Most temporary exhibitions, approx 12 per year, are originated by the staff, many as part of the program to investigate less well-known aspects of American art. They include both studies of individual artists & thematic studies.
Publications: American Art, journal; calendar of events; quarterly member newsletter; major exhibitions are accompanied by authoritative publications; smaller exhibitions are accompanied by checklists & often brochures
Activities: The Office of Education Programs carries on an active program with the schools & the general public, offering imaginative participatory tours for children, as well as lect & symposia for adults. A research program in American art is maintained for vis scholars & training is carried on through internships in general museum practice & conservation; docent training; concerts; gallery talks; tours; fels offered; circulates exhibitions throughout the United States on a regular basis; currently 8 traveling exhibitions touring the country as part of the Treasures to Go Tour, the most extensive art tour ever; museum shop sells books, magazines, original art, reproductions & prints
L **Library of the Smithsonian American Art Museum,** 750 9th St NW, Washington, DC 20560. Tel 202-275-1912; Fax 202-275-1929; Elec Mail lynaghp@saam.si.edu; Internet Home Page Address: www.sil.si.edu; *Asst Librn* Patricia Lynagh; *Cataloger* Kent Boese; *Chief Librn* Cecilia Chin
Open Mon - Fri 10 AM - 5 PM; Estab 1964 to serve the reference & research needs of the staff & affiliated researchers of the National Museum of American Art, The National Portrait Gallery, the Archives of American Art & other Smithsonian bureaus; Open to graduate students & other qualified adult researchers
Income: $160,000 (financed by federal appropriation)
Purchases: $65,000
Library Holdings: Book Volumes 127,055; Clipping Files 84,183; Exhibition Catalogs; Fiche 555; Manuscripts; Other Holdings Auction Catalogs 16,675; Pamphlets; Periodical Subscriptions 607; Reels; Video Tapes
Collections: Ferdinand Perret Art Reference Library: collection of scrapbooks of clippings & pamphlets; special section on California art & artists consisting of approximately 325 ring binders on art & artists of Southern California; vertical file of 400 file drawers of material on art & artists, with increasing emphasis on American art & artists
M **Renwick Gallery,** 17th St & Pennsylvania Ave NW, Washington, DC 20560. Tel 202-357-2531; Tel 202-275-1515; Fax 202-786-2810; Elec Mail ktrapp@nmoa.si.edu; *Cur-in-Charge* Kenneth Trapp
Open daily 10 AM - 5:30 PM, cl Christmas; Designed in 1859 by architect James Renwick, Jr as the original Corcoran Gallery of Art, the building was renamed for the architect in 1965 when it was transferred by the Federal government to the Smithsonian Institution for restoration; Restored to its French Second Empire elegance after 67 years as the United States Court of Claims, the building has two public rooms with period furnishings, the Grand Salon & the Octagon Room, as well as eight areas for its permanent collection & temporary exhibitions of American crafts, design & decorative arts
Special Subjects: Crafts, Period Rooms
Collections: American crafts, design & decorative arts
Publications: Major exhibitions are accompanied by publications, smaller exhibitions by checklists & brochures
Activities: Docent training; film programs; lect & workshops emphasizing the creative work of American craft artists; tours; concerts

SMITHSONIAN INSTITUTION

M **SMITHSONIAN INSTITUTION,** 1000 Jefferson Dr, SW, Washington, DC 20560. Tel 202-357-2700 (voice); Tel 202-357-1729 (TTY); Internet Home Page Address: www.si.edu; *Secy* Lawrence Small; *Under Secy for Science* J. Dennis O'Connor; *Under Secy Designate for Finance & Admin* Robert D. Bailey; *Under Secy for American Museums & Nat'l Programs* Sheila Burke; *Dir Int'l Art Museums* Thomas Lentz; *Sr Business Officer* Gary Beer
Open daily 10 AM - 5:30 PM, cl Dec 25; no admis fee; Estab 1846, when James Smithson bequeathed his fortune to the United States, under the name of the Smithsonian Institution, an establishment in Washington for the increase & diffusion of knowledge. To carry out the terms of Smithson's will, the Institution performs fundamental research; preserves for study & reference approx 140 million items of scientific, cultural & historical interest; maintains exhibits representative of the arts, American history, aeronautics & space exploration; technology; natural history & engages in programs of education & national &

international cooperative research & training; The Smithsonian Institution is the world's largest museum complex composed of 14 museums & the National Zoo in Washington, DC & the Cooper-Hewitt, National Design Museum & the National Museum of the American Indian in New York City; see separate listings for complete information on the bureaus listed below; Average Annual Attendance: 31,000,000; Mem: several programs, call for info

Income: Financed by federal appropriations & private monies

Special Subjects: American Indian Art, Decorative Arts, Ceramics, Portraits, African Art, Crafts, Asian Art

Activities: Classes for adults & children; dramatic programs; docent training; lect open to the public; concerts; gallery talks; tours; awards; scholarships & fels; museum shops sell books, magazines, original art, reproductions, prints, slides & gifts; for information call Smithsonian Institution Traveling Exhibitions at 202-357-3168; museum stores sell books, reproductions, prints & slides

M **SMITHSONIAN INSTITUTION,** National Museum of African Art, 950 Independence Ave SW, Washington, DC 20560-0708. Tel 202-357-4600; Fax 202-357-4879; *Chief Cur* David Binkley; *Dir Pub Affairs* Janice Kaplan; *Dir* Roslyn A Walker
Open Mon - Sun 10 AM - 5:30 PM, cl Christmas Day; summer hours open Thurs until 8PM; No admis fee; Estab 1964 to foster public understanding & appreciation of the diverse cultures & artistic achievements in Africa; museum joined the Smithsonian Institution in 1979. Moved in 1987 to the Smithsonian's new museum complex, the Quadrangle on the National Mall; Average Annual Attendance: 500,000
Income: $4,013,000 (financed by federal funding, mem & contributions)
Special Subjects: African Art
Collections: More than 7,000 traditional & contemporary art from throughout the African continent; Eliot Elisofon Photographic Archives of 200,000 slides & 78,000 black & white photographs & 140,000 ft of motion picture film & videotape
Exhibitions: Permanent Exhibitions: Images of Power & Identity; The Art of the Personal Object; The Ancient West African City of Benin, AD 1300-1897; The Ancient Nubien City of Kerma, 2500-1500 BC; Ceramic Art at the National Museum of African Art
Publications: Booklets; exhibition catalogs; multimedia slide kit; pamphlets; videotapes
Activities: Classes for adults & children; docent training; lect open to public; concerts; gallery talks; films; tours; residency fellowship program; book several traveling exhibitions per yr; organize traveling exhibitions; museum sales shop sells books, magazines, reproductions, prints, slides, quality crafts, original art, cassettes & CD's, jewelry & other imports from Africa

M **Freer Gallery of Art,** Tel 202-357-4880; Fax 202-357-4911; Elec Mail arnolje@asia.si.edu; Internet Home Page Address: www.si.edu; *Dir* Milo C Beach
Open daily 10 AM - 5:30 PM, cl Christmas Day; No admis fee; Estab 1923 to exhibit 19th-century & early 20th-century American art; Italian-Renaissance-Style gallery constructed of granite & marble; A permanent installation in the gallery is the Peacock Room, a dining room once part of a London townhouse & lavishly decorated with a blue & gold peacock design by James McNeill Whistler in 1876; Eugene & Agnes E Meyer Auditorium provides a venue for free public programs, including concerts of Asian music & dance, films, lectures, chamber music & dramatic presentations; Average Annual Attendance: 500,000
Income: Financed by endowment, federal appropriation, gifts & purchases
Special Subjects: American Western Art, Ceramics, Manuscripts
Collections: James McNeill Whistler Collection; art from China, Japan, Korea, South & Southeast Asia & the Near East; Buddhist sculpture; Chinese paintings; Indian & Persian manuscripts; Japanese folding screens; Korean ceramics
Activities: Classes for adults & children; dramatic programs; docent training; teacher workshops; lect open to public, 5-6 vis lectrs per year; concerts; gallery talks; tours; films; scholarships offered; originate traveling exhibitions; museum shop sells books, magazines, original art, reproductions, prints, slides, textiles, music, ceramics & jewelry
—**Anacostia Museum,** 1901 Fort Pl SE, Washington, DC 20020.

L **National Museum of African Art,** 950 Independence Ave SW, Washington, DC 20013-7012; PO Box 37012, Washington, DC 20013-7012. Tel 202-633-4681; Fax 202-357-4879; Internet Home Page Address: www.siris.si.edu; *Librn* Janet L Stanley; *Libr Technician* Karen F Brown
Open Mon - Fri 9 AM - 5 PM; Estab 1971 to provide major resource center for African art & culture; Library is part of the Smithsonian Institution Libraries system; For reference only
Income: Financed through Smithsonian budget
Library Holdings: Auction Catalogs; Audio Tapes; Book Volumes 32,000; Clipping Files; DVDs; Exhibition Catalogs; Maps; Pamphlets; Periodical Subscriptions; Video Tapes

M **Arthur M Sackler Gallery,** Tel 202-357-4880; Fax 202-357-4911; Elec Mail arnolje@asia.si.edu; Internet Home Page Address: www.si.edu; *Dir* Milo C Beach
Open daily 10 AM - 5:30 PM, cl Christmas day; No admis fee; Estab 1987 for exhibition, research & educ on the arts of Asia; Connected by an underground exhibition space to the neighboring Freer Gallery of Art; Average Annual Attendance: 500,000
Income: Financed by endowment & federal appropriation
Special Subjects: Architecture, Drawings, Bronzes, Anthropology, Archaeology, Costumes, Ceramics, Crafts, Etchings & Engravings, Decorative Arts, Collages, Furniture, Glass, Asian Art, Antiquities-Byzantine, Coins & Medals, Calligraphy, Embroidery, Antiquities-Oriental, Antiquities-Persian, Antiquities-Egyptian, Antiquities-Roman, Enamels, Antiquities-Assyrian, Bookplates & Bindings
Collections: Arthur M Sackler Collection (ancient Near Eastern ceramics & metalware, Chinese bronzes & jades, Chinese paintings & lacquerware, sculpture from South & Southeast Asia); Vever Collection (Islamic arts of the book, 11th-19th century); arts of village India; contemporary Chinese ceramics; Indian, Chinese, Japanese & Korean paintings; 19th & 20th century Japanese prints & contemporary porcelain; photography
Publications: Asian Art & Culture, annual; Arthur M Sackler Gallery Calendar, bi-monthly
Activities: Classes for adults & children; dramatic programs; docent training; teacher workshops; lect open to public, 5-6 vis lectrs per year; concerts; gallery talks; tours; films; scholarships offered; originate traveling exhibitions; museum

shop sells books, magazines, original art, reproductions, prints, slides, jewelry, cards, gifts, ceramics, music & textiles
—**Archives of American Art,** AA-PG Bldg Smithsonian Inst, Washington, DC 20560.

L **Library,** Tel 202-357-4880; Fax 202-786-2936; *Head Librn* Lily C J Kecskes; *Librn* Kathryn D Phillips; *Librn* Reiko Yoshimura; *Archivist* Colleen Hennessey
Open to public for reference
Library Holdings: Audio Tapes; Book Volumes 65,000; Cassettes; Clipping Files; Exhibition Catalogs; Fiche; Filmstrips; Kodachrome Transparencies; Lantern Slides; Manuscripts; Memorabilia; Motion Pictures; Other Holdings Sales catalogs; Pamphlets; Periodical Subscriptions 500; Photographs; Prints; Reels; Reproductions; Slides; Video Tapes
Special Subjects: Art History, Decorative Arts, Calligraphy, Etchings & Engravings, Ceramics, Archaeology, Bronzes, Art Education, Asian Art, Bookplates & Bindings, Carpets & Rugs, Embroidery, Enamels, Flasks & Bottles, Architecture
—**Cooper-Hewitt Museum,**
See separate entry in New York, NY
—**Hirshhorn Museum & Sculpture Garden,** Seventh & Independence Aves, SW, Washington, DC 20560.
—**John F Kennedy Center for the Performing Arts,** Washington, DC 20566. Administered under a separate Board of Trustees
—**National Air & Space Museum,** Seventh & Independence Ave, SW, Washington, DC 20560.
—**National Museum of American Art,** Eighth & G Sts, NW, Washington, DC 20560.
Includes the Renwick Gallery
—**National Gallery of Art,** Constitution Ave at Fourth St NW, Washington, DC 20565.

M **National Museum of American History,** 14th St & Constitution Ave, Washington, DC 20560.
Open daily 10 AM - 5:30 PM, cl Dec 25; Estab 2004; mus shares & honors the cultural achievements of the Native Americans from North, Central & South America; Mem: Charter mem dues start at $20
Special Subjects: American Indian Art, Etchings & Engravings, Sculpture
—**National Portrait Gallery,** F St at Eighth, NW, Washington, DC 20560.
—**Arthur M Sackler Gallery,** 1050 Independence Ave SW, Washington, DC 20560.
—**Freer Gallery of Art,** Jefferson Dr at 12th St SW, Washington, DC 20560.
—**National Museum of African Art,** Washington, DC 20560.
—**National Museum of the American Indian,** 4th St & Independence Ave SW, Washington, DC 20560. Tel 202-633-1000; *Dir* Jr W Richard West
Daily 10 AM - 5:30 PM, cl Dec 25; See separate listing in New York, NY; Mem: dues Sky Meadows Circle $100, Everglades Circle $50, Riverbed Circle $35, Golden Prairie Circle $20
Collections: Wood, stone carvings & masks from the coast of NW America; Painted & quilled hides; clothing & feathered bonnets from North American Plains; pottery & basketry from Southwestern US; 18th c materials from the Great Lakes Region; C B Moore coll from Southeastern US; Navajo wearings; works on paper & canvas; funerary, religious & ceremonial objects

M **SMITHSONIAN NATIONAL MUSEUM OF AMERICAN HISTORY,** (National Museum of American History) 14th St & Constitution Ave NW, Washington, DC 20560; PO Box 37012, Rm 5110 MRC 0623 Washington, DC 20013-7012. Tel 202-357-2700; Tel 202-357-2510; Elec Mail info@si.edu; Internet Home Page Address: http://americanhistory.si.edu; *Dir* Brent D Glass
Open daily 10 AM - 5:30 PM, cl Dec 25; No admis fee; Estab 1964; The Mus, a bureau of the Smithsonian Institution, is devoted to the collection, care, study & exhibition of objects that reflect the experience of the American people; Average Annual Attendance: 5,000,000
Collections: Agriculture, armed forces, automobiles, ceramics, locomotives, musical instruments, numismatics, political history, textiles, popular culture, domestic life, technology information, electricity, science, medicine
Exhibitions: American Encounters; First Ladies: Political Role & Public Image; From Parlor to Politics: Women & Reform in America; A More Perfect Union: Japanese Americans & the United States Constitution; Field to Factory: Afro-American Migration 1915 - 1940; Information Age: People, Information & Technology; The Ceremonial Court; Engines of Change: The American Industrial Revolution 1790 - 1860; several rotating exhibitions per year; The American Presidency; A Glorious Burden; Within These Walls...; American on the Move
Publications: Exhibition brochures & catalogs; related research publications
Activities: Classes for adults & children; docent training; internship & fellowship programs; lect open to public; lending original objects of art to Smithsonian affiliated museums; museum shop sells books, magazines, reproductions, prints, souvenirs, jewelry, clothing

L **Branch Library,** 14th St & Constitution Ave NW, Washington, DC 20560. Tel 202-357-2036, 357-2414; Fax 202-357-4256; Internet Home Page Address: www.sil.si.edu; *Librn* Rhoda Ratner
Open Mon - Fri 10 AM - 5 PM; Library is part of the Smithsonian Institution Libraries system; Open to staff & vis scholars
Income: Financed through SIL budgets
Library Holdings: Book Volumes 165,000; Fiche; Periodical Subscriptions 450; Reels
Special Subjects: Decorative Arts, Photography, Graphic Design, Historical Material, Furniture, Metalwork, Carpets & Rugs, Pottery, Silver, Textiles

M **SOCIETY OF THE CINCINNATI,** Museum & Library at Anderson House, 2118 Massachusetts Ave NW, Washington, DC 20008-2810. Tel 202-785-2040; Fax 202-785-0729; Internet Home Page Address: www.thesocietyofthecincinnati.org; *Dir Library* Ellen McCallister Clark; *Deputy Dir & Cur* Emily L Schulz; *Exec Dir* Jack D Warren Jr
Museum open Tues-Sat 1-4PM; library open Mon - Fri 10AM-4PM by appointment; No admis fee; Museum estab 1938. Serves as the National Headquarters Museum & Library of the Society of the Cincinnati. Collects, preserves & interprets the history of American Revolution, the society of Cincinnati & Anderson House & its occupants; Historic house museum of Anderson House, a 1905 beaux-arts mansion & the Winter residence of Larz

Anderson III & his wife Isabel Weld Perkins from 1905-1937. One temp exhib gallery displays two changing exhib each yr; Average Annual Attendance: 8,000
Library Holdings: Auction Catalogs; Book Volumes; CD-ROMs; Clipping Files; Compact Disks; DVDs; Exhibition Catalogs; Fiche; Manuscripts; Maps; Memorabilia; Original Documents; Pamphlets; Periodical Subscriptions; Photographs; Prints; Video Tapes
Special Subjects: Decorative Arts, Drawings, Etchings & Engravings, Historical Material, Metalwork, Painting-American, Prints, Silver, Textiles, Manuscripts, Maps, Painting-British, Painting-European, Painting-French, Painting-Japanese, Tapestries, Graphics, Sculpture, Watercolors, Bronzes, Costumes, Religious Art, Ceramics, Portraits, Posters, Furniture, Glass, Jade, Jewelry, Porcelain, Oriental Art, Asian Art, Carpets & Rugs, Ivory, Coins & Medals, Baroque Art, Miniatures, Renaissance Art, Dioramas, Period Rooms, Antiquities-Roman, Military Art, Bookplates & Bindings
Collections: Original furnishings & collections of Larz & Isabel Anderson & objects related to the history of the Society of the Cincinnati & the American Revolution; the history of the art of war in the 18th century
Exhibitions: Temporary exhibitions change every six months; (10/14/2006-04/25/2007) North Carolina in the American Revolution
Publications: Why America Is Free: The Insignia of the Society of the Cincinnati by Minor Myers, Jr (1998); Exhibition catalogs & brochures; Liberty without Anarchy: A History of the Society of the Cincinnati (2004)
Activities: Docent training; lect open to public, 4-8 vis lectr per year; concerts; tours; Clement Ellis Conger Internship; Mass Society of the Cincinnati Internship; Cox Book Prize given every 3 yrs to author of distinguished work of American history in era of American Revolution; lends original object of art to qualified mus & other institutions; museum shop sells books, note cards & Anderson Hauge ornament

SPECIAL LIBRARIES ASSOCIATION
For further information, see National and Regional Organizations

M **STUDIO GALLERY,** 2108 R St NW, Washington, DC 20008. Tel 202-232-8734; Elec Mail info@studiogallerydc.com; Internet Home Page Address: www.studiogallerydc.com; *Co-Chmn* Micheline Frank; *Co-Chmn* Harriet Lesser; *Dir* Lana Lyons; *Treas* Stanley Wenowr
Open Wed - Sat 11 AM - 5 PM, Sun 1 - 5 PM; No admis fee; Estab 1964 as a showcase for local artists; Fine contemporary art; Average Annual Attendance: 20,000; Mem: 30; dues $1400; monthly meetings
Income: Nonprofit
Activities: Outreach programs; yoga nights; lect open to public; gallery talks; individual paintings & original works of art lent

M **SUPREME COURT OF THE UNITED STATES,** US Supreme Court Bldg, One First St NE Washington, DC 20543. Tel 202-479-3298; Fax 202-479-2926; Internet Home Page Address: www.supremecourtus.gov; *Visitor Prog Coordr* Tricia Brooks; *Photograph Coll Mgr* Franz Jantzen; *Coll & Exhibits Coordr* Matthew Hostedt; *Photographer* Steve Petteway; *Colls Mgr* Mary Van Balgooy; *Assoc Cur* Matthew Hostedt; *Cur* Catherine Fitts
Open Mon - Fri 9 AM - 4:30 PM, cl federal holidays; No admis fee; Curator's Office estab 1973; Three exhibit spaces on ground floor; portrait collection displayed on ground floor & in restricted areas of the building; Average Annual Attendance: 1,000,000
Library Holdings: Audio Tapes; Clipping Files; Manuscripts; Memorabilia; Original Art Works; Original Documents; Photographs; Prints; Records; Sculpture; Slides; Video Tapes
Collections: Portraits of all former Justices throughout history; marble busts of the Chief Justices and certain Associate Justices; historic images such as photos, etchings & drawings of the Justices & the architecture of the building; memorabilia, archival & manuscript materials on the Supreme Court history; 18th & 19th centuries American & English furniture & decorative arts
Exhibitions: Permanent & temporary exhibits
Publications: Exhibit brochures
Activities: Lect in the courtroom every hour on the half hour open to pub; continuously running film describing the functions of the Supreme Court; tours; individual paintings & original objects of art lent to museums & historical organizations; museum shop operated by Supreme Court Historical Society sells gift items, books & reproductions

M **THE TEXTILE MUSEUM,** (Textile Museum) 2320 S St NW, Washington, DC 20008-4088. Tel 202-667-0441; Fax 202-483-0994; Elec Mail info@textilemuseum.org; Internet Home Page Address: www.textilemuseum.org; *Pres & Bd Trustees* David Fraser; *Dir* Ursula E McCracken; *Cur Western Hemisphere* Ann P Rowe; *Dir Mktg & Communications* Rachel Bucci; *Assoc Cur Eastern Hemisphere* Sumru Belger Krody
Open Mon - Sat 10 AM - 5 PM, Sun 1 - 5 PM; No admis fee, suggested contribution $5; Estab 1925 to further the understanding of mankind's creative achievements in textile arts; Mus is devoted exclusively to the handmade textile arts; Average Annual Attendance: 35,000; Mem: 4000; dues Mid-Atlantic & foreign $50, national $45, students $25
Income: Financed by endowment, mem & grants
Library Holdings: Auction Catalogs; Book Volumes; Cassettes; Exhibition Catalogs; Kodachrome Transparencies; Lantern Slides; Pamphlets; Periodical Subscriptions; Slides; Video Tapes
Special Subjects: Textiles, Carpets & Rugs
Collections: Collection of oriental carpets including, Caucasian, Chinese, Egyptian (Mamluk), Persian, Spanish & Turkish; Collections of African, Chinese, Coptic, India, Indonesian, Islamic, pre-Columbian Peruvian & 20th century ethnographic textiles
Publications: The Textile Museum Bulletin, quarterly membership newsletter; The Textile Museum Journal, semiannual
Activities: Workshops for adults & children; seminars & demonstrations; docent training; family programming; lect open to public, 50 vis lectrs per year; gallery talks; tours; individual textiles & original objects of art lent; originate traveling exhibitions; museum shop sells books, magazines, original art, ethnographic textiles, jewelry & one of a kind items

L **Arthur D Jenkins Library of Textile Arts,** 2320 S St NW, Washington, DC 20008. Tel 202-667-0441; Fax 202-483-0994; Elec Mail mmallia@textile.museum.org; Internet Home Page Address: www.textile.museum.org; *Librn* Mary Mallia; *Libr Asst* Doris P. Hendersho
Open Wed - Fri 10 AM - 2 PM, Sat 10 AM - 4 PM; None; Estab 1925 as a reference library dealing with ancient & ethnographic textiles & rugs of the world
Income: Financed by endowment, mem & gifts
Library Holdings: Auction Catalogs; Book Volumes 20,000; CD-ROMs; Cassettes; Clipping Files; DVDs; Exhibition Catalogs; Manuscripts; Pamphlets; Periodical Subscriptions 164; Photographs; Slides; Video Tapes
Special Subjects: Art History, Decorative Arts, Crafts, Archaeology, Art Education, Asian Art, American Indian Art, Anthropology, Costume Design & Constr, Afro-American Art, Carpets & Rugs, Embroidery, Antiquities-Assyrian, Antiquities-Byzantine, Architecture
Collections: Art, Costume, Cultural History; Rugs, Costumes & Textiles of the traditional Cultures of the Americas, Asia, Africa, the Middle East & the Pacific Rim; Textile processes; fashion
Publications: Annual Bibliography of Textile Literature (copublished by the Textile Mus & Textile Soc of Am)

L **TRINITY COLLEGE LIBRARY,** 125 Michigan Ave NE, Washington, DC 20017. Tel 202-884-9350; Fax 202-884-9362; Elec Mail trinitylibrary@trinitydc.edu; Internet Home Page Address: www.library.trinitydc.edu; *Pub Svcs* Merlyn Drummond; *Periodicals* Doris Gruber; *Dir* Susan Craig
Open during school semesters, Mon - Thurs 9 AM - 11 PM, Fri 9 AM - 7 PM, Sat 9 AM - 6 PM, Sun Noon - 10 PM; Estab 1897 as an undergraduate college library, serving the college community
Income: $253,548 (financed by college budget)
Library Holdings: Book Volumes 200,000; Cassettes; Periodical Subscriptions 600; Reels; Slides

M **UNITED STATES CAPITOL,** Architect of the Capitol, Washington, DC 20515. Tel 202-228-1222; Fax 202-228-4602; Internet Home Page Address: www.aoc.gov; *Architect of the Capitol* Alan M Hantman; *Cur* Dr Barbara A Wolanin; *Photo Branch* Michael Dunn; *Registrar* Pamela Violante McConnell
Open daily 9 AM - 4:30 PM; No admis fee; Cornerstone layed 1793. Capitol is working building with mus value; Restored historic chambers; paintings & sculptures scattered through rooms & halls of Congress; reference library; Average Annual Attendance: 1,500,000
Income: Financed by United States Congressional appropriation & appropriate donations
Library Holdings: Book Volumes
Special Subjects: Architecture, Painting-American, Prints, Sculpture, Watercolors, Bronzes, Etchings & Engravings, Landscapes, Decorative Arts, Manuscripts, Portraits, Restorations, Period Rooms, Stained Glass
Collections: Works by Andrei, Brumidi, Crawford, Cox, Franzoni, French, Greenough, Leutze, Peale, Powers, Rogers, Trumbull, Vanderlyn, Weir; 800 paintings & sculptures, manuscripts, 70,000 photographs & 120,000 architectural drawings; The Nat Statuary Hall Collection
Exhibitions: Capital Visitor Center, changes periodically.; Congressional Student Annual Exhibition
Publications: Constantino Brumidi, History of the United States Capitol
Activities: US Capitol Guide Service tours; fellowships

A **UNITED STATES COMMISSION OF FINE ARTS,** National Building Museum Ste 312, 441 F St NW Washington, DC 20001. Tel 202-504-2200; Fax 202-504-2195; Elec Mail fine-arts@os.coi.gov; *Secy* Charles H Atherton
Open Mon - Fri 9 AM - 5 PM; Estab by Act of Congress in 1910 to advise the President, members of congress & various governmental agencies on matters pertaining to the appearance of Washington, DC. The Commission of Fine Arts is composed of seven members who are appointed by the President for four-year terms. Report issued periodically, principally concerned with architectural review; Plans for all new projects in the District of Columbia under the direction of the Federal & District of Columbia Governments which affect the appearance of the city & all questions involving matters of design with which the Federal Government may be concerned must be submitted to the Commission for comment & advice before contracts are made. Also gives advice on suitability of designs of private buildings in certain parts of the city adjacent to the various departments & agencies of the District & Federal Governments, the Mall, Rock Creek Park & Georgetown
Income: Financed by annual appropriations enacted by Congress
Publications: 15 publications on area architecture, 1964-1978; Commission of Fine Arts, 1910-1985

UNITED STATES DEPARTMENT OF THE INTERIOR
For further information, see National and Regional Organizations

M **UNITED STATES DEPARTMENT OF THE INTERIOR MUSEUM,** 1849 C St NW, MS-1024, Dept of the Interior Washington, DC 20240. Tel 202-208-4743; Fax 202-208-1535; Internet Home Page Address: www.doi.gov/museum/; *Museum Specialist* Anne James; *Museum Specialist* Kim Robinson; *Museum Cur* Debra Berke
Open Mon - Fri 8:30 AM - 4:30 PM, cl federal holidays; some areas require reservations to view artwork; No admis fee; Estab 1938 to explain through works of art & other media the history, aims & activities of the Department; Museum occupies one wing on the first floor of the Interior Department Building; Average Annual Attendance: 26,000
Income: Federally funded
Special Subjects: Painting-American, Sculpture, Watercolors, Eskimo Art
Collections: Colburn Collection of Indian basketry; collection of Indian, Eskimo, South Sea Islands & Virgin Islands arts & crafts, documents, maps, charts, etc; Gibson Collection of Indian materials; Indian arts & crats; murals; dioramas of Interior history scenes; oil paintings of early American survey teams by William Henry Jackson; watercolor & black & white illustrations; wildlife paintings by Walter Weber
Exhibitions: Changing exhibits gallery at museum entrance has new exhibits every three months; Permanent exhibits include: Overview of Interior history &

activities; architectural history of the headquarters building; interpretation of a turn of the century totem pole
Activities: Educ dept; lect open to public, 10-12 vis lectrs per year; gallery talks; tours

M **UNITED STATES NAVY,** Art Gallery, 805 Kidder Breese SE, Washington Navy Yard Washington, DC 20374-5060. Tel 202-433-3815; Fax 202-433-5635; Internet Home Page Address: www.history.navy.mil; *Cur* Gale Munro
Open Mon - Fri 9 AM - 3 PM; No admis fee; Estab 1800 to document history of US Navy & Naval personnel; Average Annual Attendance: 3,000
Income: Financed by Naval Historical Center
Special Subjects: Painting-American, Prints, Watercolors, Woodcuts, Etchings & Engravings, Posters, Marine Painting, Cartoons, Military Art
Collections: Graphic arts, paintings, sketches; Sculptures
Exhibitions: US Naval History; Traveling Exhibits
Publications: United States Navy Combat Art
Activities: Internships; individual paintings & original objects of art lent to AAM accredited museums & US military museums officially recognized by their service; originate traveling exhibition; sales shop sells reproductions, prints, slides & brochures

A **UNITED STATES SENATE COMMISSION ON ART,** United States Capitol Bldg, Rm S-411, Washington, DC 20510-7102. Tel 202-224-2955; Fax 202-224-8799; Elec Mail curator@sec.senate.gov; Internet Home Page Address: www.senate.gov/curator/collections.htm; *Chmn* Trent Lott; *VChmn* Thomas A Daschle; *Assoc Dir* Melinda K Smith; *Museum Specialist* Richard L Doerner; *Admin* Scott M Strong; *Cur* Diane Skvarla; *Staff Asst* Clare Colgrove; *Historic Preservation Off* Kelly Steele; *Assoc Registrar* Jamie Arbolino; *Registrar* Deborah Wood
Rooms in Capitol under jurisdiction of Commission are open daily 9 AM - 4:30 PM; No admis fee; Commission estab 1968 to acquire, supervise, hold, place & protect all works of art, historical objects & exhibits within the Senate wing of the United States Capitol & Senate Office Buildings; Average Annual Attendance: 3,000,000
Income: Financed by United States Senate appropriation
Collections: Paintings, sculpture, historic furnishings & memorabilia located within the Senate wing of the Capitol & Senate Office Buildings; Preservation Projects: Old Senate & Old Supreme Court Chamber restored to their appearances 1850
Exhibitions: Senate Art & Stamps; The Supreme Court of the United States, the Capitol Years 1801-1935; Isaac Bassett, The Venerable Doorkeeper, 1831-1895; The Political Cartoons from Puck
Publications: The Senate Chamber 1810-1859; The Supreme Court Chamber 1810-1860; A Necessary Fence: The Senate's First Century; An Assembly of Chosen Men: Popular Views of the Senate's Chambers 1847-1886; U S Senate graphic Arts Collection: An Illustrated Checklist; Beumidi Corridor; Vice Presidential Bust Collection

L **Reference Library,** United States Capitol Bldg, Rm S-411, Washington, DC 20510-7102. Tel 202-224-2976; Elec Mail curator@sec.senate.gov; Internet Home Page Address: senate.gov/curator/index.html;
Open daily 9 AM - 4:30 PM; A reference collection on fine & decorative arts; supplemented by the United States Senate Library
Income: $1000 (financed by United States Senate appropriation to the Commission)
Library Holdings: Book Volumes 250,000; Cards; Clipping Files; Exhibition Catalogs; Manuscripts; Memorabilia; Pamphlets; Periodical Subscriptions 30; Photographs; Slides
Special Subjects: Decorative Arts, Architecture

M **US DEPARTMENT OF STATE,** Diplomatic Reception Rooms, 2201 C St NW, Washington, DC 20520. Tel 202-647-1990, Tour Reservations: 202-647-3241; Fax 202-647-3428, Tour Fax 202-647-4231; Internet Home Page Address: www.state.gov; *Dir* Gail F Serfaty
Open for three public tours by reservations only Mon - Fri 9:30 AM, 10:30 AM & 2:45 PM; No admis fee; Estab 1961 to entertain foreign dignitaries; These rooms allow foreign & American visitors to view furniture & art of the American & Federal periods. Furnished in 18th & early 19th Century American furniture, silver, Chinese export porcelain, antique Oriental rugs, American portraits & paintings, Tour Mon - Fri; Average Annual Attendance: 100,000
Income: Financed by private donations, foundation & corporate grants & loans of furnishings & paintings
Special Subjects: Painting-American, Furniture, Porcelain, Silver, Carpets & Rugs
Collections: American furniture 1740-1825; American portraits & paintings; American silver; Chinese export porcelain
Exhibitions: Rotating exhibits
Publications: Treasures of the US Dept of State; PBS documentary film: America's Heritage

WASHINGTON SCULPTORS GROUP
For further information, see National and Regional Organizations

M **WESLEY THEOLOGICAL SEMINARY HENRY LUCE III CENTER FOR THE ARTS & RELIGION,** (Wesley Theological Seminary Center for the Arts & Religion) Dadian Gallery, 4500 Massachusetts Ave, NW, Washington, DC 20016. Tel 202-885-8674; Fax 202-885-8683; Elec Mail dsokolove@wesleysem.edu; Internet Home Page Address: www.luceartsandreligion.org; *Cur* Deborah Soklove; *Dir* Catherine Kapinan; *Program Admin* Dennis Crolley
Open Mon - Fri 11 AM - 5 PM; No admis fee; Estab 1989 to provide visual demonstration of intrinsic relationship between art & religion; Average Annual Attendance: 5,000
Income: $50,000 (financed by gifts & grants, subsidized partly by parent institution)
Activities: Classes for adults; dramatic programs; poetry readings; dance & music concerts; lect open to public, 5 vis lectrs per year; gallery talks; lending collection contains paintings & art objects; book traveling exhibitions; originate traveling exhibitions

M **WHITE HOUSE,** 1600 Pennsylvania Ave NW, Washington, DC 20502. Tel 202-456-2550; Fax 202-456-6820; *Cur* William G Allman; *Asst Cur* Lydia Tederick; *Coll Mgr* Donna Hayashi-Smith
Open Tues - Sat 10 AM - 12:30 PM, cl Sun, Mon & most holidays. Passes must be requested from your Congress Person along with security information. Date of Birth and SS# must be submitted.; No admis fee
Income: Financed by federal government appropriation
Special Subjects: Architecture, Painting-American, Prints, Sculpture, Decorative Arts, Manuscripts, Portraits, Furniture, Glass, Porcelain, Metalwork, Historical Material, Period Rooms
Collections: 18th & 19th century period furniture; 18th, 19th & 20th century paintings & prints; glassware; manuscripts; porcelain
Publications: Art in the White House: A Nation's Pride; The First Ladies; The Living White House; The President's House: A History; The Presidents of the United States; White House Glassware: Two Centuries of Presidential Entertaining; The White House: An Historic Guide; White House History, magazine; The White House: Historic Furnishings & First Families

M **WOODROW WILSON HOUSE,** 2340 S St, NW, Washington, DC 20008. Tel 202-387-4062; Fax 202-483-1466; Elec Mail sandrews@woodrowwilsonhouse; Internet Home Page Address: www.woodrowwilsonhouse.org; *Ex Dir* Frank J Aucella; *Cur* Margaret Nowack
Open Tues - Sun 10 AM - 4 PM, cl Mon; Admis adults $5, students & seniors $4, National Trust members free; Estab 1963, owned by the National Trust for Historic Preservation, it works to foster interest & appreciation of the 28th President, Woodrow Wilson; Wilson House is a 1915 Georgian-Revival townhouse designed by Waddy B Wood, with formal garden. From 1921 it served as the home of President & Mrs Wilson; Average Annual Attendance: 16,000; Mem: 350; dues $50 & up
Income: Financed by endowment, mem, admis, sales & fundraising
Special Subjects: Architecture, Painting-American, Decorative Arts, Furniture, Historical Material, Period Rooms
Collections: Early 20th century art, furnishings, clothing; presidential memorabilia; decorative arts
Publications: Woodrow Wilson News, quarterly
Activities: Lect open to public; 5-6 vis lectrs per yr; concerts; tours; individual paintings & objects of art lent to qualified museums; museum shop sells books, reporductions, prints & slides

FLORIDA

BAY LAKE

M **DISNEY'S ANIMAL KINGDOM THEME PARK,** 1200 N Savannah Circle E, Bay Lake, FL 32830; PO Box 10000, Lake Buena Vista, FL 32830. Tel 407-939-6382; Fax 318-939-6240; Internet Home Page Address: www.disneyworld.com; *VPres* Elizabeth Stevens, PhD; *Dir Animal Progs* Jackie Ogden, PhD; *Dir Animal Operations* John Lehnhardt; *Dir Veterinary Svcs* Mark Stetter, DVM; *Dir Educ & Sci* Jill Mellen, PhD; *Dir Engineering Svcs* Steve Burns
Open summer 9 AM - 6 PM, Winter 9 AM - 5 PM; Admis adults & seniors $58.31, children ages 3 - 9 $46.60; Estab 1995, opened 1998; 500-acre Zoological Theme Park dedicated to humanity's enduring love of animals & nature. A large portion of the park exhibits wildlife in naturalistic habitats
Library Holdings: Book Volumes; Periodical Subscriptions; Video Tapes
Collections: Over 350 species of mammals, birds, reptiles, amphibians, invertebrates & fish; Home to 4 million trees, plants, shrubs, vines, grasses & ferns representing over 3,000 species; Kilimanjaro Safaris: an exciting expedition through a habitat like the African Savanna in an open-air vehicle; Dinoland USA: Boneyard attraction in which children can crawl through a play maze built around the fossil remains of Triceratops, T-Rex, and other vanished giants
Publications: Weekly brochures
Activities: Educ prog for adults & children; lects & guided tours; ann events for Earth Day, Plant Conservation Day & International Migratory Bird Day; 12 merchandise areas; restaurants on-site

BOCA RATON

A **BOCA RATON MUSEUM OF ART,** Mizner Pk, 501 Plaza Real Boca Raton, FL 33432. Tel 561-392-2500; Fax 561-391-6410; Elec Mail info@bocamuseum.org; Internet Home Page Address: www.bocamuseum.org; *Pres* Joseph Borrow; *Exec Dir* George S Bolge; *Sr Cur* Wendy M. Blazier; *Accountant* Vivienne Wilson; *Art School Reception* Lynn Nance; *Cur Educ* Claire Clum; *Dir Art School* Rebecca Sanders; *Dir Finance* Carolyn J Benham; *Mus Shop Mgr* Barbara Mango; *Receptionist* Amy Cassaro; *Group Sales Coordr* Sharon Flynn; *Asst Exec Dir* Valerie Johnson; *Facility Mgr* Robin Archible; *Dir Develop* Louise C Adler
Open Tues, Thurs & Sat 10 AM - 5 PM, Wed & Fri 10 AM - 9 PM, Sun Noon - 5 PM, cl Mon & holidays; Admis adults $8 - $17, seniors $6 - $15, students $4 - $6, members & children under 12 free; Estab 1951 to foster & develop the cultural arts; Large Main Gallery, mus shop located in one building. Second building houses art school & storage. 4500 sq ft expansion houses a permanent collection; Average Annual Attendance: 150,000; Mem: 4300; dues single $70, family $90; annual meeting in Apr
Income: Financed by mem, fundraising, art school & grants
Library Holdings: Auction Catalogs; Book Volumes; Clipping Files; Exhibition Catalogs; Pamphlets; Slides
Special Subjects: Drawings, Etchings & Engravings, Graphics, Landscapes, Photography, Posters, Prints, Sculpture, Watercolors, Painting-American, Asian Art, Decorative Arts, Folk Art, African Art, Ceramics, Hispanic Art, Latin American Art, Portraits, Pre-Columbian Art, Islamic Art, Painting-European, Primitive art, Mexican Art

Collections: John J Mayers Collection, works by Braque, Demuth, Glackens, Matisse & Picasso; Photography from 19th century to present; African, Oceanic & Columbian art & contemporary sculpture
Exhibitions: Changes every 6-8 weeks; state-wide competition & show; annual outdoor art festival
Publications: Exhibition catalogues; quarterly member magazine
Activities: Classes for adults & children; docent training; childrens gallery educ programs, art trips; lect open to public; 5 vis lect per yr; concerts; gallery talks; tours; juried exhibition; national outdoor art festival with awards given for Best in Show & Merit; individual paintings & original objects of art lent; 6-10 book traveling exhibitions; various; museum shop sells books, original art, reproductions, prints, gift items

L **Library,** 501 Plaza Royal, Mizner Park Boca Raton, FL 33432. Tel 561-392-2500; Fax 561-391-6410; Elec Mail info@bocamuseum.org; Internet Home Page Address: www.bocamuseum.org; *Planned Giving Officer* Louise C. Adler; *Exec Dir* George Bolge; *Dir Mktg* Julie Jonsons Mullin-Kaminski; *Dir Admin* Carolyn Benham
Open Tues, Thurs & Sat 10 AM - 5 PM, Wed & Fri 10 AM - 9 PM, Sun Noon - 5 PM, cl Mon; Admis adults $8, seniors $6, students $4, for spec exhibs adults $15, seniors $12, students $7; Estab 1952; 4000+ works in permanent collection; Average Annual Attendance: 200,000; Mem: 4800
Library Holdings: Book Volumes 4000; Exhibition Catalogs; Photographs; Slides
Special Subjects: Decorative Arts, Photography, Drawings, Painting-American, Painting-British, Painting-French, Painting-German, Painting-Italian, Painting-Russian, Painting-Spanish, Sculpture, Painting-European, Watercolors, Ceramics, Painting-Israeli, Porcelain, Portraits
Collections: Contemporary Art, Pre-Columbian, Photography, Modern Masters, African, Sculpture
Publications: catalogs; bi-monthly newsletter
Activities: Classes for adults & children; docent training; art school; lect open to public, 12 vis lect per yr; concerts; gallery talks; tours; sponsoring of competitions; ann All Fla exhib awards, ann Art Fest; film & video series; scholarships offered; museum shop sells books & reproductions

M **FLORIDA ATLANTIC UNIVERSITY,** University Galleries/Ritter Art Gallery/Schmidt Center Gallery, 777 Glades Rd, Boca Raton, FL 33431. Tel 561-297-2660; 297-2966; Fax 561-297-2166; Elec Mail wfaulds@fau.edu; Internet Home Page Address: www.fau.edu/galleries; *Dir University Galleries* W Rod Faulds
Open Tues - Fri 1 PM - 4 PM, Sat 1 - 5 PM; No admis fee; Estab 1983 to present a wide range of innovative contemporary art exhibitions and related pub prog & to provide exhibit space for faculty & students; Two 2,500 sq ft spaces & public spaces for projects/installations; Average Annual Attendance: 15,000; Mem: 200
Income: Financed by Univ (state)appropriations, student activities fees & pvt/pub grants
Collections: AE Beanie Backus paintings
Exhibitions: Annual Juried Student Show; traveling exhibitions
Publications: Exhibit catalogues
Activities: Artist in residence programs with university dept of art; docent training for university art students; lect open to public; concerts; gallery talks; readings; tours; competitions with awards; book 1 - 3 traveling exhibitions per yr; traveling exhibitions organized & circulated to other university galleries

L **Library,** Tel 561-391-2200; Elec Mail imca@worldnet.att.net; *Librn* Abigail Roeloffs
Open Tues - Fri 11 AM - 6 PM, cl Mon
Income: $160,000 (financed by contributions)
Library Holdings: Book Volumes 1650; Clipping Files; Memorabilia; Motion Pictures; Photographs; Prints; Reproductions; Slides; Video Tapes
Collections: Archives collection
Activities: Celebrity Guest Cartoonist program

BRADENTON

A **ART LEAGUE OF MANATEE COUNTY,** Art Ctr, 209 Ninth St W Bradenton, FL 34205. Tel 941-746-2862; Fax 941-746-2319; Elec Mail artleague@almc.org; Internet Home Page Address: www.almc.org; *Dir* Patricia Richmond; *Pres (V)* Bill Mears
Open Sept - July Mon - Fri 9 AM - 4:30 PM, cl Aug & holidays; No admis fee; Estab 1937 to offer opportunities in further educ in the visual arts by providing space for exhibitions, classes, demonstrations, critiques & the exchange of ideas & information by vis artists; Average Annual Attendance: 25,000; Mem: 660; dues $5 & up; annual meeting in April
Exhibitions: Work by members & local artists one person shows & circulating exhibitions changing at three week intervals from Oct to May
Activities: Art school instruction in painting, drawing, clay techniques & variety of handcrafts; creative development for children; special art programs; gallery talks; sales shop sells original arts & prints

L **Library,** Art League of Manatee County, 209 Ninth St W Bradenton, FL 34205. Tel 941-746-2862; Fax 941-746-2319; *Dir* Pat Richmond; *Asst Dir* Heather O'Leary
Open Mon - Fri 9 AM - 4:30 PM; Mem: 700; dues $45+
Income: Financed by donations
Library Holdings: Book Volumes 850; Cassettes; Clipping Files; Original Art Works; Pamphlets; Photographs; Records; Slides; Video Tapes
Activities: Classes for adults & children

CLEARWATER

M **NAPOLEONIC SOCIETY OF AMERICA,** Museum & Library, 1115 Ponce de Leon Blvd, Clearwater, FL 33756. Tel 727-586-1779; Fax 727-581-2578; Elec Mail napoleonic1@juno.com; Internet Home Page Address: www.napoleonsociety.org; *Pres* Robert M Snibbe
Open 9 AM - 5 PM; No admis fee; Estab 1983; Circ 1,500 worldwide; Mem: 1000; dues $48; annual meeting in Sept
Income: $309,199 (financed by mem)

Library Holdings: Book Volumes
Special Subjects: Porcelain, Prints, Bronzes, Painting-French, Historical Material, Miniatures
Publications: Member's Bulletin, quarterly, 40pp
Activities: Lect open to public; gallery talks; fellowships; sales shop sells magazines, original art, reproductions, prints

CORAL GABLES

M **UNIVERSITY OF MIAMI,** Lowe Art Museum, 1301 Stanford Dr, Coral Gables, FL 33124. Tel 305-284-3535; Fax 305-284-2024; Internet Home Page Address: www.lowemuseum.org; *Assoc Dir* Denise Gerson; *Dir* Brian Dursum
Open Tues - Sat 10 AM - 5 PM, Sun Noon - 5 PM, Thurs Noon - 7 PM, cl Mon; Admis general $5, seniors & students $3, members, University of Miami students & children under 6 free, group rates available; Estab 1952 to bring outstanding exhibitions & collections to the community & to the University; gallery maintained; Maintains reference library; wheelchair accessible; Average Annual Attendance: 95,000
Special Subjects: American Indian Art, African Art, Pre-Columbian Art, Textiles, Decorative Arts, Oriental Art, Baroque Art
Collections: African Art; Washington Allston Trust Collection; Virgil Barker Collection of 19th & 20th Century American Art; Alfred I Barton Collection of Southwestern American Indian Art; Esso Collection of Latin American Art; Samuel H Kress Collection of Renaissance & Baroque Art; Samuel K Lothrop Collection of Guatemalan Textiles; Asian Art; Pre-Columbian; American & European Paintings; Cintas Foundation Collection of Spanish Old Master Paintings
Exhibitions: Varied, changing exhibitions throughout the year.; student exhibs; sculpture; Cuban American art
Publications: Exhibition catalogs; newsletter, bimonthly
Activities: Classes for children; docent training; lect open to public, 6 vis lectrs per year; concerts; gallery talks; tours; individual paintings & original objects of art lent to other museums; originate traveling exhibitions; museum shop sells books, magazines, ceramics, jewelry, children's art toys; decorative gifts

DADE CITY

L **PIONEER FLORIDA MUSEUM ASSOCIATION, INC,** Pioneer Florida Museum & Village, PO Box 335, Dade City, FL 33526-0335. Tel 352-567-0262; Fax 352-567-1262; Elec Mail inf@pioneerfloridamuseum.org; Elec Mail curator@pioneerfloridamuseum.org; Internet Home Page Address: www.pioneerfloridamuseum.org; *Cur* Donna Swart
Open Tues - Sat. 10 AM - 5 PM; Sun. 1 PM - 5 PM; Admis adults $5, seniors $4, students 6-18 $2; Estab 1961 to preserve & promote Pioneer life; Average Annual Attendance: 18,000; Mem: 400; dues life family $250, life individual $150, family $35, individual $25; annual meeting last Sun in Oct
Income: $80,000 (financed by endowment, mem, state approriation, special events, donations, memories & grants)
Activities: Lect open to public, vis lectr vary; tours; sales shop sell books

DAYTONA BEACH

M **DAYTONA BEACH COMMUNITY COLLEGE,** Southeast Museum of Photography, 1200 International Speedway Blvd, PO Box 2811 Daytona Beach, FL 32120-2811. Tel 386-254-4469; Fax 386-254-4487; Elec Mail millerk@dbcc.edu; Internet Home Page Address: www.smponline.org; *Dir* Kevin R Miller
Open Tues 11 AM - 7 PM & 5 - 7 PM, Wed - Fri 10 AM - 3 PM, Sun 1 - 4 PM, cl Mon; No admis fee; Estab 1992; Specialist photography museum; contemporary, historical, new media; Average Annual Attendance: 22,999; Mem: 3,000
Income: Financed by college sponsored annual budget $500,000
Special Subjects: Photography
Collections: Photographic Collection of Karsch, Chartier - Breson, Friedlander, Perlmutter

M **HALIFAX HISTORICAL SOCIETY, INC,** Halifax Historical Museum, 252 S Beach St, Daytona Beach, FL 32114. Tel 386-255-6976; Fax 386-255-7605; Elec Mail mail@halifaxhistorical.org; Internet Home Page Address: www.halifaxhistorical.org; *Pres* Sonya Watkins; *Dir* Suzanna Heddy; *First VPres* Dr Leonard Lempel; *Second VPres* Marylin Negrea; *Third VPres* Beth Mindlin; *Recording Sec* Theresa Bolton; *Corresponding Sec* Virginia Buckner; *Treas* Keith Freeman
Open Tues - Sat 10 AM - 4 PM; Admis adult $4, children 12 & under $1, children free on Sat; Estab 1949 to preserve & interpret history of the Halifax area; Two story interior. Formerly the 1910 Merchant's Bank; Average Annual Attendance: 18,000; Mem: 647; dues $25 individual, $35 family, and up; annual meeting first Thurs in Jan
Income: Financed by dues, donations, grants, gift shop, fund raising
Special Subjects: Folk Art, Pottery, Furniture
Collections: Charles Grove Burgoyne Collection; The Models of Lawson Diggett; Bill McCoy Collection; artifacts of World War II; 18th century Spanish & English artifacts; Indian arrowheads, canoe, pottery; racing memorabilia; Victorian clothing & furniture
Exhibitions: Grandma's Attic; Permanent & rotating exhibitions
Publications: Monthly newsletter; Six Columns & Fort New Smyrna; biannual publication, Halifax Herald; various pamphlets
Activities: Educ dept; lect open to public, 7 vis lectrs per year; recognition plaques; tours; book traveling exhibitions 4 per year; museum shop sells books

M **THE MUSEUM OF ARTS & SCIENCES INC,** 1040 Museum Blvd, Daytona Beach, FL 32114. Tel 386-255-0285; Fax 386-255-5040; Elec Mail wdatherholt@moas.org; Internet Home Page Address: www.moas.org; *Cur History & Science* Jan McCormick; *Cur Exhib* Richard Lussky; *Dir* Wayne David Atherholt; *Dep Dir Facilities* Steve Brozyna; *Art Cur* Gary R Libby; *Art Cur* David Swayer
Open Tues - Fri 9 AM - 4 PM, Sat & Sun Noon - 5 PM, cl national holidays & Mon; Admis $8, children & students with ID $1, museum members free; Estab

1971; 90,000 sq ft of exhibition galleries, hall gallery & lobby gallery are maintained: Mus includes Planetarium, A Frischer Sculpture Garden, Gallery of American Art, Root Hall & Gallery, Gallery of African Art, Gallery of Florida History & Prehistory of Florida Gallery. Maintains reference library, Gallery of Cuban art, Gallery of Chinese Art, Galleries of Decorative Arts; Average Annual Attendance: 240,000; Mem: 10,000; dues $50; annual meeting in Dec
Income: $2,500,000 (financed by endowment, mem, city & county appropriations, donations, earned income)
Purchases: American Art 1720-2004. American Decorative Arts, Chinese Art, Cuban Art, European Art, African Art
Library Holdings: Auction Catalogs; Book Volumes; Exhibition Catalogs; Manuscripts; Maps; Photographs; Sculpture
Special Subjects: Folk Art, Landscapes, Marine Painting, Portraits, Pottery, Pre-Columbian Art, Painting-American, Prints, Silver, Textiles, Woodcuts, Maps, Painting-British, Sculpture, Architecture, Drawings, Graphics, Hispanic Art, Latin American Art, Photography, Sculpture, Watercolors, American Indian Art, American Western Art, Bronzes, African Art, Anthropology, Archaeology, Ethnology, Religious Art, Ceramics, Primitive art, Etchings & Engravings, Afro-American Art, Decorative Arts, Manuscripts, Painting-European, Posters, Furniture, Glass, Jade, Jewelry, Porcelain, Oriental Art, Painting-Dutch, Painting-French, Carpets & Rugs, Ivory, Coins & Medals, Baroque Art, Calligraphy, Renaissance Art, Medieval Art, Antiquities-Oriental, Painting-Spanish, Painting-Italian, Antiquities-Persian, Antiquities-Greek, Gold, Stained Glass, Painting-Australian, Painting-German, Pewter, Painting-Russian, Enamels
Collections: Aboriginal Art including Florida Indian; African Art; American Art 1620-1900; American Fine Art; American Illustration: Norman Rockwell; Cuban Collection; Decorative arts including silver & furniture; Florida Contemporary Collection; Pre-Columbian Art; Chinese Art; Jewelry
Exhibitions: Center for Florida History; The Levine Collection of Gems and Jewelry; Colonial Cuba: The Lithographs of Eduardo LaPlante; Treasures from the age of Napoleon; American Paintings 1800-1900
Publications: Arts & Sciences Magazine, 4 times per year; catalogs, monthly; A Treasury of American Art; Cuba: A History in Art; Coast to Coast: Contemporary Landscape in Florida
Activities: Classes for adults and children; docent training; lect open to public, 15 vis lectrs per year; gallery talks; concerts; tours; competitions with awards; scholarships offered; exten dept serves Volusia County; artmobile individual paintings & original objects of art lent to other museums, municipalities & public spaces; lending collection contains 2000 nature artifacts, 1000 original art works, 1000 original prints, 250 paintings, 100 photographs & sculptures; book traveling exhibitions 4 per year; originate traveling exhibitions to Florida & national AAM accredited museums; museum shop sells books, magazines, original art, reproductions

L **Library,** 1040 Museum Blvd, Daytona Beach, FL 32114; 352 S Nova Rd, Candler, FL 32114. Tel 386-255-0285; Internet Home Page Address: www.moas.org; *Librn* Marge Sigerson
Tues - Fri 9 AM - 4 PM; Open to members & school children; reference library
Income: Financed by Mus
Purchases: Periodicals & reference materials
Library Holdings: Book Volumes 10,000; Clipping Files; Exhibition Catalogs; Manuscripts; Original Art Works; Periodical Subscriptions 2000; Photographs; Prints; Slides; Video Tapes
Special Subjects: Art History, Decorative Arts, Calligraphy, Drawings, Ceramics, Archaeology, American Western Art, Bronzes, Art Education, Asian Art, American Indian Art, Anthropology, Aesthetics, Afro-American Art, Architecture
Collections: Cuban: General Fulgencio Batista Collection; Antique Coin Books

DELAND

M **DELAND MUSEUM OF ART,** 600 N Woodland Blvd, Deland, FL 32720. Tel 386-734-4371; Fax 386-734-7697; Elec Mail coolidge@delandmuseum.com; Internet Home Page Address: www.delandmuseum.com; *Exec Dir* Jennifer Cooledge; *Exhibitions* David Fithian
Open Tues - Sat 10 AM - 4 PM, Sun 1 - 4 PM, cl Mon; Admis adults $5, children under 12 free; Estab 1951 to provide art educ; Lower gallery: 12 ft carpeted walls, 3100 sq ft; upper gallery: 12 ft carpeted walls, 2100 sq ft; Average Annual Attendance: 75,000; Mem: 800; dues family $50, individual $30, srs $25
Income: $600,000 (financed by mem, city & state appropriation & Volusia County & earned income & donations)
Purchases: $10,000 - $20,000
Collections: Contemporary Florida Artists 1900 - Present
Exhibitions: Rotating exhibitions
Activities: Classes for adults & children; docent programs; spring & summer art camp for children & teens; outreach; lect open to public, 10-18 vis lectrs per year; gallery talks; tours; competitions with awards; sponsor art festival; lending of original objects of art to to Arts in Public Places program; book traveling exhibitions 1 per year; originate traveling exhibitions 5 per year; retail store sells books, original art & reproductions, prints, crafts, gift items

M **STETSON UNIVERSITY,** Duncan Gallery of Art, Campus Box 8252, Deland, FL 32723. Tel 386-822-7266; Elec Mail cnelson@stetson.edu; Internet Home Page Address: www.stetson.edu/departments/art; *Dir* Dan Gunderson; *Asst Dir* Christine Nelson
Open Mon - Fri 10 AM - 4 PM, Sat & Sun 1 - 4 PM; during school year call for summer hours; cl national holidays; No admis fee; Estab 1964 as an educational gallery to augment studio teaching program; There is a large main gallery, 44 x 55 ft, with a lobby area 22 x 44 ft; Average Annual Attendance: 8,000; Mem: 50, Friends of Art Organization
Income: University art budget
Purchases: $1,000
Library Holdings: Slides; Video Tapes
Special Subjects: Drawings, Painting-American, Prints, Watercolors, Ceramics
Collections: 20th Century American Prints, Ceramics, Drawings, Oils, Watercolors
Exhibitions: Various regional & national artists exhibitions; themed group exhibitions; student juried exhibitions spring & senior thesis exhibitions; Carol Prusa, Herb Jackson, Edgow Jerins, Tania Bruguera

Publications: Art alumni archives, yearly; catalogs; seasonal exhibition announcements
Activities: Concerts; lect open to public, varied guest lectrs per year, gallery talks; student competitions with prizes

DELRAY BEACH

M **CORNELL MUSEUM OF ART & HISTORY,** 51 N Swinton Ave, Delray Beach, FL 33444. Tel 561-243-7922; Fax 561-243-7022; Elec Mail museum@old.school.org; Internet Home Page Address: www.oldschool.org; *Dir* Gloria Rejune Adams; *Mus Asst* Bill Burbank; *Prog Asst* Daphne Dowell
Open daily 10:30 AM - 4:30 PM; Admis adults $6, seniors (over 65) $4, children under 13 free, members free; Estab 1990; Average Annual Attendance: 13,000; Mem: Dues $45, family dues $60; annual meeting in Jan
Income: Grants from State of Florida; private donors; memberships, TDC, city of Delray Beach
Library Holdings: Book Volumes; Clipping Files; Exhibition Catalogs; Memorabilia; Original Art Works; Original Documents; Pamphlets; Periodical Subscriptions; Photographs; Sculpture; Slides
Special Subjects: Photography, Pre-Columbian Art, Painting-American, Painting-British, Painting-European, Drawings, Sculpture, American Indian Art, Bronzes, African Art, Folk Art, Etchings & Engravings, Furniture, Painting-Spanish, Antiquities-Etruscan
Collections: Small permanent collection
Exhibitions: Fotofusion; Inspirations 2001; Holiday Designer Vignettes; Quilt 21; All Florida juried exhib
Publications: Quarterly newsletter
Activities: Classes for adults & children; docent training; lect open to public; 6 vis lects per year; concerts; gallery talks; tours; Florida cultural institutions program award; scholarships offered; lending collection available; museum shop sells books, original art, reproductions, prints, slides, jewelry, pottery

M **PALM BEACH COUNTY PARKS & RECREATION DEPARTMENT,** Morikami Museum & Japanese Gardens, 4000 Morikami Park Rd, Delray Beach, FL 33446. Tel 561-495-0233; Fax 561-499-2557; Elec Mail morikami@co.palm-beach.fl.us; Internet Home Page Address: www.morikami.org; *Cur* Thomas Gregersen; *Dir Educ* Reiko Nishioka; *Museum Store Mgr* Sallie Chisolm; *Admin Assoc* Debbie Towers; *Horticulture Supv* Anthony Cleckley; *Coll Cur* Noelle Altamirano; *Dir* Larry Rosensweig; *Dir Mktg* Erin Molloy; *Adminr* Bonnie White Lemay; Faye Morin
Open Tues - Sun 10 AM - 5 PM, cl Mon & holidays; Admis adults $9, seniors $8, children 6-18 $5; Estab 1977 to preserve & interpret Japanese culture & Japanese-American culture; Five small galleries in Japanese style bldg & two larger galleries in main museum bldg; Average Annual Attendance: 150,000; Mem: 2700; dues $50; annual meeting Apr
Income: $3,500,000 (financed by mem & county appropriation)
Purchases: $9000
Library Holdings: Auction Catalogs; Book Volumes; Clipping Files; Exhibition Catalogs; Periodical Subscriptions
Special Subjects: Porcelain, Graphics, Photography, Anthropology, Ethnology, Costumes, Crafts, Folk Art, Pottery, Woodcuts, Decorative Arts, Painting-Japanese, Dolls, Asian Art, Historical Material
Collections: Archived collections pertaining to the Yamato Colony; Japanese Fine Arts (hanging scrolls, folding screens, paintings, textiles, prints, ceramics); Japanese Folk Arts (dolls, tools, home furnishings, folk figures, miniature buildings, toys)
Exhibitions: Ningyo: Antique Japanese Dolls, Japanese Folk Art from Mitzie Verne Coll
Publications: Newsletter, quarterly; Calendar bi-monthly; Exhibition catalogs 1-2 per yr
Activities: Classes for adults & children; docent training; lect for mem only; 4-6 vis lectr per yr; concerts; tours; book traveling exhibitions, 2-3 per yr; originate traveling exhibitions; museum shop sells books, magazines, reproductions, prints & slides

L **Donald B Gordon Memorial Library,** Morikami Museum, 4000 Morikami Park Rd Delray Beach, FL 33446. Tel 561-495-0233; Fax 561-499-2557; Elec Mail morikami@co.palm-beach.fl.us; Internet Home Page Address: www.morikami.org; *Coll Cur* Noelle Shuey Altamirano
Open by appointment Tues - Sun 10 AM - 5 PM, cl Mon & holidays; Admis adult $9, seniors $8, children 6-18 & college students $6, mems & children under 6 free; Estab 1977 to provide printed & recorded materials on Japan; For reference only; Average Annual Attendance: 250,000; Mem: 2300. Dues based on tiered levels
Income: Financed by donations
Purchases: $1000
Library Holdings: Auction Catalogs; Book Volumes 4500; Clipping Files; Exhibition Catalogs; Periodical Subscriptions 25
Special Subjects: Art History, Folk Art, Decorative Arts, Film, Photography, Calligraphy, Commerical Art, Drawings, Etchings & Engravings, Graphic Arts, Painting-Japanese, Prints, Sculpture, Historical Material, Ceramics, Crafts, Ethnology, Asian Art, Porcelain, Anthropology, Furniture, Ivory, Costume Design & Constr, Antiquities-Oriental, Dolls, Enamels, Miniatures, Oriental Art, Pottery, Religious Art, Textiles, Architecture
Collections: Memorabilia of George S Morikami
Exhibitions: Permanent exhib on Yamato colony and authentic tea house
Publications: My Morikami, published 3 times per year
Activities: Classes for adults & children; docent training; guided tours; outreach programs; lect. open to public; 2 vis lectrs per year; gallery talks; tours; museum shop sells books, magazines, reproductions, jewelry, textiles, children's items, decorative items

FORT LAUDERDALE

L **ART INSTITUTE OF FORT LAUDERDALE,** Technical Library, 1799 SE 17th St, Fort Lauderdale, FL 33316. Tel 954-463-3000, Ext 541; Fax 954-463-1339; Internet Home Page Address: www.artinstitute.edu; *Library-LRC Dir* Diane Rider; *Librn* Rick Fought; *Assoc Dir* Art McKinney
Open Mon - Thurs 8 AM - 8 PM, Fri 8 AM - 5 PM; Estab 1973 as a techinical library for the applied & fine arts

Purchases: $8000
Library Holdings: Audio Tapes; Book Volumes 1200; Cassettes 50; Clipping Files 2000; Filmstrips; Kodachrome Transparencies; Motion Pictures; Periodical Subscriptions 157; Video Tapes 600
Activities: Educ dept; lect open to public; competitions; scholarships & fels offered; sales shop sells books, prints & supplies
Courses: Picture Files

A **BROWARD COUNTY BOARD OF COMMISSIONERS,** Cultural Affairs Div, 100 S Andrews Ave, Fort Lauderdale, FL 33301. Tel 954-357-7457; Fax 954-357-5769; Internet Home Page Address: www.co.broward.fl.us/arts.htm; *Asst Dir* Duane Sinclair; *Admin Asst* Will E Groves; *Public Serv Intern* James Sherman; *Pub Art & Design Asst* Doris Brown Penn; *Grants Adminr* Sara Nickels; *Grants Financial Analyst* Karen Smith; *Grants Asst* Greta Penenori; *Mktg Adminr* Jody Horne-Leshinsky; *Mktg Intern* Yvette Buzard; *FAU Marketing Intern* Marianne Schmandt; *Dir* Mary A Becht
Estab 1976 to enhance the cultural environment of Broward County through development of the arts; develops & distributes government & private resources for the visual arts, performing arts, literary arts, museums & festivals; acts as the liaison between cultural organizations, all levels of government & the private sector in incouraging & promoting cultural development
Publications: Annual Calendar; Arts Education Directory; Cultural Directory; Cultural Quarterly; Cultural Treasures of Broward County Brochure; Voices & Venues Newsletter, bi-monthly
Activities: schols & grants offered

M **MUSEUM OF ART, FORT LAUDERDALE,** One E Las Olas Blvd, Fort Lauderdale, FL 33301-1807. Tel 954-525-5500; Fax 954-524-6011; Elec Mail glenmiller@yahoo.com; Internet Home Page Address: www.museumofart.org; *Cur Coll* Jorge Santis; *Exec Dir* Dr Kathleen Harleman; *Dir Develop* Linda Nadler; *Dir Mktg & Pub Relations* Glen Miller; *Cur Educ* Fran Mulcahey; *Dir Visitor Servs* Lynn Mandeville
Open Tues - Sat 10 AM - 9 PM, Sat 10 AM - 5 PM, Sun Noon - 5 PM, cl Mon & national holidays; Admis non-members $12, seniors 65 & over $8, student with identification card $6, children 5-18 $2, members & children under 5 free; Estab 1958 to bring art to the community & provide cultural facilities & programs; Library, exhibit space & auditorium are maintained; Average Annual Attendance: 100,000; Mem: 3500; dues professional $5000, $2500 & $1000, benefactor $1000, patron $500, contributing $250, sustaining $125, family-dual $65, individual $50
Income: financed by public grants, private philanthropy
Library Holdings: Book Volumes; Exhibition Catalogs; Pamphlets; Periodical Subscriptions; Prints; Slides
Special Subjects: Pre-Columbian Art, Painting-American, Period Rooms, Sculpture, Graphics, Latin American Art, Painting-American, Sculpture, Ceramics, Primitive art, Painting-Dutch
Collections: Golda & Meyer B Marks Cobra Art Collection; William Glackens Collection; American & European paintings, sculpture & graphics from late 19th century-present; pre-Columbian & historic American Indian ceramics, basketry & stone artifacts; Modern Cuban Collection; West African tribal sculpture; Warhol, Picasso, Dali
Publications: quarterly newsletter, season calendar
Activities: Educ program; classes for children; docent training; slide lect program in schools by request; lect open to public, 3 vis lects per year; gallery talks; tours; films; competitions; individual paintings & original objects of art lent to other museums; mus shop sells books, original art, reproductions, prints

L **Library,** One E Las Olas Blvd, Fort Lauderdale, FL 33301-1807. Tel 954-525-5500; Fax 954-524-6011; Elec Mail museumofart@hotmail.com; Internet Home Page Address: www.museumofart.org; *Cur Educ* Fran Mulcahy; *Dir of Develop* Lynn Mandeville; *Dir Finance* Robert Granson
Open Tues - Sat 10 AM - 5 PM, Sun Noon - 5 PM; Founded 1958; 35,000 sq ft gallery space
Library Holdings: Book Volumes 7500; Periodical Subscriptions 15; Slides
Collections: William Glackens; Cobra; Contemporary Cuban Collections
Activities: Classes for adults & children; docent training; lect open to public; organize traveling exhibitions; mus shop sells books & novelty items

M **MUSEUM OF DISCOVERY & SCIENCE,** 401 SW Second St, Fort Lauderdale, FL 33312-1707. Tel 954-467-6637; Fax 954-467-0046; Internet Home Page Address: www.mods.org; *Pres* Kim L Cavendish
Open Mon - Fri 10 AM - 5 PM, Sat 10 AM - 8:30 PM, Sun Noon - 5 PM, cl Christmas Day, open on all other holidays; Blockbuster IMAX Theater open Mon - Sun with daily showings; Admis adults $9, seniors $8, children 3-12 $7, special group rates available; Estab 1977 to increase science literacy; Average Annual Attendance: 534,000; Mem: 5500; dues $75; annual meeting in Sept
Income: $5,500,000
Special Subjects: Graphics, Prints
Exhibitions: Choose Health; Florida EcoScapes; Gizmo City; Great Gravity Clock; KidScience, No Place Like Home; Science Fair; Sound; Space Base; Runways to Rockets; Living in the Everglades
Publications: Explorations, quarterly
Activities: Classes for adults & children; camps; sleepovers; outreach programs; films daily; docent training; lect open to public, some to members only, 8-10 vis lectrs per year; gallery talks; tours; book traveling exhibitions 5 per year; originate traveling exhibitions to other museums; museum shop sells books, original art, reproductions, prints & science related activities

FORT MYERS

M **EDISON COMMUNITY COLLEGE,** Gallery of Fine Art, 8099 College Pky, PO Box 60210 Fort Myers, FL 33906. Tel 941-489-9313; Fax 941-489-9482; Elec Mail RBishop@Edison.edu; *Cur & Dir* Ron Bishop
Open Tues - Fri 10 AM - 4 PM, Sat 11 AM - 3 PM, Sun 1 - 5 PM; No admis fee; Estab 1979 to provide exhibitions of national & regional importance & related educational programs; Main gallery 2000 sq ft, high security; adjunct performing arts hall gallery; Average Annual Attendance: 15,000
Income: Financed by endowment & state appropriation

Exhibitions: Rotating exhibits
Activities: Tours for adults & children; docent training; lect open to public, 2 - 4 vis lectrs per year; gallery talks; scholarships & fels offered; book traveling exhibitions 2 - 4 per year; originate traveling exhibitions to other museums in Florida; sales shop sells posters & catalogs

GAINESVILLE

M **CITY OF GAINESVILLE,** Thomas Center Galleries - Cultural Affairs, PO Box 490, Sta 30, Gainesville, FL 32602; 302 NE Sixth Ave, Bldg A, Gainesville, FL 32061. Tel 352-334-5064; Fax 352-334-2146; Internet Home Page Address: www.gvlculturalaffairs.org; *Mgr* Coni Gesualdi; *Gallery Coordr* Erin Friedberg
Open Mon - Fri 9 AM - 5 PM, Sat & Sun 1 - 4 PM; No admis fee; Estab 1979 to increase local arts awareness; Two small galleries in a historic building; Average Annual Attendance: 9,000
Income: $8,000 (financed by city appropriation, grants & donations)
Special Subjects: Graphics, Latin American Art, Painting-American, Photography, Watercolors, Textiles, Folk Art, Pottery, Woodcarvings, Woodcuts, Landscapes, Portraits, Furniture, Glass, Oriental Art, Historical Material, Period Rooms
Exhibitions: Contemporary American Artists, predominantly Floridian; 6 shows per year in main gallery; 8 shows per year in mezzanine gallery
Publications: Exhibition brochures
Activities: Lect open to public, 4 vis lectrs per year; gallery talks; tours; competitions with prizes; workshops & receptions for artists

UNIVERSITY OF FLORIDA

M **University Gallery,** Tel 352-392-0201 x229; Fax 352-846-0266; Elec Mail galleries@arts.ufl.edu; Internet Home Page Address: www.arts.ufl.edu/galleries; *Dir* Amy Vigilante; *Coordr* Yue Zhang
Open Tues 10 AM - 8 PM, Wed - Fri 10 AM - 5 PM, Sun 1 - 5 PM, cl Mon, Sat & holidays; No admis fee; Estab 1965 as an arts exhibition gallery, open 11 months of the year, showing monthly exhibitions with contemporary & historical content; Gallery located in independent building with small lecture hall, limited access & completely secure with temperature & humidity control, adjustable track lighting; display area is in excess of 3000 sq ft; Average Annual Attendance: 8,000; Mem: 50; dues professional $100 & up, family $50, individual $25
Income: $97,000 (financed by state appropriation & community mem)
Purchases: $2,000
Special Subjects: Latin American Art, Painting-American, Photography, Prints, Pre-Columbian Art, Folk Art, Oriental Art, Painting-British
Collections: Contemporary Art
Exhibitions: Changing monthly exhibitions; Annual University of Florida Art Faculty (January); Annual student juried exhibition; MFA thesis exhibitions
Publications: Exhibition catalogs; periodic bulletins
Activities: Lect open to public; gallery talks; Henri Theil Memorial Purchase Award; exten dept serves area schools; lending collection contains cassettes, original art works, photographs & slides; originate traveling exhibitions organized & circulated

L **Architecture & Fine Arts Library,** Tel 352-392-0222; Fax 352-846-2747; Internet Home Page Address: www.uflib.ufl.edu/afa; *Architecture Fine Arts Bibliographer & Head Librn* Ann Lindeln
Open Mon - Thurs 8 AM - 10 PM, Fri 8 AM - 5 PM, Sat 1 - 5 PM, Sun 2 - 10 PM; Estab 1853 as a state art & architecture information center
Library Holdings: Auction Catalogs; Book Volumes 104,000; CD-ROMs; Exhibition Catalogs; Fiche; Manuscripts; Pamphlets; Periodical Subscriptions 600; Photographs; Reels; Reproductions; Video Tapes
Special Subjects: Folk Art, Intermedia, Landscape Architecture, Decorative Arts, Graphic Arts, History of Art & Archaeology, Latin American Art, American Western Art, Advertising Design, Interior Design, Asian Art, American Indian Art, Afro-American Art, Gold, Architecture
Collections: Rare book collection

M **Samuel P Harn Museum of Art,** Tel 352-392-9826; Fax 352-392-3892; Elec Mail chale@harn.ufl.edu; Internet Home Page Address: www.harn.ufl.edu; *Dir* Rebecca M. Nagy, PhD; *Cur Contemporary Art* Kerry Oliver-Smith; *Cur Modern Art* Dulce Roman; *Dir Educ* Bonnie Bernau; *Dir Marketing* Christine Hale; *Dir Devel* Phyllis DeLaney; *Cur Photography* Thomas Southall; *Cur Asian Art* Charles Mason; *Cur African Art* Susan Cooksey
Open Tues - Fri 11 AM - 5 PM, Sat 10 AM - 5 PM, Sun 1 - 5 PM; No admis fee; Estab 1990 to collect, preserve, display & interpret art; One of the Southeast's largest university art museums with almost 90,000 square feet. Also a museum store off the Galleria (entrance). Maintains a reference library available to Alliance members & staff only.; Average Annual Attendance: 90,000; Mem: 800; dues $40-2,500
Special Subjects: Landscapes, Collages, Pottery, Textiles, Drawings, Hispanic Art, Latin American Art, Painting-American, Photography, Prints, Sculpture, Watercolors, Bronzes, Pre-Columbian Art, Ceramics, Primitive art, Woodcarvings, Painting-European, Asian Art
Collections: African Art; American Art; Asian Ceramics; Pre-Columbian; Oceanic; Contemporary Art; Modern Art; Photography
Publications: Inform, quarterly magazine
Activities: Classes for adults & children; docent training; lect open to public; concerts; gallery talks; tours; individual paintings & objects of art lent; senior outreach program; book traveling exhibitions; originate traveling exhibitions; museum shop sells books, magazines, original art, reproductions & prints

HOLLYWOOD

M **ART & CULTURE CENTER OF HOLLYWOOD,** Art Gallery, 1650 Harrison St, Hollywood, FL 33020. Tel 954-921-3274; Fax 954-921-3273; Elec Mail info@artandculturecenter.org; Internet Home Page Address: www.artandculturecenter.org; *Exec Dir* Joy Satterlee; *Artistic Dir* Tiffany Hill; *Mktg & Design Mgr* Alesh Houdek; *Dir Philanthropy* Steve Klotz; *Cur Arts Educ* Susan Rakes; *Publ Relations & Community Partnership Mgr* Charmain Yobbi; *Art Dir* Tiffany Hill
Open Tues - Sat 10 AM - 5 PM, Thurs 10 AM - 8 PM, Sun 1 - 4 PM; Admis nonmembers $5, seniors, students & children 4-13 $3, center mems & children

age 3 & younger with an adult free; Estab 1975 as a private non-profit corporation for the study, educ & enjoyment of visual & performing arts; Great Gallery, major exhibit space, is 6300 sq ft with 400 running ft; group tours are also held there. Two Hall galleries. Maintains reference library. Gallery hosts at least 4 thought provoking, stimulating contemporary art exhibs each yr; Average Annual Attendance: 15,000; Mem: 430; dues $25-$500; no annual meeting

Income: $1.6 million (financed by mem city appropriation, private, pub & philanthropic support

Library Holdings: Book Volumes; Exhibition Catalogs; Video Tapes

Special Subjects: Decorative Arts, Etchings & Engravings, History of Art & Archaeology, Illustration, Interior Design, Landscapes, Architecture, Art Education, Art History, Ceramics, Conceptual Art, Mexican Art, Mixed Media, Flasks & Bottles, Furniture, Gold, Porcelain, Portraits, Painting-American, Silver, Textiles, Bronzes, Maps, Painting-British, Painting-European, Painting-Japanese, Drawings, Graphics, Latin American Art, Photography, Sculpture, Watercolors, African Art, Pre-Columbian Art, Religious Art, Crafts, Folk Art, Pottery, Primitive art, Woodcarvings, Woodcuts, Judaica, Collages, Posters, Glass, Jade, Jewelry, Oriental Art, Asian Art, Antiquities-Byzantine, Metalwork, Painting-Dutch, Painting-French, Ivory, Coins & Medals, Restorations, Tapestries, Calligraphy, Miniatures, Painting-Flemish, Painting-Polish, Antiquities-Oriental, Painting-Spanish, Painting-Italian, Antiquities-Persian, Islamic Art, Antiquities-Egyptian, Antiquities-Greek, Antiquities-Roman, Mosaics, Cartoons, Painting-Australian, Painting-German, Reproductions, Antiquities-Etruscan, Painting-Russian, Enamels, Painting-Scandinavian

Collections: 19th & 20th century American & contemporary Florida artists; Contemporary paintings & sculpture; Ethnographic arts

Exhibitions: (11/17/2006-1/14/2007) New Art as a Universal Language; (1/26/2007-3/25/2007) Sugar & Spice & Everything Nice; (4/16/2007-5/20/2007) All-Media Juried Biennial; Got No Strings: Bits'N Pieces Giant Puppetry, 5/20/2007, 6/2/2007, 8/12/2007

Publications: Members news letters, exhibition brochures/catalogs

Activities: Classes for adults & children; docent training; dramatic programs; spring & summer camp for children; free family days; free admission days; parents night out; lects open to the public; 4 vis lectrs per yr; gallery talks; concerts; tours; competitions with awards; scholarships offered; individual paintings & original objects of art lent to local art & educational exhibitions; lending collection contains 1000 books, 150 oiginal art works, 50 original prints, 70 paintings & 30 sculptures; book traveling exhibitions, 1-3 per year; museum shop sells books, original art & prints

HOLMES BEACH

M **ISLAND GALLERY WEST,** 5368 Gulf Dr, Holmes Beach, FL 34217. Tel 941-778-6648; Internet Home Page Address: www.amisland.com/gallery; Open Mon - Sat 10 AM - 5 PM; No admis fee; Estab 1991 to exhibit & sell local artists' work; Art work by local & regional artists working in a wide variety of media; Mem: 30; juried in by current artist members

Activities: Artist demonstrations Sat 10AM-Noon; museum shop sells original art

JACKSONVILLE

M **CUMMER MUSEUM OF ART & GARDENS,** DeEtte Holden Cummer Museum Foundation, 829 Riverside Ave, Jacksonville, FL 32204. Tel 904-356-6857; Fax 904-353-4101; Internet Home Page Address: www.cummer.org; *Dir Educ* Hope McMath; *Dir Finance* Lisa Steffen; *Dir* Maarten van de Guchte; *Chief Cur* Jeanette Toohey; *Dir Develop* Deborah Broder; *Dir Communications* Maria Haynes; *Dir Vis Servs* Susan Mahla; *Dir Operations* Vance Shrum Open Tues & Thurs 10 AM - 9 PM, Wed, Fri & Sat 10 AM - 5 PM, Sun Noon - 5 PM; Admis adults $8, seniors, military & students $5, members & children under 5 free; Estab 1960 to build the foremost survey collection of art in the Southeast; Eleven galleries of paintings & decorative arts surround garden court sited on 2-1/2 acres of formal gardens; Average Annual Attendance: 120,000; Mem: 3,100; dues $30-$10,000

Income: $1,000,000 from grants, city & state funds, endowment, mem, donations

Purchases: $600,000

Library Holdings: Auction Catalogs; Book Volumes; Exhibition Catalogs; Original Documents; Pamphlets; Periodical Subscriptions; Photographs; Prints

Special Subjects: Graphics, Painting-American, Sculpture, Decorative Arts, Painting-European, Porcelain, Oriental Art, Tapestries

Collections: European & American painting, sculpture, graphic arts, tapestries & decorative arts; Netsuke, Inro & porcelains; Oriental Collection of jade, ivory; Early Meissen porcelain

Publications: Collection handbooks; exhibition catalogs; yearbooks

Activities: 5 vis lects per yr

L **Library,** 829 Riverside Ave, Jacksonville, FL 32204. Tel 904-356-6857; Fax 904-353-4101; Internet Home Page Address: www.cummer.org; *Chief Cur* Jeanette Toohey

Open for reference

Income: $8500

Purchases: $8000

Library Holdings: Book Volumes 6000; Exhibition Catalogs 1200; Periodical Subscriptions 17; Slides 10,000

M **FLORIDA COMMUNITY COLLEGE AT JACKSONVILLE,** South Gallery, 11901 Beach Blvd, Jacksonville, FL 32246-7625. Tel 904-646-2023; Fax 904-646-2336; Elec Mail ellewis@fccj.edu; *Gallery Coordr* Lynn Lewis Mon - Tues & Wed - Fri 10 AM - 4 PM, Thurs 10 AM - 7 PM; No admis fee; Estab 1985

Collections: FCCJ Permanent Collection

Exhibitions: George Merritt Milton; Student Annual Juried School; Toshiko Takaezu; Joyce Tenneson; Hiram Williams; Arnold Newman

Activities: Classes for adults & children; lects open to public; 4 vis lects per yr; gallery talks

M **JACKSONVILLE MUSEUM OF MODERN ART,** 333 N Laura St, Jacksonville, FL 32203. Tel 904-366-6911; Fax 904-366-6901; Elec Mail jmomapres@mindspring.com; *Art Librn* Barbara Salvage; *Cur* George Kinghorn; *Operations Mgr* Cindy Stutzman; *Dir Educ* Allison Graf; *Dir* Jane Craven; *VChmn* Arthur Milam; *Retail Operations Mgr* Felicia Bowen Open Tues & Fri 11 AM - 5 PM, Wed & Thurs 11 AM - 9 PM, Sat 11 AM - 4 PM, Sun Noon - 5 PM, cl Mon, holidays; Admis adults $6, children, students & seniors $4, children under 2 free; Estab 1948 as an art center for the greater Jacksonville area; Average Annual Attendance: 100,000; Mem: 3200; dues $25; annual meeting spring

Income: Financed by mem

Special Subjects: Painting-American, Prints, Pre-Columbian Art

Collections: Pre-Columbian art; 20th century paintings, prints & sculpture

Exhibitions: Photons; Phonons - Kinetic Art; The Nature of Sculpture; Wyeth Family Exhibition

Publications: Calendar, monthly; exhibition catalogues

Activities: Classes for adults & children; docent training; art enrichment program; dramatic programs; lect open to public, 10 vis lectrs per year; concerts; gallery talks; tours; competitions; scholarships offered; book traveling exhibitions; originate traveling exhibitions; museum shop sells books, magazines, original art, reproductions, prints, jewelry & children's toys

L **Library,** 333 N Laura St, Jacksonville, FL 32203. Tel 904-366-6911; Fax 904-366-6901; *Art Librn* Barbara Salvage Library in renovation and will re-open Fall 2002; Open to teachers in Duval County schools

Library Holdings: Book Volumes 200; Periodical Subscriptions 20

L **JACKSONVILLE PUBLIC LIBRARY,** Fine Arts & Recreation Dept, 122 N Ocean St, Jacksonville, FL 32202. Tel 904-630-2665; Fax 904-630-2431; Internet Home Page Address: www.jpl.coj.net; *Dept Head* Carole Schwartz; *Dir* Ken Sivulich; *Sr Librn* Carol Smith Open Mon - Thurs 10 AM - 8 PM, Fri & Sat 10 AM - 6 PM, most Sun 1 - 6 PM; No admis fee; Estab 1905 to serve the pub by giving them free access to books, films, recordings, pamphlets, periodicals, maps, plus informational services & free programming

Income: Financed by city appropriation

Library Holdings: Book Volumes 48,000; Motion Pictures 2000; Other Holdings Compact discs 6000; Periodical Subscriptions 200; Records 10,000; Slides 3500; Video Tapes 6000

Publications: Annual Report

M **JACKSONVILLE UNIVERSITY,** Alexander Brest Museum & Gallery, 2800 University Blvd, Jacksonville, FL 32211. Tel 904-256-7371; Fax 904-256-7375; Elec Mail mwest@ju.edu; *Dir* Prof Jack Turnock Open Mon - Fri 9 AM - 4:30 PM; No admis fee; Estab 1972 to exhibit decorative arts collection; Two galleries exhibiting decorative arts & Pre-Columbian art & artifacts. Three galleries contain contemporary art on rotating schedule; Average Annual Attendance: 12,000

Income: Financed by endowment & private funds

Special Subjects: Drawings, Painting-American, Sculpture, Watercolors, Bronzes, African Art, Pre-Columbian Art, Woodcarvings, Decorative Arts, Furniture, Glass, Jade, Porcelain, Oriental Art, Asian Art, Carpets & Rugs, Ivory, Coins & Medals, Antiquities-Persian, Gold

Collections: Porcelain; Ivory; Pre-Columbian; Steuben; Tiffany

Publications: Museum catalog

Activities: Classes for adults; docent training; lect open to public; competitions

M **MUSEUM SCIENCE & HISTORY,** 1025 Museum Circle, Jacksonville, FL 32207. Tel 904-396-7062, Ext 214; Fax 904-396-5799; Internet Home Page Address: www.themosh.org; *Exec Dir* Margo Dundon; *Pub Rels* Amy Colson Open Mon - Fri 10 AM - 5 PM, Sat 10 AM - 6 PM, Sun 1 - 6 PM; Admis $7, seniors & military $5.50, children (3-12) $5; Estab 1941; Lobby & three floors contain exhibit areas, classrooms & studios; Average Annual Attendance: 225,000; Mem: 2000; member families dues vary

Income: Financed by mem, city appropriation & grants

Special Subjects: Historical Material

Collections: Historical; Live Animal Collection; Physical Science Demonstrations

Exhibitions: Alexander Brest Planetarium (16th largest in US); health; science; wildlife

Publications: Teacher's Guide, annually; brochures, quarterly newsletters; annual report

Activities: Classes for children; dramatic programs; docent training; lect open to public; tours; museum shop and sales shop selling books, prints, museum-oriented items and toys for children

JUPITER

M **EDNA HIBEL ART FOUNDATION,** Hibel Museum of Art, John MacArthur Camps, 5353 Parkside Dr Jupiter, FL 33458. Tel 561-622-5560; Tel 800-771-3362; Fax 561-622-4881; Elec Mail info@hibelmuseum.org; Elec Mail nancy@hibelmuseum.org; Internet Home Page Address: www.hibelmuseum.org; *Dir* Nancy Walls; *Chmn* Theodore Plotkin; *Exec Trustee* Edna Plotkin; *Dir Educ* Carol Davis; *Prog Coordr* Adra Farriss Open Mar - Oct Tues - Sat 11 AM - 4 PM, Sun 1 - 4 PM; No admis fee; Estab 1977 to extend the appreciation of the art of Edna Hibel specifically & visual art in general; 14 galleries & spaces devoted to paintings, lithographs, sculpture & porcelain art by artist Edna Hibel, also features antique furniture, snuff bottles, paper weights & art book collections. Maintains reference library; Average Annual Attendance: 25,000; Mem: 10,000; dues $30; meeting Feb & Mar

Income: $$80,000 (financed by donations, mem, mus gift shop sales, mus gallery sales & private donations)

Purchases: $80,000

Library Holdings: Book Volumes; DVDs; Memorabilia; Original Documents; Photographs; Sculpture

Special Subjects: Drawings, Graphics, Painting-American, Prints, Sculpture, Watercolors, Etchings & Engravings, Landscapes, Dolls, Furniture, Glass, Jade, Jewelry, Porcelain

Collections: Craig Collection of Edna Hibel's Work; English & Italian 18th Century furniture; 18th & 19th Century paperweights; 19th & 20th Century library art books; Paintings; Porcelain Art; Lithographs; Serigraphs, Sculpture by Edna Hibel; Porcelain Dolls; Archeological antiquities & preshistoric minerals, fossils & geodes
Exhibitions: Graphics, paintings, porcelains & sculptures by Edna Hibel; (1/2/2007-3/30/2007) Waldsee exhib: Reflections of the Holocost
Publications: Edna Hibel Society Newsletter, 3 per year; exhibition catalogs; exhibition posters
Activities: Classes fo adults & children; docent training; lect open to public; concerts; gallery talks; tours; sponsoring of competitions; book traveling exhibs 4-5; originate traveling exhibitions 2 per year; museum gallery sells original art, reproductions, prints, collectibles

L **Hibil Museum & Gallery,** 661 Maplewood Dr, Ste 12, Jupiter, FL 33458; 5353 Parkside Dr, Jupiter, FL 33458. Tel 561-622-1380; Fax 561-622-3475; Elec Mail nancy@hibelmuseum.org; Elec Mail nancy@hibelmuseum.org; Internet Home Page Address: www.hibel.org; *Dir* Carol Davis; *Dir* Nancy Walls; *Prog Coordr* Adra Farriss
Open Tues - Fri 11:30 AM - 3:30 PM, Sat by appointment; No admis fee; Estab 2003, displaying & selling the art of Edna Hibel to support the Hibel Mus of Art; For reference only; Average Annual Attendance: 1,000
Income: Financed through sales & Edna Hibel Art Foundation
Library Holdings: Audio Tapes; Book Volumes 500; Cassettes; Clipping Files; DVDs; Exhibition Catalogs; Framed Reproductions; Memorabilia; Original Art Works; Pamphlets; Photographs; Prints; Reproductions; Sculpture; Slides; Video Tapes
Activities: Classes for adults & children; docent training; lect open to public, 2 vis lectrs per year; lect to school classes & cultural activities for elementary school children; concerts; gallery talks; tours; book traveling exhibs 4-5 per yr; sales shop sells books, reproductions & original art, prints, collectable art plates, gift boxes, jewelry, posters, stone lithographs & serigraphs

KEY WEST

M **HERITAGE HOUSE MUSEUM AND ROBERT FROST COTTAGE,** 410 Caroline St, Key West, FL 33040. Tel 305-296-3573; Elec Mail heritagehouse@aol.com; Internet Home Page Address: www.heritagehousemuseum.org
Open Mon - Sat 10 AM - 4 PM; Caribbean Colonial House built in the 1830s. Original furnishings, antiques & seafaring artifacts collected by seven generations of a notable Key West family. On-site Heritage House Garden was once the gathering place for Robert Frost, Tennessee Williams, Gloria Swanson and other Key West celebrities
Special Subjects: Historical Material, Furniture, Period Rooms
Collections: Garden houses Margaret Lang Orchid Collection, containing nearly 200 examples of flowers.; Frost Conference Room for meetings or workshops with up to 15 participants; furnishings, antiques & seafaring artifacts
Publications: Key West: Conch Smiles, a Native's Collection of Legends, Stories, Memories by Jeane Porter
Activities: Guided tours; Robert Frost Poetry Festival; writers workshops; cultural events

M **KEY WEST ART & HISTORICAL SOCIETY,** East Martello Museum & Gallery, 3501 S Roosevelt Blvd, Key West, FL 33040. Tel 305-296-3913; Fax 305-295-6649; Internet Home Page Address: www.kwahs.org; *Pres* Bob Feldman; *Exec Dir* Claudia Pennington; *Dir Operations* Diane Rippe
Open Mon - Sun 9:30 AM - 5 PM; cl Christmas; Admis $6 adults, children 7-15 $3, active military free, seniors and local residents $4, children under 6 free; Estab 1962 to preserve history of the Florida Keys; 2300 square feet Civil War fort, last standing Martello fort in country; Average Annual Attendance: 25,000; Mem: 2000; dues $40, family $100, student $40; annual meeting in Apr
Income: Financed by mem, donations, admis & gift shop sales
Special Subjects: Folk Art
Collections: Carvings & paintings of Mario Sanchez; junkyard art of Stanley Papio
Exhibitions: History of Key West
Publications: Martello; two newsletters
Activities: Art & music series for adults & children; lect open to public, 6 vis lectrs per year; children's competitions with prizes; individual paintings & original objects of art lent to qualifying museums; book traveling exhibitions; museum shop sells books, reproductions, prints, postcards, children's educ material

M **OLD ISLAND RESTORATION FOUNDATION INC,** Wrecker's Museum - Oldest House, 322 Duval St, Key West, FL; 1501 Olivia St, Key West, FL 33040. Tel 305-294-9502; *Dir* David Rumm
Open 10 AM - 4 PM; Admis $5; Estab 1976 to present the maritime history of Key West's wrecking industry in the 19th century; Furnished period house with paintings throughout; Average Annual Attendance: 14,000; Mem: 200; dues $15-$20; annual meeting in Apr
Income: $36,000 (financed through admis fees & fundraising)
Purchases: $1500 (three 19th century ship models)
Collections: Oil on canvas by Edward Moran; All Sailing Ships & Scenes; Watercolors by Marshall Joyce; Watercolors by unknown artists
Exhibitions: Rotating exhibitions

LAKE WORTH

M **PALM BEACH INSTITUTE OF CONTEMPORARY ART,** Museum of Art, 601 Lake Ave, Lake Worth, FL 33460. Tel 561-582-0006; Fax 561-582-0504; Elec Mail info@palmbeachica.org; Internet Home Page Address: www.palmbeachica.org; *Dir* Michael Rush; *Asst to Dir* Paula Matthews; *Registrar* Phillip Estland; *Asst Cur* Jody Servan; *Asst Cur* Sybille Canthal; *Curatorial Asst* Haley Shaw; *Dir of Educ* Kara Walkerbone
Open Noon - 6 PM, Tues - Sun, 1st & 3d Fri Noon - 8 PM; Admis adults $3, seniors & students $2; Estab 2000 for exhibition of contemporary art; Mus is a

renovated 1939 Art Deco Movie Theatre with two main galleries & a new media lounge; Average Annual Attendance: 10,000
Income: Pvt income
Exhibitions: Changing exhibits, rotating four per yr
Publications: Catalogs; posters
Activities: Classes for children; docent training; lect open to public, some to members only, 3 vis lectrs per year; lending collection contains art objects; book traveling exhibitions 1-2 per year

LAKELAND

M **ARTS ON THE PARK,** Lakeland Center for Creative Arts, 115 N Kentucky Ave, Lakeland, FL 33801. Tel 863-680-2787; *Pres* Victor Prebor; *VPres* Nancy Adams; *Treas* Robert Tarsitano; *Exec Dir* Zoey Stiles
Open Tues - Fri Noon - 7 PM; No admis fee; Estab 1979 to encourage Florida artists through shows & competitions; 1600 sq ft ground floor, plus second floor library, office, studio in restored contributing structure in Lakeland's Munn Park Historic District; Average Annual Attendance: 30,000; Mem: 1200; dues sponsor $100-$999, individual $35, senior citizens $25
Income: $80,000 (financed by mem, city, business & industry)
Publications: Art Paper, quarterly newsletter; Onionhead, quarterly literary magazine
Activities: Docent training; lect open to public, 2 vis lectrs per year; concerts; gallery talks; tours; competitions with awards; scholarships & fels offered; exten dept serves county; originate traveling exhibitions

M **FLORIDA SOUTHERN COLLEGE,** Melvin Art Gallery, 111 Lake Hollingsworth Dr, Lakeland, FL 33802. Tel 863-680-4220, 680-4225, 680-4111; Fax 863-680-4147; Elec Mail jrogers@flsouthern.edu; *Prof Art History & Chair* James Rogers, PhD; *Assoc Prof Art & Dir Studio Prog* William Otremsky, MFA; *Asst Prof Art & Dir Graphic Design Prog* Lisa Erdman, MFA; *Asst Prof Art Graphic Design* Ligia Carvallo, MFA; *Adjunct Asst Prof Art History* Nadine Pantano, PhD; *Adjunct Prof Art* Joseph Mitchell, MFA; *Adjunct Asst Prof Art* Ryan Bailey, MFA; *Adjunct Instructor Art* Eric Blackmore, BFA; *Adjunct Asst Prof Art Educ* Jacquelyn Hanson, MA; *Adunct Instructor Art* Catherine Stetson, BA; *Adjunct Asst Prof Art* Greg Wortham, MFA; *Prof Emerita* Beth Ford, MA; *Adjunct Asst Prof Art* Erika Schmidt, MFA; *Departmental Secy* Monica Schreiber
Open Mon - Fri 1:30 - 4:30 PM; No admis fee; Estab 1971 as a teaching gallery; Large 3,000 sq ft main gallery; small one room adjacent gallery; Average Annual Attendance: 3,000-5,000
Collections: Brass Rubbings Collection in Roux Library; Laymon Glass Collection in Annie Pfeiffer Chapel; permanent collection in various offices & buildings
Exhibitions: (1999) Downing Bamitz Art faculty exhibits; Florida artist group
Activities: Lect open to public, 3 vis lectr per year; gallery talks; concerts; awards

M **POLK MUSEUM OF ART,** 800 E Palmetto St, Lakeland, FL 33801-5529. Tel 863-688-7743; Fax 863-688-2611; Elec Mail info@polkmuseumofart.org; Internet Home Page Address: www.polkmuseumofart.org; *Exec Dir* Daniel Stetson; *Pres* Chris McLaughlin; *Cur of Art* Todd Behrens; *Adminr* Terry D'Orsaneo; *Deputy Dir* Judy Barger; *Cur Educ* Rebecca Larson
Open Tues - Sat 10 AM - 5 PM, Sun 1 - 5 PM; Admis adults $5, seniors $4, students & children free; Estab 1966 series of galleries for temporary and permanent exhibitions; 12,000 sq ft of exhibition space, including outdoor sculpture garden; Average Annual Attendance: 125,000; Mem: 1,000; dues platinum patron $5,000, gold patron $2,500, patron $1,000, benefactor $500, advocate $250, sponsor $100, family $50, individual $35, student-teacher $25, 10% discount on all senior citizen mem; annual meeting in June
Income: Financed by mem, cities of Lakeland, Bartow, Auburndale & Winter Haven, Polk County School Board, grants, endowment & special projects
Library Holdings: Auction Catalogs; Book Volumes; Exhibition Catalogs; Periodical Subscriptions 28; Photographs; Prints; Slides
Special Subjects: Painting-American, Photography, Prints, Pre-Columbian Art, Decorative Arts, Oriental Art, Asian Art, Carpets & Rugs, Juvenile Art, Gold, Antiquities-Assyrian
Collections: Ellis Verink Collection of photographs; 15th-19th Century European Collection of ceramics; Pre-Columbian Collection; assorted decorative arts; Asian arts; contemporary paintings, photographs, prints & sculpture featuring Florida artists; South African textiles & fibers
Exhibitions: Changing exhibitions; 6 student gallery exhibitions including 12th Congressional District Competition & juried competition for high school students; Permanent display of Pre-Columbian art; temporary displays of student, contemporary and historic art
Publications: Exhib catalogues and gallery guides, quarterly newsletter, ann report
Activities: Official school site; classes for adults & children; dramatic programs; docent training; workshops; circulating exhibits; lect open to public; lect for members only; 12-15 vis lects per year; concerts; gallery talks; docent-guided tours; competitions with awards; lifetime art achievement award; art films; outreach programs; annual outdoor art festival; scholarships & fels offered; extension program serves Polk Cty, Florida; book traveling exhibitions 4 per year; originate traveling exhibitions to other museums in Florida; museum shop sells books, original art, reproductions, jewelry, home decorative objects

L **Penfield Library,** 800 E Palmetto St, Lakeland, FL 33801. Tel 863-688-7743; Fax 863-688-2611; Elec Mail info@polkmuseumofart.org; Internet Home Page Address: www.polkmuseumofart.org
By appointment only; Estab 1970 as a reference library for Polk County residents
Library Holdings: Book Volumes 1750; Clipping Files; Exhibition Catalogs; Periodical Subscriptions 28; Photographs; Prints
Special Subjects: Art History, Folk Art, Pre-Columbian Art, History of Art & Archaeology, Latin American Art, American Western Art, Art Education, American Indian Art, Mexican Art, Southwestern Art, Oriental Art, Architecture

LARGO

A GULF COAST MUSEUM OF ART, INC, 12211 Walsingham Rd, Largo, FL 33778. Tel 727-518-6833; Fax 727-518-1852; Internet Home Page Address: www.gulfcoastmuseum.org; *Cur Educ* Patt Fosnaught; *Finance Dir* Becky Donald; *Admin Asst* Pat May; *Exec Dir* Michelle Turman; *Pub Rel Coordr* Karen Barth; *Registrar* Laurel DeLoach; *Membership Coordr* Patty Sriram
Open Tues - Sat 10 AM - 4 PM, Sun Noon - 4 PM, cl holidays; Admis adults $8, senior citizens $6, students $4, mems & children 12 & under free; Estab 1936 as a regional center for the visual arts; Gallery has 45,000 sq ft of space, 2 studio buildings. Maintains reference library & auditorium; Average Annual Attendance: 80,000; Mem: 600; dues $30-$1000
Income: Financed by tuition, mem dues, donations, grants & endowment
Purchases: Contemporary Florida Art & American Fine Crafts, primarily from the Southeastern U. S.
Special Subjects: Drawings, Landscapes, Metalwork, Photography, Prints, Sculpture, Silver, Textiles, Watercolors, Painting-American, Woodcuts, Ceramics, Crafts, Juvenile Art, Portraits, Glass, Jewelry, Woodcarvings
Collections: American Fine Crafts; Contemporary Florida Art; 1960's to present works
Exhibitions: Average 15 exhibitions per year including regional artists, traveling exhibits & those organized by Art Center
Publications: 3 times yearly newsletter, exhibit catalogues
Activities: Classes for adults & children; lect open to public, 4 vis lectrs per year; gallery talks; tours; competitions with awards; individual paintings & original objects of art lent to accredited institutions; Lending collection contains 350 paintings & craft objects; book traveling exhibitions 1-3 per year; originate traveling exhibitions to museums & art centers within the state; museum shop sells books, magazines, reproductions & original art by Florida artists
L Art Reference Library, 12211 Walsingham Rd., Largo, FL 33778. Tel 727-518-6833; Fax 727-518-1852; Internet Home Page Address: www.gulfcoastmuseum.org; *Cur Educ* Kim Lomas
Open Mon - Fri 8:30 AM - 4:30 PM; Estab 1949 to provide reference material & current periodicals to Art Center members & students
Library Holdings: Book Volumes 2000; Exhibition Catalogs; Filmstrips; Periodical Subscriptions 3; Slides

MAITLAND

M MAITLAND ART CENTER, 231 W Packwood Ave, Maitland, FL 32751-5596. Tel 407-539-2181; Fax 407-539-1198; Elec Mail RCmailMAC@aol.com; Internet Home Page Address: www.maitartctr.org; *Educ Coordr* Ann E Spalding; *Prog Coordr* Dawn Feavyour; *Cur Coll* Richard D Colvin; *CEO & Exec Dir* James G Shepp; *Staff Coordr* Carol B Shurtleff; *2nd VChmn* Priscilla Cockerell; *Treas* Renae Vaughn; *VChmn* Stockton Reeves; *Secy* Belinda Townsend; *Community Relations* Pamela Wells; *1st VChmn* Wallace G Harper
Open Mon - Fri 9 AM - 4:30 PM, Sat & Sun Noon - 4:30 PM, cl major holidays; No admis fee; Estab 1938 to promote exploration & educ in the visual arts & contemporary crafts; listed in National Register of Historic Places; Four galleries totaling 202 running ft; Average Annual Attendance: 60,000; Mem: 625; dues $20-$1000; annual meeting in Sept
Income: Financed by mem, city & state appropriations, donations, special events, endowment
Special Subjects: Drawings, Graphics, Painting-American, Photography, Prints, Sculpture, Watercolors, Crafts, Pottery, Woodcarvings, Woodcuts, Etchings & Engravings, Landscapes, Collages, Posters, Eskimo Art, Glass, Porcelain
Collections: Architectural work including 6-acre compound & memorial chapel designed by Smith; graphics; paintings & sculptures of Andre Smith; etchings & drawings
Publications: Exhibit catalogs; quarterly class schedules; quarterly newsletter
Activities: Classes for adults & children; docent training; lect open to public, 2 vis lectrs per year; concerts; gallery talks; tours; individual paintings & original objects of art lent to museums & art centers; book traveling exhibitions 1 per year; originate traveling exhibitions to museums, art centers, libraries & universities; museum shop sells original art, reproductions, cards, jewelry & children's items
L Library, 231 W Packwood Ave, Maitland, FL 32751-5596. Tel 407-539-2181; Fax 407-539-1198; Elec Mail rcolvin@itsmymaitland.com; Internet Home Page Address: www.maitlandartcenter.org; *Membership & Staff Coordr* Carol B Shurtleff; *Dir* James G Shepp; *Cur Coll* Richard D Colvin; *Educ Coordr* Ann E Colvin; *Prog Dir* Gloria Capozzi; *Mus Store Mgr & Receptionist* Sue Harnish
Open Mon - Fri 9 AM - 4:30 PM, Sat & Sun Noon - 4:30 PM, cl major holidays; Admis non members $3, 65 & older $2, students $1, members no fee; Estab 1970 to promote knowledge & educ in American Art; Open for reference; Average Annual Attendance: 60,000; Mem: 625
Income: Financed by City of Maitland, mem, tuition, special events, grants, contributions, gallery donations
Library Holdings: Book Volumes 4500; Exhibition Catalogs; Periodical Subscriptions 10
Special Subjects: Photography, Painting-American, Posters, Prints, Sculpture, Portraits, Watercolors, Printmaking, Porcelain, Pottery, Woodcarvings, Woodcuts
Collections: Works by Andre Smith (1880 - 1959); exhibiting artists
Exhibitions: Connecting Andre Smith & Zora Neale Hurston: Maitland & Eatonville as Joining Communities; Fashion, Fun & Fantasy: Creative Garments by Ruth Funk; Decorative Arts of West Africa; Engravings by Albert Decaris; The Romantic Landscape: Prints & Drawings by Jules Andre Smith; A Shadow Falls on Beaverbrook: A Murder Mystery by Frank Besedick; A Showcase of Stone Lithography; George Spivey: American Primitive Painter
Activities: Classes for adults & children; lect open to public, 2 vist lect per year; concerts; gallery talks; tours; originate traveling exhibitions; museum shop sales reproductions, prints, jewelry & greeting cards

MELBOURNE

M BREVARD MUSEUM OF ART & SCIENCE, 1463 Highland Ave, Melbourne, FL 32935. Tel 321-242-0737; Fax 407-242-0798; Elec Mail info@artandscience.org; Internet Home Page Address: www.artandscience.org; *Cur Exhibitions* Jackie Borsanyi; *Mus School Dir* Bobbie McMillan; *Mem Coordr* Evelyn Taylor
Open Tues - Sat 10 AM - 5 PM, Sun 1 PM - 5 PM, cl Mon; Admis adults $5, seniors. $3, students & children $2; Estab 1978 to exhibit art for the educ, information, & enjoyment of the pub; Exhibition facility with three changing with approx 6000 sq ft of exhibition space; Average Annual Attendance: 70,000; Mem: 3500; dues patron $125 & up, general $55, senior $25; annual meeting third Tues in May
Income: $400,000 (financed by mem, city & county appropriation, corporate gifts & grants)
Purchases: $1500
Library Holdings: Auction Catalogs; Audio Tapes; Book Volumes; CD-ROMs
Collections: Contemporary regional & national artists; drawings, paintings, prints of Ernst Oppler; small objects collection of Ethnic Art; Clyde Butcher Photographs; Shared Vision; Chase Collection
Exhibitions: Ernst Oppler & the Russian Ballet; Annual Members Juried Exhibition
Publications: Quarterly newsletter; calendar for members; handouts & catalogues for changing exhibitions
Activities: Classes for adults & children; docent training; artist-in-residence program; lect open to public, 30 vis lectrs per year; concerts; gallery talks; tours; sponsoring of competitions; scholarships offered; lending collection contains 71 nature artifacts, 90 original prints, 89 photographs, 73 sculptures, 20 mixed media, 106 glass, 65 brass, 112 porcelain pieces; book traveling exhibitions 1-2 per year; originate traveling exhibitions to qualifying institutions; museum shop sells books, magazines, original art, reproductions, prints; junior museum, Children's Science Center

MIAMI

THE AMERICAN FOUNDATION FOR THE ARTS
For further information, see National and Regional Organizations

M BAKEHOUSE ART COMPLEX, INC, 561 NW 32nd St, Miami, FL 33127. Tel 305-576-2828; Fax 305-576-0316; Elec Mail bakehouse@bellsouth.net; Internet Home Page Address: www.bakehouseartcomplex.org; *Exec Dir* Doris I Meltzer; *Pres Board* Robert Apfel, DDS
Open daily 12 PM - 5 PM; No admis fee; Estab 1986; 4100 sq ft gallery; Average Annual Attendance: 6,500; Mem: 3100; dues sponsor $500, supporter $250, friend $100, family $60, individual $40; annual meeting in Sept
Income: $350,000 (financed through mem, studio rents, grants & contributions)
Special Subjects: Portraits, Restorations, Painting-Spanish, Painting-Australian
Exhibitions: (2001) 3-man show
Activities: Classes for adults & children; lect open to public; 4-6 vis lect per year; concerts; tours; competitions with awards; scholarships & fels; individual painting & original object of art lent to city facilities & developers; retail store sells original art

M FLORIDA INTERNATIONAL UNIVERSITY, The Art Museum at FIU, University Park, PC 110 Miami, FL 33199. Tel 305-348-2890; Fax 305-348-2762; Internet Home Page Address: www.fiu.edu; *Asst Dir* Regina C Bailey; *Cur Educ* Tricia Alesi; *Registrar* Barry Sparkman; *Dir* Dahlia Morgan; *Asst Cur* Elena Bertoli; *Asst Cur Educ* Laura Lavernia
Open Mon 10 AM - 9 PM, Tues - Fri 10 AM - 5 PM, Sat & Sun Noon - 4 PM; No admis fee; Estab 1977; 2500 sq ft of flexible exhibition space in the main administration building & outdoor art park; Average Annual Attendance: 50,000; Mem: 200; dues $250 & up
Income: Financed by state appropriation & supported by Friends of the Art Mus, private foundations & municipal councils
Special Subjects: Sculpture
Collections: Cintas Foundation Collection; The Metropolitan Collection; Margulies Sculpture Collection
Exhibitions: Art Park, 57 total sculptures;
Publications: Exhibition catalogues
Activities: Dade County Public Schools Museum Education Program; lect open to public, 4 vis lectrs per year; gallery talks; tours; concerts; book traveling exhibitions; originate traveling exhibitions

M MIAMI ART MUSEUM, 101 W Flagler St, Miami, FL 33130. Tel 305-375-3000; Fax 305-375-1725; Internet Home Page Address: www.miamiartmuseum.org; *Asst Dir* Jose Garcia; *Sr Cur* Peter Boswell; *Dir* Suzanne Delelanty; *Dir Mktg* Elizabeth Cross DeTullio
Open Tues - Fri 10 AM - 5 PM, Third Thurs 10 AM - 9 PM, Sat & Sun Noon - 5 PM, cl Mon; Admis adult $5, children $2.50, students with valid ID $2.50; Estab 1984 to exhibit, collect, preserve & interpret international art with a focus on the art of the Western Hemisphere from the World War II era to the present; 16,000 sq ft of gallery space on two levels; 3300 sq ft sculpture court; 1800 sq ft auditorium; Average Annual Attendance: 50,000; Mem: 1700; dues $45
Income: Financed by corporations, individuals, foundations, mem, Florida Department of State, Florida Arts Council, & Division of Cultural Affairs
Library Holdings: Exhibition Catalogs; Pamphlets; Photographs; Reproductions; Slides
Collections: 165 works of art by Bertoia, Davis, Dubuffet, Frankenthaler, Gottlieb, Jarr, Rauschenberg, Rickey, Simpson, Snelson, Stella
Exhibitions: average 12 exhibs per yr
Publications: MAM News, quarterly; exhib brochures
Activities: Docent programs; films; concerts; lect for mem only, 10 vis lectrs per year; gallery talks; tours; book traveling exhibitions 10 per year; originate traveling exhibitions; MAM store sells books, magazines, reproductions, prints, jewelry, art-greeting cards, posters & gift items

A **MIAMI WATERCOLOR SOCIETY, INC,** PO Box 561953, Miami, FL 33156-1953. Tel 305-380-6348; Fax 305-663-5885; Elec Mail miamiwatercolor@aol.com; Elec Mail miamiwatercolor@aol.com; *First VPres & Co-Chmn* Diane Lary; *First VPres & Co-Chmn* Kathy Maling; *Second VPres* Evelyn Chesney; *Treas* Daisy Armas-Garcia; *Corresp Secy* Virginia Reynolds-Botwin; *Recording Secy* Marilyn Bakst; *Pres* Clarice Londono; *Trustee* June A Fried; *Trustee* Emily Sokoloff; *Third VPres* Karen Deilke
Special Subjects: Watercolors
Exhibitions: Two annual juried exhibitions; several unjuried exhibitions
Activities: Educ dept; workshops several times per year; monthly demonstrations; lect open to public; 9 vis lectrs per yer; competitions with awards; scholarships offered

M **MIAMI-DADE COLLEGE,** (Miami-Dade Community College) Kendal Campus, Art Gallery, 11011 SW 104th St, Miami, FL 33176-3393. Tel 305-237-2322; Fax 305-237-2901; Elec Mail lfontana@mdcc.edu; Internet Home Page Address: www.mdc.edu; *Acting Dir* Lilia Fontant
Open Mon, Thurs & Fri 8 AM - 4 PM, Tues - Wed Noon - 7:30 PM; No admis fee; Estab 1970 as a teaching laboratory & pub service; Average Annual Attendance: 15,000
Income: Financed by state appropriation
Purchases: $250,000
Special Subjects: Afro-American Art, Drawings, Etchings & Engravings, Folk Art, Historical Material, Photography, Painting-American, Woodcuts, Sculpture, Latin American Art, Painting-American, Photography, Prints, Sculpture, African Art, Painting-Spanish
Collections: Contemporary American paintings, photographs, prints, sculpture includes: Beal, Boice, Bolotowsky, Christo, Ferrer, Fine, Gibson, Henry, Hepworth, Hockney, Judd, Komar, Lichtenstein, Marisol, Melamid, Michals, Motherwell, Nesbitt, Oldenburg, Parker & Pearlstein; Bedia, Schnabel
Exhibitions: Fritz Bultman; Connie Fox; Philip Gieger; John Hull; William King; Melissa Weinman; Richard Williams; Magdalena Abakanowicz; Diane Lechleitner; Kay Walking Stick
Publications: 6 catalogs per year
Activities: Lect open to public, 4-6 vis lectrs per year; concerts; gallery talks; individual paintings & original objects of art lent; lending collection contains original art works, original prints, paintings, photographs, sculpture; traveling exhibitions organized & circulated

M **Wolfson Galleries,** 300 NE Second Ave, No 1365, Miami, FL 33132. Tel 305-237-3278; Fax 305-237-3819; Elec Mail csalazar2@mdcc.edu; Internet Home Page Address: www.mdcc.edu; *Dir Cultural Affairs* Olga Garay; *Gallery Dir* Amy Cappellazzo; *Dir* Carolina Salazar; *Chmn* Mercedes Quiroga
Open Mon - Fri 10 AM - 4 PM, Thurs Noon - 6 PM; No admis fee; Gallery estab 1990 to exhibit contemporary art, host residencies; educational art; Secured spaces with alarm systems, no windows; 2700 sq ft, 1100 sq ft, 600 sq ft (3 spaces); Average Annual Attendance: 20,000
Income: $299,000, as part of Wolfson Campus Galleries (financed by endowment, annual grants & state appropriation)
Collections: Centre Gallery - Youth Matters; Edurance: The Information (The History of the Body in performance arts; Inter-American Gallery - Linda Matalon: Gathering & protecting, Carol Sun
Publications: Exhibition catalogs
Activities: Educational packets; workshops; symposia; lect open to public, 12 vis lectrs per year; book traveling exhibitions 3 per year; originate traveling exhibitions 1 per year

L **MIAMI-DADE PUBLIC LIBRARY,** 101 W Flagler St, Miami, FL 33130. Tel 305-375-2665; Fax 305-372-6428; Internet Home Page Address: www.mdpls.org; *Asst Dir* William Urbizu; *Art Svcs Librn* Barbara Young Mead-Donaldson; *Dir* Raymond Santiago; *Technical Svcs Adminr* Susan Lee; *Asst Dir* Sylvia Moura-Ona; *Youth Svcs Adminr* Lucrece Louisdhon-Lovinis; *Branch Adminr* Don Chauncey; *Branch Adminr* Elise Ledy Kennedy
Open Mon - Wed & Fri - Sat 9 AM - 6 PM, Thurs 9 AM - 9 PM, Sun (Oct - May) 1 - 5 PM; No admis fee; Estab 1947 to provide the informational, educational and recreational needs of the community; Gallery maintained, Artmobile maintained
Income: Financed by special millage
Library Holdings: Cassettes 2000; Clipping Files; Exhibition Catalogs; Fiche; Framed Reproductions 800; Motion Pictures 5500; Original Art Works 1200; Pamphlets; Periodical Subscriptions 100; Photographs; Prints; Records 4000; Reels; Reproductions; Video Tapes 6000
Special Subjects: Latin American Art, Afro-American Art
Collections: African American original graphics; Latin American original graphics; Oriental collection of original graphics; Creole Collection
Publications: Exhibition catalogs
Activities: Lectures open to public; concerts; gallery talks; tours; exten dept; artmobile; reproductions lent; book traveling exhibitions, 1-2 per year; originate traveling exhibitions, permanent collection of works on paper

NATIONAL FOUNDATION FOR ADVANCEMENT IN THE ARTS
For further information, see National and Regional Organizations

M **NEW WORLD SCHOOL OF THE ARTS,** Gallery, 25 NE Second St, Miami, FL; 300 NE Second Ave, Miami, FL 33132-2297. Tel 305-237-3620; Fax 305-237-3794; Elec Mail nwsapost.mel@mdcc.edu; *Asst Dean* Louise Romeo; *Gallery Dir* Randell Von Bloomberg; *Dean Visual Arts* Dr Mel Alexenberg
Open 9 AM - 5 PM; No admis fee; Estab 1990 to exhibit contemporary art & design; Major gallery in downtown Miami showing contemporary art & design from USA & abroad & faculty & student art work; Average Annual Attendance: 54,000
Income: Financed by county & state appropriation
Publications: Exhibition catalogs
Activities: High School & BFA programs; lect open to public, 25 vis lectrs per year; concerts; gallery talks; tours; juried student exhibitions; scholarships offered; book traveling exhibitions 2 per year; originate traveling exhibitions 1 per year

A **SOUTH FLORIDA CULTURAL CONSORTIUM,** Miami Dade County Cultural Affairs Council, 111 NW First St, Ste 625, Miami, FL 33128-1964. Tel 305-375-4634; Fax 305-375-3068; Internet Home Page Address: www.tropiculturemiami.com; *Deputy Dir* Deborah Margol; *Exec Dir* Michael Spring
Estab 1976 to provide planning, coordination, promotion & advocacy, as well as funding support & technical assistance to & marketing for Dade County's & South Florida's cultural organizations & activities; create a nurturing environment for the development of cultural excellence & diversity; address the needs of cultural community that includes the visual & performing arts, history, historic preservation & folklife, the sciences, festivals & special events, & the literary & media arts

M **VIZCAYA MUSEUM & GARDENS,** 3251 S Miami Ave, Miami, FL 33129. Tel 305-250-9133; Fax 305-285-2004; *Dir* Joel M. Hoffman
Open daily (mus) 9:30 AM - 4:30 PM, (house) 9:30 AM - 5 PM, (gardens) 9:30 AM - 5:30 PM, cl Christmas; Admis house & gardens $10, children 6-12 $5; Estab 1952 to preserve & interpret art & design in historical contents; Vizcaya is a house mus with a major collection of European decorative arts & elaborate formal gardens. The Hour, formerly the home of James Deering, was completed in 1916 & contains approximately 70 rooms; The Vizcaya Village, in the process of renovation, includes elevin national historic landmark buildings; Average Annual Attendance: 185,000; Mem: 1500; dues $35 & up; annual meeting third Wed in Apr
Special Subjects: Sculpture, Bronzes, Textiles, Ceramics, Decorative Arts, Furniture, Carpets & Rugs, Tapestries, Renaissance Art, Period Rooms, Antiquities-Oriental, Antiquities-Roman
Collections: Italian & French Furniture of the 16th-18th & early 19th centuries; Notable Specialized Collections of Carpets. Tapestries, Furniture, Roman Antiques & Bronze Mortars; 16th-19th Centuries Decorative Arts; Archives
Publications: Vizcayan Newsletter, quarterly
Activities: Tours for children; docent training; lect open to public; concerts; tours; individual paintings & original objects of art lent to accredited museums; museum shop sells books, magazines, original art, reproductions, prints & slides

L **Vizcaya Volunteer Guides Library,** 3251 S Miami Ave, Miami, FL 33129. Tel 305-250-9133, Ext 2242; Fax 305-285-2004; *Librn* Frances Hall
Open to mus volunteers & students of the decorative arts for reference only
Income: Financed by donations
Library Holdings: Book Volumes 4000; Cassettes; Exhibition Catalogs; Kodachrome Transparencies; Memorabilia; Other Holdings Archival material; Periodical Subscriptions 18; Photographs; Slides
Special Subjects: Decorative Arts, Interior Design, Furniture
Collections: Slide collection for reference & teaching

MIAMI BEACH

M **BASS MUSEUM OF ART,** 2121 Park Ave, Miami Beach, FL 33139. Tel 305-673-7530; Fax 305-673-7062; Elec Mail info@bassmuseum.org; Internet Home Page Address: www.bassmuseum.org; *Dir* Diane W Camber; *Asst Dir* Peter McElwain; *Cur* Ruth Grim; *Cur Educ* Wanda Texon; *Registrar* Rachel Talent; *Dir Develop* Doreen LoCicero; *Exec Asst* Mary Heaton; *Admissions* L Gabby Peters; *Bldg Supv* James Lawrence; *Pub Relations & Mktg Mgr* Tony Newhoff; *Mem Assoc* Denise Wolpert; *Mus Store Mgr* Bianca Lanza; *Cur New Media* Denise Delgado
Open Tues, Wed, Fri & Sat 10 AM - 5 PM, Thurs 10 AM - 9 PM, Sun 11 AM - 5 PM, cl Mon; Admis adults $6, students & seniors $4; Estab 1963 for the collection & exhibition of works of art. Collection features European art, architectural drawings & contemporary art; The museum is a two-story 1930 art deco structure with a new wing designed by Arata Isozaki; Average Annual Attendance: 100,000
Income: $1,900,000 (financed by city, mem & grants from state, county & federal government)
Special Subjects: Painting-American, Ceramics, Decorative Arts, Painting-European, Furniture, Painting-British, Painting-Dutch, Baroque Art, Painting-Flemish, Antiquities-Oriental
Collections: Permanent collection of European textiles, Old Master paintings, Baroque sculpture, Asian art, ecclesiastical artifacts, 19th & 20th century graphics, paintings & architectural drawings & arts
Exhibitions: The Making of Miami Beach: The Architecture of L Murray Dickson; Yayoi Kusama Exhibition
Publications: Quarterly magazine; exhibition catalogues; permanent collection catalogue
Activities: Classes for adults; lect open to public; concerts; films; individual & original objects of art lent to other museums; originate traveling exhibitions; sales shop selling books & original art

A **WOLFSONIAN-FLORIDA INTERNATIONAL UNIVERSITY,** 1001 Washington Ave, Miami Beach, FL 33139. Tel 305-531-1001; Fax 305-531-2133; Elec Mail visitorservices@thewolf.fiu.edu; Internet Home Page Address: www.wolfsonian.org; *Dir* Cathy Leff; *Head Librn* Frank Luca; *Head Registrar* Kim Bergen
Open Mon, Tues, Fri & Sat 11 AM - 6 PM, Thurs 11 AM - 9 PM, Sun Noon - 5 PM, cl Wed; Admis $5 adult, seniors, students and children 6-12 $3.50; Estab 1986
Library Holdings: Book Volumes; Manuscripts; Memorabilia; Other Holdings; Pamphlets; Prints
Special Subjects: Architecture, Drawings, Graphics, Historical Material, Manuscripts, Photography, Porcelain, Posters, Prints, Sculpture, Silver, Textiles, Watercolors, Stained Glass, Decorative Arts, Portraits, Furniture, Glass, Maps, Bookplates & Bindings, Dioramas, Coins & Medals
Collections: Architecture & Design Arts; Decorative & Propaganda Arts (pertaining to period 1885-1945); Fine Arts; Rare & Reference Library
Exhibitions: See America; Aluminum By Design; The Visual Front: Posters of the Spanish Civil War
Publications: The Journal of Decorative and Propaganda Arts

Activities: Educ program; lect for mem only, concerts, gallery talks, tours, fellowships; 1 - 2 book traveling exhib per yr; museum shop sells books, design objects

MIAMI LAKES

M **JAY I KISLAK FOUNDATION, INC,** 7900 Miami Lakes Dr W, Miami Lakes, FL 33016. Tel 305-364-4208; Fax 305-821-1267; Elec Mail astetser@kislak.com; Internet Home Page Address: www.KislakFoundation.org;
Open Mon-Fri by appointment; No admis fee; One large gallery
Collections: Pre-Columbian art & artifacts; rare books & manuscripts
Exhibitions: (2002) Myths & Dreams, traveling book exhibition
Publications: Columbus to Catherwood (book)
Activities: Classes for children; open to Miami-Dade County pub schools

NAPLES

M **NAPLES ART GALLERY,** 275 Broad Ave S, Naples, FL 33940. Tel 941-262-4551; *Co-Pres* Suzanne DeBruyne; *Co-Pres* Paul DeBruyne
Open Mon - Thurs 10 AM - 6 PM, Fri & Sat 10 AM - 9 PM, Sun Noon - 5 PM; No admis fee; Estab 1965 to present works of prominent American artists for display in home or office; Contains foyer with fountain & four additional gallery rooms & sculpture garden; 4600 sq ft of gallery space; Average Annual Attendance: 15,000
Income: $1,000,000 (financed by sales)
Exhibitions: CW Mundy, Marilyn Simandle, EJ Paprocki, Edouard Cortes (1882-1969)
Publications: Exhibit brochures

NORTH MIAMI

M **MUSEUM OF CONTEMPORARY ART,** 770 NE 125th St, North Miami, FL 33161. Tel 305-893-6211; Fax 305-891-1472; Internet Home Page Address: www.mocanomi.org; *Educ Cur* Adrienne von Lates; *Registrar* Kim Stillwell; *Dir* Bonnie Clearwater; *Prog Mgr* Jeremy T. Chestler
Open Tues - Sat 11 AM - 5 PM, Sun Noon - 5 PM; Admis adults $5, students & seniors $3; Estab 1981 to feature national, international & Florida artists; 1 main gallery; Average Annual Attendance: 30,000; Mem: 2000; dues $25-$1,000
Income: Financed by mem, city appropriation, private donations, corporations foundations
Special Subjects: Architecture, Drawings, Graphics, Hispanic Art, Latin American Art, Painting-American, African Art, Ceramics, Etchings & Engravings, Landscapes, Afro-American Art, Collages, Furniture, Glass, Jewelry
Exhibitions: 8-10 rotating exhibits
Publications: Catalogs; newsletter, quarterly
Activities: Classes for adults & children; docent training; lect open to public; concerts; gallery talks; tours; scholarships offered; originate traveling exhibitions & performances; museum shop sells books, magazines, original art

NORTH MIAMI BEACH

M **SAINT BERNARD FOUNDATION & MONASTERY,** 16711 W Dixie Hwy, North Miami Beach, FL 33160. Tel 305-945-1462; Fax 305-945-6986; Elec Mail monastery@earthlink.net; Internet Home Page Address: www.spanishmonastery.net; *Exec Dir* Dr Ronald Fox
Open Mon - Sat 9 AM - 5 PM, Sun 1:30 - 5 PM; Admis adults $5, seniors $2.50, children 7-12 $2, under 6 free; A reconstruction of a monastery built in Segovia, Spain, in 1141, with original stones brought to the United States by William Randolph Hearst
Income: Financed by members & donations of visitors
Special Subjects: Religious Art, Historical Material
Collections: Historic and Religious Material; paintings; sculpture
Activities: Tours; arts festivals; sales shop sells books, slides & religious objects

OCALA

M **CENTRAL FLORIDA COMMUNITY COLLEGE ART COLLECTION,** 3001 SW College Rd, PO Box 1388 Ocala, FL 34478. Tel 352-237-2111; Fax 352-237-0510; Internet Home Page Address: www.c.cc.fl.us; *Pres* Charles Dassance
Open Mon - Fri 8 AM - 4:30 PM; No admis fee; Estab 1962 as a service to the community; Gallery is the lobby to the auditorium; Average Annual Attendance: 5,000
Income: Financed by state appropriations
Collections: Contemporary Artists of Various Media; CFCC Foundation Permanent Collection
Exhibitions: Various exhib mostly student & instr
Activities: Classes for adults; scholarships offered

M **FLORIDA STATE UNIVERSITY AND CENTRAL FLORIDA COMMUNITY COLLEGE,**(Florida State University Foundation - Central Florida Community College Foundation)The Appleton Museum of Art, 4333 NE Silver Springs Blvd, Ocala, FL 34470-5000. Tel 352-236-7100; Fax 352-236-7137; Elec Mail jrosengren@appleton.fsu.edu; Internet Home Page Address: www.appletonmuseum.org; *Deputy Dir Finance/Admin* Jim Rosengren; *Facilities Dir* Russell Days; *Dir Curatorial Affairs* Dr Leslie Hammond; *Assoc Educ/Vol Coordr* Margie Shambaugh; *Assoc Dir* Sandra Talarico; *Coordr* Colleen Harper
Tues - Sun 10 AM - 6 PM, cl New Year's, Thanksgiving & Christmas; Admis adults $6, seniors & students with ID $4, children under 10 free; Estab 1987 to provide cultural & educational programs; Average Annual Attendance: 50,000; Mem: 3500; dues $15-2500
Income: $1,000,000 (financed by endowment, mem & state appropriation)

Special Subjects: Painting-American, Sculpture, Watercolors, Bronzes, African Art, Pre-Columbian Art, Textiles, Religious Art, Landscapes, Decorative Arts, Painting-European, Portraits, Furniture, Glass, Jade, Porcelain, Oriental Art, Asian Art, Marine Painting, Metalwork, Painting-French, Carpets & Rugs, Ivory, Maps, Medieval Art, Antiquities-Persian, Islamic Art, Antiquities-Egyptian, Antiquities-Greek, Antiquities-Roman, Painting-German, Antiquities-Etruscan
Collections: Appleton Museum of Art Collection; Antiquities; Asian, Pre-Columbian & African; Decorative Arts; European Painting & Sculpture
Publications: Gallery guides; museum catalog; quarterly newsletter
Activities: Educ dept; classes for adults & children; docent training; lect open to public, 10 vis lectrs per year; concerts; gallery talks; tours; individual paintings & original objects of art lent to other institutions; lending collection contains books, photographs & slides; book traveling exhibitions 8-10 per year; originate traveling exhibitions to state institutions; museum shop sells books, original art, reproductions, posters & jewelry

ORLANDO

M **MENNELLO MUSEUM OF AMERICAN ART,** 900 E Princeton St, Orlando, FL 32803. Tel 407-246-4278; Fax 407-246-4329; Internet Home Page Address: mennello.museum@cityoforlando.net; Internet Home Page Address: www.mennellomuseum.org; *Exec Dir* Frank Holt; *Office Mgr* Kim Robinson
Open Tues - Sat 10:30 AM - 4:30 PM, Sun Noon - 4:30 PM, cl Mon; Admis adults $4, seniors (55+) & students $1, children under 12 free; Estab 1998; Average Annual Attendance: 16,000; Mem: 300, dues $25 and up
Income: $535,000 (financed by city appropriation)
Purchases: $300,000
Library Holdings: Auction Catalogs 150; Audio Tapes 300; Book Volumes 400; CD-ROMs; Exhibition Catalogs; Kodachrome Transparencies 400; Manuscripts; Memorabilia; Original Art Works; Pamphlets; Periodical Subscriptions 10; Photographs; Records; Reproductions; Sculpture; Slides; Video Tapes
Special Subjects: Drawings, Graphics, Hispanic Art, Photography, Prints, Sculpture, Watercolors, American Indian Art, American Western Art, Bronzes, Southwestern Art, Textiles, Ceramics, Folk Art, Woodcarvings, Woodcuts, Etchings & Engravings, Landscapes, Afro-American Art, Decorative Arts, Furniture, Silver, Scrimshaw
Collections: American Art
Exhibitions: Earl Cunningham: Dreams Realized; Traveling exhibitions throughout the year
Publications: Exhibit catalog; Members magazine
Activities: Classes for adults & children; docent programs; lect open to public, 6 vis lectrs per year; concerts; gallery talks; tours; sponsoring of competitions; book traveling exhibitions 2 per year; originate traveling exhibitions to other museums; museum shop sells books, magazines, original art, shirts, audio tapes, educational toys, notecards, jewelry & prints

M **ORLANDO MUSEUM OF ART,** 2416 N Mills Ave, Orlando, FL 32803-1483. Tel 407-896-4231; Fax 407-896-9920; Internet Home Page Address: www.omart.org; *Exec Dir* Marena Grant Morrisey; *Cur* Hansen Mulford; *Cur of Educ* Susan Rosoff; *Mktg Mgr* Sherry M. Lewis; *Registrar* Andrea Long; *Chmn* Colin Lawton Johnson; *Mus Shop Mgr* Jamieson Thomas; *Pres* Hal Kantor; *Controller* Joyce W. Aide
Open Tues - Fri 10 AM - 4 PM, Sat & Sun Noon - 4 PM, cl Mon; Admis adults $8, seniors & college students $7, students 6-18 $5; ages 5 & younger and OMA members no charge; Estab 1924 to encourage the awareness of & participation in the visual arts. Accredited by the American Assoc of Museums; 81,884 sq ft mus; seven galleries including exhibitions of 19th & 20th Century American Art, Pre-Columbian & African Art; Average Annual Attendance: 341,066; Mem: 3216; dues $40 & up; annual meeting in Dec
Income: Financed by mem, United Arts of Central Florida, Inc & State of Florida
Library Holdings: Auction Catalogs; Book Volumes; Clipping Files; Pamphlets; Periodical Subscriptions
Special Subjects: Etchings & Engravings, Photography, Painting-American, Sculpture, Painting-American, Prints, American Western Art, African Art, Pre-Columbian Art, Afro-American Art
Collections: 19th & 20th Century American painting, sculpture, prints & photography; Pre-Columbian from Central & South America; African Art
Publications: Members Magazine, 4 times per year; mem newsletter, 12 times per year; exhibition catalogues
Activities: Classes for adults & children; dramatic programs; docent training; lect open to public, 2 vis lectrs per year; concerts; gallery talks; tours; competitions with awards; scholarships offered; individual prints & original objects of art lent to museums; book traveling exhibitions 3-4 per year; originate traveling exhibitions; museum shop sells books, magazines, reproductions, art exhibit & art related merchandise; original art; prints

L **Orlando Sentinel Library,** 2416 N Mills Ave, Orlando, FL 32803-1483. Tel 407-896-4231; Fax 407-896-9920; Elec Mail info@omart.org; Internet Home Page Address: www.omart.org; *Exec Dir* Marena Grant Morrisey; *Cur* Hansen Mulford; *Cur of Educ* Susan Rosoff; *Mktg Mgr* Michelle Ghorbanian; *Registrar* Andrea Long; *Chmn* Colin Lawton Johnson; *Mus Shop Mgr* Jamieson Thomas; *Pres* Hal Kantor; *Controller* Joyce W Aide
Open Tues - Fri 10 AM - 4 PM, Sat & Sun Noon - 4 PM, cl Monday & Holidays; Admis adult $6, seniors & students $4, children between 4 & 11 $2; Estab 1924
Library Holdings: Auction Catalogs; Book Volumes 3600; Clipping Files; Exhibition Catalogs; Pamphlets; Periodical Subscriptions 10
Special Subjects: Art History, Landscape Architecture, Decorative Arts, Painting-American, Pre-Columbian Art, Prints, History of Art & Archaeology, Ceramics, American Western Art, Art Education, Furniture, Mexican Art, Glass, Aesthetics, Afro-American Art
Collections: Traditional & Contemporary American Art; African Art; Pre-Columbian Art
Activities: Classes for adults and children; docent training; lect open to the public; concerts; gallery talks; tours; museum shops sells books, original art & prints

A **PINE CASTLE CENTER OF THE ARTS,** 6015 Randolph St, Orlando, FL; 731 E Fairlane Ave, Orlando, FL 32809. Tel 407-855-7461; Fax 407-812-7202; Elec Mail joan.h.pyle@cwix.com; Elec Mail sansoneb@pinecastle.org; *Dir* Bettielee Sansone
Open by appointment only; No admis fee; Estab 1965 as a nonprofit community

cultural center which provides programs in visual arts, folk crafts, local history, music & drama, & sponsors special projects for handicapped & senior citizens; One room 15 x 15 ft in main building; 85 yr old cracker farm house; 208 yr old log cabin; Average Annual Attendance: 25,000
Income: Financed by private citizens
Collections: Oral histories of area Old-timers, along with photographs, memorabilia & antiques
Exhibitions: Festival
Publications: Pioneer Days Annual Historical Magazine
Activities: Classes for adults & children; dramatic programs; concerts in the park

L **UNIVERSITY OF CENTRAL FLORIDA LIBRARIES,** PO Box 162666, Orlando, FL 32816-2666. Tel 407-823-2564; Fax 407-823-2529; Internet Home Page Address: www.library.ucf.edu; *Dir* Barry B Baker; *Assoc Dir Admin* Frank R Allen; *Head of Acquisitions* Jeannette Ward; *Head Spec Coll* Carla M Summers
Open in spring Mon - Thurs, 7:45 AM - 1 AM, Fri 7:45 AM - 7 PM, Sat 9 AM - 7 PM, Sun Noon - 1 AM; summer Mon - Thurs & Sun, 7:45 AM - 11 PM; Estab 1968
Collections: Bryant West Indies Collection, artifacts, original paintings, rare books

M **VALENCIA COMMUNITY COLLEGE,** Art Gallery-East Campus, 701 N Econlockhatchee Trail, PO Box 3028 Orlando, FL 32802. Tel 407-299-5000, Ext 2298; Fax 407-249-3943; Internet Home Page Address: www.valencia.cc.fl.us; *Pres* Sanford Shugart; *Gallery Cur* David Walsh
Open Mon - Fri 8:30 AM - 4:30 PM; No admis fee; Estab 1982
Income: Financed by state appropriation, grants & private donations
Purchases: $1500
Collections: Permanent collection: Mixed Media; Small Works: Mixed Media
Activities: Individual paintings & original objects of art lent; lending collection contains 250 items; originate traveling exhibitions 2 per year

ORMOND BEACH

M **ORMOND MEMORIAL ART MUSEUM AND GARDENS,** 78 E Granada Blvd, Ormond Beach, FL 32176. Tel 904-676-3347; Fax 904-676-3244; *Dir* Ann Burt; *Educ Specialist* Jeanne Malloy; *Admin Asst* Vanessa Elliott
Open Mon - Fri 11 AM - 4 PM, Sat & Sun Noon - 4 PM; admis $2 donation; Estab 1946 to house the symbolic oil paintings of Malcolm Fraser; Four connecting rooms opens to two galleries; Average Annual Attendance: 15,000; Mem: 1000; dues $20-$1,000; monthly meetings & annual meeting in Sept
Income: $238,000 (financed by endowment, mem & city appropriation)
Collections: Malcolm Fraser Symbolic Paintings - permanent collection; Catherine Combs lusterware; Florida landscapes
Exhibitions: Paintings, photography, crafts, sculpture & multi-media exhibits
Publications: Halifax Magazine
Activities: Classes for adults & children; lect open to the public; workshops & children's events; private tours available; gallery tours

PALM BEACH

M **FLAGLER MUSEUM,** Coconut Row & Whitehall Way, PO Box 969 Palm Beach, FL 33480. Tel 561-655-2833; Fax 561-655-2826; Elec Mail flagler@emi.net; Internet Home Page Address: www.flaglermuseum.us; *Dir* John Blades; *Public Affairs Dir* Nicole Shuey; *Chief Cur* Sandra Barghini; *Visitor Services Dir* Rick Rager; *Educ Dir* Andrea Fossum; *Dir Mem Svcs* Tanya Mikus; *Chief Security* Bill Fallacaro; *Facilities Mgr* Ivor Jones
Open Tues - Sat 10 AM - 5 PM, Sun Noon - 5 PM, cl Mon; Admis adults $8, children 6-12 $3, under 6 free; Estab 1959 for preservation & interpretation of the Whitehall mansion, the 1902 residence built for Standard Oil partner & pioneer developer of Florida's east coast, Henry Morrison Flagler; Fifty-five room historic house with restored rooms & special collections, special events & exhibitions; Average Annual Attendance: 80,000; Mem: 2000; dues $50-$5000
Income: Financed by endowment, mem & admis
Special Subjects: Architecture, Painting-American, Sculpture, Textiles, Decorative Arts, Furniture, Glass, Silver, Carpets & Rugs, Historical Material, Period Rooms, Laces, Reproductions
Collections: Original family furnishings, china, costumes; furniture; glassware; paintings; silver; sculptures; extensive lace collection
Exhibitions: Various temporary exhibits
Publications: Flagler Museum, An Illustrated Guide; Inside Whitehall, Member's Newsletter, quarterly; exhibit catalogs
Activities: Docent training; lect open to public; gallery talks; concerts; tours; fels offered; museum shop sells books, reproductions & prints

A **THE SOCIETY OF THE FOUR ARTS,** 3 Arts Plaza, Palm Beach, FL 33480. Tel 561-655-7226; Fax 561-655-7233; *Pres* Wiley R Reynolds; *VPres* Robert M Grace; *VPres* Robert A Magowan; *Dir* Robert W Safrin; *Deputy Dir* Nancy Mato; *Chmn Bd & Dir* Eugene Dixon Jr
Open Dec - mid - Apr Mon - Sat 10 AM - 5 PM, Sun 2 - 5 PM; Admis to exhibition galleries free; $3 donation suggested; Estab 1936 to encourage an appreciation of the arts by presentation of exhibitions, lectures, concerts, films & programs for young people & the maintenance of a fine library & gardens; Five galleries for exhibitions, separate general library, gardens & auditorium; Average Annual Attendance: 40,000 (galleries & library); Mem: 1500; dues life $10,000, sustaining $550; annual meeting third Fri in Mar
Income: Financed by endowment, mem, city appropriation toward maintenance of library & contributions
Exhibitions: 56th Annual National Exhibition of Contemporary American Paintings; French Oil Sketches & The Academic Tradition: Nostalgic Journeys; American Illustration from the Delaware Art Museum; Augustus Vincent Tack; Landscape of the Spirit Organized by the Philips Collection, Washington DC
Publications: Calendar; schedule of events, annual
Activities: Programs for young people; lect open to public when space permits, otherwise limited to members, 13 vis lectrs per year; concerts; films; competitions

open to artists resident in United States; juror selects about 70 paintings for inclusion in annual exhibition

L **Gioconda & Joseph King Library,** 3 Four Arts Plaza, Palm Beach, FL 33480. Tel 561-655-2766; Fax 561-659-8510; Elec Mail famlibrary@aol.com; Internet Home Page Address: www.fourarts.org; *Art Reference Librn* Nila Bent; *Librn* Joanne Rendon
Open Mon - Fri 10 AM - 5 PM, cl Sat May - Nov; No admis fee; Estab 1936; Circ Non-circulating collection; Mem: Dues $25 family, $12 mems
Income: Financed by endowment, mem & city appropriation
Library Holdings: Auction Catalogs 1,000; Book Volumes 10,000; Exhibition Catalogs 5,000; Periodical Subscriptions 70; Video Tapes 50
Special Subjects: Art History, Folk Art, Landscape Architecture, Decorative Arts, Mixed Media, Photography, Drawings, Etchings & Engravings, Graphic Design, Islamic Art, Painting-American, Painting-British, Painting-Dutch, Painting-Flemish, Painting-French, Painting-German, Painting-Italian, Painting-Japanese, Painting-Russian, Painting-Spanish, Prints, Sculpture, Painting-European, History of Art & Archaeology, Portraits, Watercolors, Ceramics, Conceptual Art, Crafts, Latin American Art, Painting-Israeli, American Western Art, Bronzes, Printmaking, Cartoons, Fashion Arts, Interior Design, Art Education, Asian Art, Video, American Indian Art, Porcelain, Primitive art, Eskimo Art, Furniture, Ivory, Jade, Costume Design & Constr, Glass, Mosaics, Stained Glass, Aesthetics, Afro-American Art, Metalwork, Antiquities-Oriental, Antiquities-Persian, Carpets & Rugs, Dolls, Embroidery, Handicrafts, Jewelry, Miniatures, Oriental Art, Pottery, Religious Art, Restoration & Conservation, Silver, Silversmithing, Tapestries, Textiles, Woodcuts, Marine Painting, Landscapes, Antiquities-Assyrian, Antiquities-Byzantine, Antiquities-Egyptian, Antiquities-Etruscan, Antiquities-Greek, Antiquities-Roman, Painting-Scandinavian, Laces, Architecture
Collections: John C Jessup Collection; Henry P McIntosh Collection; James I Merrill Collection; Addison Mizner Collection, over 300 reference books & scrapbooks
Publications: Booklist, semi annual
Activities: Library tours; 4 vis lectrs per yr; book talks with authors

PANAMA CITY

M **VISUAL ARTS CENTER OF NORTHWEST FLORIDA,** 19 E Fourth St, Panama City, FL 32401. Tel 850-769-4451; Fax 850-785-9248; Elec Mail vac@visualartsmuseum.us; Internet Home Page Address: www.visualartscenter.org; *Exec Dir* Kimberly Branscome; *Admin Dir* Denise Walker; *Educ & Fundraising Coordr* Jerry Pilcher
Open Mon, Wed & Fri 10 AM - 4 PM, Tues & Thurs 10 AM - 8 PM, Sat 1 - 5 PM, cl Sun; Admis adults $3.50, seniors & military $2.50, student $1.50, children under 6, mem & every Tues free; The Center occupies the old city hall, jail & fire station on the corner of Fourth St & Harrison Ave in downtown Panama City. Main gallery hosts contemporary artists, juried competitions & mus coordinated collections. The lower galleries feature emerging artists & community sponsored competitions & collections; Impressions Gallery for children; Average Annual Attendance: 20,000; Mem: 540; family $60, individual $35, student $15
Income: financed by mem, grants & corporate sponsors
Collections: Permanent collection contains works of artists from Northwest Florida
Exhibitions: Rotating exhibits of all types of art
Publications: Images, newsletter, every 3 months
Activities: Classes for adults & children; docent programs; gallery talks; tours; competitions with prizes; individual paintings & original objects of art lent to businesses; book traveling exhibitions 2 per year; junior museum

L **Visual Arts Center Library,** 19 E Fourth St, Panama City, FL 32401. Tel 850-769-4451; Fax 850-785-9248; Elec Mail vac@visualartcenter.org; Internet Home Page Address: www.vac.org.cn; *Admin Dir* Joanne Kennedy; *Exhibit Coordr* Christopher Arrant; *Educ Coordr* Tiffany Woesneer; *Exec Dir* Tina L Dreyer; *Vol Coord* Lee Venus; *Pres Bd* Todd Neves
Open Mon, Wed & Fri 10 AM - 4 PM, Tues & Thurs 10 AM - 8 PM, Sat 1 - 5 PM, cl Sun; No admis fee; For reference & limited lending; Art gallery, exhibition space, art education & classes; Mem: 750; dues $15-$100
Income: Financed by mem, grants, corporate sponsors
Library Holdings: Book Volumes 200; Original Art Works; Video Tapes
Collections: linolium block prints
Activities: Classes for adults & children; docent training; 20 lect per year open to public; gallery talks; tours; sponsoring of competitions

PEMBROKE PINES

M **BROWARD COMMUNITY COLLEGE - SOUTH CAMPUS,** Art Gallery, 7200 Hollywood Blvd, Pembroke Pines, FL 33024. Tel 954-963-8895, 963-8969; Fax 954-963-8934; *Gallery Dir* Dr Kyra Belan
Open Mon - Fri 10 AM - 2 PM; No admis fee; Estab 1991 to offer contemporary art exhibitions & cultural enrichment activities to college students & to the surrounding community; Gallery is 31 ft x 31 ft with a glass wall & high ceilings
Income: Financed by grants
Exhibitions: Studio Art Club Annual Juried Exhibition
Activities: Lect open to public, 6 vis lectrs per year; competitions

PENSACOLA

A **HISTORIC PENSACOLA PRESERVATION BOARD,** T.T. Wentworth Jr. Florida State Museum, Historic Pensacola Village, 120 Church St Pensacola, FL 32501; PO Box 12866, Pensacola, FL 32576-2866. Tel 850-595-5985; Fax 850-595-5989; Elec Mail lrobertson@historicpensacola.org; Internet Home Page Address: www.historicpensacola.org; *Museum Adminr* Tom Muir; *Dir* John P Daniels; *Museum Cur* Lynne Robertson; *Museum Cur* Lisa Dunbar; *Historian* Richard Brosnaham
Open Tues - Sat 10 AM - 4 PM; June - Aug open Mon; cl on state holidays; Admis adult $6, seniors $5, children 4-16 $2.50; Estab 1967 to preserve, maintain & operate for the education & enjoyment of the public certain buildings & objects of historical interest in Pensacola & the surrounding areas (northwest Florida);

Multi-building complex includes two museums & three historic houses; main gallery includes history of development of West Florida as well as area for temporary exhibits; Average Annual Attendance: 50,000; Mem: 350; dues $35 per year basic family membership
Income: $650,000 from state, supplemented with funding from city & county governments & earned income from rentals, store sales, admissions & memberships
Collections: Archives; costumes; decorative arts; Early 19th & 20th century local artists; Marine lumbering & farming tools & equipment; T.T. Wentworth Jr collection of historical artifacts & documents; Manual G. Runyan art collection
Activities: Docent training; classes for adults & children; sales shop sells books, reproductions & local crafts; historical toys & sovenirs; Discovery Gallery, 120 Church St Pensacola, FL 32501

M **PENSACOLA JUNIOR COLLEGE,** Visual Arts Gallery, Anna Lamar Switzer Center for Visual Arts, 1000 College Blvd, Pensacola, FL 32504. Tel 850-484-1000; Tel 850-484-2554; Fax 850-484-1829; Elec Mail apeterson@pjc.edu; Internet Home Page Address: www.pjc.edu/visarts; *Dir* Allan Peterson
Open Mon - Thurs 8 AM - 9 PM, Fri 8 AM - 3:30 PM, cl weekends; No admis fee; Average Annual Attendance: 20,000
Income: Financed by state appropriation
Collections: Contemporary ceramics, glass, drawings, paintings, prints, photographs, sculpture
Exhibitions: (2005) Thomas Mann, Metalsmith
Publications: Catalog, brochure or poster for each exhibition
Activities: Classes for adults; lect open to public, approx 4 vis lectrs per year; workshops; gallery talks; competitions with awards given; scholarships offered; individual paintings & original objects of art lent to other museums & lending collection contains original art works; traveling exhibitions organized & circulated

M **PENSACOLA MUSEUM OF ART,** 407 S Jefferson St, Pensacola, FL 32502. Tel 850-432-6247; Fax 850-469-1532; Elec Mail info@pensacolamuseumofart.org; Internet Home Page Address: www.pensacolamuseumofart.org; *Exec Asst* Sandra Gentry; *Exec Dir* Maria V Butler; *Assoc Cur* Heather K Roddenberry; *Educ Coordr* Kelly M. Snyder; *Registrar & Prepar* Nicholas J. Christopher; *Media Coordr* Stephanie Kress
Open Tues - Fri 10 AM - 5 PM, Sat & Sun 12 - 5 PM, cl Mon & national holidays; Admis adults $5, students & military $2, members free; Estab 1954 to further & disseminate art history & some studio instruction with regard to the general pub & to increase knowledge & appreciation thereof; Mus is a historical building, old city jail built in 1908 & has 13,000 sq ft of exhibition area; Average Annual Attendance: 85,000; Mem: 850; dues $20-$500; annual meeting in Oct
Income: Financed by mem
Special Subjects: Painting-American, Photography, Prints, Watercolors, African Art, Folk Art, Woodcuts, Etchings & Engravings, Decorative Arts, Portraits, Glass
Collections: Art, African pieces, contemporary art, glass; 20th & 21st century works, all media
Exhibitions: Changing loan exhibitions
Publications: Quarterly newsletter
Activities: Classes for children; docent training; lect open to public, lectr varies; gallery talks; individual paintings & original objects of art lent to other museums or galleries; book traveling exhibitions 9 per year; originate traveling exhibitions to regional museums; museum shop sells books, magazines, jewelry, cards, stationery, children's items & puzzles

L **Harry Thornton Library,** 407 S Jefferson St, Pensacola, FL 32501. Tel 850-432-6247; Fax 850-469-1532; Elec Mail info@pensacolamuseumofart.org; Internet Home Page Address: www.pensacolamuseumofart.org; *VPres* Margaret N Lorren; *Exec Asst* Sandra J Gentry; *Cur Educ* Vivian L Spencer; *Asst Cur & Registrar* Heather Roddenberry; *Exec Dir* Maria Butler
Open Tues - Fri 10 AM - 5 PM, Sat 10 AM - 4 PM, cl Sun & Mon & national holidays; Estab 1968 to provide reference material for public & members; Reference library
Income: Financed by mem, city appropriation & grants by state & federal government
Purchases: $250
Library Holdings: Audio Tapes; Book Volumes 1500; Exhibition Catalogs; Periodical Subscriptions 10; Slides
Special Subjects: Photography, Painting-American, Sculpture, Glass, Afro-American Art
Collections: Complete set of E Benezit's Dictionaire des Peintres, Sculpteurs, Dessinateurs et Graveurs; Encyclopedia of World Art and other art references books
Publications: Exhibitions catalogs; newsletter, 10 per year
Activities: Classes for adults & children; docent training; lect open to public, lectrs varies; concerts; gallery talks; purchase & category awards

M **UNIVERSITY OF WEST FLORIDA,** Art Gallery, 11000 University Pky, Pensacola, FL 32514. Tel 850-474-2696; *Asst Dir* John Markowitz; *Dir* Debra Bond
Open Mon - Tues, Thurs - Fri 10 AM - 5 PM; Wed 10 AM - 8 PM; cl Sat & Sun; No admis fee; Estab 1970 to hold exhibitions which will relate to our role as a senior level university; Galleries include a foyer gallery 10 x 40 ft & a main gallery of 1500 sq ft. It is fully air-conditioned & has carpeted walls with full facilities for construction & display; Average Annual Attendance: 8,500
Income: Financed by state appropriation
Special Subjects: Photography, Prints
Collections: Photographs & prints by a number of traditional & contemporary artists
Activities: Lect open to public, 3 vis lectrs per year; gallery talks; tours; competitions with awards; films; scholarships offered; individual paintings & original objects of art lent to university offices; book traveling exhibitions

L **Library,** 11000 University Pky, Pensacola, FL 32514-5750. Tel 850-474-2213; Fax 850-474-3338; Elec Mail ddebolt@uwf.edu; Internet Home Page Address: www.library.uwf.edu/speccoll; *Dir Special Coll* Dean DeBolt
Mon - Fri 8 AM - 4:30 PM; Estab 1967
Income: Financed by state appropriations & Friends of the Library

Library Holdings: Book Volumes 8200; Filmstrips; Memorabilia; Periodical Subscriptions 150
Collections: Includes collections of papers about Gulf Coast artists & art organizations

M **WEST FLORIDA HISTORIC PRESERVATION, INC,** (T T Wentworth Jr) T T Wentworth, Jr Florida State Museum & Historic Pensacola Village, PO Box 12866, Pensacola, FL 32591. Tel 850-595-5985; Fax 850-595-5989; Elec Mail rbrosnaham@uwf.edu; Internet Home Page Address: www.historicpensacola.org; *Exec Dir* Richard Brosnaham; *Assoc Dir* Robert Overton; *Cur* Lynne Robertson; *Cur* Carolyn Prime; *Educ Dir* Gale Messerschmidt; *Living History Coordr* Sheyna Priest; *School Prog & Tour Coordr* Dena Bush
Open Mon - Sat 10 AM - 4 PM; Admis Historic Pensacola Village: adult $6, seniors $5, children ages 4-16 $2.50, Wentworth Museum: free; Estab 1967 to conserve historical items & make them available to the public; art sections to encourage art & exhibit local art work; Three floors of exhibts with permanent & change exhibts & children's hands-on gallery; historic houses & museums of industry & commerce; also maintains library & archiveby appointment (on site use only); Average Annual Attendance: 50,000; Mem: 350; dues patron $100, family $60, couples $45, individual $35; students $20
Income: Univ of W Florida; long & short term rentals; admissions & store sales
Library Holdings: Book Volumes; Clipping Files; Maps; Memorabilia; Original Art Works; Original Documents; Pamphlets; Photographs; Prints; Records; Slides; Video Tapes
Special Subjects: Decorative Arts, Historical Material, Landscapes, Marine Painting, Architecture, Ceramics, Flasks & Bottles, Furniture, Photography, Porcelain, Portraits, Pottery, Prints, Period Rooms, Woodcuts, Maps, Drawings, Graphics, Painting-American, Watercolors, Archaeology, Textiles, Costumes, Crafts, Folk Art, Woodcarvings, Etchings & Engravings, Posters, Dolls, Glass, Coins & Medals, Embroidery, Laces
Collections: Works of local & some nationally famous artists; archaeology; coins; porcelain; furnishings; tools and equipment; photographs; documents; maps & prints; dolls & doll houses
Publications: quarterly membership newsletter
Activities: Classes for adults & children; docent training; summer camp for children; museology classes through UWF; internships; living history prog; craft demonstations; lect for members only, 2-3 vis lect per yr; concerts; gallery talks; tours; museum shop sells books & souveniers; Discovery Gallery on 3rd floor of Wentworth Museum

SAFETY HARBOR

M **SAFETY HARBOR MUSEUM OF REGIONAL HISTORY,** 329 S Bayshore Blvd S, Safety Harbor, FL 34695. Tel 727-726-1668; Fax 727-725-9938; Elec Mail Shmuseum@ij.net; Internet Home Page Address: www.safety-harbor-museum.org; *Interim Dir* Marilyn K Bartz; *Office Mgr* Shelby Papuga; *Asst Office Mgr* Ron Fekete
Open Tue - Fri 10 AM - 4 PM, Sat & Sun 1 - 4 PM; Admis adult $3, children $2 (12 to 18), seniors $2; Estab 1977 to promote, encourage, maintain & operate a mus for the preservation of knowledge & appreciation of Florida's history; to display & interpret historical materials & allied fields; Indian art in the form of murals, pottery & artifacts; Average Annual Attendance: 6,500; Mem: 155; dues $25-2,500; quarterly meetings
Income: $2,000 (financed by mem, grants & donations)
Special Subjects: Historical Material, Maps, American Indian Art, Archaeology, Dioramas
Collections: Florida archaeological artifacts & historical memorabilia
Exhibitions: 2-4 Temporary exhibits
Activities: Docent training; lect open to public, 7 vis lectrs per year; gallery talks; tours; originate traveling exhibitions; museum shop sells books & Native American reproductions

SAINT AUGUSTINE

A **CITY OF SAINT AUGUSTINE,** (Historic Saint Augustine Preservation Board) PO Box 210, Saint Augustine, FL 32085. Tel 904-825-5033; Fax 904-825-5096; Elec Mail hpht@aug.com; Internet Home Page Address: www.historicstaugustine.com; *Cur* John Powell; *Chmn* William R Adams
Open daily 9 AM - 5:15 PM, cl Christmas; Admis to six buildings adults $6.50, students $2.50, children under 6 free; Estab 1959 to depict daily life in the 1740s (Spanish) through its living history mus; Average Annual Attendance: 94,000
Collections: Spanish artifacts; fine & decorative arts; restored & reconstructed colonial buildings from the 18th & 19th centuries
Exhibitions: Permanent & temporary exhibitions
Publications: Brochures & booklets

M **LIGHTNER MUSEUM,** 75 King St, Museum-City Hall Complex, PO Box 334 Saint Augustine, FL 32085. Tel 904-824-2874; Fax 904-824-2712; Elec Mail lightner@aug.com; Internet Home Page Address: www.lightnermuseum.org; *Cur* Barry W Myers; *Registrar* Irene L Lawrie; *Visitors Svcs* Helen Ballard; *CEO* Robert W Harper III; *VChmn* Edward G Mussallem; *Mus Shop Mgr* Janice Phelan; *Asst to Dir* Helen C Amato; *Bus Mgr* Angela Blankenship
Open 9 AM - 5 PM, cl Christmas; Admis adults $6, students $2, children under 12 free when accompanied by adult; Estab 1948; Average Annual Attendance: 160,000
Income: Financed by admis
Special Subjects: American Indian Art, Textiles, Costumes, Ceramics, Decorative Arts, Judaica, Furniture
Collections: 19th century material culture, decorative arts, & fine arts
Activities: Classes for adults & children; dramatic programs; docent training; lect open to public, 4 vis lectrs per year; concerts; gallery talks; tours; individual paintings & original objects of art lent to museums; book traveling exhibitions; originate traveling exhibitions to other museums; sales shop sells books, magazines, reproductions, prints

L Library, PO Box 334, Saint Augustine, FL 32085-0334. Tel 904-824-2874; *CEO* Robert W Harper III
Library for reference only
Income: Financed by the mus
Library Holdings: Book Volumes 4600; Clipping Files; Exhibition Catalogs; Memorabilia; Original Art Works; Pamphlets; Periodical Subscriptions 10; Photographs; Prints; Reproductions; Sculpture

A SAINT AUGUSTINE ART ASSOCIATION GALLERY, 22 Marine St, Saint Augustine, FL 32084. Tel 904-824-2310; Fax 904-824-0716; Elec Mail staart@bellsouth.net; Internet Home Page Address: www.staaa.org; *Pres* Pam Pahl; *VPres* Diane Bradley; *Treas* Jeralyn Lowe; *Exec Dir* Judith Westley
Open Tues - Sat Noon - 4 PM, Sun 2 - 5 PM, cl Mon & holidays; No admis fee; Estab 1924, incorporated 1934 as a non-profit organization to further art appreciation in the community by exhibits & instructions, also to provide a gallery where local artists may show their work & pub & tourists may see them free; Gallery is 100 ft x 180 ft with carpeted walls for exhibition; Average Annual Attendance: 5,000; Mem: 700; dues $40 & up; annual meeting in Mar
Income: Financed by mem, dues, donations, arts & crafts festivals
Collections: Donations of art works by St Augustine artists or members representing St Augustine
Exhibitions: Rotating monthly shows on different themes
Activities: Classes for adults & children; docent training; workshops; lect open to public, 8-10 vis lectrs per year; gallery talks; tours; competitions with prizes; concerts on a rental basis

SAINT AUGUSTINE HISTORICAL SOCIETY
M Oldest House Museum Complex, Tel 904-824-2872; Fax 904-824-2569; Elec Mail oldhouse@aug.com; Internet Home Page Address: www.oldcity.com/oldhouse; *Dir* Taryn Rodriguez-Boette; *Coll Mgr* Reis Libby; *Museum Store Mgr* Michael Usina; *Library Mgr* Charles Tingley; *Mus Manager* Art Lillquist
Open daily 9 AM - 5 PM; cl Christmas Day, Thanksgiving Day, Easter; Admis adults $6, seniors $5.50, students $4; Estab 1883 to preserve the Spanish heritage of the United States through exhibits in historic mus with collection of furnishings appropriate to the periods in Saint Augustine history (1565 to date); Maintains a research library, rotating exhibits gallery; Average Annual Attendance: 58,000; Mem: 600; dues $35; annual meeting in 3rd Tues in Jan
Income: Financed by admis, grants, endowment, mus store, donations
Library Holdings: Clipping Files; Manuscripts; Maps; Memorabilia; Motion Pictures; Original Art Works; Original Documents; Pamphlets; Periodical Subscriptions; Photographs; Prints; Slides; Video Tapes
Special Subjects: History of Art & Archaeology, Interior Design, Art Education, Art History, Flasks & Bottles, Portraits, Pre-Columbian Art, Architecture, Painting-American, Photography, American Indian Art, Anthropology, Archaeology, Costumes, Ceramics, Pottery, Manuscripts, Furniture, Porcelain, Silver, Historical Material, Maps, Coins & Medals, Period Rooms, Painting-Spanish, Reproductions
Collections: Archaeological material recovered from this area, both aboriginal & colonial; period furnishings: Spanish America (1565-1763 & 1783-1821); British (1763-1783); American (1821-present)
Publications: El Escribano, annual; East Florida Gazette, bi-ann
Activities: Classes for adults; elder hostels; continuing education for architects & interior designers; summer camp; lect open to public; gallery talks; tours; 8 vis lect per yr; individual paintings lent to other museums; museum shop sells books, reproductions, prints & gift items relating to St Augustine history
L Library, Tel 904-825-2333; Fax 904-824-2569; Elec Mail sahs@aug.com; Internet Home Page Address: www.oldcity.com/oldesthouse; *Exec Dir* Taryn Rodrigues-Boette; *Library Dir* Charles Tingley; *Asst Library Mgr* Leslie Wilson; *Asst Librn* Bill Temme
Open Tues - Fri 9 AM - 4:30 PM, cl holidays; Circ Non-circulating; Research library
Income: Financed by endowment & admis from Oldest House
Library Holdings: Audio Tapes; Book Volumes 10,000; Cassettes; Clipping Files; Kodachrome Transparencies; Manuscripts; Memorabilia; Micro Print; Motion Pictures; Original Art Works; Other Holdings Original documents; Pamphlets; Periodical Subscriptions 40; Photographs; Prints; Records; Reels; Reproductions; Sculpture; Slides; Video Tapes
Special Subjects: Manuscripts, Maps, Painting-American, Painting-Spanish, Historical Material, History of Art & Archaeology, Ceramics, Archaeology, Anthropology, Furniture, Period Rooms, Costume Design & Constr, Glass, Pottery, Religious Art, Restoration & Conservation, Coins & Medals, Architecture
Collections: Paintings of early artist & of early Saint Augustine; 200 linear feet of maps, photographs, documents & photostats of Spanish Archival Materials as touching directly on Saint Augustine's History during the early Spanish, British & American periods (1565 to present)
Publications: East Florida Gazette, quarterly; El Escribano, annually
Activities: Lect open to public, 9 vis lectrs per year

SAINT PETERSBURG

M MUSEUM OF FINE ARTS, SAINT PETERSBURG, FLORIDA, INC, 255 Beach Dr NE, Saint Petersburg, FL 33701. Tel 727-896-2667; Fax 727-894-4638; Elec Mail jennifer@fine-arts.org; *Dir* Michael Milkovich; *Cur Coll & Exhib* Dr Jennifer Hardin; *Admin Asst* Gale C Laubach; *Mem Coordr* Anastasia Medina; *Coordr Exhib* Allison Ben David; *Registrar* Louise Reeves; *Financial Officer* Don Bremer; *Museum Shop* Ellen Holte; *Cur Educ* Rebecca Russell; *Photog & Installations* Thomas Gessler; *Dir Pub Relations* David Connelly; *Asst Cur Educ* Patricia Buster; *Librn* Jordana Bernstein
Open Tues - Sat 10 AM - 5 PM; Sun 1 - 5 PM; cl Mon; Admis adults $6, seniors $5, students $2; Estab 1962 to increase & diffuse knowledge & appreciation of art; to collect & preserve objects of artistic interest; to provide facilities for research & to offer popular instruction & opportunities for esthetic enjoyment of art; Twenty galleries of works from the collection including period rooms; Average Annual Attendance: 100,000; Mem: 4000; dues $30 & higher; annual meeting in May

Income: $1,200,000 (financed by endowment, mem, fundraising, city & state grants)
Library Holdings: Auction Catalogs; Book Volumes; Clipping Files; Exhibition Catalogs; Filmstrips; Framed Reproductions; Periodical Subscriptions; Video Tapes
Special Subjects: Hispanic Art, American Indian Art, American Western Art, African Art, Pre-Columbian Art, Southwestern Art, Religious Art, Decorative Arts, Judaica, Historical Material, Period Rooms
Collections: Art: African, Ancient, Asian, Native American & Pre-Columbian; decorative arts; 19th & 20th Century photographs; paintings; Steuben glass; prints; sculpture; 18th & 19th century European Art; 19th & 20th century American Art
Publications: Mosaic, quarterly newspaper; brochures & exhibition catalogs; catalog of the collection
Activities: Classes for adults & children; docent training; lect open to public; 30 vis lectrs per year; films; tours; performing arts; dance; concerts; theatre; storytellers; named best art museum by Tampa Bay Magazine and Weekly Planet; individual paintings & original objects of art lent to other museums; lending collection contains color reproductions, films on art; originate traveling exhibitions to museum and university galleries; museum shop sells books, museum reproductions, prints, museum replicas, jewelry, pottery & crafts by local & national artisans, stationery, children's art educational games & puzzles, t-shirts with museum logo
L Art Reference Library, 255 Beach Dr NE, Saint Petersburg, FL 33701. Tel 727-896-2667; 727-894-4638; Internet Home Page Address: www.fine-arts.org
Open Tues - Thurs 10 AM - Noon, 1 - 4:45 PM; Estab 1962 as reference library
Income: Financed by grants & contributions
Library Holdings: Book Volumes 25,000; Exhibition Catalogs 3,000; Periodical Subscriptions 25
Special Subjects: Decorative Arts, Photography, Painting-American, Painting-British, Painting-Dutch, Painting-Flemish, Painting-French, Painting-Italian, Painting-Spanish, Sculpture, Painting-European, Gold

M SALVADOR DALI MUSEUM, 1000 Third St S, Saint Petersburg, FL 33701. Tel 727-823-3767, 822-6270; Fax 727-894-6068; Elec Mail daliweb@mindspring.com; Internet Home Page Address: www.salvadordalimuseum.org; *Exec Dir* T Marshall Rousseau; *Vol Coordr* Cindy Hanks; *Pres* Thomas A James; *Dir of Mktg* Kathy White
Open Mon - Sat 9:30 AM - 5:30 PM, Sun Noon - 5:30 PM, cl Mon; Admis adults $10, seniors $7, students $5; Estab 1971 to share the private Dali Collection of Mr & Mrs A Reynolds Morse with the pub; formerly in Cleveland, Ohio, the museum re-opened Mar 7, 1982 in Saint Petersburg, Fla; Average Annual Attendance: 215,000; Mem: 1,500; dues individual $40
Income: Financed by private collector, State University Systems & donations
Collections: 93 oils & 5 large masterworks by Dali make up a retrospective of his work from 1914 to the present; numerous drawings & watercolors
Exhibitions: Dali Alchemy; Dali Les-Chants-De Maldoror; Alice in Wonderland
Publications: Dali Draftmanship; Guide to Works by Dali in Public Museums; Introductionto Dali; Dali-Picasso; Poetic Homage to Gala-Dali; Dali Primer; Dali's World of Symbols: Workbook for Children; Dali Newsletter; exhibition catalogues
Activities: Adult classes; docent training; lect open to public, 2 vis lectrs per year; film series; gallery talks; tours; museum shop sells books, reproductions, prints, slides, postcards
M Museum, 1000 Third St S, Saint Petersburg, FL 33701. Tel 727-823-3767; Fax 727-894-6068; Internet Home Page Address: www.salvadordalimuseum.org; *Cur* Joan R Kropf; *Dir* Charles Hine Dr.; *Librn* Elen Woods; *Cur Exhibs* Dr William Jeffett
Mon - Wed & Fri 9:30 - 5:30, Thur 9:30 - 8:30, Sun noon - 5:30; Admis Adults $15, seniors & military $13.50, children 4 & under free; Estab 1982 for research purposes; Permanent collection/temporary exhibitions; contains 5000 references to Dali in books, periodicals & newspapers; Average Annual Attendance: 213,000; Mem: 750; individual $40; family $70
Income: Financed privately by Salvador Dali Foundation; public/grants
Library Holdings: Audio Tapes; Book Volumes 32; Cassettes; Clipping Files; Exhibition Catalogs; Framed Reproductions 1028; Kodachrome Transparencies 3000; Manuscripts; Memorabilia; Motion Pictures 10; Original Art Works 165; Other Holdings Illustrated editions; Pamphlets; Periodical Subscriptions 20; Photographs; Prints 750; Slides; Video Tapes 50
Collections: Films & Tapes on or by Dali
Exhibitions: (8/2006-1/2007) Dalí by the Decades; (2/2/2007-6/24/2007) Dalí & the Spanish Baroque; Dalí: Sources Revealed
Publications: Pollock to Pop: America's Brush with Dalí; Jordi Colomer: Arabian Stars
Activities: Classes for adults & children; docent training; lect for members only; 10 vis lectrs per yr; gallery talks; tours; lending original objects of art; Items sold: books; reproductions; prints; slides

SARASOTA

A ART CENTER SARASOTA, 707 N Tamiami Trail, Sarasota, FL 34236. Tel 941-365-2032; Fax 941-366-0585; Elec Mail artsarasota@aol.com; Internet Home Page Address: www.artsarasota.org; *Pres* Alan P Sloan; *Admin Dir* Jackie Cory
Open Tues - Sat 10 AM - 4 PM, Sun Noon - 4 PM, cl Sat; Admis donation $2; Estab 1926, incorporated 1940, to promote the educational & cultural advantages of Sarasota in the field of contemporary art; Three galleries: east & sales galleries supports small exhibits & one-man shows; west gallery for curated & member shows; Average Annual Attendance: 26,000; Mem: 1200; dues $50 & up; annual meeting each Oct
Income: Financed by mem, donations & educ prog
Exhibitions: 20 exhibitions annually including curated & member exhibitions - every 6 wks in 3 galleries
Publications: Bulletin, monthly; yearbook
Activities: Classes for adults & children; workshops; lect open to public; gallery talks; tours; demonstrations; sponsoring of competitinos; scholarships offered; originate traveling exhibitions; museum shop sells books, original art, reproductions & prints

M **FLORIDA STATE UNIVERSITY,** John & Mable Ringling Museum of Art, 5401 Bay Shore Rd, Sarasota, FL 34243. Tel 941-359-5700; Fax 941-359-5745; Elec Mail info@ringling.org; Internet Home Page Address: www.ringling.org; *Exec Dir* John Wetenhall; *Conservator* Michelle Scalera; *Librn* Linda McKee
Open daily 10 AM - 5:30 PM; Admis adults $15, seniors $12, children 12 & under free; Estab 1928; Bequeathed to the State of Florida by John Ringling & operated by the state; built in Italian villa style around sculpture garden on 60 plus landscaped acres; original 19th century theater from Asolo, near Venice, in adjacent building; Ringling Residence & Circus Galleries on grounds; Average Annual Attendance: 300,000 paid combination, 700,000 free attendance & special events; Mem: 3000; dues benefactor $10,000, patron $5000, fellow $1000, friend $250, centennial $100, family $50, individual $30
Special Subjects: Drawings, Prints, Sculpture, Archaeology, Painting-European, Coins & Medals, Baroque Art
Collections: Archaeology of Cyprus; Baroque pictures, especially those of Peter Paul Rubens; European painting, sculpture, drawings & prints from the 16th, 17th & 18th centuries; medals & 18th century decorative arts; developing collection of 19th & 20th century painting, sculpture, drawings & prints
Exhibitions: Selections from the Permanent Collection; Old Masters.
Publications: Calendar, bi-monthly; Collection Catalogues; Exhibition Catalogues; Newsletter, quarterly
Activities: Educ dept; docent training; state services; lect open to public & some for members only; concerts; gallery talks; exten dept serves the state; individual paintings & original objects of art lent to affiliates & other qualified museums nationally & internationally on board approval; lending collection contains 1000 individual paintings, 1000 objects of art; originate traveling exhibitions to affiliates; sales shop sells books, reproductions, prints & slides

L **The John and Mable Ringling Museum of Art,** 5401 Bay Shore Rd, Sarasota, FL 34243. Tel 941-359-5743; Fax 941-359-5745; Elec Mail library@ringling.org; Internet Home Page Address: www.ringling.org; *Sr Asst* Artis Wick; *Librn* Linda R McKee
Open Wed & Fri 1 - 5 PM; all other hours Mon - Fri by appointment; Reference only
Library Holdings: Auction Catalogs; Book Volumes 60,000; Exhibition Catalogs; Other Holdings Art auction catalogues; Rare books; Periodical Subscriptions 135
Special Subjects: Art History, Painting-Dutch, Painting-Flemish, Painting-Italian
Collections: John Ringling Library of rare books, circus books

M **RINGLING SCHOOL OF ART & DESIGN,** Selby Gallery, 2700 N Tamiami Trail, Sarasota, FL 34234. Tel 941-359-7563; Fax 941-309-1969; Elec Mail selby@ringling.edu; Internet Home Page Address: www.ringling.edu/selbygallery; *Dir* Kevin Dean; *Asst Dir* Laura Avery; *Gallery Asst* Candise Curlee
Open Mon - Sat 10 AM - 4 PM, Tues 10 AM - 7 PM; No admis fee; Estab 1986; Exhibitions of internationally known artists; Average Annual Attendance: 20,000
Income: Financed by the school
Exhibitions: Rotating exhibits
Activities: Originate traveling exhibitions

L **RINGLING SCHOOL OF ART & DESIGN,** Verman Kimbrough Memorial Library, 2700 N Tamiami Trail, Sarasota, FL 34234. Tel 941-359-7587; Fax 941-359-7632; Internet Home Page Address: www.rsad.edu; *Dir Library* Kathleen List; *AV Librn* Allen Novak; *Technical Servs Librn* Janet Thomas
Open Mon - Thurs 8 AM - 11 PM, Fri 8 AM - 6 PM, Sat Noon - 6 PM, Sun 10 AM - 10 PM; Estab 1932 to serve the curriculum needs of an undergraduate, visual arts college; Circ 30,000
Income: $100,000 (financed by library assoc, parent institution & capital expense)
Purchases: $100,000
Library Holdings: Book Volumes 43,000; Periodical Subscriptions 300; Slides 110,000
Special Subjects: Decorative Arts, Film, Illustration, Photography, Drawings, Graphic Arts, Graphic Design, History of Art & Archaeology, Conceptual Art, Interior Design, Asian Art, Aesthetics, Architecture

A **SINO-AMERICAN FIELD SCHOOL OF ARCHAEOLOGY (SAFSA),** 4206 73rd Terrace E, Sarasota, FL 34243. Tel 941-351-8208; Fax 941-351-8208; Elec Mail fmfsafsa@juno.com;
Not open to public, students only; Estab 1988 to exhibit & teach museology in collaboration with the Fudan Univ Mus, Shanghai,China; Holds the complete material of the Gao-shan culture & currently building the American collection. Now contains the monoprints of Harry Bertoia
Income: Financed by university & student tuition fees
Exhibitions: The Institute of Archeology in Xi'an has its permanent exhib & addition by archeoligical field work
Publications: archaeology for museologists; chinese chronological history
Activities: Organizing summer archaeology practicum, collaboration with the Shaanxi Province, Institute of Archaeology, and Xi'an Jiaotong University, Shaanxi, China, classes for adults & high school senior & univ (college) students; lectures for Inmatriculated Students only, 4 vis lectures per yr, tours; originate traveling exhibitions

M **THE TURNER MUSEUM,** 930 N Tamiami Trail, Unit 516 Sarasota, FL 34236-4067; PO Box 11073, Sarasota, FL 34278-1073. Tel 941-365-4688; Fax 941-365-4688; Elec Mail turnermuseum@turnermuseum; Internet Home Page Address: www.turnermuseum.org; *Chmn* Douglas Graham; *Chief Cur* Isis Graham; *Webmaster* Jacques Sennefeld
Open by appointment only; Admis $10; Estab 1973 to promote JMW Turner & Thomas Moran; Maintains reference library; Mem: over 1000; dues $100, students $5; annual meeting in Dec
Library Holdings: Auction Catalogs; Book Volumes; Cards; Exhibition Catalogs; Original Art Works; Original Documents; Photographs; Prints; Slides; Video Tapes
Special Subjects: Prints, Painting-British, Painting-European, Graphics
Collections: JMW Turner - Works on Paper
Publications: Turner's Cosmic Optimism; The Intrepid Collection (ebook)
Activities: Sells books & original art

STUART

M **HISTORICAL SOCIETY OF MARTIN COUNTY,** Elliott Museum, 825 NE Ocean Blvd, Stuart, FL 34996-1696. Tel 561-225-1961; Elec Mail hsmc@bellsouth.net; Internet Home Page Address: www.goodnature.org/elliottmuseum; *Pres & CEO* Robin Hicks-Connors; *Cur* Susan Duncan; *Bus Mgr* Nicole Ramsey
Open daily 10 AM - 4 PM including holidays; Admis adults $6, children between 6 & 13 $2; Estab 1961; American Art, antiques & vintage automobiles; Average Annual Attendance: 30,000; Mem: 1000; dues $25-$1000
Library Holdings: Auction Catalogs; Book Volumes; Cards; Clipping Files; Exhibition Catalogs; Kodachrome Transparencies; Manuscripts; Maps; Memorabilia; Original Art Works; Original Documents; Pamphlets; Periodical Subscriptions; Prints; Sculpture; Slides; Video Tapes
Special Subjects: Painting-American
Collections: Contemporary American artists (realistic); Walter Brightwell, Nina D Buxton, Cecilia Cardman, E I Couse, James Ernst, Jo Gabeler, Diana Kan, Hui Chi Mau, Rose W Traines; antiques; Automobiles & historic fashions
Activities: Classes for adults & children, dramatic programs, docent training, annual classic car show; concerts; 2 vis lectrs per year; gallery talks; local school tours, morning; museum shop sells books, reproductions, original art, jewelry, educational toys

TALLAHASSEE

A **FLORIDA DEPARTMENT OF STATE, DIVISION OF CULTURAL AFFAIRS,** Florida Arts Council, 1001 DeSoto Park Dr, Tallahassee, FL 32301. Tel 850-245-6470; Fax 850-245-6497; Internet Home Page Address: www.dos.state.fl.us/dca; Telex 488-5779; *Arts Adminr* Lee Modica; *Dir* JuDee Pethjohn; *Pub Relations Specialist* Erin Long
Open 8 AM - 5 PM; Estab 1969 to advise the Secretary of State in fostering the arts in Florida
Exhibitions: Capitol Complex Exhibition
Activities: Fels offered to individual artists

A **FLORIDA FOLKLIFE PROGRAMS,** Bureau Historic Preservation, 500 S Bronough St Tallahassee, FL 32399-0250. Tel 850-487-2333; Fax 850-922-0496; Elec Mail tbucuvalas@mail.dos.state.fl.us; WATS 800-847-7278; *Bureau Chief* Fred Gaske; *Folk Arts Coordr* Dr Tina Bucuvalas; *Folklife Adminr* Gregory Hansen
Open Mon - Fri 8 AM - 5 PM; No admis fee; Estab 1979 to encourage local folk artisions to appreciate this importent art form; The Bureau is under Secretary of Jim Smith & carries on a year-round calendar of folk activities in an effort to encourage statewide pub interests & participation in the folk arts & folklore
Activities: Classes for adults & children; lect open to public; concerts; Florida Folk Heritage Award; apprenticeships offered; originate traveling exhibitions

L **Library,** Grey Bldg, Rm 402, 500 S Bronough St Tallahassee, FL 32399-0250. Tel 850-245-6333; Elec Mail tbucuvalas@mail.dos.state.fl.us; Internet Home Page Address: http://dhr.dos.state.fl.us/folklife/index.html; WATS 800-847-7278; Open to pub for reference Mon - Fri 8 AM - 5 PM
Library Holdings: Audio Tapes; Book Volumes 500; Cards; Cassettes; Clipping Files; Exhibition Catalogs; Filmstrips; Kodachrome Transparencies; Manuscripts; Original Art Works; Pamphlets; Periodical Subscriptions 10; Photographs; Records; Slides; Video Tapes
Special Subjects: Folk Art, Ethnology
Collections: Folklife
Activities: Folklife apprenticeship prog; Fla Folk Heritage awards; Folklife Days; Music in the Sunshine State radio series

M **FLORIDA STATE UNIVERSITY,** Museum of Fine Arts, 250 Fine Arts Bldg, Copeland & Tennessee Sts Tallahassee, FL 32306-1140. Tel 850-644-6836; Fax 850-644-7229; Elec Mail apcraig@mailer.fsu.edu; Internet Home Page Address: www.mofa.fsu.edu; *Sr Preparator* Wayne Vonada; *Cur Educ* Viki D Wayner; *Fiscal Officer & Registrar* Jean Young; *Dir & Ed-in-Chief* Allys Palladino-Craig; *Communications Coordr* Teri Yoo; *Special Proj* Preston McLane
Open Mon - Fri 9 AM - 4 PM, Sat & Sun 1 - 4 PM (Fall & Spring semesters); cl school holidays; No admis fee; Estab 1950; Three upper galleries; two lower galleries, one for permanent collection; sculpture courtyard; Average Annual Attendance: 48,000; Mem: 300, friends of the Gallery; 150, Artists' League
Income: Financed by state appropriations, grants & private sector
Library Holdings: Book Volumes 300; Exhibition Catalogs 600; Original Art Works 4000; Prints; Sculpture
Special Subjects: Painting-American, Sculpture
Collections: Asian prints; Carter Collection of Pre-Columbian Art; contemporary American graphics, photography & paintings; European painting
Publications: Exhibition catalogues; Athanor, art history journal
Activities: Educ dept; docent training; lect open to public, 5 vis lectrs per year; gallery talks; tours; exten dept; individual paintings & original objects of art lent by appropriate request; book traveling exhibitions 1-2 per year; originate traveling exhibitions to museums in Florida and nationally

M **LEMOYNE ART FOUNDATION, INC,** 125 N Gadsden St, Tallahassee, FL 32301. Tel 850-222-8800; Fax 850-224-2714; Elec Mail art@lemoyne.org; Internet Home Page Address: www.lemoyne.org; *Pres* Frank Helms; *Exec Dir* MaryBeth Foss; *Cur, Artistic Dir* Sam Fleeger
Open Tues - Sat 10 AM - 5 PM; Sun 1 - 5 PM; cl Mon; Admis adult $1, members & children under 12 free, Sun free; Estab 1964 as a non-profit organization to serve as gallery for contemporary, quality art of Florida artists; sponsor the visual arts in Tallahassee; an educational institution in the broadest sense; Located in Meginnes-Munroe House, built c 1840; four main galleries & gallery shop; LeMoyne Gift Shop in adjacent historic building; Average Annual Attendance: 103,881; Mem: 100; dues $30-$5000
Income: Financed by mem, sales, grants & fund raisers
Special Subjects: Ceramics

Collections: Contemporary Florida Artists; George Milton Traveling Exhibit of Old & New Testament Paintings; Hiram Williams Permanent Collection of Drawings & Paintings; William Watson Collection of Ceramics; Karl Zerbe Serigraphs
Publications: Newsletter, bi-monthly; exhibit catalogs
Activities: Classes for adults & children, summer art camp & workshops; lect open to public, 4 vis lectrs per year; gallery talks; tours; competitions; individual paintings and original objects of art lent to businesses and members; lending collection contains original art works, original prints; paintings and sculpture; Artisans Gallery sells original fine art, craft items & prints

M **TALLAHASSEE MUSEUM OF HISTORY & NATURAL SCIENCE,** 3945 Museum Dr, Tallahassee, FL 32310. Tel 850-575-8684; Fax 850-574-8243; Elec Mail rdaws@tallahasseemuseum.org; Internet Home Page Address: www.tallahasseemuseum.org; *Dir* Russell S Daws; *Cur Coll & Exhib* Linda Deaton; *Animal Cur* Michael Jones; *Dir* Russell S Daws
Open Mon - Sat 9 AM - 5 PM; Sun 12:30 - 5 PM; Admis adults $6.50, children 4-15 $4.50, members free; Estab 1957 to educate children & adults about natural history, native wildlife, North Florida history, art & culture; Facilities include 1880's farm, historic buildings, exhibit & class buildings, 40 acres of nature trails & animal habitats; Average Annual Attendance: 120,000; Mem: 5000; dues $45; annual meeting third Thurs in Oct
Income: $1,400,000 (financed by mem, fundraisers, admis & government appropriation)
Special Subjects: Architecture, Archaeology, Crafts, Folk Art, Pottery, Historical Material, Period Rooms, Reproductions
Collections: Pre-Columbia Florida Indian Pottery; Historic Buildings; Furnishings
Exhibitions: Changing exhibit on art, clothing, crafts, history & science; permanent or semi-permanent (3 years) exhibits on local history & natural history
Publications: Guidebook Series; Newsletter, monthly; School Handbook
Activities: Classes for adults & children; docent training; lect open to public, 8-12 vis lectrs per year; concerts; gallery talks; tours; scholarships offered; museum shop sells books, reproductions & prints

L **Library,** 3945 Museum Dr, Tallahassee, FL 32310. Tel 850-575-8684; Fax 850-574-8243; Elec Mail rdaws@tallahassee.museum.org; Internet Home Page Address: www.tallahasseemuseum.org; *CEO & Exec Dir* Russell S Daws
Open to members
Income: $1,400,000 (financed by earned income, donations, grants & special events)
Library Holdings: Book Volumes 500; Periodical Subscriptions 12
Collections: Ivan Gundrum Pre-Columbian Florida Indian Artifacts (reproductions) representing the Weeden Island culture 500 - 1500 AD
Publications: Monthly Tallahassee Museum Newsletter

TAMPA

ARTHUR MANLEY SOCIETY
For further information, see National and Regional Organizations

C **CASPERS, INC,** Art Collection, 4908 W Nassau St, Tampa, FL 33607. Tel 813-287-2231; Fax 813-289-7850; *Pres* Chuck Peterson; *Marketing Mgr* Steve Scott; *CEO* Joseph Casper
Open Mon - Fri 8 AM - 5 PM; Estab 1981 to enhance the employees' environment
Collections: Collection features works by artists with some relationship to Florida

A **CITY OF TAMPA,** Public Art Program, 1420 N Tampa St, Tampa, FL 33602; 600 N Ashley Dr, Tampa, FL 33602. Tel 813-274-8531; Fax 813-274-8732; Elec Mail robin.nigh@tampagov.net; *Admin* Robin Nigh
Estab 1985 to visually enhance & enrich the public environment for both residents & visitors of Tampa; Mem: Public Art Committee meets monthly
Collections: wide variety of public art
Publications: Public Art Brochure; Save Outdoor Sculpture

SOCIETY OF NORTH AMERICAN GOLDSMITHS
For further information, see National and Regional Organizations

M **TAMPA MUSEUM OF ART,** 600 N Ashley, Tampa, FL 33602. Tel 813-274-8130; Fax 813-274-8732; Internet Home Page Address: www.tampamuseum.com; *Chief Cur* Elaine Gustafson; *Preparator* Bob Hellier; *Registrar* Leslie Hammond; *Dir* Emily S Kass
Open Tues, Wed, Fri & Sat 10 AM - 5 PM, Thurs 10 AM - 8 PM, Sun 1 - 5 PM; Admis adults $5, seniors $4, students & children 6-18 $3, under 6 free; Estab 1970 to educate the pub through the display of art; 7 galleries with antiquities, sculpture, photography & paintings; Average Annual Attendance: 82,500; Mem: 1950; dues $35
Income: $1,400,000 (financed by local government, grants, mem & contributions)
Special Subjects: Decorative Arts, Etchings & Engravings, Folk Art, Glass, Gold, Photography, Textiles, Bronzes, Drawings, Latin American Art, Painting-American, Prints, Sculpture, Watercolors, Ceramics, Crafts, Pottery, Woodcarvings, Woodcuts, Portraits, Jewelry, Painting-Dutch, Juvenile Art, Coins & Medals, Painting-Flemish, Antiquities-Greek, Antiquities-Roman, Antiquities-Etruscan
Collections: Greek & Roman antiquities; 20th century painting, sculpture & photography; 19th century photography & sculpture
Exhibitions: Rotating exhibits every 8-10 weeks
Publications: Catalogs; Newsletter, bi-monthly; school calender
Activities: Classes for adults & children; docent training; films; workshops; lect open to public; concerts; gallery talks; tours; individual paintings & original objects of art lent to fellow museums, lending collection contains cassettes, color reproductions, Kodachromes, phonorecords, photographs, slides & videos; book traveling exhibitions 10 per year; originate traveling exhibitions to other museums; museum shop sells books, original art, reproductions, prints, jewelry, toys, t-shirts, cards & stationary

L **Judith Rozier Blanchard Library,** 600 N Ashley Dr, Tampa, FL 33602. Tel 813-274-8130; Fax 813-274-8732; Internet Home Page Address: www.tampamuseum.com; *Interium Dir* Ken Rollins; *Cur Contemporary Art* Elaine

D Gustafson; *Registrar* Devon Larsen; *Chmn* Cornelia Corbett; *Cur Public Information* Meredith Elorfi; *Store Mgr* Stephanie Saunders; *Admin Mgr* John P Wren; *Cur Educ* Dawn Johnson; *Dir Develop* Steve Klindt
Thurs - Sat 10 AM - 5 PM, 3rd Thurs 10 AM - 9 PM, Sun 11 AM - 5 PM, cl Mon; Adult $8, senior & military $6, students & child 6 - 18 yrs $3, children under 6 yr free; 1979; For reference only; Average Annual Attendance: 60,000; Mem: 1956; dues $35 & up
Library Holdings: Audio Tapes; Book Volumes 1200; Cassettes; Exhibition Catalogs 700; Fiche; Other Holdings CD Rom programs; Pamphlets; Periodical Subscriptions 32; Slides; Video Tapes
Special Subjects: Art History, Photography, Painting-American, Pre-Columbian Art, Prints, Sculpture, Painting-European, Watercolors, Art Education, Antiquities-Etruscan, Antiquities-Greek, Antiquities-Roman, Coins & Medals
Publications: Art Muse Quarterly Newsletter
Activities: Classes for adults & children; docent training; letr open to the public, 5-10 vis lect per yr; gallery talks; tours; sponsoring of competitions; 6-10 book traveling exhib; mus shop sells books, magazines, original art & prints

M **UNIVERSITY OF SOUTH FLORIDA,** Contemporary Art Museum, College of Fine Arts, 4202 E Fowler Ave, CAM Bldg 101 Tampa, FL 33620-7360. Tel 813-974-4133; Fax 813-974-5130; Elec Mail mmiller@satie.arts.usf.edu; Internet Home Page Address: www.arts.usf.edu/museum; *Dir & Chief Cur* Margaret A Miller; *Asst Dir* Alexa A Favata; *Prog Asst* Lissie Cosme
Open Mon - Fri 10 AM - 5 PM, Sat 1 - 4 PM; No admis fee; Estab 1961 to provide exhibitions of contemporary art; Mus located on W Holly Dr on Tampa Campus; Average Annual Attendance: 55,000; Mem: dues corporate $1000-$100,000, private $5-$1000
Income: Financed by state appropriation, grants, mem fees & corporate art program
Special Subjects: Drawings, Painting-American, Photography, Prints, Sculpture, African Art, Pre-Columbian Art, Posters
Collections: African art, Pre-Columbian artifacts; art bank collection of loan traveling exhibitions (approx 60 small package exhibitions); contemporary photography; contemporary works on paper; painting; sculpture
Exhibitions: (2001) Lucy Orta: Nexus Architecture & Connector II, Never, Never Land; Contemporary Art from Cuba: Irony & Survival on the Utopian Island
Publications: Exhibition catalogs
Activities: Docent training; lect open to public, 4 vis lectr per year; gallery talks; tours; through Art Bank program original prints are lent to institutions, universities & arts organizations; book traveling exhibitions 2 per year; originate traveling exhibitions organized & circulated to universities, galleries & colleges; museum shop sells books, magazines, artists' created jewelry, architecture related products

L **Library,** Tampa Campus, 4202 E Fowler Ave LIB 122 Tampa, FL 33620-5400. Tel 813-974-2729; Fax 813-974-9875; Internet Home Page Address: www.lib.usf.edu; *Adminr* Jim Gray; *Art Reference Librn* Ilene Frank
Open Mon - Thurs 7:30 AM - 1 AM, Fri 7:30 AM - 9 PM, Sat 10 AM - 8 PM, Sun Noon - 1 AM; Open to students & pub
Income: Financed by state appropriations & grants
Library Holdings: Audio Tapes; Book Volumes 930,000; Cards; Cassettes; Clipping Files; Fiche; Filmstrips; Framed Reproductions; Manuscripts; Motion Pictures; Pamphlets; Periodical Subscriptions 5450; Photographs; Prints; Reels; Reproductions; Video Tapes
Special Subjects: Historical Material
Collections: Rare art books

UNIVERSITY OF TAMPA
M **Henry B Plant Museum,** Tel 813-254-1891, Ext 22; Internet Home Page Address: www.plantmuseum.com; *Cur & Registrar* Susan Carter; *Museum Relations* Jeannette Twachtmann; *Cur Educ* Amy Franklin-David; *Museum Store Mgr* Sue Gauthier; *Dir* Cynthia Gandee; *Mgr Operations & Mem* Heather Brabham; *Cur Asst* Alexandra Fernandez
Open Tues - Sat 10 AM - 4 PM, Sun Noon - 4 PM, cl holidays; Admis suggested donation $5; Estab 1933 in the former Tampa Bay Hotel built in 1891, to explain the importance of the Tampa Bay Hotel & Henry Plant to the area; This building which contains Victorian furnishings & artifacts, original to the Tampa Bay Hotel, is now on the register as a National Historical Landmark built by the railroad industrialist H B Plant; Average Annual Attendance: 25,000; Mem: 500
Income: Financed by city appropriation, University of Tampa, mem & donations
Special Subjects: Furniture, Porcelain
Collections: Late Victorian furniture & objects d'art of same period; Venetian mirrors; Wedgwood, Oriental porcelains
Exhibitions: Exhibits relating to 19th century life; Plant system railroads & steamships, Annual Christmas Stroll
Publications: Henry B Plant Museum, Today & Moments In Time, a pictorial history of the Tampa Bay Hotel; Tampa Bay Hotel: Florida's First Magic Kingdom (video); member newsletter, quarterly; series of Jean Stallings; educational series about Henry Plant & Victorian period
Activities: Docent training; lect open to public & lect for members only; museum store sells books, original art reproductions, Victorian style gifts, antique estate jewelry, estate silver, linens

M **Scarfone/Hartley Galleries,** Tel 813-253-3333, 253-6217; Fax 813-258-7497; Elec Mail dcowden@ut.edu; Internet Home Page Address: www.ut.edu; *Dir of Galleries* Dorothy Cowden; *Pres of the Univ* Ron Vaughn
Open Fri 10 AM - 4 PM, Sat 1 - 4 PM, cl June - July; No admis fee; Estab 1977 to exhibit works of art as an extension of the classroom & to utilize the space for pub functions which would benefit from the artistic environment created by showing current trends of all art forms of artistic merit; 6,000 sq ft of exhib space; Average Annual Attendance: 12,000; Mem: 75; donation dues $25-$1000
Income: Financed by donations & fundraisers
Collections: Contemporary artists
Exhibitions: Studio F; Monotype Exhibition; Gerge Sugarman, John Walker, Hoang Van Bui, Sam Messer, Ed Paschke, Miriam Schapiro
Publications: Exhibiton brochures, 10 times a yr
Activities: Classes for adults; lect open to public; 8 vis lectrs per yr; gallery talks; student annual juried awards; scholarships offered; lend artwork to other art or educational institutions; lending collection contains 100 pieces of original art; originate traveling exhibitions to mus & galleries

TEQUESTA

M LIGHTHOUSE CENTER FOR THE ARTS INC, (Lighthouse Gallery & Art School) 373 Tequesta Dr, Gallery Sq N Tequesta, FL 33469. Tel 561-746-3101; Fax 561-746-3241; Elec Mail info@lighthouse.org; Internet Home Page Address: www.lighthousearts.org; *Exec Dir* Margaret Inserra; Carmen Y Navy, Dir Finance; *Dir Operations* Cynthia E Palmieri; *School of Art Admin* Colleen Burch
Open Mon - Sat 9 AM - 4 PM; No admis fee for mem, non-mem $5 fee; Estab 1963 to create pub interest in all forms or the fine arts; Average Annual Attendance: 50,000; Mem: 800; dues $75; annual meeting in Nov
Income: financed by membership, donations, grants
Special Subjects: Drawings, Painting-American, Photography, Sculpture, Watercolors, Ceramics, Collages, Calligraphy
Exhibitions: Temporary & traveling exhibitions; Celebration of the Arts juried exhibit
Publications: Calendar of Events, monthly; Newsletter, quarterly
Activities: Classes for adults & children; workshops; Fine Arts Festival; Jazz Concert; Formal Beaux Art Ball; Holiday Tea; lect open to public, 10 vis lectrs per year; concerts; tours; competitions with awards; scholarships offered; individual paintings & original objects of art lent to local doctors offices, local restaurants & banks; lending collection contains books, original art works, original prints, paintings & sculptures; sales shop sells original art, gift shop items
L Not Profit Art Center, 373 Tequesta Dr, Gallery Sq N Tequesta, FL 33469. Tel 561-746-3101; Fax 561-746-3241; Elec Mail info@lighthousearts.org; Internet Home Page Address: www.lighthousearts.org; *Exec Dir* Sonya Davis
Open Mon - Sat 10 AM - 4:30 PM; Library estab 1964; Exhibitions, cultural events, museum store; Average Annual Attendance: 50,000; Mem: $75 & up annually
Income: financed by membership, donations, sponsorships & grants
Library Holdings: Book Volumes 600; Clipping Files; Exhibition Catalogs; Original Art Works; Pamphlets; Periodical Subscriptions 10; Prints
Special Subjects: Painting-American, Watercolors, Ceramics, Landscapes
Collections: Permanent collection of American artists
Activities: Educ prog; classes for adults & children; docent training; artbridge outreach; lect open to the public; 1,500 vis lect per year; concerts; gallery talks; tours; sposoring of competitions; scholarships; mus shop sells original art

VALPARAISO

M HERITAGE MUSEUM ASSOCIATION, INC, The Heritage Museum of Northwest Florida, 115 Westview Ave, Valparaiso, FL 32580. Tel 850-678-2615; Fax 850-678-4547; Internet Home Page Address: www.heritage-museum.org; *Educ Coordr* Stacy Knight; *Dir* Barbara Lee Moss; *Cur Coll* Louise McGirr
Open Tues - Sat 11 AM - 4 PM; Admis 16 and older $1, children under 16 & members free; Estab 1971 to collect, preserve, & display items related to the history & development of the area; Average Annual Attendance: 8,000; Mem: 240; dues $20
Income: $50,000 (financed by mem, city & county appropriation, fundraising & donations)
Special Subjects: American Indian Art, Anthropology, Archaeology, Textiles, Crafts, Folk Art, Pottery, Dolls, Glass, Silver, Historical Material, Maps, Embroidery, Laces
Collections: Paleo & archaic stone artifacts; pioneer household utensils, agricultural implements, artisans' tools, tools used in the turpentine & lumber industries; photos & files of research materials
Publications: :Heritage Press" newsletter
Activities: Adult & children's classes; docent programs; lect open to public, 6 vis lectrs per year; original objects of art lent to museums & for special school & college exhibits; book traveling exhibitions, 4 per year; museum shop sells books, original art & original handcrafts

WEST PALM BEACH

A HISTORICAL SOCIETY OF PALM BEACH COUNTY, 139 N County Rd Ste 25, The Paramount Bldg West Palm Beach, FL 33480. Tel 561-832-4164; Fax 561-832-7965; Elec Mail info@historicalsocietypbc.org; Internet Home Page Address: www.historicalsocietypbc.org; *Dir Research & Archives* Debi Murray; *Office Mgr* Margaret W Tamsburg; *Pres & CEO* Loren A Mintz; *Cur Colls* Steven F Erdmann
Open Tues - Fri 10 AM - 3 PM; No admis fee; Estab 1937 to preserve & disseminate history of Palm Beach County; Average Annual Attendance: 7,000; Mem: 700; dues $50-$2,500; annual meeting in Apr
Income: $90,000 (financed by mem, donations & grants)
Collections: Addison Mizner architectural drawings; History of Palm Beach County; other local architect drawings
Publications: Newsletter, monthly Oct - May
Activities: Lect open to public, 6 vis lectrs per year; tours; competitions-Judge James R Knott Award for excellence in historical research-public history; original objects of art lent to qualified non-profit organizations; lending collection contains film strips, framed reproductions, original art works, original prints, photographs, slides & artifacts from permanent collection; sales shop sells books & reproductions

M NORTHWOOD UNIVERSITY, Jeannette Hare Art Gallery, 2600 N Military Trail, West Palm Beach, FL 33409-2999. Tel 561-478-5538; Fax 561-640-3328; *Arts Coordr* Samara Strauss
Open daily 10 AM - 5 PM, Sun 2 - 6 PM; No admis fee; Estab 1959 to provide aesthetic, creative & spiritual elements as part of a business education; Average Annual Attendance: 10,000
Collections: Art About the Automobile; International Costume Collection; Tamassy Collection, old master works on paper; Wally Findlay Collection
Publications: Arts Report, annual; exhibition catalogues
Activities: Lect open to public, 4 vis lectrs per year; book traveling exhibitions 3-4 per year

M NORTON MUSEUM OF ART, 1451 S Olive Ave, West Palm Beach, FL 33401. Tel 561-832-5196; Fax 561-659-4689; Elec Mail museum@norton.org; Internet Home Page Address: www.norton.org; *Dir & CEO* Dr Christina Orr-Cahall; *Dir Membership* Graham Russell; *Dir Pub Relations* Sarah Flynn; *Registrar* Pamela Parry; *VPres* Anne Smith; *Dir Advancement* Jacquelin W Crebbs; *Dir Mktg & Pub Relations* Kipper Lance; *Chair, Cur Dept* Roger B Ward; *Cur Photography* Virginia Heckert; *Cur American Art* Kevin Sharp; *Mus Shop Mgr* Heather Blades-Premet; *Cur Chinese Art* John Finlay
Open Tues - Sat 10 AM - 5 PM; Sun 1 - 5 PM; Admis adults $6, students 13-21 $2, mems & children under 12 free; The Norton Museum of Art was founded in 1940, dedicated in 1941 for the educ & enjoyment of the pub; additions were made in 1946, 49, 52 & 66. Acquisitions & gifts are continually being made to the mus. Building & major collections were given by Ralph Hubbard Norton & Elizabeth Calhoun Norton. The Gallery, designed by the Palm Beach architects, Wyeth, King & Johnson, opened to the pub in 1941, with an original collection of 500 works of art. Mr Norton continued to acquire works of art for the mus until his death in 1953, when the remainder of his private collection was given to the mus; Sculptures are exhibited throughout the Gallery & in the patio garden. Maintins research library; Average Annual Attendance: 120,000; Mem: 4000; dues family $60 & $40; annual meeting in Nov
Income: Financed by endowment, mem, city appropriation, Palm Beach County Tourist Development Council, donations & fundraising events
Special Subjects: Painting-American, Sculpture, Bronzes, Jade, Painting-French
Collections: French Collection contains late 19th & early 20th century paintings including Impressionist & Post-Impressionist masterpieces; American holdings include works of art from 1900 to the present; Chinese collections contain archaic bronzes, archaic jades, Buddhist sculpture, jade carvings & ceramics
Exhibitions: Rotating exhibits
Publications: Exhibition catalogs
Activities: Educ dept; dramatic programs; docent training; lect open to public, 8 vis lectrs per year; films; concerts; gallery talks; tours; competitions with awards; individual paintings & original objects of art lent to museums around the world; originate traveling exhibitions; museum shop sells books, magazines, reproductions, prints & slides

M Museum, 1451 S Olive Ave, West Palm Beach, FL 33401. Tel 561-832-5196; Fax 561-659-4689; Elec Mail museum@norton.org; Internet Home Page Address: www.norton.org; *Dir* Dr Christina Orr-Cahall; *Chmn Curatorial Dept, Cur of European Art* Dr Roger War; *Dir Admin & SW Wing Project Mgr* Jane Pangborn
Open Mon - Sat 10 AM - 5 PM, Sun 1 - 5 PM, cl Mon May - Oct and major holidays; Admis $8; Estab 1941; Largest art museum in Florida featuring European, Chinese, American, Contemporary Art and Photography
Library Holdings: Audio Tapes; Book Volumes 3800; Clipping Files; Exhibition Catalogs; Fiche; Filmstrips; Kodachrome Transparencies; Memorabilia; Pamphlets; Periodical Subscriptions 30; Photographs; Reels; Slides
Collections: Individual Artist Reviews, Catalogues, etc; American Art, Chinese Art, Contemporary, European Art, Photography
Publications: Visions magazine, 3 times per year; Images newsletter, 6 times per year
Activities: Classes for adults & children; dramatic programs; docent training; lect open to public, 10 vis lectrs per year; concerts; gallery talks; tours; original & individual paintings lent; book traveling exhibitions 6 in 2002-2003 season; museum shop sells books, original art, prints

A PALM BEACH COUNTY CULTURAL COUNCIL, 1555 Palm Beach Lakes Blvd Ste 300, West Palm Beach, FL 33401. Tel 561-471-2901; Fax 561-687-9484; Elec Mail willrayfl@aol.com; Internet Home Page Address: www.pbccc.org; *Pres & CEO* Will Ray; *VPres & CPO* William Nix; *Controller* Bob Faub; *Dir Grants* Beth Doherty
Estab 1978 by Alex W Dreyfoos Jr as the Palm Beach County Council of the Arts to develop, coordinate, & promote the arts & cultural activities throughout Palm Beach County; recognized by the Board of County Commissioners as the county's advisory agency for cultural development & administers a portion of local tourist development funds under contract with county government; Mem: Dues $50
Income: Financed by donations
Activities: Lectr for mem only; 5 vis lectr per year

M ROBERT & MARY MONTGOMERY ARMORY ART CENTER, 1703 South Lake Ave, West Palm Beach, FL 33401. Tel 561-832-1776; Fax 561-832-0191; Elec Mail workshops@armoryart.org; Internet Home Page Address: www.armoryart.org; *Dean of School of Art* Paul Aho; *Dir Mktg* Julia Dietrich; *Exec Dir* Amelia Ostrosky
Open daily 9 AM - 5:30 PM, cl Sun; $5 suggested donation; Estab 1986; Mem: dues student $25, individual $50
Activities: Educ program; classes for adult & children; lects open to pub; 2 vis lects per yr

M YESTERYEAR VILLAGE, 9067 Southern Blvd, South Florida Fair West Palm Beach, FL 33421; PO Box 210367, West Palm Beach , FL 33421. Tel 561-795-6400; Fax 561-753-2124; Internet Home Page Address: www.southfloridafair.com/yesteryearvillage.html; *CEO & Dir* Brantley B Christian; *Develop & Mem* Vicki Chouris; *Chmn* Harold Murphy; *Pub Rels* John Picano; *Fin Dir* Matt Wallsmith; *Cur* Elizabeth K Speigle; *Security* Barry Reed
Open Tues - Sun 11 AM - 5 PM; Admis adults $5, seniors $4, children $3, under age 5 free; Estab 1990; mus contains 30 restored bldgs, working sawmill, blacksmith, gen store & more

WHITE SPRINGS

M FLORIDA DEPARTMENT OF ENVIRONMENTAL PROTECTION, Stephen Foster State Folk Culture Center, PO Drawer G, White Springs, FL 32096. Tel 904-397-2733; Fax 904-397-4262; *Park Mgr* Valinda Subic
Open 8 AM - Sunset daily; Admis Florida resident vehicle operator $1, each passenger $.50, children under 6 free; out-of-state vehicle operator $2, each passenger $1; Estab 1950 as a memorial to Stephen Collins Foster; operated by the State Department of Natural Resources; Mus contains eight dioramas of Foster's best known songs. The North wing holds a collection of minstrel

materials; the South wing 19th century furniture & musical instruments; the 200 foot tall Foster Tower, a collection of pianos; Average Annual Attendance: 90,000
Special Subjects: Furniture, Dioramas
Collections: Dioramas; furniture; minstrel materials; musical instruments; pianos

WINTER PARK

M **ALBIN POLASEK MUSEUM & SCULPTURE GARDENS,** 633 Osceola Ave Winter Park, FL 32789. Tel 407-647-6294; Fax 407-647-0410; Elec Mail info@polasek.org; Internet Home Page Address: www.polasek.org; *Exec Dir* Debbie Komanski; *Dir Mus Operations* Claire Pousanby; *Cur* Karen Louden
Open Tues - Sat 10 AM - 4 PM, Sun 1 - 4 PM; Admis $5 adults, $4 seniors, $3 student, mem & under 12 free; Estab 1961 to promote legacy of internationally known sculptor Albin Polasek; Retirement home, galleries and pvt chapel in a 3 acre sculpture garden; Average Annual Attendance: 14,000; Mem: Sustaining $2,000, participating $1,000, contributing $500, supporting $100, family $40, individual $25, senior $20, student/teacher $10
Income: $200,000 (financed by endowment, mem & gifts)
Purchases: $3000
Library Holdings: Book Volumes; Periodical Subscriptions
Special Subjects: Painting-American, Sculpture, Painting-European
Collections: Sculpture of Albin Polasek (largest collection in the world); Works of Augustus St Gaudens, Charles Grafly, Alphonse Mucha & Charles Hawthorne; Sculpture by Ruth Sherwood
Publications: Sculpture Views newsletter
Activities: Classes for children; docent training; lect open to public; gallery talks; tours; concerts; museum shop sells books, original art, reproductions, prints, note cards, magnets & Moravian items

A **ARCHITECTS DESIGN GROUP INC,** 333 N Knowles Ave, Winter Park, FL 32789; PO Box 1210, Winter Park, FL 32790. Tel 407-647-1706; Fax 407-645-5525; Elec Mail adj@architectsdesigngroup.com; Internet Home Page Address: www.architectsdesigngroup.com; *Pres* I S K Reeves V FAIA; *Mktg Dir* Tonya Cranin
Open by appointment 9 AM - 3 PM; Estab 1971 to exhibit Native American antique art; Corporate headquarters for architecture firm
Collections: Antique American Indian Art; Florida Contemporary Art; Native American Art
Activities: Originate traveling exhibitions to museums & cultural institutions in the Southeast

M **CHARLES MORSE MUSEUM OF AMERICAN ART,** Charles Hosmer Morse Museum of American Art, 445 North Park Ave, Winter Park, FL 32789. Tel 407-645-5311; Fax 407-647-1284; *Dir* Laurence Ruggiero
Open Tues - Sat 9:30 AM - 4 PM, Sun 1 - 4 PM, cl Mon, Christmas Day, New Year's Day, Fourth of July, Thanksgiving, Labor Day & Memorial Day; Admis adults $3.50, students & children $1, mems free; Estab to display work of Louis Comfort Tiffany & his contemporaries from an extensive collection on a rotating basis; A small, intimate jewel box of a gallery consists of nine rooms & display areas. New mus will have 14 galleries; Mem: 732; dues sustaining $1000, student $5
Income: $1,000,000 (financed through admis, mem & gifts)
Collections: Louis Comfort Tiffany Collection of blownglass, lamps, metalware, paintings, personal correspondence & effects, personal windows & photographs; Tiffany & other American art pottery numbering some 500 items; 4000 objects focusing on American art from 1800-1950 including art glass, drawings, paintings & prints
Publications: INSIDER, monthly newletter to members
Activities: Classes for adults; docent training; lect; concerts; gallery talks; tours; competitions with awards; exten dept serves schools, nursing homes & public parks; original objects of art lent to nursing homes, bank lobbies & art center; museum shop sells books, prints, slides, postcards, posters & notepaper

M **ROLLINS COLLEGE,** George D & Harriet W Cornell Fine Arts Museum, 1000 Holt Ave, Winter Park, FL 32789. Tel 407-646-2526; Fax 407-646-2524; Internet Home Page Address: www.rollins.edu/cfam; *Registrar & Collections Mgr* Linda Ehmen; *Exec Asst* Vicki Brodnax; *Mem Coordr* Mary K Adessa; *Educ Coordr* Becky Savill; *Dir* Dr Arthur R Blumenthal; *Cur & Exhib Designer* Theo Lotz
Open Tues - Fri 10 AM - 5 PM, Sat & Sun 1 - 5 PM, cl Mon; No admis fee; Formerly the Morse Gallery of Art, estab 1942. New Fine Arts Center completed in 1976, dedicated & opened on Jan 29, 1978. Rollins College is a liberal arts college & the Cornell Fine Arts Mus is part of the college. Cornell Fine Arts Mus was accredited by the American Assoc of Museums in 1981; The mus houses the college's permanent collection of more than 6000 works & provides a focus for the arts in Central Florida. Mus consists of the McKean, the Yust & Knapp Galleries; Average Annual Attendance: 24,000; Mem: Dues Benefactor $1000, Collector's Club $300, patron $150, sponsor $150, family $60, alumni $25, student/teacher $15, friend (individual $40)
Income: $520,000 (funded by endowment & grants)
Purchases: Over 500 contemporary American & European artworks
Special Subjects: Painting-American, Photography, Sculpture, American Indian Art, Bronzes, Anthropology, Archaeology, Textiles, Costumes, Ceramics, Crafts, Folk Art, Primitive art, Afro-American Art, Decorative Arts, Collages, Asian Art, Coins & Medals, Baroque Art, Antiquities-Egyptian, Antiquities-Roman, Cartoons, Pewter, Antiquities-Etruscan, Painting-Russian
Collections: American paintings & portraits; European paintings from the 15th to 20th centuries; print; bronzes; decorative arts; Smith Watch Key Collection of 1200 keys; Bloomsbury Collection of Kenneth Curry
Publications: Exhibit catalogs, 3 per year; newsletter, 5 per year
Activities: Classes for adults & children, docent training; lectrs open to the public, 10-15 vis lectrs per year; gallery talks; tours; originate traveling exhibitions

GEORGIA

ALBANY

M **ALBANY MUSEUM OF ART,** 311 Meadowlark Dr, Albany, GA 31707. Tel 229-439-8400; Fax 229-439-1332; Elec Mail info@albanymuseum.com; Internet Home Page Address: www.albanymuseum.com; *Dir Marketing & Develop* Calandra Jefferson; *Interim Dir* Rives Sexton; *Finance & Operation* Bonny Dorough; *Cur Educ* Nick Nelson; *Bldg & Grounds Mgr* Alphonso Bogans; *Chief Security* Benjamin Baker
Open Tues - Thurs 10 AM - 5 PM; Suggested admis, adults $4, children & seniors $2; Estab 1964; new museum facility opened 1983; Average Annual Attendance: 35,000; Mem: 1,200; business partners $1,500, director's circle $1,000, dual patron $250, individual patron $125, family $50, individual $25
Income: $625,000 (financed by state, federal & foundation grants, mem & special events)
Purchases: Recent purchases include paintings by Reginald Marsh & Ernest Lawson
Library Holdings: Auction Catalogs; Book Volumes; Exhibition Catalogs; Pamphlets; Periodical Subscriptions; Video Tapes
Special Subjects: Painting-American, African Art, Afro-American Art, Antiquities-Egyptian, Antiquities-Greek, Antiquities-Roman
Collections: African Collection; Art of the Southern Region; 20th Century American Art
Exhibitions: (2002) Contemporary African Art sculpted by Beverly Buchanan
Publications: Bimonthly newsletter; exhibition catalogs
Activities: Classes for adults & children; workshops; docent training; lect open to public, 6 vis lectrs per year; concerts; gallery; films; talks; tours; sponsoring of competitions; Children's Art Fair; individual paintings & original objects of art lent to other museums; originate traveling exhibitions to other museums; mus shop sells books, magazines, reproductions

AMERICUS

M **GEORGIA SOUTHWESTERN STATE UNIVERSITY,** Art Gallery, 800 Wheatly St, Americus, GA 31709-4693. Tel 912-931-2204; Fax 912-931-2927; *Art Coordr* Jack R Lewis; *Chmn* Jeffrey Green
Open Mon - Fri 8 AM - 5 PM; No admis fee; Estab 1971
Tuition: Res $1200 per sem: non-res $2700 per sem

ATHENS

UNIVERSITY OF GEORGIA

M **Georgia Museum of Art,** Tel 706-542-4662; Fax 706-542-1051; Elec Mail buramsey@arches.uga.edu; Internet Home Page Address: www.uga.edu/gamuseum; *Cur of Educ* Cecelia Hinton; *Deputy Dir* Annelies Mondi; *Dir Communications* Bonnie Ramsey; *Museum Dir* William Eiland; *Cur Decorative Arts* Ashley Callahan; *Dir of Develop* Joan Roeber Jones; *Mem Coordr* Tim Brown; *Spec Events Coordr* Michele Turner; *Museum Shop Mgr* Nancy Lendred; Paul Manoguerra, Cur of American Art; *Cur of Exhibitions* Dennis Harper; *Bus Mgr* Marge Massey; *Cur European Art* Giancarlo Fiorenza
Open Tues & Thurs - Sat 10 AM - 5 PM, Wed 10 AM - 9 PM, Sun 1 - 5 PM, cl Mon; No admis fee; suggested $2 donation; Estab 1945; open to the pub 1948 as a fine arts mus; 10 exhib galleries. Maintains reference library; Average Annual Attendance: 120,000; Mem: 1,100; dues $15 - $1,000; ann meeting May
Income: Financed through univ, mem & grants
Purchases: American & European prints & paintings
Library Holdings: Auction Catalogs; Book Volumes; Exhibition Catalogs; Pamphlets; Periodical Subscriptions
Special Subjects: Drawings, Graphics, Painting-American
Collections: American & European Paintings (19th & 20th century); Drawings; European & American Graphics, Japanese Graphics, 15 century to the present
Publications: Newsletter, four times annually; biannually; exhibtion catalogs
Activities: Classes for adults & children; docent training; senior citizen programs; volunteer docents prog; lect open to pub, 10-12 vis lectrs per yr; concerts; tours; gallery talks; competitions with awards; individual paintings & original objects of art lent to other museums & galleries; Senior Outreach Program; originate traveling exhibs; mus shop sells books & reproductions

L **University of Georgia Libraries,** Tel 706-542-7463; Internet Home Page Address: www.visart.uga.edu; *Art Librn* Marilyn Healey
Open by appointment; Reference library only
Income: Financed by state appropriation
Library Holdings: Audio Tapes; Book Volumes 58,500; Cards; Cassettes; Clipping Files; Exhibition Catalogs; Fiche; Manuscripts; Micro Print; Motion Pictures; Pamphlets; Periodical Subscriptions 265; Photographs; Records; Reels; Slides; Video Tapes
Collections: Rare books & manuscripts collection; illustration archives on microfiche; stereographs from William C Darrah Collection; private press collection; handmade paper collection

L **Dept of Art Lamar Dodd School of Art,** Tel 706-542-1618, 542-1600 (art dept); Fax 706-542-0226; Internet Home Page Address: www.visart.uga.edu; *Slide Librn* Janet Williamson; *Dir* Carmon Colangelo
Open 8 AM - 5 PM and by special arrangement; Estab 1955 to house slides & AV equipment for use by faculty & students for classroom lecturing; Reference & instructional library
Library Holdings: Cassettes; Slides 165,000; Video Tapes
Special Subjects: Decorative Arts, Photography, Etchings & Engravings, Islamic Art, Painting-American, Ceramics, Latin American Art, Archaeology, American Western Art, Asian Art, Furniture, Mexican Art, Oriental Art, Antiquities-Assyrian, Coins & Medals

M **US NAVY SUPPLY CORPS SCHOOL,** US Navy Supply Corps Museum, 1425 Prince Ave, Athens, GA 30606-2205. Tel 706-354-7349; Fax 706-354-7239; Elec Mail dan.roth@cnet.navy.mil; Internet Home Page Address: www.nscs.snet.navy.mil; *Cur & Dir* Dan Roth
Open Mon - Fri 9 AM - 5:15 PM, cl federal holidays; No admis fee; Estab 1974. Exhibits depict the history & activities of US Navy Supply Corps &

commemorate noteworthy individuals associated with the Corps; Mus housed in National Register Carnegie Library building (c1910); Average Annual Attendance: 2,000
Income: Financed by federal appropriation
Special Subjects: Historical Material, Military Art
Collections: Nautical paintings, ship models, gallery gear, navigational equipment, uniforms, personal memorabilia; Archives: official records, manuals, photographs, yearbooks, scrap books, newsletter, directories
Publications: Base guide; museum brochure
Activities: Sales shop operates out of Navy Supply Corps Foundation Office

ATLANTA

L ALTANTA-FULTON PUBLIC LIBRARY, Art-Humanities Dept, One Margaret Mitchell Sq NW, Atlanta, GA 30303. Tel 404-730-1700; Fax 404-730-1757; Elec Mail mjackson@af.public.lib.ga.us; *Dir* Mary Kaye Hooker; *Mgr* Mavis Jackson
Open Mon, 9 AM - 6 PM, Tues - Thurs 9 AM - 8 PM; Fri & Sat 9 AM - 6 PM, Sun 2 - 6 PM; Estab 1950 to provide materials in the fine arts; Some exhibit space maintained
Income: Financed by county & state appropriation
Library Holdings: Book Volumes 4; Cassettes 10,000; Compact Disks 7500; Prints; Records
Exhibitions: exhibitions change monthly
Activities: Classes for adults; lect open to public

M ALTERNATE ROOTS, INC, 1083 Austin Ave NE, Atlanta, GA 30307. Tel 404-577-1079; Fax 404-577-7991; Elec Mail altroots1@earthlink.net; Internet Home Page Address: www.alternateroots.org; *Dir* Alice Lovelace; *Dir Mem Svcs* Eleanor Brownfield
Estab 1976 to support the creation & presentation of original performing art that is rooted in a particular community of place, tradition or spirit; Mem: 250; dues $50; annual meeting
Income: Financed by grants, mem, private contributions
Activities: Classes for adults

ASSOCIATION OF MEDICAL ILLUSTRATORS
For further information, see National and Regional Organization

L ATLANTA COLLEGE OF ART, 1280 Peachtree St NE, Atlanta, GA 30309. Tel 404-733-5020; Fax 404-733-5312; Elec Mail acalib@woodruffcenter.org; *Visual Resource Cur* Kevin Fitzgerald; *Head Librn* Moira Steven; *Asst Librn* Jerry Wang; *Circ Manager* Bonnie Jean Woolger; *Weekend/Evening Circ Manager* Yolanda Travis
Open Mon - Thurs 8;45 AM - 9 PM, Fri 8:45 AM - 3:30 PM, Sat Noon - 5 PM; Estab 1950 to provide art information & research facility to the Atlanta College of Art community & the southeast art community; Circ 12,000
Purchases: $22,800
Library Holdings: Book Volumes 32,000; Clipping Files; DVDs 10; Exhibition Catalogs; Other Holdings Artists' books 1,500; Periodical Subscriptions 185; Slides 98,000; Video Tapes 400
Special Subjects: Art History, Photography, Drawings, Graphic Design, Painting-American, Interior Design
Collections: Artists' Books; rare books; circulating art books
Exhibitions: Student art book competition
Activities: Classes for adults & children; films; vis artists program; Joane Paschall award for student artists' book competition

M ATLANTA CONTEMPORARY ART CENTER, 535 Means St N.W., Atlanta, GA 30318. Tel 404-688-1970; Fax 404-577-5856; Elec Mail info@thecontemporary.org; Media Contact swoodard@thecontemporary.org; Internet Home Page Address: www.thecontemporary.org; *Exec Dir* Sam Smulian; *Communications Dir* Stan Woodard; *Dir Exhib & Educ* Helena Reckitt; *Financial Mgr* Michelle Frost; *Treas* Sarah Danielson; *Bd Pres* Marcia Weber; *Dir Devel* Deborah Ryan; *Asst Cur* Mary Walton
Open Tues - Sat 11 AM - 5 PM; Admis non-mem $5, students & seniors $3, mems free; Estab 1973 as a nonprofit & multidisciplinary facility committed to promoting experimentation, education & excellence in visual, performing & book arts; Contemporary art; Average Annual Attendance: 50,000; Mem: 1,300; dues $25 - $1,000; annual meeting in July
Income: $800,000
Collections: Exhib every 8 weeks
Publications: Artist books; exhibit catalogs; Contemporary News, bi-monthly newsletter
Activities: Classes for adults; lect open to public, 5-8 vis lectrs per year; gallery talks; video tours; theatre; media programs; docent & internship programs; book traveling exhibitions 3 per year; originate traveling exhibitions; sales shop sells Nexus artist books, contemporary catalogs

M ATLANTA HISTORICAL SOCIETY INC, Atlanta History Center, 130 W Paces Ferry Rd, Atlanta, GA 30305. Internet Home Page Address: www.atlhist.org; *Dir Colls Resources* Pam Meister; *Dir Research & Progs* Andy Ambrose; *Dir Develop* Kinsey Harper; *Dir Operations* Sue Nichols; *Exec Dir* Rick Beard
Open Mon - Sat 10 AM - 5:30 PM, Sun Noon - 5:30 PM, Library/Archives open Tues - Sat 10 AM - 5 PM; Admis $10, discount for seniors, youth, children & groups; $1 additional to tour Tullie Smith Farm; $2 additional to tour Swan House, library/archives free; Estab 1926, dedicated to presenting the stories of Atlanta's past, present & future through exhibits, programs, collections & research; Atlanta History Museum with state-of-the-art exhibits, shop, cafe, classrooms, 100 seat theater; two National Historic Register houses: Swan House, a 1928 classically styled mansion with original furnishings & the 1840's Tullie Smith Farm with outbuildings & livestock; 1890s Victorian playhouse; 33 acres of gardens & woodland trails labeled for self-guided tours; McElreath Hall, housing an extensive library/archives; member's room & a 400 seat auditorium; Average Annual Attendance: 175,000; Mem: 6000; dues $30-$1000; annual meeting

Income: $6,000,000 (financed through endowment, county appropriation, donations, admis & shop sales, cafe sales & facility rental)
Purchases: $22,500
Special Subjects: Architecture, Photography, Textiles, Costumes, Decorative Arts, Manuscripts, Dolls, Historical Material, Maps, Dioramas, Period Rooms
Collections: Burrison Folklife Collection; Thomas S Dickey Civil War Ordnance Collection; DuBose Civil War Collection; Philip Trammell Shutze Collection of Decorative Arts; costumes & textiles; general Atlanta history
Exhibitions: Metropolitan Frontiers: Atlanta, 1835-2000; Shaping Traditions: Folk Arts in a Changing South; Turning Point: The American Civil War
Publications: Atlanta History: A Journal of Georgia & the South, quarterly; Atlanta History Center News, quarterly; Atlanta History Programs Calendar, quarterly
Activities: Classes for adults & children; family programs; docent programs; lect open to public, 15 vis lectrs per year; symposia; workshops; special events; guided tours; originate traveling exhibitions; retail store sells books, prints, magazines, slides, original art, reproductions, folk crafts, educational toys & Atlanta history memorabilia

M ATLANTA INTERNATIONAL MUSEUM OF ART & DESIGN, 285 Peachtree Center Ave, Atlanta, GA 30303. Tel 404-688-2467; Fax 404-521-9311; Internet Home Page Address: www.atlantainternationalmuseum.org; *Dir Develop* John Jones; *Exec Dir* Angelyn S Chandler
Open daily 11 AM - 5 PM; Admis $3; Estab 1989 to promote understanding of world cultures through exhibits & educational programs of art & design; Includes 3 galleries; Average Annual Attendance: 15,000; Mem: 700; $40 & up; ann meeting in Sept
Income: $350,000 (financed by endowment, mem, city & state appropriation & corporate sponsorship)
Special Subjects: Architecture, Hispanic Art, Latin American Art, Mexican Art, American Indian Art, African Art, Ethnology, Textiles, Costumes, Ceramics, Crafts, Folk Art, Woodcarvings, Decorative Arts, Glass, Jewelry, Asian Art, Silver, Antiquities-Byzantine, Carpets & Rugs, Calligraphy, Antiquities-Egyptian, Antiquities-Greek
Publications: Exhibit catalogue
Activities: Classes for adults & children; docent training; family workshops; 1st Thursdays Downtown Atlanta Arts Walk; lect open to public, 10 vis lectrs per year; originate traveling exhibitions 1 per year; sales shop sells books & original art

M CENTER FOR PUPPETRY ARTS, 1404 Spring St, Atlanta, GA 30309. Tel 404-873-3089; Fax 404-873-9907; Elec Mail puppet@mindspring.com; Internet Home Page Address: www.puppet.org; *Financial Dir* Lisa Rhodes; *Producer* Bobby Box; *Museum Mgr* Susan Kinney; *Educ Dir* Alan Louis; *Outreach Coordr* Erica Baerden; *Exec Dir* Vincent Anthony; *Vice Chmn* Barbara Wylly
Open 9 AM - 5 PM; Admis adult $5, children & seniors $4; Estab 1978 to educate pub of the art of puppetry; Puppetry - National & International Exhibits displayed in 9 rooms with hands-on displays includes 1 special exhibit which changes every 6 months; Mem: dues $25 - $1,000 & up
Income: $1,300,000 (financed by endowment, mem, city & state appropriations)
Special Subjects: Latin American Art, Photography, African Art, Pre-Columbian Art, Costumes, Religious Art, Folk Art, Woodcarvings, Afro-American Art, Posters, Asian Art, Historical Material, Restorations
Collections: Global collection of puppets
Exhibitions: Permanent Collection: Puppet Power Wonders (800 puppets)
Publications: Articles, brochures, catalogs & reports
Activities: Classes for adults & children; docent training; lect open to public, 2-3 vis lectrs per year; gallery talks; tours; scholarships offered; lending collection contains original objects of art & photographs; book traveling exhibitions 3 per year; originate traveling exhibitions 2 per year; museum shop sells books & puppets

L Library, 1404 Spring St, Atlanta, GA 30309. Tel 404-873-3089; Fax 404-873-9907; Internet Home Page Address: www.puppet.org; *Museum Mgr* Susan Kinney; *Exec Dir* Vincent Anthony
Open by appointment; No admis fee; For reference only; Library estab 1978
Library Holdings: Audio Tapes; Book Volumes 1,500; Cassettes; Clipping Files; Exhibition Catalogs; Framed Reproductions; Memorabilia; Original Art Works; Pamphlets; Photographs; Prints; Records; Reproductions; Slides; Video Tapes

A CITY OF ATLANTA, Bureau of Cultural Affairs, 675 Ponce deLeon Ave (City Hall East), 5th Flr, Atlanta, GA 30308. Tel 404-817-6815; Fax 404-817-6827; *Budget* Eloise Joyner; *Prog Adminr* Eddie Granderson; *Project Coordr* Lisa Walker; *Public Art Prog* Stacey Sacavsky
Estab 1974 to improve the social fabric & quality of life for Atlanta's citizens & visitors by supporting the arts & cultural activities & by nurturing the arts community
Activities: Contracts for art services; music programs; public art programs; special projects

M City Gallery East, 675 Ponce de Leon Ave NE, Atlanta, GA 30308. Tel 404-817-6981; Fax 404-817-6827; Elec Mail citygalleryeast@mindspring.com; *Dir* Karen Comer
Open Mon - Sat 8:30 AM - 5:30 PM; Estab to present contemporary fine art produced by regional, national & international professional artists; focused primarily on Atlanta-based artists; goal: display work that is stimulating & innovative & that presents a new perspective or cross-collaboration with other art disciplines; 8000 sq ft exhibition space; Average Annual Attendance: 30,000
Income: Financed by prog of Bureau of Cultural Affairs
Exhibitions: 5 exhibs per yr
Publications: Catalogs: Larry Walker: Four Decades (2001) & Beverly Buchanan: Habitats & Shotgun Shacks (2000)
Activities: Sponsors lect, forums, demonstrations & performances in collaboration with service agencies; gallery talks; tours

M Atlanta Cyclorama, 800 Cherokee Dr SE, Atlanta, GA 30315. Tel 404-658-7625; Fax 404-658-7045; *Dir* Pauline Smith
Open June 1 - Labor Day 9:30 AM - 5:30 PM, Labor Day - May 9:30 AM - 4:30 PM; Admis adults $5, children 6-12 $3, children under 6 free; Estab 1886; Located in Grant Park & listed in the National Historic Register; 184-seat revolving platform

Special Subjects: Painting-American, Costumes, Historical Material
Collections: Civil War artifacts; lifelike figures in Civil War costume & period props; panoramic painting depicting the Battle of Atlanta
Activities: Sales shop sells books, videos & Civil War era souvenirs

A **Chastain Arts Center,** 135 W Wieuca Rd NW, Atlanta, GA 30342. Tel 404-252-2927; Fax 404-851-1270; Elec Mail cac135@atlantaga.gov; Internet Home Page Address: www.ocaatlanta.com; *Dir* Erin Bailey
Open Mon - Thurs 9:30 AM - 9:30 PM, Fri - Sat 9:30 AM - 5 PM; Estab 1968; Located in Chastain Park; oldest City-operated arts facility in Atlanta; Average Annual Attendance: 2,000
Special Subjects: Drawings, Prints, Pottery, Jewelry
Activities: Classes for adults & children; dramatic prog; workshops

M **City Gallery at Chastain,** 135 W Wieuca Rd NW, Atlanta, GA 30342. Tel 404-257-1804; Fax 404-851-1270; Elec Mail cac135@atlantaga.gov; Internet Home Page Address: www.ocaatlanta.com; *Gallery Dir* Erin Bailey
Open Mon - Sat 1 - 5 PM; No admis fee; Estab to expose the Atlanta community to exhibitions that address the social & personal political issues of our time; Venue for display of contemporary art by local, regional & national artists & designers
Exhibitions: Exhibitions addressing design, architecture & popular culture in educational manner
Activities: Lect; gallery tours; symposiums in conjunction with exhibitions

M **Gilbert House,** 2238 Perkerson Rd SW, Atlanta, GA 30315. Tel 404-766-9049; Fax 404-765-2806; *Dir* Erin Bailey
Open by appointment; Tues - Fri 10 AM - 5 PM; Estab 1984; Built in 1865 by Jeremiah Gilbert immediately after the Civil War; registered historic landmark located on 12 acres
Activities: Art classes for adults & children; exhibitions of art work

A **Southeast Arts Center,** 215 Lakewood Way SE, Atlanta, GA 30315. Tel 404-658-6036; Fax 404-624-0746; *Dir* Alberta Ward
Open Mon - Thurs 9 AM - 9 PM, Fri 9 AM - 6 PM, Sat 10 AM - Noon; Classes $75 for 8 wks; Center known for its state-of-the-art photography studio which provides professional instruction for young people & adults; near Lakewood Amphitheater; other classes include: Ceramics, Handbuilt Pottery & Raku Firing, Jewelrymaking, Sewing & Art for Youth
Special Subjects: Photography, Pottery, Ceramics, Jewelry

L **Arts Clearinghouse,** 675 Ponce DeLeon Ave, Atlanta, GA 30308. Tel 404-817-6815; Fax 404-817-6827; *Dir* Shawn Redding
Estab as a comprehensive arts information & resources referral center; Offers open files on all Hotline presenters: listings of available studio space in Atlanta, health insurance policies for self-employed artists, sets of grant guidlines from National Endowment for the Arts & local arts funding agencies, as well as information on pub art commissions nationwide
Library Holdings: Book Volumes 150; Periodical Subscriptions 30
Activities: Art in education program; professional development workshops; arts hotline; materials for the arts program

M **EMORY UNIVERSITY,** Michael C Carlos Museum, 571 S Kilgo, Atlanta, GA 30322. Tel 404-727-4282; Fax 404-727-4292; Internet Home Page Address: www.carlos.emory.edu; *Assoc Dir* Catherine Howett Smith; *Dir Exhib & Collections* Nancy Roberts; *Dir Educ* Elizabeth S Hornor; *Dir* Bonnie Speed
Open Tues - Sat 10 AM - 5 PM, Thurs 10 AM - 8 PM, Fri 10 AM - 9 PM, Sun Noon - 5 PM; Admis suggested donation $7; Estab 1919; Mus redesigned in 1985 by Michael Graves, Post-Modernist architect; 15,400 sq ft; permanent exhibition galleries & special exhibition galleries; Average Annual Attendance: 120,000; Mem: 1,250; dues teacher $30, individual $40, Dual $60, Family $75, Doric $150, Ionic $250, Corinthian $500
Income: $2,500,000
Special Subjects: Latin American Art, Mexican Art, Photography, Sculpture, Watercolors, African Art, Archaeology, Pre-Columbian Art, Ceramics, Pottery, Woodcarvings, Etchings & Engravings, Manuscripts, Glass, Jade, Jewelry, Oriental Art, Asian Art, Antiquities-Egyptian, Antiquities-Greek, Antiquities-Roman, Antiquities-Etruscan
Collections: Art collection from Renaissance to present, African, classical Greek & Egyptian; Old World art & archaeology, including works from Egypt, Mesopotamia, ancient Palestine; Pre-Columbian, American Indian & Far Eastern holdings; Works on Paper, Asian, African
Exhibitions: 3 major and 4 small; Rotating exhibits; (12/1/2006-1/14/2007) Discovering Rome: Maps and Monuments of the Eternal City; (12/16/2006-3/11/2007) Domains of Wonder: Selected Masterworks of Indian Painting; (2/10/2007-5/27/2007) Recent Aquisitions; Veneralia 2007; (6/16/2007-10/14/2007) Cradle of Christianity: Jewish and Christian Treasures from the Holy Land; Fall 2007: Robert Rauschenberg's Currents Series: Features and Surfaces; (1/12/2008-4/6/2008) Discovering Bronze Age Greece: Art and Archaeology from the Ashmolean Museum; Veneralia 2008; Fall 2008: Nubian Renaissance: Egypt's 25th Dynasty and the Civilizations of Ancient Sudan
Publications: Exhibition catalogues
Activities: Classes for adults & children; classes for teachers; docent training; lect open to public; 10 vis lectrs per year; concerts; gallery talks; tours; scholarships & fels offered; exten dept; original objects of art lent to other institutions; book traveling exhibitions 2-4 per year; originate traveling exhibitions; museum shop sells books, magazines, original art, reproductions, prints, gifts, jewelry, CD ROMs, videos & catalogues

A **GEORGIA COUNCIL FOR THE ARTS,** Georgia's State Art Collection, 260 14th St NW, Ste 401, Atlanta, GA 30318-5360. Tel 404-685-2787; Fax 404-685-2788; Internet Home Page Address: www.gaarts.org; *Exec Dir* Susan S Weimer
Offices open Mon - Fri 8 AM - 5 PM; Gallery by appointment only; No admis fee; Estab 1968 as a state agency providing funding to non-profit, tax-exempt organizations for arts programming & support; Art work of Georgians; Mem: 24 members appointed by governor; meetings four times per yr
Income: $3,900,000 (financed by state appropriation plus federal funding)
Publications: Guide to Programs, annual (one for organizations & one for artists)

L **GEORGIA INSTITUTE OF TECHNOLOGY,** College of Architecture Library, Georgia Institute of Technology, Atlanta, GA 30332-0155. Tel 404-894-4877; Elec Mail kathy.brackney@library.gatech.edu; Internet Home Page Address: www.library.gatech.edu/architect/; *Head Librn* Kathryn S Brackney
Open Mon - Thur 8 AM - 12 AM, Fri 8 AM - 6 PM, Sat 9 AM - 6 PM, Sun Noon - 12 AM
Income: Financed by state appropriation
Library Holdings: Book Volumes 33,800; Periodical Subscriptions 160; Reels

A **GEORGIA LAWYERS FOR THE ARTS,** BCA 5th Floor, 675 Ponce de Leon Ave Atlanta, GA 30308; Suite J-101, 887 West Marietta St, NW Atlanta, GA 30318. Tel 404-873-3911; Fax 404-873-3911; Elec Mail gla@glarts.org; Internet Home Page Address: www.glarts.org; *Exec Dir* Lisa M Kincheloe Esq; *Dir of Vol Services* Andrew Pequignot
Open Mon - Fri 9 AM - 5 PM by appointment only; No admis fee; Estab 1975 to provide legal services & educational programming to artists and arts organizations in Georgia; Mem: Dues individual artists $30, nonprofit arts organizations $50
Collections: Copyrights; fundraising; art law related to literature
Publications: An Artists Handbook on Copyright; Handbook on the Georgia Print Law; Art Law in Georgia: A Guide for Artists and Art Organizations
Activities: Education program; classes for adults; network of volunteer attorneys who provide free legal services to low income artists; lect open to public; 50-60 vis lectrs per yr; workshops and seminars on legal issues

L **GEORGIA STATE UNIVERSITY,** School of Art & Design, Visual Resource Center, University Plaza, Atlanta, GA 30303. Tel 404-651-2257; Fax 404-651-1779; *Cur* Ann England
Open Mon - Fri 8:30 AM - 5 PM; No admis fee; Estab 1970 to make visual & literary resource materials available for study, teaching & research; Average Annual Attendance: 20,000
Library Holdings: Book Volumes 300; Exhibition Catalogs; Original Art Works; Pamphlets; Periodical Subscriptions 18; Reproductions; Slides 255,000; Video Tapes 45
Special Subjects: Aesthetics, Afro-American Art
Collections: Rare book collection, original prints emphasis impressionism, 19th-early 20th century artists; extensive Pre-Columbian slide collection, History of textile, Metalsmithing & jewelry making, History of photography
Activities: Lect open to public, 5-10 vis lectrs per year; films; artist's slide presentations; discussions

M **Art Gallery,** University Plaza, 10 Peachtree Center Ave Rm 117 Atlanta, GA 30303; School of Art & Design, PO Box 4107 Atlanta, GA 30302-4107. Tel 404-651-2257; Fax 404-651-1779; Elec Mail artgallery@gsu.edu; Internet Home Page Address: www.gsu.edu/artgallery; *Dir* Cathy Byrd
Open Mon - Sat 8 AM - 8 PM, Sun 10 AM - 8 PM during exhibitions; No admis fee; Two galleries for student and facility exhibits, national and international traveling shows.
Publications: Catalogues
Activities: Lec open to public; gallery talks

M **HIGH MUSEUM OF ART,** 1280 Peachtree St NE, Atlanta, GA 30309. Tel 404-733-4400, 733-4444; Fax 404-733-4502; Internet Home Page Address: www.high.org; *Dir* Michael E Shapiro; *Registrar* Frances Francis; *Dir Architectural Planning & Design* Marjorie Harvey; *Dep Dir* Philip Verre; *Dir Finance & Operations* Rhonda Matheison; *Dir Mus Advancement* Sheldon Wolf; *Cur Am Art* Sylvia Yount; *Cur Photography* Tom Southall; *Cur Decorative Arts* Stephen Harrison; *Dir Mus Advan* Sandra K Kidd; *Cur Modern & Contemporary* Carrie Przybilla; *Chief Cur* David Brenneman; *Cur Media Arts* Linda Dubler; *Cur African Art* Carol Thompson; *Cur Folk Arts* Lynne Spriggs; *Pres. Mem Guild* Jim Kaltenbach; *Mgr Exhib* Jody Cohen; *Mus Shop Mgr* Adrienne Pierce; *Mgr Publ* Kelly Morris; *Community Rels Mgr* Jacqueline P King; *VChmn Board Dir* FT Stent
Open Tues - Sat 10 AM - 5 PM, Sun Noon - 5 PM, cl Mon; Admis adults $6, seniors & students $4, children ages 6-17 $2, children under 6 & mems free, Thurs 1 - 5 PM free; Estab 1926 to make the best in the visual arts available to the Atlanta public in exhibitions & supporting programs; Four floors (46,000 sq ft) exhibition space; top floor for traveling exhibitions; semi-flexible space (moveable walls); ramp & elevator for accessibility; Average Annual Attendance: 500,000; Mem: 39,000; dues $25 & up
Income: $7,500,000 (financed by endowment, mem, Members Guild of the High Museum of Art, city & state appropriations, museum shop sales, grants & foundations, ticket sales & operating income)
Library Holdings: Auction Catalogs; Book Volumes; Exhibition Catalogs; Periodical Subscriptions
Collections: American painting & sculpture; European painting & sculpture, 20th Century painting, photography & sculpture; African Art; Works on Paper; 18th & 19th Century decorative art featuring Herter Brothers, William Whitehead & John Henry Belter; contemporary crafts; 20th Century furniture; regional historical decorative arts & English ceramics; 19th Century American landscape paintings; contemporary art since 1970; Western art early Renaissance - present; decorative arts; graphics; sculpture; African & sub-Saharan; 19th - 20th century photography
Publications: HighLife, bi-monthly mem magazine; exhibition catalogues
Activities: Workshops for adults, children & families; docent training; lect open to public; family days; tours; performing arts programs; senior citizen programs; gallery talks; speakers bureau; traveling exhibitions organized and circulated; two museum shops sell books, reproductions, slides, prints, stationery, children's books & toys, crafts, jewelry & gift items

L **Library,** 1280 Peachtree St NE, Atlanta, GA 30309. Tel 404-733-4528; Fax 404-733-4503; Elec Mail colkim@woodruff-arts.org; *Librn* Rachel Hodges
Library Holdings: Book Volumes 14,000; Clipping Files; Exhibition Catalogs; Periodical Subscriptions 50; Slides
Special Subjects: Art History, Constructions, Folk Art, Decorative Arts, Film, Drawings, Etchings & Engravings, Ceramics, Conceptual Art, Crafts, American Western Art, Art Education, Aesthetics, Afro-American Art, Architecture

L **SAVANNAH COLLEGE OF ART AND DESIGN,** (Atlanta College of Art) Georgia Artists Registry, 1600 Peachtree St NW, Atlanta, GA 30309. Tel 404-253-3278; Fax 404-253-3254; Elec Mail acox@scad.edu; *Dir* Anne Cox
Open Mon - Fri 9 AM - 5 PM & by appointment; No admis fee; Estab 1978 to provide access to many current Georgia artists; Digital image & slide bank referal

service; Average Annual Attendance: 800 info requests; Mem: 700; limited to Ga artists; no membership fee

Income: Financed by public & by the Col

Library Holdings: CD-ROMs; Clipping Files; Compact Disks; Exhibition Catalogs; Photographs; Slides

Special Subjects: Decorative Arts, Photography, Calligraphy, Drawings, Graphic Design, Painting-American, Sculpture, Portraits, Ceramics, Conceptual Art, Crafts, Bronzes, Video, Metalwork, Pottery, Landscapes

Collections: 10,000 images

Publications: Artists Proof, semiannual newsletter

M **SYMMES SYSTEMS,** Photographic Investments Gallery, 3977 Briarcliff Rd NE, Atlanta, GA 30345-2647. Tel 404-320-1012; *Pres* Edwin C Symmes Jr
Open by appointment; No admis fee; Estab 1979 to display & produce traveling exhibits of classical photography

Collections: 19th century photographic images in all media; 20th century black & white & color photos by masters

Exhibitions: 19th Century Albumen Prints of Westminster Cathedral; Netsuke: An Insight into Japan; Color Photography by E C Symmes; 19th & 20th Century Images of China.

Activities: Lect open to public; original objects of art lent; lending collection contains 1500 19th century Albumen prints; originate traveling exhibitions; museum shop sells original art

AUGUSTA

M **GERTRUDE HERBERT INSTITUTE OF ART,** 506 Telfair St, Augusta, GA 30901. Tel 706-722-5495; Fax 706-722-3670; Elec Mail ghia@ghia.org; Internet Home Page Address: www.ghia.org; *Dir* Kim W Overstreet
Open Tues - Fri 10 AM - 5 PM, Sat by appointment, groups by special appointment, cl Sun & Mon, Thanksgiving, Christmas & New Year's; No admis fee; donations accepted; Estab 1937 for the advancement & encouragement of art & educ in art; Main gallery located on second fl of historic home; Average Annual Attendance: 5,000; Mem: 450

Special Subjects: Graphics, Sculpture, Painting-European, Renaissance Art

Exhibitions: Circulating exhibitions; monthly exhibitions; one-person and group exhibitions; the National Annual Juried Exhibition

Activities: Classes for adults & children; docent training; lect open to public, 4 vis lectrs per year; concerts; gallery talks; tours; competitions with awards; scholarships offered; book traveling exhibitions

C **MORRIS COMMUNICATIONS CO. LLC,** (Morris Communications Corporation) Corporate Collection, 725 Broad St, PO Box 936 Augusta, GA 30913. Tel 706-724-0851; Fax 706-722-7125; *Chmn & CEO* W S Morris III; *Dir* Louise Keith Claussen

Collections: Alaskan Art; American Paintings; Western Bronzes; Wildlife (birds); European Paintings

M **MORRIS MUSEUM OF ART,** One Tenth St, Augusta, GA 30901-1134. Tel 706-724-7501; Fax 706-724-7612; Elec Mail mormuse@themorris.org; Internet Home Page Address: www.themorris.org; *Dir* Kevin Grogan; *Cur Educ* David Tucker; *Tour & Vol Coordr* Sarah Alexander; *Registrar* Kelly Woolbright; *Finance Officer* Louis P Gangarosa Jr; *Store Mgr* Kelly Boyd; *Coordr Mktg & Pub Relations* Laurie Lockhear; *Librn & Archivist* Cary Wilkins; *Office Mgr* Brenda Hall; *Chief Security* Rex Bell; *Exhibition Designer & Preparator* Dwayne Clark; *Spec Events Coordr* Janna Crane; *Coordr Mem Svcs* Lauren Powell; *Library Asst* Latoy Hollomon; *Assoc Cur Educ for Educational Services* Drew Brown; *Dir External Affairs* Phyllis Giddens; *Assoc Cur Educ for Educational Services* Lydia Williams; *New Media & Image Coordr* Laura Pasch
Open Tues - Sat 10 AM - 5 PM, Sun 12 - 5 PM; Admis adults $5, seniors 65 & over, military & students $3; Estab 1992 to emphasize painting in the South; Maintains reference library; Average Annual Attendance: 40,000; Mem: dues $15-$5000

Income: Financed by endowment, mem, foundation funds & fundraising activities

Purchases: Southern Art permanent collection

Library Holdings: Auction Catalogs; Audio Tapes; Book Volumes 9,000; CD-ROMs; Cassettes; Clipping Files; Compact Disks; DVDs; Kodachrome Transparencies; Manuscripts; Maps; Motion Pictures; Original Art Works; Original Documents; Periodical Subscriptions; Photographs; Slides; Video Tapes

Special Subjects: Drawings, Painting-American, Textiles, Folk Art, Primitive art, Landscapes, Portraits

Collections: The first museum in the country dedicated to celebrating and exploring the art and artists of the South. The museum has a permanent collection of some 5,000 paintings and works on paper. It is a broad-based survey collection, encompassing a history of painting in the South and ranging from delicate watercolors by eighteenth century nature artists to vibrant works by some of today's best-known Southern artists.

Exhibitions: A Southern Collection: Masterworks from a Permanent Collection of Painting in the South

Publications: Exhibition catalogs

Activities: Educ dept; classes for adults & children; dramatic programs docent training; lect open to public, 12 vis lectrs per year; 18 concerts; gallery talks; tours; Smithsonian Affiliations Internship; individual paintings lent to museums; book traveling exhibitions, 6-8 per yr; originate traveling exhibitions circulate principally to southeastern museums; museum shop sells books, magazines, original art, reproductions, prints, slides & gift items

BRUNSWICK

A **GOLDEN ISLES ARTS & HUMANITIES ASSOCIATION,** 1530 Newcastle St, Brunswick, GA 31520. Tel 912-262-6934; Fax 912-262-1029; Elec Mail info@goldenislesarts.org; Internet Home Page Address: www.goldenislesarts.org; *Exec Dir* Heather Heath; *Production Dir* Rob Nixon
Open Mon - Fri 9 AM - 5 PM, Sat 10 AM - 2 PM; Estab 1989 as a county coordinating arts council & presenter; The Ritz Theatre Lobby; Average Annual Attendance: 10,000; Mem: 700; dues family $50, single $35; annual meeting in July

Income: $285,000 (financed by mem, programs, services & grants)

Activities: Children's classes; dramatic programs; lect open to public, 4-5 vis lectrs per year; photographic & visual arts competitions; ribbons & cash awards; concerts; scholarships offered; book traveling exhibitions 1 per year

COLUMBUS

M **COLUMBUS MUSEUM,** 1251 Wynnton Rd, Columbus, GA 31906. Tel 706-649-0713; Fax 706-649-1070; Elec Mail information@columbusmuseum.com; Internet Home Page Address: www.columbusmuseum.com; *Cur Educ* Kristen Miller Zohn; *Assoc Cur History* Mike Bunn; *Dir Develop* Nancy Burgin; *Asst to Dir* Patricia Butts; *Art Handler* Chris Land; *Art Handler* Matt Albrecht; *Registrar* Aimee Brooks; *Deputy Dir Opers* Kimberly Beck; *Dir* Charles T Butler; *Youth & Family Programs Coordr* Melanie Ross; *Pub Relations Coordr* Alicia Niles; *Asst Cur Art* Paula Katz; *Asst Registrar* Mellda Alexander; *Exhibit Designer & Production Coordr* Roger Reeves; *Mus Shop Mgr* Charlene Marx; *School & Educ Svcs Coordr* Nicola Sarn; *Devel Coordr* Natalie Worthen; *Special Events* Wren Gilliam
Open Tues - Sat 10 AM - 5 PM, Sun 1 - 5 PM, third Thurs every month 10 AM - 8 PM, cl Mon & legal holidays; No admis fee; Estab 1954 to build a permanent collection; encourage work by Georgia & Southern artists; establish loan shows & traveling exhibitions in all fields of American art & history; 11,000 sq ft history gallery, 2,000 sq ft interactive gallery, 25,000 sq ft art gallery. Maintains reference library; Average Annual Attendance: 75,000; Mem: 2900; dues $45 - $5,000; annual meeting in May

Library Holdings: Auction Catalogs; Book Volumes; DVDs; Memorabilia; Periodical Subscriptions

Special Subjects: Decorative Arts, Historical Material, Marine Painting, Ceramics, Collages, Glass, Metalwork, Furniture, Portraits, Period Rooms, Sculpture, Tapestries, Architecture, Drawings, Graphics, Painting-American, Photography, Prints, Watercolors, American Indian Art, African Art, Archaeology, Ethnology, Pre-Columbian Art, Textiles, Costumes, Crafts, Folk Art, Pottery, Primitive art, Woodcarvings, Woodcuts, Etchings & Engravings, Landscapes, Afro-American Art, Posters, Eskimo Art, Dolls, Jade, Jewelry, Porcelain, Oriental Art, Asian Art, Silver, Painting-British, Historical Material, Ivory, Maps

Collections: American art from all periods & all media; Artifacts relating to the culture of the Chattahoochee Valley & Southeastern United States; permanent collection includes Landscapes, Paintings & Portraits by Early & Contemporary American Painters, with strong Collection of American drawings & primitive arts

Publications: Annual report; gallery guides; newsletter, quarterly; web news

Activities: Classes for adults & children; docent training; workshops; lect open to public, 5-7 vis lectrs per yr; concerts; gallery talks; tours; scholarships offered; individual paintings & original objects of art lent to qualified institutions which are recognized & meet facilities accreditation standards; book traveling exhibitions 6-10 per year; originate traveling exhibitions to other museums; museum shop sells books, original art, reproductions, jewelry & children's toys & gift items; junior museum

M **COLUMBUS STATE UNIVERSITY,** The Gallery, Dept of Art, 4225 University Ave Columbus, GA 31907-5645. Tel 706-568-2047; Fax 706-568-2093; Elec Mail burden_jeff@colstate.edu; Internet Home Page Address: www.colstate.edu; *Dept Head* Jeff Burden
Open Mon - Fri 9 AM - 5 PM; No admis fee; Average Annual Attendance: 6,000

Income: $11,000 (financed by student activities)

Purchases: Permanent collection

Library Holdings: Auction Catalogs; Audio Tapes; Book Volumes; CD-ROMs; Video Tapes

Exhibitions: Annual art students show; faculty show; regional guest artist & nationally prominent artists

Publications: newsletters

Activities: Classes for adults & college students; lect open to public, 1-5 vis lectr per year; tours; competitions with awards; scholarships offered; mus shop sells slides

DALTON

A **CREATIVE ARTS GUILD,** 520 W Waugh St, PO Box 1485 Dalton, GA 30722-1485. Tel 706-278-0168; Fax 706-278-6996; Elec Mail cagarts@creativeartsguild.org; Internet Home Page Address: www.creativeartsguild.org; *Pres* Sam Turner; *Exec Dir* Terry Tomasello; *Guild Mgr* Lee Ann Lawson; *Creative Dir* Judy Reed; *Dir Mktg* Amy McFalls
Open Mon - Thurs 9 AM - 7 PM, Fri 9 AM - 4:30 PM, others by appt; No admis fee; Estab 1963 to build & maintain an environment supportive of the arts in NW Georgia; Average Annual Attendance: 130,000; Mem: 1,000; dues family $35, annual meeting in June

Income: $500,000 (financed by mem, commissions, grants, tuitions & fund raising events)

Library Holdings: Book Volumes

Collections: Permanent collection of regional art

Exhibitions: Changing monthly shows of crafts; graphics; photography; original art; sculpture; fiber

Publications: Bulletins to members, monthly

Activities: Classes for adults & children; dramatic programs; visual & performing arts programs for schools; concerts; gallery talks; competitions with awards; arts & crafts festivals; individual paintings & original objects of art lent to area schools & organizations

DECATUR

M **AGNES SCOTT COLLEGE,** Dalton Art Gallery, 141 E College Ave, Decatur, GA 30030. Tel 404-471-6049; Elec Mail tmcgehee@agnesscott.edu; Internet Home Page Address: www.agnesscott.edu; *Chmn Art Dept* Donna Sadler; *Printmaker* Anne Beidler; *Art Historian* Roger Rothman
Open Mon - Fri 10 AM - 9 PM, Sat 9 AM - 5 PM, Sun 2 - 5 PM; No admis fee; Estab 1965 to enhance art program; Gallery consists of four rooms, 300 running ft of wall space, light beige walls & rug; Dana Fine Arts Bldg designed by John Portman

Income: Financed by endowment
Collections: Clifford M Clarke; Harry L Dalton; Steffen Thomas; Ferdinand Warren
Exhibitions: 4 exhibitions per yr
Activities: Lect open to public

DUBLIN

M **LAURENS COUNTY HISTORICAL SOCIETY,** Dublin-Laurens Museum, 311 Academy Ave, PO Box 1461 Dublin, GA 31040-1461. Tel 478-272-9242; Elec Mail history@nlamerica.com; *Dir* Scott B Thompson Sr
Open Tues - Fri 1 - 4:30 PM; No admis fee; Estab 1967; Average Annual Attendance: 5,000; Mem: 500; dues $15-$200 graduating
Income: $25,000 (financed by mem, city & county appropriation, contributions)
Collections: Indian Artifacts; Art Originals-Lila Moore Keen
Exhibitions: Historical Photographs
Publications: Laurens County Historical Society Newsletter, quarterly

FORT BENNING

M **NATIONAL INFANTRY MUSEUM,** US Army Infantry Sch Bldg 3, Fort Benning, GA 31905-5593. Tel 706-545-2958; Fax 706-545-5158; Elec Mail hannerz@benning.army.mil; Internet Home Page Address: www.benningmwr.com; *Dir & Cur* Frank Hanner; *Mus Shop Mgr* Andrea Jones; *Registrar* Edward Annable
Open Mon - Fri 10 AM - 4:30 PM; Sat - Sun 12:30 - 4:30 PM; No admis fee; Estab 1959 to trace history of U.S. infantrymen from early colonial times to present day; Gallery contains 30,000 sq ft; Hall of Flags, Gallery of Military Art, Benning Room, West Gallery: 1750-1865, Center Galleries 1870-1970, Medal of Honor Hall & Airborne Diorama; Average Annual Attendance: 110,000
Income: $200,000 (financed by federal funds)
Collections: Military related art; Presidential Documents & Memorabilia; Regimental Quartermasters Sales Store
Activities: Lect open to public; concerts; gallery talks; tours; individual paintings & original objects of art lent; museum shop sells books, reproductions & prints

FORT VALLEY

L **FORT VALLEY STATE COLLEGE,** H A Hunt Memorial Library, 1005 State College Dr, Fort Valley, GA 31030-3298. Tel 912-825-6342; Fax 912-825-6916; Elec Mail fvsclib@uscn.cc.uga.edu; *Library Dir* Carole Taylor
Open 8 AM - 5 PM; No admis fee; Estab 1939
Income: Financed by state assistance
Special Subjects: Art History, Historical Material, Art Education, Afro-American Art
Collections: Afro - American Art; Graphic Arts
Exhibitions: History of College
Activities: Classes for adults; lending collection contains books

JEKYLL ISLAND

M **JEKYLL ISLAND MUSEUM,** Stable Rd, Jekyll Island, GA 31520; 381 Riverview Dr, Jekyll Island, GA 31527. Tel 912-635-2119; 635-2122; Fax 912-635-4420; Elec Mail jekyllisland@compuserve.com; Internet Home Page Address: www.jekyllisland.com; *Exec Dir Jekyll Island* Bill Donohue; *Dir Mus & Historic Preservation* F Warren Murphey; *Cur Educ* Gretchen Greminger; *Chief Cur* John Hunter
Open Memorial Day - Labor Day Mon - Sun 9:30 AM - 5 PM, Labor Day - Memorial Day Mon - Sun 9:30 AM - 4 PM; Admis adults $10, students 6-18 years $6; Estab 1954; Average Annual Attendance: 51,000
Income: Financed by fees & admis
Special Subjects: Portraits, Furniture, Stained Glass
Collections: 1890 Furniture; Tiffany Stained Glass Windows; portraits
Activities: Programs for adults & children; lect open to public; tours; museum shop sells books, reproductions, slides & turn-of-the-century related items

LAGRANGE

M **CHATTAHOOCHEE VALLEY ART MUSEUM,** 112 LaFayette Pky, LaGrange, GA 30240. Tel 706-882-3267; Fax 706-882-2878; *Cur Educ* Dianne Frazier; *Finance Officer* Susie Hursey; *Admin Officer* Owen Holleran; *Exec Dir* Keith Rasmussen
Open Tues - Fri 9 AM - 5 PM, Sat 11 AM - 5 PM, cl Sun & Mon; No admis fee; Estab 1963 to provide visual art experience & educ to people of West Georgia; 100 year old former Troup County Jail refurbished for use as galleries having about 350 running ft of wall space & 7000 sq ft of floor space on two floors; Average Annual Attendance: 22,000; Mem: 450; dues $10 - $5,000; annual meeting in Jan
Income: $150,000 (financed by mem, foundation grant, civic organizations & fundraisers)
Purchases: $10,000, Purchase Awards, LaGrange National Competition
Special Subjects: Drawings, Graphics, Painting-American, Photography, Prints, Watercolors, American Indian Art, Textiles, Ceramics, Folk Art, Pottery, Woodcarvings, Woodcuts, Etchings & Engravings, Afro-American Art, Marine Painting, Carpets & Rugs, Juvenile Art, Stained Glass
Collections: Contemporary American art of all types & media
Exhibitions: Rotating exhibits, twelve per yr
Publications: Quarterly newsletter
Activities: Classes for adults & children; lect open to public, 2-4 vis lectrs per year; gallery talks; tours; competitions with awards; individual paintings & original objects of art lent to business patrons; book traveling exhibitions 1-4 per year; originate traveling exhibitions; museum shop sells prints, original art & reproductions

M **LA GRANGE COLLEGE,** Lamar Dodd Art Center Museum, LaGrange, GA 30240; LaGrange, GA 30240. Tel 706-882-2911; Fax 706-884-6567; *Dir* John D Lawrence
Estab 1988
Collections: 20th Century Photography; American Indian Collection; Retrospective Collection
Exhibitions: Two shows every six weeks

MACON

M **MUSEUM OF ARTS & SCIENCES, INC,** 4182 Forsyth Rd, Macon, GA 31210. Tel 478-477-3232; Fax 478-477-3251; Internet Home Page Address: www.masmacon.com; *Exec Dir* Michael Brothers
Open Mon - Thurs 9 AM - 5 PM, Fri 9 AM - 9 PM, Sat 9 AM - 5 PM, Sun 1 - 5 PM; Admis adults $6, seniors $5, students $4, children $3, members free; No admis fee Mon 9 AM - 5 PM & Fri 5 - 9 PM; Estab 1956 as a general art & science museum with a planetarium; South Gallery 50 ft x 60 ft; North Gallery 25 ft x 35 ft; Hall Gallery 8 ft x 32 ft; Newberry Hall 1759 sq ft; Average Annual Attendance: 85,000; Mem: 2200; dues $25-$1000
Special Subjects: Drawings, Painting-American, Prints, Sculpture, Painting-European
Collections: American art with emphasis on the Southeast drawings, paintings, prints & sculpture; gems & minerals; doll collection; quilt collection; ethnographic
Publications: Museum Muse, quarterly newsletter; catalogues
Activities: Classes for adults & children; docent training; lect open to public, 2-6 vis lectrs per year; concerts; gallery tours; guided tours; movies; special events; summer children's camps; individual paintings & original objects of art lent to other museums; book traveling exhibitions, 5 - 10 per year; originate traveling exhibitions to circulate to schools or appropriate institutions in Georgia & Southeast; museum shop sells books, magazines, original art, reproductions, prints, small educational toys, t-shirts, gem & minerals, gift items, rocks, shells, science kits

M **TUBMAN AFRICAN AMERICAN MUSEUM,** 340 Walnut St, Macon, GA 31201. Tel 478-743-8544; Fax 478-743-9063; Elec Mail tubman@mindspring.com; Internet Home Page Address: www.tubmanmuseum.com; *Asst Dir* Anita Ponder; *Dir Educ* George Crawley; *Exec Dir* Carey Pickard
Open Mon - Sat 9 AM - 5 PM; Admis $3, children 12 yrs & under $2; Estab 1981, emphasis on regional contemporary art & historical objects; Nine galleries, one mural entitled from Africa to America; Average Annual Attendance: 65,000; Mem: 500; dues $10-$1000; annual meeting in Dec
Income: Financed by endowment, mem, city & state appropriation, store
Special Subjects: African Art, Crafts, Folk Art, Afro-American Art
Collections: African & African-American art & artifacts; 70 foot long mural is signature possession; Medal of Honor, Sgt Rodney Davis
Exhibitions: Rotating exhibits every 2 1/2 months
Activities: Classes for children; dramatic programs; docent training; festival last Sun in Apr; black-tie fundraiser All That Jazz in Nov; lect open to public; Shelia award; scholarships & fels offered; museum shop sells books, magazines, original art, prints, reproductions & African crafts

L **Keil Resource Center,** 340 Walnut St, Macon, GA 31201. Tel 912-743-8544; Fax 912-743-9063; Internet Home Page Address: www.tubmanmuseum.org; Open Mon - Fri 9 AM - 5 PM; Estab 1987; For reference only
Income: Financed by endowment, mem, city & state appropriations, store
Library Holdings: Book Volumes 2500; Video Tapes
Special Subjects: Art History, Folk Art, Film, Mixed Media, Photography, Painting-American, Prints, Sculpture, Theatre Arts, Printmaking, Art Education, Afro-American Art, Pottery, Textiles

MADISON

M **MORGAN COUNTY FOUNDATION, INC,** Madison-Morgan Cultural Center, 434 S Main St, Madison, GA 30650. Tel 706-342-4743; Fax 706-342-1154; Elec Mail cultural@mail.morgan.public.lib.ga.us; Internet Home Page Address: www.madisonmorgancultural.org; *Chmn Bd* Sarah Burbach; *Admin Dir* Rhonda Smith; *Dir Visual Arts* Angela Nichols; *Interim Dir* Tina Lilly
Open Tues - Sat 10 AM - 5 PM, Sun 2 - 5 PM; Admis fee adults $3, seniors $2.50, students $2, members free; Estab 1976 to enhance the educational & cultural life of Georgia & the Southeast; Four galleries for changing exhibits, housed in former classrooms (approx 25 ft x 35 ft of historic 1895 school facility; heart pine floors, no daylight, tungsten track lighting only, with heat, air conditioning & electronic security; Average Annual Attendance: 30,000; Mem: 1500; dues $15-$1,000; annual meeting second Mon in July
Income: $460,000 (financed by endowment, mem, state grants, admis fees for services & sponsorship contributions)
Exhibitions: Usually two simultaneous exhibits, each 8-12 wks, of work by regional artists &/or collections of museums & private collections from the region or across the nation; Annual Juried Regional Art Exhibit
Publications: Exhibit brochures & catalogs, 4-5 per yr; Madison Georgia - An Architectural Guide
Activities: Performing arts programs; docent training; gallery tours; demonstrations; lect open to public, 5-10 vis lectrs per year; concerts; gallery talks; tours; competitions with awards; book traveling exhibitions 5-10 per year; originate traveling exhibitions; museum shop sells books, original art & reproductions

MARIETTA

M **MARIETTA-COBB MUSEUM OF ART,** 30 Atlanta St NE, Marietta, GA 30060. Tel 770-528-1444; Fax 770-528-1440; Elec Mail info@mariettacobbartmuseum.org; Internet Home Page Address: www.mariettacobbartmuseum.org; *Dir* Patricia Duggan; *Office Mgr* Heather Schlesinger
Open Tues - Fri 11 AM - 5 PM, Sat 11 AM-4 PM; Admis adults $5, seniors & students $3; Estab 1990 to provide the communities of Cobb County, the city of

Marietta & visitors to the area exposure to the visual arts through a diversity of visual art experiences, educational services & outreach activities based upon visiting exhibitions & the acquisition, conservation & exhibition of a permanent collection focused on American Art; Galleries 1-3 on main floor, gallery 4 on second level; Average Annual Attendance: 15,000; Mem: 600; dues individual $25 & up

Income: Financed by mem & donations, grants, foundations grants, county grants, city grants

Special Subjects: Painting-American, Prints, Sculpture

Collections: Collection of 400 works of art focusing on 19th & 20 century American Art

Activities: Classes for adults & children; docent training; lect open to public; individual paintings & original objects of art lent to other museums; museum shop sells original art; junior museum

MOUNT BERRY

M **BERRY COLLEGE,** Moon Gallery, Art Dept Berry College, Mount Berry, GA 30149. Tel 706-236-2219; Fax 706-236-7835; *Pres* Dr Scott Colley
Open Mon - Sat 10 AM - 5 PM, Sun 1 - 5 PM; Admis adults $5, children 6-12 $3; Estab 1972; Medium size gallery, carpeted floors & walls, tracking spots; Average Annual Attendance: 3,500

Exhibitions: Guest lecturer & juror for student Honors show

Activities: Classes for adults & children; lect open to public, 6-8 vis lectrs per year; gallery talks; competitions with awards; scholarships offered; individual paintings & original objects of art lent; lending collection contains books, cassettes, color reproductions, 20 original prints, paintings, records, photographs & 5000 slides; book traveling exhibitions; originate traveling exhibitions

L **Memorial Library,** Mount Berry, GA 30149. Tel 706-236-2221; Fax 706-236-9596; Elec Mail lfoldes@berry.edu; *Prof Art* Dr T J Mew III; *Dir* Lance Foldes
Open Mon - Thurs 8 AM - 12 AM, Fri 8 AM - 8 PM, Sat 1 - 6 PM, Sun 1 PM - 12 AM during academic year, Mon - Thurs 8 AM - 10 PM, Fri 8 AM - 5 PM during summer; Estab 1926 for educational purposes

Library Holdings: Audio Tapes; Book Volumes 350; Cassettes; Clipping Files; Exhibition Catalogs; Filmstrips; Manuscripts; Memorabilia; Motion Pictures; Original Art Works; Pamphlets; Periodical Subscriptions 25; Photographs; Prints; Records; Slides; Video Tapes

Special Subjects: Ceramics

PEACHTREE CITY

M **AMERICAN PRINT ALLIANCE,** 302 Larkspur Turn, Peachtree City, GA 30269-2210. Tel 770-486-6680; Elec Mail printalliance@mindspring.com; Internet Home Page Address: www.printalliance.org; *Dir* Carol Pulin PhD
Estab 1992 to provide educ & resource information for the promotion of the print arts; Internet gallery for prints, paperwork, & artists' books; Average Annual Attendance: 18,000; Mem: 15 councils; mem open to non-profit printmakers' councils: dues $100, individual $35; Ann meeting in Feb or Mar

Income: Financed by mem & journal subscriptions

Exhibitions: Memorial Portfolio: September 11th

Publications: Contemporary Impressions, semi-annual; Guide to Print Workshops in Canada & The United States

Activities: Conferences; lect open to pub; originate traveling exhibs 1 per yr to museums, universities, & community centers

RABUN GAP

M **HAMBIDGE CENTER FOR THE CREATIVE ARTS & SCIENCES,** Betty's Creek Rd, PO Box 339 Rabun Gap, GA 30568. Tel 706-746-5718; Fax 706-746-9933; Elec Mail center@hambidge.org; Internet Home Page Address: www.hambidge.org; *Dir Mktg* Peggy McBride; *Exec Dir* Dimmie Ziegler; *Dir Residency* April Hawkins; *Dir Gallery* Fran Lanier
Open yr round; No admis fee; Estab 1934, residency prog since 1988; Listed on the National Register of Historic Places, 600 acres; Average Annual Attendance: 120; Mem: 775, variable dues

Income: Nonprofit organization

Special Subjects: Crafts, Folk Art

Exhibitions: Fine Craft Exhibs, Anual Jugtown Ann Pottery Show

Activities: Classes for adults & children; 2-8 week residencies for professional artists/authors; speakers' forums open to public; guided nature walks; 4 vis lectrs per yr; historic mills; gallery talks; fels; sales shop sells books, original art, prints

SAINT SIMONS ISLAND

A **GLYNN ART ASSOCIATION,** 319 Mallory St, Saint Simons Island, GA 31522. Tel 912-638-8770; Fax 912-634-2787; Elec Mail glynnart@earthlink.net; Internet Home Page Address: www.glynnart.org; *Pres* Barbara Mueller; *Dir* Pat Weaver; *VPres* Judy Ellington; *Treas* Judith Hall; *Secy* Carla Zell
Open 9 AM - 5 PM; No admis fee; Estab 1953; 1,100 sq ft, largest portion devoted to local art, smaller portion for one man exhibits, traveling shows & competitions; Average Annual Attendance: 8,000; Mem: 600; dues $20-$500; annual meeting in June

Income: $100,000 (financed by mem, state appropriation & commission on sales of art)

Exhibitions: Miniature competition from all over & more than 100 local artists

Publications: Glynn Art News, monthly newsletter

Activities: Classes for adults & children; docent training; lect open to public, 4 vis lectrs per year; competitions with prizes; scholarships & fels offered; sales shop sells books, prints & original art

SAVANNAH

M **SHIPS OF THE SEA MARITIME MUSEUM,** 41 Martin Luther King, Jr Blvd Savannah, GA 31401. Tel 912-232-1511; Fax 912-234-7363; Elec Mail shipssea@bellsouth.net; Internet Home Page Address: www.shipsofthesea.org; *Exec Dir* Tony Pizzo; *Asst Dir* Karl DeVries; *Gift Shop Mgr* Eileen Lewis
Open Tues - Sun 10 AM - 5 PM; Admis adult $7, seniors & students $5; Estab 1966 to promote Savannah's maritime history & preserve William Scarbrough house; Average Annual Attendance: 50,000

Income: Financed privately

Special Subjects: Painting-American, Marine Painting, Historical Material, Scrimshaw

Collections: Figureheads, maritime antiques, paintings, porcelains, scrimshaw, ship models

Exhibitions: Savannah & Civil War at Sea; Steamship Company (Savannah Line)

Publications: Exhibit catalogues, Flotsam & Jetsam; William Scarbrough's House

Activities: Educ Prog; classes for children; lect open to public; concerts; tours; museum shop sells books & magazines, gift shop

M **TELFAIR MUSEUM OF ART,** 121 Barnard St, PO Box 10081 Savannah, GA 31401. Tel 912-790-8800; Fax 912-232-6954; Elec Mail hadaways@telfair.org; *Admin* Sandra S Hadaway; *Designer* Milutin Pavovic; *Chief Cur Educ* Harry H DeLorme; *Cur Fine Arts & Exhibs* Holly K McCullough; *Registrar* Stephanie Lathan; *Deputy Dir* William Rousseau; *Financial Officer* Soudra J Sharer; *Cur* Tania J Sammons
Open Tues - Sat 10 AM - 5 PM, Mon Noon - 5 PM, Sun 1 - 5 PM; Admis adults $9, seniors & AAA $8, students, children 6-12 $1; Estab 1875 to collect & to preserve, exhibit & interpret; 4 galleries 2400 sq ft, Rotunda gallery 3400 sq ft, Sculpture gallery 2700 sq ft. Maintains reference library; Average Annual Attendance: 188,000; Mem: 2000; dues $25-$10,000; annual meeting in Apr

Income: Financed by endowment, mem, city & state appropriation, banks & corporate foundations & federal government

Library Holdings: Auction Catalogs; Book Volumes; Exhibition Catalogs

Special Subjects: Decorative Arts, Portraits, Painting-French, Period Rooms, Painting-German

Collections: American decorative arts; American & European artists; Late 18th century to present; 19th & 20th century American & European paintings; works on paper

Exhibitions: Special & traveling exhibitions

Publications: The Octagon Room; We Ain't What We Used to Be; Christopher P H Murphy (1869-1939): A Retrospective; Nostrums for Fashionable Entertainmens: Dining in Georgia 1800-1850; Classical Savannah: Fine and Decorative Arts 1800-1840; Looking Back: Art in Savannah 1900-1960; Ladies, Landscapes and Loyal Retainers: Japanese Art from a Private Collection; Frederick Carl Frieseke: The Evolution of an American Impressionist: Southern Melodies: A Larry Connatser Retrospective; GA Triennal

Activities: Docent training; programs & classes for children; lect open to public, 6-15 vis lectrs; concerts; gallery talks; Effingham County; Chatham County; parks & playgrounds; individual paintings & original objects of art lent to other musems internationally; lending collection contains over 4000 original art works, over 100 sculptures, 2,186 fine arts and 1,968 decorative; book traveling exhibitions 6-10 per year; originate traveling exhibitions to other art museums throughout US; museum shop sells books, reproductions, prints, posters, postcards; original art

L **Telfair Academy of Arts & Sciences Library,** 121 Barnard St, PO Box 10081 Savannah, GA 31412. Tel 912-232-1177; Fax 912-232-6954; Elec Mail hadaways@telfair.org; Internet Home Page Address: www.telfair.org; *Dir & CEO* Diane Lesko PhD; *CFO* Ethel K Pendergrass; *Dir Marketing & Pub Relations* Cathy Towles; *Cur Educ* Harry DeLorme; *Cur Fine Arts & Exhibits* Hollis Koons McCullough; *Registrar* Stephanie Lathan; *Mus Shop Mgr* Stephanie B Trask; *Develop Officer* James Battin; *Admin* Sandra S Hadaway; *Designer & Preparator* Milutin Pavlovic; *VPres* John Neises; *Asst Cur* Elizabeth Moore
Open Sun 1 - 5 PM, Mon Noon - 5 PM, Tues - Sat 10 AM - 5 PM; Admis adults $6, seniors $5, students $2, children 6-12 $1, children under 6 free, combination Owens-Thomas House & Telfair Academy $10; Estab 1875 to collect, preserve, exhibit, & interpret the objects in its collection of fine & decorative arts & its National Historic Landmark buildings; For reference only, for scholars & the public; Average Annual Attendance: 144,500; Mem: 1420; dues grand benefactor $10,000; benefactor $5,000; sponsor $2,500; grand patron $1,500; patron $1,250; sustainer $1,000; friend $600; supporting $300; donor $100; family $60; individual $35; special $25

Income: 2,000,000 (financed by membership, grants, fundraising events & endowments)

Purchases: 40,000

Library Holdings: Book Volumes 3,500; Exhibition Catalogs; Periodical Subscriptions 130

Exhibitions: 4-6 traveling exhibitions per year

Publications: Quarterly newsletter; exhibition brochures & catalogs

Activities: Organize traveling exhibitions to local institutions, also to NY & willing to lend nationwide

SUWANEE

A **HANDWEAVERS GUILD OF AMERICA,** 1255 Buford Highway, Ste 211, Suwanee, GA 30024. Tel 678-730-0100; Fax 678-730-0836; Elec Mail hga@weavespindye.org; Internet Home Page Address: www.weavespindye.org; *Exec Dir & Ed* Sandra Bowles
Open Mon - Fri 8 AM - 5 PM; No admis fee; Estab 1969 to promote fiber arts; Mem: 10,000; dues $35; annual meeting in summer

Income: Financed by mem dues, contributions, advertising & conferences

Publications: Shuttle, Spindle & Dyepot, quarterly publication for members

Activities: Fiber programs for adults, classes for children; awards to selected fiber art shows; scholarships & fels offered; originate traveling exhibitions to fiber guilds

VALDOSTA

M **VALDOSTA STATE UNIVERSITY,** Art Gallery, 1500 N Patterson St, Valdosta, GA 31698-0110. Tel 229-333-5835; Fax 229-245-3799; Elec Mail kgmurray@valdosta.edu; Internet Home Page Address: www.valdosta.edu/art; *Dir Gallery* Karin Murray; *Acting Head Art Dept* A Blake Pearce; *Cur* Dick Bjornseth
Open Mon - Thurs 10 AM - 4 PM, Fri 10 AM - 3 PM; No admis fee; Estab 1970 for educational purposes serving students, faculty, community & region; Gallery is an open rectangular room with approximately 122 running ft of exhibition space; Average Annual Attendance: 20,000
Income: Financed by state appropriations
Special Subjects: African Art
Collections: African art; Lamar Dodd
Exhibitions: 8-9 exhibitions per year; national juried Valdosta works on paper exhibition; faculty show
Activities: Classes for adults; dramatic programs; docent training; lect open to public, 3-5 vis lectrs per year; Valdosta State Orchestra; concerts; gallery talks; tours; competitions; vis artists; demonstrations; scholarships offered; originate traveling exhibitions

WAYCROSS

M **OKEFENOKEE HERITAGE CENTER, INC,** 1460 N Augusta Ave, Waycross, GA 31503. Tel 912-285-4260; Fax 912-283-2858; Elec Mail ohc@access.net; Internet Home Page Address: www.okeheritage.org; *Coordr Exhibits & Prog* Tina Highsmith Rowell; *Pub Affairs* Mike Taylor; *Admin Asst* Betty Callahan; *After School Employee* Chris Sills; *After School Employee* Arthur Reed
Open Mon - Sat 10 AM - 5 PM, cl Sun & holidays; Admis adults $2, youth 5-18 $1, under 4 & mems free; Estab 1975 to house displays on arts & history; Two gallery areas; Average Annual Attendance: 10,000; Mem: 350; dues business $10,000, guardian $5,000, corporate patron $3,000, sponsor & corporate sponsor $1,000, donor & business donor $500, friend & business friend $300, heritage club $100, sustaining $50, family $30, individual $20, student $5
Income: $85,000 (financed by endowment, mem, grants, contributions, admis, special activities, gift shop)
Special Subjects: Painting-American, Prints, Crafts
Collections: 1912 Baldwin Steam Locomotive train & caboose; 1940's Homestead; 1870's house exhibit; 1890's printshop; prints, crafts, paintings & photographs
Exhibitions: Annual art show (Sept); Sacred Harp (Permanent); Individual Artists Children Art Show
Publications: Quarterly exhibit catalogues; newsletter
Activities: Classes for adults & children; demonstrations; workshops; lect open to public; concerts; gallery talks; tours; competitions; purchase awards; book traveling exhibitions; museum shop sells books, original art, reproductions, prints gifts & souvenirs

WHITE

M **WEINMAN MINERAL MUSEUM,** 51 Mineral Museum Dr, White, GA 30184. Tel 770-386-0576 ext 402; Fax 770-386-0600; Internet Home Page Address: www.weinmanmuseum.org; *Dir & Cur* Jose Santamaria; *Educ* Terry Everett; *Asst Dir* Mary Vinson; *Registrar & Archivist* Cherry Johnson; *Guest Svcs* Conilia Dover
Open Tues - Sat 10 AM - 5 PM, Sun 1 - 5 PM; cl Mon & maj holidays; Admis adults $4, seniors $3.50, children $3; Estab 1982; Average Annual Attendance: 21,685; Mem: dues Corporate $250 - 1000, Sponsor $250, Friend $100, Family $50, Indiv $25, Student $20
Library Holdings: Book Volumes 1500; Periodical Subscriptions 3000
Collections: Exhibits related to geological objects: minerals, fossils, rocks, gems & mining artifacts. Emphasis on minerals & fossils from the state of Georgia & its mining heritage.
Exhibitions: Rockfest: Outdoor gem & mineral show with free admis to mus; Holiday Open House: free activies, refreshments & admis
Publications: Weinman Mineral Museum News, Quarterly
Activities: Educ progs for adults & children

HAWAII

HONOLULU

A **ASSOCIATION OF HAWAII ARTISTS,** PO Box 10202, Honolulu, HI 96816. Tel 808-395-3238; Fax 808-923-1062; *Pres* Jennifer Rothchild
Estab 1926 to promote congeniality & stimulate growth by presenting programs; to contribute to the cultural life of the State of Hawaii; Average Annual Attendance: 1,000; Mem: 250; dues $15-$30; monthly meeting every second Tues
Income: Financed by mem
Publications: Paint Rag, monthly
Activities: Lect open to public, 2-3 vis lectrs per year; demonstrations; competitions with cash awards, plaques & rossettes

M **BERNICE PAUAHI BISHOP MUSEUM,** 1525 Bernice St, Honolulu, HI 96817-0916. Tel 808-847-3511; Fax 808-841-8968; *Dir* W Donald Duckworth
Open Mon - Sun 9 AM - 5 PM, cl Christmas; Estab 1889 to preserve & study the culture & natural history of Hawaii
Exhibitions: Awesome Treasures of Hawaii & the Pacific: A Hands-On Adventure; Treasures; Ocean Planet
L **Library,** 1525 Bernice St, Honolulu, HI 96817-0916. Tel 808-848-4148; Fax 808-847-8241; Elec Mail library@bishopmuseum.org; Internet Home Page Address: www.bishopmuseum.org; *Head Librn* Duane Wenzel; *Archivist* DeSoto

Brown; *Reference Librn* Patty Belcher; *Librn* Janet Short; *Archivist* Ron Schaeffer; *Reference Archivist* Judy Kearney
Open daily 9 AM - 5 PM, cl Christmas; Admis adult $14.95, youth & seniors $11.95; Estab 1889 to stimulate awareness & appreciation of the natural & cultural world of Hawaii & the Pacific; Average Annual Attendance: 200,000; Mem: 10,000; dues $30 - $55
Library Holdings: Book Volumes 40,000
Special Subjects: Folk Art, Historical Material, History of Art & Archaeology, Archaeology, Ethnology, Anthropology
Collections: Books; Insect Specimens; Journals; Manuscripts; Pacific & Hawaiian Cultural Objects; Photographics; Plant Specimens; Zoological Specimens; Maps; Fine Art; Moving Images
Activities: Classes for adults & children; docent training; lect open to public; concerts; gallery talks; tours; competitions with awards; originate traveling exhibitions; museum shop sells books; original art & reproductions
L **Archives,** 1525 Bernice St, Honolulu, HI 96817-0916. Tel 808-848-4182; Fax 808-841-8968; *Archivist* DeSoto Brown; *Archivist* Linda Lawrence; *Archivist* Ron Schaeffer
Open Tues - Fri Noon - 3 PM, Sat 9 AM - Noon; Estab 1991
Library Holdings: Manuscripts 3,500; Photographs 1,000,000
Collections: Cylinders, discs & reel to reel tapes; Maps; Moving Images; Oils on Canvas; Works of Art on Paper

M **THE CONTEMPORARY MUSEUM,** 2411 Makiki Heights Dr, Honolulu, HI 96822. Tel 808-526-1322; Fax 808-536-5973; Internet Home Page Address: www.tcmhi.org; *Assoc Dir & Chief Cur* James Jensen; *Dir Develop* Kathy Hong; *Dir Georgianna M* Lagoria; *Assoc Cur* Allison Wong; *Educ Cur* Wei Fang; *Assoc Cur* Michael Rooks; *Mgr Fin & Oper* John Talkington
Open Tues - Sat 10 AM - 4 PM, Sun Noon - 4 PM, cl Mon & major holidays; Admis adults $5, students & seniors $3, children under 13 & members free; Estab 1961 as Contemporary Arts Center to provide a showcase for local, national & international contemporary artists; From 1940 the present, reorganized & open in 1988 in present facility situated in 3 1/2 acres of gardens; five galleries comprise 5000 sq ft of exhibition space. Also includes exhibition annex & First Hawaiian Center in downtown Honolulu; mantains lending & reference library; Average Annual Attendance: 45,000; Mem: 2,500; dues $45 & up
Income: $1,500,000 (financed by endowment, mem, grants, contributions & earned income)
Library Holdings: Auction Catalogs; Book Volumes; Clipping Files; Exhibition Catalogs
Collections: Permanent collection of over 1400 works from 1940 to present in all media by local, national & international artists; stage set by David Hockney on permanent view
Publications: Fifth biennial exhibition of Hawaii Artists color catalog of Enrique Martinez Celaya & Tadashi Sato; Claude Horan catalogue
Activities: Classes for adults & children; docent training; dramatic programs; lect open to public, 4 vis lectrs per year; concerts; gallery talks; tours; artmobile lent to museums; organize traveling exhibitions to circulate to other small museums; museum shop sells books, original art, reproductions, prints & unique & fun jewelry by national & local artists

M **THE CONTEMPORARY MUSEUM AT FIRST HAWAIIAN CENTER,** 999 Bishop St, Honolulu, HI 96813; 2411 Makiki Heights Dr, Honolulu, HI 96822. Tel 808-526-1322; Fax 808-536-5973; Elec Mail awong@tcmhi.org; Internet Home Page Address: www.tcmhi.org; *Cur* Allison Wong; *Dir* Georgianna Lagoria
Open Mon - Thurs 8:30 AM - 4 PM, Fri 8:30 AM - 6 PM, cl weekends & major holidays; No admis fee; Estab 1996 to provide a place for artists of Hawaii to display their work; Downtown satellite location: ground floor lobby & a second floor gallery that extends along Merchant St behind a glass curtain wall made of over 4000 panels of stone, glass & aluminum; Average Annual Attendance: 26,000; Mem: 2243
Income: underwritten by First Hawaiian Bank
Collections: Contemporary Art (all media) from 1940's to the present
Activities: Educ dept tours; lect

M **HONOLULU ACADEMY OF ARTS,** 900 S Beretania St, Honolulu, HI 96814. Tel 808-532-8700; Fax 808-532-8787; Internet Home Page Address: www.honoluluacademy.org; Cable HONART; *Dir* Stephen Little; *Cur Western Art* Jennifer Saville; *Mgr Textile Coll* Sara Oka; *Cur Asian Art* Julia White; *Cur Educ* Karen Thompson; *Cur Art Center* Carol Khewhok; *Keeper, Lending Center* Gwen Harada; *Registrar* Sanna Deutsch; *Deputy Dir* Carol Fox; *Develop Dir* Karen Sumner; *Head Librn* Ron Chapman
Open Tues - Sat 10 AM - 4:30 PM, Sun 1 - 5 PM, cl Mon & major holidays; Admis general $7, seniors, students & military $4, children under 12 free, members free; Estab 1927 as the only art museum of a broad general nature in the Pacific; to provide Hawaii's people of many races with works of art representing their composite cultural heritage from both East and West; Main building is a Registered National Historic Place; Average Annual Attendance: 250,000; Mem: 7,000; dues $15 & up
Income: $8,261,641
Library Holdings: Auction Catalogs 12,000; Book Volumes 45,000; Clipping Files 56; Exhibition Catalogs 2,000; Periodical Subscriptions 40
Special Subjects: Painting-American, Photography, Prints, American Indian Art, American Western Art, Bronzes, African Art, Pre-Columbian Art, Textiles, Costumes, Ceramics, Etchings & Engravings, Landscapes, Painting-European, Painting-Japanese, Furniture, Jade, Porcelain, Oriental Art, Asian Art, Painting-French, Painting-Flemish, Renaissance Art, Medieval Art, Painting-Italian, Islamic Art
Collections: European and American Decorative Arts, Painting, Prints, Sculpture; Ancient Mediterranean and Medieval Christian Art; Kress Collection of Italian Renaissance Painting; Chinese Bronze, Ceramics, Furniture, Lacquerware, Painting, Sculpture; Islamic Ceramics; Japanese Ceramics, Folk Arts, Painting, Prints, Screens, Sculpture; Korean Ceramics; Traditional Arts of Africa, Oceania and the Americas; Western and Oriental Textiles
Exhibitions: Approx 50 temporary exhibitions annually
Publications: Art Books and Pamphlets; Catalog of the Collection; Catalogs of Special Exhibitions

Activities: Classes for adults & children; docent training; lectr; concerts; sponsoring of competitions; films & videos illustrating contemporary & historic range of the medium; guided tours; gallery talks; arts festivals; workshops; music programs; research in Asian & Western Art; lending collection contains paintings, prints, textiles, reproductions, photographs, slides and ethnographic objects (about 21,000); sales shop sells books, original art, reproductions, prints, jewelry, stationary/note cards & gifts

L **Robert Allerton Library,** 900 S Beretania St, Honolulu, HI 96814. Tel 808-532-8755; Fax 808-532-8787; *Librn* Ronald Champman
Open Tues - Sat 10 AM - Noon & 1 - 4 PM; cl Sun & Mon; Estab 1927; Reference library for staff & members
Library Holdings: Book Volumes 40,000; Clipping Files; Exhibition Catalogs; Fiche; Pamphlets; Periodical Subscriptions 250; Photographs; Reels; Slides
Special Subjects: Art History, Oriental Art

M **JUDICIARY HISTORY CENTER,** 417 S King St, Honolulu, HI 96813. Tel 808-539-4999; Fax 808-539-4996; Elec Mail jhc@aloha.net; Internet Home Page Address: www.JHCHawaii.org; *Educ Specialist* Matt Mattice; *Cur* Susan Shaner; *Dir* Lani Lapilio
Open Mon - Fri 9 AM - 4 PM; No admis fee; Estab to interpret the history of Hawaii's courts & legal system; Average Annual Attendance: 40,000; Mem: 150; dues $15 - $1,000
Income: Financed by appropriation
Collections: Art (paintings, prints); Artifacts; Documents (judicial & legal); furniture
Exhibitions: The Monarchy Courts; Martial Law in Hawaii 1941 - 1944; Restored Court Room 1913; Who's Who in the Courtroom
Activities: Educ dept; dramatic programs; docent programs; tours

M **RAMSAY MUSEUM,** 1128 Smith St, Honolulu, HI 96817-5194. Tel 808-537-2787; Fax 808-531-6873; Elec Mail ramsay@lava.net; Internet Home Page Address: www.ramsaymuseum.org; *Installation Designer* Les Kiyabu; *Installation Designer* Penny Kiyabu; *Dir* Russ Sowers; *Cur of Website* William Burlingame
Open Mon - Fri 10 AM - 5 PM, Sat 10 AM - 4 PM, cl Sun; No admis fee; Estab 1981 for solo showcases; Specializes in showcasing the work of Hawaii-based artist; maintains reference library; Average Annual Attendance: 8,500
Special Subjects: Drawings, Painting-American, Photography, Prints, Sculpture, Etchings & Engravings
Collections: Original art by artists of Hawaii; Original drawings by Ramsay
Exhibitions: Collection of 50 quill & ink drawings by Ramsay; Exhibit of 50 multi-media art works by artists of Hawaii; monthly exhibitions.
Publications: Exhibit catalogues
Activities: Docent programs; lect open to public, 12 vis lectrs per year; competitions with awards; scholarship offered; lending collection contains framed works; sales shop sells original art, reproductions, prints & cards

M **TENNENT ART FOUNDATION GALLERY,** 203 Prospect St, Honolulu, HI 96813. Tel 808-531-1987; *Dir* Elaine Tennent
Open Tues - Sat 10 AM - Noon; Sun 2 - 4 PM or by appointment; No admis fee; Estab 1954; dedicated to aesthetic portrayal of Hawaiian people and to house works of Madge Tennent; Gallery is set in a terraced garden with a variety of plants & trees; Mem: 300; dues family $25, individual $15; annual meeting in Feb
Income: Financed by trust
Collections: Madge Tennent's Personal Art Books Collection
Publications: Prospectus, quarterly newsletter
Activities: Special exhibitions and social events sponsored by Friends of Tennent Art Gallery; lect; tours; concerts; museum shop sells note cards & reproductions

L **Library,** 203 Prospect St, Honolulu, HI 96813. Tel 808-531-1987; *Dir* Elaine Tennent
Open by appt only; Open for reference
Income: financed by trust
Library Holdings: Book Volumes 350

M **UNIVERSITY OF HAWAII AT MANOA,** Art Gallery, 2535 McCarthy Mall, Honolulu, HI 96822. Tel 808-956-6888; Fax 808-956-9659; Elec Mail gallery@hawaii.edu; Internet Home Page Address: www.hawaii.edu/artgallery; *Assoc Dir* Sharon Tasaka; *Design Asst* Wayne Kawamoto; *Dir* Tom Klobe
Open Mon - Fri 10:30 AM - 4 PM; Sun Noon - 4 PM; cl Sat; No admis fee; Estab 1976 to present a program of regional, national & international exhibitions; Gallery is seen as a major teaching tool for all areas of specialization. It is located in the center of the art building & is designed as a versatile space with a flexible installation system that allows all types of art to be displayed; Average Annual Attendance: 50,000
Income: Financed by state govt, grants, pvt contributions
Collections: Japanese, European, American & Polish posters
Exhibitions: (2006-2008) International Shoebox Sculpture Exhibition
Publications: Exhibition catalogs
Activities: Classes for adults; lect open to public; gallery talks; competitions; scholarships & fels offered; book traveling exhibitions; 1 biennially; originate traveling exhibitions to public and university museums; sales shop sells exhibit catalogs

KANEOHE

M **HAWAII PACIFIC UNIVERSITY,** Gallery, 45-045 Kamehameha Hwy, Kaneohe, HI; 1164 Bishop St, Honolulu, HI 96813. Tel 808-544-0287; Fax 808-544-1136; Elec Mail nellis@hpu.edu; Internet Home Page Address: www.hpu.edu; *Admin* Nancy L Ellis; *Cur* Sanit Khewhok
Open Mon - Sat 8 AM - 5 PM; No admis fee; Estab 1983 as a cultural & academic resource for students & community; 12,000 sq ft; Average Annual Attendance: 8,500
Income: Financed by college funds & private donations
Exhibitions: 6 exhibitions per year featuring contemporary artists working in Hawaii
Activities: Lect open to public; gallery talks; competitions

LAHAINA

A **LAHAINA ARTS SOCIETY,** Art Organization, 648 Wharf St Ste 103, Lahaina, HI 96761. Tel 808-661-0111, 661-3228; Fax 808-661-9149; Elec Mail las@mauigateway.com; *Pres* Darshan Zenith; *Sales* Barbara Hutchinson
Open daily 9 AM - 5 PM; No admis fee; Estab 1962 as a nonprofit organization interested in perpetuating culture, art & beauty by providing stimulating art instruction, lectures & art exhibits; Gallery located in old Lahaina Courthouse; Main Gallery is on ground floor; Old Jail Gallery is in the basement; Average Annual Attendance: 50,000; Mem: 250; dues $50; annual meeting Oct
Income: financed by mem & annual fundraising event, Beaux Arts Ball
Exhibitions: Exhibits once a month
Publications: Newsletter, monthly; exhibition catalogs
Activities: Classes for children; lect for members only; gallery talks; competitions with scholarships; workshops; scholarships offered; gallery sales shop sells original art, prints, cards, ceramics, handcrafted jewelry & sculptures

M **WHALERS VILLAGE MUSEUM,** 2435 Ka'anapali Pkwy, Lahaina, HI 96761. Tel 808-661-4567; Tel 808-661-5992 (Info); Internet Home Page Address: www.whalersvillage.com/museum/museum.htm
Open daily 9:30 AM - 10 PM; History-oriented mus brings to life Lahaina's whaling era (1825 - 1860) as told through the eyes of an ordinary sailor & whaleman and illustrates the challenges of daily life on the sea
Special Subjects: Anthropology, Archaeology, Decorative Arts, Folk Art, Historical Material, Photography, Sculpture, Scrimshaw
Collections: 19th-century scrimshaw; pictures carved on whale teeth & bone; antique ornaments & utensils made from whale ivory & bone; one of the world's largest scale models of a whaling ship on display; photo murals & interpretive graphics
Activities: Self-guided tours; informational videos shown throughout the day; scrimshaw, jewelry, books & museum-related items for sale

LAIE

A **POLYNESIAN CULTURAL CENTER,** 55-370 Kamehameha Hwy, Laie, HI 96762. Tel 808-293-3005; Fax 808-293-3022; Elec Mail clawsone@polynesia.com; *Pres & Gen Mgr* Von D Orgill
Open Mon - Sat 11 AM - 9 PM, cl Sun, Thanksgiving, New Year's & Christmas; Admis adults $14, children $7; Estab 1963 by the Church of Jesus Christ of Latter Day Saints as an authentic Polynesian village; Center is a 42 acre living museum with two amphitheaters, it represents villages of Hawaii, Samoa, Tonga, Fiji, Tahiti, New Zealand & the Marquesas; Average Annual Attendance: 1,000,000
Income: Financed by admis
Collections: Decorative arts, ethnic material, graphics, paintings & sculpture
Publications: Brochures
Activities: Classes for adults & children; workshop training in Polynesian arts & crafts; 2 hr Polynesian Show of Cultures nightly; lect open to public; scholarships offered

LIHUE

M **KAUAI MUSEUM,** 4428 Rice St, Lihue, HI 96766; PO Box 248, Lihue, HI 96766. Tel 808-245-6931; Fax 808-245-6864; Elec Mail museum@kauaimuseum.org; Internet Home Page Address: www.kauaimuseum.org; *Dir* Carol Lovell; *Cur* Margaret Lovett; *VPres Board* Tim Dehavega; *Mus Shop Mgr* Winifred Yulo
Open Mon - Fri 9 AM - 4 PM, Sat 10 AM - 4 PM, cl Sun; Admis adults $7, seniors $5, students $3, children 12 - 6 $1, children 6 & under free; Estab 1960 to provide the history through the permanent exhibit, the Story of Kauai & through art exhibits; ethnic cultural exhibits in the Wilcox Building to give the community an opportunity to learn more of ethnic backgrounds; Average Annual Attendance: 30,000; Mem: 1,700; dues $25-$1,000; annual meeting in Feb
Income: Financed by mem dues, government grants
Collections: Hawaiian collection with particular emphasis on items dealing with the island of Kauai; school art exhibits, ethnic & heritage displays
Exhibitions: Downstairs: Hawaiian Home; Quilts; Upstairs
Publications: Hawaiian Quilting on Kauai; Early Kauai Hospitality; Amelia; Moki Goes Fishing; Kauai: The Separate Kingdom; Kauai Museum Quilt Collection
Activities: Classes for adults & children; docent training; lect open to public, 8 vis lectr per year; concerts; tours; book traveling exhibitions 3 per year; museum shop sells books, magazines, original art, reproductions, prints

MAKAWAO MAUI

M **HUI NO EAU VISUAL ARTS CENTER,** Gallery and Gift Shop, 2841 Baldwin Ave, Makawao Maui, HI 96768. Tel 808-572-6560; Fax 808-572-2750; Elec Mail info@huinoeau.com; Internet Home Page Address: www.maui.net/~hui; *Artistic Progs Dir* Inger Tully; *Prog Mgr* Linda Doyle; *Develop Officer* Tannis Grimes; *Business Mgr* Micah Mesina; *Facilities Mgr* Jim Graper
Open Mon - Sun 10 AM - 4 PM; No admis fee; Estab 1934 to encourage & promote the development of artistic expression & creativity in the individual & to stimulate a broader appreciation & understanding of the visual arts as a vital language in our culture; 1,000 sq ft exhibit space in historic living & dining areas; Average Annual Attendance: 30,000; Mem: 1,050; dues $40
Income: Financed by endowment, mem, state appropriation & earned income
Special Subjects: Drawings, Painting-American, Photography, Prints, Watercolors, Textiles, Ceramics, Pottery, Etchings & Engravings, Landscapes, Jewelry, Porcelain, Marine Painting, Metalwork, Historical Material
Publications: Hui News, bi-monthly; Hui brochure
Activities: Classes for adults & children; visitor program; Hawaiian culture & art; lect open to public, 12 vis lectrs per year; competions with awards; gallery talks; tours; scholarships offered; book traveling exhibitions 1-2 per year; originate traveling exhibitions 1-2 per year; retail store sells books, original art, reproductions & prints

WAILUKU

M MAUI HISTORICAL SOCIETY, Bailey House, 2375A Main St, Wailuku, HI 96793. Tel 808-244-3326; 242-5080 (Research); Fax 808-244-3920; Elec Mail baileyhouse@aloha.net; Internet Home Page Address: www.mauimuseum.org; *Pres* Brian Motto; *Exec Dir* Roselyn Lightfoot
Open Mon - Sat 10 AM - 4 PM, cl Sun; Admis Donation requested adults $5, seniors $4, children (7-12) $1, 6 & under free; Estab 1957 to preserve the history of Hawaii, particularly Maui County; housed in former residence of Edward Bailey (1814-1903); Average Annual Attendance: 21,000; Mem: 800; dues $25-$100; annual meeting in July
Income: $100,000 (financed by mem, gift shop purchases & admis fees)
Special Subjects: Landscapes
Collections: Landscape Paintings (1860-1900); Paintings of Hawaiian Scenes by Edward Bailey; Prehistoric Hawaiian Artifacts
Exhibitions: Exhibits depicting missionary life, throughout the year
Publications: Imi Ike, journal
Activities: Classes for children; docent training; lect open to public, 4-6 vis lectrs per year; tours; originate traveling exhibitions to schools & other museums; museum shop sells books, reproductions, prints, slides & arts & crafts

IDAHO

BOISE

M BOISE ART MUSEUM, 670 Julia Davis Dr, Boise, ID 83702. Tel 208-345-8330; Fax 208-345-2247; Internet Home Page Address: www.boiseartmuseum.org; *Exec Dir* Melanie Fales; *Cur Art* Sandy Harthorn; *Asst Cur Art* Amy Pence-Brown; *Cur Educ* Melanie Fales; *Asst Cur Educ* Terra Feast
Open Tues - Sat 10 AM - 5 PM, Sun Noon - 5 PM, cl Mon & holidays; Admis general $5, seniors & college students $3, grades 1 - 12 $1, children under 6 free, first Thurs of month free; Estab 1931, inc 1961, gallery opened 1936; Art Mus offers premier exhibs, educational progrs & community events; Average Annual Attendance: 75,000; Mem: 2,000; dues family $50, individual $35; annual meetings in May
Income: Financed by mem, Beaux Arts Societe, grants, private & corporate donations, art festival
Special Subjects: Painting-American, Photography, Sculpture, Primitive art, Painting-European, Oriental Art
Collections: African Sculpture (masks); American Ceramics; American, European & Oriental Collections of Painting, The Minor Arts, Sculpture; American Realism; Arranged Image Photography; collection of works by Northwest Artists; Contemporary Prints
Exhibitions: Triennial exhibition for Idaho artists; 16 exhibitions annually of all media, regional to international; Contemporary & Historical rotating shows
Publications: Annual report; quarterly bulletin; occasional catalogs & posters of exhibitions
Activities: Classes in art for adults & children; docent training; docent tours; concerts; outdoor arts festival; Beaux Arts Societe (fund raising auxiliary); lectrs for mems only; 5 vis lectrs per year; gallery talks; tours; sponsoring of competitions; Idaho Triennial High School; originate traveling exhibitions statewide & Northwest region; museum shop sells books, original art, reproductions, cards & jewelry

A IDAHO COMMISSION ON THE ARTS, 2410 Old Penitentiary Rd, PO Box 83720 Boise, ID 83720-0008. Tel 208-334-2119; Fax 208-334-2488; Elec Mail bgarrett@ica.state.id.us; Internet Home Page Address: www2.state.id.us/arts; *Dir Artist Svcs* Barbara Garrett; *Dir Literature* Cort Conley; *Dir Arts Educ* Ruth Piispanen; *Dir Folk & Trad Arts* Maria Carmen Gambliel; *Dir Community Develop* Kathleen Keys
Open 8 AM - 5 PM; No admis fee; Estab 1966 to promote artistic development within the state & to make cultural resources available to all Idahoans
Publications: Newsletter 6 times a year

M IDAHO HISTORICAL MUSEUM, 610 N Julia Davis Dr, Boise, ID 83702. Tel 208-334-2120; Fax 208-334-4059; Elec Mail jochoa@shs.state.id.us; Internet Home Page Address: www.state.id.us/ishs; *Registrar* Jody Ochoa; *Cur* Joe Toluse; *Museum Adminr* Kenneth J Swanson
Open Mon - Sat 9 AM - 5 PM, Sun & holidays 1 - 5 PM; No admis fee; Estab 1881; Average Annual Attendance: 100,000; Mem: Dues $500 life mem, $100 bus, $25 patron, $15 couple, $10 individual
Income: Financed by donations and mem
Special Subjects: Archaeology, Textiles, Costumes, Decorative Arts, Furniture, Period Rooms
Collections: History artifacts
Exhibitions: Story of Idaho
Activities: Classes for children; dramatic programs; docent training; lect open to public; tours; competitions; individual paintings & original objects of art lent to agencies & institutions; lending collection contains 7 slide programs; book traveling exhibitions; originate traveling exhibitions to state schools & libraries; museum shop sells books & gifts

CALDWELL

M ALBERTSON COLLEGE OF IDAHO, Rosenthal Art Gallery, 2112 Cleveland Blvd, Caldwell, ID 83605. Tel 208-459-5321; Fax 208-454-2077; Elec Mail gclaassen@albertson.edu; Internet Home Page Address: www.acofi.edu/art/galleries/rosenthal.htm; *Prof Art* Steven M Fisher; *Assoc Prof Art* Lynn Webster; *Dir* Dr Garth Claassen
Open Tues - Thurs 1 PM - 4 PM or by appointment; No admis fee; Estab 1980
Income: Financed by college funds
Special Subjects: Painting-American, Prints

Collections: Luther Douglas, Sand Paintings; Paintings; Prints Collection
Exhibitions: Temporary & traveling exhibitions on an inter-museum loan basis
Publications: Exhibit Brochures
Activities: Lect; gallery talks; guided tours; films

EAGLE

A INTERNATIONAL SOCIETY OF MARINE PAINTERS, 936 E Cembra St, Eagle, ID 83616. Tel 208-938-4736; Elec Mail dlarge@schoonerlinks.com; Internet Home Page Address: www.ismart.com; *Pres* David Large; *VPres* Richard Levesque
Estab 1984; Mem: mem $15 - $25
Income: Financed by dues & contributions
Special Subjects: Marine Painting
Exhibitions: Annual Marine Artist Breakfast in Glouster, MA & Bradenton, FL
Publications: Seascaped, every 3 months
Activities: Originate traveling exhibitions to major art galleries, art centers & marine museums

EMMETT

M GEM COUNTY HISTORICAL SOCIETY AND MUSEUM, 501 E 1st St, Emmett, ID 83617. Tel 208-365-9530; Tel 208-365-4340; Elec Mail gemcohs@bigskytel.com; Internet Home Page Address: www.gemcohs.org
Summer: Wed - Fri 10:30 AM - 5:30 PM, Sat 12 PM - 5 PM. Winter: Wed - Fri 10:30 AM - 4 PM. Also open by appt; No admis fee, donations accepted; Opened in 1973 with the focus being the interpretation of life in early Emmett, ID, beginning with the Native Americans who first inhabited the land to the contributions of the trappers, miners, and settlers; Mem: Dues Family $15; Indiv $10
Special Subjects: Historical Material, Photography, Furniture, Period Rooms
Collections: Large coll of photographs; full-sized period displays of a general store, a turn-of-the-century parlor, a laundry room, and a combined doctor's and dentist's office; special tribute to the men and women who have served in the armed forces; several outstanding pianos, office machines, and other local items; Hunt Memorial House, a turn-of-the-century cottage holding the belongings of former Governor and Mrs Frank W Hunt; Little Red Schoolhouse; Bunkhouse which houses tribute to birds indigenous to the county as well as a tribute to the cattle & sheep industry; blacksmith's shop with variety of tools
Activities: Special events

FORT HALL

M SHOSHONE BANNOCK TRIBES, (Shoshone Bannock Tribal Museum) Shoshone Bannock Tribal Museum, I-15, Exit 80, Fort Hall, ID 83203; PO Box 306, Fort Hall, ID 83203. Tel 208-237-9791; Fax 208-237-0797; Elec Mail rdevinney@shoshonebannocktribes.com; Internet Home Page Address: www.shoban.com; *Mgr & Coordr* Rosemary A Devinney
Open June - Aug daily 9:30 AM - 5 PM; Sept - May Mon - Fri 9:30 AM - 5 PM; cl on all Tribal Holidays; Admis adults $2.50, children $1, no admis fee for Native Americans with Tribal ID; group rates (5 minimum); Mus was built in 1985 and was closed for several years. It re-opened in 1993 by volunteers with the help of community mems who donated & loaned many photos and precious heirlooms to the mus; Learn all about the Shoshone-Bannock people who live on the Fort Hall Indian Reservation in southeastern Idaho
Income: By the Shoshone-Bannock tribal government
Special Subjects: American Indian Art, Historical Material, Prints, Photography, Bronzes, Crafts, Jewelry, Dioramas
Collections: photographs, displays & exhibs dating back to 1895; authentic arts & crafts made by tribal mems; reference books on the Shoshone-Bannock people as well as other North American tribes; artifacts from archeological excavations
Exhibitions: Tribal History; Photographs; Beadwork; Paintings; Family History
Activities: Mus shop sells books, prints, music, beadwork & crafts

IDAHO FALLS

M EAGLE ROCK ART MUSEUM AND EDUCATION CENTER, INC, 300 S Capital Ave, Idaho Falls, ID 83402; PO Box 2735, Idaho Falls, ID 83403. Tel 208-524-7777; Fax 208-529-6666; Elec Mail info@eaglerockartmuseum.org; Internet Home Page Address: www.eaglerockartmuseum.org; *Pres* John Griffith; *VPres* Val Crapo; *Dir* Christine Hatch; *Exec Asst* Ellie Hampton; *Secy* Donna Avery; *Treas* Carla Benson, CPA
Open Mon 6 PM - 9 PM, Wed - Sat 10 AM - 4 PM, Sun 1 PM - 4 PM. Cl Tues; Idaho Falls Art Guild estab 1948, Eagle Rock Art Mus opened 2002; Mus serves southeastern ID through the coll, preservation & exhibition of works of art by ID artists; Mem: Dues Benefactor $2,500; Director's Club $1,000; Patron $500; Sustaining $250; Supporting $100; Family $50; Contributing $35; Student $15
Special Subjects: Painting-American
Collections: 45 original paintings obtained during the past 40+ years from internationally known and local artists who conducted painting workshops in Idaho Falls
Activities: Children's events; ann events: Regional High School Art Contest, Elementary School Art Exhib, Junior High School Art Exhib, Eagle Rock Art Guild Ann Spring Show, Sidewalk Show, Holiday Show, Christmas Exhib; museum-related items for sale

MOSCOW

M APPALOOSA MUSEUM AND HERITAGE CENTER, 2720 W Pullman Rd, Moscow, ID 83843. Tel 208-882-5578; Fax 208-882-8150; Elec Mail museum@appaloosa.com; Internet Home Page Address: www.appaloosamuseum.org; *Cur* Sherry Caisly; *Pres* King Rockhill
Open Mon - Fri 10 AM - 5 PM, Sat 10 AM - 4 PM; No admis fee donations appreciated; Estab 1974 to collect, preserve, study & exhibit those objects that

illustrate the story of the Appaloosa Horse; Average Annual Attendance: 5,000; Mem: 33,000; annual meeting in May
Income: $38,000 (financed by grants from Appaloosa Horse Club, shop sales & fundraising)
Purchases: $1,600
Library Holdings: Audio Tapes 30; Book Volumes 500; Framed Reproductions 10; Maps 10; Original Art Works 40; Original Documents 100; Photographs 15,000; Prints 200; Sculpture 20; Video Tapes 30
Special Subjects: Drawings, Painting-American, Photography, Prints, American Indian Art, American Western Art, Bronzes, Costumes, Crafts, Landscapes, Manuscripts, Maps, Leather, Reproductions
Collections: Bronzes by Shirley Botoham, Less Williver, Don Christian & William Menshew; reproductions of Chinese, European & Persian Art relating to Appaloosas; reproductions of Charles Russell art; original Western by George Phippen, Reynolds; Native American Items, saddle & other tack art work; Trace History of Appoloosa Horses from prehistoric times to present
Exhibitions: Horse demonstrations; programs with groups
Publications: quarterly newsletter
Activities: Programs for children; lect open to public, 1-2 vis lectr per year; gallery talks; tours; trail ride; auction; museum shops sells books, jewelry, cards & games, toys, clothing & Appaloosa Horse reproductions, original art & prints

POCATELLO

M IDAHO STATE UNIVERSITY, John B Davis Gallery of Fine Art, PO Box 8004, Pocatello, ID 83209. Tel 208-236-2361; Fax 208-282-4791; Elec Mail kovarudo@isu.edu; Internet Home Page Address: www.isu.edu/departments.art; *Chair* Rudy Kovacs; *Dir Gallery* Amy Jo Johnson
Open Mon - Fri 10 AM - 4 PM; No admis fee; Estab 1956 to exhibit art; Gallery contains 130 running ft of space with 8 ft ceilings; Average Annual Attendance: 2,600
Income: $2600 (financed by city appropriation)
Purchases: $350
Collections: Permanent collection
Exhibitions: Big Sky Biennial Exhibit; Regional Group Graduate Exhibit; exhibitions & national exhibitions; MFA Thesis Exhibits, bi-weekly one-man shows; student exhibits
Activities: Lect open to public, 5-10 vis lectrs per year; gallery talks; tours; competitions with awards; scholarships offered; exten dept servs surrounding communities; individual paintings lent to school offices & community; originate traveling exhibitions

TWIN FALLS

M HERRETT CENTER FOR ARTS & SCIENCES, (College of Southern Idaho) Jean B King Art Gallery, 315 Falls Ave, Twin Falls, ID 83301; PO Box 1238, Twin Falls, ID 83303-1238. Tel 208-732-6655; Fax 208-736-4712; Elec Mail herrett@csi.edu; Internet Home Page Address: www.csi.edu; *Dir* James Woods; *Colls Mgr* Phyllis Oppenheim; *Art Gallery Mgr* Mike Green; *Exhibits Mgr* Joey Heck; *Display Technician* Nick Peterson; *Office Mgr* Wilma Titmus
Open Labor Day - Memorial Day; Tues & Fri 9:30 AM - 9 PM, Sat 1 - 9 PM; No admis fee; Estab 1965; Art Gallery, Natural History Gallery, four anthropology galleries (700-2400 sq ft); Average Annual Attendance: 37,000
Special Subjects: American Indian Art, Anthropology, Archaeology, Pre-Columbian Art, Decorative Arts, Eskimo Art
Collections: Pre-Columbian, Prehistoric & Ethnographic Indian Artifacts
Exhibitions: Exhibits change every 5-6 weeks
Activities: Classes for adults & children; lect open to public, vis lectr; gallery talks; tours; original objects of art lent to other public institutions; originate traveling exhibitions to schools, libraries & museums; museum shop sells books, original art, prints, museum replicas & novelties

WEISER

M SNAKE RIVER HERITAGE CENTER, 2295 Paddock Ave, PO Box 307 Weiser, ID 83672. Tel 208-549-0205; Fax 208-549-2740; *VPres & Bd Dir* Pat Harberd; *Treas, Project Dir & Bd Dirs* Rae Anne Odoms; *Secy* Sue Jorgensen
Open summer Wed - Sat Noon - 4:30 PM, winter by appointment (under construction); Admis by donation; Estab 1962 to preserve the history of Washington County, Idaho; Housed in a 1920 five story, solid concrete building of the Intermountain Institute, founded in 1899; Average Annual Attendance: 3,600; Mem: 200; dues $15
Income: $30,000 (financed by mem, county appropriation, gifts & fundraising)
Library Holdings: Audio Tapes; Book Volumes; Cards; Cassettes; Framed Reproductions; Manuscripts; Maps; Memorabilia; Original Art Works; Original Documents; Other Holdings; Periodical Subscriptions; Photographs; Prints; Records; Reproductions; Sculpture; Slides
Collections: Washington County memorabilia & artifacts of Snake River Country; Baseball Hall of Famer Walter Johnson's Collection
Exhibitions: Shoshoni Indian Display; Vintage Fashion Collection
Publications: Museum newsletter; annual report
Activities: Classes for adults & children; dramatic progs; 2 vis lectrs per year; concerts & tours; traveling historical trunk to Idaho schs; original objects of art lent; 2 book traveling exhibitions per year; museum shop sells books, original art, reproductions, prints, reproductions of early pioneer textiles

ILLINOIS

ALTON

M ALTON MUSEUM OF HISTORY & ART, INC, Loomis Hall, 2809 College Ave Alton, IL 62002. Tel 618-462-2763; Fax 618-462-6390; Elec Mail altonmuseum@yahoo.com; *Pres Emeritus* Charlene Gill; *Secy* Cathy Austin; *Gift Shop Chmn* June Booker; *Pres* Lois Lobbig; *VPres* David Culp
Open Mon - Fri 10 AM - 4 PM, Sat & Sun 1 - 4 PM; Admis adult $2, children 12 and under $.50; Estab 1971 to collect, preserve & exhibit; Second location: The

Koenig House, 829 E Fourth St, Alton, IL 62002; Average Annual Attendance: 14,000; Mem: 250; dues $15-$100; annual meeting 2nd Wed in Apr
Income: $30,000-40,000 (financed by mem, endowment & tours)
Library Holdings: Original Art Works; Pamphlets; Photographs; Video Tapes
Special Subjects: Architecture, Drawings, Graphics, Painting-American, Prints, Folk Art, Primitive art, Landscapes, Afro-American Art, Manuscripts, Dolls, Furniture, Glass, Historical Material, Maps, Coins & Medals, Dioramas
Collections: Architecture of Lost Alton; Black Pioneers of River Bend; early glass blowing; Robert Wadlow's life & memorabilia; Mississippi River Pilot House; Shurtleff College; Western Military Academy
Exhibitions: Early Industry & Education; The History of the Black Pioneers of the River Bend; Ice Cutting on the Mississippi; Lost Alton Architecture; Senior Art Show; Robert Wadlow - The World's Tallest Recorded Man; Wood River Massacre of 1814; changing art exhibits throughout the year
Publications: Newsletter
Activities: Classes for adults & children; docent training; lect open to public, 2-4 vis lectrs per year; gallery talks; tours; sponsoring of competitions; museum shop sells books, original art, reproductions & prints

AURORA

M AURORA REGIONAL FIRE MUSEUM, New York Ave & Broadway, Aurora, IL 60507; PO Box 1782, Aurora , IL 60507. Tel 630-892-1572; Internet Home Page Address: www.auroraregionalfiremuseum.org; *Mus Mgr* Deborah Davis; *Cur* David Lewis
Open Thurs - Sun 1 PM - 4 PM; clo maj holidays; Estab 1990; housed in Central Fire Station built in 1894; preserves & presents the history of firefighting in Aurora & surrounding communities; Average Annual Attendance: 3000 by estimate; Mem: dues Life $500, Inst $100, Patron $50, Family $25, Indiv $15, Student/Senior $10
Collections: 300 various firefighting periodicals; 100 fire service books; 50 local firefighting-related scrapbooks
Publications: Fire Museum News, quarterly newsletter
Activities: Formal educ for adults & children; films; lects; ann event: Fire Engine Muster; museum-related items for sale

M AURORA UNIVERSITY, Schingoethe Center for Native American Cultures, Dunham Hall, 1400 Marseillaise, 347 S Gladstone Aurora, IL 60506-4892. Tel 630-844-5402; Fax 630-844-8884; Internet Home Page Address: www.aurora.edu/museum; *Cur Coll* Mary Kennedy; *Educ Cur* Meg Bero; *Dir* Dona Bachman
Open Mon - Fri 10 AM - 4 PM, Sun 1- 4 PM, cl Sat; No admis fee; Estab 1990 to advance cultural literacy about Native peoples; Two permanent exhibit galleries with rotating displays from the mus collection; total of 3,500 sq ft; Average Annual Attendance: 10,000; Mem: 50; dues donor $50 - $500, individual $20
Income: $150,000 (financed by mem & endowment)
Special Subjects: Latin American Art, Mexican Art, American Indian Art, Archaeology, Ethnology, Pre-Columbian Art, Southwestern Art, Textiles, Folk Art, Eskimo Art
Collections: Ethnographic material from North, Central & South America; Native American Fine Art; Prehistoric & Pre-Columbian material
Exhibitions: (2002) Reflection of the Natural World; rotating
Publications: Spreading Wings; quarterly newsletter to membership
Activities: Summer workshops for adults & children; outreach materials for educators; docent programs; lect open to public; museum shop sells books, original art & reproductions

BISHOP HILL

M ILLINOIS HISTORIC PRESERVATION AGENCY, Bishop Hill State Historic Site, PO Box 104, Bishop Hill, IL 61419. Tel 309-927-3345; Fax 309-927-3343; Elec Mail bishophill@winco.net; Internet Home Page Address: www.bishophill.net; *Asst Site Mgr* Cheryl Dowell; *Site Mgr* Martha J Downey
Open Wed - Sun Mar - Oct 9 AM - 5 PM, Nov - Feb 9 AM - 4 PM; Admis suggested donation adult $2, ages 17 & younger $1; Estab 1946 to preserve & interpret the history of Bishop Hill Colony 1846-1861; Restored Colony Church, 1848 & restored Colony Hotel, 1860, Bishop Hill Mus 1988, Folk paintings of Olof Krans; Average Annual Attendance: 73,000
Income: Financed by state appropriation
Special Subjects: Architecture, Painting-American, Archaeology, Textiles, Crafts, Folk Art, Primitive art, Decorative Arts, Portraits, Furniture, Restorations
Collections: Bishop Hill Colony artifacts-agricultural items, furniture, household items, textiles & tools; Olof Krans Collection of folk art paintings
Activities: Lect open to public

BLOOMINGTON

M ILLINOIS WESLEYAN UNIVERSITY, Merwin & Wakeley Galleries, School of Art, Bloomington, IL 61702-2899. Tel 309-556-3150; Fax 309-556-3411; Elec Mail mdutka@titan.iw.edu; Internet Home Page Address: www.titan.iwu.edu/~art/galler.html; *Dir* Jennifer Lapham
Open Mon - Fri Noon - 4 PM, Tues 7 - 9 PM, Sat & Sun 1 - 4 PM; Estab 1945
Income: Financed by endowment & mem
Special Subjects: Drawings, Painting-American, Prints
Collections: 250 drawings, paintings & prints including works by Baskin, Max Beckmann, Helen Frankenthaler, Philip Guston, John Ihle, Oliviera, Larry Rivers & Whistler
Exhibitions: Rotating exhibits
Publications: Exhibition Posters; Gallery Schedule, monthly;
Activities: Dramatic programs; lect open to public, 5 vis lectrs per year; concerts; tours; competitions with awards; original objects of art lent, on campus only; book traveling exhibitions; originate traveling exhibitions organized & circulated
L Sheean Library, 201 E University St, Bloomington, IL 61702-2899. Tel

309-556-3003; Fax 309-556-3706; Elec Mail bdelvin@titan.iwu.edu; Internet Home Page Address: www.iwu.edu/library; *Fine Arts Librn* Robert C Delvin
Open Mon - Thurs 7:45 AM - 1:30 PM; Sat 10 AM - 10 PM; Sun 11 AM - 1:30 AM
Income: Financed by endowment
Library Holdings: Slides 35,000

A **MCLEAN COUNTY ART ASSOCIATION,** McLean County Arts Center, 601 N East St, Bloomington, IL 61701. Tel 309-829-0011; Fax 309-829-4928; Elec Mail info@mcac.org; Internet Home Page Address: www.mcac.org; *Exec Dir* Douglas C Johnson; *Cur* Alison Hatcher; *Educ Coordr* Noelle Hoover; *Preparator* Adam Farcus; *Project Coodr* Kendra Johnson
Open Tues 10 AM - 7 PM, Wed - Fri 10 AM - 5 PM, Sat Noon - 4 PM, Dec only Sun Noon - 4 PM; No admis fee; Estab 1922 to enhance the arts in McLean County. Provides display galleries, sales & rental gallery featuring local professional artists; Brandt Gallery is 2500 sq ft hosting local shows & traveling exhibits; Average Annual Attendance: 10,000; Mem: 600; annual meeting first Fri in May
Income: Financed by mem, art & book sales
Collections: Small permanent collection with concentration on midwestern artists
Exhibitions: Annual Amateur Competition & Exhibition; Annual Holiday Show & Sale; 10-2 other exhibits, local & traveling
Publications: Quarterly newsletter
Activities: Classes for adults & children; lect open to public; gallery talks; tours; competitions with awards; gift shop sells fine crafts & original art, conservation framing shop

M **MCLEAN COUNTY HISTORICAL SOCIETY,** McLean County Museum of History, 200 N Main, Bloomington, IL 61701. Tel 309-827-0428; Fax 309-827-0100; Elec Mail mcmh@mchistory.org; Internet Home Page Address: www.mchistory.org; *Librn & Archivist* William Steinbacher-Kern; *Cur* Susan Hartzold; *Exec Dir* Greg Koos; *Dir Educ* Laura Wheaton; *Dir Vol* Mary Ann Schierman
Open Mon - Sat 10 AM - 5 PM, Tues 10 AM - 9 PM, Sun 1 - 5 PM (Sept - May); Admis adults $2, children $1, mems free, Tues free; Estab 1892 to promote history of McLean County; Maintain long term exhibits, changing exhibits and traveling exhibits; Average Annual Attendance: 27,000; Mem: 1300
Income: $625,000 (financed by endowment, government & mem)
Library Holdings: Book Volumes 10,000; CD-ROMs; Clipping Files; Fiche; Kodachrome Transparencies; Lantern Slides; Manuscripts; Maps; Memorabilia; Original Art Works; Original Documents; Other Holdings; Pamphlets; Periodical Subscriptions; Photographs; Prints; Records; Sculpture; Slides; Video Tapes
Special Subjects: Photography
Collections: Civil War; Illinois History; local history; Material Culture; Folk Art; Potraits; Photography
Exhibitions: Encounter on the Prairie
Activities: Classes for adults & children; book groups; lect open to public; tours; extension prog with Central Illinois Elementary Schools; book 3 traveling exhibs per yr; retail store sells books, prints

CARBONDALE

M **SOUTHERN ILLINOIS UNIVERSITY CARBONDALE,** University Museum, 2469 Faner Hall N, SIUC Carbondale, IL 62901; 1000 Faner Dr, Mail Code 4508 Carbondale, IL 62901. Tel 618-453-5388; Fax 618-453-7409; Elec Mail museum@siu.edu; Internet Home Page Address: www.museum.siu.edu; *Dir* Dona Bachman; *Cur Colls* Lorilee Huffman; *Exhibits Designer* Nate Steinbrink; *Educ Prog Dir* Robert De Hoet
Open Tues - Fri 10 - 4 PM, Sat - Sun 1 PM - 4 PM; No admis fee; Estab 1874 to reflect the history & cultures of southern Illinois & promote the understanding of the area; to provide area schools & the University with support through educational outreach programs; to promote the fine arts; 12,000 sq ft in 7 gallery spaces, 3 devoted to permanent collections; Average Annual Attendance: 40,000; Mem: Dues $10 - $500
Income: Financed by state appropriated budget, federal, state & private grants, donations & University Mus associates
Special Subjects: Drawings, American Indian Art, African Art, Anthropology, Archaeology, Ethnology, Costumes, Ceramics, Crafts, Folk Art, Etchings & Engravings, Decorative Arts, Dolls, Furniture, Glass, Carpets & Rugs, Dioramas, Enamels
Collections: Decorative Arts; European & American paintings, drawing & prints from 13th-20th century with emphasis on 19th & 20th century; photography, sculpture, blacksmithing & art & crafts; Oceanic Collection; Southern Illinois history; 20th century sculpture, metals, ceramics; Asiatic holdings; archaeology; costumes; textiles; geology; zoology
Exhibitions: A variety of changing exhibitions in all media; ethnographic arts; fine & decorative arts; history & the sciences
Publications: Annual report; seasonal museum newsletter; exhibition catalogs
Activities: Classes for children; docent training; lect open to public; loan collection lent to campus offices only; book traveling exhibitions; originate traveling exhibitions circulated to museums, art centers, libraries & schools; museum shop sells original art, reproductions, jewelry, pottery & crafts

L **Morris Library,** Carbondale, IL 62901-6632. Tel 618-453-2818; Fax 618-453-8109; Elec Mail lkoch@lib.siu.edu; Internet Home Page Address: www.lib.siu.edu
Primarily lending
Income: Financed by college funds, gifts, pub & private grants
Library Holdings: Book Volumes 35,000; Cards; Cassettes 475; Exhibition Catalogs; Fiche; Periodical Subscriptions 180; Records; Reels

CHAMPAIGN

M **PARKLAND COLLEGE,** Art Gallery, 2400 W Bradley Ave, Champaign, IL 61821-1899. Tel 217-351-2485; Internet Home Page Address: www.parkland.cc.il.us/gallery; *Gallery Dir* Denise Seif
Open Mon - Fri 10 AM - 3 PM; No admis fee; Estab 1981 to exhibit contemporary fine art; Average Annual Attendance: 10,000

Income: Nonprofit, supported by Parkland College & in part by Illinois Arts Council, a state agency
Exhibitions: State of the Art - Biennial National Watercolor Invitational; Midwest Ceramics Invitational - Biennial, 2-person shows
Publications: Bi-annual exhibitional catalogs & brochures
Activities: Local high school art student seminar; lects open to public; 9 vis lectrs per year; gallery talks; originate traveling exhibitions

UNIVERSITY OF ILLINOIS

M **Krannert Art Museum and Kinkead Pavillion,** Tel 217-333-1861; Fax 217-333-0883; Elec Mail kam@uiuc.edu; Internet Home Page Address: www.kam.uiuc.edu; *Dir* Kathleen Harleman; *Registrar* Kathleen Jones; *Dir Marketing & Special Events* Diane Schumacher; *Dir Develop* Carrie Turner; *Dir Educ* Anne Sautman; *Cur* Robert LaFrance; *Cur* Judith Hoos Fox
Open Tues - Sat 9 AM - 5 PM, Thurs until 9 PM, Sun 2 - 5 PM; No admis fee; Estab 1961 to house & administer the art collections of University of Illinois, to support teaching & research programs & to serve as an area art mus; Gallery is 48,000 sq ft, with 30,000 devoted to exhibition space; Average Annual Attendance: 135,000; Mem: 800; dues $45 & up
Income: Financed by mem, state appropriation & grants
Special Subjects: Afro-American Art, Etchings & Engravings, Folk Art, Marine Painting, Ceramics, Metalwork, Mexican Art, Furniture, Gold, Photography, Portraits, Pottery, Pre-Columbian Art, Painting-American, Prints, Bronzes, Manuscripts, Painting-British, Painting-European, Painting-French, Painting-Japanese, Tapestries, Drawings, Graphics, Hispanic Art, Painting-American, Prints, Sculpture, Watercolors, American Indian Art, American Western Art, African Art, Pre-Columbian Art, Southwestern Art, Textiles, Religious Art, Primitive art, Woodcarvings, Woodcuts, Landscapes, Decorative Arts, Collages, Painting-European, Posters, Glass, Jade, Jewelry, Porcelain, Oriental Art, Asian Art, Silver, Antiquities-Byzantine, Painting-Dutch, Ivory, Baroque Art, Calligraphy, Miniatures, Painting-Flemish, Renaissance Art, Embroidery, Medieval Art, Antiquities-Oriental, Painting-Spanish, Painting-Italian, Islamic Art, Antiquities-Egyptian, Antiquities-Greek, Antiquities-Roman, Stained Glass, Painting-German, Pewter, Enamels, Antiquities-Assyrian, Painting-New Zealander
Collections: American paintings, sculpture, prints & drawings; Ancient Near Eastern Classical & Medieval Art; European Paintings; European & American Decorative Arts; Pre-Columbian Art; Asian Art; African Art
Publications: Catalogs, 3 or 4 annually
Activities: Classes for adults & children; docent training; Art-to-Go Outreach; lect open to public; concerts; gallery talks; tours; 15-20 vis lects per yr; individual paintings & original objects of art lent to museums & university galleries; book traveling exhibitions; originate traveling exhibitions; museum cafe

M **Spurlock Museum,** Tel 217-333-2360; Fax 217-244-9419; Elec Mail ksheahan@uiuc.edu; Internet Home Page Address: www.spurlock.uiuc.edu; *Dir* Dr Douglas Brewer; *Asst to the Dir* Dee Robbins; *Dir Educ* Tandy Lacy; *Collections Mgr* Christa Deacy-Quinn; *Registrar* Jennifer White; *Information Technician* Jack Thomas; *Vol Coordr* Beth Watkins; *Asst Educator* Kim Sheahan; *Asst Coll Mgr* John Holton; *Asst Registrar* Carol Kussmann; *Head of Security* Harold Bush
Open Tues 12 - 5 PM, Wed - Frid 9 AM - 5 PM, Sat 10 AM - 4 PM; No admis fee; Estab 1911; Five permanent galleries covering Africa, the Americas, the ancient Mediterranean, East & Southeast Asia, Oceania & Europe; Average Annual Attendance: 30,000; Mem: 300
Income: $320,000
Special Subjects: Historical Material, Ceramics, Glass, African Art, Judaica, Asian Art, Coins & Medals, Antiquities-Egyptian, Antiquities-Greek, Antiquities-Roman
Collections: Original & reproduction artifacts of Greek, Roman, Egyptian, Mesopotamian, African, Asian & European cultures, including sculpture, pottery, glass, implements, coins, seals, clay tablets, inscriptions, manuscripts & items of everyday life
Activities: Classes for adults & children; docent training; lect open to public, 3 vis lectrs per year; concerts; workshops; gallery talks; tours; original objects of art lent for special shows in established museums

M **Museum of Natural History,** Tel 217-333-2360; Fax 217-244-9419; Elec Mail darobbin@uiuc.edu; Internet Home Page Address: www.spurlock.uiuc.edu; *Dir Educ* Tandy Lacy; *Dir* Douglas Brewer; *Spec Museum Registrar* Jennifer White; *Asst to Dir* Dee Robbins; *Collections Manager* Christa Deacy-Quinn; *Information Technologist* Jack Thomas; *Asst Editor* Kim Sheahan; *Vol Coordr* Beth Watkins
Main galleries closed; hallway exhibits open when the university is in session; No admis fee; Estab 1868 for research & educ in anthropology, botany, geology & zoology; Average Annual Attendance: 40,000; Mem: 100
Income: Financed by State University support
Collections: Anthropology, Herpetology, Malacology, Mammalology & Paleontology collections, 400,000 specimens
Activities: Classes for children

L **Ricker Library of Architecture & Art,** Tel 217-333-0224; Fax 217-244-5169; Internet Home Page Address: www.library.uiuc.edu/arx; *Librn* Dr Jane Block; *Asst Librn* Jing Liao
Open Mon - Thurs 8:30 AM - 8 PM, Fri 8:30 AM - 5 PM, Sat 1 AM - 5 PM, Sun 1 - 10 PM; Estab 1878 to serve the study & research needs of the students & faculty of the university & the community; Circ 50,000; Ricker Library lends material through UIUC Interlibrary Loan
Income: (financed by state appropriation, blanket order, gifts & UIUC Library Friends)
Library Holdings: Book Volumes 45,000; CD-ROMs; Clipping Files; Exhibition Catalogs; Fiche; Pamphlets; Periodical Subscriptions 350; Photographs; Reels; Reproductions; Sculpture; Video Tapes
Special Subjects: Art History, Collages, Decorative Arts, Illustration, Drawings, Graphic Design, History of Art & Archaeology, Ceramics, Conceptual Art, Crafts, Interior Design, Art Education, Asian Art, Handicrafts, Architecture
Collections: Architectural Folio; Prairie School Architects; Ricker Papers; Frank Lloyd Wright
Publications: Acquisitions list, 4 per year; annual periodicals list

CHARLESTON

M EASTERN ILLINOIS UNIVERSITY, Tarble Arts Center, South 9th Street at Cleveland Ave, Charleston, IL 61920-3099; 600 Lincoln Ave, Charleston, IL 61920. Tel 217-581-2787; Fax 217-581-7138; Elec Mail mwatts@eiu.edu; Internet Home Page Address: www.eiu.edu/~tarble; *Cur Educ* Kit Morice; *Dir* Michael Watts; *Functions Coordr* Dennis Malak
Open Tues - Fri 10 AM - 5 PM, Sat 10 AM - 4 PM, Sun 1 - 4 PM, cl Mon & major holidays; No admis fee; Estab 1982 to encourage the understanding of & participation in the arts; Main Gallery consists of fifteen 20 ft x 20 ft modular units with natural & incandescent lighting; Brainard Gallery, 20 ft x 50 ft; Gallery 40 ft x 20 ft; Sales/Rental Gallery, 20 ft x 20 ft; Average Annual Attendance: 18,000; Mem: 300; dues $50 - $1,000
Income: Financed by state appropriation, mem contributions, sales & rental commissions, grant & foundation funds
Special Subjects: Watercolors, Folk Art, Woodcuts, Etchings & Engravings
Collections: Contemporary works on paper by Midwest artists; American Scene Works on Paper; Paul Turner Sargent paintings; Contemporary American Art; Indigenous Contemporary Illinois Folk Arts
Exhibitions: Solo exhibitions & group shows.; Annual Exhibitions: Art Faculty Exhibition, All-Student Show (juried, undergraduate), Graduate Art Exhibition (group thesis), Drawing/Watercolor: Illinois (biennial juried competition), International Children's Exhibition; Folk Arts from the Collection
Publications: Exhibition catalogs
Activities: Classes & workshops for children & adults; docent training; lect open to public; concerts; gallery talks; individual paintings & original objects of art lent to qualified professional galleries, arts centers & museums; book traveling exhibitions 2-4 per year; originate traveling exhibitions; sales shop sells books, original art & craft pieces; Sales/Rental Gallery rents & sells original works

CHICAGO

AMERICAN CENTER FOR DESIGN
For further information, see National and Regional Organizations

M ARC GALLERY, 734 N Milwaukee Ave Chicago, IL 60622. Tel 312-733-2787; Fax 312-733-2787; Internet Home Page Address: www.icsp.net/asc; *VPres* Carolyne King; *Pres* Nancy Bechtol
Open Wed, Fri & Sat 11 AM - 5 PM, Thurs 11 AM - 6 PM & by appointment; No admis fee; Estab 1973 for the exhibition of alternative artworks & education to the public about contemporary art; Mem: 20; mem open to female professional artists; dues $55/mo
Special Subjects: Painting-American, Sculpture
Exhibitions: ARC National Show & Solo Shows, 77 exhibitions annually, seven per month in seven separate galleries, group shows, member shows
Activities: Educ dept; community outreach programs; lect open to public; gallery talks; juried exhibitions & awards; originate traveling exhibitions

A ART DEALERS ASSOCIATION OF CHICAGO, 730 N Franklin, Chicago, IL 60610. Tel 312-649-0065; Fax 312-649-0255; Elec Mail cadachgo@aol.com; Internet Home Page Address: www.chicagoartdealers.org; *Exec Dir* Natalie van Straaten
Estab 1968; Mem: Membership: 40
Activities: Artist workshops; gallery talks; weekly tours; annual Vision celebration in July

A THE ART INSTITUTE OF CHICAGO, 111 S Michigan Ave, Chicago, IL 60603-6110. Tel 312-443-3600; Fax 312-443-0849; Internet Home Page Address: www.artic.edu; *Chmn Bd Trustees* John H Bryan; *Pres & Dir* James N Wood; *School Pres* Anthony Jones; *Exec VPres Admin Affairs* Patricia Woodworth; *Exec VPres Develop & Pub Affairs* Edward W Horner Jr; *Cur American Arts* Judith Barter; *Cur European Painting & Prints & Drawings* Douglas W Druick; *Cur European Painting Before 1750* Martha Wolff; *Exec Dir Conservation* Frank Zuccari; *Exec Dir Mus Educ* Robert Eskridge; *Exec Dir Imaging & Technical Serv* Alan B Newman; *Cur Photography* David Travis; *Cur Africa, Oceania & the Americas* Richard F Townsend; *Cur Architecture* John Zukowsky; *Dir Foundation & Corporate Relations* Lisa Key; *Cur Textiles* Christa C Mayer Thurman; *Cur European Decorative Arts, Sculpture & Classical Art* Bruce Boucher; *Exec Dir of Museum Registration* Mary Solt; *Exec Dir Pub Affairs* Eileen E Harakal; *Exec Dir Publications* Susan F Rossen; *Dir Government Relations* Karin Victoria; *Exec Dir Graphics & Communications Serv* Lyn Quadri Delli; *Cur Asian Art* Jay Xu; *Exec Dir Libraries* Jack Perry Brown; *Dir Community Relations* Linda Steele; *Cur European Painting* Larry Feinberg; *Cur European Painting* Gloria Groom; *Cur European Decorative Arts & Sculpture* Ghenete Zelleke; *Cur Photography* Colin Westerbeck; *Cur Prints & Drawings* Martha Tedeschi
Open Mon, Wed, Thurs & Fri 10:30 AM - 4:30 PM, Tues 10:30 - 8 PM, Sat 10 AM - 5 PM, Sun & holidays Noon - 5 PM, cl Christmas & Thanksgiving; Admis adults $10 suggested, seniors & children $6 suggested, Tues no admis fee; Estab & incorporated 1879 to found, build, maintain & operate museums of fine arts, schools & libraries of art, to form, preserve & exhibit collections of objects of art of all kinds & to carry on appropriate activities conducive to the artistic development of the community. Maintains reference library; Average Annual Attendance: 1,300,000; Mem: 145,000; dues life $2,500, family $75, individual $60, national associates $50 & students $40
Income: $125,000,000 (financed by endowments, gifts, grants, auxiliary activities & others)
Library Holdings: Auction Catalogs; Book Volumes 425,000; CD-ROMs; Clipping Files; Compact Disks; Exhibition Catalogs; Fiche; Original Documents; Pamphlets; Periodical Subscriptions 1500; Slides 450,000
Special Subjects: Architecture, Etchings & Engravings, Prints, Sculpture, Asian Art, Bronzes, Decorative Arts, Folk Art, Pewter, African Art, Afro-American Art, American Indian Art, Ceramics, Collages, Hispanic Art, Latin American Art, Glass, Laces, Baroque Art, Antiquities-Egyptian, Enamels, Gold, Islamic Art, Medieval Art, Oriental Art
Collections: Paintings, sculpture, Asian art, prints & drawings, photographs, decorative arts, architectural fragments, tribal arts & textiles; The painting collection reviews Western art, with an especially fine sequence of French Impressionists & Post Impressionists; the print collection illustrates the history of printmaking from the 15th-20th centuries with important examples of all periods. It is particularly rich in French works of the 19th century including Meryon, Redon, Millet, Gauguin & Toulouse-Lautrec; textiles are displayed in the Agnes Allerton Textile Galleries which includes a study room & new conservation facilities; collections also include African, Oceanic & ancient American objects; The Architecture Collection includes 19th & 20th century drawings & architectural fragments in the Institute's permanent collection including the more than 40,000 architectural drawings from the Burnham Library of Architecture; The Columbus Drive Facilities include the reconstructed Trading Room from the Chicago Stock Exchange; Arthur Rubloff Paperweight collection is on view; the America Windows, monumental stained glass windows designed by Marc Chagall are on view in the gallery overlooking McKinlock Court; decorative arts & sculpture range from medieval to the twentieth century; the Asian collection contains a world renowned collection of Ukiyo-e prints
Publications: News & Events every two months; catalogs; Ann Report
Activities: Classes & workshops for adults & children; teacher training; docent training; performances; lect open to public; concerts; gallery walks & talks; guided lect tours; individual paintings & original objects of art lent to museums around the world; originate traveling exhibitions to selected museums; museum shop sells books, reproductions, prints, slides, decorative accessories, crafts, jewelry, greeting cards & postcards; jr mus at Kraft Educ Center

L Ryerson & Burnham Libraries, 111 S Michigan Ave, Chicago, IL 60603-6110. Tel 312-443-3666; Fax 312-443-0849; Elec Mail ryerson@artic.edu; Internet Home Page Address: www.artic.edu; *Head Technical Svcs* Anne Champagne; *Head Reader Servs* Susan Augustine; *Head Slide Librn* Leigh Gates; *Architecture Librn* Mary Woolever; *Archivist* Bart Ryckbosch; *Dir Libraries* Jack Perry Brown
Open Wed - Fri 12:30 - 5 PM, Thurs 12:30 - 8 PM, Sat 10 AM - 5 PM; Estab 1879; Open to members, staff of mus, students & faculty of the School of Art Institute & vis scholars & curators, for reference only
Income: $1,860,000
Purchases: $600,000
Library Holdings: Audio Tapes; Book Volumes 243,000; Cassettes; Clipping Files; Exhibition Catalogs; Fiche; Kodachrome Transparencies; Lantern Slides; Manuscripts; Memorabilia; Pamphlets; Periodical Subscriptions 1,500; Photographs; Reels; Slides 430,000; Video Tapes
Special Subjects: Art History, Folk Art, Decorative Arts, Drawings, Etchings & Engravings, Graphic Arts, Painting-American, History of Art & Archaeology, Ceramics, Conceptual Art, Crafts, Latin American Art, Bronzes, Asian Art, Furniture, Mexican Art, Ivory, Jade, Glass, Metalwork, Carpets & Rugs, Embroidery, Enamels, Gold, Goldsmithing, Jewelry, Oriental Art, Marine Painting, Laces, Architecture
Collections: Burnham Archive: Chicago Architects, letters, reports; including special Louis Sullivan, Frank Lloyd Wright & D H Burnham Collections; Percier & Fontaine Collection; Chicago Art & Artists Scrapbook: newspaper clippings from Chicago papers from 1880 to 1993; Mary Reynolds Collection: Surrealism; Bruce Goff Archive; Collins Archive of Catalan Art & Architecture
Publications: Architectural Records In Chicago, research guide; Burnham Index to Architectural Literature (1990)

A The Woman's Board of the Art Institute of Chicago, 111 S Michigan Ave, Chicago, IL 60603-6110. Tel 312-443-3629; Fax 312-443-1041; Internet Home Page Address: www.artic.edu; *Pres* Cleopatra B Alexander
Open Mon - Fri 9 AM - 5 PM; Mus admis fee; Estab 1952 to supplement the Board of Trustees in advancing the growth of the Institute & extending its activities & usefulness as a cultural & educational institution; used by mem only; Mem: 82; annual meeting May
Income: Financed by contributions

A Auxiliary Board of the Art Institute of Chicago, 111 S Michigan Ave, Chicago, IL 60603. Tel 312-443-3674; Fax 312-443-1041; *Pres* Susan O'Brien-Lyons
Open Mon - Fri 9 AM - 5 PM; Estab 1973 to promote interest in programs & activities of the Art Institute among younger men & women; Mem: 60; dues $500; annual meeting in June

A Antiquarian Society of the Art Institute of Chicago, 111 S Michigan Ave, Chicago, IL 60603. Tel 312-443-3641; Fax 312-443-1041; *Pres* Janis N Notz
Open daily 9 AM - 5 PM; Estab 1877; Support American Arts & European Decorative Arts; Mem: 600; by invitation; annual meeting in Nov
Income: Financed by donations, benefits, annual dues
Exhibitions: Preview of Charles Renmie Mackintosh
Publications: Antiquarian Society Catalogue, every 10 years
Activities: Lect for members; tours; trips

A Dept of Prints & Drawings, 111 S Michigan Ave, Chicago, IL 60603-6110. Tel 312-443-3660; Fax 312-443-0085; Internet Home Page Address: www.artic.edu; *Prince Trust Cur Prints & Drawings & Searle Cur European Paintings* Dr Douglas W Druick; *Cur Earlier Prints & Drawings* Suzanne Folds McCullagh; *Cur* Martha Tedeschi; *Res Cur* Peter Zegers; *Assoc Cur* Mark Pascale; *Assoc Cur* Jay Clarke; *Coll Mgr* Barbara Hinde; *Coll Asst & Receptionist* Elvee O'Kelley; *Dept Sec* Ji E Bark; *Paper Conservator* David Chandler; *Paper Conservator* Harriet Stratis; *Conservation Tech* Christine Conniff-O'Shea; *Conservation Tech* Caesar Citraro; *Chmn* Anne Searle Bent; *Co-Chmn* Mr David C Hilliard; *Chmn Emer* Edward McCormick Blair Sr; *Asst Paper Conservator* Kristi Dahm; *Research Asst* Emily Vokt; *Cur Earlier Prints & Drawings* Anne Vogt Fuller; *Cur Earlier Prints & Drawings* Marion Titus Searle
call for appt; Estab & incorporated 1922 to study prints & drawings & their purchase for the institute; Mem: 260; dues $25 - $500
Income: Financed by mem contributions
Activities: Lect; gallery talks

A Society for Contemporary Art, 111 S Michigan Ave, Chicago, IL 60603. Tel 312-443-3630; Fax 312-443-1041; *Pres* Nancy A Lauter
Estab & incorporated 1940 to assist the Institute in acquisition of contemporary works; Mem: 160; dues $150 - $1,000; annual meeting in May
Income: Financed by mem contributions
Activities: Lect; seminars & biennial exhibition at the Institute; 8 vis lectrs per yr

A Department of Asian Art, 111 S Michigan Ave, Chicago, IL 60603. Tel 312-443-3834; Fax 312-443-9281; Elec Mail asianart@artic.edu; *Assoc Cur Chinese Art* Elinor Pearlstein; *Asst Cur Japanese Art* Janice Katz; *Pritzker Cur Asian Art* Jay Xu

Estab 1925 to promote interest in the Institute's collection of Asian art; Mem: 50; dues $50
Collections: Chinese paintings, furniture; bronze; jade; ceramics; Japanese paintings, ceramics; Clarence Buckingham collection of Japanese Woodblock Prints; Buddhist art; Indian and southeast Asian paintings and sculpture; Korean ceramics
Activities: Lect open to public; symposia on exhibitions

A **Department of Textiles, Textile Society,** 111 S Michigan Ave, Chicago, IL 60603. Tel 312-443-3696; Fax 312-214-4304; Internet Home Page Address: www.artic.edu; *Cur* Christa Thurman
Open daily 10:30 AM - 4 PM by appointment only; Estab 1978 to promote appreciation of textiles through lectures, raising of funds, special publications & exhibitions for the Department of Textiles
Income: Membership fees, funds raised by the soc for periodic purchases

M **Kraft Education Center/Museum Education,** 111 S Michigan Ave, Chicago, IL 60603. Tel 312-443-3680; Fax 312-443-0084; Internet Home Page Address: www.artic.edu; *Dir Museum Educ* Robert Eskridge
Open Mon - Wed & Fri 10:30 AM - 4:30 PM, Thur 10:30 AM - 8 PM; Admis adults $12, children, students & sr $7; Estab 1964; The new center includes a main exhibition gallery, family room, classrooms, a Teacher Resource Center, a seminar room, an auditorium, conference room & staff offices
Income: Financed by grants, gifts & endowment; renovation financed by Kraft General Foods & the Woman's Board; exhibitions supported by grants from John D & Catherine T MacArthur Foundation & NEA
Exhibitions: Faces, Places, and Inner Spaces: Interactive Ehibit
Publications: Family Self Guides & teacher packets to permanent collections & special exhibitions; gallery shows; yearly publications; Volunteer Directory; Information for Students & Teachers; quarterly brochures on family programs, teachers' services, school & general programs
Activities: Docent training; teacher & family workshops; lect open to the public; gallery walks & games; tours; performances; artist demonstrations

L **Teacher Resource Center,** 111 S Michigan Ave, Chicago, IL 60603. Tel 312-443-3719; Fax 312-606-0496; Elec Mail trc@artic.edu; Internet Home Page Address: www.artic.edu/aic/students; *Coordr* Jocelyn Moralde; *Asst* Elijah Burgher
Open Tues 1 - 4 PM, Thurs 1 - 7 PM, Sat 11 AM - 4 PM; Open for reference; Average Annual Attendance: 2,000
Income: Financed by endowment
Library Holdings: Book Volumes 1500; CD-ROMs; Cassettes; Compact Disks; Exhibition Catalogs; Periodical Subscriptions; Slides; Video Tapes
Activities: Classes for adults; gallery games; architectural walks; student self-guides; extension program in Chicagoland, 100 mile radius of museum; sales shop sells prints, slides, videos, postcards

A **THE ARTS CLUB OF CHICAGO,** 201 E Ontario St, Chicago, IL 60611. Tel 312-787-3997; Fax 312-787-8664; Elec Mail gillianartsclub@mindspring.com; *Pres* Stanley M Freehling; *Dir* Kathy S Cottong
Open Mon - Fri 11 AM - 6 PM; No admis fee; Estab 1916 to maintain club rooms for members & provide public galleries for changing exhibitions; Gallery has 230 running ft of wall space; Average Annual Attendance: 15,000; Mem: 1,200; annual meeting in Nov
Income: Financed by mem dues
Purchases: Occasional purchases gifts & bequests
Library Holdings: Book Volumes; Exhibition Catalogs
Collections: Modern Collection incl Braque, Calder, Noguchi, Picabia, Picasso
Publications: Exhibition Catalogs
Activities: Lect open to members only; concerts; vis lect 100 per yr; gallery talks; book traveling exhibitions 1-2 per year

L **Reference Library,** 201 E Ontario St, Chicago, IL 60611. Tel 312-787-3997; Fax 312-787-8664; *Dir* Kathy Cottong
Open Mon - Fri 11 AM - 6 PM; No admis fee; Estab 1916; Contemporary art; Average Annual Attendance: 20,000; Mem: 1,200
Library Holdings: Book Volumes 3750; Exhibition Catalogs; Periodical Subscriptions 8
Activities: Lect for members only

M **BALZEKAS MUSEUM OF LITHUANIAN CULTURE,** 6500 S Pulaski Rd, Chicago, IL 60629. Tel 773-582-6500; Fax 773-582-5133; Elec Mail editor@lithuanianmuseum.org; *Pres* Stanley Balzekas Jr; *VPres* Joseph Katauskas; *Dir Educ & Edit* Karile Vaitkute; *Chmn Mem* Raminta Dill; *Office Mgr* Rita Stringel; *Cur Folk Art* Frank Zapolis; *Mus Cur* Rita Janz; *Dir Genealogy Dept* Robert Balzekas; *Chm Numismatic D* Frank Passic; *Dir Audiovisual* Edward Mankus; *Cur Cartography D* Edward Pocius
Open daily 10 AM - 4 PM; Admis adults $4, seniors & students $3, children $1; Estab 1966 as a repository for collecting and preserving Lithuanian cultural treasures; Average Annual Attendance: 38,000; Mem: 2700; dues $25-$35
Income: $10,000 (financed by mem & donations)
Special Subjects: Graphics, Photography, Archaeology, Textiles, Folk Art, Maps, Coins & Medals
Collections: Amber; archeology; archives; coins; fine art; folk art; graphics; maps; numismatics; paintings; philately; photography; rare books; rare maps; textiles; wooden folk art; Textiles; Wooden folkart; Maps; Paintings; Graphics
Exhibitions: Various exhibits of paintings, graphics & sculpture
Publications: Lithuanian Museum Review, quarterly
Activities: Classes for adults & children; demonstrations; folk art workshops; lect open to public, 10 vis lectrs per year; tours; original objects of art lent to other museums & galleries; lending collection contains books, nature artifacts, original art works, paintings, photographs & slides; originate traveling exhibitions; museum shop sells books, magazines, original art, reproductions, prints, folk art, amber jewelry, souvenirs & t-shirts

L **Research Library,** 6500 S Pulaski Rd, Chicago, IL 60629. Tel 773-582-6500; Fax 773-582-5133; Elec Mail editor@lithuanianmuseum.org; Internet Home Page Address: www.lithaz.org; *Pres* Stanley Balzekas; *Librn* Robert A Balzekas
Open daily 10 AM - 4 PM; Estab 1966 to preserve Lithuanian-American literature & culture; Circ Non-circulating; Open to pub for reference only
Library Holdings: Audio Tapes; Book Volumes 40,000; Cards; Cassettes; Clipping Files; Exhibition Catalogs; Framed Reproductions; Manuscripts; Memorabilia; Micro Print; Original Art Works; Pamphlets; Photographs; Prints; Records; Reproductions; Sculpture; Slides; Video Tapes

Special Subjects: Art History, Folk Art, Decorative Arts, Photography, Graphic Arts, Maps, Prints, Historical Material, History of Art & Archaeology, Archaeology, Ethnology, Anthropology, Furniture, Architecture
Collections: Reproductions of Lithuanian artists; Information on Lithuanian artists & their works; orginal art work: painting, sculpture & rare maps
Exhibitions: Exhibs vary
Activities: Classes in variety of Lithuanian crafts

M **BOULEVARD ARTS CENTER,** 6011 S Justine St, Chicago, IL 60636. Tel 773-476-4900; Fax 773-476-5951; Elec Mail boulevardarts@msn.com; Internet Home Page Address: www.boulevardarts.ccts.cs.depaul.edu; *Exec Dir* Pat Devine-Reed; *Artistic Dir* Marti Price
Estab 1984; Gallery shows, music with AAMC, dance, visual arts, wood carving, stone carving; Mem: Dues $30
Income: Financed by endowment, mem, city appropriation & state appropriation
Activities: Classes for adults & children; dramatic programs; lect open to public & members; sales shop sells original art

M **CHICAGO ARCHITECTURE FOUNDATION,** 224 S Michigan Ave, Chicago, IL 60604. Tel 312-922-3432; Fax 312-922-2607; Elec Mail losmond@architecture.org; Internet Home Page Address: www.architecture.org; *Pres* Lynn J Osmond; *John Hancock Shop* Dave Woollard; *Santa Fe Shop* Maribel Salazar; *Dir Pub Program* Bonita Mall; *Vice Chmn* Jan Grayson; *Dir Finance & Admis* Patrick Furlong
Open Mon-Sat 9AM-7PM ; No admis fee; Estab in 1966; comprehensive program of tours, lectures, exhibitions & special events to enhance pub awareness & appreciation of Chicago architecture; Average Annual Attendance: 200,000; Mem: 7000; dues $40
Income: Financed by mem, shop & tour center, foundation, government & private grants
Special Subjects: Architecture
Exhibitions: City Space
Publications: In Sites Newsletter, quarterly
Activities: Classes for adults; docent training; lect open to public, vis lectr; tours; competitions; sales shop sells books, magazines, architecturally inspired gift items, stationery & posters

A **CHICAGO ARTISTS' COALITION,** 70 E Lake St, Ste 230, Chicago, IL 60601. Tel 312-781-0040; Fax 312-781-0042; Elec Mail info@caconline.org; Internet Home Page Address: www.caconline.org; *Exec Dir* Olga Stgefan; *Ed* John Biederman; *Mem Coordr* Stephanie Kluk; *Project Coordr* Kurt Shag Schawlbe
Open Mon - Fri 10 AM - 5 PM; Estab 1975 to provide services, benefits, information & support to visual artists. Resource center includes reference books, pamphlets & catalogs; Mem: 2200; mem open to professional fine & graphic artists; dues $48, monthly board meetings; annual meeting in Oct
Income: $200,000 (financed by mem, city & state appropriation, donations, earned income projects, corporations & foundations)
Library Holdings: Book Volumes; Exhibition Catalogs; Pamphlets; Slides
Exhibitions: Chicago Art Open, annual
Publications: Artists' Gallery Guide; Artists' Bookkeeping Book; Artists' Self-Help Guide; Chicago Artists News, 11 times per yr
Activities: Lect open to public, 10-12 vis lectrs per year; gallery talks; tours; Special Achievement Award for Service to the Visual Arts in Chicago

M **CHICAGO CHILDREN'S MUSEUM,** 700 E Grand Ave, Chicago, IL 60611. Tel 312-527-1000; Fax 312-527-9082; Internet Home Page Address: www.chichildrensmuseum.org; *Chmn of the Brd* Prudence R Beidler; *Vol Coordr* LaWanda MR May; *CEO & Pres* Peter England; *VPres Finance* Judson Vosburg; *VPres Human Resources* Sandra Kay-Weaver; *VPres External* Cecile Keith Brown; *VPres Communication* Jeanne Salis; *Mus Shop Mgr* Andy Laities; *VPrex Exhib* Louise Belmon-Skinner
Open Tues - Sun 10 AM - 5 PM, cl Mon (except in summer); Admis adults & children $6.50, Thurs 5 - 8 PM free (except in summer); Estab 1982 to inspire discovery & self-expression in children through interactive exhibits & programs; Average Annual Attendance: 500,000; Mem: dues $65
Income: $6,500,000 (financed by mem, foundation, corporate, government, individual support, earned income)
Exhibitions: Safe 'N' Sound; Under Construction; Water Ways; Inventing Lab; Infotech Arcade; Treehouse Trails; Play Maze
Activities: Classes for adults & children; docent programs; retail store sells books, prints, educational toys & games, music, videotapes, sweatshirts, tee-shirts

A **CHICAGO HISTORICAL SOCIETY,** Clark St at North Ave, Chicago, IL 60614. Tel 312-642-4600, 642-4650; Fax 312-266-2077; Elec Mail bunch@chicagohistory.orf; Internet Home Page Address: www.chicagohistory.org; *Dir Historical Documentation* Olivia Mahoney; *Dir Exhibs* Tamara Biggs; *Dir Publications* Rosemary Adams; *Deputy Dir Research* Russell Lewis; *VPres Finance* Robert Nauert; *Deuty Dir Interpretation & Educ* Phyllis Rabineau; *Dir Visitor Servs* Ginny Fitzgerald; *Dir Merchandising* Beth Hubbartt; *CEO & Pres* Lonnie G Bunch; *Dir Human Resources* Bobbie Carter; *Dir History Educ* D Lynn McRainey; *Vice Chmn* Hill Hammock; *Dir Marketing* Karen Brown; *Dir Collection Svcs* Katherine Plourd; *Dir Information Svc* Cheryl Obermeyer; *Dir Properties* Larry Schmitt; *Dir. Corporate Event* Kathy Horky; *Dir Accounting* Shari Massey
Open Mon-Sat 9:30AM-4:30PM, Sun Noon-5PM; Admis adults $5, seniors & students 13-22 $3, children 6-12 $1, children under 6 free, no admis fee Mon; Estab 1856 to collect, interpret & present the rich, multi-cultural history of Chicago & Ill as well as selected areas of Am history to the public; Average Annual Attendance: 175,000; Mem: 8500; dues family $50, individual $40, sr citizens & students $35; annual meeting in Oct
Income: $7,200,000 (financed by endowment, mem, city & state appropriations & public donations)
Special Subjects: Historical Material
Collections: Architectural Archive; costumes; decorative arts; industrial & architectural photographs; manuscripts; paintings; sculpture; Chicago Daily News Photo Collection

Exhibitions: Chicago History Galleries; We the People; America in the Age of Lincoln; A House Divided
Publications: Books, Calendar of Events & newsletter, quarterly; catalogs; Chicago History, quarterly
Activities: Classes for adults; lect open to public, 15-20 vis lectrs per year; gallery talks; tours; sales shop selling books, magazines, prints, reproductions, slides

L **CHICAGO PUBLIC LIBRARY,** Harold Washington Library Center, Art Information Center, Visual & Performing Arts, 400 S State St 8th Fl Chicago, IL 60605. Tel 312-747-4800; Fax 312-747-4832; Elec Mail art@chipublib.org; Internet Home Page Address: www.chicagopubliclibrary.org; *Commissioner* Mary A Dempsey; *Head Art Information Center; Dance Librn/Photography* Robert Sloane; *Picture Coll Librn* Angela Holtzman; *Serials/Architecture* Laura Morgan; *Performing Arts Librn* Wil Sumner; *Fine Arts Librn* Carol LeBras; *Chicago Artists' Archive* Leslie Petterson
Open Mon-Thurs 9AM-7PM, Fri & Sat 9AM-5PM, Sun 1-5PM; No admis fee; Estab 1872 as a free public library & reading room; The original building was built in 1897. New location of central library. The Harold Washington Library Center was opened to the public in 1991
Income: Financed by city & state appropriation
Library Holdings: Book Volumes 175,000; Clipping Files; DVDs 250; Exhibition Catalogs; Fiche 6192; Memorabilia; Original Art Works; Other Holdings Videodiscs; Pamphlets; Periodical Subscriptions 515; Photographs; Records; Reels; Reproductions; Sculpture; Slides; Video Tapes 1500
Special Subjects: Decorative Arts, Bookplates & Bindings, Architecture
Collections: Chicago Artists Archives: exhibition catalogues beginning in 1973, primarily English language catalogues; folk dance collection of 50 loose leaf volumes; dance videocassettes documenting history, styles & local choreography; picture collection of over one million items of secondary source material covering all subject areas; clipping files of Chicago architecture & dance - Ann Barzel Dance Film Archive
Exhibitions: Various rotating exhibits featuring materials from the collections
Activities: Dance & art programs; lect open to public; concerts; documentary film series; tours

COLUMBIA COLLEGE CHICAGO
L **Library,** Tel 312-344-7900; Fax 312-334-8062; Elec Mail askalibrarian@colum.edu; Internet Home Page Address: www.lib.colum.edu; *Dean of Lib* Jo Cates; *Head Technical Serv* R Conrad Winke; *Head Access Serv* Roland C Hansen; *Head Ref & Instruction* Arlie Sims; *Head Coll Mgt* Kim Hale; *Head Digital Med Serv* Dennis McGuire
Open Mon - Thurs 8 AM - 10 PM, Fri 8 AM - 6 PM, Sat 9 AM - 5 PM, Sun 12 - 5 PM; Estab 1893 to provide library & media services & materials in support of the curriculum & to serve the college community as a whole; Circ 101,902; For lending & reference
Library Holdings: Book Volumes 260,000; Compact Disks 8500; DVDs 2400; Exhibition Catalogs; Fiche; Periodical Subscriptions 1400; Slides 135,000; Video Tapes 13,000
Special Subjects: Film, Photography, Commerical Art, Graphic Arts, Graphic Design, Painting-American, Theatre Arts, Interior Design, Video
Exhibitions: Art of the Library Exhibit ongoing quarterly exhibits
M **The Museum of Contemporary Photography,** Tel 312-663-5554; Fax 312-344-8067; Elec Mail mocp@colum.edu; Internet Home Page Address: www.mocp.org; *Asst Dir* Natasha Egan; *Mgr Exhib* Stephanie Conaway; *Dir* Rod Slemmons; *Assoc Cur* Karen Irvine; *Mgr Col* Debrah Peterson; *Manager of Educ* Corinne Rose; *Mgr Develop Communication* Jessica Jahner
All year Mon - Wed & Fri 10 AM -5 PM, Thurs 10 AM - 8 PM, Sat noon - 5 PM; No admis fee; Estab 1976 to exhibit, collect & promote contemporary photography; 4000 sq ft on two levels; newly designed 1500 sq ft main exhibition gallery permits a spacious installation of 200 photographs; upper level gallery can accommodate an additional 200-300 prints; Average Annual Attendance: 90,000; Mem: 450; dues $20-2500
Special Subjects: Photography
Collections: Contemporary American photography, including in-depth holdings of works by Harold Allen, Harry Callahan, Barbara crane, Louise Dahl-Wolfe, Dorothea Lange, Danny Lyon, Barbara Morgan, David Plowden, Anne Naggle & Joel Peter-Witkin
Exhibitions: Rotate exhibitions five times per yr
Publications: Exhibit catalogs
Activities: Educ dept: classes at Chicago Public Schools; lect open to public, 5 vis lectrs per year; gallery talks; tours; lending collection contains photographs; book traveling exhibitions 1-2 per year; originate traveling exhibitions; museum shop sells books & posters

A **CONTEMPORARY ART WORKSHOP,** 542 W Grant Pl, Chicago, IL 60614. Tel 773-472-4004; Fax 773-472-4505 (Call First); Elec Mail info@contemporaryartworkshop.org; Internet Home Page Address: www.contemporaryartworkshop.org; *Pres* John Kearney; *Dir* Lynn Kearney; *Asst Dir* Anne Stapes
Open Tues - Fri 12:30 - 5:30 PM, Sat Noon - 5:00 PM; No admis fee; Estab 1949 as an art center & a Workshop-Alternative Space for artists; it is the oldest artist-run art workshop in the country; Studios for 20 artists & two galleries for exhibition of developing & emerging artists from Chicago & other parts of the country are maintained; Average Annual Attendance: 7,000
Income: Financed by contributions, foundations, Illinois Arts Council, Chicago Council on Fine Arts & earnings by the workshop fees
Special Subjects: Drawings, Sculpture, Painting-American, Collages
Exhibitions: Mark Adkins, Tyler Cufley, Dana Defino, Jodie Lawrence, David Lozano, Carrie Shield, Elizabeth Tyson, Kelly VanderBrug, Michelle Wasson, Cariana Carianne, Annie Hogan, Stacie Johnson, Brian Kapemekas, Ji Youn Lee, Matt Pulford, Rita Rubas, Donna Seitzer, Johnathan Stein, Fraser Taylor; John Kearney, Carl Baratta, Laura Mackip, Tracey Taylor
Activities: Lect open to public, 5 vis lectrs per year; gallery talks; tours; gallery sells artwork

M **DUSABLE MUSEUM OF AFRICAN AMERICAN HISTORY,** 740 E 56th Pl, Chicago, IL 60637. Tel 773-947-0600; Fax 773-947-0677; Internet Home Page Address: www.dusable.org; *Founder* Margaret T Burrough; *Registrar* Theresa Christopher; *Chief Cur* Selean Holmes
Open Mon - Sat 10 AM - 5 PM, Sun Noon - 5 PM; Admis adults $2, children & students $1, groups by appointment; Estab 1961 as history & art museum on African American history; Mem: Dues corp $1000, family $35, general $25, student & senior citizen $15
Special Subjects: Photography, Prints, Sculpture, Afro-American Art
Collections: Historical archives; paintings; photographs; prints; sculpture
Publications: Books of poems, children's stories, African & African-American history; Heritage Calendar, annual
Activities: Lect; guided tours; book traveling exhibitions; sales shop sells curios, sculpture, prints, books & artifacts

M **FIELD MUSEUM,** 1200 S Lake Shore Dr, Chicago, IL 60605. Tel 312-665-7932; Fax 312-922-0741; Internet Home Page Address: www.fieldmuseum.org; *Pres Emeritus* Willard L Boyd; *Pres* John W McCarte Jr
Open daily 9 AM - 5 PM, cl Thanksgiving, Christmas, New Year's; Admis adults $8, senior citizens & students $4, children 3-11 $4, Wed free; Estab 1893 to preserve & disseminate knowledge of natural history; 22 anthropological exhibition halls, including a Hall of Primitive Art are maintained; Average Annual Attendance: 1,400,000; Mem: 25,000; dues $30 & $35
Income: Financed by endowment, mem, city & state appropriations & federal & earned funds
Special Subjects: Primitive art
Collections: Anthropological, botanical, geological & zoological collections totaling over 19,000,000 artifacts & specimens, including 100,000 art objects from North & South America, Oceania, Africa, Asia & prehistoric Europe
Exhibitions: Permanent exhibitions: Ancient Egypt Exhibition; Prehistoric Peoples Exhibition; Dinosaur Hall; The American Indian; Pacific Exhibition
Publications: In the Field, monthly; Fieldiana (serial)
Activities: Classes for adults & children; lect open to public, 25 vis lectrs per year; concerts; gallery talks; tours; exten dept serving Chicago area; original objects of art lent to qualified museum or other scholarly institutions; traveling exhibitions organized & circulated; museum shop selling books, magazines, prints, slides
L **Library,** 1200 S Lake Shore Dr, Chicago, IL 60605. Tel 312-665-7887; Fax 312-427-7269; *Librn & Spec Coll Librn* Benjamin Williams
Open Mon - Fri 8:30 AM - 4:30 PM
Library Holdings: Book Volumes 250,000; Periodical Subscriptions 4000
Special Subjects: Archaeology, Asian Art, American Indian Art, Anthropology, Antiquities-Egyptian
Collections: Rare Book Room housing 6500 vols

C **THE FIRST NATIONAL BANK OF CHICAGO,** Art Collection, One Bank One Plaza, Ste IL1-0525 Chicago, IL 60670. Tel 312-732-5935; *Dir Art Prog & Cur* Lisa K Erf; *Registrar* John W Dodge; *Cur Asst* Karen Indeck
Open to public by appointment only; No admis fee; Estab 1968 to assemble works of art to serve as a permanent extension of daily life; Collection displayed throughout bank building and overseas offices
Special Subjects: African Art, Afro-American Art, Anthropology, Antiquities-Byzantine, Antiquities-Etruscan, Antiquities-Oriental, Antiquities-Roman, Archaeology, Architecture, Asian Art, Bookplates & Bindings, Bronzes, Carpets & Rugs, Cartoons, Ceramics, Drawings, Enamels, Eskimo Art, Etchings & Engravings, Ethnology, Sculpture, Textiles, Watercolors, Woodcarvings, Woodcuts
Collections: Art from Africa, America, Asia, Australia, the Caribbean Basin, Europe, Latin America, Near East & the South Seas ranging from Sixth Century BC to the present
Activities: Individual objects of art lent only to major exhibitions in museums; originate traveling exhibitions

M **GALLERY 312,** 312 N May St, Chicago, IL 60607. Tel 312-942-2500; Fax 312-942-0574; Elec Mail gall312@megsinet.com; Internet Home Page Address: www.gallery312.org; *Prog Dir* Paul Brenner; *Gallery Asst* Tami Miyahara
Open Tues - Sat 11 AM - 5 PM; No admis fee; Estab 1994; a non-profit, artist-run venue committed to the exploration and exhibition of ideas and art making relevant to today's world; 8000 sq ft exhibition space
Exhibitions: Established contemporary artists & museum curated shows as well as an annual summer show of under-represented, emerging artists & Young at Art, art created by children
Activities: Lect open to pub; gallery talks

M **GLESSNER HOUSE MUSEUM,** 1800 S Prairie Ave, Chicago, IL 60616. Tel 312-326-1480; Fax 312-326-1397; Elec Mail glessnerhouse@earthlink.net; Internet Home Page Address: www.glessnerhouse.org; *Exec Dir & Sr Cur* Corina Carusi; *Prog & Vol Coordr* Betsy Hutula
Tours Wed - Sun 1 PM - 3 PM; Admis adults $7, students & seniors $6; Estab 1994 to engage diverse audiences in exploring urban life & design through preservation & interpretation of the historic home of John Frances Glessner. Glessner House Museum works to increase public awareness, understanding, and appreciation for the history, culture and architecture of Chicago as represented in the lives & home of the Glessner household and the surrounding Prairie Avenue district; Average Annual Attendance: 10,000; Mem: 4400; dues $35
Income: Financed by mem, tours, programs & grants
Collections: William DeMorgan Ceramics; Emil Galle Glass; Morris & Co Textiles; Isaac Scott Collection: decorative arts; English arts & crafts; etchings; frames; furnishings; steel engravings
Publications: Prairie Avenue News, quarterly
Activities: Classes for adults & children; docent training; dramatic programs; lect open to public, 10 vis lectrs per year; forum discussions, symposia; original objects of art lent to galleries which are mounting exhibitions on architecture; lending collection contains architectural ornaments; mus shop sells books, magazines, prints, stationery & small gift items

M **HENRY B CLARKE HOUSE MUSEUM,** 1827 S Indiana Ave, Chicago, IL 60616. Tel 312-745-0040; Fax 312-745-l0077; Elec Mail clarkehouse@interaccess.com; Internet Home Page Address: www.cityofchicago.org/culturalaffairs; *Cur* Edward M Maldonado
Open Wed - Sun Noon - 3 PM; Admis $7; Estab 1982; Chicago's oldest building & only Greek Revival structure. House was built in 1836 & includes period rooms; Average Annual Attendance: 12,000; Mem: 600; dues $35
Library Holdings: Auction Catalogs 600; Book Volumes
Collections: Early 19th century period furniture & decorative objects
Activities: Docent training; classes for children; lect open to public, 4 vis lectrs per year; concerts; tours; sales shop sells books & magazines

M **HYDE PARK ART CENTER,** 5307 S Hyde Park Blvd, Chicago, IL 60615. Tel 773-324-5520; Fax 773-324-6641; Elec Mail hpac@juno.com; Internet Home Page Address: www.hydeparkart.org; *Educ Dir* Eliza Duenow; *Exec Dir* Chuck Thurow; *VChmn* Deone Jackman
Open Mon - Sat 11 AM - 5 PM; No admis fee; Estab 1939 to stimulate an interest in art; Average Annual Attendance: 14,000; Mem: 450; dues family $35
Income: $600,000 (financed by endowment, mem, city & state appropriation, foundations, corporations & private contributions)
Special Subjects: Drawings, Painting-American, Photography, Sculpture, Watercolors, Textiles, Ceramics, Crafts, Folk Art, Etchings & Engravings
Publications: Quarterly newsletter, exhibition catalogues
Activities: Classes for adults & children; lect open to public; gallery talks; scholarships offered; extn prog serves south & west sides of Chicago; sales shop sells original art

A **ILLINOIS ALLIANCE FOR ARTS EDUCATION (IAAE),** 200 N Michigan Ave, Ste 404, Chicago, IL 60601. Tel 312-750-0589; Fax 312-750-9113; Elec Mail iaae@artsmart.org; Internet Home Page Address: www.artsmart.org; *Prog Admin Coordr* Marissa Hockfield; *Exec Dir* Tracie Constantino, PhD
Open daily 9 AM - 5 PM; Estab 1972 to safeguard and expand arts educ for all Illinois students; Mem: 150, dues $45 for individuals, $100 for institutions
Income: $200,000 (financed by nat, state and local govt, also pvt foundations, corporate gifts & the Kennedy Center Alliance for Arts Educ Network)
Publications: Finding Dollar$, a Statewide Guide for Artists & Schools to Locate Funds for Arts Educ Progs; Integrated Curriculum Arts Project, lesson plan book
Activities: Arts integration workshops for pub school teachers; conferences & professional develop workshops for teachers & adminrs; ArtSmart prog to raise pub awareness of importance of arts educ; annual service recognition awards

M **ILLINOIS STATE MUSEUM,** Chicago Gallery, 100 W Randolph, Ste 2-100, Chicago, IL 60601. Tel 312-814-5322; Fax 312-814-3471; Internet Home Page Address: www.museum.state.il.us/; *Preparations* Doug Stapleton; *Educ & Pub Relations* Judith Lloyd; *Dir Art* Kent Smith
Open Mon - Fri 9 AM - 5 PM; No admis fee; Estab 1985 for the purpose of promoting an awareness of the variety of art found & produced in Illinois; Three large galleries & three smaller galleries provide a flexible space for a diverse exhibition program. Exhibits are produced by the Illinois State Mus & the State of Illinois Art Gallery; Average Annual Attendance: 47,000
Special Subjects: Painting-American, Photography, Sculpture, American Indian Art, Folk Art, Historical Material
Publications: Exhibit catalogs
Activities: Lect open to public; gallery talks; internships offered; book traveling exhibitions 6 per year; originate traveling exhibitions; museum shop sells books & original art

M **Illinois Artisans Shop,** 100 W Randolph St, Chicago, IL 60601. Tel 312-814-5321; Fax 312-814-2439; Elec Mail cpatterson@museum.state.il.us; Internet Home Page Address: www.museum.state.il.us; *Dir ILL Artisans Prog* Carolyn Patterson; *Mgr ILL Artisans Shop* Cara Schlorff
Open Mon - Fri 9 AM - 5 PM; No admis fee; Estab 1985; A nonprofit program to showcase the craft work of Illinois artisans accepted in a consignment shop & to educate the pub about the scope of craft art; Mem: 1400 artists in program; qualification for mem; juried art work
Income: Financed by state appropriation & retail sales of art work
Exhibitions: Rotating exhibits
Publications: Craft Events in Illinois, biannual; Illinois Artisan Newsletter, periodic
Activities: Educ dept; public demonstrations; monthly workshops; lect open to public; sales shop sells original art

M **Illinois Artisans & Visitors Centers,** 14967 Gun Creek Trail, Whittington, IL 62897-1000. Tel 618-629-2220; Fax 618-629-2704; *Dir ILL Artisans Prog* Carolyn Patterson; *Dir SIACM* Mary Lou Galloway; *Mgr IL Artisans Shop* Romaula Coleman; *Dir* Ellen Gantner
Open daily 9 AM - 5 PM; No admis fee; Estab 1990; A nonprofit program to showcase the craft work of Illinois artisans accepted in a consignment shop & to educate the pub about the scope of craft art; Mem: 1500 artists in program; qualification for mem: juried art work
Income: Financed by state appropriation & retail sales of art work
Activities: Demonstrations; classes for adults & children; lect open to public; gallery talks; sales shop sells books, original art, prints

M **Museum Store,** 502 S Spring St, Springfield, IL 62706-5000. Tel 217-782-7387; Fax 217-782-1254; Elec Mail webmaster@museum.state.il.us; Internet Home Page Address: www.museum.state.il.us; *Dir* R Bruce McMillian; *IL Artisans Prog* Carolyn Patterson; *Mus Shop Mgr* Cara Schlorff; *Assoc Dir Policy* Karen A Witter; *Zoology Chair* James R Purdue; *Cur Zoology* Everett D Cashatt; *CFO* Charlotte A Montgomery; *So IL Art* Debra Tayes; *Cur Botany* Eric Grimm; *Cur Anthropology* Terry Martin; *Cur Decorative Arts* Janice Wass; *Assoc Cur Educ* Nina Walthall; *Anthropology Chair* Michael D Wiant; *Exhib Design* Joe Hennessy; *Librn* Pat Burg; *Geology Chair* Jeffrey J Saunders; *So IL Art* Mary Lou Galloway; *IL Art Gallery* Jane Stevens; *Dickson Mounds Mus* Judith A Franke; *Cur Art* Robert Sill; *Lockport Gallery* Jim Zimmer; *Educ Chair* Beth Shea; *Assoc Dir Science* Bonnie W Styles; *Exhib Prep* Paul Countryman; *Board Chmn* George Rabb; *Dir Develop* Estie Karpman; *Asst Cur Zoology* H David Bohlen
Open Mon - Sat 10:00 AM - 5 PM, Sun Noon - 5 PM; No admis fee; Estab 1990; A not-for-profit program to showcase the craft work of Illinois artisans accepted in a consignment shop & to educate the pub about the scope of craft art; Average Annual Attendance: 230,000; Mem: 1500 artists in program

Income: Financed by state appropriation & retail sales of art work
Activities: Demonstrations; lect open to public; musem shop sells books, original art, prints, reproductions, educational toys for children

M **INTUIT: THE CENTER FOR INTUITIVE & OUTSIDER ART,** 756 N Milwaukee Ave, Chicago, IL 60622. Tel 312-243-9088; Fax 312-243-9089; Elec Mail intuit@art.org; Internet Home Page Address: www.outsider.art.org; *Assoc Dir* Martha Watterson; *Dir Communications* Rebecca Mazzei
Open Wed - Sun - 5 PM; No admis fee; Estab 1991 to educate the public on outsider art; Maintains reference library; Average Annual Attendance: 10,000; Mem: 500; dues $40
Income: $400,000 (financed by mem & grants)
Library Holdings: Auction Catalogs; Audio Tapes; Book Volumes; Cards; Cassettes; Clipping Files; Compact Disks; DVDs; Exhibition Catalogs; Memorabilia; Other Holdings; Pamphlets; Periodical Subscriptions; Photographs; Slides; Video Tapes
Special Subjects: Folk Art, Primitive art
Publications: The Outsider, 3 times per year
Activities: Docent training; lect open to public; 12 vis lectrs per yr; concerts, gallery talks, tours; films; approx once per yr; museum shop sells books, magazines, original art, reproductions & gift items

M **LOYOLA UNIVERSITY OF CHICAGO,** Martin D'Arcy Museum of Art, 6525 N Sheridan Rd, Chicago, IL 60626. Tel 773-508-2679; Fax 773-508-2993; Internet Home Page Address: www.darcy.luc.edu; *Asst Dir* Rachel Baker; *Dir* Dr Sally Metzler
Open Tues - Sat Noon - 4 PM (during school yr); No admis fee; Estab 1969 to display the permanent university collection of Medieval, Renaissance & Baroque decorative arts & paintings; One gallery set up as a large living room with comfortable seating, classical music, view of Lake Michigan & art objects in view; Average Annual Attendance: 6,200; Mem: 1,500; dues $50
Income: Financed by donations, endowment, mem & university support
Special Subjects: Sculpture, Bronzes, Textiles, Painting-European, Silver, Ivory, Gold, Enamels
Collections: Decorative arts, furniture, liturgical objects, paintings, sculptures & textiles
Publications: Exhibition catalogs
Activities: Educ dept; lect open to public, 9 vis lectrs per week; concerts; gallery talks; tours on request; paintings & original objects of art lent to qualified museums; lending collection contains original art works, paintings & sculpture

M **MEXICAN FINE ARTS CENTER MUSEUM,** 1852 W 19th St, Chicago, IL 60608. Tel 312-738-1503; Fax 312-738-9740; Elec Mail carlost@mfamchicago.org; Internet Home Page Address: www.mfacmchicago.org; *Exec Dir* Carlos Tortolero; *Visual Arts Dir* Ceareo Moreno; *Permanent CollPER* Rebecca D Meyers; *Assoc Dir* Juana Guzman
Open Tues - Sun 10 AM - 5 PM; No admis fee; Estab 1982; Average Annual Attendance: 110,000; Mem: 1,500; dues $15 & up
Income: $4,000,000 (financed by mem, city, state & federal appropriation, corporations & foundations)
Special Subjects: Latin American Art, Mexican Art, Photography, Prints, Folk Art
Collections: Mexican prints, photography & folk art collection; Latino art collection
Exhibitions: Jose Guadalupe Posada; rotating 4 per year
Activities: Classes for children in docent programs; lect open to the public, 4 vis lectr per year; museum shop sells books, original art, folk art & prints

M **MUSEUM OF CONTEMPORARY ART,** 220 E Chicago Ave, Chicago, IL 60611. Tel 312-280-2660; Fax 312-397-4095; Internet Home Page Address: www.mcachicago.org; *Chief Cur* Elizabeth Smith; *Dir* Robert Fitzpatrick; *Dir Mktg* Angelique Williams; *Educ Dir* Wendy Woon; *Dir of Admin* Helen Dunbeck; *Assoc Dir & Chief Develop Officer* Greg Cameron; *Chief Registrar & Exhib Mgr* Jennifer Draffen; *Dir Pub Relations* Karla Loring; *Dir of Performance Prog* Peter Taub; *Dir Special Events & Rentals* Gina Crowley
Open Tues 10 AM - 8 PM, Wed - Sun 10 AM - 5 PM, cl Mon, Thanksgiving, Christmas & New Year's Day; Suggested admis adults $10, students, seniors & children under 12 $6, members & children under 10 free, Tues evenings free; Estab 1967 as a forum for contemporary arts in Chicago; Average Annual Attendance: 350,000; Mem: 15,000, dues $50 - $65
Income: $11,300,000 (financed by endowment, mem, pub & private sources)
Special Subjects: Afro-American Art, Drawings, Collages, Photography, Painting-American, Prints, Sculpture, Oriental Art, Asian Art, Painting-Italian, Painting-German
Collections: Permanent collection of 20th century & contemporary, constantly growing through gifts & purchases
Publications: Bimonthly calendar, exhibition catalogs, membership magazine
Activities: Classes for adults; docent training; teacher workshops; lect; gallery talks; tours; performance; films; book traveling exhibitions; originate traveling exhibitions; museum shop sells books, designer jewelry & other gifts, magazines, original art & reproductions

L **Library,** 220 E Chicago Ave, Chicago, IL 60611. Tel 312-397-3894; Fax 312-397-4099; Elec Mail akaiser@mcachicago.org; *Librn* Dennis McGuire
Library collection, non-circulating; for reference
Income: Financed by endowment, mem, pub & pvt sources
Library Holdings: Book Volumes 15,000; Cassettes 400; Other Holdings Artist Files 125 drawers; Artists' Books 4300; Periodical Subscriptions 125; Slides 45,000; Video Tapes 300
Special Subjects: Art History, Conceptual Art

M **MUSEUM OF HOLOGRAPHY - CHICAGO,** 1134 W Washington Blvd, Chicago, IL 60607. Tel 312-226-1007; Fax 312-829-9636; Elec Mail hologram@ameritech.net; Internet Home Page Address: www.holographiccenter.com; *Dir* Loren Billings
Open Wed - Sun 12:30 - 4:30 PM, group tours Mon, Tues by appointment; Admis adults $5, children $3.50; Estab 1976 to perform all functions of a mus; 15,000 sq ft of exhibition space, oak panel walls, special display wings, sales gallery; school

facilities comprise 4600 sq ft of fully equipped laboratories & darkrooms with additional lecture facilities; Average Annual Attendance: 25,000
Income: $780,000 (financed by sales, research grants, teaching, consulting, mus store, school, tours & rentals)
Collections: Holograms from throughout the world
Exhibitions: Holography.
Publications: Holography; class text books
Activities: Classes for adults; lect open to public, 6 vis lectrs per year; book traveling exhibitions; museum shop sells books, originals & holograms

L David Wender Library, 1134 W Washington Blvd, Chicago, IL 60607. Tel 312-226-1007; Fax 312-829-9636; Internet Home Page Address: www.holographiccenter.com; *Exec Dir* Loren Billings
Open Wed - Sun 12:30 - 5 PM; Estab 1976; For reference only
Income: Financed by Museum of Holography
Library Holdings: Book Volumes 350; Exhibition Catalogs; Framed Reproductions; Kodachrome Transparencies; Motion Pictures; Periodical Subscriptions 10; Slides; Video Tapes

M MUSEUM OF SCIENCE & INDUSTRY, 5700 S Lake Shore Dr, Chicago, IL 60637. Tel 773-684-1414; Fax 773-684-7141; Internet Home Page Address: www.msichicago.org; *Pres & CEO* David Mosena; *VPres Admin* Candida Miranda; *VPres Prog* Phelan Fretz; *Dir Educ* Jean Franczyk
Open summer Mon-Sun 9:30AM-4:30 PM, winter Mon-Fri 9:30AM-4PM, Sat, Sun & holidays 9:30AM-5:30PM; Admis adults $7, seniors $6, children $3.50, Thurs free; Estab 1926 to further pub understanding of science, technology, industry, medicine & related fields; Visitor-participation exhibits depicting scientific principles, technological applications & social implications in fields of art science; Average Annual Attendance: 2,000,000; Mem: 59,470; dues life $1500, family $75, individual $50
Income: $16,200,000 (financed by endowment, mem, city & state appropriation, contributions & grants from companies, foundations & individuals)
Exhibitions: AIDS: The War Within; The Coal Mine; Imaging: The Tools of Science; Colleen Moore Fair Castle; Take Flight; U-505 Submarine
Publications: AHA quarterly
Activities: Classes for adults & children; dramatic programs; field trips; summer camps; teacher workshops; lect open to public, 4 vis lectrs per year; competitions; outreach activities; lending collection contains communications, transportation & textile equipment; book traveling exhibitions; originate traveling exhibitions; museum shop sells books, magazines, prints, slides, postcards & souvenirs

M NAB GALLERY, 1117 W Lake, Chicago, IL 60607. Tel 312-738-1620; *Assoc Dir* Craig Anderson; *Assoc Dir* Robert Horn
Open Sat & Sun Noon - 5 PM; No admis fee; Estab 1974 as an artist-run space to show original artworks; Exhibits of Museum & Contemporary Art; Average Annual Attendance: 3,000; Mem: 10; open to artists with professional portfolio; dues $500; monthly meetings
Income: $15,000 (finaced by mem)
Exhibitions: Local Artists Juried Exhibit: Horvath, Lee, Sons, Dallas, Esserman, Vanlaar
Activities: Classes for adults; lect open to public; concerts; competitions; integrated art events

L NEWBERRY LIBRARY, 60 W Walton St, Chicago, IL 60610-3394. Tel 312-943-9090; Fax 312-255-3513; Internet Home Page Address: www.newberry.org; *Pres & Librn* Charles T Cullen; *Librn* Mary Wyly; *VPres Finance & Admin* Jim Burke; *VPres Research & Educ* Jim Grossman; *VPres Develop* Toni M Harkness
Open Tues - Thurs 10 AM - 6 PM, Fri & Sat 9 AM - 5 PM; No admis fee; Estab 1887 for research in the history & humanities of Western Civilization; Circ Non-circulating; For reference only. Two small galleries are maintained for exhibitions; Mem: 1950; dues $35; annual meeting in Oct
Income: $4,500,000 (financed by endowment, mem, gifts, federal, corporate & foundation funds)
Purchases: $400,000
Library Holdings: Audio Tapes; Book Volumes 1,400,000; Cards; Clipping Files; Exhibition Catalogs; Fiche; Manuscripts 5,000,000; Memorabilia; Motion Pictures; Original Art Works; Pamphlets; Periodical Subscriptions 900; Photographs; Records; Reels; Video Tapes
Special Subjects: Art History, Graphic Arts, Manuscripts, Maps, History of Art & Archaeology, Ethnology, American Western Art, American Indian Art, Southwestern Art
Collections: Edward Ayer Collection, manuscripts & maps related to European expansion to the Americas & the Pacific; Everett D Graff Collection of Western Americana books & manuscripts; John M Wing Foundation Collection on history of printing & aesthetics of book design; Rudy L Ruggles Collection on American constitutional & legal history
Publications: A Newberry Newsletter, quarterly; Center for Renaissance Studies Newsletter, 3 times per yr; Mapline, quarterly newsletter; Meeting Ground, bi-annual newsletter; Origins, quarterly newsletter
Activities: Classes for adults; dramatic programs; docent training; lect open to public, some open to members only, 35 vis lectrs per year; concerts; gallery talks; tours; scholarships & fels offered; individual paintings & original objects of art lent to museums & libraries on restricted basis; book traveling exhibitions 1-2 per year; sales shop sells books, reproductions, slides

M NORTH PARK UNIVERSITY, (North Park College) Carlson Tower Gallery, 3225 W Foster, Chicago, IL 60625. Tel 773-244-6200; Fax 773-244-5230; Internet Home Page Address: www.northpark.edu; *Dir Gallery* Tim Lowly
Open Mon - Fri 9 AM - 4 PM, occasional weekend evenings; No admis fee; Educational development of aesthetic appreciation
Special Subjects: Religious Art
Collections: Original contemporary Christian, Illinois & Scandinavian art
Activities: Classes for adults; lect open to public, 1-2 vis lectrs per year; concerts; exten dept serves Chicago; book traveling exhitions, 1-2 per year

M NORTHEASTERN ILLINOIS UNIVERSITY, Gallery, Art Dept, 5500 N Saint Louis Ave Chicago, IL 60625. Tel 773-442-4944; Fax 773-442-4920; Internet Home Page Address: www.neiu.edu/~avt/gal.html; *Dir* Heather Weber
Mon-Fri 10AM-6PM & by appointment; No admis fee; Estab Feb 1973 for the purpose of providing a link between the University & the local community on a

cultural & aesthetic level, to bring the best local & midwest artists to this community; Gallery is located in the Fine Arts building on the University campus; Average Annual Attendance: 8,000
Income: Financed by Department of Art funds and personnel
Exhibitions: Various exhib
Publications: Postcard announcements; brochures; catalogs
Activities: Lectures open to the public; gallery talks; tours

M NORTHERN ILLINOIS UNIVERSITY, Art Gallery in Chicago, 215 W Superior St, 3rd Fl, Chicago, IL 60610. Tel 312-642-6010; Elec Mail nweber@niu.edu; Internet Home Page Address: www.vpa.niu.edu/museum; *Dir* Heather Weber
Open Wed - Sat 11 AM - 5 PM; No admis fee; Estab 1985; 1,700 sq ft, 200 linear ft, movable walls, 10.5 ft ceilings; Average Annual Attendance: 3,000; Mem: 200; dues $25
Income: Financed by state appropriation
Exhibitions: Rotating exhibitions every six to eight weeks
Publications: Occasional catalogues
Activities: Lect open to public, 5 vis lectrs per year; panel discussions & seminars; tours; gallery talks; book traveling exhibitions; originate traveling exhibitions

M PALETTE & CHISEL ACADEMY OF FINE ARTS, 1012 N Dearborn St, Chicago, IL 60610. Tel 312-642-4400; Fax 312-642-4317; Elec Mail fineart@paletteandchisel.org; Internet Home Page Address: www.paletteandchisel.org; *Pres* Linda Boatman; *Exec Dir* William Ewers
Gallery open Mon - Fri 10 AM - 7 PM, Sat Noon - 4 PM, workshops are open to the pub on a regular basis; No admis fee; Estab & incorporated 1895 to provide a meeting/work place for the visual arts; Building contains galleries, classrooms, studios & library; Mem: 430; dues $360; patron & nonresident mem available
Collections: Permanent Collection: works by James Montgomery Flag; J Jeffery Grant; A W Mauach; Richard Schmid & others
Exhibitions: Five Members Award Shows; guest artists & organizations frequently exhibited
Publications: The Quick Sketch, monthly
Activities: Educ events; classes for artists; lect open to public; tours; competitions with awards; scholarships offered

M PEACE MUSEUM, 100 N Central Park Ave, Chicago, IL 60610; 100 N Central Park Ave, Chicago, IL 60624. Tel 773-638-6450; Fax 773-638-6452; Elec Mail rebeccaw@peacemuseum.org; Internet Home Page Address: www.peacemuseum.org; *Exec Dir* Rebecca Williams; *Exhib Coordr* Kellye King
Open Tues - Fri 1 - 5 PM, Sat by appointment; Suggested donation of $3 per person; Estab 1981 to provide peace educ through the arts; presents issue-oriented exhibits; 2500 sq ft space featuring small display of permanent collection & 4-6 changing exhibits; Average Annual Attendance: 35,000; Mem: 4000; dues $35-2000
Income: Financed by foundation grants, donations & mem
Library Holdings: Audio Tapes; Book Volumes; Cassettes; Compact Disks; Framed Reproductions; Manuscripts; Maps; Pamphlets; Periodical Subscriptions; Records; Slides; Video Tapes
Collections: 10,000 artifacts from civil rights, domestic violence prevention, peace, social justice, violence prevention efforts
Exhibitions: Rotating Exhibits
Publications: The Peace Release: A Handbill of the Peace Museum
Activities: Classes for adults & children; docent training; lect open to public, 10-15 vis lectrs per year; competitions; individual paintings & original objects of art lent to other galleries, art directors of publications & universities; lending collection contains 2000 books, 300 cassettes, 500 framed reproductions, 100 original art works, 100 original prints, 150 photographs, 2000 slides & peace posters; book traveling exhibitions; originate traveling exhibitions to library exhibit spaces, galleries, schools & community centers; museum shop sells books, magazines & prints

C PLAYBOY ENTERPRISES, INC, 680 N Lake Shore Dr, Chicago, IL 60611. Tel 312-751-8000; Fax 312-751-2818; *VPres & Art Dir* Tom Staebler; *Business Mgr & Art Cur* Barbara Hoffman
Open to pub by appointment only in groups; Estab 1953 to gather & maintain works commissioned for reproduction by Playboy Magazine
Collections: Selected works from 4000 illustrations & fine art pieces, works include paintings & sculpture representing 20th Century artists such as Robert Ginzel, Roger Hane, Larry Rivers, James Rosenquist, Seymour Rosofsky, Roy Schnackenberg, George Segal, Andy Warhol, Robert Weaver, Tom Wesselman, Karl Wirsum & others
Publications: Catalogs pertaining to Beyond Illustration - The Art of Playboy; The Art of Playboy - from the First 25 Years
Activities: Lect; tours; annual illustration awards; individual paintings & original objects of art lent to museums & schools; originate traveling exhibitions to galleries, universities, museums & cultural centers

L Library, 680 N Lake Shore Dr, Chicago, IL 60611. Tel 312-751-8000, Ext 2420; Fax 312-751-2818; *Librn* Mark Durand
Library Holdings: Book Volumes 10,000; Clipping Files; Exhibition Catalogs; Original Art Works; Periodical Subscriptions 75; Photographs

M POLISH MUSEUM OF AMERICA, 984 N Milwaukee Ave, Chicago, IL 60622. Tel 773-384-3352; Fax 773-384-3799; *Pres* Joanna Kosinski; *Dir* Jan M Lorys
Open daily 11 AM - 4 PM; No admis fee, suggested donation adults $2, children $1; Estab 1937, to promote & preserve Polish & Polish-American culture; A specialized mus & gallery containing works of Polish artists & Polish-American culture artists is maintained; Average Annual Attendance: 6,000; Mem: dues $25
Income: Financed by donations & fundraising
Special Subjects: Costumes, Religious Art, Folk Art, Decorative Arts, Historical Material, Maps, Coins & Medals, Painting-Polish, Military Art
Collections: Originals dating to beginning of 20th century, a few older pieces; Pulaski at Savannah (Batowski); works of Polish artists, Polish-American artists & works on Polish subject; Nikifor, Jan Styka, Wojciech Kossak; paintings from the

collection of the Polish Pavilion from 1939 World's Fair in NY; large collection of Paderewski memorabilia, including the last piano he played on
Exhibitions: Modern Polish Art; folk art; militaria
Publications: Exhibit Catalogs; Art Collection Catalog
Activities: Lect open to public, 5 vis lectrs per year; tours; museum shop sells books, reproductions, prints, Polish Folk items, amber & crystal

L Research Library, 984 N Milwaukee Ave, Chicago, IL 60622. Tel 773-384-3352; Fax 773-384-3799; Elec Mail pma@prcua.org; Internet Home Page Address: www.prcua.org/pma; *Librn* Malgorzata Kot; *Dir* Jan M Lorys; *Treas* Camille Kopielski; *Chmn* Wallace M Ozog; *Secy* Sabina Logisz; *Archivist* Halina Misterka; *Asst Cur* Bohdan Gorczynski; *VPres* Joan Kosinski; *Mus Shop Mgr* Mary Jane Robles
For reference only; interlibrary circulation
Library Holdings: Audio Tapes; Book Volumes 63,000; Cassettes; Clipping Files; Exhibition Catalogs; Fiche; History; Framed Reproductions; Manuscripts; Memorabilia; Motion Pictures; Original Art Works; Pamphlets; Periodical Subscriptions 125; Photographs 3000; Prints; Records; Reels; Reproductions 1000; Sculpture; Slides 2000; Video Tapes
Special Subjects: Maps, Posters, Coins & Medals
Collections: Haiman; Paderewski; Polish Art
Activities: Lect

A THE RENAISSANCE SOCIETY, Cobb Hall - Rm 418, 5811 S Ellis Chicago, IL 60637. Tel 773-702-8670; Fax 773-702-9669; Elec Mail pscott@midway.uchicago.edu; Internet Home Page Address: www.renaissancesociety.org; *Dir* Susanne Ghez; *Educ Dir* Hamza Walker; *Develop Dir* Lori Bartman
Open Tues - Fri 10 AM - 5 PM, Sat & Sun Noon - 5 PM, cl summer; No admis fee; Founded 1915 to advance the understanding & appreciation of the arts in all forms; Mem: 500; dues $40; annual meeting in June
Exhibitions: Six changing exhibitions per yr
Publications: Exhibit catalogs
Activities: Educ dept; lect open to public; concerts; gallery talks; tours; film programs; performances; mus shop; editions

M ROY BOYD GALLERY, 739 N Wells St, Chicago, IL 60610-3520. Tel 312-642-1606; Fax 312-642-2143; Elec Mail info@royboydgallery.com; Internet Home Page Address: royboydgallery.com; *Co-Dir* Ann Boyd; *Co-Dir* Roy Boyd
Open Tues - Sat 10 AM - 5:30 PM; No admis fee; Estab 1972 to exhibit art
Special Subjects: Drawings, Painting-American, Photography, Prints, Sculpture, Watercolors, Bronzes, Collages
Collections: Contemporary American paintings; Russian & Baltic photography; sculpture & works on paper

L SAINT XAVIER UNIVERSITY, Byrne Memorial Library, Art Dept, 3700 W 103rd St Chicago, IL 60655. Tel 773-298-3352, 3364; Fax 773-779-5231; Internet Home Page Address: www.sxu.edu/libr/library; *Dir* JoAnn Ellingson
Open Mon-Thurs 7:45 AM-10 PM, Frid 7:45 AM-7 PM, Sat 8 AM-6 PM, Sun Noon-10 PM; Estab 1847
Income: Financed by college funds & contributions
Library Holdings: Book Volumes 160,600; Cards; Kodachrome Transparencies; Motion Pictures; Original Art Works; Periodical Subscriptions 890; Records; Slides 10,000; Video Tapes
Collections: Permanent art collection

L SCHOOL OF ART INSTITUTE OF CHICAGO, Video Data Bank, 112 S Michigan Ave, Chicago, IL 60603. Tel 312-345-3550; Fax 312-541-8073; Elec Mail info@vdb.org; Internet Home Page Address: www.vdb.org; *Dir* Kate Horsfield
Open Mon - Fri 9 AM - 5 PM; No admis fee; School estab 1892, library estab 1976 to distribute, preserve & promote videos by & about contemporary artists; Average Annual Attendance: 500,000
Income: $550,000 (finance by grants & earned income)
Library Holdings: Video Tapes 3000
Special Subjects: Art History, Film, Mixed Media, Photography, Painting-American, Painting-British, Painting-German, Sculpture, Video
Collections: Video Tapes: Eary Video History, Independent Video/Alternative Media, Latin/South America, Media Literacy, On Art & Artists
Publications: Annual catalog of holdings

L SCHOOL OF THE ART INSTITUTE OF CHICAGO, John M Flaxman Library, 37 S Wabash, Chicago, IL 60603. Tel 312-899-5097; Fax 312-899-1851; Elec Mail ceike@artic.edu; *Reference Librn* Kate Jarboe; *Head Technical Svcs* Fred Hillbruner; *Bibliographer* Henrietta Zielinski; *Artists' Book Coll Specialist* Doro Boehme; *Cataloger* Sylvia Choi; *Dir* Claire Eike
Open Mon - Thurs 8:30 AM - 9:30 PM, Fri 8:30 AM - 6 PM, Sat 10AM - 4 PM, Sun Noon - 6 PM; Estab 1967 to provide a strong working collection for School's programs in the visual & related arts; Circ 54,002; Average Annual Attendance: 80,000
Income: 701,445 (financed by the operational budgets of the school of Art Institute of Chicago)
Purchases: $189,870
Library Holdings: Audio Tapes 1,000; Book Volumes 65,000; CD-ROMs 75; Cassettes 700; Clipping Files; Compact Disks 1,000; DVDs 100; Exhibition Catalogs; Fiche; Filmstrips 750; Motion Pictures 663; Other Holdings 4,000; Periodical Subscriptions 350; Records 100; Video Tapes 1,000
Collections: Joan Flasch Artists Book Collection; Film Study Collection; Tony Zwicker Archives

SOCIETY OF ARCHITECTURAL HISTORIANS
For further information, see National and Regional Organizations

M SPERTUS INSTITUTE OF JEWISH STUDIES, Spertus Museum, 618 S Michigan Ave, Chicago, IL 60605. Tel 312-322-1747; Fax 312-922-3934; Elec Mail musm@spertus.edu; *Coll Mgr* Arielle Weininger; *Asst Registrar* Tom Gengler; *Exhib Cur* Olga Weiss; *Sr Educator* Susan Bass Marcus; *Educator* Jung Mee Jamie Kim; *Educator* Amanda Friedeman; *Coll Photographer* Michele Liebowitz; *Dir* Rhoda Roseu; *Mus Operations Mgr* Rena Lipman; *Sr Cur* Staci Boris
Open Sun-Wed 10AM-5PM, Thurs 10AM-7PM, Fri 10AM-3PM, Artifact Center open Sun-Thurs 1-4:30PM, Fri 1-3:00PM; Admis family $10, adults $5, children,

students & seniors $3, Fri free; Estab 1967 for interpreting & preserving the 3500-year-old heritage embodied in Jewish history; Mus houses a distinguished collection of Judaica from many parts of the world, containing exquisitely designed ceremonial objects of gold, silver, bronze & ivory; Average Annual Attendance: 35,000
Income: Financed by contributions & subsidy from Spertus Institute
Special Subjects: Drawings, Graphics, Painting-American, Photography, Sculpture, Archaeology, Ethnology, Costumes, Religious Art, Ceramics, Folk Art, Etchings & Engravings, Decorative Arts, Judaica, Manuscripts, Posters, Jewelry, Metalwork, Painting-French, Historical Material, Juvenile Art, Coins & Medals, Gold, Pewter
Collections: Permanent collection of sculpture, paintings & graphic art; ethnographic materials spanning centuries of Jewish experience; a permanent Holocaust memorial; Judaica, paintings, ceremonial silver, textiles, archaeology
Exhibitions: Biennial International Competition for Jewish Ceremonial Art; ongoing schedule of changing exhibitions
Publications: Special publications with exhibits; Calendar of Events
Activities: Classes for adults & children; docent training; lect open to public, 20 vis lectrs per year; gallery talks; tours; competitions with awards; individual paintings & original objects of art lent to other museums & institutions; book traveling exhibitions 2 per year; originate traveling exhibitions to other museums; museum shop sells books, original art & reproductions; The Artifact Center is a hands on exhibit on art & archaeology in ancient Israel

L Asher Library, 618 S Michigan Ave, Chicago, IL 60605. Tel 312-922-8248; Fax 312-922-0455; Elec Mail asherlib@spertus.edu; Internet Home Page Address: www.spertus.edu; *Assoc Dir* Kathleen Bloch; *Reference Librn* Dan Sharon; *Dir* Glenn Ferdman; *Archivist* Joy Kingsolver; *Conservator* Melissa Oresky
Open Mon, Tues& Wed 9AM-6PM, Thurs 9AM-7PM, Fri 9AM-2:30PM, Sun 11AM-4:30PM; Reference library open to public. Includes Badona Spertus Art Library
Library Holdings: Audio Tapes; Book Volumes 100,000; Cassettes; Exhibition Catalogs; Fiche; Manuscripts; Pamphlets; Periodical Subscriptions 556; Photographs; Records; Slides; Video Tapes
Special Subjects: Judaica

M SWEDISH-AMERICAN MUSEUM ASSOCIATION OF CHICAGO, 5211 N Clark St, Chicago, IL 60640. Tel 773-728-8111; Fax 773-728-8870; Elec Mail museum@samac.org; Internet Home Page Address: www.SwedishAmericanMuseum.org; *Pres* Bob Orelind; *First VPres* Nels Nelson; *Treas* Chris Petersen; *Exec Dir* Kerstin B Lane
Open Tues - Fri 10 AM - 4 PM, Sat & Sun 11 AM - 4 PM; No admis fee, donations appreciated; Estab 1976 to display Swedish arts, crafts, artists, scientists, and artifacts connected with United States, especially Chicago; Material displayed in the four story museum in Andersonville, once a predominantly Swedish area in Chicago; Average Annual Attendance: 40,000; Mem: 1800; dues $5-$500
Income: $500,000 (financed by mem & donations)
Special Subjects: Photography, Prints, Watercolors, Textiles, Costumes, Religious Art, Ceramics, Crafts, Folk Art, Pottery, Woodcarvings, Etchings & Engravings, Decorative Arts, Manuscripts, Portraits, Furniture, Glass, Jewelry, Porcelain, Carpets & Rugs, Historical Material, Coins & Medals, Embroidery, Stained Glass, Painting-Scandinavian
Collections: Artifacts used or made by Swedes, photographs, oils of or by Swedes in United States
Publications: FLAGGAN quarterly
Activities: Classes for adults & children; docent training; lect open to public, 3-4 vis lectrs per year; concerts; gallery talks; tours; awards; individual paintings lent; book traveling exhibitions 2-3 per year; museum shop sells books, magazines, reproductions, prints & gifts; junior museum named Children's Museum of Immigration

M TERRA MUSEUM OF AMERICAN ART, 664 N Michigan Ave, Chicago, IL 60611. Tel 312-664-3939; Fax 312-664-2052; Elec Mail terra@terramuseum.org; Internet Home Page Address: www.terramuseum.org; *Founder* Daniel J Terra; *Dir* Elizabeth Glassman; *Cur Educ* Tammy Steele; *Mgr School & Teacher Progs* Scott Sikkema; *Librn* Janice McNeill; *Coordr, Membership & Vols* Brooke Barrier; *Registrar* Cathy Ricciardelli; *Mgr Retail Opers* Barbara Voss; *Cur* Ellizbeth Kennedy; *VPres Finance* Don Ratner; *Mus Shop Mgr* Barbara Voss; *Marketing* Steven Reardon; *Educ* Elizabeth Whiting; *Preparator* Thomas Skwerski; *Educ* Dori Jacobsohn; *TFA Bd Chmn* Marshall Field
Open Tues 10 AM - 8 PM, Wed - Sat 10 AM - 6 PM, Sun Noon - 5 PM, cl Mon; Admis adults $7, seniors $3.50, students with ID, educators, members & children under 14 free, Tues & Sun free; Estab 1980 to educate the public through the exhibition of the Terra Collection and visiting exhibitions of American paintings; Six floors; museum store located on bottom floor; second through third floors dedicated to traveling exhibits; top floors contain permanent collection; Average Annual Attendance: 100,000; Mem: 2,500; dues $40-$1500
Income: Financed by endowment & mem
Special Subjects: Drawings, Painting-American, Photography, Prints, Sculpture, Portraits
Collections: Permanent collection consists of 19th & 20th century art by such artists are George Caleb Bingham, Winslow Homer, Georgia O'Keeffe & John Singer Sargent
Exhibitions: Rotating exhibs
Publications: Exhibition catalogues
Activities: Classes for adults & children; dramatic programs; docent training; lect open to public, 12 vis lectrs per year; gallery talks; tours; competitions; individual paintings & original objects of art lent for exhibitions with merit; book traveling exhibitions 3-4 per year; museum shop sells books, original art, reproductions, prints, jewelry & pottery; a sister museum, Musee d'Art American Giverny is located at 99 Rue Claude Monet, Giverny 27620, Gasny, France

L Library, 664 N Michigan Ave, Chicago, IL 60611. Tel 312-664-3939; Fax 312-664-2052; Elec Mail terra@terramuseum.org; *Librn* Janice McNeill
Open Mon, Wed & Fri 9 AM - 5 PM; No admis fee for mems; For reference only
Income: Privately financed
Library Holdings: Book Volumes 6000; Exhibition Catalogs; Other Holdings Auction Catalogs; Pamphlets; Periodical Subscriptions 18
Special Subjects: Art History, Painting-American, Watercolors, American Western Art, Printmaking

L **UKRAINIAN NATIONAL MUSEUM & LIBRARY,** 2249 W Superior St, Chicago, IL 60612. Tel 312-421-8020; Elec Mail hankewych@msn.com; *Dir & Pres* Jaroslaw J Hankewych; *Dir* Dr George Hrycelak
Open Thurs - Sun 11 AM - 4 PM; Suggested donation $5; Estab 1954, to collect & preserve Ukrainian cultural heritage; Average Annual Attendance: 6,000; Mem: 200; dues $40; annual meeting in Jan-Feb; sales shop sells forms of folk art
Income: Financed through mem & donations
Library Holdings: Book Volumes 18,000; Cards; Clipping Files; Framed Reproductions; Kodachrome Transparencies; Manuscripts; Memorabilia; Original Art Works; Pamphlets; Periodical Subscriptions 100; Photographs; Sculpture; Slides
Special Subjects: Embroidery, Folk Art, Portraits, Pottery, Tapestries, Textiles, Woodcarvings
Collections: Ukrainian Folk Art
Exhibitions: Chernobyl Nuclear accident in pictures
Activities: Tours; lending collection contains 18,000 books; traveling exhibitions organized & circulated

UNIVERSITY OF CHICAGO

M **Lorado Taft Midway Studios,** Tel 773-753-4821; Fax 773-834-7630; Internet Home Page Address: www.cova.uchicago.edu; *Dir* Robert Peters
Open Mon - Fri 8:30 AM - 4:30 PM, cl Sat & Sun; Studios of Lorado Taft and Associates, a Registered National Historic Landmark; now University of Chicago, Committee on Art & Design
Exhibitions: Graduate MFA & Undergraduate Exhibitions
Activities: Special performances; scholarships offered

M **Smart Museum of Art,** Tel 773-702-0200; Fax 773-702-3121; Elec Mail smart-museum@uchicago.edu; Internet Home Page Address: www.smartmuseum.uchicago.edu; *Admin Asst* June F Bennett; *Chief Preparator & Facilities Mgr* Rudy Bernal; *Sr Cur* Richard Born; *Mgr Educ Progs* Lauren Boylan; *Security Supv* Paul Bryan; *Pub Relations & Mktg Dir* Christine Carrino; *Asst Registrar* Natasha Derrickson; *Pub Services & Events Mgr* Julie Freeney; *Dir* Anthony G Hirschel; *Consulting Cur* Wu Hung
Open Tues, Wed, Fri 10 AM - 4 PM, Thurs 10 AM - 8 PM, Sat - Sun 11 AM- 5 PM; No admis fee; Estab 1974 to assist the teaching & research programs of the University of Chicago by maintaining a permanent collection & presenting exhibitions & symposia of scholarly & general interest; Gallery designed by E L Barnes; exhibit space covers 9500 sq ft & also contains print & drawing study room, Elden Sculpture Garden; Average Annual Attendance: 60,000; Mem: 650; dues individual $40
Income: Financed by mem, university, special funds, corporations, foundations & government grants
Special Subjects: Drawings, Painting-American, Photography, Prints, Sculpture, Decorative Arts, Painting-European, Oriental Art, Antiquities-Greek, Antiquities-Roman
Collections: American, Ancient, Baroque, decorative arts, drawings, Medieval, Modern European, Oriental & Renaissance paintings, photographs, prints, sculpture
Activities: Classes for adults & children; docent training; lect open to public, 5-6 vis lectrs per year; concerts; gallery talks; tours; individual paintings & original objects of art lent to professional art museums; book traveling exhibitions 1-3 per year; originate traveling exhibitions to professional art museums; sales shop sells books, post cards, posters, jewelry & photographs

M **Oriental Institute Museum,** Tel 773-702-9514; Fax 773-702-9853; Elec Mail oi-museum@uchicago.edu; Internet Home Page Address: www.oi.uchicago.edu; *Registrar* Raymond Tindel; *Archivist* John Larson; *Museum Dir* Karen L Wilson; *Head of Conservation* Laura D Alissandro; *Head of Museum Educ* Carole Krucoff
Open Tues 10 AM-4 PM, Wed 10 AM-8:30 PM, Thurs-Sat 10 AM-4 PM, Sun Noon-4 PM, cl Mon; No admis fee; Estab 1894 as a mus of antiquities excavated from Egypt, Mesopotamia, Assyria, Syria, Palestine, Persia, Anatolia & Nubia, dating from 7000 years ago until the 18th Century AD; Egyptian and Persian Galleries open; Average Annual Attendance: 62,000; Mem: 2650; dues $30 & up
Income: Financed by parent institution, admis donations, federal, state grants & proceeds from sales
Special Subjects: Architecture, Photography, Sculpture, Watercolors, Bronzes, Archaeology, Textiles, Costumes, Religious Art, Ceramics, Pottery, Manuscripts, Dolls, Furniture, Glass, Jewelry, Historical Material, Ivory, Dioramas, Medieval Art, Antiquities-Persian, Islamic Art, Antiquities-Egyptian, Gold, Leather, Antiquities-Assyrian
Collections: Ancient Near Eastern antiquities from pre-historic times to the beginning of the present era plus some Islamic artifacts; Egypt: colossal statue of King Tut, mummies; Iraq: Assyrian winged human-headed bull (40 tons); Mesopotamia temple & house interior, reconstructions, sculpture, jewelry; Iran: Persepolis bull; column & capital; Palestine: Megiddo ivories & horned alter
Publications: Annual report; News & Notes, monthly; museum guidebook; brochures
Activities: Classes for adults & children; dramatic programs; docent training; family programs; lect open to public, 8-10 vis lectrs per year; gallery talks; tours; competitions with awards; original objects of art lent to museums & institutions; lending collection contains kodachromes, original art works & mini museum boxes; book traveling exhibitions; museum shop sells books, original art, reproductions, prints, slides, items of jewelry, clothing, household furnishings from the Near East
—**Oriental Institute Research Archives,** Tel 773-702-9537; Fax 773-702-9853; Elec Mail oi-library@uchicago.edu; Internet Home Page Address: www.oi.uchicago.edu; *Libm* Charles E Jones
Open daily 10 AM-4 PM by appointment; Circ Non-circulating; Open to staff, students & members for reference
Library Holdings: Audio Tapes; Book Volumes 38,000; Cards; Cassettes; Clipping Files; Exhibition Catalogs; Fiche; Kodachrome Transparencies; Lantern Slides; Manuscripts; Memorabilia; Motion Pictures; Pamphlets; Periodical Subscriptions 500; Photographs; Reels; Slides
Special Subjects: Antiquities-Greek, Anthropology, Antiquities-Assyrian, Antiquities-Byzantine, Antiquities-Egyptian, Antiquities-Persian, Archaeology, Asian Art, Historical Material, History of Art & Archaeology, Islamic Art, Textiles

L **Visual Resources Collection,** Tel 773-702-0261; Fax 773-702-5901; Internet

Home Page Address: www.humanities.uchicago.eduhumanitiesartslide.htmlartfulprojectslide; *Cur* John L Butler-Ludwig
Open Mon - Fri 9 AM - 5 PM, cl Sat & Sun; Estab 1938; Circ Restricted circulation-faculty & students; For reference only
Library Holdings: Lantern Slides 88,000; Other Holdings 500,000; Photographs 740,000; Slides 386,000

L **Max Epstein Archive,** Tel 773-702-7080; Fax 773-702-5901; *Cur* Meg Klinkow
Open Mon - Fri 9 AM - 5 PM, cl Sat & Sun; Estab 1938; Circ Non-circulating; For reference only
Income: Financed by gifts & donations
Library Holdings: Book Volumes 55,500; Other Holdings Mounted photographs of art; catalogued & mounted photographs added annually 8000; auction sales catalogs, Union Catalog of Art Books in Chicago
Collections: Photographs of architecture, sculpture, painting, drawing & decorative arts illustrating Far Eastern, South Asian & Western art history; illustrated Bartsch Catalogue; DIAL Index; Marburger Index; Papal Medals Collection; Courtauld Institute Illustrated Archive; Courtauld Photo Survey; Armenia Architecture; Dunlap Society Architecture

M **UNIVERSITY OF ILLINOIS AT CHICAGO,** Gallery 400, Art & Design Hall (MC034), 400 S Peoria St Chicago, IL 60607-7034. Tel 312-996-6114; Fax 312-355-3444; Internet Home Page Address: gallery400.aa.uic.edu; *Dir* Lorelei Stewart; *Asst Dir* Anthony Elms
Open Tues - Fri 10 AM - 6 PM, Sat Noon - 6 PM; No admis fee; Estab 1983; 2,900 square ft loft exhibition space & additional 1300 square ft hall for lectures, films & video screenings; Average Annual Attendance: 10,000
Income: $250,000 (financed by state & federal grants, college of A&A, private donations & foundations)
Library Holdings: DVDs; Exhibition Catalogs; Periodical Subscriptions; Video Tapes
Special Subjects: Photography, Prints, Sculpture, Posters
Publications: The Alchemy of Comedy...Stupid by Edgar Arceneaux
Activities: Lect open to public, 18 vis lectrs per year; gallery talks; tours; book traveling exhibitions average 1 every 2 yr; originate traveling exhibitions 1 per year, Univ galleries, artist organizations

DANVILLE

M **VERMILION COUNTY MUSEUM SOCIETY,** 116 N Gilbert St, Danville, IL 61832. Tel 217-442-2922; Fax 217-442-2001; Elec Mail sosricht@aol.com; Internet Home Page Address: www.vermilioncountymuseum.org; *Dir* Susan Richter; *Bookkeeper* Wendy Wilder; *Cur* Kathy Darding
Open Tues - Sat 10 AM - 5 PM, Sun 1 - 5 PM, cl Mon, Thanksgiving & Christmas; Admis 14 yrs & older $2.50, under 14 yrs free, school & scout groups free; Estab 1964; in 1855 doctor's residence and courthouse replica building; Average Annual Attendance: 5,500; Mem: 1,001; dues life $250, patron $75, business $100, organization & family $15, individual $25, student & seniors $15
Income: Financed by endowment fund, mem.
Library Holdings: Book Volumes; Clipping Files; Manuscripts; Maps; Original Documents; Pamphlets; Periodical Subscriptions; Photographs; Prints; Records; Slides; Video Tapes
Special Subjects: American Indian Art, Decorative Arts, Manuscripts, Furniture, Historical Material, Maps, Restorations, Period Rooms
Collections: Costumes; decorative arts; graphics; historical material; paintings; sculpture
Publications: Heritage, quarterly magazine
Activities: Classes for children; dramatic programs; lect open to public, 2 vis lectrs per year; tours; children competitions; museum shop sells books, magazines, original art, prints & handmade items

L **Library,** 116 N Gilbert St, Danville, IL 61832. Tel 217-442-2922; Fax 217-442-2001; Internet Home Page Address: www.vermilioncountymuseum.org; *Mus Shop Mgr* Susan E Richter; *VPres* Donald Richter
Open Tues-Sat 10AM-5PM, Sun 1-5PM, cl Mon, Thanksgiving, Christmas; Open to the public for reference
Income: Financed by endowment fund
Library Holdings: Book Volumes 400; Clipping Files; Photographs; Slides; Video Tapes
Collections: Medical equipment, furniture, photographs, arrowheads
Publications: The Heritage of Vermilion County, quarterly; bimonthly newsletter

DE KALB

M **NORTHERN ILLINOIS UNIVERSITY,** NIU Art Museum, Altgeld Hall, 2nd Flr, De Kalb, IL 60115. Tel 815-753-1936; *Dir* Peggy M Doherty
Open Mon - Fri 10 AM - 5 PM, Thurs 10 AM - 7 PM, Sat Noon - 4 PM; No admis fee; Estab 1970; Main Gallery is 6000 sq ft; Average Annual Attendance: 50,000
Income: Financed by state appropriation & grants from public agencies & private foundations
Special Subjects: Painting-American, Watercolors, American Indian Art, Woodcuts, Etchings & Engravings, Asian Art
Collections: Contemporary & Modern paintings, prints, sculptures, & photographs, Burmese Art; Native American Art
Activities: Lect open to public; gallery talks; tours; original objects of art lent to accredited museums; book traveling exhibitions

L **The University Libraries,** De Kalb, IL 60115. Tel 815-753-0616; *Arts Librn* Charles Larry
Open Mon - Thurs 7:30 AM - 10 PM, Sat 9 AM - 10 PM, Sun 1 PM - 2 AM; Estab 1977 to provide reference service & develop the collection
Library Holdings: Book Volumes 47,000; Cards; Exhibition Catalogs; Fiche; Motion Pictures; Other Holdings Art book titles 975; Rare bks 250; Periodical Subscriptions 164; Reels; Slides; Video Tapes

DECATUR

M MILLIKIN UNIVERSITY, Perkinson Gallery, Kirkland Fine Arts Ctr, 1184 W Main St Decatur, IL 62522. Tel 217-424-6227; Fax 217-424-3993; Internet Home Page Address: www.millikin.edu; *Dir* Charles Rogers; *Dir Gall* Jim Schitinger
Open Mon - Fri Noon - 5 PM; No admis fee; Estab 1970; Gallery has 3200 sq ft & 224 running ft of wall space
Income: Financed by university appropriation
Special Subjects: Drawings, Painting-American, Prints, Sculpture, Watercolors
Collections: Drawings; painting; prints; sculpture; watercolors
Exhibitions: (2000-01) Works From the Permanent Collection. (2001) Annual Student Exhibition; Annual Senior Group Exhibition; Millikin National Works on Paper.; (2001-02) Works from the Permanent Collection
Publications: Monthly show announcements
Activities: Lect; guided tours; gallery talks

EDWARDSVILLE

L SOUTHERN ILLINOIS UNIVERSITY, Lovejoy Library, Fine Arts Dept, PO Box 1063 Edwardsville, IL 62026. Tel 618-650-2000; Fax 618-650-2381; *Friends of Lovejoy Librn* Donna Bardon
Open Mon - Thurs 8 AM - 11:30 PM, Fri 8 AM - 9 PM, Sat 9 AM - 5 PM, Sun 1 - 9 PM; Estab 1957, as a source for general University undergraduate & graduate instruction, & faculty research
Library Holdings: Book Volumes 500,000; Fiche; Motion Pictures; Other Holdings Illustrated sheet music covers; Periodical Subscriptions 6000; Records; Reels; Slides; Video Tapes
Special Subjects: Art History, Calligraphy, Archaeology, American Western Art, Bronzes, Advertising Design, Art Education, Asian Art, American Indian Art, Anthropology, Aesthetics, Afro-American Art, Bookplates & Bindings, Carpets & Rugs, Architecture
Exhibitions: Louis Sullivan Collection of Terra Cotta
Activities: Photography contest; tours; scholarships

ELMHURST

M ELMHURST ART MUSEUM, PO Box 23 Elmhurst, IL 60126; 150 Cottage Hill Ave Elmhurst, IL 60126. Tel 630-834-0202; Fax 630-834-0234; Elec Mail info@elmhurstartmuseum.org; Internet Home Page Address: www.elmhurstartmuseum.org; *Dir* D Neil Bremer; *Cur* Melissa Ganje; *Controller* Heather Pastore; *Asst Dir* Stephanie Grow; *Devel & Marketing Coordr* April Arnold; *Vistor Svcs Coordr* Jeff Francik; *Educ Coordr* Amy Janken
Open Tues, Thurs & Sat 10 AM - 4 PM, Wed 1 - 8 PM, Fri & Sun 1 - 4 PM; Admis adult $4, seniors $3, students $2, children under 12 free, members & Tues free; Opened 1997 to exhibit contemporary art, Chicago vicinity to national; Three exhibition galleries, 1 artists' guild gallery & entrance gallery; Average Annual Attendance: 3,000; Mem: 1200; dues individual $30 for 1 yr, $55 for 2 yr
Income: Financed by endowment, mem, corporate sponsorships, city & state appropriation
Special Subjects: Architecture, Drawings, Painting-American, Prints, Sculpture, Watercolors, American Western Art, Ceramics, Folk Art, Woodcarvings, Woodcuts, Etchings & Engravings, Afro-American Art, Portraits, Asian Art, Painting-Dutch, Painting-French, Historical Material, Ivory, Juvenile Art
Collections: Contemporary Art-American & Chicago vicinity
Exhibitions: Annual competitions; children's exhibits; one person & group shows; permanent collections; traveling exhibits
Activities: Classes for adults & children; docent training; lect open to public, 10-12 vis lectrs per year; concerts; gallery talks; tours; competitions with awards; individual paintings & objects of art lent to other museums & the Federal Reserve; book traveling exhibitions 2-3 per year; museum shop sells books, original art, reproductions, prints & gift items

M LIZZADRO MUSEUM OF LAPIDARY ART, 220 Cottage Hill Ave, Elmhurst, IL 60126. Tel 630-833-1616; Internet Home Page Address: www.lizzadromuseum.org; *Dir* Dorothy Asher; *Exec Dir* John S Lizzadro
Open Tues - Sat 10 AM - 5 PM, Sun 1 - 5 PM, cl Mon; Admis adults $4, senior citizens $3, students $2, ages 7-12 yrs $1, under 7 free, no charge on Fri; Estab 1962 to promote interest in the lapidary arts & the study & collecting of minerals & fossils; Main exhibit area contains hardstone carvings, gemstone materials, minerals; lower level contains earth science exhibits, gift shop; Average Annual Attendance: 30,000; Mem: 350; dues $30 per yr
Income: Financed by endowment
Special Subjects: Jade, Oriental Art, Asian Art, Ivory, Dioramas, Mosaics
Collections: Hardstone Carving Collection
Exhibitions: Educational exhibits, push button exhibits, rotating special exhibits
Publications: Annual
Activities: Lect open to the public, 12 vis lectrs per year; educational films; tours; demonstrations; sales shop sells books, jewelry, magazines, hardstone & gemstone souvenirs

ELSAH

M PRINCIPIA COLLEGE, School of Nations Museum, Elsah, IL 62028. Tel 618-374-2131, Exten 5238; Fax 618-374-5122; *Cur* Bonnie Gibbs
Open Tues & Fri by appointment only
Special Subjects: American Indian Art, Textiles, Ceramics, Crafts, Decorative Arts, Dolls, Glass, Asian Art, Metalwork
Collections: American Indian collection including baskets, bead work, blankets, leather, pottery, quill work and silver; Asian art collection includes arts and crafts, ceramics, textiles from China, Japan and Southeast Asia; European collections include glass, metals, snuff boxes, textiles and wood; costumes and dolls from around the world
Exhibitions: Changing exhibits on campus locations; permanent exhibits in School of Nations lower floor

Activities: Special programs offered throughout the year; objects available for individual study

EVANSTON

L C G JUNG INSTITUTE OF CHICAGO, 1567 Maple Ave, Evanston, IL 60201. Tel 847-475-4848; Fax 847-475-4970; *Asst Dir & Ed* Mary Nolan; *Exhibit Coordr* Barbara Zaretsky; *Librn & AV Production Mgr* Mark Swanson; *Exec Dir* Peter Mudd
Open Mon - Fri 10 AM - 5 PM, Sat 10 AM - 4 PM; No admis fee; Estab 1965; For reference only
Library Holdings: Audio Tapes; Book Volumes 4000; Clipping Files; Exhibition Catalogs; Manuscripts; Motion Pictures; Pamphlets; Reproductions; Slides; Video Tapes
Special Subjects: Folk Art, Film, Islamic Art, Pre-Columbian Art, History of Art & Archaeology, Judaica, Archaeology, Ethnology, Asian Art, American Indian Art, Anthropology, Oriental Art, Religious Art
Collections: Archive for Research in Archetypal Symbolism (ARAS), photographs & slides
Publications: Transformation, quarterly

A EVANSTON ART CENTER, 2603 Sheridan Rd, Evanston, IL 60201. Tel 847-475-5300; Fax 847-475-5330; Internet Home Page Address: www.evanstonartcenter.org; *Exec Dir* Peter Gordon; *Exec Dir* Brooke Marler; *VPres* Alice Kreiman
Open Mon-Sat 10AM-4PM, Mon-Thurs 7-10PM, Sun 1-4PM; No admis fee; Estab 1929 as a community visual arts center with exhibits, instructions & programs; Focuses primarily on changing contemporary arts exhibitions with emphasis on emerging & under-recognized Midwest artists; Average Annual Attendance: 35,000; Mem: 1800; dues $30, annual meeting in Aug
Income: Financed by state & city arts councils & mem
Exhibitions: Primarily artists of the Midwest, all media
Publications: Concentrics, quarterly; exhibition catalogs
Activities: Classes for adults & children, outreach programs, teaching cert renewal; lectr

M EVANSTON HISTORICAL SOCIETY, Charles Gates Dawes House, 225 Greenwood St, Evanston, IL 60201. Tel 847-475-3410; Fax 847-475-3599; Elec Mail evanstonhs@nwu.edu; Elec Mail evanstonhs@northwestern.edu; Internet Home Page Address: www.evanstonhistorical.org; *Cur* Eden Juron Pearlman; *Develop Officer* Kim Olson-Clark; *Educ Officer* Leslie Goddard
Open Thurs - Sun 1 - 5 PM; Admis $5, seniors & children $3; Estab 1898 to collect, preserve, exhibit & interpret Evanston's history; Average Annual Attendance: 4,000; Mem: 1,050; dues $25-$500; annual meeting in June
Income: Financed by mem & private donations
Special Subjects: Architecture, Painting-American, Photography, Sculpture, American Indian Art, Textiles, Costumes, Ceramics, Crafts, Landscapes, Decorative Arts, Manuscripts, Portraits, Posters, Dolls, Furniture, Glass, Jewelry, Porcelain, Silver, Metalwork, Carpets & Rugs, Historical Material, Maps, Dioramas, Period Rooms, Laces, Stained Glass, Military Art
Collections: Historical collections reflecting the history of Evanston & its people, especially since the mid 1800s, including costumes & archival material
Exhibitions: Charles Gates Dawes House permanent exhibit; other rotating exhibits year round; Evanston Takles the Woman Question, the Story of Evanston women who influenced the National Women's Movement; The Sick Can't Wait, the story of Evanston Community Hospital; Your Presence Is Requested, the Story of African-American Social Organization
Publications: TimeLines, mem newsletter, quarterly; annual report
Activities: Docent training; school outreach & in-house educational programs; lect open to public; gallery talks; tours; individual paintings & original objects of art lent to other cultural institutions; lending collection contains 60 paintings & 30 sculptures; originate traveling exhibitions; museum shop sells books & museum & Victorian related gifts

NORTHWESTERN UNIVERSITY

M Mary & Leigh Block Gallery, Tel 847-491-4000; Fax 847-491-2261; Elec Mail d-mickenberg@northwestern.edu; Internet Home Page Address: www.blockmuseum.northwestern.edu; *Public Relations & Develop* Mary Stewart; *Dir* David Mickenberg; *Asst Cur* Debora Wood; *Dir Develop* Ann Murray
Open Tues & Wed Noon - 5 PM, Thurs - Sun Noon - 8 PM; No admis fee; Estab 1980, to serve the university, Chicago & North Shore communities; Average Annual Attendance: 30,000; Mem: 500; dues $25-$1000
Income: Financed by mem, college, grants
Collections: 4,000 works of art, 20th & 21st centuries, including Renaissance & Baroque
Exhibitions: Three to four rotating exhibits per yr
Publications: Exhibition catalogs
Activities: Lect open to public; concerts; gallery talks; tours; book traveling exhibitions; originate traveling exhibitions circulated through other university galleries & museums; sales shop sells catalogs & posters

L Art Collection, University Library, Tel 847-491-7484, 491-6471; Fax 847-467-7899; Elec Mail r_clement@northestern.edu; Internet Home Page Address: www.library.northwestern.edu/art; *Head Art Coll* Russell T Clement
Open Mon - Thurs 8:30 AM - 10 PM, Fri & Sat 8:30 AM - 5 PM, Sun 1 - 10 PM; No admis fee; Estab 1970 as a separate library collection. Serves curriculum & research needs of the Art History and Art Theory & Practice departments
Income: Financed through the university & endowment funds
Library Holdings: Book Volumes 110,000; Exhibition Catalogs
Special Subjects: Art History, Illustration, Photography, Etchings & Engravings, Graphic Arts, Painting-American, Painting-Dutch, Painting-Flemish, Painting-French, Painting-German, Painting-Italian, Prints, Sculpture, Painting-European, History of Art & Archaeology, Architecture

FREEPORT

M FREEPORT ARTS CENTER, 121 N Harlem, Freeport, IL 61032. Tel 815-235-9755; Fax 815-235-6015; Elec Mail artscenter@aeroinc.net; *Office Mgr* Barb Noble; *Dir* Stephen H. Schwartz; *VPres* Jim Lee
Open Tues 10 AM - 6 PM, Wed - Sun 10 AM - 5 PM, cl Mon; Admis adults $3, seniors & students $2; Estab 1975 to house W T Rawleigh Art Collection & to

promote the arts in the region; Five permanent galleries & three galleries featuring temporary exhibitions; Average Annual Attendance: 18,000; Mem: 775; dues $15-$5000; annual meeting in May
Income: $130,000 (financed by endowment, mem, grants & corporate support)
Special Subjects: Painting-American, Prints, Sculpture, American Indian Art, African Art, Ethnology, Pre-Columbian Art, Textiles, Primitive art, Etchings & Engravings, Painting-European, Jade, Asian Art, Painting-Flemish, Laces, Painting-Italian, Antiquities-Egyptian, Antiquities-Greek, Antiquities-Roman, Antiquities-Etruscan
Collections: Native American pottery, basketry & beadwork; art from Madgascar; European 19th century oil paintings & sculpture; antiquities from Egypt, Greece, Rome & MesoAmerica; Oriental art; 20th century American prints & paintings; Oceanic Cultures
Exhibitions: The Vietnam Experience, Embroidery Guild of America
Activities: Classes for adults & children; docent training; lect open to public; gallery talks; tours; competitions; scholarships offered; exten dept serves Ogle, Carroll, Jo Daviess Counties; individual paintings & original objects of art lent to bona fide galleries with full insurance; lending collection contains paintings & sculptures; book traveling exhibitions; originate traveling exhibtiions organized & circulated
L **Library,** 121 N Harlem Ave, Freeport, IL 61032. Tel 815-235-9755; Fax 815-235-6015; Elec Mail arts@aeroinc.net; *Dir* Jennifer Kirker; *Ofc Mgr* Patricia Pasch; *Pres (Board)* John Graff; *Coll Mgr* Jessica Caddell
Tues 10AM-6PM, Wed-Fri 10AM-5PM, Sat & Sun Noon - 5 PM, cl Mon & holidays; Admis free; Estab 1975; Open to members & pub for research & reference; Average Annual Attendance: 18,000; Mem: 750
Income: mem, gifts
Library Holdings: Book Volumes 500; Periodical Subscriptions 10
Special Subjects: Collages, Photography, Drawings, Etchings & Engravings, Islamic Art, Painting-American, Painting-British, Pre-Columbian Art, Sculpture, Historical Material, Ceramics, Latin American Art, Ethnology, Bronzes, Asian Art, American Indian Art, Porcelain, Eskimo Art, Southwestern Art, Ivory, Jade, Glass, Afro-American Art, Antiquities-Oriental, Antiquities-Persian, Embroidery, Enamels, Gold, Jewelry, Oriental Art, Pottery, Textiles, Landscapes, Antiquities-Byzantine, Antiquities-Egyptian, Antiquities-Etruscan, Antiquities-Greek, Reproductions, Flasks & Bottles, Laces, Pottery
Collections: 19th century European paintings & sculptures; Native American; Antiquities; Asian decorative arts; Ethnographic; Contemporary American; Textiles
Publications: Annual report; bimonthly newsletter
Activities: Classes for adults & children; docent training; family art workshops; lect open to pub; concerts; gallery talks; tours; museum shop sells books, original art & note cards

GALENA

M **CHICAGO ATHENAEUM,** Museum of Architecture & Design, 601 S Prospect St, Galena, IL 61036. Tel 847-777-4444; Fax 815-777-2471; Elec Mail tcamuseum@netscape.net; Internet Home Page Address: www.chi-athenaeum.org; *Dir & Pres* Christian K Narkiewicz-Laine; *Dir of Design* Timothy A Patula; *Dir Exhib Installation & Architect* Alexander Kozionnyi; *Chmn* Neil Kozokoff; *VPres* Ioannis Karalias; *Secy* Belinda Shastal
Temporarily closed; Admis non mems $3, seniors & students $2, mems are free; Estab 1988; dedicated to all areas in the art of design - architecture, industrial & product design, graphics & urban planning; One floor of temporary exhibits; Average Annual Attendance: 500,000; Mem: 2500; dues $50-$250
Income: Financed by mem, grants & pvt & pub funding
Special Subjects: Architecture, Graphics, Photography, Textiles, Decorative Arts, Posters, Furniture, Glass
Collections: Architectural Drawings & Models, International Collection; Design-Chicago (1910-1960) Collection; Design-International Product & Graphic Collection; Japanese Graphic Design Collection; Contemporary Art Collection; Contemporary Fabric & Textile
Exhibitions: Large Scale Pub Sculpture; Landmark Chicago; American Architectural awards, Good Design
Activities: Seminars; lect open to public, 15 vis lectrs per year; competitions; book traveling exhibitions 8 per year; originate traveling exhibitions 6 per year; museum shop sells glass, toys, jewelry, fashion, book & international high design

GALESBURG

A **GALESBURG CIVIC ART CENTER,** 114 E Main, Galesburg, IL 61401. Tel 309-342-7415; Elec Mail artcenter@misslink.net; Internet Home Page Address: www.gallatinriver.net; *Office Mgr* Angela Flanders; *Dir* Julie Layer; *Archivist* Joanne Goudie; *Develop & Mem* Martha Francois; *VPres* Cyd Pelotte; *Office Mgr* Shelly Goddin; *CEO* Heather L Norman
Open Tues - Fri 10:30 AM - 4:30 PM, Sat 10:30 AM - 3 PM, cl Sun & Mon; No admis fee; Estab 1923 as a non-profit organization for the furtherance of art; The main gallery has about 100 running feet of wall space for the hanging of exhibits. The sales-rental gallery runs on a commission basis & is open to professional artists as a place to sell their work under a consignment agreement; Average Annual Attendance: 20,000; Mem: 750; dues begin at $18; annual meeting second Wed in June
Income: Financed by mem & grants
Collections: Regional/national artists in a variety of media (change monthly); Art-in-the-Park annual fair
Exhibitions: GALEX - national juried competition all media
Publications: The Artifacts, newsletter
Activities: Classes for adults & children; gallery talks; tours; competitions with awards; lending collection contains original art works, paintings, photographs & sculpture; museum shop sells original art, prints

GREENVILLE

M **GREENVILLE COLLEGE,** Richard W Bock Sculpture Collection, Almira College House, College Ave Greenville, IL 62246. Tel 618-664-1840, ext 6724; Internet Home Page Address: www.greenville.edu; *Dir & Cur* Sharon Davis
Open Wed 1-4PM, Fri 1-5PM, Sat 10AM-2PM & by appointment, cl summer & holidays; No admis fee, donations accepted; Estab 1975 to display an extensive

collection of the life work of the American sculptor in a restored home of the mid-19th century period; Five large rooms and two floors have approximately 1800 square ft of exhibition space; Average Annual Attendance: 2,500
Income: Financed by endowment, college appropriation, gifts and donations
Special Subjects: Drawings, Painting-American, Sculpture, Posters, Furniture, Oriental Art
Collections: Furniture and furnishings of the 1850-1875 era; late 19th and early 20th century drawing, painting and sculpture; Frank Lloyd Wright artifacts, designs and drawings
Publications: Exhibit catalog; general museum brochures
Activities: Lect open to the public, 1-2 vis lectr per year; gallery talks; individual paintings and original objects of art lent to museums only; lending collection contains original art works, paintings, photographs, sculpture and drawings; traveling exhibitions organized and circulated; museum shop sells books, magazines
L **The Richard W Bock Sculpture Collection & Art Library,** College Ave Greenville, IL 62246. Tel 618-664-1840, ext 6724; Internet Home Page Address: www.greenville.edu; *Librn* Sharon Davis
Open by appt only; For reference only, students & academia only
Library Holdings: Book Volumes 1000; Exhibition Catalogs; Memorabilia; Records

JACKSONVILLE

M **ART ASSOCIATION OF JACKSONVILLE,** David Strawn Art Gallery, 331 W College, PO Box 1213 Jacksonville, IL 62651. Tel 217-243-9390; Elec Mail strawnartgallery@earthlink.net; *Dir* Kelly M Gross; *Pres* Sue Freeman
Open Sept - May, Tues - Sat 4 - 6 PM, Sun 1 - 3 PM; No admis fee; Estab 1873, endowed 1915, to serve the community by offering monthly shows of visual arts and weekly classes in a variety of media. The two main rooms house the monthly exhibitions and a third large room houses a collection of Pre-Columbian pottery; The Gallery is in a large building, previously a private home; Average Annual Attendance: 1,800; Mem: 470; dues $15 & up; annual meeting July
Income: Financed by endowment & mem
Special Subjects: Pre-Columbian Art, Pottery
Collections: Pre-Columbian Pottery; pottery discovered in the Mississippi Valley
Exhibitions: (9/9/2006-9/24/2006) Antique Maps of Illinois, John Power; (10/7/2006-10/29/2006) American Exploration, AG Edwards Collection; (11/4/2006-11/22/2006) Furniture, Sculpture, Ceramics & Metalworks, Bill Heyduck & Co; (12/2/2006-12/22/2006) Student Watercolor Show; (1/6/2007-1/28/2007) Watercolor/Oil Paintings, Joel Smith; (2/3/2007-2/25/2007) Barbara Paraday - Mixed Media; (3/3/2007-3/25/2007) Illustrations - Youth Art Month, Steven Todd; (4/7/2007-4/29/2007) Photographs - China & Tibet, John & Jonathan Galbreath; (5/5/2007-5/27/2007) Mixed Media, Br Mel Meyer
Activities: Classes for adults & children, art educ; lect workshops open to public, 9 vis lectr per yr, 9 gallery talks per season, tours on demand, educ schols

JOLIET

M **JOLIET JUNIOR COLLEGE,** Laura A Sprague Art Gallery, J Bldg, 1215 Houbolt Rd Joliet, IL 60436-8938. Tel 815-729-9020, Ext 2423, 2223; Fax 815-744-5507; Internet Home Page Address: www.jjc.cc.il.us; *Dir Gallery* Joe B Milosevich
Open Mon - Fri, 8 AM - 8 PM; No admis fee; Estab 1978, to present exhibitions related to academic programs, the college & the community; Gallery, approx 20 x 25 ft; located on second floor of Spicer-Brown Hall
Income: Financed by college appropriations
Collections: Permanent collection of student work, annual
Activities: Lect open to public, 2-3 vis lectrs per year; gallery talks; tours; sponsor student competitions with awards

LAKE FOREST

L **LAKE FOREST LIBRARY,** Fine Arts Dept, 360 E Deerpath, Lake Forest, IL 60045. Tel 847-234-0636; Fax 847-234-1453; Internet Home Page Address: lfkhome.northstarnet.org/library; *Adult Svcs Coordr* Felicia Song; *Graphic Artist* Patricia Kreischer; *Admin Librn* Kaye Grabbe
Open Mon - Thurs 9 AM - 9 PM, Fri 9 AM - 5 PM, Sat 9 AM - 5 PM, Sun 1 - 5 PM (Sept - May); No admis fee; Estab 1898 to make accessible to the residents of the city, books & other resources & services for educ, information & recreation; Circ 400,000; Gallery exhibits small local shows
Income: $1,799,718 (financed by city 93% & state 1% appropriations & local library generated income 6%)
Collections: Folk art; painting; landscape architecture
Publications: Lake Forest Library Newsletter, four times per year
Activities: Annual 10-12 $5,000 student art awards

LE ROY

L **J T & E J CRUMBAUGH MEMORIAL PUBLIC LIBRARY,** 405 E Center, PO Box 129 Le Roy, IL 61752-0129. Tel 309-962-3911; Elec Mail crumbaughlibrary@yahoo.com; *Librn* Lois Evans; *Circ* Fae Morris
Open Mon - Sat 10 AM - 5 PM; No admis fee; Estab 1927
Library Holdings: Book Volumes 14,000; Other Holdings Genealogy Files 655; Local History Scrapbooks 72; Periodical Subscriptions 50; Reels 59
Special Subjects: Historical Material
Collections: Books; genealogy, local history
Publications: JT&EJ Crumbaugh Spiritualist Church & Memorial Library - 1998 (updated every 10 years); Tracing Your Roots (updated every 2 years)
Activities: Classes for children; summer reading program; holiday story times & programs

LOMBARD

L HELEN M PLUM MEMORIAL LIBRARY, 110 W Maple St, Lombard, IL 60148. Tel 630-627-0316; Fax 630-627-0336; Internet Home Page Address: www.plum.lib.il.us; *Adult Servs* Donna Slyfield; *Dir* Robert A Harris
Open Mon - Fri 9 AM - 9 PM, Sat 9 AM - 5 PM, Sun 1 -5 PM; No admis fee; Estab as a pub library
Income: $2,243,693 (financed by local government)
Purchases: $434,451
Library Holdings: Audio Tapes; Book Volumes 210,815; CD-ROMs; Cassettes; Compact Disks; DVDs; Fiche; Filmstrips; Micro Print; Pamphlets; Periodical Subscriptions 358; Prints; Records; Sculpture; Slides; Video Tapes
Special Subjects: Art History, Folk Art, Decorative Arts, Painting-American, Crafts, Handicrafts
Publications: Brochure, annual
Activities: Lect open to public; original objects of art lent to public

MACOMB

M WESTERN ILLINOIS UNIVERSITY, Western Illinos University Art Gallery, 1 University Circle Macomb, IL 61455. Tel 309-298-1587; Fax 309-298-2400; Elec Mail JR-Graham@wiu.edu; Internet Home Page Address: www.wiu.edu/artgallery; *Pres* Alvin Goldfarb; *Cur Exhib* John R Graham
Open Mon - Fri 9 AM - 4 PM & Tues 6 - 8 PM; No admis fee; Estab 1945 to present art as an aesthetic and teaching aid; Building has three galleries with 500 running ft; Average Annual Attendance: 9,000
Income: Financed through state appropriation
Special Subjects: Painting-American, Prints, Drawings, Graphics, Sculpture, Watercolors, Ceramics, Woodcuts
Collections: WPA & 20th Century: Prints, Drawing, Paintings & Ceramics; Old Masters Prints
Activities: Classes for adults; lect open to public, 8 vis lectrs per year; gallery talks; tours; competitions with awards; individual paintings lent; lending collection contains 100 paintings; traveling exhibitions organized & circulated

MOLINE

C DEERE & COMPANY, One John Deere Pl, Moline, IL 61265. Tel 309-765-8000; Fax 309-765-4735; *Coll Cur* Lisa Spurgeon
Estab 1964 to complement the offices designed by Eero Saarinen & Kevin Roche; to provide opportunities for employees & visitors to view & enjoy a wide variety of art pieces from many parts of the world; Collection displayed at Deere & Company Headquarters
Collections: Artifacts, paintings, prints, sculpture & tapestries from over 25 countries
Activities: Concerts; tours

MOUNT VERNON

M CEDARHURST CENTER FOR THE ARTS, Mitchell Museum, Richview Rd, PO Box 923 Mount Vernon, IL 62864. Tel 618-242-1236; Fax 618-242-9530; Elec Mail mitchellmuseum@cedarhurst.org; Internet Home Page Address: www.cedarhurst.org; *Dir Visual Arts* Kevin Sharp; *Exec Dir* Sharon Bradham; *Dir Develop* Cindy Hoard; *Dir Operations* Greg Hilliard; *Dir Educ* Jennifer Sarver; *Mus Shop Mgr* Beth McDonald; *Dir Craft Fair* Sheila Jones; *Dir Admin* Sarah Lou Bicknell
Open Tues - Sat 10 AM - 5 PM, Sun 1 - 5 PM, cl Mon & national holidays; No admis fee; Estab 1973 to present exhibitions of paintings, sculpture, graphic arts, architecture & design representing contemporary art trends; to provide continued learning & expanded educ; Marble faced structure houses two galleries for exhibition, 3000 sq ft & 1300 sq ft; flexible designs; an administrative gallery for highlighting regional artists; Average Annual Attendance: 60,000; Mem: 800; dues $40; annual meeting in Nov
Income: Financed by endowment & mem
Special Subjects: Graphics, Painting-American, Sculpture, Woodcarvings, Glass, Jade, Silver, Ivory
Collections: Paintings by late 19th & early 20th century American artists; some drawings & small sculptures; silver, small stone, wood & ivory carvings; jade; small bronzes; 85 acre Cedarhurst Sculpture Park
Exhibitions: Changing exhibits; Southern Illinois Artists Open Competition
Publications: Form Beyond Function: Recent Sculpture by North American Metalsmiths; quarterly newsletter; Recent Graphics from American Print Shops; Sculpture at Cedarhurst, catalogue; Kathleen Holmes: Bedtime Stories; Harold Gregor's Illinois
Activities: Classes for adults & children; dramatic programs; docent training; workshops; demonstrations; field trips; lect open to public, 8-10 vis lectr per year; concerts; gallery talks; tours; competitions with awards; scholarships offered; book traveling exhibitions 1 per year; originate traveling exhibitions to qualified museums & college galleries with adequate staff & facilities; museum shop sells books, original art, regional glass & ceramics & jewelry

L Cedar Hurst Library, Richview Rd, Mount Vernon, IL 62864; PO Box 923, Mount Vernon, IL 62864. Tel 618-242-1236; Fax 618-242-9530; Elec Mail mitchell@midwest.net; Internet Home Page Address: www.cedarhurst.org; *Librn* Rhonda Sparks
Open Tues - Sat 10 AM - 5 PM; Open to public for reference only
Library Holdings: Audio Tapes; Book Volumes 1250; Exhibition Catalogs; Kodachrome Transparencies; Pamphlets; Periodical Subscriptions 20; Records; Slides; Video Tapes
Special Subjects: Painting-American

NAPERVILLE

L NORTH CENTRAL COLLEGE, Oesterle Library, 320 E School Ave, Naperville, IL 60540. Tel 630-637-5700; Fax 630-637-5716; Internet Home Page Address: www.noctro.edu; *Technician* Belinda Cheek; *Pub Servs Librn* Ted Schwitzner; *Reference Librn* Carol Murdoch; *Dir* Carolyn A Sheehy
Open Mon - Thurs 8 AM - midnight, Fri 8 AM - 8 PM, Sat 9 AM - 5:30 PM, Sun Noon - 11 PM; Estab 1861 to provide academic support; For lending & reference. Art Gallery houses 4-5 exhibitions per yr

Library Holdings: Audio Tapes; Book Volumes 120,000; Cassettes; Clipping Files; Compact Disks; Fiche; Filmstrips; Manuscripts; Memorabilia; Motion Pictures; Original Art Works; Pamphlets; Periodical Subscriptions 751; Photographs; Records; Reels; Video Tapes
Collections: Sang Collection of Fine Bindings

NILES

M THE BRADFORD GROUP, (The Bradford Museum of Collector's Plates) 9333 Milwaukee Ave, Niles, IL 60714. Tel 847-966-2770; Fax 847-966-3121
Open Mon - Fri 8:30 AM - 4:30 PM; No admis fee; Estab 1978 to house and display limited-edition collector's plates for purposes of study, education and enjoyment
Income: Financed by The Bradford Exchange
Special Subjects: Porcelain
Collections: 800 Limited-Edition Collector's Plates

NORMAL

ILLINOIS STATE UNIVERSITY

L Museum Library, Tel 309-438-3451; *Cur* Debra Risberg
Museum library open to scholars, students & staff
Library Holdings: Book Volumes 150; Periodical Subscriptions 8
Special Subjects: Decorative Arts, Pre-Columbian Art, American Indian Art

M University Galleries, Tel 309-438-5487; Fax 309-438-5161; Elec Mail Gallery@ilstu.edu; Internet Home Page Address: www.cfa.ilstu.edu/galleries; *Dir* Barry Blinderman; *Cur* Bill Conger; *Reg* Tracy Berner
Open Tues 9:30 AM - 9 PM, Wed - Fri 9:30 AM - 4:30 PM, Sat - Mon Noon - 4 PM; No admis fee; Estab 1973 to provide changing exhibits of contemporary art for the students & community at large; The main gallery I contains rotating exhibitions; galleries II & III display student & faculty work, graduate exhibitions, studio area shows & works from the permanent collection; Average Annual Attendance: 10,000
Income: Financed by university & Illinois Arts Council
Library Holdings: Exhibition Catalogs; Original Art Works; Prints; Sculpture
Special Subjects: Drawings, Ceramics, Collages, Painting-American, Prints, Sculpture, Photography
Collections: Contemporary art emphasis; prints & drawings
Exhibitions: Student Annual; Normal Editions Workshop print show
Publications: Exhibition catalogs
Activities: Classes for children; lect open to public, 3-4 vis lectrs per year; gallery talks; tours; individual paintings & original objects of art lent for other exhibitions; lending collection contains original art works, original prints, paintings, photographs & sculpture; originate traveling exhibitions; museum shop sells books

OAKBROOK

C MCDONALD'S CORPORATION, Art Collection, One McDonald's Plaza, Oakbrook, IL 60521. Tel 630-623-3585; Fax 630-623-5361; Internet Home Page Address: www.mcdonalds.com; *Cur* Susan Pertl
Open to group tours by appointment; No admis fee; Estab 1971; Walking tour through location
Income: Financed through McDonald's Corporation
Collections: Collection of contemporary paintings & sculpture & of works by established & emerging artists; glass sculptures
Exhibitions: Exhibitions at yearly conventions & Olympics
Activities: Lect; The Spirit of McDonald's Competition; individual paintings & original objects of art lent; lending collection consists of more than 1000 pieces

PALATINE

AMERICAN SOCIETY OF ARTISTS, INC

For further information, see National and Regional Organizations

PARIS

M BICENTENNIAL ART CENTER & MUSEUM, 132 S Central Ave, Paris, IL 61944. Tel 217-466-8130; Fax 217-466-8130; Elec Mail bacm@1choice.net; *Exec Dir* Janet Messenger; *Admin Asst* Jean Evitt; *Treas* Lorraine Whittacre; *Chmn & Pres (V)* Anne J. Johnson; *Chm* Christie Russell
Open Tues - Fri Noon - 4 PM, Sat & Sun 1 - 3 PM; No admis fee; Estab 1975 to encourage & bring art to area; Five galleries, 234 running ft; Average Annual Attendance: 4,179; Mem: 325; annual meeting in Oct
Income: $30,000 (financed by mem, contributions & fundraising)
Collections: Paintings & scultpures primarily 20th century period, including extensive collection of Alice Baber works
Exhibitions: Annual Fall Art Show; Annual Paint Illinois; changing exhibits each month
Publications: Monthly newsletter
Activities: Classes for adults & children; docent training; gallery talks; tours; judged competitions; scholarships offered; lending library; book traveling exhibitions 1-2 per year

PEORIA

M BRADLEY UNIVERSITY, Heuser Art Center, 1501 W Bradley Ave, Peoria, IL 61625. Tel 309-677-2967; Fax 309-677-3642; Elec Mail payresmc@bradley.edu; Internet Home Page Address: www.bradley.edu; *Gallery Dir* Pamela Ayres; *Dir Art Div* Harold Linton
Open Mon-Fri 10 -11:30 AM & 1:30-4 PM, Thurs until 7 PM; No admis fee; Exhibition space 639 sq ft; Average Annual Attendance: 2,000

Income: Financed by University
Library Holdings: Audio Tapes 100; Book Volumes 10,000; Exhibition Catalogs 300; Video Tapes 100
Collections: 1500 contemporary print & drawings
Exhibitions: Rotating exhibits; Purchase prizes Bradley Nat Print & Drawing Exhib
Activities: Classes for adults; docent training; lect open to the public; gallery talks; tours; competitions with awards; master print program; individual paintings lent on campus

M **LAKEVIEW MUSEUM OF ARTS & SCIENCES,** 1125 W Lake Ave, Peoria, IL 61614-5985. Tel 309-686-7000; Fax 309-686-0280; Internet Home Page Address: www.lakeview-museum.org; *Cur* Kristan McKinsey; *Cur Exhib* Cory Tibbitts; *Cur Educ* Barbara Melcher-Brethorst; *Science Planetarium Dir* Sheldon Schafer; *Dir of Public Relations* Kathleen Woith; *Exec Dir* Jim Richerson
Open Mon - Sat 10 AM - 5 PM, Sun 1 - 5 PM, Wed 10 AM - 8 PM, cl Mon; Admis adults $5.00, students & seniors $3.00, children 3 & under free; Estab 1965, new building opened 1965, to provide enjoyment & educ by reflecting the historical, cultural & industrial life of the Central Illinois area; Two changing exhibition galleries, Illinois Folk Art Gallery & Children's Discovery Center; Average Annual Attendance: 250,000; Mem: 3600; dues family $50, individual $30, student $20; annual meeting in June
Income: $500,000
Special Subjects: Archaeology
Collections: Archaeological; decorative arts; Regional American Fine & Folk Art; paintings & graphics; fine arts; anthropology, natural sciences
Exhibitions: Changing exhibitions dealing with the arts & sciences
Publications: Bi-monthly bulletin; Lakeviews, bi-monthly; exhibition catalogues
Activities: Classes for adults & children; docent training; lect open to public, 8-10 vis lectrs per year; concerts; gallery talks; tours; competitions with awards; individual & original objects of art lent to sister institutions; museum store sells books, magazines, original art, reproductions, prints & craft items; junior museum

A **PEORIA ART GUILD,** 203 Harrison Peoria, IL 61602. Tel 309-637-2787; Fax 309-637-7334; Elec Mail info@peoriaartguild.org; Internet Home Page Address: www.peoriaartguild.org; *Dir* E. Kate Zabela; *Business Mgr* Diana Hasamear; *Dir Exhib* Michelle Traver; *Dir Educ* Susie Mathews
Open Mon - Thurs 10 AM - 6 PM, Fri & Sat 10 AM - 5 PM, cl Sun; No admis fee, donations appreciated; Estab 1878 to encourage development & appreciation of the visual arts; 3000 sq ft floor space; Average Annual Attendance: 40,000; Mem: 1000; dues $30
Income: Financed by mem, Illinois Arts Council, sales & rental, private donations
Collections: Framed & unframed 2-D design, ceramics, sculpture, jewelry, weaving & wood designs; winning works from the Bradley National Print & Drawing Exhibition; 150 featured artists from the US and international
Exhibitions: One-person shows; group theme shows, shows annually; Marsha S. Glaten; Anthony Swan, photojournalism
Activities: Classes for adults & children; workshops; lect open to public, 5-6 vis lectrs per year; gallery talks; tours; awards; individual paintings rented to business & members of the community; lending collection contains original art work, prints, paintings, photographs & sculptures; sales shop sells original art & prints

M **PEORIA HISTORICAL SOCIETY,** 942 NE Glen Oak, Peoria, IL 61603; 611 SW Washington St, Peoria, IL 61602. Tel 309-674-1921; Fax 309-674-1882; Internet Home Page Address: peoriahistoricalsociety.org; *Dir* Katherine Belsley; *Pres* Fred Kowalske; *Dir Coll* Susannah Bowles
Judge John C Flanagan House open for tours by appt & Wed - Sun 1-4 PM (Mar - Dec); Pettengill-Morron House open by appt only; Admis adults $4, children 15 & under $2; Estab 1934 to acquire, preserve & display artifacts & records relating to the history of Peoria & the Central Illinois Valley; to encourage & support historical research & investigation & to promote & sustain pub interest in history of Peoria & the Central Illinois Valley; Two historic house museums: Flanagan House is post-colonial, Pettingill-Morron house is Victorian; Average Annual Attendance: 10,000; Mem: 700; dues $25 & up; annual meeting in May
Income: Financed by mem, endowments; private gifts & grants
Library Holdings: Audio Tapes; Book Volumes; CD-ROMs; Cards; Cassettes; Clipping Files; Framed Reproductions; Kodachrome Transparencies; Manuscripts; Maps; Memorabilia; Original Art Works; Original Documents; Other Holdings; Pamphlets; Periodical Subscriptions; Photographs; Prints; Records; Reproductions; Sculpture; Slides; Video Tapes
Special Subjects: Pottery, Period Rooms
Collections: Household items & artifacts from 1840; Library housed in special collections center of Bradley University; Peoria Pottery; Lincoln artifacts; Civil War, WW I & II; Peoria businesses; French exploration; fur trade
Exhibitions: Rennick Award (art works relating to historic sites), History Fair; Victorian Mourning Rituals; Peoria's Past Rediscovered; English exploration
Publications: Bi-monthly Newsletter to members
Activities: Educ program; docent training; internship programs; lect open to public, 7 vis lectr per year; competitions with prizes; tours; Historic Preservation award; Regional History Fair winner, Centenarians & Volunteer of Yr awards; exten program serves mus, cultural & educational institutions; organize traveling exhibs to regional business & educational institutions; boutique at Pettengill-Morron House (The Butler's Pantry); sells books & gifts

QUINCY

A **QUINCY ART CENTER,** 1515 Jersey St, Quincy, IL 62301. Tel 217-223-5900; Fax 217-223-6950; Elec Mail qac@ksni.net; Internet Home Page Address: www.quincynet.com/artcenter; *Exec Dir* Julie D Nelson; *Mus Shop Mgr* Catherine E Codd; *VPres* Cynthia Colvin
Open Tues - Sun 1 - 4 PM, cl Mon & holidays; Donations accepted; Estab 1923, incorporated 1951 to foster pub awareness & understanding of the visual arts; Average Annual Attendance: 14,000; Mem: 500; dues $30 & up
Income: Financed by grants, donations, mem fees & Beaux Art Ball
Collections: Crafts, graphics, paintings & sculpture by contemporary American & European artists

Exhibitions: Annual Quad-State Juried Exhibition, Annual High School Student Exhibition;
Publications: Calendar, brochures &/or catalogs for temporary exhibitions
Activities: Classes for adults & children; docent training; lect open to public; gallery talks; tours; competitions with awards; scholarships offered; inter-museum loan; museum shop sells original art

A **QUINCY SOCIETY OF FINE ARTS,** 300 Civic Ctr Plaza, Ste 244, Quincy, IL 62301-4162. Tel 217-222-3432; Fax 217-228-2787; Elec Mail art@artsqcy.org; Internet Home Page Address: www.artsqcy.org; *Dir* Rob Dwyer
Open Mon - Fri 8 AM - 5 PM; Estab 1947 as a community arts council to coordinate & stimulate the visual & performing arts in Quincy & Adams County; Mem: 48 art organizations; non-profit, arts & humanities
Income: Financed by endowment, mem & contribution, Illinois Arts Council, National Endowment for the Arts
Publications: Cultural Calendars, monthly; pamphlets & catalogs; Arts Quincy, monthly
Activities: Workshops for adults & students in visual & performing arts

M **QUINCY UNIVERSITY,** The Gray Gallery, 1800 College Ave, Quincy, IL 62301-2699. Tel 217-228-5371; Internet Home Page Address: www.quincy.edu; *Dir Gallery* Robert Lee Mejer
Open Mon - Thur 8 AM - 10 PM, Fri 8 AM - 6 PM, Sat 1 - 5 PM, Sun 1 - 10 PM; No admis fee; Estab 1968 for cultural enrichment & exposure to contemporary art forms in the community; Exhibitions are held in the Brenner library foyer & The Gray Gallery; Average Annual Attendance: 6,000
Income: Financed through the coll & student activities assoc
Special Subjects: Drawings, Prints
Collections: 19th century Oriental & European prints; permanent collection of student & faculty works; 20th century American prints & drawings
Exhibitions: Watercolors by Bruce Bobick; Waterbase Monotypes Dennis Olsen
Publications: Brochures, 1-2 times annually; gallery calendars, annually
Activities: Lect open to public, 1 vis lectr per year; gallery talks; tours; student show with awards; individual paintings & original objects of art lent; slide reviews of potential artists/shows; book traveling exhibitions 1-2 per year

L **Brenner Library,** 1800 College Ave, Quincy, IL 62301. Tel 217-222-8020; Fax 217-228-5354; Elec Mail qulib@darkstar.rsa.lib.il.ms; Internet Home Page Address: www.quincy.edu; *Dean of Library* Pat Tomczak
Open by appointment only; Reference only for pub; lending for faculty & students
Income: $1,600 (financed by college revenues)
Purchases: $1,600 annually for books
Library Holdings: Book Volumes 7890; Cassettes; Exhibition Catalogs; Filmstrips; Lantern Slides; Motion Pictures; Periodical Subscriptions 20; Prints; Records; Slides; Video Tapes

ROCK ISLAND

M **AUGUSTANA COLLEGE,** Augustana College Art Museum, NW Corner Seventh Ave & 38th St, Rock Island, IL 61201; 639 38th St, Rock Island, IL 61201. Tel 309-794-7469; Fax 309-794-7678; Elec Mail sherrymaurer@augustana.edu; Internet Home Page Address: www.augustana.edu; *Dir Gallery* Sherry C Maurer
Open Tues - Sat Noon - 4 PM; No admis fee; Estab 1973 for the display of visual arts exhibits commensurate with a liberal arts college curriculum; Main gallery serves as an entrance to large auditorium; lower gallery is smaller than main gallery; two galleries total 217 ft wall space; Art Collection Gallery, opened in 1999 is located off lower gallery; Average Annual Attendance: 50,000
Income: $53,785
Purchases: $3000
Special Subjects: Drawings, Etchings & Engravings, Ceramics, Painting-American, Prints, Textiles, Sculpture, Watercolors, African Art, Woodcuts, Painting-Scandinavian
Collections: Contemporary, Eastern & Western prints; Swedish American Art; modern Oriental
Publications: Exhibit catalogs
Activities: Classes for children; lect open to public; 3-4 vis lectrs per year; concerts; gallery talks; tours; competitions with prizes; individual paintings & original objects of art lent upon requests considered on individual basis; book traveling exhibitions, 2-3 per year

A **QUAD CITY ARTS INC,** 1715 Second Ave, Rock Island, IL 61201. Tel 309-793-1213; Fax 309-793-1265; Elec Mail info@quadcityarts.com; Internet Home Page Address: www.quadcityarts.com; *Exec Dir* Judi Holdorf; *Gallery Mgr* Dawn Wohlford-Metallo; *Dir Advancement* Glenda Huntsman
Open Mon, Tues, Thurs 10 AM - 5 PM, Wed & Fri 10 AM - 9 PM, Sat 10 AM - 6 PM; No admis fee; Estab 1974 to bring visual arts to the people; Rotating formal gallery exhibit space & art consignment gallery for regional artists; Average Annual Attendance: 12,800
Activities: Lect open to public; concerts; gallery talks; tours; sales shop sells original art & prints

ROCKFORD

A **ROCKFORD ART MUSEUM,** 711 N Main St, Rockford, IL 61103. Tel 815-968-2787; Fax 815-316-2179; Elec Mail staff@rockfordmuseum.org; Internet Home Page Address: www.rockfordartmuseum.org; *Financial Officer* Dave Schroepfer; *Educ Coordr* Mindy Wilson; *Exec Dir* Linda Dennis; *Cur* Jennifer Jaskowiak; *Communications Coordr* David Dixon; *Pub Rels & Spec Events* Sarah McNamara; *Registrar* Jeremiah Blankenbaker; *Mus Asst* Stacey Sauer
Open Mon - Tues & Fri - Sat 10 AM - 5 PM, Thurs 10 AM - 7 PM, Sun Noon-5 PM; Admis adults $5, seniors $3, students & children free; Estab 1913 to enrich the quality of life by communicating the pleasure, appreciation & meaning of the visual arts through a program of exhibition, interpretation, education & collection; 17,000 sq ft exhibition space; Average Annual Attendance: 40,000; Mem: 1000
Income: Financed by mem, grants, state appropriation & private donations

Collections: Permanent collection 19th & 20th century American oil paintings, graphics, sculpture, photography, ceramics, glassware, textiles, watercolors & mixed media
Exhibitions: Annual Greenwich Village Art Fair; Annual Young Artist's Exhibition; numerous one-person and group shows; Rockford-Midwestern Show (biennial)
Publications: Exhibition brochures & catalogs; magazine, quarterly
Activities: Classes for adults & children; docent training; artist-in-residence; museum school program; lect open to public, 5 vis lectrs per year; gallery talks; tours; competitions with cash awards; book traveling exhibitions; museum shop sells books, original art, reproductions, prints, jewelry, ceramics & crafts

M **ROCKFORD COLLEGE ART GALLERY,** Clark Arts Ctr, 5050 E State St Rockford, IL 61108. Tel 815-226-4034; Fax 815-394-5167; *Dir* Maureen Gustafson
Open daily 2 - 5 PM (academic calendar); Estab 1970
Activities: Gallery & group tours; lect open to public, 6 vis lectrs per year; originate traveling exhibitions 1 per year

SKOKIE

L **SKOKIE PUBLIC LIBRARY,** 5215 Oakton, Skokie, IL 60077. Tel 847-673-7774; Fax 847-673-7797; Internet Home Page Address: www.skokie.lib.il.us; *Assoc Dir Pub Svcs* Barbara Kozlowski; *Asst Dir for Technical Svcs* Camille Cleland; *Dir* Carolyn Anthony
Open Mon - Fri 9 AM - 9 PM, Sat 9 AM - 5 PM, Sun 1 - 5 PM; No admis fee; Estab 1941 as a general pub library serving the residents of Skokie; reciprocal borrowing privileges offered to members of pub libraries in North Suburban Library System; Art gallery is maintained
Income: $5,959,242 (financed by independent tax levy)
Purchases: $735,930
Library Holdings: Audio Tapes 28,031; Book Volumes 385,284; Cassettes; Clipping Files; Fiche; Framed Reproductions; Original Art Works 20; Other Holdings 8968; Pamphlets; Periodical Subscriptions 1807; Reels; Reproductions; Sculpture 12; Slides; Video Tapes 9667
Special Subjects: Art History, Painting-American, Sculpture, Painting-European, Watercolors, Crafts, Dolls, Embroidery, Handicrafts, Architecture
Exhibitions: Artistic Teapots - Fabric Artists; Michael Crespo Paintings; Evanston Arts Center Faculty Show; Old Lives, New Lives: Soviet Jewish Women (photographs); The Reading Room: a Sound Installation
Activities: Lect open to public; book traveling exhibitions

SPRINGFIELD

M **ILLINOIS STATE MUSEUM,** Illinois Art Gallery & Lockport Gallery, Spring & Edwards St, Springfield, IL 62706. Tel 217-782-7440; Fax 217-782-1254; *Dir* R Bruce J McMillan; *Cur Decorative Arts* Janice Wass; *Cur Asst Decorative Art* Irene Boyer; *Registrar Art* Carole Peterson; *Admin* Amy Jackson; *Exhibits Designer Art* Philip Kennedy; *Cur Art* Robert Sill; *Dir Art* Kent J Smith
Open Mon - Sat 8:30 AM - 5 PM, Sun Noon - 5 PM; No admis fee; Estab 1877 as mus of natural history, art added in 1928. Collection, exhibition & publication of art produced by or of interest to Illinois & its citizens. Six major changing exhibitions annually; Changing exhibition space: Springfield Art Gallery 3000 sq ft; Arts of Science Gallery (six changing exhibitions), 1364 sq ft; permanent collection galleries present fine, decorative & ethnographic arts, 6400 sq ft permanent exhibit of Illinois Decorative Arts, At Home in The Heartland 3000 sq ft; Average Annual Attendance: 300,000; Mem: 650; dues $25-$500
Income: $266,000. Art Section only (Springfield program financed by state appropriations, Chicago & Lockport programs privately funded)
Purchases: $5000
Special Subjects: Graphics, Painting-American, Photography, Sculpture, Folk Art, Decorative Arts
Collections: Decorative art including ceramics, metal work, textiles, glass, furniture; fine art including paintings, sculpture, prints, drawings, photography, contemporary crafts, folk art
Exhibitions: 18 exhibitions annually featuring contemporary & historical paintings, sculpture, photography, graphics, decorative arts & history, with emphasis on Illinois material
Publications: Living Museum (also in Braille), quarterly; exhibit & collection catalogs; Biennial report
Activities: Classes for adults & children; dramatic programs; lect & symposia open to public; concerts; gallery talks; tours; competitions with awards; film series; individual paintings lent to other museums, historical sites & galleries; book traveling exhibitions 3 per year; originate traveling exhibitions organized & circulated 3 per year; museum shop sells books & original art; Illinois Artisans Shop sells consigned work by Illinois Artisans, facilities in Chicago, Springfield & near Rend Lake

L **Library,** Spring & Edwards St, Springfield, IL 62706-5000. Tel 217-782-6623; Elec Mail pburg@museum.state.il.us; *Librn* Patricia Burg
Open Mon - Sat 8:30 AM - 5 PM, Sun Noon - 5 PM; Estab to provide informational materials & services to meet the requirements of the mus staff in fields pertinent to the purpose & work of the mus; Circ 100 per month
Income: Financed by state appropriation
Purchases: $2600
Library Holdings: Book Volumes 1500; Clipping Files; Exhibition Catalogs; Manuscripts; Memorabilia; Pamphlets; Periodical Subscriptions 27; Slides; Video Tapes
Special Subjects: Anthropology
Collections: Anthropology and Ornithology

A **SPRINGFIELD ART ASSOCIATION OF EDWARDS PLACE,** 700 N Fourth St, Springfield, IL 62702. Tel 217-523-2631, 523-3507; Fax 217-523-3866; Elec Mail spiartassc@aol.com; *Exec Dir* Dean Atkins
Open Daily 9 AM - 5 PM, Sat 10- 3 PM; No admis fee; Estab 1913 to foster appreciation of art, to instruct people in art & to expose people to quality art; Mem: 650; dues $50-$500; monthly meeting

Income: $200,000 (financed by mem & grants, interest, tuition & benefits)
Collections: Contemporary American Indian; African sculpture; early American paintings; furniture; Mexican; Oriental & Japanese artifacts & textiles; paintings; pottery; prints; textiles
Exhibitions: 3 to 4 exhibitions are scheduled annually with one juried exhibition; work is borrowed from museum & artist nationwide
Publications: Membership brochures, quarterly; newsletters
Activities: Classes for adults & children; docent training; art outreach program in school in community; lect open to public; gallery talks; tours; scholarships offered; book traveling exhibitions

L **Michael Victor II Art Library,** 700 N Fourth, Springfield, IL 62702. Tel 217-523-3507; Fax 217-523-3866; Elec Mail spiartassc@aol.com; *Library Dir* Kathleen Harvey
Open 9 AM - 5 PM daily, Mon - Fri & Thurs evenings 6:30 - 9:30 PM, Sat 10 AM - 3PM, cl Sun; Estab 1965 to provide total community with access to art & art related books
Library Holdings: Book Volumes 7000; Compact Disks; Exhibition Catalogs; Pamphlets; Periodical Subscriptions 20; Reproductions; Slides; Video Tapes
Special Subjects: Art History, Collages, Calligraphy, Commerical Art, Ceramics, Conceptual Art, American Western Art, Cartoons, Art Education, Asian Art, American Indian Art, Aesthetics, Afro-American Art, Carpets & Rugs, Architecture
Activities: Classes for children; lect series, 8 visiting lect per year; film program

VERNON HILLS

M **CUNEO FOUNDATION,** Museum & Gardens, 1350 N Milwaukee, Vernon Hills, IL 60061. Tel 847-362-3042; Fax 847-362-4130; *Dir* James Bert
Open Tues - Sun 10 AM - 5 PM; Estab 1991
Income: $300,000 (financed by endowment, mem & admis)
Special Subjects: Decorative Arts, Tapestries, Period Rooms, Painting-Italian
Collections: Architecture; decorative arts; furniture; paintings

WATSEKA

M **IROQUOIS COUNTY HISTORICAL SOCIETY MUSEUM,** Old Courthouse Museum, 103 W Cherry, Watseka, IL 60970. Tel 815-432-2215; Fax 815-432-2215; Internet Home Page Address: www.oldcourthousemuseum.com; *Pres* David Todd; *VPres* Paul Bowers; *Chmn Management Comt* Rolland Light; *Treas* Stephanie Bowers; *Art Gallery Chmn & Secy* Marilyn Wilken
Open Mon - Fri 10 AM - 4 PM, Sat by appointment only - call ahead; Donation adults $2, children $.50; Estab 1967 to further the interest in history, art & genealogy; Two rooms for county artists; Average Annual Attendance: 10,000; Mem: 800; dues $10 - $100
Income: Financed by donations by visitors, artists, memberships & art committee sells crafts
Library Holdings: Book Volumes; Fiche; Maps; Memorabilia
Special Subjects: Decorative Arts, Glass, Flasks & Bottles, Furniture, Manuscripts, Maps, Costumes, Crafts, Dolls, Coins & Medals, Dioramas
Collections: Paintings, prints, posters & pictures
Publications: Genealogical Stalker, quarterly; newsletter, quarterly; historic reprints
Activities: Lectures open to public; concerts; tours; competitions with awards; museum shop sells books, souvenirs, original art, maps & Indian items

WHEATON

A **DUPAGE ART LEAGUE SCHOOL & GALLERY,** 218 W Front St, Wheaton, IL 60187. Tel 630-653-7090; Internet Home Page Address: www.dupageartleague.org; *Treas* Jennifer Fronek; *VPres Educ* Joanne Laudolff; *VPres Exhibits* Sally Hines; *VPres Organization* Cora Chin; *VPres Buildings & Grounds* Kay Wahlgren; *VPres Activities* Diane Walenda; *Pres* Theresa Balke; *VPres Organization* Bernie Malovany; *Pres Emeritus* Marge Hall; *VPres Finance* Bob Wahlgren; *Secy* Tanya Berley; *VP Office Mgmt* Marion Mueller
Open daily 9 AM - 5 PM, Sat 9 AM - 2 PM, mems must be 17 yrs & up; No admis fee; Estab 1957 primarily as an educational organization founded to encourage artists & promote high artistic standards through instruction, informative programs & exhibits; Three galleries are maintained where members exhibit & sell their work; Mem: 450; dues $40; annual meeting in May
Income: Financed through mem, gifts & donations
Library Holdings: Book Volumes
Exhibitions: Monthly exhibits; nine juried shows per yr; holiday gift gallery; Fine Art Gallery with monthly exhibits of local artists (Gallery I), one-man or one-woman shows (Gallery II), Fine Crafts (Gallery III)
Publications: Monthly newsletter
Activities: Classes for adults & children; programs; demonstrations; lect open to public, 8 vis lectrs per year; gallery talks; competitions; awards; scholarships offered; individual paintings & original objects of art lent to local libraries & businesses; sales shop sells original art & fine crafts (jewerly, ceramics, woodworks fiber & glass)

WINNETKA

A **NORTH SHORE ART LEAGUE,** Winnetka Community House, 620 Lincoln Ave Winnetka, IL 60093. Tel 847-446-2870; Fax 847-446-0609; Elec Mail info@northshoreartleague.org; Internet Home Page Address: www.northshoreartleague.org; *Exec Dir* Valerie Niskarer; *Pres* Susan Underwood
Open Mon - Fri 9 AM - 5 PM; No admis fee; Estab 1924, inc 1954, to promote interest in creative art through education, exhibition opportunities, scholarship & art programs; Mem: 500; dues $40; annual meeting in May
Income: Financed by mem dues, shows & tuition from classes, contrubutions
Exhibitions: Members Show; National Craft Festival (May); National Art Festival (Oct)
Publications: Art League News, quarterly

Activities: Classes for adults & children; lect for mems only; sponsor juried competitions with awards; scholarships offered for children

INDIANA

ANDERSON

A ANDERSON FINE ARTS CENTER, 32 W 10th St, PO Box 1218 Anderson, IN 46016. Tel 765-649-1248; Fax 765-649-0199; Elec Mail andersonart@voyager.net; Internet Home Page Address: www.andersonart.org; *Pres Board Trustees* Kenneth Zinser; *Educ Coordr* Jill Render; *Gallery Asst* Tim Swain; *Exec Dir* Deborah McBratney-Stapleton
Open Tues - Fri Noon - 5 PM, Sat 10 AM - 5 PM, Sun 2 - 5 PM, cl Mon & national holidays; Admis adults $2, senior citizens $1.50, students $1, Tues & 1st Sun of month free; Estab 1967 to serve the community by promoting & encouraging interest in the fine arts through exhibitions, programs & education activities & the development of a permanent collection; Three galleries contain 1705 sq ft; also a small sales & rental gallery & a studio/theatre; Average Annual Attendance: 30,000; Mem: 700; dues sponsor $1000 or more, sustaining $500-$999, benefactor $250-$499, patron $100-$249, contributor $50-$99, friend $25-$49; annual meeting in May
Income: Financed by mem, endowments, grants, individual & corporate contributions
Collections: Midwestern & 20th century American prints, paintings & drawings
Exhibitions: Annual Winter Show Exhibits; annual Christmas Tree Exhibit; annual Indiana Artists - Local Exhibit; annual photo exhibits; one-man shows
Publications: Calendar of Events, quarterly; catalogue of the permanent collection; exhibition catalogs
Activities: Classes for adults & children; dramatic programs; docent training; educational outreach; lect open to public, 4-6 vis lectr per year; concerts; gallery talks; tours; competitions with awards; Art Lady Project in the Public Schools; individual paintings & original objects of art lent to businesses, educational facilities & other museums; lending collection contains 300 original art works, 150 original prints, 300 paintings, 10 sculpture & 1000 slides; book traveling exhibitions; museum shop sells books, original art, reproductions, prints, slides, pottery, handcrafted items, glass, fine cards & note papers

BLOOMINGTON

L INDIANA UNIVERSITY, Fine Arts Library, Art Museum Bldg, Bloomington, IN 47405. Tel 812-855-3314; Fax 812-855-3443; Elec Mail irvine@indiana.edu; Internet Home Page Address: www.indiana.edu/~libfinea; *Slide Librn* Eileen Fry; *Head Librn* Betty Jo Irvine; *Head Pub Servs* Terri Duffin
Hours vary; Estab c1940; Circ 50,000; For lending
Income: Financed by state & student fees
Library Holdings: Auction Catalogs; Book Volumes 130,000; CD-ROMs; Cassettes; Clipping Files 50,000; Compact Disks; Exhibition Catalogs; Fiche 24,000; Periodical Subscriptions 390; Reproductions 58,000; Slides 325,000; Video Tapes 200
Special Subjects: Art History, Collages, Commerical Art, Graphic Arts, Ceramics, Crafts, Asian Art, Primitive art, Aesthetics, Afro-American Art, Antiquities-Oriental, Antiquities-Byzantine, Antiquities-Etruscan, Antiquities-Greek, Antiquities-Roman, Architecture

INDIANA UNIVERSITY
M Art Museum, Tel 812-855-5445; Fax 812-855-1023; Elec Mail iuam@indiana.edu; Internet Home Page Address: www.artmuseum.iu.edu; Cable ARTMUSEUM INDVERS; *Dir* Adelheid Gealt; *Assoc Dir Develop* Jeremy Hatch; *Assoc Dir Editorial Servs* Linda Baden; *Assoc Dir Curatorial Services & Cur African & Oceanic Pre-Columbian Art* Diane Pelrine; *Cur Ancient Art* Adriana Calinescu; *Registrar* Anita Bracalente; *Cur Educ* Ed Maxedon; *Asst Registrar* Kathy Taylor; *Cur 19th & 20th Century Art* Jenny McComas; *Assoc Dir Admin* David Tanner; *Cur Works on Paper* Nan Brewer; *Cur Asian Art* Judy Stubbs; *Security Mgr* Debbie Scholl
Open Tues - Sat 10 AM - 5 PM, Sun Noon - 5 PM, cl Mon; No admis fee; Estab 1941 to serve as a teaching & cultural resource for the University community & the public at large; Gallery has 3 permanent exhibits: Wester Art, Medieval - present; Africa, Oceania & Americas; special exhibits (temporary & travelling); Average Annual Attendance: 60,000
Income: Financed by col & grants
Special Subjects: Drawings, Prints, American Western Art, Bronzes, African Art, Ethnology, Ceramics, Primitive art, Etchings & Engravings, Asian Art, Antiquities-Byzantine, Carpets & Rugs, Coins & Medals, Baroque Art, Calligraphy, Antiquities-Oriental, Antiquities-Persian, Antiquities-Egyptian, Antiquities-Greek, Antiquities-Roman, Antiquities-Etruscan, Antiquities-Assyrian
Collections: African, ancient to modern, Far Eastern, Oceanic, the Americas, prints, drawings, photographs & sculpture
Exhibitions: 5 rotating exhibs per yr
Publications: Guide to the collection, exhibition catalogs, occasional papers, newsletter
Activities: Classes for adults & children; docent training; lect open to public; gallery talks; tours; concerts series; competition with awards; book traveling exhibitions, 1-2 per year; organizes traveling exhibitions, mainly other universities & art museums; museum shop sells books, magazines, reproductions, prints, slides
M The Mathers Museum of World Cultures, Tel 812-855-6873; Fax 812-855-0205; Elec Mail mathers@indiana.edu; Internet Home Page Address: www.indiana.edu/~mathers/home; *Conservator* Judith Sylvester; *Asst Dir* Judith Kirk; *Cur Coll* Thomas Kavanagh; *Business Mgr* Sandra Warren; *Dir* Geoffrey W Conrad; *Cur Educ* Ellen Sieber; *Co-cur of exhibits* Elaine Gaul; *Co-cur of Exhibits* Matthew Sieber; *Registrar* Laura Hohman
Open Tues - Fri 9 AM - 4:30 PM, Sat & Sun 1 - 4:30 PM; No admis fee; Estab 1964 as Indiana University Mus, institute renamed in 1983. Mus of World Cultures housing over 30,000 artifacts; Mem: Dues $25-$45

Income: Financed by mem & col
Special Subjects: Anthropology, Folk Art, Historical Material
Collections: Anthropology, folklore & history with collections of American primitives, Latin American primitives & folk art
Exhibitions: Museum features changing exhibitions
Publications: Papers & monograph series
Activities: Docent program; museum training classes; lect; tours; film series; school loan collection

ELKHART

M MIDWEST MUSEUM OF AMERICAN ART, 429 S Main St, PO Box 1812 Elkhart, IN 46515. Tel 219-293-6660; Fax 219-293-6660; Elec Mail mdwstmsmam@aol.com; Internet Home Page Address: www.midwestmuseum.us; *Cur Exhib & Educ* Brian D Byrn; *Dir* B Jane Burns; *Admin Asst* Joan Grimes
Open Tues - Fri 11 AM - 5 PM, Sat - Sun 1 - 4 PM; Admis adults $4, seniors $3, students $2, family (3 or more) $7; Estab 1978 to provide high quality exhibitions, educational programs & permanent collection of 19th & 20th century American art for the public; Nine galleries on two floors (approx 9500 sq ft of exhibit space); Average Annual Attendance: 25,000; Mem: 710; dues $10-$250
Income: $100,000 (financed through mem, grants, foundations, contributions)
Library Holdings: Auction Catalogs; Audio Tapes; Book Volumes; Cards; Cassettes; Clipping Files; Exhibition Catalogs; Original Art Works; Photographs; Prints; Sculpture; Slides; Video Tapes
Special Subjects: Decorative Arts, Etchings & Engravings, Folk Art, Collages, Drawings, Graphics, Latin American Art, Painting-American, Photography, Prints, Sculpture, Watercolors, Bronzes, Southwestern Art, Ceramics, Pottery, Primitive art, Woodcuts, Landscapes, Portraits, Glass
Collections: Paintings: Arthur Bowen Davies; Joan Mitchell; Robert Natkin; Maurice Pendergast; Grant Wood; Red Grooms; Carl Olaf Seltzer; Norman Rockwell; LeRoy Neiman; Roger Brown; Art Green; George Luks; Glen Cooper Henshaw; Pennerton West; Robert Reid; Sculpture: Felix Eboigbe; Frederick MacMonnies; Fritz Scholder; Overbeck Art Pottery Collection; Jaune Quick-To-See
Exhibitions: Ansel Adams - 2007
Publications: Midwest Museum Bulletin, bimonthly
Activities: Classes for adults and children; docent training; lect open to public, 50 vis lectr per year; concerts; gallery talks; tours; competitions with awards; regional juried competition & national youth art awards; individual paintings & original objects of art lent to other museums only; originate traveling exhibitions to other museums & university galleries; museum shop sells books, magazines, original art, reproductions, prints & original crafts

L RUTHMERE MUSEUM, Robert B. Beardsley Arts Reference Library, 302 E Beardsley Ave, Elkhart, IN 46514-2719. Tel 219-264-0330; Fax 219-266-0474; Elec Mail library@ruthmere.org; Internet Home Page Address: www.ruthmere.org; *Librn & Archivist* Marilou C Ritchie
Open Wed 10 AM - 3 PM, Thurs 1 PM - 3 PM; Museum open Tues - Sat 10 AM - 3 PM; Estab 1980 as a reference library
Income: Financed by mem
Library Holdings: Auction Catalogs; Book Volumes 1800; Periodical Subscriptions 15; Slides
Special Subjects: Art History, Decorative Arts, Painting-American, Sculpture, Porcelain, Furniture, Pottery, Restoration & Conservation, Architecture

EVANSVILLE

A ARTS COUNCIL OF SOUTHWESTERN INDIANA, 123 NW 4th St Ste 3, Evansville, IN 47708. Tel 812-422-2111; Fax 812-422-2357; Elec Mail arts@artswin.org; *Dir* Kathy Solecki; *Asst* Linda O'Connor
Estab 1970 to increase the awareness & accessibility of the arts in Southwestern Indiana through community programs, arts in educ & festivals; serves as an umbrella organization for over 50 cultural organizations, providing technical assistance, marketing & linkage with local, state & national arts organizations; Mem: 400; $20 & up
Income: Financed by endowment, mem, city appropriation & state appropriation
Exhibitions: Business/Arts Month
Publications: Artist directory; artist registry; Arts Talk Newsletter, quarterly; cultural calendar; cultural directory; media directory
Activities: Classes for general community; arts-in-education program; artist residencies in elementary schools; art workshops; lect open to public; concerts; festivals; outreach program provided to six rural counties

M EVANSVILLE MUSEUM OF ARTS, HISTORY & SCIENCE, 411 SE Riverside Dr, Evansville, IN 47713. Tel 812-425-2406, 421-7506 (TTY); Fax 812-421-7507; Elec Mail mary@emuseum.org; Internet Home Page Address: www.emuseum.org; *Pres Bd Dir* Tom Bryan; *Dir Emeritus* Siegfried Weng; *Cur Educ* Susan Donahue; *Cur Coll* Mary Bowen; *Registrar* Joycelyn Todosco; *Dir Science Planetarium* Mitch Luman; *Dir* John W Streetman; *Cur History* Tom Lonnberg
Open Tues - Sat 10 AM - 5 PM, Sun Noon - 5 PM, cl Mon; No admis fee; Estab 1926 to maintain & perpetuate a living mus to influence & inspire the taste & cultural growth of the community, to provide facilities for the collection, preservation & exhibition of objects, data & programs related to the arts, history, science & technology; First Level: 19th century village of homes, shops, offices & town hall, America at War Gallery, two science & technology galleries, classrooms; Second Level: furnished Gothic Room with linefold paneling; Sculpture Gallery: galleries for Dutch & Flemish art, 18th century English art, 19th & 20th century American & European art, Anthropology Gallery; two galleries for monthly exhibits; Third Level: Planetarium; Average Annual Attendance: 100,000; Mem: Dues Founders Society $2,500+, President's Circle $1,000-2,499, Dirs Assoc $500-$999, Donor $250-$499, Patron $125-$249, Contributor $70-$124, Friend $35-$69; annual meeting third Tues in May
Income: $1,295,000 (financed by mem, city & state appropriations)

Special Subjects: Painting-American, Sculpture, Watercolors, African Art, Anthropology, Ethnology, Textiles, Folk Art, Woodcuts, Etchings & Engravings, Decorative Arts, Manuscripts, Painting-European, Dolls, Furniture, Glass, Oriental Art, Painting-British, Painting-Dutch, Maps, Tapestries, Painting-Flemish, Period Rooms, Antiquities-Egyptian
Collections: 19th & 20th Century Indiana Art, 20th Century American Still Life
Publications: Bulletin, 5 times yearly; catalogs of exhibitions
Activities: Classes for adults & children; docent training; lect open to public, 4-5 vis lectr per year; concerts; gallery talks; tours; museum shop sells books, magazines, original art

L **Henry R Walker Jr Memorial Art Library,** 411 SE Riverside Dr, Evansville, IN 47713. Tel 812-425-2406; Fax 812-421-7509; Elec Mail mary@emuseum.org; Internet Home Page Address: www.emuseum.org; *Cur* Mary Bowker; Jocelyn Todisco
Open Tues - Sat 10 AM - 5 PM, Sun Noon - 5 PM; No admis fee; For reference only
Library Holdings: Book Volumes 4000; Clipping Files; Exhibition Catalogs; Manuscripts; Memorabilia; Original Art Works; Pamphlets; Periodical Subscriptions 30; Photographs; Prints; Reproductions; Sculpture; Slides
Activities: Classes for adults & children; docent training; lect open to public; concerts; museum shop sells books & original art

UNIVERSITY OF EVANSVILLE
M **Krannert Gallery,** Tel 812-488-2043; Fax 812-488-2101; Elec Mail bb32@evansville.edu; *Chmn Art Dept* William Brown; *Dean Arts & Sciences* Jean Beckman
Open Mon - Sat 9 AM - 5 PM; No admis fee; Estab 1969-70 to bring to the University & pub communities exhibitions which reflect the contemporary arts, ranging from crafts through painting & sculpture; Pub access exhibition space 80 x 40 & located in Fine Arts Building
Income: Financed by Department of Art funds
Exhibitions: Drawing Exhibition; Indiana Ceramics; New Aquisitions; Student Scholarship Exhibition; Undergraduate BFA Exhibition; Faculty Exhibition; Painting Invitational; Sculpture Invitational; Evansville Artists Guild Show; Photography Exhibition; Various invitationals to other univ
Activities: Lect open to public, 2 vis lectrs per year; gallery talks; competitions with awards; individual paintings & original objects of art lent to university community

L **University Library,** Tel 812-479-2247; Fax 812-471-6996; Elec Mail mg29@evansville.edu; Internet Home Page Address: www.ue.edu; *Acquisitions Librn* Marvin Guilfoyle; *Librn* William F Louden; *Head Reference Librn* Randy Abbott
Open 8 AM - 11 PM
Library Holdings: Book Volumes 265,000; CD-ROMs; Compact Disks; Fiche; Micro Print 458; Video Tapes
Collections: Knecht Cartoon Collection

L **WILLARD LIBRARY,** Dept of Fine Arts, 21 First Ave, Evansville, IN 47710. Tel 812-425-4309; Fax 812-421-9742, 425-4303; Elec Mail willard@willard.lib.in.us; Internet Home Page Address: www.willard.lib.in.us; *Dir* Greg Hager; *Special Coll* Lyn Martin; *Children's Librn* Tina Sizemore; *Adult Librn* Brian Rhoden
Open Mon - Tues 9 AM - 8 PM, Wed - Fri 9 AM - 5:30 PM, Sat 9 AM - 5 PM, Sun 1 - 5 PM; Estab 1885
Income: $5000 (financed by endowment & city appropriation)
Library Holdings: Book Volumes 7500; Original Art Works; Periodical Subscriptions 16; Photographs; Records

FORT WAYNE

L **ALLEN COUNTY PUBLIC LIBRARY,** Art, Music & Audiovisual Services, 900 Webster St, Fort Wayne, IN 46801. Tel 219-421-1200 Ext 1210; Fax 219-422-9688; Elec Mail shuxhold@.acpl.lib.in.us; Internet Home Page Address: www.acpl.lib.in.us; *Assoc Dir* Steven Fortriede; *Art, Music & Audiovisual Mgr* Stacey Huxhold; *Dir* Jeffrey R Krull
Open Mon - Thurs 9 AM - 9 PM, Fri 9 AM - 6 PM, Sat 9 AM - 6 PM, Sun 1 - 6 PM; Estab 1968 to provide a reference collection of the highest quality & completeness for the community & its colleges, a place where local artists & musicians could exhibit their works & perform to provide a circulating collection of slides & musical scores sufficient to meet the demand; The gallery is reserved for painting, sculpture, graphics, photography, ceramics & other art crafts
Income: $253,699 (financed by local property taxes)
Library Holdings: Audio Tapes; Book Volumes 85,000; Cassettes 9000; Compact Disks 17,000; DVDs 2000; Memorabilia; Motion Pictures; Periodical Subscriptions 52; Records; Slides 25,000; Video Tapes 11,000
Special Subjects: Art History, Landscape Architecture, Decorative Arts, Photography, Drawings, Graphic Arts, Graphic Design, Painting-American, Prints, Sculpture, Portraits, Watercolors, Ceramics, Crafts, Video
Exhibitions: Exhibits monthly
Activities: Lect open to public, vis lectr; concerts; lending collection contains books, slides, videos, CDs, cassettes & books-on-tape; sales shop sells books, posters, videos, CDs & cassettes

M **ARTLINK, INC,** 437 E Berry St, Ste 202, Fort Wayne, IN 46802-2801. Tel 219-424-7195; Fax 219-424-8453; Elec Mail deb@artlinkfw.com; Internet Home Page Address: www.artlinkfw.com; *Exec Dir* Deb Washler; *Admin Asst* Suzanne Galazka; *Gallery Receptionist* Dolores Keesee; *Gallery Receptionist* Diane Groenert
Open Tues - Sat Noon - 5 PM, Sun 1 - 5 PM, Sat & Sun evenings 6 - 9 PM; Admis non-mem $2, mem free; Estab 1979 to promote the work of emerging & mid-career artists as well as educational opportunities for the community; 2,200 sq ft main gallery in renovated Hall Community Arts Center, home of four not-for-profit arts organizations. Hallway gallery space available for high school exhibits, local artists & art organizations; Average Annual Attendance: 14,000; Mem: 670; dues $10-$200, individual $20

Income: Financed by mem, Arts United, Indiana Arts Commission, foundations & donations
Publications: Genre newsletter, quarterly; annual print show catalogue
Activities: Classes for adults, summer classes for children; docent training; workshops 2-3 per year; lect open to public, 2-3 vis lectr per year; competitions with awards; sponsoring of competitions; museum shop sells original art & prints

A **ARTS UNITED OF GREATER FORT WAYNE,** The Canal House, 114 E Superior St Fort Wayne, IN 46802. Tel 219-424-0646; Fax 219-424-2783; *Chmn* Leonard Goldstein; *Comptroller* Christine Jones; *Mgr Facility* Leslie Hammer; *Dir Develop* James Sparrow; *Pres* Geoff Gephart
Open Mon - Fri 8 AM - 5 PM; No admis fee; Estab 1955 to raise funds for cultural organizations in Fort Wayne & to foster a positive atmosphere for arts growth
Income: Financed by pub allocations & private donations
Collections: Bicentennial Collection
Publications: Discovery, quarterly newspaper; fine arts calendar
Activities: Own & manage the Performing Arts Center, umbrella organization for 57 arts organizations

M **FORT WAYNE MUSEUM OF ART, INC,** 311 E Main St, Fort Wayne, IN 46802. Tel 260-422-6467; Fax 260-422-1374; Elec Mail mail@fwmoa.org; Internet Home Page Address: www.fwmoa.org; *Dir* Charles A Shephard III; *Assoc Cur of Colls* Sachi Yanari-Rizzo; *Bus Mgr* Lon R Braun; *Dir Develop* Kimberly Brant; *Registrar* Leah Reeder
Open Tues - Sat 10 AM - 5 PM, Sun Noon - 5 PM; Admis fee adults $5, students (K-college) $3, family $10; Estab 1922 to heighten visual perception of American fine arts & perception of other disciplines; Average Annual Attendance: 65,000; Mem: 1550; dues $35 for an individual & up; annual meeting in June
Income: Financed by endowment, mem, Arts United & grants
Library Holdings: Book Volumes; Periodical Subscriptions
Special Subjects: Painting-American, Prints, Sculpture
Collections: Dorsky & Tannenbaum Collection (contemporary graphics); Fairbanks Collection (paintings & prints); Hamilton Collection (paintings & sculpture); Thieme Collection (paintings); Weatherhead Collection (contemporary paintings & prints); contemporary pieces by living America artists; paintings, sculptures & works on paper from 1850 to present by artists from the US & Europe; works by significant regional artists
Publications: Books; calendar, bi-monthly; catalogs; fact sheets; posters
Activities: Classes for adults & children; docent training; lect open to public; gallery talks; tours; artmobile for area schools; book traveling exhibitions 5-6 per year; originate traveling exhibitions; museum shop sells books, magazines & original art

M **THE LINCOLN MUSEUM,** (Lincoln National Life Insurance Co) 200 E Berry St, Fort Wayne, IN 46801-7838; PO Box 7838, Fort Wayne, IN 46801-7838. Tel 260-455-3864; Fax 260-455-6922; Elec Mail thelincolnmuseum@lnc.com; Internet Home Page Address: www.thelincolnmuseum.org; *Pres & CEO* Joan Flinspach; *Dir Colls, Archivist* Carolyn Texley; *Dir Visitor Svcs* Julie Miller; *Lincoln Scholar Dir* Gerald Prokopowicz; *Registrar & Library* Cindy VanHorn; *Dir Devel* Sara Gabbard; *Educational Prog* Jan Shupert-Arick; *Visitor Svcs & Vol* Amy Gerhard; *Office Mgr* Linda Shannon
Open Tues - Sat 10 AM - 5 PM, Sun 1 - 5 PM, cl Mon; Admis fee adults $2.99, seniors & children $1.99, members free; Estab 1928 for collection of Lincolniana; as research library & mus; Average Annual Attendance: 50,000; Mem: 800
Income: financed by Lincoln Financial Group Foundation, Inc; programs funded through Friends of The Lincoln Museum
Library Holdings: Clipping Files; Exhibition Catalogs; Manuscripts; Original Art Works; Original Documents; Periodical Subscriptions; Photographs
Collections: Lincolniana; Civil War; 19th Century Art (1809-1865)
Exhibitions: Abraham Lincoln and the American Experiment (permanent exhibition)
Publications: Lincoln Lore, quarterly; R Gerald McMurtry Lecture, annually
Activities: Classes for adults & children; dramatic programs; docent training; lect open to public; gallery talks; tours; museum shop sells books, reproductions & prints

M **UNIVERSITY OF SAINT FRANCIS,** John Weatherhead Gallery, 2701 Spring St, Fort Wayne, IN 46808. Tel 219-434-3100; Fax 219-434-7444; Elec Mail rcartwri@sfc.edu; *Dean* Rick Cartwright
Open Mon - Fri 10 AM - 5 PM; No admis fee; Estab 1965 to provide art programs to students & community; Gallery, approx 25 x 15 ft each, is maintained in two rooms, located on the third floor, Bonaventure Hall; Average Annual Attendance: 2,000
Activities: Lect open to public, 1-2 vis lectr per year; tours; competitions with awards; traveling exhibitions organized & circulated

FRANKFORT

M **FRANKFORT COMMUNITY PUBLIC LIBRARY,** Anna & Harlan Hubbard Gallery, 208 W Clinton St, Frankfort, IN 46041. Tel 765-654-8746; Fax 765-654-8747; Elec Mail fcpl@accs.net; Internet Home Page Address: www.accs.net/fcpl; *Prog Dir* Flo Burdine; *Dir* Bill Caddell
Open Mon - Thurs, 9 AM - 8 PM, Fri & Sat 9 AM - 5 PM; open Sun, Sept - May, 1 - 5 PM
Special Subjects: Painting-American, Prints, Bronzes, Folk Art
Collections: Bronzes; folk art; Indiana art; paintings; prints

HAMMOND

M **PURDUE UNIVERSITY CALUMET,** Library Gallery, PO Box 2590, Hammond, IN 46323-2094. Tel 219-989-2249; Fax 219-989-2070; *Secy Art Committee* Barbara R Stoddard
Open Mon - Thurs 8 AM - 9:30 PM, Fri 8 AM - 5 PM, Sat 10 AM - 4 PM, Sun 1 - 5 PM; No admis fee; Estab 1976 to present varied art media to the university community & general public; Average Annual Attendance: 25,000

Income: $3000
Collections: 19th century Chinese Scroll collection; 1930 art deco bronze sculptured doors from City Hall
Exhibitions: Area Professional Artists & Students Shows; group shows; traveling shows (Smithsonian Institution, French Cultural Services, Austrian Institute)
Activities: Book traveling exhibitions

HUNTINGTON

M HUNTINGTON UNIVERSITY, (Huntington College) Robert E Wilson Art Gallery, Merillat Centre for the Arts, 2303 College Ave Huntington, IN 46750-1299. Tel 260-359-4272; Fax 260-359-4249; Elec Mail rcoffman@huntington.edu; Internet Home Page Address: www.huntington.edu/mca; *Gallery Dir* Ms Rebecca Coffman
Open Mon - Fri 9 AM - 5 PM; No admis fee; Estab 1990 to provide community with art exhibits & support college art program; Gallery is 25 x 44 ft; Average Annual Attendance: 3,000
Income: $5,000 (financed by college & gifts)
Collections: Robert E Wilson Collection (paintings & sculpture); Huntington University - Permanent Student Art Collection
Activities: Art in the schools; gallery talks; vis lectr 300 per yr; student exhibition awards; book traveling exhibitions three per year

INDIANAPOLIS

M CHILDREN'S MUSEUM, 3000 N Meridian, PO Box 3000 Indianapolis, IN 46208. Tel 317-924-5431; Fax 317-921-4019; *VPres* Kay Cunningham; *VPres* Karen Donnelly; *Staff Librn* Greg Jackson; *Pres & CEO* Dr Jeffrey Patchen; *Pub Relations Mgr* Donna Lolla
Open 10 AM - 5 PM; Admis fee adults $8, children 2-17 $3.50, under 2 free; Estab 1926 to enrich the lives of children; History, physical science, natural science, world cultures, pastimes, center of exploration, trains, dolls, playscape, planetarium, 2 theaters, cinedome; Average Annual Attendance: 1,000,000; Mem: 6800; dues family $60; annual meeting Apr
Income: $10,000,000 (funded by endowment, mem, fundraising)
Collections: Caplan Collection; Toys and artifacts from around the world
Exhibitions: Prelude Awards
Publications: Bi-monthly newsletter
Activities: Children's classes; dramatic programs; docent programs; lect open to public; competitions in theatre, visual arts, vocal music, literature, dance & instrumental music; retail store sells books & toys

M COLUMBUS MUSEUM OF ART AND DESIGN, (Indianapolis Museum of Art) 4000 Michigan Rd, Indianapolis, IN 46208-3326. Tel 317-923-1331; Fax 317-931-1978; Elec Mail ima@ima-art.org; Internet Home Page Address: www.ima-art.org; *Dir & CEO* Anthony Hirschel; *Dir Business Operations* Maurice Cox; *CFO* Dr Anne Munsch; *Deputy Dir* Diana DeGrazia; *Cur Asian Art* James Robinson; *Assoc Cur Asian Art* John Teramoto; *Assoc Cur Contemporary Art* Lisa Freiman; *Cur Decorative Arts* Barry Shifman; *Cur Textiles & Costumes* Niloofar Imami-Paydar; *Cur Prints & Drawings* Martin Krause; *Cur African, S Pacific, Precolumbian* Theodore Celenko Jr; *Cur Painting & Sculpture to 1800* Ronda Kasl; *Assoc Cur Painting & Sculpture* Harriet Warkel; *Dir Exhib & Special Projects* Sue Ellen Paxson; *Chief Exhib Designer* Sherman O'Hara; *Dir Community Relations* Marsha Oliver; *Dir Cur Coll Support & Chief Conservator* Martin Radecki; *Dir Institutional Advancement* Leann Standish; *Dir Educ* Linda Duke; *Dir Oldfields & IMA Grounds* Mark Zelonis; *Dir Lilly House Prog* Bradley Brooks; *Dir Human Resources* Pamela Fogle; *Dir Info Sys & Tech* Rhonda Winter; *Dir Mktg & Communications* Kathy Lang; *Dir Retail Operations* Douglas Smith; *Dir Visitor Svcs* Brian Kwapil; *Registrar* Vanessa Burkhart; *Head Librn* Ursula Kolmstetter; *Chmn* John T Thompson; *VChmn* Daniel C Appel; *Pres* Myrta J Pulliam; *VPres* John L Krauss; *VPres* Lawrence A O'Connor Jr; *Treas* James M Cornelius; *Secy* Patricia J LaCrosse
Open Tues, Wed, Fri & Sat 10 AM - 5 PM, Thurs 10 AM - 9 PM, Sun 10 AM - 5 PM, cl Mon & major holidays; Admis for Indianapolis Museum of Art, adults $7, students & seniors $5, children (12 & under) and IMA members free; Lilly House, adults $5, students & seniors $4, children (12 & under) and IMA members free; combination tickets for Indianapolis Museum of Art and Lilly House adults $10, students & seniors $7; additional charge for some special exhibitions; Estab 1883; the mission of the Indianapolis Museum of Art is to enable a large and diverse audience to see, understand and enjoy the best of the world's visual arts; to this end, the Museum collects, preserves, exhibits and interprets original works of art; The IMA includes the Museum's six pavillions and Oldfields-Lilly House & Gardens, a historic house museum and 26-acre estate as part of a 152-acre campus; Average Annual Attendance: 500,000; Mem: 10,000
Income: Financed by corporations, foundations, private individuals & endowment
Special Subjects: Drawings, Painting-American, Prints, Watercolors, Bronzes, Textiles, Ceramics, Decorative Arts, Painting-European, Portraits, Furniture, Jade, Porcelain, Oriental Art, Period Rooms
Collections: J M W Turner Collection of prints, watercolors & drawings; W J Holliday Collection of neo-impressionist art; Clowes Fund Collection of Old Master paintings; Eli Lilly Collection of Chinese art & the Eiteljorg Collection of African art; European & American painting & sculpture, contemporary art, textiles & costumes, decorative arts
Publications: Brochures; handbook of permanent collections; Bi-monthly magazine (Previews) for members; catalogues for IMA-organized exhibitions, The Story of the Indianapolis Museum of Art, Oldfields
Activities: Classes for adults & children; dramatic programs; docent training; lect open to public, 15-30 vis lectrs per year; concerts; gallery talks; tours; book traveling exhibitions 12-20 per year; originate traveling exhibitions; museum shop & sales shop sell books, magazines, original art, reproductions, prints, slides & jewelry

M Clowes Fund Collection, Clowes Pavilion, 1200 W 38th St Indianapolis, IN 46208. Tel 317-923-1331; Fax 317-931-1978; Elec Mail ima@ima-art.org; *Dir* Bret Waller

Open Tues, Wed, Fri & Sat 10 AM - 5 PM, Thurs 10 AM - 8:30 PM, Sun Noon - 5 PM, cl Mon; No admis fee; Mem: 10,000
Income: Financed by endowment
Special Subjects: Painting-Italian
Collections: Italian Renaissance; Fra Angelico, Bellini, Gaddi, Luini, Tintoretto & others; Spanish-El Greco Ribera & others; Northern Renaissance-17th & 18th century Dutch, Hals, Rembrandt & others; French-Clouet, Corneille de Lyon; English-Reynolds, Constable & others; Flemish-Breughel, Bosch & others
Activities: Classes for adults & children; dramatic programs; docent training; lect open to public, 30 vis lectrs per year; concerts; gallery talks; tours; book traveling exhibitions 12-20 per year; originate traveling exhibitions to other art museums; museum shop sells books

L Stout Reference Library, 4000 Michigan Rd, Indianapolis, IN 46208. Tel 317-920-2647; Fax 317-926-8931; Elec Mail library@ima.museum; Internet Home Page Address: www.ima.museum; *Head Librn* Ursula Kolmstetter; *Librn Asst* Shelly Borntrager Quattrocchi; *Asst Art Reference Librn* Alba Fernandez-Keys
Open Library: Tues, Wed, Fri 2 - 5 PM, Thurs 2 - 8 PM; Estab 1908 to serve needs of Mus staff & public; For reference only
Income: Financed by endowment, mem, city appropriation & federal grants
Library Holdings: Auction Catalogs; Book Volumes 50,000; DVDs; Exhibition Catalogs; Other Holdings Artists Files 30,000; Pamphlets; Periodical Subscriptions 490; Reels; Video Tapes
Special Subjects: Carpets & Rugs, Textiles
Collections: Indiana Artists
Publications: Exhibition catalogs as needed; Indianapolis Museum of Art Bulletin, irregularly; newsletter, bimonthly; 100 Masterpieces

L Jane S. Dutton Educational Resource Center, 4000 Michigan Rd, Indianapolis, IN 46208-3326. Tel 317-923-1331, Ext 226 and 920-2675 (direct line); Fax 317-920-0399, 931-1978; Elec Mail jferger@ima.museum & resourcecenter@ima.museum; Internet Home Page Address: www.ima-art.org; *Visual Resources Librn* Jane Ferger
Open Tues, Wed, Fri & Sat 10 AM - 5 PM, Thurs 10 AM - 8 PM; Estab 1972 to provide visuals on the history of art & to document & record the mus prog, colls & activities; Circ 6,000; Average Annual Attendance: 1,000
Income: Financed by endowment and museum budget
Purchases: $5,000
Library Holdings: CD-ROMs; DVDs 200; Original Art Works; Other Holdings; Periodical Subscriptions 1; Slides 165,000; Video Tapes 1000
Activities: Tours; lending of original and reproduction objects of art to general public & schools; sells resources relating to museum colls

M Columbus Gallery, 390 The Commons, Indianapolis, IN 47201. Tel 812-376-2597; Fax 812-375-2724; Elec Mail marketing@cmad.org; Internet Home Page Address: www.cmadart.org; *Interim Dir* Jenny Simms; *Admin Asst* Stephanie Kinnick; *Gallery Attend* Sarah Wilkinson
Open Tues - Sat 10 AM - 5 PM, Fri 10 AM - 8 PM, cl Sun & Mon; No admis fee; Estab 1974; Gallery contains 2,400 sq ft of exhibit space on Second floor of The Commons; Average Annual Attendance: 9,000; Mem: 300; dues family $35, individual $20; annual meeting in Feb
Income: Financed by auction & donations, including annual fund campaign
Exhibitions: Four exhibitions a year of local interest & design
Activities: School programs; lect open to public, 6-8 vis lectr per year; gallery talks; tours; sponsor competitions; Youth Memorial Award; through school prog Artsmart lend different art packs to schools; book traveling exhibs - 4-6 per yr

M EITELJORG MUSEUM OF AMERICAN INDIANS & WESTERN ART, 500 W Washington, Indianapolis, IN 46204. Tel 317-636-9378; Fax 317-264-172; Internet Home Page Address: www.eiteljorg.org; *Pres & Chief Exec Officer* John Vanausdall; *Dir Communications* Cindy Dashnaw; *Communications Coordr* Anthony Scott
Open Tues - Sat 10 AM - 5 PM, Sun Noon - 5 PM; Admis adults $7, seniors $6, children (5-17) $4, children under 4 free; Dedicated to the preservation & interpretation of the history of the American frontier experience, particularly as it relates to the culture & art of North American Indians & to the exploration, settling & development of the continent; Average Annual Attendance: 101,000; Mem: 3000; dues $40 individual, $50 family
Income: Financed through mem, grants & donations
Special Subjects: Drawings, Painting-American, Photography, Prints, Sculpture, Watercolors, American Indian Art, American Western Art, Bronzes, Southwestern Art, Textiles, Pottery, Etchings & Engravings, Landscapes, Decorative Arts, Portraits, Eskimo Art, Jewelry, Scrimshaw
Collections: Collections of Taos Artists; 19th & 20th Century Art Work; Native American Art and Cultural Objects
Exhibitions: Exhibitions rotate four times per yr
Activities: Classes for adults & children; dramatic programs; docent training; lect open to public; gallery talks; tours; museum shop sells books, magazines, original art, prints, jewelry

M HISTORIC LANDMARKS FOUNDATION OF INDIANA, Morris-Butler House, 1204 N Park Ave, Indianapolis, IN 46202. Tel 317-639-4534; Fax 317-639-6734; Elec Mail mbhouse@historiclandmarks.org; Internet Home Page Address: www.historiclandmarks.org; *Adminr* Tiffany C Sallee; *Community Affairs Coordr* Roberta Campbell; *Dir Tour Svcs* Tina Connor; *CEO & Pres* J Reid Williamson; *Dir Eastern Region* Scott Zimmerman; *Dir Southern Region* Jane Cassidy; *VChmn* James E Hughes; *Dir Western Region* Mark Dollase; *Dir Develop* Mary Anna Hunt; *Financial Resources* Mary Burger; *Dir Indianapolis Office* Amy Kotsbauer; *Dir Community Svc* Marsh Davis; *Hon Chmn* Randall T Shepard; *Dir Northern Region* Todd Zieger
Open Tues - Sat 10 AM - 4 PM, Sun 1 - 4 PM (tours on the half hour), cl Mon; Admis adult $5, seniors $4, students & children $2; Home built 1865 & restored by Historic Landmarks Foundation of Indiana. Estab in 1969 to document age of picturesque eclecticism in architecture & interior decoration. Interpretation, exhibition & preservation of Victorian Indianapolis architecture, culture, history & society (1850-1890); 16 rooms completely furnished. Facilities for receptions & meetings. All paintings by Indiana artists and/or previously owned by Mid-Victorian homeowners (1850-1890); Average Annual Attendance: 10,000; Mem: Annual dues $15 - $100
Income: Financed by private funds & admis fees

Special Subjects: Architecture, Painting-American, Prints, Sculpture, Watercolors, Textiles, Ceramics, Primitive art, Landscapes, Decorative Arts, Portraits, Furniture, Glass, Porcelain, Silver, Carpets & Rugs, Restorations, Period Rooms, Laces, Painting-Italian
Collections: Rococo, Renaissance & Gothic Revival furniture; paintings by early Indiana artists; Victorian ceramics, silver & glass; Victorian textiles
Activities: Classes for children & adults; dramatic programs; docent training; lect open to public; tours; individual paintings & original objects of art lent to professional museums; lending collection contains original art work & decorative arts

L **Information Center Library,** 340 W Michigan St, Indianapolis, IN 46202. Tel 317-639-4534; Fax 317-639-6734; Elec Mail info@historiclandmarks.org; Internet Home Page Address: www.historiclandmarks.org; *Pres* J Marshall Davis; *Educ & Information Dir* Suzanne Stanis
Open Mon-Sun 9 AM - 5 PM, by appointment; For reference only
Income: Financed by pvt funds & admis fees
Library Holdings: Audio Tapes; Book Volumes 3000; Clipping Files; Kodachrome Transparencies; Motion Pictures; Periodical Subscriptions 100; Slides; Video Tapes
Special Subjects: Landscape Architecture, Historical Material, Interior Design, Restoration & Conservation, Architecture
Activities: Classes for adults & children; docent training; lect open to the public; tours; sponsoring of competitions

A **HOOSIER SALON PATRONS ASSOCIATION, INC,** Art Gallery, 714 E 65th St Indianapolis, IN 46220. Tel 317-253-5340; Fax 317-253-5468; Elec Mail hoosiersalon@iquest.net; Internet Home Page Address: www.hoosiersalon.org; *Pres* Renata Harris; *VPres* Jerry Semler; *Exec Dir* Amy Kindred; *Asst Dir* Karen Seltzer; *Dir New Harmony Gallery* Maggie Rapp
Main gallery open Tues - Fri 11 AM - 5 PM, Sat 11 AM - 3 PM; No admis fee; Estab 1925 to promote work of Indiana artists; 1,800 square feet featuring artwork by Indiana artists; Average Annual Attendance: 60,000; Mem: 600 (artists), 450(patrons); dues patrons $50 & up, artists $30 artists eligible after 1 yr residence in Indiana
Income: Financed by mem, art sales, grants, gifts & patrons
Collections: Paintings, prints, sculpture
Exhibitions: 6-7 special exhib per yr at galleries in Indianapolis & New Harmony, IN
Publications: Annual Salon Exhibition Catalog; History of the Hoosier Salon; Hoosier Salon Newsletter, four times a year
Activities: Educ dept includes CD Rom "Landscape Painting in Indiana; A Modern Art"; gallery talks & tours at annual exhibit; juried competition with awards 40 awards in 2004 total value $28,050; original prints & paintings lent to qualified organizations; originate traveling exhibitions circulating to 30 sites around the state of IN, usually 20 works in 6 groups; sales shop sells books, prints, original art & sculpture

M **INDIANA STATE MUSEUM,** 650 S Washington St, Indianapolis, IN 46204. Tel 317-232-1637; Fax 317-232-7090; Elec Mail inmuseum@ismhs.org; Internet Home Page Address: www.in.gov/ism/; *Deputy Dir* Kathleen McLary; *Dir Coll* James May; *Chief Cur Natural History* Ronald Richards; *Cur Americana* Dale Ogden; *Cur Anthropology* William Wepler; *Registrar* Linda Badger; *Dir Creative Exhib* Robin MacKintosh; *Cur Educ* Cynthia Ewick; *Exec Dir* Richard A Gantz; *Comms Mgr* Jessica Di Santo; *Pres FSM Vol* Debbie Specht; *Mgr Educ* Colleen Smyth; *Chmn Bd Trustees* John Goss; *VPres & COO* Jeff Myers; *Conservator* Peter Lundskow; *Mgr Exhib* Jennifer Spitzer; *Vol Coordr* Don Campbell; *CEO* Douglas R Noble; *VPres* Roger Pluckinbaum; *Asst Dir Admin* Bill Bruggen; *Dir Mktg & Communications* Gerda Fogle; *Chmn Board Trustees* Colleen Thomas; *Exec Dir* Doug Nobel; *Asst Dir Historic Site* Rachel Perry; *Dir Prog* David McDaniel; *Dir Exhib Production* Jim Mackintosh; *Educ Mgr* Colleen Smith
Open daily 9 AM - 5 PM, Sun 11 AM - 5 PM; Admis adults $7; seniors $6.50; children $4; Estab 1869 for collections; current mus building opened 1967 to collect, preserve & interpret the natural & cultural history of the state; Numerous galleries; Average Annual Attendance: 150,000; Mem: 1200; dues $39 - $100; annual meeting in June
Income: Financed by state appropriation
Special Subjects: Archaeology, Architecture, Furniture, Painting-American, Silver, Textiles, Sculpture, Photography, Anthropology, Costumes, Ceramics, Decorative Arts, Manuscripts, Dolls, Historical Material
Exhibitions: Indiana art shows annually; Annual Toy Soldiers Playground; Indiana Sports Gallery
Publications: Hoosierisms, quarterly; brochures for individual historic sites
Activities: Educ prog; classes for children; docent training; in-school programs; lect open to public, 4 vis lectrs per year; concerts; gallery talks; tours; exten prog statewide; I-Reach lends to various organizations; 1-2 book traveling exhibitions; museum shop selling books, reproductions & prints

INDIANA UNIVERSITY - PURDUE UNIVERSITY AT INDIANAPOLIS
M **Indianapolis Center for Contemporary Art-Herron Gallery,** Tel 317-920-2420; Fax 317-920-2401; Elec Mail drussick@rupui.edu; Internet Home Page Address: www.herron.iupui.edu/newlow/gallery/default; *Dir & Cur Art Gallery* David Russick
Open Mon - Wed 10 AM - 5 PM, Thurs 10 AM - 7 PM, Fri 10 AM - 5 PM, Sat 10 AM - 5 PM; No admis fee; School estab 1860. Gallery estab 1978 & is located in the Mus Building & exhibits contemporary art on an international scale; 3000 sq ft, 14 ft ceilings, marble floors, climate control; Average Annual Attendance: 40,000; Mem: 250; dues $25-$500
Income: Financed by state appropriation, grants & private support
Exhibitions: Biannual Faculty Show; Senior Show & Student Show
Activities: Docent training; tours; lect open to public; 15 vis lectrs per year; gallery talks; tours; competitions; awards; exten dept serving Indianapolis & surrounding communities; facilitators of civic art projects; book traveling exhibitions 2 per year; originate traveling exhibitions; museum shop sells t-shirts, posters, catalogs
 —**Herron School of Art Library,** Tel 317-278-9484; Fax 317-278-9497; Internet Home Page Address: www.ulib.iupui.edu/herron; *Dir* Sonja Staum; *Circulation Mgr* Praseth Kong; *Visual Resource Specialist* Danita Davis

Open (during academis yr) Mon - Thurs 8 AM - 7 PM, Fri 8 AM - 5 PM, Sat 9 AM - 1 PM; Estab 1970 as a visual resource center for the support of the curriculum of the Herron School of Art
Income: Financed by state appropriation
Library Holdings: Audio Tapes 615; Book Volumes 27,500; Clipping Files; DVDs; Exhibition Catalogs; Lantern Slides; Other Holdings Laser disc; Pamphlets; Periodical Subscriptions 100; Photographs; Prints; Reproductions; Slides 160,000; Video Tapes 1,500
Special Subjects: Art History, Advertising Design, Afro-American Art, American Indian Art, American Western Art, Antiquities-Greek, Architecture, Art Education, Ceramics, Collages, Commerical Art, Conceptual Art, Crafts, Display, Drawings

A **INDIANAPOLIS ART CENTER,** Churchman-Fehsenfeld Gallery, 820 E 67th St, Indianapolis, IN 46220. Tel 317-255-2464; Fax 317-254-0486; Elec Mail inartctr@netdirect.net; Internet Home Page Address: www.indplsartcenter.org; *VPres & Dir Programs* David S Thomas; *Exhib Dir* Julia Muney Moore; *Pres & Exec Dir* Joyce Sommers; *Exhib Asst* Stephanie Robertson; *Dir Marketing* Kathy Pataluch; *Dir Finance* Roberta Druif; *Pub Relations Asst* Amy Lamb; *Office Mgr* Tobi Buchanan; *Mus Shop Mgr* Melanie Reckas; *Educ Asst* Angela Ryan; *Finance Assoc* Jan Johnson; *Outreach Assoc* Bernadette Ostrozouch; *Educ Assoc* Carole Eney; *Dir Operations* Pamela Rosenberg; *Dir Develop* Heather Caruso; *Dir Outreach* Gloria Pearson
Open Mon - Fri 9 AM - 10 PM, Sat 9 AM - 6 PM, Sun Noon - 3 PM; No admis fee, suggested donation $2; Estab 1934 to engage, enlighten & enhance community through art educ, participation & observation; Art Center houses 3 galleries: Churchman-Fehsenfeld Gallery, Allan Clowes Gallery & Sarah Hurt Gallery; maintains collection for on-site reference only; Average Annual Attendance: 325,000; Mem: 2200; dues family $45, individual $35, senior and student $25
Income: Financed by endowment, mem, city & state appropriation
Publications: Paper Canvas, quarterly; quarterly program & class schedule; periodic exhibition catalogues
Activities: Over 90 art classes offered for all ages & skill levels in all medias. Outdoor river front stage has music theatre & dance; summer fine arts camps; workshops; lect open to public, 5-10 vis lectrs per year; concerts; gallery talks; tours; competitions with awards; scholarships offered; artmobile; book traveling exhibitions 1-2 per year; originate traveling exhibitions to other art centers & museums; sales shop sells books, original art & prints

L **INDIANAPOLIS MARION COUNTY PUBLIC LIBRARY,** Interim Central Library, PO Box 211, Indianapolis, IN 46206-0211; 202 N Alabama, Indianapolis, IN 46206-0211. Tel 317-269-1741; Fax 317-269-5229; Internet Home Page Address: www.imcpl.org; *Mgr* Kathy Diehl
Open Mon & Tues 9 AM - 9 PM, Wed - Fri 9 AM - 6 PM, Sat 9 AM - 5 PM, Sun 1 - 5 PM; none; Estab 1873
Income: Financed by state appropriation and county property tax
Library Holdings: Book Volumes 25,000; Cassettes; Clipping Files; DVDs; Exhibition Catalogs; Periodical Subscriptions 200; Video Tapes
Collections: Julia Connor Thompson Collection on Finer Arts in Homemaking
Activities: Lect open to public; concerts; tours

M **MARIAN COLLEGE,** Allison Mansion, 3200 Cold Spring Rd, Indianapolis, IN 46222-1997. Tel 317-955-6120; Fax 317-955-6407; Internet Home Page Address: www.marian.edu; *Event Coordr* Kathi Ashmore
Conference Center open by appointment; Admis $3 per person, minimum group of 50; Estab 1970; house in the National Register of Historical Places since 1936; The interior of the mansion is oak, walnut & marble. The grand stairway in the main hall leads to the balcony overlooking the hall, all hand-carved walnut. A private collection of 17th century paintings
Income: Financed by donations
Collections: 17th century paintings
Activities: Concerts; tours; corporate meeting site; rent to pub

M **NATIONAL ART MUSEUM OF SPORT,** University Place at IUPUI, 850 W Michigan St Indianapolis, IN 46202-5198. Tel 317-274-3627; Fax 317-274-3878; Elec Mail arein@iupui.edu; Internet Home Page Address: www.namos.iupui.edu; *Admin* Ann M Rein
Open Mon - Fri 8 AM - 5 PM; No admis fee, donations accepted; Estab 1959 to preserve, exhibit & promote understanding of sport-related art; Public areas including four lobbies of University Place Conference Ctr; Average Annual Attendance: 100,000; Mem: 167; dues $25 - $150
Income: Donations, grants
Purchases: 2000 - Rhoda Sherbell sculpture of Casey Stengel Cathy Claycomb - Croupade - copper on opalescent glass
Library Holdings: Auction Catalogs; Exhibition Catalogs; Framed Reproductions; Kodachrome Transparencies; Memorabilia; Photographs; Reproductions; Sculpture; Slides; Video Tapes
Special Subjects: Drawings, Painting-American, Bronzes, Etchings & Engravings, Eskimo Art, Cartoons
Collections: Over 800 paintings, sculptures & works on paper representing over 40 sports
Exhibitions: (6/15/2007-8/15/2007) "Vision of Victory" presented by Mutual of Omaha; (11/1/2007-12/15/2007) Art Student League Sport Art Winners
Publications: Score Board, quarterly newsletter; catalogs
Activities: Slide/script prog - also on PowerPoint - for schls; tours; video: The Art of Sport; Penrod Sport Art Purchase Prize; individual paintings & original objects of art lent to archivally sound institutions with adequate security & qualified staff; occasional book traveling exhibs (Neiman Exhibits); originate traveling exhibitions

M **UNIVERSITY OF INDIANAPOLIS,** Christel DeHaan Fine Arts Gallery, 1400 E Hanna Ave, Indianapolis, IN 46227. Tel 317-788-3253; Fax 317-788-6105; Elec Mail dschaad@uindy.edu; Internet Home Page Address: www.uindy.edu; *Chmn* Dee Schaad
Open Mon - Fri 9 AM - 4 PM; No admis fee; Estab 1964 to serve the campus & community; Average Annual Attendance: 6,000
Income: Financed by institution support
Purchases: $15,000

Collections: Art Department Collection; Krannert Memorial Collection
Exhibitions: Student, faculty & local artists exhibits
Publications: Announcements; annual catalog & bulletin
Activities: Classes for adults; lect open to public; concerts; gallery talks; competitions with prizes; scholarships offered

LAFAYETTE

M **ART MUSEUM OF GREATER LAFAYETTE,** (Greater Lafayette Museum of Art) 102 S Tenth St, Lafayette, IN 47905. Tel 765-742-1128; Fax 765-742-1120; Elec Mail glma@glmart.org; Internet Home Page Address: www.glmart.org; *Dir Educ* Paige Sharp; *Pres (V)* Rob Lindsey; *Dir Collections & Exhibs* Michael Hathaway; *Mem & Spec* Kate O'Brien
Open Tues - Sun 11 AM - 4 PM, cl Mon & major holidays; No admis fee; Estab 1909 to encourage & stimulate art & to present exhibitions of works of local, regional & national artists & groups as well as representative works of American & foreign artists; Average Annual Attendance: 30,000; Mem: 700; dues $25 & up; annual meeting in Oct
Income: Financed by art assoc foundation, endowment, mem, school of art & special events
Special Subjects: Drawings, Graphics, Hispanic Art, Painting-American, Photography, Prints, Sculpture, Watercolors, American Indian Art, Southwestern Art, Textiles, Religious Art, Ceramics, Crafts, Folk Art, Pottery, Woodcarvings, Woodcuts, Etchings & Engravings, Afro-American Art, Decorative Arts, Portraits, Porcelain
Collections: Permanent collection of over 600 works of art obtained through purchase or donation since 1909; Laura Anne Fry American Art Pottery; Alice Baber Collection of Contemporary American Art; American art collection specializing in Hoosier artist's work
Exhibitions: Frank Lloyd Wright; Samara Winged Seats of Indiana, exhibit by Doug Calisch
Publications: Annual report; bi-monthly calendar; exhibition catalog
Activities: Classes for adults & children; lect open to public, 2-5 vis lectr per year; tours; competitions with awards; Akeley memorial lect series; scholarships & fels offered; individual paintings & original objects of art lent to Museum members on a monthly basis & to corporations; sales shop sells books, original art

L **Library,** 102 S Tenth St, Lafayette, IN 47905. Tel 765-742-1128; Fax 765-742-1120; Internet Home Page Address: www.glmart.org; *Exec Dir* Gretchen Mehring; *Cur Registrar* Michal Hathaway; *Dir of Educ* Paige Sharp
Open Tues - Sun 11AM - 4 PM; Suggested admis $2; Estab 1909; Average Annual Attendance: 30,000; Mem: 700; dues start at $25
Income: Private, nonprofit
Library Holdings: Audio Tapes; Book Volumes 1000; Cassettes; Clipping Files; Exhibition Catalogs; Framed Reproductions; Motion Pictures; Original Art Works; Pamphlets; Periodical Subscriptions 15; Photographs; Prints; Reproductions; Sculpture; Slides; Video Tapes
Special Subjects: Art History, Folk Art, Decorative Arts, Photography, Etchings & Engravings, Graphic Arts, Painting-American, Painting-Japanese, Painting-European, Crafts, Latin American Art, American Western Art, Art Education, American Indian Art, Oriental Art
Collections: American art with emphasis on Indiana
Activities: Classes for adults & children; museum shop

M **TIPPECANOE COUNTY HISTORICAL ASSOCIATION,** Museum, 909 South St, Lafayette, IN 47901. Tel 765-476-8411; Fax 765-476-8414; Elec Mail mail@tcha.mus.in.us; Internet Home Page Address: tcha.mus.in.us; *Exec Dir* Phillip C Kwiatkowski; *Operations Mgr* David Becker; *CEO, Exec Dir* Kevin O'Brien; *VPres* Jane Boswell; *Dir Pub Relations & Mktg* Laura Loy; *Asst Dir* Gina Settle; *Cir Coll* Paul Schueler
Open daily 1 - 5 PM, cl Mon; Admis adults $2, children (4-12) $1.50; Estab 1925 to collect, preserve, research & interpret the history of Tippecanoe County & the immediate surrounding area; Housed in a Victorian house (1851-52), there are exhibits of various phases of county history in nine rooms; Average Annual Attendance: 20,000; Mem: 1,000; dues $10 - $500; annual meeting in Jan
Income: Financed by endowment, mem, county & state appropriation, sales & programs
Special Subjects: Architecture, Painting-American, Costumes, Decorative Arts, Dolls, Furniture, Historical Material, Dioramas, Period Rooms
Collections: Broad range, incorporating any object relative to county history
Exhibitions: Changing exhibits; fixed exhibits include The Building Years 1840-1900, miniature rooms, paintings & porcelains
Publications: Tippecanoe Tales, occasional series on various phases of Tippecanoe County history; Weatenotes, 11 times a year; Books on various historical topics, every 2 yrs
Activities: Classes for adults & children; docent training; lect open to public; tours; individual paintings & original objects of art lent to other museums; sales shop sells books, reproductions, original crafts on consignment

L **Alameda McCollough Library,** 1001 South St, Lafayette, IN 47901; 909 South St, Lafayette, IN 47901. Tel 765-476-8411; Fax 765-476-8414; Elec Mail library@tcha.mus.in.us; Internet Home Page Address: tcha.mus.in.us; *Dir Colls & Library* Paul J Schueler
Open Tues 1 PM - 5 PM, Wed 1 PM - 7 PM, 3rd Sat of month 10 AM - 2 PM; Estab 1925, local history, genealogical research; Archives by appt; library open to public; Average Annual Attendance: 2,500; Mem: 1,200
Library Holdings: Audio Tapes; Book Volumes 8,200; Clipping Files; Lantern Slides; Manuscripts; Maps; Memorabilia; Original Art Works; Original Documents; Pamphlets; Periodical Subscriptions 36; Photographs; Reels 575
Special Subjects: Painting-American, Historical Material
Collections: 250 archival collections, photo archives, George Winter Manuscript and art collection
Activities: Classes for adults and children; lectrs open to the public, 25 vis lectrs per year; tours; gallery talks; sales shop sells books & prints

MADISON

M **JEFFERSON COUNTY HISTORICAL SOCIETY MUSEUM,** 615 W First St, Madison, IN 47250. Tel 812-265-2335; Elec Mail jchs@seidata.com; Internet Home Page Address: www.seidata.com/~jchs; *Pres* Robert Wolfschlag
Open Mon - Fri 10 - 4:30 PM, Sat, May 1 - Oct 31, 10 - 4:30 PM. Sun, May 1 -

Oct 31, 1 - 4 PM; Admis $4; Estab 1900 to preserve & display art & artifacts worthy of note & pertinent to local area history & culture; Museum has a permanent gallery of Civil War & steamboating, other gallery has rotating exhibits; Average Annual Attendance: 2,000; Mem: 400; family $35, single $25
Collections: William McKendree Snyder Collection, paintings, portraits; Jefferson County artifacts-textiles, primitives; 1895 Madison Railroad Station
Publications: Beloved Madison
Activities: Classes for children; museum shop sells books

MUNCIE

BALL STATE UNIVERSITY

M **Museum of Art,** Tel 765-285-5242; Fax 765-285-4003; Internet Home Page Address: www.bsu.edu/artmuseum; *Dir* Peter F Blume; *Assoc Dir* Carol Schafer; *Cur Educ* Tania Said Schuler
Open Mon - Fri 9 AM - 4:30 PM, Sat & Sun 1:30 - 4:30 PM, cl legal holidays; No admis fee; Estab 1936 as a university & community art museum; Ten galleries, sculpture court & mezzanine; Average Annual Attendance: 29,000
Income: Financed by university, community & federal government
Special Subjects: Architecture, Drawings, American Indian Art, American Western Art, African Art, Ethnology, Ceramics, Etchings & Engravings, Decorative Arts, Furniture, Glass, Asian Art, Coins & Medals, Baroque Art, Antiquities-Oriental, Antiquities-Egyptian, Antiquities-Greek, Antiquities-Roman, Antiquities-Etruscan
Collections: Ball-Kraft Collection of Roman & Syrian glass; Italian Renaissance art & furniture; 18th, 19th & 20th century European & American paintings, prints & drawings; David T Owskley Collection of Ethnographic Art
Exhibitions: Annual Art Student Exhibit; Biennial Art Faculty Exhibit; Jenny Holzer: Truisms; Engaging Technology: A History & Future of Intermedia
Publications: Exhibition catalogs
Activities: Art for lunch talks; children's activity sheets; docent training; lect open to public, 2-5 vis lectr per year; gallery talks; tours; individual paintings & original objects of art lent to qualified museums; book traveling exhibitions 4 per year; museum shop sells posters, postcards & catalogues

L **Architecture Library,** Tel 765-285-5857, 285-5858; Fax 765-285-3726; Elec Mail aetrendler@b8u.edu; Internet Home Page Address: www.bsu.edu/library/collections/archlibrary; *Librn* Amy Trendler; *Asst Librn* Helen Turner; *Visual Resources Cur* Cindy Turner
Open Mon - Thurs 8 AM - 10 PM, Fri 8 AM - 5 PM, Sat 9 AM - 5 PM, Sun 1 - 10 PM; hours vary during academic vacations, interims & summer sessions; Estab 1965 to provide materials necessary to support the academic programs of the College of Architecture & Planning; Average Annual Attendance: 45,000
Income: Financed through University
Library Holdings: Book Volumes 22,000; CD-ROMs 100; DVDs 8; Other Holdings Student theses & 30,000 digital images; Periodical Subscriptions 100; Slides 119,000; Video Tapes 40
Special Subjects: Landscape Architecture, Decorative Arts, Drawings, Graphic Design, Industrial Design, Interior Design, Furniture, Drafting, Restoration & Conservation, Architecture

NASHVILLE

A **BROWN COUNTY ART GALLERY FOUNDATION,** Brown County Art Gallery & Foundation, One Artist Dr, PO Box 443 Nashville, IN 47448. Tel 812-988-4609; Elec Mail brncagal@aol.com; Internet Home Page Address: www.geocities.com/brncagal; *Pres* Dr Emanuel Klein; *VPres* Sara Hess; *Secy* Richard Hess; *Treas* Kim Cornelius; *Museum Coordr* Richard Halvorson; *Gallery Mgr* Juanita Moberly; *Gallery Mgr* Pam Crawford; *Grants & Fund-raising Advisor to Bd* Susanne Gaudin; *Legal Affairs Advisor to Board* Sharon A Wildey
Open Fri, Sat & Sun 10 AM -5 PM; Sun 2 - 5 PM Jan & Feb only; cl Thanksgiving, Christmas & New Years; No admis fee; Estab 1926 to unite artists and laymen in fellowship; to create a greater incentive for development of art and its presentation to the public; to estab an art gallery for exhibition of work of members of the Association; 6 gallery rooms; Average Annual Attendance: 35,000; Mem: 30 artists; 200 supporting members; for foundation mem art patron, for assn mem professional artist; dues life $1,000, individual $20; annual meeting in May
Income: Financed by mem & foundation
Library Holdings: Auction Catalogs; Book Volumes; Memorabilia; Original Documents; Photographs; Sculpture; Video Tapes
Special Subjects: Prints, Watercolors, Painting-American
Collections: 81 paintings & pastels by the late Glen Cooper Henshaw; over 200 paintings by early Brown County Artists
Exhibitions: Three exhibits each year by the artist members & paintings from permanent collection
Publications: Annual catalog
Activities: Classes for adults & children; docent training; lect open to public, various vis lectrs per year; gallery talks; tours; sales shop sells books, original art, reproductions, prints & videos

M **T C STEELE STATE HISTORIC SITE,** 4220 TC Steele Rd, Nashville, IN 47448. Tel 812-988-2785; Fax 812-988-8457; Elec Mail tcsteele@bloomington.in.us; Internet Home Page Address: www.tcsteele.org; *Cur* Andrea Smith de Tarnowsky
Open Tues - Sat 9 AM - 5 PM, Sun 1 - 5 PM, cl Mon, holidays & during winter, contact site for exact dates; Admis adults $3.50, senior citizens & adult group rate $3, children $2, children's group rate $1.50; Estab 1945 to protect, collect & interpret the art & lifestyle of T C & Selma Steele; 1,200 sq ft, with 80 T C Steele paintings on display at any one time; Average Annual Attendance: 17,000; Mem: Support organization, The Friends of TC Steele
Income: Financed by state appropriation & admissions
Special Subjects: Painting-American, Textiles, Furniture
Collections: 347 paintings, historic furnishing, decorative arts photos, books. No purchases, all part of willed estate
Activities: Lect open to public; concerts; gallery talks; tours; annual special events; individual paintings & original objects of art lent to other museums & universities; lending collection contains original art works & paintings; framed

reproductions; originate traveling exhibitions to other museums & historic sites; museum shop sells books, reproductions, prints & gift items relations to site/collections

NEW ALBANY

M CARNEGIE CENTER FOR ART & HISTORY, 201 E Spring St, New Albany, IN 47150. Tel 812-944-7336; Fax 812-981-3544; Elec Mail carnegie@myexcel.com; *Pres* Ed Cook; *Art Dir* Julie Schweitzer; *Dir Educ* Laura Wilkins; *Registrar* Helen Streepey; *Maintenance* Paris Brock; *Dir of Develop* Suellen Wilkinson
Open Tues - Sat 10 AM -5:30 PM; No admis fee; Estab 1971, to exhibit regional professional artists work on a monthly basis & to promote the arts & history of our community; Two galleries are maintained, approx dimensions: 18 x 25 ft & 15 x 25 ft; Average Annual Attendance: 7,000; Mem: 400; dues $10 - $5,000; annual meeting in Dec
Income: Financed by county appropriation, mem & fundraising
Special Subjects: Historical Material
Collections: Permanent collection of historical items
Exhibitions: Floyd County in World War I; 1920s to Depression Years; A History Sampler; Annual July Juried Art Exhibit; Hand Carved, Animated Folk Art Diorama on permanent display
Publications: Bulletins
Activities: Classes for adults & children; lect open to public; concerts; tours; competitions with awards; book traveling exhibitions annually

NEW HARMONY

M UNIVERSITY OF SOUTHERN INDIANA, New Harmony Gallery of Contemporary Art, 506 Main St, New Harmony, IN 47631; PO Box 627, New Harmony, IN 47631. Tel 812-682-3156; Fax 812-682-4313; Elec Mail avasherdea@usi.edu; Elec Mail emyersbro@usi.edu; Internet Home Page Address: www.nhgallery.com; *Dir* April Vasher-Dean; *Asst Dir* Erika Myers-Bromwell
Open Tues - Sat 10 AM - 5 PM, Sun Noon - 4 PM (April-Dec), cl Mon; No admis fee; Estab 1975 for exhibition of contemporary midwest art & artists; Average Annual Attendance: 25,000
Income: Financed by contributions & grants
Collections: Univ Southern Ind Collection
Exhibitions: Changing exhibitions every six weeks
Activities: Lect open to the public, 4 vis lectr per year; gallery talks; gallery sells original art

NOTRE DAME

M SAINT MARY'S COLLEGE, Moreau Galleries, Moreau Center for the Arts, 239 Moreau Bldg Notre Dame, IN 46556. Tel 574-284-4655; Fax 574-284-4715; Elec Mail khoefle@saintmarys.edu; Internet Home Page Address: www.stmarys.edu/~gallery; *Gallery Dir* K Johnson Bowles
Open Mon - Fri 10 AM - 4 PM, Sat 10 AM - Noon, Sun 1 - 3 PM, cl weekends; No admis fee; Estab 1956 for educ, community-related exhibits & contemporary art; Gallery presently occupies three spaces; all exhibits rotate; Average Annual Attendance: 6,000
Income: Financed through college
Special Subjects: Prints
Collections: Cotter Collection; Dunbarton Collection of prints; Norman LaLiberte; various media
Exhibitions: Rotating exhibitions
Publications: Catalogs, occasionally
Activities: Lect open to public; tours; concerts; gallery talks; competitions with awards; individual paintings & original objects of art lent; originate traveling exhibitions

UNIVERSITY OF NOTRE DAME
M Snite Museum of Art, Tel 574-631-5466; Fax 574-631-8501; Internet Home Page Address: www.nd.edu/~sniteart/97/main3.html; *Cur* Stephen B Spiro; *Cur* Douglas Bradley; *Cur* Stephen Moriarty; *Registrar* Robert Smogor; *Chief Preparator* Greg Denby; *Sr Staff Asst* Anne Mills; *Exhib Designer* John Phegley; *Admin Asst* Susan Fitzpatrick; *Dir & Cur* Charles R Loving; *Cur Educ* Diana Matthias; *Cur Educ* Jacqueline Welsh; *Assoc Dir* Ann Knoll; *Cur Arts* Linda Canfield; Dinali Cooray; *Marketing & Pub Relations* Gina Costa; *Cur Rev* James F Flanigan C.S.C.; *Cur* Joanne Mack Ph.D.; *Staff Accountant* Carolyn Niemier; *Asst Preparator* Ramiro Rodriguez; *Coordr* Heidi Williams
Open Tues & Wed 10 AM - 4 PM, Thurs - Sat 10 AM - 5 PM, Sun 1 - 5 PM (when classes are in session); No admis fee; Estab 1842; Wightman Memorial Art Gallery estab 1917; O'Shaughnessy Art Gallery estab 1952; Snite Museum estab 1980 to educate through the visual arts; during a four year period it is the objective to expose students to all areas of art including geographic, period & media, open 1980; Galleries consist of 35,000 sq ft; Average Annual Attendance: 60,000; Mem: 250; dues from $15 - $5,000; annual meeting in May
Special Subjects: Drawings, Painting-American, Photography, Prints, Sculpture, American Indian Art, African Art, Pre-Columbian Art, Painting-European, Porcelain, Oriental Art, Painting-British, Painting-French, Baroque Art, Painting-Italian
Collections: African art; American Indian & pre-Columbian art; Baroque paintings, northern & Italian; 18th & 19th century American, English, 17th, 18th & 19th Century French paintings & Master drawings; Kress Study Collection; 19th century French oils; Reilly Collection of Old Master Drawings through 19th century; Fedderson Collection of Rembrandt Collections
Exhibitions: Annual Faculty Exhibition: Annual Student Exhibition
Publications: Exhibition catalogs, 3-5 times per yr; Calendar of Events, semi-annually
Activities: Classes for adults & children; dramatic programs; docent training; lect open to public, 3-5 vis lectr per year; concerts; gallery talks; tours; fellowships;

individual paintings & original objects of art lent to qualified institutions; book traveling exhibitions 10-12 per year; originate traveling exhibitions to national museums

L Architecture Library, Tel 574-631-6654; Fax 574-631-9662; Elec Mail library.archlib.1@nd.edu; Internet Home Page Address: www.architecture.library.nd.edu; *Library Supv* Deborah Webb; *Librn* Marsha Stevenson
Open Mon - Thurs 8 AM - 10 PM, Fri 8 AM - 6 PM, Sat 10 AM - 5 PM, Sun 1 - 10 PM, intersessions Mon - Fri 8 AM - 5 PM; Estab 1930 as a branch of the university library
Income: Funding by University
Library Holdings: Book Volumes 28,000; CD-ROMs 6; Fiche; Lantern Slides 4,500; Periodical Subscriptions 119; Reels; Video Tapes 100
Special Subjects: Landscape Architecture, Historical Material, Interior Design, Furniture, Restoration & Conservation, Antiquities-Greek, Antiquities-Roman, Architecture
Collections: Furniture book collection; Rare books on architecture

PORTLAND

M JAY COUNTY ARTS COUNCIL, Hugh N Ronald Memorial Gallery, 131 E Walnut St, PO Box 804 Portland, IN 47371-0804. Tel 219-726-4809; Fax 219-726-2081; Elec Mail artsland@jayco.net; Internet Home Page Address: www.artsland.org; *Exec Dir* Eric Rogers; *Dir Visual Arts* Carol Kennedy; *Staff Performing Artist* Kathleen Byrd; *Dir Admin* Heidi Brunswick; *Develop Asst* Sue Burk
No admis fee; Estab 1967; Local, regional, national & international contemporary art in a wide range of media
Exhibitions: Contemporary regional art
Activities: Classes for adults & children; dramatic programs; scholarships offered; originate traveling exhibitions 4-8 per year

RICHMOND

M EARLHAM COLLEGE, Leeds Gallery, National Rd W, Richmond, IN 47374-4095. Tel 765-983-1200; Fax 765-983-1304; Internet Home Page Address: www.earlham.edu; *Pres College* Douglas C Bennett; *Dir Permanent Coll* Kristan Fedders; *Art Dept Convener* Nancy Taylor
Open daily 9 AM-6 PM; No admis fee; Estab 1847 as a liberal arts college; Leeds Gallery estab 1970
Collections: Regional artist: George Baker, Bundy (John Ellwood), Marcus Mote; prints by internationally known artists of 19th & 20th centuries; regional artists; rotating collections from all areas
Activities: Dramatic programs; lect open to public, 5-6 vis lectr per year; concerts; individual paintings & original objects of art lent; traveling exhibitions organized & circulated; sales shop sells books

A RICHMOND ART MUSEUM, PO Box 816, Richmond, IN 47375. Tel 765-966-0256, 973-3369; Fax 765-973-3738; Internet Home Page Address: www.richmondartmuseum.org; *Dir Operations* Shaun T Dingwerth; *Exec Dir* Kathleen D. Glynn
Open Jan - Dec Tues - Fri 10 AM - 4 PM, Sun 1 - 4 PM, cl holidays; No admis fee; Estab 1898 to promote creative ability, art appreciation & art in pub schools; Maintains an art gallery with four exhibit rooms: two rooms for permanent collection & two rooms for current exhibits; Average Annual Attendance: 10,000; Mem: 600; dues students $5 - $1,000; annual meeting in Nov
Income: Financed by mem, grants, donations
Special Subjects: Photography, Prints, Painting-American, Ceramics
Collections: Regional & state art; American, European, Oriental art; Overbeck Pottery
Exhibitions: Annual Area Artists Exhibition; Hands-On Exhibition for grade school children High School Art Exhibition
Publications: Art in Richmond - 1898-1978; quarterly newsletter
Activities: Classes for adults & children; docent training; lect open to public, 4 vis lectr per year; gallery talks; tours; competitions with merit & purchase awards; scholarships offered; individual paintings & original objects of art lent to corporations that annually support the museum or to other galleries for exhibition; lending collection contains books, original art works, original prints & photographs; originate traveling exhibitions; museum shop sells books, original art & prints

L Library, 350 Hub Etchison Pky, Richmond, IN 47374. Tel 765-966-0256; Fax 765-973-3738; Elec Mail shaund@rcs.k12.in.us; Internet Home Page Address: www.richmondartmuseum.org; *Exec Dir* Shaun Dingwerth
Open Mon-Fri 10AM-4PM; Open to members; library primarily for reference & art research
Library Holdings: Audio Tapes; Book Volumes 800; Exhibition Catalogs
Special Subjects: Art History, Decorative Arts, Photography, Graphic Arts, Painting-American, Painting-British, Painting-Dutch, Painting-Flemish, Sculpture, Painting-European, Ceramics, Printmaking, Pottery, Landscapes, Reproductions
Activities: Classes for children

ROCHESTER

M FULTON COUNTY HISTORICAL SOCIETY INC, Fulton County Museum, 37 E 375 N, Rochester, IN 46975-8384. Tel 574-223-4436; Elec Mail fchs@rtcol.com; Internet Home Page Address: www.icss.net/~fchs; *Dir Museum* Melinda Clinger; *Pres* Ruby Reed; *Treas* Lola Riddle; *Cataloger* Peggy Van Meter; *Maintenance* Mark Sult; *Pres Emerita* Shirley Willard
Open 9 AM - 5 PM; No admis fee; Estab 1963 to preserve Fulton County & Northern Indiana history; 64 X 184 ft; new exhibit quarterly; Average Annual Attendance: 35,000; Mem: 600; dues $15; annual meeting third Mon in Nov
Income: $106,000 (financed by mem, sales & festivals, grants & donations)
Library Holdings: Audio Tapes; Book Volumes; Cards; Cassettes; Clipping Files; Filmstrips; Framed Reproductions; Manuscripts; Maps; Memorabilia; Motion

Pictures; Original Art Works; Original Documents; Other Holdings; Pamphlets; Periodical Subscriptions; Photographs; Prints; Records; Reels; Reproductions; Sculpture; Slides; Video Tapes
Collections: Antiques; Elmo Lincoln, first Tarzan; old farm equipment; old household furniture; Woodland Indians
Exhibitions: Traditional & Indian Crafts; Round Barn Festival; Trail of Courage; Redbud Trail; Living History Village of 11 Bldgs (Loyal Indiana) portrays 1900-1925
Publications: Fulton County Images, bi-annual
Activities: Classes for adults & children; dramatic programs; docent programs; Indian dances; living history festivals; Children's Activity Day in July; lect open to public, 3 vis lectr per year; gallery talks; tours; competitions with prizes; Vol of Yr.; Benefactor of Yr; retail store sells books, prints, magazines, original art & reproductions, prints, Indian crafts, traditional crafts

SOUTH BEND

L ENVIRONIC FOUNDATION INTERNATIONAL LIBRARY, 916 Saint Vincent St, South Bend, IN 46617-1443. Tel 574-233-3357; Fax 574-289-6716; Elec Mail environics@aol.com; *Founder* Patrick Horsbrugh; *Pres* William R Godfrey
Estab 1970
Library Holdings: Clipping Files; Original Art Works; Slides; Video Tapes
Special Subjects: Landscape Architecture, Graphic Design, Painting-British, Watercolors, Archaeology, Advertising Design, Interior Design, Lettering, Anthropology, Furniture, Period Rooms, Stained Glass, Aesthetics, Landscapes, Architecture

A SOUTH BEND REGIONAL MUSEUM OF ART, 120 S Saint Joseph St, South Bend, IN 46601. Tel 574-235-9102; Fax 574-235-5782; Elec Mail sbrma@sbt.infi.net; *Chief Cur* Bill Tourtillotte; *Exec Dir* Susan R Visser
Open Tues - Fri 11 AM - 5 PM, Sat & Sun noon - 5 PM; Admis non-mems $3, mems free; Estab in 1947 for museum exhibitions, lectures, film series, workshops, and studio classes; The Art Center is located in a three-story building designed by Philip Johnson. There are four galleries: the Warner Gallery features traveling shows or larger exhibits organized by the Art Center & the Art League Gallery features one or two-person shows by local or regional artists; also a community & permanent gallery; Average Annual Attendance: 50,000; Mem: 1,000; dues sustaining $100, family $60, active $40, student & senior citizens $30
Income: Financed by mem, corporate support, city & state appropriations
Special Subjects: Drawings, Photography, Prints, Sculpture, Textiles, Painting-American, Pottery, Folk Art, Woodcuts, Afro-American Art, Ceramics, Collages, Crafts, Woodcarvings
Collections: European and American paintings, drawings, prints and objects; 20th century American art with emphasis on regional and local works
Exhibitions: 4 rotating exhibits
Publications: Checklists; exhibition catalogues; quarterly newsletter
Activities: Studio classes for adults & children; docent training & tours; outreach educational program conducted by Art League; workshops; lect open to public, 3 vis lectr per year; gallery talks; artist studio tours; competitions with prizes; film series; paintings and original works of art lent to accredited museums; lending collection contains prints, paintings, phono records and sculpture; museum shop sells gift items and original works of art
L Library, 120 S Saint Joseph St, South Bend, IN 46601. Tel 574-235-9102; Fax 574-235-5782; Elec Mail sbrma@sbt.infi.net; *Exec Dir* Susan R Visser
No admis fee for members; non-members $3; Estab 1947 to provide art resource material to members of the Art Center
Library Holdings: Book Volumes 1100; Exhibition Catalogs; Motion Pictures; Periodical Subscriptions 63; Records
Special Subjects: Collages, Photography, Drawings, Painting-American, Prints, Sculpture, Ceramics, Crafts, Afro-American Art, Pottery, Textiles, Woodcarvings, Woodcuts, Folk Art
Activities: Educ program; classes for adults & children; docent training; lect open to public, 4 vis lects per year; concerts; gallery talks; tours; sponsoring of competitions; scholarships; museum shop sells books, original art

TERRE HAUTE

M INDIANA STATE UNIVERSITY, University Art Gallery, Ctr Performing & Fine Arts, Terre Haute, IN 47809; Fine Arts Bldg, Terre Haute, IN 47809. Tel 812-237-3720; Elec Mail artdept@ruby.indstate.edu; Internet Home Page Address: www.indstate.edu
Open Mon - Wed & Fri, 11 AM - 4 PM, Thurs 1 - 8 PM; No admis fee
Collections: Paintings & sculpture
Exhibitions: Changing exhibitions of national & regional contemporary art during school terms; periodic student & faculty exhibitions
Activities: Lect

M SWOPE ART MUSEUM, 25 S Seventh St, Terre Haute, IN 47807-3692. Tel 812-238-1676; Fax 812-238-1677; Elec Mail swopc@thnet.com; Internet Home Page Address: www.swope.org; *Registrar* Elizabeth Petrulis; *Dir* Kent Ahrens
Open year round Tues, Wed & Fri 10 AM - 5 PM, Thurs 10 AM - 8 PM, Sat & Sun Noon - 5 PM; No admis fee to permanent collection; Estab 1942 to present free of charge American art of the 19th & 20th centuries; Average Annual Attendance: 15,000; Mem: 500; dues individual $30; annual meeting third Wed in Sept
Income: $300,000 (financed by mem & trust fund, annual donations & grants)
Purchases: Caprice 4 by Robert Motherwell; Girl With Cat by William Zorzach
Special Subjects: Painting-American, Prints, Sculpture, American Western Art, Southwestern Art
Collections: American art of 19th & 20th centuries
Publications: Membership newsletter; catalogs to special exhibitions
Activities: Docent training; lect open to public, 10 vis lectr per year; concerts; gallery talks; tours; competitions with awards; individual paintings & original

objects of art lent to other museums; originate traveling exhibitions; mus shop sells books, original art, reproductions, note cards, gift items & prints
L Research Library, 25 S Seventh St, Terre Haute, IN 47807-3692. Tel 812-238-1676; Fax 812-238-1677; Elec Mail info@swope.org; Internet Home Page Address: www.swope.org; *Registrar & Preparator* Lisa Petrulis; *Business Mgr* Katie Wood; *Admin Asst* Mary Lou Jennings; *Publications* Kristi Finley; *Dir* David L Vollmer; *Cur of Coll & Programs* Nathan Richie
Open Tues - Fri 10 AM - 5 PM, Sat & Sun Noon - 5 PM; No admis fee; Estab 1942; Circ 1,200; Open to pub; Average Annual Attendance: 15,000; Mem: 500; dues $40; ann meeting 4th Mon in Sept
Income: $337,072 (financed by endowments, sales, individuals, corporations, sponsorships, foundations, federal & state support, fund raising, donations, memorial contributions)
Purchases: John Rogers Cox, White Cloud; Mary Fairchild MacMonnies, Garden in Giverny; Frederick Puckstuhl, Evening; William Edouard Scott, Etaples; Carl Woolsey, Rod to the Village; Abraham Walkowitz, Abstraction; Isadore Duncan, Untitled
Library Holdings: Book Volumes 1182; Periodical Subscriptions 3; Video Tapes 9
Special Subjects: Art History, Landscape Architecture, Photography, Drawings, Etchings & Engravings, Graphic Arts, Graphic Design, Painting-American, Prints, Sculpture, Historical Material, History of Art & Archaeology, Watercolors, Ceramics, Printmaking, Industrial Design, Art Education, American Indian Art, Furniture, Glass, Aesthetics, Afro-American Art, Woodcuts, Landscapes, Architecture
Collections: American 19th & 20th century art works; Gilbert Wilson art
Publications: Newsletter 3 times per year
Activities: Classes for adults & children; docent training; lects open to the pub, 8-16 vis lectrs per yr; gallery talks; tours; merit & purchase awards for Ann Wabash Valley Juried Exhib; Extension program to Vigo County School District; lending of original objects of art to museums and other art institutions; sales gallery shop sells original art, reproductions, prints, T-shirts, sweatshirts, postcards, caps, bags, buttons, jewelry

UPLAND

M TAYLOR UNIVERSITY, Chronicle-Tribune Art Gallery, Art Dept, 236 W Reade Ave Upland, IN 46989. Tel 765-998-2751, Ext 5322; Fax 765-998-4680; Elec Mail scsmith@tayloru.edu; Internet Home Page Address: www.tayloru.edu/upland/dept/visualarts; *Chmn* Dr Rachel Smith
Open Mon - Sat 8 AM - 5 PM, cl Sun; No admis fee; Estab 1972 as an educational gallery
Income: Financed by educational funding
Exhibitions: Visiting Artists Exhibits
Activities: Gallery talks; schols offered

VALPARAISO

M VALPARAISO UNIVERSITY, Brauer Museum of Art, VU Center of the Arts, Valparaiso, IN 46383. Tel 219-464-5365; Fax 219-464-5244; Internet Home Page Address: www.valpo.edu/artmuseum; *Asst Cur & Registrar* Gloria Ruff; *Exhibits Preparator* Adam Heet; *Dir* Gregg Hertzlieb; *Docent Coordr* Betty Gehring
Open Tues - Fri 10 AM - 5 PM, Wed 10AM - 8:30 PM, Sat & Sun Noon - 5 PM, cl Mon; No admis fee; Estab 1953 to present significant art to the University community & people of northwest Indiana; Average Annual Attendance: 14,000
Income: $14,000 (financed by endowment)
Purchases: $45,000
Special Subjects: Drawings, Painting-American, Prints, Religious Art
Collections: Sloan Collection: 19th & 20th Century American Paintings, Prints & Drawings
Exhibitions: Rotating Exhibits
Activities: Docent training; lect open to the public; gallery talks; tours; individual paintings and original objects of art lent to museums and art centers

VEVAY

M SWITZERLAND COUNTY HISTORICAL SOCIETY INC, Life on the Ohio: River History Museum, 208 E Market St, Vevay, IN 47043; PO Box 201, Vevay, IN 47043. Tel 812-427-3560; Elec Mail sw.co.museums@adelphia.net; Internet Home Page Address: http://scpl.info/historicalsociety.html; *Pres* Martha Bladen; *Secy* Ellyn Kern; *Treas* Ruth Osborne
Daily 10 AM - 5 PM; Admis adults $3, mems no admis fee; Estab 2004 to exhibit & educate the history of Switzerland County as it relates to the historic Ohio River through the steamboat era; River history mus; Average Annual Attendance: 2000; Mem: 150; dues vary; monthly meetings
Income: Financed through memberships, donations, grants & volunteer hours
Library Holdings: Book Volumes; Clipping Files; Original Documents; Other Holdings Genealogy Reference Materials; Photographs
Special Subjects: Landscapes, Marine Painting, Painting-American, Woodcuts, Manuscripts, Maps, Watercolors
Collections: Steamboat models; Pilot Wheel; Extensive coll of photos & documents; Historical colls; Distribution & transportation artifacts; Tools & equip for materials; Original paintings & prints with river themes
Exhibitions: (3/2007) Floods on the Ohio River; (6/2007) Building with the Markland Locks & Dan; (9/2007) Historic Photos of Switzerland County; Delta Queen, steamboat memorabilia, ongoing
Activities: Tours; mus shop sellls books, reproductions, prints
M Switzerland County Historical Museum, 212 E Market St, Vevay, IN 47043; PO Box 201, Vevay, IN 47043. Tel 812-427-9830; Elec Mail sw.co.museums@adelphia.net; Internet Home Page Address: http://scpl.info/historicalsociety.html; *Pres* Martha Bladen; *Treas* Ellyn Kern; *Treas* Ruth Osborne
Open daily 10 AM - 5 PM; Admis adults $3, mems no admis fee; Estab 1950 to unite those people interested in the history of Switzerland County, IN &

surrounding region for its protection, preservation & promotion; Average Annual Attendance: 2,000; Mem: 150; dues vary by category; monthly meetings
Income: Financed by memberships, donations, grants, volunteer hours
Library Holdings: Clipping Files; Manuscripts; Maps; Memorabilia; Original Documents; Other Holdings Genealogy & Family History Files; Periodical Subscriptions; Photographs
Special Subjects: American Indian Art, Archaeology, Decorative Arts, Folk Art, Historical Material, Architecture, Ceramics, Glass, Flasks & Bottles, Furniture, Portraits, Pottery, Painting-American, Woodcuts, Manuscripts, Maps, Religious Art, Porcelain, Restorations, Stained Glass
Collections: Historical collections; Early Swiss settlement; Indian artifacts; Tools & primitive farm equipment
Exhibitions: (4/2007) Ken Maynard-Cowboy movie star; (5/2007) Creative Women in Our County's History; (7/2007) Historic Flags of America; (8/2007) Books Reflecting Swiss Heritage
Activities: Classes for children; quilting prog & exhibits; 3 vis lect per year; concerts; tours; lending of original objects of art to public library & visitor's center; originate trav exhib, ann trunk show of IN history to public schools; mus shop sells books, reproductions, prints

WEST LAFAYETTE

M PURDUE UNIVERSITY GALLERIES, 1396 Physics Bldg, West Lafayette, IN 47907-2036; Physics Bldg Rm 205, 525 Northwestern Ave Lafayette, IN 47907-2036. Tel 765-494-3061; Fax 765-496-2817; Elec Mail gallery@purdue.edu; Internet Home Page Address: www.purdue.edu/galleries; *Asst Dir* Michael Atwell; *Dir Gallery* Craig Martin; *Admin Asst* Anderson Mary Ann
Open Mon - Fri 10 AM - 5 PM, Thurs 10 AM - 8 PM, Sun 1 - 5 PM; No admis fee; Estab 1978 to provide aesthetic & educational programs for art students, the university & greater Lafayette community; Galleries are located in three different buildings to provide approximately 5000 sq ft of space for temporary exhibitions; Average Annual Attendance: 15,200
Income: Financed through the university & private & corporate contributions
Special Subjects: Drawings, Mexican Art, Photography, Prints, American Indian Art, Pre-Columbian Art, Ceramics, Woodcuts, Etchings & Engravings, Oriental Art
Collections: American Indian baskets; photographs; Contemporary paintings, prints, sculpture; ceramics; Pre-Columbian textiles; Art of the Americas
Exhibitions: by faculty, students, regionally & nationally prominent artists
Publications: Exhibit catalogs
Activities: Classes for adults & children; lect open to public; 3-34 vis lect per yr; gallery talks; competitions with awards, tours; exten program serving professional mus and galleries; book traveling exhibitions, 1-2 per year; traveling exhibitions organized & circulated

IOWA

AMES

M IOWA STATE UNIVERSITY, Brunnier Art Museum, Scheman Bldg, Ames, IA 50011. Tel 515-294-3342; Fax 515-294-7070; Elec Mail museums@muse.adp.iastate.edu; *Dir* Lynette Pohlman; *Educ Coordr* Matthew DeLay; *Admin Spec* Janet McMathon; *Assoc Cur* Dana Michels; *Develop Secy* Susan Olson; *Cur Historic House* Eleanor Ostedorf; *Educ Asst* Jackie Wilson
Open Tues, Wed & Fri 11 AM - 4 PM, Thurs 11 AM - 4 PM & 5 - 9 PM, Sat & Sun 1 - 4 PM, cl Mon; No admis fee; Estab 1975, to provide a high level of quality, varied & comprehensive exhibits of national & international scope & to develop & expand a permanent decorative arts collection of the western world; Gallery is maintained & comprised of 10,000 sq ft of exhibit space, with flexible space arrangement; Average Annual Attendance: 50,000; Mem: 400 mems; $40 ann dues
Income: $400,000 (financed through state appropriations & grants)
Special Subjects: Prints, American Indian Art, Ceramics, Pottery, Decorative Arts, Posters, Dolls, Furniture, Glass, Jade, Porcelain, Oriental Art, Enamels
Collections: Permanent collection of ceramics, dolls, furniture, glass, ivory, wood, sculpture, fine arts
Publications: Christian Petersen, Sculptor
Activities: Classes for children; docent training; lect open to public, 10 - 15 vis lectr per year; book traveling exhibitions, 3-4 per year; traveling exhibitions organized & circulated; museum shop sells books, magazines, catalogs, jewelry, dolls, glass & original works

A OCTAGON CENTER FOR THE ARTS, 427 Douglas Ave, Ames, IA 50010-6213. Tel 515-232-5331; Fax 515-232-5088; Elec Mail octagonarts@ames.net; *Pres* Andrew Bice; *VPres* Michelle Farnum; *Treas* Bob Shaffer; *Supv Educ* Kate Fisher; *Cur & Shop Supv* Letitia Hansen; *Exec Dir* Teresa Albertson; *Dir Develop* Michael Miller
Open Tues - Sat 10 AM - 5 PM, Sun 2 - 5 PM; Admis suggested donation or contribution, family (up to five people) $3, individual $2; Estab 1966 to provide year-round classes for all ages; exhibitions of the work of outstanding artists local, regional & worldwide & also special programs in the visual & performing arts; Average Annual Attendance: 33,000; Mem: 365, open to anyone interested in supporting or participating in the arts; dues $15-$500 & up; annual meeting in May; individual $35, household $50, supporter $100, founders $300 & up
Income: $375,000 (financed by mem, city and state appropriations, class fees and fund raising)
Collections: Feinberg Collection of Masks from Around the World
Exhibitions: Octagon Arts Festival-art festival of over 125 Midwest artists; clay, fiber, glass, wood exhibition;
Publications: Exhibition catalogs; newsletter, quarterly
Activities: Classes in the arts for adults & children; special classes for senior citizens & physically & emotionally challenged; outreach programs; lect open to public, 5-8 vis lectr per year; gallery talks; tours; competitions with awards;

scholarships offered; book traveling exhibitions; museum shop sells books, original art, prints & original fine crafts

ANAMOSA

A PAINT 'N PALETTE CLUB, Grant Wood Memorial Park & Gallery, 17314 Hwy 64, Anamosa, IA 52205; 555 S 11th St, Marion, IA 52302. Tel 319-462-2680; *VPres* Joyce Dusanek; *Pres* Wilbur Evarts
Open June 1 - Oct 15; Sun 1 - 5 PM; other times for groups & organizations; No admis fee (donations accepted); Estab 1955 to maintain Antioch School, the school attended by a famous Iowa artist from 1897-1901 Grant Wood; school restored to 1900 vintage; to provide a studio & gallery for local artists & for pub enjoyment. A log cabin art gallery on the grounds of the Grant Wood Memorial Park contains the work of some local & vis artists; Average Annual Attendance: 3,000; Mem: 32, members must have art experience; dues $10
Income: $800 (financed by dues and donations)
Library Holdings: Audio Tapes; Original Art Works
Collections: Prints of Grant Wood, Iowa's most famous artist; original amateur art; arts and crafts
Exhibitions: Special exhibits throughout the season; Annual Art Show
Publications: Bulletin, monthly
Activities: Occasional classes for adults & children; lect open to public, 3-5 vis lectr per year; tours; competitions; films; lending of original objects of art; sales shop sells prints, original art, prints, reproductions, postcards & commemorative coins

ARNOLDS PARK

M IOWA GREAT LAKES MARITIME MUSEUM, 243 W Broadway, Arnolds Park, IA 51331; PO Box 609, Arnolds Park, IA 51331. Tel 712-332-2183; Fax 712-332-2186; Internet Home Page Address: www.okobojimuseum.org; *CEO & Dir* Steven R Anderson; *Chmn* Rick Johnson; *Cur* Mary Kennedy
Open daily 9 AM - 9 PM; cl Easter, Thanksgiving & Christmas; No charge, donations accepted; Estab 1987; Maritime & antique mus that provides a look at the history of the Iowa Great Lakes region. Coll includes wooden boats, steamships, sand pales, fishing lures & paddlefish; Average Annual Attendance: 75,000; Mem: dues Lifetime $1000, Benefactor $100, Captain $50, Gen $25
Library Holdings: Book Volumes (150) local history; Periodical Subscriptions (1500) wooden boat magazines
Collections: Artifacts; recreational artifacts; tools & equip for materials; furnishings; personal artifacts; photographs; Wooden boats from the Iowa Great Lakes area
Publications: Biannual newsletter: The Steam Whistle
Activities: Formal educ for adults; lects; guided tours

BURLINGTON

A ART GUILD OF BURLINGTON, Arts for Living Center, Seventh & Washington St, PO Box 5 Burlington, IA 52601. Tel 319-754-8069; Fax 319-754-4731; Elec Mail arts4living@aol.com; Internet Home Page Address: www.artguildofburlington.org; *Pres* Debbie Bessine; *Dir* Lois Rigdon
Open Tues - Fri Noon - 5 PM, weekends 1 - 4 PM, cl Mon & all major holidays, with the exception of Thanksgiving; No admis fee; Estab 1966 with the mission "All the arts for everyone," the Art Guild purchased the Center (a church building built 1868) in 1974, which has now been placed on the National Register of Historic Places; Former sanctuary, 70' x 60'; Average Annual Attendance: 8,000; Mem: 450; dues benefactor $1,000, down to student $10
Income: Financed by mem & donations
Library Holdings: Book Volumes; Video Tapes
Exhibitions: Exhibitions of regional professional artists
Publications: Monthly newsletter
Activities: Classes for adults & children; dramatic progs; docent training; films; special workshops; lect open to public; concerts; gallery talks; tours; Len Everett Scholarship; Juried Art Show; scholarships offered; book traveling exhibitions 2-3 per year; traveling exhibitions organized & circulated; sales shop sells books, original art, reproductions, prints

CEDAR FALLS

M CITY OF CEDAR FALLS, IOWA, James & Meryl Hearst Center for the Arts, 304 W Seerley Blvd, Cedar Falls, IA 50613. Tel 319-273-8641; Fax 319-273-8659; Elec Mail huberm@ci.cedar-falls.ia.us; Internet Home Page Address: www.hearstartscenter.com; *Dir* Mary Huber
Open Tues - Fri 8 AM - 5 PM, Tues & Thurs evenings 5 - 9 PM, Sat & Sun 1 - 4 PM; No admis fee; Estab 1988; Municipal arts center serving the Cedar Valley in Iowa; Average Annual Attendance: 45,000; Mem: 650; dues $15 - $250; annual meeting in June
Income: $320,000 (financed by city appropriation, individual contributions, program fees & grants)
Special Subjects: Drawings, Painting-American, Photography, Prints, Sculpture, Portraits, Posters, Reproductions
Collections: Book by Creative Education; complete set of illustrations for Legend of Sleepy Hollow; Gary Kelley Illustrations; children's book illustration
Exhibitions: All-Iowa Competitive Exhibit (The AA Show); annual competition exhibition; annual sculpture garden exhibit; 28 exhibitions per year
Publications: Quarterly class brochure; This Month at the Hearst; special collection & membership brochures, annual
Activities: Classes for adults & children; dramatic programs; docent training; lect open to public, 4-5 vis lectrs per year; concert; gallery talks; tours; poetry readings; contemporary music series; chamber music series; sponsoring of competitions, including $1,000 Best in Show, $500 Second Pl, $250 Third Pl, $100 Honorable Mention; scholarships & fellowships offered; exten dept serves 30 mile radius; individual paintings & original objects of art lent to art organizations

& museums; book traveling exhibitions 2-3 per year; originate traveling exhibitions; museum shop sells books

M **UNIVERSITY OF NORTHERN IOWA,** UNI Gallery of Art, 104 Kamerick Art Bldg, Cedar Falls, IA 50614-0362. Tel 319-273-2077; Fax 319-273-7333; Elec Mail GalleryOfArt@uni.edu; *Dir* Darrell Taylor
Open Mon - Thurs 9 AM - 9 PM, Fri 9 AM - 5 PM, Sat & Sun Noon - 5 PM; No admis fee; Estab 1978 to bring to the University & the community at large the finest quality of art from all over the world; The 4700 sq ft gallery is divided into five separate exhibition rooms; high security mus space with climate control & a highly flexible light system; the Gallery adjoins a pub reception space & a 144 seat auditorium; the facility also has two permanent collections' storage areas, a work shop, a general storage room & a fully accessible loading dock; Average Annual Attendance: 12,000
Income: Financed by state appropriation
Purchases: 20th century art work
Special Subjects: Painting-American, Painting-European
Collections: 20th century American & European Art
Exhibitions: 9 rotating & 9 mini-exhibs per yr
Publications: Exhibition catalogs
Activities: Volunteer training; lect open to public, 5 vis lectr per year; performances; gallery talks; tours; competitions; student art exhib competition with awards; individual paintings & original objects of art lent to comparable orgs & institutions; book traveling exhibitions

L **Art & Music Collection Rod Library,** Cedar Falls, IA 50613-3675. Tel 319-273-6252; Fax 319-273-2913; Internet Home Page Address: www.library.uni.edu/artmusic/index.shtml; *Dept Head* Kate Martin; *Art & Music Librn* Dr Alan Asher; *Art & Music Library Asst* Susan Basye
Open Mon - Thurs 7:30 AM - midnight, Fri 7:30 AM - 6 PM, Sat noon - 6 PM, Sun 10 AM - midnight; Main Library estab 1964, additions 1975 & 1995; to serve art & music patrons; Circ 18,872; For lending & reference
Income: Financed by state
Purchases: $38,099
Library Holdings: Audio Tapes; Book Volumes 50,800; Cassettes 830; Clipping Files; Compact Disks 766; Exhibition Catalogs; Fiche; Micro Print; Original Art Works; Pamphlets; Periodical Subscriptions 138; Prints; Records 10,028; Reproductions 692; Slides 6012

CEDAR RAPIDS

M **AFRICAN AMERICAN HISTORICAL MUSEUM & CULTURAL CENTER OF IOWA,** 55 12th Ave SE, Cedar Rapids, IA 52401; PO Box 1626, Cedar Rapids, IA 52406. Tel 319-862-2101; Fax 319-862-2105; Internet Home Page Address: www.blackiowa.org; *CEO & Dir* Thomas Moore; *Develop Mem* Jamie Toennies; *Vol Pres, Bd of Dirs* Mayor LaMetta Wynn; *Treas* Thomas Levi Sr; *Cur* Susan Kuecker; *Archivist* Eva Hinrichsen; *Mus Shop Mgr* Donna Harris
Open Mon - Sat 10 AM - 4 PM; cl New Year's Day, Martin Luther King Jr's Birthday, Memorial Day, July 4th, Labor Day, Thanksgiving Day, Christmas Day; Admis adults $4, tours & grp rates $3, children $2.50, mems no admis fee; Estab 1994; Historical mus & cultural ctr; has permanent exhib that interprets Iowa's African-American journey from Africa to Iowa; staffed for educ programming & community outreach; Mem: dues Corporate $250 & up, Century $200, Golden $100, Family $50, Indiv $25, Youth $5
Library Holdings: Book Volumes 400; Periodical Subscriptions 200
Collections: African-Americans in Iowa with a special emphasis on eastern Iowa; also includes an archive
Publications: Griot, quarterly newsletter
Activities: Formal educ progs for adults & children; docent prog; guided tours; lects; loan exhibs; participatory, temp & traveling exhibs; Ann Events: Juneteenth, Gold Outing, Banquet, Kwanzaa; museum-related items for sale

M **CEDAR RAPIDS MUSEUM OF ART,** 410 Third Ave SE, Cedar Rapids, IA 52401. Tel 319-366-7503; Fax 319-366-4111; Elec Mail info@crma.org; Internet Home Page Address: www.crma.org; *Cur* Sean Ulmer; *Dir* Terence Pitts; *Business Mgr* Deanna Pedersen; *Educ Coordr* Cherie Butler; *Mus Store Mgr* Casey Dunagan; *Registrar* Teri Van Dorston; *Develop Dir* Kelly Leusch; *Develop Dir* Tris Dows; *Membership & Communications Coordr* Katie Giorgio
Open Tues - Sat 10 AM - 4 PM, Thurs 10 AM - 8 PM, Sun Noon - 4 PM; Admis adult $7, sr citizens $6, students under 18 free; Estab 1905; First & second floors maintain changing exhibits & the Permanent Collection; Average Annual Attendance: 35,000; Mem: 1000; dues patron $125, family $55, individual $35, students & senior citizens $30
Income: Financed by endowment, mem & revenues
Special Subjects: Drawings, Painting-American, Prints, Sculpture, Landscapes, Portraits
Collections: Largest concentrated collection of Grant Wood, Marvin Cone and Mauricio Lasansky art in existence; print collection
Publications: Newsletter, tri-annual
Activities: Classes for adults & children; docent training; lect for members only; concerts; gallery talks; tours; individual paintings & original objects of art lent to other museums; originate traveling exhibitions; museum shop sells books, original art, reproductions, prints; Grant Wood Studio & Visitor Center

L **Herbert S Stamats Library,** 410 Third Ave SE, Cedar Rapids, IA 52401. Tel 319-366-7503; Fax 319-366-4111; Elec Mail info@crma.org; Internet Home Page Address: www.crma.org; *Dir* Terence Pitts
Open Tues - Sat 10 AM - 4 PM, Thurs 10 AM - 7 PM, Sun Noon - 3 PM; adults $4, seniors $3, students 18 & under - free; Estab Art Assn 1905; first and second floors maintain permanent & changing exhib; Mem: 1000; dues - family $40, individual $30, senior/student $20
Income: endowment, grants & memberships
Library Holdings: Book Volumes 3000; Cassettes; Filmstrips
Activities: Classes for adults & children; docent training; lect open to public; 18-22 vis lects per yr; concerts; gallery talks; tours; museum shop sells books, original art, reproductions, prints

M **COE COLLEGE,** Eaton-Buchan Gallery & Marvin Cone Gallery, 1220 First Ave NE, Cedar Rapids, IA 52402. Tel 319-399-8217; Fax 319-399-8557; Elec Mail dchance@coe.edu; Internet Home Page Address: www.coe.edu; *Chmn Art Dept* John Beckelman; *Gallery Dir* Delores Chance
Open daily 3 - 5 PM; No admis fee; Estab 1942 to exhibit traveling exhibitions & local exhibits; Two galleries, both 60 x 18 ft with 125 running ft of exhibit space & 430 works on permanent exhibition; Average Annual Attendance: 5,000
Income: $7,090 (financed through college)
Collections: Coe Collection of art works; Marvin Cone Alumni Collection; Marvin Cone Collection; Conger Metcalf Collection of paintings; Hinkhouse Collection of contemporary art; Grant Wood Collection; Works of nearly 300 artists spanning several centuries & 5 continents
Exhibitions: Circulating exhibits; one-person & group shows of regional nature
Publications: Exhibition brochures, 8-10 per year
Activities: Lect open to public, 5-6 vis lectr per year; gallery talks; tours; competitions; individual paintings & original objects of art lent to colleges & local galleries; lending collection contains original art work, original prints, paintings, sculpture & slides; traveling exhibitions organized & circulated

M **Stewart Memorial Library & Gallery,** 1220 First Ave NE, Cedar Rapids, IA 52402-5092. Tel 319-399-8023; Fax 319-399-8019; Elec Mail rdoyle@coe.edu; Internet Home Page Address: www.coe.edu; *Dir Library Svcs* Richard Doyle
Open Mon - Thurs 8 AM - midnight, Fri 8 AM - 6 PM, Sat 9 AM - 6 PM, Sun 1 PM - 12 AM; June - Aug Mon - Fri 8 AM - 4 PM
Collections: 200 permanent collection works

M **MOUNT MERCY COLLEGE,** White Gallery, 1330 Elmhurst Dr NE, Cedar Rapids, IA 52402. Tel 319-363-8213; Fax 319-363-5270; Elec Mail vanallen.david@mcleodusa.net; *Dir* David Van Allen
Open Mon - Thurs 7 AM - 9 PM; No admis fee; Estab 1970 to show work by a variety of fine artists. The shows are used by the art department as teaching aids. They provide cultural exposure to the entire community; One room 22 x 30 ft; two walls are glass overlooking a small courtyard; Average Annual Attendance: 1,000
Income: Financed through the college
Purchases: $300
Collections: Small collection of prints & paintings
Exhibitions: Annual High School Art Exhibit; Senior Thesis Exhibit
Publications: Reviews in Fiber Arts; American Craft & Ceramics Monthly
Activities: Classes for adults; dramatic programs; lect open to public; gallery talks; competitions with awards; 3 vis lectrs per yr; scholarships; lending original objects of art: campus locations; sales shop: original art, prints, Mexican folk art

L **Library,** Art Dept, 1330 Elmhurst Dr NE Cedar Rapids, IA 52402-4797. Tel 319-363-8213, Ext 244; Fax 319-363-9060; Elec Mail library@mmc.mtmercy.edu; Internet Home Page Address: www.mtmercy.edu; *Librn* Marilyn Murphy
Open Mon-Thurs 8 AM - midnight, Fri 8 AM - 9 PM, Sat 9:30 AM - 5 PM, Sun 1 PM - midnight; No admis fee; Estab 1928; Circ 35,000; Ref library & circ
Income: By the college
Library Holdings: Audio Tapes; Book Volumes 2000; Cards; Cassettes; Exhibition Catalogs; Fiche; Filmstrips; Framed Reproductions; Kodachrome Transparencies; Lantern Slides; Micro Print; Motion Pictures; Original Art Works; Pamphlets; Periodical Subscriptions 38; Photographs; Prints; Records; Reels; Reproductions; Sculpture; Slides; Video Tapes

CLINTON

M **CLINTON ART ASSOCIATION,** River Arts Center, 229 Fifth Ave S, PO Box 132 Clinton, IA 52733-0132. Tel 319-242-3300, 242-8055; Elec Mail gwenwes@webtv.net; *Dir* Gwen Chrest
Open Tues-Sat 11AM - 4 PM, Sun 1- 4 PM, cl Christmas & New Year; No admis fee; Estab 1968 to bring visual art to the community; Small gallery is housed in an abandoned building of an army hospital complex and is loaned to the association by the Clinton Park and Recreation Board. A separate Pottery School has been maintained since 1975; Average Annual Attendance: 16,000; Mem: 420; dues single membership $10; annual meeting first Tues in May
Income: Financed by mem & through grants from the Iowa Arts Council
Special Subjects: Painting-American, Photography, Prints, Sculpture, Pottery, Woodcarvings, Woodcuts, Etchings & Engravings, Glass
Collections: Painting (watercolor, oil, acrylic, pastel); beaded loin cloth; photographs; lithograph; engraving; sculptures; etching; prints; pottery; fabric; pencil; wood; slate; Ektaflex Color Printmaking System; glass; ink; lucite; rugs; woodcarving
Exhibitions: Rotating exhibits
Publications: Newsletter every two months
Activities: Classes for adults & children in watercolor, oil, rosemaling, macrame, photography & pottery making; docent training; lect open to public; gallery talks; tours; individual paintings lent by members to businesses; lending collection contains books, lantern slides and slides; sales shop sells original art, prints & stationery

DAVENPORT

M **DAVENPORT MUSEUM OF ART,** 1737 W 12th St, Davenport, IA 52804. Tel 319-326-7804; Fax 319-326-7876; Elec Mail asc@ci.davenport.ia.us; Internet Home Page Address: www.art-dma.org; *Dir Develop* Joan Baril; *Cur Coll & Exhib* Michelle Robinson; *Cur Educ* Ann Marie Hayes; *Librn* Sheryl Haut; *Supt* E J Johnson; *Registrar* Patrick J Sweeney; *Dir* Wm Steven Bradley; *Asst Cur Educ* Sarah Coussens; *Shop Mgr* Chris Sweeney; *Dir Marketing* Angela Carlson; *VPres* Glen Gierke; *Bus Mgr* Sue O'Malley
Open Tues - Sat 10 AM - 4:30 PM, Sun 1 - 4:30 PM, cl Mon & holidays; Admis $3 charged for all main gallery exhibitions; Estab 1925 as a mus of art & custodian pub collection & an educ center for the visual arts; Consists of three levels including a spacious main gallery, exhibition area & two additional floors with galleries; six multipurpose art studios & ceramic gallery, studio workshop & an outdoor studio-plaza on the lower level; Average Annual Attendance: 100,000; Mem: 600; dues household $50, individual $30, senior citizens $20, student $15

Income: $900,000 (financed by private & city appropriation)
Special Subjects: Mexican Art, Painting-American, Painting-European, Oriental Art, Painting-British, Painting-French, Painting-German
Collections: 19th & 20th Century American; Regionalism including Grant Wood, Thomas Hart Benton, John Steuart Curry; European; Mexican - Colonial; Haitian; Oriental
Exhibitions: Beverly Pepper: The Moline Makers; Byron Burford; Mississippi Corridor; Grandma Moses; Selections: The Union League of Chicago Collection; Thomas Eakins (photographs); Joseph Sheppard; Mauricio Lasansky; Sol LeWitt; Stephen Antonakos - Neons; Frederic Carder: Portrait of a Glassmaker; Paul Brach Retrospective; David Hockney (photographs); Rudie (holograms); McMichael Canadian Collection; Kassebaum Medieval & Renaissance Ceramics; Collected Masterworks: The International Collections of the Davenport Museum of Art; Mexico Nueve; A Different War: Vietnam In Art; Judaica: Paintings by Nathan Hilu & Ceramics by Robert Lipnick; Faith Ringgold: 25 Year Survey
Publications: Quarterly newsletter; biennial report; Focus 1: Michael Boyd - Paintings from the 1980s; Focus 2: Photo Image League - Individual Vision/Collective Support; Focus 3: A Sense of Wonder - The Art of Haiti; Focus 4: Artists Who Teach: Building our Future; Haitian Art: The Legend & Legacy of the Naive Tradition; Three Decades of Midwestern Photography, 1960 - 1990
Activities: Classes for adults & children; docent training; lect open to public; concerts; gallery talks; tours; competitions with prizes; scholarships & fels offered; book traveling exhibitions organized & circulated; originate traveling exhibitions; museum shop sells books & original art; Arterarium environmental installation
L **Art Reference Library,** 1737 W 12th St, Davenport, IA 52804. Tel 319-326-7804; Fax 319-326-7876; Internet Home Page Address: www.art-dma.org; *Dir* Linda A Downs; *Cur* Michelle Robinson; *Dir Educ* Ann Marie Hayes
Open Tues - Sat 10 AM - 4:30 PM, Sun 1 - 4:30 PM, Cl Mon; Admis $4 adults; children, students & mus mem free; Estab 1925 as first municipal art mus in Iowa; Circ non-circulating library; Open for reference; Average Annual Attendance: 50,000; Mem: $50 household; $25 individuals; $25 teachers
Library Holdings: Book Volumes 6000; Periodical Subscriptions 20; Video Tapes
Collections: 3500 works of art (American, European, Haitian & Mexican-Colonial)
Exhibitions: Treasures of Mexican Colonial Painting, Marcus Burlee; Tracing the Spirit: Ethnographic Essays on Haitian Art, KAren McCarthy Brown; Grant Wood: An American Master Revealed
Activities: Classes for adults & children; docent training; continuing education classes for teachers; lec open to pub; 12 vis lect per yr; gallery talks; tours; sponsored competitions with awards; schol offered; organize traveling exhibs to accredited art museums; mus shop sells books, reproductions & gift items related to collections & traveling exhibs

M **PUTNAM MUSEUM OF HISTORY AND NATURAL SCIENCE,** (Putnam Museum of History & Natural Science) 1717 W 12th St, Davenport, IA 52804. Tel 563-324-1933; Fax 563-324-6638; Elec Mail museum@putnam.org; Internet Home Page Address: www.putnam.org; *Dir* Christopher J Reich; *Chief Cur* Eunice Schlichting; *Dir Educ* Donna Murray; *Exhibits Mgr* Michael Murphy
Open Mon - Fri 9 AM - 5 PM, Sat 10 AM - 5 PM, Sun 11 AM - 5 PM; Admis adults $6, senior citizens $5, ages 3-12 $4, members & children 2 & under free; Estab 1867 as Davenport Academy of Natural Sciences; To provide educational & enriching experiences through interpretive exhibits & mus programming; Average Annual Attendance: 210,000; Mem: 2000; dues contributing $75, family $65, individual $40, senior citizen $35
Income: $3,000,000 (financed by contributions, grants, endowments, mem & earned income)
Special Subjects: Drawings, Prints, Watercolors, Archaeology, Textiles, Costumes, Ceramics, Decorative Arts, Manuscripts, Dolls, Furniture, Glass, Asian Art, Silver, Carpets & Rugs, Historical Material, Maps, Coins & Medals, Embroidery, Antiquities-Oriental, Antiquities-Persian, Antiquities-Egyptian, Antiquities-Greek, Antiquities-Roman, Antiquities-Etruscan
Collections: Natural history; American Indian, pre-Columbian; anthropology; arts of Asia, Near & Middle East, Africa, Oceanic; botany; ethnology; paleontology; decorative arts; local history
Exhibitions: Permanent & changing exhibition programs
Activities: Formally organized educ programs for children & adults; films; lect; gallery talks; guided tours; IMAX Theatre presentations; Environment Stewardship award; individual paintings & original objects of art lent to museums & educational organizations for special exhibitions only; book traveling exhibitions 6 per year; originate traveling exhibitions; mus store sells books, original art, prints, miscellaneous collections-related merchandise for children & adults
L **Library,** 1717 W 12th St, Davenport, IA 52804. Tel 563-324-1933; Fax 563-324-6638; Elec Mail museum@putnam.org; Internet Home Page Address: www.putnam.org; *Dir, CEO* Christopher J Reich; *Chief Cur* Eunice Schlichting; *IMAX(R) Theater Mgr* Dean K Fich; *Dir Visitor Svcs* Nancy Morehouse; *Exhibits Mgr* Michael Murphy; *VPres* Lori Estes; *Mktg Mgr* Kathy Gould; *Coordr Visitor Svcs* Beth Knaack; *Dir Finance* Jennifer Voss; *Cur Natural Science* Christine Chandler; *Dir Educ* Donna Murray; *Dir Special Projects* Sally Hinz; *Mus Shop Mgr* Frances Pullias
Open by appointment only; Available for use by special request; for reference only
Library Holdings: Book Volumes 25,000; Lantern Slides; Motion Pictures; Original Art Works; Photographs; Prints; Records

DECORAH

M **LUTHER COLLEGE,** Fine Arts Collection, 700 College Dr, Decorah, IA 52101-1042. Tel 563-387-1195; Fax 563-387-1657; Elec Mail kempjane@luther.edu; *Gallery Coordr* David Kamm; *Supv* Jane Kemp
Open Sept - June 8 AM - 5 PM; Estab 1900; Five galleries on campus; Average Annual Attendance: 10,000
Income: $4000
Special Subjects: Drawings, Landscapes, Photography, Prints, Painting-American, Sculpture, Watercolors, American Western Art, Bronzes, Pre-Columbian Art, Southwestern Art, Religious Art, Ceramics, Pottery, Primitive art, Woodcarvings, Woodcuts, Etchings & Engravings, Portraits, Posters, Eskimo Art, Carpets & Rugs, Antiquities-Greek, Antiquities-Roman, Enamels, Painting-Scandinavian

Collections: Gerhard Marcks Collection (drawings, prints & sculpture); Marguerite Wildenhain Collection (drawings & pottery); contemporary & historic prints; Inuit sculpture; pre-Columbian poetry; Scandinavian immigrant painting
Publications: Occasional catalogs & brochures
Activities: Lect open to public; lending collection contains individual paintings & original objects of art; book traveling exhibitions 12 per year

M **VESTERHEIM NORWEGIAN-AMERICAN MUSEUM,** 523 W Water St, Decorah, IA 52101; PO Box 379, Decorah, IA 52101. Tel 563-382-9681; Fax 563-382-8828; Elec Mail vesterheim@vesterheim.org; Internet Home Page Address: www.versterheim.org; *Cur* Tova Brandt; *Textiles Cur* Lauraan Gilberton; *Deputy Dir* Steven Johnson; *Dir* Janet Blohm Pultz; *Registrar* Jennifer Johnston Kovarik
Open May - Oct 9 AM - 5 PM daily, Nov - Apr Tues - Sun 10 AM - 4 PM, cl Thanksgiving, Christmas, Easter & New Year's; Admis adults $5, children (7-18) $3, (summer), adults $4, children $2 (winter) special rates for sr citizens & groups; Estab 1877, Vesterheim embodies the living heritage of Norwegian immigrants to America. Sharing this cultural legacy can inspire people of all backgrounds to celebrate tradition; Main Building with four floors of exhib, plus numerous historic buildings including two from Norway make up the complex of Vesterheim; Average Annual Attendance: 20,000; Mem: 7000; dues basic mem $35
Income: $2,000,000 (financed by endowment, mem, donations, admis, sales)
Library Holdings: Book Volumes; CD-ROMs; Clipping Files; DVDs; Exhibition Catalogs; Maps; Original Documents; Pamphlets; Periodical Subscriptions; Records; Video Tapes
Special Subjects: Architecture, Watercolors, Costumes, Crafts, Pottery, Woodcarvings, Woodcuts, Landscapes, Decorative Arts, Portraits, Glass, Jewelry, Porcelain, Carpets & Rugs, Period Rooms, Laces, Pewter, Leather
Collections: Through 21,000 objects including Norwegian & Norwegian-American house furnishings, costumes, tools & implements, church furniture, toys & the like, the Museum tells the story of the Norwegian immigrant
Exhibitions: Annual competitive exhibitions in Norwegian rosemaling, weaving, woodcarving & knifemaking; other temp exhib on spec topics
Publications: Vesterheim Magazine, semi annual; Newsletter, semi-annual; Norwegian Tracks, quarterly; Time Honored Norwegian Recipes; Rosemaling Letter, quarterly; Vesterheim: Samplings from the Collection; Rosemaler's Recipes Cookbook; Ole Goes to War: Men from Norway Who Fought in America's Civil War; Marking Time: The Primstav Murals of Sigmund Aarseth
Activities: Classes for adults; childrens educ prog; docent training; dramatic progs; lect open to public, 4 vis lectr per year; gallery talks; tours; sponsoring of competitions; Vesterheim gold medal award; book traveling exhibitions; originate traveling exhibitions for museums, special events; museum shop sells art & craft supplies, books, original art, prints, related gift items, woodenware, artist supplies for rosemaling & woodworking
L **Reference Library,** 523 W Water St, Decorah, IA 52101. Tel 563-382-9681; Fax 563-382-8828; Elec Mail vesterheim@vesterheim.org; Internet Home Page Address: www.vesterheim.org; *Textiles Cur & Conserv* Lauran Gilbertson; *Dir Facilities & Historic Sites* Steven Johnson; *Exec Dir* Janet Pultz; *Dir Vesterheim Gen* Carol Culbertson; *Pres* Jon R Hart; *Controller* Joan Leuenberger; *Dir Retail Svcs* Julie Peters; *Dir Media* Charlie Langton; *Registrar & Librn* Carol Hasvold; *Cur* Tova Brandt; *Dir Educ* Jennifer Johnston; *Asst to Dir* Martha Tanner
Reference library open to the public
Library Holdings: Book Volumes 15,000; Clipping Files; Filmstrips; Memorabilia; Periodical Subscriptions 70; Photographs
Special Subjects: Decorative Arts, Calligraphy, Drawings, Etchings & Engravings, Ceramics, Crafts, Ethnology, Anthropology, Costume Design & Constr, Carpets & Rugs, Dolls, Embroidery, Dioramas, Coins & Medals, Architecture

DES MOINES

M **EDMUNDSON ART FOUNDATION, INC,** Des Moines Art Center, 4700 Grand Ave, Des Moines, IA 50312-2099. Tel 515-277-4405; Fax 515-271-0357; Internet Home Page Address: www.desmoinesartcenter.org; *Pres Board Trustees* Kirk V Blunck; *Dir* Susan Lubowsky-Talbott; *Deputy Dir* M Jessica Rowe; *Sr Cur* Jeff Fleming
Open Tues, Wed, Fri & Sat 11 AM - 4 PM, Thurs 11 AM - 9 PM, Sun Noon - 4 PM, cl Mon; No admis fee; Estab 1948 for the purpose of displaying, conserving & interpreting art; Large sculpture galleries in I M Pei-designed addition; the main gallery covers 36 x 117 ft area. New Meier wing, opened 1985, increased space for exhibitions 50 percent; Average Annual Attendance: 319,000; Mem: 3000, dues $20 & up
Income: $4,000,000 (financed by endowment, mem, gifts, grants, shop sales, tuition & state appropriation)
Library Holdings: Auction Catalogs; Book Volumes; CD-ROMs; Clipping Files; Exhibition Catalogs; Original Documents; Periodical Subscriptions; Slides
Special Subjects: Graphics, Painting-American, Sculpture, African Art
Collections: African art; graphics; American & European sculpture & painting of the past 200 years
Publications: Bulletin, bimonthly; catalogs of exhibitions
Activities: Classes for adults & children; docent training; lect open to pub, 6 vis lectr per year; concerts; gallery talks; tours; competitions; traveling exhibitions organized & circulated; museum shop sells books, original art, prints & postcards
L **Des Moines Art Center Library,** 4700 Grand Ave, Des Moines, IA 50312-2099. Tel 515-277-4405; Fax 515-271-0357; Internet Home Page Address: www.desmoinesartcenter.org
Open by appointment only; Estab 1948 for research of permanent collection, acquisitions, exhibition preparation, class preparation & lectures; Open to the public for reference by appointment
Library Holdings: Auction Catalogs; Book Volumes 14,700; CD-ROMs; Clipping Files; Exhibition Catalogs; Original Documents; Periodical Subscriptions 70; Slides

M **POLK COUNTY HERITAGE GALLERY,** Heritage Art Gallery, Polk County Office Bldg, 111 Court Ave Des Moines, IA 50309-2294. Tel 515-286-2242; Fax 515-286-3082; Internet Home Page Address: www.co.polk.ia.us; *Pres* Tom Green
Open Mon - Fri 11 AM - 4:30 PM; No admis fee; Estab 1980; exhib space for visual art in the Polk County office building built in 1908 & on the register of historic places; Average Annual Attendance: 4,000

Exhibitions: Greater Des Moines Exhibited (annually, winter); Iowa Exhibited (annually, spring)
Activities: Cash awards for two annual competitions

L **PUBLIC LIBRARY OF DES MOINES,** Central Library Information Services, 1000 Grand Ave, Des Moines, IA 50309-1791. Tel 515-283-4152, Ext 3; Fax 515-237-1654; Elec Mail reference@pldminfo.org; *Head Librn* Pam Deitrick; *Dir* Kay K Runge
Open Mon - Thurs 10 AM - 8 PM, Fri 10 AM - 6 PM, Sat 9 AM - 5 PM, cl Sun; No admis fee; Estab 1866, dept estab 1970 to serve art & music patrons; Circ 20,120
Income: Financed by city appropriation
Library Holdings: Book Volumes 4500; Periodical Subscriptions 12; Video Tapes

M **SALISBURY HOUSE FOUNDATION,** 4025 Tonawanda Dr, Des Moines, IA 50312-2999. Tel 515-274-1777; Fax 515-274-0184; Elec Mail salhouse@dwx.com; Internet Home Page Address: www.salisburyhouse.org; *Assoc Dir* Ann Pross; *Dir* Scott Brunscheen
Pub tours Tues - Sat 11AM & 2 PM (call to confirm); closed Jan and Feb; Admis adults $5, children 12 years & under $2; Estab 1954 as a historic house museum; Historic Mansion is modeled after the King's House in Salisbury, England & contains Tudor age furniture, classic paintings & sculpture from East & West, tapestries, Oriental rugs; Average Annual Attendance: 30,000
Income: Financed through admis, mem, contributions, cultural programs, private & corporate function facility fees, endowment
Library Holdings: Cards; Clipping Files; Kodachrome Transparencies; Manuscripts; Memorabilia; Original Art Works; Original Documents; Prints
Special Subjects: Architecture, Painting-American, Sculpture, American Indian Art, African Art, Southwestern Art, Textiles, Religious Art, Woodcarvings, Decorative Arts, Manuscripts, Painting-European, Furniture, Glass, Painting-British, Carpets & Rugs, Historical Material, Tapestries, Calligraphy, Period Rooms, Medieval Art, Antiquities-Oriental, Antiquities-Persian, Bookplates & Bindings
Collections: Collection of paintings by Coenth, Raeburn, Romney, Joseph Stella, Sir T Lawrence, Van Dyck; permanent collection of tapestries by Brussels Brabant, Flemish, French Verdure; permanent collection of sculpture by Archapinko, Bordelle, Martini; permanent collection of Chinese, India & Oriental (Persian) rugs
Exhibitions: Permanent collection
Activities: Docent training, dramatic progs; lect open to the public, 4 vis lectrs per year; concerts; tours; individual paintings & original objects of art lent; lending collection contains motion pictures, original art works, paintings; museum shop sells reproductions, brochures, postcards, stationery, books, prints & videos

DUBUQUE

M **DUBUQUE MUSEUM OF ART,** 701 Locust St at Washington Park, Dubuque, IA 52001. Tel 319-557-1851; Fax 319-557-7826; Elec Mail dbqartmuseum@mcleodusa.net; Internet Home Page Address: www.dbqartmuseum.com; *Pres* Tim Conlon; *Exec Dir* Nelson Britt; *Dir Develop* Geri Shafer; *Coll & Gallery* Heather Norman; *Exec Asst* Diane Sass; *Educ Coordr* Margaret Buhr
Open Tues - Fri 10 AM - 5 PM, Sat & Sun 1 - 4 PM, cl Mon; No admis fee; Estab 1874, to preserve, collect, exhibit, interpret & teach the fine arts to those in the Dubuque area & surrounding communities; Average Annual Attendance: 13,425; Mem: 400; dues $15-$4000; annual meeting in May
Income: Financed by dues & donations
Collections: Permanent collection consists of regional & historic art, drawings, paintings, prints, sculptures & watercolor
Exhibitions: Crafts show; ceramics, drawing, paintings, sculptures
Publications: Art News, quarterly
Activities: Classes for adults & children; lect open to public, 12-14 vis lectr per year; concerts; gallery talks; tours; competitions with awards; museum shop sells books, misc. children's gift items & jewelry

EPWORTH

M **DIVINE WORD COLLEGE,** Father Weyland SVD Gallery, 102 Jacoby Dr SW, Epworth, IA 52045-0380. Tel 319-876-3353; Fax 319-876-3353; *Assoc Prof Art* Dona Schlesier
Open Mon - Sun 9 AM - 5 PM; No admis fee; Estab 1985; Carpeted walls, track lighting
Exhibitions: Art of Africa & Papua New Guinea; 5 exhibits each year

FAIRFIELD

L **FAIRFIELD ART ASSOCIATION,** 607 W Broadway Ste 130, Fairfield, IA 52556; PO Box 904, Fairfield, IA 52556. Tel 641-472-5374; Tel 614-469-3225; Internet Home Page Address: www.fairfieldpublicaccess.org; *Pres* Suzan Kessel
Open Mon - Thurs 9:30 AM - 8:30 PM, Fri 9:30 AM - 6 PM, Sat 9:30 AM - 4:30 PM, winter Sun 1:30 - 4:30 PM, cl national holidays; No admis fee
Income: Financed by endowment & mem
Library Holdings: Periodical Subscriptions 180
Collections: Graphics; paintings
Activities: Classes for adults & children; lect open to the public; competitions

A **MAHARISHI UNIVERSITY OF MANAGEMENT,** Department of Fine Arts, c/o MIU-Faculty Mail, 1000 N Fourth St, PO Box 1019 Fairfield, IA 52557. Tel 641-472-6966; Elec Mail cthatcher@mumarts.edu; *Cur* Terrence Kennedy; *Dir* C Gregory Thatcher
Open daily 10 AM - Noon June - Aug for children's art classes; No admis fee; Estab 1985 to foster development of the arts in the region; One gallery 20 ft X 40 ft for exhibition of contemporary & historic art; 20 artist studios; event room for

lectures & performances; classrooms for teaching visual arts courses; Average Annual Attendance: 2,000
Income: Financed by endowment
Collections: Contemporary art in all media
Exhibitions: Annual Juried Show; David Hanson: Coal Strip, Montana (photography); Sales & Rental Exhibition; Selected Masterworks
Publications: Exhibit catalogues
Activities: Classes for adults & children; dramatic programs; lect open to public, 15 vis lectr per year; competitions with awards

FORT DODGE

M **BLANDEN MEMORIAL ART MUSEUM,** 920 Third Ave S, Fort Dodge, IA 50501. Tel 515-573-2316; Fax 515-573-2317; Elec Mail info@blanden.org; Internet Home Page Address: www.blanden.org; *Dir* Margaret Skove; *Educ* Linda Flaherty; *Membership & Develop* Roxanne Flattery; *Business Office* Pamela Kay; *Security & Maintenance* Mark Jessen
Open Tues - Sat 11 AM - 5 PM; No admis fee; Estab 1930 as a permanent municipal, non-profit institution, educational & aesthetic in purpose; the mus interprets, exhibits & cares for a permanent collection & traveling exhibitions; Houses works of art in permanent collection; Average Annual Attendance: 17,000; Mem: 600; dues $25-$1,000
Income: $500,000 (financed by city & state appropriation, mem, Blanden Charitable Foundation & private support)
Special Subjects: Painting-American, Sculpture, Bronzes, African Art, Ceramics, Woodcuts, Etchings & Engravings, Painting-European, Oriental Art
Collections: Arts of China & Japan; 15th - 20th Century Works on Paper; Pre-Columbian & African Art; Regional Art; Twentieth century American & European masters, paintings & sculpture
Publications: Annual report; exhibition catalogues; handbook of the permanent collection; membership information; quarterly bulletin
Activities: Classes for adults & children; docent training; dramatic programs; volunteer training (front desk); lect open to public, 10 vis lectr per year; concerts; gallery talks; tours; competitions with awards; scholarships offered; exten outreach art appreciation program; loans to art museums meeting necessary professional requirements including climate conditions, security & other physical needs specifications of the art collection; book traveling exhibiitions; originate traveling exhibitions

L **Museum Library,** 920 Third Ave S, Fort Dodge, IA 50501. Tel 515-573-2316; Fax 515-573-2317; Elec Mail blanden@dodgenet.com; Internet Home Page Address: www.blanden.org; *Dir* Charles P Helsell; *Adminr* Peg Stickrod; *Educ* Nick Friess; *Prog Coordr* Char Gustafson
Open Tues, Wed & Fri 10 AM - 5 PM, Thurs 10 AM - 8:30 PM, Sat & Sun 1 - 5 PM; Estab 1972 as reference library for museum
Income: $90,000 (financed by mem, city appropriation & charitable foundation)
Library Holdings: Book Volumes 6000; Cards; Clipping Files; Exhibition Catalogs; Filmstrips; Framed Reproductions 148; Periodical Subscriptions 12; Reproductions; Sculpture 9; Slides; Video Tapes
Activities: Classes for adults & children; docent training; concerts; gallery talks; tours; museum shop sells books & original art

GRINNELL

M **GRINNELL COLLEGE,** Art Gallery, Grinnell, IA 50112. Tel 641-269-3371; Fax 641-269-4283; Elec Mail jenkins@grinnell.edu; *Exhib Design* Milton Severe; *Cur* Kay Wilson
Open Sun - Fri 1 - 5 PM; No admis fee; Estab 1983 for exhibition & study of art on paper; Average Annual Attendance: 4,000
Income: $75,000 (financed by endowment)
Purchases: $30,000
Special Subjects: Drawings, Graphics, Photography, Prints, Watercolors, African Art, Woodcuts, Etchings & Engravings
Collections: Works of Art on Paper
Publications: Exhibition catalogs
Activities: Lect open to public, 8 vis lectr per year; book traveling exhibitions 8 times per year; originate traveling exhibitions 4 times per year; museum shop sells original art

INDIANOLA

M **SIMPSON COLLEGE,** Farnham Gallery, 701 NC, Indianola, IA 50125. Tel 515-961-1486; Fax 515-961-1498; Elec Mail richmond@simpson.edu; *Head Art Dept* David Richmond; *Asst Prof* Justin Nostrala
Open Mon - Fri 8 AM - 4:30 PM; No admis fee; Estab 1982 to educate & inform the public; Two small gallery rooms each 14 ft, 4 in x 29 ft; Average Annual Attendance: 1,200
Income: college fees
Collections: Small permanent collection being started
Activities: Classes for adults; lect open to public, 4 vis lectr per year; gallery talks; scholarships offered; individual paintings lent; originate traveling exhibitions

IOWA CITY

A **ARTS IOWA CITY,** Art Center & Gallery, 129 E Washington St, Iowa City, IA 52240. Tel 319-337-7447; *Pres-Elect* Tom Wegman; *Treas* Holly Hotchkiss; *Pres* Carol Spaziani
Open Tues - Sat 11 AM - 4 PM; No admis fee; Estab 1975; Large gallery space for group or theme shows; solo rooms for single artist shows; installation space; Average Annual Attendance: 5,000; Mem: 250-300; dues family $35, individual $25; meeting first Mon of month
Income: $70,000 (financed by mem, sales & grants)
Exhibitions: Ten exhibitions per year are mounted. In April a national exhibition of works using paper &/or fiber as a medium is organized & installed. Monthly

exhibitions include works of local artists & from local collections; each group show is accompanied by a solo show & an installation in separate gallery spaces
Publications: Paper Fiber Show Catalog, annually; membership pamphlet; bimonthly newsletter
Activities: Classes for adults & children; dramatic programs; concerts; gallery talks; competitions; workshops; fiscal agent for individual artists; participant in arts festival

UNIVERSITY OF IOWA
M **Museum of Art,** Tel 319-335-1727; Fax 319-335-3677; Elec Mail uima@uiowa.edu; Internet Home Page Address: www.uiowa.edu/uima; *Research Cur* Christopher Roy; *Mgr Exhib & Colls* Jeff Martin; *Dir* Howard Creel Collinson; *Dir of Educ* Dale William Fisher; *European & American Art* Kathleen Edwards
Open Wed, Sat, Sun noon - 5 PM, Thurs, Fri noon - 9 PM; cl Thanksgiving, Christmas & New Year's Day; No admis fee; Estab 1969 to collect, exhibit & preserve for the future, works of art from different cultures; to make these objects as accessible as possible to people of all ages in the state of Iowa; to assist the pub, through educational programs & publications, in interpreting these works of art & expanding their appreciation of art in general; 48,000 sq ft in 16 galleries, including a central sculpture court; Average Annual Attendance: 50,000; Mem: Sponsor $5,000; Director's Circle $1,000; Patron $500; Curator's Circle $250; Benefactor $150; Basic $100; Contributors $25-$99
Income: Financed by mem, state appropriation & private donations
Special Subjects: Drawings, Etchings & Engravings, Painting-French, Sculpture, Drawings, Graphics, Painting-American, Photography, Prints, Sculpture, Watercolors, American Indian Art, African Art, Pre-Columbian Art, Textiles, Ceramics, Pottery, Woodcarvings, Woodcuts, Etchings & Engravings, Decorative Arts, Jade, Oriental Art, Asian Art, Silver, Islamic Art, Painting-German, Antiquities-Etruscan
Collections: African & Pre-Columbian art; Chinese & Tibetan bronzes; Oriental jade; 19th & 20th century European & American paintings & sculpture; prints, drawings, photography, silver
Exhibitions: The Elliott Collection of 20th Century European paintings, silver & prints; a major collection of African sculpture; Approximately 24 changing exhibitions each year, both permanent collection, original & traveling exhibitions
Publications: Calendar 2 times per year; exhibition catalogs
Activities: Docent training; lect open to public, 10-20 vis lectr per year; concerts; gallery talks; tours; works of art lent to other museums; traveling exhib; originate traveling exhibitions; sales shop sells posters, postcards & catalogs
L **Art Library,** Tel 319-335-3089; Elec Mail art-lib@uiowa.edu; Internet Home Page Address: www.lib.uiowa.edu/art/index; *Head Librn* Rijn Templeton
Open Mon - Thurs 8:30 AM - 8:30 PM, Fri 8:30 AM - 5 PM, Sat 1 - 5 PM, SUN 1 - 7 PM; call for seasonal hours; Estab 1937 to support the University programs, community & state needs; Circ 40,000
Income: Financed by state appropriation
Library Holdings: Book Volumes 100,000; CD-ROMs; Clipping Files; Exhibition Catalogs; Fiche; Memorabilia; Pamphlets; Periodical Subscriptions 230; Reels

KEOKUK

A **KEOKUK ART CENTER,** 300 Main St, PO Box 862 Keokuk, IA 52632. Tel 319-524-8354; *Dir* Thomas Seabold
Open Tues - Sat 9 AM - 4PM & by appointment; No admis fee; Estab 1954 to promote art in tri-state area; Gallery maintained in Keokuk Public Library, 210 N Fifth St; Average Annual Attendance: 2,000; Mem: dues sustaining $50, patron $25, family $12, individual $6, student $2; annual meeting first Mon in May
Collections: Paintings, sculpture
Exhibitions: Changing exhibits
Publications: Newsletter, quarterly
Activities: Classes for adults & children; docent training; lect open to public; gallery talks; tours; competitions with cash awards; scholarships; book traveling exhibitions; originate traveling exhibitions

MARSHALLTOWN

A **CENTRAL IOWA ART ASSOCIATION, INC,** Fisher Community Ctr, 709 S Center Marshalltown, IA 50158. Tel 641-753-9013;
Open Mon - Thurs 11 AM - 5 PM; Estab 1942, incorporated 1959; The large auditorium has changing monthly exhibitions of varied art; glass cases in corridor & studio display contemporary ceramics of high quality; Average Annual Attendance: 3,000; Mem: 330; dues $15; annual meeting Dec/Jan
Income: Financed by mem, contributions & United Way
Special Subjects: Etchings & Engravings, Porcelain, Sculpture, Watercolors, Pottery, Bronzes, American Indian Art, Ceramics, Woodcarvings, Primitive art
Collections: Fisher Collection-Utrillo, Cassatt, Sisley, Vuillard, Monet, Degas, Signac, Le Gourge, Vlaminck and Monticelli; sculpture-Christian Petersen, Rominelli, Bourdelle; ceramic study collection-Gilhooly, Arneson, Nagle, Kottler, Babu, Geraedts, Boxem, Leach, Voulkos; traditional Japanese wares
Exhibitions: Monthly art & crafts in Fisher Community Center Auditorium
Publications: Newsletter, monthly; brochures
Activities: Classes for adults & children in ceramics, sculpture, jewelry, painting; lect open to public, 3 vis lectr per year; gallery talks; tours; awards; individual paintings & original objects of art lent; book traveling exhibitions; originate traveling exhibitions; sales shop sells original art, reproductions, prints, pottery, wood, fiber & metal
L **Art Reference Library,** Fisher Community Ctr, Marshalltown, IA 50158. Tel 515-753-9013; Fax 641-753-4899; Elec Mail ciaa@marshallnet.com; *Dir Prog* Hilary Helms
Open Mon - Fri 11 AM - 5 PM, Sat - Sun with special arrangements; No admis fee; Estab 1958 for fine art collecting classes; For reference only; Average Annual Attendance: 5,000; Mem: 400
Library Holdings: Book Volumes 700; Cassettes; Original Art Works; Photographs; Sculpture; Slides
Collections: Impressionists; Ceramics

Activities: Classes for adults & children; concerts; tours; sales shop sells art supplies

MASON CITY

M **CHARLES H MACNIDER MUSEUM,** 303 Second St SE, Mason City, IA 50401-3988. Tel 641-421-3666; Fax 641-422-9612; Elec Mail macnider@macniderart.org; Internet Home Page Address: www.macniderart.org; *Educ Coordr* Linda Willeke; *Registrar & Cur Asst* Mara Linskey
Open Tues & Thurs 9 AM - 9 PM, Wed, Fri & Sat 9 AM - 5 PM, Sun 1 - 5 PM, cl Mon & holidays; No admis fee; Estab 1964, opened 1966 to provide experience in the arts through development of a permanent collection, through scheduling of temporary exhibitions, through the offering of classes & art instruction, through special programs in film, music & other areas of the performing arts. The mus was estab in an English-Tudor style of brick & tile, enhanced by modern, design coordinated additions; It is located in a scenic setting, two & a half blocks from the main thoroughfare of Mason City. Gallery lighting & neutral backgrounds provide a good environment for exhibitions; Average Annual Attendance: Over 23,000; Mem: 400; dues from contributions $35-$1000 or more
Income: $460,000 (financed by mem, city appropriation & grants)
Special Subjects: Painting-American, Photography, Prints, Sculpture, Watercolors, Ceramics, Pottery, Woodcuts, Etchings & Engravings, Landscapes, Portraits
Collections: Permanent collection with an emphasis on American art, with some representation of Iowa art; contains paintings, prints, sculpture, pottery; artists represented include Baziotes, Birch, Benton, Burchfield, Bricher, Calder, Cropsey, De Staebler, Dove, Flannagan, Francis, Gottlieb, Graves, Guston, Healy, Hurd, Lasansky, Levine, Marin, Maurer, Metcalf, Sloan & Oliveira; Bil Baird: World of Puppets
Exhibitions: Biennial Area Competitive Show; Biennial Iowa Crafts Competition; Full schedule of temporary exhibs
Publications: Annual report; newsletter, quarterly; occasional exhibit fliers or catalog
Activities: Classes for adults & children; docent training; lect open to public; 5 vis lect per yr; concerts; gallery talks; tours; competitions; individual paintings & original objects of art lent to other museums & art centers; museum shop sells original art, jewelry & cards
L **Library,** 303 Second St SE, Mason City, IA 50401. Tel 641-421-3666; Fax 641-422-9612; Internet Home Page Address: www.macniderart.org;
Open Tues & Thurs 9 AM-9 PM, Wed, Fri & Sat 9 AM-5 PM, Sun 1 PM-5 PM; Estab as reference library for staff; Circ Non-circulating; Reference library within the structure of the mus for reference only & staff only
Library Holdings: Book Volumes 1500; Clipping Files; Exhibition Catalogs; Motion Pictures; Periodical Subscriptions 30; Slides; Video Tapes
Special Subjects: Art History, Folk Art, Photography, Drawings, Graphic Design, Painting-American, Prints, Portraits, American Western Art, Printmaking, Art Education, American Indian Art, Pottery, Landscapes, Architecture

L **MASON CITY PUBLIC LIBRARY,** 225 Second St SE, Mason City, IA 50401. Tel 641-421-3668; Fax 641-423-2615; Elec Mail library@mcpl.org; Internet Home Page Address: www.mcpl.org; *Dir* Andrew Alexander; *Reference* Barbara Madson; *Art Librn* Kenneth Enabnit; *Reference* Katrina Bowen
Open Mon - Wed 8:30 AM-8:30 PM, Thurs-Sat 9:30AM-5:30 PM, cl Sun; No admis fee; Estab 1869 to service pub in providing reading material & information; Circ 197,635; Monthly exhibits of local & regional artists located in main lobby of library
Income: Financed by city, county appropriation & Federal Revenue Sharings
Library Holdings: Book Volumes 110,000; Cassettes; Clipping Files; Fiche; Filmstrips 350; Framed Reproductions; Memorabilia; Motion Pictures; Original Art Works; Other Holdings Original documents; Pamphlets; Periodical Subscriptions 325; Prints; Records; Reels
Collections: Permanent collection of regional artists; signed letters of authors
Exhibitions: Rotating exhibitions; Monthly exhibitions
Activities: Exten dept serves general public; gallery holdings consist of art works & reproductions paintings which are lent to public

MOUNT VERNON

M **CORNELL COLLEGE,** Peter Paul Luce Gallery, McWethy Hall, 600 First St W Mount Vernon, IA 52314. Tel 319-895-4491; Fax 319-895-4519; Elec Mail scoleman@cornell.college.edu; Internet Home Page Address: www.cornell-iowa.edu; *Chmn Dept Art* Christina McOmber; *Dir Gallery* Susan Coleman; *Prof* Doug Hanson; *Prof* Anthony Plant; *Instr* Sandy Dyas; *Instr* Maria Schutt; *Instr* Sara Fletcher
Open Mon - Fri 9 AM - 4 PM, Sun 2 - 4 PM; No admis fee; Estab in 2002 with a gift from the Peter Paul Luce Foundation to display student works as well as professional artists
Income: Financed by Cornell College
Special Subjects: Painting-American, American Indian Art, Carpets & Rugs, Baroque Art
Collections: Thomas Nast drawings & prints; Sonnenschein Collection of European Drawings of the 15th - 17th Century
Exhibitions: 4 exhibits per year plus 10-20 student thesis shows
Publications: Hugh Lifton, The Cornell Years (2001)
Activities: Lect open to public, 4 vis lectr per year; gallery talks

MUSCATINE

M **MUSCATINE ART CENTER,** 1314 Mulberry Ave, Muscatine, IA 52761. Tel 563-263-8282; Fax 563-263-4702; Elec Mail art@muscanet.com; Internet Home Page Address: www.muscatineartcenter.org; *Dir* Barbara C Longtin; *Registrar* Virginia Cooper; *Educ Coordr* Maria Norton; *Office Coordr* Cynthia Carver
Open Tues - Fri 10 AM - 5 PM, Thurs 7 PM - 9 PM, Sat & Sun 1 - 5 PM, cl Mon & legal holidays; No admis fee; Estab 1965 to collect, preserve & interpret work of art & objects of historical & aesthetic importance; Average Annual

Attendance: 14,000; Mem: 500; dues benefactor $1000, patron $500, supporting $100, contributing $60, sustaining $25, family $40, individual $25; annual meeting in June

Income: Financed by city appropriation & Muscatine Art Center Support Foundation

Special Subjects: Graphics, Painting-American, Decorative Arts, Historical Material

Collections: Muscatine History; Button Collection; Paperweight Collection; American painting prints, especially Mississippi River views; American art pottery; children's books; decorative arts; glassware; graphics; oriental carpets; toys; 27 French Impressionist paintings & drawings

Publications: Newsletter, quarterly

Activities: Classes for children; docent training; lect open to public, 2 - 5 vis lectr per year; concerts; gallery talks; tours; individual paintings & original objects of art lent to qualified museums for exhibition purposes; book traveling exhibitions 5-7 per year; originate traveling exhibitions 1-2 per year

M **Museum,** 1314 Mulberry Ave, Muscatine, IA 52761. Tel 563-263-8282; Elec Mail art@muscanet.com; Internet Home Page Address: www.muscatineartcenter.org; *Dir* Barbara C Longtin; *Registrar* Virginia Cooper; *Educ Coordr* Maria Norton; *Ofc Coordr* Cynthia Carver

Open Tues - Fri 10 AM - 5 PM, Thurs 7 PM - 9 PM, Sat & Sun 1 PM - 5 PM; Donations accepted; Estab 1965; For reference only; Average Annual Attendance: 17,000

Library Holdings: Book Volumes 2600; Memorabilia; Pamphlets; Periodical Subscriptions 10

Special Subjects: Decorative Arts, Drawings, Landscapes, Ceramics, Glass, Furniture, Photography, Portraits, Painting-American, Prints, Period Rooms, Textiles, Maps, Sculpture, Watercolors, Costumes, Pottery, Woodcarvings, Painting-French, Carpets & Rugs

Collections: American decorative & fine arts

Activities: Classes for children; lect open to pubilc; tours

ORANGE CITY

M **NORTHWESTERN COLLEGE,** Te Paske Gallery, Student Ctr, Orange City, IA 51041. Tel 712-737-7000, 737-7003; *Exhib Coordr* John Kaericher; *Rotation Exhib Coordr* Rein Vanderhill

Open Mon - Sat 8 AM - 10 PM; No admis fee; Estab 1968 to promote the visual arts in northwest Iowa and to function as a learning resource for the college and community; Average Annual Attendance: 2,000

Income: Financed by school budget

Special Subjects: Etchings & Engravings

Collections: Approx 75 original works of art:; etchings, woodcuts, serigraphs, lithographs, mezzotints, paintings, sculpture and ceramics by modern and old masters of Western World and Japan

Exhibitions: Contemporary American Artists Series; student shows

Activities: Classes for adults; lect open to public, 2-3 vis lectr per year; gallery talks; competitions

OTTUMWA

L **AIRPOWER MUSEUM LIBRARY,** 22001 Bluegrass Rd, Ottumwa, IA 52501. Tel 641-938-2773; Fax 641-938-2084; Elec Mail aaaapmhq@pcsia.net; Internet Home Page Address: www.aaa-apm.org; Estab 1971

Library Holdings: Filmstrips; Photographs; Video Tapes

Special Subjects: Film, Photography, Drawings, Maps, Video

Collections: Aviation Collection, blueprints, books, brochures, clothing, drawings, films, lithographs, maps, models, paintings, periodicals, photographs, videos

Publications: Airpower Museum bulletin, annual

SIOUX CITY

A **SIOUX CITY ART CENTER,** 225 Nebraska St, Sioux City, IA 51101. Tel 712-279-6272; Fax 712-255-2921; Internet Home Page Address: www.siouxcityartcenter.org; *Bd Trustees Pres* Steve Kammerer; *Board Dirs Pres* Jay Chesterman; *Dir* Al Harris-Fernandez, PhD; *Admin Asst & Contact* Jill Collins; *Cur* Michael Betancourt; *Educ Specialist* Nan Wilson

Open Tues, Wed, Fri & Sat 10 AM - 5 PM, Thurs Noon-9PM, Sun 1 - 5 PM, cl Mon & holidays; No admis fee; Estab 1938 to provide art experiences to the general pub; Four exhibition galleries consisting of nationally known artists from the midwest regional area; includes a permanent collection gallery & changing exhibitions; Average Annual Attendance: 65,000; Mem: 725; dues $15-$5000; monthly meetings

Income: Financed by mem, city & state appropriation

Special Subjects: Drawings, Etchings & Engravings, Graphics, Landscapes, Photography, Prints, Sculpture, Watercolors, Painting-American, Woodcuts

Collections: Permanent collection of over 700 works; consists of paintings & prints of nationally known regional artists, contemporary photography & sculpture & crafts

Exhibitions: (6/2005-6/2007) Patrick Dougherty, a commissioned, site-specific installation on the Art Center's front grounds; (10/7/2006-1/7/2007) The 60th Juried Exhibition, featuring works by 60 artists from seven states; (3/2007-9/2007) Celebration, Our Siouxland, Our Art Center; (2007) Marilyn Monroe: Life as a Legend

Publications: Annual Report; quarterly newsletter; class brochures, quarterly; exhibition catalogs; exhibition announcements

Activities: Classes for adults & children; docent training; workshops; outreach programs to schools; Artsplash Festival of the Arts Sat & Sun of Labor Day weekend; lect open to public; gallery talks; tours; concerts; competitions; awards given in conjunction with juried exhibitions & YAM; scholarships offered; original objects of art & individual paintings lent to qualified institutions with approved facilities & security; book traveling exhibitions 3-4 per year; traveling exhibitions organized & circulated to regional art museums; museum shop sells books, magazines, original art, prints, jewelry & property items

L **Library,** 225 Nebraska St, Sioux City, IA 51101. Tel 712-279-6272; Fax 712-255-2921; Elec Mail aharris@sioux-city.org; Internet Home Page Address: www.siouxcityartcenter.com; *Admin Asst* Jill Collins

Open by appointment; No admis fee; Estab 1938; Reference library - non-circulating

Income: Financed by endowment, gifts, contributions, state appropriations

Library Holdings: Book Volumes 1500; Cassettes; Exhibition Catalogs; Periodical Subscriptions 20; Slides

STORM LAKE

M **WITTER GALLERY,** 609 Cayuga St, Storm Lake, IA 50588. Tel 712-732-3400; Elec Mail wittergallery@yahoo.com; *Pres* Mary Mello-Nee; *VPres* Mary Gill; *Dir* Jennifer Jochims

Open Tues - Fri 1- 5 PM, Thurs 1 - 6 PM, Sat 9 AM - 2 PM; No admis fee; Estab 1972 to encourage the appreciation of fine arts & to support fine arts educ, exhibits, lectures & workshops; Gallery occupies a wing of the Storm Lake Pub Library building. It has about 1800 sq ft of floor space & 120 linear ft of hanging wall space; Average Annual Attendance: 10,000; Mem: 300; dues sponsor $250, supporting $100, sustaining $50, active $25

Income: $20,000 (financed by endowment, mem, city appropriation, fundraising projects)

Library Holdings: Exhibition Catalogs; Memorabilia; Original Art Works; Original Documents; Photographs; Slides

Special Subjects: Prints

Collections: Paintings & collected artifacts of Miss Ella Witter; prints by Dorothy D Skewis

Exhibitions: Iowa Women in Art: Pioneers of the Past- touring exhibition of work by Ella Witter and Dorothy Skewis

Publications: Witter Gallery News & Events, The Palette Monthly

Activities: Classes for adults & children; art appreciation programs in area schools; lect open to public, 10 vis lectr per year; gallery talks; concerts; tours; biennial juried competition with cash awards; originate traveling exhibitions; gift gallery sells notecards & orig art - pottery, jewerly, prints, silk scarfs

WATERLOO

M **WATERLOO CENTER OF THE ARTS,** (Waterloo Museum of Art) 225 Commercial St, Waterloo, IA 50701. Tel 319-291-4490; Fax 319-291-4270; Internet Home Page Address: www.wplwloo.lib.ia.us/; *Dir* Cammie V Scully; *Educ Dir* Bonnie Winninger; *Dir Mktg* Maureen Newbill; *Cur* Kent Shankle

Open Mon - Fri 10 AM - 5 PM, Sat & Sun 1 - 4 PM; No admis fee; Estab 1947 to provide an art forum for the Waterloo area; Maintains reference library; Average Annual Attendance: 110,000, plus junior art gallery attendance of 16,000; Mem: 500; dues individual $15 & up; annual meeting 3rd Thurs of June

Income: Financed by city funds, mem, grants & donations

Special Subjects: Painting-American, Prints, Sculpture, African Art, Afro-American Art, Decorative Arts

Collections: American decorative Arts; Contemporary American art; Haitian/Caribbean paintings & sculpture

Exhibitions: Rotating exhibits 7 per yr

Activities: Classes for preschool through senior adults; dramatic programs; docent training; lect open to public; concerts; gallery talks; tours; competitions; scholarships & fels offered; individual paintings & original objects of art lent to other museums; originate traveling exhibitions; museum shop sells books & original art; junior museum

WEST BRANCH

L **HERBERT HOOVER PRESIDENTIAL LIBRARY & MUSEUM,** 210 Parkside Dr, West Branch, IA 52358. Tel 319-643-5301; Fax 319-643-5825; Elec Mail library@hoover.nara.gov; Internet Home Page Address: www.hoover.nara.gov; *Library Dir* Timoth Walch; *Reference Archivist* Matt Schaefer; *Cur Mus* Maureen Harding; *Educ Specialist* Mary Evans; *Admin Officer* Rosemary Paul; *Asst Reference Archivist* Spencer Howard

Open daily 9 AM - 5 PM, cl Thanksgiving, Christmas, New Year's Day; Admis $4, children 17 & under free; Estab 1962 as a research center to service the papers of Herbert Hoover & other related manuscript collections; a museum to exhibit the life & times of Herbert Hoover from his 90 years of public service & accomplishments; Average Annual Attendance: 65,000

Income: Financed by federal appropriation

Library Holdings: Audio Tapes; Book Volumes 23,041; Clipping Files; Manuscripts; Memorabilia; Motion Pictures; Original Documents; Other Holdings Original documents; Still photographs; Pamphlets; Periodical Subscriptions 30; Photographs; Records; Reels; Slides

Collections: 64 Chinese porcelains; oil paintings; 190 Original Editorial Cartoons; 340 posters; 26 World War I Food Administration; 464 World War I Painted and Embroidered Flour Sacks

Exhibitions: Permanent exhibits on Herbert & Lou Henry Hoover; subjects related to Hoover & the times; temporary exhibits cover subjects related to the memorabilia collection, the decades & activities of Hoover's life & state & national interest

Activities: Classes for children; docent training; lect open to public, 2-3 vis lectr per year; tours; sales shop sells books, prints, slides and medals

KANSAS

ABILENE

L **DWIGHT D EISENHOWER PRESIDENTIAL LIBRARY,** 200 SE Fourth St, Abilene, KS 67410. Tel 785-263-4751; Fax 785-263-4218; Internet Home Page Address: www.eisenhower.archives.gov; *Dir* Daniel Holt; *Cur Mus* Dennis Medina

Open daily 9 AM - 4:45 PM, cl Thanksgiving, Christmas & New Year's; Admis $8, sr citizens $5, under 16 free; Estab 1961 as library, in 1954 as museum; Average Annual Attendance: 126,000

Income: Financed by Federal Government appropriation
Library Holdings: Audio Tapes; Book Volumes 22,850; Cassettes; Clipping Files; Filmstrips; Manuscripts; Memorabilia; Micro Print; Motion Pictures; Original Art Works; Photographs; Prints; Records; Reels; Sculpture; Slides; Video Tapes
Collections: Research Library and Museum contains papers of Dwight D Eisenhower and his associates, together with items of historical interest connected with the Eisenhower Family. Mementos and gifts of General Dwight D Eisenhower both before, during, and after his term as President of the United States
Activities: Educ dept; docent training; lect open to the public, 5 vis lectr per year; libr tours; film series open to pub first three weeks of Mar every yr; individual paintings & original objects of art lent; lending collection contains original art work & prints, paintings & sculpture; originate traveling exhibitions; museum shop sells books, prints, reproductions & slides

ALMA

M **WABAUNSEE COUNTY HISTORICAL MUSEUM,** PO Box 387, 227 Missouri Alma, KS 66401. Tel 785-765-2200; Elec Mail wabcomuseum@earthlink.net; *Cur* Alan Winkler
Open Tues - Sat 10 AM - 4 PM, Sun 1 - 4 PM; No admis fee; Estab 1968 for the purpose of preserving art & artifacts in Wabaunsee County; Paintings are hung throughout the museum in available space. Maintains reference library; Average Annual Attendance: 1,500; Mem: 190; yr $20; annual meeting first Sat in June
Income: $25,000 (financed by mem & endowment)
Library Holdings: Audio Tapes
Collections: General Louis Walt display, blacksmith shop, clothing, farm tools & equipment; Indian arrowhead display; mainstreet USA-historical town; 1928 Reo firetruck; old time telephone shop; postal display; organization display case, 1918-1965; leather-making display; early day doctor's office; 1880 school room; Paintings by local artist August Ohst (1851-1939)
Publications: Stories of the Past, Historical Society newsletter, biannually
Activities: Hist tours spring & fall; sales shop sells books, postcards, stationery, t-shirts & sweat shirts

ASHLAND

M **CLARK COUNTY HISTORICAL SOCIETY,** Pioneer - Krier Museum, 430 W Fourth St, PO Box 862 Ashland, KS 67831-0862. Tel 316-635-2227; Fax 316-635-2227; Elec Mail rogers@ucom.net; *Cur* Floretta Rogers
Open Mon - Sat 10 AM - Noon & 1 - 5 PM, Sun 1 - 5 PM; Admis donations requested; Estab 1967 to collect & preserve Southwest Kansas history; Maintains reference library; Average Annual Attendance: 2,000; Mem: 400; dues lifetime $25; annual meeting in Nov
Income: $29,795 (financed by mem, county taxes & donations)
Special Subjects: Painting-American, Photography, American Indian Art, Archaeology, Southwestern Art, Textiles, Woodcarvings, Etchings & Engravings, Manuscripts, Portraits, Dolls, Furniture, Glass, Porcelain, Metalwork, Carpets & Rugs, Historical Material, Maps, Coins & Medals, Tapestries, Dioramas, Period Rooms, Laces, Reproductions
Collections: Archeological collection; Barbed Wire Collection; Early Settlers Collection; Elephant Collection; Gun Collection; Implement Seat collection - Memorabilia of five famous people from Clark County, Kansas; Track Stars, Jerome C Berryma 1921-1925, Wes Santee 1950's; Aerobatic Champion Harold Krier, Notre Dame Coach Jesse Harper; World Renown Counter-Tenor Rodney Hardesty
Publications: Notes on Eary Clark County, Kansas, book; Kings & Queens of the Range, book; Cattle Ranching South of Dodge City - The Early Years (1870 - 1920), book
Activities: Demonstrations & group tours; historical tours; books; original art; reproductions

ATCHISON

M **MUCHNIC FOUNDATION & ATCHISON ART ASSOCIATION,** Muchnic Gallery, 704 N Fourth St, PO Box 308 Atchison, KS 66002. Tel 913-367-4278; Fax 913-367-2939; Elec Mail atchart@ponyexpress.net; Internet Home Page Address: www.atchison-art.org; *Cur* Gloria Davis
Open Mar - Dec Wed 10 AM - 5 PM, Sat & Sun 1PM - 5PM; Admis $2; Estab 1970 to bring fine arts to the people of Atchison; 19th century home furnished with original family belongings downstairs; upstairs there are five rooms devoted to the art gallery; Average Annual Attendance: 3,000; Mem: 120; board meeting second Mon of each month
Income: Financed by Muchnic Foundation, Atchison Art Asn art shows
Purchases: $7,000
Special Subjects: Painting-American, Period Rooms
Collections: Paintings by regional artists: Don Andorfer; Thomas Hart Benton; John Stuart Curry; Raymond Eastwood; John Falter; Jim Hamil; Wilbur Niewald; Jack O'Hara; Roger Shimomura; Robert Sudlow; Grant Wood; Jamie Wyeth; Walter Yost
Activities: Classes for adults; docent training; lect open to public; tours; scholarships & fels offered; individual paintings lent to local museums; book traveling exhibitions 3 per year; originate traveling exhibitions; sales shop sells books, original art & prints

BALDWIN CITY

M **BAKER UNIVERSITY,** Old Castle Museum, 515 Fifth St, PO Box 65 Baldwin City, KS 66006. Tel 785-594-6809; Fax 785-594-2522; *Dir* Brenda Day
Open Mon-Fri 8AM-4:30PM, other times and days by appointment only; Admis by donation; Estab 1953 to display items related to life in early Kansas; Average Annual Attendance: 1,500
Income: Financed by endowment, University & donations
Special Subjects: Pottery, Historical Material, Pewter

Collections: Country store; Indian artifacts & pottery; 19th century print shop; quilts; silver & pewter dishes & table service; tools; old quilts; old cameras; Santa Fe Trail Artifacts
Exhibitions: John Brown material; Indian Pottery; Indian artifacts; old guns
Activities: Lect open to public

CHANUTE

M **MARTIN AND OSA JOHNSON SAFARI MUSEUM, INC,** 111 N Lincoln Ave, Chanute, KS 66720. Tel 620-431-2730; Fax 620-431-2730; Elec Mail osajohns@safarimuseum.com; Internet Home Page Address: www.safarimuseum.com; *Dir* Conrad G Froehlich; *Cur* Jacquelyn L Borgeson; *Store Mgr* Shirley Rogers-Naff
Open Mon - Sat 10 AM - 5 PM, Sun 1 - 5 PM; Admis adults $4, students & seniors $3, children 6-12 $2, children under 6 free; Estab 1961 to be the repository of the Johnson Archives; Average Annual Attendance: 6,000; Mem: 500; dues $25
Income: $200,000 (financed by mem, city appropriation, donations & gift shop)
Special Subjects: African Art
Collections: Fine art-natural history subjects; Martin & Osa Johnson-films, photos, manuscripts; Ethnographic-African, Borneo, South Pacific
Exhibitions: Johnson Exhibition, Imperato African Gallery, Selsor Art Gallery (special exhibit space)
Publications: Empty Masks; Exploring with Martin & Osa Johnson (book); Wait-A-Bit News, quarterly newsletter
Activities: Educ dept; classes for adults & children; docent training; lect open to public, vis lectrs; tours; sponsoring of competitions; Barbar Enlow Henshall award for vol serv; mus boxes for school use; individual paintings & original objects of art lent to qualified institutions; mus shop sells books, prints, original art, imported carvings, brass, fabric & ethnic toys

M **Imperato Collection of West African Artifacts,** 111 N Lincoln Ave, Chanute, KS 66720. Tel 620-431-2730; Fax 620-431-2730; Elec Mail osajohns@safarimuseum.com; Internet Home Page Address: www.safarimuseum.com; *Dir* Conrad G Froehlich; *Cur* Jacquelyn Borgeson
Open Mon - Sat 10 AM - 5 PM, Sun 1 - 5 PM; Admis adults $4, seniors & students $3, children 6-12 $2, children under 6 free; Estab 1974; Average Annual Attendance: 6,000; Mem: 500; $25 dues
Income: $200,000 (financed by members, city, donations, gift shop)
Collections: West African sculpture including masks, ancestor figures & ritual objects, household items, musical instruments
Exhibitions: African culture exhibit of East & West African items; ceremonial masks
Publications: Collection catalogs
Activities: Tours

M **Johnson Collection of Photographs, Movies & Memorabilia,** 111 N Lincoln Ave, Chanute, KS 66720. Tel 620-431-2730; Fax 620-431-2730; Elec Mail osajohns@safari.museum.com; Internet Home Page Address: www.safarimuseum.com; *Dir* Conrad G Froehlich; *Cur* Jacquelyn Borgeson
Open Mon - Sat 10 AM - 5 PM, Sun 1 - 5 PM; Admis adults $4, seniors & students $3, children 6-12 $2, children under 6 free; Estab 1961; Average Annual Attendance: 6,000; Mem: 500; $25 dues
Income: $200,000 (financed by members, city, donations, gift shop)
Collections: Photographs & movie footage of the South Seas, Borneo & East Africa between 1917-1936; Manuscript material, archival collection, & artifacts collected by the Johnsons
Exhibitions: Life of the Johnsons

M **Selsor Art Gallery,** 111 N Lincoln Ave, Chanute, KS 66720. Tel 620-431-2730; Fax 620-431-2730; Elec Mail osajohns@safarimuseum.com; Internet Home Page Address: www.safarimuseum.com; *Dir* Conrad G Froehlich; *Cur* Jacquelyn Borgeson
Open Mon - Sat 10 AM - 5 PM, Sun 1 - 5 PM; Admis $4, seniors & students $3, children 6-12 $2, children under 6 free; Estab 1981; Average Annual Attendance: 6,000; Mem: 500; $25 dues
Income: $200,000 (financed by members, city, donations, gift shop)
Collections: Original paintings; scratch boards & sketches; bronze, ivory & amber sculpture; lithographs
Exhibitions: Rotating exhibits
Activities: Tours; objects of art lent to qualified institutions; mus shop sells books

L **Scott Explorers Library,** 111 N Lincoln Ave, Chanute, KS 66720. Tel 620-431-2730; Fax 620-431-2730; Elec Mail osajohns@safarimuseum.com; Internet Home Page Address: www.safarimuseum.com; *Dir* Conrad G Froehlich; *Cur* Jacquelyn Bergeson
Open Mon - Sat 10 AM - 5 PM, Sun 1 - 5 PM; Estab 1980 for research and reference
Library Holdings: Book Volumes 14,000

EL DORADO

M **COUTTS MEMORIAL MUSEUM OF ART, INC,** 110 N Main St, P O Box 1 El Dorado, KS 67042-0001. Tel 316-321-1212; Fax 316-321-1215; Elec Mail coutts@coutts.kscoxmail.com; Internet Home Page Address: couttsmuseum.org; *Co Dir* Rhoda Hodges; *Co Dir* Teresa S Scott
Open Mon, Wed & Fri 1 - 5 PM, Tues & Thurs 9 AM - Noon & 1 - 5 PM, Sat Noon - 4 PM; No admis fee; Estab 1970 as a Fine Arts museum; Fine art & antiques; Average Annual Attendance: 4,000; Mem: 251, $25 per person, quarterly 3rd Thurs
Income: Financed by endowment & gifts
Special Subjects: Latin American Art, Mexican Art, Painting-American, American Indian Art, American Western Art, Bronzes, Ceramics, Folk Art, Etchings & Engravings, Landscapes, Decorative Arts, Collages, Furniture, Glass, Oriental Art, Asian Art, Painting-British, Carpets & Rugs, Miniatures, Cartoons
Collections: Frederick Remington sculpture collection completed in 1992 (recasts)
Exhibitions: Annual All County Student Art Show; rotating 4-6 wks; 10-11 exhibits a year, changing every 4 weeks
Publications: Quarterly newsletter

Activities: Lect open to public, 4-6 vis lectr per year; tours; competitions with awards; scholarships offered; individual paintings & original objects of art lent; book traveling exhibitions 1-2 per year

EMPORIA

M EMPORIA STATE UNIVERSITY, Norman R Eppink Art Gallery, 1200 Commercial, Emporia, KS 66801. Tel 620-341-5246 or 341-5689; Fax 620-341-6246; Elec Mail reichenb@emporia.edu; *Asst Prof of Art* Roberta Eichenberg
Open Mon - Fri 9 AM - 4 PM, cl university holidays; No admis fee; Estab 1939 to bring a variety of exhibitions to the campus; Main Gallery is 25 x 50 ft & has a 50 ft wall for hanging items; adjacent gallery is 16 x 50 ft; display gallery contains eighteen 40 inch x 28 inch panels; Average Annual Attendance: 10,000
Income: Financed by state, grant & endowment funds
Purchases: Annual purchase of contemporary drawings from the Annual National Invitational Drawing Exhibition & varied works from invited exhibiting artists
Library Holdings: Slides
Collections: Artifacts; contemporary drawings and paintings; sculpture
Publications: Exhibition catalogs
Activities: Lect open to public, 6 vis lectr per year; concerts; gallery talks; tours; scholarships offered; individual paintings & original objects of art lent to university offices; book traveling exhibitions 4-6 per year; originate traveling exhibitions to schools

HAYS

M FORT HAYS STATE UNIVERSITY, Moss-Thorns Gallery of Arts, 600 Park St, Hays, KS 67601. Tel 785-628-4247; Fax 785-628-4087; Elec Mail ctaylor@fhsu.edu; Internet Home Page Address: www.fhsu.edu; *Chmn* Leland Powers; *Secy* Colleen Taylor
Open Mon - Fri 8:30 AM - 4 PM, weekends on special occasions; summer hours: Mon - Thurs 8 AM - 4:30 PM, Fri 8 AM - 11 AM; No admis fee; Estab 1953 to provide constant changing exhibitions for the benefit of students, faculty & other interested people in an educ situation; Rarick Hall has 2200 sq ft with moveable panels that can be used to divide the gallery into four smaller galleries; Mem: 88
Income: Financed by state appropriation
Purchases: $2000
Special Subjects: Drawings, Painting-American, Prints
Collections: Vyvyan Blackford Collection; contemporary prints; national exhibition of small paintings, prints & drawings; regionalist collection (1930s); Oriental scroll collection
Publications: Exhibitions brochures; Art Calendar, annually
Activities: Lect open to public, 4 vis lectr per year; gallery talks; tours; competitions with prizes; concerts; exten dept servs western Kansas; individual paintings & original objects of art lent to individuals, organizations & institutions; lending collection contains original art works & prints, paintings, sculpture & slides; traveling exhibitions organized & circulated
L Forsyth Library, 600 Park St, Hays, KS 67601. Tel 785-628-4431; Fax 785-628-4096; Elec Mail jgross@fhsu.edu; Internet Home Page Address: www.fhsu.edu; *Reference Librn* Donna Northam; *Dir* John Ross; *Office Asst* Janet Basgall
Reference Library
Library Holdings: Book Volumes 6000; Exhibition Catalogs; Filmstrips; Periodical Subscriptions 1100

HUTCHINSON

A HUTCHINSON ART ASSOCIATION, Hutchinson Art Center, 405 N Washington, Hutchinson, KS 67501. Tel 620-663-1081; Elec Mail hutchart@hac.kscoxmail.com; Internet Home Page Address: www.hutchartcenter.com; *Pres* Pam Gertken; *Dir* Brett Beatty
Open Tues - Fri 9 AM - 5 PM, Sat & Sun 1 - 5 PM; Estab 1949 to bring exhibitions to the city of Hutchinson & maintain a permanent collection; Three galleries & educational area; Average Annual Attendance: 5,000; Mem: 500; dues $15-$1,000; monthly meetings
Income: Financed by mem & endowment
Special Subjects: Metalwork, Prints, Watercolors, Ceramics, Glass
Collections: Permanent collection of watercolors, prints, ceramics, glass, wood, oils & metals
Exhibitions: Two all-member shows per yr; one traveling show per month
Activities: Classes for adults & children; lect open to public, 3 vis lectr per year; gallery talks; tours; annual art fair with prizes; monthly public receptions to meet artists currently exhibiting; scholarships offered; book traveling exhibitions; sales shop sells original art, prints, cards, ceramics, handblown glass, jewelry, sculpture, carved wood & stoneware

A KANSAS WATERCOLOR SOCIETY, PO Box 1796, Hutchinson, KS 67502-1796. Tel 316-268-4921; Fax 316-268-4980; Elec Mail kansaswatercolor@sbcglobal.net; Internet Home Page Address: kansaswatercolor.com; *Pres* Jim Rigg; *Exec Secy* MaryLou Sunderland
Not open to pub; No admis fee; Estab 1970 to promote watercolor in Kansas; Mem: 185; dues $20, annual meeting in June
Income: Financed by mem, entry fees, patrons & Kansas Arts Commission
Exhibitions: Rotating exhibits
Publications: Newsletter, quarterly
Activities: Demonstrations & workshops; lect open to public; gallery talks; tours; competitions with awards; traveling exhibitions organized & circulated

INDEPENDENCE

M INDEPENDENCE HISTORICAL MUSEUM, PO Box 294 Independence, KS 67301. Eigth & Myrtle Independence, KS 67301. Tel 620-331-3515; Elec Mail museum@comgen.com; *Mus Coordr* Julie Gosnell; *VPres* Ellie Culp; *VPres* Joy Barta
Open Wed - Sat 10 AM - 2 PM, Sun 1-4PM, cl holidays; Admis by donation; Estab 1882 to secure an art collection for the community; The mus has a large 19

ft gallery which contains original paintings; Indian art & artifacts; military room, Western room; country store, period bedroom, early 1900 kitchen, children's room, historical oil room, & blacksmith shop; Average Annual Attendance: 6,000; Mem: 200; dues $25-$1000; meeting monthly Sept - May
Income: Financed by mem, bequests, gifts, art exhibits, various projects & donations
Special Subjects: Period Rooms
Collections: William Inge Memorabilia Collection; American Indian Collection; Oriental Collection
Exhibitions: Annual Art Exhibit: Quilt Affair; various artists & craftsmen exhibits
Activities: Docent training; lect open to public, 2 vis lectr per year; tours; competitions with awards; sales shop sells KS items

LAWRENCE

M UNIVERSITY OF KANSAS, Spencer Museum of Art, 1301 Mississippi St, Univ of Kansas Lawrence, KS 66045-7500. Tel 785-864-4710; Fax 785-864-3112; Elec Mail spencer@ku.edu; Internet Home Page Address: www.spencerart.ku.edu/; *Cur Prints & Drawings* Stephen Goddard; *Registrar* Janet Dreiling; *Mng Ed & Pub Relations* Bill Woodard; *Educ & Progs* Kristina Mitchell; *Cur European & American Art* Susan Earle; *Graphic Designer* Amanda Schwegler; *Dir* Saralyn Reece Hardy; *Exhib Designer* Richard Klocke; *Docents* Jerrye Van Leer; *Asst Dir* Carolyn Chinn Lewis; *Progs* Amanda Martin Haman; *Grant Writer* Lee Blackledge; *Coll Mgr* Sofia Galarza Liu; *Accounting Specialist* Karley Ast; *Security* Cindy Waterman
Open Tues - Sat 10 AM - 5 PM, Thurs 10 AM - 9 PM, Sun Noon - 5 PM, cl Mon; No admis fee; donations accepted; Dedicated in Spooner Hall 1928, Spencer dedicated 1978. The Museum has traditionally served as a laboratory for the visual arts, supporting curricular study in the arts & art history. Primary emphasis is placed on acquisitions & publications, with a regular schedule of changing exhibitions; Museum has a two level Central Court, seven galleries devoted to the permanent collections & five galleries for temporary exhibitions; altogether affording 29,000 sq ft; Average Annual Attendance: 100,000; Mem: Dues $50
Income: Financed by mem, state appropriation & state & federal grants, contributions & foundations
Library Holdings: Auction Catalogs; Book Volumes
Special Subjects: Drawings, Graphics, Painting-American, Photography, Prints, Sculpture, Watercolors, Bronzes, Textiles, Woodcuts, Etchings & Engravings, Painting-European, Painting-Japanese, Glass, Asian Art, Silver, Painting-British, Painting-Dutch, Carpets & Rugs, Baroque Art, Calligraphy, Renaissance Art, Embroidery, Medieval Art, Painting-Italian
Collections: American paintings; ancient art; Asian art; graphics; Medieval art; 17th & 18th century art, especially German; 19th century European & American art; 20th century European & American art
Publications: Calendar, monthly; Murphy Lectures, annually; The Register of the Spencer Museum of Art, annually; exhibition catalogs, 1-2 per year
Activities: Classes for adults & children; docent training; lect open to public, 12 & more vis lectr per year; concerts; gallery talks; tours; internships offered; book traveling exhibitions; traveling exhibitions organized & circulated; museum shop sells books, reproductions, prints, slides, posters, postcards, jewelry & gifts
L Murphy Library of Art & Architecture, University of Kansas, 1425 Jayhawk Blvd Lawrence, KS 66045. Tel 785-864-3020; Fax 785-864-4608; Elec Mail scraig@ukans.edu; Internet Home Page Address: www.2ku.edu/artlib; *Librn* Susan V Craig
Open during school yr, Mon - Thurs 8 AM - 10 PM, Fri 8 AM - 6 PM, Sat Noon - 5 PM, Sun 1 - 10 PM; Estab 1970 to support academic programs & for research; Circ Open to faculty, students & pub; some restrictions on circulating items
Library Holdings: Book Volumes 110,000; CD-ROMs; Exhibition Catalogs; Fiche; Other Holdings Auction catalogs; Pamphlets; Periodical Subscriptions 700; Reels
Special Subjects: Art History, Decorative Arts, Photography, Graphic Design, Painting-American, Painting-Dutch, Painting-Flemish, Painting-Japanese, Prints, Art Education, Asian Art, Textiles, Architecture
L Architectural Resource Center, School of Architecture & Urban Design, 1465 Jayhawk Blvd Lawrence, KS 66045-7614. Tel 785-864-3244; Fax 785-864-5393; Elec Mail u-stammler@ku.edu; *Dir* Ursula Stammler
Open Mon - Fri 10 AM - 5 PM, Sun - Thurs 7:30 PM - 9:30 PM; Slide Library, estab 1968, is primarily a teaching tool for faculty, but also accessible to students; Donald E & Mary Bole Hatch Architectural Reading Room, estab 1981, is adjacent to studios in School of Architecture & supports the immediate reference needs of students; For reference only
Income: Financed by endowment & state appropriation
Library Holdings: Book Volumes 3000; Periodical Subscriptions 30; Slides 82,000
Special Subjects: Architecture

LINDSBORG

BETHANY COLLEGE
L Wallerstedt Library, Tel 785-227-3380, Ext 8342; Fax 785-227-2860; Elec Mail carsond@bethanylb.edu; Internet Home Page Address: www.bethanylb.edu/home; *Dir* Denise Carson; *Inter-Library Loan Librn* Elaine Bean; *Librn* Dawn K Quane
Open Mon - Thurs 7:30 AM - 10:30 PM, Fri 7:30 AM - 5 PM, Sat 11 AM - 4 PM, Sun 2:30 - 10:30 PM; Estab 1881; For reference only
Library Holdings: Book Volumes 121,000; Exhibition Catalogs
M Mingenback Art Center, Tel 785-227-3380, Ext 8145; Elec Mail Kahlerc@bethanylb.edu; Internet Home Page Address: www.bethanylb.edu; *Assoc Prof* Mary Kay; *Prof* Dr Bruce Kahler; *Asst Prof* Frank Shaw; *Asst Prof* Ed Pogue; *Assoc Prof* Caroline Kahler; *Instr* Jim Turner
Open daily 8 AM - 5 PM, cl summer & holidays; No admis; Estab 1970 as an educational gallery for student & professional exhibitions; Materials are not for pub display, for educational reference only; Average Annual Attendance: 1,500
Income: Financed by collections
Special Subjects: Sculpture, Watercolors, Ceramics
Collections: Oil paintings, watercolors, prints, etchings, lithographs, wood engravings, ceramics & sculpture

Exhibitions: Lucia Student Exhibition; Messiah Exhibition; Rotating exhibs; Graduated Sr Exhibits
Activities: Classes for adults; lect open to public, 3 vis lects per year; gallery talks; competitions with prizes; scholarships offered

M **BIRGER SANDZEN MEMORIAL GALLERY,** 401 N First St, PO Box 348 Lindsborg, KS 67456. Tel 785-227-2220; Fax 785-227-4170; Elec Mail fineart@sandzen.org; Internet Home Page Address: www.sandzen.org; *Dir* Larry L Griffis; *Cur* Ronald Michael; *Secy* Muriel Gentine
Open Tues - Sat 1 - 5 PM, Sun 1 - 5 PM; No admis fee; Estab 1957 to permanently exhibit the paintings & prints by the late Birger Sandzen, teacher at Bethany College for 52 years; Ten exhibition areas; Average Annual Attendance: 10,000; Mem: 350; dues $30-$5,000; annual meeting May for Board of Directors
Income: Financed by admis fees, sales & mem
Library Holdings: Book Volumes; Cards; Clipping Files; Exhibition Catalogs; Memorabilia; Original Documents; Pamphlets; Periodical Subscriptions; Photographs; Slides; Video Tapes
Special Subjects: Art History, Ceramics, Prints, Woodcuts, Sculpture, Painting-American, Photography, Watercolors, Jade, Oriental Art, Asian Art
Collections: H V Poor, Lester Raymer, Birger Sandzen, John Bashor, Elmer Tomasch, Doel Reed & Carl Milles; Prairie Print Maker Society prints
Exhibitions: Guest artist & special exhibits, Spring & Fall. Work from permanent collections throughout the year.
Publications: Birger Sandzen: An Illustrated Biography; The Graphic Work of Birger Sandzen; Sandzen & the New Land, catalogue
Activities: Classes for children; docent training; lect open to public, 3 - 7 vis lectr per year; concerts; gallery talks; tours; Birger & Alfrida Sandzen Award for Excellence in Music; Aesthetics biannual juried competition; lending of original objects of art to art museums; 1-2 book traveling exhibitions per year; originate traveling exhibitions to art museums & cultural organizations; sales shop sells books, original art, reproductions, prints & cards

LOGAN

M **DANE G HANSEN MEMORIAL MUSEUM,** PO Box 187, Logan, KS 67646. Tel 785-689-4846; Fax 785-689-4892; Internet Home Page Address: www.hansenmuseum.org; *Dir* Lee Favre
Open Mon - Fri 9 AM - Noon & 1 - 4 PM, Sat 9 AM - Noon & 1 - 5 PM, Sun & holidays 1 - 5 PM, cl Thanksgiving, Christmas & New Year's; No admis fee; Estab 1973; Traveling exhibitions; Average Annual Attendance: 9,000; Mem: 300; dues sustaining $50, patron $25, benefactor $10
Collections: Coins; guns; paintings; sculptures
Activities: Classes for adults & children; lect open to public; concerts; gallery talks; tours; 6 traveling book exhibitions per year

MANHATTAN

L **KANSAS STATE UNIVERSITY,** Paul Weigel Library of Architecture Planning & Design, 323 Seaton Hall, College of Architecture Planning & Design Manhattan, KS 66506. Tel 785-532-5968; Internet Home Page Address: www.lib.ksu.edu/branches/architecture/weigel.html; *Library Asst* Judy Wyatt; *Ref Librn* Ann Scott; *Librn* Jeff Alger
Open Mon - Thurs 8 AM - 10 PM, Fri 8 AM - 5 PM, Sat 1- 5 PM, Sun 2 - 10 PM; No admis fee; Estab 1917; Circ 29,861
Income: $40,000 (financed by state appropriations & gifts)
Library Holdings: Book Volumes 38,806; Clipping Files; Fiche; Periodical Subscriptions 225; Reels
Special Subjects: Landscape Architecture, Graphic Design, Historical Material, Drafting, Restoration & Conservation, Architecture
Publications: Subject catalog

M **RILEY COUNTY HISTORICAL SOCIETY,** Riley County Historical Museum, 2309 Claflin Rd, Manhattan, KS 66502. Tel 785-565-6490; *Archivist* Linda Glasgow; *Dir* D Cheryl Collins; *Exhibits* Barbara Poresky; *Registrar* Corina Hugo
Open Tues - Fri 8:30 AM - 5 PM; Sat & Sun 2 - 5 PM; No admis fee; Estab 1916 to exhibit history & current & historical arts & crafts; Maintains reference library; Average Annual Attendance: 25,000; Mem: 1000; dues individual $10, family $15; dinner meetings in Jan, Apr, July & Oct
Income: Financed by Riley County budget
Special Subjects: Architecture, Photography, Textiles, Decorative Arts, Manuscripts, Portraits, Dolls, Furniture, Glass, Historical Material, Maps, Period Rooms
Collections: Photo Collections; Riley County History
Exhibitions: Household Work Week; The Land & the People - standing exhib
Publications: RCHS Newsletter, 10 times per year; Tracing Traditions, a coloring book for children
Activities: Classes for children, dramatic programs, docent programs; lect open to public; book traveling exhibitions 2 per year; originate traveling exhibitions to schools & club meetings; sales shop sells books, Kansas crafts, wheatweaving, wood cuts, pottery & wood carvings & Kans themed items
L **Seaton Library,** 2309 Claflin Rd, Manhattan, KS 66502. Tel 785-565-6490; *Library Archivist* Linda Glasgow; *Dir* D Cheryl Collins; *Exhibits* Barbara Poresky; *Registrar* Corina Hugo
By appointment only; Reference, non-circulating collection
Income: Financed by Riley County
Library Holdings: Audio Tapes; Book Volumes 4000; Clipping Files; Lantern Slides; Manuscripts; Memorabilia; Motion Pictures; Pamphlets; Photographs; Slides; Video Tapes
Special Subjects: Manuscripts, Maps, Historical Material, Architecture
Collections: Photo Collection; Family files, maps, club records, school records, bus records, county government & city records

MCPHERSON

M **MCPHERSON COLLEGE GALLERY,** Friendship Hall, 1600 E Euclid McPherson, KS 67460. Tel 316-241-0731; Fax 316-241-8443; Internet Home Page Address: www.mcpherson.edu; *Dir* Wayne Conyers
Open Mon - Fri 8 AM - 10 PM; No admis fee; Estab 1960 to present works of art to the college students & to the community; A long gallery which is the entrance

to an auditorium, has four showcases & 11 panels 4 x 16 ft; Average Annual Attendance: 2,500
Income: Financed through college
Special Subjects: Painting-American, Prints, Watercolors
Collections: Oils, original prints, watercolors
Exhibitions: change monthly
Activities: Classes for adults; scholarships offered; book traveling exhibitions

M **MCPHERSON MUSEUM,** 1130 E Euclid, McPherson, KS 67460. Tel 620-241-8464; Fax 620-241-8464; *Display Arrangement* Nadine Logback; *Office* Patty Johnson; *Museum Dir* Shirley Ade
Open Tues - Sun 1 - 5 PM, cl Mon & holidays; Admis by donation; Estab 1890; Average Annual Attendance: 7,000; Mem: 193, dues $15 & $25
Income: Financed by city appropriation
Special Subjects: Painting-American, African Art, Archaeology, Costumes, Furniture, Historical Material, Maps, Coins & Medals, Period Rooms, Antiquities-Oriental
Collections: Fossils of mammoths, mastodons, saber tooth tigers & many other fossils; oriental & African collection; Pioneer artifacts & Indian artifacts
Exhibitions: Gatsby Summer Afternoon, Wedding Gown, Edwardian Christmas Exhibit
Publications: McPherson Museum Memoranda

MONTEZUMA

M **STAUTH FOUNDATION & MUSEUM,** Stauth Memorial Museum, 111 N Aztec St, PO Box 396 Montezuma, KS 67867-0396. Tel 620-846-2527; Fax 620-846-2810; Elec Mail stauthm@ucom.net; Internet Home Page Address: www.stauthmemorialmuseum.org; *Dir & Financial Dir* Kim Legleiter; *Staff Asst* Linda Koehn
Open Tues - Sat 9 AM - Noon & 1 - 4:30 PM, Sun 1:30 - 4:30 PM; No admis fee; Estab 1996; Four galleries; Average Annual Attendance: 8,000
Income: $95,000 (financed by endowment & donations)
Special Subjects: Latin American Art, Photography, Sculpture, African Art, Costumes, Primitive art, Woodcarvings, Etchings & Engravings, Decorative Arts, Posters, Dolls, Furniture, Glass, Jewelry, Oriental Art, Asian Art, Metalwork, Ivory, Scrimshaw, Coins & Medals, Tapestries, Enamels
Collections: Coins-foreign; decorative arts; jewelry-foreign; natural history collection; slides-over 10,000; Remington bronze miniatures & other western bronze miniatures
Exhibitions: Around The World with Claude & Donald Stauth; The Ralph Fry Wildlife Collection; Wall Western Collection
Activities: Lect open to public, 2 vis lectr per year; book traveling exhibitions 7 - 10 per year

NORTH NEWTON

L **BETHEL COLLEGE,** Mennonite Library & Archives, 300 E 27th St, North Newton, KS 67117-0531. Tel 316-284-5304; Fax 316-284-5843; Elec Mail mla@bethelks.edu; Internet Home Page Address: www.bethelks.edu/services/mla; *Archivist* John D Thiesen; *Librn* Barbara A Thiesen; *Asst Archivist* James Lynch
Open Mon - Thurs 10 AM - 5 PM; No admis fee; Estab 1936 to preserve resources related to Mennonite history for the use of researchers
Income: $70,000 (financed by college & church conference support)
Library Holdings: Audio Tapes; Cassettes; Clipping Files; Exhibition Catalogs; Fiche; Filmstrips; Framed Reproductions; Kodachrome Transparencies; Lantern Slides; Manuscripts; Memorabilia; Motion Pictures; Original Art Works; Pamphlets; Photographs; Prints; Records; Reels; Reproductions; Slides; Video Tapes
Special Subjects: Photography, Manuscripts, Painting-American, Painting-Dutch, Painting-German, Historical Material, Ethnology, Religious Art
Collections: 500 paintings and etchings by Mennonite artists; Photographs of Hopi and Cheyenne Indians
Publications: Mennonite Life, on-line only
Activities: Lects

NORTON

C **FIRST STATE BANK,** 105 W Main, PO Box 560 Norton, KS 67654-0560. Tel 785-877-3341; Fax 785-877-5808; Elec Mail firstate@ruraltel.net; Internet Home Page Address: www.firstatebank.com; *chmn* Norman L Nelson; *Pres* John P Engelbert; *Contact* Lee Ann Shearer
Open Mon - Fri 9 AM - 3 PM, Sat 8:30 AM - 11:30 AM; No admis fee; Estab 1965 as a gallery of those who ran for President of the United States & lost; 58 portraits & biographies; Average Annual Attendance: varies
Income: through the bank
Special Subjects: Historical Material
Collections: Also Ran Gallery; Elephants display
Exhibitions: Permanent
Publications: Booklet that includes the biographies & history given out at visit

RUSSELL

M **DEINES CULTURAL CENTER,** 820 N Main St, Russell, KS 67665-1932. Tel 785-483-3742; Fax 785-483-4397; Elec Mail deinescenter@russellks.net; *Dir* Nancy Selbe
Open Tues - Sun 1 - 5 PM; No admis fee; Estab 1990 to promote the arts & humanities; Average Annual Attendance: 2,500; Mem: 175; dues $25
Income: $30,000 (financed by mem & city appropriation)
Special Subjects: Painting-American, Photography, Prints, Sculpture, Watercolors, Pottery, Woodcuts
Collections: E Hubert Deines Wood Engravings
Exhibitions: Monthly exhibits

Activities: Classes for adults & children; recitals; book traveling exhibitions 1 per year

SALINA

A ASSOCIATION OF COMMUNITY ARTS AGENCIES OF KANSAS, PO Box 1363, Salina, KS 67402-1363. Tel 785-825-2700; Fax 785-823-1992; Elec Mail acaakshar@aol.com, acaaeeilen@aol.com; *Exec Dir* Ellen Morgan
Estab 1970 to work with community arts agencies & organizations to develop an environment in which the arts can flourish; facilitator & advocate for the growth of the arts in Kansas communities

M SALINA ART CENTER, 242 S Santa Fe, PO Box 743 Salina, KS 67402-0743. Tel 785-827-1431; Fax 785-827-0686; Elec Mail info@salingartcenter.org; Internet Home Page Address: www.salinaartcenter.org; *Dir* Saralyn Reece Hardy; *Dir Community Develop* Wendy Moshier; *Communications Coordr* Pamela Harris
Open Tues, Wed, Fri & Sat noon - 5 PM, Thurs noon - 7 PM, Sun 1- 5 PM, cl Mon; No admis fee; Estab 1979 as an international & national private non-profit, non-collecting contemporary art & educ center; One floor, 50 ft x 150 sq. ft.; Average Annual Attendance: 50,000; Mem: 500; dues $40 basic
Income: $350,000 (financed by mem & private donations)
Exhibitions: Contemporary Art; changing exhibitions; Annual Juried Show
Publications: Brochures; newsletters
Activities: Classes for adults & children; docent programs; lect open to public, 6-8 vis lectr per year; competitions; traveling exten dept serves rural Kansas; book traveling exhibitions 4 per year; originate traveling exhibitions 5 per year

TOPEKA

M KANSAS STATE HISTORICAL SOCIETY, Kansas Museum of History, 6425 SW Sixth Ave, Topeka, KS 66615-1099. Tel 785-272-8681; Fax 785-272-8682; Internet Home Page Address: www.kshs.org; *Exec Dir* Terry Marmet; *Cur Fine Art* Laura Vannorsdel; *Cur of Decorative Art* Blair Tarr; *Dir Mus* Robert Keckeisen
Open Tue - Sat 9 AM - 5:00 PM, Sun 1:00 - 5:00 PM; Admis adults $4, students $2; Estab 1875 to collect, preserve & interpret the historical documents & objects of Kansas history; Average Annual Attendance: 75,000; Mem: 3400; dues life $1000, special $50 - $1000, family $35, individual $25, student $15; meetings in spring & fall
Income: $784,000 (financed by endowment & state)
Special Subjects: Historical Material, Cartoons
Collections: Regional collection for period from middle 19th century to present, especially portraiture, native art, political cartoons & folk art
Exhibitions: Rotating Exhibits
Publications: Kansas History: Journal of the Central Plains, quarterly; exhibit catalogs
Activities: Classes for adults & children; dramatic programs; docent training; craft demonstration program; lect open to public, 4 vis lectr per year; provided by staff to public organizations on request; tours; slide tape programs; exten dept serves entire state of Kansas; traveling trunks on Kansas topics; book traveling exhibitions 1-2 per year; sales shop sells books, prints, cards, slides, postcards, folk art, crafts, souvenirs and jewelry; junior museum

M TOPEKA & SHAWNEE COUNTY PUBLIC LIBRARY, Alice C Sabatini Gallery, 1515 SW Tenth St, Topeka, KS 66604-1374. Tel 785-580-4516; Fax 785-580-4496; Elec Mail sbest@mail.tscpl.org; Internet Home Page Address: www.tscpl.org; *Gallery Dir* Sherry L Best; *Exec Dir* David L Leamon; *Gallery Assoc* Zan Popp; *Gallery Assoc* Michael Hager; *Gallery Assoc* Heather Popp
Open Mon - Fri 9 AM - 9 PM, Sat 9 AM - 6 PM, Sun 12 - 6 PM; No admis fee; Estab 1870 to serve the city & the Northeast Kansas Library System residents with public information, both educational & recreational; to be one of the areas cultural centers through services from the Gallery within the library; Gallery reopened in 2001 with a 1864 sq ft plus space, professional lighting, security system; gallery furniture; Average Annual Attendance: 15,000+
Income: Financed by city, county & property taxes
Library Holdings: Book Volumes; Periodical Subscriptions
Special Subjects: Architecture, Drawings, Latin American Art, Mexican Art, Painting-American, Prints, Watercolors, American Indian Art, American Western Art, Bronzes, African Art, Religious Art, Ceramics, Pottery, Primitive art, Woodcarvings, Etchings & Engravings, Landscapes, Glass, Jewelry, Oriental Art, Asian Art, Metalwork, Carpets & Rugs, Enamels
Collections: Art Nouveau Glass, 19th Century Chinese Decorative Arts; Hirschberg Collection of West African Arts; Johnson Collection of Art; Wilder Collection of Art Glass & Pottery; Contemporary American Ceramics; Glass paperweight collection; New Mexican Woodcarving; Rare Book Room; Regional painting, drawing & prints
Exhibitions: Juried seven state Topeka Competition of 3D contemporary works; Permanent collections, children's & group exhibits
Publications: Creative Expression in Rural West Africa; Rookwood Pottery: One Hundred Year Anniversary
Activities: Lect open to public, 1-2 vis lectr per year; docent training; concerts; gallery talks; tours; special programs for exhibits; competitions with awards; cash & purchase awards to Topeka Competition; Institute for Museum and Library Svcs: Museum assessment program grant; individual paintings & original objects of art lent to other qualified museums; 1-2 book traveling exhibitions annually; museum shop sells books

M WASHBURN UNIVERSITY, Mulvane Art Museum, 17th & Jewell, Topeka, KS 66621. Tel 785-231-1010, Ext 1324; Fax 785-234-2703; Elec Mail soppolsu@washburn.edu; Internet Home Page Address: www.washburn.edu/mulvane; *Dir* Edward Barr; *Asst Dir* Amanda Martin-Hamon; *Educ Coordr* Barbara Yoder; *Registrar* Carol Emert; *Office Asst* Elizabeth V Wunder; *Asst Educ Coordr* Kandis Barker
Open Tues & Wed 10 AM - 7 PM, Thurs & Fri 10 AM - 4 PM, Sat & Sun 1 - 4 PM, cl holidays; summer hours: May - Aug Tues-Fri 10 AM - 4 PM, Sat - Sun 1 PM - 4 PM; No admis fee; Estab 1922; Building gift of Joab Mulvane: provides three galleries with 319 running ft of hanging space with carpeted walls & temperature & humidity controlled; Average Annual Attendance: 30,000; Mem: 600; dues sustainer $2500, contributer $1000, fellow $250, sponsor $100, family $50, individual $30
Income: $250,000
Purchases: $10,000
Special Subjects: Graphics, Painting-American, Prints, Sculpture, Watercolors, Southwestern Art, Ceramics, Woodcuts, Etchings & Engravings, Glass, Asian Art
Collections: 18th-19th Century Japanese Fine & Decorative Art; 19th & 20th Century American Art; 16th-20th Century European Prints
Exhibitions: Contemporary Mountain-Plains regional painting, prints, sculpture, ceramics; changing exhibitions include a Kansas Artist Exhibit & Annual Mountain-Plains Art Fair
Publications: Exhibition brochures
Activities: Classes for adults & children; outreach programs: Art in School, Art After School; docent training; lect open to public, 4-6 vis lectr per year; gallery talks; tours; scholarships; individuals painting & original objects of art lent to accredited art museums; book traveling exhibitions; museum shop sells books, original art, reproductions, jewelry, note cards, toys, unusual gifts for all ages

WAMEGO

M HISTORIC COLUMBIAN THEATRE FOUNDATION MUSEUM & ART CENTER, 521 Lincoln Ave, PO Box 72 Wamego, KS 66547. Tel 785-456-2029; Fax 785-456-9498; Elec Mail ctheatre@kansas.net; *Gallery & Educ Dir* Judy Boyer; *Artistic Dir & Exec Dir Theatre* Scott Kickhaefer; *Exec Dir Business* Barbara Hopper
Open Tues-Fri 9 AM - 5 PM, Sat 10AM-3PM, cl Mon; No admis fee, suggested donation $3; Estab 1994; Average Annual Attendance: 24,000; Mem: 400; dues $25-$1500; annual meeting 2nd Sat in July
Income: $460,000 (financed by endowment, mem, grants, gifts, earned income (ticket sales) & underwriters)
Special Subjects: Architecture, Painting-American, Decorative Arts, Historical Material
Collections: A 20-painting collection from the Columbian Exposition, the 1893 Chicago World's Fair, representing 60 percent of the decorative art from the Government Building. Includes 6 large oil on canvas paintings (restored & on display) by Ernest Theador Behr
Exhibitions: Swogger gallery houses an average of 6-8 rotating exhibits per year featuring artists & collections from or pertaining to the region &/or the mission of the Columbian
Activities: Classes for adults; dramatic programs; lect open to public; gallery/building tours; sales shop sells books, magazines & prints

WICHITA

FRIENDS UNIVERSITY
M Whittier Fine Arts Gallery, Tel 316-295-5877; Fax 316-295-5656; *Cur* Annie Lowrey
Open daily in the fall 7 AM - 10 PM, daily in the summer 7 AM-6 PM, cl summer weekends; No admis fee; Estab 1963 to bring art-craft exhibits to campus as an educational learning experience & to supply the local community with first class exhibits; 1224 sq ft of exhibit space; Average Annual Attendance: 20,000
Publications: Exhibition catalogs
Activities: 4 vis lectr per yr; gallery talks; tours; exten dept

L Edmund Stanley Library, Tel 316-295-5880; Fax 316-295-5080; Internet Home Page Address: www.library.friends.edu; *Asst Library Dir Reference* Max Burson; *Library Dir* David Pappas; *Information Literacy* Rhonda Bethel
Open summer 9 AM-7 PM, fall Mon - Fri 7:45 AM-10 PM, Fri 7:45 AM - 4 PM; Admis $10 for community card to check out books; Estab 1979; 500 sq ft of exhibition space, ideal for crafts & locked cases
Library Holdings: Audio Tapes; Book Volumes 85,000; Cassettes; Compact Disks; DVDs; Fiche; Filmstrips; Maps; Original Documents; Periodical Subscriptions 640; Photographs; Video Tapes

M GALLERY XII, 412 E Douglas Ave, Ste A, Wichita, KS 67202. Tel 316-267-5915; *Publicity Chair* Hermine Greywall; *Pres* Doug Billings
Open Mon - Sat 10 AM - 5 PM, final Fri of month 7 - 10 PM; No admis fee; Estab 1977 as art cooperative; Gallery specializes in original art by Kansas artists; Average Annual Attendance: 10,000; Mem: dues $400; 24 mem; local artists juried by current mems
Income: financed by mem
Library Holdings: Original Art Works; Photographs; Prints; Sculpture; Slides
Exhibitions: monthly featured exhibits: May - Jun-Mueller, Wong; July - Williford; Aug - Finnell; Sept - Fiorelli; Oct - Dove; Nov - Enquist; Dec - all mems
Publications: Edition of 20 hand-pulled black & white lithographs
Activities: Exten program serves local nonprofit organizations; local source for pub & pvt schools - field trips, tours & lab; organize traveling exhibs to nonprofits in Kansas; gallery sells original art by Kansas artists, prints

M MID-AMERICA ALL-INDIAN CENTER, Indian Center Museum, 650 N Seneca, Wichita, KS 67203. Tel 316-262-5221; Fax 316-316-262-4304; Elec Mail maaic@sbcglobal.net; Internet Home Page Address: www.theindiancenter.org; *Exec Dir* John D'Angelo
Open Tues - Sat 10 AM - 4 PM; Admis adults $7, seniors $5, children 6-12 $3, under 6 free; Estab 1976 to preserve the Indian heritage, culture & traditions; Average Annual Attendance: 70,000; Mem: 400; dues benefactor $500 & up, patron $250 - $499, friend $100 - $249, contributor $50 - $99, family $35 - $49, individual $25 - $34
Income: Financed by admis, donations, mem & gift shop sales
Library Holdings: Book Volumes
Special Subjects: American Indian Art
Collections: Lincoln Ellsworth Collection; Mildred Manty Memorial Collection; Native American arts & artifacts; Plains beadwork; Northwest Coast & Eskimo crafts; Southwest pottery, paintings, sculpture, carvings & basketry

Exhibitions: Four changing exhibits per year, prehistory or specialty exhibits; three dimensional traditional art; two & three dimensional contemporary art
Activities: Classes for adults & children; docent training; lect open to the public; gallery talks; tours; museum shop sells books, magazines, original art, reproductions & prints

L **Black Bear Bosin Resource Center,** 650 N Seneca, Wichita, KS 67203. Tel 316-262-5221; Fax 316-262-4216; Elec Mail maaic@earthlink.net; Internet Home Page Address: www.theindiancenter.com/resource.html; *Dir* Shelly Berger
Open Tues - Sat 10 AM - 5 PM by appointment only; Reference only
Income: financed by donations, gifts
Library Holdings: Book Volumes 400; Filmstrips; Motion Pictures; Pamphlets; Slides
Collections: Indian art & history

A **SOCIETY OF DECORATIVE PAINTERS, INC,** Decorative Arts Collection Museum, 393 N McLean Blvd, Wichita, KS 67203-5968. Tel 316-269-9300, Ext. 103; Fax 316-269-9191; Elec Mail janvavra@decorativeartscollection.org; Internet Home Page Address: decorativeartscollection.org/; *Finance Adminr* Yvonne Banman; *Art Coll Coordr* Jan Vavra
Open Mon - Fri 8:30 AM - 4:30 PM; Admis $3, tour groups $25; Estab 1982 to preserve & collect items of decorative painting & educate the public about the art form; Average Annual Attendance: 500; Mem: 1,000
Income: Financed by mem & gifts
Library Holdings: Book Volumes; Original Documents; Photographs; Slides
Special Subjects: Porcelain, Watercolors, Painting-American, Decorative Arts, Painting-Dutch, Painting-Japanese, Painting-Canadian, Painting-Russian, Painting-Scandinavian
Collections: Decorative Arts Collection - antique & contemporary decorative art; various media
Publications: Friends, newsletter, twice a year
Activities: Classes for adults and children; industry contribution recognition awards; DAC juried art awards; lending collection; originate traveling exhibitions; sales shop sells books, magazines, jewelry & original art

M **WICHITA ART MUSEUM,** 1400 W Museum Blvd, Wichita, KS 67203. Tel 316-268-4921; Fax 316-268-4980; Elec Mail info@wichitaartmuseum.org; Internet Home Page Address: www.wichitaartmuseum.org; *Dir* Charles K. Steiner; *Registrar* Mackenzie Massman; *Chief Cur* Stephen Gleissner; *Chief Develop Dir* Lynn Hawks
Open Tues-Sat 10 AM - 5 PM, Sun Noon - 5 PM, cl Mon & holidays; Admis adults $5, seniors & adult students $4, youth 5-17, $2, under 5 free; Estab 1935 to house & exhibit art works belonging to permanent collection; to present exhibits of loaned art works, to ensure care & maintain the safety of works through security, environmental controls & appropriate curatorial functions & to interpret collections & exhibitions through formal & educational presentations; Facility designed by Edward Larrabee Barnes opened Oct 1977, expanded & renovated, opened 2003. Maintains reference library; Average Annual Attendance: 85,000; Mem: dues $35 up
Income: $1,827,507 (city) & pvt funds
Library Holdings: Auction Catalogs; Book Volumes 9,000; Clipping Files; Exhibition Catalogs; Manuscripts; Pamphlets; Periodical Subscriptions
Special Subjects: Drawings, Mexican Art, Painting-American, Sculpture, Watercolors, Pre-Columbian Art, Southwestern Art, Textiles, Woodcarvings, Porcelain
Collections: Roland P Murdock, American Art; M C Naftzger Collection of Charles M Russell (paintings, drawings & sculpture); Kurdian Collection of Pre-Columbian Mexican Art; Virginia & George Ablah Collection of British Watercolors; L S & Ida L Naftzger Collection of Prints & Drawings; Gwen Houston Naftzger Collection of Boehm & Doughty Porcelain Birds; Florence Naftzger Evans Collection of Porcelain & Faience; F. Price Cossman Collection of Steuben Glass
Publications: Catalog of Roland P Murdock Collection; bimonthly newsletter; exhibition brochures & catalogues; Toward an American Indentity: Selections from the Wichita Art Mus
Activities: Classes for children; docent training; tours of collection; lect open to public; gallery talks; tours; extension program to teachers & parents; lending of items from Art Resource Center (books & visual materials); museum shop sells books, magazines, reproductions, slides & art related gifts; research library

L **Emprise Bank Research Library,** 1400 W Museum Blvd, Wichita, KS 67203. Tel 316-268-4921; Fax 316-268-4980; Elec Mail info@wichitaartmuseum.org; Internet Home Page Address: www.wichitaartmuseum.org; *Librn* Lois F Crane; *Dir* Charles K Steiner; *Chief Cur* Stephen Gleissner; *Registrar* Mackenzie Massman; *Chief Develop Dir* Lynn Hawks
Tues-Sat 10 AM - 5 PM, Sun Noon - 5 PM, cl Mon & holidays; None; Estab 1963 as research library for mus staff; Reference only
Library Holdings: Auction Catalogs; Book Volumes 10,000; Clipping Files; Exhibition Catalogs; Manuscripts; Other Holdings Auction catalogs; Museum handbooks; Pamphlets; Periodical Subscriptions 15; Video Tapes
Special Subjects: Art History, Folk Art, Decorative Arts, Drawings, Etchings & Engravings, Painting-American, Pre-Columbian Art, Prints, Sculpture, Watercolors, American Western Art, American Indian Art, Landscapes
Collections: Elizabeth S Navas Papers; Gene Morse Collection; Howard E Wooden Papers

A **WICHITA CENTER FOR THE ARTS,** 9112 E Central, Wichita, KS 67206. Tel 316-634-2787; Fax 316-634-0593; Internet Home Page Address: www.wcfta.com; *Chmn Board* Carol Wilson; *Treas* Becky Turner; *Exec Dir* Howard W Ellington
Open Tues - Sun 1 - 5 PM, cl national holidays & week of July 4th; No admis fee; Estab 1920, incorporated 1932, as an educational & cultural institution; Gallery contains 1000 running ft of exhibit space; up to five exhibits each six-week period; Average Annual Attendance: 55,000; Mem: 1250; dues $35 & up
Income: Financed by private contributions
Collections: Prints and drawings, paintings, sculpture, American decorative arts & contemporary crafts
Exhibitions: Exhibitions change each six weeks; one man shows; special programs; Biennial National Craft Exhibit
Publications: 6 newsletters per year

Activities: Visual & performing arts classes for adults & children; theatre productions; docent training; lect open to public, up to 6 vis lectr per year; gallery talks; classic film series; competitions with awards; scholarships; individual paintings & original objects of art lent to other art museums; book traveling exhibitions; originate traveling exhibitions; sales shop sells books & original art

L **Maude Schollenberger Memorial Library,** 9112 E Central, Wichita, KS 67206. Tel 316-686-6687; Fax 316-634-2787; *Chmn Board* Carol Wilson; *Exec Dir* Howard W Ellington
Open Mon - Fri 1 PM - 5 PM; Estab 1965; For reference
Income: Financed by private contributions
Library Holdings: Auction Catalogs; Book Volumes 400; Clipping Files; Exhibition Catalogs; Manuscripts; Memorabilia; Original Art Works; Photographs; Sculpture

L **WICHITA PUBLIC LIBRARY,** 223 S Main St, Wichita, KS 67202. Tel 316-261-8500; Fax 316-262-4540; Elec Mail seifa@wichita.lib.ks.us; Internet Home Page Address: www.wichita.lib.ks.us; *Adult Serv Div Coordr* Larry Vos; *Div Coordr Youth Svcs* Julie Linnemann; *Dir* Cynthia Burner-Harris
Open Mon - Thurs 10 AM - 9 PM, Fri & Sat 10 AM - 5:30 PM, Sun 1 - 5 PM; No admis fee; Estab 1876 & grown to be informational center & large free public library to improve the community with educational, cultural & recreational benefits through books, recordings, films, art works & other materials; Circ 1,100,000
Income: Financed by local taxes
Library Holdings: Framed Reproductions; Motion Pictures; Records; Reels
Special Subjects: Folk Art, Decorative Arts, Film, Graphic Arts, Crafts, American Western Art, Advertising Design, American Indian Art, Furniture, Glass, Afro-American Art, Coins & Medals, Architecture
Collections: Kansas Book Collection; John F Kennedy Collection; Harry Mueller Philately Book Collection; Driscoll Piracy Collection
Exhibitions: Preview of Academy Award Short Subjects; Rotating exhibits
Activities: Lect; tours

M **WICHITA STATE UNIVERSITY,** Ulrich Museum of Art & Martin H Bush Outdoor Sculpture Collection, 1845 Fairmount, Wichita, KS 67260-0046. Tel 316-978-3664; Fax 316-978-3898; Elec Mail ulrich@wichita.edu; Internet Home Page Address: www.ulrich.wichita.edu; *Coll Mgr* Mark Janzen; *Cur Exhibs* Kevin Mullins; *Publicity & Outreach Coordr* Cori Dodds; *Dir* Ted Ayres; *Office Mgr* Linda Doll; *Secy* Linda Maxwell; *Cur Modern & Contemporary Art* Katie Geha; *Educ Coordr* Aimee Geist
Open Tues - Fri 11 AM - 5 PM, Sat & Sun 1 - 5 PM, cl Mon & national holidays; No admis fee; Estab 1974. Collecting, preserving, exhibiting & interpreting modern & contemporary art; 5 galleries on 2 floors, 18 ft ceiling, 10,000 sq ft exhibition space; natural light with UV filter & halogen spots; painted sheet rock walls; 3 galleries with concrete floors, 2 galleries with carpeted floors; 2 galleries with floating walls; computer driven security system for locks & alarms; Average Annual Attendance: 14,000; Mem: 307; dues free--$1000, students free
Income: $550,476 (financed by endowment, mem, city & state appropriation)
Special Subjects: Photography, Painting-American, Drawings, Prints, Sculpture
Exhibitions: (1/28/2007-4/1/2007) WSU School of Art & Design Faculty Biennial; (2/1/2007-3/4/2007) Modernisms: Selections from the Collection 1900-1940; (3/15/2007-4/22/2007) Joseph Beuys: Celtic+; (4/22/2007-8/5/2007) Poets on Painters; (5/3/2007-6/3/2007) WSU School of Art & Design MFA Thesis Exhibition; (8/24/2007-10/22/2007) Adventures in a Temperate Climate: A Retrospective of Paintings by Martin Mull; (9/14/2007-11/26/2007) Ulrich Project Series: Christoph Ruckhäberle; (11/9/2007-1/7/2008) Michelle Grabner: Remain in Light; (12/8/2007-1/7/2008) WSU School of Art & Design MFA Thesis Exhibition
Publications: Not So Cute & Cuddly: Dolls & Stuffed Stoys in Contemporary Art
Activities: Docent program; lect open to public, 4 vis lectr per year; concerts; gallery talks; tours; scholarships & fels offered; book traveling exhibitions 4 per year; originate traveling exhibitions

WINFIELD

L **SOUTHWESTERN COLLEGE,** Memorial Library - Art Dept, 100 College St, Winfield, KS 67156. Tel 620-229-6225; Fax 620-229-6382; Elec Mail gzuck1@swcart.edu; Internet Home Page Address: www.sckans/library; *Dir* Gregory J Zuck
Open school year Mon - Thurs 8 AM - midnight, Fri 8 AM - 4 PM, Sat Noon - 4 PM, Sun 3 - 10 PM, summer Mon - Thurs 8 AM - 5 PM, Fri 8 AM - 4 PM; Estab 1885 as a four-year liberal arts college; Circ 77,000
Income: Financed by college budget
Library Holdings: Book Volumes 77,000; Exhibition Catalogs; Fiche; Periodical Subscriptions 120; Reels
Collections: Arthur Covey Collection of paintings, mural sketches, etchings, lithographs, drawings & watercolors; Cunningham Asian Arts Collection of books, catalogues & exhibition catalogs
Publications: databases
Activities: Tours

KENTUCKY

ASHLAND

C **ASHLAND INC,** PO Box 391, Ashland, KY 41114. Tel 606-329-3333; Fax 606-329-3559; *Corporate Art Admin* Tim Heaberlin
Collection may be viewed through special arrangements; Estab 1972, primary function is decorative art, but also to establish a creative atmosphere; to enhance community cultural life; Collection displayed in public areas of corporate office buildings
Collections: Mainly contemporary printmaking, emphasis on Americans; paintings, sculpture, wall hangings

Activities: Tours; competitions, sponsorship consists of purchase awards for local art group & museum competitions; provides purchase & merit awards for certain museum & university competitions; individual objects of art lent; originate traveling exhibitions to museums, colleges, universities & art centers in general marketing areas

BEREA

M **BEREA COLLEGE,** Doris Ulmann Galleries, Art Dept, CPO 2342 Berea, KY 40404. Tel 859-986-9341, Ext 5530; Fax 859-986-9494; Elec Mail robert f.boyce@berea.edu; *Chmn* Robert Boyce
Open Mon - Thurs 8 AM - 9 PM, Fri 8 AM-5 PM, Sun 1 - 5 PM; No admis fee; Estab 1936 for educational purposes; Three gallery areas; exhibitions change monthly; loan & rental shows, regional artists, work from Berea College collection; Average Annual Attendance: 6,500
Income: Financed by college budget
Special Subjects: Drawings, Painting-American, Photography, American Indian Art, African Art, Textiles, Costumes, Ceramics, Woodcuts, Etchings & Engravings, Dolls, Glass, Jewelry, Asian Art, Coins & Medals, Renaissance Art, Painting-Italian, Antiquities-Greek
Collections: Kress Study Collection of Renaissance art; Doris Ulmann photographs; prints, textiles, paintings, sculpture, ceramics; Asian Art
Activities: Lect open to public, 2-6 vis lectr per year; gallery talks; tours; scholarships offered; individual paintings & original objects of art lent to other colleges, museums & galleries; lending collection contains 500 framed reproductions

L **Art Dept Library,** CPO 2342, Berea, KY 40404. Tel 859-986-9341, Ext 5276; Fax 859-986-9494; *Dir Cert Apprentice* Walter Hyleck
Open Mon - Thurs 8 AM - 9 PM, Fri 8 AM-5 PM, Sun 1 PM-5 PM; Estab 1936; Reference library only
Income: Financed by college budget
Purchases: $1,200 annually
Library Holdings: Book Volumes 3800; Cassettes; Clipping Files; Exhibition Catalogs; Filmstrips; Framed Reproductions; Kodachrome Transparencies; Lantern Slides; Manuscripts; Memorabilia; Original Art Works; Pamphlets; Periodical Subscriptions 30; Photographs; Prints; Records; Reproductions; Sculpture; Slides; Video Tapes

A **KENTUCKY GUILD OF ARTISTS & CRAFTSMEN INC,** 103 Parkway, PO Box 291 Berea, KY 40403. Tel 859-986-3192; Fax 859-985-9114; Elec Mail info@kyguild.org; Internet Home Page Address: www.kyguild.org; *Dir* Allison Kaiser; *Prog Admin Mgr* Pam Bischoff; *Prog Asst* Summer Raftery
Open Mon - Fri 10 AM - 4 PM; No admis fee; Estab 1961 for the pursuit of excellence in the arts & crafts & to encourage the pub appreciation thereof; Average Annual Attendance: 20,000; Mem: 450; must be a Kentucky resident & be juried for exhibiting status; dues exhib mem $40, individual $30; ann meeting in Mar
Income: $165,000 (financed by grants, contributions, corporate donations, admis & mem fees)
Publications: The Guild Record, 4 times per yr; Online Update - electronic newsletter; Art & Craft Insight Network = Art & Craft Learning Opportunities
Activities: Classes for adults & children; docent training; workshops; lect open to public; demonstrations; competitions with awards; 2 ann retail fairs; traveling exhibs organized & circulated to Ky & surrounding states

BOWLING GREEN

M **CAPITOL ARTS ALLIANCE,** (Capitol Arts Center) Ervin G Houchens Gallery, Mezzanine Gallery, 416 E Main St, Bowling Green, KY 42101. Tel 270-782-2787; Fax 270-782-2804; Elec Mail info@capitolarts.com; Internet Home Page Address: www.capitolarts.com; *Pres* Steve Jones; *Dir Educ* Tom McIntyre; *Gallery Dir* Lynn Robertson
Open Mon - Fri 9 AM - 4 PM; No admis fee; Estab 1981 as a community arts center; Main floor Ervin G Houchens & upper level Mezzanine Gallery
Exhibitions: Rotating exhibitions selected annually by a review panel including an All State Juried Exhibition; Youth Art (K-6th grade); Women In the Arts; rotate Scholastic (9th-12th grade) with other city sites
Activities: Classes for children; dramatic programs; summer arts camp; lect open to public, 1 vis lectr per year; concerts; competitions with awards

WESTERN KENTUCKY UNIVERSITY

L **Kentucky Library & Museum,** Tel 270-745-5083; Fax 270-745-6264; Internet Home Page Address: www.wku.librarydlsc.edu; *Dept Head* Timothy Mullin; *Libr Coordr* Connie Mills; *Librarian* Jonathan Jeffery; *Manuscript Libr* Pat Hodges; *Univ Archivist* Sue Lynn McDaniel; *Ky Spec* Nancy Baird; *Exhib Cur* Donna Parker; *Coll Cur* Sandy Staebell
Open Mon-Fri 8:30AM-4:30PM, Sat 9:30AM-4PM; $2; Estab 1939 to preserve KY's cultural heritage; Open to the public; Average Annual Attendance: 18,000; Mem: 400, $50
Library Holdings: Audio Tapes; Book Volumes 70,000; Cassettes; Clipping Files; Framed Reproductions; Kodachrome Transparencies; Lantern Slides; Manuscripts; Maps; Memorabilia; Original Art Works; Other Holdings Broadsides; Maps; Postcards; Pamphlets; Periodical Subscriptions 1800; Photographs; Records; Reels; Slides
Collections: Ellis Collection of steamboat pictures; Gerard Collection of Bowling Green Photographs; McGregor Collection of rare books; Neal Collection of Utopian materials; Kentucky Geneology Collection; Collections of and about Shakers and other religious denominations; Collections about state and national politics and politicians, literary figures, wars, businesses, every day life and univ archives; Decorative and Fine Arts; Costumes, Quilts and Folk Art; Felts Log House
Activities: Classes for adults & children, dramtic programs; open to the public, gallery talks, sponsoring of competitions; sells books, prints, gifts.

M **University Gallery,** Tel 270-745-3944; Fax 270-745-5932; Elec Mail art@wku.edu; Internet Home Page Address: www.wku.edu/dept/academic/ahss/art.html; Internet Home Page Address: www.wku.edu/art/; *Dept Head* Kim Chalmers
Open Mon - Fri 8:30 AM - 4:30 PM; No admis fee; Estab 1973 for art exhibitions relating to university instruction & regional cultural needs; Average Annual Attendance: 12,000
Income: Financed by state appropriation
Exhibitions: Annual student & faculty shows

CRESTVIEW

M **THOMAS MORE COLLEGE,** TM Gallery, 333 Thomas More Pky, Crestview, KY 41017. Tel 606-344-3420, 344-3419; Fax 606-344-3345; *Dir* Barb Rauf
Open Mon - Sat 8:30 AM - 10 PM; No admis fee; Estab for cultural & educational enrichment for the institution & area; Average Annual Attendance: 2,000
Special Subjects: Drawings, Graphics, Photography, Sculpture, Ceramics
Exhibitions: Full academic season of exhibitions
Activities: Lect open to public, 4 vis lectr per year; gallery talks; scholarships & fels offered; book traveling exhibitions

DANVILLE

M **MCDOWELL HOUSE & APOTHECARY SHOP,** (Ephraim McDowell-Cambus-Kenneth Foundation) 125 S Second St, Danville, KY 40422. Tel 859-236-2804; Fax 859-236-2804 (Press Star twice after dialing number); Elec Mail mcdhse@kih.net; Internet Home Page Address: www.mcdowellhouse.com; *Dir* Carol Johnson Senn; *Asst Dir* Alberta Moynahan; *Admin Asst* Anna Ingram
Open Mon - Sat 10 AM - Noon & 1 - 4 PM, Sun 2 - 4 PM, cl Mon Nov 1 - Mar 1; Admis adults $5, senior citizens $3, students $2, children under 12 $1, group rates available; Estab 1935 to preserve the home of the Father of Abdominal Surgery in Danville, 1795 - 1830; Average Annual Attendance: 5,000; Mem: 600; dues $25-$1,000 & up
Income: $60,000 (financed by endowment, mem, private contribution from groups & individuals)
Special Subjects: Architecture, Painting-American, Pottery, Portraits, Dolls, Furniture, Jewelry, Silver, Carpets & Rugs, Historical Material, Maps, Coins & Medals, Miniatures, Period Rooms, Embroidery, Pewter
Collections: All furnishings pre-1830; apothecary collection: late 18th & early 19th Century, 320 pieces; portraits & folk art, 1795-1830
Publications: Annual newsletter
Activities: Docent training; lect open to public, 5 vis lectr per year; tours; sales shop sells books, prints, slides, pewter mugs, dvds, videos of tours

FORT KNOX

M **CAVALRY-ARMOR FOUNDATION,** Patton Museum of Cavalry & Armor, 4554 Fayette Ave, PO Box 208 Fort Knox, KY 40121-0208. Tel 502-624-3812; Fax 502-624-2364; *Cur* Charles R Lemons
Open year round weekdays 9 AM - 4:30 PM, holidays & weekends May 1 - Sept 30 10 AM - 6 PM, Oct 1 - Apr 30 10 AM - 4:30 PM, cl Dec 24 & 25 & Dec 31 - Jan 1; No admis fee; Estab 1975 to preserve historical materials relating to Cavalry & Armor & to make these properties available for public exhibit & research. The Museum is administered by the US Army Armor Center, Fort Knox & is one of the largest in the US Army Museum System; Galleries feature a variety of armored equipment & vehicles, weapons, art & other memorabilia which chronologically present the development of the Armor branch from the beginning of mechanization to the present
Income: Financed through state
Exhibitions: Permanent & rotating exhibitions
Activities: Retail store sells books & prints

FRANKFORT

M **KENTUCKY HISTORICAL SOCIETY,** Old State Capitol & Annex, 100 W Broadway, Frankfort, KY 40601-1931. Tel 502-564-1792; Fax 502-564-4701; Internet Home Page Address: www.kyhistory.org; *CEO* Kevin Grassagnino; *Asst Dir* James E Wallace; *Mus Shop Mgr* Nina Elliott; *Research & Pub* Melba Porter Hay; *Interim Deputy Dir* Margaret K Lane; *Pub Relations* Joedy Isert; *Mus Div Dir* Nancy Glaser
Open Mon - Sat 9 AM - 4 PM, Sun 1 - 5 PM; No admis fee; Estab 1836 as a general history & art mus emphasizing the history, culture & decorative arts of the Commonwealth of Kentucky & its people; The Old Capitol Galleries located in the Old State House consist of two rooms totaling 2740 sq ft which are used by the Mus to display its fine arts exhibitions, painting, silver, furniture & sculpture, one temporary exhibits gallery in Old Capitol Annex; Average Annual Attendance: 250,000; Mem: 5000; dues for life $300 individual $35
Income: $7 million (financed by state appropriation)
Special Subjects: Historical Material, Period Rooms
Collections: Kentucky & American furniture coverlets, furniture, paintings, quilts, silver, textiles
Exhibitions: 3 - 4 exhibitions per year
Publications: The Register, The Bulletin, quarterly
Activities: Lect open to public, 4 vis lectr per year; tours; individual paintings & original objects of art lent to qualified museums; lending collection consists of original art works, original prints; paintings; sculpture & historical artifacts; book traveling exhibitions; traveling exhibitions organized and circulated; museum shop sells books & reproductions

L **Library,** Tel 502-564-3016; Fax 502-564-4701; Internet Home Page Address: www.kyhistory.org; *Head Librn* Anne McDonnell
Open Mon - Sat 9 AM - 4 PM, Thurs 9 AM - 8 PM, Sun 1 PM - 5 PM; No admis fee; Estab 1836; Reference library; Average Annual Attendance: 25,000; Mem: Division of institution
Income: financed through the institution
Library Holdings: Book Volumes 85,000

M **KENTUCKY NEW STATE CAPITOL,** Division of Historic Properties, Capitol Ave, 700 Louisville Rd Frankfort, KY 40601. Tel 502-564-3000, Ext 222; Tour Desk: 502-564-3449; Fax 502-564-6505; *Cur* Lou Karibo
Open Mon - Fri 8 AM - 4:30 PM, Sat 9 AM - 4 PM, Sun 1 - 4 PM; No admis fee
Income: Funded by state appropriation
Collections: First Lady, Miniature Dolls; Oil Paintings of Chief Justices; Statues of Famous Kentuckians including Abraham Lincoln & Jefferson Davis
Publications: Brochures; exhibition catalogs
Activities: Tours; sales shop sells books, reproductions & prints

M **KENTUCKY STATE UNIVERSITY,** Jackson Hall Gallery, Art Dept, Frankfort, KY 40601. Tel 502-597-5995, 597-5994; Elec Mail JAlexandra@qwmail.kysu.edu; *Area Head* John Bater
Open Mon - Fri 8 AM - 4:30 PM; No admis fee; Estab 1886 to present exhibition of African art; Gallery; Average Annual Attendance: 1,000
Income: Financed through small grants & university appropriations
Library Holdings: Book Volumes 500
Collections: A small collection of student & faculty work; African Art
Exhibitions: Rotating exhibits
Activities: Lect open to public, 2 vis lectr per year; competitions; scholarships offered; book traveling exhibitions 2-3 per year

M **LIBERTY HALL HISTORIC SITE,** Liberty Hall Museum, 218 Wilkinson St, Frankfort, KY 40601. Tel 502-227-2560; Fax 502-227-3348; Internet Home Page Address: www.libertyhall.org; *Cur* Eric Brooks; *Dir* Sara Harger
Open for tours Tues-Sat at 10:30 AM, Noon, 1:30 & 3 PM, Sun 1:30 & 3 PM, cl Mon; No admis fee; Estab 1937 as an historic museum; A Georgian house built in 1796, named Historic Landmark in 1972; Average Annual Attendance: 2,500
Income: Privately funded non-profit institution
Special Subjects: Period Rooms
Collections: 18th century furniture; china; silver; portraits
Activities: Guided tours
L **Library,** 218 Wilkinson St, Frankfort, KY 40601. Tel 502-227-2560; Fax 502-227-3348; Elec Mail libhall@dcr.net; Internet Home Page Address: www.libertyhall.org; *Exec Dir* Sara Farley Harger; *Treas* Helen Chenery; *Educ Coordr* Megan Canfield; *VPres* Katherine M DaAvis
Open by appointment only; No admis fee; Estab 1965; Non-circulating library; Average Annual Attendance: 100
Income: Privately funded nonprofit institution
Library Holdings: Book Volumes 2000
Collections: Books belonging to John Brown, Kentucky's first US senator & builder of Liberty Hall
M **Orlando Brown House,** 220 Wilkinson St, Frankfort, KY 40601. Tel 502-875-4952; Fax 502-227-3348; Internet Home Page Address: www.libertyhall.org; *Dir* Sara Harger
Open for tours Tues-Sat 10:30 AM, Noon, 1:30 & 3PM, Sun 1:30 & 3 PM; No admis fee; Estab 1956; Built in 1835 by architect Gilbert Shryock; Average Annual Attendance: 2,500
Income: Privately funded non-profit institution
Collections: Paul Sawyier paintings; original furnishings
Activities: Guided tours

HARRODSBURG

M **OLD FORT HARROD STATE PARK MANSION MUSEUM,** S College St, PO Box 156 Harrodsburg, KY 40330. Tel 859-734-3314; Fax 859-734-0794; Elec Mail joan.huffman@ky.gov; Internet Home Page Address: www.parks.ky.gov/stateparks/fh; *Park Supt* Joan Huffman
Open daily 9 AM - 5:00 PM; Admis $4.50 adults; $2.50 children; winter rates $2 adults, $1 children; seniors $4; Estab 1925; History museum, Union, Confederate & Lincoln memorabilia; music & gun collection; Average Annual Attendance: 30,000
Income: State agency
Special Subjects: Period Rooms
Collections: Antique China; Confederate Room; Daniel Boone & George Rogers Clark Room; furniture; gun collection; Indian artifacts; Lincoln Room; musical instruments; silver
Exhibitions: Permanent collection
Activities: Dramatic programs; concerts; tours; awards for top 10 events; one Smithsonian exhibit; sells books, original art, reproductions & prints

M **SHAKER VILLAGE OF PLEASANT HILL,** 3501 Lexington Rd, Harrodsburg, KY 40330. Tel 859-734-5411; Fax 859-734-7278; Elec Mail lcurry@shakervillageky.org; Internet Home Page Address: www.shakervillageky.org; *Pres & CEO* James C Thomas; *Dir Museum* Larrie Spier Curry; *Pub Relations Dir & Marketing* Diana Ratliff; *Educ Specialist* Susan Lyons Hughes; *VPres & Controller* Madge Adams; *Dir Personnel* Candace Parker; *VChmn Bd* Alex Campbell; *Dir Craft Stores* Lorrin Ingerson; *Historic Farming Specialist* Ralph E Ward
Open year-round; Apr - Oct daily 9:30 AM - 5:30 PM, hrs vary in winter; Admis adults $12.50, children 12-17 $7, children 6-11 $5; Estab 1961 to restore, preserve & interpret the architecture, artifacts & culture of Shakers; 2800 acres, 34 historic buildings (1805-1855); Primary exhibition building: 40 room Centre family dwelling (1824-1834); stone, three story dwelling full of artifacts & furniture of Shakers; Shaker Life Exhib with permanent & changing exhib gallery; Average Annual Attendance: 80,000; Mem: 1200; dues family $50, annual meeting in Feb
Income: Financed by mem, endowment, inn & lodging, sales, village-generated income
Special Subjects: Architecture, Archaeology, Textiles, Costumes, Religious Art, Crafts, Folk Art, Decorative Arts, Manuscripts, Furniture, Historical Material
Collections: Shaker culture including furniture, textiles, manuscripts, cultural artifacts, architecture, period rooms & shops
Publications: Pleasant Hill & Its Shakers; The Gift of Pleasant Hill; Keepsake Art Calendar; Two Cookbooks

Activities: Classes for adults & children; dramatic programs; docent training; self-guided village tours; guided tours; lect open to public, 15-25 vis lectr per year; concerts; tours; lending collection contains videos; museum shop sells reproductions, prints & slides

HIGHLAND HEIGHTS

M **NORTHERN KENTUCKY UNIVERSITY,** Main Gallery & Third Floor Gallery, Nunn Dr Highland Heights, KY 41099-1002. Tel 859-572-5148; Fax 859-572-6501; Elec Mail knight@nku.edu; *Chmn* Thom McGovern; *Dir* David Knight
Open Mon - Fri 9 AM - 9 PM or by appointment; No admis fee; Estab 1968, new location 1990, to provide an arts center for the University & community area; Two galleries are maintained, the smaller 15 X 30; Average Annual Attendance: 20,000
Income: Financed by university & state funds
Special Subjects: Photography, Prints, Sculpture, Folk Art
Collections: Permanent collection of Red Grooms Monumental Sculpture in Metal; Donald Judd Monumental Sculpture; earth works, other outdoor sculpture, prints, painting, photographs, folk art
Exhibitions: Student exhibitions; state, regional & national visiting artists
Publications: Bulletins, 4-5 per year
Activities: Lect open to public, 3-5 vis lectr per year; gallery talks; tours; individual paintings & original objects of art lent to university members to be used in their offices only; lending collection contains 379 prints, paintings, photographs & ceramics; traveling exhibitions to Universities & Colleges

LEXINGTON

M **BODLEY-BULLOCK HOUSE MUSEUM,** 200 Market St, Lexington, KY 40507. Tel 859-259-1266; Internet Home Page Address: www.cr.nps.gov/nr/travel/lexington/bod.htm
Open by appt year-round; cl holidays; Mus housed in historic mansion built in 1814 for Lexington Mayor Thomas Pindell. House was later sold to General Thomas Bodley, a veteran of the War of 1812. House served as headquarters for both Union & Confederate forces during Civil War. House was purchased in 1912 by Dr Waller Bullock, an accomplished sculptor
Special Subjects: Historical Material, Furniture
Activities: Tours by appt

M **HEADLEY-WHITNEY MUSEUM,** 4435 Old Frankfort Pike, Lexington, KY 40510. Tel 859-255-6653; Fax 859-255-8375; Internet Home Page Address: www.headley-whitney.org; WATS 800-310-5085; *Pres & Acting Exec Dir* Charles D Mitchell; *Cur* Travis Robinson
Open Tues - Fri 10 AM - 5 PM, Sat & Sun Noon - 5 PM, cl Jan & major holidays; Admis adults $6, senior citizens $5, AAA $3, students $4, members & children 5 & under free; Estab 1968 in central Kentucky for the care collection, preservation & interpretation of the decorative arts; Five principal galleries are maintained which include Asian ceramics, the work of the founder, jewelry designer, George W Headley III & temporary exhibits on the decorative arts; Average Annual Attendance: 15,000; Mem: 600; dues $1000, $500, $250, $125, $65, $35; annual meeting in July
Income: Financed by admis, mem, benefits, grants, contributions, trust, affiliated with Smithsonian
Library Holdings: Auction Catalogs; Original Documents; Periodical Subscriptions
Special Subjects: Glass, Gold, Textiles, Ceramics, Decorative Arts, Jewelry, Porcelain, Oriental Art, Asian Art
Collections: Antique boxes, gemstones, Kentucky Silver, Oriental porcelains & textiles
Exhibitions: Quarterly exhibitions
Publications: The Jewel newsletters quarterly, for mem
Activities: Classes for adults & children; docent training; outreach programs; lect open to public, 3-6 vis lectr per year; gallery talks; tours; original objects of art lent; lending collection contains slides, selected works from permanent collections by special arrangement; book traveling exhibitions; originate traveling exhibitions; museum shop sells books, original art, reproductions, slides, jewelry & porcelains
L **George Headley Library,** 4435 Old Frankfort Pike, Lexington, KY 40510. Tel 859-255-6653; Fax 859-255-8375; Internet Home Page Address: www.headley-whitney.org; WATS 800-310-5085; *Exec Dir* Sarah E Henrich; *Cur* Cara Lundy; *Educ* Anne Gay
Open Tues - Fri 10 AM - 5 PM, Sat & Sun noon - 5 PM; Estab 1968; Circ Non-circulating; Decorative art, bibelots; Mem: 450
Income: Financed by state government, foundations, admis, mem, benefits, grants, contributions & trust
Library Holdings: Book Volumes 1500; Exhibition Catalogs; Memorabilia; Original Art Works; Reproductions; Sculpture
Special Subjects: Art History, Decorative Arts, Ceramics, Bronzes, Fashion Arts, Asian Art, Furniture, Glass, Antiquities-Oriental, Antiquities-Persian, Embroidery, Enamels, Antiquities-Egyptian, Antiquities-Greek, Antiquities-Roman
Publications: The Jewel, quarterly for mem of museum
Activities: Classes for adults & children; docent training; lec open to public; organize traveling exhibs to AAM mem orgs; museum shop sells books, reproductions, fine jewelry & related items

A **LEXINGTON ART LEAGUE, INC,** Loudoun House, 209 Castlewood Dr Lexington, KY 40505. Tel 859-254-7024; Fax 859-254-7214; Elec Mail info@lexingtonartleague.org; Internet Home Page Address: www.lexingtonartleague.org; *Exec Dir* Allison Kaiser; *Visual Art Specialist* Kate Sprengnether; *Mktg & Media Specialist* Jonathan Goolsby; *Educ & Event Specialist* Marin Fiske
Open Tues - Sun 1 - 4 PM; No admis fee; Estab 1957, to encourage an active interest in the visual arts among its members & community as a whole; Three visual art galleries; Project Space has installation & work in new media; Average Annual Attendance: 200,000; Mem: 700; open to all interested in visual arts; dues $45; annual meeting in May

Income: Financed by mem, art fairs, donations, grants
Library Holdings: Book Volumes; Periodical Subscriptions
Exhibitions: Changing monthly exhibitions; member, group, one person exhibitions
Publications: Annual Membership Book; email newsletter
Activities: Classes for adults; lect open to pub, 4 vis lectr per year; gallery talks; competitions; juried awards for most exhibits; scholarships offered; originate traveling exhibitions

M **LIVING ARTS & SCIENCE CENTER, INC,** 362 N Martin Luther King Blvd, Lexington, KY 40508. Tel 859-252-5222; Fax 859-255-7448; Elec Mail lasc6898@aol.com; Internet Home Page Address: www.livingarts&science.org; *Cur* Jim Brancaccio; *Dir* Marty Henton
Open Mon - Fri 9 AM - 4 PM, Sat 10 AM - 1 PM; No admis fee; Estab 1968 to provide enrichment opportunities in the arts & sciences; Gallery features 8-10 exhibits per year of regional art; Average Annual Attendance: 25,000; Mem: 400; dues $30-500; annual meetings
Income: Financed by grants, fundraising events, memberships & tuition
Exhibitions: Rotating exhibitions; Two science exhib per year
Publications: Exhibition catalogs
Activities: Classes for adults & children; lect open to public; tours; children's art, artist-in-residence; class scholarships offered; book traveling exhibitions once per year

M **TRANSYLVANIA UNIVERSITY,** Morlan Gallery, Mitchell Fine Arts Ctr, 300 N Broadway Lexington, KY 40508. Tel 859-233-8210; Fax 859-233-8797; Elec Mail nwolsk@mail.transy.edu; *Dir* Nancy Wolsk
Open Mon - Fri Noon - 5 PM; No admis fee; Estab 1978 to exhibit contemporary art & liberal art; Gallery is housed in The Mitchell Fine Arts Building; Average Annual Attendance: 3,000
Income: Financed by endowment
Special Subjects: Portraits, Historical Material
Collections: 19th century natural history works; 19th century portraits; decorative arts
Exhibitions: Temporary exhibitions, primarily contemporary works, various media
Activities: Lect open to public, 2 vis lectr per year; concerts; gallery talks; tours; competitions; originate traveling exhibitions

L **UNIVERSITY OF KENTUCKY,** Hunter M Adams Architecture Library, 200 Pence Hall, Lexington, KY 40506-0041. Tel 859-257-1533; Fax 859-257-4305; Elec Mail fharders@pop.uky.edu; Internet Home Page Address: www.ukyedu/library; *Library Technician* Lalana Powell; *Librn* Faith Harders
Open Mon - Thurs 8 AM - 10 PM, Fri 8 AM - 6 PM, Sat 2 - 5 PM, Sun 3 - 10 PM, summer Mon - Fri 8 AM - 4:30 PM; Estab 1963
Library Holdings: Audio Tapes; Book Volumes 34,000; Cassettes; Fiche 1903; Other Holdings Architectural drawing; Periodical Subscriptions 91; Reels 606; Sculpture
Special Subjects: Interior Design, Furniture, Architecture

UNIVERSITY OF KENTUCKY
M **Art Museum,** Tel 859-257-5716; Fax 859-323-1994; Internet Home Page Address: www.uky.edu/ArtMuseum; *Registrar* Barbara Lovejoy; *Preparator* Hugh Burton; *Ed Cur* Deborah Borrowdale-Cox; *Dir* Kathleen Walsh-Piper; *Marketing Coordr* Jane Andrus; *Pub Relations & Publ Coordr* Dorothy Freeman; *Cur* Janie Welker; *Budget Officer* Sharon Sim; *Develop Officer* Amy Nelson
Open Tues-Sun Noon-5PM, Fri Noon-8PM, cl Mon; No admis fee ; Estab 1976 to collect, preserve, exhibit & interpret world art for the benefit of the university community & the region; New building completed & opened Nov 1979; 20,000 sq ft of galleries & work space; Average Annual Attendance: 24,000; Mem: 585; dues $45 & up
Income: $325,000 (financed by state appropriation & gifts)
Special Subjects: Graphics, Painting-American, Sculpture, African Art, Pre-Columbian Art, Painting-European
Collections: European & American paintings, sculpture & graphics, 15th-20th Century; photographs; Pre-Columbian; African & Asian artifacts; decorative arts
Exhibitions: Rotation of collection-based & traveling exhibitions
Publications: Museum Newsletter; exhibitions catalogs; posters, family guide
Activities: Classes for adults & children; docent training; lect open to public, 3 vis lectr per year; gallery talks; tours; book traveling exhibitions 5 per year; museum shop sells books, prints, posters, postcards, novelties
L **Lucille Little Fine Arts Library,** Tel 859-257-2800; Fax 859-257-4662; Elec Mail megshaw@uky.edu; Internet Home Page Address: www.uky.edu/libraries/litfal.html; *Librn* Meg Shaw; *Dir* Gail Kennedy
call or see website; Open to students, faculty & general public
Library Holdings: Book Volumes 53,000; Clipping Files; DVDs; Fiche 812; Pamphlets; Periodical Subscriptions 202; Reels 223; Video Tapes 24
Special Subjects: Art History, Photography, Theatre Arts, Art Education
L **Photographic Archives,** Tel 859-257-8611, 257-9611; Fax 859-257-1563; Internet Home Page Address: www.uky.edu/libraries/special; *Dir Spec Coll & Archives* William J Marshall; *Photographic Archivist* Lisa R Carter
Open Mon-Fri 8AM-5PM, Sat 8AM-Midnight; Estab for reference & loan purposes for general pub, staff & students; Circ Non-circulating
Library Holdings: Audio Tapes; Book Volumes 100,000; Exhibition Catalogs; Motion Pictures; Other Holdings Manuscript materials; Periodical Subscriptions 60
Collections: Over 350,000 photographs documenting the history of photography as well as Kentucky, Appalachia & surrounding areas

LOUISVILLE

M **CONRAD-CALDWELL HOUSE MUSEUM,** 1402 St James Ct, Louisville, KY 40208. Tel 502-636-5023; Fax 502-636-1264; Elec Mail info@conradcaldwell.org; Internet Home Page Address: www.conradcaldwell.org
Open Sun & Wed - Fri 12 - 4 PM, Sat 10 AM - 4 PM; also by appt; Admis adults $5, seniors $4, students $3; Estab as mus in 1987; purchased & operated by St James Ct Historic Foundation; With its woodwork, stained glass, gargoyles & arches, mansion defines Richardsonian-Romanesque architecture. Mansion was built for Theophilus Conrad, who made his fortune in the tanning business. House was purchased by the Caldwell family in 1905 and it later served as the Rose Anna Hughes Presbyterian Retirement Home
Special Subjects: Historical Material, Furniture, Period Rooms
Activities: Tours; facilities can be rented for special events

A **EMBROIDERERS GUILD OF AMERICA,** Margaret Parshall Gallery, 426 W Setterson St, Louisville, KY 40202. Tel 502-589-6956; Fax 502-584-7900; Elec Mail egahq@egausa.org; Internet Home Page Address: www.egausa.org; *Exec Dir* Anita Streeter; *Mem Coordr* Jim Kearins; *Accountant* Judy Kopp; *Gallery Cur & Educ Dir* Laura Olah; *Receptionist* Carolyn Leslie
Open Mon -Fri 9 AM - 4:30 PM; No admis fee; Estab 1958; Permanent & special exhibs of a wide range of embroidery; Mem: 16,000; dues $40; annual meeting in fall; interest in embroidery & needle arts
Income: Financed by endowment & mem
Library Holdings: Auction Catalogs; Book Volumes; Kodachrome Transparencies; Manuscripts; Memorabilia; Original Art Works; Original Documents; Slides; Video Tapes
Special Subjects: Costumes, Embroidery, Textiles, American Western Art, Decorative Arts, American Indian Art, Crafts, Dolls
Collections: 900 Embroidery Pieces
Exhibitions: Through the Needle's Eye; varied throughout the yr
Publications: Needle Arts Magazine
Activities: Classes for adults & children; lects for mems only; organize traveling exhibs to mus & galleries; mus shop
L **Dorothy Balicock Memorial Library,** 335 W Broadway, Ste 100, Louisville, KY 40202. Tel 502-589-6956; Fax 502-584-7900; *Office Mgr* Bonnie Key
Lending & reference library for members only
Library Holdings: Slides; Video Tapes
Special Subjects: Embroidery, Tapestries, Textiles

A **THE FILSON HISTORICAL SOCIETY,** (The Filson Club) 1310 S Third St, Louisville, KY 40208. Tel 502-635-5083; Fax 502-635-5086; Elec Mail filson@filsonhistorical.org; Internet Home Page Address: www.filsonhistorical.org; *Dir* Dr Mark V Wetherington; *Ref Asst* Robin Wallace; *Cur Special Coll* Jim Holmberg
Open Mon - Fri 9 AM - 5 PM, cl national holidays; Research $10 non-mem fee; Estab 1884 to collect, preserve & publish historical material, especially pertaining to Kentucky & the upper South; Changing exhibits; Average Annual Attendance: 20,000; Mem: 4,500; dues $50 & up
Income: Financed by mem dues & private funds
Purchases: All historical materials, including appropriate paintings
Library Holdings: Book Volumes; Clipping Files; Fiche; Manuscripts; Maps; Original Art Works; Original Documents; Pamphlets; Periodical Subscriptions; Photographs; Prints; Sculpture
Collections: Books & manuscripts; large collection of portraits of Kentuckians; artifacts, textiles, silver, photographs, maps, prints
Publications: Filson Club History Quarterly; Series 1 & Series 2 Publications (39 volumes)
Activities: Classes for adults & children; dramatic programs; family history; reading & discussion groups; dramatic programs for children; tours of historic sites; lects; public & academic conferences; lect open to public; gallery talks; tours; Rothert Award for Best Article in Scholarly Quarterly; scholarships & fellowships offered; individual paintings & original objects of art lent to accredited museums & historical societies; sales shop sells books
L **Reference & Research Library,** 1310 S Third St, Louisville, KY 40208. Tel 502-635-5083; Fax 502-635-5086; Elec Mail filson@filsonclub.org; Internet Home Page Address: www.filsonclub.org; *Librn* Judith Partington
Open Mon - Fri 9 AM - 5 PM, Sat 9 AM - Noon; Estab 1884 to collect, preserve & publish Kentucky historical material & associated material
Income: Financed by endowments, mem & gifts
Library Holdings: Book Volumes 55,000; Clipping Files; Manuscripts; Memorabilia; Original Art Works; Pamphlets; Photographs; Prints; Reels; Sculpture
Collections: Extensive Civil War Collection
Exhibitions: Portraits of Kentuckians
Publications: Filson Club History Quarterly; Series & Series 2 publication (40 vols)
Activities: Lect open to public 6 - 10 per year; tours; individual paintings & original objects of art lent to other organizations for special exhibits; museum shop sells books, reproductions & prints

M **KENTUCKY DERBY MUSEUM,** 704 Central Ave Gate 1, Louisville, KY 40201. Tel 502-637-1111; Fax 502-636-5855; Elec Mail info@derbymuseum.org; Internet Home Page Address: www.derbymuseum.org; *Dir Mktg & Develop* Sherry Crose; *Cur Exhib* James Doiron; *Dir Cur Svcs* Jay R Ferguson; *Exec Dir* Lynn Ashton; *Dir Facilities* Dan Shomer; *VPres* Betty Donovan; *Pub Relations Mgr* Laura Payne; *Cur Coll* Chris Goodlett; *Dir Retail Operations* Judy Bortner; *Mem Coordr* Suzanne Shearer; *Mus Educator* Ross Moore; *Cur Educ* Sandy Flaksman; *Dir Operations* Dennis Loomer
Open Mon-Sat 9AM-5PM, Sun Noon-5PM, cl Christmas, Thanksgiving, Oaks Day & Derby Day; Admis adult $7, senior citizen $6, children 5-11 $2, children under 5 free; Estab 1985 to expand appreciation for Kentucky Derby & Thoroughbred racing; Maintains reference library; Average Annual Attendance: 200,000; Mem: 1100; dues $25-$2000
Income: $1,500,000 (financed by Earned revenues)
Special Subjects: Painting-American, Photography, Bronzes, Costumes, Manuscripts
Collections: Archives from industry; Kentucky Derby memorabilia; 19th & 20th century Equine Art; Thoroughbred Racing Industry Collection (artifacts)
Exhibitions: Permanent exhibits about Derby & Thoroughbred Racing Industry; African-Americans in Thoroughbred Racing
Publications: Inside Track newsletter, quarterly
Activities: Classes for children; competitions with prizes; individual paintings lent to qualified museums; originate traveling exhibits; originate traveling exhibitions statewide; museum shop sells books, original art, prints

M **KENTUCKY MUSEUM OF ART & CRAFT,** (Kentucky Art & Craft Gallery) 715 W Main St, Louisville, KY 40202. Tel 502-589-0102; Fax 502-589-0154; Elec Mail kacf@aye.net; Internet Home Page Address: www.kentuckycrafts.org; *Deputy Dir Prog* Brion Clinkingbeard; *Exec Dir* Mary Miller; *Dir Pub Relations* Helen Overfield; *Assoc Cur* Mary Ellen Furlong; *Sales Gallery Dir* Anessa Arehart; *Dir Educ* Shayne Hull; *Develop Assoc* Ali Shaw; *Deputy Dir Opers* Briget Wathen; *Dir Finance* Pat Gould; *Dir Corporate Sales* Ann Drury
Open Mon - Fri 10 AM - 5 PM, Sat 11 AM - 5 PM; No admis fee; Estab 1981 to advance & perpetuate Kentucky's art & craft heritage; Works by over 400 Kentucky craftspeople displayed & sold in restored 19th century building; Average Annual Attendance: 65,000; Mem: 500; dues $500, $250, $150, $75 & $40
Income: Financed by mem dues, state appropriation, corporations, foundations & fund-raising events
Library Holdings: Book Volumes; CD-ROMs; Exhibition Catalogs; Original Art Works; Periodical Subscriptions; Photographs; Slides
Special Subjects: Decorative Arts, Drawings, Folk Art, Glass, Portraits, Pottery, Painting-American, Prints, Textiles, Sculpture, Tapestries, Graphics, Photography, Watercolors, Southwestern Art, Costumes, Ceramics, Crafts, Woodcarvings, Furniture, Jewelry, Oriental Art, Asian Art, Silver, Juvenile Art, Mosaics
Collections: Small collection of contemporary Kentucky crafts
Exhibitions: Rotating exhibits
Activities: Classes for adults & children; workshops for artists & craftspeople; lect open to public, 2 vis lectr per year; gallery talks; tours; scholarships & fels offered; book traveling exhibitions, 6 per year; originate traveling exhibitions annually; gallery shop sells books, original art & functional & decorative crafts

A **LOUISVILLE VISUAL ART ASSOCIATION,** 3005 River Rd, Louisville, KY 40207. Tel 502-896-2146; Fax 502-896-2148; Elec Mail feedback@louisvillevisualart.org; Internet Home Page Address: www.louisvillevisualart.org; *Admin Dir* Lisa Work; *Artistic Dir* CJ Pressma; *Treas* Bob Miller; *VPres* Tom Dieruf; *Secy* Jane Morgan; *Exhib Coordr* Paula Cundiff; *VPres* David Doctor; *VPres* Jane Weinberg; *Educ Coordr* Linda Sanders
Open Mon - Fri 9 AM - 5 PM, Sat 9 AM - 3 PM, Sun Noon - 4 PM; No admis fee; Estab 1909 to provide programs for local & regional artists, adults & children; slide registry; Located at designated national historic landmark building, the water tower at Louisville's original water pumping station 1; Gallery area: Price Gallery 125-150 running ft, Brown Hall 125-150 running ft, 3500 sq ft total; Average Annual Attendance: 200,000; Mem: 5000; dues $25 and up; monthly meeting of Board of Dir
Income: $750,000 (financed by endowment, mem, state appropriation, Louisville Fund for the Arts, grants, rental of space & annual fundraising events)
Exhibitions: Group Invitational; regional artist emphasis; regional competitions
Publications: Exhibit catalogs
Activities: Classes & workshops for adults & children; docent training; lect open to public, 50 vis lectr per year; concerts; gallery talks; tours; competitions with awards; scholarships offered; exten dept serves Jefferson, Bullitt, Oldham & Shelby Counties in Kentucky & Clark, Floyd & Harrison Counties in Indiana; individual paintings & original objects of art lent to prospective buyers; book traveling exhibitions 1-2 per year; originate traveling exhibitions; sales shop sells magazines, original art, prints, jewelry, pottery, glass & hand crafted items

M **RIVERSIDE, THE FARNSLEY-MOREMEN LANDING,** 7410 Moorman Rd, Louisville, KY 40272. Tel 502-935-6809; Fax 502-935-6821; Internet Home Page Address: www.riverside-landing.org; *CEO & Dir* Patti Linn; *Vol Chmn* Reba Doutrick; *Mus Shop Mgr* Heather French
Open Tues - Sat 10 AM - 4:30 PM, Sun 1 - 4:30 PM; cl New Year's Day, Thanksgiving Day & the day after & Christmas Day; Admis family $10, adults $4, seniors $3.50, students & children $2, mems no admis fee; Estab 1993; 300-acre historic farm site with focus on the restored 1837 Farnsley-Moremen House. The museum's mission is to promote, preserve, restore & interpret historic farm life on the Ohio River; Average Annual Attendance: 25,341; Mem: dues Family $35, Indiv $20
Collections: coll of printed materials on local history, reproduction toys & games, and other site-specific publs; structures; furnishings; archaeological specimens; decorative arts; tools & equipment for materials
Publications: Riverside Review, quarterly newsletter
Activities: Formal educ progs for adults & children; docent prog; concerts; lects; guided tours; Ice Cream Social; Riverside Heritage Festival; Plant & Herb Sale; A Riverside Christmas; research in historic interiors & decorative arts for the 1840s - 1880s in Louisville, KY; museum-related items for sale

M **SOUTHERN BAPTIST THEOLOGICAL SEMINARY,** Joseph A Callaway Archaeological Museum, 2825 Lexington Rd, Louisville, KY 40280. Tel 502-897-4141, 897-4039; Fax 502-897-4880; Elec Mail jdrinkard@sbts.edu; Internet Home Page Address: www.sbts.edu; *Cur* Dr Joel F Drinkard Jr
Open Mon - Fri 8 AM - 5 PM, Sat 9AM-5PM, other hours by special arrangement; No admis fee; Estab 1961
Income: Financed by the seminary & donations
Special Subjects: Sculpture, Archaeology, Textiles, Religious Art, Pottery, Antiquities-Byzantine, Antiquities-Egyptian, Antiquities-Assyrian
Collections: Biblical archeology; coptic religious materials; glass; materials excavated from Jericho, AI & Jerusalem; mummy; numismatics; ostraca; pottery; sculpture; textiles; copy of the Rosetta Stone
Exhibitions: Rotating exhibits
Activities: Guided tours; films

M **SPEED ART MUSEUM,** 2035 S Third St, Louisville, KY 40208. Tel 502-634-2700; Fax 502-636-2899; Elec Mail info@speedmuseum.org; Internet Home Page Address: www.speedmuseum.org; *Chmn Bd Governors* Joseph A Paradis III; *Registrar* Charles Pittenger; *Business Mgr* David Knopf; *Cur* Ruth Cloudman; *Dir* Peter Morrin
Open Tues, Wed, Fri 10:30AM-4PM, Thurs 10:30AM-8PM, Sat 10AM-5PM, Sun Noon-5PM; Donation; Estab 1927 for the collection & exhibition of works of art of all periods & cultures, supported by a full special exhibition program & educational activities; Galleries are arranged to present painting, sculpture & decorative arts of all periods & cultures; special facilities for prints & drawings; Average Annual Attendance: 120,000; Mem: 6000; dues family $65
Income: Financed by endowment
Collections: Comprehensive permanent collection; contemporary, Native & African American collections
Publications: Newsletter, quarterly; Bulletin, occasional
Activities: Classes for children; docent training; lect open to public, 10-12 vis lectr per year; concerts; gallery talks; tours; competitions; individual paintings & original objects of art lent to members; lending collection contains 200 paintings; museum shop sells books, original art, reproductions

L **Art Reference Library,** 2035 S Third St, Louisville, KY 40208. Tel 502-634-2710; Fax 502-636-2899; Elec Mail mbenedict@speedmuseum.org; *Librn* Mary Jane Benedict
Open Tues-Fri 10:30AM-4PM, Library (by appointment only)
Income: Financed by general budget
Purchases: $10,000
Library Holdings: Book Volumes 18,147; Clipping Files; Exhibition Catalogs; Manuscripts; Other Holdings Vertical files 48; Pamphlets; Periodical Subscriptions 41; Photographs; Reproductions; Slides
Special Subjects: Art History, Constructions, Folk Art, Decorative Arts, Photography, Drawings, Etchings & Engravings, Painting-American, Painting-British, Painting-Dutch, Painting-Flemish, Painting-French, Painting-German, Painting-Italian, Prints, Sculpture, Painting-European, Historical Material, History of Art & Archaeology, Watercolors, Ceramics, Conceptual Art, Crafts, Latin American Art, Bronzes, Asian Art, American Indian Art, Porcelain, Furniture, Costume Design & Constr, Glass, Aesthetics, Afro-American Art, Antiquities-Oriental, Oriental Art, Pottery, Silver, Silversmithing, Tapestries, Textiles, Woodcuts, Landscapes, Antiquities-Egyptian, Antiquities-Greek, Antiquities-Roman, Painting-Canadian, Architecture
Collections: J B Speed's Lincoln Books; Frederick Weygold's Indian Collection
Publications: Acquisitions list, bibliographies, in-house periodical index, index to J B Speed Art Museum bulletins, index to dealers catalogs

UNIVERSITY OF LOUISVILLE

M **Hite Art Institute,** Tel 502-852-6794; Fax 502-852-6791; Internet Home Page Address: www.art.louisville.edu; *Chmn* James Grubola; *Gallery Dir* John Begley; *Studio Program Head* Ying Kit Chan; *Art History Program Head* Linda Gigante; *Art Librn* Gail Gilbert
Open Mon - Fri 8:30 AM - 4:30 PM, cl Sat 10 AM - 2 PM, Sun 1 - 6 PM; No admis fee; Estab 1935 for educ & enrichment; There are three galleries: Morris Belknap Gallery, Dario Covi Gallery, Gallery X; Average Annual Attendance: 35,000
Income: Financed by endowment & state appropriation
Special Subjects: Drawings, Prints
Collections: Teaching collection; paintings; drawings; prints
Publications: Exhibition catalogs
Activities: Lect open to public, 9-12 vis lectr per year; gallery talks; tours; Winthrop Allen Memorial Prize for creative art; scholarships offered; original objects of art lent to other departments on campus & to other exhibitions; lending collection includes Kentucky regional art, prints & drawings, alumni; book traveling exhibitions

L **Margaret M Bridwell Art Library,** Tel 502-852-6741; Elec Mail gailgilbert@louisville.edu; Internet Home Page Address: http://library.louisville.edu/art/; *Head Art Library* Gail R Gilbert; *Asst to Librn* Kathleen A Moore
Open Mon - Thurs 8 AM - 9 PM, Fri 8 AM - 5 PM, Sat 10 AM - 2 PM, Sun 1 - 6 PM; Estab 1956 to support the programs of the art department; For reference only
Income: Financed by endowment & state appropriation
Purchases: $125,000
Library Holdings: Book Volumes 85,000; CD-ROMs 147; Clipping Files; DVDs 115; Exhibition Catalogs; Fiche 2,500; Manuscripts; Memorabilia; Pamphlets; Periodical Subscriptions 310; Video Tapes 536
Special Subjects: Art History, Decorative Arts, Photography, Drawings, Etchings & Engravings, Graphic Design, Painting-American, Painting-British, Painting-Flemish, Painting-French, Painting-German, Painting-Italian, Painting-Spanish, Prints, Sculpture, Painting-European, Watercolors, Archaeology, Printmaking, Interior Design, Art Education, Afro-American Art, Pottery, Textiles, Woodcuts, Antiquities-Byzantine, Antiquities-Etruscan, Antiquities-Greek, Antiquities-Roman, Architecture
Collections: Original Christmas cards; posters; Ainslee Hewett bookplate collection; artist's books

L **Ekstrom Library Photographic Archives,** Tel 502-852-6752; Fax 502-852-8734; Elec Mail special.collections@louisville.edu; *Cur* James C Anderson; *Exhib Coordr & Cur Fine Prints* Barbara Crawford; *Imaging Manager* Bill Carmen
Open Mon - Wed, Fri 10 AM - 4 PM, Thurs 10 AM - 8 PM; No admis fee; Estab 1967 to collect, preserve, organize photographs & related materials; primary emphasis on documentary photography; Circ Restricted circ; Four exhibits per year
Income: Financed through the University & revenue
Library Holdings: Book Volumes 1000; Clipping Files; Exhibition Catalogs; Photographs 1,200,000; Reels 200
Collections: Antique Media & Equipment; Lou Block Collection; Will Bowers Collection; Bradley Studio--Georgetown; Theodore M Brown--Robery J Doherty Collection; Caldwell Tank Co Collection; Caulfield & Shook, Inc; Lin Caulfield Collection; Cooper Collection; Flexner Slide Collection; Erotic Photography; Fine Print Collection; Arthur Y Ford Albums; Forensic Photographic Collection; Vida Hunt Francis Collection; K & IT Railroad Collections; Mary D Hill Collections; Goiswold Collections; Joseph Krementz Collection; Kentucky Mountain Schools Collection; The Macauley Theater Collection; Manvell Collection of Film Stills; Boyd Martin Collection; Kate Matthews Collection; J C Rieger Collections; Roy Emerson Stryker Collections
Publications: Exhibition catalogues; collections brochures; guide to special collections
Activities: Lect open to public, vis lectr per year varies; gallery talks; educational groups; individual prints lent to museums & galleries; book traveling exhibitions; originates traveling exhibitions; sales shop sells reproductions, prints, slides & postcards, reference and research services

L **Visual Resources Center,** Tel 502-852-5917; Elec Mail alex@louisville.edu; Internet Home Page Address: www.louisville.edu; *Asst Cur* Theresa Berbet

Open Mon - Fri 8:30 AM - 4:30 PM; Estab 1930s to provide comprehensive collection of slides for use in the university instructional program; 300,000 catalogued slides primarily illustrating history of western art for faculty & students of fine arts; Circ restricted
Library Holdings: Clipping Files; Kodachrome Transparencies; Other Holdings Computer Digital Image Bank; Slides 350,000
Special Subjects: Photography, Painting-American, Pottery, Architecture
Collections: American Studies; Calligraphy; Manuscript of Medieval Life

MAYSVILLE

M **MASON COUNTY MUSEUM,** 321 Moody St, Mason, TX 76856. Tel 915-347-6137; Fax 606-564-4327; Elec Mail masonmuseum@maysvilleky.net; Internet Home Page Address: www.webpages.maysvilleky.net/masonmuseum/; *Pres & Registrar* Jerry Andrews; *Dir* Dawn C Browning; *Librn* Myra Hardy; *Business Mgr* Gayle H McKay; *Librn* Lynn David; *Educ Coordr* Anne Pollitt; *Cur Books & Art* Sue Ellen Grannis; *VPres* Mike Innis; *Chmn* Judy Schoenfeld; *Treas* Marjorie Tinsley; *Libr Asst* Marian Robinson; *Receptionist* Anna Arnold; *VChmn* Mitzi VanMeter; *VPres* Jean Humphries; *Reference Tech* Betty C Haggard; *VPres* Weldon Whittaker
Open Mon - Sat 10 AM - 4 PM; Admis adults $3, children $.50; Estab 1878 to maintain historical records & artifacts for area; Average Annual Attendance: 3,000; Mem: 150; dues $20-$100
Income: $150,000 (financed by endowment and members)
Special Subjects: Painting-American, Photography, Sculpture, Watercolors, Textiles, Costumes, Pottery, Landscapes, Portraits, Posters, Furniture, Silver, Marine Painting, Historical Material, Maps, Dioramas
Collections: Paintings & maps related to area; genealogical library
Exhibitions: (2002) Welding Exhibit
Publications: Quarterly Newsletter
Activities: Gallery talks; tours; individual paintings & original objects of art lent; book traveling exhibitions; museum shop sells books, prints, postcards & souvenirs

MOREHEAD

M **MOREHEAD STATE UNIVERSITY,** Kentucky Folk Art Center, 102 W First St, Morehead, KY 40351. Tel 606-783-2204; Fax 606-783-5034; Elec Mail g.barker@morehead-st.edu; Internet Home Page Address: www.kyfolkart.org; *Cur* Adrian Swain; *Dir* Garry Barker
Open Mon - Sat 9 AM - 5 PM, Sun 1 - 5 PM; Admis $3; Estab 1985 to promote contemporary folk art; Includes two galleries: Lovena & William Richardson Gallery which houses Collection & the Garland & Minnie Adkins Gallery housing rotating exhibits; Average Annual Attendance: 10,000; Mem: 400; dues $15-$5000; annual meeting in Sept
Income: $335,000 (financed by mem, state appropriations, grants & earnings)
Purchases: $5000 (African-American, Kentucky)
Special Subjects: Painting-American, Sculpture, Watercolors, Textiles, Folk Art, Pottery, Primitive art, Woodcarvings, Afro-American Art
Collections: Kentucky Folk Art
Exhibitions: Kentucky Folk Art from permanent collection; Kentucky Quilts: Roots & Wings
Publications: KFAC Newsletter, quarterly
Activities: Classes for adults & children; dramatic programs; docent training; lect open to public; 10 vis lectr per year; individual paintings & original objects of art lent; lending collection contains 800 items; book traveling exhibitions 2 per year; originate traveling exhibitions; sales shop sells books, magazines, original art, prints

MOREHEAD STATE UNIVERSITY

M **Claypool-Young Art Gallery,** Tel 606-783-5546; Elec Mail j.reis@morehead-st.edu; Internet Home Page Address: www.morehead-st.edu/colleges/humanities/art/gallerypage/html; *Chmn* Robert Franzini; *Gallery Dir* Jennifer Reis
Open Mon - Fri 8 AM - 4 PM, by appointment; No admis fee; Estab 1922 to provide undergraduate & graduate programs in studio & art educ; An exhibition gallery is maintained for traveling exhibitions, faculty & student work. The Claypool-Young Art Gallery is tri-level with 2344 sq ft of exhibition space; Average Annual Attendance: 8,000
Income: Financed by appropriation
Special Subjects: Prints
Collections: Establishing a permanent collection which to date consists principally of prints by major contemporary figures; several works added each year through purchase or bequest. Additions to lending collection include: The Maria Rilke Suite of lithographs by Ben Shahn consisting of 23 pieces; the Laus Pictorum Suite by Leonard Baskin, consisting of 14 pieces; & three lithographs by Thomas Hart Benton: Jesse James, Frankie & Johnny, & Huck Finn
Exhibitions: A large number of solo exhibitions along with invitational shows & group exhibits; 8 exhibits per yr, student shows & regional shows
Activities: Educ dept; classes for children; lect open to public; concert; gallery talks; tours; competitions

MURRAY

M **MURRAY STATE UNIVERSITY,** Art Galleries, 604 Price Doyle Fine Arts Ctr, 15th & Olive Sts Murray, KY 42071-3342. Tel 502-762-3052; Fax 502-762-3920; Elec Mail sarah.henrich@murraystate.edu;
Open Mon - Fri 8 AM - 4 PM, Sat & Sun 1 - 4 PM, cl University holidays; No admis fee; Estab 1971; Gallery houses the permanent art collection of the University; the Main Gallery is located on the sixth floor & its dimensions are 100 x 40 ft; the Upper Level is divided into three small galleries that may be used as one or three; the Curris Center Art Gallery is also part of the offerings; Average Annual Attendance: 12,000
Income: Financed by state appropriation and grants

Special Subjects: Drawings, Painting-American, Photography, Prints, Sculpture, Textiles, Etchings & Engravings, Portraits, Furniture, Juvenile Art
Collections: Asian Collection (given by Asian Cultural Exchange Foundation); Collection of Clara M Eagle Gallery; Harry L Jackson Print Collection; WPA prints, drawings; Magic Silver Photography Collection
Exhibitions: Biennial Magic Silver Show (even years); Annual Student Exhibition; Biennial Faculty Exhibitions (odd years); Contemporary Regional Arts
Publications: Brochures and posters for individual shows
Activities: Vis artists; workshops; demonstrations; lect open to public, 8 vis lectr per year; gallery talks; tours; competitions with merit & purchase awards; exten dept serving Jackson Purchase Area of Kentucky; individual paintings & original objects of art lent; lending collection consists of original prints, paintings, photographs & sculpture; books traveling exhibitions; traveling exhibitions organized and circulated

OWENSBORO

M **BRESCIA UNIVERSITY,** (Brescia College) Anna Eaton Stout Memorial Art Gallery, 717 Frederica, Owensboro, KY 42301. Tel 270-685-3131; Elec Mail maryt@brescia.edu; *Dir Gallery* Lance Hunter; *Chmn Dept Art* Sr Mary Diane Taylor
Open Mon - Fri 8 AM - 4:30 PM, Sat 8 AM - Noon; No admis fee; Estab 1950; Gallery space is 20 x 30 ft, walls are covered with neutral carpeting; Average Annual Attendance: 4,000
Activities: Lect open to public, 2-3 vis lectr per year; competitions with awards; scholarships offered; book traveling exhibitions; originate traveling exhibitions

M **OWENSBORO MUSEUM OF FINE ART,** 901 Frederica St, Owensboro, KY 42301. Tel 270-685-3181; Fax 270-685-3181; Elec Mail omfa@mindspring.com; *Dir* Mary Bryan Hood; *Asst Dir* Jane Wilson; *Dir Operations* Jason Hayden; *Bus Mgr* Connie Birchall; *Registrar* Tony Hardesty; *Dir Educ* Shelley Edelschick; *Admin Asst* Liz Seibert
Open Tues - Fri 10 AM - 4 PM, Sat & Sun 1 - 4 PM, cl Mon & national holidays; No admis fee, donations accepted; Estab 1977; Three Wings: Decorative Arts in restored pre-Civil War mansion; temporary exhibitions gallery; stained glass gallery; atrium sculpture; Average Annual Attendance: 70,000; Mem: 800; dues $5-$10,000
Income: Financed by endowment, mem, city & county appropriations, grants
Library Holdings: Auction Catalogs; Audio Tapes; Book Volumes; Cassettes; Clipping Files; Exhibition Catalogs; Kodachrome Transparencies; Slides; Video Tapes
Special Subjects: Afro-American Art, Drawings, Graphics, Painting-American, Photography, Prints, Sculpture, Watercolors, American Indian Art, Bronzes, African Art, Textiles, Religious Art, Ceramics, Crafts, Folk Art, Woodcarvings, Etchings & Engravings, Landscapes, Decorative Arts, Collages, Portraits, Furniture, Glass, Asian Art, Juvenile Art, Period Rooms, Stained Glass
Collections: 14th-18th century European drawings, graphics, decorative arts; 19th-20th century American, French & English paintings, sculpture & stained glass, 20th century studio glass, American folk Art
Publications: Exhibition catalogues; newsletters
Activities: Classes for adults & children; docent training; seminars & critiques led by major American artists; performing arts events; lect open to public, 4-6 vis lectr per year; concerts; gallery talks; tours; competitions with awards; pre-tour visits to the classroom; film series; individual & original objects of art lent to museums; book traveling exhibitions 3-5 per year; museum shop sells books, original art & decorative arts objects

L901 Frederica St, Owensboro, KY 42301. Tel 270-685-3181; Fax 270-685-3181; Elec Mail mail@omfa.museum; Internet Home Page Address: www.omfa.museum; *Dir* Mary Bryan Hood
Open Tues - Fri 10 AM - 4 PM; Sat & Sun 1 PM - 4PM; Voluntary Admis, suggested: $2 Adult, $1 Children; Estab 1977; A restored Carnegie Library Bldg, Exhib Wing & Atrium Sculpture & Civil War era mansion feature 14 galleries having 30,000 sq ft
Library Holdings: Book Volumes 2000; Clipping Files; Exhibition Catalogs; Manuscripts; Pamphlets; Photographs; Reproductions; Video Tapes
Special Subjects: Collages, Folk Art, Drawings, Etchings & Engravings, Graphic Arts, Painting-American, Historical Material, Ceramics, Crafts, American Western Art, Bronzes, American Indian Art, Furniture, Glass, Stained Glass, Afro-American Art, Pottery, Woodcarvings, Landscapes
Activities: Classes for adult & children; docent training; films; media demonstrations; visual arts festivals; concerts; gallery talks; tours; sponsoring of competitions; books; original art; decorative art items; jewelry

PADUCAH

M **MUSEUM OF THE AMERICAN QUILTER'S SOCIETY,** 215 Jefferson St, PO Box 1540 Paducah, KY 42002-1540. Tel 270-442-8856; Fax 270-442-5448; Elec Mail info@quiltmuseum.org; Internet Home Page Address: www.quiltmuseum.org; *Exec Dir* Mary Leuise Zumwalt; *Cur & Registrar* Judy Schwender; *Dir Pub Rels* Jessica Byassee; *Cur Educ* Carrie Cox
Open Mon - Sat 10 AM - 5 PM yr round, Apr 1 - Oct 31 also open Sun 1 PM - 5 PM; Admis adult $8, seniors & student $6, adult groups of 15 or more $5, children 12 & under & school groups free; Estab 1991; Three climate controlled galleries - Gallery A (7000 sq ft) displays selection from MAQS Collection. Gallery B (2900 sq ft) and Gallery C (3500 sq ft) display temporary exhibits of contemporary & antique quilts; Average Annual Attendance: 45,000; Mem: 1700
Income: $882,702; financed by private & corporate donations & grants
Library Holdings: Book Volumes
Special Subjects: Textiles, Crafts, Folk Art, Decorative Arts, Embroidery
Collections: Quilts made in 1980 to present; Antique/Special Community Interest Quilts; Education Coll & Paul D Pilgrim Coll; Miniature Quilt Coll
Exhibitions: Quilts in the MAQS Coll; Temporary Antique & Contemporary Exhibs (8 - 12 Exhibs per Yr)
Publications: MAQS Friends, quarterly newsletter; MAQS Quilts: The Founders Coll

Activities: Classes for adults & children; docent training; lect open to pub; school tours; gallery talks; annual schoolblock contest; sponsoring of competitions; scholarships offered; extension program to schools & sr groups; originate traveling exhibs circulate to quilt & art museums; museum shop sells books, magazines, reproductions, prints & fine crafts in all media

M **RIVER HERITAGE MUSEUM,** 117 S Water St, Paducah, KY 42001. Tel 270-575-9958; Fax 270-444-9944; Internet Home Page Address: www.riverheritagemuseum.org; *Exec Dir & Mus Shop Mgr* Julie Harris; *Develop Mem & Pub Rels* Nate Heider; *Vol Chmn* Ken Wheeler; *Educ* E J Abell
Open Apr - Nov Mon - Sat 9:30 AM - 5 PM, Sun 1 PM - 5 PM; cl at noon on Christmas Day; cl Easter, Thanksgiving Day & Christmas Day; Admis adults $5, seniors $4.50, tours & grps $4, children $3, mems no admis fee; Estab 1990; mus explores the history & significance of the river & the impact it has on people's lives through its use of state-of-the-art interactive exhibs, music stations, films, colls & aquariums; Average Annual Attendance: 10,600; Mem: dues Captain $1000, Pilot $500, Engineer $250, Crew $100, First Mate $50, Deckhand $25
Collections: Riverboat; steamboat; paddlewheel models; river memorabilia; nautical memorabilia; Civil War artifacts
Publications: The Anchor, quarterly newsletter
Activities: Events: Marine Industry Day; Sand In the City; River Trek; films; guided tours; participatory exhibs; rental gallery; school loan svc; mus shop sells books, clothing, jewelry, educ toys & related items

A **YEISER ART CENTER INC,** 200 Broadway, Paducah, KY 42001-0732. Tel 270-442-2453; Elec Mail yacenter@paducah.com; Internet Home Page Address: www.yeiserartcenter.org; *Gallery Specialist* Catherine Bates; *Admin Specialist* Landee Bryant
Open Tues - Sat 10 AM - 4 PM, cl Sun, Mon & major holidays; Admis by donation; Estab 1957 as a nonprofit cultural and educational institution to provide the community and the membership with visual art exhibitions, classes and related activities of the highest quality; Average Annual Attendance: 16,000; Mem: 600; monthly programs & mem meetings
Income: $150,000 (financed by mem fees, donations, commissions & grants)
Purchases: $100,000
Collections: Primarily regional/contemporary with some 19th century works on paper & Japanese prints; teaching collection; Collection includes R Haley Lever; Matisse; Goya; Emil Carlsen; Philip Moulthrop; Ron Isaacs
Exhibitions: Fantastic Fibers, Annual national Fibers Exhibit; National State Annual Competition; changing exhibitions of historical & contemporary art of regional, national & international nature
Publications: Fantastic Fibers, annual catalog; exhibit catalog; monthly newsletter
Activities: Classes for adults & children; dramatic programs; docent training; lect open to public, 12 vis lectr per year; gallery talks; tours; competitions with awards; sponsoring of competitions; scholarships offered; individual and original objects of art lent to qualified institutions; lending collection contains original art works, prints and paintings; originate traveling exhibitions; sales shop sells books, prints, original art, reproductions, glass, jewelry & pottery

PARIS

M **HISTORIC PARIS - BOURBON COUNTY, INC,** Hopewell Museum, 800 Pleasant St, Paris, KY 40361. Tel 859-987-7274; Fax 859-987-8107; *Exec Dir* Betsy Kephart
Open Wed-Sat Noon-5 PM, Sun 2 PM-4 PM; Admis $2; Estab 1994 to display Kentucky fine art & Bourbon County history; Six gallery rooms & a hall; building originally constructed in Beaux Arts Style as a post office; Average Annual Attendance: 2,500; Mem: 100; dues $35
Income: $95,000; (financed by mem, donations & pledges)
Special Subjects: Costumes, Crafts, Decorative Arts, Furniture, Glass
Collections: Bourbon County History (books, clothing, furniture, photography, others); Kentucky Fine Art (paintings)
Exhibitions: Victorian Children's Room; Civil War; Main Street Views-photography of Doris Ullman; Agricultural Heritage Exhibit
Activities: Classes for children; dramatic programs; docent training; lect open to public, 3-5 vis lectr per year

WHITESBURG

C **APPALSHOP INC,** Appalshop Films Media Center, 306 Madison St, Whitesburg, KY 41858. Tel 606-633-0108; Orders: 800-545-7467; Fax 606-633-1009; Elec Mail info@appalshop.org; Internet Home Page Address: www.appalshop.org
Open 9 AM - 5 PM; Estab 1969 as the Community Film Workshop of Appalachia, part of a national program to train poor & minority young people in the skills of film & television production, now an incorporated nonprofit media arts center; In 1982 a renovated 13,000 sq ft warehouse, became the Appalshop Center with offices, video & radio editing suites, a 150 seat theater, an art gallery & educational facilities. Recently a community radio station was added
Publications: Newsletter, annual
Activities: Films, plays, music & educational programs to schools, college, museums, libraries, churches, festivals, conferences & community in the region, throughout the US & in Europe, Asia & Africa

WILMORE

M **ASBURY COLLEGE,** Student Center Gallery, One Macklem Dr, Wilmore, KY 40390-1198. Tel 859-858-3511; Fax 859-858-3921; Elec Mail rudymedlock@asbury.edu; *Prof Art History* Dr Linda Stratford; *Head Art Dept* Prof Rudy Medlock; *Photography & Graphic Arts* Prof Keith Barker; *Printing & Drawing* Prof Doug Mellon; *Painting & Drawing* Prof Chris Siegre Lewis; *Art Education* Prof Becky Faulkner; *Art Education* Prof Joann Cullip
Open 11 AM - 1 PM & 6 - 9 PM; No admis fee; Estab 1976 for the purpose of exhibiting the works of national, local, and student artists; Track lighting in a 20 x 20 ft space; Average Annual Attendance: 2,000

Income: Financed by college funds
Special Subjects: Drawings, Painting-American, Photography, Prints, Sculpture, Watercolors, Religious Art, Ceramics, Pottery, Woodcuts, Etchings & Engravings, Landscapes, Portraits, Glass, Stained Glass
Publications: Newsletter
Activities: Classes for adults; lect open to public, 4 vis lectr per year; gallery talks; tours; scholarships offered

LOUISIANA

ALEXANDRIA

M **ALEXANDRIA MUSEUM OF ART,** 933 Main St, Alexandria, LA 71301; P.O.Box 1028, Alexandria, LA 71309-1028. Tel 318-443-3458; Fax 318-443-0545; Elec Mail boutlaw@themuseum.org; Internet Home Page Address: www.themuseum.org; *Assoc Dir* Frances Morrow; *Pres (V)* Oday Lovergne; *Cur Art* Ted Barnes; *Visitor Svcs* Cherry Davis; *Registrar* Leslie Gruesbeck; *Registrar* Preston Gilchrist; *Bookkeeper* Billy Outlaw; *Art Educ* Natalie Walker
Open Tues - Fri 9 AM - 5 PM, Sat 10 AM - 4 PM; Admis adults $4 seniors, military & students $3, children $2; call for group rates; Estab 1977 to explore American art of 20th century with emphasis on contemporary art of the south; National Register Building in Downtown Historic District; 2900 sq ft gallery remodeled in 1984; 933 window works - installation gallery visible through 8 x 8 street front window; accredited by AAM; Average Annual Attendance: 35,000; Mem: 1000; dues individual $25-$1000; business $250-$5000
Income: $250,000 (financed by mem, grants & donations)
Purchases: $30,000
Special Subjects: Folk Art, Photography, Prints, Sculpture, Painting-American, Watercolors
Collections: Contemporary Louisiana Art; N Louisiana Folk Crafts; Contemporary Southern Art; Prints & Drawings; Artist's Books
Publications: quarterly newsletter; September Competition catalog, annual; Heart of Spain catalog
Activities: Classes for adults & children; docent training; workshops; lect open to public, 6 vis lectr per year; gallery talks; tours; annual Sept competition, international, all media with awards; exten dept serves 9 parishes in Central Louisiana; individual paintings & original objects of art lent; lending collection contains color reproductions, 1500 kodachromes, original art works & video cassettes; book traveling exhibitions; traveling exhibitions organized & circulated; museum shop sells books, original art

M **LOUISIANA STATE UNIVERSITY AT ALEXANDRIA,** University Gallery, Student Ctr, Highway 71 S Alexandria, LA 71302. Tel 318-473-6449; *Cur Alexander Museum* Roy V de Ville
Open Mon - Fri 10 AM - 3 PM; No admis fee; Estab 1960 as university art department gallery; Gallery located in student union for both students & public. Meets all state & university guidelines for climate control; Average Annual Attendance: 800
Income: Financed by university
Exhibitions: Local & student art shows
Publications: University Gallery Catalogue, quarterly
Activities: Docent training; lect open to public, 3-4 vis lectr per year; competitions; individual paintings & original objects of art lent

BAKER

M **HERITAGE MUSEUM & CULTURAL CENTER,** 1606 Main St, Baker, LA 70704-0707; PO Box 707, Baker, LA 70704-0707. Tel 225-774-1776; Fax 225-775-5635; Elec Mail bakermuseum@bellsouth.net; Internet Home Page Address: www.bakerheritagemuseum.org
Open Mon - Sat 10 AM - 4 PM; No admis fee, donations accepted; Estab 1974 in a restored c.1906 local residence; mus collects, preserves, documents & exhibits items relating to local history
Special Subjects: Historical Material, Costumes, Crafts, Coins & Medals, Restorations
Exhibitions: Mus has traveling box exhibits including: The Ballot Box, The Money Box, The Sewing Box, The Music Box, The Letter Box, The Hat Box, The Memory Box & The Way We See It
Publications: Musings, community newsletter
Activities: Guided tours; Educ progs; Christmas displays; speakers; originates traveling exhibs

BATON ROUGE

M **EAST BATON ROUGE PARKS & RECREATION COMMISSION,** Baton Rouge Gallery Inc, 1442 City Park Ave, Baton Rouge, LA 70808-1037. Tel 225-383-1470; Fax 225-336-0943; *Asst Dir* Nancy Stapleton; *Dir Publicity* Lori Jefferson; *Dir* Kathleen Pheney; *Dir Publications* Oneal A Isaac
Open Tues - Sun Noon - 6 PM; No admis fee; Estab 1966 to educate & promote contemporary art; Nonprofit, cooperative, contemporary gallery made up of general members from community & artist members; Average Annual Attendance: 12,000; Mem: 40 artist, 200 community; dues $35; annual meeting in Nov
Income: $50,000 (financed by mem & East Baton Rouge Parks & Recreation Commission)
Special Subjects: Hispanic Art, Painting-American, Photography, Sculpture, Watercolors, Ceramics, Etchings & Engravings, Landscapes, Afro-American Art
Collections: Southern regional artists based around Baton Rouge & New Orleans
Exhibitions: Rotating exhibitions
Activities: Docent training; lect open to public; concerts; gallery talks; tours; competitions with awards; individual paintings & original objects of art lent to State of Louisiana

M LOUISIANA ARTS & SCIENCE MUSEUM, (Louisiana Arts & Science Center Museum) 100 S River Rd, PO Box 3373 Baton Rouge, LA 70821. Tel 225-344-5272; Fax 225-344-9477; *Asst Dir* Sam Losavio; *Museum Cur* Mala Jalenak; *Cur Art Educ* Lara Gautreau; *Cur Science Educ* Jamie Creola; *Challenger Center Sr Flight Dir* Gayle Glusman; *Pub Relations Coordr* Wendy Gilmore; *Registrar* Catherine McKenzie; *Exec Dir* Carol S Gikas
Open Tues - Fri 10 AM - 3 PM, Sat 10 AM - 4 PM, Sun 1 - 4 PM, cl Mon; Admis adults $3, university students, senior citizens & children 2-12 $2, members, children under 2 & 1st Sat of the month free; Estab 1960. General mus - art & science; Center administers the Mus in the renovated Illinois Central Railroad Station with an auditorium & sculpture garden. Mus contains changing exhibits of art, science, a science gallery & a Challenger Learning Center. Maintains reference library; Average Annual Attendance: 80,000; Mem: 1200; Dues $20-$1000
Income: Financed by mem, city appropriation & donations
Special Subjects: Drawings, Graphics, Painting-American, Prints, Sculpture, Bronzes, African Art, Textiles, Costumes, Ceramics, Folk Art, Pottery, Landscapes, Painting-European, Eskimo Art, Dolls, Antiquities-Egyptian, Antiquities-Greek, Antiquities-Roman
Collections: 18th & 20th century European & American paintings; contemporary photographs; Clementine Hunter paintings; Ivan Mestrovic; sculpture; Egyptian artifacts; Eskimo graphics & soapstone carvings; North American Indian crafts; Tibetan religious art
Exhibitions: Discovery Depot, a participatory gallery that introduces children to art; Egyptian Mummies & Artifacts; Miniature Train; 4 train cars & locomotive
Publications: LASC Calendar, quarterly
Activities: Classes for adults & children; workshops, YouthALIVE; lect open to public, 5-10 vis lectr per year; gallery talks; tours; individual paintings & original objects of art lent to other museums & galleries; book traveling exhibitions 8-10 per year; originate traveling exhibitions; museum shop sells books, educational toys & t-shirts
L Library, PO Box 3373 Baton Rouge, LA 70821; 100 S River Rd, Baton Rouge, LA 70802. Tel 225-344-5272; Fax 225-344-9477; Internet Home Page Address: www.lasm.org; *Exec Dir* Carol S Gikas; *Asst Dir* Sam Losavio
Open Tues - Fri 10 AM - 3 PM, Sat 10 - 4 Pm, Sun 1 PM - 4 PM, cl Mon; Estab 1971; Small reference library open to staff only. Two floor gallery for changing exhibitions; Average Annual Attendance: 69,000; Mem: 2000
Library Holdings: Book Volumes 1000; Exhibition Catalogs; Pamphlets; Periodical Subscriptions 32; Slides; Video Tapes
Special Subjects: Photography, Painting-American, Sculpture, Painting-European
Collections: 18th-20th American & European art; 2d largest collection of Ivan Mestrovic in U.S.
Publications: LASM Quarterly membership newsletter; exhibition catalogues
Activities: Classes for adults & children; docent training; lect open to public, 6 vis lects per year; gallery talks; workshops; school group programs; extension art programs in local schools; 8-10 traveling exhibitions

LOUISIANA STATE UNIVERSITY
M Museum of Art, Tel 225-578-4003; Fax 225-578-9288; *Exec Dir* Steven Rosen; *Asst to Exec Dir* Diana Wells; *Registrar* Fran Huber; *Mem Coordr* Kelly Lastrapes
Open Tues - Fri 9 AM - 4 PM, Sat & Sun 1 - 4 PM; No admis fee; Estab 1959 to serve as a constant reminder of the major cultural heritage the United States received from the British people; Two temporary galleries house loan exhibitions & local art work; Average Annual Attendance: 55,000; Mem: 400; dues $25 - $500
Income: Financed by endowment, mem & state funds
Library Holdings: Auction Catalogs; Exhibition Catalogs; Original Art Works; Photographs; Prints; Sculpture
Special Subjects: Drawings, Graphics, Painting-American, Watercolors, Decorative Arts, Silver, Painting-British
Collections: Hogarth & Caroline Durieux graphic works; early Baton Rouge subjects; early New Orleans-made silver; English & American drawings, decorative arts, paintings, watercolors; Newcomb Crafts: 19th century lighting devices
Publications: Catalogues; newsletter
Activities: Lect, 2 vis lectr per year; gallery talks; tours; competitions; originate traveling exhibitions
L Library, Tel 225-388-5652; Internet Home Page Address: www.lib.lsu.edu; *Dean LSU Libraries* Jennifer Cargill
Open Mon - Thurs 9:15 AM - noon, Fri & Sat 10 AM - 5 PM, Sun noon - midnight, cl university holidays; No admis fee, guided tours $2 per person; Reference library; Average Annual Attendance: 7,500
Library Holdings: Book Volumes 700; Clipping Files; Exhibition Catalogs; Original Art Works; Photographs; Prints; Sculpture
Collections: English - American decorative arts, drawings, paintings
Exhibitions: English period rooms 17th & 19th century; American period rooms 18th & 19th centuries; Collection of Newcomb Crafts; New Orleans made Silver; Hogarth Prints; Works by Caroline Durieux; 18th century lighting devices
Publications: Exhibit catalogs
Activities: Lect for members only, 1-2 per year; tours; individual paintings & objects of art lent to other museums
M Union Art Gallery, Tel 225-578-5117/578-5467; Fax 225-578-4329; Elec Mail j.stahl@lsu.edu; Internet Home Page Address: www.lsu.edu; *Art Dir* Judith R Stahl
Open Mon - Fri 9 AM - 6 PM, Sat & Sun noon - 5 PM; No admis fee; Estab 1964, designed for exhibitions for university & community interests; Gallery is centrally located on the main floor of the LSU Union with 2000 sq ft; Average Annual Attendance: 55,000; Mem: 4,000; dues $35
Income: Financed by fundraising, grants & university support
Collections: Contemporary American Art
Exhibitions: Annual Student Art Exhibition; 7 annual rotating exhibits
Publications: Brochures and postcards for exhibits, exhibit catalogs and semester calendars
Activities: Lect open to public, 2-4 vis lectr per year; concerts; gallery demonstrations; competitions with awards
M School of Art Gallery, Tel 225-389-7180; Fax 225-389-7185; Elec Mail artgallery@lsu.edu; Internet Home Page Address: www.lsu.edu/artschoolgallery; *Dir* Stuart Baron; *Gallery Coordr* Kristin Malia Krolak; *Asst Dir School of Art* Melody Guichet

Open Tues - Fri 10 AM - 4 PM ; No admis fee; Estab 1934 for special exhibitions planned by faculty committee.; Average Annual Attendance: 10,000
Special Subjects: Drawings, Photography, Sculpture, Jewelry
Collections: Department collection of contemporary graphic works, prints & drawings
Activities: Lect open to public, 2-3 vis lectr per year; gallery talks; tours; sponsoring of competitions; scholarships & fels offered; book traveling exhibitions, 2 per year; originate traveling exhibitions
L Design Resource Center, Tel 225-578-0280; Fax 225-578-0280; Elec Mail smooney@lsu.edu; Internet Home Page Address: www.lib.lsu.edu/desi; *Librn* Sandra Mooney; *Library Assoc* Carolyn Valentine
Open Sun 2 - 10 PM, Mon - Thurs 8 AM - 10 PM, Fri 8 AM - 5 PM, Sat noon - 4 PM; No admis fee; Estab 1986; Circ 10,000; Lending library, academic (curriculum support collection); Average Annual Attendance: 26,000
Library Holdings: Book Volumes 15,000; CD-ROMs; DVDs; Maps; Other Holdings Vertical files 8 drawers, blueprints; Periodical Subscriptions 100; Video Tapes
Special Subjects: Art History, Landscape Architecture, Decorative Arts, Graphic Design, Industrial Design, Interior Design, Furniture, Drafting, Architecture

L SOUTHERN UNIVERSITY, Architecture Library, Southern University Post Office Branch, Baton Rouge, LA 70813. Tel 225-771-3290; Fax 225-771-4709; Elec Mail lucille@lib.subr.edu; Internet Home Page Address: www.subr.edu; *Librn* Lucille Bowie
Open Mon - Fri 8 AM - 9 PM, Fri 8 AM-5 PM, cl week-ends; Estab 1971 to encourage support of fine arts & architecture; Circ 12,000
Income: Financed by state appropriation
Library Holdings: Book Volumes 7500; Cassettes; Fiche; Motion Pictures; Pamphlets; Periodical Subscriptions 87; Reels; Slides; Video Tapes

CROWLEY

A CROWLEY ART ASSOCIATION, The Gallery, 220 N Parkerson, PO Box 2003 Crowley, LA 70527-2003. Tel 337-783-3747; *Gallery Coordr* Becky Faulk; *Treas* Brenda Istre
Open daily 10 AM - 4 PM; No admis fee; Estab 1980 to promote art in all forms; 1,100 sq ft; Average Annual Attendance: 1,000; Mem: 250; dues $15; monthly meetings
Income: Financed by mem, fundraisers & grants
Exhibitions: Juried Art Show
Publications: Monthly newsletter
Activities: Classes for adults & children; lect open to public, 3 vis lectr per year; competitions; retail store sells original art

FRANKLIN

M GREVEMBERG HOUSE MUSEUM, 407 Sterling Rd (Hwy 322), Franklin, LA 70538-0400; PO Box 400, Franklin, LA 70538-0400. Tel 337-828-2092; Fax 337-828-2028; Internet Home Page Address: www.grevemberghouse.com; *Vol Pres* Donna J Tesi MD; *Pub Rels* Didi Battle; *Treas & Archivist* Margie L Luke; *Lead Interpreter* Craig Landry
Open daily 10 AM - 4 PM; cl New Year's Day, Good Friday, Easter Sunday, Thanksgiving Day, Christmas Eve & Day; Admis adults $6, seniors, students & grp rates $5, children $3, mems no admis fee; Estab 1972; 1851 Greek-revival townhouse that showcases 19th c life in south Louisiana; listed on National Register of Historic Places; managed by St Mary Landmark's 17-mem vol Bd of Trustees; Average Annual Attendance: 1633; Mem: dues Sustaining $1000, Patron $250, Sponsor $100, Supporting $50, Couple $40, Single $25
Special Subjects: Decorative Arts, Historical Material, Furniture, Portraits, Painting-American
Collections: Antique furnishings from the period of 1820 - 1870 based on items listed in the estates of Gabriel and Frances Wikoff Grevemberg, with exceptions allowed for items of local historic significance from other periods
Publications: Landmark Lagniappe, semiannual newsletter
Activities: Research in the translation of Grevemberg family papers from French to English; mid-19th c south Louisiana graveyards; Victorian Christmas Celebration; guided tours

JENNINGS

M ZIGLER MUSEUM, 411 Clara St, Jennings, LA 70546. Tel 337-824-0114; Fax 337-824-0120; Elec Mail zigler-museum@charter.net; Internet Home Page Address: www.jeffdavis.org; *Cur* Dolores Spears; *Pres Bd Trustees* Gregory Marcantel
Open Tues - Sat 9 AM - 1 PM, Sun 1 - 4 PM; Admis fee adults $2, children free; Estab 1963 to place the art of western civilization & the area in a historical context; West Wing has permanent collection of American & European paintings & sculptures. East Wing contains a gallery of wildlife art. Central galleries are reserved for a new art exhibit each month; Average Annual Attendance: 20,000
Income: Income from private foundation
Purchases: 29 paintings by William Tolliver; One painting by Vlaminck; One painting by Whitney Hubbard; One painting by van Dyck; One painting by Herring
Special Subjects: Painting-American, Sculpture, Painting-European, Dioramas
Collections: Bierstadt; Chierici; Constable; Crane; Gay; Heldner; George Inness Jr; Pearce; Pissarro; Reynolds; Sloan; Frank Smith; Vergne; Whistler; Gustave Wolff; Robert Wood; Sculpture: J Chester Armstrong; Wildlife Art; Louisiana Art
Exhibitions: Rotating exhibits; Produce for Victory-Posters of the American Home Front
Publications: Brochure
Activities: Classes for adults; docent training; lect open to public; tours; individual paintings & original objects of art lent; originates traveling exhibitions that travel to other museums; museum shop sells books, original art, prints, Indian basets & hand-painted porcelain

LAFAYETTE

M LAFAYETTE MUSEUM ASSOCIATION, Lafayette Museum-Alexandre Mouton House, 1122 Lafayette St, Lafayette, LA 70501. Tel 337-234-2208; *Pres* Yvonne D Bienvenu
Open Tues - Sat 9 AM - 5 PM, Sun 3 PM - 5 PM, cl Mon; Admis $3, seniors & students $1; Estab 1954 as a historical house; Average Annual Attendance: 3,000
Income: $35,000 (financed by endowment, city appropriation)
Purchases: Refurbishing two rooms in mus
Special Subjects: Costumes, Historical Material
Collections: Historical Costumes & Dress, Documents, Furnishings, Objects
Activities: Children's tours

M LAFAYETTE NATURAL HISTORY MUSEUM & PLANETARIUM, 433 Jefferson St, Lafayette, LA 70501. Tel 337-291-5544; Fax 337-291-5464; *Cur Exhibits* Cliff Deal; *Cur Planetarium* David Hostetter; *Secy* Karen Miller-LeDoux; *Museum & Planetarium Tech* Dexter LeDoux; *Educ Cur* Mary Ann Bernard; *Mus Adminr* Mary Henderson; *Cur Educ* Dawn Edelen
Open Mon - Fri 9 AM - 5 PM; Admis adults $5, seniros 65 & over $3, children 4 - 17 yrs $2, children 3 & under free; Estab 1969 to provide a focus on the physical world in order to benefit the citizens of the community; 5,800 sq ft of exhibition space, interior walls constructed as needed; Average Annual Attendance: 65,000; Mem: 300; annual meeting in Oct
Income: $650,000 (financed by mem & city & parish appropriation)
Purchases: $4000
Library Holdings: Audio Tapes; Book Volumes; CD-ROMs; Cassettes; Clipping Files; Compact Disks; Exhibition Catalogs; Manuscripts; Maps; Memorabilia; Original Documents; Pamphlets; Periodical Subscriptions; Photographs; Prints; Records; Reels; Reproductions; Video Tapes
Special Subjects: Drawings, Graphics, Photography, Prints, Sculpture, African Art, Anthropology, Archaeology, Ethnology, Costumes, Crafts, Folk Art, Primitive art, Etchings & Engravings, Landscapes, Afro-American Art, Manuscripts, Posters, Furniture, Historical Material, Maps, Restorations, Tapestries, Embroidery, Bookplates & Bindings
Collections: Acadian artifacts; Audubon prints; Historical Louisiana maps; Louisiana Indian artifacts; Louisiana moths & butterflies; Louisiana shells; Meteorites
Exhibitions: Rain or Shine: Louisiana Weather; Travailler C'est Trop Dur: The Tools of Cajun Music; Audubon's World: A Window Into Nature; Louisiana Snakes Alive; Louisiana Crawfish: Perspectives on a New World Traveler; Outlook Universe; Waterways of Louisiana; Wildflowers of Louisiana; Rain or Shine: Louisiana Weather; Lunchbox Memoris; Exotica
Activities: Classes for adults & children; docent training; tours; lending collection contains 20 nature artifacts, original art works, 400 photos, 1000 slides, 200 Louisiana Indian & Acadian artifacts to home schools, scouts; book traveling exhibitions; original traveling exhibitions in Louisiana; museum shop sells books, reproductions, prints, slides, t-shirts & educational gifts

UNIVERSITY OF LOUISIANA AT LAFAYETTE
M University Art Museum, Tel 337-482-5326; Fax 337-482-5907; Internet Home Page Address: www.louisiana.edu/UAM; *Dir Asst* Elizabeth Touchet; *Dir* Herman Mhire
Open Tues - Fri 9 AM - 4 PM, Sun 2 PM - 5 PM; No admis fee; Estab 1968 as an art museum, for education of the population of the region; Average Annual Attendance: 15,000; Mem: 200; dues $10-$1000
Income: $100,000 (financed by mem & state appropriation)
Purchases: Lowe Collection of Outsider Art
Special Subjects: Drawings, Graphics, Painting-American, Photography, Prints, Sculpture, Watercolors, Ceramics, Folk Art, Pottery, Woodcuts, Etchings & Engravings, Landscapes, Afro-American Art, Decorative Arts, Collages, Portraits, Furniture, Glass, Oriental Art, Silver, Coins & Medals, Miniatures, Antiquities-Egyptian
Collections: Henry Botkin Collection; Cohn Collection-19th & 20th Century Japanese Prints; Louisiana Collection-19th & 20th Century Art, all media; Lowe Collection-Outsider Art
Publications: Books; exhibition catalogues
Activities: Lect open to public, 5 vis lectr per year; concerts; gallery talks; tours; book traveling exhibitions 1-3 per year; originate traveling exhibitions one per year

LAKE CHARLES

M IMPERIAL CALCASIEU MUSEUM, 204 W Sallier St, Lake Charles, LA 70601. Tel 337-439-3797; Fax 337-439-6040; *Dir* Mary June Malus
Open Tues - Fri 10 AM - 5 PM, Sat & Sun 1 - 5 PM; Admis adults $2, students $1; Estab Mar 1963 by the Junior League of Lake Charles & housed in City Hall; After several moves in location, the mus is now housed in a building of Louisiana Colonial architecture which incorporates in its structure old bricks, beams, balustrades & columns taken from demolished old homes. In Dec 1966 administration was assumed by the Fine Arts Center & Mus of Old Imperial Calcasieu Mus, Inc, with a name change in 1971. Site of the building was chosen for its historic value, having been owned by the Charles Sallier family, the first white settler on the lake & the town named for him. The mus depicts the early history of the area; Average Annual Attendance: 12,500; Mem: 350; dues $50-$1500
Income: Financed by mem
Special Subjects: Period Rooms
Collections: Artifacts of the Victorian Period, especially Late Victorian
Exhibitions: American Indian Artifacts in Calcasieu Collections; Antique Quilts & Coverlets; Calcasieu People & Places in 19th Century Photographs; Christmas Around The World; special exhibitions every six weeks, with smaller exhibits by other organizations at times
Activities: Docent training; lect open to members only, 2-3 vis lectr per year; gallery talks; book traveling exhibitions 1 per year; originate traveling exhibitions; sales shop sells books, original art

M Gibson-Barham Gallery, 204 W Sallier St, Lake Charles, LA 70601. Tel 337-439-3797; Fax 337-439-6040; *Coordr* Mary June Malus
Open Tues - Sat 10 AM - 5 PM, Sun 1 - 5 PM, cl Mon; Admis adults $2, students $1; Estab 1963 to collect & display history & artifacts at five parishes in the original Imperial Land Grant; 1000 running ft; Average Annual Attendance: 10,000; Mem: 300; dues $50
Income: financed by membership, donations
Special Subjects: Drawings, Graphics, Painting-American, Photography, Prints, American Indian Art, Costumes, Ceramics, Crafts, Folk Art, Pottery, Etchings & Engravings, Decorative Arts, Manuscripts, Dolls, Furniture, Jewelry, Carpets & Rugs, Historical Material, Maps, Coins & Medals, Period Rooms, Embroidery, Laces, Pewter
Exhibitions: 6-10 rotating exhibitions per year
Activities: Lect open to public, 2 vis lectr per year; gallery talks; tours; individual paintings & original objects of art lent to established museums or collectors; book traveling exhibitions 3-4 per year; originate traveling exhibitions; sales shop sells books & original art

L Gibson Library, 204 W Sallier St, Lake Charles, LA 70601. Tel 337-439-3797; Fax 337-439-6040; *Coordr* Mary June Malus
Open Mon - Fri 10 AM - 5 PM, Sat & Sun 1 - 5 PM; No admis fee; Estab 1971, to display early school books & bibles; Circ non-circulating; Reference Library; Mem: Part of museum
Income: Financed by mem, memorials & gifts
Library Holdings: Audio Tapes; Book Volumes 100; Cassettes; Memorabilia; Original Art Works; Pamphlets; Periodical Subscriptions 100; Photographs; Sculpture; Slides; Video Tapes
Special Subjects: Folk Art, Decorative Arts, Photography, Manuscripts, Maps, Painting-American, Prints, Historical Material, Crafts, Porcelain, Furniture, Drafting, Period Rooms, Pottery, Pewter
Collections: Audubon animal paintings; Audubon bird paintings; Calcasieu photographs; Boyd Cruise
Exhibitions: History of Imperial Calcasieu Parish, with settings & objects

LEESVILLE

M MUSEUM OF WEST LOUISIANA, 803 S Third St, Leesville, LA 71446. Tel 337-239-0927; Internet Home Page Address: www.museumofwestla.org
Open Tues - Sun 1 - 5 PM; other times by appt; No admis fee, donations accepted; Opened in 1987 for the purpose of preserving & displaying artifacts illustrative of the history, culture, folk art & resources of Vernon Parish and the West Central area of the Louisiana Territory
Special Subjects: Archaeology, Decorative Arts, Folk Art, Furniture, Dolls, Military Art
Collections: Archaeological artifacts; logging implements; railroad memorabilia; quilts; clothing; cooking & household items; furniture & special displays; POW paintings & WWII memorabilia; children's toys & dolls
Activities: Pioneer Park is available for special events; museum-related items for sale

MADISONVILLE

LAKE PONTCHARTRAIN BASIN MARITIME MUSEUM, 133 Mabel Dr, Madisonville, LA 70447. Tel 985-845-9200; Fax 985-845-9201; Elec Mail info@lpbmaritimemuseum.org; *CEO & Dir* Nixon Adams
Open Tues - Sat 10 AM - 4 PM, Sun 12 PM - 4 PM, cl Thanksgiving, Christmas Eve & Day; Admis adults & seniors $2, mems & age 12 & under no admis fee; Unique nautical & cultural heritage of Lake Pontchartrain, research in archeological survey of shipwrecks in the Lake Pontichartrain; Average Annual Attendance: 1000 - 9999; Mem: dues Supporting $500, Friend $100, Family $25
Exhibitions: Madisonville Wooden Boat Festival, ann festival held the third weekend in Oct, 10 AM - 6 PM

MINDEN

L WEBSTER PARISH LIBRARY, 521 East & West Sts, Minden, LA 71055. Tel 318-371-3080; *Asst Librn* Beverly Hammett; *Librn* Eddie Hammontree
Open Mon, Wed, Thurs 8:15 AM - 8 PM, Tues, Fri, Sat 8:15 AM - 5 PM; Estab 1929 to serve as headquarters & main branch for county; Circ 145,508
Income: $221,353 (financed by parish tax)
Library Holdings: Book Volumes 60,000; Cassettes; Clipping Files; Filmstrips; Framed Reproductions; Original Art Works; Pamphlets; Periodical Subscriptions 800; Photographs; Records; Reels; Slides; Video Tapes
Activities: Exten dept serves the elderly; individual paintings lent to registered borrowers, lending collection contains 54 art prints & 50 b & w photographs depicting parish history

MONROE

M NORTHEAST LOUISIANA CHILDREN'S MUSEUM, 323 Walnut St, Monroe, LA 71201. Tel 318-361-9611; Fax 318-361-9613; Elec Mail nelcm@nelcm.org; Internet Home Page Address: www.nelcm.org
Open Tues - Fri 9 AM - 2 PM, Sat 10 AM - 5 PM; Admis $5 per person; Group Rate: $3 per person for groups of 15 or more
Exhibitions: The Kids' Cafe: sponsored by the Louisiana Restaurant Assoc, exhib recreates a true-to-life restaurant environment where each child can explore the different typs of jobs found in a restaurant; Health Hall: children may drive an ambulance to the ER, listen to a patient's heart & check out his x-ray, as well as learn about how the body works; The Think Tank: visitor is challenged to use problem-solving skills to figure out puzzles, utilize creativity in putting on a puppet show, as well as explore The Gravity Wall; Stuffee: 9-ft soft sculptured doll sponsored by the Ouachita Medical Alliance Society, whose internal organs are removable & teach us how our body works; Toddler Town: a picket fence-surrounded area designated for toddlers, features soft blocks & educational toys

Activities: Monthly events; Birthday Parties & events; Summer Drop-Off Days for children ages 4 - 8; traveling & permanent exhibs; educational-related items for sale

M **TWIN CITY ART FOUNDATION,** Masur Museum of Art, 1400 S Grand St, Monroe, LA 71202. Tel 318-329-2237; Fax 318-329-2847; Elec Mail masur@ci.monroe.la.us; Internet Home Page Address: www.ci.monroe.la.us/mma; *Dir* Sue Prudhomme
Open Tues - Thurs 9 AM - 5 PM, Fri - Sun 2 - 5 PM; No admis fee; Estab 1963 to encourage art in all media & to enrich the cultural climate of this area; Gallery has 400 running ft hanging space; Average Annual Attendance: 20,000; Mem: 380; dues $250, $125, $35
Income: $225,000 (financed by mem & appropriations)
Special Subjects: Painting-American, Photography, Prints, Sculpture, Watercolors, Woodcuts
Collections: Contemporary art all media, approximately 300 works
Publications: Brochures of shows, monthly
Activities: Classes for adults & children; lect open to public, 4 vis lectr per year; tours; competitions; book traveling exhibitions

M **UNIVERSITY OF LOUISIANA AT MONROE,** (Northeast Louisiana University) Bry Gallery, 700 University Ave, Bry Hall Monroe, LA 71209-0310. Tel 318-342-1375; Fax 318-342-1369; Elec Mail aralexander@uln.edu; Internet Home Page Address: www.uln.edu/art/bryhall.html; *Head* Ron J Alexander, MFA
Open 8 AM - 4:30 PM; No admis fee; Estab 1931; Gallery is 24 sq ft x 26 sq ft with 14 ft ceilings; Average Annual Attendance: 8,000
Collections: Kit Gilbert; Pave Brou of New Orleans
Activities: Classes for adults & children; docent training; 6 vis lectr per year; gallery talks; exten dept

NEW IBERIA

M **NATIONAL TRUST FOR HISTORIC PRESERVATION,**
Shadows-on-the-Teche, 317 E Main St, New Iberia, LA 70560. Tel 337-369-6446; Fax 337-365-5213; Internet Home Page Address: www.shadowsonteche.org; *Dir* Patricia Kahle
Open daily 9 AM - 4:30 PM, cl Christmas, New Year's Day & Thanksgiving Day; Admis adults $7, children 6-11 $4, group rates available; The Shadows is a property of the National Trust for Historic Preservation. Preserved as a historic house mus: operated as a community preservation center, it is a National Historic Landmark. On the Bayou Teche, it faces the main street of modern New Iberia, but is surrounded by 2 1/2 acres of landscaped gardens shaded by live oaks. Built in 1831, the Shadows represents a Louisiana adaptation of classical revival architecture. The life & culture of a 19th century southern Louisiana sugar plantation are reflected in the possessions of four generations of the Weeks family on display in the house. It fell into ruin after the Civil War, but was restored during the 1920s by Weeks Hall, great-grandson of the builder; Average Annual Attendance: 22,000; Mem: 450
Income: Financed by mem in Friends of the Shadows, admis fees & special events
Collections: Paintings by Louisiana's itinerant artist Adrien Persac & period room settings (1830s-60s); paintings by Weeks Hall; furnishings typical of those owned by a planter's family between 1830 and 1865
Activities: Docent training; interpretive programs which are related to the Shadows historic preservation program; Members Day during National Historic Preservation Week; concerts; tours; museum shop sells books, original art and prints

NEW ORLEANS

A **ARTS COUNCIL OF NEW ORLEANS,** 818 Howard Ave, Ste 300, New Orleans, LA 70113. Tel 504-523-1465; Fax 504-529-2430; Elec Mail mai@artscouncilofneworleans.org; Internet Home Page Address: www.artscouncilofneworleans.org; *Pres & CEO* Shirley Trusty Corey; *COO* Scott Hutcheson; *Grants Dir* Joclyn L Reynolds
Estab 1975 to support & expand the opportunities for diverse artistic expression & to bring the community together in celebration of rich multicultural heritage; provides a variety of Cultural Planning, Advocacy, Public Art, Economic Development, Arts Education, Grants & Service Initiatives focused on its vision of New Orleans as a flourishing cultural center; Average Annual Attendance: 1,000; Mem: Dues organization $154, individuals free with qualifications
Activities: Lect open to public & members; workshops

A **CONFEDERATE MEMORIAL HALL,** Confederate Museum, 929 Camp St, New Orleans, LA 70130. Tel 504-523-4522; Fax 504-523-8595; Elec Mail Memhall@aol.com; Internet Home Page Address: www.confederatemuseum.com; *Chmn Memorial Hall Committee* Dr Keith Cangelosi; *Cur* Pat Ricci
Open Mon - Sat 10 AM - 4 PM; Admis adults $5, students & senior citizens $4, children $2; Estab 1891 to collect & display articles, memorabilia & records surrounding the Civil War; Gallery is maintained in a one story brick building; one main hall paneled in cypress, one side hall containing paintings of Civil War figures & display cases containing artifacts; Average Annual Attendance: 15,000; Mem: 2000; dues benefactor $500, patron $250, assoc $100, support $50, gen $25, student $10; annual meeting Mar
Income: Financed by mem & admis
Publications: Louisiana Historical Association Newsletter; Louisiana History, quarterly
Activities: Lect open to public; competitions; sales shop sells books, reproductions & novelties

A **CONTEMPORARY ARTS CENTER,** 900 Camp St, New Orleans, LA 70130. Tel 504-528-3805; Fax 504-528-3828; Elec Mail kwitmyer@cacno.org; Internet Home Page Address: www.cacao.org; *Dir* Jay Weigel; *Visual Arts Cur* David S Rubin; *VPres* Mark Fullmer
Open Tues - Sun 11 AM - 5 PM, cl Mon; Admis $5, members free, Thurs no admis fee; Estab 1976 to support experimentation & innovative products of work

in visual arts & performing arts. Interdisciplinary arts center; Average Annual Attendance: 100,000; Mem: 3000; dues $25 & up; annual meeting in June
Special Subjects: Glass
Exhibitions: Art for Arts Sake; White Linen Night; Absolut; Jazz America Series; (2001) Louisiana Open; (2001) Vie Muniz; (2002) Paintings by Al Held; (2002) Christian Mascaly; (2002) Sandy S. Koglund
Activities: Classes for children; lect open to public; concerts; gallery talks; tours; sales shop sells magazines, original art & prints

M **THE HISTORIC NEW ORLEANS COLLECTION,** 533 Royal St, New Orleans, LA 70130-2179. Tel 504-504-598-7171; Fax 504-598-7108; Elec Mail hnocinfo@hnoc.org; Internet Home Page Address: www.hnoc.org; *Chmn* Mary Louise Christovich; *Dir The Historic New Orleans Collection* Priscilla Lawrence; *Dir Mus Prog* John Lawrence; *Dir Williams Research Ctr* Dr Alfred Lemmon; *Public Relations Dir* Elsa Schneider; *Dir Publications* Jessica Dormon; *Head Librn* Gerald F Patout; *Reference Librn* Pamela D-Arceneaux; *Catalog Librn* Amy Baptist; *Head Reading Room* John Magill; *Manuscripts Librn* Mark Cave; *Prints/Photo Cur* Sally Stassi
Open Tues - Sat 10 AM - 4:45 PM; No admis fee to Gallery, admis to Williams Residence & Louisiana History Galleries, tour by guide $3; Estab in 1792 by Jean Francois Merieult; renovated by Koch & Wilson to accommodate the Louisiana History galleries which house a collection of paintings, prints, documents, books & artifacts relating to the history of Louisiana from the time of its settlement, gathered over a number of years by the late L Kemper Williams & his wife. The foundation was estab with private funds to keep original collection intact & to allow for expansion; Research Center for State & Local History/Mus; Average Annual Attendance: 45,000
Income: Financed by endowment
Library Holdings: Book Volumes 18,000; CD-ROMs; Compact Disks; Exhibition Catalogs; Manuscripts; Maps; Memorabilia; Motion Pictures; Original Art Works; Original Documents; Other Holdings Broadside 200; Pamphlets 10,000; Periodical Subscriptions 30; Photographs; Prints; Records; Slides; Video Tapes
Special Subjects: Architecture, Drawings, Photography, Prints
Collections: Charles L Franck, photographs (1900-1955); Dan Leyrer, photographs (1930-1970); Clarence Laughlin, photographs (1935-1965); James Gallier Jr & Sr, architectural drawings (1830-1870); Morries Henry Hobbs, prints (1940); B Lafon, drawings of fortifications (1841); B Simon, lithographs of 19th-century businesses; Alfred R & William Waud, drawings of Civil War & post-war; maps, paintings, photographs, prints, three-dimensional objects
Exhibitions: Various exhibs
Publications: Guide to Research at the Historic New Orleans Collection; exhibition brochures & catalogs; historic publications; monograph series; quarterly newsletter; Guide to The Vieux Carre Survey, a guide to a collection of material on New Orleans; Qtr newsletter
Activities: Docent training; lect open to public; tours; competitions with awards; gallery talks; Williams prize; individual paintings & original objects of art lent to museums, institutions, foundations, libraries & research centers; museum shop sells books, original art, magazines, reproductions and prints, slides & ephemera; research collections

M **LONGUE VUE HOUSE & GARDENS,** 7 Bamboo Rd, New Orleans, LA 70124. Tel 504-488-5488; Fax 504-486-7015; Elec Mail lschmalz@longuevue.com; Internet Home Page Address: www.longue.com; *Dir* Pam O'Brien; *Asst Dir* Mary E D'Aquin Fergusson; *Cur* Lydia H Schmalz; *Museum Shop Mgr* Lee Doane; *VPres & VChmn* Jay Aronson; *Cur Educ* Rebecca Manzar; *Dir Programs* Bonnie Goldblum; *Marketing Dir* Ashley McIntire; *Operations & Sales* Debbie Bordeaux; *Operations & Sales* Anna Bell Jones
Open Mon - Sat 10 AM - 4:30 PM, Sun 1 - 5 PM; Admis adults $10, seniors $9, students & children $5; Estab 1968 to preserve & interpret Longue Vue House & Gardens; Period 1930-40 house & gardens; Average Annual Attendance: 51,000; Mem: 1700; dues family $50, individual $25, student & senior citizens $20; biannual meetings in spring & fall
Income: $1,240,000 (financed by endowment, fundraising & admis)
Special Subjects: Textiles, Ceramics, Furniture
Collections: 18th - 19th century English & American furniture; textile collection of 18th - 20th century English, French, & American fabrics, needlework, Karabagh & Aubusson rugs, 19th - 20th century French wallpapers; 18th - 20th century British ceramics; Chinese exports; contemporary & modern art, including Vasarely, Gabo, Picasso, Michel, Agam, Hepworth, & Laurens
Exhibitions: Rotating exhibits
Publications: The Art of the Craftsmen: Ruppert Kohlmaier; The Decorative Arts at Longue Vue; The Queen's Table
Activities: Classes for adults & children; docent training; lect open to public, 25 vis lectr per year; gallery talks; tours; original objects of art lent to other like institutions contingent on facilities; museum shop sells books, reproductions, prints, slides, decorative arts

M **LOUISIANA DEPARTMENT OF CULTURE, RECREATION & TOURISM,** Louisiana State Museum, 751 Chartres St, PO Box 2448 New Orleans, LA 70176. Tel 504-568-6968; Fax 504-568-4995; Internet Home Page Address: www.lsm.art.state.la.us; *Chmn* Andrew Rinker; *Dir Cur Serv* Sam Rykels; *Registrar* Ann Woodniff; *Museum Dir* David M Kahn
Open Tues - Sun 10 AM - 4 PM; Admis adults $6, seniors & students $5, children 12 & under free, educational groups free by appointment; Estab 1906, to collect, preserve & present original materials illustrating Louisiana's heritage; Gallery is maintained & has eight historic buildings in New Orleans with facilities in Patterson, Natchitoches, Thibodaux & Baten Rouge containing paintings, prints, maps, photographs, decorative arts, furniture, costumes & jazz; Average Annual Attendance: 320,000; Mem: 3000; dues $20-$35; annual meeting in May
Income: $3,000,000 (financed by state appropriation)
Special Subjects: Photography, Decorative Arts
Collections: Carnival costumes (2000 items); Colonial documents (500,000 folios); decorative art (8000 items); flat textiles (1000 items); historic costumes (6000 items); jazz & Louisiana music (40,000 objects); Louisiana silver (300); maps & cartography (3000); Newcomb pottery & allied arts (750); paintings (1500 canvases); photography (70,000 images); post Colonial manuscripts (500,000); prints (3000 works); rare Louisiana books (40,000); Sculpture (125 works)

Exhibitions: 8 -12 rotating exhibitions per year
Publications: Louisiana's Black Heritage; Louisiana Portrait Gallery. Vol I; A Social History of the American Alligator; A Medley of Cultures: Louisiana History at the Cabildo; exhibit catalogs
Activities: Classes for adults & children; docent training; dramatic programs; lect open to public, 6-10 vis lectr per year; tours; concerts; gallery talks; individual paintings & original objects of art lent to museums; book traveling exhibitions 2-3 per year; originate traveling exhibitions; museum shop sells books, original art, reproductions, prints, maps & crafts

L **Louisiana Historical Center Library,** 751 Chartres Ave,; PO Box 2448, New Orleans, LA 70116. Tel 504-568-6968; Fax 504-568-6969; Elec Mail ism@crt.state.la.us; Internet Home Page Address: www.lsm.crt.state.la.us; *Cur Maps & Documents* Kathryn Page; *Dir* James F Sefcik; *Dir of Curatorial Services* James Carboni; *Dir Mktg & Pub Relations* Lorry Lovell
Open 9 AM - 5 PM Tue - Sun; Admis adults $5, students, seniors, active military $4; Estab 1930, to collect materials related to Louisiana heritage
Library Holdings: Book Volumes 40,000; Clipping Files; Manuscripts; Maps; Original Art Works; Original Documents; Other Holdings Non-circulating Louisiana historical material; Pamphlets; Periodical Subscriptions 5; Records; Reels; Sculpture; Slides
Collections: Costumes, textiles, science & technology, maps & manuscripts, material culture, visual arts, jazz
Activities: Classes for adults & children; docent training; lect open to public; concerts; gallery talks; tours; sponsoring of competitions; originate traveling exhibitions; museum shop sells books, reproductions, prints

M **NEW ORLEANS ACADEMY OF FINE ARTS,** Academy Gallery, 5256 Magazine St, New Orleans, LA 70115. Tel 504-899-8111; Fax 504-897-6811; Elec Mail noafa@bellsouth.com; Internet Home Page Address: noafa.com; *Pres* Dorothy J Coleman; *Dir Academy* Auseklis Ozolis; *Gallery Dir & Adminr* Patsy Baker Adams
Open Mon - Fri 9 AM - 4 PM, Sat 10 AM - 4 PM; No admis fee; Estab 1978 to provide instruction in the classical approaches to art teaching adjunct to school; Average Annual Attendance: 300
Income: Financed by the academy & endowments
Exhibitions: Rotating exhibits
Activities: Classes for adults; lect open to members only, 3 vis lectr per year; academic awards in painting, drawing, sculpture

M **NEW ORLEANS GLASSWORKS GALLERY & PRINTMAKING STUDIO,** (New Orleans School of GlassWorks, Gallery & Printmaking Studio) New Orleans ArtWorks Gallery, 727 Magazine St, New Orleans, LA 70130. Tel 504-529-7279; Fax 504-539-5417; *Pres* Geriool Baronne
Open Mon - Sat 11 AM - 5 PM; No admis fee; Estab 1990 to educate visitors about glassworking, printmaking & book binding; 2,500 sq ft front room collectors' gallery with daily demonstrations in the glass, print & book arts studio; Average Annual Attendance: 20,000; Mem: approx 25; dues $40, monthly meetings
Income: Financed by mem, sale of art works & admissions, national & international corporate funding, tax deductible donations & grants
Library Holdings: Auction Catalogs; Cards; Exhibition Catalogs; Memorabilia; Original Art Works; Other Holdings; Prints; Sculpture
Special Subjects: Prints, Sculpture, Etchings & Engravings, Decorative Arts, Furniture, Glass, Metalwork, Enamels
Exhibitions: Gilles Chambrier; Victor Cikansky; Curtiss Brock; Andrew Brott; Dale Chihuly; Josh Cohen; Erwin Eisch; Harvey Littleton; Fabienne Picaud; Adam Ridge; Richard Royal; Anthony Schafermeyer; Pino Signoretto; Paul Stankard; Frank Van Denham; Udo Zembok; Claire Kelly; Miriam Martin
Activities: Docent training; concerts; gallery talks; tours; sponsoring of competitions; classes for adults & children; lect open to mems only, 4 vis international master artists per year; daily demonstrations in working artists studio; 12 vis lectrs per yr, one on the first Sat of each month; scholarships offered; original objects of art lent; leading museums for exhibits; dinner receptions while master glassblowers and artists create pieces, tours & demonstrations in their studios; book traveling exhibs at leading museums & universities; gallery sells original art, books, glasswork & prints made in school's glass sculpture & printmaking studio, bookbinding, bronze pours, papermaking

M **NEW ORLEANS MUSEUM OF ART,** One Collins Diboll Circle, City Park New Orleans, LA 70124; PO Box 19123 New Orleans, LA 70179-0123. Tel 504-488-2631; Fax 504-484-6662; Elec Mail webmaster@noma.org; Internet Home Page Address: www.noma.org; *Pres Bd* S Stewart Farnet; *Dir* E John Bullard; *Chief Cur Exhib* Patricia Pecorara; *Cur Decorative Arts* John W Keefe; *Asst Dir for Art* Steve Maklansky; *Ed Arts Quarterly* Wanda O'Shello; *Cur Educ* Kathy Alcaine; *Registrar* Paul Tarver; *Librn* Sheila Cork; *Dep Dir* Jacqueline Sullivan; *Cur Asian Art* Lisa Rotondo-McCord; *Cur Paintings* Victoria Cooke; *Cur African Art* William A. Fagaly; *Asst Registrar* Jennifer Ickes; *Public Information Officer* Brandi Hand; *Asst to the Dir* Emma Haas; *Sculpture Garden Mgr* Jinn Jeffrey; *Graphics Coordr* Aisha Champagne; *Controller* Gail Asprodites
Open Wed-Sun 10 AM - 5 PM, cl Mon, Tues & legal holidays; Admis adults (18-64) $8, children (3-17) $4, special exhibition fee; Estab 1910; building given to city by Issac Delgado, maintained by municipal funds & private donations to provide a stimulus to a broader cultural life for the entire community. Stern Auditorium, Ella West Freeman wing for changing exhibitions; Wisner Educ wing for learning experiences; Delgado Building for permanent display shop; 135,000 sq ft space, three fl; Average Annual Attendance: 220,000; Mem: 13,000; dues $35-$1000; annual meeting in Nov
Income: Financed by mem, city appropriation, federal, state & foundation grant, corporate contributions & individual donations
Special Subjects: Afro-American Art, Decorative Arts, Folk Art, Furniture, Porcelain, Portraits, Painting-American, Period Rooms, Silver, Bronzes, Painting-European, Painting-French, Sculpture, Photography, American Indian Art, African Art, Glass, Oriental Art, Asian Art, Painting-Dutch, Painting-Flemish
Collections: Old Master paintings of various schools; Kress Collection of Italian Renaissance & Baroque Painting; Chapman H Hyams Collection of Barbizon & Salon Paintings; Pre-Columbian & Spanish colonial painting & sculpture; works by Edgar Degas; 20th century English & Continental art, including Surrealism &

School of Paris; Japanese Edo period painting; African Art; photography; graphics; Melvin P Billups Glass Collection; 19th & 20th century United States & Louisiana painting & sculpture; Latter- Schlesinger Collection of English & Continental Portrait Miniatures; Victor Kiam Collection of African, Oceanic American Indian, & 20th century European & American Painting & Sculpture; The Matilda Geddings Gray Foundation Collection of Works by Peter Carl Faberge; Rosemunde E & Emile Kuntz Federal & Louisiana Period Rooms; 16th - 20th century French art; Bert Piso Collection of 17th century Dutch painting; Imperial Treasures by Peter Carl Faberge from the Matilda Geddings Gray Foundation Collection; 18th, 19th & 20th Century French Paintings; Morgan-Whitney Collection of Chinese Jades; Rosemonde E & Emile Kuntz Rooms of Late 18th - Early 19th Century American Furniture
Exhibitions: (3/3/2007-8/26/2007) The Changing Role of Women in French Society in the 19th Century from the National Museums of France; (6/16/2007-8/26/2007) Albert Duer: Graphic Master Works from the Konrad Liebmann Foundation, Hanover; (9/8/2007-10/28/2007) Gaston Lachaise 1882-1935; (11/10/2007-2/24/2008) Blue Winds Dancing: The Whitecloud Collection of Native American Art
Publications: Arts Quarterly; catalogs of New Orleans Museum of Art organized exhibitions; History of New Orleans Museum of Art
Activities: Classes for adults & children; docent training; teacher workshops; lectr open to public, 20-25 vis lectr per year; concerts; gallery talks; tours including multi-language; VanGo Museum on Wheels; competitions; Isaac Delgado Memorial Award ann to outstanding art patron; individual paintings & original objects of art lent in metropolitan New Orleans; book traveling exhibitions 5 per year to schools and libraries; originate traveling exhibitions to other art museums in USA and Europe; museum shop sells books, original art, reproductions, prints, cards, slides, toys & jewelry

L **Felix J Dreyfous Library,** 1 Collins Diboll Cir, PO Box 19123 New Orleans, LA 70179. Tel 504-658-4100; Fax 504-658-4199; Internet Home Page Address: www.noma.org; *Librn* Sheila Cork
Admis non-LA residents $8, adults $7, seniors 65 & over $4, children 3 & under free; Estab 1971 to provide information for reference to the curators, mus members & art researchers; Open Wed-Sun 10 AM - 4:30 PM; Average Annual Attendance: 100,000
Income: Financed by mem, donations & gifts
Library Holdings: Audio Tapes; Book Volumes 20,500; Cassettes; Clipping Files; Exhibition Catalogs; Fiche; Memorabilia; Pamphlets; Periodical Subscriptions 50; Reels; Slides; Video Tapes
Special Subjects: Photography
Collections: WPA Project - New Orleans Artists
Exhibitions: (3/3/2007-6/2/2007) Femme, Femme, Femme: Paintings of Women in French Society from Daumier to Picasso frm the Mus of France; (6/16/2007-8/26/2007) Albert Duer: Graphic Master Works from the Konrad Liebmann Foundation, Hanover; (9/8/2007-10/28/2007) Gaston Lachaise 1882-1935, EWF Galleries; (11/10/2007-2/24/2008) Blue Winds Dancing: The Whitecloud Coll of Native American Art, EWF Galleries; (3/15/2008-5/25/2008) Humans, Animals & the Spirit World: Art from Village & Trial India, from the Bhansali Coll, EWF Galleries; (6/28/2008-9/21/2008) The Baroque World of Fernando Botero, EWF Galleries; (11/8/2008-2/1/2009) Monet to Gauguin: The Traveling Artist in the Age of Impressionism, EWF Galleries
Activities: Mus shop sells collectibles; books; jewelry & art related items

M **THE OGDEN MUSEUM OF SOUTHERN ART, UNIVERSITY OF NEW ORLEANS,** 925 Camp St, New Orleans, LA 70130. Tel 504-539-9614; Fax 504-539-9602; Internet Home Page Address: www.ogdenmuseum.org; *CEO & Dir* J Richard Gruber, PhD; *Develop Mem* Beverly Sakauye; *VChmn* William Goldring; *Educ* Ann Rowson Love; *Pub Rels* Mary Beth Haskins; *Fin Dir* Tambi Farish; *Registrar & Archivist* Rose Macaluso; *Cur* David Houston; *Security* Henry St Phillip; *Mus Shop Mgr* Jan Katz
Open Tues - Wed & Fri - Sun 9:30 AM - 5:30 PM, Thurs 9:30 AM - 8:30 PM; cl New Year's Day, Mardi Gras, July 4th, Thanksgiving & Christmas; Admis adults $10, seniors $8, students $5, discount to groups, free admission for Louisiana residents on Thurs 9:30 - 4:30 PM; Founded 1994, Grand Opening 2003; Mus showcases the visual art & culture of the American south; Average Annual Attendance: 50,000 - 99,999
Special Subjects: Decorative Arts, Drawings, Glass, Photography, Painting-American, Prints, Sculpture, Crafts
Collections: Coll showcases the visual art of the southern states & WA DC from 1733 - present
Activities: Docent training; live music by Southern musicians every Thurs night: Ogden After Hours; lects; guided tours; hobby workshops; Sunday afternoon programming; Sundays At the O

M **UNIVERSITY OF NEW ORLEANS,** Fine Arts Gallery, 2000 Lake Shore Dr, New Orleans, LA 70148. Tel 504-280-6493; Fax 504-280-7346; Elec Mail finearts@uno.ed; Internet Home Page Address: www.uno.edu; *Gallery Dir* Doyle Gertjejansen
Open Mon - Fri 8 AM - 4:30 PM; No admis fee; Estab 1974 to expose the students & community to historic & contemporary visual arts; Gallery consists of 1800 sq ft, 165 lineal ft of wall space, 20 ft ceilings, natural & artificial lighting; Average Annual Attendance: 15,000
Income: Financed by state appropriation
Exhibitions: Rotating exhibits
Activities: Credit & non-credit classes for adults in conjunction with University of New Orleans; lect open to public, 20 vis lectr per year

L **Earl K Long Library,** Lakefront, New Orleans, LA 70148. Tel 504-280-6354; Fax 504-286-7277; Internet Home Page Address: www.library.uno.edu; *Chmn Reference Svcs* Robert T Heriard
Open Mon-Thurs 8AM-11AM; Fri 8AM-8PM, Sat 9AM-6PM, Sun Noon-8PM; Estab 1958 for scholarly & professional research; Circ 110,140; For lending & reference
Income: $2,401,104 (financed by state appropriation)
Purchases: $797,407
Library Holdings: Book Volumes 394,729; Cards; Fiche; Other Holdings Art per subs 250; Art vols 12,974; Periodical Subscriptions 4500; Reels

THE WOMAN'S EXCHANGE

M University Art Collection, Tel 504-865-5685; Fax 504-865-5761; *Cur* Joan G Caldwell
Open Mon - Fri 9 AM - 4:45 PM, cl school holidays & Mardi Gras; No admis fee; Estab 1980
Special Subjects: Drawings, Graphics, Photography, Prints, Sculpture, Watercolors, Religious Art, Pottery, Decorative Arts, Manuscripts, Historical Material, Maps
Collections: Linton-Surget Collection; La Artists; Modern British Prints; 19th & 20th Century paintings; photograph collection
Activities: Gallery talks; tours; original objects of art lent to other institutions; book traveling exhibitions; originate traveling exhibitions

M Newcomb Art Gallery-Carroll Gallery, Tel 504-865-5328; Fax 504-865-5329; Internet Home Page Address: www.tulane.edu; *Cur* Sally Main; *Dir* Erik Neil
Open Mon - Fri 10 AM - 5 PM, Sat & Sun Noon - 5 PM; No admis fee; Estab 1996 featuring permanent collection of objects related to the artistic production of Newcomb College & Tulane University; 3,500 sq ft designed with natural & artificial lighting; Average Annual Attendance: 7,000
Special Subjects: Architecture, Painting-American, Pre-Columbian Art, Pottery, Decorative Arts, Glass, Stained Glass
Collections: Newcomb Decorative & Minor Arts; Newcomb Pottery
Publications: Deb Kass: The Warhol Project
Activities: Classes for children; docent training; ect open to public, 8-12 vis lectr per year; gallery talks; tours; awards; scholarships offered; individual paintings & original objects of art lent to AAM certified/accredited institutions; book traveling exhibitions 2-4 per year; originate traveling exhibitions

L Architecture Library @Howard-Tilton Memorial Library, Tel 504-865-5391; Fax 504-862-8966; Elec Mail heckerf@mailhost.tcs.tulane.edu; Internet Home Page Address: www.voyager.tcs.tulane.edu; *Head* Frances E Hecker
Open fall & spring Mon - Thurs 8 AM - 10 PM, Fri 8 AM - 5 PM, Sat 10 AM - 5 PM, Sun 2 - 10 PM; summer Mon - Thurs 8:30 AM - 6 PM, cl Sat & Sun; For reference only
Library Holdings: Book Volumes 16,000; Clipping Files; Exhibition Catalogs; Periodical Subscriptions 249
Special Subjects: Architecture

M Gallier House Museum, Tel 504-525-5661; Fax 504-568-9735; Elec Mail hgrimagallier@aol.com; Internet Home Page Address: www.hgghh.org; *Cur* Richard Scott; *Bus Mgr* Steve Smith; *Deputy Dir* Jan Bradford; *Dir* Stephen Moses
Open Mon - Fri 10 AM - 3:30 PM, cl Sat & Sun; Admis adult $6, students, seniors, children 8-18 $5; Estab 1971 to preserve & exhibit the house of James Gallier Jr & 19th century decorative arts; Average Annual Attendance: 20,000; Mem: 500; dues $10-$250
Library Holdings: Book Volumes 1000; Clipping Files; Manuscripts; Original Art Works; Pamphlets; Periodical Subscriptions 10; Photographs; Prints; Sculpture; Slides; Video Tapes
Special Subjects: Decorative Arts, Architecture, Art History, Furniture, Porcelain, Period Rooms, Silver, Textiles
Collections: 19th century architecture, art, decorative arts, New Orleans lifestyles
Exhibitions: Architectural Details; Architectural displays & house exhibitions
Publications: Quarterly newsletter
Activities: Classes for adults & children; docent training; lect open to pubic; 2 vis lectr per year; retail store sells books, Victorian gifts

OPELOUSAS

M OPELOUSAS MUSEUM OF ART, INC (OMA), Wier House, 106 N Union St Opelousas, LA 70570. Tel 337-942-4991; Fax 337-942-4930; Elec Mail omamuseum@aol.com; *Dir* Nan Wier; *Cur Exhib* Keith J Guidry
Open Tues - Fri1 - 5 PM, Sat 9 AM - 5 PM; No admis fee; Estab 1997 to display traveling art exhibitions; Shows exhibitions from major museums, private collections & community & local exhibitions; Average Annual Attendance: 3,500; Mem: 500+
Special Subjects: Historical Material, Architecture, Drawings, Hispanic Art, Latin American Art, Mexican Art, Painting-American, Photography, American Indian Art, American Western Art, Folk Art, Etchings & Engravings, Landscapes, Afro-American Art, Decorative Arts, Collages, Painting-Canadian, Marine Painting, Painting-French, Maps, Juvenile Art, Medieval Art, Painting-Spanish, Painting-Italian, Painting-German, Military Art, Painting-Israeli
Activities: Lect open to public; lect for members only; 6 vis lectrs per year; tours; book traveling exhibitions 4 per year; originate traveling exhibitions 2 per year

PATTERSON

M WEDELL-WILLIAMS MEMORIAL AVIATION MUSEUM, 394 Airport Cir Rd, Patterson, LA 70392. Tel 985-395-7067; Internet Home Page Address: www.lsm.crt.state.la.us/wedellex.htm
Estab by the Legislature as the state's official aviation mus, mus is named after Jimmie Wedell & Harry Williams, two Louisiana aviators who formed an air service in 1928; Mus is committed to preserving & presenting artifacts & documents reflecting aviation history in Louisiana
Special Subjects: Historical Material
Collections: Airworthy replica of Wedell's "44" racer; 1939 D175 Beechcraft; Presidential Aero-Commander 680 that was used during the Eisenhower administration; race trophies from the 1930s; the state's largest coll of model airplanes; vintage hot air balloon basket
Activities: Model airplane-building classes; astronomy workshop for children

PORT ALLEN

M WEST BATON ROUGE PARISH, (West Baton Rouge Historical Association) West Baton Rouge Museum, 845 N Jefferson Ave, Port Allen, LA 70767. Tel 225-336-2422; Fax 225-336-2448; Elec Mail contact_us@wbrmuseum.org; Internet Home Page Address: www.wbrmuseum.org; *Educ Cur* Jeannie Giroir Luckett; *Admin Asst* Alice LeBlanc; *Cur* Lauren Davis
Open Tues - Sat 10 AM - 4:30 PM, Sun 2 - 5 PM; Admis adults $4 seniors & students $2, West Baton Rouge Parish residents free; Estab 1968 to foster interest

in history, particularly that of West Baton Rouge Parish; to encourage research, collection & preservation of material illustrating past & present activities of the parish; to operate one or more museums; to receive gifts & donations; to accept exhibits & historical materials on loan; A large room housing a scale model of a sugar mill (one inch to one ft, dated 1904) & parish memorabilia; restored French creole cottage (circa 1830); a room 31 X 40 ft for art exhibits; restored plantation quarters cabin (1850); Average Annual Attendance: 18,000; Mem: 300; dues $10; annual meeting in Jan
Income: $250,000 (financed by mem, gifts & millage levied on parish)
Library Holdings: Original Documents; Pamphlets; Photographs; Prints
Special Subjects: Architecture, Costumes, Crafts, Manuscripts, Furniture, Maps, Restorations, Period Rooms
Collections: Art collection of parish artifacts; c1830 French Creole Cottage; contemporary Louisiana (drawings, paintings, prints & sculpture); early 19th century furnishings; historic documents & family papers; maps; needlework; newcomb pottery; duck decoys; c1880s Share Cropper Cabins (2); early 20th century shot gun dwelling
Exhibitions: Gallery with six shows yearly
Publications: Ecoutez, 4 times a yr
Activities: Classes for children; docent training; lect open to public, 1 vis lectr per year; tours; book traveling exhibitions semi-annually; museum shop sells books, magazines, original art, reproductions & prints

SAINT MARTINVILLE

M LONGFELLOW-EVANGELINE STATE COMMEMORATIVE AREA, Hwy 31, 1200 N Main Saint Martinville, LA 70582. Tel 337-394-4284, 394-3754, 888-677-2900; Fax 337-394-3553; Elec Mail longfellow@crt.state.la.us; Internet Home Page Address: www.crt.state.la.us; *Site & Cur Mus* Suzanna Laviolette; *Mgr* Reinaldo Barnes
Open daily 9 AM - 5 PM, cl Thanksgiving, Christmas & New Year; Admis adults $2, adults over 61 free, children under 13 free, all school groups free; Estab 1934 to display & describe 19th century French lifeways & folk items; Artworks are displayed in a 19th century plantation home, in the interpretive center of the site & in the 18th century cabin; Average Annual Attendance: 26,000
Income: Financed by state appropriations
Special Subjects: Architecture, Painting-American, Photography, Prints, Textiles, Religious Art, Ceramics, Crafts, Folk Art, Pottery, Landscapes, Decorative Arts, Portraits, Dolls, Furniture, Glass, Porcelain, Painting-French, Historical Material, Coins & Medals, Period Rooms, Embroidery, Laces, Pewter, Reproductions
Collections: Early 19th century portraits; 18th, 19th & 20th centuries textile arts; local craft & folk art; Louisiana cypress furniture; 19th century antiques; religious art of the 19th century; wood carvings; Plantation House; Acadian Art
Exhibitions: Attaqapas Trade Days (Fall); Creole Holidays (Dec); Plantation Days (Spring)
Activities: Dramatic programs; docent training; lect open to public, 4 vis lectr per year; tours; workshops

SHREVEPORT

M CENTENARY COLLEGE OF LOUISIANA, Meadows Museum of Art, 2911 Centenary Blvd, PO Box 41188 Shreveport, LA 71134-1188. Tel 318-869-5169; Fax 318-869-5730; Elec Mail ddufilho@centenary.edu; Internet Home Page Address: www.centenary.edu/departme/meadows; *Dir* Diane Dufilho
Open Tues - Fri Noon - 4 PM, Sat & Sun 1 - 4 PM; No admis fee; Estab 1975 to house the Indo-China Collection of Drawings & Paintings by Jean Despujols; Eight galleries; main gallery on first floor 25 x 80 ft; other galleries 25 x 30 ft; linen walls, track lights and no windows; Average Annual Attendance: 18,000
Income: Financed by endowment
Special Subjects: Ethnology, Painting-French
Collections: 360 works in Indo-China Collection, dealing with Angkor Region, The Cordillera, Gulf of Siam, Laos, The Nam-Te, The Thai, Upper Tonkin, Vietnam
Exhibitions: Rotating exhibits
Publications: Partial Catalog of Permanent Collection with 21 color plates
Activities: Docent training; lect open to public, 4 vis lectr per year; gallery talks; tours; individual paintings & original objects of art lent to qualified museums; lending collection includes one motion picture

M LOUISIANA STATE EXHIBIT MUSEUM, 3015 Greenwood Rd, Shreveport, LA 71109; PO Box 38356, Shreveport, LA 71133. Tel 318-632-2020; Fax 318-632-2056; *Admin* Forrest Dunn; *Dir* Mary R Zimmerman
Open Mon - Fri 9 AM - 4 PM, Sat & Sun noon - 4 PM, cl major holidays; Admis $5 adults, $1 students 6 - 17, children under 5 free; Estab 1939 to display permanent & temporary exhibitions demonstrating the state's history, resources & natural beauty; Art Gallery is maintained; Average Annual Attendance: 200,000
Income: Financed by state appropriation
Special Subjects: Archaeology, Historical Material
Collections: Archaeology; dioramas; historical artifacts; Indian artifacts; murals
Publications: brochures
Activities: Public Archaeology program; films; concerts; tours

M R W NORTON ART FOUNDATION GALLERY, 4747 Creswell Ave, Shreveport, LA 71106-1899. Tel 318-865-4201; Fax 318-869-0435; Elec Mail gallery@rwnaf.org; Internet Home Page Address: www.rwnaf.org; *Pres Bd* M Lewis Norton; *Secy Bd* Jerry M Bloomer; *Bldg & Grounds Supt* Gerry Ward; *Dir Pub Relations* Jerry M Bloomer; *Communications Dir* Everl Adair
Open Tues - Fri 10 AM - 5 PM, Sat & Sun 1 - 5 PM, cl Mon & holidays; No admis fee; Estab 1946, opened 1966. Founded to present aspects of the development of American & European art & culture through exhibition & interpretation of fine works of art & literature, both from the Gallery's own collections & from those of other institutions & individuals; American & European art spanning over four centuries spotlighting art of the American West by Frederic Remington and Charles Russell; Average Annual Attendance: 30,000
Income: Financed by endowment

Library Holdings: Auction Catalogs; Book Volumes; Exhibition Catalogs; Pamphlets; Periodical Subscriptions
Special Subjects: Painting-American, Sculpture, American Western Art, Pottery, Painting-European, Portraits, Silver, Tapestries, Miniatures
Collections: American miniatures & colonial silver; contemporary American & European painting & sculpture; painting & sculpture relating to Early American history; Paintings by 19th century American artists of the Hudson River School; Portraits of famous confederate leaders; 16th Century Flemish tapestries; Wedgwood pottery; paintings & sculpture by western American artists Frederic Remington & Charles M Russell
Publications: Announcements of special exhibitions; catalogs (47 through 1992); catalogs of the Frederic Remington & Charles M Russell Collections & of the Wedgwood Collection
Activities: Educ dept; lect open to public; gallery talks; tours; book traveling exhibs 4-5 per yr; mus shop sells exhibition catalogs, catalogs of permanent collection

L **Library,** 4747 Creswell Ave, Shreveport, LA 71106-1899. Tel 318-865-4201; Fax 318-869-0435; Internet Home Page Address: www.softdisk.com/comp/norton; *Sec Bd* Jerry Bloomer
Open Tues - Fri 1 - 5 PM; None; Estab 1946 to acquire and make available for public use on the premises, important books, exhibition catalogs, etc relating to the visual arts, literature, American history and genealogy, as well as other standard reference and bibliographic works for reference only; Circ Non-circulating; A mus of Am & European art spanning over 4 centuries; Average Annual Attendance: 20,000 - 30,000
Income: Financed by endowment
Library Holdings: Book Volumes 12,000; Clipping Files; Exhibition Catalogs; Manuscripts; Memorabilia; Other Holdings Original documents; Auction catalogs; Pamphlets; Periodical Subscriptions 100; Photographs; Reels; Slides
Special Subjects: Art History, Decorative Arts, Illustration, Photography, Drawings, Etchings & Engravings, Graphic Arts, Manuscripts, Painting-American, Painting-British, Painting-Flemish, Painting-French, Painting-German, Prints, Sculpture, Painting-European, History of Art & Archaeology, Portraits, Watercolors, Ceramics, American Western Art, Bronzes, Printmaking, Porcelain, Southwestern Art, Glass, Stained Glass, Metalwork, Dolls, Goldsmithing, Miniatures, Pottery, Silver, Silversmithing, Marine Painting, Landscapes, Coins & Medals, Pewter, Architecture
Collections: James M Owens Memorial Collection of Early Americana (725 volumes on Colonial history, particularly on Virginia); large collection of books on Frederic Remington & Charles M Russell
Activities: Conduct tours & slide programs; sales of collection & special exhib catalogs

L **SOUTHERN UNIVERSITY LIBRARY,** 3050 Martin Luther King Jr Dr, Shreveport, LA 71107. Tel 318-674-3400; Fax 318-674-3403; Internet Home Page Address: www.susla.edu; *Dir* Orella R Brazile
Open Mon-Thurs 8AM-9PM, Fri 8AM-5PM, Sat 9AM-1PM; Estab 1967 to supplement the curriculum & provide bibliographic as well as reference service to both the academic community & the pub
Library Holdings: Book Volumes 48,789; Cassettes 1121; Clipping Files; Fiche 24,308; Filmstrips 414; Framed Reproductions; Motion Pictures 59; Original Art Works; Pamphlets 750; Periodical Subscriptions 379; Prints; Records 293; Reels; Reproductions 12; Sculpture; Slides 22,874; Video Tapes 240
Collections: Black Collection, pictures, clippings & books; Louisiana Collection; Black Ethnic Archives (local people)
Exhibitions: Show Local Artists Exhibitions

MAINE

ALNA

M **WISCASSET, WATERVILLE & FARMINGTON RAILWAY MUSEUM (WW&F),** 97 Cross Rd, Alna, ME 04535; PO Box 242, Alna, ME 04535. Tel 207-563-2516; Fax 207-563-5207; Internet Home Page Address: www.wwfry.org; *Pres* Alfred E Wylie; *Mem Chmn & Mus Shop Mgr* Allan C Fisher; *Fin Dir* Richard V Bourdon; *Publicity* James Patten; *Archivist* Marcel Levesque
Memorial Day - Columbus Day: Sat & Sun 9 AM - 5 PM; after Columbus Day - before Memorial Day: Sat 9 AM - 5 PM; Admis adults $5, children $3; Estab 1989; Operating restored two-ft gauge railroad with mus & shops; Average Annual Attendance: 1000 - 9999; Mem: Dues Indiv Life $200, Indiv Annual $20
Collections: Numerous books, photos, documents, artifacts, and original railroad equip from 2-ft gauge railroad
Publications: WW&F Newsletter, six times per yr; WW&F Musings, 128-pg book
Activities: Docent prog; guided tours; training progs for professionals; films; ann picnic; Halloween & Christmas trains

AUGUSTA

M **UNIVERSITY OF MAINE AT AUGUSTA,** Jewett Hall Gallery, 46 University Dr Augusta, ME 04330. Tel 207-621-3243; Fax 207-621-3293; Elec Mail kareng@maine.edu; *Dir* Karen Gilg
Open Mon - Thurs 10 AM - 7 PM, Fri 10 AM - 5 PM; No admis fee; Estab 1970 to provide changing exhibitions of the visual arts for the university students and faculty and for the larger Augusta-Kennebec Valley community; the principal exhibition area is a two level combination lounge and gallery; Average Annual Attendance: 9,000
Income: Financed by university budget
Collections: Drawings, paintings, outdoor sculpture
Exhibitions: Five major art exhibits
Activities: Lect open to public, 2-3 vis lectr per year; gallery talks; tours

BANGOR

M **UNIVERSITY OF MAINE,** Museum of Art, 40 Harlow St, Bangor, ME 04401-5102. Tel 207-561-3350; Fax 207-561-3351; Elec Mail umma@umit.maine.edu; Internet Home Page Address: www.umma.umaine.edu; *Admin Assoc* Kathryn Jovanelli; *Dir* Wally Mason; *Educ Coordr* Gina Platt; *Registrar/Preparator* Steve Ringle
Open Mon - Sat 9 AM - 5 PM; Admis $3; Estab 1946 to add to the cultural life of the university student; to be a service to Maine artists; to promote good & important art, both historic & modern; The mus is licated in downtown Bangor's Historic Norumbega Hall; Average Annual Attendance: 23,450
Income: Financed by state appropriation to university, donations & grants
Special Subjects: Painting-American, Prints, Drawings, Photography, Watercolors, Woodcuts, Etchings & Engravings, Portraits, Posters
Collections: The Mus of Art's permanent coll has grown to a stature which makes it a nucleus in the state for historic & contemporary art. It includes more than 6000 original works of art & is particularly strong in American mid-20th century works
Exhibitions: (10/20/2006-1/13/2007) Richard Estes Prints, John Marin: A Print Survey; (1/26/2007-4/14/2007) Saul Leiter: Early Colors; (4/27/2007-6/30/2007) Linda Butler: Yangtze Remembered
Publications: Biennial catalogs & exhibition notes, newsletter
Activities: Classes for adults and children; lects open to the pub & mems only, 4-6 vis lectr per year; gallery talks, tours; scholarships & fels offered; museums by mail program; individual paintings & original objects of art lent to qualified museums & campus departments; book traveling exhibitions 1-5 per year; originate traveling exhibitions 1-3 year

BATH

M **MAINE MARITIME MUSEUM,** 243 Washington St, Bath, ME 04530. Tel 207-443-1316; Fax 207-443-1665; Internet Home Page Address: www.bathmaine.com; *Exec Dir* Thomas R Wilcox Jr; *Dir Library* Nathan Lipfert; *Cur* Anne Witty
Open daily 9:30 AM - 5 PM, cl New Year's Day, Thanksgiving, Christmas; Admis adults $9.50, children under 17 $6.50, under 6 free, seniors $8.50, group rates available; Estab 1964 for the preservation of Maine's maritime heritage; Several galleries; Average Annual Attendance: 65,000; Mem: 1800; dues $25 & up; annual meeting in Sept.
Income: Financed by mem, gifts, grants & admis
Special Subjects: Marine Painting
Collections: Marine art; navigational instruments; ship models; shipbuilding tools; shipping papers; traditional watercraft
Exhibitions: Historical Percy & Small Shipyard; Lobstering & the Maine Coast; Maritime History of Maine; small watercraft; other rotating exhibits
Publications: Rhumb Line, quarterly
Activities: Classes for adults & children; docent training; lect open to public, 20 vis lectr per year; group tours; concerts; gallery talks; individual paintings & original objects of art lent to non-profit institutions with proper security & climate control; Mus shop sells books, reproductions, prints & related novelties

L **Archives Library,** 243 Washington St, Bath, ME 04530. Tel 207-443-1316; Fax 207-443-1665; Elec Mail lipfert@bathmaine.com; Internet Home Page Address: www.mainemaritimemuseum.org; *Dir Library* Nathan Lipfert; *Librn* Cathy Matero
Open Mon - Fri & by appointment; Estab 1964; Circ Non-circ; Small reference library; Average Annual Attendance: 1,800
Income: Financed by mem, admis, gifts & grants
Library Holdings: Audio Tapes 220; Book Volumes 10,000; Clipping Files; Kodachrome Transparencies; Memorabilia; Motion Pictures; Original Art Works; Other Holdings Manuscripts; Pamphlets; Periodical Subscriptions 50; Photographs 40,000; Reels 620; Slides; Video Tapes 482
Special Subjects: Manuscripts, Maps, Painting-American, Painting-European, Historical Material, Marine Painting, Scrimshaw, Painting-Australian
Collections: Sewall Ship Papers, shipbuilding firms business papers
Exhibitions: Maritime History of Maine, Lobstering & the Maine Coast
Activities: Mus shop sells books, magazines, original art, reproductions & prints

BLUE HILL

M **PARSON FISHER HOUSE,** Jonathan Fisher Memorial, Inc, 44 Mines Rd, Rte 15, Blue Hill, ME 04614; PO Box 537, Blue Hill, ME 04614. Tel 207-374-2459; Fax 207-374-5082; Elec Mail sandra8962@aol.com; Internet Home Page Address: www.jonathanfisherhouse.org; *Pres* Eric Linnell; *Adminr* Sandra Linnell
Open July - Sept Mon - Sat 2 - 5 PM; Admis $2; Estab 1965 to preserve the home & memorabilia of Jonathan Fisher. The house was designed & built by him in 1814; Average Annual Attendance: 300; Mem: 260; dues endowment $1000, contributing $100, sustaining $25, annual $10; annual meeting in Aug
Income: Financed by admis fees, dues, gifts & endowment funds
Purchases: Original Fisher paintings or books
Collections: Furniture, Manuscripts, Paintings & Articles made by Fisher
Exhibitions: Annual Arts & Crafts Fair
Activities: Lect open to public, 1-2 vis lectr per year; individual paintings & original objects of art lent to state museum or comparable organizations for exhibit; sales shop sells reproductions

BOOTHBAY HARBOR

A **BOOTHBAY REGION ART FOUNDATION,** One Townsend Ave, Boothbay Harbor, ME; PO Box 124, Boothbay Harbor, ME 04538. Tel 207-633-2703; Elec Mail localart@gwi.net; Internet Home Page Address: www.boothbayartists.org; *Pres* James Taliana; *Gallery Mgr* June Rose
Open Apr 15 - Oct 12 Mon - Sat 11 AM - 5 PM, Sun Noon - 5 PM; No admis fee; Estab 1964, originated to help develop an art curriculum in the local schools, presently functions to bring art of the region's artists to enrich the culture of the community; Store front gallery providing exhibit space in heart of Boothbay

Harbor; includes prints, drawings, pastels, oils & watercolors; Average Annual Attendance: 6,000; Mem: 250; dues $25 & up; annual meeting third Tues in Oct

Income: Financed by mem, contributions & commissions

Exhibitions: Seven juried & invitational shows of graphics, paintings & sculpture by artists of the Boothbay Region

Activities: Adult & children workshop, Jan, Feb & Mar (fee); scholarships offered; lending collection includes 100 original art works & 100 paintings

BRUNSWICK

M **BOWDOIN COLLEGE,** Peary-MacMillan Arctic Museum, 9500 College Station, Brunswick, ME 04011-9112. Tel 207-725-3416; Fax 207-725-3499; Internet Home Page Address: www.bowdoin.edu/arcticmuseum; *Cur* Genevieve LeMoine; *Exhib Coordr* David Maschino; *Dir* Susan A Kaplan; *Mus Outreach Coordr* Nancy Wagner; *Asst Cur* Anne Witty; *Exhib Technician* Steve Bunn
Open Tues - Sat 10 AM - 5 PM, Sun 2 - 5 PM, cl Mon & holidays; No admis fee; Estab 1967; Museum consists of 3 galleries containing ivory, fur & soapstone Inuit artifacts, Arctic exploration equipment, natural history specimens, prints & paintings; Average Annual Attendance: 13,943

Special Subjects: Painting-American, Photography, Sculpture, American Indian Art, Anthropology, Ethnology, Primitive art, Eskimo Art, Painting-Canadian, Historical Material, Ivory, Maps, Leather

Collections: Inuit artifacts & drawings; exploration equipment; Arctic photos & films; Arctic related manuscripts & books

Exhibitions: One permanent exhibition on Arctic exploration & Inuit culture; temporary exhibits every 6 months

Activities: Docent training; lect open to public, 3-7 vis lectr per year; tours; individual paintings & original objects of art or ethnographic objects lent to other museums; museum shop sells books, cards & original native art

M **Museum of Art,** 9400 College Station, Brunswick, ME 04011-8494. Tel 207-725-3275; Fax 207-725-3762; Elec Mail artmuseum@bowdoin.edu; Internet Home Page Address: www.bowdoin.edu/art; *Asst Dir* Suzanne K Bergeron; *Cur* Alison Ferris; *Dir* Katy Kline; *Registrar* Laura Latman; *Preparator* Jose Ribas
Open Tues - Sat 10 AM - 5 PM, Sun 2 - 5 PM, cl Mon & holidays; No admis fee; Estab 1891-1894; Ten galleries containing paintings, medals, sculpture, decorative arts, works on paper & antiquities; Average Annual Attendance: 28,000

Special Subjects: Drawings, Painting-American, Photography, Prints, Watercolors, Pre-Columbian Art, Textiles, Ceramics, Woodcarvings, Woodcuts, Decorative Arts, Collages, Portraits, Asian Art, Silver, Painting-Dutch, Painting-French, Coins & Medals, Painting-Flemish, Antiquities-Greek, Antiquities-Roman, Painting-German, Pewter, Antiquities-Etruscan, Antiquities-Assyrian

Collections: Assyrian reliefs; European & American paintings, decorative arts, drawings, prints, sculpture & photographs; Far Eastern ceramics; Greek & Roman antiquities; Kress Study Collection; Molinari Collection of Medals & Plaquettes

Exhibitions: 14 - 20 temporary exhibitions per year; three major exhibitions per year

Activities: Docent training; lect open to public, 6-10 vis lectr per year; gallery talks; tours; individual paintings & original objects of art lent to accredited museums; book traveling exhibitions 3 per year; originate traveling exhibitions to other accredited museums; museum shop sells books, reproductions, slides, jewelry

DAMARISCOTTA

M **ROUND TOP CENTER FOR THE ARTS INC,** Arts Gallery, PO Box 1316, Damariscotta, ME 04543. Tel 207-563-1507; Elec Mail rtca@lincoln.midcoast.com; Internet Home Page Address: lincoln.midcoast.com/-artca; *Artistic Dir* Nancy Freeman; *Admin Dir* Sue Atwater
Open Mon - Fri 11 AM-4PM, Sat Noon-4PM, Sun 1-4 PM; No admis fee; Estab 1988 for presentation & participation in quality arts with emphasis on educ; Average Annual Attendance: 16,500; Mem: 1300; dues individual $30, family $40; annual meeting in Mar

Income: $150,000 (financed by mem)

Special Subjects: Painting-American

Collections: All facets & eras of visual arts history; classical music collection; theatre script collection

Exhibitions: 6-8 rotating exhibitions per yr

Publications: Catalogues, gallery booklets & newsletters

Activities: Classes for adults & children; dramatic programs; lect open to public, 5-10 vis lectr per year; museum shop sells prints, crafts & paintings

L **Round Top Library,** PO Box 1316, Damariscotta, ME 04543. Tel 207-563-1507; Elec Mail rtca@lincoln.midcoast.com; Internet Home Page Address: www.lincoln.midcoast.com/-artca; *Artistic Dir* Nancy Freeman; *Admin Dir* Sue Atwater
Open Mon - Fri 11 - 4 PM, Sat 12 - 4 PM, Sun 1 - 4 PM; Estab 1989 for arts research & reference; For reference only; Mem: Part of center

Income: $150,000 (financed by endowment)

Library Holdings: Book Volumes 2500; Exhibition Catalogs; Original Art Works; Pamphlets; Records; Sculpture

Special Subjects: Art History, Mixed Media, Historical Material, American Western Art, American Indian Art, Primitive art, Mexican Art, Afro-American Art, Oriental Art, Architecture

DEER ISLE

M **HAYSTACK MOUNTAIN SCHOOL OF CRAFTS,** 89 Haystack School Dr, Deer Isle, ME 04627-0518; PO Box 518, Deer Isle, ME 04627-0518. Tel 207-348-2306; Fax 207-348-2307; Internet Home Page Address: www.haystack-mtn.org; *Chmn Bd* Wayne Higby; *Dir* Stuart J Kestenbaum; *Pres* RoseAnne Somerson; *Treas* Stewart Thomson
Open tours Wed 1PM; $5 adults; Estab 1950 to provide craft educ workshops

Special Subjects: Glass, Mixed Media, Furniture, Gold, Textiles, Woodcuts, Graphics, Southwestern Art, Ceramics, Crafts, Woodcarvings, Decorative Arts, Jewelry, Porcelain, Silver, Metalwork, Embroidery

Publications: Annual brochure

Activities: One & two week summer sessions in ceramics, graphics, glass, jewelry, weaving, blacksmithing, papermaking, furniture, sculpture & fabrics; lect open to public, 15 vis lectr per year; scholarships offered

L **Library,** PO Box 518, Deer Isle, ME 04627-0518. Tel 207-348-2306; Fax 207-348-2307; Elec Mail haystack@haystack-mtn.org; Internet Home Page Address: www.haystack-mtn.org; *Dir* Stuart J Kestenbaum; *Asst Dir* Ellen Wieske
Open June-Aug tours Wed 1PM; $5 for tours; Estab. for educ in the crafts; For reference only; Average Annual Attendance: 500

Income: Privately financed

Library Holdings: Book Volumes 1000; Exhibition Catalogs; Kodachrome Transparencies; Maps; Memorabilia; Periodical Subscriptions 10; Slides; Video Tapes

Special Subjects: Decorative Arts, Mixed Media, Graphic Arts, Graphic Design, Ceramics, Crafts, Printmaking, Porcelain, Furniture, Glass, Metalwork, Enamels, Gold, Goldsmithing, Handicrafts, Jewelry, Silver, Silversmithing, Textiles, Woodcuts, Embroidery, Pottery, Woodcarvings

Publications: Monograph series

Activities: Classes for adults & children; lect open to the public; 40 vis lectrs per year; AIA 25 year award, ACC Gold Medal award; schols and fels offered; museum shop sells books

ELLSWORTH

M **HANCOCK COUNTY TRUSTEES OF PUBLIC RESERVATIONS,** Woodlawn Museum, 19 Black House Dr, Ellsworth, ME 04605; PO Box 1478, Ellsworth, ME 04605. Tel 207-667-8671; Fax 207-667-7950; Elec Mail info@woodlawnmuseum.com; Internet Home Page Address: www.woodlawnmuseum.com; *Pres* Lowell Thomas Jr; *Exec Dir* Joshua C Torrance
Open May & Oct Tues - Sun 1 - 4 PM, June - Sept Tues - Sat 10 AM - 5 PM, Sun 1 - 4 PM; Admis adults $7.50, children & students $3; Estab 1929; Historical estate operated by the Hancock County Trustees of Pub Reservations; Average Annual Attendance: 10,000; Mem: 450

Income: Financed by private trust fund, donations & admis

Special Subjects: Drawings, Graphics, Painting-American, Photography, Prints, Watercolors, Textiles, Ceramics, Woodcarvings, Etchings & Engravings, Decorative Arts, Manuscripts, Portraits, Dolls, Furniture, Glass, Jewelry, Silver, Carpets & Rugs, Historical Material, Maps, Miniatures, Period Rooms, Embroidery, Antiquities-Oriental

Collections: fine examples of American & European fine & decorative arts in original setting; carriages & sleighs

Publications: Colonel John Black of Ellsworth (1781 - 1856); David Cobb an American Patriot; Legacy of the Penobscot Million; Quarterly newsletter

Activities: Classes for adults & children; docent training; dramatic program; lectrs for members only; 6 vis lectrs per year; concerts; gallery talks; tours; museum shop sells books, postcards & reproductions

M **THE NEW ENGLAND MUSEUM OF TELEPHONY, INC.,** The Telephone Museum, 166 Winkumpaugh Rd, Ellsworth, ME 04605; PO Box 1377, Ellsworth, ME 04605. Tel 207-667-9491; Elec Mail switchboard@downeast.net; Internet Home Page Address: www.thetelephonemuseum.org; *Pres & Dir* Sandra Galley; *Fin Dir* Dave Thompson; *VPres* Jeffrey V. Webber
Open Jul - Sept Thurs - Sun 1 PM - 4 PM, open by appt June & Oct, cl Nov - May; Admis adults $5, children $2.50; Estab 1983; Mus traces the history of telecommunications through hands-on working exhibs of telephone switching systems. By illustrating the technical, social & corporate evolution of the telephone network the mus provides a basis for understanding modern communication systems; Average Annual Attendance: approx 350; Mem: dues The LongLines Club (life members) $1,000, Sustaining $250, Participating $100, Family or Org $35, Indiv $20

Collections: Technical documents; personal & corporate papers; manuals & reference materials; Large-scale electro-mechanical telephone switching systems; switchboards; telephone sets; central office equip; outside plant equip

Publications: The Pole Line, biannual newsletter; Subscriber Directory, annual; The Telephone: A Love/Hate Relationship, Aug 2004; Military Communications, Aug 2004; Telstar and Andover, Maine, Aug 2004

Activities: Lects; guided tours; ann Telephone Fair (Open House); spec exhibs; PROJECT DAYS: allows mus mems to work on equip restoration projs; research in early telephone lines in Hancock Co, Maine; children's workshops

HALLOWELL

A **KENNEBEC VALLEY ART ASSOCIATION,** Harlow Gallery, 160 Water St, Hallowell, ME 04347. Tel 207-622-3813; *Treas* David Hodson; *Secy* Linda Murray
Open Fri 7 - 9 PM, Sat & Sun 11 AM - 5 PM; No admis fee; Estab 1963 to foster an interest in appreciation of fine art, to promote local artists & provide space for cultural events; Single gallery on ground level having central entrance & two old storefront windows which provide window display space; Average Annual Attendance: 700; Mem: 100; dues $25; meeting second Mon each month

Income: Financed by mem, dues, donations, art sales & rent

Exhibitions: Monthly exhibitions include individual, member shows & juried shows

Publications: Newsletter, monthly

Activities: Classes for adults & children, poetry readings; lect open to the public, 8-10 vis lectrs per year; gallery talks; scholarships offered

KENNEBUNK

M **BRICK STORE MUSEUM & LIBRARY,** 117 Main St, Kennebunk, ME 04043. Tel 207-985-4802; Fax 207-985-6887; Internet Home Page Address: www.brickstoremusuem.org; *Registrar* Kathryn Hussey; *Exec Dir* Tracy Baetz; *Archivist* Roz Magnuson; *Asst Archivist* Kathy Ostrander; *Community Outreach* Cheryl Price
Open Tues - Fri 10 AM - 4:30 PM, Sat 10 AM - 1 PM; Admis by donation; Estab 1936 to preserve & present history & art of southern Maine; Non-circulating reference library only; Average Annual Attendance: 4,000; Mem: 450; dues vary

Library Holdings: Audio Tapes; Book Volumes 4000; Cards; Clipping Files; Compact Disks; Exhibition Catalogs; Fiche; Filmstrips; Framed Reproductions; Manuscripts; Maps; Memorabilia; Original Art Works; Original Documents; Other Holdings Architectural drawings & plans; Pamphlets; Periodical Subscriptions; Photographs; Prints; Reels; Reproductions; Sculpture; Video Tapes
Special Subjects: Decorative Arts, Historical Material, Landscapes, Marine Painting, Architecture, Glass, Furniture, Portraits, Painting-American, Textiles, Maps, Costumes, Porcelain, Dioramas, Laces, Bookplates & Bindings
Collections: Art Library of Edith Cleaves Barry; Maritime - Kenneth Roberts, Booth Tarkington & Maine authors in general; Papers of Architect William E Barry; 40,000 items: photographs, documents, fine art & decorative arts; Abbott Graves paintings; Joh Brewster Jr painings; William Badger paintings
Publications: Chapters in Local History newsletter; Architectural Walking Tour Book
Activities: Docent training; history camp, architectural walking tours, field trips; lect open to public, 1-3 vis lect per year; concerts; concerts; tours; individual paintings & original objects to other nonprofit museums; originate traveling exhibitions to schools & senior citizen groups; museum shop sells books, original art & reproductions

KINGFIELD

M STANLEY MUSEUM, INC, School St, PO Box 77 Kingfield, ME 04947. Tel 207-265-2729; Fax 207-265-4700; Elec Mail stanleym@tdstelme.net; Internet Home Page Address: www.stanleymuseum.org; *Dir* Susan S Davis; *Office Mgr* Marjorie Trenholm
Open Tues - Sun 1 - 4 PM May 1 - Oct 3l, Mon - Fri 1 - 4 PM Nov 1 - Apr 30; Admis adults $2, children $1; Estab 1981; Average Annual Attendance: 3,000; Mem: 700; dues $30-$1,000; annual meeting in July
Income: $100,000 (financed by endowment, mem, donations & grants)
Purchases: $35,000 (steam car)
Special Subjects: Architecture, Drawings, Painting-American
Collections: Chansonetta Stanley Emmons (photography, glass plate negatives); Raymond W Stanley Archives; Collection of Steam cars, photography & violins
Activities: Classes for adults & children in dramatic & docent programs; lect open to public, 10 vis lectr per year; tours; original objects of art lent to other museums & galleries; museum shop sells books, magazines, reproductions, prints & gift items

LEWISTON

M BATES COLLEGE, Museum of Art, Olin Arts Ctr, 75 Russell St Lewiston, ME 04240-6028. Tel 207-786-6158; Fax 207-786-8335; Elec Mail museum@bates.edu; Internet Home Page Address: www.bates.edu/museum.xml; *Cur Coll* Bill Low; *Educ Coordr* Anthony Shostak; *Dir* Mark H.C. Bessire; *Asst Cur* Liz Kelton Sheehan
Open Mon - Sat 10 AM - 5 PM, cl major holidays; No admis fee; Estab in the Olin Arts Center, Oct 1986 to serve Bates College & the regional community; Average Annual Attendance: 25,000
Special Subjects: Painting-American, Prints, Oriental Art, Painting-British, Painting-French, Painting-Italian
Collections: Marsden Hartley Memorial Collection; 19th & 20th Century American & European Collection (painting, prints & sculpture)
Exhibitions: Wenda Gu
Publications: Documenting China: Contemporary Photography and Social Change
Activities: Lect open to public; gallery talks; tours; individual paintings & original objects of art lent to museums, college & university galleries

M CREATIVE PHOTOGRAPHIC ARTS CENTER OF MAINE, Dorthea C Witham Gallery, 59 Canal St, Box 921 Lewiston, ME 04243. Tel 207-782-1369; Fax 207-782-5931; *Asst Exec Dir* Dorothea Witham; *Faculty Dean* Jere DeWaters; *Exec Dir* J Michael Patry
Open daily 9 AM - 4:30 PM; No admis fee; Estab 1993 for lectures & exhibition photos; Largest photographic gallery in the Northeast. Specializing in international, national & regional photographers (John Sexton, Marcie Bronstein, Reha Ackaya); 2 other smaller galleries; maintains reference library; Average Annual Attendance: 6,000; Mem: 100; monthly meetings
Income: $20,000 (financed by mem, city appropriation & grants)
Purchases: John Sexton Portfolio
Special Subjects: Photography
Collections: Robert Darby Collection; Diane F Furbush Collection, J David Hathaway Collection; J Michael Patry Collection
Exhibitions: Biannual Student Show; exhibits by Lance Gross; Reha Ackaya, Marcie Bronstein, John Sexton
Publications: Iris, bimonthly
Activities: Classes for adults & children; docent training; lect open to public, 12 vis lectr per year; competitions with awards; scholarships offered; lending collection contains 200 items; book traveling exhibitions 1 per year; originate traveling exhibitions 1 per year; sales shop sells books, original art, prints, slides, cameras & film

LIBERTY

M DAVISTOWN MUSEUM, Liberty Location, 58 Main St # 4, Liberty, ME 04949; PO Box 346, Liberty, ME 04949. Tel 207-589-4900; Fax 207-589-4900; Elec Mail curator@davistownmuseum.org; Internet Home Page Address: www.davistownmuseum.org
Open July 1 - Labor Day Thurs - Sun: 10 AM - 5 PM; after Labor Day - Christmas & first Sat in Mar - June: Sat 10 AM - 5 PM, Sun 11 AM - 5 PM; also open by appt. Cl Christmas - first Sat in Mar; No admis fee, donations accepted; Regional tool, history & art mus located in Liberty Village, Maine; features colonial & 18th - 19th century hand tools; mus is forum for the work of local & regional artists
Special Subjects: Historical Material, Photography

Collections: Extensive coll of 18th & 19th century tools; outdoor flower garden; contemporary Maine sculpture; sculpture garden exhibiting the work of over a dozen Maine artists on 2 1/2 acres of field, located at the Hulls Cove site
Activities: Ann art exhib featuring local artists

MONHEGAN

M MONHEGAN MUSEUM, One Lighthouse Hill, Monhegan, ME 04852. Tel 207-596-7003; Elec Mail monheganmuseum@earthlink.net; *Pres* Edward L Deci; *Cur* Tralice P Bracy; *Cur Annual Exhibs* Emily Gray; *Cur Coll* Jennifer Pye
Open daily 11:30 AM - 3:30 PM (July-Aug), 12:30 - 2:30 PM (Sept); Estab 1968 to preserve the history of Monhegan Island; Housed in the historic Monhegan Island Light Station; Average Annual Attendance: 6,000; Mem: 300; dues $5-$1,000
Income: $25,000 (financed by endowment, mem & donations)
Special Subjects: Painting-American, Photography, Prints, Landscapes, Marine Painting, Historical Material, Period Rooms
Collections: Art, natural history, social history & fishing industry exhibits all related to Monhegan Island

NEW GLOCESTER

M UNITED SOCIETY OF SHAKERS, Shaker Museum, 707 Shaker Rd, New Glocester, ME 04260. Tel 207-926-4597; Elec Mail usshakers@aol.com; Internet Home Page Address: www.shaker.lib.me.us; *Archivist & Librn* Tina Agren; *Cur* Michael Graham; *Dir* Leonard L Brooks
Open Mon - Sat 10 AM - 4:30 PM Memorial Day - Columbus Day; Admis for tours; adults $6.50, children 6-12 yrs $2, under 6 free with adult; Estab 1931, incorporated 1971, to preserve for educational & cultural purposes Shaker artifacts, publications, manuscripts & works of art; to provide facilities for educational & cultural activities in connection with the preservation of the Shaker tradition; to provide a place of study & research for students of history & religion; 4 historic bldgs
Library Holdings: Book Volumes; Cassettes; Clipping Files; Exhibition Catalogs; Kodachrome Transparencies; Lantern Slides; Manuscripts; Maps; Original Art Works
Special Subjects: Architecture, Drawings, Photography, Watercolors, Anthropology, Archaeology, Textiles, Costumes, Religious Art, Ceramics, Crafts, Folk Art, Pottery, Landscapes, Decorative Arts, Manuscripts, Dolls, Furniture, Glass, Carpets & Rugs, Historical Material, Maps, Miniatures, Embroidery, Leather
Collections: Drawings & paintings by Shaker artists; Shaker textiles; community industries; furniture; manuscripts; metal & wooden ware
Exhibitions: Poland Spring and the Shakers
Publications: The Shaker Quarterly, annual
Activities: Classes for adults; workshops in summer for herb dyeing, oval box making, cultivating, weaving, spinning, photography, baskets; lect open to public; concerts; tours; individual paintings & original objects of art lent to institutions mounting exhibits; originate traveling exhibitions; museum shop sells books, magazines, prints, slides, herbs produced in the community, yarn from flock, woven items

L The Shaker Library, 707 Shaker Rd, New Glocester, ME 04260. Tel 207-926-4597; Elec Mail brooksl@shaker.lib.me.us; Internet Home Page Address: www.shaker.lib.me.us; *Dir* Leonard Brooks; *Cur* Michael Graham; *Archivist & Librn* Tina S Agren
Open Tues, Wed & Thurs 8:30AM-4:30PM, appointments required; Estab 1882; For reference only
Library Holdings: Audio Tapes; Book Volumes 12,000; Cassettes; Clipping Files; Exhibition Catalogs; Filmstrips; Kodachrome Transparencies; Manuscripts; Maps; Micro Print 317; Motion Pictures; Original Art Works; Original Documents; Other Holdings Ephemera; Periodical Subscriptions 57; Photographs; Prints; Records; Reels 353; Slides; Video Tapes
Special Subjects: Folk Art, Mixed Media, Photography, Manuscripts, Maps, Posters, Historical Material, History of Art & Archaeology, Crafts, Video, Furniture, Textiles, Woodcuts, Architecture
Collections: Shaker; Radical Christian
Publications: The Shaker Quarterly
Activities: Classes for adults & children; lect open to public; concerts

OAKLAND

M MACARTNEY HOUSE MUSEUM, 110 Main St, Oakland, ME 04963; PO Box 59, Oakland, ME 04963. Tel 207-465-7549; *Vol Pres* Alberta Porter; *Vol Treas* Richard Lord; *Cur* Ruth W Wood
Open Jun - Aug Wed 1 - 4 PM; No admis fee, donations accepted; Estab 1979; Historical period home specializing in Oakland area history; Mem: dues Life $50, Family $7.50, Indiv $5

OGUNQUIT

M OGUNQUIT MUSEUM OF AMERICAN ART, 543 Shore Rd, Ogunquit, ME 03907-0815; PO Box 815, Ogunquit, ME 03907-0815. Tel 207-646-4909; Fax 207-646-6903; Elec Mail ogunquitmuseum@aol.com; *Dir & Cur* Michael Culver
Open July - Oct 31, Mon - Sat 10:30 AM - 5 PM, Sun 2 - 5 PM, cl Labor Day; Admis adults $5, senior citizens & students $4, children under 12 free; Estab 1953 to exhibit, collect & preserve American art; Museum consists of five interior galleries with 6000 sq ft; central gallery provides an expansive view of the Atlantic Ocean & the rockbound coast; outdoor sculpture garden; Average Annual Attendance: 13,000; Mem: 600; dues benefactor $5000, patron $1000, donor $500, business $250, associate $100, couple $50, individual $25
Income: Financed by endowment, mem, donations
Purchases: works by Will Barnet, Gertrude Fiske, Robert Henri, Winslow Homer, Edward Hopper, Jack Levine, Fairfield Porter

Library Holdings: Exhibition Catalogs; Original Documents; Photographs; Slides; Video Tapes
Special Subjects: Drawings, Painting-American, Sculpture
Collections: Paintings, drawings & sculpture by 20th Century contemporary Americans, including Marsh, Burchfield, Hartley, Lachaise, Tobey, Kuhn, Strater, Graves, Levine & Marin
Exhibitions: (2001) solo exhibits of paintings by Neil Welliver, George Lloyd, John Folinsbee, J J Enneking; (2003) 50th Anniversary Exhibition of Selections from Collection
Publications: Exhibition catalog, annually; Museum Bulletin
Activities: Educ dept; docent training; lect open to public, 2 vis lectr per year; gallery talks; tours; concerts; individual paintings & original objects of art lent to other museums; lending collection contains 1500 original art works; originate traveling exhibitions; museum shop sells books, magazines, original art, reproduction prints, posters, postcards, museum catalogs & art books

L **Reference Library,** 543 Shore Rd, Ogunquit, ME 03907; PO Box 815, Ogunquit, ME 03907. Tel 207-646-4909; Fax 207-646-6903; Elec Mail ogunquitmuseum@aol.com; Internet Home Page Address: ogunquitmuseum.org; *Dir & Cur* Michael Culver; *Bd Pres* Timothy Ellis
Open July - Oct 31, Mon - Sat 10:30 AM - 5 PM, Sun 2 - 5 PM; Admis adults $5, seniors $4, students $3; Estab 1953; For reference only; Average Annual Attendance: 13,000; Mem: 780, dues $30 - $5,000
Income: financed by endowments, memberships, donations
Library Holdings: Book Volumes 400; Clipping Files; Exhibition Catalogs; Manuscripts; Memorabilia; Pamphlets; Photographs; Reproductions
Activities: Docent training; lect open to public, 6 visting lect per year; concerts; gallery talks; tours; museum shop sells books, reproductions & prints

PEMAQUID POINT

A **PEMAQUID GROUP OF ARTISTS,** Pemaquid Art Gallery, Lighthouse Park, Pemaquid Point, ME; PO Box 105, South Bristol, ME 04568-0105. Tel 207-644-8105, 677-2752; *Pres* Julie Babb; *Treas* Maude Olsen; *Vice Pres* Debra L Arter; *Recording Secy* Sally Loughridge; *Gallery Mgr* Bill Olsen
Open Mon - Sat 10 AM - 5 PM, Sun 1 - 5 PM; Donation optional; Estab 1929 to exhibit & sell paintings, sculpture, carvings by members & to give scholarships; Maintains an art gallery, open Jun - Oct; Average Annual Attendance: 8,000; Mem: 31; must be residents of the Bristol Peninsula, Damariscotta or Newcastle & pass jury; dues $30; annual meeting in Sept
Income: Financed by dues, patrons, commissions on paintings & sculpture
Exhibitions: Summer members exhibition
Activities: schols offered; gallery sells original art

PORTLAND

L **MAINE COLLEGE OF ART,** Joanne Waxman Library, 522 Congress St, Portland, ME 04101. Tel 207-775-5153; Fax 207-772-5069; Elec Mail laurag@saturn.caps.maine.edu; Internet Home Page Address: http://library.meca.edu; *Librn* Laura Graveline
Open Mon - Thurs 8 AM - 9 PM, Fri 8 AM - 5 PM, Sat & Sun 11 AM - 4 PM; No admis fee; Estab 1973, to support the curriculum & serve the needs of students & faculty; Circ 12,000; Lending library
Library Holdings: Audio Tapes; Book Volumes 19,700; Cassettes; Exhibition Catalogs; Lantern Slides; Other Holdings Ephenera Files; Periodical Subscriptions 98; Video Tapes 150
Special Subjects: Art History, Decorative Arts, Calligraphy, Drawings, Etchings & Engravings, Graphic Arts, Graphic Design, Ceramics, Conceptual Art, Advertising Design, Lettering, Asian Art, Aesthetics, Jewelry, Landscapes

M **The Institute of Contemporary Art,** 522 Congress St, Portland, ME 04101. Tel 207-879-5742, Ext 229; Fax 207-780-0816; Elec Mail ica@meca.edu; Internet Home Page Address: www.meca.edu/ica; *Dir Educ* Cindy M Foley; *Dir* Mark H C Bessire
Open Tues, Wed, Fri - Sun 11 AM - 4 PM, Thurs 11 AM - 9 PM; No admis fee; Gallery estab 1983 to present temporary exhibitions of contemporary art & design; Newly renovated 3300 sq ft gallery located on first floor of Beaux Arts building; Average Annual Attendance: 20,000
Income: $38,700
Special Subjects: Conceptual Art, African Art
Publications: Exhibition catalogues, 2 yearly
Activities: Tours of exhibitions; classes for children; docent training; lect open to public; 6 vis lects per year; gallery talks; tours; organize traveling exhibitions

A **MAINE HISTORICAL SOCIETY,** 489 Congress St, Portland, ME 04101; 485 Congress St, Portland, ME 04101. Tel 207-879-0427; Fax 207-775-4301; Elec Mail info@mainehistory.org; Internet Home Page Address: www.mainehistory.org; Internet Home Page Address: www.mainememory.net; *Admin Asst & Receptionist* Sara Archbald; *Exec Dir* Richard D'Abate; *Cur* John Mayer; *Head Library Svcs* Nick Noyes; *Dir Maine Memory Network* Dan Kaplan
Maine History Gallery and Store, Wadsworth-Longfellow House tours - call ahead for seasonal hours, cl state & federal holidays; Admis charged; Estab 1822 to collect, preserve & teach the history of Maine; the Soc owns & operates a historical research library & the Wadsworth - Longfellow House of 1785; Average Annual Attendance: 30,000; Mem: 2,700; dues $15 & up; annual meeting in May or June
Income: Donations, admis
Collections: Architecture; books archival; material culture; photographs; special collection-prints
Publications: Maine Historical Society, quarterly; tri-annual monograph
Activities: Classes for adults; docent training; lect open to public, 4 vis lectr per year; gallery talks; tours; individual paintings & original objects of art lent; museum shop sells books, reproductions & prints

M **Wadsworth-Longfellow House,** 489 Congress St, Portland, ME 04101. Tel 207-774-1822; Fax 207-775-4301; Elec Mail info@mainehistory.org; Internet Home Page Address: www.mainehistory.org; *Exec Dir* Richard D'Abate

Open Mon - Sat 10 AM - 4 PM; Admis adults $7, children $3, 17 & under, children under 5 free, seniors and students $6; Average Annual Attendance: 19,000; Mem: Part of the society
Income: Financed by donations, admis, dues & endowment income
Library Holdings: Manuscripts; Maps; Original Documents; Periodical Subscriptions; Photographs
Special Subjects: Architecture, Costumes, Ceramics, Landscapes, Decorative Arts, Manuscripts, Furniture, Miniatures, Period Rooms, Embroidery
Collections: Maine furniture; glass; historic artifacts; paintings; photographs; pottery; prints; textiles; Maine artists; Maine portraits, seascapes
Publications: Quarterly, special publications
Activities: Classes for adults; docent training; lects open to public; individual paintings & original objects of art lent to museums; museum shop sells books, reproductions, prints

L **Library and Museum,** 489 Congress St, Portland, ME 04101. Tel 207-774-1822; Fax 207-775-4301; Elec Mail info@mainehistory.org; Internet Home Page Address: www.mainehistory.org; *Reference Asst* William D Barry; *Reference Asst* Stephanie Phillbrick; *Cataloger* Nancy Noble; *Dir Library Svcs* Nicholas Noyes
Open Tues - Sat 10 AM - 4 PM; Admis $10; Estab 1822; Circ Non-circ; For reference only; Average Annual Attendance: 5,500; Mem: 2,500
Income: Part of society
Library Holdings: Auction Catalogs; Audio Tapes; Book Volumes 65,000; CD-ROMs; Cards; Cassettes; Clipping Files; Compact Disks; Exhibition Catalogs; Fiche; Lantern Slides; Manuscripts; Maps; Memorabilia; Motion Pictures; Original Art Works; Original Documents; Other Holdings; Pamphlets; Periodical Subscriptions; Photographs; Prints; Reels; Sculpture; Slides
Special Subjects: Folk Art, Decorative Arts, Photography, Graphic Arts, Painting-American, Historical Material, Printmaking, Cartoons, Interior Design, American Indian Art, Costume Design & Constr, Goldsmithing, Miniatures, Marine Painting, Architecture
Publications: Maines History Society Newsletter
Activities: Classes for adults & children; docent training; lect open to public; 3-5 vis lects per year; gallery talks; tours; fellowships; Baxter Award; Ring Award; NW Allen Award; lending collection contains original objects of art, Maine statewide; museum shop sells books, reproductions & prints

M **MHS Museum,** 489 Congress St, Portland, ME 04101. Tel 207-774-1822; Fax 207-775-4301; Elec Mail info@mainehistory.org; Internet Home Page Address: www.mainehistory.org; Internet Home Page Address: www.mainememory.net; Internet Home Page Address: www.vintagemaineimages.com; *Exec Dir* Richard D'Abate
Open May - Oct, daily 10 AM - 5 PM; winter hrs Mon-Sat 10 AM - 5 PM; Admis adults $7; students & seniors $6; children 6-17 & under $3; Estab 1822 to preserve & promote the understanding of Maine history; Changing exhibitions; one or two exhibitions at a time; Average Annual Attendance: 17,000; Mem: 2,500; dues $40; annual meeting in the Spring
Income: Mem, donations, grants, admissions
Library Holdings: Book Volumes; Fiche; Manuscripts; Maps; Memorabilia; Original Art Works; Original Documents; Pamphlets; Periodical Subscriptions; Photographs
Special Subjects: Glass, Painting-American, Archaeology, Costumes, Folk Art, Decorative Arts, Historical Material
Collections: Archaeological artifacts; costumes; decorative arts; folk art; history artifacts; paintings; books, manuscripts, maps, photos
Exhibitions: Rotating 1-2 times per yr
Publications: Maine History, qtr
Activities: Classes for adults & children; docent training; lect open to public, 5 vis lectr per year, gallery talks; tours; individual paintings & original objects of art lent to other museums & historical societies; lending collection contains original art works, books, photographs, slides, paintings & sculptures; book traveling exhibitions; originate traveling exhibitions; museum shop sells books, reproductions & prints

M **PORTLAND MUSEUM OF ART,** 7 Congress Square, Portland, ME 04101. Tel 207-775-6148; Fax 207-773-7324; Elec Mail pma@maine.rr.com; Internet Home Page Address: www.portlandmuseum.org; *Chief Cur* Jessica Nicoll; *Registrar* Ellie Vuilleumier; *Educ Dir* Dana Baldwin; *Dir Mktg & Pub Relations* Kristen Levesque; *Financial Officer* Elena Murdoch; *Dir* Daniel O'Leary; *Pub Relations & Mktg Asst* Amelia Carignan; *Dir Develop* Marilyn A Lalumiere; *VPres* Lawrence R Pugh; *VChmn* Charlton H Ames; *Dir Corporate* Amy Porter; *Cur Modern Art* Carrie Haslett; *Dir* Daniel E O'Leary; *Mus Shop Mgr* Eileen Arsenault
Open Mon 10 AM-5 PM, Tues, Wed, Sat & Sun 10 AM-5 PM, Thurs & Fri 10 AM-9 PM; Admis adults $6, sr citizens & students $5, children 6 -12 yrs $1, children under 6 free, Fri 5 - 9 free; Estab 1882 as a non-profit educational institution based on the visual arts & critical excellence; The Museum includes the McLellan-Sweat House, built in 1800, a Registered National Historic Landmark; the LDM Sweat Memorial Galleries, built in 1911; & the Charles Shipman Payson Building, built in 1983, designed by Henry N Cobb. This building is named for Mr Charles Shipman Payson, whose gift of 17 Winslow Homer paintings spurred expansion; Average Annual Attendance: 160,000; Mem: 7,000; dues $20 - $5000
Income: $3,200,000 (financed by endowment, mem, private & corporate donations, grants from national, state & municipal organizations)
Purchases: $62,000
Special Subjects: Painting-American, Prints, Sculpture, Decorative Arts, Painting-European, Glass
Collections: 19th & 20th century American & European paintings; neo-classic American sculpture; contemporary paintings; State of Maine Collection of artists associated with Maine including Winslow Homer, Andrew Wyeth & Marsden Hartley; American decorative arts of the Federal period; American glass
Publications: Bulletin, monthly; exhibition catalog; general information brochure
Activities: Classes for adults & children; docent training; lect open to public; tours; gallery talks; concerts; films; competitions; members' openings of exhibitions; individual paintings & original objects of art lent to museums; museum shop sells books, reproductions, prints, posters, cards, jewelry, gifts & items by Maine craftsmen

L PORTLAND PUBLIC LIBRARY, Art - Audiovisual Dept, 5 Monument Square, Portland, ME 04101. Tel 207-871-1725; Fax 207-871-1714; Internet Home Page Address: www.portlandlibrary.com; *Dir* Sheldon Kaye; *Art & AV Librn* Tom Wilsbach; *AV Mgr* Patti Delois
Open Mon, Wed & Fri 9 AM - 6 PM, Tues & Thurs Noon - 9 PM, Sat 9 AM - 5 PM; Estab 1867 as the public library for city of Portland; Circ 51,700
Income: Financed by endowment, city & state appropriation
Purchases: $32,000
Library Holdings: Book Volumes 18,000; Cassettes; Clipping Files; Exhibition Catalogs; Fiche; Motion Pictures; Original Art Works; Pamphlets; Periodical Subscriptions 96; Records; Reels; Sculpture; Video Tapes
Collections: Costume Book Collection; Maine Sheet Music; Press Books - Anthoensen Press, Mosher Press; The Drummond Collection (opera)
Exhibitions: Monthly exhibits concentrating on Portland & Maine artists
Activities: Lect open to the public

M VICTORIA MANSION - MORSE LIBBY HOUSE, (Victoria Mansion, Inc) 109 Danforth St, Portland, ME 04101-4504. Tel 207-772-4841; Fax 207-772-6290; Elec Mail information@victoriamansion.org; Internet Home Page Address: www.victoriamansion.org; *Adminr* Jessica Lundgren; *Museum Shop Mgr* Alice Ross; *Dir* Robert Wolterstorff; *Asst Dir* Julia Kirby; *Devel Coordr* Elizabeth Klebe; *Site Mgr/Educ Asst* Timothy Brosnihan
Open Mon - Sat 10 AM - 4 PM, Sun 1 - 5 PM May - Oct, spec Christmas hours; Admis adults $10, seniors $9, children (6-17) $3, under 6 free; Estab 1941 Italian Villa, Victorian Period architecture built by Henry Austin of New Haven, Connecticut in 1858-1860; interiors by Gustav Herter; Average Annual Attendance: 20,000; Mem: 360; dues $35; annual meeting in Apr
Income: $480,000 (financed by endowment, mem, grants & contributions
Library Holdings: Manuscripts; Memorabilia; Original Documents; Photographs; Slides
Special Subjects: Textiles, Architecture, Decorative Arts, Furniture, Porcelain, Carpets & Rugs, Historical Material, Restorations, Period Rooms, Stained Glass
Collections: Mid 19th Century Decorative Arts (luxury) & Architecture; Original Interior-Exterior & Original Furnishings, Gifts of the Victorian Period; Porcelain tableware
Exhibitions: Christmas Opening Exhibition
Activities: Classes for adults & children; docent training; lect open to public, 2-4 vis lectrs per year; tours; museum shop sells books & Victorian style gifts

PRESQUE ISLE

M NORTHERN MAINE MUSEUM OF SCIENCE, Univ of Maine at Presque Isle, 181 Main St, Presque Isle, ME 04769. Tel 207-768-9482; Internet Home Page Address: www.umpi.maine.edu/info/nmms/museum.htm; *Dir* Kevin McCartney, PhD; *Cur Chemistry* Michael Knopp, PhD; *Cur Herbarium* Robert J Pinette, PhD; *Cur Colls* Jeanie McGowan; *Cur Outdoor Areas* Chad Loder; *Cur Mathematics* Richard Rand, PhD; *Cur Mathematics* Richard Kimball; *Asst Cur Mathematics* Frank Kitteredge; *Asst Cur Physics* Alan Dearborn; *Asst Cur Entomology* Beth Taylor; *Cur Colls (Emeritus)* Earl Oman; *Asst Cur Agriculture (Emeritus)* Alvin Reeves, PhD
Mus mission is to support science educ in northern Maine by means of exhibs & progs for educators & students
Special Subjects: Anthropology, Archaeology
Collections: The Maine Solar System Model built by the People of Aroostook County, Maine; whale vertebrae & jawbone; dinosaur & miscellaneous animal & insect models; meteorology station; Coral Reef exhib & mural; mineral & rock exhibs
Activities: Tours; Library of Traveling Trunks; Campus Nature Trail

RANGELEY

M RANGELEY LAKES REGION LOGGING MUSEUM, 2695 Main St, Rangeley, ME 04970; POB 154 , Rangeley, ME 04970. Tel 207-864-5595; Elec Mail myocom@gmu.edu; Internet Home Page Address: http://mason.gmu.edu/~myocom; *Vol Mus Folklorist, Cur & Archivist* Dr Margaret Yocom; *Vol Pres & Dir* Rodney C Richard Sr; *Festival Coordr* Stephen A Richard; *Vol Treas* Laura Haley; *Vol Secy* Lucille Richard
Open Jul - Labor Day Sat & Sun 11 AM - 2 PM; No admis fee, donations accepted; Estab 1979; mus preserves & celebrates the heritage of logging in the western mountains of Maine; collects & displays artifacts that speak of the history & folklife of logging; Average Annual Attendance: under 500 by estimate; Mem: dues Indiv $5
Special Subjects: Folk Art, Historical Material
Collections: Tools & equipment for logging; folk culture; paintings; photographs; letters; journals; botanicals (nonliving); quilts; knitting; woodcarvings
Publications: Logging in the Maine Woods: The Paintings of Alden Grant, book by Yocom; Working the Woods, book by Yocom & Mundell
Activities: 2-day logging festival; Craft Show & Sale; Auction; lects; grp visits; museum-related items for sale

ROCKLAND

M WILLIAM A FARNSWORTH LIBRARY & ART MUSEUM, Museum, 356 Main St, PO Box 466 Rockland, ME 04841. Tel 207-596-6457; Fax 207-596-0509; Internet Home Page Address: www.farnsworthmuseum.org; *Dir* Christopher B Crosman; *Assoc Dir* Victoria Woodhull; *Chief Cur* Suzette McAvey; *Coll Cur* Helen Ashton Fisher
Summer: daily, 10-5; (please call for shoulder season hours); Admis $9, Rockland res, members, 17 & under free; Estab 1948 to house, preserve & exhibit American art; Twelve galleries house permanent & changing exhibitions; Average Annual Attendance: 79,000; Mem: 2500; dues $50 individual, $75 dual
Income: Financed by pvt donations, grants, dues
Special Subjects: Painting-American, Decorative Arts, Painting-European

Collections: American Art; two historic houses; emphasis on Maine art; works on paper; prints; sculpture; photography; decorative artifacts; manuscripts
Publications: Exhibition catalogs & brochures 6-8 per year; quarterly newsletter for members
Activities: Classes for adults & children; docent training; interactive computer programs; lect open to public, 6-10 vis lectrs per yr; concerts; gallery talks; tours; films; outreach programs; scholarships; individual paintings & original objects of art lent to other museums & galleries; originate traveling exhibitions; museum shop sell books, reproductions, notecards, educational toys & contemporary design objects; Julia's Gallery for Young Artists

L Library, 16 Museum St., Rockland, ME 04841-0466; P.O. Box 466, Rockland, ME 04841-0466. Tel 207-596-6457; Fax 207-596-0509; Elec Mail farnsworth@midcoast.com; Internet Home Page Address: www.farnesworthmuseum.org; *Dir* Christopher B Crosman; *Assoc Dir* Victoria Woodhull; *Cur 19th & 20th Century* Pamela Belanger; *Chief Cur* Suzette L McAvoy; *Coll Cur* Helen Ashton Fisher
Summer: daily, 10-5; Winter: Tues-Sat 10-5; please call for shoulder season hours; Admis $9 gen, Rockland res, mems, 17 & younger free; Estab 1948; Circ non-circulating; Art reference only. Archives on American artists, including papers of Louise Nevelson, Andrew Wyeth, N C Wyeth, George Bellows, Robert Indiana & Waldo Peirce; Average Annual Attendance: 75,000; Mem: 2,500 - Dues $50 individual, $75 dual
Income: Income from pvt donations, grants, dues
Library Holdings: Auction Catalogs; Audio Tapes; Book Volumes 4000; Clipping Files; Exhibition Catalogs; Kodachrome Transparencies; Manuscripts; Maps; Memorabilia; Motion Pictures; Original Art Works; Other Holdings American artists' file; Pamphlets; Periodical Subscriptions 13; Photographs; Prints; Sculpture; Slides; Video Tapes
Special Subjects: Art History, Folk Art, Etchings & Engravings, Painting-American, Prints, Watercolors, Printmaking, Marine Painting
Collections: American art with an emphasis on Maine Art; paintings, works on paper, prints, sculpture, photography, decorative arts, artifacts & manuscripts; N.C. Andrew, James Wyeth
Publications: Maine in America: American Art at the Farnsworth Museum
Activities: Classes for adults & children; docent training; interactive computer programs; lectr open to public; 6-10 vis lectrs per yr; concerts; gallery talks; tours; scholarships offered; extension programs to Maine schools statewide; originate traveling exhibitions; museum shop sells books, reproductions; Julia's Gallery for Young Artists

ROCKPORT

A CENTER FOR MAINE CONTEMPORARY ART, Art Gallery, 162 Russell Ave, PO Box 147 Rockport, ME 04856; PO Box 147 Rockport, ME 04856. Tel 207-236-2875; Fax 207-236-2490; Elec Mail info@cmcnow.org; Internet Home Page Address: www.cmcanow.org; *Cur* Britta Konau; *Pres* Oliver L Wilder; *Educ Dir* Cathy Melio
Open Tues - Sat 10 AM - 5 PM, Sun 1 PM - 5 PM Year round hours; Admis $5; To advance contemporary art in Maine through exhibitions & educational programs; Gallery building was an old livery stable & fire station overlooking Rockport Harbor; Average Annual Attendance: 15,000; Mem: 1200; dues $25-$50; annual meeting in Feb
Income: Financed by mem, contributions, grants, ann art auction & craft sale
Exhibitions: Seasonal: varied exhibitions of contemporary Maine art; Annual Juried Craft Fair
Publications: Newsletter; exhibition catalogues; brochures
Activities: Classes for adults & children; docent training; professional develop for artists; lect open to public, 8 vis lectrs per year; concerts; gallery talks; tours; originate traveling exhibitions to museums, galleries & universities who meet facility requirements; sales shop sells books, magazines, original art, prints, t-shirts & craft items by Maine craftspeople

A MAINE PHOTOGRAPHIC WORKSHOPS/ROCKPORT COLLEGE, (Maine Photographic Workshops) PO Box 200, Rockport, ME 04856. Tel 207-236-8519; Fax 207-236-2558; *Founder & Dir* David H Lyman
Open Mon - Sun 9 AM - 5 PM & 7 - 9 PM June - Aug; Admis lectures $3; Estab 1973 as photographic center; Contains four separate spaces for the display of vintage & contemporary photographers; Average Annual Attendance: 10,000; Mem: 1,400; dues $20; annual meetings Nov
Income: $2,000,000 (financed by mem, tuitions, sales & accommodations)
Collections: Eastern Illustrating Archive containing 100,000 vintage glass plates; The Kosti Ruohomaa Collection, prints of Life photographers; Master Work Collection; Paul Caponigro Archive, prints
Exhibitions: Forty photographic exhibitions
Publications: The Work Print, bi-monthly newsletter; Catalogues - Programs, semi-annual
Activities: Classes for adults & children; dramatic programs; lect open to public, 50 vis lectrs per year; competitions with awards; schols offered; lending collection contains photographs; book traveling exhibitions; originate traveling exhibitions; sales shop sells books, magazines, original art, reproductions, prints, photographic equipment & supplies

L Carter-Haas Library, Union Hall, PO Box 200 Rockport, ME 04856. Tel 207-236-8314; Fax 207-236-2558; Elec Mail library@theworkshops.com; *Library Mgr* Rachel Jones
Open Mon - Wed 1 - 10 PM, Thurs 10 AM - 3 PM; Estab 1975 to support student studies
Purchases: $5,000
Library Holdings: Audio Tapes; Book Volumes 6,500; Cards; Cassettes; Clipping Files; Exhibition Catalogs; Filmstrips; Framed Reproductions; Kodachrome Transparencies; Lantern Slides; Memorabilia; Micro Print; Motion Pictures; Original Art Works; Pamphlets; Periodical Subscriptions 45; Photographs; Records; Reproductions; Slides; Video Tapes
Special Subjects: Film, Photography
Activities: schols offered

SACO

M SACO MUSEUM, (York Institute Museum) 371 Main St, Saco, ME 04072. Tel 207-283-3861; Fax 207-283-0754; Internet Home Page Address: www.sacomaine.org/history_culture/york/home.html; *Coll Mgr* Ryan Nutting; *Exhibit Develop* Lauren Fensterstock; *Exec Dir* Marilyn Solvay
Open Mon, Tues, Wed & Fri Noon - 4 PM, Thurs Noon - 8 PM, cl Sat & Sun; Admis adult $4, seniors $3, students & groups $1; Estab 1867 as a museum of regional history & culture; Permanent collections feature Maine furniture, decorative arts & paintings, 1750-1880. Special exhibitions on regional art, social history & student art; Average Annual Attendance: 5,000; Mem: 300; dues benefactor $1,000, sponsor $500, donor $100, contributing $50, family $30, senior citizen family $25, single $20
Income: Financed by endowment, private & corporate contributions, federal, state & municipal support
Special Subjects: Architecture, Painting-American, Photography, Sculpture, Watercolors, Archaeology, Textiles, Costumes, Ceramics, Folk Art, Landscapes, Decorative Arts, Manuscripts, Portraits, Dolls, Furniture, Glass, Porcelain, Silver, Metalwork, Maps, Coins & Medals, Miniatures, Period Rooms, Pewter
Collections: Federal period Maine books, ceramics, decorative arts, glass, manuscripts, maps, natural history paintings, pewter, sculpture, silver
Activities: Classes for adults & children; art workshops; dramatic programs; docent training; lect open to public, 1-2 vis lectr per month; concerts; gallery talks; historic walking tours; house tour; individual paintings & original objects of art lent to other museums; museum shop sells books

SEARSPORT

M PENOBSCOT MARINE MUSEUM, Church St, Rte 1, PO Box 498 Searsport, ME 04974-0498. Tel 207-548-2529, store 548-0334; Fax 207-548-2520; Elec Mail museumoffices@penobscotmarinemuseum.org; Internet Home Page Address: penobscotmarine.museum.org; *Educ Coord* John Arrison; *Dir Develop* David Blanchard; *Store Mgr* Lynn Bradshaw; *Cur* Benjamin A G Fuller; *Dir* T M Deford
Open Memorial Day weekend - mid Oct, Mon - Sat 10 AM - 5 PM, Sun Noon - 5 PM; Admis adults $8, seniors $6, youth 7-15 $3, 6 & under free; Estab 1936 as a memorial to the maritime record of present & former residents of the State of Maine in shipbuilding, shipping & all maritime affairs; The Museum consists of eight historic buildings, including the Old Town Hall (1845), Nickels-Colcord Duncan House (1880); Fowler True Ross House (1825); Cap Merithew House; Dutch House; two new buildings: Stephen Phillips' Memorial Library (1983) & Douglas & Margaret Carver Memorial Art Gallery/Auditorium (1986) & Educ Center; Average Annual Attendance: 15,000; Mem: 1,000; dues $25 & up; annual meeting in June
Income: Financed by endowment, mem, grant, gifts & admis
Special Subjects: Porcelain, Scrimshaw, Period Rooms
Collections: Marine Artifacts; China Trade Exports; 450 paintings & prints; Ship Models; small water craft; decorative arts; ceramics; glass; textiles & extensive archives
Exhibitions: Permanent exhibit: The Challenge of the Downeasters; Marine Painting of Thomas & James Buttersworth; Working the Bay; Bound for Whampoa-The China Trade
Publications: Searsport Sea Captains, 1989; Lace & Leaves: The Art of Dolly Smith, 1994 (exhibit catalogue); annual report; newsletter, 3 times per year
Activities: Classes for adults & children; docent training; lect open to public, 12 vis lectrs per year; concerts; scholarships offered; individual paintings & original objects of art lent to other institutions in accordance with museum policies; originate traveling exhibitions; sales shop sells Marine books, magazines, original art & reproductions & prints

L Stephen Phillips Memorial Library, Church St, PO Box 498 Searsport, ME 04974-0498. Tel 207-548-2529; Fax 207-548-2520; Elec Mail library@penobscotmarinemuseum.org; Internet Home Page Address: www.penobscotmarinemuseum.org; *Librn/Archivist* John Arrison
Open June - Oct; Mon-Fri 9 AM- 4 PM, Nov - May: Tues - Fri 9 AM - 4 PM; No admis fee; Estab 1936 to support research at Penobscot Marine Museum and to serve the public; Open for reference to researchers; Average Annual Attendance: 1,050; Mem: 1,000; dues $25 and up; annual meeting in June
Library Holdings: Audio Tapes; Book Volumes 12,000; Cassettes; Clipping Files; Exhibition Catalogs; Fiche; Filmstrips; Manuscripts; Maps 3,000; Memorabilia; Motion Pictures; Original Art Works; Original Documents; Other Holdings Nautical charts; Pamphlets; Periodical Subscriptions 40; Photographs 15,000; Prints; Records; Reels; Slides; Video Tapes
Special Subjects: Art History, Folk Art, Decorative Arts, Photography, Etchings & Engravings, Manuscripts, Maps, Historical Material, Ceramics, Asian Art, Furniture, Drafting, Marine Painting, Flasks & Bottles, Scrimshaw, Architecture
Publications: The Bay Chronicle newsletter

SOUTH PORTLAND

M PORTLAND HARBOR MUSEUM, Fort Rd - SMCC, South Portland, ME 04106. Tel 207-799-6337; Fax 207-799-3862; Elec Mail director@portlandharbormuseum.org; Internet Home Page Address: www.portlandharbormuseum.org; *Exec Dir* Mark R Thompson; *Vol Chmn* Penelope P Carson; *Cur* Hadley A Schmoyer; *Asst to the Dir* Rebecca Lamet
Open daily Memorial Day - Columbus Day 10 AM - 4:30 PM; Apr, May & Columbus Day - Nov: 10 AM - 4 PM; cl Jan - Mar & Dec; Admis adults & seniors $4, children & students free, grp rates vary; Estab 1985; Mus collects, preserves & presents Casco Bay's ongoing maritime culture; Average Annual Attendance: 4,000; Mem: dues Helm & Assoc Business $250, Patron & Basic Business $100, Supporting $50, Family $35, Indiv $25, Student $15
Collections: concentration on artifacts bearing on the maritime history & culture of Portland Harbor & Casco Bay covering a time period from prehistory through the present; artifacts; photographs; communication artifacts; technology; tools & equipment for materials
Publications: Portland Harbor Beacon, quarterly newsletter

Activities: Educ Program "The Age of Clipper Ships"; lect series; guided tours of local forts; temporary exhibs; museum-related items for sale

SOUTHPORT

M HENDRICKS HILL MUSEUM, 417 Hendricks Hill Rd, Rte 27, Southport, ME 04576; PO Box 3, Southport, ME 04576. Tel 207-633-1102
Open July 1 - Labor Day Tues, Thurs & Sat 11 AM - 3 PM; also open by appt in Sept; No admis fee, donations accepted; Mus is housed on farmhouse built in 1810; 11 rooms of household furnishings, archival material & fishing equipment dating from 1850 - 1960; separate boatshop houses boats, tools & ice harvesting equipment
Special Subjects: Historical Material, Furniture
Collections: Geneaological material, photographs & postcards depicting Southport Island life
Activities: Reference room with Southport Town Reports

SOUTHWEST HARBOR

M WENDELL GILLEY MUSEUM, 4 Herrick Rd, PO Box 254 Southwest Harbor, ME 04679. Tel 207-244-7555; Elec Mail info@wendellgilleymuseum.org; Internet Home Page Address: www.wendellgilleymuseum.org; *Pres* Eleanor T M Hoagland; *Exec VPres* Robert L Hinckley; *Exec Dir* Nina Z Gormley; *VPres* Carol L Weg; *Carver-in-Residence* Steven Valleau; *Educator* Jennifer Linforth
Open June, Sept & Oct Tues - Sun 10 AM - 4 PM, July - Aug Tues - Sun 10 AM - 5 PM, May, Nov & Dec Fri - Sun 10 AM - 4 PM; Admis adults $5.00; Estab 1981 to house collection of bird carvings & other wildlife related art; Gallery occupies 3000 sq ft on one floor of a solar heated building; handicapped access; Average Annual Attendance: 21,000; Mem: 2000; dues $35-$1000; annual meeting in Jan
Income: $219,000 (financed by mem, admis, sales & fundraising events)
Special Subjects: Prints, Folk Art, Woodcarvings
Collections: Decorative wood carvings of birds & working decoys by Wendell Gilley; Birds of America, 1972 ed J J Audubon; Birds of Mt Desert Island by Carroll S Tyson (prints); Photos by Eliot Porter
Exhibitions: Bird Carvings by Wendell Gilley (rotating); Audubon prints (rotating); Ann temporary contemporary & historical art exhibits
Publications: The Eider, bi-annual newsletter
Activities: Classes for adults & children; films; lect open to public, gallery talks; tours; scholarships offered; original objects of art lent to qualified institutions; book traveling exhibitions 1 per year; museum shop sells books, original art, carving tools, gift items, jewelry, posters & toys

WATERVILLE

M COLBY COLLEGE, Museum of Art, 5600 Mayflower Hill, Waterville, ME 04901-4799. Tel 207-872-3228; Fax 207-872-3807; Internet Home Page Address: www.colby.edu/museum; *Asst Dir* Greg Williams; *Dir* Daniel Rosenfeld; *Cur* Sharon Corwin
Open Tues - Sat 10 AM - 4:30 PM, Sun 12 - 4:30 PM, cl major holidays; No admis fee; Estab 1959 to serve as an adjunct to the Colby College Art Program & to be a mus center for Central Maine; Average Annual Attendance: 20,000; Mem: Friends of Art at Colby, 700; dues $25 & up
Income: Financed by college funds, mem & donations
Collections: Bernat Oriental ceramics & bronzes; American Heritage collection; The Helen Warren & Willard Howe Cummings Collection of American Art; American Art of the 18th, 19th & 20th centuries; Jette Collection of American painting in the Impressionist Period; John Marin Collection of 25 works by Marin; Adelaide Pearson Collection; Pre-Columbian Mexico; Etruscan art; Paul J Schupf Wing for the works of Alex Katz
Publications: Exhibition catalogs; periodic newsletter
Activities: Docent training; lect open to public; gallery talks; tours; individual paintings lent to other museums; originate traveling exhibitions; museum shop sells books, note cards, postcards & posters

L Bixler Art & Music Library, 5660 Mayflower Hill, Waterville, ME 04901. Tel 207-872-3232; Fax 207-872-3141; Elec Mail mericson@colby.edu; Internet Home Page Address: http://www.colby.edu/library/collections/art_music; *Librn* Margaret Ericson
No admis fee; Circ 14,000 vols/yr; For reference & academic lending to college community
Library Holdings: Book Volumes 32,000; CD-ROMs 35; Compact Disks 5,300; DVDs 20; Other Holdings Music; Periodical Subscriptions 68; Records 5,000 LPS; Slides 60,000; Video Tapes 400
Special Subjects: History of Art & Archaeology, Latin American Art, Asian Art, American Indian Art, Afro-American Art, Oriental Art

M THOMAS COLLEGE ART GALLERY, 180 W River Rd, Waterville, ME 04901. Tel 207-859-1362; Fax 207-877-0114; *Pub Rels Dir* Mark Tardif; *Coordr* Jane Witham
Open Mon - Fri 8 AM - 5 PM; No admis fee; Estab 1968 for presentation of instructional shows for student & community audiences; Average Annual Attendance: 1,500
Income: Financed through college funds
Exhibitions: Monthly exhibitions by local artists

L Mariner Library, 180 W River Rd, Waterville, ME 04901-5097. Tel 207-859-1362; Fax 207-877-0114; Internet Home Page Address: www.thomas.edu/library; *Librn* Steven Larochelle; *Asst Librn* Cynthia Mitchell
Open Mon - Thurs 8 AM - 10 PM, Fri 8 AM - 4:30 PM, Sun 2 - 9 PM, Cl Sat; For reference only
Income: state appropriation; funded by college
Library Holdings: Book Volumes 21,500; Periodical Subscriptions 400; Slides

M WATERVILLE HISTORICAL SOCIETY, Redington Museum, 62 Silver St, Unit B, Waterville, ME 04901. Tel 207-872-9439; Internet Home Page Address: www.rediingtonmuseum.org; *Resident Cur* Harry Finnemore; *Resident Cur* Donnice Finnemore; *Librn* Diane Johnson; *Pres Historical Society* Frederic P Johnson; *VPres* Margaret Ann Marden; *Secy* Jane M Dornish; *Treas* Allan Rancourt
Open Memorial Day - Labor Day Tues - Sat 10 AM - 2 PM; tours 10 & 11 AM, 1

& 2 PM; Admis adults $3, children 12 & under $2; Estab 1903; Average Annual Attendance: 600; Mem: 250; dues friend $100, family $40, single $20; annual meeting second Thurs in June

Income: Financed by mem & city appropriation & limited endowment

Special Subjects: Flasks & Bottles, Maps, Costumes, Decorative Arts, Manuscripts, Dolls, Furniture, Glass, Historical Material

Collections: Early Silver & China; 18th & 19th century furniture; 19th century apothecary; portraits of early local residents; Victorian clothing; Indian artifacts; Early photos, tools & toys

Activities: Lect open to public, tours

WISCASSET

A **LINCOLN COUNTY HISTORICAL ASSOCIATION, INC,** Pownalborough Courthouse, PO Box 61, Wiscasset, ME 04578. Tel 207-882-6817; Elec Mail lcha@wiscasset.net; Internet Home Page Address: www.lincolncountyhistory.org; *Exec Dir* Margaret M. Shield

July & August Tues - Sat 10 AM - 4 PM, June & Sept Sat 10 AM - 4 PM; Admis adults $4, children 7-17 $2; Incorporated 1954, to preserve buildings of historic interest; Average Annual Attendance: 700; Mem: 350; dues $25 & up; ann meeting in July

Income: Financed by dues, fundraisers, admis, bequests & donations

Special Subjects: Architecture, Embroidery, Historical Material, Manuscripts, Porcelain, Reproductions, Textiles, Painting-American, Pottery, American Western Art, Decorative Arts, Folk Art, American Indian Art, Crafts, Archaeology, Furniture, Glass, Woodcarvings, Period Rooms, Maps, Scrimshaw, Flasks & Bottles, Restorations

Collections: Furniture; hand tools; household articles; textiles

Publications: Newsletter; occasional monographs

Activities: School programs & docent training; lect open to pub approx 250 per yr; tours; gallery talks; slide shows; mus shop sells books, original art, reproductions

L **Library,** PO Box 61, Wiscasset, ME 04578. Tel 207-882-6817; *Dir* Anne R Dolan
Open by appointment for reference & research
Library Holdings: Book Volumes 200

M **1811 Old Lincoln County Jail & Lincoln County Museum,** 133 Federal St, PO Box 61 Wiscasset, ME 04578. Tel 207-882-6817; Elec Mail lcha@wiscasset.net; Internet Home Page Address: www.lincolncountyhistory.org; *Exec Dir* Margaret M. Shiels

Open July & Aug Tues - Sat 10 AM - 4 PM, June & Sept Sat 10 AM - 4 PM, Oct-May by appointment; Admis adults $4, children 7-17 $2; Estab 1954 for historical preservation; Average Annual Attendance: 1,500; Mem: 350; dues $20 & up, annual meeting in July

Income: Financed by mem, donations, restricted funds & bequests

Special Subjects: American Indian Art, Archaeology, Decorative Arts, Folk Art, Historical Material, Glass, American Western Art, Furniture, Photography, Porcelain, Portraits, Painting-American, Prints, Period Rooms, Silver, Maps, Architecture, Watercolors, Textiles, Costumes, Ceramics, Crafts, Woodcarvings, Scrimshaw, Restorations, Embroidery, Pewter, Reproductions

Collections: Early American tools; jail artifacts; quilts; prison equipment; samplers; textiles; Scrimshaw; Ephemera; Photographs; Baskets; Fans

Exhibitions: shows once a year

Publications: Lincoln County Chronicle - Newsletter

Activities: Docent training; lect open to public, over 2 vis lectr per year; tours; gallery talks; museum shop sells books; original art; reproductions; cards; postcards

M **Maine Art Gallery,** Warren St, Wiscasset, ME 04578; PO Box 315, Wiscasset, ME 04578. Tel 207-882-7511; Elec Mail meartgallery@gwi.net; Internet Home Page Address: www.maineartgallery.org; *Bd Pres* Sally Loughridge Bush; *Gallery Mgr* Kay Liss; *Treas* Marcia Mansfield; *Asst Mgr* Michele Roberge

Open early May thru late Nov daily 10 AM - 4 PM, Sun 11 AM - 4 PM, closed Winter; No admis fee, donations appreciated; Estab 1958 as a cooperative, non-profit gallery created by the Artist Members of Lincoln County Cultural & Historical Assoc to exhibit the work of artists living or working in Maine; Gallery occupies a red brick federal two-story building built in 1807 as a free Academy. The building is now on National Historical Register; Average Annual Attendance: 6,000; Mem: 200; dues $35; bd meets 4 times per year

Income: Financed by patrons, art sales & fundraising

Exhibitions: Summer Exhibition: A juried show in parts of 4 weeks featuring approx 100 painters & sculptors living or working in Maine; 6 exhibitions per year, 1 juried show, 1 members show, 4 invitational or from show proposals

Activities: Classes for adults; lect open to public; gallery talks; school art classes; visits

YORK

A **OLD YORK HISTORICAL SOCIETY,** 207 York St, PO Box 312 York, ME 03909. Tel 207-363-4974; Fax 207-363-4021; Elec Mail oyhs@gwi.org; Internet Home Page Address: www.oldyork.org; *Dir Community Relations* Cheryl Farley; *Dir Educ* Anne Poubeau; *Registrar* Cynthia Young-Gomes; *Cur* Thomas B Johnson; *Librn* Virginia Spiller; *Dir* Scott Stevens

Open mid-June - mid-Oct Tues - Sat 10 AM - 5 PM, Sun 1 - 5 PM; Admis adults $7, children 6-16 $4; children under 6 free; Estab 1740s, restored 1980, customs house & store; today houses exhibit on Yorks maritime heritage; Administers Old Gaol, oldest jail in US; 18th Century Jefferds Tavern; Elizabeth Perkins House; John Hancock Warehouse; Emerson-Wilcox House; Schoolhouse. Maintains reference library; Average Annual Attendance: 24,000; Mem: 650; dues $35 & up; annual meeting in June

Special Subjects: Architecture, Embroidery, Etchings & Engravings, Historical Material, Porcelain, Silver, Textiles, Painting-American, Decorative Arts, Folk Art, Pewter, Ceramics, Portraits, Dolls, Furniture, Glass, Period Rooms, Scrimshaw, Tapestries

Collections: American & European furniture; decorative arts from southern Maine; ceramic & glass collection; tools & maritime artifacts

Activities: Classes for adults & children; dramatic programs; docent training; lect open to public, 3-5 per year; concerts; tours; fellowship; sales shop sells books, reproductions, prints, Maine crafts & books & other gift items

M **Elizabeth Perkins House,** PO Box 312, York, ME 03909. Tel 207-363-4974; Fax 207-363-4021; Elec Mail oyhs@oldyork.org; Internet Home Page Address: www.oldyork.org; *Exec Dir* Scott Stevens; *Admin Asst* Janet Welch; *Dir Educ* Anne Poubeau; *Registrar* Cynthia Young-Gomes; *Pres* James B Bartlett; *Dir Community Relations* Cheryl Farley; *Dir Develop* Sue McDonough; *Cur Coll* Thomas B Johnson; *VPres* Mary MacLean; *Supv Bldgs* Dana Moulton; *Librn* Virginia Spiller

Open mid-June - mid-Oct Tues - Sat 10 AM - 5 PM, Sun 1 - 5 PM; Admis adults $7, children 6-16 $4, children under 6 free; Mem: 650, $35 & up, meeting June

Income: financed by members, donations

Special Subjects: Period Rooms

Activities: Tours

M **Old School House,** PO Box 312, York, ME 03909. Tel 207-363-4974; Fax 207-363-4021; Elec Mail oyhs@gwi.org; *Exec Dir* Scott Stevens

Open mid-June - mid-Oct Tues - Sat 10 AM - 5 PM, Sun 1 - 5 PM; Admis adults $7, children 6-16 $4, children under 6 free; Mem: 650, 35 & up

Income: financed by members, grants

Special Subjects: Costumes

Exhibitions: period schoolhouse

M **Jefferds Tavern,** 207 York St, PO Box 312 York, ME 03909. Tel 207-363-4974; Fax 207-363-4021; Elec Mail oyhs@oldyork.org; Internet Home Page Address: www.oldyork.org; *Exec Dir* Scott Stevens

Jun - mid-Oct Mon - Sat 10 AM - 5 PM; Admis adults $7, children 6-16 $4; Estab 1750, moved to current location in 1959; visitor and educ center; Mem: 650, dues $35 & up

Exhibitions: period room 18th century tavern

M **John Hancock Warehouse,** Lindsey Rd, York, ME 03909. Tel 207-363-4974; Fax 207-363-4021; *Exec Dir* Scott Stevens

Open mid-June - mid-Oct Sat - Tues 10 AM - 5 PM, Sun 1 PM - 5 PM; Admis adults $7, children 6-16 $4; Mem: 650, dues $35 & up

M **Old Gaol Museum,** PO Box 312, York, ME 03909. Tel 207-363-4974; Fax 207-363-4021; *Exec Dir* Scott Stevens; *Cur* Tom Johnson; *Educator* Anne Poubeak; *Dir Community Relations* Cheryl Farley; *Admin Asst* Janet Welch; *Registrar* Cynthia Young-Gomes; *Librn* Virginia Spiller

Open June - Columbus Day Weekend Tues - Sat 10 AM - 5 PM, Sun 1 - 5 PM; Admis $7 adults, seniors $6, ages 6 - 16 $3; Estab 1900 as a local history mus to maintain, care for & develop historical collections of a regional nature & to promote historic research & historically educational programs; Mus consists of the oldest jail in the United States & an 18th century tavern arranged as period rooms. Two gallery rooms house traveling shows & temporary exhibitions of an historical nature; thirty-two period rooms in 3 other buildings; Average Annual Attendance: 10,000; Mem: 650; dues family $50, single $35; annual meeting Aug

Income: $70,000 (financed by endowment)

Library Holdings: Book Volumes; Fiche; Manuscripts; Maps; Original Art Works; Periodical Subscriptions

Special Subjects: Architecture, Painting-American, Textiles, Decorative Arts, Manuscripts, Portraits, Furniture, Glass, Porcelain, Historical Material, Scrimshaw, Period Rooms, Embroidery, Pewter

Collections: Regional collection of American furniture & decorative arts; rare books; manuscripts

Exhibitions: Changing exhibitions

Publications: Old Gaol Museum (history), E H Pendleton; York Maine Then & Now; Enchanted Ground, George Garrett; Old York Newsletter, quarterly

Activities: Classes for adults & children; dramatic programs; docent training; lect open to public; Elizabeth B Perkins fellowship offered; museum shop sells books, reproductions, old-time toys, gifts & cards

L **Administration Building & Library,** 207 York St, York, ME 30909; PO Box 312, York, ME 03909-0312. Tel 207-363-4974; Fax 207-363-4021; Elec Mail oyhs@oldyork.org; Internet Home Page Address: www.oldyork.org; *Librn* Virginia Speller

Library open Thurs - Fri 9 AM - 12 PM, Sat 10 - 4; Admis $5 per day for non-members; fee for members; Reference only; Average Annual Attendance: 27,700

Library Holdings: Audio Tapes; Book Volumes 8000; Cassettes; Clipping Files; Exhibition Catalogs; Fiche; Kodachrome Transparencies; Lantern Slides; Manuscripts; Memorabilia; Micro Print; Motion Pictures; Original Art Works; Original Documents; Pamphlets; Periodical Subscriptions 16; Photographs; Prints; Records; Reels; Slides; Video Tapes

Special Subjects: Decorative Arts

Collections: Manuscripts of York Area

Activities: Classes for adults & children; lect open to public, 6 vis lectrs per year; gallery talks; tours; scholarships & fellowships offered; individual paintings & original objects of art lent; museum shop sells books, magazines & prints

MARYLAND

ANNAPOLIS

M **HAMMOND-HARWOOD HOUSE ASSOCIATION, INC,** Hammond-Harwood House, 19 Maryland Ave, Annapolis, MD 21401. Tel 410-263-4683; Fax 410-267-6891; Elec Mail hammondharwood@annapolis.net; *Exec Dir* Carter Lively; *Asst Dir & Cur* Heather Foster

Open Mon - Sat 10 AM - 4 PM, Sun Noon - 4 PM; cl Mon - Thurs in Jan & Feb; Admis adults $5, students between 6 & 18 $3; Estab 1938 to preserve the Hammond-Harwood House (1774), a National Historic Landmark; to educate the pub in the arts & architecture of Maryland in the 18th century; Average Annual Attendance: 15,000; Mem: 400; dues varied; meeting May & Nov

Income: Financed by endowment, mem, attendance & sales

Library Holdings: Audio Tapes; Clipping Files; Manuscripts; Original Documents; Photographs; Prints; Slides

Special Subjects: Painting-American, Prints, Furniture, Porcelain, Oriental Art, Silver

Collections: Paintings by C W Peale; Chinese export porcelain; English & American furnishings, especially from Maryland; prints; English & American silver; colonial architectural interiors designed by William Buckland
Publications: Maryland's Way (Hammond-Harwood House cookbook); Hammond-Harwood House Guidebook
Activities: Interpretive programs; docent training; classes for adults; classes for children; docent training; lect open to public; lectrs for mems only; tours; individual paintings & original objects of art lent to bonafide museums within reasonable transporting distance; museum shop sells books & prints; books

M **MARYLAND HALL FOR THE CREATIVE ARTS,** Chaney Gallery, 801 Chase St, Annapolis, MD 21401. Tel 410-263-5544; Fax 410-263-5114; Elec Mail cmanucy@mdhallarts.org; Internet Home Page Address: www.marylandhall.org; *Exec Dir* Linnell R Bowen; *Dir Exhibs* Christina Manucy
Open Mon - Sat 9 AM - 5 PM; No admis fee; Estab 1979 to exhibit work of contemporary regional artists; Two room post modern space with 100 ft of wall space & 1100 sq ft of floor area. Contemporary grid-track lighting. Second gallery 450 sq ft, track lighting, also outdoor sculpture; Average Annual Attendance: 7,000; Mem: 2,000; dues $25 & up
Income: Financed by local, state & special grant funds
Special Subjects: Drawings, Photography, Sculpture, Watercolors, Woodcarvings, Woodcuts, Afro-American Art
Exhibitions: Rotating exhibitions, twelve per yr
Publications: Postcards
Activities: Classes for adults & children; dramatic programs; concerts; gallery talks; competitions

M **ST JOHN'S COLLEGE,** Elizabeth Myers Mitchell Art Gallery, 60 College Ave, Annapolis, MD 21404-2800; PO Box 2800, Annapolis, MD 21404-2800. Tel 410-263-2371, Ext 256, (Direct line) 626-2556; Fax 410-263-4828; Elec Mail hydee.schaller@sjca.edu; Internet Home Page Address: www.stjohnscollege.edu; *Exhibit Preparator* Sigrid Trumpy; *Exhibit Preparator* Maya Whitner; *Outreach Coordr* Lucinda Edinberg; *Dir* Hydee Schaller
Open Sept - May Tues - Sun Noon - 5 PM, Fri 7 - 8 PM; No admis fee; Estab 1989 for museum quality exhibits for the area; One gallery of 1300 sq ft, rectangle with corner windows, one gallery of 525 sq ft, rectangular, no windows; Average Annual Attendance: 10,000; Mem: 800 members; 427 memberships; dues $5-$1000
Exhibitions: (10/18/2006-12/14/2006) Joan Miro: Illustrated Books; (1/3/2007-3/1/2008) Six Dynasties of Chinese Art; (3/10/2007-4/30/2008) Robert Motherwell & Jasper Johns: Poetic Works as Metaphor
Publications: Catalogs; exhibition programs; gallery guides
Activities: Educ dept offers studio courses in painting, life drawing & sculpture for adults & children; docent training; lectr open to public, 6 vis lectrs per year; gallery talks; tours; concerts; book traveling exhibitions 3-4 per year; originate traveling exhibitions

M **UNITED STATES NAVAL ACADEMY,** USNA Museum, 118 Maryland Ave, Annapolis, MD 21402-5034. Tel 410-293-2108; Fax 410-293-5220; Internet Home Page Address: www.usna.edu/museum; *Sr Cur* James W Cheevers; *Cur Ship Models* Robert F Sumrall; *Cur Robinson Coll* Sigrid Trumpy; *Exhibit Specialist* Robert Chapel; *Dir* Dr J Scott Harmon; *Registrar* Donald Leonard; *Research Assoc* Grant Walker
Open Mon - Sat 9 AM - 5 PM, Sun 11 AM - 5 PM; No admis fee; Estab 1845 as Naval School Lyceum for the purpose of collecting, preserving & exhibiting objects related to American naval history; Mus contains two large galleries totaling 9000 sq ft, with other exhibits in other areas of the campus; Average Annual Attendance: Approx 250,000
Income: Financed by federal government appropriations & private donations
Purchases: $36,170
Special Subjects: Drawings, Painting-American, Prints, Sculpture, Ceramics, Manuscripts, Silver, Metalwork
Collections: Ceramicwares; Drawings; Medals; Naval Uniforms; Paintings, Prints, Sculpture of Naval Portraits & Event; Ship Models; Silver; Weapons
Publications: Collection catalogs & special exhibition brochures, periodically
Activities: Lect; tours upon request; individual paintings & original objects of art lent to other museums & related institutions for special, temporary exhibitions; originate traveling exhibitions

L **Naval Academy Museum,** 118 Maryland Ave, Annapolis, MD 21402-5034. Tel 410-293-2108; Fax 410-293-5220; Internet Home Page Address: www.usna.edu/museum; *Dir* J Scott Harmon; *Sr Cur* James W. Cheevers; *Cur of Ship Models* Robert F Sumrall; *Cur of Beverley R Robinson Collection* Sigrid Trumpy
Mon - Sat 9:00 AM to 5:00 PM, Sun 11:00 AM to 5:00 PM; No admis fee; Estab 1845; Open to students, scholars & public with notice, reference only; Average Annual Attendance: 160,000
Income: Financed by the academy
Library Holdings: Book Volumes 400; Exhibition Catalogs; Periodical Subscriptions 15
Special Subjects: Historical Material, Marine Painting
Collections: US Navy Trophy Flag Collections
Exhibitions: 100 Years & Forward, Rogers Collection of Ship Models

BALTIMORE

M **ALBIN O KUHN LIBRARY & GALLERY,** Univ Maryland Baltimore County Campus, 1000 Hilltop Circle Baltimore, MD 21250. Tel 410-455-2270, 455-3188, 455-3827, Ext 2232; Fax 410-455-1153; Internet Home Page Address: www.umbc.edu; *Dir* Cynthia Wayne
Open Mon - Fri Noon - 4:30 PM, Thurs Noon - 8 PM, Sat 1 - 5 PM; Estab to promote scholarly exhibitions of original works of art & historic materials for UMBC & the greater Baltimore & Maryland region
Exhibitions: Three to four exhibitions annually of photographs, rare books, manuscripts & historic artifacts
Activities: Classes for children; lect open to public, tours; symposia

M **BALTIMORE CITY COMMUNITY COLLEGE,** Art Gallery, Fine & Applied Arts Dept, 2901 Liberty Heights Ave Baltimore, MD 21215. Tel 410-462-8000; Fax 410-462-7614; *Coordr Arts* Carlton Leverette
Open Mon - Fri 10 AM - 4 PM; No admis fee; Estab 1965 to bring to the Baltimore & college communities exhibitions of note by regional artists & to serve as a showplace for the artistic productions of the college art students & faculty; Consists of one large gallery area, approx 120 running ft, well-lighted through the use of both natural light (sky domes) & cove lighting which provides an even wash to the walls
Income: Financed through the college
Special Subjects: Graphics, Painting-American
Collections: Graphics from the 16th century to the present; paintings by notable American artists & regional ones
Exhibitions: Groups shows & three-man shows representing a broad cross section of work by regional artists; art faculty show; three-man show featuring graphic designs & paintings; exhibition of portraits by 15 artists; annual student show
Publications: Gallery anouncements
Activities: Lect open to public; gallery talks

M **THE BALTIMORE MUSEUM OF ART,** 10 Art Museum Dr, Baltimore, MD 21218. Tel 443-573-1700; Fax 443-573-1582; Elec Mail amannix@artbma.org; Internet Home Page Address: www.artbma.org; *Dep Dir Finance & Admin* Christine Dietze; *Dep Dir for Marketing & Communications* Becca Seitz; *Dep Dir Operations & Capital Planning* Alan Dircan; *Sr Cur Painting & Sculpture at Large* Sona Johnston; *Cur Painting & Sculpture* Katherine Rothkopf; *Cur Textiles* Anita Jones; *Assoc Cur Art of Africa, Asia, the Americas & Pacific Islands* Frances Klapthor; *Dir Retail Operations* Doreen Bolger; *Dir Communications* Anne Mannix; *Deputy Dir Devel* Judith Gibbs; *Librn* Linda Tompkins-Baldwin; *Sr Cur Contemporary* Darsie Alexander; *Assoc. Cur. Art of Africa, Asia, The Americas & Pacific Islands* Karen Milbourne; *Dir. Communications* Anne Mannix; *Deputy Dir Curatorial Affairs* Jay Fisher; *Assoc Cur Drawings & Photographs* Rena Hoisington; *Sr Cur Dec Arts & American Painting & Sculpture* David Park Curry
Open Wed - Fri 11 AM - 5 PM, Sat - Sun 11 AM - 6 PM, cl Mon, Tues & major holidays; No admis fee; Estab 1914 to house & preserve art works, to present art exhibitions, art-related activities & offer educational programs & events; The original building was designed by John Russell Pope in 1929; addition in 1982 with cafe, auditorium & traveling exhibition galleries; sculpture gardens opened in 1980 & 1988; wing for Contemporary Art opened in 1994, maintains reference library; Average Annual Attendance: 250,000; Mem: 8000; dues $40 & up
Income: $12,200,000 (financed by city, state, county & Federal appropriation; corporate, individual & foundation gifts; mem, earned revenue & endowment income)
Library Holdings: Auction Catalogs; Book Volumes; CD-ROMs; Cassettes; Clipping Files; Exhibition Catalogs; Fiche; Lantern Slides; Manuscripts; Memorabilia; Micro Print; Motion Pictures; Original Art Works; Original Documents; Other Holdings; Pamphlets; Periodical Subscriptions; Photographs; Prints; Reels; Reproductions
Special Subjects: Architecture, Drawings, Latin American Art, Mexican Art, Painting-American, Photography, Prints, Sculpture, American Indian Art, American Western Art, African Art, Pre-Columbian Art, Ceramics, Afro-American Art, Decorative Arts, Painting-European, Portraits, Furniture, Jewelry, Asian Art, Painting-Spanish, Antiquities-Egyptian, Mosaics, Gold, Painting-Israeli
Collections: The Cone Collection, featuring works of Matisse & Picasso & other 20th century American & European artists; The George A Lucas Collection, drawings, especially 19th Century French; American European & Asian decorative arts & textiles; 18th to 20th Century American paintings; European paintings & sculpture from the Renaissance to present; 1st to 3rd Century mosaics from Antioch, Syria; Maryland furniture & silver; photographs; pre-Columbian, Native American African & Oceanic arts; prints; West Wing Contemporary Art
Exhibitions: (10/1/2006-12/31/2006) A View Toward Paris: The Lucas Collection of 19th Century French Art; (10/1/2006-2/18/2007) Front Room: Dan Steinhilber; (10/11/2006-3/11/2007) The City Real and Ideal; (10/25/2006-6/17/2007) The Persistent Figure in Modern Sculpture; (12/17/2006-4/1/2007) Meditations on African Art: Light; (2/11/2007-5/13/2007) Pissarro: Creating the Impressionist Landscape; (10/28/2007-3/3/2008) Matisse: Painter as Sculptor; (6/28/2006-2/4/2007) In Praise of the Prince of Fenyang: Decoding a Chinese Embroidery
Publications: Exhibition catalogs; members newsletter; posters & postcards; gallery guides; family guides
Activities: Classes for adults & children; docent training; lect open to public; concerts; films; gallery talks; tours; individual paintings & original objects of art lent to other art museums regionally to internationally; lending collection contains original art works, original prints, paintings, photographs & sculpture; book traveling exhibitions; originate traveling exhibitions; museum shop sells books, reproductions, slides, Jewelry & children's gifts

L **E Kirkbride Miller Art Library,** 10 Art Museum Dr, Baltimore, MD 21218. Tel 443-573-1778; Fax 443-573-1781; Elec Mail ltompkins@artbma.org; Internet Home Page Address: www.artbma.org; *Library Dir* Linda Tompkins-Baldwin; *Asst Librn* Emily Connell
Open by appointment
Library Holdings: Book Volumes 55,000; Clipping Files; Exhibition Catalogs; Other Holdings 15,000; Pamphlets; Periodical Subscriptions 302
Special Subjects: Decorative Arts, Photography, Drawings, Etchings & Engravings, Painting-American, Prints, Sculpture, Painting-European, Ceramics, Printmaking, American Indian Art, Porcelain, Primitive art, Eskimo Art, Furniture, Glass, Afro-American Art, Carpets & Rugs, Pottery, Tapestries, Textiles, Woodcuts, Laces, Painting-Australian, Embroidery

M **THE CONTEMPORARY MUSEUM,** Museum for Contemporary Arts, 100 W Centre St, Baltimore, MD 21201. Tel 410-783-5720; Fax 410-783-5722; Elec Mail ihofmann@contemporary.org; Internet Home Page Address: www.contemporary.org; *Dir* Irene Hofmann
Wed - Sun 12 PM - 5 PM; No admis fee; Estab 1989 to explore connections between the art of our time & our world; Average Annual Attendance: 25,000; Mem: 400; dues starting at $40
Income: Financed by endowment, mem, grants, private donations & IMS

Exhibitions: Mining the Museum: an installation by Fred Wilson; Catfish Dreamin'; A Sculpture on a Truck by Alison Saar; Going for Baroque (Collaboration with Walters Art Gallery)
Publications: Mining the Museum; Outcry; Artists Answer AIDS; Going for Baroque
Activities: Gallery talks; tours; originate traveling exhibitions to contemporary mus; mus shop sells books, magazines

L ENOCH PRATT FREE LIBRARY OF BALTIMORE CITY, Fine Arts Dept, 400 Cathedral St Baltimore, MD 21201. Tel 410-396-5430, 396-5490; Fax 410-396-1409; Elec Mail far@epfl.net; Internet Home Page Address: www.epfl.net; *Dept Head* Shirley Viviano; *Dir* Carla Hayden; *Chief State Library Resource Center* Wesley Wilson
Open Mon - Wed 10 AM - 8 PM, Thurs 10 AM - 5:30 PM, Fri & Sat 10 AM - 5 PM, Sun 1 - 5 PM Sept - May; No admis fee; Estab 1882 to provide materials, primarily circulating on the visual arts and music; Exhibition space in display windows, interior display cases, corridors and special departments
Income: Financed by city and state appropriation
Purchases: $20,000
Library Holdings: Book Volumes 97,000; Filmstrips; Framed Reproductions; Other Holdings Framed prints; Unframed pictures; Records; Reproductions; Slides
Publications: Book lists, periodically
Activities: Lect & film showings

M EUBIE BLAKE JAZZ MUSEUM & GALLERY, 847 N Howard St, Suite 323 Baltimore, MD 21201. Tel 410-225-3130; Fax 410-225-3139; Elec Mail eubieblake@erols.com, or eblake847@aol.com; Internet Home Page Address: www.eubieblake.org; *Exec Dir* Camay Murphy; *Exec Asst* Mark Ayers; *Prog Dir* Troy Burton
Call for hours; call for fees; Estab 1983; The gallery is for minority & emerging artists; maintains a library; Average Annual Attendance: 10,000; Mem: 100; dues $20; annual meeting in Feb
Income: $2,300,000 (financed by mem, city & state appropriation)
Special Subjects: Afro-American Art
Collections: Eubie Blake Collection
Exhibitions: Monthly exhibits
Publications: Ragtime, quarterly newsletter
Activities: Classes for children; dramatic programs; lect open to public; 4 vis lectrs per year; competitions; concerts; tours; museum shop sells books, original art & prints

M GOUCHER COLLEGE, Rosenberg Gallery, 1021 Dulaney Valley Rd Baltimore, MD 21204. Tel 410-337-6333, 337-6073; Fax 410-337-6405; Elec Mail lburns@goucher.edu; Internet Home Page Address: www.goucher.edu/rosenberg; *Exhib Dir & Coll Coordr* Laura Burns
Open Mon - Fri 9 AM - 5 PM during the academic calendar & on evenings & weekends of pub events; No admis fee; Estab 1964 to display temporary & continuously changing exhibitions of contemporary & historically important visual arts; Gallery spaced located in the lobby of the Kraushaar Auditorium; 144 running ft of wall space; Average Annual Attendance: 125,000
Income: Financed privately
Special Subjects: Drawings, Painting-American, Photography, Prints, Sculpture, Ceramics
Collections: Ceramics; coins; drawings; paintings; prints; sculpture; photography
Publications: Exhibit brochures, 4 per year
Activities: Lect open to public; gallery talks; book traveling exhibitions 1 per year

JOHNS HOPKINS UNIVERSITY
M Archaeological Collection, Tel 410-516-7561; *Dir Near Eastern & Egyptian Art* Dr Betsy Bryan; *Cur* Dr Eunice Maguire; *Asst Cur* Violaine Chauvet
Acad year Mon Noon - 2 PM, Tues 10 AM - 1 PM, Wed 2 - 5 PM, Thur 12:30 - 3:30 PM, Fri 10 AM - 1 PM; Estab 1876; Small exhibit space in Gilman Hall # 129
Special Subjects: Antiquities-Egyptian, Antiquities-Roman
Collections: Egyptian through Roman material 3500 BC to 500 AD
M Evergreen House, Tel 410-516-0341; Fax 410-516-0864; Elec Mail ckelly@jhu.edu or bnowell@jjhu.edu; *Marketing Coordr* Beth Nowell; *Dir* Cindy Kelly; *Cur* Jackie O'Regan
Open Mon - Fri 10 AM - 4 PM, Sat & Sun 1 - 4 PM, Last tour daily at 3 PM; Admis fee adults $6, seniors $5, students $3; Estab 1952 for promotion of cultural & educational functions & research; Formerly the residence of Ambassador John W Garrett which he bequeathed to the University; Average Annual Attendance: 10,000; Mem: 200; dues $25 - $250
Special Subjects: Drawings, Hispanic Art, Painting-American, Bronzes, Ceramics, Etchings & Engravings, Landscapes, Decorative Arts, Manuscripts, Furniture, Glass, Jade, Oriental Art, Asian Art, Metalwork, Painting-French, Carpets & Rugs, Historical Material, Painting-Spanish, Antiquities-Persian, Mosaics, Painting-German, Painting-Russian, Enamels, Bookplates & Bindings
Collections: Bakst Theater Decorations; European Ceramics; Japanese Inro, Netsuke & Lacquer: Chinese Ceramics; Oriental Rugs; Rare Book Collection; Tiffany Glass; Twentieth Century European Paintings
Exhibitions: Changing exhibitions
Activities: Classes for adults; docent training; lect open to public; concerts; individual paintings & original objects of art lent to other museums, national & international; museum shop sells books, reproductions & prints
L George Peabody Library, Tel 410-659-8179; Fax 410-659-8137; *Librn Asst* Erika Cooper; *Librn* Carolyn Smith
Open Mon - Fri 9 AM - 3 PM
Library Holdings: Book Volumes 250,000
Special Subjects: Decorative Arts, Architecture
Collections: British History; art and architecture; decorative arts; religion; travel; geography; maps
M Homewood House Museum, Tel 410-516-5589; Fax 410-516-7859; Internet Home Page Address: www.jhu.edu/historichouses; *Dir* Cindy Kelly; *Cur* Catherine Arthur

Open Tues - Sat 11 AM - 4 PM, Sun Noon - 4 PM; Admis fee $6, seniors $5, students $3; Estab 1987; a historic house mus; Restored Federal Period country seat of Charles Carroll, Jr, with period furnishings; Average Annual Attendance: 10,000; Mem: 350; annual dues $25
Special Subjects: Architecture, Archaeology, Textiles, Ceramics, Decorative Arts, Porcelain, Silver, Restorations, Period Rooms, Pewter
Collections: English & American decorative arts of the late 18th & early 19th Century
Activities: Classes for adults; historically relevant activities for children & young people; concerts; tours; achitectural lecture series; internships offered; museum shop sells books, original art, object reproductions, prints, slides, exclusive Homewood items & jewelry

M MARYLAND ART PLACE, 8 Market Pl Ste 100, Baltimore, MD 21202. Tel 410-962-8565; Fax 410-244-8017; Elec Mail map@mdartplace.org; Internet Home Page Address: www.mdartplace.org; *Interim Exec Dir* Julie Cavnor; *Pres* Karen Bokram; *Dir Prog* Casey Page; *Develop Asst* Melissa Markley; *Registry Coordr* Joy McClure
Open Tues - Sat 11 AM - 5 PM; No admis fee; Estab 1981, to provide opportunities for artists to exhibit work, nurture & promote new ideas & forms; Three galleries within one floor; Average Annual Attendance: 30,000; Mem: 4000; dues $25-$1000 and up
Income: $450,000 (financed by mem, federal, state & corporate appropriation)
Special Subjects: Drawings, Graphics, Hispanic Art, Painting-American, Ceramics, Folk Art, Landscapes, Collages
Exhibitions: Varies
Publications: Annual catalogs; exhibition brochures, 4-6 per year; quarterly newsletter
Activities: Critics' residencies including writing workshop & annual public forum; lect open to public, 4 vis lectrs per year; concerts; gallery talks; tours; competitions; book traveling exhibitions 1 per year; originate traveling exhibitions 1-2 per year

M MARYLAND HISTORICAL SOCIETY, Museum of Maryland History, 201 W Monument St, Baltimore, MD 21201. Tel 410-685-3750, Ext 70; Fax 410-385-2105; Internet Home Page Address: www.mdhs-org/; *Cur Coll* Nancy Davis; *Dir* Dennis Fiori
Open Wed - Fri - Sat 9 AM - 5 PM, Sun 11 AM - 5 PM; free admission & parking 1st Thurs of every month, 5 - 8 PM; Admis adults $4, seniors & students $3; Estab 1844 to collect, display & interpret the history of the State of Maryland; Average Annual Attendance: 70,000; Mem: 5000; dues family $60; annual meeting in June
Income: Financed by endowment, mem, city & state appropriations
Library Holdings: Audio Tapes; Book Volumes; Clipping Files; Compact Disks; DVDs; Exhibition Catalogs; Filmstrips; Framed Reproductions; Kodachrome Transparencies; Lantern Slides; Manuscripts; Maps; Memorabilia; Motion Pictures; Original Documents; Other Holdings; Pamphlets; Periodical Subscriptions; Photographs; Records; Reproductions; Slides
Special Subjects: Architecture, Painting-American, Textiles, Pottery, Glass, Porcelain, Silver, Metalwork
Collections: Architectural drawings; crystal & glassware; ethnic artifacts, all of Maryland origin or provenance; metalwork; paintings, both portrait & landscape; porcelain & pottery; silver; textiles & costumes; furniture
Exhibitions: Continually changing exhibitions refelecting the history & culture of the state
Publications: Maryland Historical Society Magazine, quarterly; MDHS/news 3 times per yr
Activities: Classes for adults & children; docent training; lect open to public; 12 vis lectrs per yr; concerts; gallery talks; tours; competitions with awards; exten dept; individual paintings & original objects of art lent to other organizations in State of Maryland; originate traveling exhibitions; museum shop sells books, original art, prints
L Library, 201 W Monument St, Baltimore, MD 21201. Tel 410-685-3750; Fax 410-385-2105; Elec Mail webcomments@mdhs.org; Internet Home Page Address: www.mdhs-org/library; *Cur Coll* Nancy Davis; *CEO* Dennis Fiori; *Registrar* Louise Brownell; *COO* John W Eller; *Head Librn* Bea Hardy; *VPres* Barbara P Katz; *Mus Shop Mgr* Barbara Gamse
Open Tues - Sat 10 AM - 5 PM; Estab 1844; Library for reference only; Average Annual Attendance: 70,000; Mem: 6,500
Library Holdings: Audio Tapes; Book Volumes 70,000; Cassettes; Clipping Files; Exhibition Catalogs; Fiche; Filmstrips; Kodachrome Transparencies; Lantern Slides; Manuscripts; Memorabilia; Motion Pictures; Pamphlets; Periodical Subscriptions 125; Photographs; Prints; Records; Reels; Reproductions; Slides; Video Tapes

M MARYLAND INSTITUTE, College of Art Exhibitions, 1300 Mount Royal Ave, Baltimore, MD 21217. Tel 410-225-2280; Fax 410-225-2396; *Pres* Fred Lazarus IV; *Gallery Dir* Will Hipps; *Asst Dir Exhib* Anthony Cervino
Open Mon - Sat 10 AM - 5 PM, Sun Noon - 5 PM; No admis fee; Estab 1826, including the Decker & Meyerhoff Galleries, the Graduate Thesis Gallery & 2 student galleries; Average Annual Attendance: 10,000
Income: Financed by endowment & student tuition
Exhibitions: Changing exhibitions of contemporary work in Meyerhoff & Decker Galleries
Publications: Several small catalogs; two major publications per year
Activities: Lect open to public; concerts; gallery talks; tours; original objects of art lent
L Decker Library, 1401 Mt Royal Ave, Baltimore, MD 21217; 1300 Mt Royal Ave, Baltimore, MD 21217. Tel 410-225-2311; Fax 410-225-2316; *Library Dir* Cindy Barth
Open Mon - Sat 10 AM - 5 PM, Sun Noon - 5 PM; Circ Non-circulating; Open to the pub for reference only.
Library Holdings: Book Volumes 64,000; Periodical Subscriptions 310

M MEREDITH GALLERY, 805 N Charles St, Baltimore, MD 21201. Tel 410-837-3575; Fax 410-837-3577; Internet Home Page Address: www.meredithgallery.com; *Assoc Dir* Terry Heffner; *Dir* Judith Lippman
Open Tues - Fri 10 AM - 4 PM, Sat 11 AM - 4 PM; No admis fee; Estab 1977 to exhibit a variety of contemporary art by living American artists, including art

furniture, ceramics, glass; The building is divided into two floors with regular monthly exhibits & ongoing representation of gallery artists; Average Annual Attendance: 4,000
Activities: Classes for adults & children; educational lect on current exhibitions; lect open to public; gallery talks; tours

MORGAN STATE UNIVERSITY
M **James E Lewis Museum of Art,** Tel 443-885-3030; Fax 410-319-4024; Elec Mail gtenabe@moac.morgan.edu; *Dir & Cur* Gabriel S Tenabe; *Asst Cur* Eric Briscoe; *Dir of Marketing & Develop* Virginia Jenkins; *Museum Registrar* Deborah Nobles-McDaniel; *Secy* Tyvonia Young
Open Mon - Fri 10 AM - 4:30 PM, Sat, Sun, holidays by appointment only, cl Easter, Thanksgiving, Christmas; No admis fee; Estab 1950; Average Annual Attendance: 5,000
Income: $5,500
Collections: 19th & 20th centuries American & European sculpture; graphics; paintings; decorative arts; archaeology; African & New Guinea Sculptures
Publications: Monthly catalogs
Activities: Lect open to public, vis lectr; lending collection contains kodachromes; originate traveling exhibitions organized & circulated
L **Library,** Tel 443-885-3488; Internet Home Page Address: www.library.morgan.edu; *Dir* Karen Robertson
Open Mon - Thurs 8 AM - 11 PM, Fri 8 AM - 9 PM, Sat 9 AM - 9 PM, Sun 1 - 11 PM
Library Holdings: Book Volumes 8800; DVDs; Photographs

M **NATIONAL MUSEUM OF CERAMIC ART & GLASS,** 2406 Shelleydale Dr, Baltimore, MD 21209. Tel 410-764-1042; *Admin* Shirley B Brown; *Pres* Richard Taylor; *VPres* Bruce T Taylor, MD; *Secy & Treas* Robert B Brown
Estab 1994 to exhibit ceramic art & glass & develop educational progs; Average Annual Attendance: 9,000; Mem: 478; dues $25-$150; meetings in Oct & Apr
Income: Financed by mem, city & state appropriation & grants
Special Subjects: Sculpture, Pre-Columbian Art, Ceramics, Crafts, Pottery, Glass, Porcelain, Mosaics, Stained Glass, Enamels
Activities: Classes for adults & children; original objects of art lent

M **NATIONAL SOCIETY OF COLONIAL DAMES OF AMERICA IN THE STATE OF MARYLAND,** Mount Clare Museum House, Carroll Park, 1500 Washington Blvd Baltimore, MD 21230. Tel 410-837-3262; Fax 410-837-0251; Elec Mail mtclaremuseum@aol.com; Internet Home Page Address: www.mountclare.org; *Dir* Jane Woltereck; *Asst Dir* Micahel Connolly; *Cur* Carolyn Adams
Open Tues - Sat 10 AM - 4 PM; Admis adults $6, seniors $5, students (under 18) $4; Estab 1917 to preserve the home of Charles Carroll, Barrister & teach about the colonial period of Maryland history. Maintained by the National Soc of Colonial Dames; Rooms of the house are furnished with 18th & early 19th century decorative arts, much of which belonged to the Carroll family who built the house in 1760 & has been designated a National Historic Landmark; Average Annual Attendance: 5,000
Income: Financed by admis, gift shop sales & contributions from pub & private sectors
Library Holdings: Book Volumes
Special Subjects: Architecture, Tapestries, Painting-American, Textiles, Ceramics, Decorative Arts, Furniture, Glass, Porcelain, Oriental Art, Silver, Period Rooms, Pewter
Collections: American paintings; 18th & early 19th century English & American furniture; English silver; Irish crystal; Oriental export porcelain; other English & American decorative arts
Publications: Brochure on Mount Clare; Mount Clare: Being an Account of the Seat Built by Charles Carroll, Barrister Upon His Lands at Patapsco; booklet on the house
Activities: School tours; tavelling trunk shows; colonial camp; tours; original objects of art lent to historical societies; museum shop sells books, reproductions, gift items & historical replicas
L **Library,** Carroll Park, 1500 Washington Blvd Baltimore, MD 21230. Tel 410-837-3262; Fax 410-837-0251; WATS www.users.errolls/mountclaremuseumhouse.org;
Open Tues - Fri 11 AM - 4 PM, Sat & Sun 1 - 4 PM; Open to members & the pub for reference only
Library Holdings: Book Volumes 1000; Framed Reproductions; Original Art Works; Pamphlets; Photographs; Slides
Special Subjects: Decorative Arts
Collections: 18th century furniture; decorative arts; part of the library of Charles Carroll, Barrister-at-law, builder of the house, 1756

A **STAR-SPANGLED BANNER FLAG HOUSE ASSOCIATION,** Flag House & 1812 Museum, 844 E Pratt St, Baltimore, MD 21202. Tel 410-837-1793; Fax 410-837-1812; Elec Mail info@flaghouse.org; Internet Home Page Address: www.flaghouse.org; *Dir* Sally Johnston; *Cur & Grants Mgr* Kathleen Browning
Open Tues - Sat 10 AM - 4 PM, cl Sun; Admis adults $5, students 13-18 & children 12 & under $3, seniors $4, military personnel w/id $2; Estab 1927 for the care & maintenance of 1793 home of Mary Pickersgill, maker of 15 star, 15 stripe flag used at Fort McHenry during Battle of Baltimore, war of 1812, which inspired Francis Scott Key to pen his famous poem, now our national anthem; also to conduct an educational program for pub & private schools; Mus houses artifacts, portraits & library. 1793 house furnished & decorated in Federal period to look as it did when Mary Pickersgill was in residence; Average Annual Attendance: 10,000; Mem: 500; dues $20; annual meeting in Apr
Income: Financed by mem, admis, special events fund-raisers & sales from mus shop
Collections: Original antiques of Federal period
Publications: The Star (newsletter), quarterly
Activities: Classes for children; dramatic programs; docent training; lect open to public, 10 vis lectrs per year; tours; competition with cash awards; original objects of art lent to Pickersgill Retirement Home; museum sales shop sells books, reproductions, prints, slides, Baltimore souvenirs, flags from all nations, maps, country crafts & small antiques

M **Museum,** 844 E Pratt St, Baltimore, MD 21202. Tel 410-837-1793; Fax 410-837-1812; Internet Home Page Address: www.flaghouse.org; *Dir* Sally S Johnston
Open Tues - Sat 10 AM - 4 PM; Admis $3-$5; Estab 1927; Mem: 500; dues $30; annual meeting in Apr
Income: mem, admis, special events fundraisers, sales from museum shop
Special Subjects: Porcelain
Collections: House furnished in authentic federal period furniture & artifacts; books, photographs & documents
Publications: The Star, quarterly
Activities: Lect open to public, 5 vis lectrs per year; museum shop sells books & flags of all descriptions

M **UNITED METHODIST HISTORICAL SOCIETY,** Lovely Lane Museum, 2200 Saint Paul St, Baltimore, MD 21218. Tel 410-889-4458; Elec Mail lovlnmus@cavtek,net; Internet Home Page Address: www.lovelylanemuseum.com; *Dir of Librn* James Reaves; *Asst Librn* Wanda Hall; *Exec Sec* Edwin Schell
Open Mon & Fri 10 AM - 4 PM, Sun after church; groups by appointment; No admis fee; research fee for non-member genealogists; Estab 1855; a religious collection specializing in Methodism; The main mus room contains permanent exhibits; three other galleries are devoted largely to rotating exhibits; Average Annual Attendance: 4,000; Mem: 417; dues $25-$300; annual meeting in May
Income: $58,000 (financed by mem & religious denomination)
Purchases: $868
Library Holdings: Clipping Files; Manuscripts; Maps; Memorabilia; Original Documents; Pamphlets; Periodical Subscriptions; Photographs; Prints; Slides
Special Subjects: Archaeology, Historical Material, Portraits, Maps, Photography, Religious Art, Decorative Arts, Manuscripts, Calligraphy, Bookplates & Bindings
Collections: Archaeological items from Evans House; Artifacts with Methodist significance; medallions; Methodist Library & Archives; oil portraits & engraving of United Methodist leader, quilts; Papers of Leading Methodists
Publications: Third Century Methodism, quarterly; annual report
Activities: Docent training; lect open to public, 1-2 vis lectr per year; tours; competitions with awards; individual paintings & original objects of art lent to institutions able to provide proper security upon application & approval by Board of Directors; originate traveling exhibitions to United Methodist Churches & Conferences; museum shop sells books, prints, reproductions
L **Library,** Lovely Lane Museum, 2200 Saint Paul St Baltimore, MD 21218-5897. Tel 410-889-4458; Elec Mail lovlnmus@bcpl.net; *Asst Librn* Betty Ammons; *Librn* Suni Johnson; *Secy* Edwin Schell
Open Thurs & Fri 10 AM - 4 PM & by appointment; No admis fee; Estab 1855 specializing in United Methodist history & heritage; Open to general pub for reference; Average Annual Attendance: 4,000; Mem: 600
Income: $43,000
Purchases: $700
Library Holdings: Audio Tapes; Book Volumes 4000; Cassettes; Clipping Files; Filmstrips; Kodachrome Transparencies; Lantern Slides; Manuscripts; Memorabilia; Micro Print; Motion Pictures; Original Art Works; Other Holdings Archives; Pamphlets; Periodical Subscriptions 17; Photographs; Prints; Records; Reels; Reproductions; Sculpture; Slides; Video Tapes
Special Subjects: Film, Etchings & Engravings, Manuscripts, Maps, Painting-American, Posters, Prints, Historical Material, Portraits, Archaeology, Bookplates & Bindings, Religious Art, Textiles, Architecture
Publications: Third Century Methodism, 3 per year
Activities: Tours

M **WALTERS ART MUSEUM,** 600 N Charles St, Baltimore, MD 21201. Tel 410-547-9000; Fax 410-783-7969; Internet Home Page Address: www.thewalters.org; *Chair Board Trustees* Adena Testa; *Dir* Dr Gary Vikan; *Assoc Dir* William R Johnston; *Dir Conservation & Technical Research* Terry Drayman Weisser; *Registrar* Joan Elizabeth Reid; *Pres Bd Trustees* Robert S Feinberg; *Cur Renaissance & Baroque Art* Joaneath Spicer; *Cur Asian Art* Hiram Woodward; *Asst Cur Medieval Art* Kelly Holbert; *Cur Mss & Rare Books* William Noel; *Dir Develop* Ed Crane; *Dir Educ* Jackie Copeland; *Librn* Kathleen Stacey; *Sr Dir Adminstr* Harold Stevens; *Dir Marketing & Communications* Ann H Wilson
Open Tues - Sun 11 AM - 5 PM, cl Mon, New Year's Day, Fourth of July, Thanksgiving, Christmas Day, Christmas Eve; Admis adults $5, seniors $3, members free, students $3, & children 6 - 17 $3, free admis on Sat 11 AM - Noon; Estab 1931 by the will of Henry Walters & opened in 1934 as an art mus. Hackerman House Mus of Asian Art opened in 1990; A Renaissance revival wing of 1905 with a contemporary wing of five floors opened in 1974, covering 126,000 sq ft of exhibition space with auditorium, library & conservation laboratory; Average Annual Attendance: 300,000; Mem: 9250; dues $40 & up
Income: $16,963,476 (financed by endowment, mem, city & state appropriation, grants & admis
Library Holdings: Auction Catalogs; Book Volumes; CD-ROMs; Compact Disks; Exhibition Catalogs; Kodachrome Transparencies; Maps; Photographs; Prints; Slides
Special Subjects: Painting-American, Religious Art, Decorative Arts, Painting-European, Jewelry, Asian Art, Antiquities-Byzantine, Painting-British, Painting-French, Baroque Art, Renaissance Art, Medieval Art, Antiquities-Oriental, Antiquities-Persian, Islamic Art, Antiquities-Egyptian, Antiquities-Greek, Antiquities-Roman, Antiquities-Etruscan, Antiquities-Assyrian
Collections: The Collection covers the entire history of art from Egyptian times to the beginning of the 20th century. It includes important groups of Roman sculpture, Etruscan, Byzantine & medieval art; Oriental art; Sevres porcelains; Near Eastern Art & European paintings
Publications: Bulletin, bi-monthly; journal, annually; exhibition catalogues
Activities: Classes for adults & children; dramatic programs; docent training; seminars; lect open to public; concerts; gallery talks; tours; films; fellowships offered; exten dept serves Baltimore City & nearby counties; book traveling exhibitions 3-4 per year; originate traveling exhibitions to museums throughout the world; museum shop sells books, reproductions, slides, Christmas cards, notepaper
L **Library,** 600 N Charles St, Baltimore, MD 21201. Tel 410-547-9000, Ext 274; Fax 410-783-7969; Elec Mail gvikan@thewalters.org; Internet Home Page Address: www.thewalters.org; *Head Librn* Kathleen Stacey; *Asst Librn* Nancy Paterson; *Dir Educ* Jacquiline Tibbs Copeland; *Assoc Dir & Cur* William R

Johnston; *CEO, Dir* Gary Vikan; *Cur Renaissance* Joaneath Spicer; *Assoc Cur 18th Century Art* Eik Kahng; *Mus Shop Mgr* Alice McAuliffe; *VChmn* Adena W Testa; *Cur Mss* William Noel; *Dir Marketing & Communication* Ann Hume Wilson; *Registrar* Joan-Elisabeth Reid; *VPres* Robert Feinberg; *Controller* Harold Stephens; *Cur Asian Art* Hiram Woodward; *Cur Ancient Art* Regine Schulz; *Dir Conservation* Terry Drayman-Weisser
Open Tues - Fri 11 AM - 5 PM; Estab 1934 serves staff of the mus & open to the pub by appointment; Non-circulating
Income: $154,000
Purchases: $73,000
Library Holdings: Auction Catalogs; Book Volumes 104,000; DVDs; Maps; Photographs; Reproductions
Special Subjects: Decorative Arts, Drawings, Painting-American, Sculpture, History of Art & Archaeology, Ceramics, Archaeology, American Western Art, Stained Glass, Religious Art, Restoration & Conservation, Silver, Silversmithing, Antiquities-Assyrian, Architecture

CHESTERTOWN

A HISTORICAL SOCIETY OF KENT COUNTY, 101 Church Alley, Chestertown, MD 21620; PO Box 665, Chestertown, MD 21620. Tel 410-778-3499; Fax 410-778-3747; Elec Mail hskcmd@friend.ly.net; Internet Home Page Address: www.kentcounty.com/historicalsociety; *Exec Dir* Kate Myer
Open May - Oct Wed - Fri 10 AM - 4 PM, Sat & Sun 1 - 4 PM; Admis adults $3 children & students free; Estab 1936 to foster an appreciation of our colonial heritage, to encourage restoration; Headquarters are in the early 18th century Geddes-Piper House (circa 1784), beautifully restored and furnished; Mem: 700; dues family $30, single $25; annual meeting in Apr
Income: Financed by mem and Candlelight Tour (2d Sat of Sept 5-9PM)
Collections: Furniture, pictures; Indian artifacts; fans; Chinese porcelain teapots; Maps; Portraits; Archival library (genealogy)
Exhibitions: Permanent house museum
Activities: Lect for members & community; tours; open house with traditional costuming; book scholarships offered; sales shop sells books & maps

COLLEGE PARK

M UNIVERSITY OF MARYLAND, COLLEGE PARK, The Art Gallery, 1202 Art-Sociology Bldg, College Park, MD 20742. Tel 301-405-2763; Fax 301-314-7774; Elec Mail ag210@umail.umd.edu; Internet Home Page Address: www.artgallery.umd.edu; *Dir* Scott Habes; *Asst Dir* Jennie Fleming; *Exhib Designer* John Shipman
During Exhibs Open Mon - Fri 11 AM - 4 PM, Wed 11 AM - 6 PM, Sat 11 AM - 4 PM, (during exhibitions) cl summer & holidays; No admis fee; Estab 1966 to present historic & contemporary exhibitions; Gallery has 4000 sq ft of space, normally divided into one large & one smaller gallery; Average Annual Attendance: 8,000
Income: Financed by university & department funds, grants, catalog sales, traveling exhibitions
Special Subjects: Painting-American, Prints, Sculpture, African Art
Collections: 20th century paintings, prints & drawings, including WPA mural studies, paintings by Warhol, Prendergast & Gottlieb; prints by Hundertwasser, Appel, Kitaj, Rivers & Chryssa; 20th century Japanese prints by Hiratsuka, Kosaka, Matsubara, Iwami, Ay-O & others; West African sculpture
Exhibitions: Masters of Fine Arts Thesis Exhibitions; Regional Artists & National Artists
Publications: Exhibition catalogs, 1 - 2 per year
Activities: Lect, symposiums & films open to public; 2-3 vis lectrs per year; gallery talks; tours; individual paintings & original objects of art lent; lending collection contains original art work & print, paintings, photographs & sculpture; one book traveling exhib every other yr; originate traveling exhibitions; exhibition catalogs sold in gallery
L Art Library, Art-Sociology Bldg, College Park, MD 20742. Tel 301-405-9061; Fax 301-314-9725; Internet Home Page Address: www.lib.umd.edu/umcp/art/art.html; *Reference Librn* Louise Green; *Library Asst* Amrita Kaur; *Library technical Asst* Warren Stephenson; *Head Art Library* Lynne Woodruff; *Library Technical Asst* Bonnie Cawthorne
Open Mon - Thurs 8:30 AM - 10 PM, Fri 8:30 AM - 5 PM, Sat 10 AM - 5 PM, Sun 1 - 10 PM; Estab 1979 in new building to serve the needs of the art & art history departments & campus in various art subjects
Income: Financed by university library system
Library Holdings: Book Volumes 95,000; CD-ROMs 30; Exhibition Catalogs; Fiche; Periodical Subscriptions 234; Reels; Reproductions 33,000
Special Subjects: Photography, Graphic Arts, Advertising Design, American Indian Art, Afro-American Art
Collections: Art & Architecture in France; Index photographic de l'art de France; Index Iconologicus; Decimal Index to art of Low Countries; Marburg index; Index of American Design; Deloynes Collections; Southeast Asia Collection
Publications: Bibliography; Checklist of Useful Tools for the Study of Art; Western Art; Asian Art
Activities: Tours
L Architecture Library, College Park, MD 20742. Tel 301-405-6317 (architecture), 405-6320 (Libr Colls); *Head* Anita Carrico
Open Mon - Thurs 8:30 AM - 10 PM, Fri 8:30 AM - 5 PM, Sat 1 - 5 PM, Sun 5 - 10 PM; Estab 1967 for lending & reference; Circ 25,000
Library Holdings: Book Volumes 37,000; Clipping Files; Fiche 200; Filmstrips; Other Holdings Bd per 6200; Periodical Subscriptions 180; Reels 600
Special Subjects: Landscape Architecture, Interior Design, Architecture
Collections: World Expositions: books & pamphlets on buildings, art work & machinery
Publications: Architecture Library (brochure), annual; Access to Architectural Literature: Periodical Indexes, annual
L National Trust for Historic Preservation Library Collection, Hornbake Library, College Park, MD 20742. Tel 301-405-6320, 405-3300; Fax 301-314-2709; Elec Mail nt_library@umail.umd.edu; Internet Home Page Address:

www.lib.umd.edu/umcp/ntl/ntl.html; *Librn* Sally Sims Stokes; *Prog Management Specialist* Kevin Hammett
Open Mon - Fri 10 AM - 5 PM; Accessible via Maryland Room in Hornbake Library; For reference only
Income: Financed by the University of Maryland
Library Holdings: Audio Tapes; Book Volumes 11,000; Cassettes; Clipping Files; Fiche; Manuscripts; Motion Pictures; Pamphlets; Periodical Subscriptions 300; Photographs; Video Tapes
Special Subjects: Historical Material, Period Rooms, Restoration & Conservation, Architecture

COLUMBIA

M AFRICAN ART MUSEUM OF MARYLAND, 5430 Vantage Point Rd, PO Box 1105 Columbia, MD 21044-0105. Tel 410-730-7106; Fax 410-730-7105; Elec Mail africanartmuseum@erols.com; Internet Home Page Address: www.africanartmuseum.org; *Dir* Doris Hillian Ligon; *Events Coordr* Carole L Oduyoye; *Dir Develop* Claude M Ligon, PhD; *Chmn Bd Trustees* Milton A Mayo
Open Tues - Fri 10 AM - 4 PM, Sun Noon - 4 PM; Admis adults $2, seniors & under 12 $1, members free; Estab 1980 working towards better understanding of African art & culture; Exhibits African Art: traditional and contemporary; Average Annual Attendance: 40,000; Mem: 300; dues family $40, individual $25, students & senior citizens $20
Income: Financed by memberships, grants, corporate support, endowment
Library Holdings: Original Documents; Photographs; Sculpture; Slides; Video Tapes
Special Subjects: Photography, Architecture, Bronzes, African Art, Archaeology, Ethnology, Textiles, Costumes, Jewelry, Historical Material, Ivory, Maps, Islamic Art
Collections: African art consisting of household items, jewelry, masks, musical instruments, sculpture & textiles; 202 Gold Weights Harold Courlander Coll
Exhibitions: 2-3 exhibits per yr;
Publications: Museum Memos, quarterly; The Quartet jazz quarterly; The Qu
Activities: Workshops & classes for children & families; docent training; lect open to public, 5 or more vis lectrs per year; concerts; gallery talks; ann tours to Africa; Akua'ba & Dir's awards given; original objects of art lent to other museums & institutions; museum shop sells books, magazines, original art, reproductions, prints, jewelry, clothing, textiles & crafts

CUMBERLAND

M ALLEGANY COUNTY HISTORICAL SOCIETY, Gordon-Roberts House, 218 Washington St, Cumberland, MD 21502. Tel 301-777-8678; Fax 301-777-8678; Elec Mail hhouse@allconct.org; Internet Home Page Address: http://www.historyhouse.allconet.org/; *Dir* Sharon Nealis; *Pres* Amy Monaco; *VPres* Larry Kelly
Open Tues - Sat 10 AM - 4 PM; Admis $7, seniors $6, children under 12 $5; Estab 1937; 1867 Victorian house, each room furnished with furniture, antiques, pictures, paintings; Average Annual Attendance: 10,000; Mem: 500; dues individual $20, couple $30; meetings in Jan, May, Sept & Nov
Income: $16,000 (financed by mem)
Library Holdings: Book Volumes; Maps; Original Documents; Photographs; Prints; Slides
Special Subjects: Decorative Arts, Landscapes, Architecture, Ceramics, Photography, Manuscripts, Painting-American, Prints, Watercolors, Textiles, Costumes, Portraits, Dolls, Furniture, Glass, Porcelain, Carpets & Rugs, Historical Material, Maps, Restorations, Tapestries, Period Rooms, Laces, Pewter
Collections: period clothing & furnishings; Paintings, Books, Textiles
Publications: Quarterly newsletter
Activities: Classes for adults & children; docent training; dramatic programs; lect open to public; tours; competitions; concerts; 2 vis lectrs per yr; originate traveling exhibitions to area schools; museum shop sells books, prints, teapots & tea accessories, toys

M CUMBERLAND THEATRE, Lobby for the Arts Gallery, 101-103 N Johnson St, Cumberland, MD 21502. Tel 301-759-4990; Fax 301-777-7092; Elec Mail sgiarritta@hereintown.net; Internet Home Page Address: www.cumberlandtheatre.com; *Asst Dir* Bev Walker
Open daily Noon - 8 PM; No admis fee; Estab 1987 to showcase artists & educate audiences; 24 x 30 ft, well-lighted & equipped for work of all sizes; Average Annual Attendance: 24,000; Mem: 29; ann meeting in Nov; meeting monthly
Income: $260,000 (financed by mem, city & state appropriation)
Exhibitions: Juried exhibits accompany the theatrical season
Activities: Dramatic programs; book traveling exhibitions 2 per year; originate traveling exhibitions 22 per year; museum shop sells original art

EASTON

M ACADEMY ART MUSEUM, 106 South St, Easton, MD 21601. Tel 410-822-2787; Fax 410-822-5997; Elec Mail academy@goeaston.net; Internet Home Page Address: www.art-academy.org; *Dir* Christopher Brownawell
Open Mon, Tues, Fri & Sat 10 AM - 4 PM, Tues, Weds, Thurs 10 AM - 8 PM; Admis fee $3; free to members; Estab 1958 to promote the knowledge, appreciation & practice of all the arts; a private nonprofit art museum; The Academy is housed in two 18th century structures - the original schoolhouse in Easton & an adjacent residence that has been renovated & linked with new construction. The 30,000 sq ft facility includes six galleries, five studios, a 1000 volume resource center; Average Annual Attendance: 65,000; Mem: 3000; dues benefactor $5000, patron $1000, sustaining $500, contributing $250, friend $100, dual/family $65, individual $50
Income: Financed by mem, contributions, government, corporate & foundation grants, admis, tuitions, endowment & investments
Collections: Permanent art collection includes 19th & 20th century prints & paintings, including artists Felix Buhot, Robert Rauschenberg, James McNeill

Whistler, Ander Zorn, The Ashcan School - the majority & other historically important 19th & 20th century artists
Exhibitions: The Academy mounts 16 exhibits per year featuring local, regional & nationally known artists;
Publications: Academy. Printed quarterly
Activities: Classes in drawing, painting, sculpture, fine crafts plus weekend workshops & open studio sessions; dance & music classes for all ages; childrens' summer arts program in all disciplined & arts media; lect open to public, 8 vis lect per year; gallery talks; tours; dramatic programs; annual members shows with prizes awarded; exten dept serving regional schools & Eastern Shore of Maryland

ELLICOTT CITY

A HOWARD COUNTY ARTS COUNCIL, 8510 High Ridge Rd, Ellicott City, MD 21043. Tel 410-313-2787; Fax 410-313-2790; Elec Mail info@hocorts.com; Internet Home Page Address: www.hocoarts.org; *Deputy* Amy Poff; *Exec Dir* Coleen West
Open Mon - Fri 9 AM - 8 PM, Sat 9 AM - 4 PM; No admis fee; Estab 1981 to serve pub fostering arts, artists & art organizations; Two exhibition galleries, 2000 sq ft; 10-12 rotating exhibitions annually, studios, classrooms, black boxtheater, meeting rm; Average Annual Attendance: 40,000; Mem: Dues $25-$500; annual meeting in Sept
Income: $800,000 (financed by pub & pvt funds, spec events & earned income
Activities: Classes for adults & children; dramatic programs; 3-4 vis lectrs per year; concerts; gallery talks; tours; sponsoring of competitions; juror's awards; scholarships offered; sales shop sells original art

FORT MEADE

M FORT GEORGE G MEADE MUSEUM, 4674 Griffin Ave, Fort Meade, MD 20755-5094. Tel 301-677-6966; Fax 301-677-2953; Elec Mail johnsonr@emh1.ftmeade.army.mil; FTS 923-6966; *Exhibits Specialist* Barbara Taylor; *Museum Technician* Mark Henry; *Cur* Robert S Johnson
Open Wed - Sat 11 AM - 4 PM, Sun 1 - 4 PM, cl Mon, Tues & holidays; No admis fee; Estab 1963 to collect, preserve, study & display military artifacts relating to the United States Army, Fort Meade & the surrounding region; Average Annual Attendance: 40,000
Income: Financed by federal funds
Special Subjects: Graphics, Photography, Textiles, Costumes, Manuscripts, Posters, Historical Material, Maps, Cartoons, Military Art
Collections: Military art; World War I, World War II & Civil War Periods
Exhibitions: Development of Armor, 1920-1940; History of Fort George G Meade
Activities: Lect open to the public, 4 vis lectrs per year; gallery talks; tours; living history programs

FROSTBURG

M FROSTBURG STATE UNIVERSITY, The Stephanie Ann Roper Gallery, 1011 Braddock Rd, Frostburg, MD 21532. Tel 301-687-4797; Fax 301-687-3099; Elec Mail ddavis@frostburg.edu; *Chair* Dustin P Davis; *Admin Asst* Sharon Gray
Open Sun - Wed 1 - 4 PM; No admis fee; Estab 1972 for educational purposes; Average Annual Attendance: 1,000
Income: Financed by state appropriation
Special Subjects: Prints, Folk Art
Collections: Folk art; prints
Activities: Educ dept; lect open to public, 5 vis lectrs per year; gallery talks; competitions with awards; book traveling exhibitions 4 per year

L Lewis J Ort Library, 1 Stadium Dr, Frostburg, MD 21532. Tel 301-687-4395; Fax 301-687-7069; Elec Mail mprice@frostburg.edu; *Exhib Librn* Mary Jo Price; *Dir* Dr David M Gillespie
Open Mon - Fri 8 AM - 12 AM, Sat & Sun 1 PM - 12 AM
Library Holdings: Audio Tapes; Book Volumes 500,000; Cassettes; Exhibition Catalogs; Fiche; Filmstrips; Kodachrome Transparencies; Motion Pictures; Periodical Subscriptions 1300; Prints; Reproductions; Slides; Video Tapes
Collections: Extensive poster collection Communist USA 1920's to present

HAGERSTOWN

M WASHINGTON COUNTY MUSEUM OF FINE ARTS, City Park, 91 Key St, PO Box 423 Hagerstown, MD 21741. Tel 301-739-5727; Fax 301-745-3741; Elec Mail info@wcmfa.org; Internet Home Page Address: www.wcmfa.org; *Admin Asst* Christine Shives; *Dir* Joseph Ruzicka; *Pres* Spence W Perry; *Mus Shop Mgr* Cindy Walser; *Cur* Amy Hunt; *Mus Shop Mgr* Lucy Edmunds; *Educ Coordr* Linda Dodson
Open Tues - Fri 9 AM - 5 PM, Sat 9 AM - 4 PM, Sun 1 - 5 PM, cl Mon; No admis fee; Estab 1930 to exhibit, interpret & conserve art; The mus consists of eleven galleries; Average Annual Attendance: 75,000; Mem: 980; dues $25 & up
Income: Financed by government, mem & donations
Special Subjects: Drawings, Painting-American, Prints, Sculpture, Glass, Jade, Oriental Art, Laces
Collections: American pressed glass; sculpture; 19th & early 20th century American art
Exhibitions: Exhibits drawn from the Permanent Collection - 19th & 20th Century American Art
Publications: American Pressed Glass; Old Master drawings; bi-monthly bulletin; catalogs of major exhibitions; catalog of the permanent collection
Activities: Classes for adults & children; dramatic programs; docent training; lect open to public, 10 vis lectr per year; concerts; gallery talks; tours; competitions with awards; original objects of art lent to accredited museums; originate traveling exhibitions; sales shop sells books & original art

L Library, City Park, PO Box 423 Hagerstown, MD 21741. Tel 301-739-5727; Fax 301-745-3741; Elec Mail info@wcmfa.org; Internet Home Page Address: wcmfa.org; *Dir* Jean Woods; *Dir* Joseph Ruzicka; *Cur* Dr Ann Wagner; *Admin Asst* Christine Shives

Open Tues - Fri 9 AM - 5 PM, Sat 9 AM - 4 PM; Free; 1931 - Fine Arts Museum; Open to the pub for reference only; Average Annual Attendance: 72,000; Mem: 950+, $25 - $10,000
Income: financed by government, members, donations
Library Holdings: Book Volumes 5000; Cards; Cassettes; Clipping Files; Exhibition Catalogs; Filmstrips; Motion Pictures; Pamphlets; Periodical Subscriptions 7; Slides; Video Tapes
Activities: Classes for adults & Children; docent training; concerts; gallery talks; tours

LAUREL

M MARYLAND-NATIONAL CAPITAL PARK & PLANNING COMMISSION, Montpelier Arts Center, 9652 Muir Kirk Rd, Laurel, MD 20708. Tel 301-953-1993, 410-792-0664; Fax 301-206-9682; Elec Mail montpelier.arts@pgparks.com; Internet Home Page Address: www.pgparks.com; *Dir* Richard Zandler; *Asst Dir* Ruth Schilling Harwood; *Technical Dir* John Yeh
Open daily 10 AM - 5 PM; No admis fee; Estab 1979 to serve artists regionally & to offer high quality fine arts experiences to pub; Main Gallery houses major invitational exhibitions by artists of regional & national reputation; Library Gallery houses local artists' exhibitions; Resident Artists' Gallery provided to artists who rent studio space; Small library of donated volumes; Average Annual Attendance: 56,000; Mem: 83; 50 individuals; 30 families
Income: $300,000 (financed by county appropriation, grants, classes & studio rentals)
Library Holdings: Book Volumes; Periodical Subscriptions
Publications: Exhibit catalogs; promotional invitations; jazz concerts
Activities: Classes for adults & children; workshops in specialized areas; lect open to pub, 3-4 vis lectrs per year; gallery talks; concerts (14 jazz, 7 blues & folk, 4 classical recitals); tours; competitions with exhibitions awards/honoranims; book traveling exhibitions, annually; originate traveling exhibitions; Jazzmont label produces and sells jazz CD's

ROCKVILLE

M JEWISH COMMUNITY CENTER OF GREATER WASHINGTON, Jane L & Robert H Weiner Judaic Museum, 6125 Montrose Rd, Rockville, MD 20852. Tel 301-881-0100; Fax 301-881-5512; Internet Home Page Address: www.jccgw.org; *Pres* Samuel Lehrman; *Exec Dir* Michael Witkes; *Gallery Dir* Karen Falk
Open Mon - Thurs Noon - 4 PM & 7:30 - 9:30 PM, Sun 2 - 5 PM; No admis fee; Estab 1925 to preserve, exhibit & promulgate Jewish culture; Center houses mus & Goldman Fine Arts Gallery; Average Annual Attendance: 25,000
Income: Financed by endowment, corporate, private & pub gifts, grants & sales
Exhibitions: Monthly exhibits, Sept-June; Fine art, fine craft, documentary photography; seven to eight temporary exhibitions yearly including Israeli Artists & American & emerging artist
Publications: Exhibition catalogues; brochures
Activities: Classes for adults & children; docent training; lect open to public; concerts; gallery talks; tours; book traveling exhibitions; originate traveling exhibitions; museum shop sells books, original art, reproductions & prints

SAINT MARY CITY

M ST MARY'S COLLEGE OF MARYLAND, The Dwight Frederick Boyden Gallery, SMC, Saint Mary City, MD 20686. Tel 301-862-0246; Fax 301-862-0958; *Registrar* Jan Kiphart; *Dir Gallery* Casey Page
Open Mon - Thurs 10:30 AM - 5 PM, Fri 10:30 AM - 4:30 PM; No admis fee; 1600 sq ft exhibition space for temporary exhibits of art; five bldgs with art hung in public areas
Income: Financed by St Mary's College
Purchases: Collection is from donation
Collections: Study; developmental; Long Term Loan; SMC; Permanent
Activities: Gallery talks; individual paintings & original objects of art lent to local, nonprofit organizations; lending collection contains original art works & prints, paintings & sculptures

SAINT MICHAELS

M CHESAPEAKE BAY MARITIME MUSEUM, Navy Point, PO Box 636 Saint Michaels, MD 21663. Tel 410-745-2916; Fax 410-745-6088; Elec Mail commeuts@cbmm.org; Internet Home Page Address: www.cbmm.org; *Dir* John R Valliant; *Dir Center Chesapeake Studies* Melissa McLoud; *Cur* Pete Lesher; *Cur* Lindsley Rice
Open daily 10 AM - 6 PM (Summer), 10 AM - 5 PM (Fall), 10 AM - 4 PM (Winter); cl New Year's Day, Thanksgiving, Christmas; Admis adults $10, seniors $9, children $5; Estab 1965 as a waterside mus dedicated to preserving the maritime history of the Chesapeake Bay; Consists of twenty buildings on approx 18 acres of waterfront property including Hooper's Strait Lighthouse, 1879; Average Annual Attendance: 85,000; Mem: 7000; dues $40--$75
Income: Financed by mem, admis & endowment
Library Holdings: Audio Tapes 170; Book Volumes 9800; Clipping Files; Manuscripts; Maps; Original Art Works; Original Documents; Pamphlets; Periodical Subscriptions 17; Photographs 35,000; Prints; Slides; Video Tapes
Special Subjects: Prints, Manuscripts, Photography, Watercolors, Folk Art, Woodcarvings, Marine Painting, Historical Material
Collections: Paintings; ship models; vessels including skipjack, bugeye, log canoes, & many small crafts; waterfowling exhibits; working boat shop
Exhibitions: (11/2006-7/2007) Waters of Despair, Waters of Hope: African-Americans on the Chesapeake
Publications: Beacons of Hooper Strait (2000)
Activities: Classes for adults & children; docent training; lect open to public, 4 vis lectrs per year; concerts; tours; individual paintings & original objects of art lent to other museums; 1-2 book traveling exhibs per yr; museum shop sells books, magazines, reproductions, prints

L **Howard I Chapelle Memorial Library,** Navy Point, PO Box 636 Saint Michaels, MD 21663. Tel 410-745-2916; Fax 410-745-6088; Internet Home Page Address: www.cbmm.org; *Cur* Pete Lesher; *Dir Center for Chesapeake Studies* Melissa Mcloud; *Coll Mgr* Julie Cox
Open by appointment; Estab 1965 for preservation of Chesapeake Bay maritime history & culture; Non-circulating research facility; Average Annual Attendance: 500
Income: Financed by endowment
Library Holdings: Auction Catalogs; Book Volumes 9800; Cards; Clipping Files; Manuscripts; Pamphlets; Periodical Subscriptions 17; Photographs 35,000
Special Subjects: Folk Art, Woodcarvings, Marine Painting
Collections: Ships plans, registers, manuscripts; oral histories
Activities: Classes for adults & children; docent training; lect open to the public; 4 vis lec per yr; 1-2 book traveling exhibs per yr; museum shop sells books, magazines & prints

SALISBURY

M **SALISBURY UNIVERSITY,** (Ward Foundation) Ward Museum of Wildfowl Art, 909 S Schumaker, Salisbury, MD 21801. Tel 410-742-4988; Fax 410-742-3107; Elec Mail ward@wardmuseum.org; Internet Home Page Address: www.wardmuseum.org; *Mem Rose* Taylor; *Archives* Barbara Gehrm; *Gift Shop Mgr* Barbara Reed; *Dir Develop* Sharon Goebel; *Dir Educ* Amy Walls; *Business Mgr* Chris Parks; *Exec Dir* Kenneth Basile; *Special Events* Kevin Collens; *Cur Folklore* Lora Bohinelli
Open Mon - Sat 10 AM - 5 PM, Sun Noon - 5 PM; Admis adults $7, seniors $5, students $3, group tour $17, Sun for family $8.50; Estab 1968 as a non-profit organization dedicated to preservation & conservation of wildfowl carving; Main gallery & balcony contain 3000 carvings, prints & paintings of wildfowl-related items, including World Championship carvings; Average Annual Attendance: 30,000; Mem: 2300; dues family $60, individual $35
Income: $1,000,000 (financed by mem, city & state appropriations, grants, donations, gift shop sales)
Library Holdings: Auction Catalogs 200; Audio Tapes 200; Book Volumes 300; Cassettes 200; Clipping Files; Kodachrome Transparencies 1000; Memorabilia; Original Art Works; Pamphlets; Periodical Subscriptions; Photographs; Prints
Collections: Decoys & decorative bird carvings, fowling skiffs & firearms
Exhibitions: Annual Fall Exhibition of paintings & sculptures; Antique decoy auction; The Ward Exhibition of Wildfowl Art; World Carving Championship
Publications: Wildfowl Art Journal, quarterly; Ward Foundation News, quarterly
Activities: Classes for adults & children, docent training; lect open to public; tours; competition with awards; carving workshops held in Apr, June & Feb; individual paintings & original objects of art lent; lending collection contains color reproductions, framed reproductions, original art works, original prints, paintings, photographs, sculpture; museum shop sells books, magazines, original art, reproductions, prints, slides, decoys and video shows

SALISBURY UNIVERSITY
M **University Gallery,** Tel 410-543-6271; Fax 410-548-3002; Elec Mail rbshedaker@ssu.edu; *Gallery Dir* Kenneth Basile; *Gallert Asst* Rachael Shedaker
Open Sept - Dec & Feb - May Tues - Fri 10 AM - 5 PM, Sat & Sun 1 - 4 PM, cl Fri; No admis fee; Estab 1967 to provide a wide range of art exhibitions to the University & community, with emphasis on educational value of exhibitions; Gallery Open to pub & is located in Fulton Hall; Average Annual Attendance: 8,000
Income: Financed mainly by Salisbury State University with additional support from the Maryland State Arts Council, The Salisbury/Wicomico Arts Council & other agencies
Special Subjects: Prints
Exhibitions: Annual faculty & student shows; wide range of traveling exhibitions from various national & regional arts organizations & galleries; variety of regional & local exhibitions; speakers & special events; sculpture gardens
Publications: Announcements
Activities: Workshops for children, students & general public; film series; lect open to public; 1-2 vis lectr per year
L **Blackwell Library,** Tel 410-543-6130; Fax 410-543-6203; Internet Home Page Address: www.salisbury.edu/library; *Dean of Libraries & Instructional Resources* Dr Alice H Bahr
Open Mon - Thurs 8 AM - midnight, Fri 8 AM - 10 PM, Sat 10 AM - 8 PM, Sun Noon - midnight; Estab 1925, to support the curriculum of Salisbury University; Circ 2,500; Library has total space of 66,000 sq ft; Average Annual Attendance: 295,250
Library Holdings: Audio Tapes 340; Book Volumes 266,139; Cards 2,278; Cassettes 487; Clipping Files; Compact Disks 48; DVDs 124; Fiche 733,160; Periodical Subscriptions 1,235; Reels 15,533; Video Tapes 106

SILVER SPRING

L **MARYLAND COLLEGE OF ART & DESIGN LIBRARY,** 10500 Georgia Ave, Silver Spring, MD 20902. Tel 301-649-4454; Fax 301-649-2940; Elec Mail mcadlibrary@aol.com; Internet Home Page Address: www.mcadmd.org; *Head Librn* Kate Cooper
Open Mon - Fri 9 AM - 5 PM; Estab 1977 to facilitate & encourage learning by the students & to provide aid for the faculty; Circ 8000; College maintains Gudelsky Gallery
Purchases: $7000
Library Holdings: Auction Catalogs; Book Volumes 12,000; Cassettes 50; Clipping Files; Motion Pictures; Periodical Subscriptions 35; Slides 30,000; Video Tapes
Special Subjects: Art History, Decorative Arts, Calligraphy, Drawings, Graphic Arts, Graphic Design, History of Art & Archaeology, Afro-American Art, Antiquities-Assyrian, Antiquities-Byzantine, Antiquities-Egyptian, Antiquities-Etruscan, Antiquities-Greek, Antiquities-Roman, Architecture
Activities: Classes for adults & children

SOLOMONS

M **CALVERT MARINE MUSEUM,** PO Box 97, Solomons, MD 20688. Tel 410-326-2042; Fax 410-326-6691; Internet Home Page Address: www.calvertmarinemuseum.com; *Registrar* Robert J Hurry; *Exhib Designer* James L Langley; *Master Woodcarver* Skip Edwards; *Cur Maritime History* Richard J Dodds; *Cur Estuarine Biology* Kenneth Kaumeyer; *Cur Paleontology* Stephen Godfrey; *Dir* C Douglass Alves Jr; *Deputy Dir* Sherrod A Sturrock; *Bus Mgr* Ken Wease; *Develop Dir* Vanessa Gill
Open Mon - Sun 10 AM - 5 PM; Admis $7 or $6; Estab 1970, to provide the public with a marine oriented museum on maritime history, estuarine natural history, marine paleontology and natural & cultural history of the Patuxent River region; 5,500 sq ft gallery is maintained on maritime history of the region, three to four shows per yr; Average Annual Attendance: 65,000; Mem: 3800; dues family $50, individual $35
Income: $3,400,000 (financed by county appropriation & Calvert Marine Society)
Purchases: $1000
Special Subjects: Watercolors, Archaeology, Woodcarvings, Manuscripts, Marine Painting, Historical Material, Maps
Collections: J S Bohannon Folk Art Steamboat Collection; local Chesapeake Bay Ship Portraits; Tufnell Watercolor Collection; Louis Feuchter Collection; A Aubrey Bodine Collection; C Leslie Oursler Collection; August H O Rolle Collection
Publications: Bugeye Times, quarterly newsletter; Cradle of Invasion: A History of the US Amphibious Training Base, Solomons, Maryland, 1942-45; The Drum Point Lighthouse, brochure; Early Chesapeake Single-Log Canoes: A Brief History & introduction to Building Techniques; The Last Generation: A History of a Chesapeake Shipbuilding Family; The Othello Affair; The Pursuit of French Pirates on the Patuxent River, Maryland, August 1807; War on the Patuxent, 1814: A Catalog of Artifacts; Watercraft Collection, brochure; Working the Water: The Commercial Fisheries of Maryland's Patuxent River; Solomons Island & Vicinity An Illustrated History & Walking Tour; miscellaneous special publications on history
Activities: Classes for adults and children; docent training; lect open to the public, 8 lectrs per year; concerts; gallery talks; tours; individual paintings & original objects of art lent to other appropriately qualified nonprofit organizations; lending collection contains 3000 black & white photographs, lantern slides, art works, original prints, 2800 slides; museum shop sells books, magazines, original art, prints, reproductions, hand crafts
L **Library,** 14150 Solomons Island Rd, PO Box 97 Solomons, MD 20688. Tel 410-326-2042 x 14; Fax 410-326-6691; Elec Mail information@calvertmarinemuseum.com; Internet Home Page Address: www.calvertmarinemuseum.com; *Librn* Paul Berry; *Registrar* Robert J Hurry
Open Mon - Fri 9 AM - 4:30 PM, cl weekends; Estab 1970; Library open for research and reference, local maritime history, palentology; Average Annual Attendance: 100
Income: $2500 (finance by Calvert County government, mem, gift shop, donations & grants)
Purchases: $1000
Library Holdings: Audio Tapes; Book Volumes 6500; CD-ROMs 10; Cassettes 15; Clipping Files; Exhibition Catalogs; Fiche 10; Manuscripts; Maps; Memorabilia; Micro Print; Original Art Works; Pamphlets; Periodical Subscriptions 40; Photographs 12,500; Prints; Records; Reproductions; Slides 10,000; Video Tapes 175
Collections: marine/maritime paintings, ship models
Activities: Classes for children; lect open to public, 3-4 vis lect per yr; concerts; museum shop sells books, prints, ship models & jewelry

TOWSON

TOWSON UNIVERSITY CENTER FOR THE ARTS GALLERY
M **The Holtzman MFA Gallery,** Tel 410-704-2808; Fax 410-704-2810; Elec Mail cbartlett@towson.edu; *Dir & Prof* Christopher Bartlett
Open Tues - Sat Noon - 4 PM; No admis fee; Estab 1973 to provide a wide variety of art exhibitions, primarily contemporary work, with national importance; The main gallery is situated in the fine arts building directly off the foyer. It is 30 x 60 ft with 15 ft ceiling & 15 x 30 ft storage area; Average Annual Attendance: 10,000
Income: $18,000 (financed by state appropriation, cultural services fees & private gifts)
Special Subjects: Prints, Marine Painting, Historical Material, Maps
Collections: African art; Asian arts, through Roberts Art Collection; contemporary painting & sculpture; Maryland Artists Collection
Exhibitions: Teresa Barkley: A Life in Quilts; Wunderkammer: A Cabinet of Curiosities, Ann Chahbandour & Rebecca Kamen Installation
Publications: Calendar, each semester; exhibition posters & catalogs
Activities: Lect open to public, 4 vis lectrs per year; gallery talks; book traveling exhibitions 2-3 per year
M **Asian Arts & Culture Center,** Tel 410-704-2807; Fax 410-704-4032; Internet Home Page Address: www.towson.edu/asianarts; *Cur* Suewhei T Shieh
Open during academic year Mon - Fri 11 AM - 4 PM, Sat hours posted for each exhibition; No admis fee; Estab 1972 to provide an area to display the Asian art collections of the University & present art & culture programs on Asia through-out school year; The gallery is located on the second floor of the Fine Arts Building; also includes a small reference library; Average Annual Attendance: 10,000; Mem: Dues Dragon Circle $1,000 & up, Phoenix Circle $500-$999, Tiger Soc $250-$499, Crane Club $100-$249, general mem $30-$99
Income: Financed by membership, grants & corporate sponsorship
Special Subjects: Sculpture, Bronzes, Southwestern Art, Textiles, Costumes, Ceramics, Folk Art, Pottery, Woodcuts, Decorative Arts, Painting-Japanese, Furniture, Porcelain, Oriental Art, Asian Art, Metalwork, Antiquities-Oriental
Collections: Asian Ceramics; ivory; metalwork; furniture; paintings; prints; textiles; sculptures
Exhibitions: Permanent collection; special loan exhibitions; exhibitions on contemporary art of Asia
Publications: Asian Arts & Culture Center newsletter, biannual
Activities: Classes for adults & children; lect open to public, 2 vis lectrs per year; gallery talks; tours; workshops; concerts; performances; individual & original

objects of art lent to educational & cultural institutions; 4-5 book traveling exhibitions per year

WESTMINSTER

M WESTERN MARYLAND COLLEGE, Esther Prangley Rice Gallery, Dept of Art & Art History, Westminster, MD 21157. Tel 410-857-2595; Fax 410-386-4657; Elec Mail scorerst@wmdc.edu, mlosch@wmdc.edu; Internet Home Page Address: www.wmdc.edu; *Dir* Michael Losch
Open Mon - Fri Noon - 4 PM, call in advance; No admis fee; Estab to expose students to original works by professional artists; Top floor of Peterson Hall/Art Bldg
Income: Financed by college funds
Collections: Permanent collection of international artifacts; Egyptian, African, Native American, Asian, Prints (Picasso, Daumier, Mark Tobey)
Exhibitions: Rotating artist and one student show per yr

MASSACHUSETTS

AMESBURY

M THE BARTLETT MUSEUM, 270 Main St, PO Box 692 Amesbury, MA 01913. Tel 978-388-4528; *Cur* Hazele Kray; *Pres* John McCone; *Treas. (V)* Wayne Gove; *Mus Shop Mgr.* Gina Moscardini
Open Memorial Day - Labor Day Fri - Sun 1 - 4 PM; Estab 1968; Two-room Victorian-style Ferry School built in 1870. Name later changed to The Bartlett School in honor of Josiah Bartlett, signer of America's Declaration of Independence, near whose home the school was sited; Mem: dues patron $100 & up, contributing $25, family $15, individual $5, student $1
Special Subjects: Architecture, Painting-American, Sculpture, Costumes, Manuscripts, Portraits, Furniture, Silver, Historical Material, Maps, Dioramas, Period Rooms
Collections: Natural science artifacts
Activities: Workshops

AMHERST

M AMHERST COLLEGE, Mead Art Museum, South Pleasant St, Amherst, MA 01002. Tel 413-542-2335; Fax 413-542-2117; *Cur American Art* Martha Hoppin; *Dir* Jill Meredith
Open Tues, Wed, Fri, Sat & Sun 10 AM - 4:30 PM, Thurs 10 AM - 9 PM, cl Mon; No admis fee; Estab 1949; Average Annual Attendance: 13,500; Mem: 500; annual meetings in the spring
Special Subjects: Oriental Art
Collections: African Art; American art; Ancient art; English art; Western European & Oriental Collections
Publications: American Art at Amherst: A Summary Catalogue of the Collection at the Mead Art Gallery; American Watercolors & Drawings from Amherst College; Mead Museum Monographs; catalogues for major exhibitions
Activities: Educ dept; lect open to public, 3 vis lectrs per year; gallery talks; tours; individual paintings & original objects of art lent for exhibition only to other museums
L Robert Frost Library, Amherst, MA 01002. Tel 413-542-2677; Fax 413-542-2662; *Reference & Fine Arts Librn* Michael Kasper
Circulating to Amherst College students & five college faculty
Library Holdings: Book Volumes 40,000; Exhibition Catalogs; Fiche; Periodical Subscriptions 82; Slides

ARTS EXTENSION SERVICE
For further information, see National and Regional Organizations

L JONES LIBRARY, INC, 43 Amity St, Amherst, MA 01002. Tel 413-256-4090; Fax 413-256-4096; Elec Mail reference@joneslibrary.org; Internet Home Page Address: www.joneslibrary.org; *Asst Dir, Children's Librn* Sondra M Radosh; *Reference Librn* Pauline M Peterson; *Adult Svc Librn* Beth Girshman; *Cur* Tevis Kimball; *Dir* Bonnie Isman
Open Mon, Wed, Fri & Sat 9 AM - 5:30 PM, Tues & Thurs 9 AM - 9:30 PM, Sun 1 - 5 PM (Mon - Sat 10 AM - 5 PM Sept - May); Special Collections has limited hours; No admis fee; Estab 1919 as a public library; Circ 500,000; Gallery; Average Annual Attendance: 500,000
Income: Financed by endowment & city appropriation
Library Holdings: Audio Tapes; Book Volumes 183,400; Cassettes; Clipping Files; Framed Reproductions; Manuscripts; Memorabilia; Original Art Works; Pamphlets; Periodical Subscriptions 150; Photographs; Records; Reels; Sculpture; Slides
Collections: Ray Stannard Baker; Emily Dickinson; Robert Frost; Julius Lester; Harlan Fiske Stone; Sidney Waugh Writings; local history & geneology; Burnett Family
Exhibitions: Permanent collection & rotating exhibits on local history
Activities: Lect open to public; concerts; tours

UNIVERSITY OF MASSACHUSETTS, AMHERST
M University Gallery, Tel 413-545-3670; Fax 413-545-2018; Elec Mail ugallery@acad.umass.edu; Internet Home Page Address: www.umass.edu/fac/universitygallery; *Gallery Mgr* Craig Allaben; *Coll Registrar* Justin Griswold; *Dir* Loretta Yarlow; *Educ Cur* Eva Fierst
Open Tues - Fri 11 AM - 4:30 PM, Sat & Sun 2 - 5 PM during school yr; No admis fee; Estab 1975; Main Gallery 57-1/2 x 47 ft, East Gallery 67-1/2 x 20-1/2 ft, West Gallery 56-1/2 x 23-1/2 ft, North Gallery 46-1/2 x 17-1/2 ft; Average Annual Attendance: 15,000; Mem: 150; dues $25 & up
Income: University

Special Subjects: Etchings & Engravings, Drawings, Painting-American, Photography, Prints, Sculpture, Southwestern Art, Pottery
Collections: 20th century American works on paper including drawings, prints & photographs
Publications: Exhibition catalogs
Activities: Lect open to public, 2-3 vis lectrs per year; gallery talks; tours; individual art works from the permanent collection loaned to other institutions; originate traveling exhibitions; peer institutions/museums
L Dorothy W Perkins Slide Library, Tel 413-545-3314; Fax 413-545-3880; Internet Home Page Address: www.umass.edu; *Cur Visual Coll* Nathalie Bridegam
Open Mon - Fri 1 PM - 4:15 PM; Graduate student reference slide library; Circ 60,000 (slides); campus only
Library Holdings: Other Holdings Interactive video disks; Magnetic disks 50; Study Plates 7000; Slides 270,000

ANDOVER

A ANDOVER HISTORICAL SOCIETY, 97 Main St, Andover, MA 01810. Tel 978-475-2236; Fax 978-470-2741; Elec Mail info@andhist.org; Internet Home Page Address: www.andhist.org; *Pres (V)* Diane Hender; *Dir Educ & Re* Juliet Mofford
Open Tues - Fri 9 AM - 5 PM, Sat 9 AM - 3 PM, Mon by appt; Admis adults $4, student & seniors $2; 1819 period rm, museum & barn as well as research lib & archives; Average Annual Attendance: 8,335
Exhibitions: Amos Blanchard Home , Contemporary Andover Artist Series, quarterly changing exhibits
Activities: 3rd grade sch children, family day programs; walking tours, house & garden tours; originate traveling exhibitions

A NORTHEAST DOCUMENT CONSERVATION CENTER, INC, 100 Brickstone Sq, Andover, MA 01810-1494. Tel 978-470-1010; Fax 978-475-6021; Elec Mail nedcc@nedcc.org; Internet Home Page Address: www.nedcc.org; *Registrar* Jonathan Goodrich; *Develop & Pub Rels Coordr* Julie Carlson; *Exec Dir* Ann Russell
Estab 1973 to improve preservation programs of libraries, archives, mus & other historical & cultural organizations; to provide highest quality services to institutions that cannot afford in-house conservation facilities or that require specialized expertise; & to provide leadership to the preservation field; Headquarters located in a fire-proof 1920's mill building with masonry construction, including concrete floors 8″ thick; 20,000 sq ft; state-of-the-art security systems & environmental controls

M PHILLIPS ACADEMY, Addison Gallery of American Art, Chapel Ave, Andover, MA 01810. Tel 978-749-4015; Fax 978-749-4025; Internet Home Page Address: www.addisongallery.org; *Assoc Dir & Cur Art Before 1950* Susan Faxon; *Registrar* Denise Johnson; *Assoc Cur Art After 1950 & Photography* Allison Kemmerer; *Preparator* Leslie Maloney; *Mem Pub Relations* Maria Lockheardt; *Cur Asst* Julianne McDonough; *Educ Dir* Julie Bernson; *Assoc Registrar* James Sousa
Open Tues - Sat 10 AM - 5 PM, Sun 1 - 5 PM, closed Aug; No admis fee; Estab 1931 in memory of Mrs Keturah Addison Cobb, to enrich permanently the lives of the students by helping to cultivate & foster in them a love for the beautiful. The gift also included a number of important paintings, prints & sculpture as a nucleus for the beginning of a permanent collection of American art; Maintains small reference library for mus use only; Average Annual Attendance: 35,000; Mem: 600, dues $50-10,000
Income: Financed by endowment & gifts
Purchases: American art
Library Holdings: Book Volumes; Exhibition Catalogs; Other Holdings; Slides
Special Subjects: Drawings, Painting-American, Photography, Prints, Sculpture
Collections: 18th, 19th & 20th centuries drawings, paintings, prints, sculpture; photographs; film; videotapes
Exhibitions: (1/2007-3/2007) Models as Muse; (4/2007-7/2007) William Wegman
Publications: William Wegman; Coming of Age; Jennifer Bartlett
Activities: Educ Program, classes for children; lect open to public, 8-10 vis lectrs per year; concerts; gallery talks; fellowships; book traveling exhib: 2-3; organize traveling exhibs for nat and internat mus; mus Shop: sales shop; books; reproductions

ASHLAND

M ASHLAND HISTORICAL SOCIETY, 2 Myrtle St, Ashland, MA 01721; PO Box 145, Ashland, MA 01721. Tel 508-881-8183; *Pres (V)* Clifford Wilson; *Cur* Catherine Powers
Open Wed 7 - 9 PM, Sat 10 AM - Noon; Estab 1909
Special Subjects: Painting-American, Portraits, Historical Material, Period Rooms
Publications: Monthly newsletter for members

ATTLEBORO

M ATTLEBORO MUSEUM, CENTER FOR THE ARTS, 86 Park St, Attleboro, MA 02703. Tel 508-222-2644; Fax 508-226-4401; *Pres Bd Trustees* Gerry Hickman; *Treas* Jack Brandley; *Dir* Dore VanDyke
Open Tues - Fri 10 AM - 5 PM, Sat 10 AM - 5 PM, Sun Noon - 4 PM; cl Mon; No admis fee, donations accepted; Estab 1927 to exhibit the works of contemporary New England artists, as well as the art works of the museum's own collection. These are pub openings plus several competitive exhibits with awards & an outdoor art festival; Three galleries with changing monthly exhibits of paintings, drawings, sculpture, ceramics, jewelry, glass, metals & prints; Average Annual Attendance: 7,800; Mem: 230; dues life mem & corporate $1000, patron $500, benefactor $250, sponsor & supporting $125, assoc $40, family $ 50, artist mem $35 student & senior citizen $25
Income: Financed by mem, gifts, local & state grants

Library Holdings: Auction Catalogs; Audio Tapes; Cards; Clipping Files; Original Art Works; Original Documents; Pamphlets; Periodical Subscriptions; Photographs; Prints; Records; Sculpture; Slides
Special Subjects: Painting-American, Prints
Collections: Paintings & prints
Exhibitions: Holiday Show; Annual Area Artist Exhibit; Individual & Group Exhibits of Various Media & Subject; Competitive Painting Show; Fall Members Show; Competitive Photography Show; Selections from the Permanent Collection; Hi-art
Publications: Newsletter, every 2 months
Activities: Classes for adults & children; workshops; lect open to public; vis lectr; 2 concerts per year; gallery talks; tours; competitions, schols offered; painting & photography; 1st, 2nd, 3rd place awards & Honorable Mention; original objects of art lent; museum shop sells photograph albums, ceramics & jewelry

BEVERLY

M **BEVERLY HISTORICAL SOCIETY,** Cabot, Hale & Balch House Museums, 117 Cabot St, Beverly, MA 01915. Tel 978-922-1186; *Dir & Cur* Page Roberts; *Pres* Doreen Ushakoff
Cabot Museum open yearly Wed - Fri 10 AM - 4 PM & alternate Sat; Balch House open May 28 - Oct 15; Hale House open June - Sept; Admis adults $4, children under 16 $2; The Balch House built in 1636 by John Balch contains period furniture. The Hale House was built in 1694 by the first minister, John Hale. Cabot House built in 1781-82 by prominent merchant & private owner, John Cabot; Average Annual Attendance: 2,000; Mem: 450; dues families $15, single $10; annual meeting in Oct
Special Subjects: Historical Material
Collections: 120 paintings containing portraits, folk & Revolutionary War scenes; 1000 pieces furniture, toys, doll houses, military & maritime items & pewter, books, manuscripts & photographs
Exhibitions: Beverly Mariners & the China Trade; Two Hundred Years at the House of Cabot; Collection of 19th century Accessories
Publications: Quarterly newsletter
Activities: Docent training; lect open to public & some for members only; gallery talks by arrangement; tours; individual paintings & original objects of art lent to other museums & libraries; sales shop sells books & postcards
L **Library,** 117 Cabot St, Beverly, MA 01915. Tel 978-922-1186; *Dir* Page Roberts
Open Wed - Fri 10 AM - 4 PM, alternate Sat; Admis adults $5, children under 16 $2
Library Holdings: Audio Tapes; Book Volumes 4100; Clipping Files; Manuscripts; Memorabilia; Motion Pictures; Pamphlets; Periodical Subscriptions 8; Photographs; Prints; Sculpture; Slides

BOSTON

ARCHAEOLOGICAL INSTITUTE OF AMERICA
For further information, see National and Regional Organizations

M **THE ART INSTITUTE OF BOSTON AT LESLEY UNIVERSITY,** Main Gallery, 700 Beacon St, Boston, MA 02215. Tel 617-585-6676; Fax 617-437-1226; *Pres* Stan Trecker; *Dir Gallery & Exhib* Bonnell Robinson
Open Mon - Sat 9 AM - 6 PM, Sun Noon - 5 PM; No admis fee; Estab 1969 to present major contemporary & historical exhibitions of the work of established & emerging artists & to show work by students & faculty of the Institute; 3,000 sq ft of gallery; Average Annual Attendance: 4,000
Exhibitions: (1999-00) Faculty Honorarium; Works from the Collaboration of Richard Benson & Callaway Editions; Luis Gonzalez Palma (Guatamalan photographer); Contemporary Book Design; Edward Sorel; Pedro Meyer; Edward Gorell; Chuck Close; Magnuw Photographers
Activities: Classes for adults & children; professional programs in fine & applied arts & photography; lect open to public, 5 vis lectrs per year; lect series coordinated with exhibitions; gallery talks; competitions, local & regional; exten dept serves Greater Boston area; individual paintings & original objects of art lent to other galleries; curate & mount exhibitions for major public spaces
L **Library,** 700 Beacon St, Boston, MA 02115. Tel 617-262-1223; Fax 617-437-1226; Elec Mail ubolis@aiboston.edu; *Librn* Valda Bolis; *Library Asst* Alison Huftalen; *Slide Cur* Iziar Garcia
Open Mon - Thurs 7:30 AM - 9 PM, Fri 7:30 AM - 5 PM, Sat Noon - 6 PM, Sun 2 - 8 PM; Estab 1969 to support school curriculum; Circ 500 per month
Purchases: $14,500
Library Holdings: Audio Tapes 10; Book Volumes 10,000; CD-ROMs 5; Clipping Files 10,000; Exhibition Catalogs; Kodachrome Transparencies; Other Holdings Vertical File 350; Periodical Subscriptions 76; Slides 36,000; Video Tapes 300
Special Subjects: Art History, Collages, Constructions, Intermedia, Illustration, Photography, Commerical Art, Drawings, Etchings & Engravings, Graphic Arts, Graphic Design, Painting-American, Painting-British, Painting-Dutch, Painting-Flemish, Painting-French, Painting-German, Painting-Italian, Painting-Japanese, Painting-Russian, Posters, Pre-Columbian Art, Prints, Sculpture, Painting-European, History of Art & Archaeology, Portraits, Watercolors, Ceramics, Crafts, Latin American Art, Printmaking, Cartoons, Art Education, Asian Art, Video, American Indian Art, Primitive art, Afro-American Art, Metalwork, Pottery, Religious Art, Woodcarvings, Antiquities-Egyptian, Painting-Scandinavian, Architecture
Activities: Classes for adults; lect open to public; 6 vis lectrs per year; gallery talks, sponsoring competitions, scholarships, fellowships

A **ARTS IN PROGRESS INC,** 2201 A Washington St, Boston, MA 02119. Tel 617-427-9312; Fax 617-983-2237; Elec Mail artsinprog@aol.com; Internet Home Page Address: www.artsinprog.org; *Board Chmn* John Vogel
Estab 1981 to foster education & healthy development of low-moderate income children & youth through the arts
Income: Financed by government, corporate & foundation grants; Business & private donations; earned income
Activities: Classes for children; dramatic programs

A **BOSTON ARCHITECTURAL CENTER,** 320 Newbury St, Boston, MA 02115. Tel 617-536-3170; Fax 617-585-0110; *Pres* Ted Landsmark; *Office Coordr* Diane Sparrow
Open Mon - Thurs 9 AM - 10:30 PM, Fri & Sat 9 AM - 5 PM, Sun Noon - 5 PM; No admis fee; Estab 1889 for educ of architects & designers; Small exhibition space on first floor; Average Annual Attendance: 2,000; Mem: 300; dues $40; annual meeting in June
Activities: Classes for adults; lect open to public, 16 vis lectrs per year; competitions; exten dept servs professional architects; traveling exhibitions organized & circulated
L **Library,** 320 Newbury St, Boston, MA 02115. Tel 617-585-0115; Fax 617-285-0151; *Chief Librn* Susan Lewis
Open by appointment only
Income: $2,000
Library Holdings: Book Volumes 2000
Collections: 18th, 19th & early 20th centuries architectural books from the collections of practicing architects

A **THE BOSTON PRINTMAKERS,** c/o Emmanuel College, 400 The Fenway Boston, MA 02115. Tel 617-735-9898; Elec Mail prints@emmanuel.edu; Internet Home Page Address: www.bostonprintmakers.org; *VPres* Sidney Hurwitz; *Secy* Carolyn Muscar; Cynthia Nartonis; Renee Cavalucci; *Treas.* Marjorie Javan
Estab 1947 to aid printmakers in exhibiting their work; to bring quality work to the public; Average Annual Attendance: 15,000; Mem: 250; dues $25; mem by jury selection; annual meeting June; North American Printmaker
Income: Financed by mem, entry fees, and commission on sales
Purchases: $4700
Exhibitions: Prints, artist books, etchings, lithograph, mixed media, monotypes, serigraph & woodcut; biennial open, juried North American print biennial and Arches biennial student exhibition
Publications: Exhibition catalogs
Activities: Lect open to the public; gallery talks; competitions with awards and prizes; purchase & materials awards at biennial; individual paintings and original objects of art lent to local museums, galleries, libraries and schools including Duxbury Art Complex Museum, Boston Public Library, DeCordova Museum; book 5 traveling exhibitions per year; traveling exhibitions organized and circulated to galleries at libraries, universities and schools

BOSTON PUBLIC LIBRARY Tel 617-536-5400; Fax 617-236-4306; Internet Home Page Address: www.bpl.org; *Keeper, Prints* Sinclair Hitchings; *Cur Fine Arts* Janice Chadbourne; *Pres (V)* Bernard A. Margolis
L **Central Library,** Tel 617-536-5400; Fax 617-236-4306; Elec Mail bmargolis@bpl.org; Internet Home Page Address: www.bpl.org; *Pres* Bernard A Margolis; *Cur of Fine Arts* Janice Chadbourne; *Cur of Music* Diane Ota; *Keeper of Prints* Sinclair Hitchings; *Keeper of Rare Books* Roberta Zonghi; *Prog Mgr* Constance Dudgeon
Open Mon - Thurs 9 AM - 9 PM, Fri & Sat 9 AM - 5 PM, Sun 1 - 5 PM; No admis fee; Estab library 1848; Circ Reference only; Building contains mural decorations by Edwin A Abbey, John Elliott, Pierre Puvis de Chavannes, & John Singer Sargent; bronze doors by Daniel Chester French; sculptures by Frederick MacMonnies, Bela Pratt, Louis Saint Gaudens; paintings by Copley & Duplessis; & bust of John Deferrari by Joseph A Coletti; Average Annual Attendance: 2,500,000
Income: Financed by city & state appropriation
Library Holdings: Book Volumes 6,000,000; Periodical Subscriptions 16,704
Publications: Exhibition catalogues
Activities: Classes for adults & children; lect open to public; concerts; tours
L **Fine Arts Dept: Reference Department,** Tel 617-536-5400, Ext 2275; Fax 617-536-7758; Elec Mail fine_arts@bpl.org; Internet Home Page Address: www.bpl.org; *Cur of Fine Arts* Janice Chadbourne; *Sr Fine Arts Reference Librn* Evelyn W Lannon; *Reference Librn* Cecile Gardner; *Reference Librn* Kimberly Tenney
Open Mon - Thurs 9 AM - 9 PM, Fri & Sat 9 AM - 5 PM, Oct - May Sun 1 - 5 PM; Estab for visual, design and decorative arts reference collections and services; Circ Non-circ
Library Holdings: Auction Catalogs; Book Volumes 203,915; CD-ROMs; Clipping Files; Exhibition Catalogs; Fiche 125,292; Lantern Slides; Manuscripts; Memorabilia; Original Documents; Other Holdings Architectural drawings; Pamphlets; Periodical Subscriptions 240; Photographs; Reels 9,145; Reproductions
Special Subjects: Art History, Decorative Arts, Painting-American, Ceramics, Architecture
Collections: Clarence Blackall scrapbooks & sketchbooks; Connick Stained Glass Archives; Ralph Adams Cram papers; Cram & Ferguson architectural drawings; Maginnis & Walsh architectural drawings; Peabody & Stearns Architectural Drawings; W G Preston Architectural Drawings; Archives of American Art (unrestricted) Microfilm; Society of Arts & Crafts Archives; Vertical files on local artists, galleries, museums societies; Vertical & image files on Boston's built-environment
Activities: Educ prog; Bibliographic instruction; student orientations
M **Albert H Wiggin Gallery & Print Department,** Tel 617-536-5400, Ext 2280; Fax 617-262-0461; Elec Mail prints@bpl.org; Internet Home Page Address: www.bpl.org; *Asst Keeper of Prints* Karen Smith Shafts; *Photographs* Aaron Schmidt; *Librn* Jane Winton
Open Gallery Mon - Thurs 9 AM - 9 PM, Fri & Sat 9 AM - 5 PM, cl Sun; Print Study Room Mon - Fri 9 AM- 5 PM, cl Sat & Sun
Library Holdings: Book Volumes 3600; Clipping Files; Exhibition Catalogs; Lantern Slides 6,623; Memorabilia; Original Art Works; Photographs 650,379; Prints
Special Subjects: Drawings, Etchings & Engravings, Historical Material, Portraits, Prints, Woodcuts, Architecture, Photography, Prints, Watercolors, Posters
Collections: Collection of 18th, 19th & 20th century French, English & American prints & drawings, including the Albert H Wiggin Collection; 20th century American prints by Boston artists; 19th century photographs of the American West & India & Middle East; Boston Pictorial Archive; paintings; postcards; Boston Herald Traveler Photo Morgue; ephemera; Chromolithographs of Louis Prang & Co., Historic American Coll
Exhibitions: Eight or nine per year drawn from the print department's permanent collections

Activities: Lect open to public, 1-2 vis lectr per year; internships offered

L Rare Book & Manuscripts Dept, Tel 617-536-5400, Ext 2225; Internet Home Page Address: www.bpl.org/WWW/rb/rbd; *Librn* Eugene Zepp; *Cur Rare Books* Susan Godlewski; *Cur Manuscripts* William Faucon
Open 9 AM - 5 PM Weekdays; Estab 1934; Average Annual Attendance: 1,400
Income: Financed by trust funds
Purchases: Books, manuscripts, maps, prints & photographs relevant to our current subject strengths
Library Holdings: Book Volumes 276,000; Lantern Slides; Manuscripts; Memorabilia; Micro Print; Periodical Subscriptions 4; Photographs; Reels
Special Subjects: Landscape Architecture, Calligraphy, Etchings & Engravings, Ethnology, Fashion Arts, Costume Design & Constr, Bookplates & Bindings, Antiquities-Greek, Antiquities-Roman, Coins & Medals
Collections: FEER World's Fair Collection; Americana; book arts; Boston theater; history of printing; juvenilia; landscape & gardening; theater costume design
Exhibitions: Exhibits change every 3-4 months & feature books, manuscripts, maps & prints that make up department collections
Activities: Seminars; lect open to public, 3 vis lectrs per year; concerts; tours; sales shop sells postcards & pamphlets

M BOSTON UNIVERSITY, Boston University Art Gallery, 855 Commonwealth Ave, Boston, MA 02215. Tel 617-353-3329; Fax 617-353-4509; Elec Mail gallery@bu.edu; Internet Home Page Address: www.bu.edu/art; *Acting Dir & Cur* Stacey McCarroll; *Asst Dir* Rebekah Lamb
Open Tues - Fri 10 AM - 5 PM, Sat & Sun 1 - 5 PM; No admis fee; Estab 1960; One exhibition space, 250 running ft, 2500 sq ft
Collections: Contemporary & New England Art
Exhibitions: Rotating 8 week Exhib
Publications: Annual exhibition catalogs
Activities: Lect open to public; 2-3 vis lect per year; gallery talks; book traveling exhibitions 1 per year; originate traveling exhibitions

A BOSTON VISUAL ARTISTS UNION, 551 Fremont, Boston, MA; PO Box 399, Newton, MA 02160. Tel 617-695-1266; *Spec Projects* Martin Ulman; *Dir* Carol Spack
Estab 1970 to bring the artist out of the studio & into the market; A small reference library, slide registry & print bins of members' works are maintained at a members home; Mem: 50; dues $40
Income: Financed by dues & occasional Massachusetts Cultural Council Support
Publications: BVAU News, every other month
Activities: Schols & fels offered

M THE BOSTONIAN SOCIETY, Old State House Museum, 206 Washington St, Boston, MA 02109. Tel 617-720-1713; Internet Home Page Address: www.bostonhistory.org; *Exec Dir* Brian Lemay
Open daily 9 AM - 5 PM; Admis adults $5, seniors & students $4, children ages 6-18 $1; Estab 1881 to collect & preserve the history of Boston; Average Annual Attendance: 90,000; Mem: 1250; dues supporter $150, family $80, individuals $50, student/teacher $25, seniors $40
Income: Financed by endowment, mem, admis, grants, state & federal appropriations
Special Subjects: Manuscripts, Drawings, Painting-American, Prints, Sculpture, Watercolors, Ceramics, Folk Art, Decorative Arts, Portraits, Marine Painting, Maps, Scrimshaw, Coins & Medals
Collections: Paintings & artifacts relating to Boston history; Maritime art; Revolutionary War artifacts; prints
Exhibitions: Ongoing exhibitions
Publications: Proceedings of The Bostonian Society; The Bostonian Society Newsletter
Activities: Classes for children; lect open to public; concerts; gallery talks; walking tours; Boston History Award; individual paintings & original objects of art lent to other museums; museum shop sells books, decorative arts, reproductions, prints & toys

L Library, 15 State St, 3rd Flr, Boston, MA; Old State House, 206 Washington St Boston, MA 02109. Tel 617-720-1713; Fax 617-720-3289; Elec Mail library@bostonhistory.org; Internet Home Page Address: www.bostonhistory.org; *Librn* Christopher Carden
Open Tues - Thurs 9:30 AM - 4:30 PM; Admis nonmembers $10; college students $5; Estab 1881 to collect & preserve material related to the history of Boston; For reference only; Mem: Dues benefactor $500, supporter $100, family $50, individual $30, 62 & over, student $20
Purchases: $1500
Library Holdings: Book Volumes 7500; Clipping Files; Fiche; Lantern Slides; Manuscripts; Memorabilia; Original Art Works; Other Holdings Documents; Ephemera; Postcards; Scrapbooks; Pamphlets; Periodical Subscriptions 10; Photographs 20,000; Prints 2000; Reproductions; Slides 1000
Special Subjects: Photography, Manuscripts, Maps, Prints, Historical Material
Publications: Bostonian Society Newsletter, quarterly

M BROMFIELD ART GALLERY, 560 Harrison Ave, Boston, MA 02118-2436; 27 Thayer St, Boston, MA 02118. Tel 617-451-3605; Elec Mail bromfieldartgallery@earthlink.net; Internet Home Page Address: www.bromfieldartgallery.com; *Pres* Florence Montgomery; *Secy* Arthur Hendigg; *Treas* Barbara Poole; *Media & Exhibitions Coordr* Heidi M Marsten
Open Wed - Sat Noon - 5 PM; No admis fee; Estab 1974 to exhibit art; Two galleries, approx 500 sq ft; Average Annual Attendance: 3,000; Mem: 20; dues $750; monthly meetings
Income: Financed by mem and sales
Activities: Lect open to public, 5 vis lectrs per year; gallery talks; sponsoring of competitions

M CHILDREN'S MUSEUM INC, Museum Wharf, 300 Congress St Boston, MA 02210. Tel 617-426-6500, Ext 233; Fax 617-426-1944; Internet Home Page Address: www.bostonkids.org;
Open Tues - Sun 10 AM - 5 PM, Fri 10 AM - 9 PM, cl Mon except most Boston Pub School vacation days, holidays & the summer; Admis adults $7, seniors & children (2-15) $6, children 1 yr & members free; Mem: Dues benefactor $500,

sponsor $250, supporter $125, family plus $75, grandparent family plus & family $65, grandparent family $55, basic $45, grandparent basic $35

M CHINESE CULTURE INSTITUTE OF THE INTERNATIONAL SOCIETY, (Chinese Culture Institute) Tremont Theatre & Gallery, 276 Tremont St, Boston, MA 02116. Tel 617-338-4274; Elec Mail internationalsociety@yahoo.com; Internet Home Page Address: www.internationalsociety.org; *Visual Art Coordr* Yen Hung; *Pres* Doris Chu PhD; *Humanities Coordr* Meng Lang; *Theatre & Gallery Mgr* Wang Hong-Chen; *Music Coordr* Michael McLaughlin
Gallery opens 1 PM - 7PM; Theatre, 7 PM - 10 PM; No admis fee to gallery; admis fee varies for theatre; Estab 1980 to promote artists of excellence; Average Annual Attendance: 25,000; Mem: 500; dues $30-$500; annual meeting in Sept
Income: Financed by mem, city & state grants, corporations & individuals
Special Subjects: Painting-American, Sculpture, Watercolors, Textiles, Costumes, Ceramics, Crafts, Folk Art, Woodcuts, Decorative Arts, Collages, Asian Art, Tapestries, Calligraphy
Exhibitions: 7 shows each year, group & solo
Publications: exhibition catalogs for some shows
Activities: Classes for adults & children; dramatic programs; stage productions; workshops; forums; lect open to public; concerts, gallery talks; sales shop sells books, prints, arts & crafts

C FLEET BOSTON FINANCIAL, Gallery, 100 Federal St, Boston, MA 02110. Tel 617-434-2200, 434-6314, 434-3921; Fax 617-434-6280; Elec Mail llambrechts@bkb.com; *Dir & Cur* Lillian Lambrechts
Collections: Contemporary paintings; historical documents; non-contemporary paintings & textiles; photography; sculpture
Publications: Exhibition catalogs, 6-10 times per yr
Activities: Originate traveling exhibitions

M GIBSON SOCIETY, INC, Gibson House Museum, 137 Beacon St, Boston, MA 02116-1504. Tel 617-267-6338; Fax 617-267-5121; Elec Mail gibsonmuseum@aol.com; *Dir Educ* Edward Gordon; *Dir* Barbara Thibault; *Office Adminr* Alison Barnet
Open May 1 - Oct 31, tours at 1, 2 & 3 PM; Nov 1 - Apr 30, Sat & Sun only, tours at 1, 2 and 3 PM; Admis $5; Estab 1957 as a Victorian House museum; memorial to Gibson family; Victorian time capsule, early Back Bay Town House, eight rooms with Victorian & Edwardian era furnishings; Average Annual Attendance: 2,300
Income: Financed by trust fund & admis
Special Subjects: Period Rooms
Collections: Decorative arts; paintings; sculpture; Victorian period furniture; objects associated with Gibson & related families
Activities: Lect open to public, 15 vis lectrs per year; guided tours; summer lect series July & Aug, Thurs 5:30 PM; original objects of art lent to museums & galleries; sales shop sells postcards

A GUILD OF BOSTON ARTISTS, 162 Newbury St, Boston, MA 02116. Tel 617-536-7660; Fax 617-437-6442; Elec Mail info@guildofbostonartists.org; Internet Home Page Address: www.guildofbostonartists.org; *Pres* Paul Ingbretson; *Gallery Mgr* Elizabeth Hamilton; *Gallery Mgr* Kristin Bazinet; *VPres* David Lowrey
Open Tues - Sat 10:30 Am - 5:30 PM, Sun, Mon by apt only; No admis fee; Estab & incorporated 1914, nonprofit cooperative organization; Exhibiting 70 of New England's finest contemporary realist painters; front gallery features continual show of general membership; President's gallery showcases one-man & historical exhibits; Mem: Active 65-75, associates under 100; annual meeting Apr; qualification for membership: living in New England, working in contemporary realism tradition, willing to lead workshops, demos & classes
Income: Sales
Exhibitions: Rotating exhibitions; two educational exhibits
Publications: Gallery Guide & Concierge Boston
Activities: Artist demonstrations; painting workshops & classes for adults; lect open to public, receptions, gallery talks & tours; Young Collectors Club

A HISTORIC NEW ENGLAND, (Society for the Preservation of New England Antiquities) Harrison Gray Otis House, 141 Cambridge St Boston, MA 02114. Tel 617-227-3956; Fax 617-227-9204; Internet Home Page Address: www.historicnewengland.org; *Pres* Carl R Nold
Open Wed - Sun 11 AM - 5 PM; Admis adults $8, children under 12 $4; Estab & incorporated 1910, the Otis House serves as both headquarters & mus for Historic New England; Formerly known as Society for the Preservation of New England Antiquities; Soc owns over 35 historic houses throughout New England, 25 of which are open to the pub; Average Annual Attendance: 8,000; Mem: 6,500; dues $35 & up; annual meeting in June
Income: financed by members, grants
Special Subjects: Architecture, Decorative Arts, Furniture, Period Rooms
Collections: American & European decorative arts & antiques with New England history; photographs; houses
Publications: Historic New England Magazine (3xs); monthly newsletter "What's Happing"; house guide, annual report
Activities: Classes for adults; lect open to public, 5-10 vis lectrs per year; originate traveling exhibitions; museum shop sells books/merchandise

L Library and Archives, Harrison Gray Otis House, 141 Cambridge St Boston, MA 02114. Tel 617-227-3957; Fax 617-973-9050; Elec Mail lcordon@historicnewengland.org; Internet Home Page Address: www.historicnewengland.org; *Cur Library & Archives* Lorna Condon; *Librn/Archivist* Emily R Novak
Wed - Fri 9:30 - 4:30; Admis nonmembers $5, students $3, mems free; Estab 1910 to document New England architecture and material culture from the 17th century to the present; For reference; Mem: 6000; dues individual $35, household $45
Library Holdings: Auction Catalogs; Book Volumes; Clipping Files; Exhibition Catalogs; Fiche; Filmstrips; Kodachrome Transparencies; Lantern Slides; Manuscripts; Maps; Memorabilia; Original Art Works; Original Documents; Pamphlets; Photographs; Prints; Slides
Special Subjects: Landscape Architecture, Decorative Arts, Photography, Drawings, Etchings & Engravings, Manuscripts, Historical Material, Advertising Design, Furniture, Drafting, Bookplates & Bindings, Architecture

Collections: 450,000 photographs & negatives; 20,000 architectural drawings; 10,000 books included rare; 10,000 newspaper clippings; 5,000 pamphlets; 10,000 trade cards, trade catalogues & billheads; 2,500 prints; 800 maps & atlases; 700 drawings & watercolors; 600 linear ft manuscripts; historic New England's institut archives
Activities: Internships; lect open to public; tours; Historic New England book prize; museum shop sells books & reproductions

A INQUILINOS BORICUAS EN ACCION, 405 Shawmut Ave, Boston, MA 02118. Tel 617-927-1707; Fax 617-536-5816; Internet Home Page Address: www.IBA/etc.org; *Exec Dir* David Cortiella
Open Mon - Fri 8:30 AM - 5:30 PM; Estab 1968 to support the development & empowerment of the Villa Victoria community in Boston's south end
Activities: Classes for children

M INSTITUTE OF CONTEMPORARY ART, 955 Boylston St, Boston, MA 02115-3194. Tel 617-266-5152; Fax 617-266-4021; Elec Mail info@icaboston.org; Internet Home Page Address: www.icaboston.org; *Dir* Jill Medvedow; *Communications Mgr* Melissa Kuronen; *Exhib Mgr* Tim Obetz; *Asst Cur Registrar* Nora Donnelly; *Dir External Relations* Paul Bessire; *Grants Coordr* Elizabeth Essner; *Dir Finance* Michael Taubenberger; *Dir Educ* Ena Fox; *Individual Support Mgr* Karen DeTemple; *Asst Cur* Gilbert Vicario; *ICA/Vita Brevis Project Dir* Carole Anne Meehan
Open Wed & Fri Noon - 5 PM, Thurs Noon - 9 PM, Sat & Sun 11 AM - 5 PM; Admis $7, seniors & ID & seniors $5, mems free; New England's premier contemporary art museum, the ICA presents provocative exhibitions by national and international artists that explore the ideas, issues and images of our times. For over 65 years the ICA has been the first to show many of the most innovative and inspired artists from around the world; Average Annual Attendance: 55,000; Mem: 1600; dues $40 & up; annual meeting in Sept
Income: Financed by mem, gifts & grants, earned income
Publications: Exhibition catalogs
Activities: Educ dept; classes for adults & children; docent training; lect open to public, 20 vis lectrs per year; film series; video; concerts; gallery talks; tours; competitions; ICA Artist prize; book traveling exhibitions annually; originate traveling exhibitions, circulating to other national & international contemporary art museums; museum shop sells books, magazines, t-shirts, catalogs, cards, posters

M ISABELLA STEWART GARDNER MUSEUM, 280 Fenway, Boston, MA 02115; 2 Palace Rd, Boston, MA 02115. Tel 617-566-1401; Fax 617-566-7653; Internet Home Page Address: www.gardnermuseum.org; *Dir* Anne Hawley
Open Tues - Sun 11 AM - 5 PM, cl Mon & national holidays; Admis adults $10 ($11 on weekends), seniors $7, college students $5, college students on Wed $3, children under 18 free; Estab 1903, the mus houses Isabella Stewart Gardner's various collections; Mus building is styled after a 16th century Venetian villa; all galleries open onto a central, glass-roofed courtyard, filled with flowers that are changed with the seasons of the year; Average Annual Attendance: 175,000; Mem: 3000; dues $25 & up
Income: Financed by endowment, fundraising, mem donations & door charge
Special Subjects: Painting-American, Oriental Art, Painting-Dutch, Painting-French, Painting-Flemish, Painting-Italian, Antiquities-Greek, Antiquities-Roman
Collections: Gothic & Italian Renaissance, Roman & classical sculpture; Dutch & Flemish 17th century; Japanese screens; Oriental & Islamic ceramics, glass, sculpture; 19th century American and French paintings; major paintings of John Singer Sargent & James McNeill Whistler
Exhibitions: Laura Owens, Community Creations, Isabella Gardner: Her Life & Memories
Publications: Guide to the Collection; Oriental & Islamic Art in the Isabella Stewart Gardner Museum; Drawings - Isabella Stewart Gardner Museum; Mrs Jack; Sculpture in the Isabella Stewart Gardner Museum; Textiles - Isabella Stewart Gardner Museum; children's books - Isabella Stewart Gardner Museum; Fenway Court; History & Companion Guide; Special Exhibition Catalogs
Activities: Programs for children; lect open to public, 10 vis lectrs per year; concerts; gallery talks; tours; symposia; sales shop selling books, reproductions, prints, slides, postcards & annual reports, jewelry, gifts

L Isabella Stewart Garden Museum Library & Archives, 2 Palace Rd, Boston, MA 02115. Tel 617-278-5121; Fax 617-278-5177; Elec Mail collection@isgm.org; Internet Home Page Address: www.gardnermuseum.org; *Librn & Asst. Cur.* Richard Lingner; *Archivist* Kristin Parker; *Cur.* Alan Chong
Open by appointment Mon, Wed, Fri & Sat; Estab 1903; Open to scholars who need to work with mus archives; building designed in style of 15th century Venetian palace; Mem: 3000
Income: endowments & mem donations
Library Holdings: Auction Catalogs; Book Volumes 800; Clipping Files; Exhibition Catalogs; Manuscripts; Memorabilia; Periodical Subscriptions 19; Photographs
Special Subjects: Art History
Collections: Objects spanning 30 centuries; 1000 rare books spanning 6 centuries including papers of museum founder; rich in Italian Renaissance painting
Exhibitions: Rotating exhibits
Activities: Educ program; lect open to public, 6-8 vis lectrs per year; symposia; concerts; gallery talks; tours; sales shop sells books, gifts, reproductions, prints, slides & postcards

M KAJI ASO STUDIO, Gallery Nature & Temptation, 40 Saint Stephen St, Boston, MA 02115. Tel 617-247-1719; Fax 617-267-4920; Elec Mail administrator@kajiasostudio.com; Internet Home Page Address: www.kajiasostudio.com; *Music Dir* Katie Sloss; *Dir & Adminr* Kate Finnegan; *Gallery Dir* Gary Tucker; *Ceramic Dir* Jeanne Gugino
By appointment; No admis fee; Estab 1973 to foster new/emerging artists representational to abstract-positive feeling; Two rooms on 1st floor 10' x 14' in historic brownstone; track lighting; Mem: 40; monthly dues $150
Exhibitions: Watercolor, Oil, Drawing, Ceramic, Japanese Calligraphy & Sumi Painting
Publications: Dasoku Journal of Arts, biannual
Activities: Classes for adults; concerts

MASSACHUSETTS COLLEGE OF ART
L Morton R Godine Library, Tel 617-879-7150; Fax 617-879-7110; Internet Home Page Address: www.mca.edu/library/arts; *Slide Cur* Staci Stull; *Archivist* Paul Dobbs; *Dir* James Kaser
Sch Year, Mon - Fri 8 AM - 10 PM, Sat - Sun 8 AM - 5 PM; For lending
Library Holdings: Audio Tapes; Book Volumes 95,000; Cards; Cassettes; Compact Disks; DVDs; Exhibition Catalogs; Fiche 8000; Filmstrips; Memorabilia; Motion Pictures; Original Art Works; Pamphlets; Periodical Subscriptions 491; Photographs; Prints; Records; Sculpture; Slides; Video Tapes 1200
Special Subjects: Art History, Art Education

A MASSACHUSETTS HISTORICAL SOCIETY, 1154 Boylston St, Boston, MA 02215. Tel 617-536-1608; Fax 617-859-0074; Elec Mail mg.masshist@nelinet.org; Internet Home Page Address: www.masshist.org; *Dir* William M Fowler Jr; *Cur* Anne Bentley
Open Mon - Fri 9 AM - 4:45 PM, cl Sat, Sun & holidays; No admis fee; Estab 1791; Art works by appt only; Average Annual Attendance: 3,000
Income: Financed by endowment
Collections: Archives; historical material; paintings; sculpture
Exhibitions: Temporary exhibitions
Publications: Annual brochure; irregular leaflets; various books
Activities: Lect; special exhibits for members & their guests

L Library, 1154 Boylston St, Boston, MA 02215. Tel 617-536-1608; Fax 617-859-0074; Elec Mail library@masshist.org; Internet Home Page Address: www.masshist.org; *Librn* Peter Drummey; *Ref Librn* Nicholas Graham; *VPres* Levin Campbell; *CEO* William M Fowler
Open Mon - Fri 9 AM - 4:45 PM; No admis fee; Estab 1971; Library rsch only; Average Annual Attendance: 3,000
Income: Endowment
Library Holdings: Book Volumes 250,000; Manuscripts 3500; Prints
Special Subjects: Photography, Manuscripts, Maps, Painting-American, Prints, Portraits, Miniatures, Coins & Medals
Publications: Portaits in the Massachusetts Historical Society, Boston 1988 (one edition)
Activities: Lect

A MAYORS OFFICE OF ARTS, ROURISM AND SPECIAL EVENTS, (Boston Art Commission of the City of Boston) City Hall Galleries, Boston City Hall, Rm 802, Boston, MA 02201. Tel 617-635-3911; Fax 617-635-3031; Elec Mail sarah.hutt@ciytofboston.gov; Internet Home Page Address: www.cityofboston.gov/arts; *Commissioner* Julie A Burns; *Dir Visual Arts Prog* Sarah Hutt; *Gallery Dir* John Connolly
Open Mon - Fri 9 AM - 5 PM; No admis fee; 1965 to showcase Boston art & its cultural heritage; gallery space throughout bldg; Average Annual Attendance: 100,000; Mem: none
Purchases: Artwork available to public for purchase
Special Subjects: Photography, Sculpture, Painting-American, Afro-American Art, Ceramics, Crafts, Juvenile Art, Archaeology
Exhibitions: Jan-Feb Black History Mo; March - Women's History; April-May Boston Public Schools Ann Art Show; June-Dec Juried Art Show
Publications: Catalog and guide to the art work owned by the City of Boston, in preparation; Passport to Public Art
Activities: Competitions, lectures (12), concerts, gallery talks & tours

M MUSEUM OF AFRO-AMERICAN HISTORY, Smith Ct & 46 Jay St, Boston, MA 02108; 14 Beacpm St Ste 719, Boston, MA 02108. Tel 617-725-0022; Fax 617-720-5225; Elec Mail history@afroammuseum.org; Internet Home Page Address: www.afroammuseum.org; *Exec Dir* Beverly Morgan Welch
Open Mon - Sat 10 AM - 4 PM; No admis fee, suggested donation $5; A nonprofit educ institution founded to study the social history of New England's Afro American communities & to promote an awareness of that history by means of educational programs, publications, exhibits & special events. The African Meeting House, the Abiel Smith School, the African Meeting House on Nantucket, & the Black Heritage Trail are the chief artifacts of the Mus of Afro American History; 2 galleries; Mem: 200; dues Frederick Douglass Sociey $1000, Sojourner Truth society $500, friend $100, family $50, $25, students & seniors $15
Income: Financed by grants, mem & donations
Collections: 19th Century African American History; Hamilton Sutton Smith Glass Plate Negatives
Exhibitions: Rotating exhibits
Activities: Educ dept; lect open to public, 4 vis lectrs per year; concerts; gallery talks; tours; individual sculptures & original objects of art lent; book traveling exhibitions; museum shop sells books, magazines, original art, reproductions, prints, slides & gifts

M MUSEUM OF FINE ARTS, 465 Huntington Ave, Boston, MA 02115. Tel 617-267-9300; Fax 617-247-6880; Elec Mail webmaster@mfa.org; Internet Home Page Address: www.mfa.org; *Deputy Dir Operations* John Stanley; *Deputy Dir External Relations* Patricia Jacoby; *Dir Curatorial Administration* Katie Getchell; *Dir Objects Conser* Arthur C Beale; *Cur Educ* Ellen Zieselman; *Cur Prints & Drawings* Clifford S Ackley; *Exec Dir & Pres* Joseph Carvalho; *VChmn* William F Pounds; *Deputy Dir Educ* Deborah Dluhy; *Cur Textiles & Fashions* Elizabeth Ann Coleman; *Mus Shop Mgr* Laurie Darby; *Dir Human Resources* Peg O'Hare; *Dir Pub Relations* Dawn Griffin; *Dir Libr & Archives* Maureen Melton; *Dir Mem* Lisa Krassner; *Cur Musical Instruments* Darcy Kuronen; *Cur Asiatic Art* Wu Tung; *Mgr Exhib* Jennifer Bose; *VPres* Susan W Paine; *Cur Ancient Egyptians* Rita E Freed; *VChmn* Donald D'Amour; *Chmn Art* Elliot Davis; *Pub Programs* Kathleen Simpson; *Dir* Heather Haskell; *Dir* Malcolm Rogers; *Mgr Special Events* Martha Landry; *Dir IS* John Hallis; *Preparator* Charles Sloan; *Cur 20th Century* Joe Traugott; *Admin* Carmella Jasso; *Asst Dir* Bonnie Anderson; *Asst Dir* Aline Brandaeur; *Financial Specialist* Theresa Garcia; *Cur Gov's Gallery* Terry Bumpass; *Librn* Mary Jebsen; *Registrar* Patricia Loiko; *Dir* Marsha C Bol; *Mus Shop Mgr* John Stafford; *Registrar* Joan Tafoya; *VPres Marketing* Susan Davison; *Coll Mgr* Wendy Stayman; *VPres Financial* Richard Dunbar; *Dir Mus Fine Arts* Margaret Mudd; *Cur Contemporary Art* Cheryl Brutvan; *Cur Classical Art* John Herrmann; *Dir Marketing* Martha Rush-Mueler; *Cur Photography* Steven A Yates; *Deput Dir* Katherine Getchell; *Chmn Art Europe* George TM Shackelford; *Dir Finance* Mark Kerwin
Open Mon & Tues 10 AM - 4:45 PM, Wed - Fri 10 AM - 9:45 PM, Sat & Sun 10

AM - 5:45 PM, Thurs & Fri after 5 PM only West Wing is open; Admis adults $10, seniors & college students $8, children 17 & under & members free; Estab & incorporated in 1870; present building opened 1909; Average Annual Attendance: 1,132,700; Mem: 82,000; dues assoc $135, family $80, individual $60
Special Subjects: Prints, Sculpture, Decorative Arts, Porcelain, Oriental Art, Silver, Period Rooms, Antiquities-Egyptian, Antiquities-Greek, Antiquities-Roman
Collections: Ancient Nubian & Near Eastern art; Art of Africa, Oceania & Ancient Americas; Chinese, Japanese & Indian art; Egyptian, Greek & Roman art; European & American decorative & minor arts, including period rooms, porcelains, silver, Western & Asian tapestries, costumes & musical instruments; master paintings of Europe & America; print collection from 15th century to present; sculpture
Exhibitions: Specially organized exhibitions are continually on view; Art of the Ancient Americas, African & Oceanic art (Permanent installation)
Publications: Journal, yearly; calendar of events, bi-monthly; exhibition catalogs; collection catalogs
Activities: Classes for adults & children; lect open to public; concerts; gallery talks; tours; films; museum shop sells books, magazines, original art, reproductions, prints & slides
L **Library,** 300 Massachusetts Ave, Boston, MA 02115; 465 Huntington Ave, Boston, MA 02115. Tel 617-369-3385; Fax 617-369-4257; Internet Home Page Address: www.mfa.org/library; *Dir Library & Archives* Maureen Melton; *Head Librn* Deborah Barlow Smedstad; *Mgr Technical Svcs* Laila Abdel-Malek
Open Mon-Fri 1 - 5 PM; No admis fee; Estab 1870 to house, preserve, interpret & publish its collections; For reference only; Average Annual Attendance: 1,000,000; Mem: 59,000
Library Holdings: Book Volumes 300,000; Clipping Files; Exhibition Catalogs; Pamphlets 117,000; Periodical Subscriptions 650
Special Subjects: Decorative Arts, Drawings, Etchings & Engravings, Painting-American, Prints, Sculpture, Painting-European, Ceramics, Furniture, Mosaics, Carpets & Rugs, Restoration & Conservation, Textiles
Activities: Classes for adults & children; docent training; dramatic programs; lect open to public; concerts; gallery talks; tours; book traveling exhibitions
L **Dept of Photographic Services,** 220 State St, Springfield, MA 01103. Tel 617-267-9300; Fax 617-247-2312; *Dir* Dan Reardon
Library Holdings: Slides 120,000
Special Subjects: Decorative Arts, Photography, Painting-American, Prints, Sculpture, Architecture

M **MUSEUM OF THE NATIONAL CENTER OF AFRO-AMERICAN ARTISTS,** 300 Walnut Ave, Boston, MA 02119. Tel 617-442-8014; Fax 617-445-5525; *Dir & Cur* Edmund B Gaither; *Asst to Dir* Gloretta Baynes; *Artistic Dir* Elma Lewis
Open June - Aug daily 1 - 6 PM, Sept - May daily 1 - 5 PM; Admis adult $1.25, children $.50; Estab 1969 to promote visual art heritage of Black people in the Americas and Africa; Suite of three special exhibition galleries; suite of three African Art Galleries; suite of three permanent collection galleries; one local artist gallery; Average Annual Attendance: 10,000; Mem: 250; dues $25
Income: $250,000 (financed by private gifts, contracts, etc)
Special Subjects: Afro-American Art
Collections: Early 19th & 20th Century Afro-American Prints & Drawings; visual fine arts of the black world; Caribbean Collection
Exhibitions: Aspelpa: A Nubian King's Buriel Chamber
Publications: Newsletter, quarterly
Activities: Dramatic programs; lect open to the public, 6 vis lectrs per yr; concerts; gallery talks; tours; competitions with awards (Edward Mitchell Barrister Award); book traveling exhibitions; traveling exhibitions organized and circulated; sales shop sells books, magazines, prints and small sculpture

M **NATIONAL ARCHIVES & RECORDS ADMINISTRATION,** John F Kennedy Presidential Library & Museum, Columbia Point, Boston, MA 02125. Tel 617-514-1600; Fax 617-514-1652; Internet Home Page Address: www.jfklibrary.org; *Dir* Deborah Leff; *Cur* Frank Rigg; *Deputy Dir* Thomas Putnam
Open daily 9 AM - 5 PM, cl holidays; Admis adults $10, seniors & college students $8, youth 13-17 $7, children 12 & under free; Estab 1964 to preserve collections of Kennedy papers & other material pertaining to his career; to educate public about J F Kennedy's career & political system; to make materials available to researchers; Library is a nine-story building overlooking Boston Harbor, has two theaters & an exhibition floor; Average Annual Attendance: 250,000
Income: Financed by federal government & national archives trust fund
Library Holdings: Audio Tapes; Cards; Cassettes; Fiche; Filmstrips; Lantern Slides; Memorabilia; Micro Print; Motion Pictures; Original Art Works; Pamphlets; Photographs; Prints; Reproductions; Slides; Video Tapes
Special Subjects: Historical Material
Collections: 48,000,000 documents & personal papers of John F Kennedy, Robert Kennedy & many others associated with life & career of John F Kennedy; 7,550,000 ft of film relating to political career, 200,000 photographs, 1300 oral histories, 22,000 paintings & museum objects (personal); manuscripts of Ernest Hemingway, 10,000 photographs of him with family & friends; 800 glass plates collection of Josiah Johnson Hawes
Activities: Classes for children; lect open to public; Tours; fels & research grants; museum shop sells books, reproductions, prints and slides

NEW ENGLAND WATERCOLOR SOCIETY
For further information, see National and Regional Organizations

M **NICHOLS HOUSE MUSEUM, INC,** 55 Mount Vernon St, Boston, MA 02108. Tel 617-227-6993; Fax 617-723-8026; Elec Mail nhm@earthlink.net; Internet Home Page Address: www.nicholshousemuseum.org; *Historian* William H Pear; *Exec Dir* Flavia Cigliano; *Asst Dir* Mary Maresca
May - Oct Tues - Sat Noon - 4 PM, Nov - Apr Thurs - Sat Noon - 4 PM; Admis $7; Estab 1961; Historic house museum offers a unique glimpse of late 19th, early 20th century life of Boston's Beacon Hill; original federal design attributed to architect Charles Bulfinch; Average Annual Attendance: 3,000; Mem: 280; dues donor $250, sponsor $100, $35-55; annual meeting in May
Income: $133,000 (financed by endowment, admis sales, donations, grants, mem)

Special Subjects: Tapestries, Prints, Textiles, Decorative Arts, Furniture, Carpets & Rugs, Period Rooms
Collections: Decorative Arts Collection; Portraits; Oriental Rugs; Sculptures by Augustus Saint-Gaudens
Activities: Docent training; lect open to public; tours; INLS 2002 Conservation Project; NEH 2002 Conservation Project; museum shop sells books

L **PAYETTE ASSOCIATES ARCHITECTS PLANNERS,** Library, 285 Summer St, Boston, MA 02210. Tel 617-342-8201, Ext 234; Fax 617-342-8202; *Librn* Ardys Kozbial
Library Holdings: Book Volumes 1500; Clipping Files; Periodical Subscriptions 120; Slides
Special Subjects: Architecture
Collections: Interiors Sample Library; Manufacturer's Catalogs; Medical & Laboratory Planning

M **PHOTOGRAPHIC RESOURCE CENTER,** 602 Commonwealth Ave, Boston, MA 02215-2400. Tel 617-353-0700; Fax 617-353-1662; Elec Mail pnc@bu.edu; Internet Home Page Address: www.prc.boston.org; *Exec Dir* Terrence Morash; *Programs and Admin* Ingrid Trinkunas; *Pres Bd Dir* Richard Grossman; *Cur* Leslie Brown
Open Tues - Sun Noon - 5 PM, Thurs Noon - 8 PM; Admis general $3, seniors & students $2, free Thurs 5 PM - 8 PM; Estab 1977 for the photographic arts; Mem: 2600; dues $30
Library Holdings: Auction Catalogs; Audio Tapes; Book Volumes 4000; Clipping Files; Exhibition Catalogs; Periodical Subscriptions; Video Tapes
Special Subjects: Photography, Historical Material
Activities: Photography workshops with guest artists; lect open to public, 2-3 vis lectrs per year; Leopold Godowsky Color Photography Award; 1 book traveling exhibition; originate traveling exhibitions

M **THE REVOLVING MUSEUM,** 22 Shattuck St, Lowell, MA 01852. Tel 978-937-2787; Fax 978-937-2788; Elec Mail gallery@revolvingmuseum.org; Internet Home Page Address: www.revolvingmuseum.org; *Artistic Dir* Jerry Beck
Open Tues - Sun 11 AM - 4 PM; No admis fee; Estab for pub art Projects, educational programs, exhibitions & special events that encourage collaboration & dialogue with artists, youth & community members; to increase pub understanding of the importance of the arts & arts education; to advance cultural awareness; Average Annual Attendance: 15,000; Mem: See website
Income: Donations, grants, earned revenue
Activities: Classes for children; mus shop sells books, original art & other museum related items

A **THE SOCIETY OF ARTS & CRAFTS,** 175 Newbury St, Boston, MA 02116. Tel 617-266-1810; Fax 617-266-5654; Elec Mail societycraft@earthlink.net; Internet Home Page Address: www.societyof crafts.org; *Exhib Mgr* Margaret Pace-DeBruin; *Retail Gallery Mgr* Kristen Johnson; *Exec Dir* Beth Ann Gerstein
Open Mon - Fri 10 AM - 6 PM, Sat 10 AM - 6 PM, Sun Noon - 5 PM, cl Sun in Aug; No admis fee; Estab 1897 to promote high standards of excellence in crafts & to educate the pub in the appreciation of fine craftsmanship; Two galleries, second level exhibitions; Average Annual Attendance: 8,000; Mem: 700; dues family/dual $60, single $35
Income: financed by mem, gallery sales, grants
Exhibitions: Juried exhibitions presented year round;
Publications: Mass Crafts, guide to crafts in central New England, annual
Activities: Lect open to public, vis lectr; gallery talks; awards; sales shop sells fine handmade crafts in ceramics, wood, glass, metal & fiber

L **SUFFOLK UNIVERSITY,** (New England School of Art & Design at Suffolk University) New England School of Art & Design Library, 75 Arlington St, Boston, MA 02116. Tel 617-994-4282; *Librn* Brian Tynemouth, MLS; *Libr Mgr* Ellen Sklaver
Open Mon - Fri 9 AM - 9 PM, Sat 9 AM - 5 PM, Sun noon - 6 PM; Circ 4300; For lending; Mem: Open to students
Income: Financed by Suffolk Univ
Purchases: $22,000
Library Holdings: Auction Catalogs; Book Volumes 9500; CD-ROMs 198; Clipping Files; DVDs 67; Pamphlets; Periodical Subscriptions 55; Slides 20,000; Video Tapes 152
Special Subjects: Art History, Landscape Architecture, Decorative Arts, Illustration, Commerical Art, Drawings, Graphic Design, Advertising Design, Interior Design, Furniture, Drafting, Architecture
Activities: schols & fels offered

A **URBANARTS INSTITUTE AT MASSACHUSETTS COLLEGE OF ART,** (UrbanArts, Inc) 621 Huntington Ave, Boston, MA 02115. Tel 617-879-7970; Fax 617-879-7969; Elec Mail ricardo.barreto@massart.edu; Internet Home Page Address: www.urbanartsinstitute.org; *Exec Dir* Ricardo Barreto; *Project Mgr* Christine Lanzl
Estab to provide services which integrate the arts into American Urban environments in the context of Urban design & community building
Income: Fees for services
Activities: Facilitation of public art projects; conferences & symposia

M **USS CONSTITUTION MUSEUM,** Bldg 22, Charlestown Navy Yard, PO Box 1812 Boston, MA 02129. Tel 617-426-1812; Fax 617-242-0496; Elec Mail info@ussconstitutionmuseum.org; Internet Home Page Address: www.ussconstitutionmuseum.org; *Deputy Dir* Anne Gimes Rand; *Dir Educ* Michael Bonanno; *Exec Dir* Burt Logan; *Dir Educ* Celeste Bernardo; *Cir Corp Members* Marianne Cohen; *Dir Retail Opers* Chris White; *Chmn, VPres* G West Saltonstall; *Cur* Margherita Desy; *Dir Finance & Admin* Adrian Bresler
Open 9 AM - 6 PM, varies by season; No admis fee (subject to change); Estab 1972 to collect, preserve & display items relating to the sailing frigate USS Constitution; Average Annual Attendance: 300,000; Mem: 2800; dues $35-$1000; annual meeting in the fall
Income: $1,850,000 (financed by endowment, mem, admis, gift shop, federal, state & private grants)

Special Subjects: Graphics, Photography, American Western Art, Costumes, Ceramics, Manuscripts, Portraits, Furniture, Marine Painting, Coins & Medals, Military Art
Collections: Documents relating to the sailing frigate USS Constitution; Personal possessions of crew members; Shipbuilding & navigational tools; Souvenirs depicting Old Ironsides; USS Constitution images (paintings, prints & photos)
Exhibitions: Around the World Aboard Old Ironsides; Old Ironsides in War & Peace; Annual Juried Ship Model Show
Publications: Chronicle, quarterly newsletter
Activities: Classes for adults & children; dramatic programs; family programs; docent training; summer teen internship program; teachers' workshops; lect open to public, 6-12 vis lectrs per yr; tours; originate traveling exhibitions; sales store sells books, prints, magazines, slides, reproductions, clothing, souvenirs & sponsors book signings

A VOLUNTEER LAWYERS FOR THE ARTS OF MASSACHUSETTS INC, 249 A St., Studio 14 Boston, MA 02210. Tel 617-350-7600; Fax 617-350-7610; Elec Mail mail@vlama.org; Internet Home Page Address: www.vlama.org; *Exec Dir* James F Grace
Open Mon - Fri 9 AM - 5 PM; Estab 1989 to provide arts related legal assistance to artists & arts organizations
Income: Financed in part by the Massachusetts Cultural Council, a state agency & by the Boston Bar Assoc
Activities: Lect open to public; legal referral program

L WENTWORTH INSTITUTE OF TECHNOLOGY LIBRARY, 550 Huntington Ave, Boston, MA 02115-5901. Tel 617-989-4040; Fax 617-989-4091; Elec Mail punchw@admin.wit.edu; Internet Home Page Address: www.wit.edu/library; *Dir* Walter Punch; *Reference* Pia Romano; *Architectural Librn* Priscilla Biondi; *Circulation Mgr* Dan O'Connell; *Access Mgr* Kurt Oliver
Open 90 hrs per week; None
Library Holdings: Audio Tapes; Book Volumes 75,000; Clipping Files; DVDs; Memorabilia; Micro Print; Periodical Subscriptions 600; Photographs; Video Tapes
Special Subjects: Art History, Landscape Architecture, Historical Material, Advertising Design, Industrial Design, Interior Design, Drafting, Architecture

BROCKTON

L BROCKTON PUBLIC LIBRARY SYSTEM, Joseph A Driscoll Art Gallery, 304 Main St, Brockton, MA 02301. Tel 508-580-7890; Elec Mail lshannon@ocln.org; Internet Home Page Address: www.brocktonpubliclibrary.org; FTS 508-580-7898; *Dir* Harry R Williams III; *Head Adult Serv* Lucia M Shannon
Open Mon, Tues Noon - 8 PM, Wed - Sat 9 AM - 5 PM; No admis fee; Estab 1913; Special room for monthly art exhibitions; Average Annual Attendance: 20,000
Library Holdings: Book Volumes 258,768
Collections: W C Bryant Collection of 19th & 20th century American paintings, chiefly by New England artists; gifts of 20th century paintings which includes four paintings by Hendricks Hallett & an oil painting by Mme Elisabeth Weber-Fulop; loan collection of 20th century painters from the Woman's Club of Brockton; mounted photographs of Renaissance art & watercolors by F Mortimer Lamb
Exhibitions: Monthly exhibitions by local & nationally known artists

M FULLER MUSEUM OF ART, 455 Oak St, Brockton, MA 02401-1399. Tel 508-588-6000; Fax 508-587-6191; Elec Mail director@fullercraft.org; Internet Home Page Address: www.fullermuseum.org; *Cur* Denise Markonish; *Dir Develop* Michael Darmody; *Dir Educ* Dawn Wilson; *Dir* Jennifer Atkinson; *Sch Dir* Linda Marcus; *Finance & Operations* David Sullivan; *Asst Dir Develop* Kristin Villiotte
Open Tues - Sun Noon - 5 PM; Admis adults $5, seniors $3, children free; Estab 1969 to provide a variety of art exhibitions & educ programs of regional & national interest; The center houses six galleries; Average Annual Attendance: 35,000; Mem: 850; dues $30
Income: $784,000 (financed by endowment, mem, gifts & government grants)
Special Subjects: Drawings, Graphics, Painting-American, Photography, Prints, Sculpture, Watercolors, African Art, Pre-Columbian Art, Ceramics, Pottery, Woodcuts, Etchings & Engravings, Decorative Arts, Portraits, Furniture, Glass, Jewelry, Silver
Collections: Contemporary American art; Early American & Sandwich glass; 19th & 20th century American paintings; contemporary regional crafts
Publications: Quarterly newsletter & calendar of events
Activities: Classes for adults & children; dramatic programs; docent training; special programs for children; lect open to public, 4 vis lectrs per year; gallery talks; tours; concerts; individual paintings & original objects of art lent to accredited museums of the American Association of Museums; lending collection contains paintings & art; book traveling exhibitions 12 per year; originate traveling exhibitions; museum shop sells book, original art, reproductions, prints, contemporary crafts, t-shirts & mugs
L Library, 455 Oak St, Brockton, MA 02401. Tel 508-588-6000; Fax 508-587-6191; Internet Home Page Address: www.fullermuseum.org; *Dir* Jennifer Atkinson
Open to members, staff & students
Library Holdings: Book Volumes 500; Exhibition Catalogs; Pamphlets

CAMBRIDGE

A CAMBRIDGE ART ASSOCIATION, 25 R Lowell St, Cambridge, MA 02138. Tel 617-876-0246; Fax 617-876-1880; Elec Mail cambridgeart@mindspring.com; Internet Home Page Address: www.cambridgeart.org; *Dir* Kathryn Schultz; *Dir Sales & Rental* Susan Vrotsus; *Asst to Dir* Jodi Hays Gresham
Open Tues - Sat 11 AM - 5 PM, Sun 1 - 5 PM, cl Aug; No admis fee; Estab 1944 to exhibit, rent & sell members' work & to encourage an interest in fine arts & crafts in the community; 2 gallery spaces located in & near Harvard Sq; Mem: 575; dues artist $75, friends $40, students $15; jury of artist mems meets 4 times per yr to review work, slides & resumes
Income: Financed by dues, sale of art, annual appeal & endowment

Exhibitions: Invited shows in Rental Gallery & Craft Gallery; foreign exhibition each year; members' juried exhibitions in Main Gallery every month; National Prize Show (June)
Publications: Newsletter, quarterly
Activities: Classes for members; lect & demonstrations; competitions with prizes

M CAMBRIDGE ARTS COUNCIL, CAC Gallery, 344 Broadway, 2nd fl, Cambridge, MA 02139. Tel 617-349-4380; Fax 617-349-6757; Elec Mail cac@mlittman@cambridgema.gov; Internet Home Page Address: www.cambbridgeartscouncil.org; *Exec Dir* Jason Weeks; *Dir Pub Art* Lillian Hsu; *Dir Community Arts* Jane Beal; *Dir Mktg & Pub Rel* Mara Littman; *Community Arts Admin* Elizabeth White
Open Mon & Thurs 8:30 AM - 8 PM, Tues & Wed 8:30 AM - 5 PM, Fri 8:30 AM - Noon; No admis fee; Estab 1974 by city ordinance & incorp 1976 as public nonprofit. As the offical arts agency for the City of Cambridge, MA, it's mission is to ensure arts remain vital for people living, working & vis Cambridge.; alternative exhib space operated by the CAC & dedicated to showcasing visual artwork reflective of contemp artistic practice; Average Annual Attendance: 2,500
Collections: Rotating collections
Exhibitions: 6-8 exhibitions annually; Exhibition focus: contemporary public art & community engagement
Activities: Lect open to pub; gallery talks; tours; rotating collection to municipal bldgs & offices only

L CAMBRIDGE HISTORICAL COMMISSION, (City of Cambridge Historical Commission) 831 Massachusetts Ave, 2nd Floor, Cambridge, MA 02139. Tel 617-349-4683; Fax 617-349-3116; Elec Mail histcomm@cambridgema.gov; Internet Home Page Address: www.cambridgema.gov/~Historic; *Exec Dir* Charles M Sullivan; *Preservation-Planner* Sarah Burks; *Dir Survey* Susan Maycock; *Asst Dir* Kathleen Rawlins; *Designated Property Adminr* Paul Trudeau; *Archival* Alice Dodds; *Oral Historian* Sarah Boyer
Open to researchers; No admis fee; Estab 1963
Income: $490,000 (financed by city appropriation)
Library Holdings: Book Volumes 1000; Clipping Files; Kodachrome Transparencies; Manuscripts; Maps; Memorabilia; Original Art Works; Original Documents; Pamphlets; Periodical Subscriptions; Photographs; Prints; Slides
Special Subjects: Architecture
Collections: Architectural & social history of Cambridge
Publications: Cambridgeport (1971); Northwest Cambridge (1977); Photographic History of Cambridge (1984); East Cambridge (1988); Crossroads: Stories of Central Square, 1912-2000 (2001)
Activities: Educ dept; Classes for children; offsite lectrs & tours for special children; Cambridge Historical Commission Reservation Recognition Program; historic preservation grants to nonprofit institutions; lectrs open to the public

HARVARD UNIVERSITY

M Harvard University Art Museums, Tel 617-495-9400; Fax 617-495-9936; Elec Mail huam@fas.harvard.edu; Internet Home Page Address: www.artmuseums.harvard.edu; *Deputy Dir* Richard Benefield; *Registrar* Maureen Donovan; *Mem, Dir Fellows & Spec Prog* Mary Rose Bolton; *Visitor Servs* Margaret Howland; *Dir Straus Center Conservation* Henry Lie; *Pub Relations* Matthew Barone; *Acting Dir* Marjorie B Cohn
Open Mon - Sat 10 AM - 5 PM, Sun 1 - 5 PM, cl national holidays; Admis (applies to all three museums) adults $6.50, seniors $5, students $5, children under 18 free, Sat AM; Estab 1895; 225,000 vol fine arts library (Fogg Art Mus) & Rubel Asiatic Research Collection (Sackler) available for use by request only; extensive visual collection; reading room; classrooms; Average Annual Attendance: 129,898; Mem: 2,700; dues corporate/institutional $1,000-$10,000, patron $1,000, Forbes fellow $500, contributor $100, junior fellow (ages 21-40) $100, family $50, individual $35, students & seniors $25, admis only $20
Income: Financed by endowment, mem & federal grants
Collections: European and North American painting, prints and photography (Fogg Museum); Ancient, Asian & Islamic and Indian art (Sackler Museum); German Expressionist painting (Busch Reisinger Museum)
Publications: Director's report, quarterly newsletter; exhibit catalogs; gallery guides
Activities: Classes for adults & children; docent training; lect open to pub; gallery talks; tours; seminars; concerts; Mus shop sells books, magazines, reproductions & prints
 —**Busch-Reisinger Museum,** Tel 617-495-9400; Fax 617-495-9936; Elec Mail artmuseums@fas.harvard.edu; *Asst Cur* Emilie Norris; *Cur Asst* Tawney Becky; *Cur* Peter Nisbet
Open Mon - Sat 10 AM - 5 PM, Sun 1 - 5 PM, cl national holidays; Admis adult $5, seniors $4, students $3, under 18 & Sat AM free; Estab 1901 & opened in 1920, it has one of most important & extensive collections of Central & European art outside of Europe, ranging from the Romanesque to the present day. This coll serves the teaching prog of the Dept of Fine Arts, outside scholars & the gen pub; Werner Otto Hall contains 7 galleries, 6 for German Art (1880-1980), 1 for rotating exhibits; Average Annual Attendance: 83,696; Mem: 2,700; dues individual $35
Special Subjects: Painting-European, Renaissance Art
Collections: 18th Century Painting Collection; Late Medieval, Renaissance & Baroque Sculpture Collection; 16th Century Porcelain Collection; 20th Century German Works Collection; largest collection of Bauhaus material outside Germany; drawings; paintings; prints; sculpture
Publications: Newsletter
Activities: Classes for children; lect open to public; concerts; gallery talks; tours; symposia; individual paintings & original objects of art lent to other museums, considered on request; book traveling exhibitions 1-2 per year; originate traveling exhibitions; Mus shop sells books, reproductions, prints & small gift items
 —**William Hayes Fogg Art Museum,** Tel 617-495-9400; Fax 617-495-9936; Elec Mail artmuseums@fas.harvard.edu; *Deputy Dir* Frances A Beane; *Cur Drawings* William W Robinson; *Cur Prints* Marjorie B Cohn; *Cur Painting* Ivan Gaskell; *Dir* James Cuno
Open Mon - Sat 10 AM - 5 PM, Sun 1 - 5 PM, cl national holidays; Admis adults $5, seniors $4, students $3, Sat AM free; University estab 1891; mus estab 1927; serves both as a pub mus & as a laboratory for Harvard's Dept of Fine Arts,

which trains art history mus professionals; The Straus Center for Conservation operates a training program for conservators & technical specialists; Average Annual Attendance: 83,696; Mem: 2,700; dues $35 & up

Income: Financed by endowment, mem & federal grants

Special Subjects: Painting-European, Antiquities-Egyptian, Antiquities-Greek, Antiquities-Oriental, Antiquities-Roman, Bronzes, Ceramics, Decorative Arts, Drawings, Jade, Painting-American, Photography, Prints, Sculpture, Silver

Collections: Maurice Wertheim Collection of Impressionist & Post-Impressionist Art; European & American paintings, sculpture, decorative arts, photographs, prints & drawings; English & American silver; Wedgwood

Exhibitions: (Permanent) Circa 1874: The Emergence of Impressionism; France & The Portait, 1799-1870; Subliminations: Art & Sensuality in the Nineteenth Century.

Publications: Annual report; newsletter, 4 - 5 per year

Activities: Docent training; lect open to public; concerts; gallery talks; tours; individual paintings & original objects of art lent to other museums, considered on individual basis; book traveling exhibitions 1-2 per year; originate traveling exhibitions; Mus shop sells books, reproductions, prints & small gift items

—**Arthur M Sackler Museum,** Tel 617-495-9400; Fax 617-495-9936; Elec Mail artmuseums@fas.harvard.edu; *Deputy Dir* Frances A Beane; *Cur Chinese Art* Robert Mowry; *Cur Ancient Art* David Gordon Mitten; *Dir* James Cuno

Estab 1985 to serve both as a pub mus & a laboratory for Harvard's Dept of Fine Arts, which trains art historians & mus professionals

Special Subjects: Antiquities-Egyptian, Bronzes, Ceramics, Jade, Prints, Sculpture, Asian Art, Islamic Art, Jewelry, Manuscripts, Metalwork, Textiles

Collections: Ancient coins; Asian bronzes, ceramics, jades, painting, prints & sculpture; Egyptian antiquities; Greek red & black figure vases; Greek & Roman bronze & marble sculpture; Greek, Roman & Near Eastern jewelry & metalwork; Islamic & Indian ceramics, illuminated manuscripts; metalwork, paintings & textiles

Exhibitions: (Permanent)Serveran Silver Coinage

Activities: Mus shop sells books, prints & reproductions

L Fine Arts Library, Tel 617-495-3373; Fax 617-496-4889; Elec Mail altenhof@fas.harvard.edu; *Chief Cataloguer* Susan Myerson; *Librn* Katharine Martinez

Open to Harvard Community Mon - Thurs 9 AM - 10 PM, Fri 9 AM - 6 PM, Sat 10 AM - 5 PM, Sun 1 - 6 PM; Estab 1895 to support the teaching dept of fine arts & the research needs of the curatorial depts of Fogg Art Mus & an international community of scholars in art history; Circ 116,000

Income: $1,956,510 (financed by endowment)

Purchases: $520,688

Library Holdings: Book Volumes 262,744; Exhibition Catalogs; Fiche 67,855; Other Holdings Ephemera; Pamphlets 57,435; Periodical Subscriptions 1152; Photographs 424,549; Reels; Slides 654,897

Collections: DIAL Index; Marburger Index; The Index of Jewish Art; The Knoedler Index on Microfiche; Manuscript Archives of American artists and art scholars; Oriental and Islamic Art; Rubel Asiatic Research Collection: Library collection on the arts of the Far East; 40,000 catalogued auction sales catalogs

Publications: Catalog of Auction Sales Catalogs; Fine Arts Library Catalog (1971); Dictionary Catalog; The Catalogs of the Rubel Asiatic Research Collection (microfiche editions, 1984); Guide to the Card Catalogs of Harvard University, 1895 - 1981 (1984); Iconographic Index to Old Testament (1987); Iconographic Index to New Testament (1992); Vol I: Narrative Paintings of the Italian School (1992)

L Frances Loeb Library, Tel 617-495-9163; Fax 617-496-5929; Internet Home Page Address: www.gsd.harvard.edu/library; *Librn* Hugh Wilburn

Estab 1900 to serve faculty & students of graduate school of design; Circ 55,000

Income: $1,100,000 (financed by endowment & tuition)

Purchases: $208,381

Library Holdings: Audio Tapes 350; Book Volumes 266,852; Cassettes 326; Clipping Files; Exhibition Catalogs; Fiche; Filmstrips 65; Kodachrome Transparencies; Lantern Slides; Manuscripts; Memorabilia; Motion Pictures; Original Art Works; Other Holdings Drawings; Pamphlets; Periodical Subscriptions 1100; Photographs; Records; Reels; Slides 169,515; Video Tapes

Special Subjects: Architecture

Collections: Cluny Collection; Le Corbusier Collection; Edward Larrabee Barnes Collection; Charles Elliot Collection; Daniel Kiley Collection; John C Olmsted Collection; H H Richardson Collection; Charles Mulford Robinson Collection; Hugh Stubbins Collection; Joseph Luis Sert Collection

Activities: Tours

M Semitic Museum, Tel 617-495-4631; Fax 617-496-8904; Elec Mail greene5@fas.harvard.edu, davis4@fas.harvard.edu; Internet Home Page Address: www.fas.harvard.edu/~semitic; *Asst Dir* Joseph A Greene; *Asst Cur* James A Armstrong; *Cur Cuneiform Coll* Piotr Steinkeller; *Dir* Lawrence Stager

Open Mon - Fri 10 AM - 4 PM, Sun 1 - 4 PM; No admis fee, donations accepted; Estab 1889 to promote sound knowledge of Semitic languages & history; an archaeological research mus; Average Annual Attendance: 3,000-5,000; Mem: 250; dues $35 & up

Income: Financed by endowment, mem, private research grants, gifts

Special Subjects: Archaeology, Costumes, Antiquities-Byzantine, Coins & Medals, Antiquities-Persian, Islamic Art, Antiquities-Egyptian, Antiquities-Greek, Antiquities-Roman

Collections: Excavated archaeological & excavation archives materials from Egypt, Mesopotamia, Syria-Palestine, Cyprus, Arabia, North Africa; ethnographic collection (Ottoman period)

Exhibitions: Ancient Cyprus: The Cesnola Collection; Nuzi & The Hurrians: Fragments from a Forgotten Past; (2003) Life in Ancient Israel

Publications: Harvard Semitic Series; exhibit catalogs; Harvard Semitic Monographs; Semitic Museum Newsletter; Studies in the Archaeology & History of the Levant

Activities: Classes for adults & children; docent training; teacher workshop; lect-film series; tours; lect open to public, 5-8 vis lectrs per year; gallery talks; tours; scholarships offered; exten dept serves Harvard University; original objects of art lent to universities & museums; Mus shop sells books, reproductions, prints, jewelry, posters & novelty items

M LONGFELLOW NATIONAL HISTORIC SITE, 105 Brattle St, Cambridge, MA 02138. Tel 617-876-4491; Fax 617-876-6014; Elec Mail FRLA_longfellow@nps.gov; Internet Home Page Address: www.nps.gov/long; *Cur* Janice Hodson; *Sie Mgr* James M Shea; *Mus Tech* Margaret L Clarke; *Supt* Myra Harrison; *Archives Specialist* Anita Isreal; *Mus Educator* Paul Blandford

Open daily 10 AM - 4:30 PM; Admis $2 (under 16, over 62 free); Estab 1972 to acquaint the pub with the life, work & time of the American poet Henry W Longfellow; Average Annual Attendance: 18,000

Income: Financed by US Department of the Interior

Special Subjects: Period Rooms

Collections: Paintings, sculpture, prints, letters, furniture & furnishings once belonging to Henry W Longfellow & his daughter Alice; 19th century photographic collection including views of China & Japan; American, European & Asian Collections

Activities: Classes for adults & children; lect open to public; concerts; tours; individual paintings & original objects of art lent to qualified institutions; sales shop sells reproduction & slides

MASSACHUSETTS INSTITUTE OF TECHNOLOGY

M List Visual Arts Center, Tel 617-253-4680; Fax 617-258-7265; Elec Mail hiroco@mit.edu; Internet Home Page Address: www.mit.edu/lvac; *Cur* Bill Arning; *Registrar* John Rexine; *Admin Officer* David Freilach; *Gallery Mgr* Tim Lloyd; *Dir* Jane Farver; *Pub Art Cur* Kathleen Goncharov; *Educ/Outreach Coordr* Hiroko Kikuchi

Open Tues - Sun Noon - 6 PM, Fri Noon - 8 PM; No admis fee; Estab 1963 to organize exhibitions of contemporary art in all media; Contemporary Art gallery; Average Annual Attendance: 15,000

Income: Financed by MIT, pub & private endowments, art councils, corporations & individuals

Special Subjects: Drawings, Painting-American, Photography, Prints, Sculpture

Collections: Major public sculpture, paintings, drawings, prints, photographs & site-specific commissions all publicly sited through the campus. All collections are being enlarged through donations & purchases

Exhibitions: Six - eight exhibitions per year of contemporary art in all mediums

Publications: Exhibition catalogs, artists' books

Activities: Educ Dept; tours; films; lect open to public, 10 vis lectrs per year; gallery talks; Vera List Prize for Writing on the Visual Arts; lending collection of original art to student, faculty & admin staff; Student Loan Print Collection of over 300 pieces; book traveling exhibitions 2 per year; originate traveling exhibitions to major museums 2 per year; museum shop sells exhibition catalogues

M MIT Museum, Tel 617-253-4444; Fax 617-253-8994; Elec Mail museum@mit.edu; Internet Home Page Address: web.mit.edu/museum; *Assoc Dir* Mary Leen; *Mgr Exhibits* Donald Stidsen; *Cur Hart Nautical Coll* Kurt Hasselbalch; *Cur Science & Technology* Deborah Douglas; *Registrar* Joan Whitlow; *Cur Architecture & Design* Gary Van Zante

Open Tues - Fri 10 AM - 5 PM, Sat & Sun Noon - 5 PM; Admis for people outside MIT community adult $5, children $2; Estab 1971 as a mus facility to document, interpret & communicate the activities & achievements of MIT; Main exhibition facility & two campus galleries; Average Annual Attendance: 74,000; Mem: not applicable

Income: Financed by University & outside funding

Special Subjects: Architecture, Photography, Watercolors, Portraits, Marine Painting, Historical Material, Maps

Collections: Architectural drawings; biographical information; holograms; maritime; objects d'art; paintings; photographs; portraits; scientific instruments & apparatus

Exhibitions: (9/29/2006-12/22/2006) Front + Back: Investigating a Renaissance Drawing; (7/22/2006-6/30/2007) MIT Professor George Owan: Eminent Designer and Yachtsman

Publications: Gallery exhibition notes; collection catalogs

Activities: Classes for adults, children & family programs; lect open to public, 1-2 vis lectr per year; gallery talks; tours; individual paintings & original works lent to other museums; originate traveling exhibitions; museum visitor services desk sells books, prints, MIT- & exhibit-related items, educational toys

—**Hart Nautical Galleries & Collections,** Tel 617-253-5942; Fax 617-258-9107; Elec Mail kurt@mit.edu; Internet Home Page Address: http://web.mit.edu/museum/; *Cur* Kurt Hasselbalch

Gallery open daily 9 AM - 7 PM; reference Mon - Fri 10 AM - 5 PM by appointment only; Estab 1922 to preserve history of naval architecture, shipbuilding & related nautical technology; Galleries include permanent exhibit of ship models & MIT Ocean Engineering exhibit; Average Annual Attendance: 16,000

Income: Financed by University & pvt gifts

Special Subjects: Maps, Marine Painting

Activities: Individual paintings & original objects of art lent to qualified museums; lending collection contains prints, slides & models; museum shop sells books

L Rotch Library of Architecture & Planning, Tel 617-258-5594, 258-5599; Fax 617-253-9331; Elec Mail awhites@mit.edu; Internet Home Page Address: www.mit.edu; *Instruction Coordr* Peter Cohn; *Librn Aga Khan Program for Islamic Architecture* Omar Khalidi; *Coll Mgr* Michael Leininger; *Librn* Ann Whiteside

Open Mon - Thurs 8:30 AM - 11 PM, Fri 8:30 AM - 7 PM, Sat 10 AM - 6 PM, Sun 2 - 10 PM, special hrs when school is not in session; Estab 1868 to serve the students & faculty of the School of Architecture & Planning & other members of the MIT community

Library Holdings: Audio Tapes; Book Volumes 202,692; CD-ROMs; Cassettes; Compact Disks; DVDs; Exhibition Catalogs; Fiche; Kodachrome Transparencies; Lantern Slides; Motion Pictures; Pamphlets; Periodical Subscriptions 1944; Photographs; Reels; Slides; Video Tapes

Special Subjects: Art History, Film, Illustration, Photography, Drawings, Graphic Arts, Graphic Design, Painting-American, Sculpture, Painting-European, Historical Material, History of Art & Archaeology, Conceptual Art, Drafting, Architecture

CHATHAM

M CHATHAM HISTORICAL SOCIETY, The Atwood House Museum, Stage Harbor Rd, Chatham, MA 02633; PO Box 381, Chatham, MA 02633. Tel 508-945-2493, 945-1205; Elec Mail chs2002@msn.com; Internet Home Page Address: www.atwoodhouse.org; *Cur* Ernest Rohdenburg; *Pres* Spencer Y Grey
Open June - Sept Tues - Fri 1 - 4 PM; Admis $3, student with ID $1; Estab 1926 to preserve local Chatham history; Murals Barn houses Alice Stallknecht murals of Chatham people, The New Gallery houses Frederick Wight paintings of local sea captains; The Maritime Gallery houses paintings of ships & sea captains; Average Annual Attendance: 1,650; Mem: 1,400; dues family $25; meetings in Feb & Aug
Income: Financed by mem dues & donations
Purchases: Local historical artifacts & paintings
Special Subjects: Marine Painting, Historical Material
Collections: Harold Brett, paintings; Harold Dunbar, paintings; Frederick Wright, paintings; Sandwich Glass; 17th & 18th century furnishings; antique tools; china; items brought back by Chatham sea captains; maritime paintings; ship models; Crowell miniature decoys & sea shells from around the world
Exhibitions: Exhibits change every year
Publications: Exhibition catalogs
Activities: Classes for children; Docent training; talks & slideshows (winter only); tours; scholarships & fels offered; museum shop sells books & prints

CHESTNUT HILL

M BOSTON COLLEGE, McMullen Museum of Art, Devlin Hall 108, Chestnut Hill, MA 02467. Tel 617-552-8587; Fax 617-552-8577; Elec Mail artmuseum@bc.edu; *Cur* Alston Conley; *Collechous & Admin Specialist* John McCoy; *Exhib Coordr* Naomi Blumberg; *Dir* Nancy Netzer
Open Mon - Fri 11 - 4 PM, Sat & Sun noon - 5 PM; No admis fee; Estab 1986 to enhance the teaching mission of the University & extend it to a wider audience; Two floors; flexible galleries; Maintains lending & reference library; Average Annual Attendance: 50,000; Mem: 200; dues $50 & up
Income: Financed through University funds & donations
Exhibitions: Rotating exhibitions
Activities: Classes for adults; docent training; lect open to public, 10 vis lectrs per year; concerts; gallery talks; tours; scholarships offered; individual paintings & original objects of art lent to other exhibitions; book traveling exhibitions 3 per year; originate traveling exhibitions to other museums 3 per year

COHASSET

M COHASSET HISTORICAL SOCIETY, Pratt Building (Society Headquarters), 106 S Main St, Cohasset, MA 02025; PO Box 627, Cohasset, MA 02025. Tel 781-383-1434; Fax 781-383-1190; Elec Mail cohassethistory@yahoo.com; Internet Home Page Address: www.cohassethistoricalsociety.org; *Exec Adminr* Lynne DeGiacomo; *Historian* David Wadsworth
Headquarters open Mon - Fri 10 AM - 4 PM; Admis by donations; Estab 1928 as the headquarters house of the Cohasset Historical Society; Paintings & artifacts of local significance are displayed in various rooms; Cohasset Historical Society's library & archives, costumes, textile coll located here; Average Annual Attendance: 2,000; Mem: 400; dues sustaining $50, family $35, single $25; annual meetings in Oct & Apr
Library Holdings: Book Volumes 1000; DVDs 100; Lantern Slides 100; Manuscripts 100; Maps 100; Memorabilia 5000; Original Art Works 50; Original Documents 5000; Pamphlets 50; Periodical Subscriptions 5; Photographs 3500; Slides 1000; Video Tapes 25
Special Subjects: Historical Material, Furniture, Painting-American, Manuscripts, Maps, Textiles, Costumes, Decorative Arts, Manuscripts, Dolls, Maps
Collections: Works of art; historical artifacts & archives; costumes; textiles; theatre; Maritime Museum located at 4 Elm St., Cohasset; Historic Museum at 4 Elm St, Cohasset
Publications: Historical Highlights, newsletter 4 times per yr; Images of Americ; Cohasset (2004)
Activities: Lect open to public Sept - Jun, 6 vis lectrs per yr; tours; mus shop sells books
M Cohasset Maritime Museum, 4 Elm St, Cohasset, MA; PO Box 627, Cohasset, MA 02025. Tel 781-383-1434; Fax 781-383-1190; Elec Mail cohasseth1story@yahoo.com; Internet Home Page Address: www.cohassethistoricalsociety.org; *Sr Cur* David H. Wadsworth
Open June - Sept Tues - Fri 1:30 - 4:30 PM; No admis fee; Estab 1957 to display the seafaring history of Cohasset; Average Annual Attendance: 800; Mem: 370
Special Subjects: Architecture, Costumes, Portraits, Historical Material
Collections: Local maritime history, fishing gear of 19th century, lifesaving, shipwreck memorabilia, pictures & charts
M Captain John Wilson Historical House, 4 Elm St, Cohasset, MA 02025. Tel 781-383-1434; Fax 781-383-1190; Elec Mail cohassethistory@yahoo.com; Internet Home Page Address: cohassethistoricalsociety.org; *Pres* Kathleen L. O'Malley; *Exec Admin* Lynne DeGiacomo
Open mid-June - Labor Day 1:30 - 4:30 PM, cl Sat, Sun, Mon; No admis fee - Donations welcome; Estab 1928; Historic house mus; Average Annual Attendance: 1,000; Mem: 400; Dues - sustaining $50, family $35, single $25
Income: Financed by dues, donations & grants, in-kind serv & goods
Library Holdings: Auction Catalogs; Book Volumes 200; Clipping Files; Lantern Slides; Manuscripts; Maps; Memorabilia; Original Art Works; Original Documents; Other Holdings; Pamphlets; Periodical Subscriptions; Photographs 2000; Prints; Reels 3; Reproductions; Slides 2000; Video Tapes 25
Special Subjects: Historical Material
Collections: Old household furnishings, toys, kitchenware & artwork from the old homes of Cohasset
Publications: Qu newsletter; Historical Highlights
Activities: Classes for adults & children; lects open to public; 8 lects per year; gallery talks, tours, schols; mus shop sells books

CONCORD

A CONCORD ART ASSOCIATION, 37 Lexington Rd, Concord, MA 01742. Tel 978-369-2578; Fax 978-371-2496; Elec Mail concordart@concentric.ne; Internet Home Page Address: www.concordart.org; *Dir & VPres* George Nick; *Cur* Betsy Adams; *Pres* Virginia McIntyre; *Dir* Elizabeth Adams
Open Tues - Sat 10 AM - 4:30 PM, Sun Noon - 4 PM, cl Mon; No admis fee; Estab 1916 for the encouragement of art & artists; Housed in a 1740 house with four galleries, rent out to weddings & meetings; Average Annual Attendance: 10,000; Mem: 1000; dues life member $500, business & patron $100, family $75, individual $50, artist $40, student $20, sr citizen $25, corporate $1000
Income: Financed by mem
Collections: Bronze sculptures; colonial glass
Exhibitions: Changing exhibition per year; (2000) Frances N Roddy Memorial Competition (juried); (2001) Small Originals
Publications: Exhibition notices
Activities: Classes for adults and children; lect open to public, 4-6 vis lectrs per year; tours; competitions with prizes; original objects of art lent; rm for member's use

M CONCORD MUSEUM, 200 Lexington Rd, PO Box 146 Concord, MA 01742. Tel 978-369-9763; Fax 978-369-9660; Elec Mail cm1@concordmuseum.org; Internet Home Page Address: www.concordmuseum.org; *Cur* David Wood; *Business Mgr* Nick Purinton; *Dir Educ* Judith Stern; *Pub Relations Officer* Carol Haines; *Exec Dir* Desiree Caldwell; *Group Tour* Cameron Martin; *Registrar* Erin McGough
Open Apr - May & Sept - Dec Mon - Sat 9 AM - 5 PM, Sun Noon - 5 PM, Jun - Aug 9 AM - 5 PM daily; Admis adults $8, seniors & students $7, children $5, members free; Estab 1886 to further public understanding & appreciation of Concord's history & its relationship to the cultural history of the nation by collecting, preserving & interpreting objects used or made in the Concord area. The museum serves as a center of learning and cultural enjoyment for the region & as a gateway to the town of Concord for visitors from around the world; Twenty galleries & period rooms including six Why Concord? history galleries; Average Annual Attendance: 45,000; Mem: 1200; dues $45 & up; annual meeting in Apr
Income: $500,000 (financed by mem, admis, grants, endowment & giving)
Special Subjects: Archaeology, Decorative Arts, Historical Material, Landscapes, Ceramics, Metalwork, Furniture, Painting-American, Silver, Textiles, Costumes, Etchings & Engravings, Portraits, Glass, Porcelain, Maps, Dioramas, Period Rooms, Embroidery, Pewter
Collections: The Concord Museum collection includes the lantern that hung in the church steeple on the night of Paul Revere's famous ride, a collection of Thoreau's possessions, including the desk where he penned Walden and Civil Disobedience, and Emerson's Study. The museum's collections contain many 17th-19th-century furniture, clocks, silver, ceramics & needlework.
Publications: Newsletter, quarterly; Concord: Climate for Freedom by Ruth Wheeler; Forms to Sett On: A Social History of Concord Seating Furniture; Musketaquid to Concord: The Native & European Experience; Native American Source Book: A Teacher's Guide to New England Natives; The Concord Museum: Decorative Arts from a New England Collection
Activities: Classes for adults & children; docent training; lect open to public; 8 vis lectrs per year; concerts; gallery talks; tours; museum shop sells books, reproductions, prints, gift items & crafts which complement the museum collection

A LOUISA MAY ALCOTT MEMORIAL ASSOCIATION, Orchard House, 399 Lexington Rd, PO Box 343 Concord, MA 01742. Tel 508-369-4118; Fax 508-369-1367; Elec Mail louisa@acunet.net; *Dir Educ* Cara Shapiro; *Cur* Patty Bruttomesso; *Dir* Lisa A Simpson
Open Apr - Oct Mon - Sat 10 AM - 4:30 PM, Sun 1 - 4:30 PM, Nov - Mar Mon - Fri 11 AM - 3 PM, Sat 10 AM - 4:30 PM, Sun 1 - 4:30 PM, cl Easter, Thanksgiving, Christmas & Jan 1 - 15; Admis adults $5.50, seniors & students $4.50, children $3.50; Estab 1911, preservation of house & family effects for educational purposes; Historic House Museum. Maintains reference library; Average Annual Attendance: 45,000; Mem: 500; dues family $40, individual $25
Income: Financed by mem, admis, gift shop sales, donations & grants
Special Subjects: Architecture, Costumes, Drawings, Manuscripts, Photography, Porcelain, Prints, Sculpture, Silver, Textiles, Watercolors, Decorative Arts, Portraits, Dolls, Furniture, Glass, Period Rooms, Dioramas
Collections: Books & photographs of Alcott's; Household furnishings; House where Little Women was written; May Alcott's paintings & sketches
Publications: Exhibit catalogs
Activities: Classes for adults & children; dramatic programs; living history performances; lect open to public, 5 vis lectrs per year; tours; original objects of art lent to other museums; lending collection contains books, original art works, original prints, paintings, photographs & sculpture; sales shop sells books, magazines, prints & exclusive reproductions

COTUIT

M CAHOON MUSEUM OF AMERICAN ART, 4676 Falmouth Rd, PO Box 1853 Cotuit, MA 02635-1853. Tel 508-428-7581; Fax 508-420-3709; Elec Mail cmaa@cahoonmuseum.org; Internet Home Page Address: www.cahoonmuseum.org; *Mus Store Mgr* Gwen Manross; *Dir & Cur* Cindy Nickerson; *Asst to Dir* Adam Rhude; *Deputy Dir* Lou Ann Harrington
Open Tues - Sat 10 AM - 4 PM, cl Jan & major holidays; No admis fee for members & children under 12; Estab 1984; A stately 1775 Georgian colonial farmhouse maintained with period furnishings stenciled floorboards, numerous fireplaces, a 200-year old beehive oven & wall stenciling; Average Annual Attendance: 10,000; Mem: 600; dues patron $1000, sponsor $500, associate $250, contributor $100, family/dual $50, individual $30; annual meeting 3rd Wed in May
Income: $200,000 financed by fundraisers, memberships, admissions, annual appeal, gift shop
Special Subjects: Folk Art, Landscapes, Portraits, Marine Painting

Collections: Primitive paintings of Ralph and Martha Cahoon; 19th and early 20th Century American Art including works by James E. Buttersworth, William Matthew Prior, William Bradford & John J. Enneking
Exhibitions: Six - eight yearly exhibitions
Publications: Spyglass Newsletter, quarterly
Activities: Classes for adults; lect open to public; docent tours SmART! field trip program for elementary school classes; gallery talks; gift shop sells books, prints, jewelry, gifts

CUMMINGTON

M TOWN OF CUMMINGTON HISTORICAL COMMISSION, Kingman Tavern Historical Museum, 41 Main St, Cummington, MA 01026; PO Box 10, Cummington, MA 01026. Tel 413-634-5527; *Chmn* Stephen Howes; *VChmn* Donald Pearce; *Secy* Stephanie Pasternak; *Archivist* Sondra Huntley
Open 2 - 5 PM, Jul & Aug; Admis donation suggested; Estab 1968 to have & display artifacts of Cummington & locality; 17 rm house with artifacts of Cummington & area including 17 miniature rms, two flr barn, tools, equipment, carriage shed, cider mill; Average Annual Attendance: 300; Mem: 7, appointed by selectmen
Income: $30,000 (financed by endowment & donations)
Library Holdings: Cards; Clipping Files; Memorabilia; Original Documents; Photographs
Collections: Art of WWII Refugees; paintings of local New England artists
Publications: Only One Cummington, history of Cummington; Vital Records, Town of Cummington 1762 - 1900
Activities: Demonstrators; lect open to public; 2 vis lect per year; museum shop; books

DEERFIELD

M HISTORIC DEERFIELD, The Street, PO Box 321 Deerfield, MA 01342. Tel 413-774-5581; Fax 413-775-7220; Internet Home Page Address: www.historic-deerfield.org; *Chair* Mary Maples Dunn; *Pres* Philip Zea
Open Daily 9:30 AM - 4:30 PM; Admis adult $14, children $7; Estab 1952 to collect, study & interpret artifacts related to the history of Deerfield, the culture of the Connecticut Valley & the arts in early American life; Maintains 14 historic house museums, Flynt Center of Early New England life; Average Annual Attendance: 50,000; Mem: dues $35 and higher; annual meeting 2nd or 3rd Sun in Oct
Income: $1,923,527 (financed by endowment, mem, rental, royalty & museum store income)
Purchases: $163,694
Special Subjects: Textiles, Ceramics, Decorative Arts, Furniture, Silver, Embroidery, Pewter
Collections: American & English silver; American & European textiles & costume; American needlework; American pewter; Chinese export porcelain; early American household objects; early American paintings & prints; early New England furniture; English ceramics; American furniture
Publications: Historical Deerfield Quarterly; Annual Report
Activities: Classes for children & families; lect open to public, 17 vis lectr per year; gallery talks; tours; scholarships & fels; Mus shop sells books, reproductions, slides & local crafts
L Henry N Flynt Library, Memorial St, PO Box 53 Deerfield, MA 01342. Tel 413-774-5581; Fax 413-774-3081; Elec Mail library@historic-deerfield.org; *Librn* David C Bosse
Open Mon - Fri 9 AM - 5 PM; No admis fee; Estab 1970 to support research on local history & genealogy & the museum collections; also for staff training; For reference & research on early New England & Conn River Valley
Income: Grants & Historic Deerfield budget
Purchases: 1000 vols per year
Library Holdings: Book Volumes 18,000; Cards; Clipping Files; Exhibition Catalogs; Fiche; Filmstrips; Manuscripts; Memorabilia; Pamphlets; Periodical Subscriptions 110; Reels 550; Video Tapes 25
Special Subjects: Folk Art, Landscape Architecture, Decorative Arts, Painting-American, Historical Material, Ceramics, Porcelain, Furniture, Glass, Pottery, Silver, Silversmithing, Textiles, Landscapes, Architecture
Collections: Decorative Arts; Works dealing with the Connecticut River Valley
Publications: Research at Deerfield, An Introduction to the Memorial Libraries, irregular
Activities: museum sales shop sells books, reproductions, prints & slides

A POCUMTUCK VALLEY MEMORIAL ASSOCIATION, Memorial Hall Museum, 8 Memorial St, Deerfield, MA 01342; PO Box 428, Deerfield, MA 01342. Tel 413-774-7476, 774-3768; Fax 413-774-5400, 774-7070; Elec Mail info@old-deerfield.org; Internet Home Page Address: www.old-deerfield.org; *Pres* Carol Letson; *Cur* Suzanne Flint; *Dir* Timothy C Neumann
Open May 1 - Oct 31 Mon - Sun 9:30 AM - 4:30 PM; Admis adults $6, students $3, children (6-12) $3; Estab 1870 to collect the art & other cultural artifacts of Connecticut River Valley & western Massachusetts; Maintains 15 galleries; Average Annual Attendance: 17,000; Mem: 800; dues $10; annual meeting last Tues in Feb
Income: $1,900,000 (financed by endowment, mem, sales & fundraising)
Collections: Folk art; furniture; Indian artifacts; paintings; pewter; textiles; tools; toys; dolls
Publications: PVMA Newsletter, quarterly
Activities: Classes for children; dramatic programs; lect open to the public; concerts; tours; individual paintings & original objects of art lent to other museums; lending collection contains original art works, original prints, paintings & artifacts; museum shop sells books, original art, reproductions & slides

DENNIS

M CAPE COD MUSEUM OF ART INC, (Cape Museum of Fine Arts Inc.) 60 Hope Lane Rt 6A Dennis Village, PO Box 2034 Dennis, MA 02638. Tel 508-385-4477; Fax 508-385-7533; Internet Home Page Address: www.cmfa.org; *Exec Dir* Elizabeth Ives Hunter; *Mgr Exhib* Michael Giagumto; *Deputy Dir* Debra Hemeon; *Pub Relations Mgr* Rory Marcus; *Dir Educ* Linda McNeil Kemp; *Registrar* Angela Bilsky; *Develop Officer* Gigi Ledkovsky
Open May - Oct Mon - Sat 10 AM - 5 PM, Sun 1 - 5 PM; Oct -May Tues - Sat 10 AM - 5 PM, Thurs evs until 8 PM; Admis adults $8, mem & ages 18 & under free; Estab 1981 for artists associated with Cape Cod; Three permanent collection galleries, temporary exhibitions; maintains reference library; Average Annual Attendance: 35,000; Mem: 2,000; dues $50-$5000
Income: $1,000,000 (financed by endowment, mem, events to earned income)
Purchases: New England Torso, bronze by Gilbert Franklin
Library Holdings: Book Volumes; Clipping Files; Exhibition Catalogs; Memorabilia; Original Documents; Periodical Subscriptions; Slides
Special Subjects: Graphics, Painting-American, Prints, Sculpture, Watercolors, Bronzes, Ceramics, Woodcarvings, Woodcuts, Etchings & Engravings, Glass
Collections: Artists associated with Cape Code
Publications: Art Matters Quarterly; exhibit catalogues
Activities: Classes for adults & children; docent training; lect open to public, 8 vis lectrs per year; concerts; gallery talks; tours; individual paintings & original objects of art lent; book traveling exhibitions 1 per year; traveling exhibs for AAM members; museum shop sells books, magazines & prints

DUXBURY

M ART COMPLEX MUSEUM, Carl A. Weyerhaeuser Library, 189 Alden St., Duxbury, MA 02331; PO Box 2814 Duxbury, MA 02331. Tel 781-934-6634; Fax 781-934-5117; Elec Mail info@artcomplex.org; Internet Home Page Address: www.artcomplex.org; *Sr Cur* Catherine Mayes; *Communications Coordr* Laura Doherty; *Registrar* Maureen Wengler; *Asst to Dir* Mary Curran; *Dir & CEO* Charles A Weyerhaeuser; *Librn* Cheryl O'Neill; *Spec Projects Cur* Craig Bloodgood; *Consulting Cur* Alice R M Hyland; *Community Coord* Doris Collins; *Grounds & Maintena* William Thomas; *Coordr Educ* Sally Dean Mello; *Staff Asst* Elaine Plakias
Open Wed - Sun 1 - 4 PM; No admis fee; Estab 1971 as a center for the arts; Circ Non-circulating; Average Annual Attendance: 10,000
Income: Financed by endowment
Library Holdings: Auction Catalogs; Book Volumes 6000; Clipping Files; Exhibition Catalogs; Manuscripts; Pamphlets; Periodical Subscriptions 15; Slides; Video Tapes
Special Subjects: Prints, Asian Art
Collections: American paintings, prints & sculpture; European paintings & prints; Asian art; Native American art; Shaker furniture
Publications: Complexities (newsletters); exhibit catalogues
Activities: Educ dept; workshops for children & adults; docent training; lect open to public; concerts; gallery talks; tours of vis groups; individual art works lent to other institutions
L Library, 189 Alden St, PO Box 2814 Duxbury, MA 02331. Tel 718-934-6634; *Dir* Charles Weyerhaeuser; *Librn* Cheryl O'Neill
Open Wed-Sun 1 PM-4 PM; Estab 1971; Circ Non-circulating; Open to the pub for reference; Average Annual Attendance: 12,000
Income: Financed by endowment
Library Holdings: Book Volumes 5000; Clipping Files; Exhibition Catalogs; Pamphlets; Periodical Subscriptions 20; Slides; Video Tapes
Special Subjects: Prints, Asian Art
Activities: Docent reading group

ESSEX

M ESSEX HISTORICAL SOCIETY, Essex Shipbuilding Museum, 66 Main St, PO Box 277 Essex, MA 01929. Tel 978-768-7541; Fax 978-768-2541; Elec Mail info@essexshipbuilding.museum.com; Internet Home Page Address: www.essexshipbuildingmuseum.org; *Cur* Courtney Ellis Peckham; *Pres* Tom Ellis; *Treas* Charles Storey; *Operations Mgr* Catherine Ageloff
Nov - May, Weekends 10 AM - 5 PM; June - Oct, Wed - Sun 10 AM - 5 PM; Admis $7; Estab 1976 to preserve & interpret Essex history with special emphasis on its shipbuilding industry; Maintains reference library; Average Annual Attendance: 4,500; Mem: 600; dues $35, annual meeting in May
Special Subjects: Drawings, Photography, Prints, Archaeology, Crafts, Woodcarvings, Landscapes, Decorative Arts, Marine Painting, Historical Material, Maps
Collections: Collection of ship building tools, documents, paintings, plans & photographs, models-both scale & builders; fishing schooner hulls; shipyard site 300 years old
Exhibitions: Five rigged ship models & 15 builder's models on loan from the Smithsonian Institution's Watercraft Collection; Frame-Up (on going); Caulker's Art (on going).
Publications: A list of vessels, boats & other craft built in the town of Essex 1860-1980, a complete inventory of the Ancient Burying Ground of Essex 1680-1868; Essex Electrics, 1981; Dubbing, Hooping & Lofting, 1981
Activities: Classes for adults & children; lect open to public, 5-7 vis lectrs per year; gallery talks; tours; museum shop sells books, prints, original art, reproductions, & audio-video cassettes, t-shirts, models, plans, magazines & notecards

FALL RIVER

M FALL RIVER HISTORICAL SOCIETY, 451 Rock St, Fall River, MA 02720. Tel 508-679-1071; Fax 508-675-5754; *Pres* Elizabeth Denning; *VPres* Andrew Mann Lizak; *Cur* Michael Martins
Open Tues - Fri (Apr - Nov) Tours 10 & 11 AM, 1, 2 & 3 PM, (June - Sept) Tours 1, 2, 3 & 4 PM, open house day after Thanksgiving Day before New Year's

Day; Admis adult $5, children 6-14$3.00, children under 6 free; Estab 1921 to preserve the social & economic history of Fall River; Average Annual Attendance: 6,000; Mem: 659; dues $45 family, $25 individual
Income: Financed by endowment, mem
Special Subjects: Painting-American, Costumes, Decorative Arts
Collections: Fall River School Still Life Paintings & Portraits; Antonio Jacobsen marine paintings; Period costumes, furs, fans; Victorian furnishings & decorative arts; Victorian Decorative Stenciling: A Lost Art Revived
Exhibitions: Still Life painting by 19th Century Artists of the Fall River School
Activities: Small private tours for local schools; lect open to public, 4 vis lectrs per year; individual paintings lent; shop sells books, prints, postcards, paperweights

FITCHBURG

M **FITCHBURG ART MUSEUM,** 185 Elm St, Fitchburg, MA 01420; Merriam Pkwy Fitchburg, MA 01420. Tel 978-345-4207; Fax 978-345-2319; Elec Mail info@fitchburgartmuseum.org; Internet Home Page Address: www.fitchburgartmuseum.org; *VPres* Anna Colangelo; *Dir* Peter Timms; *Treas* Dexter Stevens; *Business Mgr* Sheryl Demers; *Dir Educ* Roger Dell; *Dir Mem* Mary Ellen Letarte; *VPres* Robert Rossi; *Dir Corporate Mem Svcs* Jane Keough; *Dir Pub Progs* Kristina Durocher; *Dir Studio Progs* Susan Dekant
Open Tues - Sun Noon - 4 PM; Admis fee $5, seniors $3; Estab 1925; Three building complex incl two museums with nine large galleries & two entrance halls & one administration building, new gallery of decorative arts; Average Annual Attendance: 22,000; Mem: 1200; dues $35 - 1000; annual meeting Dec
Income: Financed by endowment & mem
Purchases: Mary Verplanck McEvers, 1771 by John Sargent Copley
Special Subjects: Drawings, Painting-American, Prints
Collections: Drawings, paintings & prints; A Walk Through The Ancient World (household & sacred articles from ancient cultures)
Exhibitions: Rotating exhibits; (2004) African Art; Egyptian, Greek, Roman & Decorative Arts
Publications: Exhibitions catalogs; event notices
Activities: Classes for adults & children; docent training; Partnership School (object-based learning); lect open to public, 12 vis lectrs per year; gallery talks; tours; competitions with awards; scholarships; individual paintings & original objects of art lent to colleges & museums; sales shop sells reproductions & jewelry

FRAMINGHAM

M **DANFORTH MUSEUM CORPORATION,** Danforth Museum of Art, 123 Union Ave, Framingham, MA 01702. Tel 508-620-0050; Fax 508-872-5542; Elec Mail dmadev@conversent.net; Internet Home Page Address: www.danforthmuseum.org; *Interim Dir* Hope Coolidge; *Cur Asst* Laura McCarty
Open Wed - Sun Noon - 5 PM; Admis $5; Estab 1975 to provide fine arts & art-related activities to people of all ages in the South Middlesex area; There are seven galleries, including a children's gallery with hands-on activities; Average Annual Attendance: 30,000; Mem: 1500; dues individual $30, family $45, friend $100, supporter $250, sponsor $500, patron $1000, seniors get $10 off any category, annual meeting in Oct
Income: Financed by mem, Framingham State College & Town of Framingham, federal & state grants; foundations & corporate support
Special Subjects: Ceramics, Glass, Photography, Pottery, Painting-American, Drawings, Painting-American, Prints, Watercolors, Crafts
Collections: Old master & contemporary prints, drawings & photography; 19th & 20th centuries American paintings; African & Oceanic art
Exhibitions: Varied program of changing exhibitions, traveling shows, selections from the permanent collection, in a variety of periods, styles & media
Publications: Newsletter; exhibition brochures & catalogues, museum school brochure
Activities: Classes for adults & children; docent training; programs for area schools; lect open to public; concerts; gallery talks; tours; competitions; book traveling exhibitions 2-3 per year; originate traveling exhibitions to other museums & galleries nationally; museum shop sells original art & reproductions; junior gallery
L **Library,** 123 Union Ave, Framingham, MA 01701. Tel 508-620-0050; Fax 508-872-5542; *Dir* Ronald L Crusan; *Cur Asst* Laura McCarty
Open Wed - Sun Noon - 5 PM; Estab 1975 as an educational resource of art books & catalogues; For reference only; research as requested
Library Holdings: Auction Catalogs; Book Volumes 6500; Clipping Files; Exhibition Catalogs; Pamphlets; Video Tapes
Collections: Bibliographies for the museum exhibitions; art book collection

GARDNER

M **MOUNT WACHUSETT COMMUNITY COLLEGE,** East Wing Gallery, 444 Green St, Gardner, MA 01440. Tel 978-632-6600, Ext 168; Internet Home Page Address: www.mwcc.mass.edu; *Chmn Dept Art* Gene Cauthen; *Painting Prof* John Pacheco; *Ceramics Prof* Joyce Miller; *Adjunct Faculty* Joslin Stevens; *Adjunct Faculty* Susan Montgomery; *Adjunct Faculty* Keith Hollingwood
Open Mon - Thurs 8 AM - 9 PM, Fri 8 AM - 5 PM; No admis fee; Estab 1971 to supply resources for a two-year art curriculum; develop an art collection; Well-lighted gallery with skylights & track lighting, white panelled walls; two open, spacious levels with Welsh tile floors; Average Annual Attendance: 8,000-10,000
Income: Financed by city & state appropriations
Purchases: Pottery by Makato Yabe, print by Bob Roy, 17 student paintings, ten student prints, five student ceramic works, eight student sculpture, two bronze works
Collections: Approximately 100 works; framed color art posters & reproductions; prints; ceramic pieces; student collection
Exhibitions: Annual student competition of painting, sculpture, drawing, ceramics, printmaking; local, national & international artists & former students' works

Publications: Annual brochure
Activities: Continuing educ classes for adults & children; lect open to public, 8-10 vis lectrs per year; gallery talks; tours; competitions with awards; exten dept serves Mount Wachussett
L **Library,** 444 Green St, Gardner, MA 01440. Tel 978-632-6600, Ext 126; Fax 978-632-1210; Internet Home Page Address: www.mwcc.mass.edu; *Asst Librn* Christina Coolidge; *Dir* Linda R Oldach
Open Mon - Thurs 8 AM - 9:30 PM, Fri 8 AM - 5 PM, Sun 2 - 6 PM (when school is in session); Estab 1964; Circ 12,998; Lending library
Income: Financed by state appropriation
Library Holdings: Book Volumes 70,000; Cassettes; Fiche; Filmstrips; Memorabilia; Pamphlets; Periodical Subscriptions 325; Records; Reels; Slides
Exhibitions: Periodic exhibitions

GLOUCESTER

M **CAPE ANN HISTORICAL ASSOCIATION,** (Cape Ann Historical Museum) 27 Pleasant St, Gloucester, MA 01930. Tel 978-283-0455; Fax 978-283-4141; Internet Home Page Address: www.cape-ann.com/historical-museum; *Dir* Ronda Faloon; *Museum Educator* Ann Baylies; *Mus Shop Mgr* Jeanette Smith; *Pres* John Cunningham; *Assoc Cur Coll* James Craig; *Prog Dir* Elena Sarni
Open Tues - Sat 10 AM - 5 PM, Sun 1 - 4 PM, cl Feb; Admis adults $6.50, seniors $4.50, students $4.50, members free; Estab 1873 to foster appreciation of the quality & diversity of life on Cape Ann past & present; Fine arts, decorative arts & American furniture; Fisheries/maritime galleries; granite industry gallery; 1804 furnished house; maintains reference library; Average Annual Attendance: 13,000; Mem: 1500; dues $30-$1000
Library Holdings: Auction Catalogs; Audio Tapes; Clipping Files; Exhibition Catalogs; Manuscripts; Maps; Memorabilia; Original Documents; Pamphlets; Periodical Subscriptions; Photographs
Special Subjects: Painting-American, Photography, Sculpture, Watercolors, Pottery, Etchings & Engravings, Landscapes, Decorative Arts, Portraits, Furniture, Jade, Porcelain, Silver, Marine Painting, Coins & Medals, Dioramas, Period Rooms, Embroidery, Pewter
Collections: Fitz Hugh Lane Collection, paintings; 20th Century-Maurice Prendergast, John Sloan, Stuart Davis, Marsden Hartley, Milton Avery; Granite Industry of Cape Ann, Maritime & Fishing Industry; 20th Century Sculpture-Walker Hancock, Paul Manship
Exhibitions: (3/2007-6/2007) Zygmund Jankowski Paintings; (7/7/2007-9/16/2007) The Mysteries of Fitz Henry Lane; Les Bartlett photography - Chapters on a Quary Wall
Activities: Classes for adults & children; outreach to area schools; on-site programs for students; lect open to the public; vis lec 2-3 per yr; concerts; gallery talks; tours; individual paintings & original objects of art lent to museums, galleries & local businesses; mus shop sells books, magazines, reproductions, prints, slides, jewelry, postcards, note paper & Cape Ann related items
L **Cape Ann Historical Museum,** 27 Pleasant St, Gloucester, MA 01930. Tel 978-283-0455; Fax 978-283-4141; Internet Home Page Address: www.capeannhistoricalmuseum.org; *Dir* Judith McCulloch
Open 10 AM - 5 PM Tues - Sat, cl Feb; admis adults $6.50, sr $6, students $4.50; Estab 1876; Reference only
Income: mem, donations, admis, sales
Library Holdings: Auction Catalogs; Book Volumes 3000; Clipping Files; Exhibition Catalogs; Manuscripts; Memorabilia; Motion Pictures; Original Art Works; Pamphlets; Photographs; Prints; Records; Reproductions; Sculpture
Special Subjects: Art History, Decorative Arts, Photography, Manuscripts, Maps, Painting-American, Sculpture, Historical Material, Portraits, Watercolors, Porcelain, Period Rooms, Silver, Marine Painting
Collections: Fitz Hugh Lane Collection; 20th century art, fisheries/maritime, granite quarrying
Exhibitions: Leon Kroll
Activities: Classes for children; 6 lect open to public per yr; mus shop sells books, reproductions, prints

M **HAMMOND CASTLE MUSEUM,** 80 Hesperus Ave, Gloucester, MA 01930. Tel 978-283-7673, 283-7620; Fax 978-283-1643; Internet Home Page Address: www.hammondcastle.org; *Acting Dir & Cur* John W Pettibone; *VPres* Craig Lentz
Open daily June - Aug 10 AM - 6 PM, weekends Sept - May 10 AM - 3 PM; Admis adults $6.50, seniors & students $5.50, children between 4 & 12 $4.50; Estab 1931 by a famous inventor, John Hays Hammond Jr. Incorporated in 1938 for the public exhibition of authentic works of art, architecture and specimens of antiquarian value and to encourage and promote better education in the fine arts, with particular reference to purity of design and style; Built in style of a medieval castle with Great Hall, courtyard and period rooms, Dr Hammond combined elements of Roman, Medieval and Renaissance periods in his attempt to recreate an atmosphere of European beauty; Average Annual Attendance: 60,000
Income: Financed by tours, concerts, special events & rentals
Collections: Rare collection of European artifacts; Roman, Medieval and Renaissance Periods
Publications: Exhibition catalogs; Hammond Biography
Activities: Classes for children; docent training; educational & teacher workshops; lect open to public; concerts; self guided & group tours; exten dept servs neighboring schools; sales shop sells books, reproductions, crafts, jewelry, art cards & postcards

A **NORTH SHORE ARTS ASSOCIATION, INC,** 11 Pirate's Lane, Gloucester, MA 01930. Tel 978-283-1857; Fax 978-282-9819; Elec Mail arts@northshoreartsassoc.org; Internet Home Page Address: northshoreartsassoc.org; *Pres* Andrea van Gestel; *VPres* Nancy Caplan; *VPres* Carole Loiacono; *Treas* Carleen Muniz; *Gallery Dir* Carol Mortimore
Open daily 10 AM - 5 PM, Sun Noon - 5 PM, May 1 - Oct 31; No admis fee; Estab 1922 by the Cape Ann Artists to promote American art by exhibitions; Gallery owned by association; maintains reference library; Average Annual Attendance: 8,000; Mem: 375; dues artist $60, patron $40, associate $35; annual meeting in Aug
Income: Financed by dues, contributions & rentals

Library Holdings: Cards; Exhibition Catalogs; Original Art Works; Original Documents; Pamphlets; Prints; Reproductions; Sculpture
Collections: Member paintings
Exhibitions: 3 summer exhibits
Publications: Calendar of Events; exhibit catalogs; brochures
Activities: Classes for adults & children; dramatic programs; docent training; art auctions; childrens festival; lect open to public, 3 vis lectrs per year; concerts; gallery talks; lending of original objects of art to other museums; sales shop sells books & original art

GREAT BARRINGTON

M **SIMON'S ROCK COLLEGE OF BARD,** Doreen Young Art Gallery, 84 Alford Rd, Great Barrington, MA 01230. Tel 413-528-7420; Fax 413-528-7365; Elec Mail wjackson@simons-rock.edu; Internet Home Page Address: www.simons-rock.edu; *Chmn Art Dept* Bill Jackson; *Gallery Coordr* Dan DuVall
Open Fri, Sat & Sun 2 - 10 PM; No admis fee; Estab 1964 as a liberal arts college; One large 30 ft x 50 ft gallery
Income: Financed by the college
Exhibitions: A continuing exhibition program of professional & student works in drawing, painting, graphics, sculpture & crafts; Richard Webb (painting); William Jackson (sculpture); Jane Palmer (ceramics); Arthur Hillman (prints); The African-Afro-American Connection (photos); Brigitte Keller (painting); Harriet Eisner (painting); Linda Kaye-Moses (jewelry); Taff Fitterer (painting)
Activities: Gallery talks; tours
L **Library,** 84 Alford Rd, Great Barrington, MA 01230. Tel 413-528-7274; Tel 413-528-0771; Elec Mail goodkind@simons rock.edu; Internet Home Page Address: www.simons-rock.edu; *Librn* Joan Goodkind
Open daily 8:30 AM - 12 AM; No admis fee; Estab 1964; 20 ft x 30 ft
Income: Financed by the college
Library Holdings: Book Volumes 60,500; Cassettes; Fiche; Periodical Subscriptions 350; Records; Reels
Exhibitions: In the Atrium Gallery, exhibits change monthly

HADLEY

M **PORTER-PHELPS-HUNTINGTON FOUNDATION, INC,** Historic House Museum, 130 River Dr, Hadley, MA 01035. Tel 413-584-4699; Internet Home Page Address: www.pphmuseum.org; *Pres* Elizabeth Wheeler; *VPres* Tom Harris; *Exec Dir* Susan J Lisk
Open May 15 - Oct 15 Sat - Wed 1 - 4:30 PM; Admis fee $4, children under 12 $1; Estab 1948; Historic house built in 1752; twelve rooms house the accumulated belongings of ten generations of one family; carriage house; corn barn; historic gardens; sunken garden; Average Annual Attendance: 5,500; Mem: 500; dues $25 - $1,000; annual meeting in Dec
Income: $65,000 (financed by endowment, grants, programs & mem)
Special Subjects: Drawings, Architecture, Glass, Furniture, Silver, Painting-American, Photography, Prints, Watercolors, Textiles, Costumes, Decorative Arts, Manuscripts, Portraits, Jewelry, Porcelain, Historical Material, Maps, Scrimshaw, Miniatures, Pewter
Collections: Porter-Phelps-Huntington family collection of 17th, 18th & 19th century furniture, paintings, papers, decorative arts; clothing collection; Porter-Phelps - Hunting Family Paper on deposit at Amherst College Special Collections & Archives
Activities: Dramatic programs; History Inst for the Teachers; lect open to public, 1 vis lectr per year; concerts; tours; individual paintings & objects of art lent to other museums; museum shop sells books, cards & pamphlets

HARVARD

M **FRUITLANDS MUSEUM, INC,** 102 Prospect Hill Rd, Harvard, MA 01451. Tel 978-456-3924; Fax 978-456-8078; Elec Mail mvolmar@fruitlands.org; Internet Home Page Address: www.fruitlands.org; *Cur* Michael Volmar, PhD; *Dir Educ* Joanne Myers; *Educ Asst* Heather McDonald; *Dir* Maud Ayson
Open mid-May thru - Oct Daily 10 AM - 5 PM; Admis adults $8, seniors & college students $6, ages 4 - 17 $4; Estab 1914, incorporated 1930 by Clara Endicott Sears. Fruitlands was the scene of Bronson Alcott's Utopian experiment in community living; The Fruitlands Farmhouse contains furniture, household articles, pictures, handcrafts, books & valuable manuscript collection of Alcott, Lane & Transcendental group. The Shaker House, built in 1794 by the members of the former Harvard Shaker Village, was originally used as an office. Moved to its present location, it now forms the setting for the products of Shaker Handcrafts & Community Industries. American Indian museum contains ethnological exhibits. Picture gallery contains portraits by itinerant artists of the first half of the 19th century & landscapes by Hudson River School; Average Annual Attendance: 18,000; Mem: 650; senior/students $25, individual $40, family $65, Patron $125, Fruitlands Benefactor $350; annual meeting in June
Income: Financed by earned income, Sears Trust, mem fees, gifts & grants
Purchases: Books, paintings & ethnographic materials
Special Subjects: Sculpture, American Indian Art
Collections: Hudson River Landscapes; Philip Sears Sculpture Collection; Shaker Handcraft Furniture & Household articles & pictures
Publications: Under the Mulberry Tree, quarterly
Activities: Docent training; lect open to public, 2-4 vis lectrs per year; concerts; individual & original objects of art lent to other museums in the area; lending collection includes original art works, prints, paintings; book traveling exhibitions; museum shop sells books, magazines, reproductions & prints
L **Library,** 102 Prospect Hill Rd, Harvard, MA 01451. Tel 978-456-3924; Fax 978-456-8078; Elec Mail mvolmar@fruitlands.org; Internet Home Page Address: www.fruitlands.org; *Cur* Michael A Volmar PhD
Open year round by appointment; Estab 1914 for staff resource & scholarly research
Library Holdings: Book Volumes 10,000; Filmstrips; Manuscripts; Memorabilia; Motion Pictures; Original Art Works; Periodical Subscriptions 10; Photographs; Records; Reels; Slides; Video Tapes

Special Subjects: Art History

HAVERHILL

L **HAVERHILL PUBLIC LIBRARY,** Special Collections, 99 Main St, Haverhill, MA 01830. Tel 978-373-1586 ext 642; Fax 978-373-8466 (library); Elec Mail library@haverhill.com; Internet Home Page Address: www.haverhillpl.org; *Cur Special Coll* Greg Laing; *Dir Library* Joseph Dionne
Mon - Wed 10 AM - 1 PM, 2 - 5 PM, 6 - 9 PM, Thurs - Sat 10 AM - 1 PM, 2 - 5:30 PM, cl Sun; Estab 1873
Income: Financed by private endowment
Library Holdings: Audio Tapes; Book Volumes 8650; Cassettes; Clipping Files; Kodachrome Transparencies; Lantern Slides; Manuscripts; Motion Pictures; Original Art Works; Periodical Subscriptions 16; Photographs; Prints; Video Tapes
Special Subjects: Photography, Manuscripts, Prints
Collections: Illuminated manuscripts; mid-19th century photographs, work by Beato and Robertson, Bourne, Frith, Gardner, Naya, O'Sullivan, and others; small group of paintings including Joseph A Ames, Henry Bacon, Sidney M Chase, William S Haseltine, Thomas Hill, Harrison Plummer, Winfield Scott Thomas, Robert Wade
Exhibitions: Changing exhibits

HOLYOKE

M **WISTARIAHURST MUSEUM,** 238 Cabot St, Holyoke, MA 01040. Tel 413-322-5660; Fax 413-534-2344; Elec Mail admin@wistariahurst.org; Internet Home Page Address: www.wistariahurst.org; *Chmn Holyoke Historical Commission, Chmn* Olivia Mausel; *Mus Dir* Carol Constant; *Cur* Kate Navarra Thibodeau; *Event & Volunteer Coordr* Melissa Boisselle
Open year-round Sat, Sun & Mon noon - 4 PM; Admis adults $5, seniors $3, members & children under 12 free; Historic house museum estab to show history of Holyoke 1850-1930; Sponsored by the City of Holyoke under the jurisdiction of the Holyoke Historical Commission; Average Annual Attendance: 1,200; Mem: annual meeting May
Income: Financed by city appropriation
Special Subjects: Architecture, American Indian Art, Ethnology, Costumes, Landscapes, Manuscripts, Portraits, Eskimo Art, Dolls, Furniture, Glass, Oriental Art, Miniatures, Period Rooms, Embroidery
Collections: Late 19th & early 20th centuries furniture, paintings, prints, decorative arts & architectural details; period rooms; Historical Landscape Tour
Publications: Museum newsletter, twice a year (Spring & Fall)
Activities: Programs for adults & children; docent training; visual arts gallery; lect open to public; 25 vis lect per yr; concerts; tours; museum shop sells books

IPSWICH

M **THE TRUSTEES OF RESERVATIONS,** The Mission House, Castle Hill, 290 Argilla Rd. Ipswich, MA 01938. Tel 978-921-1944; Fax 978-921-1948; Elec Mail history@ttor.org; Internet Home Page Address: www.thetrustees.org; *Chm (V)* Elliot M. Surkin; *Dir Devel* Ann Powell; *Communications & Michael Triff; Dir Historic Resources* Susan C S Edwards; *Dir Finance & Admin* John McCrane; *Dir Land Conservation* Wesley Ward; *Exec Dir* Andrew Kendall; *Bd Pres (V)* Janice Hunt
Open Memorial Day through Columbus Day Daily 10 AM - 5 PM; Admis adults $5, children 6-12 $2.50; Built 1739, the home of John Sergeant, first missionary to the Stockbridge Indians, it is now an Early American Mus containing an outstanding collection of Colonial funishings. Mus opened in 1930; Average Annual Attendance: 3,000
Special Subjects: Period Rooms
Publications: Yearly brochure

LEXINGTON

M **NATIONAL HERITAGE MUSEUM,** (Museum of Our National Heritage) 33 Marrett Rd, Lexington, MA 02421. Tel 781-861-6559; Fax 781-861-9846; Elec Mail info@monh.org; Internet Home Page Address: www.monh.org; *Others* TTY: 781-274-8539; *Dir Educ & Pub Progs* Joanne Myers; *Dir Coll & Exhibits* Hilary Anderson; *Dir Admin & Finance* June Cobb; *Designer* Mike Rizzo; *Cur Masonic Coll* Aimee Newell; *Archivist* Catherine Swanson; *Reference Librn* Helaine Davis
Open Mon - Sat 10 AM - 5 PM, Sun Noon - 5 PM, Library open Mon - Sat 10 AM - 5 PM, cl Sun; No admis fee; Estab 1972 as an American history museum, including art and decorative art; Four modern galleries for changing exhibits, flexible lighting & climate control. Two galleries of 3000 sq ft, two 1500 sq ft; Average Annual Attendance: 70,000; Mem: 298; dues assoc mem $250, contributing $100, family $60, individual $40, senior and student $30
Income: $2,900,000 (financed by endowment & appeal to Masons)
Library Holdings: Auction Catalogs; Book Volumes; Cassettes; Compact Disks; DVDs; Exhibition Catalogs; Kodachrome Transparencies; Manuscripts; Maps; Original Documents; Other Holdings; Pamphlets; Periodical Subscriptions; Photographs; Slides; Video Tapes
Special Subjects: Historical Material, Painting-American, Decorative Arts
Collections: General American & American Paintings; American decorative art; objects decorated with Masonic, patriotic & fraternal symbolism
Exhibitions: In Motion: African American Migration continues though 2/25/2007; Handled with Care continues through 4/22/2007; Images of Women in WWI posters opens; Pets in America opens; The Art of the Needle: Master. Quilts from the Shelburne Mus opens; Raymond Loewy: Designs for a consumer Culture opens; Telephones opens
Publications: Exhibition catalogs
Activities: Docent training; lect open to public; 12 vis lectrs per year; concerts; gallery talks; tours for school groups; paintings and art objects lent; originate traveling exhibitions; museum shop sells books and a variety of gift items related to exhibit program; museum courtyard cafe

LINCOLN

M DECORDOVA MUSEUM & SCULPTURE PARK, 51 Sandy Pond Rd, Lincoln, MA 01773-2600. Tel 781-259-0505; Fax 781-259-3650; Internet Home Page Address: www.decordova.org; *Dir Develop* Melissa Kane; *Cur* Rachel Lafo; *Dir Educ* Claire Loughheed; *Dir* Paul Master-Karnik; *Asst Dir* Jessica Nelson
Open Tues - Sun 11 AM - 5 PM; Admis adults $6, 6-21 & seniors $4, students & members free; Estab 1948 to exhibit, to interpret, collect & preserve modern & contemporary American art; 8000 sq ft is broken into five galleries; Average Annual Attendance: 140,000; Mem: 3500; dues $35-$1000
Income: $2,500,000 (financed by endowment, individual/corporate mem, foundation & government grants)
Purchases: $60,000
Special Subjects: Painting-American, Graphics, Painting-American, Photography, Prints, Sculpture, Woodcuts, Etchings & Engravings, Landscapes, Portraits, Glass
Collections: American art; 20th century American painting, graphics, sculpture & photography; emphasis on artists associated with New England
Publications: Exhibition catalogs; newsletter
Activities: Classes for adults & children; docent training; lect open to public; concerts; gallery talks; guided tours; arts festivals; outreach programs; individual paintings & original objects of art lent to corporate program members; book traveling exhibitions 2-3 per year; originate traveling exhibitions; museum shop sells books, magazines, original art, art supplies & contemporary crafts

M DeCordova Museum, 51 Sandy Pond Rd, Lincoln, MA 01773-2699. Tel 781-259-8355; Fax 781-259-3650; Elec Mail info@decordova.org; Internet Home Page Address: www.decordova.org; *Dir* Paul Master-Karnik; *Cur* Rachel Rosenfield Lafo; *Cur.* Nick Capasso
Open Tues - Sun 11 AM - 5 PM for visitors of the mus only; adult $9, seniors, students & youth 6-12 $6; Estab 1950 to display American contemporary & modern art by New England artists; Painting, prints, photog, drawing, sculpture, mixed media & installation art; Average Annual Attendance: 145,000; Mem: Dues individual $60, household $90, friend $150, sponsor $300, patron $600, Julian Club $1000, individual teacher $50, household teacher $80, school & library $150
Library Holdings: Book Volumes 3000; Exhibition Catalogs; Other Holdings Museum catalogs; Periodical Subscriptions 10
Collections: New England Art, 2200 artworks of various media
Activities: Classes for adults & children; docent training; teacher training & resources; lect open to pub; 4 vis lects per yr; exten program serves Boston area; individual objects of art lent to schools & corporations; sales shop sells books, magazines, original art, handcrafted gifts, jewelry & wearable art

LOWELL

M AMERICAN TEXTILE HISTORY MUSEUM, 491 Dutton St, Lowell, MA 01854. Tel 978-441-0400; Fax 978-441-1412; Elec Mail espear@athm.org; Internet Home Page Address: www.athm.org;John H. Pearson Jr.; *Vice-Chmn* Hiram M. Samel; *Chmn Emeritus* Edward B. Stevens; *Pres & CEO* Michael J. Smith; *Dir Finance & Admin* Frances Kelley; *Dir Advancement* Ellen Spear; *Cur* Karen Herbaugh; *Dir Exhib* Diane Fagan Affleck; *Dir Textile Conservation Center* Vicky Kruckeberg; *Librn* Clare Sheridan; *Dir Museum Educ* Linda Carpenter; *Mgr Museum Store* Linda Williams; *Registrar* Bonnie Sousa; *Coordr* Cindy Bernstein; *Bldg Supv* Richard Dubois; *Weave Shed Supv* Michael Christian
Open Tues - Fri 9 AM - 4 PM, Sat & Sun 10 AM - 5 PM; $6 adults (17 & over); $4 children (6-16) & seniors (62 & over); no charge museum members and children under six; Estab 1960 to preserve artifacts, documents & pictorial descriptions of the American textile industry & related development abroad; Textile & social history exhibition & special exhibition gallery; Average Annual Attendance: 43,478; Mem: 1,082 4-5 events; Student/senior $20; Individual $40; Dual $55; Family $75; Contributing $100; Supporting $250; Patron $500
Income: Financed by endowment
Library Holdings: Book Volumes; Exhibition Catalogs; Lantern Slides; Manuscripts; Motion Pictures; Original Art Works; Original Documents; Other Holdings Engineering & architectural plans; Pamphlets; Photographs; Records; Slides; Video Tapes
Special Subjects: Photography, Prints, Textiles
Collections: Hand looms, industrial machinery, spinning wheels, textile collection; books, manuscripts, prints & photographs, clothing
Exhibitions: Textiles in America
Publications: Exhibition catalogs; Linen Making in America
Activities: Classes for adults; docent training; dramatic programs; vacation & summer workshops; lects open to public; 15 vis lects per year; tours; competitions; gallery talks; lending collection contains slides; 1-2; various institutions; sales desk sells textiles, books, prints & postcards; original art

L Library, 491 Dutton St, Lowell, MA 01854. Tel 978-441-0400; Fax 978-441-1412; Internet Home Page Address: www.athm.org; *Librn* Clare Sheridan
Open by appointment; For reference only
Income: Financed by endowment
Library Holdings: Book Volumes 30,000; Exhibition Catalogs; Manuscripts; Memorabilia; Motion Pictures; Original Art Works; Other Holdings Ephemera; Original documents; Pamphlets; Periodical Subscriptions 50; Photographs; Prints; Reels; Reproductions; Sculpture
Publications: Checklist of prints and manuscripts

M THE BRUSH ART GALLERY & STUDIOS, 256 Market St, Lowell, MA 01852. Tel 978-459-7819; *Exec Dir* E Linda Poras
Open Tues - Fri 11 AM - 5 PM; Estab 1982; Nonprofit; in national historic park. Gallery with changing exhibitions plus 13 artist studios; Average Annual Attendance: 200,000; Mem: dues $25-$40
Income: Financed by mem, grants, fundraising & sales
Activities: Classes for adults & children; lect open to public; scholarships offered; sales shop sells original art

A LOWELL ART ASSOCIATION, INC, Whistler House Museum of Art, 243 Worthen St, Lowell, MA 01852. Tel 978-452-7641; Fax 978-454-2421; Elec Mail mlally@whistlerhouse.org; Internet Home Page Address: www.whistlerhouse.org; *Exec Dir* Michael H Lally; *Exhibits Mgr* Rae Ann Partridge
Open Wed - Sat 11 AM - 4 PM; Admis Adults $5, Seniors & Children $4; Estab 1878 to preserve the birthplace of James McNeill Whistler; to promote the arts in all its phases & to maintain a center for the cultural benefit of all the citizens of the community; Average Annual Attendance: 5,000; Mem: 500; dues family $45, adults $35, senior citizens $25, students $20
Income: Financed by endowment, mem, admis, grants & earned income
Special Subjects: Prints, Painting-American, Portraits
Collections: Mid 19th through early 20th century American Art: Hibbard, Benson, Noyes, Spear, Paxton, Phelps; Whistler etchings & lithographs; Gorky
Exhibitions: Galleries of works from permanent collection & periodic exhibits by contemporary artists
Publications: Brochures; S P Howes: Portrait Painter, catalog
Activities: Classes for adults & children; docent training; lect open to public, 3 vis lectrs per year; concerts; gallery talks; tours; programs of historical interest; book traveling exhibitions 1-2 per year; originate traveling exhibitions to small museums & schools; museum shop sells books, original art, reproductions, prints & postcards

MALDEN

L MALDEN PUBLIC LIBRARY, Art Dept & Gallery, 36 Salem St, Malden, MA 02148. Tel 781-324-0218, 381-0238; Fax 781-324-4467; Elec Mail maldensup@sbln.lib.ma.us; Elec Mail mbln@lib.ma.us; Internet Home Page Address: www.mbln.lib.ma.us/malden/index.htm; *Dir & Librn* Dina G Malgeri
Gallery has changing hrs; please contact for available times; No admis fee; Estab 1879, incorporated 1885 as a public library and art gallery; Circ 239,493; Maintains three galleries, the main gallery being the Ryder Gallery, and the others known as the Upper & Lower Galleries
Income: $421,530 (financed by endowment, city and state appropriations)
Library Holdings: Exhibition Catalogs; Framed Reproductions; Manuscripts; Memorabilia; Original Art Works; Pamphlets; Photographs; Prints; Reproductions; Sculpture
Activities: Lect open to public, 6-12 vis lectrs per year; concerts; gallery talks; tours

MARBLEHEAD

A MARBLEHEAD ARTS ASSOCIATION, INC, King Hooper Mansion, 8 Hooper St Marblehead, MA 01945. Tel 781-631-2608; Fax 781-639-7890; Elec Mail maa@marbleheadarts.org; Internet Home Page Address: www.marbleheadarts.org; *Dir* Diane Stakoe; *Pres* Joe Puleo; *Admin Asst* Nancy Graves
Open Tues - Sat noon - 4 PM, Sun 1 - 5 PM; Suggested donation $2 fee for group tour with docent; Estab 1922. Owns & occupies the historic King Hooper Mansion, located in historic Marblehead; Contains fine paneling, ballroom, gallery & garden by Shurclif, one gift shop with member wares. Maintains three art galleries; Mem: 750 assoc members; mem upon application (open); dues family $50; individual $35, seniors $30, artist $45; annual meeting in June
Income: Financed by mem & mansion rentals, gallery & shop sales, tuition fees & programs
Special Subjects: Etchings & Engravings, Prints
Collections: Works of: Sam Chamberlain; Claire Leighton; Lester Hornby; Sam Thal; Nason; Grace Albee & Phillip Kappel; 1940's Friends of Contemporary Prints
Exhibitions: Annual Town Show; Annual Member Show; Monthly Exhibits
Publications: Newsletter, monthly
Activities: Classes for adults & children; drama programs; docent training; lect open to public, 5-10 vis lectrs per year; concerts; gallery talks; tours; competitions with awards; scholarships offered; museum shop sells books, original art, reproductions, prints, quilting, cards, pottery, sculpture & painted furniture; art related items

MARBLEHEAD HISTORICAL SOCIETY

M John Oren Johnson Frost Gallery, Tel 781-631-7945; Fax 781-631-0917; Internet Home Page Address: www.marbleheadhistory.org; *Dir* Pam Peterson; *Treas* Peter J Hart; *Archives* Karen MacInnis; *Cur* Judy Anderson; *Pres* Richard L Tuve; *Registrar* Jean Fallon
Open Tues - Fri 10 AM - 4 PM; No admis fee; 1920s folk art paintings & models by J O J Frost depicting life in Marblehead & fishing at sea in the past; Average Annual Attendance: 2,700; Mem: 1,500; dues based on sliding scale
Income: Financed by endowment, mem, & admis
Collections: Ceramics, decorate arts, documents, dolls, folk art, furniture, glass, military items, nautical items, period rooms, portraits, ship paintings, textiles
Exhibitions: Permanent exhibit; Rotating exhibit
Publications: Semi-annual newsletter
Activities: Classes for children; docent training; workshops; lect open to public, 4 vis lectrs per year; gallery talks; tours; sales shop sells books, prints & postcards

M Jeremiah Lee Mansion, Tel 781-631-1768; Fax 781-631-0917; *Pres* Richard Tuve III; *Admin Dir* Wendy L Hubbard; *Pres* Richard Tuve II
Open June 1 - Oct 15 Tues - Sat 10 AM - 4 PM, Sun 1 - 4 PM; Admis adult $5, student $4.50, child under 10 $4; Estab 1768; Georgian-style Four-story mansion made of woodcut blocks to simulate stone with elegant rococo interior carving & original hand-painted English wallpaper depicting Roman ruins; 18th-century-style-garden; top floor has been converted to a museum of Marblehead history with an extensive early doll collection; Average Annual Attendance: 2,700; Mem: 1,500; dues based on sliding scale
Income: Financed by endowment, mem & admis
Collections: Ceramics, decorative arts, documents, dolls, folk art, furniture, glass, military items, nautical items, period rooms, portraits, ship paintings & textiles
Publications: Semi-annual newsletter
Activities: Classes for children; docent training; workshops; lect open to public, vis lectr; gallery talks; tours; sales shop sells books, prints & postcards

L Library, Tel 781-631-7945; *Research* Karen MacInnis; *Historian* Janice Rideout
Open Tues - Fri 10 AM - 4 PM; Admis non-members $5, members free; Estab 1898 to collect & maintain artifacts of Marblehead history; No galleries. Art & decorative art displayed in historic 1768 mansion; Average Annual Attendance: 4,000; Mem: 1,500; dues $15-$100
Library Holdings: Auction Catalogs; Audio Tapes; Book Volumes; CD-ROMs; Cassettes; Clipping Files; Framed Reproductions; Kodachrome Transparencies;

Lantern Slides; Manuscripts; Maps; Memorabilia; Motion Pictures; Original Art Works; Original Documents; Other Holdings; Pamphlets; Periodical Subscriptions; Photographs; Prints; Reproductions; Slides; Video Tapes
Special Subjects: Manuscripts, Historical Material
Collections: Art, artifacts, furniture & documents pertaining to Marblehead
Publications: Members semiannual newsletter
Activities: Classes for adults & children; docent training; lect open to public, 3 vis lectrs per year; tours; sales shop sells books, original art, reproductions, prints & postcards

MARION

A **MARION ART CENTER,** Cecil Clark Davis Gallery, 80 Pleasant St, Marion, MA 02738; PO Box 602, Marion, MA 02738. Tel 508-748-1266; Fax 508-748-2759; Internet Home Page Address: www.marionartcenter.org; *Pres* Joy Horstmann; *Dir* Wendy Bidstrup
Open Tues - Fri 1 - 5 PM, Sat 10 AM - 2 PM; No admiss fee; Estab 1957 to provide theater, concerts & visual arts exhibitions for the community & to provide studio art, theater arts, music & dance classes for adults & children; Two galleries, 125 ft of wall space, 500 sq ft floor space; indirect lighting; entrance off Main St; Average Annual Attendance: 2,000; Mem: 650; dues angel $1,000, patron $500, donor $250, sponsor $100, family $50, basic $25; annual meeting in Jan
Income: Financed by mem dues, donations & profit from ticket & gallery sales
Collections: Cecil Clark Davis (1877-1955), portrait paintings
Exhibitions: Monthly one person & group shows
Publications: Annual mem folder; monthly invitations to opening; quarterly newsletter
Activities: Classes for adults & children; dramatic programs, pvt lessons in piano & voice; lect open to public; concerts; gallery talks; competitions; scholarships; sales shop sells fine crafts, small paintings, prints, cards, original art and reproductions

MEDFORD

M **TUFTS UNIVERSITY,** Tufts University Art Gallery, Aidekman Arts Center, 40 Talbot Ave Medford, MA 02155. Tel 617-627-3518; Elec Mail galleryinfo@tufts.edu; Internet Home Page Address: www.ase.tufts.edu/gallery; *Dir* Amy Ingrid Schlegel PhD; *Preparator & Registrar* Doug Bell; *Outreach Coordr* Jeanne V Koles; *Staff Asst* Kristen Perkins
Tues - Wed & Fri - Sun 11 AM - 5 PM, Thurs 11 AM - 8 PM, cl holidays & Aug; No admis fee; Average Annual Attendance: 10,000
Special Subjects: Painting-American, Photography, Prints, Antiquities-Egyptian, Antiquities-Greek, Antiquities-Roman
Collections: Primarily 19th & 20th centuries American paintings, prints & drawings; contemporary paintings, photographs & works on paper
Exhibitions: Fourteen shows annually, three of which are thesis exhibits of candidates for the MFA degree offered by Tufts in affiliation with the School of the Boston Museum of Fine Arts; New media wall, sculpture court; Annual summer exhibition of Medford & Somerville artists
Publications: Catalogues & brochures
Activities: Docent training; tours for adults; lect open to pub, 4 vis lectr per year; gallery talks; tours; intra-univ art loan prog; originate traveling exhibitions

MILTON

M **CAPTAIN FORBES HOUSE MUS HOUSE,** 215 Adams St, Milton, MA 02186. Tel 617-696-1815; Fax 617-696-1815; Elec Mail forbeshousemuseum@verizon.net; *Dir* Christine M. Sullivan; *Admin* Nadine Leary; *Mktg & Events Coordr* Lauren Pauly; *Develop Coordr* Sara Collard
Open Tues - Thurs & Sun 1 - 4 PM; Admis $5, seniors & students $3, children under 12 free; Estab 1964 as a Historic House museum; for preservation, research, education: 19th century through Forbes family focus; Average Annual Attendance: 1,000; Mem: 400; dues life member $1,000, benefactor $500, sponsor $250, donor $100, friend $50, family $40, individual $25
Income: $70,000 (financed by endowment, mem & fundraising)
Library Holdings: Book Volumes 2500; Exhibition Catalogs; Manuscripts; Memorabilia; Micro Print; Original Art Works; Pamphlets; Periodical Subscriptions 6; Photographs; Prints
Special Subjects: Decorative Arts, Porcelain, Period Rooms
Collections: Abraham Lincoln Civil War Collections & Archives; Forbes Family Collection of China trade & American furnishings
Exhibitions: Annual Abraham Lincoln essay contest for grades K - 8th grade
Publications: Forbes House Jottings, four times per year
Activities: Classes for adults & children; docent training; lect open to public, 3 vis lectrs per year; tours; competitions & awards; lending collection contains decorative arts, Lincoln memorabilia, original art works, original prints & sculpture; museum sells books & cards

NANTUCKET

A **ARTISTS ASSOCIATION OF NANTUCKET,** 19 Washington St., & 1 Gardner Perry Ln Nantucket, MA 02554; PO Box 1104, Nantucket, MA 02554. Tel 508-228-0722; Fax 508-228-9700; Elec Mail aanoff@verizon.net (office); Elec Mail anngallery@verizon.net (gallery); Internet Home Page Address: www.nantucketarts.org; *Pres (V)* Katie Frinkle Legge; *Gallery Dir* Robert Foster; *Admin* Meghan Valero; *Dir Arts Prog* Liz Hunt O'Brien
Open spring daily Noon - 5 PM, summer daily 10 AM - 6 PM; No admiss fee; Estab 1945 to provide a place for Nantucket artists of all levels & styles to show their work & encourage new artists; Maintains one gallery: at 19 Washington St, 2 fls; Average Annual Attendance: 50,000 - 70,000; Mem: 600; dues patron $50 - $500, artist $100; annual meeting Aug
Income: $75,000 - $100,000 (financed by mem, fundraising & commissions, large patron gifts)

Library Holdings: Auction Catalogs; Book Volumes; Clipping Files; Exhibition Catalogs; Original Art Works; Periodical Subscriptions
Collections: 600 pieces, most by Nantucket artists; Wet Paint Auction
Exhibitions: Annual Craft Show; juried shows; changing one-person & group member shows during summer; occasional off-season shows
Publications: Monthly newsletter; annual brochure
Activities: Classes for adults & children; workshops; lect open to public, 5-6 vis lectrs per year; gallery talks, competitions with awards; scholarships; individual paintings & original objects of art lent to local hospital & public offices; sales shop sells original art, prints & lithographs

M **EGAN INSTITUTE OF MARITIME STUDIES,** The Coffin School, 4 Winter St Nantucket, MA 02554. Tel 508-228-2505; Fax 508-228-7069; Elec Mail egan@eganinstitute.com; Internet Home Page Address: www.eganinstitute.com; *Assoc Dir & Cur* Margaret Moore; *Dir* Nathaniel Philbrick
Open daily 1 - 5 PM, May - Oct; Admis $1; Estab 1996; Historic 1854 Greek Revival building with 1 main gallery & 2 special exhibition galleries; maintains reference library; Average Annual Attendance: 3,000
Income: Financed by the foundation
Special Subjects: Architecture, Painting-American, Photography, Watercolors, Etchings & Engravings, Landscapes, Decorative Arts, Manuscripts, Portraits, Marine Painting, Painting-British, Historical Material, Maps
Collections: Coffin School memorabilia; 19th century American portraits & landscapes; 19th & 20th century marine paintings; ship models
Exhibitions: Nantucket Spirit; The Life and Art of Elizabeth R. Coffin
Publications: Millhill Press-book
Activities: Adult classes; lect open to public, 7-10 vis lectrs per year; lending collection contains paintings & objects of art; sales shop sells books & prints

M **NANTUCKET HISTORICAL ASSOCIATION,** Historic Nantucket, 15 Broad St, PO Box 1016 Nantucket, MA 02554. Tel 508-228-1894; Fax 508-228-5618; Elec Mail nhainfo@nha.org; Internet Home Page Address: www.nha.org; *Exec Dir* Jean M Weber; *Cur Library & Archives* Georgen Gilliam; *CEO* Frank D Milligan; *Dir Develop* Jean Grimmer; *Museum Shop Mgr* Georgina Winton; *VPres* Arie Kopelman; *Chief Cur* Niles Parker
Open June - Oct 10 AM - 5 PM; Admis a visitor pass to all buildings, adults $10, children 5-14 $5, individual building admis $2-$5; Estab 1894 to preserve Nantucket & maintain history; Historic Nantucket is a collection of 10 historic buildings & 3 museums throughout the town, open to the pub & owned by the Nantucket Historical Assoc. Together they portray the way people lived & worked as Nantucket grew from a small farming community to the center of America's whaling industry; maintains reference library; Mem: 3000; dues $30-$1000; annual meeting in July
Income: Financed by endowment, contributions, events, mem & admis
Special Subjects: Painting-American
Collections: Portraits, Oil Paintings, Watercolors, Needlework Pictures, baskets, furniture, photographs, scrimshaw, textiles, whaling tools & all other manner of artifacts related to Nantucket & Maritime History; all objects exhibited in our historic houses & museums which cover the period 1686-1930
Publications: Art on Nantucket; Historic Nantucket, quarterly, magazine for members
Activities: Classes for children; docent training; lect open to public, 24 vis lectrs per year; concerts; gallery talks; tours; research fels offered; museum shop sells books, reproductions, prints, slides, period furniture, household items, silver, bone & ivory scrimshaw, candles & children's toys

NEW BEDFORD

L **NEW BEDFORD FREE PUBLIC LIBRARY,** Art Dept, 613 Pleasant St, New Bedford, MA 02740. Tel 508-991-6279; Fax 508-979-1481; Elec Mail tcoish@sailsinc.org; Internet Home Page Address: www.ci.new-bedford.ma.us/nbfpl.htm; *Dept Head Reference* Martine Hargraves; *Dept Head Genealogy & Whaling Coll* Paul Cyr; *Dept Head Technical Svcs* Vicki A Lukas; *Dir* Theresa Coish; *Archivist* Ernestina Furtado
Open Mon - Thurs 9 AM - 9 PM, Fri & Sat 9 AM - 5 PM, cl Sun & holidays, Art Room open by appointment only; No admis fee; Estab 1852; Rare art books, prints, catalogs, 19th & 20th Century Am art; portraits, whaling & maritime art
Income: Financed by endowment, city, & state appropriation
Library Holdings: Cassettes; Exhibition Catalogs; Fiche; Filmstrips; Framed Reproductions; Lantern Slides; Manuscripts; Maps; Memorabilia; Motion Pictures; Original Art Works; Original Documents; Pamphlets; Periodical Subscriptions; Photographs; Prints; Records; Reels; Sculpture; Slides; Video Tapes
Special Subjects: Etchings & Engravings, Painting-American, Watercolors, American Western Art, Woodcarvings, Marine Painting, Landscapes
Collections: Paintings by Clifford Ashley, Albert Bierstadt, F D Millet, William Wall, John James Audubon, MacKnight Watercolors, William Bradford
Activities: Art programs for children & adults; lect open to pub; vis lectrs; scholarships offered; individual & original objects of art lent to city offices & credible organizations

M **OLD DARTMOUTH HISTORICAL SOCIETY,** New Bedford Whaling Museum, 18 Johnny Cake Hill, New Bedford, MA 02740. Tel 508-997-0046; Fax 508-997-0018; Internet Home Page Address: www.whalingmuseum.org; *Cur* Michael Jehle; *Dir* Anne Brengle
Open daily 9 AM - 5 PM, Sun 1 - 5 PM; Admis $6 youth & seniors $5, children between 6 & 14 $4, children under 6 free; Estab 1903 to collect, preserve & interpret objects including printed material, pictures & artifacts related to the history of the New Bedford area & American whaling; Average Annual Attendance: 50,000; Mem: 3000; dues $15-$850; annual meeting in May
Income: $713,000 (financed by endowment, mem, private gifts, grants, special events & admis)
Special Subjects: Drawings, Painting-American, Photography, Prints, Sculpture, Ethnology, Costumes, Crafts, Folk Art, Etchings & Engravings, Decorative Arts, Manuscripts, Portraits, Dolls, Furniture, Glass, Marine Painting, Historical Material, Ivory, Maps, Scrimshaw, Restorations, Miniatures, Embroidery, Laces

Collections: Paintings, watercolors, drawings, prints, photographs, whaling equipment, ship models, including 89 foot 1/2 scale model of whaler Lagoda
Exhibitions: 66 Ft Skeleton of Blue Whale; Two Brothers Gowlart; changing exhibits every 6 months
Publications: Bulletin from Johnny Cake Hill, quarterly; exhibition catalogs; calendar, quarterly
Activities: Classes for adults & children; docent training; lect open to public, 12 vis lectrs per year; gallery talks; tours; individual paintings & original objects of art lent to other museums; lending collection contains microfilm, nature artifacts, original art works, original prints, paintings, photographs & sculptures; traveling exhibitions organized & circulated; museum shop sells books, magazines, reproductions, prints, slides & gift items

L **Whaling Museum Library,** 18 Johnny Cake Hill, New Bedford, MA 02740. Tel 508-997-0046; Fax 508-997-0018; Internet Home Page Address: www.whalingmuseum.org
Open by appointment only Mon - Fri 10 AM - Noon & 1 - 5 PM, first Sat of each month; For reference only
Income: Financed by private gifts & grants
Library Holdings: Book Volumes 15,000; Clipping Files; Exhibition Catalogs; Filmstrips; Manuscripts; Memorabilia; Pamphlets; Periodical Subscriptions 12; Reels

NEWBURYPORT

M **HISTORICAL SOCIETY OF OLD NEWBURY,** Cushing House Museum, 98 High St, Newburyport, MA 01950. Tel 978-462-2681; Fax 978-462-0134; *Cur* Jay S Williamson
Open Tues - Fri 10 AM - 4 PM, Sat 11 AM - 3 PM, cl Sun & Mon; Admis adults $3; Estab 1877 to preserve heritage of Old Newbury, Newbury, Newburyport & West Newbury; Average Annual Attendance: 3,000; Mem: 600; dues patron $500, benefactor $250, sustaining $250, friend $100, friend $50, family $35, individual $20
Income: $50,000 (financed by dues, tours, endowments, fund-raisers)
Special Subjects: Architecture, Painting-American, Textiles, Decorative Arts, Manuscripts, Furniture, Historical Material, Period Rooms, Embroidery
Collections: China; dolls; furniture; glass; miniatures; needlework; paintings; paperweights; sampler collection; silver; military & other historical material representative of over three centuries of Newbury's history
Exhibitions: 150th Anniversary of Newbury
Publications: Old-Town & The Waterside, 200 years of Tradition & Change in Newbury, Newburyport & West Newbury - 1635-1835
Activities: Docent training; lect open to public, 8 vis lectrs per year; gallery talks; tours for children; Garden Tour; annual auction; scholarships & fels offered; exten dept serves Merrimack Valley; individual paintings & original objects of art lent to nonprofit cultural institutions; museum shop sells books

M **NEWBURYPORT MARITIME SOCIETY,** Custom House Maritime Museum, 25 Water St, Newburyport, MA 01950. Tel 978-462-8681; Fax 978-462-8740; Elec Mail nms@shore.net; *Exec Dir* Mark J Sammons
Open Mon - Sat 10 AM - 5 PM, Sun 1 - 5 PM, open Wed afternoon Apr - Dec, cl Jan - Mar; Admis adults $3, children $2, under 5 free; Estab 1975 to exhibit the maritime heritage of the Merrimack Valley; 7 galleries housed in an 1835 custom house designed by Robert Mills. The structure is on the National Register of Historic Places; Average Annual Attendance: 4,000; Mem: 300; dues $25 & up; annual meeting in Mar
Income: $30,000 (financed by mem, admis, fundraisers, gifts & grants)
Library Holdings: Book Volumes; Manuscripts; Maps; Original Documents; Photographs; Prints
Special Subjects: Historical Material, Portraits, Manuscripts, Maps, Painting-American, Photography, Ethnology, Decorative Arts, Marine Painting
Collections: Collection of portraits, ship models & decorative art objects 1680-1820; original collection of ethnographic items owned by Newburyport Marine Society Members, half hull models of Merrimack River Valley Ships; portraits of sea captains; navigational instrument & models; Lowell's Boat Shop, Amesbury; core exhibits on populations, natural resources, urban seaport, coast guard
Publications: Newsletter, quarterly
Activities: Classes for adults & children; lect open to public, 10 vis lectrs per year; gallery talks; individual paintings & original objects of art lent to other museums & historical agencies; book traveling exhibitions; museum shop sells books, reproductions, prints, nautical & Newburyport related items

NEWTON

M **NEWTON HISTORY MUSEUM AT THE JACKSON HOMESTEAD,** (Jackson Homestead) 527 Washington St, Newton, MA 02458. Tel 617-796-1450; Fax 617-552-7228; Elec Mail fmorrissey@ci.newton.ma.us; *Cur Manuscripts* Susan Abele; *Cur Objects* Sheila Sibley; *Dir* David Olson; *Museum Aid* Fae Morrissey
Tues - Sat 11 AM - 5 PM, Sun 2 - 5 PM; Admis $1 - $2; Estab 1950 to encourge inquiry into Newton, MA within the broad context of American history; Permanent & temporary exhibitions highlight Newton's role as one of the country's earliest railroad suburbs & the Homestead as a station on the Underground Railroad; Average Annual Attendance: 7,500
Income: mem, grants & contributions
Library Holdings: Audio Tapes; Book Volumes; Cards; Cassettes; Clipping Files; Exhibition Catalogs; Lantern Slides; Manuscripts; Maps; Memorabilia; Original Art Works; Original Documents; Photographs; Slides; Video Tapes
Special Subjects: Drawings, Painting-American, Photography, Archaeology, Textiles, Costumes, Ceramics, Landscapes, Manuscripts, Portraits, Dolls, Furniture, Silver, Historical Material, Maps, Embroidery, Pewter
Collections: Costumes, furniture, household & personal items, paintings, textiles, tools, toys
Activities: Classes for adults & children; special programs & events; docent training; lect open to public, 8 per yr; concerts; gallery talks; tours; mus shop sells books and reproductions

L **Research Library,** 527 Washington St, Newton, MA 02458. Tel 617-552-7238; Fax 617-552-7228; *Dir* Susan Abele
Mon - Thurs 8:30 AM - 5 PM
Income: grants & contributions
Library Holdings: Audio Tapes; Book Volumes 500; Cassettes; Manuscripts; Memorabilia; Pamphlets; Photographs; Reels; Slides; Video Tapes

NORTH EASTON

L **AMES FREE-EASTON'S PUBLIC LIBRARY,** 53 Main St, North Easton, MA 02356-1429. Tel 508-238-2000; Fax 508-238-2980; Elec Mail library@easton.ma.us; Internet Home Page Address: www.amesfreelibrary.org; *Reference Librn & Adult Svcs* Geoffrey Dickinson; *Children's Librn* Karen Gabbert Armand; *Exec Dir* Annalee Bundy; *Asst Dir* Madeline Miele Holt; *Admin Asst* Michelle DuPrey; *Circ & Interlibrary Loan* Joan Roan; *Cataloger* Anne Marie Large; *Computer Instr* Whitney Anderson; *Serials Technician* Donna Costa
Open Mon & Thurs 10 AM - 8 PM, Tues & Wes 1 - 8 PM, Fri - Sat 10 AM - 5 PM; No admis fee; Estab 1879; Circ 97,000
Income: $684,760 (financed by local endowment) & public funds
Purchases: $90,110
Library Holdings: Audio Tapes 187; Book Volumes 56,000; Cassettes; Clipping Files; Periodical Subscriptions 137; Video Tapes
Special Subjects: Decorative Arts, Architecture
Collections: Architecture (Richardsonian); Decorative Arts
Activities: Classes for adults & children; Dramatic prog; Story Hours; storytellers; booktalks

NORTH GRAFTON

M **WILLARD HOUSE & CLOCK MUSEUM, INC,** 11 Willard St, North Grafton, MA 01536-2011. Tel 508-839-3500; Elec Mail Willard@erols.com; *Chmn Dr* Roger W Robinson; *VPres* Sumner Tilton; *Dir* John R Stephens; *Pres* Richard Currier; *Educ Coordr* Cynthia Dias-Reid
Open Tues - Sat 10 AM - 4 PM, Sun 1 - 4 PM, cl Mon & holidays; Admis adults $6, seniors $5, children $3; Estab 1971 for educ in the fields of history, horology, decorative arts & antiques; Maintains nine rooms open in house mus; Average Annual Attendance: 2,500; Mem: 200; dues $20 individual, $35 family
Income: Financed by endowment, mem, admis, gifts & sales
Library Holdings: Auction Catalogs; Book Volumes; Memorabilia; Original Documents; Pamphlets; Periodical Subscriptions; Photographs; Prints; Slides
Special Subjects: Architecture, Textiles, Costumes, Folk Art, Decorative Arts, Portraits, Dolls, Furniture, Glass, Jewelry, Silver, Carpets & Rugs, Historical Material, Coins & Medals, Restorations, Calligraphy, Period Rooms, Embroidery, Gold, Pewter
Collections: Native American Artifacts Collection; Willard Clockmaking Family Collection, furnishings, memorabilia & portraits; 18th & 19th Century Early Country Antique Furniture Collection; 19th Century Embroidery Collection; 18th & 19th Century Firearms Collection; 19th Century Children's Toy Collection; 19th Century Costume Collection; 19th Century Oriental Rug Collection
Exhibitions: Annual Clock Collectors Workshop; Annual Christmas Open House
Publications: Mem newsletter, quarterly
Activities: Classes for adults & children; docent training; lect open to public; 1 vis lectr per year; tours; museum shop sells books, magazines, clocks, antiques

NORTHAMPTON

L **FORBES LIBRARY,** 20 West St, Northampton, MA 01060. Tel 413-587-1011, 587-1013; Fax 413-587-1015; Elec Mail fkaufman@cwmars.org; Internet Home Page Address: www.forbeslibrary.org; *Arts & Music Librn* Faith Kaufmann
Open Mon 1 - 9 PM, Tues 9 AM - 6 PM, Wed 9 AM - 9 PM, Thurs 1 - 5 PM, Fri - Sat 9 AM - 5 PM, cl Sun & holidays; Estab 1894 to serve the community as a general public library and a research facility; Circ 292,950; Gallery and exhibit cases for regional artists, photographers and craftspeople
Library Holdings: Audio Tapes 40,000; Book Volumes 400; Cassettes 2000; Compact Disks 4000; DVDs 200; Exhibition Catalogs; Original Art Works; Original Documents; Periodical Subscriptions 52; Photographs; Prints; Reels; Video Tapes 2000
Special Subjects: Photography, Posters
Collections: Bien edition of Audubon Bird Prints; Library of Charles E Forbes; Walter E Corbin Collection of Photorahic Prints & Slides; Connecticut Valley History; Genealogical Records; Official White House Portraits of President Calvin Coolidge & Grace Anna Coolidge; World War I & II Poster Collection; Local History Photograph Collection & Print Collection
Exhibitions: Monthly exhibits of works by regional artists, photographers and craftspeople; Calvin Coolidge Presidential Library & Mus
Activities: Films; readings; lects open to public; Concerts; Gallery talks; exten dept serves elderly & house bound

M **HISTORIC NORTHAMPTON MUSEUM & EDUCATION CENTER,** 46 Bridge St, Northampton, MA 01060. Tel 413-584-3669, 584-6011; Fax 413-584-7956; Elec Mail hstnhamp@jauanet.com; Internet Home Page Address: www.historic-northampton.org; *Exec Dir* Kerry Buckley
Open Tues - Fri 10 AM - 4 PM, weekends Noon - 4 PM, cl Mon & holidays; Estab 1905 to collect, preserve & exhibit objects of human history in Northampton & Connecticut Valley; The mus maintains three historic houses from about 1728, 1798 & 1813; a barn from about 1825 with newly added educ center; a non-circulating reference library; Average Annual Attendance: 9,500; Mem: 500; dues business $100 - $500, individual $20 - $100; annual meeting in Nov
Income: $95,000 (financed by endowment, mem, gifts)
Special Subjects: Photography, Textiles, Costumes, Decorative Arts, Furniture
Collections: Collections focus on material culture of Northampton & the upper Connecticut River Valley, costumes, textiles, ca. 1900 Howes Brothers

photographs; archaeological artifacts from on-site excavation, decorative arts; oil paintings of local personalities & scenes; Collection of costumes, textiles, furniture & decorative art
Publications: Newsletter, quarterly; booklets on local subjects; brochures & flyers
Activities: Classes for adults & children; docent programs; workshops; internships; lect open to public; gallery talks; scholarships offered; museum shop sells books, merchandise related to museum's collections, reproductions of collection items, maps, period toys & games

M **SMITH COLLEGE,** Museum of Art, Elm Street at Bedford Terrace, Northampton, MA 01063. Tel 413-585-2760; Fax 413-585-2782; Elec Mail artmuseum@ais.smith.edu; Internet Home Page Address: www.smith.edu/artmuseum; Others TTY 413-585-2786; *Dir & Chief Cur* Suzannah J Fabing; *Cur Educ* Nancy Rich; *Cur Paintings & Sculpture* Linda Muehlig; *Archivist & Editor* Michael Goodison; *Assoc Dir Museum Servs* David Dempsey; *Registrar, Coll Manager* Louise Laplante; *Assoc Cur Prints, Drawings & Photographs* Aprile Gallant
Tues - Sat 10 AM - 4 PM, Sun Noon - 4 PM; Cl Mon & Holidays; adult $5, senior (65 & over) $4, student (13 & over w/ID) $3, youth (6-12) $2; Collection founded 1879; Hillyer Art Gallery built 1882; Smith College Museum of Art established 1920; Tryon Art Gallery built 1926; present Smith College Museum of Art in Tryon Hall opened 1973; renovated and expanded 2003; Average Annual Attendance: 36,000; Mem: 1200; dues student $10 & up
Special Subjects: Drawings, Painting-American, Photography, Prints, Decorative Arts, Painting-European
Collections: Examples from most periods and cultures with special emphasis on European and American paintings, sculpture, drawings, prints, photographs and decorative arts of the 17th-20th centuries
Exhibitions: Temporary exhibitions and installations 12-24 annually
Publications: Catalogues
Activities: Lect; gallery talks; tours; concerts; individual works of art lent to other institutions; sales shop sells publications, post and note cards, posters, art-related merchandise

L **Hillyer Art Library,** Elm Street at Bedford Terrace, Northampton, MA 01063. Tel 413-585-2940; Fax 413-585-6975; Elec Mail bpolowy@smith.edu; Internet Home Page Address: www.smith.edu/libraries/libs/hillyer/; *Librn* Barbara Polowy; *Art Library Asst* Josephine Hernandez
Open Mon - Thurs 8 AM - 11 PM, Fri 8 AM - 9 PM, Sat 10 AM - 9 PM, Sun Noon - Midnight; Estab 1918 to support courses offered by art department of Smith College; Circ 23,500; For reference use only
Income: Financed by endowment
Library Holdings: Auction Catalogs 10,000; Book Volumes 93,000; CD-ROMs 120; Exhibition Catalogs 37,000; Periodical Subscriptions 325
Special Subjects: Art History, Drawings, Etchings & Engravings, Painting-American, Painting-British, Painting-Italian, Painting-Spanish, Sculpture, Painting-European, History of Art & Archaeology, Antiquities-Oriental, Antiquities-Etruscan, Antiquities-Greek, Antiquities-Roman, Architecture

NORTON

WHEATON COLLEGE
M **Watson Gallery,** Tel 508-286-3578; Fax 508-286-3565; Elec Mail amurray@wheatonma.edu; Internet Home Page Address: www.wheatoncollege.edu/acad/art/gallery; *Dir* Ann H Murray; *Prog Coordr for the Arts* Betsy Cronin; *Cur Coll & Registrar* Amy Friend
Open Mon - Sat 12:30 - 4:30 PM except during col vacations; No admis fee; Estab 1960, gallery program since 1930 to provide a wide range of contemporary one person & group shows as well as exhibitions from the permanent collection of paintings, graphics & objects; Gallery is of fireproof steel-frame, glass & brick construction; Average Annual Attendance: 5,000
Income: Financed by college budget & occasional grants
Purchases: Marble portrait bust of Roman boy; Etruscan antefix head; Head of Galienus, Roman c 260 AD; Cycladic Figurine, 2500-1100 BC Greek Black Figure Amphora, 6th c BC
Special Subjects: American Indian Art, Etchings & Engravings, Landscapes, Marine Painting, Flasks & Bottles, Pre-Columbian Art, Painting-American, Prints, Textiles, Bronzes, Painting-British, Painting-French, Sculpture, Drawings, Watercolors, Ceramics, Woodcarvings, Woodcuts, Decorative Arts, Glass, Asian Art, Antiquities-Byzantine, Ivory, Coins & Medals, Antiquities-Greek, Antiquities-Roman, Mosaics, Stained Glass, Antiquities-Etruscan
Collections: 19th & 20th centuries prints, drawings, paintings & sculpture; decorative arts; Wedgewood, 18th & 19th centuries glass; ancient bronzes, sculptures & ceramics
Exhibitions: Changing exhibitions
Publications: Exhibition catalogs; Prints of the 19th Century: A Selection from the Wheaton College Collection; The Art of Drawing; The Art of the Print & The Art of Painting and Sculpture: Selections from the Permanent Collection
Activities: Lect open to public, 5-8 vis lectrs per year; concerts; gallery talks; tours; sponsoring of competitions; individual paintings & original objects of art lent to colleges, other museums & galleries; originate traveling exhibitions organized & circulated

OAK BLUFFS

A **MARTHA'S VINEYARD CENTER FOR THE VISUAL ARTS,** Firehouse Gallery, 88 Dukes County Ave, Oak Bluffs, MA 02557; PO Box 4377, Vineyard Haven, MA 02568. Tel 508-693-9025; Elec Mail dreyerc@earthlink.net; *Pres* Chris Dreyer
Open from Memorial Day weekend, daily Noon - 6 PM, cl Mon; No admis fee; Estab 1991; Old firehouse, semi-cooperative space; Average Annual Attendance: 500; Mem: 100; $40 ann dues; ann meeting Aug
Income: Financed by mem, donations, grant from local cultural council
Exhibitions: July - Aug weekly shows of member art
Publications: Arts Directory, annually
Activities: Classes & workshops; scholarships offered; originate traveling exhibition

ONSET

M **PORTER THERMOMETER MUSEUM,** 49 Zarahemia Rd, Onset, MA 02558-0944; Box 944, Onset, MA 02558-0944. Tel 508-295-5504; Fax 508-295-8323; Elec Mail thermometerman@aol.com; Internet Home Page Address: www.members.aol.com/thermometerman/index.html; *Asst Cur* Barbara A Porter; *Cur* Richard T Porter; *Chmn Bd* Dr Winifred Loughlin
Call for hours; No admis fee; Estab 1990; In home, lower level; Average Annual Attendance: 300+; Mem: 10+ members, no dues, third Thurs of each month at 7 PM
Income: $200 (financed by city appropriation)
Purchases: $200
Library Holdings: Clipping Files; Kodachrome Transparencies; Maps; Memorabilia; Original Documents; Photographs; Prints
Special Subjects: American Indian Art, American Western Art, African Art, Southwestern Art, Ceramics, Crafts, Woodcarvings, Woodcuts, Decorative Arts, Pewter, Reproductions
Collections: Thermometers of all types (also by gifts from around the world); 4869 actual devices, 131 articles in print & 53 videos
Exhibitions: annual salutes to winter, spring, summer & fall; traveling lecture (history show and tell)
Publications: Dozens of tour books, articles; Galilaos Bulk, Past and Present
Activities: Classes for children; classes for home schooled children; lect open to public, 20 vis lectrs per year; gallery talks; tours; lending of original objects of art to Bluehill Observatory Air Force Museum & Christian Science Mother Church Library; book traveling exhibitions 6 per year; originate traveling exhibitions 2 per year to Cape Cod Factory Outlet Mall; mus shop

PAXTON

M **ANNA MARIA COLLEGE,** Saint Luke's Gallery, Moll Art Ctr, 50 Sunset Lane Paxton, MA 01612. Tel 508-849-3318; Internet Home Page Address: www.annamaria.edu/; *Chmn Art Dept* Alice Lambert
Open Mon - Fri 1 - 5 PM, Sat 2 - 4 PM, Sun 1 - 4 PM; No admis fee; Estab 1968 as an outlet for the art student and professional artist, and to raise the artistic awareness of the general community; Main Gallery is 35 x 15 ft with about 300 sq ft of wall space; Average Annual Attendance: 500
Income: Financed by the college
Special Subjects: Painting-American, Sculpture, Furniture
Collections: Small assortment of furniture, paintings, sculpture
Exhibitions: Annual senior art exhibit; local artists; faculty & students shows
Publications: Exhibit programs
Activities: Educ Dept; lect open to public; individual paintings & original objects of art lent to campus offices

PITTSFIELD

L **BERKSHIRE ATHENAEUM,** Reference Dept, One Wendell Ave, Pittsfield, MA 01201. Tel 413-499-9480 ext 4; Fax 413-499-9489; Elec Mail pittsref@cwmars.org; Internet Home Page Address: www.berkshire.net/PittsfieldLibrary; *Dir* Ron Latham; *Supv Reference* Madeline Kelly; *Music & Arts Librn* Mary Ann Knight
Open Mon - Thurs 9 AM - 9 PM, Fri 9 AM - 5 PM, Sat 10 AM - 5 PM; reduced hrs July & Aug; None; Estab 1872
Income: Financed by city & state appropriations
Library Holdings: Book Volumes; Cassettes 300; Compact Disks; Other Holdings Compact discs 2,000; Periodical Subscriptions 15-20; Video Tapes
Collections: Mary Rice Morgan Ballet Collection: a reference room of programs, artifacts, prints, original art, rare & current books on dance & costume design
Activities: Lect open to the pub, concerts

M **BERKSHIRE MUSEUM,** 39 South St, Pittsfield, MA 01201. Tel 413-443-7171; Fax 413-443-2135; Elec Mail info@berkshiremuseum.org; Internet Home Page Address: www.berkshiremuseum.org; *Dir Develop* Susan Bronson; *Dir Finance & Administration* Michael W. Willson; *Dir Mktg* Susan J. Birnbryer; *Cur Natural Science* Thom Smith; *Aquarium Asst* Scott Jervas; *Registrar* Kathryn Bebe; *Librn* Rollin Hotchkiss; *Shop Mgr* Lenore Sundberg; *Dir* Anne Mintz; *Mem Assoc* Carly Phelan; *Coordr Educ Prog* Matt Le Roux
Open to pub Tues - Sat 10 AM - 5 PM, Sun Noon - 5 PM, Mon 10 AM - 5 PM, July & Aug; Admis Adults $6, seniors & students $5, members & children 3-18 $4, members & children under 3 free; Estab 1903 as a mus of art, natural science & history; Maintains reference library for staff & teachers; Average Annual Attendance: 100,000; Mem: 2000; dues sustaining $75 & up, family $55, single $35; annual meeting in Sept
Income: Financed by endowment, mem, fundraising & gifts
Special Subjects: Drawings, Painting-American, American Indian Art, American Western Art, Anthropology, Ethnology, Costumes, Ceramics, Folk Art, Etchings & Engravings, Landscapes, Decorative Arts, Dolls, Furniture, Glass, Jewelry, Painting-British, Painting-Dutch, Coins & Medals, Painting-Flemish, Dioramas, Painting-Italian, Antiquities-Egyptian, Antiquities-Greek, Antiquities-Etruscan
Collections: Paintings of the Hudson River School (Inness, Moran, Blakelock, Martin, Wyant, Moran, Church, Bierstadt & others); early American portraits; Egyptian, Babylonia & Near East arts; grave reliefs from Palmyra; Paul M Hahn Collection of 18th century English & American silver; Old Masters (Pons, de Hooch, Van Dyck & others); contemporary painting & sculpture; three Norman Rockwell paintings
Publications: Schedule of events, quarterly
Activities: Classes for adults & children; lect open to the public, 20 vis lectrs per year; concerts; gallery talks; tours; sponsoring of competitions; scholarships; individual paintings & original objects of art lent to corporate & individual members; book traveling exhibitions 4-6 per year; originate traveling exhibitions primarily to New England institutions; museum shop sells gifts, books, original art, reproductions, jewerly, toys & games

M CITY OF PITTSFIELD, Berkshire Artisans, 28 Renne Ave, Pittsfield, MA 01201-4720. Tel 413-499-9348; Fax 413-442-6803; Elec Mail berkart@taconic.net; Internet Home Page Address: www.berkshireweb.com/artisans; *Commissioner of Cultural Affairs & Artistic Dir* Daniel M O'Connell, MFA
Open Mon - Fri 11 AM - 5 PM, summer Mon - Fri 11 AM - 5 PM, Sat Noon - 5 PM; No admis fee; Estab 1976; Three story 100 yr old brownstone, municipal gallery; Average Annual Attendance: 56,000; Mem: 350; dues $10; annual meeting in Sept
Income: $100,000 (financed by endowment, mem, city, state & federal appropriations)
Special Subjects: Drawings, Hispanic Art, Painting-American, Photography, Prints, Sculpture, Watercolors, Textiles, Crafts, Pottery, Woodcuts, Landscapes, Glass, Tapestries
Exhibitions: Doe, Warner Freidman, Dave Novak, Jay Tobin, Daniel Balvez, John Dilg, Sally Fine, Linda Bernstein, David Merritt
Publications: The Berkshire Review
Activities: Classes for adults & children; dramatic programs; docent training; lect open to public, 12 vis lectrs per year; concerts; gallery talks; tours; competitions; scholarships & fels offered; artmobile; lending collection contains paintings, art objects; traveling exhibition 12 per year; originate traveling exhibitions 12 per year; museum shop sells books, prints, magazines, slides, original art, public murals

M HANCOCK SHAKER VILLAGE, INC, US Rte 20, Pittsfield, MA 01202; PO Box 927, Pittsfield, MA 01202. Tel 413-443-0188; Fax 413-447-9357; Elec Mail info@shancockshakervillage.org; Internet Home Page Address: www.hancockshakervillage.org; *Cur Coll* Christian Goodwillie; *Interpretation & Educ* Todd Burdick; *Mus Shop Mgr* Barbara Quirino; *Pres* Lawrence J Yerdon; *Dir Mktg* Sally Majewski; *Pres* Ellen Spear; *Dir Visitor Servs* Laura Marks
Open daily 9:30 AM - 5 PM; Admis adults $15.00, children free; Estab 1961 for the preservation & restoration of Hancock Shaker Village & the interpretation of Shaker art, architecture & culture. Period rooms throughout the village; Exhibition Gallery contains Shaker inspirational drawings & graphic materials; Average Annual Attendance: 78,000; Mem: 1200; dues individual $40
Income: Financed by mem, donations
Special Subjects: Period Rooms
Collections: Shaker architecture, furniture & industrial material; Shaker inspirational drawings
Publications: Newsletter, quarterly; specialized publications
Activities: Classes for adults & children; docent training; workshops; seminars; lect open to public; gallery talks; tours; individual paintings & original objects of art lent to qualified museums with proper security & environmental conditions; museum shop sells books, magazines, reproductions & prints
L Library, US Rte 20, PO Box 927 Pittsfield, MA 01202. Tel 413-443-0188; Fax 413-447-9357; Internet Home Page Address: hancockshakervillage.org; *Cur Coll* Sharon Duane Koomler
Open daily late Oct - late May 10 AM - 3 PM, Memorial Day - late Oct 9:30 AM - 5 PM; Estab 1961; Reference library open to students & scholars by appointment
Library Holdings: Auction Catalogs; Audio Tapes; Book Volumes 3800; Clipping Files; Exhibition Catalogs; Fiche; Framed Reproductions; Manuscripts; Maps; Original Art Works; Original Documents; Other Holdings Graphics; Maps; Pamphlets; Periodical Subscriptions; Photographs; Prints; Records; Reels; Slides; Video Tapes
Collections: Buildings; furniture; farm & crafts artifacts; inspirational drawings; over 10,000 Shaker objects
Publications: The Gift Drawing Collection of Hancock Shaker Village; Seen & Received: The Shakers' Private Art
Activities: Docent training; lectures; galley talks; tours; museum shop sells books, original art, reproductions & prints

PLYMOUTH

M PILGRIM SOCIETY, Pilgrim Hall Museum, 75 Court St, Plymouth, MA 02360. Tel 508-746-1620; Fax 508-747-4228; *Pres* Jeffrey Fischer; *Dir & Librn* Peggy M Baker; *Cur Exhib* Karen Goldstein
Open daily 9:30 AM - 4:30 PM; Admis family $15, adults $5, seniors $4.50, children $3; Estab 1820 to depict the history of the Pilgrim Colonists in Plymouth Colony; Average Annual Attendance: 27,000; Mem: 809; dues $20; annual meetings in Dec
Income: Financed by endowment, mem & admis
Special Subjects: Decorative Arts, Furniture
Collections: Arms & armor, decorative arts, furniture & paintings relating to the Plymouth Colony settlement (1620-1692) & the later history of Plymouth
Exhibitions: Permanent collections; exhibitions change year round
Publications: The Pilgrim Journal, bi-annually
Activities: Lect open to public, 8 vis lectrs per year; museum shop sells books, magazines, reproductions, prints, slides, ceramics, souvenir wares
L Library, 75 Court St, Plymouth, MA 02360. Tel 508-746-1620; Fax 508-747-4228; *Dir & Librn* Peggy M Baker
Open by appointment only; No admis fee; Estab 1820 to collect material relative to the history of Plymouth; For reference only
Library Holdings: Audio Tapes; Book Volumes 10,000; Cassettes; Clipping Files; Exhibition Catalogs; Kodachrome Transparencies; Lantern Slides; Manuscripts; Memorabilia; Motion Pictures; Original Art Works; Pamphlets; Periodical Subscriptions 5; Photographs; Prints; Records; Reels; Reproductions; Sculpture; Slides

A PLYMOUTH ANTIQUARIAN SOCIETY, 126 Water St, Plymouth, MA 02361; PO Box 3773, Plymouth, MA 02361. Tel 508-746-0012; Elec Mail pasm@mindspring.com; *Pres* Rui Santos; *Exec Dir* Donna Curtin; *Mus Shop Mgr* Betty Sander
Open June - Oct 10 AM - 4 PM, days vary, call for more information; Admis adults $4.50, children (5-14) $2; Estab 1919 to maintain & preserve the three museums: Harlow Old Fort House (1677), Spooner House (1747) & Antiquarian

House (1809); Average Annual Attendance: 5,000; Mem: 500; dues Individual $25, family $40; annual meeting in Nov
Income: Financed by mem & donations
Collections: Antique dolls, artwork, china, furniture, costumes, toys & textiles
Activities: Classes for adults & children; lect open to pub; gift shop open for special events, call for more information

PROVINCETOWN

A FINE ARTS WORK CENTER, 24 Pearl Street, Provincetown, MA 02657. Tel 508-487-9960; Fax 508-487-8873; Elec Mail fawc@capecod.net; *Asst to Exec Dir* Etta Baurhenn; *Exec Dir* Hunter O'Hanian
Activities: Summer workshop program, senior writers programs; fellowships offered

A PROVINCETOWN ART ASSOCIATION & MUSEUM, 460 Commercial St, Provincetown, MA 02657. Tel 508-487-1750; Fax 508-487-4372; Elec Mail info@paam.org; Internet Home Page Address: www.paam.org; *Exec Dir* Christine McCarthy; *Registrar* Peter Macara; *Archivist & Preparator* Jim Zimmerman; *Develop Assoc* Shila McGrinness; *Educ Coordr* Lynn Stanley
Open daily Mon - Thurs 11 AM - 8 PM, Fri 11 AM - 10 PM, Sat & Sun 11 AM - 5 PM; Admis adult $5, seniors & children $1, mems free; Estab in 1914 to promote & cultivate the practice & appreciation of all branches of the fine arts, to hold temporary exhibitions, forums & concerts for its members & the pub; Five galleries are maintained; Average Annual Attendance: 45,000; Mem: 1,700; mem open; dues $50
Income: $875,000 (financed by mem, private contributions, state agencies, earned income & others)
Library Holdings: Auction Catalogs; Audio Tapes; Book Volumes; CD-ROMs; Exhibition Catalogs; Memorabilia; Original Art Works; Photographs; Reproductions; Slides; Video Tapes
Special Subjects: Etchings & Engravings, Graphics, Photography, Prints, Sculpture, Watercolors, Painting-American, Woodcuts, Collages, Marine Painting
Collections: Permanent collection consists of artists work who have lived or worked on the Lower Cape
Publications: Exhibitions catalogues & newsletters
Activities: Classes for adults & children; docent training; lect open to public, 6-8 vis lectrs per year; concerts; gallery talks; tours; schol; Leed Certification (Silver) US Green Buildings Commission award; individual paintings & original objects of art lent to other museums; book traveling exhibitions; originate traveling exhibition; museum shop sells books, magazines, original art, prints, reproductions
L Library, 460 Commercial St, Provincetown, MA 02657. Tel 508-487-1750; Fax 508-487-4352; Elec Mail Info@paam.org; Internet Home Page Address: www.paam.org; *Exec Dir* Christine McCarthy
Open yr round, check for times; admis non mem $2; Estab 1914; Average Annual Attendance: 35,000; Mem: 1300; individual $50
Library Holdings: Auction Catalogs; Book Volumes 500; Clipping Files; Compact Disks; Exhibition Catalogs; Pamphlets; Photographs
Special Subjects: Photography, Drawings, Etchings & Engravings, Painting-American, Sculpture, Landscapes, Portraits
Collections: Memorabilia of WHW Bicknell; Provincetown Artists; Outer Capa American Art from 1900 - Present
Activities: Classes for adults & children; lect open to public, 8 per yr; concerts; gallery talks; tours; original art objects lent to museums; originate traveling exhib to other museums; museum shop sells books, magazines, original art, reproductions, prints

QUINCY

M ADAMS NATIONAL HISTORIC PARK, 135 Adams St, Quincy, MA 02169. Tel 617-773-1177; Fax 617-471-9683; Elec Mail kelly_cobble@nps.gov; Internet Home Page Address: www.nps.gov/adam; *Supt* Marianne Peak; *Cur* Kelly Cobble
Open daily April 19 - Nov 10 9 AM - 5 PM; Admis adults $5, children under 16 admitted free if accompanied by an adult; Estab 1946; The site consists of three houses, part of which dates to 1731; a library containing approx 14,000 books, a carriage house, a woodshed & grounds which were once owned & enjoyed by four generations of the Adams family; Average Annual Attendance: 81,000
Income: Financed by Federal Government
Library Holdings: Clipping Files; Maps; Original Art Works; Original Documents; Pamphlets; Photographs; Slides
Special Subjects: Historical Material, Ceramics, Decorative Arts, Portraits, Furniture, Period Rooms, Bookplates & Bindings
Collections: Original furnishings belonging to the four generations of Adamses who lived in the house between 1788 and 1937
Activities: Classes for children; dramatic progs; docent training; lect (4per yr); concerts; tours; sales shop sells books, reproductions & prints

ROCKPORT

A ROCKPORT ART ASSOCIATION, Old Tavern, 12 Main St Rockport, MA 01966. Tel 978-546-6604; Fax 978-546-9767; *Pres* David Curtis; *Exec Dir* Carol Linsky
Open summer daily 10 AM - 5 PM, Sun Noon - 5 PM, winter daily 10 AM - 4 PM, Sat 10 AM - 5 PM, Sun Noon - 5 PM; No admis fee; Estab 1921 as a non-profit educational organization established for the advancement of art; Four galleries are maintained in the Old Tavern Building; two large summer galleries are adjacent to the main structure; Average Annual Attendance: 75,000; Mem: 1300; mem open to Cape Ann resident artists (minimum of one month), must pass mem jury; contributing mem open to public; photography mem subject of resident/jury restrictions
Income: Financed by endowment, mem, gifts, art programs & sales
Collections: Permanent collection of works by Cape Ann artists of the past, especially those by former members

Exhibitions: Special organized exhibitions are continually on view; fifty exhibitions scheduled per year
Publications: Quarry Cookbook; Rockport Artists Book 1990; Reprints (recent); Rockport Artists Book 1940; Rockport Sketch Book
Activities: Classes & workshops for adults & children; lect open to the public; painting lectr/demonstrations; Tavern Door shop sells books, cards & notes by artist members

A **SANDY BAY HISTORICAL SOCIETY & MUSEUMS,** Sewall Scripture House-Old Castle, 40 King St & Castle Lane, PO Box 63 Rockport, MA 01966. Tel 978-546-9533; *Cur* Cynthia Peckham
Open mid-June to mid-Sept; Admis $3, mem free; Estab 1925 to preserve Rockport history; Sewall Scripture House built in 1832, Old Castle built 1700 (circa); Average Annual Attendance: 300; Mem: 500; dues $10; annual meeting first Fri in Sept
Income: $15,000 (financed by endowment & mem)
Collections: Extensive Granite Tools & Quarry Materials; 55 local paintings in oil, prints, watercolor; old quilts, samplers, textiles; Genealogical reference libr
Exhibitions: A Town That Was; Some Rockporters Who Were (for the Sesqui-centennial of the town); Deceased Artists
Publications: Mem bulletins, 3-4 annually; brochures
Activities: Docent training, monthly programs; tours

SALEM

M **PEABODY ESSEX MUSEUM,** Corner Essex & New Liberty, Salem, MA 01970; East India Sq, Salem, MA 01970. Tel 978-745-9500; Fax 978-744-6776; Elec Mail pem@pem.org; Internet Home Page Address: www.pem.org; *Exec Dir* Dan L Monroe
Open daily 10 AM - 5 PM; clo Thanksgiving, Christmas, New Year's Day; Admis adults $13, seniors $11, students $9, children 16 & under & residents of Salem, Mass free; Estab 1799; The recently transformed Peabody Essex Museum presents art and culture from New England and around the world. In addition to its vast collections, the museum offers changing exhibitions and a hands-on education center. The museum campus features numerous parks, period gardens, and 24 historic properties, including Yin Yu Tang, the only example of Chinese vernacular architecture in the United States; Average Annual Attendance: 150,000; Mem: 4200; dues $30-$65; annual meeting in Nov
Income: $6,000,000 (financed by endowment, mem, gifts & admis)
Special Subjects: American Indian Art, Decorative Arts, Marine Painting, Architecture, Ceramics, Furniture, Photography, Porcelain, Painting-American, Textiles, Sculpture, African Art, Oriental Art, Asian Art, Ivory, Scrimshaw
Collections: American art and Architecture; Asian, Asian Export, Native American, African, Oceanic, Maritime and Photography
Exhibitions: Essex County Landscape Artist; Fashions and Draperies for Windows and Beds; Library Exhibit - Conservation: Some Problems and Solutions; Life and Times in Shoe City: The Shoe Workers of Lynn; Nathaniel Hawthorne Exhibition
Publications: Peabody Essex Museum Collections, quarterly; The American Neptune, quarterly; The Review of Archaeology, semiannually; member's magazine, quarterly; occasional books
Activities: Classes for adults & children; docent training; lect open to public; organize traveling exhibitions: Geisha, Beyond the Painted Smile; mus shop sells books, reproductions, prints, furniture, jewelry, ceramics

L **Phillips Library,** 132 Essex St, Salem, MA 01970. Tel 978-745-9500; Fax 978-741-9012; Elec Mail pem@pem.org; Internet Home Page Address: www.pem.org
Open Tues, Wed, & Fri 10 AM - 5 PM, Thurs 1 - 8 PM, cl Mon ; For reference only
Library Holdings: Book Volumes 400,000; Clipping Files; Exhibition Catalogs; Fiche; Kodachrome Transparencies; Lantern Slides; Manuscripts; Memorabilia; Motion Pictures; Original Art Works; Pamphlets; Periodical Subscriptions 200; Slides
Special Subjects: Folk Art, Decorative Arts, Etchings & Engravings, Ceramics, Crafts, Archaeology, Ethnology, Asian Art, American Indian Art, Anthropology, Furniture, Ivory, Glass, Bookplates & Bindings, Architecture
Collections: The library supports the entire range of the collections of this international & multi-disciplinary museum of arts & cultures
Publications: Peabody Essex Museum Collections; Monographic Series, annual; The American Neptune, quarterly journal of maritime art & history

M **Andrew-Safford House,** 13 Washington Sq W, Salem, MA 01970. Tel 978-745-9500; Elec Mail pem@pem.org; Internet Home Page Address: www.pem.org; *Cur* Dean Lahikainen
Open Mon - Sat 10 AM - 5 PM, Sun Noon - 5 PM, cl Mon, Nov - March; Admis adults $8.50, seniors & students $7.50, children 6-16 $5, children under 6 free; Built in 1818-1819 & purchased by the Institute in 1947 for the purpose of presenting a vivid image of early 19th century urban life; It is the residence of the Institute's director

M **Peirce-Nichols House,** 80 Federal St, Salem, MA 01970. Tel 978-745-9500; Elec Mail pem@pem.org; Internet Home Page Address: www.pem.org; *Cur* Robert Saarnio
Open Mon - Sat 10 AM - 5 PM, Sun Noon - 5 PM, Nov - March cl Mon; Admis adults $8.50, seniors & students $7.50, children 6-16 $5, children under 6 free; Built in 1782 by Samuel McIntire; Maintains some original furnishings & a counting house

M **Cotting-Smith-Assembly House,** Brown St, Salem, MA 01970. Tel 978-744-2231; Fax 978-744-0036; Elec Mail pem@pem.org; Internet Home Page Address: www.pem.org; *Exec Dir* Dan L Monroe
Open Mon - Sat 10 AM - 5 PM, Noon - 5 PM, Nov - March cl Mon; Admis adults $8.50, seniors & students $7.50, children 6-16 $5, children under 6 free; Built in 1782 as a hall for social assemblies; remodeled in 1796 by Samuel McIntire as a home residence; Not open to pub

SANDWICH

M **HERITAGE MUSEUMS & GARDENS,** 67 Grove St, Sandwich, MA 02563. Tel 508-888-3300; Fax 508-888-9535; Elec Mail info@heritagemuseums.org; Internet Home Page Address: www.heritagemuseumsandgardens.org; *Dir* Stewart Goodwin; *Deputy Dir Mus Prog & Srvcs* Sunnee Spencer; *Deputy Dir Admin* Lucy Bukowski; *Asst Dir* Nancy Tyrer; *Cur Military History* James Cervantes; *Cur Botanical Science* Jeanie Gillis; *Dir Exhib & Coll* Jennifer Younginger; *Cur Antique Auto Mus* Robert Rogers; *Dir* Gene A Schott; *Dir Devel* Wendy Perry
Jan & Feb open weekends, Mar, Apr, Nov & Dec Wed - Sun 10 AM - 4 PM, May - Oct Daily 10 AM - 6 PM; Admis adults $12, seniors $10, children $6; Estab 1969 as a mus of Americana. Heritage Museums & Gardens is a Massachusettes charitable corporation; Maintains three galleries which house collections; Average Annual Attendance: 100,000; Mem: $2000; dues $45-$1000
Income: Financed by endowment, mem & admis
Special Subjects: American Indian Art, Folk Art, Primitive art, Scrimshaw
Collections: American Indian artifacts; folk art; primitive paintings; Scrimshaw; Antique Automobiles; Folk Art; Fine Arts; Tools; Weapons; Military Miniatures; Native American Art
Exhibitions: Landscape Paintings; Antique & Classic Automobiles; Hand painted Military Miniatures & Antique Firearms; Restored 1912 Charles I D Looff Carousel; Currier & Ives prints.
Publications: Exhibit catalogues; quarterly newsletter
Activities: Classes for adults & children; dramatic programs; docent training; lect, 7-10 vis lectrs per year; concerts; gallery talks; tours; exten dept serving Cape Cod area; individual paintings & original objects of art lent; lending coll includes fs, original prints, paintings & nature artifacts; 1-2; museum shop sells books, magazines, original art, reproductions & prints.

M **THE SANDWICH HISTORICAL SOCIETY, INC,** Sandwich Glass Museum, 129 Main St, PO Box 103 Sandwich, MA 02563. Tel 508-888-0251; Fax 508-888-4941; Elec Mail sgm@capecod.net; Internet Home Page Address: www.sandwichglassmuseum.org; *Dir* Bruce Courson; *Cur* Nezka Pfeifer; *Develop Coordr* Eliane Thomas
Open Apr - Dec daily 9:30 AM - 5 PM, Feb & Mar, Wed - Sun 9:30 AM - 4 PM, cl Thanksgiving, Christmas & Jan; Admis adults $3.50, children 6-16 $1; Estab 1907 to collect, preserve local history; Thirteen galleries contain the products of the glass companies that operated in Sandwich from 1825-1907. Also displayed are artifacts and memorabilia relating to the history of Sandwich; Average Annual Attendance: 45,000; Mem: 605; dues family $30, individual $20; meeting dates: third Tues in Feb, Apr, June, Aug & Oct
Income: $382,000 (financed by endowment, mem, admis & retails sales)
Special Subjects: Painting-American, Ceramics, Decorative Arts, Furniture, Glass, Historical Material, Embroidery, Reproductions
Collections: Glass-Sandwich, American, European; Artifacts relating to the history of Sandwich
Exhibitions: Exhibitions vary; call for details
Publications: Acorn, annual; The Cullet, 3 times per year
Activities: Classes for adults & children; docent training; lect open to public; museum shop sells books, reproductions & glass

L **Library,** 129 Main St, PO Box 103 Sandwich, MA 02563. Tel 508-888-0251; Fax 508-888-4941; Internet Home Page Address: www.sandwichglassmuseum.org; *Dir* Bruce Courson
Open Apr - Dec, 9:30 AM - 5 PM, Feb & Mar, Wed - Sun 9:30 AM - 4 PM, cl Mon, Tues, Christmas, Thanksgiving, & Jan; Circ Non-circulating; For reference only, staff & gen pub
Purchases: $900
Library Holdings: Audio Tapes; Book Volumes 3000; Clipping Files; Exhibition Catalogs; Lantern Slides; Manuscripts; Memorabilia; Motion Pictures; Periodical Subscriptions 21; Photographs; Prints; Reels; Slides; Video Tapes
Special Subjects: Decorative Arts, Manuscripts, Maps, Historical Material, Ceramics, Furniture, Glass, Embroidery, Jewelry, Reproductions

M **THORNTON W BURGESS SOCIETY, INC,** Museum, 4 Water St, PO Box 972 Sandwich, MA 02563. Tel 508-888-4668; Fax 508-888-1919; Elec Mail twbmuseum@capecod.net; Internet Home Page Address: www.thorntonburgess.org; *Exec Dir* Jeanne Johnson; *Pres* Bob King; *Cur* Bethany S Rutledge
Open Mon - Sat 10 AM - 4 PM, Sun 1 - 4 PM (Apr - Oct); Admis by donation; Estab 1976 to inspire reverence for wildlife & concern for the natural environment; 1756 house; Average Annual Attendance: 60,000; Mem: 1800; dues family $30, individual $20; annual meeting in Feb
Income: Financed by mem, gift shop, mail order sales & admis revenue
Special Subjects: Decorative Arts, Dolls, Glass
Collections: Collection of Thornton Burgess' writings; natural history specimens; original Harrison Cady illustrations from the writings of the children's author & naturalist
Publications: Newsletter, 3 times per year; program schedule, 2 times per year
Activities: Classes for adults & children; docent programs; lect open to public; lending collection contains books, framed reproductions & nature artifacts

SOUTH HADLEY

M **MOUNT HOLYOKE COLLEGE,** Art Museum, Lower Lake Rd, South Hadley, MA 01075-1499. Tel 413-538-2245; Fax 413-538-2144; Elec Mail artmuseum@mtholyoke.edu; Internet Home Page Address: www.mtholyoke.edu/go/artmuseum; *Cur* Wendy Watson; *Business & Events Mgr* Debbie Davis; *Registrar & Coll Mgr* Linda Best; *Publications & Pub Relations Mgr* Mary Elizabeth Strunk; *Educ Coordr* Jane Gronau
Open Tues - Fri 11 AM - 5 PM, Sat - Sun 1 - 5 PM, cl Mon & certain College holidays, same schedule year-round; No admis fee; Estab 1876, mus now occupies a building dedicated in 1970. In addition to its permanent collections, mus also organizes special exhibitions of international scope; Art mus with 8 galleries houses the permanent collection & special exhibitions; Average Annual Attendance: 15,000; Mem: Dues $25-$1000
Income: Financed by endowment, mem & college funds

Special Subjects: Drawings, Painting-American, Prints, Sculpture, Pre-Columbian Art, Painting-European, Asian Art, Antiquities-Egyptian, Antiquities-Greek, Antiquities-Roman
Collections: Asian art, European & American paintings, sculpture, photographs, prints & drawings; Egyptian, Greek, Roman, Pre-Columbian; Ancient coins (mostly Greek & Roman)
Exhibitions: 7-8 rotating special exhibitions per year
Publications: Newsletter, bi-annually; exhibition catalogues; calendar, bi-annual
Activities: Educ dept; docent training; lect open to public, 5-6 vis lectrs per year; concerts; gallery talks; tours; individual paintings lent to qualified museums; book traveling exhibitions 1-2 per year; originate traveling exhibitions to qualified museums; museum shop sells reproductions, mugs, tote bags & posters

L Art Library, 50 College St, South Hadley, MA 01075-6404. Tel 413-538-2225; Fax 413-538-2370; Elec Mail sperry@mtholyoke.edu; Internet Home Page Address: www.mtholyoke.edu; *Dir* Susan L Perry
Open to college community only
Library Holdings: Book Volumes 15,550; Periodical Subscriptions 64; Slides

SOUTH SUDBURY

M LONGFELLOW'S WAYSIDE INN MUSEUM, Wayside Inn Rd off Rte 20, South Sudbury, MA 01776. Tel 978-443-1716; Tel 800-339-1776; Fax 978-443-8041; Elec Mail innkeeper@wayside.org; Internet Home Page Address: www.wayside.org; *Chmn Trustees* Richard Davidson; *Innkeeper* Robert H Purrington
Open daily 9 AM - 8 PM cl Christmas Day & July 4th; No admis fee, donations accepted; Estab 1716 as one of the oldest operating Inn in America. The ancient hostelry continues to provide hospitality to wayfarers from all over the world; 18th century period rooms including Old Barroom, Longfellow Parlor, Longfellow Bed Chamber, Old Kitchen, Drivers and Drovers Chamber. Historic buildings on the estate include Redstone School of Mary's Little Lamb fame, grist mill, and Martha Mary Chapel; Average Annual Attendance: 170,000
Income: Nonprofit organization
Special Subjects: Painting-American, Prints, Decorative Arts, Furniture, Period Rooms
Collections: Early American furniture and decorative arts; Howe family memorabilia; paintings; photographs of the Inn; prints; historic papers
Exhibitions: Various exhibits
Activities: Classes for adults; colonial crafts demonstrations and workshops; lect open to public, 5 vis lectrs per year; tours; sales shop selling books, original art, reproductions & prints

SPRINGFIELD

A SPRINGFIELD CITY LIBRARY, 220 State St, Springfield, MA 01103. Tel 413-263-6828; Fax 413-263-6825; Internet Home Page Address: www.springfieldlibrary.org; *Dir* Emily Bader; *Asst Dir* Lee Fogerty; *Head Adult Information Svcs* John Clark
Open Mon & Wed 11 AM - 8 PM, Tues 9 AM - 6 PM, Fri & Sat 9 AM - 5 PM, Sun 12 PM - 5 PM; cl holidays; No admis fee; Estab 1857, Department opened 1905; Circ 611,893 (totals for system); In addition to the City Library system, the Springfield Library & Mus Assn owns & administers, as separate units, the George Walter Vincent Smith Mus, the Springfield Mus of Fine Arts, the Science Mus & the Connecticut Valley Historical Mus; Average Annual Attendance: 1,100,000; Mem: 3,400; $35 & up
Library Holdings: Audio Tapes 36,000; Book Volumes 700,000; Video Tapes 26,500
Exhibitions: Occasional exhibitions from the library's collections & of work by local artists

M SPRINGFIELD COLLEGE, William Blizard Gallery, Visual & Performing Arts Dept, 263 Alden St Springfield, MA 01109. Tel 413-747-3000, 748-0204; Fax 413-748-3580; *Chmn* Ronald Maggio; *Dir Gallery* Holly Murray
Open Mon - Fri 9 AM - 4 PM, Fri 8 AM - 8 PM, Sat 9 AM - 8 PM, Sun Noon - 12 AM; Estab 1998 to bring a wide range of quality exhibits in all areas of the visual arts to the Springfield College campus & surrounding community
Income: Financed by William Simpson Fine Arts Comt
Library Holdings: Book Volumes; Cassettes; Filmstrips; Micro Print; Motion Pictures; Original Art Works; Periodical Subscriptions; Prints; Video Tapes
Exhibitions: Rotating exhibits monthly
Activities: Lect open to public; gallery talks

M SPRINGFIELD LIBRARY & MUSEUMS ASSOCIATION, Museum of Fine Arts, 220 State St, Springfield, MA 01103. Tel 413-263-6800; Fax 413-263-6889; Internet Home Page Address: www.springfieldmuseums.org; *Pres & Exec Dir* Joseph Carvalho; *Dir Finance* Holly Smith-Bove; *Dir* Heather Haskell; *Dir Museum Educ* Kathleen Simpson; *Dir Coll Management* Wendy Stayman; *Asst Cur Art* Julia Courtney
Open Tues - Fri 10 AM - 4 PM, Sat & Sun 11 AM - 4 PM, cl Mon, Tues & holidays; Admis adults $10, seniors & college students $7, children $3 (includes admis to four museums); Estab 1933 as a unit of the Springfield Library & Mus Assoc through the bequests of Mr & Mrs James Philip Gray, to collect, preserve & display original artwork; Building contains galleries, theater, offices; Average Annual Attendance: 108,000; Mem: 3645; dues $35 & up
Income: pub & private
Special Subjects: Graphics, Painting-American, Sculpture, Primitive art, Woodcuts, Painting-European, Oriental Art, Painting-British, Painting-Dutch, Painting-French, Painting-Italian
Collections: American paintings, sculpture & graphics, primitive to contemporary; European paintings & sculpture, early Renaissance to contemporary; Japanese woodblock prints
Exhibitions: Special exhibitions, historic to contemporary are continually on view in addition to permanent collection; changing exhibitions
Publications: Handbook to the American & European Collection, Museum of Fine Arts, Springfield; exhibition catalogs

Activities: Classes for adults & children; docent training; lect open to public, 50 vis lectrs per year; concerts; gallery talks; tours; individual paintings & original objects of art lent to museums & galleries; book traveling exhibitions 5-8 per year; originate traveling exhibitions; museum shop sells books, children's items, gift items, jewelry, posters, reproductions & prints

M Connecticut Valley Historical Society, Tel 413-263-6800; Fax 413-263-6898; Internet Home Page Address: www.quadrangle.org; *Head Library & Archive Coll* Margaret Humbertson; *Pres & Exec Dir* Joseph Carvalho; *Vice Pres Mktg & Devel* Susan Davison; *Vice Pres Finance* Richard Dunbar
Open Wed-Fri Noon - 4 PM, Sat & Sun 11 AM - 4 PM; Admis adults $7, seniors & college students $5, children $3, under 6 free. Includes admis to all four mus at Quadangle; Estab 1927 to interpret history of Connecticut River Valley; Average Annual Attendance: 463,493; Mem: Mem: 3645; dues $35 & up; annual meeting in Sept
Special Subjects: Decorative Arts, Folk Art, Historical Material, Furniture, Portraits, Painting-American, Silver, Embroidery, Pewter
Collections: Decorative arts of Connecticut Valley, including furniture, paintings & prints, pewter, firearms, glass, silver, early games; Genealogy Library
Exhibitions: Many exhibits pertaining to history & decorative arts of Connecticut River Valley
Publications: Say Goodbye to the Valley
Activities: Classes for adults & children; lect open to the public; lect for mems only; gallery talks; tours; book traveling exhibitions 1-2 per year; museum shop sells books, note cards, genealogy shirts & tote bags

M Springfield Science Museum, 220 State St, Springfield, MA 01103. Tel 413-263-6800; Fax 413-263-6884; Internet Home Page Address: www.springfieldmuseums.org; *Exec Dir & Pres* Joseph Carvalho; *Dir* David Stier; *Dir Finance* Holly Smith-Bove; *Dir Museum Educ* Kathleen Simpson; *Dir Coll Mgmt* Wendy Stayman
Open Wed - Fri Noon - 4 PM, Sat & Sun 11 AM - 4 PM; Admis adults $7, seniors & college students $5, child $3 (includes admis to four museums); Estab 1899 to collect, preserve & exhibit material related to natural & physical science; Average Annual Attendance: 144,927; Mem: 3645; dues $35 & up; annual meeting in Sept
Income: Financed by mem, city, contract, admis & program fees; local, state & federal grants
Collections: Aquarium; Dinosaur Hall; early aviation artifacts; Exploration Center; habitat groupings of mounted animals; Native American & African artifacts; Planetarium; live-animal eco-center
Activities: Classes for adults & children; docent programs; outreach programs; lect open to public; book traveling exhibitions 2-3 per year; museum shop sells books & gift items & scientific objects

M SPRINGFIELD MUSEUMS ASSOCIATION, George Walter Vincent Smith Art Museum, 220 State St, Springfield, MA 01103. Tel 413-263-6890, 263-6800; Fax 413-263-6889; Internet Home Page Address: www.springfieldmuseums.org; *Pres & Exec Dir* Joseph Carvalho; *Dir* Heather Haskell; *Dir Museum Educ* Kathleen Simpson; *Collections Management Admin* Wendy Stayman; *VPres of Marketing & Develop* Susan Davison; *VPres of Finance* Richard Dunbar
Open Wed - Fri Noon - 4 PM; Sat & Sun 11 AM - 4 PM; Admis adults $7, children $3, seniors & college students $5 includes admissions to 4 museums; Estab 1896 to preserve, protect, present, interpret, study & publish the collections of fine & decorative arts; administered by the Springfield Museums Assn; Maintains eleven galleries housing permanent collection & one gallery reserved for changing exhibitions; Average Annual Attendance: 87,073; Mem: 3645; dues $35 & up; annual meeting in Sept
Income: Financed by endowment, mem, city & state appropriations
Special Subjects: Painting-American, Ceramics, Painting-European, Oriental Art, Carpets & Rugs, Calligraphy
Collections: 19th century American & European Paintings; Japanese Bronzes-Arms & Armor; Near Eastern Carpets; Oriental Arts (calligraphy, ceramics, lacquer, painting, sculpture, textiles); Oriental Cloisonne; plaster casts of ancient & Renaissance sculptural masterworks
Publications: Annual report; special exhibition catalogs; quar mems magazine
Activities: Classes for adults & children; demonstrations; gallery walks; public programs; activity rooms; docent training; lect open to public, 50 vis lectrs per year; concerts; gallery talks & tours; lending of original objects of art to other museums; book traveling exhibitions 5-10 per year; mus shop sells books, reproductions

STOCKBRIDGE

M NATIONAL TRUST FOR HISTORIC PRESERVATION, Chesterwood Estate & Museum, 4 Williamsville Rd, Glendale Section Stockbridge, MA 01262; PO Box 827, Stockbridge, MA 01262-0827. Tel 413-298-3579; Fax 413-298-3973; Elec Mail chesterwood@nthp.org; Internet Home Page Address: www.chesterwood.org; *Buildings & Ground Supt* Gerard J Blache; *Mgr Collections & Interpretation* Linda Wesselman Jackson; *Mgr Resources Develop* Maureen Hannon; *Dir* J Andrew Brian
Open daily 10 AM - 5 PM, May 1 through Oct 31; Admis adults $10, children 6 -18 $5, National Trust & Friends of Chesterwood members free; group rates available by advanced arrangement; Estab 1955 to preserve & present the country home & studio of Daniel Chester French; Chesterwood, a National Trust Historic Site, was the former estate of Daniel Chester French (1850-1931), sculptor of the Lincoln Memorial, Minute Man & leading figure of the American Renaissance. The 122 acre property includes: the sculptor's studio (1898) & residence (1900-1901), both designed by Henry Bacon, architect of the Lincoln Memorial; Barn Gallery, a c1825 barn adapted for use as exhibition space & a museum gift shop, a 1909 garage adapted as a visitors' center & country place garden with woodland walk laid out by French. Maintains reference library; Average Annual Attendance: 33,000; Mem: 625; individual dues $35
Library Holdings: Book Volumes; Clipping Files; Exhibition Catalogs; Kodachrome Transparencies; Manuscripts; Maps; Memorabilia; Original Art Works; Original Documents; Other Holdings; Photographs; Prints; Sculpture; Slides
Special Subjects: Architecture, Painting-American, Sculpture, Bronzes, Textiles, Landscapes, Decorative Arts, Painting-European, Portraits, Furniture, Painting-Italian

Collections: Sculpture by or owned by Daniel Chester French; decorative arts; memorabilia; plaster models, marble & bronze casts of French's work & paintings
Exhibitions: Annual Outdoor Contemporary Sculpture Exhibition; Annual Antique Car Show; Christmas at Chesterwood; Barn Gallery Exhib; Antique Carriage Show; Friday Teas; EB Longman; Speaking Exhib on Work with French; special exhibits dealing with aspects of historic preservation in the Berkshire region & French's life, career, social & artistic milieu & summer estate
Publications: The Pedestal, newsletter; Contemporary Sculpture at Chesterwood, annual catalogue
Activities: Classes for adults & children, docent training; demonstrations open to public, 6 vis lectrs per year; gallery talks; tours; competitions; landscape tours, sculpture demonstrations; original objects of art lent to qualified institutions; museum shop sells books, cards, reproductions & gift items

L **Chesterwood Museum Archives,** 4 Williamsville Rd, Glendale Section Stockbridge, MA 01262-0827; PO Box 827, Stockbridge, MA 01262-0827. Tel 413-298-3579; Fax 413-298-3973; Elec Mail chesterwood@taconic.net; Internet Home Page Address: www.nationaltrust.org; *Archivist* Wanda Magdeleine Styka
Open by appointment only, staff & spec hrs, gen pub; Estab 1969; Library consists of books on sculpture, historic preservation, decorative arts, history of art, architecture, garden & landscape design, including books collected personally by sculptor Daniel Chester French, Mary Adams French (wife) & Margaret French Cresson (daughter) as well as archival material; serves art, social, landscape & architectural historians & historic preservationists
Library Holdings: Audio Tapes; Book Volumes 5000; Cards; Cassettes; Clipping Files; Exhibition Catalogs; Lantern Slides; Manuscripts; Memorabilia; Motion Pictures; Original Art Works; Pamphlets; Periodical Subscriptions 5; Photographs; Prints; Reels; Sculpture; Slides; Video Tapes
Special Subjects: Art History, Landscape Architecture, Decorative Arts, Photography, Painting-American, Sculpture, Historical Material, History of Art & Archaeology, Portraits, Bronzes, Furniture, Period Rooms, Restoration & Conservation, Coins & Medals, Architecture
Collections: Oral histories: Daniel Chester French & his summer estate Chesterwood; blueprints & plans of sculpture commissions & of Chesterwood; period photographs of French & his family, summer estate & sculptures; papers, correspondence, photograph albums & scrapbooks of D C French & Margaret French Cresson, sculptor, writer & preservationist; literary manuscripts of Mary Adams French
Exhibitions: (2001) Daniel Chester French: Transforming a Nation through Sculpture
Publications: The Chesterwood Pedestal, newsletter; educational brochures; annual exhibit catalogues
Activities: Intern archivist program; museum shop sells books, reproductions, prints

M **NORMAN ROCKWELL MUSEUM STOCKBRIDGE, MASSACHUSETTS,** 9 Glendale Rd, PO Box 308 Stockbridge, MA 01262. Tel 413-298-4100; Fax 413-298-4142; Elec Mail inforequest@nrm.org; Internet Home Page Address: www.nrm.org; *Pres Board* Daniel Cain; *Assoc Dir Exhib & Prog* Stephanie H Plunkett; *Assoc Dir External Relations* Mary Ellen Hern; *Cur Norman Rockwell Art* Linda Pero; *Dir* Laurie Norton Moffatt; *Assoc Dir Marketing Commission* Kimberly Rawson
Open May - Oct daily 10 AM - 5 PM, Nov - Apr Mon - Fri 10 AM - 4 PM, Sat & Sun 10 AM - 5 PM, cl Thanksgiving, Christmas, New Year's Day; Admis adult $12.50; Estab 1967 to collect, manage, preserve, study, interpret & present to the public material pertaining to the life & career of Norman Rockwell; Circ 156,000; Consists of a main building (1993), situated on 36 acres in a country setting with galleries for permanent & changing exhibitions, classrooms, the Norman Rockwell Reference Center, meeting room & store. Norman Rockwell Studio is located on the museum site.; Average Annual Attendance: 80,000; Mem: 2,700; dues $50-$5000; annual meeting in Sept
Income: Financed by admis, mem, donations, sales & grants
Library Holdings: Auction Catalogs; Audio Tapes; Book Volumes; CD-ROMs; Cards; Cassettes; Clipping Files; Compact Disks; DVDs; Exhibition Catalogs; Fiche; Filmstrips; Framed Reproductions; Kodachrome Transparencies; Lantern Slides; Manuscripts; Maps; Memorabilia; Micro Print; Motion Pictures; Original Art Works; Original Documents; Other Holdings; Pamphlets; Periodical Subscriptions; Photographs; Prints; Records; Reels; Reproductions; Sculpture; Slides; Video Tapes
Special Subjects: Drawings, Photography, Portraits, Painting-American
Collections: Largest permanent collection of original Rockwell art (more than 500 original paintings & drawings); artifacts & furnishings of Norman Rockwell's studio; archives including business letters, memorabilia, negatives & photographs
Exhibitions: (5/27/2006-1/28/2007) Norman Rockwell's 323 Saturday Evening Post Covers; (6/10/2006-10/29/2006) Frederic Remington & the American Civil War: A Ghost Story; (10/7/2006-10/31/2006) Stuffed Shirts: Sculptural Scarecrows Inspired by Rockwell; (11/11/2006-1/14/2007) More Than Words: Artists' Illustrated Letters from the Smithsonian's Archives of American Art; (1/27/2007-5/28/2007) Picturing Health: Norman Rockwell and the Art of Illustration; (2/3/2007-3/4/2007) 21st Annual Berkshire County High School Art Show; (6/9/2007-10/27/2007) The Age of Glamour: Al Parker & the American Women's Magazine, 1940-1965; (11/10/2007-5/31/2008) LitGraphic: The World of the Graphic Novel; (6/14/2008-10/26/2008) Double Identity: American Artists as Illustrators; The Pleasure of Recognition: Rockwell's Inspirations Summer/Fall 2009
Publications: Norman Rockwell: A Definitive Catalogue; The Portfolio, quarterly newsletter; Programs & Events, quarterly calendar
Activities: Classes for adults & children; docent training; lect open to public; tours; educator's seminars, art workshops for adults & children; school programs; family days; special performances & events; free admission days; schols & internships offered; individual paintings & original objects of art lent to qualifying not for profit educational institutions; originate traveling exhibitions; museum shop sells books, prints, reproductions & gift items

L **Library,** PO Box 308, Stockbridge, MA 01262. Tel 413-298-4100; Fax 413-298-4145; *Assoc Dir Curatorial & Professional Affairs* Maureen Hart Hennessey; *Cur* Linda Pero
Open Tues, Thurs 1 - 4 PM

Library Holdings: Audio Tapes; Book Volumes 300; Cassettes; Clipping Files; Lantern Slides; Manuscripts; Memorabilia; Motion Pictures; Periodical Subscriptions 10; Photographs; Prints; Records; Reproductions; Slides; Video Tapes
Activities: schols offered

TAUNTON

M **OLD COLONY HISTORICAL SOCIETY,** Museum, 66 Church Green, Taunton, MA 02780. Tel 508-822-1622; Elec Mail oldcolony@oldcolonyhistoricalsociety.org; Internet Home Page Address: www.oldcolonyhistoricalsociety.org; *VPres* David F Gouveia, MD; *Cur* Jane Emack-Cambra; *Dir, CEO* Katheryn P Viens; *Asst to Dir* Elizabeth Bernier
Open Tues - Sat 10 AM - 4 PM, mus tours 10:30 AM, 1:30 PM & 2:30 PM; Admis adults $2, seniors & children 12-18 $1, children under 12 free; Estab 1853 to preserve & perpetuate the history of the Old Colony in Massachusetts; Four exhibition halls; Average Annual Attendance: 7,000; Mem: 700; dues $10-$250; annual meeting third Thurs in Apr
Income: $120,000 (financed by endowment, mem, service fees, grants)
Special Subjects: Textiles, Furniture, Silver
Collections: Fire fighting equipment; furniture, household utensils, Indian artifacts, military items; portraits, silver, stoves
Publications: Booklets; pamphlets
Activities: Classes for adults & children; docent training; workshops; lect open to public, 8-10 vis lectrs per year; fels offered; museum shop sells books & souvenirs

L **Library,** 66 Church Green, Taunton, MA 02780. Tel 508-822-1622; *Library Asst* Greta Smith; *Cur* Jane Emack-Cambra; *Dir* Katheryn P Viens
Open Tues - Sat 10 AM - 4 PM; Admis genealogy $5, other research $2; Estab 1853; For reference only; research services available for a fee
Library Holdings: Audio Tapes; Exhibition Catalogs; Manuscripts; Memorabilia; Pamphlets; Periodical Subscriptions 10; Photographs; Prints; Reels; Slides
Special Subjects: Art History, Folk Art, Decorative Arts, Manuscripts, Maps, Painting-American, Ceramics, Furniture, Glass, Metalwork, Dolls, Coins & Medals, Pewter, Flasks & Bottles, Architecture

TYRINGHAM

M **SANTARELLA MUSEUM & GARDENS,** 75 Main Rd, PO Box 414 Tyringham, MA 01264. Tel 413-243-3260; Fax 413-243-9178; *Dir* Hope C Talbert
Open 10 AM - 5 PM (May - Oct), cl Tues & Wed; Admis $4, children under 6 free; Estab 1996 to exhibit & sell paintings, prints & sculptures by recognized artists, including world masters; The building was designed as a sculpture studio by the late Sir Henry Kitson; Average Annual Attendance: 15,000
Income: Financed privately
Special Subjects: Architecture, Sculpture, Bronzes, Decorative Arts
Collections: Santarella Sculpture Gardens; Henry Hudson-Kitson Studios
Exhibitions: One-person shows by established artists; Outdoor sculpture exhibitions (various artists)
Activities: Lect open to public; 2 vis lectrs per yr; gallery talks; tours; museum shop sells books, original art, reproductions & prints

WALTHAM

M **BRANDEIS UNIVERSITY,** Rose Art Museum, PO Box 9110, Waltham, MA 02454; 415 South St, Waltham, MA 02453-2728; MS 069, Waltham, MA 02454-9110. Tel 781-736-3434; Fax 781-736-3439; Elec Mail jketner@brandies.edu; Internet Home Page Address: www.brandies.edu/rose; *Registrar* Ben Thompson; *Preparator* Roy Dawes; *Dir* Joseph D Ketner II; *Educator* Stephanie Molinard; *Cur* Raphaela Platow; *Mem Coordr* Allison Slaby
Open Tues - Sun Noon - 5 PM; admis adult $3; Estab 1961 to exhibit and collect modern and contemporary art; Sept - Jul revolving displays of Brandeis Art; Average Annual Attendance: 10,000; Mem: 250; $125 basic mem
Purchases: William Kentridge; Barry McGee; Robin Rhode
Special Subjects: Painting-American, Prints, American Indian Art, African Art, Pre-Columbian Art, Ceramics
Collections: The permanent collections consist of: African art; American Indian art; contemporary art (post World War II); Japanese prints; modern art (1800 to World War II), including the Riverside Museum Collections & the Teresa Jackson Weill Collection; Pre-Columbian art; pre-modern art (before 1800); Mr & Mrs Edward Rose Collection of early ceramics; Helen S Slosberg Collection of Oceanic art; Tibetian art
Exhibitions: (2004) Barry McGee; (2004) Francesco Clemente; (2004) Yun-Fei Ji
Publications: Exhibition catalogs
Activities: Classes for children; docent training; lect open to public; gallery talks; concerts; tours; individual paintings & original objects of art lent to students & individuals within the university; lending collection contains original art works, original prints, paintings; book traveling exhibitions 1 per year

L **Leonard L Farber Library,** Norman & Rosita Creative Arts Ctr, 415 South St, PO Box 9110 Waltham, MA 02254-9110. Tel 781-736-4681; Fax 781-736-4675; *Librn* Darwin Scott
Open Mon - Thurs 8:30 AM - Noon, Fri 8:30 AM-8 PM, Sat 11 AM -8 PM, Sun 11 AM-Midnight; Estab 1948 to provide materials & services for the teaching, research & pub interest in the arts of the Brandeis community; For lending & reference
Library Holdings: Book Volumes 40,000; Cards; Cassettes; Exhibition Catalogs; Fiche; Micro Print; Periodical Subscriptions 130; Photographs; Records; Reels
Special Subjects: Art History
Collections: Dr Bern Dibner Collection of Leonardo Da Vinci - Books; Benjamin A & Julia M Trustman Collection of Honore Daumier Prints (4000); extensive collection of books on Daumier
Exhibitions: Rotating exhibition of Daumier Prints

WELLESLEY

M **CRANE COLLECTION, GALLERY OF AMERICAN PAINTING AND SCULPTURE,** (Crane Collection Gallery) 564 Washington St, Wellesley, MA 02482-6409. Tel 781-235-1166; Fax 781-235-4181; Elec Mail cranecollection@conversent.com; Internet Home Page Address: www.cranecollection.com; *Gallery Mgr* Liz Hoff; *Pres* Bonnie L Crane; *Asst* Dianne Arnheim
Open Mon - Sat 10 AM - 5 PM; No admis fee; Estab 1983 to exhibit 19th & early 20th century American paintings; Art gallery with changing inventory in the heart of the town of Wellesley, MA; Average Annual Attendance: 2,500
Library Holdings: Auction Catalogs; Book Volumes; Exhibition Catalogs; Original Art Works; Sculpture
Special Subjects: Painting-American, Period Rooms
Collections: 19th century & early 20th century American paintings & sculptures, including Hudson River School, Boston School & regional artists
Exhibitions: Boston School: Then & Now; Summer Scenes II; Bruce Crane; Tonalism; Inspiration of Cape Ann; City Scenes; Little Picture Show; American Barbizon; Interiors; Russian Light I, II & III
Publications: The Gentle Art of Still Life; Russian Light

WELLESLEY COLLEGE

M **Davis Museum & Cultural Center,** Tel 781-283-2051; Fax 781-283-2064; Internet Home Page Address: www.davismuseum.wellsly.edu; *Dir* David Mickenberg; *Dir Museum Develop & Membership* Nancy Gunn; *Assoc Dir* Dennis McFadden; *Registrar* Bo Mompho; *Cur* Anja Chávez; *Cur* Elizabeth Wyckoff; *Cur* Dabney Hailey; *Cur* Elaine Mehalakes
Open Tues & Fri - Sat 11 AM - 5 PM, Wed 11 AM - 8 PM, Sun 1 - 5 PM; cl New Year's Day, Thanksgiving and Dec 24 - Jan 2; No admis fee; Estab 1889, dedicated to acquiring a collection of high quality art objects for the primary purpose of teaching art history from original works; Main gallery houses major exhibitions; Corridor Gallery, works on paper; Sculpture Court, permanent installation, sculpture, reliefs, works on wood panel; Average Annual Attendance: 18,000; Mem: 650; dues donor $100, contributor $50, regular $25
Income: Financed by mem, through college & gifts
Special Subjects: Drawings, Portraits, Painting-American, Painting-British, Painting-European, Hispanic Art, Latin American Art, Photography, Prints, Sculpture, Watercolors, African Art, Pre-Columbian Art, Religious Art, Woodcuts, Etchings & Engravings, Landscapes, Baroque Art, Painting-Flemish, Renaissance Art, Medieval Art, Painting-Spanish, Painting-Italian, Antiquities-Greek, Antiquities-Roman
Collections: Paintings; sculpture; graphic & decorative arts; Asian, African, ancient, medieval, Renaissance, Baroque, 19th & 20th century European & American art; photography; Prints; Drawings
Publications: Exhibition catalogs; Wellesley College Friends of Art Newsletter, annually
Activities: Docent training; lect open to public & members only; gallery talks; tours; VTS viewing sessions for students; lending collection contains original prints; book traveling exhibitions; originate traveling exhibitions; sales shop sells catalogs, postcards & notecards
L **Art Library,** Tel 781-283-3258; Fax 781-283-3647; Elec Mail webmaster@wellelsy.edu; Internet Home Page Address: www.wellesley.edu; *Art Librn* Brooke Henderson
Circ 18,000
Income: Financed by College appropriation
Library Holdings: Book Volumes 57,259; CD-ROMs 61; Cassettes 265; Exhibition Catalogs; Fiche 1700; Kodachrome Transparencies; Lantern Slides; Pamphlets; Periodical Subscriptions 158; Photographs
Special Subjects: Art History, Decorative Arts, Photography, Painting-American, Painting-Italian, Painting-European, History of Art & Archaeology, Archaeology, Asian Art, Oriental Art, Antiquities-Roman, Architecture

WELLFLEET

M **WELLFLEET HISTORICAL SOCIETY MUSEUM,** Wellfleet Historical Society Museum, 266 Main St PO Box 58 Wellfleet, MA 02667-0000. Tel 508-349-2954; Internet Home Page Address: www.wellfleethistoricalsociety.com; *Co-Cur* Durand Echeverria; *Cur* Joan Hopkins Coughlin; *Treas* Pat Bauer; *VPres* Nina Anderson; *VPres* Suzanne Albee
Open late June - early Sept, Tues - Sat 2 - 5 PM, Tues & Fri 10 AM - Noon; Admis $1; Estab 1953; Average Annual Attendance: 200; Mem: 350; dues $3.50; 5 general meetings per yr
Income: $4000 (financed by mem)
Purchases: $1000
Special Subjects: Dolls
Collections: Books; china & glass; documents; Indian artifacts; paintings & photographs; personal memorabilia of Wellfleet; pewter; shellfish & finfish exhibit; shop models; shipwreck & marine items
Publications: Beacon, annual
Activities: Lect open to public, 5 vis lectrs per year; walking tours during summer

WENHAM

A **WENHAM MUSEUM,** 132 Main St, Wenham, MA 01984. Tel 978-468-2377; Fax 978-468-1763; Internet Home Page Address: www.wenhammuseum.org; *Pres* Elizabeth Stone; *Office Admin* Felicia Connolly; *Doll Cur* Diane Hamblin; *Cur* Bar Browdo; *Dir* Emily Stearns
Open Tues - Sun 10 AM - 4 PM, cl Mon & major holidays; Admis adults $5, seniors $4, children $2 & up $3, mem free; Estab 1921 as Historical Soc, incorporated 1953, to acquire, preserve, interpret & exhibit collections of literary & historical interest; to provide an educational & cultural service & facilities; Maintains three permanent galleries & one gallery for changing exhibits; Average Annual Attendance: 10,000; Mem: 650; dues family $55, individual $30; annual meeting Apr
Income: Financed by endowment, mem, earned income

Collections: Dolls; doll houses; figurines; costumes & accessories 1800-1960; embroideries; fans; needlework; quilts; toys
Exhibitions: Ice Cutting Tool Exhibit; 19th Century Shoe Shops; Still Lifes; Quilts Old & New; Samplers; Tin & Woodenware; Weavers; Wedding Dresses
Publications: Annual report; newsletter
Activities: Classes for children; lect open to the public; gallery talks; tours; museum shop sells books, miniatures, original needlework, dolls & small toys
L **Timothy Pickering Library,** 132 Main St, Wenham, MA 01984. Tel 978-468-2377; Fax 978-468-1763; Elec Mail info@wenhammuseum.org; Internet Home Page Address: www.wenhammuseum.org; *Exec Dir* Lindsay Diehl; *Mus Shop Mgr* Diane McMahon
Research by appointment; Open to members & the pub for reference
Income: Endowments, earned income, mem
Library Holdings: Book Volumes 2200; Manuscripts; Memorabilia; Pamphlets; Photographs

WEST NEWTON

M **BOSTON SCULPTORS AT CHAPEL GALLERY,** The Second Church in Newton, 60 Highland St West Newton, MA 02465. Tel 617-244-4039; Internet Home Page Address: www.bostonsculptors.com; *Dir* Julie Scaramella
Open Wed - Sun 1 - 5:30 PM; No admis fee; Estab 1992 as an alternate venue for contemporary sculpture; Collaborative gallery operated by 20 sculptors; Average Annual Attendance: 5,000 - 7,000; Mem: 20
Income: Dues & sales
Exhibitions: Group & solo invitations - Sept - June
Activities: Lect open to public, gallery talks: Best of Boston Award; mus shop sells original art & postcards

WESTFIELD

M **WESTFIELD ATHENAEUM,** Jasper Rand Art Museum, 6 Elm St, Westfield, MA 01085. Tel 413-568-7833; Fax 413-568-1558; Elec Mail pcramer@exit3.com; Internet Home Page Address: www.ci.westfield.ma.us/athen.html; *Pres* James Rogers; *Treas* Mark Morin; *Dir* Patricia T Cramer; *Asst Dir* Donald G Buckley
Open Mon - Thurs 8:30 AM - 8 PM, Fri & Sat 8:30 AM - 5 PM, cl Sat in July & Aug; No admis fee; Estab 1927 to provide exhibitions of art works by area artists & other prominent artists; Gallery measures 25 x 30 x 17 feet, with a domed ceiling & free-standing glass cases & wall cases; Average Annual Attendance: 13,500; Mem: Annual meeting fourth Mon in Nov
Income: Financed by endowment
Exhibitions: Changing exhibits on a monthly basis

WESTON

M **REGIS COLLEGE FINE ARTS CENTER,** Carney Gallery, 235 Wellesley St, Weston, MA 02493-1571. Tel 781-768-7034 (Dir); Fax 781-768-7030; Internet Home Page Address: www.regiscollege.edu; *Dir* Steven B Hall; *Assoc Dir* Nancy Rosata; *Technical Dir* Richard Archer
Open Mon - Fri 10 AM - 4 PM; No admis fee; Estab 1993 and houses the music, art and theater depts as well as the Casey Theatre & Carney Gallery; Carney Gallery is one room, 20 x 30 ft; Average Annual Attendance: 1,500
Income: Financed by college
Exhibitions: Rotate every 6 wks, focus on works of contemporary women artists
Activities: Lect open to the public; 1-4 vis lect per year

WILLIAMSTOWN

M **STERLING & FRANCINE CLARK ART INSTITUTE,** 225 South St, PO Box 8 Williamstown, MA 01267. Tel 413-458-9545, 458-2303; Fax 413-458-2324; Elec Mail info@clarkart.edu; Internet Home Page Address: www.clarkart.edu/; *Dir* Michael Conforti; *Cur Prints, Drawings & Photographs* James A Ganz; *Sr Cur of Paintings & Sculpture* Richard Rand; *Registrar* Mattie Kelley; *Deputy Dir* Anthony King; *Publications Mgr* Curtis Scott; *Dir Research & Academic Progs* Michael Ann Holly; *Contact Person* Sally Morse Majewski
Open July - Aug Tues - Sun 10 AM - 5 PM, cl Mon, New Year's Day, Thanksgiving & Christmas; Admis (July - Oct); no admis fee (Nov - May); Estab 1955 as a mus of fine arts with galleries, art research library & pub events in auditorium; Maintains reference library; Average Annual Attendance: 175,000; Mem: 3500; dues $50 & up
Library Holdings: Auction Catalogs; Book Volumes; CD-ROMs; Exhibition Catalogs; Periodical Subscriptions; Slides
Special Subjects: Drawings, Sculpture, Porcelain, Silver, Painting-Dutch, Painting-French, Painting-Flemish, Painting-Italian
Collections: English and American silver; Dutch, Flemish, French, Italian Old Master paintings from the 14th-18th centuries; French 19th century paintings, especially the Impressionists; 19th century sculpture; Old Master prints & drawings; porcelains; selected 19th century American artists (Homer & Sargent); Early photography; American furniture
Exhibitions: The Permanent Collection & Traveling Exhibitions; (10/8/2006-12/31/2006) Alpine Views: Alexandre Calame & the Swiss Landscape; (2/4/2007-4/29/2007) Claude Lorrain-The Painter as Draftsman: Drawings from the British Museum; (6/23/2007-9/16/2007) The Unknown Monet: Pastels & Drawings
Publications: Calendar of Events, quarterly; Journal, annually
Activities: Classes for adults & children; docent training; lect open to public, 25-40 vis lectrs per year; concerts; gallery talks; tours for school children; fellowships; individual paintings & original objects of art lent to other museums whose facilities meet criteria, for exhibitions of academic importance; book traveling exhibitions 1-2 per year; originate traveling exhibitions circulating to selected partners; museum shop sells books, reproductions, prints, slides, jewelry, glass, games, puzzles, gifts
L **Clark Art Institute Library,** 225 South St, PO Box 8 Williamstown, MA 01267.

Tel 413-458-2303 ext 332; Fax 413-458-2336; Elec Mail library@clarkart.edu; Internet Home Page Address: www.clarkart.edu/library; *Librn* Susan Roeper
Open Mon - Fri 9 AM - 5 PM, cl holidays; Estab 1962; For reference only
Purchases: $260,000
Library Holdings: Auction Catalogs; Book Volumes 170,000; Exhibition Catalogs; Fiche; Other Holdings Auction sale catalogues 30,000; Periodical Subscriptions 640; Photographs; Reels; Reproductions; Slides
Collections: Mary Ann Beinecke Decorative Art Collection; Duveen Library & Archive; Juynboll Collection

M WILLIAMS COLLEGE, Museum of Art, 15 Lawrence Hall Dr, Ste 2 Williamstown, MA 01267-2666. Tel 413-597-2429; Fax 413-458-9017; Elec Mail wcma@williams.edu; Internet Home Page Address: www.wcma.org; *Assoc Dir* John Stomberg; *Prendergast Cur* Nancy Mowll Mathews; *Sr Cur of Modern & Contemporary Art* Deborah M Rothschild; *Dir Educ* Rebecca Hayes; *Cur Colls* Vivian Patterson; *Registrar* Diane Hart; *Asst to Dir* Amy Tatro; *Dir Membership & Events* Judith M Raab; *Interim Dir* Marion Goethals; *Pub Relations Coord* Suzanne Augugliaro; *Mgr of Coll Info* Rachel Tassone; *Mus Facility & Security Supv* Theodore Wrona; *Andrew M Mellon Foundation Assoc Cur Acad Prog* Stefanie Spray Jandl
Open Tues - Sat 10 AM - 5 PM, Sun 1 - 5 PM; No admis fee; Estab 1926 for the presentation of the permanent collection & temporary loan exhibitions for the benefit of the Williams College community & the general pub; Original 1846 Greek Revival building designed by Thomas Tefft; 1983 & 1986 additions & renovations designed by Charles Moore & Robert Harper of Centerbrook Architects & Planners. Building also houses Art Department of Williams College; Average Annual Attendance: 50,000; Mem: 370; $25-$2,500
Special Subjects: Latin American Art, African Art, Pre-Columbian Art, Religious Art, Folk Art, Afro-American Art, Decorative Arts, Oriental Art, Asian Art, Historical Material, Baroque Art, Renaissance Art, Medieval Art, Islamic Art
Collections: Ancient & medieval art; Asian & African art; modern & contemporary art; 18th-20th century American art; 20th century American photography
Publications: Brochures; exhibition catalogs, 3-4 per year
Activities: After school programs for children, teachers workshops; docent training; lect open to public, 10 vis lectrs per year; concerts; gallery talks; tours; individual paintings & original objects of art are lent to other museums; book traveling exhibitions 1 per year; originate traveling exhibitions to museums; museum shop sells books, jewelry, magazines, posters & postcards

L Sawyer Library, 55 Sawyer Library Dr, Williamstown, MA 01267-2566. Tel 413-597-2501; Fax 413-597-4106; Elec Mail david.pilachowski@williams.edu; Internet Home Page Address: www.williams.edu/library/sawyer; *Librn* David Pilachowski; *Asst Librn* Betty Milanesi
Open Mon - Thurs 8 AM - 10 PM, Sat 9 AM - 10 PM, Sun 9 AM - 2 AM; No admis fee
Income: Financed by endowments, gifts, Williams College
Library Holdings: Book Volumes 697,023; Periodical Subscriptions 3024; Slides 22,800

L Chapin Library, Stetson Hall, 26 Hopkins Hall Dr Williamstown, MA 01267-0426; PO Box 426, Williamstown, MA 01267. Tel 413-597-2462; Fax 413-597-2929; Elec Mail chapin.library@williams.edu; Internet Home Page Address: www.williams.edu/resources/chapin; *Custodian* Robert L Volz; *Asst Librn* Wayne G Hammond; *Admin Asst* Elaine Yanow
Open Mon - Fri 10 AM - Noon & 1 - 5 PM; No admis fee; Library estab 1923; For reference only; Average Annual Attendance: 4,000
Income: Financed by Williams College, endowments & gifts
Library Holdings: Auction Catalogs; Audio Tapes; Book Volumes 52,000; Cassettes; Clipping Files; Compact Disks; DVDs; Exhibition Catalogs; Kodachrome Transparencies; Manuscripts; Maps; Memorabilia; Motion Pictures; Original Art Works; Original Documents; Pamphlets; Periodical Subscriptions 20; Photographs; Prints; Records; Sculpture; Slides; Video Tapes
Special Subjects: Art History, Decorative Arts, Film, Illustration, Calligraphy, Commerical Art, Drawings, Etchings & Engravings, Graphic Arts, Graphic Design, Historical Material, Advertising Design, Cartoons, Lettering, Architecture
Activities: Lect open to public; 1 vis lect per year

A WILLIAMSTOWN ART CONSERVATION CENTER, 225 South St, Williamstown, MA 01267. Tel 413-458-5741; Fax 413-458-2314; Elec Mail wacc@williamstownart.org; Internet Home Page Address: www.williamstownart.org; *Dir* Thomas J Branchick
Open by appointment; Estab 1977
Income: $1,000,000 (financed by state appropriation & earned income)
Activities: Internships; lect open to public, 2-4 vis lectrs per year; IIC Keck Award 1996

WINCHESTER

M ARTHUR GRIFFIN CENTER FOR PHOTOGRAPHIC ART, 67 Shore Rd, Winchester, MA 01890. Tel 781-729-1158; Fax 781-721-2765; Elec Mail agcfpa@gis.net; Internet Home Page Address: www.griffincenter.org; *Exec Dir* Maria Lane; *Asst* Kaye Denny; *Asst* Ann Todisco
Open Tues - Sun Noon - 4 PM; Admis $5; Estab 1992 to promote historic & contemporary photography through photographic exhibitions; 1,500 sq ft modern gallery for photography; 6 shows per year; Average Annual Attendance: 5,000; Mem: 1,000
Income: mem, entrance fee & photo sales
Special Subjects: Photography
Collections: Photographic works of Arthur Griffin
Exhibitions: Annual Juried Photography Show
Publications: The Griffin News, newsletter
Activities: Classes for adults & children; lect open to public, 12-20 vis lectrs per year; gallery talks; juried competitions; original objects of art lent; book traveling exhibitions; originate traveling exhibitions to museums & galleries; museum shop sells books, original art & prints, magazines

WORCESTER

AMERICAN ANTIQUARIAN SOCIETY

For further information, see National and Regional Organizations

L BECKER COLLEGE, William F Ruska Library, 61 Sever St, Worcester, MA 01615-0071. Tel 508-791-9241, Ext 211; Fax 508-849-5131; Elec Mail plummer@go.becker.edu; *Asst Dir* Sharon Krauss; *Catalog & Reference Librn* Alice Baron; *Dean Library* Bruce Plummer
Open Mon - Thur 8 AM - 9 PM, Fri 8 AM - 5 PM, Sat 11 AM - 3 PM, Sun 2 PM - 10 PM; Estab 1887
Library Holdings: Slides; Video Tapes
Special Subjects: Graphic Design, Interior Design
Collections: Graphic Design; Interior Design
Publications: Acquisition List; Faculty Handbook, annual

M CLARK UNIVERSITY, The Schiltkamp Gallery/Traina Center for the Arts, 950 Main St, Worcester, MA 01610. Tel 508-793-7113; Fax 508-793-8844; Internet Home Page Address: www.clarku.edu; *Dir* Sarah Buie
Open Mon - Fri 9 AM - 5 PM; Sat Noon - 5 PM; Sun Noon - 10 PM; No admis fee; Estab 1976 to provide the Clark community & greater Worcester community the opportunity to view quality exhibitions of art, primarily, but not exclusively, contemporary; First floor foyer of the Traina Center for the Arts; Average Annual Attendance: 2,000
Income: Financed through the University
Exhibitions: Six to eight exhibitions per year of, primarily emerging artists & well-known artists
Publications: Announcements of exhibitions
Activities: Exhibitions; art events; gallery talks; Lectrs open to the public; 4-6 lectrs per year

L COLLEGE OF THE HOLY CROSS, Dinand Library, One College St, Worcester, MA 01610-2349. Tel 508-793-3372; Fax 508-793-2372; Elec Mail jhogan@holycross.edu; Internet Home Page Address: www.holycross.edu; *Dir* Dr James Hogan; *Assoc Dir* Karen Reilly
Open Sun - Thurs 8:30 AM - 1 AM, Fri & Sat 8:30 AM - 11 PM; mid-May - Sept summer hrs Mon - Fri 8:30 AM - 4:30 PM; Estab 1843 to support the academic study & research needs of a liberal visual arts department
Library Holdings: Book Volumes 600,000 for all campus, 23,294 in N clas; Compact Disks; DVDs; Exhibition Catalogs; Original Art Works; Periodical Subscriptions 1,500; Sculpture; Slides 94,000
Special Subjects: Art History, Decorative Arts, Film, Commerical Art, Graphic Arts, Painting-American, Theatre Arts, Fashion Arts, Industrial Design, Art Education, Antiquities-Byzantine, Antiquities-Greek, Architecture
Exhibitions: various exhibitions
Publications: Art reference bibliographies, semi-annual

M HIGGINS ARMORY MUSEUM, 100 Barber Ave, Worcester, MA 01606-2444. Tel 508-853-6015, 853-6015; Fax 508-852-7697; Elec Mail higgins@higgins.org; Internet Home Page Address: www.higgins.org; *Pres* Michael Pagano; *Dir & CEO* Kent dur Russell; *Dir Develop* Linda Barringer; *Program Dir* Heather Feland; *Sr Cur* Walter Karchester Jr; *Pual S Morgan Cur* Jeffrey Forgeng; *Registrar* Barbara Edsall; *VPres & VChmn* Stephan Pitcher; *Mus Shop Mgr* Anne Burke
Open Tues - Sat 10 AM - 4 PM, Sun Noon - 4 PM, cl Mon & major holidays; Admis adults $6.75, seniors $6, children 6-16 $5.75; Estab 1931 to collect & maintain arms, armor & related artifacts; Circ 6000; Museum has a Gothic Hall with high vaulted ceilings; Average Annual Attendance: 60,000; Mem: 400; dues $35-$100; annual meeting in Apr
Income: Financed by admis, mem, grants, gift shop & endowment
Special Subjects: Drawings, Graphics, Photography, Sculpture, African Art, Archaeology, Ethnology, Religious Art, Ceramics, Primitive art, Woodcarvings, Decorative Arts, Manuscripts, Painting-European, Glass, Asian Art, Carpets & Rugs, Historical Material, Juvenile Art, Tapestries, Miniatures, Mosaics, Gold, Stained Glass, Reproductions
Collections: Arms & armor from antiquity through the 1800s; art from related periods: paintings; tapestries; stained glass; woodcarvings
Exhibitions: Two special exhibitions per year
Publications: Quarterly calendar; Scholarly monographs
Activities: Classes for adults & children; dramatic programs; docent training; lect open to public, 10 vis lectrs per year; concerts; gallery talks; tours; competitions; scholarships offered; extension dept serves New York State to Miami; individual paintings & original objects of art lent to other museums; lending collection contains paintings, sculptures & several thousand objects of armor; book traveling exhibitions; originate traveling exhibitions; museum shop sells books, magazines, original art, reproductions, prints, slides & gifts

L Olive Higgins Prouty Library & Research Center, 100 Barber Ave, Worcester, MA 01606-2444. Tel 508-853-6015; Fax 508-852-7697; Elec Mail higgins@higgins.org; Internet Home Page Address: www.higgins.org; *Cur & Librn* Josephine Jacobs; *Vol Librn* Alan Catalano; *Cur* Jeffrey Forgeng; *Cur Asst* Christina Bauer
Open Wed 2 - 4 PM & by appointment; No admis fee for members; Estab 1968; Average Annual Attendance: 250
Library Holdings: Book Volumes 3000; Clipping Files; Exhibition Catalogs; Manuscripts; Memorabilia; Photographs
Special Subjects: Art History, Metalwork
Activities: Classes for adults & children; docent training; lect open to public, 6-12 vis lectrs per year; concerts; gallery talks; tours; extension dept servs New England & Middle Atlantic States; individual paintings & original objects of art lent to other museums; lending collection contains 3000 original art works, 40 paintings & 6 sculptures; museum shop sells books, magazines, reproductions & souvenirs

M WORCESTER ART MUSEUM, 55 Salisbury St, Worcester, MA 01609-3196. Tel 508-799-4406; Fax 508-798-5646; Elec Mail information@worcesterart.org; Internet Home Page Address: www.worcesterart.org; *Deputy Dir Administration* David Sjosten; *Dir Educ* Honee A Hess; *Cur Prints, Drawings & Photography* David L Acton; *Registrar* Deborah Diemente; *Chief Preparator & Exhib Designer* Patrick Brown; *Dir Operations* Francis Pedone; *Mgr Facility Usage* Janet Rosetti; *Cafe Mgr* Laurie Krohn-Andros; *Cur Asian Art* Louise Virgin; *Librn* Deborah Aframe; *Mus Shop Mgr* Susan Giordano; *Cur Contemporary Art* Susan Stoops; *Pres* Sarah Berry; *Dir Develop* Martin Richman; *Dir* James A Welu; *Chief Conservator* Rita Albertson
Open Wed - Fri 11 AM - 5 PM, Thur 11 AM - 8 PM, Sat 10 AM - 5 PM, Sun 1 -

5 PM, cl Mon, Tues & holidays; Admis adult $8, seniors & full-time students with current ID $6, members & children under 18 free, Sat 10 AM - noon free to all; Estab Museum 1896, School 1898. The Museum and School were founded for the promotion of art and art education in Worcester; for the preservation and exhibition of works and objects of art and for instruction in the industrial, liberal and fine arts. There are 42 galleries housed in a neoclassical building. The Higgins Education Wing, built in 1970, houses studios and classrooms and contains exhibition space for shows sponsored by the Education Department; Average Annual Attendance: 130,000; Mem: 4400, dues $45 - $65; annual meeting in Nov
Income: $6.5 million (financed by endowment, mem, private corporate contributions & government grants)
Library Holdings: Auction Catalogs; Book Volumes; Exhibition Catalogs; Pamphlets; Periodical Subscriptions; Slides
Special Subjects: Decorative Arts, Drawings, Etchings & Engravings, Landscapes, Ceramics, Sculpture, Painting-American, Prints, Watercolors, Pre-Columbian Art, Religious Art, Woodcuts, Jade, Asian Art, Silver, Painting-British, Painting-Dutch, Painting-French, Coins & Medals, Baroque Art, Painting-Flemish, Renaissance Art, Medieval Art, Antiquities-Oriental, Antiquities-Egyptian, Antiquities-Roman, Mosaics
Collections: John Chandler Bancroft Collection of Japanese Prints; American Paintings of 17th - 20th Centuries; British Paintings of 18th and 19th Centuries; Dutch 17th and 19th Century Paintings; Egyptian, Classical, Oriental and Medieval Sculpture; French Paintings of 16th - 19th Centuries; Flemish 16th - 17th Century Paintings; Italian Paintings of the 13th - 18th Centuries; Mosaics from Antioch; Pre-Columbian Collection; 12th Century French Chapter House; Paul Revere silver & engravings; Contemporary art
Exhibitions: (2005) Hope & Healing: Painting in Italy in a Time of Plague 1500-1800
Publications: American Portrait Miniatures: The Worcester Art Museum Collection; In Battle's Light: Woodblock Prints of Japan's Early Modern Wars; Calendar of Events, quarterly; The Second Wave: American Abstractions of the 1930s & 1940s; A Spectrum of Innovation: American Color Prints, 1890 - 1960; Paths to Impressionism: French & American Landscape Paintings; Photography at the Worcester Art Museum: Keeping Shadows
Activities: Classes for adults & children; docent training; lect open to public, 10-15 vis lectrs per year; symposia; concerts; gallery talks; tours; scholarships offered; organize traveling exhibitions; museum shop sells books, reproductions, jewelry & exhibition-related merchandise
L **Library,** 55 Salisbury St, Worcester, MA 01609-3196. Tel 508-799-4406, Ext 3070; Fax 508-798-5646; Internet Home Page Address: www.worcesterart.org; *Librn* Debby Aframe; *Asst Librn* Christine Clayton
Open Wed - Fri 11 AM - 5 PM, Sat 10 AM - 5 PM Sept - May & by appointment during academic year; Estab 1909 to provide resource material for the Museum Departments; Maintains non-circulating collection only
Library Holdings: Auction Catalogs; Book Volumes 46,000; Exhibition Catalogs; Other Holdings Auction & sale catalogues; Pamphlets; Periodical Subscriptions 100; Slides
Special Subjects: Painting-American, Painting-Flemish, Painting-European, Asian Art, Antiquities-Greek, Antiquities-Roman
Exhibitions: Periodic book displays related to museum exhibitions and special library collections
Activities: Tours

M **WORCESTER CENTER FOR CRAFTS,** Krikorian Gallery, 25 Sagamore Rd, Worcester, MA 01605. Tel 508-753-8183; Fax 508-797-5626; Elec Mail wcc@worcestercraft.org; *Exec Dir* Maryon Attwood; *Pub Relations & Mktg* Amy Black; *Develop* David Leach
Open Mon - Fri 8:30 AM - 8:30 PM, Sat 10 AM - 5 PM, cl Sun; No admis fee; Estab 1856 for educational exhibits of historic & contemporary crafts; Professionally lighted & installed 40 x 60 gallery with six major shows per yr in main gallery; Average Annual Attendance: 20,000; Mem: 1000; dues $40 & up
Income: Financed by mem, grants, contributions & endowment
Special Subjects: Crafts
Collections: Collection contains 200 books, 2000 Kodachromes, 300 photographs
Exhibitions: 10 exhibits per yr; major exhibit focus on 3-D art, reflects work from studio-visual art
Publications: On-Center, newsletter; school for professional crafts brochures; 3 course catalogs, yearly
Activities: Classes for adults & children; weekend professional workshops; 2 year full-time program in professional crafts; lect open to public, 4 vis lectrs per year; gallery talks; tours; scholarships & fels offered; City Outreach Program brings crafts to pub schools; book traveling exhibitions 2 per year; traveling exhibitions organized and circulated anywhere in Massachusetts; supply shop & gift shop sell books, original craft objects

MICHIGAN

ADRIAN

M **SIENA HEIGHTS COLLEGE,** Klemm Gallery, Studio Angelico, 1247 E Siena Heights Dr, Adrian, MI 49221. Tel 517-264-7863; Fax 517-264-7739; Elec Mail pbarr@sienahts.edu; Internet Home Page Address: www.sienahts.edu/~art; *Dir* Dr Peter Barr
Open Tues- Fri 9 AM - 4 PM, Sun Noon - 4 PM, cl major holidays & summers; No admis fee; Estab 1970's to offer cultural programs to Lenawee County & others; Average Annual Attendance: 6,000
Income: Funded by college
Special Subjects: Graphics, Decorative Arts
Exhibitions: Invitational Artists Shows; major national culturally-based exhibitions; professional artists & student shows; fall semester 3 month-long solo or group exhibitions
Activities: Classes for adults; lect open to public, gallery talks; tours; performances; scholarships offered
L **Art Library,** 1247 E Siena Heights Dr, Adrian, MI 49221. Tel 517-264-7152; Fax

517-264-7711; Elec Mail sbeck@sienahts.edu; Internet Home Page Address: www.sienahts.edu/~libr/library.htm; *Public Servs Librn* Melissa M Sissen; *Cataloging* Mark Dombrowski
Open Mon - Fri 8:30 AM - 11 PM, Sat Noon - 5 PM, Sun 1 - 11 PM
Income: Funded by college
Library Holdings: Audio Tapes; Book Volumes 10,000; Cards; Cassettes; Clipping Files; Fiche; Filmstrips; Pamphlets; Periodical Subscriptions 35; Photographs; Records; Reels; Slides; Video Tapes

ALBION

M **ALBION COLLEGE,** Bobbitt Visual Arts Center, 611 E Porter, Albion, MI 49224. Tel 517-629-0246; Fax 517-629-0752; Elec Mail bwickre@albion.edu; Internet Home Page Address: www.albion.edu; *Chmn & Prof* Lynne Chytilo, MFA; *Prof Emer* Frank Machek, MFA; *Prof* Douglas Goering, MFA; *Assoc Prof* Dr Bille Wickre, PhD; *Assoc Prof* Anne McCauley, MFA; *Asst Prof Art History* Kara Marrow; *Visiting Asst Prof* Gary Wahl; *Asst Prof* Anne Barber
Open Mon - Thurs 9 AM - 9 PM, Fri 9 AM - 5 PM, Sat 10 AM - 2 PM; No admis fee; Estab 1835 to offer art education at college level & general art exhibition program for campus community & public; Maintains one large gallery & one print gallery
Income: Privately funded
Special Subjects: Prints, African Art, Ceramics, Glass
Collections: African Art; ceramics; glass; prints
Exhibitions: From the Print Collection; Pieces from the Permanent Collection; various one-person & group exhibitions, contemporary artists
Activities: Lect open to public, 4-8 vis lectrs per year; gallery talks; competitions with awards; scholarships offered; individual paintings & original objects of art lent to academic institutions, museums & galleries; lending collection contains 2350 original prints; originate traveling exhibition

ALPENA

M **JESSE BESSER MUSEUM,** 491 Johnson St, Alpena, MI 49707-1496. Tel 517-356-2202; Fax 517-356-3133; Elec Mail jbmuseum@northland.lib.mi.us; *Dir* Jan V McLean, PhD
Open Tues - Sat 10 AM - 5 PM, Sun Noon - 4 PM; Adults $3, seniors, students & children $2; Estab assoc 1962, building open to pub 1966, an accredited mus of history, science & art serving northern Michigan; Mus has a research library, a planetarium, a Foucault Pendulum, Indian artifact collection, Avenue of shops, lumbering exhibits & preserved furnished historical buildings on grounds. Also on grounds, sculptured fountain by artist Glen Michaels. Three galleries are utilized for shows, traveling exhibits, & changing exhibitions of the Museum's collection of modern art & art prints, decorative arts & furniture. There are 260 running ft of wall space on lower level, 1250 sq ft & 16 45 sq ft on upper level galleries; Average Annual Attendance: 25,000
Income: Financed by Besser Foundation, federal & state grants, private gifts & donations, Museums Founders Soc, Operation Support Grant from Michigan Council for the Arts, & other sources
Special Subjects: Drawings, Graphics, Painting-American, Photography, Prints, American Indian Art, Archaeology, Costumes, Ceramics, Crafts, Folk Art, Pottery, Etchings & Engravings, Landscapes, Decorative Arts, Manuscripts, Posters, Dolls, Furniture, Glass, Porcelain, Marine Painting, Maps, Dioramas, Laces
Collections: Art prints; Clewell pottery; contemporary Native American art; maps of the Great Lakes; modern art; photography
Exhibitions: Changing exhibitions of all major collecting areas & touring exhibits; Northeast Michigan Juried Art
Activities: Classes for adults & children; art workshops; seminars; docent training; lect open to public, 5 vis lectrs per year; gallery talks; tours; competitions with awards; book traveling exhibitions 8 per year; originate traveling exhibitions; museum shop sells books, magazines, original art, handicrafts
L **Philip M Park Library,** 491 Johnson St, Alpena, MI 49707. Tel 517-356-2202; Fax 517-356-2202; *Dir* Jan V McClean, PhD; *Coll Mgr* Janet Smoak
Library open Tues - Sat 10 AM - 5 PM, Sun Noon - 4 PM; Admis adults $3, children 5 - 7 & seniors $2; Museum estab 1966; Art, history & science exhibits; Average Annual Attendance: 25,000
Library Holdings: Book Volumes 4200; Cassettes; Clipping Files; Exhibition Catalogs; Fiche; Manuscripts; Maps; Original Documents; Pamphlets; Periodical Subscriptions 46; Photographs; Prints; Reels; Slides; Video Tapes
Special Subjects: Art History, Folk Art, Decorative Arts, Painting-American, Prints, Ceramics, Printmaking, American Indian Art, Glass, Dolls, Pottery, Restoration & Conservation, Flasks & Bottles, Architecture
Collections: History, art, & science
Activities: Educ program; classes for adults & children; docent training; gallery talks, tours, competitions

ANN ARBOR

A **ANN ARBOR ART CENTER,** Art Center, 117 W Liberty, Ann Arbor, MI 48104. Tel 734-994-8004, ext 110; Fax 734-994-3610; Elec Mail a2artcen@aol.com; Internet Home Page Address: www.annarborartcenter.org; *CEO & Pres (V)* Marsha Chamberlin; *Gallery Dir* Deborah Campbell; *Dir Operations* Martin Rifedorph; *Dir Education* Casey Gallagher; *Chm (V)* William Newman
Open Mon - Fri 9 AM - 6 PM, Sat 10 AM - 6 PM, Sun Noon - 5 PM; Estab 1909 to provide for the well-being of the visual arts through programs that encourage participation in & support for the visual arts, as well as foster artistic development; Maintains 750 sq ft of exhibit gallery space with monthly shows; & 1300 sq ft sales - rental gallery next to exhibit areas; classes in studio art & art appreciation; special events; Average Annual Attendance: 52,000; Mem: 1300; dues vary; annual meeting in Feb
Income: Financed by mem, Michigan Council for the Arts grant, rental of studios & retail sales
Exhibitions: Michigan Artists for the Home, 2 week show in art furnished new home with all works for sale

Publications: Class catalog, quarterly; gallery announcements, monthly; lecture listings, quarterly; newsletter, quarterly

Activities: Classes for adults & children; artist workshops on professional development; lect open to public, 4-6 vis lectrs per year; gallery talks; tours; competitions with prizes; scholarships offered; exten dept lends individual paintings & original objects of art to organizations & community facilities; sales shop sells original art & fine contemporary crafts

A **ARTRAIN, INC,** 1100 N Main St Ste 106, Ann Arbor, MI 48104. Tel 734-747-8300; Fax 734-7428530; Internet Home Page Address: www.artrainUSA.org; *Chmn* Burt Althaver; *Exec Dir* Debra Polich
No admis fee; Estab 1971 to tour major art exhibits throughout the nation & provide catalyst for community arts development; Traveling art museum in a train; consists of converted railroad cars with large walls & cases; Average Annual Attendance: 122,000

Income: Financed by endowment, state appropriation, individual foundation & corporation campaigns

Publications: Exhibition catalogs; newsletter

Activities: Classes for children; docent training; lect open to public; competitions; book traveling exhibitions; museum shop sells exhibit related items

A **MICHIGAN GUILD OF ARTISTS & ARTISANS,** Michigan Guild Gallery, 118 N Fourth Ave, Ann Arbor, MI 48104. Tel 734-662-3382; Fax 734-662-0339; Elec Mail stoddard@michiganguild.org; Internet Home Page Address: www.michiganguild.org; *Gallery Coordr* Esther Kirshenbaum; *Gallery Coordr* Pamela Stoddard; *Exec Dir* Josephine Kelsey; *Receptionist* Audrey Libke
Open Mon - Fri 9 AM - 5 PM; No admis fee; Estab with no percentage, small artist fee for artists who have never had an exhib locally & artists with new, unshown work; Small, street level; highly thought of locally; Average Annual Attendance: 2,000; Mem: 1100; dues $45-$75; annual meeting in July

Income: Financed by mem fees & art fair fees

Publications: Mem newsletter, bi-monthly

Activities: Educ dept provides workshops; lect open to public; concerts; member art shown in pub places

UNIVERSITY OF MICHIGAN

M **Museum of Art,** Tel 734-764-0395; Fax 734-764-3731; Elec Mail umma.info@umich.edu; Internet Home Page Address: www.umma.umich.edu; *Dir* James Steward; *Chief Admin Officer* Kathryn Huss; *Dir Mus Communications* Karen Goldbaum; *Dir Educ* Ruth Slavin; *Dir Development & External Relations* Melanie Hoff
Open year round Tues, Sat, Sun 11 AM - 6 PM, Wed, Thu, Fri 11 AM - 10 PM; No admis fee; Estab 1946, as a university art mus & mus for the Ann Arbor community; Average Annual Attendance: 120,000; Mem: 1400; dues individual $40

Income: Financed by state appropriation other federal and state agencies, and private donations

Special Subjects: Drawings, Painting-American, Photography, Prints, Sculpture, Watercolors, American Western Art, African Art, Religious Art, Etchings & Engravings, Landscapes, Afro-American Art, Painting-European, Painting-Japanese, Portraits, Porcelain, Asian Art, Restorations, Tapestries, Baroque Art, Painting-Flemish, Renaissance Art, Medieval Art, Painting-Italian, Stained Glass

Collections: Arts of the Western World from the Sixth Century AD to the Present; Asian, Near Eastern, African & Oceanic, including ceramics, contemporary art, decorative art, graphic arts, manuscripts, painting, sculpture

Exhibitions: (1/20/2007-3/18/2007) Embracing Eatonville; (3/31/2007-6/3/2007) Imagining Eden: Connecting Landscapes

Publications: Bulletin of the Museum of Art & Archaeology, irregular; bimonthly Insight, Catalogues & Gallery Brochures, irregular

Activities: Educ dept; docent training; community days; lect open to public, vis lectrs; gallery talks; tours; concerts; individual paintings & original objects of art lent to other museums; originate traveling exhibitions to national & international museums; mus shop sells publications, posters, postcards & gifts

M **Kelsey Museum of Archaeology,** Tel 734-764-9304; Fax 734-763-8976; Internet Home Page Address: www.lsa.umich.edu/kelsey; *Dir* Sharon C Herbert; *Cur* Elaine K Gazda; *Assoc Cur* Janet Richards; *Assoc Cur* Terry Wilfong; *Assoc Cur* Thelma Thomas; *Assoc Dir & Assoc Cur Educ* Lauren E Talalay; *Conservator* Suzanne Davis; *Exhibit Preparator* Scott Meier; *Coordr of Mus Visitor Programs* Todd Gerring; *Cur* Margaret Root; *Assoc Cur* Sue Alcock; *Conservator* Claudia Chemello; *Communications Editor* Margaret Lourse; *Mus Coll Mgr* Michelle Fortenot; *Mus Coll Mgr* Sebastian Encina
Open Tues - Fri 9 AM - 4 PM, Sat & Sun 1 - 4 PM; No admis fee; Estab 1928; Four small galleries are maintained; Average Annual Attendance: 37,000

Special Subjects: Sculpture, Bronzes, Textiles, Pottery, Ivory, Antiquities-Egyptian, Antiquities-Greek, Antiquities-Roman

Collections: Objects of the Graeco-Roman period from excavations conducted by the University of Michigan in Egypt & Iraq; Greece, Etruria, Rome & provinces: sculpture, inscriptions, pottery, bronzes, terracottas; Egyptian antiquities dynastic through Roman; Roman & Islamic glass, bone & ivory objects, textiles, coins; 19th century photographs

Publications: Biannual newsletter; Bulletin of the Museums of Art & Archaeology, irregular; Kelsey Museum Studies Series, irregular

Activities: Educ dept; docent training; traveling educational kits, family day events; lect open to public, 4 vis lectrs per year; tours; original objects of art lent to other museums upon request; book traveling exhibitions; originate traveling exhibitions to museums with similar collections; sales shop sells books, t-shirts, totebags, pencils, postcards, games, jewelry, reproductions & exhibition catalogs

M **Jean Paul Slusser Gallery,** Tel 734-936-2082; Fax 734-615-6761; Elec Mail slussergallery@umich.edu; Internet Home Page Address: www.umich.edu/~webteam/SOAD/; *Dir* Todd Cashbaugh
Open Tues & Thurs Noon - 8 PM, Wed, Fri, Sat & Sun 11 AM - 4 PM; No admis fee; Estab 1974; Gallery is located on the main floor of the Art & Architecture Building. Comprised of 3600 sq ft of exhibition space; Average Annual Attendance: 11,000

Income: Financed by School of Art general fund

Collections: Artifacts of the School's history; works by faculty & alumni of the University of Michigan School of Art

Exhibitions: Emese Bencsur; Olafur Eliasson; Annika Eriksson; Anna Gaskell; Liam Gillick; Carsten Holler; Pierre Huyghe; Koo Jeong-a; Aernout Mik; Manfred Pernice; Stephanie Rowden; Superflex; Apolonija Sustersic; Elin Wikstrom; Andrea Zittel

Publications: catalogues

Activities: Lects open to public, 11 vis lectrs per year; gallery talks; books 2 traveling exhibs per yr; sales shop sells books

L **Asian Art Archives,** Tel 734-764-5555; Fax 734-647-4121; Elec Mail wholden@umich.edu; *Sr Assoc Cur* Wendy Holden
Open Mon - Fri 9 AM - 5 PM; Estab 1962 for study & research. Contains 180,000 black & white photographs of Asian art objects or monuments. Library also houses the Asian Art Photographic Distribution, a nonprofit business selling visual resource materials dealing with Chinese & Japanese art. Houses Southeast Asia Art Foundation Collection of 100,000 slides & photographs of Southeast Asian art; For research only

Income: $5000 (financed by endowment, federal funds)

Purchases: $4000 - $5000

Library Holdings: Book Volumes 50; Clipping Files; Exhibition Catalogs; Fiche 10,000; Other Holdings Black/white negatives 26,000; Photographs 80,000; Reels; Reproductions 3000; Slides

Special Subjects: Art History, Decorative Arts, Calligraphy, Graphic Arts, Islamic Art, Ceramics, Bronzes, Asian Art, Ivory, Jade, Glass, Gold, Landscapes, Coins & Medals, Architecture

Collections: National Palace Museum, Taiwan, photographic archive; Chinese art, painting, decorative arts; Southeast Asian Art Archive, sculpture, architecture; Islamic Art Archive; Asian Art Archive, Chinese & Japanese arts, painting

Publications: Newsletter, East Asian Art & Archaeology (three issues per year)

L **Fine Arts Library,** Tel 734-764-5405; Fax 734-764-5408; Elec Mail finearts@umich.edu; Internet Home Page Address: www.lib.umich.edu/finearts; *Head Fine Arts Library, Head Librn* Deirdre Spencer; *Information Resources Specialist* Laura Navarra; *Information Resources Asst* Myrtle Hudson; *Information Resources Supv* Katherine Kuehn
Open Mon - Thurs 8 AM - 10 PM, Fri 8 AM - 5 PM, Sat 1 PM - 6 PM, Sun 1 - 10 PM, summer hrs Mon - Thurs 8 AM - 8 PM, Fri 8 AM - 5 PM, Sun 1 - 5 PM, cl Sat; Estab 1949, to support the academic programs of the History of the Art Department, including research of faculty & graduate students; Circ 17,200

Income: Financed by state appropriation

Library Holdings: Book Volumes 100,000; Compact Disks; Exhibition Catalogs; Fiche; Filmstrips; Other Holdings Marburger index of photographic documentation of art in Germany; Pamphlets; Periodical Subscriptions 232; Reels

Special Subjects: Art History, Islamic Art, Painting-American, Painting-British, Painting-Dutch, Painting-Flemish, Painting-European, History of Art & Archaeology, Oriental Art, Antiquities-Byzantine, Antiquities-Etruscan, Antiquities-Greek, Antiquities-Roman

L **Slide & Photograph Collection,** Tel 734-764-5400; Fax 734-647-4121; *Photographer* Jeri Hollister; *Sr Assoc Cur & Asian Art Archives* Wendy Holden
Open Mon - Fri 8 AM - 5 PM; Estab 1911, as a library for teaching & research collection of slides & photos of art objects; limited commercial distribution; nonprofit slide distribution projects; (Asian Art Photographic Distribution; Univ of Mich Slide Distribution); For research only

Income: Financed by state appropriation

Library Holdings: Lantern Slides; Photographs 200,000; Reproductions; Slides 290,000

Special Subjects: History of Art & Archaeology

Collections: Berenson's I Tatti Archive; Courtauld Institute Illustration Archive; Islamic Archives; Palace Museum Archive (Chinese painting); Romanesque Archive (sculpture & some architecture concentrating on Burgundy, Southwestern France, Spain & southern Italy); Southeast Asian & Indian Archives

Activities: Materials lent only to University of Michigan faculty & students

L **Media Union Library,** Tel 734-647-5735; Fax 734-764-4487; Elec Mail mu.ref@umich.edu; Internet Home Page Address: www.lib.umich.edu/ummu/; *Visual Resources Librn & Selector Art & Design, Architecture & Urban Planning Librn* Rebecca Price; *Head Librn & Dir Arts & Engineering Librs* Michael D Miller; *Art & Design Field Librn* Annette Haines
Open 24 hrs daily for students, 8 AM - 10 PM for non-students; Estab to support the teaching & research activities of the School of Art & the College of Architecture & Urban Planning

Library Holdings: Audio Tapes; Book Volumes 75,000; CD-ROMs 120; Cards; Cassettes 100; Clipping Files; DVDs 10; Exhibition Catalogs; Fiche; Filmstrips; Kodachrome Transparencies; Lantern Slides 17,000; Manuscripts; Maps 100; Micro Print; Original Art Works; Other Holdings Digital Images 20,000; Pamphlets; Periodical Subscriptions 400; Photographs 30,000; Reels; Sculpture; Slides 105,000; Video Tapes 1350

Special Subjects: Tapestries

Activities: 1500 computer workstations with various software

BATTLE CREEK

M **ART CENTER OF BATTLE CREEK,** 265 E Emmett St, Battle Creek, MI 49017. Tel 616-962-9511; Fax 616-969-3838; Elec Mail acbc@net-link.net; *Educ Dir* Joanna Stelloh; *Admin Asst* Keri Steele; *Museum Shop Mgr* Besty Wagner; *Outreach Coord* Linda Tafolla; *Exec Dir* Dean Adkins; *Pres (V)* Lorrie Zorbo; *Cur Exhibs* Katherine O'Brien; *Operation Mgr* Sue Case
Open Mon - Sat 10 AM - 5 PM, Sun Noon - 5 PM, cl Aug & legal holidays; No admis fee, $2 donation; Estab 1948 to offer classes for children & adults & to present monthly exhibitions of professional work; Four galleries of varying sizes with central vaulted ceiling gallery, track lighting & security; Average Annual Attendance: 30,000; Mem: 750; dues $15; annual meeting in Sept

Income: Financed by mem, endowment fund, grants, UAC, special projects, tuition, sales of artwork

Collections: Michigan Art Collection featuring 20th century Michigan artists

Exhibitions: Group & Solo Shows: Paintings; Photography; Prints; Sculpture; Crafts; American Art 40s & 50s; Artist's competitions

Publications: Newsletter, bi-monthly

Activities: Classes for adults & children; docent training; workshops & programs; lect open to public, 5 vis lectrs per year; gallery talks; tours; competitions with prizes; scholarships offered; individual paintings & original objects of art lent to

qualified institutions; book traveling exhibitions 1-2 per year; originate traveling exhibitions to museums & art centers; museum shop sells original art by Michigan artists; KidSpace hands-on gallery

L Michigan Art & Artist Archives, 265 E Emmett St, Battle Creek, MI 49017. Tel 616-962-9511; Fax 616-969-3838; Elec Mail artcenterofbc@yahoo.com; Internet Home Page Address: www.artcenterofbattlecreek.org; *Exec Dir* Linda Holderbaum; *Educ Coordr* Kay Doyle; *Office Mgr* Keri Steele
Tues - Fri - 10 AM - 5 PM, Sat 11 AM - 3 PM; Adult $3, seniors & students $2, free Thurs; Estab 1946; 3 exhib galleries; Average Annual Attendance: 10,000; Mem: 300
Library Holdings: Book Volumes 550; Clipping Files; Exhibition Catalogs; Original Art Works; Periodical Subscriptions 12; Photographs; Sculpture; Slides
Special Subjects: Art History, American Indian Art, Afro-American Art, Antiquities-Egyptian
Exhibitions: Exhibs change monthly
Activities: Classes for adults & children; docent training; lects open to public; gallery talks; tours; sponsoring of competitions; sales shop; original art

BAY CITY

M BAY COUNTY HISTORICAL SOCIETY, Historical Museum of Bay County, 321 Washington Ave, Bay City, MI 48708. Tel 517-893-5733; Fax 517-893-5741; *Exec Dir* Gay McInerney
Open Mon - Fri 10 AM - 5 PM, Sat & Sun Noon - 4 PM; No admis fee; Estab 1919 to preserve, collect, & interpret the historical materials of Bay County; 2 new permanent galleries; 1 features 7 period rooms; the other interactive displays - Selling Mrs. Consumer & Bay City: Seaport to the World ; Average Annual Attendance: 60,000; Mem: 500; dues corporate $500, patron $100, small business $50, sustaining $25; annual meeting in Apr
Income: Financed by mem, gift shop, county funds
Special Subjects: Photography, American Indian Art, Anthropology, Archaeology, Textiles, Crafts, Landscapes, Decorative Arts, Historical Material, Period Rooms
Collections: Hand crafts, photographs, portraits, quilts; Patrol Craft Sailor Association National Collections; mid-1800 - post WW II historical material; native American materials & paintings; sugar beet history (memorabilia & materials)
Publications: Anishinabe - People of Saginaw; Ghost Towns & Place Names; Historic Architecture of Bay City, Michigan; Vanished Industries; Women of Bay County
Activities: Classes for adults & children; home tours; historical encampment; living history programs; traveling displays & educational kits; lect open to public, 2-3 vis lectrs per year; gallery talks; tours; museum shop sells books, reproductions, hand crafts, historical gifts

BIRMINGHAM

A BIRMINGHAM-BLOOMFIELD ART CENTER, Art Center, 1516 S Cranbrook Rd, Birmingham, MI 48009. Tel 248-644-0866; Fax 248-644-7904; Internet Home Page Address: www.bbartcenter.org; *Pres* Steven Horn; *VPres* Amy Kantgias; *Treas* Barbara Gasper; *Assoc Dir* Cynthia K Mills; *Financial Mgr* Diane Henninger; *Educ* Debra Callahan; *Exhib* Chelsea Romero; *Exec Dir* Jane Linn; *Student Servs* Marjorie Sikora; *Festival & Gallery Shop Dir.* Peggy Kerr; *Mem & Communications Mgr* Diane Taylor; *Develop Dir* Sarah Jacobs
Open Mon - Thurs 9 AM - 7 PM, Fri 9 AM - 5 PM, Sat 9 AM - 5 PM, cl Sun; No admis fee; Estab 1957 to provide a community-wide, integrated studio-gallery art center; to enhance life within our region by promoting the appreciation and understanding of the arts; 5 gallery spaces; Average Annual Attendance: 30,000; Mem: 2000; dues $50 & up; annual meeting in May
Income: $1,200,000 (financed by mem, tuitions, special events funding & donations)
Collections: Sol LeWitt Wall Drawing
Exhibitions: Annual Michigan Fine Arts Competition; juried exhibits & competitions; local high school exhibit; local and regional artist groups; traveling exhibition
Publications: class brochure; bi-annual newsletter
Activities: Classes for adults & children; Art Smart Program; lect open to public, 2-3 vis lectrs per year; local & international art tours; competitions with prizes; holiday shop; children's art camp and interdisciplinary art camps; annual festival; scholarships offered; gallery shop sells original art

BLOOMFIELD HILLS

M CRANBROOK ART MUSEUM, (Cranbrook Academy of Art) Cranbrook Art Museum, 39221 Woodward Ave, Box 801 Bloomfield Hills, MI 48303-0801. Tel 248-645-3323; Fax 248-645-3324; Elec Mail artmuseum@cranbrook.edu; Internet Home Page Address: www.cranbrook.edu; *Cur of Exhib* Brian Young; *Admin Mgr* Denise Collier; *Preparator* Abbey Newbold; *Dir* Greg Wittkopp; *Admin Asst, Tour Coordr* Vanessa Glasby; *Registrar* Roberta Frey Gilboe; *Mgr, The Store* Heather Ashare; *Cur Educ* Elena Ivanova
Open Wed - Sun 11 AM - 5 PM, every 4th Fri 11 AM - 9 PM, cl Mon, Tues & major holidays; Admis adults $6, students & seniors $4, under 12 free; Estab 1930; Modern and contemporary art, crafts, architectural and design museum; Average Annual Attendance: 37,000; Mem: 900; dues family $65, individual $45
Special Subjects: Architecture, Drawings, Graphics, Painting-American, Photography, Prints, Sculpture, Textiles, Ceramics, Crafts, Pottery, Etchings & Engravings, Decorative Arts, Furniture, Porcelain, Silver, Metalwork, Tapestries
Collections: Artists associated with Cranbrook Academy of Art: ceramics by Maija Grotell; architectural drawings & decorative arts by Eliel Saarinen; porcelains by Adelaide Robineau; sculpture by Carl Milles; contemporary paintings; 19th century prints; study collection of textiles; prints & ceramics; Shuey Collection: paintings and sculptures by Albers, Dubuffet, Judd, Dekooning, Lichtenstein, Martin, Motherwell, Rauschenberg, Riley, Stella, Wartol and more
Exhibitions: 13 exhibitions annually of contemporary art, architecture & design
Activities: Docent training; dramatic programs; lect open to public, 18 vis lectrs per year; gallery talks; tours; concerts; individual paintings & original objects of

art lent to other institutions; book traveling exhibitions 1-2 per yr; originate traveling exhibitions & circulate to other museums national & international; museum shop sells books, magazines, original art, reproductions, gift items & cards

L Library, 39221 Woodward Ave, Bloomfiled Hills, MI 48303-0801; PO Box 801, Bloomfield Hills, MI 48303-0801. Tel 248-645-3355; Fax 248-645-3464; Internet Home Page Address: www.cranbrook.edu/library; *Dir Library* Judy Dyki; *Librn* Mary Beth Kreiner; *Librn* Denise Dorantes; *Library Asst* Heather Stapelman
Open Mon - Thurs 9 AM - 5 PM & 7 - 10 PM, Fri 9 AM - 5 PM, Sat 1 - 5 PM, Sun 1 - 5 PM; Estab 1928 to support research needs of Art Academy & Mus; Library is for Academy students, faculty & staff; open to pub for reference only
Income: Financed by academy
Library Holdings: Audio Tapes; Book Volumes 25,000; Cassettes 800; Clipping Files; DVDs 800; Exhibition Catalogs; Other Holdings Masters theses; Periodical Subscriptions 190; Slides 45,000; Video Tapes 1,400
Special Subjects: Art History, Photography, Graphic Arts, Sculpture, Ceramics, Printmaking, Metalwork, Architecture

DEARBORN

M ARAB AMERICAN NATIONAL MUSEUM, 13624 Michigan Ave, Dearborn, MI 48126. Tel 313-582-AANM; Fax 313-582-1086; Elec Mail aanm@accesscommunity.org; Internet Home Page Address: www.theaanm.org; *Dir* Dr Anan Ameri
Open Wed, Fri & Sat 10 AM - 6 PM, Thurs 10 AM - 8 PM, Sun 12 - 5 PM. Cl Mon & Tues, New Year's Day, Thanksgiving Day & Christmas Day; Admis adults $6, seniors 62 & up, students w/ID & children 6 - 12 $3, children 5 & under no admis fee; 2005; Average Annual Attendance: 35,000; Mem: 2,000; $65 family, twice yr
Special Subjects: Drawings, Historical Material, Ceramics, Glass, Metalwork, Photography, Textiles, Manuscripts, Maps, Sculpture, Graphics, Ethnology, Costumes, Religious Art, Pottery, Woodcarvings, Decorative Arts, Posters, Furniture, Jewelry, Oriental Art, Calligraphy, Islamic Art, Mosaics, Reproductions
Collections: Art; three-dimensional artifacts; documents; personal papers; photographs
Exhibitions: "Coming to America" is an exhibit that examines the history of Arab American immigration from 1500 to the present, with spec emphasis on waves of immigration since the 1800s; "Living in America" focuses on the life of Arab Americans in the US at different time periods, and examines such topics as family life, religion, activism and political involvement, institution-building, work, and leisure.; "Making an Impact " highlights the contributions of individuals and community organizations
Activities: Adult & children classes; tours avail by appt; 10 vis lctr per yr; AANM book awards; museum shop sells books, original art & reproductions

C FORD MOTOR COMPANY, Henry Ford Museum & Greenfield Village, 20900 Oakwood Blvd Dearborn, MI 48124; PO Box 1970 Dearborn, MI 48121-1970. Tel 313-271-1620; Internet Home Page Address: www.hfmgu.or; *Marketing* Carol Zazo; *Publicist* Wendy Metrou
Open Mon - Fri 9 AM - 5 PM, cl Christmas & Thanksgiving; Admis $7.50 - $14; Estab 1929

DETROIT

A CASA DE UNIDAD UNITY HOUSE, 1920 Scotten, Detroit, MI 48209. Tel 313-843-9598; Fax 313-843-7307; Elec Mail casadeu@www.net.com; Internet Home Page Address: www.casadeu.com; *Co-Dir* Marta Lagos; *Co-Dir* David Conklin
Open Mon - Fri 9 AM - 5 PM ; Estab 1981 as a cultural arts & media center exhibiting works of Latino artists
Income: Financed by city & state appropriation, individual & corporate donations
Activities: Annual Unity in the Community Festival; sales shop sells books & poetry

L CENTER FOR CREATIVE STUDIES, College of Art & Design Library, 201 E Kirby, Detroit, MI 48202-7803. Tel 313-872-3118, Ext 263; Fax 313-872-8377; Elec Mail admission@ccscad.edu; Internet Home Page Address: www.ccscad.edu; *Slide Librn* Donna Rundels; *Librn* Jean Peyrat; *Visual Cur* Lisa Morrow; *Dir* Lynell Morr; *Reference Librn* Beth Walker
Open Mon - Fri 8:30 AM - 4:30 PM, Sat 1 - 4 PM; Estab 1966 to serve students & faculty of an undergraduate art school. Primarily a how-to, illustrative collection
Income: Financed by private school
Library Holdings: Book Volumes 23,000; Exhibition Catalogs; Periodical Subscriptions 72; Slides 70,000
Special Subjects: Photography, Graphic Design, Crafts, Advertising Design, Industrial Design

M CENTRAL UNITED METHODIST CHURCH, Swords Into Plowshares Peace Center & Gallery, 33 E Adams, Detroit, MI 48226. Tel 313-963-7575; Fax 313-963-2569; Elec Mail swordsintoplowshares@prodigy.net; Internet Home Page Address: www.swordsintoplowshares.org; *Admin Asst* Lois St Aubin White
Open Tues, Thurs & Sat 11 AM - 3 PM; No admis fee; Estab 1985 to use the arts for peace in the world; Main gallery 1,475 sq ft, height 13 ft 7 inches; multipurpose gallery 1,043 sq ft, height 7 ft 8 inches; second floor balcony gallery 357 sq ft, height 7 ft 3 inches. Maintains reference library; Average Annual Attendance: 7,000; Mem: annual meeting in Mar
Income: $55,000 (financed by endowment, individuals, city & state appropriation, grants, sales, local churches)
Library Holdings: Audio Tapes; Book Volumes; Cassettes; Clipping Files; Exhibition Catalogs; Kodachrome Transparencies; Lantern Slides; Memorabilia; Original Art Works; Photographs; Reproductions; Sculpture; Slides; Video Tapes
Special Subjects: Architecture, Graphics, Painting-American, Prints, American Indian Art, Religious Art, Ceramics, Folk Art, Pottery, Woodcarvings, Etchings & Engravings, Landscapes, Afro-American Art, Painting-Japanese, Posters,

Painting-Canadian, Painting-French, Maps, Calligraphy, Embroidery, Cartoons, Painting-Australian, Painting-German, Reproductions, Painting-Israeli
Collections: Peace Art Collection (permanent)
Publications: Harbinger Newsletter, 3-4 times per year; periodic exhibit catalogs
Activities: Classes for adults & children; docent training; 4 -6 concerts per year; gallery talks; tours; individual paintings & original objects of art lent; book traveling exhibitions 5-6 per year; museum shop sells books, original art, reproductions, cards, t-shirts & posters

M DETROIT ARTISTS MARKET, 4719 Woodward Ave Detroit, MI 48201-0000; 4710 Woodward Ave Detroit, MI, 48201. Tel 313-832-8540; Fax 313-393-1772; Elec Mail info@detroitartistsmarket.org; Internet Home Page Address: www.detroitartistsmarket.org; *VChmn* Tracy Lark; *VChmn* Lisa Wetzen; *Exec Dir* Aaron Timlin; *Chmn Bd* Ryan Husayny; *Gallery Mgr* Christine Stamas; *Develop Dir* Kerri Schlottman; *Dir Events & Educ* Rachel Timlin
Open Tues - Sun 11 AM - 6 PM; No admis fee; Estab 1932 to educate pub & promote, exhibit & sell artwork by local Michigan artists; Average Annual Attendance: 10,000; Mem: 1300; dues $15 - $1000
Income: $250,000 (financed by endowment, mem, state appropriation, mini-grants, MCA, contributions, percent of art work sales)
Exhibitions: Small Group Exhibition; All Media Juried Exhibition; The Garden Sale.
Publications: Catalogs, 1-2 per yr; quarterly newsletter; Journal of exhibitions available for each exhibition including an essay & biographical information of participating artists
Activities: Educ program; lect open to public; tours; competitions with awards; scholarships offered; sales shop sells magazines, original art & unique gift items

M DETROIT FOCUS, 33 E Grand River, PO Box 32823 Detroit, MI 48232-0823. Tel 313-533-2900; *Gallery Mgr* Robert Crise Jr
Open Thurs - Sat 11 AM - 5 PM, summer to 6 PM; No admis fee; Estab 1978 as an exhibition space for Michigan visual artists; Average Annual Attendance: 10,000; Mem: 400; dues from $25; meetings annually
Income: $21,000 (financed by mem, city & state appropriation, fundraising)
Exhibitions: Juried exhibitions, visual & performance art
Publications: Detroit Focus Quarterly; exhibition catalogues
Activities: Lect open to public, 5 vis lectrs per year; competitions with awards; originate traveling exhibitions

M DETROIT INSTITUTE OF ARTS, 5200 Woodward Ave, Detroit, MI 48202. Tel 313-833-7900; Fax 313-833-3756; Internet Home Page Address: www.dia.org; *COO* Nettie Seabnoks; *Cur African, Oceanic & New World Cultures Art* Nii Quarcoopome; *Cur European Painting* George Keyes; *Dir Educ* Nancy Jones; *Cur Graphic Arts* Nancy Sojka; *Cur Modern Art* MaryAnn Wilkinson; *Head Conservator* Barbara Heller; *Cur European Sculpture & Decorative Arts* Alan Darr; *Dir* Graham W.J. Beal; *Dir Develop* Ronald Miller; *Cur Native American Art* David Penney; *Cur Film* Elliot Wilhelm; *Cur African American Art* Valerie Mercer; *Cur American Art* Kenneth Meyers; *CFO* Loren Lau
Open Wed - Thurs 10 AM - 4 PM, Fri 10 AM - 9 PM, Sat - Sun 10 AM - 5 PM, cl Mon, Tues & holidays; Recommended admis adults $4, child $1; Estab & incorporated 1885 as Detroit Mus of Art; chartered as municipal department 1919 & name changed; original organization continued as Founders Soc Detroit Institute of Arts; present building opened 1927; Ford Wing addition completed 1966; Cavanagh Wing addition opened 1971. In 1998 the Founders Soc signed a 20 yr operating agreement with City of Detroit to run the DIA as a 501(c)(3) org; Average Annual Attendance: 500,000; Mem: 43,000; dues Pres Assoc $10,000, Dirs Assoc $5,000, Sustaining Assoc 42,500, Assoc $1,500, Conservator $1,000, Contributor $500, Patron $250, Affiliate $150, Family/Friend $75, Individual $50, Senior Citizen (age 65 & over) $45
Library Holdings: Auction Catalogs; Audio Tapes; Book Volumes; Exhibition Catalogs; Manuscripts
Special Subjects: Anthropology, Folk Art, Historical Material, Marine Painting, Architecture, Ceramics, Glass, Metalwork, Mexican Art, American Western Art, Antiquities-Assyrian, Flasks & Bottles, Furniture, Gold, Porcelain, Portraits, Prints, Period Rooms, Silver, Textiles, Bronzes, Woodcuts, Manuscripts, Maps, Sculpture, Tapestries, Drawings, Graphics, Hispanic Art, Latin American Art, Painting-American, Photography, Watercolors, American Indian Art, African Art, Anthropology, Archaeology, Ethnology, Pre-Columbian Art, Southwestern Art, Costumes, Religious Art, Crafts, Pottery, Woodcarvings, Etchings & Engravings, Landscapes, Afro-American Art, Decorative Arts, Judaica, Collages, Painting-European, Painting-Japanese, Posters, Eskimo Art, Dolls, Jade, Jewelry, Oriental Art, Asian Art, Antiquities-Byzantine, Painting-British, Painting-Dutch, Carpets & Rugs, Ivory, Scrimshaw, Coins & Medals, Restorations, Baroque Art, Calligraphy, Miniatures, Painting-Flemish, Painting-Polish, Renaissance Art, Dioramas, Embroidery, Laces, Medieval Art, Antiquities-Oriental, Painting-Spanish, Painting-Italian, Antiquities-Persian, Islamic Art, Antiquities-Egyptian, Antiquities-Greek, Antiquities-Roman, Mosaics, Stained Glass, Painting-German, Pewter, Leather, Military Art, Reproductions, Antiquities-Etruscan, Painting-Russian, Painting-Israeli, Enamels, Painting-Scandinavian, Painting-New Zealander
Collections: Robert H Tannahill Collection of Impressionist & Post Impressionist paintings; German Expressionist Art; African, Oceanic & New World Cultures; Graphic Art, Photography; Modern Art; 20th century Art; American Art: Painting, Sculpture, Furniture, and Decorative Arts; European Painting, sculpture and Decorative Art; Asian Art; Ancient Art; Elizabeth Parke Firestone Collection of 18th Century Silver; William Randlogh Hearst Collection of Arms & Armor & Flemish Tapestries; Grace Whitney Hoff Collection of Fine Bindings; Paul McPharlin Collection of Theatre & Graphic Arts
Publications: Exhibition catalogues; bulletin; annual report; collection catalogues
Activities: Classes for adults & children; dramatic programs; docent training; lect open to public; gallery talks; tours; concerts, Detroit filmtheatre; scholarships & fels offered; book traveling exhibitions; originate traveling exhibitions; Mus shop sells books, calendars, games, jewelry, prints, slides & t-shirts

L Research Library, 5200 Woodward Ave, Detroit, MI 48202. Tel 313-833-7926; Fax 313-833-9169; Elec Mail jmoldwin@dia.org; Internet Home Page Address: www.dia.org; *Library Consultant* Jennifer L S Moldwin; *Library Asst* Mary Galvin
Open by written request only; Estab 1905 to provide material for research, interpretation & documentation of mus collection; For reference only

Income: Financed by city & memberships
Library Holdings: Book Volumes 500,000; Exhibition Catalogs; Lantern Slides; Pamphlets; Periodical Subscriptions 205; Photographs
Special Subjects: Art History, Archaeology, Asian Art, American Indian Art, Afro-American Art, Bookplates & Bindings, Antiquities-Oriental, Antiquities-Persian, Antiquities-Assyrian, Antiquities-Byzantine, Antiquities-Egyptian, Antiquities-Etruscan, Antiquities-Greek, Antiquities-Roman, Architecture
Collections: Albert Kahn Architecture Library; Paul McPharlin Collection of Puppetry; Grace Whitney-Hoff Collection of Fine Bindings

L DETROIT PUBLIC LIBRARY, Art & Literature Dept, 5201 Woodward Ave, Detroit, MI 48202-4093. Tel 313-833-1470; Fax 313-833-1474; Elec Mail esimmons@detroit.lib.mi.us; Internet Home Page Address: www.detroitpubliclibrary.org; *Library Dir* Nancy Skowronski; *Mgr Art & Literature Dept* Ellen Simmons; *Asst Dir Main Library* Margaret Bruni; *Asst Mgr* Julie Fornell; *Librn* Pati Bolourchi; *Librn* Peggy Hart
Open Tues & Wed Noon-8 PM, Thurs, Fri, Sat 10 AM-6PM; ann fee for library card for non- Detroit res $100; Estab 1865. Serves residents of Michigan with circulating and reference materials
Income: Financed by city and state appropriation
Library Holdings: Book Volumes 81,000; Clipping Files; Exhibition Catalogs; Pamphlets; Periodical Subscriptions 550; Photographs
Special Subjects: Art History, Landscape Architecture, Decorative Arts, Photography, Calligraphy, Etchings & Engravings, Painting-American, Sculpture, Ceramics, American Western Art, Industrial Design, Furniture, Afro-American Art, Architecture
Activities: Tours

M DETROIT REPERTORY THEATRE GALLERY, 13103 Woodrow Wilson, Detroit, MI 48238. Tel 313-868-1347; Fax 313-868-1705; *Gallery Dir* Gilda Snowden
Open by arrangement only; Estab 1957 to show Detroit Art; 1 fl in lobby of theater; Average Annual Attendance: 30,000
Income: Financed by endowment & state appropriation
Special Subjects: Drawings, Photography, Prints, Watercolors, Textiles, Folk Art, Woodcarvings, Woodcuts, Etchings & Engravings, Afro-American Art, Decorative Arts, Collages, Portraits, Reproductions
Exhibitions: One person shows for emerging Detroit Area Artists; Amy Kelly, Robert Hyde, Jay Jurma, Kris Essen, Kathy Arkley, Renee Dooley, Albert Nassar, Sabrina Nelson; New exhibit for every show
Publications: Exhibition catalogs
Activities: Adult classes; dramatic programs

M HERITAGE MUSEUM FINE ARTS CENTER FOR YOUTH, (Your Heritage House) 110 E Ferry St, Detroit, MI 48202. Tel 313-871-1667; *Dir* Josephine Harreld Love
Open weekdays 9 AM - 5 PM, weekends by appointment; Estab 1969; Average Annual Attendance: 15,000; Mem: 500; regular dues $50; annual meetings in Sept
Income: Financed by mem, city & state appropriation, individuals, groups & business donations, foundation support
Collections: Art for Youth; Black Heritage; graphics; Puppetry; Paintings; objects & works of interest to children; dolls; many works of art by renowned artists
Publications: Catalogues; imprints
Activities: Classes for adults & children; lect open to public, 3-6 vis lectrs per yr; concerts; gallery talks; tours; scholarships offered; sales shop sells books, cards & catalogs of exhibits

L Library, 110 E Ferry St, Detroit, MI 48202. Tel 313-871-1667; *Dir* Josephine Harreld Love
Open Mon - Fri 11 AM - 4 PM; Estab 1940's to provide fine arts material for children; For reference only
Income: city & state appropriation, individuals, groups and business donations
Library Holdings: Cards; Clipping Files; Exhibition Catalogs; Manuscripts; Memorabilia; Other Holdings Rare books & music scores; Pamphlets; Photographs; Prints
Collections: Black Heritage; Puppetry of the World

M NATIONAL CONFERENCE OF ARTISTS, Michigan Chapter Gallery, NW Activities Center, 18100 Meyers, Ste 395 Detroit, MI 48235. Tel 313-875-0923; Fax 313-875-7537; Elec Mail info@ncamich.org; Internet Home Page Address: www.ncamich.org; *Gallery Dir* Shirley Woodson; *Proj Dir* Raymond Wells; *Museum Liaison* Bamidele Demerson
Open Mon - Fri 11 AM - 5 PM, Sat 11 AM - 4 PM; Estab 1959 to promote cultural support for artists & community through visual arts; Average Annual Attendance: 4,500; Mem: 300; dues $50; monthly meetings & forums
Income: $50,000 (financed by mem, city & state appropriation, corporate, National Endowment for the Arts & private donations)
Special Subjects: African Art, Afro-American Art
Collections: Documentation of African American Artists: Books, Journals, Slides, Photographs, Periodicals, AudioTapes, Videotapes
Publications: NCA Newsletter, quarterly
Activities: Classes for adults & children; docent programs; lect open to public, gallery talks, tours, 15 vis lectrs per yr; originate traveling exhibitions 3 per year; sales shop sells art videos, books, original art & prints

M PEWABIC SOCIETY INC, Pewabic Pottery, 10125 E Jefferson, Detroit, MI 48214. Tel 313-822-0954; Fax 313-822-6266; Internet Home Page Address: www.Pewabic.com; *Exec Dir* Terese Ireland
Open Mon - Sat 10 AM - 6 PM; No admis fee; Estab 1903 to continue its tradition of leadership in the areas of ceramic production & education; Average Annual Attendance: 50,000; Mem: 1200; dues $50 family, $35 individual
Income: Financed by mem, donations & grants
Special Subjects: Ceramics
Collections: The work of the founder (Mary Chase Stratton)
Exhibitions: 8 annually - vary each year
Activities: Classes for adults & children; residencies & internships; lect open to public; tours; competitions; original objects of art lent; originate traveling exhibitions; sales shop sells original art

EAST LANSING

M **MICHIGAN STATE UNIVERSITY,** Kresge Art Museum, East Lansing, MI 48824. Tel 517-355-7631; Fax 517-355-6577; Elec Mail kamuseum@pilot.msu.edu; Internet Home Page Address: www.msu.edu/unit/kamuseum; *Dir Emeritus* Joseph Ishikawa; *Educ Coordr* Dr Carol Fisher; *Registrar* Lynne Campbell; *Dir* Dr Susan Bandes; *Cur* April Kingsley
Open Mon - Wed & Fri 10 AM - 5 PM, Thurs 10 AM - 8 PM, Sat & Sun Noon - 5 PM; summer hours: Tues - Fri 11 AM - 5 PM, Sat & Sun Noon - 5 PM, cl Mon; No admis fee; Estab 1959; Average Annual Attendance: 30,000; Mem: 500; dues $15 - $1000
Income: Financed by Michigan State University, endowment funds & Friends of Kresge Art Museum
Purchases: Paolo di Giovanni Fei triptych, 1985; John Marin watercolor, 1986; Gaston Lachaise, 1987; Jasper Johns; Duane Hanson, 1998
Special Subjects: Drawings, Graphics, Bronzes, African Art, Ethnology, Ceramics, Etchings & Engravings, Afro-American Art, Decorative Arts, Collages, Eskimo Art, Glass, Asian Art, Antiquities-Byzantine, Coins & Medals, Baroque Art, Calligraphy, Antiquities-Oriental, Antiquities-Persian, Antiquities-Egyptian, Antiquities-Greek, Antiquities-Roman, Antiquities-Etruscan, Enamels, Antiquities-Assyrian
Collections: Work from neolithic period to present; European paintings & sculpture; American paintings & sculpture; prints from 1500 to present; complete prints of Peter Takal; Small Asian, African, pre-Columbian collections
Exhibitions: Shows making up a yearly calendar of about 12 exhibitions supplementing the permanent collection; special exhibits; staff and student shows
Publications: Kresge Art Museum Bulletin; Exhibition calendar & publications
Activities: Docent training; workshops; lect open to public; gallery talks; tours; symposia; scholarships offered; individual paintings & original objects of art lent to qualified institutions, museums or galleries; book traveling exhibitions 2-3 per year; originate traveling exhibitions to other art museums; sales shop sells books, prints, cards & miscellaneous items

L **Fine Arts Library,** East Lansing, MI 48824-1048. Tel 517-353-4593; Fax 517-432-1445; Internet Home Page Address: www.lib.msu.edu/coll/main/finearts/art.htm; *Head Art Library* Mary L Black; *Library Asst III* Victoria Walker
Open Mon - Thurs 8 AM - 11 PM, Fri 8 AM - 8 PM, Sat 10 AM - 6 PM, Sun 10 AM - 11 PM; Estab 1973 to support the research and teaching needs in the visual arts of Michigan State University; Primarily reference & non-circulating
Income: Financed by state appropriation
Library Holdings: Book Volumes 65,000; Clipping Files; Exhibition Catalogs; Fiche; Other Holdings Picture files; Periodical Subscriptions 175; Reels
Special Subjects: Art History, Decorative Arts, Graphic Arts, Painting-American, Painting-British, Painting-Dutch, Painting-Flemish, Painting-German, Painting-Italian, Painting-European, History of Art & Archaeology, Interior Design, Furniture, Architecture

ESCANABA

M **WILLIAM BONIFAS FINE ART CENTER GALLERY,** Alice Powers Art Gallery, 700 First Ave S, Escanaba, MI 49829. Tel 906-786-3833; Fax 906-786-3840; Internet Home Page Address: www.bonifasarts.org; *Adminr* Samantha Gibb-Roff; *Gallery Dir* Pasgua Warstler
Open Tues - Fri 10 AM - 5:30 PM, Sat 10 AM - 5 PM; No admis fee; Estab 1974 to advance the arts in the area; 40 x 80, lower gallery inside Center; additional upper gallery; Mem: Dues patron $50 & up, family $35, individual $25
Collections: Local artists workeling shows & regional artwork
Exhibitions: Northern Exposure; Smithsonian Matthew Brady Photographs; Michigan Watercolor Society; Regional & Touring Exhibits
Publications: Arts News quarterly
Activities: Classes for adults & children; dramatic programs; docent training; lect open to public, 6-12 vis lectrs per year; tours; concerts; gallery talks; sponsor competitions; awards in connection with annual regional competition; scholarships offered; individual paintings & original objects of art lent to arts organizations & businesses in return for promotional assistance; book traveling exhibitions to 6-8 area schools per year

FLINT

M **BUCKHAM FINE ARTS PROJECT,** Gallery, 134-1/2 W Second St, Flint, MI 48502. Tel 810-239-6334; Internet Home Page Address: www.gfn.org/buckham; *VPres* Thomas Nuzum; *Pres* Nancy Moran; *Treas* S.E. Morello
Open Wed & Thurs 11:30 AM - 5 PM, Fri 12:30 - 6 PM; No admis fee; Estab 1984 to present contemporary arts; 40 x 60 ft gallery with 14 ft arched ceiling, no permanent interior walls; Average Annual Attendance: 5,000; Mem: 250; dues $15-$200; annual meeting in first week of Mar
Income: $35,000 (financed by mem, state appropriation, grants, gifts, commissions from sales)
Exhibitions: New exhibitions on rotating monthly basis, eleven each year
Activities: Exhibitions; performances; readings; lect open to public; competitions with prizes; gallery talks; book traveling exhibitions 1 per year; museum shop sells original art

M **FLINT INSTITUTE OF ARTS,** 1120 E Kearsley St, Flint, MI 48503. Tel 810-234-1695; Fax 810-234-1692; Elec Mail info@flintarts.org; Internet Home Page Address: www.flintarts.org; *Asst Dir Develop* Deborah S Gossel; *Cur Educ* Monique Desormeau; *Mem Coordr* Suzanne G Walters; *Asst Dir Admin* Michael Melenbrink; *Mus Shop Mgr* Lisa Roeser; *Registrar* Melissa Miller Farr; *Dir* John B Henry; *Cur* Kristie Everett Zamora; *Pub Relations* Rachelle Richert; *Vol/Spl Events Coordr* Tanya Lane; *Operations Mgr* Bryan Christie; *Security Supv* John T Crocker; *Pub Relations Coordr* Valerie Shook; *Preparator* Don Howell; *VPres* Linda L Pylypiw
Open Tues - Sat 10 AM - 5 PM, Sun 1 - 5 PM, Fri (May - Oct) 7 - 9 PM; No admis fee; Estab 1928 with a mission to collect, document, preserve & exhibit art of various periods & cultures; to provide educational opportunities; & to ensure the availability of these resources for the public benefit; 1 large temporary & 9 rotating permanent collection; Average Annual Attendance: 74,000; Mem: 2,500; dues $20 & up; annual meeting third Tues in June; payment of membership fee qualification for membership
Income: financed by endowments, grants, contributions & earned income, including memberships
Special Subjects: Painting-American, Sculpture, African Art, Textiles, Decorative Arts, Painting-European, Furniture, Glass, Oriental Art, Renaissance Art
Collections: African, American, Asian & European art; 15th - 18th century decorative arts; 17th - 19th century European paintings & sculptures; 18th - 20th century American paintings, sculpture, decorative arts; graphics, Native American art
Publications: Exhibition catalogs; bimonthly magazine for members & public
Activities: Classes for adults & children; 6 public lectrs per year; concerts; gallery talks; tours; Flint Art Fair; workshops/family activities; exten program serves ArtReach, Art on the Go (senior centers & nursing homes); organize traveling exhibitions to museums & galleries; museum shop sells books, gift items, stationery, cards & jewelry; original art, reproductions

L **Library,** 1120 E Kearsley St, Flint, MI 48503. Tel 810-234-1695; Fax 810-234-1692; Internet Home Page Address: www.flintarts.org; *Exhib Coordr* Kristie Everett Zamora; *Dir* John B Henry III; *Develop Dir* Deborah Gossel; *Cur Educ* Monique Desormeau; *Bus Mgr* Michael Melenbrink
Open Tues - Sat 10 AM - 5 PM, Sun 1 - 5 PM; No admis fee, donations accepted; Estab 1928; Average Annual Attendance: 85,000
Library Holdings: Book Volumes 4500; Exhibition Catalogs; Periodical Subscriptions 19
Special Subjects: Folk Art, Decorative Arts, Photography, Drawings, Etchings & Engravings, Painting-American, Painting-European, Ceramics, Crafts, Asian Art, American Indian Art, Furniture, Oriental Art, Pottery, Architecture
Collections: American & European Fine Arts; Native American, African, Chinese & Japanese
Publications: Bimonthly magazine; exhibit catalogs
Activities: Classes for adults & children; docent training; film series; museum art school; annual art fair; lects open to public, 8 vis lectrs per year; concerts; gallery talks; tours; exten program lends original objects of art to other museums; 1 book traveling exhibition per year; museum shop sells books

GRAND RAPIDS

M **CALVIN COLLEGE,** Center Art Gallery, 3201 Burton St SE, Grand Rapids, MI 49546. Tel 616-526-6271; Fax 616-526-8551; Internet Home Page Address: www.calvin.edu/centerartgallery
Open Sept - May Mon - Thurs 9 AM - 9 PM, Fri 9 AM - 5 PM, Sat Noon - 4 PM; No admis fee; Estab 1974 to provide the art students, & the college community & the pub at large with challenging visual monthly exhibitions; Gallery is well-lit, air-conditioned 40 x 70 ft with 10 ft ceiling along the sides & 8 ft ceiling in the center; Average Annual Attendance: 12,000
Income: Financed through private budget
Special Subjects: Drawings, Prints, Sculpture, Textiles, Ceramics
Collections: Dutch 17th & 19th centuries paintings & prints; Japanese prints; contemporary paintings, prints, drawings, sculpture, weaving & ceramics
Exhibitions: Invitational exhibits by various artists, exhibits of public & private collections & faculty & student exhibits
Publications: Various exhibition brochures
Activities: Classes for adults; lect open to public; concerts; gallery talks; competitions; scholarships offered

M **CITY OF GRAND RAPIDS MICHIGAN,** (Public Museum of Grand Rapids) Public Museum of Grand Rapids, 272 Pearl NW, Grand Rapids, MI 49504-5371. Tel 616-456-3977; Fax 616-456-3873; Elec Mail staff@grmuseum.org; Internet Home Page Address: www.grmuseum.org; *Asst Dir* Kay A Zuris; *Cur Coll* Christian Carron; *Cur Exhib* Thomas Bantle; *Colls Mgr* Marilyn Merdzinski; *Dir* Timothy J Chester; *Develop* Mary Esther Lee; *Cur Educ* Paula Gangopadhyay; *Dir Pub Relations* Deidra Mayweather; *Dir Planetarium* David DeBruyn
Open Mon - Sat 9 AM - 5 PM, Sun Noon - 5 PM; Admis adults $7, seniors $6, children $2.50; Estab 1854 for the interpretation of environment, history & culture of West Michigan & Grand Rapids; Maintains non-circulating reference library; 150,000 sq ft museum (Van Andel Museum Center) with 9600 sq ft temporary gallery; 140,000 sq ft research center, historic house museum; Average Annual Attendance: 400,000; Mem: 4000; dues $35-500; annual meeting in May
Income: $6,500,000 (financed by endowment, mem, city & state appropriations, grants, contributions & foundations)
Library Holdings: Audio Tapes; Book Volumes; Clipping Files; Exhibition Catalogs; Filmstrips; Lantern Slides; Manuscripts; Maps; Memorabilia; Motion Pictures; Original Art Works; Original Documents; Other Holdings; Pamphlets; Photographs; Prints; Records; Slides
Special Subjects: Flasks & Bottles, Photography, Portraits, Pottery, Pre-Columbian Art, Painting-American, Prints, Textiles, Manuscripts, Maps, Drawings, Graphics, American Indian Art, Anthropology, Archaeology, Ethnology, Costumes, Ceramics, Etchings & Engravings, Decorative Arts, Dolls, Furniture, Glass, Porcelain, Oriental Art, Asian Art, Carpets & Rugs, Historical Material, Ivory, Coins & Medals, Dioramas, Period Rooms, Laces, Antiquities-Egyptian, Pewter
Collections: Costumes & household textiles; Decorative arts; Ethonology; Furniture of the 19th & 20th centuries; Industrial & agricultural artifacts; Anthropology; Paleontology
Exhibitions: Permanent exhibitions: Furniture City; Habitats; Streets of Old Grand Rapids; Anishinabek: People of this Place
Publications: Museum, quarterly; Discoveries, monthly; exhibition catalogs
Activities: Classes for adults & children; dramatic programs; docent training; classes in film, music & dance; lect open to public; 20 vis lect per year; concerts; gallery talks; tours; individual paintings, objects of art & historical & anthropological artifacts lent to nonprofit educational institutions; book traveling exhibitions 2 per year; originate traveling exhibitions; museum shop sells books, magazines, original art, reproductions, prints, publications & catalogs

M **GRAND RAPIDS ART MUSEUM,** 155 Division N, Grand Rapids, MI 49503. Tel 616-831-1000, 831-1029; Fax 616-559-0422; Elec Mail pr@gr-artmuseum.org; Internet Home Page Address: www.gramonline.org; *CEO & Dir* Celeste M Adams; *Develop Dir* Peggy Helsel; *Educ Dir* Karen Cunningham; *Pub Relations Mgr* Kristen Krueger-Corrado; *Sr Cur & Prints* Richard Axson; *Finance Dir* Karen Kamnetz Fay; *VPres* Marilyn F Martin; *Retail Mgr* Rachel Allen; *Asst Cur* Jennifer Niemur; *Registrar* Kathleen Ferres
Open Sun, Tues - Thurs & Sat 11 AM - 6 PM, Fri 11 AM - 9 PM, cl Mon to pub, cl New Years Day, Independence Day, Thanksgiving & Christmas; Admis adults $5, students & seniors $2, children 6-17 $1, children 5 & under free; Museum allocated a 1910 Beaux Arts former post office & courthouse, renovated & opened in Sept 1981; Average Annual Attendance: 90,000; Mem: 2500; dues corporate benefactor $2500, corporate patron $1000, corporate donor $600, corporate $300, benefactor $2500, grand patron $500-$1000, Masters $1000, Beaux Arts $500, collections patron $300, sponsor $350, donor $150, Arts Alive/Friends of Art $100, patron $74, family $50, individual $35, full-time student $15; annual meeting in Sept
Income: $919,000 (financed by endowment, mem, state appropriation & federal grants)
Purchases: $30,000
Special Subjects: Graphics, Painting-American, American Indian Art, American Western Art, African Art, Costumes, Ceramics, Crafts, Folk Art, Etchings & Engravings, Afro-American Art, Collages, Painting-Japanese, Furniture, Glass, Oriental Art, Metalwork, Painting-Dutch, Coins & Medals, Miniatures, Painting-Polish, Painting-Spanish, Antiquities-Egyptian, Painting-Russian, Painting-Scandinavian
Collections: American & European 19th & 20th Centuries paintings; prints & photographs; Renaissance to Contemporary drawings; 20th Century design & decorative arts; German expressionist paintings; master prints of all eras; Renaissance paintings; sculpture
Publications: Catalogs of major exhibitions; quarterly newsletter
Activities: Classes for adults & children; dramatic programs; docent training; lect open to public, 7-10 vis lectrs per year; concerts; gallery talks; tours; competitions with awards; exten dept serves elementary schools; individual paintings & original objects of art lent to museums; lending collection contains books, original art works, original prints, paintings, photographs, sculpture & slides; book traveling exhibitions; originate traveling exhibitions; museum & sales shops sells books, magazines, original art, reproductions, gift items & prints; Gram for Kids

L **McBride Art Reference Library,** 155 Division N, Grand Rapids, MI 49503. Tel 616-831-2901; Fax 616-559-0422; *Registrar* K. Ferres; *Asst Cur* S. Holian
Open by appointment only; Estab 1969; Reference library
Income: Financed by mem, gifts, museum general budget allowance
Purchases: $2000
Library Holdings: Audio Tapes; Book Volumes 6000; Cassettes; Clipping Files; Exhibition Catalogs 10,000; Pamphlets; Periodical Subscriptions 12; Reproductions; Slides; Video Tapes
Special Subjects: Art History, Collages, Constructions, Calligraphy, Commerical Art, Ceramics, American Western Art, Bronzes, Advertising Design, Art Education, Asian Art, Anthropology, Aesthetics, Afro-American Art, Coins & Medals
Activities: Docent Training

L **GRAND RAPIDS PUBLIC LIBRARY,** 111 Library St NE, Grand Rapids, MI 49503. Tel 616-988-5400; Fax 616-988-5419; Elec Mail kcorrado@grpl.org; Internet Home Page Address: www.grpl.org; *Dir* Marcia Warner; *Marketing & Communications Mgr* Kristen Krueger-Corrado; *Librn* Marla Ehlers
Open Mon - Thurs 9 AM - 9 PM, Fri & Sat 9 AM - 5:30 PM, Sun 1 - 5 PM; No admis fee; Estab 1871 to provide information & library materials for people in Grand Rapids; Circ 1,523,566; Average Annual Attendance: 950,000
Income: Financed by city & state appropriations
Library Holdings: Book Volumes; CD-ROMs; Cassettes; Clipping Files; Compact Disks; DVDs; Fiche; Filmstrips; Lantern Slides; Manuscripts; Maps; Memorabilia; Micro Print; Original Art Works; Original Documents; Pamphlets; Periodical Subscriptions; Photographs; Prints; Records; Reels; Reproductions; Video Tapes
Special Subjects: Furniture
Collections: The Furniture Design Collection
Activities: Classes for adults & children; lect open to the pub, 50 vis lect per yr; sales shop sells books & magazines

L **KENDALL COLLEGE OF ART & DESIGN,** Kendall Gallery, 17 Fountain St NW, Grand Rapids, MI 49503-3002. Tel 616-451-2787; Fax 616-451-9867; Internet Home Page Address: www.kcad.edu; *Dir Exhibitions* Sarah Joseph
Open Mon 10 AM - 5 PM; No admis fee; Estab to serve Kendall students & faculty, as well as surrounding community; Focus on contemporary art by nat and international artists; Average Annual Attendance: 8,506
Income: Financed by tuition
Special Subjects: Art History, Folk Art, Photography, Commerical Art, Graphic Arts, Painting-American, Pre-Columbian Art, Prints, Sculpture, History of Art & Archaeology, Ceramics, Interior Design, Asian Art, Drafting, Landscapes
Activities: Lects open to public; 7-12 vis lect per year; gallery talks; sponsoring competitions

M **URBAN INSTITUTE FOR CONTEMPORARY ARTS,** 41 Sheldon Blvd, Grand Rapids, MI 49503. Tel 616-454-7000; Fax 616-454-9395; Elec Mail info@uica.org; Internet Home Page Address: www.uica.org; *Acting Dir* Margorie Kuipers; *Exec Dir* Gail Philbin; *Film Coordr* Vincent Jofchak; *Visual Arts Coordr* Janet Teunis; *Financial Dir* Brenda Cain; *Music Coordr* Jody Grantz
Open Tues - Sat 11 AM - 4 PM, third Fri of each month 11 AM - 8:30 PM, cl Sun & Mon; No admis fee; Estab 1976, dedicated to the development of a vital cultural community; Visual arts gallery-multi disciplinary arts center; Average Annual Attendance: 15,000; Mem: 650; dues families $60, individuals $35, students $20
Income: Financed by grants, donations, mem, ticket sales, studio rental & fundraising events
Publications: Monthly newsletter
Activities: Film program & literature readings, music, performance arts, visual arts; lect open to public, 3 vis lectrs per year; dance events

GROSSE POINTE SHORES

M **EDSEL & ELEANOR FORD HOUSE,** 1100 Lake Shore Rd, Grosse Pointe Shores, MI 48236. Tel 313-884-4222; Fax 313-884-5977; Elec Mail info@fordhouse.org; Internet Home Page Address: www.fordhouse.org; *Pres* John Franklin Miller; *VPres External Relations* Ann Fitzpatrick; *VPres Internal Operations* David Janssen
Open Tues - Sat 10 AM - 4 PM (Apr - Dec), Tues - Sun noon - 4 PM (Jan - Mar); Admis adults $6, seniors $5, children $4; Estab 1978 to help educate public on local history, fine & decorative arts; Average Annual Attendance: 38,000
Income: Financed by endowment
Special Subjects: Architecture, Drawings, Mexican Art, Painting-American, Sculpture, Costumes, Decorative Arts, Furniture, Glass, Porcelain, Asian Art, Metalwork, Painting-French, Carpets & Rugs, Period Rooms, Antiquities-Persian
Collections: Collection paintings, prints, archival photographs, French & English antique furniture, silver, glass, ceramics, historic textiles
Exhibitions: Rotating exhibits
Publications: Exhibit catalogs
Activities: Classes for adults & children, seasonal children's programs; docent training.; lect open to public, 4 - 6 vis lectrs per year; tours; individual paintings & original objects of art lent to other museums; book traveling exhibitions 2 - 3 per year; museum shop sells books, reproductions & original art

HARTLAND

A **HARTLAND ART COUNCIL,** PO Box 126, Hartland, MI 48353. Tel 810-632-6022; *Pres* Nadine Cloutier
No admis fee; Estab 1973 to promote arts in Hartland community; Mem: 35; dues $10 - $100; annual meeting in May
Income: financed by mem, admissions & grants
Collections: Paintings, photographs, sculptures, fibers, works of Michigan artists exhibited in local public buildings
Publications: Recollections, exhibit catalog

HOLLAND

M **HOPE COLLEGE,** De Pree Art Center & Gallery, 275 Columbia Ave, Holland, MI 49423. Tel 616-395-7500; Fax 616-395-7499; Internet Home Page Address: www.hope.edu; *Dir* John Hanson; *Mgr* Steve Nelson; *Admin* Kristin Van Haitsma
Open Mon - Sat 10 AM - 5 PM, Sun 1 - 5 PM; No admis fee; Estab as a place for the college & community to enjoy art; Academic gallery featureing historical and contemporary exhibitions; Average Annual Attendance: 5,000
Collections: 625 items of western & non-western art
Publications: Exhibition catalogs, e.g. Going Dutch: Contemporary Artists and the Dutch Tradition
Activities: Lect open to public; gallery talks

INTERLOCHEN

L **INTERLOCHEN CENTER FOR THE ARTS,** PO Box 199, Interlochen, MI 49643. Tel 231-276-7420; *Head Librn* Evelyn R Weliver
Open daily 8 AM - 5 PM & 6:30 - 9:30 PM; Estab 1963; Circ 9000; Special music library with over 50,000 titles
Library Holdings: Book Volumes 23,000; Periodical Subscriptions 140
Publications: Interlochen Review, annual
Activities: Dramatic programs; lect open to public; concerts; tours; competitions; awards; scholarships & fels offered; originate traveling exhibitions

JACKSON

M **ELLA SHARP MUSEUM,** 3225 Fourth St, Jackson, MI 49203. Tel 517-787-2320; Fax 517-787-2933; Internet Home Page Address: www.ellasharp.org; *Dir Pub Relations* Heather Price; *Pres* Lynnea Lostis
Open Tues - Fri 10 AM - 4 PM, Sat & Sun 11 AM - 4 PM, cl Mon & major holidays; Admis family $10, adults $4, seniors & students $3, children 5-15 $2, children under 5 free; Estab 1965 to serve the people of Jackson & to provide a place for cultural educ in the community & a temporary gallery where a variety of exhibits are held; Included are a large & small gallery; Average Annual Attendance: 80,000; Mem: 2000; dues $65, $55, $45, $35; annual meeting in June
Income: Financed by endowment & mem along with grants
Collections: China; coverlets & quilts; furniture from Victorian period; items related to Jackson history
Exhibitions: Rotating Exhibits
Publications: Annual Report; bulletins and catalogs; newsletter, monthly; research material as requested
Activities: Classes for adults & children; dramatic programs; docent training; lect open to public, 7-10 vis lectrs per year; gallery talks; tours; competitions; awards; schols offered; art objects lent to schools; lending collection contains photographs; museum shop sells books, reproductions & gifts

KALAMAZOO

M **KALAMAZOO INSTITUTE OF ARTS,** 314 S Park St, Kalamazoo, MI 49007. Tel 269-349-7775; Fax 269-349-9313; Elec Mail kiadev@iserv.net; Internet Home Page Address: www.kiarts.org; *Exec Dir* James A Bridenstine; *Dir Sch* Denise Lisiecki; *Dir Devel* Gordon Bolar; *Exec Asst* Elaine Biddle; *Registrar* Susan VanArendonk; *Music Educ* Mary Jo Lemanski; *Mus Shop Mgr* Karyn Juergens; *Communication Coordr* John Ephland; *Mem Coordr* Darlene Pontello; *Mem & Develop* Angelnette Thomas; *Cur Mus Educ* Susan Eckhardt; *Dir Finance & Personnel* Thomas A Fox; *Dir Facilities* Ron Boothby; *Vol Coordr* Sharon Williams; *Librn* Rebecca Steel; *Cur* Don Desmett
Open Tues - Wed & Fri - Sat 10 AM - 5 PM, Thurs 10 AM - 8 PM, Sun Noon - 5 PM, cl Mon; No admis fee; Incorporated 1924 to further interest in the arts,

especially in the visual arts; new building opened in 1998; Four permanent collection galleries & four temporary exhibition galleries devoted to pieces from the permanent collection; Average Annual Attendance: 200,000; Mem: 2500; dues $20 & up; annual meeting Sept

Income: $800,000 (financed by endowment, private donations, corporate & foundation grants, state & federal grants & mem)

Special Subjects: Drawings, Hispanic Art, Latin American Art, Painting-American, Photography, Prints, Watercolors, Bronzes, African Art, Pre-Columbian Art, Ceramics, Woodcarvings, Woodcuts, Etchings & Engravings, Landscapes, Portraits

Exhibitions: Various rotating exhib call for information

Publications: Exhibition catalogs, issued irregularly; newsletters, monthly

Activities: Classes for adults & children; docent training; museum educ dept; lect open to public; tours, 12 vis lectrs per year; gallery talks; tours; competitions with awards; art & antique auction; scholarships; exten dept serves Southwest Michigan; individual paintings lent for selected museum exhibitions; Lending collection contains photographs, paintings, prints & ceramics; originate traveling exhibitions; gallery shop sells books, magazines, original art, reproductions, prints, slides, craft items, jewelry & cards

L Library, 314 S Park St, Kalamazoo, MI 49007. Tel 269-349-7775; Fax 269-349-9313; Elec Mail museum@kiarts.org; Internet Home Page Address: www.kiarts.org; *Exec Dir* James A Bridenstine; *Head Librn* Dennis Kreps; *Dir Colls & Exhibs* Susan Vanarendonk; *Dir of School* Denise Lisiecki; *Dir Museum Educ* Susan Eckhardt; *Registrar* Kathleen Buday; *Public Rels & Mktg* Paul Stermer

Open Tues - Wed & Fri - Sat 10 AM - 5 PM, Thurs 10 AM - 8 PM, Sun Noon - 5 PM; No admis fee; Kalamazoo Institue of Arts estab 1924 to stimulate the creation & appreciation of visual arts; Library estab 1961 as a reference for curatorial staff & school faculty; 10 galleries for temporary exhibitions & permanent collection; library for public reference only, open to members for circulation (2,000 items annually); Average Annual Attendance: 150,000; Mem: 2000; dues $25 & up; annual meeting in Sept

Income: Privately financed through donation & membership sales

Library Holdings: Book Volumes 10,500; Clipping Files 1000; Exhibition Catalogs; Pamphlets; Periodical Subscriptions 52; Slides 10,000; Video Tapes 200

Special Subjects: Art History, Folk Art, Photography, Etchings & Engravings, Painting-American, Painting-British, Painting-European, Watercolors, Ceramics, Printmaking, Lettering, Jewelry, Pottery, Woodcuts

Collections: Art on paper; ceramics; watercolors; sculpture; 20th century American art; German Expressionist prints

Exhibitions: (1/7/2007-3/11/2007) Car as Art; (5/25/2007-8/19/2007) Lorna Simpson

Publications: Exhibit catalogues; biennial reports

Activities: Classes for adults & children; docent training; public programs; lect; tours; concerts; gallery talks; sponsors competitions; scholarships; sales shop sells books, original art, stationery, children's items & jewerly

M WESTERN MICHIGAN UNIVERSITY RICHMOND CENTER FOR VISUAL ARTS, (Western Michigan University-Art Dept) School of Art, 1903 W. Michigan, Department of Art Kalamazoo, MI 49008. Tel 269-387-2455; Fax 269-387-2477; Elec Mail donald.desmett@wmich.edu; Internet Home Page Address: www.wmich.edu/art/exhibitions/exhibitions/index.html; *Exhib Dir* Don Desmett

Open Mon - Fri 10 AM - 6 PM, Sat noon - 5 PM; No admis fee; Estab 1965 to provide visual enrichment to the university & Kalamazoo community. The School of Art Galleries are located in the Richmond Center for Visual Arts; Gallery II is a space located on the ground floor of Sangren Hall; Space Gallery is on the ground floor of Knauss Hall & the Student Art Gallery is in East Hall. Sculpture Tour is a rotating outdoor exhibit of traveling sculpture for which a catalog is available; Average Annual Attendance: 50,000

Income: Financed by state appropriation

Special Subjects: Prints

Collections: Contemporary print collection; 19th & 20th century American & European Art

Exhibitions: Rotating exhibition on contemporary arts

Publications: Sculpture Tour 92-93, 93-94, 94-95, 96-97, 98-99, 00-01, 01-06

Activities: Classes for adults; lect open to public, 8 vis lectrs per year; gallery talks; tours; awards; scholarships offered; collection contains 2000 original art works, 750 original prints; traveling exhibitions 7 per year

LAKESIDE

M LAKESIDE STUDIO, 15486 Red Arrow Hwy, Lakeside, MI 49116. Tel 616-469-1377; Fax 616-469-1101; Elec Mail lakesidegal@triton.net; Internet Home Page Address: www.lakesidegalleries.com; *Exec Dir* John Wilson

Open daily 10 AM - 5 PM; No admis fee; Estab 1968, international; Represents international artists, American, Soviet, Chinese, Dutch work done by Artists-in-Residence

Income: Financed by pvt ownership

Exhibitions: Rotating exhibits

Activities: Award placement in Artist-in-Residence Program through selection process; museum shop sells original art

LANSING

M LANSING ART GALLERY, 113 S Washington Sq, Lansing, MI 48933. Tel 517-374-6400; Fax 517-374-6385; Elec Mail lansingartgallery@yahoo.com; Internet Home Page Address: www.lansingartgallery.org; *Pres* Anne Hodgins; *Dir* Catherine Babcock

Open Tues - Fri 10 AM - 4 PM, Sat & 1st Sun of the month 1 - 4 PM; No admis fee; Estab 1965 as a private nonprofit gallery to promote the visual arts in their many forms to citizens of the greater Lansing area; Maintains large exhibit area, gallery shop & rental gallery; Average Annual Attendance: 18,000; Mem: 500; dues $25-$2500; annual meeting in June

Income: $180,000 (financed by mem, sales, grants, contributions & fees)

Publications: Image, quarterly

Activities: Classes for adults; classes for children; docent training; lect open to public, 10 vis lectrs per year; gallery talks; tours; competitions with awards; scholarships; individual paintings & original objects of art available for lease or purchase, including original art works, original prints, paintings, photographs & sculpture; book traveling exhibitions, 1-2 per year; sales shop sells books, original art, sculpture

LELAND

M LEELANAU HISTORICAL MUSEUM, 203 E Cedar St, PO Box 246 Leland, MI 49654. Tel 231-256-7475; Fax 231-256-7650; Elec Mail leemuse@traverse.com, info@leelanauhistory.org; Internet Home Page Address: www.leelanauhistory.org; *Cur* Laura Quackenbush

Open June 1 - Sept, Tues - Sat 10 AM - 4 PM, Sun 1 - 4 PM, remainder of yr Fri & Sat 10 AM - 1 PM; Admis adult $2, student $1; Estab 1959 for the preservation & exhibition of local history; One gallery for temporary exhibits of traditional & folk arts, 40 ft x 20 ft; Average Annual Attendance: 5,000; Mem: 550; dues $25; annual meeting in Aug

Income: $160,000 (financed by endowment, mem, fundraising & activities & grants)

Special Subjects: American Indian Art, Ethnology, Crafts, Folk Art, Manuscripts, Historical Material, Laces

Collections: Collections of local paintings, both folk & fine art; Leelanau County Native American baskets, birch bark crafts

Publications: Lee Muse newsletter, quarterly

Activities: Educ dept; sales shop sells books, reproductions, local crafts & original needlework kits

MARQUETTE

M NORTHERN MICHIGAN UNIVERSITY ART MUSEUM, Lee Hall, 1401 Preque Isle Ave Marquette, MI 49855. Tel 906-227-1481, 227-2194; Fax 906-227-2276; Elec Mail wfrancis@nmu.edu; Internet Home Page Address: art.nmu.edu/department/ADmuseum; *Gallery Dir* Wayne Francis

Open Mon - Fri 9 AM - 5 PM, Sun 1 - 4 PM; No admis fee; Estab 1975 to bring exhibits of the visual arts to the University, community & the upper peninsula of Michigan; Gallery covers approx 2000 sq ft of space, with security system & smoke detectors; Average Annual Attendance: 10,000

Income: $6500 (financed by University funds)

Collections: Contemporary printing & sculpture; student collection; Japanese & American illustration; Japanese prints & artifacts; permanent collection

Exhibitions: Average of one to two major exhibits each month; (1999) Art Student League Exhibition; Electronic Imaging Exhibition; Senior Exhibition; Children's Exhibition; Lake Superior Art Appreciation Exhibition.

Publications: Exhibit Announcement, monthly

Activities: Educ dept; lect open to public, 5 vis lectrs per year; gallery talks; competitions; individual paintings & original objects of art lent; traveling exhibitions organized & circulated

MIDLAND

M ARTS MIDLAND GALLERIES & SCHOOL, (Midland Center for the Arts, Inc) 1801 W Saint Andrews Rd, Midland, MI 48640. Tel 517-835-7401; Internet Home Page Address: www.mcfta.org; *Dir* Bruce Winslow; *Pres* Michael Tiknis

Open 10 AM - 6 PM; No admis fee; Estab 1971; Average Annual Attendance: 100; Mem: dues

Income: $105,000 (financed by endowment & mem)

Collections: Collection of local history photographs; Collection of local books

Publications: Salt of the Earth, Yates; Midland Log

Activities: Classes for children; docent programs; lect open to public, 3 vis lectrs per year; museum shop sells books, original art & reproductions

A ARTS MIDLAND GALLERIES & SCHOOL, 1801 W St Andrews, Midland, MI 48640. Tel 989-631-5930; Fax 989-631-7890; Internet Home Page Address: www.mcfta.org; *Dir* B B Winslow; *Prog Coordr* Cheryl Gordon; *Admin Asst* Emmy Mills; *Studio School Coordr & Registrar* Armin Mersmann

Open Mon - Sun 10 AM - 6 PM; No admis fee; Estab 1956 to generate interest in & foster understanding & enjoyment of the visual arts; Exhibition space consists of three galleries, one 40 x 80 ft & two smaller 20 x 40 ft space; spot tracking lighting; Average Annual Attendance: 20,000; Mem: 550; dues family $45, senior citizen $30; annual meeting in fall; monthly board meetings

Income: $200,000 (financed by endowment, mem, grants, fees for services, fundraising events)

Exhibitions: Great Lakes Regional Art Exhibition; Annual All Media Juried Competition & Exhibition (open to all Michigan artists age 18 & over); Annual Juried Summer Art Fair; Juried Holiday Art Fair

Publications: Calendar of events; quarterly newsletter for members; yearly report

Activities: Classes for adults & children; docent training; workshops; Picture Parent; lect open to public, 4 vis lectrs per year; gallery talks; self-guiding tours; tours; juried art fairs; competitions with awards; scholarships offered; book traveling exhibitions 5-10 per year; originate traveling exhibitions

L GRACE A DOW MEMORIAL LIBRARY, Fine Arts Dept, 1710 W Saint Andrews, Midland, MI 48640. Tel 517-837-3430; Fax 517-837-3468; Internet Home Page Address: www.gracedowlibrary.org/; *Dir* Melissa Barnard; *Chair* Cherie Hutter

Open Mon - Fri 9 AM - 9 PM, Sat 10 AM - 5 PM; during school year, Sun 1 - 5 PM; No admis fee; Estab 1955 as a pub library; Maintains art gallery

Income: Financed by city appropriation & gifts

Library Holdings: Audio Tapes; Book Volumes 12,000; Cassettes; Clipping Files; Framed Reproductions; Motion Pictures; Original Art Works; Other Holdings Compact discs; Pamphlets; Periodical Subscriptions 80; Prints; Records; Reproductions; Video Tapes

Collections: Alden B Dow Fine Arts Collection
Exhibitions: Exhibits from local artists, art groups & schools
Activities: Films

MONROE

A **MONROE COUNTY COMMUNITY COLLEGE,** Fine Arts Council, 1555 S
Raisinville Rd, Monroe, MI 48161. Tel 734-242-7300; Fax 734-242-9711; Internet
Home Page Address: www.monroe.cc.mi.us; *Dean* Dr William McCloskey
Open Mon & Tues 8:30 AM - 7 PM, Wed - Fri 8:30 AM - 4:30 PM; No admis
fee; Estab 1967 to promote the arts; Average Annual Attendance: 120; Mem: 50;
dues $5
Income: $3000 (financed by endowment, mem & county appropriation)
Activities: Classes for children; gallery talks; competitions with awards;
scholarships

MOUNT CLEMENS

A **THE ART CENTER,** 125 Macomb Pl, Mount Clemens, MI 48043. Tel
810-469-8666; Fax 810-469-4529; *Exec Dir* Jo-Anne Wilkie
Open Tues - Fri 11 AM - 5 PM, Sat 9 AM - 2 PM, cl Mon; No admis fee; Estab
1969 to foster art appreciation and participation for people of Macomb County;
The only public facility of its kind in the northeast Detroit metro area; The Center
has two rooms, 17 x 27 ft, connected by lobby area in the former Carnegie
Library Bldg, a Historical State Registered building; Average Annual Attendance:
10,000; Mem: 500; dues individual $25; annual meeting in June
Income: Financed by mem, city & state appropriation, commissions from sales,
class fees & special fundraising events
Exhibitions: Annual season of exhibitions both regional & statewide by
established & emerging Michigan artists
Publications: Newsletter, quarterly
Activities: Classes for adults and children; docent training; tours; competitions;
gallery & gift shops sell original art

MOUNT PLEASANT

M **CENTRAL MICHIGAN UNIVERSITY,** University Art Gallery, Wightman 132
Dept Art Mount Pleasant, MI 48859. Tel 517-774-3974, 774-3800; Elec Mail
julia.morrisroe@cmich.edu; Internet Home Page Address:
www.ccfa.cmich.edu/uag; *Dir* Julia Morrisroe; *Gallery Asst* Melissa Meyers;
Gallery Asst Jay Chick; *Dir Educ* Cara O'Brien
Open Mon - Tues, Thurs - Fri 10 AM - 5 PM, Wed Noon - 8 PM, Sat Noon - 5
PM, cl school holidays; No admis fee; Estab 1987 to serve Mount Pleasant &
university community; offer nat and international artists exhibs of contemporary
art; Corner of Franklin & Preston Streets. 154 linear ft of wall space & 2100 sq ft
of unobstructed floor space; Average Annual Attendance: 10,000
Income: financed by art dept & grantst
Library Holdings: Prints
Publications: Subverting the Market: Artwork on the Web Exhib Catalogue
Activities: Educ program; collaborate with public schools; lect open to public, 6-8
vis lectrs per year; gallery talks; tours; competitions with awards; organize
traveling exhibs to colleges & universities

MUSKEGON

M **MUSKEGON MUSEUM OF ART,** 296 W Webster Ave, Muskegon, MI 49440.
Tel 231-720-2570; Fax 231-720-2585; Internet Home Page Address:
www.muskegonartmuseum.org; *Exec Dir* Judith Hayner; *Registrar* Art Martin; *Pub
Relations* Marguerite Curran-Gawron; *Cur Educ* Ellen V Sprouls; *Pres* Michael
Schubert; *Sr Cur* E Jane Connell; *Preparator* Keith Downie; *Mus Gift Store Mgr*
Shawnee Larabee
Tues, Wed, Fri, Sat 10 AM-4:30 PM, Thurs 10 AM-8PM, Sun Noon-4:30, cl Mon;
Admis adults 18 yr & older $4, mem free; Estab 1912, Hackley Gallery designed
by S S Beman, Chicago architect; Permanent coll & changing exhib galleries;
Average Annual Attendance: 25,000; Mem: 1100; centennial $10,000+, hackley
circle $2,000-$9,999, benefactor $1,000-$1,999, patron $500-$999, friend
$150-499, household $55, individual $45
Income: $500,000 (financed by endowment, underwriting, mem & fundraising)
Library Holdings: Auction Catalogs; Book Volumes; Exhibition Catalogs
Special Subjects: Painting-American, Painting-European
Collections: American paintings; glass by Louis Comfort Tiffany, Harvey
Littleton, Lipofsky, & others; Answering the Horn by Winslow Homer;
Impressionist paintings; modern & Old Masters prints; Study in Rose & Brown by
James Whistler; Tornado Over Kansas by John Steuart Curry; New York
Restaurant by Edward Hopper
Publications: Catalogs of American & European paintings from the Permanent
Collection
Activities: Classes for adults & children; docent training; workshops; lect open to
public; gallery talks; tours; sponsoring of competitions; regional art awards;
individual & original objects of art lent to qualified museums; book traveling
exhibitions; originate traveling exhibitions; museum shop sells books &
reproductions

L **Library,** 296 W Webster Ave, Muskegon, MI 49440. Tel 231-720-2570; Fax
231-722-3041; *Librn* Susan Talbat-Stanaway
Estab 1977; Open to pub

OLIVET

M **OLIVET COLLEGE,** Armstrong Collection, Mopt Ctr, 320 S Main St Olivet, MI
49076. Tel 616-749-7000 Ext 7661; Fax 616-749-7178; Internet Home Page
Address: www.olivet.edu; *Dir* Donald Rowe; *Chmn Arts & Comm Depts* Gary
Wortheimer
Call for hrs; Estab 1960 to collect artifacts & display for educational purposes;
Average Annual Attendance: 1,200

Special Subjects: Prints, Sculpture, Primitive art
Collections: American Indian, Mesopotamian, Philippine & Thailand Artifacts;
Modern American Prints; Primitive Art; Sculpture
Exhibitions: Invitational shows; one-man shows; student shows; traveling shows

L **Library,** 320 S Main St, Olivet, MI 49076. Tel 616-749-7608; Fax 616-749-7178;
Internet Home Page Address: www.olivet.edu; *Library Dir* Mary Jo Blackport
Open during school yr Mon - Thurs 8 AM - Noon, Fri 8 AM - 5 PM, Sat 11 AM
- 5 PM, Sun 2 - 11 PM
Library Holdings: Book Volumes 78,000; Micro Print

ORCHARD LAKE

M **ST MARY'S GALERIA,** 3535 Indian Trail, Orchard Lake, MI 48324. Tel
248-683-0345; *Dir* Marian Owczarski
Open Mon - Fri upon request, first Sun of the month Noon - 5 PM & anytime
upon request; No admis fee; Estab to house major Polish & Polish-American art;
Average Annual Attendance: 6,700
Special Subjects: Painting-Polish
Collections: Contemporary Polish Painting; Sculpture by Marian Owczarski;
History of Polish Printing: Rare Books & Documents; Polish Folk Art; Polish
Tapestry; Paintings of A Wierusz Kowalski; Watercolors by J Falat; Watercolors
by Wojciech Gierson; Louvre by Night, a sketch by Aleksander Gierymski; oil
paintings by Jacek Malczewski; lithographs by Irene Snarski & Barbara Rosiak
Exhibitions: Various exhib
Activities: Lect open to public; concerts; gallery talks; tours; competitions for
youngsters & artists

PETOSKEY

M **CROOKED TREE ARTS COUNCIL,** Virginia M McCune Community Arts
Center, 461 E Mitchell St, Petoskey, MI 49770. Tel 231-347-4337; Fax
231-347-5414; Internet Home Page Address: www.crookedtree.org; *Dir* Dale Hall
Open Mon - Sat 10 AM - 5 PM; No admis fee; Estab 1981 as a non-profit arts
council & arts center; 40 ft x 25 ft exhibition gallery featuring monthly shows,
modern lighting & security systems; 85 x 45 ft gallery featuring work of Michigan
artists on consignment; Average Annual Attendance: 50,000; Mem: 1600; dues
family $50, individual $30; annual meeting in Sept
Income: $300,000 (financed by endowment, city & state appropriation, ticket
sales, tuition income, fundraisers)
Exhibitions: Monthly exhibits
Publications: Art news, bimonthly
Activities: Classes for adults & children; dramatic programs; docent programs;
music & dance classes; 3 competitions per year (crafts, fine arts, photography);
cash prizes; book traveling exhibitions 7 per year; sales shop sells original art,
reproductions, prints, art postcards

PONTIAC

A **CREATIVE ARTS CENTER,** 47 Williams St, Pontiac, MI 48341. Tel
248-333-7849; Fax 248-333-7841; Elec Mail info@cacpontiac.com; Internet Home
Page Address: www.cacpontiac.com; *Exec Dir* Carol Paster
Open Tues - Sat 10 AM - 5 PM, cl holidays; No admis fee; Estab 1965 to present
the best in exhibitions, educational activities, & community art outreach; Main
gallery is a two story central space with carpeted walls; Clerestory Gallery is the
second floor balcony overlooking the main gallery; Average Annual Attendance:
80,000; Mem: 160; dues organizational $50, general $35, artists & citizens $20,
annual meeting in Mar
Income: Financed by endowment, mem, city & state appropriation, trust funds,
United Way, Michigan Council for the Arts
Exhibitions: Temporary exhibits of historic, contemporary & culturally diverse
works
Publications: Biannual newsletter, Creative Arts Center
Activities: Classes for adults & children; dramatic programs, music, dance, visual
arts programs; lect open to the public, 30 vis lectrs per year; gallery talks;
concerts; tours; competitions with awards; scholarships offered; book traveling
exhibitions semi-annually; originate traveling exhibitions; sales shop sells books &
original art work

PORT HURON

M **PORT HURON MUSEUM,** 1115 Sixth St, Port Huron, MI 48060. Tel
810-982-0891; Fax 810-982-0053; Elec Mail info@phmuseum.org; Internet Home
Page Address: www.phmuseum.org; *Dir, CEO* Stephen R Williams; *Asst Dir*
Cynthia Lowrey; *Cur Educ* Gloria Justice; *Cur Coll* T.J. Gaffney; *VPres* Mary Lou
Creamer; *Site Mgr Edison De* Joe Burgett; *Admin Asst* Audrey Walzak; *Site Mgr
Huron Lig* Wayne Arnold
Open Wed - Sun 1 - 4:30 PM; Admis adults $3, seniors & students $2, 6 & under
free; Estab 1968 to preserve area historical & marine artifacts; exhibit living
regional artists; exhibit significant shows of national & international interest.
Maintains reference library; Two galleries are maintained for loaned exhibitions &
the permanent collection; also a decorative arts gallery & a sales gallery; Average
Annual Attendance: 125,000; Mem: 1800; dues family $30, individual $15
Income: $200,000 (financed by endowment, mem, city appropriation, state &
federal grants & earned income through program fees)
Special Subjects: Painting-American, Photography, Prints, Watercolors, American
Indian Art, Anthropology, Archaeology, Textiles, Costumes, Folk Art, Landscapes,
Decorative Arts, Painting-European, Portraits, Painting-Canadian, Dolls, Furniture,
Glass, Jewelry, Silver, Marine Painting, Carpets & Rugs, Maps, Embroidery,
Cartoons
Collections: Civil War Collection; marine artifacts; 19th century American
decorative arts (paintings & prints)
Exhibitions: Blue Water Art
Publications: Exhibit catalogs; monthly newsletter

Activities: Classes for adults & children; docent training; lect open to public, 6 vis lectrs per year; concerts; gallery talks; tours; competitions with awards; film series; festivals; music & theatre programs; book traveling exhibitions, 8 per year; museum shop sells books, magazines, original art

M **SAINT CLAIR COUNTY COMMUNITY COLLEGE,** Jack R Hennesey Art Galleries, 323 Erie St, PO Box 5015 Port Huron, MI 48061-5015. Tel 810-989-5709; Fax 810-984-2852; Elec Mail dkorff@stclair.cc.mi.us; Internet Home Page Address: www.stclair.cc.mi.us; *Coordr Galleries & Exhibits* David Korff
Open Mon - Fri 8 AM - 4:30 PM; No admis fee; Estab 1975 to serve the community as an exhibition site & to serve the faculty & students of the college as a teaching tool; Maintains three galleries connected by common hall with approximately 2,000 sq ft; Average Annual Attendance: 3,000
Special Subjects: Painting-American, Prints, Sculpture, Woodcarvings, Metalwork
Collections: Paintings, print, and sculpture (wood and metal)
Activities: Educ dept; lect open to public; concerts; competitions with awards; scholarships offered; book traveling exhibitions, one per year or as funds permit

ROCHESTER

M **OAKLAND UNIVERSITY,** Oakland University Art Gallery, Oakland Univ, 208 Wilson Hall Rochester, MI 48309-4401. Tel 248-370-3005; Fax 248-370-4208; Elec Mail goody@oakland.edu; Internet Home Page Address: www.oakland.edu; Internet Home Page Address: www.oakland.edu/mbag; *Dir & Cur* Dick Goody
Open Tues - Fri Noon - 5 PM, Sat & Sun 1 - 5:30 PM, evening 7 - 9:30 PM in conjunction with Meadow Brook Theater Performances Tues - Fri 7 PM through first intermission, Sat & Sun 5:30 PM through first intermission; No admis fee; Estab to provide exhib schedule that emphasizes excellence in fine arts, provide exhib opportunities for emerging & mid career Mich artists & raise awareness & enthusiasm about contemporary art in South Eastern Mich; 2400 sq ft across hallway from theatre auditorium; Average Annual Attendance: 35,000; Mem: dues $30 - $1500
Income: Financed by university budget, mem, fees, contributions & outside grant funding
Special Subjects: African Art, Pre-Columbian Art, Furniture, Oriental Art
Collections: Art of Africa, Oceania and Pre-Columbian America; contemporary art and Sculpture Park; Oriental art; numerous fine prints
Exhibitions: Minimum of 6 exhibs annually
Publications: Exhibition catalogs
Activities: Lect open to public; symposiums; gallery talks; slide presentations in conjunction with exhibitions; paintings & original art objects lent within university; on loan exhibs

ROYAL OAK

M **DETROIT ZOOLOGICAL INSTITUTE,** Wildlife Interpretive Gallery, 8450 W 10 Mile, PO Box 39 Royal Oak, MI 48068-0039. Tel 248-398-0903; Fax 248-398-0504; *Cur Educ* Gerry Craig
Open daily 10 AM - 5 PM (Summer), 10 AM - 4 PM (Winter); No admis fee with zoo admis; Estab 1995 to celebrate & interpret humans' relationship with animals; The permanent art collection of the Wildlife Interpretive Gallery is displayed on the mezzanine level of the main rotunda, under the glass dome. Commissioned works are on display throughout the building. A temporary art gallery has 4 shows annually focusing on fine arts or educ exhibits; Average Annual Attendance: 1,200,000; Mem: 55,000; dues $50-$500
Special Subjects: Painting-American, Photography, Prints, Sculpture, African Art, Pre-Columbian Art, Textiles, Ceramics, Eskimo Art, Asian Art, Metalwork, Tapestries, Embroidery, Antiquities-Persian, Antiquities-Egyptian
Activities: Classes for adults & children; dramatic programs; lect open to public, 4-6 vis lectrs per year; exten services to schools with performing arts program; book traveling exhibitions 4 per year; originate traveling exhibitions 1-2 per year

SAGINAW

M **SAGINAW ART MUSEUM,** 1126 N Michigan Ave, Saginaw, MI 48602. Tel 989-754-2491; Fax 989-754-9387; Elec Mail lreker@saginawartmuseum.org; Internet Home Page Address: www.saginawartmuseum.org; *Dir Develop* Marsha Braun; *Cur Educ* Kara Harris; *Dir Mem* Victoria Adams; *Facilities Mgr* Rick LeFevre; *Exec Dir* Les Reker; *Grants Mgr* Peter Howey
Open Tues - Sat 10AM - 5PM, Thurs 10AM - 8PM, Sun 1 - 5PM; Admis $5, Wed free, children under 16 free; Estab 1947; Average Annual Attendance: 25,000; Mem: 450
Library Holdings: Auction Catalogs; Memorabilia; Original Documents; Video Tapes
Special Subjects: Folk Art, Landscapes, Architecture, Collages, Glass, American Western Art, Photography, Portraits, Pottery, Prints, Bronzes, Woodcuts, Painting-British, Painting-Japanese, Tapestries, Drawings, Graphics, Hispanic Art, Painting-American, Sculpture, Watercolors, American Indian Art, Southwestern Art, Textiles, Costumes, Religious Art, Ceramics, Crafts, Woodcarvings, Etchings & Engravings, Decorative Arts, Painting-European, Posters, Porcelain, Oriental Art, Asian Art, Marine Painting, Painting-Dutch, Painting-French, Carpets & Rugs, Historical Material, Painting-Polish, Embroidery, Laces, Medieval Art, Antiquities-Oriental, Painting-German, Military Art, Antiquities-Etruscan, Painting-Russian
Collections: African, Asian & Etruscan, painting, sculpture 7 decorative areas; 18th-21st Century American/European/Asian painting, sculpture & decorative art; Eanger Irving Couse, Corot, Inness, Cropsey, Minor, Arneson, Held, Blakelock
Exhibitions: (10/2006-1/2007) Treasures of African Tribal Art; (9/13/2008-11/9/2008) Life as a Legend: Marilyn Monroe
Publications: Annual report
Activities: Classes for adults & children; docent training; lect open to public; concerts; gallery talks; tours; exten dept serves mid-Michigan region, lending

original objects of art to local libraries & corporations; book traveling exhibs annually; organize traveling exhibs; mus shop sells books, reproductions & decorative art

SAINT JOSEPH

M **ST JOSEPH ART ASSOCIATION,** Krasl Art Center, 707 Lake Blvd, Saint Joseph, MI 49085-1398. Tel 269-983-0271; Fax 269-983-0275; Elec Mail info@krasl.org; Internet Home Page Address: www.krasl.org; *Exec Dir* Donna Metz; *Dir Educ* Julia Gourley; *Dir Admin* Patrice Rose; *Cur* Susan Wilczak
Open Mon - Thurs, Sat 10 AM - 4 PM, Fri 10 AM - 1 PM, Sun 1 - 4 PM; No admis fee; Estab 1980 to provide visual arts educational opportunities; Average Annual Attendance: 29,000; Mem: 1100; dues $25 & up; annual meeting 1st wk in Nov
Income: $550,000 (financed by endowment, mem, state appropriations & foundations)
Purchases: $53,600 (Sculptures by Dunbar, Isherwood & Tye)
Special Subjects: Sculpture
Collections: Krasl Art Center Sculpture Collection
Publications: Krasl Newsletter, bimonthly; exhibit cataloges
Activities: Clases for adults & children; lect open to public, 10-12 vis lectrs per year; scholarships offered; sales shop sells books & prints

TRAVERSE CITY

M **NORTHWESTERN MICHIGAN COLLEGE,** Dennos Museum Center, 1701 E Front St, Traverse City, MI 49686. Tel 231-995-1055; Fax 231-995-1597; Elec Mail dmc@nmc.edu; Internet Home Page Address: www.dennosmuseum.org; *Dir Mus* Eugene A Jenneman; *Registrar* Kim Hanninen; *Cur & Educ Coordr* Diana Bolander; *Museum Shop Mgr* Terry Tarnow; *Asst to Dir* Judith Albers; *Auditorium Coordr* Robert Weiler
Open Mon - Sat 10 AM - 5 PM, Sun 1 - 5 PM; Admis adults $4, children $2, family $10 (subject to change with exhib); Estab 1991; 40,000 sq ft complex features three changing exhibit galleries & a sculpture court; a hands on Discovery Gallery; & a Gallery of Inuit Art, the museum's major permanent collection. The 367 seat Milliken Auditorium offers theater & musical performances throughtout the year; Average Annual Attendance: 60,000; Mem: 1200; dues $35 individual, $50 family, and up; Scholarships
Income: $900,000 (financed by earned income/endowment)
Collections: Canadian Inuit sculpture & prints
Activities: Classes for adults & children; docent training; lect open to public, 12-15 vis lectrs per year; concerts; Governor's Award for Arts & Culture; gallery talks; tours; individual paintings & original objects of art lent to mus; lending coll contains original art works & original prints; originate traveling exhibs to mus; mus shop sells books, magazines, original art, reproductions & prints

YPSILANTI

M **EASTERN MICHIGAN UNIVERSITY,** Ford Gallery, 114 Ford Hall, Bldg 114 Ypsilanti, MI 48197. Tel 734-487-1268; Fax 734-487-2324; Internet Home Page Address: www.emich.edu; *Dept Head* Tom Venner; *Dir Gallery* Larry Newhouse
Open Mon & Thurs 10 AM - 5 PM, Tues & Wed 10 AM - 7 PM, Fri & Sat 10 AM - 2 PM; No admis fee; Estab 1925, in present building since 1982, for educational purposes; Art Dept gallery is maintained displaying staff & student exhibitions from a wide variety of sources; also on large, well-lighted gallery with lobby & a satellite student-operated gallery are maintained
Income: Financed by state appropriation
Purchases: $500
Exhibitions: Seven changing exhibitions annually; Annual Faculty Exhibition; Annual Juried Student Exhibition; Biannual Michigan Drawing Exhibition
Publications: Exhibition catalogs
Activities: Classes for adults; lect open to public; gallery talks; competitions

L **Art Dept Slide Collection,** Ford Hall, Rm 214, Ypsilanti, MI 48197. Tel 734-487-1268; Fax 734-487-2324; Elec Mail cpawloski@emich.edu; Internet Home Page Address: http://webstage.emich.edu/art; *Visual Resource Librn* Carole Pawloski
Open 8 AM - 5 PM; Estab 1978 to foster slide circulation for art faculty
Library Holdings: Lantern Slides; Slides 100,000; Video Tapes
Special Subjects: Painting-American, Pre-Columbian Art, History of Art & Archaeology, American Western Art, American Indian Art, Furniture, Mexican Art, Afro-American Art, Oriental Art, Restoration & Conservation
Collections: 100,000 art slides; 4,000 digital images
Activities: Classes for adults; lectr open to pub & lectr for mem only; gallery talks; Extension program serves entire University

MINNESOTA

BLOOMINGTON

M **BLOOMINGTON ART CENTER,** 1800 W Old Shakopee Rd, Bloomington, MN 55431. Tel 952-563-8587; Fax 952-563-8576; Elec Mail info@bloomingtonartcenter.com; Internet Home Page Address: www.bloomingtonartcenter.com; *Dir* Susan Anderson; *Exhib Dir* Rachel D Flentje
Open Mon - Fri 8 AM - 10 PM, Sat 9 AM - 5 PM, Sun 1 - 5 PM; No admis fee; Estab 1976 to serve emerging local artists; Circ 13,000; Inez Greenberg Gallery, 1800 sq ft; Atrium Gallery, single artist shows; Average Annual Attendance: 24,000; Mem: 700; dues individual $25, family 35
Income: $390,000 (financed by mem & city appropriation)
Exhibitions: Ongoing

Activities: Classes for adults & children in visual, literary & dramatic programs; lect open to public, 3 vis lectrs per year; competitions with prizes; sales shop sells books, original art & prints

BRAINERD

M **CROW WING COUNTY HISTORICAL SOCIETY,** 320 W Laurel St, PO Box 722 Brainerd, MN 56401. Tel 218-828-4434; Fax 218-828-4434; Elec Mail history@brainerd.net; *Exec Dir* Mary Lou Moudry
Open June - Aug, Mon - Fri 10 AM - 4 PM & Sat 10 AM - 2 PM, Sept - May, Tues - Fri 1- 5 PM & Sat 10 AM - 2 PM; Admis adult $3; Estab 1927 to preserve & interpret county history; Average Annual Attendance: 6,000; Mem: 350; dues $15-$250; annual meeting in Apr
Income: $60,000 (financed by mem, county, state grants, private donations)
Special Subjects: Architecture, Drawings, Painting-American, Photography, Archaeology, Costumes, Etchings & Engravings, Manuscripts, Portraits, Dolls, Furniture, Glass, Jewelry, Carpets & Rugs, Maps, Embroidery
Exhibitions: N.P. Railroad; Sarah Thorp Heald & Freeman Thorp Paintings: Home & Community: Rotating Artifacts Reflecting Country Life; American Indian Tools & Beadwork; When Lumber Was King; Mining; 19th & Early 20th Century Furnishings
Publications: The Crow Wing County Historian, quarterly newsletter
Activities: Docent training; lect open to public; tours; competitions with awards; museum shop sells books, Victorian items, American Indian items, notecards & stationery, archival supplies

BROOKLYN PARK

M **NORTH HENNEPIN COMMUNITY COLLEGE,** Art Gallery, 7411 85th Ave N, Brooklyn Park, MN 55445. Tel 763-424-0702; Fax 763-424-0929; Internet Home Page Address: www.nh.cc.mn.us; *Dir* Susan McDonald
Open Mon, Thurs & Fri 8 AM - 4:30 PM, Tues & Wed 8 AM - 7 PM; No admis fee; Estab 1966 to make art available to students & community; Two gallery spaces: smaller gallery is for one person exhibs & installation; larger gallery is for group exhibitions; Average Annual Attendance: 8,000
Income: Financed by state appropriation & foundation grants
Collections: Student works & local artists in Minnesota
Exhibitions: Mid-West Artist on regular basis
Activities: Lect open to the public; concerts; gallery talks; tours; student show with prizes; individual paintings & original objects of art lent to faculty members on campus; book traveling exhibs 1-2 per year; sales shop sells books

COMFREY

M **JEFFERS PETROGLYPHS HISTORIC SITE,** 27160 Co Rd 2, Comfrey, MN 56019. Tel 507-628-5591; Fax 507-628-5593; Internet Home Page Address: www.jefferspetroglyphs.com; *Site Mgr* Tom Sanders; *Site Tech* Ilene Haugen
Open May & Sept: Fri & Sat 10 AM - 5 PM, Sun 12 - 5 PM; Memorial Day - Labor Day: Mon, Wed, Thurs & Fri 10 AM - 5 PM, Sat 10 AM - 8 PM, Sun 12 - 8 PM; cl Oct - Apr; Admis adults $5, seniors $4, children 6 - 12 $3, grps $1.50, mems no admis fee; Estab 1966; Historical site; sacred site to the American Indians; mus concentrates on American Indian history & spirituality which dates back to the plain's Archaic Period (5000 BC - 600 AD); mus situated on over 40 acres of prairie; Average Annual Attendance: 10,000; Mem: dues North Star Circle $1000, Sustaining $500, Contributing $250, Assoc $125, Household $65, Sr Household of two adults 65 & over $55, Indiv $55, Sr Indiv $45
Collections: Over 2000 carvings on quartzite rock ranging from 5000 - 10,000 yrs old that are symbols of thunderbirds, bison, turtles, lightning strikes, humans & other figures; book vols on Native American history & culture; book vols on prairie flowers & grasses
Publications: The Jeffers Petroglyphs, book
Activities: Research in archaeology, geology, petroglyphs, and prairie grasses & flowers; training progs for professional mus workers; educ progs for children, col students & adults; guided tours; Native American books, jewelry, soap, dreamcatchers & other museum-related items for sale

DULUTH

M **SAINT LOUIS COUNTY HISTORICAL SOCIETY,** 506 W Michigan St, Duluth, MN 55802. Tel 218-733-7586; *Dir* JoAnne Coombe
Open Mon - Sat 10 AM - 5 PM, Sun Noon - 5 PM; Admis family $15, adults $5, seniors & juniors $3, 3 & under free; Estab in 1922. Housed in the Saint Louis County Heritage & Arts Center along with A M Chisholm Mus, Duluth Ballet, Duluth-Superior Symphony, Duluth Playhouse, Duluth Art Institute, Matinee Musicale & Lake Superior Mus of Transportation; Soc exhibit areas consist of three galleries interspersed in viewing areas; Average Annual Attendance: 100,000; Mem: 900; dues $9 & up
Income: $236,000 (financed by pub support, dues, earned profit, & volunteer service)
Special Subjects: American Indian Art, Furniture, Historical Material
Collections: E Johnson Collection; drawings; paintings; Ojibwe & Sioux beadwork, quillwork, basketry; Logging Exhibit; Herman Melheim hand-carved furniture
Exhibitions: Changing exhibits on topics related to the history of northeastern Minnesota & Lake Superior region
Publications: Books & pamphlets on topics related to the history of northeastern Minn; quarterly newsletter
Activities: Workshops; lect; tours to places of historical interest within the region

M **UNIVERSITY OF MINNESOTA, DULUTH,** Tweed Museum of Art, 1201 Ordean Ct, Duluth, MN 55812. Tel 218-726-8222; Fax 218-726-8503; Elec Mail tma@d.umn.edu; Internet Home Page Address: www.d.umn.edu/tma/; *Technician* Peter Weiznegger; *Dir* Martin DeWitt; *Cur/Registrar* Peter Spooner; *Mus Educ* Susan Hudec
Open Tues 9 AM - 8 PM, Wed - Fri 9 AM - 4:30 PM, Sat & Sun 1 - 5 PM; No admis fee; donations family $5, individual $2, seniors & students free; Estab 1950 to serve both the univ & community as a center for exhib of works of art & related activities; Nine galleries within the mus; Average Annual Attendance: 50,000; Mem: 500; dues $10-$1000
Income: Financed by mem, state appropriation & foundation
Purchases: 50% (state; 20% income & endowments/ 15% private foundations; 15% members
Library Holdings: Auction Catalogs 300; Audio Tapes 50; Book Volumes 2,000; CD-ROMs 50; Clipping Files 500; Periodical Subscriptions 5; Slides 1000; Video Tapes 300
Collections: Jonathan Sax Collections of 20th Century American Prints; George P Tweed Memorial Art Collections of 5,000 paintings with emphasis on Barbizon School and 19th Century American; 20th century American paintings & sculptures; 15th - 19th century European paintings; Glenn C Nelson international ceramics; Don and Carol Wiiken contemporary glass collection; Royal Canadian Mounted Police illustrations; George Morrison collection
Exhibitions: 8-10 major exhibits annually
Publications: European Paintings in the Tweed Museum of Art by David Stark; American Painting in the Tweed Museum of Art by J Gray Sweeney
Activities: Classes for adults & children; docent training; lect open to public, 18-20 vis lectrs per year; concerts; gallery talks; tours; individual paintings & original objects of art lent to qualifying mus & institutions; lending collection contains original art works, original prints & paintings; one-two book traveling exhibs per yr; traveling exhibs organized & circulated to national & international museums & galleries; museum shop sells books, magazines, original art, reproductions, prints

ELYSIAN

M **LESUEUR COUNTY HISTORICAL SOCIETY,** Chapter One, PO Box 240, Elysian, MN 56028-0240. Tel 507-267-4620, 362-8350; Fax 507-267-4750; Elec Mail museum@lchs.mus.mn.us; Internet Home Page Address: www.lchs.mus.mn.us; *VPres* Patricia Nusbaum; *Genealogist* Shirley Zimprich; *Pres* Audrey Knutson; *Treas* Michael La France
Open May - Sept Sat & Sun 1 - 5 PM, June - Aug Wed - Sun 1 - 5 PM; No admis fee; Estab 1966 to show the works of Adolf Dehn, Roger Preuss, David Maass; Lloyd Herfindohl & Albert Christ-Janer to preserve early heritage & artifacts of the pioneers of LeSueur County; Mus is depository of Dehn, Preuss, Maass & Lloyd Herfindahl; examples of originals, prints & publications of the artists are on display; Average Annual Attendance: 1,000; Mem: 700; dues annual $15; annual meeting
Income: $17,000 (financed by mem, county appropriation, county government & grants)
Purchases: $51,000
Special Subjects: Painting-American, Architecture, Drawings, Painting-American, Photography, Costumes, Ceramics, Folk Art, Pottery, Etchings & Engravings, Landscapes, Manuscripts, Portraits, Posters, Dolls, Furniture, Glass, Metalwork, Carpets & Rugs, Historical Material, Maps, Juvenile Art, Miniatures, Period Rooms, Leather, Enamels
Collections: Adolf Dehn; David Maass; Roger Preuss; Lloyd Herfindahl; Albert Christ-Janer
Exhibitions: Exhibitions of works by Adolf Dehn, David Maass, Roger Preuss, Lloyd Herfindohl, Albert Christ-Janer
Publications: Newsletters, quarterly
Activities: Slide carousel to show the sites & early history of the County & works of the Artists; classes for children; lect open to public; gallery talks; tours; lending collection contains books, cassettes, color reproductions, latern slides, original prints, paintings, motion pictures & 1000 photographs; museum shop sells books, original art

L **Collections Library,** PO Box 240, Elysian, MN 56028-0240. Tel 507-267-4620, 362-8683; *Dir* Shirley Zimprich
Open by appointment only; Estab 1970 to collect locally & state-wide for purposes of genealogy; history of the artists
Library Holdings: Audio Tapes 300; Book Volumes 300; Cassettes; Clipping Files; Framed Reproductions; Lantern Slides; Original Art Works; Periodical Subscriptions 3; Prints; Reels 120; Reproductions; Slides
Collections: Original Adolf Dehn Watercolors & Lithographs; Duck Stamp Prints of Roger Preuss & David Maass; Lloyd Herfindahl; All Media
Exhibitions: Lloyd Herfindahl
Publications: Newsletters, 4 per yr

FOUNTAIN

A **FILLMORE COUNTY HISTORICAL SOCIETY,** 202 County Rd, Ste 8, Fountain, MN 55935. Tel 507-268-4449; *Exec Dir* Jerry D Henke; *Asst Dir* Alma Syvertson
Open 9 AM - 4 PM; No admis fee, donations accepted; Estab 1934 to preserve & illustrate the written & photographic history; Average Annual Attendance: 8,000; Mem: 350; dues $5-$150; annual meeting second Sat in Oct
Income: $50,000 (financed by mem, county appropriations, donations)
Purchases: An Original Bernard Pietenpol Airplane
Collections: Bue Photography; Antique Agricultural Equipment; Hand Made Wooden Tools; Vintage Clothing & Tractors
Exhibitions: Rotation exhibitions
Publications: Rural Roots, quarterly
Activities: Gift shop sells books

GLENWOOD

M **POPE COUNTY HISTORICAL SOCIETY,** Pope County Museum, S Hwy 104, Glenwood, MN 56334; 809 S Lakeshore Dr, Glenwood, MN 56334. Tel 320-634-3293; Fax 320-634-3293; Elec Mail pcmmuseum@runestone.net; *Cur* Merlin Peterson; *Asst* Jackie Gartner; *Educator* Rose Meade
Open Tues - Sat 10 AM - 5 PM; Admis adults $3, students $1.50, children $.50; Estab 1932 to display & preserve artifacts & geneology files; 8,000 sq ft & seven historic buildings; Average Annual Attendance: 4,500; Mem: Mem:400; dues $10; annual meeting

Income: $70,000 (financed by county appropriation, admis & gifts)
Special Subjects: Architecture, Drawings, Painting-American, Photography, American Indian Art, Southwestern Art, Textiles, Costumes, Religious Art, Crafts, Woodcarvings, Landscapes, Decorative Arts, Manuscripts, Portraits, Eskimo Art, Dolls, Furniture, Glass, Metalwork, Historical Material, Period Rooms, Embroidery, Painting-Scandinavian
Publications: Semi-annual newsletter
Activities: Educ dept; classes for children; guided tours for students; gallery talks; sales shop sell books & prints

INTERNATIONAL FALLS

M **KOOCHICHING MUSEUMS,** (Koochiching County Historical Society Museum) 214 Sixth Ave, International Falls, MN 56649. Tel 218-283-4316; Fax Fax: 218-283-8243; *Exec Dir* Edgar Oerichbauer
Open Mon - Fri 9 AM - 5 PM; Admis adults $2, students $1; Estab 1958 to collect, preserve & exhibit the material & social cultures of Koochiching County, North Central Minnesota & the southern border portions of southern Ontario; 2 mus; The Koochiching Historical Society & The Bronco Mus; Mem: 500; dues $15-$1000
Income: Financed by county, mem, admis funds & grants
Special Subjects: Painting-American, Photography, Textiles, Crafts, Pottery, Landscapes, Manuscripts, Portraits, Dolls, Furniture, Glass, Jewelry, Porcelain, Maps, Coins & Medals, Period Rooms, Embroidery, Laces
Collections: 100 paintings relating to the history of the region, including many by local artists & six of which were commissioned for the museum, various small collectors, football memorabilia
Exhibitions: Permanent coll
Publications: Koochiching Chronicle, quarterly
Activities: Classes for adults & children; dramatic programs; lect open to public; tours; originate traveling exhibs; sales shop sells books, Indian craft items, post cards, unique gifts

LITTLE FALLS

M **CHARLES A LINDBERGH HISTORIC SITE,** 1620 Lindbergh Dr S, Little Falls, MN 56345. Tel 320-616-5421; Fax 320-616-5423; Internet Home Page Address: www.mnhs.org; *Historic Site Mgr* Charles D Pautler
Open Memorial Day - Labor Day: Tues - Sat 10 AM - 5 PM, Sun 12 - 5 PM; Sept - Oct: Sat 10 AM - 4 PM, Sun 12 - 4 PM; cl Mon except holidays; open by appt year-round; Admis adults $7, seniors $6, students $5, children $4; spec rates for grps; mems no admis fee; Estab 1969; Childhood home of Charles A Lindbergh where he lived from 1902-1920; also contains visitor ctr which has state-of-the-art exhibs on Lindbergh's life & that of his wife, Anne Morrow Lindbergh; visitors can take guided tour of the 1906 home, tour three levels of mus exhibs & galleries in the visitor ctr & see films containing footage from Lindbergh's life; Average Annual Attendance: 14,000
Collections: 200 books vols on politics 1870 - 1920; 100 book vols of children's books; 50 vols on secondary reference resources; over 100 folders & research on Lindbergh & aviation
Activities: Guided tours; films; hobby workshops; lects; research in Lindbergh's aviation 1924 - 1927, Lindbergh's involvement in the anti-war effort 1939 - 1940; gen aviation history 1903 - 1940; Lindbergh's Pacific War experience 1944; participatory & traveling exhibs; spec events: Children's Day, Family Fun Day, Air Show, Film Festival; Lindbergh & aviator books, souvenirs, children's items & other museum-related items for sale

MANKATO

M **MANKATO AREA ARTS COUNCIL,** Carnegie Art Center, 120 S Broad St, Mankato, MN 56001. Tel 507-625-2730; Elec Mail artctr@hickorytech.net; *Grantsperson & Historian* Rosemary Froen; *Shop & Gallery Coordr* Hope Cook
Open Wed, Fri & Sat 1 - 4 PM, Thurs 1 - 7 PM; No admis fee; Estab 1980 to provide exhibition space for regional artists; Three galleries (Rotunda Gallery, Community Room & Fireplace Gallery) housed in historic Carnegie Library; Average Annual Attendance: 5,000; Mem: 300; dues $20 & up; annual meeting in Oct
Exhibitions: Monthly regional shows by visual artists
Activities: Classes for adults & children; lect open to public, tours, gallery talks; sales shop sells books, original art, prints & reproductions

M **MINNESOTA STATE UNIVERSITY, MANKATO,** Nelson Hall, 136 Mankato Ave Mankato, MN 56002. Tel 507-389-6412; *Dir* Harlan Bloomer
Open Mon - Wed 9 AM - 9 PM, Thurs & Fri 9 AM - 5 PM, Sun 1 - 4 PM; No admis fee; Estab 1979 to provide cultural enrichment in the visual arts to the campus & community through a prog of exhibs from local, regional & national sources & student exhibs; Gallery has 150 running ft of carpeted display area, track lighting & climate controlled
Income: Financed by univ
Special Subjects: Drawings, Painting-American, Prints, Crafts, Bookplates & Bindings
Collections: American bookplates; contemporary prints, drawings, paintings, photographs, sculpture & crafts; student works in all media

MINNEAPOLIS

M **AMERICAN SWEDISH INSTITUTE,** 2600 Park Ave, Minneapolis, MN 55407. Tel 612-871-4907; Fax 612-871-8682; Elec Mail info@americanswedishinst.org; Internet Home Page Address: www.americanswedishinst.org; *Dir* Bruce Karstadt; *Cur* Curt Pederson; *Librn & Archivist* Marita Karlisch
Open Tues, Thurs, Fri & Sat Noon - 4 PM, Wed Noon - 8 PM, Sun 1 - 5 PM, cl Mon & national holidays; Admis adults $5, seniors $4, students under 12 $3 & children under 6 free; Estab & incorporated 1929 to preserve, collect, procure & exhibit objects related to Swedish-Americans in the Midwest from 1845; Building donated by Swan J Turnblad & contains, in a home setting, a fine coll of Swedish artifacts, plus many items of gen cultural interest pertaining to Scandinavia. The Grand Hall, paneled in African mahogany, is considered to be the finest example in US. Throughout the mansion there are eleven porcelain tile fireplaces; Average Annual Attendance: 50,000; Mem: 6000; dues, life $3000, patron $150, sustaining $100, family (husband, wife & all children under age 18, living at home) $50, regular (single) $35, non-resident single, or husband & wife outside of fifty mile radius of Twin Cities $35, students attending school, below the age of 18 $20, other mem levels available
Library Holdings: Book Volumes; Clipping Files; Fiche; Lantern Slides; Manuscripts; Maps; Memorabilia; Motion Pictures; Original Documents; Other Holdings; Photographs; Video Tapes
Special Subjects: Sculpture, Ceramics, Woodcarvings, Glass, Porcelain, Tapestries, Painting-Scandinavian
Collections: Paintings, sculpture, tapestries, ceramics, china, glass, pioneer items & textiles, immigration related objects
Publications: ASI Posten (newsletter), monthly; ASI catalog
Activities: Classes for adults & children; dramatic progs; docent training; lect open to public; concerts; gallery talks; tours; scholarships offered; individual paintings lent to other museums; book traveling exhibs 1-2 per year; bookstore sells books, magazines, original art, reproductions & prints

A **ARTS MIDWEST,** 2908 Hennepin Ave, Ste 200, Minneapolis, MN 55408. Tel 612-341-0755; Fax 612-341-0902; Elec Mail general@arts.midwest.org; Internet Home Page Address: www.artsmidwest.org; Others TDD 612-341-0901; *Exec Dir* David J Fraher
Estab 1985, provides funding programs, conferences & publications to individuals & organizations in Illinois, Indiana, Iowa, Michigan, Minnesota, North Dakota, Ohio, South Dakota & Wisconsin. Works in collaboration with corporations, foundations, state government arts agencies, the National Endowment for the Arts & art enthusiasts to connect the arts to audiences, enabling individuals & families to share in & enjoy the arts & cultures of the region & the world
Publications: Inform, bimonthly newsletter; Insights on Jazz, booklets; Midwest Jazz, quarterly newsmagazine

M **CENTER FOR ARTS CRITICISM,** 2822 Lyndale Ave S, Minneapolis, MN 55408. Tel 612-874-2818; Fax 612-871-6927; *Exec Dir* Bienvenida Matias
Estab 1984 for sole purpose of addressing the need for more quantity, quality & diversity in arts & cultural criticism

C **FEDERAL RESERVE BANK OF MINNEAPOLIS,** 90 Hennepin Ave, Minneapolis, MN 55401-1804. Tel 612-204-6067; *Cur* Mary Lange
Open by appointment with Cur; Estab 1973 to enhance the working environment of bank; to support the creative efforts of ninth district artists; Collection displayed throughout the bank in offices, lounges, public areas and work areas
Collections: Regional collection consists of works by artists living & working in the Ninth Federal Reserve District

M **INTERMEDIA ARTS MINNESOTA,** 2822 Lyndale Ave S, Minneapolis, MN 55408. Tel 612-871-4444; Fax 612-871-2769; Elec Mail allstaff@intermediaarts.org; Internet Home Page Address: www.intermediaarts.org; *Exec Dir* Tom Borrup
Open Noon - 5 PM daily; Suggested donation $2; Estab 1973; 2,000 sq ft space used for installations, screenings & performances; Average Annual Attendance: 5,000; Mem: 250; dues $35
Income: Financed by donations, grants
Exhibitions: Exhibition supporting New Works in Media & interdisciplinary Arts
Publications: Annual report; calendar of events
Activities: Professional develop for teaching artists; lect open to public, 3 vis lectrs per year; gallery talks; tours; scholarships & fels offered; museum shop sells t-shirts

M **LUTHERAN BROTHERHOOD GALLERY,** Gallery of Religious Art, 625 Fourth Ave S, Minneapolis, MN 55415. Tel 612-340-7000; Fax 612-340-8447; Elec Mail cic@luthbro.com; Internet Home Page Address: www.luthbro.com; *Consultant & Cur* Richard L Hillstrom
Open Mon - Fri 10 AM - 4 PM; No Admis fee; Estab 1982 as a cultural & educational gallery; Art is exhibited in a modest sized gallery & in the corporate library
Income: Financed by mem, gifts, donations
Collections: Bing & Grondahl Plate Collection; Martin Luther Commemorative Medals 16th-20th centuries; collection restricted to religious prints & drawings (15th-20th centuries)
Exhibitions: 8-10 Exhibitions per year
Activities: Originate traveling exhibs

A **MIDWEST ART CONSERVATION CENTER,** (Upper Midwest Conservation Association) 2400 Third Ave S, Minneapolis, MN 55404. Tel 612-870-3120; Fax 612-870-3118; Elec Mail info@preserveart.org; Internet Home Page Address: www.preserveart.org; *Exec Dir* Colin Turner; *Field Svcs* Neil Cockerline; *Painting Conservator* Joan Gorman; *Painting Conservator* David Marquis; *Objects Conservator* Donna Haberman; *Paper Conservator* Elizabeth Buschor; *Textile Conservator* Beth McLaughlin; *Objects Conservator* Nicole Grabow
Estab 1977 for art conservation & education; Mem: 170; dues $50-600; annual meeting in the Fall
Income: $1,000,000 (financed by mem, earned income & grants)

L **MINNEAPOLIS COLLEGE OF ART & DESIGN,** Library, 2501 Stevens Ave S, Minneapolis, MN 55404. Tel 612-874-3791; Fax 612-874-3795; Elec Mail library@mcad.edu; Internet Home Page Address: www.library.mcad.edu; *Reference Librn* Sarah Nolan; *Slide Librn* Allan Kohl; *Dir* Suzanne Degler
Open Mon - Thurs 8:30 AM - 10 PM, Fri 8:30 AM - 6 PM, Sat Noon - 6 PM, Sun Noon - 7 PM, summer Mon - Fri 10 AM - 3 PM, slide library has different hours; No admis fee (students only); Estab to provide library & materials in support of the curriculum of the College; includes a library & slide library; Circ 32,000, circulation limited to students, staff, alumni & faculty

Income: Financed by student tuition, grants & gifts
Library Holdings: Book Volumes 60,000; CD-ROMs; Cassettes; Clipping Files; Compact Disks; DVDs; Exhibition Catalogs; Kodachrome Transparencies; Pamphlets; Periodical Subscriptions 175; Records; Slides 145,000; Video Tapes
Special Subjects: Film, Illustration, Photography, Drawings, Graphic Design, Sculpture, Printmaking, Video

M **MINNEAPOLIS INSTITUTE OF ARTS,** 2400 Third Ave S, Minneapolis, MN 55404. Tel 612-870-3000, 870-3046; Fax 612-870-3004; Internet Home Page Address: www.artsmia.org; *Assoc Dir* Patricia Grazzini; *Chmn Educ* Kathryn C Johnson; *Cur Prints & Drawings* Richard Campbell; *Cur Photo* Carroll T Hartwell; *Cur Oriental Arts* Robert Jacobsen; *Registrar* Catherine Ricciardelli; *Cur Decorative Arts* Christopher Monkhouse; *Cur Paintings* Charles Stuckey; *Cur Textiles* Lotus Stack; *Cur Ethnographic Arts* Louise Lincoln; *Dir* Evan Maurer
Open Tues - Sat 10 AM - 5 PM, Thurs 10 AM - 9 PM, Sun Noon - 5 PM, cl Mon; Admis to museum's permanent coll free; exhibs adults $2, student $1, free to members, seniors, those under 12 & AFDC Cardholders; Estab 1883 to foster the knowledge, understanding & practice of the arts; The first gallery was opened in 1889 & the original bldg was constructed in 1911-15. The south wing was added in 1926 & the entire structure features the classical elements of the day. The mus was expanded to twice the original size in 1972-74 & has incorporated modern themes designed by Kenzo, Tange & URTEC of Tokyo; Average Annual Attendance: 570,000; Mem: 21,000; dues family $65, individual $35, dual $50; annual meeting in Oct
Income: Financed by endowment, mem, county & state appropriations & admis
Special Subjects: Drawings, Painting-American, Photography, Prints, Sculpture, American Indian Art, African Art, Pre-Columbian Art, Decorative Arts, Painting-European, Oriental Art, Period Rooms, Antiquities-Greek, Antiquities-Roman
Collections: Collection representing all schools & periods of art: American & European paintings, decorative arts, period rooms, photography, prints & drawings, sculpture; Ancient, African, Oceanic, Oriental & native North & South American arts & textiles
Exhibitions: Rotating exhibitions
Publications: Bulletin, biannually; exhibitions catalogs; member's magazine, monthly
Activities: Classes for adults & children; docent training; workshops; lect open to public, 15 vis lectrs per year; concerts; gallery talks; tours; paintings & original art objects lent to other professional arts organizations; originate traveling exhibitions; museum shop sells books, magazines, original art, reproductions, prints, slides & jewelry

L **Art Research & Reference Library,** 2400 Third Ave S, Minneapolis, MN 55404. Tel 612-870-3117; Fax 612-870-3004; Internet Home Page Address: www.artsmia.org; *Assoc Librn* Sarah Quimby; *Visual Resource Librn* Heidi Raatz; *Head Librn* Janice Lea Lurie
Open Tues - Fri 11:30 AM - 4:30 PM, hours vary around holidays; Estab 1915 to provide a reference collection based around the museum's collection of works of art; Has exhibitions of books & prints. For reference only
Library Holdings: Auction Catalogs; Book Volumes 50,000; Exhibition Catalogs; Pamphlets; Periodical Subscriptions 125
Collections: Leslie Collection: History of Books & Printing; Minnick Collection: Botanical, Floral & Fashion Books
Exhibitions: Jean Cocteau
Publications: Imperial Silks by Robert Jacobsen; Chaining the Sun: Portraits by Jeremiah Gurney, by Christian Peterson; Classical Chinese Furniture in the Minneapolis Institute of Arts by Robert Jacobsen; Progressive Design in the Midwest by Jennifer Komar Olivarez

A **Friends of the Institute,** 2400 Third Ave S, Minneapolis, MN 55404. Tel 612-870-3045; Fax 612-870-3004; Internet Home Page Address: www.artsmia.org; *Pres* Val McLinn
Open Mon - Fri 8:30 AM - 4:30 PM; Estab 1922 to broaden the influence of the Institute in the community & to provide volunteer support within the mus; Mem: 1900; annual meeting in May
Activities: Coordinates docent prog, mus shop, sales & rental gallery, speaker's bureau, information desk, special lect, exhibs & fundraising projects

C **THE PILLSBURY COMPANY,** Art Collection, Pillsbury Ctr, 200 S Sixth St Minneapolis, MN 55402. Tel 612-330-4966; *Pres* Juliana L Chugg
Estab to create exciting & attractive environment & support the arts; Collection displayed on internal walls of corporate headquarters building
Collections: Contemporary & Western American art, primarily oil paintings, prints & watercolors

M **UNIVERSITY OF MINNESOTA,** Katherine E Nash Gallery, 208 Art Bldg, 216 21st Ave S Minneapolis, MN 55455; 225 19th Ave S, Minneapolis, MN 55455. Tel 612-624-7530; Fax 612-625-7881; Elec Mail nash@tc.umn.edu; Internet Home Page Address: www.artdept.umn.edu; *Dir* Nick Shank
Open Tues, Wed & Fri 10 AM - 4 PM, Thurs 10 AM - 8 PM, Sat 11 AM - 5 PM; No admis fee; Provides educational exhibition space; Student exhibits
Special Subjects: Ceramics, Painting-American, Prints, Photography, Sculpture, Metalwork
Exhibitions: Rotating exhibitions every 3-4 weeks
Activities: Lect open to public, 5-8 vis lectrs per year; gallery talks; purchase awards; McKnight Fel

UNIVERSITY OF MINNESOTA
M **Frederick R Weisman Art Museum,** Tel 612-625-9494; Fax 612-625-9630; Elec Mail wandir@umn.edu; Internet Home Page Address: www.weisman.umn.edu; *Dir* Lyndel King; *Educ Dir* Colleen Sheehy; *Registrar* Karen Duncan; *Public Affairs* Ann Benrud; *Technical Dir* John Allen; *Mus Shop Mgr* Kay McGuire; *Accounts Supvr* Carol Stafford; *Develop Dir* Brenda Teats
Open Tues, Wed & Fri 10 AM - 5 PM, Thurs 10 AM - 8 PM, Sat & Sun 11 AM - 5 PM, cl Mon; No admis fee; Estab 1934; the progs of the Weisman Art Museum are geared to meet broad objectives of an all-Univ mus, as well as the specific teaching & research needs of various University of Minnesota depts; Average Annual Attendance: 130,000; Mem: 1,000
Income: Financed by state appropriation, grants & gifts

Library Holdings: Periodical Subscriptions 176
Special Subjects: Drawings, Painting-American, Prints, Sculpture
Collections: Paintings, drawings & prints by American artists working in the first half of the 20th century, & contains notable works by Avery, Biederman, Dove, Feininger, Hartley, MacDonald-Wright, Marin, Maurer, Nordfeldt & O'Keeffe; print collection includes works by artists of all schools & periods; Ceramic collections include ancient American Indian Pottery; ancient Chinese & Korean objects; ancient Greek vases, German, French & English 18th & 19 century porcelain, international 20th century ceramics
Exhibitions: The Weisman Art Museum stresses a program of major loan exhibitions, held concurrently with smaller exhibitions organized for specific teaching purposes or from the permanent collection
Activities: Docent training; concerts; tours; lending program to University, staff & students of Minnesota faculty of framed two-dimensional material; museum shop sells books, magazines, reproductions, cards

M **The Studio/Larson Gallery,** Tel 612-625-0214; Fax 612-626-3547; Elec Mail studio@tcsu.umn.edu; Internet Home Page Address: www.coffman.umn.edu/studio; *Coordr* Tricia Schweitzer
Open Mon - Wed 10 AM - 5 PM, Thurs 10 AM - 8 PM, Fri 10 AM - 4 PM, Sat Noon - 5 PM, Sun 1 - 4 PM; No admis fee; Estab 1976 to make art accessible to univ community & gen pub; Average Annual Attendance: 30,000
Income: Financed by student fees
Exhibitions: 7-10 Exhibitions, annually
Activities: Educ dept; lect; gallery talks

L **Art Book Collection, Wilson Library,** Tel 612-624-7343, 624-0303; Elec Mail h-sche@tc.umn.edu; Internet Home Page Address: wilson.lib.umn.edu/; *Librn* Herbert G Scherer
Open Mon - Fri 7 AM - 9 PM, Sat 9 AM - 5 PM, Sun Noon - 9 PM; Estab 1950 to serve undergraduate & graduate teaching programs in Art History & Humanities to PhD level & in Studio Art to MA level; to provide art related books to other departments & to the entire academic community as best we can
Library Holdings: Book Volumes 85,000; Cassettes 52; Exhibition Catalogs 5000; Fiche 7000; Pamphlets; Periodical Subscriptions 339
Special Subjects: Art History
Activities: Lect; tours

L **Architecture & Landscape Library,** Tel 612-624-6383, 624-1638; Fax 612-625-5597; Elec Mail j-morn@tc.umn.edu; Internet Home Page Address: arch.lib.umn.edu/; *Library Head* Joon Mornes
Open Mon - Fri 9 AM - 9 PM, Sat & Sun 1 - 6 PM; Circ 20,641; Used as a reference lending library
Income: Financed by University
Library Holdings: Book Volumes 38,000; Periodical Subscriptions 165; Reels 244; Video Tapes
Special Subjects: Landscape Architecture, Interior Design, Architecture

L **Children's Literature Research Collections,** Tel 612-624-4576; Fax 612-625-5525; Elec Mail clrc@tc.umn.edu; Internet Home Page Address: special.lib.umn.edu/clrc/; *Cur* Karen Nelson Hoyle
Open Mon - Fri 8:30 AM - 4:30 PM; No admis fee; Estab 1949 to collect books, manuscripts & illustrations for use by researchers & for exhibits; For reference & research only
Income: Financed by endowment, University of Minnesota libraries
Library Holdings: Audio Tapes; Book Volumes 140,000; Cassettes; Clipping Files; Exhibition Catalogs; Fiche; Filmstrips; Manuscripts; Original Art Works; Original Documents; Other Holdings Toys; Pamphlets; Periodical Subscriptions 37; Photographs; Records; Slides; Video Tapes
Special Subjects: Illustration, Manuscripts, Painting-American, Posters
Collections: Figurine Collection
Publications: Kerlan Newsletter, 4 times per yr
Activities: Classes for adults; lect open to public, 6 vis lectrs per year; competitions with awards; fels; scholarships offered; individual paintings lent to art galleries; travelling exhibits; lending coll contains books, original art work, manuscript material; book traveling exhibs 6 per year; originate traveling exhibs in Sweden, Spain & US; sales shop sells notecards, posters, books, keepsakes & catalogs, publs

M **The Bell Museum of Natural History,** Tel 612-624-7083; Fax 612-626-7704; Elec Mail slanyon@biosci.cbs.umn.edu; Internet Home Page Address: www.1.umn.edu/bellmuse/; *Touring Exhib Coordr* Ian Dudley; *Cur Exhib* Donald T Luce; *Dir* Scott M Lanyon
Open Tues - Fri 9 AM - 5 PM, Sat 10 AM - 5 PM, Sun Noon - 5 PM; Admis adults $3, seniors & students $2, children under 3 & members free, free admis Sun; Estab 1872 to explore the diversity of life in the natural world; Dioramas, Discovery Room, temporary exhibits gallery; Average Annual Attendance: 60,000; Mem: 600; dues $20-$35
Special Subjects: Drawings, Painting-American, Prints, Watercolors, Etchings & Engravings, Dioramas
Collections: Owen T Gromme Collection; Francis Lee Jaques Collection; three separate Audubon collections; works by other artist-naturalists
Exhibitions: Exotic Aquatics; Francis Lee Jaques-Images of the North Country; The Peregrine Falcon-Return of an Endangered; The Photography of Jim Brandenburg; 18 touring exhibits
Publications: Imprint & Calendar, quarterly
Activities: Classes for adults & children; docent training; lect open to public, 2 vis lectr per year; gallery talks; tours; competitions; lends to other non-profit art museums; lending coll contains original art works, original prints, paintings & sculpture; originate traveling exhibs to libraries, art mus, nature centers, environmental learning centers & schools

M **WALKER ART CENTER,** Vineland Pl, Minneapolis, MN 55403. Tel 612-375-7600; Fax 612-375-7618; Elec Mail information@walkerart.org; Internet Home Page Address: www.walkerart.org; *Pres* Ralph W Burnet; *Chmn Bd* H Brewster Atwater; *Admin Dir* Ann Bitter; *Chief Cur* Richard Flood; *Publ & Design Mgr* Lisa Middag; *Registrar* Gwen Bitz; *Dir Develop* Christopher Stevens; *Design Dir* Andrew Blauvelt; *Dir Film & Video* Cis Bierinckx; *Pub Information* Margaret Patridge; *Dir* Kathy Halbreich
Open Tues, Wed, Fri & Sat 10AM-5PM, Thurs 10AM-9PM, Sun 11AM-5PM, cl Mon; Admis adults $6, students & seniors $4; Estab 1879 by T B Walker, reorganized 1939 as Walker Art Center, Inc; building erected 1927; new museum building opened 1971; The Center consists of nine galleries, three sculpture

terraces, the Center Bookshop 11 acre Sculpture Garden, Conservatory & the Gallery 8 Restaurant; Average Annual Attendance: 906,605; Mem: 8000; dues household $45, individual & special $25; annual meeting in Sept
Income: Financed by corporate & individual contributions, endowment, mem, state & federal appropriation, grants, book shop, museum admis & prog ticket sales
Special Subjects: Drawings, Painting-American, Photography, Prints, Sculpture
Collections: Joseph Beuys Collection; Jasper Johns Collection; Sigmar Polke Collection; Complete Archive of Tyler Graphics: Contemporary Print Collection; Edmond R Ruben Film Study Collection
Exhibitions: Selections from Permanent Collection
Publications: Brochures; calendar of events; exhibition catalogs
Activities: Classes for adults & children; docent training; internships; lect open to public, 25 vis lectr per year; concerts; gallery talks; school & adults tours; films; individual paintings & original objects of art lent to museums; book traveling exhibitions; traveling exhibitions organized & circulated; museum shop selling books, magazines, posters, jewelry & gift items

L **T J Peters Family Library,** 1750 Hennepin Ave, Minneapolis, MN 55403. Tel 612-375-7680; Fax 612-375-7590; Elec Mail rosemary.furtak@walkerart.org; Internet Home Page Address: www.walkerart.org; *Librn* Rosemary Furtak; *Archivist* Jill Vetter; *Visual Resources Librn* Barbara Economon
Open by appointment to outside researchers; Open to museum personnel & scholars by appointment. For reference only; Average Annual Attendance: 500 outside researchers
Library Holdings: Auction Catalogs; Audio Tapes 2000; Book Volumes 35,000; Cassettes; Clipping Files; Compact Disks; Exhibition Catalogs; Lantern Slides; Motion Pictures; Original Documents; Other Holdings Artists' books 1500; Periodical Subscriptions 110; Photographs; Slides; Video Tapes
Special Subjects: Decorative Arts, Film, Photography, Graphic Arts, Graphic Design, Prints, Sculpture
Collections: Catalogs dating back to 1940

C **WELLS FARGO, MINNEAPOLIS,** Arts Program, Sixth & Marquette Ave, Minneapolis, MN 55479-1025. Tel 612-667-5136; Fax 612-667-2112; *Cur Coll* David Ryan
Open Mon - Fri 8 AM - 5 PM; Estab 1987 to acquire a core collection focusing on modernism comprised of 19th & early 20th century decorative & applied arts & paperworks; Twenty vitrines are installed on the first & second floors of Norwest Center
Purchases: 400 acquisitions to date
Collections: Decorative & applied arts & paperworks dating from 1880 to 1940
Publications: Exhibition brochures
Activities: Lect open to employees only; tours; original objects of art lent to other museums

MOORHEAD

M **HERITAGE HJEMKOMST INTERPRETIVE CENTER,** 202 First Ave N, PO Box 157 Moorhead, MN 56561. Tel 218-233-5604; *Exhibit Coordr* Rachel Asleson; *Exec Dir* Bev Woodward
Open Mon - Sat 9 AM - 5 PM, Thurs 9 AM - 9 PM, Sun Noon - 5 PM; Admis adults $3.50, senior citizens $3, youths 5-17 $1.50; Estab 1986 to interpret River Valley heritage & enrichment through interdisciplinary exhibits & programs; 7000 sq ft exhibition area for traveling exhibits; Average Annual Attendance: 40,000; Mem: Dues $25; annual meeting in Mar
Income: $280,000 (financed by mem & attendance)
Special Subjects: Anthropology, Folk Art
Exhibitions: Focus on humanities, but are supplemented by art and/or science exhibits
Publications: Heritage Press, bimonthly
Activities: Docent programs; lect open to public; book traveling exhibitions 3 per year; sales shop sells books, prints, slides & Scandinavian items

NORTHFIELD

M **CARLETON COLLEGE,** Art Gallery, One N College St, Northfield, MN 55057. Tel 507-646-4342; Fax 507-646-7042; Elec Mail lbradley@carleton.edu; *Dir & Cur* Laurel Bradley PhD; *Registrar* James F Smith
Open daily Noon - 5 PM, Tues - Fri 7 - 10 PM; No admis fee; Estab 1971 for art exhibitions & programs emphasizing quality & interdisciplinary ideas; One gallery 30 x 40 ft, secure; Average Annual Attendance: 5,000
Income: $100,000 (financed by parent organization)
Special Subjects: Painting-American, Photography, Prints, Woodcuts, Asian Art, Antiquities-Greek, Antiquities-Roman
Collections: American Paintings; Asian Objects; Photographs (1945-Present); Prints European & American (19th-20th century)
Activities: Lect open to public, 10 vis lectr per year; book traveling exhibitions 1-2 per year; originate, organize & book traveling exhibitions

A **NORTHFIELD ARTS GUILD,** 304 Division St, Northfield, MN 55057. Tel 507-645-8877; Fax 507-645-6201; Elec Mail nfldarts@rconnect.com; *Shop Mgr* Bunny Lantz; *Prog Dir* Patsy Dew; *Bookkeeper* Kathy Bjerke; *Exec Dir* Karen Helland; *Office Mgr* Sheryl Joy
Open Mon - Wed, Fri & Sat 10 AM - 5 PM, Thurs 10 AM - 8 PM; Estab 1958 as a non-profit organization which offers classes & programming in visual arts, theater, music, dance & literary art; Mem: 570 households
Publications: NAG Notes, quarterly
Activities: Classes for adults & children; dramatic programs; dance school; lect open to public; concerts; gallery talks; scholarships offered; museum shop sells books, original art

M **SAINT OLAF COLLEGE,** Flaten Art Museum, 1520 Saint Olaf Ave, Northfield, MN 55057. Tel 507-646-3556; Fax 507-646-3776; Elec Mail ewaldj@stolaf.edu; Internet Home Page Address: www.stolaf.edu/collections/artmuseum; *Dir* Jill Ewald
Open Mon, Tues, Wed & Fri 10 AM - 5 PM, Thurs 10 AM - 8 PM, Sat & Sun 2 - 5 PM; No Admis fee; Estab 1976; 2500 flexible sq ft, shows regional, national, international work, no unsolicited shows; Average Annual Attendance: 4,000

Purchases: $45,000
Library Holdings: Exhibition Catalogs; Original Art Works; Photographs; Prints; Sculpture
Special Subjects: Graphics, Painting-American, Prints, Watercolors, Bronzes, Textiles, Religious Art, Woodcuts, Etchings & Engravings, Landscapes, Painting-Japanese, Oriental Art, Painting-British, Renaissance Art
Collections: Chris Janer prints & paintings; Nygaard sculpture; Contemporary and traditional paintings; sculpture, prints & work by Norwegian artists; Japanese woodcuts; Southwestern Native American Pottery
Exhibitions: Edward Anders Sovik, FAIA Architect; Layers of Meaning: A Story of Double Weave; The Figure and the Land (photography)
Publications: Exhibit announcements, catalogs every 5-6 weeks
Activities: Supports academic programs & classes; lect open to public, 4 vis lectr per year; gallery talks; book traveling exhibitions 1-2 per year

OWATONNA

A **OWATONNA ARTS CENTER,** Community Arts Center, 435 Garden View Lane, PO Box 134 Owatonna, MN 55060. Tel 507-451-0533; Elec Mail owatonnaartscent@qwest.org; *Dir & Cur* Silvan A Durben; *Pres* Earl Anderson; *Dir Educ* Judy Srsen; *Treas* Joy Carlson Martin; *Vpres* Vern White; *Admin Asst* Sharon Stark
Open Tues - Sun 1 - 5 PM; No admis fee except for specials; Estab 1974 to preserve local professional artists' work & promote the arts in the community; The West Gallery (32 x 26 x 12 ft) & the North Gallery (29 x 20 x 12 ft) provide an interesting walk through space & a versatile space in which to display two & three dimensional work; the two galleries can be combined by use of moveable panels & the Sculpture Garden which was completed in 1979 of multi-level construction; Average Annual Attendance: 17,000; Mem: 400; dues basic $40 & up, sustaining $200 & up; annual meeting third Sun in Oct
Income: $102,000 (financed by mem & fund raising activities plus sustaining fund from industries & business)
Collections: Marianne Young World Costume Collection of garments & jewelry from 27 countries; painting, prints, sculpture by local professional artists; 2 Bronzes by John Rood, Paul Grandland; steel sculpture by Hammel; print collection of Adolph Den
Exhibitions: Annual Christmas Theme Display; Annual Outdoor Arts Festival; Annual Steele County Show
Publications: Newsletter to members & other arts organizations
Activities: Classes for adults & children; festivals; concerts; monthly; tours; scholarships offered; original objects of art & Costume Collection lent to other arts organizations

L **Library,** 435 Dunnell Dr, PO Box 134 Owatonna, MN 55060. Tel 507-451-0533; Fax 612-224-8854; *Dir* Silvan Berben; *Admin Asst* Julie Enzenaurer
Open Tues - Sat 1 PM - 5 PM by appointment; Open to members only; for reference
Library Holdings: Book Volumes 255

PARK RAPIDS

M **NORTH COUNTRY MUSEUM OF ARTS,** Third & Court Streets, PO Box 328 Park Rapids, MN 56470. Tel 218-732-5237; *Treas* Carol Nelson; *Cur & CEO* Sawn M Kast; *VChmn* Floyd Harvala; *Chmn of Bd* Terry Morris; *Sec* Alice D Holz; *Newsletter Ed* Joan Brandach
Open May - Oct Tues - Sun 11 AM - 5 PM; Admis $1; Estab 1977 to provide a cultural and educational center to house a permanent study collection of old school European paintings & to house traveling exhibitions for the benefit of persons of all ages through contact & work with art in its many forms; Maintains Great Gallery, Members Gallery, four Revolving Galleries & studio; Average Annual Attendance: 6,000; Mem: 120; dues family $20, individual $15; annual meeting in Oct
Income: $25,000 (financed by mem, individual & corporate grants & gifts)
Special Subjects: African Art, Painting-European, Period Rooms
Collections: 160 Nigerian arts, crafts & artifacts; 45 Old School European paintings; 18 Contemporary Prints; 10 Contemporary paintings & artwork; 19 Drawings of Native American Children
Exhibitions: Annual Juried High School Fine Arts Exhibition
Activities: Classes for adults & children; docent training; lect open to the public, 2-3 lectr per year; concerts; gallery talks; tours; competitions; book traveling exhibitions 5-6 per year; originate traveling exhibits; museum shop selling original art, books, reproductions, prints and other memorabilia

ROCHESTER

A **ROCHESTER ART CENTER,** 320 E Center St, Rochester, MN 55904; 40 Civic Center Dr SE, Rochester, MN 55904. Tel 507-282-8629; Fax 507-282-7737; Elec Mail info@rochesterartcenter.org; Internet Home Page Address: www.rochesterartcenter.org; *Exec Dir* Denise Sorom; *Dir Membership, Mktg & Pub Programs Mgr* Jennifer Buddenhagen; *Admin Operations Dir* Joan Lovelace; *Chief Cur* Kristopher Douglas; *Develop Dir* Kathryn Ross; *Facility Dir* Phillip Ahnen; *Cur Educ* Scott Stulen; *Educ Coordr* Michele Heidel
Open Tues - Sat 10 AM - 5 PM, Thurs 10 AM - 9 PM, Sun Noon - 5 PM, cl Mon; Admis adults $3, seniors $2, students & children free; Estab 1946 as a center for contemporary visual arts & crafts, Rochester Art Center sponsors an on-going program of exhibitions, educational classes, lectures, workshops & community services in the arts; Average Annual Attendance: 40,000; Mem: 1000; dues $20-$50
Income: city & state appropriations, fund raising & class tuition, private donations, corporate & foundation grants
Exhibitions: Varied exhibits in Contemporary Fine Arts & Crafts
Publications: Quarterly newsletter
Activities: Classes for adults & children; docent training; lect open to public; concerts; gallery talks; tours; scholarships; originate traveling exhibitions; sales shop sell books, jewelry & gift items

SAINT CLOUD

SAINT CLOUD STATE UNIVERSITY

M **Atwood Memorial Center Gallery,** Tel 320-255-2205; Fax 320-529-1669; Internet Home Page Address: www.stcloudstate.edu/!utb; *Asst Dir* Janice Courtney; *Prog Dir* Jessica Ostman
Open Mon - Fri 7 AM - 11 PM, Sat 8 AM - 11 PM, Sun Noon - 11 PM; No admis fee; Estab 1967 as a university student union facility; Gallery area is part of program, designed for maximum exposure, where students may relax or study while enjoying exhibits; space is flexible; also area for music listening and small theatre; additional exhibits displayed in prominent area
Income: Financed by student enrollment fee assessment
Collections: Collections of artists work from the central Minnesota area
Exhibitions: Monthly exhibits in various media
Activities: Artists' residencies, lect & workshops that coincide with exhibits

M **Kiehle Gallery,** Tel 320-255-4283; Fax 320-529-1669; Internet Home Page Address: www.stcloudstate.edu/!utb; *Chmn* Joseph Akin
Open Mon - Fri 8 AM - 4 PM; No admis fee; Estab 1974 to expose college community to ideas & attitudes in the field of visual arts; The gallery has 1600 sq ft of enclosed multi use gallery floor space & 2500 sq ft outside sculpture court; Average Annual Attendance: 15,000
Income: Financed by student fund appropriation
Activities: Lect open to public, 5 vis lectr per year; gallery talks; competitions; individual paintings & original objects of art lent to other departments on campus; lending collection contains original prints, paintings, photographs & sculpture; traveling exhibitions organized & circulated

A **VISUAL ARTS MINNESOTA,** (Saint Cloud Community Arts Council) 913 W St Germain Saint Cloud, MN 56301. Tel 320-257-3108; Fax 320-257-3111; Elec Mail vam@visualartsminnesota.org; Internet Home Page Address: www.visualartsminnesota.org; *Exec Dir* Paige La Due Henry
Estab 1973 to serve as an advocate & a resource for visual artists, art groups, educators & the community; Mem: 100; dues $20-$250
Income: Grants, pvt support (nonprofit)
Collections: Works donated by artists or friends/family of artists popular at various times in the community; collection can be loaned for a small fee
Exhibitions: Arts Around Town; High School Art Competition; Lemonade Arts Festival
Publications: Quarterly articles
Activities: Classes for adults & children; lect open to public, 10 vis lectr per year; gallery talks; scholarships offered; individual painting & original objects of art lent for public display; lending collection contains original art works, original prints, sculptures & slides; sales shop sells books & original art

SAINT JOSEPH

M **COLLEGE OF SAINT BENEDICT,** Art Gallery, Benedict Arts Ctr, Saint Joseph, MN 56374-2099. Tel 320-363-5792; Fax 320-363-6097; Elec Mail lcotton@csbsju.edu; *Exec Dir of Fine Arts Programming* Anna Thompson; *Dir Exhib* Lisa Cotton
Open daily 9 AM - 4:30 PM; No admis fee; Estab 1963
Income: Financed by college
Special Subjects: Drawings, Painting-American, Prints, Sculpture, Ceramics, Crafts
Collections: Contemporary collection of crafts, drawings, paintings, prints and sculpture; East Asian Collection of ceramics, crafts, drawings, fibers and prints; Miscellaneous African, New Guinea, Indian and European
Exhibitions: Ongoing exhibitions
Activities: Lect open to the public, 8 vis lectr per year; gallery talks; tours; scholarships offered; individual paintings & originial objects of art lent to faculty & staff members of the college

SAINT PAUL

C **3M,** Art Collection, 3M Ctr, Bldg 225-1S-01, Saint Paul, MN 55144-1000. Tel 651-733-1110; Fax 651-737-4555; *Cur, Art Coll* Charles Thames
Estab 1902, dept estab 1974; Concourse Gallery provides changing exhibitions drawn from the collection
Collections: Collection of paintings, drawings, sculpture, watercolors, original prints, photographs & textiles
Publications: Exhibition brochures
Activities: Tours by appointment only & must be scheduled two weeks in advance; individual paintings & original objects of art lent to scholarly exhibitions

M **ARCHIVES OF THE ARCHDIOCESE OF ST PAUL & MINNEAPOLIS,** 226 Summit Ave, Saint Paul, MN 55102. Tel 651-291-4429; Fax 651-290-1629; Elec Mail archives@archspm.org; *Archivist* Steven T Granger; *Asst Archivist* Patrick Auzelc
Open Tues - Wed 9 AM - 5 PM by appointment; Admis $30; Estab 1987 to collect & preserve materials of archival value relating to the Catholic church of the Archdiocese of Saint Paul & Minneapolis; Average Annual Attendance: 300
Income: Financed by Diocesan funds
Special Subjects: Religious Art
Collections: Artifacts; documents; letters; painting; papers & photographs
Activities: Lect, 2 vis lectr per year

M **COLLEGE OF VISUAL ARTS,** Gallery, 173 Western Ave, Saint Paul, MN 55102. Tel 651-290-9379; Fax 651-224-8854; Elec Mail cvagallery@cva.edu; Internet Home Page Address: www.cva.edu; *Pres* Joe Culligan; *Gallery Mgr* Karen Kasel; *Academic Dean* Ann Ledy
Open Mon - Tu, We & Fri 10 AM - 6 PM; Th 12 PM - 8PM; Sat 12PM - 5PM; No admis fee; Estab 1948; galleries were established in adjunct to art education; Average Annual Attendance: 1,200
Income: Financed by endowment

Exhibitions: 8-10 shows per year of the work of local artists, visiting artists, faculty & students. The emphasis on contemporary art
Activities: Lect open to public, varied vis lectr per year; gallery talks; competitions with prizes

L **Library,** 394 Dayton Ave, Saint Paul, MN 55102. Tel 651-310-0575; Fax 651-310-0590; Internet Home Page Address: http://www.cva.edu; *Librn* Mary Beth Raby; *Libr Dir* Kathryn Heuer
Open Mon - Thurs 8 AM - 10 PM, Fri 8 AM - 4:30 PM, Sat noon - 4 PM, Sun 6 - 10 PM; Estab 1924 library for the Col of Visual Arts; Circ 20,500
Library Holdings: Book Volumes 7300; DVDs 40; Periodical Subscriptions 40; Slides 33,000; Video Tapes 210
Special Subjects: Art History, Illustration, Photography, Drawings, Graphic Design, Painting-American, Sculpture, Printmaking
Activities: Classes for adults & children; lect open to public; gallery talks; tours; scholarships offered

L **Gallery,** Drew Fine Arts Complex, 1536 Hewitt Ave Saint Paul, MN 55104. Tel 651-523-2386; Internet Home Page Address: www.hamlin.edu/depts/art; *Dir Exhibits* Leonardo Lasansky
Open Mon - Fri 10 AM - 4 PM, cl holidays; No admis fee; Display of original modern works from BC to 21st century; extensive color slide library of paintings, architecture, sculpture, minor arts & graphics, prints, ceramics

M **MACALESTER COLLEGE,** Macalester College Art Gallery, 1600 Grand Ave, Saint Paul, MN 55105. Tel 651-696-6416; Fax 651-696-6266; Elec Mail gallery@macalester.edu; Internet Home Page Address: www.macalester.edu; *Cur* Devin Coleman
Open Mon - Fri 10 AM - 4 PM, Sat & Sun Noon-4 PM, cl June -Aug, national holidays & school vacations; No admis fee; Estab 1964 as a college facility to bring contemporary art exhibitions to the students, faculty & community; Average Annual Attendance: 18,000
Special Subjects: Painting-American, Photography, Prints, Sculpture, African Art, Textiles, Ceramics, Pottery, Painting-European, Porcelain, Asian Art, Tapestries, Painting-German
Collections: African Art; Asian & British Ceramics; Oriental Art; contemporary & historical prints, paintings, sculpture & crafts
Exhibitions: Temporary, traveling & student exhibitions with special emphasis on international & multi-cultural
Activities: Lect open to the public; concerts; gallery talks; tours; competitions with awards; individual paintings & original objects of art lent; lending collections contains original prints, paintings & sculpture; book traveling exhibitions; traveling exhibitions organized and circulated; sales shop sells art books & supplies

L **DeWitt Wallace Library,** 1600 Grand Ave, Saint Paul, MN 55105. Tel 651-696-6345; Internet Home Page Address: www.macalester.edu; *Dir Library* Teresa Fishel
Open Sep-May daily 8AM-Noon; No admis fee; Estab 1964; Circ 66,531
Library Holdings: Book Volumes 273,668; Cards; Cassettes; Fiche; Framed Reproductions; Pamphlets; Periodical Subscriptions 1311; Reels
Special Subjects: Art History
Activities: Individual paintings & original objects of art lent to faculty & staff of the college

A **MINNESOTA HISTORICAL SOCIETY,** 345 Kellogg Blvd W, Saint Paul, MN 55102-1906. Tel 651-296-6126; Tel 800-657-3773; Fax 651-296-3343; Internet Home Page Address: www.mnhs.org; *Media Relations Mgr* Marjorie Nugent; *CEO & Dir* Nina M Archabal; *Dir Historic Sites* William Keyes; *Pub Relations* Lory Sutton; *Develop Officer* Mark Haidet; *MHS Pres* Greg Britton; *Head Exhib* Dan Spock; *Dir Finance* William Irrgang; *Mus Shop Mgr* Meta DeVine; *Deputy Dir* Michael Fox; *Deputy Dir External Relations* Andrea Kajer
Open Tues, Wed, Fri & Sat 10 AM - 8 PM, Tues 10 AM - 9 PM, Sun Noon - 5 PM, cl Mon except state holidays; Admis $8 adults, $6 seniors & college students, $4 children 6-17, MHS members & children 5 & under no charge; Estab 1849 to collect, preserve & make available to the pub the history of Minnesota; 40,000 sq ft of exhibition space; Average Annual Attendance: 500,000; Mem: 17,000; dues household $45, individual $35, senior citizens $30; annual meeting in Nov
Income: Financed by endowment, mem & state appropriation
Library Holdings: Audio Tapes; Book Volumes; CD-ROMs; Cards; Cassettes; Clipping Files; Compact Disks; Memorabilia; Original Documents; Other Holdings; Pamphlets; Periodical Subscriptions; Photographs; Prints; Slides; Video Tapes
Special Subjects: Historical Material
Collections: Archives; art works; books; maps; manuscripts; museum artifacts relating to the history of Minnesota; newspapers; photographs
Exhibitions: Minnesota A to Z; Exhibits on families, communities; Minnesota Music, Minnesota Territory
Publications: Minnesota History, quarterly; History Matters, 6 issues per year; books & exhibit catalogs
Activities: Classes for adults & children; lect open to the public; tours; concerts; gallery talks; 2-3 book traveling exhibitions per year; originate traveling exhibitions; museum shop sells books, magazines, prints, reproductions, original art, slides & other merchandise

L **Library,** 345 Kellogg Blvd W, Saint Paul, MN 55102-1906. Tel 651-296-2143; Fax 651-297-7436; Elec Mail reference@mnhs.org; *Asst Dir Library* Michael Fox; *Dir Library* Richard Morphy
Open Tues, Wed, Fri & Sat 10 AM - 5 PM; No admis fee; For reference
Library Holdings: Audio Tapes; Book Volumes 500,000; Cassettes; Clipping Files; Exhibition Catalogs; Fiche; Filmstrips; Kodachrome Transparencies; Manuscripts; Memorabilia; Motion Pictures; Pamphlets; Records; Reels; Sculpture; Slides; Video Tapes
Collections: 19th & 20th centuries art relating to Minnesota

M **North West Company Fur Post,** 12551 Voyager Ln, Pine City, MN 55063; PO Box 51, Pine City, MN 55063. Tel 320-629-6356; Fax 320-629-4667; *Site Mgr* Patrick Schifferdecker
Open May 1 - Labor Day Mon - Sat 10 AM - 5 PM, Sun 12 noon - 5 PM; Sept - Oct Fri - Sat 10 AM - 5 PM, Sun 12 noon - 5 PM; Admis adults $7, seniors $6, tours & groups $5, children $4, mems free; Estab 1965; mus is reconstruction of an 1804 Northwest company wintering post & Ojibwe encampment; 2700 sq ft

exhib space; handicapped-accessible; historical site; Average Annual Attendance: 10,888; Mem: see Minn Historical Society for mem details

Collections: Recreated 1804 Ojibwe encampment
Activities: Formal educ progs for children; concerts; guided tours; hobby workshops & hands-on activities; museum shop sells books, original art, reproductions, prints & misc gift items

M **MINNESOTA MUSEUM OF AMERICAN ART,** 50 W Kellogg Blvd, Ste 341, Saint Paul, MN 55102. Tel 651-266-1030; Fax 651-291-2947; Elec Mail info@mmaa.org; Internet Home Page Address: www.mmaa.org; *Dir* Bruce Lilly; *Registrar & Exhib Coordr* Eunice Haugen; *Cur & Educ Mgr* Theresa Downing; *External Affairs* Nell Hurley; *Visitor Svcs Coordr* Chad Lemke; *Human Resources & Events Mgr* Natalee Obee; *Curatorial & Educ Assoc* Paula McCartney; *Prog & Events Coordr* Lauren Schad
Open Tues - Wed & Fri - Sat 11 AM - 4 PM, Thurs 11 AM - 8 PM, Sun 1 - 5 PM, cl Mon, major holidays; No admis fee; Estab 1927 as the Saint Paul Gallery & School of Art; Riverfront Gallery is at the corner of Kellogg Blvd & Market St; Average Annual Attendance: 50,000; Mem: 800; dues household $50, individual $35
Income: $900,000 (financed by endowment, individual contributions, mem, allocation from United Arts Fund & foundation & government grants)
Library Holdings: Audio Tapes; Book Volumes; CD-ROMs; Cassettes; Clipping Files; Compact Disks; Exhibition Catalogs; Pamphlets; Periodical Subscriptions; Slides
Special Subjects: Drawings, Painting-American, Photography, Prints, Sculpture, Watercolors, Bronzes, Ceramics, Crafts, Pottery, Etchings & Engravings, Collages, Portraits, Posters, Glass
Collections: American Art; contemporary art of the Upper Midwest; Paul Manship; Late 19th & 20th Century Art, Native American
Exhibitions: (8/5/2006-12/31/2006) George Morrison: Finding Abstraction
Publications: Annual report; exhibition catalogs; periodic gallery guides; quarterly newsletter
Activities: Family Art Day, four per year; Art Dialogue, four per year; lect open to public; gallery talks; tours; originated traveling exhibition to midsized art museums

L **SAINT PAUL PUBLIC LIBRARY,** Central Adult Public Services, 90 W Fourth St, Saint Paul, MN 55102. Tel 651-266-7000; Elec Mail charlenm@library.stpaul.libmn.us; Internet Home Page Address: www.stpaul.lib.mn.us; *Dir Library* Carol Williams; *Fine Arts Coll Develop* Charlene McKenzie
Open Mon 11:30 AM - 8 PM, Tues, Wed & Fri 9 AM - 5:30 PM, Thurs 9 AM - 8 PM, Sat 11 AM - 4 PM; Estab 1882; Circ 92,642
Income: Financed by city appropriation
Purchases: $42,700
Library Holdings: Book Volumes 16,000; Clipping Files; Exhibition Catalogs; Other Holdings Compact discs 4000; Periodical Subscriptions 95; Video Tapes 4500
Collections: Field collection of popular sheet music

M **UNIVERSITY OF MINNESOTA,** Paul Whitney Larson Gallery, 2017 Buford, Saint Paul, MN 55108. Tel 612-625-0214; Fax 612-624-8749; Internet Home Page Address: www.spsc.umn.eduvacprespective.html; *Gallery Mgr* Tricia Schweitzer
Open Mon - Wed 10 AM - 5 PM, Thurs 10 AM - 8 PM, Fri 1 - 4 PM; No admis fee; Estab 1979 to bring art of great variety into the daily lives of students & university community; Intimate gallery featuring traditional & contemporary visual arts
Income: Financed by student fees
Publications: Annual report & activity summary
Activities: Mini-courses; lect open to public, arts & crafts sales; films & videos
M Goldstein Gallery, 364 McNeal Hall, 1985 Buford Ave Saint Paul, MN 55108. Tel 612-624-7434; Fax 612-624-2750; Elec Mail gmd@umn.edu; Internet Home Page Address: www.goldstein.cdes.umn.edu; *Dir* Un Nelson-Mayson; *Asst Cur* Dr Kathleen Campbell; *Admin* Barbara Porwitt
Open Mon - Fri 10 AM - 4 PM, Thurs 10 AM - 8 PM, Sat & Sun 1:30 - 4:30 PM; No admis fee; donations welcome; Estab 1976, collects, exhibits & researches design; Maintains reference library; Average Annual Attendance: 6,000; Mem: 315; mem $20 & up; annual meeting in June
Income: Financed by private gifts, mem & grants
Library Holdings: Book Volumes; Clipping Files; Exhibition Catalogs; Periodical Subscriptions
Special Subjects: Interior Design, Graphics, Textiles, Costumes, Ceramics, Crafts, Pottery, Decorative Arts, Furniture, Glass, Porcelain, Silver, Metalwork, Carpets & Rugs, Tapestries, Embroidery, Laces, Pewter, Leather
Collections: Historic costumes; 20th century designer garments; historic & contemporary decorative arts; furniture; textiles; graphic communication
Publications: Exhibition catalogs
Activities: Educ dept classes for adults; lect open to public, 4 vis lectr per year; gallery talks; tours; awards; original objects of art lent to other institutions; book traveling exhibitions 1 per year; museum shop sells books

A **WOMEN'S ART REGISTRY OF MINNESOTA GALLERY,** 550 Rice St, Saint Paul, MN 55103. Tel 651-292-1188
Estab 1975; Office only; Mem: 2800; dues $30
Income: Financed by mem, grants for projects & operating expenses
Collections: Members work on display in one area
Exhibitions: Local & national exhibitions; Annual Juried Members Exhibit
Publications: Quarterly newsletter
Activities: Educ dept; lect open to the public; competitions with awards; scholarships & fels offered; individual paintings lent & original objects of art lent to non-profit groups for fee; originate traveling exhibitions

ST PAUL

M **MINNESOTA HISTORICAL SOCIETY,** (Minnesota State Capitol Historic Site) Minnesota State Capitol Historic Site, 75 Rev Dr Martin Luther King Jr Blvd, St Paul, MN 55155. Tel 651-296-2881; Fax 651-297-1502; Internet Home Page Address: www.mnhs.org/statecapitol; *Historic Site Mgr* Carolyn Kompelien; *Asst Site Mgr* Brian Pease; *Tour Registrar* Candice Christensen; *Site Tech* Jaymie Korman
Open Mon - Fri 9 AM - 5 PM with the last tour at 3 PM; Sat 10 AM - 3 PM with the last tour at 2 PM; Sun 1 - 4 PM, last tour at 3 PM; cl all holidays except President's Day; Mus no admis fee; Special Events: adults $7, seniors $6, children 6 - 12 $4, educ grps $2 - $4, mems $2 discount; Estab 1969; Minn State Capitol bldg designed by renowned 19th-c architect Cass Gilbert; architectural masterpiece that holds a spec place in Minn's history. Experience the activities & beauty within; 377,000 sq ft exhib space; Average Annual Attendance: 205,508; Mem: North Star Circle $1000, Sustaining $500, Contributing $250, Associate $125, Household $65, Sr Household $55, Indiv $55, Sr Indiv $45
Collections: Over 800 pieces of orig 1905 furniture; works of art throughout the capitol that includes 33 canvas murals, 16 paintings, 15 plaques, 30 statues/busts, 37 governor's portraits and 21 historic battle flags; over 200 vols on historical info on the state capitol
Publications: Minnesota History, quarterly magazine
Activities: Year-round progs on four themes of the capitol: Art, Architecture, Minn History & State Govt; formal educ for adults, students & children; guided tours; temporary exhibs; Capitol Building Alterations; Study Historical Figures for interpretation, historical calendar of days for capitol; books, postcards, small gifts & other museum-related items for sale; cafe on-site (session only)

WORTHINGTON

A **NOBLES COUNTY ART CENTER GALLERY,** 407 12th St, PO Box 313 Worthington, MN 56187. Tel 507-372-8245; *Co-Dir* Martin Bunge; *Co-Dir* Jean Bunge; *Pres* Margaret Anderson
Open Mon - Fri 2 - 4:30 PM, cl Sat, Sun & holidays; No admis fee; Estab 1960 to nourish the arts & to bring arts & cultures of other communities & nations, civilizations to Nobles County & the surrounding area so residents become more universal in their thinking; Facilities are large & spacious. Located on the ground floor; handicapped accessible; Average Annual Attendance: 3,000; Mem: 100; dues $10-$500; annual meeting in Jan
Income: Financed by mem dues, donations, memorial gifts, county appropriation bequest & grants
Collections: International art
Exhibitions: Two juried fine art shows per year; annual student exhibition; the work of area artists; new exhibit every month
Publications: Gallery, monthly newsletter; monthly press releases
Activities: Classes for adults & children; lect open to public; concerts; gallery talks; tours; competitions with awards; originate traveling exhibitions

MISSISSIPPI

BELZONI

M **THE ETHEL WRIGHT MOHAMED STITCHERY MUSEUM,** 307 Central St, Belzoni, MS 39038. Tel 662-247-3633; Fax 662-247-1433; Elec Mail hwilson493@aol.com; Internet Home Page Address: www.mamasdreamworld.com; *Cur* Carol Mohamed Ivy; *Asst Cur* Amy Harris Hawkins; *Asst Cur & Webmaster* Hazel Mohamed Wilson
Open by appt only; Admis adults $2, children & bus driver no admis fee; Mus is former home of Ethel Wright Mohamed, award-winning artist who lived from 1906-1992 and was also known as "Mississippi's Grandma Moses of Stitchery"; mus contains stitchery created by the artist that centered on her family & life
Special Subjects: Decorative Arts, Tapestries
Collections: Coll of stitchery & sketches
Publications: My Life in Pictures, by Ethel Wright Mohamed
Activities: Guided tours; museum-related items for sale

CLARKSDALE

M **CARNEGIE PUBLIC LIBRARY,** Delta Blues Museum, 114 Delta Ave, PO Box 280 Clarksdale, MS 38614. Tel 662-627-6820; Fax 662-627-7263; Internet Home Page Address: www.deltabluesmuseum.org
Open Mon - Sat 9 AM - 5 PM; Estab 1979 to preserve & promote understanding of MS Delta blues music & heritage; Average Annual Attendance: 16,000
Income: $125,000 (financed by gift shop, federal & state grants, mem & corporate donors)
Collections: Books & tapes; Interpretative exhibits; memorabilia; photography & art (sculpture, paintings); recordings; stage & music; videos
Exhibitions: All Shook Up; Bancas to Blues: West African Stringed Instrument traditions & the origin of pre-civil War American Music; MS Roots of American Music; Vintage American Guitar Collection
Publications: Delta Blues Museum Brochure
Activities: Monthly Blues performances; lect open to public, 10 vis lectr per year; sales shop sells books, compact discs, prints, magazines, original art, reproductions, souvenirs, gifts, audiotapes

CLEVELAND

M **DELTA STATE UNIVERSITY,** Fielding L Wright Art Center, PO Box D-2, Cleveland, MS 38733. Tel 662-846-4720; Fax 662-846-4726; *Exhib Chmn* Patricia Brown; *Chmn Dept* Collier B Parker
Open Mon - Thurs 8 AM - 8 PM, Fri 8 AM - 4 PM, cl weekends & school holidays; No admis fee; Estab 1968 as an educational gallery for the benefit of the

students, but serves the entire area for changing art shows; it is the only facility of this nature in the Mississippi Delta Region; Three gallery areas; Average Annual Attendance: 3,600
Income: Financed by state appropriation
Collections: Delta State University permanent collection; Ruth Atkinson Holmes Collection; Marie Hull Collection; Smith-Patterson Memorial Collection; Whittington Memorial Collection; Joe & Lucy Howorth Collection; John Miller Photography Collection; James Townes Medal Collection; Photography Study Collection
Publications: Announcements of exhibitions, monthly during fall, winter & spring; exhibit catalogs
Activities: Lect open to public, 10 vis lectr per year; gallery talks; tours; competitions; exten dept serving the Mississippi Delta Region; individual paintings & original objects of art lent to offices of campus; lending collection contains color reproductions, film strips, motion pictures, original art works, 30,000 slides; traveling exhibitions organized & circulated

L **Roberts LaForge Library,** Le Flore Cir Cleveland, MS 38733. Tel 662-846-4440; Fax 662-846-4443; Elec Mail refdesk@deltastate.edu; Internet Home Page Address: www.library.deltastate.edu; *Dir Library Svcs* Terry S Latour; *Asst Dir* Jeff H Slagell
Open Mon-Thurs 7:30 AM-10 PM, Fri 7:30 AM-4 PM, Sat 10 AM-5 PM, Sun 2 PM-10 PM; No admis fee; Estab as gen academic library covering all topics for students & staff; Mabelle Smith and William Mountjoy Garrad Collection of Art
Income: col funding
Library Holdings: Audio Tapes; Book Volumes 7500; CD-ROMs; Cards; Cassettes; Clipping Files; Compact Disks; DVDs; Exhibition Catalogs; Fiche; Filmstrips; Framed Reproductions; Kodachrome Transparencies; Micro Print; Original Art Works; Periodical Subscriptions 31; Photographs; Prints; Records; Reels; Sculpture; Slides 381; Video Tapes 78
Special Subjects: Art History, Film, Illustration, Photography, Drawings, Etchings & Engravings, Graphic Design, Painting-European, Historical Material, History of Art & Archaeology, Portraits, Printmaking, Interior Design, Art Education, Pottery
Collections: Sculptures & paintings for variety of Mississippi Delta artists

COLUMBUS

M **COLUMBUS HISTORIC FOUNDATION,** (Columbus & Lowndes County Historical Society) Blewett-Harrison-Lee Museum, 316 Seventh St N, Columbus, MS 39701. Tel 662-329-3533, 800-327-2686; *Cur* Carolyn Neault; *CAS Gen* Steph D Lee
Open Fri 10 AM - 4 PM or by appointment; Admis $5, students free; Estab 1960 for a memorabilia 1832-1907 pertaining to Lowndes County preserved & exhibited; Average Annual Attendance: 2,000; Mem: 210; dues $5; annual meeting third Thurs in Sept
Income: $600 (financed by mem, bequests, donations, memorials, sale of souvenirs)
Special Subjects: Historical Material
Collections: 100 years of artifacts, books, china, crystal, clothes, flags, furniture, jewelry, pictures, portraits, swords, wedding gowns
Activities: Docent training; tours for school children; awards; museum shop sells books & souvenirs

M **MISSISSIPPI UNIVERSITY FOR WOMEN,** Fine Arts Gallery, Box 70, Fine Arts Bldg Columbus, MS 39701. Tel 662-329-7341; Tel 662-241-6976; Fax 662-241-7815; *Dir Gallery* Lawrence Feeney; *Recorder* Shawn Dickey
Open Mon - Fri 2AM-Noon 1PM-4PM every day the univ is open; No admis fee; Estab 1948, new bldg 1960, renovated 1998; 3 galleries with 350 running ft wall space, the main gallery with 173 ft wall space covered with fabric; Average Annual Attendance: 1,200
Income: Financed by state appropriation & private funds
Special Subjects: Drawings, Painting-American, Prints
Collections: American Art; paintings, sculpture, photographs, drawings, ceramics, prints; Permanent collection of Mississippi artists
Exhibitions: Frequent special and circulating exhibitions; Selections from permanent collection, periodically
Activities: Visiting artists program; workshops; lect open to public, 4 vis lectrs per year; gallery talks; tours; scholarships; individual paintings & original objects of art lent to offices & public student areas on the campus; lending collection contains 400 original prints, 300 paintings, 100 records; book traveling exhibitions; originate traveling exhibitions

GREENWOOD

M **COTTONLANDIA MUSEUM,** 1608 Hwy 82 W, Greenwood, MS 38930-2725. Tel 662-453-0925; Fax 662-455-7556; Elec Mail rsperson@techinfo.com; *Exec Dir* Robin Seage Person; *Mus Shop Mgr* Lyllian Tubbs; *Sec to Dir* Nancy Fleming; *Dir Asst* Rebekah Scrivener; *VPres* Carolyn Manning
Open Mon - Fri 9 AM - 5 PM, Sat - Sun 2 - 5 PM; Admis adults $4.00, children $1.00, & seniors 65 & over $3.50; Estab 1969 as a mus for tourism & learning facility for schools; Two well lighted rooms plus available space in mus for temporary & competition, permanent hangings in some corridors; Average Annual Attendance: 7,500; Mem: 270; dues vary; annual meeting early Nov
Income: Financed by mem, county appropriation, donation & admis
Library Holdings: Book Volumes; Clipping Files; Original Documents; Periodical Subscriptions; Photographs
Collections: Permanent collection of works of past Cottonlandia Collection; competition winners; other accessions by Mississippi Artists
Exhibitions: Temporary exhibs change every two months
Activities: Classes for adults; lect open to the public; gallery talks; tours; competitions with awards; individual paintings lent; lending collection contains nature artifacts; museum shop sells books, original art, reproductions, prints & natural stone jewelry

GULFPORT

A **BILOXI ART ASSOCIATION,** (Biloxi Art Association Inc & Gallery) 2204 20th St, Gulfport, MS 39501-2929. Tel 228-832-7489; Elec Mail ephart@digiscape.com; Internet Home Page Address: www.geocities.com/biloxiartms; *Pres* Elizabeth Huffmaster; *VPres* Rhonda Herring; *Treas* Elizabeth Rosetti
Open Thurs - Sat 11:30 AM - 4:30 PM; No admis fee; Estab 1965 to promote art, educate general pub & to encourage local people to view & buy art at a very nominal fee; Gallery maintained on volunteer basis by 23 members of Biloxi Art Assn & Gallery; Average Annual Attendance: 5,000; Mem: 48; mem open to artists at all levels; dues $15, students $10; meetings third Tues of each month
Income: $750 (financed by mem)
Collections: Works by local artists
Publications: Biloxi Art Assn & Gallery Newsletter, monthly
Activities: Workshops; lect open to public; competitions with awards; individual paintings & original objects of art lent; lending collection contains original art works, original prints, paintings & sculpture; revolving art exhibit in 10 locations on Mississippi Gulf Coast; sales shop sells & exhibits original art & prints

HATTIESBURG

M **TURNER HOUSE MUSEUM,** 500 Bay St, Hattiesburg, MS 39401. Tel 601-582-1771; *Dir & Cur* David Sheley
Open by appointment; No admis fee; Estab 1983; Contains collections of art & antiques
Income: Funded by J H Turner Foundation
Collections: 18th century furniture; silver; crystal chandelier; Persian rugs; old masters; tapestries
Activities: Tours

L **UNIVERSITY OF SOUTHERN MISSISSIPPI,** McCain Library & Archives, Southern Sta, PO Box 5053 Hattiesburg, MS 39406-5053. Tel 601-266-7011; Internet Home Page Address: www.lib.usm.edu/mccain.html; *Dir* Kay L Wall MLS; *Cur* Dolores A Jones MLS; *Archivist* Dr Bobs M Tusa; *Librn* David Richards, MLS
Open Mon - Fri 8 AM - 5 PM; No admis fee; University estab 1912, library estab 1976; For reference only
Collections: Cleanth Brooks Collection; de Grummond Children's Literature Research Collection (historical children's literature & illustrations); Earnest A Walen Collection; Genealogy Collection
Publications: Juvenile Miscellany, 2 times per year

JACKSON

M **CRAFTSMEN'S GUILD OF MISSISSIPPI, INC,** Agriculture & Forestry Museum, 1150 Lakeland Dr, Jackson, MS 39216. Tel 601-981-0019, 981-2499; Fax 601-981-0488; Elec Mail mscrafts@mscraftsmensguild.org; Internet Home Page Address: www.mscraftsmensguild.org; *Exec Dir* Julia Daily
Open Mon - Sat 9 AM - 5 PM; No admis fee; Estab 1973 to preserve, promote, educate, market & encourage excellence in regional crafts; Two galleries: Mississippi Crafts Center, Natchez Trace milepost marker 102.6, Ridgeland 39158, sales demonstrations, festival of regional crafts; Chimneyville Craft Gallery; Average Annual Attendance: 100,000; Mem: 400; dues $75; annual meeting in Jan
Income: $360,000 (financed by mem, state arts commission grant, corporate & private contributions & earned income)
Special Subjects: Afro-American Art, American Indian Art, Glass, Metalwork, Furniture, Crafts, Folk Art, Jewelry, Mosaics, Leather
Exhibitions: Weekend exhibitions, April - Oct
Activities: Classes for adults & children; suitcase museum for schools & civic groups; gallery talks; 2006 Governor's Award for Excellence in the Arts; original objects of art lent to Mississippi schools & civic groups, could arrange in Southeastern region; lending collection contains original art works, video tapes, script & lesson plan; originate traveling exhibitions; sales shop sells original craft

M **MISSISSIPPI DEPARTMENT OF ARCHIVES & HISTORY,** Old Capitol Museum of Mississippi History, 100 S State St, Jackson, MS 39201; PO Box 571, Jackson, MS 39205-0571. Tel 601-359-6920; Fax 601-359-6981; Elec Mail ocmuseum@mdah.state.ms.us; Internet Home Page Address: www.mdah.state.ms.us; *Cur Colls* Michael Wright; *Dir Educ & Programs* Lucy Allen; *Dir Mus Div* Donna Dye; *Dir Exhibits* Clay Williams
Open Mon - Fri 8 AM - 5 PM, Sat 9:30 AM - 4:30 PM, Sun 12:30 - 4:30 PM; No admis fee; Estab 1961 for educ in Mississippi history & culture through interpretation of the collection; Oil portraits hung throughout the 3-story Greek Revival former capitol; four rooms set aside for temporary exhibits; Average Annual Attendance: 75,000
Income: Financed by state appropriations
Special Subjects: Architecture, Drawings, Graphics, Painting-American, American Indian Art, Anthropology, Archaeology, Costumes, Ceramics, Crafts, Folk Art, Afro-American Art, Decorative Arts, Manuscripts, Dolls, Furniture, Glass, Jewelry, Historical Material, Maps, Coins & Medals, Dioramas, Embroidery, Laces, Leather
Collections: 188 oil portraits; artifacts of Mississippi history & culture from earliest times to the present
Exhibitions: Permanent exhibits tracing the history of Mississippi from the earliest times through the Civil Rights movement of the 1960s-1970s
Activities: Programming for children & adult groups; traveling trunk program for schools; concerts; gallery talks; tours; dramatic programs; statewide social studies teachers workshop; docent training; lect open to public, 4-5 vis lectr per year; video loan service to schools; museum shop sells books, magazines, original art

M **MISSISSIPPI MUSEUM OF ART,** 201 E Pascagoula St, Jackson, MS 39201. Tel 601-960-1515; Fax 601-960-1505; Elec Mail mmart@netdoor.com; Internet Home Page Address: www.msmuseumart.org; *Exec Dir* Betsy Bradley; *Cur & Registrar* René Paul Barilleaux; *Dir Admin* Sheryl Trim; *Dir Develop* Carol Penick; *Office Mgr* Shante Pittman; *Pub Relations Officer* Tiffany Hardy
Open Mon - Sat 10 AM - 5 PM, Sun Noon - 5 PM; Admis fee; Chartered in 1911; Mus opened 1978; East Exhibition Galleries 6500 sq ft; West Exhibition Galleries

2600 sq ft; Graphics Study Center 800 sq ft, houses exhibitions area, study & storage rooms; Open Gallery 2000 sq ft, includes special power, lighting & water requirements for technological media; Upper & Lower Atrium Galleries 4500 sq ft & outdoor Sculpture Garden; Nonprofit Corporation; Average Annual Attendance: 40,000; Mem: 1800; dues Rembrandt Soc $1000, benefactor $500, donor $250, patron $100, family $50, individual $35, senior $25

Income: $130,000 (financed by endowment, mem, contributions, pub sector grants & appropriations, earned income)

Purchases: A Bierstadt, Edward Potthast, Eugene Auffrey, Birney Imes III (45 color photographs) Thomas Salley Croprey, A B Davies

Library Holdings: Book Volumes; Clipping Files; Exhibition Catalogs; Memorabilia; Original Art Works; Pamphlets; Periodical Subscriptions; Photographs; Prints

Collections: Japanese Prints; 19th & 20th century American & European Art, photographs, Southern Mississippi Art; Pre-Columbian art & prints

Exhibitions: Light of the Spirit: Portraits of Southern Outsider Artists; Seescape: Collages by Irwen Kremen; Of Home and Family: Art in Nineteenth Century Mississippi; The American West: Out of Myth, Into Reality; Andrew Wyeth: Close Friends; Salvador Dali: Modern Spanish Master; Mississippi Invitational; Mississippi Watercolor Society Grand National

Publications: Bi-monthly newsletter; selected exhibition catalogs; (book) Andrew Wyeth: Close Friends

Activities: Classes for adults & children; docent training; weekend activities for children; lect open to public, some for members only, 3 vis lectr per year, 10 vis artists per year; tours; competitions; music series; scholarships offered; individual paintings & original objects of art lent to qualifying museums & other institutions & educational/cultural centers; lending collection contains 3500 original art works, 700 original prints, 300 paintings, 150 photographs & 50 sculptures; book traveling exhibitions; originate traveling exhibitions to other museums, art, educational & cultural institutions, Mississippi, Affiliate Network; museum shop sells books, magazines, reproductions, prints, slides, paper goods, designer items, Mississippi crafts

L **Howorth Library,** 201 E Pascagoula St, Jackson, MS 39201. Tel 601-960-1515; Fax 601-960-1505; Elec Mail mmart@netdoor.com; Internet Home Page Address: www.msmuseumart.org; *Cur Educ* J Marshall Adams; *Asst Cur Edu* Lianne Takemori; *VChmn* Chuck Dunn; *Auxiliary VPres* Margo Heath; *Dir Finance* Sheryl Trim; *Registrar* Tobin Fortenberry; *Dir* Betsy Bradley; *Office Mgr* Sonya Croins; *Chief Preparator* LC Tucker; *Dir Develop* Shari Veazey; *Asst to Dir* Nina Moss; *Vistor Info Center* Annette French; *Asst Preparator* Melvin Johnson; *Deputy Dir Prog* Rene Paul Barilleaux; *Mus Shop Mgr* Erdell Hart
Open Mon - Fri 10 AM - 5 PM by appointment; For reference only, open to the general pub
Income: Museum funded
Library Holdings: Book Volumes 10,000; Clipping Files; Exhibition Catalogs; Pamphlets; Periodical Subscriptions 12; Slides; Video Tapes
Collections: Walter Anderson Collection on Slides; Marie Hull Collection of Art Reference Books; Metropolitan Miniature Album; Museums permanent collection; E Benezit Vol 1 - 14, 1999
Activities: Classes for children; docent training; lect open to public; concerts; gallery talks; tours; sponsoring of competitions; 5 vis lect per year

LAUREL

M **LAUREN ROGERS MUSEUM OF ART,** Fifth Ave & Seventh St, PO Box 1108 Laurel, MS 39441. Tel 601-649-6374; Fax 601-649-6379; Elec Mail lrma@teclink.net; Internet Home Page Address: www.lrma.org; *Registrar* Tommie Rodgers; *Mktg Dir* Ginger Walters; *Head Librn* Donnelle Conklin; *Dir* George Bassi; *Business Mgr* Jo-Lyn Helton; *Develop Dir* Allyn Borne; *Cur* Jill Chancey
Open Tues - Sat 10 AM -4:45 PM, Sun 1 - 4 PM, cl Mon; No admis fee; Estab 1923 as a reference & research library & mus of art for pub use & employment; Six smaller galleries open off large American Gallery; these include European Gallery, Catherine Marshall Gardiner Basket collection, Gibbons Silver Gallery plus 2 temporary exhibit galleries; Average Annual Attendance: 20,000; Mem: Dues $15-$1000
Income: Financed by endowment (Eastman Memorial Foundation), mem, donations, fundraising, events government appropriations, grants
Special Subjects: Painting-American, Prints, Painting-European, Silver, Period Rooms, Bookplates & Bindings
Collections: European Artists of the 19th Century; 18th Century English Georgian Silver; 18th & 19th Century Japanaese Ukiyo-e Woodblock Prints; 19th & 20th Century American Paintings; Native American
Exhibitions: Annual schedule of exhibitions by regional & nationally recognized artists; collections exhibits
Publications: Gibbons Silver Catalog; Jean Leon Gerome Ferris, 1863-1930: American Painter Historian; Handbook of The Collections; Mississippi Portraiture
Activities: Workshop for adults & children; musical concerts; docent training; lect open to public; concerts; gallery talks; tours; individual art objects lent to AAM Accredited museums or galleries; museum shop sells books, prints, Choctaw baskets, silver, jewelry, toys, Mississippi arts & crafts & t-shirts

L **Library,** PO Box 1108, Laurel, MS 39441. Tel 601-649-6374; Fax 601-649-6379; Elec Mail lrmalibrary@c-gate.net; Internet Home Page Address: www.lrma.org; *Head Librn* Donnelle Conklin
Open Tues-Sat 10AM-4:45PM, Sun1-4PM, cl Mon; Estab 1923; Circ Non-circ; For reference only; Mem: Membership: part of museum
Income: Financed by endowment (Eastman Memorial Foundation), mem, donations
Library Holdings: Auction Catalogs; Book Volumes 11,000; Cassettes; Clipping Files; Exhibition Catalogs; Manuscripts; Memorabilia; Pamphlets; Periodical Subscriptions 60; Photographs; Reproductions; Slides 500; Video Tapes
Special Subjects: Painting-American, Prints, Painting-European, Silver
Collections: Museum archives
Publications: by Native Hands: Woven treasures from the Lauren Rogers Mus of Art

MERIDIAN

M **MERIDIAN MUSEUM OF ART,** Seventh St at Twenty-Fifth Ave, PO Box 5773 Meridian, MS 39301; PO Box 5773, Meridian, MS 39302. Tel 601-693-1501; Fax 601-485-3175; Elec Mail meridianmuseum@aol.com; *Dir* Terence Heder
Open Tues - Sun 1 - 5 PM, cl Mon; No admis fee; Estab 1970 to provide exhibition space for local, state & nationally known artists. Mus has four galleries; Housed in a national landmark building, the mus offers over twenty exhibitions annually in four galleries; Average Annual Attendance: 10,500; Mem: 500; dues $30-$5000; annual mem meeting mid-Jan
Income: Financed by mem & appropriation
Special Subjects: Drawings, Painting-American, Photography, Prints, Sculpture, Pottery, Decorative Arts
Collections: 20th century Southern fine arts & photography; 18th century European portraits; contemporary & traditional crafts & decorative arts
Exhibitions: Wanda Atkinson, Mary Lembke, 30th Annual Bi-State, MS Collegiate Art Completition, S L Dickey, Mississippi Art Colony
Activities: Classes for adults & children; youth art classes held each summer; symposia lect open to public; gallery talks; tours; competitions with awards; original objects of art lent to museums, traveling shows & offices in the city; book traveling exhibitions 2 per year; originate traveling exhibitions for circulation to museums & galleries; museum shop sells original art, reproductions & crafts

OCEAN SPRINGS

M **WALTER ANDERSON MUSEUM OF ART (ACCREDITED),** 510 Washington Ave, Ocean Springs, MS 39564. Tel 228-872-3164; Fax 228-875-4494; Elec Mail wama@walterandersonmuseum.org; Internet Home Page Address: www.walterandersonmuseum.org; *Educ* Cindy Quay; *Registrar* Dennis Walker; *Memberships* Sharon Davis; *Store Mgr* Robert Sweeting; *Cur Coll* Dr Patricia Pinson; *Develop Officer* Daisy Karem-Read; *Admin Asst* Julie Franc; *Exec Dir* Marily Lyons
Open Mon - Sat 9:30 AM - 5 PM, Sun 1 - 5 PM; Admis $6 adults, $5 seniors, $4 students, $3 children (5 & under free); Estab 1991 to exhibit the works of Walter Anderson & other artists; The museum's skylighted interior of warm southern pine includes a main galleria & 2 galleries which echo the natural beauty of it's setting; Average Annual Attendance: 30,000; Mem: 800; dues $20-$1,000
Income: Financed by mem, attendance, grants, fundraisers, shop proceeds & donations
Library Holdings: Book Volumes; Clipping Files; Exhibition Catalogs; Pamphlets; Periodical Subscriptions; Photographs; Prints; Video Tapes
Special Subjects: Art Education, Art History, Photography, Pottery, Woodcuts, Sculpture, Drawings, Painting-American, Watercolors, Woodcarvings, Reproductions
Collections: Work of Walter Inglis Anderson; ceramics; textiles; wood carving; works of art on paper; Peter & Mac Anderson (brothers of Walter)
Publications: Motif, quarterly newsletter
Activities: Classes for adults & children; docent programs; lect open to members & to public, 5-20 vis lectr per year; concerts; gallery talks; tours; Governor's award for excellence in art; 3 state educational outreach programs; museum shop sells books, prints, reproductions, games & educational materials

OXFORD

M **ROWAN OAK,** William Faulker's Home, 916 Old Taylor Ave, Oxford, MS 38655; Univ of Miss, PO Box 1848, University, MS 38677. Tel 662-915-7073; Fax 662-915-7035; Internet Home Page Address: www.olemiss.edu; *Dir* Albert Sperath; *Interim Cur* William Griffith
Open Tues - Sat 10 AM - 4 PM; cl New Years Day, Jul 4, Thanksgiving, Christmas Eve & Day; Admis adults, seniors & students $3, children no admis fee; Estab 1977; Rowan Oak was home of William Faulkner from 1930 - 1962; house & grounds have been recently restored & are a National Historic Landmark as well as Literary Landmark owned & maintained by the Univ of MS; Average Annual Attendance: 15,000 by estimate
Collections: Furnishings; personal artifacts

M **UNIVERSITY OF MISSISSIPPI,** University Museum, University Ave & Fifth St, Oxford, MS; University of Mississippi, PO Box 1848 University, MS 38677. Tel 662-915-7073; Fax 662-915-7035; Elec Mail museums@olemiss.edu; Internet Home Page Address: www.olemiss.edu; *Coll Mgr* William Griffith; *Prog Coordr* Deborah Freeland; *Dir* Albert Sperath; *Educator* Chandora Williams
Open Tues - Sat 9:30 AM - 4:30 PM, Sun 1 - 4 PM, cl Mon & univ holidays; No admis fee; Estab 1977 to collect, conserve & exhibit objects related to history of the University of Mississippi & to the cultural & scientific heritage of the people of the state & region; Main gallery contains 3000 sq ft with 12 ft ceilings for permanent collections & 800 sq ft with 18 ft ceilings for temporary exhibits; meeting room has 1100 sq ft for temporary wall hung exhibits; each of the four galleries of the Mary Buie Mus contains 400 sq ft for permanent collection; Lawrence & Fortune Galleries; Walton Young Historic House; Average Annual Attendance: 19,000; Mem: 150
Income: $190,000 (financed by state appropriation)
Special Subjects: Prints, Drawings, Painting-American, Photography, Sculpture, Watercolors, African Art, Anthropology, Textiles, Folk Art, Woodcarvings, Etchings & Engravings, Afro-American Art, Decorative Arts, Portraits, Dolls, Furniture, Glass, Jewelry, Porcelain, Asian Art, Silver, Historical Material, Antiquities-Greek, Antiquities-Roman
Collections: Theora Hamblett Collection (paintings, glass, drawings); Lewisohn Collection of Caribbean Art; Fulton-Meyer Collection of African Art; Millington-Barnard Collection of 19th Century Scientific Instruments; David Robinson Collection of Greek & Roman antiquities; antique dolls; Victorian memorabilia; American decorative arts; Southern folk art
Exhibitions: (2004) William Dunlap (2004) Painting & Constructions
Publications: Department essays; exhibit catalogs
Activities: Classes for adults & children; docent training; childrens' hands-on gallery; lect open to public, 30 vis lect per year; gallery talks; tours; school

outreach program; museum shop sells books, magazines, original art, reproductions, prints, souvenirs related to collections

L **University Museums Library,** Oxford, MS 38677. Tel 915-232-7073; Elec Mail museums@olemiss.edu; *Dir* Bonnie J Krause
Open to members, students, researchers for reference
Library Holdings: Book Volumes 600
Special Subjects: Art History, Graphic Arts, Antiquities-Greek, Antiquities-Roman

M **University Gallery,** 116 Meek Hall, University, MS 38677. Tel 662-915-7193; Fax 662-915-5013; Elec Mail art@olemiss.edu; Internet Home Page Address: www.olemiss.edu/; *Chair & Prof* Dr Nancy L Wicker
Open daily 8:30 AM - 4:30 PM; No admis fee; Estab 1954 as a teaching gallery; Average Annual Attendance: 1,000
Income: Financed by state appropriation & tuition
Collections: Faculty & student work; some work bought from traveling exhibitions
Exhibitions: Faculty, students, alumni & visiting artists
Activities: Lect open to public, 1-2 vis lectr per year; gallery talks; individual paintings & original objects of art lent to departments within the University; lending collection contains original art works, original prints, paintings & sculpture

RAYMOND

M **HINDS COMMUNITY COLLEGE DISTRICT,** Marie Hull Gallery, 505 E Main St, Katherine Denton Art Building Raymond, MS 39154-1100. Tel 601-857-3277; Elec Mail gsmccarthy@hindscc.edu; Internet Home Page Address: www.hindscc.edu; *Chmn & Dir* Gayle McCarty
Open Mon - Thurs 8 AM - 3 PM, Fri 8 AM - Noon; No admis fee; Estab 1971 as a community service & cultural agent for the visual arts; Main gallery measures 60 x 60 ft; an adjacent gallery 8 x 45 ft; reception area 15 x 25 ft; Average Annual Attendance: 2,500
Income: $2,900 (financed by Art Department budget)
Collections: Permanent collection of state artist, with 400 pieces in prints, sculptures & paintings
Exhibitions: Sponsors 6 exhibits during college session
Activities: Lect open to public, 3 vis lectr per year; gallery talks; tours; sponsor competitions; scholarships & fels offered

RIDGELAND

M **CRAFTSMEN'S GUILD OF MISSISSIPPI, INC,** Mississippi Crafts Center, Natchez Trace Pky, PO Box 69 Ridgeland, MS 39158. Tel 601-856-7546; Fax 601-856-7546; *Dir* Martha Garrott
Open Mon - Sun 9 AM - 5 PM; No admis fee; Estab 1975 to provide access to & educ in fine crafts to the pub & to provide a marketing venue for juried mem artists; A dogtrot log cabin on the Natchez Trace Parkway nat park; Average Annual Attendance: 30,000; Mem: 250; mem by Standards Committee evaluation; dues $50; annual meeting in Dec
Income: Financed by sales & grants
Special Subjects: Afro-American Art, American Indian Art, Folk Art, Metalwork, Pottery, Textiles, Sculpture, Crafts, Woodcarvings, Jewelry, Scrimshaw, Stained Glass, Pewter, Leather
Collections: Choctaw Indian crafts created by members; crafts created by members
Activities: Classes for adults & children; craft demonstration, lect & festivals; lect open to public, 1-2 vis lectr per year; gallery talks; artmobile; original objects of art lent by negotiation in response to requests; lending collection contains original art works, photographs & slides; originate traveling exhibitions; sales shop sells books & original art, primarily original craft objects (Native American to contemporary)

STONEVILLE

A **MISSISSIPPI ART COLONY,** PO Box 387, Stoneville, MS 38756. Tel 888-452-5332; Internet Home Page Address: www.msartcolony.com; *Dir* Mrs Jamie Tate; *Pres* Bryon Myrick; *VPres* Keith Alford; *Treas* Evelyn Breland; *Secy* Patty Pilic
Estab 1948 to hold workshops at least twice yearly, for painting & drawing instruction and occasionally other areas; to organize juried show, with prizes awarded, that travels state of Mississippi between workshops; Average Annual Attendance: 50; Mem: $200; annual dues $20
Income: Financed by mem
Exhibitions: Two travel exhibitions each year; Painting workshops
Publications: Bulletin, newsletter
Activities: Annual fall workshop last week in Sept, $300; competitions judged; awards; scholarships; traveling exhibitions in Mississippi museums

TOUGALOO

TOUGALOO COLLEGE
M **Art Collection,** Tel 601-977-7743; Fax 601-977-7714; *Pres* Joe A Lee; *VPres Academic Affairs* Dr Lewis L Jones; *Photographer* John Wright; *Dir* Ron Schnell; *Chair* Johnnie Mae Gilbert
Open by appointment; No admis fee; Estab 1963 to service the community & the metropolitan Jackson area; Located in Student Union Building & Library; Average Annual Attendance: 2,500
Income: Financed by endowment & department budget
Collections: Afro-American; African; International Print Collection with emphasis on European art; New York School (abstract, expressionism, minimal art, surrealism)
Exhibitions: African Collection; Afro-American Collection; Faculty & Student Show; Local artists

Publications: Mississippi Museum of Art, African Tribal Art; Calder-Hayter-Miro; G M Designs of the 1960s; Hans Hofmann, Light Prints; brochure; catalog; newspaper of special events
Activities: Classes for adults; dramatic programs; lect open to public, 2-3 vis lectr per year; concerts; gallery talks; tours by appointment; scholarships offered; exten dept; individual paintings & original objects of art lent to libraries, universities & museums; lending collection contains 8000 lantern slides, 700 original art works, 350 original prints, 140 paintings, 150 sculpture, industrial designs & typography; book traveling exhibitions; originate traveling exhibitions; museum shop sells original art

L **Coleman Library,** Tel 601-977-7778; Fax 601-977-7714; *Dir Library Services* Charlene Cole
Open Mon - Thurs 8 AM - midnight, Fri 8 AM - 5 PM, Sat 1 - 4 PM, Sun 3 - 9 PM; No admis fee; Estab 1963; Open to students & faculty
Income: Financed by rental fees
Library Holdings: Audio Tapes; Book Volumes 135,000; Cards; Cassettes; Clipping Files; Exhibition Catalogs; Fiche; Filmstrips; Framed Reproductions; Kodachrome Transparencies; Manuscripts; Memorabilia; Motion Pictures; Original Art Works; Pamphlets; Periodical Subscriptions 432; Photographs; Prints; Records; Reels; Reproductions; Sculpture; Slides
Special Subjects: Folk Art, Graphic Arts, Archaeology, American Western Art, Advertising Design, American Indian Art, Anthropology, Glass, Aesthetics, Afro-American Art, Antiquities-Oriental, Antiquities-Persian, Antiquities-Egyptian, Antiquities-Greek, Antiquities-Roman
Collections: Tracy Sugerman (wash drawings, civil rights studies 1964); African masks & sculpture
Exhibitions: Four major exhibits per year
Publications: Tougaloo College Art Collections
Activities: Lect open to public, 2 vis lectr per year; symposium; gallery talks; tour

TUPELO

C **BANK OF MISSISSIPPI,** Art Collection, One Mississippi Plaza, PO Box 789 Tupelo, MS 38802. Tel 662-680-2000; *Pres* Aubrey B Patterson Jr; *Chief Financial Officer* Nash Allen
Estab to encourage local artists & provide cultural enrichment for customers & friends; Works displayed throughout building
Purchases: $500
Collections: Oils, prints, watercolors

L **LEE COUNTY LIBRARY,** 219 N Madison, Tupelo, MS 38804. Tel 662-841-9029; Fax 662-840-7615; Elec Mail lils@li.lib.ms.us; Internet Home Page Address: www.li.lib.ms.us; *Technical Services Librn* Barbara Anglin; *Dir* Louann McDonald; *Reference Librn* Brian Hargett; *Bookmobile Librn* Ann Grimes
Open Mon - Thurs 9:30 AM - 8:30 PM, Fri & Sat 9 AM - 5 PM, cl Sun; Estab 1941 to provide books & other sources of information to serve the intellectual, recreational & cultural needs of its users; Maintains art gallery; The Mezzanine Gallery & Helen Foster Auditorium are used as exhibit space for works by University Art students, local professional artists & traveling exhibitions
Income: Financed by city, state & county appropriations
Library Holdings: Book Volumes 200,000; Cassettes; Fiche; Framed Reproductions; Photographs; Prints; Records; Sculpture; Video Tapes
Collections: The Tupelo Gum Tree Festival purchase prizes, these include paintings and pottery
Activities: Children's summer reading series: Children's series Thurs at 10am; Helen Foster lect series every April with renowned authors

MISSOURI

ARROW ROCK

M **ARROW ROCK STATE HISTORIC SITE,** 4th and Van Bruen St, Arrow Rock, MO 65320. Tel 660-837-3330; Fax 660-837-3300; Elec Mail dspasso@4mail.dns.state.mo.ks; Internet Home Page Address: www.mostateparks.com/arrowrock; *Admin* Mike Dickey
Open daily 7 AM-10 PM, Dec-Feb: Fri-Sun from 10 AM - 4 PM, Visitor Center open 10 AM - 4 PM.; Free; Estab 1923 to preserve, exhibit & interpret the cultural resources of Missouri, especially those associated with George Caleb Bingham & his era in central Missouri; The 1837 home of G C Bingham serves as a mus house & the 1834 Tavern; Average Annual Attendance: 80,000
Income: Financed by state appropriation
Collections: Bingham Collection; Central Missouri Collection (textiles, furnishing & glass of the 19th century)
Exhibitions: Annual Art Fair; Annual Summer Workshop Exhibit; Annual Craft Festival
Publications: Friends of Arrow Rock Letter, quarterly
Activities: Classes for children; tours

CAPE GIRARDEAU

L **SOUTHEAST MISSOURI STATE UNIVERSITY,** Kent Library, One University Plaza, MS 4600 Cape Girardeau, MO 63701. Tel 573-651-2235; Fax 573-651-2666; Elec Mail scron@semoum.semo.edu; Internet Home Page Address: www2.semo.edu/library; *Dir* Carl Pracht
Open Mon-Thur 7:45AM-11:30 PM, Fri 7:30AM-6PM, Sat 9AM-5PM, Sun 1:30-11:30PM; No admis fee; Exhibition areas on second & third levels; Artium Gallery on fourth level. The Jake K Wells Mural, 800 sq ft covers the west wall of the library foyer, depicting the nature & the development of the southeast region of the state
Income: Financed by the univ & grants
Library Holdings: Book Volumes 400,000

Collections: Charles Harrison Collection (rare books including some of the finest examples of the book arts); books & manuscripts from the 13th to the 20th centuries
Exhibitions: Exhibits by local artists
Activities: Tours

CLINTON

M HENRY COUNTY MUSEUM & CULTURAL ARTS CENTER, 203 W Franklin St, Clinton, MO 64735. Tel 660-885-8414; Fax 660-890-2228; Elec Mail hcmus@midamerica.net; Internet Home Page Address: www.henrycountymomuseum.org; *Dir* Alta Dulaban
Open Mon - Sat, 10 AM - 4 PM; Admis $3 adults, students under 12 free; Estab 1976; Turn of the 20th Century museum; Average Annual Attendance: 4,500; Mem: 600; dues $15 individual, $25 family; semi-annual meetings
Income: Financed by members
Special Subjects: Metalwork, Prints, Maps, Painting-French, Painting-Japanese, Sculpture, Architecture, Drawings, Painting-American, Watercolors, Archaeology, Ethnology, Textiles, Costumes, Religious Art, Pottery, Woodcarvings, Decorative Arts, Portraits, Eskimo Art, Dolls, Furniture, Glass, Porcelain, Asian Art, Carpets & Rugs, Miniatures, Period Rooms, Antiquities-Oriental, Antiquities-Persian, Antiquities-Greek, Mosaics, Stained Glass, Military Art
Collections: Paintings of Mr & Mrs Lewis Freund
Exhibitions: Lewis Freund WPA Work at all Times
Activities: Classes for adults & children; docent training; 3 vis lectr per yr; tours; sponsoring of competitions; scholarships; book traveling exhibs, 1-2007, Between Fences, from MO Humanities; museum shop sells books & prints

COLUMBIA

A STATE HISTORICAL SOCIETY OF MISSOURI, 1020 Lowry, Columbia, MO 65201-7298. Tel 573-882-7083; Fax 573-884-4950; Elec Mail shsofmo@umsystem.edu; Internet Home Page Address: www.umsystem.edu/shs; *Exec Dir* Dr James W Goodrich; *Volunteer Pres* Richard Franklin
Open Mon-Fri 8:00 AM-4:30 PM, Sat 9 AM - 4:30 PM; No admis fee; donations accepted; Estab 1898 to collect, preserve, make accessible & publish materials pertaining to the history of Missouri & the Middle West; Circ Non-circulating; Major art gallery 54 ft x 36 ft; corridor galleries; Average Annual Attendance: 14,200; Mem: 5500; dues $20 individual, $30 family; annual meeting in fall
Income: Financed by state appropriation
Library Holdings: Book Volumes 461,000; Clipping Files; Lantern Slides; Manuscripts; Maps; Original Art Works; Original Documents; Pamphlets; Periodical Subscriptions; Photographs; Reels; Slides; Video Tapes
Special Subjects: Cartoons, Drawings, Photography, Prints, Watercolors, Painting-American, Portraits
Collections: Works by Thomas Hart Benton, George C Bingham, Karl Bodmer, Fred Geary, Carl Gentry, William Knox, Roscoe Misselhorn, Frank B Nuderscher, Charles Schwartz, Fred Shane, Frederick Sylvester; contemporary artists collection containing work of over fifty outstanding Missouri related artists; original cartoon collection of works by Tom Engelhardt, Daniel Fitzpatrick, Don Hesse, Bill Mauldin, S J Ray and others
Publications: Missouri Historical Review, quarterly; R Douglas Hurt & Mary K Dains, eds; Thomas Hart Benton: Artist, Writer & Intellectual (1989); Marking Missouri History (1998), James Goodrich & Lynn Gentzler eds
Activities: Lect open to public; Tours; 8-10 vis lectr per yr; individual paintings lent, loans based on submitted requests; sales shop sells books & prints
L Gallery and Library, 1020 Lowry St, Columbia, MO 65201-7298. Tel 573-882-7083; Fax 573-884-4950; Elec Mail shsofmo@umsystem.edu; Internet Home Page Address: www.umsystem.edu/shs; *Exec Dir* Dr Gary R Kremer; *VPres* Bruce H Beckett
Open Mon-Fri 8AM-4:30PM, Sat 9AM-4:30PM; no charge; donations accepted; Estab 1898; Open to public for reference use only; Mem: 5,613; $20 individual, $30 family
Income: Financed by state appropriation
Library Holdings: Audio Tapes; Book Volumes 460,000; Cassettes; Clipping Files; Exhibition Catalogs; Fiche; Lantern Slides; Manuscripts; Maps 2,922; Original Art Works; Pamphlets; Periodical Subscriptions 984; Photographs; Prints; Records; Reels; Slides; Video Tapes
Special Subjects: Photography, Manuscripts, Maps, Historical Material
Collections: George Caleb Bingham Collection; Thomas Hart Benton Collection; Karl Bodmer Ninety colored engravings; Eugene Field Collection; Mahan Memorial Mark Twain Collection; Bishop William Fletcher McMurray Collection; Francis A Sampson Collection of rare books

M STEPHENS COLLEGE, Lewis James & Nellie Stratton Davis Art Gallery, 1200 Broadway, Columbia, MO 65215. Tel 573-876-7627; Fax 573-876-7248; Elec Mail irene@stephens.edu; *Dir* Robert Friedman; *Cur* Irene Alexander
Open Mon - Fri 10 AM - 4 PM, cl school holidays & summer; No admis fee; Estab 1964 to provide exhibitions of art for the general interest of the local community & for the education of the student body in general; Average Annual Attendance: 500
Income: $2000 (financed by endowment)
Special Subjects: Graphics, Painting-American, Sculpture, Primitive art
Collections: Modern graphics; modern paintings; primitive sculpture
Exhibitions: Elizabeth Layton's Drawing on Life; Ron Meyers: Ceramics; Margaret Peterson Paintings; Burger Sandzen exhibit
Activities: Lect open to public, 6 vis lectr per year; gallery talks; exhibitions; competitions with awards

UNIVERSITY OF MISSOURI
M Museum of Art & Archaeology, Tel 573-882-3591; Fax 573-884-4039; Elec Mail muswww@showme.missouri.edu; Internet Home Page Address: www.research.missouri.edu/museum; *Cur European & American Art* Joan Stack; *Interim Cur Ancient Art* James Terry; *Registrar* Jeffrey Wilcox; *Cur Educ* Dale

Fisher; *Preparator* Barb Smith; *Fiscal Officer* Dana Armontrout; *Dir* Marlene Perchinske; *Asst Dir* Patricia Podzorski; *Publ Dir* Judith Bock; *Admin Asst* Erin Dalcourt
Open Tues - Fri 9 AM - 5 PM, Thurs 6 - 9 PM, Sat & Sun Noon - 5 PM, cl Mon & holidays; No admis fee; Estab 1957 to exhibit a study collection for students in Art History & Archaeology; a comprehensive collection for the enjoyment of the general area of Missouri; Housed in renovated 1890's building. Ten galleries for permanent collection & special exhibitions; Average Annual Attendance: 35,000; Mem: 600
Income: $1,088,667 (financed by mem, grants & state appropriation)
Special Subjects: Drawings, Prints, Sculpture, Pre-Columbian Art, Painting-European, Oriental Art, Asian Art, Antiquities-Byzantine, Antiquities-Persian, Antiquities-Egyptian, Antiquities-Greek, Antiquities-Roman, Antiquities-Etruscan, Antiquities-Assyrian
Collections: Ancient Art-Egypt, Western Asia, Greek & Roman; European & American painting & sculpture; Early Christian-Byzantine & Coptic; Modern paintings & sculpture; Prints & drawings; African, Pre-Columbian; Oriental-Chinese & Japanese; South Asian-Indian, Thai, Tibetan, Nepalese
Exhibitions: Expressions of Africa, ongoing; Reinstallation of the Weinberg Gallery of Ancient Art, ongoing; Africa Through the Eyes of Women Artists; Waterways West: Photographs from Missouri River Portfolios; Traditions in Change: Art for Oceania; Newspaper Lithographs by Honore Daumier; Breaking Barriers: Artists Reinvent the Museum; Art of WWII, Works from the Missouri Collection; Image & Imagination in African Art
Publications: Muse, annually; exhibition catalogues; The News, 3 per year; calendars, 3 per year; Glen Lukens: Innovations in Clay, Testament of Time; Antiquities from the Holy Land
Activities: Classes for adults & children; docent training; workshops on conservation; lect open to public, 5-10 vis lectr per year; tours; gallery talks; original objects of art lent to institutions; book traveling exhibitions 2-3 per year; originate traveling exhibitions; museum shop sells books, prints, reproductions
L Art, Archaeology & Music Collection, Tel 573-882-4581; Fax 573-882-8044; Internet Home Page Address: www.missouri.edu/~lsww; *Librn* Michael Muchow; *Music* Anne Barker; *Reference Desk Coordr* Cynthia Cotner
Open Mon-Thurs 7:30 AM-12 AM, Fri 7:30 AM-9 PM, Sat 9 AM-9 PM, Sun Noon-12 AM; Estab 1841 to house material for the faculty & students of the University
Income: Financed by state appropriation
Library Holdings: Book Volumes 81,000; CD-ROMs; Exhibition Catalogs; Fiche; Periodical Subscriptions 300; Records; Reels; Video Tapes

CRESTWOOD

KAPPA PI INTERNATIONAL HONORARY ART FRATERNITY
For further information, see National and Regional Organizations

FAYETTE

M CENTRAL METHODIST UNIVERSITY, Ashby-Hodge Gallery of American Art, 411 Central Methodist Square, Fayette, MO 65248. Tel 660-248-6234 or 6304; Fax 660-248-2622; Elec Mail jgeist@coin.org; Internet Home Page Address: www.centralmethodist.edu; *Cur* Dr Joe Geist
Tues-Thurs & Sun 1:30-4:30 PM, other times by appointment; No admis fee; Estab 1994; focus on American art; Average Annual Attendance: 5,000
Special Subjects: Photography, Painting-American, Sculpture, Watercolors
Collections: Ashby Collection of American Art
Exhibitions: (1/16/2007-03/8/2007) The Still Life of Al Jackson; (3/26/2007-5/3/2007) Two of a Kind Makes a Pair: The Works of Jerry & Joanne Berneche

FENTON

L MARITZ, INC, Library, 1400 S Highway Dr, Fenton, MO 63099. Tel 636-827-1501; Fax 636-827-3006; *Mgr* Jan Meier
Estab 1968; Circ 12,000; For reference & lending
Library Holdings: Book Volumes 7500; Periodical Subscriptions 250
Special Subjects: Illustration, Graphic Arts

FLORIDA

M MARK TWAIN BIRTHPLACE, State Historic Site Museum, 37352 Shrine Rd, Florida, MO 65283. Tel 573-565-3449; Fax 573-565-3718; Elec Mail mark.twain.birthplaced.state.historic.site@dnr.mo.gov.; Internet Home Page Address: mostatesports.com/twainsite.htm; *Site Adminr* John Huffman; *Interpretive Resource Technician* Connie Ritter
Open every day 10 AM - 4:30 PM, daylight savings 10 AM - 5 PM, cl Thanksgiving Day, Christmas and New Years; Admis adults $2.50, children between 6 & 12 $1.50, children under 6 free; Estab 1960 to preserve the birth cabin of Samuel L Clemens, interpret his life and inform visitors of local history; Foyer and two large exhibit areas, research library; Average Annual Attendance: 24,000
Income: Financed by state appropriation
Special Subjects: Historical Material, Sculpture, Painting-American, Photography, Manuscripts, Portraits, Furniture
Collections: Samuel Clemens memorabilia; manuscripts; period furnishings and paintings
Exhibitions: Permanent exhibits depicting the life of Samuel Clemens
Activities: Lects; tours; craft demonstrations; sales of books

FULTON

M WESTMINSTER COLLEGE, Winston Churchill Memorial & Library in the United States, 501 Westminster Ave, Fulton, MO 65251. Tel 573-592-5369; *Archivist* Warren Hollrah; *Dir* Dr Gordon Davis; *Asst Dir* Sara Winingear
Open Mon - Sat 10 AM - 4:30 PM, Sun 10 AM - 4:30 PM; cl Thanksgiving, Christmas & New Year's; Admis adults $3.50, senior citizens $2.50, children 12 &

under $1; group rates; Estab 1969 to commemorate life & times of Winston Churchill & attest to ideals of Anglo-American relations; Special exhibits gallery changes quarterly; ecclesiastical gallery contains historic robes & communion vessels; connecting gallery houses historic map collection; Average Annual Attendance: 22,000; Mem: 900

Income: Financed by endowment, mem, admis, friends fundraising, gift shop sales

Special Subjects: Historical Material, Maps

Collections: Churchill & family memorabilia, including documents, manuscripts & photographs; Churchill oil paintings; rare maps

Exhibitions: Churchill paintings; Iron Curtain speech memorabilia

Publications: MEMO, quarterly newsletter

Activities: Churchill classes for WC students; docent training; lect open to public; concerts; tours; scholarships & fels offered; individual paintings & original objects of art lent to other museums & libraries; book traveling exhibitions 2-4 per year; originate traveling exhibitions; museum shop sells books, original art, reproductions, prints, slides, Churchill busts & memorabilia, English china, posters, collectible English toy soldiers

M **WILLIAM WOODS UNIVERSITY,** Cox Gallery, One University Ave, Fulton, MO 65251. Tel 573-592-4245; Fax 573-592-1623; *Dir* Terry Martin; *Chmn Visual, Performing & Communication Div* Paul Clervi
Open Mon - Fri 9 AM - 4:30 PM; No admis fee; Estab 1967 to be used as a teaching aid for the Art Center; Maintains 3200 sq ft sky-lighted gallery with a mezzanine

Income: Financed by endowment

Activities: Lect open to public, 2 vis lectr per year; tours; gallery talks; scholarships

HOLLISTER

L **WORLD ARCHAEOLOGICAL SOCIETY,** Information Center & Library, 120 Lakewood Dr, Hollister, MO 65672. Tel 417-334-2377; Elec Mail ronwriterartist@aol.com; Internet Home Page Address: www.worldarchaeologicalsociety.com; *Dir* Ron Miller
Not open to public; Estab 1971 to study related areas of archaeology, anthropology & art history & to help worldwide mail & telephone queries; Lending & reference by special arrangement; Mem: dues $16, outside US $20; must sign good archaeology requirements on member card

Income: Financed by endowment & newsletter sales

Purchases: serials & books

Library Holdings: Book Volumes 7,000; Clipping Files; Original Art Works; Periodical Subscriptions 32; Photographs; Prints; Slides

Special Subjects: Art History, Illustration, Pre-Columbian Art, Sculpture, History of Art & Archaeology, Archaeology, Ethnology, Asian Art, Primitive art, Anthropology, Antiquities-Oriental, Antiquities-Egyptian, Antiquities-Greek, Antiquities-Roman, Architecture

Collections: Steve Miller Library of Archaeology; Rose O'Neil Art

Publications: WAS Newsletter, occasional; special publications, occasional

Activities: WAS award for best book, illustration & photo; individual paintings & original objects of art lent; query for art prints

INDEPENDENCE

M **CHURCH OF JESUS CHRIST OF LATTER-DAY SAINTS,** Mormon Visitors' Center, Mormon Visitors Center, 937 W Walnut Independence, MO 64050-0000. Tel 816-836-3466; Fax 816-252-6256; Internet Home Page Address: www.LDS.org; *Dir* Barrie G McKay
Open daily 9 AM - 9 PM; No admis fee; Estab 1971 as a center of Church of Jesus Christ of Latter Day Saints beliefs & history for residents of Missouri, Ohio & Illinois; Average Annual Attendance: 50,000

Income: Financed by The Church of Jesus Christ of Latter Day Saints

Special Subjects: Portraits, Woodcuts, Religious Art

Collections: Large 30 ft mural of Christ; painting; computer reproductions; Short movies about history & life experiences of Jesus Christ

Exhibitions: Paintings; movies; audio-visual shows; historical maps exhibits; special flag display; log cabin 1800s (original)

Publications: Brochures

Activities: Lect open to public; free guided tours

M **JACKSON COUNTY HISTORICAL SOCIETY,** The 1859 Jail, Marshal's Home & Museum, 217 N Main St, Independence, MO 64050. Tel 816-252-1892; Fax 816-461-1897; Internet Home Page Address: www.jchs.org; *Operating Committee Chmn* Jake Simonitsch; *Dir* Geoff Barr
Open Mon - Sat 10 AM - 5 PM, Sun 1 - 4 PM, Mar, Nov & Dec Mon 10 AM - 4 PM, cl Jan & Feb; Admis adults $4.00, senior citizens $3.50, children 6-16 $1, under 5 free, group rates available; Estab 1958 for interpretation of Jackson County history; 1859 Federal town house of county marshal, attached limestone jail which served as federal headquarters during the Civil War. Restored historical interior c 1860s. Restored cell of Frank James c 1882; Average Annual Attendance: 12,000; Mem: 1,000; dues $20-$1,000

Income: Financed by mem, tours, fundraising events

Special Subjects: Historical Material, Period Rooms

Collections: Jackson County history, 1800-present; home furnishings of mid-19th century in restored areas

Exhibitions: Permanent exhibits on Jackson County history; changing exhibits

Publications: Jackson County Historical Society Journal, bi-annual

Activities: Classes for children; docent training; lect open to public; tours; museum shop sells books

L **Research Library & Archives,** Independence Sq Courthouse, Rm 103, Independence, MO 64050. Tel 816-252-7454; Fax 816-461-1510; Internet Home Page Address: www.jchs.org; *Dir Archives* David Jackson
Open Tues - Fri 10 AM - 4 PM, Sat 10 AM - 1 PM; No admis fee; Estab 1966; Gallery collects, preserves, & makes available for research exhibition & education materials that relate to Jackson County history; Mem: $20-1,000

Income: Financed by mem, fees, donations, sales

Library Holdings: Audio Tapes; Book Volumes 2000; Clipping Files; Filmstrips; Kodachrome Transparencies; Lantern Slides; Motion Pictures; Periodical Subscriptions 15; Photographs; Reels; Slides; Video Tapes

Collections: Photograph collection for reference; extensive manuscript collection

M **John Wornall House Museum,** 146 W 61 Terrace, Independence, MO 64113. Tel 816-444-1858; Fax 816-361-8165; Elec Mail jwornall@crn.org; *Dir* Rebecca Fye; *Asst Dir* Karla Horkman
Open Tues - Sat 10 AM - 4 PM, Sun 1 - 4 PM; Admis adults $3, senior citizens $2.50, children 5-12 $2, children 4 & under free, group rates available; Estab 1972 restored to interpret the daily lives of prosperous frontier farm families between 1830-1875 in early Kansas City; House was used as field hospital by both armies during the Civil War. Built in 1858; opened to pub in 1972; Average Annual Attendance: 7,000; Mem: 200: dues $25-500

Income: Financed by mem, tours & fund raisings

Special Subjects: Decorative Arts, Architecture, Furniture, Maps

Collections: Home furnishings of prosperous farm families

Exhibitions: Special exhibitions on subjects dealing with interpretation of home & Civil War period

Activities: Classes for adults & children; docent training; tours; lects open to pub; 2-3 vis lects per yr; museum shop sells books, holiday & gift items

L **NATIONAL ARCHIVES & RECORDS ADMINISTRATION,** Harry S Truman Museum and Library, 500 West Hwy 24 & Delaware Independence, MO 64050. Tel 816-833-1400; Fax 816-833-4368; Elec Mail library@truman.nara.gov; Internet Home Page Address: www.trumanlibrary.org; *Acting Dir* Scott Roley
Open Mon - Sat 9 AM - 5 PM, Thurs 9 AM - 9 PM, Sun Noon - 5 PM; Admis adults $5, seniors $4.50, children 6-18 $3.50,under 6 free; Estab 1957 to preserve & make available for study & exhibition the papers, objects & other materials relating to President Harry S Truman & to the history of the Truman administration; Gravesite of President & Mrs Truman in the courtyard. Administered by the National Archives & Records Administration of the Federal Government; Average Annual Attendance: 150,000

Income: Financed by federal appropriation, federal trust fund & private donations

Library Holdings: Audio Tapes; Book Volumes 40,000; Clipping Files; Framed Reproductions; Manuscripts; Memorabilia; Motion Pictures; Original Art Works; Other Holdings Documents; Pamphlets; Periodical Subscriptions 23; Photographs; Prints; Records; Reels; Sculpture; Slides

Collections: Papers of Harry S Truman, his associates, and of officials in the Truman administration; Portraits of President Truman; paintings, prints, sculptures & artifacts presented to President Truman during the Presidential & Post-Presidential periods; original political cartoons; mural by Thomas Hart Benton

Exhibitions: Permanent & temporary exhibits relating to the life & times of Harry S Truman; the history of the Truman administration; the history & nature of office of the Presidency

Publications: Historical materials in the Truman Library

Activities: Educ dept; lect; conferences & commemorative events; tours to tour groups; film series; research grants; sales shop sells books, reproductions, slides & postcards

JEFFERSON CITY

M **MISSOURI DEPARTMENT OF NATURAL RESOURCES,** Missouri State Museum, State Capitol, Room B-2 Jefferson City, MO 65101. Tel 573-751-2854; Fax 573-526-2927; Internet Home Page Address: www.mosateparks.com; *Mus Dir* Kurt Senn; *Asst Dir* Linda Endersby; *Interpretive Progs & Tours* Chris Sterman; *Cur Exhibs* Julie Kemper; *Cur Colls* Kate Keil
Open daily 8 AM - 5 PM, cl New Years, Easter, Thanksgiving, Christmas; No admis fee; Estab 1920; History art & natural history of Missouri; Average Annual Attendance: 250,000

Income: Financed by state sales tax, affiliated with Missouri Department of Natural Resources

Special Subjects: Painting-American, Anthropology, Costumes, Historical Material

Collections: Art murals by T H Benton, Berninghaus, Frank Brangwyn, N C Wyeth; historical material and natural specimens representing Missouri's natural and cultural resources; Indian artifacts; History hall

Exhibitions: Permanent & temporary exhibits

Publications: Pamphlets

Activities: Guided tours of Capitol; audio-visual presentations; gallery tours; state parks & historic sites; books

M **Elizabeth Rozier Gallery,** State Capitol, Rm B-2, Jefferson City, MO 65101. Tel 573-751-2854; Fax 573-526-2927; *Dir* Kurt Senn; *Asst Dir* Linda Endershy; *Cur* Julie Kemper
Open 10 AM - 4 PM, Tues - Sat; No admis fee; Estab 1981 to provide art, crafts & history educational exhibits; Located in mid-nineteenth century building with a large & small gallery; Average Annual Attendance: 6,000

Income: Financed by state sales tax affiliated with Missouri Dept of Natural Resources

Special Subjects: Historical Material

Exhibitions: New exhibit every month

Activities: Lects open to pub; 2 vis lects per year; gallery talks; tours

JOPLIN

A **GEORGE A SPIVA CENTER FOR THE ARTS,** 222 W Third St, Joplin, MO 64801. Tel 417-623-0183; Fax 417-623-3805; Elec Mail spiva@spivaarts.org; Internet Home Page Address: www.spivaarts.org; *Exec Dir* Jo Mueller; *Assoc Dir* Carol Adamec; *Bd Pres* John Good; *Bd VPres* Sharrock Dermott; *Admin Asst* Wendy Vrooman; *Develop Dir* Tracie Skaggs
Open Tues - Sat 10 AM - 5 PM, Sun 1 - 5 PM, cl Mon & national holidays; No admis fee - donations are appreciated; Estab 1948, incorporated 1959, as a non-profit, cultural center with the purpose of increasing knowledge & appreciation of the visual arts in Joplin & surrounding area; to offer educational classes, workshops & to exhibit works of educational & artistic value; Average Annual Attendance: 15,000; Mem: 600; dues $20-$1000; annual meeting in Dec

Library Holdings: Book Volumes; Clipping Files; Exhibition Catalogs; Periodical Subscriptions
Collections: Permanent collection
Exhibitions: PhotoSpiva; Annual Membership Show
Publications: Calendar; newsletter
Activities: Classes for adults & children; docent training; dramatic progs; lect open to public, 3 vis lectr per year; tours; competitions with awards; mus shop sells original art

L **WINFRED L & ELIZABETH C POST FOUNDATION,** Post Memorial Art Reference Library, 300 Main St, Joplin, MO 64801. Tel 417-782-7678; Elec Mail lsimpson@postlibrary.org; Internet Home Page Address: www.postlibrary.org; *Dir* Leslie T Simpson
Open Mon & Thurs 9:30 AM - 7:30 PM, Tues, Wed, Fri & Sat 9:30 AM - 5:30 PM; No admis fee; Estab 1981 to provide information on the fine & decorative arts to members of the community; Circ non-circulating; Located in a wing of the Joplin Public Library; Average Annual Attendance: 6,500
Income: Financed by private endowment
Library Holdings: Book Volumes 3500; Clipping Files; Exhibition Catalogs; Original Art Works; Pamphlets; Periodical Subscriptions 25; Photographs; Reproductions; Sculpture
Special Subjects: Art History, Decorative Arts, Photography, Historical Material, Furniture, Architecture
Collections: 16th-17th Century Antiques & Artworks; Joplin, Missouri historic architecture collection; fine arts books collections; mounted reproductions
Exhibitions: Monthly exhibits of works by area artists
Publications: From Lincoln Logs to Lego Blocks: How Joplin Was Built by Leslie Simpson
Activities: Educ dept; film & slide programs; 1 vis lectr per yr; tours; sales shop sells books

KANSAS CITY

M **AVILA COLLEGE,** Thornhill Art Gallery, 11901 Wornall Rd, Kansas City, MO 64145. Tel 816-501-2443; Fax 816-501-2459; Internet Home Page Address: www.avila.edu; *Academic Dean* Sr Marie Joan Harris, PhD; *Chmn Humanities* Carol Coburn PhD; *Pres* Thomas Gordon PhD; *Asst Dir* Martin Benson
Open Mon - Fri 10 AM - 5 PM, Sat 12 AM - 5 PM, cl Sun; No admis fee; Estab 1978; Gallery space 60 x 35 ft is maintained with carpeted floor and walls and track lighting; Average Annual Attendance: 2,000
Income: Financed through school budget
Collections: Avila College Art Collection
Exhibitions: Japanese Woodblock Prints, Faculty Bienniele
Activities: Lect open to public; gallery talks; sponsoring of competitions

C **COMMERCE BANCSHARES, INC,** Fine Art Collection, Commerce Bank Art Dept, 922 Walnut St Kansas City, MO 64105. Tel 816-760-7885; Fax 816-234-2356; Elec Mail robin.trafton@commercebank.com; *CEO & Pres* David W Kemper; *Cur* Robin Trafton; *Dir Art Coll* Laura Kemper Fields
Open Mon - Sat 8 AM - 5 PM; No admis fee; Estab 1964; 125 ft barrel vaulted gallery with 13 ft ceiling to exhibit mus quality paintings
Activities: Individual paintings lent on restricted basis

HALLMARK CARDS, INC
C **Fine Art Programs,** Tel 816-274-4726; Fax 816-545-6591; *Dir Fine Art Prog* Keith F Davis
Estab 1949
Collections: Hallmark Photographic Collection; Hallmark Art Collection; drawings; paintings; photographs; prints
Publications: Exhibition catalogs; New Acquisitions brochures, annually
Activities: Lect; purchase awards for art shows; individual objects of art lent to reputable institutions for temporary exhibitions; originate traveling exhibitions
L **Creative Library,** Tel 816-274-5525; Fax 816-274-7245;
Open to Hallmark personnel only; Estab to provide pictorial research
Income: Financed by corp funds
Library Holdings: Book Volumes 22,000; Periodical Subscriptions 150
Special Subjects: Illustration
Collections: Old & rare collection

M **KANSAS CITY ART INSTITUTE,** (Kansas City Art Institute) 4420 Warwick Blvd, Kansas City, MO 64111-1821. Tel 816-753-5784; Fax 816-753-5806; Elec Mail info@kemperart.org; Internet Home Page Address: www.kemperart.org; *Cur* Dana Self; *VChmn of Board* R Crosby Kemper; *Educ Coordr* Kristy Peterson; *Bus Mgr* Walter Reich Dietrich; *Develop & Mem Admin* Linda Off; *Mktg & Comm Mgr* Margaret A Keough; *Dir Rachael* Blackburn; *Spec Events* Amy Polen; *Registrar* Dawn Giegerich; *Vistor Svcs Coordr* Camille Bailey; *Gen Mgr* Pam Tibbs; *Admin Asst* Patricia Rogers; *Mus Shop Mgr* Megan Flores; *Accounting* Teresa Metz; *Preparator* Jason Myers
Open Tues - Thurs 10 AM - 4 PM, Fri & Sat 10 AM - 9 PM, Sun 11 AM - 5 PM; No admis fee; Estab 1994 as a regional resource for modern & contemporary art in all medias; 24,000 sq ft, 2 galleries plus atrium & open areas & courtyard; Average Annual Attendance: 120,000; Mem: 2000; dues $35 - $1000
Special Subjects: Architecture, Drawings, Graphics, Hispanic Art, Latin American Art, Mexican Art, Painting-American, Photography, Prints, Sculpture, Watercolors, American Indian Art, African Art, Textiles, Ceramics, Crafts, Woodcuts, Etchings & Engravings, Landscapes, Afro-American Art, Decorative Arts, Collages, Painting-Japanese, Portraits, Posters, Painting-Canadian, Furniture, Glass, Jewelry, Painting-Dutch, Painting-French, Painting-Polish, Painting-Spanish, Painting-Italian, Painting-Australian, Painting-German, Painting-Russian, Painting-Israeli, Painting-Scandinavian, Painting-New Zealander
Collections: Bebe & Crosby Kemper Collection
Exhibitions: Changing contemporary art exhibs
Activities: Educ Dept; classes for adults & children; dramatic progs; docent training; family days; artist lects; artist-in-residence prog; lect open to pub, 10 vis lects per yr; concerts; gallery talks; tours; individual paintings & original objects

of art lent to other museums; book traveling exhibs; originate traveling exhibs to various museums & universities; mus shop sells books & original art

L **Jannes Library,** 4538 Warwick Blvd, Kansas City, MO 64111; 4415 Warwick Blvd, Kansas City, MO 64111-1874. Tel 816-802-3390; Fax 816-802-3338; Elec Mail library@ckai.edu; Internet Home Page Address: http://library.kcai.edu; *Library Dir* Mary J Poehler; *Asst Dir* Sally Closson; *Slide Librn* Deborah Tinsley; *Circulation Specialist* Leesa Duby
Open Mon - Thurs 8:30 AM - 10 PM, Fri 8:30 AM - 5 PM, Sat Noon - 5 PM, Sun 5 - 10 PM; Estab 1924 to serve students & faculty of Art Institute
Income: $75,622 (financed by Art Institute budget)
Library Holdings: Book Volumes 30,000; Other Holdings Picture file; Periodical Subscriptions 120; Slides 100,000
Special Subjects: Photography

M **KANSAS CITY ARTISTS COALITION,** 201 Wyandotte, Kansas City, MO 64105. Tel 816-421-5222; Fax 816-421-0656; Internet Home Page Address: www.kansascityartistscoalition.org; *Exec Dir* Janet F Simpson; *Asst Dir* Megan Lynch; *Exec Asst* Melody Crane
Open Wed - Sat 11 AM - 5 PM; No admis fee; Estab 1975 to promote contemporary art & artists from Kansas City & the Midwest; nonprofit organization; Average Annual Attendance: 19,000; Mem: 800; dues $45
Exhibitions: Exhibs of high-quality, innovative work by emerging & mid-career artists; exhib series features a diverse combination of local, regional & national artists; Biennial City-wide Open Studio Event
Publications: Forum, online
Activities: Exhib & lect open to pub; competitions with awards; workshops

A **KANSAS CITY MUNICIPAL ART COMMISSION,** 414 E 12th St, City Hall, 17th Fl Kansas City, MO 64106. Tel 816-513-2529; Fax 816-513-2523; Elec Mail porter_arneill@kcmo.org; Internet Home Page Address: www.kcmo.org/pubworks.nsf/web/art?opendocument; *Dir* Porter Arneill
Estab 1926. Administers the One-Percent-for-Art Program in Kansas City, setting aside one percent of all construction costs for new building & renovation projects for artwork
Exhibitions: Shown at various pub locations, such as libraries, col campuses & museums on a rotating basis
Activities: Originate traveling exhibs

M **LEEDY VOULKO'S ART CENTER,** 2012 Baltimore Ave, Kansas City, MO 64108. Tel 816-474-1919; Fax 816-221-8474; Internet Home Page Address: www.leed-voulkos.com; *Exec Dir* James Leedy; *Managing Dir* Holly Swangstu
Open Wed - Sat 11 AM - 5 PM or by appointment; Estab 1985 to showcase contemporary arts & crafts; 10,000 sq ft of exhib space; Average Annual Attendance: 50,000
Exhibitions: Showcase contemporary art in all media-changing exhibits every six weeks
Activities: Classes for adults & children; 4 vis lect per year; gallery talks; museum shop sells books & original art

M **LIBERTY MEMORIAL MUSEUM & ARCHIVES,** The National Museum of World War I, 100 W 26th St, Kansas City, MO 64108. Tel 816-784-1918; Fax 816-784-1929; Elec Mail info@lmakc.org; Internet Home Page Address: www.libertymemorialmuseum.org; *Archivist* Jonathan Casey; *Cur* Doran L Cart; *Dir* Eli Paul
Tues - Sun 10 AM - 5 PM; Admis $3 - $5; Estab 1919 to exhibit World War I memorabilia; Two rectangular spaces 45 x 90 ft; permanent & temporary exhibits; expanded mus space of 32,000 sq ft open Nov 2006; Average Annual Attendance: 62,000; Mem: 1000+; ann meeting Nov
Income: Financed by city appropriation & pvt donations
Purchases: 1917 Harley Davidson Army Motorcycle
Library Holdings: Kodachrome Transparencies; Lantern Slides; Manuscripts; Maps; Memorabilia; Motion Pictures; Original Art Works; Original Documents; Other Holdings; Periodical Subscriptions; Photographs; Prints; Records; Reels; Sculpture; Slides; Video Tapes
Special Subjects: Etchings & Engravings, Historical Material, Painting-American, Prints, Painting-French, Drawings, Photography, Costumes, Manuscripts, Posters, Maps, Coins & Medals, Painting-German, Military Art
Collections: WWI: books, documents, militaria, original sketches & paintings, photos, posters, sheet music
Exhibitions: Trench Warfare; Aviation; Artillery; Medical Care; Uniforms; Women at War
Publications: Quarterly newsletter
Activities: Children's progs; lect open to pub; 2-4 visiting lect per yr; mus shop sells books, reproductions, postcards & posters

MID AMERICA ARTS ALLIANCE & EXHIBITS USA
For further information, see National and Regional Organizations

M **NELSON-ATKINS MUSEUM OF ART,** 4525 Oak St, Kansas City, MO 64111-1873. Tel 816-751-4000; Internet Home Page Address: www.nelson-atkins.org; *Chief Exec Off & Dir* Marc F Wilson; *Cur American Art* Margi Conrads; *Dir, External Affairs* Peter H Hansen; *Chief Cur* Deborah Emont Scott
Open Tues - Thurs 10 AM - 4 PM, Sat 10 AM - 5 PM, Sun Noon - 5 PM, Fri 10 AM - 9 PM; No admis fee; Estab 1933 as a gen mus serving the greater Kansas City region; Circ 135,000; Maintains reference library; Average Annual Attendance: 350,000; Mem: 11,000; dues $50 - $10,000
Income: Financed by endowment, mem, contributions & endowment
Library Holdings: Auction Catalogs; Book Volumes; Other Holdings; Periodical Subscriptions
Special Subjects: Drawings, Hispanic Art, Photography, Prints, American Indian Art, American Western Art, African Art, Costumes, Ceramics, Woodcuts, Etchings & Engravings, Landscapes, Afro-American Art, Decorative Arts, Glass, Jewelry, Asian Art, Carpets & Rugs, Ivory, Restorations, Baroque Art, Calligraphy, Period Rooms, Medieval Art, Antiquities-Assyrian
Collections: Burnap Collection of English pottery, Oriental ceramics, paintings, sculpture, bronze, Egyptian tomb sculpture, American painting, period rooms &

furniture; Cloisters; contemporary works of art; Impressionist painting; the finest Oriental furniture coll outside of the Orient; sculpture garden; Oriental Art; American, American Indian; Asian, Ancient Chinese, European, Africa, Oceania Sculpture & Modern/Contemporary (continuous); Hallmark Photographic Collection

Publications: Explore art calendar, 6 times per yr; Member magazine, 2 times per yr

Activities: Classes for adults & children; dramatic programs; docent training; lect open to pub, 50 vis lectr per yr; gallery talks; tours; individual paintings and original objects of art lent to qualified organizations & exhibs; mus shop sells books, magazines, original art, reproductions & slides

L **Spencer Art Reference Library,** 4525 Oak St, Kansas City, MO 64111-1873. Tel 816-751-1216; Fax 816-561-7154; Internet Home Page Address: www.nelson-atkins.org; *Sr Asian Catalogue Librn* Jane Cheng; *Sr Catalogue Librn* Katharine Reed; *Slide Librn* Noriko Ebersole; *Sr Librn Pub Servs & Coll Develop* Dr Jeffrey Weidman; *Acquisitions Librn* Sharon Zhang
Open Tues - Sat 1 - 4 PM; For reference only
Library Holdings: Auction Catalogs 35,000; Audio Tapes; Book Volumes 100,000; Cassettes; Clipping Files; Exhibition Catalogs; Fiche; Filmstrips; Manuscripts; Motion Pictures; Other Holdings International auction catalogues; Per titles 1200; Pamphlets; Periodical Subscriptions 500; Photographs; Reels; Slides 70,000; Video Tapes
Special Subjects: Art History, Collages, Constructions, Folk Art, Intermedia, Landscape Architecture, Decorative Arts, Illustration, Mixed Media, Photography, Calligraphy, Drawings, Etchings & Engravings, Islamic Art, Manuscripts, Maps, Painting-American, Painting-British, Painting-Dutch, Painting-Flemish, Painting-French, Painting-German, Painting-Italian, Painting-Japanese, Painting-Russian, Painting-Spanish, Posters, Pre-Columbian Art, Prints, Sculpture, Painting-European, Historical Material, History of Art & Archaeology, Judaica, Portraits, Watercolors, Ceramics, Conceptual Art, Crafts, Latin American Art, Archaeology, Ethnology, Painting-Israeli, American Western Art, Bronzes, Printmaking, Advertising Design, Fashion Arts, Interior Design, Lettering, Art Education, Asian Art, Video, American Indian Art, Porcelain, Primitive art, Anthropology, Eskimo Art, Furniture, Mexican Art, Southwestern Art, Ivory, Jade, Period Rooms, Costume Design & Constr, Glass, Mosaics, Painting-Polish, Stained Glass, Aesthetics, Afro-American Art, Bookplates & Bindings, Metalwork, Antiquities-Oriental, Antiquities-Persian, Carpets & Rugs, Embroidery, Enamels, Gold, Goldsmithing, Handicrafts, Jewelry, Leather, Miniatures, Oriental Art, Pottery, Religious Art, Restoration & Conservation, Silver, Silversmithing, Tapestries, Textiles, Woodcarvings, Woodcuts, Marine Painting, Landscapes, Antiquities-Assyrian, Antiquities-Egyptian, Antiquities-Etruscan, Antiquities-Greek, Antiquities-Roman, Coins & Medals, Painting-Scandinavian, Pewter, Flasks & Bottles, Scrimshaw, Laces, Painting-Australian, Painting-Canadian, Painting-New Zealander, Display, Architecture
Collections: Bender Library on prints & drawings; Oriental study collection with emphasis on Chinese art

M **Creative Arts Center,** 4525 Oak St, Kansas City, MO 64111-1873. Tel 816-751-1236; Fax 816-561-7154; Internet Home Page Address: www.nelson-atkins.org; *CEO & Dir of Mus* Marc F Wilson
Open Tues - Sat 10 AM - 5 PM; No admis fee
Activities: Art classes for children ages 3-18 & adults; workshops for schools; family workshops & events; tours

M **PRINT CONSORTIUM,** 6121 NW 77th St, Kansas City, MO 64151. Tel 816-587-1986; Elec Mail eickhors@mwsc.edu; Internet Home Page Address: www.printexhibits.com; *Exec Dir* Dr William S Eickhorst
Estab 1983 to promote printmaking as a fine art; Mem: 300; mem open to professional printmaking artists; dues $25
Income: Financed by mem & exhib rental
Collections: Prints by estab professional artists from the US & 9 foreign countries
Publications: Artist's Proof, quarterly newsletter
Activities: Book traveling exhibs 4-6 per yr; originate traveling exhibs to museums, art centers, cols & universities

M **SOCIETY FOR CONTEMPORARY PHOTOGRAPHY,** PO Box 32284, 2012 Baltimore Kansas City, MO 64171. Tel 816-471-2115; Fax 816-471-2462; Elec Mail scp@sky.net; Internet Home Page Address: www.scponline.org; *Exec Dir* Kathy Aron
Open Wed - Sat 11 AM - 5 PM; No admis fee; Estab 1984 to bring fine art photography to Kansas City; Dedicated to teaching & learning about photography from local, national & international photographers. The society is committed to bring gallery shows to the Midwest as well as supporting emerging local artists; Mem: 425; dues $35, students $20; ann meeting in Dec
Income: Financed by mem & grants
Exhibitions: Exhibitions vary; call for details
Publications: Update, bimonthly; exhibit catalogs
Activities: Classes for adults & children; lect open to pub, 8 vis lectr per yr; competition with awards

THE STAINED GLASS ASSOCIATION OF AMERICA
For further information, see National and Regional Organizations

C **UMB FINANCIAL CORPORATION,** PO Box 419226, Kansas City, MO 64141-6226. Tel 816-860-7000; Fax 816-860-7610; Elec Mail carol.sturn@umb.com; Internet Home Page Address: www.umb.com; *Chmn* R Crosby Kemper
Estab 1947 to display classic & contemporary art for viewing by patrons & employees; Collection is displayed in lobbies & customer access areas in various UMB Banks in Oklahoma, Colorado, Kansas, Missouri & Illinois
Collections: Americana Collection, including American portraits (George Caleb Bingham, Benjamin Blythe, Gilbert Stuart, Charles Wilson Peale), regional coll (William Commerford, Peter Hurd, J H Sharp, Gordon Snidow), modern art (Fran Bull, Olive Rush, Wayne Thiebaud, Ellsworth Kelly)
Activities: Objects of art lent to galleries for spec exhibits

M **UNIVERSITY OF MISSOURI-KANSAS CITY,** Gallery of Art, 5100 Rockhill Rd, Kansas City, MO 64110. Tel 816-235-1502; Fax 816-235-6528; Elec Mail csubler@cctr.umkc.edu; Internet Home Page Address: www.umkc.edu/gallery; *Dir* Craig Subler
Open Tues - Fri Noon - 5 PM, Sat & Sun 1 - 5 PM, Summer Tues - Fri Noon - 5

PM; No admis fee; Estab 1977 to bring a broad range of art to both students and the community; 1,725 sq ft; Average Annual Attendance: 5,000; Mem: 100; dues $50
Income: Financed by endowment, city & state appropriation, contribution
Publications: Exhib catalogues
Activities: Adult classes; lect open to pub; book traveling exhibs; originate traveling exhibs that circulate to museums & galleries in US & abroad

MARYVILLE

M **NORTHWEST MISSOURI STATE UNIVERSITY,** DeLuce Art Gallery, Dept of Art, 800 University Dr Maryville, MO 64468. Tel 660-562-1326; Fax 660-562-1900, 562-1346; Elec Mail plaber@mail.nwmissouri.edu; *Chmn Dept Art* Lee Hageman; *Olive DeLuce Art Gallery Coll Cur* Philip Laber
Open Mon - Fri 1 - 4 PM; No admis fee; Estab 1965 to provide exhibitions of contemporary works in all media as part of the learning experiences in the visual arts; Gallery is maintained with 150 running ft exhib space with high security, humidity-controlled air conditioning & flexible lighting; Average Annual Attendance: 6,000
Income: Financed by state appropriation
Collections: Percival DeLuce Memorial Collection consisting of American paintings, drawings, prints and decorative arts; some European furniture and prints
Exhibitions: Rotating exhibits
Activities: Classes for adults; lect open to pub, 6 vis lectr per year; gallery talks; tours; schols offered; individual & original objects of art lent within the institution; lending coll contains original art works, original prints, paintings & drawings; book traveling exhibs 3 per yr

MEXICO

M **AUDRAIN COUNTY HISTORICAL SOCIETY,** Graceland Museum & American Saddlehorse Museum, 501 S Muldrow Ave Mexico, MO 65265; PO Box 398 Mexico, MO 65265. Tel 573-581-3910; Elec Mail achs@swbell.net; *Exec Dir* Kathryn Adams
Open Tues - Sat 10 AM - 4 PM, Sun 2 - 5 PM, cl Mon, Jan & holidays; Admis $3, children 12 & under $1; Estab 1959; Average Annual Attendance: 2,500; Mem: 600; dues $15 & up
Income: $25,000 (financed by endowment & mem)
Collections: Currier & Ives; Photographs; Lusterware; Dolls; Tom Bass Artifacts

L **MEXICO-AUDRAIN COUNTY LIBRARY,** 305 W Jackson, Mexico, MO 65265. Tel 573-581-4939; Fax 573-581-7510; Elec Mail mexicoaudrain@netscape.net; Internet Home Page Address: www.maain.com/library/; *Children's Librn* Aletha Taylor; *Acquisitions Librn* Ruth Taylor; *Dir* Ray Hall; *Head Librn* Christal Brunner
Open winter hours, Mon - Thurs 9 AM - 9 PM, Fri & Sat 9 AM - 5:30 PM; summer hours Mon-Sat 9 AM - 5:30 PM; No admis fee; Estab 1912 to provide library services to the residents of Audrain County, Missouri; Exhibit room with different exhibits each month; childrens dept has a continuously changing exhibit
Income: Financed by donations
Library Holdings: Book Volumes 112,529; Filmstrips; Kodachrome Transparencies; Motion Pictures; Other Holdings Art print reproductions; Newspapers; Periodical Subscriptions 127; Records
Collections: Audrain County history; paintings by Audrain County artists
Exhibitions: Local Federated Womens Club sponsored a different exhibit each month during the fall, winter & spring, these included local artists, both adult & young people, & recognized artists of the area; The Missouri Council of the Arts also provide traveling exhibits that we display
Activities: Classes for children; story hour (one hour, four days a wk); individual paintings & original objects of art lent

OSAGE BEACH

NATIONAL OIL & ACRYLIC PAINTERS SOCIETY
For further information, see National and Regional Organizations

SAINT CHARLES

M **LINDENWOOD UNIVERSITY,** Harry D Hendren Gallery, 209 South Kings Hwy, Department of Art Saint Charles, MO 63301. Tel 636-949-4862; Fax 636-949-4610; Elec Mail etillinger@lindenwood.edu; Internet Home Page Address: www.lindenwood.edu; *Chmn* Dr Elaine Tillinger; *Dean Fine Arts & Performing Arts* Dean Marsha H Parker
Open Mon - Fri 9 AM - 5 PM, Sat & Sun 1 - 4 PM; No admis fee; Estab 1969 as a college exhib gallery; Gallery is approximately 3,600 sq ft with skylight & one wall of side light; 2 additional galleries; Lindenwood Univ Cultural Ctr off campus; Studio East on campus; Average Annual Attendance: 4,000
Income: Financed by endowment
Special Subjects: Prints
Collections: Contemporary American & European prints in various media including Works by Paul Jenkins, William Hayter, Will Barnet, Mauricio Lazansky, Werner Drewes, William Sett
Exhibitions: Rotating Exhibits
Activities: Lect open to pub, 5-6 vis lectr per yr; gallery talks; tours; original objects of art lent; lending coll contains photographs; traveling exhibs organized & circulated through the Missouri State Council on the Arts; artist workshops at Daniel Boone Village (owned by Univ)

SAINT JOSEPH

M **THE ALBRECHT-KEMPER MUSEUM OF ART,** 2818 Frederick Ave, Saint Joseph, MO 64506. Tel 816-233-7003; Fax 816-233-3413; Elec Mail akma@albrecht-kemper.org; Internet Home Page Address: www.albrecht-kemper.org; *Registrar* Ann Tootle; *Dir Pub Events* Robyn Enright; *Dir* Terry Oldham
Open Tues - Fri 10 AM - 4 PM, Sat & Sun 1 - 4 PM, cl Mon; Admis adult $3, seniors $2, students $1, group rates available; Estab 1913 to increase pub

knowledge & appreciation of the arts; Repository of 18th, 19th, 20th Century American art, serving as a cultural arts center for Northwest Missouri; Average Annual Attendance: 17,000; Mem: 550; dues $35 & up, students $15; ann meeting in Apr

Income: Financed by mem & fundraising events

Special Subjects: Drawings, Painting-American, Prints, Watercolors, American Indian Art, American Western Art, Woodcuts, Etchings & Engravings, Landscapes, Marine Painting

Collections: Collections of American Art consisting of paintings by George Bellows, Thomas Hart Benton, Albert Bierstadt, Alfred Bricher, William Merritt Chase, Francis Edmonds, George Hall, Robert Henri, Edward Hopper, George Inness, Eastman Johnson, Fitz Hugh Lane, Ernest Lawson, William Paxton, Rembrandt Peale, John Sloan, Gilbert Stuart, Andrew Wyeth; drawings by Leonard Baskin, Isabel Bishop, Paul Cadmus, Kenneth Callahan, William Gropper, Gabor Peterdi, Robert Vickrey & John Wilde; prints by John Taylor Arms, George Catlin, Thomas Nason; sculpture by Deborah Butterfield, L E Gus Shafer & Ernest Trova

Publications: Annual report including catalog of year's acquisitions, exhibition catalogs & brochures; Art Matters Quarterly

Activities: Classes for adults & children; docent training; lect open to pub; performances & progs in fine arts theater; concerts; gallery talks, tours, competitions; individual paintings & original objects of art lent to other museums; originate traveling exhibs to other museums; mus shop sells books, magazines & misc items

L **Bradley Art Library,** 2818 Frederick Ave, Saint Joseph, MO 64506. Tel 816-233-7003; Fax 816-233-3413; Internet Home Page Address: www.albrecht-kemper.org; *Dir* Terry Oldham
Museum hours; Non-circulating art reference library open to the pub
Library Holdings: Book Volumes 2,500; Periodical Subscriptions

A **ALLIED ARTS COUNCIL OF ST JOSEPH,** 118 S Eighth St, Saint Joseph, MO 64501. Tel 816-233-0231; Fax 816-233-6704; Elec Mail wbloss@stjoearts.org; Internet Home Page Address: www.stjoearts.org; *Exec Dir* Wally Bloss; *Operations Mgr* Cathy Kelly
Open Mon - Fri 8 AM - 5 PM; No admis fee; Estab 1963 to bring the Arts & people together; Remote at Heartland Hospital; Mem: 1800
Income: Financed by state appropriation
Activities: Classes for children; Biennial Artist awards

M **MISSOURI WESTERN STATE COLLEGE,** Gallery 206 Foyer Gallery, 4525 Downs Dr, Thompson E Potter FA Bldg Saint Joseph, MO 64507. Tel 816-271-4282; Fax 816-271-4181; Elec Mail sauls@griffon.mwsc.edu; Internet Home Page Address: www.mwsc.edu; *Pres* Dr James Scanlon; *VPres* Dr James Roever; *Chmn Dept Art* Allison Sauls PhD
Open Mon - Fri 8:30 AM - 4 PM; No admis fee; Estab 1971 to bring an awareness of contemporary directions in art to students & to the community; Foyer gallery is in front of building, next to theater; 120 ft long, 30 ft wide, with 25 ft high ceiling; rug paneling on walls; modern decor, gallery 206 is on second fl; 25 sq ft, 10 ft ceiling; rug paneling on walls, carpeted; Average Annual Attendance: 10,000
Income: Financed by state appropriation
Exhibitions: Invitational of juried art exhibs
Activities: Classes for adults; lect open to pub, 3-4 vis lectr per yr; gallery talks; tours; book traveling exhibs

M **SAINT JOSEPH MUSEUM,** 3406 Frederick Avenue, PO Box 8096 Saint Joseph, MO 64508. Tel 816-232-8471; Fax 816-232-8482; Elec Mail sim@stjosephmuseum.org; *Registrar & Cur Coll* Carol Wills; *Cur Ethnology* Marilyn S Taylor; *Cur Educ & Librn* Sarah M Elder; *Dir* Richard A Nolf; *Cur History* Jackie Lewin
Open Mon - Sat 9 AM - 5 PM, Sun & holidays 1 - 5 PM; Admis adults $2, children between 7 & 15 $1, under 7 free; free on Sun & holidays; Estab 1927 to increase & diffuse knowledge & appreciation of history, art & the sciences & to aid the educational work that is being done by the schools of Saint Joseph & other educ organizations; Mini-gallery, usually for small, low security traveling exhibits; Average Annual Attendance: 30,000; Mem: 400 dues $30 & up; ann meeting in Jan
Income: $550,000 (financed by mem & city appropriation)
Special Subjects: American Indian Art, Anthropology, Archaeology, Ethnology, Costumes, Manuscripts, Eskimo Art, Dolls, Furniture, Glass, Scrimshaw, Dioramas
Collections: Harry L George Collection of Native American Art
Exhibitions: Lewis & Clark; Native American material
Publications: The Happenings (newsletter), bimonthly
Activities: Classes for children; craft prog; lect open to pub; mus shop sells books, reproductions, prints, slides & gift items
L **Library,** 3406 Frederick Avenue, PO Box 8096 Saint Joseph, MO 64508. Tel 816-232-8471; Fax 816-232-8482; Elec Mail sjm@stjosephmuseum.org; *Cur Educ* Sarah Elder; *Dir* Richard A Nolf
Open Mon - Sat 9 AM - 5 PM, Sun 1 - 5 PM, Library open Mon - Fri 9 AM - Noon & 1 - 4 PM by appointment only; No admis fee; Estab 1926 to hold mus colls; Circ For research only; Mini gallery for traveling exhibits. Maintained as a reference library only
Purchases: $1200
Library Holdings: Book Volumes 5000; Clipping Files; Framed Reproductions; Manuscripts; Memorabilia; Original Art Works; Periodical Subscriptions 40; Photographs; Prints; Sculpture
Publications: The Happenings, bimonthly newsletter
Activities: Classes for children; tours; originate traveling exhibs to schools

SAINT LOUIS

M **AMERICAN KENNEL CLUB,** Museum of the Dog, 1721 S Mason Rd, Saint Louis, MO 63131. Tel 314-821-3647; Fax 314-821-7381; Elec Mail dogarts@aol.com; *Cur & Mgr* Barbara Jedda McNab
Open Tues - Sat 9 AM - 5 PM, Sun Noon - 5 PM; Admis adults $3, sr citizens & children $1; Estab 1984; Average Annual Attendance: 12,000; Mem: 650; dues $25 minimum; ann meeting in Oct

Purchases: Kathy Jacobson - Dog Walking in Central Park
Special Subjects: Drawings, Painting-American, Prints, Sculpture, Watercolors, Ceramics, Folk Art, Pottery, Primitive art, Woodcarvings, Woodcuts, Etchings & Engravings, Painting-European, Portraits, Posters, Porcelain, Silver, Painting-British, Historical Material, Period Rooms, Cartoons, Reproductions
Collections: Fine Art: art, artifacts & literature dedicated to the dog
Exhibitions: Artists' Registry Exhibition
Publications: SIRIUS, quarterly newsletter
Activities: Classes for adults; docent progs; lect open to pub; book traveling exhibs 2 per yr; mus shop sells books & prints

L **Reference Library,** 1721 S Mason Rd, Saint Louis, MO 63131. Tel 314-821-3647; Fax 314-821-7381; Elec Mail dogarts@aol.com; Internet Home Page Address: www.akc.org;
Open Tues - Sat 9 AM - 5 PM, Sun Noon - 5 PM; Admis adults $3, sr citizens $1.50, children $1; Estab 1982; For reference only; Average Annual Attendance: 10,000; Mem: 800; dues from patron $1,000 to individual $35
Income: $400,000 (financed by endowment, mem & gift shop sales)
Library Holdings: Book Volumes 2000; Cassettes; Exhibition Catalogs; Framed Reproductions; Memorabilia; Motion Pictures; Original Art Works; Periodical Subscriptions 10; Photographs; Prints; Sculpture; Slides; Video Tapes
Collections: Fine Arts Collection; paintings, drawings & sculptures; decorative arts
Publications: Newsletter, SIRIUS (3 times per yr)
Activities: Fun Day activities for children; Guest Dog of the Week events; gallery talks; tours; sales shop sells books, magazines, jewelry, wearables & luggage

A **ARTS & EDUCATION COUNCIL OF GREATER SAINT LOUIS,** 3526 Washington Ave, Saint Louis, MO 63103. Tel 314-535-3600; Fax 314-535-3606; Internet Home Page Address: www.getart-stlouis.org; *Pres* James F Weidman; *Chmn* Peter F Mackie
Estab 1963 to coordinate, promote & assist in the development of cultural & educ activities in the Greater St. Louis area; to offer planning, coordinating, promotional & fundraising service to eligible organizations & groups, thereby creating a valuable community-wide assoc; Mem: 150
Income: Financed by funds from pvt sector
Exhibitions: Saint Louis Arts Awards
Publications: Ann report; calendar of cultural events, quarterly; quarterly newsletter

M **ATRIUM GALLERY,** Atrium Gallery, 7638 Forsyth Blvd Saint Louis, MO 63105-0000. Tel 314-726-1066; Fax 314-726-5444; Elec Mail atrium@earthlink.net; Internet Home Page Address: www.gallery-guide.com; *Dir* Carolyn Miles
Open Tues - Sat 10 AM - 6 PM; also by appointment; No admis fee; Estab 1986; Commercial gallery featuring contemporary artists who are active regionally & nationally featuring one-person shows
Income: Financed by donations
Activities: Buffet luncheon/lect art series; 8 vis lectr per yr; salon progs featuring talks by exhibiting artists, 6 programs per yr

C **THE BOATMEN'S NATIONAL BANK OF ST LOUIS,** Art Collection, One Boatmen's Plaza, 800 Market St Saint Louis, MO 63101. Tel 888-279-3121; *Pres & Chmn* Andrew B Craig; *Sr VPres Advertising & Public Relations* Alfred S Dominick Jr
Open Mon - Fri 8 AM - 4 PM; No admis fee; Bank estab 1938; corporate art collection estab for purposes of investment & the pleasure of art; Art emphasizes Western theme & bank's affiliation with opening of the West
Collections: The Political Series by George Caleb Bingham; Transportation Series by Oscar E Berninghause; Exhibition into the Rockies Mountains - watercolors by Alfred Jacob Miller; Tarahumara Series by George Carlson

M **CHATILLON-DEMENIL HOUSE FOUNDATION,** DeMenil Mansion, 3352 DeMenil Pl, Saint Louis, MO 63118. Tel 314-771-5828; Fax 314-771-3475; Elec Mail demenil@sbcglobal.net; *Dir* Kevin O'Neill; *Communications* Victoria Questell
Open Tues - Sat 10 AM - 3 PM; Admis $5; Estab 1965 to educate & inform the community on 19th century life & culture; Average Annual Attendance: 8,000; Mem: 500; dues $35 - $1,000; ann meeting in May
Income: Financed by mem, grants & donations
Special Subjects: Architecture, Painting-American, Decorative Arts, Portraits, Furniture, Porcelain, Silver, Historical Material, Period Rooms
Collections: Decorative art from c1770 through 19th century; period rooms with furnishings; paintings; 1904 St. Louis World's Fair
Exhibitions: Historic Photos-French & Indian Families in American West
Publications: Newsletter, quarterly
Activities: Educ programs; docent training; retail store sells books, reproductions, eclectic merchandise

M **CONCORDIA HISTORICAL INSTITUTE,** 801 DeMun Ave, Saint Louis, MO 63105. Tel 314-505-7900; Fax 314-505-7901; Elec Mail chi@chi.lcms.org; Internet Home Page Address: www.chi.lcms.org; *Assoc Dir Archives* Marvin A Huggins; *VPres* Lawrence Rast; *Dir* Martin R Noland; *Asst Dir Reference* Mark A Loest
Open Mon-Fri 8:30 PM - 4:30 PM, cl international holidays; No admis fee; Estab 1847, to collect & preserve resources on the history of Lutheranism in America. Affiliated with The Lutheran Church, Missouri Synod; Average Annual Attendance: 13,000; Mem: 1800; dues life $500, over 65 $300, organization $75, patron $50, sustaining $30, active & subscription $35
Special Subjects: Hispanic Art, Painting-American, African Art, Costumes, Crafts, Etchings & Engravings, Manuscripts, Furniture, Asian Art, Coins & Medals
Collections: Church archives & vast historical materials; crafts; handcrafts; Reformation & Lutheran coins & medals; Works by Lutheran artists & paintings & artifacts for Lutheran worship; Native artwork from Foreign Mission Fields, especially China, India, Africa & New Guinea
Exhibitions: Temporary exhibitions
Publications: Concordia Historical Institute Quarterly; Historical Footnotes; Regional Archivist, a newsletter and 'how to' serial for archives; bulletins

Activities: Lect open to pub; competitions with awards; Distinguished Service Award & awards of commendation for contributions to Lutheran History & archives; sales shop sells books, slides & craft items

A **CONTEMPORARY ART MUSEUM ST LOUIS,** 3750 Washington Ave, Saint Louis, MO 63108. Tel 314-535-4660; Fax 314-535-1226; Elec Mail paul.ha@contemporarystl.org; Internet Home Page Address: www.contemporarystl.org; *Cur* Sharon Fitzgerald; *Exec Dir* Paul Ha; *Asst Cur* Andrea Green; *Exhib Mgr* Brandon Anschultz
Open Tues, Wed, Fri, Sat 10 AM - 5 PM; Thurs 10 AM - 7 PM, Sun 11 AM - 4 PM; No admis fee, donations accepted; Estab 1980 to promote & advocate contemporary arts; Multi-disciplinary visual arts center; Average Annual Attendance: 16,000; Mem: 500; dues $35 & up, artist & student $25
Income: $500,000 (financed by mem, corporation & foundation funds)
Exhibitions: Architectural photographer Robert Tettus; Jeanetta Eyre Canadian artist; Zwelethu Mthethwa South African artist; Julie Moos
Publications: Exhibit catalog; quarterly newsletter
Activities: Educational outreach; workshops; lect open to public; 12 - 15 vis lectr per year; concerts; gallery talks; tours; book traveling exhibitions

M **CRAFT ALLIANCE,** 6640 Delmar Blvd, Saint Louis, MO 63130. Tel 314-725-1177; Fax 314-725-2068; Internet Home Page Address: www.craftalliance.org; *Pres* Schuyler Gott Andrews; *Educ Dir* Luanne Rimel; *Gallery Dir* Greg Wilkerson; *Communications Mgr* Rachel Gagnon; *Develop Dir* Jessica Arnold
Open Mon - Wed 10 AM - 6 PM, Thurs & Fri 10 AM - 8 PM, Sat 10 AM - 6 PM, Sun Noon - 6 PM; No admis fee; Estab 1964 for exhib & sales of craft objects; 1500 sq ft; Average Annual Attendance: 20,000; Mem: 750; $45 minimum dues per yr; Scholarships
Income: Financed by mem, Missouri Arts Council, St Louis Arts & Educ Council, Regional Arts Commission
Exhibitions: Monthly exhibits by nat & international artists
Publications: Mem newsletter; Winter-Spring, Summer & Fall catalogs
Activities: Classes for adults & children; vis artists prog; outreach; sales shop sells books, magazines & original art

M **LAUMEIER SCULPTURE PARK,** 12580 Rott Rd, Saint Louis, MO 63127. Tel 314-821-1209 ext 10; Fax 314-821-1248; Elec Mail info@laumeier.org; Internet Home Page Address: www.laumeier.org; *Exec Dir* Glen P Gentele; *Cur Interpretation* Clara Collins Coleman; *Cur Educ* Karen Mullen; *Dir Installation & Coll Mgmt* Kim Humphries; *Deputy Dir* Jennifer Duncan; *Librn* Joy Wright
Park open daily 8 AM - half hour past sunset; Museum open Tues - Sat 10 AM - 5 PM, Sun Noon - 5 PM; No admis fee except special events; Estab 1976 to exhibit contemporary sculpture by internationally acclaimed artists; 5 indoor galleries feature changing exhib 3 per yr; Average Annual Attendance: 350,000; Mem: 1,400; dues Laumeier Society $2,500 & up, Collector's Circle $1,000 - $2,499, Director's Circle $500, Sculptor's Forum $250, Casting Circle $100, Household $50, Student, Senior & Out of Town $35
Income: Financed by mem, corporate gifts & grants
Library Holdings: Auction Catalogs; Audio Tapes; Book Volumes; Clipping Files; Compact Disks; DVDs; Exhibition Catalogs
Special Subjects: Sculpture
Collections: Outdoor contemporary sculpture collection by Vito Acconci, Terry Allen, Jackie Ferrara, Ian Hamilton Finlay, Richard Fleischner, Charles Ginnever, Dan Graham, Hera, Jene Highstein, Richard Hunt,; Donald Judd, William King, Alexander Liberman, Robert Lobe, Mary Miss, Robert Morris, David Nash, Manuel Neri, Dennis Oppenheim, Beverly Pepper, George Rickey, Tony Rosenthal; Alison Saar, Richard Serra, Judith Shea, Niki de Saint Phalie, Michael Steiner, Mark Di Suvero, Ernest Trova, Ursula von Rydingsvard, David Von Schlegell, Meg Webster
Exhibitions: (05/2003) John Heny, New Monuments; (2003) Franco Mondini - Ruiz; Mark diSuvero
Publications: Objectivity, quarterly newsletter
Activities: Classes for adults & children; docent training; lect open to pub, 4 vis lectr per yr; concerts; gallery talks; tours; schols offered; original objects of art lent to estab institutions; lending collection contains 40 sculptures, slides & videotapes; originate traveling exhibs; mus shop sells books, original art, reproductions & slides

M **MARYVILLE UNIVERSITY SAINT LOUIS,** Morton J May Foundation Gallery, 650 Maryville University Dr, Saint Louis, MO 63141. Tel 314-529-9415; Fax 314-529-9940; Elec Mail nrice@maryville.edu; *Gallery Dir* Nancy N Rice; *Dir Art & Design Prog* Eleanor Lawler; *Dir* Roxanne Philipps
Open Mon - Thurs 9 AM - 10 PM, Fri & Sat 8 AM - 5 PM, Sun 2 - 10 PM; No admis fee; Estab to show work of artists, many of whom have no gallery affiliation; Average Annual Attendance: 3,000
Income: $3,300 (university)
Library Holdings: Book Volumes; Exhibition Catalogs; Kodachrome Transparencies; Periodical Subscriptions; Records; Slides; Video Tapes
Special Subjects: Painting-American
Activities: Curating experience for advanced students; lect open to pub, 3-4 vis lectr per yr; gallery talks; sponsoring of competitions; individual paintings & original objects of art lent to organizations, art guilds & schools

A **MISSOURI ARTS COUNCIL,** 111 N Seventh St, Ste 105, Saint Louis, MO 63101. Tel 314-340-6845; Internet Home Page Address: www.missouriartscouncil.org; *Exec Dir* Mary McElwain; *Pub Info* Deborah Edelman; *Asst Dir Progs* Beverly Strohmeyer
Estab 1965 to promote & develop cultural resources on the arts & as sets in Missouri
Income: Financed by state appropriation
Activities: Some internships offered

M **MISSOURI HISTORICAL SOCIETY,** Jefferson Memorial Bldg, Lindel & De Baliviere Saint Louis, MO 63112-0040; PO Box 11940, Saint Louis, MO 63112-0040. Tel 314-746-4599; Fax 314-746-4548; Elec Mail info@mohistory.org; Internet Home Page Address: www.mohistory.org; *CEO* Robert Archibald; *Exec VPres* Karen M Goering; *VPres Communications* Nicola Longford; *Cur Photographs* Duane Sneddeker; *Dir Educ* Kathleen Cuba; *VPres Institution* Diane Ryberg; *Head Colls* Linda Landry; *Mus Shop Mgr* Kimberly Weaver; *Dir Exhib* Becki Hartke; *CFO* Carolyn Schmidt
Open Tues - Sun 10 AM - 6 PM, Tues 10 - 8 PM; No admis fee; Estab 1866 to col & preserve objects & information relating to the history of St Louis, Missouri & the Louisiana Purchase Territory; Circ 6000; dues from $45 & up; Estab 1866 to preserve the history of St Louis & the American West; Average Annual Attendance: 200,000; Mem: 5500; dues from $35; ann meeting Sept; Scholarships, Fellowships
Income: Financed by pvt endowment, mem, special events, city & county taxes
Special Subjects: Historical Material
Collections: 19th & 20th century art of St Louis and the American West; paintings; photographs; prints
Exhibitions: Lindbergh Memorabilia; St Louis Memory & History: 1904 Worlds Fair; St. Louis Gilded Age; 5 rotating exhibs per yr
Publications: Gateway Heritage, quarterly journal; MHS magazine, bimonthly, mems only pub
Activities: Classes for adults & children; dramatic progs; docent training; outreach program festivals; lect open to pub, 30 vis lectr per yr; concerts; gallery talks; tours; individual paintings & original objects of art lent to qualified museums & galleries that meet AAM standards; book traveling exhibs; originate traveling exhibs; Sales shop sells books, prints, slides, souvenirs, china

M **Missouri History Museum,** Lindell & DeBaliviere, Saint Louis, MO 63112-0040; PO Box 11940, Saint Louis, MO 63112-0040. Tel 314-746-4599; Fax 314-746-4548; Internet Home Page Address: www.mohistory.org/lrc.html; *Pres* Robert R Archibald
Open Mon 10 AM - 6 PM, Tues 10 AM - 8 PM, Wed - Sat 10 AM - 6 PM; No admis fee; Estab 1866 to provide history of St. Louis, Missouri & Westward expansion; Average Annual Attendance: 320,000; Mem: 14,042
Income: Financed by pvt endowment, special events, city & county taxes
Library Holdings: Book Volumes 75,000; Cassettes; Clipping Files; Manuscripts; Pamphlets; Periodical Subscriptions 503; Photographs 500,00; Prints 2000; Reels; Sculpture 150
Special Subjects: American Indian Art, Anthropology, Decorative Arts, Historical Material, Architecture, American Western Art, Furniture, Manuscripts, Maps, Archaeology
Publications: Gateway
Activities: Educ prog; dramatic prog; docent training; lect; concerts; gallery talks; tours; 2-3 book traveling exhib per year; Mus shop sells books, magazines, original art, reproductions & prints

M **THE SAINT LOUIS ART MUSEUM,** One Fine Arts Dr, Saint Louis, MO 63110-1380. Tel 314-721-0072; Fax 314-721-6172; Elec Mail pubrelations@slam.org; Internet Home Page Address: www.slam.org; *Dir* Brent Benjamin; *Community Relations Asst* Brian Adkisson
Open Tues - Sun 10 AM - 5 PM, Fri Open till 9 PM, cl Mon; No admis fee except for featured exhibitions; Estab 1879, originally called St Louis School & Mus of Fine Arts, an independent entity within Washington Univ; Average Annual Attendance: 500,000; Mem: 16,000; dues $25,000, $10,000, $5,000, $1,500, $1,000, $500, $250, $150, $100, $75, $55
Income: Property tax provides 60% of operating income & balance from grants & pvt donations
Library Holdings: Auction Catalogs; Audio Tapes; Book Volumes; CD-ROMs; Clipping Files; Compact Disks; DVDs; Exhibition Catalogs; Original Documents; Periodical Subscriptions; Photographs; Slides; Video Tapes
Collections: African; American; Ancient & Islamic; Asian; Contemporary; Decorative Arts & Design; Early European; Modern; Oceanic; Pre-Columbian & American Indian; Prints, Drawings & Photographs
Exhibitions: 10-12 rotating exhibs per yr; (10/15/2006-1/7/2007) New Ireland: Art of the South Pacific; (2/18/2007-4/29/2007) Walking Dreams: The Art of the Pre-Raphaelites from the Delaware Art Mus; (6/17/2007-9/16/2007) Symbols of Power: Napoleon & the Art of the Empire Style, 1800-1815
Publications: The St Louis Art Museum Bulletin, semi-annual; annual report; bimonthly magazine/calendar
Activities: Classes for adults & children; docent training; lect open to pub, 26 vis lectr per yr; concerts; gallery talks; tours; competitions with prizes; exten dept serves state of Missouri; individual paintings & original objects of art lent to other museums; book traveling exhibs; traveling exhibs organized & circulated; mus shop sells books, magazines, prints & reproductions

L **Richardson Memorial Library,** One Fine Arts Dr Forest Park, Saint Louis, MO 63110-1380. Tel 314-655-5252; Fax 314-721-4911; Elec Mail library@slam.org; Internet Home Page Address: www.slam.org; *Head Librn* Marianne L Cavanaugh; *Archivist* Norma Sindelar; *Archives Asst* Ann Shuck; *Pub Serv Librn* Clare Vasquez; *Slide Cur* Cheryl Vogler; *Technical Servs Librn* Christopher Handy
Open Tues - Fri 10 AM - 5 PM, Sat 11AM-3PM (Sept-May); No admis fee; Estab 1915 to provide reference & bibliographical service to the mus staff & the adult pub; to bibliographically support the colls owned by the mus; For research only
Income: Financed by endowment & city appropriation
Library Holdings: Auction Catalogs; Book Volumes 85,000; CD-ROMs; Clipping Files; Exhibition Catalogs; Fiche; Lantern Slides; Other Holdings Art auction catalogs since 1824; Pamphlets; Periodical Subscriptions 200; Reels; Slides 75,000
Special Subjects: Art History, Decorative Arts, Photography, Etchings & Engravings, Painting-American, Ethnology, Asian Art, American Indian Art, Furniture, Glass, Afro-American Art, Antiquities-Oriental, Carpets & Rugs, Antiquities-Greek, Antiquities-Roman
Collections: Museum Archives, includes records of Louisiana Purchase Expo (1904) & papers of Morton D May

L **SAINT LOUIS PUBLIC LIBRARY,** Fine Arts Dept, 1301 Olive St Saint Louis, MO 63103. Tel 314-241-2288; Fax 314-241-3840; Internet Home Page Address: www.slpl.org; *Mgr Fine Arts Dept* Suzy Enns Frechette
Open Mon 10 AM - 9 PM, Tues - Fri 10 AM - 6 PM, Sat 9 AM - 5 PM; Estab Art Dept in 1912

Library Holdings: Book Volumes 115,000; CD-ROMs; Cassettes; Clipping Files 500; Compact Disks 12,000; Exhibition Catalogs; Motion Pictures; Original Art Works 4; Pamphlets; Periodical Subscriptions 45; Reproductions 300; Sculpture 5; Slides 17,500
Special Subjects: Art History, Decorative Arts, Illustration, Photography, Graphic Arts, Interior Design, Afro-American Art, Architecture
Collections: Steedman Architectural Library; Local Architects & Buildings Files; Local Artists Files

A **ST. LOUIS ARTISTS' GUILD,** Two Oak Knoll, Saint Louis, MO 63105. Tel 314-727-6266; Fax 314-727-9190; Elec Mail vwoods@stlouisartistsguild.org; Internet Home Page Address: www.stlouisartistsguild.org; *Pres* Joanne Stremsterfer; *Dir* Vicki Woods; *Educ Coordr* Sue Berg; *First VPres* Irv Davis; *Second VPres* Brad Wastler; *Ofc Mgr* Robyn Conroy; *Mus Shop Mgr* Karen Roodman
Open Tues - Sun Noon - 4 PM, cl Mon; No admis fee; Estab 1886 for the purpose of promoting excellence in the arts; Maintains reference library; Average Annual Attendance: 30,000; Mem: 900+, dues $55
Income: Financed by mem
Special Subjects: Cartoons, Drawings, Photography, Prints, Sculpture, Silver, Watercolors, Painting-American, Pottery, Bronzes, Woodcuts, Afro-American Art, Ceramics, Crafts, Portraits, Furniture, Glass, Woodcarvings
Exhibitions: 15-20 exhibits per yr
Publications: Quarterly newsletter
Activities: Classes for adults & children; lect open to pub, 5 vis lectr per yr; gallery talks; tours; competitions with awards; workshops; sales shop sells original art

M **TROVA FOUNDATION,** Philip Samuels Fine Art, 1011 E Park Industrial, Saint Louis, MO 63130. Tel 314-727-2444; Fax 314-727-6084; Elec Mail rgiancola@universalsewing.com; *Dir* Clifford Samuels; *Pres* Philip Samuels
Open Mon - Fri by appointment only; Estab 1988; Contemporary painting, collage, drawing & sculpture

M **UNIVERSITY OF MISSOURI, SAINT LOUIS,** Gallery 210, Art Dept, 210 Lucas Hall Saint Louis, MO 63121. Tel 314-516-5000; Fax 314-516-5816; *Dir* Terry Suhre; *Chmn* Jack Rushing
Open Tues Noon - 8 PM, Wed - Fri 10 AM - 5 PM, Sat 10 AM - 2 PM, cl Sun & Mon; Estab 1972 to exhibit contemporary art of national importance & to provide visual enrichment to campus & community; Average Annual Attendance: 5,000
Income: Financed by state appropriation & grants
Publications: Exhibition catalogs: Color Photography; Light Abstractions
Activities: Educ dept on art history; lect open to pub; originate traveling exhibs

WASHINGTON UNIVERSITY
M **Mildred Lane Kemper Art Museum,** Tel 314-935-4523; Fax 314-935-7282; Elec Mail kemperartmuseum@wush.edu; Internet Home Page Address: www.kemperartmuseum.wush.edu; *Cur* Sabine Eckmann; *Registrar* Sara Hignite; *Facilities Mgr & Art Preparator* Jan Hessel; *Admin* Jane Neidhardt; *Security Supv* Peter Kline; *Exec Dir* Mark S Weil; *Educ Events Coordr* Stephanie Parrish; *Prof & Cur of Numismatics* Sarantis Symeonoglou; *Dir Develop* Lynn Giardina; *Asst Registrar* Rachel Keith; *Admin Secy* Lisa Wilson
Open Tues - Thurs 10 AM - 4:30 PM, Fri 10 AM - 8 PM, Sat & Sun 12 - 4:30 PM, cl mid-May - Labor Day; No admis fee; Estab 1881, present building opened 1960, for the students of Washington University & the community at large to share resources, enrich exhibits, preserve exhibits, acquire & research art; A modern building containing two fls of gallery space for exhibit of the permanent coll & special exhibs. Also houses a library of art, archaeology, architecture & design; Average Annual Attendance: 40,215
Income: Financed by univ & pvt support
Special Subjects: Photography, Portraits, Prints, Woodcuts, Painting-Japanese, Sculpture, Drawings, Painting-American, Watercolors, American Indian Art, American Western Art, Religious Art, Ceramics, Woodcarvings, Etchings & Engravings, Landscapes, Collages, Painting-European, Posters, Asian Art, Painting-British, Painting-Dutch, Painting-French, Coins & Medals, Baroque Art, Renaissance Art, Painting-Spanish, Painting-Italian, Antiquities-Egyptian, Antiquities-Greek, Painting-German
Collections: Emphasis on modern artists, including Miro, Ernst, Picasso, Leger, Beckman; many Old Masters, 19th & 20th, 21st century European & American paintings, sculpture, drawings & prints
Exhibitions: Exhibit works from the Washington University Art Collection, Special Loan Exhibits, Student & Faculty Shows
Publications: Exhibition catalogs
Activities: Educ prog; docent training; lect open to pub, 15-20 vis lectr per yr by artists, art historians & architects; symposia; music concerts; gallery talks; tours; films; 2004 Emily Hall Tremaine Exhibition Award --$125,000; individual paintings & original objects of art lent to other museums; book traveling exhibs 1 per yr; originate traveling exhibs to other museums; primarily American & European venues (i.e. McNay Museum/San Antonio, TX & Opelvilleu, Russelsheim, Germany; sales shop sells books, exhib catalogs & postcards
L **Art & Architecture Library,** Tel 314-935-5268; Fax 314-935-4362; Elec Mail art-and-architecture@library.wustl.edu; Internet Home Page Address: library.wustl.edu/units/artarch/; *Art & Architecture Librn* Ellen Petraits; *Reference Librn* Carmen Doering
Open Mon - Thurs 8:30 AM - 11 PM, Fri 8:30 AM - 5 PM, Sat 11 AM - 5 PM, Sun 1 PM - 9 PM, cl nights & weekends during vacations & intersessions; Supports the academic programs of the School of Art, the School of Architecture & the Department of Art History & Archaeology
Income: Financed through the university
Library Holdings: Book Volumes 101,000; DVDs 50; Exhibition Catalogs; Periodical Subscriptions 310; Reproductions; Video Tapes 550

M **WEBSTER UNIVERSITY,** Cecille R Hunt Gallery, 8342 Big Bend Blvd, Saint Louis, MO 63119. Tel 314-968-7171; Elec Mail langtk@websteruniv.edu; Internet Home Page Address: www.webster.edu/depts/finearts/art/; *Dept Chair* Tom Lang
Open Mon - Fri 10 AM - 4 PM, Sat 10 AM - 2 PM, cl Christmas; No admis fee; Estab 1950; Average Annual Attendance: 4,000

Income: Financed by col funds, donations & contributions
Exhibitions: Exhibs of local, national & international artists in all media; rotating exhibits
Publications: Monthly news releases; exhibition catalogs; books
Activities: Lect open to pub, 6 vis lectr per yr; competitions with awards; Hunt Awards for student shows; individual paintings & original objects of art lent

L **Eden-Webster Library,** 475 E Lockwood Ave, Saint Louis, MO 63119. Tel 314-961-2600 exten 7812; Fax 314-968-7113; Elec Mail sgold@library2.webster.edu; Internet Home Page Address: www.library.webster.edu; *Reference Librn* Sue Gold
Open Mon - Thurs 8 AM - Midnight, Fri 8 AM - 6 PM, Sat 10 AM - 6 PM, Sun Noon - Midnight; For reference & lending
Income: Financed by col funds
Library Holdings: Audio Tapes; Book Volumes 244,774; Cards; Cassettes; Exhibition Catalogs; Fiche; Filmstrips; Manuscripts; Micro Print; Motion Pictures; Pamphlets; Periodical Subscriptions 1300; Photographs; Prints; Records; Reels; Reproductions; Slides; Video Tapes

SAINTE GENEVIEVE

M **ST GENEVIEVE MUSEUM,** Merchant & DuBourgh St, Sainte Genevieve, MO 63670. Tel 573-883-3461; *Treas* Delores Koetting; *Pres* Jim Baker
Open Mon - Sat 10 AM - 4 PM, Sun 11 AM - 4 PM, Nov - Mar 12 PM - 4 PM; Admis adults $2, students $.50; Estab 1935; Average Annual Attendance: 8,000; Mem: Dues business $50, family $25, individual $10
Income: Financed by mem, admis, sales
Special Subjects: American Indian Art, Archaeology, Historical Material, Maps, Dolls, Jewelry, Coins & Medals, Embroidery, Laces
Collections: Indian artifacts; salt spring kettles, hair jewelry, guns, quilts
Activities: Mus shop sells books

SPRINGFIELD

A **SOUTHWEST MISSOURI MUSEUM ASSOCIATES INC,** Springfield Art Museum, 1111 E Brookside Dr, Springfield, MO 65807. Tel 417-837-5700; Fax 417-837-5704; Elec Mail watercolorusa@ci.springfield.mous; printsusa@ci.springfield.mous; Internet Home Page Address: www.ci.springfield.mo.us/egov/art/index.html; *Dir* Jerry Berger
Open Tues, Wed, Fri, Sat 9 AM - 5 PM, Thurs 9 AM - 8 PM, cl Mon; Admis donation; Estab 1928 to inform & interest citizens in appreciation of art & to maintain an art mus as an essential pub institution; Mem: 1300; dues sustaining life $1000, life $500, supporting $50, family $40, at large $30, art group: resident $20, exten groups $10
Income: $14,000 (financed by mem)
Publications: Bimonthly newsletter, in cooperation with the Museum
Activities: Gift shop sells books, original art, prints, reproductions, stationery & gift items; maintain a sales gallery

M **SPRINGFIELD ART MUSEUM,** 1111 E Brookside Dr, Springfield, MO 65807. Tel 417-837-5700; Fax 417-837-5704; Elec Mail jberger@ci.springfield.mo.us; *Cur Coll* James M Beasley; *Dir* Jerry A Berger; *Mus Educ* Dan Carver; *Librn* Susan Potter; *Exec Secy* Tyra Knox
Open Tues, Wed, Fri & Sat 9 AM - 5 PM, Thurs 9 - 8 PM, Sun 1 - 5 PM, cl Mon; No admis fee; Estab 1928 to encourage appreciation & foster educ of the visual arts; Mus has four temporary exhib galleries for traveling & spec exhibs totaling approx 7500 sq ft; new wing opened in 1994 with 13,400 sq ft including four galleries for the permanent coll; 400-seat auditorium & sales gallery; Average Annual Attendance: 50,000; Mem: 1,300; dues $15-$1000; ann meeting second Wed in May
Income: $500,000 (financed by mem, city & state appropriations)
Purchases: $40,000
Library Holdings: Auction Catalogs; Book Volumes; Exhibition Catalogs; Periodical Subscriptions; Video Tapes
Special Subjects: Afro-American Art, American Indian Art, Art History, Mixed Media, American Western Art, Prints, Bronzes, Silversmithing, Painting-Japanese, Drawings, Painting-American, Photography, Sculpture, Watercolors, Southwestern Art, Ceramics, Folk Art, Pottery, Woodcarvings, Woodcuts, Etchings & Engravings, Landscapes, Decorative Arts, Collages, Portraits, Furniture, Glass, Asian Art, Painting-British, Painting-Dutch, Painting-Spanish
Collections: American & European decorative arts; American drawing & photography; American painting & sculpture of all periods; American prints of all periods with emphasis on the 20th Century; European prints, drawings & paintings from the 17th-20th Centuries
Exhibitions: (4/7/2007-6/3/2007) John Grabach: Century Man; (6/9/2007-8/5/2007) Watercolor USA; (11/17/2007-1/6/2008) Prints USA
Activities: Classes for adults & children; lect open to pub; concerts; gallery talks; tours; competitions with awards; originate traveling exhib; mus shop sells books, original art, reproductions, pottery, jewelry, cards, stationery & t-shirts
L **Library,** 1111 E Brookside Dr, Springfield, MO 65807-1899. Tel 417-837-5700; Fax 417-837-5704; Elec Mail gloria_short@ci.springfield.mo.us; Internet Home Page Address: www.springfieldmogov/egov/art; *Librn* Gloria A Short
Open Tues - Sat 9 AM - Noon & 1 - 5 PM; none; Estab 1928 to assist those persons interested in securing information regarding art & artists, craftsmen from ancient times to the present; Circ 971; Lending & reference library; Average Annual Attendance: 2,060
Income: Financed by city
Purchases: $6,000 (library acquisitions), $60,000 (artwork acquisitions)
Library Holdings: Auction Catalogs; Audio Tapes; Book Volumes 5615; Cassettes; Clipping Files; Exhibition Catalogs; Filmstrips; Manuscripts; Other Holdings Art access kits; Exhibition cards; slide kits; Pamphlets; Periodical Subscriptions 53; Slides; Video Tapes
Special Subjects: Art History, Folk Art, Decorative Arts, Watercolors, Ceramics, Archaeology, American Western Art, Bronzes, Art Education, American Indian Art, Afro-American Art, Architecture

Collections: American & European paintings, prints & sculpture-primarily 19th & 20th century

Exhibitions: WUSA - Watercolor USA, open to US residents MOAK (Missouri, Oklahoma, Arkansas, Kansas), a biennial multi-media juried exhib; Prints USA - a biennial print juried exhib

Publications: Exhib catalogs; bimonthly newsletter; watercolor USA Catalog, annually

Activities: Classes for adults & children; docent training; lect open to pub, 2 vis lectr per yr; gallery talks; tours; competitions with prizes; lending coll contains 6000 books, 446 slide sets; sales of books, original art

WARRENSBURG

M **CENTRAL MISSOURI STATE UNIVERSITY,** Art Center Gallery, 217 Clark St, Warrensburg, MO 64093-5246. Tel 660-543-4498; Fax 660-543-8006; Elec Mail gallatin@cmsu1.cmsu.edu; Internet Home Page Address: www.cmsu.edu; *Gallery Dir* Morgan Dean Gallatin

Mon - Fri 8 AM - 5 PM, Sat 10 AM - 2 PM, cl Sun; No admis fee; Estab 1984 for the purpose of educ through exhib; Small outer gallery & large main gallery located in the University Art Center; Average Annual Attendance: 3,500

Income: Financed by state appropriation & univ funding

Collections: University permanent coll Buffalo Soldiers

Activities: Classes for adults; 4 vis lectr per yr; gallery talks; competitions with awards

MONTANA

ANACONDA

A **COPPER VILLAGE MUSEUM & ARTS CENTER,** 401 E Commercial, Anaconda, MT 59711. Tel 406-563-2422; *Pres* Mary Lynn McKenna; *Dir* Carol Jette; *Dir* Jim Johnston

Open Tues - Sat 10 AM - 4 PM, cl Mon & holidays; No admis fee; Estab 1971 as Community Arts Center, gallery & regional historical mus; Average Annual Attendance: 15,000; Mem: 150; dues $5 - $100

Income: Financed by endowment, mem, fundraising events & individual donations

Collections: Permanent coll holds paintings & prints

Exhibitions: Monthly exhibits of local, national & international art work

Publications: Quarterly newsletters, brochures

Activities: Classes for adults & children; dramatic progs; docent training; lect open to pub, 4 vis lectr per yr; concerts; gallery talks; tours; awards; book traveling exhibs 4-8 per yr; originate traveling exhibs which circulate to Montana Galleries; sales shop sells books, original art, prints, pottery, glass & jewelry

L **Library,** 401 E Commercial, Anaconda, MT 59711. Tel 406-563-2422; *Dir* Carol Jette

Open Tues - Sat 10 AM - 4 PM, clo Mon & holidays; Library open to the pub for reference

Library Holdings: Book Volumes 45; Clipping Files; Memorabilia; Motion Pictures; Pamphlets; Periodical Subscriptions 11; Reproductions; Sculpture; Slides

Publications: Newsletters, quarterly; brochures

Activities: Book traveling exhibitions

BILLINGS

M **MONTANA STATE UNIVERSITY AT BILLINGS,** Northcutt Steele Gallery, 1500 N 30th Street, Billings, MT 59101-0298. Tel 406-657-2324; Fax 406-657-2187; Elec Mail njussila@msu-b.edu; *Pub Relations* Patricia Tom; *Dir* Neil Jussila

Open Mon - Fri 8 AM - 4:30 PM; No admis fee

Income: Financed by univ

Exhibitions: Ann faculty & student exhib

Activities: Vis artist program

M **PETER YEGEN JR YELLOWSTONE COUNTY MUSEUM,** Logan Field, PO Box 959 Billings, MT 59103; 1950 Terminal Cir, Billings, MT 59105. Tel 406-256-6811; Internet Home Page Address: www.pyjrycm.org; *Dir* Suzanne Warner

Open Mon - Fri 10:30 AM - 5 PM, Sat 10:30 AM - 3 PM, cl Sun; No admis fee; Estab 1953; 5,000 sq ft, 2 fls, 25,000 artifacts; Average Annual Attendance: 15,000; Mem: dues lifetime $1000, corporate $100, family $25, individual $20, senior $15; ann Open House in Sept/Oct

Income: $32,000 (financed by county, mem, memorials, donations & grants)

Special Subjects: Photography

Collections: Dinosaur bones; Montana Pioneers; Native American; Northern Pacific Steam Switch Engine; Yellowstone Valley; Photographs; Ranching Artifacts; Roundup Wagon; Sheep Wagon

Exhibitions: Dinosaur bones; Leory Greene (local artist) paintings of Crow Indians, 1930-1968; Indian artifacts; military items; Western memorabilia; Lewis & Clark fur trading post exhibit

Publications: Cabin Chat, quarterly newsletter

Activities: Lect for mems only; tours; originate traveling exhibs; mus shop sells books, original art (beadwork)

A **YELLOWSTONE ART MUSEUM,** 401 N 27th St, Billings, MT 59101. Tel 406-256-6804; Fax 406-256-6817; Elec Mail artinfo@artmuseum.org; Internet Home Page Address: www.yellowstone.artmuseum.org; *Dir* Robyn G Peterson; *Sr Cur* Robert C Manchester; *Pres Bd* Carol L H Green; *Dir Develop* Julie Murphy; *Cur Educ* Linda Ewert; *Mktg Mgr* Renee Giovando; *Dir Finance* Diane Cameron; *Registrar* Nancy Wheeler; *Membership Mgr* Kristi Niles

Open Tues - Sat 10 AM - 5 PM, Sun Noon - 5 PM, Thurs 10 AM - 8 PM, open Mondays Memorial Day - Labor Day; Admis adults $7, seniors & students $5,

children $3, mems free; Estab 1964 to offer a broad prog of art exhibs, both historical & contemporary, of the highest quality, to provide related educ progs; two large galleries & five smaller ones in a large brick structure; Average Annual Attendance: 40,000; Mem: 2,000; dues $40 & up; ann meeting in June

Income: $1,157,000 (financed by mem, contributions, county appropriations, grants, mus shop & fundraising events)

Purchases: Current work by regional artists

Library Holdings: Auction Catalogs; Book Volumes; CD-ROMs; Cards; Cassettes; Memorabilia; Original Art Works; Original Documents; Periodical Subscriptions; Photographs; Prints; Slides

Special Subjects: Drawings, Landscapes, Manuscripts, Metalwork, Photography, Sculpture, Watercolors, Painting-American, American Western Art, Bronzes, American Indian Art, Ceramics, Archaeology, Furniture, Glass, Painting-European, Southwestern Art

Collections: Contemporary Print Collection; Poindexter Collection of Abstract Expressionists; Contemporary Regional Artists; Will James; Montana Modernism

Exhibitions: 10 - 12 changing exhibitions per yr

Publications: Newsletter; exhib catalogues, 4-6 per yr

Activities: Classes for adults & children; docent training; lect open to pub, 4-6 vis lectr per yr; concerts; gallery talks; tours; sponsoring of competitions; individual paintings & original art objects lent to museums & art centers; Art Suitcase prog goes out to all 4th & 5th grade students including rural areas; 2-4 book traveling exhibs; originate traveling exhibs circulate to other museums; mus shop sells books, magazines, original art, reproductions, prints, jewelry, textiles, clothing, home furnishings; junior mus on site, Young Artists' Gallery

M **ZOO MONTANA,** 2100 S Shiloh Rd, Billings, MT 59106. Tel 406-652-8100; Fax 406-652-9281; Elec Mail zoomt@zoomontana.org; Internet Home Page Address: www.zoomontana.org; *Dir* Jackie Andrich-Worstell; *Educ* Janice Blancett; *Pub Rels* Mihail Kennedy; *Asst Dir* Clark Bosch; *Mus Shop Mgr* Kim Frank; *Cur* Travis Goebel

Open Mar - May & Sept - Oct: daily 10 AM - 4 PM, May - Aug: daily 10 AM - 5 PM, Oct: Wed - Sun 10 AM - 5 PM, Nov - Mar: Sat & Sun 10 AM - 4 PM; cl New Year's, Thanksgiving & Christmas; Admis adults $6, seniors $4, children $3, mems no admis fee; Estab 1993; zoo & botanical garden that specializes in cold climate species; Average Annual Attendance: 60,000 by estimate; Mem: dues Household or Grandparent $50, Indiv $45

Collections: Wooded trails; native & exotic animals; exotic & medicinal plants from MT as well as northern regions of the world; Discovery Center; Sensory Garden; Interactive Barn

Publications: Zoo Montana, quarterly newsletter

Activities: Docent prog; formal educ for children; internships; guided tours; participatory & traveling exhibs; lects; concerts; Ann events: Wendy's Family Fun Day, July; High-on-the-Hog, Sept; Boo at the Zoo & Pumpkin Panda-monium, Oct; Zoobilee, Nov; Fantasy of Lights, Dec; museum-related items for sale

BOZEMAN

MONTANA STATE UNIVERSITY

M **Museum of the Rockies,** Tel 406-994-2251; Fax 406-994-2682; Internet Home Page Address: www.museumoftherockies.org; *Cur Art & Photog* Steve Jackson; *Dean & Dir* Marilyn Wessel

Open 9 AM - 9 PM Memorial Day - Labor Day; winter, Tues - Sat 9 AM - 5 PM, Sun 1 - 5 PM, cl Mon; Admis varies call for schedule; Estab in 1958 to interpret the physical & cultural heritages of the Northern Rockies region; Average Annual Attendance: 160,000; Mem: 4200; dues directors circle $500, sustaining $250, contribution $100, family $50, non-resident family $40, individual $25, MSU student $15

Income: Financed by MSU, fundraising, grants & revenue

Special Subjects: Drawings, American Indian Art, American Western Art, Bronzes, Anthropology, Archaeology, Ethnology, Ceramics, Folk Art, Etchings & Engravings, Decorative Arts, Collages, Dolls, Furniture, Carpets & Rugs, Embroidery, Cartoons

Collections: Art Works by R E DeCamp; Edgar Paxton; C M Russell; O C Seltzer; William Standing; geology; paleontology; astronomy, archaeological artifacts; history & western art; regional native Americans

Exhibitions: Rotation Gallery features changing exhibs

Publications: Quarterly newsletter; papers

Activities: Classes for adults & children; docent training; progs in science, history & art; lect open to pub, 20 vis lectrs per yr; planetarium shows; field trips; field schools; gallery talks; tours; traveling portable planetarium, book traveling exhibs; originate traveling exhibs; mus shop sells books, magazines, original art, reproductions, prints, slides, crafts, toys, hats, t-shirts, stationery

M **Helen E Copeland Gallery,** Tel 406-994-2562; Fax 406-994-3680; Elec Mail dungan@montana.edu; Internet Home Page Address: www.montana.edu/wwwart; *Gallery Dir* Erica Howe Dungan

Open Mon - Fri 8 AM - 5 PM; No admis fee; Estab 1974 to present exhibitions of national interest & educate students; A new building with a small gallery space adjacent to offices & studio classrooms; Average Annual Attendance: 10,000

Income: Financed by univ appropriation

Collections: Japanese Patterns; Native American Ceramics; WPA Prints

Exhibitions: 7-8 exhibs ann including graduate & undergraduate exhibs

Activities: Lect open to pub, 4 vis lectrs per yr; competitions; individual paintings lent to univ offices; book traveling exhibs; originate traveling exhibs to Montana Galleries

L **Creative Arts Library,** Tel 406-994-5305; Fax 406-994-2851; Elec Mail alikk@montana.edu; Internet Home Page Address: www.msu.edu; *Ref Librn* Alessia Zanin-Yost

Open Mon - Thurs 8 AM - 10 PM, Fri 8 AM - 5 PM, Sat & Sun 1 - 10 PM; Estab 1974 to support the Schools of Architecture & Art

Income: Financed by state appropriation

Library Holdings: Book Volumes 30,000; Other Holdings Matted reproductions; Periodical Subscriptions 150

BROWNING

M **MUSEUM OF THE PLAINS INDIAN & CRAFTS CENTER,** PO Box 410, Browning, MT 59417-0410. Tel 406-338-2230; Fax 406-338-7404; Elec Mail mpi@3river.com; Internet Home Page Address: www.iacb.doi.gov; *Cur* Loretta F Pepion
Open June - Sept, daily 9 AM - 4:45 PM, Oct - May Mon - Fri 10 AM - 4:30 PM, cl New Year's Day, Thanksgiving Day and Christmas; Admis Jun - Sept adult $4, groups of 10 or more $1 per person, children (6-12) $1; Estab 1941 to promote the development of contemporary Native American arts & crafts, administered and operated by the Indian Arts and Crafts Board, US Dept of the Interior; Average Annual Attendance: 80,000
Income: Financed by federal appropriation
Special Subjects: American Indian Art, Crafts
Collections: Contemporary Native American arts & crafts; historic works by Plains Indian craftsmen & artists
Exhibitions: Historic arts created by the tribal peoples of the Northern Plains; Traditional costumes of Northern Plains men, women & children; Art forms related to the social & ceremonial aspects of the regional tribal cultures; Winds of Change: Five Screen Multi-Media Presentation of the Evolution of Indian Cultures on the Northern Plains; One-Person exhibs of Native American artists & craftsmen; Architectural decorations, including carved wood panels by sculptor John Clarke & a series of murals by Victor Pepion
Publications: Continuing series of brochures for one-person shows, exhib catalogues
Activities: Gallery talks; tours; demonstrations of Native American arts & crafts; traveling exhibs organized and circulated; sales shop sells books, original art

BUTTE

M **BUTTE SILVER BOW ARTS CHATEAU,** 321 W Broadway, Butte, MT 59701. Tel 406-723-7600; Fax 406-723-5083; Elec Mail glenv@in-tch.com; Internet Home Page Address: www.artschateau.org; *Dir* Glenn Vodish
Open Sept - May Mon - Sat Noon - 5 PM, June - Aug Tues - Sat 10:30 AM - 5:30 PM, Sun 1 - 4 PM, cl major holidays; Admis family $6, single $3, seniors & children $2; Estab 1977 to further all forms of art; 1898 French Chateau converted to galleries & museum; Mem: 350; dues Business: benefactor $1000, patron $750, sustaining $500, contributing $100, active $10; Individual: benefactor $1000, patron $500, sustaining $100, contributing $50, family $25, active $10; ann meeting Jan
Collections: Contemporary regional art; Elizabeth Lochria Coll of Native American Portraits
Exhibitions: Exhibs change every 3 months
Publications: Newsletter
Activities: Classes for adults & children, dramatic progs; lect open to pub, 10 vis lectrs per yr; gallery talks; tours; book traveling exhibs 4 per yr; art supply store sells original art, reproductions, prints & recitals

CHESTER

M **LIBERTY VILLAGE ARTS CENTER & GALLERY,** 410 Main St, PO Box 269 Chester, MT 59522. Tel 406-759-5652; Fax 406-759-5652; Elec Mail lvac@mtintouch.net; Internet Home Page Address: www.libertyvillagearts.org; *Treas* Laurie S Lyders; *Dir* Craig Waldron
Open Tues - Fri & Sun 12:30 PM - 4:30 PM, cl New Years, Easter, Thanksgiving & Christmas; No admis fee; Estab 1976 to provide community with traveling exhibs & educ center; Renovated Catholic Church circa 1910; Average Annual Attendance: 1,500-2,000; Mem: 70; dues patron $100 & up, Friend of the Arts $50-$99, family $25, individual $20; ann meeting in Oct
Collections: Works by local artists, paintings & quilts
Exhibitions: Traveling exhibs
Activities: Classes for adults & children; workshops; film series; lect open to pub, 3 vis lectrs per year; gallery talks; competitions with awards; book traveling exhibs; originate traveling exhibs; mus shop sells books, original art & prints

DILLON

M **THE UNIVERSITY OF MONTANA - WESTERN,** Art Gallery Museum, 710 S Atlantic, Dillon, MT 59725-3958. Tel 406-683-7232; WATS 800-WMC-MONT; *Dir* Randy Horst
Open Mon - Fri Noon - 4:30 PM; No admis fee; Estab 1970 to display art works of various kinds, used as an educ facility; Located in the south end of Old Main Hall houses the Seidensticker Wildlife Coll of taxidermy; Average Annual Attendance: 7,000
Income: Financed through col funds
Collections: Seidensticker WildlifeTrophy Collection
Activities: Educ dept

L **Lucy Carson Memorial Library,** 710 S Atlantic St, Dillon, MT 59725-3598. Tel 406-683-7541; Fax 406-683-7493; Elec Mail m.shultz@wmc.edu; Internet Home Page Address: www.wmc.edu/academics/library; *Library Dir* Mike Shultz
Open Mon - Thurs 7:30 AM - 11 PM, Fri 7:30 AM - 5 PM, Sat 11 AM - 6 PM, Sun 3 - 11 PM; Library open to the pub
Income: Financed by coll & state
Library Holdings: Book Volumes 4500; Cassettes; Compact Disks; DVDs; Fiche; Filmstrips; Framed Reproductions; Lantern Slides; Maps; Memorabilia; Micro Print; Motion Pictures; Original Art Works; Original Documents; Periodical Subscriptions 12; Photographs; Prints; Reels; Reproductions; Sculpture; Slides; Video Tapes 140
Collections: Emerick Arts Collection

DRUMMOND

M **OHRMANN MUSEUM AND GALLERY,** 6185 Hwy 1, Drummond, MT 59832. Tel 406-288-3319; Elec Mail ohrmann@blackfoot.net; Internet Home Page Address: www.ohrmannmuseum.com; *Artist & Owner* Bill Ohrmann
Open daily 10 AM - 5 PM; Located 2 1/2 miles S of Drummond on Hwy 1, mus houses the paintings, woodcarvings, bronzes & steel sculptures of Bill Ohrmann

Special Subjects: Painting-American, Bronzes, Woodcarvings
Activities: Artist's works available for sale

GLENDIVE

M **FRONTIER GATEWAY MUSEUM,** I-94, Exit 215 (State St), Glendive, MT 59330; PO Box 1181, Glendive, MT 59330. Tel 406-377-8168; *Cur* Louise Cross; *Treas* Janet Meland
Open Mon - Sat 9 AM - noon & 1 - 5 PM, Sun & holidays 1 - 5 PM; cl mid-Sept to mid-May; No admis fee, donations accepted; Founded 1963; Gen historical mus of Glendive & Dawson Counties in MT; 10,080 sq ft exhib space situated on 7 bldgs on one acre; Average Annual Attendance: 1785; Mem: dues Life $50, Indiv $5
Library Holdings: Book Volumes 650; Clipping Files 33 drawers; Maps 263; Photographs 7 file drawers
Collections: Prehistoric to contemporary coll consists of fossils, mammoth, mastodon, buffalo, indians, cattlemen, homesteads, smalltowns, fashions; personal artifacts; tools & equipment for materials; paleontological items; structures; folk culture; technology; furnishings
Publications: Report to the Membership, ann newsletter
Activities: Open house; tours; demonstrations; lects; hobby workshops; museum-related souvenirs for sale

GREAT FALLS

M **C M RUSSELL MUSEUM,** 400 13th St N, Great Falls, MT 59401. Tel 406-727-8787; Fax 406-727-2402; *Cur* Elizabeth Dear; *Registrar* Kim Smith; *Dir* Michael Warner
Open during winter Tues - Sat 10 AM - 5 PM, Sun 1 - 5 PM, cl Mon; summer (May 1 - Oct 30) Mon - Sat 9 AM - 6 PM, Sun Noon - 5 PM; Admis adults $6, students $3, seniors $4, children under 5 free; Estab 1953 to preserve art of Charles M Russell, western painter; Mus includes Russell's home & original studio; has seven galleries of Western art & photographs & Indian artifacts. Maintains reference library; Average Annual Attendance: 65,000; Mem: 1,750; dues $25 - $3,000 & up; ann meeting in May
Income: Financed by operating budget
Special Subjects: Drawings, Latin American Art, Mexican Art, Painting-American, Photography, Prints, Sculpture, American Indian Art, American Western Art, Bronzes, Anthropology, Archaeology, Ethnology, Pre-Columbian Art, Southwestern Art, Folk Art, Pottery, Etchings & Engravings, Decorative Arts, Manuscripts, Portraits, Historical Material, Period Rooms, Cartoons, Reproductions
Collections: Works by Charles M Russell & other Western works including Seltzer, Couse, Wieghorst, Sharp, Heikka, Reiss, Farny; Historical & contemporary; Contemporary & western art; Native American art
Exhibitions: Traveling exhibs of western art; permanent exhibs
Publications: Magazine, semi-annually; newsletter, 10 times per yr
Activities: Classes for adults & children; docent training; Tipi Camp; lect for mems only, 0-6 vis lectrs per yr; gallery talks; tours; individual paintings & original objects of art lent to qualified museums; book traveling exhibs 1 per yr; mus store sells books, magazines, reproductions, prints, jewelry, pottery

L **Frederic G Renner Memorial Library,** 400 13th St N, Great Falls, MT 59401. Tel 406-727-8787; Fax 406-727-2402; *Elec Mail* nicole@cmrussell.org; Internet Home Page Address: www.cmrussell.org; *Registrar* Kim Smith; *Exec Dir & Cur* Anne Morand; *Develop Dir* Oliver Sundby; *Mus Shop Dir* Pat Bryan; *Educ & Tours* Patricia Boyle; *Librn* Sharon McGowen; *Bison Cur* Dr Lynne Spriggs
Summer: Mon-Sat 9 AM - 6 PM, SUN Noon- 5 PM; Winter: Tues-Sat 10 AM - 5 PM; Admis Adults $8, seniors $6, children & students $3, under 5 free; Library estab 1965 to provide research material on Western art & artists, primarily C M Russell & The History of Montana & The West; Museum estab 1953 to showcase CM Russell's work; Circ 3,000; For reference only; Average Annual Attendance: 56,000; Mem: 2,000, $35 - $2,500
Income: (financed by pvt contributions)
Library Holdings: Auction Catalogs; Audio Tapes; Book Volumes 2700; CD-ROMs; Clipping Files; Exhibition Catalogs; Kodachrome Transparencies; Manuscripts; Memorabilia; Micro Print; Motion Pictures; Original Documents; Pamphlets; Periodical Subscriptions 4; Photographs; Prints; Reproductions; Slides; Video Tapes
Special Subjects: Art History, Painting-American, Prints, Sculpture, Historical Material, Ethnology, American Western Art, Bronzes, American Indian Art, Southwestern Art, Carpets & Rugs, Landscapes
Collections: Joseph Henry Sharp Collection of Indian Photographs; Yost Archival Collection; Flood Archival Collection
Publications: Russell's West Quarterly, quarterly
Activities: Classes for adults & children; dramatic prog; docent training; native american classes; summer day camps; lect open to pub & members; 6 vis lect per year; concerts; gallery talks; tours; sponsoring of competitions; Trigg award; sells books, magazines, original art, reproductions, prints, slides; Discovery Gallery: Hands-on Experience for Children & Families

M **CASCADE COUNTY HISTORICAL SOCIETY,** High Plains Heritage Center, High Plains Heritage Ctr, 422 2nd St S Great Falls, MT 59405. Tel 406-452-3462; Fax 406-461-3805; Elec Mail hphc@highplainsheritage.org; Internet Home Page Address: www.highplainsheritage.org; *Exec Dir* Cindy Kittredge; *Cur Colls* Michelle Reid; *Archives* Judy Ellinghausen; *Bookkeeper* Ron Paulick; *Gift Shop Mgr* Minnie Hawthorne; *Archives Asst* Georges de Giorgio; *Coll Asst* Heather Dorociak; *Gift Shop Clerk* Darlene Osborne
Open summer: Mon - Fri 10 AM - 5 PM, Sat & Sun Noon - 5 PM: Winter: Tues - Fri 10 AM - 5 PM, Sat & Sun Noon - 5 PM, cl holidays; Admis $2 per person, mems and children under 6 free; Estab 1976 to preserve & interpret the history of the Central Montana area & the diverse area heritage; The historical mus is housed in the Internal Harvester building built in 1929. The archives are located in the pub library; Average Annual Attendance: 82,000; Mem: Dues benefactor $500; patron $250; sponsor $125; sustainer $75; family $40; historian $25; sr historian $15; ann meeting third Thurs in Feb

Income: $300,000 (financed by mem dues, donations, memorials, sales shop & grants)
Library Holdings: Auction Catalogs; Audio Tapes; Book Volumes; Cards; Cassettes; Clipping Files; Exhibition Catalogs; Framed Reproductions; Kodachrome Transparencies; Lantern Slides; Manuscripts; Maps; Memorabilia; Motion Pictures; Original Art Works; Original Documents; Pamphlets; Periodical Subscriptions; Photographs; Prints; Records; Sculpture; Slides; Video Tapes
Collections: Art, documents, manuscripts, photographs, objects reflecting the history of the local area; clothing, furniture & memorabilia from Great Falls & Cascade County
Exhibitions: Exhibits from the permanent colls, changed quarterly; Celebrate Central Montana; Handcrafted; Handcrafted: An Expression of American Tradition
Activities: Classes for adults & children; docent training; lect open to public, 10-15 vis lectrs per yr; gallery talks; tours; sponsoring of competitions; Community Heritage Preservation Award; individual paintings & original objects of art lent to other museums in central Montana; lending of original objects of art to fellow museums; book traveling exhibs 1 per yr; originate traveling exhibs to schools & smaller area town businesses in Montana; mus shop sells books, magazines, original arts, reproductions

M PARIS GIBSON SQUARE, Museum of Art, 1400 First Ave N, Great Falls, MT 59401. Tel 406-727-8255; Fax 406-727-8256; Elec Mail pgsmoa@mcn.net; *Dir* Jessica Hunter
Open Tues - Fri 10 AM - 5 PM, Sat & Sun Noon - 5 PM, cl Mon; No admis fee; Estab 1976 to exhibit contemporary & historical art; Maintains 3 galleries which consist of 1100 ft of running wall space; Average Annual Attendance: 57,000; Mem: 550-650; mem open to pub; dues $20; ann meetings in June
Income: $300,000 (financed by mem, grants, contributions & county mill)
Special Subjects: Painting-American, Photography, Prints, Sculpture, Watercolors, American Indian Art, Ceramics, Folk Art, Pottery, Primitive art, Woodcarvings, Woodcuts
Collections: Contemporary regional artists; Montana folk-art naive sculptures (polychromed wood), Lee Steen
Exhibitions: Various exhibs
Publications: Artist postcards, bimonthly exhib announcements, Exhibition Quarterly
Activities: Classes for adults & children; docent training; lect open to pub, 6-12 vis lectrs per yr; gallery talks; tours; schols & fels offered; individual paintings & original objects of art lent to other museums; lending coll contains original art works, original prints, paintings & photographs; book traveling exhibs 1-2 per yr; originate traveling exhibs to regional art institutions; mus shop sells Montana original art, reproductions, prints, ceramics, mus cards & gift items

HAMILTON

M RAVALLI COUNTY MUSEUM, 205 Bedford, Old Court House Hamilton, MT 59840. Tel 406-363-3338; Elec Mail rcmuseum@cybernet1.com; Internet Home Page Address: www.cybernet1.com/rcmuseum/; *Treas* Jean Pfeifer; *Dir* Helen Ann Bibler
Open Mon, Thurs, Fri & Sat 10 AM - 4 PM, Sun 1 - 4 PM; Admis $2; Estab 1979 to preserve the history of the Bitterroot Valley; Museum contains Flathead Indian exhibit, Discovery room encompasses Native Am lifestyles in the Bitterroot Valley, Lewis & Clark travelling through the Bitterroot, The Salish Indians, Rocky Mt Spotted Fever display, pioneer rooms, tack & trophy room, veterans room, rotating exhibits in old court room; extensive archives; railroad express agent office; Average Annual Attendance: 10,000; Mem: 350; dues corporate $100, family $25, regular $15; meetings third Mon each month
Income: Financed by county appropriation & gifts from Bitterroot Valley Historical Society
Purchases: $5000
Collections: Home furnishings reflecting early life of the Bitterroot Valley; Indian, Railroad
Exhibitions: Special Exhibits of International Interest; Special Local Collection Exhibit; Veterans Exhibit; December Christmas Exhibit, Lewis & Clark Exhibit
Publications: Bitterroot Trails One, Two, Three, Bitterroot Historical Society; McIntosh Apple Cookbook; Historic Survey of Hamilton Buildings 1890-1940; The Yellow Pine; Newsletter; The Bitterrooter, George Hayes, Rocky Mountain Spotted Fever in Western Montana; Anatomy of a Pestilence-Dr Robert Philip
Activities: Educ dept; docent training, Sunday lect, cultural progs; lect open to pub, 40 vis lectsr per yr; concerts; tours; competitions with awards; mus shop sells books, original art, reproductions, prints, porcelain, jewelry & gifts featuring Lewis & Clark

HARDIN

M BIG HORN COUNTY HISTORICAL MUSEUM, RR 1 Box 1206A, Hardin, MT 59034. Tel 406-665-1671; Fax 406-665-3068; *Dir* Diana Scheidt; *Pres* Royal Noyes; *Treas* Margaret Koebbe; *Mus Shop Mgr* Joan Miller
Open May & Sept: daily 8 AM - 5 PM, Jun - Aug: daily 8 AM - 8 PM, Oct - Apr: Mon - Fri 9 AM - 5 PM; historic bldgs cl Oct - Apr; mus cl New Year's Day, Thanksgiving Day, Christmas Day; No admis fee, donations accepted; Estab 1979; mus is located on 23-acre former vegetable farm that was donated to Big Horn County in 1979 & features orig farmhouse & barn; authentic historic structures have been restored & placed on site; Average Annual Attendance: 10,000 - 49,999 by estimate; Mem: dues Lifetime $250, Business $50, Family $20, Indiv $10
Collections: Includes items of historical significance related to the development of Big Horn County, MT from 1900 to modern times with emphasis on the cultures of people who have settled in the area, including The Crow Indians, Northern Cheyenne Indians, Japanese, German, Russian, Korean & Norwegian cultures; historic structures; horse-drawn equipment; restored tractor; farm equipment; furnishings; photographs & personal artifacts; hundreds of book vols on the Plains Indians; hundreds of local publs
Publications: On the Bighorn, quarterly newsletter

Activities: Guided tours; Tractor Show; Auction; Living History; Hands on For Students; museum-related items for sale

HELENA

M HOLTER MUSEUM OF ART, 12 E Lawrence St, Helena, MT 59601. Tel 406-422-6400; Fax 406-442-2404; Elec Mail holter@holtermuseum.org; Internet Home Page Address: www.holtermuseum.org; *Cur Educ* Katie Knight; *Co-Dir* Eliza Frazier; *Co-Dir* Liz Gans; *Cur Exhib & Coll* Brandon Reintjes; *Bus Mgr* Kelly Bourgeois
Open Tues - Fri 10 AM - 6 PM, Sat 10 AM - 5 PM; Noon - 5 PM; Admis by donation; Estab 1987 to educate & enhance the quality of life of constituents; Average Annual Attendance: 32,000; Mem: 650; dues family $50, individual $30, seniors & students $25; ann meeting in June
Income: $600,000 (financed by endowment, mem & state appropriation)
Library Holdings: Audio Tapes; Book Volumes; Exhibition Catalogs; Pamphlets; Photographs; Slides; Video Tapes
Special Subjects: Painting-American, Photography, Sculpture, Watercolors, American Indian Art, Textiles, Ceramics, Folk Art, Pottery, Woodcarvings, Landscapes, Glass, Jewelry, Porcelain, Metalwork
Collections: Contemporary Northwest Regional Art in all mediums
Exhibitions: ANA: National Juried Art Exhibition.
Publications: Exhib brochures, 9-12 times per yr; newsletter, 3 times per yr
Activities: Classes for adults & children; docent training; lect open to pub, 20-30 vis lectrs per yr; gallery talks; tours; awards for artists in ANA, national Juried exhib; schols offered; book traveling exhibs 4 per yr; originate traveling exhibs 2 per yr; sales shop sells books, original art & prints

A MONTANA HISTORICAL SOCIETY, 225 N Roberts, PO Box 201201 Helena, MT 59620. Tel 406-444-2694; Fax 406-444-2696; Internet Home Page Address: www.montanahistoricalsociety.org; *Dir* Richard Sims; *Cur* Kirby Lambert; *Dir Mus Svcs* Susan R Near; *Archivist* Jodie Foley; *Mus Shop Mgr* Richard Boyd; *Registrar* Jennifer Bottomly-O'Looney; *Preservation Officer* Mark Baumler; *Publ Mgr* Molly Holz; *Pub Relations* Tom Cook; *Educ* Julie Saylor
Open Mon - Fri 8 AM - 5 PM, Sat 9 AM - 5 PM, closed Sun & holidays; admis $5; Estab 1865 to collect, preserve & present articles relevant to history & heritage of Montana & the Northwest; Mackay Gallery of C M Russell Art; temporary exhibits gallery; Montana Homeland; Average Annual Attendance: 93,000; Mem: 4000; dues $60
Income: $545,000 (financed by State of Montana General Fund, pvt gifts & grants, federal grants, earned revenue)
Library Holdings: Auction Catalogs; Clipping Files; Exhibition Catalogs; Manuscripts; Maps; Memorabilia; Original Documents; Photographs
Special Subjects: Architecture, Costumes, Historical Material, Photography, Posters, Sculpture, Textiles, Watercolors, Painting-American, American Western Art, Bronzes, Decorative Arts, American Indian Art, Portraits, Archaeology, Furniture, Ethnology, Leather
Collections: Haynes Collection of Art, Photographs & Artifacts; Mackay Collection of C M Russell Art; Poindexter Collection of Abstract Art; Montana artists; late 19th & 20th century Western art; ethnographic & decorative arts; Bob Scriver - the artist's coll
Exhibitions: (2005) Neither Empty Nor Unknown: Montana at the Time of Lewis & Clark; Montana Homeland
Publications: Montana, Magazine of Western History, quarterly; Montana Post (newsletter), quarterly
Activities: Educational progs for adults & children; docent training; lect open to pub, 40 vis lectrs per yr; gallery talks, tours; individual paintings & original objects of art lent to museums, galleries, historical societies; lending coll includes 300 color transparencies, 200 original art works, 500,000 photographs, 40 sculptures, 1000 slides; traveling exhibs organized and circulated; sales shop selling books, magazines, prints, reproductions, slides

L Library, 225 N Roberts, Helena, MT 59620; PO Box 201201, Helena, MT 59620-1201. Tel 406-444-1799; Fax 406-444-2696; Elec Mail gashmore@state.mt.us; Internet Home Page Address: www.montanahistoricalsociety.org; *Head Librn & Archivist* Charlene Porsild; *Photograph Cur* Delores Morrow; *Cur Coll* Kirby Lambert
Open Mon - Fri 8 AM - 5 PM by appointment; For reference and research only
Income: Financed by State of Montana
Library Holdings: Book Volumes 4000; Clipping Files; Exhibition Catalogs; Manuscripts; Pamphlets; Periodical Subscriptions 100; Photographs
Special Subjects: Painting-American, Historical Material, Archaeology, Ethnology, American Western Art, American Indian Art, Anthropology
Collections: Historical artifacts; Late 19th & 20th century art; photo coll; manuscripts
Publications: Montana: The Magazine of Western History, quarterly

KALISPELL

A HOCKADAY MUSEUM OF ARTS, 302 2d Ave E, Kalispell, MT 55901. Tel 406-755-5268; Fax 406-755-2023; Elec Mail information@hockadaymuseum.org; Internet Home Page Address: www.hockadayartmuseum.org; *Chmn & Pres* Mark Norley; *Exec Dir* Linda Engh-Grady
Spet - May, Tues - Sat 10 AM - 5 PM; Jun - Aug, Mon - Sat 10 AM - 6 PM & Sun Noon - 4 PM; Admis adult $5, seniors $4, students $2, youth $1, under 6 free; Estab 1968 to foster & encourage a growing interest in & understanding of all the arts; to provide the opportunity to take a place in the main current of the arts today, as well as to observe & learn from the arts of the past; Mus is housed in the former Carnegie Library in downtown Kalispell; has six spacious exhib galleries & a gift gallery; Average Annual Attendance: 10,000; Mem: 525; $35 & up
Income: Financed by mem, contributions, grants, exhib sponsors, corporate donations & city funds
Special Subjects: Drawings, Etchings & Engravings, Landscapes, Photography, Posters, Painting-American, Pottery, American Western Art, Bronzes, American Indian Art, Ceramics, Glass, Islamic Art

Collections: Focus on the art and culture of Montana and the artists of Glacier National Park
Exhibitions: Eight to twelve traveling & regional exhibs per yr
Publications: Exhib catalogs; newsletter
Activities: Classes for adults & children; lect open to pub, 3 per yr; gallery talks; tours; mus shop sells books, original art, reproductions, prints

LEWISTOWN

A **LEWISTOWN ART CENTER,** 801 W Broadway, Lewistown, MT 59457. Tel 406-535-8278; Fax 406-535-8278; Elec Mail lac@midrivers.com; Internet Home Page Address: www.lewistown2000.com; *Dir* Karen Kuhlmann; *Office Mgr* Holly Jensen; *Educ Cir* Nadine Robertson
Open Tues - Sat 11:30 AM - 5:30 PM, cl Mon; Free; Estab 1971 for advancement & educ in the arts. The gallery exhibs change monthly showing a variety of local, state & national artwork; A sales gallery features Montana artists & local artists; Average Annual Attendance: 5,000; Mem: 500; dues $10 & up; ann meeting in August
Income: $65,000 (financed entirely by mem, donations, sponsorships by local businesses, art grants, sales from gift shop, auction & market room)
Special Subjects: Photography, Porcelain, Posters, Prints, Reproductions, Sculpture, Silver, Textiles, Watercolors, Painting-American, Pottery, Stained Glass
Collections: Collection of art work from artists from Central Montana, bronze & all other mediums
Exhibitions: In-state shows; Juried Art Auction; juried show; regional shows
Publications: Newsletter, bimonthly
Activities: Arts classes & workshops for adults & children; docent training; lect open to pub, 1-2 vis lectr per yr; gallery talks; tours; competitions with awards; schols offered; originate traveling exhibs to rural communities in Central Montana; sales shop sells books, original art, reproductions, prints, sculpture, pottery, wall hangings, jewelry, fiber arts & wood crafts

MILES CITY

A **CUSTER COUNTY ART & HERITAGE CENTER,** Waterplant Rd, PO Box 1284 Miles City, MT 59301. Tel 406-234-0635; Fax 406-234-0637; Elec Mail ccartc@midrivers.com; Internet Home Page Address: www.ccac.milescity.org; *Exec Dir* Mark Browning; *Dir Educ* Keely Perkins; *Res Artist* Jim Bailey; *Admin Asst* Jaime Burkhalter
Open Tues - Sun 1 - 5 PM, cl holidays; Summer hours 9 AM - 5 PM; No admis fee; Estab 1977 to provide an arts prog of exhibits and educ activities to residents of Southeastern Montana; Maintains The Water Works Gallery, located in the former holding tanks of the old Miles City Water Works; Average Annual Attendance: 10,000; Mem: 500; dues benefactor $500, patron $300, sponsor $100, sustaining $75, business $60, contributing $50, family $40, individual $25, student & sr citizens $15
Income: Financed by mem, fundraising events & grants
Library Holdings: Original Art Works; Photographs; Prints
Special Subjects: Photography, Prints, Sculpture, Watercolors, Painting-American, Pottery, Stained Glass, Woodcuts, Woodcarvings, Southwestern Art
Collections: Vintage photographic coll, includes ES Curtis, LA Huffman, E Cameron; Historical & Contemporary Montana Artists
Exhibitions: Changing exhibs every 4-8 wks
Publications: Biannual exhibit catalogs; quarterly newsletter
Activities: Classes for adults, children & disabled srs; lect open to pub, 10 vis lectrs per yr; gallery talks (speakers bureau); artmobile, serving art classes through artist-in-schools & communites program; 100 mile radius (30,000 sq miles) in 9 counties of SE Montana; 2 book traveling exhibs; mus store sells books & original art

MISSOULA

M **HISTORICAL MUSEUM AT FORT MISSOULA,** Bldg 322, Fort Missoula, Missoula, MT 59804. Tel 406-728-3476; Fax 406-543-6277; Elec Mail ftmslamuseum@montana.com; Internet Home Page Address: www.fortmissoulamuseum.org; *Sr Cur* L Jane Richards; *Dir Educ* Brittany Puttason-Weber; *Dir* Robert Brown; *Grants Admin* Diane Sands; *Mus Aide* Sharon Garner; *Mus Asst* Rachel Bartlett
Open Memorial Day to Labor Day Mon - Sat 10 AM - 5 PM, Sun Noon - 5 PM, Labor Day to Memorial Day Tues - Sun Noon - 5 pm; Admis adult $3, seniors $2, students $1, children under 6 free; Estab July 4, 1976 to collect and exhibit artifacts related to the history of western Montana; Changing gallery, 900 sq ft used for temporary exhibits; Meeting room gallery, 200 sq ft; Permanent gallery, 1200 sq ft; Average Annual Attendance: 40,000; Mem: 300; dues $25; quarterly meetings; Scholarships, Fellowships
Income: $350,000 (financed by mem, county appropriation & fundraising events)
Special Subjects: Architecture, American Western Art, Archaeology
Collections: Forest industry artifacts from Western Montana; Fort Missoula & the military presence in Western Montana; Missoula history
Exhibitions: The Road to Today: 250 Years of Missoula County History, changing exhibs, building exhib
Publications: The Military History of For Missoula; Missoula: The Way It Was; Purple & Gold: Missoula County High School, 1905-1965
Activities: Classes for adults & children; docent training; Forestry Day; Railroad Day; 4th of July Celebration; Frontier Day; lect open to pub; 9 vis lectrs per yr; gallery talks; tours; awards given; schols offered; book traveling exhibs; sales shop sells books, magazines, original art

M **MISSOULA ART MUSEUM,** (Art Museum of Missoula) 335 N Pattee, Missoula, MT 59802. Tel 406-728-0447; Fax 406-543-8691; Elec Mail museum@missoulaartmuseum.org; Internet Home Page Address: www.missoulaartmuseum.org; *Cur Exhibit* Stephen Glueckert; *CEO & Dir* Laura J Millin; *Chmn (V)* J Martin Burke; *Cur Educ* Ranee Taaffe; *Registrar* Jennifer Reifsneider; *Pres (V)* Cynthia Shott; *Admin Ofcr* Eva Dunn-Froebig; *Visitor Servs Coordr* Nici Holt
Open Tues - Fri 10 AM - 5 PM, Sat 10 AM - 3 PM; No admis fee; Estab 1975 to collect, preserve & exhibit international art; to educate through exhibits, art

school, special progs & forums; Housed in renovated Carnegie Library (1903) featuring soft-panel covered walls; moveable track lighting; approx 3500 sq ft of exhibit space on two flrs; fire and security alarm systems; meeting rooms; Average Annual Attendance: 25,000; Mem: 1000
Income: $500,000 (financed by mem, grants, fundraising events & ann permissive mill levy by Missoula County)
Purchases: Contemporary Art of Western United States
Library Holdings: Auction Catalogs; Audio Tapes; Book Volumes; CD-ROMs; Cards; Cassettes; Clipping Files; Exhibition Catalogs
Special Subjects: Architecture, Painting-American, Photography, American Indian Art, American Western Art, Bronzes, African Art, Ethnology, Ceramics, Crafts, Etchings & Engravings, Landscapes, Afro-American Art, Decorative Arts, Collages, Eskimo Art, Jewelry, Metalwork, Calligraphy, Embroidery
Collections: Contemporary Art of Western United States with an emphasis on Montana
Exhibitions: Paintings, Prose, Poems & Prints: Missouri River Interpretations; 23rd Annual Art Auction Exhib; Jacob Lawrence: Thirty Years of Prints (1963-1993); Beth Lo: Sabbatical Exhib.; Narrative Painting; Talking Quilts: Possibilities in Response.; Jim Todd: Portraits of Printmakers; David Regan: WESTAF Fellowship Winner; Art Museum of Missoula Permanent Coll; Lucy Capehart: Interiors
Publications: Exhibit catalogs; membership newsletter; mailers & posters advertising shows
Activities: Classes for adults & children; dramatic progs; docent training; lect open to pub & for mems only; concerts; gallery talks; tours; artmobile; lending of original objects of art; book traveling exhibs; originate traveling exhibs to museums in region; mus shop sells books, prints, artist-made jewelry & other objects of design emphasis

M **ROCKY MOUNTAIN MUSEUM OF MILITARY HISTORY,** Fort Missoula, Bldg T-310, Missoula, MT 59807; PO Box 7263, Missoula, MT 59807. Tel 406-549-5346; Elec Mail militarymuseu45@hotmail.com; Internet Home Page Address: www.geocities.com/fortmissoula; *Exec Dir* Tate R Jones
Open Jun 1 - Labor Day: daily 12 noon - 5 PM; day after Labor Day - end of May: Sun 12 noon - 5 PM; Admis no charge, donations accepted; Mus bldgs constructed in 1936 by the US Fourth Infantry Regiment & the Civilian Conservation Corps; Mus promotes the commemoration & study of the US armed svcs, from the Frontier Period to the War on Terrorism; strives to impart a greater understanding of the roles played by America's service men & women through this period of dramatic social change; Mem: dues $25
Collections: Wide coll of documents & artifacts, ranging from Civil War artillery to Vietnam-era anti-tank missles; home of Montana Civilian Conservation Corps aka "The Tree Army"

UNIVERSITY OF MONTANA

M **Gallery of Visual Arts,** Tel 406-243-2813; Fax 406-243-4968; Internet Home Page Address: www.umt.edu/art/gva.htm;
Open Mon - Fri 11 AM - 4 PM; No admis fee; Estab 1981 to present faculty, student & outside exhibs of contemporary emphasis for community interest; Gallery has 220 linear ft, 2800 sq ft; adjustable lighting; Average Annual Attendance: 15,000
Exhibitions: Various rotating exhibits call for details
Activities: Internships for gallery management; lect open to pub, 1-3 vis lectr per yr; gallery talks; tours; competitions; campus art awards; Thomas Wickes Award

M **Paxson Gallery,** Tel 406-243-2019; Fax 406-243-2797; Elec Mail manuela.well-off-man@mso.umt.edu; Internet Home Page Address: www.umt.edu/partv/famus; *Cur* Manuela Well-Off-Man; *Registrar* Caroline Peters; *Asst Cur* Bill Queen; *Asst to Cur* Katherine Ellestad; *Admin Assoc* Karen Rice
Open Tues - Thurs & Sat 11 AM - 3 PM, Fri 3 - 7 PM; No admis fee; Estab 1985 to exhibit permanent art coll & selected traveling exhibs; Gallery has 325 linear ft, 1780 sq ft; adjustable space & lighting; Average Annual Attendance: 50,000-60,000
Income: State, grants
Library Holdings: Auction Catalogs; Book Volumes; Kodachrome Transparencies; Pamphlets; Slides; Video Tapes
Special Subjects: Painting-American, Ceramics, Furniture
Collections: The Rudy Autio Contemporary Ceramic Collection; Dana Collection (American Impressionists including JH Sharp, Alfred Maurer, etc); Duncan Collection; McGill Collection; historical furniture; Millikan Collection; Historic Western & European Art; Pop Art & Contemporary Prints; Contemporary Native American Art
Activities: Classes for adults & children; docent training; internships for coll & gallery management; lect open to pub; gallery talks; tours; Campus Art Award; original objects of art lent to Montana Art Gallery Directors' Association mems & to Wildling Art Mus, Los Olivos, CA; loans of historical objects to Montana museums; lending coll contains original prints, paintings & photographs; book traveling exhibs 1-3 per yr; originate traveling exhibs to Oregon Historical Society, National Cowboy and Western Heritage Mus, CM Russell Mus, Booth Mus of Western Art, Yellowstone Art Mus, Plains Art Mus, Three Affiliated Tribes Mus, Washington State Capitol Mus; mus shop sells books, reproductions & prints

PRYOR

M **CHIEF PLENTY COUPS MUSEUM STATE PARK,** (Chief Plenty Coups Museum) PO Box 100, Pryor, MT 59066. Tel 406-252-1289; Fax 406-252-6668; Elec Mail plentycoups@plentycoups.org; Internet Home Page Address: www.plentycoups.org; *Dir* Rich Furber
Open May 1 - Sept 30 daily 10 AM - 5 PM; Admis $1 per person (park entrance fee includes mus); Estab 1972; Average Annual Attendance: 10,000
Income: Financed by state appropriation; affiliated with Montana Fish, Wildlife & Parks
Special Subjects: American Indian Art, Ethnology, Historical Material
Collections: Ethnographic materials of the Crow Indians; paintings; drawings; prehistoric artifacts
Exhibitions: Crow clothing and adornment; Pro Life Ways
Publications: Newsletter, annually

Activities: Fishing day for children; lect open to pub; 8 vis lectrs per yr; tours; sales shop sells books, magazines, original art, reproductions, prints, stationery notes, Crow crafts & beadwork

SIDNEY

M **MONDAK HERITAGE CENTER,** History Library, 120 Third Ave SE, PO Box 50 Sidney, MT 59270. Tel 406-482-3500; Fax 406-482-3500; *Dir* Judith Deitz; *Admin Asst* Melissa Lapham
Open summer Tues - Fri 10 AM - 5 PM, Sat & Sun 1 - 4 PM, winter Wed - Fri 10 AM - 4 PM, Sat & Sun 1 - 4 PM; No admis fee; Estab 1972 to preserve history of area & further interest in fine arts; For reference only; Average Annual Attendance: 3,000-5,000
Income: Financed by county appropriations, mem dues, grants & donations
Library Holdings: Audio Tapes; Book Volumes 2,000; Cassettes; Clipping Files; Fiche; Lantern Slides; Manuscripts; Maps; Original Documents; Periodical Subscriptions; Photographs; Records; Video Tapes
Special Subjects: Painting-American, American Western Art, Woodcuts, Dolls, Historical Material, Period Rooms
Publications: MonDak Historical & Arts Society Newsletter, 6 times yearly

M **Museum,** 120 Third Ave SE, PO Box 50 Sidney, MT 59270. Tel 406-433-3500; Fax 406-433-3500; Elec Mail mondakheritagecenter@hotmail.com; *Exec Dir* Judith Deitz
Open Mon - Fri 10 AM - 4 PM, Sat & Sun 1 - 4 PM; Admis $3; Estab 1967 as mus, for cultural events & shows; Open to the pub for historical reference; Average Annual Attendance: 10,000; Mem: Dues $25 & up
Income: Financed by County Mill levy
Library Holdings: Audio Tapes; Book Volumes 1500; Cards; Clipping Files; Exhibition Catalogs; Fiche; Manuscripts; Maps; Memorabilia; Original Art Works; Pamphlets; Photographs; Reels
Activities: Classes for adults & children; docent training; lect open to pub; 3 vis lectrs per yr; tours; mus shop sells books, original art, prints, regional arts & crafts

THREE FORKS

M **THREE FORKS AREA HISTORICAL SOCIETY,** Headwaters Heritage Museum, 202 S Main, Three Forks, MT 59752; PO Box 116, Three Forks, MT 59752. Tel 406-285-3644; Elec Mail museumthreeforks@aol.com; *Vol Dir, Cur & Mus Shop Mgr* Robin Cadby-Sorensen; *Vol Pres* Pat O'Brien Townsend; *Vol Treas* Patrick Finnegan; *Vol Secy* Richard Townsend
Open daily Jun 1 - Sept 30 9 AM - 5 PM; other times by appt; No admis fee, donations accepted; Estab 1979; Mus was constructed in 1910 and originally housed one of the first banks in Three Forks and contains thousands of artifacts & memorabilia depicting the local history of the Headwaters of the Missouri area; upstairs rooms depict a turn-of-the-century kitchen, schoolroom, blacksmith shop, railroad room, beauty shop & more; Average Annual Attendance: 3281; Mem: dues Founder $10,000, Sponsor $5000, Contributor $1000, Benefactor $500, Patron $250, Life $125, Sustaining $25, Family (ann) $8, Indiv (ann) $5, Business Mem dues Underwriter $500 & up, Sponsor $100 - $499, Contributor $25 - $99
Special Subjects: Flasks & Bottles, Bronzes, Historical Material
Collections: Colls are from the local families of the Missouri Headwaters; largest brown trout caught in Montana; meteorite; anvil from 1810 fur trapper's trading post; barbed wire coll; misc artifacts from 1900s - 1950s; fossils; rocks; arrowheads; maps; agricultural tools; photographs; costumes; furnishings; papers & more
Activities: Lects; guided tours; loan exhibs; traveling exhibs; docent prog; Ann Events: Festival of Discovery; Journey of Discovery; Christmas Stroll; books, postcards, souvenirs & museum-related items for sale

VICTOR

M **VICTOR HERITAGE MUSEUM,** Blake & Main St, Victor, MT 59875; PO Box 610, Victor, MT 59875. Tel 406-642-3997; *Pres* Mark K Hafer
Open Memorial Day - End of Aug: Tues - Sat 1 - 4 PM, cl holidays; No admis fee, donations accepted; Estab 1989 on land that was donated by Alvin & Ruth Cote; mus focuses on history of the town of Victor from the early 1900s, including mining, railroad & Native American history; Average Annual Attendance: 500 by estimate; Mem: dues Family $10
Collections: Permanent displays of items & artifacts that relate to Victor's history that are supplemented by thematic displays that change each yr; structures; personal artifacts; folk culture; distribution & transportation artifacts; tools & equip for communication; tools & equip for materials
Activities: Research on the Victor area & its residents prior to the 1930s; Ann event: Chocolate-Tasting Party, a fundraiser taking place on the first Mon in Dec

NEBRASKA

AURORA

M **PLAINSMAN MUSEUM,** 210 16th, Aurora, NE 68818. Tel 402-694-6531; Elec Mail plainsman@hamilton.net; Internet Home Page Address: www.plainsmanmuseum.org; *Dir* Megan Sharp; *Asst Dir* John Green
Open Apr 1 - Oct 31 Mon - Sat 9 AM - 5 PM, Sun 1 - 5 PM, Nov 1 - Mar 31 Mon - Sun 1 - 5 PM; Admis adult $6, seniors $4, students $2, AAA discounts available; Estab 1976 to tell the story of Hamilton County, Nebraska, focusing on the time from 1860 -1950; Free-standing panels in area of Historical Mus (5 large folding panels). Maintains reference library; Average Annual Attendance: 7,000; Mem: 350; dues family $25, singles $15; ann meeting Dirs meet 2nd Thurs of every month
Income: $60,000 (financed by mem, county allowance & individual donations)

Library Holdings: Book Volumes; Clipping Files; Lantern Slides; Manuscripts; Maps; Original Documents; Periodical Subscriptions; Photographs; Prints
Special Subjects: Painting-American, Photography, Textiles, Folk Art, Woodcarvings, Portraits, Dolls, Furniture, Glass, Jewelry, Historical Material, Maps, Coins & Medals, Period Rooms, Embroidery, Laces, Mosaics, Leather
Collections: One large pen & ink mural (20 ft x 8 ft) by Larry Guyton; 13 Wesley Huenefeld murals; Sidney E King coll of murals; two large murals by Ernest Ochsner; Six Pioneer Scene Mosaic fl murals; Ted Bergren woodcarvings; Early Terrance Duren drawings
Publications: Events Past & Upcoming, Plainsman newsletter, 4 times yearly
Activities: Lect open to pub; concerts; gallery talks; tours; mus shop sells books, original art, prints, audio tapes, VHS, county commemoratives

CAMBRIDGE

M **CAMBRIDGE MUSEUM,** Box 129, Cambridge, NE 69022; 612 Penn St Cambridge, NE 69022. Tel 308-697-4385; *Cur* Marjorie Ridpath; *Pres* Marilyn Kester
Open Tues - Sun 1 - 5 PM; No admis fee; Estab 1938 to give local people & tourists a place to learn about history; Average Annual Attendance: 1,074; Mem: 6
Income: Financed by donations
Purchases: $75 (Norris House painting)
Special Subjects: Archaeology, Costumes, Pottery, Furniture, Maps, Coins & Medals, Period Rooms
Collections: Painting by Musi Muse; Paintings by Leonna Cowels & Gale Kasson
Exhibitions: Rotating exhibs
Activities: Classes for children; lect open to pub - 1 per yr; originate traveling exhibs 1 per yr

CHADRON

M **CHADRON STATE COLLEGE,** Main Gallery, 1000 Main St, Chadron, NE 69337. Tel 308-432-6326; Fax 308-472-6396; Elec Mail lmacneill@csc.edu; Internet Home Page Address: www.csc.edu; *Dir Cultural Progs* Loree MacNeill; *Chair Performing & Visual Arts* Richard Bird; *Exhib & Design Coordr* Ken Korte
Open Mon - Fri 8 AM - 4 PM; No admis fee; Estab 1967 to offer opportunities for national recognized artists, students, faculty & local artists to present their works; to bring in shows to upgrade the cultural opportunities of students & the general pub; Main gallery has space for traveling & larger shows; Gallery 239 suffices for small shows; Average Annual Attendance: 5,000
Income: Financed by college budget, fine art student fee & state appropriation
Exhibitions: Arts & Crafts Fair; Bosworth, Rickenbach Exhibits; Da Vinci Model Show by IBM; Edges: Hard & Soft; Faculty Art Show; Former Students Works; Hands in Clay; Greg Lafler: Ceramics & Crafts; Photographs of the Farm Security Administration; Roten Galleries: Graphics Show; National Cone Box Traveling Show; Iowa Arts & Crafts; Mathew Brady, photographs; State of the Print; Student Art Show; Of Dustbowl Descent
Activities: Docent training; lect open to pub, 1-3 vis lectrs per yr; gallery talks; tours; competitions with awards; Purchase awards; individual objects of art lent to campus bldgs; 4 book traveling exhibs per yr; circulate to regn businesses & libraries

CHAPPELL

L **CHAPPELL MEMORIAL LIBRARY AND ART GALLERY,** 289 Babcock St, PO Box 248 Chappell, NE 69129. Tel 308-874-2626; *Head Librn* Dixie Riley; *Asst Librn* Doris McFee
Open Tues - Thurs 1 - 5 PM, Tues & Thurs evening 7 - 9 PM, Sat 2 - 5 PM; No admis fee; Estab 1935 by gift of Mrs Charles H Chappell
Income: Financed by city of Chappell
Library Holdings: Book Volumes 10,398; Periodical Subscriptions 31
Collections: Aaron Pyle Coll; permanent personal coll of art works from many countries, a gift from Mrs Charles H Chappell
Exhibitions: Rotating Exhibits
Activities: Gallery talks; library tours

GERING

M **OREGON TRAIL MUSEUM ASSOCIATION,** Scotts Bluff National Monument, Hwy 92 W, PO Box 27 Gering, NE 69341. Tel 308-436-4340; Fax 308-436-7611; Internet Home Page Address: www.NPS.gov/scbl; *Admin Mgr* John Kussack; *Business Mgr* Jolene Kaufman; *Historian* Dean Knudsen; *Supt* Valerie J. Naylor
Open June - Sept 8 AM - 8 PM, Oct - May 8 AM - 5 PM, cl Christmas & New Year's Day; Admis $5 per vehicle; Estab 1919 to preserve & display Oregon Trail landmark, artifacts, art & natural resources; 3 exhibit rooms; Average Annual Attendance: 120,000; Mem: 75; dues $10, renewal $5
Income: Financed by sales of Oregon Trail Museum Association
Collections: Watercolors, drawings, & photographs by William H Jackson; surface finds from the Oregon Trail vicinity; paleontological specimens from within Monument boundaries
Exhibitions: 6 exhibits depicting geological, prehistoric, archaeological, ethnological history of the area; 15 exhibits depicting history of western migration from 1840-1870s; photos, drawings & paintings by W H Jackson; 2 dioramas depicting interaction between white men & buffalo
Publications: The Overland Migration; brochures & handbooks
Activities: Slide presentation of history of Oregon Trail & Scotts Bluff; Living History presentation of life on the trail; lect open to pub; mus shop sells books, prints, slides, postcards

HASTINGS

M HASTINGS MUSEUM OF NATURAL & CULTURAL HISTORY, (Hastings Museum) 1330 N Burlington Ave, Hastings, NE 68901; PO Box 1286 Hastings, NE 68902. Tel 402-461-2399; Fax 402-461-2379; Elec Mail hastingsmuseum@alltel.net; Internet Home Page Address: www.hastingsmuseum.org; *Pres Bd of Trustees* Jack Steiner; *Dir* Rebecca Matticks; *Cur* Teresa Kreutzer; *Mus Coordr* Marty Harrold; *Dir Planetarium* Dan Glomski; *Educ Coordr* Marcy Burr; *Mus Shop Mgr* Janet Schawang; *Dir Mktg & Develop* Drew Ceperley; *Dir Develop* Kim Brooks; *Head Projectionist* Ross Heeren; *Guest Services Supv* Jenny Korte
Open Mon - Wed 9 AM - 5 PM, Thu - Sat 9 AM - 8 PM, Sun 10 AM - 6 PM; Cl Thanksgiving & Christmas; Admis adults $6, seniors (60+) $5.50, children (3-12) $4, tots free, large format films additional; Estab 1927 for a program of service & exhibits to augment & stimulate the total educative prog of schools & the gen pub; Animal displays in natural habitat settings; IMAX Theater open daily; Average Annual Attendance: 83,000; Mem: 5,900; premier $100, $250, $500, family $40, individual $28
Income: Financed by city appropriation & pvt donations
Special Subjects: Furniture, Glass, Coins & Medals, Dioramas
Collections: Glassware; Richards Coin Collection; George W Cole Smith & Wesson Gun Collection; American Indian Artifacts; Discover the Dream: Kool-Aid
Exhibitions: Groundwater Discovery Adventure - open year round; World's Largest Display of Whooping Cranes
Publications: Museum Highlights, quarterly
Activities: Classes for adults & children; lectrs open to the pub, vis lectrs varies per yr; exten prog serving pre-k; traveling exhibs one per Summer; mus shop sells books & selected gift items

HOLDREGE

M PHELPS COUNTY HISTORICAL SOCIETY, Nebraska Prairie Museum, PO Box 164, Holdrege, NE 68949-0164. Tel 308-995-5015; Fax 308-995-3955; Internet Home Page Address: www.nebraskaprairie.org; *VPres* Eileen Schrock; *Pres* Warner Carlson; *Treas & Exec Dir* Angela Cooper; *Secy* Joan Burbach
Open Mon - Sat 10 AM - 5 PM, Sun 1 - 5 PM, cl Jan 1, July 4, Thanksgiving, Easter, Christmas Eve & Christmas; No admis fee, suggested donation; Estab 1966 for preservation of County history & artifacts; Thomas F. Naegele Gallery, over 60 works depicting live in German POW camps in the US; Average Annual Attendance: 9,500; Mem: 450; dues life $1,000, family ann $30, ann $20; ann meeting in May
Income: Financed by mem, county mill levy, state contributions & estate gifts
Library Holdings: Book Volumes; Clipping Files; Fiche; Maps; Original Documents; Other Holdings genealogy information; Photographs; Records
Special Subjects: Architecture, Sculpture, Bronzes, Anthropology, Costumes, Ceramics, Crafts, Pottery, Woodcarvings, Dolls, Carpets & Rugs, Historical Material, Coins & Medals, Period Rooms, Embroidery
Collections: Agriculture equipment, china, furniture, historical items, photos, POW, military, Native American
Publications: Centennial History of Holdrege, 1883; History of Phelps County, 1873-1980; Holdrege Centennial Coloring Book; Prisoners On The Plains; Stereoscope, quarterly
Activities: Docent training; lect open to pub, 3 vis lectrs per yr; tours; book traveling exhibs; mus shop sells books, labels, souvenir plates, original art & reproductions

L Donald O. Lindgren Library, 2701 Burlington, Holdrege, NE 68949-0164; PO Box 164, Holdrege, NE 68949-0164. Tel 308-995-5015; Internet Home Page Address: www.nebraskaprairie.org; *Genealogy Librn* Sandra Slater; *Pres* Warner Carlson; *Interim Exec Dir* Susan Perry; *Office Mgr* Cheryl Mill; *Photo Archivist* Mary Payton
Open May - Oct Mon - Fri, 9 AM - 5 PM; Nov - Apr Mon - Fri, 10 AM - 4 PM, Sat - Sun 1 PM - 5 PM; Admis donations only; Estab 1966 for historic preservation & educ; Average Annual Attendance: 10,000; Mem: 400; dues $30; ann meeting in May
Income: $100,000 (financed by taxes, investment earnings & contributions)
Library Holdings: Audio Tapes; Book Volumes 1000; Cassettes; Clipping Files; Fiche; Kodachrome Transparencies; Lantern Slides; Manuscripts; Motion Pictures; Original Documents; Pamphlets; Periodical Subscriptions; Photographs; Prints; Video Tapes
Special Subjects: Posters, Historical Material, Crafts, Porcelain, Period Rooms, Dolls, Embroidery, Dioramas, Coins & Medals, Pottery
Collections: The Thomas F. Naegele Gallery contains 60 paintings depicting life in the POW camps at Atlanta & Indianola, Nebraska
Publications: The Stereoscope, quarterly
Activities: Classes for adults & children; docent training; lect open to public, 4 vis lectrs per year; tours; ext prog to schools; sales shop sells books, magazines, original art, reproductions, prints, toys, jewelry & ceramics

LEXINGTON

M DAWSON COUNTY HISTORICAL SOCIETY, Museum, PO Box 369, Lexington, NE 68850-0369. Tel 308-324-5340; Fax 308-324-5340; *Dir* Barbara Vondraf
Open Mon - Sat 9 AM - 5 PM, Sun by appt only; No admis fee; Estab 1958 to preserve Dawson County's heritage; Art gallery features exhibits by local artists; exhibits change monthly; Average Annual Attendance: 6,000; Mem: 450; dues life $150, family $20, individual $12.50
Income: Financed by endowment, mem, grants, county appropriation
Special Subjects: Textiles, Furniture
Collections: Agricultural Equipment; Furniture; Glassware; Household Implements; Quilts; Tools
Exhibitions: 1919 McCave Aeroplane; Restored Country Schoolhouse; Restored Train Engine & Depot; Log Cabin Gallery Show monthly exhibit
Publications: Dawson County Banner newsletter, quarterly

Activities: Docent progs; lect open to pub, 3 vis lectrs per yr; book traveling exhibs 2 per yr; retail store sells books, original art

LINCOLN

A LINCOLN ARTS COUNCIL, 920 O St, Lincoln, NE 68508. Tel 402-434-2787; Fax 402-434-2788; Elec Mail info@artscene.org; Internet Home Page Address: www.artscene.org; *Pres* David Erickson
Open 9 AM - 5 PM; Estab 1966 to promote & encourage arts in Lincoln & serves as central information & advocacy source for the arts in the capital city; Mem: 60 arts
Income: Financed by pvt contributions, grants, city of Lincoln contract & Nebraska Arts Council
Publications: Artscene arts calendar, bimonthly; pub art guide, gallery guide

M NEBRASKA STATE CAPITOL, 1445 K St, Lincoln, NE 68509-4924. Tel 402-471-3191; Fax 402-471-6952; Internet Home Page Address: www.capitol.org; *Mgr Capitol Restoration & Promotion* Robert C Ripley; *Preservation* Thomas L Kaspar
Open Mon - Fri 8 AM - 5 PM, Sat 10 AM - 5 PM, Sun & holidays 1 - 5 PM; Stone carvings of BAS reliefs; mosaic tile vaulting & fl panels; painted & mosaic murals; vernacular architectural ornamentation; Average Annual Attendance: 100,000
Income: Financed by state appropriation & pvt donations
Purchases: Eight murals commissioned to complete Capitol Thematic Prog
Special Subjects: Architecture, Painting-American, Sculpture, Woodcarvings, Decorative Arts, Posters, Furniture, Historical Material, Restorations, Tapestries, Leather
Collections: Lee Lawrie, building sculptor; Hildreth Meiere, mosaicist; muralists - Augustus V Tack, Kenneth Evett, James Penny, Elizabeth Dolan, Jean Reynal, Reinhold Marxhausen, F John Miller, Charles Clement, Stephen C Roberts
Publications: A Harmony of the Arts - The Nebraska State Capitol
Activities: Univ of Nebraska lect & service organization lect; retail store sells books & prints

M NEBRASKA WESLEYAN UNIVERSITY, Elder Gallery, 50th & Huntington, Lincoln, NE 68504. Tel 402-466-2371, 465-2230; Fax 402-465-2179; Internet Home Page Address: www.nebrwesleyan.edu; *Dir* Dr Donald Paoletta
Open Mon - Fri 10 AM - 4 PM, Sat & Sun 1 - 4 PM; No admis fee; Estab 1966 as a cultural addition to col & community; Average Annual Attendance: 10,000
Special Subjects: Painting-American, Prints, Sculpture
Collections: Campus coll; permanent coll of prints, paintings & sculpture
Exhibitions: Annual Fred Wells National Juried Exhib; Nebraska Art Educators; faculty show; students shows; other changing monthly shows
Activities: Classes for adults

M NOYES ART GALLERY, 119 S Ninth St, Lincoln, NE 68508. Tel 402-475-1061; Elec Mail julianoyes@aol.com; Internet Home Page Address: www.noyesart.com; *Dir* Julia Noyes
Open Mon - Sat 10 AM - 5 PM, cl Sun; No admis fee; Estab 1994 as a commercial, cooperative profit organization to exhibit, promote & sell works by regional artists; Located in 100-yr-old building near downtown Lincoln; main fl includes over 1200 sq ft exhibit area, office, storage & kitchen; second floor contains rented artist studios & classrooms
Income: Financed by mem, commissions on sales
Special Subjects: Decorative Arts, Drawings, Landscapes, Collages, Furniture, Pottery, Textiles, Painting-Japanese, Graphics, Painting-American, Photography, Sculpture, Watercolors, Ceramics, Crafts, Folk Art, Woodcarvings, Portraits, Glass, Asian Art, Silver, Metalwork, Miniatures, Mosaics, Stained Glass, Painting-Russian, Enamels
Exhibitions: Monthly exhibits of gallery & visiting artists' work
Publications: Exhibit announcements, monthly
Activities: Classes for adults & children; docent training; lect open to pub; 4 competitions with awards; gallery talks; tours; organize traveling exhibs to 5 locations across Nebr; mus shop; books; original art

UNIVERSITY OF NEBRASKA, LINCOLN
M Sheldon Memorial Art Gallery & Sculpture Garden, Tel 402-472-2461; Fax 402-472-4258; Internet Home Page Address: www.sheldon.unl.edu; *Dir* Janice Driesbach; *Cur Educ* Karen Janovy; *Cur* Daniel Siedell; *Adminr* P J Jacobs
Open Tues - Sat 10 AM - 5 PM, Thurs, Fri & Sat 7 - 9 PM, Sun 2 - 9 PM; No admis fee; Estab 1888 to exhibit the permanent colls owned by the Univ & to present temporary exhibs on an ann basis. These activities are accompanied by appropriate interpretive progs; The Sheldon Gallery, a gift of Mary Frances & Bromley Sheldon, was opened in 1963 & is the work of Philip Johnson. Facilities in addition to 15,000 sq ft of exhib galleries, include an auditorium, a print study, mems room a 25-acre outdoor sculpture garden; Average Annual Attendance: 125,000
Income: Financed by endowment, state appropriation & Nebraska Art Assoc
Purchases: $200,000
Special Subjects: Drawings, Graphics, Painting-American, Photography, Prints, Sculpture, Watercolors, Bronzes, Ceramics, Folk Art, Decorative Arts, Portraits
Collections: Frank M Hall Collection of contemporary paintings, sculpture, prints, drawings, photographs & ceramics; Nebraska Art Association Collection of American paintings & drawings; University Collections; Permanent collection includes more than 12,000 objects in various media
Exhibitions: Call for details
Publications: Exhib catalogs & brochures; sculpture coll catalogue
Activities: Educ dept; docent training; lect open to pub, 3-5 vis lectrs per yr; tours; exten dept serves State of Nebraska; individual paintings & original objects of art lent to campus offices & other institutions in US & abroad; originate traveling exhibs; gift shop sells reproductions of works of original art within the permanent coll, prints, jewelry, ceramics & unique gifts
L Architecture Library, Tel 402-472-1208; Fax 402-472-0665; Internet Home Page Address: www.unl.edu/library/arch; *Prof* Kay Logan-Peters; *Slide Cur* Judith Winkler

Open Mon - Thurs 8 AM - 10 PM, Fri 8 AM - 5 PM, Sat 1 - 5 PM, Sun 2 - 10 PM, summer Mon - Fri 8 AM - 5 PM; Estab to provide academic support for students & faculty in architectural concentration; Circ 21,000
Purchases: $25,000
Library Holdings: Audio Tapes; Book Volumes 65,000; Cassettes; Clipping Files; Exhibition Catalogs; Fiche; Filmstrips; Periodical Subscriptions 203; Photographs; Records; Reels; Slides 100,000; Video Tapes
Special Subjects: Architecture
Collections: American Architectural Books (microfilm); Architecture: Urban Documents (microfiche); Fowler Collection of Early Architectural Books (microfilm); National Register of Historic Places (microfiche); Historic American Building Survey Measure & Drawings; Slide coll

M **The Gallery of the Department of Art & Art History,** Tel 402-472-5541, 472-2631 (Main Art Office); Fax 308-832-9746; Internet Home Page Address: www.unl.edu; *Chmn & Dir* Joseph M Ruffo
Open Mon - Thurs 9 AM - 5 PM during exhibitions only; No admis fee; Estab 1985 to exhibit contemporary art by national artists; student & faculty exhibs; 2,300 sq ft with 238 running ft of exhib space in two spacious rooms; track lights; Average Annual Attendance: 8,000
Collections: Coll of UNL Student Work from BFA & MFA degree prog
Exhibitions: Undergrad, grad & faculty exhibs
Publications: Exhib catalogs

M **UNIVERSITY OF NEBRASKA-LINCOLN,** Great Plains Art Collection, Christlieb Gallery, 1155 Q St Lincoln, NE 68588-0250. Tel 402-472-6220; Fax 402-472-2960; Elec Mail gpac2@unl.edu; Internet Home Page Address: www.unl.edu/plains/gallery/gallery; *Cur* Reece Summers; *Cur Asst & Registrar* Stacey Walsh
Open Tues - Sat 10 AM - 5 PM, Sun 1:30 - 5 PM; No admis fee; Estab 1980 to promote educ & gen awareness of Western art with an emphasis on Great Plains; Relocated in new bldg 2002, increasing exhib space & maintaining a library of Western Americana with approx 7000 vols; Average Annual Attendance: 10,000; Mem: 150; dues $25 - $1000
Income: Financed by endowment, mem & state appropriation
Library Holdings: Book Volumes; Exhibition Catalogs
Collections: Broder Collection of 20th century American Indian paintings, Christlieb Collection of bronze sculpture, paintings & works on paper including drawings, prints & photographs depicting western subjects
Publications: Exhib catalogs & brochures
Activities: Creative Kids Outreach Prog; lect open to pub, 3-4 vis lectrs per yr; tours; gallery talks; individual paintings & original objects of art lent; lending coll contains 1600 items; traveling exhibs to schools throughout Nebr; sales shop sells books, original art & reproductions

MCCOOK

M **HIGH PLAINS MUSEUM,** 423 Norris Ave, McCook, NE 69001. Tel 308-345-3661; *Chmn Bd* Russell Dowling
Open Tues - Sat 1 - 5 PM, Sun 2-4 PM, cl Mon & holidays; No admis fee; donations accepted; Estab 1963 to preserve the items pertaining to local history & to interpret them for the pub; Mus is located in new building. New additions include complete pioneer kitchen; railroad section (inside & out); complete Old Time Pharmacy; 1942 Airbase; George W Norris Room; Governors From Nebraska; Average Annual Attendance: 5,000; Mem: 210; mem qualification is art display by local art club; dues $5 - $200; ann meeting in Apr
Income: Financed by mem & donations
Library Holdings: Memorabilia; Original Art Works; Pamphlets; Photographs; Records 33 1/2 phonograph records; Sculpture; Video Tapes
Collections: Paintings made on the barracks walls of prisoner of war camp near McCook; paintings donated by local artists; model railroad; displays pertaining to life of Southwest Nebr
Exhibitions: Art Exhibit
Publications: Flyer, 3-page pamphlet describing hours & show displays
Activities: Lect open to pub, 8 vis lectrs per yr; competitions; lending coll contains books, framed reproductions & motion pictures; mus shop sells books, postcards, rings for children, petrified wood, arrowheads, medallions

MINDEN

M **HAROLD WARP PIONEER VILLAGE FOUNDATION,** 138 E Hwy 6, Minden, NE 68959-0068. Tel 308-832-1210; Fax 308-832-1181; Elec Mail manager@pioneervillage.com; Internet Home Page Address: www.pioneervillage.org; WATS 800-445-4447; *Pres* Harold Warp; *Gen Mgr* Marshall Nelson
Open daily 8 AM; Admis adults $10, children 6-12 $5, children under 6 free; spec group rates; Estab 1953 to preserve man's progress from 1830 to present day; Foundation includes a 90-unit motel, 350-seat restaurant & 135-site campground; Elm Creek Fort; The People's Store; Bloomington Land Office; fire house; Lowell Depot; country school; sod house; China house; church; merry-go-round; horse barn; homes & shops building; antique farm machinery building; antique tractor & 350 autos & trucks; livery stable; agricultural building, blacksmith shop; Pony Express barn; Pony Express station; home appliance building; hobby house; John Roger statuary; William Jackson paintings; Albert Tilburne paintings; Average Annual Attendance: 80,000
Special Subjects: Historical Material
Collections: Airplanes; automobiles; bath tubs; bicycles; boats; clocks; fire wagons; guns; harvesters; horse drawn rigs; kitchens; lighting; locomotives; musical instruments; numismatics; paintings; plows; rare china; sculpture; street cars; telephones; threshers; toys; tractors; trucks
Publications: 500 Fasinating Facts; History of Man's Progress (1830-present); Pioneer Cookbook; Sister Clara's Letters (Over Our Hill-Past Our Place)
Activities: Classes for adults; elder hostel; docent training; children's progs, Holiday & Pioneer life in the Midwest; lect for mems only; tours; mus shop sells books, reproductions, prints & slides

NEBRASKA CITY

M **NEBRASKA GAME AND PARKS COMMISSION,** Arbor Lodge State Historical Park & Morton Mansion, PO Box 15, Nebraska City, NE 68410. Tel 402-873-7222; Fax 402-874-9885; Elec Mail arbor.lodge@ngpc.ne.gov; *Asst Supt* Mark Kemper; *Supt* Randall Fox
Open Apr - May Mon - Sun 11 AM - 5 PM, May - Sept Mon - Sun 10 AM - 5 PM, Sept-Oct 11 AM - 5 PM, cl Nov-March; Admis adults $3, children 3-12 $1, children 2 & under free; Estab 1923; Art coll of mems of the J S Morton family & outdoor scenes spread through a 52-room mansion; Average Annual Attendance: 90,000
Income: Financed by state appropriation
Special Subjects: Historical Material
Activities: Lect open to pub; tours; awards; Arbor Day Tree plantings on last weekend in April; sales shop sells books, Arbor Day tree pins & postcards

OMAHA

M **ARTISTS' COOPERATIVE GALLERY,** 405 S 11th St, Omaha, NE 68102. Tel 402-342-9617; Internet Home Page Address: www.artistsco-opgallery.com; *Pres* Susan Sutherland Barnes; *VPres* Robert Dewaele; *Bd Dir* Sally Dryer; *Board Dir* Margie Schimenti
Open Wed & Thurs 11 AM - 5 PM, Fri & Sat 11 AM - 10 PM, Sun Noon - 5 PM; No admis fee; Estab 1975 to be gathering place for those interested in visual art; to display quality local, contemporary art; to offer progs, panels & discussions on related issues to the pub; Gallery contains 4000 sq ft consisting of large open area with 1 small, self-contained gallery; Average Annual Attendance: 21,000; Mem: 35; dues $325 yearly; monthly meetings, work at gallery
Income: $10,000
Special Subjects: Painting-American
Exhibitions: Each month a different show features 2 - 4 mems of the gallery with a major show. December features an all-mem show; exchange exhibs & special exhibs are featured by arrangement
Activities: Exhib for elementary art students in Feb; elementary art exhibit for Adopt-a-School, Masters Elementary; lect open to pub, 2 vis lectrs per yr; concerts; gallery talks; tours; originate traveling exhibs to other cooperative galleries

M **BEMIS CENTER FOR CONTEMPORARY ARTS,** 724 S 12th St, Omaha, NE 68102-3202. Tel 402-341-7130; Fax 402-341-9791; Elec Mail info@bemiscenter.org; Internet Home Page Address: www.bemiscenter.org; *Exec Dir* Mark Masuoka
Open Tues - Sat 11 AM - 5 PM; No admis fee; Estab 1981; Maintains reference library, 3 galleries & 8 live/work studios; Average Annual Attendance: 20,000
Library Holdings: Auction Catalogs; Book Volumes; Periodical Subscriptions; Video Tapes
Special Subjects: Sculpture, Ceramics
Collections: Bemis coll of international contemporary art
Publications: Swivel, newsletter
Activities: Classes for adults & children; lect open to pub, 25-30 vis lectrs per yr; concerts; gallery talks; tours; awards; educ progs; art leasing prog; schols offered; individual paintings & original objects of art lent to museums & galleries; mus shop sells books & prints

M **CREIGHTON UNIVERSITY,** Lied Art Gallery, 2500 California Plaza, Omaha, NE 68178-0303. Tel 402-280-2636; Fax 402-280-2320; Elec Mail bohr@creighton.edu; Internet Home Page Address: www.creightonuniversity.edu; *Chmn Fine & Performing Arts Dept* Dr Marilyn Kielniarz; *Dir* G Ted Bohr S.J.; *Promotions Coordr* Robert Caudillo
Open Mon - Sun Noon - 4 PM; No admis fee; Mus estab 1973; Gallery handles 8 exhibits per academic yr; space provided for student thesis exhibits; 149 running ft; Average Annual Attendance: 2,000
Income: $8,000 (financed by school's gen funding)
Special Subjects: Drawings, Graphics, Painting-American, Photography, Prints, Sculpture, Ceramics, Pottery
Collections: Ceramics; drawings; graphics; paintings; photography; pottery & sculpture; printmaking
Exhibitions: Senior Thesis Exhibits; Creighton University Faculty Exhibit
Activities: Lect open to pub; gallery talks; book traveling exhibs

M **JOSLYN ART MUSEUM,** 2200 Dodge St, Omaha, NE 68102-1292. Tel 402-342-3300; Fax 402-342-2376; Elec Mail info@joslyn.org; Internet Home Page Address: www.joslyn.org; *Chief Cur, Cur Material Culture* Marsha V Gallagher; *Dir Marketing & Public Relations* Linda Rejcevich; *Assoc Cur 20th Century Art* Janet Farber; *Coll & Exhib Mgr* Theodore James; *Museum Shop Mgr* Jane Precella; *Assoc Cur European Art* Claudia Einecke; *Dir* J Brooks Sawyer; *Head Librn* Kathryn Corcoran
Open Tues - Sat 10 AM - 4 PM, Sun Noon - 4 PM, cl Mon & holidays; Admis adults $6, seniors & students $4, ages 5-17 $3.50, Sat 10 AM - Noon free; Estab in 1931 as a cultural center for the community. Joslyn houses works from antiquity to the present, with a spec emphasis on 19th & 20th century European & American art. In addition to the art galleries, there is the 1200-seat Witherspoon Concert Hall, the 200-seat Lecture Hall, Members Room & the Storz Fountain Court; Mus was a gift of Mrs Sarah H Joslyn in memory of her husband, George A Joslyn. Mus is a marble building covering a two-block area; contains large galleries with small exhibit areas surrounding the large central Storz Fountain Court & 1200-seat Witherspoon Concert Hall on the main fl. The concert hall is used for progs by major community music & cultural organizations. The ground fl includes exhibit areas, library, classroom, lect hall, mus shop & office; Average Annual Attendance: 130,000; Mem: 7000; dues $25 - $45
Income: Financed by mem
Special Subjects: Drawings, Graphics, Painting-American, Photography, Prints, Sculpture, Watercolors, American Indian Art, American Western Art, African Art, Pre-Columbian Art, Southwestern Art, Ceramics, Pottery, Woodcuts, Etchings & Engravings, Landscapes, Judaica, Portraits, Painting-British, Historical Material, Renaissance Art, Medieval Art, Antiquities-Egyptian

Collections: Ancient through modern art, including European & American paintings, sculpture, graphics; Art of the Western Frontier; Native American art
Exhibitions: Temporary exhibitions include traveling shows of national significance; Joslyn-organized shows; one-person & group shows in all media; Midlands Invitational; The Power of Appearances: Renaissance & Reformation Portrait Prints
Publications: Members calendar, bimonthly; exhib catalogs; art books
Activities: Creative & art appreciation classes for adults & children (pre-school through high school); spec workshops; film progs; spec tour prog of permanent colls & spec exhibs maintained for pub school children; lect & exhib gallery talks; tours of the colls & spec exhibs; mus shop sells books, magazines, reproductions, slides, cards, collectibles, posters & gifts

L **Milton R & Pauline S Abrahams Library,** 2200 Dodge St, Omaha, NE 68102. Tel 402-342-3300; Fax 402-342-2376; *Head Librn* Kathryn L Corcoran
Open Tues - Sat 10 AM - 4 PM; Estab 1931 for research only
Library Holdings: Book Volumes 32,000; Clipping Files; Exhibition Catalogs; Fiche; Other Holdings Vertical files 150; Pamphlets; Periodical Subscriptions 70; Reels; Slides 21,000
Special Subjects: Art History, Decorative Arts, Photography, Drawings, Etchings & Engravings, Graphic Arts, Painting-American, Painting-French, Prints, Sculpture, Painting-European, Watercolors, American Western Art, Asian Art, American Indian Art, Southwestern Art, Afro-American Art, Landscapes, Antiquities-Greek

M **OMAHA CHILDRENS MUSEUM, INC,** 500 S 20th St, Omaha, NE 68102. Tel 402-342-6164; Fax 402-342-6165; Internet Home Page Address: www.ocm.org; *Mktg, Publs Coordr* Michelle Brietzae; *Cur Science Educ* Bruce Berrigan; *Cur Arts, Humanities Educ* Angela Golger; *Visitor Servs Mgr* Brenda Norton; *Dir* Rudy Cooper
Open Tues - Sat 10 AM - 5 PM, Sun 1 - 5 PM, cl Mon; Admis $4, seniors $3, mem & children under 2 free; Estab 1976 to provide high-quality participation & educational experiences in the arts, humanities & science; Average Annual Attendance: 100,000; Mem: 2500 families; dues $45
Income: Financed by mem, admis, grants, donations from individuals, foundations & corporations
Exhibitions: Hands-on exhibits which promote learning in the arts, science & humanities; traveling exhibits; workshops by local professional educators & artists
Publications: Bimonthly calendar; mus newsletter, quarterly
Activities: Classes for children; summer camp; exten dept serves local metro area; book traveling exhibs 1 per yr; mus shop sells books, educational games & toys

M **UNIVERSITY OF NEBRASKA AT OMAHA,** Art Gallery, Fine Arts Bldg, Rm 137, Omaha, NE 68182-0012. Tel 402-554-2796; Fax 402-554-3435; Elec Mail N_Kelly@unomaha.edu; Internet Home Page Address: www.unomaha.edu; *Cur* Nancy Kelly
Open Mon - Fri 10 AM - 4:30 PM; No admis fee; Estab 1967 to heighten cultural & aesthetic awareness in the metropolitan & midlands area; Average Annual Attendance: 14,000
Income: Financed by state appropriation
Special Subjects: Prints
Collections: University Visiting Printmaker's Coll
Publications: Exhibition catalogs
Activities: Lect open to pub, 2 vis lectrs per yr; gallery talks; tours; competitions; schols

SEWARD

M **CONCORDIA UNIVERSITY,** (Concordia College) Marx Hausen Art Gallery, 800 N Columbia Ave, Seward, NE 68434. Tel 402-643-3651, Ext 7435; Internet Home Page Address: www.cune.edu/art/flgall.html; *Dir* Lynn Soloway
Open weekdays 8 AM - 5 PM, Sun 2 - 5 PM; No admis fee; Estab 1959 to provide the col & community with a wide variety of original art; both monthly exhibs & permanent coll serve primarily an educational need; spacious gallery has additional showcases
Income: Financed by col funds
Special Subjects: Prints, Ceramics
Collections: Ceramics; Contemporary Original Prints
Exhibitions: One & two artists exhibs; shows drawn from Permanent Coll & Annual Student Exhibs; The Art of Cartoons; Animal Show; The Computer & its Influence on Art & Design; Part II; Rotating exhibits
Activities: Gallery talks; original objects of art lent; lending coll of framed reproductions, original prints & paintings; book traveling exhibs, 6 per yr

WAYNE

M **WAYNE STATE COLLEGE,** Nordstrand Visual Arts Gallery, Art Dept, 1111 Main St Wayne, NE 68787. Tel 402-375-7000; Fax 402-375-7204; *Chmn Art Prof* Pearl Hansen; *Prof* Marlene Mueller; *Prof* Ray Replogee; *Prof* Wayne Anderson
Open Mon - Fri 9 AM - 5 PM; No admis fee; Estab Jan 1977 to provide art students with a space to display work; to enhance student's educ by viewing incoming regional professional work; to enrich cultural atmosphere of college & community; Small gallery, carpeted floors & walls, ceiling spotlights on tracts; Average Annual Attendance: 800
Income: Financed by city & state appropriation, as well as Wayne State Foundation
Library Holdings: Audio Tapes; Book Volumes; Slides
Special Subjects: Prints
Collections: Wayne State Foundation Print Collection
Activities: Lect open to pub, 1-2 vis lectr per yr; competitions; tours

WILBER

M **WILBER CZECH MUSEUM,** 102 W Third St, PO Box 253 Wilber, NE 68465. Tel 402-821-2485 (AM), 821-2183 (PM); *Exec Dir & Chmn* Irma Ourecky; *Gift Shop Mgr* Lillian Wanek
Open daily 1 - 4 PM & by appointment, cl holidays; No admis fee; Estab 1962 to preserve Czech culture & artifacts; Average Annual Attendance: 4,000; Mem: annual meeting in Dec

Income: Financed by donations & shop sales
Collections: Model rooms of homes & businesses of pioneer days; Dishes; Dolls
Activities: Tours for adult & school groups; sales shop sells Czech books & dictionaries, quilted items, country aprons & loom woven rag rugs

NEVADA

ELKO

M **NORTHEASTERN NEVADA MUSEUM,** (Northeastern Nevada Historical Society Museum) 1515 Idaho St, Elko, NV 89801. Tel 775-738-3418; Fax 775-778-9318; *Dir* Stephanie Alberts-Weber
Open Mon - Sat 9 AM - 5 PM, Sun 10 AM - 5 PM; No admis fee; admis charge for theatre prog; Estab 1968; gen mus concentrating on Northeastern Nevada; also area cultural center; Gallery is 4000 sq ft, 12 exhibits per yr local, state, regional & national artists; Average Annual Attendance: 100,000; Mem: 1300; dues $10 - $1000; ann meeting date varies
Income: $18,000 (financed by grants, contributions, dues, sales shop & memorials)
Special Subjects: Historical Material
Collections: History; Pre-History; Natural History; Art; Wildlife Exhibit
Exhibitions: Ann statewide touring photography exhibs; sound slide show - Nevada subjects
Publications: Historical, quarterly; Northeastern Nevada Historical Society Quarterly
Activities: Classes for children; docent training; lect open to pub, 15 vis lectrs per yr; concerts; gallery talks; tours; photog competitions with awards; Nevada photog exhibit tours to 13 Nevada communities; exten dept serving Nevada; lending coll of 35 film strips, 4000 slides (complete programs); 5000 photographs; 1700 books & 12 cassettes; originate traveling exhibs; mus shop sales books, magazines, prints, & local craft items

L **Library & Archives,** 1515 Idaho St, Elko, NV 89801. Tel 775-738-3418; Fax 775-778-9318; *Archivist* Marcia Browning
Open Mon - Sat 9 AM - 5 PM, Sun 1 - 5 PM; Estab for staff research
Income: $5000 (financed by contributions, dues, sales shop, memorials)
Library Holdings: Audio Tapes; Book Volumes 5000; Cassettes; Clipping Files; Exhibition Catalogs; Filmstrips; Framed Reproductions; Manuscripts; Memorabilia; Original Art Works; Pamphlets; Periodical Subscriptions 10; Photographs 25,000; Prints; Reproductions; Slides; Video Tapes
Special Subjects: Folk Art, Film, Historical Material, History of Art & Archaeology, Theatre Arts, American Western Art, Video, American Indian Art, Southwestern Art, Period Rooms, Flasks & Bottles
Collections: Newspaper and negative files
Publications: Quarterly historical publ

ELY

M **NEVADA NORTHERN RAILWAY MUSEUM,** 1100 Ave A, Ely, NV 89301; PO Box 450040, Ely, NV 89315. Tel 775-289-2085; Fax 775-289-6284; Internet Home Page Address: www.nnry.com; *CEO & Exec Dir* Mark S Bassett; *Fin Dir* Evva Schaefer; *Mus Shop Mgr* Carol Anderson
open daily June - Aug 8 AM - 7 PM, Sept - May 8 AM - 5 PM; cl Thanksgiving, Christmas Eve & Day, New Year's Eve & Day; Estab 1985; site of the orig railroad serving the mining district; consists of a rail yard with 48 structures, 3 steam locomotives, 8 diesel locomotives & many other rail cars; Average Annual Attendance: 10,000 - 49,999 by estimate; Mem: dues Life $1000, Centennial $100, Family $50, Active $30, Basic $15
Collections: Railroad equipment; buildings & artifacts related to NV Northern Railroad; mining rail equipment from the White Pine County mines
Publications: Ghost Tracks, quarterly newsletter
Activities: Long Steel Rail Festival; Planes, Trains & Automobiles; Polar Express; docent prog; formal educ for adults; guided tours; temp exhibs; mus related items for sale

LAS VEGAS

M **LAS VEGAS ART MUSEUM,** 9600 W Sahara Ave, Las Vegas, NV 89117. Tel 702-360-8000; Fax 702-360-8080; Elec Mail lvam@earthlink.net; Internet Home Page Address: www.lvamlastplace.com/exhibits/lvam; *Cur* James Mann; *Exec Dir* Marianne Lorenz; *Board Pres* David Carver; *Mus Shop Mgr* Joanne Ruzzi
Open Tues - Sat 10 AM - 5 PM, Sun 1 - 5 PM; Admis adults $5, seniors $3, children & students $2, mems free; Estab 1950 to bring national & international art to the community of Las Vegas; to offer artists a place to show, work & study; to offer good educ in fine arts to adults & children of the community; Three galleries that change bimonthly; Average Annual Attendance: 30,000; Mem: 3,000; dues family $50, individual $40, student & srs $25
Income: $600,000 (financed by mem, admis fees, donations & grants)
Collections: Contemporary artists
Exhibitions: Local & international exhibits; Art History Revisited; Dale Chihuly: The Stroemple Foundation
Publications: The Art Beat Newsletter, monthly; Monthly bulletin
Activities: Sculpture classes for adults; mus sponsors outreach prog for school; docent training; competitions; mus shop

M **LAS VEGAS NATURAL HISTORY MUSEUM,** 900 Las Vegas Blvd N, Las Vegas, NV 89101. Tel 702-384-3466; Fax 702-384-5343; Elec Mail lunathis@aol.com; *Develop* Connie VonBehren; *Educ* Paul Fredrick; *Colls* Michele Kissel; *Dir* Marilyn Gillespie
Open daily 9 AM - 4 PM; Admis adults $5.50, seniors $4.40, children $3, under 4 free; Estab 1989; Gallery has a classroom & a children's hands-on room; Average Annual Attendance: 60,000; Mem: 930, dues $35
Income: $400,000 (financed by mem & admis)

Purchases: $25,000 (Exhibit in Dinosaur Room)
Special Subjects: African Art
Collections: Art (prints), fossils, live animals, mounted animals, teaching coll
Publications: Newsletter, quarterly
Activities: Classes for adults & children; docent training; lect open to pub; book traveling exhibs annually; sales shop sells books & educ toys

L LAS VEGAS-CLARK COUNTY LIBRARY DISTRICT, 1401 E Flamingo Rd, Las Vegas, NV 89119. Tel 702-733-7810; 382-3493; Fax 702-732-7271; Internet Home Page Address: www.lvccld.org; *Dir* Daniel Walters; *Asst Dir* Gene Nelson; *Exten Svcs* Ann Langevin; *Branch Adminr* Beryl Andrus; *Branch Adminr* Sally Feldman; *Branch Adminr* Jane Lorance; *Bus Serv* Irene Voit; *Library Develop* Stan Colton; *District Gallery Dir* Denise Shapiro
Open Mon - Thurs 9 AM - 9 PM, Fri & Sat 9 AM - 5 PM, Sun 1 - 5 PM; No admis fee; Estab 1965 to provide informaton in all its varieties of form to people of all ages; nine branch libraries, including three art galleries; Circ 1,770,951; Galleries provide regularly rotating art exhibs of regional & national repute as well as ten solo shows per yr, & a regional mixed media competition every spring
Income: $5,500,000 (financed by state & county appropriation)
Purchases: $700,000
Library Holdings: Audio Tapes; Cassettes; Clipping Files; Fiche; Filmstrips; Framed Reproductions; Motion Pictures; Original Art Works; Pamphlets; Periodical Subscriptions 586; Photographs; Prints; Records; Reels; Reproductions; Sculpture
Collections: Model ship collection; Nevada materials
Exhibitions: Art-a-Fair; Nevada Watercolor Society; All Aboard: Railroads, Memorabilia; Neon: Smithsonian Exhibition; Expressions in Fiber; Graham & Breedlove; Sand & Water; Dottie Burton; Woodworks: Christian Brisepierre & Jack Daseler; KNPR Craftworks; It's a Small, Small World: Dollhouses, Kimberly House
Publications: Exhib brochures, monthly; library prog, bimonthly
Activities: Lect open to pub; concerts; tours; competitions with awards; exten dept & regional servs dept serving the area; individual paintings & original objects of art lent; book traveling exhibs; originate traveling exhibs; used book store sells books, magazines, original art & handcrafts

M Flamingo Gallery, 1401 E Flamingo Rd, Las Vegas, NV 89119. Tel 702-733-7810; Fax 702-732-7271; Internet Home Page Address: www.lvccld.org; *District Gallery Mgr* Denise Shapiro
Open Mon - Thurs 9 AM - 9 PM, Fri 9 AM - 5 PM, Sat 9 AM - 5 PM, Sun 1 - 5 PM; No admis fee; Estab 1970; Gallery is located in Clark County Library, main gallery has 80 running ft of exhibit space, upstairs gallery is used for photographic displays; Average Annual Attendance: 36,000 - 40,000; Mem: 500; dues $15, ann meeting in summer
Income: Financed by tax support, federal & state grants
Exhibitions: Art-A-Fair (judged and juried); Spirit Impressions; The Potter & the Weaver; Nevada Watercolor Society Annual exhibit
Publications: Bimonthly library calendar of events
Activities: Classes for adults & children; dramatic progs; string quartet; feature films; lect open to pub, 10 vis lectrs per yr; concerts; Art-A-Fair competition; monetary awards

M UNIVERSITY OF NEVADA, LAS VEGAS, Donna Beam Fine Art Gallery, 4505 Maryland Pky, Las Vegas, NV 89154-5002. Tel 702-895-3893; Fax 702-895-3751; Elec Mail jerry.schefcik@unlv.edu; Internet Home Page Address: finearts.unlv.edu/Facilities/Donna_Beam_Gallery/index.html; *Dir* Jerry Schefcik
Open Mon - Fri 9 AM - 5 PM, Sat 10 AM - 2 PM, cl holidays; No admis fee; Estab 1962 to exhibit contemporary art; Gallery measures 1400 sq ft, 175 linear ft with track lighting; Average Annual Attendance: 10,000
Income: Financed by mem & appropriation
Special Subjects: Painting-American, Photography, Prints
Collections: General collection of about 300 objects of all media. Works are from the United States & the 2nd half of the 20th century
Activities: Classes for adults & children; docent training; lect open to pub, 5 vis lectrs per yr; gallery talks; juried competitions with cash awards; individual painting & original objects of art lent; lending coll includes 150 original art works; book traveling exhibs 1 per yr; originate traveling exhibs to other universities & galleries

M THE WALKER AFRICAN AMERICAN MUSEUM & RESEARCH CENTER, 705 W Van Buren Ave, Las Vegas, NV 89106. Tel 702-649-2238; Fax 702-399-5400; *Founder & Cur* Gwendolyn Walker; *Develop Mem* Cynthia Lemley; *Educ* Margaret Crawford; *Pub Rels* Lillian McNorris; *Fin Dir* Juanita Walker; *Security* Jimmy Nunley Jr; *Mus Shop Mgr* Vivian Cook
Open Tues - Sat 10 AM - 6 PM, cl Christmas Day; Admis adults $2, children $1; Estab 1993; Mus is designed to promote & preserve the history of people of African descent (locally, nat & internat) with a concentration on the history of African-Americans in Las Vegas, NV; Mem: Dues Supporting $100; Mem $25
Library Holdings: Book Volumes 600
Special Subjects: Decorative Arts, Drawings, Photography, Prints, Graphics, African Art
Collections: Books, documents, artifacts, news articles, photographs & ann publs of local & state history
Publications: Black Pioneers of Nevada, ann booklet; From the Kitchen to the Boardroom: Nevada's Black Women, book; Courage, Strength & Faith: Nevada's Black Men, booklet publishes new other yr
Activities: African-American Cultural Arts Festival; films; research in early businesses owned by African-Americans in NV; mus shop sells books, dolls, stamps, Kwanzaa supplies & related items

RENO

M NEVADA MUSEUM OF ART, 160 W Liberty St, Reno, NV 89501. Tel 775-329-3333; Fax 775-329-1541; Elec Mail art@nma.reno.nv.us; Internet Home Page Address: www.nevadaart.org; *Exec Dir* Steven S High; *Dir Communications* Amy Oppio; *Cur* Diane Deming; *Assoc Cur Educ* Marlene Bowling; *Pres* Peter Pool; *Outreach Coordr* Kim Curler; *Dir Develop* Tom Jackson; *Cur of Educ* Rebecca Rosenberg; *Assoc Cur Educ* Alyssa Leck
Open Tues - Sun 11 AM - 6 PM, Thurs 11 AM - 8 PM, Sat & Sun 11 AM - 6 PM; Admis adult $7, seniors $5, children $1; Estab 1931 to collect, conserve &

exhibit 19th & 20th century American art with an emphasis on artwork which articulates our interaction with the land & environment. The colls are divided into five focus areas including a contemporary coll & altered landscape coll; The facility is a 15,000 sq ft state of the art building which holds three exhibs simultaneously; Average Annual Attendance: 65,000; Mem: 3700; dues corporation $1000, family $50; ann meeting in June; Scholarships
Income: Financed by endowment, mem, federal & pvt foundation grants, individual grants & earned income
Library Holdings: Auction Catalogs; Audio Tapes; Book Volumes; Cassettes; Exhibition Catalogs; Memorabilia; Periodical Subscriptions; Photographs; Prints; Video Tapes
Special Subjects: Drawings, Painting-American, Photography, Prints, Sculpture, Watercolors, American Indian Art, American Western Art, Bronzes, Textiles, Ceramics, Woodcarvings, Woodcuts, Etchings & Engravings, Landscapes, Manuscripts, Painting-European, Portraits, Glass, Marine Painting, Leather
Collections: E L Wiegand Art Collection (emphasis on the American work ethic); Altered Landscape Collection (photography); Contemporary collection; Historical Collection; Sierra Nevada Collection
Exhibitions: Rotating exhibs every 6 wks
Publications: Annual Bulletin; brochures; catalogues; calendar newsletter, quarterly; postcards for events, twice a month
Activities: Classes for adults & children; dramatic progs; hands-on exhibits; lect open to pub; 10 vis lectr per yr; gallery talks; tours; concerts; competitions; schols offered; outreach services to schools, sr citizens & other community groups in Greater Reno-Carson-Tahoe area; exchange prog with other museums; originate traveling exhibs; mus shop sells books

L Art Library, 160 W Liberty St, Reno, NV 89501. Tel 775-329-3333; Fax 775-329-1541; Elec Mail art@nma.reno.nv.us; Internet Home Page Address: www.nevadaart.org; *Exec Dir* Steven S High; *Library Coordr* Bob Smith; *Cur* Ann Wolfe; *Mus Shop Mgr* Helga Miller; *Cur Educ* Rachel Hartsough; *Registrar* Sara McRay; *Communications Dir* Malena Satre; *Develop Dir* Tom Jackson; *Deputy Dir* Amy Oppio
Open Tues - Sun 10 AM - 5 PM, Thurs 10 AM - 8 PM, cl Mon; Admis adults $10; Estab 1931; New 55,000 sq ft facility designed by Will Bruder opened in 2003
Library Holdings: Book Volumes 1400; Clipping Files; Exhibition Catalogs; Manuscripts; Memorabilia; Pamphlets; Periodical Subscriptions 6; Photographs; Reproductions
Special Subjects: Archaeology, American Western Art, Advertising Design, Art Education, American Indian Art, Anthropology, Aesthetics, Afro-American Art, Antiquities-Oriental, Antiquities-Byzantine, Antiquities-Egyptian, Antiquities-Etruscan, Antiquities-Greek, Antiquities-Roman, Architecture
Collections: Focus on art and environment; Altered landscape photography; Sierra Nevada/Great Basin; Contemporary; Historical
Activities: Classes for adults & children; docent training; museum school on site; lect open to public; concerts; gallery talks, tours; museum shop

A SIERRA ARTS FOUNDATION, 17 S Virginia St Ste 120, Reno, NV 89501. Tel 775-329-2787; Fax 775-329-1328; Elec Mail jill@sierra-arts.org; Internet Home Page Address: www.sierra-arts.org; *Pres* John Fowler; *Exec Dir* Jill Berryman; *VPres* Patricia Miller; *Prog Dir* Chad Cornwell; *Develop Dir* Cyndie Frankenhauser; *Communications Mgr* Allison Sertic
Open Mon - Fri 8:30 AM - 5 PM; No admis fee; Estab 1971 as a nonprofit, pvt community arts agency, advocates for & supports the arts; Contemporary works by emerging artists; Average Annual Attendance: 5,000; Mem: 800; dues $20 - $10,000 & up; ann meeting in June; Fellowships
Income: Financed by endowment, corporate & individual mem, grants & fundraising activities
Exhibitions: 6-wk exhibs of contemporary artworks throughout the yr
Publications: Art Resource Guide; Artist Registry, current list of culture organizations, facilities list & media list; Encore, monthly community arts magazine; Master Calendar; Services Booklet
Activities: Classes for children in elementary school; classes for at-risk youths in local detention facility shelter for runaway kids & alternative high school; dramatic prog; lects open to the pub; concerts; sponsoring of competitions;; grants offered; fels; exten dept; Endowment Income Grants Program for local individual artists; sales shop sells original art on consignment

M UNIVERSITY OF NEVADA, RENO, (University of Nevada) Sheppard Fine Arts Gallery, Church Fine Arts Complex, Art Dept, Mail Stop 224 Reno, NV 89557. Tel 775-784-6658; Fax 775-784-6655; Elec Mail mvecchio@unr.edu; Internet Home Page Address: www.unr.edu/art; *Art Dept Chmn* Howard Rosenberg; *Dir, Cur* Marjorie Vecchio; *Dept Secy* Wendy Ricco; *Asst Kathy Wood
Open Mon - Thurs 11 AM - 5 PM, Fri 11 AM - 2 PM, cl Sat, Sun & holidays; No admis fee; Estab 1960; UnivArt Gallery has 1800 sq ft finished exhib space & three student spaces; Average Annual Attendance: 15,000 - 24,000; Scholarships
Income: $20,000
Special Subjects: Illustration, Ceramics, Photography, Sculpture, Drawings
Collections: Local & regional Nevada artists
Exhibitions: Annual Student Exhibition
Publications: Exhibit catalogs
Activities: Lect open to pub, 6-10 vis lectrs per yr; gallery talks; tours; competitions with awards; poetry readings

SEARCHLIGHT

M SEARCHLIGHT HISTORIC MUSEUM & MINING PARK, 200 Michael Wendell Way, Searchlight, NV 89046; PO Box 36, Searchlight, NV 89046. Tel 702-297-1642; *Founder* Jane Bunker Overy
Open Mon - Fri 9 AM - 5 PM, Sat 9 AM - 1 PM, cl Sun & Holidays; available upon notice for pvt tour groups; No admis charge, donations accepted; Estab 1989; Through the use of photos & exhibs, the Searchlight Historic Mus tells the story of early mining days of Searchlight & it's former residents. Names include Clara Bow, Rex Bell, Edith Head, Louis Meyer, John MacReady & Lt William Nellis; Average Annual Attendance: 1000 - 9999; Mem: Dues Lifetime Accessor

$5000 & up; Lifetime Recorder $1000 - $4999; Grubstaker $100; Miner $75; Surveyor $50; Prospector $25; Promoter $15; Founder $5
Collections: Gold Mining memorabilia; historic photos & maps; early mining town piano; Clara Bow's clothing trunk & several of her hats as well as some of Rex Bell's clothing, both available on a rotating basis
Activities: Searchlight town founding celebration held on even-numbered yrs during the 1st Sat of Oct

NEW HAMPSHIRE

BOSCAWEN

A **NEW HAMPSHIRE ART ASSOCIATION, INC,** PO Box 3096, Boscawen, NH 03303. Tel 603-431-4230; *Admin* Angus Locke
Open Wed - Sat 10 AM - 5 PM, Sun 1 - 5 PM; Estab 1940, incorporated 1962, as a nonprofit organization, to promote the public's understanding & appreciation of the arts; to provide artists with a forum for their work & ideas. Offers a year-round exhib & sales gallery at its headquarters in Boscawen & Portsmith; an August exhib at Sunapee State Park; Mem: 400; dues $60; ann meeting in June
Income: Financed by grants, dues, patrons, rental art & sales
Exhibitions: Annuals at Currier Gallery of Art; Summer Annual combined with New Hampshire League of Arts & Crafts at Mount Sunapee State Park; Summer Annual Juried Exhibition at Prescott Park; Year-Round exhibits at N E Center; Durham NH; various one-person & group shows
Activities: Educ prog for schools; patron prog; lect demonstrations by mem artists; awards; originate traveling exhibs

CENTER SANDWICH

M **SANDWICH HISTORICAL SOCIETY,** 4 Maple St, Center Sandwich, NH 03227. Tel 603-284-6269; Fax 603-284-6269; Elec Mail sandwichhistory@fcgnetw.com; Internet Home Page Address: sandwichnh.com/history; *Cur* Robin Dustin; *VPres* D Bruce Montgomery; *CEO* Craig Evans; *Mus Shop Mgr* Sue Bowden
Open June - Sept Tues - Sat 11 AM - 5 PM; Admis donations accepted; Estab 1917
Collections: Paintings by Albert Gallatin Hoit (oil & water); Paintings by E Wood Perry (oil); Furniture
Publications: Annual Excursion Bulletin; newsletter, 3 per yr
Activities: Excursions, tours

CHESTER

L **CHESTER COLLEGE OF NEW ENGLAND,** (White Pines College) Wadleigh Library, 40 Chester St, Chester, NH 03036. Tel 603-887-7454; Fax 603-887-1777; Elec Mail LKandres@whitepines.edu; Internet Home Page Address: www.whitepines.edu; *Librn* Marie Lasher
Open various hours; Estab 1965 for lending & reference purposes; Circ 26,000
Library Holdings: Book Volumes 25,000; DVDs 200; Video Tapes 300

CONCORD

A **LEAGUE OF NEW HAMPSHIRE CRAFTSMEN,** League Gallery, 205 N Main St, Concord, NH 03301. Tel 603-224-1471; Fax 603-225-8452; Internet Home Page Address: www.nhcrafts.org; *Dir* Susie Lowe-Stockwell
Open Mon - Fri 9 AM - 5 PM; Estab 1932 to encourage the economic development & educ of the crafts; gallery displaying exhibits of mems' works; Average Annual Attendance: 5,000; Mem: 3,000; dues individual $20; ann meeting in Oct; Scholarships
Exhibitions: Annual Craftsmen's Fair; Living with Crafts; Annual Juried Exhibit
Publications: Newsletter, quarterly
Activities: Classes for adults; exhibits; competitions with awards; lending collection of books; traveling exhib & tours throught the year
L **Library,** 205 N Main St, Concord, NH 03301. Tel 603-224-1471; Fax 603-225-8452; *Dir* Susie Lowe-Stockwell
Open to members
Income: Financed by league operating funds
Library Holdings: Book Volumes 1100; Cassettes; Periodical Subscriptions 30
Special Subjects: Crafts

A **NEW HAMPSHIRE HISTORICAL SOCIETY,** Museum of New Hampshire History, 6 Eagle Square, Concord, NH 03301. Tel 603-228-6688; Fax 603-228-6308; Elec Mail library@nhhistory.org; Internet Home Page Address: www.nhhistory.org; *Pres* Theresa Rosenberger; *Librn* Bill Copeley; *Exec Dir* William Ueillerte; *Dir Coll* Wesley Balla
Open Tues, Wed, Fri & Sat 9:30 AM - 5 PM, Thurs 5 AM - 8:30 PM, Sun Noon - 5 PM; open Mon 9:30 AM - 5 PM, July - Oct 15 & Dec; Admis adults $5.50, seniors $4, ages 6 - 18 $2.50, children under 6 free; Estab 1823 to collect, preserve & make available books, manuscripts & artifacts pertaining to the history of New Hampshire; gallery maintained; Exhib gallery maintained; Average Annual Attendance: 50,000; Mem: 4,000; dues family $50, individual $30; ann meeting first Sat in May
Purchases: $20,000
Library Holdings: Auction Catalogs; Book Volumes; Clipping Files; Exhibition Catalogs; Manuscripts; Maps; Memorabilia; Original Art Works
Special Subjects: Photography, Silver, Textiles, Painting-American, Ceramics, Furniture
Collections: Artifacts made or used in New Hampshire including colls of glass, furniture, metals, paintings, silver & textiles; Fine and Decorative Arts; Historical Memorabilia

Exhibitions: New Hampshire Through Many Eyes; Consumer Views: Art & Tourism in the White Mountains
Publications: Historical New Hampshire, biannual; exhib catalogs; semiannual newsletter
Activities: Classes for adults & children; docent training; lect open to pub; 8 vis lects per yr; over 50 pub progs per yr; progs & tours for children; gallery talks; bus tours; 1 book traveling exhib; originate traveling exhibs to museums & libraries, local historical societies; exhibs include: Before Their Times: Child Labor Through the Lens of Lewis Hine & Soldiers, Sailors, Slaves & Ships: The Civil War Photographs of H P Moore; mus shop sells books, reproductions, prints, gifts & crafts, The White Mountains of New Hampshire

L **Library of History & Genealogy,** 30 Park St, Concord, NH 03301. Tel 603-228-6688; Fax 603-224-0463; Elec Mail bcopeley@nhhistory.org; Internet Home Page Address: www.nhhistory.org; *Librn* William Copeley; *Spec Coll Librn* David Smolen
Tues-Sat 9:30-5PM; Research fee for non-members, $7 per day; Estab 1823; Reference library only; Average Annual Attendance: 3,000; Mem: 4,500; dues $30
Library Holdings: Audio Tapes; Book Volumes 50,000; Cassettes; Exhibition Catalogs; Manuscripts; Maps; Motion Pictures; Original Art Works; Original Documents; Other Holdings Newspapers; Pamphlets; Periodical Subscriptions 150; Photographs; Prints; Records; Reels; Slides; Video Tapes
Special Subjects: Art History, Landscape Architecture, Decorative Arts, Illustration, Photography, Manuscripts, Maps, Painting-American, Posters, Prints, Sculpture, Historical Material, Ceramics, Crafts, Archaeology, Fashion Arts, Porcelain, Furniture, Glass, Bookplates & Bindings, Handicrafts, Pottery, Restoration & Conservation, Silver, Textiles, Pewter, Architecture, Folk Art, Portraits
Collections: History & genealogy of New Hampshire & New England; American art
Activities: Classes for adults & children; docent training; lect open to pub; 4 vis lectrs per yr; concerts; tours; book traveling exhibitions; organize traveling exhibitions; museum shop sells books, reproductions & New Hampshire products

M **SAINT PAUL'S SCHOOL,** Art Center in Hargate, 325 Pleasant St, Concord, NH 03301. Tel 603-229-4644; Fax 603-229-5696; *Gallery Asst* Carol Shelton; *Dir Art Center* Colin J Callahan
Open Tues - Sat 10 AM - 4:30 PM, during school yr; No admis fee; Estab 1967 to house the Art Dept of St Paul's School, to provide a cultural center for the school community as well as central New Hampshire; Secure gallery, 50 X 40 ft; Average Annual Attendance: 5,000
Income: Financed by endowment
Collections: Collection represents varied periods & nationalities, chiefly gifts to the school, drawings, graphics, painting & sculpture
Activities: Lect & classes for students & school community only; gallery receptions & lect open to the pub; tours; original objects of art lent to qualifying institutions
L **Ohrstrom Library,** 325 Pleasant St, Concord, NH 03301-2591. Tel 603-229-4862; Fax 603-229-4888; Elec Mail brettew@sps.edu; Internet Home Page Address: www.sps.edu/library; *Librn* Robert H Rettew
Open Mon - Fri 7:30 AM - 10 PM, Sat 8 AM - 10 PM, Sun 10 AM - 10 PM; Estab 1967 for art reference only; Circ 600
Income: $1000 (financed by endowment)
Purchases: Approx $1000
Library Holdings: Book Volumes 50,000; Exhibition Catalogs; Periodical Subscriptions 150; Reproductions; Slides

CORNISH

M **SAINT-GAUDENS NATIONAL HISTORIC SITE,** 139 Saint-Gauden Rd, Cornish, NH. Tel 603-675-2175; Fax 603-675-2701; Elec Mail saga@valley.net; Internet Home Page Address: www.nps.org; *Supt & Cur* John H Dryfhout; *Cur* Henry Duffy; *Chief Ranger* Gregory Schwarz
Open daily 9 AM - 4:30 PM (May 22- Oct 31); Admis 17 & over $6; Estab 1926, transferred to Federal Government (National Park Service) in 1965 to commemorate the home, studios & works of Augustus Saint-Gaudens (1848-1907), one of America's foremost sculptors. The site has historically (1907) furnished rooms, studios & gardens displaying approximately half of the work of Augustus Saint-Gaudens; Average Annual Attendance: 40,000; Mem: Friends of Saint-Gaudens Memorial
Income: Financed by federal appropriation (National Park Service)
Purchases: Works by Augustus Saint Gaudens; original furnishings of the Cornish Property
Library Holdings: Auction Catalogs; Book Volumes; CD-ROMs; Cassettes; Clipping Files
Special Subjects: Furniture, Sculpture, Period Rooms
Collections: Historic furnishings & sculpture; plaster, bronze & marble works by Augustus; Saint Gaudens
Publications: Catalogs & books, exhib checklists, postcards, pamphlets, handbooks
Activities: Gallery talks; tours; original objects of art lent to museums; book traveling exhibs; originate traveling exhibs; mus shop sells books & slides
L **Library,** St Gaudens Rd, Cornish, NH; 139 Saint-Gaudens Rd, Cornish, NH 03745. Tel 603-675-2175; Fax 603-675-2701; Internet Home Page Address: www.sgnhs.org; *Supt* B J Dunn; *Supr Interpretation* Gregory C Schwarz; *Cur & Div Chief* Henry J Duffy; *Admin Ofcr* April May GeLineau; *Mus Spec* Martha Knapp
Library open by appointment only; Museum open Memorial Day weekend - Oct 31 9:00 AM - 4:30 PM; 16 & up $5; Circ Non-circulating; Sculpture by Augustus Saint-Gaudens
Income: Financed by federal appropriations
Library Holdings: Audio Tapes; Book Volumes 1400; Clipping Files; Exhibition Catalogs; Manuscripts; Memorabilia; Pamphlets; Photographs; Slides; Video Tapes
Special Subjects: Art History, Landscape Architecture, Decorative Arts, Painting-American, Historical Material, History of Art & Archaeology, Ceramics, American Western Art, Bronzes, Art Education, Period Rooms, Jewelry, Landscapes, Coins & Medals, Architecture

Collections: Sculpture; Antique furnishings relating to Augustus Saint-Gaudens
Activities: Classes for adults & children; lect open to the public; concerts; gallery talks; tours; lend original objects of art to other mus; mus shop sells books

DURHAM

M **UNIVERSITY OF NEW HAMPSHIRE,** The Art Gallery, Paul Creative Arts Ctr, 30 College Rd Durham, NH 03824-3538. Tel 603-862-3712, 3713 (outreach); Fax 603-862-2191; Elec Mail art.gallery@unh.edu; Internet Home Page Address: www.unh.edu/art-gallery; *Asst Dir* Astrida Schaeffer; *Dir* Vicki C Wright; *Educ & Publicity Coordr* Catherine Mazur; *Admin Asst* Cynthia Farrell
Open Mon - Wed 10 AM - 4 PM, Thurs 10 AM - 8 PM, Sat & Sun 1 - 5 PM, cl Fri, University holidays & June - Aug; No admis fee; Estab 1960 renovated 1973, teaching coll for univ faculty & students outreach & pub service functions for the non-univ community; Circ 40,000 students per yr; Upper mezzanine & lower level galleries with a total of 3800 ft of exhib space; 900 ft storage room to house permanent coll & temporary loans; additional storage & ofc space; Average Annual Attendance: 8,500; Mem: 251
Income: $220,000 (financed by state, mem, sales, interest & private support)
Special Subjects: Drawings, Painting-American, Photography, Prints, Etchings & Engravings, Landscapes
Collections: 19th century American landscapes, 19th century Japanese prints & 20th century works on paper
Exhibitions: Temporary exhibs; The Art Gallery features exhibs ranging from historical to contemporary from Sept through May each yr
Publications: Exhib catalogs
Activities: Educational prog for area schools; workshops; docent training; lect open to pub, 6-8 vis lectrs per yr; concerts; gallery talks; tours; fels offered; lending of original objects of art to other museums; book traveling exhibs 1-3 per yr; originate traveling exhibs; sales shop sells books, magazines & notecards
L **Dept of the Arts Slide Library,** Paul Creative Arts Ctr, Durham, NH 03824. Tel 603-862-1366; Fax 603-862-2191; Internet Home Page Address: www.unh.edu; *Slide Librn* Barbara Steinberg
Open daily 8 AM - 4:30 PM; Estab as a teaching coll for the univ; Slides do not circulate off-campus
Library Holdings: Slides 132,000

EXETER

M **PHILLIPS EXETER ACADEMY,** Lamont Gallery, Frederic R Mayer Art Bldg - Phillips Exeter Academy, 20 Main St Exeter, NH 03833. Tel 603-777-3461; Fax 603-777-4371; Elec Mail gallery@exeter.edu; Internet Home Page Address: www.exeter.edu; *Principal* Tyler Tingley; *Asst* Christy Michaud Woods; *Dir* Karen Burgess Smith
Open Mon 1 - 5 PM, Tues - Sat 9 AM - 5 PM; No admis fee; Estab 1953 to provide an Art Center & studios for art instruction dedicated to the memory of Thomas William Lamont II, lost in action in 1945; Four bays with moveable walls to alter number & size of bays, sky lit with sol-r-veil screen
Exhibitions: Exhibits change every 4-6 weeks
Activities: Classes for Academy students; dramatic progs; lect open to pub, 5 vis lectr per yr; gallery talks; lending coll; book traveling exhibs

HANOVER

M **DARTMOUTH COLLEGE,** Hood Museum of Art, Hanover, NH 03755. Tel 603-646-2808; Fax 603-646-1400; *Cur European Art* T Barton Thueber; *Cur Exhib* Evelyn Marcus; *Cur American Art* Barbara MacAdam; *Registrar* Kellen Haak; *Business Mgr* Nancy McLain; *Assoc Registrar* Kathleen O'Malley; *Asst Registrar* Cynthia Gilliland; *Cur Educ* Lesley Wellman; *Cur Acad Progs* Katherine Hart; *Exhib Coordr* Juliette Bianco; *Pub Rels Coordr* Sharon Reed; *Tour Coordr* Linda Ide; *Chief Preparator* Nicolas Nobili; *Bus Asst* Roberta Shin; *Admin Asst to Dir* Mary McKenna; *Dir* Derrick R. Cartwright
Open Tues - Sat 10 AM - 5 PM, Sun Noon - 5 PM, Wed until 9 PM; No admis fee; Estab 1772 to serve the Dartmouth community & Upper Valley region; New building, designed by Charles Moore & Chad Floyd of Centerbrook, completed in 1985, houses ten galleries; Average Annual Attendance: 70,000; Mem: 2100; dues $45 - $1000; ann meeting in July
Income: Financed through Dartmouth College, endowment income, contributions & grants
Special Subjects: Drawings, Painting-American, American Indian Art, Bronzes, African Art, Anthropology, Landscapes, Portraits, Antiquities-Greek, Antiquities-Etruscan, Antiquities-Assyrian
Collections: The Hood Museum has about 24,000 fine art objects & about 28,000 historical anthropological objects; especially strong in areas such as 19th & 20th century American art, 17th century paintings & European & American prints; also has a survey of Native American, African, Asian & Pre-Columbian artifacts; Oceanic Collection
Exhibitions: Approximately fifteen temporary exhibs per yr on a wide range of subjects. Exhibs include those organized by the mus, traveling exhibs & exhibs drawn from permanent colls
Publications: Museum catalogues, ann
Activities: Classes for adults & children; docent training; teacher training; lect open to pub, 8-10 vis lectrs per yr; gallery talks; tours; awards; individual paintings & original objects of art lent to other museums & campus depts; book traveling exhibs 1-2 per yr; originate traveling exhibs; mus shop sells books, cards, posters, original art, reproductions & jewelry
L **Sherman Art Library,** Carpenter Hall, Hanover, NH 03755-3570. Tel 603-646-2305; Fax 603-646-1218; Internet Home Page Address: www.dartmouth.edu/library/thelibs/sherman.html; *Librn* Barbara E Reed
Open Mon - Thurs 8 AM - 12 AM, Fri 8 AM - 6 PM, Sat 9 AM - 6 PM, Sun 1 PM - 12 AM, during school terms (reduced hours in summer & during intersessions); Estab 1928
Library Holdings: Book Volumes 110,000; CD-ROMs; Exhibition Catalogs; Fiche 100,000; Other Holdings Videodiscs; Pamphlets; Periodical Subscriptions 530; Reels 111

Special Subjects: Photography, Architecture

HOPKINTON

M **NEW HAMPSHIRE ANTIQUARIAN SOCIETY,** 300 Main St, Hopkinton, NH 03229. Tel 603-746-3825; *Exec Dir* Elaine Loft
Open Thurs & Fri 10 AM - 5 PM, Sat 10 AM - 2 PM; No admis fee; Estab 1859 to preserve local & state historical genealogical records & colls, & to provide the community with cultural & historical progs of local significance; Gallery houses artifacts pertaining to local history; maintains a reference library; Average Annual Attendance: 2,000; Mem: 425; dues $15 - $200; ann meeting in Jan
Income: $7,000
Special Subjects: Furniture, Historical Material
Collections: Early American furniture, clothing, china, portraits; local historical material
Exhibitions: And the Band Played On: Civil War Bands & Music; Going Way Back to School; Open for Business; annual art show featuring works of regional artists; rotate 2 per yr
Activities: Educ prog; classes for children; pub progs; lect open to pub, 6 vis lectrs per yr; concerts; gallery talks; tours; competitions; individual paintings & original objects of art lent; mus shop sells books, prints, artisan wares, jewelry, gifts, toys, cards & magnets

KEENE

M **HISTORICAL SOCIETY OF CHESHIRE COUNTY,** 246 Main St, PO Box 803 Keene, NH 03431. Tel 603-352-1895; Fax 603-352-9226; Elec Mail hscc@hsccnh.org; Internet Home Page Address: www.hsccnh.org; *Dir* Alan Rumrill, MLS; *Educ Dir* Thomas Haynes
Open Tues, Thurs - Fri 9 AM - 4 PM, Wed 9 AM - 9 PM, Sat 9 AM - Noon; No admis fee; Estab 1927 to collect, preserve & share history of southwest New Hampshire; Average Annual Attendance: 12,000; Mem: 900; dues $30- $100; ann meeting fourth Mon in Apr
Income: $255,000 (financed by endowment & mem)
Purchases: $1,000
Special Subjects: Ceramics, Pottery, Manuscripts, Furniture, Glass, Silver, Historical Material, Maps, Period Rooms
Collections: Archival colls, books, furniture, glass, maps, photos, pottery, silver, toys; paintings
Publications: Newsletter, 5 times annually
Activities: Classes for adults & children; lect open to pub, 6 vis lectrs per yr; gallery talks; tours; book traveling exhibs 1-2 per yr; sales shop sells books & reproductions

M **KEENE STATE COLLEGE,** Thorne-Sagendorph Art Gallery, Wyman Way, Keene, NH 03435-3501; 229 Main St, Keene, NH 03435-3501. Tel 603-358-2720; Fax 603-358-2238; Elec Mail thorne@keene.edu; Internet Home Page Address: www.keene.edu/tsag; *Dir* Maureen Ahearn; *Admin Asst* Colleen Johnson; *Tech* Paul Knowlton
Open Sept - May Sat - Wed Noon - 4 PM, Thurs & Fri Noon - 7 PM, June - Aug Wed-Sun Noon - 4 PM; No admis fee; Estab 1965 to provide a year-round calendar of continuing exhibs; to sponsor related progs of artistic & educ interest & to maintain small permanent colle displayed on campus; Two adjacent galleries occupy space in new facility opened in 1993 on campus; Average Annual Attendance: 9,000; Mem: 575; dues $15
Income: Financed by endowment, state appropriation & ann college budget
Special Subjects: Painting-American, Prints, African Art
Collections: Paintings & Prints of Historical Interest included: Pierre Alechinsky; Milton Avery; Chuck Close; Robert Mapplethorpe; Paul Pollero; Gregorio Prestopino; George Rickey; Sidney Twardowicz; Artists of National Prominence including Jules Olitski; Paintings by Regional Artists
Publications: Small catalogs or brochures to accompany exhibs
Activities: Classes for children; docent training; lect open to pub, 1-5 vis lectr per yr; gallery talks; competitions & awards; book traveling exhibs; organize traveling exhibs regionally

MANCHESTER

M **THE CURRIER MUSEUM OF ART,** Currier Museum of Art, 201 Myrtle Way, Manchester, NH 03104. Tel 603-669-6144; Fax 603-669-7194; Internet Home Page Address: www.currier.org; *Pres* Patrick Duffy; *Mktg & Pub Relations* Karen Tebbenhoff; *Librn* Alison Dickey; *Cur P Andrew Spahr*; *Deputy Dir* Susan Leidy; *Dir Finance* Sherry Collins; *Registrar* Karen Papineau; *Group Tour Admin* Carol Smiglin; *Shop Mgr* Heidi Norton; *Preparator* Bob Kephart; *Assoc Cur* Dr K Sundstrom; *Dir Art Center* Bruce McColl; *Dir Develop* Jeffrey Fuller; *Asst Registrar* Alex Kalish
Open Sun, Mon, Wed, & Fri 11 AM - 5 PM, Thurs 11 AM - 8 PM, Sat 10 AM - 5 PM, cl Tues; Admis adults $7, seniors & students 18 & older $6, children under 18 & mems free; Estab & incorporated 1915 by will of Mrs Hannah M & Governor Moody Currier, which included endowment, building opened in 1929; Circ Non-circulating; Building contains six galleries, library & auditorium, two pavilions. Currier Art Center offers after-school & Sat classes for adults & children; Average Annual Attendance: 50,000; Mem: 3800; dues $25 & up
Income: Financed by endowment
Library Holdings: Auction Catalogs; Book Volumes 15,000; CD-ROMs; Clipping Files; Exhibition Catalogs; Lantern Slides; Manuscripts; Pamphlets; Periodical Subscriptions; Photographs; Records; Slides; Video Tapes
Special Subjects: Historical Material, Landscapes, Ceramics, Glass, American Western Art, Prints, Painting-French, Sculpture, Architecture, Drawings, Painting-American, Photography, Watercolors, American Indian Art, African Art, Textiles, Folk Art, Woodcarvings, Etchings & Engravings, Manuscripts, Portraits, Porcelain, Oriental Art, Asian Art, Silver, Painting-British, Painting-Dutch, Tapestries, Baroque Art, Painting-Flemish, Renaissance Art, Embroidery, Medieval

Art, Painting-Spanish, Painting-Italian, Painting-German, Pewter, Painting-Russian, Enamels, Bookplates & Bindings

Collections: American Furniture, glass & textiles 18th - 20th century; American Paintings & Sculpture 18th century to present; European Paintings, prints & sculpture, 13th - 20th century; European Masters 13th - 20th century; Fine American Decorative Art 17th - 19th century including furniture, glass textiles & silver; Frank Lloyd Wright designed residence, Zimmerman House, opened seasonally for tours

Publications: Bulletin, semiannually; calendar, quarterly; exhib catalogs, occasionally; Ann Report

Activities: Classes for adults & children; docent training; lect open to pub, 10 vis lectrs per yr; concerts; gallery talks; tours; school progs & outreach presentations for 4th & 5th graders; individual paintings & original objects of art lent to art institutions worldwide; lending coll contains original art works, original prints, paintings, photographs & sculpture; book traveling exhibs 1 per yr; originate traveling exhibs to art museums; mus shop sells books, jewelry, prints, reproductions

L **Library,** 201 Myrtle Way, Manchester, NH 03104. Tel 603-669-6144 x 127; Internet Home Page Address: www.currier.org; *Librn* Michele Turner
Open Wed - Fri 1 - 4:30 PM
Library Holdings: Auction Catalogs; Book Volumes 15,000; Clipping Files; Exhibition Catalogs; Periodical Subscriptions 26
Special Subjects: Folk Art, Decorative Arts, Photography, Architecture
Collections: Frank Lloyd Wright, general photography collection

L **MANCHESTER CITY LIBRARY,** 405 Pine St, Manchester, NH 03104-6199. Tel 603-624-6550, ext 334; Fax 603-624-6559; Internet Home Page Address: www.manchester.lib.nh.us; *Fine Arts Librn* Beverly M White
Open Mon, Tues & Thurs 8:30 AM - 8:30 PM, Wed, Fri & Sat 8:30 AM - 5:30 PM
Income: Financed by city appropriations
Purchases: $6000
Library Holdings: Book Volumes 22,694; Cassettes 6150; Framed Reproductions 99; Other Holdings Compact discs 2100; Records 3000; Video Tapes 2200
Exhibitions: Patron's art works, crafts, collectibles

A **MANCHESTER HISTORIC ASSOCIATION,** 255 Commercial St, Manchester, NH 03101; 129 Amherst St, Manchester, NH 03101. Tel 603-622-7531; Fax 603-622-0822; Elec Mail history@manchesterhistoric.org; Internet Home Page Address: www.manchesterhistoric.org; *VPres* Donald E Gardner; *Dir* Gail Nessell Colglazier; *Cur Coll* Marylou Ashooh Lazos; *Develop Coordr* Amanda Abbott; *Coordr School Prog* Deborah Longman-Marien; *Mus Shop Mgr* Judy LaFlamme; *Pub Progs Coordr* Linda Coleman; *Cur Library Coll* Eileen O'Brien; *Coordr Pub Rels* Bill Millios
Open Tues - Sat 10 AM - 4 PM, Sun Noon - 4 PM, cl national & state holidays; Admis adults $4, students & seniors $3, children under 6 free; Estab 1896 to collect, preserve & make known Manchester's historical heritage; Permanent exhibit on Manchester history; 12,000 sq ft changing exhibit gallery; Average Annual Attendance: 10,000; Mem: 700; dues $25, over & up
Library Holdings: Book Volumes; Clipping Files; Fiche; Manuscripts; Maps; Memorabilia; Micro Print; Original Documents; Periodical Subscriptions; Photographs; Video Tapes
Special Subjects: Historical Material
Collections: Amoskeag Manufacturing Company records; artifacts, books, documents, maps & photographs on Manchester History; paintings, sculpture, decorative arts relating to Manchester
Exhibitions: Permanent & changing exhibs reflecting all aspects of Manchester history; 2 -3 changing exhibits per yr
Publications: Annual report; newsletter, calendar of events, books, videos
Activities: Educ prog; classes for adults & children; walking tours; family progs; lects open to pub; concerts; gallery talks; tours; pub & school progs linked to permanent & changing exhibits; outreach progs; research library; ann Historic Preservation awards prog; mus shop sells books, original art, reproductions, gift items

L **Library,** 129 Amherst St, Manchester, NH 03101. Tel 603-622-7531; Fax 603-622-0822; Elec Mail history@manchesterhistoric.org; Internet Home Page Address: www.manchesterhistoric.org; *Dir* Gail Nessell Colglazier; *Cur* Maryloo Ashooh Lazos; *Asst Librn* Arlene Crossett; *Asst Librn* Joni Merritt
Open Tues - Sat 10 AM - 4 PM; Estab as research library open to pub
Library Holdings: Book Volumes 5000; Cassettes; Clipping Files; Manuscripts; Memorabilia; Other Holdings Maps 500; Pamphlets; Periodical Subscriptions 14; Photographs 20,000; Prints; Reproductions
Collections: Amoskeag Manufacturing Company Archives; art; architecture; cloth samples; decorative arts; documents; early textile mill records; manuscripts; 19th century music; photos; publications of local history

M **NEW HAMPSHIRE INSTITUTE OF ART,** (Manchester Institute of Arts & Sciences Gallery) 148 Concord St, Manchester, NH 03104. Tel 603-623-0313; Fax 603-641-1832; Internet Home Page Address: www.nhia.edu; *VPres Acad Affairs* Karen Burgess Smith; *Acad Affairs Asst* Christine Fales; *Dir Communications* Linda Seabury; *VPres Operations* Sandra Barry; *Interim Pres* Daniel Lyman; *VPres Finance* Erik Gross
Open Mon - Sat 9:30 AM - 5 PM; No admis fee; Estab 1898, as a pvt nonprofit educational institution in order to promote, encourage & stimulate educ in the arts & sciences; Gallery has limited space which is devoted to a variety of exhibs including historical as well as contemporary themes; Mem: 670; dues family $35, individual $25; ann meeting in June
Income: Financed by endowment, mem, tui & grants
Publications: Exhib catalogs; schedule of courses, exhibs & progs, 2 - 3 times per yr
Activities: Classes for adults & children; competitions with prizes; schols & fels offered; sales shop sells handcrafted items, books & art supplies

M **SAINT ANSELM COLLEGE,** Chapel Art Center, Saint Anselm College, 100 Saint Anselm Dr Manchester, NH 03102. Tel 603-641-7470; Fax 603-641-7116; *Dir* Donald Rosenthal; *Asst Dir* Iain McLellan, OSB
Open Tues - Sat 10 AM - 4 PM, Thurs until 9 PM; No admis fee; Estab 1967; Large gallery, formerly college chapel with painted, barrel-vaulted ceiling, stained glass windows; Average Annual Attendance: 5,000

Income: Financed through col
Special Subjects: Drawings, Painting-American, Prints, Sculpture, Crafts, Decorative Arts
Collections: New Hampshire artists & craftsmen; Prints
Exhibitions: Family Pictures: Restructuring the Family Album; Latin American Colonial Religious Art from the Mabee-Gerrer Museum; recent landscape painting; contemporary religious art
Publications: Exhib catalogues, occasional
Activities: Lect open to pub; 4 vis lectrs per yr; gallery talks; concerts; EW Poore and NH Institute of Art awards for student works; individual paintings lent to faculty & staff of Saint Anselm College; lending coll contains paintings; book traveling exhibs 1-2 per yr; originate traveling exhibs

M **SEE SCIENCE CENTER,** 200 Bedford St, Manchester, NH 03101. Tel 603-669-0400; Fax 603-669-0400; Elec Mail info@see-sciencecenter.org; Internet Home Page Address: www.see-sciencecenter.org; *CEO & Dir* Douglas Heuser; *Educ & Mem* Rebecca Mayhew; *Opers & Design* Adele Maurier; *Exhibs* Peter Gustafson
Open Mon - Fri 10 AM - 3 PM, Sat & Sun 12 PM - 5 PM; cl New Year's Day, Easter, July 4th, Thanksgiving & Christmas; Admis $5, mems & children under 1 no admis fee; A hands-on science ctr estab 1986 to promote the understanding & excitement of science for all ages; Average Annual Attendance: 50,000 - 99,999; Mem: dues Family $60
Publications: SEE News, quarterly newsletter
Activities: Guided tours; traveling exhibs

PLYMOUTH

L **PLYMOUTH STATE UNIVERSITY,** Karl Drerup Art Gallery, Draper & Maynard, MSC 21B, Plymouth, NH 03264. Tel 603-535-2614; Internet Home Page Address: www.plymouth.edu/gallery; *Dir* Catherine Amidon; *Asst* Jan Serfass
Open Mon - Tues & Thurs -Sat Noon - 5 PM, Wed Noon - 8 PM; Estab 1871 to serve the acad and personal needs of the college's students & faculty; Maintains exhib space of 1960 sq ft
Income: 40,000
Purchases: $250,000
Library Holdings: Pamphlets
Activities: Lect open to pub; library tours; bibliographic instruction; gallery talks

PORTSMOUTH

A **LA NAPOULE ART FOUNDATION,** Chateau de la Napoule, 799 South St, Portsmouth, NH 03801. Tel 603-436-3040; Fax 603-430-0025; Elec Mail LNAF@clews.org; Internet Home Page Address: www.LNAF.org; *Pres* Christopher S Clews; *Exec Dir* Noele M Clews
Daily 10 AM - 6 PM; $5; Estab 1950 as an American organization to build Franco-American relations through a wide range of educational & artistic programs; Foundation's programs & artists' residencies take place year-round at the architecturally significant Chateau de la Napoule, located West of Cannes on the shores of the Mediterranean. The Chateau houses the permanent collection of 20th century sculptor, Henry Clews & changing contemporary exhibitions fill the Strawbridge Gallery; Average Annual Attendance: 8,000
Income: Financed by private & pub funds, governmental agencies, private foundations & individuals
Library Holdings: Book Volumes; Clipping Files; Exhibition Catalogs; Framed Reproductions; Lantern Slides; Manuscripts; Maps; Memorabilia; Original Art Works; Original Documents; Other Holdings; Photographs; Prints; Reproductions; Sculpture; Slides
Special Subjects: Architecture, Drawings, Etchings & Engravings, Historical Material, Landscapes, Manuscripts, Porcelain, Posters, Sculpture, Watercolors, Painting-American, Pottery, Stained Glass, Antiquities-Oriental, Bronzes, Decorative Arts, Ceramics, Portraits, Furniture, Woodcarvings, Period Rooms, Maps, Painting-European, Painting-Italian
Collections: Definitive collection of the paintings and sculpture of 20th-century artist Henry Clews; Staffordshire Pottery of James & Ralph Clews
Exhibitions: on-going exhibitions: architecture of the chateau, extensive gardens; 3 exhibits per year of contemporary art & sculpture; exhibits of resident artists; garden sculpture
Activities: Classes for children & adults; artist residencies in France, summer cultural events including concerts & opera; awards, tours & 3 visiting lectures per year; books, reproductions, prints & Chateau-related items

A **THE NATIONAL SOCIETY OF THE COLONIAL DAMES OF AMERICA IN THE STATE OF NEW HAMPSHIRE,** Moffatt-Ladd House, 154 Market St, Portsmouth, NH; 74 Ocean Blvd, Portsmouth, NH 03862. Tel 603-436-8221; *Pres* Dorothy Orr Cole
Open Mon - Sat 10 AM - 4 PM, Sun 2 - 5 PM; Admis adults $4, children & garden $1; free to school groups; Soc estab 1892, mus estab 1913; Moffatt-Ladd House was completed in 1763; Average Annual Attendance: 2,000; Mem: 215; annual meeting in June
Income: $54,000 (financed by endowment, mem, rents & donations)
Collections: Original china & porcelain, furniture, documents, letters & papers, portraits, wallpaper & documented wallpaper
Publications: George Mason & Gunston Hall (video); George Mason & The Bill of Rights (video); The Great Seal (audiotape)
Activities: School tours; lect open to members only, 4 vis lectrs per year; guided tours open to the public; competitions with awards; scholarships offered; individual paintings lent to Currier Gallery of Art; sales table sells books, prints & historic related items

M **PORTSMOUTH ATHENAEUM,** (Portsmouth Athenaeum) Joseph Copley Research Library, Peter Randall Gallery, 9 Market Square, Portsmouth, NH 03801. Tel 603-431-2538; Fax 603-431-7180; *Pres* Michael Chubrich; *Treas* Michael Kinslea; *Keeper* Tom Hardiman; *Cataloger* Robin Silva; *Librn* Lynn Aber; *Research Librr* Ursula Wright; *Archival Proj* Susan S Kindstedt
Historic Reading Room open yearly Thurs 1 - 4 PM or by appointment; No admis fee; Estab 1817 to house mus of historical objects of local, statewide & national

interest & is listed on National Register of Historical Sites; Maintains local history research library; Average Annual Attendance: 8,500; Mem: 375; dues $175; annual meeting 2nd Wed in Jan
Income: Financed by endowment & mem
Special Subjects: Historical Material, Marine Painting, Architecture, Furniture, Manuscripts, Painting-American
Collections: American paintings; Colonial & later portraits; ship models & half-models; New England history; maritime history
Exhibitions: Rotating exhibits 3 - 4 times per year
Activities: Lect; gallery talks; concerts; tours

M **PORTSMOUTH HISTORICAL SOCIETY,** John Paul Jones House, 43 Middle & State St, Portsmouth, NH 03802-0728; PO Box 728, Portsmouth, NH 03801-0728. Tel 603-436-8420; Internet Home Page Address: www.seacoastnh.com; *Pres* Thomas R Watson; *Dir* Virginia E Morin
Open June - mid Oct, Mon - Sat 10 AM - 4 PM, Sun Noon - 4 PM; Admis adults $5, children $2.50, children under 6 free; Estab 1920 to identify & retain local history. The House was built in 1758 by Gregory Purcell, a merchant sea-captain. Purchased & restored in 1920 by the Portsmouth Historical Society; Average Annual Attendance: 7,000; Mem: 250; dues $15; ann meeting Apr
Income: Financed by mem, investment & admis fees
Special Subjects: Painting-American, Costumes, Ceramics, Furniture, Glass, Historical Material, Maps, Period Rooms, Embroidery
Collections: Guns, books, china, costumes, documents, furniture, glass, portraits and silver pertaining to the early history of Portsmouth
Activities: Lect, 3-4 vis lectrs per year; daily tours; original objects of art lent to other museums; lending coll contains looking glass & furniture; mus shop sells books, prints, slides, cards & jewelry

M **WARNER HOUSE ASSOCIATION,** MacPheadris-Warner House, 150 Daniel St, PO Box 895 Portsmouth, NH 03802-0895. Tel 603-436-5909; Internet Home Page Address: www.warnerhouse.org; *Cur* Joyce Volk; *Chmn* Bob Barth
Open 2nd week in June - 2nd week in Oct Mon - Sat 10 AM - 4 PM, Sun 1 - 4 PM; Admis adult $5, seniors $4, children 7-12 $2.50, children under 7 free; Estab 1931; Period rooms from 1717-1930; Mem: 350; dues $25 and up; ann meeting in Oct; Scholarships
Income: $50,000 (financed by endowment, mem, admis, grants & fundraising)
Special Subjects: Archaeology, Ceramics, Decorative Arts, Portraits, Furniture
Collections: Joseph Blackburn Collection (portraits); Portsmouth Furniture; Stair murals (1720); complete set of English Copperplate bed hangings made in America (1780-85); Family Memorabilia
Exhibitions: Joseph Blackburn: Portraits (1761); Archaeological Exhibits
Activities: Lect open to pub, 5 vis lectrs per yr; gallery talks; tours; original objects of art lent to museums & other historic houses

SHARON

M **SHARON ARTS CENTER,** Sharon Arts Center Exhibition Gallery, 457 Rte 123, Sharon, NH 03458; 30 Grove St, Peterborough, NH 03458. Tel 603-924-7676; Fax 603-924-6795; Elec Mail sharonarts@sharonarts.org; Internet Home Page Address: www.sharonarts.org; *School Dir* Deb DeCicco; *Dir* Randall Hoel; *CEO, Pres* Beth Rank-Beauchamp; *Dir Communications* Lajla LeBlanc; *Asst Gallery Mgr* Laurie Rebac; *Admin Asst* Barbara Nay; *Asst Gallery Mgr* Susan Schaefer; *Financial Admin* Diane Hayden
Open Mon - Sat 10 AM - 5 PM, Sun Noon - 5 PM; No admis fee; Estab 1947 to promote the educ, sales & enjoyment of the arts; Center consists of three galleries, store & classroom facility; maintains lending library to mems only; Average Annual Attendance: 32,000; Mem: 1100; dues family $50, individual $35; ann meeting in Sept
Income: Financed by endowment, mem & state appropriation, tuition & sales
Library Holdings: Book Volumes; Exhibition Catalogs
Collections: Bird carvings of Virginia & Robert Warfield; Wood engravings of Nora S Unwin
Exhibitions: Annual members exhib of paintings, drawings & sculpture; 16 exhibits per yr featuring fine artists & craftsmen throughout New England
Publications: Exhibit catalogs
Activities: Classes for adults & children; lect open to pub, 3 vis lectrs per yr; concerts; gallery talks; tours; schols offered; exten dept serves area elementary schools; individual paintings & original objects of art lent to area pvt schools, banks, Town Hall, resorts; lending coll contains 20 original prints, 50 paintings, & assorted crafts (weaving & pottery); originate traveling exhibs; sales shop sells original art, reproductions & fine crafts

NEW JERSEY

ATLANTIC CITY

L **PRINCETON ANTIQUES BOOKSERVICE,** Art Marketing Reference Library, 2915-17 Atlantic Ave, Atlantic City, NJ 08401. Tel 609-344-1943; Fax 609-344-1944; Elec Mail princeton@earthlink.net; Internet Home Page Address: www.princetonantiques.com; *Pres* Robert E Ruffolo Jr
Open by appointment 10 AM - 4 PM; No admis fee; Estab 1974 for pricing documentation of books and antiques; Open by appointment only; maintains art gallery; Average Annual Attendance: 1,000
Library Holdings: Book Volumes 250,000; Framed Reproductions; Memorabilia; Other Holdings Exhibition catalogs; Original art works & prints; Periodical Subscriptions 20
Collections: 19th century art; Postcard Photo Library Information Bank, 1900 - 1950, consisting 12,500 postcards
Activities: Mus shop sells books, original art, reproductions, prints & Atlantic City photographs & memorabilia; Sales shop sells books & original art

BAYONNE

L **BAYONNE FREE PUBLIC LIBRARY,** Cultural Center, 697 Avenue C, Bayonne, NJ 07002. Tel 201-858-6971; Fax 201-437-6928; Internet Home Page Address: www.bayonnenj.org/library; *Library Dir* Sneh Bains
Open Mon & Thurs 9 AM - 9 PM, Fri - Sat 9 AM - 5 PM; Estab 1894; Art Gallery has 194 running ft exhib space
Income: Financed by city appropriation & state aid
Library Holdings: Book Volumes 222,000; Clipping Files; Filmstrips; Periodical Subscriptions 517; Slides 736
Activities: Adult & children film progs weekly; concerts

BERKELEY HEIGHTS

L **BERKELEY HEIGHTS FREE PUBLIC LIBRARY,** 290 Plainfield Ave, Berkeley Heights, NJ 07922-1438. Tel 908-464-9333; Fax 908-464-7098; Internet Home Page Address: www.bhs.k12.nj.us/bhp2/index.htm; *Dir* Stephanie Bakos; *Asst Dir* Laura Fuhro; *Reference Head* Bridgette Brambilla
Open Mon - Thurs 9 AM - 9 PM, Fri & Sat 9 AM - 5 PM, Sun 2 - 5 PM; Estab 1953
Income: $570,000 (financed by city appropriation)
Library Holdings: Audio Tapes; Book Volumes 71,890; Cassettes; Clipping Files; Fiche; Pamphlets; Periodical Subscriptions 32; Reels; Slides; Video Tapes
Special Subjects: Art History, Folk Art, Landscape Architecture, Decorative Arts, Photography, Painting-American, Painting-British, Painting-Japanese, Painting-European, Crafts, Asian Art, American Indian Art, Glass, Afro-American Art, Architecture
Collections: Art & art history prints

BLOOMFIELD

M **HISTORICAL SOCIETY OF BLOOMFIELD,** 90 Broad St, Bloomfield, NJ 07003. Tel 973-566-6220; Fax 201-429-0170; *Pres* Ina Campbell; *2nd VPres* Alan Slaughter; *Treas* Dorothy Greenfield; *Cur* Lucy Sant Ambrogio
Open Wed 2 - 4:30 PM & by appointment; No admis fee; Estab 1966 to collect, preserve & exhibit items which may help to establish or illustrate the history of the area; Mus located in gallery of the Bloomfield Pub Library; Average Annual Attendance: 1,436; Mem: 115; dues, commercial organization $25, nonprofit organization $10, couple $10, individual $7, student under 18 $3; meeting Sept, Nov, May - 4th Mon of the month
Income: Financed by mem, Ways & Means Committee & bequests
Special Subjects: Costumes, Ceramics, Furniture, Glass, Dioramas
Collections: Miscellaneous items of books, clothing & accessories, deeds & other documents, dioramas, early maps & newspapers, furniture, household articles, letters, memorabilia, paintings, postcards, posters, tools, toys
Exhibitions: Revolving Charles Warren Eaton (items donated by people of Bloomfield and/or heirs)
Activities: Lect open to pub, 3 vis lectrs per yr; tours; sales shop sells books, prints, postcards, mugs, notepaper, medallions

BORDENTOWN CITY

M **THE ARTFUL DEPOSIT, INC.,** 201 Farnsworth Ave, Bordentown City, NJ 08505. Tel 609-298-6970; Fax 609-609-298-6975; Elec Mail galleries@theartfuldeposit.com; Internet Home Page Address: www.theartfuldeposit.com; *Owner* C J Mugavero
Open Wed - Sun; call for details; No admis fee; Estab in 1986 for display & sale of original fine art; Representation in gallery stable for approx 40 artists with local, national & international acclaim. Primary location in Bordentown, NJ. Tel: 609-298-6970; Third location in Burlington, NJ Tel: 609-747-8333
Collections: Representative of original works by Patrick Antonelle (Impressionist); Joseph Dawley (Impressionist); Hanneke de Neve (Expressionist); Ken McIndoe (Naturalist); Gennady Spirin (Illustrator)
Exhibitions: Works by Patrick Antonelle, Joseph Dawley, Hanneke de Neve, Ken McIndoe, Gennady Spirin, Thomas Kelly, Michael Budden
Activities: Gallery talks; lect open to pub

BURLINGTON

A **BURLINGTON COUNTY HISTORICAL SOCIETY,** 451 High St, Burlington, NJ 08016. Tel 609-386-4773; Fax 609-386-4828; Elec Mail bchsnj@earthlink.net; Internet Home Page Address: geocities.com/burlcohs; *VPres* Herman O Benninghoff; *CEO* Douglas E Winterick; *Pres* Louis A Colaguori; *Librn* S Bleiler; *Exec Asst* Patricia Stip
Open Mon - Thurs 1 - 4 PM, Wed 10 AM - Noon, 1 - 4 PM, every first Fri 6 - 9 PM, Sun 2 - 4 PM; Admis $3 for library & mus gallery, $3 guided tour of 3 period houses, $5 combination; Estab 1915 to preserve & interpret Burlington County history; Average Annual Attendance: 5,000; Mem: 1,000; dues $15 & up; ann meeting fourth Thurs in May
Income: Financed by endowment & donations
Special Subjects: Decorative Arts
Collections: Clocks; Decorative Arts; Delaware River Decoys; Quilts; Samplers
Exhibitions: Ingenuity & Craftmanship
Publications: Quarterly newsletter
Activities: Tours for children; docent training; lect open to pub, several vis lectrs per yr; tours; mus shop sells books, magazines & reproductions

CALDWELL

M **CALDWELL COLLEGE,** The Viscelgia Art Gallery, 9 Ryerson Ave, Caldwell, NJ 07006. Tel 973-618-3457; Internet Home Page Address: www.caldwell.edu/news/art_index; *Dir* Kendall Baker
Open Mon - Fri 9 AM - 5 PM, Sat & Sun 10 AM - 5 PM; No admis fee; Estab 1970 to provide students & area community with exposure to professional

contemporary talent, to afford opportunities for qualified artists to have one-person shows; Scholarships
Income: Financed by col budget
Exhibitions: 3-4 exhibits per yr; Alumni Show
Activities: Educ dept in connection with the col art dept; lect open to pub, 3 vis lectrs per yr; lending coll contains 12,000 kodachromes, motion pictures

CAMDEN

M RUTGERS UNIVERSITY, Stedman Art Gallery, Fine Arts Ctr, Camden, NJ 08102. Tel 856-225-6245, 225-6350; Fax 609-225-6597; Elec Mail arts@camdenrutgers.edu; Internet Home Page Address: seca.camden.rutgers.edu; Others TTY 609-225-6648; *Dir & Cur* Virginia Oberlin Steel; *Cur Educ* Noreen Scott Garrity
Open Mon - Sat 10 AM - 4 PM; No admis fee; Estab 1975 to serve educ needs of the campus & to serve community of southern New Jersey; Average Annual Attendance: 14,000
Income: Financed by endowment, state appropriation & gifts from pvt sources
Special Subjects: Painting-American, Photography, Prints, Sculpture, Watercolors, Etchings & Engravings
Collections: Modern & contemporary art; works on paper
Exhibitions: Changing exhibs of visual arts & interdisciplinary exhibs
Publications: Catalog for a major exhibition, yearly
Activities: Vis lectr; symposia, concerts & gallery talks open to pub

A WALT WHITMAN CULTURAL ARTS CENTER, INC, Second & Cooper Streets, Camden, NJ 08102. Tel 856-964-8300; *Prog Dir* Patrick Rinehart
Open Mon - Fri 10 AM - 4 PM; Estab 1975; Average Annual Attendance: 13,000; Mem: 100; dues $20
Activities: Classes for children; dramatic progs; lect open to pub, 6 vis lectrs per yr; concerts; gallery talks; tours

CLINTON

M HUNTERDON HISTORICAL MUSEUM, 56 Main St, Clinton, NJ 08809-1328. Tel 908-735-4101; Fax 908-735-0914; Elec Mail hhmredmill@yahoo.com; Internet Home Page Address: www.clintonnj.com; *Cur Educ* Amy Caputo; *Dir* Charles Spibierl
Open early Apr - late Oct, Tues - Sat 10 AM - 4 PM, Sun Noon - 5 PM; Admis adults $6, seniors $5, children 6-12 $4, pre-schoolers free; Estab 1960 for the preservation & display of artifacts from the 18th & 19th century & early 20th century for educl & cultural purposes; Four-floor grist mill, blacksmith shop, gen store, schoolhouse, log cabin, herb garden & quarry buildings; Average Annual Attendance: 26,000; Mem: 400; dues $25 - $2500; ann meeting in May
Income: $150,000 (financed by mem & donations)
Special Subjects: Historical Material
Collections: Artifacts pertaining to 18th, 19th & early 20th centuries
Exhibitions: Variety of Special Events
Activities: Classes for children; docent training; re-enactments; lect; concerts; tours; sales shop sells books & gift items

A HUNTERDON MUSEUM OF ART, 7 Lower Center St, Clinton, NJ 08809. Tel 908-735-8415; Fax 908-735-8416; Elec Mail info@hunterdonmuseumofart.org; Internet Home Page Address: www.hunteronmuseumofart.org; *Pres of Bd* Aram Papazian; *Dir Exhibitions* Kristin Accola; *Dir Educ* Betsy Zalaznick; *Exec Dir* Marjorie Frankel Nathanson; *Pres Board Trustees* Hildreth York; *Dir Devlop* Eleanor Porter Trubert; *Mus Shop Mgr* Nancy Friedman; *Dir Exhib* Donna Gustafson
Open Tues - Sun 11 AM - 5 PM; Donation requested; Estab 1952 as a nonprofit organization to provide arts enrichment through fine & performing arts; The first, second & third fls provide gallery space. The old stone mill has been remodeled retaining the original atmosphere with open broad wooden beams, white walls & plank flooring; Average Annual Attendance: 22,000; Mem: 600; dues patron $500, sponsor $250, contributor $100, family $50, individual $35, senior $25; ann meeting in Apr; Scholarships
Income: Financed by mem, city, state & county appropriations, donations, tuitions
Purchases: $100
Special Subjects: Prints
Collections: Print collection
Exhibitions: National Print Exhibition
Activities: Classes for adults & children; lect open to pub, 3 vis lectrs per yr; gallery talks; competitions with cash awards; ann juried mems show; works from print coll lent to nearby corporations; lending coll contains 200 original prints; originate traveling exhibs to Newark Museum and corp mem; sales shop sells books, original art, reproductions & crafts

CLOSTER

M BELSKIE MUSEUM, 280 High St, Closter, NJ 07624. Tel 201-768-0286; Fax 201-768-4220; Elec Mail contact@belskiemuseum.com; Internet Home Page Address: www.belskiemuseum.com; *Pres* Mike Lewis; *VPres* Walter Hubbard; *VPres* John Murphy; *VPres Legal* Ed Rogan; *Treas* Donald M Farrell
Open Sat & Sun 1 - 5 PM, special hours by appt; No admis fee, donations accepted; Founded 1993 by the Closter Lions Club; The goal of the mus is to preserve & display the work of Abram Belskie & to promote his reputation as a major sculpture, medallic artist & medical instructor of the 20th century; mus also displays works of other local & internat artists with new exhibits monthly; Average Annual Attendance: 3,000; Mem: 300; Mem Patron $100 (ann); Supporting $25 (ann)
Special Subjects: Art History, Metalwork, Photography, Pottery, Painting-American, Painting-European, Sculpture
Collections: Drawings, sculpture, medical models, medallic molds & completed medallic pieces created by Abram Belskie (1907-1988); Numerous donated original paintings

Exhibitions: Rotating exhibs of international artists & artists within the tri-state area in all mediums; ann exhibition & sale of paintings from students & teachers from the Art Students League, NY & Vytlacil School of Art; art exhibs by students from Northern Valley Regional High School, Demarest, NJ
Activities: Artist receptions; tours; museum shop sells note cards

CRANFORD

M CRANFORD HISTORICAL SOCIETY, The Hanson House, 38 Springfield Ave, Cranford, NJ 07016. Tel 908-276-0489; Elec Mail iambillsenior@hotmail.com; Internet Home Page Address: www.bobdevlin.com/crhis.html;Bob Fridlington
Open Sept - June Sun; Donations accepted; Founded 1927 and dedicated to the perpetuation of Cranford's history
Special Subjects: Historical Material, Photography, Textiles, Costumes, Restorations
Collections: Crane Phillips Living Museum, a Victorian cottage built in 1845 that served as honeymoon house for Josiah Crane Jr, great-grandson of the original miller. House depicts life in Cranford in the latter part of the 19th Century; photographs; scrapbooks; glass negatives; books; letters; Indian artifacts; costumes & textiles; The Hanson House
Publications: Cranford Home Journal; Image of America: Cranford, by Robert Fridlington & Lawrence Fuhro
Activities: Walking tours; research assistance; educ tours; school & scout progs; Autumn Harvest Festival; Christmas Open House; Victorian Garden Tour; ongoing restoration of the Craine Phillips House

DENVILLE

A BLACKWELL STREET CENTER FOR THE ARTS, PO Box 808, Denville, NJ 07834. Tel 201-337-2143; Fax 201-337-2143; Elec Mail wblakeart@nac.net; Internet Home Page Address: www.blackwell-st-artists.org; *Dir* Annette Adrian Hanna; *VPres* David Gruol; *Treas* Elaine Provost
No admis fee; Estab 1983; professional gallery for NJ & NY artists to exhibit variety of art work; Initiated in 1998 as a cyber gallery; Average Annual Attendance: 2,100; Mem: 16 artists; qualifications for mem; artists mems juried by credentials commission; dues $100 once a month plus new mem fee; monthly meeting
Income: $5,000 (financed by mem, grants & donations)
Collections: Member artists' works in many pvt colls
Exhibitions: Six or more exhibs scheduled per yr at different sites
Activities: Educ dept; lect open to pub; gallery talks; competitions & awards; yearly high school juried exhibit with awards

ELIZABETH

L FREE PUBLIC LIBRARY OF ELIZABETH, Fine Arts Dept, 11 S Broad St, Elizabeth, NJ 07202. Tel 908-354-6060; Fax 908-354-5845; Internet Home Page Address: www.ngpublib.org/eliz; *Dir* Joseph Keenan
Open Mon - Fri 9 AM - 9 PM, Sat 9 AM - 5 PM, cl Sun; No admis fee; Estab 1913, the art dept functions within the Linx library system; it offers free service to patrons of Elizabeth & Union County; Special exhibit area displays paintings & miscellaneous objects d'art
Income: Financed by city and state appropriation
Library Holdings: Book Volumes 15,000; Other Holdings Photographs & Illustrations 200,000; Reproductions 800
Collections: Japanese prints by various artists
Exhibitions: Works by artists & photographers; other special exhibs from time to time
Activities: Dramatic progs; lect open to the pub, 15 vis lectrs per yr; concerts; material available to patrons of Union County; lending coll contains film strips, projection equipment & motion pictures; printed catalogues of film strips & films available to the pub - 4500 VHS videotapes (circulating)

ENGLEWOOD

L ENGLEWOOD LIBRARY, Fine Arts Dept, 31 Engle St, Englewood, NJ 07631. Tel 201-568-2215; Fax 201-568-6895; Elec Mail englref@bccls.org; Internet Home Page Address: www.englewoodlibrary.org; *Dir Library* Don Jacobsen
Open Mon - Thurs 9 AM - 9 PM, Fri & Sat 9 AM - 5 PM, Sun 1 - 5 PM (Oct-May); No admis fee; Estab 1901 to estab a free pub library for citizens
Income: $510,000 (financed by endowment, city & state appropriation)
Library Holdings: Cassettes; Clipping Files; Filmstrips; Framed Reproductions; Motion Pictures; Original Art Works; Pamphlets; Records; Reels; Slides
Exhibitions: Members of Salute to Women In the Arts; Quilts; Rare Books & Manuscripts; World of Renaissance; rotating exhibits
Activities: Lect open to pub; concerts

GLASSBORO

M GLASSBORO HERITAGE GLASS MUSEUM, 25 East High St, Glassboro, NJ 08028. Tel 856-881-7468; Elec Mail comments@boroughofglassboro.org; Internet Home Page Address: www.glassboroonline.com
Open Wed 12 PM - 3 PM, Sat 11 AM - 2 PM, 4th Sun of every month 1 PM - 4 PM; No admis fee, donations accepted; Estab 1979; Historical mus with the purpose to preserve & perpetuate the heritage of the glass industries of the region. Mus situated in the former Whitney Brothers Glass Works land; Average Annual Attendance: 1,200; Mem: 150; $25
Library Holdings: Book Volumes; Maps; Photographs; Slides
Special Subjects: Historical Material, Flasks & Bottles, Glass
Collections: Display of amber bottles & jars from the Whitney Glass Company; Glass from other Gloucester County glass factories
Publications: Glassboro Briefs, newsletter

Activities: Educ & historic talks; volunteer progs; tours; originates traveling exhibs; sales shop sells books, glass articles

HAMILTON

M **GROUNDS FOR SCULPTURE,** 18 Fairgrounds Rd, Hamilton, NJ 08619. Tel 609-586-0616; Fax 609-586-0968; Elec Mail info@groundsforsculpture.org; Internet Home Page Address: www.groundsforsculpture.org; *Cur Educ* Christine E Finkelstein; *Mus Shop Mgr* Betsy Bowen; *Admin Asst* Yoriko Franklin; *Dir & Cur* Brooke Barrie; *Mem Mgr* Bonnie Brown; *Coordr (V)* Aylin Green; *Registrar* Jacqueline ter Kuile
Open Tues - Sun 10 AM - 9 PM, cl Mon; Admis Tues - Thurs adults $4, seniors & students $3, children under 12 free; Fri & Sat adults $7, seniors, students & children under 12 $3; Sun nonmems $10, mems free; Estab 1992 to promote greater understanding & appreciation for contemporary sculpture; Two 10,000 sq ft mus buildings with interior gallery spaces sited in a 22-acre landscaped sculpture park; Average Annual Attendance: 50,000
Income: Financed by pub charitable foundation
Special Subjects: Sculpture
Collections: Includes contemporary sculpture
Exhibitions: 3 yearly; spring, summer & fall/winter
Publications: Exhibition catalogues
Activities: Docent progs, yr round activities include art, poetry, music & dance; lect open to pub, 10 vis lectrs per yr; concerts; sales shop sells books, magazines, posters, postcards, children's art kits, full service restaurant

M **INTERNATIONAL SCULPTURE CENTER,** 14 Fairgrounds Rd Ste 8, Hamilton, NJ 08619-3447. Tel 609-689-1051; Fax 609-689-1061; Elec Mail ics@sculpture.org; Internet Home Page Address: www.sculpture.org; *Pres* Johannah Hutchison; *Chmn Bd* Joshua S Kanter
Open Mon - Fri 9 AM - 5 PM; Estab 1960, dedicated to expand the base of understanding & support of contemporary sculpture through its progs & services. The ISC serves the needs & interests of sculptors, educators, arts supporters & the gen pub; Mem: 8,000; dues $95
Income: Financed by mem dues, pvt donations & grants
Publications: A Sculpture Reader: Contemporary Sculpture Since 1980
Activities: Conferences & lectrs; lifetime achievement award; patron award; outstanding student in contemporary sculpture award; educator award

HOPEWELL

M **HOPEWELL MUSEUM,** 28 E Broad St, Hopewell, NJ 08525. Tel 609-466-0103; *Cur* Beverly Weidl; *Pres* David Mackey
Open Mon, Wed & Sat 2 - 5 PM, cl national holidays; groups by appointment only; No admis fee, donations suggested; Estab 1922 as a mus of local history from early 1700-1900, to show what the community was like for almost 300 years; Research on Mon & Wed only; Average Annual Attendance: 2,000
Income: Financed by endowment, mem & donations
Special Subjects: Period Rooms
Collections: Antique china, glass, silver & pewter; colonial furniture; colonial parlor; early needlework; Indian handicrafts; photograph collection; Victorian parlor
Publications: Hopewell Valley Heritage; Pioneers of Old Hopewell; maps

JERSEY CITY

M **JERSEY CITY MUSEUM,** 350 Montgomery St, Jersey City, NJ 07302. Tel 201-413-0303; Fax 201-413-9922; Elec Mail info@jerseycitymuseum.org; Internet Home Page Address: www.jerseycitymuseum.org; *Dir* Nina S Jacobs; *Chmn* Carlos Hernandez; *Cur of Educ* Sandra Toro; *Coll Mgr* Charles Thomas Strider; *Deputy Dir* Aleya Saad; *Exec Dir* Marion Grzesiak; *Dir Develop* Aleya Lehmann; *Mus Shop Mgr* Linda; *Cur* Rocio Aranda-Alvarado; *Dir Educ* Pamela Ford; *Pres Board Dir* Ofelia Garcia
Open Wed, Fri 11 AM - 5 PM; Thurs 11 AM - 8 PM; Sat & Sun Noon - 5 PM; Suggested: gen $4, students & seniors $2.50, mems free; Estab 1901 for the purpose of preserving & interpreting its permanent coll of art & historical objects; Maintains seven gallery spaces for contemporary & historical exhibs; Average Annual Attendance: 60,000; Mem: 500; seniors $30 individuals; $40 dual family; $25 artist
Income: Financed by state, county, city, federal appropriations as well as foundation, corporate & pvt support
Purchases: $50 friend, $100 patron, $250 cur guild, $500 dir guild
Special Subjects: Architecture, Drawings, Costumes, Ceramics, Crafts, Folk Art, Etchings & Engravings, Decorative Arts, Dolls, Coins & Medals
Collections: Paintings, drawings & watercolors by 19th century artist August Will; 19th & 20th century paintings & prints; Jersey City & New Jersey related artifacts, documents, decorative & historical objects
Exhibitions: Permanent exhibs: 19th Century Coll, 20th Century Coll; changing exhibs
Publications: Exhibition catalogs
Activities: Classes for adults & children; workshops; lect open to public; gallery talks; tours; slide & panel talks; historical tours; video & performance arts; traveling exhibs; books; reproductions; prints

M **NEW JERSEY CITY UNIVERSITY,** Courtney Art Gallery & Lemmerman Gallery, Dept of Art Grossnickel Hall, 1st Flr, 2039 Kennedy Blvd Jersey City, NJ 07305. Tel 201-200-3214; Fax 201-200-3224; Elec Mail hbastidas@njcu.edu; *Dir* Hugo Xavier Bastidas; *Dept Chair* Winifred McNiell
Open Mon - Fri 11 AM - 4 PM, or by appointment; No admis fee; Estab 1969 to bring examples of professional work to the campus in each of the areas in which students are involved: Painting, sculpture, film, photog, textiles, weaving, ceramics, graphic design; Gallery is operated by students & with the Jersey City Mus for a student internship training prog; Average Annual Attendance: 3,000
Income: Financed by city, state appropriation & Art Department

Collections: Small coll of prints & paintings
Exhibitions: Robert Blackburn, Robert Indiana, Jose Morales
Activities: Lect open to pub, 5 vis lectrs per yr; concerts; gallery talks; tours; exten dept serving community organizations; individual paintings & original objects of art lent; lending collection contains color reproductions, film strips, Kodachromes, motion pictures, photographs; originate traveling exhibs organized & circulated

M **Lemmerman Art Gallery,** Hepburn Hall, 3rd Flr, 2039 Kennedy Blvd Jersey City, NJ 07305. Tel 201-200-3214; Fax 201-200-3224; Elec Mail hbastidas@njcu.edu; *Dir* Hugo Xavier Bastidas
Open Mon - Fri 11 AM - 4 PM, or by appointment; Estab 1961 to bridge community (college) to Art of all levels; Gothic structure; Average Annual Attendance: 3,000
Income: Financed by art department, state, city
Activities: Educ dept; lect open to pub; gallery talks; tours; individual paintings lent to galleries & other institutions that have pub access; lending coll contains 31 original art works

M **SAINT PETER'S COLLEGE,** Art Gallery, 2641 Kennedy Blvd, Jersey City, NJ 07306. Tel 201-915-9238; Fax 201-413-1669; Elec Mail oscarmagnan@yahoo.com; *Dir* Oscar Magnan; *Sec* Elga Taki; *Asst to Exhibit* Dario Bianchini; *Asst to Exhib* Christine Zapella
Open Mon, Tues, Fri & Sat 11 AM - 4 PM, Wed & Thurs 11 AM - 9 PM; No admis fee; Estab 1971 to present the different art trends; Gallery is maintained with good space, lighting and alarm systems; Average Annual Attendance: 2,000
Income: Financed by the col
Special Subjects: Decorative Arts, Folk Art, Interior Design, Landscape Architecture, Architecture, Art Education, Art History, Ceramics, Collages, Glass, Mexican Art, Flasks & Bottles, Furniture, Portraits, Painting-American, Prints, Textiles, Bronzes, Painting-European, Painting-French, Painting-Japanese, Sculpture, Graphics, Latin American Art, Archaeology, Religious Art, Collages, Dolls, Jewelry, Porcelain, Oriental Art, Metalwork, Painting-Dutch, Coins & Medals, Miniatures, Painting-Flemish, Painting-Spanish, Painting-Italian, Mosaics, Stained Glass, Painting-German, Reproductions, Painting-Russian, Enamels
Activities: Classes for adults; docent training; lects open to pub, 20 vis lectrs per yr; concerts; gallery talks; tours; exten dept serving students

LAKEWOOD

M **GEORGIAN COURT COLLEGE,** M Christina Geis Gallery, 900 Lakewood Ave, Lakewood, NJ 08701-2697. Tel 732-364-2200, Ext 348, 364-2181; Fax 732-905-8571; Elec Mail velasquez@georgian.edu; *Dir* Dr Geraldine Velasquez
Open Mon - Fri 9 AM - 8 PM; No admis fee; Estab 1964 to offer art students the opportunity to view the works of professional artists & also to exhibit student work; Gallery is one large room with 100 running ft of wall area for flat work; the center area for sculpture; Average Annual Attendance: 1,000
Income: Financed through the col
Special Subjects: Architecture, Drawings, Photography, Sculpture, Ceramics, Calligraphy
Exhibitions: Monthly exhibs
Activities: Schols offered

LAWRENCEVILLE

INTER-SOCIETY COLOR COUNCIL
For further information, see National and Regional Organizations

M **RIDER UNIVERSITY,** Art Gallery, 2083 Lawrenceville Rd, PO Box 6400 Lawrenceville, NJ 08648-3099. Tel 609-895-5588; Fax 609-896-5232; Elec Mail hnaar@rider.edu; *Prof Art & Dir* Harry I Naar
Open Tues - Thurs 11 AM - 7 PM, Sun 12 - 4 PM (subject to change); No admis fee; Estab 1970 to afford mems of the community & univ the opportunity to expand their knowledge & exposure to art; Gallery has 1,513 sq ft of space divided into two rooms of different height; Average Annual Attendance: 5,000
Income: $8,000 (univ funded)
Library Holdings: Exhibition Catalogs; Reproductions
Collections: African Art, statues & masks; contemporary art; drawings; paintings; prints; sculpture
Publications: Exhibit catalogs
Activities: Classes for adults; dramatic progs; docent training; internships; gallery management class; lect open to pub, 4 or more vis lectrs per yr; concerts; gallery talks; tours; individual paintings & original objects of art lent to museums, group shows, one-person shows, major exhibs; book traveling exhibs; exhib catalogues are available for sale

LAYTON

L **PETERS VALLEY CRAFT CENTER,** 19 Kuhn Rd, Layton, NJ 07851. Tel 973-948-5200; Fax 973-948-0011; Elec Mail pv@warwick.net; Internet Home Page Address: www.pvcrafts.org; Others 973-948-5202; *Exec Dir* Jimmy Clark; *Ofc Mgr* Jennifer Brooks
Call for hrs; Estab 1970 as a nonprofit craft educ center to promote & encourage traditional & contemporary crafts through exhibs, demonstrations, workshops & educational programs; Over 300 artists work exhibited in store, gallery has changing exhibs; Average Annual Attendance: 10,000; Mem: 350; dues $40; ann meeting in Oct
Income: Financed in part by a grant from NJ State Council on the Arts/Department of State, the Geraldine R Dodge Foundation & mems, friends, corporations & local companies
Library Holdings: Book Volumes 500; Exhibition Catalogs; Original Art Works; Pamphlets; Photographs; Slides
Special Subjects: Decorative Arts, Photography, Ceramics, Crafts, Metalwork, Handicrafts, Silversmithing, Textiles, Woodcarvings
Collections: Teaching coll of craft works, art & photographs
Exhibitions: Theme Shows & changing Exhibs

Publications: Summer Workshop Catalog, ann; Valley Views Newsletter, two times per yr
Activities: Educ dept; classes for adults; lect open to pub, 80 vis lectrs per yr; tours; workshops; juried craft fair; schols & residencies; exten dept serves North Jersey; sales shop sells original art

LINCROFT

M **MONMOUTH MUSEUM & CULTURAL CENTER,** PO Box 359, Lincroft, NJ 07738. Tel 732-747-2266; Fax 732-747-8592; Elec Mail monmuseum@netlabs.net; Internet Home Page Address: www.monmouthmuseum.org; *Pres, Dir & CEO* Dorothy V Morehouse; *First VPres* Jane McCosker; *Second VPres* Barbara Goldfarb; *Asst to Dir* Catherine Jahos
Open Tues - Sat 10 AM - 4:30 PM, Sun 1 - 5 PM; Admis $4, free to Museum mems & Brookdale Community College students; Estab 1963 to advance interest in art, science, nature & cultural history; Mus houses one large gallery, the Becker Children's Wing, & The Wonder Wing for children age 6 & under. Exhibs are changed eight times per yr; also an educ area & a conference area; Average Annual Attendance: 50,000; Mem: 1600; dues family $60, individual $30, seniors $20; ann meeting in Jan
Income: Financed by mem, donations, county funds & benefits
Exhibitions: Annual Monmouth County Arts Council Juried Exhibition; Biannual NJ Watercolor Society Exhibition; All Aboard at the Monmouth Museum
Publications: Calendar of events; catalogues of exhibitions; newsletter
Activities: Classes for adults & children; docent training; lect open to pub; originate traveling trunks for use in schools; mus shop sells books & gift items

LONG BRANCH

M **LONG BRANCH HISTORICAL MUSEUM,** 368 Highland Ave, Long Branch, NJ 07740-4645. Tel 732-229-0600; *Pres & CEO* Florence Dinkelspiel; *1st VPres* Peter Msaldijan
Open by appointment only; No admis fee; Estab 1953 as post Civil War historical mus; Average Annual Attendance: 10,000; Mem: Dues $1
Special Subjects: Historical Material
Collections: Period furniture

MADISON

M **ARCHIVES & HISTORY CENTER OF THE UNITED METHODIST CHURCH,** Methodist Archive Bldg, 36 Madison Ave Madison, NJ 07940; PO Box 127, Madison, NJ 07940. Tel 973-408-3189; Fax 973-408-3909; Elec Mail cyrigoye@drew.edu; *Archivist* L Dale Patterson; *Librn* Jennifer Woodruff Tait
Open Mon - Fri 9 AM - 5 PM; No admis fee; Estab 1885 as a religious history mus; The Archives & History Center is located on Drew University Campus & it contains a mus, a library & a spacious 180,000 cubic ft archival vault. Maintains reference library
Income: Financed by gen church funds
Special Subjects: Religious Art, Historical Material
Collections: Letters; Photographs
Exhibitions: Chinese Missionaries
Publications: Methodist History, quarterly
Activities: Lect open to pub, 1 vis lectr per yr; tours; sales shop sells books, plates, cards, slides & prints

L **Library,** Drew U Campus, 36 Madison Ave Madison, NJ 07940; PO Box 127, Madison, NJ 07940. Tel 973-408-3590; Fax 973-408-3836; Internet Home Page Address: www.depts.drew.edu/lib/uma.html; *Head Librn* Jennifer Woodruff Tait
Mon - Fri 9 AM - 12 noon, 1 PM - 5 PM; none; For reference only; Average Annual Attendance: 580
Library Holdings: Audio Tapes; Book Volumes 70,000; Cassettes; Clipping Files; Compact Disks; DVDs; Fiche; Filmstrips; Lantern Slides; Manuscripts; Memorabilia; Motion Pictures; Original Art Works; Original Documents; Pamphlets; Periodical Subscriptions 600; Photographs; Prints; Records; Reels; Slides; Video Tapes
Special Subjects: Drawings, Manuscripts, Painting-American, Painting-British, Historical Material, Portraits, Ceramics, Video, Porcelain, Furniture, Religious Art
Collections: Methodist materials; pamphlets & manuscripts of John Wesley & his associates; materials pertaining to women & ethnic minorities
Activities: Gallery talks & tours

M **DREW UNIVERSITY,** Elizabeth P Korn Gallery, Rt 24 Madison, NJ 07940. Tel 973-408-3000; *Dean* Paolo Cucchi; *Chmn Art Dept* Livio Saganic
Open Tues - Fri 12:30 - 4 PM & by appointment; No admis fee; Estab 1968 to provide exhibs each school year to augment prog of courses & to serve the community
Income: Financed by Univ instructional budget
Collections: Ancient Near-East archaeological coll; Colonial America; Contemporary abstraction; Native American artifacts; 19th century academic; Oriental art
Activities: Lect open to pub, 3-4 vis lectrs per yr; gallery talks

L **Art Dept Library,** Rt 24, Madison, NJ 07940. Tel 973-408-3000; Fax 973-408-3770
Library maintained for art history courses
Purchases: $7400 annually (for purchases to support art history courses at the col level)
Library Holdings: Audio Tapes; Book Volumes 350,000; Exhibition Catalogs; Fiche; Filmstrips; Manuscripts; Original Art Works; Pamphlets; Periodical Subscriptions 1900; Photographs; Records; Slides; Video Tapes

MAHWAH

M **THE ART GALLERIES OF RAMAPO COLLEGE,** 505 Ramapo Valley Rd, Mahwah, NJ 07430. Tel 201-684-7587; *Dir* Shalom Gorewitz
Open Mon - Fri 11 AM - 2 PM, Wed 5 - 7 PM, cl Sat & Sun; No admis fee; Estab 1979 as outreach for community, faculty, staff & students to support

undergrad curriculum; Three galleries: thematic changing exhibs gallery; permanent coll gallery; alternate space gallery; Average Annual Attendance: 5,000; Mem: 300 (friends); dues $15
Income: Financed by state appropriation & grants
Special Subjects: Prints
Collections: Rodman Collection of Popular Art, Art by Haitians; Study Collection of Prints; fine art printmaking from 15th century to present
Publications: Exhibit catalogs
Activities: Classes for adults & children; dramatic progs; docent training; lect open to pub, 10 vis lectrs per yr; competitions; schols & fels offered; individual paintings lent to institutions, cols & museums; book traveling exhibs; originate traveling exhibs

MERCERVILLE

L **JOHNSON ATELIER TECHNICAL INSTITUTE OF SCULPTURE,** Johnson Atelier Library, 60 Ward Ave Extension, Mercerville, NJ 08619. Tel 609-890-7777; Fax 609-890-1816; Internet Home Page Address: www.atelier.org; *Librn* Eden R Bentley; *Dir Gallery* Gyuri Hollosy
Not open to pub; Estab 1977 to provide an information center for apprentices, instructors & staff on sculpture, art appreciation & art history; Library provides space for lects, movies, slides & critique sessions; gallery adjacent to library
Income: Financed by appropriation from the Johnson Atelier Technical Institute of Sculpture
Library Holdings: Book Volumes 2670; Clipping Files; Exhibition Catalogs; Periodical Subscriptions 23; Slides
Special Subjects: Sculpture, Bronzes
Collections: Exhibition catalogues on sculptors & group shows; slides of about 50 sculptor's work

MILLVILLE

M **WHEATON VILLAGE INC,** (Wheaton Cultural Alliance Inc) Museum of American Glass, Wheaton Village, 1501 Glasstown Rd Millville, NJ 08332. Tel 856-825-6800; Fax 856-825-2410; Elec Mail mail@wheatonvillage.org; Internet Home Page Address: www.wheatonvillage.org; *Cur* Gay LeCieire Taylor
Open Jan - Mar: Fri - Sun, 10 AM - 5 PM; Apr - Dec: Tues - Sun, 10 AM - 5 PM; Admis adults $8, seniors $7.50, students $5; Estab 1970, a cultural center dedicated to American folklore, craft & heritage; Average Annual Attendance: 60,000
Library Holdings: Auction Catalogs; Book Volumes; Exhibition Catalogs; Maps; Original Documents; Photographs; Slides; Video Tapes
Collections: American glass
Activities: Docent training

MONTCLAIR

M **MONTCLAIR ART MUSEUM,** 3 S Mountain Ave, Montclair, NJ 07042-1747. Tel 973-746-5555; Fax 973-746-9118; Elec Mail mail@montclair-art.com; *Pres* Nathanial C Harris; *Dir Communications* Anne-Marie Nolin; *Cur Registrar* Margaret Molnar; *Comptroller* Diane Parisien; *Deputy Dir for Information* Elyse Reissman; *Dir Educ* Tara Bellciscio; *Chief Cur* Gail Stavitsky
Open Tues, Wed, Fri & Sat 11 AM - 5 PM, Thurs & Sun 1 - 5 PM, cl Mon & major holidays; Admis adults $5, seniors & students $4, under 12 free, mems free, Sat 11 AM - 2 PM free; Estab 1914; Five galleries of changing exhibs; one gallery of permanent exhibs; student gallery; Average Annual Attendance: 90,000; Mem: 2700; individual $30
Income: Financed by endowment & mems
Special Subjects: Drawings, Painting-American, Prints, American Indian Art, Costumes, Silver
Collections: American costumes; The Rand Collection of American Indian Art; Whitney Silver Collection; American paintings, 18th - 20th century; bookplate collection; prints & drawings; sculpture
Exhibitions: The American Landscape: From Cole to Blakelock Dottie Atty: The Anxious Object; Three Hispanic-American Masters; Robert Kushner: Seasons; Brave Against the Enemy: Plains Indian Art from the Montclair Art Museum; Arctic Imagerly: Contemporary Inuit Drawing from a Private New Jersey Collection; Hans Weingaertner: A Retrospective; The Crayon; June Brides: Currier & Ives: Selections from the George Raimes Beach Collection; Henri & The Ash Can School
Publications: Bulletin, bimonthly; exhib catalogs
Activities: Classes for adults & children; docent training; workshops coordinated progs with school groups; dramatic progs; lect open to pub; concerts; gallery talks every Sunday; tours; mus shop sells books, notecards, reproductions, slides, Native American jewelry & crafts, jewelry & games/toys for children

L **LeBrun Library,** 3 S Mountain Ave, Montclair, NJ 07042-1747. Tel 973-746-5555; Fax 973-746-9118; Elec Mail mail@montclair-art.com; *Librn* Susanna Sabolosi
Open Wed 10 AM - 5 PM, Thurs & Fri 9 AM - 5 PM; Estab 1916 to support research & exhibs of the mus; For reference only
Library Holdings: Audio Tapes; Book Volumes 14,000; Clipping Files 8600; Exhibition Catalogs 25,000; Fiche; Other Holdings 7000; Periodical Subscriptions 50; Slides 20,000
Collections: Over 7000 bookplates

MOORESTOWN

M **PERKINS CENTER FOR THE ARTS,** 395 Kings Hwy, Moorestown, NJ 08057. Tel 856-235-6488; Fax 856-235-6624; Elec Mail create@perkinscenter.org; Internet Home Page Address: www.perkinscenter.org; *Asst Dir* Denise Creedon; *Dir* Alan Willoughby; *Dir Educ* Anissa Lewis; *Cur of Exhibs* Hope Proper; *Asst Dir Educ* Lise Ragbir; *Dir Educ* Melissa Walker
Open Thurs - Sun; No admis fee; Estab 1977 as a multi-disciplinary art center; A tudor mansion built in 1910 on 5-1/2 acre lot. The building is listed on the

National Register of Historic Places; Average Annual Attendance: 25,000; Mem: 1200; dues family $50, adult $30, student $20

Income: $1,200,000 (financed by mem, state appropriation, corporate, foundation & earned income)

Exhibitions: Annual Photography Exhib; Annual Pottery Show & Sale; Annual Works on Paper Exhib; Annual Watercolor Exhib; Director's Choice; Mems & Faculty Show

Publications: Perkinsight, quarterly newsletter & class catalog

Activities: Classes for adults & children; docent progs; lect open to pub, 5 vis lectrs per yr; awards given; schols & fels offered

MORRISTOWN

L COLLEGE OF SAINT ELIZABETH, Mahoney Library, 2 Convent Rd, Morristown, NJ 07960-6989. Tel 973-290-4237; Fax 973-290-4226; Elec Mail pchervenie@liza.st-elizabeth.edu; *Dir Library* Bro Paul B Chervenie
Open Mon 10 AM - 9 PM, Tues - Thurs 9 AM - 9 PM, Fri 9 AM - 5 PM, Sat 9 AM - 4 PM, Sun 2 - 6 PM; Estab 1899 for acad purposes
Income: Financed by pvt funds
Library Holdings: Book Volumes 140,200; Cassettes; Exhibition Catalogs; Fiche 65,664; Filmstrips 200; Original Art Works; Periodical Subscriptions 848; Photographs; Prints; Records 1800; Reels 4690; Reproductions; Sculpture
Exhibitions: Sculpture, paintings, prints by the Art Dept faculty

M MORRIS MUSEUM, 6 Normandy Heights Rd, Morristown, NJ 07960. Tel 973-971-3700; Fax 973-538-0154; Internet Home Page Address: www.morrismuseum.org; *Coll Mgr* Jenny Martin; *Chair* Mary Chandor; *VPres Institutional Advancement* Betty Heinig; *CEO & Exec Dir* Steven H. Miller
Open Tues & Wed 10 AM - 5 PM, Thurs until 8 PM, Fri & Sat 10 AM - 5 PM, Sun 1 - 5 PM, cl major holidays; Admis adults $7, students, seniors & children $4; mems free; Estab 1913 to educate diverse pub on topics in art, humanities & the sciences; 12 galleries of changing & permanent exhibs; Average Annual Attendance: 325,000; Mem: 2500; dues $40 - $65; ann meeting in Sept
Income: Mem dues, funds, grants
Special Subjects: Painting-American, Sculpture, Watercolors, American Indian Art, Bronzes, African Art, Anthropology, Archaeology, Costumes, Ceramics, Crafts, Pottery, Primitive art, Etchings & Engravings, Decorative Arts, Collages, Glass, Asian Art, Carpets & Rugs, Period Rooms
Collections: Antique dolls & toys; ethnographic materials of New Guinea, Africa & the Americas; fine & decorative arts; geology; mineralogy; paleontology; textiles; zoology; mechanical musical instruments; automata
Exhibitions: North American Indian & Woodland Indian Galleries; Rock & Mineral Gallery; Gallery; Dinosaur Gallery; Children's Room; Mammal Gallery; Model Train Gallery; juried art exhibitions; Mechanical musical instruments & automata
Publications: Sassona Norton Sculpture
Activities: Classes for adults & children; dramatic progs; docent training; lect open to pub, 6-10 vis lectrs per yr; concerts; gallery talks for schools; tours; competitions with prizes; exten dept serves schools, sr centers & hospitals; artmobile; individual paintings & original objects of art lent to other local organizations & museums; book traveling exhibs; originate traveling exhibs; mus shop sells books, reproductions, prints, exhibs-related gifts & toys

M SCHUYLER-HAMILTON HOUSE, 5 Olyphant Pl, Morristown, NJ 07960. Tel 973-267-4039; Fax 908-852-1361; Elec Mail aben85271@aol.com; *Cur* Phyllis Sanftner; *Cur* JoAnn Bownan; *Co-2nd Vice Regent* Mariane Browne; *Co-1st Vice Regent* Patricia Sanftner; *CEO* Anita Brennan
Open Sun 2 - 4 PM, other times by appointment; Admis adults $4, children under 12 free; Estab 1923 for preservation of historical landmark; House is furnished with 18th Century antiques; five large portraits of General & Mrs Philip Schuyler, their daughter, Betsey Schuyler Hamilton, Alexander Hamilton & Dr Jabez Campfield; old lithographs, silhouette of George Washington, needle & petit point; Average Annual Attendance: 1,500; Mem: 90; dues $30; ann meeting 1st Thurs in May, Chapter meets Oct - May
Income: Financed by mem, Friends of Schuyler-Hamilton, foundations & matching gifts
Special Subjects: Decorative Arts, Period Rooms
Collections: China - Canton, blue willow, Staffordshire; doll china; pewter; brass candlesticks; rugs; tunebooks
Activities: Docent training; lect for mems; tours; competitions with awards; sales shop sells stationery, cards & reproductions

NEW BRUNSWICK

C JOHNSON & JOHNSON, Art Program, One Johnson & Johnson Plaza, New Brunswick, NJ 08933. Tel 732-524-0400; *Art Cur* Michael J Bzdak
Collections: Photographic works on paper from the 1960s; photographs; works by New Jersey artists
Exhibitions: Children's book illustrations from the Jane Voorhees Zimmeds Art Museum

A MIDDLESEX COUNTY CULTURAL & HERITAGE COMMISSION, 703 Jersey Ave, New Brunswick, NJ 08901. Tel 732-745-4489; Fax 732-745-4524; *Treas* Edmund Spiro; *Exec Dir* Anna M Aschkenes
Open Mon, Wed, Thurs, Fri 8:30 AM - 4:15 PM, Tues 8:30 AM - 6:30 PM; No admis fee; Estab 1979 to provide exhib opportunities & information services for mems & educ & cultural opportunities for the gen pub; Slide file of mems' art work is maintained; Mem: 177; dues family or friend $25, mem $15, students & srs $10; monthly board meetings
Income: Financed by mem, state grants, fundraising
Exhibitions: New Brunswick Tommorrow; Annual Statewide Show
Publications: ALCNJ Newsletter, monthly
Activities: Demonstrations open to pub; competitions with awards

RUTGERS, THE STATE UNIVERSITY OF NEW JERSEY

M Jane Voorhees Zimmerli Art Museum, Tel 732-932-7237; Fax 732-932-8201; Elec Mail surname@zimmerli.rutgers.edu; Internet Home Page Address: www.runj.edu; *Dir* Phillip Dennis Cate; *Assoc Dir* Greg Perry; *Sr Cur* Jeffrey Wechsler; *Registrar* Cathleen Anderson; *Cur of Russian & Soviet Art* Alla Rosenfeld
Open Tues - Fri 10 AM - 4:30 PM, Sat & Sun Noon - 5 PM, cl Mon (all year), Tues (July & Aug), Memorial Day, Independence Day, Thanksgiving & Friday, Dec 25 - Jan 1; Admis adult $3, mems, Rutgers University students & staff (with ID), children under 18 & to public first Sun of every month free; Estab 1966 to house Fine Arts Coll & present exhibs through the school yr; Average Annual Attendance: 30,000; Mem: 1200; dues $35, $10 student
Income: Financed by state appropriation & pub & pvt sources
Purchases: $150,000
Collections: Japonisme: Western Art Influenced by Japanese Art; 19th & 20th Century French & American Prints; Russian Art; Rutgers Archives for Printmaking Studios; Rutgers Collection of Original Illustrations for Children's Literature; The Herbert D & Ruth Schimmel Rare Book Library; Soviet Nonconformist Art
Publications: Exhib brochures; exhib catalogs; triannual newsletter
Activities: Docent tours; lect open to pub; concerts; gallery talks; individual paintings & original objects of art lent to museums; originate traveling exhibs organized & circulated; mus shop sells books

L Art Library, Tel 732-932-7739; Fax 732-932-6743; Internet Home Page Address: www.libraries.rutgers.edu/rul/libs/art_lib/art_lib.shtml; *Asst Librn* Sara Harrington; *Art Librn* Joseph Consoli
Open Mon - Thurs 9 AM - 10 PM, Fri & Sat 9 AM - 5 PM, Sun 1 - 10 PM; Estab 1966 for academic research; Circ Non-circulating; For reference only
Library Holdings: Book Volumes 65,000; Clipping Files; Exhibition Catalogs; Fiche; Pamphlets; Periodical Subscriptions 240
Collections: Mary Barlett Cowdrey Collection of America Art; Howard Hibbard Collection; George Raibov Collection of Russian Art; Louis E Stern Collection of Contemporary Art; Western Art-Architectural History
Activities: Bibliographic instruction; lect; tours

M Mary H Dana Women Artists Series, Tel 732-932-9407, ext 26; Fax 732-932-6777; Elec Mail olin@rci.rutgers.edu; Internet Home Page Address: www.libraries.rutgers.edu/rul/exhibits/dana_womens.shtm; *Cur* Ferris Olin, Dr
Open Mon - Thurs 8 AM - 11 PM, Fri 8 AM - 9 PM, Sat 10 AM - 6 PM, Sun Noon - 11 PM; No admis fee; Estab 1971 to exhibit the work of emerging & established women artists; Located in galleries of Mabel Smith Douglass Library on women's campus of Rutgers University
Income: Financed from gifts from endowment, student groups & departmental funds
Exhibitions: Rotating exhibs each acad yr
Publications: Exhib catalogues
Activities: Lect open to pub; vis lectr; artists selected by jury

L Mabel Smith Douglass Library, Tel 732-932-9407 ext 26; Fax 732-932-6777; Elec Mail olin@rci.rutger
Open Mon - Thurs 8 AM - 1 AM, Fri 8 AM - 9 PM, Sat 10 AM - 6 PM, Sun Noon - 1 AM; Estab 1918
Special Subjects: Photography, Graphic Arts, Graphic Design, Theatre Arts

NEW PROVIDENCE

M CAMBRIA HISTORICAL SOCIETY, 121 Chanlon Rd, New Providence, NJ 07974. Tel 908-665-2846; *Cur* Donald Bruce; *Dir* Tamika Borden
Open Mon - Thurs & Sat 10 AM - 4 PM; Admis adult $3; Estab 1950 as a historic house mus; Average Annual Attendance: 10,000; Mem: 1600; dues $70; ann meeting in Oct
Income: $160,000 (financed by mem)
Special Subjects: Dolls, Furniture, Glass
Collections: China; dolls; furniture; glass; paintings

NEWARK

A ALJIRA CENTER FOR CONTEMPORARY ART, 100 Washington St, Newark, NJ 07102. Tel 973-643-6877; Fax 973-643-3594; Elec Mail aljirainc@aol.com; *Exec Dir* Victor Davson; *Gallery Mgr* Shana O'Hara
Open Wed - Sun Noon - 6 PM; call for information; Estab 1983 as a multi-cultural visual art organization
Exhibitions: Various exhibs; call for information

M NEW JERSEY HISTORICAL SOCIETY, 52 Park Pl, Newark, NJ 07102. Tel 973-596-8500; Fax 973-596-6957; Internet Home Page Address: www.jerseyhistory.org; *Dir Spec Projects* Ellen Snyder-Grenier; *Coll Mgr* Timothy Decker; *Library Dir* Chad Leinaweaver; *Pres & CEO* Sally Yerkovich; *Prog & Colls Dir* Janet Rassweiler
Open Tues - Sat 10 AM - 5 PM; No admis fee; Estab 1845 to col, preserve, exhibit & make available to study the materials pertaining to the history of New Jersey & its people; The mus has three changing exhib spaces & special colls library; Average Annual Attendance: 20,000; Mem: 1700; dues adults $30 & up; ann meeting third Wed in Apr
Income: Financed by endowment, mem, gifts, grants & benefits
Special Subjects: Drawings, Glass, Flasks & Bottles, Furniture, Photography, Painting-American, Archaeology, Costumes, Landscapes, Portraits, Posters, Dolls, Historical Material, Coins & Medals, Miniatures, Embroidery
Collections: Ceramics; glassware; furniture; important technical drawings from 1790-1815; New Jersey portraits, landscapes, prints & photographs; sculpture; silhouettes & miniatures; silver; toys; manuscripts; maps; New Jersey History Artifacts
Publications: Exhib catalogs; Jersey Journeys; New Jersey History, biannual; New Jersey News, monthly newsletter
Activities: Classes for adults & children; gallery talks; individual paintings & original objects of art lent to established institutions; variable book traveling exhibs; traveling exhibs organized & circulated internationally; mus shop sells books, original art, toys

L Library, 52 Park Pl, Newark, NJ 07102. Tel 973-596-8500; Fax 973-596-6957;

Elec Mail library@jerseyhistory.org; Internet Home Page Address: www.jerseyhistory.org; *Pres & CEO* Sally Yerkovich; *Cur Educ* Claudia Ocello; *Dir Library* Chad Leinaweaver
Open Tues - Sat Noon - 5 PM or by appt; No admis fee; Estab 1845 to preserve the history of NJ; Time changing galleries on historical NJ topics; Mem: 1000; $25, ann April meetings
Library Holdings: Audio Tapes 100; Book Volumes 65,000; Cassettes; Clipping Files; Exhibition Catalogs; Fiche 7800; Lantern Slides; Manuscripts; Maps 2000; Memorabilia; Original Art Works; Original Documents; Other Holdings Manuscript material 2000 linear feet; Pamphlets 12,000; Periodical Subscriptions 300; Photographs 100,000; Prints; Reels 3500 reels of microfilm; Video Tapes 200
Special Subjects: Folk Art, Landscape Architecture, Decorative Arts, Illustration, Drawings, Etchings & Engravings, Historical Material, History of Art & Archaeology, Archaeology, Interior Design, American Indian Art, Anthropology, Afro-American Art, Marine Painting, Landscapes
Collections: Manuscript, Book and Special Collections
Publications: New Jersey History; No Easy Walk Summer-Fall 2004; Resourceful New Jersey 2004-2005
Activities: Classes for children; docent training; teacher workshops; teen parent prog; lect open to pub; gallery talks; tours; mus shop sells books & reproductions

L NEW JERSEY INSTITUTE OF TECHNOLOGY, Architecture Library, 323 Martin Luther King Blvd, Newark, NJ 07102-1982. Tel 973-642-4390 (reference); Fax 973-643-5601; Internet Home Page Address: www.njit.edu/library/archlib/index.html; *Dir* Maya Gervits
Open Mon - Thurs 8 AM - 8:30 PM, Fri 8 AM - 6 PM, Sat & Sun 1 - 5 PM; No admis fee; Estab 1975 to serve the needs of the school of architecture; For lending & reference
Income: Financed by univ
Purchases: $20,000
Library Holdings: Audio Tapes; Book Volumes 10,279; Cassettes; Clipping Files; Compact Disks; DVDs; Exhibition Catalogs; Filmstrips; Maps; Pamphlets; Periodical Subscriptions 80; Slides; Video Tapes
Special Subjects: Art History, Constructions, Landscape Architecture, Photography, Maps, History of Art & Archaeology, Interior Design, Period Rooms, Restoration & Conservation, Architecture

M NEWARK MUSEUM ASSOCIATION, The Newark Museum, 49 Washington St, Newark, NJ 07102-3176. Tel 973-596-6550; Fax 973-642-0459; Internet Home Page Address: www.newarkmuseum.org; *Chmn Board of Trustees* Kevin Shanley; *Dir* Mary Sue Sweeney Price; *Deputy Dir Prog & Coll* Ward Mintz; *Deputy Dir Finance* Meme Omogbai; *Cur Classical Coll* Dr Susan H Auth; *Cur Decorative Arts* Ulysses G Dietz; *Cur Asian Coll* Valrae Reynolds; *Cur Africa, Americas & Pacific* Christa Clark; *Cur Painting & Sculpture* Joseph Jacobs; *Dir Educ* Lucy Brotman; *Merchandise Mgr* Lorelei Rowars; *Dir Exhib* David Palmer; *Prog Coordr* Sheila Anderson; *Deputy Dir Develop* Peggy Dougherty; *Pres Bd Trustees* Arlene Lieberman; *Librn* William Peniston; *Deputy Dir Mktg* Cynthia Hollod; *Dir Science* Ismael Calderon; *Cur Natural Science* Sule Oygur; *Registrar* Rebecca Buck
Open Wed - Sun Noon - 5 PM, cl Christmas, New Year's Day, July 4 & Thanksgiving; No admis fee; Estab 1909 to exhibit articles of art, science & industry & for the study of the arts & sciences; Founded in 1909 in the Newark Pub Library, the bldg was a gift of Louis Bamber, opened in 1926, held in trust by the Newark Museum Assn for the City of Newark. The North and South Wings were acquired in 1937 and 1982. The renovation of the museum was designed by Michael Graves, reopened in 1989, and won the 1992 American Institute of Architects Honor Award. It contains 60,000 sq ft of gallery space, as well as educ facilities and a 300-seat auditorium. The Ballantine House, a 1885 historical mansion, designated a National Historical Landmark in 1985, showcases the decorative arts coll in 8 period rms and 6 thematic galleries; Average Annual Attendance: 500,000; Mem: 4750; dues $35 & up; ann meeting in Jan
Income: $14,000,000 (financed by city & state appropriations, county funds) and pvt donations
Collections: Africa, the Americas (including Pre-Columbian art), and the Pacific; American paintings and sculpture; Asian art, including Japanese, Korean, Chinese, Indian, and Tibetan; the decorative arts; the Classical cultures of Egypt, Greece and Rome, including the Eugene Schaefer Collection of ancient glass; numismatics; as well as the Mini-Zoo; the Alice and Leonard Dreyfus Planetarium, and the Natural Science Collection
Publications: Newsletter, bimonthly; catalogs & bulletins on major exhibs; New Jersey Arts Annual
Activities: Extensive educ progs including classes for adults & children; docent training; lect open to pub; films; concerts; gallery talks; tours; competitions; exten dept serves community neighborhoods; individual paintings & original objects of art lent to other museums; educ loan coll contains cultural, scientific & historic objects & models; mus shop sells catalogues, reproductions, prints, original craft items from around the world

M Junior Museum, 49 Washington St, Newark, NJ 07102-3176. Tel 973-596-6605; Fax 973-642-0459; Elec Mail juniormuseum@newarkmuseum.org; Internet Home Page Address: www.newarkmuseum.org/juniormuseum/; *Mgr Family Events* Rob Craig; *Jr Mus Supv* Lynette Diaz
Open Wed - Sun Noon - 5 PM; No admis fee; Estab 1926 to provide art & science progs designed to stimulate the individual child in self-discovery & exploration of the world & to teach effective use of the Mus as a whole, which may lead to valuable lifetime interests; Average Annual Attendance: 17,000; Mem: 3500 active; dues $10 lifetime mem; ann meeting in May
Income: Financed through the Newark Mus
Exhibitions: Changing exhibs of children's artwork; ann spring & summer exhibs in Junior Gallery
Activities: Weekday pre-school & after school; Saturday morning & summer workshops for ages 3-16; parents' workshops; community outreach & school enrichment programs; special events workshops & holiday festivals & hospital outreach; Junior Gallery offering a self-guided gallery game & art activity sessions, weekend Sept-June & weekdays in summer

L NEWARK PUBLIC LIBRARY, Reference, 5 Washington St, PO Box 630 Newark, NJ 07101-0630. Tel 973-733-7779, 733-7820, 733-7745; Fax 973-733-5648; Elec Mail reference@npl.org; Internet Home Page Address: www.npl.org; *Supv* Leslie Kahn; *Supv* James Capuano; *Principal Librn* Jane Seiden; *Principal Librn* Curt Idrogo; *Principal Librn* Patricia Winship; *Sr Librn* Monica Malinowski; *Librn* Elaine Kiernan Gold; *Librn* Deirdre Schmidel; *Librn* Jeanne Murray; *Librn* Hannah Kwon
Open Sept - June Tues - Thurs 9 AM - 8:30 PM, Mon, Fri & Sat 9 AM - 5:30 PM, July - Aug Mon, Tues, Thurs & Fri 9 AM - 5:30 PM, Wed 9 AM - 8:30 PM, Sat 9:30 AM - 1:30 PM; Estab 1888, provides information on all of the visual arts to the NJ Library Network & pub; Maintains an art gallery: a total of 300 running ft
Income: Financed by city & state appropriations, endowment & gift funds
Library Holdings: Auction Catalogs; Book Volumes 75,000; CD-ROMs; Clipping Files; Exhibition Catalogs; Manuscripts 200; Original Art Works 23,000; Other Holdings Picture Collection; Periodical Subscriptions 40; Prints 20,000
Special Subjects: Art History, Decorative Arts, Illustration, Calligraphy, Drawings, Etchings & Engravings, Graphic Arts, Manuscripts, Ceramics, Crafts, Latin American Art, Cartoons, Fashion Arts, Interior Design, Lettering, Furniture, Glass, Afro-American Art, Bookplates & Bindings, Architecture
Collections: Original Prints (22,000); Historic Posters (5,000); The Richard C Jenkinson Coll of Printing History (2,300); The Wilbur Macy Stone Coll on Historic Books for Children (1,200); Illustrated Book Coll (2,800); Autographs (1,000); The McEwen Christmas Coll (900); Artists Book Coll (600); Pop-Up Book Coll (600); The Rabin & Kreuger Archives (250 folders); Shopping Bags (1,100); Historic Greeting Cards (800)
Exhibitions: Movable Books: A Paradise of Pop-Ups, A Feast of Fold Outs & a Mix of Mechanicals; Prints by Joseph Pennell; Posters & Prints from Puerto Rico, 1950-1990; 20th Century American Illustrations; A Potpourri of Pop (Pop art prints & pop-up books); Over There...1917-1918, A Victory Salute to the USA in World War I; The Essential Calendar: The Art & Design of Calendars; Prints & Posters of the Circus and Vintage Greeting Cards; Travel Posters & Memorable Works on Paper from Africa, China, India & Taiwan; Where, When and Who Took That Photograph?; Nostalgic and Unforgettable Travel Posters from the 20th Century; Robert Sabuda: Travels in Time & Space via Pop-Up Books; Original Prints by African-American Artists; John Cotton Dana: Innovative Librn, Civic Leader, Mus Founder; A Salute to Two Great 20th Century Artists: Picasso & Lichtenstein in prints, posters and rare books; A Contemporary & Historic Survey of Shopping Bags
Activities: Tours; gallery talks; originate traveling exhibs to art institutions

C PRUDENTIAL ART PROGRAM, 100 Mulberry St, Gateway Center 2-17th Flr Newark, NJ 07102. Tel 973-367-7151; *Mgr* Carol Skuratofsky
Estab 1969 to enhance the surroundings & living up to social responsibility in supporting art as a genuinely important part of life
Collections: Approximately 12,000 holdings of paintings, sculptures & unique works on paper; 2558 signed graphics; 1182 posters; 241 billboards; 200 photographs

NORTH BRANCH

A PRINTMAKING COUNCIL OF NEW JERSEY, 440 River Rd, North Branch, NJ 08876. Tel 908-725-2110; Fax 908-725-2484; Internet Home Page Address: www.printnj.org; *Dir* Stephanie Spencer
Open Wed - Fri 11 AM - 4 PM, Sat 1 - 4 PM, cl Sun; No admis fee; Estab 1973 to promote & educate the fine art of printmaking, photography & papermaking; Average Annual Attendance: 50,000; Mem: 450; dues $35 & up; ann meeting in Jan
Income: Financed by mem & individual, foundation & corporate gifts including NJ State Council on the Arts & Somerset County Parks Commission
Exhibitions: 16 exhibs per yr; national juried exhibs
Activities: Classes for adults & children; lect open to pub; competitions with awards; lending coll contains art objects, lent to corporate mems & libraries; Roving Press (traveling print mentoring prog for pub schools); book traveling exhibs 9 per yr; originate traveling exhibs 9 per yr; sales shop sells original art

OCEAN CITY

A OCEAN CITY ART CENTER, 1735 Simpson Ave, Ocean City, NJ 08226. Tel 609-399-7628; Fax 609-399-7089; Elec Mail ocart@prousa.net; Internet Home Page Address: www.pceamcityartcenter.org; *Bd Pres* Jack Devine; *Exec Dir* Eunice Bell
Open Mon - Thurs 9 AM - 9 PM, Fri 9 AM - 4 PM, Sat 9 AM - Noon, cl Sun; Estab 1967 to promote the arts; Teaching studios & a gallery for monthly changing exhibs throughout the yr; Average Annual Attendance: 10,000; Mem: 1200; dues individual $15, family $30; ann meeting in Feb; Scholarships
Income: $70,000 (financed by mem, city appropriation, New Jersey State Council on the Arts Grant 1981)
Collections: Paintings
Exhibitions: Annual Membership Show, Juried Show, Boardwalk Art Show Winners Exhib, Christmas Crafts Fair, Juried Photog Show, Craft Show
Publications: Newsletters, quarterly
Activities: Classes for adults & children; lect open to the pub, 12 vis lectrs per yr; concerts; competitions with awards; mus shop sells books, original art & crafts

OCEANVILLE

M THE NOYES MUSEUM OF ART, 733 Lily Lake Rd, Oceanville, NJ 08231. Tel 609-652-8848; Fax 609-652-6166; Elec Mail info@noyesmuseum.org; Internet Home Page Address: www.noyesmuseum.org; *Exec Dir* Michael Cagno
Open Tues - Sat 10 AM - 4:30 PM, Sun Noon - 5 PM; Admis adults $4, seniors & students $3, children under 12 free; Estab 1983 to foster awareness & appreciation of contemporary American art & crafts & folk art from the mid-Atlantic region; Four wing galleries & central gallery space devoted to

rotating exhibs of contemporary American art, folk art & crafts; Average Annual Attendance: 17,000; Mem: 400; dues benefactor $500, sustaining $250, supporting $125, family $65, individual $45, students $30

Special Subjects: Painting-American, Sculpture, Crafts, Folk Art, Pottery, Woodcarvings

Collections: American Bird Decoys; Contemporary American Fine Art & Crafts; 19th & 20th century Folk Art from the mid-Atlantic region

Exhibitions: Contemporary Fine Art; Crafts & Folk Art

Publications: NoyesNews, quarterly newsletter; exhib catalogues

Activities: Classes for adults & children; dramatic progs; docent training; lect open to pub; concerts; gallery talks; tours; individual paintings & original objects of art lent to other professional museums or exhib spaces; study coll available to NJ schools; lending coll contains original works of art: original prints, paintings, photographs & sculptures; mus shop sells books, original art & prints

L **Library,** Lily Lake Rd, Oceanville, NJ 08231. Tel 609-652-8848; Fax 609-652-6166; Elec Mail noyesnews@jerseycape.com; *Exec Dir* Lawrence Schmidt
Estab 1983; Reference library
Library Holdings: Book Volumes 500; Exhibition Catalogs; Pamphlets; Periodical Subscriptions 15; Prints; Sculpture; Video Tapes
Special Subjects: Art History, Constructions, Folk Art, Mixed Media, Drawings, History of Art & Archaeology, Ceramics, Conceptual Art, Crafts, Latin American Art, Art Education, Mexican Art, Glass, Mosaics, Oriental Art
Collections: Contemporary American Art rotating exhibitions; crafts, folk art; Meet the Artist Days

ORADELL

M **BLAUVELT DEMAREST FOUNDATION,** Hiram Blauvelt Art Museum, 705 Kinderkamack Rd, Oradell, NJ 07649. Tel 201-261-0012; Fax 201-391-6418; Elec Mail maja218@verizon.net; Internet Home Page Address: www.blauveltmuseum.com; *Dir* Marijane Singer, PhD; *Dir Educ* Rosa Lara; *Installer* Alphonse Andujar; *Mus Asst* Diane Rivera
Open Mon - Fri 10 AM - 4 PM, Sat & Sun 2 - 5 PM; No admis fee; Estab 1950; 1893 shingle & turret-style Queen Anne carriage house; Average Annual Attendance: 13,224; Mem: ann meeting in June
Library Holdings: Exhibition Catalogs; Original Art Works
Special Subjects: Drawings, Painting-American, Photography, Prints, Sculpture, Watercolors, American Western Art, Bronzes, African Art, Southwestern Art, Woodcarvings, Painting-European, Portraits, Eskimo Art, Painting-Canadian, Painting-British, Ivory, Scrimshaw, Dioramas, Painting-Scandinavian
Collections: Audubon folio; Big Game Species; Extinct Birds; Ivory Collection; Master & Contemporary Wildlife & Animal Art Paintings & Sculptures
Exhibitions: Art works by Guy Coheleach, Charles Allmond, Mary Taylor, Dwayne Harty, Charles Livingston Bull; (2004) Art And The Animal II; (2006) Simon Combes; (2007) Ray Harris-Ching & Dale Weiler
Publications: Charles Livingston Bull Catalog; Art & the Animal I; Art & the Animal II
Activities: Classes for adults & children; docent training; lect open to pub; gallery talks; tours; ann Purchase Award - Soc Animal Artists; Blauvelt Purchase Award, Ann Mem of society or animal artist; mus shop sells books, magazines, original art, reproductions, prints & videos

PALISADES PARK

L **PALISADES PARK PUBLIC LIBRARY,** 257 Second St, Palisades Park, NJ 07650. Tel 201-585-4150; Fax 201-585-2151; Elec Mail ashley@bccls.org; Internet Home Page Address: www.bccls.org/palisadespark; *Children's Librn* Steven Cavallo; *Dir* Terrie L McColl
Mon - Thurs 10:30 AM - 9 PM, Fri 10:30 AM - 5 PM; Estab 1909; Maintains a community room used for exhibits
Library Holdings: Book Volumes 40,000; Cassettes; Periodical Subscriptions 75; Video Tapes

PARAMUS

M **BUEHLER CHALLENGER & SCIENCE CENTER,** 305 N State Rte 17, Paramus, NJ 07653; PO Box 647, Paramus, NJ 07653. Tel 201-262-0984; Fax 201-251-9049; Elec Mail missionservices@bcsc.org (Coordr); Internet Home Page Address: www.bcsc.org; *Mission Coordr* Celine Penti
Call for hours & further information; Created in 1994 by the Emil Buehler Trust as the 21st center in the Challenger Learning Center network; Dedicated to inspiring students, educators and the community in the pursuit of scientific educ
Activities: Progs & Outreach progs; tours; Mission Simulations; Space Camp; Astro Camp; Family Science Morning

PARSIPPANY

A **NEW JERSEY WATERCOLOR SOCIETY,** 55 Richard St, Parsippany, NJ 07054; 83 Clifford Dr, Wayne, NJ 07470. Tel 873-887-5860; Internet Home Page Address: www.njwcs.org; *First VPres* Ken Hamilton; *Pres* Joel Popadils; *Treas* Jack O'Reilly
Estab 1938 to bring to the pub the best in NJ watercolorists - teachers; Mem: 135; dues $25; open to exhibitors in the Annual Open Exhib whose work conforms to standards of the Soc & are legal residents of the State of NJ
Exhibitions: Annual Mems Show in spring; Annual Open Statewide Juried Exhib in fall - alternating between the Ridgewood Art Institute & the Monmouth Museum, Lincroft, NJ
Publications: Illustrated catalogue; newsletter, 3 per yr
Activities: Classes for adults & children; workshops; lect open to pub, 2-4 vis lectrs per yr; competitions with awards; ann dinner; reception for Open & Mems Shows

PATERSON

M **PASSAIC COUNTY COMMUNITY COLLEGE,** Broadway, LRC, and Hamilton Club Galleries, One College Blvd, Paterson, NJ 07505-1179. Tel 973-684-6555; Fax 973-523-6085; Elec Mail jhaw@pccc.edu; Internet Home Page Address: www.pccc.edu/culturalaffairs; *Young People's Theatre Coordr* Susan Amsterdam; *Exec Dir Cultural Affairs* Maria Mazziotti Gillan; *Asst* Alin Papazian; *Gallery Cur* Jane Haw; *Outreach Coordr* Angela Helenek
Open Mon - Fri 9 AM - 9 PM, Sat 9 AM - 5 PM; No admis fee; Changing exhibits at contemporary art & permanent colls of 19th & early 20th century paintings & sculpture
Special Subjects: Painting-American, Prints, Period Rooms, Painting-British, Painting-European, Painting-French, Watercolors, Painting-Flemish, Painting-German, Painting-Scandinavian
Exhibitions: Monthly & bimonthly exhibits of local & tri-state artists. Works are mostly 2-D; paintings, drawings, mixed media, silkscreens, woodblock prints, photography, textile & some ceramics
Activities: Gallery talks, tours

M **PASSAIC COUNTY HISTORICAL SOCIETY,** Lambert Castle, Valley Rd Paterson, NJ 07503-2932. Tel 973-247-0085; Fax 973-881-9434; Elec Mail lambertcastle@yahoo.com; Internet Home Page Address: www.geocities.com/PCHSLC; *Exec Dir* Andrew Shick; *VPres* Cynthia Vandam; *VPres* Michael Blanchfield
Open Wed - Sun 1 - 4 PM; Admis adults $1.50, seniors $1, children under 15 free; Estab 1926; Located in Lambert Castle built in 1892; Average Annual Attendance: 25,000; Mem: Dues sustaining $50, family $35, regular $20, seniors $15, student $5
Income: Financed by donations, gifts, grants, mem dues
Special Subjects: Painting-American, Prints, Watercolors, Costumes, Folk Art, Landscapes, Decorative Arts, Manuscripts, Portraits, Furniture, Historical Material, Maps, Period Rooms, Painting-Italian
Collections: Koempel Spoon Collection; textiles; local historical material; paintings; photographs; decorative arts; folk art
Exhibitions: A Needle for Her Brush: Passaic County Textile Arts 1800-1950; Gaetano Federici; Heroes; Latch Key to the White House: The Lives of Garret & Jennie Hobart; Myths & Icons: The Print Collections of PCHS; Passaic County Folk Art, Life & Times in Silk City; Passaic Falls; Paterson Means Business; quilts & coverlets; The World of Catholina Lambert & His Castle; World War I posters
Publications: Castle Lite, bimonthly newsletter; pamphlets; exhib catalogues
Activities: Lect open to pub, 4-5 vis lectrs per yr; gallery talks; tours; individual paintings & original objects of art lent to qualified museums by written request; book traveling exhibs; mus shop sells books, reproductions, prints, publs, postcards, souvenirs, gifts

L **Library,** Lambert Castle, 3 Valley Rd Paterson, NJ 07503-2932. Tel 973-247-0085; Fax 973-881-9434; Elec Mail lambertcastle@yahoo.com; Internet Home Page Address: www.geocities.com/pchslc/library.html; *Dir* Andrew Shick
Open Wed - Sun 1 PM - 4 PM; Admis adults $3, seniors $2, 12-18 vis $1.50, chidren under 12 free; Estab 1926 for preservation of Passaic County history; Local history gallery includes portraits, landscapes from 1800-1930; gen gallery includes portraits & landscapes from 17th-19th century; Average Annual Attendance: 20,000; Mem: 500; dues family $35, individual $20, senior $15
Income: Financed by donations, gifts, grants
Library Holdings: Book Volumes 10,000; Clipping Files; Manuscripts; Maps; Memorabilia; Original Art Works; Original Documents; Other Holdings; Pamphlets; Photographs; Prints; Records; Sculpture
Collections: Passaic County fine & decorative arts collections
Activities: Dramatic progs; docent training; lect open to pub, 12-15 vis lect per yr; gallery talks; tours; mus shop sells books & reproductions

PLAINFIELD

L **PLAINFIELD PUBLIC LIBRARY,** Eighth St at Park Ave, Plainfield, NJ 07060-2514. Tel 908-757-1111; Fax 908-754-0063; Internet Home Page Address: www.plainfieldlibrary.info; *Dir* Joseph H Da Rold
Open Mon - Thurs 10 AM - 9 PM, Fri & Sat 10 AM - 5 PM, cl Sun; Estab 1881; Maintains an art gallery with original artworks on permanent display, group shows as scheduled
Income: Financed by endowment, city & state appropriation & federal funds
Library Holdings: Original Art Works; Video Tapes 2000
Special Subjects: Painting-American, Historical Material
Collections: Winslow Homer Collection; John Carlson; Alonzo Adams; Cloissone Collection

PRINCETON

M **MORVEN MUSEUM & GARDEN,** 55 Stockton St, Princeton, NJ 08540 Tel 609-924-8144; Fax 609-924-8331; Elec Mail info@morven.org; Internet Home Page Address: www.morven.org; *Cur Exhibs* Anne Grossen; *Cur Horticulture* Megan Varnes
Open Wed - Fri 11 AM - 3 PM, Sat & Sun Noon - 4 PM; Admis adults $5; srs & students $4; Built c 1758 by Richard Stockton, a signer of the Declaration of Independence & later the residence of New Jersey Governors; tours & exhibitions highlight Stockton Family & architectural preservation; Average annual attendence: 5000
Income: Program of the NJ State Mus; financed by gifts, grants & benefits
Collections: Archeology; Material culture relating to the house
Activities: Classes for adults; docent training; lect open to pub, 6 vis lectrs per yr; tours

PRINCETON UNIVERSITY
M **Princeton University Art Museum,** Tel 609-258-3788; Fax 609-258-5949, 258-3610; Elec Mail artmuseum@princeton.edu; Internet Home Page Address: www.princetonartmuseum.org; *Assoc Dir* Rebecca Sender; *Cur J* Michael Padgett; *Cur* Betsy Rosasco; *Cur* Laura Giles; *Registrar* Maureen McCormick; *Managing Ed* Jill Guthrie; *Dir* Susan M Taylor; *Pub Info Off* Ruta Smithson; *Cur* Cary Liu; *Cur of Educ* Caroline Cassells; *Mgr of Community Rels* Frances Z Yuan

Open Tues - Sat 10 AM - 5 PM, Sun 1 - 5 PM; No admis fee; Estab 1882, the mus has assembled a coll of more than 60,000 objects encompasing virtually every inhabited area of the globe and in time periods from prehistoric to contemporary. Strongly committed to social and intellectual exchange, the museum offers rich, interdisciplinary exhibs, progs and pub events inviting you to celebrate the arts; About 65,600 sq ft of gallery space for permanent, semi- permanent & changing installations; Average Annual Attendance: 70,000; Mem: 1250; dues $60 & up

Income: Financed by endowment, univ & by government, corporate & pvt sources

Special Subjects: American Indian Art, Archaeology, Drawings, Ceramics, Metalwork, American Western Art, Antiquities-Assyrian, Furniture, Photography, Portraits, Pottery, Prints, Silver, Painting-Japanese, Graphics, Hispanic Art, Latin American Art, Painting-American, Sculpture, Watercolors, African Art, Pre-Columbian Art, Religious Art, Folk Art, Primitive art, Woodcarvings, Etchings & Engravings, Landscapes, Decorative Arts, Collages, Painting-European, Posters, Glass, Jade, Jewelry, Porcelain, Oriental Art, Asian Art, Antiquities-Byzantine, Marine Painting, Painting-British, Painting-Dutch, Painting-French, Ivory, Scrimshaw, Baroque Art, Calligraphy, Miniatures, Painting-Flemish, Renaissance Art, Medieval Art, Antiquities-Oriental, Painting-Spanish, Painting-Italian, Antiquities-Persian, Islamic Art, Antiquities-Egyptian, Antiquities-Greek, Mosaics, Gold, Stained Glass, Painting-German, Antiquities-Etruscan, Painting-Russian, Painting-Scandinavian

Collections: Ancient Mediterranean; British & American; Chinese ritual bronze vessels; Far Eastern, especially Chinese & Japanese paintings; Medieval & later European; Pre-Columbian; Northwest Coast Indian; African

Publications: Catalogs, occasionally; Record of the Art Museum, annually; newsletter, three times per yr

Activities: Docent training; lect open to pub, 3 lect per yr; concerts; gallery talks; tours; exten prog serves Trenton, NJ schools; mus shop sells books, reproductions, prints, cards, jewelry

L **Index of Christian Art,** Tel 609-258-3773; Fax 609-258-0103; Elec Mail cph@princeton.edu; Internet Home Page Address: www.Princeton.edu/~ica; *Dir* Colum Hourihane
Open Mon - Fri 9 AM - 5 PM, cl holidays; No admis fee; Estab 1917 as a division of the Department of Art & Archaeology. It is a research & reference coll of cards & photographs designed to facilitate the study of Christian iconography in works of art before 1400. Duplicate copies exist in Washington, DC in the Dumbarton Oaks Research Center & in Los Angeles in the Getty Research Institute. European copies are in Rome in the Vatican Library & in Utrecht in the Univ

Library Holdings: Book Volumes; Cards; Exhibition Catalogs; Manuscripts; Photographs

Special Subjects: Mixed Media, Manuscripts

Publications: Studies in Iconography

Activities: Educ prog; lect open to pub, 5-6 vis lectrs per yr; sponsoring of competitions; schols offered

L **Marquand Library of Art & Archaeology,** Tel 609-258-3783; Fax 609-258-7650; Elec Mail marquand@princeton.edu; Internet Home Page Address: http://marquand.princeton.edu/; *Asst Librn* Laurel Bliss; *Librn* Paula D Matthews
Not open to pub; Estab 1908 to serve study & research needs of the students & faculty of Princeton Univ in the History of Art, Architecture & Archaeology; For reference only

Income: Financed by endowments

Library Holdings: Auction Catalogs; Book Volumes 350,000; CD-ROMs; Exhibition Catalogs; Fiche; Periodical Subscriptions 1,000; Reels

Special Subjects: Art History, Landscape Architecture, Photography, Architecture

RINGWOOD

M **RINGWOOD MANOR HOUSE MUSEUM,** Sloatsburg Rd, PO Box 1304 Ringwood, NJ 07456. Tel 973-962-2240; Fax 973-962-2247; Elec Mail ringwood@warwick.net; *Cur* Elbertus Prol; *Historic Preservation Spec* Martin Deeks
Open Wed - Fri 10 AM - 4 PM, Sat & Sun 10 AM - 5 PM, cl all holidays except, Memorial Day, Independence Day & Labor Day; No admis fee; Estab 1935; Average Annual Attendance: 35,000

Income: Financed by state appropriation & funds raised by pvt organization-sponsored spec events

Special Subjects: Decorative Arts, Historical Material, Restorations

Collections: Decorative arts; firearms; furniture; graphics; historical material; New Jersey iron making history; paintings

Activities: Guided tours; spec events; sales shop sells books, magazines, reproductions & prints

RIVER EDGE

M **BERGEN COUNTY HISTORICAL SOCIETY,** Steuben House Museum, 1209 Main St, River Edge, NJ 07661; PO Box 55 River Edge, NJ 07661. Tel 201-343-9492, 487-1739 (museum); Fax 201-498-1696; *Cur* Matt Gebhardt; *Mus Shop Mgr* Marie Ruggerio; *VPres* John Herreran; *VPres* Todd Braisted; *Secy* Janet Odence
Open Wed - Sat 10 AM - 5 PM, Sun 2 - 5 PM; No admis fee; Estab 1902 to collect & preserve historical items of Bergen County; Maintains reference library; Average Annual Attendance: 10,000; Mem: 300; dues $15; ann meeting in June

Income: Financed by mem, grants & corporate support

Collections: Collection of artifacts of the Bergen Dutch 1680-1914; Campbell Christie House (restored 18th century tavern)

Publications: In Bergen's Attic, quarterly newsletter

Activities: Classes for children; docent progs; lect open to pub, 8 vis lectrs per yr; concerts; gallery talks; mus shop sells books & reproductions

SOUTH ORANGE

M **SETON HALL UNIVERSITY,** 400 S Orange Ave, South Orange, NJ 07079. Tel 973-761-9459; Fax 973-275-2368; Internet Home Page Address: www.shu.edu; *Dir* Charlotte Nichols
Open Mon - Fri 10 AM - 5 PM; No admis fee; Estab 1963. Troast Memorial

Gallery, estab 1974, houses permanent coll of contemporary American art; Wang Fang-Yu Collection of Oriental art was estab in 1977; Average Annual Attendance: 35,000

Collections: Archaeology Colls

Activities: Lect open to pub; gallery talks

L **Walsh Library,** 400 S Orange Ave, South Orange, NJ 07079. Tel 973-761-9005; Fax 973-761-9432; Elec Mail bloombet@shu.edu; Internet Home Page Address: www.shu.edu; *Assoc Dean* Paul Chao; *Art Librn* Beth Bloom; *Dean* Dr Arthur Hafner
Open Mon - Thurs 8 AM - 11 PM, Fri 8 AM - 5 PM, Sat 9 AM - 5 PM, Sun 11 AM - 11 PM; Estab 1963

Library Holdings: Book Volumes 500,000; Slides 12,000

Collections: Art History; Museum Studies

SPRINGFIELD

L **SPRINGFIELD FREE PUBLIC LIBRARY,** Donald B Palmer Museum, 66 Mountain Ave, Springfield, NJ 07081-1786. Tel 973-376-4930; Fax 973-376-1334; *Head Technical Servs* Betty Borkin; *Ref Dept* Henriann Robins; *Head Circulation Dept* Rose Searles; *Contact Person* Susan Permohos
Open Mon, Wed, Thurs 10 AM - 9 PM, Tues, Fri, & Sat 10 AM - 5 PM, Sun 1 - 4 PM; No admis fee; Estab 1975 as a mus addition to a pub library established to preserve local history; The library, including a meeting room, serves as a cultural center

Collections: Permanent coll of circulating framed art reproductions

Activities: Lect; films; puppet shows; individual reproductions lent to library patrons; lending coll contains books, framed reproductions, records, photographs, slides & periodicals

STOCKHOLM

A **OIL PASTEL ASSOCIATION,** PO Box 374, Stockholm, NJ 07460. Tel 845-353-2483; Fax 845-358-3821; *Pres* John Elliott; *Exec Dir* Dorothy Coleman
Estab 1983 exhib forum for new & traditional types of pastel paintings; Average Annual Attendance: 2,000; Mem: 350; dues $25 per yr

Income: $4,000 (financed by donations & mem)

Exhibitions: Oil pastels; soft pastels; water-soluble pastels

Publications: Art & Artists, USA

Activities: Classes for adults; workshops; schols offered

SUMMIT

A **VISUAL ARTS CENTER OF NEW JERSEY,** 68 Elm St, Summit, NJ 07901. Tel 908-273-9121; Fax 908-273-1457; Elec Mail info@artcenternj.org; Internet Home Page Address: www.artcenternj.org; *Pres* Eric Pryor; *Dir Educ* Dannielle Mick; *Dir Opers* Ernie Palatucci
Open weekdays 9 AM - 10 PM (includes hrs for exhibs & for classes), weekends 9 AM - 4 PM; No admis fee; Estab 1933 to educate through gallery exhib & classroom instruction for diverse audience in contemporary arts; Two gallery spaces, containing 5000 ft of exhib space, specializing in visual art. Three exhib spaces, 2 plus new art park & sculpture garden.; Average Annual Attendance: 50,000; Mem: 1500; Friends mem 354; dues Friends $50, gen $40; ann meeting 3rd wk of Apr

Income: Membership grant tui (classes), fundraising

Exhibitions: Changing exhibs of contemporary visual art; Mems' Show; Juried Show; Outdoor Show

Publications: Class & exhibition catalogs; quarterly newsletter

Activities: Classes for adults & children; docent training; broad range; summer camp for children in Aug; lect open to pub & mems; gallery talks; tours; competitions with awards; trips; Arts Person of the Year Award; schols offered; exten dept serves OUTREACH Progs; sales shop sells original art, jewelry & cards

TRENTON

A **ARTWORKS, THE VISUAL ART SCHOOL OF TRENTON,** 19 Everett Alley, Trenton, NJ 08611. Tel 609-394-9436; Fax 609-394-9551; Elec Mail mccc@artworksnj.org; Internet Home Page Address: www.artsworksnj.org; *Pres* Robert Rose; *Dir* Tricia Fagan
Open Mon, Tues, Wed 5:30 PM - 9:30 PM, Sat 9 AM - 11 PM; No admis fee; Estab 1964 to establish & maintain educ & cultural progs devoted to visual arts; Skylit gallery, 2,000 sq ft, in downtown Trenton; Average Annual Attendance: 7,500; Mem: 1,000; dues $40 - $100; ann meeting in May

Income: Financed by friends, class fees, workshops & demonstration fees, trip fees, entry fees, grants, corporate & pvt contributions

Exhibitions: Exhibitions are held at the Trenton Gallery & at various locations throughout the community

Publications: The Artworks Reader, quarterly

Activities: Classes for adults & children; lect open to pub, 3-10 vis lectrs per yr; tours; competitions with awards; schols offered

L **Library,** 19 Everett Alley, Trenton, NJ 08611. Tel 609-394-9436; Fax 609-394-9551; Elec Mail mccc@artworksnj.org; Internet Home Page Address: www.artworksnj.org; *Pres* Robert Rose; *Dir* Tricia Fagan
Mon, Tues, Wed 5:30 PM - 9:30 PM, Sat 9 AM - 1 PM; Estab 1964, to serve local artists and children and adults in the community; Reference library

Library Holdings: Book Volumes 200; Slides

M **COLLEGE OF NEW JERSEY,** Art Gallery, Holman Hall CN 4700, PO Box 7718 Trenton, NJ 08650-4700. Tel 609-771-2615, 771-2633; Elec Mail masterjp@tcnj.edu; Internet Home Page Address: www.tcnj.edu/~tcag/; *Chmn & Prof* Dr Lois Fichner-Rathus; *Gallery Coordr* Judith P Masterson; *Pres* R Barbara Gittenstein
Open Mon - Fri Noon - 3 PM, Thurs 7 - 9 PM, Sun 1 - 3 PM; No admis fee; Estab to present students & community with the opportunity to study a wide range of artistic expressions & to exhibit their work; Average Annual Attendance: 2,500

Income: Financed by art dept budget & grants including NJ State Council on the Arts, Mercer County Cultural & Heritage Commission
Special Subjects: Drawings, Prints
Collections: Purchases from National Print & Drawing Show
Exhibitions: Craft Show; Faculty Show; Mercer County Competitive Art; Mercer County Competitive Photography; National Drawing Exhib; National Print Exhib; Selections from the State Mus; Sculpture Shows; Student Show; Contemporary Issues; African Arts
Publications: Catalog for African Arts; Catalog for Contemporary Issues; Catalog for National Drawing Exhibition; Catalog for National Print Exhibition
Activities: Classes for adults & children; lect open to pub, 5 vis lectrs per yr; gallery talks; tours; competitions with awards; individual paintings & original objects of art lent to other offices & depts on campus; lending coll contains original art works; original prints; paintings; traveling exhibs organized & circulated to other state cols & art schools

L FREE PUBLIC LIBRARY, Reference Dept, 120 Academy St, Trenton, NJ 08608-1302. Tel 609-392-7188, Ext 24; Fax 609-396-7655; Elec Mail greg@trenton.lib.nj.us; *Head Reference Dept* Cathy Stout; *Dir* Madathikudy K Kuriakose
Open Mon, Wed & Thurs 9 AM - 9 PM, Tues, Fri & Sat 9 AM - 5 PM, cl Sun & holidays; Estab 1900
Income: Financed by city appropriation
Library Holdings: Book Volumes 8000; Clipping Files; Exhibition Catalogs; Memorabilia; Motion Pictures 300; Other Holdings Mounted pictures 5500; Pamphlets; Periodical Subscriptions 35; Photographs; Prints; Records; Reels; Reproductions
Special Subjects: Art History, Calligraphy, Archaeology, American Western Art, Bronzes, Advertising Design, Art Education, Asian Art, American Indian Art, Aesthetics, Afro-American Art, Bookplates & Bindings, Antiquities-Greek, Antiquities-Roman, Architecture
Exhibitions: Paintings; Photographs; Crafts; Antiques Colls

M NEW JERSEY STATE MUSEUM, Fine Art Bureau, 205 W State St, PO Box 530 Trenton, NJ 08625-0530. Tel 609-292-5420; Fax 609-599-4098; Elec Mail margaret.oreilly@sos.state.nj.us; Internet Home Page Address: www.newjerseystatemuseum.org; *Cur Fine Art* Margaret M O'Reilly; *Supv Exhibits* Elizabeth Beitel; *Cur Archaeology-Ethnology* Lorraine Williams; *Cur Science* David Parris; *AE Registrar* Greg Lattanzi; *Sci Registrar* Bill Gallagher; *Cur Cultural History* James Turk; *Interim Admin* Barbara Fulton Moran
Open Tues - Sat 9 AM - 4:45 PM, Sun Noon - 5 PM, cl Mon & most state holidays; main bldg currently closed for renovation; No admis fee; Estab 1895 by legislation to collect, exhibit & interpret fine arts, cultural history, archaeology-ethnology & science with a NJ focus; changing exhibit gallery, Natural History Hall, fine & decorative arts galleries; ethnology gallery, planetarium; Closed for renovation until 2007; Average Annual Attendance: 350,000; Mem: 1,000; dues $40 & up; ann meeting in June
Income: $2,000,000 (financed by state appropriation)
Library Holdings: Auction Catalogs; Book Volumes 3000+; Exhibition Catalogs; Original Documents; Pamphlets; Periodical Subscriptions; Video Tapes
Special Subjects: Afro-American Art, Anthropology, Drawings, Etchings & Engravings, Folk Art, Historical Material, Landscapes, Marine Painting, Ceramics, Collages, Glass, Metalwork, Flasks & Bottles, Furniture, Photography, Porcelain, Prints, Bronzes, Woodcuts, Maps, Painting-French, Sculpture, Graphics, Painting-American, Watercolors, Archaeology, Ethnology, Textiles, Crafts, Pottery, Woodcarvings, Decorative Arts, Portraits, Posters, Silver, Painting-British, Carpets & Rugs, Dioramas, Embroidery, Stained Glass, Painting-German, Pewter
Collections: American fine & decorative arts of the 18th, 19th, 20th & 21st centuries; American painting with spec emphasis on the Steiglitz Circle, Regionalist, Abstract Artists; NJ fine & decorative arts; Ben Shahn's graphic work; art by African-Americans; NJ History; Archaeology & Ethnology; Natural History
Exhibitions: Changing exhibs focus on NJ artists & cultural history; Long-term exhib galleries on the fine & decorative arts, ethnology & the natural sciences
Publications: Annual report; catalogs & irregular serials; quarterly calendar; reports
Activities: Classes for adults & children; dramatic progs; docent training; lect open to pub; lect for mems; vis lectrs per yr varies; concerts; gallery talks; tours;; individual paintings & original objects of art lent to other institutions; book traveling exhibs; mus shop sells books

M OLD BARRACKS MUSEUM, Barrack St, Trenton, NJ 08608. Tel 609-396-1776; Fax 609-777-4000; Elec Mail barracks@voicenet.com; Internet Home Page Address: www.barracks.org; *Chief Historical Interpreter* Gloria Bell; *Dir* Richard Patterson; *Cur* Vivian Lea Stevens; *Office Mgr* Carolyn Cudnik; *Tour Coordr* Linda Mathies; *Develop Coordr* Cathleen Crown
Open daily 10 AM - 5 PM; Admis adults $6, seniors & students $4, children under 6 free; Built 1758, estab 1902 as mus of history & decorative arts; Located in English barracks that housed Hessian Soldiers Dec 1776 & served as American Military hospital during Revolutionary War; Average Annual Attendance: 30,000; Mem: 460; dues $30, $40, $60 $125 & $200; ann meeting Sept
Income: Financed by mem, state appropriation & donations
Special Subjects: Decorative Arts, Historical Material, Period Rooms
Collections: American decorative arts 1750-1820; Archaeological materials; early American tools & household equipment; military artifacts; 19th century New Jersey Portraits; patriotic paintings & prints
Exhibitions: Gallery exhib are rotated ann 1/05, 18th C Trenton Merchant & Manufacturer Wm Richards
Publications: The Barracks Parade, quarterly newsletter; The Barracks of Trenton & Princeton, book
Activities: Classes for children; dramatic programs; docent training; lect open to public, 3 vis lectrs per year; tours; exten dept serves elementary schools; individual paintings & original objects of art lent to museums; lending collection contains slides & reproduction military objects/costumes; book traveling exhibitions; museum shop sells books, reproductions, prints, slides, historical toys, ceramics

M TRENTON CITY MUSEUM, 319 E State St, Trenton, NJ 08608. Tel 609-989-3632; Fax 609-989-3624; Elec Mail bhill@ellarslie.org; Internet Home Page Address: www.ellarslie.org; *Dir & Cur* Brian O Hill; *Mus Shop Mgr* Mary Kay Girmschied; *Pres* Stephanie Morgano
Open Tues - Sat 11 AM - 3 PM, Sun 1 - 4 PM; No admis fee; Estab 1973 to provide a cultural window into the ongoing life of the city & its people; Mus is a historical site, an Italian Revival Mansion; only remaining example of John Notman architecture in Trenton & is located in historic Cadwalader Park, designed by Frederick Law Olmstead; Average Annual Attendance: 13,000; Mem: Dues $25 - $1,000
Income: Financed by mem & city appropriation
Special Subjects: Ceramics, Porcelain
Collections: Trenton-made Ceramics; objects made in or pertaining to Trenton; full set of Trenton directories
Exhibitions: Ellarslic Open XXIII
Publications: Newsletter 2 times per year
Activities: Classes for adults & children accompany changing exhibits; lect open to pub, 10 vis lectrs per yr; sales shop sells books, prints, original art, jewelry & toys for children

UNION

M KEAN UNIVERSITY, James Howe Gallery, College Gallery, Morris Ave Union, NJ 07083. Tel 908-527-2307, 527-2347; Internet Home Page Address: www.library.kean.edu; *Pres* Ronald Applebaun; *Dir Gallery* Alec Nicolescu
Open Mon - Thurs 10 AM - 2 PM, 5 - 7 PM, Fri 10 AM - Noon, by appointment at other times; No admis fee; Estab 1971 as a forum to present all art forms to students & the community through original exhibitions, catalogues, fine art, by guest curators, art history & mus training students; One gallery 22 x 34 ft plus an alcove 8 x 18 ft on first floor of arts & humanities building; Average Annual Attendance: 3,000
Income: Financed by state appropriation & private grants
Special Subjects: Painting-American
Collections: American painting, prints sculpture by Audobon, L Baskin, Robert Cooke, Max Ernst, Lamar Dodd, W Homer, P Jenkins, J Stella, Tony Smith, Walter Darbby Bannard, Werner Drewes, B J O Norfeldt, James Rosenquist, Robert Rauschenberg, Odilon Redon; photographs, rare books & 1935-50 design & furniture; Ben Yamimoto Art Work
Exhibitions: Rotating exhibs
Publications: Catalogues for exhibitions
Activities: Dramatic programs; lect open to public; individual paintings lent to colleges, institutions, corporations & departments on the campus

L Nancy Thompson Library, Morris Ave, Union, NJ 07083. Tel 908-527-2017; Fax 908-527-2365; Elec Mail library@turbo.kean.edu; Internet Home Page Address: www.library.kean.edu; *Dir Library Svcs* Barbara Simpson
Open Mon - Thurs 8 AM - 12 AM, Fri 8 AM - 5 PM, Sat 9 AM - 4 PM, Sun 1 - 10 PM; Estab 1855 to support instruction
Income: State appropriation & private grants
Purchases: $6,000
Library Holdings: Audio Tapes 150; Book Volumes 265,000; Exhibition Catalogs; Filmstrips; Pamphlets; Periodical Subscriptions 1350; Slides

UPPER MONTCLAIR

M MONTCLAIR STATE UNIVERSITY, Art Galleries, 1 Normal Ave, Life Hall Upper Montclair, NJ 07043. Tel 973-655-5113; Fax 973-655-5279; Elec Mail pacel@mail.montclair.edu; Internet Home Page Address: www.montclair.edu/pages/arts; *Pres* Dr Susan A Cole; *VPres* Richard Lynde; *Dean* Geoffrey Newman; *Dir* Lorenzo Pace; *Chmn Art Dept* Daryl Moore
Open Mon, Wed & Fri 9:30 AM - 4 PM, Tues & Thurs 10 AM - 6 PM; No admis fee; Estab 1973; Circ 100,000; Three galleries with 1,200 sq ft, 600 sq ft & 600 sq ft; Average Annual Attendance: 5,000
Income: financed by the college
Collections: Cosla Collection of Renaissance Art, Lida Hilton Print Collection, Wingert Collection of African & Oceanic Art
Exhibitions: Contemporary East Indian Artists; Japanese Expressions in Paper
Activities: Classes for adults; lect open to public; concerts; gallery talks; scholarships offered

L Calcia Art and Design Image Library, 1 Normal Ave, Calcia Art and Design Bldg Rm 214 Montclair, NJ 07043. Tel 973-655-4151; Fax 973-655-7833; Elec Mail hongl@mail.montclair.edu; *Visual Resources Cur* Lynda Hong
Open Mon - Fri 9:30 AM - 4 PM; Circ 100,000
Income: Financed by state funding
Library Holdings: CD-ROMs; Periodical Subscriptions 15; Slides; Video Tapes
Collections: 100,000 35mm art slides

WAYNE

M WILLIAM PATERSON UNIVERSITY, Ben Shahn Gallery, 300 Pompton Rd, Wayne, NJ 07470. Tel 973-720-2654; Fax 973-720-3290; *Dir* Nancy Einreinhofer
Open Mon - Fri 10 AM - 5 PM (Sept - June), cl Fri (May - June); No admis fee; Estab 1969 to educate & instruct students & visitors through exhibits & programs; 5000 sq ft space divided into three gallery rooms specializing in the exhibition of contemporary art; Average Annual Attendance: 10,000
Income: Financed by Univ
Collections: Permanent collection of WPC 19th century landscapes; paintings & sculptures from 1950's to present; Tobias Collection of African and Oceanic Art and Artifacts
Exhibitions: Three gallery rooms of rotating exhibits of contemporary art that change twice during each semester
Publications: Exhibition catalogs
Activities: Art at Lunch program; docent programs; lect open to public, 15 vis lectrs per year

WEST WINDSOR

M MERCER COUNTY COMMUNITY COLLEGE, The Gallery, 1200 Old Trenton Rd, West Windsor, NJ 08550. Tel 609-586-4800, Ext 3589; Elec Mail gallery@mccc.edu; Internet Home Page Address: www.mccc.edu/gallery; *Gallery Dir* Tricia Fagan
Open Tues - Thurs 11 AM - 3 PM, Wed 7 - 9 PM, Thurs 6 - 8 PM; check for additional hours; No admis fee; Estab 1971 as an educational resource for students & the community; Gallery of 2,000 sq ft primarily for exhibiting work by New Jersey and other regional artists; Average Annual Attendance: 3,600
Income: Financed by college support, pub funding, M C Cultural & Heritage Commission grant & sales commissions
Purchases: Annual purchases from Mercer county artists and student exhibitions
Special Subjects: Ceramics, Folk Art
Collections: Cybis Collection; Painting by Wolf Kahn; Sculptures by Salvadore Dali & Isaac Whitkin; Paintings by Reginald Neal; Darby Bannard; B J Nordfeldt; NJ artist collection; Art Work by Frank Rivera; Paintings by Mel Leipzig
Exhibitions: rotating exhibits every 6-8 weeks
Publications: Mailing lists for exhibition post cards; occasional catalogue (ex: 2003="Glimpses of America" catalogue)
Activities: Classes for adults & children; dramatic programs; lect open to public, 12 vis lectrs per year; concerts; gallery talks; tours; competitions with purchase awards; Mercer County Artist Purchase awards; scholarships offered; individual paintings & original objects of art lent to other galleries & museums; lending collection contains original prints; MCCC at Artworks located in Trenton, NJ; fine arts classes for adults & children in the central NJ/Bucks County, PA region. Warehouse gallery offers 5-7 annual exhibits by local & regional artists
L Library, 1200 Old Trenton Rd, Trenton, NJ 08690. Tel 609-586-4800; Internet Home Page Address: www.mccc.edu/students/library; *Library Dir* Pam Price
Open Mon - Thurs 8 AM - 10 PM, Fri 8 AM - 5 PM, Sat 9 AM - 4 PM, cl Sun; Estab 1891 to provide library services for the college; portion of the main floor is devoted to permanent display cabinets. In addition display panels are used for faculty exhibits, community exhibits & traveling exhibits
Library Holdings: Audio Tapes 1460; Book Volumes 64,518; Filmstrips; Other Holdings CD-ROMS 200; Pamphlets 644; Periodical Subscriptions 718; Records 3107; Slides 17; Video Tapes 2878
Publications: Library handbook, annually; Videocassette catalog, annually

WOODBRIDGE

M WOODBRIDGE TOWNSHIP CULTURAL ARTS COMMISSION, Barron Arts Center, 582 Rahway Ave, Woodbridge, NJ 07095. Tel 732-634-0413; Fax 732-634-8633; Elec Mail barronarts@twp.woodbridge.nj.us; *Chmn* Dr Dolores Gioffre; *Dir* Cynthia Knight
Open Mon - Fri 11 AM - 4 PM, Sun 2 - 4 PM, cl Sat & holidays; No admis fee; Estab 1977 to provide exhibits of nationally recognized artists, craftsmen & photographers, & of outstanding NJ talent; Gallery is housed in an 1877 Richardsonian Romanesque Revival building on the National Register of Historic Places; Average Annual Attendance: 8,000
Income: $71,000 (financed by endowment & city appropriation)
Activities: Classes for adults & children; lect open to public, 5 vis lectr per year; awards; concerts; poetry readings

NEW MEXICO

ALBUQUERQUE

M ALBUQUERQUE MUSEUM OF ART & HISTORY, 2000 Mountain Rd NW Albuquerque, NM 87104. Tel 505-243-7255; Fax 505-764-6546; Internet Home Page Address: www.abq.gov/museum; *Cur Art* Douglas Fairfield; *Cur History* Deborah Slaney; *Cur Exhib* Tom Antreasian; *Cur Coll* Tom Lark; *Cur Educ* Chris Steiner; *Dir* James Moore
Open Tues - Sun 9 AM - 5 PM; Admis fee adults $4, seniors $2, children ages 4 - 12 $1, children under 4 free; Estab 1967 as a city mus with the purpose of diffusing knowledge & appreciation of history & art, establishing & maintaining a museum & related reference library, collecting & preserving objects of historic & artistic interest, protecting historic sites, works of art & works of nature from needless destruction, providing facilities for research & publication & offering popular instruction & opportunities for aesthetic enjoyment; Average Annual Attendance: 123,000; Mem: Benefactor $500; supporter $250; friend $100; family/dual $50, individual $40, sr couple $38 & sr over 65 $30
Income: Financed by city appropriation & Albuquerque Museum Foundation
Special Subjects: Folk Art, Ceramics, Glass, Drawings, Graphics, Hispanic Art, Painting-American, Photography, Sculpture, Watercolors, American Indian Art, American Western Art, Bronzes, Southwestern Art, Textiles, Costumes, Crafts, Woodcarvings, Woodcuts, Etchings & Engravings, Landscapes, Decorative Arts, Collages, Furniture, Historical Material, Maps, Coins & Medals, Embroidery
Collections: Decorative arts; costumes; fine arts and crafts; objects and artifacts relevant to our cultural history from 20,000 BC to present; photography
Publications: Las Noticias, monthly
Activities: Classes for adults & children; docent training; seasonal sculpture garden & old town walking tours; lects open to public, 4 vis lectrs per year; gallery talks; tour; competition with awards; original objects of art lent to other museums; 3 - 6 months traveling exhibitions per year; originate traveling exhibitions with regional museums; sales shop selling books, original magazines, reproductions, prints, Indian jewelry, local crafts & pottery

A INDIAN ARTS & CRAFTS ASSOCIATION, Ste C, 4010 Carlise NE Albuquerque, NM 87107. Tel 505-265-9149; Fax 505-265-8251; Elec Mail iaca@ix.netcom.com; Internet Home Page Address: www.iaca.com; *Office Mgr* Maria Kramer
Estab 1974 to promote, preserve, protect & enhance the understanding of authentic handmade American Indian arts & crafts; Mem: 882; quarterly meetings in Jan, Apr, July & Oct

Income: Financed by mem dues, markets
Exhibitions: Annual Indian IACA Artists of the Year; IACA Spring Wholesale Market; IACA Fall Wholesale Market
Publications: Annual directory; brochures on various Indian arts & crafts; newsletter, 6 times per year
Activities: Marketing seminars for Indian artists & crafts persons; lect are open to public, 4-5 vis lectrs; competitions

M INDIAN PUEBLO CULTURAL CENTER, 2401 12th St NW, Albuquerque, NM 87104. Tel 505-843-7270; *VPres* Joyce Merrill; *Museum Coordr* Pat Reck; *Retail Mktg Mgr* Keith Lucero; *Dir* Ron Solimon
Open 9 AM - 5:30 PM; Admis adults $3, seniors $2, students $1; Estab 1976 to advance understanding & insure perpetuation of Pueblo culture; Pueblo Gallery houses monthly Native American art exhibits; Average Annual Attendance: 300,000; Mem: 800-1000; dues family $25, individual $15, students & senior citizens $7.50; annual meeting 3rd Tuesday in Feb
Income: Financed by admis, restaurant revenue & office space rental
Special Subjects: American Indian Art
Collections: Jewelry, paintings, photos, pottery, rugs, sculptures, textiles
Exhibitions: Monthly exhibits of Native American art; Pueblo Children's Art Contest
Publications: Pueblo Horizons, 4 times per yr
Activities: Classes for adults & children; docent training; lect open to public, 6-12 vis lectrs per year; competitions with awards; museum shop sells books, original art, reproductions, prints, slides, Native American arts & crafts (pots, rugs, kachinas)

A NEW MEXICO ART LEAGUE, Gallery & School, 3407 Juan Tabo NE, Albuquerque, NM 87111. Tel 505-293-5034; *VPres* Day Lee; *Treas* Laura Hodges; *Pres* Bonnie J West; *Secy* Dorothy Koopmans; *Second VPres* Sandee Grisham
Open Tues - Sat 10 AM - 4 PM, Sun 1 - 4 PM, cl Mon; No admis fee; Estab 1929 to promote artists of New Mexico; art gallery; Members' works exhibited in space 1400 sq ft; Average Annual Attendance: 5,000; Mem: 325; dues $35; monthly mem meetings
Income: Financed by mem, sales, classes & gallery room rentals
Collections: National Small Paintings Exhibit
Exhibitions: 24th Annual Small Painting Exhibit (national competition)
Publications: Newsletter, monthly
Activities: Classes for adults & children; lect & workshops open to the public; 6 vis lectrs per year; gallery talks; tours; competitions with awards; individual paintings lent to schools & museums; lending collection contains original art works & prints, paintings, sculptures & slides; sales shop sells original art

A SOCIETY OF LAYERISTS IN MULTI MEDIA (SLMM), 1408 Georgia NE, Albuquerque, NM 87110; PO Box 2332, Hot Springs, AR 71914. Tel 505-268-1100; Elec Mail info@slmm.org; Internet Home Page Address: www.slmm.org; *Founder* Mary Carroll Nelson; *Pres* Nancy Dunaway; *Vice Pres* Ilena Grayson; *Dir* Diane Courant; *Dir* Kathleen O'Brien; *Adminr* Carleen Hearn
Estab 1982; Network for artists; Mem: 370; assoc dues $35; annual meeting
Income: $4000 (financed by mem)
Collections: Mixed Media
Exhibitions: Exhibitions around the country; Summer 2007: The Albuquerque Museum, Exploring Multi Dimensions
Publications: Bridging Time & Space; newsletter, 2 times per year on web for members; The Art of Layering: Making Connections

UNIVERSITY OF NEW MEXICO
M University Art Museum, Tel 505-277-4001; Fax 505-277-7315; Internet Home Page Address: www.unm.edu; *Cur Exhibits* Lee Savary; *Assoc Dir* Linda Bahm; *Cur Educ* Jeanette Entwisle; *Cur Prints/Photos* Kathleen Howe
Open Tues - Fri 9 AM - 4 PM, & Tues evening 5 - 8 PM, Sun 1 - 4 PM; No admis fee; Estab 1963; Maintains five galleries; a print & photograph room which is open to the pub at certain hours; Average Annual Attendance: 49,000; Mem: 200; dues $10-$500; annual meeting in May
Income: Financed by university appropriations, grants & donations
Special Subjects: Historical Material, Collages, Sculpture, Drawings, Graphics, Painting-American, Prints, Southwestern Art, Textiles, Etchings & Engravings
Collections: Spanish Colonial art; Tamarind Archive of lithographs; 19th & 20th century American painting & sculpture, drawings; prints by American & European masters; 19th & 20th century lithographs & photography
Publications: Bulletin; exhibition catalogs
Activities: Educ dept; lect open to public; gallery talks; tours; individual paintings & original objects of art lent to other comparable institutions; traveling exhibitions organized & circulated; museum shop sells books, catalogs, magazines, cards, jewelry & gifts
M Jonson Gallery, Tel 505-277-4967; Fax 505-277-3188; Elec Mail jonsong@unm.edu; Internet Home Page Address: www.unm.edu/~jonsong; *Cur* Chip Ware; *Admin Asst* Shelley Simms
Open Tues - Fri 10 AM - 4 PM; cl Sat & Sun & holidays; No admis fee; Estab 1950 for the assemblage & preservation of a comprehensive collection of the works of Raymond Jonson; a depository for works of art by other artists & their preservation, with emphasis on the Transcendental Painting Group (1938-42); the exhibition of contemporary works of art; The structure includes a main gallery, four storage rooms, work room & office, a reception room; Average Annual Attendance: 4,000-6,000
Income: Financed through University & Jonson Trust & by donations
Library Holdings: Audio Tapes; Book Volumes; Compact Disks; Exhibition Catalogs; Kodachrome Transparencies; Manuscripts; Memorabilia; Original Documents; Photographs; Records; Slides; Video Tapes
Collections: Jonson reserved retrospective collection; other artists works & works by Jonson students
Publications: Exhibition announcements; The Art of Raymond Jonson; The Transcendental Painting Group, New Mexico 1938-1941 & other exhibition catalogs
Activities: Lect open to public, 5 vis lectrs per year; gallery talks; tours; fellowships; individual paintings & original works of art lent to museums & campus president's office; lending collection contains color reproductions, original

prints, slides, sculpture, 1000 books, 2000 original art & 2000 paintings; originate traveling exhibitions; books sold by order

L **Jonson Library,** Tel 505-277-4967, 277-1844; Fax 505-277-3188; Elec Mail jonsong@unmedu; Internet Home Page Address: www.unm.edu/njonsong/; *Cur* Chip Ware
Open Tues - Fri 10 AM - 4 PM by appointment only; For reference only, exceptions made for special projects
Library Holdings: Book Volumes 500; Clipping Files; Manuscripts; Memorabilia; Original Documents; Pamphlets; Photographs; Reproductions; Slides
Special Subjects: Painting-American, Historical Material, Southwestern Art, Woodcuts, Landscapes
Collections: The Jonson Archives containing books & magazines relating to Raymond Jonson, his letters, his diaries, catalogs, clippings, photographs & slides of works

L **Fine Arts Library,** Tel 505-277-2357; Fax 505-277-7134; Elec Mail falref@unm.edu; Internet Home Page Address: www.unm.edu; *Dir* David Baldwin; *Head Reference Librn* Carroll Botts; *Head Cataloging* Pat Fairchild; *Mgr Library Operations* David Hertzel; *Circ Supv* Kyle Nelson
Open Mon - Thurs 8 AM - 10 PM, Fri 8 AM - 6 PM, Sat 10 AM - 6 PM, Sun Noon - 8 PM fall semester hrs; Estab 1963 to provide library assistance, literature, microforms & sound recording materials to support the programs of the university in the areas of art, architecture, music & photography
Library Holdings: Audio Tapes; Book Volumes 120,000; CD-ROMs; Cards; Cassettes; Compact Disks; DVDs; Exhibition Catalogs; Fiche; Other Holdings; Pamphlets; Periodical Subscriptions 237; Records; Reels; Video Tapes
Special Subjects: Art History, Decorative Arts, Drawings, Graphic Arts, Islamic Art, Ceramics, Conceptual Art, American Western Art, Art Education, American Indian Art, Furniture, Drafting, Goldsmithing, Jewelry, Architecture
Collections: Untitled 1954 Oil on Masonite

M **VERY SPECIAL ARTS NEW MEXICO,** Very Special Arts Gallery, 4904 4th St NW Albuquerque, NM 87107. Tel 505-345-2872; Fax 505-345-2896; Elec Mail info@vfranm.org; *Exec Dir* Beth Rudolph; *Asst Dir Arts Center* Deborah Mashibini; *Gallery Cur* Wendy Zollinger
Open Mon - Fri 9 AM - 5 PM by appointment; Estab 1994 to provide art access to individuals with disabilities; Small gallery focusing on the art of individuals with disabilities, outsider, visionary & intuitive art. Exhibits the work of emerging & established artists; Average Annual Attendance: 1,000
Income: Financed by grants, private & corporate donations
Special Subjects: Drawings, Painting-American, Watercolors, Ceramics, Crafts, Folk Art
Exhibitions: 15th Anniversary Exhibit; Holiday Exhibition; Those That Can: Teach II
Publications: Arts Access, quarterly
Activities: Classes for adults & children; concerts; gallery talks; tours; awards; scholarships offered; exten dept serves New Mexico; individual paintings & original objects of art lent; sales shop sells books, original art, cards, jewelry & gift items made by artists at the center

ARTESIA

M **ARTESIA HISTORICAL MUSEUM & ART CENTER,** 505 W Richardson Ave, Artesia, NM 88210. Tel 505-748-2390; Fax 505-746-3886; Elec Mail artesiamuseum@pvtn.net; Internet Home Page Address: www.artesiamuseum.org; *Mus Mgr* Nancy Dunn; *Custodian* Margie Cervantez
Open Tues - Fri 9 AM - Noon & 1 - 5 PM, Sat 1 - 5 PM; No admis fee; Estab 1970 to preserve & make available local history; maintains reference & research library; Gallery showcases local & regional artists, exhibits drawn from permanent art collection, traveling exhibits; Average Annual Attendance: 5,000
Income: Financed by city appropriation
Special Subjects: Architecture, Drawings, Painting-American, Photography, Watercolors, American Western Art, Southwestern Art, Textiles, Pottery, Primitive art, Landscapes, Manuscripts, Furniture, Historical Material, Maps, Period Rooms, Embroidery, Laces, Leather
Collections: Art; early Area Histroy; Farm; Kitchen; Ranch; Native American Artifacts; Oil & Mineral; WWI & WWII
Exhibitions: Russell Floore Memorial Southwest Art Show (competition Sept); Artesia Arts Council Photography Show (Sept); (7/2007-8/2008) Artesia Quilters Guild
Activities: School & civic club programs; lect open to public, 1-3 vis lectr per year; gallery talks; competitions with awards, Living Treasures (annual); individual paintings & objects of art lent to other museums & organizations; book traveling exhibitions 1-2 per year

CHURCH ROCK

M **RED ROCK STATE PARK,** Red Rock Museum, PO Box 10, Church Rock, NM 87311. Tel 505-722-3829; Fax 505-863-1297; Elec Mail rrsp@ci.gallup.nm.us; Internet Home Page Address: www.ci.gallup.nm.us/rrsp; *Mus Clerk* Theadora Watchman; *Mus Specialist* Maxine Armstrong Touchine; *Park Supt* Lisa Lucere
Open Mon - Fri 8 AM - 4:30 PM, Memorial Day - Labor Day daily 8 AM - 6 PM; Admis adults $3, children $1.50; Estab 1951 to acquaint visitors with the arts & crafts of the Navajo, Zuni & Hopi Indians & other tribes of the Four Corners area; A small mus manned by Red Rock State Park; displaying Indian arts & crafts & exhibitions on natural history; Average Annual Attendance: 20,000
Income: Financed by city of Gallup, private contributions & admis fees
Special Subjects: Painting-American, American Indian Art, American Western Art, Anthropology, Archaeology, Ethnology, Southwestern Art, Costumes, Crafts, Historical Material
Collections: Kachina Carving Doll Collection; Anasazi relics; arts & crafts of Navajo, Zuni, Hopi & other Pueblos; specimens of geological, herbarium, archaeological & cultural materials of the Four Corners area
Exhibitions: Permanent exhibits: Navajo Hogan; Pueblo Culture; Elizabeth Andron Houser Collection of Native American Arts; Gallup Intertribal Indian Ceremonial Posters, Jewelry, Basketry, Navajo Rugs; temporary exhibits vary

Publications: Exhibitions catalog; quarterly newsletter
Activities: Lect open to public; gallery talks; tours; concerts; rodeos; individual paintings & original objects of art lent to other museums; book traveling exhibitions 1-4 per year; originate traveling exhibitions circulate to museums & arts & educational organizations; sales shop sells books, reproductions, magazines, prints, sandpaintings, pottery, jewelry & other Native American crafts, cassettes & compact discs of Native American music

L **Library,** PO 10, Church Rock, NM 87311. Tel 505-722-3829; Fax 505-863-1297; Elec Mail rrsp@ci.gallup.nm.us; *Museum Clerk* Theresa Warner; *Museum Specialist* Maxine Armstrong Touchine; *Park Supt* Lisa Lucere
Open Mon - Fri 8 AM - 4:30 PM, Memorial Day - Labor Day daily 8 AM - 6 PM; Admis suggested donation adults $3, children $1.50
Income: Municipally sponsored
Library Holdings: Book Volumes 350; Cards; Clipping Files; Exhibition Catalogs; Manuscripts; Pamphlets; Photographs; Prints
Special Subjects: Anthropology

CIMARRON

M **PHILMONT SCOUT RANCH,** Philmont Museum, Cimarron, NM 87714. Tel 505-376-2281; Fax 505-376-2281; *Dir* Jason Schubert; *Dir* Stephen Zimmer
Open Mon - Fri 8 AM - 5 PM; No admis fee; Estab 1967 to exhibit art & history of Southwestern United States; Average Annual Attendance: 30,000
Income: Financed by endowment & sales desk revenue
Collections: Art by Ernest Thompson Seton; American Indian Art; History of Boy Scouts of America; History of New Mexico
Exhibitions: Ernest Thompson Seton's Collection of Plains Indian Art
Activities: Docent programs; lect open to public; lending collection contains over 6000 items; retail store sells books, magazines, prints, slides

L **Seaton Memorial Library,** Tel 505-376-2281; Fax 505-376-2281; *Dir* Jason Schubert
Estab as a lending & reference facility
Income: Financed by endowment
Library Holdings: Book Volumes 6,500; Clipping Files; Exhibition Catalogs; Framed Reproductions; Manuscripts; Memorabilia; Original Art Works; Pamphlets; Periodical Subscriptions 17; Photographs; Prints

DEMING

M **DEMING-LUNA MIMBRES MUSEUM,** 301 S Silver St, Deming, NM 88030. Tel 505-546-2382; Elec Mail dim-museum@zinet.com; *Coordr* Katy Hofacket; *Archives* Art Ramon; *Dir* Sharon Lein
Open Mon - Sat 9 AM - 4 PM, Sun 1:30 - 4 PM, cl Thanksgiving & Christmas Day, open by appointment during evenings for special interest groups; No admis fee with donations; Estab 1955, moved into Old Armory 1978, to preserve Luna County history, historical items & records for reference; Art gallery is in a passageway 50 ft x 10 ft, one full block, no windows; open to local artists for displays; Average Annual Attendance: 20,000; Mem: 200; dues $3; annual meeting in Jan
Income: Financed by donations & endowment earnings
Special Subjects: American Indian Art, Anthropology, Folk Art, Pottery, Decorative Arts, Eskimo Art, Dolls, Furniture, Glass, Historical Material, Leather
Collections: Chuck wagon, vintage clothing, dolls, frontier life objects & other items on the local history; Mimbres Indian artifacts; mine equipment; minerals; paintings & saddles; camera display; phone equipment; quilt room; old lace display; National Guard display; Bataan-Corregidor display & monument; facsimile of front of Harvey House; bell collection; bottle collection, china, ceramics & silver displays; antiques; Military Room; Art Gallery
Publications: History of Luna County & Supplement One
Activities: Dramatic programs; docent training; tours; service awards; museum shop sells Indian jewelry, postcards & pottery

LAS CRUCES

M **NEW MEXICO STATE UNIVERSITY,** Art Gallery, PO Box 30001, MSC 3572, Las Cruces, NM 88001. Tel 505-646-2545; Fax 505-646-8036; Elec Mail artglry@nmsu.edu; *Dir Gallery* Charles Lovell; *Museum Educator* Jackie Mitchell; *Registrar* Laurie Thompson; *Conservator* Silvia Marinas
Open Tues - Fri 10 AM - 5 PM, Thurs 10 AM - 7 PM, Sun 1 - 5 PM; No admis fee; Gallery estab in 1974 as an educational resource for the University & southern New Mexico; 5000 sq ft exhibition space; Average Annual Attendance: 25,000; Mem: 200; dues $10 & up; annual meeting in June
Purchases: Eric Avery, Luis Jimenez, Frances Whitehead, Garo Antreasian, Hollis Sigler & Gregory Amenoff
Special Subjects: Drawings, Hispanic Art, Painting-American, Prints, Pre-Columbian Art, Southwestern Art, Religious Art, Ceramics, Crafts, Folk Art, Woodcuts, Etchings & Engravings, Landscapes
Collections: 19th Century Retablos from Mexico; 20th century prints, photographs, works on paper, graphics & paintings
Exhibitions: El Favor De Los Santos; The Retablo Collection of New Mexico State Univeristy; Close to the Border VIII
Publications: Visiones, biannual arts newsletter; semiannual exhibit catalogs
Activities: Docent training; school tours & outreach; family day; lect open to public, 12 vis lectrs per year; gallery talks; tours; competitions with awards; individual paintings & original objects of art lent to museums with appropriate security & climate control conditions; lending collection contains original art works, original prints, paintings & photographs; book traveling exhibitions up to 5 per year; organize traveling exhibitions circulating to art museums; originate traveling exhibitions

LAS VEGAS

M **NEW MEXICO HIGHLANDS UNIVERSITY,** The Fine Arts Gallery, Donnelly Library, National Ave Las Vegas, NM 87701. Tel 505-425-7511, 454-3338; *Art Dir* Bob Read
Open Mon - Fri 8 AM - 5 PM; No admis fee; Estab 1956 to acquaint University & townspeople with art of the past & present; Gallery dimensions approx 20 x 40 ft; Average Annual Attendance: 4,000-5,000

Income: Financed by state appropriation
Collections: Permanent collection
Exhibitions: Twelve individual & group shows; one statewide show
Publications: University general catalog, annually
Activities: Classes for adults & children; lect open to public, 1 vis lectr per year; concerts; gallery talks; tours; competitions; book traveling exhibitions, 1-2 per year; originate traveling exhibitions

LORDSBURG

M **SHAKESPEARE GHOST TOWN,** 2 1/2 Mile S of Main St, Lordsburg, NM 88045; PO Box 253, Lordsburg, NM 88045. Tel 505-542-9034; Internet Home Page Address: www.shakespeareghostown.com; *Dir & Pres* Emanuel D Hough; *Develop Mem* Jeane La Marca; *Pub Rels* Steve Hill
Open during regularly-scheduled tours or by appt; Admis adults & seniors $3, children 6 - 12 $2, mems & children under 6 no admis fee; Estab 1970; Shakespeare Ghost Town is the remains of a pioneer, southwestern town. Walk the streets trod by Billy the Kid, John Ringo, Curley Bill, Russian Bill, The Clantons, Jim Hughes and Sandy King. Emphasis on American SW History 1856 - 1935; Average Annual Attendance: 3000; Mem: dues Life $500, Patron $100, Sponsor or Business $50, Family $25, Individual $10
Collections: 300-vol library on Southwest History; Blacksmith shop & items; Seven historic buildings including The Grant House, Stratford Hotel, Old Mail Station, among others
Publications: Shakespeare Quarterly, newsletter
Activities: Re-enactments & living history 4 times per yr; guided tours

LOS ALAMOS

M **ART CENTER AT FULLER LODGE,** 2132 Central, Los Alamos, NM 87544. Tel 505-662-9331; Fax 505-662-9334; Internet Home Page Address: www.artful.losalamos.com; *Dir* Christine M Ward
Open Mon - Sat 10 AM - 4 PM; No admis fee; Estab 1977 to provide an art center to the regional area; to foster the interests of the artists & art interested pub of the Community; Located on first floor of historic Fuller Lodge; gallery area has been renovated; Average Annual Attendance: 12,000; Mem: 460; dues memorial $1500, life $1000, corporate $300, patron $100, sponsor $50, contributing $35, member $25
Income: Financed by mem, county appropriation, grants, gallery shop sales, annual art sale
Exhibitions: Rotating exhibits every 6 weeks
Publications: Bulletin, quarterly
Activities: Classes for adults & children; seminars for artists; lect open to public, 5 vis lectrs per year; competitions with awards; gallery talks; individual paintings & original objects of art lent; book traveling exhibitions; originate traveling exhibitions; sales shop sells original art by member artists, jewelry, cards & posters

MESILLA

M **GADSDEN MUSEUM,** PO Box 147, W Barker Rd Mesilla, NM 88046. Tel 505-526-6293; *Owner* Mary Veitch Alexander; *Asst Cur* Mary F Bird
Open Mon - Sun 9 - 11 AM & 1 - 5 PM, cl Easter, Thanksgiving, Christmas; Admis ages 12 & up $2.14, ages 6-11 $1.07; Estab 1931 to preserve the history of Mesilla Valley; Average Annual Attendance: 3,000
Income: $2,000 (financed by donations)
Special Subjects: Pottery, Historical Material
Collections: Civil War collection; clothing; gun collection; Indian artifacts, including pottery; paintings; Santo collection
Activities: Tours; museum shop sells books

PORTALES

M **EASTERN NEW MEXICO UNIVERSITY,** Dept of Art, Dept of Art 105, Sta 19, Portales, NM 88130. Tel 505-562-2510; Fax 505-562-2362; Internet Home Page Address: www.enmu.edu; *Chmn & Dir Exhibits* Jim Bryant
Open 7 AM - 9 PM; No admis fee; Estab 1935 for exhibiting student artwork; gallery is room converted for student works
Income: Financed by University funds
Collections: Student works in Art Department Collection
Exhibitions: Seen & Unseen; various exhibits, mixed media throughout the yr
Activities: Individual paintings & original objects of art lent to the university
L **Golden Library,** Sta 32, Portales, NM 88130. Tel 505-562-2624; Fax 505-562-2647; Elec Mail melveta.walker@enmu.edu; Internet Home Page Address: www.enmu.edu; *Library Dir* Melveta Walker
Open Mon - Thurs 7 AM - 11 PM, Fri 7 AM - 8 PM, Sat 10 AM - 7 PM, Sun Noon - 11 PM; Estab 1934; Public exhibits & artist presentations
Income: $3000 (financed by University & grants)
Purchases: Some student art is purchased
Library Holdings: Audio Tapes; Book Volumes 10,000; Cards; Cassettes; Exhibition Catalogs; Fiche; Filmstrips; Framed Reproductions; Kodachrome Transparencies; Micro Print; Motion Pictures; Original Art Works; Pamphlets; Periodical Subscriptions 35; Photographs; Prints; Records; Reels; Sculpture; Slides; Video Tapes

ROSWELL

M **ANDERSON MUSEUM OF CONTEMPORARY ART,** 409 E College Blvd, PO Box 1 Roswell, NM 88202. Tel 505-623-5600; Fax 505-623-5603; *Asst Dir* Marina Mahon; *Dir* Donald B Anderson
Open Mon - Fri 9 AM - Noon & 1 - 4 PM, Sat & Sun 9 AM - 5 PM; No admis fee; Estab 1994; 17,000 sq ft; 9 galleries

Collections: Collection of works by 130 artists in residence from the Roswell Museum
Exhibitions: Permanent exhibit of over 130 artists from the Roswell Museum's Arts-In-Resident Program

M **ROSWELL MUSEUM & ART CENTER,** 100 W 11th St, Roswell, NM 88201. Tel 505-624-6744; Fax 505-624-6765; Elec Mail rufe@roswellmuseum.org; Internet Home Page Address: www.roswellmuseum.org; *Pres Board Trustees* Robert Phillips; *VPres* Donald B Anderson; *Treas/Sec* Elly Mulkey; *Asst Dir* Caroline Brooks; *Cur Coll* Elizabeth Guheen; *Registrar* Julie Farnham; *Dir* Laurie Rufe; *Cur Educ* Ellen Moore
Open Mon - Sat 9 AM - 5 PM, Sun & holidays 1 - 5 PM, cl Thanksgiving, Christmas Eve, Christmas & New Year's Day; No admis fee; Estab 1937 to promote & cultivate the fine arts. Purpose: To increase public enjoyment of art, history, and cultural change with particular focus in the Southwest; 16 galleries are maintained for art & historical collections; plus Robert H Goddard rocket collection; 24,000 sq ft of exhibition space. Maintains reference library; Average Annual Attendance: 65,000; Mem: 700; dues $15 & up
Income: $750,000 (financed by mem, city & county appropriation)
Library Holdings: Auction Catalogs; Audio Tapes; Book Volumes; CD-ROMs; Cassettes; DVDs; Exhibition Catalogs; Manuscripts; Pamphlets; Periodical Subscriptions; Photographs; Video Tapes
Special Subjects: Landscapes, Pottery, Bronzes, Drawings, Hispanic Art, Mexican Art, Painting-American, Photography, Prints, Sculpture, Watercolors, American Indian Art, Ethnology, Southwestern Art, Textiles, Ceramics, Crafts, Folk Art, Woodcarvings, Woodcuts, Etchings & Engravings, Historical Material, Leather
Collections: Regional & Native American fine arts & crafts & Western historical artifacts; international graphics collection; 20th century Southwestern paintings & sculpture, drawings; Hispanic Art
Exhibitions: Permanent collection plus 10-14 temporary exhibitions annually
Publications: Bulletin, quarterly; Exhibition Catalogs
Activities: Classes for adults & children; docent training; school outreach program; lect open to public, 8-10 vis lectrs per year; concerts; gallery talks; tours; scholarships for children's classes offered; individual paintings & original art objects lent to qualified museums; book traveling exhibitions 3-4 per year; museum shop sells books, magazines, original art, reproductions & prints
L **Library,** 100 W 11th St, Roswell, NM 88201. Tel 505-624-6744; Fax 505-624-6765; Elec Mail jordan@roswellmuseum.org; Internet Home Page Address: www.roswellmuseum.org; *Librn & Mus Libr Cataloger* Candace Jordan; *Exec Dir* Jeanie Weiffenbach; *Asst Dir* Caroline Knebelsberger
Mon - Fri 1 PM - 4:45 PM; cl holidays & vacation; Estab 1937 as a study for reading, research in art, anthropology and later regional history; Circ 1,000 items ann; Reference only; Average Annual Attendance: 500
Income: Endowments, gifts, grants, City of Roswell pays much of operating expense, portion of museum's budget, whether from City of Roswell or Grant is allocated for libr purchases
Library Holdings: Audio Tapes 232; Book Volumes 5812; CD-ROMs 7; Cassettes; Clipping Files 1670; Exhibition Catalogs 1500; Filmstrips; Manuscripts 30; Maps 44; Memorabilia 20; Motion Pictures 33; Original Documents 300; Pamphlets 1500; Periodical Subscriptions 33; Photographs 2000; Slides 7000; Video Tapes 425
Special Subjects: Photography, Painting-American, Pre-Columbian Art, Sculpture, Historical Material, Ceramics, Ethnology, Printmaking, American Indian Art, Southwestern Art, Religious Art, Landscapes, Pottery
Collections: Rogers Aston Library Collection; Robert H Goddard Collection & Archives; New Mexico Artists' Files; Artist-in-Residence Files

SANDIA PARK

M **TINKERTOWN MUSEUM,** 121 Sandia Crest Rd, Sandia Park, NM 87047; PO Box 303, Sandia Park, NM 87047. Tel 505-281-5233; Elec Mail tinker4u@tinkertown.com; Internet Home Page Address: www.tinkertown.com; *Dir & Owner* Carla Ward
Open daily Apr 1 - Nov 1 9 AM - 6 PM, cl Nov - Mar; Admis adults $3, seniors $2.50, children $1, spec rates for grps; Estab 1983; Folk art mus created over the course of 40 yrs by the late Ross Ward (1940 - 2002); what was once a four-room summer cabin has been transformed into a 22-rm legacy showcasing one man's work of carvings & colls; Average Annual Attendance: 20,230
Income: $100,000 admissions & gift shop sales
Special Subjects: Drawings, Folk Art, Painting-American, Sculpture, Woodcarvings, Dolls, Miniatures, Dioramas
Collections: Over 40 yrs worth of woodcarvings including a 1880s miniature animated western town, three-ring circus, and many handmade dolls & toys; colls assembled by Ross Ward & his wife including a wedding cake couple coll made up of 140 couples; modern day & antique swords; circus banners & memorabilia including a side show giant's shoes & pants; 7 antique mechanical coin-operated arcade machines; several hundred dolls & toys; handmade antique western livery & mining memorabilia
Publications: I Did All This While You Were Watching TV-The Tinkertown Story
Activities: Festival of Tinkering, in conjunction with local school art classes; museum-related items for sale

SANTA FE

A **THE CENTER FOR CONTEMPORARY ARTS OF SANTA FE,** 1050 Old Pecos Trail, Santa Fe, NM 87501. Tel 505-982-1338; Fax 505-982-9854; Elec Mail info@ccasantafe.org; Internet Home Page Address: www.ccasantafe.org; *Dir Media Arts* Jerry Barron; *Cur & Dir Installation & Performance Arts* Chris Jonus; *Educ Dir* Molly Sturges; *Programming Coordr* Adrian Parra
Gallery open Mon - Sat Noon - 5 PM; open evenings for performances or cinema screenings; No admis fee for gallery; performances $2-$15; films: mems $5, non mem $7; Estab 1979, as a multidisciplinary contemporary arts organization. Hosts performance art: dance, poetry, musical, mixed media, films; Exhibition space, gallery, performance space, cinema.; Average Annual Attendance: 84,000 (all events); Mem: 535

Exhibitions: Visual arts exhibitions
Activities: Classes for adults & children; performing, visual, mixed media, & drawing workshops; lect open to public, 12 vis lectrs per year; concerts, film, theatre; gallery talks; tours

M **GEORGIA O'KEEFFE MUSEUM,** 217 Johnson St, Santa Fe, NM 87501. Tel 505-946-1000; Fax 505-946-1091; Elec Mail contact@okeeffemuseum.org; Internet Home Page Address: www.okeeffemuseum.org; *Dir* George G King; *Dir Develop* Marc Dorfman; *Cur* Barbara Buhler Lynes; *Dir Mktg* Linda Milanesi; *Librn* Eumie Imm-Stroukoff
Open daily 10 AM - 5 PM, Fri 10 AM - 8 PM, cl Wed Nov-June; Admis $8, NM residents $4; Estab 1997; Maintains reference library; Average Annual Attendance: 210,000; Mem: 1000+; dues vary
Income: Financed by endowment
Library Holdings: Auction Catalogs; Book Volumes; CD-ROMs; Clipping Files; Exhibition Catalogs; Original Documents; Other Holdings; Periodical Subscriptions; Sculpture
Special Subjects: Painting-American, Photography, Sculpture
Collections: Collection includes drawings, paintings, photographs, sculpture & water colors representing Georgia o'Keeffe & her work
Activities: Classes for adults & children; docent training; lects open to the public; 10 vis lectrs per yr; concerts; gallery talks; tours; scholarships; O'Keefe Mus Prize to Emerging Artist; organize traveling exhibs; sales shop sells books, prints, reproductions & home merchandise

M **GUADALUPE HISTORIC FOUNDATION,** Santuario de Guadalupe, 100 S Guadalupe St, Santa Fe, NM 87501. Tel 505-988-2027; *Pres* Leo Kahn; *Treas* Waldo Anton; *VPres* Edward Gonzales
Open Mon - Sat 9 AM - 4 PM, cl weekends Nov - Apr; Admis - donation; Estab 1790, became an international mus 1975 to preserve & extend the community's awareness through educ & in culture areas; Gallery space is used for exhibits of local artists, with emphasis on Hispanic art; Average Annual Attendance: 37,000; Mem: 435; dues life $1000 & up, benefactor $500, business patron $200, patron $100, sponsor $50, business & family $25, individual $15; annual meeting in Apr
Income: $41,000 (financed by mem, grants, corporate & private donations)
Special Subjects: Mexican Art, Religious Art, Renaissance Art
Collections: Archdiocese Santa Fe Collection, 16th century books, 18th -19th century religious artifacts; Mexican Baroque paintings; Our Lady of Guadalupe mural by Jose de Alzibar; Renaissance Venetian painting
Publications: Flyers; noticias; quarterly newsletter
Activities: Dramatic programs; docent training; performing arts; visual arts; poetry readings; lect open to public, 1-2 vis lectr per year; concerts; tours

M **INSTITUTE OF AMERICAN INDIAN ARTS MUSEUM,** Museum, 108 Cathedral Pl, Santa Fe, NM 87501; 83 Avon Nu Po Rd, Santa Fe, NM 87505. Tel 505-983-8900; Fax 505-983-1222; Elec Mail datencio@iaiancad.org; Internet Home Page Address: www.iaiancad.org; *Assoc Dir* Thomas Atencio; *Exhib Designer* Joseph Sanchez; *Cur Educ* Allyson Ryan; *Mus Shop Mgr* Maggie Ohnesorgen; *Registrar* Buffy Dailey; *Dir & Mus Studo* Charles Dailey; *Mus Studies* Barbara Lusceo Sand; *Asst Cur Coll* Tatiana Lomaheftewa-Stoc; *Pub Relations & Marketing* Colleen Roach; *Photographer* Larry Phillips; *Admin Asst* Jari Earl
Open Mon - Sat 10 AM - 5 PM, Sun Noon - 5 PM; Admis adults $4, seniors $2, children under 16 & members free; Estab 1962 to train Native American students to own, operate & manage their own museums; to collect, preserve & exhibit materials relating to the Native American; act as a resource area for Indian Museums nationwide; 2100 sq ft of exhibition galleries, 15,000 sq ft outdoor Art Park Performance Gallery; Average Annual Attendance: 100,000; Mem: Dues $25-50
Income: $1,100,000 (financed by Congressional appropriation)
Purchases: $50,000
Special Subjects: Painting-American, Photography, Prints, Sculpture, Watercolors, American Indian Art, Southwestern Art, Textiles, Ceramics, Pottery, Eskimo Art, Jewelry, Silver, Metalwork, Carpets & Rugs
Collections: National collection of contemporary Indian arts America; Vital & comprehensive collection in fields of paintings, graphics, textiles, ceramics, sculpture, jewelry, photographs, printed textiles, costumes, ethnological materials such as drums & paraphernalia for general living
Exhibitions: Semi-Annual Student Exhibitions; Triennial Faculty Exhibitions; Special Exhibitions 6-8 per year, Installation Pieces Quarterly, Semi-Annual Exhibitions of the Permanent Collection
Publications: Exhibition catalogs
Activities: schols; individual paintings & original objects of art lent to museums, state capital & colleges; originate traveling exhibitions; museum shop sells jewelry, pottery, fashions, books, magazines, original art & prints all of a contemporary nature

L **Library,** 83 Azan Nupo Rd, Santa Fe, NM 87508. Tel 505-424-2398; Elec Mail jjames@iaiancad.org; Internet Home Page Address: www.iaiancad.org/library; *Co-Chairperson* Grace Nuvayestewa
Open Mon - Thurs 8 AM - 10 PM Fri 8 AM - 5 PM, Sat 1 - 5 PM, Sun 1 - 8 PM; Estab 1962 to support college curriculum; Circ 30,000; For reference only
Income: $31,000 (financed by private fundraising & government)
Purchases: $2500
Library Holdings: Book Volumes 400; Other Holdings Artists Files, Oral Histories on video-tape; Periodical Subscriptions 25; Slides; Video Tapes 957
Special Subjects: American Indian Art, Eskimo Art

M **MUSEUM OF NEW MEXICO,** Office of Cultural Affairs of New Mexico, The Governor's Gallery, State Capitol, PO Box 2087 Santa Fe, NM 87503. Tel 505-827-3089; Fax 505-827-3026; Internet Home Page Address: www.Gov.State.NM.US; *Cur* Terry Bumpass
Open Mon - Fri 8 AM - 5 PM; No admis fee; Estab 1977 to promote New Mexico artists; Gallery located in Governor's reception area in the State Capitol; Average Annual Attendance: 50,000
Income: Financed by state appropriation & the Mus of New Mexico
Exhibitions: Exhibits of New Mexico Art (all media); New Mexican Governor's Awards Show

Activities: Educ dept; docent training; lect open to public, 200 vis lectrs per year; gallery talks; tours; A Governor's Award for Excellence in the Arts; individual paintings & original objects of art lent to other museums; book traveling exhibitions 1 per year; originate traveling exhibitions to other public galleries; museum shop sells books, original art & prints

M **MUSEUM OF NEW MEXICO,** Museum of Indian Arts & Culture Laboratory of Anthropology, 113 Lincoln Ave, Santa Fe, NM 87504-2087; PO Box 2087, Santa Fe, NM 87504. Tel 505-476-1250; Internet Home Page Address: www.state.nm.us/moifa; *Deputy Dir* Marsha Jackson; *Dir* Duane Anderson
Open daily 10 AM - 5 PM; Admis multiple visits & 2-Day pass $8, adults single visit $5, children under 17 free; Estab 1909. Mus is a state institution & operates in four major fields of interest: Fine Arts, International Folk Art, History & Anthropology; Four separate buildings, each with galleries: Southwestern art, Indian art & crafts; Average Annual Attendance: 850,000; Mem: 800; dues $35-$1000; board of regents meeting in July
Income: Financed by state appropriation, federal grants & private funds
Collections: Over 500,000 objects, artifacts & works of art in the fields of art, archaeology, folk art & history
Publications: Annual report; books; El Palacio, quarterly; exhibition catalogs; guides; magazines; monographs; pamphlets
Activities: Educ dept; docent training; lect open to public; concerts; gallery talks; tours; extension dept serves United States & Mexico; original objects of art lent to other cultural institutions; lending collection 7000 original art works; book traveling exhibitions 2-3 per year; originate traveling exhibitions; museum shop sells books, magazines, reproductions & prints

L **Fray Angelico Chavez History Library,** 120 Washington, PO Box 2087 Santa Fe, NM 87504-2087. Tel 505-476-5090; Internet Home Page Address: www.state.nm.us/moifa; *Head Library* Tomas Jaehn
Open Mon - Fri 10 AM - 5 PM; Mus houses four separate research libraries on folk art, fine arts, history & anthropology
Income: Financed by endowments, grants & state
Library Holdings: Book Volumes 15,000; Other Holdings Journals 40

M **Museum of Fine Arts, Unit of NM Dept of Cultural Affairs,** 107 W Palace, PO Box 2087 Santa Fe, NM 87503. Tel 505-476-5072; Fax 505-476-5076; Elec Mail mnmreg@mn-us.campus.org; Internet Home Page Address: www.mfasantafe.org; *Cur 20th Century Painting* Joseph Traugott; *Cur Contemporary* Laura Addison; *Educator* Ellen Zieselman; *Asst Dir* Mary Jebsen; *Mus Shop Mgr* John Stafford; *Deputy Dir* Marsha C Bol; *Chief Cur* Tim Rodgers; *Cur Photography* Steve Yates
Open Tues - Sun 10 AM - 5 PM, cl Mon; Admis adults $5, 4-day & annual passes available for $8, children free; Estab 1917 to serve as an exhibitions hall, chiefly for New Mexican & Southwestern art; Building is of classic Southwestern design (adobe); attached auditorium used for performing arts presentations; Average Annual Attendance: 290,000; Mem: 7,000
Income: Financed by state appropriation
Special Subjects: Mexican Art, Photography, Sculpture, American Indian Art, American Western Art, Ceramics
Collections: Drawings, paintings, photographs, prints & sculpture with emphasis on New Mexican & regional art, including Native American artists
Publications: Exhibition catalogs; gallery brochures
Activities: Classes for adults & children; dramatic programs; docent training; lect open to public, 10 vis lectrs per year; concerts; gallery talks; tours; competitions; individual paintings & original objects of art lent to art museums; lending collection contains original prints, paintings, photographs & sculpture; originate traveling exhibitions; museum shop sells books, original art, reproductions & prints

L **Museum of Fine Arts Library and Archive,** 107 W Palace, Santa Fe, NM 87504-2087; PO Box 2087, Santa Fe, NM 87504. Tel 505-476-5072; Fax 505-827-5076; Elec Mail susan.poorbaugh@state.nm.us; Internet Home Page Address: www.mfasantafe.org; *Librn* Susan Poorbaugh; *Dir* Martha Bol; *Asst Dir* Mary Jebsen; *Chief Cur* Tim Rodgers
Open daily 10 AM - 5 PM; Non-residents $8, state residents $6; Estab 1917 to provide fine arts research materials to mus staff, artists, writers & community; Circ 4,000; Average Annual Attendance: 80,000
Library Holdings: Audio Tapes; Book Volumes 7500; Clipping Files; Exhibition Catalogs; Manuscripts; Memorabilia; Original Documents; Other Holdings; Pamphlets; Periodical Subscriptions 45; Slides
Collections: Biography files of artists; Archives of artists & galleries associated with New Mexico
Activities: Classes for children; docent training; lect open to public; concerts; gallery talks; artmobile; museum shop sells books, reproductions & prints, slides, jewelry

M **Museum of International Folk Art,** 706 Camino Lejo, PO Box 2087 Santa Fe, NM 87504-2087. Tel 505-476-1200; Fax 505-476-1300; Internet Home Page Address: www.moifa.org; *Asst Dir* Jacqueline Duke; *Cur Latin American Folk Art* Barbara Mauldin; *Cur Spanish Colonial Coll* Robin Farwell Gavin; *Cur Textiles & Costumes* Bobbie Sumberg, PhD; *Cur Contemporary Hispano & Latino Colls* Tey Marianna Nunn PhD; *Librn* Ree Mobley; *Cur Middle Eastern-Asian Coll* Tamara Tjardes; *Dir Educ* Aurelia Gomez; *Unit Registrar* Deborah Garcia; *Coll Mgr* Paul Smutko; *Outreach Educator* Patricia Sigala; *Cur* Beaca Darshan Ball; *Dir* Dr Joyce Ice, PhD
Open daily 10 AM - 5 PM, cl Mon; Admis adults to 5 museums multiple (4 days) visits $15, single visit $7, children under 17 free, NMex residents free on Sun; Estab 1953 to collect, exhibit & preserve worldwide folk art; Average Annual Attendance: 100,000
Income: Financed by endowment, grants & state appropriation
Special Subjects: Hispanic Art, Textiles, Costumes, Folk Art
Collections: Arts of Traditional Peoples, with emphasis on Spanish Colonial & Hispanic-related cultures; costumes & textiles
Exhibitions: (Permanent) Familia y Fe/Family & Faith; Multi-Visions: A Common Bond.
Publications: American Folk Masters, 1992; the Spirit of Folk Art, 1989, Mud, Mirror & Thread: Folk Traditions of Rural India, 1993; Traditional Arts of Spanish New Mexico, 1994; Rio Grande Textiles, 1994; Recycled, Re-Seen; Folk Art from the Global Scrap Heap, 1996, The Extraordinary in the Ordinary, 1998; Masks in Mexico, fall 1999; Maiolica Ole
Activities: Classes for adults & children; docent training; lect open to public; concerts; gallery talks; tours; original objects of art lent to responsible museums

nationwide; originate traveling exhibitions; museum shop sells books, original art, reproductions & prints

L **Library,** 706 Camino Lejo, PO Box 2087 Santa Fe, NM 87504-2087. Tel 505-476-5016; Internet Home Page Address: www.state.nm.us/moifa; *Archivist* Eleanore Voutselas; *Librn* Ree Mobley
Open Tues - Fri 9 AM - Noon & 1 - 5 PM; Estab 1953 to support museum's research needs; Reference library
Income: Financed by private & state support
Purchases: $5500
Library Holdings: Audio Tapes; Book Volumes 12,500; Cassettes; Clipping Files; Exhibition Catalogs; Manuscripts; Pamphlets; Periodical Subscriptions 180; Photographs; Records; Slides
Special Subjects: Folk Art, Decorative Arts, Calligraphy, Islamic Art, Crafts, Latin American Art, Ethnology, Asian Art, Anthropology, Afro-American Art, Carpets & Rugs, Dolls, Embroidery, Handicrafts, Jewelry
Collections: Folk literature & music of the Spanish Colonist in New Mexico circa 1800-1971

M **Palace of Governors,** PO Box 2087, Santa Fe, NM 87504-2087. Tel 505-476-5100; Internet Home Page Address: www.state.nm.us/moifa; *Assoc Dir* Thomas Chavez
Open Tues - Sun 10 AM - 5 PM; Admis 4-consecutive day pass $10, adult $5; Built in 1610; History mus
Income: Financed by state appropriations & donations
Exhibitions: Society Defined; Another Mexico

M **Laboratory of Anthropology,** 708 Camino Lajo, Santa Fe, NM 87501. Tel 505-476-1250; *Librn* Laura Holt
Open Mon - Fri 10 AM - 5 PM; Estab 1936 as a research laboratory in archaeology & ethnology
Collections: Materials from various Indian cultures of the Southwest: jewelry, pottery & textiles

A **PUEBLO OF POJOAQUE,** Poeh Museum, 78 Cities of Gold Rd, Santa Fe, NM 87506. Tel 505-455-3334; Fax 505-455-0174; Internet Home Page Address: www.poehmuseum.com; *Exec Dir* George Riviera; *Dir* Christy Sturm; *Cur* Melissa Talachy
Open 9 AM - 5 PM; No admis fee; Estab to house & exhibit contemporary arts & crafts by artists of the Northern Pueblos, to facilitate the education of Native American people & the public-at-large & to preserve Pueblo culture; Average Annual Attendance: 1,200
Collections: Drawings, paintings, photography, prints, sculptures & other works on baskets, beadwork, ceramics, costumes, jewelry, paper, pottery & textiles
Exhibitions: Poeh Arts Program, semi-annual exhibit
Activities: Classes for Native American adults; original objects of art lent to museums

M **PUEBLO OF SAN ILDEFONSO,** Maria Martinez Museum, Rte 5, Box 315-A, Santa Fe, NM 87501. Tel 505-455-2031 (business office), 455-3549 (visitors' center); *Tourism Mgr* Jodi Martinez
Open Mon - Fri 8 AM - 4 PM; Mus admis is included with $3 entrance fee to the Pueblo; Estab to display pottery: history, artists & methods of pottery making
Collections: Arts & Crafts; Clothing; Painting; Pottery

M **SANTA FE,** (SITE Santa Fe) 1606 Paseo de Peralta, Santa Fe, NM 87501. Tel 505-989-1199; Fax 505-989-1188; Elec Mail sitesantafe@sitesantafe.org; Internet Home Page Address: www.sitesantafe.org; *Interim Dir* Catherine Putnam
Open Wed - Sun, 10 AM - 5 PM, Fri 10 AM - 7 PM; Admis $5, seniors & students $2.50; Estab 1995; 18,000 sq ft exhibition space available. Interior configurations vary according to exhibition demands; Average Annual Attendance: 50,000; Mem: 800; dues $35 & up
Income: Financed by mem & private funds
Library Holdings: Audio Tapes; DVDs; Exhibition Catalogs; Kodachrome Transparencies; Periodical Subscriptions; Photographs; Slides; Video Tapes
Exhibitions: Rotating exhibitions
Publications: Exhibit catalogs
Activities: Classes for adults & children; Docent progs; vol progs; lect open to public; concerts; gallery talks; tours; book traveling exhibitions 2-3 per year; originate traveling exhibs to all museums; sales shop sells books, prints, T-Shirts & hats

M **SCHOOL OF AMERICAN RESEARCH,** Indian Arts Research Center, PO Box 2188, Santa Fe, NM 87504. Tel 505-954-7205; Fax 505-954-7207; Elec Mail iarc@sarsf.org; Internet Home Page Address: www.sarweb.org; *Interim Pres* George Gumerman; *Dir* Kathy Whitaker; *Registrar* Deborah Winton; *Native American Heritage Prog Coordr* Rita Iringan; *Admin Asst* Daniel Kurnit
Open Fri 2 PM & by appointment; Admis $15, members free; Estab 1907. Dedicated to advance studies in anthropology, support advanced seminars for post-doctoral scholars, archaeological research, anthropological publication & a pub educ program; Southwest Indian Arts Building houses collections for research; open storage facility; Average Annual Attendance: 1,400; Mem: 1,100; dues family $50, individual $40; Scholarships
Income: Financed by endowment, mem, special grants & individuals
Special Subjects: American Indian Art
Collections: Basketry, Kachinas, paintings, silver jewelry, Southwest Indian pottery, textiles
Publications: Publications of Advanced Seminar Series
Activities: Lect open to public; tours; scholarships offered; individual paintings & original objects of art lent to other museums; sales shop sells books; notecards; video tapes; posters

M **WHEELWRIGHT MUSEUM OF THE AMERICAN INDIAN,** PO Box 5153, Santa Fe, NM 87502. Tel 505-982-4636; Fax 505-989-7386; Elec Mail asstdir@wheelwright.org; Internet Home Page Address: www.wheelwright.org; *Cur* Cheri Falkenstien-Doyle; *Dir* Jonathan Batkin; *Asst to Dir* Leatrice A Armstrong
Open Mon - Sat 10 AM - 5 PM, Sun 1 - 5 PM; Admis by donation; Estab 1937 to record & present creative expressions of Native American people; Main gallery is shaped like inside of Navajo hooghan or house. Friends, Slater & info ctr Gallies are smaller exhibit space; Average Annual Attendance: 54,000; Mem: 1500; dues $30-$500

Income: Financed by endowment & mem
Special Subjects: Textiles, Drawings, Photography, Prints, Sculpture, American Indian Art, Anthropology, Ethnology, Costumes, Religious Art, Ceramics, Crafts, Folk Art, Pottery, Primitive art, Manuscripts, Dolls, Jewelry, Silver, Metalwork, Historical Material, Miniatures, Embroidery, Leather
Collections: American Indian art & ethnographic material of Southwestern US, Navajo, Apache & Pueblo people
Exhibitions: Two exhibitions per yr; please call museum for info
Publications: Bulletins & books on Navajo culture; exhibition catalogs
Activities: Classes for adults & children; docent training; tours; lect; slide-lect; lect open to public, 10 vis lectrs per year; gallery talks; tours; individual paintings & original objects of art lent to museums; lending collection contains books, color reproductions, framed reproductions, Kodachromes, nature artifacts, original art works, original prints, paintings & phono records; museum shop sells books, magazines, original art, reproductions, prints, pottery, jewerly, textiles, beadwork (all original)

L **Mary Cabot Wheelwright Research Library,** 704 Camino Lejo, PO Box 5153 Santa Fe, NM 87502. Tel 505-982-4636; Fax 505-989-7386; Elec Mail wheelwright@wheelwright.org; Internet Home Page Address: www.wheelwright.org; *Dir* Jonathan Batkin; *Cur* Sherry Falkenstien-Doyel
Open to researchers for reference
Income: Financed by mem
Library Holdings: Book Volumes 4000; Other Holdings Per Issues 3000; Periodical Subscriptions 3000
Special Subjects: Art History, Folk Art, Painting-American, Historical Material, Ceramics, Crafts, Archaeology, Ethnology, American Indian Art, Anthropology, Eskimo Art, Costume Design & Constr, Carpets & Rugs, Jewelry, Architecture

TAOS

M **BENT MUSEUM & GALLERY,** 117 Bent St, PO Box 153 Taos, NM 87571. Tel 505-758-2376; Fax 505-758-2376; Elec Mail gnideon@laplaza.org; *Owner* Thomas Noeding
Open daily 10 AM - 4 PM; Admis adults $2, children 8 - 15 $1, under 8 free; Estab 1959; Home of the first territorial governor of New Mexico - Site of his death in 1847; Average Annual Attendance: 5,000
Income: Financed from admissions & gift shop
Special Subjects: American Indian Art
Collections: American Indian art; old Americana; old Taos art
Activities: Mus shop sells books, original art, reproductions, prints, Indian jewelry, pottery & dolls

M **MILLICENT ROGERS MUSEUM OF NORTHERN NEW MEXICO,** 1504 Millicent Rogers Rd, PO Box A Taos, NM 87571. Tel 505-758-2462; Fax 505-758-5751; Elec Mail mrm@newmex.com; Internet Home Page Address: www.millicentrogers.org; *Exec Dir* Jill Hoffman, PhD; *Store Mgr* Joy Jensen
Open Mon - Sun 10 AM - 5 PM, cl holidays, summer/winter cl Mon, Nov - March; Admis family groups $15, adults $10, students, seniors & groups of 10 or more $6, children under 16 $2, residents $5; Estab 1956 for the acquisition, preservation, research, display & interpretation of art & material cultures of the southwest focusing on New Mexico; The museum's permanent home is a traditional adobe building, once the private residence of Claude J K Anderson; Average Annual Attendance: 25,000; Mem: 400; quarterly Board of Trustees meeting in spring & fall
Income: Financed by endowment, mem, donations, admis, grants & revenue from mus store
Special Subjects: Architecture, Drawings, Hispanic Art, Photography, Sculpture, Watercolors, American Indian Art, American Western Art, Pre-Columbian Art, Southwestern Art, Textiles, Costumes, Religious Art, Ceramics, Crafts, Folk Art, Pottery, Decorative Arts, Furniture, Jewelry, Silver, Metalwork, Historical Material, Embroidery
Collections: American Indian Art of Western United States, emphasis on Southwestern groups; paintings by contemporary Native American artists; religious arts and non-religious artifacts of Hispanic cultures; nucleus of collection formed by Millicent Rogers
Exhibitions: Rotating exhibits & from permanent collection
Publications: Las Palabras, quarterly newsletter for members of the museum
Activities: Classes for adults & children; lect open to public, 2-3 vis lectrs per year; gallery talks; docent tours; field trips; seminars; accredited by the American Association of Museums; original works of art lent to similar institutions; museum store sells books, jewelry, original art, prints, art & craft work by contemporary Southwest artisans & artists

L **Library,** 1504 Millicent Rodgers Rd, Taos, NM 87571; PO Box A, Taos, NM 87571. Tel 505-758-2462; Fax 505-758-5751; Elec Mail mrm@newmex.com; Internet Home Page Address: www.millicentrogers.org; *Exec Dir* Shelby J Tisdale
Open daily 10 AM - 5 PM, Nov - Mar cl Mon; Admis adults $6, students & seniors $5, children $2; Estab 1956, emphasis on Native American, Hispanic & Anglo northern New Mexican artists; Average Annual Attendance: 45,000; Mem: 400
Income: Financed by admis, mem & mus store
Library Holdings: Book Volumes 6000; Clipping Files; Exhibition Catalogs; Manuscripts; Pamphlets; Periodical Subscriptions 25
Special Subjects: Art History, Folk Art, Decorative Arts, Historical Material, Latin American Art, Archaeology, Art Education, American Indian Art, Primitive art, Eskimo Art, Mexican Art, Southwestern Art
Collections: Limited edition, special edition & out of print books on Southwestern Americana; Maria Martinez pottery; over 600 Native American & Hispanic textiles; Native American costumes; Pottery & jewelry
Activities: Classes for adults & children; docent training; lect open to public; gallery talks; tours; book traveling exhibitions; originate traveling exhibitions

A **TAOS CENTER FOR THE ARTS,** Stables Gallery, 133 Paseo de Pueblo Norte, Taos, NM 87571. Tel 505-758-2052; Fax 505-751-3305; Elec Mail taa@newmex.com; Internet Home Page Address: www.taosnet.com/taa; *Pres* Doug Smith; *Exec Dir* Jeane F Marquardt
Open Mon - Fri 10 AM - 5 PM, cl Sat & Sun; No admis fee; Estab Oct 1952 as a nonprofit community art center to promote the arts in Taos for the benefit of the entire community; Average Annual Attendance: 30,000; Mem: 300; annual meeting Jan

Income: Financed by mem, contributions, grants, sales of art works & admissions
Activities: Children's program in music & theater; dramatic programs; concerts

L **TAOS PUBLIC LIBRARY,** Fine Art Collection, 402 Camino De La Placita, Taos, NM 87571. Tel 505-758-3063; Fax 505-737-2586; Internet Home Page Address: www.taoslibrary.org; *Librn* Laurie Macrae
Open Tues - Thurs 10 AM - 7 PM, Mon Noon - 5 PM, Fri 10 AM - 6 PM, Sat 10 AM - 5 PM; No admis fee; Estab 1936; Circ 60,000
Library Holdings: Book Volumes 55,000; CD-ROMs; Clipping Files; Compact Disks; DVDs; Exhibition Catalogs; Original Art Works; Pamphlets; Periodical Subscriptions 60; Photographs; Prints; Reproductions; Video Tapes
Special Subjects: Art History, Archaeology, American Western Art, American Indian Art, Southwestern Art
Activities: Childrens summer program includes arts & crafts; bilingual reading discussion program; lect

M **TAOS HISTORIC MUSEUMS,** (Kit Carson Historic Museums) PO Drawer CCC, Taos, NM 87571. Tel 505-758-0505; Fax 505-758-0330; Elec Mail thm@taoshistoricmuseums.com; Internet Home Page Address: www.taoshistoricmuseums.com; *Dir* Karen S Young
Estab 1949. In 1962 the home of Ernest L Blumenschein was given to the Foundation by Miss Helen C Blumenschein; it is now classified as a Registered National Landmark. In 1967 Mrs Rebecca S James gave the Foundation the Ferdinand Maxwell House & Property. In 1972, acquired the Hacienda de Don Antonio Serverino Martinez, prominent Taos merchant & offical during the Spanish Colonial Period; designated a Registered National Historic Landmark; Average Annual Attendance: 60,000; Mem: 280; dues patron $1000, sponsor $500, benefactor $250, sustaining $150, contributing $75, partners $50, individual $25
Income: $300,000 (financed by admis, museum shops, rentals, donations & grants)
Special Subjects: Furniture, Period Rooms
Collections: Historical and Archaeological Collection; Western Americana
Publications: Director's annual report; Taos Lightnin Newsletter, quarterly; publications on the historic sites; technical reports
Activities: Classes for adults & children; docent training; lect; gallery talks; mus shop

L **Southwest Research Center of Northern New Mexico Archives,** PO Drawer CCC, Taos, NM 87571. Tel 505-758-5440; Fax 505-758-0330; Elec Mail thm@taoshistoricmuseum.com; *Dir* Karen S Young; *Librn* Nita Murphy; *Registrar-Archivist* Joan Phillips
9 AM - 5 PM; Research Ctr estab 1999; For reference only
Income: Donations & grants
Library Holdings: Audio Tapes; Book Volumes 5000; Cassettes; Clipping Files; Exhibition Catalogs; Kodachrome Transparencies; Lantern Slides; Manuscripts; Maps; Memorabilia; Original Documents; Other Holdings Maps; Pamphlets; Periodical Subscriptions; Photographs; Reproductions; Slides
Special Subjects: Maps, Historical Material, Archaeology, American Western Art, Anthropology, Southwestern Art
Collections: Photograph archives; publs
Activities: Classes for adults

M **Ernest Blumenschein Home & Studio,** PO Drawer CCC, Taos, NM 87571. Tel 505-758-0505; Fax 505-758-0330; Elec Mail thm@taohistoricmuseums.com; Internet Home Page Address: www.taohistoricmuseums.com; *Dir* Karen S Young; *Educator* Morris Whitten; *Registrar* Joan A Phillips; *Librn* Nita Murphy
Open daily 9 AM - 5 PM, cl Christmas, Thanksgiving & New Year's Day; Admis family rate $10, adults $6, children $3, children under 6 years free with parents, group tour rates available; Home of world renowned artist & co-founder of famous Taos Soc of Artists; Restored original mud plaster adobe dating to 1797 with traditional furnishings of New Mexico & European furnishings; Average Annual Attendance: 17,000; Mem: 280; dues $15-$500
Income: Donations & admissions, shop sales
Special Subjects: Architecture, Drawings, Painting-American, American Western Art, Southwestern Art, Textiles, Ceramics, Pottery, Portraits, Furniture, Carpets & Rugs, Historical Material, Tapestries, Period Rooms
Collections: Taos Society of Artists Collection; fine art paintings
Exhibitions: Temporary exhibits of arts and crafts of the Taos area and of New Mexico
Activities: Classes for adults & children; docent training; lect open to public, 2 vis lectrs per year; tours; annual founder art show; book traveling exhibitions; mus shop sells books, original art, reproductions & prints

M **La Hacienda de Los Martinez,** PO Drawer CCC, Taos, NM 87571. Tel 505-758-1000; Fax 505-758-0330; Elec Mail thm@thoshistoricmuseums.com; Internet Home Page Address: www.taohistoricmuseums.com; *Dir* Karen S Young; *Educator* Morris Whitten; *Registrar* Joan A Phillips; *Librn* Nita Murphy
Open daily 9 AM - 5 PM, cl Thanksgiving, Christmas, New Yrs Day; Admis family rate $10, adults $6, children $3, children under 6 free with parents, group tour rates; Estab 1972, built & occupied by Don Antonio Severino Martinez 1804-1827. Last remaining hacienda open to pub in northern New Mexico. Martinez, an important trader with Mexico, also served as Alcalde of Northern New Mexico; Spanish Colonial fortress hacienda having 21 rooms & two large patios. Living mus program; Average Annual Attendance: 30,000
Income: Financed by admis, donations, & shop sales
Special Subjects: Hispanic Art, Mexican Art, Textiles, Religious Art, Woodcarvings, Furniture, Metalwork, Historical Material, Period Rooms, Embroidery
Collections: Furniture, tools & articles of Spanish Colonial period & personal family articles
Exhibitions: Various art & craft exhibits, irregular schedule
Activities: Classes for adults & children; docent training; lect open to public, 6 vis lectrs per year; tours; The Annual Taos Trade Fair; mus shop sells books, original art, reproductions & prints

M **UNIVERSITY OF NEW MEXICO,** The Harwood Museum of Art, 238 Ledoux St, Taos, NM 87571. Tel 505-758-9826; Fax 505-758-1475; Elec Mail harwood@unm.edu; Internet Home Page Address: www.harwoodmuseum.org; *Cur* Margaret E Bullock; *Dir* Charles M. Lovell; *Cur of Educ* Lucy Perrera Adams; *Develop Officer* L Rupert Chambers
Open Tues - Sat 10 AM - 5 PM, Sun Noon - 5 PM; Admis $7, Sun free to NMex residents; Estab 1923, Buildings & contents given to the University by Elizabeth Case Harwood, 1936, to be maintained as an art, educational & cultural center; maintained by the University with all activities open to the pub; Building was added to the National Register of Historic Places in 1976; major renovation expansion completed in 1997, increasing gallery size to 7; research library available by appointment; Average Annual Attendance: 19,000; Mem: 400; dues $25 - $1000 per year
Income: Financed by University of New Mexico, private contributions & grants, government grants, endowment income
Purchases: Johnny Winona Ross - Dry Wash Seeps
Special Subjects: Architecture, Drawings, Hispanic Art, Painting-American, Photography, Prints, Watercolors, American Western Art, Southwestern Art, Textiles, Religious Art, Ceramics, Woodcarvings, Etchings & Engravings, Landscapes, Decorative Arts, Portraits, Furniture, Historical Material
Collections: Permanent collection of works by Taos artists; Hispanic traditions, bultos & retables of NMex
Exhibitions: Changing exhibits each year; Diebenkorn in New Mexcio 1950-1952
Publications: Exhibit catalogs; biann newsletter
Activities: Classes for children; docent training; Discovery corner; lect open to public, 10 vis lects per year; concerts; gallery talks; tours; artist-in-Residence prog; sponsoring competitions; individual paintings & original objects of art lent to museums; lending collection contains original prints, paintings, photographs & sculpture; 1-2 exhibs per year; 1 nat exhib circulated per year; museum shop sells books, original art, crafts, jewelry & postcards

NEW YORK

ALBANY

M **ALBANY INSTITUTE OF HISTORY & ART,** 125 Washington Ave, Albany, NY 12210. Tel 518-463-4478; Fax 518-462-1522; Elec Mail information@albanyinstitute.org; Internet Home Page Address: www.albanyinstitute.org; *Dir & CEO* Christine M Miles; *Deputy Dir Coll & Pub Prgms & Chief Cur* Tammis Groft; *Deputy Dir External Rels* Marcia H. Moss; *Museum Shop Mgr* Elizabeth Belhand; *Chair* Wallace Altes; *Cur Research* Mary Alice Mackay; *Registrar* Diane Shewchuk; *Public Relations Mgr* Penelope Vavora; *Administrator* Christina Scott; *Chief Librn & Archivist* Rebecca Rich-Wulfmeyer; *Dir Educ* Erika Sanger; *Educator* Becca Mitchell; *Devel Officer* Katie Corrie; *Devel Officer* Richard Nacy; *Dir Facility Operations* Neal Benassi; *Special Events Coordr* Ralph Adrienne; *Bus & Information Systems Mgr* Alison Begor
Open Wed - Sun Noon - 5 PM, cl most NY state holidays; Admis adults $5, seniors & students $3, children under 12 free, mem free; Estab 1791, inc 1793 as the Society for the Promotion of Agriculture, Arts & Manufactures; 1829 as Albany Institute; 1900 as Albany Institute & Historical & Art Soc. Present name adopted 1926; Average Annual Attendance: 100,000; Mem: 2000; dues $35 & up; annual meeting in May
Income: Financed by endowment, mem, sales, foundation, city, county, state & federal grants & special gifts
Special Subjects: Drawings, Painting-American, Prints, Sculpture, Textiles, Costumes, Religious Art, Ceramics, Folk Art, Pottery, Etchings & Engravings, Landscapes, Decorative Arts, Collages, Portraits, Dolls, Furniture, Glass, Marine Painting, Period Rooms, Embroidery, Laces, Gold, Stained Glass, Pewter
Collections: Art, decorative arts & historical artifacts related to the art, history & culture of Upper Hudson Valley Region from the 17th century to present; 18th & 19th century paintings; Hudson River School; Ceramics; New York (especially Albany) costumes, furniture, glass, pewter, silver & other regional decorative arts; textiles
Exhibitions: Hudson River School paintings from the Institute's collection; Ancient Egypt; 18th & 19th Century Sculpture & Paintings Colonial Albany
Publications: Catalogues; several books about the history of New York State; Remembrance of Patria: Dutch Arts & Culture in Colonial America; Thomas Cole: Drawn to nature members' newsletter & calendar
Activities: Classes for adults & children; docent training; lect open to public, 10 vis lectrs per year; concerts; gallery talks; tours; individual paintings & original objects of art lent to other museums; book traveling exhibitions 4 per year; museum shops sells books, reproductions, prints & jewelry

L **Library,** 125 Washington Ave, Albany, NY 12210. Tel 518-463-4478; Fax 518-463-5506; Internet Home Page Address: www.albanyinstitute.org
Open by appointment; Estab 1791 to collect historical material concerning Albany & the Upper Hudson region, as well as books on fine & decorative art related to the Institute's holdings; For reference only
Library Holdings: Book Volumes 10,000; Clipping Files; Exhibition Catalogs 50; Lantern Slides; Manuscripts; Memorabilia; Original Documents; Other Holdings Architectural Plans; Deeds; Ephemeral; Maps; Posters; Pamphlets; Periodical Subscriptions 60; Photographs; Reels
Special Subjects: Art History, Folk Art, Decorative Arts, Historical Material, Ceramics, Crafts, Furniture, Glass, Carpets & Rugs, Silver, Textiles, Architecture

M **COLLEGE OF SAINT ROSE,** Art Gallery, 324 State St, Albany, NY 12210. Tel 518-485-3902; Fax 518-485-3920; Elec Mail flanagaj@strose.edu; Internet Home Page Address: www.strose.edu; *Dir* Jeanne Flanagan
Open Mon - Fri 10 AM - 4:30 PM, Mon - Thurs 6 - 8 PM, Sun Noon - 4 PM, cl Sat; No admis fee; Estab 1969 exhibiting contemporary art not previously seen in Capital Region; Average Annual Attendance: 2,700
Income: Financed by college funds
Special Subjects: Painting-American, Prints, Sculpture
Collections: Paintings, prints
Exhibitions: Rotating exhibits & student shows
Activities: Classes for adults; lect open to public, 6-8 vis lectrs per year; gallery talks; tours; scholarships offered

M **HISTORIC CHERRY HILL,** 523-1/2 S Pearl St, Albany, NY 12202. Tel 518-434-4791; Fax 518-434-4806; Elec Mail housemus@knick.net; Internet Home Page Address: www.historiccherryhill.org; *Cur* Erin Crissman; *Educ Dir* Rebecca Watrous; *CEO & Dir* Liselle LaFrance; *VPres* Michael Beiter; *Mus Shop Mgr* Lauren Mastin
Open Apr - June & Oct - Dec Tues - Fri Noon - 3 PM, Sat 10 AM - 3 PM, Sun 1

- 3 PM; July - Sept Tues - Sat 10 AM - 7 PM, Sun 1 - 3 PM; Admis adults $4, seniors $3, students $2, children $1; Estab 1964 to preserve & research the house & contents of Cherry Hill, built for Philip Van Rensselaer in 1787 & lived in by him & four generations of his descendents until 1963; Georgian mansion having 14 rooms of original furniture, ceramics, paintings and other decorative arts spanning all five generations & garden; Average Annual Attendance: 5,000; Mem: 250; dues $15 & up
Income: Financed by endowment fund, admis, mem, program grants, sales shop revenue
Special Subjects: Painting-American, Textiles, Costumes, Ceramics, Pottery, Landscapes, Decorative Arts, Manuscripts, Portraits, Dolls, Furniture, Porcelain, Oriental Art, Silver, Period Rooms
Collections: Catherine Van Rensselaer Bonney Collection of Oriental decorative arts; New York State furniture; silver; ceramics; textiles and paintings dating from the early 18th thru 20th centuries; Manuseyp Collection; Seasonal exhibitions in the period room
Publications: New Gleanings, quarterly newsletter
Activities: Educ dept; docent training; classroom materials; lect open to public; tours; paintings and art objects are lent to other museums and exhibitions; museum shop sells books, postcards & reproductions

A NEW YORK OFFICE OF PARKS, RECREATION & HISTORIC PRESERVATION, Natural Heritage Trust, Empire State Plaza, Agency Building One Albany, NY 12238. Tel 518-473-3390; *Exec Dir* Larry Delarose
Estab to administer individual gifts & funds; funding appropriated by state legislatures for various purposes
Exhibitions: Letchworth Art & Crafts Show

L NEW YORK STATE LIBRARY, Manuscripts & Special Collections, Cultural Educ Center, Empire State Plaza Albany, NY 12230. Tel 518-474-6282; Fax 518-474-5786; Elec Mail mscolls@mail.nysed.gov; Internet Home Page Address: www.nysl.nysed.gov; *Sr Librn* Billie Aul; *Assoc Librn* Kathi Stanley; *Dir* Elizabeth Lane
Open Mon - Fri 9 AM - 5 PM
Income: Financed by State
Library Holdings: Book Volumes; Manuscripts; Maps; Original Documents
Special Subjects: Art History, Manuscripts, Historical Material
Collections: Over 50,000 items: black & white original photographs, glass negatives, daguerreotypes, engravings, lithographs, bookplates, postcards, original sketches & drawings, cartoons, sterograms & extra illustrated books depicting view of New York State & Portraits of its citizens past & present
Exhibitions: Exhibit program involves printed & manuscript materials

M NEW YORK STATE MUSEUM, Cultural Education Ctr Rm 3023, Empire State Plaza Albany, NY 12230. Tel 518-474-5877; Fax 518-486-3696; Elec Mail cryan@mail.nysed.gov; Internet Home Page Address: www.nysd.nysed.gov; *Dir & Asst Commissioner* Clifford Siegfried; *Dir Research & Coll* John Hart; *Supr Exhibit Production* Dave LaPlante; *Dir Exhibits* Mark Schaming; *Chief Geological Survey* Robert Fakundiny; *Dir Communication* Joanne Guilmette; *Head Educ* Jeanine Grinage
Open Mon - Sun 9:30 AM - 5 PM; Donation suggested; Estab 1836 to research, collect, exhibit & educate about the natural & human history of New York State for the people of New York; to function as a cultural center in the Capital District of the Empire State; Museum has 1 1/2 acres of exhibit space; three permanent exhibit halls devoted to people & nature (history & science) themes of Adirondack Wilderness, Metropolitan New York, Upstate New York; three temporary exhibit galleries of art, historical & technological artifacts; Average Annual Attendance: 900,000
Income: $5,700,000 (financed by state appropriation, government & foundation grants & private donations)
Special Subjects: Ethnology, Decorative Arts
Collections: Ethnological artifacts of Iroquois-Algonkian (New York area) Indians; circus posters, costumes, decorative arts, paintings, photographs, postcards, prints, toys, weapons
Activities: Classes for adults & children; lect open to public; concerts; individual paintings & original objects of art lent to museums; lending collection contains nature artifacts, original art works, original prints, paintings, photographs & slides; book traveling exhibitions, 6 per year; originate traveling exhibitions; museum shop sells books, magazines, original art, reproductions, prints, slides, toys, baskets, pottery by local artists, jewelry, stationery & posters

A PRINT CLUB OF ALBANY, PO Box 6578, Albany, NY 12207; Ft Orange Sta, PO Box 6578 Albany, NY 12206-6578. Tel 518-399-7231; Fax 518-449-4756; Elec Mail semowich@att.net; Internet Home Page Address: pcaprint.org; *Pres & VPres, Print Selection Committee Chmn* Thomas Andress; *Treas* Don Bolon; *Cur Dr* Charles Semowich; *Secy* Stephanie Pardo
Open by appointment; No admis fee; Estab 1933 for those interested in all aspects of prints & printmaking; Maintains reference library; permanent collection; temporary exhibs; Average Annual Attendance: 2,000; Mem: 200; dues $90; mem open to artists who have national recognition, non-artists need interest in prints; annual meeting in May
Income: Financed by mem, city & state appropriation, sales, commissions & auction
Purchases: Prints & printmakers' archives
Library Holdings: Auction Catalogs; Book Volumes 150; Kodachrome Transparencies; Manuscripts; Original Art Works; Slides; Video Tapes
Special Subjects: Drawings, Etchings & Engravings, Prints, Woodcuts
Collections: Drawings; Plates; Prints from all periods & countries concentrating on 20th century America; 9500 items
Exhibitions: mem exhibs; Nat Open; historical shows
Publications: Exibition catalogues; newsletter, 5 per year
Activities: Educ dept; workshops; lect open to public, 3 vis lectrs per year; talks; competition with prizes; lathrop; cogswell; objects of art lent to state capital & county offices; originate traveling exhibitions; sales shop sells original art

M SCHUYLER MANSION STATE HISTORIC SITE, 32 Catherine St, Albany, NY 12202. Tel 518-434-0834; Fax 518-434-3821; Elec Mail marcy.shaffer@oprhp.stat; Internet Home Page Address: www.nysparks.com; *Historic Site Mgr* Marcy Schaffer; *Interpreter* Deborah Emmons-Andarawl; *Interpreter* Umber Gold; *Interpretive Program Dir* Darlene Rogers
Open Wed - Sat 10 AM - 5 PM, Sun 1 - 5 PM, Nov - mid April; call for winter hrs; Admis adult $3, New York seniors $2, children 5-12 $1; Estab 1917 for the preservation and interpretation of the 18th century home of Philip Schuyler, one of the finest examples of Georgian architecture in the country; The house boasts a substantial collection of Schuyler family pieces & fine examples of Chinese export porcelain, delftware & English glassware; Average Annual Attendance: 15,000
Income: Financed by state appropriation
Special Subjects: Historical Material
Collections: American furnishings of the Colonial & Federal Periods, predominantly of New York & New England origins
Publications: Schuyler Genealogy: A Compendium of Sources Pertaining to the Schuyler Families in America Prior to 1800; vol 2 prior to 1900
Activities: Educ dept; lect; tours; special events

M UNIVERSITY AT ALBANY, STATE UNIVERSITY OF NEW YORK, University Art Museum, 1400 Washington Ave, Albany, NY 12222. Tel 518-442-4035; Fax 518-442-5075; Internet Home Page Address: www.albany.edu/museum; *Exhib Designer* Zheng Hu; *Admin Asst* Joanne Lue; *Dir* Marijo Dougherty
Open Wed - Fri 10 AM - 5 PM, Sat & Sun Noon - 4 PM; No admis fee; Estab 1968. The University Art Mus at the University at Albany, State University of New York, is a window to both the University & soc, a place where contemporary art & artifacts reflecting the diversity of peoples, cultures & life experiences are exhibited. As such, the mus is a resource for all of Albany's academic programs supporting the core curriculum with world class exhibitions & scholarships. Students, faculty & staff who visit the mus draw inspiration from the exhibitions it hosts, which contribute to their understanding & appreciation of differing cultures & ideas; Average Annual Attendance: 25,000
Income: Financed by state appropriation
Special Subjects: Drawings, Painting-American, Prints, Sculpture
Collections: Paintings, prints, drawings & sculpture of 20th century contemporary art; photographs
Exhibitions: Rotating exhibition every 6 weeks
Publications: Exhibition catalogs
Activities: Lect open to public; gallery talks; tours; competitions with awards; individual art works lent to offices on the university campus only; book traveling exhibitions; originate traveling exhibition
Courses: 100 paintings, 25 photographs, 75 sculpture, individual paintings & original objects of art lent to on campus administrative offices; lending collection contains 800 original prints

L Art Dept Visual Resources, Fine Arts Bldg, Rm 121, Albany, NY 12222. Tel 518-442-4018; *Art Historian* Sarah Cohen; *Visual Resources Cur* Susan Travis; *Art Historian* Rachel Dressler; *Chair & Art Historian* Roberta Bernstein
Open daily 9 AM - 5 PM; Estab 1967 to provide instruction & reference for the university & community
Income: financed by the college
Library Holdings: Exhibition Catalogs; Filmstrips; Kodachrome Transparencies; Lantern Slides; Pamphlets; Photographs; Slides 90,000
Collections: Slides, mainly of Western art & architecture

ALFRED

L NEW YORK STATE COLLEGE OF CERAMICS AT ALFRED UNIVERSITY, Scholes Library of Ceramics, 2 Pine St, Alfred, NY 14802-1297. Tel 607-871-2494; Fax 607-871-2349; Elec Mail ccjohnson@alfred.edu; Internet Home Page Address: scholes.alfred.edu; *Pub Svcs Librn* Beverly J Crowell; *Engineering & Science Librn* Patricia LaCourse; *Art Reference Librn & Archivist* Elizabeth Gulacsy; *Information Systems Librn* Mark A Smith; *Visual Resource Cur* Suzanne O Roberts; *Access Svcs Librn* Bruce E Connolly; *Dir* Carla C Freeman; *Visual Resource Cur* Mandy Economos; *Technical Serv Librn* Elizabeth Galacsy; *Dir* Carla C Johnson
Open academic year Mon - Thurs 8 AM - 12 AM, Fri 8 AM - 8 PM, Sat 10 AM - 6 PM, Sun 11 AM - 11 PM, other periods Mon - Fri 8 AM - 4:30 PM; Estab 1947 to service art educ to the Master's level in fine art & the PhD level in engineering & science related to ceramics; Circ Artbooks 5,808; slides 42,859; The College has a 2500 sq ft Art Gallery which is managed by the Art & Design Division; Average Annual Attendance: 80,497
Income: $671,884 (financed by endowment & state appropriation)
Purchases: $55,000
Library Holdings: Audio Tapes 51; Book Volumes 64,495; CD-ROMs 33; Cassettes 643; Clipping Files; Exhibition Catalogs; Fiche; Filmstrips; Lantern Slides 200; Motion Pictures; Original Art Works; Other Holdings Art books 26,188; Audio cassettes 171; College arc; Pamphlets 1408; Periodical Subscriptions 707; Reels; Slides 158,890; Video Tapes 15
Special Subjects: Art History, Folk Art, Decorative Arts, Photography, Commerical Art, Graphic Design, Painting-American, Painting-European, History of Art & Archaeology, Ceramics, Crafts, Bronzes, Printmaking, Asian Art, Glass
Publications: Scholes Library Bulletin, biannual
Activities: Tours

ALMOND

M ALMOND HISTORICAL SOCIETY, INC, Hagadorn House, The 1800-37 Museum, 7 Main St, PO Box 209 Almond, NY 14804. Tel 607-276-6781; *VPres* Hazel Bracken; *Treas* Wayne Kellogg; *Pres* Charlotte Baker
Open Fri 2 - 4 PM & by appointment; Admis by donations; Estab 1965 to preserve local history, genealogy & artifacts; The Little Gallery 4 ft x 12 ft, burlap covered walls, 4 display cases, 8-track lighting system; Average Annual Attendance: 2,000; Mem: 395; mem open to those interested in local history; life

member \$100, business or professional \$12, family \$10, couple \$8, individual \$5; annual meeting in Nov
Income: \$25,908 (financed by endowment, mem, city appropriations)
Collections: 1513 genealogies of local families; town & village records; slide collection of local houses; 1500 costumes & hats; 50 quilts; toys; school books; maps; cemetary lists; photographs, scrapbooks
Exhibitions: Local architecture: drawings & photographs; history of the local post office
Publications: The Cooking Fireplace in the Hagadorn House; Forgotten Cemeteries of Almond; My Father's Old Fashioned Drug Store; Recollections of Horace Stillman; School Days
Activities: Classes for children; lect open to public, 4 vis lectrs per year

AMENIA

A **AGES OF MAN FOUNDATION,** (Ages of Man Fellowship) 57 Sheffield Rd, Box 5 Amenia, NY 12501. Tel 845-373-9380; *VPres* Andrew Rauhauser; *Pres* Dr Nathan Cabot Hale; *Sub Dir* Dr Niels Berg
Open 10 AM - 5 PM; No admis fee, suggested donation; Estab 1968 for the building & design of a sculpture chapel based on the thematic concepts of the Cycle of Life; Average Annual Attendance: 35; Mem: 20; dues \$100; meetings May & Nov
Income: Financed by mem & contributions
Collections: Sculpture & architectural models of the chapel; biological references; forms of nature
Exhibitions: varied sculpture concepts to document historical background & concept of the human form
Publications: Project report, yearly; Abstraction in Art & Nature; Perception of Human Form in Sculpture: A History of Figurative Understanding by NC Hale, PhD
Activities: Art history; apprenticeship & journeyman instruction in Cycle of Life design; lect open to public, 20 vis lectrs per year; gallery talks; original objects of art lent to museums, art associations, educational institutions; originate traveling exhibitions

AMHERST

M **AMHERST MUSEUM,** 3755 Tonawanda Creek Rd, Amherst, NY 14228-1599. Tel 716-689-1440; Fax 716-689-1409; Elec Mail amhmuseum@adelphia.net; Internet Home Page Address: www.amherstmuseum.org; *Cur Educ* Jean W Neff; *Exec Dir* Joseph G Weickart; *Cur* Jessica A Norton; *Textile Cur* Kristie Rhoback
Open Nov - Mar Tues - Fri 9:30 AM - 4:30 PM, Apr - Oct Tues - Fri 9:30 AM - 4:30 PM, Sat & Sun 12:30 - 4:30 PM, cl Mon & Municipal Holidays; Admis adults \$5, children between 5 & 12 \$1.50, mems & children under 4 free; Estab 1972 to preserve town of Amherst history; Maintains reference library, local history exhibits & temporary art exhibits; Average Annual Attendance: 40,000; Mem: 825; dues family \$35, individual \$20
Income: \$550,000 (financed by mem, town appropriation, earned income)
Library Holdings: Audio Tapes; Book Volumes; Clipping Files; Fiche; Filmstrips; Lantern Slides; Manuscripts; Maps; Memorabilia; Original Documents
Special Subjects: Costumes, Folk Art, Decorative Arts, Furniture, Glass, Carpets & Rugs, Historical Material, Maps, Dioramas, Period Rooms, Embroidery
Collections: American Material Culture; 19th Century Historic Buildings; textiles & costumes
Exhibitions: The Erie Canal; Pioneer Kitchen; Niagara Frontier Wireless Radio Gallery; How They Moved Here; What's Cooking: Women in the Kitchen; Wedding Belles: The Fashionable Bride 1840-1990; Street of Shops
Publications: Ephemera, quarterly newsletter; researching Amherst House Histories, booklet; Glancing Back: A Pictorial History of Amherst NY
Activities: Classes for adults & children; docent training; special events; lect open to public, 2-5 vis lectrs per year; museum shop sells books, prints, reproductions, folk art & unique gift items
L **Neiderlander Research Library,** 3755 Tonawanda Creek Rd, Amherst, NY 14228-1599. Tel 716-689-1440; Fax 716-689-1409; Elec Mail amhmuseum@adelphia.net; Internet Home Page Address: www.amherstmuseum.org; *Exec Dir* Lynn S Beman; *Librn* Toniann Scime
Open Tues-Frid 9:30 AM-4:30 PM, Sat & Sun by appointment; Admis adults \$5, students \$1.50; For reference only
Library Holdings: Book Volumes 3000; Clipping Files; Fiche; Kodachrome Transparencies; Lantern Slides; Manuscripts; Memorabilia; Pamphlets; Photographs; Prints; Reels; Slides; Video Tapes
Collections: 19th-20th century photographs & archival materials related to Town of Amherst, NY & Village of Williamsville, NY
Publications: Genealogical Society newsletter
Activities: Lect open to public

M **DAEMEN COLLEGE,** Fanette Goldman & Carolyn Greenfield Gallery, Duns Scotus Hall, 4380 Main St Amherst, NY 14226. Tel 716-839-8241; Fax 716-839-8516; Internet Home Page Address: www.daemen.edu; *Dir* Kevin Kegler
Open Mon - Fri 9 AM - 4 PM; No admis fee; Estab to add dimension to the art program & afford liberal arts students opportunity to view art made by established artists as well as art students; Gallery area is part of main building (Duns Scotus Hall), recently renovated exterior & entrance; Average Annual Attendance: 1,500
Income: Financed by College Art Department
Activities: Lect open to public, 4 - 5 vis lectrs per year
L **Marian Library,** 4380 Main St, Amherst, NY 14226-3592. Tel 716-839-8243; Fax 716-839-8475; Internet Home Page Address: www.daemen.edu; *Reference Librn* Andrea Sullivan; *Ref Librn* Randolph Chojecki; *Asst Head Librn* Frank Carey; *Head Librn* Glenn V Woike; *Circulation & ILL Librn* Kara McGuire
Library Holdings: Book Volumes 140,000; DVDs 500; Periodical Subscriptions 940; Slides 4911; Video Tapes 1536
Special Subjects: Art History, Calligraphy, Graphic Arts, Graphic Design, Painting-American, Art Education, Textiles

AMSTERDAM

M **MOHAWK VALLEY HERITAGE ASSOCIATION, INC,** Walter Elwood Museum, 300 Guy Park Ave, Amsterdam, NY 12010-2228. Tel 518-843-5151; Fax 518-843-6098; *Dir* Mary Margaret Gage; *Supt Greater Amsterdam School District* Lawrence Przaskos; *Pres* Mary Ann Tomlinson
Open Sept - June Mon - Fri 8:30 AM - 4 PM & weekend by appointment; July 1 - Labor Day Mon - Thurs 8:30 AM - 3:30 PM, Fri 8:30 AM - 1 PM; No admis fee; Estab 1940 to preserve local heritage & natural history; Gallery displays changing exhibits, local & professional collections & museum's works of art; Average Annual Attendance: 4,000; Mem: 675; dues \$5 - \$500; annual meeting 3rd Tues in June
Income: \$25,000 (financed by mem & fundraisers)
Special Subjects: Painting-American, Etchings & Engravings
Collections: Oil paintings by turn of the century local artists; photographs of early Amsterdam & vicinity; steel engravings by turn of the century artists
Exhibitions: Paintings by the Monday Art Group (local area artists); Rotating exhibitions
Activities: Adult classes; museum shop sells books, maps

ANNANDALE-ON-HUDSON

M **BARD COLLEGE,** Center for Curatorial Studies, 33 Garden Rd, Annandale-on-Hudson, NY 12504-5000; P O Box 5000, Annandale-on-Hudson, NY 12504-5000. Tel 845-758-7598; Fax 845-758-2442; Elec Mail ccs@bard.edu; *Asst Dir* Marcia Acita; *Librn* Susan Leonard
Open Wed - Sun 1 - 5 PM; No admis fee; Estab 1992 for the presentation of contemporary art; Circ Non-circulating; 9,500 sq ft of exhibition space, changing exhibitions; Average Annual Attendance: 8,000
Special Subjects: Drawings, Painting-American, Photography, Painting-European, Painting-British, Restorations, Painting-German
Collections: Marieluise Hessel Collection; contemporary art from 1960s to the present in all media, including installations & video
Activities: Educ programs; teacher training programs; lect open to public, 12 vis lectrs per year; gallery talks; individual paintings & original objects of art lent to museums in Europe & the United States, 10 outgoing loans per year; book traveling exhibitions 1 per year; originate traveling exhibitions

M **BARD COLLEGE,** Fisher Art Center, PO Box 5000 Annandale-on-Hudson, NY 12504. Tel 845-758-7674; Fax 845-758-7683; *Co-Chair* Judy Pfaff; *Co-Chair* Arthur Gibbons
Open daily 9 AM - 5 PM; No admis fee; Estab 1964 as an educational center; Art center has a gallery, slide library and uses the college library for its teaching
Exhibitions: Four guest-curated exhibitions of contemporary art & two student exhibitions per year; End of Yr Sr Thesis Exhibit
Publications: Catalogs
Activities: Lect open to public; 10 vis lectr per yr; gallery talks; tours
L **Center For Curatorial Studies Library,** Tel 914-758-7567; Fax 914-758-2442; Elec Mail ccs@bard.edu; *Librn* Susan Leonard
Estab 1990; For reference only; non-circulating research collection supporting the graduate program in Curatorial Studies
Library Holdings: Book Volumes 11,000; Clipping Files 1000; Exhibition Catalogs; Memorabilia; Pamphlets; Periodical Subscriptions 52; Slides 10,000; Video Tapes
Special Subjects: Art History, Mixed Media, Photography, Painting-American, Painting-British, Painting-German, Painting-Italian, Sculpture, Painting-European, Conceptual Art, Video, Aesthetics, Restoration & Conservation

ASTORIA

M **AMERICAN MUSEUM OF THE MOVING IMAGE,** 35 Ave at 36 St, Astoria, NY 11106. Tel 718-784-4520; Fax 718-784-4681; Internet Home Page Address: www.ammi.org; *Sr Historian* Richard Kaszarski PhD, MA; *Chief Cur Film & Video* David Schwartz, MA; *Cur Digital Media* Carl Goodman, MA; *Dir* Rochelle Slovin, MA
Open Tues - Fri Noon - 5 PM, Sat & Sun 11 AM - 6 PM; Admis adults \$8.50, children \$4.50, seniors \$5.50, members free; Estab 1988, devoted to art, history, technique & technology of moving image media; Temporary gallery on first floor, 1800 sq ft; 2nd & 3rd floors 5500 sq ft of permanent exhibition space; Average Annual Attendance: 90,000; Mem: 1500; dues \$50-\$1000
Special Subjects: Costumes, Cartoons
Collections: The museum has a collection of over 70,000 artifacts relating to the material art form of movies & television, magazines, dolls, costumes, clothing
Exhibitions: Behind the Screen; Computer Space; Television Set Design: Late Show with David Letterman
Publications: Behind the Screen; Who Does What in Motion Pictures & Television
Activities: Classes for children; ESL programs; docent training; adult tours; lect open to public, 50 vis lectrs per year; gallery talks; tours; originate traveling exhibitions; museum shop sells books, magazines, & reproductions

AUBURN

M **CAYUGA MUSEUM OF HISTORY & ART,** 203 Genesee St, Auburn, NY 13021. Tel 315-253-8051; Fax 315-253-9829; *Dir* Eileen Mchuch; *Educator* Collin Sullivan; *Cur* Gina Stenkavitz
Open Tues - Fri 10 AM - 5 PM, Sat & Sun Noon - 5 PM, cl Mon, New Year's, Labor Day, Thanksgiving, Christmas; No admis fee; Estab 1936 for research & Cayuga County history; Average Annual Attendance: 45,000; Mem: 200; dues \$30-\$250; annual meeting in May
Income: Financed by endowment, mem, county & city appropriation
Special Subjects: American Indian Art
Collections: Fine & Decorative Arts; Native American Collection; Soundfilm
Exhibitions: Ongoing series of changing exhibits

Activities: Classes for adults & children; docent training; lect open to public; tours; lending collection contains motion pictures & slides; museum shop sells reproductions & small gifts

L **Library,** 203 Genesee St, Auburn, NY 13021. Tel 315-253-8051; *Librn* Stephanie Przybylek
Open to researchers for reference
Library Holdings: Book Volumes 16,000; Periodical Subscriptions 10
Collections: Clarke Collection

M **SCHWEINFURTH MEMORIAL ART CENTER,** (Schweinfurth Art Center) 205 Genesee St, Auburn, NY 13021. Tel 315-255-1553; Fax 315-255-0871; Elec Mail mail@schweinfurthartcenter.org; Internet Home Page Address: www.myartcenter.org; *Asst Dir* Stephanie Bielejec; *Dir* Donna Lamb; *Prog Coordr* Suzy Tankersley
Open Tues - Fri 10 AM - 5 PM, Sat 10 AM - 5 PM, Sun 1 - 5 PM; Admis $3 - $5; Estab 1981; community art center focusing on fine art, architecture & design; 4000 sq ft contemporary gallery; Average Annual Attendance: 20,000; Mem: 500; dues $20-$1000
Income: $240,000 (financed by endowment, mem, city & state , federal, public & private)
Exhibitions: Regional artists, traveling & annual childrens exhibit (Feb); annual quilt exhibit (Nov -Dec)
Publications: Monthly calendar
Activities: Classes for adults & children; docent training; gallery talks; scholarships offered; originate traveling exhibitions; sales shop sells books, original art & gifts; special events

AURIESVILLE

M **THE NATIONAL SHRINE OF THE NORTH AMERICAN MARTYRS,** 136 Shrine Rd Auriesville, NY. Tel 518-853-3033; Internet Home Page Address: www.martyrsshrine.org; *Asst Dir* John J Paret; *Assoc Dir* John M Doolan; *Dir* John G Marzolf; *Sec* Ferne Carron
Open Mon - Sat 10 AM - 4 PM, Sun 9:30 AM - 5 PM; No admis fee; Estab 1885 as a religious & historic shrine; Average Annual Attendance: 60,000
Income: Financed by donations
Publications: The Pilgrim, quarterly

BALDWIN

M **BALDWIN HISTORICAL SOCIETY MUSEUM,** 1980 Grand Ave, Baldwin, NY 11510. Tel 516-223-6900, 223-8080 (Chamber of Commerce); *Cur* Gerry Griffin; *Pres* Jack Bryck; *VPres* Connie Grando; *Treas* Robert Grando
Open to the pub Mon, Wed, Fri 9 AM - 11:30 AM - Sun 1 - 4 PM or by appointment; No admis fee; Estab 1971, mus estab 1976 to preserve Baldwin history memorabilia including historical photographs; Average Annual Attendance: 500; Mem: 225; dues family $10, individual $5; monthly meetings except Jan, Feb, July & Aug
Income: $5000 (financed by mem, fundraising)
Special Subjects: Painting-American, Photography, Costumes, Ceramics, Etchings & Engravings, Manuscripts, Furniture, Glass, Jewelry, Maps
Collections: Collection of local history photographs, postal cards, advertising objects, decorative art objects, manuscripts
Exhibitions: Selection of Baldwin's memorabilia
Publications: Newsletter
Activities: Classes for adults & children in local history programs; lect open to public, 4 vis lectrs per year; annual American History award given to a senior in History

BALLSTON SPA

A **SARATOGA COUNTY HISTORICAL SOCIETY,** Brookside Museum, Six Charlton St, Ballston Spa, NY 12020. Tel 518-885-4000; Elec Mail info@brooksidemuseum.org; Internet Home Page Address: www.brooksidemuseum.org; *Public Prog Dir* Linda Gorham; *Exec Dir* Joy Houe
Open Tues - Fri 10 AM - 4 PM, Sat 10 AM - 2 PM, cl Sun & Mon; Admis family $5, adults $2, seniors, $1.50, children $1; Estab 1965 to inform pub on the history of Saratoga County; 4 small galleries; Average Annual Attendance: 7,500; Mem: 500; dues individual $25
Income: $130, 000 (financed by endowment, mem, city appropriation & grants)
Special Subjects: Historical Material
Collections: History of Saratoga County, books, manuscripts, objects, photographs
Exhibitions: Saratoga County: The Story of Brookside changing exhibitions; Go to the Head of the Class; Taking the Waters
Publications: Gristmill, 1 per year; columns, 6 per year
Activities: Classes for adult & children; lect open to public; sales shop sells books & gifts

BAYSIDE

M **QUEENSBOROUGH COMMUNITY COLLEGE,** Art Gallery, 222-05 56th Ave, Bayside, NY 11364-1497. Tel 718-631-6396, 281-5095; Fax 718-423-9620; *Gallery Conservator* Oscar Sossa; *Dir* Faustino Quintanilla
Open 9 AM - 5 PM; No admis fee; Estab 1981 to provide the college & Queens Community with up to date documentation outline on the visual arts; Average Annual Attendance: 12,000; Mem: 500; dues $25
Income: $214,793 (financed by endowment & mem)
Purchases: Ruth Rothschild & Hampton Blake
Library Holdings: CD-ROMs; Exhibition Catalogs; Original Documents; Slides
Special Subjects: Painting-American, Prints
Collections: Contemporary art; works on paper; Richard Art Schwager; Roger Indiana; Paul Jenkins; R Dichtenstein; Larry Rives; Frank Stella; Judy Ritka; Alfonso Ossorio; Jules Allen; Jimmy Ernst; Josef Albers; Sirena

Exhibitions: Siri Berg-Suzane Winkler; The Priva B Gross International Works On/Of Paper; Permanent Collection: Larry Rives
Publications: Signal; Politics & Gender; Romanticism & Classicism; Power of Popular Imagery; Art & Politics
Activities: Lect open to public, 4-8 vis lectrs per year; competitions with awards; scholarships offered; individual paintings & original objects of art lent for exhibit purposes to organizations that follow loan criteria; lending collection contains original art works, photographs, sculptures & videos (art-New York & others); originate traveling exhibitions annually; mus & acredited galleries; museum shop; books; original art; reproductions; prints; cards & jewelry; junior museum

L **QUEENSBOROUGH COMMUNITY COLLEGE LIBRARY,** Kurt R Schmeller Library, 56th Ave & Springfield Blvd, Bayside, NY 11364. Tel 718-631-6226; Fax 718-281-5118; Internet Home Page Address: www.web.acc.qcc.cuny.edu/library; *Coordr Technical Svcs* Devin Feldman; *Chief Librn* Kyu Hugh Kim
Open Mon - Thurs 8:30 AM - 9 PM, Fri 8:30 AM - 5 PM, Sat 10 AM - 4 PM; No admis fee; Estab 1961 to serve the students and faculty of the college
Income: Financed by city and state appropriation, state and local grants, through the University, Friends of Library and pvt donations
Purchases: $80,000
Collections: Book & periodical collection includes material on painting, sculpture & architecture; print collection; reproductions of famous paintings; reproductions of artifacts & sculpture; vertical file collection
Publications: Library Letter, biannual

BELLMORE

M **LONG ISLAND GRAPHIC EYE GALLERY,** 2510 Williams Ct, Bellmore, NY 11710. Tel 516-826-7980; Fax 516-679-3670; Elec Mail marafeig@earthlink.net; Internet Home Page Address: www.studiomara.com
Open Wed - Sun 12 PM - 5 PM; No admis fee; Estab 1974
Income: Financed by mem & individual project grants
Special Subjects: Prints
Collections: Slide collection; Private collections
Exhibitions: Annual Winter Show: Journeys-Group Show; Group, individual & juried shows throughout the year; Washington Square Outdoor Art Exhibit
Activities: Educ dept; lect & demonstrations in print & other media open to public, 3-4 vis lectrs per year; Salmagundi Award; Bell Award; competitions with awards; scholarships offered; sales shop sells reproductions, prints

BINGHAMTON

M **ROBERSON MUSEUM & SCIENCE CENTER,** 30 Front St, Binghamton, NY 13905. Tel 607-772-0660; Fax 607-771-8905; Elec Mail info@roberson.org; Internet Home Page Address: www.roberson.org; *Cur & Registar* Eve Daniels; *Exec Dir* Terry McDonald; *Dir Exhibits* Peter Klosky; *Dir Educ* Katherine Howorth-Bouman
Open Tues, Wed, Fri 10:30AM-4:30PM, Thurs 10:30AM-8PM, Sun-Mon closed; Admis adults $7, students $5, children under 4 free; Estab 1954 as a regional museum of art, history & science educ; The Roberson Mus & Science Center, built in 1905-06 contains eight galleries; the Martin Building, built in 1968, designed by Richard Neutra, contains five galleries; the A Ward Ford Wing, completed in 1983 contains the Irma M Ahearn Gallery; Average Annual Attendance: 20,000; Mem: 1600; dues $35-$55
Income: $1,500,000 (financed by endowment, mem, city, county & state appropriations, federal funds & foundations)
Special Subjects: Drawings, Painting-American, Photography, Prints, Decorative Arts, Furniture
Collections: Loomis Wildlife Collection: Northeastern Birds & Mammals; Regional fine & decorative arts, crafts, furniture; archeological & ethnological collections; natural history specimens; historical archives & photographic collections; Hands-on science displays & interactive art
Exhibitions: Voices & Visions; The Prague Project; Daniel's Story; Edwin Link: The Air Age; Local History Gallery; Decker Life Science Learning Center (DNA Lab)
Activities: Classes for adults & children; school programs; public programs & workshops; dramatic programs; docent training; lect open to public, 5 vis lectrs per year; gallery talks; tours; scholarships offered; programs sent to schools in eleven counties; individual paintings & original objects of art lent; lending collection contains slide tape programs with hands-on-activities for groups; book traveling exhibitions 2-3 per year; originate traveling exhibitions to other museums; museum shops sell books, original art, reproductions, prints, contemporary crafts, unique & unusual gifts

M **STATE UNIVERSITY OF NEW YORK AT BINGHAMTON,** University Art Museum, University Art Museum, Vestal Pky East Binghamton, NY 13901; P.O. Box Binghamton, NY 13901. Tel 607-777-2634; Fax 607-777-2613; Elec Mail hogan@bighampton.edu; *Cur Educ* Silvia Ivanova; *Cur Prints* Jacqueline Hogan; *Technical Dir* Jennifer Nyman; *Dir* Lynn Gamwell Dr.; *Dir of Develop* Marcia Steinbrecher
Open Tues - Sat 1 - 4 pm, Thurs 1 - 7 PM, cl all holidays; No admis fee; Estab 1967; Eight areas of art; Average Annual Attendance: 4,000
Income: $30,000 (financed by state appropriations)
Special Subjects: Afro-American Art, Porcelain, Pre-Columbian Art, Textiles, Maps, Painting-European, Sculpture, Drawings, Graphics, Photography, African Art, Religious Art, Ceramics, Woodcuts, Etchings & Engravings, Manuscripts, Furniture, Glass, Jade, Jewelry, Oriental Art, Asian Art, Painting-British, Carpets & Rugs, Ivory, Coins & Medals, Restorations, Painting-Flemish, Renaissance Art, Embroidery, Medieval Art, Painting-Spanish, Painting-Italian
Collections: Asian collection; Teaching collection from Egyptian to contemporary art; African
Exhibitions: Art & Science Exhibits - changes twice a year
Publications: Exhibit catalogs; books

Activities: Educ program; classes for adults & children; gallery talks; tours; lect open to public; gallery talks; seminars; tours; internships offered

BLUE MOUNTAIN LAKE

M **THE ADIRONDACK HISTORICAL ASSOCIATION,** The Adirondack Museum, PO Box 99, Route 28N & 30 Blue Mountain Lake, NY 12812. Tel 518-352-7311; Fax 518-352-7653; Elec Mail rofner@adkmuseum.org; Internet Home Page Address: www.adirondackmuseum.org; *Pres* John G Fritzinger Jr; *Cur* Caroline Welsh; *Cur* Hallie Bond; *Educ Dir* Susan Dineen; *Registrar & Colls Mgr* Tracy Meehan; *Librn* Jerold L Pepper; *Dir Fin* Mitchel Smith; *Dir Mktg & Communications* Ronald Ofner; *Dir Develop* Hillarie Logan-Dechene; *Dir* David Pamperin; *Human Resources Mgr* Colleen Bush; *Mgr Retail Operations* Vickie Sandiford; *Cur* Laura Rice
Open Memorial Day - mid Oct daily 10 AM - 5 PM; Admis Adults $14, Children 6 - 12 $7, under 5 free; Estab 1957 to interpret the history & culture of the Adirondack Park; Museum contains two large galleries for paintings; Average Annual Attendance: 85,000; Mem: 5,000; Individual $30, Family $60
Library Holdings: Audio Tapes 244; Book Volumes 8,809; Manuscripts 650; Maps 1,397; Memorabilia 16,813; Original Documents; Pamphlets; Periodical Subscriptions; Reproductions; Slides; Video Tapes
Special Subjects: Photography, Prints
Collections: Drawings, Paintings, Prints, Photographs
Publications: Newsletters, books
Activities: Classes for adults & children; lect open to public, 8 vis lectrs per year; concerts; gallery talks; tours; individual paintings & original objects of art loaned to museums & galleries; museum shop sells books, reproductions, prints, slides, postcards, clothing, jewelry & toys

L **Library,** PO Box 99, Blue Mountain Lake, NY 12812. Tel 518-352-7311; Fax 518-352-7603; *Librn* Jerold L Pepper
Open by appointment; Estab to provide research materials for mus staff (exhibit documentation) & researchers interested in the Adirondack & to preserve written materials relating to the Adirondack; For research only
Library Holdings: Audio Tapes 25; Book Volumes 8000; Cassettes; Clipping Files; Exhibition Catalogs; Fiche; Kodachrome Transparencies; Lantern Slides; Manuscripts; Other Holdings Maps; Periodical Subscriptions 13; Reels; Slides

A **ADIRONDACK LAKES CENTER FOR THE ARTS,** PO Box 205 Blue Mountain Lake, NY 12812. Tel 518-352-7333; Elec Mail alca@telenet.net; Internet Home Page Address: www.telenet.net/~alca; *Prog Coordr* Darren Miller
Open Mon - Fri 10 AM - 4 PM, summer Sat 10 AM - 4 PM, Sun 12 -4 PM; Admis concerts $5-15, films; Estab 1967; this Community Art Center offers both community & artist - craftsmen the opportunity for creative exchange; 7000 sq ft facility with 4 studios & 170 seat theatre & 3 separate galleries; Average Annual Attendance: 30,000; Mem: 600; annual meeting in July
Income: $180,000 (financed by private contributions, county, state & federal assistance, foundations, local businesses, government, mem & fundraising events)
Exhibitions: Exhibits change every month
Publications: Newsletter - Program, quarterly
Activities: Classes for adults & children; lect open to public, 2 vis lectrs per year; concerts; competitions; gallery talks; tours; scholarships offered; exten dept serves Adirondack Park

BOLTON LANDING

A **MARCELLA SEMBRICH MEMORIAL ASSOCIATION INC,** Marcella Sembrich Opera Museum, 4800 Lake Shore Dr, PO Box 417 Bolton Landing, NY 12814-0417. Tel 518-644-9839, 644-2492; Fax 518-644-2191; Elec Mail sembrich@nycap.rr.com; Internet Home Page Address: www.operamuseum.com; *Assoc Pres* Hugh Allen Wilson; *Cur* Richard Wargo; *Admin Dir* Anita Richards; *VPres* Charles O Richards; *Secy* Kathleen Conerty; *Treas* Joseph Mastrianni
Open June 15 - Sept 15 10 AM - 12:30 PM & 2 - 5:30 PM; Admis donation requested; mems free; Estab 1937 to exhibit memorabilia of Marcella Sembrich & the Golden Age of Opera; Exhibits in Sembrich's former teaching studio on the shore of Lake George; Average Annual Attendance: 1,600; Mem: 300; dues $35 & $50; annual meeting in June
Income: $70,000 (financed by mem & gifts)
Collections: Memorabilia of the life & career of Marcella Sembrich, opera star of international acclaim (1858 - 1935); paintings, sculpture, furnishings, photographs, costumes, art works, gifts & trophies from colleagues & admirers
Publications: Newsletter, biennial; Recollection of Marcella Sembrich, Biography
Activities: Lect open to public, 4 vis lectrs per year; 6 concerts per year; retail store sells books, postcards, recordings, cassettes & Sembrich CD's

BROCKPORT

M **STATE UNIVERSITY OF NEW YORK, COLLEGE AT BROCKPORT,** Tower Fine Arts Gallery, Dept of Art, Brockport, NY 14420. Tel 716-395-2209; Fax 716-395-2588; *Dir* Elizabeth McDade
Open Tues - Sat Noon - 5 PM, Tues & Wed evenings 7 - 9 PM; Estab to present quality exhibitions for purpose of educ; 160 running ft, 1,900 sq ft; Average Annual Attendance: 9,000
Income: Financed by state appropriation & student government
Collections: E E Cummings paintings & drawings
Exhibitions: Alumni Invitational III; The Faculty Selects; Rock, Scissors, Paper; Social Work: Photographs by Vincent Cianni & Jim Tynan
Activities: Lect open to public, 6 vis lectr per year; book traveling exhibitions 1-2 per year; originate traveling exhibitions

BRONX

M **BARTOW-PELL MANSION MUSEUM & GARDENS,** 895 Shore Rd, Pelham Bay Park Bronx, NY 10464. Tel 718-885-1461; Fax 718-885-9164; Elec Mail bartowpell@aol.com; Internet Home Page Address: bartowpellmansionmuseum.org; *Dir* Clarissa Cylich
Open Wed, Sat & Sun 12 - 4 PM; Admis adults $5, seniors & students $3, children under 6 free; Estab 1914

Special Subjects: Period Rooms
Collections: Greek revival restoration; period furnishings; paintings; sunken gardens

M **BRONX COMMUNITY COLLEGE (CUNY),** Hall of Fame for Great Americans, University Ave & W 181 St, Bronx, NY 10453. Tel 718-289-5161; Fax 718-289-6496; Internet Home Page Address: www.11www.cuny.edu; *Dir & Historian* Susan Zuckerman; *Historian* Art Zuckerman
Open daily 10 AM - 5 PM; Group tour donation suggested; Estab 1900; Nat landmark; Average Annual Attendance: 30,000
Library Holdings: Clipping Files; Exhibition Catalogs; Pamphlets; Sculpture
Special Subjects: Archaeology, Historical Material, Architecture, Bronzes, Sculpture, Coins & Medals, Miniatures, Stained Glass
Activities: Classes for children; dramatic progs; films; puppet shows; musical events; docent training; lect open to public; concerts; tours; NY Conservancy & Municipal Arts Society

M **BRONX COUNCIL ON THE ARTS,** Longwood Arts Gallery, 965 Longwood Ave, Bronx, NY; 1738 Hone Ave, Bronx, NY 10461-1486. Tel 718-931-9500; Fax 718-409-6445; Elec Mail bronxart@panix.comx; Elec Mail longwood@artswire.org; Internet Home Page Address: www.longwoodcyber.org; *Council Dir* William Aguado; *Longwood Dir* Eddie Torres; *Exhibs Coord* Robert Blackson
Open Mon - Fri 10 AM - 5 PM, Sat Noon - 4 PM, also by appointment; No admis fee; Estab 1985 for exhibits of interest to artists & the Bronx communities; The Gallery, housed in a former Bronx Pub School building at 965 Longwood Ave, presents solo & group exhibitions centering on contemporary themes of interest to artists & the Bronx communities; Average Annual Attendance: 500
Income: Financed by city, state & federal grants, foundation & corporate support
Exhibitions: Vietnamese Artists; Post-Colonialism; Feminism & the Body; Puerto Rican Taino Imagery in Contemporary Art; Real Life Comics; Like Butter; Maze-phantasm; Mini-Murals; Sovereign State; Here & Now, Now & Then
Activities: Lect open to public, 3 vis lectr per year; fel; originate traveling exhibitions 2 per year

M **BRONX MUSEUM OF THE ARTS,** 1040 Grand Concourse, 165th St, Bronx, NY 10456. Tel 718-681-6000; Fax 718-681-6181; Elec Mail bxarts@bronxview.com; Internet Home Page Address: www.bronxmuse.com/museum
Open Wed 3 PM-9 PM, Thurs & Fri 10 AM- 5 PM, Sat & Sun Noon-6 PM, cl Mon & Tues; Admis adults $3, students & sr citizens $2, children under 12 & mem free; Estab 1971 as a 20th century & contemporary arts museum; serves the culturally diverse populations of the Bronx and the greater New York metropolitan area; the Museum has a long-standing commitment to increasing & stimulating audience participation in the visual arts through its Permanent Collection, special exhibitions & educational programs; Mem: 125; sponsor $1000, patron $500, associate $250, sustaining $100, family $50, individual $35, student & senior citizen $25
Income: Financed by mem, city, state & federal appropriations, foundations & corporations
Collections: Collection of 20th century works on paper by artists from the geographical areas of Latin America, Africa & Southeast Asia as well as works by American descendents of these areas; File on Bronx artists
Exhibitions: Rotating Exhibits
Publications: Exhibition catalogs; educational workbooks; walking tours of the Bronx
Activities: Classes for adults, children & seniors; lect open to public; concerts; gallery talks; tours; films; annual arts & crafts festival; originate traveling exhibitions; museum shop sells books, posters, catalogs, original art, prints, jewelry, childrens & museum gift items

M **BRONX RIVER ART CENTER,** Gallery, 1087 E Tremont Ave, Bronx, NY 10460; PO Box 5002, West Farms Station Bronx, NY 10460. Tel 718-589-5819, 589-6379; Fax 718-589-5819; Internet Home Page Address: www.bronxriverart.org; *Gallery Coordr* Amir Bey; *Exec Dir* Gail Nathan
Open Mon - Thurs & Sat 3 - 6 PM; No admis fee; Estab 1980 as a professional, multi-cultural art center; 2,000 sq ft, handicapped accessible, ground floor gallery. Two main gallery rooms, natural light; Average Annual Attendance: 5,000
Income: $200,000 (fin by government & foundations)
Special Subjects: Afro-American Art
Exhibitions: Exhibitions of contemporary artists focusing on innovative multi-cultural, multi-media work
Activities: Classes for adults & children; lect open to public, 16 vis lectr per year; originate traveling exhibitions 1 per year

M **EN FOCO, INC,** 32 E Kingsbridge Rd, Bronx, NY 10468. Tel 718-584-7718; Fax 718-584-7718; Elec Mail info@enfoco.org; Internet Home Page Address: www.enfoco.org; *Exec Dir* Charles Biasiny-Rivera; *Managing Dir* Miriam Romais; *Prog Asst* Marisol Diaz
Open Mon - Wed 9:30 AM - 4:30PM; No admis fee; Estab 1974 to support photographers of color via exhibits & publications; Mem: dues basic $25, institutional $45
Collections: Photographs & posters by leading photographers of color
Exhibitions: Annual Seminar in Puerto Rico & Touring Gallery Programs; Saving the Light
Publications: Nueva Luz, annual bilingual photography journal
Activities: Tours; sponsoring of awards; New Works Awards annual; honorarium; originate traveling exhibitions; sales shop sells magazines

A **HOSTOS CENTER FOR THE ARTS & CULTURE,** 500 Grand Concord, Bronx, NY 10451. Tel 718-518-4444; Fax 718-518-6690; Elec Mail Bevgecombb@hostoscuneyedu; Internet Home Page Address: www.hostos.cuny.edu; *Dir* Wallace I Edgecombe; *Production Mgr* Jack Jacobs; *Pres* Dolores Fernandez; *Coll Asst* Annie Pena
Open Mon - Fri 9 AM - 5 AM; Estab 1993 to present artists of national & international renown; presents emerging & estab local artists; offers workshops in drama, folk arts & dance to community residents; serves as a forge for new art, &

thus has estab an individual artists' program consisting of commissions & residencies; Center consists of a museum-grade art gallery, 367-seat theater & 907-seat concert hall; Average Annual Attendance: 33,000
Income: Financed by mem, city appropriation, state appropriation, government sources, corporations
Activities: Dramatic programs; originate traveling exhibitions

M **LEHMAN COLLEGE ART GALLERY,** 250 Bedford Park Blvd W, Bronx, NY 10468. Tel 718-960-8731; Fax 718-960-6991; Elec Mail susan@lehman.cuny.edu; Internet Home Page Address: http://ca80.lehman.cuny.edu/gallery; Internet Home Page Address: www.lehman.edu/gallery; Internet Home Page Address: www.lehman.edu/publicart; *Assoc Dir* Mary Ann Siano; *Dir* Susan Hoeltzel; *Educ Cur* Sember Weinman; *Asst Cur* Patricia Cazorla
Open Tues - Sat 10 AM - 4 PM; No admis fee; Estab 1985 to exhibit work of contemporary artists; Two galleries housed in Fine Arts building on Lehman College campus, City University NY, designed by Marcel Breuer; Average Annual Attendance: 19,000; Mem: 200; dues $30-$1000
Income: Financed by endowment, mem, city & state appropriation, federal grants, & private foundations
Special Subjects: Afro-American Art, Latin American Art, African Art
Exhibitions: Changing Contemporary Exhibs
Publications: Exhibition catalogs; gallery notes
Activities: Classes for children; docent training; classes for adults; classes for children; docent training; lect open to public, 6 vis lectr per year; gallery talks; tours; book traveling exhibitions; originate traveling exhibitions; other mus

M **VAN CORTLANDT HOUSE MUSEUM,** W 246th & Broadway, Bronx, NY 10471. Tel 718-543-3344; Fax 718-543-3315; Elec Mail vancortlandhouse@juno.com; Internet Home Page Address: www.vancortlandthouse.org; *Dir* Laura Correa; *Pres* Ana Duff; *Mus Shop Mgr* Ruragna Sloane
Open Tues - Fri 10 AM - 3 PM, Sat & Sun 11 AM - 4 PM, cl Mon ; Admis adult $2, children under 14 free, Fri & Sat free to all; Estab 1898; Average Annual Attendance: 30,000
Special Subjects: Furniture, Historical Material
Collections: Furniture & objects of the 18th century
Activities: Classes for children; slide programs for visitors

M **WAVE HILL,** 675 W 252 St, Bronx, NY 10471; W 249th St & Independence Ave, Bronx, NY 10471. Tel 718-549-3200, 549-2055; Fax 718-884-8952; Elec Mail info@wavehill.org; Internet Home Page Address: www.wavehill.org; *Public Relations Dir* Julia Waters; *Pres* Kate Pearson French; *VChmn* David O Beim; *Dir Visitor Svcs* Suzy Brown; *Dir Horticulture* Scott Canning; *Dir Educ* Margot Perron
Open Tues - Sun 10 AM - 4:30 PM; No admis fee Tues and Sat mornings, adults $4, senior citizens & students $2, children under 6 free, no admis fee Nov 15-Mar 14; Estab 1960 as a pub garden & cultural center; Wave Hill House Gallery; Glyndor Gallery; Outdoor Sculpture Garden; Average Annual Attendance: 100,000; Mem: 8000; dues $35
Income: Financed by mem, city & state appropriation, private funding
Exhibitions: 28 Acres of Gardens; Visual exhibitions
Publications: Calendar, 4 per yr; exhibit catalogues, annually
Activities: Classes for adults & children; dramatic programs; natural history/environmental workshops; lect open to public, 3 vis lectr per year; concerts; originate traveling exhibitions; sales shop sells books, magazines, reproductions

BRONXVILLE

L **BRONXVILLE PUBLIC LIBRARY,** 201 Pondfield Rd, Bronxville, NY 10708. Tel 914-337-7680; Fax 914-337-0332; Internet Home Page Address: www.bronxvillelibrary.org; *Dir Library* Jane Marino; *Head of Reference* Patricia Root; *Head of Circ* Marianne Wingertzahn
Open winter Mon, Wed & Fri 9:30 AM - 5:30 PM, Tues 9:30 AM - 9 PM, Thurs 1 - 9 PM, Sat 9:30 AM - 5 PM, Sun 1 - 5 PM, summer Mon, Wed, Thurs & Fri 1 - 5:30 PM, Sat 9:30 AM - 1 PM; No admis fee; Estab as public library in 1906; Average Annual Attendance: 150,000
Income: Financed by city & state appropriations
Special Subjects: Painting-American, Prints
Collections: American painters: Bruce Crane, Childe Hassam, Winslow Homer, William Henry Howe, Frederick Waugh; Japanese Art Prints; 25 Original Currier and Ives Prints
Exhibitions: Current artists, changed monthly; original paintings and prints
Publications: newsletter, quarterly

L **SARAH LAWRENCE COLLEGE LIBRARY,** Esther Raushenbush Library, Glen Washington Rd, Bronxville, NY 10708. Tel 914-395-2474; Fax 914-395-2473; Elec Mail library@mail@slc.edu; Internet Home Page Address: www.slc.edu/library; *Dir* Charlene Chang Fagan; *Exhibits Librn* Carol Shaner; *Slide Librn* Michelle Murray; *Asst Dir* Judy Kicinski
Open Mon-Fri 9 AM - 8:30 PM, Sat & Sun 11 - 5 PM, varied during school closings; Estab to provide library facilities for students & members of the community with an emphasis on art history; Slide collection closed to the pub; non-circulating reference materials available to the pub; Mem: $45 per year
Library Holdings: Book Volumes 225,000; Periodical Subscriptions 1073; Slides 88,000; Video Tapes
Exhibitions: Changing exhibits
Activities: Lect in connection with exhibits; tours on request

BROOKLYN

M **BRIC - BROOKLYN INFORMATION & CULTURE,** Rotunda Gallery, 33 Clinton St, Brooklyn, NY 11201. Tel 718-875-4047; Fax 718-488-0609; Elec Mail rohrda@brooklynx.org; Internet Home Page Address: www.brooklynx.org/rotunda; *Dir* Janet Riker; *Gallery Asst* Joel Copaken; *Dir Educ* Meridith McNeal
Open Tues - Fri Noon - 5 PM, Sat 11 AM - 4 PM; No admis fee; Estab 1981 to exhibit the works of professional Brooklyn affiliated artists; Average Annual Attendance: 17,500

Income: $250,000 (financed by federal, state & municipal sources, private foundations, corporations & individuals)
Exhibitions: Various exhib
Activities: Classes for adults & children; lect open to public, 6-10 vis lectr per year; gallery talks; computerized slide registry

A **BROOKLYN ARTS COUNCIL,** 55 Washington St, Ste 218 , Brooklyn, NY 11201. Tel 718-625-0080; *Art Services Dir* Agnes Murray
Gallery open Mon - Fri 10 AM - 5 PM; No admis fee; Estab 1966 to promote education, excellence & exchange in the visual & performing arts; Average Annual Attendance: 600,000; Mem: 200; dues $50
Income: $600,000 (financed by city & state appropriation, corporate & foundation support, earned income & educational servies)
Exhibitions: Solo exhibitions by Brooklyn-based artists; Artist & Guest-curated group & thematic exhibitions
Publications: BACA Downtown Calendar, bimonthly
Activities: Workshops for adults & children; dramatic programs; docent training; lect open to public, 6 vis lectr per year; gallery talks; tours; competitions; junior children's museum of art

M **BROOKLYN BOTANIC GARDEN,** Steinhardt Conservatory Gallery, 1000 Washington Ave, Brooklyn, NY 11225. Tel 718-623-7200; Fax 718-622-7839; Elec Mail anitajacobs@bbg.org; Internet Home Page Address: www.bbg.org; *Dir Pub Progs* Anita Jacobs
Open Tues - Fri 8 AM - 4:30 PM, Sat & Sun 10 AM - 4:30 PM; Admis adult $3, seniors & students $1.50, children 15 & under free, free on Tues & Sat AM; Estab 1988 to display works of botanical, floral & landscape art; Multi-use space serves as an art gallery, entryway to conservatory pavillions & seasonal eating area; Average Annual Attendance: 800,000
Special Subjects: Landscapes
Collections: Living plants
Activities: Classes for adults

A **BROOKLYN HISTORICAL SOCIETY,** 128 Pierrepont St, Brooklyn, NY 11201. Tel 718-222-4111; Fax 718-222-3794; Elec Mail cclark@brooklynhistory.org; Internet Home Page Address: www.brooklynhistory.org; *VPres of Operations* Stephen Dewhurst; *Pres* Jessie M Kelly; *Cur of Coll* Cynthia Sanford; *Cur Exhibs* Ann Meyerson
Open to pub Wed, Thurs, Sat 10 AM - 5 PM; Fri 10 AM - 8 PM; cl Mon, Tues; Admis adults $6, sr $4, students $4, children under 12 free; Estab in 1863 to collect, preserve & interpret documentary & other materials relating to the history of Brooklyn & the adjoining geographical areas; Gallery used for exhibits on Brooklyn history; Average Annual Attendance: 15,000; Mem: 1,750; dues $35 - $1,250; annual meeting May
Income: $650,000 (financed by grants, endowment & mem)
Collections: Paintings, drawings, watercolors, prints, sculpture, decorative arts, archeological artifacts relating to Brooklyn's history & key citizens
Publications: Bimonthly newsletter
Activities: Educ dept; docent training; lect open to the public, 15 vis lectr per year; gallery talks; individual paintings & original objects of art lent to other institutions; lending collection contains 3000 original prints, 275 paintings, sculptures

L **Library,** 128 Pierrepont St, Brooklyn, NY 11201. Tel 718-222-4111; Fax 718-222-3794; Elec Mail reference@brooklynhistory.org; Internet Home Page Address: www.brooklynhistory.org; *Head Librn* Jeffrey P Barton; *Archivist* Katherine E Caiazza; *VPres - Collections* Marilyn H Pettit
Open Tues - Sat 10 AM - 4:45 PM; Museum only: Wed - Sat 10 - 5, Sun 12 - 5; Admis $6; Estab 1863 for the purpose of collecting, preserving & interpreting the history of Brooklyn; Open to general pub; Mem: dues $50 & up
Library Holdings: Book Volumes 170,000; Clipping Files; Manuscripts; Original Art Works; Pamphlets; Photographs 90,000
Special Subjects: Decorative Arts, Photography, Drawings, Graphic Arts, Manuscripts, Maps, Painting-American, Historical Material, Portraits, Watercolors, Furniture, Costume Design & Constr, Woodcuts, Landscapes, Laces, Folk Art, Textiles, Woodcarvings
Activities: Classes for adults & children; dramatic programs; docent training; concerts; gallery talks; tours; lect open to public; libraries; schools; colleges

M **BROOKLYN MUSEUM,** 200 Eastern Pkwy, Brooklyn, NY 11238-6052. Tel 718-638-5000; Fax 718-638-5931; Elec Mail bklynmus@echonyc.com; Internet Home Page Address: www.brooklynart.org; Telex 12-5378; Cable BRKLYN-MUSUNYK; *Chm* Robert S Rubin; *Public Information Officer* Sally Williams; *Chm Egyptian & Classical Art* Richard Fazzini; *Vice Dir Educ* Joel Hoffman; *Cur European Paintings & Sculpture* Elizabeth Easton; *Cur American Paintings & Sculpture* Linda Ferber; *Cur Contemporary Art* Charlotta Kotik; *Cur Asian Art* Amy Poster; *Cur Decorative Arts* Kevin Stayton; *Cur Arts of Africa & Pacific* William Siegmann; *Vice Dir Coll & Chief Conservator* Ken Moser; *Registrar* Liz Reynolds; *VDir Marketing* Sallie Stutz; *Dir* Arnold L Lehman; *Deputy Dir for Admin* Judith Frankfurt; *Deputy Dir Institutional Advancement* Cynthia Mayeda; *Acting Chief Cur* Kevin Stayton; *Head Publs & Editorial Svcs* James Leggio; *Vice Dir Develop* Judith Paska; *Cur Arts of Africa & Pacific Islands* William Stegmann; *Vics Chm* Bernard Selz; *Vice Dir* Joan Darragh; *Mus Shop Mgr* Kati Moran; *Vice Chm* Norman M. Feinberg; *Chief Conservator* Kenneth Moser; *Government & Com* Lavita McMath; *Cur Prints & Drawing* Marilyn Kushner; *Deputy Dir Art* Marc Mayer; *Mgr Exhib* Hannah Mason; *Vice Chm* Frieda Rosenthal; *Cur Arts of the Amer* Nancy Rosoff; *Vice Dir Finance* David Kleiser; *Information System* Mathew Morgan; *Coord (V)* Belle Tanenhaus; *Cur Photography* Barbara Millstein; *Community Committee* Alyse Castaldi; *Cur Islamic Art* Aimee Froom; *Head Librarian* Deirdre Lawrence; *Community Invole* Schawannah Wright; *Librarian* James Viskochil; *Vice Dir Operations* Stanley Zwiren
Open daily 10 AM - 5 PM, cl Mon & Tues; Voluntary admis fee; Estab 1823 as the Apprentices Library Assoc; Five floors of galleries maintained, second largest mus of art in the United States; Average Annual Attendance: 350,000; Mem: 10,000; dues donor $600, patron $350, contributor $150, family $75, individual $50, senior citizens & students $35

Income: $14,374,000 (financed by endowment, mem, city & state appropriation, gifts)
Library Holdings: Audio Tapes; Book Volumes; CD-ROMs; Cards; Clipping Files; Compact Disks; Exhibition Catalogs; Fiche; Manuscripts; Other Holdings; Periodical Subscriptions; Photographs
Collections: Art from the Americas & South Pacific; American period rooms; European & American paintings, sculpture, prints, drawings, costumes, textiles & decorative arts; major collections of Egyptian & Classical; Asian, Middle Eastern & African art; Americas & the Pacific; sculpture garden of ornaments from demolished New York buildings
Exhibitions: (Permanent) The Arts of China; The Arts of the Pacific; European Paintings Reinstallation.
Publications: Newsletter, bimonthly; catalogues of major exhibitions; handbooks
Activities: Classes for adults & children; film; docent training; lect open to public; gallery talks; tours; concerts; sponsoring of competitions; Augustus Graham medal; scholarships for student programs; individual paintings & original objects of art lent to other museums; originate traveling exhibitions; museum shops sell books, original objects, reproductions, prints, magazines, slides, T-shirts, clothes & bags

L Libraries Archives, 200 Eastern Pky, Brooklyn, NY 11238-6052. *Principal Librn Libraries & Archives* Deirdre E Lawrence
Open by appointment, call in advance; Estab 1823 to serve the staff of the mus & pub for reference
Income: Financed by city, state & private appropriation
Purchases: $50,000
Library Holdings: Auction Catalogs; Audio Tapes; Book Volumes 200,000; CD-ROMs; Clipping Files; Exhibition Catalogs; Fiche; Lantern Slides; Original Documents; Pamphlets; Periodical Subscriptions 400; Photographs; Video Tapes
Special Subjects: Art History, Decorative Arts, Photography, Drawings, Etchings & Engravings, Islamic Art, Painting-American, Pre-Columbian Art, Sculpture, History of Art & Archaeology, Ceramics, Crafts, Latin American Art, Archaeology, Fashion Arts, Interior Design, Asian Art, American Indian Art, Primitive art, Anthropology, Eskimo Art, Mexican Art, Southwestern Art, Period Rooms, Costume Design & Constr, Afro-American Art, Antiquities-Oriental, Antiquities-Persian, Oriental Art, Restoration & Conservation, Silversmithing, Antiquities-Assyrian, Antiquities-Egyptian, Antiquities-Greek, Antiquities-Roman, Folk Art
Collections: Fashion plates; original fashion sketches 1900-1950; 19th century documentary photographs
Publications: Newsletter, bi-monthly
Activities: Classes for children; docent training; programs relating to current exhibitions; lect open to public, 30 vis lectr per year; gallery talks; tours; originate traveling exhibitions to other museums

L Wilbour Library of Egyptology, 200 Eastern Pky, Brooklyn, NY 11238-6052. Tel 718-501-6219; Fax 718-501-6125; Elec Mail library@brooklynmuseum.org; Internet Home Page Address: brooklynmuseum.com
10-12, 1-4, Wed-Fri; Estab 1934 for the purpose of the study of Ancient Egypt
Income: Financed by endowment & city, state & private appropriation
Purchases: $30,000 annually
Library Holdings: Auction Catalogs; Book Volumes 37,000; Exhibition Catalogs; Fiche; Other Holdings Original documents; Pamphlets; Periodical Subscriptions 150
Collections: Seyffarth papers
Publications: Wilbour Monographs; general introductory bibliographies on Egyptian art available to visitors

L BROOKLYN PUBLIC LIBRARY, Art & Music Division, Grand Army Plaza, Brooklyn, NY 11238. Tel 718-230-2183/4; Fax 718-230-2063; Elec Mail k.badalamenti@brooklynpubliclibrary.org; Internet Home Page Address: www.brooklynpubliclibrary.org; *Acting Chief* Kay Badalamenti
Open Mon-Thurs 9AM-8PM, Fri-Sat 9AM-6PM, Sun 1-5 PM, cl July & Aug; No admis fee; Estab 1892; Lobby Gallery on 1st fl; Average Annual Attendance: 12,000
Income: Financed by city & state appropriation
Library Holdings: Audio Tapes; Book Volumes 260,000; Cards; Cassettes; Exhibition Catalogs; Filmstrips; Micro Print; Motion Pictures; Other Holdings Mounted pictures; Pamphlets; Periodical Subscriptions 420; Records; Reels; Slides; Video Tapes
Collections: Checkers Collection; Chess Collection; Costume Collection; Picture & Art Reproduction File; Song Finding Collection
Exhibitions: lect of writing on arts by Bookforum
Publications: Monthly calendar
Activities: Classes for children; programs; lect open to public; 1-2 vis lectr per yr; gallery talks; films; book traveling exhibition Pop Up Books (2000); sales shop sells books, magazines, original art

M HOLLAND TUNNEL ART PROJECTS, 61 S Third St, Brooklyn, NY 11211; 63 South 3rd St, Brooklyn, NY 11211. Tel 718-384-5738; Fax 718-384-5738; Elec Mail hollandtunnel@yahoo.com; Internet Home Page Address: www.hollandtunnelart.com; *Graphic Designer* Roy Lethen; *Pub Relations* Fran Kornfeld; *Dir* Paulien Lethen; *Asst* Sarah Dalton
Open Sat & Sun 1 - 5 PM & by appt; No admis fee; Estab 1997 connecting people with art; A prefab shed converted into a small gallery featuring local & international artistic talent; Average Annual Attendance: 2,000
Income: Dir assumes costs with artists
Exhibitions: (2001) Angels: group show of women artists; Holland Tunnel in Paros, Greece; "5"; Bound; More Than I Would Say About Most People (Nina Levy)
Publications: Catalogue for "5" (5th anniversary show)
Activities: Concerts; tours; poetry reading & artist talks; films & videos; Holland Tunnel in Paros, Greece, "Inside Harry's House" Holland Tunnel Project in the Netherlands; originate traveling exhibitions 3 per year; museum shop sells original art, flat file in gallery

INTERNATIONAL SOCIETY OF COPIER ARTISTS (ISCA)
For further information, see National and Regional Organizations

M KINGSBOROUGH COMMUNITY COLLEGE, CUNY, Art Gallery, 2001 Oriental Blvd, Brooklyn, NY 11235. Tel 718-368-5449; Fax 718-368-4872; Elec Mail pmalone@kingsborough.edu; Internet Home Page Address: www.kingsborough.edu/academicdepartments/art/gallery/index.htm; *Dir* Peter Malone
Open Mon - Fri 10 AM - 3 PM; No admis fee; Estab 1975 to show a variety of contemporary artistic styles; 42 ft x 42 ft gallery, 42 x 50 ft outdoor sculpture courtyard; Average Annual Attendance: 5,000
Income: Financed by Kingsborough Community College Assn
Activities: Lectures open to public, 4 vis lectr per yr; competitions with awards

M KURDISH MUSEUM, 144 Underhill Ave, Brooklyn, NY 11238; 345 Park Place, Brooklyn, NY 11238. Tel 718-783-7930; Fax 718-398-4365; Elec Mail Kurdishlib@aol.com; Internet Home Page Address: www.kurdishlibrarymuseum.com; *Dir* Vera Beaudin Saeedpour
Open Mon - Fri & Sun 1 PM - 5 PM; No admis fee; Estab 1988; Maintains library; Average Annual Attendance: 500
Special Subjects: Textiles, Costumes, Posters, Jewelry
Collections: Costumes, jewelry, photos, slides, coins, weavings, maps
Exhibitions: Jews of Kurdistan
Publications: International Journal of Kurdish Studies, semiannual; Kurdish Life, Quarterly
Activities: Originate traveling exhibitions; museum shop sells rugs

M MOMENTA ART, 72 Berry St, Brooklyn, NY 11211. Tel 718-218-8058; Fax 718-218-8058; Elec Mail momenta@momentaart.org; Internet Home Page Address: www.momentaart.org; *Bd Dir* Laura Parnes; *Dir* Eric Heist; *Resource Dir* Michael Waugh
Open Fri - Mon Noon - 6 PM; No admis fee; Estab 1986 as a not-for-profit exhibition organization promoting the work of under-represented & emerging artists; 1,200 sq ft in Williamsburg, Brooklyn; Average Annual Attendance: 5,000; Mem: 200; dues $30-$500
Income: $105,000 (financed by endowment, mem, city & state appropriation)
Activities: Lect open to public, 6 vis lectr per year; sales shop sells catalogs & artist multiples

L NEW YORK CITY TECHNICAL COLLEGE, Ursula C Schwerin Library, 300 Jay St, Brooklyn, NY 11201. Tel 718-260-5470; Fax 718-260-5631; Internet Home Page Address: www.nyctc.cuny.edu/library; *Admin Services Librn* Prof Paul T Sherman; *Chief Cataloguer* Morris Hownion; *Reference Coordr* Joan Grissano; *Dir Technical Servs* Sharon Swacker; *Chief Librn* Darrow Wood
Open Mon - Thurs 9 AM - 10 PM, Fri 9 AM-7 PM, Sat 11 AM-5 PM; Estab 1947
Library Holdings: Reproductions
Special Subjects: Graphic Arts, Advertising Design
Publications: Library Alert & Library Notes, occasional publications
Activities: Tours; Library Instruction; BRS Data Base Searching

L PRATT INSTITUTE, Art & Architecture Dept, 200 Willoughby Ave, Brooklyn, NY 11205. Tel 718-636-3714, 636-3685; Internet Home Page Address: www.lib.pratt.edu/plice; *Art & Architecture Librn* Joy Kestenbaum; *Dean* F William Chickering; *Dir Reader Svcs* Cynthia A Johnson
Open Mon - Thurs 9 AM - 11 PM, Fri 9 AM - 7 PM, Sat & Sun Noon - 6 PM for students, faculty & staff, others by appointment or with METRO or ALB card; Estab 1887 for students, faculty, staff & alumni of Pratt Institute; The school has several galleries, the library has exhibitions in display cases
Library Holdings: Book Volumes 85,000; Clipping Files; Exhibition Catalogs; Fiche; Maps; Motion Pictures; Periodical Subscriptions 150; Prints; Reels; Reproductions; Slides; Video Tapes
Special Subjects: Art History, Photography, Architecture

M Rubelle & Norman Schafler Gallery, 200 Willoughby Ave, Brooklyn, NY 11205. Tel 718-636-3517; Fax 212-367-2484; Elec Mail exhibits@pratt.edu; Internet Home Page Address: www.pratt.edu/exhibitions; *Asst Dirr* Nicholas Battis; *Exhibit Designer* Katherine Davis; *Dir Exhib* Loretta Yarlow
Open Mon - Fri 9 AM - 5 PM, summer 9 AM - 4 PM; No admis fee; Estab 1960; Average Annual Attendance: 14,000
Collections: Permanent collection of fiber art, paintings, pottery, prints, photographism sculpture
Activities: Lect open to public, 2 vis lectr per year; traveling exhibitions 1 per year; originate traveling exhibitions

A PROMOTE ART WORKS INC (PAWI), Laziza Electrique Dance Co, 123 Smith St, Brooklyn, NY. Tel 718-797-3116; Fax 718-855-4746; Elec Mail executive@micromuseum.com; Internet Home Page Address: www.micromuseum.com; *Technical Dir* William Laziza; *Assoc Producer* Samantha Twyford; *Chmn* Nancy Stern Bain; *Technician* Kevin McCormack; *Technician* Mike MacIvor; *Artistic Dir* Kathleen Laziza
Open by appointment; Admis 0-$25; Estab 1980; Gallery includes interactive kinetic sculpture & media installation; Average Annual Attendance: 1,200; Mem: 501(C)3
Income: $65,000 (financed by contributions & earned income)
Library Holdings: CD-ROMs; DVDs; Original Art Works; Photographs; Records; Sculpture; Slides; Video Tapes
Special Subjects: Costumes, Drawings, Photography, Folk Art, Glass
Exhibitions: Micro Museum Dec - June
Activities: Classes for adults & children; internships; archival program for public television; lect open to public, 5 vis lectr per year; Art of the Future NY Times selected for new millennium; video traveling exhibitions 1 per year; organize traveling exhibition of videotapes to schools

A The MicroMuseum, 123 Smith St, Brooklyn, NY 11201. Tel 718-797-3116; Fax 718-875-1208; Elec Mail tech@micromuseum.com; Internet Home Page Address: www.micromuseum.com; www.pawi.org; *Tech Dir* William Laziza
Open daily by appointment 9 AM - 9 PM; Admis fee 0 - $25; Estab 1993 as art lab for interdisciplinary work; Gallery features media kinetic installation; Mem: National Artists Assoc Org
Income: 63,000 (financed by contributions & earned income)
Library Holdings: Audio Tapes; Cassettes; Kodachrome Transparencies; Lantern Slides; Manuscripts; Memorabilia; Original Art Works; Photographs; Prints; Records; Reproductions; Sculpture; Slides

Collections: 78 RPM record collection from Metropolitan Museum of Art; Spontaneous Combustion
Activities: Organize traveling exhibitions of videotapes to schools

A **ST ANN CENTER FOR RESTORATION & THE ARTS INC,** 70 Washington St, Brooklyn, NY 11201. Tel 718-834-8794, Ext 17; Fax 718-522-2470; *Mng Dir* Curzon Dobell; *Exec Dir* Susan Feldmen

A **URBANGLASS,** (Urban Glass) Robert Lehman Gallery, 647 Fulton St, Brooklyn, NY 11217. Tel 718-625-3685; Fax 718-625-3889; Elec Mail info@urbanglass.org; Internet Home Page Address: www.urbanglass.org; *Exec Dir* Dawn Bennett; *Dir Develop* Brooke Benaroya; *Dir Operations* Brian Kibler; *Dir Educ* John West
Open every day 10 AM - 6 PM; No admis fee; Estab 1977 to provide facility for artists who work in glass; 1400 Sq Ft; Average Annual Attendance: 8,000; Scholarships, Fellowships
Income: nonprofit, fund raising
Exhibitions: Rotating-3 per yr
Publications: Glass: The Urban Glass Art Quarterly
Activities: Classes for adults; lect open to public, 7 vis lectr per year; gallery talks; tours; competitions; fellowships; shop sells magazines & original art

M **WATERFRONT MUSEUM,** 699 Columbia St, Brooklyn, NY 11231. Tel 718-624-4719; Elec Mail dsharps@waterfrontmuseum.org; *Pres & CEO* David Sharps; *Vol* Alison Tocci
Admis $5, grp tours by appt; Estab 1986; The Waterfront Mus & Showboat Barge is housed aboard the 1914 Lehigh Valley Railroad Barge #79 listed on the National Register of Historic Places; mus provides pub access to the NY Harbor's waterfront & progs in maritime & environmental educ; Average Annual Attendance: 5000 by estimate
Collections: Coll of artifacts from The Lighterage Era (1860 - 1960), a period in which goods traded & consumed in NYC were transferred from port docks to railroad terminals by tug & barge; 1914 LV Barge #79; maritime artifacts
Publications: Transfer Magazine: pub by Railroad Marine Info Grp
Activities: Educ progs for adults & children; cultural progs; community meetings; spec events & concerts

M **WILLIAMSBURG ART & HISTORICAL CENTER,** 135 Broadway, Brooklyn, NY 11211. Tel 718-486-7372; Internet Home Page Address: www.wahcenter.org; *Pres & Exec Dir* Terrance Lindall; *Founder & Artistic Dir* Yuko Nii
Open Sat & Sun Noon - 6 PM; No admis fee; Estab 1996; First floor is the grand Reception Hall with mahogany interior, information center, gift shop & coffee nook. Gallery on second floor presenting shows of emerging & established artists. Basement facility provides space for artists working in the areas of photography, film, video & computer arts; Average Annual Attendance: 10,000; Mem: dues $35
Income: $150,000 (financed by mem, city & state appropriation & contributions)
Purchases: $5000
Library Holdings: Auction Catalogs; Audio Tapes; Book Volumes; Cassettes; Exhibition Catalogs; Manuscripts; Maps; Original Art Works; Original Documents; Photographs; Prints; Sculpture
Collections: Contemporary art, theater, film, video, music (experimental & other), poetry, any art-related event, symposiums, etc
Exhibitions: The Calculus of Transfiguration: Meaning Form & Process in Late 20th Century Art
Publications: The Williamsburg Papers
Activities: Dramatic programs; lect open to public, 5 vis lectr per year; tours; concerts, gallery talks; sponsoring of competitions; museum shop sells books, mags, original art, prints, reproductions
L **Library,** 135 Broadway, Brooklyn, NY 11211.
Open Sat & Sun Noon to 6 PM, Mon by appointment; 40 ft x 60 ft, 20 ft ceiling in main gallery; for reference use
Income: $150,000 (financed by mem, city & state appropriation)
Purchases: $20,000
Library Holdings: Auction Catalogs; Audio Tapes; Book Volumes 2000; Cassettes; Clipping Files; Compact Disks; Kodachrome Transparencies; Manuscripts; Maps; Memorabilia; Original Art Works; Original Documents; Pamphlets; Photographs; Prints; Records; Reproductions; Sculpture; Slides; Video Tapes

BROOKVILLE

M **C W POST CAMPUS OF LONG ISLAND UNIVERSITY,** Hillwood Art Museum, 720 Northern Blvd, Brookville, NY 11548. Tel 516-299-4073; Fax 516-299-2787; Elec Mail museum@cwpost.liu.edu; Internet Home Page Address: www.liu.edu/museum; *Asst Dir* Ms Barbara Applegate; *Mus Educator* Tonito Valderrama; *Dir* Barry Stern; *Cur of Coll* Kristy Caratzola
Open Mon - Fri 9:30 AM - 4:30 PM, Thurs 9:30 AM - 8 PM, Sat 11 AM - 3 PM; No admis fee; Estab 1973; Museum has great appeal to the surrounding North Shore community as well as the student body. It is located in a multimillion dollar student complex and occupies a space of approx 5000 sq ft; Average Annual Attendance: 25,000
Income: Financed by university budget, grants & donations
Special Subjects: American Indian Art, Prints, Textiles, Drawings, Painting-American, Photography, African Art, Pre-Columbian Art, Posters, Asian Art, Antiquities-Persian, Antiquities-Egyptian, Antiquities-Greek, Antiquities-Roman, Bookplates & Bindings
Collections: Near Eastern antiquities, American abstract painting, contemporary photography; Pre-Columbian & African art; Chinese paintings 10th - 19th century
Exhibitions: Chinese Silk: Symbols of Rank & Privilege (Garments from the Ch'ing Dynasty); Esphyr Slobodkina Retrospective (Works from the Permanent Collection); Kuba Kingdom Dress: Textiles from the Congo; Obsessive Compulsive Order (Contemporary sculpture including works by Amanda Guest, Jeanne Jaffe, Lesly Dill & Gail Deery); Dennis Oppenheim: Realized/Unrealized (Works from the Permanent Collection); Theodore Roosevelt: Icon of the American Century (Artists include John Singer Sargent, Edward Curtis & Frederic Remington)

Publications: Exhibition catalogs; newsletter; study guides
Activities: Educ dept; classes for children; lect open to public; 4-5 vis lect per yr; concerts; gallery talks; tours; concerts; individual paintings & original objects of art lent; lending collection contains books, cassettes, 3000 prints; organize traveling exhibitions for international mus; museum shop sells books, original art & prints

BUFFALO

L **BUFFALO & ERIE COUNTY PUBLIC LIBRARY,** 1 Lafayette Square, Buffalo, NY 14203. Tel 716-858-8900; Fax 716-858-6211; Internet Home Page Address: www.buffalolib.org; *Dir* Michael C Mahaney; *Asst Deputy Dir Pub Svcs* Ruth Collins; *Deputy Dir Finance* Kenneth H Stone
Open Mon - Wed, Fri & Sat 8:30 AM - 6 PM, Thurs 8:30 AM - 8 PM; Estab 1954 through a merger of the Buffalo Pub, Grosvenor & Erie County Pub Libraries
Income: $25,000,000 (financed by county appropriation & state aid)
Library Holdings: Book Volumes 3,000,000; Exhibition Catalogs; Manuscripts 4178; Original Art Works; Periodical Subscriptions 3200; Photographs; Prints; Video Tapes
Special Subjects: Drawings, Etchings & Engravings, Prints, Woodcuts
Collections: J J Lankes Collection (original woodcuts); William J Schwanekamp Collection (etchings); Niagara Falls Collection (prints); Rare book room with emphasis on fine printing
Publications: Bimonthly library bulletin
Activities: Dramatic programs; consumer programs; gallery talks; tours; concerts; book talks; architectural programs

M **BUFFALO ARTS STUDIO,** 2495 Main St, Ste 500, Buffalo, NY 14214. Tel 716-833-4450 ext 14; Elec Mail gallery@buffaloartsstudio.org; Internet Home Page Address: www.buffaloartsstudio.org; *Founder & Dir* Joanna Angie; *Develop Officer* Lauren Mitchell; *Accountant* Marilyn Littles
Open Tues - Fri 11 AM - 5 PM, Sat 11 AM - 3 PM; A not-for-profit arts organization whose mission is to provide regular pub exposure for regional, national & international artists through exhib. BAS enriches the community with art classes, mural programs, pub art projects & provides affordable studio space for emerging artists; Two galleries: 75 x 25 & 40 x 40, shared art center 25,000 sq ft
Exhibitions: Regional, national & international artists; annual resident artist exhibit
Activities: Classes for adults & children; exhibits; gallery talks; tours; pub art projects city wide mural programs; sales shop sell original art

M **THE BUFFALO FINE ARTS ACADEMY,** Albright-Knox Art Gallery, 1285 Elmwood Ave, Buffalo, NY 14222. Tel 716-882-8700; Fax 716-882-1958; Elec Mail corlick@albrightknox.org; Internet Home Page Address: www.albrightknox.org; *Pres* Charles W Banta; *VPres* Thomas R Hyde; *Secy* David I Herer; *Treas* John R Sanderson; *Dir* Louis Grachos; *Sr Cur* Douglas Dreishpoon; *Cur Educ* Mariann Smith; *Assoc Cur* Claire Schneider; *Registrar* Laura Fleischmann
Open Tues - Sat 11 AM - 5 PM, Sun Noon - 5 PM, cl Thanksgiving, Christmas & New Year's Day; Admis adults $8, students & senior citizens $6, children 12 & under free; Estab 1862 as The Buffalo Fine Arts Academy. Gallery dedicated in 1905, with a new wing added in 1962; Center of modern and contemporary art, the collection offers a panorama of art through the centuries, dating from 3000 BC; Average Annual Attendance: 150,000; Mem: 9500; dues individual $50; ann meeting in Oct
Income: $4,700,000 (financed by contributions, mem. endowment, county appropriations, individual & corporate grants, earned income & special projects)
Special Subjects: Graphics, Mexican Art, Painting-American, Photography, African Art, Religious Art, Etchings & Engravings, Painting-European, Posters, Glass, Oriental Art, Asian Art, Antiquities-Byzantine, Painting-British, Painting-French, Baroque Art, Antiquities-Oriental, Painting-Italian, Antiquities-Persian, Antiquities-Egyptian, Antiquities-Greek, Antiquities-Roman, Painting-German, Antiquities-Etruscan, Painting-Israeli
Collections: Painting & drawings; prints & sculpture ranging from 3000 BC to the present with special emphasis on American & European contemporary art; sculpture & constructions
Publications: Annual report; calendar (bi-monthly); exhibition catalogs
Activities: Classes for adults & children; docent training; family workshops & programs; programs for the handicapped; outreach programs for inner-city schools; lect open to pub, 12 vis lectr per yr; concerts; gallery talks; tours; National Award for Museum Service 2000; individual paintings & original objects of art lent to major museums worldwide; lending colls contain paintings, photographs & sculptures; book traveling exhibs; originate traveling exhibs; mus shop sells books, reproductions, slides, jewelry, gift items & toys
L **G Robert Strauss Jr Memorial Library,** 1285 Elmwood Ave, Buffalo, NY 14222. Tel 716-270-8225, 270-8240; Fax 716-882-6213; Elec Mail artref@albrightknox.org; Internet Home Page Address: www.albrightknox.net/library; *Asst Librn* Tara Riese; *Head Librn* Janice Lea Lurie
Open Tues - Sat 1 - 5 PM & by appointment; Estab 1933 to support the staff research & to document the Gallery collection, also to serve the fine art & art history people doing research in the western New York area; Exhibits are prepared in a small vestibule, rare items in the library collection & print collection are displayed
Library Holdings: Audio Tapes; Book Volumes 31,000; Cassettes; Clipping Files; Exhibition Catalogs; Fiche; Manuscripts; Memorabilia; Original Art Works; Other Holdings Original documents; Pamphlets; Periodical Subscriptions 100; Photographs; Prints; Reproductions; Video Tapes
Special Subjects: Photography, Painting-American, Pre-Columbian Art, Prints, Sculpture, History of Art & Archaeology, Printmaking
Collections: Artists books; Graphic Ephemera; Illustrated books
Exhibitions: Books and Prints of Maillol; Photography in Books; Rare Art Periodicals; Woodcuts from the Library Collection; Artists' Books; Illustrated Books; Derriere Le Miroir; From the Gallery Archives; General Ide; Books with a Diffrence Circle Press Publications

L **BUFFALO MUSEUM OF SCIENCE,** Research Library, 1020 Humboldt Pky, Buffalo, NY 14211. Tel 716-896-5200, Ext 321; Fax 716-897-6723; Elec Mail library@sciencebuff.org; Internet Home Page Address: www.buffalomuseumofscience.org; *Dir Science & Coll* Dr John Grehan; *Assoc Cur Coll* Kathryn Leacock; *Cur Geology* Richard S Laub; *Admin Mus Ed* John McDonald; *Chm (V)* Philip C. Ackerman; *Pres & CEO* David E. Chesebrough; *Deputy Dir* Carroll Simon; *Controller* Albert Parker; *Mktg & Develop* Cheryl Spengler
Open Tues - Fri 10 AM - 5 PM (by appointment only); Estab 1861 to further the study of natural history among the people of Buffalo; Museum has exhibition space for permanent & temporary exhibitions; Average Annual Attendance: 200,000
Income: Financed by endowment, mem, county & state appropriation, grants, gifts
Purchases: $10,000
Library Holdings: Audio Tapes; Book Volumes 40,000; Clipping Files; Exhibition Catalogs; Fiche; Filmstrips; Manuscripts; Pamphlets; Periodical Subscriptions 500; Photographs; Reels; Video Tapes
Special Subjects: History of Art & Archaeology, Archaeology, Ethnology, Bronzes, Asian Art, American Indian Art, Anthropology, Eskimo Art, Mexican Art, Southwestern Art, Jade, Afro-American Art, Oriental Art, Dioramas, Coins & Medals
Collections: African, Asian, American, European, Oceanic & Oriental Art; E W Hamlin Oriental Library of Art & Archaeology
Publications: Bulletin of the Buffalo Society of Natural Sciences, irregular; Collections, quarterly
Activities: Classes for adults & children; docent training; travel talks; lect open to public & for members only, 5 vis lectr per year; tours; sponsor Camera Club Photo Contests; book traveling exhibitions 2-3 per year; museum shop sells books & reproductions

M **BURCHFIELD-PENNEY ART CENTER,** Buffalo State College, 1300 Elmwood Ave Buffalo, NY 14222. Tel 716-878-6012; Fax 716-878-6003; Elec Mail burchfld@buffalostate.edu; Internet Home Page Address: www.burchfield-penney.org; *Dir* Ted Pietrzak; *Head Colls & Programming & Charles Cary Rumsey Cur* Nancy Weekly; *Registrar & Coll & Traveling Exhibs Mgr* Scott Propeack; *Business Operations Mgr* Micheline Lepine; *Assoc Dir* Don Metz; *Head Mktg & Public Rels* Kathleen Hayworth; *Preparator* Tom Holt
Open Tues - Sat 10 AM - 5 PM, Sun 1 - 5 PM; No admis fee; Estab 1966 to develop a regional arts center for the exhibition, collection & interpretation of artistic expression in the Western New York area. Collections include works by Charles Burchfield & both historic & contemporary artists who have lived or worked in the area; Museum has eleven exhibition galleries; Average Annual Attendance: 40,000; Mem: 1000; dues friend $100, family $45, individual $40, artist & senior citizens $25, student (with ID) $10
Income: Financed by grants, endowment, mem, SUNY & other sources
Special Subjects: Architecture, Painting-American, Crafts, Decorative Arts
Collections: Charles E Burchfield Collection; Roycroft Collection; craft art; works by contemporary & historical artists of the western New York area
Publications: Exhibition catalogues
Activities: Docent training; lect open to public; concerts; symposia; tours; poetry readings; competitions; gallery talks; educ dept serves area schools & community organizations lending materials & presenting satellite exhibitions; organize traveling exhibitions; museum shop sells books, magazines, catalogues, craft art, reproductions & wallpapers designed by Charles Burchfield

L **Archives,** Buffalo State College, 1300 Elmwood Ave Buffalo, NY 14222-1095. Tel 716-878-4143; Fax 716-878-6003; *Head Colls & Programming* Nancy Weekly; *Registrar* Scott Propeack
Open mon - Fri 10 AM - 5 PM, by appointment; Estab 1967; For pub reference only; Significant donations by Charles Vand Penney
Library Holdings: Audio Tapes; Book Volumes 2500; Cassettes; Clipping Files; Exhibition Catalogs; Manuscripts; Memorabilia; Motion Pictures; Other Holdings Monographs; Periodicals; Slides; Video Tapes
Special Subjects: Art History, Photography, Manuscripts, Painting-American, Historical Material, Watercolors, Printmaking, Art Education, Architecture
Collections: Charles Rand Penney collections; Archives relating to Charles E Burchfield, Charles Cary Rumsey, Frank K M Rehn Gallery, J J Lankes, Martha Visser't Hooft, Buffalo Society of Artists, Patteran Society; Artpark; Artist Gallery

M **CENTER FOR EXPLORATORY & PERCEPTUAL ART,** CEPA Gallery, 617 Main St, Rm 201, Buffalo, NY 14203. Tel 716-856-2717; Fax 716-856-2720; Elec Mail cepa@aol.com; *Exec Dir* Lawrence Brose; *Assoc Dir* Kathleen Kearnan; *Artistic Dir* Sean Donaher; *Educ Coordr* Lauren Tent; *Community Educ* Crystal Tinch; *Designer & Digital Facility* Kim Meyerer; *Admin Asst* Timothy J. Hobin
Open Mon - Fri 10 AM - 5 PM, Sat Noon - 4 PM; No admis fee; Estab 1974 as a non-profit art center for the advancement of contemporary ideas & issues expressed through photographically related work; Five gallery rooms, 225 running ft of wall space, tracklight, hardwood floors; Average Annual Attendance: 50,000; Mem: 200; dues $20 - $1000
Income: $100,000 (financed by mem, city & state appropriation, NY State Council on the arts, National Endowment for the Arts)
Exhibitions: A View from Within; Keepers of the Western Door/Works by Native American Artists; Ritual Social Identity
Publications: CEPA Quarterly; Artist Project Publications, 2 artist books per year
Activities: Adult classes; lect open to public, vis lectr; competitions with awards; book traveling exhibitions 1 per year; shop sells books, original art

L **CEPA Library,** 617 Main St, Rm 201, Buffalo, NY 14203. Tel 716-856-2717; Fax 716-856-2720; Elec Mail cepa@aol.com; Internet Home Page Address: www.cepa.buffnet.net; *Exec Dir* Lawrence F Brose; *Assoc Dir* Kathleen Kearnan; *Artistic Dir* Sean Donaher; *Educ Coordr* Lauren Tent; *Commun Educ* Crystal Tinch; *Designer & Digital Facility* Kim Meyerer; *Admin Asst* J Hobin
Open Mon - Fri 10 - 5, Sat Noon - 4; pub galleries daily 9 AM - 9 PM; Estab May 1974; Reference library only
Library Holdings: Clipping Files; Exhibition Catalogs; Lantern Slides; Pamphlets; Records; Slides; Video Tapes
Special Subjects: Photography

M **HALLWALLS CONTEMPORARY ARTS CENTER,** 341 Delaware Ave, Buffalo, NY 14202. Tel 716-854-1694; Fax 716-854-1696; Elec Mail john@hallwalls.org; Internet Home Page Address: www.hallwalls.org; *Dir* Edmund Cardoni; *Visual Arts Cur* John Massier; *Dir Develop* Polly Little; *Media Cur* Joanna Raczynska; *Music Dir* Steve Baczkowski; *Technical Dir* Carl Lee
Open Tues - Fri 11 AM - 6 PM, Sat 1 PM - 4 PM; No admis fee; Estab 1974 to provide exhibition space for emerging artists; besides exhibitions, programming includes film, literature, music, performance art & video; The gallery is comprised of 1 large & 2 smaller viewing galleries; Average Annual Attendance: 25,000; Mem: 1600; dues $20-$300; annual meeting in Jan
Income: Funded by the National Endowment for the Arts, city, county & state appropriations, New York State Council on the Arts, contributions from private corporations, foundations & individuals
Collections: 400 tape video library
Publications: Consider the Alternatives: 20 Years of Contemporary Art at Hallwalls

M **HUS VAR FINE ART,** 268 Main St, Ste 102, Buffalo, NY 14202. Tel 716-856-7597; Fax 716-856-7604; Internet Home Page Address: www.husvarfineart.com; *Pres, Dir & Treas* Sean Hus Var; *Chmn* Angelo Marzullo; *Pub Rels & Cur* Angela Callisto; *Registrar* Jeff Shumaker; *Cur & Mus Shop Mgr* Nadejda Petrova
Open Mon - Fri 11 AM - 6 PM, Sat & Sun by appt only; cl New Year's Day, Thanksgiving Day, Christmas Day; Estab 2003; concentration on contemporary orig & limited edition artwork with a wide range of printing & framing svcs
Special Subjects: Decorative Arts, Drawings, Painting-American, Prints, Sculpture, Graphics
Activities: Loan & temporary exhibs; rental gallery; mus shop sells limited edition prints, frames & fine art greeting cards

CANAJOHARIE

M **CANAJOHARIE LIBRARY & ART GALLERY,** Arkell Museum of Canajoharie, 2 Erie Blvd, Canajoharie, NY 13317. Tel 518-673-2314; Fax 518-673-5243; Elec Mail etrahan@sals.edu; Internet Home Page Address: www.clag.org; *Pres of Board* Oliver Simonsen; *Dir* Eric Trahan; *Chief Cur* Diane Forsberg; *Registrar* Emily Spallina; *Head Librn* Kari Munger
Open Mon - Wed 10 AM - 7:30 PM, Thurs 10 AM - 7:30 PM, Fri 10 AM - 4:45 PM, Sat 10 AM - 1:30 PM; No admis fee; Estab 1914 as a memorial to Senator James Arkell; Two galleries total area 1500 sq ft exhibit works from permanent collection including major collection of paintings by Winslow Homer; Average Annual Attendance: 50,000; Mem: Annual meeting in Jan
Income: Financed by endowment, grants & fundraising
Library Holdings: Book Volumes; CD-ROMs; Compact Disks; Exhibition Catalogs; Framed Reproductions; Original Art Works; Original Documents; Periodical Subscriptions; Photographs; Prints; Slides; Video Tapes
Special Subjects: Painting-American, Photography, Prints, Sculpture, Watercolors, American Western Art, Bronzes, Portraits, Historical Material
Collections: Archival Materials & Artifacts on Regional History; Paintings by American artists, colonial period-present
Exhibitions: Permanent collection
Publications: Catalog of Permanent Art Collection varies
Activities: Lect provided, 5 vis lectr per year; concerts; gallery talks; tours; individual paintings & original objects of art lent to other museums & galleries; lending collection contains 28,617 books, 831 cassettes, color reproductions, paintings, 682 phono records, 376 slides, 523 video cassettes; museum shop sells books, original art, prints & reproductions

L **Library,** 2 Erie Blvd, Canajoharie, NY 13317. Tel 518-673-2314; Fax 518-673-5243; *Pres of Board* Oliver Simonsen; *Cur* James Crawford; *Dir Library* Eric Trahan
Open Mon, Tues, Wed & Fri 10 AM - 4:45 PM, Thurs 10 AM - 8:30 PM, Sat 10 AM - 1:30 PM; No admis fee; Estab 1914 to represent American Art
Library Holdings: Audio Tapes; Book Volumes 28,617; Cassettes; Clipping Files; Exhibition Catalogs; Framed Reproductions; Pamphlets; Periodical Subscriptions 146; Photographs; Records; Reels; Slides; Video Tapes
Activities: Lect open to public, 5 vis lectr per year; concerts; gallery talks; tours; lending collection contains 29,022 books, cassettes, framed reproductions & 788 phono records; museum shop sells books, magazines, original art, reproductions, prints, slides, notecards & postcards

CANTON

M **ST LAWRENCE UNIVERSITY,** Richard F Brush Art Gallery, Romoda Dr, Canton, NY 13617. Tel 315-229-5174; Fax 315-229-7445; Elec Mail ctedford@stlawu.edu; Internet Home Page Address: www.stlawu.edu/gallery; *Asst Dir* Carole Mathey; *Dir* Catherine Tedford
Open Mon - Thurs Noon - 8 PM, Fri & Sat Noon - 5 PM, cl for the summer; No admis fee; Estab 1968. The Gallery's programs are intended to complement the University's curriculum as well as benefit the general pub of Northern New York state & Southern Canada; 3 adjacent galleries (3,000 sq ft); climate controlled with track lighting; Average Annual Attendance: 5,000+
Income: Financed by university funds
Collections: 16th-20th Century European & American paintings; 20th Century American & European prints, drawings & photographs; 20th Century artists' books, portfolios
Publications: Exhibition brochures; Photographs at St Lawrence University (2000)
Activities: Lect open to public, 12-15 vis lectr per year; gallery talks; tours; art objects lent to museums; originate traveling exhibitions to university art galleries and mus

CAZENOVIA

M **CAZENOVIA COLLEGE,** Chapman Art Center Gallery, 22 Sullivan St, Cazenovia, NY 13035. Tel 315-655-7162; Fax 315-655-2190; Elec Mail jalstars@cazenovia.edu; *Dir* John Aistars
Open Mon - Thurs 1 - 4 PM & 7 - 9 PM, Fri 1 - 4 PM, Sat & Sun 2 - 6 PM; No admis fee; Estab 1977 as a college gallery for students & community; Gallery is 1,084 sq ft with track lighting; Average Annual Attendance: 1,000

Income: Financed by College
Collections: A small permanent collection of work donated to college
Exhibitions: Annual shows of faculty, students & invitational work; Cazenovia Watercolor Society
Activities: schols offered

M **STONE QUARRY HILL ART PARK,** 3883 Stone Quarry Rd, No 251, Cazenovia, NY 13035. Tel 315-655-3196; Fax 315-655-5742; Elec Mail sqhap@aol.com; Internet Home Page Address: www.stonequarryartpark.org; *Asst Dir* Sylvia Prendergnot; *Site Mgr* Bettina Frisse; *Dir* Van Titus
Open daily sunset-sunrise; No admis fee; Estab 1991; 3 1/2 miles of maintained walking trails; Average Annual Attendance: 25,000; Mem: 900; dues $25-1000; annual meeting Jan
Income: $207,000 (financed by endowment, mem & NYSCA)
Collections: Environmental land; outside sculpture

M **Winner Gallery,** 3883 Stone Quarry Rd, No 251, Cazenovia, NY 13035. Tel 315-655-3196; Fax 315-655-5742; Elec Mail squhap@aol.com; Internet Home Page Address: www.stonequarryartpark.org; *Site Mgr* Bettina Frisse; *Educ Dir* Beth Groff; *Interim Park Dir* Sylvie Prendergast
Open daily 10AM-5PM; Estab 1994 to address issues of art & environmental preservation; Average Annual Attendance: 47,000; Mem: 1200; dues $35-$5000; annual meeting in Jan
Income: $207,000 (financed by endowment, mem & NYSCA)
Special Subjects: Sculpture
Collections: treehouses, Patrick Daugherty structure (outdoor)
Activities: Classes for adults & children, summer art/nature camp for children in July; lect open to public, 2-3 vis lectr per year; concerts; gallery talks; fellowships; sales shop sells books, original art

L **Jenny Library,** 3883 Stone Quarry Rd, No 251, Cazenovia, NY 13035. Tel 315-655-3196; Fax 315-655-5742; Elec Mail sqhap@aol.com; Internet Home Page Address: www.stonequarryartpark.org; *Dir* Susan Johnson; *Asst Dir* Margret Potter; *Site Mgr* Bettina Frisse; *Educ Dir* Beth Groff
Open daily sunrise-sunset; No admis fee; Estab 1998; Circ 3500; For lending & reference; Mem: 900; dues $25-1,000; annual meeting Jan
Income: $207,000 (financed by mem & city appropriation)
Library Holdings: Book Volumes 3500; Exhibition Catalogs; Original Art Works; Sculpture; Slides
Special Subjects: Art History, Landscape Architecture, Mixed Media, Photography, Painting-American, Sculpture, Watercolors, Crafts, Theatre Arts, Printmaking, Asian Art, Porcelain, Metalwork, Oriental Art, Pottery

CHAUTAUQUA

M **CHAUTAUQUA CENTER FOR THE VISUAL ARTS,** PO Box 999, Chautauqua, NY 14722. Tel 716-357-2771; Elec Mail ccva@mainalley.com; Internet Home Page Address: www.mainalley.com/ccva; *Pres* Dick Karslake; *Exec & Artistic Dir* Cynnie Gaasch; *Asst Dir* Alissa Shields
Open daily 10 AM - 6 PM July - Sept; No admis fee; Estab 1952 to promote quality art, culture & appreciation of the arts; Main gallery with 3 smaller galleries; Average Annual Attendance: 10,000; Mem: 300; dues $25; one annual meeting
Income: Financed by mem, grants, donations & fundraising activities
Collections: 75 two dimensional purchase prizes
Exhibitions: 15 exhibitions per year including prints, paintings, glass, metals & sculpture; Annual Chautauqua National Exhibition of American Art (entering 44th year)
Publications: Chautauqua National, annual catalog; Calendar of Events, annual; Chautauqua National Prospectus, annual; annual report; promotional materials; exhibition brochures; membership brochures
Activities: Lect open to public, 17 vis lectr per year; concerts; gallery talks; docent tours; competitions with awards; annual juried National Exhibition of American Art award $2500; individual paintings & original objects of art lent to Chautauqua institution, area libraries, exhibition sites, area galleries & theatres; book traveling exhibitions annually; originate traveling exhibitions; sales shop sells books, original art, reproductions, prints, original jewelry, small gifts & handicraft from around the world

CLINTON

M **HAMILTON COLLEGE,** Emerson Gallery, 198 College Hill Rd, Clinton, NY 13323. Tel 315-859-4396; Fax 315-859-4060; Elec Mail emerson@hamilton.edu; Internet Home Page Address: www.hamilton.edu/gallery; *Assoc Dir & Cur* Susanna White
Open Mon - Fri 10AM - 5 PM, Sat & Sun 1 - 5 PM; No admis fee; Estab 1982; Housed in 1914 building; Average Annual Attendance: 20,000
Income: Financed by Hamilton College appropriations
Purchases: Martin Lewis, Rainy Day on Murray Hill, etching; George Bellows Between Rounds 1916, lithograph; Jefferson David Chalfant Working Sketch for the Chess Players, pencil; Roman, c 2nd Century AD; Two Sarcophagi Fragments, marble
Special Subjects: Photography, Drawings, Painting-American, Prints, Watercolors, American Indian Art, Etchings & Engravings, Antiquities-Egyptian, Antiquities-Greek
Collections: Greek vases, Roman glass; Native American artifacts; 16th-20th century prints, 19th-20th century paintings; Pre-Columbian Art
Publications: Exhibition catalogues
Activities: Lect open to public, 2-3 various vis lectr per year; concerts; gallery talks; tours; individual paintings & original objects of art lent

A **KIRKLAND ART CENTER,** E Park Row, PO Box 213 Clinton, NY 13323. Tel 315-853-8871; Fax 315-853-2076; Elec Mail kacinc@adelphia.net; *Dir* Annette J. Clarke
Open Tues - Fri 9:30 AM - 5 PM, Sun 2 PM - 4 PM, cl Mon; Tue - Fri 9:30 - 3 PM, Sun 2 PM - 4 PM July & Aug; No admis fee; Estab 1960 to promote the arts in the town of Kirkland & surrounding area; The center has a large main gallery,

dance studio & studio space for classes; Average Annual Attendance: 15,000 - 17,000; Mem: 700; dues adults $25; annual meeting June
Income: Financed by endowment, mem, state, county & town appropriation, fund raising events, thrift, gallery shop, United Way & United Arts Funds
Exhibitions: Works by contemporary artists
Publications: Newsletter, monthly
Activities: Classes for adults & children; performances for children; bluegrass & folk music series; film series; lect open to public; competitions

COBLESKILL

A **TRI-COUNTY ARTS COUNCIL, INC,** 107 Union St, Cobleskill, NY. Tel 518-254-0611; Fax 518-254-0612; Elec Mail tricountyarts@verizon.net; Internet Home Page Address: www.tricountyarts.org; *Exec Dir* Mark Eamer
Open Mon - Fri 10 AM - 5:30 PM, Sat 10 AM - 3 PM; No admis fee; Estab 1977; Average Annual Attendance: 5,000; Mem: 450; mem open to individual artists & business donations of $20 or more; annual meeting 1st Tues in May
Income: $180,000 (financed by mem, government, corporate & foundation support)
Exhibitions: Annual National Small Works Exhibition
Activities: Classes for children; dramatic programs; benefit concerts; acoustic jams; walk-in worskshops; technical assistance; NYSCA Decentralization Re-grant site; gallery talks; sales shop sells books, original art, reproductions, prints & pottery

COLD SPRING

M **PUTNAM COUNTY HISTORICAL SOCIETY,** Foundry School Museum, 63 Chestnut St, Cold Spring, NY 10516. Tel 845-265-4010; Fax 845-265-2884; Elec Mail pchs@highlands.com; Internet Home Page Address: www.pchs-fsm.org; *Exec Dir* Doris Shaw; *Admin Asst* Heidi Burgunder; *Cur* Trudie Grace
Open Tues - Wed 10 AM - 4 PM, Thurs 1 - 4 PM, Sat & Sun 2 - 5 PM, cl Mon & Fri; No admis fee; Estab 1906 to present local history artifacts; Average Annual Attendance: 1,000; Mem: 1,000; dues family $35 individual $25, seniors & students $10, juniors 10-13 $1; annual meeting in Feb
Income: $40,000 (financed by endowment, mem & fundraising events)
Special Subjects: Painting-American, Furniture, Historical Material, Period Rooms
Collections: Artifacts; Country Store; Furnishings & Hudson River Paintings; 19th Century Country Kitchen, West Point Foundry
Activities: School programs; lect open to public, 2 vis lectr per year; competitions with awards; individual paintings & original objects of art lent

COOPERSTOWN

A **COOPERSTOWN ART ASSOCIATION,** 22 Main St, Cooperstown, NY 13326. Tel 607-547-9777; Fax 607-547-1187; Elec Mail coopart@telenet.net; Internet Home Page Address: www.cooperstownart.com; *Dir* Janet Erway; *Asst Dir* Jennifer Hughes
Open Mon, Wed - Sat 11 AM - 4 PM, Sun 1 - 4 PM, cl Tues from Labor Day to Memorial Day; Estab 1928 to provide a cultural program for the central part of New York State; An art gallery is maintained; 3 gallery spaces; Average Annual Attendance: 14,000; Mem: 400; dues $5 & up
Income: Financed by mem
Collections: Crafts; paintings; sculpture
Exhibitions: Annual Regional & National Juried Exhibitions; Solo & Group Shows; Ann NY Craft Invitational
Publications: Annual newsletter
Activities: Classes for adults; lect open to public, 1-3 vis lectr per year; concerts; awards; individual paintings & original objects of art lent; lending collection contains paintings, sculpture, crafts

A **LEATHERSTOCKING BRUSH & PALETTE CLUB INC,** PO Box 446, Cooperstown, NY 13326. Tel 607-547-5942; *Publicity* Dorothy V Smith; *Pres* Donna Wells; *Vice Pres* Judy Curry; *Secy* Carol Dunbar; *Treas* Trudy Smith
Estab 1965 to encourage original arts and crafts work and foster general art appreciation and education; Mem: 55; dues $10; meetings quarterly; must be 18 yrs of age and a resident of Otsego County; Scholarships
Income: Financed by mem & outdoor show revenues
Exhibitions: Annual Labor Day Weekend Outdoor Arts & Crafts Show; Annual Fine Arts Exhibition; Leatherstocking Gallery Arts & Crafts Shop
Publications: Information Bulletin, quarterly
Activities: Classes for adults; all activities offered to public; member tours to art museums & exhibits; cash award to top graduating senior art student from each of the 13 county public high schools (selected by the art faculty of each school); originate traveling exhibitions circulating to local public facilities

M **NATIONAL BASEBALL HALL OF FAME & MUSEUM, INC,** Art Collection, 25 Main St, PO Box 590 Cooperstown, NY 13326. Tel 607-547-7200; Fax 607-547-2044; Internet Home Page Address: www.baseballhalloffame.org; *Pres* Dale A Petroskey; *VPres* William Haase; *Cur Coll* Peter P Clark; *Librn* James L Gates Jr; *VPres* William T Spencer; *VPres* Jeffrey Idelson
Open May - Sept daily 9 AM - 9 PM, Oct - Apr daily 9 AM - 5 PM; Admis adults $9.50, seniors $8.00, children ages 7-15 $4.50; Estab 1936 to collect, preserve & display memorabilia pertaining to the national game of baseball and honoring those who have made outstanding contributions to our national pastimes; Maintains reference library; Average Annual Attendance: 340,000; Mem: 12,500
Income: $1,500,000 (financed by admis & gift shop sales, Hall of Fame Game & contributions)
Library Holdings: Audio Tapes; CD-ROMs; Cassettes; Clipping Files; Compact Disks; Fiche; Manuscripts; Memorabilia; Motion Pictures; Original Art Works; Original Documents; Pamphlets; Photographs; Records; Reels; Slides; Video Tapes
Collections: Baseball & sport-related art & memorabilia; Library collections

Publications: National Baseball Hall of Fame & Museum Yearbook, annually; quarterly newsletter

Activities: Classes for children; gallery talks; lectrs open to public; lending of orig art to accredited mus; book traveling exhib on a case by case basis; originate traveling exhib to museums, baseball clubs; bookstore sells books, reproductions, prints, t-shirts, caps, glassware, postcards, mugs & jackets

NEW YORK STATE HISTORICAL ASSOCIATION

M **Fenimore Art Museum,** Tel 607-547-1400; Fax 607-547-1404; Elec Mail info@nysha.org; Internet Home Page Address: www.fenimoreartmuseum.org; *Pres* Dr Gilbert T Vincent; *Chief Cur* Dr Paul S D'Ambrosio; *VPres of Develop & Marketing* Thomas Costello; *Library Dir* Melissa McAfee
Open Apr - May, Oct - Dec, Tues - Sun 10 AM - 4 PM, June - Sept daily 10 AM - 5 PM; Admis adults $9, children 7-12 $4, children 6 & under free; Estab 1899 as a historical soc whose purpose is to promote the study of New York State through a state wide educational program, the operation of two museums & graduate programs offering master's degree in conjunction with the State University of New York at Oneonta; Fenimore Art Museum is an art & history museum with an extensive collection of folk, academic, decorative art & North American Indian Art. Opened a new American Indian Art wing in 1995 to house the Eugene & Clare Thaw Collection of American Indian Art; Average Annual Attendance: 40,000; Mem: 2800; dues $25 & up; annual meeting in July
Special Subjects: Painting-American, Folk Art, Decorative Arts
Collections: American folk art; American Indian Art; Browere life masks of famous Americans; James Fenimore Cooper (memorabilia); genre paintings of New York State; landscapes; portraits; Hudson River historic & contemporary school paintings
Publications: Annual Report; New York History, quarterly journal; Heritage, yearly membership magazine, occasional manuscripts, exhibit catalogues
Activities: Classes for adults & children; docent training; seminars on American culture; junior program; conferences; lect open to public; gallery talks; tours; individual paintings & original objects of art lent to selected museums; book traveling exhibitions; originate traveling exhibitions; museum shop sells books, magazines, original art, reproductions, prints & slides

M **Fenimore Art Museum,** Tel 607-547-1450; Fax 607-547-1404; Elec Mail info@nysha.org; Internet Home Page Address: www.nysha.org; *Pres* Dr Gilbert T Vincent; *Chief Cur* Paul D'Ambrosio; *Dir of Educ* Garet Livermore; *Cur of Coll* Douglas Kendall; *Chief Admin Officer* Jane Goodwin Duel; *Dir of Publs* Daniel Goodwin; *VPres of Develop & Marketing* Thomas Costello
Open June - Sept daily 10 AM - 5 PM, Oct - Nov, Tues - Sun 10 AM - 4 PM, Apr & May, Tues - Sun 10 AM - 4 PM, cl Dec - Mar; Admis adults $9, children between 7-12 $4, under 7 & members free; Estab 1945 as a museum of American art; Eleven galleries built 1932, & 18,000 sq ft wing added in 1995; Average Annual Attendance: 40,000; Mem: 2800; beginning dues $25 & up; ann meeting in July
Income: Financed by endowment, self-sustaining
Special Subjects: Decorative Arts, Folk Art, Ceramics, Photography, Portraits, Painting-American, American Indian Art, Costumes, Crafts, Landscapes, Manuscripts, Furniture, Glass, Historical Material
Collections: American folk art; The Eugene & Clare Thaw Collection of North American art; American fine art textiles, photography, decorative arts
Publications: Heritage magazine annually; New York History, quarterly
Activities: Classes for adults & children; docent training; lect open to public, 2-3 vis lectr per year; concerts; tours; special events; awards Henry Allen Moe prize, Dixan Ryan Fox Manuscript award; book traveling exhibitions; museum shop sells reproductions & gifts

L **Research Library,** Tel 607-547-1470; Fax 607-547-1405; Elec Mail library@nysha.org; Internet Home Page Address: www.nysha.org; *Assoc Dir Technical Serv* Susan Deer; *Assoc Dir Pub Serv* Wayne W Wright
Open summer Mon-Fri 10 AM - 5 PM, Sat 1 - 5 PM, spring & fall Mon - Thurs 10 AM- 6 PM, Fri 10 AM - 5 PM, Sat 1 - 5 PM; Admis $3; Estab 1968 as non-circulating research library; Open to public for reference only
Library Holdings: Audio Tapes; Book Volumes 82,000; Cassettes; Exhibition Catalogs; Manuscripts; Maps; Periodical Subscriptions 160; Records; Reels
Special Subjects: Folk Art, Decorative Arts, Painting-American, Historical Material, American Indian Art, Furniture, Textiles, Architecture

CORNING

A **ARTS OF THE SOUTHERN FINGER LAKES,** 32 W Market St, Corning, NY 14830. Tel 607-962-5871; Fax 607-962-4128; Elec Mail tarts@stny.lrun.com; Internet Home Page Address: www.earts.org; *Comm Arts Devel Dir* Lynn Rhoda; *Exec Dir* Janet T Newcomb; *Folk Arts* Peter Voorhies; *Office Asst* Laura Illig; *Offc Asst* Kristen Stewart
Open Mon - Fri 9 AM - 5 PM; No admis fee; Estab to increase resident participation in the arts; Mem: 34; annual meeting in June
Exhibitions: Artsfest; The Westend Gallery (Local Artists); Easter eggs & paper cuttings (Felicia Dvornicky)
Publications: Artscope, 6 times per year; See, Hear, Do, 12 times per year
Activities: Educ dept; infuses art into education in area schools; lect open to public; partnership awards given; regrants to local schools & nonprofit organizations

M **CORNING MUSEUM OF GLASS,** The Studio, Rakow Library, One Museum Way, Corning, NY 14830-2253. Tel 607-937-6845; Fax 607-974-8470; Elec Mail director@cmog.org; Internet Home Page Address: www.cmog.org; *Research Scientist* Robert H Brill; *Cur American Glass* Jane Spillman; *Registrar* Warren Bunn; *Managing Editor* Richard W Price; *Cur European Glass* Dr Dedo Von Kerssenbrock-Krosigk; *Exec Dir* David Whitehouse; *Cur Modern Glass* Tina Oldknow; *Deputy Dir Educ & Studio* Amy Schwartz; *Head Librn* Diane Dolbashian; *Dir Mktg & Guest Srvcs* Robert K Cassetti; *Dir Finance & Admin* Nancy J Earley
Open all year daily 9 AM - 5 PM; July & Aug 9 AM - 8 PM; Admis adult $12.50, senior citizens $11.25, students $11.25, children under 17 free; Estab 1951 to collect & exhibit the finest glass from 1500 BC to the present; Art, history, science of glass; Average Annual Attendance: 300,000; Mem: 2500; dues $25 & up

Income: $3,000,000 (financed by gifts, interest & sales)
Purchases: Glass & books
Library Holdings: Auction Catalogs; Audio Tapes; Book Volumes; Cards; Cassettes; Exhibition Catalogs; Fiche; Kodachrome Transparencies; Manuscripts; Memorabilia; Original Art Works; Original Documents; Pamphlets; Periodical Subscriptions; Photographs; Prints; Slides; Video Tapes
Special Subjects: Glass
Collections: over 30,000 objects representing all periods of glass history from 1500 BC to the present, books & related materials
Exhibitions: 3 exhibitions annually
Publications: Annual catalog for special exhibitions; Journal of Glass Studies, annual; New Glass Review, annual
Activities: Classes for adults & children; docent training; annual seminar on glass; lect open to public, 30 vis lectr per year; film series; gallery talks; tours; competitions; Rakow Award; Rakow Commission; annual student art show awards; scholarships & fels offered; original art objects lent to the other museums; lending collection contains 50,000 books, 350 lantern slides; originate traveling exhibitions; museum shop sells books, postcards, prints, reproductions & slides, glass, hands-on glass activities, story hour for youth, jr cur program, glassworking classes

L **Juliette K and Leonard S Rakow Research Library,** 5 Museum Way, Corning, NY 14830-3352. Tel 607-974-8649; Fax 607-974-8677; Elec Mail rakow@cmog.org; Internet Home Page Address: www.cmog.org; *Head Librn* Patricia J Rogers; *Reference Asst* Beth Hylen; *Cartaloger* Kelly Bliss; *Bibliographer* Peter Bambo-Kocze; *Reference Librn* Gail Bardhan
Open Mon - Fri 9 AM - 5 PM; Estab 1951 for the purpose of providing comprehensive coverage of the art, history, & early technology of glass; Circ Non-circulating; The library is a pub facility that welcomes both museum visitors & glass researchers
Library Holdings: Auction Catalogs 20,000; Audio Tapes; Book Volumes 75,000; Cassettes; Clipping Files; Compact Disks; DVDs; Exhibition Catalogs; Fiche 19,000; Framed Reproductions; Motion Pictures; Original Art Works; Original Documents; Other Holdings 20,000 auction and sale catalogs; Pamphlets; Periodical Subscriptions 1000; Photographs; Prints 550; Reels 800; Slides 215,000; Video Tapes 1500
Special Subjects: Decorative Arts, Crafts, Archaeology, Glass, Antiquities-Oriental, Antiquities-Persian, Antiquities-Assyrian, Antiquities-Byzantine, Antiquities-Egyptian, Antiquities-Etruscan, Antiquities-Greek, Antiquities-Roman, Flasks & Bottles
Collections: Archival & historical materials relating to glass & its manufacture
Activities: Docent training, classes for teachers; gallery talks, tours, schol; scholarships & fels offered; museum shop sells books, original art & slides

M **THE ROCKWELL MUSEUM OF WESTERN ART,** 111 Cedar St, Corning, NY 14830. Tel 607-937-5386; Fax 607-974-4536; Elec Mail info@rockwellmuseum.org; Internet Home Page Address: www.rockwellmuseum.org; *Cur* Sheila Hoffman; *Supv Pub Progs* Cindy Weakland; *Controller* Andrew Braman; *Dir* Kristin A Swain; *Mktg Specialist* Beth Harvey; *Dir Educ* Gigi Alvare
Open Mon - Sat 9 AM - 5 PM, Sun 9 AM - 8 PM; Admis adults $6.50, senior citizens $4.50, students $2.50, children 17 & under free; Estab 1976 to house & exhibit the collection of the Robert F Rockwell family & to collect & exhibit American Western art; Average Annual Attendance: 35,000; Mem: 300; dues $40 - $2500; meetings in June & Dec
Income: $$400,000 (financed by a grant from Corning Incorporated)
Purchases: $50,000
Special Subjects: Painting-American, Prints, American Indian Art, American Western Art, Bronzes, Etchings & Engravings
Collections: Carder Steuben glass (1903-1933); bronzes; 19th & 20th century American Western paintings & illustrations; Plains Indian beadwork & artifacts; prints; Pueblo Indian pottery; Navajo rugs
Exhibitions: Celebration of Geniuses: Ansel Adams; Fields & Streams: Hunting & Wildlife
Publications: Exhibition catalog; Newsletter, 3 times per yr
Activities: Classes for adults & children; docent training; lect open to public; gallery talks; tours; concerts; AAM Accredited; paintings, original objects of art lent to established museums; lending collection contains reproductions, original art works, original prints, Carder Steuben Glass; originate traveling exhibitions; shop sells books, magazines, reproductions, prints, Indian jewelry, postcards, crafts from the Southwest, T-shirts, Pueblo pottery, Hopi Kachinas, toys, glass

L **Library,** 111 Cedar St, Corning, NY 14830. Tel 607-937-5386; Fax 607-974-4536; Elec Mail rmuseum@stny.lrun.com; *Dir* Richard B Bessey
For reference only
Income: Financed by mem, bequests, grants, corporate donations from Corning Glass Works
Library Holdings: Book Volumes 3000; Cards; Cassettes; Clipping Files; Exhibition Catalogs; Filmstrips; Manuscripts; Original Art Works; Pamphlets; Periodical Subscriptions 40; Photographs; Slides; Video Tapes

CORNWALL ON HUDSON

M **MUSEUM OF THE HUDSON HIGHLANDS,** The Boulevard, PO Box 181 Cornwall on Hudson, NY 12520. Tel 845-534-7781; *Dir* Ross Zito; *Admin Dir* Susan Brander; *Pres* Edward Hoyt
Open Tues - Sun Noon - 5 PM; Admis $2 suggested donation; Estab 1962; primarily a children's natural history & art mus; A large octagonal gallery & a small gallery; Average Annual Attendance: 33,000; Mem: 450; artists qualify by approval of slides; dues $30 and up
Income: $140,000 (financed by mem, city appropriation & grants)
Special Subjects: Drawings
Collections: Richard McDaniels: Hudson River Drawings
Exhibitions: Rotating exhibitions, six per yr
Activities: Classes for adults & children; lect open to public, 2 vis lectr per year; competitions with awards; lending collection contains nature & history kits; book traveling exhibitions, annually; museum shop sells books, magazines, original art, reproductions, prints, toys, pottery, jewelry, batik scarfs

CORTLAND

M 1890 HOUSE-MUSEUM & CENTER FOR THE ARTS, 37 Tompkins St,
Cortland, NY 13045-2555. Tel 607-756-7551; Fax 607-756-7551; *Dir* John H
Nozynski; *Admin Asst* Grace Nicholas
Open Tues - Sun 1 - 4 PM; call to arrange tours; Estab 1978
Collections: Decorative arts; Oriental Furnishings; Paintings; 1890 - 1900
Documentary Photographs; Victorian Furniture; Victorian Silver
Exhibitions: Late Victorian Cast Iron Lawn Ornaments; Victorian Lighting;
Documentary Photographs of Restoration
Publications: Whispers Near the Inglenook
L Kellogg Library & Reading Room, 37 Tompkins St, Cortland, NY 13045-2555.
Tel 607-756-7551; Fax 607-756-7551; *Admin Asst* Grace Nicholas
Open Tues - Sun 1 - 4 PM; For lending & reference
Library Holdings: Book Volumes 1800; Periodical Subscriptions 12

M CORTLAND COUNTY HISTORICAL SOCIETY, Suggett House Museum, 25
Homer Ave, Cortland, NY 13045. Tel 607-756-6071; *Pres* Robert Ferris; *Treas*
Christine Buck; *Dir* Mary Ann Kane; *Coll Mgr* Anita Wright
Open Tues - Sat 1 - 4 PM, mornings by appointment; Admis adults (16 & up) $2;
Estab 1925 to collect, store & interpret the history of Cortland County through
programs, exhibits & records in our 1882 Suggett House; Some art displayed in
period settings, 1825-1900; Average Annual Attendance: 2,000; Mem: 800; dues
vary; meetings several times during the year
Income: $75,000 (financed by endowment, mem, county appropriations, grants,
sales & fundraisers)
Special Subjects: Folk Art, Furniture
Collections: Antique furniture, children's toys, china, folk art, glass, military
memorabilia, paintings, textiles & clothing
Publications: 15 books on local history; bulletin, 1-3 times per yr; newsletter, 1-3
times per yr
Activities: Classes for adults & children; docent training; lect open to public;
individual paintings & original objects of art lent to other museums & college
galleries; museum shop sells books
L Kellogg Memorial Research Library, 25 Homer Ave, Cortland, NY 13045. Tel
607-756-6071; *Dir* Mary Ann Kane
Open Tues - Sat 1 - 5 PM, mornings by appointment; Estab 1976 to collect,
preserve & interpret information about the history of Cortland County; For
reference only
Purchases: $500
Library Holdings: Book Volumes 5000; Cassettes; Clipping Files; Exhibition
Catalogs; Lantern Slides; Manuscripts; Memorabilia; Original Art Works; Other
Holdings Microfilm; Pamphlets; Photographs; Prints; Records; Reels;
Reproductions; Sculpture; Slides; Video Tapes
Collections: Cortland County & regional genealogical records

L CORTLAND FREE LIBRARY, 32 Church St, Cortland, NY 13045. Tel
607-753-1042; Fax 607-758-7329; *Dir* Warren S Eddy
Open Mon - Thurs 10 AM - 8:30 PM, Fri & Sat 10 AM - 5:30 PM, cl Sun; No
admis fee; Estab 1938; Circ 1122; Average Annual Attendance: 1,600
Income: financed by dept of assn library
Purchases: $2100
Library Holdings: Book Volumes 1700; Original Art Works; Periodical
Subscriptions 14; Reels
Exhibitions: Occasional monthly exhibitions held

M STATE UNIVERSITY OF NEW YORK COLLEGE AT CORTLAND, Dowd
Fine Arts Gallery, PO Box 2000, Cortland, NY 13045. Tel 607-753-4216; Fax
607-753-5728; Elec Mail graffa@cortland.edu; Internet Home Page Address:
www.cortland.edu; *Dir* Allison Graff
No admis fee; Estab 1967; Three separate spaces, total 2200 sq ft completely
secure, full environmental control. Maintains a lending & reference library;
wheelchair accessible; Average Annual Attendance: 15,000
Income: $25,000 (financed by state appropriation)
Purchases: $4500
Special Subjects: Drawings, Graphics, Latin American Art, Painting-American,
Photography, Prints, Sculpture, Textiles, Ceramics, Woodcuts, Etchings &
Engravings, Landscapes, Manuscripts, Collages, Portraits, Historical Material
Collections: Cortland College Permanent Collection
Publications: Exhibit catalogs, 2-3 per year
Activities: Docent training; lect open to public, 10-12 vis lectr per year

L STATE UNIVERSITY OF NEW YORK COLLEGE AT CORTLAND, Visual
Resources Collection, PO Box 2000, 87 Dowd Bldg Cortland, NY 13045. Tel
607-753-5519; Elec Mail joycel@cortland.edu; *Visual Resources Cur* Lisa Joyce
Open Mon - Fri 8:30 AM - 5 PM & by appointment; No admis fee; Estab 1967 to
provide visual resources to faculty, students & community
Income: Financed by state appropriation
Library Holdings: Book Volumes 1000; Exhibition Catalogs; Fiche; Filmstrips;
Kodachrome Transparencies; Lantern Slides 5000; Periodical Subscriptions 10;
Photographs 10,000; Slides 125,000; Video Tapes 100
Special Subjects: Art History

COXSACKIE

M GREENE COUNTY HISTORICAL SOCIETY, Bronck Museum, Rte 9W,
Coxsackie, NY 12051; 90 County Rte 42, Coxsackie, NY 12051. Tel
518-731-6490; Fax 518-731-7672 (May - Oct only); Internet Home Page Address:
www.gchistory.org; *Pres* Olga Santora, PhD; *Librn* Raymond Beecher; *Mus Mgr*
Shelby Mattice
Open Tues - Sat 10 AM - 4 PM, Sun 1 - 5 PM, Holiday Mons 10 AM - 4 PM;
Admis $4; Estab 1929 to preserve the history of Greene County & promote the
awareness of that history; 20 ft x 20 ft gallery located in the Bronck Mus Visitor
Center; maintains also The Vedder Memorial Library, & Bronck Museum, A

Historic House Museum; Average Annual Attendance: 1,700; Mem: 900; dues $10
& up; annual meeting in June
Income: $75,000 (financed by endowment, mem, admissions, shop sales)
Special Subjects: Drawings, Painting-American, Textiles, Costumes, Folk Art,
Pottery, Landscapes, Portraits, Furniture, Glass, Carpets & Rugs, Historical
Material, Period Rooms
Collections: American Art; Ceramics; Costumes; Furniture; Glass; 19th century
Agricultural & Handcrafts; Silver; Textiles; Tools
Exhibitions: Local History
Publications: Greene County Historical Journal, quarterly
Activities: Lect open to public, 3-5 vis lectr per year; concerts; tours; individual
paintings lent to other museums & occasionally to university galleries; lending
collection contains over 50 original prints & over 300 paintings; museum shop
sells books, antiques, collectables, memorabilia & old postcards

DOUGLASTON

A THE NATIONAL ART LEAGUE, 44-21 Douglaston Pky, Douglaston, NY
11363. Tel 718-229-9495, 718-224-3957; Elec Mail artworknal@aol.com; Internet
Home Page Address: www.nationalartleague.org; *VPres* Nat Bukar; *Pres* Robert
Stefani; *Corresp Secy* Mary Anne Klein
Open Mon - Fri 9 AM - 10PM, Sat 9 AM-5 PM; No admis fee; Estab 1930 to
unite for common interest in the study & practice of art; Mem: 300; dues $25;
monthly meetings 1st Fri every month 8 PM; Scholarships
Income: Financed by mem dues & contributions
Exhibitions: Six annual major shows, one national; gallery exhibitions
Publications: Brochures; bulletins; catalogs; Artworks newsletter, monthly
Activities: Art Classes for adults & children; demonstrations; monthly lect &
short courses; lect open to public, 10 vis lectr per year; gallery talks; competitions
with awards

EAST HAMPTON

L EAST HAMPTON LIBRARY, Pennypacker Long Island Collection, 159 Main
St, East Hampton, NY 11937. Tel 631-324-0222, Ext. 4; Fax 631-329-7184; Elec
Mail ehamlib@suffolk.lib.ny.us; Internet Home Page Address:
www.easthamptonlibrary.org; *Librn* Marci Vail; *Archivist* Steve Boerner
Open Mon - Tues & Thurs-Sat 1 PM - 4:30 PM, mornings by appointment; Estab
1930; Average Annual Attendance: 450
Income: (state, donations, fund raisers)
Library Holdings: Clipping Files; Exhibition Catalogs; Manuscripts; Maps;
Original Art Works; Original Documents; Pamphlets; Periodical Subscriptions;
Photographs; Prints
Special Subjects: Etchings & Engravings, Manuscripts, Maps, Historical Material,
Landscapes
Collections: Pennypacker Long Island Collection contains material relating to the
history & people of Long Island; Thomas Moran Biographical Art Collection
contains original pen & ink & pencil sketches by Thomas Moran, lithographs,
etchings & engravings by Moran & other members of the family, biographical
material, exhibit catalogues, books & pamphlets
Exhibitions: The Gardiner Family; rotating
Activities: Lect open to public; tours; sales shop sells books

M GUILD HALL OF EAST HAMPTON, INC, Guild Hall Museum, 158 Main St,
East Hampton, NY 11937. Tel 631-324-0806; Fax 631-329-5043; Elec Mail
museum@guildhall.org; Internet Home Page Address: www.guildhall.org; *Chmn*
Melville Strauss; *1st VChmn* Suzanne J Cartier; *2nd VChmn* Michael Lynne; *Treas*
M Bernard Aidinoff; *Cur* Christina Mossaides Strassfield; *Asst Cur & Registrar*
Maura Doyle; *Exec Dir* Ruth Appelhof
Open Winter - Spring Wed - Sat 11 AM - 5 PM, Sun Noon - 5 PM, Summer open
daily 11 AM - 5 PM, Fall same as Spring; No admis fee for members,
non-members $5; Estab 1931 as a cultural center for the visual & performing arts
with a State Board of Regents Educational Charter. Emphasis in art collection &
exhibitions is chiefly on the many artists who live or have lived in the area; Mus
has four galleries, art library & a sculpture garden; Average Annual Attendance:
80,000; Mem: 4000; dues $30-$2500; annual meeting in May
Income: $1,400,000 (financed by mem, federal, state, county & town
appropriations, corporate, foundation, individual contributions, benefits, fund
drives & mus shop)
Special Subjects: Painting-American, Photography, Prints, Sculpture
Collections: Focuses on American artists associated with the region of Eastern
Long Island, including James Brooks, Jimmy Ernst, Adolf Gottlieb, Childe
Hassam, William de Kooning, Roy Lichtenstein, Thomas Moran, Jackson Pollock,
Larry Rivers, as well as contemporary artists such as Eric Fischl, Donald Sultan &
Lynda Benglis, paintings,; works on paper, prints, photographs, sculpture
Publications: Newsletter, exhibition catalogues, annual report, monthly calendar
Activities: Classes for adults; docent training; cooperative projects with area
schools; lect open to public, 12 vis lectr per year; concerts; gallery talks; tours;
competitions; Academy of the Arts; original art objects lent to museums, libraries,
schools, public building; lending collection contains cassettes, original art works &
prints, paintings, photographs, sculpture, slides; book traveling exhibitions;
originate traveling exhibitions; museum shop sells mainly posters created for
Guild Hall by artists of region; also gift items and local crafts

EAST ISLIP

M ISLIP ART MUSEUM, 50 Irish Lane, East Islip, NY 11730-2098. Tel
631-224-5402; Fax 631-224-5417; Elec Mail info@islipartmuseum.org; Internet
Home Page Address: www.islipartmuseum.org; *Dir Coll & Exhib* Catherine
Valenza; *Cur* Karen Shaw; *Exec Dir* Mary Lou Cohalan; *Gift Shop Mgr* Margaret
Powers; *Registrar* Elizabeth Tonis; *Financial Dir* Susan Simmons; *Educ* Carolyn
Marx; *VChmn* Janette Messina
Open Wed - Sat 10 AM - 4 PM, Sun Noon-4 PM; No admis fee, suggested
donation $2; Estab 1973 for group showings of contemporary art from local &

city based artists; 3000 sq ft of exhibition space divided among 4 rooms & a hallway on the Brookwood Hall estate; Average Annual Attendance: 12,000; Mem: 500; dues $25-$5000

Income: $150,000 (financed by mem, city & state appropriation, & National Endowment for the Arts)

Exhibitions: Satellite Gallery & a Project Space

Publications: Exhibition brochures; Newsletter

Activities: Classes for adults & children; docent training; lect open to public, 15 vis lectr per year; gallery talks; tours; competitions with awards; museum shop sells books, handmade gifts, jewelry, original art, postcards, posters, reproductions

EAST OTTO

A **ASHFORD HOLLOW FOUNDATION FOR VISUAL & PERFORMING ARTS,** Griffis Sculpture Park, 6902 Mill Valley Rd, East Otto, NY 14729; 3953 N Buffalo Rd, Orchard Park, NY 14127. Tel 716-667-2808; Elec Mail griffispark@aol.com; Internet Home Page Address: www.griffispark.org; *Exec Dir* Simon Griffis; *Dir of Essex* Mark B Griffis

Open May - Oct 9 AM - dusk; Admis fee $5 adults, students & seniors, $3 children, free under 12; Estab 1966 to promote the visual & performing arts by sponsoring exhibitions & performances; Funds for the 400 acre sculpture park donated by Ruth Griffis in memory of her husband, L W Griffis Sr. The original park accommodates the work of Larry Griffis Jr. The expanded areas now include works of numerous other sculptors. Materials include welded steel, wood, aluminum & bronze, most of which has been cast at the Essex St Foundry. Sculpture park festival stage is an open-air platform for regional artist's performance of dance, music, poetry & drama; Average Annual Attendance: 30,000; Mem: 200

Income: $108,000 (financed by admissions fee, donations, mem, grants, programs & pub funds)

Exhibitions: Twelve distinctly different groups of work by Larry Griffis Jr are displayed

Publications: Brochure; postcards

Activities: Classes for adults & children; concerts; tours; 4 book travelling exhibitions per year; sales shop sells prints, original art, reproductions, metal sculptures; junior museum, Big Orbit, 30 Essex St, Buffalo, NY

ELMIRA

M **ARNOT ART MUSEUM,** 235 Lake St, Elmira, NY 14901. Tel 607-734-3697; Fax 607-734-5687; Internet Home Page Address: www.artotartmuseum.org; *Dir & Cur* John D O'Hern; *Registrar* Michael Sampson; *Pres (V)* Laurie Liberatore; *Cur Education* Karen Kucharski; *Dir Operations* Mary C. Hickey

Open Tues - Sat 10 AM - 5 PM, Sun 1 - 5 PM, cl Mon & national holidays; Admis Tues - Fri $5 adults, $4 seniors, Sat & Sun no admis fee; Estab 1913 with the permanent collection of Matthias H Arnot consisting of 17th to 19th century European art & housed in his 1890's Picture Gallery the collection now includes 19th & 20th century American art & a growing collection of comtemporary representational art; Mem: 850; dues $25 & up

Special Subjects: Painting-American, Bronzes, Ceramics, Etchings & Engravings, Asian Art, Painting-British, Painting-Dutch, Painting-French, Painting-Flemish, Antiquities-Oriental, Painting-Italian, Antiquities-Egyptian, Painting-German, Antiquities-Etruscan

Collections: American & European sculpture; Flemish, Dutch, French, English, German, Italian, Spanish & American & European paintings & works on paper; Matthias H Arnot Collection, permanent installation in restored picture gallery, Contemporary representational work

Exhibitions: Annual Regional Art Exhibition with prizes; Annual Arts & Crafts Exhibition with prizes; Representing Representation 5

Publications: Books; catalogs

Activities: Classes for adults & children, two wk summer adult painting school, docent training, & outreach programs for community groups through educ center; lect & gallery talks open to public; tours; competitions; individual paintings lent; book traveling exhibitions; originate traveling exhibitions to US museums; museum shop sells books, catalogues, original art & craft work, reproductions, slides, prints

M **ELMIRA COLLEGE,** George Waters Gallery, One Park Pl, Elmira, NY 14901. Tel 607-735-1800; Fax 607-735-1723; Internet Home Page Address: www.elmira.edu; *Dir* Leslie Kramer

Open Tues - Sat 1 - 5 PM, cl Mon & Sun (varies); No admis fee; The Gallery is located in the Elmira Campus Center; Average Annual Attendance: 1,000

Income: Financed by school budget

Exhibitions: Annual Student Exhibition

FISHKILL

M **FISHKILL HISTORICAL SOCIETY,** Van Wyck Homestead Museum, 504 Route 9, Fishkill, NY 12524-0133; PO Box 133, Fishkill, NY 12524. Tel 845-896-9560; Elec Mail vanwyckhomestead@aol.com; Internet Home Page Address: www.pojonews.com; *Librn* Roy Jorgensen; *Pres* Jack Halie; *Librn* Mary Ann Ryan

Open weekdays by appointment, Weekends 1 - 5 PM (May 30 - Oct 30); No admis fee; Estab 1962; Hudson Valley Portraits, AMMI Phillips Portraits; Average Annual Attendance: 2,000; Mem: 500; dues $9 - $500

Library Holdings: Book Volumes 800; CD-ROMs; Cassettes 12; Clipping Files; Compact Disks; Maps; Original Documents; Other Holdings; Pamphlets; Photographs; Prints

Special Subjects: Drawings, Textiles, Architecture, Painting-American, Photography, Archaeology, Costumes, Folk Art, Decorative Arts, Portraits, Dolls, Furniture, Jewelry, Porcelain, Silver, Historical Material, Miniatures, Embroidery, Laces

Collections: Hudson Valley Portraits; Ammi Phillips Paintings; decorative arts; quilts; Decorative Arts, Local Silver, Forms

Activities: Classes for children; docent training; lect open to public; 3 vis lectrs per year; concerts; sales shop sales books, prints

FLUSHING

A **BOWNE HOUSE HISTORICAL SOCIETY,** 37-01 Bowne St, Flushing, NY 11354. Tel 718-359-0528; Internet Home Page Address: www.fieldtrip.com; *Pres* Douglas Bauer; *VPres* Dominick Alaggia; *Treas* Vincent Tsang; *Dir* Yvonne Engglezos

Open Tues, Sat & Sun 2:30 - 4:30 PM; Admis adults $2, senior citizens, students & children $1; Estab 1945 for historic preservation, educ, collection of 17th, 18th & 19th century furnishing & decorative & fine art. Examples of colonial life; Average Annual Attendance: 5,000; Mem: 620; dues $250, $100, $50, $25, $10; annual meeting third Tues in May

Income: Financed by mem, private & pub contributions

Collections: Furnishings from the 17th, 18th & early 19th centuries; Furniture, pewter, fabrics, china, portraits, prints & documents

Exhibitions: Photo Documentation of ongoing Restoration

Publications: Booklets regarding John Bowne & the House; quarterly newsletter

Activities: Classes for adults & children; docent training; lect open to public; museum shop sells books, reproductions, prints, slides, products of herb garden, plates & tiles

M **QUEENS COLLEGE, CITY UNIVERSITY OF NEW YORK,** Godwin-Ternbach Museum, 405 Klapper Hall, Flushing, NY 11367. Tel 718-997-4747; Fax 718-997-4734; Elec Mail amy-winter@qc.edu; Internet Home Page Address: www.qc.edu/art/gtmus.html; *Dir & Cur* Amy Winter; *Asst Dir* Nicole Janotte; *Registrar* Nancy Williams

Open Mon - Thurs 11 AM - 7 PM, Sat 11 AM - 5 PM; No admis fee; Estab 1957 for a study collection for Queens College students & in 1981 independently chartered; Collection located in one large exhibition gallery on Queens College Campus; Average Annual Attendance: 10,000; Mem: 60, dues $25

Income: Financed by state appropriation, Friends of the Mus, federal state & local grants

Special Subjects: Portraits, Drawings, Graphics, Hispanic Art, Latin American Art, Mexican Art, Painting-American, Photography, Prints, Sculpture, Watercolors, American Indian Art, Bronzes, African Art, Pre-Columbian Art, Textiles, Religious Art, Ceramics, Folk Art, Pottery, Primitive art, Woodcarvings, Woodcuts, Etchings & Engravings, Landscapes, Decorative Arts, Manuscripts, Painting-European, Posters, Eskimo Art, Furniture, Glass, Jade, Jewelry, Porcelain, Oriental Art, Asian Art, Antiquities-Byzantine, Marine Painting, Metalwork, Painting-British, Painting-Dutch, Carpets & Rugs, Historical Material, Ivory, Coins & Medals, Restorations, Baroque Art, Painting-Flemish, Renaissance Art, Embroidery, Medieval Art, Antiquities-Oriental, Painting-Spanish, Painting-Italian, Islamic Art, Antiquities-Egyptian, Antiquities-Greek, Antiquities-Roman, Mosaics, Cartoons, Stained Glass, Painting-German, Leather, Reproductions, Antiquities-Etruscan, Painting-Russian

Collections: Ancient & antique glass; Egyptian, Greek, Luristan antiquities, Old Master & WPA prints; Renaissance & later bronzes; 16th - 20th century paintings

Publications: Brochures, exhibition catalogs; newsletter; posters

Activities: Classes for adults & children; docent training; high school creative arts program; lect open to public, 20 lectr per yr; gallery talks; tours; concerts; individual paintings & original objects of art lent to qualified art organization & museums

M **Queens College Art Center,** 65-30 Kissena Blvd, Flushing, NY 11367. Tel 718-997-3770; Fax 718-997-3753; Elec Mail suzanna_simor@qc.edu; Internet Home Page Address: www.qc.edu/qclibrary/art/artlib.html; *Cur* Alexandra de Luise; *Dir* Dr Suzanna Simor; *Admin Asst* Mollie Moskowitz

Open Mon - Thurs 9 AM - 9 PM, Fri Noon - 5 PM (when school is in session); No admis fee; Estab 1937; Gallery presents a variety of exhibitions of modern & contemporary art in diverse media; Average Annual Attendance: 30,000

Income: financed by donations, grants

Collections: modern contemporary art

Publications: exhibition catalogues

Activities: Gallery talks; lect open to public, 3-4 vis lectr per year

L **Art Library,** 65-30 Kissena Blvd, Flushing, NY 11367. Tel 718-997-3770; Fax 718-997-3753; Elec Mail suzanna_simor@qc.edu; mmoskowi@qc1.qc.edu; Internet Home Page Address: www.gc.edu/gclibrary/art/artlib/html; *Art Librn* Alexandra de Luise; *Head* Dr Suzanna Simor; *Admin Asst* Mollie Moskowitz

Open Mon - Thurs 9 AM - 8 PM, Fri 9 AM - 5 PM when school is in session, Mon - Fri 9 AM - 5 PM other times; No admis fee; Estab 1937 to support instruction; Circ 40,000

Library Holdings: Book Volumes 69,000; CD-ROMs; Clipping Files; Fiche 2000; Lantern Slides; Other Holdings Exhibition catalogs & pamphlets 43,000; Pamphlets; Periodical Subscriptions 200; Photographs; Reels; Reproductions 55,000; Slides 15,000

Activities: Lending collection contains 69,000 books, 55,000 color reproductions, 43,000 exhibition catalogs & pamphlets & 15,000 slides

A **QUEENS HISTORICAL SOCIETY,** Kingsland Homestead, 143-35 37th Ave Flushing, NY 11354-5729. Tel 718-939-0647 ext 17; Fax 718-539-9885; Elec Mail info@queenshistoricalsociety.org; Internet Home Page Address: www.queenshistoricalsociety.org; *Exec Dir* Mitchell Grubler; *Coll Mgr* Richard Hourahan; *Program Coordr* Katrina Raben

Open Mon - Fri 9:30 AM - 5 PM (research appts) Museum: Tues, Sat - Sun 2:30 PM - 4:30 PM; Admis adults $3, seniors & students $2; Estab 1968 as a historical society to collect Queens history materials; First floor for changing exhibits, & permanent exhibit on Kingsland Homestead; second floor permanent Victorian parlor room; Maintains reference library/archives; Average Annual Attendance: 5,000; Mem: 600; dues business $100-$750, family $40, individual $15, students & seniors $10; annual meeting varies

Income: $150,000 (financed by mem, city & state appropriation)

Special Subjects: Costumes, Historical Material, Manuscripts, Photography, Textiles, Painting-American, Decorative Arts, Furniture, Period Rooms, Maps

Collections: photographs, postcards, maps & atlases, personal papers of Margaret Carman, King and Murray families, Doughty; textiles, furniture, decorative arts, ephemera

Exhibitions: Kingsland: From Homestead to House Museum
Publications: Quarterly newsletter; Angels of Deliverance, The Underground Railroad in Queens, Long Island, and Beyond; So this is Flushing, Flushing Freedom Mile; Friends of Freedom: The Underground Railroad in Queens and on Long Island
Activities: Educ program; classes for children; docent training; lect open to public; 10 vis lectrs per yr; concerts; gallery talks; tours; sponsoring for competitions; 4th grade art & history contest/Queensmark program; 1-2 book traveling exhibitions per yr; originate traveling exhibitions; museum shop sells books & postcards

M **THE QUEENS MUSEUM OF ART,** New York City Bldg, Flushing Meadows-Corona Park Flushing, NY 11368-3398. Tel 718-592-9700; Fax 718-592-5778; Internet Home Page Address: www.queensmuse.org; *Dir Exhib* Valerie Smith; *Dir Educ* Jean-Paul Maitinsky; *Controller* Julie Lou; *Pres* Robert M Brennan; *Exec Dir* Laurene Buckley; *Dir Develop* Andrea Couture
Open Tues - Fri 10 AM - 5 PM, Sat & Sun Noon - 5 PM, cl Mon; Admis adult $5, seniors & children $2.50, children under 5 & members free; Estab 1972 to provide a vital cultural center for the more than 2.5 million residents of Queens County; it provides changing, high-quality, fine art exhibitions & a wide-range of educational & public programs; Museum has approx 25,000 sq ft gallery space, The Panorama of New York City (9,335 sq ft architectural scale model of New York City), theatre, workshops, offices; Average Annual Attendance: 60,000; Mem: 700; dues family $55, individual $35, seniors & students $20
Income: $2,000,000 (financed by mem, city & state appropriation, corporate & foundation grants, earned income)
Collections: The Panorama of New York City (world's largest architectural scale model); Small collection of paintings, photographs & prints; Collection of materials from 1939 - 1940 & 1964 - 1965 New York World's Fairs
Exhibitions: Tiffany Art from the Egon & Hildegard Neustadt Museum of Tiffany Art (permanent display)
Publications: Catalogs; quarterly newsletter; Panorama brochure
Activities: Guided tours for adults & children; docent training; projects involving elementary school children; films; drop-in arts & crafts workshops on Sun during school year & certain weekdays in summer; lect open to public, 10 vis lectr per year; concerts; gallery talks; tours; competitions; satellite gallery at Bulova Corporate Center in Jackson Heights, NY; museum shop sells books, reproductions, prints, exhibition catalogs, children's items & 1939-40 & 1964-65 World's Fair memorabilia

FREDONIA

M **STATE UNIVERSITY OF NEW YORK COLLEGE AT FREDONIA,** M C Rockefeller Arts Center Gallery, Fredonia, NY 14063. Tel 716-673-3537; Internet Home Page Address: www.fredonia.edu; *Part-time Dir* Cynnie Gaasch; *Chairwoman* Mary Lee Lunde
Open Wed - Sun 2 - 8 PM; No admis fee; Estab 1963 and relocated in 1969 to new quarters designed by I M Pei and Partners; The gallery serves as a focal point of the campus, uniting the college with the community; Average Annual Attendance: 5,000
Income: Financed by state appropriation and student groups
Special Subjects: Architecture, Prints, Sculpture
Collections: Primarily 20 century American art and architectural archival material, with an emphasis on prints and sculpture
Exhibitions: Graduating Seniors I; Graduating Seniors II; Graduating Seniors III; curated & traveling shows
Activities: Individual paintings and original objects of art lent to offices and public lobbies on campus

GARDEN CITY

L **ADELPHI UNIVERSITY,** Fine & Performing Arts Library, South Ave, Garden City, NY 11530. Tel 516-877-3000; Fax 516-877-3592; *Performing Arts Librn* Gary Cantrell
Open Mon - Thurs 8:30 AM - 11 PM, Fri & Sat 10 AM - 6 PM, Sun Noon-Midnight; The Fine & Performing Arts Library builds print & nonprint collections & provides reference service in fine & applied arts, music, dance, theater, photography, university archives & special collections
Income: Financed by state appropriations & through the University
Library Holdings: Book Volumes 35,000; Cassettes; Exhibition Catalogs; Fiche; Filmstrips; Manuscripts; Memorabilia; Motion Pictures; Original Art Works; Other Holdings Original documents; Pamphlets; Periodical Subscriptions 125; Photographs; Prints; Records 9000; Reels; Reproductions; Slides 1500; Video Tapes 50
Collections: Americana; William Blake; Cuala Press; Expatriate Writers; Cobbett; Morley; Hauptmann; Whitman; University Archives; Spanish Civil War; Robert McMillian Papers; Christopher Morley
Exhibitions: 85 Golden Florins
Activities: Lect

M **NASSAU COMMUNITY COLLEGE,** Firehouse Art Gallery, 1 Education Dr Garden City, NY 11530. Tel 516-572-7165; Fax 516-572-7302; Internet Home Page Address: www.art.sunynassau.edu/firehouse/; *Dir* Lisa Jaye Young; *Cur* Meg Oliveri; *Cur* Lynn Rozzi Casey
Estab 1964 to exhibit fine art & varied media; Two exhibition spaces, carpeted with track lighting
Income: Financed by state, college & county appropriation
Special Subjects: Prints, Sculpture
Collections: Painting; sculpture; prints; photography
Exhibitions: Invitational exhibits, national or regional competition; faculty & student exhibits per year
Activities: Lect open to public; competitions with awards

GARRISON

L **ALICE CURTIS DESMOND & HAMILTON FISH LIBRARY,** Hudson River Reference Collection, Routes 9D & 403, PO Box 265 Garrison, NY 10524. Tel 845-424-3020; Fax 845-424-4061; Elec Mail donick@highlands.com; Internet Home Page Address: www.dfl.highlands.com; *Library Dir* Carol Donick; Polly Townsend
Mon, Wed, Fri 10 AM - 5 PM, Tues & Thurs 2 - 9 PM, Sat 10 AM - 4 PM, Sun 1 - 5 PM ; No admis fee; Estab 1983
Library Holdings: Book Volumes 18,000; Kodachrome Transparencies 1,000; Periodical Subscriptions 100
Special Subjects: Art History, Landscape Architecture, Photography, Painting-American, Art Education, Restoration & Conservation, Landscapes, Dioramas, Display
Collections: Slide Archive: Hudson River views in 19th century painting
Exhibitions: Shows annually: Contemporary artists as well as Hudson River School Works
Activities: 4 vis lectrs per yr

GENESEO

M **LIVINGSTON COUNTY HISTORICAL SOCIETY,** Cobblestone Museum, 30 Center St, Geneseo, NY 14454. Tel 716-243-9147; Internet Home Page Address: www.livingstoncountyhistoricalsociety.org; *Treas* Wilfred Roffe; *Secy* David W Parish; *Research Secy* David Harter
Open May - Oct Sun & Thurs 2 - 5 PM; No admis fee; Estab 1876 to procure, protect & preserve Livingston County history; Average Annual Attendance: 1,500; Mem: 200; dues $10; meetings first Sun in Nov & May plus monthly programs
Income: $2,500 (financed by mem & donations)
Library Holdings: Clipping Files; Original Documents; Video Tapes
Special Subjects: Painting-American, Textiles, Pottery, Portraits, Posters, Dolls, Furniture, Glass, Silver, Pewter
Collections: China & Silver; Indian Artifacts; primitive tools; Shaker items; toy collection; war items; paintings of local landmarks & personalities
Publications: semi-ann newsletter
Activities: Classes for adults & children; work with col students at SUNY Geneseo; lect open to public, 6 vis lectr per year; sales shop sells maps, notepaper, coverlets, big tree pieces, historical society pins & magnets

M **STATE UNIVERSITY OF NEW YORK AT GENESEO,** Bertha V B Lederer Gallery, 1 College Circle Geneseo, NY 14454. Tel 716-245-5814; Fax 716-245-5815; *Dir* Douglas Anderson
Open 2 - 5 PM for exhibitions, Thurs 12 - 8 PM; No admis fee; Estab 1967; the gallery serves the college and community; Average Annual Attendance: 6,000
Income: Financed by state appropriation
Special Subjects: Graphics, Painting-American, Sculpture, Ceramics, Glass
Collections: Ceramics, furniture, graphics, paintings, sculpture
Exhibitions: Annual Student Art Exhibition
Activities: Lect open to public; lending collection contains 400-600 books

GLENS FALLS

M **HYDE COLLECTION TRUST,** 161 Warren St, Glens Falls, NY 12801. Tel 518-792-1761; Fax 518-792-9197; Internet Home Page Address: www.hydeartmuseum.org; *Dir* Randall Suffolk
Open Tues - Sat 10 AM - 5 PM, Thurs 10 AM - 7 PM, Sun Noon - 5 PM; No admis fee, call for guided tour information & cost; Estab 1952 to promote & cultivate the study & improvement of the fine arts; Historic house and modern wing with 4 temporary gallery spaces; Average Annual Attendance: 40,000; Mem: 1022; dues $15 - $5000
Income: Financed by endowment, mem, contributions, municipal support & grants
Special Subjects: Prints, Sculpture, Painting-European, Furniture, Tapestries, Painting-Italian
Collections: Works by Botticelli, da Vinci, Degas, Eakins, El Greco, Hassam, Homer, Matisse, Picasso, Raphael, Rembrandt, Renoir, Rubens, Ryder, Tintoretto & others; furniture, sculpture, tapestries
Exhibitions: Nine temporary exhibitions throughout the year
Publications: Exhibit catalogs
Activities: Classes for adults & children; docent training; lect open to public; concerts; gallery talks upon request; tours; scholarships offered; original objects of art lent to accredited museums; originate traveling exhibitions; museum shop sells books, magazines, original art & reproductions

L **Library,** 161 Warren St, Glens Falls, NY 12801. Tel 518-792-1761; Fax 518-792-9197; Internet Home Page Address: www.hydeart.museum.org; *Dir* Randall Suffolk
Open Tues - Fri 10 AM - 5 PM; For reference only
Income: Financed by the Hyde Collection Trust
Library Holdings: Book Volumes 1000; Clipping Files; Exhibition Catalogs; Filmstrips; Memorabilia; Other Holdings Original documents 3000; Periodical Subscriptions 8; Photographs
Collections: Hyde Family Archives

HAMILTON

M **COLGATE UNIVERSITY,** Picker Art Gallery, Charles A Dana Arts Ctr, Hamilton, NY 13346-1398. Tel 315-228-7634; Fax 315-228-7932; Elec Mail spuleo@mail.colgate.edu; Internet Home Page Address: www.picker.colgate.edu; *Dir* Dewey F Mosby PhD; *Assoc Cur, Coll Mgr* Diane Butler; *Gallery Asst* Dawn Figueroa; *Data Entry Specialist* Michelle Van Auken
Open daily 10 AM - 5 PM; No admis fee; Estab 1966, as an educative adjunct to study in the fine arts & liberal arts curriculum; Building designed by architect Paul Rudolph; Average Annual Attendance: 20,000; Mem: 147; dues lifetime $5000, patron $1000, sustaining $500, supporting $100, sponsoring $50, contributing $25, student $10

Income: Financed by the University & Friends of the Visual Arts at Colgate
Purchases: French Romanesque Capital & Franco-Italian Gothic Oak Panel
Library Holdings: Exhibition Catalogs; Pamphlets; Photographs; Sculpture; Slides; Video Tapes
Special Subjects: Pre-Columbian Art, Woodcuts
Collections: Herman Collection of Modern Chinese Woodcuts; Gary M Hoffer '74 Memorial Photography Collection; Luis de Hoyos Collection of pre-Columbian Art; paintings; photographs; posters; prints; sculpture; Luther W. Brady: 20th-Century Painting & Sculpture; Harry Neigher Collection of Political Cartoons, 1928-1975; Pre-Columbian Art; New Photography by Rosella Bellusci
Publications: Annual report; bulletins; exhibition catalogs
Activities: Classes for adults & children; docent training; high school teaching seminars; lect open to public & some for members only; tours; accredited by American Association of Museums; gallery talks; individual paintings & original objects of art lent; book traveling exhibitions; originate traveling exhibitions; museum shop sells gallery journal

A **THE EXHIBITION ALLIANCE,** (Gallery Association of New York State) PO Box 345, Hamilton, NY 13346-0345. Tel 315-824-2510; Fax 315-824-1683; Elec Mail mail@exhibitionalliance.org; Internet Home Page Address: www.exhibitionalliance.org; *Designer* Ted Anderson; *Exec Dir* Donna Anderson; *Develop Dir* Jo Halstead
Estab 1972 to facilitate cooperation among exhibiting institution in state/region; Mem: 200; mem open to exhibiting organization; dues $100-$500

HEMPSTEAD

M **HOFSTRA UNIVERSITY,** Hofstra Museum, 112 Hofstra University, Hempstead, NY 11549. Tel 516-463-5672, 463-5673; Fax 516-463-4743; Elec Mail elgbel@hofstra.edu; Internet Home Page Address: www.hofstra.edu/museum; *Cur Coll* Elearnor Rait; *Registrar & Exhib Coordr* Karen Albert; *Dir* Beth E Levinthal; *Asst to Dir* Jennifer Perez
Open Tues - Fri, 10 AM - 5 PM, Sat & Sun 1 PM - 5 PM; No admis fee; Estab 1963; a university mus that serves the needs of its student body & the surrounding Nassau County community; Mus includes exhibition facilities; Average Annual Attendance: 12,000; Mem: 248; dues $50
Income: Financed by university, mem & grants
Library Holdings: Exhibition Catalogs
Special Subjects: Photography, African Art, Pre-Columbian Art, Painting-European, Painting-Japanese, Oriental Art
Collections: American paintings & prints; African, Pre-Columbian, New Guinea, Japanese & Indian art; 17th & 18th century European painting; contemporary prints, painting & photographs; outdoor sculpture
Exhibitions: Mother & Child: the Art of Henry Moore; Shapes of the Mind: African Art from L I Collections; People at Work: 17th Century Dutch Art; Seymour Lipton; 1979 - 1989: American, Italian, Mexican Art for the Collection of Francesco Pellizzi; The Coming of Age of America: The First Decades of the Sculptors Guild; The Transparent Thread: Asian Philosophy in Recent American Art.; Street Scenes: 1930's - '50's; Leonard Bramer's Drawing of the 17th Century Dutch Life; T.V. Sculpture; R.B. Kitaj (Art and Literature); Indian Miniatures; Maelstrom; Preserving Our Heritage: The Realm of the Coin; Money in Contemporary Art; Appeasing the Spirits: Sui and Early Tang Tomb Sculpture from the Schloss Collection; The Butcher, The Baker, The Candlestick Maker; Jan Luyken's Mirrors of 17th Century Dutch Daily Life; Poster: The Art of 10 Masters; Rodin's Gates to Hell; Breaking the Wall of Bias: Art from Survivors; Paul Jenkins: The Early Years in Paris & New York; Moby Dick Art; Euclid to E-Books: Ideal Books Moving Ideas; Voiceless in the Presence of Realities: 9/11/01 Remembrances from the Long Island Studies Institute; Baile y Musica
Publications: Exhibition catalogs; catalogs available for all of the above listings
Activities: Classes for adults & children; lect open to public, 4 vis lectr per year; gallery talks; tours for school groups & community organizations; exhibitions related to scholarly conferences; lending of original objects of art; organize small traveling exhibitions to other museums & universities; mus shop sells books, prints, games, jewelry

HEWLETT

L **HEWLETT-WOODMERE PUBLIC LIBRARY,** 1125 Broadway, Hewlett, NY 11557. Tel 516-374-1967; Fax 516-569-1229; Internet Home Page Address: www.nassaulibrary.org/hewlett/index.html; *Art Librn* Nancy Delin; *Dir* Susan DeSciora
Open Mon - Thurs 9 AM - 9 PM, Fri 9 AM - 6 PM, Sat 9 AM - 5 PM, Sun 12:30 - 5 PM (except summer); Estab 1947 as a Co-Center for art & music; Gallery maintained
Income: Financed by state appropriation & school district
Library Holdings: Book Volumes 200,000; CD-ROMs; Cassettes; Compact Disks; DVDs; Exhibition Catalogs; Motion Pictures; Pamphlets; Periodical Subscriptions 520; Photographs; Records; Reels; Slides; Video Tapes
Special Subjects: Film, Photography, Crafts, Architecture
Exhibitions: Hold local exhibits
Publications: Index to Art Reproductions in Books (Scarecrow Press)
Activities: Classes for adults & children; lect open to the public; concerts; gallery talks; tours

HOWES CAVE

M **IROQUOIS INDIAN MUSEUM,** 324 Caverns Rd, PO Box 7 Howes Cave, NY 12092. Tel 518-296-8949; Fax 518-296-8955; Elec Mail info@iroquoismuseum.org; Internet Home Page Address: www.iroquoismuseum.org; *Dir* Erynne Ansel; *Acting Dir* John P Ferguson; *Chmn* Larry Joyce; *Educator* Mike Tarbell; *Cur* Steph Shultes
Open Tues - Sat 10 AM - 5 PM, Sun 12 - 5; closed Jan, Feb, Mar; Admis adults $7, senior citizens & students 13 -17 $5.50, children 5 -12 $4; Estab 1980 to teach about Iroquois culture today & in the past; Exhibits follow a time line from the

earliest times to present day. Archaeology exhibits trace the development of native culture from the time of Paleo-Indians (8000 BC) through the 1700s, when the Iroquois & colonists lived side-by-side in the Schoharie Valley; Average Annual Attendance: 23,000; Mem: 900; dues donor $100, family $35, individual & senior couple $25, single seniors $20
Income: $300,000 (financed by mem, admis, sales shop, fundraising & grants)
Special Subjects: American Indian Art, Anthropology, Historical Material, Landscapes, Pottery, Textiles, Maps, Sculpture, Archaeology, Ethnology, Costumes, Crafts, Woodcarvings, Furniture, Jewelry, Silver, Scrimshaw, Juvenile Art, Coins & Medals, Leather
Collections: Historic beadwork & cornhusk work; extensive collection of contemporary art (painting & sculpture) & crafts (baskets, woodwork items & beadwork); Paleo Indian to 18th century artifacts mainly from known sites in Schoharie County, NY
Exhibitions: Indian Stereotypes as External Avatars.; Art on the Longhouse Wall; Excellence in Iroquis Arts Award
Publications: Exhibition catalogs; Museum Notes, quarterly
Activities: Classes for adults & children; school programs; docent training; lect open to public, 4 vis lectr per year; awards; internships offered; exten dept includes lending collection; museum shop sells books, prints, magazines, reproductions & original art; Iroquois Indian Children's Museum

HUDSON

M **OLANA STATE HISTORIC SITE,** 5720 State Route 9-G, Hudson, NY 12534. Tel 518-828-0135; Fax 518-828-6742; Elec Mail linda.mclean@oprhp.state; Internet Home Page Address: www.olana.org; *Historic Site Mgr* Linda McLean; *Head Educ* Allan Weinreb; *Historic Site Asst* Geraldine Weidel; *Cur* Evelyn Trebilcock; *Archivist & Librn* Ida Brier; *VPres The Olana* Kay Toll; *Mus Shop Mgr* Nancy Williams; *Supervising Docent* Georgette Turner; *Asst Cur* Valerie Balint; *CEO The Olana* Sara Griffen
Open Wed - Sun 10 AM - 5 PM, by tour only (Apr 1 - Oct 31); Admis adult $3, senior citizens $2, children 5-12 $1; Opened as historic house museum 1966 to promote interest in & disseminate information of life, works & times of Frederic Edwin Church, landscape painter of the Hudson River School; The building is a Persian-style residence overlooking the Hudson River; Average Annual Attendance: House 27,000; Grounds 200,000; Mem: 700; dues $25 - $5000; annual meeting June
Income: Financed by state appropriation & The Olana Partnership
Special Subjects: Architecture, Drawings, Painting-American, Prints, Sculpture, Textiles, Ceramics, Pottery, Woodcarvings, Painting-European, Furniture, Silver, Metalwork
Collections: Extensive 19th Century Furniture Collection; oil sketches & drawings by Church; paintings by Church and other artists; Textile Collection; decorative arts, Orientalism; photographs
Publications: The Crayon, quarterly (journal produced by the Olana Partnership)
Activities: Classes for adults & children; docent training; lect open to public, 3-4 vis lectr per year; concerts; gallery talks; tours; slide programs; summer arts camp; exten dept with outreach programs, individual paintings & original objects of art lent to other museums & galleries; museum shop sells books & reproductions

L **Library,** 5720 Route 9-G, Hudson, NY 12534. Tel 518-828-0135; Fax 518-828-6742; Internet Home Page Address: www.nysparks.com; *Historic Site Mgr* Linda E McLean; *Cur* Evelyn Trebilcock; *Hist Site Asst* Geraldine Weidel; *Pres Olana Partnership* Sara Griffen
Open Apr - Oct 10 AM - 5 PM, Nov 10 AM - 4 PM, Dec holiday prog, Weekend Jan - Mar; Admis adult $7, senior $5, under 5 free; Estab in 1968 as historic house museum with library; Open to the pub with approval of Site Manager; for reference only; Average Annual Attendance: 24,611; Mem: 400
Library Holdings: Clipping Files; Exhibition Catalogs 10; Manuscripts; Memorabilia 200; Original Art Works; Original Documents; Photographs; Prints
Special Subjects: Painting-American, Pre-Columbian Art, Sculpture, Furniture, Mexican Art, Period Rooms, Antiquities-Persian, Textiles, Landscapes, Antiquities-Greek, Woodcarvings
Collections: Family papers, photographs, books, correspondence diaries, receipts
Publications: Crayon, quarterly
Activities: Classes for adults & children; docent training; lects open to public; concerts; tours; museum shops sells books, reproductions, prints

HUNTINGTON

M **HECKSCHER MUSEUM OF ART,** 2 Prime Ave, Huntington, NY 11743-7702. Tel 631-351-3250; Fax 631-423-2145; Elec Mail info@heckscher.org; Internet Home Page Address: www.hecksher.org; *VChmn* Catherine A Jansen; *CEO* Beth E Levinthal; *Registrar* William Titus; *Chief Cur* Anne DePietro; *Dir Educ* Jodi Lekacos; *Development Coordr* Susan Hirschstein; *Mus Shop Mgr* Hilde Schroter; *Office Mgr* Nancy O'Brien; *Dir Finance & Human Resources* Elaine Pathe
Open Tues 10 AM - 5 PM, Sat & Sun 1 - 5 PM, cl Mon & holidays; No admis fee, suggested donation adults $5, seniors & students $3, children 6-12 $1, mems free; Estab 1920, incorporated 1957, for the maintenance, preservation & operation of the mus building together with the preservation, exhibition & display of all objects & works of art therein; Four galleries, each 20 x 40 ft with 15 ft ceilings, track incandescent & diffused ultraviolet-free fluorescent lighting. Two galleries are used for changing exhibition & two for permanent collections; Average Annual Attendance: 45,000; Mem: 1000; dues $25 & up; annual meeting in June
Income: $979,735 (financed by endowment, mem, town appropriations & grants)
Special Subjects: Drawings, Graphics, Painting-American, Photography, Prints, Watercolors, Painting-European, Marine Painting, Painting-British, Painting-Dutch, Painting-French, Painting-Flemish, Painting-German
Collections: Permanent collection includes 1800 pieces; major works by the Moran family, George Grosz, Lucas Cranach the Elder, R A Blakelock, Arthur Dove, Helen Torr, Thomas Eakins, James M & William Hart, Asher B Durand, Esphyr Slobodkina Research & Study Center, paintings, sculptures, drawings & preparatory sketches; paintings, sculpture, drawings & prints by 16th-20th century artists, primarily American with some European; Baker/Pisano Collection; Newsday Center for Dove/Torr Studies

Exhibitions: Millennium Messages (time capsules by leading artists, architects & designers); Shaping A Generation: The Art & Artists of Betty Parsons; regional artists are featured in contemporary exhibition catalogs; Aaron Copland's America; Light Color, Spirit: Esteban Vicente; Living with Art: Early American Modernism from the Baker/Pisano Collection of the Heckscher Museum of Art; Out of the Shadows: Helen Torr, A Retrospective; The Golden Age of American Impressionism
Publications: Bi-monthly newsletter; On View, bi-monthly calendar of events; Family gallery guides in English and Spanish; Educator resource packets; Catalog of the collections; exhibition
Activities: Classes for adults & children; docent training; lect open to public, 15 vis lectr per year; concerts; gallery talks; tours; awards given; individual paintings lent to scholarly museum exhibitions; book traveling exhibitions 2-3 per year; originate traveling exhibitions to other museums & university galleries; museum shop sells books, reproductions, prints, stationery, playing cards, jewelry, children's games, toys & memorabilia

L **Library,** 2 Prime Ave, Huntington, NY 11743-7702. Tel 631-351-3250; Fax 631-423-2145; Elec Mail info@heckscher.org; Internet Home Page Address: www.heckscher.org; *Exec Dir* Beth E Levinthal
Libr open by appointment only; Estab to provide range of research materials & unique resources; Open to researchers & pub. For reference only
Income: $979,735 (financed by endowment, mem, town appropriation & grants)
Library Holdings: Auction Catalogs; Book Volumes 3803; Cards; Clipping Files; Exhibition Catalogs; Memorabilia; Pamphlets; Periodical Subscriptions 2; Reproductions; Slides
Special Subjects: Photography, Painting-American, Painting-British, Painting-Dutch, Painting-Flemish, Painting-French, Painting-German, Prints, Painting-European
Collections: Major works by the Moran family, George Grosz, Lucas Cranach the Elder, R A Blakelock, Arthur Dove, Helen Torr, Thomas Eakins, James M & William Hart, Asher B Durand, Esphyr Slobodkins Research & Study Center, paintings, sculptures, drawings & preparatory sketches
Exhibitions: The Art of Thomas Anshutz; Baudelaire's Voyages: The Poet & His Painters; The Collector's Eye: American Art from Long Island Collections; Coney Island to Caumsett: 50 years of Photography by N Jay Jaffee; Garden of Earthly Delights; Hunnington Township Art League Island Artists Exhibition; INSIGHTS Ron Schwerin: Paintings & Studies; Millennium Messages (time capsules by leading artists, architects & designers); Shaping a Generation: The Art & Artists of Betty Parsons; regional artists are featured in contemporary exhibitions
Publications: Bi-monthly newsletter; On Vie, bi-monthly calendar of events; Family Gallery Guides; Educator Resource Packets; Catalog of the collection; exhibition catalogs
Activities: Junior docent programs; Long Island's Best: Young Artitst at the Heckscher annual juried high school exhibition; Art After School Program

HYDE PARK

M **NATIONAL ARCHIVES & RECORDS ADMINISTRATION,** Franklin D Roosevelt Museum, 511 Albany Post Rd, Hyde Park, NY 12538. Tel 845-229-8114; Fax 845-229-0872; Elec Mail library@roosevelt.nara.gov; *Dir* Cynthia Koch, PhD
Open daily 9 AM - 6 PM, (Nov - Apr), 9 AM - 5 PM (Apr - Oct); Admis adults $10 for combination ticket to the Roosevelt Home & Museum, children under 16 free; Estab 1939; contains displays on President & Mrs Roosevelt's lives, careers & special interests, including personal items, gifts & items collected by President Roosevelt; Average Annual Attendance: 175,000
Income: $1,002,000 (financed by congressional appropriation, trust fund)
Purchases: $154,000
Special Subjects: Historical Material
Collections: Papers of President & Mrs Roosevelt & of various members of his administration; prints, paintings & documents on the Hudson Valley; paintings, prints, ship models, documents & relics of the history of the United States Navy as well as other marine items; early juvenile books
Publications: The Museum of The Franklin D Roosevelt Library; Historical Materials in the Franklin D Roosevelt Library; The Era of Franklin D Roosevelt
Activities: Classes for adults & children; docent training; lect open to public; gallery talks; tours to school groups competitions with prizes; scholarships & fels offered; individual paintings & original objects of art lent to museums; lending collection contains 23,000 artifacts; sales shop sells books, prints, reproductions & slides

L **Franklin D Roosevelt Library,** 4079 Albany Post Rd, Hyde Park, NY 12538. Tel 845-486-7760; Fax 845-486-1147; Elec Mail library@roosevelt.nara.gov; Internet Home Page Address: www.fdrlibrary.marist.edu; *Dir* Cynthia M Koch, PhD; *Deputy Dir* Mark Hunt; *Cur* Herman Eberhardt
Open May - Oct 9 AM - 6 PM, Nov - Apr 9 AM - 5 PM, cl Thanksgiving, Christmas & New Year's Day; Combination ticket for FDR Museum and home $14; Estab 1939 to preserve, interpret & make available for research archives & memorabilia relating to Franklin & Eleanor Roosevelt, their families & associates; Average Annual Attendance: 120,000
Income: Financed by Federal government & trust fund
Library Holdings: Audio Tapes; Cassettes; Clipping Files 500; Exhibition Catalogs; Fiche; Filmstrips; Manuscripts; Memorabilia 300; Motion Pictures; Original Art Works; Other Holdings Broadsides; Newspapers; Maps; Pamphlets; Photographs 200; Prints; Records; Reels; Sculpture; Slides; Video Tapes
Special Subjects: Posters, Pre-Columbian Art, Prints, Sculpture, Portraits, Silver, Textiles, Scrimshaw
Collections: Naval history; Hudson River Valley history; early juvenile books; illustrated ornithology; Eleanor and Franklin Roosevelt; US History: 20th Century
Exhibitions: Permanent exhibitions on lives & times of Franklin & Eleanor Roosevelt
Publications: The Era of Franklin D Roosevelt: A Selected Bibliography of Periodicals, Essays & Dissertation Literature, 1945-1971; Franklin D Roosevelt and Foreign Affairs
Activities: Education program; lect open to pub; museum shop sells books, reproductions, prints, slides, souvenir items

M **ROOSEVELT-VANDERBILT NATIONAL HISTORIC SITES,** 4097 Albany Post Rd, Hyde Park, NY 12538. Tel 845-229-9115; Fax 845-229-0739; Internet Home Page Address: www.nps.gov/hofr/home.htm; *Supt* Sarah Olson
Open daily 9 AM - 5 PM Apr - Oct, cl Tues & Wed Nov - Mar, cl Thanksgiving, Christmas & New Year's Day, Eleanor Roosevelt NHS open daily Nov, Dec, Mar & Apr, by appt only Thurs - Sun, Jan - Mar, Groups of 10 or more require reservations; Admis $1.50, under 16, over 62 & school groups free ; Vanderbilt Mansion NHS estab 1940; home of Franklin D Roosevelt NHS 1944; Eleanor Roosevelt NHS, 1977; Average Annual Attendance: 330,000
Income: Financed by Federal Government
Special Subjects: Decorative Arts
Collections: Vanderbilt & Home of FDR collections consist of original furnishings; Eleanor Roosevelt site collections are combination of originals, reproductions & like items
Exhibitions: Annual Christmas Exhibition; Antique Car Show
Publications: Vanderbilt Mansion, book; Art in the Home of Franklin D Roosevelt, brochure
Activities: Tours; sales shop sells books, postcards & slides

ITHACA

M **CORNELL UNIVERSITY,** Herbert F Johnson Museum of Art, Cornell University, Ithaca, NY 14853-4001. Tel 607-255-6464; Fax 607-255-9940; Elec Mail museum@cornell.edu; Internet Home Page Address: www.museum.cornell.edu; *Dir* Franklin W Robinson; *Sr Cur Prints, Drawings & Photographs* Nancy E Green; *Chief Cur & Cur Asian Art* Ellen Avril; *Registrar* Matthew Conway; *Dir for Develop* Marrie Neumer; *Publicity & Publications Coordr* Andrea Potochniak; *Chief Adminr & Human Resources Assoc* Cheryl L H Muka; *Assoc Dir Fin & Admin* Peter Gould; *Assoc Dir & Cur Educ* Cathy Klimaszowski; *Cur Modern & Contemporary Art* Andrea Inselmann; *Asst Cur & Master Teacher* Andrew Weislogel
Open Tues - Sun 10 AM - 5 PM, cl Mon; No admis fee; Estab 1973, replacing the Andrew Dickson White Mus of Art, originally founded in 1953 as Cornell University's Art Mus to serve students, the Tompkins County community & the Finger Lakes region; The collection & galleries are housed in an I M Pei designed building on Cornell University campus overlooking downtown Ithaca & Cayuga Lake; Average Annual Attendance: Approx 80,000; Mem: 650; dues $20 - $5000
Income: Financed by endowment, mem, grants & university funds
Special Subjects: Drawings, Painting-American, Photography, Prints, Sculpture, Watercolors, African Art, Ethnology, Pre-Columbian Art, Primitive art, Woodcuts, Painting-European, Asian Art, Coins & Medals, Painting-German
Collections: Asian art; arts of ethnographic societies; European & American paintings, drawings, sculpture, graphic arts, photographs, video
Publications: Collections handbook; exhibition catalogs; seasonal newsletter; annual report; gallery brochure
Activities: Workshops for adults & children; residency programs for artists; lect open to public, 5-10 vis lectr per year; gallery talks; tours; individual paintings & original objects of art lent to other institutions for special exhibition; originate traveling exhibitions; museum shop sells exhibition catalogs, postcards & notecards

L **Fine Arts Library,** Sibley Dome, Ithaca, NY 14853. Tel 607-255-3710; Fax 607-255-6718; Elec Mail fineartsref@cornell.edu; Internet Home Page Address: www.library.cornell.edu/finearts/; *Fine Arts Librn* Martha Walker
Open Sat 10 AM - 5 PM, Sun 1 - 11 PM, Mon - Thurs 9 AM - 11 PM, Fri 9 AM - 6 PM, hrs change for University vacation & summer session; No admis fee; Estab 1871 to serve Cornell students; Circ 68,006
Income: Financed through University funds
Purchases: $195,000
Library Holdings: Auction Catalogs; Book Volumes 207,000; CD-ROMs; Clipping Files; DVDs; Exhibition Catalogs; Fiche 5928; Periodical Subscriptions 1400; Reels 424; Video Tapes
Special Subjects: Art History, Landscape Architecture, Architecture

M **DEWITT HISTORICAL SOCIETY OF TOMPKINS COUNTY,** The History Center in Tompkins Co, 401 E State St, Ste 100, Ithaca, NY 14850. Tel 607-273-8284; Fax 607-273-6107; Elec Mail dhs@lakenet.org; Internet Home Page Address: www.lakenet.org/dewitt; *Exec Dir* Matthew Brazun
Open Tues, Thurs, & Sat 11 AM - 5 PM; No admis fee; Estab 1935 to collect, preserve & interpret the history of Tompkins County, New York; 2,000 sq ft; Average Annual Attendance: 6,000; Mem: 750; gifts $35 and up; annual meeting in last quarter
Income: $280,000 (financed by endowment, mem, county appropriation, state & federal grants, earned income & foundations)
Special Subjects: Architecture, Painting-American, Photography, Watercolors, American Indian Art, Anthropology, Archaeology, Ethnology, Textiles, Costumes, Crafts, Landscapes, Decorative Arts, Portraits, Posters, Furniture, Glass, Stained Glass
Collections: Decorative arts; local historical objects; painting & sketches by local artists; portraits; photographers - Louise Boyle, Joseph Burritt, Curt Foerster, Charles Howes, Charles Jones, Henry Head, Robert Head, Verne Morton, Sheldon Smith, John Spires, Trevor Teele, Marion Wesp
Exhibitions: Five to six rotating exhibitions per yr
Publications: The History Center Newsletter, quarterly; Calender & Newsnotes
Activities: Classes for adults & children; lect open to public, 12 vis lectr per year; museum shop sells books, reproductions of photographs; gift items

M **HINCKLEY FOUNDATION MUSEUM,** 410 E Seneca St, Ithaca, NY 14850. Tel 607-273-7053; *Dir* Macleah Carlisle
Open Sat 10 AM - 4 PM & by appointment; Admis donations accepted; Estab 1970 to collect & preserve 18th, 19th & early 20th century domestic, decorative & folk arts artifacts; One main gallery with three small galleries; Average Annual Attendance: 500; Mem: 150; dues family $15, individual $10; annual meeting in Mar
Income: $19,000 (financed by endowment, mem, grants & rent)
Purchases: 19th century washing machine, c1870 log cabin quilt; three bonnets
Special Subjects: Folk Art, Decorative Arts

Collections: Clothing; lighting devices; pewter; quilts; toys; trivets
Exhibitions: Toys
Activities: Classes for children; lect open to public, 1-2 vis lectr per year; lending collection contains approx 20 art objects; book traveling exhibition 1 per year; retail store sells books

M **ITHACA COLLEGE,** Handwerker Gallery of Art, 1170 Gannett Ctr, Ithaca, NY 14850-7276. Tel 607-274-3548; Fax 607-274-1774; Elec Mail jstojanovic@ithaca.edu; Internet Home Page Address: www.ithaca.edu; *Dir* Jelena Stojanovic; *Chmn Art History* Steven Clancy
Open Mon - Wed & Fri 10 AM - 6 PM, Thurs 10 AM - 9 PM, Sat 10 AM - 2 PM, Sun 2 - 6 PM; No admis fee; Estab 1978 for display of contemporary art & critical interpretation of image; Average Annual Attendance: 7,500
Collections: African Art, Photographs, Pre-Columbian Art, 20th Century Graphic Art
Publications: Quarterly newsletter
Activities: Critical forum; lect open to public 4 vis lectr per year

JACKSON HEIGHTS

A **OLLANTAY CENTER FOR THE ARTS,** PO Box 720636, Jackson Heights, NY 11372-0636. Tel 718-699-6772; Fax 718-699-6773; Elec Mail ollantaypm@aol.com; Internet Home Page Address: www.ollantaycenterforthearts.org; *Exec Dir* Pedro Monge-Rafuls
Estab 1977 as an Hispanic Art Heritage Center
Income: Financed by city & state appropriations, pub donations & NEA
Collections: Latino Arts Archives
Publications: Biennial journal; Ollantay Press books-Latino writers
Activities: Dramatic programs, conferences, seminars, workshops 2-3 per year

JAMAICA

M **JAMAICA CENTER FOR ARTS & LEARNING (JCAL),** 161-04 Jamaica Ave, Jamaica, NY 11432. Tel 718-658-7400; Fax 718-658-7922; Internet Home Page Address: www.jcal.org; *Dir External Affairs* Hasie Sirisena; *Deputy Dir Educ* Shirley Taylor; *Mgr External Affairs* Harlan Chaney; *Dir Operations* Anita Segarra; *Prog Dir* Alan Lynes; *Assoc Cur Performance* Blanca Vasquez; *Board Pres* Mark V Monteverdi; *Dir Finance & Admin* Jennifer Chiang; *Cur Visual Arts* Heng-Gil Han; *Exec Dir* Alexander Campos
Open Mon - Thurs 9 AM - 9 PM, Fri 9 AM - 6 PM, Sat 9 AM - 5 PM; No admis fee; Estab 1972 to provide educational opportunity in the visual & performing arts, exhibitions & performances; Five story landmark building; workshop studios for painting, drawing, maskmaking, ceramics, silkscreen & photography; 3 dance studios; 1 art gallery; 99 seat state-of-the-art theatre; 1 multi-purpose space; 1 computer lab; 1 toddler studio; 1 multi-media studio; Average Annual Attendance: 65,000
Income: $1,600,000 (financed by New York City Department of Cultural Affairs, New York State Council on the Arts, Honorable Claire Shulman, Queens Borough President, foundations, corporations & workshop tuitions)
Exhibitions: Up to 12 changing exhibitions annually in three museum quality galleries
Publications: Exhibition catalogs & posters
Activities: Classes for adults & children; dramatic programs; concerts; gallery talks; tours; competitions; scholarships offered; exten dept serves New York City; photographs & blow ups of original photographs lent; book traveling exhibitions annually

L **QUEENS BOROUGH PUBLIC LIBRARY,** Fine Arts & Recreation Division, 89-11 Merrick Blvd, Jamaica, NY 11432. Tel 718-990-0755; Fax 718-658-8342; Elec Mail username@queens.lib.ny.us; *Div Mgr* Esther Lee; *Asst Mgr* Rebecca Wilkins
Open Mon - Fri 10 AM - 9 PM, Sat 10 AM - 5:30 PM, Sun, Sept - May, Noon - 5 PM; No admis fee; Estab 1933 to serve the general public in Queens, New York
Income: Financed by city & state appropriations
Library Holdings: Audio Tapes; Book Volumes 150,000; CD-ROMs 270; Cassettes 10,500; Compact Disks 23,000; Pamphlets; Periodical Subscriptions 398; Photographs; Prints; Records 2000; Reels 4100; Reproductions 30,000; Video Tapes 20,000
Collections: The WPA Print Collection
Activities: Concerts

M **SAINT JOHN'S UNIVERSITY,** Chung-Cheng Art Gallery, Sun Yat Sen Hall, Grand Central & Utopia Parkways Jamaica, NY 11439; Sun Yat Sen Hall, 8000 Utopia Pkwy Queens, NY 11439. Tel 718-990-1526, 990-1521; Fax 718-990-1881; *Dir Gallery* Parvez Mohsin; *Admin Asst* Yacely Guerrero
Open Tues-Thurs 10AM-5PM, Fri 10AM-3PM, Sat 12PM-5PM; No admis fee; Estab 1977 to make available Oriental art objects to the pub & to expose the metropolitan area to the Oriental culture through various exhibits & activities; Gallery displays contemporary as well as ancient objects, mainly Oriental with a few western subjects & newer exhibits; national contemporary American artists; recently hosted Images from the Atomic Front; Average Annual Attendance: 50,000
Income: Financed by the University, endowments & private contributions
Special Subjects: Painting-Japanese, Jade, Porcelain, Oriental Art, Ivory, Calligraphy
Collections: Harry C Goebel Collection containing 595 pieces of rare & beautiful art objects dating from the 7th-19th century - jades; ivory carvings; netsuke; porcelains; lacquerware & paintings from Japan & China; permanent collection contains 700 pieces of Chinese porcelain, paintings, textiles, calligraphy & paper cuttings dating from 7th-20th century
Exhibitions: Two Great Textiles of Modern Chinese Paintings; The Chinese Ancient Coin Exhibit; Images from the Atomic Front; Power Animals: Artwork of Marshall Arisman
Publications: Exhibition catalogues

Activities: Lect open to public, 3 vis lectr per year; concerts; gallery talks; tours; competitions with awards; individual paintings & original objects of art lent; lending collection contains 200 original art works; original prints; 200 paintings; traveling exhibitions organized & circulated
　　—Asian Collection, Grand Central & Utopia Parkways, Jamaica, NY 11439; Sun Yat Sen Hall, 8000 Utopia Pkwy Queens, NY 11439. Tel 718-990-1526; Fax 718-990-1881; *Librn* Kenji Niki
Open to the pub for reference only
Library Holdings: Book Volumes 50,500; Cards; Exhibition Catalogs; Fiche; Manuscripts; Micro Print; Periodical Subscriptions 90; Reels
Collections: Collected Works of Chinese & Japanese Calligraphy; Japan Foundation Collection includes 200 volumes on various Japanese art subjects; Series of Chinese Arts

JAMESTOWN

L **JAMES PRENDERGAST LIBRARY ASSOCIATION,** 509 Cherry St, Jamestown, NY 14701. Tel 716-484-7135; Fax 716-483-6880; Elec Mail cway@cclslib.org; Internet Home Page Address: www.prendergastlibrary.org; *Gallery Coordr* Anne Plyler; *Dir* Catherine A Way
Open Mon - Tues & Thurs - Fri 10 AM - 8:30 PM, Wed 10 AM - 5 PM, Sat 10 AM - 4 PM; No admis fee; Estab 1891 as part of library; Circ 657,000; Maintains art gallery; Average Annual Attendance: 259,000; Mem: 43,375
Income: Financed by state & local funds
Library Holdings: Book Volumes 375,816; Cassettes 4,002; Compact Disks 3,203; DVDs 1,221; Maps 652; Original Art Works 60; Pamphlets 12,097; Periodical Subscriptions 359; Reproductions 37
Special Subjects: Prints
Collections: Prendergast paintings, 19th & 20th century paintings; Roger Tory Peterson, limited edition print collection; Alexander Calder mats
Exhibitions: Traveling Exhibitions; local one-person and group shows
Publications: Mirror Up To Nature, collection catalog
Activities: Classes for adults & children; lectures open to the public; concerts; competitions; lending collection contains books, cassettes, film strips, framed reproductions; books traveling exhibitions

M **JAMESTOWN COMMUNITY COLLEGE,** The Weeks, 525 Falconer St, Jamestown, NY 14701. Tel 716-665-9188; *Dir* James Colby
Open Tues - Wed & Fri - Sat 11 AM - 5 PM, Thurs 11 AM -l 7 PM; No admis fee; Estab 1969 to show significant regional, national & international contemporary art; Facility includes 2000 sq ft exhibition area
Income: $93,000 (financed through Faculty Student Association & private foundation funds)
Exhibitions: PhotoNominal
Publications: Exhibition catalogs, semiannual
Activities: Lect open to public, 200 vis lectr per year

KATONAH

M **CARAMOOR CENTER FOR MUSIC & THE ARTS, INC,** Caramoor House Museum, Girdle Ridge Rd, Katonah, NY 10536; PO Box 816, Katonah, NY 10536. Tel 914-232-5035, 232-1252 (Box office phone); Fax 914-232-5521; Elec Mail merceds@caramoor.org; Internet Home Page Address: www.caramoor.org; *Chmn Bd Trustees* Judy Evnin; *Mng Dir* Paul Rosenblum; *Devel Dir* Susan Shine; *CEO & Gen Dir* Michael Barrett; *Comptroller* Tammy Belanger-Turner; *Archivist* Hiton Bailey; *Dir Special Events* Melissa Montera
Open May - Oct Wed - Sun 1 PM - 4 PM, with last tour at 3 PM; Nov - Apr Mon - Fri by appt; Admis adults $9, children 16 & under free; Estab 1970 to preserve the house & its collections, the legacy of Walter T Rosen & to provide interpretive & educ programs; Period rooms from European palaces are showcase for art collection from Europe & the Orient, spanning 6 centuries; Average Annual Attendance: 60,000
Income: $365,000
Special Subjects: Photography, Sculpture, Bronzes, Textiles, Costumes, Religious Art, Ceramics, Decorative Arts, Manuscripts, Portraits, Furniture, Jade, Porcelain, Asian Art, Carpets & Rugs, Ivory, Tapestries, Renaissance Art, Period Rooms, Embroidery, Medieval Art, Painting-Italian, Stained Glass, Painting-German, Enamels
Collections: Period rooms - Fine & decorative arts from Europe & Asia (1400-1950); Tapestries; painitngs; sculpture; Urbino Maiolica; jade & cloisonné
Publications: Guidebook to collection; New book Caramoor
Activities: Classes for children; docent training; concerts; lect open to pub, 4 vis lectr per year; tours; museum shop sells books & original art, jewelry & other gift items

M **KATONAH MUSEUM OF ART,** Rte 22 at Jay St, Katonah, NY 10536. Tel 914-232-9555; Fax 914-232-3128; Internet Home Page Address: www.katonah-museum.org; *Pres* Yvonne Pollack; *VPres* Carole Alexander; *Treas* Lisabeth Stern; *Exec Dir* Neil Watson
Open Tues - Fri 1 - 5 PM, Sat 10 AM - 5 PM, Sun 1 - 5 PM, cl Mon; Admis non-mems $5, children under 12 free; Estab 1953 to present exhibitions created with loaned works of art, programs for schools, films, lectures, demonstrations & workshops; The Katonah Museum consists of 3000 sq ft of exhibition space with a sculpture garden and children's learning center; Average Annual Attendance: 50,000; Mem: 1400; dues $40 & up
Income: financed by mem, contributions & grants
Exhibitions: (2001) Jazz & Visual Improvisation; (2001) Juried Show: Breaking the Rules; (2001) Britain's Portable Empire: Campaign Furniture of the 18th & 19th Centuries; (2001) Horse Tales: 2 Centuries of American Cultural Icons
Publications: Exhibition catalogs; Forgotten Instruments, 1980; Many Trails: Indians of the Lower Hudson Valley, 1983; Shelter: Models of Native Ingenuity, 82
Activities: Classes for adults & children; docent training; teacher workshops; programs for schools; extensive educational programs for children; lect & films open to public, 2-10 vis lectr per year; gallery talks; tours; original paintings,

prints & photos lent; member school lending collection contains AV programs & slides; originate traveling exhibitions; museum shop sells books, reproductions, jewelry & gifts

M **NEW YORK STATE OFFICE OF PARKS RECREATION & HISTORIC PRESERVATION,** John Jay Homestead State Historic Site, 400 Rte 22, Katonah, NY 10536; PO Box 832, Katonah, NY 10536. Tel 914-232-5651; Fax 914-232-8085; Internet Home Page Address: www.johnjayhomestead.org; *Interpretive Progs Asst* Allan M Weinreb; *Historic Site Asst* W Steven Oakes
Open Tues- Sat 10 AM - 4 PM, Sun 11 AM - 4 PM, Apr - Nov; Admis adult $7, senior (62 & older) $5, children up to 12 yrs free; Estab 1958 to inform public on John Jay & his contributions to national, state & local history; Ten restored period rooms reflecting occupancy of the Jay family at its height; art distributed throughout; also on exhibit is the art studio of John Jay's great-great-great grandaughter, Eleanor Iselin Wade Mason; Average Annual Attendance: 25,000; Mem: 1000; Friends of John Jay Homestead, Inc; dues $25 & up; annual meeting in spring
Income: Financed by state appropriation
Library Holdings: Original Documents; Other Holdings; Photographs
Special Subjects: Painting-American, Photography, Textiles, Manuscripts, Portraits, Furniture, Silver, Historical Material, Maps, Restorations, Period Rooms, Reproductions
Collections: American art and American decorative arts; John Jay memorabilia and archives; Westchester mansion with estate & out-buildings; artworks & art-making tools of equestrian artist, Eleanor Iselin Mason Wade
Exhibitions: Federal Period Decorations; Period Home, Federal decor including art, decorative arts furnishings & memorabilia
Publications: John Jay and the Constitution, a Teacher's Guide; John Jay 1745-1829; The Jays of Bedford
Activities: Classes for adults & children; docent training; call for information; lect open to public; concerts; group tours by advance reservation; school on site and outreach; craft demonstrations; special exhibits; sale of books & prints

KENOZA LAKE

M **MAX HUTCHINSON'S SCULPTURE FIELDS,** Fulton Hill Rd, PO Box 94 Kenoza Lake, NY 12750. Tel 845-482-3669; Fax 845-482-3669; *Dir* Marion Kaselle
Open by appointment; No admis fee; Estab 1986 to exhibit large scale & outdoor sculpture; permanent & changing exhibits of sculpture mostly oriented to outdoor locations
Exhibitions: Eight sculptures by Charles Ginnever; individual works by Mel Chin, Linda Howard, Peter Barton, Jackie Ferrara, Ruth Hardinger, Henner Kuckuck, John Pohanka, Christy Rupp, Heidi Schlatter, William Tucker, Brian Wall, Robert Wick, Roger Williams
Activities: Original art sold

KINDERHOOK

M **COLUMBIA COUNTY HISTORICAL SOCIETY,** Columbia County Museum, 5 Albany Ave, PO Box 311 Kinderhook, NY 12106. Tel 518-758-9265; Fax 518-758-2499; Internet Home Page Address: www.cchsny.org; *Cur* Helen McLallen; *Exec Dir* Sharon S Palmer; *Educator* Ruth Ellen Berninger
Open Mon, Wed & Fri 10 AM - 4 PM, Sat 10 AM - 4 PM; No admis fee; Estab 1926/County Historical Society Museum Gallery with changing exhibits; 2 historic houses: 1737 Van Alen House & c1820 Vanderpoel House; In large hall, wall space 40 ft x 38 ft used for 3 exhibitions of paintings per yr; Average Annual Attendance: 12,000; Mem: 700; dues $30-1000; annual meeting third Sat in Oct
Income: $125,000 (financed by mem, endowment, activities, projects, events, private donations, admis, government & corporate grants)
Special Subjects: Painting-American, Sculpture, Decorative Arts, Furniture
Collections: Historical objects pertaining to history of county; New York regional decorative arts; furniture & costumes; paintings of 18th through 20th centuries
Exhibitions: Local history & cultural exhibits
Publications: Brochures; exhibit catalogs; quarterly newsletter
Activities: Classes for children; docent training; lect open to public; originate traveling exhibitions; museum shop sells books, gifts, prints
L **Library,** 5 Albany Ave, PO Box 311 Kinderhook, NY 12106. Tel 518-758-9265; Fax 518-758-2499; *Cur* Helen M McLallen; *Exec Dir* Sharon S Palmer
Open Mon, Wed & Fri 10 AM - 4 PM, Sat 1 - 4 PM; Estab 1926 to maintain research files on the county & regional history; For reference only
Library Holdings: Book Volumes 3300; Cassettes; Clipping Files; Exhibition Catalogs; Kodachrome Transparencies; Manuscripts; Memorabilia; Original Art Works; Pamphlets; Photographs; Prints; Slides
Special Subjects: Folk Art, Decorative Arts, Architecture
Collections: County & Regional history; Hudson Valley architecture; Dutch culture; Local & Regional paintings & decorative arts; Federalists

KINGSTON

M **FRIENDS OF HISTORIC KINGSTON,** Fred J Johnston House Museum, Corner of Main & Wall Sts, Kingston, NY 12401; PO Box 3763, Kingston, NY 12402. Tel 845-339-0720; Elec Mail fohk@verizon.net; Internet Home Page Address: www.fohk.org; *Dir* Jane Kellar; *Pred Board* Avery Leete Smith; *Pub Rels* Patricia Murphy
Open May - Oct Sat & Sun 1 - 4 PM & by appt; Admis adult $5, children $2; Estab 1965; Gallery of changing exhibs related to the city of Kingston's local history; house mus with period rooms; Average Annual Attendance: 5000 by estimate; Mem: dues Patron $500, Household $50, Student/Senior $10
Library Holdings: Book Volumes; Clipping Files; Kodachrome Transparencies; Manuscripts; Maps; Memorabilia; Original Art Works; Original Documents; Pamphlets; Photographs; Prints
Special Subjects: Drawings, Painting-American, Textiles, Ceramics, Decorative Arts, Painting-European, Period Rooms

Collections: 200 book vols on local history; items of local history for the city of Kingston, NY; 1,400 objects of American decorative arts
Exhibitions: (2005) Julia Dillon (1832-1909)
Publications: Friends of Historic Kingston, newsletter; Stockade District, walking tour brochure; Kingston New York: The Architectural Guide
Activities: Guided tours; lects; 1 vis lect per year; gallery talks; tours; temporary exhibs; mus shops sells books, prints

M **PALISADES INTERSTATE PARK COMMISSION,** Senate House State Historic Site, 296 Fair St, Kingston, NY; 312 Fair St, Kingston, NY 12401. Tel 914-338-2786; *Historic Site Mgr* Rich Goring
Open Apr - Oct Wed - Sat 10 AM - 5 PM, Sun 1 - 5 PM, Jan - Mar Sat 10 AM - 5 PM, Sun 1 - 5 PM; No admis fee; Estab 1887 as an educational community resource which tells the story of the growth of state government as well as the stories of the lives & works of local 19th century artists; Average Annual Attendance: 20,000
Special Subjects: Decorative Arts
Collections: 18th & 19th century decorative arts; 18th & 19th century paintings & other works of art, particularly those by James Bard, Jervis McEntee, Ammi Phillips, Joseph Tubb & John Vanderlyn
Publications: Exhibition catalogs
Activities: Classes for adults & children; docent training; lect open to public, 2 vis lectr per year; individual paintings & original objects of art lent to well-established institutions; lending collection contains color reproductions, original art works, original prints, paintings & sculptures; book traveling exhibitions
L **Reference Library,** 312 Fair St, Kingston, NY 12401. Tel 914-338-2786; *Historic Site Mgr* Rich Goring
Open Wed - Sat 10 AM - 5 PM, Sun 1 - 5 PM, cl Jan - Mar; Estab 1887; Open by appointment to scholars, students & researchers for reference only
Library Holdings: Book Volumes 10,000; Exhibition Catalogs; Manuscripts; Memorabilia; Pamphlets; Periodical Subscriptions 10
Collections: Collection of letters relating to the artist John Vanderlyn
Publications: Exhibit catalogs

LAKE GEORGE

M **LAKE GEORGE ARTS PROJECT,** Courthouse Gallery, Canada St, Lake George, NY 12845; One Amherst St, Lake George, NY 12845. Tel 518-668-2616; Fax 518-668-3050; Elec Mail mail@lakegeorgearts.org; Internet Home Page Address: www.lakegeorgearts.org; *Gallery Dir* Laura Von Rosk; *Dir* John Strong
Open Tues - Fri Noon - 5 PM, Sat Noon - 4 pm (during exhibitions); no admis fee; Estab 1977, gallery estab 1985 to provide income & exposure for national & regional artists; 26 ft by 30 ft; Average Annual Attendance: 400; Mem: 400; dues $20-$100; annual meeting in Dec
Income: $90,000 (financed by mem & by city & state appropriation)
Activities: Lectrs open to the public, gallery talks

LEROY

A **LEROY HISTORICAL SOCIETY,** 23 E Main St, LeRoy, NY 14482. Tel 716-768-7433; Fax 716-768-7579; Internet Home Page Address: www.iian.com/jellomuseum; *Dir* Lynne Belluscio
Open May - Oct Mon - Fri 1 - 4PM, Nov - Apr appointment only, Sun 2 - 4 PM; Admis adult $2, children $1; Estab 1940; Mem: 400; dues $18-$30; annual meeting in May
Income: financed by endowment, mem, city & state appropriations
Special Subjects: Drawings, Embroidery, Etchings & Engravings, Historical Material, Metalwork, Photography, Posters, Prints, Silver, Textiles, Watercolors, Painting-American, Pottery, Decorative Arts, Ceramics, Portraits, Dolls, Furniture, Glass, Laces, Jewelry, Period Rooms, Maps, Carpets & Rugs, Flasks & Bottles
Collections: Decorative Arts; Jell-O Museum; LeRoy related; 19th Century Art; Textiles; Tools; Western NY Redware
Publications: Quarterly newsletter
Activities: Classes for adults & children; docent training; lect open to public; tours; individual paintings & original objects of art lent to other museums; museum shop sells books & reproductions

LONG BEACH

L **LONG BEACH ART LEAGUE,** Long Beach Library, PO Box 862, Long Beach, NY 11561-0862. Tel 516-432-0195; Elec Mail mjmlido@aol.com; *Pres* Mary Mendoza; *Co-Pres* Gloria Kay; *VPres* Betty Ender
No admis fee; Estab in 1952 by a group of interested resident artists Determined to form an organization to promote art activity & appreciation with emphasis on quality & exhibitions, demonstrations; Average Annual Attendance: 500 per week; Mem: 120; dues $20; meetings 1st Wed each month
Income: Member dues, donations
Exhibitions: North by South; 10 monthly exhibits
Publications: Exhibitions brochures; Monthly newsletter
Activities: Classes for adults; workshops; demonstrations; lect; 7 vis lectrs/demos per year; gallery talks; sponsoring of competitions; cash prizes; 5 member exhibits per year up to $200; 6 exhibits yearly

L **LONG BEACH PUBLIC LIBRARY,** 111 W Park Ave, Long Beach, NY 11561. Tel 516-432-7201; Fax 516-889-4641; Elec Mail lblibrary@hotmail.com; *Asst Dir* Laura Weir; *Bus & Vocations Librn* Theresa Cahill; *Dir* George Trepp
Open Oct - May Mon, Wed, Thurs 9 AM - 9 PM, Tues & Fri 9 AM - 6 PM, Sat 9 AM - 5 PM, Sun 1 - 5 PM; Estab 1928 to serve the community with information & services, including recreational, cultural & informational materials; The Long Beach Art Association in cooperation with the library presents monthly exhibits of all types of media

Library Holdings: Book Volumes 100,000; Cassettes; Fiche; Filmstrips; Memorabilia; Pamphlets; Periodical Subscriptions 300; Photographs; Records; Reels; Video Tapes
Collections: Local history; 300 photographs of Long Beach
Exhibitions: Local talent; membership shows; juried exhibitions
Publications: Monthly newsletter
Activities: Dramatic programs; lect open to public, 18-20 vis lectr per year; concerts; gallery talks; films; tours

LONG ISLAND CITY

A **BUSINESS COMMITTEE FOR THE ARTS, INC,** 29-27 41st Ave # 4, Long Island City, NY 11101-3304. Tel 718-482-9900; Fax 718-482-9911; Elec Mail jjedlicka@bcainc.org; Internet Home Page Address: www.bcainc.org; *Pres* Judith A Jedlicka; *Dir Pub Affairs* Alexandra K Mann; *Dir Mem* Theresa Graffagnino; *Dir Nat Progs* Leonora Merkel
Estab 1967 by David Rockefeller to encourage businesses to support the arts & provide them with the resources necessary to do so
Publications: The Art of Leadership; BCA Case Studies; BCA News; A BCA Report: 1993 Survey of Arts Organizations' Business Support; The BCA Report: 1995 National Survey of Business Support to the Arts; A BCA Report: 1996 Survey of Member Companies; A BCA Report: Foreign-Based Business Giving to American Arts Organizations; Business & the Arts: Building Partnerships for the Future; Business in the Arts Award Winners: 1993 to 1996; A Businesses Guide to Investing in the Arts: Invest A Little - Get A Lot; Involving the Arts in Advertising, Marketing & Public Relations: A Business Strategy; Why Business Invests in the Arts: Facts, Figures, Philosophy (Fifth Edition-1996)

M **ISAMU NOGUCHI FOUNDATION,** Isamu Noguchi Garden Museum, 32-37 Vernon Blvd, Long Island City, NY 11106. Tel 718-721-1932; Fax 718-728-2348; Elec Mail museum@noguchi.org; *Admin Dir* Amy Hau; *Dir Coll* Bonnie Rychlak; *Head Educ* Chenta Laury; *Exec Dir* Shoji Sadao
Open Apr 1 - Oct 31 Wed, Thurs & Fri 10 AM - 5 PM, Sat & Sun 11 AM - 6 PM; Admis suggested contribution $4, senior citizens & students $2; Estab 1985 to preserve, protect & exhibit important sculptural, environmental & design work of Isamu Noguchi; Thirteen galleries & a garden exhibiting over 250 sculptures, models, drawings & photos, 24,000 sq ft factory converted by the artist; Average Annual Attendance: 20,000
Income: $400,000 (financed by Noguchi Foundation, New York City Department of Cultural Affairs & private donations)
Special Subjects: Sculpture
Collections: Sculptures in stone, wood, metal, paper, clay; models and drawings; photos of Noguchi's gardens and plazas; stage sets
Exhibitions: Permanent exhibition
Activities: Classes for adults & children; tours; docent training; artist in residence program; workshops; lect open to public; gallery talks; tours; concerts; museum shop sells books & Noguchis Akari light sculptures

M **MUSEUM FOR AFRICAN ART,** 36-01 43d Ave, Long Island City, NY 11101. Tel 718-784-7700; Fax 718-784-7718; Elec Mail museum@africanart.org; Internet Home Page Address: www.africanart.org; *Dir Exhib* Frank Herreman; *Cur* Laurie Farrell; *Dir Mktg* Carlyn Mueller; *Controller* Andrei Nadler; *Cur Exhib* Erica Blumenfeld; *Dir Educ* Heidi Holder; *Pres* Elsie Crum McCabe; *Operations Mgr* Kenita Lloyd; *Registrar* Giacomo Mirabella
Open Mon, Thurs & Fri 10 AM - 5 PM, Sat & Sun 11 AM - 6 PM, cl Tues & Wed; Admis general $5, students, children & seniors $2.50, members free; Estab 1984 to increase public understanding & appreciation of African art & culture; 2 galleries, museum shop & events room; Mem: 500; dues vary
Income: $1,100,000 (financed by mem, foundation grant entrance fees, exhibition fee & tours)
Purchases: $425,000
Special Subjects: Photography, Sculpture, Bronzes, African Art, Ethnology, Textiles, Religious Art, Ceramics, Crafts, Pottery, Primitive art, Woodcarvings, Decorative Arts, Manuscripts, Dolls, Furniture, Jewelry, Maps, Dioramas, Gold
Exhibitions: Rotating exhibitions
Publications: African Masterpieces from the Musee De L'Homme; Sets, Series & Ensembles in African Art; Exhibition Catalogues
Activities: Educ program; docent training; lect Sundays open to public, tours; book traveling exhibitions 1-2 per year; originate traveling exhibitions to circulate to other museums; museum shop sells catalogues, books, magazines, handcrafts, jewelry, musical recordings, clothes, furniture, musical instruments

M **PS1 CONTEMPORARY ART CENTER,** (PS1 Institute for Contemporary Art) 22-25 Jackson Ave, Long Island City, NY 11101. Tel 718-784-2084; Fax 718-482-9454; *Exec Dir* Alanna Heiss; *Dir Operations* Tony Guerrero; *Assoc Dir Press & Mktg* Rachael Dorsey
Open Thurs - Mon Noon - 6 PM; Admis Gen $5, students & seniors $2; Estab 1972 as artist studios & exhibition contemporary & experimental art; Located in a vast renovated 19th century Romanesque schoolhouse, the gallery contains 46,000 sq ft of exhibition space; Average Annual Attendance: 60,000; Mem: 100,000+; Dues leadership council $5,000, patrons council $1,000
Income: Financed by city & state appropriations, corporate & private donations, National Endowment for the Arts
Library Holdings: CD-ROMs; Cards; Compact Disks; Fiche; Kodachrome Transparencies; Pamphlets
Special Subjects: Architecture, Drawings, Painting-American, Photography, Sculpture, Collages, Painting-Japanese, Painting-Canadian, Painting-Dutch, Painting-French, Painting-Polish, Painting-Spanish, Painting-Italian, Painting-Australian, Painting-German, Painting-Russian, Painting-Israeli, Painting-Scandinavian, Painting-New Zealander
Collections: Architecture; fashion; film; painting; photography; sculpture; video
Exhibitions: International Studio Exhibition; Alternating 1-100 & Vice Versa by Alighiero e Boetti; Gilles Peress Farewell to Bosnia; Stalin's Choice Soviet Socialist Realism; The Winter of Love
Publications: Loop; Short Century; Mexico City; Video Acts

Activities: Classes for adults & children; dance; film; video; photography; fashion; architectural presentations; lect open to public; concerts; gallery talks; tours; competitions for studio program with awards of studio residency; scholarships offered; original works of art lent to nonprofit institutions with appropriate facilities; book traveling exhibitions; originate traveling exhibitions; sales shop sells books, catalogues, posters, postcards, clothing

M **SOCRATES SCULPTURE PARK,** 32-01 Vernon Blvd, Long Island City, NY 11106; P.O. Box 6259, Long Island City, NY 11106. Tel 718-956-1819; Fax 718-626-1533; Elec Mail info@socratessculpturepark.org; Internet Home Page Address: www.socratessculpturepark.org; *Exec Dir* Alyson Baker; *Dir of Educ* Tara Sansone; *Exhib Prog Coord* Robyn Douohue; *Develop* Lisa Gold
Open 10 AM - Sunset; No admis fee; Estab 1986; Outdoor scuiture park & artist residency program; Average Annual Attendance: 60,000
Collections: Changing exhibitions of large scale sculpture & multi media installations
Exhibitions: Annual spring exhibition; Collaborative projects; billboard; Annual Emerging Artist Fellowship Exhibition
Publications: Catalogs
Activities: Classes for adults & children; concerts; tours; fellowships

MEDINA

M **MEDINA RAILROAD MUSEUM,** 530 West Ave, Medina, NY 14103; PO Box 136, Medina, NY 14103. Tel 585-798-6106; Fax 585-798-1829; Elec Mail office@railroadmuseum.net; *CEO & Dir* Martin C Phelps; *Vol Pres* James L Dickinson; *Pub Rels & Mus Shop Mgr* Linda Klein; *VPres & Dir* Hugh F James
Open Tues - Sun 11 AM - 5 PM, cl Christmas Day; Admis adults $5, seniors $4, children $3, mem admis no admis fee; Estab 1997; Railroad & firefighting mus with displays; largest coll of railroad artifacts & memorabilia known to exist under one roof; Average Annual Attendance: 6080 by estimate; Mem: dues Corporate $100, Business $50, Family $25, Indiv $15
Collections: Over 6000 items including railroad artifacts & memorabilia; photos; models; toy coll & large firefighting artifact
Publications: Newsletter, biannual
Activities: Excursion train rides; Orphan Train Re-enactment; Military Troop Train; guided tours; loan exhibs; tv, cable or radio progs

MOUNT VERNON

L **MOUNT VERNON PUBLIC LIBRARY,** Fine Art Dept, 28 S First Ave, Mount Vernon, NY 10550. Tel 914-668-1840; Fax 914-668-1018; *Dir* Rodney Lee
Open Mon - Thurs 9 AM - 9 PM, Fri & Sat 9 AM - 5 PM, Sun 1 - 5 PM, cl Sat & Sun during July and Aug; No admis fee; Estab 1854; Library contains Doric Hall with murals by Edward Gay, NA; Exhibition Room with frescoes by Louise Brann Soverns; & Norman Wells Print Alcove, estab 1941
Income: $2,200,000 (financed by city & other funds)
Library Holdings: Audio Tapes 1,293; Book Volumes 450,000; Cassettes 1,293; Other Holdings Art books 17,000; Periodical Subscriptions 800; Photographs 11,700; Records 12,500
Special Subjects: Decorative Arts, Photography, Painting-American, Prints, Ceramics, Costume Design & Constr, Architecture
Exhibitions: Costume dolls; fans; metalwork; one-man shows of painting, sculpture & photographs; porcelains; silver; woodcarving; jewelry; other exhibits changing monthly covering a wide range of subjects from miniatures to origami
Activities: Lect open to public, 6 vis lectrs per year; concerts; gallery talks; tours; individual paintings & original objects of art lent to library members

MOUNTAINVILLE

M **STORM KING ART CENTER,** Old Pleasant Hill Rd, Mountainville, NY 10953; PO Box 280, Mountainville, NY 10953-0280. Tel 845-534-3115; Fax 845-534-4457; Internet Home Page Address: www.stormking.org; *Dir & Cur* David R Collens; *Chmn & Pres* H Peter Stern; *Admin* Georgene Zlock; *Mus Shop Mgr* Colleen Zlock; *Comptroller* Rose Wood
Open Apr 1 - Nov 15 daily 11 AM - 5:30 PM; Admis adults $10, seniors $9, students $7, children 5 & under free; Estab 1960; Average Annual Attendance: 59,000; Mem: Dues $1,000 patron, $500 sponsor, $250 donor, $100 contributor, $50 family, $35 individual
Special Subjects: Sculpture
Collections: 500 acre sculpture park with over 100 large scale 20th century American & European sculptures, including works by Abakanowicz, Aycock, Armajani, Bourgeois, Calder, Caro, di Suvero, Goldsworthy, Grosvenor, Hepworth, LeWitt, Liberman, Moore, Nevelson, Noguchi, Paik, Rickey, Serra, David Smith, Snelson, Streeter, Witkin
Publications: Earth, Sky, and Sculpture, Storm King Art Center
Activities: Docent training; Educ dept; lect open to public; concerts; guided tours of sculpture park; outdoor concerts; museum shop sells books, slides, postcards, t-shirts & maps

MUMFORD

M **GENESEE COUNTRY VILLAGE & MUSEUM,** (Genesee Country Museum) John L Wehle Gallery of Wildlife & Sporting Art, PO Box 310 Mumford, NY 14511; 1410 Flint Hill Rd Mumford, NY 14511. Tel 585-538-6822; Fax 585-538-2887 & 538-2869; Elec Mail email@gcv.org; Internet Home Page Address: www.gvc.org; *CEO & Pres* Betsy W Harrison; *Cur* Diane E Jones; *Dir Mktg & Pub Relations* Todd Butler; *Cur Coll* Dan Barber; *Dir Retail Svcs* Pat Johnston; *Dir Special Program* MIchelle Worden; *Dir Finance* Susan Barnes; *Dir Develop* Jim Mossgraber; *Cur Gallery Sport* Jill Roberts; *Mus Shop Mgr* Diane Weisbeck; *CEO & Pres* Elizabeth Harrison; *Dir Natur Ctr* Linder Bender
Open Tues - Fri 10 AM - 4 PM, Sat, Sun, holidays, May, June, Sept & Oct 10 AM - 5 PM, Tues - Sun July & Aug 10 AM - 5 PM; Admis adult $11, seniors &

students $9.50, children (4-16) years $6.50; Estab 1976; Gallery has over 600 paintings & sculptures dealing with wildlife, sporting art & western art; Average Annual Attendance: 120,000; Mem: 2001 John Truitt Hamilton Society $5,000+, MICAH Brooks Society $2,500, Julia Hyde Society $1,000; Sylvester Hosmer Society $500, Polly Hetchler Society (up to age 40) $250, Selectman $150, Family $75, Friend & One $75, Friends $50

Income: Financed by admissions, mem, corporate sponsorship, local, state, federal funding, & foundations

Special Subjects: American Western Art, Southwestern Art, Folk Art, Eskimo Art

Collections: Decorative arts, restored 19th Century buildings, paintings & sculpture

Publications: Booklets; Four Centuries of Sporting Art; Genesee Country Museum; monthly newsletter

Activities: Classes for adults & children; docent training; lect open to public; concerts; gallery talks; tours; movable mus services schools, nursing homes, etc.; museum shop sells books, magazines & gifts

NEW CITY

M **HISTORICAL SOCIETY OF ROCKLAND COUNTY,** 20 Zukor Rd, New City, NY 10956. Tel 845-634-9629; Fax 845-634-8690; Elec Mail info@rocklandhistory.org; Internet Home Page Address: www.rocklandhistory.org; *Cur* Kimberly Kennedy; *Cur Educ* Christopher Kenney; *Publications* Marjorie Bauer; *Exec Dir* Sarah E Henrich; *CEO* Erin L Martin; *VPres* Lawrence Codispot
Open Tues - Fri 9:30 AM - 5 PM, Sat & Sun 1 - 5 PM; Admis by donation; Estab 1965 to preserve & interpret history of Rockland County; Average Annual Attendance: 15,000; Mem: 2000; dues $30
Income: $250,000 (financed by endowment, mem & state appropriation)
Special Subjects: Archaeology, Historical Material
Collections: Archaeological Collection; Educational Materials Collection/Reproductions; General Collections; Historical Structures; Special Archival Collections
Exhibitions: Dollhouse Exhibition; Minatures Exhibition
Publications: South of the Mountains, quarterly journal; 28 books on local history
Activities: Classes for adults & children; docent training; lect open to public, 8 vis lectrs per year; concerts; gallery talks; tours; competitions; History Awards Program for high school seniors; History Preservation Merit Awards; Student History Awards; individual paintings, original objects of art & artifacts lent to other museums; originate traveling exhibitions in Rockland County; museum shop sells books & educational gifts

NEW PALTZ

M **HUGUENOT HISTORICAL SOCIETY OF NEW PALTZ GALLERIES,** 18 Broadhead Ave, New Paltz, NY 12561. Tel 845-255-1660; Internet Home Page Address: www.hhs-newpaltz.org; *Dir* Jack Branlein; *Office Mgr* June L Heneberry; *Publicist* Barbara Babb
Open May 1- Oct 31; Tues - Sun 10 AM - 4 PM, cl Mon; Admis standard tour adults $8, seniors $7, students 12 & up $5, children (5-11) $3, under 5 no admis fee; self-guided walking tour with brochure $3; Estab 1894 to preserve memory & material culture of Huguenot settlers; Includes three galleries: Huguenot Street National Historic Landmark District; Locust Lawn & Terwiller House, Quaker Meeting House. Primarily ancestral portraits - Vanderlyn, Waldo & Dewett. Maintains reference library; Average Annual Attendance: 5,000; Mem: 5,000; dues $20; annual meeting in June
Income: Financed by mem, endowment
Special Subjects: Architecture, Drawings, Painting-American, Photography, Archaeology, Costumes, Ceramics, Folk Art, Pottery, Decorative Arts, Manuscripts, Portraits, Dolls, Furniture, Glass, Porcelain, Painting-Dutch, Carpets & Rugs, Historical Material, Maps, Coins & Medals, Restorations, Period Rooms, Embroidery, Pewter
Collections: American primitive paintings; early 19th century furnishings, paintings, decorative arts & documents
Exhibitions: Revolving in-house displays
Publications: genealogies & histories
Activities: Lect open to public, 2 vis lectrs per year; concerts; tours; scholarships offered; individual paintings are lent to institutions & galleries; museum shop sells books, magazines, original art, reproductions, prints & slides

M **STATE UNIVERSITY OF NEW YORK AT NEW PALTZ,** Samuel Dorsky Museum of Art, 75 S Manheim Blvd, New Paltz, NY 12561; 1 Hawk Dr, New Paltz, NY 12561. Tel 845-257-3844; Fax 845-257-3854; Elec Mail pickeria@newpaltz.edu; Internet Home Page Address: www.newpaltz.edu/museum; *Coll Mgr* Wayne Lempka; *Dir* Neil C Trager; *Preparator* Bob Wagner; *Visitor Svcs* Amy Pickering; *Educ Coordr* Judi Esmond; *Assoc Cur of Coll* Dr Jaimee Uhlenbrock; *Cur* Brian Wallace
Open Tues - Sat 11 AM - 5 PM, Sun 1 - 5 PM, cls school holidays, cl Mon during legal holidays & intersessions; No admis fee; With an exhibition schedule of 10 exhibitions per year, the Samuel Dorsky Mus of Art provides support for the various art curricula & serves as a major cultural resource for the college & surrounding community; There are two wings comprising 6 galleries, 9,000 sq ft; Average Annual Attendance: 16,000; Mem: 100; $15 - $2,500
Income: Financed by university, grants, endowment & membership
Special Subjects: Metalwork, Graphics, Painting-American, Photography, Prints, African Art, Pre-Columbian Art, Ceramics, Pottery, Etchings & Engravings, Landscapes, Painting-Japanese, Posters, Asian Art, Silver, Antiquities-Byzantine, Calligraphy, Islamic Art, Antiquities-Egyptian, Painting-German
Collections: Artifacts, Folk Art, Asian Prints; Painting, principally 20th century America; Photographs; Posters; Pre-Columbian Art; Prints, African & New Guinea; Sculpture; Hudson Valley Art
Exhibitions: Rotating exhibits every 8 weeks
Publications: Exhibition catalogs; Robert Morris, Lesley Dill, George Bellows, Raoul Hague, Rimer Cardillo, Don Nice, Bolton Coit Brown
Activities: Tours & Talks; docent training; lect open to public, 8 per yr; concerts; gallery talks; competitions; tours; individual paintings & original objects of art

lent to museums & galleries; lending collection contains artifacts, original prints, paintings, photographs, sculpture, folk art, textiles, drawings & posters

L **Sojourner Truth Library,** 75 S Manheim Blvd, New Paltz, NY 12561-2493; 300 Hawk Dr, New Paltz, NY 12561-2493. Tel 845-257-3719; Fax 845-257-3718; Elec Mail leec@newpaltz.edu; Internet Home Page Address: www.lib.newpaltz.edu; *Information Access* Valerie Mitenberg; *Coll Access* Nancy Nielson; *Team Leader Bibliographic Access* Marjorie Young; *Coll Develop* Gerlinde Barley; *Dir* Chui-Chun Lee
Open Mon - Thurs 8:30 AM -11:30 PM, Fri 8:30 AM - 9 PM, Sat 10 AM - 9PM, Sun 1-11:30 PM; Circ 158,000; For lending & reference; Average Annual Attendance: 343,964
Income: Financed by state appropriation
Library Holdings: Book Volumes 476,000; CD-ROMs; Cassettes; Exhibition Catalogs; Fiche; Micro Print; Pamphlets; Periodical Subscriptions 1,029; Video Tapes
Special Subjects: Art History, Photography, Drawings, Painting-American, Painting-Japanese, Painting-European, Watercolors, Theatre Arts, Art Education, Anthropology, Oriental Art, Silversmithing
Publications: Newsletter, biannual

NEW ROCHELLE

M **COLLEGE OF NEW ROCHELLE,** Castle Gallery, Castle Pl, New Rochelle, NY 10805. Tel 914-654-5423; Fax 914-654-5014; Elec Mail jzazo@cnr.edu; Internet Home Page Address: www.cnr.edu/htm; *Dir* Jennifer Zazo; *Asst* Alana Cole-Faber
Open Tues & Wed 10 AM - 8 PM, Thurs & Fri 10 AM - 5 PM, Sat & Sun Noon - 5 PM; No admis fee; Estab 1979 as a professional art gallery to serve the college, city of New Rochelle & lower Westchester & provide exhibition & interpretation of fine arts & material culture; Located in Leland Castle, a gothic revival building, listed in National Register of Historic Places; gallery is modern facility, with flexible space
Publications: Newsletter
Activities: Docent training; lect open to public, 6 vis lectrs per year; originate traveling exhibitions

L **NEW ROCHELLE PUBLIC LIBRARY,** Art Section, One Library Plaza, New Rochelle, NY 10801. Tel 914-632-7878; Fax 914-632-0262; Internet Home Page Address: www.nrpl.org; *Head Reference* Beth Mills; *Dir* Patricia Anderson
Open Mon, Tues & Thurs 9 AM -8 PM, Wed 10 AM - 6 PM, Fri & Sat 9 AM - 5 PM, July & Aug cl Sat & Sun; Estab 1894
Library Holdings: Book Volumes 8,000; Cassettes; Clipping Files; Exhibition Catalogs; Fiche; Original Art Works; Pamphlets; Photographs; Records; Reels; Slides; Video Tapes
Exhibitions: All shows, displays & exhibits are reviewed & scheduled by professional advisory panel
Activities: Lect; demonstrations; lending collection contains framed prints & art slides

A **New Rochelle Art Association,** One Library Plaza, New Rochelle, NY 10801. Tel 914-632-7878; *Pres* Liane Merchant
Estab 1912 to encourage art in the area; Mem: 200; dues $20; monthly meeting
Income: Financed by mem
Exhibitions: Four exhibitions per year
Activities: Classes for adults; lect open to public, 4 vis lectrs per year; competitions with awards

NEW YORK

M **4D BASEMENT,** 221 E Second St, New York, NY 10003. Tel 212-995-0395; Elec Mail ugallery@ugallery.org; Internet Home Page Address: www.ugallery.org; *Artist* Robert Walter; *Dir* Darius Gubala; Daniel Pittman; Karolin Walter; *Mgr* Grzegorz Wroblewski; *Artist* Walker Fe
By appointment; No admis fee; Estab 1991 to support culture in America; Multimedia; Average Annual Attendance: 600; Mem: 205; mem open to artists with correct & perfect portfolios
Income: Privately financed
Special Subjects: Painting-American, Restorations
Exhibitions: Florescent Light; Opening Art Performance Exhibitions
Activities: Lectrs for members only; 8 lectr per yr; concerts; mus shop sells original art & art objects

M **55 MERCER GALLERY,** 55 Mercer St 3rd Fl, New York, NY 10013. Tel 212-226-8513
Open Tues - Sat 10 AM - 6 PM; No admis fee; Estab 1970 to give unaffiliated artists a space to show their work; Gallery is a cooperative gallery; Average Annual Attendance: 8,000; Mem: 22; dues $1,350; meeting every 2 months
Income: Financed by mem dues
Exhibitions: One Person & Group shows including John Bradford, David Woodell, Joe Sandman, Michael Tice, Kye Carbone, Bob Meltzmuff, Sydney Drum, Barry Malloy, Milt Connors, Megan Lipke, Catherine Hall, Joe Smith, Joy Walker, Diane Whitcomb, Ethlin Honig, Cris Blyth, Courtney Cavalieri, Masako Honjo, Annette Morris, Esme Thompson, Steve Ridell, Daniel Heyman, Virginia Vogel, Jonathan Lev, Robert Jessel, Michael Amato, Alexis Kuhr, Bobbi Goldman, Josh Dorman
Activities: Apprenticeship program; competitions; individual paintings & original objects of art lent to college shows

M **A I R GALLERY,** 511 W 25th St, Ste 301, New York, NY 10001. Tel 212-255-6651; Fax 212-255-6653; Elec Mail airinfo@airnyc.org; Internet Home Page Address: www.airnyc.org; *Dir* Dena Muller
Open Tues - Sat 11 AM - 6 PM; No admis fee; Estab 1972 as cooperative women's gallery representing 35 American women artists; also provides programs & services to women artists community; artists cooperative; Average Annual Attendance: 10,000; Mem: $500 initiation fee; $150 monthly mem dues; monthly meetings

Income: Financed by mem, city and state appropriation
Special Subjects: Painting-American, Photography, Sculpture, Woodcarvings, Woodcuts
Collections: Contemporary Women Artists
Exhibitions: One-woman exhibitions; invitational which can be international, regional and performance or theme shows
Publications: Invitational exhibition catalogues, bi-annually
Activities: Lect open to public; concerts; gallery talks; competitions with awards; individual paintings & original objects of art lent; lending collection contains original art works, original prints, paintings, photographs, sculpture, slides & videos

M ABIGAIL ADAMS SMITH MUSEUM, 421 E 61st St, New York, NY 10021. Tel 212-838-6878; Fax 212-838-7390; *Dir* Minna Schneider; *Cur* Lisa Bidell; *Dir Educ* Lori Beth Finkelstein; *Asst Educ* Deborah O'Neill; *Pub Relations* Rosalind Muggeridge
Open Tues - Sun 11 AM - 4 PM, cl Mon; Admis adults $5, seniors (65 & up) & students with ID $4, children under 12 free; Estab 1939, historic house museum representing early 19th century New York City; Eight period rooms in original 1826 interiors; 1799 Landmark building; Average Annual Attendance: 3,000; Mem: 600; dues $25-$500
Special Subjects: Architecture, Anthropology, Archaeology, Ceramics, Pottery, Landscapes, Manuscripts, Portraits, Glass, Silver, Carpets & Rugs, Historical Material, Maps, Restorations, Reproductions
Collections: Decorative arts-furniture, ceramics, metals, porcelain, silver, textiles; documents & manuscripts
Exhibitions: Period rooms in original 1820s interiors; American Decorative Arts
Publications: Newsletter & brochure, quarterly
Activities: Dramatic programs; docent programs; musical performances; craft demonstrations; lect open to public; 12-15 vis lectrs per year; candlelight tours; awards; schols & fels offered; museum shop sells books, reproductions, slides, toys & craft items

A ACTUAL ART FOUNDATION, 7 Worth St, New York, NY 10013. Tel 212-226-3109; *Treas* Perry Fugate-Wilcox; *Pres* Valerie Shakespeare
Open by appointment; No admis fee; Estab 1983 to promote Actual Art
Income: $75,000 (financed by endowment & pub fundraising)
Exhibitions: Rotating exhibitions

A AESTHETIC REALISM FOUNDATION, 141 Greene St, New York, NY 10012-3201. Tel 212-777-4490; Fax 212-777-4426; Internet Home Page Address: www.aestheticrealism.org; *Class Chmn Aesthetic Realism* Ellen Reiss; *Exec Dir* Margot Carpenter
Open Mon - Fri 10 AM - 7:30 PM, Sat 10 AM - 5 PM; Estab 1973 as a nonprofit educational foundation to teach Aesthetic Realism, the philosophy founded in 1941 by the great American poet & critic Eli Siegel (1902-1978), based on his principle - "The world, art & self explain each other; each is the aesthetic oneness of opposites"
Publications: The Right of Aesthetic Realism to Be Known, weekly periodical
Activities: Weekly public seminars & dramatic presentations; classes in the visual arts, drama, poetry, music, educ, marriage; class for children; individual consultations in person & by telephone worldwide
M Terrain Gallery, 141 Greene St, New York, NY 10012. Tel 212-777-4490; Fax 212-777-4426; Internet Home Page Address: www.terraingallery.org; *Coordr* Marcia Rackow
Open Wed-Fri 2 - 5 PM, Sat 1 - 5 PM; Estab 1955 with a basis in this principle stated by Eli Siegel: "All beauty is a making one of opposites, and the making one of opposites is what we are going after in ourselves"
Collections: Permanent collection of paintings, prints, drawings & photographs with commentary
L Eli Siegel Collection, 141 Greene St, New York, NY 10012-3201. Tel 212-777-4490; Fax 212-777-4426; Internet Home Page Address: www.aestheticrealism.org; *Librn* Richita Anderson; *Librn* Leila Rosen; *Librn* Meryl Simon
Open to faculty, students & qualified researchers by appointment; Estab 1982; The Collection houses the books & manuscripts of Eli Siegel
Library Holdings: Audio Tapes; Book Volumes 25,000; Manuscripts
Special Subjects: Art History, Film, Photography, Sculpture, Theatre Arts, Anthropology, Aesthetics
L Aesthetic Realism Foundation Library, 141 Greene St, New York, NY 10012-3201. Tel 212-777-4490; Fax 212-777-4426; Internet Home Page Address: www.terrainGallery.org; *Librn* Richita Anderson
Open to faculty, students & qualified researchers by appointment; Estab 1973
Special Subjects: Art History, Photography, Theatre Arts, Art Education, Anthropology, Aesthetics, Architecture
Collections: Published poems & essays by Eli Siegel; published & unpublished lectures by Eli Siegel

THE ALLIED ARTISTS OF AMERICA, INC
For further information, see National and Regional Organizations

M ALTERNATIVE MUSEUM, 32 W 82nd St Ste 9A, New York, NY 10024-. Tel 212-966-4444; Fax 212-226-2158; Elec Mail info@alternative museum.org; Internet Home Page Address: www.alternativemuseum.org; *Exec Dir* Geno Rodriguez; *Asst Dir* Jan Rooney; *Asst Cur & Sr Web Master* Marcus Pinto; *Chief Adminr* David Freilach; *Cur Asst* Virgil Wong
Open daily; Estab 1975; Average Annual Attendance: 70,000; Mem: 2000; dues $35-$1000

AMERICAN ABSTRACT ARTISTS
For further information, see National and Regional Organizations

AMERICAN ACADEMY OF ARTS & LETTERS
For further information, see National and Regional Organizations

AMERICAN ARTISTS PROFESSIONAL LEAGUE, INC
For further information, see National and Regional Organizations

AMERICAN CRAFT COUNCIL
For further information see National and Regional Organizations

M AMERICAN CRAFT COUNCIL, Museum of Arts & Design, 40 W 53rd St, New York, NY 10019. Tel 212-956-3535; Fax 212-459-0926; Elec Mail info@madmuseum.org; Internet Home Page Address: www.madmuseum.org; *Registrar* Linda Clous; *Dir* Holly Hotchner; *Chief Cur & VPres Progs & Coll* David Revere McFadden; *Assoc VPres Pub Relations* Patrick Keeffe; *Assoc VPres Educ* Brian McFarland; *VPres Finance & Adminstr* Robert Salerno; *Chief Devel Officer* Carolyn Cohen
Open Mon - Wed & Fri- Sun 10 AM - 6 PM, Thurs 10 AM - 8 PM; Admis adults $9, seniors & students $6, mem & children under 12 free; Estab 1956 by the American Craft Council (see National Organizations); Gallery displays contemporary art in craft, decorative arts & design media; Average Annual Attendance: 275,000; Mem: 2,400; dues benefactors $1250, patrons $500, friends $250, sponsors $150, family/dual $85, subscribing $60
Income: Financed by mem, government grants, private & corporate donations
Special Subjects: Crafts
Collections: Works of American craftsmen since 1900 in ceramics, paper, fiber, wood design, metal, glass, plastics, enamels
Exhibitions: 6-10 exhibitions per year
Publications: Arts & Design Views, quarterly newsletter; exhibition catalogs on crafts
Activities: Docent training; lect open to public, 30 vis lectrs per year; demonstrations; gallery talks; tours; competitions with awards; meet the Artist program; organize traveling exhibitions; sales shop sells books, magazines, slides

THE AMERICAN FEDERATION OF ARTS
For further information, see National and Regional Organizations

M AMERICAN FOLK ART MUSEUM, 2 Lincoln Square, Columbus Ave & 66th St New York, NY 10023-6214. Tel 212-977-7298, Gallery 595-9533; Fax 212-977-8134; Elec Mail info@folkartmuseum.org; Internet Home Page Address: www.folkartmuseum.org; *Dir* Gerard C Wertkin
Open Tues - Sun 11:30 AM - 7:30 PM, cl Mon; No admis fee, suggested donation $2; Estab 1961 for the collection & exhibition of American folk art in all media, including painting, sculpture, textiles & painted & decorated furniture; Single floor, cruciform shape gallery approx 3,000 sq ft; Average Annual Attendance: 100,000; Mem: 5,000; dues $35 & up
Income: Financed by mem, state appropriation & personal donations
Special Subjects: Painting-American, Folk Art, Furniture
Collections: American folk paintings & watercolors; folk sculpture including shop & carousel figures, shiphead figures, decoys, weathervanes, whirligigs, wood carvings & chalkware; painted & decorated furniture; tradesmen's signs; textiles including quilts, coverlets, stenciled fabrics, hooked rugs & samplers; works from 18th, 19th & 20th centuries
Publications: The Clarion, quarterly magazine
Activities: Educ dept; classes for adults; docent training; lect open to public; gallery talks; tours; outreach programs; book traveling exhibitions; originate traveling exhibitions to qualifying art & educational institutions; museum shop sells books, reproductions & prints
L Shirley K. Schlafer Library, 45 W 53rd St, New York, NY 10019. Tel 212-265-1040; Fax 212-265-2350; Elec Mail library@folkartmuseum.org; Internet Home Page Address: www.folkartmuseum.org; *Librn* James Mitchell
Open by appointment Mon - Fri; Estab 1961; Library open to pub by appointment
Library Holdings: Auction Catalogs 2000; Audio Tapes 200; Book Volumes 10,000; Clipping Files; Exhibition Catalogs; Manuscripts; Memorabilia; Pamphlets; Periodical Subscriptions 200; Photographs; Reproductions; Slides; Video Tapes 250
Collections: Archives and manuscripts of American self-taught artist Henry Darger; Archives of Historical Society of Early American Decoration; Library & archives of qulit scholar Cuesta Benberry

AMERICAN INSTITUTE OF GRAPHIC ARTS
For further information, see National and Regional Organizations

A AMERICAN JEWISH HISTORICAL SOCIETY, The Center for Jewish History, 15 W 16th St, New York, NY 10011. Tel 212-294-6160; Fax 212-294-6161; Elec Mail ajhs@ajhs.org; Internet Home Page Address: www.AJHS.org; *Pres (V)* Kenneth Bialkin; *Archive Asst* Rachel Keegan; *Exec Dir* Dr Michael Feldberg; *Dir Library & Archives* Lynn Slome; *Membership Sec* Libby Finklestein; *Museum Coll* Sarah Davis
Open Mon - Thurs 8:30 AM - 4:30 PM, cl Fri, Sat & Sun; Call for specific rates; Estab 1892 to collect, preserve, catalog & disseminate information relating to the American Jewish experience; Average Annual Attendance: 5,000; Mem: 3,000; dues $50; annual meeting in May
Income: $500,000 (financed by endowment, mem, Jewish Federation allocations, grants & donations)
Collections: Manuscripts; Portraits; Yiddish Motion Pictures; Yiddish Theater Posters
Exhibitions: Gustatory Delights in the New World; German Jews in America; Emma Lazarus, Joseph Pulitzer & The Statue of Liberty; Yiddish Theatre in America; American Jewish Colonial Portraits; Sebhardim in America
Publications: American Jewish History, quarterly; Heritage; Local Jewish Historical Society News; books; newsletters
Activities: Lect open to public, 10 vis lectrs per yr; tours; individual paintings & original objects of art lent to museums & historical societies; lending collection contains motion pictures, paintings, books, original art works, original prints & photographs
L Lee M Friedman Memorial Library, 160 Herrick Rd, Newton Centre, MA 02459. Tel 617-559-8880; Fax 617-559-8881; Elec Mail ajhs@ajhs.org; *Archivist* Lynn Slome
Open Mon - Thurs 9:30 AM - 4:30 PM, Fri researcher hrs only; No admis fee; Estab 1892 to collect, preserve & catalog material relating to Colonial American Jewish history; Open for reference
Income: $514,000 (financed by endowment, mem, contributions, grants, allocations from Jewish welfare funds)

Library Holdings: Book Volumes 95,000; Cassettes; Manuscripts; Memorabilia; Motion Pictures; Other Holdings Archives; Pamphlets; Periodical Subscriptions 120; Photographs; Prints; Records; Slides
Collections: Stephen S Wise Manuscripts Collection; Archives of Major Jewish Organizations
Exhibitions: Colonial American Jewry; 19th Century Jewish Families; On Common Ground: The Boston Jewish Experience, 1649-1980; Statue of Liberty; German American Jewry; Moses Michael Hays & Post- Revolutionary Boston
Publications: American Jewish History, quarterly; Heritage, bi-annually
Activities: Lect open to public, 2-3 vis lectr per yr; tours; originate traveling exhibitions to libraries, museum societies, synagogues

M AMERICAN MUSEUM OF NATURAL HISTORY, Central Park West at 79th St, New York, NY 10024-5192. Tel 212-769-5100; Fax 212-496-3500; Elec Mail postmaster@amnh.org; Internet Home Page Address: www.amnh.org; *Sr Vice Pres Com* Gary Zarr; *Pres* Ellen V Futter; *Vice Pres Governm* Lisa J Gugenheim; *Chm & Cur Divisio* Enid Schildkrout; *Sr. Advisor* Linda F Cahill; *Chm Bd Trustees* Lewis Bernard; *Chm & Cur Divisio* Mark A Norell; *Dir Retail* Paul Murawski; *Sr. Vice Pres & Pro* Michael J Novacek; *Vice Pres Devel* Lynn DeBow; *Chm Division Physi* James D Webster; *Sr Vice Pres & Dea* Craig Morris; *Assoc Dean Scienc* Darrel R Frost; *Sr Vice Pres Finan* Sigmund G Ginsburg; *Gen Counsel* Gerald R Singer; *Chm & Cur Divisio* Randall T Schuh; *Sr Vice Pres Oper* Barbara D Gunn; *Frederick P Rose D* Neil Degrasse Tyson; *Vice Pres Education* Myles Gordon; *Vice Pres Exhibition* David Harvey
Open Mon - Thurs & Sun 10 AM - 5:45 PM, Fri & Sat 10 AM - 8:45 PM, cl Thanksgiving & Christmas; Admis by contribution (suggested donation, adults $8, children (4.50); Estab 1869 as a museum for the study & exhibition of all aspects of natural history; Exhibition spaces include Roosevelt Memorial Hall, Gallery 3, Naturemax Gallery, Akeley Gallery, Gallery 1; Average Annual Attendance: 3,000,000; Mem: 500,000; museum shop sells books, original art, reproductions & prints
Income: Financed by special presentations, contributions
Exhibitions: Permanent exhibitions include: Hall of Asian Peoples; Hall of Ocean Life & Biology of Fishes; Arthur Ross Hall of Meteorites; Guggenheim Hall of Minerals; Margaret Mead Hall of Pacific Peoples; Shark Fact & Fantasy
Publications: Natural History, magazine; Curator; Bulletin of the American Museum of Natural History; Anthropological Papers of the American Museum of Natural History; American Museum of Natural History Novitates; annual report
Activities: Classes for adults & children; dance & music programs; lect open to public; tours; scholarships
Tuition: junior museum
L Library, Central Park West at 79th St, New York, NY 10024. Tel 212-769-5400; Fax 212-769-5009; Elec Mail libref@amnh.org; Internet Home Page Address: http://library.amnh.org; *Dir Library Servs* Tom Moritz
Open Tues - Thurs 2 - 5:30 PM
Library Holdings: Audio Tapes; Book Volumes 450,000; Clipping Files; Filmstrips; Kodachrome Transparencies; Lantern Slides; Manuscripts; Memorabilia; Motion Pictures; Original Art Works; Pamphlets; Photographs; Prints; Records; Sculpture; Slides; Video Tapes
Special Subjects: Etchings & Engravings, Historical Material, Ceramics, Archaeology, Ethnology, Bronzes, American Indian Art, Anthropology, Eskimo Art, Mexican Art, Afro-American Art, Carpets & Rugs, Gold, Goldsmithing, Architecture

AMERICAN NUMISMATIC SOCIETY
For further information, see National and Regional Organizations

AMERICAN SOCIETY OF CONTEMPORARY ARTISTS (ASCA)
For further information, see National and Regional Organizations

AMERICAN WATERCOLOR SOCIETY
For further information, see National and Regional Organizations

A AMERICAN-SCANDINAVIAN FOUNDATION, Scandinavia House: The Nordic Center in America, 58 Park Ave, New York, NY 10016. Tel 212-879-9779; Fax 212-686-1157; Elec Mail info@amscan.org; Internet Home Page Address: www.scandinaviahouse.org; *VPres* Lynn Carter; *Pres* Edward Gallagher
Open Tues - Sat 12 - 6 PM; Admis for galleries is $3; Foundation estab 1910 to promote cultural exchange Scandinavia House opened in 2000 presents best of Nordic culture incl art & design exhibs from Denmark, Finland, Iceland, Norway & Sweden; Exhibs of Scandinavian art & design; Average Annual Attendance: 75,000; Mem: 6,000; dues $40
Library Holdings: Book Volumes
Exhibitions: Contemporary Scandinavian painting, sculpture, design and crafts; artwork is selected for exhibition by a committee of professional art advisors
Publications: Scandinavian Review, 4 times a year; SCAN, newsletter 4 times a year
Activities: Language classes in conjunction with NYU School of Continuing & Professional Studies; lect open to public; concerts; gallery talks; tours; awards; scholarships & fellowships offered, AFS Cultural Award; sales shop sells books, magazines, reproductions, design objects, tableware, jewelry, toys, watches, music, holiday items

AMERICANS FOR THE ARTS
For further information, see National and Regional Organizations

M AMERICAS SOCIETY ART GALLERY, 680 Park Ave, New York, NY 10021. Tel 212-249-8950; Fax 212-249-5668; Elec Mail arts@americas-society.org; Internet Home Page Address: www.americas-society.org; *Dir* Gabriela Rangel; *Asst Cur* Isabela Villanvena; *Public Prog Coordr* Marcia Cohen
Open Tues - Sun Noon - 6 PM, cl Mon (during exhibitions); Free; Estab 1967 to broaden understanding & appreciation in the United States of the art & cultural heritage of other countries in the Western Hemisphere; One large gallery with 3-4 exhibitions a year of Latin American, Caribbean & Canadian art; Average Annual Attendance: 25,000; Mem: 900; dues $75
Income: $120,500
Special Subjects: Latin American Art, Mexican Art, Pre-Columbian Art, Decorative Arts, Furniture, Historical Material

Exhibitions: (2/2007) Paula Trope and The Meninos de Morrinho
Publications: Exhibition catalogs
Activities: Classes for adults & children in conjunction with exhibitions; docent training; lect open to public, 50-100 vis lectrs per year; gallery talks; concerts; tours; book traveling exhibitions 1 per year; originate traveling exhibitions; exhibition catalogues available for purchase at front desk

A ANDY WARHOL FOUNDATION FOR THE VISUAL ARTS, 65 Bleecker St, New York, NY 10012. Tel 212-387-7555; Internet Home Page Address: www.warholfoundation.org; *Head* Archibald Gillies

M ANTHOLOGY FILM ARCHIVES, 32 Second Ave, New York, NY 10003. Tel 212-505-5181; Fax 212-477-2714; *Dir & Vol Pres* Jonas Mekas; *Mem* Wendy Dorsett; *Chmn Bd* Barney Oldfield; *Pub Rels* Travis Miles; *Fin Dir* John Mhiripiri; *Archivist* Andrew Lampert; *Dir Colls & Spec Projs* Robert A Haller
Film screenings Mon - Fri 6 - 11 PM, Sat & Sun 3 - 11 PM; cl last week of Aug & two weeks during Christmas & New Year's; Admis adults $9, seniors & students $5, spec rates for grps, mems no admis fee; Estab 1970; mus of the cinema with progs in film & video preservation; Average Annual Attendance: 50,000; Mem: dues Preservation Donor $1500, Donor $250, Dual Adult $75, Indiv Adult $50, Senior or Student $30
Library Holdings: Book Volumes 8000; Clipping Files; Other Holdings; Periodical Subscriptions 42,000; Photographs 1200
Collections: Library coll of over 12,000 films & tapes on avant-garde, classic & documentary cinema; mail-order publ svc; approx 1 million books, photos, documents in a closed-stack facility that services scores of scholars every yr
Activities: Research projs on Jim Davis, Storm DeHirsch, Marie Menken; films; Film Preservation Honors Dinner

A ARCHITECTURAL LEAGUE OF NEW YORK, 457 Madison Ave, New York, NY 10022. Tel 212-753-1722; Fax 212-486-9173; Elec Mail info@archleague.org; Internet Home Page Address: www.archleague.org; *Exec Dir* Rosalie Genevro; *Pres* Calvin Tsao
Office open Mon - Fri 9 AM - 5 PM, gallery open 11 AM - 5 PM, cl Thurs & Sun; Admis seminars $10, mems free, gallery free to pub; Estab 1881 to promote art & architecture; serves as a forum for new & experimental ideas in the arts; Gallery contains wall installations & models; Mem: 1,600; dues over 35 years $100, under 35 years $50, students $35; ann meeting in June
Exhibitions: Annual Juried Exhibition of Young Architects Competition; New York 2; Rebuilding: Study Exhibition on WTC Site; Ten Shades of Green; Urban Life: Housing in the Contemporary City
Publications: Exhibition catalogs; posters
Activities: Lect; slide lect; competitions; awards; schols offered

A ART COMMISSION OF THE CITY OF NEW YORK, City Hall, 3rd Flr, New York, NY 10007. Tel 212-788-3071; Fax 212-788-3086; *Exec Dir* Deborah Bershad; *Pres* Gene Parker Phfiefer
Open by appointment only; No admis fee; Estab 1898 to review designs for city buildings, landscape architecture & works of art proposed for city owned property. Portraits are installed in Governors Room and other areas in City Hall; Mem: 11
Income: Financed by city appropriation
Collections: 100 portraits of historic figures, state, city and national
Publications: The Art Commission & Municipal Art Society Guide to Outdoor Sculpture by Margot Gayle & Michele Cohen; Imaginary Cities, European Views from the Collection of the Art Commission; National Directory of Design Review Agencies (1991); New York Re-Viewed, Exhibition Catalogue of 19th & 20th Century Photographs from the Collection of the Art Commission
A Associates of the Art Commission, Inc, City Hall, 3rd Flr, New York, NY 10007. Tel 212-788-3071; Fax 212-788-3086; Internet Home Page Address: www.nyc-gov/artcommision; *Exec Dir* Deborah Bershad
Estab 1913 to advise and counsel Art Commission as requested; Mem: 35; dues $35; annual meeting in Jan
Income: Financed by mem

ART DEALERS ASSOCIATION OF AMERICA, INC
For further information, see National and Regional Organizations

ART DIRECTORS CLUB, INC
For further information, see National and Regional Organizations

A ART IN GENERAL, 79 Walker St, New York, NY 10013-3523. Tel 212-219-0473; Fax 212-219-0511
Open Thurs - Sat Noon - 6 PM; No admis fee; Estab 1981 as a nonprofit arts organization, which relies on private & public support to meet its expenses; Average Annual Attendance: 10,000; Mem: 90; dues vary
Income: Financed by endowment, state & private funds
Exhibitions: Salon Show
Publications: Manual of exhibitions & programs, annual
Activities: Educ dept; interactive discussions & art workshops; classes for children; lect open to public; 40 vis lectr per year; gallery talks; tours; originate traveling exhibitions; sales shop sells books

A ART INFORMATION CENTER, INC, 55 Mercer St, 3rd Fl New York, NY 10013-5919. Tel 212-966-3443; *Pres & Dir* Dan Concholar
Open 10 AM - 6 PM or by appointment; No admis fee; Organized 1959, inc 1963, presently a consulting service for artists; The Center helps to channel the many artists in New York & those coming to New York, seeking New York outlets for their work. Advise artist seeking galleries in New York City
Income: $15,000 (financed by donations & small grants)

A ART STUDENTS LEAGUE OF NEW YORK, 215 W 57th St, New York, NY 10019. Tel 212-247-4510; Fax 212-541-7024; Internet Home Page Address: www.theartstudentsleague.org; *Exec Dir* Ira Goldberg; *Cur* Pam Koob; *Archivist* Stephanie Cassidy
Gallery open Mon - Fri 9 AM - 8:30 PM, Sat 9 AM - 4 PM; No admis fee; Estab 1875 to maintain art school & mem activities; Maintains an art gallery open to

pub for league exhibits; Average Annual Attendance: 8,000 - 9,000; Mem: 6,000; dues $25; annual meeting in Dec; 3 months full-time study required for mem
Income: Financed by tuitions & investments
Library Holdings: Book Volumes; Clipping Files; Periodical Subscriptions
Collections: Permanent collection of paintings, sculpture & works on paper by former league students & instructors
Exhibitions: Exhibitions by members, students & instructors
Publications: Linea, quarterly newsletter
Activities: Classes for adults & children; lect open to public, 3 vis lectrs per year; sponsoring of competitions; McDowell Travel Grant, Edwards-Gonzalez Travel Grant & Neosa Cohen award; scholarships offered; individual paintings & original objects of art lent to museums

L **Library,** 215 W 57th St, New York, NY 10019. Tel 212-247-4510; Fax 212-541-7024
Reference library for students & members & archive of instructors, prominent students & members, past & current
Income: Financed by tuition & endowments
Library Holdings: Auction Catalogs; Audio Tapes; Book Volumes 6,000; Cassettes; Clipping Files; Exhibition Catalogs; Filmstrips; Manuscripts; Pamphlets; Photographs; Reproductions; Slides; Video Tapes
Collections: Paintings, Sculpture & works on paper by instructors & students, past & current
Exhibitions: Exhibitions by instructors & students
Publications: Linea, newsletter of the Art Students League of New York, 3-4 issues per yr
Activities: Classes for adults & children; gallery talks; scholarships offered; sales shop sells art supplies

A **ARTISTS SPACE,** 38 Greene St, 3rd Flr, New York, NY 10013. Tel 212-226-3970; Fax 212-966-1434; Internet Home Page Address: www.artistsspace.org; *Pres* Katherine Woodard; *VPres* Leslie Tonkonow; *Treas* Richard Shebairo; *Asst Dir* Greg Hendren; *Dir* Barbara Hunt
Open Tues - Sat 11 AM - 6 PM; Estab 1973 as a nonprofit contemporary art exhibition space & artists services organization that provides artists with professional & financial support while presenting the most exciting new art developments to the pub
Activities: Administers one grant program

M **Artists Space Gallery,** 38 Greene St, 3rd Flr, New York, NY 10013. Tel 212-226-3970; Fax 212-966-1434; Internet Home Page Address: www.artistsspace.org; *Asst Dir* Greg Hendren; *Dir* Barbara Hunt
Open Tues - Sat 11 AM - 6 PM; No admis fee for exhibitions, films & events $4; Estab 1973 to assist emerging & unaffiliated artists; Five exhibition rooms & hall gallery; Average Annual Attendance: 20,000
Income: Financed by National Endowment for the Arts, New York State Council, corporate & foundation funds & private contributions
Exhibitions: Five exhibitions of local emerging artists
Activities: Gallery talks by appointment; financial aid to artists for public presentation; book traveling exhibitions; originate traveling exhibitions; junior museum

L **Irving Sandler Artists File,** 38 Greene St, 3rd Fl, New York, NY 10013. Tel 212-226-3970; Elec Mail artspace@artistsspace.org; Internet Home Page Address: www.artistsspace.org; *Cur* Jenelle Porter; *Artists File Coordr* Letha Wilson; *Dir* Barbara Hunt
Open Fri - Sat 10 AM - 6 PM; Slide file of over 2,500 New York state artists; Available to dealers, critics, curators & artists for reference only

A **ARTISTS TALK ON ART,** 10 Waterside Plaza #33 D, New York, NY 10010-2608. Tel 212-779-9250; Fax 212-213-6876; Elec Mail mail@atoa.ws; Internet Home Page Address: www.atoa.ws; *Chmn Board of Dir* Doug Sheer; *Exec Dir* Donna Marxer; *Programming Dir* Ann Lyndecker
Open Fri 7 AM - 10 PM, call for appointment; Admis $7, students & seniors $3; Estab 1974 to promote dialogue in the arts; Average Annual Attendance: 5,000; Mem: dues season pass $50
Income: $30,000 (financed by mem, state appropriation, admis, contributions & corporate funding)
Library Holdings: Audio Tapes; CD-ROMs; Cassettes; DVDs; Photographs; Prints; Video Tapes
Publications: Artists Talk on Art Calendar, semi-annually
Activities: Lect open to public, 24 vis lectrs per season; gallery talks; competitions with awards; annual: Curator's Choice contest; book traveling exhibitions 1-3 per year; originate traveling exhibitions 1-3 per year

ARTISTS' FELLOWSHIP, INC
For further information, see National and Regional Organizations

A **ARTS, CRAFT & THEATER SAFETY,** 181 Thompson St #23, New York, NY 10012. Tel 212-777-0062; Elec Mail actsnyc@cs.com; Internet Home Page Address: www.artscraftstheatersafety.org; *Pres* Monona Rossol
No off-street traffic, but 6 days/wk e-mails, letters & phone calls are answered or returned. ACTS answers an average of 35 inquiries/day; Not applicable; Estab 1958 to provide health & safety services to artists & theatrical professionals. ACTS provides lectures; US & Canadian reg compliance training & inspections; technical assist for bldg planning, renovations & ventilation projects; research & editing of safety publications; books & articles; & newsletter; Mem: Not a membership organization
Income: Nonprofit
Publications: Newsletter
Activities: Outreach activities; safety services on artists procedures, ventilation, OSHA compliance

M **THE ASIA SOCIETY MUSEUM,** (The Asia Society Galleries) 725 Park Ave, New York, NY 10021. Tel 212-288-6400; Fax 212-517-8315; Internet Home Page Address: www.asiasociety.org; Telex 22-4953 ASIA UR; Cable ASIAHOUSE NEW YORK; *Museum Dir* Melissa Chiu
Open Tues - Sun 11 AM - 6 PM, Fri 11 AM - 9 PM; closed Mon & major holidays. Summer hours change; Admis fee $10, seniors $7, students w/id $5; Estab 1956 as a nonprofit organization to further greater understanding & mutual appreciation between the US & peoples of Asia. The Asia House Gallery was inaugurated in 1960 to acquaint Americans with the historic art of Asia; In 1981 the Asia Society came into possession of its permanent collection, the Mr & Mrs John D Rockefeller 3D Collection of Asian Art, which is shown in conjunction with temporary exhibitions of traditional & contemporary Asian art; Average Annual Attendance: 122,000; Mem: 4,400; dues $50 & up; annual meeting in May
Income: Financed by endowment, mem, & grants from foundation, individual, federal & state government
Special Subjects: Asian Art
Collections: Mr & Mrs John D Rockefeller 3D Collection of Asian Art; loans obtained from the US & foreign collections for special exhibitions
Exhibitions: Rotating exhibits
Publications: Archives of Asian Art, annually
Activities: Lect by guest specialists in connection with each exhibition & recorded lect by the gallery educ staff available to visitors, 40 vis lectrs per year; concerts; gallery talks; tours; loan exhibitions originated; book traveling exhibitions 2 per year; sales shop sells books, magazines, prints & slides

A **ASIAN-AMERICAN ARTS CENTRE,** 26 Bowery, 3rd Fl, New York, NY 10013. Tel 212-233-2154; Fax 212-766-1287; Elec Mail aaartsctr@aol.com, aaartsctr@artspiral.org; Internet Home Page Address: www.artspiral.org; *Dir* Robert Lee; *Prog Mgr* Victoria Law; *Develop Mgr* Corinne Rhodes
Open Tues - Fri 12:30 PM - 6:30 PM; No admis fee; Estab 1974 to promote the cultural presence of Asian-American contemporary art in the US; Gallery has multi-purpose exhibition space; maintains research library; Average Annual Attendance: 12,000
Income: Public & private grants, sponsorships, donations
Library Holdings: Audio Tapes; Exhibition Catalogs; Kodachrome Transparencies; Memorabilia; Original Documents; Photographs; Slides; Video Tapes
Special Subjects: Folk Art
Collections: Permanent collection of works commemorating Tiananmen Square; China June 4; collection of works by contemporary Asian-American artists (400+); folk arts collection (predominantly Chinese - 150+)
Exhibitions: (2002) Folk Arts; (2002) History of the Asian American Arts Ctr; (2002) Not Your Chop Suey Chinatown; (2006) Detained; (2006) Three Women: Art & Spiritual Practice
Publications: Arts Spiral, annual, available on-line only
Activities: Classes for children; lect open to public, 5 vis lectrs per year; gallery talks; tour; scholarships; competitions with awards; originate traveling exhibitions; sales shop sells books, original art, slide & folk art

ASSOCIATION OF ART MUSEUM DIRECTORS
For further information, see National and Regional Organizations

A **ASSOCIATION OF HISPANIC ARTS,** 161 E 106th St, New York, NY 10029. Tel 212-876-1242; Fax 212-876-1285; Elec Mail ahanews@latinoarts.org; Internet Home Page Address: www.latinoarts.org; *Dir Progs & Servs* Rebecca Ramirez; *Exec Dir* Sandra M Perez; *Admin* Julia Gutierrez-Rivera; *Dir* Nicholas Arture
Open Mon - Fri 10 AM - 6 PM; No admis fee for events; Estab 1975, the Assoc of Hispanic Arts, Inc is a nonprofit art service organization dedicated to the advancement of Latino arts. We highlight & promote the achievements of Latino artists & provide technical assistance to Latino arts organizations. AHA is an innovative forum for cultural exchange, with programs designed to foster the appreciation, development & stability of the Latino cultural community
Income: Financed by grants & contracts from pub & private sector
Exhibitions: Book signings, writer readings
Publications: Hispanic Arts News, 9 times per yr; monthly listing of arts activities (in English & Spanish)

M **ATLANTIC GALLERY,** 40 Wooster St, 4th Floor, New York, NY 10013. Tel 212-219-3183; *Dir* Carol Hamann Howard; *Vpres* Nancy Balliet; *Treas* Sally Brody; *Sec* John Hawkins
Open Tues - Sat Noon - 6 PM; No admis fee; Estab 1971 as an artist-run gallery presenting the work of member & guest artists in solo exhibitions & group shows; 1 large gallery; Average Annual Attendance: 10,000; Mem: 35; dues $120; annual meeting in May
Income: Financed by mem & artists of the gallery
Exhibitions: Solo and group show every three weeks
Publications: Periodic flyers
Activities: Lect open to public; life-drawing sessions; concerts; gallery talks; tours; poetry readings; individual paintings & original objects of art lent; sales shop sells original art

AUDUBON ARTISTS, INC
For further information, see National and Regional Organizations

M **AUSTRIAN CULTURAL FORUM GALLERY,** (Austrian Cultural Institute Gallery) 11 E 52nd St, New York, NY 10022. Tel 212-319-5300; Fax 212-319-9636; Elec Mail desk@acfny.org; Internet Home Page Address: www.acfny.org; Telex 17-7142; Cable AUSTRO-CULT; *Dir* Dr Christoph Thun-Hohenstein; *Dep Dir* Mag Ernst Aichinger
Open Mon - Sat 10 AM - 6 PM; No admis fee; Estab 1962 for presentation of Austrian Art & culture in America; 4 - 10 exhibs per yr, focus on contemporary Austrian art & architecture
Publications: Austria Kultur, bimonthly
Activities: Lect open to public; gallery talks

M **BARUCH COLLEGE OF THE CITY UNIVERSITY OF NEW YORK,** Sidney Mishkin Gallery, 135 E 22nd St, New York, NY; D-0100, New York, NY 10010. Tel 212-802-2690; Internet Home Page Address: www.baruch.cuny.edu; *Dir* Dr Sandra Kraskin, PhD
Open Mon - Fri Noon - 5 PM, Thurs Noon - 7 PM; No admis fee; Estab 1983; 2,400 sq ft; Average Annual Attendance: 10,000
Income: Financed by the Baruch College Fund & federal, state & private grants
Special Subjects: Drawings, Etchings & Engravings

Collections: American & European drawings, paintings, photographs, prints & sculptures
Publications: Exhibition catalogues
Activities: Lect open to public, 3-7 vis lectrs per year; gallery talks; tours; book traveling exhibitions 1-2 per year

M **BLUE MOUNTAIN GALLERY,** 530 W 25th St 4th Fl, New York, NY 10012. Tel 646-486-4730; Fax 646-486-4345; Internet Home Page Address: www.artincontext.org/new_york/blue_mountain_gallery; *Treas* Meg Leveson; *Dir* Marcia Clark
Open Tues - Sat 11 AM - 6 PM; No admis fee; Estab 1968, an artist supported co-op gallery exhibiting works of gallery members; 20 ft x 30 ft, white walls, wood floors; Mem: 32; members must be artists willing to exhibit & sell own work & must be chosen by existing members; dues $1200; 8 meetings a yr
Income: Financed through membership
Activities: Lect open to public; gallery talks; competitions

A **CARIBBEAN CULTURAL CENTER,** Cultural Arts Organization & Resource Center, 408 W 58th St, New York, NY 10019. Tel 212-307-7420; Fax 212-315-1086; Internet Home Page Address: www.caribbeancenter.org; *Deputy Dir* Laura Moreno; *Dir* Melody Capote
Open Mon - Fri 11 AM - 6 PM; Admis $2; Estab 1976; Resource center for reference only; Average Annual Attendance: 100,000; Mem: dues $25
Income: Financed by federal, state & city appropriations, mem, foundation & corporate support
Publications: Caribe Magazine, irregular; occasional papers
Activities: Adult & children classes; concerts; conferences; curriculum development; cultural arts programs; lect open to public, 5-10 vis lectrs per year; original objects of art lent to nonprofit organizations, universities & colleges; originate traveling exhibitions; retail store sells books, reproductions, artifacts from the Caribbean, Latin America & Africa

A **CATHARINE LORILLARD WOLFE ART CLUB, INC,** 802 Broadway, New York, NY 10003. Tel 212-254-2000; Internet Home Page Address: www.clwac.org; *Pres* Eleanor Meier; *1st VPres* Elaine La Valle; *2d VPres Painting* Ruth Newquist; *2d VPres Sculpture* Janet Indick
Estab 1896, incorporated in as a nonprofit club to further fine, representational American Art; A club of professional women painters, graphic artists & sculptors; Mem: 325; dues $45 associate mem $25; monthly meetings; acceptance in 3 annual exhibs in a 10-year period
Income: Financed by mem
Exhibitions: Members Exhibition (spring); Open Annual Exhibition (fall)
Activities: Lects for mems only, 2 vis lectrs per year; Metropolitan Museum Benefit, annually; lect; demonstration programs; 8 awards approximately 10,000 in 20 shows per year

M **CATHEDRAL OF SAINT JOHN THE DIVINE,** 1047 Amsterdam Ave, New York, NY 10025. Tel 212-316-7493 (office), 316-7540 (visitors center); *Reverend Canon* Jay D Wegman
Open daily 8 AM - 6 PM; no individual admis fee, donations accepted; groups $1 per person; Estab 1974; The museum building was erected in the 1820's & forms part of the complex of the Cathedral of Saint John the Divine; Average Annual Attendance: 500,000
Income: Financed by federal government appropriations & Cathedral assistance
Special Subjects: Religious Art
Collections: Old Master Paintings; decorative arts; sculptures; silver; tapestries; vestments
Exhibitions: Monthly Photography Exhibitions; annual exhibitions planned to spotlight specific areas of the Cathedral's permanent art collection
Activities: Lect open to public, 10 vis lectrs per year; concerts; gallery talks; tours
L **Library,** 1047 Amsterdam Ave, New York, NY 10025. Tel 212-316-7495; *Vol Librn* Madeleine L'Engle
No admis fee; For reference only
Income: $3,000

M **CENTER FOR BOOK ARTS,** 28 W 27th St 3rd Fl, New York, NY 10011-0000. Tel 212-481-0295; Fax 212-481-9853; Internet Home Page Address: www.centerforbookarts.org; *Dir* Rory Golden; *Coordr* Sarah Nickels
Open Mon - Fri 10 AM - 6 PM, Sat 10 AM - 4 PM; No admis fee; Estab 1974, dedicated to contemporary bookmaking; 1 large gallery; Mem: 800; mem qualifications, must submit 5 slides of their work along with current resume; dues $45 & up
Income: Membership
Special Subjects: Crafts, Etchings & Engravings, Bookplates & Bindings
Collections: Archive of Book Arts Collection
Exhibitions: Annual Chapbook Poetry Competition; 3-4 changing exhibitions annually
Publications: Exhibition catalogues
Activities: Classes for adults & children; lect open to public, 8-10 vis lectr per year; gallery talks; tours; competitions with prizes; sales shop sells books & exhibition catalogs

M **THE CHAIM GROSS STUDIO MUSEUM,** 526 LaGuardia Pl, New York, NY 10012. Tel 212-529-4906; Fax 212-529-1966; Elec Mail grossmuseum@earthlink.com; *Pres* Irwin Hersey; *Dir* Mrs Chaim Gross; *Cur Coll* April Paul
Open Tues - Fri noon - 5 PM by appointment, cl Sun, Mon & major holidays; No admis fee; Estab 1989 to demonstrate the continuity of Gross's personal vision in sculpture over 70 years of work; Three floors including the intact studio where he worked for over 30 years; Average Annual Attendance: 5,000; Mem: 250; dues $25 - $125 & up; annual meetings in June & Dec
Income: $30,000 (financed by endowment, mem & gifts)
Purchases: Ebony carved figural group of two rabbits; carved marble head of a woman; carved wood torso (all 1930's)
Collections: Permanent collection consists of 70 years of Chaim Gross's (1904-91) sculpture in wood, stone & bronze, drawings, prints & watercolors

Activities: Docent guided tours for groups; lect open to public, 4 vis lectrs per year

C **CHASE MANHATTAN,** 600 Fifth Ave, 6th Flr, New York, NY 10020. Tel 212-270-6000; *VPres & Cur* Heidi Sendecki
Open by appointment; No admis fee
Collections: 19th century American paintings & prints; 20th century & contemporary paintings; sculpture; graphics; antique furniture; decorative arts; textiles

C **THE CHASE MANHATTAN BANK,** Art Collection, 270 Park Ave, 39th Fl, New York, NY 10017. Tel 212-270-0667; Fax 212-270-0725; *Exec Dir & VPres* Manuel Gonzalez; *Asst Cur* Stacey Gershon
Open during bank hrs; artwork displayed during exhibitions offsite, hrs vary by location; Estab 1959 to support young & emerging artists & enhance bank offices world-wide; Collection displayed in branches, offices in New York City, state & world-wide
Collections: Largely contemporary American, 17,000 works in all media
Exhibitions: Selection from the Chase Manhattan Bank Art Collection; Various exhibitions, call for details
Publications: Exhibit catalogs
Activities: Lect for employees; individual objects of art lent to museum & gallery exhibitions; originate traveling exhibitions

A **CHILDREN'S ART CARNIVAL,** 62 Hamilton Terrace, New York, NY 10031. Tel 212-234-4093; Fax 212-234-4011; Elec Mail thecac62@aol.com; *Dir* Marlene Martin
Open Mon - Thurs 9:30 AM - 6 PM, Sat 10 AM - 4 PM; No admis fee; Estab 1969 as a center for children; Maintains reference library; Average Annual Attendance: 10,000
Activities: Classes for adults & children; awards; scholarships offered; book traveling exhibitions 3 per year

M **CHILDREN'S MUSEUM OF MANHATTAN,** 212 W 83rd St, New York, NY 10024. Tel 212-721-1223; Fax 212-721-1127; Internet Home Page Address: www.cmom.org; *Exec Dir* Andrew Ackerman; *Assoc Dir Exhibits* Karen Snider; *Assoc Dir Programs* Leslie Bushara; *Comptroller* Jean Kessler
Open Wed - Sun 10 AM - 5 PM; Admis $6; Estab 1973 as a children's museum & art center featuring participatory art, science & nature exhibits; Average Annual Attendance: 320,000; Mem: 4,000; dues $95 - $5000
Income: $4,100,000 (financed by city, state, federal, corporate & foundation support, admis, mem, donations, program fees, tuition & sales shop)
Publications: Monthly calendars; program brochures
Activities: Educ dept with parent/child workshops, toddler programs, summer day camp, outreach, performing artists, volunteer/intern training, teacher training program; organize traveling exhibs to other children's mus; museum sales shop sells books, games, prints & toys

M **CHINA INSTITUTE IN AMERICA,** China Institute Gallery, 125 E 65th St, New York, NY 10021. Tel 212-744-8181; Fax 212-628-4159; Elec Mail wchang@chinainstitute.org; Internet Home Page Address: www.chinainstitute.org; *Dir Galleries* Willow Hai Chang; *Pres* Sara Judge McCalpin; *Mgr Art Education* Pao Yu Cheng; *Gallery Registrar* Wendy Sung; *Gallery Coordr* Ting Yuan
Open Mon, Wed - Sat 10 AM - 5 PM, Tues 10 AM - 8 PM, Sun 1 - 5 PM; $5 contribution; Estab 1966 to promote a knowledge of Chinese culture; Two-room gallery; Average Annual Attendance: 12,000; Mem: 950; dues gen $55, dual family $95, student/sr/ faculty/out-of-metro area resident $40, dual student/senior $75
Exhibitions: (2001) Living Heritage: Vernacular Environment in China; (2001) Exquisite Moments: West Lake and Southern Song Art; (2002) Circles of Reflection: The Carter Collection of Chinese Bronze Mirrors; (2002) Blanc de Chine: Divine Images in Porcelain; (2003) Weaving China's Past: The Amy S. Clague Collection of Chinese Textiles; (2003) Passion for the Mountains: 17th Century Landscape Paintings from the Nanjing Museum; (2004) Gold & Jade: Imperial Jewelry of the Ming Dynasty from the Nanjing Municipal Museum; (2004) The Scholar as Collector: Chinese Art at Yale; (2005) Providing for the Afterlife: Brilliant Artifacts from Shandong; (2005) Masterpieces of Chinese Lacquer from the Mike Healy Collection; (2006) Trade Taste & Transformation: Jingdezhen Porcelain for Japan 1620-1645; (2006) Shu: Reinventing Books in Contemporary Chinese Art
Publications: Exhibition catalogs
Activities: Classes for adults & children; docent training; hands on workshops; lect open to public; concerts; gallery talks; tours; one traveling exhib per year; originate traveling exhibitions; sales shop sells books

A **CHINESE-AMERICAN ARTS COUNCIL,** 456 Broadway, 3rd Fl, New York, NY 10013. Tel 212-431-9740; Fax 212-431-9789; *Exec Dir* Alan Chow; *Prog Dir* Jenny Chen
Open Mon - Fri 11 AM - 5 PM; No admis fee; Estab 1975 to provide exhibition space to Chinese-American artists; Average Annual Attendance: 600 - 800; Mem: 300; dues $10 - $100
Income: Financed by endowment, city & state appropriation & private funds
Activities: Classes for children

L **CITY COLLEGE OF THE CITY UNIVERSITY OF NEW YORK,** Morris Raphael Cohen Library, 160 Convent Ave, New York, NY 10031. Tel 212-650-7271; Fax 212-650-7604; Elec Mail prgcc@sci.ccny.cuny.edu; Internet Home Page Address: www.ccny.cuny.edu/library/; *Head Reference Div* Robert Laurich; *Chief Librn* Pamela Gillespie; *Archivist* Sydney Van Nort; *Architecture Librn* Judy Connorton; *Art/Architecture Visual Resources Librn* Ching-Jung Chen
Open Mon - Thurs 8 AM - 11 PM, Fri 8 AM - 9 PM, Sat 9 AM -6 PM, Sun Noon - 6 PM; No admis fee; Estab 1847 to support the educ at the City College; Atrium ca 7,000 sf; archives gallery 1300 sf; Average Annual Attendance: 100,000
Library Holdings: Book Volumes 22,000; Clipping Files; Exhibition Catalogs; Fiche; Memorabilia; Pamphlets; Periodical Subscriptions 60; Photographs 25,000; Slides 135,000

Special Subjects: Art History, Folk Art, Landscape Architecture, Decorative Arts, Film, Illustration, Photography, Drawings, Etchings & Engravings, Graphic Arts, Graphic Design, Islamic Art, Manuscripts, Maps, Painting-American, Painting-British, Painting-Dutch, Painting-Flemish, Painting-French, Painting-Italian, Pre-Columbian Art, Sculpture, Painting-European, Historical Material, Judaica, Portraits, Watercolors, Ceramics, Conceptual Art, Theatre Arts, Ethnology, American Western Art, Interior Design, Art Education, Video, American Indian Art, Anthropology, Furniture, Mexican Art, Costume Design & Constr, Mosaics, Afro-American Art, Enamels, Jewelry, Oriental Art, Pottery, Textiles, Landscapes, Antiquities-Etruscan, Antiquities-Greek, Antiquities-Roman, Architecture
Collections: History of Costume
Publications: Circumspice newsleetter
L **Architecture Library,** 408 Shepard Hall, Convent Ave & 138th St New York, NY 10031. Tel 212-650-8766; *Librn* Judy Connorton
Reference use for public; circulation for patrons with CUNY ID's
Library Holdings: Audio Tapes; Book Volumes 20,500; Clipping Files; Fiche; Periodical Subscriptions 48; Reels
Special Subjects: Landscape Architecture, Architecture

M **CITY OF NEW YORK PARKS & RECREATION,** Arsenal Gallery, Fifth Ave at 64th St, 3rd Fl New York, NY 10021. Tel 212-360-8163; Fax 212-360-1329; Elec Mail clare.weiss@parks.nyc.gov; Internet Home Page Address: www.nyc.gov/parks; *Cur* Clare Weiss
Open Mon - Fri 9 AM - 5 PM; No admis fee; The purpose is to show art based on natural & urban themes; Large open space in third floor of Arsenal building. Working busy space - work must be hung from monofilament line & moulding hooks
Collections: Mixed Media-Park & Nature themes
Exhibitions: Six week shows

COLLEGE ART ASSOCIATION
For further information, see National and Regional Organization

COLOR ASSOCIATION OF THE US
For further information, see National and Regional Organizations

L **COLUMBIA UNIVERSITY,** Avery Architectural & Fine Arts Library, 1172 Amsterdam Ave, MC-0301, New York, NY 10027. Tel 212-854-2425; Fax 212-854-8904; Elec Mail avery@libraries.cul.columbia.edu; Internet Home Page Address: www.columbia.edu/cu/iweb/indiv/avery/; *Dir & Librn* Angela Giral; *Assoc Dir* Kitty Chibnik; *Rare Books Cur* Claudia Funke; *Cur Drawings & Archives* Janet Parks; *Educ* Ted Goodman
Open Mon - Thurs 9 AM - 11 PM, Fri 9 AM - 9 PM, Sat 10 AM - 7 PM, Sun Noon - 10 PM; Estab 1890; Primarily for reference
Library Holdings: Book Volumes 300,000; Fiche; Manuscripts; Memorabilia; Other Holdings Original documents; Periodical Subscriptions 1,000; Photographs; Prints; Reels
Special Subjects: Art History, Architecture
Collections: Over 400,000 original architectural drawings, mainly American
Publications: Catalog of Avery Memorial Architectural Library; Avery Index to Architectural Periodicals, annually, also available as a data base
L **Dept of Art History & Archaeology,** Visual Resources Collection, 820-825 Schermerhorn Hall New York, NY 10027. Tel 212-854-3044; Fax 212-854-7329; Internet Home Page Address: www.columbia.edu/cu/arthistory/urc/; *Cur Visual Resources Coll* Andrew Gessener; *Asst Cur* Dorothy Krasowska
Library Holdings: Lantern Slides 70,000; Other Holdings Gallery announcements 15,000; Photographs 250,000; Slides 500,000
Collections: Berenson I-Tatti Archive; Dial Icongraphic Index; Haseloff Archive; Bartsch Collection; Gaigleres Collection; Arthur Kingsley Porter Collection; Ware Collection; Courtauld Collection; Marburger Index; Windsor Castle; Chatsworth Collection; Millard Meiss Collection
M **Miriam & Ira D Wallach Art Gallery,** Schermerhorn Hall, 8th Fl, New York, NY 10027. Tel 212-854-7288; Fax 212-854-7800; *Dir* Sarah Elliston Weiner; *Asst Dir* Jeanette Silverthorne
Open Wed - Sat 1 - 5 PM; No admis fee; Estab 1987 to complement the educational goals of Columbia University & to embody the research interests of faculty & graduate students in art history; 5 rooms, 2,300 sq ft, 310 running ft; Average Annual Attendance: 4,000
Income: $60,000 (financed by endowment & university)
Exhibitions: Temporary exhibitions only; 4 exhibitions annually during academic year
Publications: Exhibition catalogs
Activities: Lect open to public; gallery talks

M **CONGREGATION EMANU-EL,** Bernard Judaica Museum, One E 65th St, New York, NY 10021-6596. Tel 212-744-1400; Fax 212-570-0826; *Sr Cur* Elka Deitsch
Open daily 10 AM - 4:30 PM; No admis fee; Estab 1928 as a Judaica museum; Building is a landmark & is open for touring
Income: Financed by subvention from congregation
Collections: Congregational Memorabilia; Paintings; Borders & Boundaries: Maps of the Holy Land, 15th - 19th Centuries; Kabbalah: Mysticisim in Jewish Life
Exhibitions: Seasonal exhibits; Congregational History; Photographic exhibit of stained glass; A Temple Treasury, The Judaica Collection of Congregation Emanu-El of the City of New York
Activities: Docent training; lects open to public, 2 -4 vis lectrs per year; gallery talks & tours

L **COOPER UNION FOR THE ADVANCEMENT OF SCIENCE & ART,** Library, 30 Cooper Square, New York, NY 10003. Tel 212-353-4186; Fax 212-353-4017; Internet Home Page Address: www.cooper.edu/facilities/library/library.html; *Dir* Ulla Volk; *Visual Resources Librn* Tom Micchelli; *Engineering & Science* Carol Salomon; *Electronic Serv* Julie Castelluzzo; *Art & Architecture Librn* Claire Gunning; *Image Cur* Dana Felder
Open Mon - Thurs 9 AM - 9 PM, Fri 9 AM - 6 PM, Sat 11 AM - 5 PM, Sun Noon - 5PM; Estab 1859 to support the curriculum of the three professional schools: Art, Architecture, Engineering

Library Holdings: Audio Tapes 96; Book Volumes 103,300; CD-ROMs 608; Clipping Files 90,000; DVDs 544; Exhibition Catalogs 1,948; Fiche 19,535; Lantern Slides 9,690; Maps 2,607; Motion Pictures 186; Periodical Subscriptions 286; Reels 4,517; Slides 82,248; Video Tapes 395
Special Subjects: Art History, Collages, Constructions, Landscape Architecture, Film, Illustration, Mixed Media, Photography, Calligraphy, Commerical Art, Drawings, Etchings & Engravings, Graphic Arts, Graphic Design, Islamic Art, Manuscripts, Maps, Painting-American, Painting-British, Painting-Dutch, Painting-Flemish, Painting-French, Painting-German, Painting-Italian, Painting-Japanese, Painting-Russian, Painting-Spanish, Posters, Pre-Columbian Art, Prints, Sculpture, Painting-European, History of Art & Archaeology, Watercolors, Conceptual Art, Latin American Art, Archaeology, Painting-Israeli, Printmaking, Art Education, Asian Art, Video, American Indian Art, Primitive art, Anthropology, Mexican Art, Mosaics, Painting-Polish, Aesthetics, Afro-American Art, Antiquities-Oriental, Antiquities-Persian, Miniatures, Oriental Art, Woodcarvings, Woodcuts, Antiquities-Assyrian, Antiquities-Byzantine, Antiquities-Egyptian, Antiquities-Etruscan, Antiquities-Greek, Antiquities-Roman, Painting-Scandinavian, Painting-Australian, Painting-Canadian, Painting-New Zealander, Architecture, Portraits
Activities: Non-degree classes for adults; lect open to public, 20-30 vis lectrs per year

M **COOPER-HEWITT, NATIONAL DESIGN MUSEUM, SMITHSONIAN INSTITUTION,** (Cooper-Hewitt National Design Museum) 2 E 91st St, New York, NY 10128. Tel 212-849-8400; Fax 212-849-8401; Internet Home Page Address: www.si.edu/ndm/; *Dir* Paul Thompson; *Cur Applied Arts* Deborah Shinn; *Cur Drawings & Prints* Marilyn Symmes; *Cur Textiles* Gilian Moss; *Cur Contemporary Design* Ellen Lupton; *Cur Wallcoverings* JoAnne Warner; *Asst Dir Public Projects* Susan Yelavich; *Librn* Stephen Van Dyk
Open Tues 10 AM - 9 PM, Wed - Sat 10 AM - 5 PM, Sun Noon - 5 PM, cl Mon & federal holidays; Admis Adults $8, seniors & students $5, free admis to members & after 5 PM on Tues; Founded 1897 as the Cooper Union Museum, to serve the needs of scholars, artisans, students, designers & everyone who deals with the built environment; Museum is based on large & varied collections of historic & contemporary design & a library strong in those fields; changing exhibitions are based on the museum's vast collections or loan shows illustrative of how design affects everyone's daily life; its emphasis on educ is expanded by special courses & seminars related to design in all forms & of all periods; the galleries occupy the first & second floors; (1998) exhibitions relate to the collections & other aspects of design. Maintains library; Average Annual Attendance: 150,000; Mem: 10,000; dues $35-$2500
Income: Financed by private contributions, mem & partly Smithsonian Institution
Special Subjects: Architecture, Drawings, Latin American Art, Ceramics, Crafts, Pottery, Etchings & Engravings, Afro-American Art, Decorative Arts, Manuscripts, Posters, Furniture, Glass, Jewelry, Porcelain, Metalwork, Carpets & Rugs, Historical Material, Calligraphy, Embroidery, Gold, Cartoons, Pewter, Leather, Bookplates & Bindings
Collections: Drawings including works by Frederic Church, Winslow Homer, Thomas Moran & other 19th century American artists; ceramics; furniture & woodwork, glass, original drawings & designs for architecture & the decorative arts; 15th-20th century prints; textiles, lace, wallpaper; 300,000 works representing a span of 300 years; wall coverings
Publications: The Smithsonian Illustrated Library of Antiques; books on decorative arts; collection handbooks; exhibition catalogues; magazine
Activities: Classes for adults & children; performances; docent training; Master's Degree program in Decorative Arts through Parsons; lect open to public, 50-100 vis lectrs per year; concerts; gallery talks; tours; fellowships offered; paintings & original objects of art lent to other museums; lending collection contains original art works, original prints & 40,000 books; book traveling exhibitions; originate traveling exhibitions; museum shop sells books & objects related to historical & contemporary design
L **Doris & Henry Dreyfuss Memorial Study Center,** 2 E 91st St, New York, NY 10128. Tel 212-849-8300; Internet Home Page Address: www.si.edu/ndm/; *Librn* Stephen Van Dyk
Open Mon - Fri 9 AM - 6 PM by appointment; No admis fee; Estab to serve staff of museum & students from Parsons School of Design; Interlibrary lending only
Income: Financed through SIL budgets
Library Holdings: Book Volumes 55,000; Cards; Clipping Files; Exhibition Catalogs; Fiche; Kodachrome Transparencies; Lantern Slides; Manuscripts; Memorabilia; Micro Print; Original Art Works; Other Holdings Original documents; Pictures & photographs 1,500,900; Pamphlets; Periodical Subscriptions 300; Photographs; Prints; Reels; Reproductions; Slides; Video Tapes
Special Subjects: Decorative Arts, Graphic Design, Advertising Design, Industrial Design, Interior Design
Collections: Donald Deskey Archive; Henry Dreyfuss Archive; Ladislav Sutnar Archive; Spec Coll of Industrial & Graphic Designers

A **CREATIVE TIME,** 307 7th Ave, Ste 1904 New York, NY 10001. Tel 212-206-6674; Fax 212-255-8467; Elec Mail staff@creativetime.org; Internet Home Page Address: www.creativetime.org; *Dir Develop* Susan Kennedy; *Exec Dir* Anne Pasternak
Open Mon - Fri 10 AM - 5 PM, exhibition hrs vary depending on site; Admis performances $8, exhibitions usually free; Estab 1973 to present visual, architecture & performing art programs in public spaces throughout New York City; Spaces include a variety of temporarily unused public locations; Average Annual Attendance: 50,000; Mem: 200; members give tax-deductible contributions
Income: $500,000 (financed by National Endowment for the Arts, NY State Council of the Arts, NYC Dept of Cultural Affairs, private corporations & foundations)
Exhibitions: Art in the Anchorage
Publications: Creative Time; biannual program/project catalogs
Activities: Multimedia, dance & performance art events

M DAHESH MUSEUM OF ART, 601 Fifth Ave, New York, NY 10017. Tel 212-759-0606; Fax 212-759-1235; Elec Mail information@daheshmuseum.org; Internet Home Page Address: www.daheshmuseum.org; *Dir* J David Farmer; *Assoc Dir* Michael Fahlund; *Cur* Stephen R Edidin; *Assoc Cur* Roger Diederin; *Adminr* Maria Celi; *Registrar* Lisa Mansfield; *Admin Asst* Jean Rho; *Research Assoc* Frank Verpoorten; *Exec Asst* Suzanne Yantorno; *Asst Registrar* Richard Feaster; *Educator* Deborah Block; *Mus Preparator* Jeremy Benjamin; *Webmistress* Jennifer Marter; *VChmn* Mervat Zahid; Melissa Labelson; *Asst Cur* Lisa Small; *Admin Asst* Sarah Giannelli; *Accounting Mgr* William Ignatowich
Open Tues - Sat 11 AM - 6 PM; No admis fee; Estab 1987; Maintains reference library; Average Annual Attendance: 20,000
Special Subjects: Drawings, Graphics, Sculpture, Watercolors, Bronzes, Etchings & Engravings, Landscapes, Painting-European, Painting-British, Painting-French
Collections: European 19th & 20th Century Academic Art (paintings, sculpture & works on paper)
Publications: Dahesh Muse, newsletter 3 per year
Activities: Lect open to public, 20 vis lectrs per year; museum shop sells books, prints, reproductions, jewelry, figurines, stationery, educational toys & gifts

A DIA CENTER FOR THE ARTS, 548 W 22nd St, New York, NY 10011. Tel 212-989-5566; Fax 212-989-4055; Elec Mail info@diacenter.org; Internet Home Page Address: www.diacenter.org; *Cur* Lynne Cooke; *Exec Dir* Michael Govan
Open Wed - Sun Noon - 6 PM; Admis adults $6, seniors & students $3; Estab 1974 for planning, realization & presentation of important works of contemporary art. Committment to artist's participation in display of works in long term, carefully maintained installations; Galleries: Dan Flavin Art Institute, Bridgehampton, NY; The Lightning Field, Quemado, NM
Income: Financed by grants
Exhibitions: Dan Graham
Publications: The Foundation has published collections of poetry & translations of poetry
Activities: Educ dept; lect open to public, 3 vis lectrs per year; exhibit catalogues; Series of discussions on contemporary cultural issues; museum shop sells books & original art

M DIEU DONNE PAPERMILL, INC, 433 Broome St, New York, NY 10013. Tel 212-226-0573; Fax 212-226-6088; Elec Mail info@papermaking.org; Internet Home Page Address: www.papermaking.org; *Prog Admin* Stacey Lynch; *Exec Dir* Mina Takahashi; *Studio Collaborator* Megan Moorehouse
Open Wed - Sat Noon - 6 PM; No admis fee; Estab 1976 to promote the art of hand papermaking; Editions gallery for recent works at Dieu Donne, main gallery works in hand paper; maintains archive & reference library; Mem: Dues $35
Collections: Chase Manhattan Banks; Johnson & Johnson; Rutgers University; Zimmerli Art Museum; Metropolitan Museum of Art
Exhibitions: Melvin Edwards Aqua y Acero en Papel
Activities: Classes for adults & children; lect open to public, 5 vis lectrs per year; gallery talks; tours; competitions; scholarships offered; original objects of art lent to members & institutions; lending collection contains books, slides & works in handmade paper; originate traveling exhibitions; sales shop sells books, original art & products in handmade paper, Dieu Donne paper

A THE DRAWING CENTER, 35 Wooster St, New York, NY 10013. Tel 212-219-2166; Fax 212-966-2976; Elec Mail info@drawingcenter.org; Internet Home Page Address: www.drawingcenter.org; *Acting Exec Dir* Lisa Metcalf; *Pres* George Negroponte
Open Tues - Fri 10 AM - 6 PM, Sat 11 AM - 6 PM, cl Sun & Mon; Admis $3 suggested; Estab 1977 to express the quality & diversity of drawing through exhib & educ; 3,000 sq ft main gallery & 530 sq ft Drawing Room, located at 40 Wooster St; Average Annual Attendance: 125,000; Mem: 200; dues artist $35, individual $50
Income: Pvt & pub support
Special Subjects: Drawings
Exhibitions: Group shows of emerging artists; (11/2006-2/2007) Eleanore Mikus; (4/2007-7/2007) Gego
Publications: Exhib catalogs; Drawing Papers publ series
Activities: Classes for children; lect open to pub, gallery talks; work study program offered; book traveling exhibs 1-2 per yr; originate traveling exhibs to major national & international museums; mus shop sells books & limited edition prints

THE DRAWING SOCIETY
For further information, see National and Regional Organizations

M EARTHFIRE, Art from Detritus: Recycling with Imagination, PO Box 1149, New York, NY 10013-0866. Tel 212-925-4419; Fax 212-925-4419; Elec Mail ncognita@earthfire.org; Internet Home Page Address: www.ncognita.com; *Dir & Cur* Vernita Nemec
Open by appointment & during exhibit hrs; No admis fee; Estab 1993 for the art of recycled materials to raise environmental awareness; Circ 4 catalogs available; Exhibition available for travel and adaptable to site; Average Annual Attendance: 5,000
Income: Financed by grants, pub & private contributions
Exhibitions: Art From Detritus: Recycling with Imagination
Publications: Exhibit catalogues (1-4)
Activities: Classes for adults & children; lect open to public, gallery talks, tours; exhibition grant from Kaufmann Found for exhibit in Kansas City; originate traveling exhibitions annually, to universities, conferences, corporate galleries; museum shop sells catalogs of past exhibitions by mail, original art

M EL MUSEO DEL BARRIO, 1230 Fifth Ave, New York, NY 10029. Tel 212-831-7272; Fax 212-831-7927; Elec Mail elmuseo@aol.com; Internet Home Page Address: www.elmuseo.org; *Dir* Susana Torruella-Leval; *Dir Pub Relations* Gabrela Pardo; *Mus Educ* Angela Garcia; *Cur* Deborah Cullen; *VChmn* Tom Bechara; *Dir Finance* Janulyn McKanic; *Registrar* Noel Valentin; *Mus Shop Mgr* Ilana Stollman; *Sr Cur* Fatima Bercht; *Deputy Dir* Patricia Smalley; *VChmn* Estrellita Brodsky
Open Wed - Sun 11 AM 5 - PM, cl Mon & Tues; Admis adults $5, seniors & students with ID $3, children under 12 free when accompanied by adult; Estab

1969 to conserve & display works by Puerto Rican artists & other Hispanic artists; Located on Museum Mile. Gallery space divided in 4 wings: Northwest Wing houses Santos de Palo, East Gallery will house Pre-Columbian installation, F-Stop Gallery devoted to photography & Childrens Wing opened fall of 1982; Average Annual Attendance: 21,000; Mem: 5,000; patron, organization & business $2000, associate $1,500, sustaining $300, support $350, contributing $100, family $200, individual $300, special $50
Collections: 16mm Films on History, Culture and Art; 300 Paintings and 5000 Works on Paper, by Puerto Rican and other Latin American Artists; Pre-Columbian Caribbean Artifacts; Santos (Folk Religious Carvings)
Activities: Classes for adults & children; dramatic programs; children's workshops; lect open to public, 25 vis lectrs per year; concerts; gallery talks; tours; awards; scholarships; individual & original objects of art lent to other museums & galleries; originate traveling exhibitions; Junior Museum; 510 seat theatre

A ELECTRONIC ARTS INTERMIX, INC, 542 W 22nd St 3rd Fl, New York, NY 10011. Tel 212-337-0680; Fax 212-337-0679; Elec Mail info@eai.org; Internet Home Page Address: www.eai.org; *Exec Dir* Lori Zippay; *Dir Distribution* John Thomson
Open Mon - Fri 9:30 AM - 5:30 PM; No admis fee for individuals; group fee negotiable; Estab as a nonprofit corporation to assist artists seeking to explore the potentials of the electronic media, particularly television, as a means of personal expression
Income: Financed by videotape & editing fees & in part by federal & state funds & contributions
Collections: Several hundred video cassettes
Publications: Electronic Arts Intermix Videocassette Catalog, annual

M EMEDIALOFT.ORG, 55 Bethune St Ste A-629, New York, NY 10014-2035. Tel 212-924-4893; Fax 212-924-4893; Elec Mail xyz@eMediaLoft.org; Internet Home Page Address: eMediaLoft.org; *Co-Dir* Bill Creston; *Co-Dir, Cur & Grants Officer* Barbara Rosenthal; *Asst* Sena Clara Creston
Open Mon - Fri 10 AM - 6 PM by appointment; No admis fee; Estab 1992 for artists in video production, artists' books, photography; Video & film post production area, photo studio, darkroom; display walls, book shelves, 950 sq ft; maintains reference library; Average Annual Attendance: 300
Income: $40,000 (financed by private funds & facility fees)
Purchases: Video & audio equipment
Library Holdings: Audio Tapes; Book Volumes; Cards; Cassettes; Exhibition Catalogs; Manuscripts; Memorabilia; Motion Pictures; Original Art Works; Original Documents; Periodical Subscriptions; Photographs; Slides; Video Tapes
Special Subjects: Conceptual Art, Drawings, Photography
Collections: Artists books, art books, classic literature
Exhibitions: Artists books & photos, videotapes, super 8 film
Publications: Exhibit catalogs
Activities: Educ program; one-on-one workshops; digital video & photog workshops; screenings open to public; creative projects grant offered; original objects of art lent to exhibitors; lending collection contains artists' books, videos, photos to galleries & museums; originate traveling exhibitions to film & video artists; sales shop sells books, original art, photos, videos

C EQUITABLE LIFE ASSURANCE SOCIETY, The Equitable Gallery, 787 Seventh Ave, New York, NY 10019. Tel 212-554-2018; Fax 212-554-2456; Internet Home Page Address: www.axa-financial.com/aboutus/gallery.html; *Gallery & Coll Cur* Nancy Deihl; *VPres & Dir* Pari Stave; *Mgr* Liz Cacciatori
Open Mon-Fri 11AM-6PM, Sat Noon-5PM; Estab 1992 dedicated to providing a venue for traveling exhibitions otherwise not shown in New York City; Average Annual Attendance: 110,000
Collections: 19th & 20th century paintings, sculpture & works on paper, American emphasis; Commissioned Art Works by; Roy Lichetenstein, Scott Burton, Sol Lewitt, Sandro Chia
Activities: Support technical assistance programs; lect open to public; gallery talks; library tours; individual paintings & original objects of art lent to museums for short-term exhibitions

M EXIT ART, 475 10th Ave, New York, NY 10018. Tel 212-966-7745; Fax 212-925-2928; Elec Mail info@exitart.org; Internet Home Page Address: www.exitart.org; *Co-Founder-Cultural Production* Papo Colo; *Dir* Jeannette Ingberman; *Mgr* Toby Kress
Open Tues - Fri 10 AM - 6 PM, Sat 11 AM - 6 PM; Voluntary contribution; Estab 1982, dedicated to multi-cultural, multi-media enlightenment through presentations & publications, film festivals, exhibitions, music performances & theater; 17,000 sq ft, one fl; Average Annual Attendance: 60,000; Mem: 250; dues $30 & up
Income: Financed by donations & foundation support
Exhibitions: Wide range of varied exhibitions
Activities: Lect open to public; concerts; originate traveling exhibitions to museums, cultural spaces & university galleries; museum shop sells magazines, original art & artist made products

M FASHION INSTITUTE OF TECHNOLOGY, Museum at FIT, Seventh Ave at W 27th St, New York, NY 10001-5992. Tel 212-217-5970; Fax 212-217-5978; Elec Mail tamsen_schwartzman@fitsuny.edu; Internet Home Page Address: www.fitnyc.edu/museum; *Dir* Dr Valerie Steele; *Deputy Dir* James T Hanley
Open Tues - Fri Noon - 8 PM, Sat 10 AM - 5 PM, cl Sun, Mon & holidays; No admis fee; Estab 1967 to bring to the student body & the community at large a variety of exhibitions in fashion & the applied arts; 10,500 sq ft of space divided into three galleries, 2 for fashion and/or textile exhibits, one small gallery for student work; Average Annual Attendance: 100,000
Income: Financed by endowment & grants
Purchases: Costumes, accessories & textile collections, The Mus at FIT
Special Subjects: Textiles, Costumes, Embroidery, Laces
Collections: One of the largest working costume & textile collections in the world focusing on the 20th Century
Publications: Exhibit catalogs
Activities: Lect open to public, gallery tours, special lect & symposium; clothing & textiles lent to major museums & art institutions; originate traveling exhibitions organized & circulated; circulates with Kennedy Center

L **Gladys Marcus Library,** Seventh Ave at 27th St, New York, NY 10001-5992. Tel 212-217-5590; Fax 212-217-5268; Internet Home Page Address: www3.fitnyc.edu/library; *Reference Head* Beryl Rentof; *Reference & Spec Coll* Joshua Waller; *Reference & Systems* Lorraine Weberg; *Reference* Stephen Rosenberger; *Catalog Head* Janette Rozene; *Dir* N J Wolfe; *Asst Dir* Greta Earnest; *Evening Supv* Mata Stevenson; *Circulation & ILL* Tabitha Hanslick
Open Mon - Thurs 9 AM - 10 PM, Fri 9 AM - 6:30 PM, Sat Noon - 6 PM, Sun Noon - 5 PM; Estab 1944 to meet the academic needs of the students & faculty & to serve as a resource for the fashion industry; Circ 305,100; For reference only; Average Annual Attendance: 78,000
Income: $2,467,531, SUNY
Purchases: $349,336
Library Holdings: Audio Tapes; Book Volumes 168,897; CD-ROMs; Cards; Cassettes; Clipping Files; Compact Disks; Exhibition Catalogs; Fiche 4712; Filmstrips 357; Memorabilia; Micro Print; Motion Pictures; Original Art Works 184; Other Holdings Artist Books, Online Database; Pamphlets; Periodical Subscriptions 502; Photographs; Prints; Reels; Reproductions; Slides; Video Tapes
Special Subjects: Art History, Decorative Arts, Graphic Design, Advertising Design, Fashion Arts, Interior Design, Furniture, Costume Design & Constr, Jewelry
Collections: Oral History Project on the Fashion Industry; several sketchbook collections; Fashion Illustration
Exhibitions: Artful Line (Summer 2004)

FEDERATION OF MODERN PAINTERS & SCULPTORS
For further information, see National and Regional Organizations

M **FIRST STREET GALLERY,** 526 W 26th St, New York, NY 10012. Tel 646-336-8053; Fax 646-336-8054; Internet Home Page Address: www.firststreetgallery.net; *Acting Dir* Rallou Malliarakis; *Asst Mgr* Alan Petrulis
Open Tues - Sat 11 AM - 6 PM; Estab 1969 to promote figurative art & artists throughout the US; Artist-run cooperative exhibiting contemporary Realist work; Average Annual Attendance: 5,600; Mem: 20; dues $110; open to Realist artists only; monthly meetings
Exhibitions: Aros: 10 solo shows, 2 group shows, 1 competition show
Activities: Competitions; originate travel exhibitions

C **FORBES MAGAZINE, INC,** Forbes Collection, 62 Fifth Ave, New York, NY 10011. Tel 212-206-5549; *VPres* Margaret Kelly
Open Tues, Wed, Fri & Sat 10 AM - 4 PM, Thurs group tours; Estab 1985
Collections: Antique Toys; Faberge Imperial Eggs Collection; French Military Paintings; Presidential Papers; Toy Soldiers
Activities: Gallery talks; individual paintings & original objects of art lent to museums & galleries

L **FRANKLIN FURNACE ARCHIVE, INC,** 45 John St, No 611, New York, NY 10038-3706. Tel 212-766-2606; Fax 212-766-2740; Elec Mail mail@franklinfurnace.org; *Adminr* Harley Spiller; *Prog Dir* Delores Zorregvieta; *Archivist* Michael Katchen; *Founding Dir* Martha Wilson
Estab 1976 as a nonprofit corporation dedicated to the cataloging, exhibition & preservation of book-like work by artists, performance art & temporary installations; now presenting performance art on the Web; web site only; Mem: 1,000 members; dues $25, $50, $100, $250, $500 & $1,000; benefits increase with dues
Publications: FLUE, irregular periodical

M **FRAUNCES TAVERN MUSEUM,** 54 Pearl St, New York, NY 10004-2429. Tel 212-425-1778; Fax 212-509-3467; Elec Mail publicity@frauncestavernmuseum.org; Internet Home Page Address: www.frauncestavernmuseum.org; *Development Officer* Linda Goldberg; *Public Relations Officer* Andrea Homan; *Cur & Dir* Marion Grzesiak; *Registrar* Stephen Fenney; *Accounting* Cecelia Mahnken; *Bldg Mgr* Bruce Barraclough; *Admin* Margaret O'Shaughnessy; *Dir* Andrew Batten; *Marketing Coordr* Jennifer Eaton; *VChmn* Laurence Simpson
Open Mon - Fri 10 AM - 4:45 PM; Admis adults $3, students, children & seniors $2; Estab 1907 for focus on early American history, culture, historic preservation & New York City history; Museum is housed in the site of eighteenth-century Frauncess Tavern and four adjacent nineteenth-century buildings. The museum houses two fully furnished period rooms: the Long Room, site of George Washington's farewell to his officers at the end of the Revolutionary War, and the Clinton Room. a nineteenth-century dining room; Mem: 500; dues $20 - $1000
Collections: 17th, 18th, 19th & 20th century prints, paintings, artifacts & decorative arts relating to early American history, culture & historic preservation; New York City history; George Washington & other historic figures in American history
Exhibitions: Various exhib
Publications: Exhibit catalogs
Activities: Educ dept; docent training; lectures open to public; tours; demonstrations; films; off-site programs; individual paintings lent to qualified museums & historical organizations; lending collection contains 750 original works of art, 150 original prints, & 1,300 decorative art & artifacts; book traveling exhibitions; museum shop sells books, reproductions, prints & slides

L **FRENCH INSTITUTE-ALLIANCE FRANCAISE,** Library, 22 E 60th St, New York, NY 10022-1077. Tel 212-355-6100; Fax 212-935-4119; Internet Home Page Address: www.fiaf.org; *Library Technical Asst* Ronda Murdock; *Librn* Katherine Branning; *Dir* David S Black
Open Mon - Thurs 11:30 AM - 8 PM, Sat 10 AM - 1:30 PM, cl Fri & Sun; No admis fee; Estab 1911 to encourage the study of the French language & culture; Library lends to members, reference only for non-members; maintains art gallery
Income: Financed by endowment & mem, tax deductible contributions & foundation grants
Library Holdings: Audio Tapes; Book Volumes 30,000; CD-ROMs; Cassettes 900; Exhibition Catalogs; Periodical Subscriptions 100; Video Tapes
Special Subjects: Film
Collections: Architecture, costume, decorative arts, paintings; French literature & culture

Exhibitions: Changes monthly; concentrates on up & coming artists
Activities: Classes given; lect open to public

L **FRICK ART REFERENCE LIBRARY,** 10 E 71st St, New York, NY 10021. Tel 212-288-8700; Fax 212-879-2091; Elec Mail info@frick.org; Internet Home Page Address: www.frick.org/html/libr.htm; *Andrew W Mellon Librn* Patricia Barnett; *Chief, Coll Develop & Research* Inge Reist; *Chief, Coll Management & Access* Deborah Kempe; *Chief, Coll Preservation* Don Swanson; *Chief Public Servs* Lydia Dufour; *Chief Archivist* Sally Brazil; *Head Information Systems* Floyd Sweeting
Open Mon - Fri 10 AM - 5 PM (Sept - July), Sat 9:30 AM - 1 PM (Sept - May), cl Sun, holidays & month of Aug; Estab 1920 as a reference library to serve adults & graduate students interested in the history of European & American painting, drawing, sculpture, illuminated manuscripts; For reference only; Average Annual Attendance: 5,600
Library Holdings: Auction Catalogs 73,000; Book Volumes 250,000; CD-ROMs 87; Exhibition Catalogs 85,400; Fiche 52,000; Other Holdings Mircofiche titles; Negatives 56,000; Architectual Plans 5000 - 10,000 items; Periodical Subscriptions 700; Photographs 900,000; Reels 233; Video Tapes 13
Collections: Archives (unrecorded)
Publications: Frick Art Reference Library Original Index to Art Periodicals; Frick Art Reference Library Sales Catalogue Index (microform); Spanish Artists from the Fourth to the Twentieth Century (4 vols); The Story of the Frick Art Reference Library: The Early Years, by Katharine McCook Knox

M **FRICK COLLECTION,** One E 70th St, New York, NY 10021. Tel 212-288-0700; Fax 212-628-4417; Elec Mail info@frick.org; Internet Home Page Address: www.frick.org; *Dir* Samuel Sachs II; *Cur* Susan Grace Galassi; *Deputy Dir* Robert B Goldsmith; *Mgr Sales & Info* Kate Gerlough; *Registrar* Diane Farynyk; *Chief Cur* Colin B Bailey; *Mgr Bldgs & Secy* Dennis F Sweeney
Open Tues - Thurs & Sat 10 AM - 6 PM, Fri 10 AM - 9 PM, Sun 1 - 6 PM; cl Jan 1, July 4, Thanksgiving, Dec 24 & 25; Estab 1920; opened to public 1935 as a gallery of art; The Frick Collection is housed in the former residence of Henry Clay Frick (1849-1919), built in 1913-14 & alterations & additions were made 1931-1935 & further extension & garden were completed in 1977. The rooms are in the style of English & French interiors of the 18th century. Maintains art reference library; Average Annual Attendance: 275,000; Mem: 700 Fellows; dues $1,000 minimum contribution; 2700 friends; dues $60 minimun contribution
Income: $15,200,000 (financed by endowment, mem, bookshop & admis)
Library Holdings: Auction Catalogs; Book Volumes; Exhibition Catalogs; Fiche; Pamphlets; Periodical Subscriptions; Photographs
Special Subjects: Drawings, Prints, Sculpture, Bronzes, Painting-European, Furniture, Porcelain, Renaissance Art, Painting-Italian
Collections: 15th-18th century sculpture, of which Renaissance bronzes are most numerous; 14th-19th century paintings, with fine examples of Western European masters & suites of Boucher & Fragonard decorations; Renaissance & French 18th century furniture; 17th-18th century Chinese & French porcelains; 16th century Limoges enamels; 16th-19th century drawings & prints
Exhibitions: (2003) Anne Vallayer-Coster; Whistler, Women & Fashion
Publications: Art in the Frick Collection (paintings, sculpture & decorative arts); exhibition catalogs; The Frick Collection, illustrated catalog; guide to the galleries; handbook of paintings; Ingres & the Comtesse d'Haussonville; paintings from the Frick Collection
Activities: Lect open to public; concerts; originates traveling exhibitions; museum shop sells books, prints, slides, postcards & greeting cards

C **FRIED, FRANK, HARRIS, SHRIVER & JACOBSON,** Art Collection, One New York Plaza, New York, NY 10004. Tel 212-859-8000; Telex 747-1526; *Chmn* Arthur Fleischer Jr; *Preparator* Macyn Bolt
Open by appointment; Estab 1979 intended as a survey
Purchases: Over 1,000 pieces in all offices (NY, DC, LA & London)
Collections: Fried, Frank, Harris, Shriver & Jacobson Art Collection; Contemporary Art; Photography
Exhibitions: Permanent exhibition
Activities: Tours

M **GALLERY OF PREHISTORIC PAINTINGS,** 1202 Lexington Ave, St 314, New York, NY 10028. Tel 212-861-5152; *Dir* Douglas Mazonowicz
Open by appointment; No admis fee; Estab 1975 to make available to the pub the art works of prehistoric peoples, particularly the cave paintings of France, Spain & the Sahara Desert; Large display area; Average Annual Attendance: 10,000
Income: Financed by private funds
Special Subjects: Primitive art
Collections: Early American Indian Rock Art; Rock Art of Eastern Spain; Rock Art of the Sahara; serigraph reproduction editions of Cave Art of France and Spain
Publications: Newsletter, quarterly
Activities: Classes for adults & children; Cave Art-in-Schools Program; lect open to the public; gallery talks; tours; lending collection contains books, cassettes, framed reproductions, 1,000 Kodachromes, motion pictures, original prints, 1,000 photographs, 2,000 slides; originate traveling exhibitions organized & circulated; sales shop selling books, magazines

L **Library,** Tel 212-861-5152; *Dir* Douglas Mazonowicz
Open Mon - Fri 9 AM - 5 PM, Sat 9 AM - Noon; Estab 1975 to make information available to the general public concerning the art works of prehistoric peoples; For reference only
Library Holdings: Book Volumes 250; Cassettes; Clipping Files; Exhibition Catalogs; Framed Reproductions; Kodachrome Transparencies; Manuscripts; Motion Pictures; Pamphlets; Periodical Subscriptions 9; Photographs; Prints; Reproductions; Sculpture; Slides

C **THE GILMAN PAPER COMPANY,** 111 W 50th St, New York, NY 10020. Tel 212-246-3300; Fax 212-582-7610; *Cur* Pierre Apraxine
Collections: Conceptual art; architectural drawings; photography
Activities: Tours

M GOETHE INSTITUTE NEW YORK, German Cultural Center, 1014 Fifth Ave, New York, NY 10028. Tel 212-439-8700; Fax 212-439-8705; Elec Mail program@goethe-newyork.org; Internet Home Page Address: www.Goethe.de/newyork; *Dir* Peter Soetje; *Head Prog Dept* Diera Sixt
Open Mon, Wed & Fri, 10 AM - 5 PM, Tues & Thurs 10 AM - 7 PM; Estab 1957 to promote & support German art; Maintains library; Average Annual Attendance: 3,500-4,000
Income: Financed by German government
Special Subjects: Photography, Architecture, Drawings, Graphics, Painting-German
Activities: Lect open to public; concerts; book sale at library once per yr

A GRAPHIC ARTISTS GUILD, 90 John St Ste 403, New York, NY 10038. Tel 212-791-3400; Fax 212-791-0333; Elec Mail execdir@gag.org; Internet Home Page Address: www.gag.org; *Exec Dir* Steven Schubert; *Pres* Jonathan Combs; *VPres* Lloyd Dangle
Open 10 AM - 6 PM; Estab 1967 to improve the economic & social condition of graphic artists; to provide legal & credit services to members; to increase pub appreciation of graphic art (including illustration, cartooning & design) as an art form; Mem: 1,300
Income: Financed by mem & publication sales
Publications: Cartooning books; GAG Directory of Illustration, annual; GAG Handbook, Pricing & Ethical Guidelines, biennial; monthly newsletter
Activities: Walter Hortens Memorial Awards for Distinguished Service & Outstanding Client

GREENWICH HOUSE POTTERY
M First Floor Gallery, Tel 212-242-4106; Fax 212-645-5486; Elec Mail pottery@greenwichhouse.org; Internet Home Page Address: www.gharts.org; *Asst Dir* Lynne Lerner; *Prog Coordr* Jenine Repice; *Dir* Elizabeth Zawada
Open Mon, Thurs & Fri 10 AM - 1:30 PM & 2:30 - 5:30 PM, Tues 10 AM - 1:30 PM & 2:30 - 8 PM, Wed 3 - 8 PM, Sat 2 - 6 PM; No admis fee; First Floor Gallery displays works of its members
Activities: Classes for adults & children; lect open to public, 10 vis lectrs per year; competitions; scholarships & fellowships offered; museum shop sells original art
M Jane Hartsook Gallery, Tel 212-242-4106; Fax 212-645-5486; Elec Mail pottery@greenwichhouse.org; Internet Home Page Address: www.gharts.org; *Asst Dir* Lynne Lerner; *Prog Coordr* Jenie Repice; *Dir* Elizabeth Zawada
Open Tues - Fri 2:30 - 6:30 PM, Sat 11 AM - 5 PM or by appointment; No admis fee; Estab 1969 as a nonprofit venue for ceramic arts
Exhibitions: Artists on Their Own, annual juried exhibit
Activities: Classes for adults & children; lect open to public, 10 vis lectrs per year; competitions; scholarships offered; museum shop sells original art
L Library, Tel 212-242-4106; Fax 212-645-5486; Internet Home Page Address: www.gharts.org; *Asst Dir* Lynne Lerner; *Dir* Elizabeth Zawada
Open Tues & Thurs 4 - 6 PM, Fri & Sat 1 - 3 PM; Estab 1909; For reference only
Library Holdings: Audio Tapes; Book Volumes 700; Exhibition Catalogs; Pamphlets; Periodical Subscriptions 10; Slides; Video Tapes
Special Subjects: Ceramics

L GROLIER CLUB LIBRARY, 47 E 60th St, New York, NY 10022. Tel 212-838-6690; Fax 212-838-2445; Elec Mail ejh@grolierclub.org; Internet Home Page Address: www.grolierclub.org; *Dir & Librn* Eric Holzenberg; *Pres* William T Buice
Open Mon - Sat 10 AM - 5 PM, cl Sun, Sat in the Summer & pub in Aug; No admis fee; Estab 1884, devoted to the arts of the book; Mem: 700; annual meetings fourth Thurs of Jan
Purchases: $15,000
Library Holdings: Book Volumes 100,000; Periodical Subscriptions 35; Prints
Collections: Bookseller & auction catalogs from 17th century
Activities: Lect for members only

M GUGGENHEIM MUSEUM SOHO, 575 Broadway, New York, NY 10012. Tel 212-423-3500; Fax 212-423-3787; Elec Mail publicaffairs@guggenheim.org; Internet Home Page Address: www.guggenheim.org; *Deputy Dir & Sr Cur* Lisa Dennison; *Deputy Dir Finance & Adminr* Roy Eddey; *Conservator* Paul Schwartzbaum; *Photographer* David Heald; *Asst to Dir* Desiree Baber; *Dir Public Affairs* Betsy Ennis; *Dir* Thomas Krens; *Deputy Dir for Spec Projects* Laurie Beckelman; *Dir Marketing* Laura Miller; *Dir Develop* Melanie Forman
Open Thurs - Mon 11 AM - 6 PM, cl Tues, Wed & Christmas, open Christmas Eve & New Years Eve 11 AM - 5 PM; No admis fee; Estab 1992; Housed in a nineteenth century landmark building in SOHO's historic cast-iron district, which was designed by renowned architect Arata Isozaki
Special Subjects: Drawings, Painting-American, Photography, Sculpture, Watercolors, Painting-French, Painting-Spanish, Painting-Italian, Painting-German, Painting-Russian
Exhibitions: Special exhibitions that complement those at Solomon R Guggenheim Museum with emphasis on multi-media & interactive art; ongoing virtual reality & CD-ROM installations related to art & architecture
Activities: Dramatic programs; docent training; symposia; family activities; teacher training; lect open to public, 6 vis lectrs per year; concerts; gallery talks; tours; competitions with prizes; museum shop sells books, original art & reproductions

GUILD OF BOOK WORKERS
For further information, see National and Regional Organizations

L HAMPDEN-BOOTH THEATRE LIBRARY, 16 Gramercy Park, New York, NY 10003. Tel 212-228-1861; *Cur & Librn* Raymond Wemmlinger
Open Mon - Fri 10 AM - 5 PM & by appointment; Estab 1957 to provide scholarly & professional research on American & English theater with emphasis on 19th century
Purchases: $10,000
Library Holdings: Audio Tapes; Book Volumes 10,000; Cassettes; Clipping Files; Exhibition Catalogs; Framed Reproductions; Manuscripts; Memorabilia; Original Art Works; Pamphlets; Photographs; Prints; Records; Reels; Reproductions; Sculpture

Special Subjects: Photography, Etchings & Engravings, Painting-American, Painting-British, Prints, Sculpture, Portraits, Stage Design, Theatre Arts, Costume Design & Constr, Coins & Medals, Reproductions
Collections: Documents, letters, photos, paintings, memorabilia, prompt books of Walter Hampden, Edwin Booth, Union Square Theater; English playbill (18th & 19th century)

A HARVESTWORKS, INC, 596 Broadway, Ste 602, New York, NY 10012. Tel 212-431-1130; Fax 212-431-8473; Elec Mail harvestw@dh.net; *Production Coordr* Christina Anderson; *Dir* Carol Parkinson
Open Mon - Fri 10 AM - 6 PM; Estab 1977 to provide support & facilities for audio art & experimental music; Maintains reference library; Average Annual Attendance: 2,000; Mem: 250; dues $45
Income: $150,000 (financed by endowment, mem, city & state appropriations, recording studio)
Purchases: Pro-tools by Digi Design, Digital Audio Editing
Publications: TELLUS, the Audio Series, biannual
Activities: Adult classes; artist in residence program; lect open to public, 6 vis lectrs per year; concerts; competitions with awards; scholarships offered; lending collections contains 26 cassettes; retail store sells audio art & music cassettes & CDs

A HATCH-BILLOPS COLLECTION, INC, 491 Broadway 7th Fl, New York, NY 10012. Tel 212-966-3231; Fax 212-966-3231; Elec Mail Hatch-Billops@worldnet.att.net; *Pres* Camille Billops
By appt; Estab 1975 to collect & preserve primary & secondary resource materials in the Black Cultural Arts, to provide tools & access to these materials for artist, scholars & general pub, to develop programs in arts which use resources of Collection
Collections: Owen & Edith Dodson Memorial Collection
Activities: Classes for adults & children; dramatic programs; lect open to public; gallery talks; tours; book traveling exhibitions; originate traveling exhibitions

M HEBREW UNION COLLEGE, (Universal Technical Institute) Jewish Institute of Religion Museum, One W Fourth St, New York, NY 10012-1186. Tel 212-824-2209; Fax 212-533-0129; Elec Mail nymuseum@huc.edu; Internet Home Page Address: www.huc.edu/museums/ny; *Cur* Laura Kruger; *Dir* Jean Bloch Rosensaft; *Museum Coordr* Rachel Litcofsky; *Prog Coordr* Leah Kaplan; *Curatorial Asst* Karen Palmer; *Curatorial Asst* Judy Becker; *Curatorial Asst* Bernice Boltax; *Curatorial Asst* Margot Berman
Open Mon - Thurs 9 AM - 6 PM, Fri 9 AM - 3 PM & selected Sun 10 AM - 2 PM; No admis fee; Estab 1984 to present 4000 years of Jewish art with stress on contemporary art expressing Jewish identity & themes; 5000 sq ft of space, rare book room gallery for book arts; Average Annual Attendance: 30,000
Income: Financed by annual budget & fundraising
Special Subjects: Architecture, Graphics, Painting-American, Photography, Prints, Sculpture, Bronzes, Archaeology, Religious Art, Ceramics, Crafts, Folk Art, Etchings & Engravings, Judaica, Manuscripts, Collages, Historical Material, Maps, Juvenile Art, Calligraphy, Miniatures, Medieval Art, Painting-Russian, Painting-Israeli, Bookplates & Bindings
Collections: Biblical archaeology; contemporary art expressing Jewish identity & themes; Jewish ritual art
Exhibitions: Living in the Moment: Contemporary Artists Celebrate Jewish Time
Publications: Exhibition catalogs & brochures
Activities: Classes for adults & children; dramatic programs; docent training; lect open to the pub, 15 vis lectrs per year; concerts; gallery talks; tours; lending of original objects of art to other mus; book traveling exhibitions 3 per year; originate traveling exhibitions 6 per year; museum shop sells original art

M HENRY STREET SETTLEMENT, Abrons Art Center, 466 Grand St, New York, NY 10002. Tel 212-598-0400; Fax 212-505-8329; Elec Mail senarts@aol.com; Internet Home Page Address: www.henrystreet.org; *Dir* Susan Fleminger; *Gallery Coordr* Martin Dost
Open Tues - Sat Noon - 6 PM; No admis fee; Estab 1975 as a multi discipline community arts center for the performing & visual arts programs; Thematic group exhib of the work of contemporary artists, photo gallery for solo shows; Average Annual Attendance: 100,000
Income: government, foundations, inidivdual support
Exhibitions: Contemporary art by emerging artists, women artists & artists of color, changing thematic exhibitions; rotating
Activities: Classes for adults & children in all arts disciplines; drama, dance and music prog; docent training; gallery educ program for school and community groups; lect open to public; 5 vis lect per yr; concerts; gallery talks; tours; schol and fels offered

M HISPANIC SOCIETY OF AMERICA, Museum & Library, Broadway, Between 155th and 156th Sts New York, NY 10032; 613 W 155th, New York, NY 10032. Tel 212-926-2234; Fax 212-690-0743; Elec Mail mfo@hispanicsociety.org; Internet Home Page Address: www.hispanicsociety.org; *Pres* Theodore S Beardsley; *Dir* Mitchell A Codding; *Cur Paintings & Metalwork* Marcus Burke; *Cur Archaeology & Sculpture* Constancio del Alamo; *Cur Iconography* Patrick Lenaghan; *Cur Decorative Arts* Margaret Connors McQuade; John O'Neill, *Cur Rare Books*; *Cur Library* Gerald MacDonald
Open Tues - Sat 10 AM - 4:30 PM, Sun 1 - 4 PM; No admis fee; Estab 1904 by Archer Milton Huntington as a free public museum and library devoted to the culture of Hispanic peoples; Average Annual Attendance: 25,000; Mem: Open to the public, basic dues $50; additional group of scholarly members, 400 in 2 categories, by election only
Income: Financed by endowment
Purchases: Hispanic objects in various media
Library Holdings: Auction Catalogs; Audio Tapes; Book Volumes; CD-ROMs; Clipping Files; Exhibition Catalogs; Fiche; Filmstrips; Manuscripts; Maps; Memorabilia; Micro Print; Original Documents; Prints; Records
Special Subjects: Drawings, Graphics, Painting-American, Photography, Sculpture, Archaeology, Costumes, Ceramics, Crafts, Folk Art, Pottery, Etchings & Engravings, Landscapes, Decorative Arts, Manuscripts, Jewelry, Carpets & Rugs,

Historical Material, Maps, Coins & Medals, Baroque Art, Calligraphy, Antiquities-Greek, Enamels, Bookplates & Bindings
Collections: Archaeology; costumes; customs; decorative arts; paintings; photographic reference files; sculpture; prints; ceramics; manuscripts; ethnographic photographs; rare books
Exhibitions: Permanent gallery exhibits are representative of the arts and cultures of Iberian Peninsula from prehistory to the present; Sorolla, an 80th Anniversary Exhibition
Publications: Works by members of the staff and society on Spanish art, history, literature & bibliography, with special emphasis on the collections of the society
Activities: Classes for adults & children; docent training; lect open to public, 6 visting lect per year; concerts; gallery talks; tours; exten prog serves New York area schools; Mus shop sells books, reproductions, prints, jewelry & accessories
L **Library,** Broadway between 155th & 156th Sts, New York, NY 10032; 613 W 155th St, New York, NY 10032. Tel 212-926-2234; Fax 212-690-0743; Elec Mail info@hispanicsociety.org; Internet Home Page Address: www.hispanicsociety.org; *Cur Mss & Rare Books* John O'Neill, PhD; *Asst Cur Modern Books* Edwin Rolon, MLS
Open Tues - Sat 10 AM - 4:15 PM, cl Aug, Christmas holidays & other holidays; No admis fee; Estab 1904 as a free mus & reference library to present the culture of Hispanic peoples; Reference only
Income: Financed by endowment
Library Holdings: Auction Catalogs; Book Volumes 250,000; Clipping Files; Exhibition Catalogs; Manuscripts 200,000; Maps; Memorabilia; Original Art Works; Pamphlets; Periodical Subscriptions; Photographs; Prints; Reproductions; Sculpture
Special Subjects: Art History, Folk Art, Photography, Drawings, Etchings & Engravings, Graphic Arts, Manuscripts, Maps, Painting-Spanish, Posters, Prints, Sculpture, Painting-European, Historical Material, History of Art & Archaeology, Watercolors, Ceramics, Latin American Art, Archaeology, Ethnology, Printmaking, Porcelain, Mexican Art, Ivory, Costume Design & Constr, Glass, Aesthetics, Bookplates & Bindings, Metalwork, Carpets & Rugs, Goldsmithing, Jewelry, Miniatures, Pottery, Religious Art, Silversmithing, Tapestries, Textiles, Antiquities-Roman, Coins & Medals, Laces, Architecture, Embroidery, Portraits
Activities: Sales shop sells reproductions, prints, slides, postcards & posters

M **HUDSON GUILD,** Hudson Guild Gallery, 441 W 26th St, New York, NY 10001. Tel 212-760-9800; *Gallery Dir* James Furlong
Open Tues - Fri 10 AM - 7 PM; No admis fee; Estab 1948 for exhibition of contemporary art; A modern facility within the Hudson Guild Building. The Art Gallery is also open for all performances of the Hudson Guild Theatre; Average Annual Attendance: 2,000
Income: Financed by the New York City Department of Cultural Affairs, Con Edison, Avery Foundation, St Paul Traveler's Company
Activities: Educ prog; classes for adults & children; lect open to the public; 10 vis lect per year; gallery talks

M **ILLUSTRATION HOUSE INC,** Gallery Auction House, 110 W 25th St, New York, NY 10012. Tel 212-966-9444; Fax 212-966-9425; Elec Mail info@illustrationhouse.com; Internet Home Page Address: www.illustrationhouse.com; *Pres* Roger Reed; *Dir* Fred Taraba; *Advertising Publicity* Emmanuel Montaluo; *Advertising Publicity* Woralen Curl; *Account Subscriptions* Jenny Pham
Open 10:30 AM - 5:30 PM; No admis fee; Estab 1974 devoted to exhibition & selling original paintings & drawings of America's great illustrators (1880-1990); 1,000 sq ft
Income: Pvt income
Library Holdings: Auction Catalogs; Audio Tapes; Cards; Exhibition Catalogs; Original Art Works; Original Documents; Other Holdings Tearsheets; Periodical Subscriptions
Collections: Illustration Art Reference
Exhibitions: Art Pertaining to Illustration (1880-1980); An Eye for Character: The Illustrations of E F Ward; 100 Years of Comic Art; Pulps & Paperbacks: Sensational Art from the Twenties to the Fifties; semi-annual action of original illustration art of full range of media & genre; Exhibitions rotate for auctions four times per yr
Publications: The Illustration Collector, subscription
Activities: Sales shop sells books & original art

A **INDEPENDENT CURATORS INTERNATIONAL,** 799 Broadway, Ste 205, New York, NY 10003. Tel 212-254-8200; Fax 212-477-4781; Elec Mail info@ici-exhibitions.org; Internet Home Page Address: www.ici-exhibitions.org; *Registrar* Susan Callanan; *Exec Dir* Judith Richards; *Exhib Dir* Susan Hapgood; *Press Liason* Sue Scott; *Dir Devel* Hedy Roma
Open 9:30 AM - 6 PM; Estab 1975 as a nonprofit traveling exhibition service specializing in contemporary art
Income: $750,000
Exhibitions: Everything Can Be Different; My Reality: Contemporary Art and Culture of Japanese Animation; The Gift; Thin Skin; Walkways; Beyond Preconceptions; Pictures, Patents and Monkeys; On Collecting; Telematic Connections; Mark Lombard: Global Networks; Beyond Green: Toward a Sustainable Art; High Times, Hard Times: New York Paintings 1967-1975
Publications: Exhibition catalogs
Activities: Originate traveling contemporary art exhibitions; ICI independents; museums; university galleries & art centers; ICI independents

M **INTAR LATIN AMERICAN GALLERY,** 420 W 42nd St, New York, NY 10036. Tel 212-695-6135, 695-6134; Fax 212-268-0102; *Dir* Max Ferra
Open Mon - Fri Noon - 6 PM; No admis fee; Estab 1978. Assists & exhibits artists of diverse racial backgrounds. Devoted to artists who inhabit a dimension of their own in which the tension between singularity & universality has been acknowledged successfully; Only Hispanic gallery in area; Average Annual Attendance: 7,000
Income: Financed by endowment
Special Subjects: Latin American Art, Mexican Art, Photography, Sculpture, American Indian Art, Southwestern Art, Afro-American Art
Exhibitions: Rotating exhib

Publications: Exhibition catalogues
Activities: Lect open to public; gallery talks; originates traveling exhibitions

M **THE INTERCHURCH CENTER,** Galleries at the Interchurch Center, 475 Riverside Dr, New York, NY 10115. Tel 212-870-2200; Fax 212-870-2440; Elec Mail icelibi@metgate.metro.org; Internet Home Page Address: www.interchurch-center.org; *Dir & Cur* Dorothy Cochran
Open daily 9 AM - 5 PM; No admis fee; Estab 1969; Two exhibit spaces Treasure Room Gallery 2,000 sq ft, Corridor Gallery 20 self-lite cases which line North & South Corridor each approximately 36 x 50 ft; Average Annual Attendance: 10,000
Income: Financed by the bldg corporation
Purchases: Substantial sales throughout the yr
Special Subjects: Drawings, Graphics, Hispanic Art, Latin American Art, Mexican Art, American Indian Art, African Art, Ceramics, Crafts, Etchings & Engravings, Landscapes, Afro-American Art, Decorative Arts, Collages, Eskimo Art, Dolls, Jewelry, Oriental Art, Asian Art, Marine Painting, Calligraphy, Embroidery, Mosaics, Enamels, Bookplates & Bindings
Exhibitions: Rotating exhibits, 10 per year
Publications: 475, monthly newsletter
Activities: Educ Prog; lect open to public, 2 vis lectrs per year; concerts; gallery talks

L **The Interchurch Center,** 475 Riverside Dr, New York, NY 10115. Tel 212-870-2933; Fax 212-870-2440; Elec Mail icelib1@metgate.metro.org; *Dir & Cur Galleries* Dorothy Cochran; *Pres & Exec Dir* Mary McNamara
Open Mon - Fri 9 AM - 5 PM; Estab 1959 to enhance the employee environment & be a New York City neighborhood art resources; 2,000 sq ft (Treasure Room Gallery) & twenty (46ft x 36 ft) built in, self-light wall display cases; Average Annual Attendance: 4,000
Income: $6,000,000
Purchases: $6,000
Library Holdings: Book Volumes 14,000; Periodical Subscriptions 95
Exhibitions: Changing exhibitions on a 10 month schedule
Publications: 475 Newsletter, monthly
Activities: Noon time music & arts programming; lect open to public, 5 vis lectrs per year; concerts; gallery talks; tours

INTERNATIONAL CENTER FOR ADVANCED STUDIES IN ART
For further information, see National and Regional Organizations

A **INTERNATIONAL CENTER OF MEDIEVAL ART,** The Cloisters, Fort Tryon Park New York, NY 10040. Tel 212-928-1146; Fax 212-928-1146; Elec Mail icma@compuserve.com; Internet Home Page Address: www.medievalarts.org; *Treas* Paula Gerson; *Pres* Dorothy F Glass; *VPres* Annemarie Weyl Carr; *Adminr* Susan C Katz Karp
Estab 1956 as The International Center of Romanesque Art, Inc. The International Center of Medieval Art was founded to promote greater knowledge of the arts of the Middle Ages & to contribute to & make available the results of new research; Sponsor sessions at the annual conferences of the Medieval Institute of Western Michigan University, Kalamazoo the College Art Association Annual Conference & the International Medieval Congress at Leeds, England; keeps its members informed as to events of interest to medievalists; sponsors the Limestone Sculpture Provenance Project; Mem: 1,300; dues benefactor $1000, supporting $500, patron $250, contributing $125, joint $70, institutional $65, active foreign countries $50, active US $45, independent scholar $35, student $18; annual meeting in Feb, in conjunction with College Art Association of America
Publications: Gesta (illustrated journal), two issues per year; ICMA Newsletter, 3 issues per year; Romanesque Sculpture in American Collections I, II, III, New England Museums; Gothic Sculpture in American Collections I & II

M **INTERNATIONAL CENTER OF PHOTOGRAPHY,** 1133 Avenue of the Americas, New York, NY 10036. Tel 212-857-000; Fax 212-857-0090; Elec Mail info@icp.org; Internet Home Page Address: www.icp.org; *Dir Educ* Philip Block; *Deputy Dir External Affairs* Evan Kingsley; *Deputy Dir for Adminr* Steve Rooney; *Dir Communications* Phyllis Levine; *Dir Exhib & Chief Cur* Brian Wallace; *Interim Traveling Exhibits Coordr* Kristen Lubben; *Dir* Willis Hartshorn
Open Tues - Thurs 10 AM - 5 PM, Fri 10 AM - 8 PM, Sat & Sun 10 AM - 6 PM; Admis adults $12, students & seniors $8, volunteer contributions Fri 5 - 8 PM; Estab 1974 to encourage & assist photographers of all ages & nationalities who are vitally concerned with their world & times, to find & help new talents, to uncover & preserve forgotten archives & to present such work to the pub; Maintains five exhibition galleries showing a changing exhibition program of photographic expression & experimentation by over 2,500 photographers; Average Annual Attendance: 125,000; Mem: 4,400; dues $70 & up
Income: Financed by public & private grants
Library Holdings: Book Volumes 15,000; Clipping Files; Exhibition Catalogs; Filmstrips; Kodachrome Transparencies; Pamphlets; Periodical Subscriptions 75; Slides; Video Tapes
Special Subjects: Photography
Collections: The core of the collection is 20th century documentary photography, with a companion collection of examples of master photographs of the 20th century including Siskind, Abbott, Capa, Callahan, Feininger, Hine & Cartier-Bresson. Major holdings include works from the documentary tradition as well as fashion & other aesthetic genres
Exhibitions: (2001) Mary Ellen Mark: American Odyssey
Publications: Annual report; monographs; exhibition catalogs, programs guide
Activities: Classes for adults & children; docent training; certificate & MFA program; scholarships; lect open to public; gallery talks; tours; awards; book traveling exhibitions; originate traveling exhibitions; museum shop sells books, magazines, reproductions & cameras
L **Library,** 1114 Avenue of the Americas, New York, NY 10036-7703. Tel 212-857-0091; Elec Mail library@icp.org; Internet Home Page Address: www.icp.org/library; *Dir Pub Information* Phyllis Levine
Mon - Thurs Noon - 7 PM; Fri Noon - 6 PM (during school terms) Cl holidays; Reference only; Average Annual Attendance: 6,000
Income: Financed by pub & private grants
Library Holdings: Audio Tapes; Book Volumes 8,000; Cassettes; Clipping Files; Exhibition Catalogs; Filmstrips; Kodachrome Transparencies; Pamphlets; Periodical Subscriptions 100; Slides; Video Tapes

Special Subjects: Photography
Collections: Archives contains films, video tapes & audio recordings of programs related to photographs in the collections as well as programs about the subject & history of photography

M **Midtown,** 1133 Avenue of the Americas, at 43rd St New York, NY 10036. Tel 212-768-4682; Fax 212-768-4688; Internet Home Page Address: www.icp.org; *Dir* Willis Hartshorn
Open Tues -Thurs 10 AM - 5 PM, Fri 10 AM - 8 PM, Sat & Sun 10 AM - 6 PM; Admis $8, students & seniors $6, mem free; Estab 1989; Maintains eight exhibition galleries; Mem: 7,500; dues $60 & up
Income: Financed by pub & private grants
Exhibitions: (2001) Kiki Smith: Telling Tales; Behind Closed Doors: The Art of Hans Bellmer; Near Friends: American Photographs of Men Together 1840-1918; New Art for Web & Wall: Annette Weintraub; Crossroads
Activities: Classes for adults & children; docent training; lect open to public; gallery talks; tours; originate traveling exhibitions; museum shop sells books, magazines, prints & slides

INTERNATIONAL FOUNDATION FOR ART RESEARCH, INC
For further information, see National and Regional Organizations

JAPAN SOCIETY, INC
M **Japan Society Gallery,** Tel 212-832-1155, 755-6752; Fax 212-715-1262; Elec Mail gen@japansociety.org; Internet Home Page Address: www.japansociety.org; *Pres Japan Society* Frank L Ellsworth; *VPres Arts & Culture/Dir Japan Society Gallery* Alexandra Munroe; *Asst Dir* Hyunsoo Woo; *Exhib Mgr* Eleni Locordas; *Mgr Publ & Educ* Any Kurlander; *Gallery Officer/Asst to VP* Haruko Hoyle
Open Tues - Fri 11 AM - 6 PM, Sat & Sun 11 AM - 5 PM, cl Mon; Admis non-members $5, seniors & students $3, mems free; Estab 1907, bi-cultural membership organizations to deepen understanding and friendship between Japan and the United States; Asian/Japanese Art; Average Annual Attendance: 30,000 gallery exhibitions/80,000 includ other programs; Mem: 3,000 individual; dues $1500, $750, $500, $250, $125, $75, $55; Friends of Gallery $1500-5000
Income: Financed by mem, grants & donations
Special Subjects: Graphics, Sculpture, Textiles, Decorative Arts, Painting-Japanese, Asian Art
Collections: Japan Society permanent collection: ceramics, paintings, prints, sculpture & woodblocks
Publications: Japan Society Newsletter, monthly; exhibition catalogs accompanying each exhibition
Activities: Educ dept; classes for adults & children; docent training; lect open to public; concerts, gallery talks; tours, sponsor competitions; fellowships & Japan Society Award; 1-2 per yr; originate traveling exhibitions to museums worldwide; sell books & catalogues

L **C.V. Starr Library,** Tel 212-832-1155, Ext 256; Fax 212-715-6752; Elec Mail gen@japansociety.org; Internet Home Page Address: www.jpnsoc.com/library; *Dir* Reiko Sassa; *Asst Librn* Rebecca Leonard
Open Mon - Fri Noon - 5 PM; Admis only for members & Toyota language students; Estab 1971; Mem: 3,000; dues $55 - $1500
Income: Financed by mem
Library Holdings: Book Volumes 14,000; Clipping Files; Pamphlets; Periodical Subscriptions 35
Publications: What Shall I Read on Japan

M **THE JEWISH MUSEUM,** 1109 Fifth Ave, New York, NY 10128. Tel 212-423-3200; Fax 212-423-3232; Elec Mail info@thejm.org; Internet Home Page Address: www.jewishmuseum.org; *Dir* Joan Rosenbaum; *Dir Human Resources* Karen Granby; *Cur Archaeology* Susan L Braunstein; *COO* Mary Walling; *Dir Communications* Anne J Scher; *Dir Bus Develop* Debbie Schwab-Dorfman; *Chief Cur* Norman Kleeblatt; *Senior Mgr Creative Serv* Ken Handel; *Dir Coll & Exhib* Jane Rubin; *Dir Mktg* Grace Rapkin; *Chm (V)* Leni May; *Dir Cur Admin* Fred Wasserman; *Dir School Family* Nelly Silagy Benedek; *Deputy Dir External* Lynn Thommen; *Cur at Large* Susan Goodman; *Deputy Dir Prog* Ruth Beesch
Open Sun - Mon, Wed - Thur 11 AM - 5:45 PM, Tues 11 AM - 8 PM, Fri 11AM - 3 PM, Sat 11 AM - 5:45 PM; Admis adults $8, students with ID cards & seniors $5.50, members & children under 12 free; Estab 1904 to preserve & present the Jewish cultural tradition. Three exhibition floors devoted to the display of ceremonial objects & fine art in the permanent collection, special exhibitions from the permanent collections & photographs & contemporary art on loan; Maintains reference library; Average Annual Attendance: 180,000; Mem: 13,000; dues $75 & up
Income: Financed by mem, grants, individual contributions & organizations
Special Subjects: Architecture, Drawings, Archaeology, Ceramics, Etchings & Engravings, Decorative Arts, Carpets & Rugs, Coins & Medals, Embroidery, Cartoons
Collections: Broadcast media material; Contemporary art; graphics; Jewish ceremonial objects; paintings, textiles; comprehensive collection of Jewish ceremonial art; Harry G Friedman Collection of Ceremonial Objects; Samuel Friedenberg Collection of Plaques & Medals; Rose & Benjamen Mintz Collection of Eastern European Art; Harry J Stein-Samuel Freidenberg Collection of Coins from the Holy Land
Exhibitions: Culture & Continuity: The Jewish Journey, Pickles & Pomegranates, Marc Chagall: Early Works from Russian Collections; Modigliani: Beyond the Myth; Eva Hesse: Sculpture
Publications: Annual report; exhibition catalogs; newsletter, quarterly; poster & graphics; program brochures
Activities: Classes for adults & children; docent training; lect open to public; 10 vis lectrs per year; concerts; gallery talks; tours; individual paintings lent to other museums; book traveling exhibitions 3 per year; originate traveling exhibitions 3 per year; museum shop sells books, magazines, original art, reproductions, prints, slides, needlecrafts, posters, catalogs & postcards

L **Library,** 1109 Fifth Ave, New York, NY 10128. Tel 212-423-3200; Fax 212-423-3232; *Dir* Joan H Rosenbaum
Sun - Mon & Wed - Thurs 11 AM - 5:45 PM, Tues 11 AM - 9 PM, Fri 11 AM - 3 PM; Reference library open to the public by appointment only
Income: Financed by Jewish Museum budget & private sources
Library Holdings: Audio Tapes; Book Volumes 8,000; Cassettes; Clipping Files; Exhibition Catalogs; Other Holdings Verticle Files 2,500; Pamphlets; Photographs; Slides; Video Tapes

Special Subjects: Folk Art, Photography, Painting-American, Painting-Russian, Posters, Painting-European, Judaica, Archaeology, Ethnology, Religious Art
Collections: Esther M Rosen Slide Library (contains slides of objects in the museum's collection)

A **JOHN SIMON GUGGENHEIM MEMORIAL FOUNDATION,** 90 Park Ave, New York, NY 10016. Tel 212-687-4470; Fax 212-697-3248; Elec Mail fellowships@gf.org; Internet Home Page Address: www.gf.org; *VPres & Secy* G Thomas Tanselle; *Dir Planning & Latin America Prog* Peter Kardon; *Assoc Secy* Sue Schwager; *Treas* Coleen Higgins-Jacob; *Develop Office* Richard Hatter; *Pres* Joel Conarroe
Office hours 9 AM - 4:30 PM; Estab & incorporated 1925; offers fellowships to further the development of scholars & artists by assisting them to engage in research in any field of knowledge & creation in any of the arts, under the freest possible conditions & irrespective of race, color or creed; For additional information see section devoted to Scholarships and Fellowships
Activities: Fels offered

A **KENKELEBA HOUSE, INC,** Kenkeleba Gallery, 214 E Second St, New York, NY 10009. Tel 212-674-3939; Fax 212-505-5080; *Art Dir* Joe Overstreet; *Dir* Corrine Jennings
Open Wed - Sat 11 AM - 6 PM; No admis fee; Committed to the goals of presenting, preserving & encouraging the development of art excluded from the cultural mainstream. Supports experimental & interdisciplinary approaches. Features exhibitions of contemporary & modern painting, sculpture, experimental media, performance, poetry readings & literary forums
Collections: 20th Century African American Artists
Exhibitions: Eleanor Magid & Tom Kendall; Frank Stewart & Adal (photography)

M **KENNEDY GALLERIES,** Kennedy Talkies, Inc, PO Box 5298, New York, NY 10185-5298. Tel 212-605-0568; Fax 212-605-0569; Elec Mail inquiry@kgny.com; Internet Home Page Address: www.kgny.com; *Pres* Martha Fleischman
Open to public Tues - Sat 9:30 AM - 5:30 PM; No admis fee; 18th, 19th & 20th Century American Art
Publications: American Art Journal

M **KITCHEN CENTER FOR VIDEO, MUSIC, DANCE, PERFORMANCE, FILM & LITERATURE,** 512 W 19th St, New York, NY 10011. Tel 212-255-5793; Fax 212-645-4258; Elec Mail info@thekitchen.org; Internet Home Page Address: www.thekitchen.org; *Develop Dir* Meg Fagan; *Dir Educ & Outreach* Treva Offutt; *Exec Dir* Elise Bernhardt
Open Mon - Fri 10 AM - 5 PM, Sat 2 PM - 6 PM; Estab 1971 as artists' laboratory for individual ideas & collaborative processes; Mem: Dues friend $35 & up, supporter $100 & up, assoc $250 & up
Income: Financed by endowments, mem, contributions & gifts
Collections: The Kitchen Video Collection, over 600 titles by almost 300 artists
Exhibitions: Exhibitions held in the gallery, often incorporating video, audio & experimental performing arts; Rotating Exhibits
Activities: Classes for children

M **LAMAMA LA GALLERIA,** 6 E First St, New York, NY 10003. Tel 212-505-2476; *Dir & Cur* Merry Geng
Open Thurs - Sun 1 - 6 PM; No admis fee; Estab 1983 for exhibition of emerging artists, 2,500 sq ft, bi-level; Average Annual Attendance: 8,000
Income: Financed through grants & donations
Exhibitions: Rotating exhibitions, 14 per yr
Activities: Classes for adults & children; lect open to public, 6 vis lectr per year; concerts; gallery talks

A **LEO BAECK INSTITUTE,** 15 W 16th St, New York, NY 10011. Tel 212-744-6400; Fax 212-988-1305; Elec Mail lbi1@lbi.com; Internet Home Page Address: www.lbi.org; *Pres* Ismar Schorsch; *Art Cur* Renata Stein; *Chief Archivist* Dr Frank Mecklenburg; *Exec Dir* Carol Kahn Strauss
Open Mon - Thurs 9:30 AM - 4:30 PM, Fri 9:30 AM - 2:30 PM; No admis fee; Estab 1955 for history of German-Speaking Jews; Center includes library & archives; about 180 running ft, various display cases for books & documents; Average Annual Attendance: 2,000; Mem: 2,000; dues $100
Special Subjects: Architecture, Cartoons, Costumes, Drawings, Embroidery, Etchings & Engravings, Graphics, Historical Material, Judaica, Landscapes, Manuscripts, Metalwork, Mosaics, Painting-German, Painting-Israeli, Photography, Porcelain, Posters, Prints, Religious Art, Reproductions, Sculpture, Silver, Textiles, Watercolors
Collections: Drawings, paintings, prints, sculpture, ritual objects, textiles from 15th - 20th centuries; 19th - 20th Century German-Jewish Artists, including Max Liebermann, Lesser Ury, Ludwig Meidner, Hugo Steiner-Prag
Exhibitions: Portraits of German Jews
Publications: Year Book; LBI News, semi-annually
Activities: Lect open to public, 10 vis lectrs per year; concerts; gallery talks; tours; scholarships & fellowships offered; individual paintings & original objects of art lent to cultural art institutions; lending collection contains paintings, sculptures, 50,000 books, 5,000 original art works, 2,500 original prints, 40,000 photographs

L **Library,** 15 W 16th St, New York, NY 10011. Tel 212-744-6400; Fax 212-988-1305; Elec Mail lbaeck@lbi.cjh.org; Internet Home Page Address: www.lbi.org/; *Archivist* Frank Mecklenburg PhD; *Cur* Renata Stein; *Dir* Carol Kahn Strauss; *Head Librn* Evers
Open winter Mon - Thurs 9:30 AM - 4:30 PM; Estab 1955 to collect & preserve materials by & about history of German-speaking Jews; For reference only; Mem: $100 general, $150 Univ, $250 corporate membership
Income: Financed by endowment & mem
Library Holdings: Book Volumes 50,000; Fiche; Original Art Works 6,300; Original Documents; Pamphlets; Periodical Subscriptions 150; Photographs 30,000; Prints 5,000; Sculpture 30
Special Subjects: Folk Art, Drawings, Painting-German, Prints, Historical Material, History of Art & Archaeology, Judaica, Portraits, Stage Design, Watercolors
Collections: Archival collections relating to German-Jewish life

Publications: LBI yearbook; LBI memorial lect
Activities: Open to pub; concerts

M **LINCOLN CENTER FOR THE PERFORMING ARTS,** Cork Gallery, 70 Lincoln Ctr Plaza, 9th Fl, New York, NY 10023. Tel 212-875-5151; Fax 212-875-5145; Elec Mail jwebster@Lincolncenter.org; Internet Home Page Address: www.lincolncenter.org; *Gallery Dir Programming Dept* Jenneth Webster; *Pres* Gordon J Davis
Open daily 10 AM - 10 PM; No admis fee; Estab in 1971 to provide a show case for young & unknown artists; One 60 ft x 10 ft wall covered in white linen, two smaller walls, 11 ft & 8 ft 6 inches, respectively, plus two 15 ft bay windows; Average Annual Attendance: 15,000
Exhibitions: 26 annual exhibitions (all self-produced by art group that exhibiting)

C **LOIS WAGNER FINE ARTS INC,** 1014 Madison Ave 5F, New York, NY 10021. Tel 212-396-1407; Elec Mail wagnerfa@aol.com; *Pres* Lois Wagner
Open by appointment only; Estab 1993; 19th & 20th Century American art
Collections: American Impressionism & Realism Collection (1880-1930); Contemporary Realism Collection; figurative, landscape & still-life paintings

L **M KNOEDLER & CO, INC,** Library, 19 E 70th St, New York, NY 10021. Tel 212-794-0567; Fax 212-772-6932; *Librn* Edye Weissler
Open Mon - Fri 11 AM - 5 PM to researchers by appointment only; No admis fee; Research by appointment on a fee basis, for scholars, museum curators & students use
Income: Financed by usage fees
Library Holdings: Book Volumes 55,000; Clipping Files; Exhibition Catalogs; Fiche; Other Holdings Auction catalogs; Pamphlets; Periodical Subscriptions 27; Photographs
Special Subjects: Painting-American, Painting-European

MANHATTAN PSYCHIATRIC CENTER
M **Sculpture Garden,** Tel 212-369-0500, Ext 3022
Not open to pub; No admis fee; Estab 1977 to enhance hospital environment & offer exhibition area to new as well as estab sculptors. Hospital grounds are used to site outdoor sculpture, mostly on temporary basis. Artists may contact Manhattan Psychiatric Center directly to arrange for possible display of work
Special Subjects: Sculpture
Exhibitions: Clovis, Glen Zwygardt; The Emerging Sun, Vivienne Thaul Wechter; The Gazebo, Helene Brandt; Map of Time, Time of Map, Toshio Sasaki; Rock Garden Sanctuary, Gigi & Paul Franklin; Roman Garden Sites Continued; Steel Toys, Elizabeth Egbert

M **East River Gallery,** Tel 212-369-0500, Ext 3250; *Sr Recreation Therapist* Jill Brock
Open Mon, Wed & Fri 1 - 3 PM & by appointment; No admis fee; Estab 1994 to publicly display & sell resident artist's works; Professionally organized, publicly accessible artspace, uniquely located in a psychiatric hospital & representing the residents' creative work. The gallery is set up for the pub to view & purchase artwork, conduct research & select works for outside exhibition
Special Subjects: Folk Art
Exhibitions: Recent Work: Painting, Drawing, Sculpture; Art Works; Soho paintings, drawings & sculpture
Activities: Classes for resident artists only; lect for members only; individual paintings & original objects of art lent to gallery & restaurant owners for public shows & researchers of approved studies; sales shop sells original art

M **THE MARBELLA GALLERY INC,** 28 E 72nd St, New York, NY 10021. Tel 212-288-7809; Fax 212-288-7810; Elec Mail marbellagallery@aol.com; *Dir* Mildred Thaler Cohen
Open Tues - Sat 11 AM - 5:30 PM; No admis fee; Estab 1971 to buy & sell American art of the 19th century & early 20th century; 1,000 sq ft
Income: Pvt income
Exhibitions: Season rotating exhibitions every 6 - 7 weeks
Activities: Lect open to public; book traveling exhibitions 2 per year

M **MARYMOUNT MANHATTAN COLLEGE GALLERY,** 221 E 71 St, New York, NY 10021. Tel 212-517-0692; Fax 212-517-0413; Elec Mail mburns@mmm.edu; Internet Home Page Address: marymount.mmm.edu; *Dir* Millie Burns
Open daily 9 AM - 9 PM; No admis fee; Estab 1982 as a showcase for unaffiliated artists; Gallery is 30 x 40 ft; Average Annual Attendance: 2,500
Exhibitions: Various exhibitions
Activities: Classes for adults; lect by artist; gallery talks

M **THE METROPOLITAN MUSEUM OF ART,** Main Bldg, 1000 Fifth Ave New York, NY 10028-0198. Tel 212-535-7710 (General Information), 879-5500 (Museum Offices); Fax 212-570-3879; Elec Mail webmaster@metmuseum.com; Internet Home Page Address: www.metmuseum.org; *Anthony W & Lulu* Alice Cooney; *Sr Vice Pres Exter* Emily K Rafferty; *John Pope Henness Chmn* Everett Fahy; *Drue Heinz Chm* George R Goldner; *Alice Pratt Brown Chm* H Barbara Weinberg; *Vice Pres Communications* Harold Holzer; *Cur In Charge Cost* Harold Koda; *Jacques & Natasha* William S Lieberman; *Chief Registrar* Herb Moskowitz; *Cur In Charge Rob* Laurence B Kanter; *Assoc Dir Admin* Mahrukh Tarapor; *Cur In Charge Anci* Maria Morris Hambourg; *Museum Shop Mgr* Will Sullivan; *Lila Acheson Wallac* Dorothea Arnold; *Cur Henry R Kravis* James David Draper; *Conservator In Charge* James H Frantz; *Assoc Dir Educ* Kent Lydecker; *Sherman Fairchild Chm* Hubert Von Sonnenburg; *Arthur K Watson C* Kenneth Soehner; *Mgr Visitor Svcs* Kathleen Arffmann; *Cur in Charge Arts* Julie Jones; *Vice Pres Merchandise* Sally Pearson; *Lawrence A. Fleisch* Morrison H Heckscher; *Conservator In charge* Nobuko Kajitani; *Ed In Chief* John P O'Neill; *Vice Pres Facilities* Philip T Venturino; *Vice Pres & Sec* Sharon H Cott; *Cur In charge* Carlos Picon; *Dir & CEO* Philippe de Montebello; *Sr Vice Pres & CF* Deborah Winshel; *Distinguished Research* Dietrich Von Bothmer
Open Tues - Thurs & Sun 9:30 AM - 5:15 PM, Fri & Sat 9:30 AM - 9 PM, cl Mon; Admis suggested for adults $8, students & seniors $4, members & children under 12 accompanied by adult free; Estab 1870 to encourage & develop the study of the fine arts & the application of arts to life; of advancing the general knowledge of kindred subjects & to that end of furnishing popular instruction & recreation; Average Annual Attendance: 5,000,000; Mem: 97,245; dues patron $4000, sponsor $2000, donor $900, contributing $600, sustaining $300, dual $125, individual $70, student $30, national associate $35
Income: $78,146,461 (financed by endowment, mem, city & state appropriations & other)
Special Subjects: Drawings, Painting-American, Photography, Sculpture, Costumes, Primitive art, Decorative Arts, Painting-European, Oriental Art, Antiquities-Byzantine, Medieval Art, Antiquities-Persian, Antiquities-Egyptian, Antiquities-Greek, Antiquities-Roman, Painting-German, Antiquities-Etruscan, Antiquities-Assyrian
Collections: Acquisitions-Departments: Africana, Oceanic; American decorative arts, paintings & sculpture; Ancient Near Eastern art; arms & armor; Asian art; Costume Institute; drawings; Egyptian art; European paintings, sculpture & decorative arts; Greek & Roman art; Islamic art; Lehman Collection, medieval art & The Cloisters; musical instruments; prints; photographs; Twentieth Century Art
Exhibitions:
Publications: Bulletin, quarterly; Calendar, bi-monthly; The Journal, annually; exhibition catalogs, scholarly books
Activities: Classes for adults & children; docent training; films; programs for the disabled touch collection; lect open to public; concerts; gallery talks; tours; outreach; exten dept serves community programs for greater New York City area; color reproductions, individual paintings & original objects of art lent to other institutions; book traveling exhibitions; originate traveling exhibitions to US museums; museum shop sells books, magazines, original art, reproductions, prints, slides, children's activities, records, postcards & posters

L **Thomas J Watson Library,** 1000 Fifth Ave, New York, NY 10028-0198. Tel 212-650-2221; Fax 212-570-3847; Elec Mail watson.library@metmuseum.org; Internet Home Page Address: www.metmuseum.org; *Acquisitions Coordr* Barbara Reed; *Systems Librn* Oleg Kreymer; *Serials Librn* Evalyn Stone; *Head Reader Servs* Linda Seckelson; *Conservation Librn* Mindell Dubansky; *Interlibrary Svcs* Robyn Fleming; *Chief Librn* Kenneth Soehner; *Mgr Bibliography* Daniel Starr; *Electronic Resource Librn* Deborah Vincelli
Open Tues - Fri 10 AM - 4:40 PM, cl holidays & last 2 wks of Aug; Estab 1880; primary mission is to serve museum staff; reading privileges extended to qualified and experienced researchers and graduate students with appropriate ID; see Museum's website for details; Circ non-circulating for visitors; Closed stack reference library; Average Annual Attendance: 30,000
Income: Financed by endowment
Library Holdings: Auction Catalogs; Book Volumes 500,000; Clipping Files; Exhibition Catalogs; Fiche; Filmstrips; Manuscripts; Memorabilia; Other Holdings Auction catalogs; CD Roms 75; Original documents; Pamphlets; Periodical Subscriptions 2,250; Reels
Special Subjects: Art History, Landscape Architecture, Decorative Arts, Drawings, Islamic Art, Painting-American, Prints, Sculpture, History of Art & Archaeology, Asian Art, Porcelain, Furniture, Glass, Silver, Antiquities-Assyrian
Collections: Art Auction Catalogs

L **Dept of Drawings & Prints,** 1000 Fifth Ave, New York, NY 10028-0198. Tel 212-570-3920; Fax 212-570-3921; Internet Home Page Address: www.metmuseum.org; *Cur in Charge* Dr George R Goldner
Open Tues - Fri 10 AM - 12:30 PM & 2 - 4:30 PM by appointment; No admis fee; Estab 1917 to collect & preserve prints, illustrated books & drawings for ornament & architecture; Has 3 exhibition galleries; Average Annual Attendance: 2,600
Income: financed by museum
Library Holdings: Original Art Works; Prints
Special Subjects: Art History, Landscape Architecture, Decorative Arts, Illustration, Drawings, Etchings & Engravings, Prints, Portraits, Printmaking, Woodcuts, Architecture

L **Image Library,** 1000 Fifth Ave, New York, NY 10028. Tel 212-650-2262; Fax 212-396-5050; Internet Home Page Address: www.metmuseum.org/education/er_photo_lib.asp; *Mus Librn* Julie Zeftel; *Assoc Mus Librn* Eileen Sullivan; *Assoc Mus Librn* Claire Dienes; *Librn* Stephanie Post; *Chief Librn* Andrew P Gessner; *Assoc Mus Librn* Billy Kwan
Closed to public except by appointment; Estab 1907 to provide a circulation library of slides covering the history of art; to provide digital images; color transparencies & photographs of the collections of the Metropolitan Museum of Art for publication purposes
Library Holdings: Kodachrome Transparencies; Lantern Slides; Original Documents; Other Holdings Color transparencies; Periodical Subscriptions; Photographs; Reproductions; Slides 800,000
Special Subjects: Art History
Collections: Encyclopedic collection of art and architecture

L **Robert Goldwater Library,** 1000 Fifth Ave, New York, NY 10028-0198. Tel 212-570-3707; Fax 212-570-3879; Elec Mail goldwater.library@metmuseum.org; Internet Home Page Address: www.library.museum.org; *Head Librn* Ross Day; *Library Assoc* Joy Garnett; *Librn Asst* Erika Hauser
Open Tues - Fri 10 AM - 4:30 PM, cl Aug; Estab 1957 as the library of the Museum of Primitive Art; holding of the Metropolitan Museum as of 1976; open Feb 1982; Primarily for reference
Income: Financed by endowment
Library Holdings: Auction Catalogs; Book Volumes 35,000; Exhibition Catalogs; Fiche; Periodical Subscriptions 175; Reels
Special Subjects: Archaeology, Ethnology, Anthropology
Publications: Primitive Art Bibliographies (1963 - 1971); Catalog of the Robert Goldwater Library (1982, 4 vols)

L **Robert Lehman Collection Library,** 1000 Fifth Ave at 82nd St, New York, NY 10028. Tel 212-650-2340; Fax 212-650-2542; Elec Mail rlehmanc@mindspring.com; *Asst Mus Librn* Tatyana Pakhladzhyan
Estab 1975 to provide mus staff & researchers with a resource from which to obtain information about the Lehman Collection; Open by appointment only
Income: Financed by endowment
Library Holdings: Auction Catalogs; Book Volumes 23,500; Clipping Files; Exhibition Catalogs; Manuscripts; Memorabilia; Other Holdings Original documents; Pamphlets; Periodical Subscriptions 10; Photographs; Reproductions
Special Subjects: Art History, Decorative Arts, Drawings, Manuscripts, Painting-Italian, Painting-European, Ceramics, Bronzes, Furniture, Glass, Enamels, Gold, Goldsmithing, Miniatures, Architecture

Collections: Archives containing books, correspondence, manuscripts and reproductions; photograph collection

L The Costume Institute Library, 1000 Fifth Ave, New York, NY 10028-0198. Tel 212-650-2723; Fax 212-570-3970; Internet Home Page Address: www.metmuseum.org; *Head Library & Assoc Librn* Tatyana Pakhladzhyan; *Cur* Harold Koda; *Research Assoc* Stephane Houy-Tower
Call Tues - Fri 9 AM - 5 PM; open for appointments Tues - Fri 9:30 - 5 PM; No admis fee; Estab 1946 to study costume history, fashion & theatre design & any subject related to the subject of dress; Circ non-circulating; For reference only; Average Annual Attendance: 3,500
Income: Financed by bequest
Library Holdings: Book Volumes 25,000; Cards; Clipping Files; Exhibition Catalogs; Framed Reproductions; Manuscripts; Memorabilia; Original Art Works; Other Holdings Fashion plates; Original fashion sketches; Periodical Subscriptions 40; Photographs; Prints; Video Tapes
Special Subjects: Decorative Arts, Illustration, Crafts, Theatre Arts, Fashion Arts, Costume Design & Constr, Metalwork, Embroidery, Gold, Goldsmithing, Jewelry, Textiles, Laces, Display
Collections: Bergdorf-Goodman Fashion Sketches; Fashion Textile Archives; Mainbocher Fashion Sketches

L Library and Teacher Resource Center in the Uris Center for Education, 1000 Fifth Ave, New York, NY 10028. Tel 212-570-3788; *Assoc Mus Librn* Naomi Niles; *Sr Libr Asst* Lisa Nanni
Open Sep - May Tues - Thurs 10 AM - 5 PM, Fri & Sat 10 AM - 8 PM, Sun 11 AM - 5 PM; June -July Tues - Sat 10 AM - 5 PM, Sun 11 AM - 5 PM; Aug Tues - Sat 11 AM - 4 PM ; The Library & Teacher Center is part of the educ department
Library Holdings: Book Volumes 6,000; CD-ROMs 30; Cassettes 1,000; DVDs 30; Other Holdings Teacher materials, 300 slide sets; Periodical Subscriptions 60
Special Subjects: Art History, Painting-American, Sculpture, Painting-European, Portraits, Art Education
Publications: MMA bulletins, journal & exhibition catalogs

M The Cloisters, Fort Tryon Park, New York, NY 10040. Tel 212-923-3700; Fax 212-795-3640; Elec Mail cloisters@metmuseum.org; Internet Home Page Address: www.metmuseum.org; Cable CLOMUSE; *Chmn & Cur* Peter Barnet; *Cur* Timothy Husband; *Mgr Admin* Jose Ortiz; *Mgr Admin* Christina Alphonso; *Cur* Julien Chapuis
Open March - Oct, 9:30 AM - 5:15 PM; Nov - Feb, 9:30 AM - 4:45 PM; Admis suggested donation adults $20, seniors & children $10; Estab 1938 to display in an appropriate setting works of art & architecture of the Middle Ages; Medieval French cloisters incorporated into the building, as well as the chapter house, a chapel & Romanesque apse; also Medieval herb garden; Average Annual Attendance: 240,000; Mem: Part of Met Museum
Collections: Frescoes, ivories, precious metalwork, paintings, polychromed statues, stained glass, tapestries, and other French and Spanish architectural elements
Exhibitions: The Wild Man: Medieval Myth and Symbolism; The Royal Abbey of Saint-Denis in the Time of Abbot Suger (1122-1151)
Publications: A Walk Through The Cloisers; exhibition catalogs
Activities: Dramatic programs; lect open to public; concerts; gallery talks; tours; original objects of art lent to other museums; museum shop sells books, reproductions, prints and slides

L The Cloisters Library, Fort Tryon Park, New York, NY 10040. Tel 212-923-3700, Ext 154; Fax 212-795-3640; Internet Home Page Address: www.metmuseum.org;
Open Tues - Fri 9:30 AM - 4:30 PM; No admis fee; Estab 1938 to be used as a small highly specialized reference library for the curatorial staff at The Cloisters; scholars & accredited graduate students are welcome & qualified researchers by appointment only
Income: Financed by endowment
Library Holdings: Book Volumes 12,000; Fiche 9,000; Other Holdings Original documents; Periodical Subscriptions 58; Photographs 22,000; Reels; Slides 20,000
Special Subjects: Art History, Sculpture, Stained Glass, Enamels, Tapestries, Architecture
Collections: George Grey Barnard Papers; Harry Bober Papers; Joseph & Ernest Brummer Papers; Summer McKnight Crosby Papers; Demotte Photograph Archive; Archives of the Cloisters

L MIDMARCH ASSOCIATES MIDMARCH ARTS PRESS, Women Artists Archive and Library, 300 Riverside Dr, Apt 8A, New York, NY 10025. Tel 212-666-6990; Fax 212-865-5510; *Exec Dir* Cynthia Navaretta; *Educ* Judy Seigel; *Educ* Sylvia Moore
Open by appointment; Estab 1975 to maintain archival material on women artists world wide & to publish books on 20th centure art & artists
Income: Financed by public funding & contributions
Library Holdings: Book Volumes; Clipping Files; Exhibition Catalogs; Manuscripts; Memorabilia; Original Art Works; Original Documents; Pamphlets; Photographs; Sculpture
Special Subjects: Art History, Constructions, Decorative Arts, Film, Mixed Media, Drawings, Pre-Columbian Art, Sculpture, Watercolors, Ceramics, Conceptual Art, Crafts, Latin American Art, Theatre Arts, Architecture
Publications: Essays on Women Photographers 1840 - 1930; guide to Women's Art Organizations & Directory for the Arts, bi-annually; Regional Series on Women Artists (New England, Texas, California, Pacific Northwest), annually; Voices of Women; Women Artists of the World; Women Artists News, bimonthly; Talk That Changed Art, 1975 - 1990; Beyond Walls & Wars: Art, Politics & Multiculturalism
Activities: Educ dept; lect provided

M MORRIS-JUMEL MANSION, INC, 65 Jumel Terr, New York, NY 10032. Tel 212-923-8008; Fax 212-923-8947; Elec Mail mjm1765@aol.com; Internet Home Page Address: www.morrisjumel.org; *Dir* Kenneth Moss; *Pres* James Kerr Esq; *Gift Shop Coordr* Barbara Mitchell; *Dir Educ* Loren Silber; *Cur* Sheena Brown
Open Wed - Sun 10 AM - 4 PM, Mon - Tues by appt; Admis adults $3, students & seniors $2, children under 12 free; Estab 1904 as a Historic House Museum; Morris-Jumel Mansion consists of 11 period rooms which are restored to represent the colonial, revolutionary & nineteenth-century history of the mansion,

highlighting its owners & inhabitants (the Morris family, George Washington, Eliza Jumel & Aaron Burr); Average Annual Attendance: 30,000; Mem: 200; contributors 500; dues $35-$2500
Income: Financed by mem, contributions, private sources, state & city funds
Special Subjects: Architecture, Painting-American, Textiles, Costumes, Ceramics, Etchings & Engravings, Decorative Arts, Portraits, Furniture, Glass, Historical Material, Period Rooms, Laces, Painting-Italian
Collections: Architecture; decorative art; furniture of the 18th & 19th centuries
Publications: Morris-Jumel News, biannual
Activities: Classes for adults; classes for 4th - 11th grade students, focus on study of historical artifacts, documents & architecture; dramatic programs; docent training; lect open to public; concerts; tours; originate traveling exhibitions; museum shop sells books, reproductions, postcards & CDs

A MUNICIPAL ART SOCIETY OF NEW YORK, 457 Madison Ave, New York, NY 10022. Tel 212-935-3960; Fax 212-753-1816; Elec Mail info@mas.org; Internet Home Page Address: www.mas.org; *Pres* Kent Barwick; *Dir* Frank E Sanchis III
Open Mon - Fri 10 AM - 6 PM; No admis fee; Estab 1892, incorporated 1898; The Society is the one organization in New York where the layman, professional & business firm can work together to encourage high standards for pub art, architecture, planning, landscaping & preservation in the five boroughs; Mem: 4,500; dues $25 & up; annual meeting in June
Income: financed by members & grants
Collections: Photographs
Exhibitions: Rotating exhibits
Publications: The Livable City, quarterly

L The Information Exchange, 457 Madison Ave, New York, NY 10022. Tel 212-935-3960; Fax 212-753-1816; Elec Mail tie@mas.org; Internet Home Page Address: www.mas.org; *Acting Dir* Ann Anielewski
Open Mon - Thurs 10 AM - 4 PM; Estab 1978; For reference only
Library Holdings: Book Volumes 1600; Clipping Files 3,300; Periodical Subscriptions 100
Special Subjects: Landscape Architecture

M MUSEUM OF CHINESE IN THE AMERICAS, 70 Mulberry St, 2nd Fl, New York, NY 10013. Tel 212-619-4785; Fax 212-619-4720; Elec Mail moca-org@juno.com; Internet Home Page Address: www.moca-nyc.org; *Exec Dir* Fay Chew Matsuda; *Co-Founder* Dr John K W Tchen; *Co-Founder* Charlie Lai; *Admin Dir* Lamgen Leon; *Dir Prog* Cynthia Lee
Open Tues - Sat Noon - 5 PM, archives by appointment only; Admis adults $3, seniors & students $1, members & children under 12 free; Estab 1980 dedicated to preserving 180 years of Chinese American history; Located in a historic, century-old school building; Average Annual Attendance: 10,000; Mem: 250; dues $50 - $1000
Income: Financed by mem, pub & private funds
Special Subjects: Historical Material
Collections: Archives: Chinese American history & culture, including oral histories, photographs, documents, personal & organizational records, sound recordings, textiles, artifacts & a library of over 2,000 volumes covering Asian American topics
Exhibitions: Where is Home, Chinese in the Americas (permanent exhibition)
Activities: Workshops; lects; walking tours; family events; legacy awards; museum shop sells exhibition posters, gift items

M MUSEUM OF MODERN ART, 11 W 53rd St, New York, NY 10019-5498. Tel 212-708-9400, (Exhibit & Film Info) 708-9480; Fax 212-708-9889; Elec Mail cimm@moma.org; Internet Home Page Address: www.moma.org; Telex 6-2370; Cable MODERNART; *Pres* Marie-Josee Kravis; *Chmn Emeritus* Ronald S Lauder; *Acting Chief Cur, Dept Film & Video* Steven Higgins; *Dir* Jay Levinson; *Dir Publications* Christopher Hudson; *Dir Visitor Servs* Diana Simpson; *Chief Cur, Dept Painting & Sculpture* John Elderfield; *Chief Cur* Connie Butler; *Chief Cur, Dept Photography* Peter Galassi; *Chief Cur, Prints & Illustrated Books* Deborah Wye; *Dir Mus* Glenn D Lowry; *Dep Dir of Mktg & Communications* Ruth Kaplan; *Dep Dir for External Affairs* Michael Margitich; *Chief Cur* Barry Bergdoll; *Deputy Dir Educ* Wendy Woon
Open daily Sat - Tues 10:30 AM-5:45 PM, Fri 10 AM - 8:15 PM, cl Wed, Thanksgiving & Christmas; Admis adults $10, students & seniors $6.50, children under 16 accompanied by adult free, Thurs & Fri 4:30-8:15 pay what you wish; Estab 1929, the Museum offers an unrivaled survey of modern art from 1880 to the present; Designed in 1939 by Phillip Goodwin & Edward Durell Stone, the building is one of the first examples of the International Style in the US. Subsequent expansions took place in the 1950s & 1960s under the architect Philip Johnson, who also designed the Abby Aldrich Rockefeller Sculpture Garden. A major renovation, completed in 1984, doubled the Museum's gallery space & enhanced visitor facilities; Average Annual Attendance: 1,500,000; Mem: 52,000; dues student $25, others $45 & up
Income: Financed by admis, mem, sales of publications, other services & contributions
Special Subjects: Architecture, Drawings, Graphics, Painting-American, Photography, Prints, Sculpture, Posters
Collections: Painting & sculptures over 2,963; drawings 5,090; prints 15,822; illustrated books 20,423; photographs 15,000; architectural drawings 20,000; architectural models 60; design objects 3,000; posters & graphics 4,000; films 10,000; film stills over 3,000,000
Exhibitions: (9/2006-1/2007) New Photography '06; (10/2006-1/2007) Eye on Europe: Prints, Books & Multiples 1960-present; (10/2006-1/2007) Brice Marden: A Retrospective of Paintings & Drawings; (11/2006-1/2007) Edouard Manet & the Execution of Maximillian; (1/2007-2/2007) Doug Aitken: Sleepwalkers; (2/2007-4/2007) Reveron; (2/2007-5/2007) Jeff Wall; (3/2007-6/2007) Comic Abstraction; (6/2007-9/2007) Richard Serra: 40 Years; (7/2007-10/2007) Joann Verburg; (10/2007-1/2008) Seurat Drawings; (10/2007-1/2008) Puryear; (12/2007-3/2008) Lucian Freud Prints
Publications: Annual report; books on exhibitions & artists; Members Quarterly; Members Calendar; monographs; catalogs; exhibitions catalogs
Activities: Classes for adults & children; lect open to public; concerts; gallery talks; tours; film showings, international in scope, illustrating the historic and

esthetic development of the motion picture; scholarships & fels offered; art advisory service; originates traveling exhibitions; circulating film programs and video programs; sales shop sells publications, postcards, note & seasonal cards, posters, slides, calendars, design objects & furniture

L **Library and Museum Archives,** 11 W 53rd St, New York, NY 10019-5498. Tel 212-708-9433 (library), 708-9617 (archives); Fax 212-333-1122; Elec Mail library@moma.org; Internet Home Page Address: www.library.moma.org; *Librn, Collection Develop* Jennifer Tobias; *Chief Library & Mus Archives* Milan Hughston; *Archivist* Michelle Elligott
Open Mon, Thurs & Fri 11 AM - 5 PM by appointment; No admis fee; Estab 1929 as a research library; For museum staff, art researchers & the public
Library Holdings: Auction Catalogs; Audio Tapes; Book Volumes 260,000; CD-ROMs; Cassettes; Clipping Files; Exhibition Catalogs; Fiche; Original Documents; Other Holdings Artists files 53,000; Pamphlets; Periodical Subscriptions 300; Records; Reels; Video Tapes
Special Subjects: Art History, Collages, Film, Mixed Media, Photography, Drawings, Graphic Design, Posters, Prints, Sculpture, Conceptual Art, Latin American Art, Industrial Design, Architecture
Collections: Archives of artists' groups; artists' books; avant-garde art; Dada & Surrealism; archive of museum publications; Latin American art; personal papers of artists, writers, dealers; political art documentation archive
Exhibitions: Fluxus: Selections from the Gilbert & Lila Silverman Collection, 1988-89 (catalog)
Publications: Annual Bibliography of Modern Art; Bibliography of Modern Art on Disc; catalog of the Library of the Museum of Modern Art
Activities: Internship program

M **MUSEUM OF THE CITY OF NEW YORK,** 1220 Fifth Ave at 103d, New York, NY 10029. Tel 212-534-1672; Fax 212-423-0758; Internet Home Page Address: www.mcny.org; *Dir* Susan Henshaw Jones
Open Wed - Sat 10 AM - 5 PM, Sun & holidays 1 - 5 PM, cl Mon; Admis suggested contribution; Estab 1923 to preserve the cultural accomplishments of New York City & to meet the needs & interests of the community of today; Permanent & temporary exhibition galleries on subjects related to mission; Average Annual Attendance: 350,000; Mem: 2,500; dues $35 & up
Income: $5,000,000 (financed by private & nonprofit institutions, individual contributions, city, state & federal funds)
Special Subjects: Architecture, Drawings, Graphics, Anthropology, Archaeology, Costumes, Ceramics, Crafts, Folk Art, Etchings & Engravings, Landscapes, Decorative Arts, Manuscripts, Dolls, Furniture, Glass, Jewelry, Marine Painting, Metalwork, Historical Material, Maps, Coins & Medals, Dioramas, Embroidery, Cartoons
Collections: Costume collection; decorative arts collection; marine collections; paintings, sculpture, prints & photographs collection; theatre & music collection; toy collection
Publications: Annual report; exhibit catalogs; quarterly newsletter; quarterly programs brochure for members
Activities: Classes for adults & children; docent training; lect open to public; gallery talks; concerts; city walking tours; competitions with awards; original objects of art lent to affiliated institutions; lending collection contains sculptures, 40,000 books, 5,000 original art works, 15,000 original prints, 2,000 paintings & 300,000 photographs; book traveling exhibitions 1-2 per year; originate traveling exhibitions to other museums; museum shop sells books, reproductions, prints & slides

M **Museum,** 1220 Fifth Ave, New York, NY 10029. Tel 212-534-1672 ext. 3372; Fax 212-534-5974; Elec Mail research@mcny.org; Internet Home Page Address: www.mcny.org; *Mgr Coll Access* Melanie Bower; *Cur Decorative Arts & Manuscripts* Dr Deborah Waters; *Pres & Dir* Susan Henshaw Jones; *Deputy Dir* Dr Sarah Henry; *VPres Fin & Admin & CFO* Carl Dreyer
Research by appointment only; contact Mgr Coll Access; gallery open Tues - Sun 10 AM - 5 PM, cl Mon; Research fees $25 per 2 1/2 hour appointment, students & members at reduced rates; gallery admis recommended donation: $9 adults, $5 seniors & students, $20 family (2 adults), members free; Museum founded 1923, devoted to the history of New York City; Museum exhib focus on history of NYC and its people; Average Annual Attendance: 150,000
Income: public & private partnership
Library Holdings: Book Volumes 8,000; Clipping Files; Manuscripts; Maps; Memorabilia; Original Art Works; Original Documents; Periodical Subscriptions 25; Photographs; Prints; Reproductions; Sculpture
Special Subjects: Decorative Arts, Photography, Drawings, Etchings & Engravings, Graphic Arts, Manuscripts, Maps, Painting-American, Posters, Prints, Sculpture, Historical Material, Watercolors, Ceramics, Crafts, Cartoons, Porcelain, Furniture, Period Rooms, Costume Design & Constr, Glass, Stained Glass, Afro-American Art, Metalwork, Carpets & Rugs, Dolls, Embroidery, Gold, Jewelry, Leather, Miniatures, Silver, Woodcarvings, Woodcuts, Marine Painting, Landscapes, Dioramas, Coins & Medals, Pewter, Flasks & Bottles, Scrimshaw, Laces, Architecture, Folk Art, Portraits, Pottery, Textiles
Collections: Paintings, sculpture, prints, photography, costumes, decorative arts, toys, theater memorabilia
Exhibitions: see website www.mcny.org for correct schedule
Publications: various
Activities: Educ prog classes for children; docent training; lect open to the public; concerts; gallery talks; tours; sponsor competitions; History Day for high school and younger students; originate traveling exhibitions to nonprofit organizations in US and abroad; museum shop sells books, reproductions, prints & gift items

NATIONAL ACADEMY OF DESIGN
For further information, see National and Regional Organizations

NATIONAL ANTIQUE & ART DEALERS ASSOCIATION OF AMERICA, INC
For further information, see National and Regional Organizations

NATIONAL ASSOCIATION OF WOMEN ARTISTS, INC
For further information, see National and Regional Organizations

NATIONAL CARTOONISTS SOCIETY
For further information, see National and Regional Organizations

M **NATIONAL MUSEUM OF THE AMERICAN INDIAN,** George Gustav Heye Center, One Bowling Green, New York, NY 10004. Tel 212-514-3700; Elec Mail nin@ic.si.edu; Internet Home Page Address: www.conexus.si.edu/maihe; *Dir* W Richard West Jr; *Deputy Dir* Douglas E Evelyn; *Dir Public Affairs* Russ Tall Chief; *Asst Dir Pub Progs* Charlotte Heth; *Asst Dir Administration* Donna A Scott; *Deputy Asst Dir Exhib* James Volkert; *Asst Dir Cultural Resources* George Horse Capture; *Dir NMAI National Campaign* John Colonghi; *Asst Dir NMAI National Campaign* Maggie Bertin; *Exhib Prog Mgr* Karen Fort; *Head Exhib NY* Peter S Brill; *Public Prog Coordr* Carolyn Rapkievian; *Head Publications* Terence Winch; *Resource Center Mgr* Marty Kreipe de Montano; *Head Film & Video Center* Elizabeth Weatherford; *Community Svcs Coordr* Kevin Lewis; *Training Coordr* Alyce Sadongei; *Head Photo Archives* Pamela Dewey; *Acting Head Curatorial* Mary Jane Lenz; *Head Coll* Scott Merritt; *Head Conservation* Marian Kaminitz; *Repatriation Prog Mgr* Betty White; *Technology Prog Coordr* Robert Billingsley; *Facilities Planning Mgr* Duane Blue Spruce; *Budget Analyst* Kelly Bennett; *Human Resources Specialist* Carol Belovitch; *Admin Officer NY* Marty Lathan; *Facilities Mgr NY* Myroslaw Riznyk; *Mus Shop Mgr* Lilli Liell; *Deputy Asst Dir Public Progs* John Haworth
Open Mon - Wed & Fri - Sun 10 AM - 5 PM, Thurs until 8 PM, cl Christmas; No admis fee; Estab 1989 to recognize & affirm the historical & contemporary cultures & cultural achievements of the Native peoples of the Western Hemisphere; 20,000 sq ft exhibition galleries; Average Annual Attendance: 250,000; Mem: dues $20, $35, $100 charter mem
Income: Financed by trust, endowments & revenues, gifts, grants, contributions, mem & funds appropriated by Congress
Special Subjects: Latin American Art, Painting-American, Photography, Sculpture, American Indian Art, Anthropology, Archaeology, Ethnology, Pre-Columbian Art, Textiles, Costumes, Ceramics, Pottery, Decorative Arts, Manuscripts, Eskimo Art, Historical Material, Coins & Medals
Collections: Pre-Columbian art & historical materials; world's largest collection of art & the culture of the Indians of North, Central & South America
Exhibitions: Rotating exhibits
Publications: Books, occasionally; brochures; catalogs; recordings; Smithsonian Runner Newsletter
Activities: Guided tours for children; lect open to public; concerts; gallery talks; tours; scholarships offered; individual paintings & original objects of art lent to museums, including tribal museums & cultural centers, nonprofit institutions & other appropriate sites; originate traveling exhibitions; museum shop sells Indian crafts, jewelry, masks, pottery, beadwork, basketry, weavings, carvings, paintings, prints, books, slides, postcards & notepaper

M **THE NATIONAL PARK SERVICE, UNITED STATES DEPARTMENT OF THE INTERIOR,** Statue of Liberty National Monument & The Ellis Island Immigration Museum, Liberty Island, New York, NY 10004. Tel 212-363-3206 x150, 148, 159; Fax 212-363-6302; Elec Mail stli museum@nps.gov; *Cur Coll* Geradine Santoro; *Supervisory Archivist* George Tselos; *Chief Cur* Diana Pardue; *Library Technician* Barry Moreno; *Library Technician* Jeff Dosik; *Oral Historian* Janet Levin
Open 9:30 AM - 5 PM; No admis fee, donations accepted; Estab 1972; Exhibit areas in base of Statue of Liberty & in Ellis Island Immigration Museum; Average Annual Attendance: 4,000,000
Library Holdings: Book Volumes; CD-ROMs; Clipping Files; Kodachrome Transparencies; Manuscripts; Maps; Periodical Subscriptions; Photographs; Prints; Records; Slides
Special Subjects: Architecture, Graphics, Painting-American, Photography, Prints, Sculpture, Archaeology, Textiles, Costumes, Religious Art, Ceramics, Folk Art, Etchings & Engravings, Decorative Arts, Judaica, Manuscripts, Posters, Furniture, Historical Material, Coins & Medals, Restorations, Embroidery, Cartoons
Collections: Ellis Island Collection; Statue of Liberty Collection; Furniture Art Work, oral histories, prints, manuscripts, films & videos, books, periodicals, historic structures
Exhibitions: Ellis Island Exhibits; Statue of Liberty exhibit
Activities: Classes for children; dramatic programs; docent training; lect open to public; gallery talks; tours; individual paintings & original objects of art lent to other museums; book traveling exhibitions; sales shop sells books, magazines, reproductions, original art, prints & slides

NATIONAL SCULPTURE SOCIETY
For further information, see National and Regional Organizations

NATIONAL SOCIETY OF MURAL PAINTERS, INC
For further information, see National and Regional Organizations

M **NEW WORLD ART CENTER,** T F Chen Cultural Center, 250 Lafayette St, New York, NY 10012. Tel 212-966-4363; Fax 212-966-5285; Elec Mail chen@tfchen.org; Internet Home Page Address: www.tfchen.org; *Dir* Julie Chen; *Pres* Lucia Hou
Open Tues - Sat 1 - 6 PM, appt preferred; No admis fee; Estab 1996 to advance new artistic & cultural ideas & further global harmony; A strikingly redesigned six-story art center that aims to be the hub of a New Renaissance & act as a unifying force to bring together a world family of artists, thinkers, art lovers & visionaries focus on art educ & a global cultural of peace; Average Annual Attendance: 5,000; Mem: Dues $30 & up
Income: Financed by mem & private donations
Library Holdings: Book Volumes; Cards; Clipping Files; Exhibition Catalogs; Framed Reproductions; Original Documents; Pamphlets; Photographs; Records; Reproductions; Slides; Video Tapes
Special Subjects: Drawings, Graphics, Hispanic Art, Latin American Art, Painting-American, Photography, American Indian Art, American Western Art, African Art, Ethnology, Ceramics, Folk Art, Etchings & Engravings, Afro-American Art, Decorative Arts, Painting-European, Painting-Japanese, Portraits, Posters, Furniture, Oriental Art, Asian Art, Calligraphy, Antiquities-Oriental, Painting-Italian
Collections: Africa Art; T F Chen, Neo-Iconography paintings; Emerging Artists, all media; Italian Art; Master Artists (Picasso, Miro, Chagall & others); Vietnamese Art & Art Objects
Exhibitions: Post-Van Gogh Retrospective (1954-1998); Art from the Mediterranean; Japanese Art; group shows; (2005-2010) Art for Humanity, world tour to advance art education & a global cultural of peace

Publications: Art Books, 12 & up
Activities: Lect open to the public; gallery talks; awards: art competitions, essay on Neo-Iconography; lending of original objects of art to Taiwan museum of art; book traveling exhibitions, 2 per year; museum shop sells books, original art, reproductions & prints

A NEW YORK ARTISTS EQUITY ASSOCIATION, INC, 498 Broome St, New York, NY 10013. Tel 212-941-0130; Elec Mail reginas@anny.org; Internet Home Page Address: www.anny.org; *Hon Pres* Gwendolyn Knight Lawrence; *Treas* Lisa Feldman; *VPres* Dorris Wyman; *VPres* Frank Mann; *VPres* Wendy Gittler; *VPres* Kate O'Toole; *Secy* Marilyn Sontag; *Exec Dir* Regina Stewart
Open Tues - Fri 11 AM - 6 PM; No admis fee; Estab 1947 as a politically non-partisan group to advance the cultural, legislative, economic and professional interest of painters, sculptors, printmakers, and others in the field of visual arts. Various committees concerned with aims. Administrators of the Artists Welfare Fund, Inc; Broome Street Gallery; Mem: Over 3000; dues $35
Income: Financed by dues
Collections: Artbank; NYAEA Collection
Publications: The Artists Proof newsletter, quarterly
Activities: Lect open to public; trips to cultural institutions; advocacy; information services; artists benefits

L NEW YORK FOUNDATION FOR THE ARTS, 155 Avenue of the Americas, 14th Fl, New York, NY 10013. Tel 212-366-6900; Fax 212-366-1778; Internet Home Page Address: www.nyfa.org; *Exec Dir* Theodore Berger; *Prog Dir* Penny Dannenberg
Open Mon - Fri 9:30 AM - 5:30 PM, or by appointment; Estab to make more available research in art hazards; For reference only
Library Holdings: Book Volumes 500
Activities: Adult classes; lects

A NEW YORK HISTORICAL SOCIETY, 170 Central Park W, New York, NY 10024-5194. Tel 212-873-3400; Fax 212-874-8706; Elec Mail webmaster@nyhistory.org; Internet Home Page Address: www.nyhistory.org; *Pres* Louise Mirrer; *Dir Mus Div* Linda S Ferber; *Dir Library Div* Jean Ashton; *Dir Develop* Bill Evans; *Dir Pub Affairs* Laura Washington; *COO* Stephanie Benjamin; *Dir Educ* Adrienne Kupper; *Dir Mus Admin* Roy R Eddey; *Dir Pub Prog* Dale Gregory; *CFO* Rich Shein
Open Tues - Sun 10 AM - 6 PM, cl Mon; Admis adults $10, seniors $7, children under 12 free; Estab 1804 to collect & preserve material relating to the history of the US through the eyes of New York; Circ Research libr; Average Annual Attendance: 175,000; Mem: 4200; dues individual $55, student/senior/educator $40, dual senior $70, dual family $00, young friend $125, friend $250, Patron $500, benefactor $1,000, Gotham Fellow $2,500, chairman's council $5,000-25,000
Income: $16,000,000 (financed by endowment, grants, contributions, federal, state & local government, mem, admis)
Library Holdings: Book Volumes; Clipping Files; Exhibition Catalogs; Fiche; Manuscripts; Maps; Memorabilia; Original Art Works; Original Documents; Other Holdings ephemera; Pamphlets; Periodical Subscriptions; Photographs
Collections: The Birds of America: Audubon's 433 original watercolors; architectural drawings, decorative arts, drawings, paintings, photographs, prints & sculpture. American paintings from the Colonial period to 20th century, including genre scenes, portraits & landscapes by major artists of this period
Exhibitions: (5/30/2006-2/25/2007) Nature and the American Vision: The Hudson River School at the New York Historical Society; (6/16/2006-1/7/2007) Legacies: Contemporary Artists Reflect on Slavery
Publications: catalogs & compendia of permanent collections; portraits, drawings, Tiffany lamps, Slaver, Grant/Lee
Activities: Classes for adults & children; docent talks; lect open to public, 75 vis lectrs per yr; concerts; gallery talks; tours; symposia; fellowships; individual paintings & original objects of art lent to museums; lending collection contains 2700 paintings, 5000 drawings, 675 sculptures, 800 miniatures; Touch Collection, Web-based training; book traveling exhibitions 4 per year; organize traveling exhibitions to other museums; museum shop sells books, prints, reproductions, cards, magazines, slides, history and themed decorative objects
L Library, 2 W 77th St, New York, NY 10024. Tel 212-873-3400; Fax 212-875-1591; Internet Home Page Address: www.nyhistory.org; *Ref Librn* Mariam Touba; *Reference Librn* Joseph Ditta; *VPres Library Serv* Margaret Heilbrun; *Head Library Pub Svcs* Nina Nazionale; *Conservator* Alan Balicki; *Head Prints, Photos, & Architecture* Valerie Komor
Open Tues - Sat 10 AM - 5 PM (After Labor Day weekend until Memorial Day weekend), Tues - Fri 10 AM - 5 PM (After Memorial Day weekend until Labor Day weekend)
Library Holdings: Book Volumes 500,000; Cards 10,000; Clipping Files; Exhibition Catalogs; Fiche; Manuscripts; Memorabilia; Original Art Works; Other Holdings AV maps 15,000, Micro film 50,000, Vertical files 10,000 (including menus); Pamphlets; Periodical Subscriptions 150; Photographs; Prints; Reels
Collections: American Almanacs; American Art Patronage; American Genealogy; American Indian (accounts of & captivities; Early American Imprints; Early Travels in America; Early American Trials; Civil War Regimental Histories & Muster Rolls; Jenny Lind (Leonidas Westervelt) Maps; Military History (Military Order of the Loyal Legion of the United States, Commandery of the State of New York) Military History & Science (Seventh Regiment Military Library); Naval & Marine History (Naval History Society); 18th & 19 Century New York City & New York State Newspapers; Slavery & the Civil War; Spanish American War (Harper) Among the Manuscript Collections: Horatio Gates, Alexander McDougall, Rufus King, American Fur Company, Livingston Family, American Art Union, American Academy of Fine Arts

L THE NEW YORK KUNSTHALLE LIBRARY, 210 E Fifth St, New York, NY 10003. Tel 212-260-3060; Fax 212-260-4511
Open by appointment; Estab 1993; Research library & archives
Special Subjects: Art History, Intermedia, Painting-American, Painting-British, Painting-Dutch, Painting-Flemish, Painting-French, Painting-German,

Painting-Italian, Painting-Japanese, Painting-European, Conceptual Art, Painting-Israeli, Painting-Australian, Painting-Canadian

L THE NEW YORK PUBLIC LIBRARY, Humanities Department, Astor, Lenox & Tilden Foundations, 476 Fifth Ave, Rm 313 New York, NY 10018. Tel 212-930-0830; Elec Mail grdref@nypl.org; Internet Home Page Address: www.nypl.org; *Pres* Paul LeClerc; *Chief, Art Info Resources* Clayton Kirking
Open Mon, Thurs, Fri & Sat 10 AM - 6 PM, Tues - Wed 11 AM - 7:30 PM; Estab 1895; Entire library contains over 30,000,000 items
L Print Room, Fifth Ave & 42nd St, Rm 308, New York, NY 10018. Tel 212-930-0817; Fax 212-930-0530; Elec Mail prnref@nypl.org, phgref@nypl.org; Internet Home Page Address: www.nypl.org; *Cur Prints* Roberta Waddell
Open by application to Special Collection Office, Tues - Sat 1 - 6 PM, cl Sun, Mon & holidays; Estab 1899
Library Holdings: Book Volumes 25,000; Other Holdings Stereographs 72,000; Photographs 15,000; Prints 175,000
Collections: Samuel Putnam Avery Collection (primarily 19th century prints); Radin Collection of Western European bookplates; British & American caricatures; Beverly Chew bequest of Milton & Pope portraits; Eno Collection of New York City Views; McAlpin Collection of George Washington Portraits; Smith Collection of Japanese Prints; Phelps Stokes Collection of American Views; Lewis Wickes Hine Collection; Robert Dennis Collection of Stereoscopic Views; Pageant of America Collection; Romana Javitz Collection
Exhibitions: 2 rotating exhibits per year
L Spencer Collection, Fifth Ave & 42nd St, Rm 308, New York, NY 10018. Tel 212-930-0817; Fax 212-930-0530; Elec Mail scref@nypl.org; Internet Home Page Address: www.nypl.org; *Asst Dir for Art, Prints & Photographs & Cur Spencer Coll* Robert Rainwater
Open by application to Special Collection Office, Tues - Sat 1 - 6 PM, cl Sun & holidays
Library Holdings: Book Volumes 9000
L Art Division, Fifth Ave & 42nd St, Rm 313, New York, NY 10018. Tel 212-930-0834; Fax 212-930-0530; *Cur Art & Arch Coll* Paula A Baxter
Open Tues & Wed 11 AM - 7:30 PM, Thurs - Sat 10 AM - 6 PM, cl Sun & Mon; Estab 1911 for reference
Library Holdings: Book Volumes 275,000; Clipping Files; Exhibition Catalogs; Pamphlets
Special Subjects: Art History, Decorative Arts, Drawings, Painting-American, Ceramics, Latin American Art, Interior Design, Porcelain, Furniture, Mexican Art, Ivory, Jade, Costume Design & Constr, Glass, Metalwork, Goldsmithing, Jewelry, Oriental Art, Pewter, Architecture
Collections: Private & public collection catalogs; individual artists & architects
Exhibitions: Rotating exhibit
L Schomburg Center for Research in Black Culture, 515 Malcolm X Blvd, New York, NY 10037. Tel 212-491-2200; Internet Home Page Address: www.nypl.org; *Chief* Howard Dodson
Open for research & exhibitions Mon - Wed Noon - 8 PM, Thurs - Sat 10 AM - 6 PM; A reference library devoted to Black people throughout the world; small gallery in lobby for rotating exhibition program
Library Holdings: Book Volumes 130,000; Clipping Files; Filmstrips; Other Holdings Broadsides; Maps; Playbills; Programs; Photographs; Prints; Records; Reels
Collections: One of the largest collections in the country of books on Black Culture & Art; a research collection containing African Art, American Art by Black artists, Afro-Caribbean art & artifacts
Exhibitions: Rotating exhibits
Activities: Lect open to public; gallery talks; tours; fellowships offered; originate traveling exhibitions; sales shop sells books, reproductions, exhibition catalogs & cards
L Mid-Manhattan Library, Art Collection, 455 Fifth Ave, New York, NY 10016. Tel 212-340-0871
Open Mon, Wed & Thurs 9 AM - 9 PM, Tues 11 AM - 7 PM, Fri & Sat 10 AM - 6 PM
Library Holdings: Book Volumes 40,000; Clipping Files; Fiche; Other Holdings Vertical files of clippings on artists; Periodical Subscriptions 200; Reels; Video Tapes
—Mid-Manhattan Library, Picture Collection, 455 Fifth Ave, New York, NY 10016. Tel 212-340-0878, 340-0849; *Supervising Librn* Constance Novak Estab 1915
Collections: Approximately 5,000,000 classified pictures; Encyclopedic in scope; Approximately half of collection available for loan with a valid NYPL card, remainder available for studying & copying, not for classroom or exhibition use
M The New York Public Library for the Performing Arts, 40 Lincoln Ctr Plaza, New York, NY 10023. Tel 212-870-1830; Fax 212-870-1870; Internet Home Page Address: www.nypl.org; *Dir* Jacqueline Z Davis; *Cur Exhib* Barbara Stratyner; *Chief Designer* Donald Vlack; *Cur Dance* Madeleine Nichols; *Theatre Cur* Robert Taylor; *Cur Recordings* Donald McCormick; *Chief Librn Circulations Coll Mgr* Kevin Winkler
No admis fee; Estab 1965 to present exhibitions of high quality pertaining directly with the performing arts; Vincent Astor Gallery is 38 x 36 x 16 ft; Oenslager Gallery is 116 x 20-36 x 10 ft + 20 x 40 x 24 ft section. Both galleries have full media playback capability; Average Annual Attendance: 300,000
Income: Financed by endowment & city appropriation
Library Holdings: Audio Tapes; Book Volumes; CD-ROMs; Cassettes; Clipping Files; Compact Disks; Exhibition Catalogs; Fiche; Lantern Slides; Manuscripts; Memorabilia; Motion Pictures; Original Art Works; Original Documents; Pamphlets; Periodical Subscriptions; Photographs; Prints; Records; Reels; Slides; Video Tapes
Collections: Prints; letters; documents; photographs; posters, films; video tapes; memorabilia; dance music; recordings
Activities: Docent training; symposia; lect open to public, 20 vis lectrs per year; concerts; gallery talks; tours; awards; lending collection contains books, cassettes, motion picture videos & phono records; book traveling exhibitions 1 per year; originate traveling exhibitions 3 per year; museum shop sells books, magazines, original art, reproductions & prints

L NEW YORK SCHOOL OF INTERIOR DESIGN, New York School of Interior Design Library, 170 E 70th St, New York, NY 10021. Tel 212-472-1500, Ext 214; Fax 212-472-8175; Elec Mail paul@nysid.edu; Internet Home Page Address: www.nysid.edu; Internet Home Page Address: www.nysid.net/library; *Dir of Libr* Eric Wolf; *Libr Assoc* Christopher Spinelli; *Libr Assoc* Mary Lynch; *Asst Librn* Rebecca Uranz
Open Mon - Thurs 9 AM - 9 PM, Fri 9 AM - 5 PM, Sat 10 AM - 5 PM (reduced hrs between sems); Pub admitted with METRO referral card; Estab 1924 to supplement the courses given by the school & to assist students & faculty in their research & information needs; Circ 7000; Average Annual Attendance: 40,000
Income: $195,490 (financed by New York State grant & general operating fund)
Purchases: $44,000
Library Holdings: Auction Catalogs 250; Audio Tapes 35; Book Volumes 15,000; CD-ROMs 100; DVDs; Exhibition Catalogs; Lantern Slides; Other Holdings Product Literature; Samples; Periodical Subscriptions 102; Slides 3,500; Video Tapes 125
Special Subjects: Decorative Arts, Interior Design, Architecture

A NEW YORK SOCIETY OF ARCHITECTS, 299 Broadway, Ste 206, New York, NY 10007. Tel 212-385-8950; Fax 212-385-8961; *Pres* Philip Toscano, RA; *VPres* Harold Kahn, RA; *Treas* Richard Yaffe, RA; *Admin Off Mgr* Nereida Sanchez
Open 9:30 AM - 4:30 PM; Incorporated 1906; Mem: 450; dues $275
Income: $100,000 (financed by dues & sales)
Publications: Bulletin, bi-monthly; New York City Building Code Manual; New York City Fire Prevention Code
Activities: Educational programs; educational seminars; Honorary Membership Certificate to affiliated professions other than architect, Distinguished Service Award to members, Sidney L Strauss Memorial Award to architect or layman, Fred L Liebmann Book Award

M NEW YORK STUDIO SCHOOL OF DRAWING, PAINTING & SCULPTURE, Gallery, 8 W Eighth St, New York, NY 10011. Tel 212-673-6466; Fax 212-777-0996; Internet Home Page Address: www.nyss.org; *Chmn* Nancy Whitney; *Dean* Graham Nickson; *Dir Gallery* Kathleen McDonnell; *Prog Dir* Elisa Jensen; *Bus Mgr* Susan Terry
Open daily 10 AM - 6 PM; No admis fee; Estab 1964, a nonprofit organization; Gallery is located on ground floor of the Studio School, site of the original Whitney Mus of Art; 2 large rooms on courtyard; Average Annual Attendance: 1,000
Income: Financed by private funding
Library Holdings: Auction Catalogs; Book Volumes; Exhibition Catalogs; Periodical Subscriptions
Special Subjects: Drawings, Painting-American, Sculpture, Watercolors, Etchings & Engravings, Painting-European, Painting-British, Painting-French, Painting-Australian
Exhibitions: Founding Faculty Show, including works by Meyer Schapiro, Esteban Vicente, Mercedes Matter, Nicholas Carone, Peter Agostini; occasional drawing exhibitions; works from the Drawing Marathon; works are rotated monthly, including student works
Publications: Evening lecture schedule, exhibition series
Activities: Classes for adults; drawing instruction; lect open to public, 50-60 vis lectrs per year; gallery talks; tours; scholarship & fels offered; exten dept
L Library, 8 W Eighth St, New York, NY 10011. Tel 212-473-5932, 673-6466; Fax 212-777-0996; *Dean* Graham Nickson
Open Mon 10 AM - 10 PM, Tues & Wed 10 AM - 6 PM, Thurs 10 AM - 10 PM, Fri 10 AM - 6 PM, Sat 4 - 7 PM, cl Sun; No admis fee; Estab 1964 for pedagogical purposes; Not open to pub
Library Holdings: Audio Tapes; Book Volumes 4700; Cassettes; Clipping Files; Exhibition Catalogs; Reproductions; Slides; Video Tapes
Activities: Lectures open to public, weekly

NEW YORK UNIVERSITY
M Grey Art Gallery, Tel 212-998-6780; Fax 212-995-4024; Internet Home Page Address: www.nyu.edu/greyart; *Asst to Dir* Gwen Stolyarov; *Registrar & Gallery Mgr* Michele Wong; *Deputy Dir* Frank Poueymirou; *Dir* Lynn Gumpert
Open Tues, Thurs & Fri 11 AM - 6 PM, Wed 11 AM - 8 PM, Sat 11 AM - 5 PM; No admis fee; suggested contribution; Estab 1975 as university art mus to serve pub as well as university community. The New York University Art Collection of approx 5000 works is now under the Grey Art Gallery; Gallery space of approx 4000 sq ft used for changing exhibitions; Average Annual Attendance: 50,000
Special Subjects: Painting-American, Prints, Watercolors, Painting-European, Asian Art
Collections: American & European 20th Century Paintings, Watercolors & Prints; Ben & Abby Grey Foundation Collection of Contemporary Asian & Middle Eastern Art; New York University Art Collection
Publications: Exhibition catalogs
Activities: Lect open to public, 2-3 vis lectrs per year; individual paintings & original objects of art lent to other cultural institutions & sister organizations for exhibitions; originate traveling exhibitions; sales shop sells exhibition catalogs
M Washington Square East Galleries, Tel 212-998-5747; Fax 212-998-5752; Internet Home Page Address: www.nyu.edu/pages/galleries; *Dir* Ruth D Newman; *Faculty Dir* Dr Marilynn Karp
Open Tues 10 AM - 7 PM, Wed & Thurs 10 AM - 6 PM, Fri & Sat 10 AM - 5 PM; No admis fee; Estab 1975 for exhibitions of works by graduate student artists; Eight gallery rooms containing solo shows; Average Annual Attendance: 10,000
Exhibitions: 70 group shows annually; Annual Small Works Competition; Thesis Exhibitions
Publications: Press releases
Activities: Annual International Art Competition, Small Works
L Stephen Chan Library of Fine Arts, Tel 212-992-5825; Fax 212-992-5807; Elec Mail sharon.chickanzeff@nyu.edu; Robert.Stacy@nyu.edu; clare.hillsnova@nyu.edu; Internet Home Page Address: www.nyu.edu/gsas/dept/fineart; *Supv* Robert Stacey; *Reference Librn* Clare Hills-Nova; *Dir* Sharon Chickanzeff; *Technical Servs* John Maier
Open by appointment; Estab to provide scholarly materials for graduate studies in art history, archaeology & conservation of works of art; Circ Non-circulating; Research Llibrary

Library Holdings: Book Volumes 140,000; CD-ROMs; Exhibition Catalogs; Fiche; Periodical Subscriptions 460; Reels
Special Subjects: Art History, Painting-European, Archaeology, Asian Art, Antiquities-Oriental, Antiquities-Persian, Antiquities-Assyrian, Antiquities-Byzantine, Antiquities-Egyptian, Antiquities-Etruscan, Antiquities-Greek, Antiquities-Roman

L Institute of Fine Arts Visual Resources Collection, Tel 212-992-5800; Fax 212-992-5807; Elec Mail jenni.rodda@nyu.edu; Internet Home Page Address: www.ifa.nyu.edu; *Photographer* Nita Roberts; *Web Master* Jason Varone; *Cur* Jenni Rodda; *Information Svc Asst* Michael Konrad; *Admin Aide* Fatima Tanglao
Open Mon - Fri 9 AM - 5 PM by appointment; Circ Non-circulating; Library open to qualified researchers & academia
Library Holdings: Lantern Slides 150,000; Other Holdings B&W photographs, mounted & unmounted 750,000; 35mm slides 350,000
Collections: Biblioteca Berensen; Frank Caro Archives (b&w, Oriental); Census; Gertrude Achenbach Coor Archives; D.I.A.L.; Walter Friedlaender Archives; Corpus Gernsheim (85,000 pieces; drawings); Henry Russell Hitchcock Archives (b&w, architecture); Richard Offner Archives (b&w, Italian painting); James Stubblebine Archives (b&w, Italian painting); Emile Wolf Archives (b&w, Spanish art); scope of collection: art, art history, archaeology, architectural history; photographs are used for teaching & research purposes only

M NICHOLAS ROERICH MUSEUM, 319 W 107th St, New York, NY 10025. Tel 212-864-7752; Fax 212-864-7704; Elec Mail director@roerich.org; Internet Home Page Address: www.roerich.org; *Pres* Edgar Lansbury; *Exec Dir* Daniel Entin
Open daily 2 - 5 PM; cl Mon & holidays; No admis fee; donations accepted; Estab 1958 to show a permanent collection of paintings by Nicholas Roerich, internationally known artist, to promote his ideals as a great thinker, writer, humanitarian, scientist, and explorer, and to promote his Pact and Banner of Peace; New York brownstone with three exhibit floors; Average Annual Attendance: 20,000; Mem: 800; dues patron $100, contributing $50, associate $25
Income: Financed by mem & donations
Collections: Permanent collection of paintings by Nicholas Roerich
Publications: Altai-Himalaya, A Travel Diary; Flowers of Morya, The Theme of Spiritual Pilgrimage in the Poetry of Nicholas Roerich; The Invincible; Nicholas Roerich, An Annotated Bibliography; Nicholas Roerich, A Short Biography; Nicholas Roerich 1874-1974 Centenary Monograph; Roerich Pact & Banner of Peace; Shambhala; two books by Nicholas Roerich: On Eastern Crossroads, and Foundations of Buddhism
Activities: Lect open to public; concerts; tours; museum shop selling books, reproductions and postcards

M THE NIPPON CLUB, (The Nippon Gallery) the Nippon Gallery, 145 W 57th St, New York, NY 10019. Tel 212-581-2223; Fax 212-581-3332; Elec Mail info@nipponclub.org; Internet Home Page Address: www.nipponclub.org
Open Mon - Sat 10 AM - 6 PM, cl Sun & holidays; No admis fee; Estab 1981 for the purpose of international cultural exchange of arts & crafts from Japan & US; Located in the main lobby of a 7 story club house; gallery space is 900 sq ft; Mem: 1200; dues $420
Income: Financed by mem
Special Subjects: Crafts
Publications: The Nippon Club Directory, annual; The Nippon Club News, monthly
Activities: Classes for adults; lects for members and the public, various sports activities & cultural events, concerts, gallery talks & tours

A ORGANIZATION OF INDEPENDENT ARTISTS, INC, 19 Hudson St, No 402, New York, NY 10013. Tel 212-219-9213; Fax 212-219-9216; Elec Mail oiaonline@yahoo.com; Internet Home Page Address: www.oiaonline.org; *Dir & Newsletter Editor* Geraldine Cosentino; *Web Design* Dorcas Gelabert
Open Wed - Sat 2:30 - 5:30 PM; No admis fee at all art spaces used for exhibits; Estab 1976 to facilitate artist-curated group exhibitions in Town Gallery 402; Exhibit in Town Gallery 402. Maintains reference library and resource board; Average Annual Attendance: 20,000; Mem: 200; patrons $500, sponsors $100, friends & artists $55
Income: $25,000 (financed by mem, private donors, corporate & foundation funds)
Publications: Quarterly newsletter
Activities: Classes for adults; curating workshop open to members, sponsoring of competitions; individual paintings lent; slide registry

M PAINTING SPACE 122 ASSOCIATION INC, 150 First Ave, New York, NY 10009. Tel 212-228-4249; Fax 212-505-6854; Elec Mail susanschreiber@earthlink.net;
Open Thurs - Sun Noon - 6 PM; Estab 1979 to show work by emerging artists; 600 sq ft ground floor space; Average Annual Attendance: 20,000
Income: Financed by NYSCA & private funds
Activities: Competitions

L PARSONS SCHOOL OF DESIGN, Adam & Sophie Gimbel Design Library, 2 W 13th St 2d Fl, New York, NY 10011. Tel 212-229-8914; Fax 212-229-2806; Internet Home Page Address: www.newschool.edu/gimbel; *Archivist* X T Barber; *Visual Resource Coord* Monique Safford; *Reference Librn* Yvette Cortes; *Ref Librn* Amy Schofield; *Dir* Andrew P Gessner
Open Mon - Thurs 10 AM - 9 PM, Fri 10 AM - 6 PM, Sat Noon - 6 PM, Sun Noon - 8 PM, summer hours vary; Estab as a school in 1896, The Gimbel Library moved to its present location in 1974; collections & services support the curriculum of the school as well as general design research; Circ 165,000; Lending to Parsons students & library consortium members; limited reference to general public; Average Annual Attendance: 103,000
Income: Pvt
Library Holdings: Book Volumes 50,000; CD-ROMs 400; Exhibition Catalogs; Memorabilia; Micro Print; Original Art Works; Other Holdings Pictures 60,000; Periodical Subscriptions 201; Prints; Slides 80,000; Video Tapes 450
Special Subjects: Art History, Illustration, Photography, Graphic Design, Historical Material, Crafts, Fashion Arts, Industrial Design, Interior Design, Furniture, Metalwork, Jewelry, Oriental Art, Textiles, Architecture

Collections: Claire McCardell Fashion Sketchbooks

PASTEL SOCIETY OF AMERICA
For further information, see National and Regional Organizations

A **PEN & BRUSH, INC,** 16 E Tenth St, New York, NY 10003-5958. Tel 212-475-3669; Fax 212-475-6018; Elec Mail penbrush99@aol.com; Internet Home Page Address: www.penandbrush.org; *Exec Dir* Janice Sands; *Secy* Barbara Carlsen
Open Tues - Sun 4 - 6 PM; No Admis fee; Estab 1894, incorporated 1912 for encouragement in the arts; The Clubhouse was purchased in 1923, and contains artists studios, meeting room and 3 exhibition galleries; Average Annual Attendance: 1,000; Mem: 270; dues $250 professional women writers, artists, sculptors, craftsmen, musicians; annual meeting in Apr
Library Holdings: Other Holdings Members' Books
Collections: Collages; crafts; graphics; mixed media; oil; paintings; pastels; sculpture; watercolor
Exhibitions: Ten annual exhibitions of members' work; one man shows; solo winner shows
Publications: Pen & Brush bulletin, monthly
Activities: Dramatic programs; lect open to public; concerts; scholarships; scholarships offered; sales shop sells original art, paintings, sculpture & craft items

L **Library,** 16 E Tenth St, New York, NY 10003. Tel 212-475-3669; Fax 212-475-6018; *Pres* Liz Cenedelle
For members only
Library Holdings: Book Volumes 1000; Periodical Subscriptions 5
Publications: Bulletin, monthly

C **PHILIP MORRIS COMPANIES INC,** 120 Park Ave, New York, NY 10017. Tel 917-663-5000; Internet Home Page Address: www.philipmorris.com; *Dir Corporate Contributions* Jennifer P Goodale
Open Mon - Fri, 8 AM - 4:30 PM; No admis fee; Estab 1960's to enhance the creative & aesthetic environments of offices & grant makers; Collection displayed in offices & corridors. Since 1958, Philip Morris' support of the arts focuses on contemporary & multi cultural visual & performing arts. One of the most comprehensive cultural programs in the world
Collections: Paintings, photography, sculptures, works on paper; 500 works by established & emerging artists with a focus on contemporary art
Activities: Individual objects of art lent to museum exhibitions only. Organizations that present breakthrough ideas & explore new ground in artistic expression

M **PHOENIX GALLERY,** 210 Eleventh Ave Ste 902, New York, NY 10001. Tel 212-242-7271; Fax 212-343-7307; Elec Mail info@phoenix-gallery.com; Internet Home Page Address: www.phoenix-gallery.com; *Dir* Linda Handler
Open Tues - Sat 11 AM - 5:30 PM; No admis fee; Estab 1958; 190 linear ft of exhibition walls; Average Annual Attendance: 10,000; Mem: 33; dues non-active $2700, active $2160; meetings one per month
Income: $64,000 (financed by mem)
Collections: Contemporary Art - 33 members from all over the United States, Paris & Korea
Activities: Dramatic programs; poetry & dance programs; lect open to public, 5 vis lectrs per year; sponsoring of competitions

L **PIERPONT MORGAN LIBRARY,** 29 E 36th St, New York, NY 10016. Tel 212-685-0610; Fax 212-481-3484 & 212-685-0713; Internet Home Page Address: www.morganlibrary.org; *Dir* Dr Charles E Pierce Jr; *Dir Library & Mus Svcs* Robert Parks; *Cur Music Manuscripts* J Rigbie Turner; *Andrew W Mellon Cur* Anna Lou Ashby; *Head Reader Svcs* Inge Dupont; *Astor Cur & Dept Head Printed Books & Bindings* John Bidwell; *Cur Medieval & Renaissance Manuscripts* William M Voelkle; *Cur Drawings & Prints* Cara D Denison; *Gilder Lehrman Collection Asst Cur* Leslie Fields; *Registrar* Lucy Eldridge; *Dir Communications & Mktg* Glory Jones; *Hon Cur Seals & Tablets* Sidney Babcock; *Dir Coll Info Systems* Elizabeth O'Keefe
Open Tues - Thurs 10:30 AM - 5 PM, Fri 10:30 AM - 8 PM, Sat 10:30 AM - 6 PM, Sun Noon - 6 PM, cl Mon & holidays; Admis $8 adults, $6 students & seniors (suggested contribution); Estab 1924 for research & exhibition purposes; The Gallery has changing exhibition with Old Master drawings, Medieval & Renaissance illuminated manuscripts, rare printed books & literary, historical, & music manuscripts; Average Annual Attendance: 200,000; Mem: 1,100; dues $35, $50
Income: $4,000,000 (financed by endowment & mem)
Purchases: $1,000,000
Library Holdings: Auction Catalogs; Book Volumes 160,000; Exhibition Catalogs; Kodachrome Transparencies; Manuscripts 70,000; Original Art Works 8,000; Other Holdings Original documents; Photographs; Prints 13,000; Slides
Collections: Ancient written records including seals, cuneiform tablets and papyri; art objects; autograph manuscripts; book bindings; early children's books; Medieval & Renaissance illuminated manuscripts; later printed books; letters and documents; mezzotints; modern calligraphy; music manuscripts; original drawing from 14th-19th centuries; printed books before 1500; Rembrandt prints
Publications: Report to the Fellows, annual; books; catalogs; facsimiles
Activities: Lect open to the public; tours; sales shop sells books, reproductions, prints, slides, cards, calendars, address books and posters

M **PRINCE STREET GALLERY,** 530 W 25th St, New York, NY 10001. Tel 646-230-0246; *Dir* Mark Webber; *Asst Dir* Nancy Prusinowski
Open Tues - Sat 11 AM - 6 PM; No admis fee; Estab 1970 to provide a showing place for members, mainly figurative art; cooperative artist run gallery; Gallery has about 30 members who have shown in New York as well as throughout the country & internationally; Average Annual Attendance: 8,000; Mem: 30; mem enrollment fees $500, mem $100 per month for 12 months (local), $130 (non-local); 6 meetings per yr
Income: Financed by mem
Exhibitions: Gallery Artists: Monica Bernier, Carol Diamond, Karen Frances Fitch, Lynn Kotula, Anni Kruger, Barbara Kulicke, Elizabeth Higgins, Marion Lerner-Levine, Gerald Marcus, Nancy Prusinowski, Mary Salstrom, Norma

Shatan, Michel Tombelaine, Evelyn Twitchell, Gina Werfel, Donald Beal, Rani Carson, Peter Dickison, Arthur Elias, Robyn Whitney Fairclough, Barbara Tipping Fitzpatrick, Nancy Grilikhes, Carmeza Kolman, Arthur Kvarnstrom, Clayton Lewis, Karen Pellecchia, Paul Warren, Mark Webber
Publications: Annual catalog

C **PRINTED MATTER, INC,** 535 W 22, New York, NY 10011. Tel 212-925-0325; Fax 212-925-0464; Elec Mail aabronson@printedmatter.org; Internet Home Page Address: www.printedmatter.org; *Mgr* Max Schumann; *(Acting) Dir* AA Bronson
Open Tues - Fri 10 AM - 6 PM, Sat 11 AM - 7 PM, cl major holidays; Estab 1976 to foster appreciation, dissemination & understanding of artists' publications; Small gallery; Average Annual Attendance: 100,000
Special Subjects: Maps
Exhibitions: Conceptual artists books from the 70's & early 80's
Publications: On-line
Activities: Lectr open to pub; concerts; gallery talks; tours; sales shop sells books, magazines, artists publications & original art

A **PUBLIC ART FUND, INC,** One E 53rd St, New York, NY 10022. Tel 212-980-4575; Fax 212-980-3610; Elec Mail paforg@publicartfund.org; *Pres* Susan K Freedman; *Dir* Tom Eccles; *Project Mgr* Richard Griggs
Open Mon - Fri 10 AM - 6 PM; No admis fee; Estab 1977 to incorporate contemporary art at sites throughout New York City; one of the first organizations solely dedicated to securing a place for art work within the landscape & is recognized world-wide for its pioneering support of temporary pub art installation
Income: $220,000 (financed by National Endowment for the Arts, New York State Council of the Art, endowments, private & corporate contributions)
Exhibitions: Magdelena Abakanowicz; Fernando Botero: Botero in NY; Alexander Brodsky: Canal Street Project; Urban Paradise: Garden in the City
Publications: Catalogues; manuals on public art; newsletter; postcards
Activities: Competitions to commission new works of art; site assistance; temporary exhibition program

L **Visual Archive,** One E 53rd St 11th Floor, New York, NY 10022. Tel 212-980-4575; Fax 212-980-3610; Elec Mail E-mail: paforg@publicartfund.org; Internet Home Page Address: www.publicartfund.org; *Pres* Susan K Freedman; *Dir* Rochelle Steiner
Open by appointment only, other project specific hrs; Estab 1977
Library Holdings: Kodachrome Transparencies; Lantern Slides; Other Holdings Documentation of public art projects; Photographs; Slides 4000
Collections: Murals; outdoor sculpture; sponsors temporary installations throughout New York City
Publications: InProcess, quarterly newsletter
Activities: Lect open to the public; 4-6 vis lectrs per yr

C **RUDER FINN ARTS & COMMUNICATIONS, INC,** (Ruder Finn Inc) 301 E 57th St, New York, NY 10022. Tel 212-593-6400; Fax 212-715-1507; Internet Home Page Address: www.ruderfinn.com; *Pres* Philippa Polskin
Estab to link corporations which support the arts with museum exhibitions and performing arts events, to develop major corporate sponsored exhibitions and special projects created for public spaces; Assistance given for marketing and publicity assignments for cultural institutions and the selection, installation and documentation of corporate art collections
Activities: Originate traveling exhibitions to museums nationwide

SALMAGUNDI CLUB
For further information, see National and Regional Organizations

M **SCHOOL OF VISUAL ARTS,** Visual Arts Museum, 209 E 23rd St, New York, NY 10010-3994. Tel 212-592-2144; Fax 212-592-2095; Elec Mail galleriesandmuseum@adm.schoolofvisualarts.edu; Internet Home Page Address: www.schoolofvisualarts.edu/MuseumGalleries; *Dir* Francis Di Tommaso; *Asst Dir* Rachel Gugelberger; *Res* Laura Yeffeth; *Asst Dir* Geoffrey Detrani
Open Mon - Wed & Fri 9 AM - 6:30 PM, Thurs 9 AM - 8 PM, Sat 10 AM - 5 PM; No admis fee; Estab 1961; College gallery; Average Annual Attendance: 8,000
Special Subjects: Photography, Drawings, Graphics, Painting-American, Prints, Watercolors, Etchings & Engravings, Collages, Posters, Juvenile Art, Cartoons
Exhibitions: New York Digital Salon; The Master's Series; Sculptors Drawings; Ann international traveling exhibition of art made with computers; Ann award exhibition honoring the great visual communicators of our time
Publications: Exhibition catalogs & posters

SCULPTORS GUILD, INC
For further information, see National and Regional Organizations

A **SEGUE FOUNDATION,** Reading Room-Archive, 300 Bowery, New York, NY 10012. Tel 212-674-0199; Fax 212-254-4145; Elec Mail jsherry@panix.com; Internet Home Page Address: www.segue.org; WATS 800-869-7553; *Pres* James Sherry; *Exec Dir* Daniel Machlin
Open by appointment; Estab 1977; For reference only
Library Holdings: Audio Tapes; Cassettes; Manuscripts; Memorabilia; Other Holdings Vols & per subs 2000; Reproductions; Video Tapes
Collections: Language poetry books; periodicals; rare archival materials manuscripts; reading series footage
Publications: Poetry, literary criticism, film & performance texts

SOCIETY FOR FOLK ARTS PRESERVATION, INC (SFAP)
For further information, see National and Regional Organizations

SOCIETY OF AMERICAN GRAPHIC ARTISTS
For further information, see National and Regional Organizations

M **SOCIETY OF ILLUSTRATORS,** Museum of American Illustration, 128 E 63rd St, New York, NY 10021. Tel 212-838-2560; Fax 212-838-2561; Elec Mail society@societyillustrators.org, sil901@aol.com; Internet Home Page Address: www.societyillustrators.org; *Pres* Judy Francis; *Asst Dir* Phillis Harvey; *Dir* Terrence Brown
Open Tues 10 AM - 8 PM, Wed - Fri 10 AM - 5 PM, Sat Noon - 4 PM, cl Mon, Aug & legal holidays; No admis fee; Estab 1901; Average Annual Attendance: 30,000

Collections: Original illustrations from 1838 to present, all media
Exhibitions: Seventeen exhibitions a year; Annual Illustrators Show; Illustrators Annual Exhibition
Activities: Lect open to public, 18 vis lectrs; sponsor competitions for professional illustrators; awards; individual paintings & original objects of art lent to museums & universities; lending collection contains 1200 art works; original traveling exhibitions; museum shop sells books, prints, t-shirts & gift items

SOCIETY OF ILLUSTRATORS
For further information, see National and Regional Organizations

SOCIETY OF PHOTOGRAPHERS & ARTISTS REPRESENTATIVES
For further information, see National and Regional Organizations

A **SOCIETY OF SCRIBES, LTD,** PO Box 933, New York, NY 10150. Tel 212-741-2717; Internet Home Page Address: www.societyofscribes.org; *VPres* Priscilla Holgrem; *Treas* Pat Whitman; *Pres* Karen Goist; *Asst Treas* Margaret Harper
Estab 1974; Mem: 1000; dues overseas $32, Canada & Mexico $30, USA $25; annual meeting in Feb, annual Fair in Dec
Exhibitions: Donnell Library
Publications: NEWS OS
Activities: Adult classes in calligraphy & lettering arts & calligraphy in the graphic arts; lect & demonstrations open to public; 2-4 vis lectrs per year; gallery talks; competitions

M **SOHO 20 GALLERY,** Soho20 Chelsea, 511 W 25th St #605, New York, NY 10001. Tel 212-367-8994; Fax 212-367-8984; Elec Mail soho20@earthlink.net; Internet Home Page Address: www.soho20gallery.com; *Gallery Manager* Rebecca Ratzkin
Open Tues - Sat Noon - 6 PM; No admis fee; Estab 1973 as a women's nonprofit, artist-run gallery; 1400 sq ft for exhibition. Main gallery 1000 sq ft invitational space; Average Annual Attendance: 50 per day; Mem: 27; dues $1320; meetings first Tues each month
Income: Financed by funding programs, sponsored exhibitions
Activities: Lect open to public, 52 vis lectrs per yr; gallery talks; tours; individual paintings & original objects of art lent to corporations, universities & other galleries; originate traveling exhibitions to other museums

M **SOLOMON R GUGGENHEIM MUSEUM,** 1071 Fifth Ave, New York, NY 10128. Tel 212-360-4230; Fax 212-423-3650; *Dep Dir & Chief Cur* Lisa Dennison; *Conservator* Paul Schwartzbaum; *Photographer* David Heald; *Assoc Cur* Nancy Spector; *Dir* Thomas Krens; *CFO* Roy Eddy
Open Sun - Wed 11 AM - 6 PM, Fri & Sat 11 AM - 8 PM, cl Thurs & holidays; Admis general $12, students with valid ID cards & visitors over 65 $9, group rates for students when accompanied by a teacher, children under 12 & Fri evening free; Estab 1937 as a nonprofit organization which is maintained by the Solomon R Guggenheim Foundation; founded for the promotion, encouragement & educ in art; to foster an appreciation of art by acquainting museum visitors with significant paintings & sculpture of our time; The gallery was designed by architect Frank Lloyd Wright; Average Annual Attendance: 700,000; Mem: 7,000; dues $30-$5,000
Income: Financed by endowment, mem & state & federal appropriations
Special Subjects: Drawings, Painting-American, Photography, Sculpture, Watercolors, Painting-French, Painting-Spanish, Painting-Italian, Painting-German, Painting-Russian
Collections: Reflects the creative accomplishments in modern art from the time of the Impressionists to the constantly changing experimental art of today. The collection of nearly four thousand works, augmented by the Justin K Thannhauser Collection of 75 Impressionists & Post-Impressionist masterpieces, including the largest group of paintings by Vasily Kandinsky; one of the largest & most comprehensive collection of paintings by Paul Klee; largest number of sculptures by Constantin Brancusi in any New York museum; paintings by Chagall, Delaunay, Lager, Marc, Picasso, Bacon, Bonnard, Braque, Cezanne, Malevitch, Modigliani, Moore, Reusseau & Seurat, with concentration of works by Dubuffet, Miro & Mondrian among the Europeans; Americans such as Davis, deKooning, Diebenkorn, Gottlieb, Guston, Johns, Lichenstein, Agnes Martin, Motherwell, Nevelson, Noguchi, Pollack, younger artists include Andre, Flavin, Judd, Christenson, Hamilton, Hesse, Mangold, Nauman, Stella & Serra; paintings, drawings & sculpture collections are being enlarged
Publications: Exhibition catalogs, Guggenheim Museum Magazine (2 times per year)
Activities: Lect open to the public; concerts; gallery talks; acoustiguide tours; individual paintings & original objects of art lent to other museums & galleries; lending collection contains original art works, original prints, painting, sculpture; originates traveling exhibitions; museum shop sells books, jewelry & t-shirts

L **Library,** 575 Broadway, 3rd Floor, New York, NY 10012. Tel 212-360-4230; Fax 212-966-0903; Elec Mail swearing@guggenheim.org; Internet Home Page Address: www.guggenheim.org; *Librn* Shannon Wearing
Open by telephone appointment only, Mon - Fri 11 AM - 5 PM; Estab 1952 to document the Museum's collection of 20th century art; For reference only
Library Holdings: Book Volumes 26,000; Cards; Exhibition Catalogs; Kodachrome Transparencies; Other Holdings Artist Files; Early Avant-Garde Periodicals; Pamphlets; Periodical Subscriptions 50; Slides

M **SOUTH STREET SEAPORT MUSEUM,** 207 Front St, New York, NY 10038. Tel 212-748-8600; Fax 212-748-8610; Internet Home Page Address: www.southstseaport.org; *Historian & Librn* Norman Brouwer; *Pres* Peter Neill; *VPres* Yvonne Simons
Open Apr 1 - Sept 30 10 AM - 6 PM, Oct 1 - Mar 31 10 AM - 5 PM, cl Tues; Admis $5, mems free; Estab 1967 to preserve the maritime history & traditions of the Port of New York; Several gallery spaces: The Seaport Gallery for art exhibits; the printing press gallery at Bowne & Co Stationers; the mus children's center; Average Annual Attendance: 325,000; Mem: 9000; dues family $60, individual $40, seniors & students $30; annual meeting May
Income: Financed by mem & corporate grants

Special Subjects: Architecture, Drawings, Photography, Prints, Archaeology, Folk Art, Woodcarvings, Manuscripts, Posters, Marine Painting, Historical Material, Maps, Scrimshaw
Collections: Restored historic buildings; fleet of historic ships; permanent collection of marine art & artifacts; collections of ship models; archive of ship plans, photos & negatives
Exhibitions: Travelling In Style, ongoing; My Hammer Hand; Mens Lives; New York Trades Transformed; Peking At Sea; Recent Archeology in Lower Manhattan; Titanic; Waterfront Photography;
Publications: Seaport Magazine, quarterly
Activities: Educ dept; docent training; lect open to public; gallery talks; tours; individual paintings and original objects of art lent to institutions; museum shop sells books & prints; junior museum

L **Melville Library,** 213 Water St, New York, NY 10038. Tel 212-748-8648; Fax 212-748-8610; *Historian & Librn* Norman Brouwer
Open Mon - Frid 10:15 AM - 6 PM; For reference
Income: Mem and corporate grants
Library Holdings: Audio Tapes; Book Volumes 20,000; Clipping Files; Exhibition Catalogs; Kodachrome Transparencies; Manuscripts; Memorabilia; Motion Pictures; Original Art Works; Other Holdings Negatives; Pamphlets; Periodical Subscriptions 30; Photographs; Prints; Reels; Reproductions; Slides
Special Subjects: Folk Art, Maps, Painting-American, Painting-British, Historical Material, Archaeology, Industrial Design, Woodcarvings, Marine Painting, Scrimshaw

A **SPANISH INSTITUTE, INC,** Center for American-Spanish Affairs, 684 Park Ave, New York, NY 10021. Tel 212-628-0420, 628-0423 (class prog); Fax 212-734-4177; Internet Home Page Address: www.SpanishInstitute.org; *Pres* Inmaculada de Habsburgo
Open Mon - Sat 8 AM - 10 PM; Estab 1954 to promote understanding of Spanish culture, past & present, & current Spanish pub affairs & economic issues in the United States; enhance an understanding of the influence of Spanish culture in Americas; Housed in a McKim, Mead & White landmark building donated by Margaret Rockefeller Strong de Larrin, Marquesa de Cuevas
Income: Financed by individual & corporate mem fees, donations, foundation grants & endowment
Special Subjects: Latin American Art
Exhibitions: Exhibits of rich & varied traditions of the visual arts of Spain
Activities: Spanish language classes; lect open to public; symposia

M **STOREFRONT FOR ART & ARCHITECTURE,** 97 Kenmare St, New York, NY 10012. Tel 212-431-5795; *Founder* Kyong Park; *Dir* Sarah Herda
Open Tues - Sat 11 AM - 6 PM; No admis fee; Estab to show interdisciplinary & experimental works of art & architecture, often never previously shown in New York. Organizes large events or competitions of an experimental nature; 15 ft x 100 ft x 2 ft, triangle; Average Annual Attendance: 10,000
Income: Financed by grants and contributions
Exhibitions: Ecotec Forum, held in Corsica, France; Future Systems; Gunther Domeney (Austrian architect); Mark West (Canadian artist); Big Soft Orange, Dutch architectural exhibit
Publications: Exhibition catalogs; monthly bulletin; quarterly reports

M **THE STUDIO MUSEUM IN HARLEM,** 144 W 125th St, New York, NY 10027. Tel 212-864-4500; Fax 212-864-4800; Internet Home Page Address: www.studiomuseum.org; *Exec Dir* Lowery Sims; *Deputy Dir Progs* Thelma Golden; *Chmn* Raymond J Mguire; *Museum Shop Mgr* Jamie Glover; *Dir Educ & Pub Prog* Sandra Jackson; *Dir Develop* Cheryl Aldridge; *Dir Operations* Winston Kelly; *CFO & COO* Sheila McDaniel
Open Wed - Sat 10 AM - 6 PM, Sun Noon - 6 PM; Admis adults $7, children, students & seniors $3, mems free; Estab 1967 to exhibit the works of contemporary Black American artists, mount historical & informative exhibitions & provide culturally educational programs & activities for the general pub; 10,000 sq ft of exhib & educ space, new exhib space & cafe (spring 2005); Average Annual Attendance: 100,000; Mem: 50,000; dues $15 - $1000
Income: Financed by mem, city & state appropriation, corporate & foundation funding, federal funding, rental income, gift shop sales & individual contributions
Special Subjects: Photography, Sculpture, Afro-American Art
Collections: James Vanderzee Collection of Photography; over 1500 works of art by African-American artists including sculpture, painting & works on paper
Publications: Freestyle; Challenge of the Modern; Black Belt; Photographs
Activities: Classes for adults & children; docent training; workshops; panel discussions; demonstrations; cooperative school program; internship program; lect open to public, 10 vis lectrs per year; concerts; gallery talks; tours; scholarships offered; book traveling exhibitions; originate traveling exhibitions; museum shop sells books, magazines, original art, reproductions, prints, jewelry, baskets, crafts, pottery & catalogues

M **SWISS INSTITUTE,** 495 Broadway, 3rd Fl, New York, NY 10012. Tel 212-925-2035; Fax 212-925-2040; Elec Mail swissins@dti.net; *Dir* Annette Schindler
Open Tues - Sat 11 AM - 6 PM, cl Sun & Mon; No admis fee; Estab 1986 to promote artistic dialogue between Switzerland & the United States; 2000 sq ft; Average Annual Attendance: 10,000; Mem: 300; dues $25-$1000; annual meeting in Fall
Income: Financed by mem, corporate contributions, sponsors & foundations
Special Subjects: Painting-European
Exhibitions: Rotating
Publications: Exhibition catalogs, 3 per year
Activities: Educ dept; lect open to public, 4 vis lectrs per year; concerts; gallery talks; tours; originate traveling exhibitions

L **TAIPEI ECONOMIC & CULTURAL OFFICE,** Chinese Information & Culture Center Library, 90 Park Ave, 31st Fl, New York, NY 10016-1301. Tel 212-557-5122; Fax 212-557-3043; Elec Mail vernatang@taipei.org; Internet Home Page Address: www.taipei.org; *Dir* Jack Lee
Open Mon - Fri 1:30 - 5 PM; Estab 1991

Library Holdings: Book Volumes 42,000; Clipping Files; Motion Pictures; Pamphlets; Periodical Subscriptions 155; Prints; Reels; Reproductions; Video Tapes
Special Subjects: Oriental Art
Publications: CICC Currents, bimonthly

M **U GALLERY,** 221 E Second St, New York, NY 10009. Tel 212-995-0395; Elec Mail ugallery@ugallery.org; Internet Home Page Address: www.ugallery.org; *Artist* Robert Walter; *Dir* Darius Gubala; *Cur* Amy Banker; *Cur* Richard Ahntholz; *Asst Artist* Grzegorz Wroblewski; *Artist* Walker Fe
by Appointment; Estab 1991 to support culture in America; Multi-Media; Average Annual Attendance: 600; Mem: 205
Income: privately financed
Special Subjects: Painting-American, Restorations
Collections: Bronx Children, Cyber Culture, Local Community, Psychodic
Exhibitions: Florescent Light; Saccodik Art
Activities: Lectrs for members only, 8 vis lectr per yr; concerts; mus shop sells original art & art objects

A **UKRAINIAN INSTITUTE OF AMERICA, INC,** 2 E 79th St, New York, NY 10021. Tel 212-288-8660; Fax 212-988-2918; Elec Mail programs@ukrainianinstitute.org; Internet Home Page Address: www.ukrainianinstitute.org; *Dir Prog* Dr Walter Hoydysh
Open Tues - Sat 11 AM - 6 PM, Sun by appointment; Admission $5; Estab 1948 to develop, sponsor & promote educational activities which will acquaint the general public with history, culture & art of Ukrainian people; Ukrainian & East European art; Average Annual Attendance: 8,500; Mem: 480
Income: Financed by endowment, mem & contributions
Purchases: $2,500
Library Holdings: Original Art Works; Sculpture
Collections: Church & religious relics; folk art, ceramic & woodwork; patents of Ukrainian-American engineers; Gritchenko Foundation Collection; sculptures by Archipenko, Kruk, Mol & others; Ukrainian paintings
Publications: UIA Newsletter, irregular; Anniversary of UIA
Activities: Dramatic programs; seminars; symposiums; workshop seminars; literary evenings; lect open to public; concerts; gallery talks; Awards: Person of the Year; Chicago Ukrainian Museum of Modern Art; mus shop sells books, magazines, original art, reproductions & prints

M **THE UKRAINIAN MUSEUM,** 203 Second Ave, New York, NY 10003. Tel 212-228-0110; Fax 212-228-1947; Elec Mail info@ukrainianmuseum.org; Internet Home Page Address: www.ukrainianmuseum.org; *Admin Dir* Daria Bajko; *Mus Shop Mgr* Chrystyna Pevny; *Dir* Maria Shust; *Pres (V)* Olha Hnateyko
Open Wed - Sun 1 - 5 PM; Admis adults $3, seniors, students & children $2; Since 1976, The Ukrainian Museum preserves the cultural heritage of Ukrainian Americans through exhibitions, educational/community oriented programs for adults and children, scholarly research and publications. The museum maintains folk art, fine arts and photographic/documentary collections. Current major projects include building a new museum facility and computerization of collections data; Average Annual Attendance: 25,000; Mem: 1700; dues family $60, adults $35, seniors $35 & students $10
Income: $295,000 (financed by mem, donations & grants)
Special Subjects: Drawings, Graphics, Photography, Sculpture, Watercolors, Ethnology, Textiles, Costumes, Ceramics, Crafts, Folk Art, Pottery, Primitive art, Woodcarvings, Woodcuts, Etchings & Engravings, Landscapes, Decorative Arts, Jewelry, Metalwork, Historical Material, Coins & Medals, Embroidery
Collections: Major crafts in Ukrainian folk art: woven & embroidered textiles (including costumes & kilims), woodwork, ceramics, metalwork, Ukrainian Easter Eggs; fine arts; photographic/documentary archival collection on Ukrainian cultural heritage, among them photographs of individuals in their native dress, architectural landmarks as well as photographic records of historic events
Exhibitions: Rotating exhibits 3 times yr
Publications: Annual report; bulletins; bilingual exhibition catalogs or brochures
Activities: Classes for adults & children; lect open to public, 2-3 vis lectrs per year; gallery talks; tours; individual paintings & original objects of art lent; lending collection contains 3000 Ukrainian Folk Art, including costumes & textiles, 1000 original prints, 500 paintings, 200 works on paper; originate traveling exhibitions; museum shop sells books, magazines, original art & reproductions

L **Library,** 203 Second Ave, New York, NY 10003. Tel 212-228-0110; Fax 212-228-1947; Elec Mail info@ukrainianmuseum.org; *Dir* Maria Shust
Library for internal use only. For reference by appointment
Library Holdings: Book Volumes 4000; Exhibition Catalogs; Pamphlets; Photographs; Slides 600; Video Tapes
Special Subjects: Art History, Folk Art, Drawings, Etchings & Engravings, Sculpture, Portraits, Crafts, Archaeology, Jewelry, Leather, Pottery, Religious Art, Woodcarvings, Landscapes, Architecture
Collections: Historical photographic documentary archives; Folk Art; Ukrainian Fire
Publications: Extensive catalogues with major exhibitions; Annual reports

L **UNION OF AMERICAN HEBREW CONGREGATIONS,** Synagogue Art & Architectural Library, 633 Third Ave, New York, NY 10017. Tel 212-249-0100; Fax 212-650-4169; Internet Home Page Address: www.uahc.org; *Dir, Synagogue Mgr* Dale Glasser; *Dir Library* Karen Schnikter
Open Mon - Fri 9 AM - 5 PM; cl Sat & Sun & Jewish holidays; Estab 1957; Books for use on premises only
Income: Financed by budgetary allocation plus rental fees for slides
Library Holdings: Book Volumes 350; Slides 3400
Publications: An American Synagogue for Today & Tomorrow (book); Contemporary Synagogue Art (book)
Activities: Slide rental service

L **UNIVERSITY CLUB LIBRARY,** One W 54th St, New York, NY 10019. Tel 212-572-3418; Fax 212-572-3452; *Assoc Dir* Jane Reed; *Librn* Maureen Manning; *Conservation Librn* Laurie Bolger; *Asst Cur* Scott Overall; *Dir & Cur Collections* Andrew Berner
Open to members & qualified scholars (inquire by letter or telephone first) Mon - Fri 9 AM - 6 PM; No admis fee; Estab 1865 for the promotion of the arts &

culture in post-university graduates; Art is displayed in all areas of the building; Average Annual Attendance: 7,000; Mem: 4,250
Income: Financed by endowments & mem
Library Holdings: Book Volumes 90,000; CD-ROMs; Compact Disks; Manuscripts; Original Art Works
Collections: Art; architecture, fine printing, book illustration, works by George Cruikshank
Publications: The Illuminator, occasional

C **USB PAINE WEBER,** (Paine Webber Inc) 1285 Avenue of the Americas, New York, NY 10019. Tel 212-713-2869; Fax 212-713-9739; Elec Mail marmmstro@painewebber.com; *CEO* Donald B Marron; *Cur* Matthew Armstrong
Collection displayed throughout offices
Collections: Contemporary American & European drawings, sculptures, paintings, prints & photographs
Activities: Tours; individual paintings & objects of art lent to mus

VAN ALLEN INSTITUTE
For further information, see National and Regional Organizations

A **VENTURES EDUCATION SYSTEMS CORPORATION,** 15 Maiden Ln, Suite 200 New York, NY 10038. Tel 212-566-2522; Fax 212-566-2536; Elec Mail info@ventures.org; Internet Home Page Address: www.vesc-education.com; *Dir Communications* Janet Jamar; *Pres* Maxine Bleich
Open variable hours; Estab to encourage thinking & design skills in children grades K-12

M **VIRIDIAN ARTISTS INC,** 530 West 25th St #407, New York, NY 10001-5546. Tel 212-414-4040; Fax 212-414-4040; Elec Mail info@viridianartists.com; Internet Home Page Address: www.viridianartists.com; *Asst* Anne Erde; *Dir* Vernita Nemec
Open Tues - Sat 10:30 AM - 6 PM; Estab 1968 to exhibit work by emerging artists; Average Annual Attendance: 10,000
Special Subjects: Drawings, Painting-American, Photography, Prints, Sculpture, Landscapes, Afro-American Art, Collages, Painting-Japanese, Portraits
Exhibitions: Juried exhibitions every spring, curator from a contemporary museum
Publications: Gallery Artists; Gallery Catalogue
Activities: Nat'l juried show annually with cash or exhibition prize; exten dept lends paintings, sculpture & photographs; book traveling exhibitions 1 per year; originate traveling exhibitions 2 per year

VISUAL ARTISTS & GALLERIES ASSOCIATION (VAGA)
For further information, see National and Regional Organizations

L **VISUAL ARTS LIBRARY,** 380 Second Ave, New York, NY 10010; 209 E 23rd St, New York, NY 10010. Tel 212-592-2660; Fax 212-592-2655; Elec Mail library@adm.schoolofvisualarts.edu; Internet Home Page Address: www.schoolofvisualarts.edu; *Catalog Librn* Dawn Spicehandler; *Slide Cur* Lorraine Gerety; *Dir Library* Robert Lobe; *Assoc Dir Library* Beth Kleber
Open to students & faculty Mon - Thurs 9 AM - 9 PM, Fri 9 AM - 7 PM, Sat 10:30 AM - 5:30 PM, Sun Noon - 5 PM; No admis fee; Estab 1962 to serve needs of School of Visual Arts students and faculty; Circ 50,000; Exclusively for student & faculty use, lending to students
Income: Financed by tuition
Purchases: $80,000
Library Holdings: Audio Tapes; Book Volumes 70,000; CD-ROMs; Cassettes; Clipping Files; Compact Disks; Exhibition Catalogs; Filmstrips; Other Holdings Comic books; Periodical Subscriptions 260; Slides; Video Tapes
Special Subjects: Art History, Film, Illustration, Photography, Commerical Art, Graphic Design, Advertising Design
Publications: Library Handbook; accessions lists

M **WARD-NASSE GALLERY,** 178 Prince St, New York, NY 10012. Tel 212-925-6951; Fax 212-334-2095; Elec Mail markherd@earthlink.net; Internet Home Page Address: www.wardnasse.org; *Dir & Chmn Bd* Harry Nasse
Open Tues - Sat 11 AM - 6 PM, Sun 1 - 6 PM; Estab 1969 to provide an artist-run gallery; also serves as resource center for artists & pub; to provide internships for students; First floor, 2,000 sq ft space; Average Annual Attendance: 7,000; Mem: 300; dues $40
Income: Financed by mem
Exhibitions: Seventeen exhibitions per year ranging from 3 person shows, up to large salon shows with 100 artists
Publications: Brochure; gallery catalog, every two years; quarterly newsletter
Activities: Work study programs; lect open to public; concerts; poetry readings; multi-arts events; sales shop sells original art

M **WHITE COLUMNS,** 320 W 13th St, New York, NY 10014. Tel 212-924-4212; Fax 212-645-4764; Elec Mail info@whitecolumns.org; Internet Home Page Address: www.whitecolumns.org; *Exec Dir* Paul Ha; *Asst Dir* Lauren Ross; *Registrar* Teneille Haggard
Open Wed - Sun Noon - 6 PM; No admis fee; Estab 1970 to showcase the works of emerging artists; Exhibs, progs, & servs for emerging artists; Average Annual Attendance: 12,000; Mem: 500; dues $35-$1,000
Exhibitions: Annual benefit auction

M **WHITNEY MUSEUM OF AMERICAN ART,** 945 Madison Ave, New York, NY 10021. Tel 212-570-3600; Fax 212-570-1807; Internet Home Page Address: www.whitney.org; *Dir & CEO* Maxwell Anderson; *Deputy Dir* Willard Holmes; *Chief Financial Officer* Marvin Suchoff; *Dir Human Resources* Hillary Blass; *Assoc Dir External Affairs* Barbara Bantizoglio; *Dir Communications* Mary Haus; *Assoc Dir Pub Prog* Helena Vidal; *Operations Mgr* Donald Maclean; *Cur Prewar Art* Barbara Haskell; *Cur Postwar Art* Marla Prather; *Cur Contemporary Art* Lawrence R Rinder; *Librn & Assoc Cur Spec Coll* Carol Rusk; *Independent Study Prog Dir* Ron Clark; *Branch Dir, Philip Morris & Assoc Cur* Shamim Momim; *Cur Film & Video* Crissie Iles; *Assoc Dir Retail & Wholesale* Steve Buettner; *Assoc Dir Pub Programs* Melissa Phillips; *Librn* May Castleberry; *Dir Publs* Mary DelMonico; *Cur Prints* David Kiehl; *Cur Drawings* Janie Lee; *Assoc Dir Operations* Christy Putnam; *Head Registrary* Suzanne Quigley; *Cur Photography* Sylvia Wolf; *VChmn* Leonard A Lauder; *Branch Cur* Debra Singer; Joel S Ehrenkranz, VPres
Open Tues - Thurs & Sat - Sun 11 AM - 6 PM, Fri 1 - 9 PM cl Mon & national holidays; Admis $10, seniors 62 & over & students with ID $8, children under 12

free; Estab 1930, inc 1931 by Gertrude Vanderbilt Whitney for the advancement of contemporary American art; Museum opened 1931 on Eighth Street & moved to 54th Street in 1954; new building opened in 1966; Average Annual Attendance: 500,000; Mem: 5,000; dues $65 & up

Income: Financed by endowment, admis, grants, mem

Purchases: Numerous annual acquisitions

Special Subjects: Drawings, Painting-American, Prints, Sculpture

Collections: Drawings, paintings, prints, sculpture of mainly 20th & 21st century American artists

Exhibitions: Rotating exhibits every 3-4 months

Publications: Annual report; brochures, cards, posters; calendars; exhibition catalogues; gallery brochures

Activities: Classes for adults; docent training; symposia & panel discussions; teachers' workshops; lect open to public; gallery talks; tours; Artreach provides introductory art education to elementary & high school students; individual paintings & original objects of art lent; originate traveling exhibitions for museums here & abroad; sales shop sells books, magazines, reproductions, slides, cards & posters

L **Frances Mulhall Achilles Library,** 945 Madison Ave, New York, NY 10021. Tel 212-570-3648; Fax 212-570-7729; Internet Home Page Address: www.whitney.org; *Librn* Carol Rusk; *Asst Librn & Cataloger* Zimra Panitz; *Asst Archivist* Sarah Kanafani; *Sr Library Asst* Anne Ziegler

Open Tues, Wed, Thurs 10 AM - Noon & 2 - 5 PM by appointment for advanced research; No admis fee; Estab 1931 for encouragement & advancement of American art & art scholarship

Library Holdings: Auction Catalogs; Audio Tapes; Book Volumes 35,000; CD-ROMs; Cassettes; Clipping Files; Compact Disks; Exhibition Catalogs; Fiche; Manuscripts; Memorabilia; Original Documents; Pamphlets; Periodical Subscriptions 100; Photographs; Records; Reels; Reproductions; Slides; Video Tapes

Collections: 20th century & contemporary American art

Activities: Docent training; lect open to pub; gallery talks; tours; Bucksbaum award; lending of original objects of art; museum shop sells books, magazines, original art, reproductions, prints

M **Whitney Museum at Altria,** 120 Park Ave at 42nd St, New York, NY 10017. Tel 917-663-2550, 663-2453; Fax 917-663-5770; Internet Home Page Address: www.whitney.org; *Branch Dir* Shamin Momin

Sculpture court open Mon - Sat 7:30 AM - 9:30 PM, Sun & holidays 11 AM - 7 PM, gallery open Mon - Fri 11 AM - 6 PM, Thurs 11 AM - 7:30 PM; No admis fee; Estab 1982 to extend American art to wider audience; Sculpture court with major works & adjacent gallery for changing exhibitions; Average Annual Attendance: 100,000

Income: Financed by Altria Group, Inc

Publications: Free brochures for each exhibition

Activities: Classes for children; gallery talks Mon, Wed & Fri at 1 PM; films; performances

A **WOMEN IN THE ARTS FOUNDATION, INC,** 1175 York Ave, No 2G, New York, NY 10021; 32-35 30th St Apt D24, Long Island City, NY 11106. Tel 212-751-1915; *Newsletter Ed* Erin Butler; *Financial Coordr* Sari Menna; *Exec Coordr* Erin Butler

Estab 1971 for the purpose of overcoming discrimination against women artists both in government & the private sector; Sponsors discussions, workshops, panels and exhibits the work of women artists, both established & unknown; Average Annual Attendance: 100; Mem: 65; dues $45

Income: $12,000 (financed by endowment & mem)

Publications: Women in the Arts, bulletin-newsletter, quarterly

Activities: Public educ as to the problems & discrimination faced by women artists; lect open to public, 6 vis lectrs per year; individual paintings & original objects of art lent to museum & university art galleries for special exhibitions; original art works for exhibitions are obtained from member artists

WOMEN'S CAUCUS FOR ART

For further information, see National and Regional Organizations

M **WOMEN'S INTERART CENTER, INC,** Interart Gallery, 549 W 52 St, New York, NY 10019. Tel 212-246-1050; *VPres* Bill Perlman; *Artistic Dir* Margot Lewitin; *Dir Programming* Ronnie Geist

Open Mon - Fri 1 - 6 PM; No admis fee; Estab 1970 to present to the pub the work of significant, emerging women artists; Average Annual Attendance: 9,000; Mem: Dues $35

Income: Financed by state appropriation, National Endowment for the Arts, private foundations, corporations & individuals

Exhibitions: Community as Planner

Publications: Women's Interart Center Newsletter, quarterly

Activities: Classes for adults; lect open to public, 2 vis lectrs per year; originate traveling exhibitions

M **YESHIVA UNIVERSITY MUSEUM,** 15 W 16th St, New York, NY 10011. Tel 212-294-8330; Fax 212-294-8335; Elec Mail info@yum.cjh.org; Internet Home Page Address: www.yumuseum.org; *Cur Educ* Rachelle Bradt; *Assoc Dir Exhib & Prog* Gabriel Goldstein; *Cur & Registrar* Bonni-Dara Michaels; *Assoc Dir Operations* Jody Heher; *Contemporary Exhib Coordr* Reba Wulkan; *Dir* Sylvia A Herskowitz; *Asst to Dir & Docent Coord* Sara Gruenspect; *Project Assoc* Mary Kiplok; *Educator* Ilana Benson; *Cur* Katharina Fell

Open Tue, Wed, Thurs, Sun 11 AM - 5 PM; Admis adults $8, students & seniors $6; Estab 1973 to collect, preserve & interpret Jewish art & objects of material culture in the light of Jewish history; 8000 sq ft of upper & lower galleries; maintains reference library; Average Annual Attendance: 40,000; Mem: 550; dues $36-$1000

Special Subjects: Photography, Sculpture, Textiles, Religious Art, Decorative Arts, Judaica, Manuscripts

Collections: Architectual models, ceremonial objects, documents, ethnographic material, fine & decorative art, manuscripts, photographs, sculpture, textiles

Exhibitions: Changing exhibs of Contemporary & Historical Fine Arts; Multi-disciplinary exhibs of Jewish history & culture

Publications: Catalogs

Activities: Classes for children; dramatic programs; docent training; craft workshops; lect open to public; concerts; gallery talks; tours; individual paintings & original objects of art lent for purposes of exhibitions to institutions which provide specified levels of care; book traveling exhibitions 1 per year; originate traveling exhibitions; sales shop sells books, original art, reproductions, Judaica & children's toys

NIAGARA

M **NIAGARA UNIVERSITY,** Castellani Art Museum, 5795 Lewiston Rd, Niagara, NY 14109. Tel 716-286-8200; Fax 716-286-8289; Elec Mail cam@niagara.edu; Internet Home Page Address: www.niagara.edu/cam; *Registrar* Kathleen Fraas; *Gallery Mgr* Kurt VonVoetcsch; *Museum Shop* Anne LaBarbera; *Museum Shop* Carla Castellani; *Dir* Dr Sandra H Olsen; *Educ Coordr* Eric Jackson-Forsberg; *Asst to Dir* Sandra Knapp

Open Wed - Sat 11 AM - 5 PM, Sun 1 - 5 PM; No admis fee; Estab 1978; The gallery is a 10,000 sq ft museum that displays the permanent collection of over 3000 works of art encompassing 19th century to present with a concentration on contemporary art; Mem: 300

Income: $120,000

Special Subjects: Graphics, Painting-American, Photography, Prints, Sculpture, Watercolors, Pre-Columbian Art, Woodcuts, Afro-American Art, Collages, Painting-Canadian, Painting-British, Painting-French, Painting-German

Collections: Modern paintings, sculpture & works on paper (19th -20th centuries); Pre-Columbian Pottery

Exhibitions: Glass art: Arnold Mesches; John Moore; Michael Kessler; Arcadia Revisited: Niagara River & Falls from Lake Erie to Lake Ontario, Photographs by John Pfahl

Publications: Exhibition catalogs, 4 per yr

Activities: Classes for adults & children; Public Art Project on Underground Railroad; docent training; learning disabled prog; senior citizen outreach prog; lect open to the public, 1-6 vis lectr per year; concerts; gallery talks; tours; competitions; awards; scholarships & fels offered; individual paintings & original objects of art lent to qualified museums; originate traveling exhibitions

NORTH SALEM

M **HAMMOND MUSEUM & JAPANESE STROLL GARDEN,** Cross-Cultural Center, 28 Deveau Rd, North Salem, NY 10560; PO Box 326, North Salem, NY 10560. Tel 914-669-5033; Fax 914-669-8221; Elec Mail gardenprogram@yahoo.com; Internet Home Page Address: www.hammondmuseum.org; *Dir* Lorraine Laken; *Bookkeeper* Judy Schurmacher

Open Apr - Oct, Wed - Sat Noon - 4 PM; Admis to Museum & Garden, adult $5, seniors $4, mems & children under 12 free; Estab 1957; Exhib provide an East-West cultural experience supplemented by programs of related special events such as the Asian Arts Festival and Moonviewing Concert. The 3.5 acre Japanese Stroll Garden includes a pond, waterfall, Zen garden, bamboo grove, Maple Terrace, etc; Average Annual Attendance: 17,000; Mem: 500; dues $35-$1000

Income: Financed by mem, matching funds, private foundations & corporations

Special Subjects: Photography, Ethnology, Costumes, Asian Art

Collections: Carl Van Vechten Collection of photographs; Fans

Activities: Classes for adults & children; lect open to public, 5 vis lectrs per year; concerts; gallery talks; tours; individual paintings & original objects of art lent to other museums; lending collection contains photographs & slides; sells books, original art, prints

NORTH TONAWANDA

M **NORTH TONAWANDA HISTORY MUSEUM,** 314 Oliver St, North Tonawanda, NY 14120; 195 Goundry St, North Tonawanda, NY 14120. Tel 716-692-2681; Elec Mail nthistorymuseum@aol.com; Internet Home Page Address: www.nthistorymuseum.org; *Actg Dir & Pub Rels* Donna Zellnerneal; *Develop Mem* Cynthia Fredericks; *Historic Homes Tour & Garden Walk* Betty Brandon; *Educ* Sarah Walter; *Pres, Security & Cur* John Borycki; *Fin Dir* Kristen Palmeri; *Registrar, Archivist & Webmaster* Cindi Tysick

cl Independence Day, Thanksgiving Day, Christmas Eve & Day, New Year's Eve & Day; Donations accepted; school tours $2 per student, Seaway Trailwalks: adults $8, children $4; other history walks: adults $4, children $2; Estab 2004; History mus with emphasis on rich ethnic heritage, Erie Canal/Niagara River Influence as role of lumber & industrial ctr in 19th & 20th centuries; Mem: dues Life $250, Contributing $100, Business/Civic $50, Family of 2 or more $25, Individual $15, Senior $10

Collections: Artifacts, oral histories, photographs, directories & archival materials; 50 vols of city directories & other local history books, 10 high school yearbooks

Publications: Quarterly newsletter; Annual Report

Activities: Formal educ progs for adults & children; research in ethnic, industrial, lumber & Erie Canal heritage; ethnic heritage festivals; historic home tours & tours of other historic venues; garden walks; concerts; virtual mus online

NORTHPORT

L **NORTHPORT-EAST NORTHPORT PUBLIC LIBRARY,** Art Dept, 151 Laurel Ave Northport, NY 11768. Tel 631-261-6930; Fax 631-261-6718; Elec Mail netwalk@suffolk.lib.ny.us; Internet Home Page Address: www.suffolk.lib.ny.us/libraries/net-walk/; *Asst Dir* Eileen Minogue; *Dir* Stephanie Heineman; *Chairperson* Michael L Glennon

Open Sept - June Mon - Fri 9 AM - 9 PM, Sat 9 AM - 5 PM, Sun 1 - 5 PM; No admis fee; Estab 1914; Circ 968,285

Library Holdings: Audio Tapes; Book Volumes 215,000; Cassettes; Clipping Files; Exhibition Catalogs; Fiche; Filmstrips; Manuscripts; Other Holdings Compact discs 2250; Pamphlets; Periodical Subscriptions 720; Prints; Records; Reproductions; Sculpture; Video Tapes 7890

Publications: Library, monthly

Activities: Lect open to public, 5 vis lectrs per year; concerts; competitions

NYACK

M EDWARD HOPPER HOUSE ART CENTER, 82 N Broadway, Nyack, NY 10968. Tel 845-358-0774; Elec Mail edwardhopper.house@verizon.net; Internet Home Page Address: www.edwardhopperhouseartcenter.org; *Exec Dir* Cathrine Shiga-Gattullo
Open Thurs - Sun 1 PM - 5 PM; Admis $1; Estab 1971 to memorialize Edward Hopper & exhibit current regional artists; Four galleries on first floor of historical house. Interior of house intact; Average Annual Attendance: 2,200; Mem: 400; dues $15-$75
Income: Financed by mem
Special Subjects: Painting-American, Photography, Posters, Reproductions
Exhibitions: Exhibits by local & national American artists
Activities: Adult classes; lect open to public, 3 vis lectrs per year; juried art competitions, concerts, bookfairs; sales shop sells books & prints

OGDENSBURG

M FREDERIC REMINGTON ART MUSEUM, 303 Washington St, Ogdensburg, NY 13669. Tel 315-393-2425; Fax 315-393-4464; Elec Mail info@fredericremington.org; Internet Home Page Address: www.fredericremington.org; *Exec Dir* Lowell McAllister; *Cur* Laura Foster; *Museum Educ Specialist* Gwynn Hamilton; *Mus Shop Mgr* Debbie Kirby; *Admin Aid* Shannon Wells; *Account Mgr* Debra Ghize; *Project Coordr* Wendy Flood
Open May 1 - Oct 31 Mon - Sat 10 AM - 5 PM, Sun 1 - 5 PM, Nov 1 - Apr 30 Wed - Sat 11 AM - 5 PM, Sun 1 - 5 PM, cl legal holidays; Admis adults $6, seniors & youth $5, under 5 & mems free; organized tour groups $2 per person; Estab 1923 to house & exhibit works of art of Frederic Remington (1861-1909), a native of northern New York; The mus is in the converted Parish Mansion, built 1809-1810 & the recently constructed Newell Wing.; Average Annual Attendance: 15,000; Mem: 1400; dues family $40
Income: Financed by endowment & city appropriation
Special Subjects: Painting-American, Sculpture, Watercolors, American Western Art, Bronzes, Painting-European, Furniture, Glass, Porcelain, Silver
Collections: Remington paintings, bronzes, watercolors, drawings, photographs, letters & personal art collection; studies in plaster by Edwin Willard Deming; sculpture by Sally James Farnham; Haskell Collection of 19th century American and European paintings; Parish Collection of Belter furniture; Sharp Collection of period glass, china, silver and cameos
Exhibitions: The Children's Exhibit; The Frederic Remington Exhibit
Activities: Classes for adults & children; docent training; lect open to public; gallery talks; tours; for anyone; museum shop sells books, reproductions, prints

OLD CHATHAM

M SHAKER MUSEUM & LIBRARY, 88 Shaker Museum Rd, Old Chatham, NY 12136. Tel 518-794-9100, ext 218; Fax 518-794-8621; Elec Mail contact@shakermuseumandlibrary.org; Internet Home Page Address: www.shakermuseumandlibrary.org; *Finance Mgr* Ann Montag; *Dir* Lili Ott; *Cur* Starlyn D'Angelo
Open May - Oct daily 10 AM - 5 PM, cl Tues; Admis adults $8, reduced rates for seniors, children & groups; Estab 1950 to promote interest in & understanding of the Shaker cultural heritage; The exhibits are housed in a complex of eight buildings; Average Annual Attendance: 16,000; Mem: 475; dues $35 - $1000
Income: $700,000 (financed by earned revenue, endowment, contributions, private & public grants)
Purchases: $3000
Library Holdings: Auction Catalogs; Book Volumes; Clipping Files; Manuscripts; Maps; Memorabilia; Slides
Special Subjects: Drawings, Watercolors, Textiles, Costumes, Decorative Arts, Dolls, Furniture, Glass, Historical Material, Embroidery
Collections: 35,000 artifacts & archival material representing 200 years of Shaker history & culture including, baskets, furniture, metal work, personal artifacts, stoves, textiles, tools & equipment, transportation
Exhibitions: Orientation to Shaker History; Shakers in the 20th Century; Shaker Cabinetmakers and Their Tools; study storage related to individual collections
Publications: Members update; The Shaker Adventure; Shaker Seed Industry; pamphlets; booklets; gallery guide; catalogs; postcards, reprints, and broadsides
Activities: Classes for adults & children; docent training; seminars; lect open to public; concerts; adult tours; symposia; festivals; family events; originate traveling exhibitions; museum shop sells Shaker reproduction furniture, craft items & publications
L Emma B King Library, 88 Shaker Museum Rd, Old Chatham, NY 12136. Tel 518-794-9100, Ext 111; Fax 518-794-8621; Internet Home Page Address: www.shakermuseumandlibrary.org; *Librn* Jerry Grant
Open by appointment Mon - Fri, cl holidays; Admis research use fee; Circ non-circulating; For reference only; Mem: Part of museum
Income: financed by museum
Library Holdings: Audio Tapes; Book Volumes 2000; Cassettes; Clipping Files; Filmstrips; Kodachrome Transparencies; Manuscripts; Memorabilia; Motion Pictures; Original Art Works 100; Pamphlets; Photographs 3500; Prints; Records; Reels 189; Slides; Video Tapes
Collections: Manuscripts and records; Photographic and map archive

OLD WESTBURY

M NEW YORK INSTITUTE OF TECHNOLOGY, Gallery, Old Westbury, NY 11568. Tel 516-686-7542; *Chmn* Peter Voci
Open Mon - Fri 9 AM - 5 PM; Estab 1964; Gallery maintained for the many exhibits held during the year; Average Annual Attendance: 5,000
Exhibitions: Annual faculty & student shows; some traveling exhibitions
Publications: Graphic Guild Newsletter, quarterly
Activities: Classes in custom silk-screen printmaking; gallery talks; awards; scholarships offered; exten Dept serves all areas

L Art & Architectural Library, Education Hall, Old Westbury, NY 11568. Tel 516-686-7579; Fax 516-686-7921; Elec Mail lgold@iris.nyit.edu; *Sr Library Asst* Maria Fernandes; *Librn* Leslie Goldstein
Open Mon - Thurs 9 AM - 9 PM, Fri 9 AM - 5 PM, Sat 10 AM - 3 PM; No admis fee; Estab 1976
Library Holdings: Book Volumes 1808; Cassettes; Clipping Files; Exhibition Catalogs; Motion Pictures 23; Other Holdings CD's; Pamphlets; Periodical Subscriptions 258; Reels 1384; Slides 35,000; Video Tapes 80
Special Subjects: Art History, Folk Art, Decorative Arts, Calligraphy, American Western Art, Cartoons, Asian Art, Mexican Art, Southwestern Art, Afro-American Art, Antiquities-Egyptian
Exhibitions: Architecture dept student projects
Activities: Tours

M STATE UNIVERSITY OF NEW YORK COLLEGE AT OLD WESTBURY, Amelie A Wallace Gallery, Rte 107 (Broadway), PO Box 210 Old Westbury, NY 11568-0210. Tel 516-876-3056; Fax 516-876-4984; Internet Home Page Address: www.owestbury.edu; *Gallery Dir* Catherine Bernard; *Chmn Art Dept* Mac Adams
Open Mon - Thurs; No admis fee; Estab 1976 to serve as a teaching aid & for community enlightenment; 2,000 sq ft on three levels; Average Annual Attendance: 3,000
Income: $4,500 (financed by endowment & HYS)
Collections: none
Exhibitions: 4 annual exhibitions by contemporary artists + 2 student shows
Publications: Exhibit brochures
Activities: Lect open to public, 4 vis lectrs per year; gallery talks

ONEIDA

M MADISON COUNTY HISTORICAL SOCIETY, Cottage Lawn, 435 Main St, Oneida, NY 13421. Tel 315-363-4136; Fax 315-363-4136; Elec Mail mchs1900@dreamscape.com; Internet Home Page Address: www.dreamscape.com/mchs1900; *VPres* Barbara Chamberlain; *Exec Dir* Sydney Lostus; *Pres* Dorothy Willsey; *Coll Mgr* Michael Martin; *VPres* Carol Bass; *Treas* Tim Waddingham; *VPres* Richard Casspm; *Coll Mgr* Michael Flannagan
Open summer Mon - Sat 9 AM - 4 PM; winter Mon - Fri 9 AM - 4 PM & by appointment; Admis adults $2, seniors $1, discounts for school groups; Estab 1898 to collect, preserve & interpret artifacts indigenous to the history of Madison County; 1849 A J Davis gothic dwelling with period rooms, library & craft archive; Average Annual Attendance: 9,000; Mem: 500; dues $12-$15; annual meeting last Wed in Oct
Income: $93,000 (financed by endowment, mem, county, city & state appropriation, Annual Craft Fair)
Special Subjects: Decorative Arts
Collections: Locally produced & or used furnishings, paintings, silver, textiles & ceramics
Exhibitions: Permanent exhibit in the barn; Bittersweet: Hop Culture in Central New York
Publications: Quarterly Newsletter; Madison County Heritage, published annually; Country Roads Revisited
Activities: Educational outreach programs for nursing homes & schools; lect open to public, 10 vis lectrs per year; slides, tapes & movies documenting traditional craftsmen at work; individual paintings & original objects of art lent to qualified museums & galleries for special exhibits; sales shop sells books, magazines, prints & slides
L Library, 815 S Second Ave, Winterset, IA 50273; PO Box 15, Winterset, IA 50273. Tel 515-462-2134; Elec Mail mchistoricalsociety2@juno.com; *Librn* Mary King
Open summer Tues - Sat 9 AM - 4 PM, winter Mon - Fri 9 AM - 4 PM; Admis $2, mems free; Estab 1975 as a reference library of primary & secondary sources on Madison County History; For reference only; Average Annual Attendance: 2,800
Library Holdings: Book Volumes 2500; Clipping Files; Exhibition Catalogs; Manuscripts; Memorabilia; Pamphlets; Periodical Subscriptions 5; Photographs; Prints
Collections: Gerrit Smith family papers

ONEONTA

M HARTWICK COLLEGE, Foreman Gallery, Anderson Ctr for the Arts, Oneonta, NY 13820. Tel 607-431-4483; Fax 607-431-4191; Elec Mail winelandj@hartwick.edu; *Cur* John Wineland
Open daily Noon - 9 PM, or by appointment, cl last half of Dec & summers; No admis fee; Estab 1968, contemporary exhibitions for benefit of faculty, students & community
Special Subjects: Drawings, Painting-American, Prints, Sculpture, Baroque Art, Renaissance Art, Cartoons
Exhibitions: Changing exhibitions; student & faculty exhibitions
Publications: Exhibition catalogues
M The Yager Museum, Hartwick College, Oneonta, NY 13820. Tel 607-431-4480; Fax 607-431-4457; Elec Mail dejardinf@hartwick.edu; Elec Mail museum@hartwick.edu; Internet Home Page Address: www.hartwick.edu/museum.xml; *Dir & Cur Fine Arts* Dr Fiona M Dejardin; *Cur of Foreman Gallery* Gloria Escobar; *Business Mgr* Nancy Martin-Mathewson; *Cur Anthropology* Dr David Anthony; *Coll Mgr* Lea Foster; *Exhibit Mgr* Andrew Pastore; *Secy* Denise Wagner
Open Tues - Sun 12 PM - 4:30 PM, cl acad holidays; No admis fee; Estab 1928; Seven galleries feature travelling exhibits, anthropology, fine art & Yager collections; Average Annual Attendance: 8,500; Mem: 200
Income: Income from college budget & endowment
Special Subjects: Anthropology, Archaeology, Landscapes, Mexican Art, Painting-European, Sculpture, Drawings, Hispanic Art, Painting-American, Prints, Watercolors, American Indian Art, Ethnology, Woodcuts, Etchings & Engravings, Renaissance Art, Cartoons

Collections: Collection of North American, Mexican & South American Indian art & artifacts & mask collection; fine arts featuring European and American works from 15th - 20th centuries; Micronesia
Exhibitions: Changing exhibitions.
Publications: The Rüdisühli: A Family of Painters; Oneonta's Native Son: Carleton E. Watkins, photographer
Activities: Classes in museum studies; lect; tours; films; 6 vis lect per yr; gift shop sells cards, jewelry, pottery, books, crafts & handmade objects

M **STATE UNIVERSITY OF NEW YORK COLLEGE AT ONEONTA,** Art Gallery & Sculpture Court, Fine Arts Ctr, Ravine Dr Oneonta, NY 13820-3717. Tel 607-436-3717; Fax 607-436-3715; *Chmn Art Dept* Nancy Callahan
Open Mon - Fri 11 AM - 4 PM, Tues & Thurs 7 - 9 PM, Sat 1 - 4 PM; No admis fee; Art Gallery & Sculpture Court are major features of the Art Wing, separate fine arts & student galleries; Average Annual Attendance: 3,000
Income: Financed by city & state appropriation
Special Subjects: Sculpture
Collections: Paintings, sculpture
Exhibitions: Semi-annual student art exhibition
Activities: Organize 3-yr traveling exhibitions

ORIENT

M **OYSTERPONDS HISTORICAL SOCIETY,** Museum, Village Ln, PO Box 70 Orient, NY 11957. Tel 631-323-2480; Fax 631-323-3719; Elec Mail ohsorieut@optonline.net; *Dir* William McNaught
Open June - Sept Thurs, Sat & Sun 2 - 5 PM, other times by appointment; Admis adults $5, children under 12 & mems free; Estab 1944 to discover, procure, & preserve material related to the civil & military history of Long Island, particularly the East Marion & Orient Hamlets; Average Annual Attendance: 6,000; Mem: 700; dues family $50, individual $30; annual meeting in Sept
Income: $160,000 (financed by endowment, mem, grants & fundraising)
Library Holdings: Manuscripts; Maps; Memorabilia; Original Documents; Photographs
Special Subjects: American Indian Art, Decorative Arts, Furniture, Marine Painting, Maps
Collections: Early Indian artifacts, including arrowheads, baskets & clay vessels; 18th century furniture & decorative arts; late 19th century Victorian furniture; marine & portrait paintings; photographs; textile collection, including quilts, scarves, fans; tools & equipment related to the agricultural & sea-related occupations of this area; important manuscript collections relating to local history
Exhibitions: Toys & Dolls; Indian Artifacts; 19th Century Boarding House; 18th Century Period Rooms; Rotating exhibs
Publications: Griffin's Journal, book; Historical Orient Village, book; She Went A'Whaling, book; quarterly newsletter; Captain's Daughter, book; Coasterman's Wife, book; In the Wake of Whales, book.
Activities: Classes for adults & children; docent training; lect open to public; vis lect 4 - 5 per yr; museum shop sells books, magazines, original art, reproductions & prints

OSSINING

M **MUSEUM OF OSSINING HISTORICAL SOCIETY,** 196 Croton Ave, Ossining, NY 10562. Tel 914-941-0001; *Dir* Roberta Y Arminio; *Pres* Norman D McDonald
Open Thurs - Sun 1 - 4 PM & by appointment; No admis fee; Estab 1931 to educate the pub in the history & traditions of the vicinity; East Gallery contains changing exhibitions & a portion of the permanent collection; West Gallery contains permanent collection; Average Annual Attendance: 2,500; Mem: 497; dues patron $100, civic, commercial & contributing $25, family $15, individual $10, senior citizens & students $5
Income: Financed by mem & town appropriation
Library Holdings: Video Tapes 32
Special Subjects: Costumes
Collections: Costumes; textiles & quilts; slides & films of old Ossining; old photographs & daguerreotypes; Victorian dollhouse complete in minute detail, contains antique dolls, toys, miniatures, old school books & photographs; oil portraits; fine arts
Publications: Monthly brochure
Activities: Educ dept; class visits; special assignment guidance; lect open to public, 4 vis lectrs per year; gallery talks; tours; competitions with awards; individual paintings & original objects of art lent to schools, banks & industry; sales shop sells books, magazines
L **Library,** 196 Croton Ave, Ossining, NY 10562. Tel 914-941-0001; *Librn* Vidal Abreu
Library Holdings: Audio Tapes; Book Volumes 1000; Cassettes; Clipping Files; Exhibition Catalogs; Framed Reproductions; Lantern Slides; Memorabilia; Original Art Works; Photographs; Prints; Reels; Reproductions; Slides; Video Tapes 32

OSWEGO

M **STATE UNIVERSITY OF NEW YORK AT OSWEGO,** Tyler Art Gallery, SUNY Oswego, 126 Tyler Hall Oswego, NY 13126. Tel 315-312-2113; Fax 315-312-5642; Elec Mail davidk52@hotmail.com; *Asst Dir* Mindy Ostrow; *Dir* David Kwasigroh; *Admin Aide* Lisa M Shortslef
Open Mon - Fri 9:30 AM - 4:30 PM, Sat & Sun 12:30 PM - 4:30 PM, Sept - May; summer hours as posted; No admis fee; Estab 1969 to provide cultural stimulation & enrichment of art to the college community & to the residents of Oswego County; Two gallery spaces in Tyler Hall, the North Gallery is approx 2400 sq ft & the South Gallery is approx 1300 sq ft; Average Annual Attendance: 20,000
Income: Financed by University funds
Special Subjects: Painting-American, Sculpture, African Art, Pottery, Posters, Painting-British

Collections: Grant Arnold Collection of Fine Prints; Contemporary American Prints & Paintings
Exhibitions: Two galleries show a combined total of 14 exhibitions per school year
Publications: Brochures; occasional catalogs for exhibitions; posters
Activities: Lect open to public, 8-10 vis lectrs per year; concerts, gallery talks; lending collection contains individual & original objects of art; originates traveling exhibitions
L **Penfield Library,** Oswego, NY 13126-3514. Tel 315-312-4267; Fax 315-312-3194; Elec Mail refdesk@oswego.edu; Internet Home Page Address: www.oswego.edu/library; *Dir* Marybeth Bell; *Art Subject Librn* Nedra Peterson
Open Mon - Thurs 8 AM - 11 PM, Fri 8 AM - 9 PM, Sat 10 AM - 9 PM, Sun 11:30 AM - 11 PM; For lending & reference
Income: Financed by univ
Library Holdings: Audio Tapes; Book Volumes 437,000; Cassettes; Fiche; Filmstrips; Framed Reproductions; Motion Pictures; Original Art Works; Pamphlets; Periodical Subscriptions 1469; Records; Reels; Sculpture; Slides; Video Tapes
Special Subjects: Art History, Graphic Arts, Advertising Design, Art Education, Costume Design & Constr, Aesthetics

OYSTER BAY

L **PLANTING FIELDS FOUNDATION,** Coe Hall at Planting Fields Arboretum, PO Box 660, Oyster Bay, NY 11771. Tel 516-922-9210; Fax 516-922-9226; Elec Mail coehall@plantingfields.org; Internet Home Page Address: www.plantingfields.org; *Dir* Ellen Cone Busch; *Dir Develop* Cindy Krezel; *Coll Mgr* Marianne Della Croce
Open Apr - Sept Mon - Fri 12:30 - 3:30 PM; Admis adults $5, seniors $3.50, children 6-12 $1; Archives estab 1979 for Coe family papers, architectural drawings, photos, Planting Fields Foundation documents; For reference only. Coe Hall, a Tudor revival mansion being restored to its 1920's appearance, contains 17th-20th century paintings; Mem: $40 & up individual
Income: Financed by endowment
Library Holdings: Audio Tapes; Book Volumes 6000; Cassettes; Clipping Files; Filmstrips; Lantern Slides; Manuscripts; Memorabilia; Motion Pictures; Original Art Works; Pamphlets; Photographs; Prints; Slides; Video Tapes
Special Subjects: Landscape Architecture, Decorative Arts, Photography, Painting-British, Painting-Dutch, Painting-Italian, Painting-European, Historical Material, Portraits, American Western Art, Porcelain, Period Rooms, Stained Glass, Restoration & Conservation, Architecture
Activities: Classes for adults & children; docent training; outdoor science progams grades Pre K - 6; lect open to public, 5 vis lectrs per year; concerts; guided tours of historic house; sales shop sells books & garden related items

SOCIETY OF AMERICAN HISTORICAL ARTISTS
For further information, see National and Regional Organizations

PELHAM

M **PELHAM ART CENTER,** 155 Fifth Ave, Pelham, NY 10803. Tel 914-738-2525; Fax 914-738-2686; Elec Mail info@pelhamartcenter.org; *Exec Dir* Lisa Robb; *Prog Mgr* Jessica Cioffoletti; *Finance Mgr* Bridget Beltke; *Registrar* Marie Cosentino; *Prog Asst* Filomena Iolos con
Open Tues - Fri 10 AM - 5 PM; Sat 10 AM - 4 PM; Sunday (in Dec only) 12 - 4 PM; No admis fee; Estab 1972 as a community art center to give area residents & visitors a place, the opportunity & the resources to see, study & experience the arts in a community setting; Average Annual Attendance: 20,000; Mem: 500; dues $25-$1000
Income: $280,000 (financed by mem, tuition, earned income & gift shop sales)
Activities: Classes for adults & children; studio classes; workshops, docent programs; lect open to public, 7 exhibitions annually, 2-3 vis lectrs per year, gallery talks; scholarships offered; retail store sells unique gift items

PENN YAN

M **THE AGRICULTURAL MEMORIES MUSEUM,** 1110 Townline Rd, Penn Yan, NY 14527. Tel 315-536-1206; *Owner & Operator* Jennifer R Jensen; Hilbert J Jensen Mus Asst
Open June - Oct Sun 1 PM - 4 PM, Mon - Sat by appt, cl Nov - May; Admis adults $4, students & children 2 - 12 $1, children under 2 no admis fee; Estab 1997, dedicated in 1998; Over 40-yr coll of horse-drawn carriages/sleighs, antique tractors, gasoline engines, toys, signs & misc. Mus preserves & restores items independently
Library Holdings: Book Volumes; Filmstrips
Collections: Over 45 carriages/sleighs, 50 gasoline engines, 50 antique tractors, pedal tractors & cars, signs & misc toys
Activities: Lects; guided tours & films

PLATTSBURGH

M **STATE UNIVERSITY OF NEW YORK,** SUNY Plattsburgh Art Museum, 101 Broad St, Plattsburgh, NY 12901. Tel 518-564-2813 Kent, 564-2288 Burke, 564-2474 Main Office; Fax 518-564-2473; Internet Home Page Address: www.plattsburgh.edu/museum; *Dir* Edward R Brohel
Open daily Noon - 4 PM, cl university holidays; No admis fee; Estab 1978; Kent Gallery & Burke Gallery
Collections: Rockwell Kent Collection, paintings, prints, drawings, sketches, proofs & designs, books; china; ephemera; Nina Winkle Sculpture Garden; Slathin Collection; Louise Norton Classic Design Coll; Outlook Sculpture Park; Myers Lobby Gallery
Exhibitions: Twelve exhibitions each year; antique & contemporary, all media
Publications: Exhibition catalogs; monthly exhibition announcements; semi-annual calendar of events

Activities: Programs for undergrad students, elementary & secondary schools & community groups in area; docent programs; lect open to public, 10 vis lectrs per year; tours; competitions with awards; individual paintings lent

PLEASANTVILLE

M PACE UNIVERSITY GALLERY, Art Gallery in Choate House, 861 Bedford Rd, Pleasantville, NY 10570. Tel 914-773-3694; Fax 914-773-3676; Elec Mail tromer@pace.edu; Internet Home Page Address: www.pace.edu; *Dept Chair* Dr John Mulgrew; *Admin Asst* Teresa Romer
Open Sun - Fri Noon - 4PM, cl Sat; No admis fee; Estab 1978 to exhibit the works of nationally known professional artists & groups, & to serve as a focal point for artistic activities within the university & surrounding communities; The gallery has a commanding view of the center of campus; it is both spacious & modern
Income: Financed by the university
Activities: Lect open to public, 8-10 vis lectrs per year; gallery talks; tours

C THE READER'S DIGEST ASSOCIATION INC, World Headquarters, Pleasantville, NY 10570-7000. Tel 914-238-1006; Fax 914-244-5006; *Cur* Marianne Brunson Frisch
Art collection located throughout corporate headquarters
Collections: Over 8000 works of art, 19th century American & contemporary American artists & International artists; graphics; decorative arts; sculpture; painting; mixed media; works on paper; Photography; Bloomsbury Group

PORT CHESTER

L PORT CHESTER PUBLIC LIBRARY, One Haseco Ave, Port Chester, NY 10573. Tel 914-939-6710; Fax 914-939-4735; *Dir* Robin Lettieri
Open Mon 9 AM - 9 PM, Tues 9 AM - 8 PM, Wed - Sat 9 AM - 5 PM; No admis fee; Estab 1876 to circulate books, records, magazines, to the general public to provide reference services; Circ 103,598; Maintains a small art gallery, with mostly local artists; Average Annual Attendance: 32,493
Income: $494,600 (financed by endowment, villages & state appropriations)
Purchases: $50,500
Library Holdings: Book Volumes 85,000; Filmstrips; Framed Reproductions; Pamphlets; Periodical Subscriptions 2000; Prints; Records; Reels; Slides
Exhibitions: Water colors, oils, acrylics, photographs
Activities: Educ dept; lect & films open to public; films; career seminars & workshops; individual paintings lent

PORT WASHINGTON

L PORT WASHINGTON PUBLIC LIBRARY, One Library Dr, Port Washington, NY 11050-2794. Tel 516-883-4400; Fax 516-944-6855; *Dir* Nancy Curtin
Open Mon, Tues, Thurs & Fri 9 AM - 9 PM, Wed 11 AM - 9 PM, Sat 9 AM - 5 PM, Sun 1 - 5 PM; No admis fee; Estab 1892; Circ 303,500
Income: Financed by state appropriation & school district
Library Holdings: Audio Tapes; Book Volumes 128,000; Cards; Cassettes; Clipping Files; Filmstrips; Manuscripts; Pamphlets; Periodical Subscriptions 750; Photographs; Prints; Records; Reels; Video Tapes
Special Subjects: Illustration, Photography, Drawings, Manuscripts
Collections: Ernie Simon Collection of photographs & newspaper articles on the history of Port Washington; Sinclair Lewis Collection of books, manuscripts, photographs & ephemera; Mason Photograph Archive of photographic negatives spanning over 75 years of Port Washington social history; P W Play Troupe Archive of memorabilia covering the 60 year history of the oldest theatre group on Long Island; Collection of drawings by children's illustrator Peter Spier
Exhibitions: Lita Kelmenson (drawings & wood sculpture); Hajime Okubo (box constructions); Paul Wood (oil painting & watercolors); Photographers: Dency Ann Kane, Mariou Fuller, Christine Osinski
Publications: Monthly guide catalog

POTSDAM

M POTSDAM COLLEGE OF THE STATE UNIVERSITY OF NEW YORK, Roland Gibson Gallery, Pierrepont Ave, Potsdam, NY 13676. Tel 315-267-3290, 267-2250; Fax 315-267-4884; Elec Mail pricems@potsdam.edu; Internet Home Page Address: www.potsdam.edu/gibson; *Cur, Acting Dir* Maggie Price; *Registrar* Romi Sebald; *Secy* Claudette Fefee
Open Mon - Fri Noon - 5 PM, Tues - Thurs Noon - 7 PM, Sat Noon - 4 PM; No admis fee; Estab 1967 to serve col& community as a teaching gallery; Gallery has 4800 square feet of exhibition space on three levels with security & environmental controls; Average Annual Attendance: 18,000; Mem: 200; dues $10-$100; ann meeting in Oct
Special Subjects: Drawings, Painting-American, Prints, Sculpture, Painting-Japanese, Painting-Italian
Collections: Contemporary Japanese, Italian & American art (painting, sculpture & prints); contemporary drawing collection
Publications: Exhibition catalogs & posters
Activities: Docent training; lect open to public, 10-12 vis lectrs per year; concerts; gallery talks; tours; competitions; original objects of art lent to public institutions, art museums & art organizations; book traveling exhibitions 1-3 times per year; traveling exhibitions organized & circulated

M POTSDAM PUBLIC MUSEUM, PO Box 6158, Civic Ctr Park St Potsdam, NY 13676. Tel 315-265-6910; *Dir & Cur* Betsy L Travis
Open Tues - Sat Noon - 4 PM, cl Sun & Mon; No admis fee; Estab 1940 as an educational institution acting as a cultural & historical center for the Village of Potsdam & surrounding area. Educational services taken to area schools. Museum occupies a sandstone building, formerly a Universalist Church built in 1876; Maintains small reference library; Average Annual Attendance: 12,000

Income: Financed by village, town, state & federal appropriation
Special Subjects: Photography, Costumes, Pottery, Glass, Oriental Art
Collections: Burnap Collection of English Pottery; costumes of the 19th & 20th centuries; Mandarin Chinese hangings, china & costumes; photograph collection, artifacts & material on local history; pressed glass & art glass of the 19th & early 20th century
Exhibitions: Changing exhibitions
Publications: Newsletter, 3-4 times per year
Activities: Classes for adults & children; programs for schools; lect open to public, 8 vis lectrs per year; concerts; tours

POUGHKEEPSIE

M VASSAR COLLEGE, The Frances Lehman Loeb Art Center, 124 Raymond Ave, Poughkeepsie, NY 12604-6198. Tel 845-437-5235; Fax 845-437-5955; Internet Home Page Address: www.vassun.vassar.edu1~fllac/; *Cur* Patricia Phagan; *Registrar* Joann Potter; *Preparator* Bruce Bundock; *Dir* James Mundy; *Cur* Joel Smith; *Asst Registrar* Karen Hines; *Admin Asst* Francine Brown; *Coordr Educ Pub Prog* Kelly Thompson
Open Tues - Sat 10 AM - 5 PM, Sun 1 - 5 PM; cl Mon, Easter, Thanksgiving & the week between Christmas & New Year's; No admis fee; Estab 1864; collects Eastern & Western art of all periods; New mus opened in Nov 1993 in addition designed by Cesar Pelli; Average Annual Attendance: 37,000; Mem: 1100; dues $35 & up; bi-annual meeting fall & spring
Income: Financed by Vassar College, endowment & mem
Special Subjects: Architecture, Drawings, Painting-American, Sculpture, Watercolors, Archaeology, Ceramics, Etchings & Engravings, Painting-European, Oriental Art, Medieval Art, Painting-Italian, Antiquities-Greek, Antiquities-Roman, Antiquities-Etrusca
Collections: Matthew Vassar collection of 19th century American paintings of Hudson River School & 19th century English watercolors; Felix M Warburg Collection of medieval sculpture & graphics including Duerer & Rembrandt; 20th century art of all media including photography; European paintings, sculpture & drawings ranging from the Renaissance to the 20th century, including Bacchiacca, Cezanne, Salvator Rosa, Claesz, Tiepolo, Robert, Corot, Cezanne, Delacroix, Gifford, Van Gogh, Tanner, Munch, Klee, Bourdelle, Laurent, Davidson, Gabo, Calder, Moore; 20th Century American & European paintings including Henri, Hartley, O'Keeffe, Bacon, Nicholson, Rothko, de Kooning, Hartigan, Weber; graphics ranging from Barocci to Rembrandt to Goya to Picasso, Matisse, Braque, Kelly, Grooms & Graves; photography from Anna Atkins, Cameron, Gilpin, Steichen, Abbott, Lange, Lynes & Linda Conner; The Classical Collection includes Greek vases, Egyptian, Etruscan & Mycenaean objects, Roman glass, portrait busts, jewelry; other archaeological finds
Publications: Occasional exhibition catalogues & biannual newsletter
Activities: Docent training; gallery talks; tours; extension program lends original objects of art to other museums; book traveling exhibitions vary; originate traveling exhibitions to other museums; sales shop sells postcards, notecards, posters & exhibition catalogues

L Art Library, 124 Raymond Ave, Poughkeepsie, NY 12604-6198. Tel 914-437-5790; Internet Home Page Address: iberia/vassar.edu/art; *Librn* Thomas Hill
Open Mon - Thurs 8:30 AM - 12 AM, Fri 8:30 AM - 10 PM, Sat 9 AM - 10 PM, Sun 10 AM - Noon, cl summer; Estab 1937; Circulation to students & faculty only
Library Holdings: Book Volumes 45,000; Exhibition Catalogs; Fiche; Other Holdings CD-ROMS; Periodical Subscriptions 250; Reels

PURCHASE

M MANHATTANVILLE COLLEGE, Brownson Gallery, Brownson Bldg, 2900 Purchase St Purchase, NY 10577. Tel 914-323-5331; Fax 914-323-3131; Internet Home Page Address: www.mville.edu; *Prof Studio Art* Ann Bavar; *Prof* Randolph Williams; *Asst Prof* Alka Mukerji; *Asst Prof* Tim Ross
Open 9:30 AM - 5 PM and by appointment; No admis fee; Estab 1950s to bring artists to college & community; Average Annual Attendance: 6,400
Income: Financed by endowment & tuition
Collections: Sculpture; Photography Collection
Publications: Magazine, bimonthly; catalogs
Activities: Lect open to public, 2 vis lectrs per year; concerts; gallery talks; scholarships; original objects of art lent; originate traveling exhibitions

L Library, 2900 Purchase St, Purchase, NY 10577-0560. Tel 914-694-2200, Ext 274; Fax 914-694-6234; Elec Mail goodman@mvill.edu; Internet Home Page Address: www.mville.edu/library; *Dir* Rhonna Goodman; *Asst Library Dir* Jeff Rosedale
Open Mon - Thurs 8 AM - 2 AM, Fri 8 AM - 11 PM, Sat 9 AM - 11 PM, Sun 10 AM - 2 AM
Income: financed by endowment & tuition
Library Holdings: Book Volumes 250,000; Periodical Subscriptions 1100

C PEPSICO INC, Donald M Kendall Sculpture Garden, 700 Anderson Hill Rd, Purchase, NY 10577. Tel 914-253-2900; Fax 914-253-3553; *Former Chmn & CEO* Donald M Kendall; *Dir Art Prog* Jacqueline R Millan
Open Mon - Sun 9 AM - 5 PM; Estab 1970 to present sculpture of mus quality; Average Annual Attendance: 10,000
Collections: Forty-two large outdoor sculptures, works by Alexander Calder, Henry Moore, Louise Nevelson, David Smith, Arnaldo Pomodoro, Jacques Lipchitz,; Henry Laurens, Auguste Rodin, Miro, Giacometti, Max Ernst, Jean DuBuffet, Tony Smith, George Segal, Claes Oldenburg, George Rickey, Richard Erdman & Barbara Hepworth

M STATE UNIVERSITY OF NEW YORK AT PURCHASE, Neuberger Museum of Art, 735 Anderson Hill Rd, Purchase, NY 10577. Tel 914-251-6100; Fax 914-251-6101; Elec Mail neuberger@purchase.edu; Internet Home Page Address: www.neuberger.org; *Registrar* Patricia Magnani; *Coordr Public Information* Barbara Morgan; *Head Museum Educ* Eleanor Brackbill; *Develop Dir* Jill Westgard; *Dir* Lucinda H Gedeon
Open Tues - Fri 10 AM - 4 PM, Sat & Sun 11 AM - 5 PM, cl Mon & major holidays; Adults $5; Seniors $3; Estab 1968, opened May 1974 to serve university

& residents of New York State & Connecticut; 78,000 sq ft facility designed by Philip Johnson with nine total galleries, five outside sculpture courts; Average Annual Attendance: 75,000; Mem: Dues Directors Circle $2500, sustaining $1000, patron $500, donor $250, contributiong $100, family-dual $50, individual $35
Income: Financed by State University of New York, endowment fund, government grants, private foundations, donors & mem
Special Subjects: Drawings, Painting-American, Photography, Prints, Sculpture, African Art, Painting-European
Collections: Six thousand objects featuring 20th century European & American paintings, sculpture, drawings, prints, photographs & audio works, African & ancient art
Exhibitions: Changing contemporary art exhibitions
Publications: Exhibition catalogues; brochures; quarterly calendars
Activities: Docent training; interships for Purchase College students; tours for children, adults & citizens with special needs; lect open to public, vis lectr; concerts; gallery talks; tours; internships offered; original objects of art lent to other museums; book traveling exhibitions; originate traveling exhibitions to other museums; sales shop sells books, magazines, prints, small gift items & cards
L **Library,** 735 Anderson Hill Rd, Purchase, NY 10577-1400. Tel 914-251-6400; Fax 914-251-6437; *Interim Dir* Richard Arsenty; *Reference-Visual Arts Specialist* Martha C Smith; *Interim Dir* Mark Smith
Open Mon - Thurs 8:30 AM - 11 PM, Fri 8:30 AM - 6 PM, Sat 11 AM - 6 PM, Sun 1 - 11 PM
Income: Financed by univ
Library Holdings: Audio Tapes; Book Volumes 255,000; Cards; Cassettes; Fiche; Motion Pictures; Periodical Subscriptions 1000; Records; Reels; Reproductions; Slides; Video Tapes
Special Subjects: Art History, Photography, Drawings, Graphic Arts, Graphic Design, Painting-American, Painting-Dutch, Painting-Flemish, Painting-French, Painting-German, Painting-Italian, Prints, Painting-European, Afro-American Art

RIVERHEAD

A **EAST END ARTS & HUMANITIES COUNCIL,** 133 E Main St, Riverhead, NY 11901. Tel 516-727-0900; Fax 516-727-0966; *Exec Dir* Patricia Snyder; *Gallery Mgr* Karen Kirby
Open Mon - Sat 10 AM - 4 PM; No admis fee; Estab 1972; Average Annual Attendance: 11,000; Mem: 500; dues $20-$65
Income: Financed by public & private sector
Exhibitions: Various group shows
Activities: Classes for children; music & art pre-school-adult; summer camp ages 5-8 & 8-12; wine press concert series; lect open to public; competitions with awards; gallery talks; tours; sales shop sells books, original art & crafts, hand crafted items

ROCHESTER

M **GEORGE EASTMAN HOUSE-INTERNATIONAL MUSEUM OF PHOTOGRAPHY & FILM,** 900 East Ave, Rochester, NY 14607. Tel 716-271-3361; Fax 716-271-3970; Elec Mail tbannon@geh.org; Internet Home Page Address: www.eastman.org; *Chmn* Stephen Ashley; *Controller* Paul J Piazza; *Cur Technology Coll* Todd Gustavson; *Dir Develop* Pamela Reed Sanchez; *Operations & Finance* Daniel Y McCormick; *Dir Anthony Bannon; *Mgr Publications* Robyn Rime; *Dir Communications & Visitors Svcs* Eliza Benington-Kozlowski; *Cur Photography* Alison Devine Nordstrom; *Cur Landscape* Andy Joss; *House Cur* Kathy Connor; *Dir Interpretation* Roger Bruce; *Dir Creative Svcs* Rick Hock
Open Tues - Sat 10 AM - 5 PM, Thurs 10 AM - 8 PM, Sun 1 - 5 PM; Admis adults $8, students $6, seniors $5, children 5-12 $3, children under 4 & mems free; Estab 1949 for photography exhibitions, research & educ; Restored landmark & gardens; Average Annual Attendance: 150,000; Mem: 4200; dues family /dual $60, individual $40, senior citizens $40
Income: Financed by corp & individual gifts, foundation & government grants, earned income
Library Holdings: Book Volumes; Exhibition Catalogs
Special Subjects: Landscapes
Collections: Equipment (photographic); film; 19th, 20th & 21st century photography; George Eastman Legacy Collection
Exhibitions: George Eastman Honorary Scholar; George Eastman Award
Publications: Image, quarterly; books & catalogs
Activities: Classes for children; docent training; teacher workshops; school exhibition program; lect open to public; concerts; gallery talks; tours; fellowships; awards; exten dept; lending collection contains photographs & original objects of art; book traveling exhibitions; traveling exhibitions organized & circulated; museum shop sells books, magazines & reproductions
L **Library,** 900 East Ave, Rochester, NY 14607. Tel 585-271-3361; Fax 585-271-3970; Internet Home Page Address: www.eastman.org; *Archivist* David A Wooters; *Librn* Rachel Stuhlman; *Dir* Anthony Bannon; *Cur Photography* Therese Mulligan
Open Tues - Sat 10 AM - 5 PM, Thurs 10 AM - 8 PM, Sun 1 - 5 PM; Admis adults $8, seniors & students $6, children 5-12 $3, mems free; Estab 1947; Circ 44,500; Museum of photography and motion pictures; Average Annual Attendance: 149,000; Mem: 4,200; dues beginning at $40
Library Holdings: Audio Tapes; Book Volumes 40,000; Clipping Files; Exhibition Catalogs; Fiche; Manuscripts; Pamphlets; Periodical Subscriptions 375; Records; Reels 75; Reproductions; Slides
Special Subjects: Photography
Collections: Largest collection in the US of photographs, camera technology & Library dealing with the history & aesthetics of photography: 400,000 photographs including major collections of Edward Steichen, Alvin Langdon Coburn, Southworth & Howes, Louis Walton Sipley, Lewis Hine, Edward Muybridge & Nickolas Muray; Motion picture stills and titles
Activities: Classes for adults & children; Discovery Room for children; lect open to public; concerts; gallery talks; tours; George Eastman Award; fels offered; originate traveling exhibitions to museums and univs worldwide; museum shop sells books, reproductions, prints

M **LANDMARK SOCIETY OF WESTERN NEW YORK, INC,** The Campbell-Whittlesey House Museum, 133 S Fitzhugh St, Rochester, NY 14608-2204. Tel 585-546-7029; Fax 585-546-4788; Elec Mail mail@landmarksociety.org; *Exec Dir* Henry McCartney; *Dir Mus* Cindy Boyer
Open Thurs & Fri Noon - 4 PM, other times by appointment; Admis adults $3, children under 14 $1; Estab 1937; Mem: dues keystone $500, cornerstone $250, pillar $125, patron $75, family $35, active $25
Library Holdings: Book Volumes; Kodachrome Transparencies; Manuscripts; Maps; Memorabilia; Original Art Works; Original Documents; Periodical Subscriptions; Photographs; Prints; Reproductions; Slides; Video Tapes
Special Subjects: Architecture, Landscapes, Decorative Arts, Furniture, Historical Material, Restorations, Period Rooms
Collections: Art, furnishings & decorative arts of the 1830s; furnishings & decorative arts of early 19th century
Publications: Bi-monthly newsletter; booklets; brochures; guides; postcards
Activities: Dramatic programs; docent training; tours
L **Wenrich Memorial Library,** 133 S Fitzhugh St, Rochester, NY 14608-2204. Tel 716-546-7029; Fax 716-546-4788; Elec Mail chowk@landmarksociety.org; Internet Home Page Address: www.landmarksociety.org; *Cur* William Keeler; *Res Coordr* Cynthia Howk
Open Mon - Fri 10 AM - 4 PM & by appointment; No admis fee; Estab 1970 to preserve landmarks in Western New York; information center containing drawings, photographs, slides, books & periodicals, as well as archives of local architecture & information on preservation & restoration techniques; Mem: 3200
Income: Financed by mem & special grants
Purchases: $1000
Library Holdings: Book Volumes 5000; Clipping Files; Exhibition Catalogs; Kodachrome Transparencies; Manuscripts; Original Art Works; Pamphlets; Periodical Subscriptions 15; Photographs; Prints; Slides; Video Tapes
Special Subjects: Landscape Architecture, Decorative Arts, Historical Material, Interior Design, Furniture, Architecture
Collections: Claude Bragdon Collection of Architectural Drawings; Historic American Buildings: Survey Drawings of Local Architecture; John Wenrich & Walter Cassebeer Collection of Prints & Watercolors
Exhibitions: Adaptive Use: New Uses for Old Buildings; The Architecture of Ward Wellington Ward; Rochester Prints, from the drawings of Walter Cassebeer
Publications: Newsletter, bi-monthly
Activities: Classes for adults & children; docent training; lect open to public; tours; originate traveling exhibitions to area schools, colleges, banks, community centers; museum shop sells books, original art, reproductions, prints, apparel, jewelry & gifts

M **ROCHESTER CONTEMPORARY,** (Pyramid Arts Center) 137 East Ave, Rochester, NY 14604. Tel 585-461-2222; Fax 585-461-2223; Elec Mail info@rochestercontemporary.org; Internet Home Page Address: www.rochestercontemporary.org; *Managing Dir* Robin Jaeckel; *Prog Dir* Elizabeth Switzer
Open Wed - Sun 1 - 5 PM; $5 suggested donation; Estab 1977 to hold exhibitions & performances, nonprofit organization; Average Annual Attendance: 10,000; Mem: 450; dues $20-$250
Income: The Rochester Contemporary Art Gallery is funded in part by mem, Arts & Cultural Council for Greater Rochester, Cultural Tourism Initiative, Project of Arts & Bus Council Inc & New Eldredge, Fox & Porretti, Foster Charitable Trust, Genesee Gateway, Gleason Foundation, Klinke Endowment Fund, NY State Council on Arts, Rochester Group, Singer Real Estate, Richart & Vicki Schwartz Family Fund, Wilmorite Property Management, Fred & Floy Willmott Foundation, local businesses & our mems
Exhibitions: (2007) Upstate Invitational; (2007) Duo Series; (2007) Maker/Mentor Series; (2007) Electronic Media & Film; (2007) Members Exhibition; (2007) Invited Curators
Activities: Educ dept; workshops with guest artists; docent training; lect open to public, 10 vis lectrs per year; concerts; gallery talks; tours; competitions; Best in Show award for members exhib; sales shop sells screenings

A **ROCHESTER HISTORICAL SOCIETY,** 485 East Ave, Rochester, NY 14607. Tel 716-271-2705; Fax 716-271-9089; Elec Mail asalter@rochesterhistory.org; Internet Home Page Address: www.rochesterhistory.org; *Exec Dir* Ann C Salter; *Librn* Lois Gauch; *Coll Mgr* Patricia Ford; *VPres* Clinton Steadman
Open Mon - Fri 10 AM - 4 PM; Admis adults $3, students & seniors $2, children under 12 $1; Estab 1860, refounded 1888, to obtain & preserve relics & documents & publish material relating to Rochester's history; Headquaters at Woodside, Greek Revival Mansion built in 1839. Early Rochesterians portraits displayed throughout the house; Average Annual Attendance: 3,000; Mem: 700; annual meeting in Spring
Income: Financed by mem
Collections: Rochester costumes, furnishings & portraits
Exhibitions: 19th century mansion with gardens
Publications: Genesee Valley Occasional Papers; The Rochester Historical Society Publication Fund Series, 25 volumes; Woodside's First Family, catalog
Activities: Lect open to public, 6 vis lectrs per year; concerts; tours; individual paintings & original objects of art lent to museums & other institutions with adequate security

L **ROCHESTER INSTITUTE OF TECHNOLOGY,** Corporate Education & Training, 67 Lomb Memorial Dr, Rochester, NY 14623-5603. Tel 716-475-2411, Ext 7090; Fax 716-475-7000; Internet Home Page Address: www.rit.edu/cims/cet; WATS 800-724-2536; *Dir* Kitren Van Strander
Center has been a leading provider of professional training for the graphic arts & imaging industries for more than 40 years. The T & E Center provides seminars & hands on workshops in traditional & leading edge technologies for graphic design & publishing software, image editing & compositing, digital photography & electronic prepress & publishing. In addition, introductory & advanced programs are also offered in printing production & technologies, business & production management, & Total Quality. T & E Center programs draw upon resources from RIT's School of Printing Management & Sciences, School of Photographic Arts & Sciences & the Center for Imaging Science as well as from industry to deliver practical training to today's graphic arts professional

Publications: T & E Update, monthly
Activities: Seminars for the graphic arts & imaging industries

M **STRONG MUSEUM,** One Manhattan Sq, Rochester, NY 14607. Tel 716-263-2700; Fax 716-263-2493; Internet Home Page Address: www.rit.edu/~strwww; Others TDD 716-423-0746; *Pub Relations* Susan Trien
Open Mon - Sat 10 AM - 5 PM, Sun 1 - 5 PM; Admis adults $5, seniors & students with ID $4, children (3-16) $3, children under 3 free, mus mems free, special reduced admis, greeting & group orientation & mus shop discount to booked groups of 20 or more; Accessible to people with disabilities; lectures may be sign interpreted with three days prior notice
Collections: 500,000 objects including dolls, furniture, glassware, miniatures & toys
Exhibitions: One History Place
Activities: Family programs; Wed music; pre-school performance series

UNIVERSITY OF ROCHESTER
M **Memorial Art Gallery,** Tel 716-473-7720; Fax 716-473-6266; Internet Home Page Address: mag.rochester.edu; Others TDD 716-473-6152; *Pres Board of Mgrs* Dennis Ruggeri; *Dir* Grant Holcomb; *Dir Develop* Peggy Hubbard; *Asst Dir Admin* Kim Hallatt; *Dir Educ* Susan Dodge Peters; *Public Relations Mgr* Deborah Rothman; *Membership Mgr* Debora McDell; *Chief Cur* Marjorie B Searl; *Cur Exhib* Marie Bia
Open Tues Noon - 9 PM, Wed - Fri 10 AM - 4 PM, Sat 10 AM - 5 PM, Sun Noon - 5 PM, cl Mon; Admis adults $7, seniors & students $5, children 6-18 $2, 5 & under, mems & University of Rochester students free; $2 admis fee Tues 5 - 9 PM; Estab 1913 as a university art mus & pub art mus for the Rochester area; The original building is in an Italian Renaissance style; Average Annual Attendance: 325,000; Mem: 10,000; dues $60 & up
Income: Financed by endowment, mem, grants, earned income & University support
Special Subjects: Drawings, Hispanic Art, Prints, Sculpture, Watercolors, American Indian Art, African Art, Ceramics, Crafts, Folk Art, Pottery, Primitive art, Landscapes, Afro-American Art, Decorative Arts, Portraits, Furniture, Porcelain, Oriental Art, Marine Painting, Painting-French, Renaissance Art, Medieval Art, Antiquities-Egyptian, Antiquities-Assyrian
Collections: Covers all major periods & cultural areas from Assyria & predynastic Egypt to the present, paintings, sculpture, prints, drawings, decorative arts; special strengths are medieval, 17th century Dutch painting, English Portraiture, 19th & early 20th century French painting, American art & American folk art
Publications: Mem magazine, Articulate; calendar
Activities: Studio art classes for adults & children; docent training; lect open to public; gallery talks; tours; exten dept serving Rochester area & surrounding nine counties; lending collection contains slides; book traveling exhibitions 4-6 per year; originate traveling exhibitions 10-12 per year; gallery store sells original art, fine crafts, prints, books & paper products

L **Charlotte W Allen Library-Memorial Art Gallery,** Tel 716-473-7720, Ext 3022; Fax 716-473-6266; Elec Mail lharper@mag.rochester.edu; Internet Home Page Address: mag.rochester.edu/library; *Librn* Lucy Bjorklund Harper; *Visual Resources Coordr* Susan Nurse; *Libr Asst* Mari Lenoe
Open Wed & Fri 1 - 5 PM, Thurs 1 - 8:30 PM, Sat 10:30 AM - 2:30 PM, cl Sun - Tues; No admis fee; Estab 1913 as a research library; Circ 5,200
Income: Financed by endowment, mem & grants
Library Holdings: Book Volumes 40,450; CD-ROMs; Clipping Files; Exhibition Catalogs; Manuscripts; Memorabilia; Pamphlets; Periodical Subscriptions 60; Photographs; Reels; Reproductions; Slides; Video Tapes
Special Subjects: Art History, Folk Art, Decorative Arts, Drawings, Etchings & Engravings, Graphic Arts, Painting-American, Painting-British, Painting-European, History of Art & Archaeology, Art Education, Landscapes, Laces, Architecture
Collections: Memorial Art Gallery Archives
Activities: Teacher resource ctr

L **Art/Music Library,** Tel 585-275-4476; Fax 585-273-1032; Elec Mail artlib@library.rochester.edu; *Slide Cur* Kim Kopatz; *Librn* Stephanie J Frontz
Open Mon - Thurs 9 AM - 10 PM, Fri 9 AM - 6 PM, Sat Noon - 5 PM, Sun Noon - 10 PM; Estab to support academic programs of Department of Art & Art History & other academic departments within the University; Small gallery is maintained by Art & Art History Department & Library
Library Holdings: Audio Tapes 100; Book Volumes 60,000; CD-ROMs 25; Compact Disks 740; Exhibition Catalogs; Fiche; Kodachrome Transparencies; Lantern Slides; Periodical Subscriptions 450; Records 850; Slides 125,000

M **VISUAL STUDIES WORKSHOP,** 31 Prince St, Rochester, NY 14607. Tel 716-442-8676; Fax 716-442-1992; Elec Mail info@vsw.org; Internet Home Page Address: www.vsw.org; *Chmn Bd Trustees & Dir* Nathan Lyons; *Coordr* Scott Laird; *Coordr Book Distribution* Scott Gulransen; *Coordr Summer Institute* Joan Lyons
Open Mon - Fri 9 AM - 5 PM, Gallery open Tues - Sat Noon - 5 PM; No admis fee; Estab 1969 to establish a center for the transmission & study of the visual image; Visual Studies Workshops produce & or present approximately 20 exhibitions per year encompassing contemporary & historical issues; subjects vary from photography, film, video, artists' book works & related media; Average Annual Attendance: 20,000; Mem: 2300; dues $30
Income: Financed by mem, state appropriation, federal & corporate resources & earned income
Collections: 19th & 20th century photographs, mechanical prints & artists' books
Exhibitions: Rotating exhibits
Publications: Afterimage, bi-monthly
Activities: Classes for adults; Summer Institute program with intensive short term workshops for artists & museum professionals; lect open to public, 15 vis lectrs per year; gallery talks; tours (by appointment); original objects of art lent to institutions with proper exhibition facilities; lending collection contains 27,000 photographs of original artwork; traveling exhibitions organized & circulated to museums, colleges & universities; museum shop sells books, magazines, original art & prints

L **Research Library,** 31 Prince St, Rochester, NY 14607. Tel 716-442-8676; Fax 716-442-1992; Elec Mail library@vsw.org; *Coordr* William Johnson
Open Mon - Wed & Fri Noon - 5 PM or by appt; Estab 1971 to maintain a permanent collection for the study of the function & effect of the visual image; For reference only

Income: $80,000 (financed by grants)
Purchases: $5000
Library Holdings: Audio Tapes; Book Volumes 19,000; Cassettes; Clipping Files; Exhibition Catalogs; Kodachrome Transparencies; Lantern Slides; Motion Pictures; Original Art Works; Other Holdings Posters; Pamphlets; Periodical Subscriptions 160; Photographs; Prints; Reproductions; Slides; Video Tapes
Special Subjects: Photography
Collections: Illustrated book collection; photographic print collection
Publications: Various publications
Activities: Internship programs; workshops; graduate museum studies program; visual studies; lect open to public; gallery talks; tours

ROME

A **ROME ART & COMMUNITY CENTER,** 308 W Bloomfield St, Rome, NY 13440. Tel 315-336-1040; Fax 315-336-5912; Elec Mail racc@borg.com; Internet Home Page Address: borg.com/~race; *Dir* Deborah H. O'Shea; *Publicist & Dir Educ* Jennifer Millington; *Operation Mgr* Marilyn Schleuter
Open Mon - Thurs 9 AM - 9:30 PM, Fri - Sat 9 AM - 5 PM; No admis fee; Estab 1968 for art exhibits & classes, community events, educ; Three galleries; Average Annual Attendance: 30,000; Mem: 1000; dues family with 2 children $25, individual $15
Income: Financed by city appropriation, New York State Council on the Arts, Oneida County, United Arts Fund-Mohawk Valley, mem, donations & private foundations
Exhibitions: Various art & craft exhibitions every six weeks
Publications: Newsletter, bimonthly; community calendar, quarterly; class brochures, quarterly
Activities: Classes for adults & children; dramatic progs; lect open to public, 20 vis lectrs per yr; tours; readings; concerts; weekly films; scholarships to gifted children; monetary awards art exhibs

M **ROME HISTORICAL SOCIETY,** Museum & Archives, 200 Church St, Rome, NY 13440. Tel 315-336-5870; Fax 315-336-5912; Elec Mail robert@romehistorical.com; *Bd Pres* Virginia Batchelder; *First VPres* Fred Normand; *Exec Dir* Robert Avery; *Coll Mgr* Ann Swanson; *Library Asst* Linda Yagoda; *Admin Asst* Mary Centro
Open Tues - Fri 10 AM - 5 PM & during special events, cl holidays; No admis fee; library & archives $10 per day for non-mem; Estab 1936 as a historical mus & soc; 2 galleries for temporary exhibitions on specific topics of local interest; Average Annual Attendance: 15,000; Mem: 695; dues $20-$100; annual meeting in Aug
Income: Financed by mem, city appropriation, private foundations, federal & state grants
Library Holdings: Book Volumes; Filmstrips; Manuscripts; Maps; Memorabilia; Original Art Works; Original Documents; Other Holdings; Pamphlets; Periodical Subscriptions; Prints; Slides; Video Tapes
Special Subjects: Archaeology, Costumes, Crafts, Decorative Arts, Furniture, Glass
Collections: E Buyck; P F Hugunine; Forest Moses; Ann Marriot; Will Moses; Revolutionary War period paintings; Rome Turney Radiator; Griffiss Air Force Base
Exhibitions: Our Goodly Heritage - movie on Rome NY
Publications: Annals & Recollections, quarterly; quarterly newsletter
Activities: Classes for children; docent training; lect open to the public; 24 vis lect per yr; concerts; gallery talks; tours; medal of 1777 yearly award; outreach program to schools, sr citizens' homes & community organizations; sales shop sells books, reproductions & local artisan items

L **William E Scripture Memorial Library,** 200 Church St, Rome, NY 13440. Tel 315-336-5870; Fax 315-336-5912; *Cur Coll* Kathleen Hynes-Bouska; *Library Asst* Polly Henderson
Open Mon - Fri 9 AM - 4 PM; Admis $5 per day for non-mem; Estab 1936 for historical research of Rome & the Mohawk Valley; Circ Non-circulating; Reference library; Average Annual Attendance: 1,000
Income: Financed by mem, city appropriation grants
Library Holdings: Book Volumes 3500; Clipping Files; Manuscripts; Pamphlets; Photographs; Prints; Reels
Special Subjects: Folk Art, Decorative Arts, Manuscripts, Maps, Historical Material, Crafts, Archaeology, Furniture, Architecture
Collections: Area paintings from the Revolutionary War period to the present; Frederick Hodges Journals; The Hathaway Papers; Local Malitia Records 1830-1840; La Vita: Local newspaper printed in Rome New York 1918-1950
Exhibitions: History of Rome

ROSENDALE

A **WOMEN'S STUDIO WORKSHOP, INC,** 722 Binnewater Lane, PO Box 489 Rosendale, NY 12472. Tel 845-658-9133; Fax 845-658-9031; Elec Mail info@wsworkshop.org; Internet Home Page Address: www.wsworkshop.org; *Artistic Dir* Tana Kellner; *Exec Dir* Ann Kalmbach; *Develop Dir* Anita Wetzel; *Dir Commications & Donor Develop* Fenichel Hewitt; *Clay Prog Coordr* Marybeth Wehrung
Open Tues - Fri 10 AM - 5 PM; Estab 1974; Mem: 400; dues $35
Income: $450,000 (financed by sales, tuition & grants)
Library Holdings: Book Volumes; Kodachrome Transparencies; Original Art Works; Original Documents; Photographs; Prints; Slides
Collections: Artists' books
Exhibitions: 12 exhibitions yearly of work by grant recipients
Publications: Artists' books, 5-7 per yr
Activities: Classes for adults & children; lect open to public, 45 vis lectrs per year; tours; grants offered; exten dept; original objects of art lent; book traveling exhibitions, annually; sales shop sells workshop products, books & handmade paper

ROSLYN

L BRYANT LIBRARY, 2 Paper Mill Rd, Roslyn, NY 11576. Tel 516-621-2240; Fax 516-621-7211, 621-5905; Elec Mail rnlinfo@lilrc.org; Internet Home Page Address: www.nassaulibrary.org/bryant; *Coordr Progs & Pub Rels* Victor Caputo; *Dir* Elizabeth McCloat
Open Mon, Tues, Thurs, Fri 9 AM - 9 PM, Wed 10 AM - 9 PM, Sat 9 AM - 5 PM, Sun (Oct - May) 1 - 5 PM; No admis fee; Estab 1878 as a public library; Circ 288,865; Gallery houses monthly exhibits, mostly paintings. Has been renamed the Heckscher Museum of Art at Bryant Library
Income: $3,200,000 (financed by property tax)
Library Holdings: Book Volumes 230,320; Cassettes 25,964; Clipping Files; Fiche; Filmstrips; Manuscripts 11,933; Pamphlets 1866; Periodical Subscriptions 299; Photographs 7697; Reels; Video Tapes 5493
Special Subjects: Historical Material, Architecture
Collections: William Cullen Bryant; Christopher Morley; local history of Roslyn, Long Island, New York
Publications: Bryant Library Calendar of Events, monthly; Bryant Library Newsletter, bi-monthly; The Bryant Library: 100 Years, 1878-1978, exhibit catalogue; W C Bryant in Roslyn, book; exhibit catalog
Activities: Lect open to public; 30-40 vis lectrs per year; concerts

ROSLYN HARBOR

M NASSAU COUNTY MUSEUM OF FINE ART, One Museum Dr, Roslyn Harbor, NY 11576. Tel 516-484-9337; Fax 516-484-0710; *Dir & Chief Cur* Constance Schwartz; *Registrar* Fernanda Bennett; *Coordr Young People's Prog* Jean Henning; *Office Mgr* Rita Mack; *Cur* Franklin Hill Perrell; *Dir of Special Events* Monica Reichmann; *Curatorial Asst* Karen Petry
Open Tues - Sun 11 AM - 5 PM; Admis adult $6, sr citizens $5, children $3; Estab 1989 to exhibit major exhibitions; Art mus housed in c 1900, three story Neo-Georgian brick mansion, former estate of Childs Frick, 9 galleries & 145 acres for sculpture park, formal gardens; Average Annual Attendance: 250,000; Mem: 3000; dues $40-$5000; annual meeting in Jan
Income: $900,000 (financed by mem, county appropriation, corporate & foundation grants, admis & special events)
Special Subjects: Drawings, Painting-American, Sculpture, Watercolors, Collages, Painting-European, Painting-French, Renaissance Art, Painting-German, Painting-Russian
Collections: 20th century American prints; drawings; outdoor sculpture; architectural blueprints & drawings relating to the museum building & property.; major Latin contemporary collection
Publications: Catalogs for exhibitions
Activities: Educ program; classes for adults & children; docent training; lect open to public; gallery talks; tours; competition; originate traveling exhibitions organized & circulated to the Gallery Association of New York State; museum shop sells art books, original art & related gifts of museum exhibitions

SAINT BONAVENTURE

M SAINT BONAVENTURE UNIVERSITY, Regina A Quick Center for the Arts, Rte 417 at Constitution Ave, Saint Bonaventure, NY 14778; Drawer BH, Saint Bonaventure, NY 14778. Tel 716-375-2494; Fax 716-375-2690; Elec Mail quick@sbu.edu; Internet Home Page Address: www.sbu.edu; *Exec Dir* Joseph A LoSchiavo; *Deputy Dir* Ruta Marino
Open Tues - Fri 10 AM - 5 PM, Sat - Sun 12 PM - 4 PM; No admis fee; Estab 1995 to house the University's art coll; 18,000 sq ft of exhib space; Average Annual Attendance: 19,000
Income: Financed by university budget
Special Subjects: Decorative Arts, Drawings, Etchings & Engravings, Landscapes, Ceramics, Photography, Porcelain, Pottery, Pre-Columbian Art, Prints, Woodcuts, Painting-European, Painting-French, Painting-American, Sculpture, Watercolors, Religious Art, Jade, Painting-Dutch, Ivory, Painting-Flemish, Renaissance Art, Antiquities-Greek
Collections: Paintings; sculpture; drawings; prints; decorative arts
Publications: Art Catalog of Collection
Activities: Educ programs for K - 12 children; dramatic programs; docent training; lect open to the pub; 10 vis lectrs per year; concerts; gallery talks; tours & sponsoring of competitions; trunk program; artist residencies in schools; lending of original objects of art to other art organizations with appropriate facility report to 6 counties of Southern Tier NY: Allegany, Cattaraugus, Chautauqua & PA: McKean, Potter & Warren; organize traveling exhib

SALAMANCA

M SENECA-IROQUOIS NATIONAL MUSEUM, 814 Broad St, Salamanca, NY 14779-1331. Tel 716-945-1760; Fax 716-945-1624; Elec Mail sue.grey@sni.org; Internet Home Page Address: www.senecamuseum.org; *Dir* Jaré Cardinal; *Mus Educator* Kari Kennedy; *Shop Mgr* Nadine Jimerson
Open Mon - Fri 9 AM - 5 PM (Nov-Apr), Mon - Sat 9 AM - 5 PM, Sun 12 - 5 PM (May - Oct); Admis adult $5, college students & seniors $3.50, children 7-13 $3, bus group discount rates available; Estab 1977 to present historical & contemporary Iroquois arts & culture & ancestral materials; Six exhibit areas, dedicated to various cultural periods up to contemporary & central seating space for video; Average Annual Attendance: 20,000
Income: Seneca Nation of Indians
Special Subjects: Drawings, Painting-American, Photography, Sculpture, Watercolors, American Indian Art, Archaeology, Ethnology, Costumes, Religious Art, Ceramics, Crafts, Pottery, Woodcarvings, Decorative Arts, Dolls, Furniture, Jewelry, Silver, Metalwork, Historical Material, Maps, Dioramas, Leather, Reproductions
Collections: Archeological, anthropological & archival collections, including photography, audio; traditional & contemporary works
Publications: SINM - Collection

Activities: Games demos; interactive children's area; tours; museum shop sells books, original art, prints, hand-made Iroquois art, calendars, videos, CDs, games

SANBORN

M NIAGARA COUNTY COMMUNITY COLLEGE, Art Gallery, 3111 Saunders Settlement Rd, Sanborn, NY 14132. Tel 716-614-5775; Fax 716-614-6826; Internet Home Page Address: www.sunyniagara.cc.ny.us; *Dir Gallery* Bryan Hopkins
Open Tues - Fri 9 AM - 4 PM; No admis fee; Estab 1973 for varied exhibits that will be of interest to students & the community; Gallery has 270 sq ft of area & approx 250 running ft; Average Annual Attendance: 9,000
Income: Financed by the college
Exhibitions: African Treasures; Faculty Exhibit; Spring Student Exhibit; Student Art Exhibit; Student Illustration Exhibit/SUNY Buffalo; NCCC Student Exhibition; Runca-NCC Alumni Exhibition (paintings, mixed media)
Publications: Catalogs
Activities: Classes for adults; dramatic programs; lect, 2-3 vis lectrs per year; gallery talks

SARATOGA SPRINGS

M NATIONAL MUSEUM OF RACING, National Museum of Racing & Hall of Fame, 191 Union Ave, Saratoga Springs, NY 12866. Tel 518-584-0400; Fax 518-584-4574; Internet Home Page Address: www.racingmuseum.org; *Dir* Peter Hammell; *Cur Hall of Fame* Kate Cravens; *Cur Coll* Lori Fisher
Open Mon - Sat 10 AM - 4:30 PM, Sun Noon - 4:30 PM; Admis adult $7, seniors & students $5, children under 12 must be accompanied by parents; Estab 1950 as a mus for the collection, preservation & exhibition of all kinds of articles associated with the origin, history & development of horse racing; There are 10 galleries of sporting art. The handsome Georgian-Colonial design brick structure houses one of the world's greatest collections of equine art along with trophies, sculptures & memorabilia of the sport from its earliest days; Average Annual Attendance: 60,000; Mem: 1950; dues $35-2500
Income: Financed through annual appeal, individual contributions, grants, shop sales & endowment
Library Holdings: Book Volumes; Clipping Files; Manuscripts; Motion Pictures; Original Documents; Periodical Subscriptions; Photographs
Special Subjects: Prints, Bronzes
Collections: Oil paintings of thoroughbred horses, trophies, racing silks, bronzes, prints, racing memorabilia
Activities: Classes for children; gallery talks; tours; art & photography competitions; museum shop sells books, magazines, original art, reproductions, prints, clothing & toys

L Reference Library, 191 Union Ave, Saratoga Springs, NY 12866. Tel 518-584-0400; Fax 518-584-4574; Elec Mail nmrinfo@racingmuseum.net; Internet Home Page Address: www.nationalmuseumofracing.org; *Dir* Peter H Hammell; *Cur Coll* Lori A. Fisher; *Coll Mgr* Beth Sheffer
Library open by appointment; Estab 1970 as a reference library on Thoroughbred racing; Open to researchers, students & authors by appointment
Library Holdings: Book Volumes 3000; Clipping Files; Exhibition Catalogs; Manuscripts; Memorabilia; Original Art Works; Pamphlets; Photographs
Special Subjects: Painting-American, Painting-British

M NEW YORK STATE MILITARY MUSEUM AND VETERANS RESEARCH CENTER, 61 Lake Ave, Saratoga Springs, NY 12866. Tel 518-581-5100; Fax 518-581-5111; Elec Mail historians@ny.ngb.army.mil; *CEO & Dir* Michael Aikey; *Registrar* Christopher Morton; *Chief Cur* Courtney Burns; *Archivist* Jim Gandy; *Mus Shop Mgr* Marie Gould
Open Tues - Sat 10 - 4, Sun noon - 4; cl all NY state holidays; no admis fee; Estab 1863; New York State's military history coll that ranges from colonial times to the present; Average Annual Attendance: 1000 - 9999
Special Subjects: Drawings, Photography, Portraits, Painting-American, Prints, Silver, Textiles, Sculpture, Graphics, Watercolors, Costumes, Furniture, Leather, Military Art
Collections: Coll includes NY state's battle flag coll & the state's Veterans Oral History coll; 3000 vols of books on military history
Activities: Educ prog for adults & children; ann events: Civil War Weekends; lects; guided tours; docent prog; mus shop sells books, original art, prints

M SKIDMORE COLLEGE, Schick Art Gallery, 815 N Broadway, Saratoga Springs, NY 12866. Tel 518-580-5049; Fax 518-580-5029; Elec Mail damiller@skidmore.edu; Internet Home Page Address: www.skidmore.edu/schick; *Asst to Dir* Mary Kathryn Jablonski; *Dir* David Miller
Open Sept - May Mon - Fri 9 AM - 5 PM, Sat & Sun 1 - 4:30 PM; summer hours variable according to summer class schedules; No admis fee; Estab 1927 for educational enrichment of the college & community. Exhibitions are intended to bring awareness of both contemporary & historical trends in art; Average Annual Attendance: 20,080
Income: Financed through College
Exhibitions: Rotating exhibits monthly
Publications: Exhibition catalogs, occasionally
Activities: Lect open to public, vis lectr; gallery talks; traveling exhibitions organized & circulated

L Lucy Scribner Library, Art Reading Area, N Broadway Saratoga Springs, NY 12866. Tel 518-580-5002; Internet Home Page Address: www.skidmore.edu; *Visual Resource Assoc* Theresa Somaio; *Supv* Nancy Rudick
Open Mon - Thurs 8 AM - 1 AM, Fri 8 AM - 10 PM, Sat 9 AM - 10 PM, Sun 11 AM - 1 AM; Estab 1925
Income: Financed by col
Library Holdings: Book Volumes 392,014; Cards; Exhibition Catalogs; Filmstrips; Kodachrome Transparencies; Lantern Slides; Memorabilia; Motion Pictures; Original Art Works; Periodical Subscriptions 1653; Photographs; Prints 600; Records; Reproductions; Sculpture; Slides 53,000
Collections: Anita Pohndorff Yates Collection of Saratoga History

SAYVILLE

M ART WITHOUT WALLS INC, Art Without Walls Inc, PO Box 341, Sayville, NY 11782; PO Box 2066, New York, NY 10150-1902. Tel 631-567-9418; Fax 631-567-9418; Elec Mail artwithoutwalls@webtv.net; Internet Home Page Address: www.artwithoutwalls.net; *Exec Dir* Sharon Lippman; *Representative* Paula Lippman
Open daily 9 AM - 9 PM, weekends by appointment; No admis fee; Estab 1985 to foster non-traditional public art & the historical, social & aesthetic elements of fine art as well as art therapy programs to exhibit to the public innovative & original public art, non-traditional, Holocaust art, contemporary art & art of the handicapped & terminally ill; Average Annual Attendance: 2,000; Mem: 450; dues $50; open membership; for artists resume & annual dues $50 with slides of work
Library Holdings: Book Volumes; CD-ROMs; Cards; Clipping Files; Exhibition Catalogs; Framed Reproductions; Kodachrome Transparencies; Motion Pictures; Original Art Works; Original Documents; Pamphlets; Periodical Subscriptions; Photographs; Prints; Reproductions; Sculpture; Slides; Video Tapes
Special Subjects: Marine Painting, Metalwork, Pre-Columbian Art, Painting-American, Prints, Period Rooms, Silver, Textiles, Woodcuts, Maps, Painting-British, Painting-European, Painting-French, Sculpture, Tapestries, Architecture, Drawings, Graphics, Hispanic Art, Latin American Art, Mexican Art, Photography, Watercolors, American Indian Art, American Western Art, Anthropology, Archaeology, Ethnology, Southwestern Art, Costumes, Folk Art, Pottery, Woodcarvings, Landscapes, Afro-American Art, Judaica, Manuscripts, Collages, Painting-Japanese, Portraits, Posters, Eskimo Art, Painting-Canadian, Dolls, Jade, Jewelry, Porcelain, Oriental Art, Asian Art, Painting-Dutch, Historical Material, Ivory, Juvenile Art, Restorations, Baroque Art, Painting-Flemish, Painting-Polish, Renaissance Art, Laces, Medieval Art, Antiquities-Oriental, Painting-Spanish, Painting-Italian, Islamic Art, Antiquities-Egyptian, Antiquities-Greek, Antiquities-Roman, Mosaics, Cartoons, Stained Glass, Painting-Australian, Painting-German, Leather, Reproductions, Painting-Russian, Painting-Israeli, Painting-Scandinavian, Painting-New Zealander
Collections: American Contemporary Art; Art Therapy; International Art; Non-Traditional Art; Public Art; Holocaust Art
Exhibitions: South Street Seaport-Museum Without Walls; Central Park-Museum Without Walls
Activities: Educ prog; classes for adults & children; dramatic programs; art therapy; lect open to public, 10 vis lectrs per year; gallery talks; American Artist Award, Newsday; National Women's History Award, National Poetry Press; Suffolk County Legislature Award, Ll Hall of Fame, Suffolk County News Inspiration Award; individual paintings & original objects of art lent; book traveling exhibitions 2 per year; originate traveling exhibitions 5 per year

SCHENECTADY

A SCHENECTADY COUNTY HISTORICAL SOCIETY, Museum of Schenectady History, 32 Washington Ave, Schenectady, NY 12305. Tel 518-374-0263; Fax 518-688-2825; Elec Mail librarian@schist.org; curator@schist.org; office@schist.org; Internet Home Page Address: www.schist.org; *Pres* Edwin D Reilly Sr; *VPres* Kim A Mabee; *Treas* Richard Clowe; *Site Mgr Mabee Farm* Patricia Barrot; *Librn* Virginia Bolen; *Office Mgr* Nicolette Sitterling; *Secy Bd Trustees* Cynthia Seacord; *Cur* Kate Weller
Open Mon - Fri 1 - 5 PM, Sat 10 AM - 4 PM; Admis adults $4, children $2; Estab 1905, for the preservation of local historical materials; Three-story Victorian house has antique furniture & oil paintings from 18th century; Average Annual Attendance: 7,500; Mem: 850; dues sponsor $100, donor $50, family $40, individual $25; annual meeting 2nd Sat of Apr
Income: Financed by mem, grants, donations
Library Holdings: Book Volumes; CD-ROMs; Clipping Files
Special Subjects: Historical Material
Collections: Decorative arts; gun room; historical material; Indian artifacts; paintings; photographs; Schenectady artifacts from 18th century
Exhibitions: (7/2006-8/2006) Erie Canal
Publications: Bi-monthly newsletter
Activities: Lect open to public, 20 vis lectrs per year; concerts; tours; exten dept serves elementary schools; sales shop sells books & gifts
L Library, 32 Washington Ave, Schenectady, NY 12305. Tel 518-374-0263; Internet Home Page Address: www.schist.org; *Archivist Librn* Virginia Langoy
Open Mon - Fri 1 - 5 PM, Sat 9 AM - 1 PM; Admis research $5, mus tour $2, mems free; Estab 1905 to promote history & genealogy of the county & nearby counties; Circ Non-circulating; For reference only; Mem: 650; dues $15 & up; annual meeting in Apr
Income: Financed by mem, grants, donations
Library Holdings: Audio Tapes; Book Volumes 4000; Cassettes; Clipping Files; Fiche; Filmstrips; Manuscripts 16,000; Memorabilia; Motion Pictures; Pamphlets; Photographs; Reels; Reproductions; Slides
Activities: Educ dept; some lect open to public & some to members only; tours; sales shop sells books

M SCHENECTADY MUSEUM PLANETARIUM & VISITORS CENTER, 15 Nott Terrace Heights, Schenectady, NY 12308. Tel 518-382-7890; Fax 518-382-7893; Internet Home Page Address: www.schenectadymuseum.org; *Dir* Bart A Rosselli; *Dir Coll* Stephanie Przyblek; *Dir Comm* Jo Anne Gleba; *Asst Dir/Exh Devel* Randy Robert; *Dir Educ* Laura Dickstein-Thompson
Open Tues - Fri 10 AM - 4:30 PM, Sat & Sun Noon - 5 PM, cl Mon; Mus only admis adults $3.50, children $2; mus & planetarium adults $5.50, children $3; Founded 1934, chartered by the New York State Regents in 1937 to increase & diffuse knowledge in appreciation of art, history, industry & science by providing collections, exhibits, lectures & other programs; Sales & rental gallery is maintained; Average Annual Attendance: 60,000; Mem: 1,500; dues family $45, individual $30, student & senior citizens $15; annual meeting in Oct
Income: Mem, donations, grants
Special Subjects: Painting-American, American Indian Art, African Art, Textiles
Collections: Decorative arts; 19th & 20th century art; 19th & 20th century costumes & textiles; regional art; science & technology

Exhibitions: Electron City; Out of the Ordinary; Sense & Perception; Reptiles & Amphibians; Continuous Costume Exhibits
Publications: Annual Report; Museum Notes, bi-monthly; exhibition catalogues
Activities: Art & craft classes; Festival of Nations; Crafts Fair; Rock Festival; Haunted House; Museum Ball; docent training; lect open to public; concerts; gallery talks; tours; materials & exhibits lent to area schools, colleges & libraries; book traveling exhibitions 3-4 per year; museum shops sell books, original art, reproductions, prints & crafts
L Hall of Electrical History, Nott Terrace Heights, Schenectady, NY 12308. Tel 518-382-7890; Internet Home Page Address: www.schenectadymuseum.org; *Dir* Bart A Roselli
By appt only; No admis fee; Estab 1969; For reference & technical information only, by appointment only; Mem: Part of museum
Income: Part of museum
Collections: 1,500,000 photos & papers relating to the electrical industry from 1881 to present; 2000 artifacts

SEA CLIFF

M SEA CLIFF VILLAGE MUSEUM, 95 Tenth Ave, Sea Cliff, NY 11579; PO Box 72, Sea Cliff, NY 11579. Tel 516-671-0090; Fax 516-671-2530; Elec Mail seacliffmuseum@aol.com; *Dir, Treas & Cur* Sara Reres; *Vol Chmn* Patricia F Smith; *Mus Shop Mgr* Anne Gutierrez
Open Sat & Sun 2 - 5 PM; cl Jan & Jun - Aug; No admis fee, donations accepted; Estab 1979; Housed in former Sea Cliff Methodist Church built in 1913, the mus is made of brick & stucco and is of Tudor style; mus focuses on Sea Cliff history from 1870 - mid 20th c; Average Annual Attendance: 1000; Mem: dues Family $25, Indiv $10, Senior $10
Income: municipal govt
Collections: Over 3000 photos, artifacts, documents & costumes that span this time period
Publications: Friends, biannual newsletter
Activities: Friends Exhib Opening Reception; two lects per yr

SENECA FALLS

M SENECA FALLS HISTORICAL SOCIETY MUSEUM, 55 Cayuga St, Seneca Falls, NY 13148. Tel 315-568-8412; Fax 315-568-8426; Elec Mail sfhs@flare.net; *Pres* Philomena Cammuso; *Exec Dir* Lesa Compton
Open Mon - Fri 9 AM - 4 PM; Admis adult $3, children & students $1.50; Estab 1896 as an educational institution dedicated to the preservation & interpretation of Seneca County; Victorian 23 room house with decorative arts collection; Average Annual Attendance: 9,000; Mem: 600; dues family $30, single $15; annual meeting in Feb
Income: $100,000 (financed by endowment, mem, city, state & federal appropriation, United Way)
Special Subjects: Decorative Arts, Historical Material, Period Rooms
Collections: Victoriana; Women's Rights Memorbilia
Publications: Reprints of archival material
Activities: Classes for adults & children; docent training; school group programs; lect open to public, 8 vis lectrs per year; concerts; gallery talks, tours; original objects of art lent to other institutions; sales shop sells books & reproductions

SETAUKET

M GALLERY NORTH, 90 N Country Rd, Setauket, NY 11733. Tel 516-751-2676; Fax 516-751-0180; Elec Mail gallerynorth@aol.com; Internet Home Page Address: www.gallerynorth.org; *VPres* Elizabeth Goldberg; *VPres* William Johnson; *Asst* Carolyn Fell; *Treas* David Lebens; *Dir* Colleen W. Hanson
Open Tues - Sat 10 AM - 5 PM, Sun 1 - 5 PM; No admis fee; Estab 1965 to exhibit the work of contemporary Long Island artists & crafts people; Gallery is housed in Victorian building with 3 main exhibition rooms; Average Annual Attendance: 10,000; Mem: 185; dues $50 - $1000; quarterly meetings
Income: $210,000 (financed by mem, sales & fundraisers)
Library Holdings: Book Volumes; Memorabilia; Periodical Subscriptions
Exhibitions: Eight changing exhibitions per yr; annual outdoor art show open to artists & crafts people
Activities: Lect open to public; tours; artist workshops; competitions with awards; 6 vis lectrs per yr; gallery talks; art scholarship - graduating HS Senior; sales shop sells crafts from local artists & imported crafts, original art & reproductions

SKANEATELES

M JOHN D BARROW ART GALLERY, 49 E Genesee St, Skaneateles, NY 13152. Tel 315-685-5135; Internet Home Page Address: www.johndbarrowgallery.com; *Dir* Margaret M Whitehouse; *Treas* Elizabeth K Dreyfus
Open May 1 - Labor Day Mon - Fri 11 AM - 4 PM; mid - Sept to Christmas Tues, Thurs & Sat 1 PM - 4 PM; No admis fee; Estab in 1900 to exhibit paintings of John D Barrow; Three rooms with unusual feature of tiered paintings built in a wainscoting; Average Annual Attendance: 2,000
Income: Financed by donations
Special Subjects: Painting-American
Collections: Paintings of John D Barrow 1824 - 1906
Activities: Docent training; private & school children tours; lect open to public; gallery talks; lending of original obects of art to individuals & area businesses; postcards, ornaments

A SKANEATELES LIBRARY ASSOCIATION, 49 E Genesee St, Skaneateles, NY 13152. Tel 315-685-5135; Internet Home Page Address: www.skaneateles.com; *Pres* Meg O'Connell
Open Mon, Wed, Fri, Sat 10 AM - 5 PM, Tues & Thurs 10 AM - 8:30 PM, and by request; Library estab 1890; Gallery estab 1900 to display paintings of John D

Barrow; Annex of Library, 2 rooms, one with single & one with triple wainscoting of paintings; Mem: Ann meeting
Income: Financed by annual fundraising drive & endowments
Collections: 300 paintings by John D Barrow; 19th century landscapes & portraits
Exhibitions: Occasional special exhibitions
Activities: Annual guided tours for 4th graders; docent training; occasional open lect; gallery talks; tours; paintings lent for one year on the condition that borrower pays for restoration

SOUTH SALEM

A TEXTILE CONSERVATION WORKSHOP INC, 3 Main St, South Salem, NY 10590. Tel 914-763-5805; Fax 914-763-5549; *Dir* Patsy Orlofski
Call for hrs

SOUTHAMPTON

M THE PARRISH ART MUSEUM, 25 Jobs Lane, Southampton, NY 11968. Tel 631-283-2118; Fax 631-283-7006; Elec Mail fergusone@parrishart.org; Internet Home Page Address: www.thehamptons.com; *Dir* Trudy Kramer; *Deputy Dir* Anke Jackson; *Lewis B. & Dorothy Cullman Chief Cur, Art & Educ* Alicia Longwell; *Registrar* Chris McNamara
Open Mon, Thurs - Sat 11 AM - 5 PM, Sun 1 - 5 PM; open every day June - mid-Sept; Admis suggested donation $5, seniors & students $3, mem free; Estab 1898 to exhibit, care for & research permanent collections & loan works of art with emphasis on American 19th & 20th century art and the art of Eastern Long Island; Three main galleries are maintained; total dimensions 4288 sq ft, 355 running feet; Average Annual Attendance: 40,000; Mem: 1800; dues $15-$1000 & up; annual meeting in Oct
Income: Financed by contributions & grants
Library Holdings: Book Volumes; Clipping Files; Exhibition Catalogs; Original Documents; Periodical Subscriptions; Photographs; Prints; Slides
Special Subjects: Drawings, Photography, Sculpture, Painting-American, Etchings & Engravings, Oriental Art, Reproductions
Collections: William Merritt Chase Collection; Dunnigan Collecton of 19th century etchings; Samuel Parrish Collection of Italian Renaissance panel; Fairfield Porter Collection; American paintings, 19th & 20th century; Japanese woodblock prints & stencils
Activities: Classes for adults & children; dramatic programs; docent training; lect open to public, special lect; concerts; gallery talks; tours; individual paintings & original objects of art lent; traveling exhibitions organized & circulated; museum shops sells books, original art, jewelry, notecards, prints, educational toys; gifts, posters & stationery

STAATSBURG

M NEW YORK STATE OFFICE OF PARKS, RECREATION & HISTORICAL PRESERVATION, Mills Mansion State Historical Site, Old Post Rd, PO Box 308 Staatsburg, NY 12580. Tel 845-889-4100; 889-8851; Fax 845-889-8321; *Historic Site Mgr* Melodye Moore
Open Apr 1 - Oct 31, Wed - Sat 10 AM - 5 PM, Sun Noon - 5 PM; No admis fee; Estab 1938 to interpret lifestyle of the very affluent segment of American society during the period 1890-1929; Average Annual Attendance: 10,000
Special Subjects: Period Rooms
Collections: Original furnishings, paintings, prints, decorative art objects and tapestries from Mr and Mrs Mills
Activities: Docent training; workshops; lects open to the public; concerts; gallery tours; loans of paintings or original art objects have to be approved by New York State Office of Parks and Recreation, Division of Historic Preservation

STATEN ISLAND

M JACQUES MARCHAIS MUSEUM OF TIBETAN ART, 338 Lighthouse Ave, Staten Island, NY 10306. Tel 718-987-3500 (main office); Fax 718-351-0402; Internet Home Page Address: www.tibetanmuseum.org; *Exec Dir* Meg Ventrudo; *Cur* Sarah Johnson
Open Wed - Sun 1 - 5 PM; Admis adults $5, seniors & students $3, children under 12 $2; Estab 1945 The mission of the Jacques Marchais Museum of Tibetan Art is to foster interest, research, & appreciation of the art and culture of Tibet & other Asian countries through collections, preserving & interpreting art objects & photographs & making them available to the public through exhibitions, programs & publications; The Jacques Marchais Museum of Tibetan Art displays its collection of Tibetan art in two Himalayan-style fieldstone buildings set in a terraced hillside in Staten Island; Average Annual Attendance: 17,000
Income: Financed by membership dues & contributions, city, state & federal appropriations, foundation & corporate grants
Purchases: Art, artifacts & photographs related to Tibet & other Asian countries
Library Holdings: Auction Catalogs; Audio Tapes; Book Volumes; Cassettes; Clipping Files; Compact Disks; DVDs; Exhibition Catalogs; Lantern Slides; Manuscripts; Maps; Memorabilia; Motion Pictures; Original Art Works
Special Subjects: Decorative Arts, Historical Material, Furniture, Photography, Silver, Maps, Sculpture, Bronzes, Anthropology, Ethnology, Textiles, Religious Art, Portraits, Oriental Art, Asian Art, Metalwork, Carpets & Rugs, Calligraphy, Miniatures, Period Rooms, Reproductions
Collections: Tibetan, Mongolian, Nepalese & Chinese art including sculpture, paintings, textiles, furniture, as well as the archive & library of Jacques Marchais
Exhibitions: (2/07-8/08) From Staten Island to Shangri La: The Collecting Life of Jacques Marchais
Publications: Treasures of Tibetan Art: The Collections of the Jacques Marchais Museum of Tibetan Art
Activities: The museum features a diverse range of programming - rotating exhibitions, musical concerts, lectures, films, children's workshops, yoga, tai chi, & meditation courses.; 10-15 lectures per year open to the public; exten servs New York City; individual paintings & original objects of art lent to museums for

special exhibits; originate traveling exhibitions - 1-2 annually; museum shop sells books, crafts, Tibetan carpets, wooden masks, jewelry, CDs & music tapes, posters, prints, textiles, gift ware & unique items from various Asian countries

M THE JOHN A NOBLE COLLECTION, 1000 Richmond Terrace, Staten Island, NY 10301. Tel 718-447-6490; Fax 718-447-6056; *Dir* Erin Urban
Open weekdays 1 - 5 PM; No admis fee; Estab 1986 to present art & maritime history; Permanent installation of John A Noble's Houseboat Studio; art; gallery for changing exhibitions of prints & maritime history; Average Annual Attendance: 5,000; Mem: 500; dues $25; annual meeting in Apr
Income: $100,000 (financed by mem, state & city appropriation)
Special Subjects: Drawings, Prints, Manuscripts, Marine Painting, Historical Material
Collections: Archives; Art; Maritime Artifacts
Publications: Hold Fast, quarterly newsletter
Activities: Classes for adults & children; lect open to public; lending collection contains 80 paintings & art objects

M ORDER SONS OF ITALY IN AMERICA, Garibaldi & Meucci Museum, 420 Tompkins Ave, Staten Island, NY 10305. Tel 718-442-1608; Elec Mail gmmuseum@aol.com; Internet Home Page Address: www.community.silive.com/cc/garibaldimeucci; *Dir* Anne Alarcon
Open Tues - Sun 1 - 4:30 PM; Admis $3; Estab 1919 to collect, preserve & interpret material pertaining to Italian culture; Circ 12,000; Average Annual Attendance: 70,000; Mem: 400; dues $25
Income: $140,000 (financed by endowment, mem, city & state appropriation, Order Sons of Italy in America)
Special Subjects: Prints, Bronzes, Decorative Arts, Coins & Medals, Painting-Italian
Collections: Books; Bronzes; Coins; Decorative Arts; Medals; Paintings; Paper; Photographs; Prints; Stamps; Weapons; Giuseppe Garibaldi's "Red Shirt"
Exhibitions: Historical exhibitions; Antonio Meucci "The True Inventor of the Telephone"
Activities: Classes for adults & children; lect open to public, many programs per year

M SNUG HARBOR CULTURAL CENTER, Newhouse Center for Contemporary Art, 1000 Richmond Terrace, Staten Island, NY 10301. Tel 718-448-2500; Fax 718-442-8534; Elec Mail fverpoorten@snug-harbor.org; Internet Home Page Address: www.snug-harbor.org; *Dir Visual Arts* Frank Verpoorten
Open Tues - Sun 10 AM - 5 PM; Admis $3; Estab 1977 to provide a forum for regionally & nationally significant visual art; Average Annual Attendance: 50,000
Income: Financed by mem, city & state appropriation, corporate funds
Library Holdings: Exhibition Catalogs; Original Documents; Photographs; Prints; Records; Slides; Video Tapes
Collections: Changing exhibits
Exhibitions: Outside The Frame: Performance Art 1950's to present; Neighborhoods: The Story of Staten Island; Woman's Art Caucus; Abstraction After the Fall: Abstract Art after 1970; New Island Artists
Publications: Exhibition catalogs
Activities: Classes for adults & chidren; children's programs; docent programs; lect open to public; gallery talks; tours; mus shop sells books & reproductions

M STATEN ISLAND INSTITUTE OF ARTS & SCIENCES, 75 Stuyvesant Pl, Staten Island, NY 10301. Tel 718-727-1135; Fax 718-273-5683; Elec Mail hbehnke@statenislandmuseum.org; Internet Home Page Address: www.statenislandmuseum.org; *Chmn Board* Joe Dezio; *Cur History* Patricia Salmon; *Cur Science* Edward Johnson; *VPres Educ* Maria Fiorelli; *Dir Exhib & Programs* Diane Matyas; *VPres Mktg & Develop* Henryk Behnke
Open Tues - Fri 9 AM - 5 PM, Sat 10 AM - 5 PM, Sun 12 - 5 PM, Mon by appointment; Admis adult $2, seniors & students $1; Estab 1881, inc 1906; Average Annual Attendance: 65,000; Mem: 500; dues $25 & up
Library Holdings: Book Volumes; Manuscripts; Maps; Original Documents; Photographs; Reproductions
Special Subjects: Decorative Arts, Etchings & Engravings, Historical Material, Landscapes, Marine Painting, Ceramics, Glass, Flasks & Bottles, Furniture, Pre-Columbian Art, Painting-American, Textiles, Bronzes, Woodcuts, Manuscripts, Maps, Sculpture, Tapestries, Graphics, Painting-American, Photography, Prints, Sculpture, African Art, Ethnology, Costumes, Religious Art, Crafts, Pottery, Primitive art, Portraits, Posters, Jade, Jewelry, Porcelain, Oriental Art, Silver, Painting-Dutch, Ivory, Scrimshaw, Coins & Medals, Baroque Art, Miniatures, Renaissance Art, Embroidery, Laces, Medieval Art, Antiquities-Oriental, Antiquities-Greek, Antiquities-Roman, Reproductions
Collections: American paintings of the 19th & 20th centuries; Oriental, Greek, Roman & primitive art objects; prints & small sculptures; science & history publs; history, archives, postcards; Natural Science Collection, Entomology, Botany
Exhibitions: Decorative arts; design exhibitions in various media; major loan shows of paintings & prints; special exhibitions of graphic arts & of photography; permanent: Staten Island Ferry, The Lenape: The First Staten Islanders, Hall of Natural Science; changing art exhibits
Publications: Annual Reports; catalog; Proceedings (scholarly book), The Cemeteries of Staten Island
Activities: Fall & spring terms for adults & children classes; teacher training; lect on art & science open to public; complete program of lectr, art & natural history for school children with annual registration of 47,000; concerts; gallery talks; tours; competitions with awards; exhib circulate to College of SI; museum shop sells books, original art, reproductions, ferry mugs & magnets

L Archives Library, 75 Stuyvesant PL, Staten Island, NY 10301. Tel 718-727-1135; Fax 718-273-5683; Elec Mail salmonf@aol.com; *Archivist & Researcher* Dorothy A D'Eletto
Open Mon-Sat 9AM-5PM, Sun 1-5PM, Archives Hrs Tue-Thur 10AM-4PM; Admis adults $2, seniors $1, under 12 free; Estab for research and reference only; History, Arts & Sciences exhibitions; Mem: Dues family $50, indiv $35, others $25
Library Holdings: Audio Tapes; Book Volumes 30,000; Clipping Files; Exhibition Catalogs; Lantern Slides; Manuscripts; Maps; Memorabilia; Micro

Print; Original Art Works; Original Documents; Other Holdings; Pamphlets; Periodical Subscriptions 10; Photographs; Prints; Reproductions; Sculpture; Slides; Video Tapes

Special Subjects: Folk Art, Photography, Manuscripts, Maps, Painting-American, Prints, Portraits, Watercolors, Archaeology, Asian Art, Furniture, Glass, Landscapes, Flasks & Bottles, Architecture

Collections: George W Curtis Collection of books, manuscripts & memorabilia; reference collection of 30,000 publications in science & art history; a choice collection of Staten Island newspapers from 1834-1934 on microfilm; letters, documents, journals, files of clippings & old photographs relating to the history of Staten Island & the metropolitan region; ferry collection, architecture, environmental, genealogy

Activities: Classes for adults & children; dramatic programs; lect open to the public; museum shop sells book, reproductions & prints

STONE RIDGE

M ULSTER COUNTY COMMUNITY COLLEGE, Muroff-Kotler Visual Arts Gallery, Stone Ridge, NY 12484. Tel 845-687-5113; *Gallery Coordr* Susan Jeffers
Open Mon - Fri 11 AM - 3 PM, fall & spring semesters, cl summer; No admis fee; Estab 1963 as a center for creative activity; Gallery is maintained as an adjunct to the college's cultural & academic program; John Vanderlyn Hall has 40 x 28 ft enclosed space & is located on the campus; Average Annual Attendance: 3,000

Income: Financed by college funds
Special Subjects: Drawings, Painting-American, Photography, Prints, Sculpture
Collections: Contemporary drawings, paintings, photographs, prints, sculpture, historical works
Exhibitions: 6 exhibitions per year annual student show
Publications: Flyers announcing each exhibit, every four to six weeks
Activities: Lect open to public, 2-3 vis lectrs per year; concerts

STONY BROOK

M THE LONG ISLAND MUSEUM OF AMERICAN ART, HISTORY & CARRIAGES, 1200 Rte 25A, Stony Brook, NY 11790. Tel 631-751-0066; Fax 631-751-0353; Internet Home Page Address: www.longislandmuseum.org; *Pres & CEO* Jackie Day; *Dir Develop* Jim Rennert; *Develop Assoc* Alisha Rocchetta; *Dir Admin* Steve Blum; *Dir Pub Relations* Tara McGuire; *Dir Coll & Interpretation* William S Ayres; *Art Cur* Eva Greguski; *Coll Mgr* Christa Zaros; *Designer & Preparator* Daniel Kitchen; *Dir Educ* Betsy Radecki
Open Wed - Sat 10 AM - 5 PM, Sun Noon - 5 PM; Admis adults $7, seniors $6, students $3, children 6-12 $3, under 6 & mems free; Estab 1946 to make Long Island history & American Art available to pub; The Museums' 22 buildings, 13.5 acre complex include a History Mus, Art Mus, Carriage Mus, various period buildings, a mus store & the Hawkins-Mount House (currently not open to the pub); Average Annual Attendance: 50,000; Mem: 1000; dues $25-$5000
Library Holdings: Auction Catalogs; Book Volumes; Clipping Files; Exhibition Catalogs; Kodachrome Transparencies; Manuscripts; Maps; Original Art Works; Original Documents; Pamphlets; Periodical Subscriptions; Photographs; Prints; Records; Sculpture; Slides; Video Tapes
Special Subjects: Architecture, Drawings, Painting-American, Prints, American Western Art, Costumes, Ceramics, Crafts, Folk Art, Decorative Arts, Collages, Dolls, Furniture, Glass, Historical Material, Juvenile Art, Coins & Medals, Embroidery
Collections: Paintings & drawings by William Sidney Mount & other American Artists including Shepard Alonzo Mount, Henry S Mount, William M Davis, Edward Lange, Charles H Miller; costumes; toys & dolls; decoys; textiles; carriages & carriage accoutrements; miniature rooms; American historical artifacts
Publications: Annual Report; Quarterly Newsletter; exhibition catalogs; brochures
Activities: Classes for adults & children; docent training; lect open to public; concerts; gallery talks; tours; sponsoring of competitions; individual paintings & original objects of art lent to qualifying institutions; organizes 1-4 traveling exhibitions per year; originate traveling exhibitions to history & art museums; museum shop sells books, magazines, original art, reproductions, prints, slides & gift items

L Library, 1200 Rte 25A, Stony Brook, NY 11790. Tel 631-751-0066; Fax 631-751-0353; Internet Home Page Address: www.longislandmuseum.org; *Pres & CEO* Jacqueline Day; *Dir Colls & Interpretation* William Ayres; *Librn, Archivist & Art Cur* Eva Greguski; *Colls Mgr* Christa Zaros; *Curatorial Asst* Andrea L Forni
Open Wed - Sat 10 AM - 5 PM, Sun Noon - 5 PM; Admis adults $7, seniors 60 & up $5, students 6-17 & college with id $3, children free; Estab 1935; 3 galleries: art, history & carriage; Average Annual Attendance: 70,000
Library Holdings: Auction Catalogs; Book Volumes 2194; Cards; Clipping Files; Exhibition Catalogs; Framed Reproductions; Lantern Slides; Manuscripts; Memorabilia; Motion Pictures; Original Art Works; Other Holdings Trade catalogs; Pamphlets; Periodical Subscriptions 62; Photographs; Prints; Reproductions; Sculpture; Slides; Video Tapes
Special Subjects: Art History, Folk Art, Decorative Arts, Drawings, Graphic Arts, History of Art & Archaeology, American Western Art, Advertising Design, Fashion Arts, Art Education, Anthropology, Embroidery, Jewelry, Marine Painting, Flasks & Bottles
Collections: William Cooper, shipbuilder, 19th century, Sag Harbor; Israel Green Hawkins, Edward P Buffet, Hal B Fullerton; Daniel Williamson & John Williamson, Stony Brook, Etta Sherry; 19th through 21st century art, history & carriage artifacts; Artworks & papers of William Sidney Mount, Long Island; Carriage & horse drawn vehicles, clothing, furniture, decoys
Activities: Classes for adults & children; dramatic programs; docent training; lect open to public, 20 vis lect per yr; concerts; gallery talks; tours; average four; organize traveling exhibitions; museum shop sells books, reproductions, various jewelry & decorative items

M STATE UNIVERSITY OF NEW YORK AT STONY BROOK, University Art Gallery, Stony Brook, NY 11794-5425. Tel 516-632-7240; *Dir* Rhonda Cooper
Open Tues - Fri Noon - 4 PM, Sat 7 - 9 PM; No admis fee; Estab 1967 to serve both the campus and the community by exhibiting student and professional artists;

One gallery 41 x 73 with 22 ft ceiling; second space 22 x 73 ft with 12 ft ceilings; Average Annual Attendance: 10,000 students & members of the community per show
Income: Financed by state appropriation & donations
Publications: Catalogues, four times a year
Activities: Lects open to the public, bi-monthly, 2 - 4 vis lectrs per year; traveling exhibitions

SYRACUSE

M EVERSON MUSEUM OF ART, 401 Harrison St, Syracuse, NY 13202. Tel 315-474-6064; Fax 315-474-6943; Elec Mail eversonadmin@everson.org; Internet Home Page Address: www.everson.org; *Dir* Sandra Trop; *Acting Cur* Kathryn Martini; *Develop Dir* Helen Dewey; *Dir Pub Information* Sarah Tiedamann; *Pres Bd Trustees* Arthur Grant; *Asst Develop Dir* Barbara Godfrey; *Catalogs* Joyce Bird; *Docent Coordr* Mari Shopsis
Open Tues - Fri Noon - 5 PM, Sat 10 AM - 5 PM, Sun Noon - 5 PM, cl Mon; Admis $5 suggested donation; Estab 1896 to present free exhibitions by lending artists, chiefly American to serve as an educational element for the cultural & general community; The Syracuse China Center of the Study of American Ceramics provides 4022 sq ft of open storage for the museum's collection of 2000 pieces of American ceramics, ranging from Native American pots, circa AD 1000, to contemporary ceramic sculpture & vessel forms, also includes study collections of world ceramics, numbering 2000 objects; Average Annual Attendance: 72,000; Mem: 2000; dues general $35, seniors $25
Income: Financed by mem, county & state appropriation, New York Council on the Arts, gifts & grants
Library Holdings: Auction Catalogs; Book Volumes; Clipping Files; Exhibition Catalogs; Periodical Subscriptions
Special Subjects: Painting-American, Sculpture, African Art, Ceramics, Portraits, Porcelain, Oriental Art
Collections: African Collection; contemporary American ceramics; contemporary American painting & sculpture; 17th, 18th & 19th century English porcelain; traditional American painting & portraiture; video-tape collection; Cloud Wampler Collection of Oriental Art
Publications: Art books; Quarterly bulletin; Educational materials; exhibition catalogs
Activities: Docent training; classes for adults & children; educ dept services public schools of Syracuse; lect open to public; 4-6 vis lectrs per yr; concerts; gallery talks; tours; competitions; originate traveling exhibitions to nat museums; museum & sales shop selling books, original art, reproductions

M LEMOYNE COLLEGE, Wilson Art Gallery, Le Moyne Heights, Syracuse, NY 13214-1399. Tel 315-445-4331; Internet Home Page Address: www.lemoyne.edu; *Adj Assoc Prof Philosophy* Dr Donald Arentz; *Periodical Librn* Lynnette Stevens; *Library Dir* James J Simonis
Open Mon - Thurs 9 AM - 11 PM, Fri 9 AM - 9 PM, Sat & Sun 9 AM - 5 PM; No admis fee; Estab 1966; Average Annual Attendance: 1,500
Income: Financed through the Faculty Art Gallery Committee
Collections: Paintings, etchings, prints & watercolors
Exhibitions: Student Art Exhibitions
Activities: Individual painting & original objects of art lent

A LIGHT WORK, Robert B Menschel Photography Gallery, 316 Waverly Ave, Syracuse, NY 13244-3010. Tel 315-443-1300, 443-2450; Fax 315-443-9516; Elec Mail mwstaven@syr.edu; Internet Home Page Address: www.lightwork.org; *Assoc Dir* Gary Hesse; *Prog Coordr* Mary Lee Hodgens; *Dir* Jeffrey Hoone; *Darkroom Mgr* Vernon Burnett; *Archivist & Data Mgr* Marianne Stavenhagen; *Digital Lab Mgr* John Mannion
Galleries open daily Noon - 10 PM, darkrooms Sun - Fri, Noon - 8 PM; Galleries no admis fee, darkrooms carry semester lab fee; Estab 1973 to support artists working in the photographic arts; Maintains small reference library
Income: Financed by Nea, NYSCA, Institute of Museum & Library Services & private contributions
Special Subjects: Photography
Collections: Light Work Collection, photographic prints
Exhibitions: Temporary exhibitions held throughout the year
Publications: Contact, Sheet, 5 per year
Activities: Classes for adults; lect open to public, 4 vis lectrs per year; gallery talks; competitions with awards; artist residence grants offered; original objects of art lent; lending collection contains 2000 photographs; book traveling exhibitions occasionally; originate traveling exhibitions through New York State Gallery Association; sales shop sells magazines & prints

SYRACUSE UNIVERSITY

M SUArt Galleries, Tel 315-443-4097; Fax 315-443-9225; Elec Mail dlprince@syr.edu; Internet Home Page Address: www.suart.syr.edu; *Designer & Preparator* Bradley Hudson; *Dir* Domenic J Iacono; *Assoc Dir* David Prince; *Registrar* Laura Wellner; *Designer & Preparator* Andrew Saluti
Open Tues - Sun 11 AM - 4:30 PM; No admis fee; Estab 1952 to present art exhibitions to inform university & communities of central upstate New York areas of international heritage of art, new advances in contemporary art with emphasis on the discovery of regional values, outstanding local art including faculty & student work; Mus Training Program complements our exhibition program. 7134 sq ft of space normally divided into separate galleries by movable walls; Average Annual Attendance: 20,000
Income: Financed through University with additional outside grants
Special Subjects: Decorative Arts, Drawings, Etchings & Engravings, Folk Art, Ceramics, Glass, Metalwork, Photography, Pre-Columbian Art, Painting-American, Prints, Textiles, Bronzes, Woodcuts, Painting-French, Sculpture, Watercolors, African Art, Religious Art, Coins & Medals, Laces, Cartoons
Collections: Encyclopedic from pre-history to contemporary strength in 20th century American art & prints
Exhibitions: Various exhibitions, call for details
Activities: Classes for adults & children; lec open to public; gallery tours; private tours on request; originate traveling exhibitions organized & circulated for small & medium mus & galleries

M **Art Collection,** Tel 315-443-4097; Fax 315-443-9225; Internet Home Page Address: sumweb.syr.edu/suart/; *Assoc Dir* Domenic J Iacono; *Cur* David Prince; *Preparator* William Kramer; *Registrar* Laura Wellner; *Dir* Alfred T Collette
Open Mon - Fri 9 AM - 5 PM; No admis fee; The Art Collection is housed in a temperature & humidity-controlled area of Sims Hall, adjacent to the Art Gallery. Used primarily for exhibition, storage & care of the 35,000 object collection, this facility also includes a teaching display area to accommodate classes & individuals involved in research; Average Annual Attendance: 15,000
Income: Financed by university funds & endowments
Purchases: WPA Federal Art Projects Prints, Contemporary American Prints, 20th Century American Art
Special Subjects: Drawings, Graphics, Painting-American, Bronzes, African Art, Ceramics, Etchings & Engravings, Landscapes, Decorative Arts, Glass, Oriental Art, Painting-French, Laces, Cartoons, Painting-German
Collections: West African tribal art; Korean, Japanese & American ceramics; Indian folk art; Pre-Columbian & contemporary Peruvian ceramics; Scandinavian designs in metal, wood, clay & textiles; 20th century American works with an emphasis on the Depression & War years (prints & paintings); 19th century European Salon paintings; history of printmaking (emphasis on American artists); decorative arts; Mary Petty-Alan Dunn Center for Social Cartooning
Exhibitions: Rembrandt: The Consumate Etcher (subject to change); Thematic Interpretation in Western Art, John R Fox Collection of Korean Ceramics, American Woodblock Prints 1900-1995
Activities: Originate traveling exhibitions to small museums, university museums, galleries & libraries

L **Syracuse University Library,** Tel 315-443-2440; Fax 315-443-9510; Elec Mail artdesk1@library.syr.edu; Internet Home Page Address: libwww.syr.edu; *Fine Arts Librn* Randall Bond; *Architecture Librn* Barbara A Opar; *Music Librn* Carole Vidali; *Slide Coll Supv* Susan Miller
Open Mon - Thurs 8 AM - 10 PM, Fri 8 AM - 6 PM, Sat 10 AM - 6 PM, Sun Noon - 10 PM; Estab 1870 for reference & research in the history of art
Library Holdings: Audio Tapes; Book Volumes 82,420; Cards; Cassettes 1500; DVDs; Exhibition Catalogs 15,000; Fiche; Filmstrips; Manuscripts; Micro Print; Motion Pictures; Other Holdings Compact discs 4000; Picture file 27,000; Periodical Subscriptions 335; Photographs; Records 20,000; Reels; Slides 370,000; Video Tapes
Collections: Manuscript Collections of many American artists

TARRYTOWN

M **HISTORIC HUDSON VALLEY,** 150 White Plains Rd, Tarrytown, NY 10591. Tel 914-631-8200; Fax 914-631-0089; Elec Mail mail@hudsonvalley.org; Internet Home Page Address: www.hudsonvalley.org; *Pres* Waddell Stillman; *Librn* Catalina Hannan; *Cur* Kathleen E Johnson; *Dir Finance* David Parsons; *Dir Devel* Peter Pockriss; *Dir Human Resources* Karen Sharman; *Dir Pub Relations* Rob Schweitzer
Call office for hours, cl Tues, Thanksgiving Day, Christmas, New Year's Day & Jan - Feb; Admis to Sunnyside, Philipsburg Manor & Van Cortlandt Manor adults $9 each property, seniors $8, juniors 6-17 $5 each property; Kykuit visitation program adults $22, reservations not required; groups of 10 or more must make reservations in advance; Chartered 1951 as a nonprofit educational foundation; Owns & operates six historic properties which are Sunnyside in Tarrytown, the home of author Washington Irving; Philipsburg Manor in Sleepy Hollow, A Dutch-American gristmill-farm site of the early 1700s; Van Cortlandt Manor in Croton-on-Hudson, a manorial estate of the Revolutionary War period; Montgomery Place in Annandale-on-Hudson- a 434 acre estate overlooking the Hudson River, Catskill Mountains, and the Union Church of Pocantico Hills, with windows by Matisse. Historic Hudson Valley also operates the visitation program of Kykuit, the Rockefeller estate in Sleepy Hollow, NY; Average Annual Attendance: 200,000
Library Holdings: Auction Catalogs; Book Volumes; Clipping Files; Exhibition Catalogs; Lantern Slides; Manuscripts; Maps; Memorabilia; Original Art Works; Original Documents; Pamphlets; Periodical Subscriptions; Photographs; Prints; Reels; Reproductions
Special Subjects: Decorative Arts
Collections: Memorabilia of Washington Irving, Van Cortlandt and Philipse families; 17th, 18th and 19th century decorative arts
Exhibitions: Beauty and the Brick (online)
Publications: American Industrialization, Economic Expansion, & the Law; America's Wooden Age; Aspects of Early New York Society & Politics; Bracebridge Hall; Business Enterprise in Early New York; Diedrich Knickerbocker's A History of New York; An Emerging Independent American Economy: 1815-1875; The Family Collections at Van Cortlandt Manor; The Howe Map; The Hudson River 1850-1918, A Photographic Portrait; Life Along the Hudson; Life of George Washington; The Loyalist Americans; Material Culture of the Wooden Age; The Mill at Philipsburg Manor, Upper Mills, & a Brief History of Milling; Old Christmas; Party & Political Guidebook; A Portfolio of Sleepy Hollow Prints; Rip Van Winkle & the Legend of Sleepy Hollow; Six Publications related to Washington Irving; An American Treasure: The Hudson River Valley; Cross Roads and Cross Rivers: Diversity in New York; Beauty and the Brick; The Great Estates regions of the Hudson River; Great Houses of the Hudson River
Activities: Classes for adults and children; docent training; demonstrations of 17th and 18th century arts and crafts; lectures open to the public; guided tours by interpreters in period clothing; candlelight tours; gallery talks; John D Rockefeller Founder's Award (annual); Hudson Valley Hero (annual); sales shop sells books, original art, reproductions, prints & slides

L **Library,** 150 White Plains Rd, Tarrytown, NY 10591. Tel 914-631-8609; Fax 914-631-3591; Elec Mail hhulibrarian@hotmail.com; Internet Home Page Address: www.hudsonvalley.org; *Librn* Catalina Hannan
Tues-Thurs 9-5 by appointment; Specialized reference library with particular emphasis on 17th, 18th and 19th century living in the Hudson River Valley and Washington Irving
Income: financed by donations, gifts, grants
Library Holdings: Auction Catalogs; Book Volumes 5000; Exhibition Catalogs; Manuscripts; Periodical Subscriptions 123; Reels

M **THE NATIONAL TRUST FOR HISTORIC PRESERVATION,** (The Lyndhurst Museum) Lyndhurst, 635 S Broadway, Tarrytown, NY 10591. Tel 914-631-4481; Fax 914-631-5634; Elec Mail lyndhurst@nthp.org; Internet Home Page Address: www.lyndhurst.org; *Asst Dir* Cathryn Anders; *Cur Educ* Judith Beil
Open mid Apr - Oct Tues - Sun 10 AM - 5 PM, Nov - mid Apr weekends only 10 AM - 5 PM; Admis adults $10, seniors $9, students $4, children 12-17 $4, group rates by arrangement, free to National Trust members; National Trust Historic site & a National Historic Landmark. Lyndhurst is a Gothic revival mansion designed in 1838 for General William Paulding by Alexander Jackson Davis, one of America's most influential 19th century architects. Commissioned in 1865 by second owner George Merritt to enlarge the house, Davis continued the Gothic revival style in the additions. It was purchased in 1880 by Jay Gould & willed to his daughter, Helen. Later acquired by another daughter, Anna, Duchess of Talleyrand-Perigord, Lyndhurst was left to the National Trust in 1961; Period rooms with original furnishings owned by Lyndhurst families; Average Annual Attendance: 90,000; Mem: 1100; dues $35-$1000
Income: Financed by admis fees, mem, private contributions & special events
Special Subjects: Furniture
Collections: Collection of Gothic furniture designed by architect A J Davis in the 1830s & 1860s; Herter Brothers furniture; 19th century furnishings & paintings; Tiffany glass; Tiffany glass; Jay Gould's Coll of 19th century paintings by Daubigny, Bouguereau, Gerome & others
Publications: Lyndhurst (guide book)
Activities: Classes for children; docent training; lect open to public, 3-5 vis lectrs per year; concerts; gallery talks; tours; competition; scholarships offered; individual paintings & original objects of art lent as requested for special exhibitions by museums & historical societies; museum shop sells books, magazines, reproductions, prints, slides & gift items

TICONDEROGA

M **FORT TICONDEROGA ASSOCIATION,** PO Box 390, Ticonderoga, NY 12883. Tel 518-585-2821; Fax 518-585-2210; Elec Mail mail@fort-ticonderoga.org; Internet Home Page Address: www.fort-ticonderoga.org; *Pres* Edward W Pell; *Exec Dir* Nicholas Westbrook; *Cur* Christopher D Fox; *Cur Landscape* Ellyn Mary Farrar
Open daily early May - late Oct 9 AM - 5 PM, July & Aug 9 AM - 6 PM; Admis adults $10, children $6; Estab 1909 to preserve & present the Colonial & Revolutionary history of Fort Ticonderoga; The Mus is in the restored barracks of the Colonial fort; Average Annual Attendance: 100,000; Mem: 1000; dues $35 & up
Income: Financed by admis fees, mus shop sales & donations
Library Holdings: Auction Catalogs; Book Volumes 13,000; CD-ROMs; Exhibition Catalogs; Fiche; Manuscripts; Motion Pictures; Pamphlets; Periodical Subscriptions; Photographs; Prints; Slides; Video Tapes
Special Subjects: Decorative Arts, Etchings & Engravings, Painting-American, Photography, Prints, Archaeology, Costumes, Woodcuts, Landscapes, Manuscripts, Portraits, Historical Material, Maps, Military Art, Bookplates & Bindings
Collections: Artifacts; manuscripts; paintings; prints; rare books
Exhibitions: Held in mid-May - mid-Oct
Publications: Bulletin of the Fort Ticonderoga Museum, annual
Activities: Classes for adults & children; dramatic programs; docent training; lect open to public, 10 vis lectrs per year; concerts; tours; original objects of art lent to qualified museums; museum shop sells books, magazines, reproductions, prints & slides

L **Thompson-Pell Research Center,** PO Box 390, Ticonderoga, NY 12883. Tel 518-585-2821; Fax 518-585-2210; Elec Mail mail@fort-ticonderoga.org; Internet Home Page Address: www.fort-ticonderoga.org; *Cur* Christopher D Fox; *Exec Dir* Nicholas Westbrook
Open by appointment for reference only
Income: Financed by grants, contributions & earned income
Purchases: $30,000 per year
Library Holdings: Audio Tapes; Book Volumes 18,000; Cassettes; Clipping Files; Exhibition Catalogs; Fiche; Filmstrips; Kodachrome Transparencies; Lantern Slides; Manuscripts; Memorabilia; Motion Pictures; Original Art Works; Pamphlets; Periodical Subscriptions 30; Photographs; Prints; Records; Reels; Reproductions; Sculpture; Slides; Video Tapes
Special Subjects: Etchings & Engravings, Manuscripts, Maps, Painting-American, Painting-British, Prints, Historical Material, Portraits, Archaeology, Bookplates & Bindings, Restoration & Conservation
Publications: The Bulletin of the Fort Ticonderoga Museum, annual; The Haversack, semi-annual newsletter

TROY

A **RENSSELAER COUNTY COUNCIL FOR THE ARTS,** The Arts Center of the Capital Region, 265 River St, Troy, NY 12180. Tel 518-273-0552; Fax 518-273-4591; Elec Mail info@artscenter.cc;
No admis fee; Estab 1961, a regional center for the advancement of the arts in daily life. Though education, presentation, outreach, service advocacy; The Arts Center promotes a richer community through broad participation in the making & personal experience of art
Publications: Classes for adults & children

M **RENSSELAER COUNTY HISTORICAL SOCIETY,** Hart-Cluett Mansion, 1827, 59 Second St, Troy, NY 12180. Tel 518-272-7232; Fax 518-273-1264; Elec Mail info@rchsonline.org; Internet Home Page Address: www.rchsonline.org; *Dir* Donna Hassler; *Cur* Stacy F Pomeroy Draper; *Registrar* Kathryn Sheehan; *Pres* David Brown; *VPres* John Roy; *Admin* Cynthia Silkworth; *Dir Develop* Alane Hohenberg; *Librn* James Corsaro; *Mus Shop Mgr* Sandie Reizen; *Pub Program Mgr* Ilene Frank
Open Feb - Dec Tues - Sat 10 AM - 4 PM, call for varying hours; Admis donation for adults $3; Estab 1927 to promote historical research & to collect & exhibit materials of all kinds related to the history of the Rensselaer County area including books, papers, fine & decorative arts. The Hart-Cluett Mansion is an

historic house mus with 11 furnished rooms; Average Annual Attendance: 15,000; Mem: 600; individual dues $35, family $50; annual meeting 2nd Mon in Sept
Income: $327,000 (financed by endowment, mem, grants, foundations & other contributions)
Special Subjects: Drawings, Graphics, Prints, Sculpture, Textiles, Costumes, Ceramics, Crafts, Folk Art, Pottery, Etchings & Engravings, Landscapes, Decorative Arts, Manuscripts, Dolls, Furniture, Glass, Jewelry, Silver, Carpets & Rugs, Historical Material, Ivory, Maps, Embroidery, Laces
Collections: Three centuries of fine & decorative arts, including: ceramics; costumes; Elijah Galusha 19th century furniture; paintings by local artists including C G Beauregard, Joseph Hidley & Abel Buel Moore; portraits; quilts & coverlets; silver
Publications: Annual report; quarterly newsletter
Activities: Classes for adults & children; docent training; lect open to public, 3 vis lectrs per year; concerts; gallery talks; competitions; book traveling exhibitions; traveling exhibitions organized & circulated; museum shop sells books, prints, original art & reproductions

L Museum & Library, 57 Second St, Troy, NY 12180. Tel 518-272-7232; Fax 518-273-1264; Elec Mail info@rchsonline.org; Internet Home Page Address: www.rchsonline.org; *Cur* Stacy Pomeroy Draper; *Librn* James Corsaro; *Exec Dir* Donna J Hassler; *Dir Pub Prog* Ilene Frank; *Registrar* Kathryn Sheehan
Open Tues - Sat Noon - 5 PM, cl Dec 24 - Jan 31 & major holidays; Admis adults $4, seniors $3, youth $3, children under 12 free, group rates available; Estab 1927; Circ Non-circulating; Two historic townhouse buildings; Hart-Cluett House(1827); Carr Building; Average Annual Attendance: 10,000; Mem: 550; individual dues $35 & up, family $50; annual meeting in Sept
Income: Financed by endowment, mem, grants & events
Library Holdings: Audio Tapes; Book Volumes 2000; Clipping Files; Filmstrips; Framed Reproductions; Lantern Slides; Manuscripts; Maps; Memorabilia; Motion Pictures; Original Documents; Pamphlets; Periodical Subscriptions 4; Photographs; Prints; Slides
Special Subjects: Folk Art, Decorative Arts, Photography, Etchings & Engravings, Manuscripts, Maps, Painting-American, Historical Material, Ceramics, Crafts, Porcelain, Furniture, Period Rooms, Costume Design & Constr, Glass, Pottery, Landscapes, Architecture, Portraits
Collections: Library & museum collections relating to Rensselaer County history
Publications: Call for information
Activities: Classes for adults & children; docent training; lect open to public; gallery talks; tours; traveling exhibitions; museum shop sells books, reproductions & prints

M RENSSELAER NEWMAN FOUNDATION CHAPEL & CULTURAL CENTER, The Gallery, 2125 Burdett Ave, Troy, NY 12180; 2008 19th St, Troy, NY 12180. Tel 518-274-7793; Fax 518-274-5945; Elec Mail mcquiw@rpi.edu; Internet Home Page Address: www.rpi-edu/web/c+cc; *Dir* William McQuiston; *Treas* Thomas Phelan; *Secy* Mairin Quinn; *Pres* Michael Duffy
Open 9 AM - 11 PM; Estab 1968 to provide religion & culture for members of the Rensselaer Polytechnic Institute & Troy area, a broadly ecumenical service; Gallery maintained; Average Annual Attendance: 100,000
Income: $150,000 (financed by contributions)
Library Holdings: Audio Tapes; Book Volumes; Cassettes; Compact Disks; Filmstrips; Framed Reproductions; Original Art Works; Photographs; Sculpture; Slides; Video Tapes
Special Subjects: Sculpture, Religious Art, Medieval Art
Collections: Contemporary paintings, sculpture and needlework; liturgical vestments & artifacts; medieval sculpture
Exhibitions: Laliberte banners; Picasso traveling exhibition; New York State Council on the Arts; Smithsonian Institution Traveling Exhibition; local one man shows
Publications: Sun and Balance, three times a year
Activities: Classes for adults & children; dramatic programs; lect open to public, 10 vis lectrs per year; concerts; gallery talks; Poetry Series; Peace Fair; Festival of Religion & the Arts; Sun and Balance medal

UTICA

M MUNSON-WILLIAMS-PROCTOR ARTS INSTITUTE, (Munson-Williams-Proctor Institute) Museum of Art, 310 Genesee St, Utica, NY 13502-4799. Tel 315-797-0000; Fax 315-797-5608; Elec Mail museum@mwpai.edu; Internet Home Page Address: www.mwpai.org/museum/; *Cur Decorative Arts* Anna T D'Ambrosio; *Librn* Kathryn Corcoran; *Dir* Paul D Schweizer; *Cur Modern & Contemporary Art* Mary E Murray
Open Tues - Sat 10 AM - 5 PM, Sun 1 - 5 PM; cl Mon & holidays; No admis fee; donations accepted; Estab 1919 to collect, preserve & exhibit art, artifacts & articles of importance; Circ 17,000; The institute became active in 1953 with the purpose of establishing & maintaining a gallery & collection of art to give instruction & to have an auxiliary library. It consists of a School of Art estab 1941; a Mus of Art opened in 1960; Fountain Elms, a house-mus was restored in 1960; a Meetinghouse opened in 1963 & a Performing Arts Division. Maintains reference library; Average Annual Attendance: 182,000; Mem: 3,823; dues family $45, individual $35, student $25
Income: Financed by endowment, tuition & private contributions, voluntary donations at entrances
Purchases: 19th & 20th century American, European paintings, sculpture, graphic & 19th century decorative arts
Library Holdings: Auction Catalogs; Audio Tapes; Book Volumes; CD-ROMs; Cassettes; Clipping Files; Compact Disks; Exhibition Catalogs; Fiche; Other Holdings; Periodical Subscriptions; Slides; Video Tapes
Special Subjects: Drawings, Painting-American, Sculpture, Watercolors, Pottery, Landscapes, Decorative Arts, Portraits, Furniture, Silver, Marine Painting, Carpets & Rugs, Miniatures, Period Rooms
Collections: Arts of Central New York; 19th & 20th century European paintings & sculpture; 18th, 19th & 20th century American paintings, sculpture, 19th century decorative arts; drawings & prints
Exhibitions: Rotating exhibits & from permanent collection
Publications: Bulletin, monthly; exhibition catalogues

Activities: Classes for adults & children; docent training; workshops, dramatic programs; lect open to public, lects for mems. only, 5 vis lectrs per year; gallery talks; tours. N.Y. Upstate Organization award for Advancing Cultural Development, 2002; fellowships; individual paintings & original objects of art lent to members from the Art Lending Library; lending collection contains original prints, paintings, sculpture; book traveling exhibitions 2-3 per year; originate traveling exhibitions to museums in other areas including international museums; museum shop sells books, magazines, original art, prints, jewelry, catalogs, children's items, pottery, note cards, greeting cards & crafts

L Art Reference Library, 310 Genesee St, Utica, NY 13502. Tel 315-797-0000, Ext 2123; Fax 315-797-5608; Elec Mail library@mwpai.org; *Dir Library Svcs* Kathryn L Corcoran; *Asst Librn* Michael Schuyler; *Library Asst* Kathleen Salsbury
Open Tues - Fri 10 AM - 5 PM, Sat 10 AM - 1 PM, 2 - 5 PM, Sun 12 - 5 PM; Estab 1940 to support School of Art, Mus of Art staff, Institute Mem & general pub; circulation only to members of the Institute; Circ 5,000
Library Holdings: Auction Catalogs; Book Volumes 27,000; CD-ROMs; Clipping Files; Compact Disks 2,400; DVDs 315; Exhibition Catalogs; Manuscripts; Pamphlets; Periodical Subscriptions 50; Slides 20,000; Video Tapes 1,018
Special Subjects: Art History, Collages, Folk Art, Decorative Arts, Film, Illustration, Mixed Media, Commerical Art, Drawings, Etchings & Engravings, Graphic Arts, Graphic Design, Painting-American, Painting-German, Painting-European, Ceramics, Conceptual Art, Crafts, American Western Art, Cartoons, Fashion Arts, Asian Art, Furniture, Glass, Aesthetics, Afro-American Art, Bookplates & Bindings, Metalwork, Carpets & Rugs, Jewelry, Marine Painting, Landscapes
Collections: Fountain Elms Collection; autographs, rare books & manuscripts, book plates
Publications: Bibliographies related to museum exhibitions; bibliographic instructional materials

M SCULPTURE SPACE, INC, 12 Gates St, Utica, NY 13502. Tel 315-724-8381; Fax 315-797-6639; Elec Mail info@sculpturespace.org; Internet Home Page Address: www.sculpturespace.org; *Studio Mgr* Takashi Soga; *Exec Dir* Sydney Waller; *Prog & Comm Coordr* Colleen Passalacqua Kahler
Open by appointment only; No admis fee; Estab 1976 to provide professional artists with studio space; 5,500 sq ft open studio plus one private studio (400 sq ft); Average Annual Attendance: 1,000
Income: $200,000 (grants, special events, ann appeal)
Library Holdings: Compact Disks; Exhibition Catalogs; Original Documents; Photographs; Slides
Special Subjects: Sculpture
Publications: Sculpture Space News, semi-annual
Activities: Lect opern to public; gallery talks; Awards (20 funded residences); scholarships & fels offered; organization manages commissioned works, sells original art & limited edition sculptures

VALLEY COTTAGE

L VALLEY COTTAGE LIBRARY, Gallery, 110 Rte 303, Valley Cottage, NY 10989. Tel 914-268-7700; *Library Dir* Ellen Simpson; *Dir Exhib* Amelia Kalin
Open Mon - Thurs 10 AM - 9 PM, Fri & Sat 10 AM - 5 PM; Estab 1959; 27 x 7, artificial & natural light
Publications: Focus, quarterly

WADING RIVER

AMERICAN SOCIETY OF BOTANICAL ARTISTS
For further information, see National & Regional Organizations

WATERFORD

A NEW YORK STATE OFFICE OF PARKS, RECREATION AND HISTORIC PRESERVATION, Bureau of Historic Sites, Peebles Island, PO Box 219 Waterford, NY 12188. Tel 518-237-8643; Fax 518-235-4248; Internet Home Page Address: www.nysparks.com; *Dir* James Gold; *Asst Dir* John Lovell; *Assoc Cur* Robin P Campbell; *Coll Mgr* Anne Cassidy
Open by appointment only; No admis fee; Estab 1974 as a resource center providing technical services to state historic sites & parks in the areas of research, interpretation, collections management, curatorial & conservation services, restoration of historic structures, exhibit design, fabrication & historic archeology; All exhibits are housed at the state historic sites
Income: A branch of state government
Special Subjects: Costumes, Drawings, Embroidery, Etchings & Engravings, Historical Material, Landscapes, Manuscripts, Porcelain, Reproductions, Sculpture, Painting-American, Decorative Arts, Folk Art, Ceramics, Portraits, Archaeology, Dolls, Furniture, Glass, Period Rooms, Maps, Islamic Art, Painting-European, Carpets & Rugs, Restorations
Collections: Painting collections exist at several sites most notably Olana & Senate House. Artists include Church, Cole, Vanderlyn, Stuart, Pissaro.
Activities: Internships offered

WATERTOWN

M JEFFERSON COUNTY HISTORICAL SOCIETY, 228 Washington St, Watertown, NY 13601. Tel 315-782-3491; Fax 315-782-2913; Internet Home Page Address: www.jchs.imc.net.net; *Cur Educ* Melissa Widrick; *Dir* Fred H Rollins; *Pres* Harold Johnson; *Porgrams & Chmn* Judith N George; *Exec Sec* Elaine Bock; *Cur Coll* Elise Chan
Open May - Nov Tues - Fri 10 AM - 5 PM, Sat Noon - 5 PM; Admis $2 donation; Estab 1886; Average Annual Attendance: 12,000; Mem: 924; annual meeting in May
Income: $142,000 (financed by endowment, mem, county appropriation, grants, private foundations & gifts)
Special Subjects: Textiles, Costumes, Furniture, Glass, Historical Material

Collections: Tyler Coverlet Collection; Costume Collection; Kinne Water Turbine Collection; 19th century Furniture; Prehistoric Indian Arts, Jefferson County
Exhibitions: Fort Drum: A Historical Perspective
Publications: Bulletin, 1-2 times per yr; Museum Musings; 6 times per yr; Abraham Tuthill (catalogue)
Activities: Classes for adults & children; in-school local history programs; docent training; lect open to public, 2-6 vis lectrs per year; tours; artmobile; lending collection includes; artifacts, 155 items; book traveling exhibitions 1-2 per year; originate traveling exhibitions; museum shop sells books, toys & other souvenir items

L Library, 228 Washington St, Watertown, NY 13601. Tel 315-782-3491; Fax 315-782-2913; *Dir* Dr Timothy J Abel
All Year Tues - Fri 10 AM - 5 PM, May - Nov Sat 12 PM - 5PM; Free; 1886
Income: Endowment, county appropriation, grants, pvt foundations
Library Holdings: Book Volumes 2211; Clipping Files; Exhibition Catalogs; Framed Reproductions; Manuscripts; Memorabilia; Original Art Works; Pamphlets; Prints
Special Subjects: Decorative Arts, Historical Material, Furniture, Glass, Architecture
Publications: Museum Musings Newsletter, quarterly; Bulletin, annually
Activities: Museum shop sells books & reproductions

M ROSWELL P FLOWER MEMORIAL LIBRARY, 229 Washington St, Watertown, NY 13601. Tel 315-788-2352; Fax 315-788-2584; Elec Mail ueblertm@northnet.org; Internet Home Page Address: www.flowermemoriallibrary.org; *Dir* Barbara Wheeler
Open Labor Day - June 15, Mon, Tues & Thurs 9 AM - 9 PM, Wed 9 AM - 5:30 PM, Fri & Sat 9 AM - 5 PM, cl Sun; No admis fee; Estab 1904; The library contains murals, paintings & sculptures throughout the building
Income: $900,000 (financed by NY State and City of Watertown)
Library Holdings: Audio Tapes; Book Volumes; CD-ROMs; Cassettes; Clipping Files; Compact Disks; DVDs; Fiche; Filmstrips; Maps; Micro Print; Original Art Works; Other Holdings; Pamphlets; Periodical Subscriptions; Prints; Sculpture; Slides; Video Tapes
Collections: New York State material & genealogy; United States military history
Activities: Lectures open to the public; tours

WELLSVILLE

M THE MATHER HOMESTEAD MUSEUM, LIBRARY & MEMORIAL PARK, 343 N Main St, Wellsville, NY 14895. Tel 585-593-1636; *Dir & Owner* Barbara Williams
Hours by appt; No admis fee; Estab 1981; Home of Mather family & decendents. House & grounds share a look at lifestyles of different decades and in different parts of the world. Emphasis on pleasures for those who are blind or poorly sighted; Average Annual Attendance: 500 - 999
Income: private
Library Holdings: Audio Tapes; Book Volumes; Cards; Cassettes; Exhibition Catalogs; Kodachrome Transparencies; Memorabilia; Original Art Works; Pamphlets; Periodical Subscriptions; Prints; Sculpture; Video Tapes
Collections: Barn holds coll of artifacts, music, books, games, catalogues & toys of the 1930s; visiting 1937 automobile returned to working condition; antiques; art; arts & crafts; children's mus; historic house/site; library; musical instruments; typography mus; wildlife refuge/bird sanctuary; info sharing about cultural lifestyles; works of area artists; aids for poorly-sighted; coll on British Arts Council's Festival (1951); coll of printed materials; sampliers, tools
Publications: The Homestead Hoot, newsletter; An in-house publishing program: Sound Adventures, music and papers
Activities: Lects; concerts; guided tours; ann events: Easy Egg Hunt for ages 6 & under; Halloween Paint-Out; reading of Declaration of Independence

WEST NYACK

M ROCKLAND CENTER FOR THE ARTS, 27 S Greenbush Rd, West Nyack, NY 10994. Tel 845-358-0877; Fax 845-358-0971; Elec Mail info@rocklandartcenter.org; Internet Home Page Address: www.rocklandartcenter.org; *Exec Dir* Julianne Ramos, MFA
Open Mon - Fri 9 AM - 10 PM, Sat - Sun 9 AM - 4 PM; No admis fee; Estab 1947 to present excellence in the arts, education & services; 40 ft x 70 ft gallery space, 2 acre sculpture park, 3 exhibit areas, Emerson Gallery, Gallery One & Catherine Konner Sculpture Park; Average Annual Attendance: 25,000; Mem: 3000; dues family $45, singles $25; annual meeting in Oct
Income: $850,000 (financed by mem, state appropriations, corporations, foundations & earned income)
Exhibitions: (10/2006-12/2006) State of the Art; (2/2007-4/2007) Jiffy Pop; (10/2006-4/2007) Sculpture in the Park (annualy changing show)
Publications: Art school catalogues; exhibition catalogue
Activities: Classes for adults & children in visual, literary & performing arts; lect open to the public; performances in classical, jazz, folk music; extension program for Rockland Cty NY schools; artmobil program called Roca on the Road

WEST POINT

M UNITED STATES MILITARY ACADEMY, West Point Museum, Olmsted Hall, West Point, NY 10996-5000; 2110 South Post Rd, USMA, West Point, NY 10996. Tel 845-938-2203; Fax 845-938-7478; Internet Home Page Address: www.usma.edu/museum/; *Dir* David M Reel; *Cur Art* Gary Hood; *Cur History* Michael Mcafee; *Cur Weapons* Leslie D Jensen; *Designer* Richard H Clark; *Registrar* Marlana L Cook; *Mus Specialist* Paul Ackermann; *Adminir* Jean M Cumming; *Security Chief* Gloria J Johnson; *Collection Analyst* Brian Rayca
Open daily 10:30 AM - 4:15 PM; No admis fee; Estab 1854, supplementing the academic, cultural & military instruction of cadets; also disseminates the history of the US Army, the US Military Academy & the West Point area; Collections open to the public; Average Annual Attendance: 300,000

Income: Federal Institution
Purchases: $5000
Library Holdings: Book Volumes; Manuscripts; Maps; Memorabilia; Original Art Works; Original Documents; Pamphlets; Periodical Subscriptions; Photographs; Records
Special Subjects: Drawings, Graphics, American Indian Art, American Western Art, Bronzes, Folk Art, Etchings & Engravings, Coins & Medals, Dioramas, Cartoons
Collections: Alexander M Craighead Collection of European & American Military Art; Jonas Lie Collection of Panama Canal Oils; Liedesdorf Collection of European Armor; Peter Rindisbacher Watercolors; Thomas Sully Portrait Collection; cadet drawings from 1820-1940; European & American war posters; extensive holdings from World War I & World War II, military & homefront subjects; military artifacts including weapons, flags, uniforms, medals, etc; military paintings & prints; paintings & prints of West Point; Hudson River School artists
Exhibitions: Cadet Drawings from the 19th Century to World War I; Jonas Lie & the Building of the Panama Canal; The Land of Counterpane: Toy Soldiers; Art of the Panama Canal; Come Join Us Brothers, African Americans in the US Army; Timeless Treasures: 200 Years of West Point Memories (A bicentennial exhibition); Tabletops and Tradition: The Officer's Mess and Cadet Mess at West Point; The West Point Museum: A Museum for the Army (1854-2004)
Publications: The West Point Museum: A Guide to the Collections; Exhibition brochures
Activities: 20th century re-enactment programs and military memorabilia displays from volunteer's collections; gallery talks; tours; individual paintings & original objects of art lent to accredited museums; museum shop sells books, reproductions, prints & military souvenirs

WESTFIELD

L PATTERSON LIBRARY & ART GALLERY, 40 S Portage St, Westfield, NY 14787. Tel 716-326-2154; Fax 716-326-2554; *Arts Specialist* Sharon Gollnitz; *Dir* Deborah Williams
Open Mon - Tues & Thurs 9 AM - 8 PM, Wed & Fri - Sat 9 AM - 5 PM, cl Sun; Estab 1896 (Octagon Gallery estab 1971) to provide opportunity for education & recreation through the use of literature, music, films, paintings & other art forms; Circ 72,000; Octagon Gallery is 1115 sq ft with 11 ft ceilings & 100 ft running space, maintains lending/reference library; Average Annual Attendance: 14,000
Income: Financed by endowment & private sources
Library Holdings: Audio Tapes; Book Volumes 34,000; Cassettes 125; Clipping Files; Filmstrips; Framed Reproductions; Manuscripts; Memorabilia; Motion Pictures; Original Art Works; Pamphlets; Periodical Subscriptions 120; Photographs 10,000; Records; Reels; Sculpture; Slides; Video Tapes
Collections: Glass Plates of Local History, Mounted birds, Seashells, WWI Posters
Exhibitions: Annual Westfield Revisited Exhibition; Patterson Library Biennial Juried Show for regional artists
Activities: Classes for adults & children; docent training; lect open to public, 2 vis lectrs per year; concerts; gallery talks; tours; competitions with awards; individual paintings & original objects of art lent to local institutions; book traveling exhibitions infrequently; traveling exhibitions organized & circulated

WOODSTOCK

A CENTER FOR PHOTOGRAPHY AT WOODSTOCK INC, 59 Tinker St, Woodstock, NY 12498. Tel 845-679-9957; Fax 845-679-6337; Elec Mail info@cpw.org; Internet Home Page Address: www.cpw.org; *Exec Dir* Colleen Kenyon; *Dir Prog* Kate Menconeri
Open Noon - 5 PM, cl Mon & Tues; No admis fee; Estab 1977, a nonprofit organization, an art & educ center, an artists space; 3 large galleries showcase contemporary creative photography; Average Annual Attendance: 50,000; Mem: Open mem
Income: Financed by pub funding, foundations, individuals
Library Holdings: Auction Catalogs; Exhibition Catalogs
Collections: Permanent collection contains 5000 photographic prints & art work which incorporates photography; Maverick Festival Archive
Exhibitions: Eight shows per year
Publications: Photography magazine, quarterly (featuring best of contemporary creative photography)
Activities: Classes for adults & children; workshops; lect open to pub, 20 vis lectrs per yr; gallery talks; tours; sponsoring of competitions; fels; organize traveling exhibitions; museum shop sells books, notecards, postcards

A WOODSTOCK ARTISTS ASSOCIATION, 28 Tinker St, Woodstock, NY 12498. Tel 845-679-2940; Fax 845-679-2940; Elec Mail waa@ulster.net; Internet Home Page Address: www.woodstockart.org; *Gallery Mgr* Lisa Williams; *Dir & Permanent Coll & Archivist* Linda Freaney; *Asst Gallery Mgr* Prudence See
Open Thurs - Mon Noon - 5 PM, Sat & Sun Noon - 6 PM; Suggested donation $2; Estab 1920 to exhibit the work of artists of the region; Upstairs Gallery, Members Group Exhibitions; Downstairs Gallery-Solo exhibitions; Phoebe & Belmont Towbin Wing; Exhibitions from the Permanent Collection; exhibiting members must live within 20 miles of Woodstock; Average Annual Attendance: 20,000; Mem: 550; dues individual $60; general meetings in May & Aug; membership open only to local residents
Income: $90,000 (financed by endowment, mem, city appropriation, donations, earned income)
Special Subjects: Historical Material, Landscapes, Photography, Sculpture, Watercolors, Painting-American, Pottery, Woodcuts, Portraits, Jewelry
Collections: The Permanent Collection of Woodstock Artists includes oils, prints & sculpture; Historic Woodstock Artists
Exhibitions: Rotating juried exhibits for members; solo shows for members
Publications: Woodstock Art Heritage: The Permanent Collection of the Woodstock Artists Association (1987)
Activities: Lect open to public, 6 vis lectrs per year; concerts; gallery talks; tours; biennial sculpture; competitions with awards; ext dept; individual paintings &

original objects of art lent to Bruce Museum in Greenwich, CT & to Hechter Museum; lending collection contains books, color reproductions, original art works, original prints, paintings, sculpture, slides & videos; book traveling exhibitions; originate traveling exhibitions; museum shop sells books, gift items, original art, prints & reproductions

L WAA Archives, 28 Tinker St, Woodstock, NY 12498. Tel 845-679-2940; Internet Home Page Address: www.woodstockart.org; *Head Archivist* Linda Freaney
For reference only
Income: Financed by donations, endowments & mem
Library Holdings: Clipping Files; Memorabilia; Original Art Works; Other Holdings Documents 50,000; Photographs; Prints; Sculpture

YONKERS

M THE HUDSON RIVER MUSEUM, 511 Warburton Ave, Yonkers, NY 10701. Tel 914-963-4550; Fax 914-963-8558; Elec Mail info@hrm.org; Internet Home Page Address: www.hrm.org; *Cur* Laura Vookles; *Dir* Michael Botwinick; *Dir Education* Catherine Shiga-Gattullo; *Trustee Chm* Logan D Delany; *Dir Pub Relations* Linda Locke; *Cur Exhibs* Ellen J Keiter; *Cur Collections* Laura Vookles; *Dir Devel* Dennis Powers
Open Oct - Apr Wed - Sun Noon - 5 PM, May - Sept Wed, Thurs, Sat & Sun Noon - 5 PM, Fri Noon - 9 PM; Admis museum $4, adult $ 3, children 12 or under, seniors & mems free; Estab 1924 as a general mus of art, history & science; Average Annual Attendance: 70,000; Mem: 800
Income: $700,000 (financed by mem, city & county appropriation, state arts council, federal grants & donations)
Special Subjects: Architecture, Painting-American, Photography, Sculpture, Decorative Arts
Collections: 19th & 20th century American art, decorative arts, furniture, toys, dolls, costumes, accoutrement, silver, china, paintings, sculpture, photography
Publications: Tri-annual calendar of events; special exhibitions flyers; annual report
Activities: Docent training, classes for children; lect & special events open to public; concerts; gallery talks; tours; art lent to other museums for exhibition purposes; lending collection contains original art works, paintings, photographs, sculpture; traveling exhibitions organized and circulated to museums, college galleries - regional & national; museum shop sells books, prints & inexpensive items for children that pertain to museum disciplines, art history & science

M PHILIPSE MANOR HALL STATE HISTORIC SITE, 29 Warburton Ave, PO Box 496 Yonkers, NY 10702. Tel 914-965-4027; Fax 914-965-6485; Elec Mail heather.iannuci@oprhp.state.ny.us; Internet Home Page Address: www.nystateparks.com; *Museum Educator* Lucille Sciacca; *Historic Site Mgr* Heather Iannucci; *Res Prog Coordr* Joanna Pessa; *Historic Site Asst* Charles Casimiro
Open Apr - Oct, Wed - Sat Noon - 5 PM, Sun 1 - 4 PM; No admis fee; Estab 1908 to preserve Georgian manor house owned by the Frederick Philipse family; to interpret Philipse Manor Hall's architecture, its significance as the home of an American Loyalist & its importance as an example of 17th & 18th century Anglo-Dutch patterns in landholding & development; The State Historic Site is part of the New York State Office of Parks & Recreation; the Hall houses contemporary style exhibits of history, art & architecture hung against a backdrop of fine 18th & 19th century architectural carvings; Average Annual Attendance: 29,000
Income: Financed by state appropriation
Library Holdings: Book Volumes; Clipping Files; Kodachrome Transparencies; Maps; Memorabilia; Photographs; Prints; Slides
Special Subjects: Portraits, Historical Material
Collections: Cochran Portrait of Famous Americans; Cochran Collection of Windor Chairs
Exhibitions: Historic Trail; People's Choice: Presidential Portraits from Washington to FDR
Activities: Docent training; lect open to public, 4 vis lectrs per year concerts; tours; demonstrations; films

L YONKERS PUBLIC LIBRARY, Fine Arts Dept, 1500 Central Park Ave, Yonkers, NY 10710. Tel 914-337-1500, Ext 311; *Librn* Joanne Roche; *Librn* John Connell
Open Mon - Thurs 10 AM - 9 PM, Fri & Sat 10 AM - 5 PM, Sun Noon - 5 PM, cl Sat & Sun during summer; Estab 1962 to serve the general pub with a special interest in the arts, especially the fine arts, performing arts & the decorative & applied arts; Circ printed material approx 22,000; recorded material approx 66,000
Income: $65,000 (financed by city appropriation & gifts)
Purchases: $65,000
Library Holdings: Audio Tapes 3100; Book Volumes 14,000; Cassettes 1000; Clipping Files; Fiche; Other Holdings Scores 3000; Pamphlets 7000; Periodical Subscriptions 82; Records 15,000; Reels; Video Tapes 200

L Will Library, 1500 Central Park Ave, Yonkers, NY 10710. Tel 914-337-1500; *Librn* John Connell; *Librn* Joanne Roche
Library Holdings: Book Volumes 126,000; Periodical Subscriptions 75
Exhibitions: Exhibits work by local artists & craftsmen

NORTH CAROLINA

ASHEVILLE

M ASHEVILLE ART MUSEUM, 2 S Pack Square, PO Box 1717 Asheville, NC 28802. Tel 828-253-3227; Fax 828-257-4503; Elec Mail mailbox@ashevilleart.org; Internet Home Page Address: www.ashevilleart.org; *Cur* Frank Thomson; *Exec Dir* Pamela L Myers; *Communications Mgr* Felicity Green; *Develop Mgr* Angie Dunfee; *Visitor Serv Manager* Jeff Standen
Open year round Sat 10 AM - 5 PM, Sun 1 - 5 PM, Fri until 8 PM; Admis adults $6, students & seniors $5, special exhibition fees may apply, free to members;

Estab 1948 to provide art experiences to the Southeast & Western North Carolina area through exhibitions; Eight galleries maintained, 4 with changing exhibits; maintains reference library; Average Annual Attendance: 70,000; Mem: 1200; dues family $60, single $40; annual meeting in Oct
Income: Financed by mem, United Arts Fund Drive, auxiliary & private contributions
Purchases: Romane Bearden, James Chapin, Joseph Fiore, William Henry Jackson, George Luks
Library Holdings: Auction Catalogs; Audio Tapes; Book Volumes; CD-ROMs; Clipping Files; Exhibition Catalogs
Special Subjects: Architecture, Painting-American, Photography, Prints, Watercolors, American Indian Art, Ceramics, Crafts, Folk Art, Pottery, Afro-American Art, Portraits, Posters, Furniture, Glass, Metalwork
Collections: Studio glass; southeast regional; 20th & 21st Century American Art; Studion craft
Publications: Quarterly membership; newsletter, catalogues
Activities: Classes for adults & children; docent training; lect open to public, 2-3 vis lectrs per year; concerts; gallery talks; tours; competitions with awards; individual paintings & original objects of art lent to other museums; originates book traveling exhibitions, 12-14 per yr; museum shop sells books, magazines, origiinal art, reproductions, prints & other gift items

A SOUTHERN HIGHLAND CRAFT GUILD, Folk Art Center, Riceville Rd Blue Ridge Pky, PO Box 9545 Asheville, NC 28815. Tel 828-298-7928; Fax 828-298-7962; Elec Mail shcg@buncombe.main.nc.us; Internet Home Page Address: www.Southernhighlandguild.org; *Dir* Ruth Summers; *Archivist* Ginny Daley; *Librn* Deb Schillo; *Mem Adminr* Rebecca Orr
Open Mon - Sun 9 AM - 5 PM, cl Thanksgiving, Christmas & New Year's; No admis fee; Estab 1930 to encourage wider appreciation of mountain crafts; raise & maintain standards of design & craftsmanship & encourage individual expression; Main exhib gallery, a focus gallery & interpretive gallery; Average Annual Attendance: 300,000; Mem: 700; open to eligible craftsmen from Southern Appalachian Mountain Region upon approval of applicant's work by Standards Committee & Board of Trustees; dues group $40, single $20; annual meeting in Apr
Income: Financed by mem & merchandising
Library Holdings: Audio Tapes; Book Volumes; Clipping Files; Exhibition Catalogs; Kodachrome Transparencies; Manuscripts; Maps; Memorabilia; Motion Pictures; Original Documents; Pamphlets; Periodical Subscriptions; Photographs; Records; Reels; Slides; Video Tapes
Special Subjects: Embroidery, Textiles, Decorative Arts, American Indian Art, Ceramics, Crafts, Dolls, Enamels, Calligraphy
Collections: Object coll focused on regional contemporary crafts & historical folk arts; Library & Archives
Publications: Highland Highlights; monthly newsletter
Activities: Workshops for adults & children; lect open to public & some for members only; gallery talks; tours; competitions; lending collection contains 2500 objects/American crafts; originate traveling exhibitions to museums & nonprofit galleries

BREVARD

M BREVARD COLLEGE, Spiers Gallery, 400 N Broad St, Brevard, NC 28712. Tel 828-883-8292, Ext 2245; Fax 828-884-3790; Elec Mail bbyers@brevard.edu; Internet Home Page Address: http://www.brevard.edu/library; *Dir* Bill Byers; *Library Dir* Dr Michael M McCabe
Open Mon - Fri 9 AM - 3 PM; No admis fee; Estab 1969 as Art Department with gallery; Center has three areas, 160 ft running space, & 1500 sq ft floor space
Income: Financed by departmental appropriation
Library Holdings: Book Volumes 4500; Exhibition Catalogs; Manuscripts; Original Art Works; Original Documents; Periodical Subscriptions 25; Records; Video Tapes 400
Special Subjects: Prints, Watercolors, Pottery
Collections: Contemporary art; 1940-1970 paintings & watercolors; print & pottery collection
Exhibitions: Student & visiting artist exhibitions
Activities: Classes for adults; dramatic programs; college classes & continuing education; lect open to public, 4 vis lectrs per year; 4 gallery talks; competitions with cash awards; scholarships offered; lending collection contains books, cassettes, color reproductions, film strips, photographs, slides

L James A Jones Library, 400 N Broad St, Brevard, NC 28712-3306; One Brevard College Dr, Brevard, NC 28712-8268. Tel 828-884-8268; Fax 828-884-5424; Elec Mail library@brevard.edu; Internet Home Page Address: www.brevard.edu/library; *Library Dir* Dr Michael M McCabe; *Chmn Art* Bill Byers
Open Mon - Fri 8:30 AM - 5 PM; Estab 1934; For reference & circulation for students & faculty
Income: Financed by parent institution
Library Holdings: Book Volumes 4,725; DVDs 15; Exhibition Catalogs; Periodical Subscriptions 20; Records; Video Tapes 400
Special Subjects: Art History, Photography, Graphic Arts, Graphic Design, Painting-American, Painting-British, Sculpture, History of Art & Archaeology, Ceramics
Publications: New book list, bi-monthly

CARY

M NORTH CAROLINA NATURE ARTISTS ASSOCIATION (NCNAA), 307 Electra Dr, Cary, NC 27513. Tel 919-481-2187; *Dir* Carl Regutti
Estab 1988 for wildlife art shows & education; Mem: 125; dues $15; quarterly meetings
Income: $10,000 (financed by mem & special projects)
Exhibitions: Sponsor 3 museum exhibitions per year throughout North Carolina; museums vary each year
Activities: Classes for adults & children; lect open to public; competitions

M **PAGE-WALKER ARTS & HISTORY CENTER,** 119 Ambassador Loop, PO Box 8005 Cary, NC 27511. Tel 919-460-4963; Fax 919-469-4344; Elec Mail rstone@ci-cary.nc.us; *Supv* Sarah Maullsby
Open 10 AM - 5 PM; No admis fee; Estab 1992; Galleries housed in renovated historic hotel (circa 1868); Average Annual Attendance: 30,000; Mem: 300
Special Subjects: Architecture, Latin American Art, Painting-American, Photography, Sculpture, American Indian Art, American Western Art, African Art, Textiles, Religious Art, Folk Art, Etchings & Engravings, Afro-American Art, Manuscripts, Furniture, Glass, Jewelry, Historical Material, Maps, Restorations
Activities: Classes for adults & children; dramatic programs; docent training; lect open to public, 30 vis lectrs per year; originate traveling exhibitions

CHAPEL HILL

UNIVERSITY OF NORTH CAROLINA AT CHAPEL HILL
M **Ackland Art Museum,** Tel 919-966-5736; Fax 919-966-1400; Internet Home Page Address: www.unc.edu/depts/ackland; *Others* TDD 919-962-0837; *Dir* Gerald D Bolas; *Educ Cur* Carolyn Wood; *Exhib Cur* Barbara Matilsky
Open Wed - Sat 10 AM - 5 PM, Sun 1 - 5 PM, cl Mon, Tues & most major holidays; No admis fee; Estab 1958 as an art mus which serves the members of the university community as well as the pub; The mus houses a permanent collection & presents a program of changing exhibitions; Average Annual Attendance: 50,000; Mem: 1300; dues Mint Master $500; $100, $50 & $30
Income: Financed by endowment, mem, donations & state appropriation
Special Subjects: Drawings, Painting-American, Bronzes, African Art, Ceramics, Folk Art, Etchings & Engravings, Landscapes, Afro-American Art, Manuscripts, Painting-European, Eskimo Art, Glass, Oriental Art, Asian Art, Antiquities-Byzantine, Painting-British, Painting-Dutch, Painting-French, Juvenile Art, Baroque Art, Painting-Flemish, Antiquities-Oriental, Islamic Art, Antiquities-Greek
Publications: Newsletter, fall, winter, spring & summer
Activities: Educ programs; docent training; lect open to public, 3 vis lectrs per year; gallery talks; tours; musical performances; individual paintings & original objects of art lent to other museums; exhibition catalogs available for sale
L **Joseph Curtis Sloane Art Library,** Tel 919-962-2397; Fax 919-962-0722; Elec Mail patt@unc.edu; Internet Home Page Address: www.lib.unc.edu/art/index.html; *Libr Asst* Mara Mathews; *Art Librn* Patricia T Thompson
Open Mon - Thurs 8 AM - 9 PM, Fri 8 AM - 5 PM, Sat Noon - 5 PM, Sun 3 - 9 PM; 1985; Circ 19,000
Income: Financed by state appropriation
Library Holdings: Auction Catalogs; Book Volumes 105,000; CD-ROMs 64; Clipping Files; DVDs 25; Exhibition Catalogs; Fiche 15,174; Pamphlets; Periodical Subscriptions; Reels 401; Video Tapes 302
Activities: Bibliographic instruction

CHARLOTTE

M **DISCOVERY PLACE INC,** Nature Museum, 301 N Tryon St, Charlotte, NC 28202. Tel 704-372-6261; Fax 704-337-2670; Internet Home Page Address: www.discoveryplace.org; *CEO* John L Mackay; *VPres Mktg* Carl McIntosh
June - Aug 9 AM - 6 PM, Sat 9 AM - 6 PM, Sun 1 - 6 PM, Open Sept - May Mon - Fri 9 AM - 5 PM ; Admis adult $6.50, youth & seniors $5, children 3-5 with parent $2.75, mems and children under 2 yrs free; Estab 1981 as a science museum with hands on concept of learning by doing; A small staff reference library is maintained; Average Annual Attendance: 600,000; Mem: 7000; dues family $70, senior $35, student $30
Income: $7,500,000 (financed by city & county appropriations, fees, sales shop & private donations)
Special Subjects: Pre-Columbian Art, Primitive art, Eskimo Art
Collections: Arthropods; gems & minerals; Lepidoptera; Pre-Columbian: Mayan, North American, Peruvian; primitive art: African, Alaskan Eskimo, Oceania, South America; reptillia
Publications: Science Magazine, quarterly; activities bulletin, quarterly
Activities: Classes for adults & children; volunteer training program for demonstrators & guides; major programming for school lectures; tours; acceptable for internship from UNCC & Queens College; book traveling exhibitions 4 per year; originate traveling exhibitions that circulate to science museum collaborations; museum shop sells books, prints, shells, jewelry, school supplies & souvenirs; junior museum is primarily geared to pre-school and early elementary age children

M **LIGHT FACTORY,** 809 W Hill St, (ADP) PO Box 32815 Charlotte, NC 28232. Tel 704-333-9755; Fax 704-333-5910; Elec Mail tlf@webserve.net; Internet Home Page Address: www.lightfactory.org; *Dir Educ* Cynthia Cole; *Dir Admin* Stephanie Glick; *Exec Dir* Mary Anne Redding; *Factory Film Coordr* Wendy Fishman
Open Tues, Wed, Fri 10 AM - 5 PM, Thurs 11 AM - 9 PM, Sat & Sun 1 - 6 PM; No admis fee; Estab 1972, non-collecting mus presenting the latest in photography, video & the internet. Year-round educ programs, community outreach & special events complement its changing exhibitions; Average Annual Attendance: 20,000; Mem: 4; dues $35-$1000
Income: Financed by grants, NEA, memberships, Arts & Sci Council
Exhibitions: Rotating
Publications: Exhibit catalogs
Activities: Classes for adults & children; lect open to public, 6 vis lectrs per year; gallery talks; tours; scholarships offered; originate traveling exhibitions to museums & galleries nationally

M **MINT MUSEUM OF ART,** 2730 Randolph Rd, Charlotte, NC 28207. Tel 704-337-2000, 337-2020; Fax 704-337-2101; Elec Mail pbusher@mintmuseum.org; Internet Home Page Address: www.mintmuseum.org; *VPres* Mary Lou Babb; *VPres Finance* Mike Smith; *Dir Coll & Exhib* Charles Mo; *Pub Relations Dir* Phil Busher; *VPres Develop & Marketing* Harry Creemers; *Dir Educ* Cheryl Palmer; *Dir Community Relations* Carolyn Mints; *CEO* Phil Kline; *Cur Mint Mus* Melissa Post; *Head Design* Kurt Warnke; *Cur Decorative Arts* Barbara Perry; *Cur Pre-Columbian* Michael Whittington; *Dir Craft & Design* Mark Leach; *Mus Shop Mgr* Sandy Fisher; *Librn* Sara Wolf; *VChmn* Zach Smith; *Registrar* Martha T Mayberry
Open Tues 10 AM - 10 PM, Wed - Sat 10 AM - 5 PM, Sun Noon - 5 PM, cl Mon & holidays; Admis adult $6, college students & seniors $5, students 6-17 $3,

children 5 & under & members free; free Tues 5 PM-10 PM; Estab 1936 as an art mus in what was the first branch of the US mint erected in 1837; Mus houses seven changing galleries, 16 permanent galleries, Delhom Decorative Arts Gallery; Average Annual Attendance: 135,000; Mem: 5,3500; dues Mint Master $1000, benefactor $500, sustainer $250, patron $125, family $45, individual $30, senior citizen or student discounted
Income: Financed by endowment, mem & city appropriation, foundation & corporate giving
Special Subjects: Architecture, Drawings, Photography, American Indian Art, African Art, Costumes, Ceramics, Crafts, Etchings & Engravings, Afro-American Art, Decorative Arts, Collages, Painting-Japanese, Portraits, Porcelain, Asian Art, Antiquities-Byzantine, Painting-French, Baroque Art, Calligraphy, Period Rooms, Antiquities-Oriental, Painting-Spanish, Painting-Italian, Antiquities-Persian, Antiquities-Roman, Painting-German, Painting-Russian, Enamels, Antiquities-Assyrian
Collections: African art; decorative arts; historic pottery; 19th & 20th century European & American paintings; porcelain; pre-Columbian art; sculpture; Spanish Colonial art
Exhibitions: Rotating exhibits
Publications: Mint Museum Newsletter and calendar of events, six times a year
Activities: Classes for adults; docent training; lect open to public, 25 vis lectrs per year; concerts; gallery talks; tours; competitions; scholarships & fels offered; original objects of art lent to other museums; museum shop selling books, original art, prints, gifts, museum replicas, jewelry, cards
L **Library,** 2730 Randolph Rd, Charlotte, NC 28207. Tel 704-337-2000; Fax 704-337-2101; Internet Home Page Address: www.mintmuseum.org; *Librn* Joyce Weaver
Open Tues - Fri 10 AM - 5 PM; Open to the pub for reference only
Library Holdings: Auction Catalogs; Book Volumes 12,000; CD-ROMs; Cards; Clipping Files; Exhibition Catalogs; Original Documents; Other Holdings; Periodical Subscriptions 100; Photographs; Records; Slides; Video Tapes
Special Subjects: Art History, Collages, Decorative Arts, Painting-American, Pre-Columbian Art, Ceramics, Conceptual Art, Art Education, Asian Art, American Indian Art, Aesthetics, Afro-American Art, Antiquities-Oriental, Antiquities-Persian, Antiquities-Assyrian, Antiquities-Byzantine, Antiquities-Roman, Coins & Medals
M **Mint Museum of Craft & Design,** 220 N Tryon St, Charlotte, NC 28202. Tel 704-337-2000; Fax 704-337-2101; Elec Mail mleach@mintmuseum.org; Internet Home Page Address: www.mintmuseum.org; *Asst to Dir* Anna Sims; *Cur* Melissa Post; *Dir of Educ* Mary Beth Crawford; *Dir* Mark Richard Leach; *Researcher* Kristen Davidson
Open Tues, Wed, Thurs & Sat 10 AM - 5 PM, Fri 10 AM - 5 PM, Sun Noon - 5 PM; Admis adult $6, seniors & students $5, children 6-17 $3, members & children 5 & under free; Estab 1999; 82,000 sq ft total with 16,000 sq ft of gallery space, 26,000 sq ft of commercial rental space & 40,000 sq ft for offices, storage, workshop & museum shop; Average Annual Attendance: 100,000; Mem: 5,350
Purchases: Works by Stanislav Libinsky & Jarsolava Brychtova
Library Holdings: Auction Catalogs; Book Volumes; CD-ROMs; Exhibition Catalogs; Kodachrome Transparencies; Original Documents; Other Holdings; Periodical Subscriptions; Photographs; Records; Slides; Video Tapes
Special Subjects: Decorative Arts, Historical Material, Ceramics, Furniture, Sculpture, Crafts, Pottery, Woodcarvings, Glass, Jewelry, Porcelain, Metalwork
Collections: ceramics; fiber; glass; metal; wood; Bresler Collection of Historic Am Quilts; Allan Chasanoff Ceramic Collection; Mason Wood Collection; Founders' Circle Collection; Grice Native American Ceramic Collection
Exhibitions: Turning Wood into Art: The Jane and Arthur Mason Collection; Selections from the Allan Chasanoff Ceramic Collection
Activities: Classes for adults & children; docent training; lect open to the public; lect open to members only; gallery talks; tours; Purchase awards; fels offered; lending of original objects of art to museums; organize traveling exhibs to AAM accredited museums internationally; museum shop sells books, crafts, jewelry, original art, reproductions, prints & posters, clothing items

L **PUBLIC LIBRARY OF CHARLOTTE & MECKLENBURG COUNTY,** 310 N Tryon St, Charlotte, NC 28202-2176. Tel 704-336-2725; Fax 704-336-2677; Elec Mail infoserv@plcmc.lib.nc.us; Internet Home Page Address: www.plcmc.lib.nc.us/; *Deputy Dir* Judith Sutton; *Dir* Robert Cannon
Open Mon - Thurs 9 AM - 9 PM, Fri & Sat 9 AM - 6 PM, Sun 1 - 6 PM, cl Sun June - Aug; No admis fee; Estab 1903 to provide free public library service to citizens of Mecklenburg County; Gallery contains 90 linear feet of wall space, often dedicated to children's art; "L" Gallery with quarterly changing exhibits
Income: $10.9 million (financed by state & county appropriations)
Library Holdings: Audio Tapes; Book Volumes 1,615,682; CD-ROMs; Cassettes; Compact Disks; DVDs; Filmstrips; Motion Pictures 2772; Other Holdings Maps 6865; Prints 424; Records 27,869; Sculpture; Slides 9261; Video Tapes
Exhibitions: Theme exhibitions changing quarterly dedicated to childrens art
Activities: Computer learning center accessible to people with physical & mental disabilities

A **SPIRIT SQUARE CENTER FOR ARTS & EDUCATION,** 345 N College St, Charlotte, NC 28202. Tel 704-372-9664; Fax 704-377-9808; *Pres* Judith Allen
Open Mon - Fri, 8 AM - 5 PM; Estab 1983; 5000 sq ft for six art galleries; Average Annual Attendance: 20,000
Income: $3,000,000 (financed by mem, city & state appropriation & local arts drive)
Activities: Classes for adults & children; dramatic programs; docent training; lect open to the public, 18 vis lectrs per year; concerts; gallery talks; tours; scholarships; artmobile; museum shop sells books & original art

DALLAS

M **GASTON COUNTY MUSEUM OF ART & HISTORY,** 131 W Main St, PO Box 429 Dallas, NC 28034-0429. Tel 704-922-7681; Fax 704-922-7683; Elec Mail museum@co-gaston.nc.us; Internet Home Page Address: www.museumstogether.com; *Cur* Cheryl Bernard; *Chair* James Windham; *Exec Dir* Barbara H. Brose
Open Tues - Fri 10 AM - 5PM, Sat 1 - 5 PM, every 4th Sun 2 - 5 PM; No admis fee; Estab 1975, opened 1976 to promote the fine arts & local history in Gaston

County, through classes, workshops & exhibitions; to preserve Historic Dallas Square; promote the history of the textile industry; The mus is located in an 1852 Hoffman Hotel; the Hands-On Gallery includes sculpture & weaving which may be touched; the two small galleries are on local history, with three galleries for changing & traveling exhibitions; Average Annual Attendance: 53,000; Mem: 300 households; dues $15-0$1000; annual meeting in Oct, with 6 meetings per year
Income: $345,000 (financed by mem & county appropriation)
Purchases: $1000 per yr for regional art
Special Subjects: Painting-American, Sculpture, Textiles
Collections: Period furniture; documents; 19th - 20th century American art; objects of local history; paintings by regional artists, 450,000 documented photographs; textile history
Publications: Patchworks quarterly
Activities: Classes for adults & children; docent training; lect open to public, 2 vis lectrs per year; gallery talks; tours; Getaway Sunday, Blues Outback summer concert series, summer drop in day camp; book traveling exhibitions 2 per year; sales shop sells books, magazines, original art, reproductions, prints, stationery, postcards, gifts & jewelry

DAVIDSON

M **DAVIDSON COLLEGE,** William H Van Every Jr & Edward M Smith Galleries, 315 N Main St, PO Box 1720 Davidson, NC 28036-1720. Tel 704-894-2519; Fax 704-894-2691; Elec Mail brthomas@davidson.edu; Internet Home Page Address: www.davidson.edu; *Dir* Brad Thomas
Open Mon - Fri 10 AM - 5 PM, Sat & Sun Noon - 4 PM, cl holidays; No admis fee; Estab 1993 to provide exhibitions of educational importance; William H Van Every Jr Gallery-1400 sq ft; Edward M Smith Gallery-400 sq ft; Average Annual Attendance: 10,000
Income: $32,000
Special Subjects: Architecture, Drawings, Hispanic Art, Latin American Art, Mexican Art, Painting-American, Prints, Sculpture, Watercolors, Ethnology, Textiles, Ceramics, Folk Art, Primitive art, Woodcarvings, Woodcuts, Etchings & Engravings, Afro-American Art, Collages, Asian Art, Historical Material, Embroidery
Collections: Over 2500 works, mainly graphics, from all periods
Publications: Exhibition brochures & catalogs, 3-5 per year
Activities: Intern training; lect open to public, 5-7 vis lectrs per year; gallery talks; tours; scholarships offered; individual paintings & original objects of art lent; book traveling exhibitions 1-3 per year
L **Katherine & Tom Belk Visual Arts Center,** PO Box 7117, Davidson, NC 28035-7117. Tel 704-894-2590; Elec Mail jeerickson@davidson.edu; Internet Home Page Address: www.davidson.edu/personal/jeerickson/jeerick1.htm; *Slide Cur* Jeffrey Erickson
Estab 1993; Open to students, faculty & staff of the college
Library Holdings: Slides 65,000

DURHAM

M **DUKE UNIVERSITY,** Duke University Museum of Art, PO Box 90732, Durham, NC 27708-0732. Tel 919-684-5135; Fax 919-681-8624; Elec Mail brevans@duke.edu; Internet Home Page Address: ; *Asst Dir* David Roselli; *Cur* Sarah Schroth; *Registrar* Jeffrey Bell; *Dir* Michael P Mezzatesta; *Pub Affairs Officer* Bruce Evans; *Mktg & Mem* Kelly Dail
Open Mon - Fri 10 AM - 5 PM, Sat 11 AM - 2 PM, Sun 2 - 5 PM Cl Mon & holidays; No admis fee; Estab 1969 as a study mus with the collections being used & studied by various university departments, as well as the pub school system & surrounding communities; The museum is located on the East Campus in a renovated two-story neo-Georgian building; gallery space includes part of the first floor & entire second floor with the space divided into eight major gallery areas; Average Annual Attendance: 30,000; Mem: 850; dues $35 - $1000
Income: Financed by University
Special Subjects: African Art, Pre-Columbian Art, Etchings & Engravings, Decorative Arts, Painting-European, Renaissance Art, Medieval Art, Painting-Russian
Collections: African; Contemporary Russian; Greek & Roman; Medieval decorative art & sculpture; paintings; Pre-Columbian, ceramics & textiles; American paintings; Old Masters
Exhibitions: 3-4 temporary exhibitions per year
Publications: Exhibition catalogs 1-2 per year
Activities: Educ dept; docent training; tours; competitions with awards; lect open to public, 6-8 vis lectrs per year; concerts; gallery talks; tours; scholarships offered; individual paintings & original objects of art lent to other museums & galleries; lending collection contains paintings & sculpture; book traveling exhibitions 1-3 per year; originate traveling exhibitions to other museums 1-2 per year; museum shop sells books
L **Lilly Art Library,** PO Box 90727, Durham, NC 27708. Tel 919-660-5994; Fax 919-660-5999; Elec Mail lslilly@duke.edu; Internet Home Page Address: www.lib.duke.edu/lilly/artsearch/home.htm; *Librn & Art Bibliographer* Lee Sorensen
Open 8 AM - 2 AM; No admis fee; Estab 1930 to support the study of art at Duke University
Income: Financed by budget & endowment
Purchases: $85,000 excluding approval plan expenditure
Library Holdings: Book Volumes 155,000; CD-ROMs; Cards; Clipping Files; Compact Disks; DVDs; Exhibition Catalogs; Fiche; Motion Pictures; Pamphlets 5125; Periodical Subscriptions 416; Reels; Video Tapes
Special Subjects: Art History, Graphic Arts, Painting-American, Painting-British, Painting-Dutch, Painting-Flemish, Painting-French, Painting-German, Painting-Italian, Painting-European, History of Art & Archaeology, Judaica, American Western Art, Afro-American Art, Architecture
Collections: Emphasis on European & American Art; Germanic-Language Historiography
Publications: Duke University Libraries, quarterly

L **DUKE UNIVERSITY LIBRARY,** Hartman Center for Sales, Advertising & Marketing History, Box 90185, Durham, NC 27708-0185. Tel 919-660-5827; Fax 919-660-5934; Elec Mail hartman-center@duke.edu; Internet Home Page Address: http://library.duke.edu/specialcollections/hartman; *Reference Archivist* Lynn Eaton; *Dir* Jacqueline Reid
Open Mon - Fri 9 AM - 5 PM, Sat 1 - 5 PM; No admis fee; Estab 1992; Open to academics, businesses, general public, for on-premises use. Fees charged for extended research by staff
Library Holdings: Audio Tapes; Book Volumes 3000; Cassettes; Clipping Files; Filmstrips; Kodachrome Transparencies; Manuscripts; Memorabilia; Motion Pictures; Original Art Works; Original Documents; Other Holdings Advertising Proofs & Tearsheets; Pamphlets; Photographs; Records; Reels; Slides; Video Tapes
Special Subjects: Illustration, Commerical Art, Graphic Arts, Graphic Design, Manuscripts, Historical Material, Advertising Design
Collections: DMB&B Archives; Outdoor Advertising Association of America (OAAA) Archives; J Walter Thompson Co Archives; billboards; print advertising; TV commercials
Publications: Front & Center, semiannual newsletter

M **DUKE UNIVERSITY UNION,** Louise Jones Brown Gallery, 101 Bryan Center Box 90834, Durham, NC 27708. Tel 919-684-2911; Fax 919-684-8395; Elec Mail svt2@duke.edu; Internet Home Page Address: www.union.duke.edu; *Visual Arts Committee Chair* Susanna Temkin; *Union Student Advisor* Brian Crews
Open Mon - Fri 9 AM - 9 PM, Sat - Sun 10 AM - 6 PM; No admis fee; Founded in 1968 under the name Graphic Arts, the DUU Visual Arts Committee is dedicated to promoting the presence of the visual arts on the Duke Univ campus; Two 15X15 sq rooms with 7'2″ high walls; these two rooms are connected by two bridges. The gallery is situated in the student union of Duke Univ; Mem: 30; bi-weekly meetings
Income: Financed by endowment, commission on exhibit works sold & student fees
Exhibitions: Professional & local artists, approx 3 monthly (1 in each gallery); plus Duke student artists in 1 gallery monthly
Activities: Classes for adults; lect open to public, 1 vis lectr per year; competitions; gallery talks

M **DURHAM ART GUILD INC,** 120 Morris St, Durham, NC 27701. Tel 919-560-2713; Fax 919-560-2704; Elec Mail artguild1@yahoo.com; Internet Home Page Address: www.durhamartguild.org; *Gallery Dir* Lisa Morton; *Gallery Asst* Diane Amato
Open Mon - Sat 9 AM - 9 PM, Sun 1 - 6 PM; No admis fee; Estab 1948 to exhibit work of NC artists; 3600 sq ft gallery located in Arts Council Building; Average Annual Attendance: 10,000; Mem: 400; dues $25; annual member show in June
Income: $50,000 (financed by mem, city & state appropriations)
Special Subjects: Photography, Prints, Sculpture, Textiles, Crafts, Etchings & Engravings, Landscapes, Portraits, Furniture, Metalwork
Exhibitions: Exhibitions of work by regional artists, 8-10 per year; annual juried art show
Publications: Juried Show Catalogue, annual
Activities: Receptions; competitions with awards, special proposals accepted; originate traveling exhibitions 2 per year

M **NORTH CAROLINA CENTRAL UNIVERSITY,** NCCU Art Museum, 1801 Fayetteville St, Durham, NC 27707; PO Box 19555, Durham, NC 27707. Tel 919-560-6211; Fax 919-560-5012; Internet Home Page Address: www.nccu.edu/artmuseum/; *Dir* Kenneth G Rodgers
Open winter Tues - Fri 9 AM - 5 PM, Sun 2 - 5 PM, summer Mon - Fri 8:30 - 4:30 PM; No admis fee; Estab 1971 in a former black teaching institution with a collection of contemporary art, many Afro-American artists, reflecting diversity in style, technique, medium & subject; Three galleries are maintained; one houses the permanent collection & two are for changing shows; Average Annual Attendance: 10,500
Income: Financed by state appropriation
Special Subjects: Painting-American, Sculpture, African Art
Collections: African & Oceanic; Contemporary American with a focus on minority artists
Exhibitions: Rotating exhibits
Publications: Artis, Bearden & Burke: A Bibliography & Illustrations List; exhibition catalogs
Activities: Lect open to public; gallery talks; tours

FAYETTEVILLE

M **ARTS COUNCIL OF FAYETTEVILLE-CUMBERLAND COUNTY,** The Arts Center, 301 Hay St, PO Box 318 Fayetteville, NC 28302-0318. Tel 910-323-1776; Fax 910-323-1727; Elec Mail admin@theartscouncil.com; Internet Home Page Address: www.TheArtsCouncil.com; *Exec Dir* Deborah Mintz; *Exhibits Coordr* Dorothy Finiello; *Gen Mgr* Nancy Silver
Open Mon - Thurs 8:30 AM - 5 PM, Fri 8:30 AM - Noon, Sat Noon - 4 PM; No admis fee; Estab 1973 to nurture, celebrate & advocate all of the arts in Cumberland County; Main gallery & featured artist gallery; Average Annual Attendance: 60,000; Mem: 420
Income: Financed by contributions, grants & taxes
Special Subjects: Architecture, Drawings, Hispanic Art, Mexican Art, Painting-American, Photography, Sculpture, American Indian Art, African Art, Crafts, Pottery, Landscapes, Afro-American Art, Decorative Arts, Judaica, Manuscripts, Collages, Portraits, Posters, Dolls, Glass, Oriental Art, Juvenile Art, Leather, Military Art
Exhibitions: exhibitions for local and area residents
Publications: monthly newsletter
Activities: Arts Educ program; awards for annual juried competitions; local grants offered, grants for artists, workshops, assemblies & residencies; school tours of exhibits; varies

M **FAYETTEVILLE MUSEUM OF ART, INC,** 839 Stamper Rd, PO Box 35134
Fayetteville, NC 28303. Tel 910-485-5121; Fax 910-485-5233; Elec Mail
mima@fay-moa.org; Internet Home Page Address:
www.fayettevillemuseumart.org; *Dir* Tom Grubb; *Asst Dir* Michele Horn; *Dir
Finance & Human Resources* Paulette Reinhardt; *Office Mgr* Mima McMillan;
Educ Coordr Joyce Turner; *Educator* Michelle Downey; *Educator* Lisete Ortega;
Librn Marcia Shernoff
Open Mon - Fri 10 AM - 5 PM, Sat 10 AM - 5 PM, Sun 1 - 5 PM; No admis fee;
Estab 1971 to promote in the area an active interest in the fine and applied arts; to
establish and maintain a permanent collection; Front & main galleries are 996 sq
ft, 143 ft wall space (231 ft wall space with temporary walls); maintains lending
& reference library; Average Annual Attendance: 81,496; Mem: 600; dues
$20-3,000; ann meeting in the summer
Income: $336,000 (financed by fundraisers, mem, grants & city)
Library Holdings: Auction Tapes; Audio Tapes; Book Volumes; Cards;
Cassettes; Exhibition Catalogs; Maps; Pamphlets; Periodical Subscriptions;
Photographs; Prints; Slides; Video Tapes
Collections: African Art; American Art of all media, with concentration on North
Carolina artists
Publications: Annual competition catalogue; quarterly calendar
Activities: Classes for adults & children; docent training; lect open to public;
concerts; gallery talks; tours; competitions; awards given; individual paintings &
original objects of art lent to other museums & nonprofit organizations; lending
collection contains original art works, original prints, paintings, photographs,
sculpture & slides; book traveling exhibitions 3 - 4 per year; museum shop sells
books, pottery, notecards, jewelry, prints & educational items

GREENSBORO

M **GREEN HILL CENTER FOR NORTH CAROLINA ART,** 200 N Davie St,
Box # 4 Greensboro, NC 27401. Tel 336-333-7460; Fax 336-333-2612; Elec Mail
info@greenhillcenter.org; Internet Home Page Address: www.greenhillcenter.org;
Exec Dir Jennifer W Moore; *Educ Dir* Mary Young; *Cur* Julia Church; *Pub
Relations* Mary Pearson; *Admin Mgr* Courtney Whittington; *Shop Mgr* Angela
Holt; *Outreach Coordr* Jaymie Buchanan; *Operations Mgr for Art Quest* Renee
O'Connor
Open Tues - Sat 10 AM - 5 PM, Wed 10 AM - 7 PM, Sun 2 - 5 PM, cl Mon; No
admis fee, donation suggested; $3 fee for Art Quest, interactive gallery; Estab &
incorporated 1974 as a nonprofit institution offering exhibition & educational
programming featuring the visual arts of North Carolina; Nonprofit visual arts ctr
exhibiting works by NC artists & promoting educ with programs on site and
through outreach; Average Annual Attendance: 83,000; Mem: 700; dues $50-$2500
Income: Financed by mem, United Arts Council of Greensboro, Institute of
Museum Services, North Carolina Arts Council
Publications: Catalogues; quarterly newsletter
Activities: Classes for adults & children; docent training; artists-in-the-schools
program; lect open to public; lect for members only; by Artmobilgallery talks;
tours; exten prog serves primarily Guilford County, NC; originate traveling
exhibitions internationally; museum shop sells books & original art

A **GREENSBORO ARTISTS' LEAGUE,** 200 N Davie St, Box 7, Greensboro, NC
27401. Tel 336-333-7485; Elec Mail gal@uacgreensboro.org; Internet Home Page
Address: www.people-places.com/gal; *Exec Dir* Carla Burns; *Gallery Mgr* Mark
Trull
Open Tues, Thurs & Fri 10 AM - 5 PM, Wed 10 AM - 7 PM, Sat 10 AM - 5 PM,
Sun 2 - 5 PM; No admis fee; Estab 1956 to encourage local artists to show & sell
their works; Exhibitions gallery located in the Greensboro Cultural Center;
twenty-five exhibitions & invitational group shows; Average Annual Attendance:
100,000; Mem: 500; dues patron $100, family/supportive $50, single $30, senior
citizen/student $20; annual meeting in Jan
Income: $110,000
Special Subjects: Crafts, Furniture, Glass, Calligraphy
Exhibitions: African American Arts Festival Celebration; All Members
Exhibitions; Art Auction; Cultural Kaleidoscope; SMART; Art Rap; Summer
Salon; Fundraiser
Publications: Monthly newsletter
Activities: Classes & workshops for adults; lect open to public, 2-3 vis lectrs per
year; gallery talks; scholarships offered; exten dept; individual paintings lent;
lending collection contains original art works, original prints, paintings &
sculptures; originate traveling exhibitions 1 per year; sales shop sells original art,
reproductions & prints

M **GREENSBORO COLLEGE,** Irene Cullis Gallery, 815 W Market St, Greensboro,
NC 27401-1875. Tel 336-272-7102; Fax 336-271-6634; Elec Mail
bkowski@gborocollege.edu;
Open Mon - Fri 10 AM - 4 PM, Sun 2 - 5 PM, cl college holidays; Estab to
exhibit visual art by visiting professional artists, Greensboro College art students
& faculty; College art gallery
Exhibitions: Scholastic High School Competition, February

M **GUILFORD COLLEGE,** Art Gallery, 5800 W Friendly Ave, Greensboro, NC
27410. Tel 336-316-2438; Fax 336-316-2950; Elec Mail thammond@guilford.edu;
Internet Home Page Address: www.guilford.edu/artgallery; *Dir & Cur* Theresa
Hammond; *Pres* Kent Chabotar
Open Mon - Fri 9 AM - 5 PM, Sun 2 - 5 PM during academic yr, cl holidays;
Atrium areas open Mon - Fri 8 AM - 8 PM, Sat & Sun 10 AM - 8 PM; No admis
fee; Estab 1990; 5000 sq ft of exhibition space located in Hege Library
Special Subjects: Ceramics, Drawings, Graphics, Painting-American,
Photography, Prints, Sculpture, Watercolors, African Art, Religious Art, Woodcuts,
Etchings & Engravings, Landscapes, Glass, Coins & Medals, Baroque Art,
Calligraphy, Renaissance Art, Painting-Italian
Collections: Contemporary American Crafts; Contemporary Polish etching &
engraving; Renaissance & Baroque Period Collection; 20th Century American Art;
19th & 20th Century African

Activities: Lect open to public; gallery talks; tours; book traveling exhibitions 1-2
per year

M **UNIVERSITY OF NORTH CAROLINA AT GREENSBORO,** Weatherspoon
Art Museum, PO Box 26170, Spring Garden & Tate St Greensboro, NC
27402-6170. Tel 336-334-5770; Fax 336-334-5907; Elec Mail
weatherspoon@uncg.edu; Internet Home Page Address:
http://weatherspoon.uncg.edu; *Cur Coll* Will South; *Cur Educ* Ann Grimaldi; *Pub
& Community Relations* Loring Mortensen; *Dir* Nancy Doll; *Cur of Exhib* Xandra
Eden; *Registrar* Maggie Gregory; *Asst Registrar* Heather Moore; *Preparator* Jack
Stratton; *Preparator* Susan Taaffe; *Bus Mgr* Cathy Rogers; *Office Mgr* Shannon
Byers; *Dir of Security* Paul Siders; *Dir Develop* Linda Burr
Open Tues, Wed & Fri 10 AM - 5 PM, Thurs 10 AM - 9 PM, Sat & Sun 1 - 5
PM, cl Mon, University holidays; No admis fee; Estab 1941; Circ Ca 400; The
museum collects & presents modern & contemporary art; new facility, 46,271 sq
ft; Average Annual Attendance: 36,000; Mem: 600; dues $15 & up; annual
meeting in May
Income: State of NC, UNCG, individuals, foundations, government grants &
endowment
Purchases: Acquisition endowments
Library Holdings: Auction Catalogs; Exhibition Catalogs; Pamphlets
Special Subjects: Afro-American Art, Decorative Arts, Drawings, Collages,
Photography, Bronzes, Woodcuts, Sculpture, Graphics, Latin American Art,
Painting-American, Prints, Watercolors, Etchings & Engravings, Asian Art
Collections: Modern & Contemporary American paintings, drawings, prints &
sculpture; Dillard Collection: Works on Paper; Cone Collection: Matisse prints &
bronzes; Lenoir C. Wright Collection of Japanese Woodblock Prints
Exhibitions: (11/24/2006-12/17/2006) Dario Robleto: Falk Visiting Artist;
(10/1/2006-1/14/2007) Henri Matisse: Prints and Bronzes from the Permanent
Collection; (10/15/2006-12/23/2006) Mel Bochner: Drawing from Four Decades;
(11/12/2006-1/21/2007) Art on Paper 2006; (11/19/2006-2/25/2007) Henry Ossawa
Tanner: Painter of the Spirit; (12/3/2006-2/25/2007) Self Portraits: Works from the
Permanent Collection; (1/14/2007-4/8/2007) Denzil Hurley: Falk Visiting Artist;
(1/21/2007-3/25/2007) Jasper Johns; (1/28/2007-4/15/2007) Women's Exhibition;
(2/11/2007-4/29/2007) Catherine Opie; (3/11/2007-7/29/2007) Figured/Out;
(4/8/2007-6/17/2007) Henri Matisse: Prints and Bronzes from the Permanent
Collection; (4/29/2007-6/3/2007) UNCG Department of Art - MFA Thesis
Publications: Art on Paper Catalogue, biannually; exhibition catalogues, four per
year; gallery handouts; Matisse brochure; quarterly member newsletter;
Weatherspoon Art Museum bulletin, biannially
Activities: Class for adults; docent training; member programs; trips to national
art centers; lect open to public, 50 vis lectr per year; concerts; gallery talks; tours;
children's programs; exhibition-related film & video; opening receptions & special
events; volunteer opportunities; lend original objects of art nationally &
internationally; originate traveling exhibitions to museums across the country 2-3
times per yr; museum shop sells books, prints, gifts, exhibition-related items slides
& jewelry

GREENVILLE

M **EAST CAROLINA UNIVERSITY,** Wellington B Gray Gallery, Jenkins Fine
Arts Ctr, Greenville, NC 27858-4353. Tel 252-328-6336; Fax 252-328-6441; Elec
Mail leebrickg@mail.edu.edu; Internet Home Page Address: www.ecu.edu; *Dir*
Gilbert Leebrick; *Admin Asst* Susan Nicholls; *Preparator* Gina Cox
Open Mon - Fri 10 AM - 4 PM, Sat 10 AM - 2 PM yr round, cl University
holidays; No admis fee; Estab 1977, the Gallery presents 10 exhibitions annually
of contemporary art in various media. Understanding of exhibitions is strengthened
by educational programs including lectures, workshops, symposia & guided tours;
The gallery is a large, modern 6000 sq ft facility with track lighting & modular
moveable walls; Average Annual Attendance: 23,000; Mem: Art Enthusiasts Group
$25
Income: Financed by state appropriation, Art Enthusiasts of Eastern Carolina,
state & federal grants, corporate & foundation donations
Special Subjects: Hispanic Art, Latin American Art, Mexican Art,
Painting-American, American Indian Art, American Western Art, African Art,
Anthropology, Folk Art, Afro-American Art
Collections: African art 1000 works; Larry Rivers: The Boston Massacre - Color
Lithographs; Baltic States Ceramic Collection
Publications: Anders Knuttson: Light Paintings; The Dream World of Minnie
Evans; Jacob Lawrence: An American Master; exhibition catalogs
Activities: Classes for adults & children; lect open to public, 20 vis lectrs per
year; workshops & symposia; gallery talks; sponsoring of competitions; 5 $1,000
awards; photog image exhib; scholarships offered; individual paintings & original
objects of art lent; originate traveling exhibitions

L **Media Center,** Jenkins Fine Arts Ctr, Greenville, NC 27858-4353. Tel
252-328-6785; Fax 252-328-6441; Elec Mail adamsk@mail.ecu.edu; Internet
Home Page Address: www.ecu.edu; *Dir* Kelly Adams
Open daily 8 AM - 5 PM; Estab 1977 for Art School study of current & selected
periodicals & selected reference books & slides; For lending & reference
Library Holdings: Audio Tapes; Book Volumes 3500; Cards; Cassettes;
Exhibition Catalogs; Filmstrips; Manuscripts; Micro Print 30; Motion Pictures;
Periodical Subscriptions 62; Prints; Slides 80,000; Video Tapes

A **GREENVILLE MUSEUM OF ART, INC,** 802 S Evans St, Greenville, NC
27834. Tel 252-758-1946; Fax 252-758-1946; Internet Home Page Address:
www.gmoa.org; *Asst to Dir* Chetna Funk; *Preparator* Christopher Daniels; *Exec
Dir* Barbour Strickland; *Educ Dir* Jenny Hodges; *Exec Dir* David Shankweiler
Open Tues - Fri 10 AM - 4:30 PM, Sat & Sun 1 - 4 PM, cl Mon; No admis fee;
Estab 1939, incorporated in 1956, to foster pub interest in art & to form a
permanent collection; Six galleries 2000 sq ft including a children's gallery;
Average Annual Attendance: 28,000; Mem: 600; dues $45 & higher; annual
meeting in Spring
Income: $100,000 (financed by plus Foundation income for acquisition of art,
contributions, mem, appropriations & grants)
Collections: 20th Century Contemporary paintings; drawings; graphics; regional &
national; North Carolina artists featured

Exhibitions: Exhibitions featuring work of regional artists; National traveling exhibits; Collection exhibits
Publications: Annual Report; A Visit to GMA, brochure; monthly exhibit announcements; quarterly members' newsletter
Activities: Classes for adults & children; demonstrations; docent training; workshops; lect open to public, 8 vis lectrs per year; gallery talks; tours; individual paintings & original objects of art lent to museums & educational institutions; lending collection contains prints, paintings, sculpture & drawings; book traveling exhibitions 3-5 per year; museum shop sells books, catalogues & notecards
L **Reference Library,** 802 S Evans St, Greenville, NC 27834. Tel 252-758-1946; Fax 252-758-1946; *Exec Dir* Barbour Strickland
Open Tues - Fri 10 AM - 4:30 PM, Sat & Sun 1 - 4 PM; No admis fee; Estab as a reference source for staff
Library Holdings: Book Volumes 300; Periodical Subscriptions 150

HICKORY

M **HICKORY MUSEUM OF ART, INC,** 243 Third Ave NE, Hickory, NC 28601; PO Box 2572, Hickory, NC 28603. Tel 828-327-8576; Fax 828-327-7281; Internet Home Page Address: www.hickorymuseumofart.org; *Communication Dir* Beth Teague; *Dir Educ* Beth Calamia; *Registrar* Gina Mitchell; *Exec Dir* Arnold Cogswell Jr; *Cur* Mary Agnes Beach
Open Tues, Wed & Fri 10 AM - 7:30 PM, Sat 10 AM - 4 PM, Sun 1 - 4 PM, cl Mon; Admis adults $2, seniors & students $1, children under 12 free, Fri free; Estab 1944 to collect, exhibit & foster American art; Located in a renovated 1926 high school building; 10,000 sq ft gallery space for exhibition of permanent collection & traveling shows; Average Annual Attendance: 21,869; Mem: 700; dues $25-$5000
Income: Financed by mem, donations, local United Arts Fund grants
Library Holdings: Book Volumes; Exhibition Catalogs
Special Subjects: Drawings, Graphics, Painting-American, Photography, Prints, Sculpture, Watercolors, Religious Art, Folk Art, Pottery, Primitive art, Woodcuts, Etchings & Engravings, Landscapes, Collages, Glass, Marine Painting
Collections: very fine collection of 19th & 20th century American paintings; NC glass, American art pottery, NC pottery
Publications: Bi-monthly newsletter; calendar; exhibition catalogs
Activities: Classes for adults & children; dramatic programs; docent training; periodic art classes; films; lect open to public; concerts; gallery talks; tours; competitions with awards; exten dept serves Catawba County & surrounding area; individual paintings & original objects of art lent to other museums & galleries; book traveling exhibitions twice a year; originate traveling exhibitions which circulate to qualifying museums & galleries; museum shop sells books, reproductions & gift items
L **Library,** 243 Third Ave NE, HIckory, NC 28603; PO Box 2572, Hickory, NC 28603. Tel 828-327-8576; Fax 828-327-7281; *Dir* Arnold Cogswell
Open Tues, Wed & Fri 10 AM - 5 PM, Thurs 10 AM - 7:30 PM, Sat 10 AM - 4 PM, Sun 1 - 4 PM; Estab as reference library open to staff & pub; Circ Non-circulating
Library Holdings: Book Volumes 2000; Cassettes 50; Clipping Files; Exhibition Catalogs; Manuscripts; Memorabilia; Motion Pictures; Pamphlets; Periodical Subscriptions 8; Photographs; Reproductions; Slides 500; Video Tapes

HIGH POINT

M **HIGH POINT HISTORICAL SOCIETY INC,** Museum, 1859 E Lexington Ave, High Point, NC 27262. Tel 336-885-1859; Fax 336-883-3284; Elec Mail barbara.taylor@ci.high-point.nc.us; Internet Home Page Address: www.highpointmuseum.org; *Exec Dir* Barbara E Taylor; *Cur Coll* Eve Weipert; *Cur Educ* Edith Brady; *Community Affairs* Jennifer Colter; *Mus Store Mgr* Mary Barnett
Open Tues - Sat 10 AM - 4:30 PM, Sun 1 - 4:30 PM; No admis fee; Estab 1971 to preserve the history of High Point; Reopened May 5, 2001, History of High Point; Average Annual Attendance: 17,000; Mem: 500; dues $25 - $150; annual meeting 4th Tues in May
Library Holdings: Book Volumes; Clipping Files; Maps; Original Documents; Periodical Subscriptions; Slides
Special Subjects: Textiles, Folk Art, Pottery, Furniture
Collections: Artifacts, photos & historic documents relating to High Point & inhabitants
Publications: Quarterly newsletter
Activities: Adult classes; docent training; lect open to public, 14 vis lectrs per year; concerts; guided tours; book traveling exhibitions 2-4 per year; originate traveling exhibitions 2 per year; retail store sells books & prints

KINSTON

A **COMMUNITY COUNCIL FOR THE ARTS,** 400 N Queen St, PO Box 3554 Kinston, NC 28501. Tel 252-527-2517; Fax 252-527-8280; Internet Home Page Address: www.kinstoncca.com; *Dir Visual Arts* Amy McIntyre; *Exec Dir* Sandy Landis; *Rental Dir* Elaine Carmon
Open Tues - Fri 10 AM - 6 PM, Sat 10 AM - 2 PM; No admis fee; Estab 1965 to promote the arts in the Kinston-Lenoir County area; Six exhibition galleries & one sales gallery; Average Annual Attendance: 50,000; Mem: 750; dues renaissance $5000, sustainer $1000, patron $500, donor $150, sponsor $250, family $100, individual $50
Income: Financed by local govt appropriations, mem, grants & rentals
Library Holdings: Book Volumes; Cassettes; Clipping Files; Compact Disks; DVDs; Framed Reproductions; Memorabilia; Original Art Works; Original Documents; Other Holdings; Pamphlets; Photographs; Prints; Sculpture; Video Tapes
Collections: Louis Orr engravings-history of North Carolina; Henry Pearson Collection-donations of works by Henry Pearson & other leading modern artists; permanent collection of over 250 works; Public Art Program

Exhibitions: Large model train exhibit; National CCA Show (Jan); Pottery & Quilts Exhibitions; Annual Motorcycle Exhibition; Veterans Day & Civil War Community Exhibitions
Publications: Kaleidoscope, monthly newsletter
Activities: Classes for adults & children; docent training; dramatic programs; concerts; tours; gallery talks; competitions with awards; sponsorships; individual paintings & original objects of art lent to adjoining counties; lending collection contains original art works, original prints, paintings & sculpture; book traveling exhibitions; originates traveling exhibitions; sales shop sells books, original art, reproductions, prints & gift items; Art Center Children's Gallery

LEXINGTON

M **ARTS UNITED FOR DAVIDSON COUNTY,** (Davidson County Museum of Art) The Arts Center, 220 S Main St, Lexington, NC 27292. Tel 336-249-2742; Fax 336-249-6302; Internet Home Page Address: www.co.davidson.nc.us/arts; *Exec Dir* Erik Salzwedel
Open Mon - Fri 10 AM - 4:30 PM, Sat 10 AM - 2 PM; No admis fee; Estab 1968 to expose & to educate the public in different art forms; 2 main galleries in a Greek revival-style building built in 1911; 1986 building was renovated into an arts center; Average Annual Attendance: 20,000; Mem: 575; due $35 - $99 friend, $100 - $249 patron, $250 - $499 sponsor, $500 - $999 producer, $1000 - $1999 director's circle, $2000 - $4999 president's circle, $5000 benefactor
Income: $130,000 (financed by foundations, contributions, sponsorships, local and state appropriation, sales)
Exhibitions: Ann Juried Photography Exhib; Ann Mems Open; Juried Spotlight Exhib
Publications: Ann Guide to the Arts, quarterly
Activities: Adult & children's classes; workshops; demonstrations; museum trips; lect open to public, gallery talks; tours; competitions with awards; celebration series; artist residency in 3 sch systems; sales shop sells books, original art, reproductions, prints, pottery, jewelry & glass

LOUISBURG

M **LOUISBURG COLLEGE,** Art Gallery, 501 N Main St, Louisburg, NC 27549. Tel 919-496-2521; Elec Mail hintonwj@yahoo.com; Internet Home Page Address: www.louisburg.edu; *Dir & Cur* William Hinton
Open Jan - Apr, Aug - Dec Mon - Fri 10 AM - 5 PM, cl holidays; No admis fee; Estab 1957
Collections: American Impressionist Art; Primitive Art
Exhibitions: (2001) Fiber Constructions: A Selection of Hand Made Baskets
Activities: Arts festivals; lect; gallery talks; tours

MONROE

M **UNION COUNTY PUBLIC LIBRARY UNION ROOM,** 316 E Windsor St, Monroe, NC 28112. Tel 704-283-8184; Fax 704-282-0657; Internet Home Page Address: www.union.lib.nc.us; *Dir* Dave Eden
Open Mon - Thurs 9 AM - 8 PM, Fri & Sat 9 AM - 6 PM, Sun 2 - 4 PM; Gallery accommodates 25 large paintings & monthly exhibits of local work or traveling exhibitions
Exhibitions: Various local artists exhibitions

MOREHEAD CITY

M **CARTERET COUNTY HISTORICAL SOCIETY,** Museum of History & Art, 1008 Arandell St, Morehead City, NC 28557. Tel 252-247-7533; Fax 252-247-7533; Elec Mail historyplace@starfishnet.com; Internet Home Page Address: www.thehistoryplace.org; *Pres* Janet Eshleman; *VPres* Les Ewen; *Office Mgr* Cindy Hamilton
Open Tues - Sat 10 AM - 4 PM; No admis fee; Estab 1985 to promote the heritage of Carteret County; Maintains research library; Average Annual Attendance: 3,000; Mem: 700
Special Subjects: Archaeology, Afro-American Art, Decorative Arts, Historical Material, Military Art
Collections: Artifacts from early American Indians (8000 BC) to Tuacarora (1400's-1700's) to Civil War, World War I & II
Activities: Tours; family programs; tea room & auditorium

MORGANTON

M **BURKE ARTS COUNCIL,** Jailhouse Galleries, 115 E Meeting St, Morganton, NC 28655. Tel 828-433-7282; Fax 828-433-7282; Elec Mail director@burkearts.org; Internet Home Page Address: www.burkearts.org; *Pres* Charles V Burleson; *Exec Dir* Ann DiSanto
Open Tues - Fri 9 AM - 4 PM; No admis fee, gifts accepted; Estab 1977 to provide high quality art shows in all media; Circ 200; 3 galleries in an old jail; Average Annual Attendance: 2,500; Mem: 500; dues from $25; annual meeting in May
Income: $55,000 (financed by mem, city & state appropriations, foundations & grants)
Library Holdings: Book Volumes; Original Art Works; Records; Sculpture; Slides
Special Subjects: Drawings, Art Education, Ceramics, Conceptual Art, Pottery, Textiles, Painting-American, Prints, Sculpture, Watercolors, Religious Art, Pottery
Collections: Wachovia Permanent Collection
Exhibitions: First frost juried sculpture exhibit & sale (Nov - Dec); Tour d'Art (1st weekend Jun)
Publications: Burke County Artists & Craftsmen, every 3-4 years
Activities: Classes for adults; tours; competitions with awards, including Top 20 events of SE - Tour d'Art; fundraisers; scholarships offered; individual paintings & original objects of art lent to local businesses & corporations; lending collection

contains books, original art works, original prints, paintings, phono records, photographs & sculpture; sales shop sells original art, prints, local & regional crafts

NEW BERN

M TRYON PALACE HISTORIC SITES & GARDENS, 610 Pollock St, New Bern, NC 28562. Tel 252-514-4900; Fax 252-514-4876; Internet Home Page Address: www.tryonpalace.org; *Dir* Kay P Williams; *Communications Specialist* Carl Herko; *Cur Interpretation* Sara Kirkland; *Cur Coll* Nancy Richards; *Horticulturist* Perry Mathewes; *Registrar* Dean Knight; *Deputy Dir* Philippe Lafargue; *Conservator* David E Taylor
Open Mon - Sat 9 AM - 4 PM, Sun 1 - 4 PM; Admis adults $15, children $6; Estab 1959; Maintained are the historic house museums & galleries (Tryon Palace, Dixon-Stevenson House, John Wright Stanly House & New Bern Academy) with 18th & 19th century English & American furniture, paintings, prints, silver, ceramic objects & textiles; Average Annual Attendance: 75,000
Income: Financed by state & private bequests
Special Subjects: Architecture, Prints, Archaeology, Costumes, Ceramics, Manuscripts, Portraits, Furniture, Glass, Porcelain, Carpets & Rugs, Historical Material, Maps, Period Rooms, Pewter
Collections: Paintings by William Carl Brown; Nathaniel Dance; Gaspard Dughet; Thomas Gainsborough; Daniel Huntington; School of Sir Godfrey Kneller; Claude Lorrain; Paul LaCroix; David Martin; Richard Paton; Matthew William Peters; Charles Willson Peale; Charles Phillips; Alan Ramsay; Jan Siberechts; Edward B Smith; E Van Stuven; Simon Preter Verelst; Richard Wilson; John Wollaston; Graphics
Exhibitions: Temporary exhibitions on history & decorative arts, 3 per yr
Activities: Crafts demonstrations for adults & children; audio-visual orientation program; annual symposium on 18th & 19th century decorative arts; interpretive drama program; docent training; lect open to public, 10 vis lectrs per year; concerts; tours; scholarships offered; museum shop sells books, magazines, reproductions, prints, slides & ceramics
L Library, 610 Pollock St, PO Box 1007 New Bern, NC 28563. Tel 252-514-4900; Fax 252-514-4876; Internet Home Page Address: www.tryonpalace.org; *Librn* Dean Knight
For reference; open for use with permission
Income: Financed by state
Library Holdings: Book Volumes 8500; Clipping Files; Pamphlets; Periodical Subscriptions 45; Photographs; Slides; Video Tapes
Special Subjects: Art History, Landscape Architecture, Decorative Arts, Painting-American, Painting-British, Prints, Historical Material, Portraits, Archaeology, Interior Design, Porcelain, Period Rooms, Costume Design & Constr, Restoration & Conservation, Architecture
Collections: 18th & early 19th century decorative arts

NORTH WILKESBORO

M WILKES ART GALLERY, 913 C St, North Wilkesboro, NC 28659. Tel 336-667-2841; Fax 336-667-9264; Elec Mail info@wilkesartgallery.org; Internet Home Page Address: www.wilkesartgallery.org; *Exec Dir* Kara Milton-Elmore; *Bd Pres* Paul Coggins; *Volunteer Coordr* Vonnie Williams; *Office Mgr* Chelsy Miller
Open Tues - Fri 10 AM - 5 PM, Sat 10 AM - 2 PM, evenings for special events, cl New Year's Day, Easter, Easter Mon, Independence Day, Thanksgiving, Labor Day, Memorial Day & Christmas; No admis fee; Estab 1962 to take art to as many areas as possible; Recently completed renovation of 10,000 sq ft facility in downtown North Wilkesboro. The WAG offers 12 annual exhibits, classes & workshops for all ages; Average Annual Attendance: 10,400; Mem: 400; dues patron & corp $500, donor $250, sponsor $125, family $75; annual meeting in May
Income: Financed by mem, local governments, state arts council & corporations
Special Subjects: Graphics, Painting-American, Sculpture
Collections: Contemporary paintings, graphics, sculpture, primarily of NC artists
Exhibitions: Artist League Juried Competition; Blue Ridge Overview (amateur photography); temporary exhibitions; Fall Harvest Competition; Northwest Artist League Competition; Youth Art Month in March
Publications: Title of Exhibition, monthly brochures & catalogues; Wilkes Art Gallery Newsletter, monthly
Activities: Classes for adults & children; docent training; arts festivals; films; art & craft classes; lect open to public, 3 vis lectrs per year; gallery talks; tours; competitions with awards; concerts; individual paintings lent to medical center; originate traveling exhibitions; sales shop sells, books, crafts, original art, pottery, prints & reproductions

RALEIGH

ART LIBRARIES SOCIETY OF NORTH AMERICA
For further information, see National and Regional Organizations

A ARTSPACE INC, 201 E Davie St, Raleigh, NC 27601. Tel 919-821-2787; Fax 919-821-0383; Elec Mail info@artspacenc.org; Internet Home Page Address: www.artspacenc.org; *Exec Dir* Mary Poole
Open Tues - Fri 10 AM - 6 PM, Sat 10 AM - 6 PM; No admis fee; Estab 1986; Two fls; Average Annual Attendance: 100,000; Mem: Annual meeting in Apr
Income: $400,000 (financed by mem, city & state appropriation, rental income)
Exhibitions: Exhibits rotate every 4 - 8 weeks
Activities: Classes for adults & children; lect open to public; tours; gallery talks; scholarships; residencies for emerging artists (2 six month residencies per year) & established artists (summer); book traveling exhibitions 2 per year; originate traveling exhibition annually; sales shop sells original art, prints

ASSOCIATION OF AMERICAN EDITORIAL CARTOONISTS
For further information, see National and Regional Organizations

A CITY OF RALEIGH ARTS COMMISSION, Municipal Building Art Exhibitions, 222 W Hargett St, PO Box 590 Raleigh, NC 27602. Tel 919-890-3610; Fax 919-890-3602; Elec Mail carol.mallette@ci.raleigh.nc.us; Internet Home Page Address: www.raleighnc.gov/arts; *Chwmn* Beth Yerxa; *Exec Dir* June Guralnick; *Sec* Carol Mallette
Open Mon - Fri 8:30 AM - 5:15 PM; Estab 1984 to showcase Raleigh-based artists/art collections in the local area; First & second floor lobbies of the Raleigh Municipal Building; Average Annual Attendance: 10-20,000
Income: $4340 (financed by city & state appropriation)

M CONTEMPORARY ART MUSEUM, (City Gallery of Contemporary Art) 336 Fayetteville St 4th Flr Raleigh, NC 27601; 409 W Martin St, Raleigh, NC 27603. Tel 919-836-0088; Fax 919-836-2239; Elec Mail dd@camc.org; Internet Home Page Address: www.camnc.org; *Exec Dir* Denise Dickens; *Dir Develop* Sharon Kanter; *Prog Coordr* Nicole Welsh; *International Cur* Raphaela Platow; *VChmn* Frank Thompson
Open Mon - Fri 9 AM - 5 PM; Estab 1983 to support new & innovative works by regional, national & international artists & designers; presents & interprets contemporary art & design through a schedule of diverse exhibitions that explore aesthetic, cultural & ideological issues; To open in 2002, 22,000 sq ft building in historic section in downtown Raleigh; Average Annual Attendance: 50,000; Mem: 700; dues small business $150, student $15; annual meeting in June
Income: Financed by mem, city & state appropriation, contributions & foundations
Exhibitions: Six to eight exhibitions per year
Publications: Exhibition catalogues
Activities: Teacher workshops; mentoring program for adolescents; lect; performances; film series; gallery talks; tours; video programs; internships for college & graduate students; book traveling exhibitions; originate traveling exhibitions; sales area sells catalogs, posters, postcards, T-shirts, caps, mugs & novelty items

M MEREDITH COLLEGE, Frankie G Weems Gallery & Rotunda Gallery, Gaddy-Hamrick Art Ctr, 3800 Hillsborough St Raleigh, NC 27607-5298. Tel 919-760-8465; Fax 919-760-2347; Elec Mail bankerm@meredith.edu; *Dir* Maureen Banker
Open Mon - Fri 9 AM - 5 PM, Sat & Sun 2 - 5 PM; No admis fee; Rotunda Gallery estab 1970, Weems Gallery 1986; Weems Gallery; 30 ft x 43 ft & dividers, skylights; Rotunda Gallery: 3 story, domed space, located in administration building; Average Annual Attendance: 2,000
Special Subjects: Architecture, Drawings, Painting-American, Photography, Sculpture, American Indian Art, African Art, Costumes, Ceramics, Crafts, Woodcarvings, Etchings & Engravings, Afro-American Art, Collages, Painting-European, Posters, Dolls, Furniture, Jewelry, Carpets & Rugs, Historical Material, Juvenile Art, Painting-Italian, Painting-Russian, Enamels
Exhibitions: Weems Gallery: North Carolina Photographer's Annual Exhibition; Raleigh Fine Arts Society Annual Exhibition; Meredith College Art Faculty Exhibition; Rotunda Gallery: Annual Juried Student Exhibition
Activities: Lect open to public, 3 vis lectrs per year, competitions with awards; lending collection contains paintings & original objects of art; book traveling exhibitions annually

M NORTH CAROLINA MUSEUM OF ART, 2110 Blue Ridge Rd, Raleigh, NC 27607; 4630 Mail Service Ctr, Raleigh, NC 27699-4630. Tel 919-839-6262; Fax 919-733-8034; Elec Mail jbahus@ncmamail.dcr.state.nc.us; Internet Home Page Address: www.ncartmuseum.org; *Assoc Dir Admin* Hal McKinney; *Deputy Dir, Coll & Prog* John Coffey; *Dir Educ* Joseph F Covington; *Chief Designer* Jane McGarry; *Chief Conservator* William Brown; *Registrar* Carrie Hedrick; *Librn* Natalia Lonchyna; *Dep Dir, Devel & Mem* Ellen Stone; *Dir* Lawrence Wheeler
Open Tues - Sat 9 AM - 5 PM, Sun 10 AM - 5 PM, cl Mon & holidays; No admis fee; Estab 1947, open to pub 1956, to acquire, preserve, & exhibit international works of art for the educ & enjoyment of the people of the state & to conduct programs of educ, research & publications designed to encourage interest in & an appreciation of art; European Galleries with Dutch, Flemish, French, Italian, British, Spanish & N European Galleries, Classical, Ancient Egyptian, Jewish Ceremonial, Ancient American, African, American, 20th Century Galleries; Average Annual Attendance: 265,000; Mem: 63,000; dues $25 & up
Income: Financed by state appropriations, contributions & grants administered by the NCMA Foundation
Special Subjects: Painting-American, Sculpture, African Art, Pre-Columbian Art, Textiles, Afro-American Art, Painting-European, Painting-British, Painting-Dutch, Painting-French, Baroque Art, Painting-Flemish, Renaissance Art, Painting-Spanish, Painting-Italian, Antiquities-Egyptian, Antiquities-Greek, Antiquities-Roman, Painting-German, Painting-Israeli
Collections: Ancient art; Ancient Egyptian; Classical art; European & American painting, sculpture & decorative arts; Jewish Ceremonial; Samuel H Kress Collection; Ancient American, African, & Oceanic art; 20th century art collection
Exhibitions: North Carolina Artists Exhibitions; wide range of temporary exhibitions
Publications: Preview, bimonthly; exhibition & permanent collection catalogs
Activities: Classes for adults & children; dramatic programs; docent training; lect open to public; concerts; gallery talks; tours; competitions; outreach dept serving North Carolina; individual paintings & original objects of art lent to state institutions & offices, museums, & national & international exhibits; book traveling exhibitions; originate traveling exhibitions; museum shop sells books, reproductions, prints, slides, educational gifts for children & adults, jewelry, & other gifts
L Reference Library, 2110 Blue Ridge Rd, Raleigh, NC 27607. Tel 919-839-6262, Ext 2137; Fax 919-733-8034; Elec Mail hmckinney@ncmamail.dcr; Internet Home Page Address: www.ncartmuseum.org; *Library Asst* Patricia Stack; *Librn* Natalia Lonchyna; *Assoc Cur Europe* Dennis P Weller; *Cur European* David H Steel; *Assoc Dir Admin* Heyward H McKinney; *Registrar* Carrie Hedrick; *Deputy Dir External Affairs* Georganne Bingham; *Dir* Lawrence J Wheeler; *Dir Educ Svcs* Joseph P Covington; *Cur Ancient* Mary Ellen Soles; *Chief Designer* Doug Fisher; *Deputy Dir Finance* Randy Heaton; *Assoc Dir Modern Art* Huston Paschal; *Dep Dir Coll* John Coffey; *Dir Communication* Rebecca Moore; *Assoc Dir Educ* Rebecca M Nagy; *Chief Conservator* Bill Brown; *Deputy Dir Marketing* Emily Rosen

Open Tues - Fri 10 AM - 4 PM; Open to pub for reference
Income: Financed by State and NCMA Foundation
Purchases: $40,000
Library Holdings: Book Volumes 33,000; Clipping Files; Exhibition Catalogs; Pamphlets; Periodical Subscriptions 90
Special Subjects: Art History, Painting-American, Painting-British, Painting-Dutch, Painting-Flemish, Painting-French, Painting-German, Painting-European, History of Art & Archaeology, Judaica, Painting-Israeli, Afro-American Art, Antiquities-Egyptian, Antiquities-Greek, Antiquities-Roman

A **NORTH CAROLINA MUSEUMS COUNCIL,** PO Box 2603, Raleigh, NC 27602. Tel 919-832-3775; Fax 919-832-3085; Internet Home Page Address: www.ncmuseum.org; *VPres* Neil Fulghum; *Treas* Dean Brier; *Pres* Dusty Wescott Estab 1963 to stimulate interest, support & understanding of museums; all-vol organization; Mem: 300; dues individual $20; annual meeting in the fall
Income: Financed by mem
Publications: NCMC Newsletter, quarterly; North Carolina Museums Guide
Activities: Awards given

L **NORTH CAROLINA STATE UNIVERSITY,** Harrye Lyons Design Library, PO Box 7701, Raleigh, NC 27695-7701. Tel 919-515-2207; Fax 919-515-7330; *Librn* Lynn Crisp
Open Mon - Thurs 7:30 AM - 11 PM, Fri 7:30 AM - 10 PM, Sat 9 AM - 10 PM, Sun 1 - 11 PM; Estab 1942 to serve the reading, study, reference & research needs of the faculty, students & staff of the School of Design & the University campus, as well as off-campus borrowers; Circ 56,058; Primarily for lending
Income: Financed by state appropriation, private funds & mem
Purchases: $41,450
Library Holdings: Audio Tapes; Book Volumes 40,747; Motion Pictures; Other Holdings Trade literature, Vertical files; Pamphlets; Periodical Subscriptions 210; Slides; Video Tapes
Special Subjects: Art History, Landscape Architecture, Illustration, Graphic Arts, Graphic Design, Advertising Design, Industrial Design, Asian Art, Furniture, Aesthetics, Afro-American Art, Landscapes, Architecture
Collections: File on measured Drawings of North Carolina Historic Sites; 458 maps & plans; 300 bibliographies compiled by the Design Library staff
Publications: Index to the School of Design, student publication book Vols 1-25
M **Visual Arts Center,** Cates Ave, PO Box 7306 Raleigh, NC 27695-7306. Tel 919-515-3503; Fax 919-515-6163; *Dir* Charlotte V Brown; *Registrar* Gregory Tyler; *Cur Coll* Lynn Jones Ennis
Galleries open Wed - Fri Noon - 8 PM, Sat & Sun 2 - 8 PM, except student holidays; No admis fee; Estab 1979 to collect, exhibit & provide changing exhibitions in the decorative & design arts; Two small shared spaces, 200 running ft, 18,000 sq foot mus opened 1992. 6000 ft exhibition galleries; Average Annual Attendance: 20,000; Mem: 200; dues $25-$1500; annual meeting in Apr
Income: $250,000 (financed by student fees)
Purchases: $10,000
Special Subjects: Photography, Pre-Columbian Art, Textiles, Costumes, Ceramics, Crafts, Folk Art, Pottery, Decorative Arts, Furniture, Glass, Porcelain, Carpets & Rugs, Tapestries, Embroidery
Collections: American, Indian, Asian & pre-Columbian textiles; ceramics (fine, ironstone, porcelain, traditional); furniture; product design; photographs, comptemporary glass
Publications: Exhibit catalogs
Activities: Docent & self-guided tours; lect open to public, 6 vis lectrs per year; gallery talks; tours; competitions; scholarships offered; individual paintings & original objects of art lent to museums; exten prog serves NC, SC, Va; book 6 traveling exhibs per yr; originate traveling exhibition

A **PORTRAITS SOUTH,** 105 S Bloodworth St, Raleigh, NC 27601. Tel 919-833-1630; Fax 919-833-3391; *Pres* Grayson ReVille
Open by appointment, Mon - Fri, 8:30 AM - 5 PM; No admis fee; Estab 1980, agent for professional portrait artists; 3,500 sq ft; Mem: 100 represented artists
Income: Pvt income
Publications: Newsletters for artists, twice a year
Activities: Book traveling exhibitions 100 per year; originate traveling exhibitions 100 per year

A **VISUAL ART EXCHANGE,** 325 Blake St City Market, Raleigh, NC 27601. Tel 919-828-7834; Fax 919-828-7833; Elec Mail info@visualartexchange.org; Elec Mail visartx@aol.com; Internet Home Page Address: www.visualartexchange.org; *Exec Dir* Linda Frenette
Open Tues - Sat 11 AM - 4 PM, 1st Fri of month 6 PM - 9 PM; No admis fee; Estab 1980 to serve emerging & professional artists; Mem: 300; dues $55
Income: Financed by grants & corporate sponsors
Exhibitions: Holiday Show; New Show; Young Artist Show; International Show; Lay of the Land; Salonde Refuses
Publications: Expressions, 10 per year
Activities: Classes for adults & children; lect open to public, 10 vis lectrs per year; gallery talks; competitions with prizes; workshops; book traveling exhibitions 1 per year; originate traveling exhibitions; sales shop sells original art

ROCKY MOUNT

A **ROCKY MOUNT ARTS CENTER,** 225 S Church St, PO Box 1180 Rocky Mount, NC 27802. Tel 252-972-1163; Fax 252-972-1563; Elec Mail jackson@ci.rocky-mount.nc.us; Internet Home Page Address: www.ci.rocky-mount.nc.us/artscenter.html; *Admin Cultural Arts* Jerry Jackson; *Theatre Dir* Jerry Sipp; *Prog Coordr* Amber Young; *Theatre Prog Coordr* Jim Means; *Admin Secy* Louise Janelle; *VPres* Vel Johnson; *Dir Theatre* Maureen Daly; *Program Asst* Elizabeth Scott; *Prog Asst* Andre Jenkins
Open Mon - Wed & Fri 8:30 AM - 5 PM, Thurs 8:30 AM - 8 PM, Sat Noon - 5 PM, Sun 2 - 5 PM; No admis fee; Estab 1957 to promote the development of the creative arts in the community through educ, participation & appreciation of music, dance, painting, drama, etc; to provide facilities & guidance for developing talents & enriching lives through artistic expression & appreciation; Maintains the

Permanent Collection Gallery, Student Gallery, 4 Exhibition Galleries; Average Annual Attendance: 25,000; Mem: 600; dues $25 & up; annual meeting in Oct
Income: Financed by City Recreation Department with supplemental support by mem
Library Holdings: Book Volumes; Clipping Files; Kodachrome Transparencies; Periodical Subscriptions; Slides; Video Tapes
Collections: Regional works
Exhibitions: Outdoor Art Exhibition in the Spring; Permanent collection & traveling shows change each month; The Young at Art Annual Student Exhibition; Sculpture Salmagundi (indoor & outdoor) Annual Converging Cultures Exhibition
Publications: Arty Facts for Friends; The Playhouse Press newsletter
Activities: Conduct art classes; year-round theatre program; classes for adults & children; lect open to public, 2-4 vis lectrs per year; concerts; gallery talks; tours; sponsoring of competitions; book traveling exhibitions 5-6 per year; gallery shop sells books, original art, prints, pottery, jewelry, stationery, art supplies

SALISBURY

M **HORIZONS UNLIMITED SUPPLEMENTARY EDUCATIONAL CENTER,** Science Museum, 1637 Parkview Circle, Salisbury, NC 28144-2461. Tel 704-639-3004; Fax 704-639-3015; Internet Home Page Address: www.rss.kiz.nc.us; *Dir* Cynthia B Osterhus
Office Hours Mon - Fri 8 AM - 4 PM; Open to public by appointment; No admis fee; Estab 1968 to exhibit art work of pub schools, supplemented by exhibits of local artists from time to time during the school year; primary purpose is to supplement science educ activities in the pub schools; The center is comprised of two areas, one approximately 24 x 65 ft, the other 15 x 70 ft with an adjoining classroom for instruction & demonstrations; Average Annual Attendance: 19,000
Income: Financed by mem, state & county appropriation & from local foundations
Collections: Planetarium; touch tank Rain Forest
Activities: Classes for adults & children; lect open to public, 5 vis lectrs per year; gallery talks; tours; individual & original objects of art lent; summer camps

M **WATERWORKS VISUAL ARTS CENTER,** 123 E Liberty St, Salisbury, NC 28144. Tel 704-636-1882; Fax 704-636-1895; Elec Mail info@waterworks.org; Internet Home Page Address: www.waterworks.org; *Dir Admin* Irene K Beyer; *Exec Dir* Lori M McMahon
Open Tues - Fri 9 AM - 5 PM, Sat 10 AM - 5 PM; No admis fee; Estab 1977 for exhibition & instruction of visual arts; Four galleries with changing exhibitions; Average Annual Attendance: 22,200; Mem: 400; dues $50 & up; annual meeting in the spring
Income: $309,180 (financed by mem, city, county, grants & foundations, United Arts Fund, exhibition & educational corporate sponsors)
Library Holdings: Book Volumes 750+
Special Subjects: Decorative Arts, Etchings & Engravings, Glass, Portraits, Pottery, Silver, Woodcuts, Painting-European, Drawings, Graphics, Painting-American, Photography, Prints, Sculpture, Watercolors, Bronzes, Textiles, Costumes, Religious Art, Ceramics, Crafts, Folk Art, Woodcarvings, Landscapes, Afro-American Art, Judaica, Posters, Jewelry, Painting-British, Historical Material, Juvenile Art, Mosaics, Stained Glass
Exhibitions: Rotating exhibitions throughout the year; approximateley 15 professional exhibitions per yer; 5 galley changes per year; 6 young people's exhibitions per year
Publications: Annual exhibition catalogue
Activities: Classes for adults & children; classes for special populations; classes for children in public housing; in-school programs; outreach programs; lect open to public; gallery talks; tours; competitions & cash awards; annual Dare to Imagine Award given to one talented high school senior in the Rowan-Salisbury school system each year; scholarships offered; book traveling exhibitions; museum shop sells original art

STATESVILLE

M **IREDELL MUSEUM OF ARTS & HERITAGE,** 1335 Museum Rd, Statesville, NC 28625. Tel 704-873-4734; Fax 704-873-4407; Elec Mail iredellmuseum@yahoo.com; Internet Home Page Address: www.iredellmuseum.com; *Exec Dir* Henry Poore; *Exec Asst* Terry Lutar
Open Tues - Fri 10 AM - 5 PM, Sat 10 AM - 5 PM, Sun 2 - 5 PM; No admis fee; Estab 1956 to preserve & promote the art, history & the natural heritage of Iredell County; Bowles, Grier & Henkel Galleries features monthly changing exhibits; Artifacts Room features permanent displays; Average Annual Attendance: 20,000; Mem: 300; dues based on categories of giving; yearly meetings
Income: Financed by mem, CAFD (Cooperative Arts Fund Drive), grants & sponsorships
Special Subjects: Afro-American Art, Anthropology, Etchings & Engravings, Ceramics, Metalwork, Flasks & Bottles, Photography, Portraits, Pottery, Pre-Columbian Art, Painting-American, Prints, Textiles, Woodcuts, Manuscripts, Maps, Painting-British, Sculpture, Tapestries, Drawings, Watercolors, Costumes, Folk Art, Primitive art, Woodcarvings, Landscapes, Decorative Arts, Dolls, Furniture, Glass, Oriental Art, Carpets & Rugs, Historical Material, Miniatures, Embroidery, Antiquities-Egyptian, Antiquities-Roman, Stained Glass, Painting-Australian
Collections: Collections entail Ancient Arts, Decorative Arts, Fine Arts, Natural History, Historic Cabins, Mummy (Egyptian), Glassware, Textiles, Military
Exhibitions: Summer Sampler; Heritage Day; Christmas at the Cabins; (4/7/2005) Art in Bloom (fundraiser); (2005) Art in the Green (fundraiser)

TARBORO

M **EDGECOMBE COUNTY CULTURAL ARTS COUNCIL, INC,** Blount-Bridgers House, Hobson Pittman Memorial Gallery, 130 Bridgers St, Tarboro, NC 27886. Tel 252-823-4159; Fax 252-823-6190; Elec Mail edgecombearts@earthlink.net; Internet Home Page Address: www.edgecombearts.org; *Mgr* Carol Banks; *Dir* Mr Ellis (Buddy) Hooks
Open Mon - Fri 10 AM - 4 PM, Sat - Sun 2 - 4 PM; Admis $5; Estab 1982, to present local culture as it relates to state & nation; Located in a restored 1810

plantation house, 5 rooms in period interpretation, 3 used as gallery space for 20th century art permanent & traveling exhibits; Average Annual Attendance: 5,000; Mem: 350; dues $25; monthly meeting 2nd Thurs
Income: $175,000 (fin by state, local, fed & pv)
Library Holdings: Book Volumes; Cassettes; Clipping Files; Manuscripts; Maps; Original Art Works; Pamphlets; Periodical Subscriptions; Photographs; Prints; Records
Special Subjects: Historical Material, Furniture, Textiles, Manuscripts, Maps, Architecture, Archaeology, Ceramics, Decorative Arts, Period Rooms
Collections: Pittman Collection of oil, watercolors & drawings; American Collection of oils, watercolor & drawings; Decorative arts 19th century Southern
Exhibitions: Hobson Pittman retrospect; period rooms, 1810-1870
Publications: Around the House, bi-monthly
Activities: Classes for adults & children, docent programs; lect open to the public, 5 vis lectrs per year; concerts; gallery talks; tours; exten dept lends out paintings; 1 - 2 book traveling exhibitions; originate traveling exhibitions, once per year to accredited museums; museum shop sells original art

WADESBORO

M ANSON COUNTY HISTORICAL SOCIETY, INC, 209 E Wade St, Wadesboro, NC 28170. Tel 704-694-6694; *Pres* Don Scarborough
Open Apr - Sept, 1st Sun of each month 2 - 4 PM & by appointment; No admis fee; Estab 1960 as a mus of 18th & 19th century furniture; Average Annual Attendance: 1,000; Mem: 240; dues family $15, single $10; annual meeting in Nov
Income: $12,000 (financed by mem)
Special Subjects: Furniture
Collections: Collection of 18th & 19th century furniture
Publications: Cemeteries of Anson County, Volume 1; History of Anson County, 1750 - 1976

WASHINGTON

A BEAUFORT COUNTY ARTS COUNCIL, 108 Gladden St, PO Box 634 Washington, NC 27889-0634. Tel 252-946-2504; *Admin Asst* Eleanor Rollins; *Dir* Wanda Johnson; *Prog Dir* Joey Toler; *Visual Arts Coordr* Sally Hofmann
Open Mon - Fri 9 AM - 4 PM; No admis fee; Estab 1972
Collections: Aslando Suite by Jim Moon; Johannes Oertel Collection
Exhibitions: Rotating multi-media exhibits
Activities: Book traveling exhibitions

WILMINGTON

M CAMERON ART MUSEUM, (Louise Wells Cameron Art Museum) 3201 S 17th St, Wilmington, NC 28412. Tel 910-395-5999; Fax 910-395-5030; Internet Home Page Address: www.cameronartmuseum.com; *Dir* Deborah Velders; *Deputy Dir Oper* Mebane Boyd; *Dir Educ & Comm Outreach* Daphne Holmes; *Develop Officer* Heather Wilson; *Exhib & Coll Mgr* Robert Unchester; *Pub Rel & Events Coordr* Any Kilgore
Open Wed, Thurs, Sat, Sun 11 AM - 5 PM, Fri 11 AM - 9 PM; Donations accepted; Estab 1962 to promote the visual arts in southeastern North Carolina; Average Annual Attendance: 50,000; Mem: 3000; dues $35-$1200
Income: Privately funded
Purchases: Romare Bearden, Evening: Off Shelby Road
Library Holdings: Auction Catalogs; Audio Tapes; Book Volumes; CD-ROMs; Clipping Files; DVDs; Exhibition Catalogs; Original Documents; Pamphlets; Slides; Video Tapes
Special Subjects: Decorative Arts, Drawings, Etchings & Engravings, Folk Art, Ceramics, Glass, Photography, Pottery, Prints, Textiles, Sculpture, Tapestries, Painting-American, Watercolors, Crafts, Collages, Portraits, Furniture, Asian Art, Mosaics, Stained Glass, Pewter, Bookplates & Bindings
Collections: Mary Cassatt's color prints including The Ten, Minnie Evans, Utagawa Hiroshige, Claude Howell; Jugtown Pottery; 18th century - present North Carolina Art
Exhibitions: (11/16/2006-4/19/2007) Printed in Beauty; (4/29/2007-8/19/2007) William Ivey Long
Publications: Maud Gatewood; Benowen; Mary Cassatt brochure; Five American Artists brochure
Activities: Classes for adults; docent training; lect open to pub; 3+ vis lectr per yr; concerts; gallery talks; tours; organize traveling exhibs to museums; museum shop sells books, reproductions, prints, slides, ceramics, jewelry, children's items, bags, t-shirts & station

M STATE OF NORTH CAROLINA, Battleship North Carolina, Battleship Rd #1, Wilmington, NC 28401; PO Box 480, Wilmington, NC 28402. Tel 910-251-5797; Fax 910-251-5807; Elec Mail ncbb55@battleshipnc.com; Internet Home Page Address: www.battleshipnc.com; *Asst Dir* Roger Miller; *Marketing Dir* Monique Baker; *Mus Services Dir* Kim Robinson Sincox; *Dir Sales* Leesa McFarlane; *Exec Dir* David R Scheu; *Cur Colls* Mary Ames Sheret; *Controller* Elizabeth Rob
Open daily Labor Day - Memorial Day 8AM - 5PM, Memorial Day weekend - Labor Day 8AM - 8PM; Admis adult $12, children between 6 & 11 $6, under 6 free; 65 & over, active & retired military $10; Estab 1961 as a historic ship museum to memorialize the North Carolinians of all the services that gave their lives in WWII; Average Annual Attendance: 189,000; Mem: 182; $15-$1,000 memberships; bimonthly meetings
Income: Financed by admis, sales in gift shop & snack bar, rental functions & donations
Special Subjects: Folk Art, Photography, Period Rooms, Maps, Painting-American, Watercolors, Textiles, Costumes, Manuscripts, Silver, Marine Painting, Historical Material, Military Art
Collections: Artifacts, photos & archival materials associated with or appropriate to the ships bearing the name North Carolina; BB-55 (1936-1947); CA-12 (1905-1930) & Ship-of-the-line (1818-1867); also artifacts associated with the memorial itself

Publications: Battleship North Carolina; Ship's Data 1; Battleship North Carolina, Capt Ben Blee, USN (Retired)
Activities: Classes for children; lect open to public; scholarships offered; sales shop sells books, reproduction prints, slides, souvenirs & post cards

WILSON

M BARTON COLLEGE, Barton Museum - Virginia Graves Gallery - Lula E Rackley Gallery, 400 Acc Dr, Wilson, NC 27893; PO Box 5000, Wilson, NC 27893. Tel 252-399-6477; Fax 252-399-6571; Elec Mail sfecho@barton.edu; Internet Home Page Address: www.barton.edu/departmentofart/bartonmus; Open Mon - Fri 10 AM - 3 PM; No admis fee; Estab 1960 to provide art exposure for our students & community; Gallery has 200 linear feet wall space; Average Annual Attendance: 2,000
Income: Financed by endowment income
Library Holdings: Audio Tapes; Book Volumes; Original Art Works; Original Documents; Photographs; Prints; Reproductions; Sculpture; Slides
Collections: African masks; various objects of fine and decorative arts; watercolors by Paula W Patterson
Exhibitions: National Scholastic Art Award Competition for Eastern North Carolina; Annual graduating artists exhibitions
Activities: Educ program; lect open to public; gallery talks; tours

L Library, Whitehead & Gold Sts, College Station Wilson, NC 27893. Tel 252-399-6500; Fax 252-237-4957; *Dir* Shirley Gregory
For reference only
Library Holdings: Book Volumes 2500; Exhibition Catalogs; Kodachrome Transparencies; Original Art Works; Pamphlets; Periodical Subscriptions 94; Sculpture; Video Tapes 50
Special Subjects: Art History

WINSTON SALEM

M REYNOLDA HOUSE MUSEUM OF AMERICAN ART, PO Box 7287, Winston Salem, NC 27109-7287. Tel 336-725-5325; Fax 336-721-0991; Elec Mail reynolda@ols.net; *Exec Dir* John Neff; *Asst Dir Prog* Marjorie J Northup; *Coordr Marketing & Pub Relations* Judith Smith; *Coordr Educ* Kathleen F B Hutton; *Cur American Art* Joyce K Schiller; *Assoc Dir Planning & Develop* Elizabeth L Morgan
Open Tues - Sat 9:30 - 4:30 PM, Sun 1:30 - 4:30 PM, cl Mon; Admis adult $6, seniors $5, students & under 21 free; Estab 1964 to offer a learning experience through a correlation of art, music & literature using the house & the collection of American Art as resources; Gallery located in the 40 rooms of the former R J Reynolds home; Average Annual Attendance: 50,000; Mem: 1200; board meeting in May & Nov
Income: Financed by endowment, annual fund, government & foundation grants, admis & earned income
Special Subjects: Painting-American, Prints, Costumes
Collections: Doughty Bird Collection; costume collection; permanent collection of decorative arts, furniture, paintings, prints & sculpture
Exhibitions: William Sydney Mount; special exhibitions offered annually; small exhibitions in Fall/Spring
Publications: Annual Report; Calendar of Events, 3 per year
Activities: Classes for adults and children; dramatic programs; docent training; lect open to public, 20 vis lectrs per year; concerts; gallery talks; tours; individual paintings and original objects of art lent to specific museums with reciprocity agreement; lending collection contains original prints, paintings; museum shop sells slides of paintings

L Library, PO Box 7287, Winston Salem, NC 27109-7287. Tel 336-725-5325; Fax 336-721-0991; *Librn* Ruth Mullen
Open 9:30 AM - 4:30 PM; Open to public
Library Holdings: Book Volumes 2000; Clipping Files; Compact Disks; Periodical Subscriptions 30; Records; Video Tapes
Special Subjects: Art History, Painting-American, Art Education, Costume Design & Constr, Afro-American Art
Activities: Classes for adults & children; docent training; concerts; gallery talks; original objects of art lent to museums

WINSTON-SALEM

A THE ARTS COUNCIL OF WINSTON-SALEM & FORSYTH COUNTY, 305 W Fourth St, Ste 1 C, Winston-Salem, NC 27101. Tel 336-722-2585; Fax 336-761-8286; Elec Mail info@IntoTheArts.org; Internet Home Page Address: www.IntoTheArts.org; *Pres & CEO* Robert Chumbley
Open Mon - Fri 9 AM - 5 PM; Estab 1949, The Arts Council of Winston-Salem and Forsyth County enriches the quality of life for people in Winston-Salem and neighboring communities by strengthening cultural resources, promoting the arts and united arts fundraising. Each year we award approximately $1 million in grant support to arts and cultural organizations, arts education programs and individual artists throughout the community; Housing facilities include Hanes Community Center: theatre & rehearsal rooms, Sawtooth Building: art & craft studios & exhibition galleries; Mem: Annual meeting in the fall
Income: Financed by fund drives, pub & private grants & endowments
Activities: R Philip Hanes Jr Young Leader Recognition award given

A ASSOCIATED ARTISTS OF WINSTON-SALEM, 226 N Marshall St, Winston-Salem, NC 27101. Tel 336-722-0340; Fax 336-722-0446; Elec Mail staff@associatedartists.org; Internet Home Page Address: www.associatedartists.org; *Exec Dir* Ramelle Pulitzer
Open Mon - Fri 9 AM - 9 PM, Sat 9 AM - 5 PM; No admis fee; Estab 1956 to promote & conduct activities that support the awareness, educ, enjoyment & appreciation of visual fine art; The association rents the walls of the gallery from the Arts Council; Average Annual Attendance: 75,000; Mem: 500; dues $15-$40; regular programs
Income: $100,000 (financed by mem & Arts Council funds)

Exhibitions: One Southeastern regional show; two national art competitions; professional & associate invitational shows; various member exhibitions
Publications: Exhibit catalogs; newsletter, quarterly
Activities: Membership programs; workshops; lect; demonstrations; lect open to public, 8 vis lectrs per year; gallery talks; tours; opening receptions; competitions with awards; gallery sells original art

M **OLD SALEM INC,** Museum of Early Southern Decorative Arts, 924 S Main St, PO Box 10310 Winston-Salem, NC 27108. Tel 336-721-7360; Fax 336-721-7367; Elec Mail mashley@oldsalem.org; Internet Home Page Address: www.oldsalem.org; *VPres Coll & Research* Robert A Leath; *Dir Educ & Special Progs* Sally Gant; *Cur & Dir Coll* Johanna M Brown; *Dir Publications* Gary J Alpert; *Librn & Cur Research Coll* Katie Schlee; *Dir Research Center* Martha Rowe
Open Mon - Sat 9:30 AM - 3:30 PM, Sun 1:30 - 3:30 PM; Admis adult $14, children ages 5-16 $10; Estab 1965 to bring to light the arts & antiquities produced in Maryland, Virginia, Kentucky, Tennessee, North & South Carolina & Georgia through the first two decades of the 19th century; Three galleries are furnished with Southern decorative arts or imported objects used in the South & fifteen period settings from Southern houses dating from 1690 to 1821; Average Annual Attendance: 25,000; Mem: 1250; dues $25 & up; annual meeting in Spring
Income: $225,000 (financed by endowment, mem, state appropriation & other funds)
Purchases: $50,000
Special Subjects: Ceramics, Folk Art, Landscapes, Decorative Arts, Furniture, Glass, Metalwork, Historical Material, Maps, Gold
Collections: Southern decorative arts in general, & sepcifically furniture, paintings, silver, ceramics, metalwares, & woodwork of southern origin
Exhibitions: Ongoing Research in Southern Decorative Arts; Loan Exhib - Southern Perspective: A Sampling from the Mus of Early Southern Decorative Arts -New York Winter Antiques Show, 2007
Publications: Journal of Early Southern Decorative Arts, semiannually; catalog of the collection 1991, Museum of Early Southern Decorative Arts; The Luminary, newsletter, semiannually
Activities: Classes for adults & children; graduate Summer Institute; lect open to public, 15 vis lectrs per year; gallery talks; scholarships offered; exten dept serves eight Southern States; individual paintings & original objects of art lent to museums & cultural institutions & with special permission from staff are available for special exhibits; lending collection contains 2000 original art works, 100 paintings, 18,000 photographs & 30,000 slides; originate traveling exhibitions; sales shop sells books, slides

L **Library and Research Center,** PO Box 10310, Winston-Salem, NC 27108; 924 S Main St, Winston-Salem, NC 27101. Tel 336-721-7372; Elec Mail library@oldsalem.org; *Dir Research Ctr* Martha Rowe; *Librn & Cur Research Coll* Kathryn Schlee
Open Mon - Fri 9 AM - 4:30 PM, except holidays; Estab 1965 to display & research early southern decorative arts through 1820
Library Holdings: Auction Catalogs; Book Volumes 20,000; Clipping Files; Exhibition Catalogs; Fiche; Manuscripts; Micro Print; Other Holdings Computer data base index of early Southern Artists & Artisans; Periodical Subscriptions 125; Photographs; Reels; Slides; Video Tapes
Special Subjects: Art History, Stage Design, Ceramics, Crafts, Archaeology, American Indian Art, Furniture, Costume Design & Constr, Aesthetics, Afro-American Art, Carpets & Rugs, Architecture
Publications: Journal of Early Southern Decorative Arts, bi-annually; Luminary, bi-annually
Activities: Lect open to public; tours; fellowships

M **SOUTHEASTERN CENTER FOR CONTEMPORARY ART,** 750 Marguerite Dr, Winston-Salem, NC 27106. Tel 336-725-1904; Fax 336-722-6059; Elec Mail general@secca.org; Internet Home Page Address: www.secca.org; *Exec Dir* Vicki Kopf; *Cur Educ* Terri Dowell-Dennis; *Chief Cur* David J Brown; *Business Mgr* Susan Boone; *Pres Bd* Thorns Craven; *Asst Dir Opers* Karin Burnette
Open Wed - Sat 10 AM - 5 PM, Sun 2 - 5 PM, cl Mon & Tues; Admis adults $5, students & seniors $3; Estab 1956 to identify & exhibit the country's major contemporary artists of exceptional talent; to present educational programs for children & adults; to bring the viewing public in direct contact with artists & their art; Maintained are three indoor & outdoor exhibition areas; Average Annual Attendance: 74,000; Mem: 2000; dues varying categories; annual meeting May
Income: Financed by mem, local & state arts councils, grants, sales commissions & contributions
Library Holdings: Exhibition Catalogs; Periodical Subscriptions
Special Subjects: Drawings, Hispanic Art, Latin American Art, Painting-American, Photography, Prints, Sculpture, Ceramics, Crafts, Folk Art, Landscapes, Afro-American Art, Collages, Glass, Metalwork, Juvenile Art
Exhibitions: (10/28/2006-1/7/2007) Craft: Tradition and Use; (10/28/2006-1/7/2007) Allen Wexler: Drawing Architecture; (10/28/2006-1/7/2007) Barbara Witt; (10/28/2006-1/7/2007) Gwen Bigham: Coil; (1/20/2007-7/8/2007) Sightings; (1/20/2007-4/7/2007) James Esber; (1/20/2007-4/7/2007) Susan Jamison; 4/27/2007 Spring Fundraiser & SECCA Collects VII: An Art Auction; (5/12/2007-7/8/2007) Homegrown Southeast
Publications: Catalogs, 3-4 per yr; newsletter, quarterly
Activities: Classes for adults & children; dramatic programs; docent training; lect open to public; 10 vis lectrs per yr; concerts; gallery talks; tours; sponsoring of competitions; scholarships; book 2 traveling exhibitions per yr; originate traveling exhibitions; museum shop sells original art

WAKE FOREST UNIVERSITY
L **A Lewis Aycock Visual Resource Library,** Tel 336-758-5078; Fax 336-758-6014; Elec Mail martine@wfu.edu; Internet Home Page Address: www.wfu.edu/art; *Visual Resources Librn* Martine Sherrill
Open Mon - Fri 9 AM - 5 PM; Estab 1968; Reference and research for students and faculty only
Income: Financed by University
Library Holdings: CD-ROMs; Clipping Files; Compact Disks; DVDs; Exhibition Catalogs; Kodachrome Transparencies; Lantern Slides; Original Art Works; Other Holdings Laserdisks; Pamphlets; Periodical Subscriptions 19; Photographs; Prints; Records 128,088; Slides 136,000; Video Tapes

Special Subjects: Folk Art, Islamic Art, Pre-Columbian Art, Prints, History of Art & Archaeology, American Indian Art, Mexican Art, Period Rooms, Afro-American Art, Oriental Art, Religious Art
Collections: Art Department Slide Collection; University Print Collection
M **Charlotte & Philip Hanes Art Gallery,** Tel 336-758-5585; Elec Mail faccinto@wfu.edu; Internet Home Page Address: www.wfu.edu/art; *Asst Dir* Paul Bright; *Dir* Victor Faccinto
Open Mon - Fri 10 AM - 5 PM, Sat & Sun 1 - 5 PM; No admis fee; Estab 1976 for international contemporary & historical exhibitions; 3,500 sq ft of exhibition space in two separate galleries; Average Annual Attendance: 9,000
Income: Financed by university
Collections: R J Reynolds Collection; Simmons Collection; General Collection; Portrait Collection; Print Collection; Student Union Collection of Contemporary Art
Publications: Exhibit catalog
Activities: Lect open to public, 6 vis lectrs per year

M **Museum of Anthropology,** Tel 336-758-5282; Fax 336-758-5116; Elec Mail moa@wfu.edu; Internet Home Page Address: www.wfu.edu/moa; *Cur* Beverlye Hancock; *Museum Educ* Tina Smith; *Museum Shop Assoc* Anne Gilmore; *Admin Secy* Sara Cromwell; *Dir* Stephen Whittington
Open Tues - Sat 10 AM - 4:30 PM; Estab 1968; Average Annual Attendance: 20,000; Mem: 200; dues $5-$100
Income: $19,586 (financed by mem & University)
Special Subjects: American Indian Art, Anthropology, Pottery, African Art, Ethnology, Pre-Columbian Art, Costumes, Eskimo Art, Asian Art
Collections: Archaeological & ethnographic objects from the Americas, Africa, Asia & Ocean
Activities: Classes for adults & children; docent training; lect open to public, 6 vis lectrs per year; gallery talks; tours; traveling exhibitions 1-2 per year; museum shop sells jewelry, toys, books, masks & ethnic gifts

M **WINSTON-SALEM STATE UNIVERSITY,** Diggs Gallery, 601 Martin Luther King Jr Dr, Winston-Salem, NC 27110. Tel 336-750-2458; Fax 336-750-2463; *Gallery Asst* Leon Woods; *Dir, Cur, Develop& Registrar* Belinda Tate
Open Tues - Sat 11 AM - 5 PM; No admis fee; Estab 1990 as a university exhibition space highlighting African & African-American Art; 7000 sq ft, state of the art gallery, flexible space; Average Annual Attendance: 15,000
Income: $150,000-$200,000 (financed by endowment, state appropriation, grants & donations)
Library Holdings: CD-ROMs; DVDs; Exhibition Catalogs
Special Subjects: Painting-American, Photography, Prints, Sculpture, Watercolors, African Art, Textiles, Religious Art, Pottery, Primitive art, Woodcarvings, Woodcuts, Afro-American Art
Collections: African-American Art Collection
Exhibitions: African-American Quilts; Romare Bearden, John Biggers; Memory Juggs; Jacob Lawrence; Juan Logan; Alison Saar; Richmond Barthe; Lloyd Toone
Publications: Ashe Improvisation & Recycling In African-American Art Through African Eyes; Forget-Me-Not: The Art & Mystery of Memory Jugs; Model In The Mind
Activities: Classes for adults & children; lect open to public, 10-15 vis lectrs per year; individual paintings & original objects of art lent; book traveling exhibitions 5 per year

NORTH DAKOTA

BELCOURT

M **TURTLE MOUNTAIN CHIPPEWA HISTORICAL SOCIETY,** Turtle Mountain Heritage Center, PO Box 257, Belcourt, ND 58316. Tel 701-477-6140; *Chmn Bd* Jane Martin
Open summer hrs Mon - Fri 8 AM - 4:30 PM, Sat & Sun 1 - 5 PM, winter hrs Mon - Fri 8 AM - 4:50 PM; No admis fee; Estab 1985 to promote & preserve culture; Small, well arranged, attractive gallery consisting of historical photos, memorabilia, artifacts, art works, beadwork, all pertaining to the Turtle Mountain Chippewa; Mem: 200; dues $10-$500; annual meeting in Aug
Income: $98,496 (financed by mem, sales, bazaars & promotions)
Special Subjects: Architecture, Archaeology, Manuscripts, Historical Material, Maps
Collections: Ancient tools & implements; basketry; beaded artifacts; contemporary Indian crafts; costumes; memorabilia; paintings; pottery; sculpture; stones
Publications: Newsletter, twice a year
Activities: Lect open to public; competitions with prizes; originate traveling exhibitions to high school juried art shows & tri-state museums; sales shop sells books, prints, original art & reproductions

L **Heritage Center Archives,** PO Box 257, Belcourt, ND 58316. Tel 701-477-6140; *Chmn Board* Jane Martin
Open for members only; Estab 1986; For reference
Income: Financed by city appropriation
Library Holdings: Book Volumes 200; Clipping Files; Framed Reproductions; Manuscripts; Memorabilia; Original Art Works; Pamphlets; Photographs; Prints; Reproductions; Sculpture
Special Subjects: Art History, Folk Art, Film, Drawings, Crafts, Archaeology, Ethnology, Fashion Arts, Art Education, American Indian Art, Drafting, Costume Design & Constr, Dolls, Embroidery, Display

DICKINSON

M **DICKINSON STATE UNIVERSITY,** Art Gallery, 291 Campus Dr, Dickinson, ND 58601-4896. Tel 701-483-2312; Fax 701-483-2006; Elec Mail sharon_linnehan@dsu.nodak.edu; *Assoc Dir* Camey Huncovsky; *Dir* Carol Eacret-Simmons
Open Mon - Fri 8 AM - 5 PM, Sat 1 - 4 PM; No admis fee; Estab 1972 as a visual arts gallery presenting monthly exhibits representing the work of local,

national & international artists; Gallery is a secure, large room approx 40 x 30 ft, with a 10 ft ceiling & approx 120 running ft of sheetrock display space; Average Annual Attendance: 6,000; Mem: 38

Income: Financed by North Dakota Council on the Arts, grants, students activities fees & mem

Special Subjects: Ceramics, Graphics, Painting-American

Collections: Zoe Beiler paintings; contemporary graphics

Exhibitions: K D Swan Photos; Craig Calnan Prints & Drawings; Matt Drezenski Graphics; Nancy Morrow Modern Myths; Student Exhibition; Marilyn Lee recent works; Buel Ecker Black, White & Red; Doug Pfister Chairacters; Senior Exhibition; Faculty Show

Publications: Exhibit announcements

Activities: Classes for adults & children; ongoing artist-in-residence program; lect open to public, 5 vis lectr per year; gallery talks; student competitions; scholarships offered; individual paintings & original objects of art lent to faculty members; lending collection contains 70 original art works, 20 original prints & 10 photographs; book traveling exhibitions 4 per year; originate traveling exhibitions

L **Stoxen Library,** 291 Campus Dr, Dickinson, ND 58601. Tel 701-483-2135; Fax 701-483-2006; Elec Mail eileen.kopren@dsu.nodak.edu; Internet Home Page Address: www.dsu.nodak.edu/library.asp; *Dir Acquisition & Cataloging* Rita Ennen; *Dir Pub Svcs* Eileen Kopren; *Librn Dir* Lillian Crook
Open Mon - Thurs 8 AM -11 PM, Fri 8 AM - 4 PM, Sat 1 - 4 PM, Sun 6 - 11 PM; Open to college students & general pub

Library Holdings: Book Volumes 97,000; Periodical Subscriptions 650

FARGO

M **NORTH DAKOTA STATE UNIVERSITY,** Memorial Union Gallery, PO Box 5476, Fargo, ND 58105-5476. Tel 701-231-8239, 231-7900; Fax 701-231-8043; Elec Mail peg-furshong@ndsu.nodak.edu; Internet Home Page Address: www.ndsu.nodak.edu/memorial-union/gallery; *Dir* Peg Furshong
Open Mon - Thurs 9:30 AM - 6 PM, Fri 9:30 AM - 1 PM, by arrangement; Estab 1975 to educate through exposure to wide variety of artwork; 37 ft x 28 ft track lighting, gray carpet, attendent & security system; Average Annual Attendance: 12,000

Income: $17,000 (financed by student activity fee allocation)

Library Holdings: Book Volumes; Exhibition Catalogs; Framed Reproductions; Original Art Works

Special Subjects: Drawings, Graphics, Photography, Prints, Sculpture, Watercolors, Southwestern Art, Textiles, Ceramics, Pottery, Woodcarvings, Woodcuts, Etchings & Engravings, Landscapes, Collages, Painting-European, Painting-Japanese, Portraits, Posters

Collections: Permanent collection of contemporary work by American artists

Exhibitions: Contemporary works by American artists

Activities: Educ dept; lect open to public, 4 vis lectrs per year; concerts; gallery talks; tours; competitions & awards; book traveling exhibitions 4-6 per year to museums & galleries in North Dakota & Minnesota; sales shop sells prints, reproductions & original art

M **PLAINS ART MUSEUM,** 704 First Ave N, PO Box 2338 Fargo, ND 58108-2338. Tel 701-232-3821; Fax 701-293-1082; Elec Mail museum@plainsart.org; Internet Home Page Address: www.plainsart.org; *VP Cur & Educ* Rusty Freeman; *VPres Develop & Mktg* Ann Clark; *VPres & CFO* Ben Clapp; *Pres & CEO* Edward E Pauley; *Pub Relations Mgr* Sue Petry; *Bd Dir Chmn* John Q Paulsen; *Registrar* Mark Ryan; *Bd Dir Treas* Ronald P Robson; *Bd Dir VChmn* Thomas J Riley; *Bd Dir Secy* Mark Shaul
Open Tues, Wed, Fri & Sat 10 AM - 5 PM, Thurs 10 AM - 8 PM, Sun 1 PM - 5 PM; cl Mon; Admis adults $3, seniors & educators w/ID $2.50, mems, students w/ID & youth free; every 2nd & 4th Tues each month no admis fee; tours call for reservation & pricing; Estab 1975 to bring people & art together as a public institution; we celebrate the finest of human achievement & inspire & engage diverse audiences in the creation, exhibition, collection & preservation of art; Former International Harvestory Building (1908); 3 galleries for permanent collection & traveling exhibits. Maintains reference library; Average Annual Attendance: 78,000; Mem: 1000; annual meeting in May

Income: Financed by mem, NEH, NEA & foundations grants & charitable gaming, special events, state & business grants

Collections: Contemporary American, American Indian & West African Art; The Rolling Plains Art Gallery (traveling gallery); regional, national, international, fine arts, Woodland & Plain Indian Art

Exhibitions: (1/19/2006-3/26/2006) A Patchwork of Cultures; (3/2/2006-5/28/2006) Jaune Quick-To-See Smith: Made in America; (9/14/2006-1/7/2007) Changing Hands; (10/12/2006-1/7/2007) Black is a Color; (10/2007-1/2008) Wayne Gudmundson Retrospective; (2008) Mid-America Print Council Exhibition

Publications: Plains Art Museum, quarterly; exhibition checklist & catalogs with each exhibition

Activities: Classes for adults & children; docent training; lect open to public; concerts; gallery talks; tours; competitions with prizes; family art workshops; exten dept serves North Dakota, Minnesota, Montana, South Dakota & Manitoba; artmobile; book traveling exhibitions; originate traveling exhibitions circulated to galleries and museums in a 6 state area: ND, SD, MN, WI, IA, MT; museum shop sells books, magazines, original art, posters and prints, reproductions, t-shirts, jewelry, postcards and local craft items

FORT RANSOM

M **SVACA - SHEYENNE VALLEY ARTS & CRAFTS ASSOCIATION,** Bjarne Ness Gallery at Bear Creek Hall, PO Box 21, Fort Ransom, ND 58033. Tel 701-973-4461, 973-4491; *Prog Coordr* Georgia Rusfvold
Open Sat, Sun & holidays 1 - 6 PM, June 1 - Sept 30; No admis fee, donations accepted; Estab 1966 to promote & encourage the arts in a rural setting; The Gallery is the former studio of the late Bjarne Ness; Average Annual Attendance: 2,400; Mem: 180; dues couple $8; annual meeting in Oct

Income: Financed by mem, grants & Annual Festival

Special Subjects: Painting-American, Woodcarvings

Collections: Paintings of Bjarne Ness; paintings & wood carvings by area artists in SVACA's Bear Creek Hall

Activities: Classes for adults & children

L **Library,** Box 21, Fort Ransom, ND 58033. Tel 701-973-4461;
Open to members for reference

Library Holdings: Book Volumes 100; Periodical Subscriptions 3

FORT TOTTEN

A **FORT TOTTEN STATE HISTORIC SITE,** Pioneer Daughters Museum, PO Box 224, Fort Totten, ND 58335-0224. Tel 701-766-4441; *Co-Site Supv* Rhonda Greene; *Co-Site Supv* John Mattson
Open summer site 8 AM - 5 PM, museum May 16 - Sept 15 8 AM - 5 PM; Admis adult $5, children 6-15 $2, children 5 & under free; Estab 1867 to preserve & display local & state history; Average Annual Attendance: 14,000; Mem: 150; dues $40

Income: Financed by state appropriation, donations

Collections: Buildings of historic site, outdoor museum; Pioneer Artifacts

Activities: Classes for adults & children; guided group tours; lect open to public; tours; competitions; originate traveling exhibitions; museum shop sells books & magazines; junior museum

GRAND FORKS

M **NORTH DAKOTA MUSEUM OF ART,** 261 Centennial Dr, Stop 7305 Grand Forks, ND 58202. Tel 701-777-4195; Fax 701-777-4425; Elec Mail ndmoa@ndmoa.com; Internet Home Page Address: www.ndmoa.com; *Dir & Chief Cur* Laurel J Reuter; *Exhib Coordr* Greg Vettel; *Dir Educ* Sue Fink; *Business Mgr* Amy Hovde; *Dir Develop* Bonnie Sobolik; *Asst to Dir* Brian Lofthus; *Asst Dir Educ* Matt Wallace; *Office Mgr* Connie Hulst; *Tech Asst* Justin Dalzell; *Mem Coordr* Stacy Warcup
Open Mon - Fri 9 AM - 5 PM, Sat & Sun 11 AM - 5 PM; No admis fee; Estab 1971 as a contemporary art museum; In 1989 the museum moved into a renovated 1907 campus building/gymnasium after 3 yrs of renovations; Average Annual Attendance: 50,000; Mem: 500; dues individual $35; annual meeting in June

Income: Financed by private endowments, gifts, grants, mem & earned income

Collections: American, Contemporary & International art

Publications: Exhibition catalog with some exhibits

Activities: Dramatic programs; docent training; workshops; annual concert series; readers series; lect open to the public, 25 vis lectrs per year; gallery talks; tours; originate traveling exhibitions for circulation to US museums & abroad; museum shop sells books, magazines, folk & ethnic art

M **UNIVERSITY OF NORTH DAKOTA,** Hughes Fine Arts Center-Col Eugene Myers Art Gallery, Dept of Visual Arts, Rm 127, Grand Forks, ND 58202-7099; UND Art Department, HFAC Rm 127, 3350 Campus Rd Stop 7099 Grand Forks, ND 58202-7099. Tel 701-777-2257; Elec Mail brian_paulsen@und.nodak.edu;
Open 11:30 AM - 4 PM; No admis fee; Estab 1979 to augment teaching & offer another location to display art; 96 running ft of wall space; Average Annual Attendance: 1,200

Income: Financed through university

Purchases: CE Myers Trust Fund

Special Subjects: Drawings, Sculpture, Textiles, Ceramics, Jewelry, Calligraphy

Collections: Collection chosen from Annual Print & Drawing Juried Exhibit

Exhibitions: Rotating exhibitions

MAYVILLE

M **MAYVILLE STATE UNIVERSITY,** Northern Lights Art Gallery, 330 NE 3rd St, Mayville, ND 58257. Tel 701-788-6200; Fax 701-788-6210; Elec Mail director@northernlightsart.org; Internet Home Page Address: www.northernlightsart.org; *Dir* Cynthia Kaldor; *Dir Comm Sch Arts* Mike Bakken
Open Mon - Wed & Fri 11 AM - 3 PM, Thurs 11 AM - 6 PM; No admis fee; Estab 1999; Gallery in student center bldg 40 'x 40'; Average Annual Attendance: 900; Mem: over 100 mem, $25 fee

Income: mem fees, ann auction

Exhibitions: Contemporary American & North Dakota artists; student exhibitions; visiting collections

Activities: January auction; visiting artists; gallery tours

MINOT

M **MINOT ART ASSOCIATION,** Lillian & Coleman Taube Museum of Art, 2 N Main St, Minot, ND 58703; PO Box 325, Minot, ND 58702. Tel 701-838-4445; Fax 800-879-6684; Elec Mail taube@ndak.net; *Exec Dir & Cur* Nancy F. Walter-Brown; *Gallery Asst* Butch Hedberg; *Educ Coordr* Margaret Lee
Open Jan - Dec, Tues - Fri 12 PM - 5 PM, Sat noon - 3 PM; Admis is by suggested contribution; Estab 1970 to promote means & opportunities for the educ of the pub with respect to the study & culture of the fine arts; Renovated bank; Average Annual Attendance: 20,000; Mem: Membership 500; dues $35 - $1000; board meeting 3rd Thurs of month

Income: Financed by endowment, mem, contributions, sales & grants

Special Subjects: Drawings, Folk Art

Collections: Original art works; paintings; pottery; printmaking; sculpture; all done by local & national artists

Exhibitions: Art competitions; artfests; one-person exhibits; traveling art exhibits; exhibitions change monthly

Publications: Calendar of Exhibits; bi-monthly newsletter

Activities: Classes for adults & children; dramatic progs; performing arts classes; gallery talks; concerts; tour; competitions; North Dakota juried student art awards; book traveling exhibitions 2-3 per year; traveling exhibitions organized &

circulated to North Dakota galleries; museum shop sells books, original art, reproductions, prints & cards

M **MINOT STATE UNIVERSITY,** Northwest Art Center, 500 University Ave W, Minot, ND 58707. Tel 701-858-3264; Fax 701-858-3894; Elec Mail nac@minotstateu.edu; Internet Home Page Address: www.minotstateu.edu/nwac; *Dir* Avis Veikley
Open Mon - Fri 8 AM - 4:30 PM, cl holidays; No admis fee; Estab 1975 as a supplementary teaching aid, resource for Minot State University, Northwest & Central North Dakota; Two galleries: Hartnett Hall Gallery & The Library Gallery; 600 sq ft; Average Annual Attendance: 6,000
Income: $25,000 (financed by grants)
Purchases: $2,500
Library Holdings: Exhibition Catalogs; Original Art Works; Photographs; Prints; Slides
Collections: Over 300 contemporary 2-D works on paper in all media on paper (printmaking, drawing, painting)
Exhibitions: America's 2000: All Media (Aug-Sept); America's 2000: Paperworks Exhibition (Jan-Feb)
Publications: Calendar of exhibits, annual; posters; newsletter
Activities: Classes for adults & children; artist in residence; lect open to public, 10-12 vis lectrs per year; gallery talks; tours; competitions with awards, merit, best of show & purchase; book traveling exhibitions 6-10 per year; originate traveling exhibitions to regional venues, galleries in ND

RAPID CITY

M **INDIAN ARTS & CRAFTS BOARD, US DEPT OF THE INTERIOR,** Sioux Indian Museum, 222 New York St, Rapid City, ND 57701; PO Box 1504, Rapid City, SD 57709. Tel 605-394-2381; Fax 605-348-6182; Internet Home Page Address: www.journeymuseum.org; *Cur* Paulette Montileaux; *Mus Aid* Melvin Miner
Open 9 AM - 5 PM daily(Memorial Day - Labor Day), Mon - Sat 10 AM - 5 PM, Sun 1 - 5 PM (Labor Day - Memorial Day); Admis adults (18-61) $7, seniors(62+) $6, children (11-17) $5, children 10 & under free; Estab 1939 to promote the development of contemporary Native American arts & crafts of the United States; Average Annual Attendance: 45,000
Income: Financed by federal appropriation
Special Subjects: American Indian Art, Crafts
Collections: Contemporary Native American arts & crafts of the United States; Historic works by Sioux craftsmen
Exhibitions: Continuing series of one-person exhibitions
Publications: One-person exhibition brochure series, bimonthly
Activities: Lect; tours; sales shop sells original arts & crafts

OHIO

AKRON

M **AKRON ART MUSEUM,** One South High, Akron, OH 44308-2084. Tel 330-376-9185; Fax 330-376-1180; Elec Mail mail@akronartmuseum.org; Internet Home Page Address: www.akronartmuseum.org; *Dir* Dr Mitchell Kahan; *Chief Cur & Dir Head P* Dr Barbara Tannenbaum; *Registrar* Arnold Tunstall; *Adm'nr* Gail Wild; *Dir Develop* Joan Lauck; *Cur Exhibs* Katherine Wat; *Dir Educ* Melissa Higgins; *Assoc Educator* Alison Caplan; *Communications Officer* Julie Ann Hancsak
Cl for renovation until July 2007; No admis fee; Estab 1922 as a mus to exhibit & collect art; In 1981 opened new Akron Art Mus in restored & reconstructed 1899 National Register Historic Building; Coop Himmelblau's 64,000 sq ft bldg to open 2007 connected to existing bldg; Mem: 2000; dues general $45; annual meeting in Sept
Income: $2,009,047 (financed by mem, endowment, corporate, foundation & government grants)
Library Holdings: Auction Catalogs; Audio Tapes; Book Volumes; Cassettes; Clipping Files; DVDs; Exhibition Catalogs; Kodachrome Transparencies; Pamphlets; Periodical Subscriptions; Slides; Video Tapes
Special Subjects: Photography, Decorative Arts
Collections: 20th Century American & European painting, photography & sculpture; Harry Callahan; Chuck Close; Richard Deacon; Minnie Evans; Walker Evans; Robert Frank; Philip Guston; Donald Judd; Philip Pearlstein; Elijah Pierce; Cindy Sherman; Nancy Spero; Thomas Struth; Mark Di Suvero; Andy Warhol; Carrie Mae Weems
Publications: Exhibition catalogs; annual report; quarterly newsletter
Activities: Educ dept; classes for adults & children; docent training; lect open to public, 8+ vis lectrs per year; concerts; gallery talks; tours; book traveling exhibitions 4 per year; originates traveling exhibitions; museum shop sells books, magazines, original art, reproductions & prints

L **Martha Stecher Reed Art Library,** One South High, Akron, OH 44308. Tel 330-376-9185; Fax 330-376-1180; Elec Mail eward@akronartmuseum.org; Internet Home Page Address: www.akronartmuseum.org; *Librn* Ellie Ward; *Chief Cur* Dr Barbara Tannenbaum
Open by appointment only; Open for reference, not open to pub, non-circulating
Income: $3500
Library Holdings: Auction Catalogs; Audio Tapes; Book Volumes 10,000; Cassettes; Clipping Files; DVDs; Exhibition Catalogs; Kodachrome Transparencies; Pamphlets; Periodical Subscriptions 75; Slides; Video Tapes 50
Special Subjects: Photography
Collections: Edwin Shaw Volumes, to accompany collection of American Impressionist Art
Activities: Classes for children; docent training; lects open to pub; gallery talks

L **AKRON-SUMMIT COUNTY PUBLIC LIBRARY,** Fine Arts Division, 55 S Main St, Akron, OH 44326. Tel 330-643-9035; Fax 330-643-9033; Internet Home Page Address: www.ascpl.lib.oh.us; *Librn & Dir* Steven Hawk; *Mgr History & Humanities Div* Bob Ethington
Open Mon - Thurs 9 AM - 9 PM, Fri 9 AM - 6 PM, Sat 9 AM - 5 PM, Sun 1 - 5

PM; Estab 1904 to serve the educational & recreational needs of the general public of Summit & contiguous counties
Income: $75,000 (financed by state and local taxes)
Library Holdings: Book Volumes 55,000; Clipping Files; Exhibition Catalogs; Fiche; Pamphlets; Periodical Subscriptions 150
Special Subjects: Art History, Folk Art, Decorative Arts, Illustration, Photography, Drawings, Graphic Arts, Ceramics, Crafts, Costume Design & Constr, Glass, Embroidery, Jewelry, Architecture
Activities: Book traveling exhibitions 1-3 per year

M **STAN HYWET HALL & GARDENS,** 714 N Portage Path, Akron, OH 44303. Tel 330-836-5533; Fax 330-836-2680; Internet Home Page Address: www.stanhywet.org; *Pres & CEO* Harry P Lynch; *VPres Mus Svcs & Cur* Mark Heppner; *Dir Horticulture* Tom Hrivnak
Open Feb - Mar Tues - Sat 10 AM - 4 PM, Sun 1 - 4 PM, Apr - Dec 10 AM - 4:30 PM; Admis adults $12, children 6 - 12 $6, children under 6 free; Incorporated 1957, Stan Hywet Hall is a house mus & garden, serving as a civic & cultural center. All restoration & preservation work is carefully researched to retain the original concept of the property, which represents a way of life that is gone forever; The mansion, the focal point of the estate, is a 65-room Tudor Revival manor house, furnished with priceless antiques & works of art dating from the 14th century. The property is the former home of Frank A Seiberling, (Akron rubber industrialist & co-founder of Goodyear Tire & Rubber) & was completed in 1915. There are 70 acres of formal gardens, meadow, woods & lagoons; Average Annual Attendance: 200,000; Mem: 3700; dues $55 & up; annual meeting in May
Income: $1,000,000 (financed by endowment, mem, admis, gifts, grants, rentals & special events)
Library Holdings: Audio Tapes; Book Volumes; CD-ROMs; Clipping Files; Compact Disks; DVDs; Framed Reproductions; Manuscripts; Maps; Memorabilia; Motion Pictures; Original Art Works; Original Documents; Pamphlets; Periodical Subscriptions; Photographs; Prints; Records; Reels; Reproductions; Sculpture; Slides; Video Tapes
Special Subjects: Period Rooms
Collections: Antique furniture; china; crystal; paintings; porcelain; rugs; sculpture; silver; tapestries; architectural drawings, manuscripts & photographs
Exhibitions: Permanent & temporary exhibitions through the year
Publications: Stan Hywet Hall and Gardens Annual Report, yearly; Stan Hywet Hall Newsletter, quarterly
Activities: Childrens programs; dramatic programs; docent training; classes for adults & children; lect open to public, open to members only; 6 vis lectrs per year; year round special events; concerts; tours; exten dept serves libraries; original objects of art lent to historical societies & museums; lending collection includes 5000 books & 250 slides; museum shop sells books, original art, reproductions, slides & wide variety of gift items

M **SUMMIT COUNTY HISTORICAL SOCIETY,** 550 Copley Rd, Akron, OH 44320-2398. Tel 330-535-1120; Fax 330-535-0250; Elec Mail schs@summithistory.org; Internet Home Page Address: www.summithistory.org; *Dir* Paula G Moran; *VPres* Lynn Metzger; *Pres* Donald Fair; *Business Mgr* Sandy Pecimon; *Cur* Leianne Neff Heppner; *Educ Coordr* Alison First
Office open Tues - Fri 8 AM - 4 PM, Tours Wed - Fri 12:30 & 2:30 PM; Admis adults $5, children under 12 & seniors $4; Estab 1924 for the collection, preservation & display of items of an historical nature from Summit County; 1837 Perkins mansion - Greek revival home with period rooms; John Brown house with changing displays; Average Annual Attendance: 3,500; Mem: 500; dues $40 - $500; annual meeting in late Spring
Income: $150,000 (financed by endowment, mem & foundations)
Special Subjects: Etchings & Engravings, Folk Art, Architecture, Ceramics, Photography, Painting-American, Prints, Period Rooms, Textiles, Costumes, Pottery, Portraits, Dolls, Furniture, Glass, Silver, Carpets & Rugs, Historical Material, Embroidery, Military Art
Collections: 19th & 20th century costumes & accessories; 1810-1900 era furniture; 19th century chinaware, glassware, silverware & pottery; 19th century portraits; 19th & 20th century tools, household items & toys; Native Am material; The John Brown House; Numerous works of art on paper & canvas
Exhibitions: Perkins Stone Mansion; Framework of Fashion; (2003) John Brown Stories the Artifacts Can Tell; Photography: An Invention Without Future; 10 intern-led exhibitions due to grant from the Ohio Humanities Council, a state affiliate of the National Endowment for the Humanities and the Ohio Association of Historical Societies & Museums
Publications: Old Portage Trail Review, bimonthly
Activities: Educ dept; classes for adults & children; docent training; 40-50 vis lect per yr; gallery talks; tours; Stuart B Steiner award for Volunteerism; scholarships; lending of original objects of art to city, county, regional & some out-of-state exhib; sales shop sells books, crafts, souvenirs, toys, notepaper, books, magazines & reproductions

UNIVERSITY OF AKRON

M **University Art Galleries,** Tel 330-972-5950; Fax 330-972-5960; Internet Home Page Address: art.uakron.edu/html/galleries.shtml; *Gallery Dir* Rod Bengston; *Interim Gallery Dir* Michael Butchezk
Open Mon, Tues & Fri 10 AM - 5 PM, Wed & Thurs 10 AM - 9 PM; No admis fee; Estab 1974 to exhibit the work of important contemporary artists working in all regions of the United States, as well as to provide a showcase for the work of artists working within the university community; Two galleries: Emily H Davis Art Gallery, 2000 sq ft of floor space; 200 running ft of wall space; Guzzetta Hall Atrium Gallery, 120 running ft of wall space; Average Annual Attendance: 12,000-15,000
Income: Financed by university funds & grants
Special Subjects: Photography, Ceramics, Asian Art
Collections: Contemporary Photography; Southeast Asian Ceramics & Artifacts
Exhibitions: Rotating exhibits, call for details
Publications: Catalogs & artists books in conjunction with exhibitions
Activities: Lect open to public, 5-10 per year; gallery talks; competitions; awards for Student Show; scholarships & fels offered; book traveling exhibitions; originate traveling exhibitions, circulation to other university galleries & small museums with contemporary program

ASHLAND

M ASHLAND COLLEGE ARTS & HUMANITIES GALLERY, The Coburn Gallery, 401 College Ave, Ashland, OH 44805. Tel 419-289-4142; *Dir* Larry Schiemann
Open Tues - Sun 1 - 4 PM, Tues 7 - 10 PM; No admis fee; Estab 1969; Gallery maintained for continuous exhibitions
Collections: Mostly contemporary works, some historical
Exhibitions: Invitational Printmaking; annual student exhibition; rotating exhibitions
Activities: Classes for children; dramatic programs; lect open to public; 2-3 gallery talks; tours & regular tours to leading art museums; concerts; scholarships; original objects of art lent to Akron Art Institute and Cleveland Museum of Art

ASHTABULA

A ASHTABULA ARTS CENTER, 2928 W 13th St, Ashtabula, OH 44004. Tel 440-964-3396; Fax 440-964-3396; Elec Mail aac@suite224.net; Internet Home Page Address: www.ashartscenter.org; *Visual Arts & Exhibit Coordr* Meeghan Humphery; *Business Mgr* Cindy Rimpela; *Theater Coordr* Darrell Lowe; *Pres* Rob Schimmelpfennig; *Dance Coordr* Shelagh Dubsky; *Exec Dir* Beth Koski; *Pub Relations Coordr* Pamela Hammond
Open Mon - Thurs 9 AM - 9 PM, Fri 9 AM - 7 PM, Sat 9 AM - 5 PM; No admis fee; Estab 1953 as a nonprofit, tax exempt art organization, to provide high quality instruction; One major gallery area with smaller anex-fixed panels on all walls; Average Annual Attendance: 50,000; Mem: 1000; dues family $50, individual $25; annual meeting in Oct
Income: Financed by mem, NEA, OAC, WSL, JTPA
Collections: Local & regional contemporary work, small international contemporary print collection, regional wood sculpture (major portion of collection represents local & regional talent)
Publications: Ashtabula Arts Center News, bimonthly; monthly exhibit information
Activities: Classes for adults & children; dramatic program; lect open to public, 5-10 vis lectrs per year; concerts; gallery talks; tours; competitions; cash awards; scholarships & fels offered; exten dept serves Ashtabula County hospitals & public buildings; individual paintings & original objects of art lent to schools & public buildings; lending collection contains books, cassettes, color reproductions, framed reproductions, original art works, original prints, paintings, phonorecords, photographs, sculpture & slides; book traveling exhibitions; originate traveling exhibitions

ATHENS

A DAIRY BARN CULTURAL ARTS CENTER, 8000 Dairy Ln, PO Box 747 Athens, OH 45701-0747. Tel 740-592-4981; Fax 740-592-5090; Elec Mail artsinfo@dairybarn.org; Internet Home Page Address: www.dairybarn.org; *Prog Dir* Julie Clark; *Educ Dir* Lisa Quinn; *Exec Dir* Krista Campbell; *Gallery Shop Mgr* Rachel Binegar
Open Tues & Wed, Fri - Sun Noon - 5 PM, Thurs Noon - 8 PM; Varies, call for details; Estab 1977 to promote art & culture; 7000 sq ft gallery located in historic dairy barn; Average Annual Attendance: 15,000; Mem: 650; dues $35-$50; annual meeting in Jan
Special Subjects: Landscapes, Sculpture, Watercolors, Decorative Arts, Folk Art, Ceramics, Collages, Crafts, Juvenile Art, Furniture, Glass
Exhibitions: Second Annual Southeast Ohio Dulcimer Festival; (2004) Bead International (summer)
Activities: Classes for adults & children; dramatic programs; docent training; lect open to public; concerts; gallery talks; tours; competitions with awards; exten dept serves area schools; book traveling exhibitions; originate traveling exhibitions; museum shop sells books, magazines, original art, reproductions & prints

M OHIO UNIVERSITY, Kennedy Museum of Art, Lin Hall, Athens, OH 45701-2979. Tel 740-593-1304; Fax 740-593-1305; Elec Mail kennedymuseum@ohio.edu; Internet Home Page Address: www.ohiou.edu/museum; *Registrar* Jeffrey Carr; *Cur Educ* Sally Delgado; *Cur* Jennifer McLerran
Open Tues, Wed, Fri Noon - 5 PM, Thurs Noon - 8 PM, Sat - Sun 1 - 5 PM; No admis fee; 1993; Average Annual Attendance: 10,000; Mem: 220; dues vary; annual meeting in spring
Special Subjects: Pottery, Painting-American, Photography, Prints, Sculpture, American Indian Art, African Art, Southwestern Art, Textiles, Woodcarvings, Woodcuts, Jewelry
Collections: The Edwin L & Ruth E Kennedy Southwest Native American Collection; Contemporary prints, paintings, photographs & sculpture; African masks
Exhibitions: Four rotating exhibits per yr; Permanent exhibit - rotates every 2 yrs
Activities: Classes for children; docent training; lec for members; gallery talks; tours; individual paintings & original objects of art lent for southeastern Ohio; artmobil for K-12 schools; book traveling exhibitions 1 per year
M Seigfred Gallery, School of Art, Seigfred Hall 528 Athens, OH 45701. Tel 740-593-4290, 593-0796; Fax 740-593-0457; *Dir* Jenita Landrum-Bittle
Open Tues - Fri 10 AM - 4 PM; No admis fee; Gallery is used for faculty exhibitions, student exhibitions & vis artist shows
Exhibitions: Rotating exhibits by students & faculty
L Fine Arts Library, Alden Library, Park Place Athens, OH 45701-2878. Tel 740-593-2663; Fax 740-593-0138; Elec Mail braxton@ohio.edu; *Art Librn* Gary Ginther; *Sr Libr Assoc* Elizabeth Story
Open Mon - Thurs 8 AM - 12 AM, Fri 8 AM - 9 PM, Sat 10 AM - 9 PM, Sun Noon - 12 AM; Selective exhibition of student & faculty work
Income: Financed by state appropriation
Library Holdings: Book Volumes 75,000; CD-ROMs; DVDs; Exhibition Catalogs; Fiche; Periodical Subscriptions 300
Special Subjects: Photography

Collections: Research collection in history of photography; small collection of original photographs for study purposes

BAY VILLAGE

A BAYCRAFTERS, INC, Huntington Metropark, 28795 Lake Rd Bay Village, OH 44140. Tel 440-871-6543; Fax 440-871-0452; Elec Mail info@baycrafters.com; *Dir* Sally Irwin Price
Open Mon - Sat 12 - 5 PM; No admis fee; Estab 1948 for advancement & enjoyment of arts & crafts in the region; Average Annual Attendance: 30,000; Mem: 1800, dues individuals $25, family $40, students $10, businesspeople $50
Exhibitions: Christmas Show; Emerald Necklace Juried Art Show; Juried Art Show; Renaissance Fayre; student competition; individual gallery shows; floral juried art show; Victoria Garden Party; Heritage Days
Publications: Bulletins & competition notices
Activities: Classes for adults & children; lect open to public, 9-12 vis lectrs per year; gallery talks; tours; tea room for children's birthday parties; monetary prizes awarded; scholarships offered; sales shop sells original art, reproductions, prints, pottery & other crafts work from local & out-of-town artists

BEACHWOOD

M THE TEMPLE-TIFERETH ISRAEL, The Temple Museum of Religious Art, 26000 Shaker Blvd, Beachwood, OH 44122. Tel 216-831-3233, ext 108; Elec Mail makeck@hotmail.com; *Sr Rabbi* Benjamin Alon Kamin; *Dir Mus* Susan Koletsky
Open daily 9 AM - 3 PM by appointment only; No admis fee; Estab 1950 for the display & teaching of Judaica; Two galleries, each housed in a national landmark temple; Average Annual Attendance: 10,000; Mem: 15,000; annual meeting
Special Subjects: Graphics, Watercolors, Archaeology, Ethnology, Textiles, Costumes, Religious Art, Pottery, Etchings & Engravings, Landscapes, Decorative Arts, Judaica, Manuscripts, Portraits, Glass, Silver, Metalwork, Historical Material, Maps, Embroidery, Stained Glass, Leather, Painting-Israeli
Collections: Antique Torah hangings; Holyland pottery; Israel stamps; paintings; sculpture; stained glass; Torah ornaments
Exhibitions: 50 Years of Israel Stamps from the Miriam Leikind Collection & Albert Friedberg Collection
Activities: Classes for adults & children; lect open to public, 12 vis lectrs per year; gallery talks; tours; original objects of art lent to other professional institutions; museum shop sells Judaic ritual objects
L Lee & Dolores Hartzmark Library, 26000 Shaker Blvd, Beachwood, OH 44122. Tel 216-831-3233, ext 120; Fax 216-831-4216; Elec Mail makeck@hotmail.com; *Dir & Librn* Andrea Davidson
Two buildings
Library Holdings: Audio Tapes; Book Volumes 10,000; Cassettes; Exhibition Catalogs; Filmstrips; Framed Reproductions; Manuscripts; Memorabilia; Original Art Works; Other Holdings Audio Books; Computer Software; Pamphlets; Periodical Subscriptions 50; Photographs; Prints; Records; Reproductions; Sculpture; Video Tapes
Special Subjects: Art History, Folk Art, Calligraphy, Drawings, Painting-European, Historical Material, Judaica, Archaeology, Ethnology, Painting-Israeli, Bookplates & Bindings, Embroidery, Handicrafts, Religious Art, Architecture
Collections: Permanent collection of silver, manuscripts & fabrics of Judaica over the last 200 years; pottery from antiquity
Exhibitions: 50 years of Israel Stamps from the Miriam Leikind Collection & Albert Friedberg Collection
Publications: The Loom and the Cloth: an exhibition of the fabrics of Jewish life

BEREA

M BALDWIN-WALLACE COLLEGE, Fawick Art Gallery, 275 Eastland Rd, Berea, OH 44017. Tel 440-826-2152; Fax 440-826-3380; Internet Home Page Address: www.baldwinwallcecollege.com; *Dir* Prof Paul Jacklitch
Open Mon - Fri 2 - 5 PM, cl weekends & holidays; No admis fee; The Art Gallery is considered to be a part of the art program & the department of art; its purpose is that of a teaching museum for the students of the college & the general public; Average Annual Attendance: 2,500
Income: Financed through budgetary support of the college
Special Subjects: Drawings, Painting-American, Prints, Sculpture
Collections: Approx 200 paintings and sculptures by Midwest artists of the 20th century; approx 1900 drawings and prints from 16th - 20th century, with a concentration in 19th & 20th century examples
Exhibitions: Annual Spring Student Show & Senior Exhibition
Activities: Lect open to public; gallery talks; tours; competitions; individual paintings lent to schools; book traveling exhibitions

BOWLING GREEN

M BOWLING GREEN STATE UNIVERSITY, Fine Arts Center Galleries, Fine Arts Bldg, Bowling Green, OH 43403-0211. Tel 419-372-8525; Fax 419-372-2544; Elec Mail jnathan@bgnet.bgsu.edu; Internet Home Page Address: www.bgsu.edu/departments/art/main/2galler.htm; *Dir Galleries* Jacqueline S Nathan
Open Tues - Sat 10 AM - 4 PM, Sun 1 - 4 PM, cl holidays; No admis fee; Estab 1964 to contribute to the enrichment of the broader area community while supporting the academic mission of the university; 12-14 exhibits are produced each yr with goals of stimulating and educating artists & art audiences, communicating ideas, and promoting the vitality & significance of the arts; Three galleries located in the Fine Arts building have a combined total of approximately 8000 sq ft of exhibition space; Average Annual Attendance: 9,500
Income: Financed by the University, state grants & donations
Collections: Contemporary prints; Student work
Activities: Lect open to public, 6-8 vis lectrs per year; book traveling exhibitions; originate traveling exhibitions

BROOKLYN

M **BROOKLYN HISTORICAL SOCIETY,** 4442 Ridge Rd, Brooklyn, OH 44144-0422; PO Box 44422, Brooklyn, OH 44144-0422. Tel 216-749-2804; Elec Mail groundhogsgarden@wowway.com; *VPres* Edward Koschmann; *Trustee* John Geralds; *Pres* Barbara Stepic; *Treas* Aroyce Elaine Steck
Open Tues 10 AM - 2 PM, tours by appointment; No admis fee; Estab 1970 to preserve history of area; Wheelchair accessible to 1st floor. Maintains reference library; Average Annual Attendance: 1,500; Mem: 150; dues life $100, couple $7, single $5; meetings last Wed of month, except July, Aug & Nov
Income: $10,000 (financed by fundraisers)
Library Holdings: Clipping Files; Maps; Memorabilia; Original Documents; Other Holdings; Pamphlets; Periodical Subscriptions; Photographs; Records
Special Subjects: Textiles, Dolls, Furniture, Glass, Historical Material, Maps, Period Rooms, Laces
Collections: China, dolls; pre-1900 & 1920's furniture; glass; herb garden; kitchenware; old tools; quilts & linens
Exhibitions: World War I & Brooklyn Airport; Early schools in Brooklyn
Publications: Early Schools in Brooklyn, 2003
Activities: Classes for children; docent training; quilting & rug loom weaving demonstrations; lect open to public, 4 vis lectrs per year; 3rd grade tours every May; sales shop sells handicrafts, rag rugs, quilted items, dried herb products, crafts

CANTON

M **CANTON MUSEUM OF ART,** 1001 Market Ave N, Canton, OH 44702. Tel 330-453-7666; Fax 330-452-4477; Elec Mail al@cantonart.org; Internet Home Page Address: www.cantonart.org; *Treas* Lee DeGraaf; *Exec Dir* Manuel J Albacete; *Business Mgr* Kay Scarpitti; *Pres* David Baker
Open Tues & Fri - Sat 10 AM - 5 PM, 7 - 9 PM, Tues - Thurs Sun 1 - 5 PM; No admis fee; Estab 1935, incorporated 1941; Nine modern gallery areas of various sizes; Average Annual Attendance: 50,000; Mem: 1200; dues $15 and higher; annual meeting Fall
Special Subjects: Graphics, Painting-American, Sculpture, Costumes, Decorative Arts, Portraits, Painting-Spanish, Painting-Italian
Collections: Collection focus is 19th & 20th century American watercolors and works on paper, also contemporary ceramics
Exhibitions: Approximately 25-40 traveling or collected exhibitions of commercial & industrial arts; painting; sculpture annually; French Music Hall Posters from 1890 to 1940's.
Activities: Formally organized education programs for adults & children; docent training; lect open to public, 10 vis lectrs per year; films; gallery talks; art festivals; competitions with awards; guided tours; scholarships offered; individual and original objects of art lent; book traveling exhibitions; originate traveling exhibitions; museum shop sells books, original art, prints

L **Art Library,** 1001 Market Ave N, Canton, OH 44702. Tel 330-453-7666; Fax 330-453-1034; Elec Mail staff@cantonma.org; Internet Home Page Address: www.cantonart.org; *Exec Dir* Manuel J Albacete
Open Tues - Sat 10 AM - 5 PM, Tues - Thurs 7 - 9 PM, Sun 1 - 5 PM; Admis adult $4, seniors & children $2.50; Estab 1935
Library Holdings: Audio Tapes; Book Volumes 2500; Clipping Files; Exhibition Catalogs; Pamphlets; Periodical Subscriptions 25; Prints; Slides; Video Tapes 120

CHESTERLAND

C **FEDERAL RESERVE BANK OF CLEVELAND,** c/o Tessographix, 12970 Westchester Trl Chesterland, OH 44026. Tel 440-729-7860; Elec Mail jbtesso@sbcglobal.net; Internet Home Page Address: www.tessographix.com; *Art Consultant* Jane B Tesso
Collection represents fine art and artists who have lived or worked in the 4th District of the Federal Reserve since its institution in the 1910's
Collections: High quality regional art made after 1910 including painting, sculpture, drawing, prints & photographs

CHILLICOTHE

M **PUMP HOUSE CENTER FOR THE ARTS,** PO Box 1613, Chillicothe, OH 45601-5613. Tel 740-772-5783; Fax 740-772-5783; Elec Mail pumpart@bright.net; Internet Home Page Address: www.bright.net/~pumpart; *Dir* Charles Wallace
Open Tues - Fri 11 AM - 4 PM, Sat & Sun 1 - 4 PM; No admis fee; Estab 1986; Historic Pump House restored for art center, gift shop & gallery. Arts Festival held the last weekend in June; Average Annual Attendance: 20,000; Mem: 350; dues 15-375
Income: $110,000 (financed by mem, sales of artwork & Rio Grande Univ Partnership
Library Holdings: Book Volumes; Periodical Subscriptions
Special Subjects: Painting-American, Photography, Prints, Sculpture, Watercolors, American Indian Art, Pottery, Woodcarvings, Woodcuts, Afro-American Art, Portraits, Posters, Porcelain, Silver, Painting-Dutch, Scrimshaw, Stained Glass, Pewter, Reproductions
Collections: Baskets, fine art, fine designer crafts, glass, prints, quilts, woodcarving, woodworking; All media
Activities: Classes for adults & children; dramatic programs; docent training; lect open to public, 4 vis lectrs per year; gallery talks; tours; competitions

CINCINNATI

A **CINCINNATI ART CLUB,** 1021 Parkside Pl, Cincinnati, OH 45202. Tel 513-241-4591; *Pres* Dave Klocke; *Secy* Nancy Pendery
Open daily except Wed Sept - May, 2 - 5 PM; No admis fee; Estab 1890, incorporated 1923 for purpose of advancing love & knowledge of fine art; Gallery contains a small collection of paintings by American artists; modern building 100

ft x 50 ft; Average Annual Attendance: 3,500; Mem: 280; open to all who show interest & appreciation of art; active members must be judged by proficiency of works; dues active $85, associate $75
Income: Financed by dues, rental of gallery, sales commissions, bequests
Collections: Small collection of works by former members
Exhibitions: Exhibition of members' work changed monthly. Annual Club Shows Sept, Jan, Spring (March-April) & Christmas Art Bazaar; juried annual show
Publications: Dragonfly Members Newsletter, monthly
Activities: Lect open for members only, 6-8 vis lectrs demonstrations per year; competitions with awards; scholarships offered to Cincinnati Art Academy

A **CINCINNATI INSTITUTE OF FINE ARTS,** 2649 Erie Ave, Cincinnati, OH 45208. Tel 513-871-2787; Fax 513-871-2706; Internet Home Page Address: www.fineartsfund.org; *Chmn Bd & Pres* Raymond R Clark; *VChmn* Dudley S Taft; *Exec Dir* Mary McCullough-Hudson
Open Mon - Fri 8 AM - 5 PM, cl Sat & Sun; Estab & incorporated in 1927 to provide for the continuance & growth of education & culture in the various fields of fine arts in the metropolitan community of Cincinnati; Mem: Annual meeting Oct
Income: Financed through endowments by Cincinnati Symphony Orchestra, Cincinnati Art Museum, Cincinnati Opera, Taft Museum, May Festival, Cincinnati Ballet, Contemporary Arts Center, Playhouse in the Park, Special Projects Pool & Annual Community Wide fine Arts Fund Drive
Publications: Quarterly calendar

M **CINCINNATI INSTITUTE OF FINE ARTS,** Taft Museum of Art, 316 Pike St, Cincinnati, OH 45202-4293. Tel 513-241-0343; Fax 513-241-2266; Elec Mail taftmuseum@taftmuseum.org; Internet Home Page Address: www.taftmuseum.org; *Dir Mus* Phillip C Long; *Chief Cur* Lynne Ambrosini; *Cur Abby S Schwartz*; *Chmn Bd Overseers* Robert Lawrence; *Business Mgr* Teri Haught; *Deputy Dir External Affairs & Admin* Lea Emery; *Mgr Mktg Communications* Alex Breyer; *Dir Develop* Joseph Curry
Open Tues, Wed, Fri 11 AM - 5 PM, Thurs 11 AM - 8 PM, Sat 10 AM - 5 PM, Sun Noon - 5 PM, cl New Year's Day, Thanksgiving & Christmas; Admis adults $7, seniors & students $5, children 18 or younger free; Estab 1927, a gift of Mr and Mrs Charles P Taft's art collection to the Cincinnati Institute of Fine Arts including the house and an endowment fund for maintenance. Active control was taken in 1931; museum opened in 1932; Built in 1820, a National Historic Landmark. The federal period building is home to nearly 700 works of art, including European & American poaintings by masters such as Rembrandt, Sargent, Turner, Hals & Whistler; Chinese Porcelains; and European Decorative Arts. Taft Museum reopened in May 2004 after 2.5 yr renovation and expansion. Renovated museum houses new amenities including parking garage, spec exhib gallery, performance & lecture facility, cafe, expanded museum shop, redesigned garden. ; Average Annual Attendance: 60,000; Mem: 1500; dues $15-$1000
Income: Financed by endowment & annual fine arts fund drive
Special Subjects: Architecture, Drawings, Painting-American, Religious Art, Ceramics, Afro-American Art, Decorative Arts, Painting-European, Portraits, Furniture, Jade, Porcelain, Oriental Art, Asian Art, Painting-British, Painting-Dutch, Painting-French, Ivory, Miniatures, Painting-Flemish, Renaissance Art, Medieval Art, Painting-Spanish, Gold, Enamels
Collections: Furnishings include antique toiles and satins and a notable collection of Duncan Phyfe furniture; paintings including works by Rembrandt, Hals, Turner, Corot, Gainsborough, Raeburn; Whistler & other Old Masters; 200 notable Chinese Porcelains Kangxi, Yongzheng & Qianlong; 97 French Renaissance enamels; Renaissance jewelry & 16th-18th century watches from Europe
Exhibitions: three to four exhibitions scheduled per year
Publications: The Portico, quarterly
Activities: Classes for adults & children; dramatic programs; docent training; lect open to public, 10-15 vis lectrs per yr; chamber music; concerts; gallery talks; tours; individual paintings & objects of art lent to accredited museums; lending collection contains paintings, sculptures, chinese ceramics, European decorative arts; book traveling exhibitions 2-3 per year; originate traveling exhibitions to accredited museums; museum shop sells books, reproductions, prints, slides, gifts, jewelry, porcelains & art kits

M **CINCINNATI MUSEUM ASSOCIATION AND ART ACADEMY OF CINCINNATI,** Cincinnati Art Museum, 953 Eden Park Dr, Cincinnati, OH 45202-1557. Tel 513-721-5204; Fax 513-721-0129; Elec Mail information@cincyart.org; Internet Home Page Address: www.cincinnatiartmuseum.org; *Dir* Timothy Rub; *Dir Develop* Jill Barry; *Dir Operations* Debbie Bowman; *Chief Cur & Cur Decorative Arts* Alita Vogel; *Cur Ed* Ted Lind; *Cur Prints & Drawings* Kristin L Spangenberg; *Cur Classical, Near Eastern Art* Glenn E Markoe; *Cur Am Painting & Sculpture* Julie Aronson; *Assoc Cur Photography & Design* Dennis Kiel; *Dir Mktg* Cindy Fink; *Head Exhibits & Registration* Katie Haigh; *Cur European Painting & Sculpture* Betsy Wiesman; *Deputy Dir* Stephen Bonadies; *Head Conservator* Fred Wallace; *Head Library & Archives* Mona Chapin; *Cur Asian Art* Hou-mei Sung
Open Tues - Sat 11 AM - 5 PM, Sun Noon - 6 PM, cl Mon & Thanksgiving & Christmas; No admis fee; Estab 1881 to collect, exhibit, conserve & interpret works of art from all periods & civilizations (range of 5000 years of major cultures of the world); Circ 12,000; Exhibition galleries cover an area of approx 4 acres, occupying three floors, assembly areas & social center on ground level; altogether some 80 galleries given over to permanent collections, with additional galleries set aside for temporary exhibitions; Average Annual Attendance: 300,000; Mem: 12,500; dues $35 & up
Income: $9,200,000 (financed by endowment, mem, city appropriation, private donations, admis & Cincinnati Fine Arts Fund, mus shop earnings, federal, state, city & private grants)
Library Holdings: Auction Catalogs; Book Volumes; Cards; Clipping Files; Exhibition Catalogs; Fiche; Framed Reproductions; Manuscripts; Maps; Memorabilia; Micro Print; Original Documents; Pamphlets; Periodical Subscriptions; Photographs; Prints; Video Tapes
Special Subjects: Decorative Arts, Ceramics, Silver, Textiles, Prints, Sculpture, Watercolors, American Indian Art, Bronzes, African Art, Pre-Columbian Art, Southwestern Art, Costumes, Religious Art, Woodcarvings, Woodcuts, Landscapes, Oriental Art, Asian Art, Antiquities-Byzantine, Painting-French, Carpets & Rugs,

Coins & Medals, Baroque Art, Calligraphy, Miniatures, Painting-Flemish, Renaissance Art, Medieval Art, Antiquities-Oriental, Painting-Spanish, Painting-Italian, Antiquities-Persian, Islamic Art, Antiquities-Egyptian, Antiquities-Greek, Antiquities-Roman, Painting-German, Antiquities-Etruscan, Antiquities-Assyrian
Collections: Artists; art in Cincinnati; Egyptian, Greek, Roman, Near and Far Eastern arts; musical instruments; paintings (European & American); world costumes, textiles; arts of Africa & the Americas; world prints, drawings & photographs; world sculpture; world decorative arts & period rooms
Publications: Catalogues for exhibitions & collections
Activities: Classes for adults & children; dramatic progs; docent training; lect open to public, 4-8 vis lectrs per year; gallery talks; tours concerts; artmobile; book traveling exhibitions 4-6 per year; originate traveling exhibitions 2 per year; museum shop sells books, magazines, reproductions, prints & slides

L **Mary R Schiff Library,** 953 Eden Park Dr, Cincinnati, OH 45202-1596. Tel 513-639-2976; Fax 513-721-0129; Elec Mail mchapin@cincyart.org; Internet Home Page Address: www.cincinnatiartmuseum.org; *Head Librn* Mona L Chapin; *Asst Librn* Peggy Runge; *Reference Librn* Corinne Dean
Open Tues - Fri 11 AM - 5 PM, Sat 11 AM - 5 PM (during the school year); No admis fee; Estab in 1881 to satisfy research needs of museums staff, academy faculty & students; Circ 5,000 vols per yr; For reference
Income: Financed by endowment
Library Holdings: Auction Catalogs 20,000; Book Volumes 68,000; Clipping Files; Exhibition Catalogs; Fiche; Manuscripts; Memorabilia; Pamphlets; Periodical Subscriptions 150; Photographs; Prints; Reproductions; Video Tapes 600
Special Subjects: Art History, Folk Art, Decorative Arts, Commerical Art, Drawings, History of Art & Archaeology, American Western Art, American Indian Art, Furniture, Costume Design & Constr, Afro-American Art, Oriental Art, Antiquities-Assyrian, Architecture
Collections: Files on Cincinnati Artists, Art in Cincinnati, The Cincinnati Art Museum & the Art Academy of Cincinnati; Reference collection covering 5000 years of art & art history

M **COLLEGE OF MOUNT SAINT JOSEPH,** Studio San Giuseppe, Art Dept, 5701 Delhi Rd Cincinnati, OH 45233-1670. Tel 513-244-4314; Fax 513-244-4222; Elec Mail jerry-bellas@mail.msj.edu; *Dir* Gerald Bellas
Open Mon - Fri 10 AM - 5 PM, Sat & Sun 1:30 - 4:30 PM, cl holidays; No admis fee; Estab 1962 to exhibit a variety of art forms by professional artists, faculty & students; Average Annual Attendance: 5,000
Activities: Lect open to public; concerts; gallery talks; tours

L **Archbishop Alter Library,** 5701 Delhi Rd, Cincinnati, OH 45233-1670. Tel 513-244-4216; Fax 513-244-4355; Internet Home Page Address: www.msj.edu/library; *Dir* Paul Jenkins; *Head Pub Svcs* Susan M Falgner
Open academic yr Mon - Thurs 8 AM - 10:30 PM, Fri 8 AM - 7 PM, Sat 10:30 AM - 5:30 PM, Sun Noon - 10:30 PM; Estab 1920 to serve students of art department; Circ 1,200
Library Holdings: Audio Tapes; Book Volumes 97,863; Cassettes; Compact Disks; DVDs; Exhibition Catalogs; Filmstrips; Periodical Subscriptions 706; Prints; Slides; Video Tapes
Collections: Salv Dali Prints
Exhibitions: Student art exhibit
Activities: Competition with award

M **CONTEMPORARY ARTS CENTER,** 44 E Sixth St, Cincinnati, OH 45202. Tel 513-345-8400; Fax 513-721-7422; Elec Mail admin@cacmail.org; Internet Home Page Address: www.contemporary arts center.org; *Chair* J Joseph Hale Jr; *Pres* Tom Neyer; *Treas* William A Hummel; *Dir* Charles Desmarais; *Preparator* Tom Allison; *Communications & Pub Relations* Susan Jackson; *Deputy Dir* Andrée Hymel Bober; *Sr Cur* Thom Collins; *Cur Exhibs* Matt Distel; *VPres* Carol Olsen; *Dir Grants & Government Relations* Heather Sherwood; *Comptroller* Chad Stewart; *Asst Cur of Educ* Laura Stewart; *Asst to Dir* Bettina Bellucci; *Dir Develop* Edwina Brandon; *Cur Educ* Lisa Buck; *Dir Visitor Svcs* Liz Emslander; *Dir Mktg* Andi Ferguson; *Facility Mgr* Dave Gearding; *Dir Major Gifts & Planned Giving* Robert P Kellison, CFRE; *Store Mgr & Gallery Coordr* Jason Maag; *Accounting Clerk* Leigh Mosley; *Mem Coordr* Sonia Wilson
Open Mon & Fri 11 AM - 9 PM, Tues - Thurs & Sun 11 AM - 6 PM, Sat Noon - 6 PM; Admis to be determined; mems free; Estab 1939. The Center is a mus for the presentation of current developments in the visual & related arts. It does not maintain a permanent collection but offers changing exhibitions of international, national & regional focus; Average Annual Attendance: 150,000; Mem: 2200; dues from $45-$5000
Income: $2,595,000 (financed by endowment, fine arts fund drive, city state art council & federal groups, corporate sponsorship)
Publications: Catalogues of exhibitions, 1-2 per year
Activities: Classes for adults & children; docent training; performance programs; lects open to mems only, 8-10 vis lectrs per year; concerts; gallery talks; programs for adults & children; tours; book traveling exhibs 2-5 per year; originate traveling exhibs organized & circulated; museum shop sells books, cards, reproductions & prints

L **Library,** Tel 513-345-8400 (admin office); Fax 513-721-7418; *Dir* Charles Desmarais; *Sr Cur* Thom Collins
For in-house only
Library Holdings: Exhibition Catalogs; Periodical Subscriptions 10

M **HEBREW UNION COLLEGE - JEWISH INSTITUTE OF RELIGION,** Skirball Museum Cincinnati, 3101 Clifton Ave, Cincinnati, OH 45220. Tel 513-221-1875 x 358; Fax 513-221-0316; Elec Mail rjero@huc.edu;Rebecca Jero
Open Mon - Thurs 11 AM - 4 PM, Sun Noon - 5 PM, cl Nat & Jewish holidays; No admis fee; Estab 1913 to interpret Judaism to the general public through Jewish art & artifacts; also the archaeology work of the college in Israel; 2,450 sq ft of exhibition space; traveling exhibition gallery; Average Annual Attendance: 5,000; Mem: 300; dues $35-$500
Income: Financed by endowment, donations & grants
Special Subjects: Painting-American, Archaeology, Textiles, Religious Art, Folk Art, Manuscripts, Antiquities-Roman, Painting-Israeli
Collections: Jewish ceremonial art; archaeology artifacts; paintings, drawings & sculpture by Jewish artists; photography; textiles

Exhibitions: An Eternal People: The Jewish Experience (permanent)
Activities: Docent training; lect open to public, tours

M **HILLEL FOUNDATION,** Hillel Jewish Student Center Gallery, 2615 Clifton Ave, Cincinnati, OH 45220-2885. Tel 513-221-6728; Fax 513-221-7134; Internet Home Page Address: www.HillelCincinnati.org; *Exec Dir* Rabbi Abie Ingber
Open Mon - Thurs 9 AM - 5 PM, Fri 9 AM - 3 PM; No admis fee; Estab 1982 to promote Jewish artists & educate students; Jewish artists in various media (exhibit & sale) & collection of antique Judaica from around the world. Listed in AAA guide
Income: Financed by contributions, fundraisers, & The Jewish Federation of Cincinnati
Special Subjects: Architecture, Judaica
Collections: Antique architectural Judaica from synagogues throughout the US; Art in various media by living Jewish artists
Exhibitions: (2001) Rotating exhibits

L **PUBLIC LIBRARY OF CINCINNATI & HAMILTON COUNTY,** Art & Music Dept, 800 Vine St, Cincinnati, OH 45202-2071. Tel 513-369-6955; Fax 513-369-3123; Elec Mail artmusichead@plch.lib.oh.us; telnet: plchlib.oh.us; Internet Home Page Address: www.plch.lib.oh.us; *Dir* Kimber L Fender; *Art & Music Dept* Judy Inwood
Open Thurs, Fri & Sat 9 AM - 6 PM, Sun 1 - 5 PM; Estab 1872 to provide the community with both scholarly & recreational materials in area of fine arts; Circ 112,400; Display cases in the department to exhibit collections
Income: $85,000 (financed by taxes, state & county appropriations)
Library Holdings: Audio Tapes; Book Volumes 207,337; Cards; Cassettes; Clipping Files 825,560; Exhibition Catalogs 6,440; Fiche 9375; Filmstrips; Lantern Slides; Memorabilia; Micro Print; Motion Pictures; Original Art Works; Other Holdings Vertical file; Pamphlets; Periodical Subscriptions 60; Photographs; Prints 5,340; Records; Reels 505; Reproductions; Slides; Video Tapes
Special Subjects: Art History, Folk Art, Landscape Architecture, Mixed Media, Photography, Calligraphy, Drawings, Painting-American, Pre-Columbian Art, History of Art & Archaeology, American Western Art, Advertising Design, American Indian Art, Mexican Art, Southwestern Art, Aesthetics, Afro-American Art, Religious Art, Antiquities-Assyrian
Collections: Langstroth Collection, chromolithographs of 19th Century; Plaut Collection, 20th century artist's books, slides, audio tapes & DVDs; Valerio Collection, Italian art; Film & recording center collection of videos, slides & audio tapes; Contemporary Artists' Book Collection
Activities: Tours; sales shop sells books, reproductions, prints, tote bags, toys & stationery items

UNIVERSITY OF CINCINNATI

M **DAAP Galleries-College of Design Architecture, Art & Planning,** Tel 513-556-3210; Fax 513-556-3288; Elec Mail anne.timpano@uc.edu; Internet Home Page Address: www.uc.edu/arch; *Dir* Anne Timpano
Open Mon - Fri 10 AM - 5 PM, summer hours vary; No admis fee; Estab 1967 to preserve & maintain the University's art collection & to present quality contemporary & historical exhibitions of works by artists of local, regional & national reputation. Operates three exhibition facilities: Reed Gallery, Tangeman Gallery & Machine Shop Gallery; Gallery is maintained & presents quality contemporary & historical exhibitions of works by artists of local, regional & national reputation; Average Annual Attendance: 10,000
Income: Financed through university, grants & co-sponsorships
Special Subjects: Drawings, Graphics, Painting-American, Photography, Prints, Sculpture, Watercolors, Bronzes, Pre-Columbian Art, Etchings & Engravings, Landscapes, Portraits, Posters, Asian Art, Antiquities-Greek, Painting-German, Painting-Russian, Painting-Scandinavian
Collections: Art of the United States, Europe, Asia & the Americas
Publications: Fragments, catalogue
Activities: Lect open to public; performances; film & dance; gallery talks; tours; originate small traveling exhibitions

L **Design, Architecture, Art & Planning Library,** Tel 513-556-1335; Fax 513-556-3006; Elec Mail elizabeth.meyer@uc.edu; Internet Home Page Address: www.libraries.uc.edu; *Visual Resources Librn* Elizabeth Meyer
Open Mon - Thurs 8 AM - 10 PM, Fri 8 AM - 5 PM, Sat 1 - 5 PM, Sun 1 - 10 PM, summer hours vary; Estab 1925 to support the programs of the College of Design, Architecture, Art & Planning; Circ 42,000; Average Annual Attendance: 78,000
Library Holdings: Book Volumes 90,000; Exhibition Catalogs; Fiche; Kodachrome Transparencies; Other Holdings Artists' Book Collection; Periodical Subscriptions 400; Reels 1000; Video Tapes
Special Subjects: Art History, Graphic Design, Industrial Design, Interior Design, Art Education, Architecture
Collections: architecture, art educ, art history, fashion arts, graphic design

L **Visual Resource Center,** Tel 513-556-0279; Fax 513-556-3006; Elec Mail adrienne.varady@uc.edu; Internet Home Page Address: www.libraries.uc.edu; *Cur* Adrienne Varady
Open Mon - Thurs 8 AM - 10 PM, Fri 8 AM - 5 PM, Sat 1 - 5 PM, Sun 1 - 10 PM; Library contains 210,000 slides
Library Holdings: Memorabilia; Slides
Special Subjects: Drafting, Architecture

M **XAVIER UNIVERSITY,** Art Gallery, 3800 Victory Pky, Cincinnati, OH 45207-7311. Tel 513-745-3811; Fax 513-745-1098; *Dir* M Katherine Vetz; *Publicist* Terri Yontz
Open Mon - Fri 10 AM - 4 PM; No admis fee; Estab 1987 as academic facility for students, faculty & community; Spacious galleries with white walls & hardwood floors; main gallery 21 x 50 ft, adjacent gallery 20 x 20 ft
Income: Privately financed
Special Subjects: Drawings, Graphics, Anthropology, Ceramics, Crafts, Etchings & Engravings, Embroidery
Exhibitions: Professional artists; qualified students of Xavier University; temporary exhibitions only
Activities: Classes for adults; lect open to public, 4-6 vis lectrs per year; gallery talks; give awards; scholarships & fels offered

CLEVELAND

L CLEVELAND BOTANICAL GARDEN, Eleanor Squire Library, 11030 East Blvd, Cleveland, OH 44106. Tel 216-721-1600, 721-1643; Fax 216-721-2056; Elec Mail bholley@cbgarden.org; Internet Home Page Address: www.cbgarden.org; *Develop Officer* Lynne Feighan; *VPres* William E Conway; *Deputy Dir* Mark Druckenbrod; *Dir* Brian Holley; *Mus Shop Mgr* Cynthia Kennard
Open Tues - Sun Noon - 5 PM; Estab 1930; Circulation to members only
Income: Financed by endowment
Library Holdings: Audio Tapes; Book Volumes 16,000; Cassettes; Clipping Files; Exhibition Catalogs; Original Art Works; Pamphlets; Periodical Subscriptions 120; Photographs; Prints; Sculpture; Slides
Special Subjects: Landscape Architecture, Landscapes
Publications: The Bulletin, monthly

M CLEVELAND CENTER FOR CONTEMPORARY ART, 8501 Carnegie Ave, 2nd Flr Cleveland Pay House Cleveland, OH 44106. Tel 216-421-8671; Fax 216-421-0737; Elec Mail info@contemporaryart.org; Internet Home Page Address: www.contemporaryart.org; *Chief Preparator & Registrar* Ann Albano; *Dir of Sales* Pam Young; *Dir* Jill Snyder; *Dir Finance* Grace Garver; *Sr Adjunct Cur* Margo Crutchfield; *Mus Shop Mgr* Heather Young; *Dir Educ* Johanna Plummer; *Dir Marketing* Kelly Bird; *Exhibn Mgr* Ray Juaire; *Asst Cur* Amy Gilman; *Admin Asst* Andrea Kormos; *Mgr Community Relations* John Chaich; *Deputy Dir* Lynda Bender; *VPres* Tim Callahan
Open Tues - Fri 11 AM - 6 PM, Sat & Sun Noon - 5 PM, cl Mon; No admis fee; Estab 1968 to enrich the cultural life of the community; Five galleries 20,000 sq ft, which change exhibits every 6-8 wks. Located in a renovated building which is part of the Cleveland Playhouse complex. Maintains reference library; Mem: 600; dues center circle $500; sustaining $129; contributing $50; family $35; single $25; student or artist $15
Income: $175,000 (financed by mem, state appropriation, federal & state agencies & local foundations)
Publications: Exhibition catalogues
Activities: Educ dept; docent training; lect open to public; 20 vis lectrs per year; gallery talks; tours; individual & original objects of art lent to corporate members; originate traveling exhibitions; museum shop sells original art works, books, prints & reproductions
L Library, 8501 Carnegie Ave, Cleveland, OH 44106. Tel 216-421-8671; Fax 216-421-0737; *Dir* Jill Snyder
Reference Library; Mem: 900; dues $35
Library Holdings: Book Volumes 2000; Clipping Files; Exhibition Catalogs; Periodical Subscriptions 10; Photographs; Slides

M CLEVELAND INSTITUTE OF ART, Reinberger Galleries, University Circle, 11141 East Blvd Cleveland, OH 44106. Tel 216-421-7407; Fax 216-421-7438; Internet Home Page Address: www.cia.edu; *Pres* David L Deming; *Gallery Dir* Bruce Checefsky
Open Mon 9:30 AM - 9 PM, Tues - Fri & Sat 9 AM - 5 PM, cl Sun; No admis fee; Estab 1882 as a five-year, fully accredited professional college of art; Gallery is maintained with extensive exhibitions
Income: Financed by federal, state, local grants & private foundations
Publications: Link (alumni magazine), quarterly; posters to accompany each exhibit; bi-annual school catalog
Activities: Classes for adults & children; lect open to public, 5-10 vis lectrs per year; gallery talks; tours; book traveling exhibitions; originate traveling exhibitions
L Jessica Gund Memorial Library, 11141 East Blvd, Cleveland, OH 44106. Tel 216-421-7440; Fax 216-421-7439; *Patron Srvcs Librn* Lori Nofziger; *Technical Svcs Librn* Hyosoo Lee; *Image & Instruc Srvcs Librn* Laura Ponikvar; *Library Dir* Cristine Rom
Open Mon - Thurs 8 AM - 9 PM, Fri 8 AM - 5 PM, Sat 9 AM - 5 PM, Sun hrs vary; Estab to select, house & distribute library material in all media that will support the Institute's studio & academic areas of instruction
Income: Financed by tuition, gift, endowments
Library Holdings: Audio Tapes; Book Volumes 42,000; CD-ROMs; Cassettes; Clipping Files; Compact Disks; DVDs; Exhibition Catalogs; Fiche; Manuscripts; Memorabilia; Micro Print; Original Art Works; Original Documents; Other Holdings Artists' books 1300; Periodical Subscriptions 225; Slides; Video Tapes
Special Subjects: Intermedia, Decorative Arts, Illustration, Mixed Media, Photography, Commerical Art, Drawings, Graphic Arts, Graphic Design, Sculpture, Ceramics, Conceptual Art, Crafts, Printmaking, Advertising Design, Industrial Design, Interior Design, Video, Glass, Metalwork, Enamels, Goldsmithing, Jewelry, Silversmithing, Textiles
Activities: Library tours
A Cleveland Art Association, Develop Office-University Circle, 11141 East Blvd Cleveland, OH 44106. Tel 216-421-7359; Fax 216-421-7438; *Pres* Megan Weingait
Open during gallery hrs-varies; Estab & inc 1916, re-incorporated 1950 as a non-profit organization, to unite artists & art lovers of Cleveland into a working body whose purpose it shall be to advance, in the broadest possible way, the art interest of the city; Gallery utilizes space periodically at Reinberger Gallery; Mem: 140; dues $60, active mem
Income: $30,000 (financed through endowment, sales & dues)
Purchases: $12,000
Collections: Collection of art by Cleveland artists which includes ceramics, drawings, glass, paintings, prints & small sculpture
Exhibitions: Lending collection exhibited annually; art auction
Activities: Competitions; awards; scholarships offered; works of art lent to members for one-year period

M CLEVELAND MUSEUM OF ART, 11150 East Blvd, Cleveland, OH 44106-1796. Tel 216-421-7340; Fax 216-421-0411; Elec Mail info@cma-oh.org; Internet Home Page Address: www.clemusart.com; *Dir* Katherine Lee Reed; *Dir Finance* Thomas Gentile; *Chief Cur* Diane DeGrazia; *Cur Baroque & Sculpture* Henry Hawley; *Dir Design & Facilities* Jeffrey Strean; *Dir Educ* Margene Williams; *Head Librn* Ann B Abid; *Cur Islamic Art & Textiles* Louise Mackie; *Cur Japanese & Korean Art* Michael R Cunningham; *Cur Chinese Art* Ju-hsi Chou; *Cur Indian & SE Asian Art* Stanislaw Czuma; *Cur Greek & Roman Art* Michael Bennett; *Cur Musical Arts* Karel Paukert; *Head Publications* Laurence Channing; *Mgr Communications & Marketing* William Prenevost; *Registrar* Mary Suzor; *Dir Human Resources* Kristin Rogers; *Chief Conservator* D Bruce Christman; *Pres* Michael J Horvitz
Open Tues, Thurs, Sat & Sun 10 AM - 5 PM, Wed & Fri 10 AM - 9 PM; No admis fee; Estab & incorporated 1913; building opened 1916; Gallery addition in 1958; Educ Wing in 1971; New Library & Gallery addition in 1984; Average Annual Attendance: 630,000; Mem: 25,000; dues $25 & up
Income: $28,674,306 (financed by trust & endowment income, earned revenue, mem, gifts & grants)
Purchases: $15,436,000
Special Subjects: Painting-American, Sculpture, Textiles, Ceramics, Decorative Arts, Painting-European, Painting-Japanese, Oriental Art, Antiquities-Egyptian, Antiquities-Greek, Antiquities-Roman
Collections: Ancient Near Eastern, Egyptian, Greek, & Roman art; drawings & prints; European & American paintings, sculpture & decorative arts of all periods, with notable collections of medieval art, 18th-century French decorative arts & 17th-century European painting & 19th-century European & American painting; Islamic art; North American Indian, African & Oceanic art; Oriental art, including important collections of Chinese & Japanese painting & ceramics & Indian sculpture; photographs; Pre-Columbian American art; textiles, especially from Eygpt & medieval Persia
Publications: Cleveland Studies in the History of Art, quarterly; members magazine, monthly; collection catalogs; exhibition catalogs
Activities: Classes for adults & children, studio workshops; teacher resource center; lect open to public, 14 vis lectrs per year; concerts; gallery talks; tours; originate traveling exhibitions; museum shop sells books, reproductions & slides
L Ingalls Library, 11150 East Blvd, Cleveland, OH 44106. Tel 216-707-2530; Fax 216-421-0921; Internet Home Page Address: library.cma-oh.org/webclient.html; *Asst Librn Acquisitions* Helen Carter; *Assoc Librn Reader Serv* Louis V Adrean; *Serials Librn* Kay Downey; *Assoc Librn Bibliography Access* Lori Thorrat; *Systems Librn* Frederick Friedman-Romell; *Dir Libr and Archives* Elizabeth A Lantz; *Archivist* Leslie Cade; *Interim Image Librn* Frederick Friedman-Romell
Wed 10 AM - 9 PM; Estab 1916; Circ 38,000; Open to mus members, vis graduate students, faculty, curators; Average Annual Attendance: 5,000
Library Holdings: Auction Catalogs 82,000; Book Volumes 418,000; CD-ROMs; Clipping Files 21,000; Compact Disks; DVDs; Exhibition Catalogs; Fiche; Lantern Slides; Original Documents Digital Images, 220,000; Other Holdings; Pamphlets; Periodical Subscriptions 1300; Photographs 388,000; Prints; Reels; Slides 20,000; Video Tapes 600
Special Subjects: Art History, Decorative Arts, Etchings & Engravings, Islamic Art, Painting-American, Painting-British, Painting-Dutch, Painting-Flemish, Painting-French, Painting-German, Painting-Italian, Painting-European, History of Art & Archaeology, American Western Art, Asian Art, American Indian Art, Afro-American Art, Antiquities-Oriental, Antiquities-Persian, Oriental Art, Antiquities-Assyrian, Antiquities-Byzantine, Antiquities-Egyptian, Antiquities-Etruscan, Antiquities-Greek, Antiquities-Roman
A Print Club of Cleveland, 11150 East Blvd, Cleveland, OH 44106. Tel 216-707-2242; Fax 216-421-1994; Elec Mail info@clevelandart.com; Internet Home Page Address: www.clevelandart.org; *Pres* Charles Rosenblatt; *VPres* Ken Hegyes; *Treas* Henry Ott-Hansen; *Mem* Lois Weiss
Estab 1919 to stimulate interest in prints & drawings through educ, collecting & commissioning of new works & enhancement of the museum's collection by gifts & purchases; Mem: 250; dues $200 & up; annual meeting in Jan
Income: Financed by endowment, dues, sells prints from club inventory & sponsors annual fine print fair
Publications: The Print Club of Cleveland 1969-1994, Available at Museum Sales Desk, $19.94 plus postage
Activities: Lect open to public & members, 1 vis lectr per year; gallery talks; tours; awards; Ralph E King Award

L CLEVELAND PUBLIC LIBRARY, Fine Arts & Special Collections Dept, 325 Superior Ave, Cleveland, OH 44114-1271. Tel 216-623-2848, 623-2818; Fax 216-623-2976; Elec Mail fine@cpl.org, white@cpl.org; Internet Home Page Address: www.cpl.org/fahome.html; *Head Special Colls* Stephen Zietz; *Head Main Library* Joan Clark; *Dir* Andrew Venable
Open Mon - Sat 9 AM - 6 PM, Sept - June Sun 1 - 5 PM; Estab 1869; Circ 5,624,099
Income: $34,577,461
Library Holdings: Book Volumes 190,092; Clipping Files; Compact Disks 35,000; Fiche 31,196; Manuscripts; Micro Print; Other Holdings Folklore & Chess Archives; Original Documents; Special Collections-Rare Book vols 178,906 & per sub 425; Pamphlets; Periodical Subscriptions 217; Photographs; Prints; Reels 2008
Special Subjects: Art History, Decorative Arts, Primitive art, Oriental Art, Architecture
Collections: Cleveland Artist Original Graphics; Architectural plans, blue prints & drawings
Publications: Descriptive pamphlets of holdings
Activities: Lect & collections open to public; tours available for groups; sales shop sells books, reproductions, prints & gift items

L CLEVELAND STATE UNIVERSITY, Library & Art Services, Rhodes Tower 322, Cleveland, OH 44115. Tel 216-687-2492; *Supv Art Svcs* Pamela Eyerdam
Estab 1965 to house coll of visual arts
Purchases: $16,000
Library Holdings: Audio Tapes; Book Volumes 15,000; Cards; Cassettes; Clipping Files; Exhibition Catalogs; Fiche; Filmstrips; Micro Print; Motion Pictures; Original Art Works; Other Holdings Color Reproductions; Pamphlets; Periodical Subscriptions 96; Photographs; Prints; Records; Reels; Reproductions; Slides 65,000; Video Tapes

Collections: 19th & 20th century European & American art; medieval art; Indian & West African art

M **Art Gallery,** 2307 Chester Ave, Cleveland, OH 44114; 2121 Euclid Ave AB 108, Cleveland, OH 44115-2214. Tel 216-687-2103; Fax 216-687-9340; Elec Mail artgallery@csuohio.edu; Internet Home Page Address: www.csuohio.edu/art/gallery; *Asst Dir* Tim Knapp; *Dir* Robert Thurmer
Open Mon - Fri 10 AM - 5 PM, Sat Noon - 4 PM; No admis fee; Estab 1965 to present important art to University & Northeast Ohio community; 4,500 sq ft hardwood floor space, 260 running ft wall space, 14 ft high track lighting, air conditioned, humidity controlled, motion detectors & closed circuit 24 hr surveillance by university police; Average Annual Attendance: 54,000
Income: $140,000 (financed by student fees & grants)
Special Subjects: Religious Art
Exhibitions: People's Art Show (biennial, fall, even years); Cleveland Biennial Juried Show (fall, odd years); Solo faculty exhibitions, fall semester, thematic curated exhibitions, spring semester
Publications: Exhibition Catalog, 2-3 times per year
Activities: Educ dept; docent training; on-time studio workshops on request; lect open to public, 4 vis lectrs per year; concerts; gallery talks; tours; competitions with awards; book traveling exhibitions; originate traveling exhibitions

L **NORTHEAST OHIO AREAWIDE COORDINATING AGENCY (NOACA),** Information Resource Center, 1299 Superior Ave, Cleveland, OH 44114-3204. Tel 216-241-2414, Ext 240; Fax 216-621-3024; Elec Mail kgoldberg@mpo.noaca.org; Internet Home Page Address: www.noaca.org; *Librn* Kenneth P Goldberg
Open Mon - Fri 8 AM - 5 PM; Estab 1965, staff checkout only, public phone inquiries or browsing welcome; calling for appointment advisable; Transportation or environment-related displays scattered around Agency
Library Holdings: Auction Catalogs; Audio Tapes; Book Volumes 5825; Cassettes; Clipping Files; Compact Disks; DVDs; Exhibition Catalogs; Fiche; Filmstrips; Manuscripts; Maps; Memorabilia; Micro Print; Original Art Works; Original Documents; Pamphlets; Periodical Subscriptions 205; Photographs; Prints; Reels; Reproductions; Sculpture; Slides; Video Tapes
Special Subjects: Photography, Commerical Art, Graphic Design, Maps, Judaica, Advertising Design, Industrial Design, Interior Design, Furniture, Metalwork, Restoration & Conservation, Display
Collections: Architectural Preservation & Restoration; Land use & sprawl-related issues; Urban Planning & Urban Design; Ohio architecture; Ohio history
Publications: Decision Maker; NOACA News; various reports related to planning, transportation & environmental issues; Seeking Grants in Times of Uncertainty
Activities: Northeast Ohio

M **SAINT MARY'S ROMANIAN ORTHODOX CATHEDRAL,** Romanian Ethnic Museum, 3256 Warren Rd, Cleveland, OH 44111. Tel 216-941-5550; Fax 216-941-3368; Internet Home Page Address: www.smroc.org; *Dir* George Dobrea
Open Mon - Fri 8:30 AM - 4:30 PM, & on request; No admis fee; Estab 1960; Average Annual Attendance: 5,000
Income: Financed by parish appropriation
Special Subjects: Folk Art
Collections: Anisoara Stan Collection; O K Cosla Collection; Gunther Collection; Romanian art, artifacts, costumes, ceramics, painters, rugs, silver & woodwork; icons on glass & wood; books
Activities: Lect open to public; tours; individual paintings & original objects of art lent to other ethnic museums & faiths for exhibits; lending collection contains 100 original art works, 250 original prints, 50 paintings, sculpture, 2000 costumes, rugs & artifacts

M **SPACES,** 2220 Superior Viaduct, Cleveland, OH 44113. Tel 216-621-2314; Fax 216-621-2314; Elec Mail info@spacesgallery.org; Internet Home Page Address: spacesgallery.org; *Assoc Dir* Julie Fehrenbach; *Gallery Mgr* Marilyn Ladd-Simmons; *Dir* Susan R Channing; *Exhib Coordr* Christine Kuper; *Residency Coordr* Sarah Beiderman; *Visitor Assoc* Brinda Woods
Open Tues - Thurs 11 AM - 5:30, Fri & Sat 11 AM - 5 PM, Sun 1 - 5 PM; No admis fee; Estab 1978 to show innovative work by living artists; Single room, 6000 sq ft & 12 ft ceiling. Exhibitions, usually 6 artists per show, change monthly; Average Annual Attendance: 15,000; Mem: 300
Income: $420,000 (financed by mem, state appropriation & foundations)
Exhibitions: 6 exhibitions annually
Publications: Exhibition catalogs, 3 annually
Activities: Lect open to the public, gallery talks, tours

M **WESTERN RESERVE HISTORICAL SOCIETY,** 10825 East Blvd, Cleveland, OH 44106. Tel 216-721-5722; Fax 216-721-8934; Internet Home Page Address: www.wrhs.org; *CFO* Anne Palmer; *COO* Kermit Pike; *Exec Dir* Patrick Reymann
Mus open Mon - Sat 10 AM - 5 PM, Sun Noon - 5 PM; Admis adults $7.50, seniors $6.50, students $5, group rates available; Estab 1867 to discover, collect & preserve whatever relates to the history, biography, genealogy & antiquities of Ohio; Average Annual Attendance: 210,000; Mem: 5300; dues from $40 - $500
Income: Operating budget $7.3 million
Special Subjects: Historical Material, Period Rooms
Collections: Airplanes; automobiles; costumes; decorative, fine & domestic arts
Exhibitions: People at the Crossroads-Settling the Western Reserve, 1796- 1870; Chisholm Halle Custom Wing; Crawford Auto-Aviation collection
Publications: Books on Regional History; Western Reserve Historical Society News, bi-monthly
Activities: Classes for adults & children; docent training; lect open to public, 25 vis lectrs per year; tours; gallery talks; awards; individual paintings & objects of art lent to qualified institutions; originate traveling exhibitions to children's museums and history museums; sales shop sells books, magazines, reproductions & prints

L **Library,** 10825 East Blvd, Cleveland, OH 44106-1788. Tel 216-721-5722; Fax 216-721-0891; Internet Home Page Address: www.wrhs.org; *COO* Kermit J Pike; *Dir Mus Servs* Ed Pershey; *VPres* Patrick H Reymann; *Dir Research* John Grabowski; *Dir Educ* Janice Ziegler; *CFO* John Holtzhauser; *Dir Marketing & Communications* Rita Kueber
Mon - Sat 10 AM - 5 PM, Sun Noon - 5 PM; Adults $8, Seniors $7.50, children ages 3-12 $5; Estab 1867; For reference only

Library Holdings: Audio Tapes; Book Volumes 250,000; Cards 200; Exhibition Catalogs; Fiche 2000; Lantern Slides; Manuscripts 5,000,000; Other Holdings Microfilm 40,000; Pamphlets; Periodical Subscriptions 100; Photographs; Prints; Records; Reels 25,000; Slides
Special Subjects: Folk Art, Decorative Arts, Photography, Manuscripts, Maps, Prints, Furniture, Period Rooms, Glass, Architecture
Collections: Library Archives; History Museum
Activities: Lects open to pub; mus shop, books, reproductions, prints & gifts

COLUMBUS

M **CAPITAL UNIVERSITY,** Schumacher Gallery, 2199 E Main St, Columbus, OH 43209. Tel 614-236-6319; Fax 614-236-6490; Internet Home Page Address: www.schumachergallery.org; *Dir* Dr Cassandra Lee Tellier; *Asst Dir* David Gentilini
Open Mon - Sat 1 - 5 PM; No admis fee; Estab 1964 to provide the best available visual arts to the students; to serve the entire community with monthly traveling shows, community programming & permanent colls; Gallery is 16,000 sq ft, that includes six display galleries of permanent holdings, gallery area for temporary monthly exhibits, galleries, fabrication room, lect area seating 25; Average Annual Attendance: 7,000
Income: Financed by foundation grants & individual gifts
Special Subjects: Graphics, Painting-American, Sculpture, Watercolors, American Indian Art, African Art, Pre-Columbian Art, Primitive art, Painting-European, Eskimo Art, Asian Art, Painting-British
Collections: Ethnic Arts (including American Indian, African, Inuit, Oceanic); American paintings, sculpture & graphics of 20th century; Period works from 16th - 19th century; Major Ohio Artists; Graphics; Asian Art
Exhibitions: Seven individual & group visiting shows per yr; individual exhibits include contemporary artists & loans from individuals & other museums
Activities: Lect open to public; gallery talks; competitions; individual paintings & original art objects lent by special request only

L **Art Library,** 2199 E Main St, Columbus, OH 43209; 1 College & Main, Columbus, OH 43209. Tel 614-236-6615; Fax 614-236-6490; *Dir* Dr Albert Maag
Open to students, faculty, staff & for reference only to the pub
Library Holdings: Book Volumes 5300; Periodical Subscriptions 15

L **COLUMBUS COLLEGE OF ART & DESIGN,** Packard Library, 107 N Ninth St, Columbus, OH 43215-1758. Tel 614-224-9101; Internet Home Page Address: www.ccad.edu; *Head Librn* Chilin Yu; *Librn* Gail Storer; *Visual Resources Cur* Ann Shifflet
Open Mon - Thurs 8 AM - 9:30 PM, Sat 1 PM - 5 PM during academic yr; Estab 1879 to support the programs of the Columbus Col of Art & Design; Circ 23,000; Open to pub for reference only
Income: tuition, grants & gifts
Library Holdings: Book Volumes 52,000; CD-ROMs; Clipping Files; Compact Disks; DVDs 500; Exhibition Catalogs; Fiche; Kodachrome Transparencies; Lantern Slides; Original Art Works; Pamphlets; Periodical Subscriptions 275; Photographs; Reproductions; Sculpture; Slides; Video Tapes
Special Subjects: Art History, Intermedia, Landscape Architecture, Film, Illustration, Mixed Media, Photography, Commerical Art, Drawings, Graphic Arts, Graphic Design, Painting-American, Sculpture, Painting-European, Portraits, Ceramics, Printmaking, Advertising Design, Fashion Arts, Industrial Design, Interior Design, Lettering, Asian Art, Video, Costume Design & Constr, Glass, Textiles

M **COLUMBUS CULTURAL ARTS CENTER,** 139 W Main St, Columbus, OH 43215. Tel 614-645-7047; Fax 614-645-5862; Elec Mail jljohnson@columbus.gov; Internet Home Page Address: www.culturalartscenteronline.org; *Arts Adminr* Jennifer Johnson
Open Mon - Fri 8:30 AM - 4:30 PM, Mon - Thurs 6:30 PM - 9:30 PM, Sat & Sun 1 - 4:30 PM; No admis fee; Estab 1978, visual arts facilities & gallery; Maintains small reference library; Average Annual Attendance: 50,000
Income: Financed by city of Columbus gen funds
Library Holdings: Book Volumes
Exhibitions: local, regional, & national artists monthly exhibitions
Publications: Quarterly catalog
Activities: Classes for adults & youth outreach. Studio classes for adults offered in 8-wk terms include painting, drawing, relief printing, sculpture, jewelry, weaving, copper enameling, ceramics, surface design, stone carving & bronze casting; lect open to pub, 58 vis lectrs per yr; gallery talks; tours; festivals

L **COLUMBUS METROPOLITAN LIBRARY,** Humanities, Fine Art & Recreation Division, 96 S Grant Ave, Columbus, OH 43215. Tel 614-645-2690; Fax 614-645-2883; Elec Mail humfa&rec@cml.lib.oh.us; *Exec Dir* Larry Black; *Div Mgr* Suzanne Fisher; *Dir Main Library* Deb McWilliam
Open Mon - Thurs 9 AM - 9 PM, Fri & Sat 9 AM - 6 PM, Sun 1 - 5 PM school season; Estab 1873 to promote lifelong learning among residents of central Ohio by ensuring access to information, providing a diverse coll & advancing literacy by encouraging children & families to read
Income: Financed by state & county appropriation
Library Holdings: Audio Tapes; Book Volumes 172,693; Cassettes; Exhibition Catalogs; Original Art Works; Other Holdings Catalogs; Pamphlets; Periodical Subscriptions 2181; Photographs; Records; Reels; Slides; Video Tapes
Special Subjects: Art History, Decorative Arts, Film, Photography, Theatre Arts, Architecture
Publications: Metroscene Main Library Magazine, bimonthly; Novel Events Newsletter, bimonthly
Activities: Summer reading for children; lect open to pub; tours; exten dept serves Franklin County

M **COLUMBUS MUSEUM OF ART,** 480 E Broad St, Columbus, OH 43215. Tel
614-221-6801; Fax 614-221-0226; Internet Home Page Address:
www.columbusmuseum.org; *Chief Cur* Catherine Evans; *Assoc Registrar* Elizabeth
Hopkin; *Exec Dir* Nannette V Maciejunes; *Dir Fin & Admin* Kim Aufdencamp;
Deputy Dir Oper Rod Bonc; *Assoc Cur Contemp Art* Joe Houston; *Assoc Cur
American Art* Melissa Wolfe; *Assoc Cur European Art* Dominique Vasseur; *Deputy
Dir Institutional Advanc* Nancy Duncan Porter; *Dir Educ* Cynthia Meyers Foley;
Assoc Registrar Exhibs Jennifer Seeds; *Chief Registrar & Exhib Mgr* Melinda
Knapp; *Deputy Dir Research & Planning* Louisa Green; *Dir Mkg &
Communications* Melissa Ferguson; *Dir Vis Svcs & Volunteers* Pam Edwards; *Dir
Human Resources* Kathy Polster; *Dir Facilities* David Leach
Open Tues - Sun 10 AM - 5:30 PM, Thurs until 8:30 PM, cl Mon & holidays;
Suggested admis, adults $6, children (6 & older) & seniors & students with valid
ID $4, free for all Sun; Estab 1878; Present main building constructed in 1931 in
a Renaissance Revival style; addition built in 1974; Russell Page Sculpture
Garden added in 1979. Interactive children's area. Maintains reference library;
Average Annual Attendance: 198,000; Mem: 8500; dues $65 household
Income: Financed by ann contributions, endowment, mem & pub support
Special Subjects: Drawings, Painting-American, Photography, Prints,
Pre-Columbian Art, Religious Art, Ceramics, Pottery, Etchings & Engravings,
Landscapes, Decorative Arts, Painting-European, Painting-Japanese, Portraits,
Eskimo Art, Glass, Porcelain, Oriental Art, Painting-British, Painting-Dutch,
Painting-French, Painting-Flemish, Renaissance Art, Painting-Italian,
Painting-German
Collections: 16th - 18th century European paintings; Late 19th & early 20th
century European and American paintings, sculpture & works on paper;
Photography; Contemporary; 20th century Folk Art; 19th century American
textiles; Schiller Collection of Social Commentary Art 1930-1970
Publications: Exhib & permanent coll catalogs; interpretive materials; bimonthly
mems' magazine & calendar of events; six-month guide to progs & events; gallery
handouts
Activities: Classes for adults & children; docent training; summer arts camp; lect
open to pub, 15 vis lectrs per yr; concerts; gallery talks; tours; competitions;
schols offered; exten dept serves Speaker Bureau & Docents-in-the-Schools;
individual paintings & original objects of art lent to other museums & government
buildings; lending coll contains 30 color reproductions, 5000 slides & videos;
originate traveling exhibs; mus shop sells books, reproductions & prints

L **Resource Center,** 480 E Broad St, Columbus, OH 43215. Tel 614-221-6801; Fax
614-221-8946; Elec Mail cgenshaft@cmaohio.org; *Dir Educ* Carole Genshaft
Estab 1974 as a reference center for staff, mem, teachers & docents
Library Holdings: Auction Catalogs; Audio Tapes; Book Volumes 5000; Clipping
Files; Exhibition Catalogs; Motion Pictures; Pamphlets; Periodical Subscriptions
25; Slides 15,000
Special Subjects: Art History, Folk Art, Decorative Arts, Photography, Drawings,
Etchings & Engravings, Painting-American, Painting-Dutch, Painting-Flemish,
Painting-French, Pre-Columbian Art, Sculpture, Painting-European, Portraits,
Watercolors, Ceramics, Cartoons, Art Education, Asian Art, American Indian Art,
Eskimo Art, Antiquities-Oriental, Oriental Art, Religious Art, Woodcuts,
Landscapes, Folk Art, Portraits, Textiles, Woodcarvings
Activities: Classes for adults, children & families; docent training; lect open to
public; 30 vis lect per yr; concerts; gallery talks; tours; sponsoring of
competitions; scholarships; lending of original objects of art to city, county
government; other museums; mus shop: books, magazines, reproductions; Eye
Spy: Adventures in Art at museum

A **GO ANTIQUES, INC,** (Antique Networking, Inc) 94 N High St, Ste 300, Dublin,
OH 43017. Tel 614-923-4250; Fax 614-923-4251; Elec Mail kathy@antiqnet.com;
Internet Home Page Address: www.goantiques.com; *Pres* Jim Kamniker; *Sr VPres
Business Develop* Kathy Kamniker; *VPres Operations* Michael Glick
Open 24/7 online, goantiques.com; No admis fee; Estab 1992

M **OHIO HISTORICAL SOCIETY,** National Road-Zane Grey Museum, 1982
Velma Ave, Columbus, OH 43211-2497. Tel 614-297-2300; Fax 614-297-2318;
Internet Home Page Address: www.ohiohistory.org; WATS 800-752-2602; *Mgr*
Alan King; *Chief Educ* Sharon Antle; *Cur History* William Gates; *Mus Shop Mgr*
Susan Brouillette; *CEO* Gary C Ness; *Cur Natural History* Robert Glotzhober;
Actg Chief Coll Michael Harsh
Open daily March - Nov 9:30 AM - 5 PM; Admis $5; Estab 1973; American art
pottery; Average Annual Attendance: 15,000; Mem: 40,000; dues $50; ann meeting
in Sept
Income: Financed by endowment, mem & state appropriation
Special Subjects: Ceramics, Pottery, American Indian Art, American Western Art,
Southwestern Art, Dioramas
Collections: Zanesville Art Pottery & Tile
Exhibitions: Zanesville Art Pottery & Tile
Activities: Lects open to the pub, 6 per yr; tours; sales shop sells books, original
art, reproductions, prints, souvenirs

A **OHIO HISTORICAL SOCIETY,** 1982 Velma Ave, Columbus, OH 43211-2497.
Tel 614-297-2300; Fax 614-297-2411; *Chief Educ Div* Sharon Antle; *Head
Archaeology* Martha Otto; *Head Natural History* Carl Albrecht; *Head Historic
Preservation* Amos Loveday; *Dir* Gary Ness
Open Mon - Sat 9 AM - 5 PM, Sun 10 AM - 5 PM; No admis fee; Estab 1885,
Ohio Historical Soc was chartered on this date, to promote a knowledge of history,
natural history & archaeology, especially of Ohio; to collect & maintain artifacts,
books & archives relating to Ohio's history; Main gallery covers over one acre of
fl space & includes exhibits on history, natural history, archaeology; also houses a
natural history demonstration laboratory & audiovisual theatre; Average Annual
Attendance: 500,000; Mem: 12,000; dues individual $32; ann meeting in Sept
Income: Financed by endowment, mem, state appropriation & contributions
Collections: Archaeology; artifacts; ceramics; clothing; furniture; glassware;
paintings
Publications: Museum Echoes, newsletter, monthly; Ohio History, scholarly
journal, quarterly; Timeline, popular journal, bimonthly
Activities: Classes for adults & children; docent training; lect open to pub;
photographic competitions with awards; individual paintings & original art objects
lent; lending coll to mus & art galleries; books traveling exhibs; originate

traveling exhibs; sales shop sells books, magazines, reproductions, prints, slides
and other souvenir items, postcards, jewelry

L **Archives-Library Division,** 1982 Velma Ave, Columbus, OH 43211. Tel
614-297-2510; Fax 614-297-2546; *Div Chief & State Archivist* George Parkinson;
Head Collections Michael Harsh; *Head Conservation* Vernon Will
Open Tues - Sat 9 AM - 5 PM; Estab 1885, to collect, preserve & interpret
evidences of the past; For reference only; Average Annual Attendance: 13,000
Income: $1,100,000 (financed by state appropriation & pvt revenue)
Purchases: $80,000
Library Holdings: Audio Tapes; Book Volumes 148,600; Cassettes 2500;
Exhibition Catalogs; Filmstrips; Kodachrome Transparencies; Lantern Slides;
Manuscripts 1000; Memorabilia; Motion Pictures; Other Holdings Maps 5000;
Pamphlets; Periodical Subscriptions 300; Photographs 50,000; Prints; Records;
Reels 47,500; Reproductions; Slides; Video Tapes
Collections: Broadsides; Ohio government documents; Ohio newspapers;
Temperance coll; maps; papers of early Ohio political leaders; posters; rare books;
trade catalogs; photographs; manuscripts
Publications: Ohio History (biannual); Timeline (bimonthly)
Activities: Classes for adults & children; docent training

OHIO STATE UNIVERSITY

M **Wexner Center for the Arts,** Tel 614-292-0330; Fax 614-292-3369; Internet
Home Page Address: www.wexarts.org; *Cur Media Arts* William Horrigan; *Exhib
Designer* Jim Scott; *Dir Performing Arts* Charles R Helm; *Dir Communications*
Darnell Lautt; *Dir Educ* Patricia Trumps; *Dir* Sherri Geldin; *Chief Cur Exhib*
Helen Molesworth; *Dir of Devel* Jeffrey Byars
Tues, Wed, Fri 11 AM - 6 PM, Thurs 11 AM - 9 PM, Sat, Sun Noon - 6 PM, cl
Mon; No admis fee for gallery, performances and screenings vary; Estab 1989 the
Wexner Center for the arts is Ohio State University's multidisciplinary,
international laboratory for exploration and advancement of contemporary art.
Through exhib, screenings, performance, artist residencies, and educ prog the
Wexner Center acts as a forum where estab and emerging artists can test ideas and
where diverse aud can participate in cultural experiences that enhance
understanding of the art of our time; Administers the permanent coll & exhibs in 4
professionally-equipped galleries & is the center for long-range planning in visual
arts; Average Annual Attendance: 273,000; Mem: 1,835
Income: $7,623,260 (financed by operating funds from the univ, prog support
from the Wexner Center Foundation & government foundation & corporate grants,
earned income)
Special Subjects: Painting-American
Collections: Contemporary Coll; Study Coll of graphic arts & manuscripts; Wiant
Coll of Chinese art
Exhibitions: Various exhibits
Publications: Exhib catalogs
Activities: Docent training; lect open to pub, 12 vis lectrs per yr; concerts; gallery
talks; tours; invitational juried exhibs; Wexner Prize, presented ann; rent traveling
exhibs 1-5 per yr; originate traveling exhibs

L **Fine Arts Library,** Tel 614-292-6184; Fax 614-292-4573; Elec Mail
wyngaard.1@osu.edu; *Head Librn* Susan E Wyngaard; *Asst* Maria van Boekel;
Asst Gretchen Donelson
Open Mon - Thurs 8 AM - 10 PM, Fri 8 AM - 5 PM, Sat Noon - 6 PM, Sun 2 -
10 PM, while classes are in session; vacation, 10 AM - 5 PM daily; No admis fee;
Estab during 1930's to support teaching & research in art, art educ, design, history
of art & photography; Average Annual Attendance: 200,000
Purchases: $120,000
Library Holdings: Book Volumes 130,000; Cards; Exhibition Catalogs; Fiche;
Original Art Works; Periodical Subscriptions 350; Reels; Slides; Video Tapes 250
Special Subjects: Art History, Collages, Constructions, Folk Art, Intermedia,
Decorative Arts, Illustration, Mixed Media, Photography, Calligraphy, Commerical
Art, Drawings, Etchings & Engravings, Graphic Arts, Graphic Design,
Manuscripts, Maps, Painting-American, Painting-British, Painting-Dutch,
Painting-Flemish, Painting-French, Painting-German, Painting-Italian,
Painting-Japanese, Painting-Russian, Painting-Spanish, Posters, Prints, Sculpture,
Painting-European, History of Art & Archaeology, Judaica, Portraits, Watercolors,
Ceramics, Conceptual Art, Crafts, Latin American Art, Archaeology, Ethnology,
Painting-Israeli, Bronzes, Printmaking, Advertising Design, Industrial Design,
Interior Design, Art Education, Asian Art, Video, Porcelain, Primitive art, Eskimo
Art, Furniture, Mexican Art, Ivory, Jade, Drafting, Glass, Mosaics, Painting-Polish,
Stained Glass, Afro-American Art, Metalwork, Antiquities-Oriental,
Antiquities-Persian, Carpets & Rugs, Embroidery, Enamels, Gold, Goldsmithing,
Handicrafts, Jewelry, Miniatures, Oriental Art, Pottery, Religious Art, Silver,
Silversmithing, Tapestries, Woodcarvings, Woodcuts, Marine Painting, Landscapes,
Antiquities-Assyrian, Antiquities-Greek, Antiquities-Roman, Dioramas,
Painting-Scandinavian, Painting-Australian, Painting-Canadian, Painting-New
Zealander, Display, Architecture

L **Visual Resources Library,** Tel 614-292-0520; Fax 614-292-4401; Internet Home
Page Address: www.history-of-art.ohio-state.edu; *Asst* Nora Kilbane; *Cur*
Stephanie Janquith
Open Mon - Fri 9 AM - 5 PM, summer hours vary; Estab 1925 to provide visual
resources for instruction & research in history of art; Teaching - Reference Coll,
restricted circulation, staff & students
Income: Financed by state funds through State Univ System
Library Holdings: Audio Tapes 30; Book Volumes 150; Exhibition Catalogs;
Framed Reproductions; Original Art Works; Photographs 230,000; Prints;
Reproductions; Slides 270,000; Video Tapes 150
Special Subjects: Islamic Art, Asian Art
Collections: Asian art & architecture; history of Western art & architecture;
African art & architecture

L **Cartoon Research Library,** Tel 614-292-0538; Fax 614-292-9101; Elec Mail
cartoons@osu.edu; Internet Home Page Address: www.ohio-state.edu/cgaweb; *Cur*
Lucy Shelton Caswell
Open Mon - Fri 9 AM - 5 PM, hrs vary between terms; Estab 1977
Income: Financed by state appropriation
Library Holdings: Cassettes; Clipping Files; Exhibition Catalogs; Manuscripts;
Memorabilia; Motion Pictures; Original Art Works; Photographs; Records; Reels;
Slides
Special Subjects: Illustration, Photography, Manuscripts, Posters, Cartoons
Collections: Cartoonist Collection, clippings, proofs & scrapbooks (hundreds of

artists represented)

L **The Education, Human Ecology, Psychology and Social Work Library,** Tel 614-292-2075; Internet Home Page Address: www.osu.edu; *Librn* Leta Hendricks
Open Mon - Thurs 8 AM - 12 AM, Fri 8 AM - 10 PM, Sat 10 AM - 2 PM, Sun 11 AM - 12 AM, summers vary
Library Holdings: Audio Tapes; Book Volumes 23,000; Cassettes; Exhibition Catalogs; Fiche; Filmstrips; Motion Pictures; Pamphlets; Periodical Subscriptions 200; Slides; Video Tapes
Special Subjects: Folk Art, Decorative Arts, Crafts, Fashion Arts, Furniture, Carpets & Rugs, Embroidery, Jewelry, Textiles
Collections: Costumes; Crafts; Textiles & Clothing

COSHOCTON

M **JOHNSON-HUMRICKHOUSE MUSEUM,** 300 N Whitewoman St, Roscoe Village Coshocton, OH 43812. Tel 740-622-8710; Fax 740-622-8710, Ext 51; Elec Mail jhmuseum@clover.net; Internet Home Page Address: www.jhm.lib.oh.us; *Dir* Patti Malenke; *Registrar* Sharon Buxton
Open daily Noon - 5 PM May through Oct, 1 - 4:30 PM Nov through Apr, cl Mon, Thanksgiving, Christmas Eve, Christmas, New Year's Day & Easter Sun; Admis $5, adult $2, seniors $1.50, children 5-12 $1; Estab 1931, as a gift of two pioneer residents; Five galleries: American Indian, Decorative Arts, Historical Ohio & Special Exhibits; Average Annual Attendance: 16,000; Mem: Dues, indiv $20, family $30, contributing $50, supporting $100, sustaining $200, benefactor $350 & founder $500
Special Subjects: Prints, American Indian Art, Pottery, Decorative Arts, Oriental Art
Collections: American Indian baskets and bead work; Aztec, Toltec and Mayan pottery heads; Chinese and Japanese cloisonne, embroideries, ivory, jade, lacquers, metals, porcelains, prints, samari armor & swords, wood carvings; European glass, laces, pewter, porcelains, prints; Eskimo artifacts; material from Coshocton County Mound Builders; 19th century furnishings and implements used by Coshocton County pioneer families; Newark holy stones
Exhibitions: Permanent collection exhibitions changed periodically; traveling exhibitions.
Publications: American Indian Barketry; Newark Holy Stones Symposium; Pop-Gosser China; quarterly newsletter
Activities: Educ dept; classes for adults & children; lect open to pub; 4 vis lectrs per yr; tours; mus shop sells books, collection-oriented items & original art

CUYAHOGA FALLS

M **RICHARD GALLERY & ALMOND TEA GALLERY,** Divisions of Studios of Jack Richard, 2250 Front St, Cuyahoga Falls, OH 44221. Tel 330-929-1575; Elec Mail jrichard@gallery.com; *Agent* Jane Williams; *Dir* Jack Richard
Open Tues - Fri 11:30 AM - 5 PM, Sat 11 AM - 1:30 PM, Tues Eve 7 - 10 PM, cl Sun & Mon, other hours by appointment; No admis fee; Estab 1960, for exhib of local, regional & national works of art; Average Annual Attendance: 12,000
Income: Financed privately
Library Holdings: Auction Catalogs; CD-ROMs; Clipping Files; DVDs; Framed Reproductions; Kodachrome Transparencies; Original Art Works; Pamphlets; Photographs; Prints; Sculpture; Slides; Video Tapes
Collections: Ball; Brackman; Cornwell; Grell; Gleitsmann; Loomis; Terry Richard; Oriental
Exhibitions: 50 Women Plus; student exhibits; Japanese Prints; mems exhibits; 30 one-person exhibits; Pastel Exhibit; Age Old Masters; Brackman Masterpieces; Flowers, Flowers, Flowers; Great American Nude; Progress & Change in Paintings
Activities: Classes for adults & children; lect open to pub, 5 vis lectrs per yr; gallery talks; tours; competitions with awards; sponsoring of competitions; schols offered; individual paintings & original objects of art lent; lending coll contains paintings, prints & cassettes; book traveling exhibs; originate traveling exhibs; sales shop sells books, magazines, original art, reproductions, prints & slides; frame shop

L **Library,** 2250 Front St, Cuyahoga Falls, OH 44221. Tel 330-929-1575; *Dir* Jack Richard
For reference & limited lending only
Library Holdings: Book Volumes 1300; Clipping Files; Framed Reproductions; Kodachrome Transparencies; Motion Pictures; Original Art Works; Photographs; Prints; Records; Reproductions; Slides; Video Tapes

DAYTON

M **DAYTON ART INSTITUTE,** 456 Belmonte Park N, Dayton, OH 45405-4700. Tel 937-223-5277; Fax 937-223-3140; Elec Mail info@daytonartinstitute.org; Internet Home Page Address: www.daytonartinstitute.org; *Cur Asian Art* Li Jian; *Dir Develop* Robyn Orzel; *Dir Pub Relations* Renee Roberts; *Dir & CEO* Alexander Lee Nyerges; *Dir Educ Research* Susan Anable; *Mus Shop Mgr* Diane Haskel; *Cur African Art* Niangi Batulukisi; *Chief Cur* Michael K Komanecky; *Mem Coordr* Laura Letton; *Dir Planned Gifts* Denise Cagigas; *VPres* Albert W Leland
Open daily 10 AM - 4 PM, Thurs 10 AM - 8 PM; No admis fee; some spec exhibs may carry an admis fee; Estab 1919 for the pub benefit; Some of the galleries include: African Gallery, Glass Gallery, Contemporary Gallery, European 16th-18th Century Galleries, Experiencenter Gallery, Regional Artists Gallery, Special Exhibs Gallery & an Asian Wing & an American wing; Average Annual Attendance: 300,000; Mem: 12,000; dues $35 - $5000+; ann meeting Jan
Income: $1,300,000 (financed by federal, state & local funds, mem dues, endowment & corporate grants)
Special Subjects: Painting-American, Painting-European, Oriental Art
Collections: American Coll; European Art From Medieval Period to Present; Oriental Coll
Publications: Annual report; bulletin; Calendar of Events, monthly; gallery guides & catalogs, periodically; Mem Qu

Activities: Classes for adults & children; docent training; lect open to pub, 3-6 per yr; gallery talks; tours; concerts; ann festival; Leonard League Volunteer Organization; schols offered; mus shop sells books, reproductions, original art, toys & jewelry

L **Library,** 456 Belmonte Park N, Dayton, OH 45405-4700. Tel 937-223-5277; Fax 937-223-3140; Elec Mail library@daytonartinstitute.org; Internet Home Page Address: www.daytonartinstitute.org; *Ref Librn* Alice Saidel; *Librn* Ellen Rohmiller
Open Mon - Wed 10 AM - 4 PM, Thurs 10 AM - 7 PM; Estab 1922; Open to the pub for art reference only
Income: Financed by Dayton Art Institute budget
Library Holdings: Book Volumes 30,000; Clipping Files; Exhibition Catalogs; Other Holdings Auction catalogs - from 1975-present; Pamphlets; Periodical Subscriptions 50; Slides
Collections: Louis J P Lott & Walter G Schaeffer, architectural libraries; Metcalf slides of European stained glass (pre-WWII)

M **DAYTON VISUAL ARTS CENTER,** 40 W Fourth St, Dayton, OH 45387-0416. Tel 937-224-3822; Elec Mail dvac@daytonvisualarts.org; Internet Home Page Address: www.daytonvisualarts.org; *Exec Dir* Jane A Black; *Admin Asst* Barb Cline
Open Mon - Fri 10 AM - 4 PM, Sat 1 - 4 PM; No admis fee; Estab 1991 to showcase important regional contemporary art; New gallery space located in downtown Dayton; Average Annual Attendance: 15,000; Mem: 700; dues $30 - $500; monthly meetings
Income: Financed by mem, county appropriation & grants
Publications: Sketches, quarterly newsletter; exhibit catalogues
Activities: 6-8 exhibs annually in gallery; professional develop workshops & critiques for artists; lect, forums & field trips; gallery talks open to pub; schols offered; sales gallery of original art during Nov-Dec & at off-site locations during the yr; ann art auction in April

M **PATTERSON HOMESTEAD,** 1815 Brown St, Dayton, OH 45409. Tel 937-222-9724; Fax 937-222-0345; Internet Home Page Address: www.pattersonhome.com; *Cur Facilities Mgr* Kerrington Adams; *Cur* Raymond Shook; *Rental Supv* Michael Smoot; *Maintenance Supv* Mike Shively; *Dir* Denise Darlin; *Maintenance Supr* Bill LaFleur
Open Apr - May 1 - Oct 31, Wed -Sat 1 - 4 PM, cl legal holidays; $2 suggested donation; Estab 1953; Patterson Homestead is an (1816-1850) Federal style farmhouse
Special Subjects: Furniture
Collections: Antique & period furniture, ranging from the hand-hewn to highly decorative Victorian Eastlake pieces, including Chippendale, Hepplewhite; Sheraton & American Empire styles; oil portraits of mems of the Patterson family; manuscript coll
Exhibitions: Temporary exhibitions
Activities: Programs for children & grad students affiliated with Wright State Univ; docent prog; lects; tours

WRIGHT STATE UNIVERSITY

M **Art Galleries,** Tel 937-775-2978; Fax 937-775-4082; Internet Home Page Address: www.wright.edu/artgalleries;
Open Tues - Fri 10 AM - 4 PM, Sat & Sun Noon - 5 PM, cl Mon & holidays; No admis fee; Estab 1974, devoted to exhibs of & research in contemporary art; Four galleries; multi-level contemporary building with over 5000 sq ft & over 500 running ft of wall space. Available also are areas outside on the campus; Average Annual Attendance: 25,000
Income: Financed through the univ & grants
Collections: Collection of Contemporary Art
Publications: Artist's books & exhib catalogs, 2 per yr
Activities: Lect open to pub; individual paintings & art objects lent to faculty & administrative areas; lending coll contains original art works, original prints, paintings, drawings, photographs & sculpture; originate traveling exhibs; sales desk sells catalogs

L **Dept of Art & Art History Resource Center & Slide Library,** Tel 937-775-2896; Internet Home Page Address: www.wright.edu; *Slide Cur* Pat Robinow
Open Mon, Wed, Fri 9 AM - 5 PM, Tues & Thurs 10 AM - 2 PM; Estab 1970 to serve Wright State Univ & art professionals in the greater Dayton area; Circ Approx 475 slides per wk; For lending & reference
Library Holdings: Audio Tapes; Book Volumes 250; Cassettes; Exhibition Catalogs; Other Holdings Art school catalogs; Periodical Subscriptions 15; Slides; Video Tapes
Special Subjects: Art History, Drawings, Etchings & Engravings, Painting-American, Painting-British, Painting-Dutch, Painting-Flemish, Painting-French, Painting-German, Painting-Italian, Painting-Russian, Painting-European, History of Art & Archaeology, Painting-Polish, Architecture

DOVER

M **WARTHER MUSEUM INC,** 331 Karl Ave, Dover, OH 44622. Tel 330-343-7513; Elec Mail info@warthers.com; Internet Home Page Address: www.warthers.com; *Pres & Gen Mgr* Mark Warther
Open daily 9 AM - 5 PM; Admis $9.50 adults, students 6 - 17 yrs old $5.50; Estab 1936 to display carvings; Average Annual Attendance: 100,000
Income: $250,000 (financed by admis)
Special Subjects: Woodcarvings, Ivory
Collections: Carvings of American Railroad History; Carvings of ivory, ebony & walnut depicting the evolution of the steam engine
Exhibitions: Carvings of American Railroads by Ernest Warther
Activities: Retail store sells books, souvenirs, gen gifts, handcrafted cutlery, reproductions, prints & slides

ELYRIA

M **SOUTHERN LORAIN COUNTY HISTORICAL SOCIETY,** Spirit of '76 Museum, 509 Washington Ave, Elyria, OH 44035. Tel 216-647-4367; *VPres* Phyllis Perkins; *Cur* Diane Stanley; *Pres* Dick Landis
Open Apr - Oct Sat & Sun 2:30 - 5 PM, groups of ten or more any time by reservation; No admis fee; Estab 1970 to memorialize Archibald M Willard who

created the Spirit of '76, nation's most inspirational painting; Average Annual Attendance: 2,000; Mem: 259; dues couple $10, individual $5; ann meeting in Apr
Income: $10,000 (financed by mem, gifts & gift shop)
Purchases: $10,000
Special Subjects: Painting-American, Costumes, Portraits, Furniture, Historical Material
Collections: Archibald M Willard Paintings; artifacts of local interest; memorabilia of Myron T Herrick
Publications: Quarterly newsletters
Activities: Sales shop sells books, reproductions, prints & miscellaneous items

FINDLAY

M UNIVERSITY OF FINDLAY, Dudley & Mary Marks Lea Gallery, 1000 N Main St, Findlay, OH 45840. Tel 419-434-4534; Fax 419-434-4531; *Dir* Ed Corle
Open Mon - Fri 9 AM - 4:30 PM; Estab in 1962 as an auxiliary to the col art department; Gallery is maintained
Income: Financed by endowment & tui
Special Subjects: Prints
Exhibitions: Annual Student Exhibition; Contemporary Art & Crafts; Regional & Nat Faculty & Student Exhibits
Publications: Individual exhib catalogs
Activities: Classes for adults & children; dramatic progs; lect open to pub, 2-3 vis lectrs per yr; gallery talks; tours; competitions with awards; schols; fels; individual paintings & original objects of art lent, primarily to College offices

GALLIPOLIS

A FRENCH ART COLONY, PO Box 472 Gallipolis, OH 45631; 520 First Ave Gallipolis, OH 45631. Tel 740-446-3834; Fax 740-446-3834; Elec Mail facart@zoomnet.net; *Bd Mem* Janice M Thaler; *Cur* Saundra Koby; *Bd Mem* Peggy Evans; *Prog Dir* Mary Bea McCalla; *Bd Mem* Gladys Grant
Open Tues - Fri 10 AM - 3 PM, Sun 1 - 5 PM; No admis fee; Estab 1964 to promote the arts throughout the region; Mem: 325; dues $20 & up
Income: Financed by mem & donations
Exhibitions: Exhibits change monthly & include: International, Juried Festival, Ceramics, Watercolors, Oils & Mixed-Media
Publications: Newsletter, bimonthly
Activities: Classes for adults & children; dramatic progs; community programs; creative writing; visual art progs & classes; docent training; lect open to pub; concerts; tours; competitions; 10 - 12 purchase awards; book traveling exhibs; mus shop sells prints
L Library, 530 First Ave, PO Box 472 Gallipolis, OH 45631. Tel 740-446-3834; Elec Mail facart@zoomnet.net; *Dir* Mary Bea McCalla
Open Tues - Fri 10 AM - 3 PM, Sat & Sun 1 - 5 PM; Estab 1972 as small reference library dealing primarily with visual arts
Library Holdings: Book Volumes 2000; Cassettes; Clipping Files; Exhibition Catalogs; Lantern Slides; Memorabilia; Pamphlets; Periodical Subscriptions 5; Photographs; Prints; Reproductions; Slides

GAMBIER

M KENYON COLLEGE, Olin Art Gallery, Olin Library, Kenyon College Gambier, OH 43022. Tel 740-427-5000; Fax 740-427-5272; Internet Home Page Address: www.cycle.kenyon.edu; *Coordr* Ellen Sheffield; *VPres Library* Daniel Temple
Open daily 8:30 AM - 8:30 PM, through school yr only; No admis fee; Estab 1973 as teaching arm of the Art Dept of Kenyon Col
Income: Financed by col
Collections: Art collection and items of some historical importance
Activities: Lect open to pub; gallery talks; tours; Honors Day cash awards

GRANVILLE

M DENISON UNIVERSITY, Art Gallery, Burke Hall of Music & Art, Granville, OH 43023. Tel 740-587-6255; Fax 740-587-5701; Elec Mail vanderheijde@denison.edu; Internet Home Page Address: www.denison.edu/art/artgallery; *Acting Dir* Merijn van der Heijden
Open Mon - Sun 1 - 4 PM; No admis fee; Estab 1946 for educ & exhib purposes; Four galleries for exhibs; one seminar room; storage for permanent colls ; Average Annual Attendance: 25,000
Income: Financed through Univ
Special Subjects: Painting-American, Photography, Prints, Sculpture, American Indian Art, African Art, Textiles, Ceramics, Folk Art, Woodcarvings, Woodcuts, Etchings & Engravings, Painting-European, Furniture, Asian Art, Baroque Art, Cartoons
Collections: American and European paintings, prints, drawings and sculpture; Burmese textiles, lacquerware and Buddhist sculpture; Chinese bronzes, robes and porcelains; Cuna Indian Molas, Uchus and ceremonial objects; American Indian pottery, baskets and rugs; African sculpture and basketry
Exhibitions: Faculty show; senior student shows; special exhibs from permanent coll; visiting artists exhibs
Activities: Lect open to pub, 4-6 vis lectrs per yr; gallery talks; tours; fels offered; exten dept; individual paintings & original objects of art lent to other museums
L Slide Library, Cleveland Annex, Granville, OH 43023. Tel 740-587-6480; Fax 740-587-5701; Elec Mail hout@denison.edu; Internet Home Page Address: www.denison.edu; *Art Image Cur & Developer* Jacqueline Pelasky Hout
Open Mon - Fri 9 AM - 4 PM; Open to faculty & to students for reference only
Library Holdings: Slides 200,000

HAMILTON

M FITTON CENTER FOR CREATIVE ARTS, 101 S Monument Ave, Hamilton, OH 45011-2833. Tel 513-863-8873; Fax 513-863-8865; Elec Mail cathy@fittoncenter.org; Internet Home Page Address: www.fittoncenter.org; *Exec Dir* Rick H Jones; *Arts in Common Dir* Henry Cepluch; *Exhib* Cathy Mayhugh; *Dir Riverside Acad & SPECTRA* Jackie Quay
Office open Mon - Fri 8:30 AM - 6 PM, Sat 9 - Noon, cl Sun; No admis fee; Estab 1992 to reveal community excellence through the arts; Two large galleries

with foyer on second floor. Large lobby display area on ground fl. Student gallery on ground fl; Average Annual Attendance: 20,000; Mem: 900; dues $25 & up; ann meeting in the fall
Income: Financed by NEA, Ohio Arts Council, corporations, Hamilton Community Foundation & mem
Special Subjects: Graphics, Hispanic Art, Latin American Art, Painting-American, Photography, Prints, Sculpture, African Art, Pre-Columbian Art, Textiles, Pottery, Primitive art, Landscapes, Afro-American Art, Decorative Arts, Manuscripts, Painting-Japanese, Portraits, Posters, Jewelry, Asian Art, Silver, Historical Material, Leather, Reproductions
Publications: The Schooled Mind: Spectra+; quarterly newsletter; ann report
Activities: Classes for adults & children; dramatic progs; performing arts series; teacher workshops; lect open to pub; concerts; gallery talks; tours; competitions with prizes; schols offered

M PYRAMID HILL SCULPTURE PARK & MUSEUM, Hamilton-Cleves Rd, SR 128, 1763 Hamilton Cleves Hamilton, OH 45013. Tel 513-868-8336; Fax 513-868-3585; Internet Home Page Address: www.pyramidhill.org; *Exec Asst* Sandy Moore; *Trustee* Harry T Wilks
Open daily 10 AM - 6 PM, (winter) Sat & Sun 10 AM - 4 PM, cl Mon; Admis weekend $4, weekday $3, children 5-12 $1.50; Estab 1995; 265 acres, 7 lakes with fountains, pavilion, amphitheater & tea room; Average Annual Attendance: 120,000; Mem: 1183; dues founder's society $5000, ambassador $2500, benefactor $1000, sponsor $500, patron $250, contributor $125, family $40, individual $35
Collections: Monumental Sculpture, 41 pieces
Exhibitions: Jon Isherwood
Publications: Quarterly newsletter
Activities: Classes for adults & children; dramatic progs; bus trips (art excursions); summer series for children; horticultural luncheon; lect open to pub; concerts; dances; evening arts series

KENT

KENT STATE UNIVERSITY
M School of Art Gallery, Tel 330-672-7853, 672-2192 (Art Dept); Fax 330-672-4729; Internet Home Page Address: www.kent.edu/art; *Dir* Dr Fred T Smith; *Chmn Art Dept* William Quinn
Open Mon - Fri 10 AM - 4 PM, Sun 2 - 5 PM, cl school holidays; No admis fee; Estab 1950 as part of the instructional prog at Kent State; One main gallery 2200 sq ft; two student galleries; Eells Gallery; Blossom Music Center; Average Annual Attendance: 22,000; Mem: 76; dues $10; ann meeting in June
Income: Financed by Univ, grants & fundraising
Special Subjects: Painting-American, Prints, Sculpture
Collections: Michener Coll, contemporary prints & paintings; permanent coll sculpture, paintings, prints, crafts & photog, textiles
Exhibitions: Annual Invitational; faculty & student one-man & group exhibitions; traveling exhibitions from museums
Publications: Brochures; catalogs, 2-3 per yr
Activities: Classes for students in mus preparation; lect open to pub, 10-15 vis lectrs per yr; gallery talks; tours; competitions; individual paintings & original objects of art lent to offices on campus; book traveling exhibs 3 per yr

LAKEWOOD

A BECK CENTER FOR THE ARTS, 17801 Detroit Ave, Lakewood, OH 44107. Tel 216-521-2540; Fax 216-228-6050; Elec Mail yvette@beckcenter.org; Internet Home Page Address: www.lkwdpl.org/beck; *Pres Board Trustees* Fred Unger; *Dir Development* John Farina; *Educ & Outreach* Rachel Spence; *Dir Educ* Edward Gallagher; *Exec Dir* Jim Walton; *Dir Mktg* Yvette A Hanzel; *Artistic Dir* Scott Spence
Open Mon - Fri 9 AM - 8 PM, Sat Noon - 6 PM, performance evenings Thurs & Fri 6 - 9 PM, 8 - 10 PM, Sun 2 - 4 PM; No admis fee; Estab 1976 to present a wide variety of the fine & graphic arts; A cooperative art gallery, home to 73 artists, juried art shows & visual art progs; Average Annual Attendance: 50,000
Income: Financed by individual, corporate & foundation donations, box office & class registration revenue
Collections: Contemporary pieces including acrylics, collages, etchings, oils, sculpture & watercolors
Exhibitions: Kwo, Miller, Thurmer (paintings & sculpture); Touching Stories, from Cleveland Mus of Art; Hungarian Art; Krabill (paintings)
Publications: Bulletins; Programs, every five weeks
Activities: Classes for adults & children; dramatic progs; music; dance; visual arts; creative arts therapy; docent training; lect open to pub; 5 vis lectr per year; concerts; gallery talks; competitions with awards; exten dept serves youth in schools; sales shop sells original art, prints, jewelry & all art media

LIMA

M ARTSPACE-LIMA, 65 Town Square, Lima, OH 45801. Tel 419-222-1721; Fax 419-222-6587; Elec Mail artspace@worcnet.gen.oh.us; *Exec Dir* Patricia Good; *Dir Operations & Ed* Nancy Lohr; *Gallery Shoppe Coordr* Tammy Belisle
Open Mon - Fri 10 AM - 5 PM, Sat Noon - 3 PM, Sun 2 - 4 PM; No admis fee; Estab 1940 for the promotion of visual arts through educ & exhib; Maintains resource center; Average Annual Attendance: 200,000; Mem: 500; dues family $40, individual $30; ann meeting in Sept
Income: $10,000 (financed by mem, grants & fundraising events)
Special Subjects: Architecture, Drawings, American Indian Art, American Western Art, Bronzes, Anthropology, Archaeology, Ethnology, Costumes, Ceramics, Crafts, Folk Art, Woodcuts, Etchings & Engravings, Afro-American Art, Decorative Arts, Collages, Dolls, Furniture, Glass, Asian Art, Coins & Medals, Calligraphy, Cartoons, Enamels
Exhibitions: 10 exhibits annually
Publications: Perspectives, newsletter
Activities: Classes for adults & children; docent progs; teacher in-services; lect open to pub, 6 vis lectrs per yr; gallery talks; tours; competitions with awards;

schols offered; individual paintings & original objects of art lent to local businesses, pub school classrooms & art teachers; mus shop sells books, original art, reproductions, prints & children's art kits

MANSFIELD

A **MANSFIELD FINE ARTS GUILD,** Mansfield Art Center, 700 Marion Ave, Mansfield, OH 44903. Tel 419-756-1700; Fax 419-756-0860; Internet Home Page Address: www.mansfieldartcenter.com; *Dir* H Daniel Butts III
Open Tues - Sat 11 AM - 5 PM, Sun Noon - 5 PM, cl Mon & national holidays; No admis fee; Estab 1945, incorporated 1956 to maintain an art center in which exhibs, lects, gallery talks, spec progs, symposia & series of classes for adults & children are provided for the North Central Ohio area; maintained by mem, commission on sales & classes; Gallery dimensions 5000 sq ft with flexible lighting, movable walls, props, etc to facilitate monthly exhib changes; Average Annual Attendance: 25,000; Mem: 1050; dues $2 5- $1000; ann meeting in Apr
Income: Financed by mem, grants, donations
Exhibitions: Changing exhibs of member artists' work; traveling shows & locally organized one-man, group & theme exhibs changing monthly throughout the yr
Publications: Catalogs; class schedules; monthly newsletter
Activities: Classes for adults & children; lect open to pub, 6 vis lectrs per yr; gallery talks mainly for school groups; competitions; schols offered
L **Library,** 700 Marion Ave, Mansfield, OH 44903. Tel 419-756-1700; Internet Home Page Address: www.mansfieldartcenter.com; *Art Dir* H Daniel Butts III
Open by appointment only; Estab 1971; The library is basically a collection of monographs & studies of styles & periods for teacher & student reference
Income: financed by arts center
Library Holdings: Book Volumes 500

MARIETTA

M **MARIETTA COLLEGE,** Grover M Hermann Fine Arts Center, 215 Fifth St, Marietta, OH 45750. Tel 740-376-4696; Fax 740-376-4529; Internet Home Page Address: www.marietta.edu; *Chmn* Valdis Garoza
Open Mon - Fri 8 AM - 10:30 PM, Sat & Sun 1 - 10:30 PM; No admis fee; Estab 1965; Gallery maintained; Average Annual Attendance: 20,000
Special Subjects: Painting-American, Sculpture, American Western Art, African Art, Crafts
Collections: Permanent coll of contemporary American paintings, sculpture & crafts; significant coll of African & pre-Columbian art
Activities: Lect open to pub; competitions

M **THE OHIO HISTORICAL SOCIETY, INC,** Campus Martius Museum & Ohio River Museum, 601 Second St, Marietta, OH 45750-2122. Tel 740-373-3750; Tel 800-860-0145; Fax 740-373-3680; Elec Mail cmmoriv@ohiohistory.org; Internet Home Page Address: www.ohiohistory.org; *Mgr* Andrew J Verhoff; *Secy* Leann Hendershot; *Educational Specialist* Sherry Potochnik
Campus Martius Mus: Mar - Oct Wed - Sat 9:30 AM - 5 PM, Sun 12 - 5 PM, Memorial Day, July 4, Labor Day 12 - 5 PM; Ohio River Mus: Memorial Day Oct Sat 9:30 AM - 5 PM, Sun 1 2 - 5 PM, Memorial Day, July 4, Labor Day 12 - 5 PM; Admis fee adults $7, student $3, mem & children under 6 free; Estab 1929 the Campus Martius Mus is the Ohio Historical Soc's gateway to the settlement of Ohio & the movement of people into & within the state; buildings, artifacts, audio and video exhibits tell the story; estab 1941 the Ohio River Mus is the Ohio Historical Soc's interpretive ctr for river history, especially steamboats; exhibits include a steam towboat, river diorama, small craft, steamboat artifacts, models, paintings & a video history of steamboats; Campus Martius Mus has 12,500 sq ft of exhib space on three floors plus a two-story home, a portion of the original fort of 1790-95 enclosed within the building. The Ohio River Mus has approximately 4500 sq ft of exhib space in three separate buildings connected by walkway; Average Annual Attendance: 18,000
Income: Financed by state appropriation, mem, grants, fundraising, admis & sales
Special Subjects: Drawings, Painting-American, Photography, American Indian Art, Archaeology, Textiles, Costumes, Crafts, Folk Art, Pottery, Landscapes, Decorative Arts, Portraits, Dolls, Furniture, Glass, Jewelry, Porcelain, Silver, Marine Painting, Historical Material, Restorations, Period Rooms, Pewter
Collections: Steamer W P Snyder Jr; Tell City Pilothouse, a replica of the 18th century flatboat; decorative arts from 19th century Ohio; early Ohio paintings, prints, & photographs; items from early Putnam, Blennerhassett & other families; Ohio Company & Marietta materials; Ohio River landscapes
Activities: Classes for adults & children; tours; mus shop sells books & souvenir items

MASSILLON

M **MASSILLON MUSEUM,** 121 Lincoln Way E, Massillon, OH 44646. Tel 330-833-4061; Fax 330-833-2925; *Dir* John Klassen; *Arts Educ* Amy Craft; *Arts Admin* Christine Shearer; *Admin Asst* Kelly Rasile; *Bldg Mgr* Jeff Hoskinson
Open Tues - Sat 9:30 AM - 5 PM, Sun 2 - 5 PM; No admis fee; Estab 1933 as a mus of art & history; The mus places emphasis on the Ohio area by representing the fine arts & crafts & the Massillon area with an historical coll; Average Annual Attendance: 24,000; Mem: 350; dues $25 & higher
Income: Financed by local property tax
Special Subjects: Crafts
Collections: Ceramics, china, costumes, drawings, furniture, glass, jewelry, paintings, prints
Exhibitions: Monthly exhibs
Publications: Pamphlet of activities & exhibs, quarterly
Activities: Classes for adults & children; docent training; lect open to pub, 3 vis lectrs per yr; gallery talks; tours; exten dept serves pub schools; individual paintings & original objects of art lent to area museums

MAYFIELD VILLAGE

L **MAYFIELD REGIONAL LIBRARY,** 6080 Wilson Mills Rd, Mayfield Village, OH 44143. Tel 440-473-0350; Fax 440-473-0774; *Art Librn* Kenneth Neal
Open Mon - Thurs 9 AM - 9 PM, Fri & Sat 9 AM - 5:30 PM, Sun 1 - 5 PM (during school months); No admis fee; Estab 1972; Circ 100,000

Income: Financed by county-CCPL
Exhibitions: Original art works by local artists; Exhibs on a monthly basis

MIDDLETOWN

A **MIDDLETOWN ARTS CENTER,** (Middletown Fine Arts Center) 130 N Verity Pky, PO Box 441 Middletown, OH 45042. Tel 513-424-2417; Fax 513-424-1682; Elec Mail mfac@siscom.net; Internet Home Page Address: www.middletownartscenter.com; *Dir* Peggy Davish; *Pres* Rick Davies
Open Tues - Thurs 9 AM - 9 PM, Mon 9 AM - 4 PM, Sat 9 AM - Noon, cl Sun; No admis fee; Estab 1963 to offer exhibs & classes to the pub; Auditorium for large exhibs; gallery for small exhibs; Average Annual Attendance: 400-500; Mem: 596; dues minimum $15; ann meeting in July
Income: Funds generated through mem & donations
Exhibitions: 10-12 exhibitions per year including Annual Area Art Show; Annual Student Show; plus one & two-man invitational shows of regional artists
Publications: Brochures publicizing exhibs; quarterly newsletters; schedule of classes
Activities: Classes for adults, children & the handicapped; lect open to pub, 1-3 vis lectr per year; tours; competitions with awards; schols offered; individual paintings & original objects of art lent usually to businesses for display; lending coll contains books, original art works & paintings; book traveling exhibs; sales shop sells pottery, jewelry & paintings produced at Center
L **Library,** 130 N Verity Pky, PO Box 441 Middletown, OH 45042. Tel 513-424-2417; Fax 513-424--1682; Elec Mail mfac@siscom.net; Internet Home Page Address: www.middletownfinearts.com; *Adminr* Peggy Davish
Open Tues - Thurs 9 AM - 9 PM, Mon 9 AM - 4 PM, Sat 9 AM - Noon, cl Sun; Estab 1963, to provide information and enjoyment for students and instructors; Circ 30; Library open for lending or reference
Income: Financed through ann budget & donations
Purchases: $150
Library Holdings: Book Volumes 1500; Periodical Subscriptions 6; Slides
Special Subjects: Art History, Folk Art, Decorative Arts, Illustration, Photography, Drawings, Sculpture, Historical Material, Portraits, Watercolors, Ceramics, Conceptual Art, Crafts, Art Education, Southwestern Art
Collections: All books pertain only to art subjects: Art history; ceramics; crafts; illustrations; references; techniques; theory
Activities: Classes for adults & children; one vis lectr per yr; sponsoring of competitions; schols

NORTH CANTON

L **NORTH CANTON PUBLIC LIBRARY,** The Little Art Gallery, 185 N Main St, North Canton, OH 44720. Tel 330-499-4712, Ext 12; Fax 330-499-7356; Elec Mail harberla@oplin.lib.oh.us; Internet Home Page Address: www.northcantonlibrary.org/lag; *Chmn Art Committee* David Smetana; *Cur* Laurie G Fife Harbert; *Library Dir* Karen Sonderman; *Asst* Debbie Hansel
Open Mon - Thurs 9 AM - 9 PM, Fri 9 AM - 6 PM, Sat 9 AM - 5 PM, Sun 1 - 5 PM (Labor Day - Memorial Day); No admis fee; Estab 1936 to encourage & promote appreciation & educ of fine art & other related subjects; also recognizes & encourages local artists by promoting exhibs of their work; 600 sq ft; approx 30-50 works on view at a time; Average Annual Attendance: 7,000; Mem: 175; dues $15; meetings in Sept, Nov, Feb, Apr & Jun
Income: Financed by city & state appropriation
Purchases: $500
Library Holdings: Book Volumes 54,014; Original Art Works; Periodical Subscriptions 180; Photographs; Sculpture
Special Subjects: Photography, Drawings, Etchings & Engravings, Painting-American, Prints, Sculpture, Watercolors, Ceramics, Glass, Stained Glass, Embroidery, Jewelry, Pottery, Religious Art, Textiles, Landscapes
Collections: Original works by contemporary artists; religious reproductions; reproductions for juvenile
Exhibitions: Monthly exhibits; Stark County Competitive Artists Show
Activities: Classes for adults & children; classes for home schooled students; gallery talks; tours; competitions with awards; lending of original objects of art to estab art organizations

OBERLIN

A **FIRELANDS ASSOCIATION FOR THE VISUAL ARTS,** 39 S Main St, Oberlin, OH 44074. Tel 440-774-7158; Fax 440-775-1107; Elec Mail favagallery@oberlin.net; Internet Home Page Address: www.favagallery.org; *Exec Dir* Elizabeth Manderen; *Dir Gallery* Kyle Michalak
Gallery open Tues - Sat 11 AM - 5 PM, Sun 1 - 5 PM; No admis fee; Estab 1979 as a nonprofit community art organization; Average Annual Attendance: 6,000; Mem: 325; dues basic $30 - $45, contributors up to $1000; ann meeting in May
Income: $185,000 (financed by grants, mem, fees, tui, commissions, contributions fundraisers & the Ohio Arts Council)
Exhibitions: Monthly changing exhibits by Contemporary regional artists; Annual Juried Six-State Photography; Annual FAVA Members' Holiday Show; Biennial national juried Artist as Quiltmaker Exhibition
Activities: Classes for adults, teens & children; family workshops; lect open to pub, 6 vis lectrs per yr; competitions with awards; schols for low income children; sales shop sells books, original art, reproductions & prints

INTERMUSEUM CONSERVATION ASSOCIATION
For further information, see National and Regional Organizations

M **OBERLIN COLLEGE,** Allen Memorial Art Museum, 87 N Main St, Oberlin, OH 44074. Tel 440-775-8665; Fax 440-775-8799 or 6841; Elec Mail leslie.miller@oberlin.edu; Internet Home Page Address: www.oberlin.edu/allenart; *Dir* Stephanie Wiles; *Registrar* Lucille Stiger; *Cur Educ* Jason Trimmer; *Mus Preparator* Michael Holubar; *Asst Preparation* Stephen Fixx; *Asst to Dir* Leslie Miller; *Cur Western Art* Andria Derstine; *Asst Registrar* Selina Bartlett; *Admin Asst* Laura Winters
Open Tues - Sat 10 AM - 5 PM, Sun 1 - 5 PM, cl Mon; No admis fee; Estab 1917 to serve teaching needs of Oberlin Col & provide cultural enrichment for

Northern Ohio region; Original building was designed by Cass Gilbert, a new addition opened in 1977 & was designed by Venturi, Rauch & Assoc; Average Annual Attendance: 32,000; Mem: 525; dues Director's Circle $1000, supporting $500, contributing $100, family $50, individual $40, student & senior $20, Oberlin College student $15
Income: Financed by endowment, mem & Oberlin College gen fund
Library Holdings: Auction Catalogs; Book Volumes; CD-ROMs; Compact Disks; Exhibition Catalogs; Fiche; Lantern Slides; Manuscripts; Maps; Micro Print; Original Documents; Periodical Subscriptions; Slides; Video Tapes
Special Subjects: Painting-American, Sculpture, Oriental Art, Painting-Dutch, Painting-Flemish
Collections: The collection which ranges over the entire history of art is particularly strong in the areas of Dutch & Flemish paintings of the 17th century, European Art of the late 19th & early 20th centuries, contemporary American art, old masters & Japanese prints
Exhibitions: 4 -6 exhibs per yr drawn from permanent colls & loan edhibs
Publications: AMAM Newsletter, 2 times per yr; exhib catalogues
Activities: Classes for adults & children; docent training; lect open to pub, 2-4 vis lectrs per yr; gallery talks; concerts; tours; travel progs; original objects of art lent to other institutions for spec exhib; art rental coll contains 400 original art works for lending to students on a semester basis; books; cards

L Clarence Ward Art Library, Allen Art Bldg, 83 N Main St Oberlin, OH 44074. Tel 440-775-8635; Fax 440-775-5145; Elec Mail art.help@oberlin.edu; *Art Librn* Barbara Q Prior
Open Mon - Thurs 8:30 AM - 5:30 PM & 7 - 11 PM, Fri 8:30 AM - 5:30 PM, Sat 12:30 - 5:30 PM, Sun 12:30 - 5:30 PM & 7 - 11 PM; Estab 1917 to serve the library needs of the art dept, the Allen Memorial Art Mus & the Oberlin Col community in the visual arts; Circ 22,000; Average Annual Attendance: 35,000
Income: Financed by appropriations from Oberlin Col Libraries
Library Holdings: Auction Catalogs; Book Volumes 100,000; CD-ROMs; Clipping Files; Compact Disks; DVDs; Exhibition Catalogs; Motion Pictures; Other Holdings Auction sales catalogs 10,000; Periodical Subscriptions 250; Video Tapes
Special Subjects: Art History, Landscape Architecture, Illustration, Photography, Islamic Art, Painting-American, Painting-British, Painting-Dutch, Painting-Flemish, Painting-French, Painting-German, Painting-Italian, Painting-Japanese, Painting-Russian, Painting-Spanish, Posters, Prints, Sculpture, Painting-European, History of Art & Archaeology, Judaica, Watercolors, Conceptual Art, Archaeology, Bronzes, Printmaking, Asian Art, Video, Aesthetics, Afro-American Art, Antiquities-Oriental, Oriental Art, Religious Art, Restoration & Conservation, Woodcarvings, Woodcuts, Landscapes, Antiquities-Etruscan, Antiquities-Greek, Portraits
Collections: Jefferson & Arts Collections of early architectural books; artists' books; mail art
Publications: Bibliographies & library guides
Activities: Classes for students; tours

OXFORD

M MIAMI UNIVERSITY, Art Museum, Patterson Ave, Oxford, OH 45056. Tel 513-529-2232; Fax 513-529-6555; Internet Home Page Address: www.muohio.edu/artmuseum/; *Cur Coll* Edna Carter Southard; *Cur Educ* Bonnie C Mason; *Museum Registrar* Beverly Bach; *Preparator* Mark DeGennaro; *Dir* Richard Wicks, PhD
Open Tues - Fri 10 AM - 5 PM, Sat & Sun Noon - 5 PM, cl Mon & university holidays; No admis fee; Estab 1978, Art Mus facility opened Fall 1978, to care for & exhibit Univ art colls, to arrange for a variety of traveling exhibitions & for the educational & cultural enrichment of the University & the region; Mus is maintained with exhib space of 9000 sq ft, consisting of 5 galleries in contemporary building designed by Walter A Netsch, Skidmore, Owing & Merrill, Chicago; operates the McGuffey Mus, home of William Holmes McGuffey, a national historic landmark; accredited by the American Assoc of Museums; Average Annual Attendance: 35,000; Mem: 1000; dues $25 & up
Income: Financed by gift & state appropriation
Special Subjects: Painting-American, Photography, Prints, Sculpture, Textiles, Folk Art, Decorative Arts
Collections: Charles M Messer Leica Camera Collection; Ancient Art; Decorative Arts; International Folk Art, largely Middle European, Middle Eastern, Mexican, Central & South America; European & American paintings, prints & sculpture; African art; Chinese Art; Gandharan art; Native American Art; Oceanic Art; photography; textiles
Exhibitions: Twelve per yr; Looking Back: 20th Century American Art; From Puri to Bombay: Art of India
Publications: Brochures; catalogs, approx 6-8 per year; quarterly newsletter
Activities: Progs for adults & children; docent training; lect open to pub, 5-6 vis lectrs per yr; concerts; gallery talks; tours; individual paintings & original objects of art lent to qualified museums in US; book traveling exhibs 2-3 per yr; originate traveling exhibs; mus shop sells books, magazines, original art, prints, notecards, jewelry & collectibles

L Wertz Art & Architecture Library, Alumni Bldg, Rm 7, Oxford, OH 45056. Tel 513-529-6638; Fax 513-529-4159; Internet Home Page Address: www.lib.muohio.edu; *Library Assoc* Angela Webster; *Librn* Stacy Brinkman; *Sr Lib Tech* Justin Bridges
Open Mon - Thurs 8 AM - 10 PM, Fri 8 AM - 5 PM, Sat 1 - 5 PM, Sun 1 - 10 PM during acad yr; No admis fee; Estab to support the progs of the Schools of Art & Architecture & related disciplines
Income: Part of univ
Library Holdings: Book Volumes 65,000; Exhibition Catalogs; Other Holdings Per & serial subs 400
Special Subjects: Folk Art, Landscape Architecture, Decorative Arts, Photography, Islamic Art, Painting-American, History of Art & Archaeology, Latin American Art, American Western Art, Art Education, Asian Art, American Indian Art, Mexican Art, Southwestern Art, Afro-American Art, Jewelry, Oriental Art, Marine Painting, Architecture

A SOCIETY FOR PHOTOGRAPHIC EDUCATION, Miami University, Dept of Art, 110 Art Bldg Oxford, OH 45056; Miami Univ, School of Interdisiciplinary Studies, 126 Peabody Hall Oxford, OH 45056. Tel 513-529-8328; Fax 513-529-9301; Elec Mail speoffice@spenational.org; Internet Home Page Address: www.spenational.org; *Exec Dir* Jennifer Pearson Yamashiro, PhD; *Exec Asst* Clark Poritius; *Admin Asst/Exhib Fair Coordr* Kelly O'Malley; *Registrar* Alison Smith; *Exposure Ed* Carla Williams; *Nat Conf Coord* Ashley Peel Pinkham; *Advertising Coordr* Diane Warner
Open Mon - Fri 9 AM - 5 PM; Estab 1963 to provide a forum for discussion of photog; Open to all with an interest in photog; Average Annual Attendance: 1,200; Mem: 1,800; dues $50 - $90; ann meeting in Mar
Income: $250,000 (financed by mem & conference registrations)
Publications: Exposure, biannual; SPE Newsletter, quarterly; ann mem directory & resource guide; Conference Prog Guide, ann
Activities: Lect open to pub, 40-45 vis lectrs per yr; tours; schols offered

PORTSMOUTH

M SOUTHERN OHIO MUSEUM CORPORATION, Southern Ohio Museum, 825 Gallia St, PO Box 990 Portsmouth, OH 45662. Tel 740-354-5629; Fax 740-354-4090; Elec Mail sara@somacc.com; Internet Home Page Address: www.somacc.com; *Dir* Sara Johnson; *Asst Dir* Beth Haney; *Cur Performing Arts* Pegi Wilkes; *Galleries & Coll Mgr* Darren Baker
Open Tues - Fri 10 AM - 5 PM, Sat 1 - 5 PM; Admis adults $2, children $1; Estab 1977 to provide exhibs & performances; Mus facility is a renovated & refurbished neoclassical building, 21,000 sq ft, constructed in 1918 as a bank. Facility has three temporary exhibit galleries & a theatre; maintain reference library; permanent colls; Average Annual Attendance: 19,000; Mem: 1000; dues family $35
Income: $300,000 (financed by endowment, mem & city appropriation, fundraisers & grants)
Library Holdings: Book Volumes; Exhibition Catalogs; Photographs
Collections: Clarence Carter Paintings; watercolors & prints; Historic photograph collection, Native American artifacts - Hopewell & Adena cultures of Ohio River Valley
Exhibitions: Contemporary & traditional arts, history, or humanities
Publications: Annual report; exhib catalogs
Activities: Classes for adults & children; dramatic progs; docent training; gallery talks; tours; concerts; lect open to pub, 5 vis lectrs per yr, concerts, gallery talks, tours, sponsor competitions; exten dept serves county; book traveling exhibs; originates traveling exhibs periodically to Ohio museums & galleries; mus shop sells books, gift items, jewelry & prints

SPRINGFIELD

M CLARK COUNTY HISTORICAL SOCIETY, Heritage Center of Clark County, 117 S Fountain Ave, Springfield, OH 45501. Tel 937-324-0657; *Pres* William R Swaim; *Exec Dir* Floyd Barmann; *Sr Cur* Virginia Weygardt; *CEO* Robert Fuhrman; *Dir Opers* Roger Sherrock
Open Tues - Fri 9 AM - 5 PM; Sat 11 AM - 5 PM; Sun 1 - 5; cl Mon; No admis fee; Estab 1897 for coll & preservation of Clark County history & historical artifacts; Average Annual Attendance: 4,000-5,000; Mem: 600; dues individual $15, family $50, friend $100, patron $250, student $5; ann meeting Nov
Income: $55,000 (financed by appropriation)
Special Subjects: Historical Material
Collections: European Landscapes; Oil Paintings, mostly mid-late 19th century, of prominent Springfielders; artifacts
Publications: Newsletter, monthly; ann monograph
Activities: Monthly meetings & lect open to pub; tours; restoration project: The David Crabill Homestead (1826), located at Lake Lagonda in Buck Creek State Park; individual paintings & original objects of art lent to museums; lending coll contains 150 original artworks, 50 original prints, 75 paintings & 2000 photographs; sales shop sells books

L Library, 117 S Fountain Ave, Springfield, OH 45504; P O Box 2157, Springfield, OH 45501. Tel 937-324-0657; Fax 937-324-1992; *Cur* Virginia Weygandt; *Dir* Robert Fuhrman; *Dir Opers & Personnel* Roger Sherrock; *Develop Secy* Barbara Brown; *Pub Historian* Tamara Wait
Mus Tues - Sat 9 AM - 5 PM; library Tues, Wed, Sat 9 AM - 5 PM; No admis fee; Estab 1897; For reference only
Library Holdings: Book Volumes 4000; Clipping Files; Manuscripts; Maps; Memorabilia; Original Art Works; Original Documents; Periodical Subscriptions; Photographs; Reels; Slides
Collections: Photograph Collection; Local History Collection
Publications: Chronicles of Clark County
Activities: Classes for adults & children; docent training; Benjamin F Prince Award; mus shop sells books, reproductions & gen merchandise

M SPRINGFIELD MUSEUM OF ART, 107 Cliff Park Rd, Springfield, OH 45501. Tel 937-325-4673; Fax 937-325-4674; Elec Mail smoa@main-net.com; Internet Home Page Address: spfld-museum-of-art.org; *Pres* Lisa Henry; *Dir* Mark J Chepp; *Mus Educ* Lynda Collins; *Progs & Mem* Patricia Funk; *Deputy Dir* Dominique Vasseur; *VPres* Samuel Petroff; *Facilities Mgr* Rusty Davis
Open Tues, Thurs, Fri 9 AM - 5 PM; Wed 9 AM - 9 PM; Sat 9 AM - 3 PM; Sun 2 - 4 PM; cl Mon; No admis fee; Estab 1951 for educ & cultural purposes, particularly the encouragement of the appreciation, study of, participation in & enjoyment of the fine arts; Average Annual Attendance: 30,000; Mem: 1000; dues benefactor $100, sustaining $50, family $35, individual $25; meetings third Tues in June
Income: $250,000 (financed by endowment, mem & tui fees)
Collections: 19th & 20th Century Artists (mostly American, some French)
Exhibitions: Rotating exhibits every 2-3 months
Publications: Newsletter, bimonthly
Activities: Classes for adults & children; docent training; lect open to pub, vis lectr; tours; gallery talks; competitions; schols offered; individual paintings & original objects of art lent; sales shop selling original art

L **Library,** 107 Cliff Park Rd, Springfield, OH 45501. Tel 937-325-4673; Fax 937-325-4674; Elec Mail smoa@main-net.com; Internet Home Page Address: www.springfieldart.museum; *Dir* Mark Chepp; *Mus Cur* Thomas Skwerski; *Mus Educ* Deena Pinales; *Develop Dir* Rosemary Navlty
Open Tues, Thurs, Fri 9 AM - 5 PM, Wed 9 AM - 9 PM, Sat 9 AM - 3 PM, Sun 2 - 4 PM; No admis fee; Estab 1973 for art study; For reference only; Average Annual Attendance: 35,000
Income: Financed by endowment & mem
Library Holdings: Book Volumes 4500; Clipping Files; Exhibition Catalogs; Pamphlets; Slides 400
Special Subjects: Art History, Photography, American Western Art, Art Education, American Indian Art, Afro-American Art
Activities: Classes for adults & children; docent training; lects open to the pub; concerts; gallery talks; tours; sponsoring of competitions; scholarships; schols; book traveling exhibs, 8-10 per yr; mus shop

SYLVANIA

L **LOURDES COLLEGE,** Duns Scotus Library, 6832 Convent Blvd, Sylvania, OH 43560. Tel 419-824-3761; Fax 419-824-3511; Internet Home Page Address: www.lourdes.edu/library/index.html; *Dir Libr Servs* Sr Sandra Rutkowski; *Asst Librn* Sr Karen Mohar
Open Mon - Thurs 8:30 AM - 9 PM, Fri - Sat 8:30 AM - 4 PM, Sat - 9 AM - 4 PM, cl Sun; Open to students & guests; Estab 1949; Art pieces exhibited on walls of three acad bldgs; classroom & library; Average Annual Attendance: 600
Income: Financed through col
Library Holdings: Audio Tapes; Book Volumes 67,000; Cassettes; Fiche 13,599; Manuscripts; Memorabilia; Original Art Works; Periodical Subscriptions 420; Prints; Reproductions; Sculpture; Slides; Video Tapes
Special Subjects: Art History, Decorative Arts, Calligraphy, Commerical Art, Drawings, Etchings & Engravings, Graphic Arts, Ceramics, Crafts, American Western Art, Art Education, Asian Art, American Indian Art, Afro-American Art, Enamels
Collections: 350 art pieces in library cataloged
Activities: Lect open to pub; tours; schols & fels offered

TOLEDO

A **SPECTRUM GALLERY,** Toledo Botanical Garden, 5403 Elmer Dr Toledo, OH 43615. Tel 419-531-7769; *Gallery Coordr* Mandi Gorbelt; *Pres* Buzz Meyers; *1st VPres* Mary Jane Erard; *Treas* Millard Stone; *VPres* Marge Cadaret
Open Wed - Sun Noon - 4 PM; No admis fee; Estab 1975 to encourage & support pub appreciation of fine art & to organize & promote related activities; promote mutual understanding & cooperation among artists, artist groups & the pub promote beautification of Toledo through use of art work; Clubhouse (3 galleries, sales room office & working studio) part of Artist Village in Toledo Botanical Garden; large adjacent Art Educ Center; Average Annual Attendance: 15,000-20,000; Mem: 200
Income: $20,000 (financed by mem & fundraising events, sales of art, donations & art classes)
Exhibitions: Juried Membership Show; Crosby Festival of the Arts; Toledo Festival; spot exhibitions
Publications: Spectrum (newsletter), monthly
Activities: Classes for adults & children; lect open to pub, 4-5 vis lectrs per yr; competitions; traveling exhibs organized & circulated; sales shop sells original art

A **TOLEDO ARTISTS' CLUB,** Toledo Botanical Garden, 5403 Elmer Dr Toledo, OH 43615. Tel 419-531-4079; *Pres* Ronald Gosses; *Ofc Mgr* Claudia Gast; *First VPres* Elaine Scarvelis; *Secy* Betsy Ford; *Treas* Doug Longenecker
Open Tues - Fri 1 - 5 PM, Sat 1 - 4 PM; No admis fee; Estab 1943 to promote art in the area; Clubhouse-Gallery opened in Crosby Gardens, Toledo in August 1979; new gallery dedicated Oct 1994; classroom enlarged 2000; Mem: 400; dues $30 (variable); monthly board meetings
Income: Financed by mem & exhibs, sales of paintings, ann art auction
Exhibitions: Approximately 40 pieces of artwork exhibited each month in main gallery; includes paintings, pottery, sculpture, stained glass
Publications: Newsletter, monthly
Activities: Classes for adults & children; workshops; demonstrations; lect open to the pub; competitions with awards; jointly present Crosby Gardens Art Festival in June with Crosby Gardens, Toledo Forestry Division & the Arts Commission of Greater Toledo; Arts in the Garden in Aug; Heralding the Holidays in Dec; sales shop selling original art

M **TOLEDO MUSEUM OF ART,** 2445 Monroe St at Scottwood Ave, PO Box 1013 Toledo, OH 43697. Tel 419-255-8000; Fax 419-255-5638; Elec Mail information@toledomuseum.org; Internet Home Page Address: www.toledomuseum.org; Cable TOLMUSART; *Pres Bd Trustees* George M Jones III; *Dir* Don Bacigalupi; *Reg* Patricia Whitesides; *Assoc Dir Business Operations* Carol Bintz; *Cur European Painting & Sculpture Before 1900* Lawrence Nichols; *Cur of Asian Art & Art Mgmt Work Group Mgr* Carolyn M Putney; *Assoc Cur Ancient Art, Coordr Scholarly Publs* Sandra E Knudsen; *Pub Relations Mgr* Jordan Rundgren
Open Tues - Thurs & Sat 10 AM - 4 PM, Fri 10 AM - 10 PM, Sun 11 AM - 5 PM, cl Mon & major holidays; No admis fee; Estab & incorporated 1901; building erected 1912, additions 1926 & 1933. Mus contains Canaday Gallery, Print Galleries, School Gallery, Collector's Corner for sales & rental, a museum store; jewelry gallery; glass pavilion erected 2006; Average Annual Attendance: 330,000; Mem: 9000; dues $50 & up
Income: Financed by funds & mem
Special Subjects: Painting-American, Prints, Sculpture, Ceramics, Decorative Arts, Painting-European, Glass, Medieval Art, Antiquities-Oriental, Antiquities-Egyptian, Antiquities-Greek, Antiquities-Roman, Antiquities-Assyrian
Collections: Ancient to modern glass; European paintings, sculpture & decorative arts; American paintings, sculpture & decorative arts; books & manuscripts;

Egyptian, Greek, Roman, Near & Far East art, African art; Modern & Contemporary Art, Jewelry
Exhibitions: (11/11/2006-01/28/2007) In Stabiano: Exploring the Ancient Seaside Villas of the Roman Elite; The Art of Glass: Masterworks from the Toledo Museum of Art (ongoing)
Publications: American Paintings; Ancient Glass; Art in Glass; Corpus Vasorum Antiquorum I & II; European Paintings; Guide to the Colls
Activities: Classes for adults & children; lect; concerts; tours; book traveling exhibs; originate traveling exhibs

L **Library,** 2445 Monroe St, Toledo, OH 43620; PO Box 1013, Toledo, OH 43697. Tel 419-254-5770; Fax 419-255-5638; Elec Mail information@toledomuseum.org; Internet Home Page Address: www.toledomuseum.org; *Assoc Librn (Technical)* Kathleen Tweney; *Head Librn* Anne O Morris; *Cataloger* Katherine White Miller
Open Mon - Thurs 10 AM - 9 PM, Fri 10 AM - 5 PM, Sat Noon - 4 PM; Sun 1 - 4:30 PM during university sessions; Summer: Mon - Fri 10 AM - 5 PM, Sat noon - 4 PM; Estab 1901 to provide resources for the museum's staff; Circ 4,700; Primarily for reference but does lend to certain groups of users; Average Annual Attendance: 10,000; Mem: 152; dues $10 - $100
Income: Financed by mus & mem
Library Holdings: Auction Catalogs; Audio Tapes 300; Book Volumes 80,000; Clipping Files 21,000; Exhibition Catalogs 18,000; Fiche; Periodical Subscriptions 300; Reels 75; Slides; Video Tapes
Special Subjects: Art History, Decorative Arts, Photography, Graphic Arts, Painting-American, Painting-European, Glass

VAN WERT

M **WASSENBERG ART CENTER,** 643 S Washington St, Van Wert, OH 45891. Tel 419-238-6837; Fax 419-238-6828; Elec Mail artcentr@bright.net; Internet Home Page Address: www.vanwert.com/wassenberg; *Admin Asst* Kay R Sluterbeck; *Exec Dir* Michele L Smith
Open daily 1 - 5 PM, cl Mon; No admis fee; Estab 1954 to encourage the arts in the Van Wert area; Two large gallery areas, basement classroom; maximum exhibit 150 pieces; Average Annual Attendance: 1,500; Mem: 350; dues individual $20, various other
Income: $20,000 (financed by endowment, mem, fundraisers)
Library Holdings: Audio Tapes; Book Volumes 250; Cassettes; Filmstrips; Original Art Works; Periodical Subscriptions 6; Prints; Reproductions; Sculpture; Slides; Video Tapes
Collections: Wassenberg Coll; Prints & Original Art; All subjects & media
Exhibitions: Annual June Art Exhibit; Annual Oct Photography Exhibit; 8 different free exhibits per year
Publications: Gallery Review, quarterly
Activities: Classes for adults & children; docent programs; lect open to pub, some only to mems; competitions; book traveling exhibs 6-8 per yr

VERMILION

M **GREAT LAKES HISTORICAL SOCIETY,** Inland Seas Maritime Museum, 480 Main St, PO Box 435 Vermilion, OH 44089. Tel 440-260-0230; Elec Mail glhsl@inlandseas.org; Internet Home Page Address: www.inlandseas.org; WATS 800-893-1485; *Exec Dir* Christopher Gillcrist
Open daily 10 AM - 5 PM, cl major holidays; Admis adults $5, seniors $4, youth $3, children under 6 free; Estab 1944 to promote interest in discovering and preserving material about the Great Lakes and surrounding areas; Maintains an art gallery as part of the Maritime History Mus; Average Annual Attendance: 20,000+; Mem: 2500; dues family $49; ann meetings in May
Income: $500,000 (financed by endowment, mem, sales from mus store & fundraising)
Special Subjects: Drawings, Photography, Prints, Marine Painting, Historical Material, Maps, Dioramas, Reproductions
Collections: Collection of Ship Models; Marine Relics; Paintings & Photographs dealing with the history of the Great Lakes; paintings by Sprague, Shogren, LaMarre, Nickerson, Forsythe & Huntington
Exhibitions: Annual Antique Boat Show Exhibition
Publications: Chadburn (newsletter), quarterly; Inland Seas, quarterly journal
Activities: Classes for adults & children; dramatic progs; docent training; boat building & lofting classes; lect open to pub, 16 vis lectrs per yr; gallery talks; tours; competitions with prizes; individual painting lent to other museums; book traveling exhibs 1 per yr; originate traveling exhibs; mus shop sells books, reproductions, prints, slides & videotapes

WEST LIBERTY

M **PIATT CASTLES,** 10051 Township Rd, PO Box 497 West Liberty, OH 43357-0497. Tel 937-465-2821; Fax 937-465-7774; Elec Mail macochee@logan.net; Internet Home Page Address: www.piattcastles.org; *Pres & CEO* Margaret Piatt; *VPres* James White; *Prog Asst* Beverly Lee
Open May - Sept daily 11 AM - 5 PM, Mar Sat & Sun Noon - 4 PM, Sept, Oct, Apr & May daily Noon - 4 PM, June - Aug 11 AM - 5 PM; Admis adults $8, students $6, children 5-12 $5; sr & AAA discount; Estab 1912; Paintings & sculptures displayed throughout both homes - room like settings; Average Annual Attendance: 40,000
Special Subjects: Decorative Arts, Architecture, American Indian Art, Furniture, Restorations, Period Rooms
Collections: Early American family furnishings; Native American artifacts; Rare Art; Weapons
Publications: Brochures; Don Piatt of Mac-O-Chee, Wit and Wisdom of Donn Piatt
Activities: Dramatic progs; docent training; ann vintage baseball game; storytelling; Christmas prog; musical events; tours; gallery talks; concerts; art festival; mus shop sells books & original art

WESTERVILLE

M THE AMERICAN CERAMIC SOCIETY, Ross C Purdy Museum of Ceramics, 735 Ceramic Pl, Westerville, OH 43081. Tel 614-890-4700; Fax 614-899-6109; *Cur* William Gates; *Asst Cur* Yvonne Manring; *Dir Communications* Mark Glasper
Open Mon - Fri 8:30 AM - 5 PM; No admis fee; Estab 1981 to display past, present & future of the ceramic industry; Primarily a reference facility; Average Annual Attendance: 2,500; Mem: Ann meeting in Apr
Purchases: Ceramic hip implant, Rockingham pitcher & 30-piece ceramic tile coll
Special Subjects: Pottery, Glass, Porcelain
Collections: Consists of over 2000 pieces representing a cross section of traditional & high-tech ceramics produced in the last 150 yrs; commercial ceramics
Exhibitions: Traditional ceramic products such as brick, glass, dinnerware. High-tech displays include aerospace, bioceramics, automotive engines, sporting goods, military & environmental applications
Activities: Tours; lending collection contains 2000 original objects of art

AMERICAN CERAMIC SOCIETY
For further information, see National and Regional Organizations

L James I Mueller Ceramic Information Center, 735 Ceramic Pl, Westerville, OH 43081. Tel 614-890-4700; Fax 614-899-6109;
Estab 1954; For reference only; lending to members
Library Holdings: Book Volumes 1000; Clipping Files; Exhibition Catalogs; Fiche; Pamphlets; Periodical Subscriptions 100; Photographs; Video Tapes
Special Subjects: Ceramics, Glass

WILBERFORCE

AFRICAN AMERICAN MUSEUMS ASSOCIATION
For further information, see National and Regional Organizations

M OHIO HISTORICAL SOCIETY, National Afro American Museum & Cultural Center, 1350 Brush Row Rd, PO Box 578 Wilberforce, OH 45384-0578. Tel 937-376-4944; Fax 937-376-2007; Elec Mail msampson@ohiohistory.org; Internet Home Page Address: www.ohiohistory.org; *Actg Dir* Vernon Courtney; *Cur* Floyd Thomas, PhD; *Coordr Traveling Exhibs* Edna Diggs
Open Tues - Sun; Admis adults $4, seniors $3.60, children $1.50; Estab 1987; Maintains staff reference library, four gallery spaces totaling 5000 sq ft; Average Annual Attendance: 45,000
Special Subjects: Painting-American, Photography, Sculpture, Ethnology, Crafts, Folk Art, Afro-American Art, Manuscripts, Dolls, Historical Material, Coins & Medals
Collections: African American Art, Focus on Black Nationalist/Black Protest art of the 1960s & 70s; African Coll (ethnographic material)
Exhibitions: Dolls; Photography
Activities: Individual paintings & original objects of art lent to qualified museums; lending coll contains original art works & paintings; book traveling exhibs; originate traveling exhibs from small institutions to the Smithsonian; mus shop sells books, orginal art, reproductions & prints

WILLOUGHBY

M ARCHAEOLOGICAL SOCIETY OF OHIO, Indian Museum of Lake County, Ohio, Technical Center Bldg B, Willoughby, OH 44094; P O Box 883, Willoughby, OH 44096-0883. Tel 440-352-1911; *Dir* Ann Dewald; *Dir Emeritus* Gwen G King
Open Mon - Fri 9 AM - 4 PM, Sat & Sun 1 - 4 PM, cl major holiday weekends; Admis adults $2, students (K-12) $1, seniors $1.50, children free; Estab 1980 to educate & preserve arts & crafts of all cultures of Native Americans; Average Annual Attendance: 7,000; Mem: 250; dues $20 - $1,000
Income: Financed by mem
Library Holdings: Clipping Files
Special Subjects: American Indian Art, Archaeology, Eskimo Art
Collections: Crafts & art of all cultures of Native Americans of North America; Prehistoric artifacts from 10,000 BC to 1650 AD of early Ohio area & Reeve Village Site, Lake County, Ohio
Activities: Classes for adults & children; docent training; lect open to pub; tours; competitions with awards; mus shop sells books, Native American crafts
L Indian Museum Library, 391 W Washington St, Painesville, OH 44077. Tel 440-352-1911; *Dir* Ann Dewald
For reference
Income: Financed by mem
Library Holdings: Book Volumes 700; Periodical Subscriptions 4
Special Subjects: Archaeology, American Indian Art, Eskimo Art

A FINE ARTS ASSOCIATION, School of Fine Arts, 38660 Mentor Ave, Willoughby, OH 44094. Tel 440-951-7500; Fax 440-975-4592; Elec Mail faa@bbs2.rmrc.net; Internet Home Page Address: www.fineartsassociation.org; *Pres* Richard T Spote Jr; *Exec Dir* Charles D Lawrence
Open Mon - Fri 9 AM - 8 PM, Sat 9 AM - 5 PM; No admis fee; Estab 1957 to bring arts education to all people regardless of their ability to pay, race or social standing; Main floor gallery houses theme, one-man & group monthly exhibs; 2nd floor gallery houses monthly school exhibits; Average Annual Attendance: 70,000; Mem: 500; dues $25 & up; ann meeting in Sept
Income: Financed by class fees and donations
Exhibitions: Monthly exhibs, theme, one man & group; ann juried exhibit for area artists
Activities: Classes for adults & children; dramatic progs; lect open to pub, 10 vis lectrs per yr; gallery talks; tours; concerts; competitions with awards; schols; mus shop sells original art

WOOSTER

M THE COLLEGE OF WOOSTER, The College of Wooster Art Museum, Ebert Art Ctr, 1220 Beall Ave Wooster, OH 44691. Tel 330-263-2495; Fax 330-263-2633; Elec Mail kzurko@wooster.edu; Internet Home Page Address: www.artmuseum.wooster.edu; WATS 800-321-9885; *Dir* Kitty McManus Zurko; *Admin Asst* Joyce Fuell; *Preparator* Douglas McGlumphy
Open Tues - Fri 10:30 AM - 4:30 PM, Sat & Sun 1 - 5 PM, cl during col breaks; No admis fee; College art mus; Average Annual Attendance: 9,000
Income: Financed by col gen fund & grants
Special Subjects: Graphics, Painting-American, Prints, American Indian Art, Bronzes, African Art, Ethnology, Pre-Columbian Art, Textiles, Ceramics, Woodcuts, Collages, Portraits, Furniture, Glass, Porcelain, Oriental Art, Painting-French, Carpets & Rugs, Historical Material, Coins & Medals, Tapestries, Antiquities-Oriental, Antiquities-Egyptian, Antiquities-Greek
Collections: John Taylor Arms Print Collection; African art; ancient & contemporary ceramics; Chinese snuff bottles & bronzes; Cypriote pottery; decorative arts; ethnographic materials; WWII posters
Exhibitions: Traveling exhibs & special in-house exhibs. Average six yearly exhibs drawn either from the colls or focusing on the work of contemporary artists
Publications: Exhibition catalogs, brochures
Activities: Lesson plans; lect & receptions open to pub, 3-4 vis lectrs per year; gallery talks; tours; sponsoring of competitions; organize traveling exhibs to other museums, col & univ galleries

MIDWEST ART HISTORY SOCIETY
For further information, see National and Regional Organizations

M WAYNE CENTER FOR THE ARTS, 237 S Walnut St, Wooster, OH 44691. Tel 330-264-2787; Fax 330-264-9314; Elec Mail WayneCtr@wayneartscenter.org; Internet Home Page Address: www.wayneartscenter.org; *Publicity Coordr* Kay Wharton; *Exec Dir* Bill Buckingham; *Educ Coordr* Stephanie Pevec; *Bus Mgr* Dick Swartz
Open Mon - Fri 9 AM - 9 PM; No admis fee for exhibs; performances vary; Estab 1973 to strengthen our community by enriching people's lives through the arts; The Ctr for the Arts is housed in a former school bldg, offering large & open galleries & studios; Average Annual Attendance: 30,000; Mem: 1,000+
Income: donations; memberships; ticket fees; grants; sponsorships
Special Subjects: Painting-American, Prints, Bronzes, African Art, Ceramics, Porcelain, Oriental Art, Tapestries
Exhibitions: Monthly showing of local, regional and nationally renowned artists
Publications: Artalk newsletter, quarterly
Activities: Classes for adults & children; community outreach progs; lect open to pub, 10-15 vis lectrs per yr; gallery talks; concerts; book traveling exhibs

WORTHINGTON

A WORTHINGTON ARTS COUNCIL, 777 High St, 2nd Fl Worthington, OH 43085. Tel 614-431-0329; Fax 614-431-2491; Elec Mail arts@worthingtonarts.org; Internet Home Page Address: www.worthingtonarts.org; *Exec Dir* Elizabeth A Jewell; *Arts Coordr* Anne E Raynor
Estab 1977 to encourage & stimulate the practice & appreciation of the arts by providing opportunities in the community to participate in, experience & enjoy the arts so as to enrich the quality of daily life & further cultural growth of Worthington & to help the art & cultural organizations of the city grow & flourish
Activities: Visual arts series & sculpture on village green; classes for children; lect open to pub; performance series; schols offered; teacher in-service workshops

XENIA

A GREENE COUNTY HISTORICAL SOCIETY, 74 W Church St, Xenia, OH 45385-2902. Tel 513-372-4606; Fax 513-376-5660; Elec Mail GCHSXO@aol.com; *Exec Secy* Joan Baxter; *VPres* John Balmer
Open Tues & Fri 9 AM - Noon & 1 - 3:30 PM; Admis adult $2; Estab 1929 to preserve the history of Greene County, OH; Average Annual Attendance: 2,000; Mem: 450; dues individual $10, seniors $6; ann meeting in June
Income: Financed by mem, county appropriation & various fund raising activities
Collections: Clothing; Medical; Military; Railroad (historic model)
Exhibitions: Conestoga Wagon; Log House & furnishings; Railroad; Victorian House & furnishings
Publications: Broadstone 1918 History Reprint; Next Stop... Xenia
Activities: Lect open to pub, 12 vis lectrs per yr; sales shop sells books, notepaper, materials relating to county

YELLOW SPRINGS

M ANTIOCH COLLEGE, Noyes & Read Gallery/Herndon Gallery, 795 Livermore St, Yellow Springs, OH 45387. Tel 937-769-1149; *Dir* Nevin Mercede
Open Mon - Sat 1 - 5 PM; No admis fee; Estab 1972. Noyes Gallery to offer works to students & the community that both challenge & broaden their definitions of Art; Read Gallery is primarily a student gallery; Herndon Gallery offers works in many medias, including painting, photography & video
Exhibitions: World Community of Ceramists

YOUNGSTOWN

M BUTLER INSTITUTE OF AMERICAN ART, Art Museum, 524 Wick Ave, Youngstown, OH 44502. Tel 330-743-1107; Fax 330-743-9567; Internet Home Page Address: www.butlerart.com; *Dir* Dr Louis A Zona; *Dir Educ* Carole O'Brien; *Registrar* Rebecca Davis
Open Tues, Thur - Sat 11 AM - 4 PM; Wed 11 AM - 8 PM; Sun Noon - 4 PM; No admis fee; Estab 1919 & is the first mus building to be devoted entirely to

American Art; Eighteen galleries containing 11,000 works of American artists; Average Annual Attendance: 212,000; Mem: 4000; dues $10-$5000; ann meetings in Sept

Income: Financed by endowment, grants & gifts

Library Holdings: Auction Catalogs; Clipping Files; Exhibition Catalogs; Kodachrome Transparencies; Photographs; Slides

Special Subjects: Drawings, Painting-American, Prints, Sculpture, Watercolors, American Indian Art, Ceramics, Marine Painting

Collections: Comprehensive coll of American art covering three centuries; American Impressionism; The American West & Marine & Sports Art colls; Principle artists: Winslow Homer, Albert Bierstadt, Martin Johnson Heade, Georgia O'Keeffe, Charles Sheeler, Helen Frankenthaler, John S Sargent, J M Whistler, Mary Cassatt, Thomas Cole, Edward Hopper, Romare Bearden, Andy Warhol & Robert Motherwell; American Glass Bells, Miniatures of all the Presidents of the United States (watercolor); Robert Rauschenberg

Exhibitions: Patrick Boyd: Holograms; Robert Rauschenberg, Darryl Pottorf, Peter Henley, Paul Jenkins: watercolors; Nam June Paik; Lynn Chadwick: Sculptor/Revelations; Five Decades of Jules Olitski; Don Gummer, Bill Viola: Threshold

Publications: Exhib catalogues; bimonthly newsletter; biennial report

Activities: Classes for adults; docent training; lect open to the pub, 15 vis lectrs per yr; concerts; gallery talks; tours; competitions with awards; individual paintings & original objects of art lent to qualified mus, institutions, worldwide; book traveling exhibs 10 per yr; traveling exhibs organized & circulated; mus shop sells books, original art, reproductions, prints, slides, crafts, jewelry, original pottery & art related materials; Trumbell Branch, Salem Branch

L **Hopper Resource Library,** 524 Wick Ave, Youngstown, OH 44502. Tel 330-743-1107, 743-1711
Open Tues, Thurs, Fri & Sat 11 AM - 4 PM, Wed 11 AM - 8 PM, Sun Noon - 4 PM; No admis fee; For reference only; Average Annual Attendance: 122,000; Mem: 3090

Income: Financed by endowment, grants & gifts

Library Holdings: Book Volumes 1500; Clipping Files; Exhibition Catalogs; Framed Reproductions; Kodachrome Transparencies; Memorabilia; Pamphlets; Periodical Subscriptions 10; Photographs; Slides

M **YOUNGSTOWN STATE UNIVERSITY,** The John J McDonough Museum of Art, One University Plaza, Youngstown, OH 44555. Tel 330-742-1400; Fax 330-742-1492; Elec Mail sbkreism@cc.ysu.edu; Internet Home Page Address: www.ysu.edu; *Interim Dir* Angela Delucia
Open Thurs - Sat 11 AM - 4 PM, Sun Noon - 4 PM; cl Tues; No admis fee; Estab 1991 to serve as a professional exhib facility for all art students & studio art faculty, to present visual arts progs of educ & artistic significance to the community, to exhibit works of established & emerging regional artists & present works from other university & larger mus colls; The purely post-modern structure has 18,000 sq ft & includes two outdoor sculpture terraces. Maintains lending library; Average Annual Attendance: 20,000

Exhibitions: Exhibs vary; call for list

Publications: Exhib catalogs; gallery guides

Activities: In-service workshops, art workshops; tours; competitions; lending coll contains slides; Contemporary Latino Voices; Aspects of Photography: Work on Loan from Mother Jones Magazine; GNATLAND: An Installation by Kay Willens; Governor's Institute for Gifted & Talented Students; Scholastic Art Awards Exhib

ZANESVILLE

A **ZANESVILLE ART CENTER,** 620 Military Rd, Zanesville, OH 43701. Tel 740-452-0741; Fax 740-452-0797; Elec Mail info@zanesvilleartcenter.org; Internet Home Page Address: www.zanesvilleartcenter.org; *Registrar* Carla Kelley; *Pres Bd Trustees* Dr Dean Cole; *Asst Dir* Debbie Lowe; *VPres* Dr. Carl Minning; *Maintenance* Gary Strawfer; *Secy* Vicki Moore
Open Tues, Wed & Fri 10 AM - 5 PM, Thurs 10 AM - 8:30 PM, Sat & Sun 1 - 5 PM, cl Mon & holidays; No admis fee; Estab 1936 to provide a pub center for the arts, permanent colls & temporary exhibs, classes in arts, library of art volumes & a meeting place for art & civic groups; There are 10 galleries for Old Masters & modern paintings, 300 yr old panel room of the Old Masters & handicapped facilities; Average Annual Attendance: 25,000; Mem: 350; dues $25 & up

Income: Financed by endowment & mem

Collections: American, European & Oriental paintings, sculptures, ceramics, prints, drawings & crafts; children's art; Midwest & Zanesville ceramics & glass

Exhibitions: Rotating exhibits

Publications: Bulletin, trimonthly

Activities: Classes for adults & children; docent training; lect open to pub, 5 vis lectrs per yr; concerts; gallery talks; tours; competitions with awards; individual paintings lent to pub institutions; lending coll contains art works, original prints, photographs sculptures, 6000 pieces of original art works & 2000 paintings; sales shop sells books & original art

L **Library,** 620 Military Rd, Zanesville, OH 43701. Tel 740-452-0741; Fax 740-452-0797; *Admin Asst* Debbie Lowe; *Registrar* Carla Kelly; *Dir* Philip Alan LaDouceur
Open Tues, Wed & Fri 10 AM - 5 PM, Thurs 10 AM - 8:30 PM, Sat & Sun 1 - 5 PM, cl Mon & major holidays; No admis fee; Estab 1936 to provide fine arts & crafts information & exhibs

Income: Financed by endowment, mem, trust funds & investments

Library Holdings: Book Volumes 8000; Clipping Files; Exhibition Catalogs; Filmstrips 20; Framed Reproductions 10; Kodachrome Transparencies 10,000; Lantern Slides; Periodical Subscriptions 10; Photographs; Prints; Sculpture; Slides 10,000

Special Subjects: Decorative Arts, Drawings, Etchings & Engravings, Ceramics, Crafts, Cartoons, Asian Art, Furniture, Afro-American Art, Antiquities-Oriental, Dolls, Enamels, Antiquities-Egyptian, Antiquities-Greek, Antiquities-Roman

Collections: photographs, prints & sculpture

Publications: Bulletins; gallery brochures

Activities: Classes for adults & children; docent training; lect open to pub, 2-5 vis lectrs per yr; concerts; gallery talks; tours; competitions with awards; schols

offered; artmobile; individual paintings & original objects of art lent; originate traveling exhibs; sales shop

OKLAHOMA

ANADARKO

M **NATIONAL HALL OF FAME FOR FAMOUS AMERICAN INDIANS,** PO Box 548, Anadarko, OK 73005. Tel 405-247-5555; *Dir & Exec VPres* Joe McBride; *Treas* George F Moran; *Secy* Carolyn N McBride
Open Mon - Sat 9 AM - 5 PM, Sun 1 - 5 PM; No admis fee; Estab 1952 to honor famous American Indians who have contributed to the culture of America, including statesmen, innovators, sportsmen, warriors; to teach the youth of our country that there is a reward for greatness; An outdoor mus in a landscaped area containing bronze sculptured portraits of honorees; Average Annual Attendance: 23,000; Mem: 250; dues life $100, Individual or Family $25; ann meeting Aug

Income: Finance by mem, city & state appropriation & donation

Purchases: $2500 - $20,000

Special Subjects: American Indian Art, Bronzes

Collections: Bronze sculptured portraits & bronze statues of two animals important to Indian culture

Publications: Brochure

Activities: Dedication ceremonies for honorees in August; sales shop sells books & postcards

M **SOUTHERN PLAINS INDIAN MUSEUM,** PO Box 749, 715 E Central Anadarko, OK 73005. Tel 405-247-6221; Fax 405-247-7593; *Chief Cur* Rosemary Ellison
Open June - Sept Mon - Sat 9 AM - 5 PM; Sun 1 - 5 PM; Oct - May Tues - Sat 9 AM - 5 PM, Sun 1 - 5 PM; cl New Year's Day, Thanksgiving & Christmas; Admis adult $3, groups of 10 or more $1, children ages 6-12 $1, children under 6 free, Sun no admis fee; Estab 1947-48 to promote the development of contemporary Native American arts & crafts of the United States. Administered & operated by the Indian Arts & Crafts Board, US Department of the Interior; Average Annual Attendance: 40,000

Income: Financed by federal appropriation

Purchases: Primarily dependent upon gifts

Special Subjects: American Indian Art, Crafts

Collections: Contemporary native American arts & crafts of the United States; Historic Works by Southern Plains Indian Craftsmen

Exhibitions: Historic Southern Plains Indian Arts; changing exhibs by contemporary native American artists & craftsmen; continuing series of one-person exhibs

Publications: One-person exhib brochure series, quarterly

Activities: Gallery talks

ARDMORE

A **CHARLES B GODDARD CENTER FOR THE VISUAL & PERFORMING ARTS,** 401 First Ave SW, Ardmore, OK 73402; PO Box 1624, Ardmore, OK 73402. Tel 580-226-8891; Elec Mail godart@brightok.net; *Treas* Charles Williams; *Dir* Mort Hamilton; *Admin Asst* Fran Anderson; *Chmn* Millard Ingram
Open Mon - Fri 9 AM - 4 PM, Sat & Sun 1 - 4 PM; No admis fee; Estab Mar 1970 to bring fine art progs in the related fields of music, art & theater to local community at minimum cost, gallery to bring traveling exhibs to Ardmore; Four exhibit galleries; maintains lending & reference library; Average Annual Attendance: 35,000; Mem: 480; dues $15 - $1000

Collections: Western & Contemporary Art, paintings, sculpture, prints; Small coll of Western Art & bronzes; American Graphic Art; photography

Exhibitions: Ardmore Art Exhibition; exhibits change monthly

Publications: Outlook, bimonthly

Activities: Classes for adults & children in art & theatre; docent training; dramatic progs; extensive new art studio with classes for adults & children; lect open to pub, 5 vis lectrs per yr; concerts; gallery talks; competitions with awards; tours; individual paintings & original objects of art lent to qualified institutions & museums

BARTLESVILLE

M **THE FRANK PHILLIPS FOUNDATION INC,** Woolaroc Museum, State Hwy 123, Route 3 Box 2100 Bartlesville, OK 74003; PO Box 1647, Bartlesville, OK 74005. Tel 918-336-0307; Fax 918-336-0084; Elec Mail zephyrrose@aol.com; Internet Home Page Address: www.woolaroc.org; *Dir* Robert R Lansdown; *Cur Art* Linda Stone; *Cur Coll* Ken Meek; *Gen Mgr* Dick Miller
Open Tues - Sun 10 AM - 5 PM, cl Mon, Thanksgiving & Christmas; Admis 12 & older $5, under 12 free, 65 & older $4; Estab 1929 to house art & artifacts of the Southwest. Mus dedicated by Frank Phillips; Gallery has two levels, 8 rooms upstairs & 4 rooms downstairs; Average Annual Attendance: 125,000; Mem: 300

Income: Financed by endowment & revenues generated by admis fees & sales

Special Subjects: Archaeology, Drawings, Etchings & Engravings, American Western Art, Pottery, Painting-American, Prints, Textiles, Graphics, Watercolors, American Indian Art, Bronzes, Anthropology, Archaeology, Ethnology, Southwestern Art, Dolls, Historical Material, Mosaics

Collections: American Indian artifacts; prehistoric artifacts; paintings, drawings, graphics, minerals, oriental material, sculpture, weapons

Exhibitions: various exhibits call for details

Publications: Woolaroc Story; Woolaroc, mus guidebook

Activities: Educ prog; docent training; gallery talks; tours; lending coll contains transparencies to be used to illustrate educ publs; book traveling exhibs; mus & sales shops sell books, magazines, original art, reproductions, prints, slides, Indian-made jewelry and pottery, postcards

L **Library,** State Hwy 123, Route 3 Box 2100 Bartlesville, OK 74003; PO Box

1647, Bartlesville, OK 74003. Tel 918-336-0307; Fax 918-336-0084; Elec Mail lstone@woolaroc.com; *Dir* Robert R Lansdown
Open to employees only; Circ Reference library open to employees only; private facility
Library Holdings: Book Volumes 1000; Clipping Files; Exhibition Catalogs; Kodachrome Transparencies; Pamphlets; Photographs; Slides

CLAREMORE

M **WILL ROGERS MEMORIAL MUSEUM & BIRTHPLACE RANCH,** (Will Rogers Memorial & Museum) 1720 W Will Rogers Blvd, PO Box 157 Claremore, OK 74018. Tel 918-341-0719; Fax 918-343-8119; Elec Mail wrinfo@willrogers.com; Internet Home Page Address: willrogers.com; *Cur* Gregory Malak; *Dir* Michelle Lefebvrre-Carter; *Library & Colls* Steven Gragert
Open daily 8 AM - 5 PM; No admis fee, donations accepted; Estab 1938 to perpetuate the name, works & spirit of Will Rogers; There are nine main galleries, diorama room, foyer & gardens. The large Jo Davidson statue of Will Rogers dominates the foyer; the north gallery includes photographs & paintings of Will Rogers & his ancestors (including a family tree, explaining his Indian heritage) & many other personal items; east gallery has saddle collection & other Western items; Jo Mora dioramas; additional gallery, research library & theatre; children's mus in basement. Maintains reference library; Average Annual Attendance: 202,000
Income: $750,000 (financed by state appropriation & ivt donations)
Library Holdings: Audio Tapes; Book Volumes; CD-ROMs; Clipping Files; Framed Reproductions; Manuscripts; Memorabilia; Motion Pictures; Original Art Works; Original Documents; Photographs; Prints; Records; Sculpture; Slides; Video Tapes
Collections: Collections of Paintings by various artists commissioned by a calendar company with originals donated to Memorial; Count Tamburini Oil of Will Rogers; Jo Mora Dioramas (13); Large Equestrian Statue by Electra Wagoner Biggs; Mural by Ray Piercey; Original of Will Rogers by Leyendecker; Paintings of Will & his parents by local artists; Original of Will Rogers by Charles Banks Wilson; 7-foot oil on canvas by Wayne Cooper of Will Rogers on horseback; Gordon Kuntz Coll (81 original movie poster collection of Will Rogers' movies)
Publications: Brochures and materials for students
Activities: Lect open to pub; tours; assist with publishing project: The Papers of Will Rogers; originate traveling exhibs; sales shop sells VHS tapes, Will Rogers & Oklahoma items; Will Rogers Youth Museum

L **Media Center Library,** 1720 W Will Rogers Blvd, PO Box 157 Claremore, OK 74018-0157. Tel 918-341-0719; Fax 918-341-8246; WATS 800-324-9455; *Librn* Patricia Lowe; *Cur* Greg Malak; *Dir* Joseph Carter
Reference library for research by appointment only
Library Holdings: Audio Tapes; Book Volumes 2500; CD-ROMs; Cassettes; Clipping Files; Exhibition Catalogs; Filmstrips; Framed Reproductions; Kodachrome Transparencies; Manuscripts; Memorabilia; Motion Pictures; Original Art Works; Original Documents; Other Holdings Original writings on CD Rom; Pamphlets; Periodical Subscriptions 15; Photographs 1500; Prints; Records; Reproductions; Sculpture; Slides; Video Tapes
Collections: Will Rogers Collection

CUSHING

L **LACHENMEYER ARTS CENTER,** Art Resource Library, 700 S Little, PO Box 586 Cushing, OK 74023-0586; PO Box 586, Cushing, OK 74023. Tel 918-225-7525; Elec Mail roblarts@brightok.net; *Dir* Rob Smith
Open Mon, Wed & Fri 9 AM - 5 PM, Tues & Thurs 5 - 9 PM; No admis fee; Estab 1984 to provide art classes & art exhibits to the pub
Income: Financed by endowment
Library Holdings: Book Volumes 125; Periodical Subscriptions; Video Tapes
Activities: Classes for adults & children

GOODWELL

M **NO MAN'S LAND HISTORICAL SOCIETY MUSEUM,** Sewell St, PO Box 278 Goodwell, OK 73939-0278. Tel 580-349-2670; Fax 580-349-2670; *Pres* Gerald Dixon; *VPres* Ronald Kincanon; *Site Mgr* Sue Weissinger
Open Tues - Sat 9 AM - 5 PM, cl Sun, Mon & holidays; No admis fee; Estab 1934 to procure appropriate mus material with spec regard to portraying the history of No Man's Land (Oklahoma Panhandle) & the immediate adjacent regions; The gallery is 14 ft x 40 ft (560 sq ft); Average Annual Attendance: 4,000; Mem: 307; dues life $100, organization $100, individual $15
Income: Financed by state appropriation & donations
Special Subjects: Painting-American, Watercolors, American Indian Art, American Western Art, Anthropology, Archaeology, Ethnology, Southwestern Art, Textiles, Folk Art, Historical Material, Embroidery
Collections: Duckett Alabaster Carvings; Oils by Pearl Robison Burrows Burns
Exhibitions: Nine exhibits each yr by regional artists
Activities: Sales shop sells prints

LANGSTON

M **LANGSTON UNIVERSITY,** Melvin B Tolson Black Heritage Center, PO Box 907, Langston, OK 73050. Tel 405-466-2231; Fax 405-466-2979; Elec Mail brblack@lunet.edu; *Cur* Bettye Black; *Asst Cur* Edward Grady; *Dir Library* Niambi Kamoche
Open Mon, Wed & Fri 8 AM - 5 PM, Tues - Thurs 8 PM - 10 PM, Sun 2 - 10 PM; No admis fee; Estab 1959 to exhibit pertinent works of art, both contemporary & traditional; to serve as a teaching tool for students; Average Annual Attendance: 6,000
Income: Financed by state appropriation
Library Holdings: Book Volumes; Cassettes; Clipping Files; Compact Disks; Fiche; Filmstrips; Original Documents; Periodical Subscriptions; Records; Slides
Special Subjects: Afro-American Art

Collections: African American Art & Artifacts; Paintings & Photographs; Books, tapes, video colls
Activities: Classes for adults; lect, 5 - 9 vis lectrs per yr; gallery talks; tours

LAWTON

M **TRUST AUTHORITY,** Museum of the Great Plains, 601 NW Ferris, PO Box 68 Lawton, OK 73502. Tel 580-581-3460; Fax 580-581-3458; Elec Mail develop@museumgreatplains.org; Internet Home Page Address: www.museumgreatplains.org; *Photo Lab Technician* Brian Smith; *Cur Spec Coll* Debby Baroff; *Dir* John Hernandez; *Dir Develop* Rex Givens; *Educator* Maurianna Johnson
Open Tues - Sat 10 AM - 5 PM, Sun 1 - 5 PM; Admis adult $3, seniors $2, children between 7 & 11 $1.50, children under 7 free; Estab 1960 to collect, preserve, interpret & exhibit items of the cultural history of man in the Great Plains of North America. Galleries of the Mus of the Great Plains express a regional concept of interpreting the relationship of man to a semi-arid plains environment; 27,000 sq ft; Average Annual Attendance: 25,000; Mem: 700; dues $20 - $100
Income: Financed by endowment, city appropriations & contributions
Special Subjects: Architecture, Photography, American Indian Art, American Western Art, Anthropology, Archaeology, Ethnology, Southwestern Art, Costumes, Crafts, Manuscripts, Historical Material, Maps, Restorations, Period Rooms
Collections: Archaeological, ethnological, historical & natural science colls relating to man's inhabitance of the Great Plains; photographs relating to Plains Indians, agriculture, settlement, ranching
Exhibitions: Changing History, archaeology & ethnological exhibits
Publications: Great Plains Journal, ann; Museum Newsletter, quarterly
Activities: Classes for adults & children; dramatic programs; docent training; lect open to pub, 6 vis lectrs per yr; gallery talks; tours; lending colls contains framed reproductions, kodachromes, photographs & slides; originate traveling exhibs; mus shop sells books, magazines, original art, reproductions, prints & slides

L **Research Library,** 601 N W Ferris, PO Box 68 Lawton, OK 73502. Tel 580-581-3460; Elec Mail mgp@sirinet.net; *Cur Spec Coll* Deborah Baroff
Open Tues - Fri 8 AM - 5 PM; Estab 1961 to provide research materials for the 10-state Great Plains region; Lending to staff only
Income: Financed by endowment, city & state appropriations
Library Holdings: Book Volumes 30,000; Clipping Files; Exhibition Catalogs; Filmstrips; Kodachrome Transparencies; Manuscripts; Memorabilia; Motion Pictures; Original Art Works; Other Holdings Documents 300,000; Pamphlets; Periodical Subscriptions 150; Photographs 22,000; Prints; Reels; Slides
Special Subjects: Photography, Painting-American, Historical Material, Archaeology, Ethnology, American Western Art, American Indian Art, Anthropology, Southwestern Art, Period Rooms, Coins & Medals
Collections: Archives; photographic collections
Publications: Great Plains Journal, annual; Museum of the Great Plains Newsletter, irregularly

MUSKOGEE

M **ATALOA LODGE MUSEUM,** 2299 Old Bacone Rd, Muskogee, OK 74403-1597. Tel 918-781-7283; Fax 918-683-4588; Elec Mail jtimothy@bacone.edu; Internet Home Page Address: www.bacone.edu; *Dir* John Timothy
Open Mon - Fri 8 AM - 5 PM, cl Noon - 1 PM; Admis $2, group $1.50 per person, student $1; Estab to enhance Indian culture by having a coll of artifacts from various Indian tribes; Three large rooms; Average Annual Attendance: 3,000
Income: Financed through Bacone Col
Special Subjects: American Indian Art
Collections: Indian art; Indian crafts & artifacts; silverwork, weapons, blankets, dolls, beadwork, pottery, weaving & basketry, items of daily use
Exhibitions: Rotating exhibits
Activities: Tours; sales shop sells books, magazines, original art, reproductions, prints, ceramics, beadwork, silver smithing work, baskets & handcrafted items

M **FIVE CIVILIZED TRIBES MUSEUM,** Agency Hill, Honor Heights Dr Muskogee, OK 74401. Tel 918-683-1701; Fax 918-683-3070; Elec Mail the5tribesmuseum@azalea.net; Internet Home Page Address: www.fivetribes.com; *Pres Board Dirs* Richard Bradley; *Dir* Clara Reekie; *Admin Asst* Michael Parks; *Store Mgr* Deena Wood
Open Mon - Sat 10 AM - 5 PM, Sun 1 - 5 PM; Admis adults $2, seniors $1.75, students $1, children under 6 free; Estab 1966 to exhibit artifacts, relics, history, and traditional Indian art of the Cherokee, Chickasaw, Choctaw, Creek, and Seminole Indian Tribes; Average Annual Attendance: 30,000; Mem: 1000; dues vary; ann meeting in Mar
Income: $48,000 (financed by mem & admis)
Special Subjects: Photography, Sculpture, American Indian Art, Bronzes, Pottery, Woodcarvings, Maps
Collections: Traditional Indian art by known artists of Five Tribes heritage, including original paintings & sculpture; large collection of Jerome Tiger originals
Exhibitions: Four Annual Judged Exhibitions: Competitive Art Show; Students Competitive Show; Craft Competition; Masters' Exhibition
Publications: Quarterly newsletter
Activities: Docent training; lect open to pub; gallery talks; tours; competitions with awards; individual paintings & original objects of art lent to other museums & spec exhibits with board approval; lending coll contains original art works; mus shop selling books, original art, reproductions, prints, beadwork, pottery, basketry & other handmade items

L **Library,** Agency Hill, Honor Heights Dr Muskogee, OK 74401. Tel 918-683-1701; Fax 918-683-3070; Internet Home Page Address: www.fivetribes.com; *Dir* Clara Reekie
Open Mon - Sat 10 AM - 5 PM by appointment only; Estab 1966 to preserve history, culture, traditions, legends, etc of Five Civilized Tribes (Cherokee, Creek, Choctaw, Chickasaw, and Seminole tribes); Maintains an art gallery

Income: Financed by mus
Library Holdings: Book Volumes 3500; Cassettes; Clipping Files; Exhibition Catalogs; Framed Reproductions; Lantern Slides; Manuscripts; Memorabilia; Original Art Works; Other Holdings Original documents; Pamphlets; Periodical Subscriptions 5; Photographs; Prints; Reproductions; Sculpture
Special Subjects: Manuscripts, Maps, Historical Material, American Indian Art
Publications: Newsletter, every three months

NORMAN

M **FIREHOUSE ART CENTER,** 444 S Flood, Norman, OK 73069. Tel 405-329-4523; Fax 405-292-9763; Elec Mail firehouse@telepath.com; *Exec Dir* Nancy McClellan
Open Mon - Fri 9:30 AM - 5:30 PM, Sat 10 AM - 4 PM, Sun 1 - 5 PM; No admis fee; Estab 1971; 7-8 exhibits per year of contemporary work by local, state, regional & national artists; Average Annual Attendance: 10,000; Mem: 600; dues family $25; ann meeting in Aug
Income: $411,000 (financed by mem, city & state appropriation, grants, donations, fundraising)
Exhibitions: Annual Holiday Gallery; February Competitons in Chocolate Art; changing monthly exhibits
Activities: Classes for adults & children; workshops; lect open to pub, 2 vis lectrs per yr; gallery talks; competitions; schols offered; retail store sells original art & prints

UNIVERSITY OF OKLAHOMA

M **Fred Jones Jr Museum of Art,** Tel 405-325-3272; Fax 405-325-7696; Internet Home Page Address: www.ou.edu/fjjma; *Dir & Chief Cur* Eric M Lee, PhD; *Cur of Educ* Susan Baley; *Mus Preparator* Ross Cotts; *Mgr Admin & Operations* Becky Zurcher; *Supv Security* Joyce Cummins; *Community Rels Ofcr* Mary Jane Rutherford; *Asst Dir & Cur of Coll* Gail Kana Anderson; *Registrar* Susan Slepka Squires; *Cur of Ceramics* Jane Aerbersold; *Secy I* Jan Ragon; *Pub Rels* Stephanie Royse; *Cur of Native American Art* Mary Jo Watson, PhD
Open Tues - Fri 10 AM - 4:30 PM, Thurs 10 AM - 9 PM, Sat & Sun Noon - 4:30 PM, cl Mon;; No admis fee; Estab 1936 to provide cultural enrichment for the people of Oklahoma; to collect, preserve, exhibit & research art of various periods; Approx 15,000 sq ft for permanent & temporary exhibs on two indoor levels; 34,000 sq ft expansion added to existing bldg which totals 29,000 sq ft; Average Annual Attendance: 50,000; Mem: 495; dues $15 - $1000; meetings in Sept & Jan
Income: Financed by state, univ allocation, foundation endowment, Board of Visitors & grants
Purchases: Focus upon French Impressionism, American art, Native American art, contemporary art & photography
Special Subjects: Photography, African Art, Painting-European
Collections: French Impressionism; American art; Native American art; contemporary art; photography; icons
Publications: Calender of activities; posters; announcements; exhib catalogues
Activities: Docent training; classes for children; dramatic progs; 5-10 lectrs per yr open to pub; concerts; gallery talks; tours; family days; student exhibs with awards; 3 per yr; sales shop sells books, magazines, reproductions, prints, jewelry, notecards, children's toys & other gifts
L **Architecture Library,** Tel 405-325-5521; Fax 405-325-6637; Internet Home Page Address: libraries.ou.edu/depts/architecture; *Library Technician* Tracy Chapman; *Fine & Applied Arts Librn* Susan Booker
Open fall Mon - Thurs 8 AM - 8 PM, Fri 8 AM - 5 PM, Sun 4 - 8 PM, summer Mon - Fri 8 AM - 5 PM, cl wkends
Library Holdings: Book Volumes 17,000; Periodical Subscriptions 42
Special Subjects: Landscape Architecture, Interior Design, Architecture
L **Fine Arts Library,** Tel 405-325-4243; Fax 405-325-4243; Elec Mail drmosser@ou.edu; Internet Home Page Address: libraries.ou.edu; *Library Technician III* Dennis Mosser; *Fine & Applied Arts Librn* Susan Booker
Open fall sem Mon - Thurs 8 AM - 9 PM, Fri 8 AM - 5 PM, Sat 11 AM - 4 PM, Sun 2 - 9 PM; Estab to provide instructional support to the acad community of the univ & gen service to the people of the state; Circ 6900
Income: Financed by state appropriation
Library Holdings: Book Volumes 27,000; CD-ROMs; Fiche; Periodical Subscriptions 50; Reels; Video Tapes

OKLAHOMA CITY

C **AMERICAN HOMING PIGEON INSTITUTE,** 2300 Northeast 63rd St, Oklahoma City, OK 73111-8208. Tel 405-478-5155; Fax 405-478-4552; Elec Mail pidgeoncenter@aol.org; *Admin Asst* Linda Oughton; *Facilities Mgr & Gen Mgr* Randy Good Pasture
Estab 1973 to preserve & display the rich heritage of domestic pigeons & doves & to foster the keeping of registered pigeons as a unique & rewarding hobby; Mem: 1000; dues $20
Income: Financed by mem
Purchases: Several pigeon art book colls
Activities: Classes for children; exten dept

M **INDIVIDUAL ARTISTS OF OKLAHOMA,** 811 N Broadway, Oklahoma City, OK 73146; PO Box 60824 Oklahoma City, OK 73146. Tel 405-232-6060; Fax 405-232-6061; Elec Mail iao@sbcglobal.net; Internet Home Page Address: www.iaogallery.org; *Dir* Suzanne Owens
Open Tues - Fri 11 AM - 4 PM, Sat 1 - 4 PM; No admis fee; Estab 1979 to promote Oklahoma artists of all disciplines; Average Annual Attendance: 7,000; Mem: 400; dues $35; ann meeting in summer
Income: Financed by mem, fundraising & art sales
Exhibitions: Monthly exhibits of 3 visual artists, including spec photog gallery
Publications: Artzone, monthly newsletter
Activities: Lect open to pub, 1-2 vis lectrs per yr; competitions; concerts, gallery talks; film & video; traveling exhibs 1 per yr; originate traveling exhibs 1 per yr statewide

M **NATIONAL COWBOY & WESTERN HERITAGE MUSEUM,** 1700 NE 63rd St, Oklahoma City, OK 73111. Tel 405-478-2250; Fax 405-478-4714; Elec Mail info@nationalcowboymuseum.org; Internet Home Page Address: www.nationalcowboymuseum.org/; *Exec Dir* Chuck Schroeder; *Coll Cur* Ed Muno; *Develop Dir* Ron Area; *Dir Pub Rels* Lynda Haller; *CFO* Denny Zimmerman; *Asst Dir* Mike Leslie; *Research Ctr Dir* Charles E Rand; *Mktg Dir* Leslie Baker
Open daily 9 AM - 5 PM, cl New Year's Day, Thanksgiving & Christmas Day; Admis adults $8.50, seniors $7, children 6-12 $4, children under 5 free; group rates available; Estab 1954, opened 1965 to preserve and interpret the heritage of the American West for the enrichment of the pub.; Two spacious galleries showcase exhibits from the museum's nationally known contemporary Western art coll, including Prix de West award winners from the National Acad of Western Art Exhibs held here annually since 1973 & from 1995 as the Prix De Weit Exhib; Average Annual Attendance: 229,000; Mem: 8000; dues $35
Income: Financed by endowment, mem, grants & donations
Library Holdings: Auction Catalogs; Audio Tapes; Book Volumes; CD-ROMs; Cassettes; Clipping Files; Compact Disks; DVDs; Exhibition Catalogs; Manuscripts; Memorabilia; Original Documents; Pamphlets; Periodical Subscriptions; Photographs; Prints; Video Tapes
Special Subjects: Drawings, Photography, Pottery, Painting-American, Sculpture, Watercolors, American Indian Art, American Western Art, Southwestern Art, Landscapes, Portraits, Historical Material, Period Rooms
Collections: Albert K Mitchell Russell-Remington Collection; Contemporary Western Art; Fechin Collection; James Earle & Laura G Fraser Studio Collection; Schreyvogel Collection; Taos Collection; John Wayne Collection, kachinas, guns, knives & art; western art; Great Western Performers Portrait Collection; Rodeo Portrait Collection; Photographic Coll (Rodeo & Historical)
Exhibitions: Annual National Academy of Western Art (Prix de West Invitational); Traditional Cowboy Arts Asn (TCAA) Exhib & Sale (Exquiste cowboy gear collector's quality)
Publications: Ketch Pen Magazine, biannual; Persimmon Hill Magazine, quarterly
Activities: Classes for adults & children; docent training; lect open to pub, lect for mems only, 4 vis lect per yr; schols & fels offered; originate traveling exhibs, circulated to requesting agencies, univs, museums, galleries; organize traveling exhib that circulate to other museums; mus shop sells books, magazines, reproductions & prints

M **OKLAHOMA CITY MUSEUM OF ART,** 415 Couch Dr, Oklahoma City, OK 73102. Tel 405-236-3100; Fax 405-236-3122; Elec Mail lspears@okcmoa.com; Internet Home Page Address: www.okcmoa.com; *Dir* Carolyn Hill; *Fin Dir* Rodney Lee; *Registrar* Matthew Leininger; *Cur Film* Brian Hearn; *Develop Coordnr* Jim Eastep; *Chief Cur* Hardy George, PhD; *Assoc Cur* Alison Amick; *Commun Mgr* Leslie Spears; *Facility Oper Mgr* Jack Madden; *Safety & Security Chief* Adam Edwards; *Event & Tour Coordr* Whitney Cross
Open Tues, Wed, Fri, Sat 10 AM - 5 PM; Thurs 10 AM - 9 PM; Sun Noon - 5 PM, cl Mon & major holidays; Admis adults $9, students & seniors $7, children under 5 & mems free; Estab 1945; Circ Library; 15 galleries, theatre, library, classrooms, store & full service cafe; Average Annual Attendance: 130,000; Mem: 4000; dues $50 - $1000; ann meeting in June
Income: Prt funded by earned income, corp, foundations & indiv contributions & interest earned on endowments
Library Holdings: Auction Catalogs; Audio Tapes; Book Volumes; DVDs; Exhibition Catalogs; Kodachrome Transparencies; Periodical Subscriptions; Slides; Video Tapes
Special Subjects: Painting-British, Drawings, Latin American Art, Painting-American, Photography, Prints, Sculpture, Watercolors, Woodcuts, Etchings & Engravings, Landscapes, Painting-European, Portraits, Glass, Oriental Art, Asian Art, Painting-French, Ivory, Maps, Painting-Italian, Painting-German
Collections: 19th-20th century American paintings including works by Bellows, Tiffany, Chase, Cropsey, Benton, Moran, Hassam; 20th century American paintings & graphics, including Henri, Marin, Kelly, Indiana, Francis, Davis, Warhol; Sculpture by Bertoia, Bontecou, Calder, Henry Moore; Most comprehensive collection of Chihuly glass in world; Washington Gallery of Modern Art collection; RA Young collection & Westheimer family collectiion
Exhibitions: (2/1/2007-4/29/2007) Napoleon: An Intimate Portrait; (12/14/2006-1/14/2007) Holiday Print Show - festive prints from Oklahoma City MOA; (3/1/2007) (continuin) - Leaving a Mark: Oklahoma Print Collectiions; Dale Chihuly: The Exhibition
Publications: Calendar, bimonthly, exhibition catalogs, posters, brochures, permanent collection catalogues
Activities: Museum school classes for youth & adults; docent training; most comprehensive film prog in region; lect open to pub, 10 vis lectrs per yr; gallery talks; tours; films; individual paintings & original objects of art lent to other accredited museums; lending collection contains original art works, original prints, paintings & photographs; book traveling exhibs 2 per yr; originate traveling exhibs; mus shop sells books, cards, reproductions, prints, original art, jewelry, stationery, textiles, jewelry, cards & art related merchandise
L **Library,** 415 Couch Dr, Oklahoma City, OK 73102. Tel 405-263-3100, 800-579-9278; Fax 405-946-7671; Internet Home Page Address: www.okcmoa.com; *Dir & Cur* Carolyn Hill; *Exec Asst* Susie Bauer; *Educ Coordr* Doris McGranahan; *Chief Cur* Haedy George PhD
Open Tues - Sat 10 AM - 5 PM, Thurs until 9 PM, Sun Noon - 5 PM, cl Mon; Admis gen $7, seniors & students $5, children 5 & under free; Estab 1989 to bring a quality fine arts mus & related educ programming to Oklahoma; Library for reference only; Average Annual Attendance: 25,000; Mem: 1500
Income: Nonprofit organization financed through pvt contribution
Library Holdings: Book Volumes 6800; Clipping Files; Exhibition Catalogs; Periodical Subscriptions 15; Slides; Video Tapes
Special Subjects: Art History, Film, Photography, Painting-American, Painting-British, Painting-Dutch, Painting-Flemish, Painting-French, Painting-German, Painting-Italian, Sculpture, Painting-European, History of Art & Archaeology, Printmaking, Art Education, Asian Art, Video
Activities: Classes for adults & children; docent training; tours; museum shop sells books, prints, textiles, decorative objects & jewelry

M **OKLAHOMA CITY UNIVERSITY,** Hulsey Gallery-Norick Art Center, 2501 N Blackwelder, Oklahoma City, OK 73106. Tel 405-521-5226; Fax 405-557-6029; Internet Home Page Address: www.okcu.edu; *Admin Asst* Maria Amos; *Dir* Kirk Niemeyer
Open Mon - Fri 10 AM - 4 PM, Sun 1 - 5 PM; No admis fee; Estab 1985 to educ in the arts; Gallery is 2,200 sq ft with fabric covered walls & moveable display forms; Average Annual Attendance: 2,000
Income: Financed by endowment & the Unive
Collections: Oklahoma City University Art Coll; Art donated by individuals & organizations from Oklahoma
Exhibitions: Oklahoma City University Student Exhibit; Oklahoma High School Print & Drawing Exhibit; exhibits change monthly
Activities: Classes for adults; lect open to pub, 2-3 vis lectrs per yr; individual paintings & original works of art lent to various departments of the Oklahoma City Univ campus

L **Scheme Shop,** 2501 N Blackwelder, Oklahoma City, OK 73106. Tel 405-521-5082; Fax 405-521-5493; Elec Mail dhall@okcu.edu; *Dir* Dale Hall
Open Mon - Fri 9 AM - 5 PM, hours vary on weekends, call for appointment; For lending & reference
Income: Financed by endowment, donation & University
Library Holdings: Book Volumes 207; Exhibition Catalogs; Original Art Works; Photographs; Prints; Reproductions; Sculpture; Video Tapes

M **OKLAHOMA HISTORICAL SOCIETY,** State Museum of History, Wiley Post Historical Bldg, 2100 N Lincoln Blvd Oklahoma City, OK 73105. Tel 405-522-5248; Fax 405-522-5402; Elec Mail statemuseum@ok-history.mus.ok.us; Internet Home Page Address: www.pages.prodigy.net/mtwo/smhpage.html; *Dir* Dan Provo; *Asst Dir Coll* Jeff Briley; *Admin Asst* Trish Liscomb
Open Mon - Sat 9 AM - 5 PM, cl State holidays; No admis fee; Estab 1893 to provide an historical overview of the State of OK, from prehistory to the present, through interpretive exhibits, 3-D artifacts, original art & photographs; Average Annual Attendance: 150,000; Mem: 3500; dues $15; ann meeting Apr
Income: Financed by state appropriations & mem; soc depends on donations for additions to its colls
Special Subjects: Painting-American, American Indian Art, American Western Art, Anthropology, Archaeology, Ethnology, Decorative Arts, Historical Material, Period Rooms, Military Art
Collections: Anthropology; archaeology; historical artifacts; documents; American Indian art; Oklahoma art; Western art
Exhibitions: Permanent exhibits depicting pre-history, Oklahoma Indian Tribes' history, the Five Civilized Tribes' occupancy of Indian Territory, the land openings of the late 19th and early 20th centuries, statehood, and progress since statehood; spec exhibits 2-3 times per yr
Publications: Mistletoe Leaves, monthly newsletter; The Chronicles of Oklahoma, Society quarterly; various brochures and reprints
Activities: Special presentations & films for children & adults; interpretive progs; self-guided tours; individual paintings & original objects of art lent to qualified museums; lending coll contains paintings, 19th century beadwork & Indian artifacts; originate traveling exhibs; sales shop sells books, magazines

L **Library Resources Division,** 2100 N Lincoln Blvd, Oklahoma City, OK 73105. Tel 405-521-2491; Fax 405-521-2492; Elec Mail libohs@ok-history.mus.ok.us; Internet Home Page Address: www.ok-history.mus.ok.us; *Dir Library Resources Div* Edward C Shoemaker; *Deputy Dir* Robert Thomas; *Dir Educ* Whit Edward; *Mus Shop Mgr* Mike Tippit; *Manuscripts & Archives* William Welge; *Okla Mus* Dan Provo; *Exec Dir* Bob Blackburn; *VChmn* Denzil Garrison
Open Tues - Sat 9 AM - 5 PM, Mon 9 AM - 8 PM, cl Sun & legal holidays; Estab 1893 to collect & preserve historical materials & publications on Oklahoma history; For reference only
Income: financed by state appropriations & members
Library Holdings: Book Volumes 65,000; Clipping Files; Fiche; Pamphlets; Periodical Subscriptions 80; Photographs; Reels 12,493
Publications: Chronicles of Oklahoma, quarterly; Mistletoe Leaves, monthly newsletter

M **OMNIPLEX,** 2100 NE 52nd, Oklahoma City, OK 73111. Tel 405-602-6664 (Omniplex), 427-5461; Fax 405-424-5106; Elec Mail omnipr@omniplex.org; Internet Home Page Address: www.omniplex.org; *Exec Dir* Chuck Schillings
Open Tues - Sat 9 AM - 5 PM, Sun 11 AM - 6 PM; Admis adults $5, children & seniors $3, one price for entire center; Estab 1958 to focus on the inter-relationships between science, arts & the humanities & to supplement educ facilities offered in the pub schools in the areas of arts & sciences; The Kirkpatrick Center houses Omniplex, a hands-on science mus; mus shop; George Sutton bird paintings; Oklahoma Aviation & Space Hall of Fame & Mus; Center of American Indian Gallery; Sanamu African Gallery; Oriental Art Gallery; International Photography Hall of Fame; Oklahoma Zoological Society Offices; Kirkpatrick Planetarium; miniature Victorian house; antique clocks; US Navy Gallery; retired senior volunteer program; Oklahoma City Zoo offices; Average Annual Attendance: 350,000
Income: Financed by mem, pvt donations, Allied Arts Foundation, admis fees, & class tui
Special Subjects: Painting-American, Prints, African Art, Pre-Columbian Art, Oriental Art, Ivory
Collections: European & Oriental Ivory Sculpture; Japanese Woodblock Prints; Oceanic art; Pre-Columbian & American Indian art; Sutton paintings; Traditional & Contemporary African art; 1,000 photographs in Photography Hall of Fame
Exhibitions: Changing exhibs every 6 - 10 weeks; Dinosaurs
Publications: Insights, quarterly; Omniplex Newsletter, monthly
Activities: Classes for adults & children; docent training; lect open to pub; tours; book traveling exhibs; mus shop sells books, prints, science-related material, cards & jewelry

OKMULGEE

M **CREEK COUNCIL HOUSE MUSEUM,** 106 W Sixth St, Okmulgee, OK 74447. Tel 918-756-2324; Fax 918-756-3671; Elec Mail creekmuseum@prodigy.n; *Dir* David Anderson; *VPres* Terry Bernis; *Mus Shop Mgr* Becka Hutchinson
Open Tues - Sat 10 AM - 4:30 PM; No admis fee; Estab 1867, first Council House built, present Council House erected in 1878 to collect & preserve artifacts

from Creek history; Five rooms downstairs containing artifacts; four rooms upstairs showing art work, early time of Okmulgee; rooms of House of Warriors & House of Kings; Average Annual Attendance: 10,000-12,000
Income: Financed by mem & city appropriation
Special Subjects: Period Rooms
Collections: Creek Artifacts
Exhibitions: Annual Oklahoma Indian Art Market (juried competitions)
Activities: Seminars on Creek Culture & history; Ann Wild Onion Feast (traditional tribal foods); lect open to pub, 5-10 vis lectrs per yr; gallery talks; artmobile; book traveling exhibs; mus shop sells books, original art, reproductions, prints & Native American art & craft items

L **Library,** 106 W Sixth St, Okmulgee, OK 74447. Tel 918-756-2324; Fax 918-756-3671; *Dir* David Anderson
Open Tues - Sat 10 AM - 4:30 PM & by appointment; Estab 1923 to collect & educate all Native American Tribes with emphasis on Muscogee Creek; For reference only, staff & academia
Library Holdings: Audio Tapes; Book Volumes 250; Clipping Files; Exhibition Catalogs; Framed Reproductions; Manuscripts; Memorabilia; Motion Pictures; Original Art Works; Pamphlets; Periodical Subscriptions 10; Photographs; Prints; Reels; Sculpture; Video Tapes

PONCA CITY

A **PONCA CITY ART ASSOCIATION,** 819 E Central, PO Box 1394 Ponca City, OK 74601. Tel 580-765-9746; *Office Mgr* Donna Secrest
Open Wed - Sun 1 - 5 PM; No admis fee; Estab 1947 to encourage creative arts, to furnish place & sponsor art classes, art exhibits & workshops; Historical mansion; Mem: 600; dues $15 family; ann meeting third Tues in Apr
Income: $10,000 (financed by mem, flea market, corporate & pvt)
Collections: Permanent fine arts coll; additions by purchases & donations
Exhibitions: Eight per year
Publications: Association Bulletin, 6 per yr
Activities: Classes for adults & children; lect open to pub; tours; competitions for mems only with awards; schols offered; individual paintings lent to city-owned buildings; sales shop sells original art, reproductions & prints

M **PONCA CITY CULTURAL CENTER & MUSEUM,** 1000 E Grand Ave, Ponca City, OK 74601. Tel 405-767-0427; *Exec Dir* Kathy Adams
Open Mon, Wed - Sat 10 AM - 5 PM, Sun & holidays 1 - 5 PM; cl Tues, Thanksgiving, Christmas Eve & Christmas Day, New Year's Eve & New Year's Day; Admis adults $1; The Cultural Center & Mus, a National Historic House since 1976, houses the Indian Mus, the Bryant Baker Studio, the 101 Ranch Room, & the DAR Memorial Mus; The Indian Mus, estab in 1936, places an emphasis on materials from the five neighboring tribes (Ponca, Kaw, Otoe, Osage, and Tonkawa) whose artistic use of beading, fingerweaving & ribbon-work are displayed throughout the Mus. The Bryant Baker Studio is a replica of the New York Studio of Bryant Baker, sculptor of the Pioneer Woman Statue, a local landmark, & the studio contains original bronze & plaster sculpture. The 101 Ranch Room exhibits memorabilia from the world renowned Miller Brothers' 101 Ranch, located south of Ponca City in the early 1900s. The mus is the former home of Ernest Whitworth Marland, oilman & philanthropist & the tenth governor of Oklahoma; Average Annual Attendance: 35,000; Mem: Dues $10 - $1000
Income: Financed by the City of Ponca City & donations
Special Subjects: Sculpture, American Indian Art, Archaeology
Collections: Bryant Baker original sculpture; 101 Ranch memorabilia; Indian ethnography and archeology of Indian tribes throughout the United States
Exhibitions: Smithsonian Indian Images; Indian costumes, jewelry, pottery, baskets, musical instruments & tools
Publications: Brochure
Activities: Tours; sales shop sells books, arrowheads, Indian arts & crafts

L **Library,** 1000 E Grand Ave, Ponca City, OK 74601. Tel 405-767-0427; *Exec Dir* Kathy Adams
Open Mon, Wed - Sat 10 AM - 5 PM, Sun 1 - 5 PM, cl Tues; Primarily research library
Income: Financed by Ponca City
Library Holdings: Book Volumes 230; Periodical Subscriptions 13
Special Subjects: Archaeology, Anthropology

L **PONCA CITY LIBRARY,** Art Dept, 515 E Grand, Ponca City, OK 74601. Tel 580-767-0345; Fax 580-767-0377; *Head Technical Svcs* Paula Cain; *Dir* Holly LaBossiere
Open Mon - Thurs 9 AM - 9 PM, Fri 9 AM - 6 PM, Sat 9 AM - 5 PM, Sun 2 - 5 PM, cl Sun in June, July & Aug; Estab 1904 to serve the citizens of Ponca City; Circ 150,000; Gallery maintained
Library Holdings: Book Volumes 75,000; Cassettes; Framed Reproductions; Original Art Works; Pamphlets; Periodical Subscriptions 250; Photographs; Sculpture
Collections: Oriental Art Coll; Sandzen Coll; paintings

SHAWNEE

M **SAINT GREGORY'S ABBEY & UNIVERSITY,** Mabee-Gerrer Museum of Art, 1900 W MacArthur Dr, Shawnee, OK 74804. Tel 405-878-5300; Fax 405-878-5133; Elec Mail info@mabeegerrermuseum.org; *Dir* Debby Williams; *Coll Mgr* Chris Owens, OSB
Open daily Tues - Sat 10 AM - 4 PM, Sun 1 - 4 PM, cl Mon & holidays; No admis fee; Estab 1915 to contribute to the cultural growth & appreciation of the gen pub of Oklahoma as well as of the student body of Saint Gregory's Univ; A new 16,000 sq ft gallery was completed in 1979. In 1990, 1500 sq ft was added which includes a new gallery, a multi-purpose room & theater. Collections are being enlarged by purchases & by gifts; Average Annual Attendance: 40,000
Income: Financed by endowment, Abbey, mem & foundation funds
Special Subjects: Painting-American, Prints, Pre-Columbian Art, Religious Art, Etchings & Engravings, Painting-European, Antiquities-Egyptian, Antiquities-Greek, Antiquities-Roman

Collections: Artifacts from ancient civilization; African, Eygptian, Roman, Grecian, Babylonian, Pre-Columbian North, South and Central American Indian, and South Pacific; etchings, engravings, serigraphs and lithographs; oil paintings by American and European artists; Native American; Icons: Greek, Russian & Balkan; Retablos from Mexico & New Mexico
Activities: Classes for adults & children; docent training; lect open to pub, 4 vis lectrs per yr; gallery talks; tours; individual paintings & original objects of art lent to other museums

STILLWATER

M **OKLAHOMA STATE UNIVERSITY,** Gardiner Art Gallery, Dept of Art, Bartlett Ctr for Studio Arts, 108 Bartlett Ctr Stillwater, OK 74078-0120. Tel 405-744-9086; Fax 405-744-5767; Elec Mail nwilkin@okway.okstate.edu; Internet Home Page Address: www.okstate.edu/artsci/art/gallery.html; *Dir* B J Smith
Open Mon - Fri 8 AM - 4 PM, Sun 1 - 5 PM; No admis fee; Estab 1970 as a visual & educ exten of the department's classes & as a cultural service to the community & area; One gallery located on the ground fl, Bartlett Center for the Studio Arts; 250 running ft of wall space, 12 ft ceiling; Average Annual Attendance: 5,500
Income: Financed by col
Collections: 7250 drawings, prints, paintings, sculptures & ceramics, mostly mid-late 20th century
Exhibitions: Exhibitions change every 3-4 weeks year round; faculty, student, invitational & traveling shows
Publications: Exhib brochures; exhib schedules
Activities: Book traveling exhibs
L **Architecture Library,** 201A Architecture Bldg, Stillwater, OK 74078-0185. Tel 405-744-6047; Elec Mail bobos@okstate.edu; Internet Home Page Address: www.library.okstate.edu; *Architecture Librn* Susan Bobo
Open fall & spring semesters Mon - Thurs 8:30 AM - 10 PM & 7 - 10 PM, Fri 8:30 AM - 5:30 PM, Sat & Sun 1 - 5 PM, hrs may vary; Estab 1976 to meet the needs of the faculty & students of the School of Architecture
Income: financed by college
Purchases: $14,000
Library Holdings: Book Volumes 13,000; Other Holdings Compact discs; Periodical Subscriptions 40; Photographs; Slides; Video Tapes

TAHLEQUAH

A **CHEROKEE HERITAGE CENTER,** Willis Rd, Tahlequah, OK 74465. Tel 918-456-6007, 888-999-6007; Fax 918-456-6165; Internet Home Page Address: www.CherokeeHeritage.org; *Exec Adminr* Mary Ellen Meredith; *Dir Mktg* Marilyn Craig
Open Mon - Sat 10 AM - 5 PM, Sun 1 - 5 PM, cl Jan; Admis adult $8.50, children $4.25, 6 & under free; rates vary with each show; Estab 1963 to commemorate & portray the history, traditions & lore of a great Indian tribe & to assist in improving local economic conditions; Maintains an art gallery, primarily Indian art; Average Annual Attendance: 150,000; Mem: 1500; dues $25 & up
Income: Financed by mem, admis & grants
Special Subjects: Historical Material, Manuscripts, Photography, Textiles, Pottery, Archaeology
Collections: Indian artists interpretations of Trails of Tears
Exhibitions: Trail of Tears Art Show, annually; various shows, lectures & classes
Publications: The Columns, quarterly
Activities: Classes for adults; lect open to pub; mus shop sells books, reproductions, prints & slides
L **Library & Archives,** PO Box 515, Tahlequah, OK 74465. Tel 918-456-6007, 888-999-6007; Fax 918-456-6165; Internet Home Page Address: www.CherokeeHeritage.org; *Archivist & Cur* Tom Mooney
Open Mon - Fri 8 AM - 5 PM; Admis fees vary, call for details; Estab 1976 to preserve remnants of Cherokee history & to educate the general pub about that cultural heritage; a respository of Indian art & documents; Maintains an art gallery with work by artists of several different tribes; heavy emphasis given to the Cherokee experience
Income: Financed by mem, admis & grants
Library Holdings: Audio Tapes; Book Volumes 3000; Cassettes; Clipping Files; Filmstrips; Framed Reproductions; Kodachrome Transparencies; Manuscripts; Memorabilia; Original Art Works; Other Holdings Archival materials in excess of 500 cu ft; Manuscripts; Pamphlets; Periodical Subscriptions 10; Photographs; Prints; Reels 127; Sculpture; Slides
Exhibitions: Annual Trail of Tears Art Show (Indian artists' interpretation of the Trail of Tears theme); Cherokee Artists Exhibition; rotating exhibitions; special exhibitions, periodically (primarily Indian artists)
Publications: Quarterly columns
Activities: Classes for adult; tours

TULSA

C **BANK OF OKLAHOMA NA,** Art Collection, PO Box 2300, 1 William Ctr Tulsa, OK 74192. Tel 918-588-6000; Fax 918-588-8692; *VPres Exec Committee* Scott Ellison
Open 8 AM - 5 PM; Estab 1968 to enhance work environment; Coll displayed on 7 floors of the Bank of Oklahoma Tower
Purchases: $15,000
Collections: Modern Art
Activities: Lect; tours; schols offered to University of Tulsa

M **PHILBROOK MUSEUM OF ART,** 2727 S Rockford Rd, Tulsa, OK 74114-4104; PO Box 52510, Tulsa, OK 74152-0510. Tel 918-749-7941; Fax 918-743-4230; Internet Home Page Address: www.philbrook.org; *Dir Exhib & Coll* Christine Kallenberger; *Interim Dir & Deputy Dir* David Singleton; *Mus Shop Mgr* Susan Shrewder; *Preparator* George Brooks; *Dir Develop* Janis Updike Walker; *Facility Coordr* Charisse Cooper; *Cur Native American & Non-Western Art* Christina Burke; *Mgr Marketing & Pub Relations* Amy Pagan; *Dir Educ & Public Prog* Pam Hodges; *Mgr Gardens* Melinda McMillian-Fox; *Cur European & American Art* James Peck
Open Tues, Wed, Fri & Sat 10 AM - 5 PM, Thurs 10 AM - 8 PM, Sun 10 AM - 5 PM; Admis adults $5.50 to $1.50, children 18 & under free; Estab 1939 as a gen art mus in an Italian Renaissance Revival Villa, the former home of philanthropist & oil baron Waite Phillips; Twenty-three acres of formal & natural gardens. Also contains a special exhib gallery; Average Annual Attendance: 128,000; Mem: 4500; dues $50 & up; ann meeting in June
Income: Financed by endowment, mem, earned income, corporate & pvt gifts & pub grants
Library Holdings: Auction Catalogs; Audio Tapes; Book Volumes; CD-ROMs; Clipping Files; Exhibition Catalogs; Pamphlets; Periodical Subscriptions; Photographs; Slides; Video Tapes
Special Subjects: Painting-American, Prints, Sculpture, Watercolors, American Indian Art, African Art, Ceramics, Painting-European, Furniture, Glass, Oriental Art, Asian Art, Painting-Italian
Collections: Laura A Clubb Collection of American & European Paintings; Clark Field Collection of American Indian Baskets & Pottery; Gillert Collection of Southeast Asian Ceramics; Gussman Collection of African Sculpture; Samuel H Kress Collection of Italian Renaissance Paintings & Sculpture; Roberta C Lawson Collection of Indian Costumes & Artifacts; Tabor Collection of Oriental Art; American Indian paintings & sculpture; European, early American & contemporary American oils, watercolors & prints; period furniture
Exhibitions: (10/15/2006-4/29/2007) A History of the Oklahoma Annual Artists Exhibition; (11/19/2006-12/3/2006) Festival of Trees; (12/10/2006-1/28/2007) The Academic Tradition: Drawings, Prints & Watercolors from the Philbrook Collection; (1/28/2007-4/22/2007) Changing Hands 2- Art Without Reservation: Contemporary Native North American Art from the West & Northwest; (2/4/2007-8/5/2007) The Oklahoma Scene: Printmakers of the 1930's & 1940's; (6/10/2007-9/2/2007) Untamed: The Art of Antione-Louis Barye; (8/12/2007-1/13/2008) Views of Rome: Prints by Piranesi & Rossini; (11/11/2007-1/20/2008) Frank Lloyd Wright & The House Beautiful; (4/6/2008-6/1/2008) Painting the Italian Landscape: Views from the Uffizi; (6/29/2008-9/21/2008) The Object Project
Publications: Quarterly magazine; exhibition catalogs
Activities: Dramatic progs; classes for adults & children; docent training; lect open to pub, 27 vis lectrs per yr; concerts; gallery talks; tours; scholarships; individual & original objects of art lent to museums, corporations & city government; book traveling exhibs 2 - 4 per yr; originate traveling exhibs; mus shop sells books, magazines, original art, reproductions, prints, slides, jewelry, children's toys, garden items & gift items
L **HA & Mary K Chapman Library,** 2727 S Rockford Rd, Tulsa, OK 74114-4104; PO Box 52510, Tulsa, OK 74152-0510. Tel 918-748-5306; Fax 918-743-4230; Elec Mail tyoung@philbrook.org; Internet Home Page Address: www.philbrook.org; *Librn* Thomas E Young
Open Tues - Fri 10 AM - Noon, 1 - 5 PM, Mon by appointment; Estab 1940; Reference-resource center for the curatorial staff, teaching faculty, volunteers & mem
Library Holdings: Auction Catalogs; Book Volumes 15,000; Clipping Files; Exhibition Catalogs; Pamphlets; Periodical Subscriptions 135; Reproductions; Slides
Special Subjects: Art History, Folk Art, Landscape Architecture, Decorative Arts, Photography, Painting-American, Painting-Italian, Pre-Columbian Art, Painting-European, History of Art & Archaeology, American Western Art, American Indian Art, Primitive art, Oriental Art, Pottery
Collections: Roberta Campbell Lawson Library of source materials on American Indians; Oklahoma Artists Files

M **SHERWIN MILLER MUSEUM OF JEWISH ART,** (Gershon & Rebecca Fenster Museum of Jewish Art) 2021 E 71st St, Tulsa, OK 74136. Tel 918-492-1818; Fax 918-492-1888; Elec Mail info@jewishmuseum.net; Internet Home Page Address: www.jewishmuseum.net; *Registrar* Suzanne Smith; *Exec Dir* Stephen M Goldman
Open Mon - Fri 10 AM - 5 PM, Sun 1 - 5 PM; adults $5.50, $4.50 seniors & groups, students $3; Estab 1966 to collect, preserve & interpret cultural, historical & aesthetic materials attesting to Jewish cultural history, Jewish history of Oklahoma & the Holocaust; Average Annual Attendance: 8,000; Mem: 450; dues $35 - $2,500, ann meeting in Dec
Income: $450,000 (financed by endowment & mem)
Library Holdings: Audio Tapes; Cassettes; Compact Disks; DVDs; Exhibition Catalogs; Memorabilia; Original Documents; Photographs; Prints; Records; Reels; Reproductions; Sculpture; Slides; Video Tapes
Special Subjects: Judaica
Collections: Anti-semitica; archeology of old world; ethnographic materials; fine art by Jewish artists & on Jewish themes; ritual & ceremonial Judaica; Holocaust, Oklahoma Jewish Archive
Exhibitions: Permanent Jewish History & Practice exhibit; Permanent Holocaust exhibit
Publications: quarterly newsletter
Activities: Classes for adults & children, docent training; lect open to pub; gallery talks; tours; awards; individual paintings & original objects of art lent to other museums & religious institutions

M **THOMAS GILCREASE INSTITUTE OF AMERICAN HISTORY & ART,** Gilcrease Museum, 1400 Gilcrease Museum Rd, Tulsa, OK 74127-2100. Tel 918-596-2700; Fax 918-596-2770; Internet Home Page Address: www.gilcrease.org; WATS 888-655-2278; *Interim Dir* Gary Moore; *Exec Dir* Joe Schenk
Open Tues - Sat 10 AM - 4 PM, cl Christmas; No admis fee; Estab by the late Thomas Gilcrease as a pvt institution; acquired by the City of Tulsa 1954 (governed by a Board of Directors & City Park Board); building addition completed 1963 & 1987; Average Annual Attendance: 130,000; Mem: 4500; dues $30 & up
Income: Financed by city funds & fundraisers
Special Subjects: Drawings, Hispanic Art, Latin American Art, Mexican Art, Painting-American, Photography, Sculpture, American Indian Art, American Western Art, Bronzes, Anthropology, Ethnology, Pre-Columbian Art, Southwestern Art, Folk Art, Pottery, Etchings & Engravings, Landscapes, Manuscripts, Portraits, Eskimo Art, Historical Material, Maps, Gold, Leather
Collections: American art from Colonial period to 20th century with emphasis on art of historical significance, sculpture, painting, graphics. Much of the work

shown is of documentary nature, with emphasis on the Native American material & the opening of the Trans-Mississippi West. Art Collections include 100,000 books; 10,000 paintings by 400 American artists; artifact collections include 300,000 objects including both prehistoric & historic materials from most of the Native American cultures in Middle & North America

Exhibitions: Special exhibitions periodically; rotating exhibits during fall, winter, spring seasons; Gilcrease Rendezvous; 8000 sq ft permanent exhibit of Art from Mexico

Publications: The Journal, biannual

Activities: Classes for adults & children; docent training; lect open to pub; gallery talks; tours; individual paintings & original objects of art lent to comparable art institutions; book traveling exhibs 3-4 per yr; originate traveling exhibs to other museums; mus shop sells books, magazines, original art, reproductions, prints, slides, pottery & jewelry

L **Library,** 1400 Gilcrease Museum Rd, Tulsa, OK 74127. Tel 918-596-2700; Fax 918-596-2770; *Cur Archival Coll* Sarah Erwin
Open Tues - Sat 9 AM - 5 PM, Sun 11 AM - 5 PM, cl Christmas; No admis fee; donations $3 per family, $5 per family; Library open for research by appointment, contains 90,000 books & documents, many rare books & manuscripts of the American frontier period, as well as materials concerning the Five Civilized Tribes
Income: Financed by city appropriation
Library Holdings: Book Volumes 40,000; Exhibition Catalogs; Manuscripts; Memorabilia; Pamphlets; Periodical Subscriptions 10; Photographs
Special Subjects: Manuscripts, Historical Material, American Western Art, American Indian Art

M **UNIVERSITY OF TULSA,** Alexandre Hogue Gallery, Art Dept, 600 S College Ave Tulsa, OK 74104. Tel 918-631-2202; Fax 918-631-3423; *Dir* Ron Predel
Open Mon - Fri 8:30 - 4:30 PM; No admis fee; Estab 1966 to display the works of regionally & nationally known artists; 176 running ft; Average Annual Attendance: 1,000
Income: Financed by Univ
Exhibitions: Annual Student Art Competition; National Scholastic Art Awards Scholarships & Competition; various regional & local artists on a rotating basis
Activities: Lect open to pub, 6 vis lectrs per yr; competition with awards; schols offered; individual paintings & original objects of art lent

WOODWARD

M **PLAINS INDIANS & PIONEERS HISTORICAL FOUNDATION,** Museum & Art Center, 2009 Williams Ave, Woodward, OK 73801. Tel 580-256-6136; Fax 580-256-2577; Elec Mail pipm@swbell.net; *Dir & Cur* Louise James; *Dir Asst* Robert Roberson
Open Tues - Sat 10 AM - 5 PM, cl Sun & Mon; No admis fee; Estab 1966 to preserve local history & to support visual arts; Average Annual Attendance: 15,000; Mem: 450; dues $25 - $500; ann meeting in Nov
Income: Financed by mem & trust fund
Special Subjects: American Indian Art
Collections: Early day artifacts as well as Indian material
Exhibitions: Juried contests for high school students & photographers; Fine Arts, Creative Crafts (guest artist featured each month in the gallery)
Publications: Below Devil's Gap (historical book); brochures; quarterly newsletter; Oklahoma's Northwest Territory Map; Woodward County Pioneer Families, 1907-57 (2 volumes)
Activities: Classes for adults & children; docent training; lect open to pub; tours; competitions with prizes; book traveling exhibs 3 per yr; mus shop sells books, magazines, original art & prints & Northwest Oklahoma artisans crafts

OREGON

ASHLAND

SOUTHERN OREGON UNIVERSITY
M **Stevenson Union Gallery,** Tel 541-552-6465; Fax 541-552-6440; Internet Home Page Address: www.sou.edu
Open Mon - Fri 8 AM - 9 PM, Sat 9:30 AM - 2 PM; No admis fee; Estab 1972 to offer col & community high quality arts; Located on the third floor of Stevenson Union, the gallery is about 1200 sq ft; Average Annual Attendance: 20,000
Income: Financed by student fees
Collections: Small permanent collection of prints, paintings by local artists & a sculpture by Bruce West
Exhibitions: Ceramics, paintings, photography, prints, sculpture, faculty & student work.; Annual Student Art Show; Installations, Alternative Works
Activities: 3 vis lectrs per yr; competitions
M **Schneider Museum of Art,** Tel 541-552-6245; Fax 541-552-8241; Elec Mail Gardiner@sou.edu; Internet Home Page Address: www.sou.edu/sma; *Preparator & Registrar* Stephen Fraizer; *Dir* Mary Gardiner; *Ofc Coordr* Robin Parsons; *Cur* Josine Ianco Starrels; *Arts Educ & Progs Coordr* Rebecca Olien
Open Tues - Sat 10 AM - 4 PM, first Fri 10 AM - 7 PM; Donations; Estab 1986; Univ Art Mus - Contemporary Art Focus; Average Annual Attendance: 20,000; Mem: 350; dues $30 - $250+; ann meeting in Oct
Income: Financed by endowment, mem, state appropriations & federal grants
Special Subjects: Drawings, Landscapes, Painting-American, Latin American Art, Painting-American, Prints, African Art, Oriental Art
Collections: Waldo Peirce-oils, watercolors & lithographs & a diverse collection of contemporary American art; Pre-Columbian work
Exhibitions: (1/9/2007-2/24/2007) Measures of Time: David Burnett; (3/9/2007-4/28/2007) Selections from the Permanent Collection; (5/11/2007-6/23/2007) Southern Oregon Univ Art Faculty Biennial
Activities: Classes for adults & children; docent training; lect open to public, lects for mem only, 2 lect per yr; concerts; gallery talks; tours; lending original objects of art to other mus; book traveling exhibitions 1 per year; exhibs change every 7-8 wks

ASTORIA

M **COLUMBIA RIVER MARITIME MUSEUM,** 1792 Marine Dr, Astoria, OR 97103. Tel 503-325-2323; Fax 503-325-2331; Elec Mail information@crmm.org; Internet Home Page Address: www.crmm.org; *CEO & Dir* Jerry Ostermiller; *Cur* David Pearson; *Mus Shop Mgr* Rachel Wynne; *Educ Dir* Betsey Ellerbroek; *VPres* Cheri Folk
Open daily 9:30 AM - 5 PM, cl on Thanksgiving & Christmas; Admis adults $5, seniors $4, children $2, children under 6 free; Estab 1962 as a maritime mus, to collect, preserve & interpret maritime history of Pacific Northwest; Maintains seven galleries of nautical history including works of art; Average Annual Attendance: 97,000; Mem: 2000; dues $15; ann meeting in Oct
Income: $500,000 (financed by admis, sales, mem & individual & corporate donations
Special Subjects: Marine Painting
Collections: Maritime Paintings, Prints & Photography; Ship Models & nautical artifacts; Lightship Columbia
Exhibitions: Rotating & temporary exhibit space in Great Hall; visiting vessels as available
Publications: The Quarterdeck, quarterly
Activities: Classes for adults; volunteer opportunities; docent training; lect open to pub, 6 vis lectrs per yr; tours; competitions; outreach program to schools; individual paintings & original objects of art lent to accredited museums; mus shop sells books, limited edition prints, posters, reproductions, contemporary scrimshaw & jewelry
L **Library,** 1792 Marine Dr, Astoria, OR 97103. Tel 503-325-2323; Fax 503-325-2331; Internet Home Page Address: www.crmm.org; *Mem Records Coordr* Christina Young; *Cur* Dave Pearson
Open by appointment only; Estab as reference library for maritime activities relevant to the Northwest; Circ Non-circulating; Library for use on the premises; majority of contents are not relevant to art; Mem: 2000
Income: Financed by admis, trusts, mem dues & donations
Library Holdings: Book Volumes 6000; Cassettes; Clipping Files; Exhibition Catalogs; Manuscripts; Motion Pictures; Original Art Works; Pamphlets; Periodical Subscriptions 196; Photographs; Prints; Reproductions
Special Subjects: Maps, Historical Material, Drafting, Marine Painting, Scrimshaw
Publications: The Quarterdeck, quarterly

BANDON

NATIONAL COUNCIL ON EDUCATION FOR THE CERAMIC ARTS (NCECA)
For further information, see National and Regional Organizations

BEND

M **HIGH DESERT MUSEUM,** 59800 S Hwy 97, Bend, OR 97702-7962. Tel 541-382-4754; Fax 541-382-5256; Internet Home Page Address: www.Highdesert.org; *VPres Operations* Forrest Rodgers; *Dir Communications* Denise Costa; *VPres Progs & Exhibs Dir* Kevin Britz
Open daily 9 AM - 5 PM, cl Jan 1, Thanksgiving Day & Christmas; Admis adults $7.75, seniors $6.75, youth 13-18 $6.75, children between 5-12 $3.75; Estab 1974 to bring to life natural & cultural history of region; Brooks Gallery, Spirit of the West Gallery & Nancy R Chandler Memorial Gallery; Average Annual Attendance: 185,000; Mem: 5000; dues $35 & up; ann meeting in Sept
Income: Financed by mem, donations, grants, admis & sales
Special Subjects: Architecture, Drawings, Mexican Art, Painting-American, Prints, American Indian Art, American Western Art, Anthropology, Archaeology, Southwestern Art, Textiles, Primitive art, Woodcarvings, Manuscripts, Furniture, Historical Material, Maps, Painting-Spanish
Collections: Historical artifacts; Western art; wildlife sculpture, oils, watercolor, photography; Sherry Sander, sculpture; Georgia Gerber, sculpture; Joe Halco, sculpture; Rod Frederick, prints; Philip Hyde, photography
Exhibitions: Spirit of the West; The Plato of the Indians; Raptors of the Desert Sky
Publications: High Desert Quarterly; biannual exhibit catalogues
Activities: Classes for adults & children; docent progs; teacher in-service training; lect open to publ, 5-8 vis lectrs per yr; gallery talks; awards given; book traveling exhibs 1 per yr; mus shop sells books, magazines, original art, reproductions, prints, slides, folk art, jewelry, educ games & toys, nature items

COOS BAY

M **COOS ART MUSEUM,** 235 Anderson Ave, Coos Bay, OR 97420-1610. Tel 541-267-3901, 267-3948; Fax 541-267-4877; Internet Home Page Address: www.coosart.org; *Mus Adminr* Reed Lockhart; *VPres* Lynda Shapiro
Open Tues - Fri 10 AM - 4 PM, Sat 1 - 4 PM, cl Sun & Mon; Admis donations requested; Estab 1950 (relocated to an historic former Post Office Building in downtown district) to bring contemporary art to Northwestern Oregon through colls, exhibs & educ programming; Four galleries; Average Annual Attendance: 11,000; Mem: 400; dues family $35, single $25; annual meeting first quarter of yr
Special Subjects: Painting-American, Prints, Sculpture, Woodcuts
Collections: Contemporary American Printmakers; paintings, photographs, sculpture
Exhibitions: Changing exhibits of painting, print, sculpture
Publications: Annual Museum Newsletter; exhibit announcements, every 6 wks
Activities: Classes & workshops for adults & children; Artists-in-Education Program for pub schools; lect open to pub; concerts; gallery talks; tours; schols; rental & sales

COQUILLE

A **COQUILLE VALLEY ART ASSOCIATION,** 10144 Hwy 42, Coquille, OR 97423. Tel 541-396-3294; *VPres* Betty Banks; *Treas* Patsy Weaver; *Pres* Diana Amling
Open Tues - Sat 1 - 4 PM, cl Sun, Mon & holidays; No admis fee; Estab 1950 to

teach art & art appreciation; Gallery maintained on main floor of Art Assoc owned old refurbished schoolhouse; Mem: 120; dues $35 seniors $30; ann meetings first Wed in Apr

Income: Financed by mem, auctions, plant and rummage sales

Exhibitions: Exhibits by local members, as well as by others throughout the US

Publications: Monthly newsletter

Activities: Classes for adults & children; lect open to pub, 4-5 vis lectrs per yr; awards; individual paintings lent to banks, lobbies, automobile showrooms & music stores; sales shop sells original art, miniatures & handicraft

L **Library,** 10144 Hwy 42, Coquille, OR 97423. Tel 541-396-3294; *Pres* Diana Amling
Open to mems only

CORVALLIS

OREGON STATE UNIVERSITY

M **Fairbanks Gallery,** Tel 541-737-5009; Fax 541-737-8686; Elec Mail drussell@oregonstate.edu; *Gallery Dir* Douglas Russell
Open Mon - Fri 8 AM - 5 PM, weekends during special events; No admis fee; Estab 1933 to display work of contemporary artists; 120 linear ft; Average Annual Attendance: 5,000

Income: Financed by state appropriation & grants

Collections: Fine art print collection includes: Goya to Rauschenberg; Japanese Print Collection; Wendel Black Print Collection; German Expressionism

Activities: Lect open to public; gallery talks

M **Memorial Union Art Gallery,** Tel 541-737-8511; Fax 541-737-1565; Elec Mail ksumner@orst.edu; Internet Home Page Address: osumu.org/mu/events_coucourse1.htm; *Dir* Kent Sumner
Open daily 8 AM - 11 PM; Estab 1928; Average Annual Attendance: 50,000

Income: $70,000

Collections: William Henry Price Memorial Collection of Oil Paintings

Exhibitions: Various exhibs, call for details

Publications: Calendar & exhib pamphlets

Activities: Educ prog; lect; exten dept serving the State; individual paintings lent to schools; material available to responsible galleries for fees

M **Giustina Gallery,** Tel 541-737-2402; Fax 541-737-3187; *Gallery Dir* Melanie Fahrenbruch
Open Mon - Fri 8 AM - 5 PM, additional hrs during special events at LaSells Stewart Center; No admis fee; Estab 1981 to display work of contemporary artists; Gallery is 4,800 sq ft

Income: Financed by grants & state appropriation

Exhibitions: Exhibs changing monthly

EUGENE

M **LANE ARTS COUNCIL,** Jacobs Gallery, One Eugene Ctr, Eugene, OR 97401; 99 W 10th Ave Ste 100, Eugene, OR 97401. Tel 541-684-5635; Fax 541-485-2478; *Gallery Dir* Tina Rinaldi
Open Tues - Sat 11 AM - 3 PM and during Hult Ctr performances; No admis fee; Estab 1982 for art appreciation & educ; Gallery in lower level of Hult Center for the Performing Arts. Functions as a meeting & reception area, as well as a gallery; Average Annual Attendance: 10,000

Income: $70,000 (financed by gallery sales commissions & cost reimbursements from artists, fundraising & community donations)

Exhibitions: Exhibits selected rotating jury (3 mems) & scheduled by Jacobs Gallery Exhibition Committee

M **LANE COMMUNITY COLLEGE,** Art Dept Gallery, 4000 E 30th Ave, Eugene, OR 97405. Tel 541-463-5864; Fax 541-744-4185; Internet Home Page Address: www.lanecc.edu/artgallery
Open Mon - Fri 8 AM - 5 PM; No admis fee; Estab 1970 as an educational gallery exhibiting works by National & Northwest artists; 1 fl; Average Annual Attendance: 15,000

Income: Financed through county funds & state funds

Exhibitions: Rotating exhibs every three weeks

Activities: Lect open to pub, 9 vis lectrs per yr; gallery talks; competitions; schols offered

M **MAUDE KERNS ART CENTER,** (Maude I Kerns Art Center Galleries) 1910 E 15th Ave, Eugene, OR 97403. Tel 541-345-1571; Fax 541-345-6248; Elec Mail mkart@pond.net; Internet Home Page Address: www.premiererelink.com/clients/mkac; Internet Home Page Address: www.mkartcenter.org; *Pres* Bryce Krehbiel; *Exec Dir* Hilary Moster
Open Mon - Fri 10 AM - 5:30 PM, Sat Noon - 4 PM; Admis suggested $2 donation; Estab 1950, the Center is a nonprofit educational organization dedicated to promoting quality in the arts & crafts through classes, exhibs, workshops, community projects & special events; The center houses 3 galleries: Henry Korn Gallery, Brockelbank Gallery & Maude I Kerns Salon Gallery. Features monthly shows of contemporary artists, the work of Maude Kerns, Ceramics Co-op; Average Annual Attendance: 12,000; Mem: 500; dues family $55, individual $35; annual meeting in Jan/Feb

Income: $300,000 (financed by mem, class tui, art sales, contributions, grants, proceeds from ann outdoor fundraising festival)

Special Subjects: Drawings, Graphics, Ceramics, Crafts, Etchings & Engravings, Furniture, Glass, Jewelry

Collections: Maude I Kerns Collection

Exhibitions: Every 6 weeks exhibits featuring individual theme & group shows by Pacific Northwest artists; satellite gallery temporarily at 68 W Broadway downtown Eugene

Publications: Quarterly newsletter

Activities: Classes for adults & children; dramatic progs; volunteer program; workshops; seminars; lect open to pub; concerts; gallery talks; tours; competitions; schols offered; exten dept

M **NEW ZONE VIRTUAL GALLERY,** 2740 Onyx St, Eugene, OR 97401. Tel 541-343-5651; Fax 541-313-5651; Elec Mail ross@newzone.org; Internet Home Page Address: www.newzone.org; *Dir* Jerry Ross
Open Tues, Fri & Sat, 7 PM - 1 AM; Admis $3; Estab 1978 as a modern experimental gallery; A cyberspace gallery featuring experimental 2-D & 3-D art; Average Annual Attendance: 1,500; Mem: 20; dues $50; monthly meetings

Income: $10,000 (financed by federal & local arts grants)

Collections: Eric Peterson Collection (etchings); Mike Randells Collection (abstract figurative); Jerry Ross Collection (oils, landscape, figurative, portraits)

Exhibitions: Exhibits by members; invitationals

Publications: Exhibit brochures

Activities: Lect open to pub; competitions; sales shop sells prints

UNIVERSITY OF OREGON

M **Museum of Art,** Tel 541-346-3027; Elec Mail smcgough@oregon.uoregon.edu; lmfong@oregon.uoregon.edu; *Educ Dir* Lisa Abia-Smith; *Assoc Dir* Lawrence Fong; *External Affairs* Christie McDonald; *Acting Dir* Del Hawkins
Open Thurs - Sun Noon - 5 PM, Wed Noon - 8 PM, cl Mon, Tues & university holidays; Suggested donation $3; Estab 1930 to promote among university students & faculty & the general pub an active & continuing interest in the cultures of Asia; Average Annual Attendance: 50,000; Mem: 600; dues $10-$10,000; annual meeting in Spring

Income: $1,000,000 (financed by state appropriation, endowment income & private donations)

Special Subjects: Painting-American, Textiles, Oriental Art, Asian Art

Collections: Greater Pacific Basin Collection; Asian Art representing the cultures of China, Japan, Cambodia, Korea, Mongolia, Tibet, Russia, American & British works executed in the traditional Oriental manner; Northwest Art

Exhibitions: Various exhibits

Publications: Exhibition catalog

Activities: Docent training; lect open to pub, 5 vis lectrs per yr; gallery talks; individual paintings & original objects of art lent to other museums that can provide suitable security & climate control; book traveling exhibs 2-3 per yr; originate traveling exhibs to other art museums; sales shop sells books, slides, cards, gifts

M **Aperture Photo Gallery - EMU Art Gallery,** Tel 541-346-4373; Fax 541-346-4400; Internet Home Page Address: www.darkwing.uoregon.edu/cultural; *Asst Dir* Linda Dievendorf; *Asst Dir* Debby Martin
Open daily 7:30 AM - 12 AM; No admis fee; Estab 1981 to provide space for work of university community

Income: Financed by student fees

Exhibitions: Periodic art exhibs on portable display boards in various rooms; display in the art gallery of selections from the permanent coll

Activities: Classes for adults; lect

L **Architecture & Allied Arts Library,** Tel 541-346-3637; Internet Home Page Address: www.uoregon.edu./aaa/home; *Reference Librn* Kara List; *Visual Resources Cur* Christine L Sundt; *Head Librn* Ed Peague
Open Mon - Thurs 8 AM - 11 PM, Fri 8 AM - 7 PM, Sat 11 AM - 7 PM, Sun 11 AM - 11 PM; Estab 1915 to provide resources for the courses, degree programs & research of the departments in the School of Architecture & Allied Arts; Primarily for lending

Income: Financed by state appropriation

Library Holdings: Book Volumes 71,000; Exhibition Catalogs; Fiche; Periodical Subscriptions 400; Photographs 30,000; Slides 275,000

Special Subjects: Art History, Landscape Architecture, Interior Design, Aesthetics, Architecture

GRANTS PASS

M **ROGUE COMMUNITY COLLEGE,** Wiseman Gallery - FireHouse Gallery, 3345 Redwood Hwy, Grants Pass, OR 97527. Tel 541-956-7339; Fax 541-471-3588; Elec Mail tdrake@roguecc.edu; Internet Home Page Address: www.roguecc.edu/galleries; *Dir* Tommi Drake; *Dir Asst* Heather Green
Call for hours; No admis fee; Estab 1985 to present exhibits of high artistic content in a range of aesthetics which contribute to the educational environment & serve to inspire the community & to serve our community & students with an additional venue for fine art that will inspire, create & promote understanding of the arts & the part they play in our lives

Special Subjects: Painting-American, Prints, Sculpture

Collections: African tools; Japanese woodblock prints; varied paintings

Exhibitions: El Dia de los Muertos; NW Women in Art

Publications: Exhibit brochures; quarterly catalogues; monthly postals

Activities: Classes for adults & children; docent training; artist talks; workshops; lect open to pub, 10 vis lectrs per yr; gallery talks; competitions

KLAMATH FALLS

M **FAVELL MUSEUM OF WESTERN ART & INDIAN ARTIFACTS,** 125 W Main, PO Box 165 Klamath Falls, OR 97601. Tel 541-882-9996; Fax 541-850-0125; Elec Mail favellmusem@earthlink.net; Internet Home Page Address: www.favellmuseum.com; *Dir* Pat McMillan
Open Tues - Sat 9:30 AM - 5:30 PM, cl Sun; Admis adults $5, seniors 65 & over $4, youth 6 - 16 years $2; Estab 1972 to preserve Western heritage as represented by Indian artifacts & contemporary western art; Gallery features contemporary western artists combined with art & artifacts displays; Average Annual Attendance: 20,000; Mem: Patron mem

Income: $250,000 (financed by admis, sales & non-profit)

Purchases: Paintings by Charles Russell, McCarthy, Arlene Hooker Fay & James Bama; 800 works of art by 300 artists

Library Holdings: Book Volumes; Periodical Subscriptions

Special Subjects: American Indian Art, American Western Art, Pottery, Miniatures

Collections: Contemporary western art; Western Indian artifacts: pottery, stonework, baskets, bead and quiltwork; miniature firearms; archeological excavation site displays

Publications: A treasury of our Western Heritage (book on cross section of museum collection)

Activities: Lect open to pub; gallery talks; mus shop selling books, original art, prints, jewelry & gifts

A **KLAMATH ART ASSOCIATION,** PO Box 955, 120 Riverside Dr Klamath Falls, OR 97601. Tel 541-883-1833; *Pres* Will Dawson; *Co-Pres* Ken Barkee
Open Thurs - Sun Noon - 4 PM; No admis fee; Estab 1948 to provide art training for local residents; Gallery estab 1948 to provide display & teaching space for the

Association's activities; Average Annual Attendance: 5,000; Mem: 150; dues $15 - $20; meetings 7 PM third Wed of month
Income: Financed by mem, gallery sales, tuition
Collections: Ceramics; paintings; weaving (owned by members)
Exhibitions: Twelve annually; one mem show, remainder varies
Activities: Classes in painting, drawing, weaving; children's summer art classes; workshops; lect, vis lectr

M **KLAMATH COUNTY MUSEUM,** 1451 Main St, Klamath Falls, OR 97601. Tel 541-883-4208; Fax 541-884-0666; *Dir* Kim Bellabia
Open all year daily 9 AM - 5 PM Tues - Sat, cl Sun & Mon; Admis 12 & up $12, 62 & up, 5-12 $1, under 5 free; Estab 1957 to tell the story of the Klamath Country & to preserve & exhibit related material; Average Annual Attendance: 20,000
Income: Financed by county appropriation
Special Subjects: Historical Material
Collections: Indian & pioneer artifacts; four original Rembrandt etchings; Healey paintings; photograph document files
Exhibitions: Rotating exhibitions
Publications: Museum Research Papers
Activities: Mus shop sells books, reproductions of photos & area souvenirs

L **Research Library,** 1451 Main St, Klamath Falls, OR 97601. Tel 541-883-4208; Fax 541-884-0666; Elec Mail tourklco@cdsnet.net; *Dir* Kim Bellabia
Open to the pub for reference Tues - Sat 9 AM - 4:30 PM by appointment; Admis research fee; Estab 1955 to collect, preserve, document & interpret the local history
Income: Financed by County General Fund
Library Holdings: Book Volumes 10,000; Clipping Files; Manuscripts; Motion Pictures; Original Art Works; Pamphlets; Photographs 5000; Reels; Slides
Collections: Modoc Indian Books, Documents & Manuscripts
Activities: Guided tours for 4th grade students; school kits lent to area schools; sales shop sells books, prints, paintings, ceramic & other miscellaneous items

M **Baldwin Hotel Museum Annex,** 31 Main St, Klamath Falls, OR 97601. Tel 503-883-4208; Fax 541-884-0666; *Dir* Kim Bellabia
Open Tues - Sat 10 AM - 4 PM, June - Sept; Admis family $6, adults $3, students & seniors $2, under 3 free; A State & national historic landmark purchased by Klamath County in Jan 1978. Restoration of building began in Feb 1978 & it was dedicated as a mus by Oregon's Governor Robert Straub June 3, 1978. Opened to the pub Aug 19, 1978; May be viewed by tour only; Average Annual Attendance: 20,000
Income: Financed by county appropriations
Activities: Guided tours for 5th grade students; Mus shop sells books & original art

MARYLHURST

M **MARYLHURST UNIVERSITY,** The Art Gym, Marylhurst, OR 97036. Tel 503-636-8141; Fax 503-636-9526; Elec Mail artgym@marylhurst.edu; Internet Home Page Address: www.marylhurst.edu; *Dir* Terri M Hopkins
Open Tues - Sun Noon - 4 PM; No admis fee; Estab 1980; 3,000 sq ft; Average Annual Attendance: 5,000; Mem: 150; dues $15 - $500
Income: $80,000 (financed by mem, grants & college budget)
Special Subjects: Drawings, Graphics, Painting-American, Photography, Prints, Sculpture, Ceramics, Folk Art, Etchings & Engravings, Landscapes, Collages, Portraits, Furniture, Cartoons
Collections: Contemporary Northwest Art
Publications: Exhibition catalogs
Activities: Lect open to pub, 5 vis lectrs per yr; gallery talks; tours; schols offered; book traveling exhibs; originate traveling exhibs circulate to col galleries & museums; sales shop sells art gym catalogs & books

MEDFORD

A **ROGUE VALLEY ART ASSOCIATION,** Rogue Gallery & Art Center, 40 S Bartlett, Medford, OR 97501. Tel 541-772-8118; Fax 541-772-0294; Elec Mail judy@roguegallery.org; Internet Home Page Address: www.roguegallery.org; *Exec Dir* Judy Barnes; *Dir Educ* Lesley Klecan
Open Tues - Fri 10 AM - 5 PM, Sat 11 AM - 3 PM, cl Sun & Mon; No admis fee, donations accepted; Estab 1960 to provide a full range of programs, exhibits & classes to the region; Gallery 6000 sq ft, 2200 sq ft, sales & rental space, 2000 sq ft & 200 running ft of sliding panels; Average Annual Attendance: 20,000; Mem: 671; dues $20-$500; annual meeting in Jan
Income: Financed by mem dues, grants, fund raising events
Collections: Contemporary Northwest prints
Publications: Newsletter, 6 per yr
Activities: Classes for adults & children; lect open to pub, 2 vis lectrs per yr; gallery talks; tours; schols & fels offered; individual paintings lent through a rental prog to mems; lending coll contains art works, paintings, photographs & sculpture; book traveling exhibs 2-3 per yr; sales shop sells original art, crafts, books, prints, sculpture, pottery, jewelry, greeting cards

M **SOUTHERN OREGON HISTORICAL SOCIETY,** Jacksonville Museum of Southern Oregon History, 206 N Fifth St, Medford, OR; 106 N Central Ave, PO Box 480 Medford, OR 97501. Tel 541-773-6536; Fax 541-776-7994; Elec Mail educate@sohs.org; Internet Home Page Address: www.sohs.org; *Dir Develop* Dorann Gunderson; *Finance Dir* Maureen Smith; *Cur Coll & Exhibs* Mary Ames Sheret; *VIP Coordr* Dawna Curler; *Head Art & Media* Dana Hendrick; *Mem Coordr* Susan Cox-Smith; *Cur Educ* Sabrina Rode; *Prog Dir* Emila Chamberlin; *Oral Historian* Jay Leighton; *Exec Dir* Brad Linder
Open Wed - Sat 10 AM - 5 PM, Sun Noon - 5 PM; Admis adults $3, seniors & children over 6 $2, children under 6 free; Estab 1946 to preserve, promote & interpret the history of southern Oregon; Incl are the Peter Britt Gallery (19th century photography artifacts); Children's Mus (next door in old county jail, a hands-on mus, includes the Pinto Gallery of Bozo the Clown). The historic sites include the Cornelius C Beekman House (1876), Beekman Bank (1863), Catholic

Rectory (circa 1861), US Hotel (1880); Average Annual Attendance: 114,194; Mem: 1810; dues $30; annual meeting in Nov
Income: Financed by mem, pub & private grants & county historical fund
Special Subjects: Drawings, Painting-American, Photography, Watercolors, Archaeology, Textiles, Costumes, Folk Art, Decorative Arts, Dolls, Furniture, Glass, Historical Material, Period Rooms, Embroidery
Collections: Relate to the scope & diversity of human experience in Jackson County & the southern Oregon region
Exhibitions: Rotating exhibits
Publications: Table Rock Sentinel, bimonthly; ArtiFACTS, monthly newsletter
Activities: Classes for adults & children; docent training; lect open to pub; concerts; gallery talks; tours; sales shop sells books, magazines & reproductions; junior mus

L **Library,** 106 N Central Ave, Medford, OR 97501-5926. Tel 541-773-6536; Fax 541-776-7994; *Library Mgr* Carol Harbison-Samuelson; *Archivist & Historian* William Alley; *Library Archives Coordr* Jacquelyn Sundstrand
Open Tues - Fri 1 - 5 PM; Open to public for reference only
Income: Financed by mem, sales & county tax
Library Holdings: Book Volumes 4900; Cassettes; Clipping Files; Exhibition Catalogs; Fiche; Filmstrips; Manuscripts; Maps; Memorabilia; Original Art Works; Other Holdings Ephemera, art on paper; Pamphlets; Periodical Subscriptions 30; Photographs; Prints; Reels; Video Tapes
Special Subjects: Photography, Maps, Painting-American, Historical Material, Portraits, Watercolors, Archaeology, American Western Art, Anthropology, Furniture, Gold, Restoration & Conservation, Textiles, Architecture
Publications: Southern Oregon History, quarterly

MONMOUTH

M **WESTERN OREGON UNIVERSITY,** Campbell Hall Gallery, 345 Monmouth Ave, Monmouth, OR 97361. Tel 503-838-8241; Fax 503-838-8474; Elec Mail johnsos@wou.edu; Internet Home Page Address: www.wou.edu; *Head Art Dept* Don Hoskisson; *Dir Gallery* Suellen Johnson
Open Thurs & Fri 8 AM - 5 PM during scheduled exhibits, Mon - Wed 8 AM - 6 PM; No admis fee; Estab to bring contemporary art work to the community & the college for study & visual understanding; Library located in Art Department, Campbell Hall; Average Annual Attendance: 3,000-4,000
Income: $6,000 (financed by state appropriation & student fees)
Exhibitions: Contemporary Northwest Visual Art; rotating faculty & student exhibits
Activities: Educ program; lect open to public, 6 vis lectrs per year; gallery talks; tours; competitions with awards; scholarships offered

NORTH BEND

M **COOS COUNTY HISTORICAL SOCIETY MUSEUM,** 1220 Sherman, North Bend, OR 97459. Tel 541-756-6320; Fax 541-756-6320; Elec Mail museum@ucii.com; Internet Home Page Address: www.coohistory.org; *Dir* Ann Koppy; *Pres* Reg Pullen; *VPres* Steve Grief
Open Tues - Sat 10 AM - 4 PM; Admis $2, children 12 & under $1; Estab 1891 to collect, preserve & interpret history of Coos County; Average Annual Attendance: 7,255; Mem: 450; dues $10-$250; annual meeting in June
Income: $60,000 (financed by endowment, mem, admis, sales & donations)
Collections: Maritime objects; Native American artifacts; photographs; tools/implements of pioneer lifeways
Exhibitions: Pioneer Kitchen; Formal Parlor (c1900); rotating Exhibits; Maritime
Publications: Coos Historical Journal, annual; trimonthly newsletter
Activities: Lect open to pub, vis lectr; lending coll contains 100 items

PORTLAND

L **ART INSTITUTES INTERNATIONAL AT PORTLAND,** 1122 NW Davis St, Portland, OR 97209. Tel 503-228-6528; Fax 503-228-4227; Elec Mail aipdadm@aii.edu; Internet Home Page Address: www.aii.edu; *Pres* Dr Steven Goldman; *Dean Educ* Eric Lindstrom; *Librn* Nancy Thurston
Open daily 7:30 AM - 6 PM, open some evenings, Sat 10 AM - 4:30 PM; No admis fee; Estab 1964 to provide practical instruction in retail merchandising, interior design, display, fashion design, advertising & promotion, fashion history & textiles, industrial design; Average Annual Attendance: 200
Library Holdings: Book Volumes 14,000; Clipping Files; Periodical Subscriptions 120; Slides; Video Tapes 300
Special Subjects: Art History, Fashion Arts, Industrial Design, Interior Design, Furniture, Costume Design & Constr, Textiles
Collections: Collection of Fashion & Costume History Books; Collection in Furniture & Interior Decoration Fields; Collection of Graphic Design & Multimedia
Exhibitions: Rotating exhib
Activities: Schols offered

M **BLUE SKY GALLERY,** Oregon Center for the Photographic Arts, 1231 NW Hoyt St, Portland, OR 97209. Tel 503-225-0210; Elec Mail bluesky@blueskygallery.org; Internet Home Page Address: www.blueskygallery.org; *Dir* Kirsten Rian
Open Tues - Sat Noon - 5 PM; No admis fee; Estab 1975; Average Annual Attendance: 12,000; Mem: Dues $35 per year
Income: 501(c)3 - mems, grants, sales
Exhibitions: Monthly rotating exhibits
Activities: Lect open to pub; 12 vis lects per yr

M **CONTEMPORARY CRAFTS MUSEUM & GALLERY,** (Contemporary Crafts Gallery) 3934 SW Corbett Ave, Portland, OR 97201; 3934 SW Corbett Ave, Portland, OR 97239. Tel 503-223-2654; Fax 503-223-0190; Elec Mail info@contemporarycrafts.org; Internet Home Page Address: www.contemporarycrafts.org; *Dir* Darcy Edgar; *Vis Artist-in-Residence* Kyoko Tokumaru; *Dir* David Cohen; *Cur* William Henning; *Exhib Coordr* Lisa Donte
Open Tues - Sat 10 AM - 5 PM, Sun 1 - 5 PM, cl Mon; No admis fee; Estab 1937 to promote, exhibit & preserve the art of craft; Gallery is maintained also as

a consignment outlet & holds exhibits monthly; Average Annual Attendance: 30,000; Mem: 1000; dues $30
Income: $114,000 (financed by mem)
Library Holdings: Book Volumes; Clipping Files; Exhibition Catalogs; Memorabilia; Original Documents; Pamphlets; Periodical Subscriptions; Slides
Special Subjects: Crafts
Collections: Craft objects in ceramic, glass, metal, wood & fiber
Publications: Contemporary Crafts News, quarterly
Activities: Docent training; performances; clinics; symposia; lect open to public, some for members only; 10-12 vis lectrs per year; gallery talks; tours; competitions; artist-in-residence; originate traveling exhibitions; sales shop sells books, fine crafts, original art

M Contemporary Crafts Gallery, 3934 SW Corbett Ave, Portland, OR 97239. Tel 503-223-2654; Fax 503-223-0190; Elec Mail info@contemporarycrafts.org; Internet Home Page Address: www.contemporarycrafts.org; *Dir* David Cohen; *Dir of Exhibitions* Lisa Conte; *Marketing Assoc* Katherine Boree; *Sales Gallery Mgr* Simon Mangiaracina
Open Tues - Sat 10 AM - 5 PM, Sun 1 - 5 PM; No admis fee; Estab 1937 to further fine crafts in the NW; 1700 sq ft exhib space plus permanent collection gallery; Average Annual Attendance: 40,000; Mem: 525
Income: Financed by grants, contributions, fundraising
Library Holdings: Book Volumes 430; Cassettes; Clipping Files; Exhibition Catalogs; Lantern Slides; Manuscripts; Original Documents; Other Holdings; Periodical Subscriptions 260; Photographs; Slides; Video Tapes
Publications: 3934 Corbett, Soul of a Bowl
Activities: Classes for children; lect open to the pub, 10 vis lectrs per yr; concerts; gallery talks; tours; sponsoring of competitions; fels; purchase awards for competitions; sales shop sells original art & fine crafts on consignment

L MULTNOMAH COUNTY LIBRARY, Henry Failing Art & Music Dept, 801 SW Tenth, Portland, OR 97205. Tel 503-988-5123; Internet Home Page Address: www.multcolib.org; *Multnomah County Libr Interim Dir* Molly Raphael; *Dir Central Library* Vailey Oehlke
Open Mon & Thurs 10 AM - 6 PM, Tues & Wed 10 AM - 8 PM, Sun 12 - 5 PM; No admis fee; Estab 1864 as a pub library service to Multnomah County
Library Holdings: Book Volumes over 60,000; Clipping Files 800,000
Special Subjects: Art History, Decorative Arts, Photography, Painting-American, Painting-French, Painting-Italian, Prints, Sculpture, Painting-European, History of Art & Archaeology, Watercolors, Ceramics, Crafts, Latin American Art, Asian Art, Oriental Art, Pottery, Architecture
Exhibitions: Rotating exhibits in the Collins Gallery

L OREGON COLLEGE OF ART & CRAFT, (Oregon College of Art Craft) Hoffman Gallery, 8245 SW Barnes Rd, Portland, OR 97225. Tel 503-297-5544; Fax 503-297-9651; Elec Mail adebow@ocac.edu; Internet Home Page Address: www.ocac.edu; *Pres* Bonnie Laing-Malcolmson; *Develop Officer* Barb Audiss; *Exhibs Dir* Arthur DeBow; *Dir Communications* Jody Creasman; *Exten Prog Dir* Sara Black
Open daily 10 AM - 5 PM, cl holidays; No admis fee, except for special events & classes; Estab 1907 to teach seven disciplines in the arts & crafts; Hoffman Exhibition Gallery features national & international craftspeople. Maintains library; Average Annual Attendance: 30,000; Mem: 600; dues $35 - $1000; annual meeting in June
Income: Financed by tui, endowment, mem, state appropriation & National Endowments of the Arts, Washington, DC
Library Holdings: Book Volumes; Exhibition Catalogs; Periodical Subscriptions; Slides
Special Subjects: Art History, Collages, Folk Art, Decorative Arts, Calligraphy, Etchings & Engravings, Ceramics, Crafts, Asian Art, Furniture, Costume Design & Constr, Glass, Bookplates & Bindings, Carpets & Rugs, Embroidery, Enamels
Collections: Permanent collection of historic, traditional craftwork
Exhibitions: Annual Juried Student Show; Thesis Show; Craft Biennial; Biennial faculty show
Publications: Course schedules, quarterly; gallery announcements, 12 per yr; newsletter to mems, 2 per yr; 2 yr catalog; 2 yr viewbook
Activities: Classes & workshops for adults; classes for children; BFA & certificate program in crafts; lect open to pub; 10-12 vis lect per year; concerts; gallery talks; tours; schols offered; exten prog serves fine craft: book arts, ceramics, drawing, fibers, metals, photography, wood; mus shop sells books, magazines, original art, prints & crafts

L Library, 8245 SW Barnes Rd, Portland, OR 97225. Tel 503-297-5544; Fax 503-297-9651; *Librn* Lori Johnson; *Librn* Jean Peick
Open Mon - Thurs 8:30 AM - 7 PM, Fri 9 AM - 5 PM, Sat & Sun Noon - 5 PM; Estab 1979; Craft reference library for students & faculty & others interested in crafts
Library Holdings: Book Volumes 5500; DVDs; Exhibition Catalogs; Original Art Works; Pamphlets; Periodical Subscriptions 90; Photographs; Prints; Slides; Video Tapes
Special Subjects: Photography, Drawings, Painting-American, Ceramics, Printmaking, Glass, Metalwork, Textiles, Architecture
Activities: Interlibrary loan services available

A OREGON HISTORICAL SOCIETY, Oregon History Center, 1200 SW Park Ave, Portland, OR 97205. Tel 503-222-1741; Fax 503-221-2035; Elec Mail orhist@ohs.org; Internet Home Page Address: www.ohs.org; *COO* Phil Edin; *CFO* Myron Roberts; *Dir Artifact Coll & Exhibits* Marsha Matthews; *Dir* Norma Paulus; *Maps Librn* Elizabeth Winroth; *COO* Glenn Mason; *Dir Develop & Mktg* Sharon Blus; *CFO* Jeff Peterson; *Film Archivist* Michele Kribs; *Mus Shop Mgr* Lilla Villasenor; *Pub Information Officer* Ken DuBois; *Dir Image Coll* Susan Seyl; *Dir Research Library* Maryann Campbell; *VPres* John Burns; *Dir Oregon Folklife* Nancy Nusz; *Oregon Historical* Marianne Keddington-Lang
Open Tues, Wed, Fri & Sat 10 AM - 5 PM, Thurs 10 AM - 8 PM, Sun Noon - 5 PM; Admis adults $6, students $3, $1.50 children 6 - 12; Estab 1873, incorporated 1898, to collect, preserve, exhibit & publish materials pertaining to the Oregon country; Approx 20,000 sq ft of exhibit space; Society maintains historic 1856 James F. Bybee House, Howell Territorial Park, Sauvie Island; Average Annual Attendance: 150,000; Mem: 7000; dues individual & family $40 - $60, senior $35, student $25; annual meeting Nov

Income: $6,792,754 biennially (financed by state appropriation, mem, grants, gifts & donations)
Collections: Artifacts, Manuscripts, paintings, photographs, collection by Oregon Country & Oregon State artists
Publications: Oregon Historical Quarterly; books; maps; pamphlets; newsletter, OHS Spectator
Activities: Classes for adults & children; docent training; gallery talks; Fellowships; ALA Cleo Award AAM; mus shop sells books, reproductions & prints

L Research Library, 1200 SW Park Ave, Portland, OR 97205. Tel 503-306-5240; Fax 503-219-2040; Elec Mail orhist@ohs.org; Internet Home Page Address: www.ohs.org; *Libr Dir* Maryann Campbell
Open Wed 1 - 5 PM; Admis Fee $10 non-mems; Estab 1898; For reference only; Average Annual Attendance: 4,000
Income: Dept within Oregon Hist Soc
Library Holdings: Audio Tapes; Book Volumes 100,000; Cards; Cassettes; Clipping Files; Exhibition Catalogs; Fiche; Filmstrips; Framed Reproductions; Kodachrome Transparencies; Lantern Slides; Manuscripts; Maps; Memorabilia; Micro Print; Motion Pictures; Original Art Works; Original Documents; Other Holdings Original documents; Pamphlets; Periodical Subscriptions 620; Photographs; Prints; Records; Reels; Reproductions; Sculpture; Slides; Video Tapes
Special Subjects: Film, Manuscripts, Maps, Painting-American, Historical Material, Architecture
Collections: 4500 separate manuscript collections containing 18,000,000 pieces; 2,500,000 historic photographs & negatives; 15,000 maps; Oral history; Microfilm; Film
Activities: Geneology & archives workshops

M PORTLAND ART MUSEUM, 1219 SW Park Ave, Portland, OR 97205. Tel 503-226-2811; Fax 503-226-4842; Elec Mail admin@pam.org; Internet Home Page Address: www.portlandartmuseum.org; *Dir Develop* Lucy Buchanan; *Chief Cur & Cur Asian Art* Donald Jenkins; *Cur Native American Art* Bill Mercer; *Cur Photog* Terry Toedtemeier; *Cur Prints & Drawing* Gordon Gilkey; *Cur Educ* Judy Schultz; *Registrar* Ann Eichelberg; *Exec Dir* John E Buchanan Jr
Open Tues - Sun 10 AM - 5 PM, first Thurs of each month until 9 PM; Admis adults $7.50, adult groups $6, seniors & students (over 18) $6, students (5-18) $4, school groups $2.50, mem & children under 2 free. Special exhib fees & extended hours may apply; Estab 1892 to serve the pub by providing access to art of enduring quality, by educating a diverse audience about art & by collecting & preserving a wide range of art for the enrichment of present & future generations; The mus campus consists of two buildings. The main building, designed by Pietro Belluschi, was built in three stages. The Ayer (1932) & Hirsch (1939) wings comprise the museum's current 19 galleries (26,942 sq ft). The Hoffman wing (1968) is undergoing renovation. Maintains reference library; Average Annual Attendance: 400,000; Mem: 16,000; dues $35 & up; ann meeting in Sept
Income: Financed by admis, endowment, grants, contributions & mem
Special Subjects: Drawings, Graphics, Painting-American, Photography, Prints, Sculpture, American Indian Art, African Art, Pre-Columbian Art, Ceramics, Etchings & Engravings, Decorative Arts, Painting-European, Eskimo Art, Oriental Art, Asian Art, Silver, Carpets & Rugs, Coins & Medals, Calligraphy, Renaissance Art, Laces, Antiquities-Oriental, Antiquities-Greek
Collections: Elizabeth Cole Butler Collection of Native American Art; Gebauer Collection of Cameroon Art; Vivian & Gordon Gilkey Graphics Art Collection; Samuel H Kress Collection of Renaissance Painting & Sculpture; Mary Andrews Ladd Collection of Japanese Prints; Lewis Collection of Classical Antiquities; Alice B Nunn Collection of English Silver; Rassmussen Collection of Northwest Coast Indian & Eskimo Arts; Evan H Roberts Memorial 19th & 20th Century Sculpture Collection; American 19th & 20th century paintings, sculpture & decorative arts; Asian sculptures, paintings, bronzes, ceramics & other decorative arts; European paintings, sculpture & decorative arts; Persian & Indian miniatures; Pre-Columbian Art; 20th century photographs, modern & contemporary art, sculpture
Exhibitions: Oregon Biennial Juried Group Exhibition
Publications: Annual report; Exhibition catalogs; collection catalogs
Activities: Educ program; workshops for students & adults; docent training; lect open to the pub, 20-25 vis lectrs per yr; gallery talks; tours; competition; individual paintings & original objects of art lent to museums & art galleries; book traveling exhibs 4-5 per yr; originate traveling exhibs; mus shop sells books & reproductions

L Crumpacker Family Library, 1219 SW Park Ave, Portland, OR 97205. Tel 503-276-4215; Fax 503-226-4842; Elec Mail library@pam.org; Internet Home Page Address: www.pam.org; *Library Dir* Debra Royer
Open Mon - Thurs 10 AM - 5 PM; Estab 1892 to provide reference for pub & Portland Art Association members, mus staff
Library Holdings: Auction Catalogs; Audio Tapes; Book Volumes 33,000; CD-ROMs; Cassettes; Clipping Files; Exhibition Catalogs; Lantern Slides; Motion Pictures; Original Documents Portland Art Assn Archive; Other Holdings Northwest artist archive; Pamphlets; Periodical Subscriptions 75; Photographs; Records; Slides 5000; Video Tapes
Special Subjects: Art History, Folk Art, Islamic Art, Painting-American, Pre-Columbian Art, American Western Art, Asian Art, American Indian Art, Mexican Art, Afro-American Art, Oriental Art
Activities: Educ program; docent training; lect open to pub; gallery talks; tours; museum shop sells books, gift items; Rental Sales Gallery sells original art

A Northwest Film Center, 1219 SW Park Ave, Portland, OR 97205. Tel 503-226-2811; Fax 503-226-4842; Elec Mail paminfo@pam.org; Internet Home Page Address: www.pam.org/pam/; *Dir* Bill Foster; *Mus Shop Mgr* Cindy Boswell; *Cur Prints & Drawings* Annette Dixon; *Cur Photog* Terry Toedtemeier; *Assoc Cur American Art* Margaret Bullock; *Dir Operations* Rob Bearden; *Chmn Bd* Tom Holce; *Cur Native American Art* Bill Mercer; *Conservator* Elizabeth Chambers; *Cur Asian Art* Donald Jenkins; *Chief Cur* Bruce Guenther; *Librn* Debra Royer; *Cur Educ* Elizabeth Garrison; *Consulting Cur European Art* Penelope Hunter-Stiebel; *Exec Dir* John E Buchanan; *Registrar* Ann Eichelberg; *Dir Finance* Judy Poe; *Dir Develop* Lucy Buchanan; *Merchandising Mgr* Doug Mouw
Open Tues - Sat 10 AM - 5 PM; Admis $6; Estab 1972 as a regional media arts center; Maintains film archive, circ film library, film & video exhib prog & classes; Average Annual Attendance: 60,000

Income: financed by admissions, grants, contributions, mems, endowments
Library Holdings: Filmstrips; Other Holdings
Exhibitions: Annual Northwest Film & Video Festival; Best of the Northwest: New Work by Film & Video Artists in Oklahoma, Washington, Iowa, Montana & Alaska; Portland International Film Festival; Young Peoples Film Festival
Activities: Film screening program; courses in film and video; video/filmmaker-in-schools program; lect open to public, 24 vis lectrs per year; competitions with awards; scholarships & fels offered; exten dept; originate traveling exhibitions

M **PORTLAND CHILDREN'S MUSEUM,** 4015 SW Canyon Rd Portland, OR 97221. Tel 503-223-6500; Elec Mail vstanford@ci.portland.or.us; Internet Home Page Address: www.portlandcm2.org; *Exec Dir* Verne Stanford; *Dir Operations* David Cohen; *Dir Learning Servs* Margaret Eickmann; *Dir Prog* Divonna Ratliff; *Develop Dir* Candace Horter
Open Tues - Thurs & Sat 9 AM - 5 PM, Fri 9 AM - 8 PM, Sun 11 AM - 5 PM, cl Mon; Admis $5; Estab 1949; reorganized in 2000 as a pvt not-for-profit childrens mus dedicated to inspiring creative behavior in children; Mus has 6 art studios, 2 party rooms, cafe & mus store; Average Annual Attendance: 95,000; Mem: 2500; dues $30 - $250
Income: Financed 85% by earned income & 15% contribution
Collections: Children's art; natural history, toys, dollhouses, miniatures; multicultural artifacts relating to children's culture; teaching collection
Exhibitions: KidCity Market, WaterWorks, Me & My Shadow, Zounds!, Mirror, Mirror, Changing Visions, Construct, Vroom Room, Kids Clinic, Once Upon A Time, Baby's Garden & Art Loft
Activities: Hands-on art activity for children; mus shop sells educ books & toys for children, creative teaching material for teachers, parents & caregivers

M **PORTLAND COMMUNITY COLLEGE,** North View Gallery, 12000 SW 49th Ave, Portland, OR 97219. Tel 503-977-4269; Fax 503-977-4874; *Dir* Hugh Webb
Open Mon - Fri 8 AM - 4 PM; No admis fee; Estab 1970; Gallery's primary focus on contemporary Northwest artists, through solo shows, group invitations, installations & new genres; Average Annual Attendance: Over 20,000 in the Portland Metro area
Income: Financed by the college
Exhibitions: Contemporary art of the Northwest
Activities: Lect open to pub; 4-6 vis lectrs per yr; schols & fels offered

PORTLAND STATE UNIVERSITY
M **Littman Gallery,** Tel 503-725-5656; Fax 503-725-5680; *Coordr* Ann Amato; *Co-Coordr* Sarah Humiston
Open Mon - Fri Noon - 4 PM; No admis fee; Estab 1980 to exhibit art in variety of media, style & geographic distribution; Gallery space has 1500 sq ft
Exhibitions: 7-10 exhibs annually
Activities: Lect open to pub; 3 vis lectrs per yr; gallery talks
M **White Gallery,** Tel 503-725-5656; Fax 503-725-5080; *Coordr* Ann Amato
Open Mon - Fri 8 AM - 10 PM, Sat 9 AM - 7 PM; No admis fee; Estab 1970 as a student operated gallery exhibiting works by professional artists representing primarily photography
Collections: Permanent collection contains work by local professional artists with a few nationally recognized artists
Exhibitions: 11 exhibitions annually
Activities: Lect open to pub; gallery talks; individual paintings & original objects of art lent to other schools or museums; lending coll contains original prints, paintings & sculpture

M **REED COLLEGE,** Douglas F Cooley Memorial Art Gallery, 3203 SE Woodstock Blvd, Portland, OR 97202-8199. Tel 503-777-7251, 777-7790; Fax 503-788-6691; Internet Home Page Address: www.reed.edu; *Acting Dir* Silas B Cook
Open Tues - Sun Noon - 5 PM, Drawings Room open by appointment for study of works on paper; No admis fee; Estab 1989 to enhance the teaching of art, art history & the humanities. The prog brings to the col & the community exhibs of art from a variety of periods & traditions as well as significant contemporary art not otherwise available in the Northwest
Special Subjects: Prints
Collections: Pre-20th century prints; 20th century prints, drawings, paintings, photographs & sculptures
Publications: Brochures; catalogues
Activities: Pub openings; lects; gallery talks

A **REGIONAL ARTS & CULTURE COUNCIL,** Metropolitan Center for Public Arts, 108 NW 9th Ave Ste 300, Portland, OR 97209. Tel 503-823-5111; Fax 503-823-5432; Elec Mail info@racc.org; Internet Home Page Address: www.racc.org; Telex 503-823-6868; *Chmn* Mary Edmeades; *Dir* Eloise Damrosch; *Office Mgr* Marci Cochran
Open Mon - Fri 8:30 AM - 5:30 PM; No admis fee; Estab 1973, to promote and encourage progs to further the development and pub awareness of and interest in the visual and performing arts
Income: Financed by city & county appropriation
Purchases: Visual Chronicle of Portland, one percent for Public Art projects
Collections: Works by local artists
Publications: Newsletter, bimonthly
Activities: Artist in Residence Program for elementary schools; competitions with awards; schols offered; individual paintings & original objects of art lent

M **UNIVERSITY OF PORTLAND,** Buckley Center Gallery, 5000 N Willamette Blvd, Portland, OR 97203. Tel 503-283-7258; *Co-Dir* Michael Miller; *Co-Dir* Mary Margaret Dundore
Open Mon - Fri 8:30 AM - 8 PM, Sat 8:30 AM - 4 PM; Estab 1977
Exhibitions: Noel Thomas; Terry Waldron; Martha Wehrle

L **UNIVERSITY OF PORTLAND,** Wilson W Clark Memorial Library, 5000 N Willamette Blvd, PO Box 83017 Portland, OR 97283-0017. Tel 503-943-7111; Elec Mail library@up.edu; *Dir* Rich Hines; *Reference Librn* Heidi Senior; *Technical Svcs Librn* Susan Hinken
Open Mon - Thurs 7:30 AM - 12 AM, Fri 7:30 AM - 10 PM, Sat 10 AM - 6 PM, Sun Noon - 12 AM; Estab 1901 to support the university curriculum; Circ 50,000; Maintains an art gallery with a rotating exhibit

Income: Financed through the univ
Library Holdings: Book Volumes over 121,000; Compact Disks; Fiche; Filmstrips; Manuscripts; Maps; Original Art Works; Original Documents; Periodical Subscriptions; Records; Sculpture; Slides; Video Tapes over 4000
Collections: Rotating collections

A **WEST HILLS UNITARIAN FELLOWSHIP,** Doll Gardner Art Gallery, 8470 SW Oleson Rd, Portland, OR 97223. Tel 503-246-3351, 244-1379; Internet Home Page Address: www.whuuf.org
Open Mon, Tues & Thurs 12:30 - 3 PM, Sun Noon - 1 PM; No admis fee; Estab 1970 to give professional artists one or two-man shows in a lovely gallery space & to expose the congregation & pub to fine visual art; The entire sanctuary wall space is like a large gallery & the building is light, airy with a woodsy backdrop
Income: $30,000 (financed by mem)
Collections: Paintings, wall sculptures by local artists
Publications: Bulletin, weekly; newsletter, monthly
Activities: Classes for adults & children; dramatic progs; lect open to pub, 8 vis lectrs per yr; concerts

ROSEBURG

PASTEL SOCIETY OF OREGON
For further information, see National and Regional Organizations

SAINT BENEDICT

L **MOUNT ANGEL ABBEY LIBRARY,** 1 Abbey Rd, Saint Benedict, OR 97373. Tel 503-845-3317; Fax 503-845-3500; Elec Mail paulah@mtangel.edu; *Head Librn* Paula Hamilton
Open 8:30 AM - 5 PM & 6:30 - 9:30 PM, weekends 10:30 AM - 4:30 PM; No admis fee; Estab 1882; The library serves Mount Angel Abbey, Mount Angel Seminary & the pub. It sponsors art exhibits in the foyer designed for this purpose & makes the auditorium available for concerts
Library Holdings: Book Volumes 275,000; Fiche 10; Framed Reproductions 30; Manuscripts; Original Art Works 100; Periodical Subscriptions 1000; Prints 30
Exhibitions: Local artists; changes monthly
Publications: Angelus, quarterly
Activities: Classes for adults

SALEM

A **SALEM ART ASSOCIATION,** 600 Mission St SE, Salem, OR 97302. Tel 503-581-2228; Internet Home Page Address: www.salemart.org; *Exec Dir* Debby Leahy
Open Tues - Fri 10 AM - 5 PM, Sat & Sun Noon - 5 PM; No admis fee; Estab 1919 to collect, preserve & interpret history & art; Sales gallery & exhib galleries featuring contemporary art; Average Annual Attendance: 125,000; Mem: 1500; dues $25; ann meeting in Sept
Income: $900,000 (financed by sales, Salem Art Fair & Festival special fundraisers, admis, mem & donations)
Exhibitions: 10 exhibits yearly in 2 galleries
Publications: Art Matters newsletter, 3 per year; class schedule, 5 per year
Activities: Classes for adults & children; lect open to pub; gallery talks; sales shop sells original art

M **Bush Barn Art Center,** 600 Mission St SE, Salem, OR 97302. Tel 503-581-2228; Internet Home Page Address: www.salemart.org; *Dir Exhib* Julie Larson; *Exec Dir* Kenneth Dale
Open Tues - Fri 10 AM - 5 PM, Sat & Sun Noon - 5 PM; No admis fee; Estab 1965 to exhibit the best art of the past & the present; Houses the A N Bush Gallery & Corner Gallery which features 10 exhibs each yr & a sales gallery of Northwest art & crafts; Average Annual Attendance: 20,000
Exhibitions: Native American Abstract Design
Activities: Docent training; awards; schols offered; individual paintings rented to mems only (2-D work only)

M **Bush House Museum,** 600 Mission St SE, Salem, OR 97302. Tel 503-363-4714; Internet Home Page Address: www.salemart.org; *Bush House Coordr* Patricia Narcum-Perez; *Bush House Coordr* Sara Heil Swanborn
Open Summer Tues - Sun Noon - 5 PM, Winter Tues - Sun 2 - 5 PM; Admis adults $4, seniors & students $3, children 6-12 $2, ages 5 & under free; Estab 1953 to preserve & interpret the legacy of Asahel Bush II and his children; Contains 16 room mansion with original furnishings; Average Annual Attendance: 10,000
Special Subjects: Decorative Arts, Furniture
Collections: Decorative art, furniture, books, documents & antiques, Victorian
Activities: Classes for children, docent training; tours; museum shop sells books, post cards & brochures

L **Archives,** 600 Mission St SE, Salem, OR 97302. Tel 503-363-4714; Internet Home Page Address: www.salemart.org; *Bush House Coordr* Patricia Narcum-Perez
Open Tues - Sun Noon - 4 PM by appointment only; No admis fee; Estab 1953; Circ Non-circulating; For reference only
Library Holdings: Audio Tapes; Book Volumes 150; Cassettes; Clipping Files; Manuscripts; Memorabilia; Motion Pictures; Photographs; Video Tapes
Collections: Bush family papers 1840-1950
Exhibitions: Victorian Historic House with furniture

M **WILLAMETTE UNIVERSITY,** Hallie Ford Museum of Art, 700 State St, Salem, OR, 97301; 900 State St, Salem, OR 97301. Tel 503-370-6855; Fax 503-375-5458; Elec Mail museum-art@willamette.edu; Internet Home Page Address: www.willamette.edu/museum_of_art/; *Dir* John Olbrantz; *Asst to Dir* Carolyn Harcourt; *Coll Cur* Mary Parks; *Educ Cur* Elizabeth Garrison; *Preparator* Keith Lachowicz
Open Tues - Sat 10 AM - 5 PM; Sun 1 PM - 5PM; Admis adult $3, students & seniors $2, children under 12 free; Estab 1998 to support the liberal arts curriculum of Willamette Univ & to serve as an intellectual & cultural resource

for the campus, the City of Salem & surrounding area; The Hallie Ford Mus of Art maintains a 27,000 sq ft facility which includes permanent galleries devoted to colls of regional art, Native American Art, & Asian, European & American Art; Average Annual Attendance: 30,000; Mem: 375 mem; Dues $25 - $1,000
Income: Financed by endowment, mem, admissions, grants, sales
Collections: Regional art; Native American art; American, European, Asian art; American, European, Asian works on paper
Exhibitions: Temporary exhibs devoted to historic & contemporary art
Publications: Newsletter - Brushstrokes; Exhib Catalogues: Eden Again: The Art of Carl Hall; Rick Bartow: My Eye; In the Fullness of Time: Masterpieces of Egyptian Art from American Colls
Activities: Docent training; lect; gallery talks; films; workshops; artist demonstrations; symposia; poetry readings; concerts; organize traveling exhibs to regional & nat museums; mus shop sells books

SPRINGFIELD

A EMERALD EMPIRE ART GALLERY ASSOCIATION, 500 Main St, Springfield, OR 97477. Tel 541-726-8595; Elec Mail art@emerald.com; Internet Home Page Address: www.emerald-art.com; *Pres* Izzy Fletcher; *Ofc Mgr* Dotty Light; *Ofc Mgr* Maureen Mannila
Open Mon - Fri 11 AM - 4 PM; No admis fee; Estab 1957 to promote cultural arts in Springfield & surrounding areas; Downtown area is 12,000 sq ft; Mem: 90; dues assoc mem $150, contributing mems $50; monthly meetings 3rd Tues
Income: Financed by mem dues, commission on sales, fundraisers
Collections: Paintings donated by workshop teachers
Exhibitions: Exhibs bimonthly at local shopping malls & convention centers; Host to Springfield Mayor Annual Art Show
Publications: Monthly Art League Bulletin
Activities: Classes for adults, material available to anyone; lect open to pub; picture of the month award; competitions; individual paintings & original objects of art lent; traveling exhibs organized & circulated; sales shop sells original art

THE DALLES

A THE DALLES ART ASSOCIATION, The Dalles Art Ctr, 220 E Fourth The Dalles, OR 97058. Tel 541-296-4759; Elec Mail thedallesart@earthlink.net; Internet Home Page Address: www.tdartcenter.org; *Dir* Carolyn Wright
Open Tues - Sat 11 AM - 5 PM; No admis fee; Estab 1959 for presentation of community arts activities; Gallery maintained; Average Annual Attendance: 5,000+; Mem: 250; dues corporate $250, sponsor $100, business $75, family $45, individual $35, senior $25; meeting held second Wed of each month
Income: Financed by dues, fundraising events, grants, sponsorships & sales
Exhibitions: Member & guest exhibits; state services exhibits
Publications: Bimonthly newsletter
Activities: Classes for adults & children; docent training; lect open to pub; competitions; gallery shop sells original art, jewelry, pottery, basketry, glass

PENNSYLVANIA

ALLENTOWN

M ALLENTOWN ART MUSEUM, Fifth & Courts Sts, PO Box 388 Allentown, PA 18105-0388. Tel 610-432-4333; Fax 610-434-7409; Elec Mail membership@allentownartmuseum.org; Internet Home Page Address: www.allentownartmuseum.org; *Registrar* Carl Schafer; *Pres Board Trustees* Sanford T Beldon; *Dir Admin* Lisa Miller; *Mus Shop Mgr* Sharon Yurkanin; *Cur Colls & Exhibs* Christine I Oaklander; *Bldg Operations Mgr* Douglas Bowerman; *PhD* David Brigham; *Develop Mgr -Individ* Valerie Thomas; *Cur Educ* Lise Dube; *Cur Textiles* Ruta Saliklis
Open Tues - Sat 11 AM - 5 PM, Sun Noon - 5 PM, cl Mon; Admis general $4, seniors $3, students $2, mems & children 12 & under free; Sun no admis fee; Estab 1939 to acquire, protect, display & interpret the visual arts from the past & present, world wide; Building & land cover three quarters of a city block; 28,000 sq ft wing was added in 1975 to more than double the space; Average Annual Attendance: 67,000; Mem: 2300; dues $15 and up
Income: $850,000 (financed by endowment, mem, city, county & state appropriation & contributions)
Special Subjects: Architecture, Drawings, Painting-American, Photography, Bronzes, Ceramics, Folk Art, Etchings & Engravings, Landscapes, Decorative Arts, Painting-European, Furniture, Jade, Jewelry, Oriental Art, Painting-Dutch, Historical Material, Baroque Art, Painting-Flemish, Period Rooms, Embroidery, Laces, Painting-Italian, Painting-German, Pewter
Collections: American 18th, 19th & 20th century paintings, sculptures, prints & drawings; Chinese porcelains; English & American silver; Japanese Prints; Samuel H Kress Collection of European paintings & sculpture, c 1350-1750 (Bugiardini, Lotto, de Heem, Rembrandt, Ruisdael, Steen & others); Textile study room; 20th century photographs; Frank Lloyd Wright period room, 1912
Publications: Calendar of events, quarterly; catalogs of major exhibitions; descriptive gallery handouts
Activities: Classes for adults & children; docent training; 3 family events each year; lect open to public; gallery talks; tours; competitions; concerts; museum shop sells books, jewelry & other art related games & stationery; Art Ways, interactive children's gallery

M LEHIGH COUNTY HISTORICAL SOCIETY, PO Box 1548 Allentown, PA 18105; Old Court House, Hamilton at Fifth Allentown, PA 18101. Tel 610-435-1074; Fax 610-435-9812; Elec Mail lchs@voicenet.com; Internet Home Page Address: www.voicenet.com/~lchs; *Exec Dir* Bernard Fishman; *Cur Coll* Andree Mey; *Coll Mgr* Morgan McMillan; *Archivist* Jan Ballard; *Cur Educ* Sarah Nelson; *Dir Develop* David Voellinger; *Mem Coordr* Linda Buesgen; *Research Librn* Carol Herrity; *Bookkeeper* Elaine Johaneman; *Educ Asst* Lorinda Macaulay; *Properties Mgr* Beverly Renaldi; *Ofc Mgr* Pat Arnold; *VPres* Raymond Holland; *VChmn* Robert M McGovern
George Taylor House open June - Sept Sat & Sun 1 - 4 PM; Trout Hall Apr - Nov Tues - Sat Noon - 3 PM, Sun 1 - 4 PM; Troxell-Steckel House June-Oct Sat &

Sun 1 - 4 PM; Lehigh County Mus Mon - Fri 9 AM - 4 PM, Sat & Sun 1 - 4 PM; Claussville School, Lock Ridge Furnace, Saylor Cement Kilns, Haines Mill & Frank Buchman House May - Sept Sat & Sun 1 - 4 PM; Admis $2 for non-mems at Taylor House, Trout Hall, Troxell-Steckel House, Claussville School; others free; Estab 1904 for coll, preservation & exhib of Lehigh County history; Lock Ridge Furnace Mus 1868, Frank Buchman House 1894, Haines Mill Mus 1760 & 1909, Lehigh County Mus 1814-1914, Trout Hall 1770, George Taylor House 1768, Saylor Cementy Industry Mus 1868, Troxell-Steckel House 1756, Claussville One-Room Schoolhouse 1893; Average Annual Attendance: 36,000; Mem: 1,300; dues $15 - $1,000; ann meeting 3rd Wed in Apr
Income: $900,000 (financed by endowment, mem, tax-based support, foundations, corporate & business support)
Special Subjects: Architecture, Drawings, Painting-American, Photography, Watercolors, Anthropology, Archaeology, Ethnology, Textiles, Costumes, Crafts, Folk Art, Decorative Arts, Manuscripts, Portraits, Furniture, Glass, Porcelain, Historical Material, Maps, Dioramas, Period Rooms, Embroidery, Pewter, Leather
Collections: Extensive regional history archives, 10,000 books, 65,000 photographs & negatives, 1600 linear feet of pamphlets, documents, newspapers, maps, microfilm; 32,000 objects related to social history, daily life, agriculture & industry, textiles, fine & folk art, architectural elements, businesses, American Indians, decorative arts, furniture; historic structures & elements of historic structures
Publications: Proceedings, biennial; Town Crier, quarterly newsletter; occasional books & monographs
Activities: Workshops; lect open to public, 15 vis lectrs per year; concerts; tours; museum shop sells books, pamphlets & local souvenirs

L Scott Andrew Trexler II Library, Old Court House, Hamilton at Fifth, Allentown, PA; PO Box 1548, Allentown, PA 18105. Tel 610-435-4664; Fax 610-435-9812; Internet Home Page Address: www.voicenet.com/~lchs; *Librn & Archivist* Jan Ballard; *Reference Librn* Carol M Herrity
Open Mon - Sat 10 AM - 4 PM; No admis fee for mems, $5 for non-mems; Estab 1974; For reference only; Average Annual Attendance: 2,000
Income: $45,000
Purchases: $14,000
Library Holdings: Audio Tapes 10; Book Volumes 10,000; Cassettes 200; Framed Reproductions; Lantern Slides 1000; Manuscripts 1000; Memorabilia 1000; Original Art Works; Pamphlets 200; Periodical Subscriptions 20; Photographs 50,000; Prints; Reels 400
Collections: Allentown imprints; broadsides; Civil War; early German newspapers; fraktur; Native American materials; photographs
Publications: Proceedings, semi-annual; Town Crier

M MUHLENBERG COLLEGE, Martin Art Gallery, 2400 Chew St, Allentown, PA 18104-5586. Tel 484-664-3467; Fax 484-664-3113; Elec Mail kburke@muhlenberg.edu; Internet Home Page Address: www.muhlberg.edu; *Gallery Coordr* Kathryn Burke
Open Tues - Sat 12 PM - 9 PM; No admis fee; Estab 1976; The building was designed by architect Philip Johnson; the focal point of its design & function is a 220 ft glass-covered galleria which bisects the structure; Average Annual Attendance: 8,000
Income: Financed by the col
Collections: Master prints; Rembrandt, Durer, Whistler, Goya; 20th century American & contemporary art
Exhibitions: Year round schedule of 6 to 8 exhibitions
Publications: Exhibition catalogs
Activities: Lect open to pub; films; gallery talks

AUDUBON

M NATIONAL AUDUBON SOCIETY, (Mill Grove Audubon Wildlige Sanctuary) John James Audubon Center at Mill Grove, 1201 Pawlings Rd Audubon, PA 19403. Tel 610-666-5593; Fax 610-630-2209; Elec Mail jbochnowski@audubon.org; Internet Home Page Address: www.montcopa.org; *Dir* Jean Bochnowski; *Education Mgr* Antonia Nocero; *Mus Mgr* Linda Boice; *Mus Collections Specialist* Nancy Powell
Open Tues - Sat 10 AM - 4 PM, Sun 1 - 4 PM, cl Mon; Admis adults $4, seniors (60 & over) $3, children $2; Estab 1951 to display the major artwork of John James Audubon, artist-naturalist, who made Mill Grove his first home in America 1803-06; This is a National Historic Landmark & features original artworks by Audubon, plus examples of all his major publs; Average Annual Attendance: 20,000
Special Subjects: Prints, Painting-American, Period Rooms
Collections: Birds of America (double elephant folio, 4 vols, Audubon & Havell); Birds of America (first ed Octavo, 7 vols, Audubon, Lithos by Bowen); Quadrupeds of North America (Imperial size, 2 vols, Audubon & Bachmann); Quadupeds of North America (Octavo, 3 vols, Audubon, Lithos by Bowen)
Activities: Classes for adults & children; docent training; lect open to public; gallery talks, tours; museum shop sells books, prints & other items

BETHLEHEM

M HISTORIC BETHLEHEM PARTNERSHIP, Kemerer Museum of Decorative Arts, 459 Old York Rd, Bethlehem, PA 18018; 427 N New St, Bethlehem, PA 18018-. Tel 610-868-6868; Fax 610-332-2459; Elec Mail info@historicbethlehem.org; Internet Home Page Address: www.historicbethlehem.org; *Dir Develop* Louise Sylvester; *Coll Mgr* Bonnie Stacy; *Dir Educ* Noel Poirier; *Exec Dir* Charlene Donchez Mowers
Open Tues - Sun Noon - 4 PM; Admis adults $6, children 6-12 $3, under 6 free; Estab 1954 for pub educ. Devoted to the display of antiques & historical & other objects illustrative of the growth of the museum's geographical area; Gallery on second floor of the south wing provides changing exhibits; Average Annual Attendance: 10,000; Mem: 400
Income: $180,000 (financed by endowment & mem)
Special Subjects: Architecture, Drawings, Costumes, Ceramics, Folk Art, Decorative Arts, Dolls, Furniture, Carpets & Rugs, Embroidery

Collections: Bohemian Glass, Early Bethlehem Oil Paintings & Prints, 18th & 19th Century Furniture, Oriental Rugs, Pennsylvania German Fracturs, Victoriana, quilts & coverlets, locally made tall case clocks & silver
Exhibitions: Changing gallery exhibitions; changing temporary museum; private collection exhibits
Publications: Newsletter, quarterly
Activities: Docent training; lect open to public; gallery talks; tours; competitions; museum shop sells books, reproductions, prints & decorative arts items

M LEHIGH UNIVERSITY ART GALLERIES, Museum Operation, Zoellner Arts Ctr, 420 E Packer Ave Bethlehem, PA 18015. Tel 610-758-3615; Fax 610-758-4580; Elec Mail rv02@lehigh.edu; Internet Home Page Address: www.luag.org; *Dir Exhib & Coll* Ricardo Viera; *Asst to Dir* Denise Stangl; *Ed* Patricia Kandianis; *Coll Mgr* Mark Wonsidler; *Reg* Judy Gemmel; *Preparator* Jeffrey Ludwig
Open Mon - Fri 9 AM - 10 PM, Sat 9 AM - Noon, cl Sun (DuBois Gallery), Wed - Sat 11 AM - 5 PM, Sun 1 - 5 PM (Zoellner Gallery); Mon - Thurs 9 AM - 10 PM, Fri 9 AM - 5 PM (Siegel Gallery Iacocca Hall); No admis fee; Estab to bring diverse media & understanding to the Lehigh students & general pub of the Lehigh Valley area; Collection is maintained in three galleries; DuBois Gallery has four floors of approx 250 running ft of wall hanging space per floor; Zoellner Gallery has two floors of exhibition space; Average Annual Attendance: 25,000 (per all galleries)
Income: Financed by endowment & gifts
Special Subjects: Afro-American Art, Etchings & Engravings, Landscapes, Woodcuts, Graphics, Hispanic Art, Latin American Art, Painting-American, Photography, Prints, Sculpture, Watercolors, Bronzes, African Art, Pre-Columbian Art, Textiles, Folk Art, Primitive art, Painting-European, Painting-Japanese, Portraits, Porcelain, Antiquities-Byzantine, Painting-British, Painting-French, Coins & Medals, Antiquities-Oriental, Antiquities-Roman, Antiquities-Etruscan
Collections: Baker Collection of Chinese Porcelain; Berman Collection of Japanese prints, Paintings & Outdoor Sculpture; Dreyfus Collection of French Paintings. Folk & Outsider Art; Grace collection of Paintings; photography collection; Ralph Wilson Collection of American Paintings & Graphics; Latin American Photography
Exhibitions: (6/17/2006-9/29/2006) Warhol Flowers; (8/30/2006-11/17/2006) Carlos Lizama: Visualization & Global Identity; (9/9/2006-12/17/2006) Latin American Photography II: Selections from the LUAG Collection; (9/29/2006-12/10/2006) Resistance Unarmed: Colombian Communities Building Alternatives to War; (10/11/2006-1/26/2007) A View of Italian Neorealism; Santiago Calatrava: Early Drawings, 1980-82
Publications: Calendar, twice per year; exhibition catalogs
Activities: University classes & workshops for children; docent training; lect open to public, 4 vis lectrs per year; gallery talks; individual paintings & original objects of art lent to other schools & galleries; originate traveling exhibitions; gallery shop sells books, original art, prints, hadncrafted ceramics & jewelry

M MORAVIAN COLLEGE, Payne Gallery, Main & Church Sts, Bethlehem, PA 18018; 1200 Main St, Bethlehem, PA 18018. Tel 610-861-1675, 861-1680 (office); Fax 610-861-1682; Elec Mail medjr01@moravian.edu; Internet Home Page Address: www.moravian.edu; *Dir* Dr Diane Radycki; *Asst to Dir* David Leidich; *Chmn Art Dept* Anne Dutlinger
Open Tues - Sun 11 AM - 4 PM; No admis fee; Estab 1982 to present historic & contemporary art to a diverse audience; Main floor & mezzanine have a combined total of 200 running ft; Average Annual Attendance: 15,000
Income: Financed by endowment & through the col
Purchases: Coll of paintings by W Elmer Schofield, Susan Eakins, John Marin, Albert Bierstadt, Cecilia Beaux, Reginald Marsh & Gustavus Grunewald acquired
Special Subjects: Drawings, Painting-American, Photography, Prints, Watercolors, Woodcuts
Collections: American Impressionists of the New Hope Circle; Collection of 19th & 20th century landscape paintings of Eastern Pennsylvania; Previously Underrecognized Women of the Philadelphia School; Collection of contemporary paintings & prints; Edward S Curtis's The North American Indian, 20 volumes (1928)
Publications: Exhib catalogues
Activities: Lect open to the pub; competitions with awards; concerts; gallery talks; schols offered

BLOOMSBURG

M BLOOMSBURG UNIVERSITY OF PENNSYLVANIA, Haas Gallery of Art, Arts Dept Old Science Hall, Bloomsburg, PA 17815. Tel 570-389-4646; Fax 570-389-4459; Elec Mail rhuber@bloomu.edu; Internet Home Page Address: www.bloomu.edu; *Chmn Dept of Art* Dr Christine Sperling; *Dir Gallery* Vincent Hron
Open Mon - Fri 9 AM - 4 PM; No admis fee; Estab 1966 as an educational & cultural exten of the College's Dept of Art; Gallery covers 2350 sq ft with track lighting & three dome skylights; Average Annual Attendance: 16,000
Income: Financed by community activities & grants
Collections: Permanent Collection
Exhibitions: Ten spring exhibs annually in a variety of media
Publications: Exhib catalogs & brochures, monthly
Activities: Lect open to public, gallery talks; tours

BOALSBURG

M COLUMBUS CHAPEL & BOAL MANSION MUSEUM, PO Box 116, Boalsburg, PA 16827. Tel 814-466-6210; Elec Mail office@boalmuseum.com; Internet Home Page Address: www.boalmuseum.com; *CEO* Christopher Lee
Open June - Labor Day daily (except Mon) 10 AM - 5 PM, May, Sept & Oct 1:30 - 5 PM; Admis adults $10, children $6; Estab 1952 as a nonprofit educational organization devoted to preservation of this unique American & international heritage & collection; Christopher Columbus relics imported from Spain in 1909 to the 1789 Boal Family Mansion; Average Annual Attendance: 25,000

Income: Financed by admis
Library Holdings: Book Volumes; Manuscripts; Memorabilia; Original Art Works; Original Documents; Photographs; Prints; Sculpture
Special Subjects: Painting-American, Furniture, Glass, Painting-Flemish, Painting-Spanish, Painting-Italian, Painting-German
Collections: Chapel contains 16th & 17th century Spanish, Italian & Flemish art; furniture, china & glassware; mansion contains 18th & 19th century French, Spanish, Italian, Flemish & American art; weapons: American, French & German (1780-1920)
Activities: Classes for adults & children, docent training, experimental action learning for grade 5; lects open to public, 2 lects per year; concerts; gallery talks; tours; three ann awards for educ, preservation & community serv; mus shop or sales shop sells books, prints

BRYN ATHYN

M ACADEMY OF THE NEW CHURCH, Glencairn Museum, 1001 Cathedral Rd, PO Box 757 Bryn Athyn, PA 19009. Tel 267-502-2600; Fax 267-502-2686; Elec Mail info@glencairnmuseum.org; Internet Home Page Address: www.glencairnmuseum.org; *Pres* Prescott Rogers; *Dir* Stephen H Morley; *Educ Coordr* Diane Fehon; *Tour Coordr* Lisa Parker Adams; *Cur* C Edward Gyllenhaal; *Colls Mgr* Bret Bostock; *Outreach & Public Relations Coordr* Joralyn Echols; *Concert Coordr* Peter Childs
Open Mon - Fri 9 AM - 5 PM by appointment, Tours: Sat 11 & 11:30 AM, 12:30 & 1 PM; Admis adults $7, seniors $6, students & children $4, children under 5 free.; Estab 1878 to display, study & teach about works of art & artifacts which illustrate the history of world religions; Museum housed in family crafted Romanesque style building (1939), former home of Raymond & Mildred Pitcairn; Average Annual Attendance: 18,000; Mem: 567; dues Individual $25; Family $35; Frequent Visitor $75
Income: Financed by endowment
Library Holdings: Book Volumes; Exhibition Catalogs
Special Subjects: Decorative Arts, Historical Material, Glass, Textiles, Maps, Tapestries, Architecture, Drawings, Painting-American, Photography, Sculpture, Watercolors, American Indian Art, African Art, Archaeology, Costumes, Religious Art, Ceramics, Pottery, Primitive art, Woodcarvings, Landscapes, Manuscripts, Portraits, Furniture, Jewelry, Oriental Art, Asian Art, Metalwork, Carpets & Rugs, Ivory, Scrimshaw, Coins & Medals, Calligraphy, Dioramas, Period Rooms, Embroidery, Medieval Art, Antiquities-Oriental, Islamic Art, Antiquities-Egyptian, Antiquities-Greek, Antiquities-Roman, Mosaics, Stained Glass, Antiquities-Etruscan, Enamels, Antiquities-Assyrian
Collections: American Indian; Ancient Near East; Egypt; Greece & Rome; Medieval sculpture, stained glass & treasury objects; 19th & 20th Century art by Swedenborgian artists; oriental rugs; Asian; African Beads
Exhibitions: Tiffany Angel Windows, spring 2007
Publications: Biannual newsletter
Activities: Programs for school groups; college internship prog; lectures open to the public, 4 vis lectrs per year; concerts; gallery talks; tours; individual paintings & original art objects are lent to museums & institutions which provide satisfactory evidence of adequate security, insurance, fire protection; museum shop sells books, original art, jewelry, postcards, cds & dvds

BRYN MAWR

L BRYN MAWR COLLEGE, Rhys Carpenter Library for Art, Archaeology, Classics & Cities, 101 N Merion Ave, Bryn Mawr, PA 19010. Tel 610-526-7912; Fax 610-526-7911; Elec Mail cmackay@brynmawr.edu or jblatchl@brynmawr.edu; Internet Home Page Address: www.brynmawr.edu/Library; *Head Librn* Camilla MacKay; *Reference Librn* Jeremy Blatchley; *Library Asst* Christine Purkiss
Open during academic year Mon - Thurs 8 AM - 12 AM, Fri 8 AM - 8 PM, Sat 10 AM - 7 PM, Sun 12 Noon - 12 AM, summer Mon - Fri 9 AM - 9 PM (hours vary); No admis fee; Estab 1931 to serve the needs of the general college program, the undergraduate majors & graduate students through the PhD degree in History of Art; Classical & Near Eastern archaeology, classics & the undergraduate program in Growth & Structure of Cities
Income: Financed by college funds
Library Holdings: Auction Catalogs; Book Volumes 100,000; Compact Disks; Exhibition Catalogs; Fiche; Framed Reproductions; Kodachrome Transparencies; Lantern Slides; Original Art Works; Pamphlets; Periodical Subscriptions 400; Photographs; Prints; Reels; Reproductions; Sculpture; Slides; Video Tapes
Special Subjects: Art History, Landscape Architecture, Islamic Art, Manuscripts, Painting-American, Painting-British, Painting-Dutch, Painting-Flemish, Painting-French, Painting-German, Painting-Italian, Painting-Japanese, Painting-Russian, Painting-Spanish, Painting-European, Latin American Art, Archaeology, Asian Art, Furniture, Antiquities-Persian, Carpets & Rugs, Antiquities-Assyrian, Antiquities-Byzantine, Antiquities-Egyptian, Antiquities-Greek, Coins & Medals, Architecture
Exhibitions: Changing exhibitions curated by college collections

CARLISLE

M DICKINSON COLLEGE, The Trout Gallery, W High St, PO Box 1773 Carlisle, PA 17013-2896. Tel 717-245-1344; Fax 717-254-8929; Elec Mail trout@dickinson.edu; Internet Home Page Address: www.dickinson.edu/trout; *Registrar & Exhib Preparator* James Bowman; *Cur Educ* Wendy Pires; *Dir* Phillip Earenfight; *Admin Asst* Stephanie Keifer; *Outreach Publicity Coordr* Dottie Reed
Open Tues - Sat 10 AM - 4 PM; Jun - Aug Wed - Sat 10 AM - 4 PM; Estab 1983 as display & care facilities for college's art coll, serves college & community; Two floors with exhib & permanent coll space; Average Annual Attendance: 8,000
Income: $200,000 (financed by endowment, college & special grants)
Purchases: Auguste Rodin's St John the Baptist; Joseph Stella's Bold Flowers; African Art; Baselitz's Madchen mit Harmonika IV
Library Holdings: Auction Catalogs; Book Volumes; Exhibition Catalogs
Special Subjects: Drawings, Graphics, Painting-American, Photography, Prints, American Indian Art, African Art, Pre-Columbian Art, Southwestern Art, Religious

Art, Ceramics, Pottery, Primitive art, Woodcuts, Etchings & Engravings, Landscapes, Decorative Arts, Portraits, Posters, Oriental Art, Asian Art, Painting-French, Historical Material, Baroque Art, Calligraphy, Renaissance Art, Painting-Spanish, Islamic Art, Antiquities-Egyptian, Antiquities-Roman
Collections: Carnegie Collection of prints; Cole Collection of Oriental & decorative arts; Gerofsky Collection of African art; Potamkin Collection of 19th & 20th century work; Old Master & modern prints; photographs
Exhibitions: (11/3/2006-1/13/2007) Progress on the Land: Industry & the American Landscape, 1875-1945; 1/26/2007 Ellen Day Hale & the Painter-Etcher Movement; (2/9/2007-3/31/2007) Anthony Cervino: Sculpture; (4/27/2007-7/7/2007) Sr Studio Art Majors Exhib; (9/7/2007-1/12/2008) A Kiowa's Odyssey
Publications: Exhibition catalogues, 3 - 5 per year
Activities: Classes for adults & children; lect open to public, 4 - 8 vis lectrs per year; book traveling exhibitions 2 - 4 per year; originate traveling exhibitions

CHADDS FORD

M BRANDYWINE RIVER MUSEUM, US Rte 1, PO Box 141 Chadds Ford, PA 19317. Tel 610-388-2700; Fax 610-388-1197; Elec Mail inquiries@brandywine.org; Internet Home Page Address: www.brandywinemuseum.org; *Bus Mgr* John Anderson; *Assoc Cur* Virginia O'Hara; *Cur Coll* Gene E Harris; *Dir Pub Rels* Halsey Spruance; *Registrar* Jean A Gilmore; *Supv Educ* Mary W Cronin; *Librn* Ruth Bassett; *CEO & Dir* James H Duff; *Asst Pub Rels* Cathy Barkasy; *Vol Coordr* Donna M. Gormel; *Chmn (V)* George A. Weymouth; *Chief Security* Gregory Papiernik; *VPres* Wendell Fenton; *Assoc Cur N C W* Christine B. Podmaniczky; *Mus Shop Mgr* Erika Gross; *Dir Develop* R. Scott Schroder; *Asst Educ* Jane V. Flitner; *Pub Rels Dir Asst* Jennifer Maguire; *Spec Events Coordr* Dawn Dowling
Open daily 9:30 AM - 4:30 PM, cl Christmas; Admis adults $8, seniors & students (6 - 12) $5, mems and children under 6 free; Estab 1971, devoted to the preservation, documentation & interpretation of art history in the Brandywine Valley, the history of American illustration, American still-life paintings & the relationship of regional art to the natural environment; Six galleries of permanent colls & special exhibs, changing approx 5 times per yr; Average Annual Attendance: 160,000; Mem: 4600; dues vary
Library Holdings: Book Volumes; Clipping Files; Exhibition Catalogs; Manuscripts; Maps; Memorabilia; Original Documents
Special Subjects: Drawings, Painting-American, Prints, Sculpture, Watercolors, Etchings & Engravings, Landscapes
Collections: American illustration; American still-life painting, drawing & sculpture, including a major Wyeth Family Collection; art of the Brandywine Valley from early 19th century; regional artists of the 20th century
Publications: The Catalyst, quarterly; Catalogue of the Collection; exhibition catalogs
Activities: Docent training; family programs; school progs; lects for mems; guided tours; volunteer activities; individual paintings & original objects of art lent to other museums for exhib purposes; book traveling exhibs; traveling exhibs, organized & circulated to other museums; mus shop sells books, reproductions, prints, gifts, jewelry, children's items & cards
L Library, PO Box 141, Chadds Ford, PA 19317. Tel 610-388-2700; Fax 610-388-1197; *Librn* Ruth Bassett; *Coll Librn* Gail Stanislow
Open daily 9:30 AM - 4:30 PM; For reference to staff & volunteers; by appointment to the pub
Purchases: $4000
Library Holdings: Book Volumes 6500; Clipping Files; Exhibition Catalogs; Manuscripts; Other Holdings Artist memorabilia; Posters; Pamphlets; Periodical Subscriptions 20; Photographs; Reproductions; Video Tapes 25
Special Subjects: Art History, Illustration, Painting-American
Collections: Howard Pyle's published work; Other collections related to American illustration & American art history; Wyeth family memorabilia

CHESTER

M WIDENER UNIVERSITY, Art Collection & Gallery, University Center, 14th St Chester, PA 19013. Tel 610-499-1189, 499-4000; Fax 610-499-4425; Internet Home Page Address: www.widener.edu; *Coll Mgr* Rebecca Warda
Open Tues 10 AM - 7 PM, Wed - Sat 10 AM - 4:30 PM; call for summer hrs; Estab 1970
Income: Financed by endowment & univ funding
Special Subjects: Painting-American, Sculpture, Pre-Columbian Art, Painting-European, Oriental Art
Collections: 18th & 19th century Oriental art objects; 19th century European landscape & genre pictures; 20th century American paintings & sculpture
Exhibitions: Contemporary exhibs, 6 - 7 per yr
Publications: Exhib catalog
Activities: Lect; guided tours

CLARION

M CLARION UNIVERSITY, Hazel Sandford Gallery, Merick-Boyd Bldg, Clarion, PA 16214. Tel 814-226-2412, 393-2000, 393-2412 (gallery); Fax 814-226-2723; WATS 800-669-2000; *Chmn* Joe Thomas; *Dir* Diane Malley
Open Mon - Fri 11 AM - 4:30 PM; No admis fee; Estab 1970 for aesthetic enjoyment & artistic educ of students; Gallery is 66 ft long, 17ft 3 inches wide; lit by some 50 adjustable spotlights; one side of gallery is glassed in; other side is fabric-covered panels & a dozen free-standing panels, available for hanging; Average Annual Attendance: 4,000; Mem: 95
Income: Financed by univ & mem
Collections: Original paintings, drawings & prints, purchased from selected artists who have shown at gallery; sculpture & ceramics; photographs
Exhibitions: Rotating Exhibits
Publications: Monthly announcements of shows
Activities: Lect open to pub, 2-3 vis lectrs per yr; concerts; gallery talks; tours; competitions; individual paintings & original objects of art lent to departments on

campus & other state colleges; lending collection contains original art works, original prints, paintings, photographs & sculpture; book traveling exhibs

COLLEGEVILLE

M URSINUS COLLEGE, Philip & Muriel Berman Museum of Art, Main St, PO Box 1000 Collegeville, PA 19426-1000; 601 E Main St, Collegeville, PA 19426. Tel 610-409-3500; Fax 610-409-3664; Elec Mail lbarnes@acad.ursinus.edu; *Asst Dir* Nancy E Fago; *Admin Asst* Laura Steen; *Dir* Lisa Tremper Hanover
Open Tues - Fri 10 AM - 4 PM, Sat & Sun Noon - 4:30 PM; No admis fee; Estab 1987 to support the educational goals of Ursinus College & to contribute to the cultural life of the campus & regional community; Main gallery: 3200 sq ft; sculpture court; upper gallery 800 sq ft; Average Annual Attendance: 32,000; Mem: 250; dues minimum $50; ann meeting in June
Income: $150,000 (financed by endowment, mem, Ursinus College, government, foundation & corporate grants)
Purchases: $25,000
Special Subjects: Drawings, Latin American Art, Painting-American, Prints, Sculpture, Watercolors, Textiles, Religious Art, Folk Art, Pottery, Woodcuts, Etchings & Engravings, Landscapes, Painting-European, Painting-Japanese, Portraits, Posters, Furniture, Marine Painting, Painting-British, Painting-Dutch, Painting-French, Tapestries, Painting-Flemish, Painting-Spanish, Painting-Italian, Painting-German, Painting-Russian, Painting-Israeli
Collections: Philip & Muriel Berman Collection; Lynn Chadwick Sculpture Collection; 18th, 19th & 20th century European & American Art (drawings, paintings, prints & sculpture); Japanese Prints & Scrolls
Exhibitions: Temporary exhibitions, 10 per year; selections from permanent collections on continuous view
Publications: Quarterly exhib calendar; exhibs catalogues; museum newsletter, 3 times per year
Activities: Lect open to pub, 6 vis lectrs per yr; concerts; gallery talks; tours; individual paintings & original objects of art lent to museums & galleries for exhib; book traveling exhibs 4-6 per yr; originate traveling exhibs; sales shop sells books & prints

DOYLESTOWN

M BUCKS COUNTY HISTORICAL SOCIETY, Mercer Museum, 84 S Pine, Doylestown, PA 18901. Tel 215-345-0210; Fax 215-230-0823; Elec Mail info@mercermuseum.org; Internet Home Page Address: www.mercermuseum; *Exec Dir* Douglas Dolan; *Cur Coll* Cory Amsler; *Chmn* Peter Zabaga
Open Jan - Dec, Mon, Wed - Sat 10 AM - 5 PM, Tues 10 AM - 9 PM, Sun Noon - 5 PM; Admis adults $6, seniors $5.50, students $2.50, under 6 free; Estab 1880; Inside this poured, reinforced concrete building, four galleries wrap around a towering central court where different hand crafts are exhibited inside small cubicles. Additional artifacts hang from ceilings, walls and railings. A six-story tower on each end completes the building; Average Annual Attendance: 55,000; Mem: 2400; dues $35 & up; ann meeting in Fall
Special Subjects: Crafts, Folk Art
Collections: Over 50,000 artifacts representing more than 60 early American crafts, their tools and finished products; large American folk art collection; the history and growth of our country as seen through the work of the human hand
Exhibitions: Continuous small changing exhibits.
Publications: Newsletter, quarterly
Activities: Classes for adults & children; lect open to pub; gallery talks; individual paintings & original objects of art lent; originate traveling exhibs; mus shop sells books, reproductions, prints
L Spruance Library, 84 S Pine, Doylestown, PA 18901. Tel 215-345-0210; Fax 215-230-0823; Elec Mail bchs@libertynet.org; Internet Home Page Address: www.bchs.org; *Librn* Cynthia Earman; *Asst Librn* Beth Lander
Open Tues 1 - 9 PM, Wed - Fri 10 AM - 5 PM, Sat 10 AM - 5 PM, cl July 4th, Thanksgiving, Christmas & New Year's Day; No admis fee for BCHS members only; fee for museum; Circ Non-circulating; Open to the pub for reference only; Bucks County history, Delaware Valley
Library Holdings: Book Volumes 20,000; Clipping Files; Manuscripts; Other Holdings Archives; Pamphlets; Periodical Subscriptions 100; Photographs; Reels
Collections: Life of Henry Mercer, papers
Activities: Classes held through historical society

M JAMES A MICHENER ART MUSEUM, 138 S Pine St, Doylestown, PA 18901. Tel 215-340-9800; Fax 215-340-9807; *Assoc Dir* Judy Hayman; *Registrar* Jackie Wampler; *Membership Coordr* Joan Welcker; *Assoc Cur Educ* Susan Plumb; *Cur Exhib & Sr Cur* Brian Peterson; *Cur Pub Progs* Zorianne Siokalo; *Dir* Bruce Katsiff; *Dir Pub Rels* Linda Milanesi
Open Tues - Fri 10 AM - 4:30 PM, Sat & Sun 10 AM - 5 PM; Admis $6; Estab 1987; Average Annual Attendance: 80,000; Mem: 2450; dues $30 - $1000
Special Subjects: Drawings, Painting-American, Photography, Prints, Sculpture, Watercolors
Collections: American Art Collection, special focus on the arts in Bucks County, Pennsylvania; 20th Century American Sculpture Collection
Activities: Classes for adults & children; docent training; museum trips; walking tours; lect open to public, 15-20 vis lectrs per year; concerts; gallery talks; tours; scholarships offered; individual paintings & original objects of art lent to museums & cultural institutions; originate traveling exhibitions; museum shop sells books, magazines, original art, reproductions, prints, pottery, crafts, toys, stationery, tiles & jewelry

EASTON

M LAFAYETTE COLLEGE, Williams Center Gallery, Lafayette College Williams Center, Hamilton & High St Easton, PA 18042. Tel 610-330-5361, 330-5010; Fax 610-330-5642; Elec Mail artgallery@lafayette.edu; Internet Home Page Address: www.lafayette.edu/williamsgallery; *Center Dir* H Ellis Finger; *Asst Dir* Williams Center; *Dir Gallery* Michiko Okaya
Open Mon - Tues & Thurs - Fri 10 AM - 5 PM, Wed 10 AM - 8 PM, Sat & Sun 2 - 5 PM & by appointment; No admis fee; Estab 1983 to present a variety of

exhibs for enrichment of campus & community's exposure to visual arts; Versatile space with movable panels & 160 running ft of wall space, climate control & track lighting; Average Annual Attendance: 6,000
Income: Financed by endowment, prog subsidy, government grants
Special Subjects: Decorative Arts, Drawings, Etchings & Engravings, Landscapes, Ceramics, Pottery, Textiles, Woodcuts, Painting-British, Painting-European, Painting-French, Sculpture, Graphics, Painting-American, Photography, Prints, Watercolors, Portraits, Cartoons
Collections: 19th & 20th century American painting, prints, photographs & sculpture
Exhibitions: Richard Anusziewicz; Tomie Arai & Lynne Yamamoto; Bill Barrette; Ping Chong Performance Artist: In the Absence of Memory; The Emperors Old Clothes: Ancient Andean Textiles; Grace Hartigan (paintings); Kate Moran; William Tucker & Robert Watts; Looking East: Art Potters & Asian Influence: Gregory Gillespie & Carol Hepper
Publications: Annual exhibit catalogue; brochures; exhibit handouts
Activities: Lect open to pub, gallery talks; 5-8 vis lectr per yr; museum shop sells slides

ELKINS

TEMPLE UNIVERSITY
M **Tyler School of Art-Galleries,** Tel 215-782-2776; Fax 215-782-2799; *Dean* Rochelle Toner; *Dir Exhib* Kevin Melchionne
Open Wed - Sat 11 AM - 6 PM; No admis fee; Track lighting; Average Annual Attendance: 12,000
Income: Financed by state appropriation & grants
Exhibitions: Peter Eiseman: Tow Projects; Martin Poryear: The Cave Project
Publications: Brochures, posters, announcements or exhibitions catalogs for major shows
Activities: Lect open to pub, 10-15 vis lectrs per yr; gallery talks; special events
L **Tyler School of Art Library,** Tel 215-782-2849; Fax 215-782-2799; Internet Home Page Address: www.library.temple.edu/tyler; *Librn* Andrea Goldstein
Open Mon - Thurs 8:30 AM - 9 PM, Fri 8:30 AM - 4:30 PM, Sat 9 AM - 5 PM, Sun 1 - 9 PM; Estab 1935 to provide library services to students & faculty; Circ 27,254
Income: $118,368 (financed by appropriation from Central University Library)
Purchases: $32,600
Library Holdings: Book Volumes 38,000; Cassettes; Exhibition Catalogs; Fiche; Other Holdings Auction sale catalogs; Pamphlets; Periodical Subscriptions 100; Prints; Reels; Video Tapes
—**Slide Library,** Tel 215-782-2848; Fax 215-782-2848; Elec Mail sliderm@vm.temple.edu; Elec Mail slidelib@unix.temple.edu; *Asst Cur* Beth Peckman; *Slide Cur* Kathleen Szpila
Library Holdings: Slides 390,000
Special Subjects: Art History, Decorative Arts, Ceramics, Graphic Design, Photography

EPHRATA

A **HISTORICAL SOCIETY OF THE COCALICO VALLEY,** 249 W Main St, PO Box 193 Ephrata, PA 17522. Tel 717-733-1616; *Librn* Cynthia Marquet
Open Mon, Wed & Thurs 9:30 AM - 6 PM, Sat 8:30 AM - 5 PM; No admis fee; Estab 1957; Average Annual Attendance: 1,200; Mem: 585; dues family $25, individual $18
Income: Endowment, mem, publs
Special Subjects: Historical Material, Folk Art, Furniture, Edit description of #2036000 using edit table maintainance
Collections: Pennsylvania German Folk Art
Publications: Journal of the Historical Society of the Cocalico Valley, annual
Activities: Classes for children; lect open to pub, 10 vis lectrs per yr

ERIE

M **ERIE ART MUSEUM,** 411 State St, Erie, PA 16501. Tel 814-459-5477; Fax 814-452-1744; Elec Mail contact@erieartmuseum.org; Internet Home Page Address: www.erieartmuseum.org; *Pres* Mary Beth McMaster; *Dir* John Vanco; *Treas* Nicholas Gianaris; *Admin Asst* Crystal Bowe; *Publicist* Dan Stasiewski; *Registrar* Vance Lupher; *Educ Coordr* Heather Dana; *Asst Cur* Abigail Watson; *Frame Shop Mgr* Joe Popp; *Vol Coordr* Sam Ansbro; *Office Mgr* Jenae Gary
Open Tues - Sat 11 AM - 5 PM, Sun 1 - 5 PM; Admis adults $4; students $3; sr $3; children $2 free Wednesdays; Estab 1898 for the advancement of visual arts; Galleries are located in historic building; Average Annual Attendance: 40,000; Mem: Dues family $65, individual $35
Income: $600,000 (financed through pvt donations, fundraising, mem & grants)
Special Subjects: Textiles, Graphics, Painting-American, Photography, Prints, Sculpture, American Indian Art, Bronzes, Pre-Columbian Art, Southwestern Art, Ceramics, Crafts, Pottery, Etchings & Engravings, Landscapes, Decorative Arts, Collages, Dolls, Jade, Porcelain, Oriental Art, Asian Art, Silver, Juvenile Art, Embroidery, Antiquities-Oriental, Cartoons
Collections: Indian Bronze & Stone Sculpture; Chinese Porcelains, Jades, Textiles; American Ceramics (historical & contemporary); Graphics (European, American & Oriental); Photography; Paintings & Drawings (predominately 20th century); Contemporary Baskets
Exhibitions: Annual Spring Show; Art of China & Japan; Art of India; Chicago Works - Art from the Windy City; Early Color Photography; Paperthick: Forms & Images in Cast Paper; A Peculiar Vision: The Work of George Ohr, the Mad Potter of Biloxi; Frederick Hurten Rhead: An English Potter in America; The Tactile Vessel - New Basket Forms; TECO - Art Pottery of the Prairie School
Publications: Four exhibition catalogues
Activities: Classes for adults & children; docent training; lect open to pub, 3-5 vis lectrs per yr; concerts; gallery talks; tours; competitions; individual paintings & original objects of art lent to pub buildings, colleges & universities; traveling exhibs organized & circulated; mus shop sells books, postcards, pencils, t-shirts & mugs. Frame shop offers retail framing

M **ERIE COUNTY HISTORICAL SOCIETY,** (Erie Historical Museum) 419 State St, Erie, PA 16501. Tel 814-454-1813; Fax 814-454-6890; Elec Mail echs@velocity.net; Internet Home Page Address: www.eriecountyhistory.org
Open Sept - May Wed - Sat 11 AM - 4 PM, June - Aug Tues - Sat 11 AM - 4 PM, hours subject to change; Admis adults $4, seniors $3, children $2; Estab 1903 to collect & preserve Erie County history; Mus has exhibits of all 3 properties it owns. Victorian mansion built in 1891-1892 & designed by Green & Wicks of Buffalo, NY, History Ctr features formal galleries, Battles Mus are c. 1860 historic houses; Average Annual Attendance: 24,270; Mem: 600; dues corporate $500, family $45, individual $30, student $10
Income: Financed by soc
Library Holdings: Manuscripts; Maps; Memorabilia; Original Art Works; Original Documents; Periodical Subscriptions; Photographs; Records; Reels; Slides; Video Tapes
Special Subjects: American Indian Art, Drawings, Folk Art, Historical Material, Marine Painting, Ceramics, Furniture, Photography, Portraits, Pottery, Period Rooms, Silver, Textiles, Bronzes, Manuscripts, Maps, Watercolors, Costumes, Crafts, Posters, Dolls, Jewelry, Asian Art, Carpets & Rugs, Embroidery, Stained Glass
Collections: Moses Billings (paintings); George Ericson-Eugene Iverd (paintings); genre paintings; Native American pottery; Southwest & Northwest Coast baskets; Victorian decorative arts; Local histoy & maritime
Activities: Classes for adults & children; docent tours; lesson tours for students; concerts; lect open to public; local history & preservation awards prog; museum shop sells books, original art, reproductions & prints

FARMINGTON

A **TOUCHSTONE CENTER FOR CRAFTS,** RR 1, Box 60, Farmington, PA 15437-9707. Tel 724-329-1370; Fax 724-329-1371; Elec Mail tcc@hhs.net; Internet Home Page Address: www.touchstonecrafts.com; *Admin Asst* Debbie Moore
Open Mon - Fri 9 AM - 5 PM; Class fees; Estab 1972 to promote excellence in art & craft educ; Average Annual Attendance: 6,000; Mem: 400
Income: $290,000 (financed by mem, grants & donations)
Special Subjects: Ceramics, Jewelry
Exhibitions: Once a year
Activities: Classes for adults & children; lect open to pub, 4 vis lectrs per yr; concerts; tours; schols offered; outreach programs; field trips; artist-in-residency projects; sales shop sells books, magazines, original art, reproductions, prints, ceramics, jewelry, t-shirts, sweatshirts, hats, iron works & glass art

FRANKLIN CENTER

M **FRANKLIN MINT MUSEUM,** US Rt 1, Franklin Center, PA 19091. Tel 610-459-6168; Fax 610-459-6880; Internet Home Page Address: www.franklinmint.com; *Cur* Judie Ashworth; *Mgr Pub Relations* Michelle Dooley
Open Mon - Sat 9:30 AM - 4:30 PM, Sun 1 - 4:30 PM; No admis fee; Estab 1973 to make available to the general pub a location where the collectibles created by The Franklin Mint can be viewed; The Franklin Mint is a showcase for fine art collectibles honoring some of the most beloved 20th century icons; Average Annual Attendance: 55,000
Income: Financed by Franklin Mint
Special Subjects: Bronzes, Bronzes, Dolls, Porcelain, Coins & Medals, Pewter, Reproductions
Exhibitions: Permanent exhib of 20th century cultural icons including the white beaded Princess Diana gown & Jackie Kennedy's original triple strand faux pearl necklace; art exhibs of famous artists & objects, as well as acclaimed works by artists affiliated with The Franklin Mint; approximately 9 exhibits annually; ann auto festival in Sept
Activities: Occassional lect series; Franklin Mint Gallery Store selling jewelry, dolls, diecast & other collectibles

GETTYSBURG

M **ADAMS COUNTY HISTORICAL SOCIETY,** 111 Seminary Ridge, Gettysburg, PA 17325; PO Box 4325, Gettysburg, PA 17325. Tel 717-334-4723; Fax 717-334-0722; Elec Mail info@achs-pa.org; Internet Home Page Address: www.achs-pa.org; *Exec Dir* Wayne E Motts; *Coll Mgr* Benjamin F Nelly; *Admin Asst* Sheryl Snyder; *Research Asst* Timothy H Smith
Research lib open Tues, Wed, Sat 9 AM - 12 PM, 1 - 4 PM, Thurs 6 - 9 PM, mus by appt only; Admis $3 museum, non-member researcher $5; Historical Soc estab 1939, mus estab 1987; Museum of local history; Average Annual Attendance: 5,750; Mem: 1,100; dues family $50, supporting $35; meetings Jan - May & Sept - Dec
Income: $200,000 (financed by mem, appeal, grants, sale of publs)
Special Subjects: American Indian Art, Folk Art, Historical Material, Glass, Flasks & Bottles, Furniture, Portraits, Silver, Textiles, Manuscripts, Maps, Costumes, Religious Art, Dolls, Historical Material, Coins & Medals, Period Rooms, Stained Glass, Military Art
Collections: Blacksmith Shop/Earth Science; Barber Shop Equipment; 1940's Doll House; Uniforms; Spanish & American/WW I & WW II; 1930 Conoco Gas Station
Publications: Annual journal & 6 newsletters per year
Activities: Classes for adults; lect open to pub; tours; lending coll consists of lantern slides; originate traveling exhibs; mus shop sells books & maps

GLENSIDE

M **BEAVER COLLEGE ART GALLERY,** 450 S Easton Rd, Glenside, PA 19038. Tel 215-572-2131; Fax 215-881-8774; Elec Mail toricha@beaver.edu; Internet Home Page Address: www.beaver.edu; *Gallery Dir* Richard Torchia; *Asst Dir* Sarah Biemiller
Open Mon - Fri 10 AM - 3 PM, Sat & Sun Noon - 4 PM; No admis fee; Estab 1974 to show contemporary art generally; Gallery dimensions 20 x 50 ft; Average Annual Attendance: 5,000; Mem: 150; dues $35

Income: College & board funding
Collections: Benton Spruance Print Collection
Exhibitions: Contemporary artist solo & thematic exhibitions
Publications: Brochures for major exhibitions
Activities: Lect open to pub, 4 vis lectrs per yr; gallery talks; competitions with awards

GREENSBURG

L SETON HILL COLLEGE, Reeves Memorial Library, College Ave, Greensburg, PA 15601. Tel 724-834-2200; Fax 724-834-4611; *Reference & Pub Servs Librn* Denise Sticha
For lending & reference; Circ 40,000
Library Holdings: Audio Tapes; Book Volumes 101,000; Cards; Cassettes; Filmstrips; Motion Pictures; Original Art Works; Pamphlets; Periodical Subscriptions 500; Records; Sculpture; Slides; Video Tapes

M WESTMORELAND MUSEUM OF AMERICAN ART, 221 N Main St, Greensburg, PA 15601-1898. Tel 724-837-1500; Fax 724-837-2921; Elec Mail info@wmuseumaa.org; Internet Home Page Address: www.wmuseumaa.org; *CEO & Dir* Judith H O'Toole; *Cur* Barbara Jones; *Dir External Rels & CFO* Sara Jane Lowry; *Preparator* PJ Zimmerlink; *Asst to Dir* Janet Carns; *Registrar* Douglas W Evans; *Dir Mktg & Pub Rels* Judith Ross
Open Wed - Sun 11 AM - 5 PM, Thurs 11 AM - 9 PM, cl Mon & Tues & major holidays; suggested donation: adults $3, children under 12 free; Estab 1949 to operate & maintain a free pub art mus; The mus houses three galleries for changing exhibs; eight galleries for permanent coll; Average Annual Attendance: 28,665; Mem: 1400; dues $25 - $2000 & up
Income: Financed by endowment, grants & gifts
Special Subjects: Drawings, Painting-American, Photography, Sculpture, Watercolors, Bronzes, Textiles, Ceramics, Folk Art, Pottery, Etchings & Engravings, Decorative Arts, Portraits, Dolls, Furniture, Glass, Silver, Carpets & Rugs
Collections: Extensive toy collection; 18th, 19th & early 20th century American decorative arts, furniture, paintings, sculpture & works on paper; 19th & early 20th century Southwestern Pennsylvania paintings
Publications: Viewer, quarterly newsletter
Activities: Classes for children; docent training; lect open to public, 4-6 vis lectrs per year; gallery talks; tours; individual paintings & original objects of art lent to other museums & institutions accredited by AAM; lending collection contains original art works & paintings; book traveling exhibitions 1-2 per year; museum shop sells books, magazines, reproductions, slides, toys, postcards & notepaper

L Art Reference Library, 221 N Main St, Greensburg, PA 15601-1898. Tel 724-837-1500; Fax 724-837-2921; Elec Mail info@wmuseumaa.org; Internet Home Page Address: www.wmuseumaa.org; *Dir & CEO* Judith H O'Toole; *Preparator* P J Zimmerlink; *Mus Shop Mgr* Claudia Harbaugh; *Cur Educ* Susan Nemet; *Dir Mktg & Pub Relations* Judy Linz Ross; *Cur* Barbara L Jones; *Asst Pub & Finance* Pat Erdelsky; *Registrar* Douglas R Evans; *VPres* Jack Smith; *Asst to Dir* Janet Carns; *Mus Shop Mgr* Joan DeRose; *Dir Develop & Finance* Amy Baldonieri
Open Tues - Sat 10 AM - 5 PM, Sun 1 - 5 PM, cl Mon & holidays; Estab 1949 for art reference; For reference only; Average Annual Attendance: 20,000
Income: Financed by endowment, grants & gifts
Purchases: $1200
Library Holdings: Book Volumes 8000; Clipping Files; Exhibition Catalogs; Pamphlets; Periodical Subscriptions 15

GREENVILLE

M THIEL COLLEGE, Weyers-Sampson Art Gallery, 75 College Ave, Greenville, PA 16125. Tel 724-589-2095; Fax 724-589-2021; *Dir Spec Events* Marianne Colenda; *Dir Permanent Coll* Sean McConnor
No admis fee; Estab 1971 to provide students, faculty, college staff & the community with a gallery featuring a variety of exhibs & give students an opportunity to show their work; Two galleries 20' x 38' & 20' x 31', grey carpeted walls & track lighting; Average Annual Attendance: 1,000
Income: $1,000 (financed by college budget)
Collections: 18th & 19th century paintings & prints
Exhibitions: Monthly exhibs by students & faculty
Activities: Lect open to pub; gallery talks

HARRISBURG

M ART ASSOCIATION OF HARRISBURG, School & Galleries, 21 N Front St, Harrisburg, PA 17101. Tel 717-236-1432; Fax 717-236-6631; Elec Mail carrie@artassocofhbg.com; Internet Home Page Address: www.artassocofhbg.com; *Cur* Terrie Hosey; *Dean* Kim Bowie; *Pres* Carrie Wissler-Thomas; *Gallery Asst* Kay McKee; *Webmaster* Randall Miller III; *Gallery Asst* Bryan Molloy
Open Mon - Thurs 9:30 AM - 9 PM, Fri 9:30 AM - 4 PM, Sat 10 AM - 4 PM, Sun 2 - 5 PM; No admis fee; Estab 1926 to act as showcase for mem artists and other professionals; community services offered; Building is historic Brownstone Building, former Governor's mansion (1817) & holds 4 floors of galleries, classrooms & a garden; Average Annual Attendance: 20,000; Mem: 800, dues $35 - $1000; ann meeting in May
Income: Financed by mem, tuitions, contributions, grants
Collections: Old area masters; member's work; Lavery & Lebret
Exhibitions: Annual International Juried Exhibition; Art School Annual; invitational shows; mem shows, 2 times per yr; community shows in 10 locations - 90 total per yr
Publications: Monthly exhibition announcements; newsletter, 6 times per year; quarterly school brochure
Activities: Classes for adults and children; lect open to pub; competitions open to all states; monetary awards; concerts; gallery talks; tours; schols offered; sales shop sells original art & prints by mem artists

A CITIZENS FOR THE ARTS IN PENNSYLVANIA, (Pennsylvania Arts Alliance) 2001 N Front St, Harrisburg, PA 17102. Tel 717-234-0959; Fax 717-234-1501; Elec Mail paarts@aol.com; Internet Home Page Address: www.paarts.org; *Managing Dir* Jenny Hershour
Estab 1986 to develop & strengthen Pennsylvania arts at the local, state & federal levels by networking arts administrators, arts organizations, artists & volunteers & by providing technical assistance & professional training programs & services
Publications: Newsletter
Activities: Conferences & educational workshops

A PENNSYLVANIA DEPARTMENT OF EDUCATION, Arts in Education Program, 333 Market St, 8th Flr, Harrisburg, PA 17126-0333. Tel 717-783-3958; Fax 717-783-3946; Elec Mail bcornell@statepa.us; *Dir Arts in Special Educ Project* Mary Lou Dallam; *Dir Governor's School for the Arts* Felicia Harris; *State Adviser* Beth Cornell
The Arts in Education Program provides leadership & consultative & evaluative services to all Pennsylvania schools & arts educ agencies in arts prog development & instructional practices. Infusion of arts processes into differentiated curriculums for all students is a particular thrust. The prog offers assistance in designing aesthetic learning environments & consultation in identifying & employing regional & community resources for arts educ

A PENNSYLVANIA HISTORICAL & MUSEUM COMMISSION, 300 North St, Harrisburg, PA 17120-0024. Tel 717-787-2891; Fax 717-783-1073; Internet Home Page Address: www.phmc.state.us/; *Sr Cur Art Coll* N Lee Stevens; *Dir Anita D Blackaby;* *VChmn* Janet Klein; *Chief Div Historic Sites* Nadine Steinmetz; *Chief Div Historic Sites* Robert Sieber; *Chief Div Historic Sites* Bruce Bazelon; *Exec Dir* Brent D Glass; *Chief Div Architecture* Barry Loveland; *Dir Bur of Historic Sites* Jean Cutler; *Dir Bureau of Architecture* Frank Suran; *Dir Bur of Historic Sites* Donna Williams; *Dir Bur of Man* John C Wesley
Open Tues - Sat 9 AM - 5 PM, Sun Noon - 5 PM, cl Mon; No admis fee; Estab 1945 to interpret the history & heritage of Pennsylvania; Mem: 3000; dues vary; ann meeting second Wed in Apr
Income: $18,000,000 for entire commission
Exhibitions: Art of the State, ann spring-summer juried statewide exhib; Contemporary Artists Series; changing history exhibits
Publications: Pennsylvania Heritage, quarterly
Activities: Classes for adults & children; docent training; lect open to pub; concerts; tours; exhibits; special events

M The State Museum of Pennsylvania, 300 North St, Harrisburg, PA 17120-0024. Tel 717-787-4979; Fax 717-783-4558; Internet Home Page Address: www.statemuseumpa.org; *Sr Cur Art* N Lee Stevens; *Chief Cur* Williams Sisson; *Acting Registrar* Mary Jane Miller
Open Tues - Sat 9 AM - 5 PM, Sun Noon - 5 PM; offices Mon - Fri 8:30 AM - 5 PM; No admis fee; Mus estab 1905; Average Annual Attendance: 350,000; Mem: 700; dues $45 family, $35 individual; ann meeting second Wed in Jan
Income: Financed by state & pvt funds
Special Subjects: Anthropology, Archaeology, Decorative Arts, Historical Material
Collections: Anthropology; archaeology; art photography; ceramics; decorative arts; folk art; glass; Indian artifacts; paintings & sculpture; paleontology & geology; silver; textiles; works on paper; 2 million objects in all disciplines relating to Pennsylvania
Publications: Books, brochures, quarterly calendar, quarterly newsletter
Activities: Classes for adults & children; docent training; lect open to pub; concerts; gallery talks; tours; awards; individual paintings & original objects of art lent to qualified & approved institutions; book traveling exhibs 1-2 per yr; originate traveling exhibs; mus shop sells books, reproductions, prints & gift items
—**Brandywine Battlefield Park,** US Rte 1, Box 202, Philadelphia, PA 19317-0202. Tel 610-459-3342; Fax 610-459-9586; *Mus Educ* Helen Mahnke; *Educ Coordr* Richard Wolfe; *Admnr* Toni Collins
Open 9 AM - 5 PM; Estab 1947 to commemorate Battle of the Brandywine, Sept 11, 1777; 2 historic Quaker farmhouses; Average Annual Attendance: 90,000; Mem: 95; dues $35; ann meeting in summer
Income: $295,000 (financed by endowment, mem & state appropriation)
Activities: Classes for children

L Library, Tel 717-783-9898; Fax 717-787-4558, 787-4822; *Educ* Robert McFadden
Open Tues - Sat 9 AM - 5 PM, Sun Noon - 5 PM; Open to the pub for use on premises only, by appointment
Library Holdings: Book Volumes 27,000; Clipping Files; Exhibition Catalogs; Fiche; Motion Pictures; Periodical Subscriptions 200; Reels; Video Tapes
Special Subjects: Decorative Arts, Historical Material, Archaeology

M Railroad Museum of Pennsylvania, Rte 741, Strasburg, PA 17579; PO Box 15, Strasburg, PA 17579. Tel 717-687-8628; Fax 717-687-0876; Elec Mail info@rrmuseumpa.org; Internet Home Page Address: www.rrmuseumpa.org; *Cur* Bradley Smith; *Office Mgr* Cindy Adair; *Librn & Archivist* Kurt Bell; *Asst Educ* Troy Grubb; *Dir* David W Dunn; *Restoration Mgr* Allan Martin; *Educ* Patrick Morrison; *Dir Mus Advancement* Deborah Reddig
Open Mon - Sat 9 AM - 5 PM, Sun Noon - 5 PM, cl Mon Nov - Apr; Admis adults $7, seniors $6, children $5; Estab 1975 for preservation of significant artifacts appropriate to railroading; Maintains reference library & railroad art gallery; Average Annual Attendance: 150,000; Mem: 1,900; dues $35; ann meeting in the fall
Income: $1,800,000 (financed by state appropriation & pvt fundraising)
Library Holdings: Auction Catalogs; Book Volumes; Cards; Filmstrips; Kodachrome Transparencies; Lantern Slides; Manuscripts; Maps; Memorabilia; Motion Pictures; Original Art Works; Original Documents; Pamphlets; Periodical Subscriptions; Photographs; Prints; Records; Reels; Slides; Video Tapes
Special Subjects: Painting-American, Photography, Prints, Textiles, Manuscripts, Historical Material, Maps, Restorations, Dioramas
Collections: Railroad Rolling Stock; locomotives & related artifacts including tools, maps, manuals, timetables, passes, uniforms, silverware & lanterns; Railroad art & photographs
Publications: Milepost, 5 times annually
Activities: Children programs; docent progs; lect open to pub, 5-10 vis lectrs per yr; concerts; gallery talks; tours; schols offered; individual paintings & original objects of art lent; lending coll includes paintings & art objects; mus shop sells books, magazines, original art, reproductions, prints & slides

A SUSQUEHANNA ART MUSEUM, Home of Doshi Center for Contemporary Art, 301 Market St, Harrisburg, PA 17101. Tel 717-233-8668; Fax 717-233-8155; Internet Home Page Address: www.squart.org; *Pres* William Lehr; *VPres* Patty Morgan; *Cur* Jonathon VanDyke
Open Mon - Fri 11 AM - 3 PM, Sat 11 AM - 5 PM, cl Sun; No admis fee; Estab 1989 as a nonprofit; gallery is on street level; Average Annual Attendance: 7,000; Mem: 300
Income: $31,000 (financed by grants from Pennsylvania Council on the Arts, Allied Fund for the Arts, mem & corporate contributions)
Exhibitions: 4 exhibs per yr
Activities: Student internships; lect open to pub; gallery talks; tours; Maya Schock Educational Fund awarded; invitational craft show & sale

HAVERFORD

A MAIN LINE ART CENTER, Old Buck Rd & Lancaster Ave, Haverford, PA 19041. Tel 610-525-0272; Fax 610-525-5036; Elec Mail jherman@mainlineart.org; Elec Mail mlacjh@aol.com; Internet Home Page Address: www.mainlineart.org; *Exec Dir* Judy Herman; *Dir Prog* Alison McKenzie
Open Mon - Thurs 9 AM - 9 PM, Fri 9 AM - 5 PM, Sat & Sun 9 AM - 5 PM; No admis fee; Estab 1937 to develop and encourage the fine arts; Three large, well-lit galleries, completely modernized to accommodate exhibits including sculptures, ceramics, paintings, crafts; Average Annual Attendance: 1,200; Mem: 800; dues family $60; individual $45; children $30
Income: Financed by mem, tui, fundraising, & sponsors
Exhibitions: Ann mem exhib
Publications: Brochures, five times per yr
Activities: Classes for adults, teens & children; gallery talks; trips; tours; member exhibitions juried; competitions with awards; curated exhibitions

HERSHEY

M HERSHEY MUSEUM, 170 W Hershey Park Dr, Hershey, PA 17033. Tel 717-520-5722; Fax 717-534-8940; Elec Mail info@hersheymuseum.org; Internet Home Page Address: www.hersheymuseum.org; *Exec Dir* David L Parke; *Office Mgr* Sharon Smith; *Asst Cur* Amy Bischof; *Cur Educ* Tanya Richter; *Sr Cur Educ* Lois Miklas; *Shop Mgr* Janet Hester; *Dir Pub Rels & Marketing* Denise Hernandez; *Cur Coll & Exhib* James McMahon
Open daily 10 AM - 5 PM, summer daily 10 AM - 6 PM; Admis adults $6, children 3-15 $3.00, 2 & under free; Estab 1933 to preserve & collect history of Hershey, Central Pennsylvania heritage (Pennsylvania Germans); Average Annual Attendance: 110,000; Mem: 2600; dues family $40
Special Subjects: American Indian Art, Folk Art, Historical Material, Ceramics, Glass, Painting-American, Textiles, Crafts, Pottery, Woodcarvings, Decorative Arts, Furniture, Porcelain
Collections: History of Hershey (the town, the business, & M S Hershey); 19th century Pennsylvania German Life American Indian
Publications: Quarterly newsletter
Activities: Classes for adults & children; docent training; family progs; progs in schools; lect open to pub; concerts; gallery talks; tours; mus shop sells books & craft items relating to mus colls; childrens' discovery room

HONESDALE

M WAYNE COUNTY HISTORICAL SOCIETY, 810 Main St, PO Box 446 Honesdale, PA 18431. Tel 570-253-3240; Fax 717-253-5204; Elec Mail wchs@ptd.net-librarian; Internet Home Page Address: www.waynehistorypa.org; *Pres* Mark Wiest; *Mus Shop Mgr* Ron Brill; *VPres* Christopher Davis; *Exec Dir* Sally Talaga; *2nd VPres* Carol Dunn; *Secy* Margaret Steffen; *Treas* Robert Knash; *Exec Secy* Julie Chisneil; *VPres* Jeffery Musselman; *Pres* Greg Long; *Pub Rels & Tours* Ann Pilarczyk; *Librn* Gloria McCullough; *Secy* Donna Garrett; *Dir* Andrea Evangelist; *VPres* Skip Hillier; *1st VPres* Ann O'Hara
Open Wed - Sun 2 - 4:30 PM, cl Mon; Tues & holidays; Admis adult $3, students under 18 free; Estab 1955 to discover, preserve & pass on the history of Wayne County; Main building built in 1815 is furnished partially as a home; one-room school house, log cabin, building rebuilt 1890s general store & ladies dress shop; Average Annual Attendance: 2,000; Mem: 650; dues $10 - $300; ann meeting in Apr, quarterly meetings in Jan, Apr, July & Oct
Income: Financed by mem, county commissioners
Special Subjects: Painting-American, Anthropology, Archaeology, Textiles, Costumes, Ceramics, Portraits, Dolls, Furniture, Glass, Historical Material, Maps, Period Rooms, Military Art
Collections: Memorabilia of Wayne County inhabitants, furnishings, artisans' tools, carriages, Indian artifacts
Publications: Quarterly Newsletter
Activities: Dramatic progs; lect open to pub, 5 vis lectrs per yr; tours

M WAYNE COUNTY HISTORICAL SOCIETY, Museum, 810 Main St, PO Box 446 Honesdale, PA 18431-0446. Tel 570-253-3240; Fax 570-253-5204; Elec Mail wchs@ptd.net; Internet Home Page Address: www.waynehistorypa.org; *VPres* Ann O'Hara; *VPres* Carol Dum; *Treas* Bob Knash; *Pres* Harry Hillier; *Dir* Sally Talaga; *Librn* Gloria McCullough; *Shop Mgr* Ron Brill
Open Sat 10 AM - 4 PM, Wed - Sat 10 AM - 4 PM (Mar - Dec); Admis adults $3, children 12-18 $2, children under 12 free; Estab 1924 as a repository of artifacts, publs, archival & other items relating to Wayne County; Historic building; Average Annual Attendance: 19,750; Mem: 750; dues $25 - $30; 12 meetings per yr
Income: $82,000 (financed by dues, donations, sales & grants)
Special Subjects: Painting-American, Photography, American Indian Art, Archaeology, Manuscripts, Portraits, Furniture, Glass, Historical Material, Maps
Collections: Artifacts of Wayne County History; Jennie Brownscombe (paintings), Native American Archaeology Coll, Costume Coll, Cut Glass Coll, Early Glass Coll

Exhibitions: Wayne County Glass, Window Pane to White House Crystal; Datt Canal Company permanent exhibit
Publications: Quarterly newsletter
Activities: School group tours; docent training; lect open to public, 4 vis lectrs per year; tours; ann historic preservation awards; sales shop sells books, maps, t-shirts, train memorabilia & art reproductions

HUNTINGDON

M JUNIATA COLLEGE MUSEUM OF ART, Moore & 17 thSt, Huntingdon, PA 16652. Tel 814-641-3505; Fax 814-641-3607; Elec Mail siegel@juniata.edu; Internet Home Page Address: www.juniata.edu/museum; *Cur & Dir* Nancy Siegel
Open Sep - Apr Mon - Fri 10 AM - 4 PM, Sat Noon - 4 PM; May - Aug Wed - Fri Noon - 4 PM; No admis fee; Estab 1998 to serve the Pennsylvania & mid-Atlantic arts community; 2 galleries, 1,000 sq ft each, 1 permanent coll & 1 temporary exhib; Average Annual Attendance: 3,000; Mem: 35; dues $15 - 500
Income: Financed by parent institution (Juniata College) & endowments
Purchases: W B Stottlemyer Coll of Art
Special Subjects: Decorative Arts, Drawings, Etchings & Engravings, Photography, Woodcuts, Painting-British, Painting-French, Graphics, Painting-American, Prints, Watercolors, American Indian Art, Landscapes, Posters, Painting-Dutch, Painting-Italian, Painting-German
Collections: American Portrait miniatures; Contemporary works on paper; Hudson River School paintings; Navajo weavings; Old Master prints & paintings; 19th century Japanese prints
Publications: Exhib publs
Activities: Mus studies prog; lect open to pub; book traveling exhibs 4 per yr

INDIANA

M INDIANA UNIVERSITY OF PENNSYLVANIA, Kipp Gallery, 470 Sprowls Hall, 11th St Indiana, PA 15705. Tel 724-357-6495; Fax 724-357-7778; Elec Mail field27@hotmail.com; Internet Home Page Address: www.iup.edu; *Dir Gallery* Dr Richard Field
Open Tues - Fri 1 - 4 PM, Thurs evenings 7 - 9 PM, Sat & Sun 1 - 4 PM, cl Mon; No admis fee; Estab 1970 to make available a professional gallery prog to Western Pennsylvania & to the university community; Versatile space with portable wall system, track lighting, secure, humidity controlled; Average Annual Attendance: 12,000
Income: Financed by Student Coop Assoc
Exhibitions: Student Honors Show; National Metal & Clay Invitational; rotating exhibits
Activities: Lect open to pub, 3-5 vis lectrs per yr; gallery talks; tours; book traveling exhibs; traveling exhibs organized & circulated

JENKINTOWN

M ABINGTON ART CENTER, 515 Meetinghouse Rd, Jenkintown, PA 19046. Tel 215-887-4882; Fax 215-887-5789; Elec Mail info@abingtonartcenter.org; Internet Home Page Address: www.abingtonartcenter.org; *Exec Dir* Laura E Burnham; *Dir Develop* Drusilla Buscemi
Open Tues - Sat 10 AM - 5 PM; No admis fee; Estab 1939; Mem: 649; dues $35 - $50
Income: Financed by mem, donations, earned income
Exhibitions: Sculpture garden; semi-permanent installations; Exhibs feature work by regional contemporary artists
Publications: Exhibit catalogs

KUTZTOWN

KUTZTOWN UNIVERSITY

M Sharadin Art Gallery, Tel 610-683-1561; Fax 610-683-4547; Elec Mail talley@kutztown.edu; Internet Home Page Address: www.kutztown.edu/acad/artgallery; *Gallery Dir* Dan R Talley
Open Tues - Fri 10 AM - 4 PM; Sat Noon - 4 PM, Sun 2 - 4 PM; No admis fee; Estab 1956 to make high quality contemporary art available to the college, community & region; 2400 sq ft facility that presents contemporary art, design & crafts; Average Annual Attendance: 6,000
Income: Financed by state & pvt appropriations
Collections: Approximately 400 works in prints, drawings & paintings
Publications: Brochure listing gallery shows; ann catalog
Activities: Artist-in-residence series; lectr prog

L Rohrbach Library, Tel 610-683-4480; Fax 610-683-4747; *Reference Librn* Janet Bond; *Dean Library Serv* Margaret Devlin
Open Mon - Thurs 7:45 AM - 5 PM, Fri 7:45 AM - 5 PM, Sat 9 AM - 5 PM, Sun 2 - 12 AM during school; Estab 1866; Circ 118,592
Library Holdings: Audio Tapes; Book Volumes 414,000; Cards 17,331; Cassettes; Exhibition Catalogs; Fiche 1,201,000; Filmstrips; Micro Print 212,908; Motion Pictures; Pamphlets; Periodical Subscriptions 1926; Records; Reels 35,000; Slides
Special Subjects: Art History, Art Education
Collections: Curriculum Materials; maps; Russian Culture

M NEW ARTS PROGRAM, INC, NAP Museum, Gallery, Resource Library, 173 W Main St, PO Box 82 Kutztown, PA 19530-0082. Tel 610-683-6440; Fax 610-683-6440; Elec Mail nap@napconnection.com; Internet Home Page Address: www.napconnection.com; *Dir* James F L Carroll; *Admin Asst* Joanne Carroll
Open Wed - Fri 11 AM - 3 PM; No admis fee; Estab 1974 for artists to have consultation residencies, exhibs, performance & presentations; Circ 100; 325 sq ft, 65 linear ft; Average Annual Attendance: 3,500; Mem: dues $30
Income: $70,000 (financed by mem, state appropriation, foundations, sales, supporting individuals & business)
Library Holdings: Audio Tapes 100; Book Volumes 1200; Cassettes 100; Exhibition Catalogs 1500; Original Art Works 250; Original Documents; Other

Holdings 400; Pamphlets 100; Periodical Subscriptions 35; Photographs; Prints 1200; Records 200; Reels 25; Slides 40,000; Video Tapes 1000
Collections: Prints, paintings, drawings, 40,000 slides
Exhibitions: Artist Salon Invitational (small works); NAP Video Festival Biennial; one juried solo and residency exhibition & 3 invitation solo exhibits
Publications: In & Out of Kutztown; NAP Text(s), biennial video festival bookleT; Preview Flyers, annual
Activities: Two TV programs monthly; Fanfold Cards; Dance on Paper; ideas from individual impressions & modes; Prints of non-printmakers; In & Out of New York; First Time Composers & Musicians Since 1974; Keith Haring Video; presentations open to public; 8 vis presentations per year; concerts; gallery presentations; sponsoring of competitions; exhibition residency and consultation; biennial video festival, lectrs open to the public; solo exhibition competition; museum shop sells exhibition books, NAP t-shirts, CD connection, videos, catalogs

L PENNSYLVANIA GERMAN CULTURAL HERITAGE CENTER AT KUTZTOWN UNIVERSITY, (Pennsylvania Dutch Folk Culture Society Inc) Pennsylvania German Heritage Library, Box 306 Kutztown, PA 19530. Tel 610-683-1589; Elec Mail henry@kutztown.edu; *Asst Dir* Darlene E Moyer; *Librn* Lucy Kern
Open Mon - Fri 10 AM - Noon and 1 - 4 PM, cl holidays; Admis non-mems $5, mems free; Estab 1978 to preserve the Pennsylvania German Heritage Culture; Reference library for genealogy, history & folk art; Mem: Dues $25
Income: Financed by donations & mems
Library Holdings: Audio Tapes; Book Volumes 1500; CD-ROMs; Cassettes; Clipping Files; Filmstrips; Manuscripts; Maps; Memorabilia; Pamphlets; Periodical Subscriptions 4; Photographs; Prints; Records; Reels 27; Slides; Video Tapes
Special Subjects: Folk Art, Maps, Historical Material, Crafts, Handicrafts, Textiles
Collections: Approx 10,000 items relating to 18th & 19th century homelife, farmlife & schooling
Publications: Review
Activities: Classes for adults & children; Easter on the Farm; Children's Cultural Camp; Christmas on the Farm; lects open to the pub; school tours; mus shop sells books & items relating to PA German history & culture

LANCASTER

M HERITAGE CENTER OF LANCASTER COUNTY MUSEUM, 13 W King St, Lancaster, PA 17603. Tel 717-299-6440; Fax 717-299-6916; Elec Mail heritage@taonline.com; Internet Home Page Address: www.lancasterheritage.com; *Cur Educ* Kim Fortney; *Cur* Wendel Zercher; *Exec Dir* Peter S Seibert
Open Apr - Dec 10 AM - 5 PM; No admis fee; Estab 1976 to preserve & exhibit Lancaster County decorative arts; Five major galleries; Average Annual Attendance: 30,000; Mem: 800; dues vary; ann meeting third Wed in May
Income: Financed by endowment, mem, city appropriation, grants & fundraising efforts
Special Subjects: Painting-American, Sculpture, Folk Art, Portraits, Furniture, Silver, Metalwork, Calligraphy, Pewter
Collections: Lancaster County Decorative Arts & Crafts; furniture, silver, regional painting; folk art; architectural
Exhibitions: Rotating exhibs
Activities: Classes for adults & children; lect open to pub; tours; individual paintings & original objects of art lent to other museums; mus shop sells books & reproductions

M LANCASTER MUSEUM OF ART, 135 N Lime St, Lancaster, PA 17602. Tel 717-394-3497; Fax 717-394-0101; Elec Mail info@lmapa.org; Internet Home Page Address: www.lmapa.org; *Dir* Cindi Morrison
Open Mon - Sat 10 AM - 4 PM, Sun Noon - 4 PM; No admis fee; Estab 1965 to present contemporary art exhibits; 4,000 sq ft facility in historic 1845 mus; Average Annual Attendance: 35,000; Mem: 1,000; dues, various categories
Income: $750,000 (financed by mem, local foundations, corporations
Collections: Permanent collection focusing on works by regional artists
Exhibitions: Exhibition schedule includes 15 exhibits per year
Publications: Quarterly newsletter
Activities: Classes & workshops for adults & children; docent training; lect open to pub, 2 vis lectrs per yr; gallery talks; tours; competition with awards; mus shop sells original art & prints

M LANDIS VALLEY MUSEUM, 2451 Kissel Hill Rd, Lancaster, PA 17601. Tel 717-569-0401; Fax 717-560-2147; Elec Mail stemiller@state.pa.us; Internet Home Page Address: www.landisvalleymuseum.org; *Dir* Stephen S Miller; *Cur* Bruce Bomberger; *Cur Community Life* Susan Messimer; *Events Coordr* Susan Kelleher; *Mus Shop Mgr* Shelby Chunko; *Farm & Garden Mgr* Joseph Meyer; *Heirloom Seed Project* Joseph Schott; *Bus Mgr* Judy Weese; *Board Pres* Peter Barber; *Interpretation Supr* April Frantz; *Marketing & Develop* Marilyn Monath
Open Mon - Sat 9 AM - 5 PM, Sun Noon - 5 PM, cl some holidays; Admis adults $7, seniors $6, children 6-17 $5, children under 6 free, group rates available; Estab 1925 to collect, preserve & interpret Pennsylvania rural life & Pennsylvania German culture, circa 1750 to 1940; farm implements, crafts, tools, domestic furnishings & folk art; The outdoor mus has 25 exhibit buildings, including restored 18th & 19th century structures & historical garden landscapes, as well as historical animal breeds; Average Annual Attendance: 57,000; Mem: 480; dues information upon request
Income: Financed by state appropriation & local support group
Special Subjects: Architecture, Crafts, Folk Art, Decorative Arts, Furniture, Glass, Calligraphy
Collections: Baskets, books, ceramics & glass, farm equipment, Fraktur; ironware, musical instruments, Pennsylvania German furniture, textiles, toys & weapons; tools, vehicles
Exhibitions: Dreamers and Visionaries: Focusing on the Landis Valley Legacy
Publications: Newsletter, 4 times per yr; Valley Gazette; special exhibit catalogs
Activities: Classes for children; tours; research coll contains ceramics & glass, textiles, tools & equipment; mus shop sells original art, prints, craft items and period reproductions

L Library, 2451 Kissel Hill Rd, Lancaster, PA 17601. Tel 717-569-0401; Fax 717-560-2147; Elec Mail stemiller@state.pa.us; Internet Home Page Address: www.landisvalleymuseum.org; *Dir* Stephen Miller
Library open by appointment only; Library estab 1925; Open to staff, scholars by appointment for reference only
Income: Financed by state appropriations
Library Holdings: Book Volumes 12,000; Periodical Subscriptions 25
Special Subjects: Folk Art, Decorative Arts, Historical Material, Crafts, Furniture, Glass, Embroidery, Handicrafts

M ROCK FORD FOUNDATION, INC, Historic Rock Ford & Kauffman Museum, 881 Rock Ford Rd, Lancaster, PA 17602. Tel 717-392-7223; Fax 717-392-7283; Elec Mail rockford@melrose.net; Internet Home Page Address: www.rockfordplantation.org; *Pres Bd* Pamela Stoner; *Exec Dir* Samuel C Slaymaker
Open Apr - Oct Tues - Sun 11 AM - 3 PM, cl Mon; Estab 1959 for preservation of General Edward Hand Mansion; Average Annual Attendance: 6,000; Mem: 600; dues $15 - $100; ann meeting first Fri in Dec
Income: $120,000 (financed by mem, endowment, shop sales & special events)
Purchases: $10,000
Special Subjects: Folk Art, Decorative Arts, Furniture, Period Rooms
Collections: American furniture & decorative arts 1780 - 1802; Pennsylvania Folk Arts 1780 - 1850
Publications: Newsletter, semi-annual
Activities: Children's classes; docent programs; retail store sells books & reproductions

LEWISBURG

M BUCKNELL UNIVERSITY, Edward & Marthann Samek Art Gallery, Elaine Langone Ctr, Lewisburg, PA 17837. Tel 570-577-3792; Fax 570-577-3215; Elec Mail peltier@bucknell.edu; Internet Home Page Address: www.departments.bucknell.edu/center-gallery/; *Operations Mgr* Cynthia Peltier; *Dir* Dan Mills; *Asst Registrar* Jeffrey Brunner
Open Mon - Fri 11 AM - 5 PM, Sat & Sun 1 - 4 PM; No admis fee; Estab 1983; Gallery contains a study coll of 20 paintings and one sculpture of the Renaissance given by the Samuel H Kress Foundation; Average Annual Attendance: 9,000
Income: Financed by endowment, tui, gifts, & grants
Exhibitions: Rotating exhibits 5 times per yr
Activities: Lect open to pub, 8 vis lectrs per yr; concert; gallery talks; tours; competitions; individual paintings & original objects of art lent; occasionally 1-2 book traveling exhibs per yr; originate traveling exhibs to Univ galleries & museums

M FETHERSTON FOUNDATION, Packwood House Museum, 15 N Water St, Lewisburg, PA 17837. Tel 570-524-0323; Fax 570-524-0548; Elec Mail info@packwoodhousemuseum.com; Internet Home Page Address: www.Packwoodhousemuseum.com; *Exec Dir* Richard A Sauers; *Asst to Dir* Jennifer Snyder
Open Tues - Sat 10 AM - 5 PM, last tour at 3:30 PM daily; Admis adults $6, seniors $5, students $3, under 11 free; Estab 1976 to serve the community as an educational institution; Historic house with decorative arts, 18th-20th century & changing exhibits galleries; Average Annual Attendance: 4,500; Mem: 300; dues life-time $2,500, benefactor $500, patron $250, friend $125, family $45, individual $30, student $5
Income: Financed by endowment, admis, mem, mus shop & grants
Special Subjects: Painting-American, Photography, Sculpture, Textiles, Pottery, Decorative Arts, Portraits, Furniture, Glass, Porcelain, Silver, Carpets & Rugs, Historical Material, Dioramas, Period Rooms, Pewter
Collections: Edith H K Fetherston Collection (paintings); American Fine Arts; Central Pennsylvania artifacts; Fine Period Clothing ranging from 1890s to 1960s; 1780-1940 decorative arts: ceramics, furniture, glass, metalwork, textiles
Exhibitions: Holiday Exhibit: Packwood House
Publications: Chanticleer, quarterly newsletter for members
Activities: Classes for adults & children; docent training; lect open to pub; 3 vis lectrs per year; tours; gallery talks; Scholastic Arts Exhibit; mus shop sells books, original art, prints, slides, reproductions & local handcrafted items

LORETTO

M SOUTHERN ALLEGHENIES MUSEUM OF ART, Saint Francis College Mall, PO Box 9 Loretto, PA 15940. Tel 814-472-3920; Fax 814-472-4131; Elec Mail sama@sfcpa; Internet Home Page Address: www.sama-sfc.org; *Johnstown Art Extension Coordr* Nancy Ward; *Dir* Michael M Strueber
Open Tues - Fri 10 AM - 5 PM, Sat & Sun 1 - 5 PM, cl Mon; No admis fee; Estab & dedicated June 1976 to facilitate interest, understanding & the appreciation of the visual arts of the past, present & future through the exhibition of our permanent as well as temporary colls; Large open main gallery with flexible space, second floor graphics gallery; Average Annual Attendance: 10,000; Mem: 1000
Income: Financed by mem, business, corporate & foundation grants
Purchases: Contemporary American Art especially by living Pennsylvania artists are purchased for the permanent collection
Special Subjects: Drawings, Painting-American, Prints, Sculpture, Ceramics
Collections: American paintings; 19th & 20th century drawings, graphics & sculpture; 19th century ceramics & crafts
Publications: Exhibition catalogues
Activities: Classes for adults & children; intern program in cooperation with area colleges; school programs; lect open to public, 8 vis lectrs per year; gallery talks; tours; exten dept serves Altoona, Johnstown & Ligonier; individual paintings & original objects of art lent to other institutions on request for special exhibitions; lending collection contains 2000 lantern slides; book traveling exhibitions 1-3 per year; originate traveling exhibitions to art galleries

M Southern Alleghenies Museum of Art at Johnstown, Pasquerilla Performing Arts Ctr, Univ of Pittsburgh at Johnstown Johnstown, PA 15904. Tel 814-269-7234;

Fax 814-269-7240; Elec Mail ncward@pitt.edu; Internet Home Page Address: sama-sfc.org; *Cur* Nancy Ward
Open Mon - Fri 9:30 AM - 4:30 PM, before & during all performing arts events; No admis fee; Estab 1982 to bring regional art to a wider audience & provide educational opportunities; Gallery 135 running ft; Average Annual Attendance: 38,500
Income: Financed by mem, city appropriation, private & foundation support, state & federal art agency funding
Special Subjects: Drawings, Painting-American, Photography, Prints, Sculpture, Watercolors, Textiles, Ceramics, Folk Art, Woodcuts, Etchings & Engravings, Landscapes, Collages, Portraits, Posters, Asian Art
Collections: American Art
Activities: Classes for adults & children; docent programs; film series; workshops; lect open to public, 8 vis lectrs per year; gallery talks; tours; book traveling exhibitions 1 per year; originate traveling exhibitions nationally to other museums

MEADVILLE

M ALLEGHENY COLLEGE, Bowman, Megahan & Penelec Galleries, Allegheny College, Box U, Meadville, PA 16335. Tel 814-332-4365; Fax 814-724-6834; Elec Mail robert.raczka@allegheny.edu; Internet Home Page Address: www.allegheny.eduacademicsartartgalleries; *Gallery Dir* Robert Raczka
Open Tues - Fri 12:30 - 5 PM, Sat 1:30 - 5 PM, Sun 2 - 4 PM, cl Mon; No admis fee; Estab 1971 as one of the major exhibition spaces in northwest Pennsylvania; the galleries present exhibits ranging from works of contemporary artists to displays relevant to other fields of study; Galleries are housed in three spacious rooms, white walls, terrazzo floor, 10 ft ceilings; Average Annual Attendance: 5,000
Income: Financed by college funds & grants
Collections: Allegheny College Permanent Collection
Activities: Lect open to the public, 5 vis lectrs per yr; gallery talks; tours; individual paintings & original objects of art lent to art galleries & museums; book traveling exhibitions

A MEADVILLE COUNCIL ON THE ARTS, PO Box 337 Meadville, PA 16335. Tel 814-336-5051; Elec Mail mca@toolcity.net; *Exec Dir* Julie Farr
Open Tues, Thurs & Fri 12:30 - 4 PM; No admis fee; Estab 1975 for local arts information & programming; to create community arts center; Gallery has 50 ft of wall space; Average Annual Attendance: 2,000; Mem: 500; dues businesses $100-$1000, individual $15 - $500; annual meeting June
Income: $100,000 (financed by mem & state appropriation)
Purchases: Yearly piece for permanent collection
Exhibitions: Annual October Evenings Exhibition; annual county wide exhibits; monthly gallery shows for local artists and crafters exhibits
Publications: Monthly calendar; monthly newsletter
Activities: Classes for adults & children; dramatic programs; special populations; lect open to public, 6 vis lectrs per year; concerts; $1250 visual arts awards, annual juried show; gallery talks; scholarships offered; extension program serving community service organizations

MERION

M BARNES FOUNDATION, 300 N Latch's Lane, Merion, PA 19066. Tel 610-667-0290; Fax 610-664-4026; Internet Home Page Address: www.barnesfoundation.org; *Pres Board Trustees* Dr Bernard Watson; *Exec Dir* Kimberly Camp; *Dir Educ* Robin Muse-Mclea; *Dir Develop* Daniel Dupont; *Dir of Arboretum* Dr Jacob Thomas; *Dir Licensing & Repr* Andrew Stewart
Open Fri & Sat 9:30 AM - 5 PM (Sept - June), Wed - Fri 9:30 AM - 5:00 PM (July & Aug); Admis $5, audio tour $7; Estab 1922 to promote the advancement of educ & the appreciation of fine art & horticulture; 181 Renoirs, 69 Cezannes, Picasso Van Gogh & many others; Average Annual Attendance: 65,000; Mem: 600; dues $75
Income: Grants, individual contributions & earned income
Library Holdings: Auction Catalogs; Book Volumes; Exhibition Catalogs; Lantern Slides; Manuscripts; Maps; Original Documents; Photographs; Video Tapes
Special Subjects: Drawings, Painting-American, Watercolors, African Art, Southwestern Art, Textiles, Ceramics, Pottery, Decorative Arts, Painting-European, Furniture, Asian Art, Painting-Dutch, Painting-French, Carpets & Rugs, Tapestries, Painting-Flemish, Antiquities-Oriental, Antiquities-Egyptian, Painting-German
Collections: Permanent collection of post-impressionism & early French modern art. Includes works by Cezanne, Matisse & Renoir; 18th century American decorative art; Native American decorative art; African Art; Greek, Roman & Egyptian antiquities; Botanical collection featuring magnolias, fern, stewartia
Activities: Classes for adults; docent training, K-12 teacher training & ACE evaluation for undergraduate credit; lect for mems only, 3-4 vis lectrs per year, tours; museum shop sells books, reproductions & prints

MILL RUN

M WESTERN PENNSYLVANIA CONSERVANCY, Fallingwater, Rte 381 S, PO Box R Mill Run, PA 15464-0167. Tel 724-329-8501; Fax 724-329-0553; Elec Mail fallingwater@paconserve.org; Internet Home Page Address: www.fallingwater.org; *Cur Bldgs & Coll* Cara Armstrong; *Mus Prog Asst* Clinton Piper; *Dir* Lynda Waggoner; *VPres Institutional Advancement* Genny McIntyre; *Dir Communications* Cynthia Ference-Kelly
Open daily 10 AM - 4 PM, Mid-Mar - Nov; Admis $16; Estab 1963 to preserve, maintain & make available for public education & appreciation Frank Lloyd Wright's Fallingwater; 1935 Frank Lloyd Wright weekend house for Edgar J Kaufmann family of Pittsburgh built between 1936-1939; Average Annual Attendance: 130,000; Mem: 300: dues $20-$40
Income: $2,800,000 (financed by mem, grants, admis, sales & royalties)
Purchases: Donated circa 1940 Berber Rug
Special Subjects: Architecture

Collections: Ceramics; Decorative Arts, including furniture by Frank Lloyd Wright; Glass; Paintings & Graphic Works by Picasso, Diego Rivera; 19th century Japanese Prints; Sculptures by Lipschitz, Arp & Voulkos; Textiles
Activities: Classes for adults & children; docent training; tours; mus shop sells books, original art, reproductions, prints & slides

NAZARETH

M MORAVIAN HISTORICAL SOCIETY, Whitefield House Museum, 214 E Center St, Nazareth, PA 18064. Tel 610-759-5070; Fax 610-759-2461; Elec Mail info@moravianhistoricalsociety.org; Internet Home Page Address: www.moravianhistoricalsociety.org; *Exec Dir* Susan Dreydoppel
Open Sun - Fri 1 - 4 PM, Sat 10 AM - 4 PM, other times by appointment; Admis adults $5, students & senior citizens $3; Built in 1740 by George Whitefield, famous preacher, bought by the Moravians in 1741 & continued in use by various segments of the church. Now the seat of the Moravian Historical Soc (organized on Apr 13, 1857 to elucidate the history of the Moravian Church in America; not however, to the exclusion of the general history of the Moravian Church); used as a mus, which houses many unique & distinctive items pertaining to early Moraviana & colonial life; Average Annual Attendance: 3,500; Mem: 500; dues $50 & up; ann meeting in Oct
Income: Financed by endowment, mem & donation
Library Holdings: Book Volumes; Clipping Files; Lantern Slides; Manuscripts; Maps; Original Art Works; Original Documents; Pamphlets; Periodical Subscriptions; Photographs; Prints; Slides
Special Subjects: Etchings & Engravings, Manuscripts, Painting-American, Watercolors, Religious Art, Folk Art, Decorative Arts, Portraits, Eskimo Art, Furniture, Historical Material, Maps
Collections: Clothing & textiles; John Valentine Haidt Collection of Paintings; Indian & foreign mission artifacts; musical instruments; pottery & Stiegel glass; rare books; manuscripts
Publications: Transactions, biennial
Activities: Classes for adults & children; docent training; lect open to pub, 1-2 vis lectr per yr; concerts; gallery talks; library tours; original objects or art lent to recognized & approved museums; lending coll contains individual & original objects of art; originate travel exhibs mostly to Moravian organizations; mus shop sells books

NEW BRIGHTON

M MERRICK ART GALLERY, 1100 5th Ave, New Brighton, PA 15066; PO Box 312 New Brighton, PA 15066. Tel 724-846-1130; Fax 724-846-0413; *Dir & Educ Dir* Cynthia A Kundar; *Trustee* Theodore C Merrick; *Asst Trustee* Karen Capper
Open Tues - Sat 10 AM - 4 PM; Sun 1 - 4 PM, cl Mon & holidays; reduced hours during summer; No admis fee; charge for docent tour; Estab 1880 to preserve & interpret the collection of paintings & other objects owned by Edward Dempster Merrick, the founder. Also to foster local art through classes & one-man shows; All galleries are on the second floors of two parallel buildings with a connecting bridge; there are three small rooms & one large one. Three rooms have skylight monitors overhead; Average Annual Attendance: 6,000; Mem: 350; dues $25, $15 & $10; ann meeting Jan or Feb
Income: Financed by endowment & mem
Special Subjects: Painting-American, Painting-European
Collections: Most paintings date from the 18th & 19th century. American artists Emil Bott; Birge Harrison; Thomas Hill; A F King; Edward and Thomas Moran; E Poole; F K M Rehn; W T Richards; W L Sonntag; Thomas Sully; Charles Curran; John F Kensett; Andrew Melrose; Ralph A Blakelock; Asher B Durand; Worthington Whittredge. European artists Gustave Courbet; Hans Makart; Pierre Paul Prud'hon; Richard Westall; Franz Xavier; Winterhalter; Peter Baumgartner; Leon Herbo; Jaques Bertrand; Rocks & minerals; Zoological
Publications: Newsletter, bimonthly
Activities: Classes for adults & children; docent training; gallery talks; mus shop sells books

NEW CASTLE

M HOYT INSTITUTE OF FINE ARTS, 124 E Leasure Ave, New Castle, PA 16101. Tel 724-652-2882; Fax 724-657-8786; Elec Mail hot@hoytartcenter.org; Internet Home Page Address: www.hotartcenter.org; *Pres Bd Trustees* David Henderson Esq; *Exec Dir* Kimberly Koller Jones; *Prog Dir* Robert Karstadt; *Asst Dir Prog* Patricia McLatchy
Tues & Thurs 10 - 8, Wed, Fri & Sat 10 - 5; No admis fee; Estab 1965 to encourage the development of the arts within the community; Maintains reference library; Average Annual Attendance: 17,000; Mem: 530; dues $30 - $2,500
Income: Classes, commissions, events, rentals, competitions, sponsorship, grants
Library Holdings: Auction Catalogs; Book Volumes; Exhibition Catalogs; Maps; Original Art Works; Original Documents; Periodical Subscriptions; Reproductions; Video Tapes
Special Subjects: Drawings, Painting-American, Photography, Sculpture, Watercolors, American Western Art, Textiles, Ceramics, Crafts, Pottery, Landscapes, Decorative Arts, Jewelry, Metalwork, Period Rooms, Cartoons, Pewter, Enamels
Collections: Historic & contemporary works of national & regional artists
Exhibitions: Hoyt Regional Art Show; Hoyt MidAtlantic Show; Juried Art Shows; Arts & Heritage Festival
Publications: Quarterly newsletter
Activities: Classes for adults & children; dramatic progs; 21 vis lects per yr; concerts; gallery talks; tours; sponsoring of competitions; lect open to pub, lects year-round; concerts; competitions; festivals; individual paintings & original objects of art lent to New Castle Public Library; multiple venues; annual jazz festival; 1-2 traveling exhibs per yr; mus shop sells original art; prints; jewelry

NEW WILMINGTON

M WESTMINSTER COLLEGE, Art Gallery, Market St, New Wilmington, PA 16172. Tel 724-946-7266; Fax 724-946-7256; Internet Home Page Address: www.westminster.edu; *Dir* Kathy Koop
Open Mon - Sat 9 AM - 9 PM, Sun 1 - 9 PM; No admis fee; Estab 1854 to organize & present 7 exhibs per season, to organize traveling exhibs, publish art

catalogs of national interest & to conduct visiting artists program; Average Annual Attendance: 15,000

Income: Financed by endowment, state & local grants

Special Subjects: Drawings, Painting-American, Prints

Collections: 19th & 20th century paintings; 20th century drawings & prints

Exhibitions: Seven exhibs annually by regional & national artists

Publications: Catalogs; Westminster College Art Gallery, annually

Activities: Lect open to pub, 4 vis lectrs per yr; gallery talks; traveling exhibs organized & circulated

NEWTOWN

M BUCKS COUNTY COMMUNITY COLLEGE, Hicks Art Center, Fine Arts Dept, 25 Swamp Rd Newtown, PA 18940. Tel 215-968-8425; Fax 215-504-8530; *Dir Exhib* Fran Orlando; *Chmn* Frank Dominguez

Open Mon & Fri 9 AM - 4 PM, Tues - Thurs 9 AM - 8 PM, Sat 9 AM - Noon; No admis fee; Estab 1970 to bring outside artists to the community; Gallery covers 960 sq ft; Average Annual Attendance: 5,000

Income: Financed by county and state appropriation

Exhibitions: Six exhibits each academic yr, ending with student ann exhibit

Activities: Lect open to pub, 4 vis lectrs per yr; competitions; gallery talks; Artmobile; 1 book traveling exhib per yr

PAOLI

M WHARTON ESHERICK MUSEUM, PO Box 595, Paoli, PA 19301-0595. Tel 610-644-5822; Fax 610-644-2244; Elec Mail whartonesherickmuseum@netzero.net; *Exec Dir* Robert Leonard; *Cur* Mansfield Bascom; *Pres* Laurence A Liss; *Dir Progs & Mems* Paul Eisenhauer;

Open Sat 10 AM - 5 PM, Sun 1 - 5 PM, weekdays groups only Mon - Fri 10 AM - 4 PM, cl Jan - Feb & major holidays; Admis adults $10, children under 12 $5; Estab 1971 for the preservation and exhib of the Studio and coll of sculptor Wharton Esherick (1887-1970), one of America's foremost artist/craftsmen. Esherick worked mostly in wood and is best known for his sculptural furniture; Studio is set high on hillside overlooking the Great Valley & is one of Wharton Esherick's monumental achievements. He worked forty years building, enlarging & altering it. A National Historic Landmark; Average Annual Attendance: 5,500; Mem: 450; dues family $75, individual $40

Income: $202,000 (financed by mem, endowment, admis, sales & grants)

Library Holdings: Clipping Files; Exhibition Catalogs; Original Documents; Photographs; Prints; Records

Special Subjects: Architecture, Painting-American, Sculpture, Ceramics, Crafts, Woodcarvings, Woodcuts, Decorative Arts, Furniture

Collections: 200 pieces of the artist's work, including furniture, paintings, prints, sculpture in wood, stone and ceramic, utensils and woodcuts

Exhibitions: Annual Thematic Woodworking Competition/Exhibition; Annual Woodworking Competition; Excellence in Wood Craft Show; Philadelphia Mus of Art Craft Show; Pennsylvania Acad of Fine Arts

Publications: Brochures; coll & exhibit catalogues

Activities: Lect open to pub; 6 vis lect per year; tours; competitions with awards; individual paintings & original objects of art lent to museums or exhibs; lending coll contains original art works & sculptures; originate traveling exhibs to colleges, galleries & museums; sales shop sells books, magazines, reproductions; slides, posters, notecards, & postcards

PHILADELPHIA

M AFRICAN AMERICAN MUSEUM IN PHILADELPHIA, 701 Arch St, Philadelphia, PA 19106. Tel 215-574-0380; Fax 215-574-3110; Elec Mail gadams@aampmuseum.org; Internet Home Page Address: www.aampmuseum.org; *Pres & CEO* Harry Harrison; *Exhib Dir* Richard Watson; *Educ Dir* Stephanie Wilson; *Develop Dir* Joseph Tozzi; *Registrar* Judith Mueller; *COO* Cynthia Moultrie; *Bookings Mgr* Gladys Adams; *Mem Mgr* Shirley Borwning

Open Tues - Sat 10 AM - 5 PM, Sun Noon - 5 PM, cl New Years, Memorial Day, July 4, Labor Day, Thanksgiving & Christmas; Admis adults $6, seniors, children & students $4; group rates adults, children & students $3; Estab 1976; Gallery has 4 changing exhibits; Average Annual Attendance: 60,000; Mem: 1000; dues benefactor $1,000, fellow $500, business $400, patron $250, assoc $150, family $55, individual $40, students & seniors $20

Special Subjects: Archaeology, Etchings & Engravings, Collages, Woodcuts, Drawings, Graphics, Painting-American, Photography, Prints, Sculpture, Watercolors, Textiles, Costumes, Religious Art, Crafts, Woodcarvings, Afro-American Art, Portraits, Posters, Dolls, Furniture, Historical Material, Coins & Medals, Military Art

Collections: Joseph E Coleman Collection; Jack T Franklin Photographic Collection; Dr Ruth Wright Hayre Collection; Anna Russell Jones Collection; Negro Baseball Leagues Collection of photographs & documents; Chief Justice Robert N C Nix Sr Collection, legal writings & memorabilia; Afro-American; artifacts relating to African American contributions to political, religions & family life, Civil Rights Movement, arts & entertainment, sports, medicine, law & technology; paintings, prints & sculpture by African American artist; archival documents; Negro Baseball Leagues Collection of photographs & documents

Exhibitions: 4 artists of distinction

Publications: Annual report; brochure; exhib catalog

Activities: Classes for adults & children; docent training; lect open to pub; concerts; gallery talks; tours; awards; fels; individual paintings & original objects of art lent to museums & institutions which conform to our security & climatic specifications; book traveling exhibs 2 per yr; originate traveling exhibs; mus shop sells books, magazines, original art, reproductions, prints & novelties

AMERICAN COLOR PRINT SOCIETY
For further information, see National and Regional Organizations

M AMERICAN SWEDISH HISTORICAL FOUNDATION & MUSEUM, 1900 Pattison Ave, Philadelphia, PA 19145. Tel 215-389-1776; Fax 215-389-7701; Elec Mail ashm@libertynet.org; Internet Home Page Address: www.americanswedish.org; *Assoc Dir* Brirgitta W Davis; *Exec Dir* Richard Waldron; *Cur* Margaretha Talerman; *Mus Admin* Timothy Cartlidge; *Coordr Pub Inform* Anne L. Egler; *Maintenance* Frank Sanders; *Chmn (V)* Robert E. Savage

Open Tues - Fri 10 AM - 4 PM, Sat & Sun Noon - 4 PM; cl Mon & holidays; Admis adults $5, students $4, children under 12 free; Estab 1926 to create an awareness & understanding of the contributions of Swedish-American people & of Sweden; 14 galleries containing materials interpreting over 300 years of Swedish influence on American life; Average Annual Attendance: 15,000; Mem: 750; dues family $40, individual $35; ann meeting in Sept

Special Subjects: Architecture, Drawings, Costumes, Crafts, Folk Art, Etchings & Engravings, Decorative Arts, Furniture, Glass, Coins & Medals, Embroidery

Collections: History and culture of Americans of Swedish descent

Exhibitions: Scandanavian history & culture; temporary exhibitions of paintings, arts & crafts by Scandanavian & Swedish-American artists

Publications: Newsletter, quarterly

Activities: Classes for adults & children; dramatic programs; docent training; workshops; lect open to pub; concerts; gallery talks; humanitarian award; tours; individual paintings & original objects of art lent to other museums & cultural attractions; book traveling exhibs 1-2 per yr; mus shop sells books, prints, Swedish crafts, household decorations & jewelry

L Library, 1900 Pattison Ave, Philadelphia, PA 19145. Tel 215-389-1776; Fax 215-389-7701; Elec Mail info@americanswedish.org; Internet Home Page Address: www.americanswedish.org; *Exec Dir* Richard Waldron; *Cur Exhib* Margaret Talerman; *Assoc Dir* Birgitta W Davis

Open Tues - Fri 10 AM - 4 PM, Sat & Sun Noon - 4 PM; Admis adults $5, seniors & students $4, children under 12 free; Estab 1926 to create an awareness of Swedish & Swedish-American contribution to the US; 13 galleries with paintings, sculpture & artifacts. For reference only; Average Annual Attendance: 20,000; Mem: 750; dues $35; ann meeting in Sept

Library Holdings: Book Volumes 15,000; Clipping Files; Exhibition Catalogs; Memorabilia; Periodical Subscriptions 5; Records; Reels; Slides

L ART INSTITUTE OF PHILADELPHIA LIBRARY, 1622 Chestnut St, Philadelphia, PA 19103. Tel 215-405-6402; Fax 215-405-6399; Internet Home Page Address: www.artinstitute.edu; *Library Dir* Ruth Schachter

Open Mon - Fri 8 AM - 10 PM, Sat 9 AM - 3 PM pub by appointment only; Estab 1966; Reference library for students & staff only

Library Holdings: Book Volumes 21,500; Exhibition Catalogs; Periodical Subscriptions 200; Video Tapes

Special Subjects: Art History, Decorative Arts, Film, Illustration, Commerical Art, Graphic Arts, Graphic Design, Painting-American, Advertising Design, Cartoons, Fashion Arts, Industrial Design, Interior Design, Lettering, Architecture

M ARTFORMS GALLERY MANAYUNK, 106 Levering St, Philadelphia, PA 19127. Tel 215-483-3030; Fax 215-483-8308; Elec Mail artformsgallery@mac.com; Internet Home Page Address: www.artforms.org; *Dir* Marjie Lewis Quint; *Gallery Mgr* Lindsey Baker

Open Wed - Thurs & Sun Noon - 5 PM, Fri - Sat Noon - 9 PM; No admis fee; Estab 1994 to show contemporary art & provide exhib opportunities to area artists; Mem: 25; mem selected by committee; dues $750; monthly meeting 1st Mon each month

Income: $62,800 (financed by mem, city appropriation, grants & contributions)

Collections: Contemporary Art - 2-D paintings, collage prints, ceramic sculpture, wood & stone sculpture & photography

Exhibitions: Juried exhibitions

Activities: Lect open to pub, 1-2 vis lectr per yr; concerts; gallery talks; competitions; musical presentations; schols offered; sales shop sells original art

M ATHENAEUM OF PHILADELPHIA, 219 S Sixth St, Philadelphia, PA 19106-3794. Tel 215-925-2688; Fax 215-925-3755; Elec Mail athena@philaathenaeum.org; Internet Home Page Address: www.philaathenaeum.org; *Asst Dir Progs* Eileen Magee; *Architectural Archivist* Bruce Laverty; *Circulation Librn* Ellen Rose; *Dir* Roger W Moss; *Bibliographer* Jill L Lee; *Cataloger* Alison Warner

Open Mon - Fri 9 AM - 5 PM; No admis fee; Estab 1814 to collect, preserve & make available original sources on American cultural history, 1814-1914; Haas gallery: 4 exhibs ann; Average Annual Attendance: 25,000; Mem: 1375; ann meeting first Mon in Apr

Income: $1,000,000 (financed by endowments, dues & fees)

Library Holdings: Book Volumes; CD-ROMs; Manuscripts; Memorabilia; Original Art Works; Original Documents; Pamphlets; Periodical Subscriptions; Photographs; Prints

Special Subjects: Architecture, Decorative Arts

Collections: Permanent study collection of American decorative arts, 1810-1850; 19th & 20th century architectural books; architectural drawings; trade catalogues

Publications: Annotations, quarterly newsletter; Athenaeum Architectural Archive; Annual Report; Bookshelf, 6 per yr; Monographs, 3 - 5 per yr

Activities: Lect open to pub, 5 - 10 vis lectrs per yr; concerts; gallery talks; tours; competitions with awards; Charles E Peterson Research Fellowships; architectural research; originate traveling exhibs to small historic site museums; sells books, prints & slides

L Library, 219 S Sixth St, Philadelphia, PA 19106. Tel 215-925-2688; Fax 215-925-3755; Elec Mail laverty@philaathenaeum.org; Internet Home Page Address: www.philaathenaeum.org; *Cur Architecture* Bruce Laverty; *Circulation Librn* Ellen Rose

Open Mon - Fri 9 AM - 5 PM by appointment for reference only; No admis fee; Estab 1814; Haas Gallery; Mem: 1300

Library Holdings: Book Volumes 75,000; Cards; Cassettes; Fiche; Manuscripts; Original Art Works; Other Holdings Architectural drawings & related materials; Periodical Subscriptions 50; Reels

Special Subjects: Decorative Arts, Architecture

Collections: Nineteenth century fiction and literary periodicals; trade materials relating to the building arts; architectural drawings; manuscripts; photographs

Publications: Biographical dictionary of Philadelphia Architects, monograph

Activities: Tours of National Historic Landmark library building; symposia; lects open to pub, lects for mems only; gallery talks; tours; fels offered; sales shop sells books

M **ATWATER KENT MUSEUM OF PHILADELPHIA,** 15 S Seventh St, Philadelphia, PA 19106. Tel 215-685-4830; Fax 215-685-4837; Elec Mail jeffreyrray@hotmail.com; Internet Home Page Address: www.philadelphiahistory.org; *Cur Coll* Jeffrey Ray; *Exec Dir* Viki Sand; *Cur of Historical Society of PA Coll* Kristen Froehlich; *Dir Interpretive Programming* David Egner
Open Mon, Wed, Thurs, Fri, Sat & Sun 10 AM - 5 PM, cl Tues & holidays; Admis adults $5, seniors & children 13 - 17 $3, children 12 & under free; Estab 1938. The mus is dedicated to the history of Philadelphia; The main interpretive gallery covers the growth of Philadelphia from 1680-1880. Smaller galleries on William Penn, his life & times; The History of the city through maps; Municipal services: fire, police, gas & water; Average Annual Attendance: 30,000; Mem: dues $40 - $1000
Income: $1.2 million (financed by grants, contributions, earned revenue & city support
Collections: Artifacts of the colonial city; costumes; print & painting collection; manufactured & trade goods; maritime artifacts; toys & dolls; ceramics & glassware; urban archaeology; Art & Artifact Collection of the Historical Society of PA
Exhibitions: Traveling Neighborhood Exhibits
Activities: Classes for children; dramatic progs; after-school prog; lect open to pub; gallery talks; media events; tours; 1500 original art works, 2500 original prints, 100 paintings available on loan to museums with adequate security systems; originate traveling exhibs to community organizations & schools; mus shop sells books, prints & Philadelphia products

A **BRANDYWINE WORKSHOP,** Center for the Visual Arts, 730 S Broad St, Philadelphia, PA 19146. Tel 215-546-3675; Fax 215-546-2825; Elec Mail brandwn@libertynet.org; Internet Home Page Address: www.blackboard.com/brndywne; *Pres & Exec Dir* Allan L Edmunds; *Admin Coordr* Lisa Sok
Open Mon - Fri 11 AM - 5 PM, Sat by appointment only; No admis fee; Estab 1972 to develop interest & talent in printmaking & other fine visual arts; Over 39,000 sq ft with 2 buildings in downtown Philadelphia. Facilities include offset lithography presses, screen printing & computer/video technology lab & classrooms. Printed Image Gallery for professional exhibits of works on paper by contemporary artists; Average Annual Attendance: 2,600 - 10,000; Mem: 220; dues $30 & up
Income: Financed by mem, city & state apppropriations, pvt corporations & foundations
Special Subjects: Prints, Afro-American Art, American Indian Art
Collections: Contemporary fine art prints, including etchings, woodblocks, offset lithographs, silkscreens
Exhibitions: USA Artworks; Contemporary Print Images; Rotating exhibits
Activities: Classes for adults & teenagers; docent training; teacher in-service training; free computer/video classes for high school students; lect open to pub, 6 vis lectrs per yr; gallery talks; tours; fels offered; original objects of art donated to historically black colleges, major mus collections, centers for research & Library of Congress; lending coll contains original prints; book traveling exhibs 1 per yr; originate traveling exhibs; mus shop sells books, original art, prints, note cards, calendars, t-shirts, caps, tote bags & mugs

C **CIGNA CORPORATION,** CIGNA Museum & Art Collection, 1601 Chestnut St-TLO7E, Philadelphia, PA 19192-2078. Tel 215-761-4907; Fax 215-761-5596; Elec Mail melissa.hough@cigna.com; *Cur* Sue Levy; *Adminr* Jean F Ronolich; *Dir* Melissa Hough; *Assoc Cur* Dinyelle Wertz
Exhibits available by appointment Mon - Fri 9 AM - 5 PM; No admis fee; Estab 1925; Exhibits on company history, fire fighting history, Maritime history & American fine art; Average Annual Attendance: 5,000
Income: Financed by company
Special Subjects: Afro-American Art, Architecture, Ceramics, Drawings, Eskimo Art, Etchings & Engravings, Collages, Crafts, Decorative Arts, Dioramas
Collections: Historical fire & marine art & artifacts; 18th - 20th century American Art, 2-D works, ceramics & sculpture
Exhibitions: Ships & the Sea
Publications: The Historical Collection of the Insurance Company of North America
Activities: Lect open to pub; lending coll contains over 9000 pieces of historic fire & marine art & artifacts, 20th century American art & sculpture; loans are processed to qualifying institutions; book traveling exhibs 1 - 3 per yr; originate traveling exhibs

M **CLAY STUDIO,** 139 N Second St, Philadelphia, PA 19106. Tel 215-925-3453; Fax 215-925-7774; Elec Mail info@theclaystudio.org; Internet Home Page Address: www.theclaystudio.org; *Managing Dir* Kathryn Narrow; *Exec Dir* Amy Sarner Williams; *Artistic Dir* Jeff Guido; *Gallery Assoc* Megan Brewster
Open Tues - Sun Noon - 6 PM; No admis fee; Estab 1974; Two galleries with exhibits changing monthly of various ceramic artwork of solo, group & historical shows; Average Annual Attendance: 24,000; Mem: Dues $50 & up
Income: Financed through mem, donations & grants, tui, host fees
Special Subjects: Ceramics
Collections: Ceramic Arts
Exhibitions: Annual Fellowship Artist Solo Show; Annual Resident Artist Group Show; Clay Studio Associate Artists Exhibition; Innercity Students from the Claymobile Show
Activities: Classes for adults & children; lect open to pub, 4 - 6 vis lectrs per yr; gallery talks; tours; spring jurying for group & solo exhibition & one year residency program; schols; exten dept serves Philadelphia & suburbs; sales shop sells books, magazines, original art

M **CLIVEDEN,** 6401 Germantown Ave, Philadelphia, PA 19144. Tel 215-848-1777; Fax 215-438-2892; Elec Mail chewhouse@aol.com; Internet Home Page Address: www.cliveden.org; *Cur History* Phillip Sietz; *VChmn* Robert A MacDonnell; *Pub Rels Coordr* Anne Roller; *Exec Dir* Kris S Kepford
Open Apr - Dec Thurs - Sun Noon - 4 PM, cl Easter, July 4th, Thanksgiving & Christmas; Admis adults $6, students $4; Estab 1971 in celebration of American

Revolutionary War History; 18th Century house mus; Average Annual Attendance: 14,000; Mem: 250,000
Special Subjects: Historical Material, Period Rooms
Collections: 18th Century house museum with decorative arts, furniture, paintings, collections site related only, no acquisitions
Activities: Classes for children; docent training; guided tours for individuals & groups; mus shop sells books, reproductions, prints, gift items

A **THE COMMUNITY EDUCATION CENTER,** 3500 Lancaster Ave, Philadelphia, PA 19104. Tel 215-387-1911; Fax 215-387-3701; *Exec Dir* Arlene Wooley
Open Mon - Fri 9 AM - 5 PM; No admis fee; Estab 1973 to support emerging talent; 35 ft x 60 ft room, 14 ft ceilings; Average Annual Attendance: 1,500; Mem: dues family $30, single $20
Income: $180,000 (financed by mem, city & state appropriation, foundation, corporate & pvt donors)
Activities: Classes for adults & children; lect open to pub, 4 vis lectrs per yr

A **CONSERVATION CENTER FOR ART & HISTORIC ARTIFACTS,** 264 S 23rd St, Philadelphia, PA 19103. Tel 215-545-0613; Fax 215-735-9313; Elec Mail ccaha@ccaha.org; Internet Home Page Address: www.ccaha.org; *Exec Dir* Ingrid E Bogel
Open Mon - Fri 9 AM - 5 PM; Estab 1977 as a nonprofit regional conservation laboratory serving cultural, educational & research institutions as well as private individuals & organizations throughout the United States; Maintains small reference library; Mem: Dues $150
Income: $1,000,000 (financed by earned income & grants)
Activities: Schols offered

M **THE FABRIC WORKSHOP & MUSEUM,** 1315 Cherry St, 5th Flr, Philadelphia, PA 19107-2026. Tel 215-568-1111; Fax 215-568-8211; Elec Mail fwmuseum@libertynet.org; *Dir Pub Relations* Laurie McGahey; *Dir* Marion Boulton Stroud
Open Mon - Fri 9 AM - 6 PM, Sat Noon - 4 PM; No admis fee; Estab 1977 devoted to experimental fabric design & silkscreen printing by nationally recognized & emerging artists representing all mediums, incl painting, sculpture, ceramics, architecture & theater. Invites artists to collaboratively explore new directions for their work, while furthering the use of fabric as an integral medium for contemporary art
Collections: Extensive permanent coll of unique contemporary art (over 2300 artworks)
Exhibitions: Ongoing series of exhibs including print multiples, monoprints, sculptural objects, installation pieces, performance costumes, furniture & functional objects, along with preliminary objects & paintings for artists projects & related sculptures & ceramics
Publications: An Industrious Art; exhibit catalogs
Activities: Classes for adults & children; high school & college apprentice training progs; workshops; lect open to pub, study tours; print demonstrations; mus sales shop sells unique, artist-designed functional objects & workshop publs

A **FAIRMOUNT PARK ART ASSOCIATION,** 1616 Walnut St, Ste 2012, Philadelphia, PA 19103-5313. Tel 215-546-7550; Fax 215-546-2363; Elec Mail postmaster@fpaa.org; *Pres* Charles E Mather III; *VPres* Gregory M Harvey; *Exec Dir* Penny Balkin Bach; *Asst Dir* Laura S Griffith; *Treas* Theodore T Newbold; *Office Mgr* Ginger Osbourne; *Prog Mgr* Charles Moleski; *Prog & Exhib Coordr* Sarah Katz
Open by appointment only (not open to pub); Estab 1872 to promote integration of art & urban planning & to promote appreciation of pub art through progs & advocacy efforts; Mem: 350; dues $25 - $100; ann meeting May
Income: Financed by mem, grants & endowment
Exhibitions: New Land Marks; Public Art, Community & the Meaning of Place
Publications: New Land Marks
Activities: Lect for mem only; 1 vis lectr per yr

FREE LIBRARY OF PHILADELPHIA
L **Art Dept,** Tel 215-686-5403; Fax 215-563-3628; Internet Home Page Address: www.library.phila.gov; *Library Pres & Dir* Elliot Shelkrot; *Head Librn Art, Dept* Deborah Litwack
Open Mon - Thurs 9 AM - 9 PM, Fri 9 AM - 6 PM, Sat 9 AM - 5 PM, Sun 1 - 5 PM, cl Sun July - Aug; Estab 1891, art department estab 1896, to serve the citizens of the City of Philadelphia; Reference & research coll
Income: Financed by endowment, city & state appropriations
Purchases: $71,000
Library Holdings: Book Volumes 60,000; CD-ROMs; Clipping Files; Exhibition Catalogs; Fiche; Other Holdings Vertical files 40,000; Pamphlets; Periodical Subscriptions 220; Reels
Collections: 18th & 19th century architectural pattern books; John Frederick Lewis Collection of books on fine prints & printmaking; 368 original measured drawings of colonial Philadelphia buildings, Philadelphia Chapter, American Institute of Architects
Exhibitions: Rotating exhibs
L **Print & Picture Collection,** Tel 215-686-5405; Fax 215-563-3628; Elec Mail lightnerk@library.phila.gov; Internet Home Page Address: www.library.phila.gov; *Head* Karen Lightner
Open Mon - Fri 9 AM - 5 PM; Estab 1954 by combining the Print Department (estab 1927) & the Picture Collection
Library Holdings: Original Art Works
Collections: (non-circulating) Americana (1200); Hampton L Carson Collection of Napoleonic prints (3400); Fine Art Prints (8000); Fine Art Photographs (3000); graphic arts (2000); greeting & tradesmen cards (27,000); John Frederick Lewis Collection of portrait prints (211,000); Philadelphiana (15,000); Rosenthal Collection of American Drawings (900); Benton Spruance lithographs (450); (circulating) picture coll of pictures in all media & universal in subject coverage (1,000,000)
L **Rare Book Dept,** Tel 215-686-5416; Fax 215-563-3628; Elec Mail refrbd@library_phila.gov; *Head* William Lang; *Asst Head* Karen Lightner

Open Mon - Fri 9 AM - 5 PM; No admis fee; Estab 1949; Average Annual Attendance: 3,000
Special Subjects: Illustration, Manuscripts
Collections: American Sunday-School Union; Early American children's books including Rosenbach Collection of Early American Children's books (1682-1836); Elisabeth Ball Collection of Horn books; Borneman & Yoder Collection of Pennsylvania German Fraktur; Hampton L Carson Collection of legal prints; Frederick R Gardner Collection of Robert Lawson original drawings; Kate Greenaway; Grace Clark Haskell Collection of Arthur Rackham; John Frederick Lewis Collection of cuneiform tablets & seals, Medieval & Renaissance manuscripts & miniatures, Oriental manuscripts & miniatures (mostly Mughul, Rajput & Persian); Thornton Oakley Collection of Howard Pyle & His School, books & original drawings; Beatrix Potter, including H Bacon Collamore Collection of original art; Evan Randolph Collection consisting of angling prints from the 17th to the 20th century & prints of Philadelphia from 1800-1950; original drawings, paintings, prints & other illustrative material relating to the works of Dickens, Goldsmith, Poe & Thackeray
Activities: Individual paintings & original objects of art lent to other institutions for exhib not to exceed 3 months; lending coll contains books, original artworks & paintings

M **GERMANTOWN HISTORICAL SOCIETY,** 5501 Germantown Ave, Philadelphia, PA 19144-2691. Tel 215-844-0514; Fax 215-844-2831; Elec Mail ghs@libertynet.org; Internet Home Page Address: www.libertynet.org/ghs; *CEO* Mary K Dabney; *Librn* Marion Rosenbaum; *Asst to the Dir* Lynn Klein; *Editor Germantown Crier* Judith Callard; *VPres* Alex B Humes; *Mus Shop Mgr* Heike Rass-Paulmier
Open Tues & Thurs 9 AM - 5 PM, Sun 1 - 5 PM & groups by appointment; Admis fee $5, children under 12 $2; libr $7.50, students with ID $5; Estab 1900 as an educ center; Maintains reference library; Average Annual Attendance: 7,000; Mem: 450; dues $30
Income: $200,000 (financed by endowment, mem, city & state appropriations, foundations & corporations)
Library Holdings: Audio Tapes; Book Volumes; Lantern Slides; Manuscripts; Maps; Memorabilia; Micro Print; Motion Pictures; Original Documents; Pamphlets; Photographs; Prints; Slides; Video Tapes
Special Subjects: Drawings, Costumes, Dolls, Furniture
Collections: African-American history; costume; family papers; furniture; genealogy; German immigration; glass negatives; industrial heritage; local business archives; local history; photographs; textiles; toys & dolls; Wissahickon natural area
Exhibitions: Germans, Generals & Gentlemen; Urban Village
Publications: The Germantown Crier, semiannual
Activities: Classes for adults & children; lect open to pub; individual paintings & original objects of art lent to institutions meeting professional standards; mus shop sells books, magazines & original art

L **Library,** 5501 Germantown Ave, Philadelphia, PA 19144-2697. Tel 215-844-0514; Fax 215-844-2831; Elec Mail ghs@libertynet.org; Internet Home Page Address: www.libertynet.org/ghs; *Exec Dir* Mary K Dabney
Open Tues & Thurs 9 AM - 5 PM, Sun 1 - 5 PM; Admis $7.50; Estab 1878; For reference only
Income: Financed by contributions, foundation grants & pub funding
Library Holdings: Audio Tapes; Book Volumes 3000; Cassettes; Clipping Files; Exhibition Catalogs; Fiche; Framed Reproductions; Kodachrome Transparencies; Lantern Slides; Manuscripts; Memorabilia; Motion Pictures; Original Art Works; Pamphlets; Photographs; Prints; Records; Reels; Reproductions; Slides; Video Tapes
Special Subjects: Photography, Manuscripts, Maps, Painting-American, Historical Material, Portraits, Watercolors, Furniture, Dolls, Restoration & Conservation, Textiles
Exhibitions: Orientation to Germantown Historical Society & other sites; on-going, others vary

M **GIRARD COLLEGE,** Stephen Girard Collection, 2101 S College Ave, Philadelphia, PA 19121. Tel 215-787-2680; Fax 215-787-2710; Internet Home Page Address: www.girardcollege.com; *Assoc Dir Historical Resources* Elizabeth Laurent; *Pres* Joseph T Devlin; *Cultural Assoc* Virginia Yeldham
Open Thurs 10 AM - 2 PM and by appointment; Admis fee; Estab 1848; The art and historical colls of Girard Col are housed on the second fl of Founder's Hall. Of white marble and monumental scale, the bldg is generally regarded the finest example of Greek Revival architecture in America. Designed by Thomas U Walter in 1832 and constructed 1833-1848, Founder's Hall was the school's original classroom bldg; Average Annual Attendance: 1,500
Income: Financed by endowment
Special Subjects: Historical Material, Architecture, Graphics, Painting-American, Sculpture, Watercolors, Decorative Arts, Furniture, Glass, Porcelain, Silver, Period Rooms
Collections: Furniture, silver, porcelain, paintings, marble busts & statues which belonged to Stephen Girard (1750 - 1831) founder of Girard College; Philadelphia's finest single-owner coll from the early historical period
Exhibitions: Continuous display in room settings

M **HIGH WIRE GALLERY,** 1315 Cherry St, 4th Fl Philadelphia, PA 19107. Tel 215-829-1255; Elec Mail tmosher201@aol.com; Internet Home Page Address: www.highwired.tv; *VPres* Jeff Waring; *Treas* Marge Peterson; *Pres* Ted Mosher; *Secy* Lisa Spera
Open Wed - Sun Noon - 6 PM; No admis fee; Estab 1985 as an independent cooperative arts & performance space; Exhibs of plastic arts & poetry, dance, music & performance in the heart of Philadelphia's Old City arts district; Average Annual Attendance: 30,000; Mem: 24; mem qualification-juried review; dues $540; meetings 1st Mon each month
Income: $13,000 (financed by mem & donation)
Exhibitions: Members Solo Exhibitions; Poets & Prophets (poetry series); This Not That (open art forum); musical & dance performances
Activities: Lect open to pub; weekly public art forums; lending coll contains individual paintings & original objects of art

L **HISTORICAL SOCIETY OF PENNSYLVANIA,** 1300 Locust St, Philadelphia, PA 19107-5699. Tel 215-732-6200; Fax 215-732-2680; Elec Mail hsppr@hsp.org; Internet Home Page Address: www.hsp.org; *Pres* David Moltke-Hansen; *Dir Library* Lee Arnold; *Business Mgr* Penelope Bauer; *Mem Coordr* Marquis Upshur; *Ed* Tammy Miller; *COO* Thomas Woodward; *Dir Archives* Rachel Onuf; *Graphics Head* Laura Beadsley
Open Tues, Thurs & Fri 9:30 AM - 4:45 PM, Wed 1 - 8:45 PM, Sat 10 AM - 4:45 PM, cl; Admis $6, students $3 to library; Estab 1824, the library collects & preserves documentary records relating primarily to 18th century national US history, 19th century regional Pennsylvania & 20th century Delaware Valley history, ethnic, immigration & family history; Average Annual Attendance: 11,000; Mem: 1700; dues $45; meetings 5 times per yr
Income: (financed by endowment, mem dues & contributions)
Purchases: $49,204
Special Subjects: Photography, Drawings, Etchings & Engravings, Graphic Arts, Manuscripts, Maps, Posters, Prints, Historical Material, Portraits, Watercolors, Cartoons, Woodcuts, Reproductions, Architecture
Collections: Unmatched collection of more than 19 million manuscripts, archives, graphics from pre-Revolution through the present; Balch Institute holdings document ethnic & immigrant experience in the USA since 1877
Publications: Guide to the Manuscript Collections of the Historical Society of Pennsylvania; Pennsylvania Magazine of History & Biography, quarterly; Serving History in a Changing World: The Historical Society of Pennsylvania in the Twentieth Century; Index to the Pennsylvania Magazine of History and Biography (vols 76-123, 1952-99)
Activities: Workshops for adults; conferences on history & historical research; orientations to documentary colls; 25 vis lectrs per yr; 2 exhibits per yr

M **INDEPENDENCE NATIONAL HISTORICAL PARK,** 143 S 3d St, Philadelphia, PA 19106. Tel 215-597-9373, 597-8787; Fax 215-597-5556; Internet Home Page Address: www.nps.gov/inde; *Chief Mus Branch* Karie Diethorn
Open daily 9 AM - 5 PM; No admis fee; Estab 1948 to preserve & protect for the American people, historical structures, properties & other resources of outstanding national significance & associated with the Revolution & growth of the Nation; Seventeen pub buildings with 54 period rooms & 38 on-site exhibits. Maintains reference library; Average Annual Attendance: 4,500,000
Income: Financed by federal agency
Library Holdings: Auction Catalogs; Manuscripts; Original Art Works; Periodical Subscriptions
Special Subjects: Painting-American, Archaeology, Decorative Arts, Portraits, Period Rooms
Collections: 18th century American period furnishings; decorative arts; American portraits from 1740-1840
Exhibitions: Rotating exhibs
Activities: Classes for adults & children; docent training; lect open to pub, 6 vis lectrs per yr; tours; individual paintings & original objects or art lent to qualified professional institutions; mus shop sells books, magazines, reproductions, prints & slides

L **Library,** 313 Walnut St, Philadelphia, PA 19106. Tel 215-597-8787; Fax 215-597-5556; Elec Mail andrea_ashley@nps.gov; Internet Home Page Address: www.nps.gov/inde; *Archivist* Karen Stevens; *Librn Technician* Andrea Ashby; *Chief Cur* Karie Diethorn; *Chief Architect* Charles Tonetti; *Pub Affairs Officer* Phil Sheridan; *Chief Historian* James Meuleer; *Chief Cultural Resources* Doris Fanelli; *Supt* Martha B Aikens; *Chief Interpretation* Chris Schillizzi
Open to pub Mon - Fri 9:30 AM - 4:30 PM by appointment only; No admis fee; Circ 300
Income: financed by federal funds
Library Holdings: Audio Tapes; Book Volumes 9500; Cassettes; Clipping Files; Exhibition Catalogs; Fiche; Kodachrome Transparencies; Manuscripts; Motion Pictures; Other Holdings Research notecard file; Pamphlets; Periodical Subscriptions 12; Photographs; Records; Reels; Slides; Video Tapes
Collections: Decorative arts of Philadelphia & Pennsylvania for the 18th century

M **INDEPENDENCE SEAPORT MUSEUM,** 211 S Columbus Blvd & Walnut St, Penn's Landing Waterfront Philadelphia, PA 19106-3100. Tel 215-925-5439; Fax 215-925-6713; Elec Mail seaport@libertynet.org; Elec Mail seaport@indsm.org; Internet Home Page Address: phillyseaport.org; *Educator* William Ward; *CEO & Pres* John S Carter; *Coll Mgr* Craig Bruns; *Cur* David Beard; *VPres Operations* Karen Cronin; *Controller* Louann Cook; *VPres Develop* Maynard W Poole; *VPres Interpretation* Roberta Cooks; *Pub Relations Coordr* Tania Karpinich; *Pub Relations Coordr* Alanna Buchanan; *VChmn* Walter D'Alessio; *Mus Shop Mgr* Vicki Agnew
Open Mon - Sun 10 AM - 5 PM; Admis adults $8, seniors $6, children $4; Estab 1960 to preserve & interpret the maritime heritage of the Bay & River Delaware & the Ports of Philadelphia; Gallery 1, The Sea Around Us, general maritime history; Gallery 3, changing exhibits; Gallery 4 changing exhibits; Average Annual Attendance: 41,5000; Mem: 965; dues $35 minimum; ann meeting May
Income: Financed by endowment, mem & federal, pvt & corporate gifts
Special Subjects: Manuscripts, Marine Painting, Historical Material, Scrimshaw
Collections: Paintings by major American marine artists; Philadelphia Views; 19th-20th century maritime prints
Publications: Annual Report; books & catalogs, intermittently; Spindrift, quarterly newsletter
Activities: Classes for adults & children; lect for mems only, 10 vis lectrs per yr; concerts; gallery talks; competitions; individual paintings & original objects of art lent to recognized nonprofit museums with adequate facilities & pertinent need, six months only; mus shop sells books

L **Library,** 211 S Columbus Blvd & Walnut St, Philadelphia, PA 19106-3100. Tel 215-925-5439; Fax 215-925-6713; Internet Home Page Address: seaport.philly.com
Open by appointment only; No admis fee; Estab 1960; Open to members & scholars, for reference only
Income: Financed by federal funding, donations
Library Holdings: Book Volumes 12,000; Cassettes 150; Exhibition Catalogs; Fiche; Kodachrome Transparencies; Lantern Slides; Manuscripts; Motion Pictures; Original Art Works; Other Holdings Boat plans 9000; Rare books & maps; Pamphlets; Periodical Subscriptions 100; Photographs 25,000; Prints; Reels; Slides 2000

Collections: Photographic file of Birch prints; photographic file of ships built by New York Shipbuilding Corp; art reference books on marine artists

M **LA SALLE UNIVERSITY,** Art Museum, 20th & Olney Ave, Philadelphia, PA 19141. Tel 215-951-1221; Fax 215-951-5096; Elec Mail wistar@lasalle.edu; Internet Home Page Address: www.lasalle.edu; *Dir* Daniel Burke; *Cur* Caroline Wistar; *Cur* Madeleine Viljoen
Open Tues - Fri 11 AM - 4 PM, Sun 2 - 4 PM; cl Mon & Sat; No admis fee; Estab 1975 for educ purposes and to house the coll begun in 1965, also as support for the art history prog and as a service to the community; Average Annual Attendance: 11,000; Mem: 60; dues $5 - $1000
Income: Financed by endowment, univ budget, grants, pub & pvt donations
Special Subjects: Drawings, Painting-American, Prints, Watercolors, Painting-European
Collections: 15th - 20th century paintings, drawings, watercolors, Old Master & those of 19th & 20th centuries prints; Western, European & American art, with a few pieces of sculpture & decorative art; rare illustrated 15th - 20th century Bibles; portrait prints
Exhibitions: Two special exhibs are held each semester
Publications: La Salle Art Museum Guide to the Collection
Activities: Classes for adults; lects open to pub, 2-3 vis lectrs per yr; concerts; gallery talks; tours; individual paintings & original objects of art lent to museums

L **LIBRARY COMPANY OF PHILADELPHIA,** 1314 Locust St, Philadelphia, PA 19107. Tel 215-546-3181, 546-8229; Fax 215-546-5167; Elec Mail refdep@librarycompany.org; Internet Home Page Address: www.librarycompany.org; *Assoc Librn* James N Green; *Cur Prints* Sarah Weatherwax; *Chief Reference* Philip Lapsansky; *Chief Conservation* Jennifer Woods Rosner; *CEO & Librn* John C Van Horne; *VPres* Elizabeth McLean; *Chief Cataloguer* Ruth I Hughes
Open Mon - Fri 9 AM - 4:45 PM; No admis fee; Estab 1731 for the purpose of scholarly research; Revolving exhibits that highlight colls; Average Annual Attendance: 2,500; Mem: 150; dues $50; ann meeting in May
Income: Financed by endowment, mem, city appropriation, state & federal grants
Library Holdings: Book Volumes 500,000; Cards; Exhibition Catalogs; Filmstrips; Framed Reproductions; Memorabilia; Original Art Works; Pamphlets; Periodical Subscriptions 160; Photographs; Sculpture
Special Subjects: Art History, Landscape Architecture, Drawings, Etchings & Engravings, Manuscripts, Historical Material, History of Art & Archaeology, Judaica, Cartoons, Fashion Arts, Afro-American Art, Bookplates & Bindings, Landscapes, Coins & Medals, Architecture
Collections: American Printing; Philadelphia prints, watercolors, drawings and photography; collection of Americana
Publications: Annual Report; Occasional Miscellany, 2 times per year; exhibition catalogs
Activities: Lect open to pub; gallery talks; tours; fel; individual & original objects of art lent to museums, libraries & cultural institutions; sale of books & publs

L **LUTHERAN THEOLOGICAL SEMINARY,** Krauth Memorial Library, 7301 Germantown Ave, Philadelphia, PA 19119-1794. Tel 215-248-4616; Fax 215-248-4577; Elec Mail lutthelib@ltsp.edu; *Head Pub Serv* Darren Poley; *Head Technical Servs* Lois Reibach; *Cur Archives* John E Peterson; *Dir Library* David J Wartluft
Open Mon - Fri 9 AM - 5 PM, during academic sessions, Mon - Thurs 5 - 10 PM; Estab 1906
Library Holdings: Audio Tapes; Book Volumes 185,000; Cassettes; Filmstrips; Kodachrome Transparencies; Lantern Slides; Manuscripts; Memorabilia; Original Art Works; Periodical Subscriptions 570; Records; Reproductions; Slides; Video Tapes
Special Subjects: Religious Art, Architecture
Collections: Liturgical arts; Modern Prints; Rentschler Coll of Last Supper Art; Schreiber Coll of Numismatic Art on Martin Luther & the Reformation
Exhibitions: 20 Religious Artists

M **MOORE COLLEGE OF ART & DESIGN,** The Galleries at Moore, 20th & The Parkway, Philadelphia, PA 19103. Tel 215-965-4027; Fax 215-568-5921; Elec Mail galleries@moore.edu; Internet Home Page Address: thegalleriesatmoore.org; *Dir Galleries & Chief Cur* Marysol Nieves; *Asst Dir* Michele Bregande
Open Tues - Fri 10 AM - 5 PM, Sat & Sun Noon - 4 PM, cl academic & legal holidays; No admis fee; Estab 1984 to display contemporary art, architecture, photog & design; Gallery is housed in moderate exhib space with flexible panels to accommodate current exhibit; Average Annual Attendance: 35,000; Mem: 175; dues $50 - $2500
Income: Financed by endowment, government & foundation grants, individual & corporate donation
Special Subjects: Architecture, Drawings, Photography, Sculpture, Watercolors, Textiles, Ceramics, Crafts, Folk Art, Portraits
Exhibitions: William Daley; Hanne Darboven; Marlene Dumas; Terry Fox; Valie Export; Dan Graham; Benedetta Cappa Marmetti; Jean-Frederic Schnyder; Pat Ward Williams; Rosamond Purcell; Mary Cassatt; Alice Neel; Karen Kilimnik; Faith Ringgold; Lisa Kereszi; Anthony Campuzano; Artur Barrio; Annual exhib curated from the Levy Registry of Philadelphia area artists; (10/10/2006-12/10/2006) Philadelphia Selections; (1/9/2007-3/18/2007) Andrea Baldeck
Publications: Bulletins, irregularly; Catalogs for major exhibitions
Activities: Educ dept; one-day family workshops; lect open to pub, 10 vis lectrs per yr; concerts; gallery talks; tours; book signings; films; performances; symposia; book traveling exhibs 1 per yr; originate traveling exhibs to other univ galleries & small exhib spaces in large museums throughout US & Canada

L **Library,** 20th & The Parkway, Philadelphia, PA 19103. Tel 215-965-4054; Fax 215-965-8544; Internet Home Page Address: www.moore.edu; *Slide Cur* Helen F McGinnis; *AV Specialist* Chuck Duguense; *Archivist* Cathleen Miller; *Cataloging Librn* Roxanne Lucchesi
Open Mon - Thurs 8 AM - 10 PM, Fri 8 AM - 5 PM, Sat 8:30 AM - 5 PM, for student use; pub use Mon - Fri 8:30 - 10 PM & by appointment; $15 yr for circ privileges alumni only; Estab to serve Moore staff & students; Circ 17,752; For lending & reference; Average Annual Attendance: 30,000

Purchases: $37,000
Library Holdings: Audio Tapes; Book Volumes 40,000; Cassettes; Clipping Files; DVDs; Exhibition Catalogs; Filmstrips; Lantern Slides; Manuscripts; Memorabilia; Motion Pictures; Original Art Works In archives; Original Documents In archives; Other Holdings Picture files; Periodical Subscriptions 230; Records; Reproductions; Slides 117,000; Video Tapes
Collections: Sartain Family Collection; Bookworks Artists Books Collection
Activities: Classes for adults and children; lect open to pub; gallery talks; tours

M **MUSE ART GALLERY,** 60 N Second St, Philadelphia, PA 19106. Tel 215-627-5310; *Dir* Sissy Pizzollo
Open Wed - Sun 11 AM - 5 PM; Estab 1970 as an art coopertive exhibiting members works; Gallery is a co-op; Average Annual Attendance: 2,500; Mem: 15; qualifications: professional exhibiting or emerging artist; dues $600; monthly meetings
Income: Financed by mem, sales commissions, Pennsylvania State Council of the Arts & pvt contributions
Exhibitions: Mems & community-oriented exhibs
Publications: Catalogues; MUSE Gallery and Her Own Space
Activities: Art consultant program; lect open to pub, 2 vis lectrs per yr; poetry readings; competitions; originate international traveling exhibs; original art for sale

M **THE MUSEUM AT DREXEL UNIVERSITY,** Chestnut & 32nd Sts, Philadelphia, PA 19104. Tel 215-895-1749; Fax 215-895-6447; Internet Home Page Address: www.drexel.edu; *Dir* Charles Morscheck
Open Mon - Fri 10 AM - 4 PM, cl Sat, Sun & holidays; No admis fee; Estab 1891; Picture Gallery 1902; Main Gallery contains the John D Lankenau & the Anthony J Drexel Collections of German & French paintings, sculpture & decorative arts of the 19th century & a changing exhib gallery; Average Annual Attendance: 10,000
Income: Financed by Drexel University
Special Subjects: Sculpture, Textiles, Ceramics, Decorative Arts, Oriental Art, Asian Art, Painting-French, Painting-German
Collections: 19th century sculpture, academic European painting, decorative arts & costumes; ceramics; hand printed India cottons; decorative arts of China, Europe, India & Japan
Exhibitions: Annual Student Art Show; Regional Artists
Activities: Lect open to pub, 8-10 vis lectrs per yr; concerts; gallery talks; book traveling exhibs

M **NEXUS FOUNDATION FOR TODAY'S ART,** (Foundation for Today's Art) 137 N Second St, Philadelphia, PA 19106. Tel 215-629-1103; Fax 215-629-8683; Elec Mail info@nexusphiladelphia.org; Internet Home Page Address: www.nexusphiladelphia.org; *Exec Dir* Nick Cassway; *Chm of Bd* Chris Vecchil
Open Wed -Sun 12 - 6 PM; No admis fee; Estab 1975, artist-run space for contemporary art, featuring experimental-emerging artists, new directions-new media; national/international exchanges; cultural outreach progs; Two contemporary galleries, each 750 sq ft; Average Annual Attendance: 5,000; Mem: 20; dues $50 per month; monthly meetings; half of exhibits feature mem artists selected for experimental & creative approach to both traditional & new media with demonstrated level of consistency & commitment; the other half feature non-mem artists & invited curators
Income: Financed by mem, state, federal & foundation grants
Activities: Workshops for graduating art students; lect open to pub, 5+ vis lectrs per yr; concerts; gallery talks; tours upon request; internships offered

M **PAINTED BRIDE ART CENTER GALLERY,** 230 Vine St, Philadelphia, PA 19106. Tel 215-925-9914; Fax 215-925-7402; Elec Mail thebride@onix.com; Internet Home Page Address: www.paintedbride.org; *Visual Arts Coordr* Christine A Millan; *Develop Dir* Renee Simpson; *Exec Dir* Gerry Givnish; *Dir of Progs* Ellen M Rosenholtz; *Exec Dir* Laurel Raczka; *Dir Develop* Heather Evans
Open Mon- Fri 10 AM - 6 PM, Sat Noon - 6 PM; No admis fee; Estab 1968; forum for work outside traditional channels to present interdisciplinary work; Average Annual Attendance: 27,000; Mem: 350
Collections: Contemporary Art & Theater
Activities: Educ workshops for all ages; lect open to the pub; concerts; gallery talks; tours; exten prog serves Philadelphia & suburbs; sales shop sells books & original art

M **PENNSYLVANIA ACADEMY OF THE FINE ARTS,** 118 N Broad St, Philadelphia, PA 19102. Tel 215-972-7600; Fax 215-569-0153; Elec Mail pafa@pafa.org; Internet Home Page Address: www.pafa.org; *Chmn Board* Donald R Caldwell; *Pres* Derek Gillman; *Dir Develop* Mary Anne Dutt Justice; *Dir Donor & Mem Servs* Melissa DeRuiter; *Cur* Sylvia Yount; *Mus Registrar* Gale Rawson; *Dir Retail Sales* Mark DeLelys; *Chief Conservator* Aella Diamantopoulos; *Dir Mktg & Comms* Laurie Grant; *Deputy Dir* Kim Sajet
Open Tues - Sat 10 AM - 5 PM, Sun 11 AM - 5 PM; Admis adults $5, seniors & students $4, children 5-18, members & children under 5 free; Estab 1805 by Charles Willson Peale to cultivate collecting, training & development of the fine arts in America; The Academy Building, opened in 1876, was restored for the American Bicentennial. Considered the masterpiece of its architect, Philadelphian Frank Furness, its style is called, alternatively, polychrome picturesque & High or Gothic Victorian. It was designated a Registered National Historic Landmark in 1975. The School Gallery features faculty & student exhibs; Average Annual Attendance: 75,000; Mem: 3000; dues $40 - 10,000
Income: Financed by endowment, mem, city & state appropriations, contributions & federal grants
Special Subjects: Architecture, Graphics, Painting-American, Prints, Sculpture, Bronzes, Woodcarvings, Woodcuts, Etchings & Engravings, Landscapes, Afro-American Art, Collages, Portraits, Posters, Marine Painting, Historical Material, Coins & Medals, Tapestries
Collections: American contemporary works; 18th, 19th & early 20th century American paintings, sculpture, drawings & prints, including Allston, West, the Peale Family, Stuart, Sully, Rush, Neagle, Mount, Eakins, Cassatt, Homer, Hopper, Hassam, Carles, Bellows, Henri, Beaux, Pippin
Publications: Annual report; Calendar of Events; exhibition & school catalogues; quarterly newsletter

Activities: Classes for adults & children; docent training; lect open to pub, 50 vis lectrs per yr; concerts; gallery talks; tours; competitions with awards; schols offered; exten dept serves senior citizens; original objects of art lent to other institutions, the White House, the Governor of Pennsylvania & embassies abroad; book traveling exhibs 2-3 per yr; originate traveling exhibs; mus shop sells books, magazines, reproductions, prints, slides, ceramics, games, stationery, jewelry, toys & pottery

L Library, 1301 Cherry St, Philadelphia, PA 19107. Tel 215-972-7600, Ext 2030; Fax 215-569-0153; Elec Mail library@pafa.org; *Librn* Aurora Deshauteurs
Open Mon - Thurs 9 AM - 7 PM, Fri 8 AM - 4:30 PM, Sat 10 AM - 1 PM, open to pub, cl during school vacations; Admis by appointment; Estab 1805, the library serves students of painting, sculpture, printmaking & research in American Art; Open to pub for reference
Income: Financed by school funds
Library Holdings: Book Volumes 13,500; Clipping Files; Exhibition Catalogs; Periodical Subscriptions 82; Slides; Video Tapes

L Archives, 118 N Broad St, Philadelphia, PA 19102. Tel 215-972-7600, ext 2066; Fax 215-567-0153; Elec Mail archives@pafa.org; Internet Home Page Address: www.pafa.org; *Archivist* Cheryl Leibold
Open weekdays by appointment only; email inquiries welcome; No admis fee
Library Holdings: Audio Tapes; Clipping Files; Exhibition Catalogs; Filmstrips; Kodachrome Transparencies; Lantern Slides; Manuscripts; Memorabilia; Other Holdings Artifacts; Pamphlets; Photographs; Slides; Video Tapes
Collections: Charles Bregler's Thomas Eakins Collection, consisting of more than 1000 art objects & documents
Publications: Brochure about the archives; Index to Annual Exhibitions, 3 vols

A Fellowship of the Pennsylvania Academy of the Fine Arts, c/o Museum of American Art of the Pennsylvania Academy of the Fine Arts, 1301 Cherry St Philadelphia, PA 19107. Tel 215-972-7600, Ext 2044; *Exec VPres* Ruth C Davis; *VPres* Margaret Engman; *VPres* William Greenwood; *Treas* William Cunningham; *Pres* Rodger Lapelle
Estab 1897 to provide opportunities for creative incentive & sharing in responsibilities for the development of facilities & activities in the field of art for its members & to maintain relations with the students of the Pennsylvania Academy of the Fine Arts; Mem: 3500; dues resident $30, nonresidents $20, students $15; meetings held Sept, Nov, Feb & May
Income: $20,000 (financed by mem & investments)
Purchases: $1000 (art collection & operating expenses)
Collections: Paintings and sculpture
Exhibitions: Annual Fellowship Show; Juried Members Exhibition
Publications: Perspective magazine, 3 times yr
Activities: Classes; lect; awards; films; workshops; auctions; picnic; ball; individual paintings & original objects of art lent to schools, library & other pub institutions; lending coll contains originial art works, original prints, paintings, photographs, sculpture, slides; originate traveling exhibs

A PHILADELPHIA ART ALLIANCE, 251 S 18th St, Philadelphia, PA 19103. Tel 215-545-4305; Fax 215-545-0767; Elec Mail info@philartalliance.org; Internet Home Page Address: www.philartalliance.org; *Pres* Carole Price Shanis; *Prog Coordr* Matt Pruden; *Cur* Amy Ingrid Schlegel, PhD; *Dir Mem* Yana Nabutovsky
Galleries open Tues - Sun 11 AM - 5 PM, cl Mon; Suggested donation $3; Estab 1915 as a ctr of contemporary art in all media; performing & literary art progs in a historic mansion; 3 fls of exhib space; Average Annual Attendance: 20,000; Mem: 500; both artist & non-artist categories are available; dues $35 - $1000
Income: Financed by mem, board & corporate, foundation & pvt contributions
Collections: Collection of archives to 1980 are located at Univ of Pa Library
Exhibitions: 20 exhibs annually
Publications: Vernissage, quarterly newsletter & exhib catalogs
Activities: Classes for children ages 4-7; dramatic progs; docent training; lect open to pub, 15 vis lectrs per yr; concerts; gallery talks; tours; 4-star restaurant named Opus 251

A PHILADELPHIA ART COMMISSION, 1515 Arch St, Philadelphia, PA 19102. Tel 215-686-1776; *Exec Dir* William J Burke; *Pres* William L Wilson
Open 8:30 AM - 5 PM; No admis fee; Estab 1911 under Philadelphia Home Rule Charter as the Art Jury, later retitled Art Commission. An Art Ordinance passed in 1959 provides for art work in city buildings and on city owned property; The Art Commission reviews architectural designs and art work covering all media for municipal locations or other locations in which municipal funds are expended. The Art Commission's files are open to inspection by anyone since the information contained therein qualifies as public information. As indicated, the material deals solely with art proposals and architectural designs. Designs cover all buildings, major highways, and bridges; Mem: 9; between 20 and 24 meetings annually
Income: Financed by city appropriation

M PHILADELPHIA MUSEUM OF ART, 26th & Benjamin Franklin Parkway, Philadelphia, PA 19130; P.O. Box 7646, Philadelphia, PA 19101-7646. Tel 215-763-8100; Fax 215-684-7600; Internet Home Page Address: www.philamuseum.org; *The George D Widener Dir & CEO* Anne d'Harnoncourt; *COO* Gail Harrity; *Dir* Cheryl McClenney-Brooker; *McNeil Cur American Art* Kathy Fostor; *Sr Cur Prints, Drawings & Photographs* Innis Shoemaker; *Cur Drawings* Ann Percy; *Cur Educ* Marla Shoemaker; *Registrar* Irene Taurins; *Special Exhibs Coordr* Suzanne Wells; *Dir Develop* Betty Marmon; *Chmn Bd* H L (Gerry) Lenfest; *Assoc Dir Colls & Project Support* Alice Beamesdofer; *Cur American Decorative Arts* David Barquist
Open Tues - Thurs 10 AM - 5 PM, Fri 10 AM - 8:45 PM; Admis adults $12, seniors, students & children $7, Sun 10 AM - 1 PM, donations accepted; Estab 1876 as an art mus & for art educ; known as Pennsylvania Mus of Art until the present name was adopted in 1938; Museum founded in 1876; buildings owned by the City, opened 1928; wings 1931 & 1940; fashion galleries 1949, 1951 & 1953; Gallatin & Arensberg Collections 1954; Far Eastern Wing 1957; decorative arts galleries 1958; Charles Patterson Van Pelt Auditorium 1959; Nepalese-Tibetan Gallery 1960; new galleries of Italian & French Renaissance Art 1960; American Wing, galleries of contemporary painting, sculpture & decorative arts & special exhibs galleries 1976; Alfred Stieglitz Center of Photography 1978; print & drawing gallery 1979; 19th century decorative arts galleries 1980 & 1981. Mus contains 200 galleries; Average Annual Attendance: 800,000; Mem: 50,000; dues $25 - $50,000

Income: $46,000,000 (financed by endowment, mem, city & state appropriations, grants, bequests & auxiliary activities)
Special Subjects: Architecture, Painting-American, Folk Art, Painting-European, Furniture, Glass, Porcelain, Oriental Art, Asian Art, Period Rooms
Collections: Indian sculpture & miniature painting & the installation of 16th century South Indian temple; Chinese & Southwest Asian sculpture, ceramics & decorative arts from the Crozier, Crofts, Williams, McIlhenny, Thompson & other colls, with installations of a Ming period Chinese palace hall & temple & a Ch'ing scholar's study; Japanese scroll paintings, prints & decorative arts, with installations of a tea house & a 14th century temple; Himalayan sculpture & painting; Middle Eastern tile, miniatures & decorative arts from the White & other colls; Oriental carpets from the McIlhenny, Williams & other colls; Pre-Columbian sculpture & artifacts from the Arensberg Colls; Medieval & Renaissance sculpture, painting & decorative arts from the Foulc, Barnard & other colls; installations of a Gothic chapel, Romanesque cloister, French Renaissance choir screen & period rooms; Barbarini-Kress Foundation tapestry series; Kienbusch Collection of Arms & Armor; French, Dutch, English & Italian painting & decorative arts of the 14th-19th centuries, from the Wilstach, Elkins, McFadden, Tyson, John G Johnson, McIlhenny, Coxe-Wright & other colls; Italian, Dutch & French drawings from the Clark & other colls; French & English 17th & 18th century decorative arts from the Rice, Bloomfield-Moore & other colls, with period rooms; French & English art-nouveau decorative arts; costume & textiles from all periods of western & eastern art, including the Whitman sampler coll; American colls include painting, sculpture & decorative arts from the colonial era to the present, with period rooms, Philadelphia furniture & silver, Tucker porcelain, Lorimer Glass Collection & the Geesey Collection of Pennsylvania German folk art; 20th century painting, sculpture & works on paper from the Gallatin, Arensberg, Tyson, White, Stern, Stieglitz, Zigrosser, Greenfield, Woodward & other collections; Ars Medica Collection of prints on the subject of sickness & healing from all periods of western art; Alfred Stieglitz Center Collection of Photography; 20th century decorative arts; Rotating exhibs
Publications: Bulletin, quarterly; exhibs catalogs; members' magazine, semi-annually; monthly calendar
Activities: Classes for adults, children & families; guide & docent training; symposia; concerts; lect open to pub; concerts; gallery talks, films; tours; traveling exhibs organized & circulated; mus shops sells books, magazines, reproductions, prints, slides, jewelry, needlework & postcards; art sales & rental gallery

M Rodin Museum of Philadelphia, 22nd & Benjamin Franklin Pky, Philadelphia, PA 19101. Tel 215-763-8100; Internet Home Page Address: www.rodinmuseum.org; Cable PHILMUSE; *Cur of Pre-1900 European Painting & Sculpture* Joseph Rishel; *Assoc Cur* Christopher Riopelle
Open Tues - Sun 10 AM - 5 PM, cl Mon & holidays; Admis by donation, contribution of $3; Estab 1926; Rodin Mus of Philadelphia houses one of the largest colls outside of Paris of works by the major late 19th Century French sculptor, Auguste Rodin; Average Annual Attendance: 35,000
Collections: Coll includes many of the most famous sculptures created by Rodin, as well as drawings, prints, letters, books & a variety of documentary material
Exhibitions: Rotating exhibs
Activities: Classes for adults & children; docent training; concerts; gallery talks; tours; individual sculptures & drawings lent to museums for exhibs; mus shop sells books, reproductions, slides, cards & memorabilia; audio tour

M Mount Pleasant, Fairmount Park, Philadelphia, PA 19101. Tel 215-763-8100 ext 4014; Internet Home Page Address: www.phila.museum.com; *Cur American Decorative Arts* Jack Lindsey; *Mgr Vol Servs* Caroline T Gladstone; *Admin Asst* Deborah W Troemner
Open daily except Mon, cl major holidays; Admis adults $1, children $.50; Historic house built in 1761; an outstanding example of the Georgian style in 18th century building & woodcarving; installed with period furnishings
Collections: Period furnishings from the mus represent the elegant way of life in Philadelphia in the 1760s
Activities: Tours

M Cedar Grove, Cedar Grove Mansion Fairmount Park, Lansdowne Dr Philadelphia, PA 19101. Tel 215-878-2123; Internet Home Page Address: www.philamuseum.org;
Open Tues - Sun 10 AM - 5 PM, cl Mon; Admis adults $1, children $.50; This Quaker farmhouse built as a country retreat in 1748 was moved stone by stone to Fairmount Park in 1928 & restored with the furnishings of the five generations of Quakers who lived in it
Collections: The furniture was given with the house & reflects changes in styles through the 17th, 18th & 19th centuries
Activities: Tours

M John G Johnson Collection, Parkway & 26th, PO Box 7646 Philadelphia, PA 19101-7646. Tel 215-684-7616; Fax 215-763-8955; *Asst Cur* Katherine Crawford Luber; *Cur* Joseph Rishel
Open Tues - Sun 10 AM - 5 PM; Admis to Philadelphia Mus of Art $6; Upon his death in 1917, prominent Philadelphia lawyer, John Graver Johnson left his extensive coll intact to the city of Philadelphia; since 1933 the coll has been housed in the Philadelphia Mus of Art; administration & trusteeship of the coll is maintained separately from the other colls in the mus
Income: Financed by trust, estab by John G Johnson, contributions city of Philadelphia & Philadelphia Mus of Art
Collections: Early & later Italian Renaissance paintings; French 19th century paintings; northern European schools of Flanders, Holland & Germany in the 15th, 16th & 17th centuries
Exhibitions: In house exhibs featuring works from permanent coll
Publications: Several catalogs for various parts of the collection including Catalog of Italian Paintings & Catalog of Flemish & Dutch Paintings
Activities: Special lect & related activities; occasional lending of collection to significant exhibitions

M Samuel S Fleisher Art Memorial, 709-721 Catharine St, Philadelphia, PA 19147. Tel 215-922-3456; Fax 215-922-5327; Elec Mail pr@philamuseum.org; Internet Home Page Address: www.fleisher.org; *Dir* Thora E Jacobson; *Conservation Scientist* Beth Price; *Cur European Decorative Art* Kathryn B Hiesinger; *Cur East Asian Art* Felice Fischer; *Sr Cur European Decorative Art* Dean Walker; *Conservator Furniture* David DeMuzio; *Cur American Art* Darrel L Sewell; *Cur Indian & Himalayan Art* Darielle Mason; *Dir & CEO* Anne d'Harnoncourt; *Cur Educ* Danielle Rice; *Sr Cur Prints & Drawing* Innis H Shoemaker; *Registrar* Irene Taurins; *Sr Conservator Paintings* Mark S Tucker; *Cur Drawings* Ann B Percy;

Cur American Decorative Art Jack Lindsey; *Cur Prints* John Ittmann; *Cur European Painting* Joseph J Rishel; *Cur Photog* Katherine Ware; *COO* Gail M Harrity; *Dir Mktg & Pub Rels* Sandra Horrocks; *Dir Develop* Alexandra Q Aldridge; *Conservator Works* Nancy Ash; *Cur Modern & Contemporary Art* Ann Temkin; *Mus Shop Mgr* Stuart Gerstein; *Dir External Affairs* Cheryl McClenney-Brooke; *Dir Operations* Robert Morrone; *Librn* Allen Townsend; *Chmn Bd* H F Gerry Lenfest

Open during exhibs Mon - Fri 9:30 AM - 5 PM, Mon - Thurs 6:30 - 9:30 PM, Sat 1 - 3 PM; No admis fee; Estab 1898 as a free art school & sanctuary (Mus of Religious Art); Permanent colls are housed in an Italian Romanesque Revival building; Gallery is used for school-related exhibs & for special shows of contemporary artists; Average Annual Attendance: 8,000; Mem: 2,800; mem contribution $25 per term

Income: $650,000 (financed by estate income, mem, materials fees, grants & gifts)

Collections: Medieval & Renaissance religious paintings & sculpture; 18th-19th century Portuguese liturgical objects; 17th-20th century Russian icons; some sculpture

Exhibitions: Challenge Series, ann schedule of four exhibs featuring work by Philadelphia area artists; annual student, faculty, adult & childrens' exhibs; occasional special subject exhibs

Activities: Classes for adults & children; lect open to pub, 4 vis lectrs per yr; concerts; gallery talks; tours; competitions; sales shop sells art materials & books

L Library, PO Box 7646, Philadelphia, PA 19101. Tel 215-684-7650; Fax 215-236-0534; Elec Mail library@philamuseum.org; Internet Home Page Address: www.philamuseum.org/library; *Arcadia Dir Libr & Archives* Danial Elliott; *Librn Collection Develop* Mary S Wassermann; *Archivist* Susan K Anderson; *Cataloger* Linda Martin-Schaff; *Reference Librn* Lilah J Mittelstaedt; *Visual & Digital Resources Librn* Evan Towle

Open Tues - Fri 10 AM - 4 PM; Estab 1876 as research library for mus staff, members & scholars (appointments recommended); For reference only

Library Holdings: Book Volumes 140,000; Clipping Files; Exhibition Catalogs; Fiche; Pamphlets; Periodical Subscriptions 450; Reels; Slides

Special Subjects: Art History, Decorative Arts, Photography, Drawings, Etchings & Engravings, Painting-American, Prints, Painting-European, Ceramics, Conceptual Art, Latin American Art, Fashion Arts, Asian Art, Period Rooms, Costume Design & Constr, Glass, Enamels, Gold, Jewelry, Miniatures, Silver, Textiles

L Slide Library, 26th St & Benjamin Franklin Pkwy, PO Box 7646 Philadelphia, PA 19101-7646. Tel 215-684-7658; Fax 215-236-0534; Elec Mail mwassermann@philamuseum.org; *Slide Librn* Mary Wassermann; *Slide Library Asst* Robyn Dillon

None; Provides slides to mus staff, not open to pub

Library Holdings: Slides 152,000

Special Subjects: Art History, Decorative Arts, Manuscripts, Painting-American, History of Art & Archaeology, Ceramics, Asian Art, Furniture, Mexican Art, Glass, Embroidery, Gold, Coins & Medals, Laces, Architecture

A Women's Committee, PO Box 7646, Philadelphia, PA 19101-7646. Tel 215-684-7931; Fax 215-236-8320; Elec Mail twcpma@philamuseum.org; Internet Home Page Address: www.philamuseum.org; *Exec Dir* Nancy G O'Meara; *Pres* Judy Pote

Open Mon - Fri 9 AM - 5 PM; Estab 1883, inc 1915; takes an active interest in the mus; Organization sponsors Art Sales & Rental Gallery, park houses & mus guides, The Philadelphia Mus of Art Craft Show, classes for blind artists & tours for the deaf

Income: Financed by fund raising events

A PHILADELPHIA SKETCH CLUB, 235 S Camac St, Philadelphia, PA 19107. Tel 215-545-9298; Elec Mail info@sketchclub.org; Internet Home Page Address: www.sketchclub.org; *Pres* William C Patterson; *VPres* Edward Warwick; *Treas* Michael DiGiacomo; *Secy* Susan Hutton De Angelus; *Exec Dir* Barbara Murray

Call for hours; No admis fee; Estab 1860 to promote the creation & appreciation of the visual arts; 30 ft X 40 ft with skylight & spotlights; Average Annual Attendance: 19,000; Mem: 200; applicants must be proposed by two mems & show portfolio of their artwork to Board of Directors; dues $150; monthly meetings 2nd Friday of each month

Income: Financed by mem, grants & fundraising activities

Special Subjects: Cartoons, Drawings, Etchings & Engravings, Graphics, Prints, Sculpture, Watercolors, Painting-American, Bronzes, Woodcuts

Collections: Permanent collection is from past & present members, oils, watercolors, etchings; fourty-four Thomas Anshutz Portraits; J Pennell Lithographs

Publications: The Portfolio, (bulletin), monthly

Activities: Classes for adults; life classes; 5 art workshops per wk; lect open to pub, 9 vis lectrs per yr; gallery talks; tours; competitions with cash awards; individual paintings & original objects of art lent to art museums who have exhibs of PSC past mems; lending coll contains original prints, paintings & sculptures

M PHILADELPHIA UNIVERSITY, (Philadelphia College of Textiles & Science) Paley Design Center, 4200 Henry Ave, Philadelphia, PA 19144. Tel 215-951-2860; Fax 215-951-2662; Internet Home Page Address: www.philadelphia.edu

Open Tues - Fri 10 AM - 4 PM; No admis fee; free guided tour by reservation; Estab 1978 to promote knowledge & appreciation of textiles & their design; Three galleries; small library of textile & costume subjects available to scholars & mems

Income: Financed by PU&S & grants from the PCA, pvt & individual foundations

Special Subjects: Textiles, Costumes

Collections: Costumes - 18th to 20th centuries; historic & contemporary textiles 1st - 20th centuries, International; Manufacturers' fabric swatches 19th & 20th centuries, American & Western European; manuscripts, records, textile fibers, tools & related materials

Publications: The Art of the Textile Blockmaker; Florabunda: The Evolution of Floral Design on Fabrics; Flowers of the Yayla, Yoruk Weaving of the Toros Mountains; The Philadelphia System of Textile Manufacture 1884 - 1984

Activities: Mus shop sells unique works by craft artists in jewelry, pottery, glass, wood, paper & textiles; ann holiday crafts market

A PLASTIC CLUB, Art Club, 247 S Camac St, Philadelphia, PA 19107. Tel 215-545-9324; Fax 215-545-9324; Elec Mail plasticclub@att.net; Internet Home Page Address: plastic.libertynet.org; *Pres* Michael Guinn; *VPres & Co-Exhib Chmn* Elizabeth H. MacDonald; *Treas & Co-Exhib Chmn* Paul Struweg; *Corresp Secy* Hilda Schoenwetter; *Recording Secy* Bonnie Schorske

Open Wed - Thurs 10 AM - 2 PM, Thurs. Evening 6:30 PM - 9:30 PM, Sat 1 PM - 4 PM & by appointment; No admis fee; Estab 1897 to promote wider knowledge of art and to advance its interest among artists; Two historic homes provide space for exhibits & a studio; Average Annual Attendance: 1,000; Mem: 105; must qualify for mem by submitting three framed paintings or other works of art to be juried; dues $60; association mems (non-exhibiting) $40; ann meeting in May; work juried by board of directors for active membership; no jurying for assoc

Income: Financed by mem, donations, gifts & money-making projects

Library Holdings: Book Volumes; Exhibition Catalogs; Manuscripts; Memorabilia; Original Art Works; Original Documents; Pamphlets; Photographs; Records

Special Subjects: Drawings, Historical Material, Landscapes, Posters, Watercolors, Painting-American, Portraits

Collections: paintings & posters

Exhibitions: Monthly exhibs of paintings by mems & invited artists.; Open Works on Paper; Open Show All Media; workshop & various theme exhibs

Publications: Calendar of Events, 3 times a year; newsletter, 4 times per yr

Activities: Classes for adults; workshops open to members & pub; lect open to pub; 1 vis lectr per year; tours; gallery talks; competitions with awards; exhib prizes; schols & fels offered; individual paintings & objects of art lent to hospitals, banks & publ buildings; lending coll contains original art works, original prints, paintings, sculpture & crafts, such as jewelry; sales shop sells original art, prints & craft items

M PLEASE TOUCH MUSEUM, 210 N 21st St, Philadelphia, PA 19103. Tel 215-963-0667; Fax 215-963-0424; Elec Mail ceo@pleasetouchmuseum.org; Internet Home Page Address: www.pleasetouchmuseum.org; *VPres Exhibits* Aaron Goldblat; *VPres Communication* Elaine Vaughn; *Pres & CEO* Nancy D Kolb; *VPres Mktg* Frank Stone; *Sr VPres* John McDevitt; *VPres Develop* Tracey Prendergast; *VPres Educ* Rebecca Sethi; *Cur* Matthew Rowley; *Chmn Bd* L Gie Liem; *Mus Shop Mgr* Joan Doyle; *VPres Finance* Farrokh Force; *Sr VPres* Laura Campbell

Open daily 9 AM - 4:30 PM, summer 9 AM - 6 PM, cl Thanksgiving, Christmas & New Year's Day; Admis $8.95, children under 1 yr are free; Estab 1976 & accredited by American Assoc of Museums (1986) to provide a developmentally appropriate mus for young children, their parents & teachers; Gallery spaces are small-scaled, objects are accessible; two-tiered interpretation for adults coming with children (arts, crafts, ethnic materials & childlife exhibits); Average Annual Attendance: 170,000; Mem: 2500; dues family units $65 (4 persons)

Income: $1,600,000 (financed by earned income: admis, store receipts, program fees; contributions, mem, governmental appropriations, foundations, corporate support & individuals)

Special Subjects: Costumes

Collections: Contemporary American toys, artificats & archives documenting American childhood; art works by contemporary artists, sculpture, environmental, paintings & crafts; cultural artifacts from around the world: costumes, playthings, musical instruments, objects from daily life: Materials from the natural sciences

Exhibitions: Alice in Wonderland

Publications: Annual report; The Please Touch Museum Cookbook; quarterly newsletter; thematic exhib catalog, biannual

Activities: Workshops for adults & children; theater progs; docent training; work with area colleges, universities & art schools; coop progs; lect open to pub, 3 vis lectrs per yr; concerts; competitions with awards; original objects of art lent; lending coll contains art works, sculpture & artifacts concerning childhood; originate traveling exhibs; mus shop sells books, posters, toys & educ materials

THE PRINT CENTER
For further information, see National and Regional Organizations

M THE ROSENBACH MUSEUM & LIBRARY, 2010 DeLancey Pl, Philadelphia, PA 19103. Tel 215-732-1600; Fax 215-545-7529; Elec Mail info@rosenbach.org; Internet Home Page Address: www.rosenbach.org; *Dir* Derick Dreher; *Librn* Elizabeth E Fuller; *Dir Educ* Bill Adair; *Assoc Dir* Mike Bousanti; *Mem Coord* Kevin Bellew; *Registrar* Karen Schoenwaldt

Open Wed 10 AM - 8 PM, Tues & Thurs - Sun 10 AM - 5 PM, open to scholars Mon - Fri 9 AM - 4:45 PM by appointment; Admis $8 for docent led tours; $5 students, seniors & groups; Estab 1953 as a nonprofit corporation; Average Annual Attendance: 80,000

Special Subjects: Drawings, Prints, Manuscripts, Porcelain, Silver, Painting-British, Carpets & Rugs

Collections: 18th & 19th century English & American antiques & silver, paintings, prints & drawings, porcelain, rugs & objets d'art; rare books & manuscripts, consisting of British & American literature, Americana, & book illustrations; 300,000 manuscripts; 30,000 books, Marianne Moore Archive; Maurice Sendak Archive; photography, Judaica, bookbindings, Egyptian antiquities, miniatures

Publications: A Selection from Our Shelves; Fantasy Sketches; The Rosenbach Newsletter; exhib catalogs

Activities: Classes for adults & children; dramatic progs; docent training; lect open to pub, 3 vis lectrs per yr; gallery talks; tours; individual paintings & original objects of art lent to mus & libraries with proper environmental & security systems; originate traveling exhibs; mus shop sells books, prints & reproductions

M RYERSS VICTORIAN MUSEUM & LIBRARY LIBRARY & MUSEUM, (Robert W Ryerss Library & Museum) 7370 Central Ave, Philadelphia, PA 19111. Tel 215-745-3061, 685-0599; *Librn* Ermioni Rousseas

Library Open Mon - Fri 10 AM - 5 PM, cl Sat & Sun; No admis fee; Estab 1910; House (Historic Register) left to City complete with contents in 1905; three period rooms; three other mus rooms with art objects - predominately Victorian; Average Annual Attendance: 20,000; Mem: 75; dues $5; meeting first Mon every month

Income: Financed by endowment, city appropriation, volunteer fundraising & trust fund

Special Subjects: Painting-American, Prints, Sculpture, Porcelain, Ivory, Period Rooms

Collections: Static collection; export china, ivory, paintings, period rooms, prints, sculpture, weapons

Activities: Tours; lending collection contains 12,000 books

L **Library & Museum,** 7370 Central Ave, Philadelphia, PA 19111. Tel 215-685-0544, 685-0599; *Librn* Peter Lurowist; *Dir* Theresa Stuhlman
Open Fri, Sat, Sun 10 AM - 4 PM; No admis fee; Estab 1910; Victoriana Collection including Asian Art & Artifacts
Library Holdings: Book Volumes 20,000; Cassettes; Memorabilia; Original Art Works; Periodical Subscriptions 40; Photographs; Prints; Sculpture; Slides
Special Subjects: Decorative Arts, Painting-American, Ceramics, Porcelain, Furniture, Ivory, Period Rooms, Antiquities-Oriental, Antiquities-Greek, Architecture
Collections: Victoriana; Asian Art & Artifacts

A **TALLER PUERTORRIQUENO INC,** Lorenzo Homar Gallery, 2721 N Fifth St, Philadelphia, PA 19133. Tel 215-426-3311; Fax 215-426-5682; Elec Mail arodriguez@tallerpr.org; Internet Home Page Address: www.tallerpr.org; *Cur* Annabella Rodriguez
Open Tues 1 - 5 PM, Wed - Sat 10 AM - 5 PM, cl Sun & Mon; No admis fee; Estab 1974 to develop, educate & promote Puerto Rican arts & cultural traditions while exploring common Latin American roots; Average Annual Attendance: 5,000; Mem: 450; dues $15 & up
Income: Financed by gov, federal, corp & pvt foundations
Purchases: Permanent coll of prints & works on paper
Library Holdings: Audio Tapes; Book Volumes; Exhibition Catalogs; Maps; Original Art Works; Original Documents; Other Holdings; Pamphlets; Periodical Subscriptions; Photographs; Prints; Records; Slides; Video Tapes
Collections: Permanent coll includes silk prints, lithographs & woodcuts
Exhibitions: Five exhibs annually
Publications: 25 Years - 25 Prints: catalogue documenting permanent collection & history of the organization
Activities: Classes for adults & children; summer arts prog; lect open to pub, 2-3 vis lectrs per yr; concerts; gallery talks; tours; schols or fels offered; originate traveling exhibs; galleries, pvt & pub orgs; mus shop sells books, crafts, reproductions & prints

M **UNIVERSITY OF PENNSYLVANIA,** Arthur Ross Gallery, 220 S 34th St, Philadelphia, PA 19104-6303. Tel 215-898-4401; Fax 215-573-2045; Elec Mail arg@pobox.upenn.edu; Internet Home Page Address: www.upenn.edu/ARG; *Coordr* Richard Dunn; *Dir* Dilys Winegrad
Open Tues - Fri 10 AM - 5 PM, Sat & Sun Noon - 5 PM; No Admis fee; Estab 1983 to make art accessible to campus community & the general pub; One large high-ceilinged room & an entrance room with approx 1700 sq ft of exhibition space; Average Annual Attendance: 12,000; Mem: 54; dues $100; ann meeting in May
Income: $290,000 (financed by endowment, grants, gifts, in-kind contributions)
Special Subjects: Drawings, Painting-American, Photography, Prints, Sculpture, African Art, Etchings & Engravings, Afro-American Art, Painting-French, Carpets & Rugs, Stained Glass
Collections: University art collection of paintings, prints, photographs, books, manuscripts, textiles & sculpture
Exhibitions: Four - six rotating per yr
Publications: Exhibition catalogues
Activities: Lect open to pub, 2-3 vis lectrs per yr; gallery talks; tours; book traveling exhibs 1 per yr; originate traveling exhibs to other univ galleries & museums

A **UNIVERSITY OF PENNSYLVANIA,** Institute of Contemporary Art, 118 S 36th St, Philadelphia, PA 19104-3289. Tel 215-898-5911; Fax 215-898-5050; Elec Mail info@icaphila.org; Internet Home Page Address: www.icaphila.org; *Dir* Claudia Gould; *Dir Devel* Marilyn Pollick; *Sr Cur* Ingrid Schaffner; *Assoc Cur* Jenelle Porter; *Asst Cur* Elyse Gonzalez; *Cur Educ* Johanna Plummer; *Mgr Mktg & Comm* Jill Katz
Open Wed - Sat Noon - 8 PM, Sun 11 AM - 5 PM, cl Mon. & Tues; Admis $6, seniors & students $3; Estab 1963 to provide a continuing forum for the active presentation of advanced development in the visual arts; Gallery space devoted to exhibiting contemporary art in all media; Average Annual Attendance: 21,000; Mem: 218; dues $40, $100, $250, $500 & up
Income: (financed by endowment, mem & grants)
Library Holdings: Audio Tapes; Cards; Cassettes; Clipping Files; Exhibition Catalogs; Kodachrome Transparencies; Original Art Works; Original Documents; Pamphlets; Periodical Subscriptions; Photographs; Prints; Records; Slides; Video Tapes
Special Subjects: Architecture, Drawings, Photography, Sculpture
Publications: Annual newsletter; calendar of events; exhibition catalogs
Activities: School groups, teacher training, teen video festival, summer program for teens; lect open to pub, 30 vis lectrs per yr; concerts; gallery talks; tours; sponsoring of competitions; fellowships; 1-2 traveling exhibs organized & circulated; sales shop sells original art, catalogs & cereal art

UNIVERSITY OF PENNSYLVANIA
L **Fisher Fine Arts Library,** Tel 215-898-8325; Fax 215-573-2066; Elec Mail finearts@pobox.upenn.edu; Internet Home Page Address: www.library.upenn.edu/finearts; *Librn* William B Keller; *Asst Librn* Heather M Glaser
Research library
Library Holdings: Book Volumes 150,000; CD-ROMs; Cassettes; Exhibition Catalogs; Fiche; Kodachrome Transparencies; Lantern Slides; Maps; Pamphlets; Periodical Subscriptions 800; Photographs; Reels; Slides; Video Tapes
Special Subjects: Art History, Landscape Architecture, Religious Art, Architecture
M **Museum of Archaeology & Anthropology,** Tel 215-898-4000; Fax 215-898-7961; Elec Mail pkosty@sas.upenn.edu; *The Williams Dir* Dr Jeremy A Sabloff; *Assoc Dir* Dr Stephen Epstein; *American History Arch Assoc Cur* Dr Robert L Schuyler; *American Sections Cur* Dr Robert Sharer; *Near East Section Assoc Cur* Dr Richard Zettler; *Babylonian Section Cur* Dr Erle Leichty; *Egyptian Section Cur* Dr David Silverman; *European Section Assoc Cur* Dr Bernard Wailes; *Mediterranean Section Cur* Dr Donald White; *Physical Anthropology Cur* Dr Francis E Johnston

Open Tues-Sat 10 AM - 4:30 PM, Sun 1 - 5 PM, cl Mon & holidays; Admis adults $5, students & seniors $2.50, children under 6, members, University of Pennsylvania faculty, staff & students free; Estab 1887 to investigate the origins & varied developments of human cultural achievements in all times & places; to preserve & maintain colls to document these achievements & to present to the pub the results of these investigations by means of permanent exhibits, temporary exhibs & special events; Average Annual Attendance: 200,000; Mem: 4800; dues individual $35, Loren Eiseley Assoc $1000
Income: $5,000,000 (financed by endowment, mem, state appropriation & univ)
Special Subjects: Anthropology, Archaeology, Ethnology
Collections: Archaeological & ethnographic artifacts relating to the Old & New World; the classical civilization of the Mediterranean, Egypt, Mesopotamia, Iran & the Far East, North & Middle America, Oceania; Africa
Exhibitions: Ancient Greek World. Living in Balance: The Universe of The Hopi, Zuni, Navajo & Apache
Publications: Expedition Magazine, quarterly; Museum Applied Science Center for Archaeology Journal; Museum Monographs; exhib catalogues
Activities: Classes for adults & children; docent training; family day; lect open to pub, 20 vis lectrs per yr; concerts; gallery talks; tours; exten dept servs Pennsylvania Commonwealth; objects of art lent to libraries & instructional centers in the state; lending coll contains motion pictures, original art works & slides; traveling exhibs organized & circulated; mus shop sells books, magazines, reproductions, slides, jewelry & craft items
L **Museum Library,** Tel 215-898-7840; Fax 215-573-2008; Internet Home Page Address: www.upenn.edu/lib; *Dir* Dr John Weeks
Open by appointment only; For reference & research only
Library Holdings: Book Volumes 110,000; Fiche; Filmstrips; Other Holdings Microforms 70,000; Pamphlets; Periodical Subscriptions 800; Reels
Special Subjects: Archaeology, Anthropology
Collections: Univ Anthropology Collection

M **THE UNIVERSITY OF THE ARTS,** Rosenwald-Wolf Gallery, 333 South Broad St, Philadelphia, PA 19102; 320 S Broad St, Philadelphia, PA 19102. Tel 215-717-6480; Fax 215-717-6468; Elec Mail ssachs@uarts.edu; Internet Home Page Address: www.uarts.edu; *Provost* Terry Applebaum; *Pres* Miguel-Angel Corzo; *Dir Exhibs* Sid Sachs
Open Sept - May Mon, Tues, Thurs & Fri 10 AM - 5 PM, Wed 10 AM - 8 PM, Sat & Sun Noon - 5 PM, June - Aug Mon - Fri 10 AM - 5 PM; No admis fee; College contains two galleries; Rosenwald - Wolf Gallery & Hamilton Hall Building Galleries; Temporary exhibs which relate to the University's diverse instruction. The galleries present high quality contemporary exhibs which attract national & international artists to the campus. Major exhibs are accompanied by catalogs, symposia & lects; Average Annual Attendance: 4,000
Income: Financed by city, state & federal appropriations, pvt & corporate support
Exhibitions: Contemporary & 20th century work in visual arts & design
Publications: Catalogs & brochures accompany major gallery exhibs
Activities: Lect open to pub; gallery talks; 2-4 vis lectrs per yr; organize traveling exhibs for museums, univ galleries
L **University Libraries,** 333 S Broad St, Philadelphia, PA 19102; 320 S Broad St, Philadelphia, PA 19102. Tel 215-717-6280; Fax 215-717-6287; Internet Home Page Address: library.uarts.edu; *Visual Resources Librn* Laura Grutzeck; *Pub Services Librn* Sara MacDonald; *Music Librn* Dr Mark Germer; *Library Dir* Carol H Graney; *Reference Librn* Mary Louise Castald; *Technical Services* Sheryl Panka-Bryman
Open fall semester Mon - Thurs 8:30 AM - 10:30 PM, Fri 8:30 AM - 6 PM, Sat Noon - 5 PM, Sun 4 - 9 PM; Estab 1876 to support the academic progs of the School; Lending to univ patrons only & mem holders; Mem: Dues alumni $20, general pub $50
Library Holdings: Audio Tapes 565; Book Volumes 111,356; CD-ROMs 253; Cassettes 450; Clipping Files; Compact Disks 6,936; DVDs; Exhibition Catalogs; Fiche; Kodachrome Transparencies; Micro Print; Other Holdings Picture files 113,000; Laserdiscs 10; Textiles; Periodical Subscriptions 551; Photographs; Prints; Records 13,560; Reels 450; Reproductions; Slides 184,000; Video Tapes 1,403
Special Subjects: Theatre Arts

L **WILLET STAINED GLASS STUDIOS,** 10 E Moreland Ave, Philadelphia, PA 19118. Tel 215-247-5721; Fax 215-247-2951; Internet Home Page Address: www.willetstainedglass.org; *Librn* Helene H Weis; *Pres* E Crosby Willet
Open by appointment; No admis fee; Estab 1890 as the largest stained glass studio in the United States; For reference only
Special Subjects: Stained Glass
Collections: Lumiere Watercolor Collection
Publications: Black & White Photos of works in progress, Designe & slides of installations
Activities: Lect open to pub; gallery talks; tours; internships offered; individual paintings & original objects of art lent; lending coll contains photographs, Kodachromes & motion pictures; traveling exhibs organized & circulated

M **WOODMERE ART MUSEUM,** 9201 Germantown Ave, Philadelphia, PA 19118. Tel 215-247-0476; Fax 215-247-2387; Elec Mail phoffman@woodmereartmuseum.org; Internet Home Page Address: www.woodmereartmuseum.org; *Dir* Dr Michael W Schantz; *Registrar* Mildred O Staib; *Cur of Edn* Meri Adelman; *Dir Develop* Patricia Hoffman; *Cur of Coll* W Douglass Paschall
Open Tues - Sat 10 AM - 5 PM, Sun 1 - 5 PM; No admis fee; suggested donation: adults $5, students & seniors $3, children 12 & under free; Estab 1940; founded by Charles Knox Smith, in trust for benefit of the pub; A large addition in 1965 provides additional gallery & studio space; Average Annual Attendance: 48,000; Mem: 2500; dues $30 & higher; annual meeting in June
Income: Financed by endowments, gifts, grants & mem fees
Purchases: Philadelphia art, past & present
Library Holdings: Cards; Clipping Files; Exhibition Catalogs
Special Subjects: Architecture, Drawings, Graphics, Painting-American, Photography, Prints, Sculpture, Ceramics, Folk Art, Etchings & Engravings, Landscapes, Decorative Arts, Painting-European, Portraits, Furniture, Porcelain, Oriental Art, Asian Art, Carpets & Rugs, Juvenile Art, Renaissance Art, Period Rooms, Embroidery, Laces, Antiquities-Oriental, Antiquities-Persian

Collections: Contemporary Philadelphia paintings, sculpture & graphics; European porcelains & furniture; European & American sculpture; Oriental rugs, furniture, porcelains; Smith Collection of European & American paintings
Exhibitions: 12 changing exhibitions annually; prizes awarded in summer Members Annual & winter Juried Annual & Special Exhibitions
Publications: Selections from the permanent coll of the Woodmere Art Museum
Activities: Classes for adults & children; docent training; lect open to pub; concerts; gallery talks; tours; competitions with prizes; individual paintings & original objects of art lent to other museums & galleries; mus shop sells books, gifts, jewelry & original art

L **Library,** 9201 Germantown Ave, Philadelphia, PA 19118. Tel 215-247-0476; Fax 215-247-2387; Elec Mail phoffman@woodmereartmuseum.com; Internet Home Page Address: www.woodmereartmuseum.org; *Cur Educ* Meri Adelman; *CEO, Dir & Cur* Michael W Schantz; *Mus Shop Mgr* Betty R Stein; *Registrar* Mildred Staib; *Dir Develop* Patricia A Hoffman; *Cur Coll* W Douglass Paschall; *VPres* Joseph Nicholson
Open by appointment only; Reference only
Library Holdings: Cards; Clipping Files; Exhibition Catalogs; Slides

PITTSBURGH

M **ART INSTITUTE OF PITTSBURGH,** John P. Barclay Memorial Gallery, 420 Boulevard of the Allies, Pittsburgh, PA 15219. Tel 412-263-6600; Internet Home Page Address: www.aip.all.edu; *Dir Resource Center* Susan Moran; *Dir* Nancy Ruttner
Open Mon, Tues & Thurs 9 AM - 8 PM, Wed & Fri 9 AM - 5 PM, Sat 9 AM - 4 PM; No admis fee; Estab 1921 as an art school & proprietary trade school
Exhibitions: Local art group shows; local artists; loan exhibs; student and faculty mems; technical art exhibits
Publications: Brochures; Catalog; School Newspaper
Activities: Classes for adults & teens; lect open to pub, 2-4 vis lectrs per yr; schols offered

L **Resource Center,** Tel 412-291-6357; *Librn* Kathy Ober
Open Mon - Fri 7:30 AM - 3 PM, Mon, Tues & Thurs 6 - 10 PM; Estab 1971 to supply our students with readily available reference materials; Circ Approx 2600
Purchases: $1295
Library Holdings: Book Volumes 5674; Cassettes; Clipping Files; Exhibition Catalogs; Fiche; Filmstrips; Framed Reproductions; Memorabilia; Pamphlets; Periodical Subscriptions 208; Records; Slides
Special Subjects: Art History, Mixed Media, Photography, Commerical Art, Graphic Arts, Crafts, Fashion Arts, Interior Design, Architecture

A **ASSOCIATED ARTISTS OF PITTSBURGH,** 937 Liberty Ave, Pittsburgh, PA 15222. Tel 412-263-2710; Fax 412-471-1765; Elec Mail aap@telerama.com; *Exec Dir* Frances A Frederick
Open Tues - Fri 11 AM - 4 PM, Sat 11 AM - 3 PM; No admis fee; Estab 1910 to give exposure to mem artists & for educ of the area in the field of art; 2 fls of galleries with changing exhibits; Average Annual Attendance: 15,000; Mem: 500 (must be juried into the group) & live within 150 miles of Pittsburgh; dues $80
Income: Financed by mem; donations from foundations, corporations & individuals
Exhibitions: Annual Exhibition at Carnegie Museum of art open to all regional artists; Changing exhibs, 10 per yr
Publications: The First 75 Years
Activities: Special progs linking students & artists; classes for adults & children; workshops for professional artists; lect open to pub; competitions with awards; individual paintings & original objects of art lent to interested individuals & businesses; sells mems artwork

L **CARNEGIE LIBRARY OF PITTSBURGH,** Reference Services, 4400 Forbes Ave Pittsburgh, PA 15213. Tel 412-622-3114; Elec Mail ref@carnegielibrary.org; Internet Home Page Address: www.carnegielibrary.org/locations/reference; *Head* Richard Kaplan; *Dir* Herbert Elish; *Librn* Kaarin Van Ausdal; *Librn* Deborah Rogers
Open Mon - Thurs 10 AM - 8 PM, Fri & Sat 10 AM - 5:30 PM, Sun 1 - 5 PM; Estab 1930 to provide reference & circulating materials on all aspects of art
Income: Financed by city, state & county appropriation
Library Holdings: Book Volumes 65,000; Clipping Files; DVDs; Exhibition Catalogs; Pamphlets; Periodical Subscriptions 85; Reproductions; Slides; Video Tapes
Special Subjects: Art History, Decorative Arts, Architecture
Collections: Architecture; archival materials; Pittsburghiana; Western Pennsylvania Architectural Survey Archival Materials

CARNEGIE MELLON UNIVERSITY
M **Frame Gallery,** Tel 412-268-2000 (main), 268-2409 (art dept); Internet Home Page Address: www.cmu.edu, www.art.cfa.cmu.edu; *Co-Dir* David Johnson; *Co-Dir* Kerry Schneider
Open Wed 3 - 6 & 7 - 9 PM, Thurs & Fri Noon - 6 PM & Thurs evening 7 - 9 PM, Sat Noon - 6 PM, Sun Noon - 3 PM; Estab 1969 to offer exhib space to students, & an opportunity to learn about gallery management through practice; Gallery is approximately 20 x 40 ft plus small back room space; Average Annual Attendance: 750
Income: $5000 (financed by univ fundings)
Exhibitions: Weekly senior art student exhibs

L **Hunt Library,** Tel 412-268-7272; Fax 412-268-7148; Elec Mail artsref@andrew.cmu.edu; Internet Home Page Address: www.library.cmu.edu; *Head Arts & Spec Colls* Bella Karr Gerlich; *Architecture Librn & Archivist* Martin Aurand; *Art Librn* Maureen Dawley; *Design & Special Colls Librn* Mary Catherine Johnsen
Open Mon - Thurs 8 AM - 3 AM, Fri 8 AM - 12 AM, Sat 9 AM - 12 AM, Sun Noon - 3 AM; Estab 1912; The Arts Library is on the 4th fl of the Hunt Library, supports College of Fine Arts prog & is open to the pub
Income: Financed by Univ Library operating funds & endowments
Library Holdings: Audio Tapes; Book Volumes 80,000; CD-ROMs; Cassettes; Clipping Files; Compact Disks; DVDs; Exhibition Catalogs; Fiche; Manuscripts;

Memorabilia; Original Art Works; Original Documents; Other Holdings Architectural drawings; electronic datafiles; Pamphlets; Periodical Subscriptions 350; Photographs; Prints; Records; Reels; Reproductions; Sculpture; Slides 120,700; Video Tapes
Special Subjects: Architecture
Collections: Architecture Archives, Swiss Poster Collection, Thomas Gonda design collection, artists books

M **Hunt Institute for Botanical Documentation,** Tel 412-268-2434; Fax 412-268-5677; Elec Mail huntinst@andrew.cmu.edu; Internet Home Page Address: huntbot.andrew.cmu.edu; *Asst Dir* Terry D Jacobsen; *Cur Art* James J White; *Librn* Charlotte Tancin; *Bibliographer* Gavin D R Bridson; *Archivist* Angela L Todd; *Dir* Robert W Kiger
Open Mon - Fri 9 AM - Noon & 1 - 5 PM, Sun 1 - 4 PM during exhibs; No admis fee; Estab 1961 for the study of botany, history of botany, botanical art & illustration
Special Subjects: Prints, Woodcuts, Drawings, Watercolors, Etchings & Engravings
Collections: Botanical Art Collection, Archives, Library
Exhibitions: (9/30/2007-12/7/2007) 12th International Exhibition of Botanical Art & Illustration
Publications: Huntia, irregular; Bulletin, semi-annually; exhib catalogues, reference works, monographs
Activities: Retail store sells books, posters & cards

M **CARNEGIE MUSEUMS OF PITTSBURGH,** (Carnegie Institute) Carnegie Museum of Art, 4400 Forbes Ave, Pittsburgh, PA 15213. Tel 412-622-3131; Fax 412-622-3112; Elec Mail cma-general@carnegiemuseums.org; Internet Home Page Address: www.cmoa.org; *Deputy Dir* Maureen Rolla; *Chmn Mus Art Board* William Hunt; *Cur Architecture* Tracy Myers; *Cur Decorative Arts* Jason Busch; *Cur Educ* Marilyn M Russell; *Cur Fine Art* Louise W Lippincott; *Chief Conservator* Ellen Baxter; *Head Publ* Arlene Sanderson; *Registrar* Monika Tomko; *Dir of Exhib* Christopher Rauhoff; *Dir Marketing* Kitty Julian; *Communications Mgr* Tey Stiteler; *Dir* Richard Armstrong; *Develop Dir* Renee Pekor; *Cur Architecture* Raymund Ryan; *Cur Contemp Art* Douglas Fogle; *Dir Tech Initiatives* William Real
Open Tues - Sat 10 AM - 5 PM, Sun noon - 5 PM, cl Mon (except July & Aug) & major holidays; Admis by suggested contribution: adults $10, seniors $7, children & students $6, mems free; Estab 1895, incorporated 1926. Original building 1896-1907; Scaife Wing 1974; Most coll & special exhibs are on view in 50,000 sf Scaife Wing designed by Edward Larabee Barnes in 1974; Average Annual Attendance: 700,000; Mem: 27,400; dues $50 & up
Income: Financed by endowment, mem, city, county & state appropriation & other funds
Library Holdings: Auction Catalogs; Fiche
Special Subjects: Drawings, Painting-American, Photography, Prints, Sculpture, Woodcuts, Decorative Arts, Painting-European, Dolls, Furniture, Oriental Art
Collections: American & European paintings & sculpture, especially Impressionist & Post-Impressionist; Contemporary International Art; Japanese woodblock prints; American & European decorative arts; Antiquities; Asian Art; African Art; Films; Video tapes; Photographs, Prints & Drawings
Publications: Annual report; Carnegie Magazine, four times per yr; catalogue of permanent coll; exhib catalogs; quarterly newsletter, email newsletters to members & non-members
Activities: Classes for adults & children; docent training; lect open to pub; concerts; gallery talks; tours incl free audio guide; Carnegie award; inter-museum loans; originate traveling exhibs; mus shop sells books, periodicals, original art, posters, reproductions, textiles, jewelry, ceramics, postcards, designer household objects: furniture, lighting, tableware

L **Carnegie Library of Pittsburgh,** 4400 Forbes Ave, Pittsburgh, PA 15213. Tel 412-622-3131; Fax 412-622-3112; Internet Home Page Address: www.carnegiemuseum.org; *Dir* Herbert Elish
Open daily 10 AM - 5 PM; Open to staff & mus docents for reference only
Library Holdings: Book Volumes 2,000,000; CD-ROMs; Cassettes; Fiche; Filmstrips; Memorabilia; Periodical Subscriptions; Photographs; Prints; Video Tapes

M **CHATHAM COLLEGE,** Art Gallery, Woodland Rd, Pittsburgh, PA 15232. Tel 412-365-1100; Fax 412-365-1505; Internet Home Page Address: www.chatham.edu; *Dir* Michael Pestel; *Dir Fine & Performing Arts* William Lenz
Open Mon - Fri 11 AM - 5 PM; No admis fee; Estab 1960 as an art gallery in a small liberal arts col, serving both the col & community by mounting exhibs of high quality; Gallery is 100 running ft, is located in Jennie King Mellon Library & is fitted with track lighting; Average Annual Attendance: 1,500
Income: Financed by col
Exhibitions: Linda Benglis; Don Reitz; Idelle Weber; Jerry L Caplan
Activities: Lect open to pub, 2 vis lectrs per yr; gallery talks; schols offered; individual paintings & original objects of art lent

M **THE FRICK ART & HISTORICAL CENTER,** Frick Art Museum, 7227 Reynolds St, Pittsburgh, PA 15208. Tel 412-371-0600; Fax 412-241-5393; Elec Mail info@frickart.org; Internet Home Page Address: www.frickart.org; *Dir Visitors Svcs* Sue Martin; *Registrar* Sarah Hall
Open Tues - Sat 10 AM - 5 PM, Sun Noon - 6 PM; Admis to Clayton Mansion adults $8, seniors $7, students $6, all other venues are free; Estab 1970 as an art mus for pub enjoyment & educ; Average Annual Attendance: 35,000
Income: Financed by endowment
Special Subjects: Bronzes, Furniture, Porcelain, Silver, Painting-French, Tapestries, Painting-Flemish, Period Rooms, Painting-Italian
Collections: Italian, French Renaissance; bronzes, Chinese porcelains, furniture, sculpture, tapestries
Publications: Exhibit catalogs
Activities: Classes for adults & children; dramatic progs; docent training; studio workshops; family progs; lect open to pub, 5-12 vis lectrs per yr; concerts; gallery talks; tours; competitions with awards; schols & fels offered; book traveling exhibs 4-6 per yr; originate traveling exhibs; mus shop sells books, catalogues, color reproductions, photographs, posters, post cards & gifts

M **MANCHESTER CRAFTSMEN'S GUILD,** 1815 Metropolitan St, Pittsburgh, PA 15233. Tel 412-322-1773; Fax 412-321-2120; *VPres Operations* Nancy Brown; *Dir Performing Arts* Marty Ashby; *Dir Educ Prog* Joshua Green; *Pres & CEO* William Strickland Jr
Estab 1968 to present photog & ceramic art of regional & nationally recognized artists
Exhibitions: Chris Gustin; Ben Fernandez; Angelia Pozo; Chris Johnson & Suzanne Lacy
Activities: Classes for adults & children; lect open to pub, 10 vis lectrs per yr; sales shop sells original art

M **MATTRESS FACTORY,** 500 Sampsonia Way, Pittsburgh, PA 15212-4444. Tel 412-231-3169; Fax 412-322-2231; Elec Mail info@mattress.org; Internet Home Page Address: www.mattress.org; *Cur* Michael Olijnyk; *Exec Dir* Barbara Luderowski; *Dir Communications* Jessica Coup
Open Tues - Sat 10 AM - 5 PM, Sun 1 - 5 PM; Admis fee Adults $6, students & seniors $4, children under 12 free; Thurs free for mem; Estab 1978 as a research & development residency program featuring site-specific installations; Average Annual Attendance: 28,000
Collections: Permanent collection of William Anastasi, Jene Highstein, Rolf Julius, Yayoi Kusama, Winifred Lutz, James Turrell, Allan Wexler & Bill Woodrow
Exhibitions: Permanent coll & changing exhibs of site-specific installations
Activities: Classes for adults, children & teachers; concerts, gallery talks & tours; mus shop, books, magazines, original art & prints

C **MELLON FINANCIAL CORPORATION,** One Mellon Financial Ctr Pittsburgh, PA 15258. Tel 412-234-4775; Fax 412-234-0831; *Art Dir* Brian J Lang
Collections: 18th & 19th century British drawings & paintings; American historical prints; 19th century American & Pennsylvanian paintings; contemporary American & British paintings; contemporary works on paper; textiles; contemporary photography

A **PITTSBURGH CENTER FOR THE ARTS,** 6300 Fifth Ave, Mellon Park, Pittsburgh, PA 15232. Tel 412-361-0873; Fax 412-361-8338; Elec Mail ldomencic@pittsburgharts.org; *Exec Dir* Laura Willumsen
Open Mon - Sat 10 AM - 5:30 PM, Sun Noon - 5 PM; No admis fee, suggested donation; Estab 1944, inc 1947 to support artists & educate pub about & through art; Galleries maintained for monthly contemporary exhibs, group & one-person shows. Headquarters for nonprofit organizations in the creative arts consists of sixteen resident and two affiliated mem groups, gallery lodged in converted mansion; Average Annual Attendance: 150,000; Mem: 6500; dues vary; patron mems
Income: Financed by school tui, mem, commission on art sales & contributions
Publications: For the Arts, regional magazine with PCA listings; artists directory; class schedule; exhib catalogs; monthly calendar
Activities: Arts & crafts classes for adults and children; dramatic progs; docent training; workshops; vocational & teacher training; summer art camps; lect open to pub; concerts; gallery talks; tours; awards; ann holiday art sales; schols & fels offered; exten dept serves western Pennsylvania; originate traveling exhibs; sales shop sells original art

L **PITTSBURGH HISTORY & LANDMARKS FOUNDATION,** James D Van Trump Library, 100 W. Station Square Dr, Ste 450, Pittsburgh, PA 15219-1134. Tel 412-471-5808; Fax 412-471-1633; Elec Mail info@phlf.org; Internet Home Page Address: www.phlf.org; *Pres* Arthur P Ziegler Jr; *Exec Dir* Louise Sturgess
Open Mon - Fri 9 AM - 5 PM; Estab 1964 to preserve the architectural legacy & historic neighborhoods of Allegheny County; Reference for mems only; Mem: 2200; dues $5
Library Holdings: Book Volumes 4700; Clipping Files; Original Art Works; Other Holdings Architectural & engineering drawings; Periodical Subscriptions 17; Photographs; Prints
Special Subjects: Landscape Architecture, Drawings, Architecture
Collections: Paintings: Aaron Gorson, Otto Kuhler, Edward B Lee, William C Wall
Activities: Classes for adults & children; dramatic progs; docent training; lect open to pub, 2 vis lectrs per yr; tours; competitions with prizes; mus shop sells books, reproductions, prints & slides

A **SILVER EYE CENTER FOR PHOTOGRAPHY,** 1015 E Carson St, Pittsburgh, PA 15203. Tel 412-431-1810; Fax 412-431-5777; *Exec Dir* Jody Guy
Open Tues - Sat Noon - 5 PM; No admis fee; Average Annual Attendance: 5,000; Mem: 260; dues $35 - $750
Income: Financed by government, corporations, foundations & individuals
Exhibitions: Rotating exhibits of national & international photography, 2 national photo competitions per yr
Publications: Members quarterly newsletter
Activities: Classes for children; outreach pub school prog; lect open to pub, 1-5 vis lectr per yr; gallery talks; lending coll contains books & videos

M **THE SOCIETY FOR CONTEMPORARY CRAFTS,** 2100 Smallman St, Pittsburgh, PA 15222. Tel 412-261-7003; Fax 412-261-1941; Elec Mail info@contemporarycraft.org; Internet Home Page Address: www.contemporarycraft.org; *Dir Exhibs* Kate Lydon; *Exec Dir* Julie Farr; *Sales Mgr* Craig Falatovich; *Develop Asst* Lynn Stys; *Dir Develop* Pam Pochapin; *Edu Coordr* Laura Rundell; *Exec Asst* Nancy Phillips; *Finance Mgr* Eileen Grande; *Group Sales & Events Coordr* Alissa Martin
Open Tues - Fri 10 AM - 5 PM, Sat 10 AM - 5 PM; No admis fee; Estab 1971 to engage pub in the creative experience through contemporary craft; Gallery features contemporary crafts by nationally & internationally recognized artists in thematic shows; Maintains reference library; Average Annual Attendance: 30,000; Mem: 440; dues $50 & up
Income: Financed by mem, donations & grants
Library Holdings: Exhibition Catalogs; Original Art Works; Periodical Subscriptions
Special Subjects: Textiles, Ceramics, Crafts, Furniture, Glass, Jewelry, Metalwork, Pewter

Collections: Ceramics; contemporary crafts; fiber; furniture; glass; jewelry; metals; mixed media
Exhibitions: (11/24/2006-3/24/2007) Bridge 9: Arthur Hash, Jon Eric Riis, and Patti Warashina; (4/13/2007-8/19/2007) FIBERARTinternational 2007; (9/7/2007-1/12/2008) Transformation 6: Contemporary Works in Glass, the Elizabeth R Raphael Founder's Prize; (2/1/2008-4/26/2008) Nick Cave; (5/16/2008-8/23/2008) Reunion: 25 Years
Publications: Exhibit catalogs
Activities: Classes for adults & children; docent training; lect open to pub, 4 vis lectrs per yr; competitions with cash awards; gallery talks; tours; biennial Raphael Prize; schols; lends original objects of art to educational insts; originate traveling exhibs 1 per yr; sales shop sells one of a kind fine craft

UNIVERSITY OF PITTSBURGH

M **University Art Gallery,** Tel 412-648-2400; Fax 412-648-2792; Internet Home Page Address: www.pitt.edu/~arthome; *Admin* Linda Hicks; *Prog Dir* Josie Piller
Open Mon - Fri 10 AM - 4 PM, Thurs 10 AM - 8 PM; No admis fee; Estab 1970 to provide exhibs for the univ community & the community at large & to provide students with gallery experience; Gallery comprised of 350 running ft in five areas; Average Annual Attendance: 4,000
Income: Financed through the univ
Special Subjects: Drawings, Painting-American, Prints, Sculpture
Collections: Drawings, paintings, prints & sculpture
Publications: Exhib catalogs, 3 per yr
Activities: Original objects of art lent; lending coll contains original art works, original prints, paintings, photographs, sculptures & drawings; originate traveling exhibs

L **Henry Clay Frick Fine Arts Library,** Tel 412-648-2410; Fax 412-648-7568; Elec Mail frickart@pitt.edu; Internet Home Page Address: www.library.pitt.edu:9696/libraries/frick/fine_arts; *Librn* Ray Anne Lockard
Open Mon - Thurs 9 AM - 9 PM, Fri 9 AM - 5 PM, Sat 11 AM - 5 PM, Sun Noon - 7 PM; Estab 1928 to support the teaching activities of the Departments of History Art & Architecture & Studio Arts; For reference only
Library Holdings: Book Volumes 82,000; CD-ROMs 20; Exhibition Catalogs; Fiche 20,000; Pamphlets; Periodical Subscriptions 250; Reels
Special Subjects: Tapestries
Collections: Facsimile mss

READING

M **ALBRIGHT COLLEGE,** Freedman Gallery, 13th & Bern Sts, Reading, PA 19612-5234. Tel 610-921-7715; Fax 610-921-7768; Internet Home Page Address: www.albright.edu; *Dir* Christopher Youngs
Open Tues, Noon - 8 PM, Wed - Fri Noon - 6 PM, Sat & Sun Noon - 4 PM, also by appointment; No admis fee; Estab 1976 to present primarily contemporary art in a context of teaching; Large Gallery: 40 ft x 50 ft; Small Gallery: 20 ft x 24 ft; Average Annual Attendance: 18,000; Mem: 220; dues Director Circle $1000, supporter $500, contributor $100, family $50, individual $25
Income: $150,000 (financed by endowment, college, mem & grants)
Special Subjects: Painting-American, Photography, Prints, Sculpture
Collections: Contemporary Painting, Prints, Sculpture, Photography
Publications: Exhibit catalogues & brochures available
Activities: Classes for children; workshops & tours; ann student juried exhibs; lect open to pub, 4 vis lectrs per yr; gallery talks; tours; Freedman Gallery Student Award; produce video-tapes on exhibs, these include interviews with artists & commentary, tapes are available for rent; film series; individual paintings & original objects of art lent to galleries & museums; originate traveling exhibs; sales shop sells catalogues, prints, t-shirts

A **BERKS ART ALLIANCE,** Institute of the Arts, 1100 Belmont Ave Reading, PA 19610-2082. Tel 610-376-1576, 775-9444; *Pres* Joanne D Just; *VPres Prog* Barbara T Post; *VPres Mem* Kay Lessig; *Rec Secy* Peggy Reisch; *Treas* Paul Flickinger; *Corresp Secy* Vicki Rhodier
Estab 1941 to maintain active art center in Reading & Berks county; Mem: 305; dues $20; ann meetings 2nd Tues of odd months: Sept, Nov, Jan, Mar, May; mems must be 18 or older interested in the purpose of the Alliance
Income: Financed by dues; commissions from mems shows, including ann juried show at Reading Public Museum, Jul & Aug
Library Holdings: Book Volumes 250; Video Tapes 50
Exhibitions: Two annual membership shows, plus solo or two-persons shows of a two week period each; juried show at Reading Public Museum, Jul & Aug
Publications: Palette, every other month Aug - Apr
Activities: Life or costume drawing workshop Thurs morning, Sept - May; open painting workshop Thurs afternoon; life drawing workshop Thurs evening; three day seminars by professional artists; sponsors ann trip to American Watercolor Society Show in New York and other bus trips to Baltimore & Washington, DC

M **READING PUBLIC MUSEUM,** 500 Museum Rd, Reading, PA 19611-1425. Tel 610-371-5850, Ext 229; Fax 610-371-5632; Elec Mail museum@ptd.net; Internet Home Page Address: www.readingpublicmuseum.org; *Dir & Cur Fine Arts* Ronald C Roth; *Asst Dir, Registrar* Deborah Winkler; *Educ Asst* Lori Irwin; *Colls Mgr* Vasti DeEsch; *Chair* Kathleen D Herbein; *VChair* John Woodward; *Treas* Paul R Roedel; *Educ Cur* Francis R Ricci
Open Tues 11 AM - 5 PM, Thurs - Sat 11 AM - 5 PM, Wed 11 AM - 8 PM, Sun Noon - 5 PM, holidays Noon - 4 PM; Admis adults $54, children 4-17 $3; Estab 1904 to promote knowledge, pleasure & cultivation of the arts & sciences; Ground floor: atrium/museum shop. First floor: natural & social sciences exhibits. Second floor: permanent & temporary art exhibs; Average Annual Attendance: 165,000; Mem: 2800; dues $30 - $50; ann meeting in July
Income: financed by pvt & grant funding
Special Subjects: Painting-American, Folk Art, Painting-European
Collections: American & European paintings; Natural Science; 19th Century Paintings; Old Masters Gallery; Pennsylvania-German Room; World History
Exhibitions: Rotating & permanent exhibs
Publications: Catalog of selections from Permanent Collection & Exhibits

Activities: Classes for adults; docent training; lect open to pub & mems, 10 vis lectrs per yr; concerts; gallery talks; tours; competitions with purchase awards; individual paintings & original objects of art lent to AAM accredited museums; lending coll contains 6000 original prints, 900 paintings, 800 photographs & 100 sculpture; mus shop sells books, reproductions of mus colls, gift items, prints & slides

L **Library,** 500 Museum Rd, Reading, PA 19611-1425. Tel 610-371-5850; Fax 610-371-5632; Elec Mail museum@ptd.net; Internet Home Page Address: www.readingpublicmuseum.org; *Dir* Dr Robert Metzger; *Treas* Paul R Roedel; *Secy* Regina Gouger Miller; *Asst Secy* Marilyn Wademan; *Chmn* Kathleen Herbein; *1st VChmn* John Woodward; *Dir, CEO* Ronald C Roth
Open Tues 11 AM - 5 PM; For reference only & staff use
Library Holdings: Audio Tapes; Book Volumes 15,000; Cassettes; Clipping Files; Exhibition Catalogs; Filmstrips; Kodachrome Transparencies; Lantern Slides; Manuscripts; Memorabilia; Other Holdings Original documents; Pamphlets; Periodical Subscriptions 31; Prints; Reproductions; Video Tapes

SCRANTON

M **EVERHART MUSEUM,** Nay Aug Park, Scranton, PA 18510. Tel 570-346-7186; Fax 570-346-0652; Internet Home Page Address: www.everhart/museum.org; *Cur Art* David Kennedy; *Dir* Michael C Illuzzi; *Devel Coordr* Debra Romiti
Open Wed - Sun Noon - 5 PM, cl Mon, Tues & major holidays; Admis adults $5, seniors & students $3, children $2; Estab & incorporated 1908, a gift to the city by Dr Isaiah F Everhart; building enlarged 1928-29; Average Annual Attendance: 52,000; Mem: 1400; dues $25 & up
Income: Financed by endowment, city, state & county appropriations & mem
Special Subjects: Painting-American, Prints, Sculpture, American Indian Art, African Art, Folk Art, Painting-European, Oriental Art
Collections: African Art; American Folk Art; American Indian objects; European & American painting, prints & sculpture; Dorflinger Glass; Oceanic Art; Oriental Art
Exhibitions: 5-6 exhibs per year & permanent colls
Publications: Newsletter, 4 times per yr; annual report; exhib catalogs
Activities: Lect open to pub; gallery talks; tours; educ progs for schools & other groups by appointment; book traveling exhibs; originate traveling exhibs & circulate to other museums; sales shop sells gifts & crafts

SELINSGROVE

M **SUSQUEHANNA UNIVERSITY,** Lore Degenstein Gallery, 514 University Ave, Selinsgrove, PA 17870-1001. Tel 570-372-4059; Fax 570-372-2775; Elec Mail livingst@susqu.edu; Internet Home Page Address: www.susqu.edu/art_gallery/; *Dir* Dr Valerie Livingston; *Registrar* Judy Marvin; *Coll Mgr* Sara Herlinger
Open Mon - Sun 1 - 4 PM, Wed Noon - 4 PM & 7 - 9 PM; No admis fee; Estab 1993 to exhibit, interpret, collect & preserve objects of art & material culture through a rich & diverse exhibition program of inquiry supporting academic investigations & contributing to the cultural life of central Pennsylvania; Gallery offers a schedule of changing exhibs focusing its program on historic, contemporary, regional, national & decorative art. Sponsors lects & opening receptions; Average Annual Attendance: 4,000
Special Subjects: Drawings, Painting-American, Etchings & Engravings, Landscapes, Decorative Arts, Manuscripts, Furniture, Glass, Historical Material
Collections: American Painting
Activities: Docent training; lect open to pub, gallery talks, 3-4 vis lectrs per yr; book traveling exhibs 2-3 per yr; traveling exhibs

SHIPPENSBURG

M **SHIPPENSBURG UNIVERSITY,** Kauffman Gallery, 1871 Old Main Dr, Shippensburg, PA 17257. Tel 717-477-1530; Fax 717-477-4049; Elec Mail clgrah@ship.edu; Internet Home Page Address: www.ship.edu; *Secy* Cathy Graham; *Dir* Steve Dolbin
Open Mon - Thurs 9 AM - 4 PM, Wed evenings 6 - 9 PM, Fri 9 AM - 12 PM; No admis fee; Estab 1972 to bring art to the col community; Average Annual Attendance: 1,500
Income: Financed by Student Association funds & univ
Exhibitions: Scholastic Art Awards - Area 6; Faculty Exhibits; Student Art Exhibits; changing exhibs every month; Senior Art Exhibits
Activities: Lect open to the pub, 4 vis lectrs per yr; gallery talks

STRASBURG

A **LANCASTER COUNTY ART ASSOCIATION, INC,** 149 Precision Ave, Strasburg, PA 17579. Tel 717-687-7061; Internet Home Page Address: www.lcaa.org; *VPres* Anne Fisher; *Treas* Harry McCandless; *Pres* Jill Weidman
Open Tues - Sun 1 - 5 PM; No admis fee; Estab 1936, inc 1950, to increase appreciation of & participation in the fine arts; Average Annual Attendance: 10,000; Mem: 300; dues $35; general mem meeting the second Sun of the month, Sept - May
Income: Financed by dues, classes, contributions & volunteer service
Exhibitions: Monthly exhibs for professional & non-professional mems
Publications: Monthly newsletter; annual mem brochure
Activities: Classes for adults & children; lect open to pub, 7-10 vis lectrs per yr; competitions with awards; schols offered

STROUDSBURG

M **MONROE COUNTY HISTORICAL ASSOCIATION,** Elizabeth D Walters Library, 900 Main St, Stroudsburg, PA 18360. Tel 570-421-7703; Fax 570-421-9199; Elec Mail mcha@ptd.net; Internet Home Page Address: www.mcha-pa.org; *Exec Dir* Amy Leiser
Open Tues - Fri 9 AM - 4 PM, 1st & 3rd Sat 10 AM - 4 PM, cl Sun & Mon; Admis adult $5, seniors $4, children $2; Estab 1921 for research; Average Annual Attendance: 5,000; Mem: 550; dues $20; ann meeting 4th Sun in Feb

Income: $116,000 (financed by endowment, mem, state appropriation & county)
Special Subjects: Painting-American, Textiles, Decorative Arts, Collages, Furniture, Historical Material, Period Rooms, Embroidery
Collections: Decorative Arts; Furniture; Indian Artifacts; Textiles
Exhibitions: Period Room; Toy Room; Rotate 4 per yr
Publications: Fanlight Newsletter, six times per year
Activities: Lect open to pub, 5 vis lectrs per yr; Historic Preservation Awards; mus shop sells books

SWARTHMORE

L **SWARTHMORE COLLEGE,** Friends Historical Library of Swarthmore College, 500 College Ave, Swarthmore, PA 19081-1399. Tel 610-328-8496; Fax 610-690-5728; Elec Mail friends@swarthmore.edu; Internet Home Page Address: www.swarthmore.edu/library/friends; *Cur* Christopher Densmore; *Cur Peace Coll* Wendy Chmielewski
Open Mon - Fri 8:30 AM - 4:30 PM, Sat 10 AM - 1 PM; cl Sat when college not in session; No admis fee; Estab 1871 to preserve & make available to the pub material by & about Quakers & their concerns, records of non-sectarian peace organizations & papers of peace movement leaders; Gallery housed in McCabe Library
Income: financed by endowment & col
Library Holdings: Audio Tapes; Book Volumes 55,000; Cassettes; Clipping Files; Kodachrome Transparencies; Lantern Slides; Manuscripts; Memorabilia; Motion Pictures; Original Art Works; Original Documents; Other Holdings charts; Maps; Original documents; Posters; Pamphlets; Periodical Subscriptions 584; Photographs; Prints; Records; Reels; Sculpture; Slides; Video Tapes
Special Subjects: Photography, Painting-American, Painting-British, Posters, Historical Material, Portraits, Religious Art
Collections: Quaker paintings; Quakers as subject in art; Meeting House Picture Collection; portraits, group pictures, residence pictures, silhouettes & sketches of individual Friends; Swarthmore College pictures; Swarthmore College Peace Collection consists primarily of archival material, records of non-sectarian peace organizations in the United States and 59 foreign countries, papers of peace leaders including Jean Addams, Emily Greene Balch, Elihu Burritt, A J Muste,Wilhelm Sollmann and others; 6000 peace posters and war posters; Benjamin West sketches; Edward Hicks journals

UNION DALE

A **ART EXCHANGE,** Main St, PO Box 21 Union Dale, PA 18470. Tel 570-679-9000; Elec Mail artexc@epix.net; Internet Home Page Address: artexc.org; *Dir* Robert Stark
Estab 1970 to provide opportunities for community participation in the creative voices & forms of expression within the region, to bring to the community the art forms of other cultures & people, to support local & regional artists in the documentation & exhib of their work; & to be a vigorous advocate for the development of the visual, verbal, performing, & craft arts within the community & region; Maintains reference library

UNIVERSITY PARK

THE PENNSYLVANIA STATE UNIVERSITY

M Palmer Museum of Art, Tel 814-865-7672; Fax 814-863-8608; Elec Mail jkm11@psu.edu; Internet Home Page Address: www.psu.edu/dept/palmermuseum/; *Cur* Dr Joyce Henri Robinson; *Registrar* Beverly Sutley; *Exhib Designer* Ronald Hand; *Cur* Dr Patrick J McGrady; *Preparator* Richard Hall; *Mus Educ* Dana Carlisle Kletchka; *Coordr Mem & Pub Rels* Roberta Seymour; *Cur of American Art* Dr Leo G Mozow; *Mus Store Mgr* Lynne McCormack
Open Tues - Sat 10 AM - 4:30 PM, Sun Noon - 4 PM, cl Mon & major holidays; No admis fee; Estab 1972 to promote a program of changing exhibs; a window to the world for the university & surrounding communities; The mus expanded in 1993 and again in 2002, has eleven galleries which accommodate continuous display of the permanent coll as well as changing exhibs that are national & international in scope; Average Annual Attendance: 46,000; Mem: 599; students $10 - $34, individual $35 - $59, family/household $60 - $99, sustaining $100 - $299, benefactor $300 - $599, sponsor $600 - $999, dir's cir $1000 & more
Income: Financed by state appropriation & donations
Purchases: American & European paintings, prints, drawings, & photographs
Library Holdings: Auction Catalogs; Book Volumes; Clipping Files; Exhibition Catalogs; Periodical Subscriptions; Slides
Special Subjects: Drawings, Graphics, Painting-American, Photography, African Art, Ceramics, Etchings & Engravings, Landscapes, Afro-American Art, Decorative Arts, Collages, Painting-European, Portraits, Furniture, Glass, Jade, Porcelain, Oriental Art, Asian Art, Marine Painting, Historical Material, Coins & Medals, Baroque Art, Painting-Italian
Collections: American & European paintings, drawings, sculpture, prints & photographs, 19th & 20th Centuries; Asian paintings, sculpture, prints & decorative art (ceramics, jade & cloissone); British, Japanese, Scandinavian & American Contemporary ceramics; Pennsylvania Prints from the late 18th to the early 20th Century; Tonkin Collection of Chinese export porcelain, Chinese jade carvings, paintings & watercolors related to the Oriental Trade; Baroque paintings, Japanese prints, ancient coins & ancient Peruvian ceramics
Exhibitions: (10/10/2006-12/22/2006) Couples Discourse; (1/30/2007-4/22/2007) Family Legacies: The Art of Betye, Lezley & Alison Saar; (2/6/2007-5/6/2007) Early Soviet Photography; (7/12/2007-9/9/2007) Ansel Adams & Edwin Land: Art, Science & Invention, Photographs from the Polaroid Collection; (9/4/2007-12/2/2007) Thomas Hart Benton's Shallow Creek (1939): A Focus Exhibition
Publications: Brochures; exhibition catalogs; posters; quarterly newsletter
Activities: Educ program; classes for adults with community academy for lifelong learning; summer workshops; docent training; lect open to pub; concerts; gallery talks; tours; symposia; book & originate traveling exhibs to other art museums; mus shop sells books, original art & reproductions, paper products

L **Arts & Humanities Library,** Tel 814-865-6481; Fax 814-863-7502; Elec Mail

henryp@psu.edu; Internet Home Page Address: www.libraries.psu.edu; *Head Arts & Humanities Library* Daniel Mack; *Arts & Architecture Librn* Henry Pisciotta
Open Mon - Thurs 7:45 AM - 12 AM, Fri 7:45 AM - 9 PM, Sat 8 AM - 9 PM, Sun Noon - 12 AM; Estab 1957 to support the academic programs of the College of Arts & Architecture & the Division of Art & Music Educ; to provide information on the arts to members of the university & community; reestablished in 1998 to support arts & humanities programs at Penn State and its community
Income: Financed through University Libraries, operating expenses & endowments
Library Holdings: Book Volumes 1,000,000; CD-ROMs 50; Compact Disks 10,000; DVDs; Exhibition Catalogs; Other Holdings Electronic texts; Image databases; Periodical Subscriptions 2300; Prints 500; Records 20,000; Video Tapes 500
Special Subjects: Prints, Art Education, Antiquities-Byzantine
Collections: Prints Collection (original prints)
M **HUB Robeson Galleries,** Tel 814-865-2563; Fax 814-863-0812; Elec Mail aqsl@psu.edu; Internet Home Page Address: www.sa.psu.edu/galleries; *Dir* Ann Shields
Open daily Noon - 8 PM, cl Mon; No admis fee; Estab 1976 to provide life-enriching visual arts experiences to the University & community; HUB Gallery; Robeson Gallery; Art Alley Exhibit Areas & Cases; Average Annual Attendance: 55,000
Income: financed by Pennsylvania State University
Collections: John Biggers and murals
Exhibitions: Central Penn Arts Exhibit; variety of contemporary exhibits
Publications: art brochure
Activities: Educ program; classes for college students; book traveling exhibs 7 per yr; sales shop
L **Architecture & Landscape Architecture Library,** Tel 814-865-3614; Fax 814-865-5073; Elec Mail arch@psulias.psu.edu; Internet Home Page Address: www.libraries.psu.edu; *Library Supv* Stephanie Movahedi-Lankarani; *Arts & Architecture Librn* Henry Pisciotta
Open Mon - Thurs 7:45 AM - 11 PM, Fri 7:45 AM - 9 PM, Sat 9 AM - 9 PM, Sun Noon - 11 PM; Estab 1978 to support the academic progs of the Dept of Architecture & Dept of Landscape Architecture to provide information on architecture & landscape architecture to members of the university & community
Income: Financed through university libraries, operating expenses & endowments
Library Holdings: Book Volumes 18,000; CD-ROMs; Exhibition Catalogs; Periodical Subscriptions 150; Video Tapes
Special Subjects: Landscape Architecture, Architecture

VILLANOVA

M **VILLANOVA UNIVERSITY ART GALLERY,** Connelly Ctr, 800 Lancaster Ave Villanova, PA 19085. Tel 610-519-4612; Fax 610-519-6046; Elec Mail maryanne.erwin@villanova.edu; Internet Home Page Address: www.artgallery.villanova.edu; *Asst Dir* Maryanne Erwin; *Art Gallery Coordr* Vladimir Pearce-Adashkevich; *Dir* Richard G Cannul O.S.A.
Open Mon - Fri 9 AM - 5 PM, call for weekend hrs; No admis fee; Estab 1979 to enrich the learning experience of Villanova University Students & the surrounding community through its programs of study & presentations of works of art in the gallery & throughout the campus; Average Annual Attendance: 2,500
Income: Financed by gifts & university budget
Collections: Abstract Art 20th century, African & Oceanic Art, Philadelphia Artists 19th & 20th century, Southeast Asian Antiquities
Activities: Classes for children; lect open to pub; lending coll contains over 4000 items

WARREN

M **CRARY ART GALLERY INC,** 511 Market St, Warren, PA 16365. Tel 814-723-4523; *Pres* David C Kasper; *VPres* Barbara Kersev
Wed-Sun for special exhibits; No admis fee; Estab 1977 for art appreciation & educ & to exhibit the work of Clare J Crary, Gene Alden Walker & guest artists; The gallery was contructed in 1962 as a private dwelling on the general plan of a Roman Villa. There are 6 gallery rooms, one housing a permanent exhibit of Crary photographs. The others will accomodate fine art exhibits of the works of other artists; Average Annual Attendance: 1500
Income: $28,000 (financed by endowment)
Collections: Photographs by Clare J Crary; Oils by Gene Alden Walker; drawings, etchings, oils, acrylics by various artists; 19th Century Japanese wood-block prints-Ukiyo-E
Exhibitions: Watercolors by Anne F Fallin, NWS, AWS.; Photos by Scott Elmquist; Paintings by Kathy Johnson; 3 woman show - Anne Fallin, Carol Henry, Janis Wells
Activities: Gallery talks; tours; book traveling exhibs

WASHINGTON

M **WASHINGTON & JEFFERSON COLLEGE,** Olin Fine Arts Center Gallery, Olin Art Ctr, 285 E Wheeling St Washington, PA 15301. Tel 724-223-6546; Fax 724-250-3319; Elec Mail rsherhofer@washjeff.edu; Internet Home Page Address: www.washjeff.edu/olin_fine_arts_center.html; *Managing Dir Olin Fine Arts Ctr* Ron Sherhofer
Open Mon - Sun Noon - 7 PM during school yr; No admis fee; Estab 1980 to provide college & community with art shows; Flexible lighting, air conditioned gallery; Average Annual Attendance: 6,000
Income: Financed by college
Purchases: Over $3,000 annually during National Painting Show
Collections: Art dept collection; college historical collection; National Painting Show collection
Exhibitions: Monthly exhibits
Publications: Exhibition catalogs
Activities: Lect open to pub; 2-3 vis lect per yr; concerts; gallery talks; tours; competitions with awards; individual paintings & original objects of art lent to

students, faculty & staff; lending coll contains 200 original art works, 100 original prints, 300 paintings, 200 photographs & 4 sculpture; book traveling exhibs 1 - 2 per yr

WAYNE

A **WAYNE ART CENTER,** 413 Maplewood Ave, Wayne, PA 19087. Tel 610-688-3553; Fax 610-995-0478; Elec Mail wayneart@worldnet.att.net; Internet Home Page Address: www.wayneart.com; *Dir* Nancy Campbell
Open Mon - Fri 10 AM - 5 PM, Sat 10 AM - 2 PM; No admis fee; Estab 1930 as a community art center; Two galleries offer rotating exhibits of work by local artists; Average Annual Attendance: 2,000; Mem: 400; dues $20; annual meeting May
Income: $60,000 (financed by mem, grants, corporations & Pennsylvania Council on the Arts)
Exhibitions: 10-12 changing exhibs per yr
Publications: promotional catalogs
Activities: Classes for adults & children; workshops; gallery talks; competitions

WEST CHESTER

A **CHESTER COUNTY HISTORICAL SOCIETY,** 225 N High St, West Chester, PA 19380. Tel 610-692-4800; Fax 610-692-4357; Elec Mail cchs@chestercohistorical.org; Internet Home Page Address: www.chestercohistorical.org; *Exec Dir* Roland H Woodward; *Educator Group Tours* Barbara Jobe; *Dir Pub Prog* William C Kashatus; *Dir Coll & Cur* Ellen Endslow
Mon, Tues, Thurs, Fri & Sat 9:30 AM - 4:30 PM, Wed 1 - 8 PM, cl Sun; Admis adults $5, seniors $4, children 6-17 $2.50, children under 6 free; Estab 1893 for the acquisition & preservation of art and information historically significant to Chester County; A historical center encompassing a reference library, historical archives, photo archives, a collection of Chester County materials covering 300 years and the County archives; Average Annual Attendance: 45,000; Mem: 2500; dues family $50, individual $35
Income: Financed by membership, sponsorship, grants and endowment
Library Holdings: Book Volumes; Clipping Files; Exhibition Catalogs; Fiche; Manuscripts; Maps; Original Art Works; Original Documents; Pamphlets; Periodical Subscriptions; Prints; Records; Reproductions; Slides; Video Tapes
Special Subjects: Costumes, Photography, Porcelain, Silver, Textiles, Painting-American, Pottery, Decorative Arts, Folk Art, Pewter, Ceramics, Portraits, Dolls, Furniture, Glass, Period Rooms
Collections: Museum houses regional collections of furniture, from 1690 to early 20th century through Victorian; ceramics, needlework, glassware, pewter, textiles, clocks, iron, dolls & costumes
Exhibitions: The Underground Railroad; Meeting for Equality: The 1852 Pennsylvania Woman's Rights Convention
Publications: Chester County History, occasionally; Newsletter, 3 times per yr for mems
Activities: Docent training, educational progs for children, Nat History Day for middle & HS students; monthly lect series & conferences, tours, concerts, gallery talks & sponsoring competitions; individual paintings and original objects of art lent to other museums; mus shop sells books, reproductions, prints, ceramics, toys & other gifts with historical significance to Chester County and the surrounding region

WHITEHALL

NATIONAL SOCIETY OF PAINTERS IN CASEIN & ACRYLIC, INC
For further information, see National and Regional Organizations

WILKES-BARRE

M **WILKES UNIVERSITY,** Sordoni Art Gallery, 150 S River St, Wilkes-Barre, PA 18766. Tel 507-408-4325; Fax 507-408-7733; Elec Mail bernier@wilkes.edu; Internet Home Page Address: www.sardoni.wilkes.edu; *Dir* Ronald R Bernier; *Coordr* Karen Evans Kaufer
Open daily Noon - 4:30 PM; No admis fee; Estab 1973 to encourage the fine arts in the Wilkes-Barre & the northeastern Pennsylvania areas; The Gallery has one exhib space, 1,500 sq ft; Average Annual Attendance: 3,000; Mem: 600; dues $30-$1000
Income: Financed by mem, foundation endowment & Wilkes University
Special Subjects: Painting-American, Sculpture, Painting-European
Collections: Mining photography; 20th century American paintings & prints; European prints
Exhibitions: Consists of loan exhibs from other col galleries, independent galleries, major museums & loan services; group & one-person exhibits feature estab modern masters & contemporary artists; curriculum-based exhibs
Publications: Calendar of Events, bimonthly; scholarly catalogs; illustrated brochures; posters
Activities: Gallery talks; tours; loans to other universities & museums; book traveling exhibs; originate traveling exhibs to schools & museums

WILLIAMSPORT

M **LYCOMING COLLEGE GALLERY,** Williamsport, PA 17701. Tel 570-321-4055; Fax 570-321-4090; *Dir* Roger D Shipley
Open Mon - Thurs 8 AM - 11 PM, Fri 8 AM - 4:30 PM, Sat 10 AM - 5 PM, Sun 1 - 11 PM; No admis fee; Estab 1980 to bring quality art work to the students & faculty as well as to the interested community; The new gallery, 30 x 60 ft, is located in the College Library; Average Annual Attendance: 5,000
Income: Financed by school budget & local & state grants
Special Subjects: Painting-American, Prints
Collections: Paintings & prints of 19th & 20th century artists

Exhibitions: One-man shows of regional artists & alumni of the Department
Activities: Gallery talks; tours; individual paintings lent; book traveling exhibs; originate traveling exhibs

YORK

L **MARTIN MEMORIAL LIBRARY,** 159 E Market St, York, PA 17401. Tel 717-846-5300; Fax 717-848-1496 (ref dept); Internet Home Page Address: www.yorklibraries.org; *Dir* William H Schell; *Dir Operations* Paula Gilbert
Open Mon - Thurs 9 AM - 9 PM, Fri 9 AM - 5:30 PM, Sat 9 AM - 5 PM; No admis fee; Estab 1935
Library Holdings: Book Volumes 100,000; Cassettes; Motion Pictures; Other Holdings Mounted pictures; Pamphlets; Periodical Subscriptions 200; Records
Publications: Annual Reports; Bulletin, monthly; Martin Memorial Library Historical Series; occasional bibliographies of special colls
Activities: Programs for adults and children; lect; concerts

A **THE YORK COUNTY HERITAGE TRUST,** (Historical Society of York County) Historical Society Museum & Library, 250 E Market St, York, PA 17403. Tel 717-848-1587; Fax 717-812-1204; Internet Home Page Address: www.yorkheritage.org; *Cur Coll* Richard Banz; *Head Librn* June Lloyd
Open Tues - Sat 10 AM - 4 PM, Sun 1 - 4 PM, Historic Houses call for times, cl Mon & all major holidays; Admis adults $6, children 12 and under free; Estab 1895 to record, preserve, collect & interpret the history of York County & Pennsylvania; Restoration Properties: General Gates House (1751); Golden Plough Tavern (1741) & Bobb Log House (1812), 157 W Market; Bonham House (1875), 152 E Market. Maintains reference library; Average Annual Attendance: 50,000; Mem: 2002; dues $35 & up; annual meeting in Nov
Income: $500,000 (financed by endowment, gifts & mem)
Library Holdings: Audio Tapes; Book Volumes 32,000; Clipping Files; Exhibition Catalogs; Manuscripts; Memorabilia; Motion Pictures; Pamphlets; Periodical Subscriptions 30; Photographs; Reels; Slides
Special Subjects: Historical Material, Manuscripts, Decorative Arts
Collections: Fraktur & other Pennsylvania decorative arts & furnishings; Works by Lewis Miller & other local artists; James Shettel Collection of theater & circus material; Horace Bonham artworks
Exhibitions: Six galleries featuring various subjects of regional interest; historic houses
Publications: The Kentucky Rifle; Lewis Miller Sketches & Chronicles; monthly newsletter; The Philadelphia Chair, 1685-1785; William Wagner-Views of York in 1830
Activities: Classes for adults; docent training; lect open to pub; 6 vis lectrs per yr; concerts; tours; mus shop sells books, reproductions & prints

L **Library,** 250 E Market St, York, PA 17403. Tel 717-848-1589; Fax 717-812-1204; Elec Mail library@yorkheritage.org; Internet Home Page Address: www.yorkheritage.org; *Librn* Lila Fou-hran-Shauil; *Asst Librn* Joshua Stahlman
Open to the public, cl Sun & Mon; $6; For reference only
Library Holdings: Audio Tapes; Book Volumes 25,000; Cassettes; Clipping Files; Manuscripts; Memorabilia; Other Holdings Maps; Vertical files 156; Pamphlets; Periodical Subscriptions 50; Photographs; Reels; Slides; Video Tapes
Special Subjects: Art History, Folk Art, Photography, Commerical Art, Drawings, Etchings & Engravings, Manuscripts, Maps, Painting-American, Prints, Sculpture, Historical Material, History of Art & Archaeology, Crafts, Theatre Arts, Archaeology, Ethnology, Printmaking, Industrial Design, Porcelain, Furniture, Drafting, Costume Design & Constr, Glass, Metalwork, Dolls, Embroidery, Gold, Goldsmithing, Jewelry, Restoration & Conservation, Silver, Silversmithing, Tapestries, Textiles, Woodcarvings, Woodcuts, Landscapes, Reproductions, Pewter, Flasks & Bottles, Architecture, Portraits, Pottery

M **TEMPLE UNIVERSITY, TYLER SCHOOL OF ART,** Temple Gallery, 45 N Second St, PA 19106; 7725 Penrose Ave, Elkins Park, PA 19027. Tel 215-782-2700; Elec Mail tylerart@vm.temple.edu; Internet Home Page Address: www.temple.edu/tyler/home/html; *Registrar* Joseph Miceli; *Dir* Kevin Melchionne; *Dean* Rochelle Toner
Average Annual Attendance: 20,000
Income: $160,000 (financed by the univ)
Exhibitions: Exhibits by Paula Suter, Mike Glier, Lorna Simpson, Louise Fishman, Pepon Osorio
Activities: Classes for children; docent training; lect open to pub; originate traveling exhibs 1 per yr

RHODE ISLAND

BRISTOL

L **ROGER WILLIAMS UNIVERSITY,** Architecture Library, One Old Ferry Rd, Bristol, RI 02809-2921. Tel 401-254-3833; Fax 401-254-3565; Internet Home Page Address: http://library.rwu.edu/archlib.html; *Visual Resources Cur* Elizabeth Berenz; *Circulation Supv* Mary Masley; *Architecture Art Librn* John Schlinke
Open 84 hrs/week; No admis fee; Estab 1987; Circ 16,000 vols
Library Holdings: Book Volumes 21,000; Maps 150; Pamphlets; Periodical Subscriptions 200; Slides 80,000
Special Subjects: Art History, Landscape Architecture, Maps, Historical Material, Industrial Design, Interior Design, Furniture, Drafting, Restoration & Conservation, Architecture
Collections: Architecture; historic preservation

KINGSTON

A **SOUTH COUNTY ART ASSOCIATION,** 2587 Kingstown Rd, Kingston, RI 02881. Tel 401-783-2195; *Pres* Sandy McCaw; *VPres* Martin Donovan; *Recording Secy* Karen Imbriale; *Treas* George Waterston; *Cur & Caretaker* Jim Duffy; *Dir* Rhonda Shumaker
Open Wed - Sun 1 - 5 PM during exhibs; No admis fee; Estab 1929 to promote an interest in art & to encourage artists & to support, in every way, the aesthetic

interests of the community; 1802 building, modern gallery space, 900 sq ft; Average Annual Attendance: 800; applicants for membership must submit three paintings and be accepted by a committee; dues lay member & artist $50; annual meeting Oct; artist must be accepted in juried show
Collections: No large permanent coll; paintings by early mems, usually not on display
Exhibitions: 13 varied exhibs per year
Publications: Newsletter, 6 issues
Activities: Classes for adults & children; lect open to pub, 4 vis lectrs per yr; gallery talks; competitions with awards; schols; original objects of art lent to other art associations; lending coll contains books, lantern slides, sculpture, original art works & slides

M **UNIVERSITY OF RHODE ISLAND,** Fine Arts Center Galleries, 105 Upper College Rd Kingston, RI 02881-0820. Tel 401-874-2775/2627; Fax 401-874-2007; Elec Mail shar@uri.edu; Internet Home Page Address: www.uri.edu/artgalleries; *Galleries Dir* Judith Tolnick; *Asst to Dir* Sharon Clark
Open Main Gallery Tues - Fri Noon - 4 PM & 7:30 - 9:30 PM, Sat 1 - 4 PM, Photography Gallery Tues - Fri Noon - 9 PM, Sat 1 - 4 PM, Corridor Gallery, Mon - Fri 9 AM - 5 PM; No admis fee; Estab 1970 to expose university & Southern New England communities to contemporary & historical art; Average Annual Attendance: 20,000
Income: Financed through university & outside grants
Special Subjects: Architecture, Drawings, Painting-American, Photography, Prints, Sculpture, American Indian Art, American Western Art, Afro-American Art, Collages
Exhibitions: 18-20 ongoing exhibs per yr
Publications: Exhibition catalogues
Activities: Educ dept; classes for adults; lect open to public, 5-10 vis lectrs per yr; concerts; gallery talks; sponsor competitions; originate traveling exhibs to university museums & galleries nationally

NEWPORT

M **NAVAL WAR COLLEGE MUSEUM,** 686 Cushing Rd, Newport, RI 02841-1207. Tel 401-841-4052; Fax 401-841-7689; Elec Mail nicolosa@nwc.navy.mil; Internet Home Page Address: www.visitnewport.com/buspages/navy/; Internet Home Page Address: www.nwc.navy.mil/museum; *Cur Exhibits* Robert Cembrola; *Admin Asst, Secy* Ruth Kiker; *Dir* Anthony S Nicolosi; *Mus Shop Mgr* Julia Koster
Open Mon - Fri 10 AM - 4 PM, Sat & Sun Noon - 4 PM (June 1-Sept 30); No admis fee; Estab 1978, Themes: history of naval warfare, history of Navy in Narragansett Bay; 7000 sq ft on two floors of Founder Hall, a National Historic Landmark; Average Annual Attendance: 17,000
Income: Financed by Federal Navy & Naval War College Foundation, Inc
Special Subjects: Costumes, Manuscripts, Marine Painting, Historical Material, Maps, Miniatures, Military Art
Collections: Paintings, Sculpture (statuary, busts), Prints
Publications: Exhibition catalogs
Activities: Staff talks on themes & exhibits; lect open to pub, 2 vis lectrs per yr; gallery talks; tours; retail store sells books, reproductions, prints, clothing, & costume jewelry

M **NEWPORT ART MUSEUM,** 76 Bellevue Ave, Newport, RI 02840. Tel 401-848-8200; Fax 401-848-8205; Elec Mail info@newportartmuseum.com; Internet Home Page Address: www.newportartmuseum.com; *Exec Dir* Christine Callahan; *Dir Educ* Judy Hambleton; *Pub Relations & Mem* Donna Maytum; *Grants* Jennifer Jeffries; *Cur* Nancy Grinnell; *Vol Coordr* Bobbie Konetzni; *Dir Operations* Sher Schroer
Open summer Mon - Sat 10 AM - 5 PM, Sun & most holidays Noon - 5 PM, winter Mon - Sat 10 AM - 4 PM, Sun & most holidays Noon - 4 PM, cl Christmas, New Year's Day, Thanksgiving, & July 4th; Admis adults $6, seniors & students $5, children 12 & under, mems free; The Griswold House, designed by Richard Morris Hunt for John N A Griswold in 1862 - 1863, has been the home of the Art Museum since 1916. Retaining some of the original interior decor of the era, the building is listed in the National Register of Historic Places. Cushing Memorial Gallery was built in 1920, commissioned from the firm of Delano & Aldrich, by friends & associates of Howard Gardiner Cushing; Buildings contain 6 galleries exhibiting contemporary visual arts, historic & regional exhibits; Average Annual Attendance: 30,000; Mem: 1950; dues $40 & up; annual meeting in June
Income: Financed by donations, endowment, mem, classes & admis
Special Subjects: Drawings, Painting-American, Photography, Prints, Sculpture, Watercolors, Woodcuts, Etchings & Engravings, Period Rooms
Collections: Drawings, Paintings, Photographs, Prints, Sculpture
Exhibitions: Changing exhibs, all media
Publications: Members' newsletters, quarterly
Activities: Day & evening classes for adults & children; docent training; lect open to pub & some for mems only, 25 vis lectrs per yr; concerts; gallery talks; tours; awards; schols offered; exten dept serves area schools; individual paintings & original objects of art lent to other museums; book traveling exhibs, 1 - 2 per yr; originate traveling exhibs

A **NEWPORT HISTORICAL SOCIETY & MUSEUM OF NEWPORT HISTORY,** 82 Touro St, Newport, RI 02840. Tel 401-846-0813; Fax 401-846-1853; Internet Home Page Address: www.newporthistorical.org; *Pres* John J Salesses; *1st VPres* Dennis McCoy; *2nd VPres* Richard Burnham; *Secy* Hope P Alexander; *Treas* Paul Steinbrenner; *Pres Emeritus* Bradford A Brecken; *Pres Emeritus* Kenneth H Lyons; *Exec Dir* Scott W Loehr; *Financial Adminr* Janet W Boyes; *Educ Dir* Jessica Files; *Dir Mktg* Leslie Lindeman; *Registrar* Kim A Krazer; *Reference Librarian & Genealogist* Bert Lippincott III, C.G.; *Mem Secy* Judy Kelley; *Historic Sites & Colls Mgr* Adams Taylor; *Newsletter Editor* James Yarnall; *Admin Asst* Cheryl Carvalho
Mus Open May 5 - June 12 Thurs - Sat, 10 AM - 4 PM, Sun 1 - 4 PM; June 15 - Sept 5 daily 10 AM - 4 PM; call for other hours; Suggested mus admis adults $4, children over age 5 $2; Estab 1853 to collect & preserve items of historical interest pertaining to the city; Maintains gallery & also owns & exhibits the first

Seventh Day Baptist Church in America (1729); the Wanton-Lyman-Hazard House (1675), the first home to be restored in Newport; the Friends Meeting House (1699), site of the annual New England Quakers Meeting for over 200 years & mus of Newport History. Maintains reference library; Average Annual Attendance: 20,000; Mem: 1250; dues 1854 Society $1,000; Sponsor $500; Contributor $100; Indiv $50; Library/Mus $35; Student $25
Income: Financed by endowment, mem, state appropriation & other contributions
Special Subjects: Architecture, Costumes, Drawings, Graphics, Historical Material, Landscapes, Manuscripts, Photography, Sculpture, Silver, Textiles, Painting-American, Decorative Arts, Dolls, Furniture, Glass, Jewelry, Marine Painting, Period Rooms, Maps
Collections: Artifacts, china, Colonial silver, dolls, glass, furniture, Newport scenes & portraits, pewter & toys, photographs; ship models; paintings; colonial silver; printing press used by James Franklin; ball gown worn by a member of the Summer Colony; figurehead from the yacht Aloha; 18th century women's shoe exhibit
Exhibitions: Numerous changing exhibits
Publications: Newport History, quarterly; Newport Historical Society Newsletter, 6 times per yr
Activities: Educ dept; lect open to pub, 12 vis lectrs per yr; gallery talks; tours; audio-visual progs; competitions with awards; mus shop sells books & prints
L **Library,** 82 Touro St, Newport, RI 02840. Tel 401-846-0813; *Librn* Bertram Lippincott III
Open Tues - Fri 9:30 AM - 4:30 PM, Sat 9 AM - Noon, summers, Sat 9:30 AM - 4:30 PM; Estab 1853 to provide resource materials; For reference only
Library Holdings: Audio Tapes; Book Volumes 9000; Clipping Files; Exhibition Catalogs; Fiche; Kodachrome Transparencies; Manuscripts; Memorabilia; Original Art Works; Pamphlets; Periodical Subscriptions 10; Photographs; Prints; Reels; Sculpture; Slides; Video Tapes
Special Subjects: Art History, Landscape Architecture, Decorative Arts, Maps, Painting-American, Historical Material, Ceramics, Furniture, Period Rooms, Costume Design & Constr, Stained Glass, Dolls, Restoration & Conservation, Silver, Silversmithing, Textiles, Pewter, Architecture
Activities: Walking tour; school progs; Explore the Newport National Historic Landmark District through interactive computer progs; video tour of Bellevue Ave

L **REDWOOD LIBRARY & ATHENAEUM,** 50 Bellevue Ave, Newport, RI 02840-3292. Tel 401-847-0292; Fax 401-841-5680; Elec Mail redwood@edgenet.net; Internet Home Page Address: www.redwood1747.org; *Dir* Cheryl V Helms; *Dir Library Svcs* Lynda Bronaugh; *Special Coll Librn* Maris Humphreys; *Dir Develop* Robin Ashook
Open Mon, Fri & Sat 9:30 AM - 5:30 PM, Tues, Wed & Thurs 9:30 AM - 8 PM, Sun 1 - 5 PM; No admis fee; Estab 1747 as a general library; Average Annual Attendance: 4,500; Mem: 1400; dues $100; annual meeting in Aug
Income: Financed by endowment, mem, ann giving, grants
Library Holdings: Auction Catalogs; Audio Tapes 300; Book Volumes 162,000; CD-ROMs 600; Cassettes; Compact Disks; Exhibition Catalogs; Manuscripts; Maps; Memorabilia; Original Art Works; Original Documents; Periodical Subscriptions 175; Records; Sculpture 40
Special Subjects: Decorative Arts, Sculpture
Collections: 150 paintings, largely portraits; 40 sculptures; 50 pieces of furniture & other decorative arts items; those on display include portraits by Washington Allston, Robert Feke, G P A Healy, Charles Willson Peale, Rembrandt Peale, John Smibert, Gilbert Stuart, Thomas Sully; many paintings by Charles Bird King, historical & classical busts, & early Newport furniture
Exhibitions: rotating exhibs
Publications: To Preserve Hidden Treasures: From the Scrapbooks of Charles Bird King; Vetruvius Americanus
Activities: Classes for children; dramatic programs; lect open to pub; 10 vis lectrs per yr; concerts; gallery talks; group tours by prior arrangement; individual paintings & original objects of art lent to Preservation Society of Newport County & other museums; sales shop sells books, slides, cards & bookbags

M **ROYAL ARTS FOUNDATION,** Belcourt Castle, 657 Bellevue Ave, Newport, RI 02840-4280. Tel 401-846-0669, 849-1566; Fax 401-846-5345; Elec Mail royalarts@aol.com; Elec Mail belcourtcastle@aol.com; Internet Home Page Address: www.belcourtcastle.com; *Exec Dir* Harle Tinney; *Pres* Mark P Malkovich III
Mar - Jun, & Nov - Dec, Thur - Mon Noon to 4 PM (5 PM summers); Jul - Oct, Wed - Mon Noon - 4 PM; December holiday prog Sun 1 - 4 PM; Feb weekends & daily during Newport Winter Festival; cl Tues, Thanksgiving Day & Christmas; Admis adult $10, seniors 65+ $8.50, student (ages 13-18) $7.50, child (ages 6-12) $5, children under 5 free; Estab 1957; 60-room private residence of the Tinney family open to visitors under the auspices of the Royal Arts Foundation; Average Annual Attendance: 30,000; Mem: annual meeting in Jan
Income: $300,000 (financed by admis fees)
Special Subjects: Architecture, Painting-American, Sculpture, Textiles, Costumes, Ceramics, Painting-European, Furniture, Jewelry, Porcelain, Oriental Art, Asian Art, Silver, Antiquities-Byzantine, Painting-British, Historical Material, Tapestries, Renaissance Art, Period Rooms, Embroidery, Antiquities-Oriental, Antiquities-Persian, Antiquities-Egyptian, Gold, Stained Glass
Activities: Lect open to pub, 4 vis lectrs per yr; guided & specialty tours (reservations by phone or web); mus shop sells books & magazines

PAWTUCKET

M **OLD SLATER MILL ASSOCIATION,** Slater Mill Historic Site, 67 Roosevelt Ave, PO Box 696 Pawtucket, RI 02862. Tel 401-725-8638; Fax 401-722-3040; Elec Mail jzavada@slatermill.org; Internet Home Page Address: www.slatermill.org; *Cur* Adrian Paquette; *Dir, CEO* Jeanne Zavada
Open June - Oct Mon - Sat 10 AM - 5 PM, Sun 1 - 5 PM, Nov - Dec 20 & Mar - May Sat & Sun 1 - 5 PM; $9 adults; $7 children; Estab 1921; Visitor Center Gallery for temporary exhibits including history, art & craft shows. Three permanent galleries in historic buildings; Average Annual Attendance: 50,000; Mem: dues $50; annual meeting in June; approx 500 mbrs
Income: $500,000 (financed by endowment, mem & city appropriation)

Special Subjects: Painting-American, Archaeology, Textiles, Costumes, Decorative Arts, Manuscripts, Furniture, Laces
Collections: Machine tools; manuscripts; photographs; textiles; textile machinery
Publications: Quarterly flyer
Activities: Adult classes; docent programs; lect open to pub, 2-3 vis lectrs per yr; tours; traveling educ progs; book traveling exhibs 4 per yr; originate traveling exhibs; sales shop sells books, prints, slides & photographs

A **RHODE ISLAND WATERCOLOR SOCIETY,** Slater Memorial Park, Armistice Blvd Pawtucket, RI 02861. Tel 401-726-1876; Fax 401-726-1876; Elec Mail riwatercolorsociety@juno.com; Internet Home Page Address: www.riws.org; *VPres* Dennis Wyckoff; *Treas* Joyce Jennings; *Pres* Sally Ann Martone; *Dir Gallery* Mary Lou Moore
Open Tues - Sat 10 AM - 4 PM, Sun 1 - 5 PM; cl Jan & every Mon; No admis fee; Estab 1896 to encourage & promote the advancement of watercolor painting; Large carpeted upper & lower tiled gallery. Lower level gallery open for classes & exhibs; Mem: 325; dues $60; annual meeting May; must submit work for jurying for mem
Income: Financed by dues, commissions, contributions & progs
Exhibitions: Annual Exhibition of Member's work; Annual Christmas Exhibition; Annual National Open Juried Watermedia Show; Annual New Members Show; 12 or more mem exhibs per yr
Publications: Member newsletter
Activities: Classes for adults; workshops; lect & demonstrations, open to members & guests; competitions with prizes; sales shop sells wrapped matted paintings from bins, reproductions, original art & prints

PROVIDENCE

BROWN UNIVERSITY
M **David Winton Bell Gallery,** Tel 401-863-2932; Fax 401-863-9323; Internet Home Page Address: www.brown.edu/bellgallery; *Dir* Jo-Ann Conklin; *Adminr* Terrence Abbott; *Cur.* Vesela Stretenovic; *Preparator* Cameron Shaw
Open Sept - June Mon - Fri 11 AM - 4 PM, Sat & Sun 1 - 4 PM, cl major holidays; No admis fee; Estab 1971 to present exhibs of interest to the univ & community; The gallery is modern, covers 2625 sq ft, 14 ft ceilings & has track lighting; Average Annual Attendance: 8,000
Income: Financed by endowment & univ funds
Special Subjects: Painting-American, Photography, Prints, Woodcuts
Collections: Substantial print & photography collection of historical & modern masters; selected color field paintings & modern sculpture
Exhibitions: Mall media juried student & faculty exhibs; International contemporary art
Publications: Exhibition catalogs
Activities: Lects open to pub; art work lent to exhibs mounted by museums & galleries; permanent coll contains 5000 original prints & photographs, over 100 modern paintings & sculptures; originates traveling exhibs
M **Annmary Brown Memorial,** Tel 401-863-1518; *Friends of the Library Coordr* Christy Law Blanchard
Open Mon - Fri 9 AM - 5 PM; No admis fee; Estab 1905 to offer representatives of schools of European & American painting; There are three galleries which house the art collection of the founder & his wife, & portraits of the Brown family & Mazansky collection of British swords; Average Annual Attendance: 3,000
L **Art Slide Library,** Tel 401-863-3218; Fax 401-863-9589; Internet Home Page Address: www.brown.edu/facilities/University_Library/libs/art/index.html; *Assoc Cur* Karen Bouchard; *Cur* Norine Duncan
Open Mon - Fri 8:30 AM - 5 PM; Estab to serve Brown Univ students, faculty & alumni; Circ 35,000; Reference books do not circulate
Income: $200,000 (financed by university funds)
Library Holdings: Book Volumes 550; Exhibition Catalogs; Fiche; Photographs 30,000; Reproductions; Slides
Special Subjects: Art History, Folk Art, Decorative Arts, Photography, Drawings, Etchings & Engravings, Manuscripts, Portraits, Industrial Design, Asian Art, Ivory, Mosaics, Metalwork, Religious Art, Landscapes, Architecture
M **Haffenreffer Museum of Anthropology,** Tel 401-253-8388; Fax 401-253-1198; Internet Home Page Address: www.brown.edu; *Deputy Dir & Cur* Barbara A Hail; *Assoc Cur & Coll Mgr* Thierry Gentis; *Dir* Shepard Krech III
Open June, July & Aug Tues - Sun 11 AM - 5 PM, academic yr Sat & Sun 11 AM - 5 PM; Admis adults $3, seniors $2, children $1, mems free; Estab 1955 to educate Brown University Students & the general pub through anthropological research on humankind, about cultural differences & human similarities & to serve its constituency with excellence; Average Annual Attendance: 18,000; Mem: Mem 250; dues $20 - $100; ann meeting in May
Special Subjects: American Indian Art, African Art, Anthropology
Collections: Worldwide material culture-artifacts, costumes, pottery, tools, sculpture, etc
Exhibitions: Various exhibs, call for details
Activities: Classes for adults & children; docent training; lect open to pub, 8 vis lectrs per yr; gallery talks; tours; artmobile; book traveling exhibs 1 per yr; originate traveling exhibs; mus shop sells books, magazines, original art, reproductions, prints, slides & objects related to the colls

M **CITY OF PROVIDENCE PARKS DEPARTMENT,** Roger Williams Park Museum of Natural History, Elmwood Ave, Providence, RI 02905. Tel 401-785-9450; Fax 401-461-5146; Elec Mail mmassaro@musnathist.com; Internet Home Page Address: www.osfn.org/museum; *Cur* Marilyn R Massaro; *Dir* Tracey Keough; *Asst Cur* Shara Chase
Open daily 10 AM - 5 PM; Admis adult $2, children $1; Estab 1896; 5 exhibit galleries (one rotates); Average Annual Attendance: 15,000
Income: Financed by state appropriations, admis & donations
Library Holdings: Auction Catalogs; Book Volumes; Exhibition Catalogs; Kodachrome Transparencies; Lantern Slides; Original Documents; Photographs; Slides
Special Subjects: Anthropology, Archaeology, Ethnology, Folk Art
Collections: Natural history, Native American, Oceanic, African ethnography

Exhibitions: All Things Connected (Native American Collection); Natural Selections (Victorian Natural History); Circle of the Sea (Oceana); rotating exhibit
Publications: Exhibit catalogs (Native American, Oceana)
Activities: Children's classes; lect open to pub; mus shop sells books, children's items, exhibit-related
L **Library,**
Estab 1896
Library Holdings: Book Volumes 10,000; Clipping Files; Exhibition Catalogs; Kodachrome Transparencies; Lantern Slides; Photographs; Slides

A **PROVIDENCE ART CLUB,** 11 Thomas St, Providence, RI 02903. Tel 401-331-1114; Fax 401-521-0195; Elec Mail galleries@providenceartclub.org; Internet Home Page Address: www.providenceartclub.org; *Pres* Harley Bartlett; *Dir Galleries* Lauren Cicione
Open Mon - Fri 12 PM - 4 PM, Sat & Sun 2 - 4 PM; No admis fee; Estab 1880 for art culture & to provide exhibition space for artists; Galleries maintained in two 18th century buildings on historic Thomas Street in Providence; Average Annual Attendance: 12,000; Mem: 650; to qualify, artists' work must pass a board of artists; personal qualifications for non-artists; dues non-artist $660, artist $490; ann meeting first Wed in June
Income: Financed by endowment & mem
Collections: Small permanent collection of paintings & sculpture by Club members since 1880
Exhibitions: Forty shows a season of which 2 - 3 are juried open shows
Publications: Newsletter for members, monthly
Activities: Lect for mems & guests; gallery talks; competitions with awards; tours; schols; schols offered

M **PROVIDENCE ATHENAEUM,** 251 Benefit St, Providence, RI 02903. Tel 401-421-6970; Fax 401-421-2860
Open Mon - Thurs 9 AM - 7 PM, Fri 9 AM - 5 PM, Sat 9:30 AM - 5:30 PM, Sun 1 - 5 PM, cl Sat & Sun, from mid - June to Labor Day; No admis fee; Estab 1753 to provide cultural services, information, rare & current materials in an historic setting; Maintains a rare book library; Mem: Estab 1367; dues $25 - $150 annual meeting in the Fall
Income: $303,544 (financed by endowment & mem)
Purchases: $40,000
Collections: Strength in the 19th century
Exhibitions: Exhibs vary each month; local artists' works shown
Publications: The Athenaeum Bulletin, summer; Annual Report, Fall
Activities: Dramatic programs; film progs; lect open to pub; tours; festivals; concerts; day trips; original objects of art lent to bonafide institutions, libraries or societies; lending coll contains books, periodicals, records, videotapes, cassettes; sales shop sells Audubon prints in limited editions, stationery, t-shirts & Athenaeum cookbooks
L **Library,** 251 Benefit St, Providence, RI 02903. Tel 401-421-6970; Fax 401-421-2860; Elec Mail info@providenceathenaeum.org; Internet Home Page Address: www.providenceathenaeum.org
Open Mon - Thurs 9 AM - 7 PM, Fri & Sat 9 AM - 5 PM, Sun 1 - 5 PM, cl Sun in summer, July & Aug; No admis fee; Estab 1753 to provide cultural services, information rare & current materials in a historic setting; Circ 106,000; Mem: Dues $35 - $185; annual meeting in spring
Income: endowment, mem fees, ann appeal
Library Holdings: Audio Tapes; Book Volumes 161,486; Cassettes; Exhibition Catalogs; Manuscripts; Memorabilia; Original Art Works; Other Holdings Posters; Pamphlets; Periodical Subscriptions 133; Prints; Records; Sculpture; Video Tapes
Special Subjects: Art History
Collections: 19th century Robert Burns coll; 19th century library - rare book library; Audubon, Old Fiction, Holder Borde Bowen collection
Activities: Childrens programs; film programs; festivals; readings & lects; tours; trips

L **PROVIDENCE PUBLIC LIBRARY,** Art & Music Services, 150 Empire St, Providence, RI 02903. Tel 401-455-8088; Fax 401-455-8013; Elec Mail mchevian@provlib.org; Internet Home Page Address: www.provlib.org; *Coordr* Margaret Chevian
Mon & Wed 12 - 8 PM, Tues & Thurs 10 AM - 6 PM, Fri & Sat 9 AM - 5:30 PM; Estab 1875 to serve needs of the public
Income: financed by endowment, city and state appropriations and federal funds
Library Holdings: Book Volumes 43,000; Clipping Files; Compact Disks; Framed Reproductions; Original Art Works; Other Holdings Posters; Periodical Subscriptions 85; Photographs; Prints; Records; Video Tapes
Special Subjects: Landscape Architecture, Decorative Arts, Illustration, Photography, Commerical Art, Drawings, Graphic Design, Painting-American, Painting-British, Sculpture, Ceramics, Crafts, Advertising Design, Cartoons, Interior Design, Furniture, Costume Design & Constr, Handicrafts, Pottery, Silversmithing, Architecture
Collections: Nickerson Architectural Collection; art & music books

M **RHODE ISLAND COLLEGE,** Edward M Bannister Gallery, 600 Mount Pleasant Ave, Providence, RI 02908. Tel 401-456-9765; Fax 401-456-9718; Elec Mail domalley@ric.edu; Internet Home Page Address: www.ric.edu/bannister; *Dir* Dennis M O'Malley
Open Mon - Wed, & Fri 11 AM - 4 PM, Thurs, Noon - 9 PM; No admis fee; Estab 1978 to provide the Rhode Island community with a varied & progressive exposure to the visual arts, to offer to the college community, with its liberal arts perspective, access to top quality exhibits, artists & workshops; View map on web site; Average Annual Attendance: 5,000
Income: Financed by state appropriation, student organizations & RIC Foundation
Collections: Teaching collection of works purchased from exhibiting artists
Publications: Brochures; semiannual calendars; monthly exhibit announcements
Activities: Lect open to the pub; average of 12 vis lectrs per yr; gallery talks

A **RHODE ISLAND HISTORICAL SOCIETY,** 110 Benevolent St, Providence, RI 02906. Tel 401-331-8575; Fax 401-351-0127; *Ed, Nathanael Green Papers* Roger Parx; *Mus Cur* Linda Eppich; *Dir Educ* Melissa Bingmann; *Pub Relations* William Greene; *Dir* Dr Murney Gerlach
Open Tues - Fri 8:30 AM - 5:30 PM, cl Sun & Mon; Admis adults $2, students $1; Estab 1822 to preserve, collect & interpret Rhode Island historical materials,

including books, manuscripts, graphics, films, furniture & decorative arts; Mem: 2,500; dues $35; annual meeting in Sept
Income: Financed by endowment, mem & city & state appropriation
Exhibitions: Changing exhibitions on Rhode Island history & decorative arts
Publications: American Paintings in the Rhode Island Historical Society, (catalogue); The John Brown House Loan Exhibition of Rhode Island Furniture; Nathanael Green Papers; Rhode Island History, quarterly; Roger Williams Correspondence; occasional monographs; newsletter, bimonthly
Activities: Classes for adults & children; children's tours; film progs; lect open to pub, 4-6 vis lectrs per yr; concerts; gallery talks; tours; lending coll contains 10,000 prints for reference and copying; traveling exhibs organized & circulated locally

M **John Brown House,** 110 Benevolent St, Providence, RI 02906. Tel 401-331-8575; Fax 401-351-0127; Internet Home Page Address: www.rihs.org; *Cur* Kirsten Hammerstrom; *Exec Dir* Bernard Fishman; *Dir Goff Institute* Morgan Grefe
Open Tues - Sat 10 AM - 5 PM, Sun Noon - 4 PM, cl weekdays Jan - Mar except by appointment; Admis adults $7, seniors & students $5.50, children 7 - 17 $3, mems free; Estab 1942, the 1786 house carefully restored & furnished with fine examples of RI & period materials; Average Annual Attendance: 9,000; Mem: 1,700; basic mem $40
Income: RIHS Institutional budget, $2.2 million (2006)
Purchases: RIHS does purchase material related to history of John Brown House & important RI archives & objects
Library Holdings: Auction Catalogs; Audio Tapes; Book Volumes; CD-ROMs; Cards; Cassettes; Clipping Files; Compact Disks; DVDs; Exhibition Catalogs; Filmstrips; Lantern Slides; Manuscripts; Maps; Memorabilia; Motion Pictures; Original Art Works; Original Documents; Other Holdings; Pamphlets; Periodical Subscriptions; Photographs; Prints; Records; Reels; Sculpture; Slides; Video Tapes
Special Subjects: Painting-American, Watercolors, Textiles, Costumes, Ceramics, Crafts, Etchings & Engravings, Landscapes, Decorative Arts, Portraits, Dolls, Furniture, Glass, Jewelry, Porcelain, Silver, Marine Painting, Carpets & Rugs, Historical Material, Maps, Coins & Medals, Miniatures, Period Rooms, Embroidery, Pewter
Collections: Carrington Collection of Chinese export objects; McCrillis Collection of Antique Dolls; furniture by Rhode Island cabinetmakers, some original to the house; portraits, china, glass, pewter & other decorative objects; Rhode Island furniture, silver, porcelain, paintings, textiles; major archival colls on Rhode Island subjects
Publications: Rhode Island History, Papers of Nathanael Greene
Activities: Educ program; classes for adults; concerts; gallery talks; schols; history makers awards; lending of original objects of art to qualified non-profit educational institutions; mus shop sells books, magazines, prints
M **Aldrich House,** 110 Benevolent St, Providence, RI 02906. Tel 401-331-8575; *Contact* Renata Luong
Open Tues - Fri 8:30 AM - 5:30 PM, cl Sun & Mon; Admis adults $2, seniors & students $1; Estab 1974; Galleries for changing exhibs of RI artists & history
Income: Financed by endowment, state & local funds, grants (state & federal) & admis rates
L **Library,** 121 Hope St, Providence, RI 02906. Tel 401-331-8575; Fax 401-751-7930; Internet Home Page Address: www.rihs.org; *Dir Library* Karen Eberhart
Open Wed & Fri 10 AM - 5 PM; Thurs 12 PM - 8 PM; Out of state non-mems $5 per day; Estab 1822 to collect, preserve & make available materials relating to state's history & development; Small exhibit area at library, also galleries at John Brown & Aldrich houses; Average Annual Attendance: 9,000; Mem: 3,000; dues individual $40; ann meetings in May
Income: $700,000 (financed by endowment, mem & state appropriation)
Library Holdings: Book Volumes 150,000; Periodical Subscriptions 2600
Collections: 5000 manuscripts collections dating from 17th century; Rhode Island Imprints, 1727-1800; Rhode Island Broadsides; Providence Postmaster Provisional Stamps; Rhode Island Post Office Covers; genealogical sources, all state newspapers, maps, films, TV news films and movies, graphics, architectural drawings; 150,000 reference volumes; 200,000 photographs; business archives; oral history tapes
Publications: Rhode Island History, quarterly
Activities: Classes for adults & children; docent training; lect open to pub, concerts; gallery talks; tours; awards; individual paintings lent; originate traveling exhibs to educational and governmental institutions; mus shop sells books & prints

M **RHODE ISLAND SCHOOL OF DESIGN,** Museum of Art, 224 Benefit St, Providence, RI 02903-2723. Tel 401-454-6500; Fax 401-454-6556; Internet Home Page Address: www.risd.edu; *Dir* Philip Johnston; *Mus Shop Mgr* Anne Tillinghast; *Pub Relations* Matthew Montgomery
Open Tues - Sun 10 AM - 5 PM, every third Thurs Noon - 9 PM, cl Mon & holidays; Admis adults $5, college students $2, children 5 - 18 $1, children under 5 free; Estab 1877 to collect & exhibit art for general educ of RISD students & the pub; Present buildings opened in 1897, 1906, 1926 & 1990; Average Annual Attendance: 100,000; Mem: 3500
Income: Financed by endowment, mem, state & federal appropriation, pvt & corporate contributions
Special Subjects: Graphics, Painting-American, Prints, Pre-Columbian Art, Decorative Arts, Furniture, Porcelain, Oriental Art, Renaissance Art, Antiquities-Greek, Antiquities-Roman
Collections: Lucy Truman Aldrich Collection of European porcelains & Oriental textiles; Ancient Oriental & ethnographic art; American painting; contemporary graphic arts; Nancy Sayles Day Collection of modern Latin American art; English watercolors; 15th - 18th century European art; 19th & 20th century French art from Romanticism through Surrealism; Albert Pilavin Collection of 20th century American Art; Pendleton House collection of 18th century American furniture & decorative arts; Abby Aldrich Rockefeller collection of Japanese prints
Exhibitions: Neoteric Jewelry; Romanticism & Revival; 19th Century American Art from Permanent Collection; Expressionist Visions; Prints & Drawings from the Museum's Collection; Form, Pattern & Function; Design in American Indian Art; Edward W Curtis Photogravures; Selections from the North American Indian
Publications: Gallery guides for select exhibits; catalogs
Activities: Classes for adults & children; docent training; lect open to pub; gallery talks; concerts; tours; outreach programs serve schools, nursing homes & hospital

children's ward in the area; traveling exhibs organized & circulated; mus shop sells books, original art, reproductions, prints, jewelry, posters & postcards

L **Fleet Library at RISD,** 15 Westminster St, Providence, RI 02903-2784; 2 College St, Providence, RI 02903-2784. Tel 401-709-5900; Fax 401-709-5903; Elec Mail cterry@risd.edu; Internet Home Page Address: www.risd.edu/risd_library.cfm; *Dir* Carol Terry; *Readers' Svrs Librn* Claudia Covert; *Special Coll Librn* Laurie Whitehill Chong; *Archivist* Andy Martinez
Open Mon - Thurs 8:30 AM - 11 PM, Fri 8:30 AM - 8 PM, Sat 10 AM - 6 PM, Sun noon - 11 PM; summer and holiday hours vary; Circ 67,000; Open to the pub for reference
Library Holdings: Auction Catalogs 14,000; Book Volumes 107,000; CD-ROMs; Clipping Files 475,000; Compact Disks; DVDs; Exhibition Catalogs; Fiche; Lantern Slides 22,000; Motion Pictures; Other Holdings Artists' books; Postcards; Posters; Periodical Subscriptions 400; Photographs; Reproductions 19,000; Slides 164,000; Video Tapes 2500
Special Subjects: Architecture

M **WHEELER GALLERY,** 228 Angell St, Providence, RI 02906. Tel 401-421-9230; Fax 401-751-7674; Elec Mail info@wheelergallery.org; Internet Home Page Address: www.wheelergallery.org; *Dir* Sue Carroll
Open Tues - Sat Noon - 5 PM, Sun 3 - 5 PM (Sept - May); No admis fee; Nonprofit artist's space showing contemporary painting, sculpture, photography, prints, ceramics, glass & installations from artists who live or work in the Providence area; Average Annual Attendance: 1,000
Income: Financed by Wheeler School
Activities: Lect open to pub, 5 vis lectrs per yr

SAUNDERSTOWN

M **GILBERT STUART MEMORIAL ASSOCIATION, INC,** Museum, 815 Gilbert Stuart Rd, Saunderstown, RI 02874. Tel 401-294-3001; Fax 401-294-3869; Elec Mail deborahethompson@aol.com; Internet Home Page Address: www.gilbertstuartmuseum.com; *Co-Dir* John Thompson; *Co-Dir* Deborah Thompson; *Pres* Curtis Givan
Open Apr - Oct Thurs - Mon 11 AM - 4 PM, cl Tues & Wed, Oct weekends only 11 AM - 4 PM; Admis adults $5, children 6 - 12 $2, children under 6 no admis fee; Designated 1966 as a national historic landmark, the furnished birthplace of America's foremost portrait painter; the home was built 1751; Restored home with grist mill; Average Annual Attendance: 4,500; Mem: 425; dues $35 family, $30 individual; annual meeting in July
Income: Financed by endowment, admis fees & grants
Library Holdings: Clipping Files; Compact Disks; Memorabilia; Photographs; Prints
Special Subjects: Portraits
Collections: Collections of artifacts, period tools & prints
Exhibitions: Artist in residence
Activities: Classes for adults; Docent training, children trained as jr docents who give weekend tours and hold spec events; dress in colonial costume ages 6-15; guided tours of the home; sales of books & prints

WAKEFIELD

M **HERA EDUCATIONAL FOUNDATION,** Hera Gallery, 327 Main St, Box 336 Wakefield, RI 02880-0336. Tel 401-789-1488; Internet Home Page Address: www.heragallery.org; *Dir* Cynthia Farnell
Open Wed - Fri 1 - 5 PM, Sat 10 AM - 4 PM; No admis fee; Estab 1974 as a women's cooperative gallery exhibiting the work of mems & non-mems; 30 ft x 40 ft in dimension with 9 ft ceiling; Average Annual Attendance: 1,500; Mem: Dues $185 - $480; monthly meetings second Wed; reduced fees for bd mems
Income: Financed by mem, contributions, grants & schols
Library Holdings: Slides of mems
Exhibitions: 10 - 11 exhibs per yr
Activities: Classes for children; readings; critiques; lect open to pub on contemporary culture, 2-3 vis lectrs per yr; gallery talks by artists; juried competition with cash award; symposia; critique group; sales shop sells reproductions, prints

WARWICK

M **COMMUNITY COLLEGE OF RHODE ISLAND,** Art Department Gallery, Knight Campus, 400 East Ave Warwick, RI 02886. Tel 401-825-2220; Fax 401-825-1148; Internet Home Page Address: www.ccri.cc.ri.us; *Chmn* Nichola Sevigney
Open Mon - Sat 11 AM - 4 PM; No admis fee; Estab 1972; Maintains reference library; Average Annual Attendance: 1,000
Exhibitions: Exhibs are changed bimonthly
Activities: Lect open to public, 10 vis lectrs per year; concerts; gallery talks; tours; competitions with awards; exten dept; individual paintings & original objects of art lent; lending collection contains 300 color reproductions, 20 filmstrips, 10,000 Kodachromes, motion pictures & clippings & small prints; originate traveling exhibition

M **Flanagan Valley Campus Art Gallery,** Louisquisset Pike, Lincoln, RI 02865-4585. Tel 401-333-7154; Fax 401-825-2265; Internet Home Page Address: www.ccri.cc.ri.us; *Dir & Librn* Tom Morrissey
Open Mon - Fri 10 AM - 2 PM; No admis fee; Estab 1974; 26 sq ft space with track lighting; Average Annual Attendance: Over 5,000
Exhibitions: Exhibitions are changed bi-monthly
Activities: Lect open to pub, 10 vis lectr per yr; concerts; gallery talks; tours; competitions with awards; exten dept; individual paintings & original objects of art lent; originate traveling exhibs

M **WARWICK MUSEUM OF ART,** Kentish Artillery Armory, 3259 Post Rd Warwick, RI 02886. Tel 401-737-0010; Fax 401-737-1796; Elec Mail warwickmuseum@hotmail.com; *VPres* Harvey Zimmerman; *Dir* Bill Reis; *Adminr* Renee Pollan; *Chief Exec Dir* Edward McGinley; *Treas* Michael Balsamo
Open Wed 4 PM - 8 PM, Thurs & Fri Noon - 4 PM, Sat & Sun 1 - 3 PM; Estab 1973 to promote a dynamic resource for all aspects of the arts; Small gallery,

formerly the Kentish Artillery, a 1800's building; Average Annual Attendance: 3,000; Mem: 550; dues $15 - $50; meetings 2nd Thurs of month
Income: $40,000 (financed by mem & city & state appropriation)
Exhibitions: Rhode Island Open Juried Exhibit (all media)
Activities: Classes for adults & children; dramatic progs; performances & art exhibits; children's summer art camp; lect open to pub, 2 vis lectrs per yr; competitions with awards; schols offered

WESTERLY

M **WESTERLY PUBLIC LIBRARY,** Hoxie Gallery, 44 Broad St, Westerly, RI 02891. Tel 401-596-2877; Fax 401-596-5600; Elec Mail jjohnson@westerlylibrary.org; *Dir* Kathryn T Taylor; *Community Svcs* Jane Johnson
Open Mon - Wed 9 AM - 9 PM, Thurs & Fri 9 AM - 6 PM, Sat 9 AM - 4 PM, Sun Oct - May Noon - 4 PM; No charge; Estab 1892 as a memorial to soldiers of the Civil War & to provide a library & activities center for the community; Art gallery maintained, 30 x 54 ft, 16 ft ceiling, with incandescent track lighting; Average Annual Attendance: 5,000
Income: Financed by endowment, city & state appropriation
Collections: Margaret Wise Brown Archive; Children's Book Week Posters
Exhibitions: Ten - twelve exhibs scheduled per yr; local artists exhib
Activities: Lect open to pub; library tours

SOUTH CAROLINA

AIKEN

M **AIKEN COUNTY HISTORICAL MUSEUM,** 433 New Berry St SW, Aiken, SC 29801. Tel 803-642-2017; Fax 803-642-2016; Elec Mail acmuseum@duesouth.net; Internet Home Page Address: www.duesouth.net; *Dir* Carolyn Miles; *Mus Shop Mgr* Nancy Johnson; *CEO* Owen Clary
Open Tues - Fri 9:30 AM - 4:30 PM, Sat & Sun 2 - 5 PM; Admis donations requested; Open 1970 to document local history; Average Annual Attendance: 7,500; Mem: 350; mem open to residents; dues $10 & up; ann meeting in Oct
Income: $71,000 (financed by endowment, mem, county subsidiary)
Purchases: All donations
Collections: Agricultural-implements; Dairy-implements; log cabins; military; Savannah River Site (nuclear); Schools-furniture & winter items; Winter Colony-furniture
Exhibitions: Selections from permanent collection
Activities: Children's classes; docent progs; book traveling exhibs 10 per yr; retail store sells books & prints

ANDERSON

A **ANDERSON COUNTY ARTS COUNCIL,** 405 N Main St, Anderson, SC 29621. Tel 864-224-8811; Fax 864-224-8864; *Exec Dir* Kimberly Spears; *Admin Dir* Annette Buchanan
Open Mon - Fri 9:30 AM - 5 PM, cl Sat, Sun & holidays; No admis fee; Estab 1972 as a nonprofit institution, encouraging & stimulating the practice & appreciation of the arts among the people living in the County of Anderson & the State of South Carolina; Gallery rotates exhibits monthly, featuring locally, regionally & nationally known artists; Average Annual Attendance: 10,000; Mem: 550; dues $1000, $500, $100, $50, $30; annual meeting last Tues of Sept
Income: Financed by mem, foundations, donations, county appropriation & grants
Exhibitions: Anderson Artist Guild Members Show; Soiree Clay Invitational; Youth Art Month; Changes
Publications: Calendar of events; newsletter; annual report
Activities: Classes for adults & children; gallery talks; tours

BEAUFORT

M **USCB ART GALLERY,** Univ S Carolina, 801 Carteret St Beaufort, SC 29902. Tel 843-521-4145; Elec Mail info@beaufortarts.com; Internet Home Page Address: www.beaufortarts.com; *Prog Coordr* Sarah Van Winkle; *Exec Dir* Eric V Holowacz
Open daily 9 AM - 5 PM; No admis fee; Estab 1990; Two-room community art gallery in Performing Arts Center at the University of South Carolina Beaufort; Average Annual Attendance: 10,000; Mem: 700; dues $10-$1000; ann meeting in May
Income: $150,000 (financed by mem, city & state appororiation)
Activities: Classes for adults; dramatic progs; lect open to pub, 1 - 4 vis lectr per yr; book traveling exhibs 2-4 per yr

CHARLESTON

M **CAROLINA ART ASSOCIATION,** Gibbes Museum of Art, 135 Meeting, Charleston, SC 29401. Tel 843-722-2706; Fax 843-720-1682; Internet Home Page Address: www.gibbesmuseum.org; *Pres Bd* Ericl Friberg; *Dir* Todd D Smith; *Registrar* Zinnia Willits; *Dir Educ* Jonell Pulliam; *Pub Relations, Mktg Mgr & Dir Commun* Maria Loftus; *Admin* Eliza Buxton; *Chief Cur* Angela Mack
Open Tues - Sat 10 AM - 5 PM, Sun 1 - 5 PM; cl national holidays; Admis $9 adults; $7 seniors, students & military; $5 children (6-18); children under 6 - free; Estab 1858 as an art gallery & mus; Circ non-circulation; Beau-Arts style building erected in 1905, renovated in 1978; gallery is 31,000 sq ft; Average Annual Attendance: 60,000; Mem: 4,000; dues $35 & up; annual meeting 3rd Mon in Oct
Income: $1,300,000 (financed by endowment, mem, city & county appropriation, grants & contributions)

Purchases: Contemporary & historical paintings, sculpture, prints, drawings & photographs
Library Holdings: Book Volumes; Clipping Files; Exhibition Catalogs; Lantern Slides; Manuscripts; Maps; Memorabilia; Original Art Works; Original Documents; Other Holdings; Pamphlets; Photographs; Slides
Special Subjects: Painting-American, Prints, Woodcuts, Portraits, Oriental Art, Miniatures
Collections: American Colonial, Federal & Contemporary Paintings & Prints; Miniature Portraits; American art related to Charleston; Japanese Woodblock prints
Exhibitions: Approx 14 per yr
Publications: Bulletins, quarterly; books; exhibit catalogs & brochures
Activities: Docent training; lect open to pub, 2 vis lectrs per yr; gallery talks; tours; exten dept serves tri-county area; individual paintings & original objects of art lent to museums; 8 per yr; originate traveling exhibs, regional & national venues to mus; mus store sells books, magazines, original art, reproductions, prints, original crafts, jewelry & various museum related products
L **Library,** 135 Meeting, Charleston, SC 29401. Tel 843-722-2706; *Dir* Paul C Figueroa
Open to scholars for reference only, by appointment
Income: Financed by pub & pvt support
Library Holdings: Book Volumes 3709; Clipping Files; Exhibition Catalogs; Kodachrome Transparencies; Manuscripts; Original Art Works; Pamphlets; Periodical Subscriptions 26; Photographs; Records; Sculpture; Video Tapes

M **CHARLESTON MUSEUM,** 360 Meeting St, Charleston, SC 29403. Tel 843-722-2996; Fax 843-722-1784; Internet Home Page Address: www.charlestonmuseum.com; *Pres* Hugh C Lane Jr; *Cur Historic Archaeology* Martha Zierden; *Cur History* Christopher Loeblein; *Cur Historic Houses* Karen King; *Cur Natural History* Albert E Sanders; *Registrar* Jan Hiester; *Cur Ornithology* Dr William Post; *Archivist* K Sharon Bennett; *Dir* Dr John R Brumgardt; *Asst Archivist* Julia Logan
Open daily Mon - Sat 9 AM - 5 PM, Sun 1 - 5 PM; Admis adults $5, children $2; Estab 1773 as a mus & library to diffuse knowledge of history, decorative arts, art, natural history, anthropology & technology; also to preserve houses & monuments; It is the oldest mus in the United States; Average Annual Attendance: 22,000; Mem: 550; dues $15 & up; annual meeting in Feb
Income: Financed by mem, city & county appropriations, admis & sales
Special Subjects: Textiles, Ceramics, Decorative Arts, Furniture, Glass
Collections: Ceramics, decorative arts, furniture, glass, maps, photos, prints & textiles, art of northern BC
Publications: Bimonthly newsletter
Activities: Tours for adults & children; docent training; 8 lects per yr; concerts; sales shop sells books, magazines & prints related to collections
L **Library,** 360 Meeting St, Charleston, SC 29403. Tel 843-722-2996; Fax 843-722-1784; Internet Home Page Address: www.CharlestonMuseum.com; *Librn* K Sharon Bennett; *Asst Archivist* Julia Logan
Estab 1773 as an educational institution, collects, preserves & uses artifacts of natural history, history, anthropology & decorative arts for staff & scholary research
Income: Financed by city & county appropriations & mem
Library Holdings: Book Volumes 5000; Clipping Files; Exhibition Catalogs; Manuscripts; Memorabilia; Other Holdings Maps; Pamphlets; Periodical Subscriptions 120; Photographs; Prints; Records
M **Heyward-Washington House,** 87 Church St, Charleston, SC 29401. Tel 843-722-0354; Fax 843-722-1784; Internet Home Page Address: www.charlestonmuseum.com; *House Adminr* Morris Loflin
Open daily 10 AM - 5 PM; Sun 1 - 5 PM; Admis adults $8, children $4.50; Built 1772; home of Thomas Heyward, Jr; purchased by the Mus in 1929; Mus is furnished with Charleston-made furniture of the period; a National Historic Landmark
Collections: House furnishings; 18th century Chippendale furniture
Activities: Daily tours
M **Joseph Manigault House,** 350 Meeting St, Charleston, SC 29403. Tel 843-723-2926; Fax 843-722-1784; Internet Home Page Address: www.CharlestonMuseum.com; *House Adminr* Anne Fox
Open Mon - Sat 10 AM - 5 PM, Sun 1 - 5 PM; Admis adults $8, children 3-12 $4; Estab 1773 to preserve & interpret Charleston natural & social history; Early history, revolutionary war, civil war natural history, children's educational room; Average Annual Attendance: 50,000; Mem: 2200; dues varies
Special Subjects: Architecture, Archaeology, Afro-American Art, Decorative Arts, Dolls, Furniture, Glass
Collections: Charleston silver; furniture & textiles; paleontological fossils; late 18th & 19th century furniture; Chinese & American porcelain
Activities: Tours

M **CITY OF CHARLESTON,** City Hall Council Chamber Gallery, 80 Broad St, Charleston, SC 29401. Tel 843-724-3799; Fax 843-720-3827; *Cur* Carol Ezell-Gilson
Open Mon - Fri 9 AM - 5 PM; No admis fee; Estab 1818 to preserve for the citizens of Charleston a portrait coll of the city's history; A unique collection of American portraits housed in the 2nd oldest city council chamber in continuous use in the US; Average Annual Attendance: 20,000
Income: Financed by city
Collections: Washington Trumbull, 1791; J Monroe Samuel Morse, 1819; A Jackson John Vanderlyn, 1824; Zachary Taylor James Beard, 1848; Marquis de Lafayette Charles Fraser, 1825; Pierre Beauregard George Healy, 1861; C Gaddsen-R Peale; portraits by Jarvis, Savage, John Blake White, James Earle, G Whiting Flagg
Publications: Catalog of paintings & sculpture
Activities: Lect open to pub; tours

M **COLLEGE OF CHARLESTON,** Halsey Institute of Contemporary Art, School of the Arts, 66 George St Charleston, SC 29424-0001. Tel 843-953-5680; Fax 843-953-7890; Elec Mail sloanm@cofc.edu; Internet Home Page Address: www.cofc.edu/halseygallery; *Gallery Dir* Mark Sloan; *Asst Dir* Katie Lee
Open Mon - Sat 11 AM - 4 PM; No admis fee; Estab 1978 as a college gallery with focus on contemporary art; Two floors in modern building located in School

of the Arts building, includes director's office & storage space; Average Annual Attendance: 5,000
Income: $175,000 (financed by state appropriation, earned income, grants & contributions
Publications: Periodic catalogs & gallery guides; Evon Streetman in Restrospect; Hung Liu: Washington Blues; The Right to Assemble; With Beauty Before Us: The Navajo of Chil Chin Beto; Appropriate to the Moment: Michael Tyzack; Cheryl Goldsleger: Improvisations
Activities: Lect open to pub, 8 - 10 vis lectrs per yr; juried student competitions; originate traveling exhibs

M **TRADD STREET PRESS,** Elizabeth O'Neill Verner Studio Museum, 38 Tradd St, Charleston, SC 29401. Tel 843-722-4246; Fax 843-722-1763; Elec Mail info@vernergallery.com; Internet Home Page Address: www.vernergallery.com; *Pres* David Verner Hamilton; *Dir* Lese Corrigan; *Secy* Daphne Vom Baur
Open 10 AM - 5 PM; No admis fee; Estab 1970 to exhibit works of Elizabeth O'Neill Verner; Average Annual Attendance: 31,200
Income: Financed by endowment
Collections: Works of Elizabeth O'Neill Verner
Exhibitions: Collected works of Elizabeth O'Neill Verner
Activities: Educ dept provides cultural presence, historic perspective programs; lectures open to public; sales store sells books, prints, original art, reproductions

CLEMSON

CLEMSON UNIVERSITY
M **Rudolph E Lee Gallery,** Tel 843-656-3883; Fax 843-656-0204; Elec Mail gallery@clemson.edu; *Dir* Denise Woodward-Detrich
Open Mon - Fri 9 AM - 4:30 PM, Sun 2 - 5 PM, cl Sat; No admis fee; Estab 1956 to provide cultural & educational resources; to collect, preserve, interpret & display items of historical, educational & cultural significance; Average Annual Attendance: 20,000
Income: Financed by state appropriation
Special Subjects: Architecture, Graphics, Painting-American
Collections: Clemson Architectural Foundation Collection; Contemporary American Paintings & Graphics
Publications: Exhibition Bulletin, annually; Posters on Exhibits, monthly
Activities: Lect open to pub, 3-5 vis lectrs per yr; gallery talks; tours; exten dept servs Southeast United States; individual paintings & original objects of art lent to museums, universities; lending collection contains original prints, paintings, sculpture; originate traveling exhibs
L **Emery A Gunnin Architectural Library,** Tel 864-656-3932; Fax 864-656-3932; Internet Home Page Address: www.lib.clemson.edu/gunnin/; *Media Resources Cur* Phyllis Pivorun; *Branch Head* Sarah McCleskey
Open during school yr Sun 2 PM - Fri 5 PM 24 hours a day, Sat Noon - 4 PM; For reference only for univ & pub use; Average Annual Attendance: 74,000
Library Holdings: Audio Tapes; Book Volumes 25,899; CD-ROMs; Cassettes; Exhibition Catalogs; Motion Pictures; Pamphlets; Periodical Subscriptions 218; Slides 84,000; Video Tapes
Special Subjects: Art History, Constructions, Decorative Arts, Drawings, Ceramics, Conceptual Art, Crafts, Archaeology, Drafting, Aesthetics
Collections: Rare Book Collection; South Carolina City & Regional Planning Documents
M **Fort Hill Plantation,** Tel 864-656-3311, 656-4789; Fax 864-656-1026; *Dir Historic Houses & Cur* Will Hiott; *Dir Visitor Services* Helen Adams
Open Mon - Fri 10 AM - 5 PM, Sat 10 AM - 5 PM, Sun 2 - 5 PM, cl holidays & Christmas week; Donations; A historic house mus located in the home of John C Calhoun. Restoration of the house & furnishings are an on-going project of the John C Calhoun Chapter of the United Daughters of the Confederacy & Clemson University
Income: Financed by Clemson University
Special Subjects: Painting-Flemish, Period Rooms
Collections: Flemish paintings; family portraits; period rooms & furnishings of original family heirlooms & memorabilia
Publications: Fort Hill, brochure
Activities: Lect; guided tours

COLUMBIA

M **COLUMBIA MUSEUM OF ART,** Main & Hampton Sts, PO Box 2068 Columbia, SC 29201; PO Box 2068 Columbia, SC 29202. Tel 803-799-2810; Fax 803-343-2150; Elec Mail margaret@colmusart.org; Internet Home Page Address: www.columbiamuseum.org; *VPres* Stephen Morrison; *Registrar* Cynthia Connor; *Human Resources Mgr* Ruth Hisaw; *Interim Chief Cur* Kevin W Tucker; *Deputy Dir & Chief Cur* William Bodine; *Dir Develop & Mem* Bonnie Adams; *Dir Educ* Christine Minkler; *Dir Mktg & Communications* Ellen Woodoff; *Dir Facility Operations* Michael Roh; *Dir Special Events* Chris Carson; *Dir Educ* Joelle Ryan-Cook; *Mus Shop Mgr* Mary Ellen Carruth
Open Tues - Sat 10 AM - 5 PM, Sun 1 - 5 PM, cl Mon; Admis adults & seniors $5, students $2, ages 5 & under & 1st Sat of every month free; Estab 1950 to extend & increase art understanding, to assist in the conservation of a valuable cultural heritage & to recognize & assist contemporary art expression; Library for reference only; Average Annual Attendance: 100,000; Mem: 4000; dues Taylor Society $500, Columbia Design League $45, family $45 & up, single $30; annual meeting in Jan
Income: $2,572,500 supported by citizens and corporations of the Midlands, City of Columbia, Richland County, SC Arts Commission, Cultural Council of Richland & Lexington Counties
Purchases: Works of art on paper, Southeastern artists & textiles
Special Subjects: Graphics, Painting-American, Textiles, Decorative Arts, Painting-European, Furniture, Renaissance Art, Painting-Italian
Collections: Kress Collection of Renaissance Paintings; International collection of fine & decorative arts from Medieval to present included Renaissance & Baroque Old Masters
Publications: Annual report; Collections Magazine, bimonthly; exhibition brochures

Activities: Educ programs for adults & children; docent training; lect open to pub, several vis lectrs; concerts; gallery talks; tours; mus shop sells books, reproductions, prints, ceramics, glass, jewelry

L **Lee Alexander Lorick Library,** PO Box 2068, Columbia, SC 29202. Tel 803-799-2810, 343-2155; Fax 803-343-2219; Elec Mail libby@colmusart.org; Internet Home Page Address: www.colmusart.org; *Library Asst* Laurie Graff; *Librn* Elizabeth Fleming
Open Tues - Sat Noon - 5 PM; Estab 1950; Open to mems & pub for reference only
Income: $10,000 (financed by mus)
Library Holdings: Audio Tapes; Book Volumes 13,000; Cassettes; Clipping Files; Exhibition Catalogs; Memorabilia; Other Holdings Vertical files; Pamphlets; Periodical Subscriptions 50; Video Tapes
Special Subjects: Art History, Decorative Arts, Art Education

A **SOUTH CAROLINA ARTS COMMISSION,** 1800 Gervais St, Columbia, SC 29201. Tel 803-734-8696; Fax 803-734-8526; Elec Mail sleonard@arts.state.sc.us; Internet Home Page Address: www.state.sc.us/arts; *Head Media* Susan Leonard; *Dir Visual Arts* Harriett Green; *Exec Dir* Suzette Surkmer
Open Mon - Fri 8:30 AM - 5 PM; No admis fee; Estab 1967 to promote & develop the arts in Southeast
Income: $225,000 (financed by state & federal income)
Purchases: Films, videotapes, video & film equipment
Collections: State Art Collection
Exhibitions: Film/Video artists exhibitions; rotating exhibits
Publications: Independent Spirit, media arts newsletter, 3 times per yr
Activities: Educ programming; lect open to pub, 4 vis lectrs per yr; concerts; gallery talks; competitions with awards; artists' workshops; grants-in-aid & fels offered; exten dept serves state; art mobile; individual paintings & original objects of art lent to other galleries & museums; lending coll contains lantern slides, 235 original art works, paintings, photographs, sculpture, slides, 100 books & 125 motion pictures; book traveling exhibs; originate traveling exhibs, circulates to 6 sites in the Southeast

L **Media Center,** 1800 Gervais St, Columbia, SC 29201. Tel 803-734-8696; Fax 803-734-8526; Elec Mail sleonard@arts.state.sc.us; *Dir* Susan Leonard
Open Mon - Fri 8:30 AM - 5 PM
Income: Financed by state & federal income
Library Holdings: Audio Tapes; Cassettes; Motion Pictures; Slides; Video Tapes
Special Subjects: Film

M **SOUTH CAROLINA STATE MUSEUM,** 301 Gervais St, PO Box 100107 Columbia, SC 29202-3107. Tel 803-898-4921; Fax 803-898-4969; Internet Home Page Address: www.museum.state.sc.us; *Deputy Dir Prog* Shelia Reily; *Dir Exhibits* A Michael Fey; *Dir Public Information & Marketing* Tut Underwood; *Exec VPres* Sue McLeese; *Chief Cur Art* Polly Laffitte; *Exec Dir* Overton G Ganong; *Dir* William Calloway; *Deputy Dir Admin* Tony Shealy; *Store Mgr* Scottie Ash; *Cur Natural History* James Knight; *Registrar* Michelle Baker; *Cur Art* Paul Matheny; *Asst Dir Exhibits* James M Brown; *VChmn* Gary Culbreath; *Cur History* Fritz Hamer; *Cur Educ* Linda McWhorter
Open Mon - Sat 10 AM - 5 PM, Sun 1 - 5 PM; Estab 1973; Four large floors in a renovated textile mill with exhibits in art, history, natural history & science & technology; Average Annual Attendance: 250,000; Mem: 6500; ann meeting in June
Income: Financed by admis, state appropriations, store revenue & supplement state money
Special Subjects: Hispanic Art, Painting-American, Photography, Sculpture, Textiles, Crafts, Folk Art, Afro-American Art, Decorative Arts, Juvenile Art, Miniatures
Collections: Art - all media; Cultural History; Natural History; Science & Technology
Exhibitions: Art - South Carolina/Kentucky Exchange; History - The Palmetto State Goes Tower: WW II & South Carolina; Natural History - Fossil Collectors & Collections; 100 Years/100 Artists: A View of 20th Century South Carolina Art
Publications: Annual report; Images, quarterly
Activities: Docent progs; lect open to pub; lending coll contains 500 paintings; book traveling exhibs 10 per yr; originate traveling exhibs 4 per yr; retail store sells books & slides

M **UNIVERSITY OF SOUTH CAROLINA,** McKissick Museum, Bull & Pendleton Sts, Columbia, SC 29208. Tel 803-777-7251; Fax 803-777-2829; Elec Mail lynn.robertson@sc.edu; Internet Home Page Address: www.cla.sc.edu/mcks; *Chief Cur* Jay Williams; *Business Mgr* Barbara Griggs; *Cur Educational Servs* Alice Bouknight; *Cur Folk Art & Research* Saddler Taylor; *Dir* Lynn Robertson; *Coll Mgr* Karen Swager; *Asst Cur* Noelle Rice
Open Mon - Fri 9 AM - 4 PM, Sat 10 AM - 5 PM, Sun 1 - 5 PM, cl July 4th, Labor Day, Thanksgiving & day after, Dec 25, Jan 1; No admis fee; Estab 1976 to centralize the university's mus colls; Contains 4 major gallery areas for temporary & changing exhibs in art, science & history; Average Annual Attendance: 70,000
Income: Financed by state appropriation & donations
Purchases: Southern Folk Art
Special Subjects: Silver
Collections: Bernard Baruch Collection of 18th Century Silver; Movietonews News Reels; James F Byrnes Collection; Howard Gemstone Collection; Richard Mandell: Art Nouveau Collection; Colburn Gemstone Collection; university memorabilia; southeastern folk art; minerals, fossils, rocks & meteorites; contemporary art works
Exhibitions: A Portion of the People: Three Hundred Years of Jewish Life in South Carolina; student & faculty art
Publications: Exhibition catalogs; Calendar of events (quarterly)
Activities: Docent training; lect open to pub, 4-5 vis lectrs per yr; concerts; gallery talks; tours; competitions; slide-tape progs & classes for students & senior citizens; community outreach to senior citizen groups & children's hospital wards; originate traveling exhibs

L **Slide Library,** McMaster College, Rm 111 Columbia, SC 29208. Tel 803-777-4236; Fax 803-777-0535; *Librn* Linda D Morgan
Open Mon - Fri 8 AM - 4 PM; No admis fee; Estab as a major teaching resource for the Art Department; Circ 200,000 holdings, 50,000 circulation

Library Holdings: Book Volumes 3000; Cassettes; Clipping Files; Exhibition Catalogs; Manuscripts; Motion Pictures; Other Holdings Slide-tape Programs & Digital Collection 21,000; Pamphlets; Periodical Subscriptions 17; Photographs; Slides 125,000; Video Tapes
Special Subjects: Art History, Folk Art, Drawings, Etchings & Engravings, Crafts, American Western Art, Bronzes, Advertising Design, Art Education, American Indian Art, Furniture, Afro-American Art, Carpets & Rugs, Antiquities-Assyrian, Architecture

FLORENCE

M **FLORENCE MUSEUM OF ART, SCIENCE & HISTORY,** 558 Spruce St, Florence, SC 29501. Tel 843-662-3351; Elec Mail flomuseum@bellsouth.net; Internet Home Page Address: www.florenceweb.com/museum.htm; *VChmn* Townsend Holt; *VPres* Vicki Stokes; *Dir* Betsy Olsen
Open Tues - Sat 10 AM - 5 PM, Sun 2 - 5 PM, cl Mon & major holidays; No admis fee; Estab 1924 (incorporated in 1936) as a general mus of art, natural science & history of South Carolina, with emphasis on the region known as the Pee Dee to acquaint the pub with fine art; Changing art exhibs, main galleries; Average Annual Attendance: 19,000; Mem: 450; dues benefactor $1000, patron $500, donor $250, sustaining $100, sponsor $50, family $30, individual $15
Income: $99,000 (financed by mem, county & city appropriation & donations)
Special Subjects: Drawings, Graphics, Painting-American, American Indian Art, African Art, Ceramics, Etchings & Engravings, Landscapes, Afro-American Art, Decorative Arts, Collages, Furniture, Glass, Oriental Art, Antiquities-Byzantine, Historical Material, Antiquities-Egyptian, Antiquities-Etruscan
Collections: Permanent Collection includes: African, Asian, Southwestern American Indians, Catawba Indian Collections; Greek & Roman Archaeological material; historical artifacts; works of local Black artist William H Johnson; works of local & regional artists; Museum Permanent Collection, Regional Artists
Exhibitions: PeeDee Regional Art Competition
Publications: Florence Museum newsletter, quarterly
Activities: Classes for adults & children; docent training; gallery talks; self-guided tours; art competitions with prizes; book traveling exhibs; original art

GREENVILLE

M **BJU MUSEUM & GALLERY,** Bob Jones University Museum & Gallery Inc, 1700 Wade Hampton Blvd, Greenville, SC 29614. Tel 864-770-1331; Fax 864-770-1306; Elec Mail contact@bjumg.org; Internet Home Page Address: www.bjumg.org; *Chmn Bd* Bob Jones III; *Dir* Erin Jones; *Cur* John Nolan; *Dir Educ* Donnalynn Hess; *Registrar* Barbara Sicko; *Dir Security & Plant Operations* James Jackson; *Events Coordr* Amy Branigan; *Tours Coordr* Rebekah Cobb; *Dir Marketing & Bus Operations* Sarah Merkle
Open Tues - Sun 2 - 5 PM, cl Mon, Dec 20 - 25, New Year's Day, July 4, Thanksgiving Day & Commencement Day in May; Admis Adults $5; Seniors (60+) $4; Students $3; Children 6-12 & members free; Estab 1951 to show the development of 14th - 19th century Old Masters paintings; 30 elegant galleries filled with art; tapestries, furniture, sculpture, & architectural motifs from the 13th through 19th centuries; Average Annual Attendance: 20,000; Mem: Dues; mem levels - $25 individual, $100 patron, $500 benefactor, $250 sustainer, $60 family
Income: Gifts from mems & donations
Library Holdings: Auction Catalogs; Book Volumes
Special Subjects: Antiquities-Assyrian, Painting-American, Sculpture, Bronzes, Archaeology, Textiles, Religious Art, Ceramics, Woodcarvings, Etchings & Engravings, Decorative Arts, Painting-European, Portraits, Furniture, Porcelain, Oriental Art, Silver, Painting-British, Painting-Dutch, Painting-French, Ivory, Coins & Medals, Tapestries, Baroque Art, Painting-Flemish, Renaissance Art, Period Rooms, Embroidery, Medieval Art, Painting-Italian, Antiquities-Persian, Antiquities-Egyptian, Antiquities-Greek, Antiquities-Roman, Mosaics, Stained Glass, Painting-German, Painting-Russian, Enamels
Collections: Bowen Collection of Biblical antiquities & illustrative material from the Holy Land; Religious art by the Old Masters from the 14th-19th centuries including Botticelli, Cranach the Elder, G David, Murillo, Ribera, Rubens, Tintoretto, Veronese, Zurbaran; Revealed Religion by Benjamin West, 7 paintings; furniture; sculpture
Publications: Catalogs; illustrated booklets; gallery newsletter, calendar of events
Activities: Educator seminars; dramatic programs; docent training; concerts; gallery talks; tours for school & adult groups by appointment; individual paintings lent to other galleries in the US & abroad; gift shop sells books, reproductions, prints, postcards, gift items & educational products (DVDs, VHS, CD-ROM)

M **GREENVILLE COUNTY MUSEUM OF ART,** 420 College St, Greenville, SC 29601. Tel 864-271-7570; Fax 864-271-7579; Elec Mail info@greenvillemuseum.org; Internet Home Page Address: www.greenvillemuseum.org; *Head Colls Management & Security* Claudia Beckwith; *Dir* Thomas W Styron; *Cur* Martha Severns; *Develop Officer* Mary Lawson; *Pub Rels* Mary McCarthy; *Comptroller* Jeanne Marsh
Open Tues - Sat 10 AM - 5 PM, Sun 1 - 5 PM, cl Mon; No admis fee; Estab 1958 for the coll & preservation of American Art; Four major galleries devoted to permanent collections of American art from the colonial to the contemporary, changing & traveling exhibitions; Average Annual Attendance: 120,000; Mem: 1422; dues $30 - $1000; ann meeting in May
Income: Financed by mem, donations & county appropriation
Special Subjects: Painting-American, Afro-American Art, Portraits
Collections: Pre World War II Southern Art; Andrew Wyeth, Watercolors; contemporary art
Exhibitions: Andrew Wyeth: Friends & Family; Southern Scenes; local artists
Publications: Exhibit catalogs
Activities: Classes for adults & children; docent training; Museum School of Art; lect open to pub, 6-10 vis lectrs per yr; gallery talks; tours; exten dept serves Greenville County schools; lending coll contains slides; mus shop sells books, original art, slides, prints, children's educ toys, regional crafts & cards

C **LIBERTY LIFE INSURANCE COMPANY,** 2000 Wade Hampton Blvd, PO Box 789 Greenville, SC 29602-0789. Tel 864-609-8111; *Pres* Francis M Hipp
Open during normal business hrs by appointment; Estab 1978 to collect textile art selections from various cultures & historical periods; Collection displayed throughout corporate headquarters

Collections: Limited edition prints, graphics & silkscreens; textile art works from around the world
Publications: The Liberty Textile Collection
Activities: Individual paintings & original objects of art lent to regional & national museums & galleries

GREENWOOD

M THE MUSEUM, (Greenwood Museum) 106 Main St, PO Box 3131 Greenwood, SC 29648. Tel 864-229-7093; Fax 864-229-9317; Elec Mail themuseum@greenwood.net; Internet Home Page Address: themuseum-greenwood.org; *Exec Dir* Matthew J Edwards; *Mus Shop Mgr* April Miller; *Pres (V)* Charles Hershey; *Coll Tech* Clay Barton
Open Wed - Fri 10 AM - 5 PM, Sat 10 AM - 4 PM, cl Mon & Tues; Admis adults $5, seniors & students $2, mem free; Estab 1967 for educ purposes; Average Annual Attendance: 5,000; Mem: 500; dues $15 & up
Income: Financed by mem, contributions & grants
Special Subjects: Drawings, Historical Material, Furniture, Mexican Art, Painting-American, Photography, Sculpture, African Art, Anthropology, Archaeology, Ethnology, Textiles, Costumes, Ceramics, Crafts, Folk Art, Pottery, Primitive art, Woodcarvings, Dolls, Furniture, Glass, Porcelain, Asian Art, Carpets & Rugs, Historical Material, Ivory, Scrimshaw, Coins & Medals, Dioramas, Period Rooms, Embroidery, Laces, Antiquities-Oriental, Antiquities-Egyptian, Antiquities-Greek, Antiquities-Roman, Pewter
Collections: Main Street Timeline 1800s-1950; Arrowheads, Thomas Edison, Carriages and Coaches; Railroad memorobelia & 7 vintage train cars
Exhibitions: Traveling exhibs, regional & international; (7/2007-8/2007) Untitled Frank Lloyd Wright show
Publications: Newsletter, quarterly
Activities: Classes for adults & children; lect open to pub, gallery talks, tours; book traveling exhibs 1 major show per yr; sales shop sells book, original art, reproductions & prints

HARTSVILLE

M COKER COLLEGE, Cecelia Coker Bell Gallery, Coker College, Gladys C Fort Art Bldg Hartsville, SC 29550; 300 E College Ave, Hartsville, SC 29550. Tel 843-383-8152; Elec Mail lmerriman@pascal.coker.edu; Internet Home Page Address: www.coker.edu/art/gallery.html; *Dir* Larry Merriman
Open Mon - Fri 10 AM - 4 PM; No admis fee; Estab 1983 to serve campus & community; 30 ft x 40 ft self-contained, movable partitions, track light, security system; Average Annual Attendance: 5,000
Income: $4,200
Exhibitions: Area artists; annual student juried show; senior students show; vis artists; 5 solo national & international exhibitions
Publications: Collection catalog
Activities: Lect open to public, 3 - 4 vis lectrs per year; gallery talks; student juried competitions with awards

MURRELLS INLET

M BROOKGREEN GARDENS, 1931 Brookgreen Gardens Dr, Murrells Inlet, SC 29576; P. O. Box 3368, Pawleys Island, SC 29585-3368. Tel 843-237-4218; Fax 843-237-1014; Internet Home Page Address: www.brookgreen.org; *CEO & Pres* Lawrence Henry; *Exec VPres* John Sands; *Asst VPres* Kira Roff; *CFO & VPres* Alexandra Kempe; *VPres & Cur* Robin R Salmon; *Asst VPres* Robert E Mottern III; *VPres Corporate* Mona Prufer; *VPres Low County* M Katherine Kellam; *Asst VPres Develop* Elizabeth Butler; *VPres Mktg* Helen Benso; *VPres Merchandise* Annette Medlin
Open 9:30 AM - 5 PM, cl Christmas, summer hrs vary; Admis adults $8.50, 6-12 years $4, under 6 free; Estab 1931 to exhibit the flora & fauna of South Carolina & to exhibit objects of art; The outdoor mus exhibits American sculpture & has changing sculpture exhibitions in indoor galleries; Average Annual Attendance: 200,000; Mem: 3000; dues $35-$5000
Income: Financed by endowment, mem, gifts, grants & admis
Special Subjects: Sculpture, American Western Art, Bronzes, Historical Material, Coins & Medals
Collections: Collection of American figurative, sculpture, pieces by sculptors; Exploring American Sculpture
Publications: Brookgreen Journal, biannual; The Garden Path, biannual; exhibition catalogues
Activities: Classes for adults & children; docent training; workshops; gallery talks; tours; awards; originate traveling exhibitions; museum shop sells books, magazines, original art, reproductions, prints, postcards, pamphlets, sculpture, jewelry & gifts
L Library, 1931 Brookgreen Garden Dr, Murrells Inlet, SC 29576. Tel 843-237-4218; Fax 843-237-1014; Elec Mail rsalmon@brookgreen.org; Internet Home Page Address: www.Brookgreen.org;
For reference only to staff
Library Holdings: Audio Tapes; Book Volumes 2200; Cassettes; Clipping Files; Exhibition Catalogs; Filmstrips; Framed Reproductions; Kodachrome Transparencies; Manuscripts; Memorabilia; Motion Pictures; Other Holdings Architectural & engineering drawings & prints; Maps; Pamphlets; Periodical Subscriptions 50; Photographs; Prints; Reels; Slides; Video Tapes

ROCK HILL

M MUSEUM OF YORK COUNTY, 4621 Mount Gallant Rd, Rock Hill, SC 29732-9905. Tel 803-329-2121; Fax 803-329-5249; Elec Mail myco@infoave.net; *Exec Dir* Van W Shields
Open Mon - Sat 9 AM - 5 PM, Sun 1 - 5 PM; Admis $5, seniors $4, children under 5 free; Estab 1948; Spring, Alternative & Lobby galleries (changing art exhibits); Average Annual Attendance: 50,000; Mem: 1248; dues vary
Income: $1,383,225 (financed by mem, admis & county appropriation)

Special Subjects: Painting-American, Sculpture, African Art, Anthropology, Archaeology, Ethnology, Textiles, Costumes, Ceramics, Woodcarvings, Decorative Arts, Posters, Historical Material, Dioramas
Collections: African animals - mounted specimens; African art & ethnography; local art; local history & archaeology; local natural history specimens
Publications: Quarterly, bi-monthly; Teacher's Guide, annual
Activities: Classes for adults & children; docent progs; lect open to pub, 10 vis lectrs per yr; competitions with purchase awards; exten dept servs county; book traveling exhibs 5 per yr; retail store sells books & prints
L Staff Research Library, 4621 Mount Gallant Rd, Rock Hill, SC 29732-9905. Tel 803-329-2121; Fax 803-329-5249; *Cur Coll* Anne Lane
For research
Income: Financed by departmental budgets
Library Holdings: Audio Tapes; Cassettes; Exhibition Catalogs; Pamphlets; Video Tapes
Special Subjects: Photography, Crafts, Archaeology, Ethnology, Art Education, American Indian Art, Primitive art, Anthropology, Restoration & Conservation

M WINTHROP UNIVERSITY GALLERIES, Rock Hill, SC 29733. Tel 803-323-2493; Fax 803-323-2333; Elec Mail stanleyt@winthrop.edu; Internet Home Page Address: www.winthrop.edu/vpa/; *Dir* Tom Stanley
Open Mon - Fri 9 AM - 5 PM, Sun 1 - 4:30 PM; No admis fee; Housed within Rutledge Building, Department of Art & Design of the School of Visual & Performing Arts at Winthrop College. Presents temporary visual art & design exhibs for the enhancement of academic achievement & understanding within the college community; Gallery is 3500 sq ft; Average Annual Attendance: 15,000
Income: Financed by state appropriation
Exhibitions: Student Exhibs; South Carolina State Art Collection; one-person shows; invitational exhibs in photo, drawing, painting, printmaking, textiles, design, ceramics & glass; Portraits et Personages: Selected Works from the Collection de l'Art Brut
Activities: Classes for adults; lect open to pub; concerts; gallery talks; schols & fels offered; originate traveling exhibs

SPARTANBURG

A ARTS PARTNERSHIP OF GREATER SPARTANBURG, INC, The Arts Partnership of Greater Spartanburg, Inc, 385 S Spring St, Spartanburg, SC 29306. Tel 864-542-2787; Fax 864-948-5353; *Pres & COO* Everett G Powers; *Dir Arts Educ* Ava Hughes; *Dir Develop* Mimi Killoren; *Dir Organization Svcs & Outreach* George Loudon
Open Mon - Fri 9 AM - 5:30 PM; No admis fee; Estab 1993 to coordinate & develop all cultural activities in the area; Mem: Ann meetings in May
Income: $1,500,000 (financed by pub, pvt & corporate donations & project grants)
Exhibitions: Changing exhibits
Publications: Membership Brochure, ann; Spartanburg Arts Calendar, monthly
Activities: Artist residences in schools; performances in school; David W Reid Award for Achievement in Excellence in the Arts in Spartanburg County; schols offered

M CONVERSE COLLEGE, Milliken Art Gallery, 580 E Main, Spartanburg, SC 29302. Tel 864-596-9177; Fax 864-596-9606; Elec Mail artdesign@converse.edu; Internet Home Page Address: www.converse.edu; *Dir* Kipp McIntyre
Open Mon - Fri 9 AM - 5 PM, cl holidays; No admis fee; Estab 1971 for educational purposes; A brick & glass structure of 40 x 60 ft; movable panels 4 x 6 ft for exhibition of work, 16 panels, 12 sculpture stands; Average Annual Attendance: 2,400
Income: Financed by endowment
Exhibitions: Invitational exhibits of regional artists; annual juried student show; senior exhibit
Activities: Educ dept; lect open to public, 5-6 vis lectrs per year; gallery talks; tours

M SPARTANBURG COUNTY MUSEUM OF ART, 385 S Spring St, Spartanburg, SC 29306. Tel 864-582-7616; Fax 864-948-5353; Internet Home Page Address: www.spartanburgartmuseum.org; *Asst Dir* Scott Cunningham; *Dir Art School* Bob LoGrippo; *Exec Dir* Theresa H Mann
Open Mon - Fri 10 AM - 5 PM, Sat 10 AM - 2 PM Sun 2 - 4 PM, (or by appointment); No admis fee; Estab 1969 to promote the works of contemporary artists in the southeastern United States; Gallery is located in the Arts Center & contains both a permanent sales section & a changing exhibit area; Average Annual Attendance: 7,000; Mem: 330; dues $25 - $1,000
Income: Financed by endowment & mem
Library Holdings: Clipping Files; Exhibition Catalogs; Memorabilia
Special Subjects: Painting-American, Photography, Prints, Sculpture, Watercolors, Textiles, Ceramics, Folk Art, Pottery, Woodcarvings, Landscapes, Portraits, Juvenile Art
Collections: Contemporary Southeastern Artists
Exhibitions: Annual Juried Exhibit; Sidewalk Art Show - Sept
Publications: Quarterly newsletter
Activities: Classes for adults & children; docent training; lect open to pub, 5 vis lectrs per yr; gallery talks; tours; competitions with awards; mus shop sells original art, books, pottery & jewelry

M UNIVERSITY OF SOUTH CAROLINA AT SPARTANBURG, Art Gallery, Division of Fine Arts, Languages & Literature, 800 University Way Spartanburg, SC 29303. Tel 864-503-5838; *Dir Gallery* Jane Nodine
Open daily 10 AM - 4 PM; No admis fee; Estab 1982, primarily as a teaching gallery. Contemporary art displayed; 800 sq ft of carpeted wall space with windows along one wall, located across from Performing Art Center
Income: $1200 (financed by Student Affairs Office of University)
Exhibitions: Annual Student Art Exhib; Exhibs of Regional Artists
Publications: Exhibition announcements
Activities: Lect open to pub, 4-6 vis lectrs per yr; competitions; book traveling exhibs 5 per yr; originate traveling exhibs 1 per yr

M WOFFORD COLLEGE, Sandor Teszler Library Gallery, 429 N Church St, Spartanburg, SC 29303-3663. Tel 864-597-4300; Fax 864-597-4329; Internet Home Page Address: www.wofford.edu; *Dir* Oakley H Coburn
Open during school yr Mon-Thurs 8 AM - 12 AM, Fri 8 AM - 7 PM, Sat 10 AM - 5 PM, Sun 1 PM - 12 AM; Estab 1969 to support educ & cultural activities of the col; Gallery located within col library; Average Annual Attendance: 100,000
Collections: Hungarian Impressionist
Exhibitions: Various exhib
Activities: Book traveling exhibs, 1 - 2 per yr

SUMTER

M SUMTER GALLERY OF ART, 200 Hasel St., PO Box 1316 Sumter, SC 29151. Tel 803-775-0543; Fax 803-778-2787; *Exec Dir* Janice Williams; *Asst Dir & Educ Coordr* Audrey Jones
Open Tues - Fri 11 AM - 5 PM, Sat 2 - 5 PM, cl Easter, Thanksgiving, Christmas & month of July; No admis fee; Estab 1970 to bring to area exhibits of works of recognized artists, to provide an outlet for local artists for showing & sale of their work & to serve as a facility where visual art may become a part of life & educ of the people, particularly children of this community; The Gallery is the 1850 home of the late Miss Elizabeth White, well-known artist of Sumter, which was deeded to the gallery in 1977 under the terms of her will. Presently using hall, four downstairs rooms, back studio & rooms upstairs; Average Annual Attendance: 8,500; Mem: 460; dues commercial patron & patron $100, family $40, individual $25; annual meeting in May
Income: $100,000 (financed by mem, earned income, exhibit sponsors, donations, County Council)
Collections: 62 paintings, etchings & drawings of Elizabeth White given to the gallery by trustees of her estate
Exhibitions: Annual Young People's Exhibit; Individual & group exhibits of paintings, sculpture, collages, photography & crafts by recognized artists primarily from Southeast; Touchable exhibit for the blind & visually impaired; Sumter Artist Guild Exhibit; Annual Sumter Teacher Exhibit
Publications: Newsletter, 2 times per year
Activities: Classes & workshops for adults & children; docent training; lect open to pub; competitions, awards given; gallery talks; tours; schols; gallery gift shop primarily sells works by South Carolinian artists. Also on sale art to wear including jewelry; reproductions; prints

WALTERBORO

M SOUTH CAROLINA ARTISANS CENTER, 334 Wichman St, Walterboro, SC 29488. Tel 843-549-0011; Fax 843-549-7433; Elec Mail artisan@lowcountry.com; Internet Home Page Address: www.southcarolinaartisanscenter.org
Open Mon - Sat 9 AM - 6 PM, Sun 1 - 6 PM; No admis fee; Estab 1994 to provide a showcase & market for the handcrafted work of the state's leading artisans; Housed in restored nine-room Victorian cottage; 2800 sq ft retail facility; Average Annual Attendance: 26,000
Special Subjects: Afro-American Art, American Indian Art, Metalwork, Photography, Pottery, Painting-American, Prints, Textiles, Sculpture, Drawings, Watercolors, Ceramics, Crafts, Folk Art, Woodcarvings, Woodcuts, Decorative Arts, Collages, Dolls, Furniture, Glass, Jewelry, Porcelain, Carpets & Rugs, Stained Glass, Pewter, Leather, Reproductions, Bookplates & Bindings
Exhibitions: Sweetgrass Baskets; Live demonstrations (3rd Sat. every month); Mary Whyte author/artist - Life of Alfreda
Publications: Hands On, newsletter monthly
Activities: Classes for adults & children; demonstrations; workshops; classes for artists; summer art camp; lect open to pub; 4 vis lects per yr; tours; sponsoring of competitions; schols; Made in SC: standardized curriculum; rural SC communities; sales shop sells books, original art & original crafts; magazines; reproductions; prints; SC food products

SOUTH DAKOTA

ABERDEEN

M DACOTAH PRAIRIE MUSEUM, Lamont Art Gallery, 21 S Main St, PO Box 395 Aberdeen, SD 57402-0395; PO Box 395 Aberdeen, SD 57401. Tel 605-626-7117; Fax 605-626-4026; Elec Mail bcmuseum@midco.net; Internet Home Page Address: www.brown.sd.us/museum; *Cur Educ* Sherri Rawstern; *Cur Exhib* Lora Schaunam; *Dir* Sue Gates; *VPres* Kim Lien
Open Tues - Fri 9 AM - 5 PM, Sat & Sun 1 - 4 PM; No admis fee; Estab 1969 to preserve the heritage of the peoples of the Dakotas: to maintain & develop exhibits that educate people about the heritage of the Dakotas; Average Annual Attendance: 60,000; Mem: 300 foundation mems
Income: Financed by county funds
Special Subjects: American Indian Art, Historical Material
Collections: Sioux & Arikara Indian artifacts; local & regional artists; photography
Publications: Annual Report; Dacotah Prairie Times, 3 per yr
Activities: Classes for adults & children; gallery talks; tours; individual paintings & original objects of art lent to museums, art centers & some materials to schools; book traveling exhibs 12 per yr; mus shop sells books, magazines, prints, original art & reproductions
L Ruth Bunker Memorial Library, 21 S Main St, PO Box 395 Aberdeen, SD 57402-0395. Tel 605-626-7117; Fax 605-626-4026; Internet Home Page Address: www.brown.sd.us/museum; *Cur Coll* Michele Porter; *Dir* Sue Gates
Open Tues - Fri 9 AM - 5 PM, Sat & Sun 1 - 4 PM, cl national holidays; Estab 1980 to store books, archives, maps, blueprints, etc; Circ Non-circulating; Reference for staff & academia only
Income: Financed by county funds

Library Holdings: Audio Tapes; Book Volumes 2800; Clipping Files; Exhibition Catalogs; Manuscripts; Original Art Works; Pamphlets; Photographs; Prints; Reproductions; Sculpture; Slides
Activities: Special classes; lect open to pub; gallery talks; tours; book traveling exhibs; originate traveling exhibs in midwest

M NORTHERN STATE UNIVERSITY, Northern Galleries, 1200 S Jay St, Aberdeen, SD 57401. Tel 605-626-2596; Fax 605-626-2263; Elec Mail mulvaner@wolf.northern.edu; *Dir Gallery* Rebecca Mulvaney
Open 8 AM - 5 PM; No admis fee; Estab 1902 to support Univ program; Four galleries: Lincoln professional secure setting, Union - student area, two hallway locations; Average Annual Attendance: 3,000
Income: $6,000 (financed by state appropriation)
Collections: Drawings, painting, photography, prints, sculpture
Exhibitions: Rotating exhibits
Activities: Educ dept; lect open to pub, 3 vis lectrs per yr; gallery talks; tours; competitions with prizes; individual paintings & original objects of art lent to regional locations; lending coll contains framed reproductions, original prints, paintings, photographs; book traveling exhibs 2 per yr

BROOKINGS

M SOUTH DAKOTA STATE UNIVERSITY, South Dakota Art Museum, Medary Ave at Harvey Dunn St, Brookings, SD 57007-0999. Tel 605-688-5423; Fax 605-688-4445; Elec Mail sdsu_sdam@sdstate.edu; Internet Home Page Address: www.sdartmuseum.sdstate.edu; *Cur Marghab Coll* Lisa Scholten; *Cur Exhib* Tilly Laskey; *Dir* Lynn Verschoor
Open Mon - Fri 10 AM - 5 PM, Sat 10 AM - 4 PM, Sun Noon - 4 PM; No admis fee; Estab 1969 as the state center for visual arts with various programs; The facility was designed by Howard Parezo, AIA, Sioux Falls, & occupies 112 x 90 ft site. There are seven galleries & a 147-seat auditorium; Average Annual Attendance: 92,000; Mem: 400, dues $20 - $25
Income: Financed by state appropriation, endowment, gifts & grants
Special Subjects: Drawings, Painting-American, Sculpture, Watercolors, American Indian Art, American Western Art, Southwestern Art, Textiles, Ceramics, Pottery, Woodcarvings, Landscapes, Eskimo Art, Carpets & Rugs
Collections: American Art; Harvey Dunn Paintings; Oscar Howe Paintings; Marghab Linens; Native American Art; Native American Tribal Art
Publications: Exhibition catalogs; newsletter; brochures
Activities: Docent training; lect open to pub, 6-10 vis lectrs per yr; gallery talks; tours; artmobile; individual paintings & original objects of art lent to professionally run museums with excellent facilities; traveling exhibs; mus shop sells books, original art, reproductions, prints, slides, cassettes, CDs, cards & stationery
L Hilton M. Briggs Library, Box 2115, Brookings, SD 57007. Tel 605-688-5106; Fax 605-688-6133; Elec Mail stevemarquardt@sdstate.edu; Internet Home Page Address: www3.sdstate.edu/academics/library; *Dean Libraries* Steve Marquardt; *Admin Asst* Denise Pike
Open Mon - Thurs 7:45 AM - Midnight, Fri 7:45 AM - 9 PM, Sat 12 noon - 9 PM, Sun 1 PM - Midnight; Open to the pub for lending through the main library
Income: Financed by state appropriation, endowment, gifts & grants
Library Holdings: Book Volumes 2000; Exhibition Catalogs; Slides; Video Tapes

CRAZY HORSE

M CRAZY HORSE MEMORIAL, Indian Museum of North America, Native American Educational & Cultural Center & Crazy Horse Memorial Library (Reference), Ave of the Chiefs, Crazy Horse, SD 57730-9506. Tel 605-673-4681; Fax 605-673-2185; Elec Mail memorial@crazyhorsememorial.org; Internet Home Page Address: www.crazyhorse.org; *CEO & Pres* Ruth Ziolkowski; *Mus & Center Dir* Anne Ziolkowski; *Head Librn* Janeen Melmer; *Dir Educ* Donovin Sprague
Open 8 AM - dark; Admis memorial $25 per car, $10 per person, under 6 free, mus & center free; Memorial estab 1947, mus estab 1974, Center estab 1995, for preservation of the culture of the North American Indian; Three wings; Average Annual Attendance: 1,100,000
Income: Financed by Crazy Horse Memorial Foundation
Library Holdings: Auction Catalogs; Audio Tapes; Book Volumes; CD-ROMs; Cassettes; Clipping Files; Framed Reproductions; Memorabilia; Original Art Works; Photographs; Prints; Sculpture
Special Subjects: Painting-American, Sculpture
Collections: North American Indian Artifacts; Mountain Sculpture/Carving Displays; Pioneer memorabilia; Paintings & Sculptures
Exhibitions: Art shows on Life of Crazy Horse (adults & students); Gift from Mother Earth Art Show (ann, second weekend in June)
Publications: Memorial: Progress; Mus: Indian Museum of North America; Crazy Horse Coloring Book
Activities: Classes for adults; lect open to pub, vis lectr; concerts; schols offered; book traveling exhibs; retail store sells books, prints, original art, reproductions

CUSTER

M GLORIDALE PARTNERSHIP, National Museum of Woodcarving, Hwy 16 W, PO Box 747 Custer, SD 57730. Tel 605-673-4404; *Co-owner* Gloria Schaffer; *Co-owner* Dale E Schaffer
Open May - Oct, Mon - Fri 8 AM - 9 PM, cl Oct - May; Admis adult $5.50, seniors $5, children 6 - 14 $3, group rates available; Estab 1972 in order to elevate the art of woodcarving; Average Annual Attendance: 74,000
Income: $200,000 (financed by mus admis)
Purchases: $100,000 for gallery & gift shop
Special Subjects: Woodcarvings
Collections: Wooden Nickel Theater; 36 scenes by original animator of Disneyland; carving studio
Exhibitions: Area woodcarvers & artists

Activities: Schols & fels offered; exten dept serves Custer Community School; mus & sales shop sells books, original art, reproductions, prints, slides

FLANDREAU

A MOODY COUNTY HISTORICAL SOCIETY, PO Box 25, Flandreau, SD 57028. Tel 605-997-3191; *Dir* Roberta Williamson; *Pres* Anna Duncan; *Experience Works* Donna Karlstad
Open Mon - Fri 9 AM - 4 PM; No admis fee; Estab 1965 to promote understanding of history of Moody County, South Dakota; Jones' one-room school; 1880 depot; 1873 Riverbend Meeting House, historic frame building in Flandreau, Moody County; Average Annual Attendance: 900; Mem: 368; dues family $10, single $5; annual meeting second Sun of Sept
Income: $17,000 (financed by county & city appropriation, donations, memorials & mem)
Special Subjects: Costumes, Historical Material, Landscapes, Manuscripts, Photography, Religious Art, Textiles, Pottery, Crafts, Portraits, Dolls, Furniture, Glass, Laces, Leather, Period Rooms, Maps, Carpets & Rugs
Collections: County artifacts, census records on microfilm, newspapers, photographs (available for reproduction), postcards; Indian Artifacts (1890-1927)
Exhibitions: Fourth of July Festival
Activities: Brown Bag luncheons from Sept - May; lect open to pub, 2 vis lectrs per yr; gallery talks; bus tours; competitions with prizes; contests; sales shop sells note papers; 1896, 1908 & 1915 Plat Books; histories of county communities

HOT SPRINGS

M PIONEER HISTORICAL MUSEUM OF SOUTH DAKOTA, 300 N Chicago, Hot Springs, SD 57747. Tel 605-745-5147; Elec Mail pioneer@pioneer-museum.com; Internet Home Page Address: www.pioneer-museum.com; *Pres* Paul Hickok; *VPres* Bob Brown; *Treas* Ken Wilcox; *Secy* Niona Case
Open June - Sept Mon - Sat 9 AM - 5 PM; Discount to families; Built in 1893 & used as a school until 1961, this historic sandstone bldg now houses a coll which includes 25 exhibit areas showcasing pioneer life in Hot Springs/Fall River County; Mem: Dues Lifetime $100; Business $25 (ann); Family $10 (ann); Individual $5 (ann)
Special Subjects: Historical Material, Furniture, Period Rooms
Collections: over 600 historical pieces of original artwork, tapestries, famous prints & photos; authentic 19th century classroom; recreated doctor's office; old washing machines, wood cook stoves, kerosene lamp & many other historical items
Activities: Ann Mem Drive; Pioneer Days & Mus Tour; museum-related books & gift items for sale

LEMMON

M GRAND RIVER MUSEUM, 114 10th St W, Lemmon, SD 57638. Tel 605-374-3911; Tel 605-374-7574; Elec Mail grmuseum@sdplains.com; Internet Home Page Address: www.grandrivermuseum.org; *Bd Dir* Edward Schmidt; *Bd Dir* Phyllis Schmidt; *Pres, Bd Dir* Stuart Schmidt; *Bd Dir* Lisa Schmidt; *Bd Dir* John Lopez; *Bd Dir* Kim Petik; *Bd Dir* Tom Dreiske; *Bd Dir* Jim Petik
May-Sep, Mon-Sat 9AM-6PM, Sun 12-PM-5PM; Donations suggested; Founded 1998 to establish a forum with topics devoted to culture & paleontology, with an emphasis on the Grand River area; Large display of dinosaur fossils & displays of cowboy, ranching & Native Am artifacts from the local area; Average Annual Attendance: 4,500; Mem: Dues Business Levels of $250 & up; Sponsor $100; Family $35
Library Holdings: Photographs; Prints
Special Subjects: Ethnology, Historical Material
Collections: Dinosaur & fossil room; Native American room; Early ranching room; exhibs on creation science
Publications: newsletter, quarterly
Activities: School & teacher progs, cultural exchange, community involvement & cooperation with other similar institutions; one visiting lecture per year; tours; museum-related sells books

MITCHELL

M MIDDLE BORDER MUSEUM & OSCAR HOWE ART CENTER, 1300 E University, PO Box 1071 Mitchell, SD 57301. Tel 605-996-2122; Fax 605-996-0323; Elec Mail mbm-ohac@santel.net; Internet Home Page Address: www.oscarhowe.com; *Exec Dir* Lori Holmberg
Open Mon - Sat 9 AM - 5 PM; No admis fee; Estab 1939 for historical preservation of pioneer & native American way of life & to promote local and regional artists as well as the Mitchell community; Housed in 4 historic buildings on grounds of Dakota Wesleyan University campus; handicapped accessible; Average Annual Attendance: 4,800; Mem: 300; dues $25 & up
Income: Financed by pvt & pub funds
Special Subjects: American Indian Art, Etchings & Engravings, Historical Material, Architecture, Glass, American Western Art, Furniture, Photography, Porcelain, Pottery, Painting-American, Prints, Period Rooms, Textiles, Bronzes, Maps, Sculpture, Watercolors, Dolls, Embroidery
Collections: Paintings by Sioux artist & South Dakota artist laureate, Oscar Howe; Charles Hargens Western art; Harvey Dunn
Exhibitions: Youth Art Exhibit (March)
Activities: Classes for adults & children; lect open to pub, 1-2 vis lect per yr; gallery talks; tours; awards (Youth Art); individual paintings & original objects of art lent to other galleries; lending coll contains paintings; book traveling exhibs; mus shop sells books, original art, reproductions, prints, jewelry, pottery Native American crafts & quilts

MOBRIDGE

M KLEIN MUSEUM, 1820 W Grand Crossing, Mobridge, SD 57601. Tel 605-845-7243; Elec Mail kleinmuseum@westriv.com; *Mus Shop Mgr* Diane Kindt; *VChmn & VPres* Ervin Dupper
Open daily 9 AM - Noon & 1 - 5 PM, cl Tues; Admis adult $2, student $1; Estab 1975; Average Annual Attendance: 4,500; Mem: 225; dues business $35, family $10; ann meeting in Apr
Income: $29,000 (financed by mem & donations)
Special Subjects: Drawings, American Indian Art, American Western Art, Archaeology, Dolls, Glass, Embroidery
Collections: Native American; Pioneer
Exhibitions: Native American Beadwork; Sitting Bull Pictorial Display; Prairie Period Rooms
Activities: Sales shop sells books & prints

PIERRE

M SOUTH DAKOTA NATIONAL GUARD MUSEUM, 301 E Dakota Ave, Pierre, SD 57501-3225. Tel 605-224-9991; Internet Home Page Address: www.state.sd.us/military/military/museum.htm; *Dir* Robert L Kusser; *Cur* Seb Axtman
Open Mon - Fri 9 AM - 4 PM; cl weekends & holidays; grp tours avail other times by appt; No admis fee, donations accepted; Originated as the 147th Field Artillery Historical Society in 1975; Mus estab 1983 to provide a facility for memorabilia & historical documents pertaining to the SD National Guard. The mus is a repository of historical info for both the Army & Air National Guard; Mem: dues Adjutants Gen Club $500 per yr, Charter Life $100, Sustaining Org $1 per mem per yr, Indiv Sustaining $10 per yr
Collections: Historical documents; military equipment; records; relics & memorabilia from Civil War, Spanish American War, WWI & WWII, Korean War, Desert Storm & Bosnian Peace-Keeping Mission; Sherman Tank; Armored Personnel Carrier; 75mm cannon; 105mm Howitzer; anti-aircraft guns; A-7-D Jet

PINE RIDGE

M HERITAGE CENTER, INC, Red Cloud Indian School, 100 Mission Dr Pine Ridge, SD 57770. Tel 605-867-5491; Fax 605-867-1291; Elec Mail ezephier@redcloudschool.org; Internet Home Page Address: www.redcloudschool.org/museum; *Pres* Peter J Klink; *VPres* Alvin Tibbitts; *Dir* Elicia Zephier
Open Mon - Fri 8 AM - 5 PM; No admis fee; Estab 1974 to exhibit Indian art & culture; Mus has four changing galleries of American & Canadian Native American art. Mainly paintings & sculpture; Average Annual Attendance: 11,000
Income: Financed by donations & grants
Special Subjects: Painting-American, American Indian Art, Southwestern Art, Folk Art, Eskimo Art, Painting-Canadian
Collections: Native American paintings & prints; Native American sculpture; star quilts & tribal arts
Exhibitions: Selections from permanent collection; Eskimo prints; Northwest coast prints; Annual Red Cloud Indian Art Show
Activities: Classes for children, docent training; tours; awards; individual paintings & original objects of art are lent to other museums & art centers; book traveling exhibs 4-6 per yr; originate traveling exhibs; mus shop sells books, original art, reproductions & prints

RAPID CITY

M RAPID CITY ARTS COUNCIL, Dahl Arts Center, 713 Seventh St, Rapid City, SD 57701. Tel 605-394-4101; Fax 605-394-6121; Elec Mail contact@thedahl.org; Internet Home Page Address: www.thedahl.org; *Finance* Diane Bullard; *Cur* Mary Maxon; *Ofc Mgr* Marilyn Jacks; *Admin Mgr* Shelly Beaty; *Exec Dir* Linda Anderson; *Develop Officer* Linda Hodgin
Open Tues - Sat 10 AM - 5 PM, Sun 1 - 5 PM, cl Mon; No admis fee; Estab 1974 to promote & nourish creativity through the arts; The art center contains 3 galleries: Cyclorama Gallery, a 200 ft oil mural of American history; Central Gallery, touring & invitational exhibitions; Ruth Brennan Gallery, the main educ gallery; Average Annual Attendance: 60,000; Mem: Ann meeting fourth Mon in July
Income: $4,280,000 (financed by earned income, city appropriation, rentals, grants & contributions)
Special Subjects: Painting-American, Prints, Watercolors
Collections: Grace & Abigail French Collection, oils & watercolors; Hazel Schwentker Collection, watercolors, inks & washes; contemporary original prints; contemporary original work by regional artists
Activities: Classes for adults & children; dramatic progs; docent training; lect open to pub, 3 lect per yr; concerts; gallery talks; tours; sponsoring of competitions; schols offered; individual paintings & original objects of art lent; originate traveling exhibs to museums, galleries, colleges & art centers

SIOUX FALLS

A AMERICAN INDIAN SERVICES, 817 N Elmood Ave, Sioux Falls, SD 57104. Tel 605-334-4060; Fax 605-334-8415; Internet Home Page Address: www.aistribalarts.com; *WATS* 800-658-4797; *Exec Dir* Marilyn Meyer
Estab 1979; Northern Plains Art Gallery; Mem: Member federally recorded tribe, proof of decendency
Income: Financed by mem, state appropriation & individual donations
Activities: Local school shows

M **AUGUSTANA COLLEGE,** Eide-Dalrymple Gallery, 29th St & S Grange Ave, Augustus Campus Sioux Falls, SD 57197; PO Box 723, 2001 S Summit Ave Sioux Falls, SD 57197. Tel 605-274-4609; Fax 605-274-4368; Elec Mail adrien_hannus@augie.edu; Internet Home Page Address: www.augie.edu/dept/art/art/eidedalrymplegallery.htm; *Dir* L Adrien Hannus PhD; *Gall Asst* Joan Ashton
Open Tues - Sun Noon - 5 PM, cl Mon; No admis fee; Estab 1960 to serve as active force in art educ by presenting art within a cross-cultural perspective; Located on campus, featuring changing exhibits of works by professional artists in the region as well as occasional ethnographic shows, houses permanent coll of signed original prints; Average Annual Attendance: 3,000
Income: Financed by College appropriation & gifts
Purchases: Japanese woodcuts, European signed prints, New Guinea masks & objects
Collections: Enthographic & primitive art; original prints
Exhibitions: New Guinea Tribal Art; Works of Jerry Aistrup; Mike Lynch - Early & Recent Works; Augustana Sr Art Show
Activities: Art & mus classes; lect open to pub, 6 vis lectrs per yr

A **AUGUSTANA COLLEGE,** Center for Western Studies, 2201 S Summit Ave, Sioux Falls, SD 57197; PO Box 727, Sioux Falls, SD 57197. Tel 605-274-4007; Fax 605-274-4999; Elec Mail cws@augie.edu; Internet Home Page Address: augie.edu/CWS; *Exec Dir* Arthur R Huseboe; *Develop Dir* Dean A Schueler; *Secy* Lisa Hollaar; *Cur & Managing Ed* Harry F Thompson
Open Mon - Fri 8 AM - 5 PM; Sat 10 AM - 2 PM; No admis fee; Estab 1970 for coll & preservation of historic material for the promotion of South Dakota & its Western artists; Artists of the Plains Gallery, original oils, watercolors, bronzes & prints by regional artists; Average Annual Attendance: 500-750; Mem: 800; dues $50 & up; ann meeting in Dec
Income: Financed by endowment, mem, gifts, grants & book sales
Collections: South Dakota Art; historical manuscripts; photos; art by regional artists
Exhibitions: 3-4 exhibits per year featuring South Dakota Artists
Publications: An Illustrated History of the Arts in South Dakota; Poems & Essays of Herbert Krause; Lewis & Clark Then and Now: A New History of South Dakota
Activities: Classes for adults; docent training; lect open to pub, 10 vis lectrs per yr; tours; competitions with awards; individual paintings & original objects of art lent to other offices on campus; book traveling exhibs 6-8 per yr; originate traveling exhibs organized & circulated to SD Art Museum; mus shop sells books, original art, reproductions

M **WASHINGTON PAVILION OF ARTS & SCIENCE,** Visual Arts Center, 301 S Main Ave, Sioux Falls, SD 57104. Tel 605-367-7397; Fax 605-367-7399; Elec Mail info@washingtonpavilion.org; Internet Home Page Address: www.washingtonpavilion.org; WATS 877-WASH-PAV; *Exec Dir, CEO* Steven A Hoffman; *Cur of Art* Howard Dalee Spencer; *Dir Visual Arts Ctr* David J Merhib
Visit website for hrs; No admis fee; Estab 1961 as a contemporary mus; Six galleries; Average Annual Attendance: 75,000; Mem: 1250; please visit website for dues information
Income: Financed by state appropriations, mem, gifts, contributions
Collections: Historical & contemporary interest, monthly 2-D work; National Printmakers collection
Exhibitions: Exhibition galleries
Publications: Monthly newsletter
Activities: Classes for adults & children; lect open to pub, receptions; concerts; gallery talks; tours; individual paintings & original art lent; mus shop sells books, magazines, original art, prints, reproductions, pottery & cards; children's studio on site
L **Library,** 301 S Main Ave, Sioux Falls, SD 57104. Tel 605-367-7397; Internet Home Page Address: www.washingtonpavilion.org
Call for hours; Open to mems only
Income: Financed by state appropriations, mem, gifts, contributions
Library Holdings: Book Volumes 320
Publications: Art News

SPEARFISH

M **BLACK HILLS STATE UNIVERSITY,** Ruddell Gallery, 1200 University, Spearfish, SD 57799. Tel 605-642-6104, Ext 6111, 642-6852; Fax 605-642-6105; *Dir* Jim Knutsen
Open Mon - Fri 8 AM - 4 PM, Sat & Sun by appointment; Estab 1936 to encourage art expression & greater appreciation in the Black Hills area. Work of the art center is promoted jointly by Black Hills State College Art Department & the Student Union; Average Annual Attendance: 2,000; Mem: 500; dues $5 & up
Exhibitions: Photography, regional & vis artists
Activities: Lect open to pub, 3 vis lectrs per yr; competitions with awards; individual paintings & original objects of art lent to other colleges & universities; sales shop sells original art
L **Library,** 1200 University, Spearfish, SD 57799. Tel 605-642-6833; Fax 605-642-6105; *Dir Library* Edmund Erickson
Open Mon - Thurs 7:30 AM - 11:30 PM, Fri 7:30 AM - 5 PM, Sat 10 AM - 5 PM, Sun 2 PM - 11 PM
Library Holdings: Book Volumes 300; Motion Pictures; Reproductions
Collections: Carnegie gift library containing 1000 prints and 150 books

VERMILLION

M **UNIVERSITY OF SOUTH DAKOTA ART GALLERIES,** W M Lee Ctr for the Fine Arts, Vermillion, SD 57069; 414 E Clark St, Vermillion, SD 57069. Tel 605-677-5481; Fax 605-677-5988; Elec Mail jday@usd.edu; Internet Home Page Address: www.usd.edu; *Dir* John A Day; *Cur* Cory Knedler
Open Mon - Fri 10 AM - 4:30 PM; Sat & Sun 1 - 5 PM; No admis fee; Estab 1976. Primary mission is educational, serving specifically the needs of the college & augmenting the university curriculum as a whole; There are three galleries. One

is a changing gallery 50' x 50' located in the Fine Arts Center. The second houses the university collection of Works by Oscar Howe, a native American painter. This facility is approximately 30' x 20'. The third is a small changing gallery approximately 18' x 20'; Average Annual Attendance: 15,000
Income: $80,000 (financed by state appropriation & student fee allotment)
Purchases: $100,000
Collections: 60 Works by Oscar Howe; variety of media by contemporary artists; Northern Plains Nature American Fine Arts
Exhibitions: Varied by year
Publications: Catalogues for major exhibs
Activities: Lect open to pub; gallery talks; tours; competitions, awards given; exten dept serves 300 miles in general region; individual paintings & original objects of art lent to professional museums & galleries; book traveling exhibs 2 per yr; originate traveling exhibs

WALL

M **WOUNDED KNEE MUSEUM,** 207 10th Ave, Wall, SD 57790; PO Box 348, Wall, SD 57790. Tel 605-279-2573 (Seasonal); Tel 970-226-3218 (Admin office); Elec Mail info@woundedkneemuseum.org; Internet Home Page Address: www.woundedkneemuseum.org
Open seasonally to Oct 12: daily 8:30 AM - 5:30 PM; call for extended hours; Admis adults $5, seniors 60 & over $4, children under 12 no admis fee; tour groups please call or email for more info; Mus tells the story of a small band of Lakota families who became the focus of the last major military operation of the US Army in its centuries-long effort to subdue the Native American tribes
Special Subjects: Historical Material, Photography, American Indian Art
Collections: Exhibs & photos surrounding the Wounded Knee Massacre; trading post
Exhibitions: Smothering the Seven Fires; Wovoka's Ghost Dance; Words That Killed; Big Foot's Trail; The Adaptable Lakota; Treaty of 1868
Publications: A Sioux Chronicle, by George E Hyde; The Ghost Dance Religion and the Sioux Outbreak of 1890, by James Mooney; Bury My Heart at Wounded Knee, by Dee Brown; Lost Bird of Wounded Knee, by Renee Samsom Flood
Activities: Group tours & self-guided tours; educ progs; memorial movie on the Lakota people; books & museum- related items for sale

YANKTON

M **YANKTON COUNTY HISTORICAL SOCIETY,** Dakota Territorial Museum, 610 Summit St, PO Box 1033 Yankton, SD 57078. Tel 605-665-3898; Fax 605-665-6314; Elec Mail dtm@willinet.net; *Pres* Fred Binder; *Dir & Cur* Doug Sall
Open Tues - Sat 10 AM - 5 PM; Sun Noon - 4 PM (Summer); Tues - Fri 1 PM - 5 PM; No admis fee; Estab 1961 as an historical museum; Average Annual Attendance: 6,000; Mem: 200; dues vary; annual meeting in Jan
Income: $20,000 (financed by city & county appropriation)
Collections: Paintings by Louis Janousek; sculptures by Frank Yaggie; historic photographs
Exhibitions: Rotating
Activities: Lectrs for mems only; mus shop sells books, reproductions & prints

TENNESSEE

CHATTANOOGA

L **CHATTANOOGA-HAMILTON COUNTY BICENTENNIAL LIBRARY,** Fine Arts Dept, 1001 Broad St, Chattanooga, TN 37402. Tel 423-757-5316; *Head of Dept* Barry Bradford
Open Mon - Thurs 9 AM - 9 PM, Fri - Sat 9 AM - 6 PM, Sept - May; No admis fee; Estab 1888, dept estab 1976
Income: Financed by city, county & state appropriation
Library Holdings: Audio Tapes; Cassettes; Clipping Files; DVDs; Motion Pictures; Periodical Subscriptions 63; Video Tapes
Special Subjects: Art History, Film, Painting-American, Painting-British, Pre-Columbian Art, Historical Material, Furniture
Collections: Collection of books, cassette tapes, compact discs, music books, phono records, 16mm film & video VHS tapes

M **HOUSTON MUSEUM OF DECORATIVE ARTS,** 201 High St, Chattanooga, TN 37403. Tel 423-267-7176; Fax 423-267-7177; Elec Mail houston@chattanooga.net; Internet Home Page Address: www.thehoustonmuseum.com; *Dir* Amy Frierson; *Visitor Services Coordr* Cheron Mashburn; *Coordr Educ Programs* Tamara G Salter
Open Mon - Fri 9:30 AM - 4 PM, Sat Noon - 4 PM, cl major holidays; Admis $8; Estab 1961, incorporated 1949; Average Annual Attendance: 12,000; Mem: 700; dues $5000, $2500, $1000, $100, $50, $45, $35, $25; ann meeting in May
Income: Financed by mem dues, annual grant from Allied Arts, Inc, profits from antiques show & admis fees, gift shop profits, individual & corporate donations
Special Subjects: Decorative Arts, Dolls, Furniture, Glass
Collections: Coverlet Collection; Early American furniture; rare coll of pressed glass (5000 pitchers, 600 patterns of pressed glass, all types of art glass, steins & Tiffany glass); ceramics, dolls, porcelains
Exhibitions: (2/23/2007-2/27/2007) Annual Antiques Show
Publications: Always Paddle Your Own Canoe: The Life, Legend & Legacy of Ann Safley Houston; Fabulous Houston; Houston Museum of Decorative Arts Coverlet Collection
Activities: Classes for adults & children; docent training; lect open to pub, 6 - 8 vis lectrs per yr; tours; mus shop sells books, reproductions, decorative art objects & items reflective of pieces in permanent coll

M HUNTER MUSEUM OF AMERICAN ART, 10 Bluff View, Chattanooga, TN 37403. Tel 423-267-0968; Fax 423-267-9844; Internet Home Page Address: www.huntermuseum.org; *Adminr* Eileen Henry; *Chief Preparator* John Hare; *Cur Coll* Ellen Simak; *Cur Educ* Sherry Babic; *Accounting Mgr* Linda Tate; *Dir* Robert A Kret
Open Tues - Sat 10 AM - 4:30 PM; Sun 1 - 4:30 PM; cl Mon; Admis adults $5, children $2.50, under 3 free; Estab 1924, chartered in 1952 to present a visual arts program of high quality, maintain a fine coll of American art & to carry out a vigorous educational program in the community & the schools; The permanent coll of American art is housed in the George Thomas Hunter Mansion constructed in 1904 & a contemporary addition was opened in 1975 with 50,000 sq ft of space in four major gallery areas, a classroom wing & an auditorium; Average Annual Attendance: 50,000; Mem: 1800; dues grand benefactor $5000, benefactor $2500, member $1000, patron $500, sponsor $250, donor $100, advocate $75, family $49, general $35, advantage hunter $35, student & senior citizens $15
Library Holdings: Cards; Cassettes; Clipping Files; Memorabilia; Original Documents; Pamphlets; Periodical Subscriptions; Photographs
Special Subjects: Painting-American, Photography, Prints, Sculpture, Glass
Collections: American paintings, later 18th century to present, including works by Bierstadt, Benton, Burchfield, Cassatt, Durand, Hassam, Henri, Inness, Marsh, Miller, Twachtman, Whistler & others; contemporary works including Beal, Bechtle, Fish, Frankenthaler, Golub, Goodman, Johns, LeWitt, Park, Pearlstein, Rauschenberg, Schapiro, Stackhouse, Wesselman, Wonner & Youngerman; contemporary American prints; sculpture by Calder, Hunt, Nevelson, Segal, Snelson & others; glass by Chihuly, Littleton, Morris, Zinsky
Publications: Brochures & announcements; bulletin, quarterly; A Catalogue of the American Collection, Hunter Museum of Art, 1985, 300-page illustrated focus on pieces in the permanent collection
Activities: Classes for adults & children; docent training; lect open to pub, 7 vis lectrs per yr; gallery talks; concerts; tours; individual paintings are lent to other museums; book traveling exhibs 18-20 per yr; originate traveling exhibs which circulate to qualified galleries & museums; mus shop sells books, reproductions, gift items, jewelry
L Reference Library, 10 Bluff View, Chattanooga, TN 37403. Tel 423-267-0968; Fax 423-267-9844; Internet Home Page Address: www.huntermuseum.org; *Dir* Robert A Kret
Open by appointment only; Estab 1958 as reference source for staff only; Circ Non-circulating
Library Holdings: Book Volumes 1500; Cards; Cassettes; Clipping Files; Exhibition Catalogs; Memorabilia; Motion Pictures; Original Art Works; Pamphlets; Periodical Subscriptions 8; Photographs; Prints; Sculpture; Slides
Special Subjects: Architecture

M UNIVERSITY OF TENNESSEE AT CHATTANOOGA, Cress Gallery of Art, Fine Arts Ctr, Vine & Palmetto Chattanooga, TN 37043; Dept of Art # 1301, 615 McCallie Ave Chattanooga, TN 37403. Tel 423-425-4600; Fax 423-425-2101; Elec Mail ruth-grover@utc.edu; Internet Home Page Address: www.utc.edu/artdept/cress; *Cur Galleries, Exhibs & Colls* Ruth Grover
Open Mon - Fri 9 AM - 5 PM, cl univ holidays; No admis fee; Estab 1949 to provide teaching gallery for art department, campus & community; 2-room gallery, main 116+ running ft, auxillary 54 running ft; Average Annual Attendance: 5,000
Income: School funding, grants and donations
Library Holdings: Exhibition Catalogs; Kodachrome Transparencies; Lantern Slides; Original Art Works; Other Holdings teaching collection with Western art & archit; Prints; Sculpture; Slides; Video Tapes
Collections: Graphics; paintings; sculpture
Exhibitions: 6 - 7 temporary exhibitions per year
Activities: Lect open to pub; 2-3 vis lectrs per yr; gallery talks; tours on request; individual paintings & original objects of art lent to various campus areas; lending coll contains original prints & paintings; temporary and traveling exhibs

CLARKSVILLE

M AUSTIN PEAY STATE UNIVERSITY, Margaret Fort Trahern Gallery, Trahern Bldg, College & 8th St Clarksville, TN 37044; PO Box 4677 Clarksville, TN 37044. Tel 931-221-7334; Fax 931-221-7432; Elec Mail holteb@apsu02.edu; *Dir* Bettye Holte
Open Mon - Fri 9 AM - 4 PM; Sat 10 AM - 2 PM; Sun 1 - 4 PM; No admis fee; Estab 1962 as a univ community service to exhibit a variety of visual media; Average Annual Attendance: 8,000
Income: Financed by univ appropriations
Exhibitions: Average 10-12 per year
Publications: Announcements of shows & artist biographies
Activities: Lect open to pub, 6-8 vis lectrs per yr; gallery talks; tours; competitions with awards; schols offered
L Art Dept Library, Tel 931-221-7333; Fax 931-221-7432; Internet Home Page Address: www.apsu.edu; *Cur Gallery* Bettye Holte; *Slide Librn* Dixie Webb
Open Mon - Fri 8:30 AM - 4 PM; Estab 1974 for Art Appreciation class, faculty only; Large single unit space with storage; Average Annual Attendance: 4,000
Library Holdings: Filmstrips; Motion Pictures; Reproductions; Slides
Special Subjects: Art History, Folk Art, Decorative Arts, Drawings, Etchings & Engravings, Graphic Arts, Islamic Art, Painting-American, Sculpture, Latin American Art, Advertising Design, Art Education, Asian Art, Mexican Art, Afro-American Art
Collections: Larson Drawing Collection
M Mabel Larsen Fine Arts Gallery, PO Box 4677, Clarksville, TN 37044. Tel 931-221-7334; Fax 931-221-7432; Elec Mail holteb@apsuoz.edu; *Dir* Bettye S Holte
Open Mon - Fri 8 AM - 4 PM, cl holidays; No admis fee; Estab 1994 to house Austin Peay State Univ permanent art colls; Average Annual Attendance: 5,000
Income: Financed by state funds
Library Holdings: Original Art Works
Collections: Larson Drawing Collection; Hazel Smith Collection; Center of Excellence Student Collection
Exhibitions: Changing exhibits of the University permanent collection
Activities: Gallery talks; competitions

COOKEVILLE

A CUMBERLAND ART SOCIETY INC, Cookeville Art Gallery, 186 S Walnut, Cookeville, TN 38501. Tel 931-526-2424; *Pres* Linda McGraw
Open Mon - Fri & Sun 1 - 4 PM; No admis fee; Estab 1961 to promote arts in the community & area; A new building with adequate gallery & studio space. The gallery is carpeted & walls are finished with wallscape & track lighting; Average Annual Attendance: 3,000; Mem: 125; dues $20, renewal $20, students $15; meeting quarterly
Income: Financed by mem, city & state appropriations)
Exhibitions: Changing exhibits, monthly
Activities: Classes for children & adults; art educ for pre-school children; lect open to pub, 6 vis lectrs per yr; gallery talks; tours; competitions with awards

HENDERSONVILLE

A HENDERSONVILLE ARTS COUNCIL, 1154 W Main St, PO Box 64 Hendersonville, TN 37077-0064. Tel 615-822-0789; *Exec Dir* Emma Dye
Open 9 AM - 3 PM; No admis fee; Estab 1975 to promote & educate through the arts; Galleries are located in 200 yr old home; Average Annual Attendance: 10,000
Exhibitions: Monthly changing exhibits
Publications: News d'Art, quarterly
Activities: Classes for adults & children; dramatic progs; concerts; mus shop sells local crafts & prints

JOHNSON CITY

EAST TENNESSEE STATE UNIVERSITY

M Carroll Reece Museum, Tel 423-439-4392; Fax 423-439-4283; Internet Home Page Address: cass.etsu.edu/museum; *Dir* Theresa Burchett-Anderson; *Secy* Sheila L West
Open Tues & Wed & Fri 9 AM - 4 PM, Thurs 9 AM - 7 PM; No admis fee, donations accepted; Estab 1965 to enhance the cultural & educational advantages of the University & the people of upper East Tennessee; The purpose of Friends of the Reece Museum is to support programs of the mus; Average Annual Attendance: 23,500; Mem: 250; dues President's Trust $10,000 plus, Benefactor $500, Sustaining $250, Patrons $100, Supporting $50, Family $30, Individual $20, Student $10
Income: Financed through the state of TN
Special Subjects: Painting-American, Prints, Pre-Columbian Art, Crafts, Historical Material, Period Rooms
Collections: Frontier Exhibit, an exhibit of historical Tennessee household & farming items, includes a log cabin & conestoga wagon; Music From the Past, a collection of early musical instruments; Old Master & contemporary prints.; Printshop of the Past; Reece Collection of memorabilia of former United States Congressman from Tennessee, B Carroll Reece; contemporary paintings; historical mater
Exhibitions: Annual Alumni Exhibit; Annual Holiday Exhibit; Rotating exhibs
Publications: CRM Calendar. quarterly, gallery guides with exhibitions
Activities: Lect, 6 vis lectrs per yr; concerts; gallery talks; tours; competitions with awards; schls offered; book traveling exhibs; originate traveling exhibs
M Elizabeth Slocumb Galleries, Tel 423-439-5315; Fax 423-439-4393; Elec Mail apack@lycos.com; Internet Home Page Address: www.etsu.edu; *Dir Exhib* Alison Pack
Open Mon - Fri 8 AM - 4:30 PM; No admis fee; Estab 1950 to augment all the progs & areas of instruction within the Art Department & to foster interest in various modes of artistic expression in the campus at large; Average Annual Attendance: 5,000
Collections: A small teaching coll of prints, paintings, ceramics, weaving, wood, photographs & graphic designs & a camera coll
Exhibitions: MFA & BFA Candidate Exhibitions; Positive/Negative, Student Honors Exhib, Faculty Exhib
Publications: Catalogs; posters
Activities: Lect open to pub; gallery talks; tours; competitions; purchase & monetary awards; schls & fels offered; originate traveling exhibs
L C C Sherrod Library, Tel 423-439-4307, 439-5309; Fax 423-461-7026; Internet Home Page Address: Sherrod.etsu.edu/aboutlib; *Dean* Rita Scher
Open Mon - Thurs 8 AM - 11 PM, Fri 8 AM - 6 PM, Sat 10 AM - 6 PM, Sun 2 - 11 PM
Income: Financed by the state
Library Holdings: Book Volumes 13,500; Memorabilia; Other Holdings; Periodical Subscriptions 62
Special Subjects: Art History, Photography, Drawings, Sculpture
Collections: Appalachian Culture & Arts; photographic archives; videotape archives

KINGSPORT

A ARTS COUNCIL OF GREATER KINGSPORT, Renaissance Center Main Gallery, 1200 E Center St, Kingsport, TN 37660-4946. Tel 423-392-8420; Fax 423-392-8422; Elec Mail artscouncil@kingsport.com; *Dir* Marilyn Schieferdecker; *Pres* John Gregory; *Finance & Grants Mgr* Cathie Faust
Open Mon - Fri 8 AM - 5 PM; No admis fee, charge for special events; Estab 1968 to promote & present all the arts to all the people in area; this includes performing arts, visual arts & classes; One gallery with monthly shows; Average Annual Attendance: 20,000; Mem: 400; dues $20 - $500
Income: Financed by mem & grants
Activities: Classes for adults & children; lect open to pub, 3 vis lectrs per yr; concerts; competitions with awards; schols; originate traveling exhibs through Southern Arts Federation

KNOXVILLE

M BECK CULTURAL EXCHANGE CENTER, INC, 1927 Dandridge Ave, Knoxville, TN 37915-1909. Tel 865-524-8461; Fax 865-524-8462; Internet Home Page Address: www.korrnet.org/beckcec; *Mrg* Avon William Rollins Sr
Open Tues - Sat 10 AM - 6 PM; No admis fee, donations accepted; Estab 1975 to

encourage, collect, preserve & display local, regional, & national Black history; Average Annual Attendance: 35,000; Mem: 1,000; annual meeting in Sept

Income: $90,000 (financed by mem, city, county & state appropriations)

Library Holdings: Audio Tapes; Cassettes; Clipping Files; Compact Disks; Original Art Works; Original Documents; Records; Sculpture; Slides; Video Tapes

Special Subjects: African Art, Afro-American Art, Cartoons

Exhibitions: Federal Judge William H Hastie Room; Library of Books & Recordings; oral histories; weekly newspapers of the local Black experience; Senior Citizens Storywriting Contest

Publications: 200 Year History of Knoxville & 125 Year History of Knoxville College; State of Black Economy in Tennessee

Activities: Classes for adults & children; school & community presentations; docent programs; lect open to the public; competitions with cash awards; traveling slide presentations; museum shop sells books, prints, music & clothing

M **KNOXVILLE MUSEUM OF ART,** 1050 World's Fair Park Dr, Knoxville, TN 37916-1653. Tel 865-525-6101; Fax 865-546-3635; Elec Mail info@kmaonline.org; Internet Home Page Address: www.knoxart.org; *Chmn* Bob Sukenik; *VPres Mus Advancement* Donna Dempster; *Cur of Colls & Exhibs* Dana Self; *Exec Dir* Todd D Smith; *Cur Educ* Sherry Spires; *Dir Mktg & Comm* Del Baker-Robertson; *Asst to Dir* Shirley Brown

Open Tues, Wed 12 PM - 8 PM; Thur, Fri 12 PM - 9 PM; Sat 11 AM- 5 PM; Sun 11 AM - 5 PM; $5 admis fee; group & sch tours available; please call 865-6101 ext. 226 to arrange for more information; Estab 1961 as a nonprofit private corporation. Grand opening was held in 1990. Located on the former World's Fair site downtown; New state-of-the-art 53,000 sq ft facility. Maintains reference library; Average Annual Attendance: 117,000; Mem: 4300; dues $40 - $1000

Income: Financed by mems, contributions, sponsorships, foundations & local, state & federal grants

Purchases: Therman Statom's 'Antartica'; John Wilsnon's 'Martin Luther King, Jr'; Warrington Colescott's 'Jazz Piano'

Library Holdings: Auction Catalogs; Book Volumes; CD-ROMs; Exhibition Catalogs; Original Documents; Pamphlets; Periodical Subscriptions; Slides; Video Tapes

Special Subjects: Drawings, Hispanic Art, Latin American Art, Mexican Art, Painting-American, Photography, Prints, Sculpture, Watercolors, American Indian Art, American Western Art, Bronzes, Folk Art, Woodcuts, Etchings & Engravings, Landscapes, Afro-American Art, Decorative Arts, Painting-European, Portraits, Porcelain, Miniatures, Period Rooms, Medieval Art

Collections: Modern & contemporary art in all media; Works by artists who worked during & after the 20th century in painting, photography, sculpture & works on paper

Publications: Bi-monthly calendar; exhibition catalogs; newsletter

Activities: Classes for adults & children; docent preparation; artists in the classrooms; school outreach; lects open to public, 5-8 vis lectrs per year; concerts; gallery talks; tours; competitions with awards; scholarships & fels offered; exten dept serves 9 county region; lending collection contains books, cassettes, color reproductions & slides; Art2Go: suitcases for classroom use; originate traveling exhibitions; museum shop sells books, original art, reproductions, prints, jewelry, accessories (apparel), greeting cards, calendars, toys, t-shirts & art-related gifts; Exploratory Gallery on-site for students & families

UNIVERSITY OF TENNESSEE

M **Frank H McClung Museum,** Tel 865-974-2144; Fax 865-974-3827; Internet Home Page Address: www.mcclungmuseum.utk.edu; *Exhib Coordr* Steve Long; *Cur Coll* Elaine A Evans; *Registrar & Colls Mgr* Robert Pennington; *Dir* Jefferson Chapman; *Cur Archaeology* Dr Lynn Sullivan; *Media Productions Coordr* Lindsay Kromer

Open Mon - Sat 9 AM - 5 PM, Sun 1 - 5 PM; No admis fee; Estab 1961 to collect, maintain & interpret paintings, works of art, items of natural history & historical objects with emphasis placed on the Tennessee area. A major purpose is to provide research materials for students & faculty of the university; Average Annual Attendance: 50,000; Mem: 520; dues $30-2,500

Income: Financed by state appropriations & private contributions

Library Holdings: Auction Catalogs; Photographs; Slides

Special Subjects: Archaeology, American Indian Art, Anthropology, Decorative Arts, Antiquities-Egyptian

Collections: Eleanor Deane Audigier Art Collection; Frederick T Bonham Collection (18th - 20th Century furniture, art objects); Lewis-Kneberg Collection (Tennessee archaeology); Grace Moore Collection (memorabilia of her career 1920 - 1940); Malacology Collection (marine species & fresh water North American mollusks)

Exhibitions: The Decorative Experience; Ancient Egypt: The Eternal Voice; Archaeology & the Native Peoples of Tennessee; Geology and the Fossil History of Tennessee

Publications: Museum member newsletter; occasional papers

Activities: Classes for children; docent training; lect open to public, 3-5 vis lectrs per year; individual paintings & original objects of art lent; book traveling exhibitions, 1-3 per year; museum shop sells books, orginial art, reproductions & Slides

M **Ewing Gallery of Art and Architecture,** Tel 865-974-3200; Fax 865-974-3198; Elec Mail spangler@utk.edu; *Registrar* Cindy Spangler; *Dir* Sam Yates

Open Mon - Thurs 8:30 AM - 8 PM, Fri 8:30 AM - 4:30 PM, Sun 1 - 4 PM; No admis fee; Estab 1981 to provide quality exhibitions focusing on contemporary art & architecture; Gallery consists of 3,500 sq ft exhibition space; Average Annual Attendance: 6,000

Collections: Contemporary American prints, paintings & drawings; Japanese prints

Activities: Lect open to public, 12 vis lectrs per year; gallery talks; tours; sponsor competitions; scholarships offered; lending collection contains individual & original objects of art; originate traveling exhibitions

A **Visual Arts Committee,** Tel 423-974-5455; Fax 423-974-9252; *Prog Dir* Ron Laffitte

Open Mon - Fri 7:30 AM - 10:30 PM, Sat 7 AM - 10 PM, Sun 1 - 6 PM; No admis fee; Estab to provide visual arts for the students of the univ & vis artist lectr series; Two major galleries: Gallery Concourse has 300 running ft; Average Annual Attendance: 20,000

Income: Financed by student activities fees

Exhibitions: 8 exhibits per year; student shows & traveling shows

Publications: Visual Arts Comt Ann Catalog

Activities: Lect open to public, 6 vis lectrs per year, competitions; Cash awards for student 2-D Art Competition and Nat Photography Competition; book 8 traveling exhibitions annually

MARYVILLE

M **MARYVILLE COLLEGE,** Fine Arts Center Gallery, 502 E Lamar Alexander Pky, Maryville, TN 37804-5907. Tel 865-981-8150, 981-8000; Fax 865-273-8873; Elec Mail sowders@maryvillecollege.edu; Internet Home Page Address: www.maryvillecollege.edu; *Chmn* Mark Hall

Open Mon - Fri during school year 9 AM - 5 PM; No admis fee; Located in fine arts center

Income: School funding

Exhibitions: Monthly rotating exhibitions

Activities: Gallery programs in connection with circulating exhibitions; art movies, four times a year

MEMPHIS

AUTOZONE
For further information, see National and Regional Organizations

A **CENTER FOR SOUTHERN FOLKLORE,** 209 Beale St, Memphis, TN 38103. Tel 901-525-3655; Fax 901-525-3945; Elec Mail esav638@prodigy.com; *Exec Dir* Judy Peiser

Open Mon & Thurs 10 AM - 8 PM, Fri & Sat 10 AM - Noon, Sun 1 - 8 PM; Admis $2; Estab 1972 as a nonprofit organization which archives, documents & presents folk art, culture & music through film, photography, exhibits & lectures; Mem: 800; dues $25

Income: $350,000 (financed by mem, state appropriation & national endowment)

Collections: African - American Quilt; Contemporary Slides - Folk Art & Culture; Folk Art; Historical & Contemporary Photographs

Activities: Classes for adults & children; cultural tourism; lect open to public; lending collection contains 50 paintings & art objects; retail store sells books, magazines & original art

M **THE DIXON GALLERY & GARDENS,** 4339 Park Ave, Memphis, TN 38117. Tel 901-761-5250; Fax 901-682-0943; Internet Home Page Address: www.dixon.org; *Dir* James J Kamm; *Cur* Vivian Kung-Haga; *Registrar* Neil O'Brien; *Vol Coordr* Jane Faquin; *Mus Shop Mgr* Sarah Beth Larson

Open Tues - Sat 10 AM - 5 PM, Sun 1 - 5 PM, cl Mon, gardens only open Mon; Admis adults $5, students $3, seniors $4, children 2-11 years $1; Estab 1976 as a bequest to the pub from the late Margaret & Hugo Dixon. Their Impressionist Art Collection & their Georgian-style home & gardens, situated on 17 acres of landscaped woodland, serve as the museum's foundation; Two wings added in 1977 & 1986 house the developing permanent collection & accommodate loan exhibitions. Formal & informal gardens, conservatory & greenhouses are located on the site; Average Annual Attendance: 180,000; Mem: 6000; dues corporate patron $1000 & up, patron $500, donor $250, young at art $150, sponsor $125, family $60, dual $55, individual $45, student $20

Income: Financed by endowment, contributions, mem, & corporate sponsorships

Special Subjects: Painting-American, Prints, Watercolors, Decorative Arts, Porcelain, Painting-French, Pewter

Collections: French Impressionist painting; Barbizon, Post-Impressionist & related schools; 18th century British paintings; Georgian period furniture & decorative arts; Warda Stevens Stout Collection of 18th century German porcelain; 18th & 19th centuries works by Pierre Donnard, Eugene Boudin, Theodore Earl Butler, A F Cals, Jean-Baptiste Carpeaux, Mary Cassatt, Paul Cezanne, Marc Chagall, William Merritt Chase, John Constable, J B C Corot, Kenyon Cox, Henri-Edmond Cross, Charles Francois Daubigny, Edgar Degas, Julien Dupre; Sir Jacob Epstein, Henri Fantin-Latour, Jean-Louis Forain, Thomas Gainsborough, Paul Gauguin, Edmond Grandjean, Francesco Guardi, Paul Guigou, Armand Guillaumin, Henri Joseph Harpignies, William James, Johan Jongkind, S V E Lepine, Maximilien Luce, Albert Marquet, Paul Mathey, Henri Matisse, Claude Monet,; Berthe Morisot, Andre & Berthe Noufflard, Henriette A Oberteuffer, Ludovic Piette, Camille Pissarro, Sir Henry Raeburn, J F Raffaelli, Auguste Renoir, Sir Joshua Reynolds, Henri Rowart, Paul Singer Sargent, Paul Signac, Alfred Sisley, Allen Tucker, J M W Turner, Horatio Walker and Richard Wilson

Publications: Exhibition catalogs; qtr newsletter

Activities: Classes for adults; workshops; docent training; lect open to public; concerts; gallery talks; tours; film series; individual paintings & original objects of art lent to museums & galleries; lending collection contains original paintings, prints, sculpture & porcelain; museum shop sells art & garden books, prints, jewelry, notecards & garden items

L **Library,** 4339 Park Ave, Memphis, TN 38117. Tel 901-761-5250; Fax 901-682-0943; Elec Mail info@dixon.org; Internet Home Page Address: www.dixon.org; *Registrar* Neil O'Brien; *Dir* James J Kamm; *Educ Coordr* Jane W Faquin

Open Tues - Sat 10 AM - 5 PM, Sun 1 - 5 PM; Admis adults $5, seniors $4, students & children free; Circ 3500; Open to members during mus hours, for reference only; Average Annual Attendance: 50,000

Income: $10,000 (financed by mem, corporate & private sponsorship & the Hugo Dixon Foundation)

Library Holdings: Auction Catalogs; Book Volumes; Cards; Clipping Files; DVDs; Exhibition Catalogs; Manuscripts; Pamphlets; Periodical Subscriptions 15; Photographs; Slides; Video Tapes

Special Subjects: Decorative Arts, Painting-French, Ceramics, Pewter

Collections: French and American Art in the 19th and 20th centuries

Activities: Classes for adults & children; dramatic programs; docent training; concerts; gallery talks; exten dept serves school outreach, 18,000 students per yr; organize traveling exhibitions; museum shops sells books, reproductions, & prints

C **FIRST HORIZON NATIONAL CORP,** (First Tennessee National Corp) First Tennessee Heritage Collection, 165 Madison Ave, Memphis, TN 38103. Tel 901-523-4291; Fax 901-523-4354; *Chmn* Ken Glass; *Tours* Leslie Lee

Mus open Mon - Fri 8:30 AM - 4 PM, Sat 9 AM - Noon; Estab 1979 to depict Tennessee's heritage & history through art; Gallery, with over 150 original works, is located in First Tennessee's corporate headquarters; Average Annual Attendance: 5,000

Income: Financed by corporation
Special Subjects: Etchings & Engravings, Sculpture, Watercolors, Painting-American, Prints
Collections: Engravings, etchings, lithographs, murals, paintings, sculpture, watercolors
Exhibitions: Permanent collection
Activities: Educ dept

C **FIRST TENNESSEE BANK,** 6891 Summer Ave, Memphis, TN 38103. Tel 901-523-4352 (Commus Dept); Fax 901-523-4354 (Commus Dept); *In Charge Art Coll* Kathy Alexander; *Office Mgr* Nancy Bradfield
Estab to provide community interest in the arts; to aid participating artists; to enhance lobby; Supports local artists & art forms on display that lend an interest to the community
Collections: Paintings by local artists in a variety of media
Activities: Sponsors Wildlife Artist Guy Coheleach

M **MEMPHIS BROOKS MUSEUM OF ART,** 1934 Poplar Ave, Memphis, TN 38104. Tel 901-544-6200; Fax 901-725-4071; Internet Home Page Address: www.brooksmuseum.org; *Cur Educ* Marina Pacini; *Registrar* Kip Peterson; *Chief Preparator* Bert Sharp III; *Asst Preparator* Paul Tracy; *CFO* Barbara Mullins; *Dir & CEO* Kaywin Feldman Jr; *Facilities Mgr* Nicolas Carranza; *Mus Shop Mgr* Daphne Hewett; *Dir Develop* Debbie Litch; *Assoc Dir Develop* Andrew Trippel; *Exec Asst Dir* Peter Dandridge; *VChmn* Joe Weller; *Assoc Registrar* Marilyn Masler; *Dir Media & Pub* Jan Bauman
Open Tues - Fri 10 AM - 4 PM; Sat 10 AM - 5 PM, Sun 1 - 5 PM, first Wed of month open 10 AM - 9 PM; Admis adults $8, seniors $6, students $2, children under 6 free; Estab 1912 to exhibit, preserve & elucidate works of art; The original building was opened in 1916 with additions in 1955 and 1973. Maintained by the city of Memphis, Public Service Department; Average Annual Attendance: 125,000; Mem: 3156; dues $35 & up
Income: $1,000,000 (financed by city appropriation & Friend's Foundation)
Special Subjects: Painting-American, Sculpture, Textiles, Glass, Porcelain, Oriental Art, Asian Art, Painting-Dutch, Painting-Flemish, Renaissance Art, Painting-Italian
Collections: American Paintings & Sculpture, 18th-20th centuries; Dutch & Flemish Paintings, 16th-18th centuries: Eastern & Near-Eastern Decorative Arts Collection (Han, Tang & Ching Dynasty); English Paintings, 17th-19th centuries; French Paintings, 16th-19th centuries; International Collection of Paintings & Sculpture, 19th & 20th centuries; Kress Collection of Italian Paintings & Sculptures, 13th-18th centuries; Dr Louis Levy Collection of American Prints; Mid-south Collection of 20th century paintings & sculptures; glass, textile & porcelain collection
Exhibitions: 4 rotating exhibitions per year
Publications: Bimonthly newsletter
Activities: Classes for adults & children; docent training; outreach program & studio art activities for student groups; lect open to public, 9 vis lectr per year; concerts; gallery talks; tours; competitions; awards; individual paintings & original objects of art lent; book traveling exhibitions 7-10 per year; originate traveling exhibitions; museum shop sells books, reproductions, prints, slides, museum replicas, jewelry & regional pottery

L **Library,** 1934 Poplar Ave, Overton Park Memphis, TN 38104. Tel 901-544-6200; Fax 901-725-4071; Elec Mail brooks@brooksmuseum.org; Internet Home Page Address: www.brooksmuseum.org
By appointment only; No admis fee; Estab 1912; Reference only; Average Annual Attendance: varies; Mem: Part of museum
Income: financed by city appropriations, memberships
Library Holdings: Book Volumes 6134; Clipping Files 4223; Exhibition Catalogs 2367; Periodical Subscriptions 24

MEMPHIS COLLEGE OF ART
L **G Pillow Lewis Memorial Library,** Tel 901-272-5130; Fax 901-272-5104; Elec Mail mstrawder@mca.edu; Internet Home Page Address: www.mca.edu; *Pres* Jeffrey D Nesin; *Dean* Ken Strickland; *Head Librn* Maxine Strawder; *Visual Resources Cur* Karla Strickland
Open Mon - Thurs 8 AM - 3 PM, Fri 8 AM - 4 PM, Sat 10 AM - 3 PM, summer hrs Mon - Fri 8:30 AM -4:30 PM; No admis fee; Estab 1936 as an adjunct educational program; The Standing Committee on Exhibitions arranges visiting shows
Library Holdings: Auction Catalogs; Book Volumes 17,000; Clipping Files; Exhibition Catalogs; Periodical Subscriptions 110; Prints; Reproductions; Slides
Special Subjects: Art History, Illustration, Mixed Media, Photography, Calligraphy, Drawings, Graphic Arts, Graphic Design, History of Art & Archaeology, Printmaking, Art Education, Bookplates & Bindings, Metalwork, Jewelry, Pottery
Collections: Jacob Marks Memorial Collection; works by college graduates & faculty; Dennis Sexsmith Visual Resources Collection
Exhibitions: Juried student shows; one & two-person faculty shows; senior exhibition; summer student show; traveling exhibitions
Publications: Exhibition catalogs
Activities: Classes for adults, children, undergraduate & graduate college students; lect; guided tours; films; competitions; book traveling exhibitions

L **Library,** Tel 901-272-5100; Fax 901-272-5104; Elec Mail brcallow@mca.edu; Elec Mail info@mca.edu; Internet Home Page Address: www.mca.edu; *Slide Cur* Bette Ray Callow; *Head Librn* Valery Strawder; *VChmn* Bryan Eagle; *Pres* Jeffrey D Nesin
Open Mon - Thurs 8 AM - 8 PM, Fri 8 AM - 5 PM
Library Holdings: Book Volumes 14,500; Other Holdings Original prints; Periodical Subscriptions 110; Reproductions; Slides 30,000
Special Subjects: Art History, Illustration, Photography, Sculpture, Printmaking, Industrial Design, Bookplates & Bindings, Metalwork, Jewelry, Pottery, Textiles, Woodcarvings

L **MEMPHIS-SHELBY COUNTY PUBLIC LIBRARY & INFORMATION CENTER,** Dept of Art, Music & Films, 3030 Poplar Ave, Memphis, TN 38111. Tel 901-415-2726; Fax 901-323-7206; Internet Home Page Address: www.memphislibrary.lib.tn.us; *Dir* Judith Drescher; *Deputy Dir* Sallie Johnson; *Sr Mgr Humanities* Gina Milburn
Open Mon - Thurs 9 AM - 9 PM, Fri & Sat 9 AM - 6 PM, Sun 1 - 5 PM; Estab

1895 to serve the reference, informational, cultural & recreational needs of residents of Memphis-Shelby County; Turner-Clark Gallery exhibits promising & established local & regional artists of various media
Income: Financed by city & state appropriation
Library Holdings: Book Volumes 63,000; Cassettes 800; Motion Pictures 3000; Periodical Subscriptions 245; Records 35,000; Video Tapes 3000

M **MISSISSIPPI RIVER MUSEUM AT MUD-ISLAND RIVER PARK,** 125 N Front St, Memphis, TN 38103. Tel 901-576-7230; Fax 901-576-6666; Internet Home Page Address: www.mudisland.com; *Gen Mgr* Trey Giuntine; *Museum Mgr* Alisa Bradley
Open Apr 12 - May 23 & Sept 2 - Oct 31 Tues - Sun 10 AM - 5 PM, May 24 - Sept 1 daily 10 AM - 8 PM; Admis adults $4, children 3-11 & seniors $3; Estab 1978 to interpret the natural & cultural history of the Mississippi River Valley; Maintains reference library; Average Annual Attendance: 150,000
Income: $350,000 (financed by city appropriation)
Special Subjects: Architecture, Graphics, American Indian Art, Anthropology, Archaeology, Costumes, Folk Art, Pottery, Afro-American Art, Manuscripts, Furniture, Glass, Jewelry, Carpets & Rugs, Historical Material, Maps, Coins & Medals, Dioramas, Period Rooms, Laces
Collections: 2-D & 3-D pieces that interpret the natural & cultural history of the lower Mississippi River
Activities: Classes for children; dramatic program; docent training; lect open to public; gallery talks; tours; competitions with prizes; book traveling exhibitions 3-5 per year; originate traveling exhibitions; museum shop sells books, magazines, reproductions & prints

M **RHODES COLLEGE,** Clough-Hanson Gallery, Clough Hall, 2000 N Parkway Memphis, TN 38112. Tel 901-843-3442; Fax 901-843-3727; Elec Mail pacini@rhodes.edu; Internet Home Page Address: www.artslide2.art.rhodes.edu/gallery.html; *Dir & Cur* Marina Pacini
Open Tues - Sat 11 AM - 5 PM; Estab 1970 to exhibit local, regional & national artists w/ mount student exhibitions; Average Annual Attendance: 2,200
Special Subjects: Textiles, Woodcarvings
Collections: Jessie L Clough Art Memorial for Teaching; Asian & European textiles; Japanese & woodblock prints; 20th Century American Prints
Exhibitions: Changing exhibitions
Publications: Annual exhibit catalog
Activities: Lect open to public; gallery talks; 1 book traveling exhibition per year

UNIVERSITY OF MEMPHIS
M **Art Museum,** Tel 901-678-2224; Fax 901-678-5118; Elec Mail artmuseum@memphis.edu; Internet Home Page Address: www.amum.org; *Dir* Leslie L Luebbers; *Asst Dir* Lisa Francisco-Abitz
Open Mon - Sat 9 AM - 5 PM year round except between changing exhibits; No admis fee; Estab 1981 to sponsor programs & mount temporary exhibitions to expand knowledge about all periods of art with a special emphasis on contemporary art; Mus has 7000 sq ft of exhibition space including two permanent exhibits of ancient Egypt & traditional African art; Average Annual Attendance: 30,000; Mem: 200
Income: Financed by state appropriation, pub & private support
Special Subjects: Architecture, Drawings, Graphics, Painting-American, Photography, Prints, Sculpture, African Art, Anthropology, Archaeology, Folk Art, Woodcarvings, Woodcuts, Etchings & Engravings, Afro-American Art, Period Rooms, Antiquities-Egyptian
Collections: Egyptian Hall: antiquities from 3500 BC - 7th century AD; Neil Nokes Collection of African Art, traditional West African masks & sculpture; Print Collection: contemporary prints; collection of over 250 prints, an overview
Exhibitions: Changing contemporary shows; Jane Highstein 20th Anniversary Celebration
Publications: AM Edition Newsletter, quarterly
Activities: Lect open to public, 5 vis lectrs per year; tours; competitions with awards; scholarships offered; permanent collections lent to other institutions with proper facilities; originate traveling exhibitions

L **Visual Resource Collection,** Tel 901-678-2938; Fax 901-678-2735; Elec Mail slsandrs@memphis.edu; Internet Home Page Address: www.uom.edu; *Colls Cur* Susan L Sanders
Open Mon - Sat 9 AM - 6 PM except when exhibitions are being changed; No admis fee; Estab 1967 to provide slides for Art Faculty, University Faculty, & some outside organizations; Circ 160,000; There is an Egyptian Museum, the Gallery Museum & a student-run museum
Income: Financed by the university
Library Holdings: Audio Tapes; Book Volumes 218; CD-ROMs; Cassettes; Clipping Files; Compact Disks; DVDs; Exhibition Catalogs; Filmstrips; Original Art Works; Periodical Subscriptions 160; Prints; Records; Reproductions; Sculpture; Slides; Video Tapes
Special Subjects: Art History, Archaeology, American Western Art, Art Education, American Indian Art, Afro-American Art, Antiquities-Oriental, Antiquities-Persian, Antiquities-Assyrian, Antiquities-Byzantine, Antiquities-Egyptian, Antiquities-Etruscan, Antiquities-Greek, Antiquities-Roman, Architecture
Collections: 35 mm slides of history of Western art, photography, non-Western art; Western Art; African Art; Native American Art; Murnane Collection of Egyptian Slides; Collection of 17th - 19th American Architecture
Activities: Education program; lect open to public; 10-15 vis. lectrs per yr; concerts; gallery talks; tours; competitions; scholarships offered; extension program includes Family Day program

MORRISTOWN

A **ROSE CENTER & COUNCIL FOR THE ARTS,** PO Box 1976, Morristown, TN 37816. Tel 423-581-4330; Fax 423-581-4307; Elec Mail rosecent@usit.net; Internet Home Page Address: www.rosecenter.org; *Exec Dir* Zack Allen; *Operations Mgr* Patty Gracey
Open Mon - Fri 9 AM - 5 PM; none; Estab 1975 to promote, implement, & sustain historical, educational & cultural activities & projects of both local & national importance; to preserve & maintain Rose School as a museum & cultural

center; Art gallery, historic gallery, children's touch mus, historical classroom-exhibits remain same, never change; Average Annual Attendance: 25,000; Mem: 450
Income: Financed by endowment, mem, city, county & state appropriation, class instruction
Library Holdings: Book Volumes; Photographs; Slides
Special Subjects: Historical Material, Decorative Arts, Folk Art, Crafts
Collections: Local historical material, crafts & art
Publications: Monthly newsletter; Qtr calendar
Activities: Classes for adults & children; dramatic programs; art camps; lect open to public; concerts; gallery talks; tours; school programs; book traveling exhibitions 1 per year; sales shop sells books & crafts, sales shop, books

MURFREESBORO

M **MIDDLE TENNESSEE STATE UNIVERSITY,** Baldwin Photographic Gallery, PO Box 305, Murfreesboro, TN 37132. Tel 615-898-2300; Fax 615-898-5682; Elec Mail tjimison@frank.mtsu.edu; *Cur* Tom Jimison
Open Mon - Fri 8 AM - 4:30 PM, Sat 8 AM - Noon, Sun 6 - 10 PM; No admis fee; Estab 1970 for the exhibition of outstanding photographers & beginners; Gallery has 193 running ft of display area; Average Annual Attendance: 30,000
Income: Financed by the university
Special Subjects: Photography
Collections: Ansel Adams; Shelby Lee Adams; Richard Avedon; Harold Baldwin; Harry Callahan; Marrie Camhi; Geri Della Rocea de Candal; Barbara Crane; Jim Ferguson; Dore Gardner; Philip Gould; Tom Jimison; Builder Levy; Minor White & others; Jim Norton; April Ottey; John Pfahl; Walter Rosenblum; John Schulze; Aaron Sisking; Marianne Skogh; H H Smith; Michael P Smith; Jerry Velsman; Ed Weston by Cole; Jack Wilgus; Sean Wilkinson; Kelly Wise
Publications: Lightyear, annually
Activities: Original objects of art lent to responsible organizations; lending collection contains photographs; book traveling exhibitions 3 per year; originate traveling exhibitions to university galleries

NASHVILLE

M **BOARD OF PARKS & RECREATION,** The Parthenon, Centennial Park, West End Ave Nashville, TN 37203; Metro Postal Service, Centennial Park Office Nashville, TN 37201. Tel 615-862-8431; Fax 615-880-2265; Elec Mail parthenon@nashville.org; Internet Home Page Address: www.parthenon.org; *Museum Store Mgr* Timothy Cartmell; *Dir* Wesley M Paine; *Dir Opers* Lauren Bufferd; *Cur* Susan Shockley; *Registrar & Asst Cur* Brenna Cothran; *Dir Educ* DeeGee Lester; *Event Coordr & Gallery Asst* Larua Carrillo
Open Tues - Sat 9 AM - 4:30 PM, June - Aug Sun 12:30 - 4:30 PM, cl Sun, Mon & legal holidays; Admis adult $3.50, children (4-17) & seniors $2; Estab 1970 to offer Nashville residents & tourists quality art for viewing in a Historical setting of significance & beauty; 2 changing exhibit galleries & James M Cowan Gallery of American Art; Average Annual Attendance: 100,000; Mem: 1,000 mem; dues seniors & students $25; individual $35; family $50
Income: Financed by city & county taxes, donations & memberships
Special Subjects: Painting-American
Collections: Cowan Collection, sixty three paintings by 19th & 20th century American artists, donated by James M Cowan; Century III Collection, sixty two art works, purchased from area artists, juried by John Canaday in celebration of Nashville's bicentennial
Exhibitions: Exhibitions change every 3 months
Publications: Century III Catalog; The Cowan Catalog; A Tale of Two Parthenons; Winslow Homer: An American Genius at the Parthenon; Carlton Wilkinson-Coming Home: A Retrospective
Activities: Docent training; lect open to public, 9 vis lectrs per year; concerts; gallery talks; guided tours; lending of original objects of art to Farnsworth Museum, ME; Berry-Hill Galleries, NY; book traveling exhibitions 1-2 per yr; sales shop sells books, souvenirs, prints & slides

M **CHEEKWOOD-TENNESSEE BOTANICAL GARDEN & MUSEUM OF ART,** 1200 Forrest Park Dr, Nashville, TN 37205-4242. Tel 615-356-8000; Fax 615-353-0919; Elec Mail cwalker@cheekwood.org; Internet Home Page Address: www.cheekwood.org; *Registrar* Kaye Crouch; *Preparator* Todd McDaniel; *Chief Cur* Celia Walker; *Pub Information* Carolyn Lawrence; *Dir Educ* Mary Grissom; *Pres* Jane Jerry; *Dir* Dr Jack Becker
Open Tues - Sat 9:30 AM - 4:30 PM, Sun 11 AM - 4:30 PM, cl Mondays, Thanksgiving, Christmas Eve, Christmas, New Year's Eve & New Year's Day; Admis adults $10, seniors $8, children 7-17 $5, children under 7 free; Estab 1957 to collect, preserve & interpret American art. Mus opened to pub in 1960 in a Georgian-style mansion built in 1929 by Mr & Mrs Leslie Cheek. The site underwent further renovation & adaptation in 1980 & 1998; Circ Non-circulating; Galleries contain 12,000 sq ft of exhibition space, divided almost equally between installation of permanent collection & traveling exhibitions. Permanent exhibitions include the American Experience fine art from the collection, Worcester porcelain collection, American and European silver and snuff bottle collection. Separate facility for modern and contemporary art. Outdoor sculpture trail (approx 1 mile) contains regional, national and international sculpture from the collection; Average Annual Attendance: 170,000; Mem: 8700; dues supporting $125, family $65, individual $40, senior (65 & over) $40, student educator $25; annual meeting 3rd Wed in June
Income: Financed by mem, admis, corporate & foundation grants, private gifts, several fundraising events
Library Holdings: Auction Catalogs; Audio Tapes; Book Volumes; CD-ROMs; Exhibition Catalogs; Pamphlets; Periodical Subscriptions; Video Tapes
Special Subjects: Graphics, Painting-American, American Western Art, Decorative Arts, Porcelain
Collections: William Edmondson Collection; American paintings; contemporary art; European & American decorative arts
Exhibitions: Andrew Wyeth Helga Pictures; A Century of Progress: 20th Century Painting in Tennessee; Glass of the Avant-Garde from Vienna Secession to Bauhaus; Young America from the National Museum of American Art

Publications: Brochures, catalogues, checklists, monographs, monthly newsletter, posters
Activities: Classes for adults & children; docent training; lect open to public; concerts; tours; workshops; individual paintings & original objects of art lent to other museums; book traveling exhibitions 5-6 per year; originate traveling exhibitions; mus shop sell books, prints & posters; junior museum

L **Museum of Art Library,** 1200 Forrest Park Dr, Nashville, TN 37205. Tel 615-356-8000; Fax 615-353-0919; *Museum Asst* Laura Lake Smith; *Registrar* Kay Crouch; *Dir* Jack Becker
By appointment; Open to staff & members for reference
Library Holdings: Book Volumes 5000; Periodical Subscriptions 58
Special Subjects: Art History, Folk Art, Decorative Arts, Photography, Graphic Arts, Painting-American, Pre-Columbian Art, Prints, Sculpture, History of Art & Archaeology, American Western Art, Printmaking, Afro-American Art, Restoration & Conservation, Architecture
Activities: Classes for adults & children; dramatic programs; docent training; lect open to public; 2 vis lectr per yr; concerts; gallery talks; tours; sponsoring of competitions; lending of original objects of art to other museums; museum shop: books, magazines; reproductions; prints

L **Botanic Hall Library,** 1200 Forrest Park Dr, Nashville, TN 37205. Tel 615-353-2148; Fax 615-353-2731; *Librn* Ida Galehouse
Library Holdings: Book Volumes 5000

M **FISK UNIVERSITY,** Fisk University Galleries, 1000 17th Ave N, Nashville, TN 37208-3051. Tel 615-329-8720; Fax 615-329-8544; Elec Mail galleries@fisk.edu; Internet Home Page Address: www.fisk.edu; *Admin Asst* T Williams; *Interim Dir* Sarah Burroughs
Open Tues-Fri 10 AM - 5 PM, Sat & Sun 1 - 5 PM; cl Mon & univ holidays; Admis voluntary donation; Estab 1949 as an educ resource center for the Fisk & Nashville communities & for the promotion of the visual arts; The Carl Van Vechten Gallery houses the Stieglitz Collection, temporary exhibits & art offices; The Aaron Douglas Gallery in the library houses selections from the permanent collection of African Art & Am Art; Average Annual Attendance: 24,000
Income: Financed through the university, state appropriations, grants & private donations
Special Subjects: Drawings, Folk Art, Photography, Painting-American, Prints, Painting-French, African Art
Collections: Cyrus Baldridge Drawings; Alfred Stieglitz Collection of Modern Art; Carl Van Vechten Photographs; African-American Collection; European & American prints & drawings; Traditional & Contemporary African Art Collection
Publications: Fisk Art Report, annually
Activities: Lect open to public, 4-6 vis lectrs per year; gallery talks; tours; book traveling exhibitions; traveling exhibitions organized & circulated; sales shop sells books & reproductions

L **Aaron Douglas Library,** 1000 17th Ave N, Nashville, TN 37208. Tel 615-329-8720; Fax 615-329-8544; Internet Home Page Address: www.fisk.edu; *Dir* Opal Baker
Open Tues-Fri 11AM-4PM, Sat & Sun 1-4PM, cl Mon & univ holidays; No admis fee; Estab 1949; Publications are used by students & instructors for research
Library Holdings: Audio Tapes; Book Volumes 1100; Clipping Files; Exhibition Catalogs; Filmstrips; Kodachrome Transparencies; Lantern Slides; Motion Pictures; Original Art Works; Pamphlets; Photographs; Reproductions; Slides

M **GENERAL BOARD OF DISCIPLESHIP, THE UNITED METHODIST CHURCH,** The Upper Room Chapel & Museum, 1908 Grand Ave, Nashville, TN 37212. Tel 615-340-7207; Fax 615-340-7293; Elec Mail kkimball@upperroom.org; Internet Home Page Address: www.upperroom.org; *Upper Room Cur* Kathryn Kimball
Open Mon - Fri 8 AM - 4:30 PM; No admis fee, contributions encouraged; Estab 1953 as a religious mus reflecting universal Christianity; Average Annual Attendance: 15,000
Income: Self supporting
Special Subjects: Hispanic Art, Painting-American, Sculpture, American Indian Art, Bronzes, African Art, Textiles, Religious Art, Ceramics, Folk Art, Woodcarvings, Afro-American Art, Judaica, Manuscripts, Painting-European, Painting-Japanese, Furniture, Porcelain, Carpets & Rugs, Coins & Medals, Tapestries, Painting-Flemish, Renaissance Art, Embroidery, Stained Glass, Reproductions
Collections: Bibles from 1577; 2/3 Lifesize Woodcarving of da Vinci's Last Supper; Nativity Scenes; Ukranian Eggs; furniture; illuminated manuscripts; oriental rugs; porcelain
Exhibitions: Woodcarving; Porcelains; Furniture; Manuscripts from 1300-1800s; Paintings-copies from several masterworks of Raphael, da Vinci, Ruebens
Publications: Upper Room Devotional Guide, every 2 months; books; magazines
Activities: Retail store sells books, magazines, slides, postcards of woodcarving

A **TENNESSEE HISTORICAL SOCIETY,** War Memorial Bldg, Ground Flr, Nashville, TN 37243. Tel 615-741-8934; Fax 615-741-8937; Elec Mail tnhissoc@tennesseehistory.org; Internet Home Page Address: www.tennesseehistory.org; *CEO* Ann Toplovich; *VPres* William P Morrelli; *Secy* Carole S Bucy
Open Mon - Fri 8 AM - 5 PM, cl national holidays; No admis fee; Estab 1849 to preserve & interpret the history of all Tennesseans; Average Annual Attendance: 700, does not include museum attendance; Mem: 2000; dues John Haywood Society $250, sustaining $75, regular $35; annual meeting in May
Income: Financed by mem dues, grants & gifts
Collections: Art, decorative art & artifacts related to Tennessee culture, history & pre-history.
Publications: Tennessee Historical Quarterly
Activities: Lect provided, 7 vis lectrs per year

M **TENNESSEE STATE MUSEUM,** Polk Cultural Ctr, 505 Deaderick Nashville, TN 37243-1120. Tel 615-741-2692; Fax 615-741-7231; Elec Mail info@tnmuseum.org; Internet Home Page Address: www.tnmuseum.org; *Exec Dir* Lois Riggins-Ezzell; *Deputy Exec Dir* Evadine McMahan; *Dir Coll* Dan Pomeroy; *External Affairs* Leigh Hendry; *Dir Exhib* Philip Kreger; *Dir Opers* Patricia Rasbury; *Dir Pub Relations* Paulette Fox; *Pub Relations Coord* Randal Jones; *Sr Cur Art & Architecture* James Hoobler
Open Sun 1 - 5 PM, Tues - Sat 10 AM - 5 PM, cl Mon, Christmas, Easter,

Thanksgiving, New Year's Day; No admis fee; Estab 1937 to preserve & interpret the historical artifacts of Tennessee through mus exhibits & statewide outreach & educational programs; A military history mus in the War Memorial Building depicts Tennessee's involvement in modern wars (Spanish-American to World War II). Exhibits highlight life in Tennessee from early man through 1920. Gallery houses changing art & history exhibits. Maintains small reference library; Average Annual Attendance: 200,000; Mem: 1500; dues $25 & up
Income: Financed by state appropriation
Purchases: Tennessee related early 19th century paintings & prints; 19th century Tennessee made silver; 19th century Tennessee made firearms
Special Subjects: Historical Material
Collections: Objects relating to Tennessee history from pre-historic times to the present, Tennessee Historical Society; portraits & paintings of & by prominent Tennesseans; contemporary Tennessee related artists' works
Publications: Exhibition catalogs; quarterly newsletter
Activities: Docent training, dramatic programs; lect open to the public, gallery talks, tours, sponsors competitions; exten dept serving statewide; individual paintings & original objects of art; book traveling exhibitions; originate traveling exhibitions; museum shop sells books, Tennessee crafts, items relating to the collection; junior museum
L **Library,** 505 Deaderick, Nashville, TN 37219. Tel 615-741-2692; Fax 615-741-7231; *Dir Coll* Dan Pomeroy
Open Tues - Fri 10 AM - 5 PM, by appt
Income: Financed by State Appropriation
Library Holdings: Book Volumes 1700; Exhibition Catalogs; Pamphlets; Periodical Subscriptions 15; Photographs; Slides; Video Tapes
Special Subjects: Folk Art, Decorative Arts, Painting-American, Historical Material, Ceramics, Crafts, American Indian Art, Costume Design & Constr, Glass, Dolls, Handicrafts, Jewelry, Coins & Medals, Flasks & Bottles, Laces

M **VANDERBILT UNIVERSITY,** Fine Arts Gallery, Fine Arts Building, 23rd & West End Ave Nashville, TN 37203; VU Station B 35-1801, 2301 Vanderbilt Pl Nashville, TN 37235. Tel 615-322-0605; Fax 615-343-3786; Internet Home Page Address: www.vanderbilt.edu/gallery; *Asst Art Cur* Amy Pottier; *Dir* Joseph S Mella
Open Mon - Fri Noon - 4 PM, Sat & Sun 1 - 5 PM , Tues - Fri Noon - 4 PM, Sat 1 - 5 PM, cl Sun & Mon (summer); No admis fee; Estab collection 1956, gallery 1961, to provide exhibitions for the university & Nashville communities, & original art works for study by Vanderbilt students; The gallery is housed in the Old Gym, built in 1880 & listed in the National Register of Historic Places; Average Annual Attendance: 3,000
Income: Financed by university resources
Special Subjects: Prints, Painting-European, Oriental Art, Renaissance Art, Painting-Italian
Collections: Herman D Doochin Collection of Asian Art; Anna C Hoyt Collection of Old Master Prints; former Peabody College Art Collection including Kress Study Collection of Italian Renaissance Paintings; Harold P Stern Collection of Oriental Art & Rare Books; Contemporary Works on Paper and other Multiples
Exhibitions: Rotating exhibits every 2-4 months
Publications: "Far From the Sea: October Foundation 1998-2003"; and others
Activities: Lect open to public; gallery talks; tours; individual paintings & original objects of art lent to museums & galleries; book traveling exhibitions 2-3 per year; originate traveling exhibitions

A **WATKINS INSTITUTE,** College of Art & Design, 100 Powell Pl, Nashville, TN 37204. Tel 615-383-4848; Fax 615-383-4849; Internet Home Page Address: www.watkins.com; *Dean Academic Affairs* Dr David Hinton; *VPres to Dean* Diana McCabe
Open Mon-Fri 8:30 AM - 9 PM, cl Sat & Sun, Christmas, New Years, July 4, Labor Day, Thanksgiving Day; Admis $35 application fee; Estab 1885 as an adult educ center for art, interior design, adult evening high school & courses of a general nature
Income: Financed by rent from business property
Collections: All-State Artist Collection (oldest collection of Tennessee art in the state); this is a purchase-award collection of oil, pastels, watercolors, graphics and sculpture; several other collections of lesser value
Exhibitions: Ten exhibitions per year
Publications: Art brochure; qtr catalogue listing courses
Activities: Classes for adults & children; lect open to public, 6-8 vis lectrs per year; competitions; individual paintings lent to schools; original objects of art lent; traveling exhibitions organized & circulated
L **Library,** 100 Powell Pl, Nashville, TN 37204. Tel 615-383-4848; Fax 615-383-4849; Internet Home Page Address: www.watkins.com; *Librn* Beverly Starks
Open 8:30 AM - 9 PM; Estab 1885
Library Holdings: Book Volumes 12,000; Filmstrips; Periodical Subscriptions 15; Slides; Video Tapes

OAK RIDGE

A **OAK RIDGE ART CENTER,** 201 Badger Rd, PO Box 7005 Oak Ridge, TN 37831-3305. Tel 423-482-1441; *Dir* Leah Marcum-Estes; *Pres* William Capshaw
Open Tues - Fri 9 AM - 5 PM, Sat - Mon 1 - 4 PM; No admis fee; Estab 1952 to encourage the appreciation & creation of the visual arts; Two galleries house temporary exhibitions & permanent collection exhibitions, one rental gallery, classrooms & library; Average Annual Attendance: 20,000; Mem: 450; dues $35; meetings 2nd Mon of month
Income: $130,000 (financed by mem & grants)
Collections: The Mary & Alden Gomez Collection; Contemporary Regional Works; European Post World War II
Exhibitions: Open Show, Juried Competition (all media); monthly exhibit
Publications: Art Matters, monthly bulletin
Activities: Classes for adults & children; docent training; forums; workshops; lect open to public, 6-8 vis lectrs per year; gallery talks; tours; competitions with awards; individual paintings & original objects of art rented to individuals &

businesses on semi-annual basis; lending collection contains original art works, VCR tapes, 2000 books & 1000 slides
L **Library,** 201 Badger Rd, PO Box 7005 Oak Ridge, TN 37831-7005. Tel 423-482-1441; *Dir* Leah Marcum-Estes
Open Tues - Fri 9 AM - 5 PM; Open to members for lending & reference
Income: financed by members & grants
Library Holdings: Audio Tapes; Book Volumes 2000; Exhibition Catalogs; Filmstrips; Memorabilia; Original Art Works; Slides; Video Tapes
Special Subjects: Pottery
Publications: Monthly newsletter

SEWANEE

L **UNIVERSITY OF THE SOUTH,** Jessie Ball duPont Library, 29 Alabama Ave, Sewanee, TN 37383. Tel 931-598-1664; Fax 931-598-1145; Elec Mail cpfeiff@sewanee.edu; *Dir* Cheryl Pfeiffer
Open Mon - Thurs 7:45 AM - 1 AM, Fri 7:45 AM - 9 PM, Sat 9 AM - 6 PM, Sun 10 AM - 1 AM; Estab 1863
Special Subjects: Collages, Drawings, Etchings & Engravings, Manuscripts, Bronzes, Furniture, Ivory, Glass, Carpets & Rugs, Embroidery, Enamels, Gold, Jewelry, Landscapes, Coins & Medals

M **UNIVERSITY OF THE SOUTH,** University Art Gallery, 68 Georgia Ave Sewanee, TN 37383. Tel 931-598-1223; Fax 931-598-3335; Elec Mail Aende@sewanee.edu; Internet Home Page Address: www.sewanee.edu/gallery/; *Gallery Dir* Arlyn Ende
Open Tues - Fri 10 AM - 5 PM, Sat & Sun Noon - 4 PM, holidays & academic holidays by appointment; No admis fee; Estab 1938 to provide exhibits of interest to students & local & regional audiences; One large space with balcony, one main entry door, carpeted walls, track lighting; Average Annual Attendance: 3,000-5,000
Income: Financed by college funds, contributions & gifts
Library Holdings: CD-ROMs; Compact Disks; DVDs; Lantern Slides; Original Art Works; Photographs; Prints; Sculpture; Slides; Video Tapes
Special Subjects: Prints, Sculpture, Drawings, Graphics, Painting-American, Photography, Watercolors, Etchings & Engravings, Manuscripts, Furniture, Silver, Historical Material, Stained Glass
Collections: Paintings & prints; Georges Rouault The Miserere Engravings; Johannes Adam Oertel paintings (1823-1909)
Exhibitions: Monthly exhibitions during school year, 4 per semester; changing shows
Publications: Exhibition Catalog 2 per year
Activities: Classes for adults; lect open to public, 4 vis lectrs per year; gallery talks; tours; sponsor competitions; original objects of art lent to qualified venues

TEXAS

ABILENE

M **GRACE MUSEUM, INC,** 102 Cypress, Abilene, TX 79601. Tel 915-673-4587; Fax 915-675-5993; Elec Mail info@thegracemuseum.org; Internet Home Page Address: www.thegracemuseum.org; *Develop Dir* Kimberly Snyder; *Cur Educ* Kathryn Best; *Pres & CEO* Judith Godfrey; *Coordr Educ Prog* Pam Harman; *Dir Finance* Vicki Hooker; *Cur Coll* Holly North; *Dir Mktg & Pub Relations* Heather Kuhu; *Office Mgr* Patricia Ditmore
Open Mon - Sat 10 AM - 5 PM, Thrs 10 AM - 8 PM, cl Sun & Mon; Admis adults $5, children $3; Estab 1937 as an art & history educ institution; Contemporary, neutral spaces; Average Annual Attendance: 80,000; Mem: 1200; dues $50 & up
Income: Financed by mem, grants, fund-raising events, sponsors & endowment
Special Subjects: Painting-American, Prints
Collections: American Paintings & Prints; Local History; T&P Railway Collection; Texas Heritage: Peter Searcy, Allen Houser, Fidencio Duran, Maxine Rerini; Photography Collection by Bill Wright
Exhibitions: Regular schedule of temporary & long-term exhibitions, including contemporary art
Publications: Brochures; biannual newsletter
Activities: Classes for adults & children; docent training; lects open to the public; 10 vis lects per yr; gallery talks; lect open to public, 2-5 vis lectrs per year; gallery talks; tours; individual paintings & original works of art lent to other museums; lending collection contains original art works, original prints, paintings, photographs, sculptures, slides; book traveling exhibitions 2-3 per year; museum shop sells books, magazines, reproductions, prints, slides, games, toys, crafts, note cards & decorative arts

M **MCMURRY UNIVERSITY,** Ryan Fine Arts Center, 514th & Sayles Blvd, Abilene, TX 79697; PO Box 8, Abilene, TX 79697. Tel 915-793-3823; Fax 915-793-4662; Internet Home Page Address: www.mcm.edu
Open Mon - Fri 8 AM - 5 PM, cl Sat & Sun; No admis fee; Estab 1970 when building was completed; Large room overlooking larger sculpture garden; Average Annual Attendance: 2,500
Income: Financed by college art budget
Exhibitions: Varied exhibitions, changing monthly, of national, regional & area artists
Activities: Classes for adults in photography; lect open to public; gallery talks; competitions; individual paintings & original objects of art lent to college offices

ALBANY

M **THE OLD JAIL ART CENTER,** 201 S Second St, Albany, TX 76430. Tel 325-762-2269; Fax 325-762-2260; Elec Mail ojac@camalott.com; Internet Home Page Address: www.theoldjailartcenter.org; *Exec Dir* Margaret Blagg; *Registrar* Shelly Crittendon; *Dir Educ* Kathryn Mitchell; *Archivist/Librn.* Daniel Alonzo
Open Tues - Sat 10 AM - 5 PM, Sun 2 - 5 PM; No admis fee; Estab 1980 to collect & display contemporary art of US & Europe; Four galleries in old 1877

jail. 8 additional galleries plus Stasney Center for Educ. Marshall R Young Courtyard for outdoor sculpture; Average Annual Attendance: 12,000; Mem: 800; dues $25
Income: $400,000
Library Holdings: Book Volumes; Exhibition Catalogs; Periodical Subscriptions; Video Tapes
Special Subjects: Architecture, Drawings, Painting-American, Photography, Prints, Sculpture, Watercolors, Bronzes, Pre-Columbian Art, Ceramics, Woodcuts, Manuscripts, Furniture, Painting-French, Carpets & Rugs, Historical Material, Maps, Antiquities-Oriental, Painting-Spanish, Painting-Italian, Painting-German
Collections: Antique Furniture & Pre-Columbian; Sculpture; Paintings & graphics; Photography; Oriental pottery & Chinese tomb figures
Publications: Exhibit catalogs; The Art Record, newsletter, semi-annual; The French Connection
Activities: Classes for adults & children; dramatic programs; docent training; lect for members only, 2 vis lectrs per year; gallery talks; tours; scholarships offered; individual paintings & original objects of art lent; lending collection contains 400 paintings & some sculpture; book traveling exhibitions annually; originate traveling exhibitions; museum shop sells books, reproductions, notecards, plus other items

L **Green Research Library,** 201 S Second St, Albany, TX 76430. Tel 915-762-2269; Fax 915-762-2260; Elec Mail ojac@camalott.com; *Registrar* Amy Kelly; *Exec Dir* Margaret Blagg
Open Tues - Sat 10 AM - 5 PM, Sun 2 - 5 PM; No admis fee; Estab 1984; For reference only
Library Holdings: Book Volumes 2000; Periodical Subscriptions 4
Special Subjects: Art History, Illustration, Photography, Drawings, Sculpture, History of Art & Archaeology, American Western Art, Art Education, Asian Art, American Indian Art, Mexican Art, Oriental Art, Antiquities-Egyptian, Antiquities-Greek, Architecture

AMARILLO

AMARILLO ART ASSOCIATION
A **Amarillo Museum of Art,** Tel 806-371-5050; Fax 806-373-9235; Internet Home Page Address: www.amarilloart.org; *Dir & Cur* Patrick McCracken; *Cur Educ* Mark Morey; *Admin Asst* Liz Seliger; *Admin Asst* Cindy Mote; *Coll Mgr* Reba Jones
Open Tues - Fri 10 AM - 5 PM, Sat & Sun 1 - 5 PM; No admis fee; Estab 1972 for visual arts; Gallery 100, 90 x 30 ft, atrium area 45 ft; Gallery 200 & 203, 90 x 32 ft, 11 ft ceiling; Gallery 305 & 307, each 32 x 28 ft, 10 ft ceiling; Average Annual Attendance: 60,000; Mem: 1800; dues $50-$500
Income: Financed by mem, college, endowment sponsorship program & exhibition underwriting
Collections: Contemporary American drawings, paintings, prints & sculpture; Asian Art Collection
Publications: Annual Report; brochures, as needed; Calendar of Events, bimonthly; catalogs on exhibits
Activities: Classes for adults & children; docent training; lectr open to public, 2 vis lectrs per year; gallery talks; tours; individual paintings & original objects of art lent to qualified institutions; originate traveling exhibitions; museum shop sells books, original art, reproductions, prints, posters, crafts

L **Library,** Tel 806-371-5050; Fax 806-373-9235; Internet Home Page Address: www.amarilloart.org; *Librn* Dru Scamahorn
Open Tues-Fri 10AM-5PM, Sat & Sun 1-5PM; Circ Non-circulating; For reference only
Library Holdings: Book Volumes 1500; Periodical Subscriptions 18

ARLINGTON

M **ARLINGTON MUSEUM OF ART,** 201 W Main St, Arlington, TX 76010-7113. Tel 817-275-4600; Fax 817-860-4800; Elec Mail ama@arlingtonmuseum.org; Internet Home Page Address: www.arlingtonmuseum.org; *Dir* Anne Allen; *Cur Educ & Grants Assoc* Elizabeth Delaney; *Prog Coordr & Assoc Cur* Rachel Bounds; *Mus Mgr* Jennifer Stark; *Dir Develop* David Loyless
Open Wed 10 AM - 8 PM, Thurs - Sat 10 AM - 5 PM; No admis fee; Estab 1989; Large converted J C Penneys with Mezzanine galleries; Average Annual Attendance: 18,000; Mem: 400; dues $25-$10,000
Income: Financed by endowment, mem, city appropriation & reception rental
Publications: Artifaces, quarterly; AMA News, biannual; exhib catalogs
Activities: Classes for adults & children; docent training; lect series open to public; gallery talks; tours; originate traveling exhibitions

M **UNIVERSITY OF TEXAS AT ARLINGTON,** Gallery at UTA, 502 S Cooper St, Box 19089 Arlington, TX 76019. Tel 817-272-3110; Fax 817-272-2805; Elec Mail bhuerta@uta.edu; Internet Home Page Address: www.uta.edu/gallery; *Dir & Cur* Benito Huerta; *Asst Cur* Patricia Healy
Open Mon-Fri 10 AM - 5 PM, Sat 12 Noon - 5 PM, cl academic holidays & summers; No admis fee; Estab 1975 on completion of Fine Arts Complex. The Gallery serves the entire university; exhibitions are contemporary; Main Gallery is air-cooled, 4000 sq ft with incandescent light; Average Annual Attendance: 15,000
Income: $25,000 (financed by state appropriation, private gifts & grants)
Special Subjects: Painting-American
Collections: Very small collection mainly American & Contemporary
Publications: Tri-fold color brochures on exhibs from past 5 years; exhib catalog; Celia Muñoz: Stories Your Mother Never Told You
Activities: Undergraduate course on museum techniques; lect open to public, 6 vis lectrs per year; gallery talks; catalogs on sale

AUSTIN

M **AUSTIN CHILDREN'S MUSEUM,** 201 Colorado, Austin, TX 78701. Tel 512-472-2499; Fax 512-472-2495; Internet Home Page Address: www.austinkids.org; *Dir* Gwen Crider
Open Tues - Sat 10 AM - 5 PM, Sun Noon - 5 PM; Admis $4.50, children under 2 free; Estab 1983 to provide innovative, participatory Museum exhibits, programs

& resources which encourage curiosity, creativity, appreciation & learning for all children, their families & those who work with children; Offers a variety of hands-on exhibits for children of all ages
Income: Financed through mem, donations & grants
Exhibitions: Feature Exhibits, Global Cityworks, Weather Gallery, Playspace, Theatre Gallery, Time Tower, Creation Station, Soundtracks Studio
Activities: Classes for children; docent training; lect; concerts; gallery talks; tours; competitions

M **AUSTIN MUSEUM OF ART,** 823 Congress Ave #100 Austin, TX 78701. Tel 512-495-9224 ext 229; Fax 512-495-9029; Elec Mail info@amoa.org; Internet Home Page Address: www.amoa.org/; *Exec Dir* Dana Friis-Hansen; *Dir Develop & External Relations* Marilla King; *Dir Educ* Eva Buttacavoli; *Art School Dir* Judith Sims
Open Tues - Sat 10 AM - 6 PM, Thurs 10 AM - 8 PM, Sun Noon - 5 PM; Admis adult $5, seniors & students $4; Estab 1961 to educate and inspire a diverse audience about the visual arts and their relevance to our time; 5000 sq ft (AMOA Gallery - Downtown); 2200 sq ft (AMOA - Laguna Gloria Gallery); Average Annual Attendance: 125,000; Mem: 2900; dues $40 - $1000; annual meeting September
Income: Financed by corporate & individual donations, special events, grants, ann fund, mem, City of Austin
Library Holdings: Auction Catalogs; Audio Tapes; Book Volumes; CD-ROMs; Cassettes; Exhibition Catalogs; Kodachrome Transparencies; Periodical Subscriptions; Slides; Video Tapes
Special Subjects: Latin American Art, Mexican Art, Photography, Afro-American Art
Collections: 20th century painting, sculpture, photographs, prints & drawings
Exhibitions: Changing exhibitions of modern & contemporary art from throughout the world
Publications: Quarterly newsletter & exhib catalogues
Activities: Art School classes for adults & children; cultural & educational programs in conjunction with exhibitions, docent tours; lect open to public, 12 vis lectrs per year; gallery talks; tours; scholarships offered; individual paintings & original objects of art lent to museums; book traveling exhibitions 3-4 per year; originate traveling exhibitions; museum shop sells books

M **CITY OF AUSTIN PARKS & RECREATION,** O Henry Museum, 409 E Fifth St, Austin, TX 78701. Tel 512-472-1903; Fax 512-472-7102; Internet Home Page Address: www.ci.austin.tx.us/parks/ohenry.htm; *Cur* Valerie Bennett
Open Wed - Sun Noon - 5 PM; No admis fee, donations accepted; Estab 1934 to preserve O Henry's works; The 1891 historic home of the famous short story writer. The home exhibits artifacts & memorabilia relating to the author; Average Annual Attendance: 10,000; Mem: 30; dues $25; annual meeting in Jan
Income: $62,000 (financed by mem, city appropriations & programs)
Special Subjects: Ceramics, Decorative Arts, Manuscripts, Furniture, Glass, Period Rooms
Exhibitions: Annual O'Henry PUN-OFF Festival of Wit & Puns; Annual Barnes & Noble Reading
Activities: Classes for adults & children; lect open both to members & public, 1 vis lectr per year; book traveling exhibitions 1 per year; originate traveling exhibitions 1 per year; museum shop sells books

M **CITY OF AUSTIN PARKS & RECREATION DEPARTMENT,** Julia C Butridge Gallery, Dougherty Arts Ctr, 1110 Barton Springs Rd Austin, TX 78704. Tel 512-397-1455; Fax 512-397-1460; Elec Mail megan.weiler@ci.austin.tx.us; Internet Home Page Address: www.ci.austin.tx.us/dougherty/butridge.htm; *Art in Pub Places Mgr* Martha Peters; *Art in Pub Places Coordr* Megan Weiler
Open Mon - Thurs 9 AM - 9:30 PM, Fri 9 AM - 5:30 PM, Sat 10 AM - 2 PM, cl Sun; No admis fee; Estab to preserve & enrich the cultural life of the city; 1800 sq ft of space in a multi-use arts facility available to organizations & artists in the Austin area
Income: Financed by city appropriation
Exhibitions: Rotating schedule presented by local artists & art organizations (all media & subject matter)
Activities: Gallery talks

M **ELISABET NEY MUSEUM,** 304 E 44th St, Austin, TX 78751. Tel 512-458-2255; Fax 512-453-0638; Elec Mail enm@ci.austin.tx.us; Internet Home Page Address: www.ci.austin.tx.us/elisabetney; *Dir* Mary Collins Blackmon
Wed 10 Am - 5 PM, Sun Noon - 5 PM; No admis fee, donations accepted; Estab 1911 to preserve the memory and legacy of 19th C. portrait sculptor, Elisabet Ney (1833-1907). Elisabet Ney portraits and personal memoribilia displayed in the artists 1892 Austin, TX studio; One of five 19th-century American sculpture studios to survive with its contents; Average Annual Attendance: 10,000
Income: $100,000 (financed by city appropriation)
Special Subjects: Architecture, Sculpture, American Western Art, Portraits, Historical Material, Restorations
Collections: Portrait sculptures of 19th-century European & Texas notables by Elisabet Ney in plaster & marble, tools, furnishings & personal memorabilia
Activities: Summer prog for children; concerts; gallery talks; tours

L **Library,** 304 E 44th, Austin, TX 78751. Tel 512-458-2255; Fax 512-453-0638; *Dir* Mary Collins Blackmon
Open Wed - Sat 10 AM - 5 PM, Sun Noon - 5 PM; Estab 1908 to collect background material on subjects relevant to the museum's history & period; For reference only
Library Holdings: Book Volumes 330; Clipping Files; Exhibition Catalogs; Manuscripts; Memorabilia; Original Art Works; Other Holdings Letters; Pamphlets; Periodical Subscriptions 7; Photographs; Slides
Special Subjects: Art History, Manuscripts, Sculpture, Historical Material, Portraits, Bronzes, Art Education, Furniture
Exhibitions: A Life in Art; Elizabet Ney in Austin
Publications: SURSUM, collected letters of Elizabet Ney
Activities: Classes for adults & children; dramatic programs; docent training; AV programs; lect open to public, 3-5 vis lectrs per year; concerts; gallery talks; tours; exten dept serves Austin area school systems

A **MEXIC-ARTE MUSEUM,** 419 Congress Ave, Austin, TX 78768; PO Box 2273, Austin, TX 78768. Tel 512-480-9373; Fax 512-480-8626; Elec Mail director@mexic-artemuseum.org; Internet Home Page Address: www.mexic-artemuseum.org; *CEO* Sylvia Orozco; *Mus Educator* Herlinda Zamora; *Graphic & Exhib Designer* Andres Martinez; *Publ Dir* Jason Rivera; *Mus Shop Mgr* Alyssa Klossner; *Bd Pres* Lulu Flores
Open Mon - Thurs 10 AM - 6 PM; Fri & Sat 10 - 5 PM; Sun 12-5 PM; Adults $5, Students $2; Estab 1984; dedicated to cultural enrichment & educ through the presentation & promotion of traditional & contemporary Mexican, Latino American art and Culture; 4500 sq ft; Average Annual Attendance: 100,000; Mem: 400
Income: 500,000
Library Holdings: Audio Tapes; Book Volumes; Cassettes; Exhibition Catalogs; Records; Video Tapes
Special Subjects: Prints, Woodcuts, Hispanic Art, Latin American Art, Mexican Art
Collections: Graphic prints from workshop of popular graphics from Mexico; Contemporary art work in all disciplines with a focus on Mexican & Latino art
Exhibitions: Mexican Calendar; Mexican Report; Mexico in Excellence
Activities: Children's hands-on activities; panel discussions; docent training; lect open to public; gallery talks; awards; tours; three visiting lect; original objects of art lent to other arts facilities; lending collection; museums; museum shop sells books, magazines, reproductions, folk art

M **SAINT EDWARD'S UNIVERSITY,** Fine Arts Exhibit Program, 3001 S Congress Ave, Austin, TX 78704. Tel 512-448-8400 exten 1338; Fax 512-448-8492; *Dir* Stan Irvin
Open Mon - Fri 8 AM - 6 PM, Sun 1 - 5 PM; No admis fee; Estab 1961 to present for the university population & general pub a monthly schedule of exhibits in the visual arts, as a means of orientation toward established & current trends in art styles in terms of their historical-cultural significance & aesthetic value, through teaching exhibitions, artfilms, pub & private collections from distributing & compiling agencies, museums, galleries & artists; Average Annual Attendance: 10,000
Income: Financed by the college
Exhibitions: Annual art student & faculty exhibitions
Activities: Classes; lect, 1 vis lectr per year; tours; literature

A **TEXAS FINE ARTS ASSOCIATION,** Jones Center For Contemporary Art, 700 Congress St, Austin, TX 78701. Tel 512-453-5312; Fax 512-459-4830; Elec Mail info@arthousetexas.org; Internet Home Page Address: www.arthousetexas.org; *Dir* Virginia Jones; *Educ, Pub Relations* Elizabeth Blackburn
Open Tues, Wed & Fri 11 AM - 7 PM, Thurs 11 AM - 9 PM, Sat 10 AM - 5 PM, Sun 1 - 5 PM; No admis fee; Estab 1911 to promote the growth, development & appreciation of contemporary visual arts & artists in Texas; 3,200 sq ft; Average Annual Attendance: 40,000; Mem: 1300; dues $25
Income: $300,000 (financed by endowment, mem, government grants & earned income)
Exhibitions: Two annual national juried survey exhibitions, one of which is New American Talent; an all media exhibition; the 2nd exhibition has a different theme each year; curated exhibitions & an annual exhibition auction
Publications: Exhibition catalogs; quarterly newsletter
Activities: Lect open to public, 3 vis lectrs per year; originate traveling exhibitions

M **UMLAUF SCULPTURE GARDEN & MUSEUM,** 605 Robert E Lee Rd, Austin, TX 78704. Tel 512-445-5582; Fax 512-445-5583; Internet Home Page Address: www.umlaufsculpture.org; *Business Mgr* Laura Wells; *Educ Coordr* Majorie Wenner; *Exec Dir* Nelie Plourde
Open Wed - Fri 10 AM - 4:30 PM, Sat & Sun 1 - 4:30 PM; Admis general $3.50, seniors $2.50, student $1; Estab 1991 to provide educational programs & experiences that encourage the appreciation of sculpture; Average Annual Attendance: 27,000; Mem: Friends of the UMLAUF Sculpture Garden; The Torchbearers (young professionals)
Income: Financed by endowment, garden rentals for weddings, receptions & parties
Library Holdings: Audio Tapes; Book Volumes; Clipping Files; Exhibition Catalogs; Filmstrips; Kodachrome Transparencies; Manuscripts; Memorabilia; Motion Pictures; Original Art Works; Original Documents; Photographs; Prints; Sculpture
Special Subjects: Drawings, Painting-American, Sculpture, Watercolors, Bronzes, Religious Art, Ceramics, Woodcarvings
Collections: Charles Umlauf Collection (sculptures & drawings); original drawings & paintings; sculptures in exotic woods, terra cotta, cast stone, bronze, alabaster & marble in detailed realism & abstractions
Publications: Garden Grapevine, Newsletter biannual
Activities: Classes for children; docent training; sculpture workshops for special needs students; lect open to public, 6-8 vis lectr per year; concerts; gallery talks; tours; original objects of art lent to other museums that fit borrowing criteria; museum shop sells books, postcards, notecards, mugs & t-shirts

UNIVERSITY OF TEXAS AT AUSTIN

L **Fine Arts Library,** Tel 512-495-4480, 495-4481; Fax 512-495-4490; Elec Mail lschwartz@austin.utexas.edu; Internet Home Page Address: www.lib.utexas.edu/fal; *Head Librn* Laura Schwartz; *Music Librn* David Hunter; *Theatre & Dance Librn* Beth Kerr
Open Mon - Thurs 8 AM - 10 PM; Fri 8 AM - 5 PM; Sat 1 - 5 PM; Sun 1 - 10 PM; Estab 1948 to support teaching & research in Fine Arts fields including PhD level in art history & to the master's level in art educ & studio art; Circ 180,000; For lending; Average Annual Attendance: 160,000
Income: Financed by state appropriation
Library Holdings: Audio Tapes; Book Volumes 300,000; CD-ROMs; Cassettes; Compact Disks; DVDs; Exhibition Catalogs; Fiche 24,000; Other Holdings 17,000; Periodical Subscriptions 900; Records 38,000; Reels 4500; Video Tapes 900
Special Subjects: Art History, Art Education
M **Jack S Blanton Museum of Art,** Tel 512-471-7324; Fax 512-471-7023; Elec Mail blantonmuseum@www.utexas.edu; Internet Home Page Address: www.blantonmuseum.org; *Cur Prints, Drawings & European Paintings* Jonathan Bober; *Assoc Dir* Paige Bartels; *Cur Educ & Academic Affairs* Anne Manning; *Cur American & Contemporary Art* Annette DiMeo Carlozzi; *Dir* Jessie O Hite; *Cur Latin American Art* Gabriel Perez-Barreiro
Open Mon, Tues, Wed & Fri 9 AM - 5 PM, Thurs 9 AM - 9 PM, Sat & Sun 1 - 5 PM; No admis fee; Estab 1963 to serve the students & faculty of the university & the general pub; Average Annual Attendance: 100,000; Mem: 1740; dues $35 & up
Special Subjects: Portraits, Painting-European, Drawings, Hispanic Art, Latin American Art, Mexican Art, Painting-American, Prints, Sculpture, Watercolors, American Western Art, Southwestern Art, Textiles, Religious Art, Woodcarvings, Woodcuts, Etchings & Engravings, Afro-American Art, Baroque Art, Renaissance Art, Antiquities-Greek, Antiquities-Roman, Reproductions
Collections: Suida-Manning Collection; Greek and Roman art; 19th & 20th Century American paintings, including Mari & James A Michener Collection of 20th Century American Art & the C R Smith Collection of Art of the American West; 20th Century Latin American art; prints and drawings from all periods; Leo Steinberg Collection
Exhibitions: Fall 2001 exhibitions open Sept 7; Masterpieces of European Painting - Permanent Installation
Publications: Exhibition catalogues; children's publications
Activities: Classes for adults & children; docent training; lect open to public, 5-15 vis lectrs per year; concerts; gallery talks; tours; symposia; vis artists; film & video series; exten dept serves Texas & the region; individual paintings & original objects of art lent to educational exhibiting organizations (universities & college museums); originate traveling exhibitions to other university art museums & city museums
L **Harry Ransom Humanities Research Center,** Tel 512-471-8944; Fax 512-471-9646; Elec Mail info@hrc.utexas.edu; Internet Home Page Address: www.hrc.utxas.edu; *Dir* Thomas F Staley PhD; *Assoc Dir* Sally Leach, MLIS; *Assoc Dir* Sue Murphy, MLIS; *Assoc Dir* Mary Beth Bigger, MLIS; *Registrar* Debra Armstron Morgan, MLIS
Open 9 AM - 5 PM; Library estab 1957 for reference only, general pub, staff & students; Circ Non-circulating; Average Annual Attendance: 11,000
Income: Financed by endowment, mem, city & state appropriation
Library Holdings: Book Volumes 1,000,000; Manuscripts; Photographs; Prints
Activities: Docent training; lect open to public, 8 vis lectrs per year; gallery talks; tours; scholarships & fels offered; individual paintings & original objects of art lent
L **Architecture & Planning Library,** Tel 512-495-4620; Internet Home Page Address: www.lib.utexas.edu/apl; *Head Librn* Janine Henri; *Cur Alexander Architectural Archive* Beth Dodd
Open fall & spring semesters Mon-Thurs 9 AM - 10 PM, Fri 9 AM - 7 PM, Sat Noon - 6 PM, Sun 1 PM - 10 PM, reduced hours during summer sessions & intersessions; Estab 1925; Circ 172,700; Average Annual Attendance: 97,500
Library Holdings: Auction Catalogs; Audio Tapes 31; Book Volumes 86,200; CD-ROMs 33; Cards 7,979; Cassettes 31; Clipping Files; Exhibition Catalogs; Fiche 25,042; Filmstrips 1; Kodachrome Transparencies 82; Lantern Slides; Manuscripts 980.47 linear ft; Maps 160; Memorabilia 48; Motion Pictures 1; Original Art Works 213; Original Documents; Other Holdings 205,266 architectural drawings; Pamphlets; Periodical Subscriptions 235; Photographs 53,986; Prints; Reels 499; Reproductions; Sculpture; Slides 155,311; Video Tapes 7
Special Subjects: Constructions, Landscape Architecture, Decorative Arts, Historical Material, Interior Design, Furniture, Drafting, Period Rooms, Stained Glass, Carpets & Rugs, Restoration & Conservation, Tapestries, Architecture
Collections: Alexander Architectural Archive
Exhibitions: Blake's Choice web exhibit (ongoing)
Publications: Texas Architecture: A Visual History from the Marian Davis & Doug Blakeley Alexander Collections; Spanish Colonial Architecture in the Alexander Architectural Archive
Activities: Classes for adults & children; tours; lending of original objects of art for exhibitions

A **WOMEN & THEIR WORK,** 1710 Lavaca, Austin, TX 78701. Tel 512-477-1064; Fax 512-477-1090; Elec Mail wtw@texas.net; Internet Home Page Address: www.womenandtheirwork.org; *Exec Dir* Chris Cowden; *Prog Dir* Katherine McQueen
Open Mon - Fri 9 AM - 6 PM, Sat 12 - 5 PM; No admis fee; Estab 1978 to promote recognition & appreciation of women's art; 2000 sq ft of exhib space & a gallery gift shop; Average Annual Attendance: 25,000; Mem: 1000; dues $40
Income: $500,000 (financed by endowment, mem, city & state appropriation, private foundations, corporations & gallery gift shop)
Exhibitions: Visual Arts Exhibs - Juried and curated exhibs of Tex artists & tourig exhibs from outside the region; Gallery Artist Sers - Solo & group exhibs showcasing emerging & mid-career visual artists selected from an ann statewide call-for-entries; Artist Commissions & Fees - Direct financial support for visual & performing artists through honoraria & grants; Dance, Music & Theater Performances - A member of the National Performance Network, Women & Their Work produces events featuring local, regional, and national performing artists, ofte in collaborative venues
Publications: Membership Report, quarterly & Artists Brochures every five wk
Activities: Classes for adults & children; docent training; workshops & symposia for teachers; lect open to public, 4 vis lectrs per year; gallery talks; tours; originate traveling exhibitions all over Texas & other sites outside the state; museum shop sells books, original art, reproductions, prints, craft items, jewelry

BANDERA

M **FRONTIER TIMES MUSEUM,** 506 13th St Bandera, TX 78003; PO Box 1918, Bandera, TX 78003. Tel 210-796-3864; Elec Mail information@frontiertimesmuseum.org; *Treas* Johnny Boyle; *Sec* Dee Bartley; *CEO* Bob Perry; *Receptionist* Dolores Rogers; *Receptionist* Rose Greenawalt; *Mgr* Jane Graham; *Collections Mgr* Rebecca Huffstutler Norton
Open Mon - Sat 10 AM - 4:30 PM; Admis adults $5, seniors $3, children under 12 years $1 (free when accompanied by teachers); Estab 1933 to preserve records,

photographs & artifacts of the American West with emphasis on the local Texas hill country area; Doane Gallery - Western & Tex regional art; Average Annual Attendance: 12,000; Mem: 25; Board of Directors meets 4 times a yr
Income: $20,000 (financed by endowment, $8000 from F B Doane Foundation)
Special Subjects: American Indian Art, Anthropology, Drawings, Etchings & Engravings, Historical Material, Flasks & Bottles, Furniture, Photography, Portraits, Pottery, Painting-American, Watercolors, American Western Art, Dolls, Jewelry, Porcelain, Coins & Medals, Embroidery, Reproductions
Collections: F B Doane Collection of Western Paintings; Louisa Gordon Collection of Antiques, including bells from around the world; J Marvin Hunter Collection of Photographs, Artifacts, Memorabilia of American West and the Texas Hill Country; Photograph Collection; many rare items
Exhibitions: Artist of the Month
Activities: Free admission to educational groups; lect open to the public, 6 vis lectrs per year; tours; museum shop sells books, magazines, reproductions & prints

BEAUMONT

M ART MUSEUM OF SOUTHEAST TEXAS, 500 Main St, Beaumont, TX 77701. Tel 409-832-3432; Elec Mail info@amset.org; Internet Home Page Address: www.amset.org; *Registrar* Monica Hay; *Cur Educ* Sandra Laurette; *Admin Asst* Patsy Brittain; *Pub Relations* Jana Fulbright; *Exec Dir* Lynn Castle; *Cur Art* Ray Daniel
Open Mon - Fri 9 AM - 5 PM, Sat 10 AM - 5 PM, Sun Noon - 5 PM, cl major holidays; No admis fee; Estab 1950 as a non-profit institution to serve the community-through the visual experience & its interpretation as an instrument for educ, cultural enrichment & aesthetic enjoyment; The mus has 2400 sq ft of exhibition space, four galleries; Average Annual Attendance: 65,000; Mem: 850; dues individual $30; annual meeting in Sept
Income: Financed by endowment, mem, city appropriation, fund raisers, grants, mus shop & contributions
Library Holdings: Audio Tapes; Book Volumes; Exhibition Catalogs; Periodical Subscriptions; Slides; Video Tapes
Special Subjects: Graphics, Painting-American, Photography, Sculpture
Collections: 19th & 20th century American folk art, painting, sculpture, graphics & photography
Publications: Qtr newsletter
Activities: Classes for adults & children; docent training; lect open to public, 9 vis lectrs per year; slide lect; gallery talks; tours; sponsors competitions with awards; scholarships offered; individual paintings & original objects of art lent to other institutions; traveling exhibitions organized & circulated; museum shop sells books, original art & reproductions
L Library, 500 Main St, Beaumont, TX 77701. Tel 409-832-3432; Fax 409-832-8508; Elec Mail inso@amset.org; Internet Home Page Address: www.amset.org; *Educ Cur* Janis Zigler Becker
Open Mon - Fri 10 AM - 5 PM; Open to staff & docents for reference only; public for reference only
Library Holdings: Audio Tapes; Book Volumes 3400; Exhibition Catalogs; Periodical Subscriptions 6; Slides
Collections: 19th & 20th century American art; videos on various artists, tours of museums throughout the world
Publications: Quarterly newsletter; exhibition catalogs

A THE ART STUDIO INC, 720 Franklin, Beaumont, TX 77701. Tel 409-838-5393; Fax 409-838-4695; Elec Mail artstudio@artstudio.org; Internet Home Page Address: www.artstudio.org; *Dir* Greg Busceme; *Admin Asst* Ren Brumfeild; *Admin Asst* Tim Postlewaitt
Open Tues-Sat 10AM-6PM; No admis fee; Estab 1983 to provide workspace for area artist/community outreach; One gallery 60 x 30 for exhibitions; one sales gallery; 2-D & 3-D work specializing in ceramics; Average Annual Attendance: 8,000; Mem: 1700; dues minimum $20
Income: $70,000 (financed by mem, individual contributions & private foundations)
Library Holdings: Book Volumes; Exhibition Catalogs; Manuscripts; Memorabilia; Original Art Works; Original Documents
Collections: Permanent ceramic collection of local & international artists' work
Publications: Issue
Activities: Classes for adults & children; juvenile & adult probation programs; dramatic programs; lect open to public; concerts; gallery talks; tours; exten dept serves Juvenile Probation Dept, low income, fixed income; retail store sells original art

M BEAUMONT ART LEAGUE, 2675 Gulf St, Beaumont, TX 77703. Tel 409-833-4179; *Pres* Frank Gerrietts; *VPres* Mary Grace Livesay; *Treas* Mary Ellen Von Netzer; *Office Mgr* Alexis McCarthy
Open Tues - Fri 10 AM - 4 PM; No admis fee; Estab 1943 to promote fine art through exhibitions & art educ; Two spacious galleries with color corrected lighting & spot lights; Average Annual Attendance: 3,500; Mem: 325; dues $20, $30, $40, $50, $75, $100, $500, $1000; annual meeting in May
Income: $26,000 (financed by mem, donations & fundraising), grants
Purchases: Five paintings through purchase awards from juried competition
Library Holdings: Book Volumes 500; Video Tapes 20
Special Subjects: Painting-American, Sculpture, Woodcarvings, Collages
Collections: Permanent collection of paintings, photography & sculpture (88 pieces)
Exhibitions: Portrait Show; 3-D Show; Neches River Festival Exhibition; Gulf Coast Educators; Photography 1993-Juried Competition; Tri-State Plus
Publications: Newletters, 12 per year; class schedules, 4 per year; show entry forms & invitations
Activities: Classes for adults & children; lect open to public, 1-2 vis lectr per year; gallery talks; competitions with awards; lending collection contains books; museum shop sells original art

M MAMIE MCFADDIN WARD HERITAGE HISTORIC FOUNDATION INC, 725 Third St, Beaumont, TX 77701; 1906 McFaddin Ave, Beaumont, TX 77701. Tel 409-832-1906; Fax 409-832-3483; Elec Mail info@mcfaddin-ward.org; Internet Home Page Address: www.mcfaddin-ward.org; *Cur Coll* Sherri Birdsong; *Buildings & Grounds Supv* Felix McFarland; *Dir* Matthew White; *Admin/Deputy Dir* William Stark Jr; *Educ Coordr* Janis Becker; *Mgr Visitor Center* Becky Fertitta
Open Tues - Sat 10 AM - 4 PM, Sun 1 - 4 PM, cl Mon; Admis adults $3, seniors $1.50, children under 8 not admitted; Estab 1982 to preserve, publish, exhibit & present knowledge of the period; Historic house mus with original collections of decorative arts of the period 1890-1950 as left by original owners; 17 rooms, 12,800 sq ft wood frame Beaux Arts Colonial Home with carriage house; Average Annual Attendance: 10,000
Income: $950,000 (financed by endowment)
Special Subjects: Decorative Arts, Period Rooms
Collections: American-made furniture; Continental European ceramics; Oriental rugs; period glass; period silver & porcelain
Publications: Brochure; souvenir booklet; Viewpoints, quarterly
Activities: Classes for children; docent training; family open house; lect open to public, 4-6 vis lectrs per year; museum shop sells books, magazines, prints & slides
L McFaddin-Ward House, 1906 McFaddin Ave, Beaumont, TX 77701. Tel 409-832-1906; Fax 409-832-3483; Elec Mail info@mcfaddin-ward.org; *Dir* Matthew White
Open Tues - Sat 10 AM - 4 PM, Sun 1 - 4 PM; Admis adults $3; Estab 1982 for staff & docent study; For reference only; Average Annual Attendance: 10,000
Income: Foundation funded
Library Holdings: Audio Tapes; Book Volumes 700; Clipping Files; Memorabilia; Pamphlets; Periodical Subscriptions 100; Photographs; Slides; Video Tapes
Collections: Decorative arts
Activities: Classes for adults & children; docent training; lect open to public, 3 vis lectrs per year; museum shop sells books, magazines, slides

BROWNSVILLE

M BROWNSVILLE ART LEAGUE, Brownsville Museum of Fine Art, 230 Neale Dr, Brownsville, TX 78520; PO Box 3404, Brownsville, TX 78520. Tel 956-542-0941; Fax 956-542-7094; Elec Mail bal@prodigy.net; *Dir* Tina Garbo Bailey; *Pres Bd* Hal Morrow; *Operations Chmn* Tencha Sloss
Open Mon - Fri 10:30 AM - 2:30 PM, Sun 1 - 5 PM, cl Thanksgiving & Christmas; No admis fee, donations requested; Estab 1935, mus opened 1977 to offer cultural advantages to lower Rio Grande Valley; Permanent collection on rotating basis housed in the Clara Ely Gallery, 90 x 14 ft; loan exhibitions & members' work in Octavia Arneson Gallery, a 90 x 26 ft gallery; students work in the Historical Neale House Gallery; Average Annual Attendance: 5,000; Mem: 150; dues $120, family $150; meetings 2d Thurs of each month
Income: Financed by donations, fundraisers, mem dues
Collections: Paintings by Marc Chagall, H A DeYoung, M Enagnit, William Hogarth, Augustus John, Dale Nichols, Jose Salazar, Ben Stahl, Fredric Taubes, Hauward Veal, James McNeil Whistler, N C Wyeth, Milford Zornes
Exhibitions: International Art Show
Publications: Brush Strokes, six per year
Activities: Classes for adults & children; workshops by vis artists; lect open to public; tours; individual paintings lent to schools; originate traveling exhibitions

CANYON

M PANHANDLE-PLAINS HISTORICAL SOCIETY MUSEUM, 2401 Fourth Ave, Canyon, TX 79015. Tel 806-651-2244; Fax 806-651-2250; *Dir* Walter R Davis II; *Cur Art* Michael R Grauer; *Asst Dir* Lisa Shippee Lambert
Open Mon - Sat 9 AM - 5 PM, Sun 1 - 5 PM, cl New Years Day, Thanksgiving, Christmas; Admis adults $4, seniors $3, children 4-12 $2, under 4 yrs free, Sundays free; Estab 1921 to preserve history of the region, including all phases of history, fine arts & natural sciences; Five galleries for American, European, Texas & Frank Reaugh art & changing exhibitions; Average Annual Attendance: 125,000; Mem: 1000; dues contributing $1000, life $500, annual $20, student $10; annual meeting May
Income: $500,000 (financed by state)
Special Subjects: Architecture, Drawings, Graphics, Hispanic Art, Latin American Art, Mexican Art, Painting-American, Photography, American Indian Art, American Western Art, Anthropology, Archaeology, Ethnology, Costumes, Ceramics, Crafts, Folk Art, Etchings & Engravings, Landscapes, Decorative Arts, Painting-Japanese, Portraits, Posters, Eskimo Art, Dolls, Furniture, Glass, Jade, Jewelry, Porcelain, Painting-British, Painting-Dutch, Painting-French, Carpets & Rugs, Ivory, Maps, Dioramas, Period Rooms, Embroidery, Antiquities-Oriental, Painting-Spanish, Painting-Italian, Antiquities-Persian, Antiquities-Egyptian, Cartoons, Painting-German, Painting-Russian, Bookplates & Bindings
Collections: Over 1300 paintings by 19th & early 20th century American Painters; 16th-19th century European painters
Exhibitions: Exhibitions rotate & change
Publications: Panhandle-Plains Historical Review, annually
Activities: Classes for adults & children; dramatic programs; docent training; outreach programs for public schools; lect open to public, 5 vis lectrs per year; gallery talks, tours; individual paintings & original objects of art lent to museums only, lending collection includes 1300 paintings; book traveling exhibitions 1 per year; museum shop sells books, reproductions, prints, slides
L Research Center, 2401 Fourth Ave, Canyon, TX 79015. Tel 806-651-2261; Fax 806-651-2250; *Archivist & Librn* Betty Bustos
For reference only
Library Holdings: Audio Tapes; Book Volumes 2000; Cards; Cassettes; Clipping Files; Exhibition Catalogs; Framed Reproductions; Kodachrome Transparencies; Lantern Slides; Manuscripts; Memorabilia; Micro Print; Motion Pictures; Pamphlets; Periodical Subscriptions 40; Photographs; Records; Reels; Reproductions; Slides; Video Tapes

Special Subjects: Art History, Decorative Arts, Commerical Art, Ceramics, Crafts, Archaeology, American Western Art, Cartoons, Art Education, American Indian Art, Anthropology, Antiquities-Oriental, Carpets & Rugs, Antiquities-Egyptian, Architecture

COLLEGE STATION

M **TEXAS A&M UNIVERSITY,** J Wayne Stark University Center Galleries, PO Box J-3, College Station, TX 77844. Tel 979-845-6081; Fax 979-862-3381; Elec Mail uart@stark.tamu.edu; Internet Home Page Address: http://stark.tamu.edu; *Dir* Catherine A Hastedt; *Admin Secy* Beverly Wagner
Open Tues - Fri 9 AM - 8 PM, Sat - Sun Noon - 6 PM; No admis fee; Estab 1974 to bring art exhibits of state & national significance to Texas A & M University; Average Annual Attendance: 45,000
Income: Financed by university funds
Special Subjects: Art Education, Art History, Painting-American
Collections: Paintings by Texas artists
Activities: Classes for adults & children; docent training; lect open to public; gallery talks; tours; book traveling exhibitions; organize traveling exhibitions; museum shop sells books & prints

A **MSC Visual Arts Committee,** Memorial Student Ctr, 1237 TAMU College Station, TX 77843-1237. Tel 979-845-9252; Fax 979-845-5117; Elec Mail kelli@msc.tamu.edu; Internet Home Page Address: www.vac.tamu.edu; Open daily 9 AM - 8 PM, Sat & Sun Noon to 6 PM; No admis fee; Estab 1989; Gallery is 16 x 60 ft with lighting; windows to interior hallway for partial viewing after hours; Average Annual Attendance: 8,000; Mem: 30
Income: Financed by student service fees allotment, donations & art sales
Exhibitions: Annual Juried Student Competition
Publications: Exhibition brochures
Activities: Lect open to public, 1 vis lectr per year; gallery talks; tours; sponsor competitions; book traveling exhibitions 7-8 per year

COLORADO CITY

M **HEART OF WEST TEXAS MUSEUM,** 340 E Third St, Colorado City, TX 79512. Tel 915-728-8285; Fax 915-728-8944; Elec Mail wtmuseum@colorado.net; Internet Home Page Address: www.coloradocity.net/MuseumHeartOfWestTexas; *Pres* A W Rowe; *Dir* Louise Crenshaw; *VPres* Jay McCollum
Open Tues - Sat 2 - 5 PM, cl Mon; No admis fee
Income: Financed by city appropriation

COMMERCE

M **TEXAS A&M UNIVERSITY - COMMERCE,** University Gallery, PO Box 3011, Commerce, TX 75429. Tel 903-886-5102; Fax 903-886-5987; Elec Mail BarbaraFrey@tamu-commerce.edu; *Dir* Barbara Frey
Open Mon - Fri Noon - 5 PM; No admis fee; Estab 1979 to provide exhibitions of interest to the University & local community; Gallery 37 x 30 ft; running ft 206, sq ft 1460; track lighting; floor electrical outlets, climate control, security system; Average Annual Attendance: 3,000
Income: Financed by state appropriation
Collections: Collection of Student Work
Exhibitions: Annual Department of Art Christmas Sale; Faculty Art Show; Graduating Senior's Show; The Lotton Exchange, Austin College; Student Art Association Members' Show; ETSU Student Awards Show; Society of Illustrators Travelling Exhibition; ETSU; ETSU Graduating Seniors Show; other rotating exhibits
Activities: Classes for children; lect open to public, 5-10 vis lectrs per year; gallery talks; tours; scholarships offered; individual paintings & original objects of art lent to regional citizens & University facilities

CORPUS CHRISTI

M **ART COMMUNITY CENTER,** Art Center of Corpus Christi, 100 Shoreline, Corpus Christi, TX 78401. Tel 361-884-6406; Fax 361-884-8836; Elec Mail info@artcentercc.org; Internet Home Page Address: artcentercc.org; *Dir* Rod S Miller; *Admin Asst* Malissa Kay Baker; *Rental Coordr* Lou B Owens
Open Tues - Sun 10 AM - 4 PM; No admis fee; Estab 1972 to promote & support local artists; 5 galleries, all media; Average Annual Attendance: 7,500; Mem: 700; dues $30-$50; annual meeting in May
Income: $75,000 (financed by city appropriation, exhibit fees & sales commissions)
Special Subjects: Drawings, Etchings & Engravings, Landscapes, Marine Painting, Ceramics, Glass, Mexican Art, Porcelain, Portraits, Pottery, Painting-American, Sculpture, Graphics, Hispanic Art, Latin American Art, Photography, Watercolors, Metalwork, Juvenile Art, Mosaics, Stained Glass
Exhibitions: Monthly exhibits by member groups; Annual Dimension Show
Publications: Artbeat, bimonthly newsletter
Activities: Classes for adults & children; gallery talks; tours; lect open to public; Dimension all-mem awards; sales shop sells books, original art, reproductions, print, clay & jewelry

M **BILLIE TRIMBLE CHANDLER ARTS FOUNDATION,** Asian Cultures Museum & Educational Center, 1809 N Chaparral St, Corpus Christi, TX 78401. Tel 361-882-2641; Fax 361-882-5718; Elec Mail asiancm@yahoo.com; Internet Home Page Address: www.geocities.com/asiancm; *Dir Educ* Diane Hansen; *Exec Dir* Catherine LaCroix; *Admin Asst* Martha Munoz
Open Tues - Sat 10 AM - 5 PM, cl New Years, Easter, Memorial Day, July 4, Labor Day, Thanksgiving & Christmas; Admis adults $3, students $2, children (5-15) $2.50, children 12 and under $1; Estab 1973; Exhibits artifacts from Japan, Korea, China, India & Philippines
Income: Financed by private donations & grants

Special Subjects: Bronzes, Costumes, Pottery, Painting-Japanese, Dolls, Jade, Jewelry, Oriental Art, Asian Art, Ivory, Calligraphy, Antiquities-Oriental
Collections: Buddhist decorative arts; oriental & decorative arts including Hakata dolls, porcelains, metal ware, cloisonne & lacquerware; oriental fan collection
Publications: Quarterly newsletter
Activities: Educ dept; gallery talks; sales shop sells general gift items of Asian origin

M **DEL MAR COLLEGE,** Joseph A Cain Memorial Art Gallery, 101 Baldwin, Corpus Christi, TX 78404-3897. Tel 361-698-1216; Fax 361-698-1511; Elec Mail krosier@delmar.edu; Internet Home Page Address: www.delmar.edu; *Chair Art & Drama Dept* Ken Rosier
Open Mon - Thurs 9 AM - 4 PM, Fri 9 AM - Noon; No admis fee; Estab 1932 to teach art & provide exhibition showcase for college & community; Gallery consists of 1750 sq ft plus other smaller areas; Average Annual Attendance: 3,300
Income: Financed by state appropriation & private donations
Special Subjects: Drawings, Sculpture
Collections: Purchases from Annual National Drawings and Small Sculpture Show
Exhibitions: Annual Juried Exhibition open to any U.S. artist
Publications: Exhibition mailer & catalog

M **SOUTH TEXAS INSTITUTE FOR THE ARTS,** Art Museum of South Texas, 1902 N Shoreline Blvd, Corpus Christi, TX 78401. Tel 361-825-3500; Fax 361-825-3520; Internet Home Page Address: www.stia.org; *Assoc Dir* Marilyn Smith; *Assoc Cur Educ* Deborah Fullerton; *Dir* William Otton; *Assoc Cur Educ* Linda Rodriguez; *Assoc Cur* Michelle Locke
Open Tues - Sat 10 AM - 5 PM; Sun 1 PM - 4 PM, Thurs 10 AM - 9 PM, cl Mon, New Year's, Christmas, Thanksgiving; Admis fee adults $3, seniors, students and military $2, 12 & under free; Estab 1960 as a nonprofit organization offering a wide range of programs to the South Texas community in an effort to fulfill its stated purpose to stimulate & encourage the fullest possible understanding & appreciation of the fine arts in all forms with particular interest in the region; A large central area, the Great Hall & a small gallery. The sky-lighted Upper Gallery on the second floor level has over 1900 sq ft of space; Average Annual Attendance: 70,000; Mem: 1000; dues $15-$5000
Income: $900,000 (financed by mem, city & state appropriations, school district)
Special Subjects: Prints
Exhibitions: Varies, call for details
Publications: Exhibition catalogs
Activities: Classes for adults & children; docent training; filmstrips; lect open to public, 10 vis lectrs per year; concerts; gallery talks; tours; competitions; book traveling exhibitions; museum shop sells books, magazines, original art & artifacts related to exhibits

L **Library,** 1902 N Shoreline Dr, Corpus Christi, TX 78401. Tel 361-884-3844; *Cur Educ* Deborah Fullerton-Ferrigno
Open Tues - Fri 10 AM - 5 PM; Admis fee adults $6, seniors, students & military $4, 12 & under free; Estab 1965, to provide reference information for visitors to mus & docent students; For reference only
Income: $2723
Purchases: $2100
Library Holdings: Audio Tapes; Book Volumes 8000; Cassettes; Clipping Files; Exhibition Catalogs; Kodachrome Transparencies; Pamphlets; Periodical Subscriptions 40; Photographs; Reproductions; Slides; Video Tapes

M **TEXAS A&M UNIVERSITY-CORPUS CHRISTI,** Weil Art Gallery, Ctr for the Arts, 6300 Ocean Dr Corpus Christi, TX 78412. Tel 361-825-2314, 825-2317; Fax 361-994-6097; Elec Mail anderson@falcon.tamucc.edu; Internet Home Page Address: www2.tamucc.edu/~dvpa/artsite/gallery/default; *Dir* Mark Anderson
Open Mon - Fri, call for hours (different times for each exhibit), cl school holidays; No admis fee; Estab 1979 to provide high quality art exhibitions to the university & the pub; Average Annual Attendance: 10,000
Income: Financed by private & state funding
Collections: The Lee Goodman Collection
Exhibitions: Contemporary Texas & Mexican Artists
Publications: Exhibition catalogs
Activities: Classes for adults & children; dramatic programs; docent training; lect open to public; gallery talks; tours; scholarships offered; exten dept serves regional & local communities

CORSICANA

L **NAVARRO COLLEGE,** Gaston T Gooch Library & Learning Resource Center, 3200 W Seventh Ave, Corsicana, TX 75110-4818. Tel 903-874-6501; Fax 903-874-4636; Elec Mail dbeau@nav.cc.tx.us; Internet Home Page Address: www.nab.cc.ts.us.org; *Dean* Darrell Beauchamp PhD
Open Mon - Thurs 8 AM - 9 PM, Fri 8 AM - 5 PM, Sun 5 - 8 PM; No admis fee; Estab 1996 to inform & educate regarding the US Civil War; Open viewing of documents in cases
Income: Financed by endowment
Purchases: $1,000,000
Special Subjects: Art History, Intermedia, Commerical Art, Historical Material, Advertising Design, American Indian Art, Drafting, Woodcarvings
Collections: Samuels Hobbitt Collection, woodcarvings; Pearce Civil War Documents Collection; Pearce Western Art Collection; Reading Indian Artifacts Collection; Roe & Ralston Law Library, documents
Exhibitions: Civil War Documents & Memorabilia; Native American Artifacts; Woodcarvings of Artist Ludwig Kleninger

DALLAS

M **THE DALLAS CONTEMPORARY,** Dallas Visual Art Center, 2801 Swiss Ave, Dallas, TX 75204. Tel 214-821-2522; Fax 214-821-9103; Elec Mail info@thecontemporary.net; Internet Home Page Address: www.thecontemporary.net; *Dir & Cur* Joan Davidow; *Operations Coordr* Maureen Doane; *Prog Coordr* Leslie Connally; *Mem Coordr* Chris Elam; *Events Coordr* Taylor McDaniel; *Educ Coordr* Lydia Regalado
Open Tues - Sat, 10 AM - 5 PM, cl Sun; No admis feepi; Estab 1981 to provide exhibition, educ & information opportunities for visual artists & art appreciators in

North Texas; 5 galleries totalling 12,000 sq ft, natural light; track lighting; Average Annual Attendance: 15,000; Mem: 800; dues $50-$2500; mem open to artists & art appreciators
Income: Financed by donations, grants, facility use fees, mem & fundraising
Exhibitions: Theme & solo exhibitions open to the public with both private & public openings; Annual Membership Exhibition
Publications: Exhibition programs & catalogs; newsletter, monthly
Activities: Tours for adults & children; self guided tours; drawing classes; off-site programs for students; classes for adults; tours & classes for children; gallery talks; Legends, in it's 12th year, honors the artist, professional, patron; traveling Exhibitions: galleries, museums in Texas & in the Southwest

A **DALLAS HISTORICAL SOCIETY,** Hall of State, Fair Park, 3939 Grand Ave PO Box 150038 Dallas, TX 75315-0038. Tel 214-421-4500; Fax 214-421-7500; Elec Mail alan@dallashistory.org; Internet Home Page Address: www.dallashistory.org; *Dir* Lisa Hemby; *Dir Colls* Alan Olson; *Archivist* Rachel Roberts
Open Tues - Sat 9 AM - 5 PM, Sun 1 - 5 PM, cl Mon; No admis fee; Estab 1922 to collect & preserve materials relative to the history of Texas & Dallas; The Hall of State is an example of Art-Deco architecture; exhibition space totals 5000 sq ft; Average Annual Attendance: 130,000; Mem: 2000; dues $50; annual meeting in Apr
Income: Financed by mem & city appropriation, private donations
Library Holdings: Auction Catalogs; Audio Tapes; Book Volumes; Cards; Cassettes; Clipping Files; Exhibition Catalogs; Filmstrips; Framed Reproductions; Kodachrome Transparencies; Lantern Slides; Manuscripts; Maps; Memorabilia; Micro Print; Motion Pictures; Original Art Works; Original Documents; Other Holdings; Pamphlets; Periodical Subscriptions; Photographs; Prints; Records; Reels; Reproductions; Sculpture; Slides; Video Tapes
Collections: Texas/Dallas Gallery; Frank Reaugh, Bound for Texas, White House in Miniature
Publications: Dallas Historical Society Register, newsletter biannual; Dallas Rediscovered: A Photographic Chronicle of Urban Expansion; When Dallas Became a City: Letters of John Milton McCoy, 1870-1881; A Guide to Fair Park, Dallas
Activities: In-class programs; classes for adults & children; dramatic programs; docent training; summer children's workshops; lects open to public, 2 vis lectrs per year; gallery talks; tours; awards; book signings; historic & current affairs open forums; sponsor local Awards for Excellence; Stanley Marcus Gale for fashion design achievement; exten dept; individual & original objects of art lent to local school & Houston Museum of Fine Arts; book traveling exhibitions 6 per year; originate traveling exhibitions; sales shops sells books, magazines, reproductions, prints, slides, photos

L **Research Center Library,** Hall of State, Fair Park, PO Box 150038 Dallas, TX 75315. Tel 214-421-4500; Fax 214-421-7500; Internet Home Page Address: www.dallashistory.org; *Dir Colls* Alan Olson; *Archives Dir* Rachel Roberts
Open Wed - Fri 1 - 5 PM by appointment only; For reference only
Library Holdings: Book Volumes 1600; Cards; Cassettes; Clipping Files; Exhibition Catalogs; Filmstrips; Framed Reproductions; Lantern Slides; Manuscripts; Maps; Memorabilia; Motion Pictures; Original Art Works; Other Holdings Archives, pages 2,000,000; Pamphlets; Periodical Subscriptions 20; Photographs; Prints; Records; Reels; Reproductions; Sculpture; Slides; Video Tapes
Special Subjects: Manuscripts, Maps, Historical Material
Collections: R M Hayes Photographic Collection of Texas Historic Sites; J J Johnson & C E Arnold Photographs of Turn-of-the-Century Dallas; Frank Reaugh Paintings; Allie Tennant Papers; Texas Centennial Papers; WWI & WWII posters; Texas Centennial posters
Exhibitions: All Together; WWI Posters of the Allied Nations; Fair Park Moderne: Art & Architecture of the 1936 Texas Centennial Exposition
Publications: Exhibit catalogs
Activities: Activities for school children; docent training; city tours

M **DALLAS MUSEUM OF ART,** 1717 N Harwood, Dallas, TX 75201. Tel 214-922-1200; Fax 214-922-1350; Elec Mail judyC@cdm-art.org; Internet Home Page Address: www.dallasmuseumofart.org; *Cur American Art* Eleanor Jones-Harvey; *New World & Pacific Cultures* Carol Robbins; *Sr Cur Decorative Arts* Charles Venable; *Lupe Murchisan Cur Contemporary Art* Charles Wylie; *Cur Ancient & South Asian Art* Dr Anne R Bromberg; *Marketing* Judy Conner; *Registrar* Gabriella Truly; *Dir Human Resources* Scott Gensemer; *Dir Develop* Diana Duncan; *Deputy Dir* Bonnie Pitman; *Pres Board* Bryant M Hanley; *CFO* Bob Robertson; *Mus Shop Mgr* Donna Herring; *Dir Protection Svcs* Joseph Peek; *Head Exhib* Tamara Woofon-Bonner; *Cur European Art* Dorothy Kosinski; John R Lane; *Assoc Cur* Suzanne Weaver; *Chmn* Jeremy Halbreich
Open Tues, Wed & Fri 11 AM - 5 PM, Sat & Sun 11 AM - 5 PM, Thurs 11 AM - 9 PM, cl Mon; No admis fee; Estab 1903 to purchase and borrow works of art from all periods for the aesthetic enjoyment and education of the public; Fifteen galleries for permanent collection; 14,000 sq ft for temporary exhibition; Average Annual Attendance: 500,000; Mem: 22,000 dues $30 - $10,000; annual meeting May
Income: $8,900,000 (financed by endowment, mem & city appropriation)
Purchases: $1,000,000
Special Subjects: Architecture, Drawings, American Indian Art, American Western Art, Bronzes, African Art, Archaeology, Ceramics, Crafts, Afro-American Art, Decorative Arts, Collages, Asian Art, Antiquities-Byzantine, Carpets & Rugs, Coins & Medals, Baroque Art, Calligraphy, Antiquities-Oriental, Antiquities-Persian, Antiquities-Egyptian, Antiquities-Greek, Antiquities-Roman, Antiquities-Etruscan, Antiquities-Assyrian
Collections: European & American painting & sculpture; ancient Mediterranean & Pre-Columbian art; African, Oceanic & Japanese art; drawings; prints; American & European decorative arts
Publications: Annual report; exhibition catalogs; President's newsletter; quarterly newsletter
Activities: Classes for adults & children; docent training; lect open to public, 50 vis lectrs per year; concerts; Jazz series; film series; gallery talks; tours; exten dept serving Dallas County; artmobile; individual paintings & original objects of art lent to other museums; book traveling exhibitions 3-4 per year; originate traveling

exhibitions; museum shop sells books, magazines, original art, prints, slides, jewelry, toys, cards & puzzles

L **Mildred R & Frederick M Mayer Library,** 1717 N Harwood St, Dallas, TX 75201. Tel 214-922-1276; *Reference Librn* Mary Leonard; *Head of Library* Jackie Allen
Open Tues, Wed & Fri Noon - 4:30 PM, Thurs Noon - 6:45 PM & Sat 1 - 4:30 PM; For reference only, open to pub for research only
Income: Financed by city & private endowment
Library Holdings: Book Volumes 32,000; Exhibition Catalogs; Other Holdings Artist File; Periodical Subscriptions 105
Special Subjects: Art History, Decorative Arts, Pre-Columbian Art

L **J ERIC JOHNSON LIBRARY,** Fine Arts Division, 1515 Young St, Dallas, TX 75201-9987. Tel 214-670-1643; Fax 214-670-1646; Internet Home Page Address: www.dallaslibrary.org; *Mgr Fine Art Div* Victor Kralisz; *Music Librn* Tina Murdock; *Art Librn* Gwen Dixie; *Theater/Film Librn* Cathy Ritchie; *Asst Mgr* Julie Travis
Open Mon - Thurs 9 AM - 9 PM; Fri & Sat 9 AM - 5 PM; Sun 1 PM - 5 PM; No admis fee; Estab 1901 to furnish the citizens of Dallas with materials and information concerning the arts; 42 ft x 32 ft; Average Annual Attendance: 1,500
Income: Financed by city appropriation, federal & state aid, Friends of the Library, endowment
Library Holdings: Auction Catalogs; Audio Tapes; Book Volumes 88,000; Clipping Files 81 drawers; Compact Disks 11,500; Exhibition Catalogs 750; Fiche; Memorabilia; Other Holdings 19,000 Music Scores; Periodical Subscriptions 375; Photographs; Prints; Records 39,000; Video Tapes 4,500
Collections: W E Hill Collection (history of American theater); Lawrence Kelly Collection of Dallas Civic Opera Set & Costume Designs; Manuscript Archives (music); Margo Jones Theater Collection; original fine print collection; John Rosenfield Collection (art and music critic); Interstate Theatre Collection; USA Film Festival Files; Local Archival Material in Film, Dance, Theatre & Music; Dallas Theater Archives; Dallas Theater Center & other local theater collections; Undermain Theater
Exhibitions: "First Timers": Students, Schools, Less Established Artists
Activities: Dramatic programs, dance programs; concerts; sales shop sells books & magazines

M **MIRACLE AT PENTECOST FOUNDATION,** Biblical Arts Center, 7500 Park Lane, PO Box 12727 Dallas, TX 75225. Tel 214-691-4661; Fax 214-691-4752; Internet Home Page Address: www.biblicalarts.org; *Dir* Ronnie L Roese; *Cur* Susan E Metcalf
Open Tues - Sat 10 AM - 5 PM, Thurs evenings by appointment, Sun 1 - 5 PM, cl New Years Day, Thanksgiving, Christmas Eve & Christmas Day; Admis adults $4, seniors $3.50, students 13-18 $3, children 6-12 $2.50, exhibition galleries free; Estab 1966 to provide a place where people of all faiths may have the opportunity to witness the Bible as it inspires mankind in the arts; Average Annual Attendance: 45,000
Income: Financed by private foundation
Special Subjects: Religious Art
Collections: Joseph Boggs Beale's Biblical Illustrations; founder's collection of oriental art; Torger Thompson's Miracle at Pentecost painting & Miracle at Pentecost pilot painting; Biblical art
Exhibitions: Annual Children's Juried Art Show
Publications: Books, Creation of a Masterpiece, Videotape, Pentecost: Gift from God, Christianity and the Arts Magazine
Activities: Educ programs; docent training; gallery talks; competitions; individual paintings & original objects of art lent; book traveling exhibitions 8-12 per year; originate traveling exhibitions to other museums; museum shop sells books, reproductions, prints, slides

SOUTHERN METHODIST UNIVERSITY
L **Hamon Arts Library,** Tel 214-768-2796; Fax 214-768-1800; Elec Mail bmitchel@smu.edu; Internet Home Page Address: www.smu.edu/cul/hamon; *Dir* Alisa Rata; *Fine Arts Librn* Beverly Mitchell
Open Mon - Thurs 8 AM - 12 AM, Fri 8 AM - 6 PM, Sat 9 AM - 5 PM, Sun 1 PM - 12 AM; No admis fee; Estab to support educational curriculum of art & art history department of university; Circ 42,500; Open to the pub for reference & research; Average Annual Attendance: 150,000
Library Holdings: Audio Tapes; Book Volumes 80,000; Cassettes; Compact Disks 9,500; DVDs; Exhibition Catalogs; Fiche; Original Art Works; Other Holdings Music scores; Pamphlets; Periodical Subscriptions 269; Reels; Video Tapes 20,000
Special Subjects: Art History, Folk Art, Decorative Arts, Film, Etchings & Engravings, Painting-American, Painting-British, Painting-Spanish, Ceramics, Fashion Arts, Costume Design & Constr, Antiquities-Byzantine, Antiquities-Egyptian, Antiquities-Etruscan, Antiquities-Greek, Antiquities-Roman, Coins & Medals, Architecture

M **Meadows Museum,** Tel 214-768-2516; Fax 214-768-1688; Internet Home Page Address: smumeadows.edu; *Dir* John L Lunsford; *Admin Asst* Barbara Pierce; *Membership & Spec Events* Jason Scoggins; *Museum Adminr* Amy Duncan; *Museum Educ* Amy Heitzman
Open Mon, Tues, Fri & Sat 10 AM - 5 PM, Thurs 10 AM - 8 PM, Sun 1 - 5 PM, cl Wed; Donations accepted; Estab 1965 to preserve & study the art of Spain; Average Annual Attendance: 44,000
Income: Financed by endowment
Special Subjects: Sculpture, Religious Art, Etchings & Engravings, Landscapes, Baroque Art, Medieval Art, Painting-Spanish
Collections: Paintings: Fernando Yanez de la Almedina (active 1505-1531); Saint Sebastian (1506); Juan de Borgona (active 1508-1514); Juan Carreno de Miranda (1614-1685); The Flaying of Saint Bartholomew (1666); Bartolome Esteban Murillo (1618-1682); The Immaculate Conception (ca 1655); Jacob Laying the Peeled Rods Before the Flocks of Laban (ca 1665); Jusepe de Ribera (1591-1652); Portrait of a Knight of Santiago (ca 1630-40); Diego Rodriguez de Silva y Velazquez (1599-1660); Sibyl With Tabula Rasa (ca 1644-1648); Francisco de Goya (1746-1828); The Madhouse at Saragossa (1794); Joan Miro (1893-1983); Queen Louise of Prussia (1929); Pablo Picasso (1881-1973); Still Life in a

Landscape (1915); Antoni Tapies Grand Noir (Great Black Relief) (1973); Sculpture: Alejo de Vahia (active ca 1480-1510); Pieta (1490-1510); Juan Martinez Montanes (1568-1649); Saint John the Baptist (ca 1630-1635); Anonymous (Follower of Pedro de Mena); Saint Anthony of Padua Holding the Christ Child (ca 1700); El Greco: St Francis Kneeling in Meditation
Publications: Exhibition Catalogue
Activities: Classes for children; docent training; outreach program; lect open to public; concerts; tours; gallery talks; internships & apprenticeships offered; individual paintings & original objects of art lent to other museums & galleries in US & Europe for scholarly exhibitions; traveling exhibitions organized & circulated; sales shop sells slides, catalogs & postcards

C **THE SOUTHLAND CORPORATION,** Art Collection, 2711 N Haskell, PO Box 711 Dallas, TX 75221-0711. Tel 214-828-7011; *Cur* Richard Allen
Collections: 19th & 20th Century Paintings, Sculpture, Photography & Works on Paper

DENTON

M **TEXAS WOMAN'S UNIVERSITY ART GALLERY,** PO Box 425469, Denton, TX 76204. Tel 817-898-2530; Fax 817-898-2496; Elec Mail visualarts@twu.edu; Internet Home Page Address: www.twu.edu/as/va/gallery.html; *Dir* Corky Stuckenbruck; *Chair* John L Weinkein
Open Mon - Fri 9 AM - 4 PM, Sat 1 - 4 PM & Sun upon request; No admis fee; Fine Arts Building consists of two galleries, each consisting of 3000 sq ft; Average Annual Attendance: 4,000
Income: Financed by Art Department & student activities fees
Exhibitions: Departmental galleries have approximately twelve exhibits per school year
Activities: Concerts; gallery talks; tours; competitions with awards; scholarships offered

M **UNIVERSITY OF NORTH TEXAS,** Art Gallery, Art Bldg, Mulberry at Welch, PO Box 305100 Denton, TX 76203-5098. Tel 940-565-2000, 565-4316; Fax 940-565-4717; *Gallery Dir* Diana Block
Open Mon & Tues Noon - 8 PM, Wed - Sat Noon - 5 PM, cl Thanksgiving; No admis fee; Estab 1960 as a teaching gallery directed to students of University of North Texas, the Denton Community & Dallas/Fort Worth area; The gallery covers 193 running ft of exhibition wall sapce, approx 10 ft high, which may be divided into smaller spaces by the use of semi-permanent portable walls; the floor is carpeted-terrazzo; Average Annual Attendance: 10,000
Income: Financed by state appropriation
Collections: Voertman Collection (student purchases); permanent collection
Publications: Exhibition announcements
Activities: Lect open to public, 4-8 vis lectrs per year; tours; competitions; individual paintings & original objects of art lent to the university offices; originate traveling exhibitions to other universities & museums
L **Visual Resources Collection,** School of Visual Arts, Denton, TX 76203. Tel 940-565-4019; Fax 940-565-4717; Elec Mail graham@unt.edu; Internet Home Page Address: www.art.unt.edu; *Visual Resources Cur* Ann Graham
Estab to provide art images for instruction; For reference only
Income: Financed by state taxes
Purchases: $6000
Library Holdings: Cassettes; Lantern Slides; Other Holdings Interactive CD 50; Laserdiscs 10, Image Database; Slides 135,000; Video Tapes 450
L **Libraries,** PO Box 305190, Denton, TX 76203-5190. Tel 940-565-2413, 565-3025, 565-2696; Fax 940-369-8760; Elec Mail dgrose@library.unt.edu; Internet Home Page Address: www.library.unt.edu; *Dean* Donald Grose; *Asst Dean* Sandra Atchison
Open Mon - Thurs 7:30 AM - 2 AM; Fri 7:30 AM - 12 AM; Sat 9 AM - 12 AM, Sun 1 PM - 2 AM; Estab 1903 to support the academic programs & faculty & student research
Income: Financed by state appropriation
Library Holdings: Audio Tapes; Book Volumes 50,000; Cassettes; Exhibition Catalogs; Fiche; Filmstrips; Motion Pictures; Original Art Works; Periodical Subscriptions 186; Prints; Records; Reels; Reproductions; Slides; Video Tapes
Special Subjects: Art History, Photography, Sculpture, Ceramics, Printmaking, Advertising Design, Art Education, Textiles
Collections: Art auction sales catalogs & information

EDINBURG

M **HIDALGO COUNTY HISTORICAL MUSEUM,** 121 E McIntrye, Edinburg, TX 78539. Tel 956-383-6911; Fax 956-383-6911; Elec Mail hchm@hiline.net; Internet Home Page Address: www.riograndeborderlands.org; *Exec Dir* Mrs Shan Rankin; *Asst Dir & Cur Exhibits* Thomas A Fort; *Cur Archives & Coll* David J Mycue; *Develop Officer* Lynne Beeching; *Educ* Rachel Brown; *Pub Relations Officer* Jim McKone; *Coll & Exhib* Robert Garcia; *Programming Officer* Mia Marisol Buentello; *Archival Asst* Esteban Lomas; *Maintenance* Nazario Reyna; *Chmn Board Trustees* Danny Gurwitz; *Admin Asst* Marisela Saenz; *Receptionist* Sandra Luna
Open Tues - Fri 9 AM - 5 PM, Sat 10 AM - 5 PM, Sun 1 - 5 PM; Admis adult $2, seniors $1.50, students $1, children $.50; Estab 1967 to preserve & present the borderland heritage of south Texas & northeastern Mexico; Maintains reference library; Average Annual Attendance: 25,000; Mem: 800; dues $25-$1000
Income: $800,000 (financed by endowment, mem, county & city appropriation, fundraising)
Special Subjects: Graphics, Hispanic Art, Latin American Art, Mexican Art, Photography, American Indian Art, American Western Art, Anthropology, Manuscripts, Portraits, Posters, Maps
Collections: Historic Artifacts of Region
Exhibitions: Regional Emphasis: Early Spanish Settlement; Mexican American War; Civil War; Ranching; Steamboat Era; Hanging Tower; Early Agriculture; Revolution on the Rio Grande
Publications: Exhibition catalogs

Activities: Classes for adults & children; dramatic programs; docent training; lect open to public, 15-20 vis lectrs per year; tours; museum shop sells books, gifts & toys

UNIVERSITY OF TEXAS PAN AMERICAN
Activities: Open to pub; 4 vis lects per yr; ann student awards "Dia de los Huertos" ann competiton; lending of original objects of art to univ offices and bldgs
M **Charles & Dorothy Clark Gallery; University Gallery,** Tel 956-381-2655; Fax 956-384-5072; Elec Mail galleries@utpa.edu; Internet Home Page Address: www.utpa.edu/dept/art/pages/artgall.html; *Gallery Dir* Patricia Ballinger
Open Mon - Fri 9 AM-5 PM, nights and weekends for theater performances; No admis fee; To serve our growing students body & community-at-large; 2 art galleries on campus of University of Texas Pan-American; Average Annual Attendance: 10,000
Income: University funding
Special Subjects: Prints, Sculpture, Ceramics, Posters
Collections: Collection includes pieces by: Josef Albers; Salvador Dali; Honore Daumier; Francisco Goya; Rudolf Hausner; Roy Lichtenstein; Georges Rouault; permanent collection of ceramics, modern sculpture, paintings, posters, pre-Columbian artifacts, prints
Exhibitions: Temporary exhibitions by contemporary artists from around the United States & Mexico; BFA student shows; MFA shows
Activities: Lect open to the public; gallery talks; tours; sponsoring of competitions; Ann Student Art Show awards; lending of original objects of art to Univ offices and buildings
M **UTPA Art Galleries,** Tel 956-381-2655; Fax 956-384-5072; Elec Mail galleries@utpa.edu; Internet Home Page Address: www.utpa.edu/dept/art/pages/artgall.html; *Gallery Dir* Patricia Ballinger
Open Mon - Thurs 10 AM - Noon, Tues & Thurs 1 - 3 PM; No admis fee; Estab 1986 to serve the university student body as well as the community at large; Average Annual Attendance: over 10,000 per yr
Income: Univ funding
Special Subjects: Prints, Sculpture, Ceramics, Posters
Collections: Collection includes pieces by: Joseph Albers; Salvador Dali; Honore Daumier; Francisco Goya; Rudolf Hausner; Roy Lichtenstein; Georges Rouault; permanent collection of ceramics, modern sculpture, paintings, posters, pre-Columbian artifacts, prints
Exhibitions: Temporary exhibitions by contemporary artists from around the United States & Mexico; BFA student shows; Masters Fine Arts Exhibitions
Activities: Lect open to the public; gallery tours; student competitions

EL PASO

M **CITY OF EL PASO,** One Arts Festival Plaza, El Paso, TX 79901. Tel 915-532-1707; Fax 915-532-1010; Elec Mail ramirezGX@ci.el-paso.tx.us; Internet Home Page Address: www.elpasoartmuseum.org; *Dir* Becky Duval Reese; *Cur of Coll* William R. Thompson; *Registrar* Elizabeth A. Schorr; *Asst Cur* Jerry Medrano; *Cur Educ* Lori Eklund; *Asst Cur Educ* Ann Camp
Open Tus - Sat 9 AM - 5 PM, Sun noon - 5 PM, cl Mon; Admis fee general admission $1, students & children $.50; free on Sun; Estab 1960 as a cultural & educational institution; Tom Lea Gallery, De Wetter Gallery, Contemporary Gallery, Samuel H. Kress Gallery; Average Annual Attendance: 80,000; Mem: 750; dues $15-$5000
Income: Financed by mem & city appropriation
Library Holdings: Auction Catalogs; Exhibition Catalogs; Pamphlets; Periodical Subscriptions
Special Subjects: Graphics, Hispanic Art, Latin American Art, Mexican Art, Painting-American, Photography, Watercolors, American Western Art, Pre-Columbian Art, Southwestern Art, Woodcuts, Afro-American Art, Painting-European, Painting-French, Baroque Art, Painting-Flemish, Renaissance Art, Painting-Spanish, Painting-Italian
Collections: Kress Collection of Renaissance & Baroque Periods; 19th & 20th century American painting; contemporary American & Mexican; Mexican Colonial paintings; works on paper, American & European
Publications: Members' newsletter, teacher newsletter
Activities: Classes for adults & children; docent training; lect open to public, concerts; gallery talks; tours; individual paintings & original objects of art lent to other museums & institutions on request; originate traveling exhibitions to accredited museums & university galleries; museum shop sells unique gifts, museum catalogs, souvenirs, books, reproductions, slides, jewelry, toys, home & office products
L **El Paso Museum of Art,** One Arts Festival Plaza, El Paso, TX 79901. Tel 915-532-1707; Fax 915-532-1010; Internet Home Page Address: www.elpasoartmuseum.org; *Cur Coll* Amy Grimm; *Cur Coll* Christian Gerstheimer; *Registrar* Michelle Ryden; *Cur Educ* Amy Reed; *Asst Cur Coll* Ben Fyffe
Open Tues - Sat 9 AM - 5 PM, Sun Noon - 5 PM, cl Mon & city holidays; No admis fee; Estab 1947; Open to the pub & mem for reference only; Average Annual Attendance: 100,000; Mem: 900
Library Holdings: Auction Catalogs; Book Volumes 1500; Cards; Exhibition Catalogs; Kodachrome Transparencies; Periodical Subscriptions 8; Slides
Special Subjects: Art History, Photography, Painting-American, Painting-Flemish, Painting-French, Painting-German, Painting-Italian, Painting-Spanish, Prints, Painting-European, Latin American Art, American Western Art, American Indian Art, Mexican Art, Aesthetics, Afro-American Art
Collections: Samuel H Kress Collection; 19th & 20th century American Art; Colonia Mexican Art
Publications: James Surls: Walking with Diamonds, 99; Eugene Thurston: The Majesty of the Southwestern Landscape, 2000
Activities: Classes for adults & children; dramatic programs; docent training; lect open to public, 25 vis lect per yr; concerts; gallery talks; tours; Design Awards, TX Assoc Museums; extension program lends original objects of art to mus; book traveling exhibitions; originate traveling exhibitions to regional mus; museum shop sells books, slides & original art
M **El Paso Museum of Archaeology,** 4301 Transmountain Rd, El Paso, TX 79924. Tel 915-755-4332; Fax 915-759-6824; Elec Mail

archaeologymuseum@elpasotexas.gov; Internet Home Page Address: www.elpasotexas.gov/arch_museum/; *Dir* Marc Thompson PhD; *Cur* Jason Jurgena; *Educ Cur* Lora Jackson

Open Tues - Sun 9 AM - 5 PM; Free; Estab 1977 as an archaeological mus to show human adaptation to a desert environment; Mus contains replica of Olla Cave, a Mogollon cliff dwelling & four other prehistoric dioramas & artifacts from the US Southwest & Mexico; Average Annual Attendance: 45,000; Mem: Student $15, individual $25, family $40

Income: Financed by city appropriation

Special Subjects: American Indian Art, Archaeology

Collections: Five dioramas depict life styles & climate changes of Paleo Indians including the hunting & gathering area & the Hueco Tanks site; Pre-Columbian (Casas Grandos) & Mogollon archaeological artifacts; Apache, Tarahumara artifact collections

Activities: Classes for children; slide lect demonstrations at schools & civic organizations; docent training; lect open to public; tours; sponsor competitions; book traveling exhibitions annually; sales shop sells books, reproductions & prints

M **CITY OF EL PASO MUSEUM AND CULTURAL AFFAIRS,** (City of El Paso Arts Resources Dept) People's Gallery, Two Civic Center Plaza, 2nd Floor, El Paso, TX 79901. Tel 915-541-4481; Fax 915-541-4902; Elec Mail fierrole@ci.el-paso.tx.us; Internet Home Page Address: www.artsandculture.org; *Dir* Yolanda Alameda

Open Mon - Fri 8 AM - 5 PM; No admis fee; Estab 1979; The gallery showcases the work of emerging & professional artists from the El Paso/Juarez region, traveling exhibits, as well as national & international artists, whose themes offer a multicultural perspective on the world in which we live; Average Annual Attendance: 48,777

Income: $7200 (financed by the city (hotel motel tax)

Special Subjects: Hispanic Art, Mexican Art, Painting-American, Photography, Watercolors, American Indian Art, American Western Art, African Art, Crafts, Folk Art, Afro-American Art, Porcelain, Asian Art, Metalwork, Painting-Spanish, Cartoons

Publications: Season Brochure, annual

Activities: Book traveling exhibitions 3 per year

M **UNIVERSITY OF TEXAS AT EL PASO,** Glass Gallery and Main Gallery, Department of Art, 500 W University Ave El Paso, TX 79968. Tel 915-747-5181; Fax 915-797-6749; Elec Mail bonansin@utep.edu; Internet Home Page Address: www.utep.edu/arts; *Dir* Kate Bonansinga

Open Mon - Thurs 8:30 AM - 5 PM; No admis fee; University estab 1916, Department of Art established 1940; Main Gallery is 1,500 sq ft for solo and group exhibs of contemporary art in support of the disciplines taught in dept of art; Average Annual Attendance: 50,000

Income: Financed by city and state appropriation

Special Subjects: Painting-American, Prints, Crafts

Publications: Exhibition catalogs

Activities: Classes for adults & children; lect open to public, 2-4 gallery talks per year; tours; competitions; extension work offered through university extension service to anyone over high school age; fees vary; originate traveling exhibitions

FORT WORTH

M **AMON CARTER MUSEUM,** 3501 Camp Bowie Blvd, Fort Worth, TX 76107-2695. Tel 817-738-1933; Fax 817-377-8523; Internet Home Page Address: www.cartermuseum.org; *Pres* Ruth Carter Stevenson; *Dir* Rick Stewart; *Exec Asst to Dir* Trish Matthews; *Sr Cur Prints & Drawings* Jane Myers; *Cur Photographs* John Rohrbach; *Cur Photographic Coll* Barbara McCandless; *Assoc Cur Prints & Drawings* Rebecca Lawton; *Librarian* Allen Townsend; *Dir Exhib & Coll Serv* Wendy Haynes; *Coll Mgr* Courtney Morfeld; *Registrar* Melissa Thompson; *Dir Develop & Mem* Melanie Boyle; *Dir Educ* Lori Eklund; *Dir Finance & Operations* Jeff Guy

Open Tues - Sat 10 AM - 5 PM, Sun Noon - 5 PM, cl Mon & holidays; No admis fee for permanent collection; Estab 1961 for the study & documentation of nineteenth & early twentieth century American art through permanent collections, exhibitions & publications; Main gallery plus eleven smaller galleries; Average Annual Attendance: 100,000; Mem: 800; dues $35 - $10,000

Income: Financed by endowment, grants & contributions

Special Subjects: Drawings, Painting-American, Photography, Prints, Sculpture, Watercolors, American Western Art, Bronzes, Etchings & Engravings, Landscapes

Collections: American paintings & sculpture; print collection; photographs

Publications: Monthly Calendar of Events, bi-annual Program & active publication program in American art & history

Activities: Classes for adults & children; docent training; lect open to public, 10 vis lectrs per year; gallery talks; tours; individual paintings & original objects of art lent to national art museums; lending collection contains original art works, paintings, photographs, sculpture & ephemera material; book traveling exhibitions 2-3 per year; originate traveling exhibitions 2-3 to national art museums; museum shop sells books, prints & gift items

L **Library,** 3501 Camp Bowie Blvd, Fort Worth, TX 76107-2062. Tel 817-738-1933; Fax 817-989-5079; Elec Mail library@cartermuseum.org; Internet Home Page Address: www.cartermuseum.org; library_set.html; *Assoc Librn, Cataloguer* Sam Duncan; *Archivist* Paula Stewart; *Visual Arts Coordr* Katherine Moloney

Open Wed & Fri 11 AM - 4 PM, Thurs 11 AM - 7 PM; Estab 1961; Average Annual Attendance: 400

Library Holdings: Auction Catalogs; Book Volumes 30,000; Clipping Files; Exhibition Catalogs; Fiche 100,000; Pamphlets; Periodical Subscriptions 130; Reels 7000; Slides

Special Subjects: Photography, Drawings, Graphic Arts, Painting-American, Prints, American Western Art, Bronzes

Collections: Western Americana; exhibition catalogs (including the Knoedler Library on fiche); American art, history & photography; Laura Gilpin Library of photographic books, pamphlets & periodicals; New York Public Library artist files and print files on microfiche; 19th century U.S. newspapers on film; extensive vertical file material on U.S. artists, museums, commercial galleries & subjects

C **BANK ONE FORT WORTH,** 500 Throckmorton, PO Box 2050 Fort Worth, TX 76102. Tel 817-884-4000; Fax 817-870-2454; *Property Mgr* Lew Massey

Estab 1974 to enhance the pub areas of bank lobby & building; to provide art for offices of individual bank officers; Collection displayed throughout bank building, offices & public space

Collections: Alexander Calder sculpture; more than 400 pieces of drawings, graphics, paintings, prints, sculpture & tapestries, focusing on art of the Southwest, including artists throughout the nation & abroad

Activities: Tours for special groups only; sponsor two art shows annually; provide cash prizes; scholarships offered

L **FORT WORTH PUBLIC LIBRARY ARTS & HUMANITIES,** Fine Arts Section, 500 W 3rd, Fort Worth, TX 76102. Tel 817-871-7737; Fax 817-871-7734; Elec Mail tstone@fortworthlibrary.org; Internet Home Page Address: www.fortworthlibrary.org; *Unit Mgr* Thelma Stone; *Librn* Elmer Sackman; *Libr Asst* Gayle Mays; *Libr Asst* 'D' Metcalf

Open Mon - Thurs 9 AM - 9 PM, Sat 10 AM - 6 PM, Sun Noon - 6 PM; No admis fee; Estab 1902

Income: Financed by appropriation

Library Holdings: Cassettes; Clipping Files; Fiche; Original Art Works; Other Holdings Articles, Books, Music scores, Pamphlets & programs, Sheet music, Special clipped picture files; Pamphlets; Photographs; Prints; Records; Video Tapes

Special Subjects: Cartoons, Bookplates & Bindings

Collections: Hal Coffman Collection of original political cartoon art; Nancy Taylor Collection of bookplate; historic picture & photograph collection autographed by various celebrities; rare books

Exhibitions: Antiques, crafts, prints, original photographs & original works; also art gallery exhbns of paintings, sculpture, photographs, folk crafts

Publications: Bibliographies; catalogs; monthly Focus

Activities: Tours

M **KIMBELL ART MUSEUM,** 3333 Camp Bowie Blvd, Fort Worth, TX 76107-2792. Tel 817-332-8451; Fax 817-877-1264; Internet Home Page Address: www.kimbellart.org; *Pres* Kay Fortson; *Dir* Timothy Potts; *Cur European Art* Nancy Edwards; *Chief Conservator* Claire Barry; *Librn* Chia-Chun Shih; *Dir Finance & Administration* Susan Drake; *Sr Cur* Malcolm Warner; *Marketing and Pub Relations* Mindy Riesenberg; *Cur of Asian Art* Jennifer Casler Price

Open Tues - Thurs & Sat 10 AM - 5 PM, Fri Noon - 8 PM, Sun Noon - 5 PM, cl Mon, July 4, Thanksgiving, Christmas & New Year's; No admis fee; Open to public 1972 for the collection, preservation, research, publication & public exhibition of art of all periods; Average Annual Attendance: 300,000; Mem: 24,000; dues $40-$10,000

Income: Financed by endowment

Special Subjects: Sculpture, African Art, Pre-Columbian Art, Painting-European, Asian Art, Antiquities-Egyptian, Antiquities-Greek, Antiquities-Roman, Antiquities-Assyrian

Collections: Highly selective collection of European paintings & sculpture from Renaissance to early 20th century; Mediterranean antiquities; African sculpture; Asian sculpture, paintings & ceramics; Pre-Columbian sculpture & ceramics

Publications: In Pursuit of Quality: The Kimbell Art Museum/An Illustrated History of the Art & Architecture; Light is the Theme: Louis I Kahn & the Kimbell Art Museum; biannual calendar; exhibition catalogs

Activities: Classes for adults & children, hearing impaired & sight impaired; docent training; lect open to public; gallery talks; tours; original objects of art & individual paintings lent to other museums organizing important international loan exhibitions; book traveling exhibitions; originate traveling exhibitions to other museums; museum shop sells books, magazines, reproductions, slides, art related videotapes, puzzles, posters

L **Library,** 3333 Camp Bowie Blvd, Fort Worth, TX 76107. Tel 817-332-8451; Fax 817-877-1264; Internet Home Page Address: www.kimbellart.org; *Librn* Chia-Chun Shih

Open by appointment only; No admis fee; Estab 1967 to support museum staff, docents & research in area; For reference use of curatorial staff

Library Holdings: Auction Catalogs 11,600; Book Volumes 37,000; Exhibition Catalogs; Fiche 20,500; Motion Pictures; Periodical Subscriptions 154; Reels; Slides

Collections: European art from ancient to early 20th century, Oriental, Pre-Columbian & African art; Witt Library on microfiche

M **MODERN ART MUSEUM,** (Fort Worth Art Association) 3200 Darnell St, Fort Worth, TX 76107. Tel 817-738-9215; Fax 817-735-1161; Elec Mail info@themodern.org; Internet Home Page Address: www.themodern.org; *Chief Cur* Michael Auping; *Cur Educ* Terri Thornton; *Membership & Spec Events* Suzanne Woo; *Registrar* Rick Floyd; *Secy* Claudia Carrillo; *Public Information Officer* Kendal Smith Lake; *Admin Asst to Cur* Susan Colegrove; *Design & Installation* Robert Caslin; *Head Design & Installation* Tony Wright; *Bus Mgr* Joe Garwood; *Computer Systems Mgr* Jim Colegrove; *Bldg Engineer* Scott Grant; *Museum Store Mgr* Mary Beth Ebert; *Asst Museum Store Mgr* Lorri Wright; *Dir* Marla Price; *Asst Cur* Andrea Karnes

Tues - Sat 10 AM - 5 PM, Sun 11 AM - 5 PM; Admis $8 general (13-adult), $4 students w/ID & seniors (60 plus), children 12 & under and members free; Modern & contemporary art; Average Annual Attendance: 200,000; Mem: 5,500; President's Circle $5,000; Individual $1,000; Contributor $500; Sustainer $200; Family $125; Assoc $100; Basic $50

Special Subjects: Architecture, Hispanic Art, Latin American Art, Mexican Art, Painting-American, African Art, Ceramics, Landscapes, Afro-American Art, Collages, Painting-European, Painting-Japanese, Painting-Canadian, Furniture, Glass, Metalwork, Painting-British, Painting-Dutch, Painting-French, Painting-Flemish, Painting-Italian, Painting-Australian, Painting-German, Painting-Israeli, Painting-New Zealander

Collections: Works by modern & contemporary masters, notably Picasso, Kandinsky, Still, Rothko, Judd, Marden, Dine, Rauschenberg, Oldenburg, Lichtenstein, Warhol, Hodgkin, Avery, Scully & Motherwell; Post 1940's art from all countries, paintings, sculpture, drawings, prints & gifts; Photography by Cindy Sherman, Carrie May Williams, Bill Viola

Publications: Quarterly calendar; "Art the Modern" (Magazine)

Activities: Classes for adults & children; docent training; lect open to public & for members only, 20 vis lectrs per year; gallery talks; tours; concerts; scholarships; originate traveling exhibitions organized & circulated; museum shop sells books, magazines & reproductions

M SID W RICHARDSON FOUNDATION, Sid Richardson Museum, 309 Main St, Fort Worth, TX 76102. Tel 817-332-6554; 888-332-6554; Fax 817-332-8671; Elec Mail info@sidrichardsonmuseum.org; Internet Home Page Address: www.sidrichardsonmuseum.org; *Dir Educ* Rebecca J Martin; *Dir* Jan Scott; *Asst Dir & Store Mgr* Monica Herman
Open Mon - Thurs 9 AM - 5 PM, Fri - Sat 9 AM - 8 PM, Sun 12 AM - 5 PM, cl major holidays; No admis fee; Estab 1982 to enable downtown visitors & workers to view the paintings in a metropolitan setting; Average Annual Attendance: 50,000
Income: Financed by the Sid W Richardson Foundation
Special Subjects: Painting-American, Watercolors, American Western Art, Bronzes
Collections: Frederic Remington, Charles M Russell & others (over 100 western art paintings)
Exhibitions: Permanent exhibit of 60 paintings by Frederic Remington, Charles M Russell & other Wester artists
Publications: Remington & Russell, The Sid Richardson Collection
Activities: Classes for adults & children; outreach program; gallery talks; tours; museum shop sells books, prints, postcards, note cards, posters, reproduction bronzes & prints on canvas

M TEXAS CHRISTIAN UNIVERSITY, University Art Gallery, Dept of Art & Art History, Campus Box 298000 Fort Worth, TX 76129. Tel 817-257-7643; Fax 817-257-7399; Elec Mail rwatson@tcu.edu; Internet Home Page Address: www.artanddesign.tcu.edu; *Dir* Ronald Watson
Open Mon 11 AM - 6 PM, Tues - Fri 11 AM - 4 PM, Sat & Sun 1 - 4 PM; No admis fee; Estab to present the best art possible to the student body; to show faculty & student work; Gallery consists of one large room, 30 x 40 ft, with additional movable panels; Average Annual Attendance: 10,000
Income: Financed by college funds
Collections: Japanese 18th Century Prints & Drawings; Contemporary Graphics; Art in the Metroplex; juried local artists
Publications: Exhibition notes, mailers & posters
Activities: Classes for adults; lect open to public, 15 vis lectrs per year; gallery talks; competitions

M UNIVERSITY OF NORTH TEXAS HEALTH SCIENCE CENTER FORTH WORTH, Atrium Gallery, 3500 Camp Bowie Blvd, Fort Worth, TX 76109-2699. Tel 817-735-2000; Elec Mail jsager@hsc.unt.edu; Internet Home Page Address: www.hsc.unt.edu/artcompetition; *Art Show Coordr* Judy Sager
Open Mon - Fri 8 AM - 5 PM, Sat 9 AM - 5 PM, Sun 1 - 5 PM; No admis fee; Estab 1986 as a nonprofit, pub service gallery; Three-story pub service gallery in North Texas featuring international groups like The SFA & SWA, PSH works in all media by a variety of artists; Average Annual Attendance: 4,000
Income: Financed by state appropriation
Collections: Permanent Collection of the Society of Watercolor Artists
Exhibitions: Annual 12-County High School Art Competition; changing monthly exhibits; Colored Pencil Society of America
Activities: Teacher workshops; competitions with prizes; 12 vis lectrs per yr; sponsoring of competitions; scholarships

GAINESVILLE

L NORTH CENTRAL TEXAS COLLEGE, Library, 1525 W California St, Gainesville, TX 76240. Tel 940-668-7731, Ext 338; Fax 940-668-6049; *Dir Library Svcs* Dana Pearson
Open Mon - Thur 8 AM - 9:30 PM, Fri 8 AM - 4:30 PM, Sun 2 - 5 PM; Estab 1924 to serve the needs of the administration, faculty & students; Circ 500
Purchases: $1500
Library Holdings: Audio Tapes; Book Volumes 50,000; Cards; Cassettes; Clipping Files; Fiche; Filmstrips; Lantern Slides; Motion Pictures; Pamphlets; Periodical Subscriptions 175; Prints; Records; Reproductions; Slides; Video Tapes
Activities: Brownbook reviews

GALVESTON

L ROSENBERG LIBRARY, 2310 Sealy Ave, Galveston, TX 77550. Tel 409-763-8854; Fax 409-763-0275; Elec Mail jaugelli@rosenberg-library.org; Internet Home Page Address: www.rosenberg-library.org; *Head Special Coll* Casey Greene; *Museum Cur* Eleanor Clark; *CEO, Exec Dir* John Augelli; *Pres* Jan Coggeshall
Open Mon - Sat 9 AM - 5 PM; cl Sun & national holidays; No admis fee; Estab 1904 to provide library services to the people of Galveston, together with lectures, concerts, exhibitions; Library includes the Harris Art Gallery, The James M Lykes Maritime Gallery, The Hutchings Gallery, together with miscellaneous art & historical exhibit galleries & halls
Income: $55,000,100 (financed by endowment, city & state appropriation)
Library Holdings: Book Volumes 250,000; Compact Disks; DVDs; Fiche; Manuscripts; Maps; Memorabilia; Motion Pictures; Original Art Works; Original Documents; Periodical Subscriptions 500; Photographs; Prints; Sculpture
Collections: Historical objects relating to Galveston & Texas; photographic & manuscript collections; historic maps & architectural drawings; large collection of paintings with a focus on regional artists & maritime subjects; large collections of American & European decorative glass, textiles, silver & Native American crafts
Exhibitions: Permanent exhibit of Galveston maritime history; rotating exhibits of framed art, decorative arts, photographs & other historic objects
Activities: Historical lect & presentations; book signings; public prog; gallery tours; joint exhibs with other local mus; active loan prog

HOUSTON

A ART LEAGUE OF HOUSTON, 1953 Montrose Blvd, Houston, TX 77006-1243. Tel 713-523-9530; Fax 713-523-4053; Elec Mail artleagh@neosoft.com; Internet Home Page Address: www.hfac.uh.edu/freeland/ALH; *Pres (V)* Margaret Poisaant; *Exec Dir* Claudia Solis
Open Mon - Fri 9 AM - 5 PM, Sat 11 AM - 5 PM; No admis fee; Estab 1948 to promote pub interest in art & the achievements of Houston area artists; Gallery maintained for monthly exhibits; Average Annual Attendance: 20,000; Mem: 1500; dues $25-$1000; annual meeting in May/June
Income: $300,000 (financed by grants, mem & fundraising functions)
Exhibitions: Monthly exhibits; Regional exhibitions; The Gala, Sharon Koprova
Publications: Exhibition catalogs; newsletter, monthly
Activities: Classes for adults & children; Cameron Foundation Artpresence docent Program; HIV & Art Outreach Program; Multiple Sclerosis Outreach Program; lect open to public; competitions with prizes; workshops, gallery talks; tours; sales shop sells calendars, craft items, original art, print reproductions

M ART MUSEUM OF THE UNIVERSITY OF HOUSTON, Blaffer Gallery, Entrance 16 off Cullen Blvd, Houston, TX 77204-4891; 120 Fine Arts Bldg, Houston, TX 77204-4018. Tel 713-743-9521; Fax 713-743-9525; Internet Home Page Address: www.blaffergallery.org; *Dir* Terrie Sultam; *Asst Dir* Nancy Hixon; *Dir Develop* Elisa Dreghorn; *Cur Educ* Katherine Veneman; *Adminr* Karen Zicterman; *Chief Preparator* Kelly Bennett; *Dir Pub Relations* Claudia Schmuckli; *Curatorial Mgr* Susan Conaway; *Cur Univ Collections* Michael Guidry; *Asst Registrar* Young Min Chung
Open Tues - Sat 10 AM - 5 PM; cl major holidays; No admis fee; Estab 1973 to present a broad spectrum of visual arts, utilizing the interdisciplinary framework of the University, to the academic community and to the rapidly increasing diverse population of greater Houston; Main gallery is 3,760 sq ft, ceiling height varies from 10-25 ft; Second floor gallery is 2,980 sq ft; Average Annual Attendance: 45,000
Income: Financed by state appropriation, university, local funds, grants, gifts
Special Subjects: Graphics, Latin American Art, Mexican Art, Painting-American, Photography, Afro-American Art, Decorative Arts, Painting-Japanese, Asian Art, Painting-British, Painting-French, Painting-Spanish, Painting-Italian, Painting-Australian, Painting-German
Exhibitions: Exhibitions change quarterly, call for details
Publications: Exhibition catalogs on originating shows
Activities: Outreach school programs; workshops; videos; docent training; lect open to public, 6-10 vis lectrs per year; concerts; gallery talks; tours; competitions with awards; book traveling exhibitions 3-4 per year; originate traveling exhibitions 1 per year to various contemporary art museums; museum shop sells books & gift items

L William R Jenkins Architecture & Art Library, 106 Space ARC, Houston, TX 77204-4431. Tel 713-743-2340; Internet Home Page Address: www.uh.edu; *Mgr* Yolanda Rodriguez; *Librn* Margaret Culbertson; *Librn* Charlene Kanter
Open Mon - Thurs 8 AM - 7:45 PM, Fri 8 AM - 4:45 PM, Sat 1 - 4:45 PM, cl Sun; For reference only, students & faculty
Income: Financed by state appropriation
Library Holdings: Book Volumes 70,000; Fiche 15,683; Pamphlets; Periodical Subscriptions 230; Reels 182
Special Subjects: Art History, Photography, Architecture

M BAYOU BEND COLLECTION & GARDENS, PO Box 6826, Houston, TX 77265. Tel 713-639-7750; Fax 713-639-7770; Elec Mail bayoubend@mfah.org; Internet Home Page Address: www.mfah.org/bayoubend; *Exec Asst* Sally White; *Cur* Michael K Brown; *Dir Educ* Kathleen B O'Connor; *Conservator* Steven Pine; *Cur Gardens* Bart Brechter
House open Tues - Fri 10 AM - 11:30 AM & 1 PM - 2:45 PM, Sat 10 AM - 11:30 AM, Sun 1 PM - 4 PM; Gardens open Tues - Sat 10 AM - 5 PM, Sun 1 PM - 5 PM; Admis House & Gardens adults $10, seniors & students with ID $8.50, children 10-17 $5, children 9 & under no admis fee. Admis Gardens adults, senior citizens & children $3, children 9 & under no admis fee; Estab 1957 dedicated to serving all people by pursuing excellence in art & horticulture through collection, exhibition & education; Twenty-eight room settings that trace the evolution of American style from 1620's to 1870's; Average Annual Attendance: 48,435; Mem: Board meetings Sep - Nov & Jan - May
Library Holdings: Auction Catalogs; Exhibition Catalogs
Special Subjects: Decorative Arts, Etchings & Engravings, Folk Art, Glass, Flasks & Bottles, Furniture, Porcelain, Portraits, Pottery, Painting-American, Prints, Period Rooms, Textiles, Silver, Carpets & Rugs, Embroidery, Pewter
Collections: American furniture, ceramics, glass, paintings, silver, textiles, works on paper
Activities: Classes for adults & children; dramatic programs; docent training; lect open to public, 2 vis lectrs per year; concerts; gallery talks; tours; scholarships & fellowships offered; exten dept; originate traveling exhibitions to libraries in greater Houston area; mus shops sells books

M CONTEMPORARY ARTS MUSEUM, 5216 Montrose, Houston, TX 77006-6598. Tel 713-284-8250; Fax 713-284-8275; Elec Mail kblanton@kmh.org; Internet Home Page Address: riceinfo.rice.edu/projects/cam/; Internet Home Page Address: www.camh.org; *CEO & Dir* Marti Mayo; *Asst Dir* Mike Reed; *Registrar* Tim Barkley; *Public Relations Dir* Kelli Blanton; *Cur* Lynn M Herbert; *Asst Public Relations Dir* Ebony McFarland; *Assoc Cur* Paola Morsiani; *Assoc Cur* Valerie Cassel; *VPres* Edward Allen; *Dir Edu & Pub Relations* Paula Newton; *VChmn* Robert P Palmquist; *Mus Shop Mgr* Sue Pruden
Open Tues, Wed, Fri & Sat 10 AM - 5 PM, Thurs 10 AM - 9 PM, Sun Noon - 5 PM; No admis fee; Estab 1948 to provide a forum for art with an emphasis on the visual arts of the present & recent past, to document new directions in art through changing exhibitions & publications, to engage the public in a lively dialogue with today's art & to encourage a greater understanding of contemporary art through educational programs; One large gallery of 10,500 sq ft and a smaller gallery of 1500 sq ft; Average Annual Attendance: 91,000; Mem: 1800; dues $30 & up
Income: $1,300,000
Exhibitions: Out of the Ordinary: New Art from Tex; Outbound: Passages from the '90's

Publications: Exhibition catalogs; quarterly calendar
Activities: Lect open to public, 5-6 vis lectrs per year; gallery talks; tours; originate traveling exhibitions; museum shop sells books & gifts

M DIVERSE WORKS, 1117 E Freeway, Houston, TX 77002. Tel 713-223-8346; Fax 713-223-4608; Elec Mail info@diverseworks.org; Internet Home Page Address: www.diverseworks.org; *Co-Dir* Diane Barber; *Co-Dir* Sixto Wagan; *Admin Dir* Stephanie Atwood
Open Wed - Sat Noon - 6 PM; No admis fee; Estab 1983 to present work by contemporary artists working in all arts media & residencies; Main gallery 40 ft x 70 ft, small gallery 20 ft x 30 ft; Average Annual Attendance: 30,000
Income: $500,000 (financed by individual & foundation contributions, federal & city funds, earned income)
Exhibitions: 10-15 exhibitions a year of Texas & National Artists; 25 exhibitions per year of dance, music, performance & theatre
Activities: Lect open to public, 20 vis lectrs per year; concerts; tours

M HOUSTON BAPTIST UNIVERSITY, Museum of American Architecture and Decorative Arts, 7502 Fondren Rd, Houston, TX 77074. Tel 281-649-3311; Fax 281-649-3489; *Dir* Lynn Miller
Open Tues - Fri 10 AM - 4 PM, Sun 2 - 5 PM, cl holidays & summer; No admis fee; Estab 1969 to depict social history of Americans & diverse ethnic groups who settled in Texas; Small reference library maintained; Average Annual Attendance: 9,000; Mem: 125; dues $25
Special Subjects: Decorative Arts, Dolls, Furniture, Miniatures
Collections: Theo Redwood Blank Doll Collection; Schissler Antique Miniature Furniture Collection; furniture & decorative arts
Activities: Docent training; lect open to public, 2-4 vis lectrs per year; tours

A HOUSTON CENTER FOR PHOTOGRAPHY, 1441 W Alabama, Houston, TX 77006. Tel 713-529-4755; Fax 713-529-9248; Elec Mail info@hcponline.org; Internet Home Page Address: www.hcponline.org; *Exec Dir* Allison Hunter; *Pres* Patricia Eifel; *Prog Dir* Madeline Yale; *Educ Coordr* Rachel Hewlett; *Exec Asst* Jennifer Hennessy; *Finance Admin* Brenda Mendiola; *Weekend Gallery Mgr* Paul Elhoff
Open Wed - Fri 11 AM - 5 PM, Sat - Sun Noon - 6 PM; No admis fee; Estab 1981; Maintains reference library; Average Annual Attendance: 10,000; Mem: 800; dues $35 & up
Income: $175,000 (financed by endowment, mem, city & state appropriation, NEA & private gifts)
Special Subjects: Photography
Exhibitions: Membership & Fellowship exhibitions
Publications: Spot, bi-annual
Activities: Classes for adults & children; outreach program; lect open to public; gallery talks; tours; competitions; fels; book traveling exhibitions; originate traveling exhibitions to museums & non-profit galleries

A HOUSTON FOTO FEST INC, 1113 Vine St Ste 101, Houston, TX 77002. Tel 713-223-5522; Fax 713-223-4411; Elec Mail info@fotofest.org; Internet Home Page Address: www.fotofest.org; *Dir Art* Wendy Watriss; *Pres* Fred Baldwin
Estab to promote public appreciation for photographic art, international & cross-cultural exchange & literacy through photography

L HOUSTON PUBLIC LIBRARY, Fine Arts & Recreation Dept, 500 McKinney Houston, TX 77002-2534. Tel 713-236-1313; Fax 713-247-3302; Elec Mail jharvath@hpl.lib.tx.us; Internet Home Page Address: www.houstonlibrary.org; *Mgr Fine Arts & Recreation* John Harvath; *Asst Mgr* Sandra Stuart
Open Mon - Fri 9 AM - 9 PM, Sat 9 AM - 6 PM, Sun 2 - 6 PM; Estab 1848 as a private library for the Houston Lyceum & opened to the pub in 1895; Circ 142,651; Monthly exhibits, including art shows are spread throughout the Central Library Building
Income: Financed by endowment, city appropriation & Friends of the Library
Library Holdings: Book Volumes 160,110; Clipping Files 24,131; Exhibition Catalogs; Other Holdings Auction Catalogs 6742; Compact Discs 9500; Sheet Music 15,325; Pamphlets; Periodical Subscriptions 400; Records
Special Subjects: Decorative Arts, Oriental Art
Activities: Lect open to public; tours; lending collection contains 9500 compact discs

M MENIL FOUNDATION, INC, (Menil Collection) The Menil Collection & Cy Twombly Gallery , 1515 Sul Ross Houston, TX 77006; 1511 Branard St, Houston, TX 77006. Tel 713-525-9400; Fax 713-525-9444; Elec Mail info@menil.org; Internet Home Page Address: www.menil.org; *Dir* Josef Helfenstein; *Financial Dir* EC Moore; *Dir Develop* William Taylor; *Cur* Matthew Drutt; *Sr Adjunct Cur* Walter Hopps; *Sr Adjunct Cur* Mark Rosenthal; *Chief Conservator* Elizabeth Lunning; *Librn* Philip T Heagy; *Registrar* Anne Adams; *Exhib Coordr* Deborah Velders; *Pres* Louise Stude-Sarofin; *Pub Relations* Vance Muse
Open Wed - Sun 11 AM - 7 PM; No admis fee; Opened in 1987, estab to organize & present art exhibitions & progs; two modern landmarks designed by Renzo Piano; Average Annual Attendance: 175,000; Mem: 1000; dues student $50, levels $100 - $10,000
Income: Financed by pvt foundation and pvt endowment & mems
Library Holdings: Auction Catalogs; Book Volumes; Clipping Files; Photographs; Prints
Special Subjects: Afro-American Art, Photography, Pre-Columbian Art, Prints, Painting-American, African Art, Religious Art, Primitive art, Antiquities-Byzantine, Renaissance Art, Medieval Art, Antiquities-Oriental, Antiquities-Persian, Antiquities-Egyptian, Antiquities-Greek, Antiquities-Roman, Antiquities-Etruscan, Antiquities-Assyrian
Collections: Antiquities from the Paleolithic to the pre-Christian eras; Art of Africa; Medieval & Byzantine art; Oceanic & Pacific Northwest tribal cultures; 20th century drawings, paintings, photographs, prints & sculpture; Permanent collection at 16,000
Publications: Exhibition catalogs
Activities: Classes for children; lect open to public, 8 vis lects per yr; Walter Hopps Award for Curatorial Achievement; originate traveling exhibitions; museum shop sells books & exhibition posters

M MIDTOWN ART CENTER, 3414 La Branch St, Houston, TX 77004-3841. Tel 713-521-8803; Tel 713-521-8803; *Dir* Ida Thompson
Varies; No admis fee; Estab 1982 as a multi-cultural, multi-disciplinary art center serving grassroots artists
Income: Financed by mem & donations
Exhibitions: Local artist exhibitions throughout the year;

M MUSEUM OF FINE ARTS, HOUSTON, 1001 Bissonnet, PO Box 6826 Houston, TX 77265. Tel 713-639-7330; Fax 713-639-7399; Elec Mail pmarzio@mfah.org; Telex 77-5232; Cable MUFA HOU; *Dir* Peter C Marzio; *Assoc Dir* Gwen Goffe; *Assoc Dir* Paul Johnson
Open Tues - Sat 10 AM - 5 PM, Thurs until 9 PM, Sun 12:15 - 6 PM; Adults $7, seniors & students $3.50, Thurs free; Estab 1900 as an art mus containing works from prehistoric times to the present; Exhibition space totals 325,000 sq ft; Average Annual Attendance: 1,500,000; Mem: 40,000; dues $45-$3,000
Library Holdings: Auction Catalogs; Book Volumes; Clipping Files; Exhibition Catalogs; Original Documents; Pamphlets; Periodical Subscriptions
Special Subjects: Painting-American, Photography, Sculpture, American Indian Art, Pre-Columbian Art, Primitive art, Decorative Arts, Painting-European, Oriental Art, Medieval Art, Antiquities-Greek, Antiquities-Roman, Gold
Collections: African, Oceanic, Pre-Columbian & American Indian art objects; American & European graphics, paintings & sculpture; European & American decorative arts including Bayou Bend Collection of American decorative Arts; Rienal Collection of European Decorative Arts; major collection of Impressionist & Post-Impressionist paintings; Medieval & Early Christian work; Oriental art; Western Americana; antiquities, photography; Lillie & Hugh Roy Cullen Sculpture Garden; Encyclopedic collection of world art in all media, spanning 5,000 years; 2 house museums for American decorative arts & European decorative arts
Publications: Bulletin, semi-annual; calendar of events, bimonthly; catalogs of exhibitions
Activities: Classes for adults & children; docent training; programs specifically for educators; lect open to public, 100 vis lectrs per year; concerts; gallery talks; tours; scholarships; individual paintings & original objects of art lent to other art institutions; originate traveling exhibitions to qualified museums; museum shop sells books, magazines, prints & slides

L Hirsch Library, 1001 Bissonnet, PO Box 6826 Houston, TX 77265-6826. Tel 713-639-7325; Fax 713-639-7399; Elec Mail pr@mfah.org; Internet Home Page Address: www.mfah.org; *Dir* Margaret Culbertson; *Dir* Peter C Marzio; *Assoc Dir Finance & Administration* Gwen Goffe; *Cur Exhibitions, Asst to Dir* Janet Landay
Open Tues, Wed & Fri10 AM - 5 PM, Thur & Fri 10 AM - 9 PM, Sat12 PM - 7 PM; No admis fee; Estab 1900; For reference only
Income: Financed by Hirsch Endowment
Library Holdings: Book Volumes 80,000; Exhibition Catalogs; Fiche; Other Holdings Archival Records; Artists' Ephemera Files; Museum Files; Pamphlets; Periodical Subscriptions 250; Reels; Slides; Video Tapes
Special Subjects: Art History, Decorative Arts, Film, History of Art & Archaeology, Latin American Art, Fashion Arts, Art Education, Asian Art, American Indian Art, Furniture, Costume Design & Constr, Glass, Afro-American Art, Gold, Jewelry
Collections: Encyclopedic collection of world art in all media, spanning 5000 years; 2 house museums for American decorative arts & European decorative arts
Publications: MFAH Houston Visitor Guide; numerous exhibition catalogs; MFAH Today, bimonthly member publication

RICE UNIVERSITY
L Alice Pratt Brown Library of Art, Architecture & Music, Tel 713-348-4832, 527-4800; Fax 713-348-5258; Internet Home Page Address: www.rice.edu/library; *Music Librn* Mary DuMont; *Art Librn* Jet M Prendeville
Open academic yr Mon-Thurs 8:30 AM - 11 PM, Fri 8:30 AM - 9 PM, Sat 9:30 AM - 9 PM, Sun 12:30 - 11 PM; Estab 1964 combined art, architecture, music collections in the Alice Pratt Brown Library estab 1986
Income: $130,300 (financed by Rice Univ)
Library Holdings: Book Volumes 87,027; Cassettes; DVDs; Exhibition Catalogs 6000; Other Holdings Scores; Periodical Subscriptions 493; Records
Special Subjects: Art History, Film, Photography, Architecture

M Rice Gallery, Tel 713-348-6069; Fax 713-348-5980; Elec Mail ruag@rice.edu; Internet Home Page Address: www.ricegallery.org; *Mgr* Jaye Anderton; *Dir* Kimberly Davenport; *Preparator* David Krueger; *Curatorial Asst* Katherine Kuster
Open Tues - Sat 11 AM - 5 PM & Thurs 11 AM - 7 PM, Sun Noon - 5 PM during academic yr; No admis fee; Estab 1971 to present site-specific installations by artists of national & international reputation; Circ Over 190,000 vols on campus in the Brown Fine Arts Library; 40 x 44 ft white box with one glass wall; Average Annual Attendance: 25,000; Mem: 150; dues range from $20-$2500
Income: $500,000 (financed by Rice University, gifts & grants)
Purchases: $450,000; non-collecting institution
Publications: Exhibit catalogs
Activities: Opportunity to work with artists during their residencies; lect & panel discussions, symposia & performances are free & open to public; gallery talks; tours; 5+ vis lects per yr

INGRAM

A HILL COUNTRY ARTS FOUNDATION, Duncan-McAshan Visual Arts Center, Hwy 39, Ingram, TX 78025; PO Box 1169, Ingram, TX 78025. Tel 830-367-5121, 367-5120; Fax 830-367-5725; Elec Mail visualarts@hcaf.com; Internet Home Page Address: www.hcaf.com; *Art Dir* Jennifer Haynes
Gallery open Mon - Fri 9 AM - 5 PM, Sat 1 - 4 PM; No admis fee except for special events; Estab 1958 to provide a place for creative activities in the area of visual arts & performing arts; also to provide classes in arts, crafts & drama; 1800 sq ft; Average Annual Attendance: 35,000; Mem: 600; dues $40 & up; annual meeting first Sat in Dec
Income: Financed by endowment, mem, benefit activities, donations & earned income
Library Holdings: Auction Catalogs; Audio Tapes; Filmstrips; Motion Pictures; Original Art Works; Original Documents; Other Holdings Sculpture; Slides; Video Tapes
Collections: 50+ pieces - contemporary paintings, prints, photographs & sculpture

Exhibitions: 8 rotating exhibits per yr; Regional Christmas Show
Publications: Spotlight, quarterly newsletter
Activities: Classes for adults & children; dramatic programs; lect open to public, 2 vis lectr per year; concerts; national juried competitions with awards; scholarships offered; museum shop sells books, magazines, original art & prints

IRVING

M IRVING ARTS CENTER, Main Gallery & Focus Gallery, 3333 N MacArthur Blvd, Irving, TX 75062. Tel 972-252-7558; Fax 972-570-4962; Elec Mail minman@ci.irving.tx.us; Internet Home Page Address: www.ci.irving.tx.us/arts; *Exec Dir* Richard E Huff; *Cur & Dir* Marcie J Inman; *VChmn* Kim Dennis; *Dir Marketing* Jo Trizila; *Asst Dir* Rosemary Meng
Open Mon - Fri 9 AM - 5 PM, Sat 10 AM - 5 PM, Sun 1 - 5 PM; No admis fee; Estab 1990
Income: Financed by hotel/motel occupancy tax
Special Subjects: Painting-American, Photography, Sculpture, Watercolors, Pottery, Woodcuts
Publications: Artimes, monthly
Activities: Classes for children; lect open to public, 3 vis lectrs per year; book traveling exhibitions 2 per year

JOHNSON CITY

M THE BENINI FOUNDATION & SCULPTURE RANCH, 377 Shiloh Rd, Johnson City, TX 78636. Tel 830-868-5244; Internet Home Page Address: www.sculptureranch.com; *Pres* Lorraine Benini
No admis fee; Estab 1984
Special Subjects: Sculpture
Collections: Contemporary Italian paintings & sculpture

KERRVILLE

M L D BRINKMAN FOUNDATION, 444 Sidney Baker S, Kerrville, TX 78028. Tel 830-257-2000; Fax 830-257-2030; *Cur* Health Thompson
Open by appointment; No Admis fee; Estab 1985 to promote western art; Closed for renovations; Average Annual Attendance: 700
Special Subjects: Painting-American, Watercolors, American Indian Art, American Western Art, Bronzes, Southwestern Art
Collections: American Western Art (1870's - Present): works on paper, paintings & sculpture, including Cowboy Artists of America
Activities: Individual paintings & original objects of art lent

M THE MUSEUM OF WESTERN ART, cowboy Artists of America Museum, 1550 Bandera Hwy, PO Box 294300 Kerrville, TX 78029. Tel 830-896-2553; Fax 830-896-2556; Internet Home Page Address: www.caamuseum.com; *Exec Dir* Michael W. Duty; *Asst Dir* Kris Westerson
Open Mon - Sat 9 AM - 5 PM, Sun 1 - 5 PM; Admis adults $5, seniors $3.50, children 6-18 $1; Estab 1983 to display contemporary art of American West; Average Annual Attendance: 45,000; Mem: 1000; dues $30-$10,000
Income: $650,000 (financed by mem dues, contributions, entrance fees & sales in mus shop)
Library Holdings: Auction Catalogs; Book Volumes; Clipping Files; Exhibition Catalogs; Memorabilia; Original Art Works; Pamphlets; Photographs; Reels; Slides; Video Tapes
Collections: Western American Realism Art by members of The Cowboy Artists of America
Publications: Visions West: History of the Cowboy Artists Museum, newsletter, quarterly
Activities: Classes for young serious art students, adults & students; docent programs; lect open to public; 4 vis lectrs per year; gallery talks; tours; scholarships offered; original objects of art lent to other museums; book traveling exhibitions 2 per year; originate traveling exhibitions; museum shop sells books, magazines, original art, reproductions & prints
L Library, PO Box 294300, Kerrville, TX 78029. Tel 830-896-2553, Ext. 226; Fax 830-896-2556; Internet Home Page Address: www.caamuseum.com; *Librn* Nan Stover; *Vol Librn* Nancy Doig
Open by appointment during museum hrs; For reference only
Income: Financed by donations & mem
Library Holdings: Book Volumes 3,000; Cards; Clipping Files; Exhibition Catalogs; Framed Reproductions; Kodachrome Transparencies; Manuscripts; Memorabilia; Original Art Works; Pamphlets; Periodical Subscriptions 10; Photographs; Prints; Slides
Special Subjects: Art History, Illustration, Painting-American, Prints, Historical Material, American Western Art, Bronzes, Printmaking, American Indian Art

KINGSVILLE

M TEXAS A&M UNIVERSITY, Art Gallery, Art Dept, Box 157 Kingsville, TX 78363. Tel 361-593-2619, 593-2111; *Dir* Santa Barrazz
Open Mon - Fri 9 AM - 4 PM; No admis fee; Estab to exhibit art work of students, as well as visitors; Average Annual Attendance: 3,000
Income: Financed by state appropriations
Exhibitions: Student Art Exhibits

LONGVIEW

M LONGVIEW MUSEUM OF FINE ART, (Longview Art Museum) 215 E Tyler St, Longview, TX 75601; PO Box 3484, Longview, TX 75606. Tel 903-753-8103; Fax 903-753-8217; Internet Home Page Address: http://www.lmfa.org; *Dir* Renee Hawkins; *Events Coordr* Paula Davis; *Publicist* Zoe Glascock; *Admin Asst* Aimee Klein
Open Tues - Fri 10 AM - 4 PM, Sat Noon - 4 PM; No admis fee; Estab 1958 by Junior Service League for the purpose of having a contemporary art museum in

the community; Circ 1000; East Gallery 15, 000 sq ft in 3 open rooms; Average Annual Attendance: 20,000; Mem: 500; $10 - $5000; $50 family; Board of Trustees monthly meetings
Income: Financed by mem & guild projects, donations & grants
Library Holdings: Book Volumes
Special Subjects: Painting-American, Photography, Prints, Sculpture, Watercolors, Ceramics, Woodcuts, Etchings & Engravings, Landscapes, Afro-American Art, Collages, Portraits, Posters, Painting-Australian
Collections: Regional Artists Collection formed by purchases from Annual Invitational Exhibitions over the past 35 years; work by contemporary Texas artists
Exhibitions: (spring) Annual Invitational Exhibit; (fall) Annual Winners Exhibit, (Apr) Annual Student Art
Publications: Exhibition catalogs
Activities: Classes for adults & children; docent training; day at museum with artist in residence for all 4th grade students; artworks creative learning center; lect open to public, 4-6 vis lectrs per year; talks; competitions with cash awards; individual paintings & original objects of art lent; originate traveling exhibitions; museum shop sells prints, museum quality crafts & gifts, gallswork & jewelry

LUBBOCK

M CITY OF LUBBOCK, Buddy Holly Center, 1801 Ave G, Lubbock, TX 79401. Tel 806-767-2686; Fax 806-767-0732; Elec Mail cprose@buddyhollycenter.org; Internet Home Page Address: www.buddyhollycenter.org; *Sales & Mktg* Shelby Morrison; *Educ Coordr* Rachel Crockett; *Exec Coordr* Patricia Earl; *Asst Dir* Catherine Prose
Open Tues - Fri 10 AM - 6 PM, Sat 11 AM - 6 PM; Estab 1984; Fine Art Gallery; Texas Musicians Hall of Fame; Buddy Holly Gallery
Collections: Buddy Holly Memorabilia; Contemporary art
Exhibitions: Buddy Holly; Illuminance; Celebration; crafts
Activities: Classes for adults & children; docent training; lect open to public; concerts; gallery talks; tours; sponsoring of competitions; museum shop sells books, magazines, original art, reproductions

M TEXAS TECH UNIVERSITY, Museum of Texas Tech University, Fourth St & Indiana Ave, Box 43191 Lubbock, TX 79409-3191. Tel 806-742-2442; Fax 806-742-1136; Elec Mail museum.texastech@ttu.edu; Internet Home Page Address: www.museum.ttu.edu; *Assoc Dir Operations* David K Dean; *Cur History* Henry B Crawford; *Cur Anthropology* Dr Eileen Johnson; *Cur Ethnology & Textiles* Mei Wan Campbell; *Cur Natural Science Research Lab* Dr Robert Baker; *Cur Vertebrate Paleontology* Dr Sankar Chatterjee; *Coll Mgr (Sciences) & Cur of Coll (Sciences)* Richard Monk; *Coll Mgr (Anthropology)* Susan Baxevanis; *Registrar* Nicola Ladkin; *Exec Dir* Gary Edson; *Educ Prog Mgr* Dr Lee Brodie; *Exhibit Design Mgr* Denise Newsome
Open Main Building Tues - Sat 10 AM - 5 PM, Thurs 10 AM - 8:30 PM, Sun 1 - 5 PM, cl Mon; Moody Planetarium Tues - Fri, 3:30 - 7:30 PM, Sat & Sun 2 - 3:30 PM; Lubbock Lake Landmark Tues - Sat 9 AM - 5 PM, Sun 1 - 5 PM, cl Mon; No admis fee forMuseum & Lubbock Lake Landmark; Moody Planetarium adult $1, student $.50, children under 5 and adults 65 & older free; Estab 1929 for pub service, research & teaching. Mus mission: collect, preserve & interpret knowledge about Texas, the Southwest & other regions as related by natural history, heritage & climate; 12 permanent galleries for art; 5 temporary galleries in Main Building, 1 gallery at Landmark; Average Annual Attendance: 150,000; Mem: 1,000; dues MTTUA $20, $40 & $60; annual meetings MTTUA in July & Nov
Income: Financed by state appropriations, Museum of Texas Tech University Association, private donations, local, regional, national research grants
Special Subjects: Folk Art, Ceramics, Flasks & Bottles, Pottery, Drawings, Hispanic Art, Latin American Art, Painting-American, Photography, Prints, Sculpture, Watercolors, American Western Art, Bronzes, African Art, Anthropology, Archaeology, Ethnology, Pre-Columbian Art, Southwestern Art, Textiles, Costumes, Religious Art, Crafts, Woodcarvings, Etchings & Engravings, Landscapes, Portraits, Dolls, Furniture, Glass, Jade, Historical Material, Ivory, Embroidery, Laces, Leather
Collections: Archaeology; ceramics; contemporary paintings; ethnology; graphics; history; Texas contemporary artists; Diamond M Fine Art; sciences; paleontology
Exhibitions: Changing exhibitions of art, sciences, photography & history; permanent exhibitions of anthropology, archaeology & history; Paleo/Indian archaeological site, Lubbock Lake Landmark
Publications: MuseNews newsletter, quarterly; Museum Journal, annually; occasional papers, as needed; Museology, as needed
Activities: Classes for adults & children; docent training; lect open to public, 8-9 vis lectrs per year; concerts; gallery talks; tours; sponsoring of competitions; scholarships offered; individual paintings & original objects of art lent to other museums; exten program serves local school districts, hostels, MHMR; book traveling exhibitions 8-10 per year; originate traveling exhibitions usually within Texas; two museum shops sell books, magazines, original art, reproductions, prints & slides
L School of Art Visual Resource Center, School of Art , Rm B10 Lubbock, TX 79409-2081. Tel 806-742-2887 exten 239; Fax 806-742-1971; Elec Mail ybprw@ttacs.ttu.edu; Internet Home Page Address: www.art.ttu.edu/artdept/artdepinfo/vrc; *Visual Resource Cur* Philip Worrell; *Sr. Office Asst.* Elissa Steinert
Open Mon - Thurs 7:30 AM - 5:00 PM, Fri 8 AM - 5 PM, summer hours vary; Reference & teaching library
Income: $10,000 (financed by state legislature appropriation, private donations & grants)
Library Holdings: Book Volumes 4000; Compact Disks; DVDs; Other Holdings CD-Roms; Periodical Subscriptions 50; Slides 110,000; Video Tapes 190
Special Subjects: Art History, Calligraphy, Advertising Design, Art Education, Asian Art, American Indian Art, Aesthetics, Antiquities-Oriental, Antiquities-Persian, Antiquities-Assyrian, Antiquities-Byzantine, Antiquities-Egyptian, Antiquities-Etruscan, Antiquities-Greek, Antiquities-Roman

LUFKIN

A MUSEUM OF EAST TEXAS, 503 N Second St, Lufkin, TX 75901. Tel 409-639-4434; Fax 936-639-4435; *Exec Dir* J P McDonald; *Admin Asst* Claudine Lovejoy; *Cur Coll* Ruth Callahan
Open Tues - Fri 10 AM - 5 PM, Sat - Sun 1 - 5 PM, cl Independence Day, Thanksgiving & Christmas; No admis fee; Estab 1975 by the Lufkin Service League to bring the fine arts to East Texas & to cultivate an interest in regional history; Average Annual Attendance: 12,000; Mem: 500; dues benefactor $5000, President's Circle $1000, patron $500, sustainer $250, sponsor $150, contributor $100, family $60, individual $25
Income: financed by mem & grants
Exhibitions: East Texas Art; Exhib change every 4 months
Publications: Bi-monthly newsletter
Activities: Classes for adults & children; docent training; trips; film series; lect open to public; gallery talks; tours; competitions with awards; book traveling exhibitions

MARFA

M CHINATI FOUNDATION, One Cavalry Row, PO Box 1135 Marfa, TX 79843; PO Box 1135 Marfa, TX 79843-1135. Tel 432-729-4362; Fax 432-729-4597; Elec Mail information@chinati.org; Internet Home Page Address: www.chinati.org; *Dir* Marianne Stockebrand PhD; *Pres* Timothy Crowley
Open Wed - Sun first 1/2 of tour 10 AM, 2nd 1/2 of tour 2 PM; Admis adults $10, seniors & students $5, members free; Estab 1986; Non profit pub foundation, permanent installations by limited number of artists; Average Annual Attendance: 10,000; Mem: 1,200
Income: financed by mem, grants & donations
Library Holdings: Cards; Exhibition Catalogs; Slides
Special Subjects: Architecture, Sculpture
Collections: Carl Andre Collection of poems; John Chamberlain Collection of 23 sculptures; Donald Judd Collection, 100 mill aluminum sculptures & 15 concrete outdoor works; Ilya Kabakov Collection, mixed media installation; Claes Oldenburg Collection of aluminum/fiberglass outdoor work; Dan Flavin works in fluorescent light
Exhibitions: Permanent installation: six buildings of work in fluorescent light by Dan Flavin; (2006-2007) Robert Irwin, Marfa Project; (2006-2007) Josef Albers, Paintings
Publications: Art in the Landscape, 1997; Chinati Foundation Handbook, 1997; Chinati Foundation Newsletter, annual
Activities: Classes for children; docent training; artist residencies; intern training; lect open to public, 7 per biennial symposium; tours; sales shop sells books; prints; reproductions; t-shirts & caps

MARSHALL

M HARRISON COUNTY HISTORICAL MUSEUM, 707 N Washington, Marshall, TX 75670; PO Box 1987 Marshall, TX 75671. Tel 903-938-2680; Fax 903-927-2534; Elec Mail museum@shreve.net; Internet Home Page Address: www.cets.sfasu.edu/Harrison/; *Pres* Alex Liebling; *CEO* Carrol Fletcher; *Mus Shop Mgr* Gwen Nolan Warren
Open Tues - Sat 10 AM - 4 PM, cl Sun & Mon; Admis adults $1; Gallery is housed in Ginocchio Hotel, built in 1896; Average Annual Attendance: 11,000; Mem: 375; dues family $35, individual $25, students $10
Income: Financed by mem, donations, admis & endowment
Special Subjects: Ceramics, Historical Material
Collections: Cut & Pressed Glass; 400 BC - 1977 Ceramics; Hand-painted China; Historical Material; Religious Artifacts; etchings; jewelry; paintings; porcelains; portraits; Pioneer implements; transportation
Publications: Historical Newsletter, quarterly
Activities: Guided tours; genealogical records researched; competitions with awards

M MICHELSON MUSEUM OF ART, 216 N Bolivar, Marshall, TX 75670; PO Box 8290, Marshall, TX 75671. Tel 903-935-9480; Fax 903-935-1974; Elec Mail leomich@shreve.net; Internet Home Page Address: www.michelsonmuseum.org; *Educ dir* Bonnie Spangler; *Vol Coordr* Virginia Cope; *Dir* Susan Spears; *VPres* Tiffany Ammerman
Open Tues - Fri Noon - 5 PM, Sat & Sun 1 - 4 PM, cl holidays; No admis fee; Estab 1985 to exhibit works of Leo Michelson & special exhibits; Three galleries, one exhibits permanent collection of works by Leo Michelson & other American artists; Average Annual Attendance: 8,000; Mem: 400; dues $15 & up
Income: $125,000 (financed by mem, city & state appropriations)
Special Subjects: Painting-American, Prints, Watercolors, Woodcuts, Painting-French, Painting-Russian
Exhibitions: Leo Michelson (1887 - 1978 Russian/American); London Brass Rubbings; Cross Cultural Legacies: An Exhibition of Ten WY'MN Artists; Marshall PTA Cultural Arts School Exhibit Winners; Marshall Schools Faculty Art Exhibit; Hoover Watercolor Society 37th Juried Traveling Exhibit
Activities: Classes for adults & children; docent programs; lect open to public; gallery talks; tours; book traveling exhibitions 4 per year; museum shop sells books, original art, reproductions & prints

MCALLEN

M MCALLEN INTERNATIONAL MUSEUM, 1900 Nolana, McAllen, TX 78504. Tel 956-682-1564; Fax 956-686-1813; Elec Mail mim@hiline.net; Internet Home Page Address: www.mcallenmuseum.org; *Cur* Vernon Weckbacher; *Dir Develop* Pat Blum; *Exec Dir* John Mueller; *Dir Educ & Outreach* Mary Cloud
Open Tues - Sat 9 AM - 5 PM, Sun 1 - 5 PM, cl holidays; Admis adults $2, students $1; Estab 1969 to exhibit arts & sciences; Five galleries. Maintains reference library; Average Annual Attendance: 65,000; Mem: 900; dues $25 & up
Income: Financed by mem, city appropriation & other funds

Special Subjects: Latin American Art, Mexican Art, Painting-American, Prints, Anthropology, Textiles, Crafts, Folk Art, Painting-European
Collections: Local, state & regional artists; Mexican folk art; Mexican Prints; US & European paintings
Exhibitions: Abstract Works from the MIM Collection.; Christmas Tree Forest; Nightscapes; Arte Rio Grande, Francis Valesco
Publications: Bulletins & brochures periodically; Newsletter, monthly
Activities: Classes for adults & children; docent training; art & craft demonstrations; lect open to public, 30 vis lectrs per year; concerts; gallery talks; tours; competitions; individual paintings & original works of art lent to museums including Museum on Wheels!; traveling exhibitions organized & circulated; museum shop sells books, reproductions, prints, slides, museum related science kits

L Library, 1900 Nolana, McAllen, TX 78504. Tel 956-682-1564, 682-5661; Fax 956-686-1813; Elec Mail mim@hiline.net; Internet Home Page Address: www.mcallenmuseum.org; *Cur Colls* Vernon Weckbacher
Open Tues - Sat 9 AM - 5 PM; Open to staff, volunteers & researchers for reference only
Library Holdings: Book Volumes 2100; Periodical Subscriptions 10; Photographs; Slides
Special Subjects: Art History, Folk Art, Photography, Painting-American, Prints, Painting-European, Watercolors, Art Education, Pottery, Textiles, Woodcarvings, Woodcuts

MIAMI

M ROBERTS COUNTY MUSEUM, Hwy 60 E, PO Box 306 Miami, TX 79059. Tel 806-868-3291; Fax 806-868-3381; *Dir* Katie Underwood; *Exec Dir* Cecil Gill
Open Tues - Fri 10 AM - 5 PM, weekends by appointment, cl Mon & holidays; No admis fee; Estab 1979; Average Annual Attendance: 3,000
Library Holdings: Book Volumes; Maps; Original Art Works; Original Documents; Other Holdings; Pamphlets; Periodical Subscriptions; Photographs; Prints; Records
Special Subjects: American Indian Art, Anthropology, Archaeology, Furniture
Collections: Locke Collection of Indian artifacts; Mead Collection of mammoth bones & fossils; Historical Museum of early Miami; Native American Art Collection
Exhibitions: Annual Nat Cow-Calling Contest with Art Show
Activities: Classes for children; quilting demonstrations daily; lect open to public; tours; museum shop sells books, shirts, jewelry & keychains, traveling exhibit

MIDLAND

M MUSEUM OF THE SOUTHWEST, 1705 W Missouri, Midland, TX 79701-6516. Tel 915-683-2882, 570-7770; Fax 915-570-7077; Internet Home Page Address: www.museumsw.org; *Planetarium Dir* Gene Hardy; *Dir* Thomas W Jones
Open Tues - Sat 10 AM - 5 PM, Sun 2 - 5 PM, cl Mon; No admis fee; Incorporated 1965 as an art & history mus with a separate planetarium providing various science exhibits; children's mus; Average Annual Attendance: 100,000; Mem: 800; dues $20-$1000; board meeting third Wed monthly
Income: Financed by mem, contributions & grants
Special Subjects: American Indian Art
Collections: Art & archaeological materials of the Southwest; Indian art collection; permanent art collection
Exhibitions: The Collection; The Search for Ancient Plainsmen: An Archaeological Experience; Under Starr Skies: Defining the Southwest; Seeing Jazz; Dreamings: Aboriginal Art of the Western Desert from the Donald Kahn Collection; Crossing Boundaries: Contemporary Quilts; 12-16 rotating exhibitions per year
Publications: Annual Report; Museum Bulletin, bimonthly
Activities: Classes for adults & children; docent training; arts & crafts classes; video showings; lect open to public & for members only, 204 vis lectrs per year; concerts; gallery talks; tours; individual paintings lent to other museums; book traveling exhibitions 6-8 per year; museum shop sells books, jewelry, gifts & original clothing

NACOGDOCHES

M STEPHEN F AUSTIN STATE UNIVERSITY, SFA Galleries, 208 Griffith Fine Arts Bldg, Stephen F Austin State University Nacogdoches, TX 75962. Tel 936-468-1131; Fax 936-468-2938; Elec Mail baileysl@sfasu.edu; *Dir* Shannon Bailey
Open Tues - Sun 12:30 - 5 PM; No admis fee; Estab as a teaching gallery & to bring in art from outside this area for our students & the East Texas community; One room approx 56 x 22 ft, plus storage; Average Annual Attendance: 5,000
Income: Financed by state educ funds & private contributions
Activities: Classes for children; docent training; workshops; lect open to public; gallery talks; tours; museum trips; competitions with awards

ODESSA

M ELLEN NOEL ART MUSEUM OF THE PERMIAN BASIN, 4909 E University Blvd, Odessa, TX 79762-8144; PO Box 13928, Odessa, TX 79768. Tel 915-550-9696; Fax 915-550-9226; Elec Mail enam@noelartmuseum.org; Internet Home Page Address: www.noelartmuseu.org; *Collection Mgr* Letha Hooper; *Dir* Marilyn Bassinger; *Mktg & Develop Officer* Michael Austin; *Develop Asst* Kira Mullins; *Bus Manager* Beverly Alstrin; *Security/Facilities Technician* Willie Sturgeon; *Cur Educ* Karen Hambree; *Educ Coordr* Annie Stanley
Open Tues - Sat 10 AM - 5 PM, Sun 2 - 5 PM, cl Mon; No admis fee; Estab 1985 to increase public awareness & appreciation of art through exposure & education; Average Annual Attendance: 20,000; Mem: 475; dues $35 & up; annual meeting in Apr
Income: $210,000 (financed by mem, grants, donations & fund raisers)

Special Subjects: Drawings, Hispanic Art, Mexican Art, Photography, Prints, Sculpture, Watercolors, American Western Art, Bronzes, Southwestern Art, Religious Art, Ceramics, Folk Art, Woodcarvings, Etchings & Engravings, Landscapes, Collages, Portraits, Posters, Jewelry, Porcelain, Silver, Juvenile Art, Renaissance Art, Embroidery
Collections: Jeff Parker Collection of contemporary US paintings & sculpture; Italian contemporary bronzes from the Meadows Foundation
Exhibitions: Rotating exhibitions, 20 per yr
Activities: Classes for adults & children; docent training; gallery walks; workshops; demonstrations; videos; lect open to public, 2-3 vis lectrs per year; concerts; competitions; scholarships offered; exten dept; lending collection, contains paintings; museum shop sells art related books, prints, video, stationary & educational toys

M **PRESIDENTIAL MUSEUM,** 4919 E University Blvd, Odessa, TX 79762-8144. Tel 432-363-7737; Internet Home Page Address: www.presidentialmuseum.org; *Exec Dir* Carey Behrends; *Cur* Timothy Hewitt
Open Tues - Sat 10 AM - 5 PM; call for admis fees; Estab 1965 & dedicated to the study & understanding of constitutional government & the election process culminating in the Presidency; Average Annual Attendance: 23,000; Mem: call
Income: Financed by Ector County & Presidential Mus board of trustees
Special Subjects: Portraits, Dolls
Collections: Campaign memorabilia; original signatures; portraits
Exhibitions: Long-term exhibitions on the presidency & first ladies; special temporary exhibitions
Publications: News & Views, 4 times per yr; library newsletter, 4 times per yr
Activities: Lect open to public, 4 vis lectrs per year; concerts; gallery talks; tours; awards; individual paintings & original objects of art lent to qualified museums & other cultural organizations; lending collection includes books, 3-D objects & memorabilia; book traveling exhibitions vary; originate traveling exhibitions to circulate to qualified museums; museum shop sells books, magazines, children's games & toys

L **Library of the Presidents,** 4919 E University Blvd, Odessa, TX 79762-8144. Tel 432-363-7737; Internet Home Page Address: www.presidentialmuseum.org; *Exec Dir* Carey Behrends
Open Tues - Sat 10 AM - 5 PM; For reference only
Library Holdings: Audio Tapes; Book Volumes 4500; Cassettes; Clipping Files; Exhibition Catalogs; Pamphlets; Periodical Subscriptions 15; Records; Slides; Video Tapes
Special Subjects: Folk Art, Decorative Arts, Photography, Historical Material, Cartoons, Restoration & Conservation, Coins & Medals, Flasks & Bottles

ORANGE

M **NELDA C & H J LUTCHER STARK FOUNDATION,** Stark Museum of Art, 712 Green Ave, PO Box 1897 Orange, TX 77630. Tel 409-883-6661; Fax 409-883-6361; Elec Mail starkmuseum@starkmuseum.org; Internet Home Page Address: www.starkmuseum.org; *Pres & CEO* Walter Riedel; *Coll Mgr* Richard Hunter; *Chief Security Officer* Tom Parks; *Librn* Jenniffer Hudson-Connors; *Dir Stark Mus of Art* Sarah E Boehme PhD; *Mus Svcs* Mary Vesty; *Dir of Educ* Sue Harris
Open Tues - Sat 10 AM - 5 PM, Sun 1 - 5 PM; No admis fee; Estab 1978 to preserve & display the Stark collection of art & promote interests in subjects relative to the same through exhibitions, publications & educational programs; Five galleries & lobby, 18,000 sq ft of total exhibition area; Average Annual Attendance: 14,000
Income: Financed by endowment
Library Holdings: Audio Tapes; Book Volumes; Manuscripts; Original Art Works; Original Documents; Photographs; Prints; Sculpture
Special Subjects: Drawings, Painting-American, Prints, American Indian Art, American Western Art, Bronzes, Southwestern Art, Etchings & Engravings, Decorative Arts, Manuscripts, Furniture, Glass, Porcelain, Carpets & Rugs, Restorations, Period Rooms
Collections: Art relating to American West 1830-1965, special emphasis on artist explorers, illustrators & New Mexico artists; Native American Art (Plains, Southwest Northwest Coast, decorative arts, glass)
Publications: Exhibition catalogs
Activities: Docent training; tours for school children and adults; gallery talks; tours; mus shop sells books, exhibit catalogs, postcards & prints, posters, mus magnets, arrowheads

PANHANDLE

M **CARSON COUNTY SQUARE HOUSE MUSEUM,** Fifth & Elsie Sts, PO Box 276 Panhandle, TX 79068; TX Hwy 207 & Fifth St Panhandle, TX 79068. Tel 806-537-3524; Fax 806-537-5628; Elec Mail shm@squarehousemuseum.org; Internet Home Page Address: www.squarehousemuseum.org; *Registrar* Alice Crawford; *Admin Asst* Billie Poteet; *Exec Dir* Viola Moore; *Chmn* Dixie Surratt; *Mus Shop Mgr* Nita Ramming; *Educ* Holly Hicks
Open Mon - Sat 9 AM - 5 PM, Sun 1 - 5 PM, cl Thanksgiving, Christmas Eve, Christmas, New Years & Easter; No admis fee; Estab 1965 as a general mus with art galleries, area & State & National historical displays; Wildlife building & displays; Historic house, listed in National Register of Historic Places; Two enclosed security controlled art galleries, an educ center & art gallery; Average Annual Attendance: 30,000
Income: Financed by endowments, income & pub contributions
Special Subjects: Drawings, Painting-American, Photography, Prints, American Indian Art, Bronzes, Anthropology, Archaeology, Ethnology, Costumes, Crafts, Folk Art, Primitive art, Etchings & Engravings, Decorative Arts, Manuscripts, Dolls, Furniture, Carpets & Rugs, Historical Material, Maps, Dioramas, Period Rooms, Laces, Leather
Collections: Paintings of area pioneers by Marlin Adams; sculpture & bronze by Jim Thomas, Grant Speed & Keith Christi; Kenneth Wyatt paintings; Ben Carlton Mead & Harold Bugbee paintings; contemporary Native American art, Native American beadwork, Acoma pottery; costumes; antiques

Publications: A Time To Purpose, county history book; Land of Coronado, coloring book; The Square House Cook Book; Voices of the Square House, poems
Activities: Classes for adults & children; dramatic programs; docent training; lect open to public, 1 vis lectr per year; concerts; gallery talks; tours; museum shop sells books, reproductions, prints & museum related gift items

ROUND TOP

M **JAMES DICK FOUNDATION,** Festival - Institute, PO Box 89, 248 Jaster Rd Round Top, TX 78954. Tel 979-249-3129; Fax 979-249-5078; Elec Mail lamarl@festivalhill.org; Internet Home Page Address: www.festivalhill.org; *Founder & Dir* James Dick; *Managing Dir* Richard R Royall; *Dir Library & Mus* Lamar Lentz
Open by appointment; Tours$5, summer concerts $20 per person, chamber music $10 per person; Estab 1971 as a center for music, the arts & humanities; Guion Room, Oxehufwud Room, Historic House Collection. Maintains reference library; Average Annual Attendance: 40,000-50,000
Income: Financed through ticket sales & donations
Library Holdings: Auction Catalogs; Book Volumes; Exhibition Catalogs; Manuscripts; Memorabilia; Motion Pictures; Original Art Works; Photographs; Prints; Records; Reels
Special Subjects: History of Art & Archaeology, Interior Design, Landscape Architecture, Art History, Furniture, Architecture, Graphics, Painting-American, Photography, American Western Art, Costumes, Ceramics, Crafts, Folk Art, Landscapes, Decorative Arts, Manuscripts, Furniture, Glass, Jewelry, Porcelain, Carpets & Rugs, Historical Material, Maps, Coins & Medals, Period Rooms, Laces, Pewter, Painting-Scandinavian
Collections: British Country Houses, Decorative Arts, Historic House Collection, Music Instruments, Painting, Swedish Decorative Arts - 16th century to present, Texas History
Exhibitions: 19th Century Dolls, Toys & Games; Paintings by Rolla Taylor; Paintings by James Painter; David Guion Room; Oxehufwud Room; Strickley Furniture
Activities: Classes for students; docent training; lect open to public; 7 vis lectrs per yr; concerts; gallery talks; tours; scholarships offered to music students; sales shop

SAN ANGELO

M **ANGELO STATE UNIVERSITY,** Houston Harte University Center, PO Box 11027, San Angelo, TX 76909. Tel 915-942-2062; Fax 915-942-2354; *Dir Prog* Rick E Greig
Open Mon - Fri 8 AM - 10:30 PM, Sat 9 AM - 10:30 PM, cl Sun; No admis fee; Estab 1970 to provide entertainment & informal educ for the students, faculty & staff; Gallery is maintained
Income: $3000 (financed by city & state appropriations)
Collections: Wax drawings done by Guy Rowe for illustration of the book In Our Image by Houston Harte
Exhibitions: Historical artifacts; modern drawings; photography; pottery; weaving; children, students and faculty exhibitions
Activities: Lect open to public, 2 vis lectr per year; gallery talks; tours; concerts; dramatic programs; competitions

M **SAN ANGELO ART CLUB,** Helen King Kendall Memorial Art Gallery, 119 W First St, San Angelo, TX 76903. Tel 915-653-4405; *Pres* Mary Taylor; *1st VPres* Mary Kollmeyer; *Secy* Sue Meacham; *Treas* Patty Towler
Open Wed 9 AM - 2 PM, Sat & Sun 1 - 4 PM; No admis fee; Club estab 1928 & gallery estab 1948 to promote the visual fine arts in San Angelo; Average Annual Attendance: 1,500; Mem: 90; dues $30; meeting first Mon each month
Income: $8,000 (financed by Memorial Endowment Fund)
Collections: Paintings by George Biddle, Gladys Rockmore Davis, Xavier Gonzales, Iver Rose & Frederick Waugh, Hazel Janick; Karl Albert, Joseph Sharp, Willard Metcalf, Robert Woods, Dwight Holmes
Exhibitions: Monthly exhibits from area artists; The Gallery supports the local art community with exhibs including an annual HS art show and an annual exhibit which supports the Concho Valley Assn for the blind
Publications: Splashes, monthly newsletter
Activities: Classes for adults & children & dramatic programs; tours; competitions with awards; individual paintings & original objects of art lent to libraries, churches & businesses

M **SAN ANGELO MUSEUM OF FINE ARTS,** One Love St, San Angelo, TX 76903. Tel 325-653-3333; Fax 325-658-6800; Elec Mail museum@samfa.org; Internet Home Page Address: www.samfa.org; *Pres* Anne Williams; *VPres* Nancy Powell; *Dir* Howard J Taylor; *Coll Mgr* Karen Zimmerly; *Develop Asst* Gracie Fernandez; *Preparator* John Mattson; *Educator* Jade Norris
Open Tues - Sat 10 AM - 4 PM, Sun 1 - 4 PM, cl Mon & major holidays; Admis adults $2, senior citizens $1, members, local students, military & children under 6 free; Estab 1981 to provide quality visual arts exhibits & stimulating programs for educational & cultural growth; 30,000 sq ft bldg designed by architect Malcom Holzman & contains three gallery spaces; Average Annual Attendance: 65,000; Mem: Dues $10 and up
Income: $600,000 (financed by endowment, sales, admis & grants)
Collections: Texas art (1942-present); American crafts (1945-present), particularly ceramics; American paintings & sculpture of all eras; Mexican & Mexican-American art of all eras; Selected European, Oriental & African art; Texas art (1942-present)
Exhibitions: (Biennial) San Angelo National Ceramic Competition
Publications: Exhibit catalogs
Activities: Classes for adults & children; programs; docent training; concerts; gallery talks; tours; lect open to public; competitions with awards; exten dept serves 14 counties in W Texas; book traveling exhibitions, 15 per year; originate traveling exhibitions; museum shop sells books, magazines, original art, reproductions, prints, educational toys, paper goods

SAN ANTONIO

L CENTRAL LIBRARY, Dept of Fine Arts, 600 Soledad St, San Antonio, TX 78205-1208. Tel 210-207-2500; Fax 210-207-2552; *Asst Dir* Nancy Gandara; *Dept Head* Mary A Wright; *Art Coll Develop Specialist* Beth Shorlemer; *Dir* Laura Isenstein
Open Mon - Fri 9 AM - 9 PM, Sat 9 AM - 5 PM, Sun 11 AM - 5 PM; Estab to provide art reference & lending materials to the residents of Bexar County; Art gallery is maintained. Also serves as a major resource center to regional libraries in South Texas
Income: Financed by city, state & federal appropriation
Purchases: $250,000
Library Holdings: Audio Tapes; Cassettes; Clipping Files; Compact Disks; Exhibition Catalogs; Fiche; Filmstrips; Memorabilia; Motion Pictures; Pamphlets; Photographs; Records; Reels; Reproductions; Video Tapes
Exhibitions: Regular Exhibition of local & National artists
Activities: Classes for children; dramatic programs; lect open to public, 2 vis lectr per year; concerts; gallery talks; tours; competitions with awards; exten dept; lending collection contains 320,000 books, 400 video cassettes, 10,000 audio cassettes, 15,000 motion pictures; book traveling exhibitions

A CENTRO CULTURAL AZTLAN, 803 Castroville Rd, Ste 402, San Antonio, TX 78237. Tel 210-432-1896; Fax 210-432-1899; *Exec Dir* Malena Gonzalez-Cid; *Arts Prog Dir* Ramon Vasquez Y Sanchez
Estab 1977 to support & strengthen Chicano/Latino culture & identity; Expression Fine Art Gallery mounts 10 art exhibits per year to showcase visual artists
Exhibitions: Annual Lowrider Car Exhibition
Publications: ViAztlan, quarterly journal of contemporary arts & letters
Activities: Guest lectr; reading recitals

M CONTEMPORARY ART FOR SAN ANTONIO BLUE STAR ART SPACE, 116 Blue Star, San Antonio, TX 78204. Tel 210-227-6960; Fax 210-229-9412; Internet Home Page Address: www.bluestarartspace.org; *Exec Dir* Bill FitzGibbons; *Facility & Gallery Mgr* Edgardo (Tico) Perez; *Gen Asst* Chris Gutierrez; *Devlop Dir* Bernice Williams; *Prog Mgr* Gretchen Stieren; *Finance Officer* Marie Castillo; *Devel Consultant* Michael Westheimer
Open Wed - Sun Noon - 6 PM; No admis fee, donations accepted; Estab 1986 to advance contemporary art by presenting culturally diverse exhibitions and programs to broaden San Antonios local contemporary art experience by nurturing and showcasing local talent and participating in a diverse exchange on regional, nat & internat levels; 11,000 sq ft warehouse; Average Annual Attendance: 60,000
Income: Financed by endowment, mem, city & state grants
Collections: Contemporary multimedia painting, prints, sculpture, photographs
Activities: Educ program for school children; lect open to public; book traveling exhibitions 6 per year

A COPPINI ACADEMY OF FINE ARTS, 115 Melrose Pl, San Antonio, TX 78212. Tel 210-824-8502; Elec Mail coppini1@sbcglobal.net; Internet Home Page Address: www.coppiniacademy.org; *Pres* Hal Martin; *Art Dir* Louis Mar
Open Fri & Sun 1 - 5 PM or by appointment; No admis fee; Estab 1945 to foster a better acquaintance & understanding between artists & patrons; to encourage worthy accomplishment in the field of art & to serve as a means of public exhibition for the work of active members; Mem: dues $35 per annum; ann meeting third Sun of Nov
Income: Membership
Collections: Oil paintings by Rolla Taylor; sculpture by Waldine Tauch & Pompeo Coppini; paintings
Exhibitions: Annual May Garden Show. Monthly changing exhibits in upper gallery by members
Publications: Coppini News Bulletin, monthly newsletter distributed to members
Activities: Educ dept; lect open to public, 6 vis lectr per year; gallery talks; tours; competitions; scholarships offered; individual paintings & original objects of art lent; originate traveling exhibitions

L Library, 115 Melrose Pl, San Antonio, TX 78212. Tel 210-824-8502; Elec Mail coppini1@sbcglobal.net; Internet Home Page Address: www.coppiniacademy.org; *Pres* Dr Hal Martin; *1st Vice Pres* Donna Bland; *Secy* Sussanne Clark; *Treas* Ron Watkins; *Art Dir* Louis Mar
Estab 1945 to promote classical art; Circ 1500; Monthly exhibits of membership & museum coll; Average Annual Attendance: 1,000; Mem: dues $35; monthly meeting 3rd Sun
Income: Trust & fund raising
Library Holdings: Book Volumes 200; Clipping Files; Original Art Works; Periodical Subscriptions 50; Photographs; Sculpture; Slides; Video Tapes
Special Subjects: Sculpture
Activities: Classes for adults & children; lects open to public; Awards - Artist of the Year; ann Schols $3000, HS Sr Art Major, 1 year

A GUADALUPE CULTURAL ARTS CENTER, 1300 Guadalupe St, San Antonio, TX 78207. Tel 210-271-3151; Fax 210-271-3480; Internet Home Page Address: www.guadalupeculturalarts.org; *Exec Dir* Maria Elena-Torralva; *Xicano Music Prog Dir* Pilar Chapa; *Dir Dance Prog* Belinda Menchaca; *Artistic Dir* Pablo Miguel Martinez
Open 9 AM - 5 PM & spec events as scheduled; Admis fee varies; Estab 1979, non-profit, multi-disciplinary arts organization dedicated to the development, preservation & promotion of Latino arts & to facilitating a deeper understanding & appreciation of Chicano/Latino & Native American cultures; Center manages the beautifully restored, historic Guadalupe Theatre, a 410 seat, handicapped accessible, multi-purpose facility that houses the Theater Gallery, a large auditorium, a proscenium stage & equipment for theatrical & cinematic presentations; Average Annual Attendance: 150,000
Income: $1,700,000
Exhibitions: Annual Tejano Conjunto Festival; Annual San Antonio Inter-Americas Bookfair.; Annual Juried Women's Art Exhibit; Annual Student Exhibit; Hecho a Mano/Made by Hand (annual fine arts & crafts market)
Activities: Visual arts program; classes & workshops; creative dramatics classes; dance program; media program; classes for adults & children; 4 - 6 vis lectrs per yr; fels; sales shop

M MCNAY ART MUSEUM, 6000 N New Braunfels Ave, PO Box 6069 San Antonio, TX 78209-6069. Tel 210-824-5368; Fax 210-805-1760; Elec Mail info@mcnayart.org; Internet Home Page Address: www.mcnayart.org; *Pres* Jane Stieren; *Dir* William J Chiego; *Cur Educ* Rose M Glennon; *Cur Tobin Theatre Coll & Library* Jody Blake; *Coll Mgr* Heather Lammers; *Librn* Ann Jones; *Dir Develop* Mac Griffith; *Museum Store Mgr* Robert Ayala; *Assoc Cur Prints & Drawings* Lyle Williams; *Pub Relations* Margaret Anne Lara
Open Tues - Sat 10 AM - 5 PM, Sun Noon - 5 PM, cl Mon, Jan 1, July 4, Thanksgiving & Christmas; No admis fee, donations appreciated; occasional charge for temporary exhibits; Estab 1954 for the encouragement & development of modern art; 30,000 vol art history reference library; Robert L B Tobin Theatre Arts Library; 23 acres of gardens; 300-seat auditorium; McNay Mus Store; handicap accessibility; Average Annual Attendance: 110,000; Mem: Dues benefactor $5000, sponsor $2500, sustaining patrons $1000, patron $500 sustaining $150, family $60, individual $35
Income: Financed by endowment, mem & private gifts
Special Subjects: Graphics, Painting-American, Sculpture, Painting-European, Medieval Art
Collections: Modern art, 19th & 20th century European & American painting, sculpture & graphics; Oppenheimer Collection of late medieval & early Renaissance sculpture & paintings; Southwest religious art & Native American decorative arts; Tobin Theatre Arts Collection related to opera, ballet & musical stage
Publications: Annual report; exhibition catalogues & brochures; Impressions, quarterly newsletter
Activities: Docent training; lect open to public, 8 vis lectr per year; concerts; gallery talks; tours; individual paintings & original objects of art lent to other museums; book traveling exhibitions 4 per year; originate traveling exhibitions; museum shop sells books & original art

L Reference Library, 6000 N New Braunfels St, San Antonio, TX 78209. Tel 210-824-5368, 805-1754; Fax 210-805-1760; Internet Home Page Address: www.mcnayart.org; *Librn* Ann Jones
Open to the pub Tues - Fri 10 AM - 4:45 PM; No admis fee; Estab 1970 as an adjunct to the mus; Circ non-circulating; For reference only
Income: Financed by endowment & gifts
Library Holdings: Book Volumes 30,000; Clipping Files; Exhibition Catalogs; Fiche; Periodical Subscriptions 224; Video Tapes

A SAN ANTONIO ART LEAGUE, San Antonio Art league Museum, 130 King Williams St, San Antonio, TX 78204. Tel 210-223-1140; Fax 210-223-2826; Elec Mail saalm@idworld.net; Internet Home Page Address: www.saalm.org; *Pres* Nancy M Bacon
Open Tues - Sat Noon - 6 PM; No admis fee; Estab 1912 as a pub art gallery for San Antonio & for the promotion of a knowledge & interest in art by means of exhibitions; 4 rooms & large hall capable of hanging 150 paintings; Mem: 820; dues $15-$500; meetings monthly Oct - May
Income: Financed by mem & fundraising projects
Collections: Davis Collection, 1920 American Art; focus on San Antonio & Texas artist; crafts, paintings, prints & sculpture
Exhibitions: Rotating exhibits
Publications: Exhibiton catalogs; monthly calendar of events
Activities: Educ dept; lect open to public, 3 vis lectr per year; gallery talks; tours; paintings & original art objects lent

L 130 King Williams St, San Antonio, TX 78204. Tel 210-223-1140; Elec Mail saalm@idworld.net; Internet Home Page Address: www.saalm.org; *Pres* Louise Cantwell
Open Tues - Sat 12 PM - 6 PM; For reference only
Income: Financed by mem & fundraising
Library Holdings: Book Volumes 350

M SAN ANTONIO MUSEUM OF ART, 200 W Jones Ave, San Antonio, TX 78215. Tel 210-978-8111; Fax 210-978-8182; Elec Mail maly.menier@samuseum.org; Internet Home Page Address: www.samuseum.org; *Dir* Dr Marion Oettinger Jr, PhD; *Consulting Cur Ancient Art* Dr Jessica Davis Powers; *Adjunct Cur Decorative Arts* Merribelk Parsons; *Dir Operations* Dan Walton; *Deputy Dir* Emily Jones; *Director Finance & Admin* Polly Vidaurri; *Dir Educ* Olga Samples-Davis; *Registrar* Karen Z Baker; *Communication Mgr* Leigh Baldwin; *Gift Shop Mgr* Arleen West; *Spec Events Liaison* Bill Wolff; *Cur Asian Art* Martha Blackwelder; *Chmn Bd Trustees* Karen Hixon
Open Wed - Sat 10 AM - 5 PM, Tues 10 AM - 8 PM, Sun Noon - 6 PM, cl Mon; Admis adult $8, senior citizen $7, students with ID &$5, child 4-11 $3, mem, children under 4 & Tues 4 - 8 PM free; Estab 1981; a renovation project, the Brewery was originally chartered in 1883; Anheuser-Busch Brewing Assoc of St Louis, during the early 1900's replaced the original wooden structures with a castle-like brick complex. 70,959 sq ft of exhibition pace; Average Annual Attendance: 110,000; Mem: 2,000; dues vary
Library Holdings: Auction Catalogs; Book Volumes; Exhibition Catalogs; Periodical Subscriptions
Special Subjects: Prints, Hispanic Art, Latin American Art, Mexican Art, Painting-American, Pre-Columbian Art, Folk Art, Painting-European, Oriental Art, Asian Art, Silver, Antiquities-Oriental, Antiquities-Egyptian, Antiquities-Greek
Collections: American photography since 1920; contemporary & modern art; 18th-20th century paintings & sculpture; European & American paintings & decorative art; Greek & Roman antiquities; Mexican folk art; Pre-Columbian art; Spanish colonial art; Asian art; Islamic art; Oceanic art
Publications: Exhibition catalogues
Activities: Classes for adults & children; docent training; teacher workshops; parent-child classes; lect open to public, 10-20 vis lectrs per year; concerts; gallery talks; tours; individual paintings & original objects of art lent to other art institutions for special exhibitions; originate traveling exhibitions to other art museums; museum shop sells books, reproductions prints, general art-interest merchandise, t-shirts, jewelry

A SOUTHWEST SCHOOL OF ART & CRAFT, 300 Augusta St, San Antonio, TX 78205. Tel 210-224-1848; Fax 210-224-9337; Elec Mail info@swschool.org; Internet Home Page Address: www.swschool.org; *Pres* Paula Owen; *Sales Gallery Mgr* Clare Watters; *Cur/Assoc* Kathy Armstrong-Gillis
Exhib spaces open Mon - Sat 9 AM - 5 PM; gallery shop open Mon-Sat 10 AM - 5 PM; No admis fee; Estab 1965; non-profit/community-based art school for all

ages & skill levels; Russell Hill Rogers Galleries Constitute 3,500 sq ft of Exhib space for contemporary art. The Ursuline Gallery displays local & regional artists; Average Annual Attendance: 250,000; Mem: 700; dues $45 & up
Income: Financed by pvt donos, earned income from art school & City of San Antonio Office of Cultural Affairs
Exhibitions: 12 changing exhibs per year-contemporary art and craft
Publications: Opening Invitations; handouts for all exhibitions including photo of artists, curator's essay, exhibition checklist; catalogues of classes
Activities: Classes for adults & children; arts workshop programs with vis artists; lect open to public, 25 vis lectr per year; tours; gallery talks; concerts; scholarships offered; gallery shop sells original art, etc

M SPANISH GOVERNOR'S PALACE, 115 Plaza de Armas, San Antonio, TX 78205; 105 Plaza de Armas, San Antonio, TX 78205. Tel 210-224-0601; Fax 210-223-5562; Elec Mail nward@sanantonio.gov; Internet Home Page Address: www.sanantonio.gov/sapar; *Cur & Museum Asst* Nora Ward; *Museum Aide* Mario Garza
Open Mon - Sat 9 AM - 5 PM, Sun 10 AM - 5 PM; Admis adults $1.50, children under 14 $.75; Estab 1749; Average Annual Attendance: 45,000
Income: $35,000 (financed by city appropriation)
Collections: Spanish-colonial furnishings, paintings, earthenware, brass & copper pieces from 16th - 17th century
Publications: Spanish Governor's Palace brochure
Activities: Mus shop sells notecards, key chains, histories, courtyard sketches, postcards

M THE UNIVERSITY OF TEXAS AT SAN ANTONIO, (The University of Texas) UTSA's Institute of Texan Cultures, 801 S Bowie St, San Antonio, TX 78205-3296. Tel 210-458-2330; Fax 210-458-2380; Elec Mail itcweb@utsa.edu; Internet Home Page Address: www.texancultures.com; *Exec Dir* Dr John L Davis; *Librn* Yu Li; *Photo Archivist* Tom Shelton; *Dir Prog* Bonny Johnston; *Dir Marketing* Aaron Parks
Open Tues - Sat 10 AM - 6 PM, Sun 12 PM - 5 PM, cl Mon; Admis adults $7, seniors 65 & olders, children 3-12 & military with ID $4; Estab 1968; Maintains reference library; Average Annual Attendance: 200,000; Mem: 400; dues $50
Income: $4,500,000 (financed by endowment, mem, state appropriation, gifts & sales)
Library Holdings: Audio Tapes; Fiche; Photographs
Special Subjects: Anthropology, Ethnology, Folk Art, Afro-American Art
Collections: Ethnic culture including Anglo, Belgian, Black, Chinese, Czech, Danish, Dutch, English, Filipino, French, German, Greek, Hungarian, Indian, Irish Italian, Japanese, Jewish, Lebanese, Mexican, Norwegian, Polish, Scottish, Spanish & Swedish (all Texans); one room school house, barn, windmill, fort & log house
Publications: Texican, quarterly
Activities: Classes for adults & children; dramatic programs; docent programs; lect open to public; concerts; gallery talks; tours; festivals; book traveling exhibitions 2-3 per year; sales shop sells books, prints, magazines, original art, reproductions & international gift items

M WITTE MUSEUM, 3801 Broadway, San Antonio, TX 78209. Tel 210-357-1881; Fax 210-357-1882; Elec Mail witte@wittemuseum.org; Internet Home Page Address: www.wittemuseum.org; *Pres & Exec Dir* Dr James C McNutt; *Dir Prog & Coll* Elisa Phelps; *Exhibits Mgr* John Edmundson; *VChmn* Margaret F Anderson; *Cur History & Textiles* Michaele Haynes; *Exec VPres* Mimi Quintanilla; *Cur Archives & Registrar* Rebecca Huffstutler; *Dir Admin Servs* Bea Abercrombie; *Dir Pub Relations* Irma Guerrero; *Dir Retail Svcs* Barbara Bowie
Open Mon, Wed & Sat 10 AM - 5 PM, Tues 10 AM - 9 PM, Sun Noon - 5 PM; summer until 6 PM; Admis adults $5.95, seniors 65 & older $4.95, children 4-11 $3.95, children 3 & under free; group discount rates; Tues free from 3 - 9 PM; Estab 1926 by Ellen Schulz (later Quillin); Historical building located on the edge of the 450 acre Brackenridge Park on the banks of the San Antonio River & ancient Indian encampment area. Three restored historic homes on the grounds-the Ruiz, Navarro & Twohig houses; Average Annual Attendance: Over 250,000; Mem: 3000; dues family $60, individual $35
Special Subjects: Painting-American, American Indian Art, Anthropology, Textiles, Costumes, Folk Art, Decorative Arts, Dolls, Furniture, Silver, Historical Material, Embroidery, Laces
Exhibitions: Various exhibitions; call for details
Activities: Classes for adults & children; dramatic programs; docent training; lect open to public; concerts; gallery talks; tours; camp-ins; family days; hands-on activities; behind-the-scenes tours; book traveling exhibitions

SHERMAN

M AUSTIN COLLEGE, Ida Green Gallery, 900 N Grand Ave, Sherman, TX 75090-4440. Tel 903-813-2251; Fax 903-813-2273; Internet Home Page Address: www.dustincollege.edu; *Chair* Mark Monroe
Open 9 AM - 5 PM weekdays; No admis fee; Estab 1972 to serve campus and community needs; Selected exhibitions of contemporary art by regional & national artists; Average Annual Attendance: 7,000
Income: Financed by endowment
Purchases: Occasional purchases of outdoor sculpture
Special Subjects: Prints
Collections: Prints
Exhibitions: Monthly, except summer
Activities: Classes for adults & children; lect open to public, 20 vis lectrs per year; gallery talks; tours; competitions; scholarships offered

SUGARLAND

M MUSEUM OF SOUTHERN HISTORY, 14080 Southwest Freeway, Sugarland, TX 77478-2190; PO Box 2190, Sugarland, TX 77478-2190. Tel 281-269-7171; Fax 281-269-7179; Elec Mail snoddys@snbtx.com; Internet Home Page Address: www.museumofsouthernhistory.com; *Pres Emeritus* Joella Morris; *Cur* Danny M Sessums; *Admin* Suzie Snoddy
Open Tues - Fri 10 AM - 4 PM, Sat & Sun 1 - 4 PM; Admis adults $4, seniors $3, children $3; Estab 1978; Maintains a reference library; Average Annual Attendance: 5,000; Mem: 300; $25, $50, $75 & $100

Income: nonprofit donations
Special Subjects: Painting-American, Costumes, Decorative Arts, Furniture, Historical Material, Period Rooms, Military Art
Collections: Antique handguns; Confederacy-money & uniforms; Medical exhibit, late 1800's; quilts; Sharecropper's Cabin; Terry's Texas Rangers; various oils, historic paintings
Publications: Quarterly newsletter
Activities: Docent training; lectrs open to the public; 5 vis lectr per yr; books & prints

SUNSET

M OLD WEST MUSEUM, RR1 Box 365C, Sunset, TX 76270. Tel 940-872-9698; Fax 940-872-8504; Elec Mail sunsettradingpost@earthlink.net; Internet Home Page Address: www.cowboymuseum.net; *Owner & Cur* Jack Glover; *Co-Owner* Cherie Glover
Open daily 9 AM - 5 PM (winter), Mon-Fri 9AM-7PM Memorial Day-Labor Day, Sat & Sun 10AM-5PM; Admis $5; Estab 1978; Average Annual Attendance: 67,000; Mem: 300; dues $35
Income: Financed by endowment & mem
Special Subjects: Architecture, Painting-American, Photography, Prints, Sculpture, American Western Art, Textiles, Costumes, Posters, Restorations
Collections: Historic clothing; sculpture; western art
Exhibitions: Western Art Show & Sale; Western Spirit Art Show
Publications: Stageline, quarterly
Activities: Classes for adults & children; docent training; lect open to public, 10 vis lectr per year; competitions; book traveling exhibitions, 2 per year; sales shop sells books, reproductions, prints

TYLER

M TYLER MUSEUM OF ART, 1300 S Mahon Ave, Tyler, TX 75701. Tel 903-595-1001; Fax 903-595-1055; Elec Mail info@tylermuseum.org; Internet Home Page Address: www.tylermuseum.org; *Head Educ* Bob Thompson; *Facilities & Special Events* Robert Owen; *Dir* Kimberley Bush Tomio; *Pres* Betty Summers; *Cur* Ken Tomio; *Educ Asst* Cindy McDaniel; *Pub Rel & Marketing* Jan McCauley; *Asst Graphics Dept* Charity Goddard; *Bookkeeper & HR Dir* Doris Bryson
Open Tues - Sat 10 AM - 5 PM, Sun 1 - 5 PM; Voluntary admis fee; some special exhibs ticketed; Estab 1971 as a museum of art from 19th century to the present & specializing in early to contemp Texas art; Two galleries are 40 x 60 ft with 20 ft ceilings; one gallery covers 25 x 45 ft; Average Annual Attendance: 26,000; Mem: 870; dues $25 - $10,000
Income: $1.1 million (financed by endowment, memberships & donations)
Library Holdings: Auction Catalogs; Book Volumes; DVDs; Exhibition Catalogs; Kodachrome Transparencies; Periodical Subscriptions; Photographs; Slides; Video Tapes
Collections: 725 works: special focus on early to contemporary Texas art; artists represented: Keith Carter, Joseph Glaso, Al Souza, Porfirio Salinas, Clyde Connell, Vernon Fisher, Terry Allen, Graydon Parrish & Norman Rockwell
Exhibitions: (2/3/2007-4/29/2007) James McNeill Whistler: Selected works from the Hunterian Art Gallery; (4/2007-12/2007) Selections from the Laura & Dan Boekman collection of contemp Mexian Folk Art
Publications: Harry Worthman: A Life in Art, 2005; Rosalie Speed: Rediscovered Texas Treasure, 2006
Activities: Classes for children; docent training; lect open to public, 4 vis lectr per yr; concerts; gallery talks; tours; high school student annual art exhib awards; extension program serves local school district (elementary school); originate traveling exhibitions to regional mus; museum shop sells books, associated items, notecards, gift items relating to Texas & special exhib

L Reference Library, 1300 S Mahon Ave, Tyler, TX 75701. Tel 903-595-1001; Fax 903-595-1055; Elec Mail info@tylermuseum.org; Internet Home Page Address: www.tylermuseum.org; *Dir* Kimberley Bush Tomio; *Special Events & Facilities Manager* Robert Owen; *Cur* Ken Tomio; *Asst Head, Educ* Danielle Stephens; *Develop Officer* Sherry Dunn; *Registrar* Anne Marie Drozd
Open Tues - Sat 10 AM - 5 PM, Sun 1 - 5 PM; No admis fee for most exhibitions; Estab 1971 as an educational & cultural center to enrich the lives of East Texas citizens & visitors through the collection, preservation, study, exhibition, interpretation & celebration of the visual arts; Circ 2,000; 3 galleries; Average Annual Attendance: 30,000; Mem: 700
Income: $750,000 (financed by memberships, private donations, grants & city appropriation)
Library Holdings: Book Volumes 2,000; Clipping Files; Exhibition Catalogs; Kodachrome Transparencies; Periodical Subscriptions 6; Photographs; Slides; Video Tapes
Special Subjects: Folk Art, Photography, Drawings, Painting-American, Painting-French, Painting-German, Prints, Sculpture, Watercolors, Ceramics, Bronzes, Porcelain, Woodcuts, Landscapes, Portraits
Collections: 19th, 20th & 21st century Contemporary art
Publications: The Preview mag semi-annually
Activities: Classes for adults & children; docent training; summer art camp for children; school tours; family days; lect open to public; 7-8 vis lectrs per yr; gallery talks; tours; performances; artist demonstrations; museum shop sells books, original art, reproductions, prints, postcards & other cards

VAN HORN

M CULBERSON COUNTY HISTORICAL MUSEUM, PO Box 231, Van Horn, TX 79855. Tel 915-283-8028; *Secy* Darice McVay; *Pres* Robert Stuckey
Open Mon - Fri 2 - 5 PM, Sat by appointment; Donations accepted; Mem: 50; dues $10; monthly meetings
Special Subjects: Archaeology, Drawings, American Western Art, Southwestern Art, Costumes, Folk Art, Manuscripts, Dolls, Furniture, Maps, Restorations, Period Rooms, Leather
Collections: Collections from old ranch families of Culberson County

Exhibitions: 1890s saloon, saddles & cowboy gear; Native American artifacts; Frontier Day

VERNON

M RED RIVER VALLEY MUSEUM, 4600 College Dr W, PO Box 2004 Vernon, TX 76385-2004. Tel 817-553-1848; Fax 817-553-1849; Elec Mail museum@rrvm.org; Internet Home Page Address: www.rrvm.org; *Clerical Hostess* Carole Hanna; *Exec Dir* Mary Ann McCuistion; *Asst Dir* Melanie Gordon; *Pres Bd Dirs* Robert Lightfoot; *VPres* Ruth Streit
Open Tues - Sun 1 - 5 PM; No admis fee, donations accept; Estab 1963 to provide for & preserve local heritage while maintaining national exhibits in the arts, history & science programs; One gallery with one hundred linear ft of hanging space; Average Annual Attendance: 8,000
Income: Financed by contributions, local government & donations
Special Subjects: Sculpture, American Indian Art
Collections: Electra Waggoner Biggs Sculpture Collection; J H Ray Indian Artifacts; Taylor Dabney Mineral Collection; Bill Bond Wild Game Trophies
Publications: Museum Newsletter, quarterly
Activities: Classes for children; lect open to public; gallery talks; tours; book traveling exhibitions; museum shop sells books, brochures, collector's items

WACO

M THE ART CENTER OF WACO, Creative Art Center, 1300 College Dr, Waco, TX 76708. Tel 254-752-4371; Fax 254-752-3506; *Dir Educ* Anne Garrett; *Cur* Sarah Logan
Open Tues - Sat 10 AM - 5 PM, Sun 1 - 5 PM; No admis fee; Estab 1972 to provide a variety of exhibitions for appreciation & classes for participation; Former residence of William Cameron, now renovated & contains one large main gallery & a small adjacent gallery, also additional exhibition space on the second floor; Average Annual Attendance: 20,000; Mem: 900; dues $30 - $1,500
Income: $200,000 (financed by endowment, mem & grants)
Exhibitions: Exhibitions vary, call for details
Publications: Catalogs; exhibit brochures; newsletter
Activities: Classes for adults & children; docent training; lect open to public, 2-3 vis lectr per year; gallery talks; tours; competitions; extension dept serves ethnic minorities & low socio-economic groups; originates traveling exhibitions; museum shop sells books, reproductions & gift items
L Creative Art Center, 1300 College Dr, Waco, TX 76708. Tel 254-752-4371; Fax 254-752-3506; *Dir Educ* Anne Garrett
Open Tues - Sat 10 AM - 5 PM, Sun 1 - 5 PM; Estab 1976 as a source for staff, faculty, patrons of the Art Center & children to enhance artistic creativity through instruction & research; Former residence of William Cameron; Mem: 900; dues $30 - $1,500
Income: Financed by mem & class fees
Library Holdings: Book Volumes 1,000; Exhibition Catalogs; Periodical Subscriptions 18
Special Subjects: Photography, Crafts, Architecture
Exhibitions: Rotating exhibitions
Activities: Classes for local school districts & adults, class fees vary
Courses: Regional Art

BAYLOR UNIVERSITY
M Martin Museum of Art, Tel 254-710-1867; Fax 254-710-1566; Elec Mail heidi hornik@baylor.edu; Internet Home Page Address: www.baylor.edu~art; *Dir* Dr Heidi Hornik
Open Tues - Fri 10 AM - 5 PM, Sat Noon - 5 PM, cl Sun & Mon; No admis fee; Estab 1967 as a teaching arm of the university to serve the area; Gallery contains one large room with storage & preparation room; Average Annual Attendance: 7,000
Income: Financed through the art dept
Purchases: Contemporary American Art
Special Subjects: Drawings, Graphics, Painting-American, Prints, Sculpture, Watercolors, African Art, Glass
Collections: Contemporary painting & sculpture; graphics; local artists; prints; sculpture from Sepik River area, New Guinea, Africa
Activities: Lect open to public, 4 vis lectr per year; gallery talks
L Armstrong Browning Library, Tel 254-710-3566; Fax 254-710-3552; Internet Home Page Address: www.browninglibrary.org; *Cur Manuscripts* Rita S Patteson; *Cur Books & Printed Material* Cynthia A Burgess; *Dir* Stephen Prickett; *Coordr* Avery Sharp
Open to visitors Mon - Fri 9 AM - 5 PM, Sat 9 AM - Noon; open for research Mon - Fri 9 AM - 5 PM, Sat by appointment; Estab 1918 to provide a setting for the personal possessions of the Brownings & to have as complete as is possible a collection for the use of Browning scholars; Gallery is maintained; Average Annual Attendance: 22,000; Mem: dues individual $50
Income: Financed by endowment & private university
Library Holdings: Audio Tapes; Book Volumes 25,000; Cassettes; Clipping Files; Filmstrips; Manuscripts; Memorabilia; Motion Pictures; Original Art Works; Original Documents; Other Holdings; Pamphlets; Periodical Subscriptions; Photographs; Prints; Records; Reels; Reproductions; Sculpture; Slides; Video Tapes
Collections: Kress Foundation Study Collection; Meynell; Pen Browning paitnings; portraits of Robert Browning & Elizabeth Barrett Browning; portraits of donors; Julia Margaret Cameron, photographs; Wedgwood; Dresden; Joseph Milsand Collection
Publications: Armstrong Browning Library Newsletter, semi-annual; Baylor Browning Interests, irregular; Studies in Browning & His Circle, annual; More Than Friend, The Letters of Robert Browning to Katherine Dekay Bronson; Robert Browning's Flowers; EBB at the Mercy of Her Publishers; Robert Browning: A Telescopic View, 1812-1889, An Exhibition Guide; Elizabeth Barrett Browning: Life in a New Rhythm, An exhibition held at the Grolier Club, 15 December 1993 through 19 February 1994; The Pied Piper: A Tale of Two Ditties

Activities: Lect open to public, 2 vis lectr per year; concerts; tours; fels offered; book traveling exhibitions; sales shop sells books, postcards, victorian style mementoes

M TEXAS RANGER HALL OF FAME & MUSEUM, 100 Texas Ranger Trl, Fort Fisher Park Waco, TX 76706; PO Box 2570, Waco, TX 76702-2570. Tel 254-750-8631; Fax 254-750-8629; Elec Mail trhf@eramp.net; Internet Home Page Address: www.texasranger.org; *Dir & Supt* Byron Johnson
Open daily 9 AM - 5 PM, cl Thanksgiving, Christmas, New Year's Day; Admis adults $5, children (6 & up) $2.50; Mem: Dues individual, student & senior $35
Income: Financed by contributions, gifts, grants, mem & state appropriations
Collections: Texas Ranger items; Western history; paintings & sculpture
Publications: The Texas Ranger Dispatch; The Online Journal of Texas Ranger History
Activities: Lect; research on Texas Rangers
L Texas Ranger Research Center, PO Box 2570, Waco, TX 76702-2570. Tel 254-750-8631; Fax 254-750-8629; Elec Mail trhf@eramp.net; Internet Home Page Address: www.texasranger.org; *Head* Christina Stopka
Open Mon - Sat 9 AM - Noon, 1-3 PM; Estab 1976; For reference only
Income: Financed by City of Waco
Library Holdings: Book Volumes 1,600; Cassettes; Clipping Files; Manuscripts; Memorabilia; Photographs; Reels; Video Tapes
Activities: Mus shop

WAXAHACHIE

M ELLIS COUNTY MUSEUM INC, 201 S College, PO Box 706 Waxahachie, TX 75168. Tel 214-937-0681; Fax 214-937-3910; Elec Mail ecmuseum@azmail.net; *Cur* Shannon Simpson
Open Tues - Sat 10 AM - 5 PM, Sun 1 - 5 PM, cl Mon; Estab 1969 to collect & maintain artifacts relating to county's history; Average Annual Attendance: 10,000-12,000; Mem: 275; dues benefactor $1000, sponsor $200, patron $100, business $50, family $20, individual $10
Income: $70,000 (financed by annual fundraiser)
Special Subjects: Decorative Arts, Furniture
Collections: Decorative Arts, Clothing, Furniture; Folding Fans; Photographs, Memorabilia; Technological Implements; Weaponry
Exhibitions: Artifacts relating to county's history
Activities: Retail store sells books, prints

WICHITA FALLS

M WICHITA FALLS MUSEUM & ART CENTER, Two Eureka Circle, Wichita Falls, TX 76308. Tel 940-692-0923; Fax 940-696-5358; Elec Mail contact@wfmac.org; Internet Home Page Address: www.wfmac.org; *Interim Dir* Jeff D Desborough; *Cur Coll & Exhib* Danny Bills; *Planetarium/Laser Show Oper* Gidget Smith; *Mem Coordr* Shirley Desborough; *Receptionist* Doris Thornburg
Open Tues - Fri 9:30 AM - 4:30 PM, Sat 10:30 AM - 4:30 PM, cl Sun & Mon; Admis fee varies with exhibits; Estab 1964 for the purpose of serving the community; Three galleries house art exhibits, two galleries house science exhibits; Average Annual Attendance: 50,000; Mem: 800; dues $30 - $1,000
Income: Financed by endowment, mem & city appropriation
Special Subjects: Prints
Collections: American prints; Photography/Lester Jones; Caldecott Collection of children's book illustrations
Publications: Events calendar, Sept, Jan, May
Activities: Classes for adults & children; dramatic programs; docent training; lect open to public, concerts; tours, competitions; lending collection of original prints to Midwestern State Universitgy; originate traveling exhibitions

WIMBERLEY

M PIONEER TOWN, Pioneer Museum of Western Art, 333 Wayside Dr, Wimberley, TX 78676. Tel 512-847-3289; Fax 512-847-6705; *Dir* Raymond L Czichos; *Secy* Kasia Zinz; *Dir Video* C L Czichos; *Secy & Treas* John D White
Open Memorial Day - Labor Day by appointment only (512-847-3289); Estab 1956 as a village & art museum
Income: Financed by donations
Special Subjects: Architecture, Sculpture, American Western Art, Bronzes, Crafts, Decorative Arts, Metalwork
Collections: Remington Bronze Collection; Jack Woods Collection (sculpture); contemporary Western artists; sculpture & metalwork

UTAH

BLANDING

M THE DINOSAUR MUSEUM, 754 S 200 W, Blanding, UT 84511. Tel 435-678-3454; Elec Mail dinos@dinosaur-museum.org; Internet Home Page Address: www.dinosaur-museum.org
Open Apr 15 - May and Sept - Oct 15 Mon - Sat 9 AM - 5 PM; cl Sun. Jun - Aug daily 8 AM - 8 PM; Admis adults $2, seniors & children $1; Mus covers history of the world of dinosaurs, complete with skeletons, fossilized skin, eggs, footprints, state-of-the-art graphics and realistic sculptures
Special Subjects: Historical Material, Sculpture
Collections: Herrerasaurus from Argentina; Plateosaurus from Germany; Herrerasaurus, from the Triassic of Argentina; Tarbosaurus from Mongolia; mummified Edmontosaurus
Exhibitions: The Art and Science of Dinosaurs in Movies: traces the changing image of the motion picture dinosaur from the silent 1919 Ghost of Slumber Mountain to present day blockbusters

Publications: Feathered Dinosaurs and the Origin of Flight, edited by Sylvia J Czerkas
Activities: Guided tours by appt; research projects

BRIGHAM CITY

M **BRIGHAM CITY CORPORATION,** Brigham City Museum & Gallery, 24 N Third W, PO Box 583 Brigham City, UT 84302. Tel 435-723-6769; Fax 435-723-6769; Elec Mail bcmuseum@brighamcity.utah.gov; Internet Home Page Address: www.brighamcity.utah.gov; *Dir* Larry Douglass; *Publicity & Heritage Writer* Mary Alice Hobbs; *Registrar* Donna Nickolaisen
Open Tues - Fri 11 AM - 6 PM, Sat 1 - 5 PM, cl Sun & Mon; No admis fee; Estab 1970 to document local history & host traveling exhibitions; Rotating gallery 2,500 sq ft, History Area 1,700 sq ft; Average Annual Attendance: 13,000
Income: Financed by Brigham City Corporation
Special Subjects: Prints, Ceramics, Folk Art, Glass
Collections: Ceramics; crystal & glass; fibers; folk art; 19th century clothing, artifacts & furniture; painting; printmaking; pioneer furniture of Brigham City
Publications: Historic Tour of Brigham City; Mayors of Brigham City
Activities: Educ dept for research, & oral histories; lect open to public; gallery talks; tours; awards; monthly rotating exhibits of art & varied collections

CEDAR CITY

M **SOUTHERN UTAH UNIVERSITY,** Braithwaite Fine Arts Gallery, 351 W Center St, Cedar City, UT 84720. Tel 435-586-5432; Fax 435-865-8012; Elec Mail museums@suu.edu; Internet Home Page Address: www.suu.edu/pra/artgallery; *Dir* Lydia Johnson
Open Mon - Fri Noon - 7 PM; No admis fee; Estab 1976 to provide a quality visual arts forum for artists' work and the viewing public; The gallery has 2,500 sq ft of space with 300 linear ft of display surface; it is equipped with facilities for two & three-dimensional media with electronic security system; Average Annual Attendance: 10,000; Mem: 100; dues $50 - $500
Income: Financed by city and state appropriations and private donations
Special Subjects: Painting-American
Collections: 18th, 19th & 20th century American art
Publications: Exhibition announcements, quarterly; newsletter, quarterly
Activities: Gallery talks; tours; competitions; book traveling exhibitions 6 per year

LOGAN

M **UTAH STATE UNIVERSITY MUSEUM OF ART,** Nora Eccles Harrison Museum of Art, Utah State Univ, 4020 Old Main Hill Logan, UT 84322-4020. Tel 435-797-0163; Fax 435-797-3423; Internet Home Page Address: www.artmuseum.usu.edu; *Dir & Chief Cur* Victoria Rowe; *Asst Educ Cur* Nadra E Haffar; *Office Mgr* Rachel Hamm; *Coll Mgr* Susanne Lambert; *Asst Educ Cur* Deb Banerjee
Open Tues - Fri 10 AM - 5 PM, Sat 12 PM - 4 PM, cl Sun, Mon & holidays; No admis fee; Estab 1983; Over 10,000 sq ft of exhibition area, half devoted to permanent exhibits & half to temporary shows; Average Annual Attendance: 30,000; Mem: 120; dues $10 - $500; annual meeting 2nd Tues of May
Purchases: $300,000
Special Subjects: American Indian Art, American Western Art, Ceramics
Collections: Native American; 20th century American art, with emphasis on Western US artists; 20th century American ceramics
Publications: Exhibition catalogs; Insight, newsletter, three times per yr
Activities: Educ prog; classes for adults & children; lect open to public & to members only, 7-10 vis lectr per year; concerts; gallery talks; scholarships; followships; scholarships & fellowships offered; book traveling exhibitions 3-4 per year; originate traveling exhibitions

OGDEN

A **ECCLES COMMUNITY ART CENTER,** 2580 Jefferson Ave, Ogden, UT 84401. Tel 801-392-6935; Fax 801-392-5295; Elec Mail eccles@ogden4arts; Internet Home Page Address: www.ogden4arts.org; *Gift Shop Mgr* Arlene Muller; *Dir* Sandy Havas; *Cur of Educ* Donna Shuiely; *Asst to Dir* Debra Muller
Open Mon - Fri 9 AM - 5 PM, Sat 9 AM - 3 PM, cl Sun & holidays; No admis fee; Estab 1959 to serve as focal point for community cultural activities & to promote cultural growth; Maintains an art gallery with monthly exhibits; Average Annual Attendance: 25,000; Mem: 600; dues $25 - $100; annual meeting in Nov
Income: $100,000 (financed by mem, state appropriation & fund raising)
Collections: Utah Artists (historic & contemporaries)
Exhibitions: Utah Pastel Society 28th Annual Statewide Competition; paintings by Jamaica Jensen; other Utah artists
Publications: Newsletter, quarterly
Activities: Classes for adults & children; docent training; lect open to public, 6 vis lectr per year; concerts; gallery talks; tours; competition with awards; scholarships offered; book traveling exhibitions; sales shop sells original art, reproductions, prints, ceramics, jewelry & artist produced cards

OGDEN UNION STATION

M **Myra Powell Art Gallery & Gallery at the Station,** Tel 801-393-9880; Fax 801-621-0230; Elec Mail rebeverlyous@msn.com; Internet Home Page Address: www.theunionstation.org; *Exec Dir* Tracy Ehrig
Open Mon - Sat 10 AM - 5 PM; No admis fee; Estab 1979 to acquaint more people with the visual arts & to heighten awareness of art; 12.5 ft x 113 ft; 39 panels 6 ft x 4 ft; Average Annual Attendance: 2,500; Mem: Practicing Artists
Income: Financed by endowment & donations
Collections: Non-objective painting, Indian Design, Landscape, Navajo Sand Painting, Aluminum Sculpture
Exhibitions: Exhibs change monthly
Activities: Lect open to public; 6 vis lect per yr; competitions with awards; schols & fellowships offered; individual paintings & original objects of art lent

M **Union Station Museums,** Tel 801-629-8444, 629-8535; Internet Home Page Address: www.theunionstation.org; *Exec Dir* Bob Geier
Open Mon - Sat 10 AM - 5 PM, Sun 11 AM - 3 PM (Memorial Day - Labor Day); Admis adults $3, senior citizens $2, children under 12 $1; Estab 1976 to serve as a cultural & civic center for Ogden, Utah; Average Annual Attendance: 40,000; Mem: Dues $15 - $1,000; meetings 1st Tues of month
Income: Financed by endowment, mem, city appropriation
Collections: Railroad memorabilia
Exhibitions: 1930s & 1940s memorabilia; Browning Firearms; Browning Classic Cars; Wattis-Dumke Model Railroad; Gem & Mineral Display; Myra Powell Gallery; Utah State Railroad Museum
Publications: The Inside Track, annual newsletter
Activities: Mus shop sells books & reproductions

PARK CITY

A **KIMBALL ART CENTER,** 638 Park Ave, PO Box 1478 Park City, UT 84060. Tel 435-649-8882; Fax 435-649-8889; Internet Home Page Address: www.kimball-art.org; *Dir* Sarah Behrens
Open Mon, Wed & Sat 10 AM - 6 PM, Sun Noon - 6 PM; Estab 1976 for monthly gallery shows & workshops in arts & crafts, fine arts; Main gallery has movable walls & is 80 x 180 ft, Badami gallery measures 17 x 20 ft; Average Annual Attendance: 250,000; Mem: 600; dues individual $40, family $70
Income: $700,000 (financed by endowment, mem & contributions)
Exhibitions: Twenty four exhibits annually in various styles & mediums
Activities: Classes for adults & children; docent training; lect open to public, 6 vis lectr per year; gallery talks; tours; competitions; opening receptions with exhibiting artists; annual art festival; book traveling exhibitions; sales shop sells original art, reproductions & prints

PRICE

M **COLLEGE OF EASTERN UTAH,** Gallery East, 451 E Fourth N, Price, UT 84501. Tel 435-637-2120; Fax 435-637-4102; Internet Home Page Address: www.ceu.edu; *Chmn* Brent Haddock
Open Mon - Fri 8:30 AM - 5 PM; No admis fee; Estab 1976 to provide an educational & aesthetic tool within the community; 2,300 sq ft; maintains reference library; Average Annual Attendance: 15,000
Income: $1,600 (financed by school appropriation)
Special Subjects: Prints
Collections: Broad collection of contemporary prints & painting
Exhibitions: Changing exhibits
Activities: Classes for adults; docent training; lect open to public, 4-5 vis lectr per year; gallery talks; tours; competitions with awards; scholarships offered; traveling exhibits organized & circulated to colleges

PROVO

BRIGHAM YOUNG UNIVERSITY

M **B F Larsen Gallery,** Tel 801-378-2881; Fax 801-378-5964;
Open 9 AM - 5 PM; No admis fee; Estab 1965 to bring to the University students & faculty a wide range of new experiences in the visual arts; B F Larsen Gallery is a three story atrium shaped gallery with exhibition areas in center floor & upper levels; Gallery 303 is large room with foyer & single entrance-exit; total exhibition space 15,260 sq ft; Average Annual Attendance: 55,000 Gallery 303; 100,000 Larsen
Income: Financed by university
Special Subjects: Drawings, Painting-American, Prints, Sculpture, American Western Art, Manuscripts
Exhibitions: Invitational exhibits; exhibits by students & faculty, curated exhibits of contemporary artists & circulating exhibits
Activities: Lect open to public; competitions; monetary & certificate awards; individual paintings & original objects of art lent to university executive, faculty & university library; book traveling exhibitions monthly

L **Harold B Lee Library,** Tel 801-378-4005; Fax 801-378-6708; Internet Home Page Address: www.lib.byu.edu; *Dir Libraries* Sterling Albrecht; *Fine Arts Librn* Christiane Erbolato-Ramsey
Open Mon - Sat 7 AM - Midnight; No admis fee; Estab 1875 to support the university curriculum
Income: Financed by endowment, mem & Latter-day Saints church funds
Library Holdings: Audio Tapes; Book Volumes 3,677,805; CD-ROMs; Cassettes; Compact Disks; Exhibition Catalogs; Fiche; Filmstrips; Memorabilia; Motion Pictures; Pamphlets; Periodical Subscriptions 16,487; Photographs 12,000; Prints; Reels; Slides; Video Tapes
Special Subjects: American Western Art
Collections: George Anderson Collection of early Utah photographs; 15th & 16th century graphic art collection; C R Savage Collection; Vought indexed & mounted art reproduction collection
Activities: Tours

M **Museum of Art,** Tel 801-422-8256; Fax 801-422-0527; Elec Mail moa_admin@byu.edu; Internet Home Page Address: www.moa.byu.edu; *Dir* Dr Campbell Gray; *Assoc Ed* Lind; *Head Cur* Cheryll May
Open Mon. Thurs & Fri 10 AM - 9 PM, Tues& Wed 10 AM - 6 PM, Sat Noon - 5 PM; No admis fee; Estab 1993 to educate patrons & community; 11 galleries; study & general purpose sculpture garden; Average Annual Attendance: 135,000+
Special Subjects: Drawings, Painting-American, Prints, Sculpture, Watercolors, American Western Art, Bronzes, Religious Art, Ceramics, Pottery, Woodcarvings, Woodcuts, Etchings & Engravings, Landscapes, Portraits, Posters, Marine Painting, Painting-French, Carpets & Rugs, Renaissance Art, Cartoons
Collections: American Art-Hudson River School of American Impressionism; Utah Art; Christian Art; Collections include: Maynard Dixon, Mahonri Young, J. Alden Weir
Exhibitions: (8/2005-8/2010) American Dreams; (11/15/2006-6/16/2007) Beholding Salvation: Images of Christ; (2/15/2007-7/8/2007) Paths to Impressionism; (2/3/2007-5/28/2007) William B. Post: Pictionalist + Photography;

(7/26/2007-5/26/2008) Minerva Teichert: Pageantry in Paint;
(8/15/2007-10/31/2007) Pocahontas: The Creation of an American Princess
Publications: Expressions, quarterly newsletter
Activities: Classes for adults & children; docent programs; academic & public programs; lect open to public, 12 vis lectr per year; concerts; gallery talks; tours; lending collection contains 17,000 items, including individual paintings & original objects of art; book traveling exhibitions 6 per year; museum shop sells books, magazines, prints, reproductions & slides

SAINT GEORGE

M DIXIE STATE COLLEGE, Robert N & Peggy Sears Gallery, 225 S 700 East, Saint George, UT 84770. Tel 435-652-7500; Fax 435-656-4000; Elec Mail starkey@dixie.edu; Internet Home Page Address: www.dixie.edu; *Dir* Mark Petersen; *Cur & Collections Mgr* Kathy C Cieslewicz
Open 9 AM - 5 PM; No admis fee; Estab 1960 to serve southwestern Utah as a visual arts exhibit center; Gallery is located in the Eccles Fine Art Center; Average Annual Attendance: 10,000-15,000
Income: Financed by state appropriation & 35% of sales from monthly shows
Special Subjects: American Indian Art, Drawings, American Western Art, Photography, Pottery, Prints, Bronzes, Woodcuts, Painting-American, Sculpture, Watercolors, Ceramics, Etchings & Engravings, Landscapes, Portraits, Carpets & Rugs
Collections: Early & contemporary Utah painters; Ceramics; Artifacts
Exhibitions: Dixie State College, Sears Invitational Show & Sale
Activities: Classes for adults; dramatic programs; lect open to public, vis lectr; concerts; gallery talks

M ST GEORGE ART MUSEUM, 175 E 200 N , Saint George, UT 84770. Tel 435-634-5942; Elec Mail museum@infowest.com; Internet Home Page Address: www.sgcity.org/arts/sgartmuseum.php
Open Tues - Sat 10 AM - 5 PM; Admis adults $2, children 3 - 11 $1, children under 3 & mems no admis fee; third Thurs of each month no admis fee from 10 AM - 9 PM; Mus houses work of Utah artists; mus is located in a fully-restored sugar beet storage structure that is part of the St George's historic district; Mem: Dues Pres Circle/Corporate Sponsor $1000; Benefactor $750; Friend $500; Patron $250; Contributor $100; Indiv $50
Special Subjects: Historical Material, Painting-American
Exhibitions: Women Artists of Santa Fe 1914-1964; Garden of Gourds by Kolene Granger
Activities: Art Festival; 3rd Thurs Conversations at 7 PM; facility available by appt for social functions

SALT LAKE CITY

M CHURCH OF JESUS CHRIST OF LATTER-DAY SAINTS, Museum of Church History & Art, 45 N West Temple, Salt Lake City, UT 84150-3470. Tel 801-240-4615; Fax 801-240-5342; Internet Home Page Address: www.lds.org; *Dir* Glen Leonard
Open Mon - Fri 9 AM - 9 PM, Sat, Sun & holidays 10 AM - 7 PM, cl Easter, Thanksgiving, Christmas & New Year's Day; No admis fee; Estab 1869 to disseminate information & display historical memorabilia, artifacts & art to the vis pub; Assists in restorations & furnishing of Church historic sites; Average Annual Attendance: 250,000
Income: Financed by Church
Special Subjects: Bronzes, Architecture, Painting-American, Photography, Sculpture, Watercolors, American Indian Art, American Western Art, Southwestern Art, Textiles, Costumes, Religious Art, Folk Art, Pottery, Primitive art, Woodcarvings, Landscapes, Decorative Arts, Portraits, Furniture, Historical Material, Stained Glass
Collections: Mostly 19th & 20th century Morman art & historical artifacts: portraits, paintings, drawings, sculpture, prints, American furniture, china, pottery, glass; Morman quilts & handwork; decorative arts; clothing & textiles; architectural elements & hardware; Oceanic & American Indian pottery, basketry & textiles
Publications: Exhibition catalogs; brochures; Image of Faith: Art of the Latter-day Saints (1995)
Activities: Docent training; seminars; gallery demonstrations; school outreach; lect open to public; gallery talks tours; International Art Competition (triannial, next: 2006); individual paintings & original objects of art lent; museum shop sells books, prints, slides & postcards

L Art Library, 45 N West Temple, Salt Lake City, UT 84150. Tel 801-240-4604; Fax 801-240-5342; Internet Home Page Address: www.lds.org; *Librn* Ron Read
Open hrs vary, by appointment; Estab as reference source for historical information on Latter-Day Saints; Reference library
Income: Financed by church
Library Holdings: Audio Tapes; Book Volumes 2,200; Cassettes; Clipping Files; Exhibition Catalogs; Fiche; Memorabilia; Motion Pictures; Original Art Works; Pamphlets; Periodical Subscriptions 25; Photographs; Reels; Sculpture; Slides; Video Tapes

A SALT LAKE ART CENTER, 20 S W Temple, Salt Lake City, UT 84101. Tel 801-328-4201; Fax 801-322-4323; Elec Mail allisons@slartcenter.org; Internet Home Page Address: www.slartcenter.org; *Dir* Ric Collier; *Office Mgr* Erin Anderson; *Asst Dir* Allison South; *Dir Develop* Julie Kielbaso; *Dir Media Center* Kent Maxwell; *Pres* J Phil White; *Co-Dir Art Center S* Rodger Newbold; *Co-Dir Art Center S* Steve Fredrick; *Cur* Jim Edwards
Open Tues - Sat 10 AM - 5 PM, Fri 10 AM - 9 PM, Sun 1 - 5 PM, cl Mon; No admis fee; Estab 1931 to educate the community in the contemporary visual arts through exhibitions & classes; Center has one large gallery of 5,000 sq ft; one small gallery of 2,000 sq ft; sales shop of 1,000 sq ft; Average Annual Attendance: 48,000; Mem: 1,250; dues family $30, individual $20; annual meeting in June
Income: Financed by mem, city & state appropriation, earned income, gifts, private & corporate contributions
Collections: Utah artists (1930-Present)

Activities: Classes for adults; docent training; studio & lect courses; lect open to public, 10 vis lectr per year; gallery talks; tours; 2 - 3 book traveling exhibitions per year; sales shop sells books, jewelry, ceramics, cards, journals & textiles

L SALT LAKE CITY PUBLIC LIBRARY, Fine Arts & Audiovisual Dept and Atrium Gallery, 209 E Fifth S St, Salt Lake City, UT 84111. Tel 801-524-8200; Fax 801-524-8272; *Head Fine Arts & Audiovisual Dept* Carolyn Dickinson; *Dir* Nancy Tessman; *Asst Mgr* Howard Brough
Open Mon - Thurs 9 AM - 9 PM, Fri - Sat 9 AM - 6 PM, Sun 1 - 5 PM; No admis fee; Estab 1898; Maintains an art gallery with monthly exhibitions
Income: Financed by city appropriation
Library Holdings: Book Volumes 400,000; Exhibition Catalogs; Filmstrips; Original Art Works; Records; Reproductions; Slides; Video Tapes
Special Subjects: Film
Collections: Art of Western United States; Utah Artists; American & European Works on Paper
Publications: Brochures accompanying individual exhibitions; Permanent Art Collection Catalogue
Activities: Films; gallery talks; tours; demonstrations; slide presentations; individual paintings & original objects of art lent to museums & non-profit galleries; originate traveling exhibitions

M UNIVERSITY OF UTAH, Utah Museum of Fine Arts, 370 South 1530 E Rm 101, Salt Lake City, UT 84112-0360. Tel 801-581-7332; Fax 801-585-5198; Elec Mail drobinsonl@umfa.utah.edu; Internet Home Page Address: www.umfa.utah.edu; *Exec Dir* David Dee; *Gallery Supt & Preperator* David Hardy; *Dir Public Prog* Virginia Catherall; *Dir Visitors Svcs* Amy Edwards; *Dir External Relations* Allison Richards; *Marketing & Public Relations Coordr* Dana Robinson; *Membership Coordr* Carrie Radant; *Cur European Art* Ursula Pimentel; *Cur American Art* Mary Francey; *Cur African, Oceanic & New World Art* Bernadette Brown
Open Tues, Thurs, Fri 10 AM - 5 PM, Wed 10 AM - 8 PM, Sat & Sun 11 AM - 5 PM; admis fee adult $4; sr & student $2; Average Annual Attendance: 110,000; Mem: 1,000; dues family $35, single $20
Income: Financed by university & private gifts
Special Subjects: Flasks & Bottles, Painting-American, Graphics, Latin American Art, Mexican Art, Photography, Watercolors, American Indian Art, African Art, Pre-Columbian Art, Textiles, Religious Art, Woodcarvings, Woodcuts, Painting-European, Painting-Japanese, Portraits, Furniture, Jade, Oriental Art, Asian Art, Silver, Painting-British, Painting-Dutch, Painting-French, Ivory, Tapestries, Baroque Art, Painting-Flemish, Renaissance Art, Medieval Art, Painting-Spanish, Painting-Italian, Antiquities-Egyptian, Antiquities-Greek, Painting-German
Collections: Winifred Kimball Hudnut Collection; Natacha Rambova Egyptian Collection; Marion Sharp Robinson Collection; Trower & Michael Collections of English, American & Peruvian Silver; Bartlett Wicks Collection; English 17th & 18th century furniture & pictures; Egyptian antiquities; French 18th century furnishings & tapestries; graphics, contemporary works; Italian Renaissance paintings & furniture; objects from the Buddhist culture; African Art; Indonesian Art; Oceanic Art, American Indian Art; North Western Coastal Art
Activities: Classes for children; docent training; lect open to public, some for mem only; concerts; gallery talks; tours; museum shop sells reproductions, prints, jewelry & apparel

L Marriott Library, Salt Lake City, UT 84112. Tel 801-581-8104; Internet Home Page Address: www.lib.utah.edu/fa; *Fine Arts Librn* Myron Patterson; *Sr Library Specialist, Fine Arts Dept* Dorothy Greenland
Open Mon - Thurs 8 AM - 10 PM, Fri 8 AM - 5 PM, Sat 9 AM - 5 PM, Sun 1 - 10 PM; Estab 1967 to serve the students & faculty of the University with research materials & specialized services; For lending & reference
Income: Financed by state appropriation
Purchases: $60,000 per yr for fine arts books
Library Holdings: Book Volumes 2,000,000; Clipping Files; Exhibition Catalogs; Periodical Subscriptions 17,000; Prints; Reproductions; Slides
Special Subjects: Folk Art, Graphic Arts, Graphic Design, Painting-American, Painting-British, Painting-Dutch, Painting-Flemish, Painting-European, American Western Art, Advertising Design, American Indian Art, Furniture, Glass, Aesthetics, Afro-American Art

M UTAH ARTS COUNCIL, Chase Home Museum of Utah Folk Arts, 617 E South Temple, Salt Lake City, UT 84102; Middle of Liberty Park, Salt Lake City, UT 84105. Tel 801-533-5760; Fax 801-533-4202; Elec Mail cedison@utah.gov; Internet Home Page Address: www.arts.utah.org; Internet Home Page Address: www.folkartsmuseum.org; *Exec Dir* Bonnie Stephens; *Folk Arts Coordr* Carol Edison
Open mid Apr - Oct Noon - 5 PM, spring & fall weekends only, daily Memorial Day - Labor Day; summer hours Tues - Thurs Noon - 5 PM, Fri - Mon 2 PM - 7 PM; No admis fee; Estab 1986 to showcase folk art in the State Art Collection; Four small galleries, one small reception area & two hallways for display in a 19th century two-story farmhouse; Average Annual Attendance: 25,000
Income: Financed by state & federal appropriations
Library Holdings: Audio Tapes; Book Volumes 600; Cassettes; Clipping Files; Motion Pictures; Pamphlets; Periodical Subscriptions 5; Photographs; Prints; Records; Slides
Special Subjects: Photography, Sculpture, Crafts, Folk Art
Collections: Ethnic; Familial; Occupational; Religious; Regional with an emphasis on traditional work by living folk artists; Native American
Exhibitions: Annual exhibit of Utah folk art; rotating exhibits
Publications: Publications & recordings featuring old-time social dance, Navajo baskets, Hispanic traditions
Activities: Lect open to the public; concerts; group tours; originates traveling exhibitions

M UTAH DEPARTMENT OF NATURAL RESOURCES, DIVISION OF PARKS & RECREATION, Territorial Statehouse, 1594 W N Temple Ste 3710, Salt Lake City, UT 84114. Tel 801-538-7200; Fax 801-538-7315; Internet Home Page Address: www.nr.state.ut.us; *Cur* Carl Camp; *Park Mgr* Gordon Chatland
Open June 1st - Sept 1st Mon -Sat 9 AM - 6 PM, cl Sun; Admis $5 per vehicle, $3 per person; Estab 1930, as a museum for pioneer relics; Restored by the state

& local Daughters of Utah Pioneers; owned & operated by Utah State Division of Parks & Recreation; Average Annual Attendance: 35,000

Income: Financed by state appropriations

Special Subjects: Photography, Prints, Period Rooms

Collections: Charcoal & pencil sketches; paintings by Utah artists; photograph prints collection; pioneer portraits in antique frames; silk screen prints; rooms arranged in period settings

Exhibitions: Rotating exhibits

Activities: Educ dept; lect; gallery talks; tours; museum shop sells books, postcards, kids' toys, old time toys & candy

A **UTAH LAWYERS FOR THE ARTS,** 170 S Main St, Ste 1500, Salt Lake City, UT 84101. Tel 801-521-3200; Fax 801-328-0537; *Pres* James W Stewart

Estab 1983 to provide pro bono legal services; Mem: 36; mem open to attorneys & law students; $30 annual fee, $15 student fee

Income: Financed by mem

Publications: Art/Law News, quarterly newsletter

A **UTAH TRAVEL COUNCIL,** Council Hall, Capitol Hill, Salt Lake City, UT 84114. Tel 801-538-1030; Fax 801-538-1399; Elec Mail skinard@travel.state.ut.us; Internet Home Page Address: www.utah.com; *Asst Dir* Spence Kinard; *Travel Publications Specialist* Janice Carpenter; *Media Dir* Tracie Cayford; *Dir* Dean Reeder

Open 8 AM - 5 PM; Sat & Sun 10 AM - 5 PM; No admis fee; Estab 1969 to promote travel & tourism to the state of Utah; Constructed in 1866 & served as seat of government for 30 years; reconstructed on Capitol Hill & presented to Utah state in 1963; contains small mix of pioneer & historic items, paintings & furniture

Income: Financed by legislative appropriation

Publications: Brochures; two newsletters

Activities: Lending collection contains motion pictures, photographs, transparencies for public use, videos on travel opportunities in Utah; originate traveling exhibitions

SPRINGVILLE

M **SPRINGVILLE MUSEUM OF ART,** 126 E 400 South, Springville, UT 84663. Tel 801-489-2727; Fax 801-489-2739; Elec Mail smaswap@sisna.com; Internet Home Page Address: www.nebo.edu/museum/museum.html; *Dir* Dr Vern G Swanson; *Asst Dir* Dr Sharon R Gray; *VPres* Tracey Fieldsted; *VPres* J Brent Haymond

Open Tues - Sat 10 AM - 5 PM, Wed 10 AM - 9 PM, Sun 3 - 6 PM, cl Mon & holidays; No admis fee; Estab 1903 for the collection & exhibition of Utah fine arts & as educational resource; Built in Spanish Moroccan style in 1937. One of the largest museums in the mountain west, it has seventeen galleries with 25,000 sq ft of exhibit space; maintains a photographic art reference library for Utah art history; Average Annual Attendance: 120,000; Mem: 350; dues family $30, individual $20, student $10; annual meeting in Apr

Income: $400,000 (financed by donations, bookstore, mem, city & state appropriations)

Purchases: $300,000 of fine art per year

Special Subjects: Painting-American, Bronzes

Collections: Artwork by Cyrus Dallin & John Hafen; 20th Century American Realism, Soviet Realism; Utah artists from 1850 to present of all styles

Exhibitions: Annual Spring Salon (Utah Invitational Fine Art); Annual Utah Autumn Exhibit; High Schools of Utah Show; National Quilt Show;

Publications: Annual exhibition catalogues

Activities: Docent programs; children's programs; art teacher in-service progs earn credit toward teaching certificate; lect open to public, 6 vis lectr per year; concerts; gallery talks; tours; competitions with awards; individual paintings & original objects of art lent to professional, governmental & educational institutions & museums; lending collection contains paintings & sculpture; originate traveling exhibitions to Utah Arts Council, other museums & to schools; museum shop sells books, magazines, reproductions, prints & catalogues

VERMONT

BENNINGTON

M **BENNINGTON MUSEUM,** W Main St, Bennington, VT 05201. Tel 802-447-1571; Fax 802-442-8305; Elec Mail rborges@benningtonmuseum.org; Internet Home Page Address: www.benningtonmuseum.org; *Membership & Public Relations Coordr* Maryann St John; *Exec Dir* Richard Borges; *Cur* Stephen Perkins; *Dir Educ* Phyllis Chapman

Open Nov 1 - May 31 9 AM - 5 PM, June 1 - Oct 31 9 AM - 6 PM; Admis family $19, adults & students $8; senior citizens $7, children under 12 free; Estab 1875 as resource for history and fine and decorative arts of New England; Local historical mus with 11 galleries, Grandma Moses Schoolhouse Mus; Average Annual Attendance: 50,000; Mem: 700; dues $40 - $1500; annual meeting in May

Special Subjects: Drawings, Costumes, Ceramics, Folk Art, Decorative Arts, Dolls, Furniture, Coins & Medals, Embroidery

Collections: Bennington pottery; Bennington Flag; American blown & pressed glass; American painting & sculpture; American furniture & decorative arts; dolls & toys; Grandma Moses paintings; rare documents

Publications: Exhibition catalogs

Activities: Classes for adults & children; docent training; lect open to public, 4 vis lectr per year; gallery talks; tours; individual paintings & original objects of art lent to other qualifying organizations; book traveling exhibitions; originate traveling exhibitions to other northern New England museums; museum shop sells books, magazines, original art, reproductions, prints & decorative arts

L **Library,** 75 Main St, Bennington, VT 05201. Tel 802-447-1571; Fax 802-442-8305; Elec Mail sperkins@benningtonmuseum.org; Internet Home Page

Address: www.BenningtonMuseum.org; *Librn* Tyler Resch; *Cur* Stephen Perkins; *Dir* Richard Borges; *Educ Dir* Phyllis Chapman

Open May - Oct 9 AM - 6 PM, Nov - Apr 9 AM - 5 PM 7 days per week; Admis family $13, adults $6, students & seniors $5, children under 12 free; Estab 1875 as Historical Societ; Regional History & Art Museum; Mem: 300

Library Holdings: Book Volumes 5,000; CD-ROMs; Clipping Files; Exhibition Catalogs; Fiche; Lantern Slides; Manuscripts; Maps; Original Documents; Pamphlets; Periodical Subscriptions 10; Photographs; Reels; Slides; Video Tapes

Special Subjects: Art History, Folk Art, Decorative Arts, Sculpture, Historical Material, Portraits, Ceramics, Furniture, Glass, Pottery, Silver, Textiles, Coins & Medals, Flasks & Bottles

Collections: Grandma Moses, furniture, silve,r pottery, glass, history, art

Exhibitions: Exhibitions change every 6 months

Activities: Classes for adults & children; docent training; outreach to scholls; lect open to public; 15 vis lectrs per year; concerts; gallery talks; tours; sponsoring of competitions; fellowships; museum shop sells books, original art, reproductions, prints

BRATTLEBORO

M **BRATTLEBORO MUSEUM & ART CENTER,** 10 Vernon St Brattleboro, VT 05301-3623. Tel 802-257-0124; Fax 802-258-9182; Elec Mail info@brattleboromuseum.org; Internet Home Page Address: www.brattleboromuseum.org; *Dir* Konstantin von Krusenstiern; *Educ Cur* Susan Calabria; *Operation Mgr* Teta Hilsdon

Open May - Feb daily except Tues 11 AM - 5 PM; Admis adults $4, seniors $3, students $2, children & members free; Estab 1972 to present art & ideas in ways that inspire, educate & engage people of all ages; The museum is located in a railroad station built in 1915, now a registered historic site. Six galleries with changing exhibitions & museum gift shop; Average Annual Attendance: 20,000; Mem: 800; dues family $70, individual $40, senior $30; annual meeting in May

Income: $200,000 (financed by mem, donations, town, state, federal grants, corporate sponsorships, program fees & gift shop sales)

Exhibitions: Approx 15 exhibits annually

Publications: Built Landscapes; Gardens of the Northeast; Seeing Japan; The Art of Frank Stout; Artful Jesters; Wolf Kahn Landscape of Light

Activities: Docent training; programs for school groups; family workshops; lect open to public, 12 vis lectr per year; concerts; gallery talks; tours; museum shop sells books, notecards, postcards & novelties

BURLINGTON

M **UNIVERSITY OF VERMONT,** Robert Hull Fleming Museum, Burlington, VT 05405. Tel 802-656-0750, 656-2090; Fax 802-656-8059; Internet Home Page Address: www.uvm.edu/~fleming; *Cur* Janie Cohen; *Business Mgr* Janet Dufrane; *Community Relations* Jennifer Karson; *Exhib Designer & Preparator* Merlin Acomb; *Museum Educator* Chris Fearon; *Registrar* Darcy Coates; *Dir* Ann Porter

Call 802-656-2090 for hours; family $5, adult $3, seniors & students $2, area college students, faculty & staff no admis fee; Estab 1873 as a fine arts museum for the area & a teaching facility for the University; Permanent gallery of 18th & 19th century American Art; permanent gallery of European painting; ethnographic gallery of rotating exhibitions. Museum also contains a reference library; Average Annual Attendance: 21,000; Mem: 700; dues Fleming Soc $1,000, benefactor $500-$999, patron $250-$499 supporting $100-$249 contributing $50-$99, family $30, individual $20, student $10

Income: Financed by mem, university appropriations & grants

Special Subjects: Drawings, Prints, Ethnology, Costumes, Oriental Art, Medieval Art, Antiquities-Greek, Antiquities-Roman

Collections: American, European, Pre-Columbian & Oriental art including paintings, sculpture, decorative arts & artifacts; costumes; ethnographic collection, especially Native American; prints & drawings of various periods

Exhibitions: American historic & contemporary; Asian; Ethnographic; Medieval & Ancient; European; Egyptian

Publications: Exhibition catalogs; newsletter-calendar, 3 per yr

Activities: Classes for adults & children; docent training; lect open to public, 20 vis lectr per year; concerts; gallery talks; tours; community outreach serves all Vermont; individual paintings & original objects of art lent to museum community; annual family day; annual heirloom appraisal day; book traveling exhibitions; originate traveling exhibitions; museum shop sells books, magazines, reproductions, prints & Vermont crafts

M **Francis Colburn Gallery,** Williams Hall, Burlington, VT 05405. Tel 802-656-2014; Fax 802-656-2064;

Open Sept - May 9 AM - 5 PM; No admis fee; Estab 1975

Exhibitions: Student, faculty & visiting artist works

L **Wilbur Room Library,** Robert Hull Fleming Museum, 61 Colchester Ave Burlington, VT 05405. Tel 802-656-0750; Fax 802-656-8059; Internet Home Page Address: www.uvm.edu/~fleming; *Dir* Ann Porter; *Asst Dir & Cur* Janie Cohen; *Curatorial Asst* Milly Meeks

Open Labor Day - April 30 Tues - Fri 9 AM - 4 PM, Sat - Sun 1 - 5 PM; Families $5, adults $3, seniors & students $2; Estab for Museum staff & volunteers & use by university & community. Books & materials related to Fleming Museum collections; For reference only

Income: University appropriations & grants

Library Holdings: Book Volumes 1,000; Clipping Files; Exhibition Catalogs; Pamphlets

Special Subjects: Decorative Arts, Painting-American, Asian Art

FERRISBURGH

A **ROWLAND EVANS ROBINSON MEMORIAL ASSOCIATION,** Rokeby Museum, 4334 Route 7, Ferrisburgh, VT 05456. Tel 802-877-3406; Fax 802-877-3406; Elec Mail rokeby@adelphia.net; Internet Home Page Address: www.rokeby.org; *Dir* Jane Williamson; *Educ* Jenn Staats

Open May - Oct Thurs - Sun 11 AM - 3 PM, open by appointment only remainder of yr; Admis fees Adult $6, seniors & students $4, children under 13 $2; Estab

1963 to exhibit & interpret lives & works of the Robinson family; Robinson family (prolific artists) art is displayed throughout the house. Work of Rachael Robinson Elmer (1878 - 1919), student at Art Students League, is most prominent. She & her father, Rowland E Robinson (1833 - 1900), were published artists; Average Annual Attendance: 2,400; Mem: 250; dues life $500, family $40, individual $25, student $10; ann meeting in mid-May

Income: Financed by mem, contributions & grants

Special Subjects: Costumes, Manuscripts, Textiles, Watercolors, Furniture

Collections: Art, oils & watercolor sketches; books & manuscripts; 17th - 20th century furnishings; textiles & costumes

Publications: Messenger

Activities: Classes for children; docent training; lect open to public; museum shop sells books & prints

GLOVER

M **BREAD & PUPPET THEATER MUSEUM,** Rte 122, Rd 2 Glover, VT 05839. Tel 802-525-6972; *Artist* Peter Schumann; *Mgr* Elka Schumann
Open June - Oct daily 10 AM - 6 PM; No admis fee; Estab 1975 to exhibit & promote the art of puppetry; Average Annual Attendance: 20,000

Income: $10,000 (financed by donations, sales of publications & art & by the Bread & Puppet Theater)

Collections: giant puppets; masks; graphics of The Bread and Puppet Theater

Publications: The Radicality of Puppet Theater

Activities: Mus shop sells books, prints, original art, posters & postcards

JERICHO

A **JERICHO HISTORICAL SOCIETY,** The Old Red Mill, PO Box 35 Jericho, VT 05465; Rt 15, Jericho, VT 05465. Tel 802-899-3225; Internet Home Page Address: jerichohistoricalsociety.com; *Pres* Wayne Howe; *VPres* Ann Squires; *Sales Shop Mgr* Gail Prior; *Archives Chmn* Ray Miglionico
Open Mon - Sat 10 AM - 5 PM, cl winter; No admis fee; Estab 1978

Income: Financed by mem & contributions

Collections: Milling Machinery (video tape); Slides of Snow Flakes & Ice Crystals (video tape)

Exhibitions: Machinery, permanent exhibit

LUDLOW

M **BLACK RIVER ACADEMY MUSEUM & HISTORICAL SOCIETY,** (Black River Historical Society) Black River Academy Museum, High St, PO Box 73 Ludlow, VT 05149. Tel 802-228-5050; Elec Mail glbrehm@tds.net; *Dir* Georgia L Brehm
Open Noon - 4 PM, summer only; Admis $2; Estab 1972; 3-story brick building built in 1889; Average Annual Attendance: 1,200; Mem: 200; dues family $50, single $20

Income: $25,000 (financed by endowment)

Collections: School memorabilia, farming implements, domestic items - 19th century, furnishings, clothing; Calvin Coolidge School Days Memorabilia

Publications: History of Ludlow, VT, J Harris (monograph); Black River Academy Booklet

Activities: Dramatic programs; classes for adults & children; concerts; tours on holidays; scholarships; traveling exhibitions 2 per year; museum shop sells books

LYNDON CENTER

M **SHORES MEMORIAL MUSEUM AND VICTORIANA,** Main St, Lyndon Center, VT 05850; PO Box 85, Lyndon Center, VT 05850. Tel 802-626-8547; Internet Home Page Address: www.vmga.org/caledonia/shores.html; *Cur* Ruth McCarty; *Historian* Venila Shores, PhD
Summer Sat & Sun 2 - 4 PM & by appt; No admis fee, donations accepted; Mus portrays a working man's home of the late Victorian era. Completed in 1896, this Queen Anne-style house was home to the Shores family of Lyndon Center, VT

Special Subjects: Historical Material, Photography, Period Rooms, Costumes, Dolls, Furniture

Collections: Photographs, organs, sheet music, miscellaneous instruments & trophies are displayed in the home's two parlors; kitchen & pantry exhib which demonstrates the time in which food preparation meant hours of hand labor. Coll includes wooden plates & bowls, a mortar & pestle, wire basket for egg collecting, long-handled bedwarmer, and a sadiron for pressing clothes; upstairs room features period clothing, exhib of war memorabilia & a doll exhib

Activities: Resource room for historical research

MANCHESTER

A **SOUTHERN VERMONT ART CENTER,** PO Box 617, West Rd Manchester, VT 05254. Tel 802-362-1405, 362-4823; Fax 802-362-3274; Elec Mail info@svac.org; Internet Home Page Address: www.svac.org; *Pres* Charles M Ams III; *Dir* Christopher Madkour; *Dir Pub Relations* Margaret Donovan
Open Tues - Sat 10 AM - 5 PM, Sun Noon - 5 PM, cl July 4th; Admis adults $5, students $2, free admis Sun; members and children under 13 free; Estab 1929 to promote educ in the arts & to hold exhibitions of art in its various forms; 10 galleries; sculpture garden; Average Annual Attendance: 25,000; Mem: Dues $55 - $75; annual meeting in Sept

Income: Financed by mem & contributions

Collections: Contemporary American sculptors & painters; loan collection

Exhibitions: Annual exhibitions for members; Fall Show; one-man & special exhibitions

Publications: Annual catalog & brochures

Activities: Classes for adults & children in painting, drawing, graphic arts, photography, sculpture & pottery; concerts; scholarship & fels offered

L **Library,** PO Box 617, West Rd, Manchester, VT 05254. Tel 802-362-1405; *Dir* Christopher Madkour
Open Tues - Fri 10 AM - 5 PM

Income: Income from contributions

Library Holdings: Book Volumes 500

MIDDLEBURY

M **HENRY SHELDON MUSEUM OF VERMONT HISTORY AND RESEARCH CENTER,** (Sheldon Museum) One Park St, Middlebury, VT 05753. Tel 802-388-2117; Fax 802-388-2112; Elec Mail info@henrysheldonmuseum.org; Internet Home Page Address: www.henrysheldonmuseum.org; *Exec Dir* Jan Albers; *Coll Mgr* Mary Epright; *Educ Coordr* Susan Peden; *Librn* Jane Ploughman; *Assoc Dir* Mary Manley
Open Mon - Sat 10 AM - 5 PM; Admis family $12, adults $5, seniors & students $4.50, youth $3; Estab 1882 for the preservation of furniture, portraits, decorative arts, artifacts & archival material of Middlebury & Addison County, VT; Museum housed in 1829 marble merchants home and with a gallery; Average Annual Attendance: 4,000; Mem: 650; dues $10 & up

Library Holdings: Book Volumes; Manuscripts; Maps; Original Documents; Pamphlets; Photographs

Special Subjects: Architecture, Glass, Furniture, Porcelain, Pottery, Painting-American, Manuscripts, Maps, Textiles, Costumes, Ceramics, Decorative Arts, Portraits, Posters, Historical Material, Period Rooms, Pewter

Collections: China; furniture; glass; historical material; landscapes; pewter; portraits; prints

Exhibitions: Changing art and history exhibits in the Cerf Gallery; permanent exhibits of 19th Century home & furnishings

Publications: Marble in Middlebury; Walking History of Middlebury; annual report; newsletter

Activities: Traditional craft classes for adults and workshops for children; lect; guided tours; gallery talks; tours; one concert annually; out-reach program to county schools; museum shop sells gifts, home accessories, jewelry, toys, games, reproductions, prints & books on Vermont history

M **MIDDLEBURY COLLEGE,** Museum of Art, Ctr for the Arts, Middlebury, VT 05753-6177. Tel 802-443-5007, 443-5235; Fax 802-443-2069; Elec Mail dperkin@middlebury.edu; Internet Home Page Address: www.middlebury.edu/museum; *Dir* Richard H Saunders; *Chief Cur* Emmie Donadio; *Designer* Ken Pohlman; *Registrar* Margaret Wallace; *Cur Educ* Sandra Olivo; *Security Mgr* Wayne Darling; *Book Store & Receptionist Coordr* Mikki Lane; *Events & Programs Coordr* Andrea Solomon; *Admin Operations Mgr* Douglas Perkins; *Preparator* John Houskeeper; *Preparator* Christine Fraioli; *Cur Asian Art* Colin MacKenzie
Open Tues - Fri 10 AM - 5 PM, Sat & Sun Noon - 5 PM, cl Mon & holidays; No admis fee; Estab 1968 as a teaching collection. Now also presents loan exhibitions, work by individuals & groups, student exhibits; In 1992 moved to new Middlebury College Center for the Arts, designed by Malcolm Holzman of Hardy, Holzman & Pfeiffer Associates; Average Annual Attendance: 15,000 - 17,000; Mem: 350; dues vary on 6 levels; annual meeting in Apr, triannual board meetings

Income: Financed through College, Friends of Art & grants

Special Subjects: Drawings, Painting-American, Photography, Prints, Sculpture, Watercolors, American Western Art, Bronzes, Woodcarvings, Etchings & Engravings, Decorative Arts, Painting-European, Portraits, Asian Art, Coins & Medals, Calligraphy, Period Rooms, Antiquities-Oriental, Antiquities-Greek, Antiquities-Roman, Antiquities-Assyrian

Collections: Asian art; drawings; paintings; photographs; prints; sculpture; antiquities

Publications: Gallery brochure; exhibition catalogues & brochures; exhibitions & events calendars

Activities: Classes for children; docent training; family workshops; teacher workshops; lect open to public, 2-3 vis lectr per year; gallery talks; Friends of Art sponsor Annual Arts Awards given to members of the local community; book traveling exhibitions 6-7 per year; originate traveling exhibitions; museum shop sells books, prints, notecards, postcards, posters

M **VERMONT STATE CRAFT CENTER AT FROG HOLLOW,** One Mill St, Middlebury, VT 05753. Tel 802-388-3177; Fax 802-388-5020; Elec Mail info@froghollow.org; Internet Home Page Address: www.froghollow.org; *Gallery Mgr* Barbara Cunningham; *Sales Mgr* Amy Bourgeois; *Pub Relations* Michael Giorgio; *Exec Dir* William F Brooks Jr
Open Mon - Sat 9:30 AM - 5:30 PM, Sun afternoon spring - fall; No admis fee; Estab 1971 to provide craft educational, informational & marketing services to school children, adults & professionals; Sales gallery exhibits the work of over 250 juried Vermont crafts people, also hosts yearly exhibition schedule featuring the work of noted crafts people world wide; Average Annual Attendance: 200,000; Mem: 1,200; dues $30 - $250; annual meeting in Nov; exhibiting members are juried into the gallery

Income: Financed by mem, federal & state grants, fundraising activities, consignment receipts & tuition

Special Subjects: Crafts

Collections: Vermont Crafts

Publications: Information services bulletin; calendar; show announcements; course brochures

Activities: Classes for adults & children; craft demonstrations; professional workshops for crafts people; pottery facility; resident potter studios; lect open to public, 4 vis lectrs per year; tours; original objects of fine craft lent to Vermont State Senate office in Washington; traveling exhibitions organized & circulated; gallery shop sells books & Vermont crafts

MONTPELIER

M **T W WOOD GALLERY & ARTS CENTER,** College Hall, Vermont College, Montpelier, VT 05602. Tel 802-828-8743; Fax 802-828-8645; Elec Mail woodartgallery@tui.edu; Internet Home Page Address: twwoodgallery.org; *Adminr* Melissa Starrow
Open Tues - Sun Noon - 4 PM; Donation; Estab 1895 by 19th century genre & portrait artist T W Wood to house & exhibit a portion of his works. Gallery acts

as archive for information about T W Wood; 3 gallery spaces: 2,700 sq ft, 800 sq ft, 500 sq ft, 15 ft high ceilings; in newly renovated 1870 College Hall on Vermont College campus; Average Annual Attendance: 10,000; Mem: 200; dues $35 - $100

Income: Financed by endowment, city appropriation, grants & mem
Special Subjects: Painting-American
Collections: Oil paintings, watercolors, prints by T W Wood, A B Durand, J G Brown, A Wyant, Edward Gay; 100 works from the 1920s & 30s, some by WPA painters Reginald Marsh, Louis Boucher, Paul Sample, Joseph Stella; early 19th century American portraits
Publications: Monograph on the Wood Collection
Activities: Classes for children; docent training; children's art camp; lect open to public, 8 vis lectrs per year; concerts; gallery talks; individual paintings & original objects of art lent to local organizations, businesses & other museums with appropriate security systems; lending collection includes original prints & photographs; museum shop sells books, original art, reproductions, slides, gifts & cards

M **VERMONT HISTORICAL SOCIETY,** Museum, 109 State St, Montpelier, VT 05609-0901. Tel 802-828-2291; Fax 802-828-8510; Elec Mail vhs@vhs.state.vt.us; Internet Home Page Address: www.vermonthistory.org; *Cur* Jacqueline Calder; *Librn* Paul Carnahan; *Dir & CEO* Gainor B Davis; *VPres* Peter T Mallary; *Educator* Amy Cunningham; *Asst Librn* Marjorie Strong; *Registrar* Mary Labate Rogstad
Open Tues - Fri 9 AM - 4:30 PM, Sat 9 AM - 4 PM, Sun Noon - 4 PM, cl Mon; call for holiday hours; Admis adults $3, seniors $2; Estab 1838 to collect, preserve and make available for study items from Vermont's past; Average Annual Attendance: 22,000; Mem: 2,600; dues $25 - $600; annual meeting in Aug or Sept
Income: Financed by endowment, mem, state appropriation & contributions
Collections: Collection of fine arts, decorative arts, tools & equipment and work of Vermont artists
Exhibitions: Generation of Change; Vermont, 1820-1850; All the Precious Past; Baseball in VT
Publications: Vermont History, 2 times per year; Vermont History News, bi-monthly
Activities: Lect open to the public; fellowships offered; museum shop sells books, prints, gifts & postcards
L **Library,** 109 State St, Montpelier, VT 05609-0901. Tel 802-828-2291; Fax 802-828-3638; Elec Mail vhs@vhs.state.vt.us; Internet Home Page Address: www.state.vt.us/vhs; *Dir* Gainor B Davis
Open Tues - Fri 9 AM - 4:30 PM; Admis user fee $5; Estab 1838; Reference Library
Income: Financed by endowment, mem, state & contributions
Purchases: $4900
Library Holdings: Audio Tapes; Book Volumes 150,000; Cassettes; Manuscripts; Motion Pictures; Pamphlets; Photographs; Reels; Video Tapes
Special Subjects: Folk Art, Landscape Architecture, Decorative Arts, Manuscripts, Historical Material, Ceramics, Crafts, Archaeology, Advertising Design, Interior Design, Furniture, Costume Design & Constr, Glass, Bookplates & Bindings, Dolls, Embroidery, Handicrafts, Landscapes, Coins & Medals, Flasks & Bottles, Architecture

PITTSFORD

M **NEW ENGLAND MAPLE MUSEUM,** Rte 7, Pittsford, VT 05763; PO Box 1615, Rutland, VT 05701. Tel 802-483-9414; Elec Mail info@maplemuseum.com; Internet Home Page Address: www.maplemuseum.com; *Pres* Thomas H Olson; *Cur & Mgr* Sandy Burckes; *Shop* Jean Lyon; *Asst Mgr* Mary Ellen Burt; *Purchasing* Dona Olson
Open daily 8:30 AM - 5:30 PM (May 20 - Oct 31), 10 AM - 4 PM (Nov 1 - Dec 23 & mid-March - May 19); Admis adults $2.50, seniors $2.00, children between 6 - 12 $.75; Estab 1977 to present the complete history of maple sugaring; Average Annual Attendance: 35,000
Income: $400,000 (financed by gift shop sales & admis)
Purchases: $2,000 per yr, mainly maple sugaring antiques
Special Subjects: Painting-American
Collections: Oil paintings on maple sugaring by Paul Winter; oil murals on early maple sugaring by Vermont artist Grace Brigham; Photo Collection 1900-1938 Maple sugaring in Vermont
Exhibitions: Permanent collection
Activities: Mus shop sells books, magazines, reproductions, slides, travel videos, Vermont crafts & specialty foods

RUTLAND

A **CHAFFEE CENTER FOR THE VISUAL ARTS,** (Rutland Area Art Association, Inc) 16 S Main St, Rutland, VT 05701. Tel 802-775-0356; Fax 802-773-4401; Elec Mail lkrchaffee@aol.com; Internet Home Page Address: www.chaffeeartcenter.org; *Pres* Pat Cuddy; *Exec Dir* Laurie Ross; *Gallery Dir* Jim Boughton; *Educ Dir* Terry Blair Michele; *Business Mgr* Charleen Godleski
Open Mon - Sat 10 AM - 5 PM, Sun Noon - 4 PM, cl Tues; Admis fee $2, children under 12 & mems free; Estab & incorporated 1961 to promote & maintain an educational & cultural center in the central Vermont region for the area artists, all artistic mediums presented; 1896 Queen Anne victorian mansion listed on state & national register; Average Annual Attendance: 30,000; Mem: 400; juried artists; dues $35; annual meeting in Feb
Income: Financed by mem, special funding, contributions, grants, foundations, activities & spec events
Exhibitions: Annual Members Exhibit, juried; Art-in-the-Park outdoor festivals; group & invitational exhibits; featured artists exhib
Publications: Calendar of events, annually; exhibition posters
Activities: Classes for adults & children; docent training; lect open to public, 4 vis lectr per year; concerts; gallery talks; competition with awards;

scholarships offered; individual printings lent to local banks, corporations & other area cultural organizations; all original artwork & prints for sale

M **NORMAN ROCKWELL MUSEUM,** 654 Rte. 4 E., Rutland, VT 05701. Tel 877-773-6095; Fax 802-775-2440; Elec Mail sales@normanrockwellvt.com; Internet Home Page Address: www.normanrockwellvt.com
Estab in 1976, this nationally-recognized coll commemorates his Vermont years & the entire span & diversity of the artist's career which ran from 1911-1978; Located in Rutland, near the corners of Rt 4 and Rt 7, two miles east on Rte 4
Special Subjects: Folk Art, Prints, Painting-American, Posters
Collections: Chronological display of more than 2,500 Rockwell magazine covers, advertisements, calendars & other publ works which shows his develop as an illustrator & links his works to the political, economic & cultural history of the US; featured works of artist Robert Duncan, member of the Cowboy Artists of America
Activities: Variety of gifts & Norman Rockwell-related items for sale

SAINT JOHNSBURY

M **FAIRBANKS MUSEUM & PLANETARIUM,** 1302 Main St, Saint Johnsbury, VT 05819. Tel 802-748-2372; Fax 802-748-1893; Elec Mail adownes@fairbanksmuseum.org; Internet Home Page Address: www.fairbanksmuseum.com; *Dir* Charles C Browne; Anna Rubin Downes
Open Tues - Sat 9 AM - 5 PM, Sun 1 - 5 PM, extended summer hours; Admis families $12, adults $5, students & senior citizens $4, children $3, group rates available; Estab 1889 as a center for exhibits, special exhibitions & programs on science, technology, the arts & the humanities; Average Annual Attendance: 90,000; Mem: 800; dues $35; monthly meeting
Income: $500,000 (financed by admis income, grants, endowment, mem & municipal appropriations)
Special Subjects: Photography, Watercolors, American Indian Art, African Art, Archaeology, Ethnology, Textiles, Costumes, Folk Art, Eskimo Art, Dolls, Oriental Art, Asian Art, Historical Material, Ivory, Maps, Coins & Medals, Dioramas, Islamic Art, Antiquities-Egyptian, Military Art
Collections: Extensive natural science, history & anthropology collections
Publications: Exhibit catalogs; quarterly newsletter
Activities: Classes for adults & children; docent training; lect open to public, 20 vis lectrs per year; concerts; gallery talks; tours; extension dept serving Northeast Vermont; artmobile; individual paintings & original objects of art lent to other accredited museums; lending collection contains 500 nature artifacts, 50 original art works, 10 paintings & 500 photographs; book traveling exhibitions one per year; museum shop sells books, magazines, original art, reproductions, prints & science-related items; junior museum

M **SAINT JOHNSBURY ATHENAEUM,** 1171 Main St Saint Johnsbury, VT 05819. Tel 802-748-8291; Fax 802-748-8086; Elec Mail inform@stjathenaeum.org; Internet Home Page Address: www.stjathenaeum.org; *Librn* Lisa Von Kann; *Exec Dir* Irwin Gelber
Open Mon & Wed 10 AM - 8 PM, Tues, Thurs & Fri 10 AM - 5:30 PM, Sat 9:30 AM - 4 PM; No admis fee, donations accepted; Estab 1873 & maintained as a 19th century gallery; given to the townspeople by Horace Fairbanks; It is the oldest art gallery still in its original form in the United States; Average Annual Attendance: 10,000
Income: Financed by endowment, town appropriation & annual giving
Collections: 19th century American landscape paintings of the Hudson River School (Bierstadt, Colman, Whittredge, Cropsey, Gifford, Hart brothers); copies of masterpieces; sculpture
Exhibitions: Permanent Collection
Publications: Art Gallery Catalogue
Activities: Docent training; lect open to public; gallery talks; tours; mus shop sells books, reproductions, art card-reproductions, prints, totebags & posters

SHELBURNE

M **SHELBURNE MUSEUM,** Museum, Rte 7, PO Box 10 Shelburne, VT 05482. Tel 802-985-3346; Fax 802-985-2231; Elec Mail info@shelburnemuseum.org; Internet Home Page Address: www.shelburnemuseum.org; *Dir* Stephan Jost; *Dir Coll* Catherine Comar
Open mid-May - mid-Oct; Admis call for rates, group rates available; Estab 1947 exhibits American fine, decorative & utilitarian arts, particular emphasis on Vermont and New England heritage; 37 buildings on 45 acres; Average Annual Attendance: 160,000; Mem: Dues $30 - $75
Income: Financed primarily by admis & fundraising from members
Special Subjects: Painting-American, Ethnology, Textiles, Ceramics, Folk Art, Decorative Arts, Painting-European, Dolls, Period Rooms
Collections: American paintings, folk art, decoys, architecture, furniture, quilts & textiles, dolls, sporting art & sculpture, ceramics, tools, sleighs & carriages, toys, farm & home implements; seven period houses; European material: Impressionist & Old Master paintings; English furniture & architectural elements; Native American ethnographic artifacts; Sidewheeler Ticonderoga, railroad memorabilia including steam train, circus material & carousel animals
Activities: Classes for children; docent training; lect open to public, 5 vis lectrs per year; concerts; gallery talks; tours; extension dept serves Vermont; book traveling exhibitions annually; mus shop sells books, reproductions, prints, slides & original art
L **Library,** Rte 7, PO Box 10 Shelburne, VT 05482. Tel 802-985-3346; Fax 802-985-2231; Elec Mail info@shelburnemuseum.org; Internet Home Page Address: www.shelburnemuseum.org; *Dir* Stephan Jost; *Librn* Polly Darnell; *Sr Cur* Jean Burks
May - Oct 31 10 AM - 5 PM; Adults $18, children $9; Estab 1947, art & Americana; Open to pub by appointment; Average Annual Attendance: 120,000; Mem: 5,500 members
Income: Financed by grants & contributions, admissions & earned income
Library Holdings: Audio Tapes; Book Volumes 6,000; Cassettes; Clipping Files; Exhibition Catalogs; Filmstrips; Kodachrome Transparencies; Manuscripts;

Memorabilia; Motion Pictures; Pamphlets; Periodical Subscriptions 66; Photographs; Prints; Records; Slides; Video Tapes

Special Subjects: Art History, Folk Art, Decorative Arts, Drawings, Etchings & Engravings, Painting-American, Painting-French, Painting-European, Historical Material, Ceramics, American Western Art, Asian Art, American Indian Art, Porcelain, Furniture, Period Rooms, Glass, Carpets & Rugs, Dolls, Handicrafts, Miniatures, Pottery, Marine Painting, Landscapes, Pewter, Flasks & Bottles, Scrimshaw, Laces, Architecture, Embroidery, Textiles, Woodcarvings

Collections: Art & Americana from the 17th - 20th centuries

Activities: Classes for adults & children; docent training; lects open to public; concerts; gallery talks; tours; fellowships; mus shop sells books, magazines, reproductions, prints

SPRINGFIELD

A **SPRINGFIELD ART & HISTORICAL SOCIETY,** The Miller Art Center, 9 Elm St, PO Box 313 Springfield, VT 05156-0313. Tel 802-885-2415; *Pres* Amanda L Page; *Dir* Robert McLaughlin

Open Tues - Fri 10 AM - 4 PM, Sat 2 - 5 PM; No admis fee; Estab 1956 for the purpose of presenting history, arts & sciences of Springfield & environs; Gallery located in a Victorian mansion built in 1861 & is maintained for monthly exhibits; Average Annual Attendance: 1,200; Mem: 250; dues $50, $25 & $15; annual meeting in Nov

Income: $25,000 (financed by endowment & mem)

Library Holdings: Audio Tapes; Book Volumes; CD-ROMs; Cassettes; Clipping Files; Manuscripts; Maps; Memorabilia; Original Art Works; Original Documents; Photographs; Prints; Sculpture; Slides; Video Tapes

Special Subjects: Architecture, Costumes, Drawings, Historical Material, Landscapes, Manuscripts, Photography, Prints, Sculpture, Textiles, Watercolors, Painting-American, Pottery, Decorative Arts, Pewter, Portraits, Dolls, Period Rooms, Maps

Collections: Primitive portraits by H Bundy, Aaron D Fletcher & Asahel Powers; Richard Lee, pewter; Bennington pottery; paintings by local artists; toys, costumes, sculpture, crafts; machine tool industry

Exhibitions: Historical exhibits: costumes; toys; photography; fine arts

Publications: Annual schedule of events & monthly notices; members quarterly newsletter

Activities: Classes for adults & children; civil war living history group; lect open to the public, 4 vis lectrs per yr; concerts; gallery talks; competitions with awards; individual paintings & objects of art lent to local galleries; lending collection contains original art work, paintings, photographs, sculpture, slides; living history - Sanitary Commission - civil war group presentations; museum shop sells books, original art, slides & prints

VIRGINIA

ALEXANDRIA

A **ART LEAGUE,** 105 N Union St, Alexandria, VA 22314. Tel 703-683-2323, 683-1780; Fax 703-683-0167; Internet Home Page Address: www.theartleague.org; *Pres* Betsy Anderson; *Exec Dir* Linda Hafer; *Asst Exec Dir* Pat Gerkin; *Treas* Marge Alderson; *VPres* Anne Bradshaw; *Gallery Dir* Madalina Diaconu; *VPres* Sy Wengrovitz; *Dir School* Alice Merrill

Open Mon - Sat 10 AM - 5 PM, Sun Noon - 5 PM; No admis fee; Estab 1953 to promote & maintain standards of art through mem juried exhibs & a large school which teaches all facets of the fine arts & some high skill crafts; Thirteen classrooms total; four classrooms in the Torpedo Factory Art Center in Old Town Alexandria, Virginia; three gallery rooms & nine classrooms in two annexes; Average Annual Attendance: 500,000; Mem: 1,400; dues $70; annual meeting in June

Exhibitions: Monthly juried shows for members; solo shows monthly

Activities: Classes for adults & children; foreign & domestic art-travel workshops; lect open to public; gallery talks; tours; sponsors competitions with awards; sales shop sells art supplies

ART SERVICES INTERNATIONAL
For further information, see National and Regional Organizations

M **GEORGE WASHINGTON MASONIC NATIONAL MEMORIAL,** 101 Callahan Dr, Alexandria, VA 22301. Tel 703-683-2007; Fax 703-519-9270; Internet Home Page Address: www.gwmemorial.org; *Exec Secy & Treas* George D Seghers; *Exec Adminr* JoAnn Guthrie; *Cur* Stephen Patrick

Open daily 9 AM - 5 PM; No admis fee; Estab 1932; Maintains a reference library; 12 exhibition rooms; auditorium; 2 museums; Average Annual Attendance: 60,000 - 70,000; Mem: 1.8 million; voluntary contributions; annual meeting Feb 22

Income: Privately funded charitable organization

Special Subjects: Painting-American, Portraits, Furniture, Carpets & Rugs, Coins & Medals, Dioramas, Stained Glass, Painting-Israeli

Exhibitions: Relics & portraits of George Washington, murals, Lafayette & Intimates of Washington

A **NORTHERN VIRGINIA FINE ARTS ASSOCIATION,** The Athenaeum, 201 Prince St, Alexandria, VA 22314. Tel 703-548-0035; Fax 703-768-7471; Elec Mail nvfaa@nvfaa.org; Internet Home Page Address: www.nvfaa.org; *Ballet Dir* Virginia Britton; *Exec Dir* Cathleen Phelps

Open Wed - Sat 11 AM - 3 PM, Sun 1 - 4 PM, cl Mon, Tues & holidays; No admis fee; Estab 1964 to promote education, appreciation, participation & pursuit of excellence in all forms of art & crafts; to enrich the cultural life of the metropolitan area & Northern Virginia; Main gallery space on main floor, with additional area available; Average Annual Attendance: 35,000; Mem: 1,150; dues $25

Income: Financed by mem & fundraisers

Exhibitions: Annual Joint Art League/Athenaeum Multi-media Juried show; Five Virginia Photographers: Sally Mann, E Gowen & Others; Thomas Hart Benton; Washington Color School: Stars & Stripes

Publications: Quarterly newsletter

Activities: Dance classes for adults & children; dramatic programs; docent training; lect open to public, gallery talks; sponsoring of competitions; scholarships offered; extension prog serving Northern Virginia

ARLINGTON

M **ARLINGTON ARTS CENTER,** 3550 Wilson Blvd, Arlington, VA 22201-2348. Tel 703-524-1494; Fax 703-527-4050; Elec Mail artscenter@erols.com; *Dir* Carol Sullivan; *Cur* Kristen Hileman

Open Tues - Fri 11 AM - 5 PM, Sat & Sun 1 - 5 PM; No admis fee; Estab to present new work by emerging & established artists from the region (Virginia, Maryland, Washington DC, West Virginia, Pennsylvania & Delaware)

Exhibitions: Annual Juried Exhibit; Annual Solo Exhibit

L **ARLINGTON COUNTY DEPARTMENT OF PUBLIC LIBRARIES,** Fine Arts Section, 1015 N Quincy St, Arlington, VA 22201. Tel 703-228-5990; Fax 703-228-5692; Internet Home Page Address: www.co.arlington.va.uf/lib/; *Branch Librn* Jayne McQuade

Open Mon - Thurs 9 AM - 10 PM, Fri & Sat 9 AM - 5 PM, Sun 1 - 9 PM; Estab 1935 to serve needs of an urban-suburban population in all general subjects

Income: Financed by county & state appropriatins

Library Holdings: Book Volumes 3,000; Other Holdings Total holdings: 323,000; Periodical Subscriptions 15

Exhibitions: Local artists, crafts people & photographers have exhibitions at the central library each month

Publications: Monthly almanac of programs, library activities & exhibits

Activities: Lect open to public, 10 vis lectr per year; workshops; film shows; extended learning institute video tapes from Northern Virginia Community College available

M **BLUEMONT HISTORICAL RAILROAD JUNCTION,** Blueprint Junction Park, 601 N Manchester St, Arlington, VA 22203; 3600 Four Mile Dr, Arlington, VA 22204. Tel 703-525-0294; *Ranger* Sedgwick Moss; *Ranger Coordr* Lynne Everly; *Vol Pub Rels* Stephen Patrick; *Park Ranger II* Lynda Kersey

open May - Sept Sat & Holidays 10 AM - 6 PM, Sun 1 - 5 PM; No admis fee, donations accepted; Estab 1992; Arlington & Alexandria's only railway mus interprets the history of these communities that grew up around the lines; housed on former southern railway caboose X-441, built in 1972; Average Annual Attendance: 2,500

Income: A feature of Arlington County parks and recreation

Collections: Photos & objects from local railway history

Activities: Guided tours

BLACKSBURG

A **BLACKSBURG REGIONAL ART ASSOCIATION,** PO Box 525, Blacksburg, VA 24063-0525. Tel 540-381-1018; Elec Mail braa@bburg.bev.net; Internet Home Page Address: arts.bev.net/braa/; *Pres* Cathy Hudgins; *Membership Chmn* Helen Castaneda; *Secy* Evelyn Saunders

Call for hours; No admis fee; contributions; Estab 1950, affiliated with the Virginia Museum of Fine Arts, dedicated to the encouragement & enjoyment of the arts; Mem: Dues including mem to the Virginia Museum, family $12, individual $8

Income: Financed by mem & patron contributions

Collections: Collection of paintings by contemporary artists who have exhibited in Blacksburg

Exhibitions: 6 rotating exhibitions per yr & juried exhibits

Publications: BRAA newsletter, quarterly; exhibit catalogs

Activities: Dramatic programs; lect open to public, 3-5 vis lectrs per year; concerts; competitions; artmobile; originate traveling exhibitions

VIRGINIA POLYTECHNIC INSTITUTE & STATE UNIVERSITY

M **Armory Art Gallery,** Tel 540-231-4859, 231-5547; Fax 540-231-7826; *Art Chair & Interim Staff Dir* Bailey Van Hook; *Gallery Coordr* Francis Thompson

Open Mon - Fri Noon - 5 PM, Sat Noon - 4 PM; No admis fee; Estab 1969 to serve needs of art department as a teaching gallery as well as to meet community needs in an area where there are few large art centers & museums; Gallery is located in same building as Art Department; exhibition area is approx 16 x 40 ft; Average Annual Attendance: 2,000 plus student use

Income: Financed through special university budget

Exhibitions: Special invited exhibitions & exhibitions by Virginia artists, students & visiting artists

Publications: Exhibition calendar; gallery announcements

Activities: Docent training to college students; lect open to public, 3 vis lectrs per year; gallery talks; individual paintings & original objects of art lent to faculty & staff offices on campus, as well as library & continuing educ center; originate traveling exhibitions

M **Perspective Gallery,** Tel 540-231-5431; Fax 540-231-5430; *Art Dir* Tom Butterfield

Open Tues - Fri Noon - 10 PM, Sat & Sun 2 - 10 PM, cl Mon; No admis fee; Estab 1969 to provide a broad arts experience for the students, faculty & the university community; Average Annual Attendance: 50,000

Income: Financed by university unions & student activities

L **Art & Architecture Library,** Tel 540-231-9271; Elec Mail h.ball@vt.edu; Internet Home Page Address: www.lib.vt.edu; *Librn* Heather Ball; *Visual Resources Cur* Brian Shelburne

Open Mon - Thurs 8 AM - 11 PM, Fri 8 AM - 5 PM, Sat 1 - 5 PM, Sun 2 - 11 PM; Estab 1928 to provide service to the College of Architecture & Urban Studies & the other divisions of the university; Circ 60,000

Income: Financed by state appropriation & gifts

Purchases: $69,500

Library Holdings: Book Volumes 65,000; CD-ROMs; Cassettes; Clipping Files; DVDs; Exhibition Catalogs; Fiche; Pamphlets; Periodical Subscriptions 300; Reels; Slides 70,000; Video Tapes
Special Subjects: Landscape Architecture, Architecture

BROOKNEAL

M **PATRICK HENRY MEMORIAL FOUNDATION,** Red Hill National Memorial, 1250 Red Hill Rd, Brookneal, VA 24528. Tel 804-376-2044; Fax 804-376-2647; Internet Home Page Address: www.redhill.org; *Admin Asst* Lynn Davis; *Exec Dir* Dr Jon Kukla; *Cur* Edith Poindexter; *Assoc Cur* Karen Gorham-Smth
Open 9 AM - 5 PM, winter, 9 AM - 4 PM; Admis fee $6; Estab 1944 to preserve & develop a memorial to Patrick Henry; One room with Rothermel painting as focal point; Average Annual Attendance: 11,000; Mem: dues $25 & up; annual meeting in May
Income: $250,000 (financed by endowment, mem, county & state appropriation)
Library Holdings: Audio Tapes; Clipping Files; Framed Reproductions; Manuscripts; Maps; Memorabilia; Motion Pictures; Original Art Works; Original Documents; Pamphlets; Photographs; Sculpture; Video Tapes
Special Subjects: Landscape Architecture, Architecture, Furniture, Photography, Portraits, Silver, Sculpture
Collections: Patrick Henry images; decorative arts; furniture & memorabilia
Exhibitions: Patrick Henry Before the Virginia House of Burgesses by P F Rothermel; Patrick Henry Memorabilia
Publications: Quarterly newsletter
Activities: Classes for adults & children; docent programs; lect open to public; 2 vis lects per year; tours; scholarships offered; National Forensic League Annual Competition; mus shop, reproductions

CHARLES CITY

M **SHIRLEY PLANTATION,** 501 Shirley Plantation Rd, Charles City, VA 23030. Tel 804-829-5121; Fax 804-829-6322; Elec Mail info@shirleyplantation.com; Internet Home Page Address: www.shirleyplantation.com; *Owner* Charles Hill Carter Jr; *Dir Marketing* Randy Carter; *Cur & Historian* Christine Crumlish Joyce; *Dir Archaeology* Dennis B Blanton
Open daily 9 AM - 5 PM except Thanksgiving and Christmas days; Admis adult $10.50, discounts for AAA, military & seniors 60 & up $9.50, youth between 6-18 $7; Estab 1613 to show the history of one distinguished family from colonial times to the present; oldest family-owned business in North America; Oldest Virginia Plantation continuous home to the Hill Carter Family, currently 10th & 11th generations; Average Annual Attendance: 55,000
Special Subjects: Architecture, Drawings, Painting-American, Anthropology, Archaeology, Ceramics, Pottery, Landscapes, Decorative Arts, Manuscripts, Painting-European, Portraits, Furniture, Glass, Porcelain, Metalwork, Painting-British, Historical Material, Maps, Coins & Medals, Painting-Flemish, Period Rooms, Antiquities-Oriental, Pewter, Bookplates & Bindings
Collections: 18th century English silver & oil portraits; 18th & 19th century furniture & handcarved woodwork
Activities: Classes for children; tours; lending collections contain books, original art works, original prints, photographs & over 18,000 documents on permanent loan to Colonial Williamsburg Foundation; museum shop sells books, reproductions, brass, silver & porcelain

M **WESTOVER,** 7000 Westover Rd, Charles City, VA 23030. Tel 804-829-2882; Fax 804-829-5528; *Mgr* F S Fisher
Grounds & garden open daily 9 AM - 6 PM; Admis $2, children $.50; house interior not open; Built about 1730 by William Byrd II, Founder of Richmond, the house is considered an outstanding example of Georgian architecture in America, with steeply sloping roof, tall chimneys in pairs at both ends, elaborate Westover doorway, a three story central structure with two end wings. The path from the Caretakers House to the house is lined with tulip poplars over 100 years old; former kitchen is a separate small brick building. East of the house (open to visitors) is the Necessary House, an old icehouse & a dry well with passageways leading under the house to the river. The Westover gates of delicate ironwork incorporate initials WEB; lead eagles on the gateposts, fence column topped with stone finials cut to resemble pineapples, beehives, & other symbolic designs. Long estab boxwood garden with tomb of William Byrd II. Members of his family, & Captain William Perry, who died Aug 1637, are buried in old church cemetery one-fourth mile west of house
Special Subjects: Architecture

CHARLOTTE

A **ARTS & SCIENCE COUNCIL,** 227 W Trade St, Ste 250, Charlotte, VA 28202. Tel 704-372-9667; Fax 704-372-8210; Internet Home Page Address: www.artandscience.org; *Pres* Harriet Sandford; *Sr VPres Resource Management* Bill Halbert; *Pub Relations Dir* Kim McMillan
Estab 1958 to provide planning, oversight & funding required to ensure & support a vibrant, culturally diverse arts & science community in Mecklenburg County
Income: Financed by government appropriations & private fund drive
Activities: Grants offered

CHARLOTTESVILLE

M **SECOND STREET GALLERY,** 201 Second St NW, Charlottesville, VA 22902. Tel 804-977-7284; Fax 804-979-9793; Elec Mail ssg@cstone.net; Internet Home Page Address: www.avenue.org/ssg; *Dir* Cris Baumer; *Treas* Ronald Bailey; *Dir* Leah Stoddard; *Asst to Dir* Jon Stuhlman
Open Tues - Sat 10 AM - 5 PM, Sun 1 - 5 PM; No admis fee; Estab 1973 as an alternative arts space to present emerging & accomplished contemporary artists from regional & national localities, to increase the appreciation of contemporary

art in Virginia region, & to increase the dialogue between artists & the community; One gallery 24 ft x 32 ft; Average Annual Attendance: 12,000; Mem: 300; dues benefactor $1,000, Patron $500, friend $100, family $50, individual $35, artists/seniors/students $25
Income: Financed by individual, corporate & foundation contributions & grants from the Virginia Commission for the Arts & fundraising activities
Publications: The Second Glance, quarterly newsletter
Activities: Lect; tours; literary readings; workshops

M **THOMAS JEFFERSON FOUNDATION, INC.,** Monticello, PO Box 316, Charlottesville, VA 22902. Tel 434-984-9801, 434-984-9822; Fax 434-977-7757; Elec Mail administration@monticello.org; Internet Home Page Address: www.monticello.org; *Pres* Daniel P Jordan
Open Mar - Oct Mon - Sun 8 AM - 5 PM, Nov - Feb Mon - Sun 9 AM - 4:30 PM, cl Christmas; Admis adults $13, children 6-11 & school groups $6; Estab 1923 to preserve education; Monticello is owned & maintained by the Thomas Jefferson Foundation, a nonprofit organization founded in 1923. The home of Thomas Jefferson, designed by him & built 1769-1809, contains many original furnishings & art objects; Average Annual Attendance: 525,000
Income: Pvt
Collections: Jeffersonian furniture; memorabilia; art objects & manuscripts
Activities: Classes for children; mus shop sells books, reproductions & prints

UNIVERSITY OF VIRGINIA

M **Art Museum,** Tel 434-924-3592, 804-924-7458 (Tours); Fax 434-924-6321; Internet Home Page Address: www.virginia.edu/~bayla; *Cur* Andrea Douglas; *Dir Educ* Jennifer Van Winkle; *Coll Mgr* Jean Collier; *Adminr* David Chennault; *Dir Develop* Claire Thompson; *Preparator* Anamarie Liddell; *Dir* Jill Hartz
Open Tues - Sun 1 - 5 PM, cl Mon; No admis fee, donations accepted; Estab 1935 to make original works of art available to the university community & to the general pub; Perm coll & temp exhibitions; teaching museum; more than 10,000 works; Average Annual Attendance: 28,000; Mem: 2,200; dues director's circle $2,500, benefactor $1,000, patron $500, sponsor $250, fellow $100, donor $60, member $35, seniors $15, student free
Income: Financed by mem, state appropriation & gifts
Purchases: Paintings by Jan de Lagoor, Picter Van den Bosch; Tsukioka Yoshitoshi prints; work by John Baldessari
Special Subjects: Photography, American Indian Art, American Western Art, African Art, Pre-Columbian Art, Ceramics, Pottery, Etchings & Engravings, Landscapes, Painting-Japanese, Portraits, Posters, Porcelain, Asian Art, Antiquities-Byzantine, Painting-French, Coins & Medals, Baroque Art, Painting-Flemish, Antiquities-Oriental, Painting-Italian, Antiquities-Greek, Antiquities-Roman, Painting-German, Antiquities-Etruscan
Collections: American art; European & American Art in the age of Jefferson; Old Master prints; East Asian art; contemporary art; American Indian art; Oceanic Art; prints, drawings, photographs, Roman Coins
Exhibitions: Various rotating exhibitions, call for schedule; Hedda Sterne, Fernand Leger
Publications: John Douglas Woodward; Shaping the Landscape Image; exhibition brochures; Newsletter
Activities: Educ programs for adults, students, children; docent training; lect open to public, 5+ vis lectrs per year; gallery talks; tours; fellowships; fels & internships offered; original works of art lent; book traveling exhibs 1-3 per yr; museum shop sells books & cards

L **Fiske Kimball Fine Arts Library,** Tel 804-924-7024; Fax 804-982-2678; Elec Mail jsr8s@virginia.edu; Internet Home Page Address: www.lib.virginia.edu/fine-arts/index.htm/; *Asst Librn & Public Services* Barbara Jackson
Open school year Mon - Thurs 8 AM - Midnight, Fri 8 AM - 8 PM, Sat 10 AM - 8 PM, Sun Noon-Midnight; Estab 1970; combination of existing art & architecture libraries to provide a research facility providing printed, microform, audio visual & electronic materials for the art, architecture & drama curriculum; Circ 115,000; Fifty percent of collection is non-circulating
Income: $212,000
Library Holdings: Audio Tapes; Book Volumes 127,000; Cassettes; Exhibition Catalogs; Fiche; Filmstrips; Kodachrome Transparencies; Manuscripts; Periodical Subscriptions 285; Photographs; Reels; Slides 171,000
Special Subjects: Art History, Film, Photography, Archaeology, Architecture
Collections: Francis Benjamin Johnson Photographs of Virgina Architecture; Rare books
Publications: Bibliography of the Arts: Including Fine & Decorative Arts, Architecture, Design & the Performing Arts, updated quarterly; Guide To Sources, irregular serial; Notable Additions to the library collection, quarterly

CHRISTIANBURG

M **MONTGOMERY MUSEUM & LEWIS MILLER REGIONAL ART CENTER,** 300 S Pepper St, Christianburg, VA 24073. Tel 540-382-5644; Fax 540-382-9127; Elec Mail info@montgomerymuseum.org; Internet Home Page Address: www.montgomerymuseum.org; *Dir* Shearon Campbell; *Pres (Vol)* Robert L. Puff
Open Mon - Sat 10:30 AM - 4:30 PM, Sun 1:30 - 4:30 PM; Admis adult $1, children $.50; Estab 1983; Average Annual Attendance: 3,500
Income: Financed by grants, gifts & members
Library Holdings: Book Volumes; Clipping Files; Memorabilia; Original Art Works; Pamphlets; Photographs; Prints; Slides
Collections: Lewis Miller Art; clothing; family genealogy; photographs; dolls, local history books, old photo albums, household items, business machines, weaving loom
Exhibitions: Rotating exhibits
Publications: Quarterly newsletter; Montgomery Museum newsletter; booklets

L **Library,** 300 S Pepper St, Christianburg, VA 24073. Elec Mail info@montgomerymuseum.org; Internet Home Page Address: www.montgomerymuseum.org; *Dir* Linda L Martin
Open Mon - Sat 10:30 AM - 4:30 PM, Sun 1:30 - 4:30 PM; Admis adult $2, children 12 & under $1, free to members; Reference

Library Holdings: Book Volumes 300; Clipping Files; Memorabilia; Original Art Works; Other Holdings: Pamphlets; Photographs; Prints; Slides
Special Subjects: Folk Art, Photography, Prints, Historical Material, Crafts, Dolls

COURTLAND

M RAWLS MUSEUM ARTS, 22376 Linden St Courtland, VA 23837. Tel 757-653-0754; Fax 757-653-0341; Elec Mail rma@beldar.com; Internet Home Page Address: www.rawlsarts.cjb.net; *Exec Dir* Barbara Easton-Moore; *Educational Outreach Coordr* Elizabeth Fox; *VPres* Dorothy Council
Open Tues - Fri 10 AM - 4 PM, Sat Noon - 4 PM; No admis fee; Estab 1958 to promote the arts in the city of Franklin & the counties of Isle of Wight, Southampton, Surry & Sussex; Main gallery is 45 ft x 50 ft, 12 ft high with track lighting, adjunct Francis Gallery also has track lighting; Average Annual Attendance: 7,500; Mem: 248; dues $15 - $42, annual meeting in June, Board of Directors meet monthly
Income: $40,000 (financed by endowment, mem & grants)
Special Subjects: Portraits, Pottery, Drawings, Painting-American, Photography, Watercolors, Crafts, Posters, Glass, Silver
Collections: Antique glass & silver; Southeastern Virginia Artists; drawings, paintings, lithographs
Exhibitions: Annual Regional Photography Exhibition; two Annual Student Art Shows; regular group exhibitions by area artists; Virginia Museum of Fine Arts Traveling Exhibitions; annual regional exhibition
Publications: R M A Bulletin
Activities: Classes for adults & children; family fun events; intensive 4-6 hour educ outreach classes addressing SOL's for four school systems; lect open to public, 4 vis lectrs per year; concerts; gallery talks; tours; sponsoring of competitions; scholarships offered; paintings & art objects lent to museums & libraries; museum shop sells books, original art & prints

DANVILLE

M DANVILLE MUSEUM OF FINE ARTS & HISTORY, 975 Main St, Danville, VA 24541. Tel 434-793-5644; Fax 434-799-6145; Elec Mail artandhistory@danvillemuseum.org; Internet Home Page Address: www.danvillemuseum.org; *Pres* Jack Neal Jr; *Exec Dir* Lynne Bjarnesen; *Ofc Mgr* Geraldine Scearce; *Museum Shop Mgr* Tim Stowe; *Educ Coordr* Sharon Hughes; *Arts Prog Coordr* Shawn Jones; *Develop Coordr* Katherine Milam
Open Tues - Fri 10 AM - 5 PM, Sat & Sun 2 - 5 PM; No admis fee; Estab 1974; Museum has two galleries: 27 x 35 ft with track lighting; one smaller gallery 24 x 17 ft with track lighting; Average Annual Attendance: 20,000; Mem: 600; dues $20 - $1,000
Income: Financed by mem, grants, fundraisers, class fees
Library Holdings: Auction Catalogs; Audio Tapes; Book Volumes; CD-ROMs; Exhibition Catalogs
Special Subjects: Architecture, Drawings, Graphics, Painting-American, Sculpture, Watercolors, Textiles, Costumes, Folk Art, Woodcarvings, Woodcuts, Etchings & Engravings, Decorative Arts, Painting-European, Portraits, Historical Material, Maps, Tapestries, Period Rooms, Laces
Collections: American Costume Collection including 2 locally made crazy quilts; Civil War; emphasis on works by contemporary Southern & Mid-Atlantic Artists; historic artifacts & documents pertaining to the history of Danville; 19th & 20th century decorative arts including furniture, silver, porcelain; Victorian American paintings & works on paper 1932 - present
Exhibitions: Rotating schedule of art & history exhibitions; Survey shows highlighting historic & modern artists in movement; Historic exhibit includes restored period rooms, a Victorian parlor, bedroom & library; Between the Lines: 1861-1865
Publications: Last Capital of the Confederacy, book; Activities Report, quarterly newsletter
Activities: Classes for adults & children; docent training; hands-on school programs; lect open to public, 3 vis lectrs per year; gallery talks; tours; museum shop sells books, magazines, original art, prints & reproductions

FARMVILLE

A LONGWOOD CENTER FOR THE VISUAL ARTS, 129 N Main St, Farmville, VA 23901. Tel 804-395-2206; Fax 804-392-6441; *Adminr* Ann Coffey; *Cur Educ* Denise Penick; *Registrar* Eric A Evans; *Dir* Kay Johnson Bowles
Open Mon - Sat Noon - 4:30 PM; No admis fee; Estab 1978
Activities: Classes for adults & children; lect open to public; gallery talks; tours; slide presentation; originate traveling exhibitions to rural communities in Southside Virginia

FORT MONROE

M HEADQUARTERS FORT MONROE, DEPT OF ARMY, Casemate Museum, Bldg 20, Bernard Rd, PO Box 51341 Fort Monroe, VA 23651-0341. Tel 757-788-3935; AUTOVON 680-3935; Fax 757-788-3886; Elec Mail mroczkod@monroe.army.mil; Internet Home Page Address: www.tsadoc.monroe.army.mil/museum; *Dir* Dennis Mroczkowski; *Exhibit Specialist* Chuck Payne; *History Specialist* Kathy Rothrock; *Archivist* David J Johnson
Open daily 10:30 AM - 4:30 PM; No admis fee; Estab 1951 to depict history of Fort Monroe; Average Annual Attendance: 65,000; Mem: 200; dues one-time-only fee based on plateaus; annual meeting in mid-Jan
Income: Financed by federal appropriation
Library Holdings: Micro Print; Motion Pictures; Original Art Works; Photographs; Prints; Sculpture; Slides
Special Subjects: Drawings, Graphics, Painting-American, Photography, Prints, American Western Art, Bronzes, Ceramics, Etchings & Engravings, Manuscripts,

Portraits, Posters, Furniture, Glass, Porcelain, Silver, Marine Painting, Historical Material, Maps, Coins & Medals, Period Rooms, Cartoons, Leather, Military Art, Reproductions
Collections: Jack Clifton Paintings; Remington Drawings; Zogbaum Drawings; Artillery Implements; Military Posters; Franz Schell
Exhibitions: Civil War Artifacts; Coast Artillery Guns in Action; Glass Bottles
Publications: Exhibition catalogs
Activities: Docent training; lect provided upon request to local organizations; tours; individual paintings & original objects of art lent to other federal agencies; originate traveling exhibitions 3 per year; museum shop sells books, reproductions, prints

FREDERICKSBURG

M JAMES MONROE MUSEUM, 908 Charles St, Fredericksburg, VA 22401. Tel 540-654-1043; Fax 540-654-1106; Internet Home Page Address: www.jamesmonroemuseum.mwc.edu; *Cur* David B Voelkel
Open Mar 1 - Nov 30 daily 10 AM - 5 PM, Dec 1 - Feb 28 daily 10 AM - 4 PM, cl Thanksgiving, Dec 24, 25, 31 & Jan 1; Admis adults $5, children 6-18 $1, children under 5 free; Estab 1927 to keep in memory the life & service of James Monroe & of his contribution to the principles of government, to preserve his treasured possessions for present & future generations; Open to the pub in 1928; owned by Commonwealth of Virginia & under the control of Mary Washington College; a National Historic Landmark; Average Annual Attendance: 12,000; Mem: $25 & up
Income: financed by state funds
Special Subjects: Sculpture, Ceramics, Portraits, Furniture, Jewelry, Silver
Collections: Louis XVI furniture purchased by the Monroes in France in 1794 & later used by them in the White House; portraits; sculpture; silver; china; jewelry; books; documents
Exhibitions: Rotating exhibs
Publications: Images of a President: Portraits of James Monroe, catalog Library of James Monroe; catalog; A Presidential Legacy
Activities: Docent training; workshops; lect open to public; gallery talks; tours; scholarships offered; extension dept serves Mary Washington College University of VA area; museum shop sells books, magazines, reproductions, prints, slides, history related objects & exclusive items from local crafts people

L James Monroe Memorial Library, 908 Charles St, Fredericksburg, VA 22401. Tel 540-654-1043; Fax 540-654-1106; Internet Home Page Address: www.jamesmonroemuseum.mwc.edu; *Dir* John N Pearce; *Cur* David Voelkel
Open by appointment only; Admis adults $5, children 6-18 $1, children under 5 free; Estab 1927 as a presidential mus & library; Open to pub; archival resources available by appointment only; Average Annual Attendance: 12,000
Income: Financed by state allocations & revenues
Library Holdings: Book Volumes 10,000; Manuscripts 27,000; Other Holdings Documents; Letters

UNIVERSITY OF MARY WASHINGTON (Mary Washington College)
M Belmont, The Gari Melchers, Tel 540-654-1015; Fax 540-654-1785; *Cur* Joanna D Catron; *Dir* David Berreth
Open Mar - Nov, Mon - Sat 10 AM - 5 PM, Sun 1 - 5 PM, Dec - Feb, Mon - Sat 10 AM - 4 PM, Sun 1 - 4 PM; Admis adults $4, adult groups, seniors & groups $3, children between 6 & 18, school & scout groups $1; Estab 1975 to exhibit, preserve & interpret the works of art & memorabilia of the late American artist Gari Melchers, in his former estate & studio; Studio consists of three gallery rooms, a work room & storage rooms; Average Annual Attendance: 13,000
Income: $450,000 (financed by endowment & state appropriation)
Special Subjects: Painting-American, Prints, Etchings & Engravings
Collections: Over six hundred works of art, paintings, drawings & etchings by Gari Melchers; Over 1,000 sketches & studies by Gari Melchers; Paintings & drawings by Berthe Morisot, Franz Snyders, Puvis de Chavannes & others; Furnishings from Europe & America
Publications: Exhibition catalogs
Activities: Docent training; aesthetics tours for school groups; outreach programs for school & nursing homes; lect open to public; gallery talks; tours; individual paintings & original objects of art lent

M University of Mary Washington Galleries, Tel 540-654-1013; Fax 540-654-1171; Elec Mail gallery@umw.edu; Internet Home Page Address: www.umw.edu; *Office Mgr* Cheryl B Lumpkin; *Dir* Thomas P Somma; *Asst Dir* Lynde McAuliffe Sharp
Open Mon, Wed & Fri 10 AM - 4 PM, Sat & Sun 1 - 4 PM; No admis fee; Estab 1956 for educ in art history & cultural history; Average Annual Attendance: 3,000
Special Subjects: Photography, Painting-American, Graphics, Watercolors, Asian Art
Collections: Asian art of all periods; 19th & 20th Century American art
Exhibitions: Nancy Witt: Materialist Painter; Drawings by Moses Soyer: from Social Realism to Romantic Realism; Leonardo da Vinci: Artist, Scientist & Engineer; Highlights from the coll of the US Nat Slavery Mus; Lookhere, Dazzle from the Virginia Mus Fine Arts
Publications: Booklets; catalogs
Activities: Classes for adults; lect open to public; 2-5 vis lectrs per year; concerts; gallery talks; tours;; book traveling exhibitions two per year; originate traveling exhibitions one per year

GLEN ALLEN

M COUNTY OF HENRICO, Meadow Farm Museum, 3400 Mountain Rd, Glen Allen, VA; PO Box 27032, Richmond, VA 23273. Tel 804-501-5520; Fax 804-501-5284; Internet Home Page Address: www.co.henrico.va.us/rec; *Historic Preservation Supv* Chris Gregson; *Coll Mgr* Kimberly Sicola; *Asst Site Mgr* Linda Eikmeier
Open Tues - Sun Noon - 4 PM; No admis fee; Estab 1981 to exhibit works of 20th century American folk artists; 20 ft x 20 ft, AV room; Average Annual Attendance: 50,000
Income: Financed by Henrico County
Special Subjects: Architecture, Archaeology, Ceramics, Crafts, Folk Art, Afro-American Art, Decorative Arts, Furniture, Carpets & Rugs, Embroidery

Collections: 19th & 20th Century folk art
Exhibitions: Annual Folk-Art Exhibit
Publications: Exhibition flyers, annually
Activities: Children's classes; lect open to public, 4 vis lectrs per year; tours; individual paintings & original objects of art lent to Virginia Beach Art Center; lending collection contains original art works, paintings & sculptures; sales shop sells books & reproductions

L **Library,** 3400 Mountain Rd, Glen Allen, VA 23060; PO Box 27032, Richmond, VA 23273. Tel 804-501-5520; Fax 804-501-5284; *Site Mgr* Anna Beegles
Open by appointment only; For reference only
Library Holdings: Audio Tapes; Book Volumes 100; Clipping Files; Exhibition Catalogs; Kodachrome Transparencies; Periodical Subscriptions 10; Photographs; Slides; Video Tapes

GREAT FALLS

INDUSTRIAL DESIGNERS SOCIETY OF AMERICA
For further information, see National and Regional Organizations

HAMPTON

A **CITY OF HAMPTON,** Hampton Arts Commission, 4205 Victoria Blvd, Hampton, VA 23669; 125 E Mellen St, Hampton, VA 23663. Tel 757-722-2787; 757-727-1621; Fax 757-727-1167; Elec Mail amtheater@city.hampton.va.us.; Internet Home Page Address: www.amtheatre.com; *Dir* Michael P Curry; *Arts Coordr* Debra Burrell; *Production Mgr* Mary Blackwell; *Box Office Mgr* Mildred Williams
Art Ctr open year round Tues 10 AM - 6 PM, Sat - Sun 1 - 5 PM, cl major holidays; theatre open Mon - Fri 9 AM - 5:30 PM; No admis fee; Created in December, 1987, housed in the Charles H Taylor Arts Center
Income: Financed by municipal funds & contributions
Library Holdings: Cards
Exhibitions: Regional artists presented at Charles H Taylor Arts Center, monthly; special events art shows; performances by international artists presented at the American Theatre
Activities: Classes for adults & children; master classes in drama & music; dramatic programs; workshops; demonstrations; lect open to public; lect for mem only; 12 vis lects per yr; concerts; gallery talks; tours; competitions with awards; lending to selected businesses; 1 - 2 book traveling exhibs

M **HAMPTON UNIVERSITY,** University Museum, Hampton, VA 23668. Tel 757-727-5308; Fax 757-727-5170; Elec Mail museum@hamptonu.edu; Internet Home Page Address: www.hamptonu.edu/museum; *Dir* Ramona Austin; *Cur Coll* Mary Lou Hultgren; *Cur of Exhibitions* Liza Broudy; *Cur of History* Vanessa D Thaxton-Ward
Open Mon - Fri 8 AM - 5 PM, Sat & Sun Noon - 4 PM, cl Sun; No admis fee; Estab 1868 as a museum of traditional art & artifacts from African, Asian, Oceanic & American Indian cultures & contemporary & traditional African-American Art; Average Annual Attendance: 60,000; Mem: Dues start at $25, students $15
Income: Financed by college funds
Special Subjects: Drawings, Painting-American, American Indian Art, African Art, Anthropology, Archaeology, Pre-Columbian Art, Afro-American Art, Asian Art, Historical Material
Collections: African, Asian, Oceanic & American Indian Art; Contemporary & traditional African-American Art; artwork & objects relating to history of university
Publications: The Internat Journal of African American Art
Activities: Educ dept; lect open to public; gallery talks; group tours by appointment; individual paintings & original objects of art lent to other museums & art galleries with appropriate security; museum shop sells reproductions, prints

HARRISONBURG

M **JAMES MADISON UNIVERSITY,** Sawhill Gallery, Duke Hall, Grace & Main St Harrisonburg, VA 22807. Tel 540-568-6211; *Gallery Dir* Stuart C Downs
Open Sept - Apr, Mon - Fri 10:30 AM - 4:30 PM, Sat & Sun 1:30 - 4:30 PM, May - Aug call for summer schedule & hours; No admis fee; Estab 1967 to schedule changing exhibitions for the benefit of students and citizens of this area; One-room gallery of 1040 sq ft with movable panels; Average Annual Attendance: 10,000 - 12,000
Income: Financed by state appropriation, and is part of operation in Art Dept budget
Special Subjects: Asian Art, Antiquities-Greek, Antiquities-Roman
Collections: Sawhill Collection, mainly artifacts from classical civilizations; Staples Collection of Indonesian Art; small group of modern works; contemporary art in all media
Exhibitions: Rotating exhibitions
Activities: Competitions

LEESBURG

M **OATLANDS PLANTATION,** (Oatlands, Inc) 20850 Oatlands Plantation Lane, Leesburg, VA 20175. Tel 703-777-3174; Fax 703-777-4427; *Events Coordr* Jeannie Whitty; *Mgr* David Boyce
Open Apr - Dec, Mon - Fri 10 AM - 5 PM, Sat 9:30 AM - 5 PM, Sun 1 - 5 PM, cl Thanksgiving Day, Christmas, New Years; Admis adults $8, seniors & youths (7-18) $7, children (5- 11) $1; special events at special rates, group rates by arrangement, free to National Trust members & friends except for special events; Oatlands is a Classical Revival Mansion constructed by George Carter, son of Robert (Councillor) Carter (circa 1800-06). It was partially remodeled in 1827 when the front portico with hand carved Corinthian capitals was added. Confederate troops were billeted here during part of the Civil War. The home remained in possession of the Carters until 1897. In 1903 Mr & Mrs William

Corcoran Eustis, of Washington DC, bought Oatlands. Their daughters gave the property to the National Trust for Historic Preservation; the property is protected by preservation easements which help ensure the estates continuing role as a center for equestrian sports & cultural events which are produced by Oatlands & various groups
Income: $600,000 (financed by grants, endowments, admis, fundraising events & shop sales)
Special Subjects: Furniture, Period Rooms
Collections: Carter & Eustis Collection of Furniture; Greek-Revival ornaments adorn interior
Exhibitions: Annual needlework Show; Christmas at Oatlands; semi annual Antique Show
Publications: Oatlands Column, quarterly newsletter
Activities: Special events

LEXINGTON

WASHINGTON & LEE UNIVERSITY

M **Gallery of DuPont Hall,** Tel 540-463-8861; Fax 540-463-8104; *Dir* Kathleen Olsen; *Chmn Dept Art* Pamela Simpson
Open Mon - Fri 9 AM - 5 PM, Sat 11 AM - 3 PM, Sun 2 - 4 PM; No admis fee; Estab 1929 in separate gallery as teaching resource of art; One room, 30 x 60 ft, is maintained for temporary exhibits; also maintained one storeroom; Average Annual Attendance: 40,000
Income: Financed through the university
Exhibitions: Annual faculty show; annual student show; monthly exhibitions; traveling exhibitions
Publications: Exhibition catalogs
Activities: Lect open to public, 5 vis lectrs per year; gallery talks; tours; book traveling exhibitions 3 per year

L **Leyburn Library,** Tel 540-463-8644; Fax 540-463-8964; Elec Mail warren.y@wlu.edu; Internet Home Page Address: www.library.wlu.edu; *Art Librn* Yolanda Merrill; *Head Librn* Barbara J Brown; *Sr Reference Librn* Dick Grefe
Open 24 hrs a day during school yr, summer Mon - Fri 8:30 AM - 4:30 PM; Open for reference to students, scholars, public; this library is part of the main university library
Library Holdings: Book Volumes 450,000; Compact Disks; DVDs; Periodical Subscriptions 35; Sculpture 4,000; Slides 40,000; Video Tapes
Special Subjects: Art History, Asian Art, Aesthetics, Antiquities-Oriental, Oriental Art
Collections: Rare books, 17th - early 20th centuries
Activities: Lect open to public, 2 vis lectrs per year; gallery talks

M **Lee Chapel & Museum,** Tel 540-463-8768; Internet Home Page Address: www.leechapel.wlu.edu; *Dir* Patricia Hobbs
Open Apr 1- Oct 31 Mon - Sat 9 AM - 5 PM, Sun 1 - 5 PM, Nov 1-Mar 31 Mon - Sat 9 AM - 4 PM, Sun 1 PM - 4 PM; No admis fee; Estab 1868 as a part of the university. It is used for concerts, speeches & other events; Museum relates the history of the university and its ties to its namesakes and is used also to display the paintings, collections & personal items of the Washington & Lee families. The Lee Chapel is a National Historic Landmark; Average Annual Attendance: 55,000
Income: Financed through the university
Special Subjects: Historical Material, Painting-American, Portraits, Period Rooms
Collections: Custis-Washington-Lee Art Collection; Lee archives; Lee family crypt; Lee's office; recumbent statute of General Lee by Valentine
Publications: Brochure
Activities: Mus shop sells books, reproductions, prints & related merchandise

LYNCHBURG

L **JONES MEMORIAL LIBRARY,** 2311 Memorial Ave, Lynchburg, VA 24501. Tel 804-846-0501; *Dir* Edward Gibson
No admis fee; Estab 1907; For reference
Income: $180,000 (financed by endowment & donations)
Purchases: $5,000
Library Holdings: Book Volumes 20,000; Clipping Files; Exhibition Catalogs; Manuscripts; Memorabilia; Original Art Works; Other Holdings Architectural drawings; Periodical Subscriptions 45; Photographs; Sculpture
Special Subjects: Drawings, Historical Material, Architecture
Collections: Lynchburg Architectural Archives

M **LYNCHBURG COLLEGE,** Daura Gallery, 1501 Lakeside Dr, Lynchburg, VA 24501-3199. Tel 804-544-8343; Fax 804-544-8277; Elec Mail rothermel@lynchburg.edu; Internet Home Page Address: www.lynchburg.edu/daura; *Dir* Barbara Rothermel; *Asst Dir* Steve Riffee
Open Mon - Tues & Thurs - Fri 9 AM - 4 PM, Wed 9 AM - 8 PM, Sun 1 -5 PM (academic yr) or by appointment; No admis fee; Estab 1974 to supplement & support the academic curriculum of Lynchburg College; Average Annual Attendance: 5,000
Income: Financed by endowment & Lynchburg College
Special Subjects: Drawings, Painting-American, Sculpture, Etchings & Engravings, Painting-Spanish
Collections: American & Virginia Art; Pierre Daura (paintings, sculpture, works on paper)
Publications: Exhibit brochures, 3-4 per year
Activities: Lect open to public, 6 vis lectrs per year; gallery talks; tours; book traveling exhibitions 1 - 2 per year; circulate through Virginia Museum of Fine Arts, Statewide Exhibits Prog

M **RANDOLPH-MACON WOMAN'S COLLEGE,** Maier Museum of Art, 2500 Rivermont Ave, Lynchburg, VA 24503. Tel 434-947-8136; Fax 434-947-8726; Elec Mail museum@rmwc.edu; Internet Home Page Address: http://maiermuseum.rmwc.edu; *Exec Dir* Karol Lawson; *Cur Educ* Martha Johnson; *Assoc Dir* Ellen Agnew
Open Sept - May Tues - Sun 1 - 5 PM, cl Mon; No admis fee; American Art Collection estab 1920 to promote scholarship through temporary exhibitions & a permanent collection; Building currently housing collection built in 1952. 5

galleries contain more than 75 paintings from the permanent collection by American artists. One gallery is used for the 6 to 8 temporary exhibitions displayed each academic year; Average Annual Attendance: 7,400
Income: Financed by endowment
Purchases: Joseph Cornell (collage); Jamie Wyeth (watercolor); John Frederick Peto (oil); Jennifer Bartlett (work on paper)
Special Subjects: Drawings, Ceramics, Folk Art, Etchings & Engravings, Collages
Collections: Extensive collection of 19th & 20th Century American paintings; European & American graphics
Exhibitions: Rotating exhibits, exhibit featuring pieces from permanent collection
Publications: Annual exhibition catalogue; biannual newsletter
Activities: Docent training; lect open to public, 3-5 vis lectr per year; concerts; gallery talks; tours; objects of art lent to other museums; originate traveling exhibitions; museum shop sells exhib catalogs, stationary & reproductions

MARTINSVILLE

M **PIEDMONT ARTS ASSOCIATION,** 215 Starling Ave, Martinsville, VA 24112. Tel 276-632-3221; Fax 276-638-3963; Elec Mail paa@piedmontarts.org; Internet Home Page Address: www.piedmontarts.org; *Dir Finance & Facility* Elnora Foster; *Admin Asst* Barbara Bradshaw; *Asst Dir & Dir Exhib* Anne Frazier; *Exec Dir* Toy L Cobbe; *Dir Mktg* Crystal France; *Dir Programs* Barbara Parker; *Educ Coordr* Heidi Pinkston
Open Tues - Fri 10 AM - 5 PM, Sat 10 AM - 3 PM, Sun 1:30 - 4:30 PM, cl Mon; No admis fee; Estab 1961 to encourage & develop awareness & appreciation of the arts & provide an opportunity for participation in the arts; Five professionally furnished galleries: two feature artists with extensive show experience & reputation, one features work by both established & emerging artists, one features work by students from local schools & one features small exhibitions of local interest; Average Annual Attendance: 35,000; Mem: 1,000; dues patrons $150 & up, family $45, single $35, senior & student $25
Income: $350,000 (financed by endowment, mem, city & state appropriations, federal government & grants from foundations)
Special Subjects: Painting-American, Photography, Prints, Sculpture, Watercolors, American Indian Art, American Western Art, African Art, Southwestern Art, Textiles, Religious Art, Pottery, Afro-American Art, Painting-European, Portraits, Posters, Porcelain, Silver, Painting-British, Painting-French, Painting-Flemish, Stained Glass, Painting-German, Reproductions, Painting-Israeli
Exhibitions: Rotating exhibits
Publications: The Arts & You, bi-monthly newsletter
Activities: Classes for adults & children; dramatic programs; docent training; performing arts series; lect open to public, 1 vis lect per yr; concerts; gallery talks; tours; sponsoring of competitions with awards; scholarships offered; book traveling exhibitions 5-6 per year

MASON NECK

M **GUNSTON HALL PLANTATION,** 10709 Gunston Rd, Mason Neck, VA 22079. Tel 703-550-9220; Fax 703-550-9480; Elec Mail historic@gunstonhall.org; Internet Home Page Address: www.gunstonhall.org; *Asst Dir* Susan A Borchardt; *Dir* Thomas A Lainhoff
Open daily 9:30 AM - 5 PM, cl Thanksgiving, Christmas, New Years Day; Admis adults $7, seniors/groups $6, students (6-18) $3; Estab 1950 to acquaint the pub with George Mason, colonial patriot & his 18th century house & gardens, covering 555 acres; Owned & operated by the Commonwealth of Virginia; Average Annual Attendance: 50,000; Mem: 2,200
Income: Financed by state appropriation & admis fee
Special Subjects: Painting-American, Decorative Arts, Furniture, Historical Material, Restorations
Collections: 18th century English & American decorative arts, furniture & paintings; 18th & 19th century family pieces
Activities: Classes for children; docent training; lect open to public, 8-12 vis lectrs per year; tours; individual paintings & original objects of art lent to other museums; sales shop sells books, reproductions; Childrens Touch Museum located in basement

L **Library,** 10709 Gunston Rd, Mason Neck, VA 22079. Tel 703-550-9220; Fax 703-550-9480; Internet Home Page Address: www.gunstonhall.org; *Dir* Thomas Lainhoff; *Cur* Susan Borchardt; *Librn* Kevin Shupp
Open Mon - Fri 9:30 AM - 5 PM & by appointment, cl Thanksgiving, Christmas & New Years Day; Estab 1950 to recreate an 18th Century Virginia gentlemen's library as a research source plus acquiring a working reference collection on George Mason, early Virginia history & the decorative arts; Average Annual Attendance: 50,000
Income: Financed by endowment
Library Holdings: Book Volumes 11,000; Cassettes; Exhibition Catalogs; Fiche; Filmstrips; Manuscripts; Memorabilia; Motion Pictures; Other Holdings Original documents; Pamphlets; Periodical Subscriptions 50; Photographs; Reels; Reproductions
Special Subjects: Decorative Arts, Manuscripts, Prints, Historical Material, Portraits, Archaeology, Porcelain, Furniture, Period Rooms, Restoration & Conservation, Silver, Textiles, Pewter, Architecture
Collections: Robert Carter Collection; Pamela C Copeland Collection; Elizabeth L Frelinghuysen Collection; Mason-Mercer Rare Book Collection

MIDDLETOWN

M **BELLE GROVE PLANTATION,** 336 Belle Grove Rd, Middletown, VA 22645; PO Box 137, Middletown, VA 22645. Tel 540-869-2028; Fax 540-869-9638; Elec Mail bellegro@shentel.net; Internet Home Page Address: www.bellegrove.org; *Exec Dir* Elizabeth McClung; *Admin Asst* Amy Keller; *Pres* Mary Robinson; *Visitor Svcs Clerk* Jennifer Boswell; *Build & Grounds* Christopher Taucci; *Mus Shop Mgr* Jacquelyn Williamson; *Bookkeeper* Kimberlee Edwards; *Cur Educ* Jacob Blosser
Open Apr - Oct Mon - Sat 10 AM - 4 PM, Sun 1 - 5 PM, Nov - Mar by appointment; Admis adult $7, seniors $6, student $3, special rates; Open to the

pub in 1967, it is preserved as a historic house & is the property of the National Trust for Historic Preservation & managed by Belle Grove, Inc, an independent local nonprofit organizaiton. It serves as a local preservation center & resource for the interpretation of regional culture in the Shenandoah Valley; Built in 1797 for Major Issac Hite, Jr, a Revolutionary War officer & brother-in-law of James Madison, Belle Grove was designed with the help of Thomas Jefferson. During the Battle of Cedar Creek in 1864, the house served as headquarters to General Phillip Sheridan. The property is a working farm & Belle Grove maintains an active prog of events for the visiting pub; Average Annual Attendance: 25,000
Library Holdings: Book Volumes; Cassettes; Clipping Files; Maps; Memorabilia; Original Art Works; Original Documents; Pamphlets; Periodical Subscriptions; Photographs; Prints; Reproductions; Video Tapes
Collections: Antique collectibles
Exhibitions: Four Portraits by Charles Peal Polk: Colonel James Madison, Nelly Conway Madison-Hite, Major Isaac Hite, Mrs James Madison
Activities: Classes for adults & children; seminars on various subjects in museum field; docent training; tours; lect open to public; concerts, tours, competitions; awards; sales shop for children

MOUNT VERNON

M **FRANK LLOYD WRIGHT POPE-LEIGHEY HOUSE,** 9000 Richmond Hwy, Mount Vernon, VA 22309. Tel 703-780-4000; Fax 703-780-8509; Internet Home Page Address: www.nationaltrust.org; *Asst Dir* Gail Donahue; *Dir* Ross Randall
Open Mar - Dec, daily 10 AM -5 PM, cl Thanksgiving, Christmas & New Years; Admis adults $6, seniors & students $5, group rates by arrangement; Estab 1964; Frank Lloyd Wright's Pope-Leighey House is a property of the National Trust for Historic Preservation, located on the grounds of Woodlawn Plantation. This residence was designed in 1939 by Frank Lloyd Wright for his clients, the Loren Pope Family. Built of cypress, brick and glass, the Usonian structure contains such features as a flat roof, radiant heat, indirect lighting, carport & custom furniture, all designed by Frank Lloyd Wright, as an example of architecture for the average-income family. Threatened by construction of an interstate highway in 1964, Mrs Marjorie Folsom Leighey, second owner, presented the property to the National Trust for Historic Preservation. It was then moved to the Woodlawn grounds; Average Annual Attendance: 28,000; Mem: 350, dues family $40
Special Subjects: Architecture
Collections: Pope & Leighy Family Collections
Exhibitions: Christmas at Pope-Leighey House; annual World War II exhibits; Annual Wright Birthday June 8
Publications: Brochure and paperback history of house
Activities: Classes for adults & children; docent training; lect open to public; 9 vis lectrs per month; tours daily; museum shop sells books, reproductions & prints

M **MOUNT VERNON LADIES' ASSOCIATION OF THE UNION,** George Washington's Mt Vernon Estate & Gardens, PO Box 110 Mount Vernon, VA 22121. Tel 703-780-2000; Fax 703-799-8698; Internet Home Page Address: www.mountvernon.org; *Regent* Mrs Robert E Lee IV; *Cur* Christine Meadows; *Librn* Dr Barbara McMillan; *Resident Dir* James C Rees
Open to the public every day in the year from 8 AM- 5 PM: entrance gate closes Mar 1 - Oct 1 at 5 PM, Oct 2 - Mar 2 at 4 PM; Admis annual pass $12, adults $9, $7.50 for groups of 12 or more children or groups of 20 or more adults, student groups $4.50, adults over 62 $8.50, children 6-11 $4, children under 6 free; Estab 1853; The home of George Washington, purchased in 1858 from his great-grand-nephew by the Mount Vernon Ladies Assoc of the Union, which maintains it. The estate includes spinning house, coach house, various quarters, restored flower & kitchen gardens; also the tomb of George & Martha Washington. George Washington: Pioneer Farm - a four acre site with a reconstruction of his sixteen sided treading barn; Average Annual Attendance: 1,000,000; Mem: Semi-annual meeting Oct & Apr
Income: Financed by admis fees & donations
Special Subjects: Furniture, Period Rooms
Collections: Mansion is fully furnished with original & period furniture, silver, portraits & prints; large collection of original Washington memorabilia, manuscripts & books
Publications: Annual Report; The Gardens & Grounds at Mount Vernon; George Washington, A Brief Biography; The Last Will & Testament of George Washington; The Maxims of Washington; Mount Vernon; The Mount Vernon Coloring Book; The Mount Vernon Cookbook; The Mount Vernon Gardens; Mount Vernon Handbook; Nothing More Agreeable: Music in George Washington's Family; George Washington: Citizen - Soldier
Activities: Sales shop sells books, reproductions, prints, slides, coloring books, t-shirts, food & Christmas items

L **Library,** George Washington Pky S, PO Box 110 Mount Vernon, VA 22121. Tel 703-799-8639, 799-5085; Fax 703-799-8698; Elec Mail bmcmillan@mountvernon.org or jkittlaus@mountvernon.org; Internet Home Page Address: www.mountvernon.org; *Librn* Barbara McMillan; *Library Asst* Jennifer Kittlaus; *Special Projects Mgr* John Rudder
Open by appointment; Reference library only
Library Holdings: Auction Catalogs; Audio Tapes; Book Volumes 12,000; Clipping Files; Compact Disks; DVDs; Exhibition Catalogs; Filmstrips; Framed Reproductions; Kodachrome Transparencies; Lantern Slides; Manuscripts; Maps; Memorabilia; Motion Pictures; Original Art Works; Pamphlets; Periodical Subscriptions 85; Photographs; Prints; Records; Reproductions; Sculpture; Slides; Video Tapes
Special Subjects: Landscape Architecture, Decorative Arts, Manuscripts, Painting-American, Painting-British, Prints, Historical Material, Portraits, Archaeology, Printmaking, Furniture, Period Rooms, Restoration & Conservation, Textiles, Architecture
Collections: American Revolution; 18th Century Agriculture; Mount Vernon; Virginia slavery; Washington family; George Washington
Publications: Annual report

M **WOODLAWN/THE POPE-LEIGHEY,** (Woodlawn Plantation) PO Box 37, Mount Vernon, VA 22121. Tel 703-780-4000; Fax 703-780-8509; *Asst Dir* Gail Donahue; *Dir* Ross Randall
Open 10 AM - 5 PM, cl New Years; Admis adults $6, seniors & students $5, group rates by arrangement; Estab 1805; Land originally part of Mount Vernon.

Built in 1800-05 for George Washington's granddaughter upon her marriage to Lawrence Lewis, Washington's nephew. It was designed with central pavilion & flanking wings by Dr William Thornton, winner of the architectural competition for the design of the United States Capitol. A group of Quakers, a pioneer anthropologist, a playwright & Senator Oscar W Underwood of Alabama were among Woodlawn's residents after the Lewises. In 1951 the foundation's trustees decided that the visiting public would be better served if Woodlawn was administered by the National Trust. The mansion furnishings are largely from the Federal & early Empire periods & include Lewis family furniture; Average Annual Attendance: 60,000; Mem: 350; dues family \$40

Special Subjects: Architecture, Drawings, Painting-American, Sculpture, Watercolors, Archaeology, Textiles, Costumes, Ceramics, Etchings & Engravings, Decorative Arts, Portraits, Furniture, Glass, Jewelry, Porcelain, Silver, Painting-British, Carpets & Rugs, Historical Material, Maps, Coins & Medals, Restorations, Miniatures, Period Rooms, Embroidery, Pewter, Leather

Exhibitions: Needlework Exhibit; A Woodlawn Christmas in December; Haunted History Tours

Publications: Friends of Woodlawn Newsletter, quarterly; Welcome to Woodlawn, booklet

Activities: Classes for adults & children; dramatic programs; docent training; special events; lect open to public; tours; individual paintings & original objects of art lent to qualified museums; lending collection consists of original prints, paintings, furnishings & textiles; museum shop sells books, reproductions, prints, antiques, foods, toys

NEWPORT NEWS

M THE MARINERS' MUSEUM, 100 Museum Dr, Newport News, VA 23606-3759. Tel 757-596-2222; Fax 757-591-7311; Elec Mail info@mariner.org; Internet Home Page Address: www.mariner.org; WATS 800-581-7245; *VPres Finance & Admin* Gary Egan; *VPres Facilities Management* John Cannup; *VPres Develop* Marguerite K Vail; *Pres* John B Hightower; *Mus Shop Mgr* Georgia Mamangakis; *Dir Educ* Anna G Holloway; *VPres Devel* Mita Vail; *Chm* Lloyd U Noland; *Vice Pres. Mktg* Karen P. Grinnan
Open daily 10 AM - 5 PM, cl Thanksgiving Day & Christmas Day; Admis adults \$6.00, students \$4.00 (ID required for students 18 & older), children ages 5 & under free, discounts offered for active duty military, AAA members & senior citizens, group rate for party of 10 or more; Estab 1930 as an educational, nonprofit institution accredited by the American Assoc of Museums, preserves & interprets maritime history & other maritime artifacts. Costumed interpreters & film Mariner, help maritime history come alive; Located in a 550 acre park which features the 5 mile Noland Trail. Museum has twelve permanent galleries, including Age of Exploration & Chesapeake galleries; paintings & decorative arts; Crabtree Collection of miniature ships; collection of International Small Craft; Great Hall of Steam; William F Gibbs: Naval Architect Gallery. Maintains reference library; Average Annual Attendance: 100,000; Mem: 2,500

Special Subjects: Drawings, Graphics, Painting-American, Photography, Prints, Sculpture, Watercolors, Anthropology, Ethnology, Pre-Columbian Art, Ceramics, Crafts, Folk Art, Pottery, Primitive art, Woodcarvings, Woodcuts, Etchings & Engravings, Decorative Arts, Manuscripts, Painting-Japanese, Portraits, Posters, Marine Painting, Painting-Dutch, Painting-French, Historical Material, Ivory, Maps, Scrimshaw, Coins & Medals, Dioramas, Stained Glass, Military Art, Bookplates & Bindings

Collections: Crabtree Collection of miniature ships; thousands of marine artifacts; over 1,000 paintings; over 1,000 ship models; ceramics, scrimshaw, small craft

Publications: Mariners' Museum Pipe, quarterly newsletter; Mariners' Museum Annual, annual journal

Activities: Classes for adults & children; docent training; lect open to members, 6 vis lectrs per year; concerts; gallery talks; tours; competitions with awards; scholarships & fellowships offered; individual paintings & original objects of art lent to museums; collection contains 120 motion pictures, 2,000 original art works, 8,000 original prints, 1,300 paintings; museum shop sells books, magazines, reproductions, prints, slides, jewelry & other maritime related items

L Library, 100 Museum Dr, Newport News, VA 23606-3759. Tel 757-591-7782; Fax 757-591-7310; Elec Mail library@mariner.org; Internet Home Page Address: www.mariner.org; *Asst to Librn* Jennifer Kirch; *Archivist* Lester Weber; *Librn* Susan Berg
Open Mon - Sat 10 AM - 5 PM, cl Sun; No admis fee; Estab 1930; For reference only

Income: Financed by endowment

Library Holdings: Book Volumes 75,000; Clipping Files; Exhibition Catalogs; Manuscripts; Memorabilia; Other Holdings Original documents; Pamphlets; Periodical Subscriptions 150; Photographs 350,000; Prints

Special Subjects: Art History, Decorative Arts, Manuscripts, Maps, Painting-American, Painting-British, Painting-Dutch, History of Art & Archaeology, Crafts, Anthropology, Eskimo Art, Drafting, Handicrafts, Marine Painting, Flasks & Bottles

A PENINSULA FINE ARTS CENTER, 101 Museum Dr, Newport News, VA 23606. Tel 757-596-8175; Fax 757-596-0807; Elec Mail pfac@cvinet.org; Internet Home Page Address: www.pfac-va.org; *Pres* Fred Westfall Jr; *VPres* Raymond Suttle Jr; *Treas* J David Grose; *VPres* Jane Susan Frank; *Cur* Diana Blanchard-Gross; *Exec Dir* Lisa Swenson
Open Mon - Sat 10 AM - 5 PM, Sun 1 - 5 PM; No admis fee; Estab 1962 to promote an appreciation of the fine arts through changing monthly exhibitions with works from the Virginia Mus, other institutions & outstanding artists, both emerging & estab; Three galleries maintained with changing exhibitions; Mem: 1,000+; dues family (incl mem) \$50, individual \$35

Income: Financed by mem

Exhibitions: Biannual exhibs

Publications: Art class schedules; newsletter to members, quarterly; notification of special events

Activities: Classes for adults & children; lect open to public, 8 vis lectrs per year; gallery talks; competitions; cash awards & certificates of distinction; gallery shop sells books, original art & crafts

NORFOLK

M CHRYSLER MUSEUM OF ART, 245 W Olney Rd, Norfolk, VA 23510-1587. Tel 757-664-6200; Fax 757-664-6201; Elec Mail museum@chrysler.org; Internet Home Page Address: www.chrysler.org; *Chief Cur* Jeff Harrison; *Cur Photo* Brooks Johnson; *Pub Relations Mgr* Rick Salzberg; *Pres Bd Trustees* Augustus Miller; *Dir* Dr William J Hennessey; *Dir Educ* John Welch; *Cur of Glass* Gary Baker; *Cur American & Contemporary Art* Lynn Marsden-Atlass; *Deputy Dir of Develop* Andrea Bear
Open Wed 10 AM - 9 PM, Thurs, Fri & Sat 10 AM - 5 PM, Sun 1 - 5 PM, cl Mon & Tues; Admis adults \$7, AAA \$6, seniors & students \$5, children under 12 free; Wed contributions only; Mus originates from a memorial assoc estab in 1901 to house a coll of tapestries & paintings donated in memory of & by Irene Leache. The Norfolk Society of Arts was founded in 1917, which raised funds throughout the 1920s to erect a building to permanently hold the coll; A Florentine Renaissance style building, named the Norfolk Museum of Arts & Sciences, opened to the pub in 1933. The Houston Wing, housing the Museum Theatre & Lounge, was added in 1956, the Centennial Wing in 1976 & another wing to house the library & additional galleries was opened in 1989. The building has been designated the Chrysler Museum since 1971, when a large portion of the collection of Walter P Chrysler, Jr was given to Norfolk. Mus contains 140,000 sq ft; Average Annual Attendance: 200,000; Mem: 4,500; dues Masterpiece Society Benefactor \$10,000; Masterpiece Society Patron \$5,000; Masterpiece Society Sponsor \$2,500; Director's Circle \$1,000; Patron \$500; Associate \$100; Household \$60 (seniors 65 & up, students, teachers & active-duty military \$50); Individual \$45 (seniors age 65 & up, students, teachers and active-duty military \$35); Corporate memberships available

Income: Financed by municipal appropriation & state appropriations as well as federal grants

Library Holdings: Auction Catalogs; Book Volumes; Clipping Files; Exhibition Catalogs; Manuscripts; Memorabilia; Original Documents; Pamphlets; Periodical Subscriptions; Video Tapes

Special Subjects: Painting-American, Glass, Oriental Art, Painting-Dutch, Painting-French, Painting-Flemish, Painting-Italian, Antiquities-Greek, Antiquities-Roman

Collections: African artists; American art from 18th century primitives - 20th century Pop Art; Bernini's Bust of the Savior; Francoise Boucher, The Vegetable Vendor; Mary Cassatt, The Family; Thomas Cole, The Angel Appearing to the Shepherds; Decorative arts including furniture, silver, gold, enameled objects & Worcester porcelain; 18th century English paintings; 14th-18th century Italian paintings; 15th-18th century Netherlandish & German works; Gaugin's Loss of Virginity; Bernice Chrysler Garbisch & Edgar William Garbish Native American paintings; Institute of Glass; Matisse, Bowl of Apples on a Table; Near & Far East Artists; Oriental artists; photography collection including Alexander Gardner, Lewis W Hine, Walker Evans, Ansel Adams, W Eugene Smith & contemporaries Joel Meyerowitz & Sheila Metzner; Pre-Columbian artists; Reni, The Meeting of David & Abigail; 16th - 20th century French paintings; works from Spanish school; 8,000 object glass collection including Tiffany glass, English cameo glass & contemporary glass sculpture

Exhibitions: Connoisseurs & Souvenirs: Silver from the Permanent Collection

Publications: Monthly members' newsletter; exhibition catalogues; Annual Report

Activities: Educ program; family programs; docent training; teacher workshops; outreach information packages; lect open to public, 15-20 vis lectrs per year; concerts; gallery talks; tours; competitions (juried); exten dept operates three historic homes; individual paintings & original objects of art lent to accredited museums; Hampton Roads; book traveling exhibitions; originate traveling exhibitions organized & circulated; museum shop sells books, prints

L Jean Outland Chrysler Library, 245 W Olney Rd, Norfolk, VA 23510-1587. Tel 757-664-6200; Fax 757-664-6201; Internet Home Page Address: www.chrysler.org; *Interim Library Mgr* Matt Wiggins; *Archivist* Joe Mosier; *Library Asst* Stacey Raffield
Open Wed - Fri 10 AM - 4:45 PM, Sat Noon - 4 PM; No admis fee; Estab 1918 to collect materials in support of the collections of the Chrysler Mus; Circ Non-circulating; Open to the pub for reference only

Income: Financed partially by endowment

Library Holdings: Book Volumes 60,000; Clipping Files; Exhibition Catalogs; Fiche; Other Holdings Auction catalogs; Periodical Subscriptions 200; Video Tapes

Special Subjects: Art History, Decorative Arts, Photography, Pre-Columbian Art, Glass

Activities: Lect open to public

M HERMITAGE FOUNDATION MUSEUM, 7637 N Shore Rd, Norfolk, VA 23505. Tel 757-423-2052; Fax 757-423-1604; Elec Mail info@hermitagefoundation.org; Internet Home Page Address: www.hermitagefoundation.org; *Pres Bd* William Hull; *Admin Asst* Jean Turmel; *Mgr, Mus Coll* Kristin C Law; *Site Mgr* Andrea Prosser; *Asst to Dir Admin & Develop* Karen Perry
Open daily 10 AM - 5 PM (closed Wed), Sun 1 - 5 PM, cl New Years Day, Thanksgiving Day, Christmas Day; Admis adults \$4, children 6-18 \$1; no fee for activity military; Estab 1937 to disseminate information concerning arts & maintain a collection of fine art materials; Large Tudor-style historic house on 12-acre estate houses major collections as well as two small changing exhibition galleries; Average Annual Attendance: 20,000; Mem: 400; dues \$30; meeting four times per yr

Special Subjects: Drawings, Landscapes, Ceramics, Glass, Mexican Art, Antiquities-Assyrian, Photography, Pottery, Painting-American, Prints, Textiles, Maps, Painting-European, Painting-French, Sculpture, Bronzes, Southwestern Art, Costumes, Religious Art, Crafts, Primitive art, Woodcarvings, Decorative Arts, Furniture, Jade, Oriental Art, Antiquities-Byzantine, Carpets & Rugs, Coins & Medals, Tapestries, Embroidery, Antiquities-Oriental, Antiquities-Persian, Antiquities-Egyptian, Antiquities-Roman, Stained Glass, Reproductions, Enamels

Collections: English oak & teakwood woodcarvings; Major collection of decorative arts from various periods & countries; Oriental collection of Chinese bronzes & ceramic tomb figures, lacquer ware, jades & Persian rugs; Spanish & English furniture; individual paintings & original objects of art lent to institutions; lending collection contains original art works, paintings, records & sculpture

Exhibitions: American Illustrator; Art on Paper; Isabel Bishop; Bernard Chaet (paintings); Contemporary American Graphics; Currier & Ives; Export Porcelain

from a Private Collection; Freshwork (Virginia photographers); Alexandra Georges (photographs); The Photographs of Wright Morris; Henry Pitz (one man show); student exhibitions from summer workshops
Activities: Classes for adults & children; dramatic programs; lect open to public & auxiliary lect for members only, 10-12 vis lectrs per year; concerts; tours; Best of Norfolk awards; individual paintings & original objects of art lent to institutions; lending collection contains 750 original art works, 300 paintings, 150 records & 50 sculpture; book traveling exhibitions; originate traveling exhibitions; museum shop sells original art, t-shirts & umbrellas

L **Library,** 7637 N Shore Rd, Norfolk, VA 23505. Tel 757-423-2052; Fax 757-423-1604; Elec Mail info@hermitagefoundation.org; Internet Home Page Address: www.hermitagefoundation.org; *Mgr Mus Coll* Kristin C Law; *Site Mgr* Andrea Prosser; *Asst to Dir Admin & Develop* Karen Perry
Open Mon - Sat 10 AM - 5 PM, Sun 1 - 5 PM, closed Wed; Admis donations for use & research; Estab 1937 for the advancement of art education; Open to students and staff for reference only
Library Holdings: Auction Catalogs; Book Volumes 800; Exhibition Catalogs; Original Documents; Periodical Subscriptions; Photographs
Special Subjects: Art History, Folk Art, Decorative Arts, Islamic Art, Painting-American, Sculpture, Historical Material, Ceramics, Crafts, Bronzes, Art Education, American Indian Art, Porcelain, Primitive art, Furniture, Ivory, Jade, Glass, Antiquities-Oriental, Antiquities-Persian, Carpets & Rugs, Embroidery, Oriental Art, Pottery, Religious Art, Restoration & Conservation, Silver, Tapestries, Textiles, Woodcarvings, Antiquities-Byzantine, Antiquities-Egyptian, Antiquities-Greek, Coins & Medals, Pewter, Laces, Architecture
Collections: Personal letters & information on Douglas Volk, Helen M Turner, Harriet W. Frishmuth, C T Loo, D Kelekian, Charles Woodsend & Karl von Rydingsvard

M **MACARTHUR MEMORIAL,** MacArthur Sq, Norfolk, VA 23510. Tel 757-441-2965; Fax 757-441-5389; Elec Mail macarthurmemorial@norfolk.gov; Internet Home Page Address: www.macarthurmemorial.org; *Dir* William J Davis; *Cur* Charles R Knight; *Admin Asst* Janice Stafford Dudley; *Archivist* James W Zobel
Open Mon - Sat 10 AM - 5 PM, Sun 11 AM - 5 PM, cl Thanksgiving, Christmas, New Years Day; No admis fee; Estab 1964 to memorialize General Douglas MacArthur; Located in the 1850 Court House which was rebuilt in 1962; nine galleries contain memorabilia; Average Annual Attendance: 51,074
Income: $563,312 (financed by city appropriation & the General Douglas MacArthur Foundation)
Collections: Objects d'art, murals, portraits, photographs
Exhibitions: 1-2 rotating exhibitions per year
Activities: Concerts; gallery talks; tours; research assistance grants & fellowships offered; individual paintings and original objects of art lent to museums; museum shop sells books, reproductions, prints, slides

L **Library & Archives,** MacArthur Sq, Norfolk, VA 23510. Tel 757-441-2965; Fax 757-441-5389; Internet Home Page Address: www.sites.communitylink.org/mac; *Archivist* James W Zobel
Open 8:30 AM - 5 PM; No admis fee; Estab 1964; Research library; Average Annual Attendance: 1,000
Income: Financed by the City of Norfolk & the General Douglas MacArthur Foundation as part of the MacArthur Memorial Museum
Library Holdings: Audio Tapes; Book Volumes 6000; Cassettes; Clipping Files; Fiche; Framed Reproductions; Manuscripts; Motion Pictures 130; Other Holdings Original documents 2,000,000, Photographs 80,000; Records; Reels; Slides; Video Tapes 120
Collections: Brigadier General Bonner F Fellers Collection (papers); Major General Courtney Whitney Collection (papers)
Activities: Classes for adults & children; lect open to public, 2-3 vis lectrs per year; tours; competitions with prizes; scholarships offered

M **OLD DOMINION UNIVERSITY,** Art Dept, University Gallery, 350 W 21st St Norfolk, VA 23517; University Gallery, Visual Art Bldg, Room 203 Norfolk, VA 23529. Tel 757-683-4047, 683-2355; Fax 757-683-5923; Elec Mail khuntoon@odu.edu; Internet Home Page Address: www.odu.edu/al/artsandletters/gallery/index.html; *Art Chmn* Dr Robert Wojtowicz; *Dir Gallery* Katherine Huntoon
Open Tues - Thurs Noon - 3 PM, Fri & Sat Noon - 5 PM, Sun 1 - 4 PM; No admis fee; Estab 1972 for the exhibition of contemporary work; also estab as a pub forum for contemporary artists, with student exposure; Average Annual Attendance: 3,000
Income: Financed by endowment & city appropriation
Library Holdings: Book Volumes 7000; Periodical Subscriptions 40
Exhibitions: Monthly exhibitions during calendar year
Activities: Lect open to public, 10 vis lectrs per year; gallery talks; tours; competitions; exten dept

L **Elise N Hofheimer Art Library,** Fine & Performing Arts Ctr, Rm 109, Norfolk, VA 23529. Tel 757-683-4059; Elec Mail cvaughan@odu.edu; *Libr Specialist II* Clayton Vaughan
Open Mon - Fri 8 AM - 9 PM, Sat 1 - 5 PM, Sun 1 - 5 PM; Estab 1963; Circ 14,500; Open to students & faculty; open to the public for reference; Average Annual Attendance: 22,000
Income: Financed by state, gifts & grants
Library Holdings: Auction Catalogs; Book Volumes 14,500; CD-ROMs; DVDs; Exhibition Catalogs; Periodical Subscriptions 36; Video Tapes
Special Subjects: Art History, Collages, Decorative Arts, Calligraphy, Etchings & Engravings, Ceramics, Conceptual Art, Cartoons, Aesthetics, Afro-American Art, Antiquities-Oriental, Antiquities-Byzantine, Antiquities-Greek, Antiquities-Roman, Architecture
Activities: Library instruction/orientation sessions; tours

PETERSBURG

M **THE CITY OF PETERSBURG MUSEUMS,** 15 W Bank St, Petersburg, VA 23803. Tel 804-733-2404; Fax 804-863-0837; Elec Mail petgtourism@earthlink.net; Internet Home Page Address: www.petersburg.va.org/tourism; *Interim Mus Mgr* George Bass; *Coll Cur* Laura Willoughby
Open Mon - Sun 10 AM - 5 PM, cl holidays; Admis adults $5, seniors, children &

groups $4; Estab 1972 as a system of city museums; Three historic sites dating from 1735-1839. Maintains reference library; Average Annual Attendance: 25,000
Special Subjects: Architecture, Portraits, Painting-American, Prints, Sculpture, Photography, Watercolors, Costumes, Decorative Arts, Furniture, Silver, Period Rooms, Stained Glass
Collections: City of Petersburg photographs & manuscripts; Military-Civil War; 19th century decorative arts; 15 Tiffany stained glass windows by Louis Comfort Tiffany Studio-Blandford Church; Period rooms 19th & early 20th century - Centre Hill Museum
Publications: Petersburg: Images of America Series; Petersburg: Postcard History Series
Activities: Docent training; lect open to public; concerts; tours; individual paintings & original objects of art lent to other museums; book traveling exhibitions; museum shop sells books, reproductions, prints & slides

PORTSMOUTH

M **PORTSMOUTH MUSEUMS,** Courthouse Galleries, 420 High St, Portsmouth, VA 23704. Tel 757-393-8543, 393-8983; Fax 757-393-5228; Internet Home Page Address: www.courthousegalleries.com; *Dir* Nancy S Perry
Open Tues 10 AM - 5 PM, Sun 1 - 5 PM, cl Mon; Admis $9 to tour four municipal museums, general fee $3; Estab 1974 to offer a wide variety of the visual arts to the citizens of Tidewater area & beyond; Average Annual Attendance: 20,000; Mem: 1200; dues corporate director's circle $5000, corporate benefactor $2500, corporate patron $1000, corporate friend $500, corporate associate $250, contributing $100, sponsoring $50, family $45, individual $25
Income: $226,000
Purchases: $1500
Special Subjects: Painting-American, Prints
Collections: Contemporary drawings & paintings, primarily by American artists
Exhibitions: Up to 10 changing exhibitions per year; Contemporary drawings & paintings
Publications: Quarterly newsletter
Activities: Classes for adults & children; workshops; lect open to public, 16 vis lectrs per year; gallery talks; tours; outreach program; book traveling exhibitions, 6 per year; museum shop sells books, prints & gifts related to exhibitions & holidays

PULASKI

M **FINE ARTS CENTER FOR THE NEW RIVER VALLEY,** 21 W Main St, PO Box 309 Pulaski, VA 24301. Tel 540-980-7363; Fax 721-994-5631; Elec Mail facnrv@swva.net; *Deputy Dir* Judy Ison; *Exec Dir* Michael B Dowell
Open 10 AM - 5 PM; No admis fee; Estab 1978 to foster & furnish activities, programs & facilities to increase understanding of the arts; Gallery area 800 sq ft, classroom area 1800 sq ft; Average Annual Attendance: 16,000; Mem: 550; dues $10-$1000; annual meeting in Sept
Income: $129,000 (financed by mem, city & state appropriation & business sponsorship)
Purchases: $80,000 (building in 1988)
Special Subjects: Painting-American, Ceramics, Crafts, Folk Art, Etchings & Engravings, Landscapes, Collages, Painting-European, Painting-Japanese, Glass, Jewelry, Asian Art, Painting-British, Painting-Dutch, Painting-French, Baroque Art, Calligraphy, Miniatures, Painting-Flemish, Painting-Polish, Painting-Italian, Painting-Australian, Painting-German, Painting-Russian, Painting-Scandinavian
Collections: Permanent collection established by donated pieces of art, sculpture & original paintings from the New River Valley Region
Exhibitions: Biennial Juried competition for artists living with in a 100 mile radius; Rotating exhibits
Publications: Centerpiece, monthly newsletter; Rainbow of Arts, childrens quarterly newsletter
Activities: Classes for adults & children; dramatic programs; docent programs; lect open to public; concerts; gallery talks; tours; competition with cash awards; scholarships & fels offered; artmobile serves New River Valley; lending collection; retail store sells books, prints, original art, local craft items, reproductions

RESTON

NATIONAL ART EDUCATION ASSOCIATION
For further information, see National and Regional Organizations

NATIONAL ASSOCIATION OF SCHOOLS OF ART & DESIGN
For further information, see National and Regional Organizations

RICHMOND

M **1708 GALLERY,** 319 W Broad St, PO Box 12520 Richmond, VA 23241. Tel 804-643-1708; Fax 804-643-7839; Elec Mail akoch@1708gallery.org; Internet Home Page Address: www.1708gallery.org; *Gallery Admin* Aimee Koch; *Gallery Coordr* Maria Dubon
Open Sept - July Tues - Fri 11 AM - 5 PM, Sat 1 - 5 PM; No admis fee; Estab 1978 to offer an alternative presentation space to emerging & professional artists; Gallery is devoted to the presentation of contemporary art; Average Annual Attendance: 10,000
Library Holdings: Exhibition Catalogs
Special Subjects: Drawings, Painting-American, Photography, Prints, Sculpture, Etchings & Engravings
Activities: Educ dept; internship program, slide show; lecs, gallery talks; sponsoring of competitions; wearable art, annual auction, The Forum: slide show; books, catalogues

A **AGECROFT ASSOCIATION,** Agecroft Hall, 4305 Sulgrave Rd, Richmond, VA 23221. Tel 804-353-4241; Fax 804-353-2151; Internet Home Page Address: www.agecrofthall.com; *Cur Educ* Alice D Young; *Cur* Deborah DeArechaga; *Exec Dir* Richard W Moxley
Open Tues - Fri 10 AM - 4 PM, Sat & Sun 12:30 - 5 PM; Admis adults $5, seniors $4.50, students $3, group rates by prior arrangements; Estab 1969 to

exhibit 15th century Tudor Manor house brought over from Lancashire, England in 1926 & rebuilt in Richmond. Furnished with period objects of art; Average Annual Attendance: 20,000
Income: Financed by endowment & admis
Purchases: 1560 portrait of William Dauntesey
Collections: 16th & early 17th century furniture & objects of art depicting Elizabethan lifestyle, when Agecroft Hall was at its pinnacle
Exhibitions: Permanent exhibit of British memorabilia 1890 - present
Activities: Classes for adults; docent training; lect open to public; concerts; gallery talks; specialized tours; museum shop sells books & reproductions

M **Museum,** Agecroft Hall, 4305 Sulgrave Rd Richmond, VA 23221. Tel 804-353-4241; Fax 804-353-2151; Internet Home Page Address: www.agecrofthall.com; *Cur Educ* Melissa Zimmerman; *Cur Coll* Debrah DeArechaga; *Exec Dir* Richard W Moxley; *Mgr Tour Svcs* Laura Krajewski
Open Tues - Sat 10 AM - 4 PM, Sun 12:30 - 5 PM; Admis adults $7, seniors $6, students $4, children under 6 free; Estab 1969 to interpret the material culture & social history of England (1485-1660); Rebuilt from 15th century English house, 7 period rooms & 2 exhibit galleries. Maintains reference library; Average Annual Attendance: 20,000
Special Subjects: Architecture, Textiles, Costumes, Ceramics, Pottery, Woodcarvings, Manuscripts, Painting-European, Portraits, Porcelain, Silver, Metalwork, Painting-British, Carpets & Rugs, Historical Material, Maps, Restorations, Tapestries, Painting-Flemish, Renaissance Art, Period Rooms, Stained Glass, Pewter, Leather, Bookplates & Bindings
Activities: Classes for adults & children; dramatic programs; quarterly living history events; workshops; summer Shakespeare festival; lect open to public, 10-12 vis lectrs per year; concerts; gallery talks; tours; original objects of art lent to Folger Shakespeare Library in Washington, DC; lending collection contains 3000 books, paintings, photographs & 500 decorative art holdings; museum shop sells books, reproductions, textiles, games, jewelry

A **ARTS COUNCIL OF RICHMOND, INC,** 111 Virginia St, Ste 202 Richmond, VA 23219. Tel 804-327-5734; Fax 804-327-5735; Elec Mail general@richmondarts.org; Internet Home Page Address: www.richmondarts.org; *Pres* Dr Stephanie Micas; *Exec Dir* Katherine Fessler
Open Mon - Fri 9 AM - 5 PM, office hours; No admis fee; Estab 1949 to promote & support the arts & to provide arts programs & services to enhance the quality of city living
Income: Financed by grants, contributions & city appropriation
Exhibitions: Rotating exhibits
Publications: Arts Spectrum Directory, annually
Activities: Management seminars; downtown arts festival, children's festival for the arts; competitions; scholastic Art schol offered; Public Art Program including art at airport

M **ARTSPACE,** 31 E 3rd St, Richmond, VA 23224; Zero E 4th St, Richmond, VA 23224. Tel 804-232-6464; Fax 804-232-6465; Elec Mail artspacegallery@worldnet.att.net; Internet Home Page Address: www.artspacegallery.org; *Treas* Nancy Rice; *Gallery Admin* Emilie Brown; *Pres* Santa Sergio DeHaven; *VPres* Susan Legge
Open Wed - Sun Noon - 4 PM; No admis fee; Estab 1988 as an association of artists interested in exhibiting their own work & providing a space for other artists to reach a wider audience in the greater Richmond area; Two medium rooms & one large room; Average Annual Attendance: 19,000; Mem: 25; artists, photographers, sculptors must submit work to mem for admittance; dues $420; accepts proposal for anyone who wants to exhibit; monthly meetings
Income: $60,000 (financed by mem, fund raising, donations, city & state grants)
Special Subjects: Mixed Media, Drawings, Painting-American, Photography, Prints, Etchings & Engravings, Bookplates & Bindings
Exhibitions: Open new exhibit 4th Fri of every month
Publications: Artspace News, newsletter, quarterly
Activities: Classes for adults; dramatic programs; docent training; lect open to public, 3-4 per year; annual support from local arts foundations; concerts; gallery talks; lending contains 30-40 items to VA area; book traveling exhibitions 2 per year; originate traveling exhibitions 2 per year; sales shop sells original art & prints

A **ASSOCIATION FOR THE PRESERVATION OF VIRGINIA ANTIQUITIES,** 204 W Franklin St, Richmond, VA 23220. Tel 804-648-1889; Fax 804-775-0802; Elec Mail ekostelny@apva.org; Internet Home Page Address: www.apva.org; *Interim Exec Dir* Elizabeth Kostelny; *Dir Properties* Louis J Malon; *Dir Develop* Chandler Battaile
Estab 1889 to acquire & preserve historic buildings, grounds & monuments in Virginia; APVA owns & administers 36 properties in Virginia. Among the properties: Jamestown Island; Water Reed Birthplace, Gloucester County; Bacon's Castle & Smith's Fort Plantation, Surry County; John Marshall House, Richmond; Scotchtown, Hanover County; Mary Washington House, Hugh Mercer Apothecary Shoe & Rising Sun Tavern, St James Cottage, Fredericksburg; Smithfield Plantation, Blacksburg; Farmers Bank, Petersburg; Cape Henry Lighthouse & Lynnhaven House, Virginia Beach; Dora Armistead House, Williamsburg; Holly Brook, Eastville. Hours & admis vary according to location; Average Annual Attendance: 650,000; Mem: 6,000; dues individual $20; annual meeting in spring
Income: Financed by mem, endowment fund donations & grants
Collections: Decorative arts; 17th - 19th century furniture, glass, ceramics, metalwork & textiles
Publications: Discovery (magazine) annually; newsletter, quarterly
Activities: Lect open to public; individual paintings & objects of art lent to other nonprofit preservation organizations' exhibits; sales shop sells books, reproductions, prints & slides, magazines, gifts, Virginia handicrafts

L **Library,** 204 W Franklin St, Richmond, VA 23220. Tel 804-648-1889; Fax 804-648-1889; Elec Mail lmalon@apva.org; Internet Home Page Address: www.apva.org; *Dir Properties* Louis J Malon
Open by appointment only; For reference use only
Library Holdings: Book Volumes 3000; Clipping Files; Exhibition Catalogs; Pamphlets; Periodical Subscriptions 12; Photographs; Slides
Special Subjects: Decorative Arts, Historical Material, Architecture

M **John Marshall House,** 818 E Marshall St, Richmond, VA 23219. Tel

804-648-7998; Internet Home Page Address: www.apva.org; *Site Coordr* Pat Archer; *Exec Dir* Elizabeth Kostelny
Open Oct - Dec Tues - Sat 10 AM - 4:30 PM, Apr - Sept Tues - Sat 10 AM - 5 PM; Admis adults $3, seniors 55 & up $2.50, children 7-12 $1.25; Historical house mus built in 1790. Portrays John Marshall's life (1790-1835) in this historic Richmond home & his contribution to the nation; Average Annual Attendance: 8,000
Special Subjects: Architecture, Painting-American, Photography, Sculpture, Archaeology, Textiles, Costumes, Ceramics, Decorative Arts, Manuscripts, Portraits, Furniture, Glass, Porcelain, Historical Material, Restorations, Period Rooms, Embroidery, Laces
Collections: Decorative arts; period furniture 1790-1835; Marshall memorabilia
Exhibitions: Marshall family pieces including his judicial robe
Activities: Lect open to public, some for members only; tours; individual paintings & original objects of art lent to Supreme Court Historical Society; retail store sells books, prints & Marshall items

C **CRESTAR BANK,** Art Collection, 919 E Main St, Richmond, VA 23219. Tel 804-782-5000; Fax 804-782-5469; Internet Home Page Address: www.suntrust.com; *Pres* C T Hill
Open daily 9 AM - 5 PM; No admis fee; Estab 1970; Collection displayed in banks and offices; separate gallery used for new exhibit each month
Collections: Contemporary Art
Activities: Competitions with awards

M **FOLK ART SOCIETY OF AMERICA,** 1904 Byrd Ave, No 312, Richmond, VA 23230; PO Box 17041, Richmond, VA 23226. Tel 804-285-4532; Fax 804-285-4532; Elec Mail fasa@folkart.org; Internet Home Page Address: www.folkart.org; *Admin Asst* Jane Newman; *VPres* Ann Oppenhimer; *Financial Dir* William Oppenhimer
Open by appointment; No admis fee; Estab 1987; Maintains reference library; Mem: Dues $25 contribution minimum
Library Holdings: Auction Catalogs; Clipping Files; Exhibition Catalogs; Kodachrome Transparencies; Original Documents; Periodical Subscriptions; Photographs; Slides; Video Tapes
Special Subjects: Latin American Art, Mexican Art, Painting-American, Southwestern Art, Religious Art, Folk Art, Woodcarvings, Afro-American Art, Eskimo Art, Historical Material
Collections: Books, files, magazines, videos
Publications: Folk Art Messenger, 3 times a yr
Activities: Lects open to pub, 1 visiting lect per yr; Awards of Distinction: to a scholar & to an artist

M **NATIONAL SOCIETY OF THE COLONIAL DAMES OF AMERICA IN THE COMMONWEALTH OF VIRGINIA,** Wilton House Museum, 215 S Wilton Rd, Richmond, VA 23226. Tel 804-282-5936; Elec Mail wiltonhouse@mindspring.com; Internet Home Page Address: www.wiltonhousemuseum.org; *Cur* Dana Hand-Evans; *Office Manager* Marianne Zwicker
Open Tues - Sat 1 PM - 4:30 PM, Sun 1:30 - 4:30 PM, cl Mon, group school tours 10 AM - 1 PM Tues - Fri; Admis $5; Estab 1935; 18th Century Georgian Mansion with period furnishings; Average Annual Attendance: 3,500
Income: Endowment, grants
Special Subjects: Architecture, Painting-American, Textiles, Ceramics, Decorative Arts, Portraits, Furniture, Glass, Silver, Maps, Period Rooms
Collections: 18th & 19th century furniture; 18th century decorative arts, porcelain; silver; textiles
Activities: Classes for adults & children; docent training; summer camps; lect open to pub, 5-7 vis lectrs per yr; school tours; mus shop sells books & reproductions

M **UNIVERSITY OF RICHMOND,** University Museums, University of Richmond Museums, Richmond, VA 23173. Tel 804-289-8276; Fax 804-287-1894; Elec Mail rwaller@richmond.edu; Elec Mail museums@richmond.edu; Internet Home Page Address: www.richmond.edu/cultural/museums; *Dir* Richard Waller; *Asst Dir* N Elizabeth Schlatter; *Mus Preparator* Jeff Eastman; *Mus Preparator* Henley Guild; *Admin Asst* Joan Maitre; *Mus Asst* David Hershey; *Coll Mgr* Sandra Higgins
Open Tues - Sun 1 - 5 PM, cl fall break, Thanksgiving wk, semester break & spring break; No admis fee; Estab 1968
Collections: I Webb Surratt; Jr Print Collection
Exhibitions: Consuelo Kanaga: An American Photographer; Looking at the Seventies; The Meyer Schapiro Portfolio from the I Webb Surrat, Jr Print Collection; More than one: Prints & Portfolios from Center Street Studio, Boston; Lewis Wickes Hine: The Final Years; Nell Blaine: Sensations of Nature; Mary Frank: Experiences; Arnold Mesches: Echoes; A Century Survey
Publications: Exhibition catalogs
Activities: Educ program; docent training; lects open to the public; 12 vis lectrs per yr; concerts; gallery talks; tours; sponsoring of competitions; museums; originate traveling exhibitions to othermuseums; museum shop sells books

M **VALENTINE RICHMOND HISTORY CENTER,** (Valentine Museum/Richmond History Center) 1015 E Clay St, Richmond, VA 23219-1590. Tel 804-649-0711; Fax 804-643-3510; Elec Mail info@valentinemuseum.com; Internet Home Page Address: www.valentinemuseum.com; *Dir* William Martin
Open Mon - Sat 10 AM - 5 PM, Sun Noon - 5 PM; Admis adults $5, students $4, children 7-12 $3, children 3-6 $1, children under 3 free; Estab 1892 as a mus of the life & history of Richmond; Average Annual Attendance: 65,000; Mem: 500; dues individual $30
Income: Financed by endowment, mem, city & state appropriation & gifts
Special Subjects: Painting-American, Photography, Prints, Sculpture, Watercolors, Costumes, Decorative Arts, Glass, Jewelry, Silver
Collections: Conrad Wise Chapman (oils, almost entire life works); William James Hubard (drawings & oils); William Ludwell Sheppard (drawings & watercolors); Edward Virginius Valentine (sculpture); outstanding collection of Southern photographs; candlesticks, ceramics, costumes, glass, jewelry, lace, paintings, photographs, prints, sculpture, local history, regional art and decorative arts; neo classical wall paintings

Exhibitions: Rotating exhibits
Publications: Valentine Newsletter, quarterly
Activities: Classes for adults & children; docent training; dramatic programs; lect open to the public; concerts; tours; exten dept serving city & area counties; originate traveling exhibitions; museum & sales shops sell books, original art, reproductions, prints, slides & silver; Family Activity Center

L **Archives,** 1015 E Clay St, Richmond, VA 23219-1590. Tel 804-649-0711; Fax 804-643-3510; Elec Mail archives@richmondhistorycenter.com; Internet Home Page Address: www.richmondhistorycenter.com
Open to researchers Tues - Fri 12 PM - 4 PM; Contact for applicable fees; Open to the pub by appointment only; non-lending, reference library
Income: Financed by state appropriation, gifts, mem, endowment
Library Holdings: Book Volumes 10,000; Clipping Files; Exhibition Catalogs; Manuscripts; Maps; Memorabilia; Original Art Works; Pamphlets; Periodical Subscriptions 20; Photographs 50,000; Prints 600; Reproductions
Special Subjects: Photography

VIRGINIA COMMONWEALTH UNIVERSITY

M **Anderson Gallery,** Tel 804-828-1522; Fax 804-828-8585; Elec Mail tpotter@saturn.vcu.edu; *Dir* Ted Potter; *Asst Dir* Amy Moorefield; *Mgr* Leon Roper; *Special Projects Coordr* Shelagh Greenwood
Open Tues - Fri 10 AM - 5 PM, Sat & Sun 1 - 5 PM, cl Mon except by appointment; No admis fee; Estab 1930, re-opened 1970 as the showcase for the contemporary arts in Richmond; to expose the university & community to a wide variety of current artistic ideas & expressions; Gallery is situated on campus in a four-story converted stable. There are seven galleries with a variety of exhib spaces; Average Annual Attendance: 20,000; Mem: 275; dues $25
Special Subjects: Painting-American, Photography, Prints
Collections: Contemporary prints & paintings; cross section of prints from the 15th to 20th century covering most periods; vintage & contemporary photography
Publications: Catalogs; newsletters; posters & brochures
Activities: Lect open to public, 10 vis lectrs per year; concerts; gallery talks; tours; competitions; lending collection contains original art works, original paintings & photographs; originate traveling exhibitions; museum shop sells books, magazines, original art & miscellaneous items

L **School of The Arts Visual Resource Center (Slide Library),** Tel 804-828-1683; Fax 804-828-6469; Elec Mail jboone@saturn.vcu.edu; *Dir* Jeanne Boone
Open Mon - Thurs 9 AM - 6 PM, Fri 9 AM - 5 PM; Estab in 1960s to currently support the teaching prog & the 16 departments of the School of the Arts, as well as the university at large, other institutions & the community
Income: Financed by state appropriation & fees from various depts within the School of the Arts
Library Holdings: Periodical Subscriptions 13; Slides 450,000
Special Subjects: Art History, Folk Art, Landscape Architecture, Decorative Arts, Film, Illustration, Photography, Drawings, Etchings & Engravings, Graphic Arts, Graphic Design, Islamic Art, Manuscripts, Maps, Pre-Columbian Art, Sculpture, Ceramics, Conceptual Art, Crafts, Latin American Art, Theatre Arts, Bronzes, Printmaking, Advertising Design, Fashion Arts, Art Education, Asian Art, American Indian Art, Furniture, Period Rooms, Costume Design & Constr, Glass, Mosaics, Stained Glass, Afro-American Art, Metalwork, Carpets & Rugs, Jewelry, Oriental Art, Landscapes, Coins & Medals, Architecture
Collections: 500,000+ slides

L **VIRGINIA DEPT HISTORIC RESOURCES,** Research Library, 2801 Kensington Ave, Richmond, VA 23221. Tel 804-367-2323; Fax 804-367-2391; Elec Mail hhubbard@dhr.state.va.us; Internet Home Page Address: www.dhr.state.va.us; *Archivist* Quatro Hubbard
Open Mon - Fri 8:30 AM - Noon, 1 - 4:45 PM; Estab 1966; For reference only
Library Holdings: Book Volumes 4500; Clipping Files; Kodachrome Transparencies; Manuscripts; Maps; Periodical Subscriptions 75; Photographs; Slides; Video Tapes
Special Subjects: Decorative Arts, Maps, Historical Material, History of Art & Archaeology, Archaeology, Anthropology, Architecture
Collections: Archaeology; Architecture; Ethnography; History
Publications: Notes on Virginia; Preservation in Progress

A **VIRGINIA HISTORICAL SOCIETY,** PO Box 7311 Richmond, VA 23221. Tel 804-358-4901; Fax 804-355-2399; Elec Mail charles@vahistorical.org; Internet Home Page Address: www.vahistorical.org; *COO, Assoc Dir* Robert Strohm; *Dir Mus* James Kelly; *CEO & Pres* Dr Charles F Bryan Jr; *Cur of Virginia Art* Dr William Rasmussen
Open Mon - Sat 10 AM - 5 PM, Mus Sun 1 - 5 PM; Admis $4, seniors (55+) $4, students and children $2, members free; Estab 1831 for collecting, preserving & making available to scholars research material relating to the history of Virginia, its colls include extensive holdings of historical portraiture; Ten galleries feature changing & permanent exhibits drawn from pub & pvt colls throughout Virginia; Average Annual Attendance: 60,000; Mem: 8000; dues $38 & up
Income: Financed by endowment & mem
Library Holdings: Auction Catalogs; Clipping Files; Exhibition Catalogs; Fiche; Kodachrome Transparencies; Lantern Slides; Manuscripts; Maps; Memorabilia; Micro Print; Motion Pictures; Original Art Works; Original Documents; Pamphlets; Periodical Subscriptions; Photographs; Prints; Records; Sculpture; Slides; Video Tapes
Collections: Books; Manuscripts; Museum Collection; Portraits
Exhibitions: The Story of Virginia, an American Experience (permanent); Virginians at Work (permanent); Silver in Virginia (permanent); The Virginia Manufactory of Arms (permanent); Arming the Confederacy (permanent)
Publications: Bulletin, quarterly; Virginia Magazine of History & Biography, quarterly
Activities: Classes for adults & children; docent training; teacher recertification; lect open to public, 10 vis lectrs per year; gallery talks; tours; William Rachel Award; fels offered; exten dept; individual paintings & original objects of art lent; lending collection contains paintings, original prints & book traveling exhibitions 2-3 per year; originate traveling exhibition 1-2 per year in Virginia; mus shop sells books, prints, reproductions

L **Library,** 428 North Blvd, PO Box 7311 Richmond, VA 23221-0311. Tel 804-358-4901; Fax 804-342-9647; Elec Mail maribeth@vahistorical.org; Internet

Home Page Address: www.vahistorical.org; *Dir, CEO* Charles F Bryan; *Asst Dir Library Servs* Frances S Pollard; *Dir Develop & Pub Relations* Pamela R Seay; *Asst Dir Mus* James C Kelly; *Assoc Dir* Robert F Strohm; *Pres* Hugh R Stallard; *Dir Pub Relations* Maribeth Cowan; *VPres* Hugh White; *Mus Shop Mgr* Doris Delk; *Cur Art* William Rasmussen; *Asst Dir Educ* Bill Obrochta; *Asst Dir Sr Archives* E Lee Shepard
Open Mon - Sat 10 AM - 5 PM; Estab 1831 for the study of Virginia history; For reference only
Income: Financed by endowment, mem, state appropriation & private donations
Library Holdings: Book Volumes 140,000; Clipping Files; Exhibition Catalogs; Fiche; Filmstrips; Manuscripts; Memorabilia; Original Art Works; Pamphlets; Periodical Subscriptions 300; Photographs 100,000; Prints; Reels; Reproductions; Sculpture
Publications: Bulletin, quarterly; Virginia Magazine of History & Biography, quarterly
Activities: Lect open to members, 3 vis lectrs per year

M **VIRGINIA MUSEUM OF FINE ARTS,** 200 N Blvd, Richmond, VA 23220-4007. Tel 804-340-1400; Fax 804-340-1548; Elec Mail webmaster@vmfa.state.va; Internet Home Page Address: www.vmfa.state.va.us; *Pres* Charlotte Minor; *Dir, CEO* Alex Nyerges; *COO* Carol Amato; *Registrar* Lisa Hancock; *Foundation VPres* David Bradley; *Statewide Exhib Coordr* Rebecca Jones; *Cur South Asian Art* Joseph M Dye III; *Conservator Objects* Kathy Gillis; *Cur Paul Mellon* Mitchell Merling; *Conservator Paintings* Carol Sawyer; *Mus Shop Mgr* Barbara Lenhardt; *Assoc Dir Mktg & Communications* Suzanne D Hall; *Cur Ancient Art* Peter Schertz; *Assoc Cur Modern & Contemporary Art* Tosha Grantham; *Assoc Dir Educ* Sandy Rusak; *Cur Modern & Contemporary Art* John Ravenal; *Cur African Art* Richard Woodward; *Assoc Cur American Arts* Elizabeth O'Leary
Open Wed - Sun 11 AM - 5 PM, cl Mon & Tues; Suggested donation $5; Estab 1934; Circ Non-circulating coll; Participating in the museum's progs are the Fellows of the Virginia Mus, who meet yearly to counsel the mus on its future plans; The Council, which sponsors & originates special progs; the Collectors' Circle, a group of Virginia art lovers which meets four times per yr to discuss various aspects of coll; the Corporate Patrons, state & local business firms who lend financial support to mus progs. Maintains reference library; Average Annual Attendance: 300,000; Mem: 20,000; dues $15 & up; annual meeting in May
Income: Financed by Commonwealth of VA
Special Subjects: Drawings, Graphics, Sculpture, Bronzes, Pottery, Etchings & Engravings, Decorative Arts, Painting-European, Furniture, Glass, Jade, Jewelry, Porcelain, Asian Art, Silver, Tapestries, Painting-Flemish, Renaissance Art, Painting-Italian, Islamic Art, Antiquities-Greek, Gold, Enamels
Collections: Lady Nancy Astor Collection of English China; Branch Collection of Italian Renaissance Paintings, Sculpture & Furniture; Ailsa Mellon Bruce Collection of 18th Century Furniture & Decorative Arts; Mrs Arthur Kelly Evans Collection of Pottery & Porcelain; Arthur & Margaret Glasgow Collection of Flemish & Italian Renaissance Paintings, Sculpture & Decorative Arts; Nasli & Alice Heeramaneck Collection of Art of India, Nepal, Kashmir & Tibet; T Catesby Jones Collection of 20th Century European Paintings & Drawings; Dr & Mrs Arthur Mourot Collection of Meissen Porcelain; The John Barton Payne Collection of Paintings, Prints & Portugese Furniture; Lillian Thomas Pratt Collection of Czarist Jewels by Peter Carl Faberge; Adolph D & Wilkins C Williams Collection of Paintings, Tapestries, China & Silver; archaic Chinese bronzes; archaic Chinese jades; comprehensive collections of early Greek vases (8th century to 4th century BC); representative examples of the arts from early Egypt to the present time, including paintings, sculpture, furniture and objects d'art; Art of So Asia; British Sporting Art; Art Deco Collection; Jerome & Rita Collection of English Silver
Exhibitions: (4/28/2007-8/12/2007) Rule Britannia! Art, Royalty & Power in the Age of Jamestown; (7/11/2007-9/30/2007) Great British Watercolors from the Paul Mellon Coll at the Yale Center for British Art; Faces at the Races: The Equine Culture in Virginia, through 9/7/07; (10/2007-2/2008) Mystery; (11/7/2007-1/27/2008) Eugene Boudin 1824-1898: Works from the Paul Mellon Coll at the Nat Gallery of Art; An Enduring Legacy: Paintings Acquired through the J Harwood & Louise B Cochrane Fund for American Art, through spring 2008; Darkroom: Photography and New Media in South Africa 1950-Present, through spring 2009
Publications: The Art of India; Dr Joseph M Dye III; James McNeil Whistler: Uneasy Pieces; Virginia Museum Calendar, bi-monthly; brochures; catalogs for special exhibitions & collections; programs
Activities: Classes for adults & children; docent training; lect open to public, concerts; gallery talks; tours; fels offered (10 - 15 per year) to Virginia artists; extension prog; statewide outreach across state of VA; book traveling exhibs, 67 go out to statewide partners; originate traveling exhibitions throughout the state of Virginia; museum shop sells books, magazines, original art, reproductions, prints, toys, gifts, notecards, jewelry, apparel

L **Library,** 200 N Boulevard, Richmond, VA 23220-4007. Tel 804-340-1495; Fax 804-340-1548; Elec Mail suzanne.freeman@vmfa.museum; Internet Home Page Address: www.pandora.vmfa.museum; *Head Fine Arts Librn* Suzanne H Freeman; *Asst Librn* Courtney C Yevich; *Reference Librn* Lee B Viverette; *Part-time Archivist* Steven H Murden
Open Thurs 11 AM - 4:30 PM by appointment only; Estab 1935 for art history research for gen pub, academia & staff; Circ Non-circulating; For reference only; Average Annual Attendance: 1,500
Income: Financed by private funds
Library Holdings: Auction Catalogs; Book Volumes 60,000; CD-ROMs 22; Clipping Files; Exhibition Catalogs; Manuscripts; Memorabilia; Original Documents; Pamphlets; Periodical Subscriptions 234; Reels
Special Subjects: Art History, Decorative Arts, Sculpture, Crafts
Collections: Weedon Collection; Hayes Collection; Maxwell Collection of East Asian Art; McGlothlin Collection of American Art; Tucker Numismatics Collections; Lewis Decorative Art Collection; Pinkney Near West European Collection; Coopersmith Collection
Activities: Classes for adults; docent training

A **VISUAL ARTS CENTER OF RICHMOND,** 1812 W Main St, Richmond, VA 23220. Tel 804-353-0094; Fax 804-353-8018; Internet Home Page Address: www.visarts.org; *Prog Dir* Malinda Collier; *Pres* Jo Kennedy; *Dir Develop* Susan Early; *Cur* Ashley Kistler; *Bus Mgr* Barbara Brown
Open Mon - Fri 9AM - 7PM, Sat 10AM - 5PM, Sun 1 - 4PM; No admis fee; Estab 1963 as a nonprofit center for the visual arts committed to promoting artistic excellence through educational programs, gallery exhibs & artists services; Average Annual Attendance: 5,000; Mem: 750 mem, ann dues vary by category
Exhibitions: (9/8/2006-10/15/2006) Garden; (10/27/2006-12/10/2006) Time for Design; (10/27/2006-12/10/2006) Alley-Oop
Publications: Exhibition catalogs
Activities: Classes for adults & children; lect open to pub; gallery talks; tours; competitions with awards; schols offered for children only; originates traveling exhibs; sales shop sells magazines

ROANOKE

M **ART MUSEUM OF WESTERN VIRGINIA,** Ctr in the Square, One Market Sq, 2nd Flr Roanoke, VA 24011-1436. Tel 540-342-5760; Fax 540-342-5798; Elec Mail info@artmuseumroanoke.org; Internet Home Page Address: www.artmuseumroanoke.org; *Exec Dir* Judy L Larson; *Dir Mktg* Cindy Hagerman; *Dir Devel* Diane Markert; *Store Mgr* Toni Yokum; *Coordr Family Prog* Nicole Oman; *Cur* Susannah Koerber; *Pres Bd Trustees* Herman Marshall; *Dir Extern Affairs* Kimberly Templeton; *Business Mgr* Willis Rowsey
Open Tues - Sat 10 AM - 5 PM, Sun 1 - 5 PM; Admis by donation, Childrens Interactive Art Space: family of 4 $7, children over 3 $3, children under 3 & members free; Estab 1951 as a general art mus with a focus on art of the South; Mus is located in a downtown cultural complex called Center in the Square. There are three major rotating galleries, one permanent collection gallery, studio classrooms, educational gallery & lecture hall; Average Annual Attendance: 101,000; Mem: 900; dues $45; annual meeting in Sept
Income: Financed by mem earned income, donations & endowment
Special Subjects: Prints, Folk Art, Decorative Arts, Oriental Art
Collections: Contemporary American Paintings, Sculpture & Grapic Arts; Folk Art; Japanese Prints & Decorative Arts; 19th Century American Paintings; Regional Art; Southern Decorative Arts
Publications: Annual Report; Docent Guild newsletter; exhibition catalogs; quarterly newsletter
Activities: Classes for adults & children; docent training; art venture family interactive center; lect open to the public, 8-10 vis lectrs per year; concerts; gallery talks; tours; artmobile; individual paintings & objects of art lent to qualified museums; book traveling exhibitions 1-3 per year; originate traveling exhibitions; museum store selling books, original art, prints, reproductions, handmade crafts including jewelry & children's items; junior museum

A **ARTS COUNCIL OF THE BLUE RIDGE,** 20 E Church Ave, Roanoke, VA 24011. Tel 703-342-5790; Fax 703-342-5720; Elec Mail tacbr@roanoke.infi.net; Internet Home Page Address: www.theartscouncil.org; *Prog Educ Dir* Judy Bates; *Dir Develop* Yvonne Olsen; *Accountant* Becky Kennedy; *Ofc Mgr* Denise Reedy; *Information Technology Coordr* Helen Nunley; *Exec Dir* Susan Jennings
Open Tues - Fri 9 AM - 5 PM; No admis fee; Estab 1976 as a liaison serve between the public & cultural & arts organizations; aids in artist registry & grant assistance. Maintains reference library; Mem: 100 organizations, 300 artist members; individual visual, performing or literary artists or arts or cultural organizations
Income: Financed by mem, city & state appropriation industrial & corporate donations & foundations
Library Holdings: Other Holdings; Pamphlets; Periodical Subscriptions
Exhibitions: City Art Show - March; High School Art Show - May; Art in Window - empty downtown store fronts
Publications: Cultural education resource guide; cultural directory; artists/registry; newsletter, artists newsletter
Activities: Advocacy; after school art progs; workshops & arts law clinics; sponsoring of competitions; schools; Kendig Awards for Support of the Arts; high school scholarships

SPRINGFIELD

L **VICANA (VIETNAMESE CULTURAL ASSOCIATION IN NORTH AMERICA) LIBRARY,** 6433 Northana Dr, Springfield, VA 22150-1335. Tel 703-971-9178; Fax 703-719-5764; *Pres* Nguyen Ngoc Bich; *Librn* Dao Thi Hoi
Open by special arrangement; No admis fee; Estab 1982
Library Holdings: Audio Tapes; Book Volumes 1500; Cassettes; Clipping Files; Exhibition Catalogs; Filmstrips; Framed Reproductions; Pamphlets; Photographs; Records; Video Tapes
Special Subjects: Art History, Folk Art, Historical Material, History of Art & Archaeology, Ceramics, Crafts, Ethnology, Art Education, Asian Art, Aesthetics, Handicrafts, Oriental Art
Collections: Historical collection-Vietnamese, English, French; slides of Vietnamese life; Vietnamese cultural artifacts

STAUNTON

A **STAUTON AUGUSTA ART CENTER,** One Gypsy Hill Park, Staunton, VA 24401. Tel 540-885-2028; Elec Mail info@saartcenter.org; Internet Home Page Address: www.saartcenter.org; *Exec Dir* Beth Hodge; *Office Mgr* Leah Rhodes
Open Mon - Fri 9 AM - 5 PM; Sat by appointment; No admis fee; Estab 1961 for art exposure & educ to area residents; Average Annual Attendance: 5,000; Mem: 550; dues $60
Income: $106,000 (financed by mem, city & state appropriations)
Exhibitions: Annual Art in the Park; Christmas Art for Gifts; Summer Studio; Juried Regional Exhibit; Youth Art Month
Activities: Classes for adults & children; lect open to public

M **WOODROW WILSON BIRTHPLACE FOUNDATION,** 20 N Coalter St, PO Box 24 Staunton, VA 24402-0024. Tel 540-885-0897; Fax 540-886-9874; Internet Home Page Address: www.woodrowwilson.org; *Dir Coll* Edmund Potter
Open daily 9 AM - 5 PM Mar - Nov, 10 AM - 4 PM Dec - Feb, cl Thanksgiving, Christmas & New Year's Day; Admis adults $6, AAA discount & seniors $5.50, students age 13 & up or with ID $4, children 6-12 $2, children under 6 free; Estab 1938 for the interpretation & collection of life & times of Woodrow Wilson. Collection is housed in the 1846 Presbyterian Manse which was the birthplace of Woodrow Wilson; Mem: 700; dues $25 & up
Special Subjects: Painting-American, Decorative Arts, Historical Material, Period Rooms
Collections: Historical Material pertinent to the Wilson family; decorative arts, furniture, manuscripts, musical instruments, paintings, photographs, prints & drawings, rare books, textiles
Publications: Brochures; guides; newsletter, quarterly; pamphlets
Activities: Classes for children; lect open to public; tours; internships offered; original objects of art lent to museums & libraries; lending collection contains original art work & sculpture; sales shop sells books, magazines, reproductions, prints & slides

L **Woodrow Wilson Presidential Library,** 20 N Coalter St, PO Box 24 Staunton, VA 24402-0024. Tel 540-885-0897; Fax 540-886-9874; Elec Mail woodrow@cfw.com; Internet Home Page Address: www.woodrowwilson.org; *Dir Coll* Edmund Potter; *Business Mgr* Janet Campbell
Open daily 10 AM - 5 PM Mar - Nov, 10 AM - 4 PM Dec - Feb, cl Thanksgiving, Christmas & New Year's Day; Admis adults $7, AAA discount $6.25, students age 13 & up or with ID $4, children 6-12 $2, children under 6 free; Estab 1938 for the interpretation & collection of life & times of Woodrow Wilson. Collection is housed in the 1846 Presbyterian Manse which was the birthplace of Woodrow Wilson; Average Annual Attendance: 22,000; Mem: 700; dues $25 & up
Income: Financed by endowment, admis & grants
Library Holdings: Book Volumes 2000; Pamphlets; Photographs
Exhibitions: Women's History; Black History; Wedding Customs
Publications: Wilson Newsletters, quarterly
Activities: Mus shop sells books, original art, reproductions, prints

STRASBURG

M **STRASBURG MUSEUM,** 440 E King St, Strasburg, VA 22657. Tel 540-465-3428; *VPres* Nicholas Racey; *Secy* Patricia Clem; *CEO, VChmn* John Adamson; *Mus Shop Mgr* Glenna Loving
Open May to Oct, daily 10 AM - 4 PM; Admis adults $2, children $.50; Estab 1970 to present the past of a Shenandoah Valley community & to preserve the pottery-making tradition of Strasburg; The mus is housed in the former Southern Railway Depot, which was originally built as a steam pottery; Average Annual Attendance: 4,000; Mem: 140; dues $30; annual meeting in Mar
Income: Financed by mem, admis fees & gifts
Collections: Artifacts & exhibits, farm & railroad crafts, pottery
Activities: Classes for adults & children in pottery making; museum shop selling books original art, pottery & other local crafts

SWEET BRIAR

L **SWEET BRIAR COLLEGE,** Martin C Shallenberger Art Library, Sweet Briar, VA 24595. Tel 804-381-6138; Fax 804-381-6173; Elec Mail ljmalloy@sbc.edu; Internet Home Page Address: www.cochran.sbc.edu; *Technical Svcs* Marjorie Freeman; *Pub Svcs* Lisa N Johnston; *Bibliographic Instruction & Branch Librn* Joe Malloy; *Serials Librn* Liz Linton; *Dir* John G Jaffe
Open Mon - Thurs 9 AM - 1 AM, Fri 9 AM - 5 PM, Sat & Sun 1 PM - 12 AM; Estab 1961, when it was separated from the main library, the library serves an undergraduate community; The Art Library is now located in the Pannell Fine Arts Center
Income: Financed by college funds
Library Holdings: Book Volumes 12,500; Cassettes; Exhibition Catalogs; Fiche; Kodachrome Transparencies; Lantern Slides; Original Art Works; Pamphlets; Periodical Subscriptions 60; Prints; Video Tapes
Special Subjects: Folk Art, Graphic Arts, Painting-American, Painting-British, Painting-Dutch, American Western Art, American Indian Art, Furniture, Glass, Aesthetics, Afro-American Art, Gold, Antiquities-Assyrian, Painting-Canadian

M **Art Gallery,** Sweet Briar, VA 24595. Tel 804-381-6248; Fax 804-381-6173; Elec Mail rmlane@sbc.edu; Internet Home Page Address: www.sbu.edu/art; *Dir* Rebecca Massie-Lane
Open Mon - Thurs Noon - 9:30 PM, Fri - Sun Noon - 5 PM, cl college recesses; No admis fee; Estab 1985 to support the educational mission at Sweet Briar College through its exhibits, collections & educational programs; Average Annual Attendance: 4,000; Mem: 215; dues $25; annual meeting in Apr
Collections: American & European drawings & prints; Japanese Woodblock prints, 18th & 19th century
Exhibitions: Rotating exhibits from permanent collection plus traveling exhibits
Activities: Classes for adults; docent training; lect open to the public, 4 vis lectrs per year; concerts; gallery talks; tours; individual paintings are lent to other museums; originate traveling exhibitions; bookshop sells books, magazines & reproductions

M **VIRGINIA CENTER FOR THE CREATIVE ARTS,** Camp Gallery, PO Box VCCA, Sweet Briar, VA 24595. Tel 804-946-7236; Fax 804-946-7239; Elec Mail vcca@vcca.com; Internet Home Page Address: www.vcca.com; *Admissions Coordr* Sheila Gully Pleasants; *Prog Dir* Craig Pleasants; *Dir* Suny Monk
Open by appointment summers only; No admis fee; Estab 1971 as a residential retreat for writers, composers & visual artists; Facilities include 23 studios, a gallery, a darkroom, a printing press, a library, private bedrooms in a modern residence. Breakfast & dinner served in dining room, lunch is delivered to studios. Access to Sweet Briar College facilities; Average Annual Attendance: 300 professional writers, composers & visual artists

Income: $512,000
Collections: Books, fiction & non-fiction; donated paintings by Fellows; donated poetry by Fellows; donated sculpture by Fellows
Exhibitions: exhibitions are in the summers, no proposals accepted
Publications: Annual newsletter; Notes From Mt San Angelo
Activities: Lect & readings open to public, 2-3 vis lectrs per year; concerts; tours; scholarships offered; individual paintings & original objects of art lent through a leasing program to businesses & individuals

VIRGINIA BEACH

A **CONTEMPORARY ART CENTER OF VIRGINIA,** (Virginia Beach Center for the Arts) 2200 Parks Ave, Virginia Beach, VA 23451. Tel 757-425-0000; Fax 757-425-8186; Internet Home Page Address: www.cavc.org; *Dir Educ* Betsy Gough-DiJulio; *Dir* Kevin Grogan; *Cur* Carla Hanzal
Open Tues - Sat 10 AM - 5 PM, Sun Noon - 4 PM; Admis adults $2, children $1; Estab 1952, as a nonprofit organization serving citizens of the greater Hampton Roads area with exhibits & programming in the visual arts; Exhibition space 800 sq ft student gallery & 1400 sq ft main gallery; Average Annual Attendance: 200,000; Mem: 3000, dues family $50 & up, single $30, sr discount $2; annual meeting in Sept
Income: Financed by mem, pub grants, private donations, various fundraising events
Collections: Best-in-Show winners from Boardwalk Art Show
Exhibitions: 10 exhibitions per year of contemporary art
Publications: ArtLetter, monthly; exhibition catalogues
Activities: Classes & workshops for adults & children; dramatic programs; docent training; film series; performing arts; lect open to public; 15 vis lectrs per year; concerts; gallery talks; tours; scholarships & fels offered; exten dept serves municipal employees; museum shop sells books, original art, reproductions, prints, crafts, jewelry, wearable art

WAVERLY

M **MILES B CARPENTER MUSEUM,** 201 Hunter St, Waverly, VA 23890. Tel 804-834-3327; *VPres* Frances B Gray; *Secy* Lois F Bennett; *Treas* Pamela D Diehl; *Pres* Shirley S Yancey
Open Thurs - Mon 2 - 5 PM, other times by appointment; Donations; Estab 1986 to maintain a museum in the home of nationally known folk artist Miles Burkholder Carpenter & to encourage art; Two-floor gallery; Average Annual Attendance: 6,000; Mem: 25 members; no dues; annual meeting last Sat in Jan
Income: $25,000 (financed by state grants & donations)
Special Subjects: Sculpture, Folk Art, Woodcarvings, Historical Material
Collections: Miles B Carpenter Permanent Collection of woodcarvings, tools & memorabilia
Exhibitions: Miles B Carpenter (woodcarvings, tools & memorabilia); Folk Art Paintings; Seven visiting exhibits
Activities: Classes for adults & children; dramatic programs; docent training; lect open to public, 4 vis lectrs per year

WILLIAMSBURG

M **COLLEGE OF WILLIAM & MARY,** Muscarelle Museum of Art, P.O. Box 8795, Williamsburg, VA 23187-8795. Tel 757-221-2700; Fax 757-221-2711; Internet Home Page Address: www.wm.edu/muscarelle; *Cur Colls & Acting Dir* Ann Madonia; *Registrar* Bill Barker; *Cur Educ* Lanette McNeil; *Exhib Mgr* Fred Rich; *Asst to Dir* Cindy Sharkey; *Spec Projects Adminr* Ursula McLaughlin; *Mem Sec* Katerine Hood
cl Mon & Tues; Wed, Sat & Sun noon - 4 PM, Thurs & Fri 10 AM - 4:45 PM; Admis fee $5 to spec traveling exhibits; Estab 1983; Average Annual Attendance: 23,000; Mem: 1000; dues $25 & up
Income: Financed by endowments, state appropriations & donations
Special Subjects: Drawings, Graphics, Painting-American, Photography, Prints, Sculpture, American Indian Art, Bronzes, African Art, Religious Art, Ceramics, Woodcuts, Etchings & Engravings, Landscapes, Collages, Painting-European, Portraits, Eskimo Art, Porcelain, Oriental Art, Asian Art, Silver, Metalwork, Painting-British, Painting-Dutch, Painting-French, Coins & Medals, Baroque Art, Painting-Flemish, Renaissance Art, Medieval Art, Painting-Italian, Islamic Art, Painting-German, Painting-Russian
Collections: African Art; Asian Art; Native American Art; 16th - 20th century American & European works on paper, paintings & sculpture
Publications: Newsletter, two times a year; exhibition catalogues
Activities: Classes for adults & children; docent training; lect open to pub; gallery talks; tours; awards; schols & fels offered; individual paintings & original objects of art lent to special exhibs organized by other museums; originate traveling exhibs that circulate to other museums, art centers, colleges; sales shop sells books, reproductions, notecards & T-shirts

M **COLONIAL WILLIAMSBURG FOUNDATION,** PO Box 1776, Williamsburg, VA 23187-1776. Tel 757-229-1000; Fax 757-220-7286; *VPres Coll & Museums* Ronald Hurst; *Pres* Colin Campbell; *Dir Pub Rels* Tim Andrews
Open 9 AM - 5 PM; Estab 1927 the worlds largest outdoor mus, providing first hand history of 18th-century English colony during period of subjects becoming Americans; The colonial area of this 18th century capital of Virginia, encompassing 300 acres with nearly 500 homes, shops, taverns, dependencies, has been carefully restored to its original appearance. Included are 90 acres of gardens & greens. The work was initiated by John D Rockefeller, Jr. There are more than 40 exhibition homes, public buildings & craft shops where guides & craftsmen in colonial costumes show visitors the way of life of pre-Revolutionary Virginia. Incl are the historic Burton Parish Church, the Governors Palace, Capitol, the Courthouse of 1770, Bassett Hall (local residence of the Rockefellers), the DeWitt Wallace Dec. Arts Mus & Abby Aldrich Rockefeller Folk Art Mus. The exhibition properties include 225 furnished rooms; Average Annual Attendance: 1,000,000

Income: Financed by admis, gifts & grants, real estate, products, restaurants & hotels
Collections: 18th-Century British & American Painting; English Pottery & Porcelains; Silver; Furniture; with frequent additions, include representative pieces, rare English pieces in the palace; exceptionally fine textiles & rugs; extensive collection of primary & secondary materials relating to British North America, the Colonial Period & the early National Period & American folk art.
Publications: The foundation publishes many books on a wide range of subjects; Colonial Williamsburg, quarterly journal
Activities: Classes & tours for adults & children; lect open to public, 30 vis lectrs per year; concerts; gallery talks; special focus tours; individual paintings & original objects of art lent; museum shop sells books, magazines, original art, reproductions, prints & slides

A **Visitor Center,** PO Box 1776, Williamsburg, VA 23187-1776. Tel 757-220-7645; *Dir* William Pfeifer
Open daily 8:30 AM - 8:30 PM; Estab 1927; Outside the historic area this modern center houses graphic exhibits of the restoration & colonial life. Continuous showings of a full-color, vista vision film, Williamsburg: The Story of a Patriot
Publications: Books & brochures on Williamsburg & colonial life; gallery book of the Fok Art Collection
Activities: Limited grant-in-aid program for researchers; slide lect; annual events including Antiques Forum; Garden Symposium; regular performance of 18th century dramas, organ recitals & concerts

L **John D Rockefeller, Jr Library,** 313 First St, PO Box 1776 Williamsburg, VA 23187-1776. Tel 757-565-8500; Fax 757-565-8509; Elec Mail jclark@cwf.org; Internet Home Page Address: www.research.history.org; *Office Mgr* Inge Flester; *Decorative Arts Librn* Susan Shames; *Reference Librn* Del Moore; *Circulation Library Asst* Joann Proper; *Spec Coll Librn & Assoc Cur Rare Books & Manuscripts* Gail Greve; *Public Svcs Librn* Juleigh Clark; *Assoc Cur Architecture Coll* George Yetter; *System Adminr & Sr Cataloger* Julie Conlee; *Acquisitions Librn* Annette Parham; *Visual Resources Editorial Librn* Marianne Martin; *Visual Resources Library Asst* Laura Arnette; *Catalog Librn* Doug Mayo; *Dir* James Horn; *Digital History Center Mgr* Jennifer Jones
Open Mon - Fri 9 AM - 5 PM, cl major holidays; No admis fee; Circ 10,000; Average Annual Attendance: 24,000
Library Holdings: Auction Catalogs 18,000; Book Volumes 76,053; Cards 800; Clipping Files; Compact Disks; DVDs; Fiche; Manuscripts 50,000; Maps 2,500; Other Holdings Architectural drawings 65,000; Compact discs-Music; Negatives 250,000; Periodical Subscriptions 380; Photographs 250,000; Reels 6000; Slides 250,000; Video Tapes 1000
Special Subjects: Decorative Arts, Archaeology, Architecture
Collections: 18th Century Arts & Trades; Historical Preservation in America; History of the Restoration of Colonial Williamsburg; Decorative Arts, Folk Art, Architecture, Auction Catalogs
Publications: Exhibit catalogs

M **Abby Aldrich Rockefeller Folk Art Center,** 307 S England St, PO Box 1776 Williamsburg, VA 23187-1776. Tel 757-220-7670; *Dir* Carolyn Weekley
Open Mon - Sun 10 AM - 5 PM; Admis adult $8, youth 6 - 17 $4, under 6 free; Estab 1939 for research, educ & the exhib of one of the country's leading colls of American folk art of the 18th, 19th & 20th centuries; 18 galleries of American folk art; Average Annual Attendance: 200,000
Special Subjects: Folk Art
Collections: Decorative usefulwares, decoys, painted furniture, paintings, sculptures, signs & textiles
Exhibitions: Toy Trains from the Carstens Collection; By Popular Demand; Amanda and Friends; A Quartet of Quilts; An Introduction to American Folk Art; Selections from Mrs. Rockefeller's Collection
Publications: Exhibition catalogs
Activities: Docent training; lect open to public; tours; paintings & sculpture lent to other museums; book traveling exhibitions; originate traveling exhibitions; museum shop sells books, reproductions, prints & slides

—**Abby Aldrich Rockefeller Folk Art Center Library,** 307 S England St, PO Box 1776 Williamsburg, VA 23187-1776. Tel 757-220-7668; Fax 757-565-8915; *Librn* Anne Motley
Open to serious scholars of folk art for reference by appointment
Library Holdings: Book Volumes 4500; Clipping Files; Exhibition Catalogs; Fiche; Filmstrips; Manuscripts; Memorabilia; Other Holdings Bound per 120 linear ft (20 titles); Pamphlets; Photographs; Prints; Records; Slides; Video Tapes
Special Subjects: Decorative Arts, Folk Art
Collections: 19th century children's books

M **DeWitt Wallace Gallery,** 325 Francis St, PO Box 1776 Williamsburg, VA 23187-1776. Tel 757-220-7724; Fax 757-565-8804; Internet Home Page Address: www.history.org; *Dir* Carolyn J Weekley
Open daily 11 AM - 6 PM, summer, daily 11 AM - 5 PM, winter; Admis adults $8, children $4; Estab 1985; The Wallace Gallery is a contemporary bi-level mus featuring an introductory gallery, an upper level balcony of the central court which presents works from the permanent collection, study galleries which are organized by specific media & changing special exhibition galleries
Special Subjects: Decorative Arts
Collections: English and American decorative arts from 1600-1830
Exhibitions: Permanent: Selected Masterworks from the Colonial Williamsburg Collection; study galleries present English & American furniture, ceramics, metals, prints & textiles.
Activities: Educ dept; lect open to public; concerts; gallery talks; tours; slide & video presentations; musical events; museum shop sells books, reproductions; prints & slides

M **JAMESTOWN-YORKTOWN FOUNDATION,** Rte 31 S, PO Box 1607 Williamsburg, VA 23187-1607. Tel 757-887-1776; Fax 757-887-1306; *Dir* Grace Van Divender; *Cur* Robert McCully; Tracy Blevins
Open daily 9 AM - 5 PM, cl Christmas & New Year's; Admis adults $5.75, children $2.75, seniors & group discounts; Estab 1976 to interpret the history of the American Revolution; Average Annual Attendance: 100,000; Mem: 260; dues $25-$5000; annual meeting in Apr
Income: $700,000 (financed by admis & state appropriation)
Purchases: $20,000
Special Subjects: Painting-American, Prints, Folk Art, Historical Material
Collections: Gen John Steele collection of furniture, silver, paintings; paintings by

Oscar DeMejo; varied series of prints, paintings & art works on theme of Revolution; 18th century Revolutionary War artifacts
Publications: Series of biographies of Revolutionary Virginia leaders
Activities: Classes for adults & children; dramatic programs; school programs; lect open to public, 2-5 per year; craft shows; book traveling exhibitions 1-2 per year; sales shop sells books, magazines, original art, reproductions, prints, slides & craft items

WASHINGTON

BAINBRIDGE ISLE

A **BAINBRIDGE ISLAND ARTS COUNCIL,** 221 Winslow Way W, Suite 201 , Bainbridge Isle, WA 98110. Tel 206-842-7901; Fax 206-842-7901; Internet Home Page Address: www.artsfund.org; *Dir* Nancy Frye; *Exec Dir* Zon Eastes
Estab 1986
Income: Financed by city & state appropriations & donations
Activities: Artist grants offered

BELLEVUE

M **BELLEVUE ART MUSEUM,** 510 Bellevue Way NE, Bellevue, WA 98004. Tel 425-519-0770; Fax 425-637-1799; Elec Mail bam@bellevueart.org; Internet Home Page Address: www.bellevue.art.org; *Dir Pub & Community Affairs* Barbara Jirsa; *Exec Dir* Kathleen Harleman; *Cur* Ginger Gregg Duggan; *Dir Development* Susan Todd; *Dir Mktg* Allison Mollner; *Mgr Corporate & Foundation Gifts* Ann Jacobus; *Head of School* Dr Nancy Loorem; *Information Systems Mgr* Ilana Trager; *Retail Sales Mgr* Gale Whitney; *Coordr Annual Fund & Mem* Jennifer Knutson
Office hrs Mon - Fri, 9 AM - 5 PM; mus open Tues, Wed, Fri & Sat, 10 AM - 5 PM, Sun Noon - 5 PM, Thurs 10 AM - 8 PM; Admis adults $6, seniors & students $4, children under 6 free; free third Thurs & last Sat every month; Estab 1975 to bring visual arts to Bellevue East King County area; Maintains 6000 sq ft for changing & temporary exhibs; Average Annual Attendance: 48,000 - 60,000; Mem: 1450; dues family $40
Income: $1,500,000 (financed by mem, pvt contributions, store sales, grants, fundraising events, arts & crafts fair)
Exhibitions: Rotating exhibitions every twelve weeks
Publications: Annual report; quarterly newsletter; exhibition catalogs; posters; membership brochures
Activities: Classes for adults & children; docent training; lect open to public, 2-4 vis lectrs per year; films; talks; tours; symposia; hands-on activities for children; awards through art & craft juries; schols offered; organize traveling exhibitions; museum store sells books, prints, jewelry, reproductions, cards & papers, original art & gifts

BELLINGHAM

M **WESTERN WASHINGTON UNIVERSITY,** Viking Union Gallery, VU Gallery 507, Rm 422, MSI-4, Bellingham, WA 98225-9106; 202 Viking Union, Bellingham, WA 98225-9106. Tel 360-650-6534, Exten 6534; Elec Mail ASP.VU.gallery@wwu.edu; Internet Home Page Address: www.as.wwu.edu/programs/asp/gallery/index.html; *Advisor* Lisa Rosenberg; *Coordr* Inna Peck; *Asst Coordr* Jamey Braden
Open Mon - Fri 10 AM - 4 PM; No admis fee; Estab 1996 to provide a wide variety of gallery exhibits for western students and the community.; The Gallery evolves every year as it has the ability to build on past experiences. Goal is to show work that has no other venue in Bellingham; Average Annual Attendance: 5,000
Income: $8,500 (financed by student activity fees)
Purchases: Projector, speakers
Exhibitions: Exhibitions change every month
Activities: Lects open to the public; one vis lect per yr; associated with the ASPOP-will do shows together; concerts; sponsoring of competitions; awards to top three in Beyond Borders; book traveling exhibitions 2 per year
M **Western Gallery,** Fine Arts Complex, Bellingham, WA 98225-9068. Tel 360-650-3900; Fax 360-650-6878; Internet Home Page Address: www.westerngallery.wwu.edu;
Open Mon, Tues, Thurs & Fri 10 AM - 4 PM, Wed 10 AM - 8 PM, Sat Noon - 4 PM when university is in session; No admis fee; Old gallery estab 1950, new gallery estab 1989 to exhibit contemporary art; Rotating exhibitions on contemporary art, 6 per yr; Average Annual Attendance: 15,000; Mem: dues Friends of Gallery Group $25 & up
Income: Financed by state appropriation & endowment for exhibs
Special Subjects: Graphics, Sculpture
Collections: Outdoor Sculpture Collection WWU (contemporary sculpture since 1960); American drawings & prints; 20th Century Chair Collection; Washington Art Consortium office and collections based at Western Gallery
Exhibitions: Rotating exhibits every 6-8 weeks
Publications: Outdoor Sculpture Collection brochures; "Sculpture in Place: A Campus as Site" published by Western Washington University
Activities: Lect open to public, 3 vis lectrs per year; gallery talks; audio tour of outdoor sculpture collection; Wed noon hour & evening discussions; book traveling exhibitions 3 per year

M **WHATCOM MUSEUM OF HISTORY AND ART,** 121 Prospect St, Bellingham, WA 98225. Tel 360-676-6981; Fax 360-738-7409; Elec Mail museuminfo@cob.org; Internet Home Page Address: www.whatcommuseum.org; *Dir* Mary Pettus; *Chief Cur* Scott Wallin; *Educ Coordr* Richard Vanderway; *Cur Coll* Janis Olson; *Pub Relations* Tom Entrikin
Open Tues - Sun Noon - 5 PM, cl Mon & holidays; No admis fee except for special exhibs, donations accepted; Estab 1940 to collect, preserve & use, through

exhibits, interpretation & research, objects of historic or artistic value & to act as a multi-purpose cultural center for the Northwest Washington area providing presentations in all aspects of the arts; Nine galleries plus permanent historical exhib spaces; Average Annual Attendance: 100,000; Mem: 1000; dues family $60, individual $35; annual meeting in Mar; open to pub
Income: Financed by pvt & pub funds
Special Subjects: Drawings, Painting-American, Photography, Sculpture, Watercolors, American Indian Art, Ethnology, Textiles, Crafts, Folk Art, Woodcarvings, Landscapes, Portraits, Dolls, Historical Material, Dioramas, Period Rooms
Collections: Contemporary Northwest Arts; Darius Kinsey, J Wilbur Sandison, Bert W Huntoon, Jack Carver & Galen Biary Historic Photographic Collections; Northwest Native American Artifacts; Regional Historic Photographs & Artifacts; H C Hanson Naval Architecture Collection
Exhibitions: Rotating exhibits every 4-6 months
Publications: Art & Events Calendar, quarterly; Exhibit catalogs; History texts
Activities: Classes for adults & children; docent training; lect open to public, 60 vis lectrs per year; concerts; gallery talks; tours; competitions; awards; scholarships offered; exten dept serves public school outreach & community outreach; book traveling exhibitions; originate traveling exhibitions; museum shop sells books, original art & reproductions; junior museum located at 227 Prospect St
L **Library,** 121 Prospect St, Bellingham, WA 98225. Tel 360-676-6981; Fax 360-738-7409; Elec Mail museuminfo@cob.org; Internet Home Page Address: www.city-govt.ci.bellingham.wa.us/museum.htm; *Photo Archivist* Toni Nagel; *CEO & Dir* Thomas Livesay; *Treas* Stan Miller; *Designer* Scott Wallin; *Educ Coordr* Richard Vanderway; *Mus Shop Mgr* Jenseen Brons; *Pres* Jeff McClure; *Accountant* Judy Frost; *Cur Coll* Janis Olson; *Cur Art* Kathleen Moles; *Dir Develop* Kathleen Iwerson
Open to pub by appointment only; 1941; For reference only; Average Annual Attendance: 110,000; Mem: 1350
Income: Pvt and pub funds, municipal museum
Library Holdings: Book Volumes 500; Original Documents; Photographs; Prints; Records; Sculpture; Slides; Video Tapes
Special Subjects: Collages, Decorative Arts, Photography, Drawings, Painting-American, Posters, Prints, Sculpture, Historical Material, Watercolors, Ethnology, Eskimo Art, Period Rooms, Dolls, Woodcuts
Activities: Classes for adults & children; dramatic prog; docent training; lec open to pub; concerts; gallery talks; tours; sponsoring of competitions; museum shop sells books, reproductions, prints & photos; Whatcom Children's Museum

CHEHALIS

L **Library,** 599 NW Front Way, Chehalis, WA 98532. Tel 360-748-0831; Elec Mail lchm@myhome.net; Internet Home Page Address: www.lewiscountymuseum.org; *Dir* Barbara Laughton
Open Tues - Sat 9 AM - 5 PM, Sun 1 - 5 PM; Admis adult $2, seniors $1.50, ages 6-17 $1, under 6 free; Estab 1979; Reference library; Average Annual Attendance: 14,000
Library Holdings: Book Volumes 150; Clipping Files; Manuscripts; Memorabilia; Pamphlets; Reproductions
Special Subjects: Photography, Manuscripts, Maps, Historical Material, Fashion Arts, Furniture, Period Rooms, Dolls, Pottery, Restoration & Conservation, Textiles, Dioramas, Flasks & Bottles, Display

CLARKSTON

A **VALLEY ART CENTER INC,** 842 Sixth St, Clarkston, WA 99403. Tel 509-758-8331; Internet Home Page Address: www.valleyarts.qps.com; *Co-Chmn* Gloria Teats; *Treas* Richard Schutte; *Exec Dir* Pat Rosenberger
Open Mon - Fri 9 AM - 4 PM & by appointment; No admis fee, donations accepted; Estab 1968 to encourage & instruct in all forms of the visual arts & to promote the cause of art in the community; A portion of the center serves as the gallery; wall space for display of paintings or other art; showcases for colls & artifacts; Average Annual Attendance: 5,000-7,000; Mem: 175; dues $10; annual meeting in Jan
Income: Financed by mem & class fees
Publications: Exhibit calendar
Activities: Classes for seniors, adults & children; lect open to public, 4 vis lectrs per year; gallery talks; tours; competitions with awards; scholarships offered; individual paintings & original objects of art lent to local businesses & individuals, including artists; lending collection contains books, original prints, paintings, records & photographs; sales shop sells books, original art, prints, pottery & soft goods

COUPEVILLE

A **COUPEVILLE ARTS CENTER,** Gallery at the Wharf, Gallery at The Wharf, 15 NW Birch St Coupeville, WA 98239. Tel 360-678-3396; Fax 360-678-7420; Elec Mail info@coupevillearts.org; Internet Home Page Address: www.coupevillearts.org; *Exec Dir* Judy G. Lynn; *Educ Dir* Soledad Sahdana-Melber; *Reg & Prog Dir* Jan Graham; *Prog Mgr* Cis Branaff
Open Mon - Fri 9 AM - 4 PM; No admis fee; Estab 1989 for arts educ; Average Annual Attendance: 1,400; Mem: 450; dues vary; annual meeting in Jan
Library Holdings: Auction Catalogs; Audio Tapes; Book Volumes; Cassettes; Exhibition Catalogs; Memorabilia
Collections: Paintings & photography donated by NFS faculty & students
Publications: Biannual catalog of visual arts workshops
Activities: Classes for adults & children; lectrs open to the pub 3-4 times per year, scholarships offered; serves Whidbey Island and lends original objects of art to businesses and libraries; sales shop sells prints and original art

ELLENSBURG

M **CENTRAL WASHINGTON UNIVERSITY,** Sarah Spurgeon Gallery, 400 E Eighth Ave, Ellensburg, WA 98926-7564. Tel 509-963-2665; Fax 509-963-1918; Elec Mail chinnm@cwu.edu; Internet Home Page Address: www.cwu.edu/~art; *Dir Art Gallery* James Sahlstrand
Open Mon - Fri 8 AM - 5 PM; No admis fee; Estab 1970 to serve as university

gallery & hold regional & national exhibits; The gallery is a large, single unit; Average Annual Attendance: 20,000

Income: Financed by state appropriations
Exhibitions: Rotating exhibits
Publications: Catalogs for all National shows
Activities: Lect open to public; competitions

M **CLYMER MUSEUM OF ART,** 416 N Pearl St, Ellensburg, WA 98926. Tel 509-962-6416; Fax 509-962-6424; Elec Mail clymermuseum@charter.net; Internet Home Page Address: www.clymermuseum.com; *Dir* Diana Tasker; *Cur* William Battermann; *Admin Asst* Ashlie Crawford
Open Mon - Fri 10 AM - 5 PM, Sat & Sun Noon - 5 PM; No admis fee; Estab 1991 to preserve & promote the works of John F. Clymer; Two rooms with art from visiting artists; Average Annual Attendance: 21,280; Mem: 150; dues $35-$1000
Income: Financed by mem, gift shop sales & fund raisers
Collections: John Ford Clymer's Works of Art, illustration, historical, outdoor
Exhibitions: Life & Art of John F Clymer; exhibits of visiting artists change every two months
Activities: Lect open to public, 6 vis lectrs per year; book traveling exhibitions 1 per year; museum shop sells books & prints

M **GALLERY ONE,** 408 1/2 N Pearl St, Ellensburg, WA 98926. Tel 509-925-2670; *Asst Dir* Edith Connolly; *Dir* Eveleth Green
Open Mon - Sat 11 AM - 5 PM; No admis fee; Estab 1968 to offer quality artistic & educational experience to all ages; 5 rooms for exhibits & 3 sales rooms; Average Annual Attendance: 60,000; Mem: 350; dues $200-$500; meeting 4th Wed each month
Income: $120,000 (financed by sales & mem)
Special Subjects: Drawings, Graphics, Painting-American, Photography, Prints, Sculpture, Bronzes, Ceramics, Crafts, Pottery, Etchings & Engravings, Landscapes, Decorative Arts, Collages, Dolls, Glass, Jewelry, Porcelain, Silver, Marine Painting, Metalwork, Scrimshaw, Stained Glass, Pewter, Enamels
Exhibitions: John Lucas (oil paintings); Kenneth Olson (oil/enamel paintings & watercolors); Jason Sheldon (wood sculpture)
Activities: Occasional classes for adults & children; lect open to public, 2 vis lectrs per year; competitions with awards; individual paintings are lent; lending collection contains original artworks, paintings & sculptures; sales shop sells original art, prints, arts & crafts

A **WESTERN ART ASSOCIATION,** 416 N Pearl St, Ellensburg, WA 98926. Tel 509-962-2934; Fax 509-962-8515; Elec Mail waa@elltel.net; Internet Home Page Address: www.westernartassoc.org; *Pres* Bill Phillip; *VPres* Larry Macguffie; *Secy* Sandy Elliot; *Treas & Exec Dir* JoAnn Wise
Open third weekend in May Fri - Sat 10 AM - 10 PM, Sun 10 AM - 3 PM; Estab 1972 to promote western art, artifacts & heritage; Annual art show, sale & auction; Average Annual Attendance: 3,000 - 8,000; Mem: 275; dues family $50, individual $25; annual meeting in Aug
Income: $125,000 (financed by mem, Annual National Ellensburg Art Show & Auction, grants & sponsors)
Special Subjects: American Western Art
Activities: Lect open to pub; competitions with prizes; Best of Show; People's Choice; other media; schos offered; individual paintings & original objects of art lent; originate traveling exhibs 1 per yr; sales shop sells prints & original art

GOLDENDALE

M **MARYHILL MUSEUM OF ART,** 35 Maryhill Museum Dr, Goldendale, WA 98620. Tel 509-773-3733; Fax 509-773-6138; Elec Mail maryhill@gorge.net; Internet Home Page Address: www.maryhillmuseum.org; *Registrar* Betty Long; *CEO* Colleen Schafroth; *CFO* Patricia Perry; *Pub Relations* Lee Musgrave; *Dir* Josie E DeFalla; *Develop Officer* Dede Killeen; *Adj Cur Native* Mary Schuck; *VPres* Barbara Bailey; *Cur Educ* Courtney Spousta
Open daily 9 AM - 5 PM Mar 15 - Nov 15; Admis adults & students (6-16) $7, under 6 free; Estab 1923 as a museum of art; Chateau-style mansion with 3 stories of galleries on 26 acres of parklands plus full scale Stonehenge nearby; cafe & museum shop; Average Annual Attendance: 80,000; Mem: 800; dues $30 individual, $50 family
Special Subjects: Drawings, Painting-American, American Indian Art, American Western Art, Bronzes, Anthropology, Archaeology, Ethnology, Costumes, Etchings & Engravings, Landscapes, Decorative Arts, Collages, Eskimo Art, Furniture, Glass, Painting-British, Historical Material, Coins & Medals, Miniatures, Antiquities-Greek
Collections: American Indian artifacts; antique & modern chessman; European & American paintings; Queen of Romania furniture & memorabilia; regional historic photgraphics; Rodin sculpture & watercolors; Russian icons; 1946 costumed French fashion mannequins, decorative arts
Publications: Brochure, souvenir & exhibition booklets
Activities: Classes for adults & children, performing arts programs, docent training; lectr open to public, 4 vis lectrs per yr; gallery talks; tours; competitions with awards; lending collection contains individual paintings & original objects of art; book traveling exhibitions, 4 annually; originate traveling exhibitions to national & international museums; museum shop sells gift items & publications on collections

KENNEWICK

A **ARTS COUNCIL OF THE MID-COLUMBIA REGION,** 5 N Morain, Kennewick, WA. Tel 509-943-6702; Fax 509-943-6164; Elec Mail arts council@tcfn.org; Internet Home Page Address: www.owt.com/arts/artscouncil; *Exec Dir* Beth Perry
Open Mon - Fri 10 AM - 5 PM, Sat 11 AM - 3 PM; Estab Apr 1968 to advocate the arts in the Mid-Columbia Region; Average Annual Attendance: 17,000; Mem: 300; dues $35
Income: $130,000 (financed by city, corporate & private mem)

Publications: Calendar, weekly
Activities: Educ programs; lect open to the public, 5 vis lectrs per year; gallery talks; tours; book traveling exhibitions 1 per year

KIRKLAND

A **NORTHWEST PASTEL SOCIETY (NPS),** 6619 132nd Ave, Kirkland, WA 98033. Tel 253-265-6532, 505-858-2551; Elec Mail lynnettfink@sprintmail.com; Internet Home Page Address: www.nwps.org; *Pres* Lynnett Fink; *1st VPres* Donna Trent; *Treas* Nancy Loughlin
Open by appointment; Estab 1988 to promote, encourage & foster creative painting with pastels, encourage pastel artists in their artistic growth & success, promote a fellowship of pastel artists & to promote public awareness about pastel; Mem: dues $30
Income: Financed by mem, gifts & donations
Exhibitions: Open juried international exhibitions & member exhibitions
Publications: Bimonthly newsletter

LA CONNER

M **MUSEUM OF NORTHWEST ART,** 121 S First St, La Conner, WA 98257; PO Box 969, La Conner, WA 98257. Tel 360-466-4446; Fax 360-466-4447; Elec Mail mona@ncia.com; Internet Home Page Address: www.museumofnwart.org; *Cur* Susan Parke; *Exec Dir* Kris Molesworth; *Dir Educ* Marget Groff; *Museum Shop Mgr* Kristin Theiss; *Office Mgr* Bev Miller; *Educ & Exhib Coord* Lisa Young; *Devel & Mrktg Coordr* Amy Wilcox
Store & galleries open daily 10 AM - 5 PM; Admis $5, members free; Estab 1981 to preserve, protect & interpret the fine visual art of the Pacific Northwest; Average Annual Attendance: 15,000; Mem: 1000; dues $35-$1000
Income: $250,000 (financed by mem, admis, grants, donations & special events)
Special Subjects: Graphics, Painting-American, Photography, Prints, Sculpture, Watercolors, Woodcarvings, Woodcuts, Etchings & Engravings, Landscapes, Collages, Glass
Collections: Northwest painting, drawing, sculpture & prints, studio glass
Publications: Catalogs; quarterly newsletter
Activities: Classes for adults & children; docent training; lect open to public; 15 vis lect per year; gallery talks; book traveling exhibitions 1 per year; originate traveling exhibitions 1 per year; museum shop sells books, original art, prints, jewelry, paper products, fiber art & sculpture

OLYMPIA

M **EVERGREEN STATE COLLEGE,** Evergreen Galleries, 2700 Evergreen Pkwy NW Olympia, WA 98505. Tel 360-867-5125; Elec Mail friedma@evergreen.edu; Internet Home Page Address: www.evergreen.edu/galleries; *Dir* Ann Friedman
Open Mon - Fri Noon - 4 PM; No admis fee; Contemporary Gallery; Average Annual Attendance: 2,000
Income: grants, fellowship, donations
Special Subjects: American Indian Art, Drawings, Etchings & Engravings, Photography, Pottery, Painting-American, Prints, Sculpture, Woodcuts
Collections: Evergreen State College Art Collection; b & w photography, prints, ceramics, paintings
Exhibitions: Contemporary West Coast & US art
Activities: Docent training; lectures; concerts; gallery talks; tours; book traveling exhib 1 or 2 per yr

M **STATE CAPITAL MUSEUM,** 211 21st Ave W, Olympia, WA 98501. Tel 360-753-2580; Fax 360-586-8322; Elec Mail dvalley@wshs.wa.gov; Internet Home Page Address: www.wshs.org; *Cur Exhib* Redmond Barnett; *Dir* Derek R Valley; *Cur Educ* Susan Rohrer; *Admin Asst* Helen Adams
Open Tues - Fri 10 AM - 4 PM, Sat Noon - 4 PM, cl Sun & Mon; Admis family $5, adult $2, seniors $1.75, children $1; Estab 1941 to interpret history of the State of Washington & of the capital city; The one-room gallery presents changing monthly shows; Average Annual Attendance: 40,000; Mem: 400; dues family $12, individual $6; annual meeting in June
Income: Financed by city & state appropriation & local funds
Special Subjects: American Indian Art, Woodcuts, Etchings & Engravings
Collections: Etchings by Thomas Handforth; Winslow Homer Woodcuts; Northwest Indian serigraphs
Exhibitions: Rotating exhibits
Publications: Museum Newsletter, bi-monthly; Museum Calender; every other month; lists all scheduled events; Columbia, The Magazine of Northwest History
Activities: Classes for adults & children; dramatic programs; docent training; lect open to the public; concerts; gallery talks; tours; individual paintings & original objects of art lent to State offices; lending collection contains original prints, paintings; originate traveling exhibitions; sales shop sells books & slides

PORT ANGELES

M **PORT ANGELES FINE ARTS CENTER,** 1203 E Lauridsen Blvd, Port Angeles, WA 98362. Tel 360-457-3532; Fax 360-457-3532; Elec Mail pafac@olypen.com; Internet Home Page Address: www.pafac.org; *Educ Dir* Barbara Slavik; *CEO* Jake Seniuk; *VChmn* Darlene Ryan; *VPres* Mim Foley
Open Thurs - Sun 11 AM - 5 PM; Donations accepted; Estab 1986; 1950's NW contemporary semi-circular home designed by Paul Hayden Kirk, converted to gallery. Changing shows of contemporary art in all media. Panoramic views & integration of natural surroundings in gallery space via many glass walls; Average Annual Attendance: 18,000; Mem: 300
Income: $90,000 (financed by endowment, mem, grants & corporate gifts)
Collections: Esther Webster Art Collection, miscellaneous donated works
Exhibitions: Art outside - year round sculpture park
Publications: On Center, quarterly

Activities: Classes for children; docent programs; lect open to public, 4-6 vis lectrs per year; concerts; readings; gallery talks; tours; sales shop sells books, handicrafts, original art & reproductions

PORT TOWNSEND

A CENTRUM ARTS & CREATIVE EDUCATION, Fort Worden State Park, PO Box 1158 Port Townsend, WA 98368-0958. Tel 360-385-3102; Fax 360-385-2470; Internet Home Page Address: www.olympus.net/centrum; WATS 800-733-3608; *Exec Dir* Carol Shiffman
Open Mon - Fri 8:30 AM - 5 PM; Estab 1973 to assist those who seek creative & intellectual growth & to present visual, literary & performing arts to the pub; Average Annual Attendance: 38,500; Mem: 100; dues $25 & up
Income: Financed by donations, fees & grants
Collections: Collection of prints from artists in residence
Activities: Resident workshops for children; Thinking Classroom program; workshops for seniors 55 & older; lect open to public, 20 vis lectrs per year; concerts; awards; gallery talks; scholarships; artist in residence program

PULLMAN

M WASHINGTON STATE UNIVERSITY, Museum of Art, PO Box 647460, Pullman, WA 99164-7460. Tel 509-335-1910 (office), 335-6607 (information); Fax 509-335-1908; Elec Mail artmuse@wsu.edu; Internet Home Page Address: www.wsu.edu/artmuse; *Asst Dir* Anna-Maria Shannon; *Cur Exhib, Coll Mgr* Roger Rowley; *Assoc Cur* Keith Wells; *Dir Develop* Robert Snyder
Open Mon - Fri 10 AM - 4 PM, Thurs 10 AM - 7 PM, Sat & Sun 1 - 5 PM; No admis fee; Estab 1973 to contribute to the humanistic & artistic educational purpose & goal of the university for the direct benefit of the students, faculty & surrounding communities; Gallery covers 5000 sq ft & is centrally located on campus; Average Annual Attendance: 28,000; Mem: 400; dues $35-$1000; annual meeting in the spring
Income: Financed by the state of Washington, private & pub grants & contributions
Library Holdings: Audio Tapes; Book Volumes; Exhibition Catalogs; Kodachrome Transparencies; Memorabilia; Pamphlets; Slides; Video Tapes
Special Subjects: Painting-American, Photography, Prints
Collections: Late 19th century to present-day American art, with particular strength in the areas of the Ash Can School & Northwest regional art; contemporary American & British prints
Exhibitions: Annual; fine arts faculty & the master of fine arts thesis; permanent collection, rental/traveling
Activities: Classes for children and adults; docent training; lect open to public, 2-5 vis lectrs per year; concerts; gallery talks; tours; competitions; 2-4 book traveling exhibitions per year

RENTON

A NORTHWEST WATERCOLOR SOCIETY, 15129 SE 139th Pl, Renton, WA 98059. Tel 425-228-2080; Internet Home Page Address: www.nwws.org; *VPres* Diana Shayne; *Treas* Paul Davis; *Pres* LeSan Riedmann
Estab 1939; Mem: 860; dues $35; monthly meetings Sept-May
Income: Financed by mem
Exhibitions: Annual National Show; Waterworks-Juried Members Show; Signature Show
Publications: Hot Press Newsletter, bimonthly
Activities: Educ dept; workshops; lect open to public; competitions with awards; scholarships offered, funded by the Northwest Watercolor Foundation Charitable Fund; lending collection contains over 50 videos

RICHLAND

A ALLIED ARTS ASSOCIATION, Allied Arts Center & Gallery, 89 Lee Blvd, Richland, WA 99352. Tel 509-943-9815; Fax 509-943-4068; Internet Home Page Address: www.alliedartsrichland.org; *Gallery Adminr* Penelope Walder; *Pres* Marion Goheen; *Pres* Judith Loomis
Open Tues - Sat 11 AM - 5 PM; No admis fee; Estab 1947 to stimulate interest in various forms of visual art; 4532 sq ft. Consists of the Townside Gallery, Motyka Room, Parkside Gallery & an Educational Wing; Mem: 400; dues $20; annual meeting in Nov
Income: $80,000
Library Holdings: Book Volumes 500
Exhibitions: Monthly Exhibitions; Annual Sidewalk Show
Activities: Classes for adults & children; docent programs; conferences; lect open to public; Szulinski Award; scholarships & fels offered; sales shop sells original art, prints, pottery & fine crafts

SEATTLE

A ALLIED ARTS OF SEATTLE, 216 First Ave S, Ste 253 Seattle, WA 98104; 216 First Ave S#253, Seattle, WA 98104-2586. Tel 206-624-0432; Fax 206-624-0433; Elec Mail aarts@speakeasy.net; Internet Home Page Address: www.alliedarts-seattle.org; *Pres* David Yeaworth
Open Mon - Fri 9 AM - 4:30 PM; No admis fee; Estab 1954 to promote & support the arts & artists of the Northwest & to help create the kind of city that will attract the kind of people who support the arts; Mem: 500; dues $35 - $250 depending on category; annual meeting Jan
Income: $70,000 (financed by mem & fundraising events)
Publications: Access: The Lively Arts, directory of arts organizations in Puget Sound, biannual; Art Deco Seattle; Image of Imagination: Terra-Cotta Seattle

A CENTER ON CONTEMPORARY ART, 1420 11th Ave, Seattle, WA 98121-1327. Tel 206-728-1980; Elec Mail coca@cocaseattle.org; Internet Home Page Address: www.cocaseattle.org; *Managing Dir* Steve Tremble; *Prog Dir* Katie J Kurtz
Open Tues - Sat 11 AM - 6 PM, Sun Noon - 4 PM; Admis $2, members free; Estab 1980 to serve as a catalyst & forum for the advancement & understanding of contemporary art; Average Annual Attendance: 40,000; Mem: 1000; dues $15-$100
Exhibitions: Nirvana: Capitalism & the Consumed Image; Square Painting
Publications: Bimonthly newsletter
Activities: Lect open to public, 3 vis lectrs per year; concerts; gallery talks; competitions with awards, five $1000 for new annual artist; book traveling exhibitions; museum shop sells items depending on exhibit

A CORPORATE COUNCIL FOR THE ARTS/ARTS FUND, 10 Harrison St, Ste 200, Seattle, WA 98109. Tel 206-281-9050; Fax 206-281-9175; Elec Mail info@artsfund.org; Internet Home Page Address: www.cca-artsfund.org; *Pres* Peter Donnelly; *VPres Community Affairs* Dwight Gee; *Dir of Finance & Operations* Julie Sponsler; *Campaign Dir* Roxanne Shepherd
Open 8:30 AM - 5:30 PM; Estab 1968 as a clearinghouse for corporate contributions to the arts, to monitor budgeting of art agencies & assess ability of business to provide funding assistance; Gallery not maintained; Mem: 304 corporate mem & 1697 individual mem; ann meeting in Oct
Income: $2,885,897 (financed by mem)
Publications: Annual Report; brochures; periodic membership reports
Activities: Annual fundraising event & campaign

M FRYE ART MUSEUM, 704 Terry Ave, Seattle, WA 98104. Tel 206-622-9250; Fax 206-223-1707; Elec Mail info@fryemuseum.org; Internet Home Page Address: www.fryeart.org; *CEO* Richard V West; *Dir Cur Affair* Debra J Byrne; *Coll Mgr* Donna L Kovalenko; *Dir Educ* Steven Broocks; *Dir Community Rels* MaryAnn Barron; *Controller* Roxie J Dufour; *Dir Exec Asst* Roxanne Hadfield; *Mus Shop Mgr* Roberta Stothart; *VPres* Richard Cleveland; *Mus Designer* Charla Reid; *Mus Designer* Beth Koutsky; *Adjunct Coll* Ann Jespersen; *Deputy Dir & CFO* Jeanne M Birmingham; *Mus Exhib Mgr* David Andersen
Open Mon - Wed & Fri 10 AM - 5 PM, Thurs 10 AM - 8 PM, Sat & Sun 11 AM - 5 PM; No admis fee; Estab 1952 to display & preserve the Charles & Emma Frye art collection; 10 galleries with over 12,000 sq ft of exhib space; 142-seat auditorium with stage (ceramics/sculpture & painting/drawings), studios (for classes) & art workshops. Maintains reference library; Average Annual Attendance: 100,000; Mem: 2000; dues $25, $40, $100 & $1000
Income: $2,500,000 (financed by endowment)
Purchases: Primarily contemporary American Realist Artists
Special Subjects: Drawings, Etchings & Engravings, Painting-American, Watercolors, Painting-French, Painting-German
Collections: American masters from the Colonial period to American representational painters of today; Munich School paintings; Northwest regional art & Alaskan paintings; 19th & 20th century American, German & French paintings; Bordin, Kaulbach, Koester, Lenbach, Leibl, Liebermann, Lhermitte, Max, Monticelli, Stuck, Winterhalter, Zugel, Zumbusch, American paintings by Pendergast, Hassam, Cassatt, Henri, Sargent, Wyeth, Homer, Eakins, Copley, Stuart
Publications: Frye Vues, quarterly
Activities: Classes for adults & children; docent training; lect open to public; 24-30 vis lectrs per yr; concerts; gallery talks; tours; individual paintings & objects of art lent; book traveling exhibitions; originate traveling exhibitions; museum shop sells books, reproductions, prints, posters, slides, videos, art catalogs, jewelry & original gifts

L Library, 704 Terry Ave, Seattle, WA 98104. Tel 206-622-9250; Fax 206-223-1707; Internet Home Page Address: www.fryeart.org; *Coll Cur* Donna Kovalenko
Open by appointment only; No admis fee; Estab 1952; 7 galleries, 3 for founding coll & 4 traveling; Average Annual Attendance: 100,000
Income: pvt
Purchases: American paintings, contemporary, German & Austrian 19th & 20th century
Library Holdings: Auction Catalogs; Book Volumes 3000; Exhibition Catalogs; Pamphlets; Periodical Subscriptions
Special Subjects: Painting-German
Collections: Founding Collection; Museum Collection since 1952
Publications: Exhibition catalogues
Activities: Classes for adults & children; docent training; lect open to public; concerts, gallery talks; museum shop sells books & merchandise to support exhibitions

M HENRY GALLERY ASSOCIATION, Henry Art Gallery, 15th Ave NE & NE 41st St, Seattle, WA 98195; University of Washington, Box 351410 Seattle, WA 98195. Tel 206-543-2280; Fax 206-685-3123; Elec Mail hartg@u.washington.edu; Internet Home Page Address: www.henryart.org; *Dir* Richard Andrews; *Dir Educ* Tamara Moats; *Cur Coll* Judy Sourakli; *Chief Cur* Elizabeth Brown; *Communications Mgr* Anna Fahey; *Communications Coordr* Leslie Schuyler; *Dir Finance* John Mullen; *Dir of Community and Donor Relations* Nancy Sears
Open Tues - Sun 11 AM - 5 PM; General admis $6, seniors $3.50, free to members & students with ID; Estab 1927 for modern & contemporary art; The Northwest's leading center for modern and contemporary art; Average Annual Attendance: 80,000; Mem: 2500; dues $25 - $10,000; ann meeting in the spring
Income: $1,300,000 (financed by endowment, mem, state appropriation & grants)
Library Holdings: Auction Catalogs; Book Volumes 2761; CD-ROMs 16; Cassettes; Clipping Files; Exhibition Catalogs; Video Tapes 101
Special Subjects: Drawings, Painting-American, Photography, Sculpture, Watercolors, Textiles, Costumes, Woodcuts, Etchings & Engravings, Landscapes, Painting-French
Collections: Mixed Media, paintings, prints, photography, sculpture, textiles & costumes
Publications: Exhibition Catalog, annually
Activities: Classes for adults & children; docent training; film series; gallery talks; tours; lect open to public; 10 - 15 vis lectr per year; gallery talks; tours; book

traveling exhibitions 3 per year; originate traveling exhibitions to other mus nationally & internationally; mus shop sells books, magazines, reproductions, jewelry, gifts, cards

A **KING COUNTY ARTS COMMISSION,** 506 Second Ave, Rm 1115, Seattle, WA 98104-2311. Tel 206-296-8671; Fax 206-296-8629; Elec Mail jimkelly@metrokc.gov; *Exec Dir* Jim Kelly
Open Mon - Fri 8:30 AM - 4:30 PM; Estab 1967 to provide cultural arts opportunities to the citizens of King County; The Arts Commission purchases & commissions many works of art for public buildings; annual grant program for organizations & artists in all artistic disciplines, also multi-cultural & disabled arts population; operates touring program of performing arts events in county locations; Mem: 16; 1 meeting per month
Income: $1,300,000 million (financed by county government, plus one percent for commissioned art in county construction projects)
Purchases: Occasional works commissioned for public art
Exhibitions: Rotating exhibits
Publications: The ARTS, bimonthly newsletter; The Touring Arts Booklet biennially; public art brochure; guide to programs, annually
Activities: Workshops; performances

M **LEGACY LTD,** 1003 First Ave, Seattle, WA 98104. Tel 206-624-6350; Fax 206-624-4108; Elec Mail legacy@drizzle.com; Internet Home Page Address: www.thelegacyltd.com; *Pres* Helen Carlson; *VPres* Paul Nicholson
Open Mon - Sat 10 AM - 6 PM; No admis fee; Estab 1933 for the coll & sale of Northwest Coast Indian contemporary & historic material
Exhibitions: Annual in-house special exhibits of historic contemporary Northwest Coast Indian & Eskimo art, ongoing exhibits of same
Activities: Sales shop sells books, magazines, original art & prints

A **PRATT FINE ARTS CENTER,** Gallery, 1902 S Main St, Seattle, WA 98144-2206. Tel 206-328-2200; Fax 206-328-1260; Elec Mail info@pratt.com; Internet Home Page Address: www.pratt.org;
Open daily 8:30 AM - 10 PM; No admis fee; admis fee for art classes; Estab 1976; Average Annual Attendance: 3,500
Exhibitions: Rotating monthly exhibits (glass, jewelry, painting, prints, metal, mixed media, sculpture)
Publications: Quarterly class schedule
Activities: Classes for adults & children; educ prog; lect open to public, 10 vis lectrs per year

M **SACRED CIRCLE GALLERY OF AMERICAN INDIAN ART,** Daybreak Star Arts Center, Discovery Park, PO Box 99100, Seattle, WA 98199. Tel 206-285-4425; Fax 206-282-3640; Internet Home Page Address: www.unitedindians.com; *Dir* Merlee Markishtum
Open Mon - Fri 10 AM - 5 PM, Sat & Sun Noon - 5 PM; No admis fee; Estab 1977 to present contemporary American Indian fine art; Average Annual Attendance: 30,000
Collections: Collections of international American Indian tribes & cultures
Exhibitions: Permanent exhibit of different American Indian tribes & cultures as well as changing exhibitions of contemporary native art
Activities: Educ program; tours; lect open to public, 2-3 vis lectrs per year; gallery talks; tours; sales shop sells books, original art, prints, t-shirts, fleecewear, contemporary cards, cedar boxes & ceramics

C **SAFECO INSURANCE COMPANY,** Art Collection, Safeco Plaza, ROC-5, Seattle, WA 98185. Tel 206-545-5550; Fax 206-545-5477; Elec Mail jackos@safeco.com; Internet Home Page Address: www.safeco.com/safeco/in_the_community/art_collection.asp; *Coll Mgr* Jackie Kosak
For employees & invited guests, by appointment only; Coll estab 1973 to support the work of both established & emerging Northwest artists through purchase and display; Small exhibition space with adjacent auditorium in mezzanine space
Purchases: Regional artist from throughout the country
Collections: Works in all media by contemporary artists
Publications: Checklists & essays for some exhibitions
Activities: Lect open to public; tours by appointment; individual paintings & original objects of art lent to nonprofit museums; lending collection contains original art work, original prints, paintings, photographs & sculptures; originate traveling exhibitions

M **SCIENCE FICTION MUSEUM AND HALL OF FAME,** Frank Gehry Bldg, 325 5th Ave Seattle, WA 98109. Tel 206-724-3428; Fax 206-770-2727; Elec Mail info@sfhomeworld.org; Internet Home Page Address: www.sfhomeworld.org; *Dir* Donna Shirley
Open May 31 - Sept 6 daily 10 AM - 8 PM; Sept 7 - May 30 Tues - Thurs 10 AM - 5 PM, Fri - Sat 10 AM - 9 PM, Sun 10 AM - 6 PM; Admis adults $12.95, seniors, military & youth 7-17 $8.95, children 6 & under and mems free; Mem: dues Fam $75, Dual $60, Indiv $40
Activities: Lects; workshops; educ progs

M **SEATTLE ART MUSEUM,** 100 University St, Downtown Seattle, WA 98122-9700; PO Box 22000, Seattle, WA 98122-9700. Tel 206-654-3100; Fax 206-654-3135; Internet Home Page Address: www.seattleartmuseum.org; *Pres Bd* Susan Brotman; *Dir* Mimi Gates; *CFO* Robert Cundall; *Pub Rels Mgr* Cara Egan
Open Tues - Sat 10 AM - 5 PM, Thurs 10 AM - 9 PM, Sun 10 AM - 5 PM; Admis adults $7, students & seniors $5, children under 6 with adult, members & first Thurs of the month free; Estab 1906, incorporated 1917, building opened 1933; gift to the city from Mrs Eugene Fuller & Richard Eugene Fuller, for recreation, educ & inspiration of its citizens; Average Annual Attendance: 400,000; Mem: 30,000
Income: State appropriations, grants, mem
Library Holdings: Auction Catalogs; Book Volumes; Clipping Files
Special Subjects: Painting-American, Prints, Primitive art, Painting-European, Painting-Japanese, Jade, Porcelain, Oriental Art, Asian Art, Antiquities-Greek, Antiquities-Roman

Collections: LeRoy M Backus Collection of Drawings and Paintings; Manson F Backus Collection of Prints; Norman Davis Collection (with emphasis on classical art); Eugene Fuller Memorial Collection of Chinese Jades from Archaic through 18th Century; Eugene Fuller Memorial Collection (with special emphasis on Japan, China, India, & including Egypt, Ancient Greece & Rome, European, Near Eastern, primitive & contemporary Northwest art); Alice Heeramaneck Collection of Primitive Art; Henry & Marth Issacson Collection of 18th Century European Porcelain; H Kress Collection of 14th - 18th Century European Paintings; Thomas D Stimson Memorial Collection (with special emphasis on Far Eastern art); Extensive Chinese & Indian Collection; 18th Century Drawing Room (furnished by the National Society of Colonial Dames of American in the State of Washington); major holdings in Northwest art, including Tobey, Callahan, Graves as well as all contemporary art, especially American artists Gorky, Pollock, Warhol & Lichtenstein; selected highlights on Asian collection on permanent display (with special emphasis on on Japanese screens, paintings, sculpture and lacquers); Katherine C White Collection of African Art
Publications: Quarterly Newsletter; Art from Africa: Long Steps Never Broke a Back; Neri di Bicci and Devotional Painting in Italy; Spain in the Age of Exploration 1492-1819
Activities: Docent training; film programs; double lecture course under the Museum Guild; adult art history classes; classes for children; lect open to public; lect for members only; 12 vis lectrs per year; tours; program for senior citizens; concerts; gallery talks; museum shop sells books, gifts & jewelry

L Library, 100 University St, Downtown, Seattle, WA 98122-9700; PO Box 22000, Seattle, WA 98122-9700. Tel 206-625-8900; Fax 206-659-3135; Elec Mail webmaster@seattleartmuseum.org; *Librn* Elizabeth de Fato; *Mus Store Mgr* Brad Bigelow; *Asst Cur Modern Art* Tara Young; *Mus Educator* Beverly Harding; *Pres Bd* Susan Brotman; *Mus Educator* Kathleen Peckham Allen; *CFO* Robert Cundall; *Mus Photography* Paul Macapia; *Cur African Art* Pamela McClusky; *Conservator* Nicholas Dorman; *Mgr Exhibitions* Zora Hutlova-Foy; *Sr Mus Educator* Sarah Loudon; *Chmn Bd* Jon Shirley; *Cur European Painting* Chiyo Ishikawa; *Exhibitions Designer* Michael McCafferty; *Deputy Dir Art* Lisa Corrin; *Sr Deputy Dir* Gail Joice; *Controller* Debbi Lewang; *Ruth J Nutt Cur Drawings* Julie Emerson
For reference only
Income: State appropriation, grants, mem
Library Holdings: Book Volumes 19,000; Periodical Subscriptions 50; Slides 75,000

L **SEATTLE PUBLIC LIBRARY,** Fine & Performing Arts Dept, 1000 Fourth Ave, Seattle, WA 98104. Tel 206-386-4612; Fax 206-386-4616; Elec Mail fpa@spl.org; *Librn* JoAnn Fenton
Estab 1889; Circ 181,772; Lending & reference library
Income: Financed by mem & foundation grants
Purchases: $26,000
Library Holdings: Audio Tapes; Book Volumes 147,202; Cassettes; Clipping Files; Exhibition Catalogs; Fiche; Framed Reproductions; Lantern Slides; Manuscripts; Original Art Works; Pamphlets; Periodical Subscriptions 310; Photographs; Prints; Records; Reproductions; Slides; Video Tapes
Special Subjects: Art History, American Western Art, Advertising Design, American Indian Art, Aesthetics, Afro-American Art, Antiquities-Oriental, Antiquities-Persian, Antiquities-Assyrian, Antiquities-Byzantine, Antiquities-Egyptian, Antiquities-Etruscan, Antiquities-Greek, Antiquities-Roman, Architecture

UNIVERSITY OF WASHINGTON
M Henry Art Gallery, Tel 206-543-2281; Fax 206-685-3123; Internet Home Page Address: www.henryart.org; *Foundations Government Relations Mgr* Felicia Gonzalez; *Sr Cur* Elizabeth A Brown; *Cur Coll* Judy Sourakli; *Public Information Mgr* Monique Shira; *Bookstore Operations Mgr* Ruth Lewing; *Cur Educ* Tamara Moats; *Dir* Richard Andrews
Open Tues - Sun 11 AM - 5 PM, Thurs until 8 PM, cl Mon; $5 by donation; Estab 1923; 8 galleries, 6000 sq ft of exhibition space; Average Annual Attendance: 100,000; Mem: 2000; dues $20 & up
Special Subjects: Drawings, Photography, Prints, Textiles, Ceramics, Pottery
Collections: 19th century American landscape painting; contemporary West Coast ceramics; works on paper, prints, drawings & photographs; 20th century Japanese folk pottery; Elizabeth Bayley Willis Collection of Textiles from India; western & ethnic textiles; 19th & 20th century western dress (formerly Costume & Textile Study Center)
Exhibitions: Masters of Fine Arts
Publications: Books, exhibition catalogues
Activities: Educ dept; lect open to public; gallery talks; tours; originate traveling exhibitions to museums in the United States & abroad; museum shop sells books & prints

L Architecture-Urban Planning Library, Tel 206-543-4067; Internet Home Page Address: www.lib.washington.edu/aup; *Librn* Betty L Wagner
Open Mon - Thur 8 AM - 9 PM, Fri 8 AM - 5 PM, Sat - Sun 1 - 5 PM; Estab 1923
Library Holdings: Book Volumes 45,000; CD-ROMs; Compact Disks; Exhibition Catalogs; Fiche 5246; Memorabilia; Pamphlets 1684; Periodical Subscriptions 300; Video Tapes
Special Subjects: Landscape Architecture, Architecture
Collections: Carl Gould Portrait

L Univ of Washington Libraries, Special Collections, Tel 206-543-1929 or 543-1879; Fax 206-543-1931; Elec Mail speccoll@u.washington.edu; Internet Home Page Address: www.lib.washington.edu/specialcoll/; *Head* Carla Rickerson; *Cur Visual Materials* Nicolette Bromberg; *Book Arts & Rare Books Cur* Sandra Kroupa; *Manuscripts & Spec Collections Cataloging Librn* Marsha Maguire; *Univ Archivist* John Bolcer; *Pacific Northwest Cur* Nicole Bouche
Classes in session, Mon - Fri 10 AM - 4:45 PM, Wed 10 AM - 7:45 PM, Sat 1 - 4:45 PM; interim, Mon - Fri 1 - 4:45 PM; No admis fee; Average Annual Attendance: 5,199
Library Holdings: Maps; Other Holdings Architectural plans, drawings & renderings 63,137; Pamphlets; Photographs; Prints
Special Subjects: Photography, Manuscripts, Bookplates & Bindings
Collections: Book arts collection; Northwest American Indian Art

Exhibitions: Best Western Books
Activities: Classes for adults; 1 per year
L **Art Library,** Tel 206-543-0648; Elec Mail art@lib.washington.edu; Internet Home
Page Address: www.lib.washington.edu/art; *Librn* Connie Okada
Open Mon - Thurs 8 AM - 9 PM, Fri 8 AM - 5 PM, Sat 1 - 5 PM, Sun 1 - 5 PM;
Estab 1940 to provide resources for the instructional & research programs of the
School of Art & serves as the Art Library for the university community
Income: Financed by state appropriation
Library Holdings: Book Volumes 44,000; Clipping Files; Exhibition Catalogs;
Fiche; Periodical Subscriptions 200; Reproductions
Special Subjects: Art History, Photography, Sculpture, Ceramics, Printmaking,
Industrial Design
—**Art Slide Library,** Tel 206-543-0649; Fax 206-685-1657; Elec Mail
jcmills@u.washington.edu; *Dir Visual Servs* Jeanette C Mills; *Cur* Debra L Cox
Slide library is a teaching collection that is only available to University of
Washington faculty, staff & students
Library Holdings: Slides 330,000
Collections: 35 mm art slides: Western, Asian, Tribal
M **Burke Museum of Natural History and Culture,** Tel 206-543-5590; Fax
206-685-3039; Internet Home Page Address: www.burkemuseum.org; *Cur Native
American Art* Robin Wright; *Cur Birds* Sievert Rohwer; *Cur Invertebrate
Paleontology* Elizabeth Nesbitt; *Cur Archaeology* Peter Lape; *Assoc Dir* Erin
Younger; *Cur New World Ethnology* James Nason; *Cur Mammalogy* G James
Kenagy; *Cur Fishes* Theodore Pietsch; *Dir* Julie Stein; *Adminr* Judy Davis; *Cur
Asian Ethnology* Stevan Harrell; *Cur Botany* Richard Olmstead; *Cur Vertebrate
Paleontology* Christian Sidor
Open daily 10 AM - 5 PM, First Thurs of the month 10 AM - 8 PM; Admis
general $8, seniors $6.50, students $5, children under 5 free; call for spec admis
fees; Estab 1885 for research & exhibs; Average Annual Attendance: 120,000;
Mem: 2000; dues $20 - $55
Income: Financed by state, endowment, gifts, self-generated revenues
Collections: Natural & cultural history of Washington State, the Pacific Northwest
& the Pacific Rim
Publications: Contributions & Monograph series
Activities: Classes for adults & children; docent training; lect open to public, 4-8
vis lectrs per year; tours; circulates study collection; museum store sells books,
native art, jewelry & cards
M **WING LUKE ASIAN MUSEUM,** 407 Seventh Ave S, Seattle, WA 98104. Tel
206-623-5124, 623-5190 (tour desk); Fax 206-623-4559; Elec Mail
folks@wingluke.org; Internet Home Page Address: www.wingluke.org; *Volunteer
Coordr* Laura Shapiro; *Dir* Ron Chew
Open Tues - Fri 11 AM - 4:30 PM, Sat & Sun Noon - 4 PM; Admis adult $4,
students & seniors $3, children $2; Estab 1966 to preserve & present the history,
art & culture of Asian Pacific Americans & to bridge Asians, Asian Pacific
Americans & Americans of other backgrounds; Changing exhib area; permanent
exhib; Average Annual Attendance: 70,000; Mem: 1000; dues $30; annual meeting
in Jan
Income: $500,000 (financed by endowment, mem, annual art auction, local &
state commissions & grants for exhibits)
Special Subjects: Asian Art
Collections: Asian American Art; Historical Artifacts & Photos
Publications: Publishes exhibit catalogs
Activities: Classes for adults & children; lect open to public, 4 vis lectrs per year;
tours
L **Library,** 407 Seventh Ave S, Seattle, WA 98104. Tel 206-623-5124; Fax
206-623-4559; Elec Mail folks@wingluke.org; Internet Home Page Address:
www.wingluke.org; *Cur Coll* Bob Fisher; *Dir* Ron Chew; *Assoc Dir* Beth
Takekawa
Open Tues - Fri 11 AM - 4:30 PM, Sat & Sun Noon - 4 PM; Admis adult $4,
seniors & students $3, ages 5-12 $2, 1st Thurs of every month free; Estab 1967;
Mem: Dues $20
Income: Financed by contributions, endowment, grants & mem
Library Holdings: Book Volumes 5000; Clipping Files; Photographs; Slides 150;
Video Tapes
Exhibitions: One Song, Many Voices: The Asian Pacific American Experience;
The Densho: Japanese American Legacy Project; rotating exhibits

SHORELINE

M **SHORELINE HISTORICAL MUSEUM,** 749 N 175th St, PO Box 55594
Shoreline, WA 98155. Tel 206-542-7111; Elec Mail shorelinehistorical@juno.com;
Internet Home Page Address: www.shorelinehistoricalmuseum.org; *VPres* Stephen
Brown; *Cur* Keith Routley
Open Tues - Sat 10 AM - 4 PM; Admis by donation; Estab 1976 to preserve local
history; Average Annual Attendance: 5,000; Mem: 360; dues family $25, annual
$10, pioneer $5; annual meeting third Wed in Nov
Income: $35,000 (financed by mem, donations, room rentals & fundraising)
Special Subjects: Historical Material, Period Rooms
Exhibitions: School room, home room; vintage radios; blacksmith shop;
transportation exhibit; post office; country store; other rotating exhibits
Publications: Newsletter, 4 times a year
Activities: Classes for children; docent training; lect open to public; tours; original
objects of art; sales shop sells books, prints, postcards & area photo cards

SPOKANE

M **EASTERN WASHINGTON STATE HISTORICAL SOCIETY,** Northwest
Museum of Arts & Culture, 2316 W First Ave, Spokane, WA 99204. Tel
509-456-3931; Fax 509-363-5303; Elec Mail themac@northwestmuseum.org;
Internet Home Page Address: www.northwestmuseum.org; *CEO* Bruce Eldredge;
Cur Art Jochen Wierich; *Cur History* Marsha Rooney; *Dir Exhibits/Progs* Larry
Schoonover; *Dir Operations* Maurine Barrett; *Dir Develop* Joyce M Cameron; *Dir
Plateau Culture Ctr* Michael Holloman; *Cur Campbell House* Patti Larkin; *Cur
Educ* Kris Major; *Media Relations Mgr* Yvonne Lopez-Morton; *Art at Work Mgr*
Ryan Hardesty
Open Tues - Sun 11 AM - 5 PM, Wed 11 AM - 8 PM; Admis $7 adult, $5 sr
citizen & children; Estab 1916 to collect & preserve Pacific Northwest History, art

& American Indian materials; 6 galleries of 15,000 sq ft, auditorium, library &
archives; Average Annual Attendance: 130,000; Mem: 3000; dues $25-5,000
Income: Financed by mem, state appropriations, fundraising, endowment &
contributions
Library Holdings: Audio Tapes; CD-ROMs; Cassettes; Clipping Files; Exhibition
Catalogs; Fiche; Kodachrome Transparencies; Lantern Slides;
Manuscripts; Maps; Memorabilia; Motion Pictures; Original Documents; Other
Holdings; Pamphlets; Periodical Subscriptions; Photographs; Slides; Video Tapes
Special Subjects: Architecture, Painting-American, Photography, Prints, American
Indian Art, Woodcarvings, Manuscripts, Historical Material, Maps
Collections: American Indian, regional history, Northwest modern contemporary
art; Historic house of 1898 by architect Kirtland K Cutter, interior designed &
decorated with period furnishings; 19th & 20th century American & European art;
representative works of Pacific Northwest artists
Exhibitions: Exhibits change regularly
Publications: Museum Notes; exhibition catalogs
Activities: Classes for adults & children; docent training; lect open to public, 8
vis lectrs per year; gallery talks; tours; individual paintings & original objects of
art lent to professional nonprofit institutions nationally; lending collection contains
books, original art works; original prints, paintings, sculptures & 135,000
photographs; book traveling exhibitions; traveling exhibitions organized &
circulated; museum shop sells books, original art, reproductions & gift items
L **Library,** 2316 W First Ave, Spokane, WA 99204. Tel 509-456-3931, Ext 113; Fax
509-456-7690; Internet Home Page Address: www.northwestmuseum.org; *Dir* Jane
Johnson; *Deputy Dir* Larry Schoonover; *Archivist* Karen De Seve; *Interim Cur Art*
Gena Schwam
For reference & research only by staff
Library Holdings: Audio Tapes; Book Volumes 800; Cassettes; Clipping Files;
Exhibition Catalogs; Filmstrips; Lantern Slides; Manuscripts; Memorabilia;
Original Art Works; Pamphlets; Periodical Subscriptions 18; Photographs; Prints;
Sculpture; Slides; Video Tapes
Special Subjects: Photography, Manuscripts, Maps, Historical Material, American
Indian Art, Architecture
Collections: Inland Empire history; American art; Asian art
Activities: Docent training; regular school tours; lect open to pub; 5-6 vis lectrs
per yr; tours
M **GONZAGA UNIVERSITY,** Art Gallery, 502 E Boone Ave, PO Box 1 Spokane,
WA 99258-0001. Tel 509-328-4220, Ext 6611; Fax 509-323-5525; Elec Mail
patnode@calvin.gonzaga.edu; *Asst Cur* Paul Brekke; Anita Martello
Open Mon - Fri 10 AM - 4 PM, Sat Noon - 4 PM, through academic yr; No
admis fee; Estab 1971 to service the Spokane Community, art department &
general university population at Gonzaga University; Jundt Gallery estab 1995;
Jundt Gallery 2720 sq ft. Arcade Gallery 1120 sq ft; Average Annual Attendance:
30,000
Income: Financed by parent institution
Purchases: Jacob Lawrence, Wayne Thiebaud & Sylvia Wald prints
Special Subjects: Drawings, Mexican Art, Painting-American, Prints, Sculpture,
Bronzes, Religious Art, Ceramics, Pottery, Woodcuts, Etchings & Engravings,
Afro-American Art, Glass, Tapestries
Collections: Dale Chihuly Glass Installation (Chandelier); Rodin Sculpture
Collection; Contemporary & old master print collection; glass; prints; student art
collection
Activities: Educ dept; docent training; lect open to public, 6 vis lectrs per year;
gallery talks; tours; student purchase awards; individual paintings lent to museums,
art centers & university galleries; lending collection contains paintings,
photographs, sculptures & 3000 original prints; book traveling exhibitions 3 per
year
L **SPOKANE PUBLIC LIBRARY,** 906 W Main St, Spokane, WA 99201. Tel
509-444-5300; *Dir* Pat Partovi
Open Tues - Wed 10 AM - 8 PM, Thurs - Sat 10 AM - 6 PM; No admis fee;
Estab 1894 basically to meet citizens educ, information, recreation & cultural
lifelong learning needs through a variety of programs & facilities; Gallery
maintained for special exhibitions
Library Holdings: Audio Tapes; Cassettes; Clipping Files; Compact Disks;
DVDs; Exhibition Catalogs; Fiche; Filmstrips; Kodachrome Transparencies;
Manuscripts; Maps; Micro Print; Motion Pictures; Original Art Works; Other
Holdings Original documents; Pamphlets; Periodical Subscriptions; Photographs;
Records; Reels; Slides; Video Tapes
Collections: AV; childrens' & young adult; fiction; genealogy; non-fiction;
northwest; periodicals; rare books
Publications: Previews, monthly
Activities: Classes for adults & children; dramatic programs; lect open to public;
concerts

TACOMA

M **TACOMA ART MUSEUM,** 1701 Pacific Ave, Tacoma, WA 98402. Tel
253-272-4258; Fax 253-627-1898; Elec Mail info@tacomaartmuseum.org; Internet
Home Page Address: www.tacomaartmuseum.org; *CEO* Janeanne Upp; *Educ
Admin* Anna Castillo; *Dir & Chief Cur* Patricia McDonnell; *Dir Develop* Barbara
Eckert; *Pres* Kathryn Van Waehonen; *Mktg & Pub Rels* Courtenay Chamberlin;
VChmn Karla Winship; *Dir Finance* Rod Bigelow
Open Tues, Wed, Fri & Sat 10 AM - 5 PM, Thurs 10 AM - 8 PM, Sun Noon - 5
PM; Admis general $5, students & seniors $4, children under 6 every 3rd Thurs
free; Estab 1891; Mus features traveling exhibitions & an interactive art gallery;
Average Annual Attendance: 65,000; Mem: 1900; dues $20-$2500
Income: $1,000,000 (financed by contributions, grants, mem & carried income)
Special Subjects: Painting-American, Prints, Sculpture, Glass, Asian Art,
Painting-French
Collections: American & French paintings; American sculpture; Chinese Textiles;
19th & 20th Century American Art; European & Asian Works of art; European
Impressionism; Japanese Woodblock prints, Northwest Art; Dale Chihuly Glass
Exhibitions: Catalin Masters - Spanish Artists, Dali, Picasso

Publications: Quarterly Bulletin; exhibit catalogs

Activities: Classes for adults & children; docent training; lect open to public, 10 vis lectrs per year; gallery talks; tours; biennial competition with awards; individual paintings & original objects of art lent to other professional museums; museum shop sells books, original art, reproductions, prints, cards, jewelry, concerts & films

L **Reference Library,** 1701 Pacific Ave, Tacoma, WA 98402-4399. Tel 253-272-4258, Ext 3024; Fax 253-627-1898; Elec Mail info@tacomaartmuseum.org; Internet Home Page Address: www.tacomaartmuseum.org; *Librn* Donna Marie Garcia
Admis adults $6.50; seniors 65 and older, students, military $5.50; children under 6 free; Open to the pub Tues - Sat 10 AM - 5 PM; Third Thurs 10 AM - 8 PM
Income: Financed by mem, donations & grants
Library Holdings: Book Volumes 3402; Cards; Clipping Files; Exhibition Catalogs 2027; Pamphlets; Periodical Subscriptions 60; Video Tapes
Special Subjects: Watercolors, Ceramics, American Western Art, Asian Art, American Indian Art, Glass, Jewelry, Textiles
Collections: Unique collection of research material on Japanese woodcut
Publications: Monthly bulletins

L **TACOMA PUBLIC LIBRARY,** Handforth Gallery, 1102 Tacoma Ave S, Tacoma, WA 98402. Tel 253-591-5666; Fax 253-627-1693; Internet Home Page Address: www.tpl.wa.us; *Mgr Community Rels* David Domkoski
Open Mon - Thurs 9 AM - 9 PM, Fri & Sat 9 AM - 6 PM; Estab 1952 to extend library services to include exhibits in all media in the Thomas S Handforth Gallery; Circ 1,237,000; Average Annual Attendance: 20,000
Income: Financed by city appropriation
Library Holdings: Audio Tapes; Book Volumes 800,000; Cassettes; Clipping Files; Exhibition Catalogs; Framed Reproductions; Memorabilia; Motion Pictures; Original Art Works; Other Holdings Audio compact discs; Pamphlets; Periodical Subscriptions 1600; Photographs; Prints; Records; Reels; Video Tapes
Special Subjects: Photography, Manuscripts
Collections: Art book; city, county, federal & state documents; rare books
Exhibitions: 8 monthly changing exhibits; exhibits featuring local & regional artists; educ & historic exhibits
Activities: Classes for children; dramatic programs; lect open to public, 3-4 vis lectrs per year; originate traveling exhibitions

M **UNIVERSITY OF PUGET SOUND,** Kittredge Art Gallery, 1500 N Lawrence, Tacoma, WA 98416; 1500 N Warner, CM 1072 Tacoma, WA 98416. Tel 253-879-2806; Fax 253-879-3500; *Dir* Greg Bell
Open Mon - Fri 10 AM - 4 PM, Sun 1 - 4 PM; No admis fee; Estab 1961 for showing of student & professional works; Exhibition space consists of 2 galleries: Small Gallery with 100 ft of running wall space & Kittredge Gallery with 160 ft of running wall space; track lighting; security alarms; Average Annual Attendance: 6,200
Collections: Abby Williams Hill, painter of Northwest scenes from 1880s to 1930s; contemporary west coast ceramics
Exhibitions: Kelsey Fernkopf (sculpture); Heidi Feichter (photo installation); Nancy Kiefer (paintings); Michael Hernandez de Luna, Michael Thompson (stamps); John McCuiston (ceramics); Toot Reid (textiles); Ken Stevens (ceramics); Tatiana Garmendia (drawings); Northwest Artist Couples; Senior Exhibition; Northwester Wood Carvers
Publications: Monthly show bulletins
Activities: Lect open to pub, 8 vis lectrs per yr; gallery talks; individual paintings & original works of art lent to professional art museums & historical museums; lending coll contains original prints, paintings & ceramic works

M **WASHINGTON STATE HISTORY MUSEUM,** 1911 Pacific Ave, Tacoma, WA 98402. Tel 253-272-3500; Fax 253-272-9518; Internet Home Page Address: www.wshs.org; *Dir* David Nicandri
Call for hours; Admis adults $7, seniors $6.25, students $5, members & children under 5 free; Estab 1891 to research, preserve & display the heritage of Washington State; Soc owns three buildings; art gallery under the direction of the Soc; two floors of exhibits (Washington State, Native American Artifacts, temporary special exhibits); Average Annual Attendance: 125,000; Mem: 3000; dues $38- $48; annual meeting in August
Income: Financed by mem, state appropriations & gifts
Special Subjects: Photography, Manuscripts, Posters, Historical Material, Maps
Collections: Pre-historic relics; Indian & Eskimo artifacts, baskets, clothing, utensils; Oriental items; Washington-Northwest pioneer relics; archives
Exhibitions: Train Exhibit (permanent); rotating exhibits
Publications: History Highlights (newsletter), quarterly; Columbia (popular historical journal), quarterly
Activities: Classes for adults & children; docent training; lect open to public, 15 vis lectrs per year; tours; interpretative programs; concerts; dramatic programs with awards; scholarships offered; individual paintings & original objects of art lent to comparable museums & cultural institutions; lending collection contains natural artifacts, photographs & sculpture; traveling exhibitions organized & circulated; museum shop sells books, magazines, reproductions, prints, postcards & stationery

L **Research Center,** 315 Stadium Way, Tacoma, WA 98403. Tel 253-798-5914; Elec Mail jwerlink@wshs.wa.gov; *Asst Cur Photo* Elaine Miller; *Asst Cur Manuscripts* Joy Werlink
Open Tues, Wed & Thurs 12:30 - 4:30 PM by appointment; No admis fee; Estab 1941 for research in Pacific Northwest history; For reference only
Income: Financed by mem, state appropriations & gifts
Library Holdings: Book Volumes 12,000; Clipping Files; Manuscripts 4,500,000; Memorabilia; Pamphlets; Photographs 500,000; Prints 30,000; Reels
Collections: Asahel Curtis Photograph Collection
Publications: Columbia Magazine, quarterly

VANCOUVER

M **CLARK COLLEGE,** Archer Gallery/Gaiser Hall, 1800 E McLoughlin Blvd, Vancouver, WA 98663. Tel 360-992-2246; Fax 360-992-2828; *Dir* Marjorie Hirsch
Open Tues - Thurs 9 AM - 8 PM, Fri 9 AM - 4 PM, Sat & Sun 1 - 5 PM; No admis fee; Gallery has 2,400 sq ft; Average Annual Attendance: 5,000

Activities: Gallery talks; Lect open to public, 4 vis lectrs per year

WALLA WALLA

A **CARNEGIE ART CENTER,** 109 S Palouse, Walla Walla, WA 99362. Tel 509-525-4270; Fax 509-525-9300; Elec Mail cac@hscis.net; Internet Home Page Address: www.carnegieart.com; *Dir* Cheryl Williams-Cosner
Open Tues - Sat 11 AM - 4:30 PM; No admis fee; Estab 1970 in 1905 Carnegie Library, built of Kansas brick & paneled with oak, incorporated 1971 as a nonprofit educ organization; Average Annual Attendance: 12,000; Mem: 800; individual dues $20
Income: Financed by endowments, dues, contributions, art sales, rentals & gift shop
Exhibitions: 10 exhibitions annually
Activities: Classes for adults & children; dramatic prog; docent training; lect open to public; 1 vis lect per year; gallery talks; tours; competitions with awards; scholarships offered; individual paintings lent; public schools; 1 -2 book traveling exhibitions; museum shop sells books, original art, reproductions, prints, pottery & handcrafted gifts

WENATCHEE

M **CHELAN COUNTY PUBLIC UTILITY DISTRICT,** Rocky Reach Dam, US 97A Chelan Hwy, PO Box 1231 Wenatchee, WA 98807-1231. Tel 509-663-8121; Visitor Center: 663-7522; Fax 509-664-2874; *CEO & Gen Mgr* Roger Braden
No admis fee; Estab 1961 as a landscape ground & exhibit galleries; History of Electricity & Edisonia, Geology, Anthropology - Local Indian & Pioneer History; Average Annual Attendance: 100,000
Income: Financed by Hydro Electric revenue
Special Subjects: Graphics, American Indian Art, Anthropology, Archaeology, Portraits, Historical Material
Collections: Electrical artifacts; Indian Artifacts (Central Columbia River Region); Nez Perce Indian Portraits
Exhibitions: Monthly art exhibits
Activities: Educ dept; teacher seminars; seasonal tours; science camp

M **NORTH CENTRAL WASHINGTON MUSEUM,** Wenatchee Valley Museum & Cultural Center, 127 S Mission, Wenatchee, WA 98801. Tel 509-664-3340; Fax 509-664-3356; Elec Mail wvmcc@cityofwenatchee.com; Internet Home Page Address: www.wenatcheevalleymuseum.com; *Cur* Mark Behler; *Dir Pub Rels* Mary Tomsen; *Art Gallery Coordr* Terri White; *Dir* Keith Williams; *Pres* Eric Jensen
Open Mon - Sat 10 AM - 4 PM, cl Sun & major holidays; Admis families $5, adult $3, children 6-12 $1, mem free; Estab 1939 to preserve & present history & the arts. Gallery program offers exhibits of regional, national & international importance; 4 floors of exhibits; Average Annual Attendance: 42,000; Mem: 700; dues $25 & up; annual meeting in Mar
Special Subjects: Prints, Ceramics, Historical Material
Collections: International Ceramics Collection; 19th Century Japanese Woodblock Prints; local historical collections; Photograph of local landscape (Chelan & Douglas Gunteol)
Exhibitions: Rotating art exhibits; rotating historical exhibits; permanent history exhibits, including Pioneer Living & Apple Industry Exhibit
Publications: The Confluence, quarterly; The Connection, quarterly
Activities: Classes for adults & children; dramatic programs; docent training; educational kits available on variety of subjects; lect open to public, 10-20 vis lectrs per year; concerts; tours; individual paintings & original objects of art lent; museum shop sells books, original art, reproductions, prints, original Apple Box Labels, stationery, jewelry & toys

M **WENATCHEE VALLEY COLLEGE,** Gallery 76, 1300 Fifth St, Wenatchee, WA 98801. Tel 509-682-6776; Elec Mail gallery76@wvc.edu; Internet Home Page Address: www.ctc.edu (select Wenatchee Campus); *Pres* John Crew
Open Mon - Fri 9 AM - 1 PM, Sat 11 AM - 3 PM; Donation accepted; Estab 1976 to serve a rural, scattered population in North Central Washington State, which without Gallery 76, would not have access to a non-sales gallery; Non-profit community art gallery housed in Sexton Hall on Wenatchee Valley College Campus; Average Annual Attendance: 4,000; Mem: 150; dues $20-$100
Income: $20,000 (financed by mem, grants, donations, fundraising events & art classes/workshops)
Collections: Paintings, prints & sculpture (25 pieces total)
Publications: Gallery News, quarterly
Activities: Classes for adults & children; docent training; lect open to public, 2-3 vis lectrs per year; gallery talks; tours; Invitational Exhibit for member artists

YAKIMA

A **THE PEGGY LEWIS GALLERY AT THE ALLIED ARTS CENTER,** (Allied Arts Gallery of the Yakima Valley) 5000 W Lincoln Ave, Yakima, WA 98908. Tel 509-966-0930; *Exec Dir* Elizabeth Miller; *Pres* Bill Merriman
Open Mon - Fri 9 AM - 5 PM; No admis fee; Estab 1962 to encourage, promote & coordinate the practice & appreciation of the arts among the people of Yakima Valley; General gallery shows changing monthly exhibits; Average Annual Attendance: 20,000; Mem: 600; dues $25 - $500; annual meeting in Sept
Income: Financed by mem
Exhibitions: Monthly exhibits by local and area artists; annual juried exhibit
Publications: Artscope (arts calendar) monthly
Activities: Classes for adults & children; dramatic programs; lect open to public, 1-3 vis lectr per year; concerts; gallery talks; tours; competitions with awards; sales shop sells original art

L **Library,** 5000 W Lincoln Ave, Yakima, WA 98908. Tel 509-966-0930; Fax 509-966-0934; Elec Mail alliedartsyakima@nwinfo.net; Internet Home Page Address: www.alliedartsyakima.org; *Exec Dir* Elizabeth Herres Miller

Open daily 9 AM - 5 PM; Free; Estab 1965 to provide NW artists a show place for their work; 1,000 sq ft of wall/floor exhib space; Average Annual Attendance: 5,000; Mem: Allied Art Council 500 mem; monthly meeting
Library Holdings: Book Volumes 400; Records
Activities: Classes for adults & children; dramatic programs; lects open to public, 1 vis lect per yr; concerts; sponsoring competitions; juried, student juried awards; schools, hospitals, sr prog served by Artmobil; mus shop sells original art

M **YAKIMA VALLEY COMMUNITY COLLEGE,** Larson Gallery, 16th & Nob Hill Blvd, PO Box 22520 Yakima, WA 98907-2520. Tel 509-574-4875; Fax 509-574-6826; Elec Mail gallery@yvcc.cc.wa.us; Internet Home Page Address: www.yvcc.cc.wa.us/~/larson; *Admin Asst* Susi Meredith; *Dir* Carol Hassen; *Asst Dir* Denise Olsen; *Admin Asst* Eileen Williams
Open Tues - Sat 10 AM - 5 PM, cl Sun & Mon; No admis fee; Estab 1949; Fine arts gallery; Average Annual Attendance: 15,000; Mem: 250; dues $25-$1000
Income: $100,000 (financed by endowment, mem & fundraising)
Collections: Contemporary art, primarily 2-D
Exhibitions: Rotating exhibitions
Activities: Classes for adults & children; docent programs; workshops June & July; lect open to public, 1-4 vis lectr per year; tours; competitions with awards

WEST VIRGINIA

CHARLESTON

M **AVAMPATO DISCOVERY MUSEUM,** (Sunrise Museum, Inc) The Clay Center for Arts & Sciences, 300 Leon Sullivan Way, Charleston, WV 25301; PO Box 11808, Charleston, WV 25339. Tel 304-561-3500; Fax 304-561-3552; Internet Home Page Address: www.theclaycenter.org; *Collections Mgr* Denise Deegan; *Dir Exhibs/Cur Art* Richard Ambrose; *CEO/Pres* Dr Judith Wellington; *Dir Performing Arts* Lakin Cook; *VPres Operations* Sarah Martin
Open Wed - Sat 10 AM - 5 PM, Sun Noon - 5 PM, cl Mon, Tues & national holidays; Admis adults $6.50, students, teachers & seniors $5, children under 3 free; Estab 1960; Circ 3,000; Formerly Sunrise Museum moving to new location in 2003. The museum will house performing arts theatre & symphony; Dual Focus in arts & science. Merged with the Clay Center, July 2006; Average Annual Attendance: 120,000; Mem: dues Benefactors' Circle $1000, patron $500, supporting $250, contributing $100, participating $75 & individual $45
Income: $5.5M (financed by endowment, mem, earned income, corporate & business contributions)
Library Holdings: Book Volumes; Exhibition Catalogs
Special Subjects: Painting-American, Sculpture, Decorative Arts
Collections: 17th through 20th century American paintings, prints & sculpture; works on paper: emphasis on 20th & 21st century American art
Exhibitions: Numerous regional & international exhibits held throughout the year
Publications: quarterly newsletter
Activities: Classes for adults & children; dramatic programs; docent training; lect open to public; 6 vis lect per year; guided tours; planetarium & film programs; concerts; gallery talks; starlab-portable planetarium; individual & original objects of art lent to other museums & public institutions; 2 or more book traveling exhibitions per year; museum shop sells books, prints & variety of scientific, educational & decorative gift items including jewelry

HUNTINGTON

M **HUNTINGTON MUSEUM OF ART,** 2033 McCoy Rd, Huntington, WV 25701. Tel 304-529-2701; Fax 304-529-7447; Elec Mail ltipton@hmoa.org; Internet Home Page Address: www.hmoa.org; *Sr Cur* Jenine Culligan; *Dir Educ* Lisa Geelhood; *Pub Relations* John Gillispie; *Comp* Kathy Saunders; *Dir* Margaret A Skove; *Dir Develop* Margaret Mary Layne
Open Tues - Sat 10 AM - 5 PM, Sun Noon - 5 PM; cl Mon; No admis fee; Estab 1952 to own, operate & maintain an art museum for the collection of paintings, prints, bronzes, porcelains & all kinds of art & utility objects; to permit the study of arts & crafts & to foster an interest in the arts; Three building complex on 52-acre site includes ten galleries, two collection courts, seven studio workshops, a 10,000 volume capacity library, 300 seat auditorium, two & one-half miles of nature trails & an amphitheatre; Average Annual Attendance: 75,000; Mem: Mem dues vary; annual meeting in June
Income: Financed by endowment, mem, city, state & county appropriations
Special Subjects: Graphics, Painting-American, Photography, American Western Art, Ethnology, Ceramics, Crafts, Folk Art, Afro-American Art, Decorative Arts, Collages, Painting-Canadian, Furniture, Glass, Antiquities-Byzantine, Painting-British, Painting-Dutch, Carpets & Rugs, Coins & Medals, Period Rooms, Painting-Spanish, Antiquities-Persian, Military Art, Painting-Russian, Antiquities-Assyrian, Painting-Scandinavian
Collections: American & European Paintings & Prints; American Decorative Arts; Georgian silver; firearms; historical and contemporary glass; Turkish prayer rugs
Publications: Exhibit catalogs; quarterly newsletter
Activities: Classes & workshops for adults & children; docent training; public lectures; concerts; theatre programs; gallery talks; tours; individual paintings & original objects of art lent to museums; tri-state area of Ohio, Kentucky, West Virg in 75-mile radius; traveling exhibitions organized & circulated; museum shop sells books, original art, reproductions, prints & crafts; Junior Art Museum

MARTINSBURG

M **ASSOCIATES FOR COMMUNITY DEVELOPMENT,** Boarman Arts Center, 229 E Martin St, Martinsburg, WV 25401. Tel 304-263-0224; *VPres Bd Dir* Mary Boyd Kearse; *Pres Bd & Dir* Barbara Gibson
Open Mon - Fri 10 AM - 5 PM; No admis fee; Estab 1987 to exhibit the work of local & regional artists & craftsmen; Mem: 200; dues $20-$1,000; quarterly meetings

Income: $88,000 (financed by mem, city appropriation, state appropriation & exhibit sponsors)
Special Subjects: Photography, Sculpture, Crafts
Exhibitions: Changing exhibits featuring a variet of arts & crafts including photography, sculpture, oil, acrylic, watercolor by local artisans; Youth Art Month Exhibit
Publications: Boarman Newsletter, quarterly; annual brochure; show invitations, 7 per year
Activities: Classes for adults & children; artist-in-residence young artists summer workshop; Christmas Show & Sale; lect open to public, 4 vis lectrs per year; competitions with awards; scholarships & fels offered; book traveling exhibitions 1 per year; sales shop sells books, prints, original art & handcrafts

MORGANTOWN

WEST VIRGINIA UNIVERSITY
L **Evansdale Library,** Tel 304-293-5039; Fax 304-293-7330; Internet Home Page Address: www.libraries.wvu.edu; *Head Librn* Jo Ann Calzonetti
Open Mon - Thurs 8 AM - 12 AM, Fri 8 AM - 5 PM, Sat 9 AM - 5 PM, Sun 6 - 10 PM
Library Holdings: Book Volumes 260,000; Periodical Subscriptions 2250
Special Subjects: Art History, Landscape Architecture, Art Education
M **Laura & Paul Mesaros Galleries,** Tel 304-293-4841, ext 3210; Fax 304-293-5731; Elec Mail kolson@wvu.edu; Internet Home Page Address: www.wvu.edu; *Cur* Kristina Olson
Open during academic yr Mon - Sat Noon - 9:30 PM, cl Sun & university holidays; No admis fee; Estab 1867
Collections: Costumes; music; paintings; theatre
Exhibitions: Call for exhibit information
Activities: Lect; gallery talks; tours; concerts; drama; competitions; temporary traveling exhibitions

PARKERSBURG

A **THE CULTURAL CENTER OF FINE ARTS,** Art Gallery, 725 Market St, Parkersburg, WV 26101. Tel 304-485-3859; Fax 304-485+3850; Elec Mail ekge@earthlink.net; Internet Home Page Address: www.wvfinearts.com; *CEO & Exec Dir* Ed Pauley; *Pres (V)* Harry Schranom
Open Tues - Sat 10 AM - 5 PM, Sun 1 - 5 PM; No admis fee for members, non-members $2, cl nat holidays; Estab 1938 for the operation & maintenance of an art center & mus facility for the appreciation & enjoyment of art, both visual & decorative, as well as art history, crafts & other related educational or cultural activities; Main gallery 7,500 sq ft & upper gallery 3,000 sq ft, completely carpeted, airconditioned & climate controlled; Average Annual Attendance: 25,000; Mem: 500; dues corporate or patron $250, sustaining $100, family $30, individual $20; annual meeting in June; rate schedule upon request
Income: $160,000 (financed by endowment, mem & state appropriation)
Library Holdings: Book Volumes; Clipping Files; Exhibition Catalogs; Framed Reproductions; Memorabilia; Periodical Subscriptions; Reproductions; Slides; Video Tapes
Collections: Advice of Dreams (oil by Beveridge Moore); Amish & African Artifacts; The Hinge (watercolor by Rudolph Ohrning); Parmenides (sculpture by Beverly Pepper); Permanent collection of over 200 2D & 3D works
Exhibitions: Six exhibitions per yr
Publications: Calendar of events, bimonthly; annual report; exhibition catalogs
Activities: Classes for adults & children; docent training; workshops; outreach program, Arts-in-the-parks; 3 major fundraisers; educational programming; lect open to public, 6 vis lectrs per year; concerts; gallery talks; tours; competition with awards; $8,000 for Realism competition, others vary by exhibit; book traveling exhibitions; originate traveling exhibitions; mus shop sells books, original art, prints, local art, jewelry, Don Whitlatch "Spring Break" print

ROMNEY

L **HAMPSHIRE COUNTY PUBLIC LIBRARY,** 153 W Main St, Romney, WV 26757. Tel 304-822-3185; Fax 304-822-3955; Internet Home Page Address: www.wvculture.org; *Librn* Brenda Riffle
Open Mon & Fri 10 AM - 8 PM, Tues - Thurs 10 AM - 6 PM, Sat 10 AM - 4 PM; No admis fee; Estab 1942; 7 Display cases changed every month; Average Annual Attendance: 45,000; Mem: 11,000
Income: $128,000 financed by state, donations, mem
Purchases: $32,000
Library Holdings: Audio Tapes; Book Volumes 38,000; Cassettes; Clipping Files; Maps; Original Documents; Pamphlets; Periodical Subscriptions 96; Photographs; Prints; Records; Reels; Video Tapes
Collections: books
Exhibitions: Children's art; private collections of rocks, antiques, displays of items of other countries; various local artists collection; weaving
Activities: Classes for adults & children; lect open to public; concerts; tours; plays; antique show; competitions with awards; individual paintings lent

WESTON

M **WV MUSEUM OF AMERICAN GLASS,** PO Box 574, Weston, WV 26452. Tel 304-269-5006; Elec Mail dmoore8715@aol.com; WVmuseumofglass@aol.com; Internet Home Page Address: http://members.aol.com/wvmuseumofglass
Open Mon - Tues & Thurs - Sat 12 PM - 4 PM; Donations accepted; Located on the corner of Maine Ave & Second St in downtown Weston, WV. Mus has the mission of sharing the diverse & rich heritage of glass as a product & historical object telling of the lives of glass workers, their families & communities, and of the tools & machines used in glass houses; Mem: Dues Benefactor $500 & up; Patron $100; Sustaining $50; Supporting $35; Ann $25
Special Subjects: Historical Material, Glass, Prints

Collections: Diverse & beautiful glass objects produced by factories during this century; five large covered jars designed by Fritz Driesbach & executed by the Blenko Glass Co, Milton, WV; three Tiffany decorative glass tiles (one signed); hand-painted Top Hat tumbler, a product of the WV Glass Specialty Co, Weston WV, signed by the artist, Al Erbe; commemorative glass bust of M J Owens, a native of WV and inventor of the automatic bottle-making machine
Publications: Black Glass Book, published by WVMAG; All About Glass, quarterly magazine for mems
Activities: Research library; events such as The Marble Festival; educational interactive displays for children; reprints, monographs, catalogs & museum-related items for sale

WHEELING

OGLEBAY INSTITUTE
A **Stifel Fine Arts Center,** Tel 304-242-7700; Elec Mail inspire@oionline.com; Internet Home Page Address: www.oionline.com/arts; *Dir* Neal Warren
Estab 1930 to present art exhibitions & to provide the opportunity for life-long learning in the fine arts fields; Three galleries located in the Stifel Mansion occupy the center of the facility on both floors; Mem: 1450; dues $15 & up
Exhibitions: Rotating exhibits
Publications: Exhibition catalogs, 7 per year
Activities: Classes for adults & children; docent training; lect open to public; concerts
M **Mansion Museum,** Tel 304-242-7272; Fax 304-242-4203; Internet Home Page Address: www.oionline.com/museum; *Dir* Holly McCluskey; *Sr Cur* John A Artzberger
Open Mon - Sat 9:30 AM - 5 PM, Sun & holidays Noon - 5 PM; Admis $5, 55 & over $4.25, students $2, children under 12 free with paying adults; Estab & incorporated 1930 to promote educational, cultural & recreational activities in Wheeling Tri-State area; Building & ground are the property of the city; an exhibition wing adjoins the main house; annual Christmas decorations; Average Annual Attendance: 83,394; Mem: 1450; dues $15 & up
Special Subjects: Ceramics, Glass, Period Rooms, Pewter
Collections: Early 19th century china; early glass made in Wheeling & the Midwest; period rooms; pewter
Exhibitions: Current exhibits of art & other allied subjects change periodically; decorative arts
Activities: Antique show & sales; antique classes; gallery talks; self-guided & prearranged group tours
L **Library,** Tel 304-242-7272; Fax 304-242-4203; *Sr Cur* John A Artzberger
Open by appointment only; Founded 1934; Highly specialized on the early history of the area
Library Holdings: Book Volumes 800; Micro Print 20; Other Holdings Documents bound 100, Maps, VF 4; Slides
Special Subjects: Decorative Arts, Historical Material
Collections: Brown Collection of Wheeling History, photographs; Wheeling City Directories; Wheeling & Belmont Bridge Company Papers
Activities: Classes for adults & children; docent training; 2 vis lectrs per yr; extension prog, 75 mile radius of Wheeling

WISCONSIN

APPLETON

M **LAWRENCE UNIVERSITY,** Wriston Art Center Galleries, PO Box 599, Appleton, WI 54912. Tel 920-832-6621; Fax 920-832-7362; Elec Mail odonnelp@lawrence.edu; Internet Home Page Address: www.lawrence.edu; *Cur & Dir* Frank Lewis
Open Tues - Fri 10 AM - 4 PM, Sat & Sun Noon - 4 PM, cl Mon; No admis fee; Estab 1950 for teaching & community exhibitions. Wriston Art Center opened Spring 1989; Three changing galleries for changing exhibits of contemporary & historical shows; Average Annual Attendance: 5,000
Collections: Ottilia Buerger Collection of Ancient Coins; Pohl Collection-German Expressionism; American regionalist art; graphics; Japanese prints & drawings
Exhibitions: Various exhib
Activities: Lect open to public, 3-6 vis lectrs per year; individual paintings & original works of art lent for exhibitions in other museums

BELOIT

M **BELOIT COLLEGE,** Wright Museum of Art, 700 College St, Beloit, WI 53511. Tel 608-363-2677; Fax 608-363-2718; Internet Home Page Address: www.beloit.edu/nmuseum/wright/index.htm; *Dir* Joy Beckman; *Cur* Judy Newland
Open Tues - Sun 11 AM - 4 PM; No admis fee; Estab 1893; Wright Art Hall built 1930 to house the collection for the enrichment of the college & community through exhibition of permanent collection & traveling & temporary art exhibitions of cultural & aesthetic value; A Georgian building architecturally styled after the Fogg Mus in Cambridge, Massachusetts. Three galleries on main floor, on a large center court; Art Department shares other floors in which two student galleries are included; Average Annual Attendance: 20,000
Purchases: 17th - 20th century graphics; Asian decorative arts
Special Subjects: Architecture, Graphics, Latin American Art, Painting-American, Photography, Anthropology, Archaeology, Portraits, Jade, Jewelry, Porcelain, Oriental Art, Asian Art, Metalwork, Painting-British, Ivory, Baroque Art, Calligraphy, Medieval Art, Antiquities-Oriental, Antiquities-Egyptian, Antiquities-Greek, Antiquities-Roman, Gold, Bookplates & Bindings
Collections: European & American (paintings, sculpture & decorative arts); Fisher Memorial Collection of Greek Casts; graphics, emphasis on German Expressionist & contemporary works; Gurley Collection of Korean Pottery, Japanese Sword Guards, Chinese Snuff Bottles & Jades; Morse Collection of Paintings & Other Art Objects; Neese Fund Collection of Contemporary Art; Oriental; Pitkin

Collection of Oriental Art; Prints by Durer, Rembrandt, Whistler & others; sculpture of various periods; 19th century photographs
Publications: Exhibition catalogs
Activities: Classes; supportive programs; docent training; lect open to public; gallery talks; tours; traveling exhibitions organized & circulated

CEDARBURG

A **WISCONSIN FINE ARTS ASSOCIATION, INC,** Ozaukee Art Center, W62 N718 Riveredge Dr, Cedarburg, WI 53012. Tel 262-377-8290; *Art Dir* Paul Yank
Open Wed - Sun 1 - 4 PM, or by appointment; No admis fee; Estab 1971; Historical landmark with cathedral ceiling; Average Annual Attendance: 10,000; Mem: 600; dues business patron $500, patron $200, sustaining $100, associate sustaining $50, family $30, individual $22, student $10; annual meeting in Oct
Income: Mem contributions, state appropriations
Collections: Paintings, sculpture, prints, ceramics
Exhibitions: Ozaukee County Show; Harvest Festival of Arts
Publications: Monthly newsletter
Activities: Classes for adults and children; docent training; lectures open to public, 2 vis lectrs per year; concerts; gallery talks; tours; competitions with awards; arts festivals

EAU CLAIRE

M **UNIVERSITY OF WISCONSIN-EAU CLAIRE,** Foster Gallery, Fine Arts Ctr, Eau Claire, WI 54702-5008. Tel 715-836-2328; Fax 715-836-4882; *Dir* Thomas Wagener
Open Mon - Fri 10 AM - 4:30 PM, Thurs 6 - 8 PM, Sat & Sun 1 - 4:30 PM; No admis fee; Estab 1970 to show finest contemporary art in all media; State University Gallery in Fine Arts Center; Average Annual Attendance: 24,000
Income: Funded by state appropriation
Purchases: Tim High: Rebel Earth/Ramath Ieh; Bill Pearson: Trout Quarte
Collections: Eau Claire Permanent Art Collection; 20th Century Artists
Exhibitions: American Indian Arts Festival; Annual Juried Student Art Show; Mental/Visual/Manual; Metalia; Midwest Photography Intnational; Outsider Art
Activities: Lect open to public, 10-12 vis lectrs per year; competition with awards; book traveling exhibitions 3-4 per year

GREEN BAY

M **NEVILLE PUBLIC MUSEUM,** 210 Museum Pl, Green Bay, WI 54303. Tel 920-448-4460; Fax 920-448-4458; Elec Mail bc_museum@co.brown.wi.us; Internet Home Page Address: www.nevillepublicmuseum.org; *Dir* Eugene Umberger; *Cur Science* John Jacobs; *Cur Colls* Louise Pfotenhauer; *Cur of Educ* Matt Welter; *Cur Art* Marilyn Stasiak; *Interim Cur of Exhibits* Dennis Grignon; *AV Technician* Larry La Malfa; *Security Chief* Gary Geyer; *Office Mgr* Jill Champeau; *Office Support Staff* Jean Hermes; *Admin Coordr* Kathy Rosera; *Cur History* Trevor Jones; *Recorder* Jacqueline Frank
Open Mon, Tues, Fri, Sat 9 AM - 5 PM, Wed & Thurs 9 AM - 8 PM, Sun Noon - 5 PM; Adult $4, children ages 5 & under free; special rate for school & youth groups; Estab 1915 as Green Bay Pub Mus; names changed 1926, estab to interpret the collections & educate through exhibits, educational programming, research & publications; Art gallery presently in use, largest 3000 sq ft. Maintains reference library; Average Annual Attendance: 66,000; Mem: 700; dues Individual $30, Family $50
Income: Financed by county appropriation & private donations
Special Subjects: Drawings, Painting-American, Photography, Prints, Sculpture, Watercolors, Costumes, Folk Art, Etchings & Engravings, Dolls, Furniture, Glass, Porcelain, Embroidery
Collections: Victoriana, antique furniture, china, glass, costumes, accessories; contemporary & historical paintings; drawings; prints & sculpture; archeology, geology, photographs, news film from local TV stations
Exhibitions: On the Edge of the Inland Sea
Publications: Musepaper, 6 times per yr
Activities: Classes for adults & children; docent training; lect open to public, vis lectrs; concerts; gallery talks; tours; competitions with awards; scholarships offered; individual paintings & original objects of art lent to other museums; book traveling exhibitions; museum shop sells books, magazines, original art, reproductions, prints, gifts & cards
L **Library,** 210 Museum Pl, Green Bay, WI 54303. Tel 920-448-4460; Fax 920-448-4458
Open to the public for reference by appt only
Library Holdings: Audio Tapes; Book Volumes 5000; Clipping Files; Exhibition Catalogs; Fiche; Kodachrome Transparencies; Memorabilia; Motion Pictures; Pamphlets; Periodical Subscriptions 20; Photographs; Reels; Slides; Video Tapes

M **UNIVERSITY OF WISCONSIN, GREEN BAY,** Lawton Gallery, 2420 Nicolet Dr, Green Bay, WI 54311. Tel 920-465-2271, 465-2916; Fax 920-465-2890; Elec Mail perkinss@uwgb.edu; *Acad Cur Art* Stephen Perkins; *Asst Cur* Tina Bechtel
Open Tues - Sat 10 - 3 PM, cl Sun & Mon; No admis fee; Estab 1974 to show changing exhibs of contemporary & 20th century art, student & faculty work; Gallery is 2,000 sq ft; Average Annual Attendance: 2,500
Income: $5,000
Purchases: Limited purchases & donations to Univ Wisc-Green Bay permanent coll
Collections: Contemporary art; student & faculty work; Native American collection
Exhibitions: Graduating Seniors Exhibition
Publications: Exhibition catalogs
Activities: Gallery & museum practices class for undergraduates; lect open to public, 2-3 vis lectrs per year; competitions; gallery talks; assorted awards for student juried art exhibition; exten prog loaned to university departments & offices; book traveling exhibitions; originates traveling exhibitions to other university galleries

GREENBUSH

M **WADE HOUSE & WESLEY W JUNG CARRIAGE MUSEUM,** Historic House & Carriage Museum, W 7824 Center St, PO Box 34 Greenbush, WI 53026. Tel 920-526-3271; Fax 920-526-3626; Elec Mail wadehous@wisconsinhistory.org; Internet Home Page Address: www.wisconsinhistory.org/wadehouse; *Dir* David Simmons; *Cur Interpretation* Jeffery Murray
Open mid-May - mid-Oct 10 AM -5 PM; Admis family rate $27, adult $10, seniors $9, child $5 (included carriage ride); Estab 1953 to educate public concerning 1860s Wisconsin Yankee town life; Average Annual Attendance: 20,000
Income: $400,000 (financed by state appropriation, admis fees)
Special Subjects: Architecture, Archaeology, Ceramics, Crafts, Decorative Arts, Furniture, Historical Material, Period Rooms
Collections: Wisconsin made Carriages; 1860s Household Furnishings
Exhibitions: 1860s Historic House Tour; Saw-mill
Activities: Classes for children; docent training; spec events; lect open to public, vis lectr; tours; museum shop sells books, reproductions, original art & prints

KENOSHA

M **KENOSHA PUBLIC MUSEUM,** 5608 Tenth Ave, Kenosha, WI 53140. Tel 262-653-4140; Fax 262-653-4143; Elec Mail mpaulat@kenosha.org; *Cur Educ* Nancy Mathews; *Sr Cur Exhib & Coll* Daniel Joyce; *Dir* Paula Touhey; *Cur I Exhib* Rachel Klees; *Develop Coordr* Peggy Gregorski; *Mus Shop Mgr* Rita Myers; *VChmn* Juan Torres; *VChmn* Barbara Lassen; *VPres* Marty Stewart Huff
Open Mon - Fri 9 AM - 5 PM, Sat 9 AM - 4 PM, Sun 1 - 4 PM; No admis fee; Estab 1935 to promote interest in general natural history & regional art; The gallery has 8000 sq ft of permanent exhib space & 1000 sq ft for temporary exhibits; Average Annual Attendance: 50,000; Mem: 2000; dues $10; ann meeting in Apr
Income: $500,000 (financed by city appropriation)
Purchases: $2200
Library Holdings: Audio Tapes; Book Volumes; Clipping Files; Framed Reproductions; Other Holdings; Pamphlets; Slides; Video Tapes
Special Subjects: Ethnology, Pottery, Oriental Art
Collections: African Art; Historic Wisconsin Pottery; Ivory Carvings: Oriental Art; Regional Artists; Regional Natural History; individual paintings lent on yearly basis to municipal & county offices to be displayed in public areas; lending collections contains cassettes, color reproductions, filmstrips, framed reproductions, motion pictures, nature artifacts & slides
Publications: Newsletter, bimonthly; Wisconsin Folk Pottery Book
Activities: Classes for adults & children; dramatic progs; docent training; youth employment in the arts prog; lect open to pub, 12 vis lectr per yr; gallery talks; tours; competitions; individual paintings lent on yearly basis to municipal & county offices to be displayed in pub areas; lending collection contains cassettes, color reproductions, filmstrips, 30 framed reproductions, 280 motion pictures, nature artifacts & slides; originate traveling exhibs; mus shop sells crafts, ethnic jewelry, earrings, Oriental boxes, toys & collectibles

L **Library,** 5500 First Ave, Kenosha, WI 53140. Tel 262-653-4140; Fax 262-653-4437; Elec Mail mpaulat@kenosha.org; Internet Home Page Address: www.kenosha.org; *Vol Librn* Pat Machmeier
Open Tues - Sat 9 AM - 5 PM, Sun & Mon noon - 5 PM; No admis fee; Estab 1937; Art works from Southeast Wisconsin artists & worldwide, Chinese ivories, decorative arts; Average Annual Attendance: 100,000
Income: Financed by municipal tax
Library Holdings: Audio Tapes; Book Volumes 3000; Cassettes; Exhibition Catalogs; Filmstrips; Framed Reproductions; Kodachrome Transparencies; Lantern Slides; Memorabilia; Motion Pictures; Pamphlets; Periodical Subscriptions 20; Photographs; Records; Slides; Video Tapes
Collections: Fine & decorative arts, natural science, anthropology
Exhibitions: Permanent art gallery & special exhibits gallery with 6 changing shows per year
Activities: Classes for adults & children; docent training; lect open to public; 4 vis lect per year; gallery talks; six book traveling exhibitions per year

LA CROSSE

M **VITERBO UNIVERSITY,** Art Gallery, 815 S Ninth St, La Crosse, WI 54601. Tel 608-796-3000 (Main), 796-3754; Fax 608-796-3736; *Dir* Ed Rushton
Open Mon - Fri 10 AM - 5 PM; No admis fee; Estab 1964 to exhibit arts & crafts which will be a valuable supplement to courses offered; Gallery is located in the center of the Art Department; 100 running feet; soft walls; good light
Income: Financed by school appropriation
Collections: Mrs Lynn Anna Louise Miller, Collection of the contemporary United States primitive; Peter Whitebird Collection of WPA project paintings
Activities: Classes for adults; dramatic programs; lect open to public; gallery talks

LAC DU FLAMBEAU

A **DILLMAN'S CREATIVE ARTS FOUNDATION,** 3305 Sand Lake Lodge Ln, Box 98, Lac du Flambeau, WI 54538. Tel 715-588-3143; Fax 715-588-3110; Elec Mail dillmans@newnorth.net; Internet Home Page Address: www.dillmans.com; *VPres* Sue Robertson; *Pres* Dennis Robertson
Open 24 hrs May - Oct; No admis fee; Estab 1987 to offer educational experience; Display on Dillman Lodge walls, hallway, studios & rack in gift shop; Average Annual Attendance: 500
Publications: Annual brochure
Activities: Classes for adults & children; lect open to public, 100 vis lectr per year; scholarships & fels offered; exten dept serves England; lending collection contains books; book traveling exhibitions 12-15 per year; originate traveling exhibitions 12-15 per year; sales shop sells books, original art & prints

L **Tom Lynch Resource Center,** 3305 Sand Lake Lodge Ln, Box 98, Lac du Flambeau, WI 54538. Tel 715-588-3143; Fax 715-588-3110; Elec Mail dillmans@newnorth.net; Internet Home Page Address: www.dillmans.com; *Pres* Dennis Robertson; *VPres* Sue Robertson; *Sec* Betsy Behnke
Open May - Oct; No admis fee; Estab 1977 for education; Lends books and tapes; sale of art works; Average Annual Attendance: 500
Income: Income from workshop fees
Library Holdings: Audio Tapes 20; Book Volumes 500; Exhibition Catalogs; Framed Reproductions 20; Original Art Works 100; Prints 4000; Reproductions 100; Video Tapes 20
Activities: Classes for adults & children; awards from Midwest Watercolor Soc & Oil Painters of Am; scholarships offered; workshops in Europe; museum shop sells books, original art, reproductions & prints

M **LAC DU FLAMBEAU BAND OF LAKE SUPERIOR CHIPPEWA INDIANS,** George W Brown Jr Ojibwe Museum & Cultural Center, 603 Peace Pipe, PO Box 804 Lac du Flambeau, WI 54538. Tel 715-588-3333, 588-2139; Fax 715-588-2355; Elec Mail bearpawn@hotmail.com; *Mus Dir* Christina Breault; *Mus Mgr* Teresa Mitchell; *Colls Technician* Nina Isham
Open May - Oct Mon - Sat 10 AM - 4 PM & Nov - Apr Mon - Fri 10 AM - 2 PM; Admis adult $3, children $2, seniors $2, tour group $4 per person; Estab 1988 to collect, preserve, protect & promote the cultural history of the Lac du Flambeau Ojibwe; Main floor: Four seasons exhibit featuring the harvesting cycle of the traditional ways of the Ojibwe Indian people plus numerous objects of the Ojibwe; Average Annual Attendance: 6,500
Income: $100,000 (financed by Tribal appropriation)
Purchases: Various historical, cultural objects, photos & documents
Library Holdings: Auction Catalogs; Audio Tapes; Cards; Cassettes; Compact Disks; Kodachrome Transparencies; Manuscripts; Maps; Memorabilia; Original Art Works; Photographs; Prints; Reproductions; Slides; Video Tapes
Special Subjects: Drawings, Photography, American Indian Art, Archaeology, Ethnology, Textiles, Costumes, Crafts, Folk Art, Woodcarvings, Etchings & Engravings, Decorative Arts, Manuscripts, Posters, Dolls, Jewelry, Carpets & Rugs, Historical Material, Maps, Dioramas, Embroidery, Leather
Collections: Manuscripts, documents & photography of the Lac du Flambeau Band of the Lake Superior Ojibwe; Objects of the cultural history of The Lake Superior Ojibwe
Exhibitions: Various exhibits of the cultural ways of the Lac du Flambeau Ojibwe
Activities: Classes for adults & children; interactive TV programs area schools; dramatic programs; lect open to public, 3 vis lectr per year; culural sharing prog; community art display; history topics; individual paintings lent throughout Wisconsin; museum shop sells books, magazines, original art, reproductions, prints, Ojibwe arts & crafts & food

MADISON

M **MADISON MUSEUM OF CONTEMPORARY ART,** (Madison Art Center) 227 State St, Madison, WI 53703. Tel 608-257-0158; Fax 608-257-5722; Elec Mail info@mmoca.org; Internet Home Page Address: www.mmoca.org; *Registrar* Marilyn Sohi; *Business Mgr* Michael Paggie; *Dir Develop* Nicole Allen; *Technical Servs Supvr* Mark Verstegen; *Gallery Shop Mgr* Leslie Genszler; *Cur Educ & Public Programming* Sheri Castelnuovo; *Dir Public Info* Katie Kazan; *Gallery Operations Mgr* Jim Kramer; *Dir* Stephen Fleischman; *Asst to Dir* Jennifer Holmes
Tues - Wed 11 AM - 5 PM, Thurs & Fri 11 AM - 8 PM, Sat 10 AM- 8 PM, Sun Noon - 5 PM, cl Mon; No admis fee, donations accepted; Estab 1969 to promote the visual arts; Circ non-circulating; Galleries on 3 levels in civic center complex; Average Annual Attendance: 150,000; Mem: 1800; dues $40 & up; annual meeting in May
Income: $1,168,000 (financed by mem, grants, gifts & earned revenue)
Purchases: $15,000
Library Holdings: Book Volumes; Clipping Files; Exhibition Catalogs; Original Documents; Periodical Subscriptions
Special Subjects: Photography, Painting-American, Drawings, Prints
Collections: Emphasis on contemporary Americans; large print & drawing collection (Japanese, European, Mexican & American); paintings; photographs
Exhibitions: Wisconsin Triennial; Young At Art
Publications: Catalogs & announcements usually accompany each exhibition; quarterly newsletter
Activities: Docent training; lect open to public, film series; gallery talks; tours; fellowships; films; organize book traveling exhibs; originate traveling exhibitions; mus store sells books, reproductions, prints, fine craft & art cart

M **SOCIETY FOR COMMERCIAL ARCHEOLOGY,** P O Box 45828, Madison, WI 53744-5828. Tel 608-264-6560; Fax 608-264-7615; Elec Mail office@sca-roadside.org; Internet Home Page Address: www.sca-roadside.org; *Pres* Carrie Scupholm; *VPres* Gregory Smith; *Cur & Libr* Beth Dodd
Estab 1976 to promote pub awareness, exchange information & encourage selective conservation of the commercial landscape; Mem: 800; dues institutional $40, individual $25; annual meetings
Income: Financed by mem & dues
Publications: Journal, twice a yr; newsletter, quarterly

M **STEEP & BREW GALLERY,** 544 State St, Madison, WI 53703. Tel 608-256-2902; Elec Mail mduerr@madison.k12.WI.us; *Dir* Mark Duerr
Open Mon - Thurs 8 AM - 10 PM, Fri & Sat 9 AM - 11 PM, Sun 11 AM - 8 PM; No admis fee; Estab 1985 as a gallery showing emerging & experimental local artists; Store front street level gallery with 1700 sq ft of space
Income: $4000 (financed by exhibition fees & commission on sales)
Purchases: Ray Esparsen, Theron Caldwell Ris, Randy Arnold
Exhibitions: Regular exhibits by various local artists
Activities: Concerts; gallery talks

UNIVERSITY OF WISCONSIN-MADISON

M **Wisconsin Union Galleries,** Tel 608-262-7592; 262-5969; Fax 608-262-8862; Elec Mail schmoldt@wisc.edu; Internet Home Page Address: www.union.wisc.edu/art; *Dir* Mark Guthier; *Gallery Dir & Cur* Robin Schmoldt

Open 10 AM - 8 PM; No admis fee; Estab 1907 to provide a cultural program for the members of the university community; Owns two fireproof buildings with four separate galleries 1700 sq ft: Memorial Union, 800 Langdon; Union South, 227 N Randall Ave; Average Annual Attendance: 125,000; Mem: 50,000 faculty, alumni & townspeople, plus 45,000 students; dues $50; annual meeting in Nov

Purchases: $1500

Special Subjects: Painting-American, Photography, Prints, Sculpture, Watercolors

Collections: Oil & watercolor paintings, photographs, prints & sculptures, mostly by Wisconsin artists

Publications: A Reflection of Time: The WI Union Art Collection

Activities: Informal classes in arts & crafts; dramatic programs; docent training; lect open to public, 5 vis lectr per year; films; gallery talks; competitions with prizes; annual student art show with purchase awards; book traveling exhibitions 4 per year

M **Chazen Museum of Art,** Tel 608-263-2246; Fax 608-263-8188; Internet Home Page Address: www.chazen.wisc.edu; *Assoc Dir* Carol Fisher; *Ed* Christine Jarid; *Registrar* Ann Sinfield; *Cur Educ* Anne Lambert; *Dir* Russell Panczenko; *Exhibs Coordr* Mary Ann Fitzgerald
Tues - Fri 9-5, Sat - Sun 11-5; No admis fee; Estab 1962, building opened 1970 to display, preserve & build a general art collection of high quality for the study & enjoyment of students, community & state; Three levels, 12 galleries covering 25,000 sq ft of exhibition space; Average Annual Attendance: 100,000; Mem: 1800; dues $20-$1000

Income: Financed by endowment, mem, state appropriation & private sources

Purchases: Vary according to income

Special Subjects: Painting-American, Religious Art, Decorative Arts, Painting-European, Furniture, Oriental Art, Renaissance Art, Medieval Art, Antiquities-Egyptian, Antiquities-Greek, Painting-Russian

Collections: Ancient Egyptian & Greek pottery, sculpture, glass and coins; Joseph E Davies Collection of Russian Icons, Russian & Soviet Paintings; Vernon Hall Collection of European Medals; Indian sculpture; Medieval painting & sculpture; Renaissance painting & sculpture; Edward Burr Van Vleck Collection of Japanese Prints; Ernest C & Jane Werner Watson Collection of Indian Miniatures; 16th - 20th century prints - general collection; 17th - 20th century European painting, sculpture, furniture & decorative arts; 18th, 19th & 20th century American painting, sculpture & furniture

Exhibitions: Six to eight temporary exhibitions per year in all media from varied periods of art history

Publications: Bienniel bulletin; calendar, bimonthly; special exhibition catalogs; newsletter

Activities: Classes for adults & children; docent training; lect open to public; 10-15 vis lects per yr; concerts; gallery talks; tours; individual paintings & original objects of art lent to other museums; book traveling exhibitions 2-4 per year; originate traveling exhibitions; sales shop sells books, magazines, original art, reproductions & toys

L **Kohler Art Library,** Tel 608-263-2256, 263-2258; Fax 608-263-2255; Elec Mail lkorenic@library.wisc.edu; Internet Home Page Address: www.library.wisc.edu/libraries/Art; *Pub Serv* Beth Abrohams; *Dir* Lyn Korenic; *Tech Serv* David Camp; *Reference Librn* Linda Duychak
Open Mon - Thurs 8 AM - 9:45 PM, Fri 8 AM - 4:45 PM, Sat & Sun 11 AM-4:45 PM; Estab 1970 to support the teaching & research needs of the Art & Art History Departments & the Chazen Mus of Art; Circ 34,000; For lending; Average Annual Attendance: 73,000

Income: Financed by state appropriation & private funding

Library Holdings: Auction Catalogs; Book Volumes 155,000; CD-ROMs; Cassettes 50; Clipping Files; Compact Disks; DVDs; Exhibition Catalogs; Fiche 21,000; Micro Print; Pamphlets; Periodical Subscriptions 460; Reels 400; Video Tapes

Activities: Tours

M **WISCONSIN HISTORICAL SOCIETY WISCONSIN HISTORICAL MUSEUM,** State Historical Museum, 30 N Carroll St, Madison, WI 53703-2707. Tel 608-264-6555; Fax 608-264-6575; Internet Home Page Address: www.wisconsinhistory.org/museum; *Dir* Ellsworth Brown; *Assoc Dir* Robert Thomasgard; *Mus Adminr* Ann Koski; *Cur Art Coll* Joseph Kapler; *Cur Visual Materials* Andy Kraushaar; *Cur Antropology* Jennifer Kolb; *Cur Costumes & Textiles* Leslie Bellais; *Chief Cur* Paul Bourcier
Open Tues - Sat 9 AM - 4 PM; Admis fee; Estab 1846, mus added 1854; organized to promote a wider appreciation of the American heritage, with particular emphasis on the collection, advancement & dissemination of knowledge of the history of Wisconsin & of the Middle West; Average Annual Attendance: 55,000; Mem: 12,000; dues $30 & up

Income: Financed by state appropriation, earnings, gifts & federal grants

Special Subjects: Architecture, Drawings, Graphics, Painting-American, Prints, American Indian Art, American Western Art, Anthropology, Archaeology, Costumes, Ceramics, Crafts, Folk Art, Woodcarvings, Etchings & Engravings, Portraits, Furniture, Jewelry, Silver, Carpets & Rugs, Coins & Medals, Cartoons, Pewter, Leather, Military Art

Collections: American Historical & ethnographic material; iconographic collection; ceramics, coins, costumes, dolls, furniture, paintings, prints, photographs, & slides

Exhibitions: Special case and gallery exhib

Publications: Wisconsin Magazine of History, quarterly

Activities: Classes for children; docent training; lect open to public; concerts; tours; individual paintings & original objects of art lent to other museums & individuals for educational purposes; book traveling exhibitions; sales shop sells books, magazines, reproductions, slides & post cards

L **Archives,** 816 State St, Madison, WI 53706-1488. Tel 608-264-6460; Fax 608-264-6472; Elec Mail archref@mail.shsw.wisc.edu; Internet Home Page Address: www.shsw.wisc.edu; *Dir & Archivist* Peter Gottlieb
Open Mon - Fri 8 AM - 5 PM, Sat 9 AM - 4 PM; Average Annual Attendance: 1,846

Income: Financed by state

Library Holdings: Book Volumes; Cassettes; Fiche; Kodachrome Transparencies; Lantern Slides; Manuscripts; Maps; Memorabilia; Motion Pictures; Original Art Works; Original Documents; Other Holdings Original documents; Maps; Photographs; Prints; Records; Reels; Reproductions; Slides; Video Tapes

MANITOWOC

M **RAHR-WEST ART MUSEUM,** 610 N 8th St, Manitowoc, WI 54220. Tel 920-683-4501; Fax 920-683-5047; Elec Mail rahrwest@manitowoc.org; *Asst Dir* Daniel Juchniewich; *Dir* Jan Smith; *Admin Asst* Elaine Schroeder
Open Mon, Tues, Thurs & Fri 10 AM - 4 PM, Wed 10 AM - 8 PM, Sat & Sun 11 AM - 4 PM, cl holidays; No admis fee; Estab 1950 as city art museum and civic center to serve the city of Manitowoc. Transitional gallery in new wing built 1975; period rooms in Victorian Rahr Mansion built c 1991; a Registered Historic home; American art wing built in 1986; Ruth West Gallery 48' x 63'; Corridor Gallery, for changing exhibits; Permanent Collections Gallery; Average Annual Attendance: 22,000; Mem: 600; dues $20 individual; receive joint membership to Milwaukee Art Museum

Income: $250,000 (financed by mem & city appropriation)

Library Holdings: Book Volumes 1500; Exhibition Catalogs; Filmstrips; Periodical Subscriptions; Video Tapes

Special Subjects: Drawings, Graphics, Painting-American, Prints, Watercolors, American Indian Art, Furniture, Glass, Ivory, Period Rooms

Collections: 19th & 20th Century American Paintings & Prints; Schwartz Collection of Chinese Ivories; contemporary art glass; porcelain; works by Francis, Johns Lichtenstein & O'Keeffe

Exhibitions: Monthly changing exhibitions; Annual exhibitions of community generated art; Traveling exhibitions of a changing schedule each yr

Publications: Catalogues of collections & exhibitions

Activities: Classes for adults & children; docent training; family activities; chocolate fantasy; lect open to public, 10 vis lectr per year; concerts; gallery talks; tours; scholarships offered; book traveling exhibitions 10 per year; museum shop sells reproductions

MARSHFIELD

M **NEW VISIONS GALLERY, INC,** 1000 N Oak, Marshfield Clinic Marshfield, WI 54449. Tel 715-387-5562; Fax 715-387-5506; Elec Mail newvisions.gallery@verizon.net; Internet Home Page Address: www.newvisionsgallery.org; *Dir* Mary Peck; *Office Mgr* Tamara Mess
Open Mon - Fri 9 AM - 5:30 PM, Sat 11 AM - 3 PM; No admis fee; Estab 1975 for the education, awareness & appreciation of visual arts; 1500 sq ft exhib space, track lighting, moveable display panels, sculpture stands; Average Annual Attendance: 75,000; Mem: 375; dues $25 - $1000 & up

Income: $115,000 (financed by mem, earned income, fundraising & gifts)

Library Holdings: Book Volumes; CD-ROMs; Video Tapes

Special Subjects: Drawings, Graphics, Painting-American, Photography, Prints, Sculpture, Watercolors, American Indian Art, African Art, Southwestern Art, Ceramics, Crafts, Pottery, Woodcuts, Etchings & Engravings, Decorative Arts, Painting-Japanese, Posters, Glass, Porcelain, Oriental Art, Asian Art, Carpets & Rugs, Juvenile Art, Painting-Australian

Collections: Australian Aboriginal Art Collection; Haitian Painting Collection; West African Art Collection; original prints

Exhibitions: Emerging Talents; New Visions' Culture & Agriculture; Annual Marshfield Art Fair; Mighty Midwest Biennial

Publications: Brochures, every 6 wks; catalogs

Activities: Classes for adults; docent training; lect open to public, gallery talks; tours; competitions with awards; lending collection contains books; book traveling exhibitions 2 annually; museum shop sells gifts produced by artists or craft studios, jewelry, pottery, card, reproduction & prints

MENOMONIE

M **UNIVERSITY OF WISCONSIN-STOUT,** J Furlong Gallery, Menomonie, WI 54751. Tel 715-232-2261; Elec Mail furlong@uwstout.edu; *Cur* Chris Zerendow
Open Mon - Fri 10 AM - 4 PM, Tues 6 - 9 PM, Sat Noon - 3PM; No admis fee; Estab 1966 to serve university & local community with exhibits of art; A single room gallery; track lighting; Average Annual Attendance: 1,500

Income: Financed by state appropriation

Special Subjects: Drawings, Painting-American, Prints, Sculpture, African Art

Collections: African Art; paintings including works by Warrington Colescott, Roy Deforest, Walter Quirt, George Roualt & Raphael Soyer; drawings; prints; sculpture

Exhibitions: Changing exhibits

Activities: Classes for children; gallery talks; individual paintings & original objects of art lent to faculty, staff & campus offices

MEQUON

M **CONCORDIA UNIVERSITY WISCONSIN,** Fine Art Gallery, 12800 N Lake Shore Dr, Mequon, WI 53092. Tel 262-243-5700; Fax 262-243-4351; Internet Home Page Address: www.cuw.edu; *Academic Dean* Dr David Eggebrecht; *Gallery Dir* Prof Jeffrey Shawhan
Open Sun, Tues, Wed & Fri 1 - 4 PM, Thurs 5 - 7 PM; No admis fee; Estab 1972 to exhibit work of area & national artists as an educational arm of the college; Average Annual Attendance: 1,000

Income: Financed through college budget

Special Subjects: Graphics, Bronzes, Painting-Russian

Collections: John Doyle Lithographs; Graphics include Roualt, Altman & local artists; John Wiley Collection; American landscape; religious art; Russian bronzes & paintings

Publications: Annual schedule

Activities: Classes for adults & children; lects for members only, 2-3 vis lectrs per year; gallery talks

MILWAUKEE

M **ALVERNO COLLEGE GALLERY,** 3401 S 39th St, PO Box 343922 Milwaukee, WI 53234-3922. Tel 414-382-6149; Fax 414-382-6354; *Dir Gallery* Valerie J Christell
Open Mon - Fri 10 AM - 3 PM, Sun Noon - 3 PM, by appointment; No admis fee; Estab 1954 for the aesthetic enrichment of community & the aesthetic educ of students

Income: $2000
Exhibitions: Senior Show; Juried Student Exhibition
Activities: Docent training; lect open to public, 4 vis lectr per year; concerts; gallery talks; tours; competitions with awards; book traveling exhibitions 1-2 per year

AMERICAN SOCIETY FOR AESTHETICS
For further information, see National and Regional Organizations

L **ASCENSION LUTHERAN CHURCH LIBRARY,** 1236 S Layton Blvd, Milwaukee, WI 53215. Tel 414-645-2933; Fax 414-645-0218; *Operations Mgr* Heidi Barret
Open Sun 8:30 - 11 AM & upon request; No admis fee; Estab 1954
Income: Financed by church budget, donations & bequests
Library Holdings: Audio Tapes; Book Volumes 13,000; Cassettes; Filmstrips; Framed Reproductions; Periodical Subscriptions 30; Video Tapes 40
Special Subjects: Decorative Arts, Crafts, Embroidery, Religious Art
Collections: Classic Art, framed pictures, organ music

C **BANK ONE WISCONSIN,** 111 E Wisconsin Ave, Milwaukee, WI 53202. Tel 414-765-3000; *Facilities Mgr* Cheri Eddy
Estab to encourage Wisconsin art & artists; Collection displayed in offices, conference rooms & corridors within Bank One Plaza
Collections: Acrylics, batik, bronze sculpture, lithographs, oils, wall sculpture, watercolors by Wisconsin artists

M **CARDINAL STRITCH UNIVERSITY,** Art Gallery, 6801 N Yates Rd, Milwaukee, WI 53217. Tel 414-414-4000; Fax 414-351-7516; Internet Home Page Address: www.stritch.edu; *Chmn Art Dept* Timothy Abler
Open Mon - Fri 10 AM - 4 PM, Sat & Sun 1 - 4 PM; No admis fee; Estab 1947 to encourage creative art in each individual
Income: Financed by endowment, city & state appropriations & tuition
Special Subjects: Painting-American, Folk Art
Exhibitions: Acquisitions from distant lands, children's art, professor's works, senior graduating exhibitions, well-known area artists; Clay, an exhibit of ten of Wisconsin's outstanding ceramic artists; Concerning the Narrative, prints, painting & sculpture; Two Views, photography; student exhibit; Global Awareness Exhibit; Ray Gloeckler, Wisconsin woodblock artist; Joanna Poehlmann, book artist; Student Show
Activities: Classes for adults & children; lect open to public, 2-4 vis lectr per year; gallery talks; tours; individual paintings & original objects of art lent to galleries, libraries & educational institutions

M **CHARLES ALLIS ART MUSEUM,** 1801 N Prospect Ave, Milwaukee, WI 53202; 1630 E Royall Pl, Milwaukee, WI 53202. Tel 414-278-8295; Fax 414-278-0335; Elec Mail eberry@cavtmuseums.org; Internet Home Page Address: www.cavtmuseums.org; *Exec Dir* Sarah Staider; *Cur Exhibitions* Laurel Turner; *Events Mgr* Judith Hooks; *Mrg Mktg* Ava Berry
Open Wed - Sun 1 - 5 PM; Admis general public $5, seniors and students $3, members & children under 13 free; Estab 1947 as a house-mus with 850 art objects from around the world & spanning 2500 years, collected by Charles Allis, first president of the Allis-Chalmers Company & bequeathed to the people of Milwaukee. The mus is part of the Milwaukee County War Memorial Complex; Average Annual Attendance: 30,000; Mem: 500; dues student $25, senior individual $35, individual $45, senior couple $55, family $60, sustainer $75-$124, patron $125-$249, sponsor $250-$499, benefactor $500-$999, philanthropist $1,000 & up ; ann meetings in Oct
Income: $575,000 (combined budget) financed by endowment, private & public contributions & rental revenue
Special Subjects: Painting-American, Ceramics, Painting-French, Renaissance Art
Collections: Chinese, Japanese & Persian ceramics; Greek & Roman antiquities; 19th century French & American paintings; Renaissance bronzes
Exhibitions: (12/10/2006-1/28/2007) Wisconsin Masters Series: Charles Dix; (2/7/2007-3/25/2007) Historical Reflections: Paintings by Nancy Lamers; (4/4/2007-4/29/2007) Language of Composition: Works by Ralph Selensky; (5/9/2007-7/29/2007) FORWARD: Survey of Wisconsin Art Now (juried); (8/8/2007-9/30/2007) Alexander Eschweiler in Milwaukee: Celebrating a Rich Architectural Heritage; (10/10/2007-12/9/2007) The Permanent Collection: Works on Paper; (12/16/2007-1/20/2008) Wisconsin Masters Series: H S Moynihan (1902-1994)
Publications: Exhibition catalogs; quarterly newsletter
Activities: Docent training; lect open to public, 10 vis lectr per year; concerts; gallery talks; tours; film series; sponsoring of competitions

M **MARQUETTE UNIVERSITY,** Haggerty Museum of Art, 530 N 13th St, PO Box 1881 Milwaukee, WI 53201-1881. Tel 414-288-7290; Fax 414-288-5415; Elec Mail haggertym@marquette.edu; Internet Home Page Address: www.marquette.edu/haggerty; *Registrar* James Kieselburg; *Admin Asst* Mary Wagner; *Communications Asst* Jason Pilmaier; *Asst Dir Administration* Lee Coppernoll; *Preparator* Tim Dykes; *Asst Cur* Jerome Fortier; *Dir* Curtis L Carter; *Assoc Cur* AnneMarie Sawkins; *Cur Educ* Lynne Shumou; *Head Preparator* Andrew Nordine
Open Mon - Wed, Fri & Sat 10 AM - 4:30 PM, Thurs 10 AM -8 PM, Sun Noon - 5 PM; No admis fee; Estab 1984 to provide exhibitions of art from Old Masters to the present; 20,000 sq ft. A modern free standing building with security & climate control. Maintains reference library; Average Annual Attendance: 40,000; Mem: 500; dues $50-$5000; annual meeting in Sept
Income: Financed through private contributions & the university
Special Subjects: Drawings, Latin American Art, Painting-American, Prints, American Indian Art, African Art, Religious Art, Etchings & Engravings, Landscapes, Decorative Arts, Painting-European, Posters, Dolls, Furniture, Glass, Porcelain, Painting-British, Painting-Dutch, Painting-French, Carpets & Rugs, Painting-Flemish, Renaissance Art, Painting-Spanish, Painting-Italian, Painting-German
Collections: Old Master, Modern, Contemporary paintings; prints, photography; decorative arts; tribal arts; German art, 1920s - 1930s
Publications: Exhibit catalogs; Italian Renaissance Masters

Activities: Educ dept; docent training; lect & workshops open to public, 15-20 vis lectr per year; gallery talks; tours; awards; concerts; individual paintings & original objects of art lent to museums; originate traveling exhibitions; museum shop sells books, magazines, reproductions, prints, merchandise & cards

M **MILWAUKEE ART MUSEUM,** 700 N Art Museum Dr, Milwaukee, WI 53202. Tel 414-224-3200; Fax 414-271-7588; Elec Mail mam@mam.org; Internet Home Page Address: www.mam.org; *Pres Bd Trustees* Frank J Pelisek; *Exec Dir* Christopher Goldsmith; *Dir Educ* Barbara Brown Lee; *Dir Adult Progs* Fran Serlin; *Registrar* Leigh Albritton; *Dir Communications* Pam Kassner; *Dir Russell Bowman; *Dir Vol Svcs* Beth Hoffman; *Dir* David Gordon; *Dir Finance & Admis* Amy Jensen; *Cur Earlier Europe* Laurie Winters; *Dir Progs* Brigid Globensky; *Mgr Retail Operations* Richard Quick; *Dir Cur Affairs* Brian Ferriso; *Librn & Archivist* L Elizabeth Schmoeger; *Dir Merchandising* Gwen Benner; *Cur Prints & Drawings* Kristin Makholm; *Mem Mgr* Kim Sosa; *Pres* Donald Baumgartner; *Dir Financial Develop* Lucia Petrie; *Asst Cur Decorative* Nonie Gadsden
Open Tues, Fri 10 AM - 9 PM & Sat 10 AM - 5 PM, Thurs Noon - 9 PM, Sun Noon - 5 PM, cl Mon; Admis adults $6, students, handicapped & senior citizens $4, children under 12 with adult & members free; Estab 1888 to create an environment for the arts that will serve the people of the greater Milwaukee community; Large flexible galleries, including a sculpture court & outdoor display areas. Fine arts & decorative arts are mixed to create an overview of a period, especially in the fine American Wings; small galleries provided for specific or unique collections; Average Annual Attendance: 150,000; Mem: 11,000; dues $45, senior citizens & students $25; annual meeting in May
Income: Financed by endowment, mem, county & state appropriations & fund drive
Special Subjects: Architecture, Painting-American, Painting-European, Antiquities-Egyptian, Antiquities-Greek, Antiquities-Roman, Painting-German
Collections: 19th & 20th Century American & European Art, including the Bradley & Layton Collections: The American Ash Can School & German Expressionism are emphasized; All media from Ancient Egypt to Modern America; The Flagg Collection of Haitian Art; The Hall Collection of American Folk Art; a study collection of Midwest Architecture_The Prairie Archives; The von Schleintz Collection
Exhibitions: Rotating exhibits & exhibits from permanent collection
Publications: Exhibs & program brochure, 3 per yr; numbers calendar, bimonthly
Activities: Classes for adults & children; docent training; lect open to public, 4-6 vis lectr per year; concerts; gallery talks; tours; competitions; films; scholastic art program; originate traveling exhibitions; museum shop sells books & magazines
L **Library,** 700 Art Museum Dr, Milwaukee, WI 53202. Elec Mail library@mam.org; *Librn* Elizabeth Schmoeger
Not open to the public
Library Holdings: Book Volumes

L **MILWAUKEE INSTITUTE OF ART & DESIGN,** Library, 273 E Erie St, Milwaukee, WI 53202. Tel 414-847-3342; Fax 414-291-8077; Internet Home Page Address: www.miad.edu/; *Asst Dir, Library Serv* Nancy Siker; *Circ Coordr* Cathryn Wilson
Open Mon - Fri 8 AM - 5 PM; Estab 1974 as an Art & Design Library for the art school
Income: Financed by institution & private grants
Library Holdings: Book Volumes 26,000; DVDs 250; Other Holdings Postcards 2,440; Pamphlets; Periodical Subscriptions 125; Slides 32,000; Video Tapes 500
Special Subjects: Decorative Arts, Photography, Graphic Design, Advertising Design, Industrial Design, Interior Design
Collections: Member of Switch Consortium

L **MILWAUKEE PUBLIC LIBRARY,** Art, Music & Recreation Dept, 814 W Wisconsin Ave, Milwaukee, WI 53233. Tel 414-286-3000; Fax 414-286-2137; Internet Home Page Address: www.mpl.org; *City Librn* Kathleen Huston; *Deputy City Librn* Paula Kiely; *Coordr Fine Arts* Thomas Altmann
Open Mon - Thurs, 9 AM - 8:30 PM, Fri & Sat 8:30 AM - 5:30 PM; No admis fee; Estab 1897
Income: Financed by budgeted funds & endowments
Library Holdings: Auction Catalogs; Book Volumes 2,400,000; CD-ROMs; Cassettes; Clipping Files; Exhibition Catalogs; Fiche; Manuscripts; Other Holdings Auction catalogs, Compact discs, Original documents, Theatre programs; Pamphlets; Photographs; Records; Video Tapes
Special Subjects: Art History, Landscape Architecture, Decorative Arts, Posters, Crafts, Coins & Medals, Architecture
Collections: Auction catalogs; Audubon Prints - complete

M **MILWAUKEE PUBLIC MUSEUM,** 800 W Wells St, Milwaukee, WI 53233. Tel 414-278-2700; Fax 414-278-6100; Elec Mail smedley@mpm.edu; Internet Home Page Address: www.mpm.edu; *Sr Marketing Dir* Amy Chionchio; *Museum Librn* Judy Turner; *Dir Media Serv Exec* Rolf Johnson; *Exec VPres* James Krivitz; *Communications Mgr* Jan Nowak; *VPres Coll & Pub Program* Allen Young; *VPres Devel, Pub Affairs & Marketing* Lisa Foemming; *VPres Finance, Chief Financial Officer* Terry Gaouette; *Dir Info Svc* Linda Gruber; *VChmn* Patricia B McKeithan; *Dir Exhib Program* James Kelly; *Dir Human Resources* Patti Sherman-Cisler; *Mus Shop Mgr* Jerry Ryack; *Pres & CEO* Roger W Bowen
Open Mon-Fri 9AM-5PM; Admis family $10, adults $6.50, sr citizens $5, children 4-17 $4, children 3 & under free; Estab 1883 as a natural history mus; Steiglenor-special exhibits gallery, Erwin C Uihlern-smaller exhibits, Clinton B Rose exhibit case; Average Annual Attendance: 413,000; Mem: 7400
Special Subjects: Photography, Anthropology, Folk Art, Decorative Arts
Collections: All major sub-disciplines of anthropology, botany, ethnology, natural history outreach, geology-paleontology; invertebrate & vertebrate zoology; decorative, fine & folk arts; film, photographs & specimen collection
Activities: Classes for children (school groups only), spec events, workshops, summer camps, IMAX dome theatre; lect open to public & members; vis lectr annually; sales shop sells pottery, jewelry, stationery, ornaments, models, games, dolls

M **MOUNT MARY COLLEGE,** Marian Gallery, 2900 Menomonee River Pkwy, Milwaukee, WI 53222. Tel 414-258-4810; Fax 414-256-1224; Elec Mail gastone@mtmary.edu; Internet Home Page Address: www.mtmary.edu; *Chmn Sr* Rosemarita Huebner; *Dir Gallery* Karen Olsen; *Cur* Elizabeth Gaston
Open Mon - Fri 9 AM - 4:30 PM, Sat 7 Sun 1 - 4 PM; No admis fee; Estab 1940

to provide both students & local community with exposure to art experiences & to provide artists, both estab professionals & aspirants with a showplace for their work; Average Annual Attendance: 1,000
Income: Financed by private funds
Special Subjects: Prints, Costumes, Etchings & Engravings, Furniture
Collections: Antique furniture, 16th Century & Victorian period; contemporary print collection; historic costume collection; watercolors by Wisconsin artists
Activities: Classes for adults & children; lect open to public, 6 vis lectr per year; concerts; gallery talks; tours; competitons & awards; scholarships offered

UNIVERSITY OF WISCONSIN
M **Institute of Visual Arts, (INOVA),** Tel 414-229-6509; Fax 414-229-6785; Elec Mail inova@cd.uwm.edu; Internet Home Page Address: www.uwm.edu/SOA/inova; *Sr Cur* Marilu Knode; *Dir* Peter Doroshenko
Open Wed - Sun Noon - 5 PM, cl holidays; No admis fee; Estab 1982 to function as university museum; also oversees operations of art history gallery & fine arts galleries with international contemporary art
Income: Financed by state appropriation
Special Subjects: Graphics, Painting-American, Photography, Prints, Sculpture, Religious Art, Oriental Art
Collections: INOVA presents its global audience with work by the most important dynamic & controversial local, national & international contemporary artists. INOVA commissions new site-specific work presenting artists in the region or the country for their first one-person exhibition
Publications: Catalogs; checklists; handouts
Activities: Lect open to public, 4 - 5 vis lectr per year; gallery talks; tours; originate traveling exhibitions 1 - 2 per year
M **Union Art Gallery,** Tel 414-229-6310; Fax 414-229-6709; Elec Mail art_gallery@aux.uwm.edu; Internet Home Page Address: www.aux.uwm.edu/union/artgal.htm; *Gallery Mgr* Steven D Jaeger; *Asst Mgr* Nichole Hickey; *Gallery Guard* Alicia Boll; *Gallery Guard* Richard Klein
Open Mon, Tues, Wed & Fri 11 AM - 3 PM, Thurs 11 AM - 7 PM, cl Sat & Sun; No admis fee; Estab 1972 to provide space for local & regional artists, along with student art, primarily undergraduate, to be shown in group exhibits established by peer selection and apart from faculty selection; 2500 sq ft, two stories high with more than 250 running feet of exhibit wall space; Average Annual Attendance: 16,500
Income: Union programming budget
Collections: Permanent Collection incl 2 & 3-D
Activities: Classes for adults; lect open to pub; concerts; competitions with awards; gallery talks; sale shop sells original art

M **VILLA TERRACE DECORATIVE ART MUSEUM,** 2220 N Terrace Ave, Milwaukee, WI 53202. Tel 414-271-3656; Fax 414-271-3986; Elec Mail eberry@cavtmuseums.org; Internet Home Page Address: www.cavtmuseums.org; *Exec Dir* James D Temmer; *Mgr Exhibs & Coll* Sarah Haberstrom; *Events Mgr* Avie Cumming; *Mgr Mktg* Eva S Berry
Open Wed - Sun 1 - 5 PM; Admis \$5, seniors (over 65) & students \$3, members & children under 13 free; Estab 1967; Art mus & formal gardens; Average Annual Attendance: 30,000; Mem: 500; dues \$20 & up
Income: \$575,000 financed through pvt & pub contributions and rental revenue
Special Subjects: Decorative Arts, Furniture
Collections: Decortive arts; furniture; glassware; paintings; wrought iron; Cyril Colnik Archive
Publications: Exhibition catalogs
Activities: Docent training; lect open to public; 3-6 vis lect per year; concerts; gallery talks; tours; ongoing temporary exhibitions; garden tours; Mayor's Landscape award

M **WILLIAM F EISNER MUSEUM OF ADVERTISING & DESIGN,** (American Advertising Museum) 208 N Water St, Milwaukee, WI 53202. Tel 414-847-3290; Fax 414-847-3299; Internet Home Page Address: www.eisnermuseum.org; *Dir* Cori Coffman
Open Wed 11 AM - 5 PM, Thurs 11 AM - 8 PM, Fri 11 AM - 5 PM, Sat noon - 5 PM, Sun 1 - 5 PM; Admis adults \$4.50, youth & seniors over 55 \$2.50; Estab 2000; an interactive educational center focusing on advertising, design & their impact on our culture; Mem: dues \$25 - \$250
Income: Financed by donations, mem, grants
Library Holdings: Book Volumes; Memorabilia; Prints; Video Tapes
Special Subjects: Graphics, Posters
Exhibitions: Rotating Exhib: Dream Girls: Images of Women in Advertising, 1890s - 1990s
Publications: Newsletter, quarterly
Activities: Tours

NEENAH

M **BERGSTROM-MAHLER MUSEUM,** 165 N Park Ave, Neenah, WI 54956-2994. Tel 920-751-4658; Fax 920-451-4755; Elec Mail info@paperweightmuseum.com; Internet Home Page Address: www.bergstrom-mahlermuseum.com; *Exec Dir* Alex Vance; *Cur* Jami Severstad; *Mgr Communications* Wendy Lloyd
Open Tues-Fri.10AM-4:30PM, Sat. 9:AM-4:30PM, Sun. 1-4:30PM; No admis fee; Estab 1959 to provide cultural & educational benefits to the pub; Average Annual Attendance: 29,000
Income: \$200,000 (financed by endowment, state & county appropriations & gifts)
Special Subjects: Painting-American, Sculpture, Glass
Collections: Over 1900 contemporary & antique paperweights; Victorian Glass Baskets; Germanic Glass; paintings; sculpture
Exhibitions: Monthly exhibitions in varied media
Publications: Museum Quarterly; Glass Paperweights of Bergstrom - Mahler Museum Collection Catalogue; Paul J Stankard: Poetry in Glass
Activities: Classes for adults & children; docent training; lect open to public; gallery talks; tours; individual paintings & original objects of art lent to museums; museum shop sells glass paperweights & glass items, original art

L **Library,** 165 N Park Ave, Neenah, WI 54956. Tel 414-751-4658; Fax 920-751-4755; *Exec Dir & Cur* Alex Vance
Open by appt only; For reference, staff only
Library Holdings: Book Volumes 2000; Memorabilia; Periodical Subscriptions 10; Slides
Special Subjects: Art History, Glass

NEW GLARUS

M **CHALET OF THE GOLDEN FLEECE,** 618 Second, New Glarus, WI 53574. Tel 608-527-2614; *Cur* Helen Altmann
Open Memorial Day-Nov 1st; Admis adults \$5, students 6-17 \$2; Estab 1955; Authentic Swiss style chalet which was once a private residence; collection from around the world; Average Annual Attendance: 5,000
Income: Financed by admis fees & village of New Glarus
Collections: Swiss wood carvings & furniture; antique silver & pewter samplers; prints; exceptional glass & china; coins; stamps; paintings; etchings; Swiss dolls
Activities: Lect open to public; tours

OSHKOSH

M **OSHKOSH PUBLIC MUSEUM,** 1331 Algoma Blvd, Oshkosh, WI 54901-2799. Tel 920-424-4731; Fax 920-424-4738; Elec Mail info@publicmuseum.oshkosh.net; Internet Home Page Address: www.publicmuseum.oshkosh.net; *Activities Coordr* Paul Poeschl; *Registrar* Joan Lloyd; *Staff Artist* Don Oberweiser; *Dir* Bradley Larson; *Pres* Eugene Winkler; *Asst Dir* Michael Breza; *Archivist* Scott Cross
Open Tues - Sat 10 AM - 4:30 PM, Sun 1 PM - 4:30 PM, cl Mon & major holidays; No admis fee; Estab 1924 to collect & exhibit historical, Indian & natural history material relating to the area & fine & decorative & folk arts. 1908 converted home with new wing, Steiger Memorial Wing, opened in 1983 for additional exhibition space; Mus housed in city owned mansion near university campus; Average Annual Attendance: 65,000; Mem: 450; dues \$25
Income: Financed by city appropriation
Library Holdings: Audio Tapes; Book Volumes; Manuscripts; Maps; Motion Pictures
Special Subjects: Painting-American, Sculpture, Archaeology, Costumes, Crafts, Folk Art, Pottery, Landscapes, Decorative Arts, Manuscripts, Portraits, Posters, Glass, Historical Material, Maps, Embroidery
Collections: American Artists: archeology; firearms; Indian Artifacts; Local & Wisconsin History; Natural History; Pressed Glass; period textiles
Exhibitions: Monthly changing exhibits; permanent exhibits; Annual Art Fair
Publications: Like A Deer Chased by the Dogs, The Life of Chief Oshkosh; Voices of History, 1941-1945
Activities: Classes for adults & children; lect open to public; 5 vis lects per year; individual paintings & original objects of art lent to museums; book traveling exhibitions 1 per year; museum shop sells books & reproductions
L **Library,** 1331 Algoma Blvd, Oshkosh, WI 54901-2799. Tel 920-424-4731; Fax 920-424-4738; Elec Mail info@publicmuseum.oshkosh.net; Internet Home Page Address: http://www.publicmuseum.oshkosh.net; *Archivist* Scott Cross
Open Tues - Sat 9 AM - 5 PM; Sun 1 - 5 PM, cl Mon & major holidays; no admis fee; Estab 1923. Research for mus exhibits & general pub; For reference only; Average Annual Attendance: 42,000; Mem: 450 members; dues \$20.00/no meetings.
Income: Financed by city & county appropriations
Purchases: \$2000
Library Holdings: Audio Tapes; Book Volumes 2500; Cassettes; Clipping Files; Exhibition Catalogs; Filmstrips; Kodachrome Transparencies; Lantern Slides; Memorabilia; Motion Pictures; Original Art Works; Other Holdings Maps; Pamphlets; Periodical Subscriptions 5; Photographs; Prints; Records; Slides; Video Tapes
Special Subjects: Archaeology
Publications: Exhibition catalogs
Activities: Lect open to public, 2-4 vis lectr per year

A **PAINE ART CENTER & GARDENS,** (Paine Art Center & Arboretum) 1410 Algoma Blvd, Oshkosh, WI 54901. Tel 920-235-6903; Fax 920-235-6303; Elec Mail mmueller@paineartcenter.com; Internet Home Page Address: www.paine.artcenter.com; *Financial Business Mgr* Doris Peitz; *Cur Horticulture* Sheila Glaske; *Exec Dir* Barbara Hirschfeld; *Cur Coll & Educ* Laurel Spencer Forsythe; *Vol/Educ* Bobbie Scott; *Mus Serv Coordr* Mitzi Mueller
Open Tues - Sun 11 AM - 4 PM, cl Mon & national holidays; Admis adults \$5, students with ID \$2, seniors \$2.50, children & members free; Estab 1947 as a nonprofit corporation to serve the needs of the upper midwest by showing fine & decorative arts & horticulture; Average Annual Attendance: 30,000; Mem: 900; dues contributing \$50, general \$35, senior citizens \$15
Income: Financed by endowment, mem & donations
Collections: American glass; decorative arts; icons; 19th & 20th century American paintings & sculpture; 19th century English & French paintings; period rooms; oriental rugs; American silver; arboretum contains displays of native & exotic trees, shrubs & herbacious plants
Exhibitions: Temporary exhibitions drawn from sources, coast to coast
Publications: Exhib catalogues; bimonthly newsletter; class schedules
Activities: Classes for adults & children; docent training; lect open to public, 3-6 vis lectr per year; concerts; gallery talks; tours; individual paintings & original objects of art lent to other museums & institutions; traveling exhibitions organized & circulated; sales shop sells books, reproductions & jewelry
L **George P Nevitt Library,** 1410 Algoma Blvd, Oshkosh, WI 54901. Tel 920-235-6903; Fax 920-235-6303; Internet Home Page Address: www.thepaine.org; *Exec Dir* Aaron Sherer
Cl Mon, open Tues - Sun 11 AM - 4 PM; No admis fee for members, family \$18, adults \$7, seniors \$6, students \$5, children 5-12 \$4, children under 5; Estab primarily for staff use as an art reference but also open to pub by appointment; Circ 3,000; For reference only; Average Annual Attendance: 30,000; Mem: 542; dues \$40 & up; annual meeting in Apr

Library Holdings: Book Volumes 5,200; Cassettes; Clipping Files; Exhibition Catalogs; Kodachrome Transparencies; Memorabilia; Original Art Works; Pamphlets; Photographs; Slides
Special Subjects: Art History, Decorative Arts, Photography, Drawings, Etchings & Engravings, Painting-American, Sculpture, History of Art & Archaeology, Ceramics, Interior Design, Asian Art, Period Rooms, Goldsmithing, Oriental Art, Architecture
Activities: Classes for adults and children; docent training; horticultural programs; 2-3 vis lects per year; gallery talks; tours; museum shop sells books, original art

M **UNIVERSITY OF WISCONSIN OSHKOSH,** Allen R Priebe Gallery, Arts & Communication Bldg, 800 Algoma Blvd Oshkosh, WI 54901. Tel 920-424-2222; Fax 920-424-1738; *Dir* Jeff Lipschutz
Open Mon - Fri 10:30 AM - 3 PM, Mon - Thurs 7 - 9 PM, Sat & Sun 1 - 4 PM; No admis fee; Estab 1971 for the purpose of offering exhibits which appeal to a wide range of people; Gallery is 60 x 40 with additional wall space added with partitions, a skylight along back ceiling; Average Annual Attendance: 15,000
Income: Financed by student allocated monies & Dept of Art
Purchases: $1500
Special Subjects: Drawings, Prints
Exhibitions: Various exhib
Activities: Lect open to public, 2-4 vis lectr per year; gallery talks; tours; competitions with awards; individual paintings & original objects of art lent to University staff & area museums

PLATTEVILLE

M **UNIVERSITY OF WISCONSIN - PLATTEVILLE,** Harry Nohr Art Gallery, One University Plaza, Platteville, WI 53818. Tel 608-342-1398; Fax 608-342-1478; *Bus Mgr for the Arts* Kris Swanson
Open Mon - Thurs, 11 AM - 7 PM, Fri 11 AM - 4 PM, Sat & Sun noon - 3 PM; No admis fee; Estab 1978; Average Annual Attendance: 9,000
Income: Financed by student fees & state funds
Collections: Pottery, paintings, sculptures
Activities: Lect open to public, 4 vis lectr per year; gallery talks; tours; competitions with awards; book traveling exhibitions

RACINE

A **WUSTUM MUSEUM ART ASSOCIATION,** 2519 Northwestern Ave, Racine, WI 53404. Tel 262-636-9177; Fax 262-636-9231; *Dir* Bruce W Pepich
Open daily 1 - 5 PM, Mon & Thurs 1 - 9 PM; No admis fee; Estab 1941 to foster & aid the estab & development to pub art galleries & museums, progs of educ & training in the fine arts & to develop pub appreciation & enjoyment of the fine arts; Estab 1846 Italianate farmhouse, 2 stories, 6-room classroom addition, 13 acres of parkland, Boerner-designed formal gardens. Maintains library; Average Annual Attendance: 50,000; Mem: 650; dues $20 & up; ann meeting in May
Income: $500,000 (financed by mem, grants & fundraising)
Special Subjects: African Art, Furniture, Glass, Eskimo Art
Collections: 300 works WPA; 20th century works on paper, studio glass, ceramics, fibers; 19th century African jewelry, metals, artists books, paintings
Exhibitions: Watercolor Wisconsin (annual); Wisconsin Photography (triennial); Annual Nationwide Thematic Show (summer); Area Arts
Publications: Exhibit brochures & catalogs; Vue, quarterly newsletter
Activities: Classes for adults & children; docent training; outreach for local school children; gang intervention programs; lect open to public, 6-10 vis lectr per year; gallery talks; tours; competitions with awards; individual paintings & original art objects lent to museums; lending collection contains books, nature artifacts, original art works; original prints & paintings; book traveling exhibitions; originate traveling exhibitions; museum shop sells books & original art, gifts & collectibles

M **Charles A Wustum Museum of Fine Arts,** 2519 Northwestern Ave, Racine, WI 53404. Tel 262-636-9177; Fax 262-636-9231; Internet Home Page Address: www.wustum.org; *Dir* Bruce W Pepich
Open Mon - Thurs 11 AM - 9 PM, Tues, Wed, Fri & Sat 11 AM - 5 PM, Sun 1 - 5 PM; No admis fee; Estab 1940 to serve as cultural center for greater Racine community; Mus contains six galleries located in 1856 Wustum homestead & 1996 addition; Average Annual Attendance: 45,000
Income: $500,000 (financed by endowment, city & county appropriations, private gifts & programs)
Purchases: $500-$1000
Special Subjects: Painting-American, Prints, Watercolors
Collections: Contemporary Wisconsin Watercolors; WPA Project paintings & prints; contemporary graphics; works on paper, ceramic sculpture, glass sculpture, all post-1850 & primarily American
Exhibitions: Rotating exhibits
Activities: Classes for adults & children; docent training; lect open to public, 2-3 vis lectr per year; gallery talks; tours; competitions with awards; film programs; individual paintings & original objects of art lent to other institutions; lending collection contains 2500 original art works, 700 original prints, 400 paintings, 200 photographs, 250 sculptures, 700 crafts & artist-made books; book traveling exhibitions; originate traveling exhibitions; museum shop sells books, original art, stationery, arts & crafts

L **Wustum Art Library,** 2519 Northwestern Ave, Racine, WI 53404. Tel 262-636-9177; Fax 262-636-9231; Internet Home Page Address: www.wustum.org; *Librn* Nancy Elsmo; *Dir* Bruce W Pepich
Open Sun - Sat 1 - 5 PM, Mon & Thurs 1 - 9 PM; Estab 1941 to provide mus visitors & students with exposure to art history & instructional books; For reference only to pub, members may check out books
Income: $2500
Library Holdings: Book Volumes 1500; Exhibition Catalogs; Pamphlets; Periodical Subscriptions 12; Video Tapes
Special Subjects: Photography, Prints, Sculpture, Watercolors, Printmaking, Porcelain, Pottery, Textiles, Woodcarvings
Publications: Quarterly catalogues

RHINELANDER

L **RHINELANDER DISTRICT LIBRARY,** 106 N Stevens St, Rhinelander, WI 54501-3193. Tel 715-369-1070; Fax 715-365-1076; *Dir* Steve Kenworthy
No admis fee; Estab 1903
Income: financed by endowment
Library Holdings: Book Volumes 1500; Photographs; Sculpture; Video Tapes
Special Subjects: Art History, Folk Art, Photography, Calligraphy, Etchings & Engravings, Painting-American, Painting-Dutch, Painting-Flemish, Painting-French, Painting-German, Painting-Italian, Sculpture, Painting-European, American Western Art, Asian Art, Architecture
Collections: Architecture; arts & crafts; books & videos; Bump Art Collection; European & American Artists; photography

RICHLAND CENTER

M **FRANK LLOYD WRIGHT MUSEUM,** AD German Warehouse, 300 S Church St, Richland Center, WI 53581. Tel 608-647-2808; *Co-Owner, Mgr & Dir* Harvey W Glanzer; *Co-Owner & Creative Dir* Beth Caulkins
Open by request May - Nov, call ahead; Admis adult $10, children $5, group rates by arrangement; Estab 1915; Warehouse is a red brick structure topped by a Mayan concrete frieze. It employs a structural concept known as the Barton Spider-web system. Interior grid of massive concrete columns provide structural support for floors & roof. Elimination of interior walls allows maximum freedom of interior space. Gift shop on first & lower level, mus & gallery on second floor
Exhibitions: Large 8 ft x 8 ft Photographic Murals of Wright's Work; Engineering scale model of Monona Terrace in Madison

RIPON

M **RIPON COLLEGE ART GALLERY,** 300 Seward St, Ripon, WI 54971. Tel 920-748-8110, 748-8115; Elec Mail kaineu@ripon.edu; *Chmn* Eugene Kain
Open Mon - Fri 9 AM - 4 PM; No admis fee; Estab 1965 to provide student body with changing exhibits; Average Annual Attendance: 4,000
Income: Financed by the college
Collections: Paintings, print, sculpture, multi-media
Exhibitions: Rotating exhibits
Activities: Individual paintings lent to schools

RIVER FALLS

M **UNIVERSITY OF WISCONSIN,** Gallery 101, Cascade St, River Falls, WI 54022. Tel 715-425-3266, 425-3911 (main); Elec Mail michael.a.padgett@uwrf.edu; Internet Home Page Address: www.uwrs.edu; *Dir Gallery* Michael Padgett
Open Mon - Fri 9 AM - 5 PM & 7 - 9 PM, Sun 2 - 4 PM; No admis fee; Estab 1973 to exhibit artists of regional & national prominence & for educational purposes; Maintains one gallery; Average Annual Attendance: 21,000
Income: Financed by state appropriation & student activities funds
Collections: National & International Artists; Regional Artists; WPA Artists
Exhibitions: Rotating exhibits
Activities: Lect open to public; gallery talks; originate traveling exhibitions

SHEBOYGAN

C **KOHLER CO,** John Michael Kohler Arts Center - Arts Industry Program, PO Box 489 Sheboygan, WI 53082. Tel 920-458-6144; Fax 920-458-4473; Internet Home Page Address: www.jmkac.org; *Cur* Kim Cridler; *Dir* Ruth Kohler
Open Mon, Wed, Fri 10 AM - 5 PM, Tues & Thurs 10 AM - 8 PM, Sat & Sun 10 AM - 4 PM; Voluntary donation; Estab 1973; Exhibition of collections made by artists in residence
Income: Financed by Kohler Co
Special Subjects: Ceramics
Collections: Original ceramic art pieces created in Kohler Co facilities by resident artists in the Art Industry Program

A **SHEBOYGAN ARTS FOUNDATION, INC,** John Michael Kohler Arts Center, 608 New York Ave, PO Box 489 Sheboygan, WI 53082-0489. Tel 920-458-6144; Fax 920-458-4473; Internet Home Page Address: www.jmkac.com; *Dir* Ruth DeYoung Kohler; *Cur* Leslie Umberger
Mon, Wed & Fri 10 AM - 5 PM, Tues & Thurs 10 AM - 8 Sat & Sun Noon - 4 PM; Voluntary donation; Estab 1967 as a visual & performing arts center focusing on contemporary American crafts & works which break barriers between art forms; Contains ten exhibition galleries, the largest being 60 ft x 45 ft, theatre, four studio-classrooms, library, sales gallery; Average Annual Attendance: 135,000; Mem: 1600; dues family $50, individual $40, student $30; contributing mem
Income: Financed by mem, grants, corporate-foundation donations, sales gallery, ticket sales
Collections: Contemporary Ceramics; Contemporary Visionary Art; Historical Decorative Arts
Publications: Biennial Report; Exhibition Checklist 6-10 annually; Exhibition Catalogues, 2-4 annually; Newsletter, bimonthly
Activities: Classes for adults & children; dramatic programs; docent training; artists-in-residence programs; demonstrations; lect open to public, 18-20 vis lectr per year; concerts; gallery talks; tours; competitions with awards; scholarships & fels offered; individual paintings & original objects of art lent to other arts institutions which meet the loan requirements, lending collection includes 6000 original art works & 100 paintings; book traveling exhibitions; originate traveling exhibitions which circulate to museums & artists organizations; sales shop sells magazines, original art, slides, postcards & notecards

STEVENS POINT

M **UNIVERSITY OF WISCONSIN-STEVENS POINT,** Carlsten Art Gallery, Fine Arts Bldg, Stevens Point, WI 54481-3897. Tel 715-346-4797; Elec Mail cheft@uwsp.edu; Internet Home Page Address: www.uwsp.edu/art-design/carlsten; *Dir* Caren Heft
Open Mon - Fri 10 AM - 4 PM, Sat & Sun 1 - 4 PM, Thurs 7 - 9 PM; No admis fee; Estab 1971; 2,000 sq ft; Average Annual Attendance: 12,000
Income: Financed through university
Exhibitions: Tom Bamberger; Juried Student Exhibition; Drawing on the Figure; BFA Exhibition; Exhibitions rotate every three weeks

STURGEON BAY

M **DOOR COUNTY,** Miller Art Museum, 107 S Fourth Ave, Sturgeon Bay, WI 54235. Tel 920-746-0707 (office), 743-6578 (gallery); Fax 920-746-0865; *Cur* Deborah Rosenthal; *Dir* Bonnie Hartmann
Open Mon - Sat 10 AM - 5 PM, Mon evenings until 8 PM; No admis fee; Estab 1975; Gallery is 5000 sq ft; 4 galleries; Average Annual Attendance: 18,000; Mem: 168; dues associate $20, active $10; annual meeting second Thurs in Nov
Income: Financed by endowment, mem, county funds, sustaining, mem & grants
Special Subjects: Drawings, Etchings & Engravings, Landscapes, Painting-American, Prints, Woodcuts, Watercolors
Collections: permanent collection contains over 500 paintings, emphasis on paintings, prints & drawings by 20th century Wisconsin artists
Exhibitions: Salon of High School Art, Wis; Wildlife Biennial Invitational; Juried Annual
Activities: Classes for adults & children; lect open to public, 4 vis lectr per year; concerts; gallery talks; tours; competitions with awards; individual paintings lent to other museums & art centers; lending collection contains 450 original art works; sales shop sells books, original art & reproductions

SUPERIOR

L **Archives,** Tel 715-392-8449; *Pres* Dr Nancy Minahan; *Coll Mgr* Bill Rehnstrand
Open Mon - Fri 10 AM - 2 PM; For reference
Income: $105,000 (financed by endowment, mem, city & county appropriations, gift shop, catering & grants)
Library Holdings: Audio Tapes; Cassettes; Clipping Files; Filmstrips; Framed Reproductions; Lantern Slides; Manuscripts; Memorabilia; Motion Pictures; Original Art Works; Other Holdings Documents; Maps; Scrapbooks; Pamphlets; Photographs; Prints; Records; Slides; Video Tapes
Special Subjects: Folk Art, Decorative Arts, Maps, Painting-American, Historical Material, Crafts, Archaeology, American Indian Art, Dolls, Restoration & Conservation, Textiles, Marine Painting, Reproductions, Architecture
Collections: David Barry Photography Collection; Chippewa Indian Artifacts; Railroad, Shipping, Logging, Farming & Mining Tools (from the area)
Activities: Dramatic programs; docent training; lect open to public; tours; scholarships offered; museum shop sells books, Victorian & Indian items

WAUSAU

M **LEIGH YAWKEY WOODSON ART MUSEUM,** 700 N 12th St, Wausau, WI 54403-5007. Tel 715-845-7010; Fax 715-845-7103; Elec Mail museum@lywam.org; Internet Home Page Address: www.lywam.org; *Pres* Neil F Slamka; *Dir* Kathy K Foley; *Cur Exhib* Andrew J McGivern; *Cur Coll* Jane Weinke; *Assoc Dir* Marcia M Theel; *Cur Educ* Jayna Hintz; *Cur Educ* Erin Colburn
Open Tues - Fri 9 AM - 4 PM, Sat & Sun Noon - 5 PM; No admis fee; Estab 1973 for acquisition of a permanent coll of bird-theme art & decorative arts; prog of changing exhibits; art educ; 7750 net sq ft of exhib space; galleries on two floors; parquet floors; 628 running ft in galleries; Average Annual Attendance: 55,000; Mem: 850; dues $45 - $2500
Income: $1.4 million (financed by mem, pvt foundation, grants & corporate contributions)
Collections: Contemporary & historic paintings & sculptures with birds as the main subject; Historical period pieces of Royal Worcester porcelain; 19th & 20 century art glass
Exhibitions: (9/9/2006-11/12/2006) Birds in Art; (11/18/2006-1/21/2007) From Sea to Shining Sea; (1/27/2007-4/1/2007) Living with Art; (4/7/2007-6/10/2007) The Magic of the Carousel
Publications: Birds in Art, annually; exhibition catalogs; Vista, quarterly newsletter
Activities: Docent programs; classes for adults, children; lect open to public; gallery talks; tours; 6-8 vis lects per yr; competitions for participation in exhibitions; individual paintings & original objects of art lent to recognized museums & art centers; book traveling exhibitions 6-8 per year; originate traveling exhibitions, circulation to established museums, art centers, galleries & libraries

L **Art Library,** 700 N 12th St, Wausau, WI 54403. Tel 715-845-7010; Fax 715-845-7103; Elec Mail museum@lywam.org; Internet Home Page Address: www.lywam.org; *Cur Educ* Jayna Hintz; *Cur Educ* Emily Wollangk; *Cur Educ* Georgia Lang
Open by appointment; No admis fee; Estab 1976; For reference only; Average Annual Attendance: 100
Income: $1500
Purchases: $1500
Library Holdings: Audio Tapes; Book Volumes 2500; Cassettes; Exhibition Catalogs 1000; Filmstrips; Motion Pictures; Pamphlets; Periodical Subscriptions 20; Slides 5000; Video Tapes 50
Special Subjects: Art History, Decorative Arts, Painting-American, Art Education, Porcelain, Glass, Aesthetics, Architecture

WEST ALLIS

M **INTERNATIONAL CLOWN HALL OF FAME & RESEARCH CENTER, INC,** State Fair Park, 640 S 84th St #526 West Allis, WI 53214. Tel 414-290-0105; Fax 414-290-0106; Elec Mail mirthcon@juno.com; Internet Home Page Address: www.theclownmuseum.org; *Exec Dir* James D Mejchar
Open Mon - Fri 10 AM - 4 PM; No admis fee; donations accepted; Estab 1986 to promote & advance the art of clowning through preservation & education; Average Annual Attendance: 15,000; Mem: 500; dues $35-$1000; annual meeting 1st weekend in Aug
Income: $150,000 (financed by endowment, mem, gift shop & admis)
Library Holdings: Cassettes; Clipping Files; DVDs; Kodachrome Transparencies; Memorabilia; Original Art Works; Photographs; Records; Slides; Video Tapes
Special Subjects: Historical Material, Prints, Costumes, Crafts, Posters, Dolls, Miniatures
Publications: Let the Laughter Loose, quarterly newsletter
Activities: Classes for adults & children; dramatic programs; docent training; lect open to public, 25 vis lectr per year, gallery talks, tours; sales shop sells books, magazines, prints, reproductions & clown novelties

WEST BEND

M **MUSEUM OF WISCONSIN ART,** West Bend Art Museum, 300 S Sixth Ave, PO Box 426 West Bend, WI 53095. Tel 262-334-9638, 334-1151; Fax 262-334-8080; Elec Mail officemanager@wbartmuseum.com; Internet Home Page Address: www.wbartmuseum.com; *Pres* Maureen Josten; *Exec Dir* Thomas D Lidtke; *Assoc Dir Operations* Nancy Shield; *Asst Dir* Graeme Reid; *Dir Develop* Elly Pick
Open Wed - Sat 10 AM - 4:30 PM, Sun 1 - 4:30 PM, cl Mon & Tues; Estab 1961 as an art museum & exhibition space for regional & national shows; The large colonial style building contains eight gallery exhibit rooms & three art classrooms; Average Annual Attendance: 18,000; Mem: 600; dues $15 & up
Income: Financed by endowment, mem & donations
Purchases: $10,000
Library Holdings: Audio Tapes; Book Volumes; Cassettes; Clipping Files; DVDs; Original Art Works; Original Documents; Photographs; Records; Reproductions
Special Subjects: Decorative Arts, Etchings & Engravings, Furniture, Drawings, Painting-American, Sculpture, Watercolors
Collections: Carl von Marr Collection; Wisconsin Art History 1850-1960
Exhibitions: Temporary exhibitions, 6-7 per yr; One from Wisconsin, monthly solo exhibit by contemporary Wisconsin artists
Publications: Carl Von Marr, American-German Artist (1858-1936); Bulletin, monthly
Activities: Classes for adults and children; docent training; lect open to public; tours; Art Aware an educational outreach (art appreciation) service to local schools; traveling exhibits, 1-3 per year; originate traveling exhibitions; museum shop sells books, reproductions, prints from collection

WHITEWATER

M **UNIVERSITY OF WISCONSIN-WHITEWATER,** Crossman Gallery, Ctr of the Arts, 950 W Main St Whitewater, WI 53190; 800 W Main St, Whitewater, WI 53190. Tel 262-472-1207, 472-5708; Fax 262-472-2808; Elec Mail flanagam@mail.uww.edu; Internet Home Page Address: www.uww.edu; *Dir* Michael Flanagan
Open Mon - Fri 10 AM - 5PM & 6 - 8 PM, Sat 1 - 4 PM, cl Sun; No admis fee; Estab 1965 to provide professional exhibits; 47 ft x 51 ft, secure alarmed facility; Average Annual Attendance: 10,000
Income: $7000 (financed by segregated student fee appropriation)
Collections: American Folk Art Collection; Regional Art Collection; Early 20th century German works on paper
Exhibitions: Ceramic Invitational; Artassa Collaboration; Chronicles of Latin America; Contemporary sculpture
Activities: Classes for adults & children; student training in gallery management; lects open to public, 3 vis lects per year; concerts; gallery talks; tours; student juried show

WYOMING

BIG HORN

M **BRADFORD BRINTON MEMORIAL & MUSEUM,** 239 Brinton Rd, Big Horn, WY 82833; PO Box 460, Big Horn, WY 82833. Tel 307-672-3173; Fax 307-672-3258; Elec Mail kls_bbm@vcn.com; Internet Home Page Address: www.bradfordbrintonmemorial.com; *Dir & Chief Cur* Kenneth L Schuster; *Registrar* Barbara R Schuster; *Recep & Gift Shop Mgr* Suzanne Jackson
Open Memorial Day - Labor Day daily 9:30 AM - 5 PM; please call for off-season hours; Admis adults $4, students over 13 & senior citizens over 62 $3; Estab 1961 to show a typical Gentleman's working ranch of the 1920s complete with Western art & orig furnishings; Reception Gallery with changing exhibs; Ranch House with original displays (art by Russell, Remington, Borein, F T Johnson); Average Annual Attendance: 12,000; Mem: 300; dues $15 & up
Special Subjects: Hispanic Art, Painting-American, Prints, Sculpture, Southwestern Art, Ceramics, Crafts, Decorative Arts, Furniture, Jewelry, Painting-British, Period Rooms
Collections: Plains Indians Artifacts; Western American Art by Frederic Remington & Charles M Russell; American art & a few pieces of European art, largely of the 19th & 20th century; china; furniture; silver
Publications: Monographs on artists in the collection from time to time, brochures on exhibitions curated
Activities: Educ dept; lect open to public, 4 vis lectr per year; tours; museum shop sells books, magazines, original art, reproductions, prints, slides, American Indian jewelry & crafts

CASPER

M **NICOLAYSEN ART MUSEUM & DISCOVERY CENTER,** Childrens Discovery Center, 400 E Collins Dr, Casper, WY 82601. Tel 307-235-5247; Fax 307-235-0923; Internet Home Page Address: www.thenic.org; *Exec Dir* Holly Turner; *Educ Cur* Linda Lyman; *Develop Dir* Carol Plummer; *Admin Asst* Val Kulhavy; *Registrar* Jillian Allison; *Mus Shop Co-Mgr* Tim Ann Day; *Mus Shop Co-Mgr* Jan Debeer
Open Tues - Sat 10 AM - 5 PM, Sun Noon-4 PM; No admis fee; Estab 1967 to

exhibit permanent collection, nationwide traveling exhibits & provide school tours, art classes & workshops; Two galleries, 2500 sq ft and 500 sq ft; Average Annual Attendance: 25,000; Mem: 1,500; dues individual $30, family $50, annual meeting third Tues in May

Income: $235,000 (financed by mem, grants & fundraising events)
Collections: Carl Link Drawings; Artists of the Region; Conrad Schwiering Studio
Exhibitions: Twenty per year.
Publications: Historic Ranches of Wyoming
Activities: Classes for adults & children; docent training; lect open to public, 5-10 vis lectr per year; concerts; gallery talks; competitions with cash awards; individual paintings & original objects of art lent to qualified exhibiting institutions; lending collection contains 2500 original art works; book traveling exhibitions; originate traveling exhibitions; museum shop sells books, original art & gifts; children's museum

L **Museum,** 400 E Collins Dr, Casper, WY 82601. Tel 307-235-5247; Fax 307-235-0923; *Discovery Center Coordr* Val Martinez; *Registrar* Debbie Oliver; *Dir* Joe Ellis
Open Tues - Sat 10 AM - 5 PM, Thurs 10 AM-8 PM, Sun Noon-4 PM; Admis fee adults $2, children under 12 $1, free Thurs, Sat & Sun; Estab 1967 to collect & exhibit regional contemporary art; 8000 sq ft including 6 small and 1 large gallery. Computer controlled temperature & humidity. Hands on discovery center for children; Average Annual Attendance: 60,000; Mem: 700; dues $50; annual meeting 3rd Tues May
Income: $235,000 (financed by donations & fundraising events)
Library Holdings: Book Volumes 66; Exhibition Catalogs; Pamphlets; Periodical Subscriptions 8; Slides
Collections: Carl Link Collection; Regional Contemporary Pottery
Activities: Classes for children; dramatic programs; lect open to public, 2000 lectr per year; gallery talks; tours; juried regional competitions; book traveling exhibitions 1-2 per year; museum shop sells books, original art, prints, pottery, glass, jewelry & cards

CHEYENNE

M **DEPARTMENT OF COMMERCE,** Wyoming Arts Council Gallery, 2320 Capitol Ave, Cheyenne, WY 82002. Tel 307-777-7742; Fax 307-777-5499; Elec Mail lfranc@missc.state.wy.us; Internet Home Page Address: www.wyoarts.state.wy.us; *Visual Arts Prog Mgr* Liliane Francuz
Open Mon - Fri 8 AM - 5 PM, cl holidays; Estab 1990 to exhibit work of artists living & working in Wyoming; Average Annual Attendance: 1,200
Exhibitions: 4-5 exhibits annually, work of Wyoming artists in all media
Activities: Lects open to public, gallery talks; State of Wyo non-profit organizations

M **WYOMING STATE MUSEUM,** 2301 Central Ave, Cheyenne, WY 82002. Tel 307-777-7022 (museum), 7021 (tours), 5320 (store), 5427 (collections); Fax 307-777-5375; Elec Mail wsm@state.wy.us; Internet Home Page Address: www.wyomuseum.state.wy.us; *Dir* Marie Wilson-McKee
Open May - Oct Tues-Sat 9 AM-4:30 PM, Nov - Apr Tues - Fri 9 AM - 4:30 PM, Sat 10 AM - 2 PM, cl Sun and holidays; No admis fee; Estab 1895 to collect, preserve & to exhibit the work of Wyoming & Western artists; Average Annual Attendance: 34,000
Income: Financed by state appropriation
Special Subjects: American Indian Art, American Western Art, Decorative Arts
Collections: Wyoming artists, historical & contemporary including Historical Hans Kleiber, William Gollings, M D Houghton, Cyrenius Hall, William H Jackson, J H Sharp
Exhibitions: Regional & Wyoming contemporary art, western art; Governor's Annual Art Exhibition, June - Aug ann
Activities: Classes for children; lect open to public, 9 vis lectr per year; gallery talks; tours; individual paintings & original objects of art lent to institutions belonging to AAM, Colo-Wyo Association of Museums (CWAM) & Mount Plains Museums Association; museum shop sells books, original art, reproductions

CLEARMONT

M **UCROSS FOUNDATION,** Big Red Barn Gallery, 30 Big Red Ln, Clearmont, WY 82835. Tel 307-737-2291; Fax 307-737-2322; Elec Mail ucross@wyoming.com; *Pres* Elizabeth Guheen; *Exec Dir* Sharon Dynak
Open Mon - Fri 9 AM - 4 PM; No admis fee; Estab 1981; Gallery is located in a renovated barn on the grounds of an artists' & writers' residency program
Special Subjects: Painting-American, Sculpture, Watercolors, Textiles
Exhibitions: Quilts by Linda Behar; 4-6 group & solo shows a year; 4 exhibits annually in winter, spring, summer & fall
Publications: Ucross newsletter, annually
Activities: Sales shop sells books, postcards & gifts

CODY

A **BUFFALO BILL MEMORIAL ASSOCIATION,** Buffalo Bill Historical Center, 720 Sheridan Ave, Cody, WY 82414. Tel 307-587-4771; Fax 307-587-5714; Elec Mail leeh@bbhc.org; Internet Home Page Address: www.bbhc.org; *Chmn* Alan Simpson; *Exec Dir* Robert Price Shimp; *Cur Plains Indian Museum* Emma Hanson; *Dir Educ* Maryanne Andrus; *Registrar* Elizabeth Holmes; *Assoc Dir* Wally Reber; *Cur Buffalo Bill Mus* Juti Winchester; *Cur Draper Mus of Natural History* Charles Preston; *Librn* Mary Robinson; *Dir Pub Relations* Lee Haines; *Cur McCracken Research Library* Kurt Graham
Open Apr 10 AM - 5 PM, May 8 AM - 8 PM, June - Sept 15 8 AM - 8 PM, Sept 16 - Oct 8 AM - 5 PM, Nov - Mar 10 AM - 3 PM, cl Mon; Admis Adults $15, senior citizens $13 & special group rate; Estab 1917 to preserve & exhibit art,

artifacts & memorabilia of the Old West; to operate Buffalo Bill Mus, Plains Indian Mus, Whitney Gallery of Western Art & Cody Firearms Mus & Draper Mus of Natural History; Average Annual Attendance: 250,000; Mem: Dues $38 & up
Income: Financed by admis & private funds
Publications: Annual exhibition catalogues; quarterly newsletter
Activities: Classes for adults & children; docent training; lect open to public; gallery talks; tours; scholarships offered; individual paintings & original objects of art lent to other institutions; book traveling exhibitions; originate traveling exhibitions around the US; museum shop sells books, original art, reproductions, prints, slides, jewelry, collectible items, Indian crafts & Kachina dolls

L **Harold McCracken Research Library,** 720 Sheridan Ave, Cody, WY 82414. Tel 307-587-4771; Fax 307-587-5714, 307-527-6042; Internet Home Page Address: www.bbhc.org; *House Cur* Nathan Bender; *Librn* Frances Clymer
Open Mon - Fri 8 AM - 5 PM (summer), Tues, Fri 10 AM - 3 PM (winter); Estab 1980 for research in Western history & art; Circ non circulating; Open to the pub for reference only; Average Annual Attendance: 250,000
Library Holdings: Audio Tapes 1500; Book Volumes 15,000; Cassettes; Clipping Files; Exhibition Catalogs; Fiche; Filmstrips 1300; Kodachrome Transparencies; Lantern Slides; Manuscripts; Memorabilia 300; Motion Pictures; Other Holdings Engraving & Architectural Drawings 200; Pamphlets; Periodical Subscriptions 86; Photographs; Prints; Records; Reels 7000; Reproductions; Slides 6500; Video Tapes
Special Subjects: Art History, Folk Art, Photography, Commerical Art, Etchings & Engravings, Manuscripts, Maps, Painting-American, Archaeology, Ethnology, American Western Art, Art Education, American Indian Art, Anthropology, Landscapes
Collections: WHD Koerner Archives; Buffalo Bill Cody Archives; Photo Collections; Rare Books
Activities: Classes for adults & children; dramatic programs; docent training; lect open to public, 20 vis lectr per year; concerts; gallery talks; tours; museum shop sells books, magazines, original art, reproductions & prints

A **CODY COUNTRY ART LEAGUE,** 836 Sheridan Ave, Cody, WY 82414. Tel 307-587-3597; Elec Mail codyart@wavecom.net; Internet Home Page Address: www.//wavecom.net/codyart; *Pres* Shirley Barhaug
Open daily in summer 9 AM-5 PM, winter Mon-Sat 9 AM-5 PM, cl Sun; No admis fee; Estab 1964 for promotion of artistic endeavor among local & area artists; also established for exhibits, displays & sales; Average Annual Attendance: 25,000; Mem: 239; dues $40 (local), $50 (out of town); annual meeting in Dec
Income: Financed by endowment, mem, grants from Wyoming Council on the Arts, yearly auction & sponsors
Activities: Classes for adults & children; dramatic programs; films; workshops; lect open to public, 2-3 vis lectr per year; competitions; sales shop sells original art & prints

JACKSON

M **NATIONAL MUSEUM OF WILDLIFE ART,** 2820 Rungius Rd, PO Box 6825 Jackson, WY 83002. Tel 307-733-5771; Fax 307-733-5787; Elec Mail info@wildlifeart.org; Internet Home Page Address: www.wildlifeart.org; *Cur* Adam Harris; *Dir Develop* Patti Boyd; *Dir* Francine Carraro, PhD; *Mktg Dir* Ponteir Sackrey
Open 9 AM - 5 PM; Admis $6; Estab 1987 devoted to Fine Wildlife Art; collection spans 500 years; Facility has 12 galleries, cafe, gift shop, 2 classrooms & 200 seat auditorium; galleries house traveling exhibits & permanent colls; Average Annual Attendance: 100,000; Mem: Annual dues $35 individual
Income: Financed by endowment, mem & admis
Special Subjects: Painting-American, Photography, Sculpture, Watercolors, American Indian Art, American Western Art, Anthropology, Southwestern Art, Landscapes, Painting-European, Historical Material, Miniatures
Collections: Wildlife Collection
Exhibitions: Special Grand Opening exhibits
Publications: NWAM newsletter, biannually
Activities: Classes for adults & children; docent training; lect open to public, 40 vis lectr per year; concerts; gallery talks; tours; competitions; schols offered; individual paintings & original objects of art lent to the Cowboy Hall of Fame, The Gilcrease Institute & Denver Art Museum; museum shop sells books, prints, magazines, gifts, housewares & jewelry

L **Library,** 2820 Rungius Rd, PO Box 6825 Jackson, WY 83002. Tel 307-733-5771, 800-313-9553; Fax 307-733-5787; Elec Mail info@wildlifeart.org; Internet Home Page Address: www.wildlifeart.org; *Dir* Francine Carraro
Open Mon - Fri 9 AM - 5 PM (Summer & Winter), Mon-Fri 9 AM - 5 PM, Sat 1 - 5 PM (Spring & Fall); Admis family $16, adults $8, seniors & students $7; Estab 1987 to enrich & inspire pub appreciation & knowledge of fine art & to explore humanity's relationship with nature by collecting fine art focused on wildlife & presenting exceptional exhibs & educational progs; 12 galleries including 6 changing exhib galleries; Mem: dues $35 - $2500
Library Holdings: Auction Catalogs; Audio Tapes; Book Volumes 1000; Clipping Files; Exhibition Catalogs; Motion Pictures; Pamphlets; Slides; Video Tapes
Special Subjects: Art History, Photography, Drawings, Etchings & Engravings, Painting-American, Painting-British, Painting-German, Sculpture, Painting-European, Watercolors, American Western Art, Bronzes, Printmaking, Art Education, American Indian Art, Southwestern Art, Miniatures, Woodcuts, Landscapes, Painting-Canadian, Architecture
Collections: JKM Collection; American Bison Collection; John Clymer Studio Collection; Carl Rungius Collection; Over 300 works of art by over 200 artists
Publications: Call of the Wild triannual newsletter & special exhibition catalogs
Activities: Classes for adults & children; docent training; lect open to the public; concerts; gallery talks; tours; Rungius Award; Red Smith Award; book traveling exhibitions, 6 per year; museum shop sells books, magazines, reproductions & prints

LARAMIE

M **UNIVERSITY OF WYOMING,** University of Wyoming Art Museum, 2111 Willett Dr, PO Box 3807 Laramie, WY 82071-3807; University of Wyoming Art Museum, 1000 E University Dept 3807 Laramie, WY 82071. Tel 307-766-6622; Fax 307-766-3520; Elec Mail uwartmus@uwyo.edu; Internet Home Page Address: www.uwyo.edu/artmuseum; *Dir & Chief Cur* Susan Moldenhauer; *Cur Educ* Scott Boberg; *Coll Mgr* E K Kim; *Sales Gallery Mgr* Roseann Chapp; *Asst Cur* Sarah Gadd; *Chief Preparater* Sterling Smith; *Art Mobile Cur* Sarah J. Schleicher; *Develop Officer* Brenda Bland; *Bus Mgr* Karen Case; *Admin Asst* Cheryl Drake; *Publicist* Betsy Bress
Open Mon - Sat 10 AM - 5 PM, (summers only) Sun 1 - 5 PM; No admis fee; Estab 1968 to serve as an art resource center for faculty, students & the general public; Exhibition space consists of 9 galleries & outdoor sculpture court; Average Annual Attendance: 90,000; Mem: 500; dues $40 & up
Income: Financed by state appropriation, friends organization, individual and corporate gifts & grants
Special Subjects: Painting-American, Prints, Sculpture, Painting-European
Collections: Collection of 7000 paintings, sculptures, works on paper, photographs, crafts & ethnographic materials, primary 17th to 20th century
Publications: Exhibition catalogs
Activities: Classes for adults & children; docent training; lect open to public, 6-12 vis lectr per year; concerts; gallery talks; tours; individual paintings and original objects of art lent to other museums regionally and nationally; artmobile; collection contains 7000 original art works; originates traveling exhibitions; museum shop

MOOSE

A **GRAND TETON NATIONAL PARK SERVICE,** Colter Bay Indian Arts Museum, P0 Drawer 170, Moose, WY 83013. Tel 307-739-3594; *District Naturalist* Mike Nicklaus
Open May 8 AM - 5 PM, June - Sept 8 AM - 8 PM, cl Oct - Apr; No admis fee; Estab 1972
Collections: David T Vernon Indian Arts Collection
Exhibitions: Native American Guest Artist's Demonstration Program; David T Vernon Indian Arts Collection

ROCK SPRINGS

A **SWEETWATER COUNTY LIBRARY SYSTEM AND SCHOOL DISTRICT #1,** Community Fine Arts Center, 400 C St, Rock Springs, WY 82901. Tel 307-362-6212; Fax 307-352-6657; Elec Mail cfac@sweetwaterlibraries.com; Internet Home Page Address: www.cfac4art.com; *Asst to Dir* Jennifer Messer; *Dir* Debora Thaxton Soule; *Receptionist* Gwendolyn Quitberg
Mon - Thurs 10 AM - 6 PM, Fri & Sat non - 5 PM; No admis fee; Estab 1966 to house permanent art collection and hold various exhibits during the year; Halseth Gallery houses permanent art coll owned by local school dist; Circ 200+; 19th - 20th century American art - collection owned by local school district; Average Annual Attendance: 8,000
Income: Financed by endowment, city appropriation, county funds & school district No 1
Library Holdings: Book Volumes; DVDs; Periodical Subscriptions; Video Tapes
Special Subjects: Drawings, Etchings & Engravings, Landscapes, Mosaics, Photography, Prints, Watercolors, Painting-American, Pottery, American Western Art, Folk Art, Woodcuts, American Indian Art, Ceramics, Collages, Woodcarvings, Scrimshaw
Collections: Over 550 pieces of original art including Norman Rockwell, Grandma Moses, Raphael Soyer among others
Publications: Calendar of events; catalogue brochure
Activities: Classes for adults & children; art workshops for children & students; dramatic programs; 3-4 concerts per year; 1-2 gallery talks per year, large tours by appointment; competitions; high school awards; artmobile; book 2-3 traveling exhibitions per year

SUNDANCE

M **CROOK COUNTY MUSEUM & ART GALLERY,** PO Box 63, Sundance, WY 82729. Tel 307-283-3666; Fax 307-283-1091; Elec Mail crcogallery@vcn.com; *Dir* Linda Evans; *Technician* De Rae Melanson
Open Mon - Fri 8 AM - 5 PM, cl holidays; No admis fee; Estab 1971 to preserve & display Crook County history, display County artists & provide a showcase for county residents collections; Average Annual Attendance: 5,000
Income: Financed by County appropriation
Special Subjects: American Western Art
Collections: Furniture, pictures, Western historical items
Publications: Brochure
Activities: Tours for school children; museum shop sells books

PACIFIC ISLANDS

PAGO PAGO, AMERICAN SAMOA

M **JEAN P HAYDON MUSEUM,** PO Box 1540, Pago Pago, American Samoa, PI 96799. Tel 011-684-633-4347; Fax 011-684-633-2059; *Chmn Board Trustees* Lauti Simona; *Exec Dir & Cur* Leleala E Ppili
Open Mon-Fri 7:30AM-4PM ; No admis fee; Estab 1971 to establish, maintain, acquire & supervise the collection, study preservation, interpretation & exhibition of fine arts objects & such relics, documents, paintings, artifacts & other historical & related materials as well as evidence that illustrate the history of the Samoan Islands & the culture of their inhabitants, particularly of American Samoa; New extension of the mus is an art gallery displaying local artists work & student arts; Average Annual Attendance: 74,000
Income: Financed by city or state appropriations and grants from NEA
Collections: Natural Sciences; Polynesian Artifacts; Samoan Village Life; US Navy History; paintings, drawings, slides, photographs, artifacts
Exhibitions: Various
Activities: Classes for adults & children; dramatic programs; lect open to public, 3 vis lectr per year; artmobile; duplicate but not original objects of art lent to schools & individuals; lending collection contains books, paintings & photographs; museum & sales shop sells books, reproductions, prints, handicrafts & postcards

PUERTO RICO

OLD SAN JUAN

A **CENTRO DE ESTUDIOS AVANZADOS ART LIBRARY,** Calle Cristo # 52, Old San Juan, PR 00902. Tel 787-723-8772; Fax 787-723-4481; Internet Home Page Address: www.prtc.net/~centro; *Dir* Ricardo Alegria; *Adminr* Pedro Puej; *Secy* Carmen Maldonado
Open Mon - Fri 8:30 AM - 5 PM, Sat 8:30 AM - 12 PM; No admis fee

M **MUSEO DE LAS AMERICAS,** 861 Santa Fe Dr, Denver, CO 80204. Tel 303-517-4401; Fax 303-607-9761; Elec Mail jose@museo.orf; Internet Home Page Address: www.museo.org; *Dir* Ricardo E Alegria; *Staff Supv* Maria del Carmen Rodriguez; *Asst Dir* Maria Angela Lopez Vilella; *Educ Dir* Julie Marino; *Registrar* Shanna Shelby; *Pub Relations & Mktg* Pauline Herrera; *Exec Dir* Jose Aguayo; *Exhib Designer* Dennis Lucero; *Admin Asst* Dalia Almaraz; *VChmn* Everett H Chavez; *Cur Coll* Tariana Navas-Nieves
Open 10 AM - 4 PM; Estab 1991 for popular arts of the Americas; Old Spanish style military quarters. Tall ceilings in show rooms; Mem: 84; dues $15 minimum
Income: Financed by endowment & mem
Exhibitions: Loiza: Herencia Negra; Popular arts of the Americas: Antonio Frasconi, Zooisla, Fotoseptiembre
Publications: Boletin Informativo Museo de las Americas, semiannual
Activities: Classes for children; lect open to public, 6 vis lectr per year; book traveling exhibitions 3 per year; originate traveling exhibitions; museum shop sells books, magazines & prints

PONCE

M **MUSEO DE ARTE DE PONCE,** Ponce Art Museum, The Luis A Ferre Foundation Inc, Avenida de las Americas Ponce, PR; Avenida de las Americas, PO Box 9027 Ponce, PR 00732-9027. Tel 787-848-0505, 840-1510; Fax 787-841-7309; Elec Mail map@museoarteponce.org; Internet Home Page Address: www.museoarteponce.org; *CEO & Dir* Dr Agustin Arteaga; *Conservator of Paintings* Lidia Aravena; *COO* Gladys Betancourt; *Chief Develop Officer* Anna Maria Dapena; *Deputy Dir Communications* Denise Berlingeri; *Chief Cur* Cheryl Hartup; *Dir Educ* Ana Margarita Hernandez
Open daily 10 AM - 5 PM; Admis adults $5, children under 12 $2.50, students with ID $1.50; Estab 1959 to exhibit a representative collection of European paintings & sculpture; Puerto Rican & Latin American art; Fourteen galleries on two floors, present works from permanent collection & a wide variety of temporary exhibitions; Average Annual Attendance: 80,000; Mem: 1000; dues family $50, individual $30
Income: Financed by endowment, mem & government
Library Holdings: Book Volumes; Exhibition Catalogs
Special Subjects: Archaeology, Decorative Arts, Drawings, Photography, Painting-American, Prints, Painting-British, Painting-French, Sculpture, Graphics, Painting-Dutch, Painting-Flemish, Painting-Spanish, Painting-Italian
Collections: African, Latin American, Pre-Columbian & Puerto Rican Santos Art; 19th century art, contemporary art, 14th - 18th century paintings & sculpture
Exhibitions: Rotating exhibits every 3 weeks
Activities: Educ dept; tours; individual paintings & original objects of art lent to other museums & government offices; book traveling exhibitions 1-2 per year; originate traveling exhibitions; museum shops sells books & reproductions
L **Library,** Avenida de las Americas, PO Box 9027 Ponce, PR 00732-9027. Tel 787-848-0505, 840-1510; Fax 787-841-7309; Elec Mail mat@caribe.net; Internet Home Page Address: www.museoarteponce.org; *Exec Dir* Hiromi Shiba
Open daily 10 AM - 5 PM; Closed for reference with the exception of special permission
Library Holdings: Book Volumes 4000; Exhibition Catalogs

RIO PIEDRAS

M **UNIVERSITY OF PUERTO RICO,** Museum of Anthropology, History & Art, Ponce de Leon Ave, Rio Piedras, PR 00931; PO Box 21908, San Juan, PR 00931-1908. Tel 787-764-0000; Fax 787-763-4799; *Cur Archaeology* Ivan Mendez; *Cur Art* Flavia Marichal; *Archaeologist* Luis A Chanlatte; *Dir* Petra Barreras
Open Mon 9 AM-1 PM, Tues 9 AM-4:30 PM, Wed & Thurs 9 AM-8:45 PM, Fri 9 AM-4:30 PM, Sat 9 AM-4:30 PM, Sun 1 PM-4:30 PM, cl national holidays; No admis fee; Estab 1940; Maintains reference library; Average Annual Attendance: 30,000
Income: Financed by government grants & pub institutions
Purchases: Puerto Rican prints & drawings; paintings of past & contemporary Puerto Rican artists
Special Subjects: Hispanic Art, Archaeology, Antiquities-Egyptian
Collections: Archaeology; Puerto Rican paintings of the past & present; sculpture & folk art; prints & drawings
Exhibitions: Temporary exhibitions from the collection & from museum loans; Contemporary Puerto Rican art

Activities: Provide concerts; gallery talks; tours; individual paintings & original objects of art lent to organizations & museums; originate traveling exhibitions; museum shop sells slides & exhibition catalogues

SAN JUAN

M ATENEO PUERTORRIQUENO, Ateneo Gallery, PO Box 1180, San Juan, PR 00902. Tel 809-722-4839; Fax 809-725-3873; Elec Mail ateneopr@caribe.net; Internet Home Page Address: www.ateneopr.com; *Pres* Eduardo Morales-Coll
Open Mon - Fri 9 AM - 5 PM, cl Sun & holidays; No admis fee; Estab 1876 & is the oldest cultural institution in Puerto Rico; Puerto Rican Art Collection; Mem: dues $25; annual meeting in June
Library Holdings: Audio Tapes; Book Volumes; CD-ROMs; Exhibition Catalogs; Maps; Memorabilia; Motion Pictures; Original Art Works; Photographs; Sculpture; Video Tapes
Special Subjects: Historical Material
Collections: Decorative arts; drawings; historical material; prints; Puerto Rican paintings; sculpture
Exhibitions: Temporary exhibitions, monthly
Publications: Cuadernos (publications on general topics); Revista Ateneo, every 4 months
Activities: Classes for adults; dramatic programs; lect open to the public; gallery talks; guided tours; films; concerts; recitals; competitions with prizes; dramas; Ateneo Medal; individual paintings & original objects of art lent to other cultural institutions; book traveling exhibitions 1 per year; sales shop sells books & reproductions
L Library, Avenido Ponce de Leon, Parada 2 San Juan, PR 00902; PO Box 9021180, San Juan, PR 00902-1180. Tel 787-722-4839; Fax 787-725-3873; *Pres* Eduardo Morales-Coll
Library Holdings: Book Volumes 15,000

INSTITUTE OF PUERTO RICAN CULTURE

M Escuela de Artes Plasticas Galleria, Tel 787-725-8120; Fax 787-725-8111; Elec Mail eap@coqui.net; Internet Home Page Address: www.eap.edu; *Coordr Exhib* Adrian Rivera; *Dir* Marimar Benitez; *Acad Dean* Marines Lopez; *Dean of Admin* Herminio Martinez
Open daily 8 AM - 4:30 PM; Estab 1973 to offer BFA degree; Average Annual Attendance: 3,500
Income: Income from govt, pub univ, registration fees
Library Holdings: Book Volumes; CD-ROMs; Exhibition Catalogs; Photographs; Slides; Video Tapes
Collections: Permanent collection of student art work
Exhibitions: Annual Student Exhibition
Activities: Classes for adults & children; BFA program; lect open to public, 15 vis lectr per year; competitions sponsored; scholarships offered
A Instituto de Cultura Puertorriquena, Tel 787-724-0700; Fax 787-724-8993; *Exec Dir* Melba Verdejo
Open Mon - Sun 8 AM - Noon & 1 - 5 PM; No admis fee; Estab 1955 to stimulate, promote, divulge & enrich Puerto Rico's cultural & historical heritage; The institute has created 16 museums around the island & has five more in preparation, including museums of historical collections, art museums & archaeological museums
Income: Financed by endowment & state appropriation
Collections: Puerto Rican art, archaeology & historical collections
Publications: Revista del Institute de Cultura Puertorriquena, quarterly
Activities: Educ dept; lect open to public; gallery talks; concerts; tours; competitions; exten dept serves cultural centers around the Island; artmobile; individual paintings & original objects of art lent to government agencies, universities & cultural centers; lending collection contains motion pictures, original art works; original prints, paintings, photographs; originates traveling exhibition; sales shop sells books, records & craft items; junior museum
M Dr Jose C Barbosa Museum & Library, Tel 787-786-8115, 724-0700; *In Charge* Alexis Boscas
Open 9 AM - 5 PM; No admis fee; The house where patriot Jose Celso Barbosa was born & raised, restored to its original status as representative of a typical Puerto Rican family home of the 19th century; Contains a small library geared to children's books
Income: Financed by state appropriations
Collections: Furniture, personal photos & documents belonging to Dr Barbosa, including medical instruments, manuscripts & books
M Centro Ceremonial de Caguana, Tel 787-894-7325; Fax 787-894-7310; *Dir* Milagros Castro
Open daily 8:00 AM - 4:30 PM; Adults $2, minors $1; Caguana Indian Ceremonial Park & Mus includes the ceremonial center of the Taino Indians in Caguana, Utuado, a small town in the center of the Island, constituting the most important archeological find of the Caribbean & the most outstanding exposition of Indian primitive engineering. The plazas & walks where the Indians held their ceremonies, celebrations & games were restored & excavated to form an archeological park. Numerous petroglyphs are exhibited in the monoliths bordering the plazas & a mus exhibits Indian objects found during the excavations at the site
Income: Financed by state appropriations
M Museo de Arte Religioso Porta Coeli, Tel 787-892-5845; Fax 787-725-5608; Elec Mail www.@icp.gobierno.pr; *Dir* Aida T Rodriguez
Open Mon -Sun 8:30 AM - 4:20 PM; Admis $1; Estab 1960 to preserve & expose religious art to our culture; 17th century restored chapel built by Dominican monks in the town of San German; Mem: 15,000
Income: Financed by state appropriations
Special Subjects: Religious Art
Collections: Paintings & sculptures from between the 11th & 19th century obtained from different churches in the island; wood & metal religious artifacts
Activities: Conferences; cultural & craft workshops; 4 vis lectr per year; concerts; tours; museum shop sells books, magazines & original art
M Museo del Grabado Latinoamericano, Tel 809-724-1844, 724-0700;
Open 8:30 AM - 4:30 PM; No admis fee; Houses representative samples of graphic art of past & contemporary Puerto Rican artists along with outstanding

works of Latin American graphic engravers. Collection of prized works from the San Juan Biennial of Latin American Graphics
Income: Financed by state appropriations
Collections: Grafics; works from Orozco, Matta, Tamayo, Martorell, Alicea, Cardillo, Nevarez, Hernandez Acevedo
M Museo y Parque Histórico Ruinas de Caparra, Tel 787-781-4795; 724-0700; Fax 787-724-8393; Internet Home Page Address: www.icp.gobierno.pr/myp; *Dir* Wilfred Serrano
Open Tues - Sat 8:30 AM - 4:20 PM; No admis fee; Contains ruins of Caparra, first nucleus of colonization in Puerto Rico, founded by Ponce de Leon in 1508 & 1509, now excavated & transformed into a park memorial plaques indicating the historic significance. While the restoration & excavation was being conducted, numerous objects related to the period were discovered, which are now on exhibit
Income: Financed by state appropriations
Collections: Cannons, flags, pistols, ceramics
L Library, Tel 787-725-7405; Fax 787-722-9097
Open for reference to pub, investigators & students
Library Holdings: Audio Tapes; Book Volumes 120,000; Cassettes; Clipping Files; Exhibition Catalogs; Filmstrips; Framed Reproductions; Kodachrome Transparencies; Lantern Slides; Manuscripts; Memorabilia; Motion Pictures; Original Art Works; Pamphlets; Photographs; Prints; Reproductions; Sculpture; Slides; Video Tapes
Collections: Pre-Columbian Archaeological Collection

M LA CASA DEL LIBRO MUSEUM, Cristo 255, San Juan, PR 00901. Tel 787-723-0354; Fax 787-723-0354; Internet Home Page Address: www.lacasadellibro.org; *Dir* Maria Teresa Arraras
Open Tues - Sat 11 AM - 4:30 PM; No admis fee; Estab 1955 as a mus-library devoted to the history & arts of the book & related graphic arts; Maintains reference library; Average Annual Attendance: 14,000; Mem: 350; dues $35 & up
Income: Financed by donations & state appropriation
Special Subjects: Manuscripts, Posters, Maps, Bookplates & Bindings
Collections: Bibliography of graphic arts; binding; book illustration; calligraphy; early printing, especially 15th & 16th Century Spanish; modern fine printing; papermaking
Exhibitions: Gallery has displays on the first floor relating to printing and other arts of the book, such as: Editions of the Quixote, Spanish Incunables, Sevilla y El Libro Sevillano, Espana 1492, Homenajea Nebrija, Conversosy Sefarditas
Activities: Classes for adults & children; visits from school groups; students of library science & workers in graphic arts; material available, no fees; gallery talks; original objects of printing arts, material must be used on premises; originate traveling exhibitions; museum shop sells books, posters & cards

M MUSEO DE ARTE DE PUERTO RICO, 299 De Diego Ave, Stop 22, Santurce San Juan, PR 00910; PO Box 41209, Santurce San Juan, PR 00940. Tel 787-977-6277; Fax 787-977-4444; Internet Home Page Address: www.mapr.org; *Dir* Carmen T Ruiz de Fischler, PhD; *Develop Mem* Myrna Z Perez; *Educ* Doreen Colon; *Vol Pres* Zoila Levis; *Pub Rels* Maria Magrina; *Treas* Sonia Dominguez, CPA; *Registrar* Teresa Borgantti; *Cur* Marysol Nieves; *Security* Pedro Vangas; *Exhibs Mgr* Myrna Lopez; *Mus Shop Mgr* Edward Maldonado
Open Tues & Thurs - Sat 10 AM - 5 PM, Wed 10 AM - 8 PM, Sun 11 AM - 6 PM; cl New Year's Day, Good Friday, Election Day, Thanksgiving Day, Christmas Day; Admis adults $6, students & children $3, seniors $2.50, mems no admis fee; Estab 2000 with the mission to promote the knowledge, appreciation & enjoyment of Puerto Rican art from Spanish Colonial times to the present; colls, conserves; interprets, exhibs & promotes works of Puerto Rican art; art from other countries also exhibited; 41,962 sq ft exhib space; 400-seat theater; botanical garden; conservation lab; 2 classrooms; 4 workshops; computer lab; seminar rm; mus equipped with elevators & ramps; restaurant & cafe on-site; Mem: dues Exec $1000, Collaborated $500, Printed $250, Family $100, Indiv $50, Students, Teachers, Physically-Impaired & Srs $25
Collections: 18th - 21st c Puerto Rican paintings, sculpture, prints & drawings, photos, installations, conceptual art & multi-media art; Master painters Jose Campeche, Francisco Oller, Rafael Tufino, Augusto Mann, Myrna Baez, Rafael Ferrer, Franciso Rodon, etc; sculpture garden; silkscreens from 1940 to the present
Publications: MAPR, quarterly newsletter; Report, annually; exhib catalogs & brochures
Activities: Docent prog; formal educ progs for adults & children; mus training for professional mus workers; lects; guided tours; arts festivals; concerts; films; loan exhibs, temporary exhibs & traveling exhibs; ann events: MAPR Ann Gala; MAPR Ann Auction

VIEQUES

M INSTITUTE OF PUERTO RICAN CULTURE, Museo Fuerte Conde de Mirasol, PO Box 71, Vieques, PR 00765. Tel 787-741-1717; Fax 787-741-1717; Elec Mail bieke@prdigital.com; Internet Home Page Address: enchanted-isle.com/elfortin/; *Dir* Robert L Rabin Siegal
Open 8:30 AM - 4:30 PM Wed - Sun; Admis adult $2, children $1, in excursions $1; Estab 1989 for the preservation of local culture; Two galleries for itinerant exhibits, 20 x 50 ft; Average Annual Attendance: 15,000
Special Subjects: Architecture, Graphics, Hispanic Art, Latin American Art, Photography, Prints, Sculpture, Watercolors, Anthropology, Archaeology, Pre-Columbian Art, Ceramics, Crafts, Folk Art, Decorative Arts, Manuscripts, Posters, Historical Material, Maps, Coins & Medals
Collections: Archaeology of Vieques, Architecture of Vieques, History of Vieques, Silkscreens & other art of Puerto Rico & Vieques, photography of Vieques
Exhibitions: La Naturaleza de Vieques: 100 Millones de Anos de Historia (The Nature of Vieques: One Hundred Million Years of History) Flora, Fauna, Geologic Formation
Activities: Classes for adults & children; docent training; student guide program; school conferences; lect open to public, 10 vis lectr per year; concerts; tours; book traveling exhibitions 6 per year; originate traveling exhibitions 6 per year; sales shop sells books, original art, prints, crafts & t-shirts

National & Regional Organizations in Canada

O **ART DEALERS ASSOCIATION OF CANADA,** 55 Saint Clair Ave W, Ste 255 Toronto, ON M4V 2Y7 Canada. Tel 416-934-1583; Fax 416-967-6320; Elec Mail art@padac.ca; Internet Home Page Address: www.padac.ca; *VPres* Patricia Feheley; *Treas* Ian Muncaster; *Pres* Jane Corkin; *Prog Mgr* Nicole Puaskett; *Appraisals Asst* Sharlene Beierlinng; *Secy* Douglas MacLean
Estab 1966 for the promotion of art & artists of merit in Canada; Mem: 70, mems must have five yrs in operation plus approved reputation, financial integrity; dues vary; ann meeting by board
Income: Financed by mem & appraisal fees
Publications: Benefits of donation brochure; gen information brochure; mem directory; print brochure
Activities: Schols offered

O **ASTED INC,** 3414, avenue du Parc, bureau 202, Montreal, PQ H2X 2H5 Canada. Tel 514-281-5012; Fax 584-281-8219; Elec Mail info@asted.org; Internet Home Page Address: www.asted.org; *Exec Dir* Louis Cabral
Estab 1974 for the professional development of French-speaking information & documentation specialists nationwide; Mem: 500; varies; Oct meetings
Income: financed by government assistance
Exhibitions: Ann exhibits
Publications: Dewey Decimal Classification, 21st French edition; Documentation et Bibliotheques, 4 times per yr
Activities: Schols offered; originate traveling exhibs

O **CANADIAN ART FOUNDATION,** 56 The Esplanade, Suite 310, Toronto, ON M5E 1A7 Canada. Tel 416-368-8854; Fax 416-368-6135; Elec Mail info@canadianart.ca; Internet Home Page Address: www.canadianart.ca; *Ed* Richard Rhodes; *Mng Ed* Bryne McLaughlin; *Sales Mgr* Wendy Ingram; *Production Mgr* Jillian Thorp-Shepherd; *Publisher & Dir* Melody Ward; *Adminr* Caroline Chisholm
Open Mon - Fri 9 AM - 5 PM; Estab 1984; Circ 22,000
Publications: Canadian Art, quarterly
Activities: Lects open to pub 2-3 per yr, gallery talks, tours, sponsoring competiions

O **CANADIAN CONFERENCE OF THE ARTS,** 804-130 Albert St, Ottawa, ON K1P 5G4 Canada. Tel 613-238-3561; Fax 613-238-4849; Elec Mail cca@mail.culturenet.ca; Internet Home Page Address: www.culturenet.ca/cca; *National Dir* Megan Williams; *Communications Mgr* Anita Grace
Estab 1945 as a national nonprofit assoc to strengthen pub & pvt support to the arts & enhance the awareness of the role & value of the arts; Mem: 850; dues individuals $35 & GST organizations based on budget; ann meeting in May
Income: Financed by mem, grants & contracts
Publications: Blizzart, quarterly; Handbook Series: Directory of the Arts; Who Teaches What; policy papers & reports
Activities: Awards-Diplome d'Honneur to persons who have contributed outstanding service to the arts in Canada; Financial Post Awards: in collaboration with The Council for Business & the Arts in Canada, encourages the corporate sector's involvement with the visual & performing arts in Canada & recognizes those corporations whose involvement is already at a high & productive level; Rogers Communications Inc Media Award; Keith Kelly Award for Cultural Leadership; Diplîe d'honneur; Rogers Communications Inc Media Award for Coverage

O **CANADIAN MUSEUMS ASSOCIATION,** Association des Musees Canadiens, 280 Metcalfe St, Ste 400, Ottawa, ON K2P 1R7 Canada. Tel 613-567-0099; Fax 613-233-5438; Elec Mail info@museums.ca; Internet Home Page Address: www.museums.ca; *Exec Dir* John G McAvity; *Pub Affairs Officer* Richard Darroch; *Head of Progs & Projects* Dawn Roach; *Head Mem Servs* Suzanne Marion; *Pres* Francine Brousseau
Estab 1947 to advance pub mus services in Canada, to promote the welfare & better administration of museums & to foster a continuing improvement in the qualifications & practices of mus professions; Mem: 2000; dues $50 - $2000; ann meeting in April
Income: Financed by mem & government grants
Publications: Muse, quarterly; Museogramme, monthly; Official directory of Canadian Museums, occasional
Activities: Correspondence course in introductory museology; bursary program; travel grants

O **CANADIAN SOCIETY FOR EDUCATION THROUGH ART,** 1487 Parish Lane, Oakville, ON L6M 2Z6 Canada. Tel 905-847-0975; Fax 905-847-0975; *Secy General* Dr A Wilson
Estab 1955; voluntary association founded in Quebec City. Mems dedicated to the advancement of art educ, the publication of current thinking & action in art educ & the promotion of higher standards in the teaching of art; Average Annual Attendance: 400; Mem: 700; dues professional $65 (CN)
Income: Financed by mem

Collections: Historical Canadian Art; Children's Art
Publications: Canadian Review of Art Education, 1-2 times per ye; Journal, 1-2 times per yr; newsletter, quarterly; special publs
Activities: Workshops; research; lect open to public; gallery talks; tours; awards; scholarships offered

O **CANADIAN SOCIETY OF PAINTERS IN WATERCOLOUR,** 258 Wallace Ave, Ste 102, Toronto, ON M6P 3M9 Canada. Tel 416-533-5100; Elec Mail cspwc@canartscene.com; Internet Home Page Address: www.canartscene.com/orgs/cspwc; *Adminr* Shirley Barrie; *Pres* Neville Clarke
Estab 1925 to promote watercolour painting in Canada; AIRD Gallery, MacDonald Block, Queen's Park - shared on a rotating basis with five other societies; monthly exhibs; Average Annual Attendance: 31,000; Mem: 260 & 175 associates; dues $125; ann meeting in May. Mem qualifications: digital images sent to national mem committee
Income: $75,000 (financed by mems dues, associates, commissions on sale of work & book sales)
Library Holdings: Clipping Files; Exhibition Catalogs; Memorabilia; Original Art Works; Photographs; Slides
Collections: Diploma Collection at Art Gallery of Peel, Brampton, Ontario; Portfolio of 75 works in collection of Her Majesty the Queen at Windsor Castle
Exhibitions: Annual Open Juried Exhibition; Members' Exhibitions; International Exchanges; International Waters with AWS & RWS; Open Waters, annual
Publications: Aquarelle; Tri-annual newsletter (quarterly)
Activities: Classes for adults; lect open to mems; competitions with awards; awards at ann open juried exhib, Open Water; originate traveling exhibs across Canada to galleries; internationally to fellow arts organizations; national watercolor weekend of demonstrations & discussions

O **INTERNATIONAL ASSOCIATION OF ART CRITICS,** ALCA Canada, Inc, 706 15 McMurrich St, Tornoto, ON M5R 3M6 Canada. Tel 416-925-5564; Fax 416-925-2972; Elec Mail info@artfocus.com; Internet Home Page Address: www.aica-int.org; *Pres (Montreal)* Normand Biron; *VPres (Sackville, NB)* Virgil Hammock; *Treas & Membership (Toronto, Ont)* Pat Fleisher; *Sec (Montreal)* Hedwidge Asselin
Estab 1970; Mem: 50; mems must be practicing published activities in accepted art press
Income: Financed by mem fees
Activities: Annual International Conference of Art Critics

O **THE METAL ARTS GUILD,** PO Box 241 Station C, Toronto, ON M6J 3P4 Canada. Tel 416-532-0392; Fax 416-532-0392; Elec Mail maguild@interlog.com; Internet Home Page Address: www.metalarts.on.-ca; *Adminr* Darya Farha
Open by appointment; Estab 1946; Gallery with changing exhibits; Mem: Dues $20 - $50
Income: Financed by contributions, gifts, mem & grants
Exhibitions: Traveling 50th Anniversary Show at venues across Canada & one US venue; Biannual show of mems' work, rotating exhibits
Publications: Magazine, 3 times per year

O **ORGANIZATION OF SASKATCHEWAN ARTS COUNCILS (OSAC),** 1102 Eighth Ave, Regina, SK S4R 1C9 Canada. Tel 306-586-1250; Fax 306-586-1550; Elec Mail info@osac.sk.ca; Internet Home Page Address: www.osac.sk.ca; *Exec Dir* Nancy Martin; *Performing Arts Coordr* Kevin Korchinski; *Performing Arts Coordr* Marianne Woods; *Visual & Media Arts Coordr* Aaron Clarke; *Visual & Media Arts Coordr* Nikole Peters; *Accountant & Conference Coordr* Margie McDonald
Open Mon - Fri 8:30 AM - 5 PM; Estab 1969 to tour exhibs of Saskatchewan artists work & tour performers from across Canada, US & of international stature; Mem: 50 Arts Councils, 70 School Center members, ann conference in Oct
Library Holdings: Audio Tapes; Book Volumes 175; Cassettes; Clipping Files; Compact Disks; DVDs; Exhibition Catalogs; Kodachrome Transparencies; Manuscripts; Pamphlets; Periodical Subscriptions 10; Records; Reproductions; Slides; Video Tapes
Activities: Classes for adults & children; dramatic progs; docent training; lects open to pub; exten dept serves lending coll

O **QUICKDRAW ANIMATION SOCIETY,** 351 11th Ave SW, Ste 201, Calgary, AB T2R 0C7 Canada. Tel 403-261-5767; Fax 403-261-5644; Elec Mail qas@shaw.com; Internet Home Page Address: www.awn.com/qas
Open Tues - Sat 10 AM - 4:30 PM; Estab 1984 to promote study of animation & provide equipment for the production of independent animated film; Mem: 150; dues subscription $15, assoc $25, Quick Kid $30, producing $50; ann meeting in Apr
Income: $150,000 from Federal, Provincial, municipal funding, mem fees, courses & workshop fees
Library Holdings: Book Volumes; Video Tapes
Exhibitions: Animated film festivals

Publications: Quickdraw Quarterly
Activities: Classes for adults; lects open to pub; Artist in Residence award; schols; lending coll contains books, videotapes, equipment for use in animated film production

O **ROYAL ARCHITECTURAL INSTITUTE OF CANADA,** 55 Murray St, Ste 330, Ottawa, ON K1N 5M3 Canada. Tel 613-241-3600; Fax 613-241-5750; Elec Mail info@raic.org; Internet Home Page Address: www.raic.org; *Exec Asst* Judy Scott; *Chief Admin Officer* Jon Hobbs
Open daily 8:30 AM - 5 PM, summer hrs Fri 8:30 Am-12:30 PM; Estab 1908 to promote a knowledge & appreciation of architecture & of the architectural profession in Canada & to represent the interests of Canadian architects; Mem: 3800; mem open to architectural grads; dues $220
Publications: RAIC Directory, annually
Activities: Lect open to pub; awards given; schols offered

L **Library,** 55 Murray St, Ottawa, ON K1N 5M3 Canada. Tel 613-241-3600; Elec Mail info@raic.org; Internet Home Page Address: www.raic.org; *Exec Asst* Judy Scott
Open daily 8:30 AM - 5 PM, summer hrs Fri 8:30 AM - 12:30 PM; Estab for archival info only; Circ Non-circulating
Library Holdings: Book Volumes 200
Special Subjects: Architecture

O **ROYAL CANADIAN ACADEMY OF ARTS,** 401 Richmond St W, Ste 375, Toronto, ON M5V 3A8 Canada. Tel 416-408-2718; Fax 416-408-2286; Elec Mail rcaarts@interlog.com; *Pres* Ron Bolt; *VPres* Alison Hymas
Estab 1880 to better the visual arts field in Canada through exhibs, assistance to young artists & to museums; Mem: 550; honor soc; mem open to visual artists who demonstrated excellence in their own medium; dues $200; ann meeting in Apr
Income: Nonprofit assoc financed by mem & donations
Exhibitions: Special exhibs of the History of the Royal Canadian Academy 1880-1980; national, multi-disciplined, juried exhib
Publications: Passionate Spirits: A History of the Royal Canadian Academy of Arts 1880-1980
Activities: Originate traveling exhibs

O **SASKATCHEWAN ARTS BOARD,** 3475 Albert St, Regina, SK S4S 6X6 Canada. Tel 306-787-4056; Fax 306-787-4199; Elec Mail sab@artsboard.sk.ca; *Exec Dir* Jeremy Morgan
Open 8 AM - 4:30 PM; No admis fee; Estab 1948 as an autonomous agency for promotion & development of the arts in Saskatchewan; Board is composed of 12 appointed mems whose major concern at the present time is the support & development of professionals & professional standards within the province
Income: Financed by ann provincial government grant
Collections: Permanent collection containing over 2000 works by Saskatchewan artists & artisans only, dating from 1950 to present
Publications: Ann Report; brochures for Saskatchewan School of the Arts classes; services & progs brochure
Activities: Progs include grants, progs and services to individuals and groups whose activities have an impact on the arts in Saskatchewan and ensures that opportunities exist for Saskatchewan residents to engage in all art forms. The Arts Board also provides awards for outstanding achievement in the arts and collects and displays works of art by Saskatchewan artists

O **SCULPTOR'S SOCIETY OF CANADA,** Canadian Sculpture Centre, The Exchange Tower, PO Box 40 Toronto, ON M5X 1B5 Canada. Tel 416-214-0389; Fax 416-214-0389; Elec Mail sculpcan@echo-on.net; *Treas* Al Green; *Pres* Morton Katz
Open Tues - Fri noon - 6 PM, Sat Noon - 4 PM; No admis fee; Estab 1928 to promote the art of sculpture, to present exhibs (some to travel internationally), to educate the pub about sculpture; 1000 sq ft exhib space; Mem: 150; to qualify for mem, sculptors must submit photos of work for jury approval; dues $150; 2 general meetings per yr, exec committee meetings, 12 per yr
Income: $20,000 (financed by mem, provincial appropriation & sales commission)
Library Holdings: Exhibition Catalogs; Original Documents; Pamphlets; Periodical Subscriptions; Photographs; Sculpture; Slides; Video Tapes
Exhibitions: Annual Graduating Students Juried Exhibition; Canadian National Exhibition; McMichael Canadian Collection; Member Show; Sculptures for the Eighties; 70th Anniversary Exhibition; Annual emerging Artist Exhibition; Art of Collecting Exhibition
Publications: Exhibition catalogues
Activities: Workshops; lect open to pub; gallery talks; tours; 4-6 vis lect per yr; competitions with awards of student exhib; originate traveling exhibs to international cultural centres, embassy galleries; sculpture gallery sells books & original art

O **SIAS INTERNATIONAL ART SOCIETY,** 253-52152 Range Rd 210, Sherwood Park, AB T8A 2A6 Canada; PO Box 3039, Sherwood Park, AB T8A 2A6 Canada. Tel 780-922-5463; *Managing Dir* Dr Klaus Bous
Admis $25; Estab 1986 to promote unity of art, science & humanity & to promote interrealism
Collections: Prem Bio chemistry of Canada; SIAS International Art Society; Ernst Fuchs, Wolfgang Hutter, Rud Hausner (engravings); Claus Cumpel (oil paintings)
Publications: Creativity from the Sub conscious; The Art of Claus Cumpel (monograph)

L **Library,** PO Box 3039, Sherwood, AB T8A 2A6 Canada. Tel 780-922-5463; *Dir* Dr Klaus Bous
Income: $56,000 (financed by mem & sponsors)
Library Holdings: Book Volumes 981; Cassettes; Manuscripts; Motion Pictures; Original Art Works; Periodical Subscriptions 11; Photographs; Prints; Records; Reproductions; Slides; Video Tapes
Special Subjects: Film, Mixed Media, Photography, Etchings & Engravings, Graphic Arts, Manuscripts, Painting-German, Painting-European, Portraits, Art Education, American Indian Art, Religious Art, Woodcuts, Reproductions

O **SOCIETY OF CANADIAN ARTISTS,** 2099 Simcoe Dr, Burlington, ON L7M 4E8 Canada. Tel 905-319-3185; Fax 905-319-3185; Elec Mail korrling@home.com; *Pres* Kjell Orring; *Shows* Peter Large; *Treas* Margaret Nurse
Estab in 1957 as the Soc of Cooperative Artists & operated the first cooperative gallery in Toronto. In 1967 the name was changed to the Soc of Canadian Artists and the gallery moved to larger premises. In 1968 the mems elected to give up the gallery and concentrate on organizing group art shows for mems in galleries across Canada; Mem: 175, mem by jury, open to artists throughout Canada
Income: Financed by mem, community fundraisings and commissions
Exhibitions: 2 shows per yr
Publications: Two Decades, members' biographical catalog; quarterly newsletter
Activities: Sponsorship of art conferences & workshops; promotion of Canadian artists; originate traveling exhibs

Canadian Museums, Libraries & Associations

ALBERTA

BANFF

M BANFF CENTRE, Walter Phillips Gallery, 107 Tunel Mountain Dr, Banff, AB T1L 1H5 Canada; PO Box 1020, Sta 14, Banff, AB T1L 1H5 Canada. Tel 403-762-6281; Fax 403-762-6659; Elec Mail walter_phillipsgallery@banffcentre.ca; Internet Home Page Address: www.banffcentre.ca/wpg; *Preparator* Mimmo Maiolo; *Cur* Sylvie Gilbert; *Cur Asst* Charlene McNichol; *Prog Asst* Nicole Burisch
Open Tues - Wed, Fri - Sun Noon - 5 PM, Thurs Noon - 9 PM; No admis fee; Estab 1977 to serve the community & artists in the visual arts prog at The Banff Centre, School of Fine Arts. Contemporary exhibits are presented; Gallery is 15.24 x 21.34 m with 60.96 m of running space; Average Annual Attendance: 20,000
Income: Financed by provincial & pub funding
Collections: Walter J Phillips Collection
Publications: Exhib catalogs
Activities: Lect open to pub; concerts; gallery talks; tours; original objects of art lent to other galleries & museums; book traveling exhibs 1 per yr; originate traveling exhibs to Canadian & international galleries; mus shop sells books & original art

L Paul D Fleck Library & Archives, PO Box 1020, Sta 43, Banff, AB T0L 0C0 Canada. Tel 403-762-6265; Fax 403-762-6266; *Dir* Patrick Lawless; *Art Librn* James Rout
Open Mon - Fri 9 AM - 9 PM, Sat & Sun 1 - 9 PM, Summer hrs daily 9 AM - 9 PM; For reference only
Library Holdings: Book Volumes 32,000; Cassettes; Exhibition Catalogs; Fiche; Periodical Subscriptions 125; Records 12,000; Slides 27,000; Video Tapes 1100
Special Subjects: Intermedia, Film, Photography, Painting-American, Conceptual Art, Art Education, Primitive art, Furniture, Costume Design & Constr, Aesthetics, Pottery, Painting-Canadian, Architecture

M PETER & CATHARINE WHYTE FOUNDATION, (Peter & Catharine Whyte) Whyte Museum of the Canadian Rockies, PO Box 160, 111 Bear St Banff, AB T0L 0C0 Canada. Tel 403-762-2291; Fax 403-762-8919; Elec Mail wmcr@banff.net; Internet Home Page Address: www.whyte.org; *Exec Dir* Douglas Leonard; *Archives* Donald Bourdon; *Pres* Cliff White; *Art Cur* Lori Ellis; *Mgr Mktg & Develop* Sally Truss
Open Mon - Sun 10 AM - 5 PM, cl Christmas & New Year's Day; Admis family $10, adults $4, students & seniors $2, children under 5 free; Estab 1968 to preserve & collect materials of importance in the Canadian Rocky Mountain regions; to exhibit, publish & make material available for research, study & appreciation. Mus estab 1970 as nonprofit mus, art gallery, archives & library; Gallery consists of three main areas: the 2 large main galleries & the Elizabeth Rummel Room upstairs; Average Annual Attendance: 50,000; Mem: 600; dues $25
Income: Financed by endowment, federal & provincial special activities grants, pvt fundings, admis & sales
Special Subjects: Photography, Prints, Watercolors, Woodcarvings, Woodcuts, Etchings & Engravings, Landscapes, Manuscripts, Eskimo Art, Painting-Canadian, Historical Material, Maps
Collections: Historical & contemporary art by artists of the Canadian Rockies; art relating to or influenced by the region
Exhibitions: Approximately 20 per year: local, regional, national & international interest; ceramics, paintings, photographs, sculpture, textiles both historic & contemporary
Publications: The Cairn, 3 times per year; gallery calendars, tri-annual
Activities: Classes for adults & children; dramatic training; lect open to pub, 20 vis lectr per yr; concerts; gallery talks; tours; films; individual paintings & original objects of art lent to certified museums & art galleries; book traveling exhibs; originate travel exhibs to other certified museums & art galleries; sales shop sells books, reproductions, note cards

CALGARY

M ALBERTA COLLEGE OF ART & DESIGN, Illingworth Kerr Gallery, 1407 14th Ave NW, Calgary, AB T2N 4R3 Canada. Tel 403-284-7632; Fax 403-289-6682; Elec Mail ron.moppett@acad.ab.ca; Internet Home Page Address: www.acad.ab.ca; *Dir & Cur* Ron Moppett; *Asst Cur* Richard Gordon; *Technician* Valerie Dowhaniuk
Open Tues - Sat 10 AM - 6 PM; No admis fee; Estab 1958 as an academic-didactic function plus general visual art exhib service to pub; Two galleries: 425 sq meters of floor space; 125 meters running wall space; full atmospheric & security controls; Average Annual Attendance: 20,000
Special Subjects: Graphics, Painting-American, Photography

Collections: Permanent collection of ceramics, graphics, paintings, photography, student honors work
Exhibitions: Contemporary art in all media by regional, national & international artists
Publications: Exhib catalogs; posters
Activities: Lect open to pub, 20 vis lectr per yr; gallery talks; individual paintings & objects of art lent to other galleries; lending coll contains original art works; book traveling exhibs 3-4 per yr

L Luke Lindoe Library, 1407 14th Ave NW, Calgary, AB T2N 4R3 Canada. Tel 403-284-7631; Fax 403-289-6682; Elec Mail christine.sammon@acad.ca; Internet Home Page Address: www.acad.ab.ca; *Library Dir* Christine E Sammon
Open Mon - Thurs 8:30 AM - 8 PM, Fri 8:30 AM - 4:30 PM, Sat 11 AM - 5 PM; Estab 1972; Circ 45,000; Mem: $15 ann fee for community borrowers
Purchases: $85,000
Library Holdings: Book Volumes 22,320; Cassettes; Clipping Files; Exhibition Catalogs; Filmstrips; Lantern Slides; Motion Pictures; Periodical Subscriptions 80; Reproductions; Slides 100,225; Video Tapes
Special Subjects: Art History, Illustration, Photography, Commerical Art, Drawings, Etchings & Engravings, Painting-American, Advertising Design, Art Education, Glass, Aesthetics, Metalwork, Goldsmithing, Antiquities-Assyrian, Architecture

M CALGARY CONTEMPORARY ARTS SOCIETY, Triangle Gallery of Visual Arts, 800 Macleod Trail SE, Ste 104, Calgary, AB T2G 2M3 Canada. Tel 403-262-1737; Fax 403-262-1764; *Dir* Jacek Malec
Open Mon - Fri 11 AM - 5 PM, Sat Noon - 4 PM; No admis fee; Estab 1988 to exhibit contemporary art in all media & provide exten progs for pub; 3500 sq ft adjacent to municipal hall; Average Annual Attendance: 20,000; Mem: 500; dues $25; ann meeting in Nov
Income: $150,000 (financed by mem, city & state appropriation, corporate & pvt donations, fundraising events)
Collections: Artist circle, donated works
Exhibitions: Rotate 10-12 exhibits per yr
Publications: Update, monthly newsletter; exhibition brochures & catalogs
Activities: Docent training; workshops; lect open to pub, 20-30 vis lectr per yr; performances; exten servs provides paintings & art rentals; book traveling exhibs 3-6 times per yr

L CALGARY PUBLIC LIBRARY, Arts & Recreation Dept, 616 Macleod Trail SE, Calgary, AB T2G 2M2 Canada. Tel 403-260-2780; Fax 403-262-5929; Elec Mail arts&rec@calgarypubliclibrary.com; Internet Home Page Address: www.calgarypubliclibrary.com
Open Mon - Thurs 10 AM - 9 PM, Fri & Sat 10 AM - 5 PM, Sun Noon - 5 PM; No admis fee; Estab to provide information & recreational materials for the gen pub
Purchases: $70,000 Canadian
Library Holdings: Book Volumes 85,000; Clipping Files; Compact Disks; DVDs; Exhibition Catalogs; Periodical Subscriptions 250; Records; Video Tapes
Special Subjects: Art History, Film, Photography, Graphic Arts, Crafts, Theatre Arts, American Western Art, Fashion Arts, Video, American Indian Art, Painting-Canadian, Architecture
Collections: Clipping files on local artists
Exhibitions: Rotating exhibit cases

M GLENBOW MUSEUM, 130 Ninth Ave SE, Calgary, AB T2G 0P3 Canada. Tel 403-268-4100; Fax 403-265-9769; Internet Home Page Address: www.glenbow.org; *VPres Coll* Patricia Ainslie; *Cur Art* Cathy Mastin; *Cur Cultural History* Sandra Morton Weizman; *Cur Ethnology* Gerald Conaty; *Mgr Mus Shop* Connie Smith; *Chmn Bd* Webster Macdonald Jr; *Pres, CEO & Dir* Michael P Robinson; *VPres Prog Exhib* Heinz Reese; *Pub Rels* Brent Buechler
Open Mon - Wed, Sat & Sun 9 AM - 5 PM, Thurs & Fri 9 AM - 9 PM; Admis $100, seniors $7.50, students & youth $6, children under 3 free; admis Thurs evening $6, Fri evening Sept - May $4, June - Aug $6; Estab 1966 for art, books, documents, Indian & pioneer artifacts that lead to the preservation & better understanding of the history of western Canada; Mus has three exhib floors; 93,000 sq ft of exhib space; Average Annual Attendance: 200,000; Mem: 5000; dues family $60 $105/2 yrs, individual $45, $80/2 yrs, sr $30, student $25
Income: $10,300 (financed by endowment, provincial & federal appropriation, self-generated revenue)
Purchases: $100,000
Special Subjects: Historical Material
Collections: Art: Representative collections of Canadian historical & contemporary art, Indian & Inuit, & works of art on paper; Ethnology: Large collection of material relating to Plains Indians; representative holdings from Africa, Australia, Oceania, Central & South America, Inuit & Northwest Coast; Library & Archives: Western Canadian historical books, manuscripts & photographs; Military history; Cultural History
Publications: Chautauqua in Canada; Max Ernst; Four Modern Masters; exhib catalogs

Activities: Classes for adults & children; dramatic progs; docent training; lect open to pub; gallery talks; tours; exten dept; individual paintings & original objects of art lent to pub museums & galleries; lending coll contains 15,000 works on paper, 5000 paintings, sculpture & 5000 items of decorative art; book traveling exhibs 25 per yr; originate traveling exhibs; mus shop sells books, magazines, reproductions & prints

L Library, 130 Ninth Ave SE, Calgary, AB T2G 0P3 Canada. Tel 403-268-4197; Fax 403-232-6569; Elec Mail glenbow@glenbow.org; Elec Mail dcass@glenbow.org; Elec Mail lmoir@glenbow.org; Internet Home Page Address: www.glenbow.org; *Librn* Lindsay Moir; *Archivist* Doug Cass
Open Tues - Fri 10 AM - 5 PM; Circ Non-circulating; Open for reference
Income: Financed by endowment & government of Alberta
Library Holdings: Auction Catalogs; Book Volumes 90,000; CD-ROMs; Cards; Clipping Files; Exhibition Catalogs; Fiche; Manuscripts; Maps; Pamphlets; Periodical Subscriptions 100; Photographs; Reels
Special Subjects: Illustration, Manuscripts, Maps, Painting-British, Prints, Printmaking, Textiles, Painting-Canadian
Collections: Western Canadian Art; Historic Canadian Art

M MUSEUM OF MOVIE ART, 3600 21st St NE, No 9, Calgary, AB T2E 6B6 Canada. Tel 403-250-7588; Fax 403-250-7589; Elec Mail 103075.526@compuserve.com; *Gen Mgr* Sol Candel
Open Mon - Fri 9:30 AM - 5:30 PM; No admis fee; Estab 1985 for the exhib of original movie posters, 1930 to present; Average Annual Attendance: 1,000
Purchases: $58,000
Special Subjects: Prints, Posters, Reproductions
Collections: Consolidated Theatre Services; Federal Estate (Gaiety Theatre)
Publications: Catalogue
Activities: Mus shop sells reproductions & prints

M MUTTART PUBLIC ART GALLERY, 117 8th Ave SW Calgary, AB T2R 0W5 Canada. Tel 403-770-1350; Fax 403-264-8077; Internet Home Page Address: www.ffa.ucalgary.ca.muttart/; *Dir & Cur* Kathryn Burns; *Mgr Develop & Mktg* Sherry Robertson; *Treas* Marilyn Olson
Open Mon - Wed & Fri Noon - 5 PM, Thurs 2 - 8 PM, Sat 10 AM - 5 PM; No admis fee; Estab 1978 to exhibit the works of emerging & estab western Canadian artists; Top floor of the restored Memorial Park Library (old Carnegie Library); Average Annual Attendance: 90,000; Mem: 500; dues family $30, individual $20, students & srs $15; ann meeting in Apr
Income: $550,000 (financed by mem, city & provincial appropriation, grants, pvt donations & corporate funds)
Special Subjects: Architecture, Drawings, Graphics, Ceramics, Folk Art, Etchings & Engravings, Landscapes, Collages, Furniture, Glass, Jewelry, Metalwork, Carpets & Rugs, Juvenile Art, Gold
Publications: Quarterly exhibit catalogues; quarterly newsletter; semiannual exhibition brochures
Activities: Classes for adults & children; professional development; lect open to pub, 10 vis lectr per yr; gallery talks; tours; family days; art appreciation club; exten dept serves city of Calgary; book traveling exhibs 6 per yr; originate traveling exhibs to Southern Alberta; sales shop sells books, t-shirts & cards

C PETRO-CANADA, Corporate Art Programme, PO Box 2844, Calgary, AB T2P 3E3 Canada. Tel 403-296-6019; Fax 403-296-4990; *Art Cur* Pauline Lindland
Estab 1984 for encouragement of Canadian art
Income: $120,000 (financed by pvt donations)
Collections: 1600 2-D works in all media by contemporary Canadian artists

QUICKDRAW ANIMATION SOCIETY
For further information, see National and Regional Organizations

C SHELL CANADA LTD, 400 Fourth Ave SW, PO Box 100, Sta M Calgary, AB T2P 2H5 Canada. Tel 403-691-3111; Fax 403-691-4350; *Coordr Coll* Dianne Engel
Collections: Works of contemporary canadian artists with media concentrations in painting, sculpture, graphics, mixed media & works on paper

M UNIVERSITY OF CALGARY, The Nickle Arts Museum, 2500 University Dr NW, Calgary, AB T2N 1N4 Canada. Tel 403-220-7234; Fax 403-282-4742; Elec Mail nickle@ucalgary.ca; Internet Home Page Address: www.ucalgary.ca/-nickle; *Curatorial Assist (Numismatics)* Geraldine Chimirri-Russell; *Asst Cur (Art)* Christine Swoiak; *Dir* Ann Davis; *Gift Shop Mgr* Robin Jaska; *Registrar* Lisa Tillotson
Open Mon - Fri 10 AM - 5 PM, Sat 1 - 5 PM, Tues 10 AM - 9 PM, cl Sun & holidays; Admis adults $2, children & sr citizens $1, students of institutions of higher learning, children under 6 & Tues free; Estab 1970, an Alberta pioneer, Samuel C Nickle, gave the University a gift of one million dollars & the mus was opened in 1979. His son, Carl O Nickle, presented the University with an immensely valuable coll of some 10,000 ancient coins, covering over 1500 yrs of human history which is housed in the Numismatics dept of the mus; Circ yes; Mus houses the permanent coll of the University; exhibs are presented on a continuous basis in the gallery on the main fl (15,000 sq ft). A smaller numismatic gallery displays a permanent coll. The smaller Teaching Gallery on the second fl (1500 sq ft) is used for small exhibs, lects, films & seminars; Average Annual Attendance: 25,000; Mem: 250; dues $10 - $40
Income: Financed by state appropriation through the University, donations, earned income & grants
Purchases: $15,000
Special Subjects: Drawings, Photography, Prints, Sculpture, Watercolors, Painting-Canadian, Coins & Medals
Collections: Ceramics; contemporary paintings; drawings; photography; prints; sculpture; watercolors; Coins & bills covering 1500 years of Human History
Exhibitions: Local, national & international exhibs are presented on a continuous basis
Publications: Exhib catalogs
Activities: Educ prog for elementary schools on numismatics, Reading the Image; lect open to pub, 10-20 vis lectr per yr; gallery talks; tours; individual paintings & original objects of art lent to other museums & art galleries, Money shows at

Canadian Nat Currency Mus; book traveling exhibs 2 per yr; originate traveling exhibs to recognized museums; mus shop sells books, magazines, original art, reproductions, prints, jewelry, gift items, exhib catalogues, posters, stationery, clothing & art objects

L Faculty of Environmental Design, 2500 University Dr, PFA 2182 Calgary, AB T2N 1N4 Canada. Tel 403-220-6601; Fax 403-284-4399; Elec Mail johnstoa@ucalgary.ca
Open Mon - Fri 9:30 AM - 4:30 PM; No admis fee; Estab 1973 as a resource facility for students & faculty in 5 prog areas: architecture, urban planning, industrial design, environmental science & environmental design; Small gallery for display of student works & traveling exhibs; workshop; photo lab facilities
Library Holdings: Audio Tapes; Book Volumes 500; Cassettes; Manuscripts; Memorabilia; Other Holdings Drawings; Models; Periodical Subscriptions 30; Slides; Video Tapes
Special Subjects: Industrial Design, Interior Design, Architecture

CZAR

M SHORNCLIFFE PARK IMPROVEMENT ASSOC, Prairie Panorama Museum, PO Box 60, Czar, AB T0B 0Z0 Canada. Tel 780-857-2155; *Cur* Helena Lawrason
Open Sun 2 - 6 PM, other days by appointment; No admis fee; Estab 1963 for the enjoyment of the pub; Average Annual Attendance: 580
Income: Finances by government grant & donations
Collections: Indian artifacts, clothing, tools, dolls, books; Salt & Pepper Coll; Two 1926 coffeemakers, homemade snowshoes (1920), Cajun accordion
Activities: Classes for children

EDMONTON

A ALBERTA CRAFT COUNCIL, 10186 106th St, Edmonton, AB T5J 1H4 Canada. Tel 780-488-6611; Fax 780-488-8855; Elec Mail acc@albertacraft.ab.ca; Internet Home Page Address: www.albertacraft.ab.ca; *Exec Dir* Tom McFall; *Mem Svcs* Al Fleming; *Mgr Admin* Nancy St Hilaire
Open Mon - Sat 9 AM - 5 PM; No admis fee; Estab 1980 to promote craft; Gallery exhibs 6 shows per yr of craft in these 5 media: clay, glass, wood, metal & fibre; Mem: Dues vary
Income: Financed by mem
Exhibitions: 6 shows per yr
Publications: Alberta Craft Magazine, 6 per year
Activities: Classes for adults; book traveling exhibs 2 per yr; originate traveling exhibs 1 every 4 yrs; sales shop sells crafts

A ALBERTA FOUNDATION FOR THE ARTS, Standard Lite Ctr, Ste 901, 10158 103rd St Edmonton, AB T5J 4R7 Canada. Tel 780-427-9968; Fax 780-422-9132; Internet Home Page Address: www.affta.ab.ca; *Chmn* John C Osler; *Arts Prog Coordr* Ross Bradley; *Exec Dir* Clive Padfield
Open Mon - Fri 8:15 AM - 4:30 PM; No admis fee; Estab 1972 to collect & to exhibit art works produced by Alberta artists; to provide financial assistance to Alberta pub, institutional & commercial art galleries, art groups & organizations for progs & special projects; to assist other galleries in Edmonton
Income: Financed by Alberta Lotteries
Collections: Alberta Foundation for the Arts Collection
Exhibitions: Exhibits are provided through a consortium of Alberta pub galleries. The progs vary from yr to yr & from region to region; Spaces & Places; Little by Little
Publications: Ann Report; exhib catalogs
Activities: Acquisition of art works by Alberta artists; exhib prog in and outside Canada; Jon Whyte Memorial Prize, Tommy Banks Award; scholarships & fels offered; individual paintings & original objects of art lent to pub government buildings; book traveling exhibs; sales shop sells books

A ALBERTA SOCIETY OF ARTISTS, PO Box 11334 Edmonton, AB T5J 3K6 Canada. Tel 780-426-0072; Fax 780-420-0944; Elec Mail north@artists-society.ab.ca; Internet Home Page Address: www.artists-society.ab.ca/home; *Pres* Raymond Theriault; *VPres* Annette Ayre; *Treas* Danielle LaBrie
Estab 1926 as an association of professional artists designed to foster and promote the development of visual and plastic fine arts primarily within the province; Mem: Approx 250; dues $60 each yr; AGM: April. New members are juried in annually based on slides or digital images of artwork
Exhibitions: Exhib organized annually by provincial & the Calgary & Edmonton branch
Publications: Highlights (newsletter), bimonthly
Activities: Through exhib, educ & communication, the ASA strives to increase pub awareness & appreciation of the visual arts in Alberta; classes for adults; lect open to pub 8 vis lect per yr; scholarships; organize traveling exhib to art galleries in Alberta & other regions of Canada

DEPARTMENT OF COMMUNITY DEVELOPMENT
M Provincial Museum of Alberta, Tel 780-453-9100; Fax 780-454-6629; Internet Home Page Address: www.pma.edmonton.ab.ca; *Asst Dir Natural History & Coll Admin* Dr Bruce McGillivray; *Asst Dir Archaeology & Ethnology* Dr Jack Ives; *Dir* Dr Philip H R Stepney; *Asst Dir Exhibits & Communications* Tim Willis; *Asst Dir Mktg & Visitor Servs* Bruce Bolton
Open Mon - Sun 9 AM - 5 PM; Admis adult $6.50, sr $5.50, youth $3, all prices subject to change during feature exhibits; Estab 1967 to preserve & interpret the human & natural history of the Alberta region; Four major exhibit areas divided equally into human & natural history under broad themes of settlement history, archaeology & anthropology, natural history & habitats; Average Annual Attendance: 200,000 - 250,000; Mem: 1200; dues $12 - $19; ann meeting in June
Income: $5,154,000 (financed by provincial government, mus shop, facility rentals, progs, special exhibits & admis)
Library Holdings: Auction Catalogs; Audio Tapes; Book Volumes; CD-ROMs; Cassettes; Clipping Files; Exhibition Catalogs; Fiche; Framed Reproductions; Lantern Slides; Maps; Memorabilia; Original Art Works; Original Documents;

Pamphlets; Periodical Subscriptions; Photographs; Prints; Records; Reels; Reproductions; Sculpture; Slides; Video Tapes
Special Subjects: Archaeology, Ethnology, Coins & Medals
Collections: Archaeological, ethnographical; fine & decorative arts; folk life; geology; historical; invertebrate zoology; mammalogy; palaeontology; ornithology: vascular & non vascular plants; ichthyology & herpetology; government history
Exhibitions: Approx 10 feature exhibits
Publications: Occasional papers; occasional series; publ series; exhibit catalogs; teacher guides
Activities: Classes for children; dramatic progs; docent training; lect open to pub, 6-20 vis lectr per yr; gallery talks; tours; concerts; schols offered; exten dept serves western Canada; individual paintings & original objects of art lent to other museums; outreach sr program; loans artifacts & speciments to pub & educational facilities; book traveling exhibs 5 times per yr; originate traveling exhibs to mems of Alberta Exhibit Network; other museums in Canada, occasional exhibits in Japan; mus shop sells books, children's articles, jewelry, logo pins, original art, reproductions, prints, slides & t-shirts

L Provincial Archives of Alberta, Tel 780-427-1750; Fax 780-427-4646; Internet Home Page Address: www.gov.ab.ca/med/mhs/paa/paa/htm; *Provincial Archivist* Dr Sandra Thomson; *Sr A-V Archivist* Marlena Wyman
Open Mon - Fri 9 AM - 4:30 PM, Tues & Wed evening until 9 PM, Sat 9 AM - 1 PM; Estab 1967 to identify, evaluate, acquire, preserve, arrange & describe & subsequently make available for pub research, reference & display those diversified primary & secondary sources that document & relate to the overall history & develop of Alberta; For reference only
Income: Financed by provincial appropriation
Purchases: $73,000
Library Holdings: Audio Tapes; Book Volumes 10,000; Cassettes; Clipping Files; Fiche; Manuscripts; Motion Pictures; Original Art Works; Other Holdings Original documents; Pamphlets; Periodical Subscriptions 100; Photographs; Prints; Records; Reels; Slides
Exhibitions: Several small displays each year highlighting recent accessions or historical themes; periodic major exhibs
Publications: Exhib catalogues; guides to colls; information leaflets; occasional papers

L Library, 2 Sir Winston Churchill Sq, Edmonton, AB T5J 2C1 Canada. Tel 780-422-6223; Fax 780-426-3105; *Exec Dir* Virginia Stephen
Open by appointment; Estab 1924; Maintained by volunteer staff. Reference library open to researchers & staff only
Library Holdings: Book Volumes 10,000; Cassettes; Clipping Files; Exhibition Catalogs; Fiche; Periodical Subscriptions 38; Reels; Sculpture 70,000; Slides 17,000; Video Tapes 150
Special Subjects: Art History, Painting-American, Sculpture, Portraits, Watercolors, Printmaking, Video, Religious Art, Woodcuts, Painting-Canadian

A LATITUDE 53 CONTEMPORARY VISUAL CULTURE, (Latitude 53 Society of Artists) 10248 106th St, Edmonton, AB T5J 1H5 Canada. Tel 780-423-5353; Fax 780-424-9117; Elec Mail info@latitude53.org; Internet Home Page Address: www.latitude53.org; *Exec Dir* Todd Janes
Open Tues - Fri 10 AM - 6 PM, Sat noon - 5 PM, cl Sun & Mon; No admis fee; Estab 1973 to encourage & promote the artistic endeavours of contemporary artists & to build a pub awareness of current & experimental cultural developments; Visual, installations, performance & fibre art. Resource center for grants & contracts; Average Annual Attendance: 24,000; Mem: 300; dues $25; ann meeting third Mon in Oct
Income: $300,000 (financed by grants, donations, pub & pvt funding, mem & fundraising events)
Library Holdings: Cassettes; Clipping Files; Exhibition Catalogs; Periodical Subscriptions
Publications: Exhib catalogues
Activities: Lect open to pub, 9 vis lectr per yr; concerts; gallery talks & tours; book traveling exhibs 10 per yr; originate traveling exhibs for other art centers

M UKRAINIAN CANADIAN ARCHIVES & MUSEUM OF ALBERTA, 9543 110th Ave, Edmonton, AB T5H 1H3 Canada. Tel 780-424-7580; Fax 780-420-0562; *Pres* Khrystyna Jendyk; *Exec Dir* Alexander Makar; *Admin Ofcr* Bohdana Badzio
Open Tues - Fri 10 AM - 5 PM, Sat Noon - 5 PM, cl Mon & Sun; No admis fee; Estab 1972; 3 stories, library & mus; Mem: Dues family $25, individual $10
Income: Financed by mem, donations & casinos
Special Subjects: Crafts, Historical Material
Collections: Drawings, historical material, national costumes, paintings, prints, sculpture & textiles
Activities: Guided tours; displays

M WHERE EDMONTON COMMUNITY ARTISTS NETWORK SOCIETY, Harcourt House Arts Centre, 10215 112 St, Edmonton, AB T5K 1M7 Canada. Tel 780-426-4180; Fax 780-425-5523; Elec Mail harcourt@telusplanet.net; Internet Home Page Address: www.harcourthouse.ab.ca; *Prog Coordr* Christal Pshyk; *Admin Asst* Linda Hamilton; *Exec Dir* Allen Ball; *Exhib Coordr* Paulette Hawkins; *Art Enrichment Coordr* Kelly Mellings
Open Mon - Fri 10 AM - 5 PM, Sat 12 PM - 4 PM; No admis fee; Estab 1988; A not-for-profit arts center which includes a pub gallery, art educ prog, & artists' studios. Two gallery spaces include the main space local, national, international (828.5 sq ft) & front room space (536.5 sq ft) for mems & local artists to display their work, open to Alberta, Canada venues only; Average Annual Attendance: 8,000; Mem: 250; dues $25; ann meeting in Apr
Income: Financed by mem, city & state appropriations
Exhibitions: Rotating exhibits
Publications: Harcourt Expressed, quarterly
Activities: Classes for adults & children; lect open to pub, 6 vis lectr per yr; originate traveling exhibs 8 per yr

GRANDE PRAIRIE

M PRAIRIE ART GALLERY, 10209 99th St, Grande Prairie, AB T8V 2H3 Canada. Tel 780-532-8111; Fax 780-539-9522; Elec Mail pag@telusplanet.net; Internet Home Page Address: www.prairieartgallery.ca; *Educator* John Kerl; *Exhib Coordr* Kathleen Wall; *Admin Asst* Penny Vey; *Dir & Cur* Donna White
Open Mon - Fri 10 AM - 5 PM, Sat & Sun 1 - 5 PM; No admis fee; Estab 1975 for exhibs; Maintains reference library; Average Annual Attendance: 54,000; Mem: 500; dues $25 corporate
Income: $220,000 (financed by mem, city appropriation, provincial & federal government grants)
Special Subjects: Painting-American, Folk Art, Decorative Arts, Painting-European, Painting-Canadian, Painting-Dutch, Painting-French, Historical Material, Painting-Flemish, Painting-Spanish, Cartoons, Painting-German, Painting-New Zealander
Collections: Alberta Art; Contemporary Western Canadian Art
Exhibitions: Rotate 6 - 8 per yr
Activities: Classes for adults & children; lect open to pub, 8 vis lectr per yr; gallery talks; tours; competitions with prizes; schols offered; exten dept serves Northwest Quadrant of Alberta; individual paintings & original objects of art lent to commercial companies, pub institutions & individuals; lending coll contains books, original art works, original prints, paintings; book traveling exhibs 10 per yr; originate traveling exhibs; sales shop sells books, jewelry, exhib catalogues, crafts

LETHBRIDGE

A ALLIED ARTS COUNCIL OF LETHBRIDGE, Bowman Arts Center, 811 Fifth Ave S, Lethbridge, AB T1J 0V2 Canada. Tel 403-327-2813; Fax 403-327-6118; *Pres* Birthe Perry; *Exec Dir* Shirley Wyngaard
Open Mon - Fri 9 AM - 9 PM, Sat 10 AM - 4 PM, cl Sun, summer hrs Mon - Fri 9 AM - 5 PM, Sat 10 AM - 4 PM, cl Sun; No admis fee; Estab 1958 to encourage & foster cultural activities in Lethbridge, to provide facilities for such cultural activities & to promote the work of Alberta & western Canadian artists; Average Annual Attendance: 20,000; Mem: 300; dues $25, ann meeting in Feb
Income: $67,000 (financed by mem & city appropriation, Alberta Culture granting & fundraising)
Exhibitions: Local & regional exhibs: Children's art, fabric makers, painters, potters; one-man shows: Paintings, photography, prints, sculpture, silversmithing; provincial government traveling exhibits
Publications: Calendar of Arts, weekly
Activities: Classes for adults & children; dramatic progs; concerts; competitions; schols offered; traveling exhibs organized & circulated; sales shop sells original art

M CITY OF LETHBRIDGE, Sir Alexander Galt Museum, c/o City of Lethbridge, 910 Fourth Ave S Lethbridge, AB T1J 0P6 Canada. Tel 403-320-3898 (mus), 329-7302 (archives); *Display Artist* Brad Brown; *Dir & Cur* Wilma Wood
Open daily July & Aug, cl statutory holidays Sept - June; No admis fee; Estab 1964 to promote the study of human history in southern Alberta; Five Galleries; One gallery is for community use; 800 sq ft & 100 ft running wall space; Average Annual Attendance: 25,000
Income: $247,000
Collections: Historical artifact coll; Archives Coll: photos, manuscripts, books, tapes, films
Exhibitions: Rotate 6-8 exhibits per yr
Activities: Children's classes; docent progs; lect open to pub, 10 vis lectr per yr; tours; book traveling exhibs 8 per yr; originate traveling exhibs to area schools, institutions, fairs; mus shop sells books & locally handcrafted items

L LETHBRIDGE PUBLIC LIBRARY, Art Gallery, 810 Fifth Ave S, Lethbridge, AB T1J 4C4 Canada. Tel 403-380-7310; Fax 403-329-1478, 327-8770; *Librn* Brian Houston; *Cur* Janet Walters
Open Mon - Fri 9:30 AM - 9 PM, Sat 9:30 AM - 5 PM, Sun 1:30 - 5:30 PM; No admis fee; Estab 1974 to expand human experience, to encourage people to look at art as well as read & attend library progs; Theatre gallery 4,000 sq ft wall space for each exhibit, 150 linear ft wall space; Average Annual Attendance: 8,000
Income: Financed by city appropriations
Library Holdings: Book Volumes 193,243; Periodical Subscriptions 500
Activities: Lect open to pub, 8-10 vis lectr per yr; tours; lending coll contains 250,000 books, 250,000 cassettes, CDs & talking books; book traveling exhibs 6 per yr; originate traveling exhibs

M SOUTHERN ALBERTA ART GALLERY, 601 Third Ave S, Lethbridge, AB T1J 0H4 Canada. Tel 403-327-8770; Fax 403-328-3913; Elec Mail info@saag.ca; Internet Home Page Address: www.saag.ca; *VPres* Eric Hillman; *Pub Prog Cur* Anine Vonkeman; *Pres* Dan Westwood; *Dir* Marilyn Smith; *Cur* Joan Stebbins; *Preparator* Paul Smith
Open Tues - Sat 10 AM - 5 PM, Sun 1 - 5 PM; No admis fee; Estab 1976 to present historical & contemporary art programs designed to further the process of art appreciation; Three gallery spaces contained in historical Lethbridge building remodeled as art gallery; Average Annual Attendance: 30,000; Mem: 325; dues family $35, single $20, artist $10, student $10; ann meeting in Feb
Income: Financed by mem, city, provincial & federal appropriation
Collections: Buchanan Collection of City of Lethbridge containing mid-20th Century Canadian work & various international pieces
Exhibitions: Historical and contemporary art changing monthly
Publications: Exhib catalogues; quarterly newsletter
Activities: Classes for children; docent training; professional development series; lect open to pub, numerous vis lectr per yr; gallery talks; tours; artmobile; originate traveling exhibs; sales shop sells magazines & reproductions

L Library, 601 Third Ave S, Lethbridge, AB T1J 0H4 Canada. Tel 403-327-8770; Fax 403-328-3913; Internet Home Page Address: www.saag.ca; *Librn* Joseph Anderson; *Asst Cur* David Diviney; *Dir* Marilyn Smith; *Cur* Joan Stebbins; *Head Pub Rels* Anine Vonkeman; *Develop Mgr* Karin Champion; *Educ Coordr* Marsha Reich; *Visitors Serv Mgr* Sue Black

Open Tues - Sat 10 AM - 5 PM, Sun 1 - 5 PM; No admis fee; Estab 1976; Contemporary pub art gallery; Average Annual Attendance: 32,000; Mem: 400+ mem

Library Holdings: Audio Tapes; Book Volumes 4000; Cassettes; Clipping Files; Exhibition Catalogs; Filmstrips; Manuscripts; Pamphlets 3200; Periodical Subscriptions 12; Reproductions; Slides; Video Tapes
Collections: Buchanan Collection - City of Lethbridge
Exhibitions: 15 exhibs annually
Publications: 6-8 publs annually
Activities: Classes for adults & children; lect open to public, 25 - 30 vis lectr per year; concerts; gallery talks; tours; video competitions; exten dept serves southern & central Alberta; lending collection contains 520 books, 22 cassettes, 56 videos (in house viewing only); book traveling exhibitions; organize traveling exhibitions; sales shop sells books, magazines, original art, prints & reproductions

M UNIVERSITY OF LETHBRIDGE, Art Gallery, 4401 University Dr, Lethbridge, AB T1K 3M4 Canada. Tel 403-329-2690; Fax 403-382-7115; Internet Home Page Address: www.uleth.ca; *Asst Cur* Victoria V Baster; *Chief Preparator* Adrian G Cooke; *Registrar* Lucie E Linhart; *Dir* Josephine Mills; *Business Mgr* Fred Greene
Open Mon - Fri Noon - 4:30 PM; No admis fee; Estab 1968 for pub service & the teaching mechanism; 29 ft x 42 ft gallery; Visual Arts Study Centre, 8:30 - 4:30 PM Mon - Fri, where any work from the coll will be made available for viewing
Income: Financed by univ & government appropriations
Collections: Permanent Coll consists of 19th century art (primarily Canadian), 20th century international art; Inuit
Exhibitions: Exhibitions with exception of the Annual BFA show are curated from the permanent collection; Faculty & Staff Exhibitions; approximately 10 shows per yr
Activities: Lect open to pub, 10-15 vis lectr per yr; tours; individual paintings & original objects of art lent to pub & commercial galleries & corporations

MEDICINE HAT

M MEDICINE HAT MUSEUM & ART GALLERY, 1302 Bomford Crescent SW, Medicine Hat, AB T1A 5E6 Canada. Tel 403-527-6266 (mus), 502-8580 (gallery); Fax 403-528-2464; Elec Mail mhmag@telusplanet.net; Internet Home Page Address: www.city.medicine-hat.ab.ca./cityservices/museum; *Dir* Donny White; *Registrar* Jerry Osmond
Open Mon - Wed 7-10 PM, Sat & Sun 1-5 PM, cl New Year's Day, Good Friday, Christmas & Boxing Day; Admis donations are welcomed; Estab 1951; Gallery has 2425 sq ft on main floor; Average Annual Attendance: 18,500; Mem: 250; dues supporting $50, bus $50, family $20, individual $10
Income: Financed by memberships, donations, fund raising & provencial appropriation
Collections: Pioneer artifacts of city & the district; Indian artifacts
Exhibitions: Rotate 15 per yr
Activities: Classes for children; films; gallery talks; exten dept serves surrounding rural district; sales shop sells books & original art

L MEDICINE HAT PUBLIC LIBRARY, 414 First St SE, Medicine Hat, AB T1A 0A8 Canada. Tel 403-502-8525; Fax 403-342-8529; Elec Mail library@city.medicine-hat.ab.ca; Internet Home Page Address: www.shortgrass-lib.ab.ca./mhpl; *Asst Chief Librn* Erin T Doyle; *Head Reference Svcs* Pat Evans; *Chief Librn* Rachel Sarjeant-Jenkins; *Head Adult Servs* Hilary Munro
Open Mon - Thurs 10 AM - 9 PM, Fri & Sat 10 AM - 5:30 PM, Sun 1 - 5:30 PM; Library has a display area for traveling and local art shows; 600 sq ft room with track lighting and alarm system
Library Holdings: Book Volumes 165,589; CD-ROMs 30; Cassettes 3224; Clipping Files; Compact Disks 3393; Motion Pictures 50; Original Art Works 30; Other Holdings Talking Books 1904; Pamphlets 3317; Periodical Subscriptions 243; Prints; Records; Reels 50; Sculpture; Video Tapes 2437
Exhibitions: Art loans from Alberta Foundation for the Arts; Exhibits of local artists
Activities: Dramatic programs; lect open to pub, 10 vis lectr per yr; concerts

MUNDARE

A BASILIAN FATHERS, PO Box 379, Mundare, AB T0B 3H0 Canada. Tel 780-764-3887; Fax 780-764-3961; *Dir* Father Paul Chomnycky
Open daily Mon - Fri 10 AM - 4 PM, weekends July - Aug 1 - 5 PM; Donations accepted; Estab 1902 to serve the people in their church, Mus estab 1953
Income: Financed by donations, government grants
Collections: Arts & Crafts; Historical Church Books; Ukranian Folk Art
L Library, PO Box 379, Mundare, AB T0B 3H0 Canada. Tel 780-764-3887; Fax 780-764-3961; Elec Mail dag@basilianmuseum.org; Internet Home Page Address: www.basilianmuseum.org; *Assoc Dir & Cur* Dagmar Rais; *Operations Mgr* Lorrie Frebrowski
Mon - Fri 10 AM - 4 PM, weekends (summer only) 1 - 5 PM; No admis fee; donations appreciated; Estab in 1953 to collect, research, preserve, exhibit & interpret artifacts & archival materials representative of Ukrainian religious and cultural life from Ukraine & Canada; Circ Non-circulating; Average Annual Attendance: 4,000
Library Holdings: Book Volumes 650
Collections: Artifacts, archival material
Publications: The Sacred Sacrament of Matrimony
Activities: School progs for children; sales shop sells books, magazines, prints, Ukrainian & religious souvenirs, cards & music

RED DEER

M RED DEER & DISTRICT MUSEUM & ARCHIVES, 4525 47A Ave, Red Deer, AB T4N 5H2 Canada. Tel 403-309-8405; Fax 403-342-6644; Elec Mail museum@museum.red-deer.ab.ca; Internet Home Page Address: www.museum.red-deer.ab.ca; *Interpretive Prog Coordr* Rod Trentham; *Exhibits Coordr* Diana Anderson; *Dir* Wendy Martindale; *Coordr Coll* Valerie Miller; *Office Mgr* Lorraine Evans-Cross; *Coordr Promotions* Teresa Neuman; *Vol Coord* Dorothy Reso-Hickman
Open Mon, Tues & Fri 10 AM - 5 PM, Wed & Thurs 10 AM - 9 PM, Sat, Sun &

holidays 1 - 5 PM; No admis fee; Estab 1978 to present the human history of the region through an on-going series of exhibs & interpretive progs; Stewart Room has 64 running ft of exhib space; Volunteer's Gallery has 124 running ft of exhibition space; Donor's Gallery has 160 running ft of exhib space; 2500 sq ft total area of circulating exhib space; 4100 sq ft of permanent exhib space; Average Annual Attendance: 60,000; Mem: 1000; dues family $15, individual $10
Income: Financed by municipal, provincial & federal grants
Special Subjects: Photography, Textiles, Primitive art, Painting-Canadian, Porcelain, Restorations, Period Rooms
Collections: Bower Collection of archaeological specimens from Central Alberta; Central Alberta human history; Inuit carving, prints & related material; Swallow Collection of Inuit & Indian Art; permanent art collection, clothing & textiles
Exhibitions: Programs featuring local, international, national & provincial artists; Alberta Community Art Clubs Assoc; Alberta Wide Juried Exhibition; Central Alberta Photographic Society Annual Exhibit; Red Deer College Student Show
Publications: Quarterly newsletter, Inventive Spirit (compendium & database of Alberta inventions)
Activities: Classes for children; mus-kits; lect open to pub; concerts; gallery talks; tours; originate traveling exhibs provincially, nationally to museums & art galleries; mus shop sells books, magazines, original art, prints, coloring books, learning tools, souvenirs, postcards, stationery & gifts; children's discovery zone

SHERWOOD PARK

SIAS INTERNATIONAL ART SOCIETY
For further information, see National and Regional Organizations

STONY PLAIN

M MULTICULTURAL HERITAGE CENTRE, 5411 51st St, Box 2188 Stony Plain, AB T7Z 1X7 Canada. Tel 780-963-2777; Fax 780-963-0233; *Cur Generations Gallery* Linda Stanier; *Exec Dir* Judy Unterschultz
Open Mon - Wed 10 AM - 4 PM, Thurs - Sun 10 AM - 8 PM; No admis fee; Estab 1974 to provide exposure to high quality art with priority given to local Alberta artists, to develop an appreciation for good art, to provide exposure for upcoming artists; Gallery has 2000 sq ft of exhib space; Multiculture Heritage Centre also consists of Opertshauser House on same site; maintains reference library; Average Annual Attendance: 85,000; Mem: 100; dues $20, ann meeting Jan
Income: Financed by government grants, free for Children & adult program, commissions from store sales, Homesteaders Kitchen revenue & fundraising
Special Subjects: Historical Material
Collections: Area history; family histories; photographs
Exhibitions: 20 exhibs per year
Publications: Monthly newsletter
Activities: Classes adults & children, dramatic progs; lect open to pub, 10 vis lectr per yr; concerts; sales shop sells books, original art, reproductions, Prints, Homesteader's Kitchen serves ethnic fares

BRITISH COLUMBIA

BURNABY

M BURNABY ART GALLERY, 6344 Deer Lake Ave Burnaby, BC V5C 2J3 Canada. Tel 604-291-9441; *Dir & Cur* Denis Gautier; *Educ Cur* Allison Gilson
Open Tues - Fri 9:30 AM - 4:30 PM, weekends & holidays 12:30 - 4:30 PM, cl Christmas; Admis $2; Estab 1967 to collect & exhibit Canadian art, with continually changing exhibs of prints, paintings, sculpture & other art forms; Gallery is housed in Ceperley Mansion in Deer Lake Park; Average Annual Attendance: 25,000; Mem: 250; dues sponsor $100, sustaining $50, family $40, single $25, sr citizen & student $10; ann meeting in June
Income: Financed by municipal, provincial & federal grants, pub & pvt donations
Special Subjects: Prints
Collections: 20th Century prints including contemporary artists; Works on paper
Exhibitions: Cheryl Sourkes: Photo Installation; Tracing Cultures II: Banko Djuras & Taras Polataiko; Tracing Culture III: Zainub Verjee: Through the Soles of My Mothers Feet; Tracing Culture IV; Day Without Art (video)
Publications: Catalogues & brochures to accompany exhibs; quarterly mems bulletin
Activities: Docent training; film series; workshops for schools; lect open to public; concerts; gallery talks; tours; exten dept serves BC; individual paintings & original objects of art lent to other exhibition centers; lending collection contains 600 original prints, 50 paintings, 25 sculpture & drawings; museum shop sells books, magazines, original art, prints, crafts & pottery by local & other artists

M SIMON FRASER UNIVERSITY, Simon Fraser Gallery, Burnaby, BC V5A 1S6 Canada. Tel 604-291-4266; Fax 604-291-3029; Elec Mail gallery@sfu.ca; Internet Home Page Address: www.sfu.ca/artgallery; *Dir* Laurie Moodie; *Chmn* Ron Heath
Mon - Fri 10 AM - 4 PM, cl Sat & Sun; No admis fee; Estab 1971 to collect, conserve & display original works of art, principally contemporary Canadian; Gallery is 150 to 310 running ft, 1200 sq ft. Permanent works are installed throughout the univ campus; Average Annual Attendance: 10,000
Income: Financed by pub univ appropriations, government grants & corporate donations
Special Subjects: Graphics
Collections: Simon Fraser Collection, including contemporary & Inuit graphics; international graphics
Publications: Biannual report
Activities: Gallery talks; individual paintings & original objects of art loaned to univ faculty & staff on campus
L W A C Bennett Library, Burnaby, BC V5A 1S6 Canada. Tel 604-291-3869; Fax

604-291-3023; Internet Home Page Address: www.lib.sfu.ca; *Librn* Lynn Copeland; *Asst Librn* Paul Copeland
Open Mon-Thurs 8 - 11:45 AM, Fri 8 AM - 6 PM, Sat & Sun 11 AM - 10 PM; Reference material available in Fine Arts Room & University Archives
Library Holdings: Audio Tapes; Book Volumes 1,000,000; Cards; Clipping Files; Exhibition Catalogs; Fiche; Filmstrips; Manuscripts; Other Holdings CD-ROM; Compact discs; Pamphlets; Periodical Subscriptions 11,500; Records; Reels; Slides; Video Tapes

CHILLIWACK

A **CHILLIWACK COMMUNITY ARTS COUNCIL,** Community Arts Centre, 45899 Henderson Ave, Chilliwack, BC V2P 2X6 Canada. Tel 604-792-2069; Fax 604-792-2640; Elec Mail chwkartscouncil@uniserve.com; *Gen Mgr* Rod Hudson; *Cur* Chuck Chapell
Open Mon - Fri 9 AM - 4 PM, Sat 10 AM - 3 PM, cl Sun; No admis fee; Estab 1959 as Arts Council, Arts Centre estab 1973 to encourage all forms of art in the community; 1 large gallery; Average Annual Attendance: 10,000; Mem: 5000; dues group & family $25, organizational $15, individual $15; annual meeting Sept
Income: Financed by endowment, mem & grants
Exhibitions: Christmas Craft Market
Publications: Arts Council Newsletter, 11 per yr
Activities: Classes for adults & children; dramatic progs; concerts; schols offered

COQUITLAM

A **PLACE DES ARTS AT HERITAGE SQUARE,** 1120 Brunette Ave, Coquitlam, BC V3K 1G2 Canada. Tel 604-664-1636; Fax 604-664-1658; Elec Mail gelliiott@placedesarts.ca; Internet Home Page Address: www.placedesarts.ca; *Dir* Gillian Elliot; Michelle Richard
Open Mon - Thurs 9 AM - 10 PM, Fri 9 AM - 9 PM, Sat 8:30 AM - 4:30 PM; No admis fee; Estab 1972 as a cultural, community crafts & resource center, an art school, gallery, dance & music school; 2 galleries - 2 shows monthly; Average Annual Attendance: 58,000
Income: Financed by municipal grant
Exhibitions: Monthly shows of emerging artists, artists & craftsmen throughout the year
Publications: Prog (12 weeks), every three months
Activities: Satellite courses for school children; classes for adults & children; visual arts, music, drama, dance; lect open to pub; concerts; gallery talks; schols offered

DAWSON CREEK

M **SOUTH PEACE ART SOCIETY,** Dawson Creek Art Gallery, 101-816 Alaska Ave, Dawson Creek, BC V1G 4T6 Canada. Tel 250-782-2601; Fax 250-782-8801; Elec Mail dcagohin@pris.bc.ca; Internet Home Page Address: www.pris.bc.ca/artgallery/; *Dir* Ellen Cores; *Treas* Judy Lafond; *Pres* Marilyn Belak
Open winter Tues - Fri 10 AM - 5 PM, summer daily 9 AM - 5 PM Sat & Sun 12 - 4 PM; donation; Estab 1961 to promote art appreciation in community; Art Gallery in elevator annex in NAR Park. NAR Park includes mus & Tourist Information Office; Average Annual Attendance: 65,000; Mem: 100; dues $25; ann meeting third Thurs of Mar
Income: $130,000 (financed by municipal building & ann sponsorship, commission from sales, provincial cultural grant, federal grant Canada council)
Library Holdings: Book Volumes; Exhibition Catalogs; Original Art Works
Exhibitions: Approximately 13 per year, local & traveling
Publications: Newsletter, quarterly
Activities: Classes for adults & children; lect open to pub, 3 vis lectr per yr; gallery talks; individual paintings lent to mems, businesses, pvt homes; lending coll contains color reproductions, slides, 145 books & 350 original prints; book traveling exhibs 4-6 per yr; circulate to galleries in British Columbia; sales shop sells original art, pottery, metal, woodwork, jewelry, stained glass, oils, soaps, weaving, cards & other items

HOPE

M **JOHN WEAVER SCULPTURE COLLECTION,** 19255 Silverhope Rd, PO Box 1723 Hope, BC V0X 1L0 Canada. Tel 604-869-5312; Fax 604-869-5117; Elec Mail johnweaver@uniserve.com; *Pres & Cur* Henry C Weaver; *Cur* Sarah Lesztak
Open by appointment
Special Subjects: Drawings, Painting-American, Sculpture, Watercolors, Bronzes, Woodcarvings, Woodcuts, Portraits, Historical Material
Collections: Bronze sculptures
Publications: Brochures, postcards & portfolios
Activities: Lect upon invitation; tours; demonstrations; lending coll contains sculptures; originate traveling exhibs; mus shop sells books & original art

KAMLOOPS

M **KAMLOOPS ART GALLERY,** 101 - 465 Victoria St, Kamloops, BC V2C 2A9 Canada. Tel 250-377-2400; Fax 250-828-0662; Elec Mail kamloopsartgallery@kag.bc.ca; Internet Home Page Address: www.kag.bc.ca; *Exec Dir* Jann L M Bailey; *Mgr, Admin Services* Wendy Lysak; *Registrar & Coll Coordr* Trish Keegan; *Financial Asst* Shauna Bell; *Office Adminr* Beverley Clayton; *Cur* Jen Budney; *Cur Asst* Kristen Lambertson; *Preparator* Vaughn Warren; *Gallery Store Coordr* Patti Procknow; *Prog Coordr* Linda Favrholdt; *Marketing Coordr* James Gordon
Open Mon - Wed, Fri & Sat 10 AM - 5 PM, Thurs 10 AM - 9 PM, Sun Noon - 4 PM; Admis various; Estab 1978; pub art mus; Exhib gallery, 4400 running ft, total

area of gallery 14,225 ft; Average Annual Attendance: 30,000; Mem: 600; dues family $45, individual $30, senior citizens, artists & students $15, child $10; ann meeting in April
Income: $1,400,000 (operating & prog grants, fundraising, sponsorships & donations)
Library Holdings: Auction Catalogs; Clipping Files; Exhibition Catalogs
Special Subjects: Drawings, Photography, Prints, Sculpture, Watercolors, Etchings & Engravings, Painting-Canadian
Collections: Contemporary Canadian Art; Canadian Prints & Drawings; photography; sculpture
Exhibitions: Monthly National & International Exhibs
Publications: Newsletter, 4 times per yr; exhib catalogs
Activities: Classes for adults & children; lect open to pub, 10-12 vis lectr per yr; concerts; gallery talks; tours; book traveling exhibs; originate traveling exhibs; mus shop sells books, magazines, original crafts, reproductions, prints & gifts

KELOWNA

M **KELOWNA MUSEUM,** 470 Queensway Ave, Kelowna, BC V1Y 6S7 Canada. Tel 250-763-2417; Fax 250-763-5722; Elec Mail info@kelownamuseum.ca; Internet Home Page Address: www.kelownamuseum.org; *Pres* Jim Grant; *Dir & Cur* Wayne Wilson; *Assoc Dir Admin* Krista Stokall; *Assoc Dir Laurel Operations* Nathalie Bomberg; *Conservator* Marta Leskard; *Exhib Coordr* Dennis Domen; *Archivist* Donna Johnson
Open Tues - Sat 10 AM - 5 PM; Donations; Estab 1936 as a community mus where traveling exhibits are received & circulated; 12,000 sq ft of display plus storage, workshop & archives; permanent galleries: Natural History, Local History, Ethnography, two exhibit galleries; Average Annual Attendance: 35,000; Mem: 200; dues $25; ann meeting in Mar
Income: Financed by mem, city & state appropriation
Special Subjects: Drawings, Latin American Art, Painting-American, American Indian Art, Bronzes, African Art, Archaeology, Ethnology, Textiles, Costumes, Ceramics, Crafts, Folk Art, Decorative Arts, Eskimo Art, Furniture, Glass, Jewelry, Asian Art, Silver, Metalwork, Miniatures, Antiquities-Egyptian, Antiquities-Greek, Antiquities-Roman
Collections: Coins & medals; decorative arts; enthnography; general history; Kelowna History; natural history
Exhibitions: Changing exhibs every 3 months
Publications: The Games Grandpa Played, Early Sports in BC; Nan, A Childs Eye View of Okanagan; Lak-La-Hai-Ee Volume III Fishing; A Short History of Early Fruit Ranching Kelowna; Sunshine & Butterflies
Activities: Classes for adults & children; lect open to pub, 6 vis lectr per yr; tours; gallery talks; individual paintings & original objects of art lent to qualified museums; book traveling exhibs 7-8 per yr; originate traveling exhibs; mus shop sells books, original art, reproductions, prints

L **Archives,** 470 Queensway Ave, Kelowna, BC V1Y 6S7 Canada. Tel 250-763-2417; Fax 250-763-5722; Elec Mail archivevs@kelownamuseum.ca; Internet Home Page Address: www.kelownamuseum.org; *Archivist* Donna Johnson
Open by appointment only; Circ Non-circulating
Library Holdings: Cassettes; Clipping Files; Fiche; Manuscripts; Maps; Micro Print; Motion Pictures; Original Art Works; Original Documents; Periodical Subscriptions; Photographs; Prints; Slides; Video Tapes
Collections: Photograph Collection

NANAIMO

M **MALASPINA COLLEGE,** Nanaimo Art Gallery, 900 Fifth St, Nanaimo, BC V9R 5S5 Canada. Tel 250-755-8790; Fax 250-741-2214; Elec Mail nag@mala.bc.ca; Internet Home Page Address: www.mala.bc.ca/nag/nag.html; *Cur* Pamela Speight; *Exec Dir* Joan Murphy; *Mktg Dir* Joel Prevost
Open Mon - Sat 10 AM - 5 PM; Admis $2 suggested donation; Estab 1976 to exhibit the works of contemporary visual artists; Two Galleries: gallery I is 1300 sq ft with 11 ft ceilings; gallery II is 775 sq ft with 10 ft ceilings; Average Annual Attendance: 20,000; Mem: 386; dues $10 & up; ann meeting in Apr
Income: Financed by mem, earned gallery shop, city & state appropriations; schools & school districts
Collections: Works by contemporary artists primarily regional but some national & international
Exhibitions: Contemporary Art, Historical & Scientific exhibits; Street Banner Painting Competition; rotate 9 exhibs per yr on campus, 12 per yr downtown facility
Publications: Nanaimo Art Gallery newsletter, 3 per yr
Activities: Classes for adults & children; docent training; lect open to pub, 6-8 vis lectr per yr; gallery talks; tours; competitions with awards; exten dept serves local elementary schools; individual paintings & original objects of art lent; lending coll contains original art work, original prints, paintings & sculpture; book traveling exhibs 1-2 per yr; mus shop sells books, original art & local crafts

PRINCE GEORGE

M **PRINCE GEORGE ART GALLERY,** 725 Civic Plaza, Prince George, BC V2L ST1 Canada. Tel 250-614-7800; Fax 250-563-3211; Elec Mail pgag@vortex.netbistro.com; Internet Home Page Address: www.tworiversartgallery.com; *Dir & Cur* Julia Whitaker; *Admin Asst* Terezia Vinczencz; *Exec Dir* Liv Butow
Open Tues - Sat 10 AM - 5 PM, Thurs 10 AM - 9 PM, Sun 1 - 4 PM, cl Mon; Admis family $9, adults $4.50, sr citizens & students $3.75, children 5-12 $2, under 5 free; Estab 1970 to foster development of arts & crafts in the community; to foster & promote artists; Old Forestry Building, 2 floors, art rental section; two 1000 sq ft galleries, offices, storage space & small foyer; Average Annual Attendance: 10,000; Mem: 1000; dues family $43, individual $27, sr citizens & students $22; ann meeting in Feb
Income: Financed by provincial & municipal grants, pvt donations
Special Subjects: Sculpture, Painting-Canadian
Collections: Original paintings by British Columbia artists

Exhibitions: Exhibitions held every 6-8 weeks, primarily Canadian Artists; Annual fundraiser
Publications: Quarterly newsletter
Activities: Classes for adults; docent training; lect open to pub, 6-10 vis lectr per yr; gallery talks; tours for school children; exten dept serves regional district; individual paintings & original objects of art rented to mems; book traveling exhibs 2 per yr; sales shop sells original paintings, drawings, pottery, handicrafts, prints, cards

PRINCE RUPERT

M MUSEUM OF NORTHERN BRITISH COLUMBIA, Ruth Harvey Art Gallery, 100 First Ave W, PO Box 669 Prince Rupert, BC V8J 3S1 Canada. Tel 250-624-3207; Fax 250-627-8009; Elec Mail mnbc@citytel.net; Internet Home Page Address: www.museumofnorthernbc.com; *Pres Board Dirs* Rhoda Witherly; *Cur* Susan Marsden; *Pub Progs Coordr* Lindsey Martin; *Gift Shop Mgr* Irene Fernandes
Open Sept - May Mon - Sat 9 AM - 5 PM, June - Aug Mon - Sat 9 AM - 8 PM, Sun 9 AM - 5 PM; Admis family $10, adult $5, group 15+ $4 per person, student $2, children under 12 $1, children under 6 & mem free; Estab 1924, new building opened 1958, to collect, maintain & display the history of the peoples of the north coast, particularly of the Prince Rupert area; especially the Tsimshian, the First Nations group in this area who have occupied the northwest coast for approx 10,000 yrs; Large main gallery, Treasure Gallery, Hallway of Nations, Monumental Gallery, Ruth Harvey Art Gallery; Average Annual Attendance: 60,000; Mem: 320; dues corporate $75, family $20, individual $15, sr citizen & student $10; ann meeting in May
Income: $250,000 (financed primarily by municipality & province)
Library Holdings: Clipping Files; Manuscripts; Maps; Memorabilia; Original Documents; Pamphlets; Photographs; Reproductions
Special Subjects: Graphics, Anthropology, Archaeology, Ethnology, Textiles, Ceramics, Crafts, Primitive art, Woodcarvings, Portraits, Painting-Canadian, Jewelry, Porcelain, Historical Material, Maps, Coins & Medals, Gold
Collections: Contemporary North Coast First Nations; historical colls; native First Nations colls; natural history; photographs
Exhibitions: A continually changing display prog; fine arts exhibs from large galleries; local artists shows
Activities: Classes for adults & children; dramatic progs; lect open to pub, 3-4 vis lectr per yr; gallery talks; tours; competitions; book traveling exhibs; mus shop sells books, native art, original art, reproductions, prints & souvenirs
L Library, 100 First Ave W, Prince Rupert, BC V8J 1A8 Canada. Tel 250-624-3207; Fax 250-627-8009; Elec Mail mnbc@citytel.net; Internet Home Page Address: www.museumofnorthernbc.com; *Cur* Susan Marsden
Open June - Aug Mon - Sat 9 AM - 8 PM, Sun 9 AM - 5 PM, Sept - May Mon - Sat 9 AM - 5 PM, cl Sun & holidays; No admis fee for use of reference library; appointments general req; Small reference library for staff & researchers
Income: $280,000 (financed by city, province, donations & gift shop)
Library Holdings: Book Volumes 1000; Clipping Files; Exhibition Catalogs; Manuscripts; Other Holdings Archival materials; Pamphlets; Periodical Subscriptions 10; Photographs; Video Tapes
Special Subjects: Prints, Primitive art, Restoration & Conservation, Textiles, Painting-Canadian
Activities: Educ dept; mus shop sells books, original art, reproductions & prints

REVELSTOKE

A REVELSTOKE ART GROUP, PO Box 2655, Revelstoke, BC V0E 2S0 Canada. Tel 250-837-4861; *Treas* Inge Anhorn
No facility at present; Donations; Estab 1949 to promote & stimulate interest in art by studying art, artists methods & work, developing local interest & interchanging ideas; Average Annual Attendance: 500; Mem: 45; dues $10; ann meeting in Apr
Income: Grants, sales & donations
Collections: Centennial coll contains 10 watercolours, acrylics & oils by Sophie Atkinson
Exhibitions: Weaving & Pottery by Local Artisans; Sr Citizens' Paintings; Snowflake Porcelain Painters; Works by members of the Revelstoke Art Group - summer
Activities: Classes for adults & children

RICHMOND

A RICHMOND ARTS CENTRE, 7700 Minoru Gate, Richmond, BC V6Y 1R9 Canada. Tel 604-231-6433; Fax 604-231-6423; Elec Mail artscentre@richmond.ca; Internet Home Page Address: www.richmond.ca; *Arts Coordr* Suzanne E Greening; *Arts Programmer* Lenore Clemens
Open Mon - Fri 9 am - 9:30 PM, Sat & Sun 10 AM - 5 PM; No admis fee; Estab 1967 to provide stimulation & nourishment to the arts in the community
Income: Financed by city appropriation
Activities: Classes for adults & children in visual & dramatic arts, ballet & jazz; concerts; special events & festivals; art truck, takes the arts out to the community; sales shop sells original art & music CDs

SOOKE

M SOOKE REGION MUSEUM & ART GALLERY, 2070 Phillips Rd, PO Box 774 Sooke, BC V0S 1N0 Canada. Tel 250-642-6351; Fax 250-642-7089; *Exec Dir* Terry Malone
Open winter Tues - Sun 9 AM - 5 PM, cl Mon, summer daily 9 AM - 5 PM; Admis donation; Estab 1977 to advance local history & art; Exhibit changes monthly featuring a different local artist or artist group, or segment of mus coll; Average Annual Attendance: 30,000
Income: Financed by donations

Special Subjects: American Indian Art, Archaeology, Ethnology, Costumes, Crafts, Dolls, Period Rooms
Collections: Fishing, Logging & Mining Artifacts; Native Indian Crafts (post & pre-contact); Pioneer Implements
Exhibitions: Polemaker's Shack; Moss Cottage; Wreck of Lord Western
Activities: Children classes; docent training; lect open to pub, 4 vis lectr per yr; tours; competitions with awards; retail store sells books & original art

SURREY

M SURREY ART GALLERY, 13750 88th Ave, Surrey, BC V3W 3L1 Canada. Tel 604-501-5566; Fax 604-501-5581; Elec Mail artgallery@surrey.ca; Internet Home Page Address: www.arts.surrey.ca; Internet Home Page Address: www.surreytechlab.ca; *Cur Progs* Ingrid Kolt; *Cur* Liane Davison
Open Mon - Wed & Fri 9 AM - 5 PM, Thurs 9 AM - 9 PM, Sat & Sun Noon - 5 PM, cl statutory holidays; Admis by donation; Estab 1975; Contemporary art; Average Annual Attendance: 50,000
Income: Financed by city & provincial appropriation, special private foundations grants & federal grants per project application
Purchases: $10,000
Library Holdings: Book Volumes; Clipping Files; Exhibition Catalogs; Manuscripts; Original Documents; Periodical Subscriptions
Special Subjects: Sculpture, Photography, Prints, Painting-Canadian
Collections: Contemporary Canadian Art
Publications: Exhib catalogues; Surrey Arts Center Calendar, bimonthly
Activities: Classes for adults & children, docent training; lect open to pub, 6 vis lectr per yr; concerts; gallery talks; tours; individual paintings & original objects of art lent to other institutions; book traveling exhibs 1 or more per yr; originates traveling exhibs; sales shop sells original art, locally made jewelry, arts & crafts, glasswork, woodwork & cards
L Library, 13750 88th Ave, Surrey, BC V3W 3L1 Canada. Tel 604-501-5566; Fax 604-501-5581; Elec Mail artgallery@surrey.bc.ca; Internet Home Page Address: www.city.surrey.bc.ca/parksrecculture/artgallery; *Cur Exhib & Coll* Liane Davison; *Cur Prog* Ingrid Kolt; *Librn* Connie Cleaver
Open Mon - Fri 9 AM - 5 PM, Sat 10 AM - 5 PM, Sun Noon - 5 PM, Thurs evenings 5 - 9 PM, cl statutory holidays; Admis by donation; Estab 1975 for exhibs & educ in contemporary art. Reference library for staff & docents only; Average Annual Attendance: 50,000
Purchases: $1000
Library Holdings: Book Volumes 550; Cards; Clipping Files; Exhibition Catalogs; Periodical Subscriptions 20; Slides

VANCOUVER

M THE CANADIAN CRAFT MUSEUM, 639 Hornby St, Vancouver, BC V6C 2G3 Canada. Tel 604-687-8266; Fax 604-684-7174; Elec Mail craftmus@direct.ca; *Exec Dir* Lori Baxter; *Admin* Annette Wooff; *Mktg & Develop Dir* Jocelyn Calderhead; *Cur* Ron Kong
Open Mon - Sat 10 AM - 5 PM, Sun & holiday Noon - 5 PM, cl Tues Sept 1 - May 1; Admis adults $5, students & sr citizens $3, group rates for 10 or more, members & children 12 & under free; Estab 1980 dedicated to presenting excellence in Canadian & international craft, craftmanship & design, both contemporary & historical; Main floor 3500 sq ft, mezzanine 350 sq ft; Average Annual Attendance: 30,000; Mem: 600; dues affinity $200, group & family $50, individual $35, sr couple $30, sr citizen & student $20, craft artists $18, non-resident $15; ann meeting in May
Income: (financed by mem, city & provincial, federal appropriations & fundraising)
Special Subjects: Textiles, Costumes, Ceramics, Crafts, Folk Art, Pottery, Woodcarvings, Decorative Arts, Dolls, Furniture, Glass, Jewelry, Silver, Metalwork, Tapestries, Calligraphy, Embroidery, Gold, Stained Glass, Leather, Enamels, Bookplates & Bindings
Collections: Permanent coll
Exhibitions: Rotating exhibs
Publications: Craftwords Newsletter, quarterly; exhibit catalogues
Activities: Docent training; lect open to pub; gallery talks; docent-led group & school tours; contemporary & historical craft lect; craft workshops for adults & children; occasional craft demonstrations; book traveling exhibs; mus shop sells exhibit catalogues, quality one-of-a-kind & production Canadian crafts

A COMMUNITY ARTS COUNCIL OF VANCOUVER, 873 Beatty St, Vancouver, BC V6B 2MG Canada. Tel 604-683-4358, 683-8099; Fax 604-683-4394; Elec Mail info@carv.bc.ca; Internet Home Page Address: www.carv.bc.ca; *Pres* Hamish Malkin; *Asst* Karen Benbassat
Open 9 AM - 5 PM; No admis fee; Estab 1946 as a soc dedicated to the support of arts, with a wide range of interest in the arts; to promote standards in all art fields including civic arts; also serves as a liaison centre; Exhib Gallery shows works of semi-professional & emerging artists; 2200 sq ft on two levels, street level entrance; Average Annual Attendance: 40,000; Mem: 500; dues $15; ann meeting in Sept
Income: Financed by British Columbia Cultural & Lotteries Fund, City of Vancouver, mem & donations
Exhibitions: Two shows per month
Publications: Arts Vancouver Magazine, 4 issues per year
Activities: Lect open to pub; performances; workshops; concerts; gallery talks; competitions; schols & fels offered

M CONTEMPORARY ART GALLERY SOCIETY OF BRITISH COLUMBIA, 555 Nelson St, Vancouver, BC V6B 6R5 Canada. Tel 604-681-2700; Fax 604-683-2710; Elec Mail info@contemporaryartgallery.ca; Internet Home Page Address: www.contemporaryartgallery.ca; *Dir & Cur* Christina Ritchie; *Cur* Reid Shier; *Prog Coordr* Sharon Diana Preus; *Gallery Asst* Robin Spisak
Open Wed - Sat 11 AM - 5 PM, Sun noon - 5 PM; No admis fee; Estab 1971 as an exhib space for regional, national & international contemporary art; The Gallery has 1,700 sq ft exhib area; Average Annual Attendance: 9,031; Mem: 500; dues $25

Income: Financed by Federal Government, British Columbia Arts Council, City of Vancouver, mem fees & fundraising

Library Holdings: Auction Catalogs; CD-ROMs; Compact Disks; DVDs; Exhibition Catalogs; Periodical Subscriptions; Slides

Collections: City of Vancouver Art Collection; Contemporary Gallery Society of B C Art Collection

Publications: Exhibition brochure & catalogs

Activities: Classes for children; lect open to pub, 8 vis lectr per yr; gallery talks; Tours; Visual Arts Develop Award; individual paintings & original objects of art lent to civic agencies; lending coll contains 3400 works; mus shop sells books

L **Art Library Service,** 555 Helson St, Vancouver, BC V6B 2R1 Canada. Tel 604-681-2700; Fax 604-683-2710; Elec Mail cag@axionet.com; *Dir & Cur* Keith Wallace; *Adminr & Prog Coordr* Sylvia Blessin

Open Tues - Sat 11 AM - 5 PM; No admis fee; A pub nonprofit soc for research, exhib, documentation and dissemination about important contemp visual art of regional, nat & internat origin; Pub art gallery; Mem: $25 ann fee

Income: Financially assisted by Can Coun, The BC Cult Services, The City of Vancouver, BC Gaming Commission & mems

Library Holdings: Exhibition Catalogs; Pamphlets; Slides

Publications: Brochures; exhibit catalogs

Activities: Classes for adults; lect open to pub; 7-10 vis lect per yr; gallery talks; originate traveling exhibs to pub art galleries; shop sells books

M **EMILY CARR INSTITUTE OF ART & DESIGN CHARLES H SCOTT GALLERY,** The Charles H Scott Gallery, 1399 Johnston St, Vancouver, BC V6H 3R9 Canada. Tel 604-844-3809; Fax 604-844-3801; Internet Home Page Address: www.eciad.ca; *Admin Asst* Kate Miller; *Cur* Greg Bellerby

Open daily 9 AM - 5 PM; No admis fee; Estab 1980 to provide mus quality exhibs & publs of critically significant visual art; 3000 sq ft gallery with all environmental & security safeguards; Average Annual Attendance: 30,000

Income: $95,000 (financed by provincial appropriation)

Exhibitions: Social Process - Collective Action, Mary Kelly 1970-75

Publications: Exhib catalogues

Activities: Tours upon request; book traveling exhibs 1-2 per yr; originate traveling exhibs; sales shop sells exhib catalogues

L **Library,** 1399 Johnston St, Vancouver, BC V6H 3R9 Canada. Tel 604-844-3840; Fax 604-844-3801; *Librn* Donna Zwierciadlowski; *Library Dir* Sheila Wallace

Open May - Aug Mon - Fri 8:30 AM - 5 PM, Sept - Apr Mon - Thurs 8:30 AM - 9 PM, Fri & Sat 8:30 AM - 5 PM; Circ 65,000

Income: Financed by government funding

Library Holdings: Audio Tapes; Book Volumes 18,000; Clipping Files; Exhibition Catalogs; Fiche; Periodical Subscriptions 165; Records; Slides 134,000; Video Tapes 1900

Special Subjects: Film, Photography, Graphic Design, Painting-American, Posters, Pre-Columbian Art, Prints, Sculpture, Painting-European, Printmaking, Industrial Design, Video, Primitive art, Pottery, Woodcarvings, Painting-Canadian

UNIVERSITY OF BRITISH COLUMBIA

M **Morris & Helen Belkin Art Gallery,** Tel 604-822-2759; Fax 604-822-6689; Internet Home Page Address: www.belkin-gallery.ubc.ca; *Dir & Cur* Scott Watson; *Adminr* Annette Wooff; *Prog Coordr* Naomi Sawada; *Preparator & Colls Mgr* Owen Sapotiuk; *Archivist* Krisztina Laszlo; *Assoc Dir & Cur* Keith Wallace

Open Tues - Fri 10 AM - 5 PM, Sat & Sun Noon - 5 PM, cl Mon & civic holidays; No admis fee; Estab 1948; The gallery has a mandate to encourage projects conceived for its special content. Our programming emphasizes contemporary art & also projects which serve to further understanding of the history of Avant-Garde; Belkin Satellite opened in 2001 and is dedicated to encourage experimental projects by emerging and established artists and curators; Gallery covers 27,000 sq ft; Average Annual Attendance: 15,000; Mem: No mem prog

Income: Financed by departmental funds

Collections: Canadian & contemporary art; Canadian Avant-Garde Narratives from 1960s to 1970s

Exhibitions: Rotating exhibs

Publications: Announcements; exhib catalogues

Activities: Master curatorial prog; lect open to pub, 2 vis lectr per yr; gallery talks; tours; originate traveling exhibs; mus shop sells exhib catalogs; junior mus located at Belkin Satellite 555 Hamilton St, Vancouver with limited hrs

L **Fine Arts, UBC Library,** Tel 604-822-3943; Internet Home Page Address: www.library.ubc.ca/fineatrs/, www.ubc.ca; *Admin Librn* D Vanessa Kam; *Reference Librn* Paula Farrar; *Library Asst* Caroline Milburn-Brown

Open Mon - Thurs 8 AM - 11 PM, Fri 8 AM - 5 PM, Sat Noon - 5 PM, Sun Noon - 8 PM; No admis fee; Estab 1948 to serve students & faculty in all courses related to fine arts, architecture & planning

Library Holdings: Auction Catalogs; Book Volumes 230,000; CD-ROMs; Clipping Files; Exhibition Catalogs; Pamphlets; Periodical Subscriptions; Reproductions

Special Subjects: Art History, Landscape Architecture, Decorative Arts, Illustration, Photography, Drawings, Etchings & Engravings, Graphic Arts, Painting-American, Painting-British, Painting-French, Posters, Pre-Columbian Art, Prints, Sculpture, Painting-European, Historical Material, History of Art & Archaeology, Watercolors, Conceptual Art, Latin American Art, Printmaking, Interior Design, Asian Art, Furniture, Costume Design & Constr, Restoration & Conservation, Woodcarvings, Woodcuts, Antiquities-Byzantine, Antiquities-Roman, Reproductions, Painting-Canadian, Architecture

Activities: Library instruction, reference svcs

M **Museum of Anthropology,** Tel 604-822-5087; Fax 604-822-2974; Internet Home Page Address: www.moa.ubc.ca; *Dir & Prof* Dr Ruth Phillips; *Cur Northwest Coast* Alexia Bloch; *Cur of Educ & Pub Prog* Jill Baird; *Cur of Ethnology & Media* Pam Brown; *Cur Ethnology & Document* Elizabeth Johnson; *Cur Ethnology & Ceramics* Carol Mayer; *Sr Conservator* Miriam Clavir; *Conservator* Heidi Swierenga; *Project Mgr Conservation* Darrin Morrison; *Mgr Admin* Moya Waters; *Mgr Admin* Anna Pappalardo; *Shop Mgr Wholesale & Supv Admin* Salma Mawani; *Shop Mgr Retail* Deborah Tibbel; *Communications Mgr* Jennifer Webb; *Coll Mgr* Ann Stevenson; *Mgr Loans & Proj* Allison Cronin; *Asst Coll Mgr* Nancy Bruegeman; *Mgr Directed Studies & the Critical Curatorial Studies Prog* Kersti Krug; *Mgr Design & Photog* Bill McLennan; *Mgr Design & Exhibits* David Cunningham; *Mgr Design & Production* Skooker Broome; *Archaeology*

Asst Cur Joyce Johnson; *Booking Coordr* Gwilyn Timmers; *Asst to Dir* Nina Chatelain; *Librn* Justine Dainard; *Archivist* Krisztina Laszlo

Open Sept - May Tues 11 AM - 9 PM, Wed - Sun 11 AM - 5 PM, May - Sept daily 10 AM - 5 PM, Tues 10 AM - 9 PM; Admis family $20, adults $7, sr citizens $5, students & children $4, group rates for 10 or more, Tues free 5 - 9 PM; Estab 1947 to develop a high quality institution that maximizes pub access & involvement while also conducting active progs of teaching, research & experimentation; Average Annual Attendance: 170,000; Mem: 750; dues family $50, individual student & sr couple $30, student & sr citizens $20

Library Holdings: Auction Catalogs; Book Volumes; Exhibition Catalogs; Pamphlets; Periodical Subscriptions

Special Subjects: Architecture, American Indian Art, American Western Art, Anthropology, Archaeology, Ethnology, Textiles, Ceramics, Crafts, Folk Art, Woodcarvings, Decorative Arts, Oriental Art, Asian Art, Historical Material, Coins & Medals, Antiquities-Oriental, Antiquities-Greek, Antiquities-Etruscan

Collections: Ethnographic areas around the world, especially the northwest coast of British Columbia; European ceramics; mus journals; oriental art & history

Activities: Classes for adults & children; volunteer training; lect open to public, 20-30 vis lectr per year; gallery talks; tours; competitions with awards; exten dept; original objects of art lent to institutions for special exhibits; book traveling exhibitions; originate traveling exhibitions; museum shop sells books, original art, jewelry, reproductions, prints, slides, postcards, note cards & t-shirts

M **VANCOUVER ART GALLERY,** 750 Hornby St, Vancouver, BC V6Z 2H7 Canada. Tel 604-662-4719, 662-4700 (Admin Offices); Fax 604-682-1086; Elec Mail curatorial@vanartgallery.bc.ca; Internet Home Page Address: www.vanartgallery.bc.ca; *Pres* George Killy; *Dir* Kathleen Bartell; *Chief Cur* Daina Augaitis; *Sr Cur* Bruce Grenville; *Head Mktg Develop* Diane Robinson; *Head Mus Svcs* Jackie Gijssen; *Conservator* Monica Smith; *Registrar* Jenny Wilson; *Librn* Cheryl Siegel; *Head Pub Progs* Cheryl Meszaros; *Assoc Cur* Chris Wooton

Open daily summer 10 AM - 5:30 PM, Thurs 10 AM - 9 PM; Admis adults $12.50, sr citizens $9, students with cards $8, students without cards $3.50, children under 12 free; Estab 1931 to foster the cultural development of the community & a pub interest in the arts; Gallery moved in 1983 into a reconstructed 1907 classical courthouse which had been designed by Francis Rattenbury. The building contains 41,400 net sq ft of gallery space. Complex contains a total gross area of 164,805 sq ft; Average Annual Attendance: 200,000; Mem: 5000; dues family $65, individual $49, sr family $27, student & sr citizen $27

Income: Financed by city, provincial & federal government grants, pvt & corporate donations

Library Holdings: Auction Catalogs; Audio Tapes; Book Volumes; CD-ROMs; Clipping Files; Exhibition Catalogs; Periodical Subscriptions; Slides

Collections: Emily Carr: 7000 works, including drawings, film, objects, paintings, photographs

Publications: Ann Report; Calendar, 5 times per annum; Exhib Catalogues

Activities: Classes for adults & children; docent training; lect open to pub, 30 vis lects per yr; gallery talks; tours; concerts; International Woman in the Arts Award; individual paintings & original objects of art lent to museums who comply with security & climate control standards; originate traveling exhibs; gallery shop sells books, magazines, reproductions, postcards, posters, native Indian art, jewelry, goods in leather, paper & wood by local artisans

L **Library,** 750 Hornby St, Vancouver, BC V6Z 2H7 Canada. Tel 604-662-4709; Fax 604-682-1086; Elec Mail casiegel@vanartgallery.bc.ca; *Librn* Cheryl A Siegel; *Librn* Lynn Brockington

Open Mon - Fri 1 - 5 PM; Estab 1931 to serve staff, docents, students & the public; For reference only; Average Annual Attendance: 3,000

Library Holdings: Book Volumes 38,000; Clipping Files; Memorabilia; Pamphlets; Periodical Subscriptions 120; Photographs

Collections: Fine arts specializing in Canadian & contemporary art

L **VANCOUVER CITY ARCHIVES,** 1150 Chestnut St, Vancouver, BC V6J 3J9 Canada. Tel 604-736-8561; Fax 604-736-0626; Elec Mail archives@city.vancouver.bc.ca; Internet Home Page Address: www.city.vancouver.bc.ca; *Dir* Reuben M Ware; *Archive Mgr* Heather M Gordon

Open Mon - Fri 9 AM - 5 PM, cl weekends & legal holidays; No admis fee; Estab 1933

Income: Financed by city appropriation

Library Holdings: Manuscripts; Other Holdings Charts; Civic Records; Drawings; Maps; Paintings; Photographs

Special Subjects: Photography, Maps, Painting-Canadian

Exhibitions: Temporary exhibs

Activities: Lect open to pub; tours

M **VANCOUVER MUSEUM,** (Vancouver Museum Commission) 1100 Chestnut St, Vancouver, BC V6J 3J9 Canada. Tel 604-736-4431; Fax 604-736-5417; Internet Home Page Address: www.vanmuseum.bc.ca; *CEO* Nancy Noble; *Cur Anthropology* Lynn Maranda; *Cur Asian Studies* Paula Swart; *Cur History* Joan Seidl

Open Tues - Sun 10 AM - 5 PM, Thurs 10 AM - 9 PM Cl all Mondays except holidays (open 10 AM - 5 PM); Admis adults $10 + tax, youths 19 & under $6, seniors $8, children 5 and under free, groups of 5 $35; Estab 1894 to collect, preserve & interpret natural & cultural history of Vancouver area; Average Annual Attendance: 70,000

Income: Financed by city of Vancouver, government grants, fundraising & gift shop sales

Special Subjects: Drawings, American Indian Art, African Art, Anthropology, Archaeology, Ethnology, Costumes, Ceramics, Folk Art, Etchings & Engravings, Decorative Arts, Eskimo Art, Dolls, Furniture, Glass, Jade, Jewelry, Asian Art, Historical Material, Ivory, Coins & Medals, Antiquities-Oriental, Antiquities-Egyptian, Antiquities-Greek, Antiquities-Roman

Collections: Vancouver Stories; Anthropology, Asian Studies, History and Natural History Colls

Publications: Occasional exhib catalogues

Activities: Classes for adults & children; docent programs; lect open to public; gallery talks; tours; competitions; traveling exhibitions; museum shop sells books, original art, reproductions & souvenirs

L **Vancouver Museum Library,** 1100 Chestnut St, Vancouver, BC V6J 3J9 Canada. Tel 604-736-4431; Fax 604-736-5417; Internet Home Page Address: www.vanmuseum.bc.ca; *CEO* Pauline Thompson
Open by appointment only; Circ Non-circulating; For reference
Library Holdings: Audio Tapes; Book Volumes 9000; Cassettes; Clipping Files; Exhibition Catalogs; Pamphlets; Periodical Subscriptions 30; Video Tapes
Special Subjects: Folk Art, Decorative Arts, Historical Material, Archaeology, Asian Art, American Indian Art, Anthropology, Eskimo Art, Mexican Art, Oriental Art

M **VANCOUVER PUBLIC LIBRARY,** Fine Arts & Music Div, 350 W Georgia St, Vancouver, BC V6B 6B1 Canada. Tel 604-331-3696; Fax 604-331-3701; Elec Mail info@vpl.ca; Internet Home Page Address: www.vpl.ca; *Pub Service Mgr* Ron Dutton; *Sr Fine Arts & Music Librn* Musa Tryon
Open Mon - Thurs 10 AM - 9 PM, Fri & Sat 10 AM - 6 PM, Sun Noon - 5 PM (winter); Estab 1930; Library estab 1887 as Vancouver Reading Room. Estab as subject div in 1930 to provide references & material in all arts; Mem: 373,000; members free to those living in the region
Library Holdings: Book Volumes 122,000 & 13,200 song books & performance scores; CD-ROMs; Compact Disks 11,500; DVDs 3,480; Exhibition Catalogs; Periodical Subscriptions 500; Video Tapes 6,000
Special Subjects: Decorative Arts, Furniture, Porcelain, Silver, Textiles, Silversmithing, Costumes, Painting-Canadian, Jewelry
Activities: Classes for adults

VERNON

M **VERNON ART GALLERY,** 3228 31st Ave, Vernon, BC V1T 9G9 Canada. Tel 250-545-3173; Fax 604-545-9096; Elec Mail vernonartgallery@home.com; Internet Home Page Address: www.galleries.bc.ca/vernon; *Dir* Susan Brandoli; *Art Educ* Liz Allardice; *Gift Shop Coordr* Trish Vanviane
Open Mon - Fri 10 AM - 5 PM, Sat 11 AM - 4 pm, cl Sun; No admis fee; Estab 1967 for the coll & exhib of art work by Okanagan, national & international artists; Two gallery spaces professionally designed & measure 5500 sq ft, also reception area, gift shop & administrative & kitchen area; Average Annual Attendance: 27,000; Mem: 420; dues family $35, individual $25, sr citizens & students $20
Income: Financed by mem, city appropriation & grants
Collections: Permanent coll consists of ceramics, paintings, prints, sculpture and serigraphs
Exhibitions: 20 exhibits ann
Publications: Art Quarterly
Activities: Classes for adults & children; docent training; lect, 3 vis lectr per yr; gallery talks; concerts; tours; performances; competitions; book traveling exhibs 3-4 per yr; originate traveling exhibs; mus shop sells books, magazines, original art, reproductions & local crafts

VICTORIA

M **ART GALLERY OF GREATER VICTORIA,** 1040 Moss St, Victoria, BC V8V 4P1 Canada. Tel 250-384-4101; Tel Admin 250 384-4171; Fax 250-361-3995; Elec Mail aggv@aggv.bc.ca; Internet Home Page Address: www.aggv.bc.ca; *Dir* Pierre Arpin; *Cur Asian Art* Barry Till; *Mgr Pub Affairs* Adrienne Holierhoek; *Financial Officer* Lynne Pankratz; *Pres* Carl Nesbitt; *Cur Contemporary Art* Lisa Baldissera; *Coll Mgr* Ann Tighe; *Dir Develop* Yolanda Meijier
Open Mon, Tues, Wed, Fri, Sat 10 AM - 5 PM, Thurs 10 AM - 9 PM, Sun 1 - 5 PM; Admis adults $5, seniors & students $3, children under 12 free; Estab 1949; Six modern galleries adjoin 19th Century Spencer Mansion-Japanese Garden; Average Annual Attendance: 56,500; Mem: 1950; dues family $55, individual $38, student & non-resident $25; ann meeting 2nd wk of June
Income: $1,500,000 (financed by mem, city, federal & provincial grants)
Special Subjects: Painting-British, Primitive art, Decorative Arts, Painting-European, Painting-Canadian, Oriental Art, Asian Art
Collections: Chinese, Indian, Persian & Tibetan Art; Contemporary Canadian, American & European; European Painting & Decorative Arts from 16th-19th centuries; Japanese Art from Kamakura to Contemporary; Primitive Arts
Exhibitions: Approx 35 exhibs in 6 exhib halls, changing every 6 wks
Publications: Mem newsletter, 4 times per yr
Activities: Classes for adults & children; docent training; gallery in the schools prog; workshops; lect open to pub, 12 vis lectr per yr; concerts; tours; gallery talks; exten dept serves BC; individual paintings & original objects of art lent to museums & local pub buildings; lending colls contains cassettes, original art works, sculpture, scrolls, 4800 books, 5000 original prints, 2000 slides; book traveling exhibs 5-20 per yr; originate traveling exhibs; sales shop sells books, magazines, reproductions, stationery, jewelry, pottery, ornaments, glass & prints

L **Library,** 1040 Moss St, Victoria, BC V8V 4P1 Canada. Tel 250-384-4101; Fax 250-361-3995; Elec Mail library@aggv.bc.ca; Internet Home Page Address: www.aggv.bc.ca; *Librn* Mrs M Niel
Open by appointment only; Estab 1951; Circ Non-circulating; For reference only; Average Annual Attendance: 100,000
Income: $1000
Purchases: $1000
Library Holdings: Book Volumes 6200; Clipping Files; Exhibition Catalogs; Fiche; Pamphlets; Periodical Subscriptions 46; Reproductions; Slides
Special Subjects: Asian Art

L **BRITISH COLUMBIA INFORMATION MANAGEMENT SERVICES,** BC Archives, 865 Yates St, PO Box 9419 Victoria, BC V8W 9V1 Canada. Tel 250-387-5885; Fax 250-387-2072; Elec Mail access@bcars.gs.gov.bc.ca; Internet Home Page Address: www.bcars.gs.gov.bc.ca/bcars.html; *Provincial Archivist* Gary Mitchell
Open Mon - Fri 9:30 AM - 4:30 PM; Estab 1893 to collect & preserve all records relating to the historical development of British Columbia
Income: Financed by provincial appropriation

Library Holdings: Audio Tapes; Book Volumes 70,380; Clipping Files; Exhibition Catalogs; Manuscripts; Original Art Works; Other Holdings Original documents; Maps; Pamphlets; Periodical Subscriptions 100; Photographs; Reels
Publications: Art reproductions

M **CRAIGDARROCH CASTLE HISTORICAL MUSEUM SOCIETY,** 1050 Joan Crescent, Victoria, BC V8S 3L5 Canada. Tel 250-592-5323; Fax 250-592-1099; Elec Mail ccastle@islandnet.com; Internet Home Page Address: www.craigdarochcastle.com; *Registrar & Technician* Delphine Castle; *Cur* Bruce Davies; *Vol Coordr* Robert Rathwell; *Exec Dir* Trish Chan; *Restoration Mgr* Frank Tosczak; *Mus Store Mgr* Karen Kinney
Open daily; Admis $10; Estab 1959 for conservation & restoration of house; Average Annual Attendance: 150,000; Mem: 500; dues $25; ann meeting in the spring
Income: $1.4 mil (financed by progs & visitation)
Library Holdings: Auction Catalogs; Audio Tapes; Exhibition Catalogs; Kodachrome Transparencies; Photographs
Special Subjects: Architecture, Painting-American, Textiles, Ceramics, Painting-Canadian, Dolls, Furniture, Carpets & Rugs, Historical Material, Restorations, Period Rooms, Embroidery, Stained Glass
Collections: Historical objects pertaining to the years 1890-1908; 5000 objects used to furnish an historical turn of the century mansion
Publications: Castle Quarterly, newsletter, annual report
Activities: Classes for children; dramatic progs; docent training; lect open to pub, 2 vis lectr per yr; gallery talks; tours; individual paintings & original objects of art lent to other qualified cultural institutions; lending coll contains books, original art works, prints & paintings; mus shop sells books & souvenirs

A **OPEN SPACE,** 510 Fort St, Victoria, BC V8W 1E6 Canada. Tel 250-383-8833; Elec Mail openspace@openspace.com; Internet Home Page Address: www.openspace.ca; *Dir* Helen Marzolf; *Gallery Admin* Jim Olson; *Technician & Preparator* Zoe Kreye; *Prog Asst* Jesse Scott
Open Tues - Sat Noon - 5 PM, cl Mon & Sun; No admis fee; Estab 1972, open space is dedicated to contemporary art through visual art, new music, performance, literature & new media; Gallery has 3000 sq ft, 220 running ft with full light grid controlled to level for works of art & for performance progs; Average Annual Attendance: 25,000; Mem: 150; dues $15 - $50
Income: $200,000 (financed by federal & provincial appropriations, city grants, donations, mem fees & self-generated revenue)
Exhibitions: 10-12 contemporary visual art exhibs per yr
Publications: catalogues & monographs published for all exhibs (list available on request)
Activities: Lect open to pub, 15 vis lectr per yr; concerts; gallery talks; tours; awards for music composers of international stature; visual art lects, new music, performance, new medium, interarts, readings

M **UNIVERSITY OF VICTORIA,** Maltwood Art Museum and Gallery, PO Box 3025, Victoria, BC V8W 3P2 Canada. Tel 250-721-8298; Fax 250-721-8997; Internet Home Page Address: www.maltwood.uvic.ca; *Dir & Cur* Martin Segger; *Pres* Dr David Turpin; *Registrar* Caroline Reidel; *Secy of Gallery* Cheryl Robinson
Open Mon - Fri 10 AM - 4 PM, Sun Noon - 4 PM; No admis fee; Estab 1963 to collect, preserve & exhibit the decorative arts, maintain teaching colls for the univ; Gallery has 3000 sq ft of environmentally controlled exhib space, three galleries programmed, loan exhibs & from coll permanent exhibit. Maintains reference library; Average Annual Attendance: 100,000
Income: $200,000 (financed by endowment & state appropriation)
Purchases: $25,000
Special Subjects: Architecture, Drawings, Graphics, Photography, American Indian Art, American Western Art, Anthropology, Archaeology, Ethnology, Costumes, Ceramics, Crafts, Folk Art, Primitive art, Etchings & Engravings, Decorative Arts, Portraits, Jewelry, Porcelain, Oriental Art, Asian Art, Ivory, Renaissance Art, Medieval Art, Islamic Art
Collections: Maltwood Collection of Decorative Art; contemporary art (Canadian); Ethnographic & design art
Exhibitions: Permanent collections, continuing and rotating
Activities: Lect open to pub, 10 vis lectr per yr; gallery talks; tours; individual paintings lent to offices & pub spaces on campus; lending coll contains 3000 original prints, 1000 paintings & sculpture; book traveling exhibs 5 per yr; originate traveling exhibs

WHITE ROCK

M **ARNOLD MIKELSON MIND & MATTER GALLERY,** 13743 16th Ave, White Rock, BC V4A 1P7 Canada. Tel 604-536-6460; Elec Mail mindandmatterart@shaw.ca; Internet Home Page Address: www.mindandmatterart.com; *Pres* Mary Mikelson; *Asst Dir* Myra Mikelson; *Mgr* Arnold Mikelson; *Asst Mgr* Sapphire Mikelson
Open Noon - 6 PM or by appointment; No admis fee; Estab 1965; 2000 sq ft gallery on three acres, upper flr mus, main flr continues exhibs of Canadian artists; Average Annual Attendance: 15,000
Income: Funded by the Mikelson Family
Special Subjects: Woodcarvings
Collections: Showcase wood sculpture by the late Arnold Mikelson
Exhibitions: Metal art, modern landscape, painting, stone sculpture, wildlife, wood sculpture; Nov-Dec, Annual Art for X-Mas; July, Arnold Mikelson Festove of Arts
Activities: Lect open to pub, 25-30 lectr per yr; gallery talks; scholarships; mus shop sells original art

MANITOBA

BOISSEVAIN

M MONCUR GALLERY, PO Box 1241, Boissevain, MB R0K 0E0 Canada. Tel 204-534-6478 or 534-6689; Elec Mail mbom@mts.net or phallett@escape.ca; Internet Home Page Address: www.moncurgallery.org; *Chmn* Shannon Moncur; *Secy* Phyllis Hallett; *Treas* Audrey Hicks
Open 8 AM - 5 PM; adult fee $2.00 per guided tour; Estab 1986; Native History; Average Annual Attendance: 500-1,000
Income: $8,000 (financed by city & state appropriation)
Special Subjects: Archaeology
Collections: Aboriginal artifacts dating back 10,000 years collected in the Turtle Mountain area

BRANDON

A THE ART GALLERY OF SOUTHWESTERN MANITOBA, Town Center, Brandon, MB R7A 0P3 Canada. Tel 204-727-1036; Fax 204-726-8139; Elec Mail agsm@mb.sympatico.ca; *Dir* Gordon McDonald; *Cur* Chris Reid
Open Mon & Thurs 10 AM - 9 PM, Tues, Wed & Fri 10 AM - 5 PM, Sun 2 - 5 PM; No admis fee; Estab 1960 to promote & foster cultural activities in western Manitoba; Average Annual Attendance: 2,400; Mem: 400; dues $6 - $20; ann meeting May
Income: Financed by mem, city & provincial appropriations & federal grants
Exhibitions: Exhibitions of regional, national & international significance
Publications: Bulletin, every 2 months
Activities: Classes for adults & children; lect open to pub, 2 vis lectr per yr; gallery talks; tours; competitions; individual paintings & original objects of art lent to mems; lending coll contains original art works, original prints, paintings, weaving

L Brandon Public Library, Town Center, Brandon, MB R7A 0P3 Canada. Tel 204-727-6648; Fax 204-726-8139; Elec Mail agsm@mb.sympatico.ca; *Chief Librn* Kathy Thornborough
Open Mon & Thurs 10 AM - 9 PM, Tues, Wed & Fri 10 AM - 5 PM, Sun 2 - 5 PM; Circ Non-circulating; Open to mems
Library Holdings: Book Volumes 78,000

CHURCHILL

M ESKIMO MUSEUM, 242 La Verendrye, PO Box 10 Churchill, MB R0B 0E0 Canada. Tel 204-675-2030; Fax 204-675-2140; *Dir* Bishop Reynald Rouleau; *Asst Cur* Cathy Widdowson; *Cur* Lorraine Brandson
Open June - Nov 8: Mon 1 - 4:30 PM, Sat 9 AM - Noon & 1 - 5 PM, Nov 9 - May 31: Mon 1 - 4:30 PM, Tues - Fri 10:30 AM - Noon & 1 - 4:30 PM, Sat 1 - 4 PM; No admis fee; Estab 1944 to depict the Eskimo way of life through the display of artifacts; Mus has large single display room; Average Annual Attendance: 10,500
Income: Administered & funded by the Roman Catholic Episcopal Corporation of Churchill Hudson Bay
Special Subjects: Sculpture, Ethnology, Eskimo Art
Collections: Contemporary Inuit carvings; ethnographic collections; prehistoric artifacts; wildlife specimens
Publications: Carved From the Land by Lorraine Brandson 1994
Activities: Films & slide shows for school groups upon request; tours upon request; original objects of art lent to special exhibits & galleries; museum shop sells books, original art, art cards, postcards & northern theme clothing (t-shirts, sweatshirts & caps)

L Library, 242 La Verendrye, PO Box 10 Churchill, MB R0B 0E0 Canada. Tel 204-675-2030; Fax 204-675-2140; *Cur* Lorraine Brandson; *Asst Cur* Diann Elliott
Open by appointment only; Circ Non-circulating; Estab mainly for Arctic Canada material
Purchases: $1,000
Library Holdings: Book Volumes 500; Clipping Files; Exhibition Catalogs; Maps; Photographs; Video Tapes
Special Subjects: Crafts, Archaeology, Ethnology, Eskimo Art, Handicrafts, Restoration & Conservation

DAUPHIN

M DAUPHIN & DISTRICT ALLIED ARTS COUNCIL, Watson Art Centre, 104 First Ave NW, Dauphin, MB R7N 1G9 Canada. Tel 204-638-6231; Fax 204-638-6231; Elec Mail art6231@mts.net; Internet Home Page Address: www.watsonartcentre.ca; *Adminr* Nina Crawford
Open Mon - Fri Noon - 5 PM; No admis fee; Estab 1973 to provide a home for the arts in the Dauphin District; 1 large gallery; Average Annual Attendance: 20,000; Mem: Dues assoc $25, family $15, individual $5; ann meeting in Mar
Income: $100,000 (financed by mem, town appropriation, provincial appropriation, donations)
Exhibitions: Rotate several exhibits per month
Publications: Arts council newsletter, quarterly
Activities: Classes for adults & children; dramatic progs; concerts; gallery talks; tours; lending coll contains paintings & art objects; book traveling exhibs 1 or 2 per yr; originate traveling exhibs; mus shop sells books & original art

WINNIPEG

L ARCHIVES OF MANITOBA, 130-200 Vaughan St, Winnipeg, MB R3C 1T5 Canada. Tel 204-945-3971; Fax 204-948-2008; Elec Mail pam@gov.mb.ca; Internet Home Page Address: www.gov.mb.ca/chc/index.html
Open Mon - Fri 9 AM - 4 PM; No admis fee; Estab 1952 to gain access to Manitoba's documentary heritage; to preserve the recorded memory of Manitoba

Income: Financed by provincial appropriation through the Minister of Culture, Heritage & Tourism
Collections: Hudson's Bay Company Archives; Documentary & archival paintings, drawings, prints & photographs relating to Manitoba
Activities: Individual paintings & original objects of art lent to pub institutions with proper security; book traveling exhibs

A MANITOBA ASSOCIATION OF ARCHITECTS, 137 Bannatyne Ave, 2nd Flr, Winnipeg, MB R3B 0R3 Canada. Tel 204-925-4620; Internet Home Page Address: www.mala.net/; *Dir* Kim Watson
Open Mon - Fri 9 AM - 5 PM; Estab 1906 as a Provincial Architectural Registration Board & professional governing body; Mem: 350; dues $375; ann meeting in Mar
Income: Financed by ann mem dues
Publications: Columns, quarterly

M MANITOBA HISTORICAL SOCIETY, Dalnavert Museum, 61 Carlton St, Winnipeg, MB R3C 1N7 Canada. Tel 204-943-2835; Elec Mail dalnavrt@escape.ca; Internet Home Page Address: www.mhs.mb.ca; *Pres Manitoba Historical Society* Jim Blanchard; *Chmn Management Comt* Bill Fraser; *Asst Cur* Nancy Anderson; *Cur* Timothy Worth
Open summer 10 AM - 5 PM, winter Noon - 4 PM, cl Mon & Fri; Admis family $8, adults $4, sr citizens & students $3, children $2; Estab 1975 to preserve & display the way of life of the 1895 well-to-do family; Average Annual Attendance: 7,000
Income: $40,000 (financed by mem, city & state appropriation & pvt donation)
Special Subjects: Period Rooms
Collections: Home furnishings of the 1895 period: clothing, decorative arts material, furniture, household items, paintings & original family memorabilia
Activities: Classes for adults & children; docent training; lect open to pub, 2 vis lectr per yr, dramatic readings; tours; sales shop sells books, postcards & tourist material

A MANITOBA SOCIETY OF ARTISTS, 504 Daer Blvd, Winnipeg, MB R3K 1C5 Canada. Tel 204-837-1754; Internet Home Page Address: www.msa.mb.ca; *Newsletter Ed* Gerald Folkerts; *VPres* Les Dewar; *Secy* Barbara K Endres
Estab 1901 to further the work of the artist at the local & community levels; Mem: 60; dues $20; ann meeting Oct
Income: Financed by mem & commission on sales
Special Subjects: Drawings, Etchings & Engravings, Landscapes, Posters, Prints, Sculpture, Watercolors, Pottery, Woodcuts, Afro-American Art, Crafts, Miniatures, Portraits, Oriental Art, Calligraphy, Dioramas
Exhibitions: Annual competition & exhibition open to all residents of Manitoba
Activities: Educ aspects include teaching by mems in rural areas & artist-in-residence work in pub schools; workshops; how to hang exhibs; lect open to pub; gallery talks; tours; competitions with awards; awards in memory of deceased mems; schols offered; originate traveling exhibs

M PLUG IN, Institute of Contemporary Art, 286 McDermot Ave, Winnipeg, MB R3B 0T2 Canada. Tel 204-942-1043; Fax 204-944-8663; Elec Mail info@plugin.org; Internet Home Page Address: www.plugin.org; *Dir* Anthony Kiendl; *Cur* Steven Matijcio; *Gallery Asst* Karin Streu
Open Tues - Wed & Fri - Sat 11 AM - 5 PM, Thurs 11 AM - 8 PM; No admis fee; Estab 1974; 5,000 sq ft; 200 linear ft of gallery wall; renovated street-level gallery in historic Exchange District; plus annex space of 5000 sq ft, 600 linear ft; Average Annual Attendance: 20,000; Mem: 350; dues $50 regular, $25 artists
Income: $650,000 (financed by mem, federal, city & state appropriation)
Publications: Memories of Overdevelopment: The Phillipine Diaspora in Contemporary Art (1998); Marcel Dzama: More Famous Drawings, Beck & Al Hanson: Playing with Matches, The Paradise Institute - Janet Cardiff & George Burts-Miller
Activities: Lect open to pub, 6 vis lectr per yr; gallery talks; tours; book traveling exhibs 4 per yr; originate traveling exhibs 4 per yr to galleries & artist-run centres; sales shop sells books & original art

M UKRAINIAN CULTURAL & EDUCATIONAL CENTRE, 184 Alexander Ave E, Winnipeg, MB R3B 0L6 Canada. Tel 204-942-0218; Fax 204-943-2857; *Pres Board Dirs* Paul Stanicky
Open Mon - Sat 10 AM - 4 PM; No admis fee; Estab as the largest Ukrainian cultural resource centre & repository of Ukrainian historical & cultural artifacts in North America; Mem: 2000; dues $15, ann meeting June
Income: $216,328 (financed by province of Manitoba, federal government, donations, mem, trust fund, fundraising events)
Collections: Ukrainian Folk Art; folk costumes; embroidery; weaving; pysanky (Easter eggs); woodcarving; ceramics; coins, postage stamps and documents of the Ukrainian National Republic of 1918-1921; works of art by Ukrainian, Ukrainian-Canadian and Ukrainian-American artists: prints, paintings, sculpture; archives: Ukrainian immigration to Canada, music colls
Publications: Visti Oseredku/News from Oseredok, members' bulletin, 2-3 times per yr
Activities: Lect open to pub; gallery talks; tours; competitions; schols offered; individual paintings & original objects of art lent to educ institutions, galleries & museums; lending coll contains color reproductions, framed reproductions, motion pictures, phonorecords, 40,000 photographs, 2000 slides; book traveling exhibs ann; originate traveling exhibs; sales shop sells books, original art, reproductions, prints, folk art, phonorecords, cassettes

M Gallery, 184 Alexander Ave E, Winnipeg, MB R3B 0L6 Canada. Tel 204-942-0218; Fax 204-943-2857; *Board Dirs* Paul Stanicky
Open Mon - Sat 10 AM - 4 PM, cl Sun; No admis fee; Mem: Dues family & organization $25, individual $15, student & sr citizen $5
Collections: 18th Century Icons; Contemporary Graphics (Archipenko, Gritchenko, Trutoffsky, Krycevsky, Hluschenko, Pavlos, Kholodny, Hnizdovsky, Mol, Levytsky, Shostak, Kuch); Contemporary Ukrainian; Canadian Coll

L Library & Archives, 184 Alexander Ave E, Winnipeg, MB R3B 0L6 Canada. Tel 204-942-0218; Fax 204-943-2857; *Pres Board Dirs* Paul Stanicky
Open Tues & Thurs 10 AM - 11 AM; For reference only; lending to mems

Library Holdings: Book Volumes 30,000; Cassettes; Clipping Files; Exhibition Catalogs; Motion Pictures; Other Holdings Ukrainian newspapers & periodicals; Pamphlets; Photographs; Records; Slides; Video Tapes
Publications: Visti, ann newsletter

M UNIVERSITY OF MANITOBA, Gallery One One One, School of Art, Main Fl Fitzgerald Bldg Winnipeg, MB R3T 2N2 Canada. Tel 204-474-9322; Fax 204-474-7605; Elec Mail djohnso@ms.umanitoba.ca; Internet Home Page Address: www.umanitoba.ca/schools/art; *Gallery Dir* Cliff Eyland; *School of Art Dir* Dale Amundson
Open Mon - Fri Noon - 4 PM; No admis fee; Estab 1965; Circ 95; Gallery III estab 1965 to provide exhibs of contempory art & activities on the univ campus; exhibitions open to the pub; Average Annual Attendance: 20,000
Collections: Contemporary Canadian & American painting, prints & sculpture; L L Fitzgerald Study Collection
Exhibitions: Exhibs of Canadian, European & American Art, both contemporary & historical; special exhibs from other categories; ann exhibs by the graduating students of the School of Art
Publications: Exhib catalogues
Activities: Discussion groups; workshops; lect open to pub, 3-6 vis lectr per yr; gallery talks; individual paintings & original objects of art lent; book traveling exhibs, 2-4 per yr; originate traveling exhibs

M Faculty of Architecture Exhibition Centre, 215 Architecture, 2 Bldg Winnipeg, MB R3T 2N2 Canada; 201 Russell Bldg, Winnipeg, MB R3T 2N2 Canada. Tel 204-474-9558; Fax 204-474-7532; Internet Home Page Address: www.umanitoba.ca; *Co-Dir* Prof Michael Cox; *Co-Dir & Prof* Patrick Harrop
Open Mon - Fri 8:30 AM - 4:30 PM, weekend by special arrangements; Estab 1959 with the opening of the new Faculty of Architecture Building to provide architectural & related exhibs for students & faculty on the univ campus; 760 sq ft, secured climate controlled; over 900 linear ft of hanging space; Average Annual Attendance: 7,500
Income: Financed by endowments, grants & pvt sponsorships
Special Subjects: Architecture, Drawings, Painting-American, Photography, Prints, Sculpture, Watercolors, Archaeology, Textiles, Ceramics, Pottery, Etchings & Engravings, Decorative Arts, Manuscripts, Portraits, Painting-Canadian, Furniture, Painting-French, Historical Material, Tapestries, Antiquities-Greek, Antiquities-Roman, Mosaics, Painting-German, Reproductions
Collections: An extensive collection of drawings, prints, paintings, sculpture, ceramics, furniture & textiles (tapestries)
Exhibitions: Exhibs from a diversity of pvt & pub sources; annual exhibs by the students in the Faculty of Architecture
Activities: Lect open to public, 6 vis lectr per year; gallery talks; symposia; individual paintings & original objects of art lent to recognized institutions; lending collection contains original art works, original prints, paintings, photographs, sculptures, furniture, textiles & ceramics

L Architecture & Fine Arts Library, 206 Russell Bldg, Univ Manitoba Winnipeg, MB R3T 2N2 Canada. Tel 204-474-9216; Fax 204-474-7539; Elec Mail mary_lochhead@umanitoba.ca; Internet Home Page Address: www.umanitboa.ca/libraries/units/archfa/; *Head* Mary Lochhead
Open Mon - Thurs 8:30 AM - 9 PM, Fri 8:30 AM - 5 PM, Sat & Sun 12:30 - 5 PM, May - Aug Mon - Fri 8:30 AM - 3 PM; Estab 1916 to serve the needs of students & faculty in the areas of architecture, fine arts, landscape architecture, environmental design, city & regional planning, graphic design, interior design & photography; Circ 100,000; Average Annual Attendance: 68,645
Income: Financed primarily by provincial government
Library Holdings: Audio Tapes 75; Book Volumes 63,000; CD-ROMs 94; Cassettes 88; Clipping Files; Fiche 560; Lantern Slides 13,000; Maps 200; Other Holdings Product catalogs 8000; Pamphlets; Periodical Subscriptions 430; Photographs; Reels 210; Reproductions 776; Slides 107,000; Video Tapes 294
Special Subjects: Landscape Architecture, Photography, Interior Design, Architecture

M UPSTAIRS GALLERY, 266 Edmonton St, Winnipeg, MB R3C 1R9 Canada. Tel 204-943-2734; Fax 204-943-7726; Elec Mail upstairs@pangea.com; Internet Home Page Address: www.upstairsgallery.mb.ca; *Dir & Owner* Faye Settler
Open Mon - Sat 9:30 AM - 5:30 PM, cl Sun; Estab 1966; Contemporary & early 20th century Canadian art; specializing in Canadian Inuit art
Special Subjects: Drawings, Prints, Sculpture, Folk Art, Woodcuts, Etchings & Engravings, Landscapes, Eskimo Art, Painting-Canadian, Marine Painting
Collections: Contemporary & early 20th Century Canadian paintings, prints & drawings; Inuit Eskimo sculpture, prints, drawings & wall hangings

M THE WINNIPEG ART GALLERY, 300 Memorial Blvd, Winnipeg, MB R3C 1V1 Canada. Tel 204-786-6641; Fax 204-788-6450; Internet Home Page Address: www.wag.mb.ca; *Dir* Patricia E. Bovey; *Mgr Financial Operations* Donald J Robinson; *Educ Mgr* Donna Mackinnon; *Assoc Dir & Cur Svcs* Donna McAlear; *Communications & Mktg Mgr* Marilyn Williams; *Librn* Kenlyn Collins; *Art Educ* Rae Harris; *Art Educ & Assoc Cur* Helen Delacretaz; *Cur Historical Art* Mary Jo Hughes; *Cur Contemporary Art & Photography* James Patten; *Personnel Mgr* Shelley Barnett; *Head of Develop* Jo-Anne Silverman
Open Tues, Thurs - Sun 10 AM - 5 PM, Wed 10 AM - 9 PM; Admis family $6, adult $4, senior citizen & student $3, children under 12 free; Estab 1912, incorporated 1963. Rebuilt & relocated 1968, opened 1972, to present a diversified, quality level prog of art in all media, representing various cultures, past & present; Circ Reference only; Building includes 9 galleries as well as displays on mezzanine level, sculpture court & main foyer; Average Annual Attendance: 142,000; Mem: 4400; dues family $50, individual $35, senior citizen couples $30, student & senior citizens $20; annual meeting in Aug
Income: $3,500,000 (financed by endowment, mem, city, state & federal appropriation)
Special Subjects: Painting-American, Sculpture, Eskimo Art, Painting-Canadian
Collections: Canadian art; contemporary Canada; contemporary Manitoba; decorative arts; Inuit art; European art; Gort Collection; Master prints & drawings; modern European art; photography
Exhibitions: The changing exhibition includes contemporary & historical works of art by Canadian, European & American artists
Publications: Tableau (calendar of events), monthly; exhibition catalogs

Activities: Classes for adults & children; docent training; lect open to public, 10 vis lectr per year; concerts; gallery talks; tours; exten dept serves Manitoba, Canada, United States & Europe; individual paintings & original objects of art lent to centres & museums; book traveling exhibitions 4 per year; originate traveling exhibitions; museum shop sells books, magazines, original art, reproductions & prints

L Clara Lander Library, 300 Memorial Blvd, Winnipeg, MB R3C 1V1 Canada. Tel 204-786-6641, Ext 237; Fax 204-788-4998; Elec Mail librarian@wag.mb.ca; Internet Home Page Address: www.wag.mb.ca; *Librn* Kenlyn Collins; *Library Technician* Emma Coady
Open Tues - Fri 11 AM - 4:30 PM, Sat 1 - 4:30 PM; Estab 1954 to serve as a source of informational & general interest materials for members & staff of the Winnipeg Art Gallery & to art history students; Circ Reference only
Income: Financed by mem, city & provincial appropriations
Purchases: $10,000
Library Holdings: Book Volumes 23,000; Clipping Files 10,000; Exhibition Catalogs; Manuscripts; Memorabilia; Original Documents; Pamphlets; Periodical Subscriptions 60
Collections: Archival material pertaining to Winnipeg Art Gallery; Rare Books on Canadian & European Art; George Swinton Collection on Eskimo & North American Indian art & culture

NEW BRUNSWICK

CAMPBELLTON

M GALERIE RESTIGOUCHE GALLERY, 39 Andrew St, PO Box 674 Campbellton, NB E3N 3H1 Canada. Tel 506-753-5750; Fax 506-759-9601; Elec Mail rgaleri@nbnet.nb.ca; *Dir* Charlene Lani
Open Tues - Sat 9 AM-5 PM, cl Sun & Mon; No admis fee; Estab 1975 for exhibitions & activities; Building has 4800 sq ft; Exhibition hall is 1500 sq ft, small gallery 400 sq ft; 230 running feet; Average Annual Attendance: 25,000; Mem: 185; dues $15
Income: $100,000 (financed by federal, provincial & city appropriations, by Friends of the Gallery & by private donations)
Exhibitions: Hands on Signs
Publications: Exhibitions catalogues; Restigouche Gallery brochure
Activities: Classes for adults & children; art & craft workshops; lect open to public, 10 vis lectr per year; concerts; gallery talks; tours; traveling exhibitions exten service; originate traveling exhibitions

FREDERICTON

M BEAVERBROOK ART GALLERY, 703 Queen St, PO Box 605 Fredericton, NB E3B 5A6 Canada. Tel 506-458-8545, 458-2028; Fax 506-459-7450; Elec Mail lglenn@beaverbrookartgallery.org; Elec Mail emailbag@beaverbrookartgallery.org; Internet Home Page Address: www.beaverbrookartgallery.org; *Educ Coordr* Adda Mihailescu; *Mgr Programming & Communications* Laurie Glenn Norris; *Fin Adminstr* Tanya Belanger; *Dir & CEO* Bernard Riordon
Open year round, 9 AM - 5:30 PM, Thurs 9 AM - 9 PM; Admis adults $5, seniors $4, students $2, children under 6 free, family of 4 $10; Estab 1959 to foster & promote the study & the pub enjoyment & appreciation of the arts; Major galleries upstairs; British, Canadian High Galleries & Marion McCain Atlantic Gallery. East wing galleries; Hosmer, Pillow-Vaughan Gallery, Sir Max Aitken Gallery & Vaulted Corridor Gallery. Downstairs galleries: exhib gallery & foyer Gallery; Average Annual Attendance: 45,000; Mem: 800; dues family $50, individual $40
Income: $1,079,000 (financed by endowment & pvt foundation)
Purchases: $594,000
Library Holdings: Auction Catalogs; Book Volumes; Exhibition Catalogs; Pamphlets; Periodical Subscriptions; Video Tapes
Special Subjects: Decorative Arts, Furniture, Portraits, Painting-European, Tapestries, Religious Art, Painting-Canadian, Porcelain, Painting-British, Painting-Flemish, Renaissance Art, Medieval Art, Painting-Spanish
Collections: Hosmer-Pillow-Vaughan collection of continental European fine & decorative arts from the 14th & 19th century; Works by Dali, Constable, Gainsbourough, Hogarth, Cornelius Krieghoff, Reynolds, Sutherland & Turner; 16th-20th century English paintings; 18th & early 19th century English porcelain; 19th & 20th century Canadian & New Brunswick paintings; Contemporary modern & historical Canadian & British art
Publications: Tableau: The magazine of the Beaverbrook Art Gallery ann report, exhib catalogues
Activities: Classes for adults & children; lect open to the pub; approx 12 vis lect per yr; gallery talks; tours; films; exten dept serving New Brunswick & Atlantic region; individual paintings lent to recognized art galleries; collection contains 1575 original art works, sculpture; 8-10 book traveling exhibs per yr; originate traveling exhibs throughout Canada; sales shop sells books, magazines & prints

L Library, 703 Queen St, PO Box 605 Fredericton, NB E3B 5A6 Canada. Tel 506-458-8545; Fax 506-459-7450; Internet Home Page Address: www.beaverbrookartgallery.org; *Librn* Barry Henderson
Open to gallery personnel only, for reference
Library Holdings: Exhibition Catalogs; Video Tapes
Special Subjects: Decorative Arts, Painting-British, Painting-Flemish, Painting-Spanish, Painting-European, Portraits, Porcelain, Furniture, Religious Art, Tapestries, Painting-Canadian
Publications: Auction Catalogs

A NEW BRUNSWICK COLLEGE OF CRAFT & DESIGN, 457 Queen St, Fredericton, NB E3B 5H1 Canada. Tel 506-453-2305; Fax 506-457-7352; Internet Home Page Address: www.nbccd.nbcc.nb.ca; *Prin* Luc Paulin
Open Mon - Fri 8:15 AM - 4:30 PM; No admis fee; Estab 1938 to educate students as professional crafts people & designers; Maintains reference library
Income: Financed by provincial government
Exhibitions: Student & staff juried shows; periodic vis exhibitions

Activities: Classes for adults & children; lect open to pub, 10 vis lectr per yr; awards; lending coll contains original art works, video tapes, slides & 3000 books

L **Library,** 457 Queen St, PO Box 6000 Fredericton, NB E3B 5H1 Canada; PO Box 6000, Fredericton, NB E3B 5H1 Canada. Tel 506-453-2305; Fax 506-457-7352; Elec Mail nbccd.email@gnb.ca; Internet Home Page Address: www.nbccd.nbcc.nb.ca; *Librn* Julie Lumbria-McDonald; *Prin* Robert Kavanagh; *Dir Admin* Stephen Goudey
Open 8:30 AM - 4:30 PM; A very small but growing library which is primarily for students & craftsmen
Income: Financed by government & book donations
Library Holdings: Book Volumes 3000; Clipping Files; Exhibition Catalogs; Filmstrips; Pamphlets; Periodical Subscriptions 60; Slides; Video Tapes 300
Special Subjects: Art History, Collages, Folk Art, Decorative Arts, Film, Illustration, Mixed Media, Photography, Calligraphy, Commerical Art, Drawings, Graphic Arts, Graphic Design, Posters, Prints, Sculpture, Portraits, Watercolors, Ceramics, Conceptual Art, Latin American Art, American Western Art, Printmaking, Advertising Design, Cartoons, Fashion Arts, Interior Design, Lettering, Art Education, Asian Art, American Indian Art, Primitive art, Mexican Art, Costume Design & Constr, Aesthetics, Afro-American Art, Metalwork, Antiquities-Oriental, Carpets & Rugs, Goldsmithing, Handicrafts, Jewelry, Oriental Art, Pottery, Religious Art, Silversmithing, Tapestries, Textiles, Antiquities-Egyptian, Antiquities-Greek, Antiquities-Roman, Display, Architecture
Publications: Computerized catalogue

M **ORGANIZATION FOR THE DEVELOPMENT OF ARTISTS,** Gallery Connexion, Justice Bldg, Queen St Fredericton, NB Canada; PO Box 696, Fredericton, NB E3B 5B4 Canada. Tel 506-454-1433; Fax 506-454-1401; Elec Mail connex@nbnet.nb.ca; Internet Home Page Address: www.galleryconnexion.ca; *Dir* Meredith Snider; *Pres* Carol Collicutt
Open Tues - Fri Noon - 4 PM, or by appointment; No admis fee; Estab 1984 to show contemporary experimental work; Maintains a reference library; Average Annual Attendance: 2,600; Mem: 110; dues full mem $30, associate $20, students $15; ann meeting in Oct
Income: $50,000 (financed by mem, provincial appropriation & Canada Council)
Exhibitions: 6 shows per yr
Publications: Connexionews, monthly
Activities: Lect open to pub, 6-10 vis lectr per yr; book traveling exhibs 6-10 per yr; originate traveling exhibs 1 per yr

M **UNIVERSITY OF NEW BRUNSWICK,** Art Centre, Memorial Hall, Bailey Ave, PO Box 4400 Fredericton, NB E3B 5A3 Canada. Tel 506-453-4623; Fax 506-453-5012; Elec Mail mem@unb.ca; *Dir* Marie Maltais
Open winter Mon - Fri 8:30 AM - 4:30 PM, summer Mon - Fri 9 AM - 4 PM; No admis fee; Estab 1940 to broaden the experience of the univ students & serve the city & province; Two galleries, each with approx 100 running ft of wall space; display case; Average Annual Attendance: 5,000
Income: Financed by provincial univ& grants for special projects
Purchases: $7,000
Special Subjects: Prints
Collections: Chiefly New Brunswick Artists; some Canadian (chiefly printmakers)
Publications: Chiefly New Brunswick Artists; Canadian artists
Activities: Classes for adults; lect open to pub, 4 vis lectr per yr; gallery talks; tours; individual paintings & original objects of art lent to pub but secure areas on this campus & the univ campus in Saint John & reproductions to students; lending coll contains framed reproductions, original prints, paintings, photographs, sculptures & slides; book traveling exhibs 4 per yr; originate traveling exhibs provincially to nationally

HAMPTON

M **KINGS COUNTY HISTORICAL SOCIETY & MUSEUM,** PO Box 5001, Hampton, NB E0G 1Z0 Canada. Tel 506-832-6009; Fax 506-832-6007; Elec Mail kingscm@nbnet.nb.ca; *Pres* Stephen Cripps; *Treas* Julie Hughes; *Genealogist* Harvey Dalling; *Co-Genealogist* Ernest Friars; *Dir* A Faye Pearson
Open Mon - Fri 10 AM - 5 PM; Admis adults $2, children $1; Estab 1968 to preserve loyalist history & artifacts; Maintains small reference library; Average Annual Attendance: 1,400; Mem: 300; dues society $15 & $ 20; ann meeting in Nov
Income: $2,250 (financed by provincial & student grants, dues, fairs & book sales)
Special Subjects: Photography, Textiles, Ceramics, Painting-Canadian, Dolls, Furniture, Glass, Jewelry, Silver, Historical Material, Maps, Coins & Medals, Embroidery
Collections: Coin; dairy; glass; 1854 brass measures; jewelry; quilts
Exhibitions: School exhibs; Women's Institute; Christmas Fair
Publications: Memories newsletter, 7 per yr
Activities: Lect open to pub, 7 vis lectr per yr; tours; originate traveling exhibs; sales shop sells books

MONCTON

M **GALERIE D'ART DE L'UNIVERSITE DE MONCTON,** 85th Edific Clement Cormier, Moncton, NB E1A 3E9 Canada. Tel 506-858-4088; Fax 506-858-4043; Internet Home Page Address: www.umoncton.ca/gaum/; *Secy* Necol LaBlanc; *Technician* Paul Bourque; *Dir* Luc Charette
Open summer Mon - Fri 10 AM - 5 PM, Sat & Sun 1 - 5 PM; winter Tues - Sat 1 - 4:30 PM, Sat & Sun 1 - 4 PM; No admis fee; Estab 1965 to offer outstanding shows to the univ students & to the pub; 400 linear ft wall space, 3500 sq ft vinyl plywood walls, controlled light, temperature, humidity systems, security system; Average Annual Attendance: 13,000
Income: $100,000 (financed through univ)
Collections: Artists represented in permanent collection: Bruno Bobak; Alex Colville; Francis Coutellier; Tom Forrestall; Georges Goguen; Hurtubise; Hilda Lavoie; Fernand Leduc; Rita Letendre; Toni Onley; Claude Roussel; Romeo Savoie; Pavel Skalnik; Gordon Smith

Exhibitions: Rotating exhibits
Activities: Classes for children; dramatic progs; lect open to pub, 10 vis lectr per yr; concerts; gallery talks; tours; individual paintings & original objects of art lent to univ personnel & art galleries & museums; lending coll contains 500 reproductions, 300 original art works, 180 original prints, 30 paintings, 20 sculpture

M **RADIO-CANADA SRC CBC,** Georges Goguen CBC Art Gallery, 250 Ave Univesité, PO Box 950 Moncton, NB E1C 8N8 Canada. Tel 506-382-8326; Fax 506-867-8031; Elec Mail ghg@nbnet.ca; Internet Home Page Address: www.radio-canada.ca/atlantique
Open Mon - Fri 9 AM - 5 PM, Sat 9 AM - 1 PM; No admis fee; Estab 1972 for maritime artist; Gallery size 15 x 25, track lighting; Average Annual Attendance: 500
Special Subjects: Painting-American, Photography, Prints, Sculpture, Watercolors, Religious Art, Woodcarvings, Woodcuts, Painting-European, Posters, Painting-Canadian, Painting-French
Activities: Classes for children; 500 vis lect per yr; gallery talks; tours

SACKVILLE

M **MOUNT ALLISON UNIVERSITY,** Owens Art Gallery, 61 York St, Sackville, NB E4L 1E1 Canada. Tel 506-364-2574; Fax 506-364-2575; Elec Mail gkelly@mta.ca; Internet Home Page Address: www.mta.ca/owens; Telex 014-2266; *Fine Arts Conservator* J Tisdale; *Fine Arts Technician* R Ibbitson; *Dir* Gemey Kelly
Open Mon - Fri 10 AM - 5 PM, Tues evenings 5 - 9 PM, Sat & Sun 1 - 5 PM, cl univ holidays; No admis fee; Estab 1895, rebuilt 1972; Building includes five gallery areas; conservation laboratory; Average Annual Attendance: 11,000
Income: Financed by Mount Allison University, government, corporate & pvt assistance
Special Subjects: Graphics, Painting-American, Sculpture
Collections: Broad coll of graphics, paintings, works on paper; 19th & 20th century Canadian, European & American Art
Publications: Exhib catalogs
Activities: Family Sundays; lects open to pub, 15 vis lectrs per yr; gallery talks; tours; individual paintings lent to other galleries & museums; book traveling exhibs 5 per yr; originate national traveling exhibs

M **STRUTS GALLERY,** 7 Lorne St, Sackville, NB E4L 3Z6 Canada. Tel 506-536-1211; Internet Home Page Address: www.3.sympatico.nb.ca/struts; *Dir* Donna Wawzonek
Open Noon - 5 PM; No admis fee; Estab 1982; 1,000 sq ft; Average Annual Attendance: 1,500; Mem: Open to professional artist, associate or student; dues professional $35, associate & student $15; ann meeting in Oct
Income: $100,000 (financed by mem, Canada Council, Province of New Brunswick)
Exhibitions: Show work by contemporary living artists & a broad range of experimental art works
Activities: Lect open to pub, 2-5 vis lectr per yr

SAINT ANDREWS

M **ROSS MEMORIAL MUSEUM,** 188 Montague St, Saint Andrews, NB E5B 1J2 Canada. Tel 506-529-5124; Fax 506-529-5129; *Dir* Margot Magee Sackett
Open late June - mid Oct, cl Sun & Mon in the fall; Admis by donation; Estab 1980; 1 small gallery; Average Annual Attendance: 8,000
Special Subjects: Architecture, Painting-American, Watercolors, American Western Art, Bronzes, Ceramics, Landscapes, Decorative Arts, Portraits, Painting-Canadian, Furniture, Carpets & Rugs
Collections: Jacqueline Davis China Collection; New Brunswick Furniture Collection; Ross Decorative Arts Collection
Exhibitions: Special summer exhibit
Activities: Classes for children; lect open to pub

A **SUNBURY SHORES ARTS & NATURE CENTRE, INC,** Gallery, 139 Water St, Saint Andrews, NB E5B 1A7 Canada. Tel 506-529-3386; Fax 506-529-4779; Elec Mail sunshore@nbnet.nb.ca; Internet Home Page Address: www.sunburyshores.org; *Pres* Mary Blatherwick; *Dir* Debbie Nielsen
Open Mon - Fri 9 AM - 4:30 PM, cl Sat & Sun; No admis fee; Estab 1964, to function as a link for & harmonize views of scientists, artists & industrialists; Gallery maintained, 200 running ft, fire & burglar protection, security during hours, controllable lighting & street frontage; Average Annual Attendance: 5,000; Mem: 400; dues family $40, individual, students & sr citizens $25; ann meeting in Aug
Income: Financed by endowment, mem, grants, revenue from courses & activities, including special projects
Collections: Instructor Artwork
Exhibitions: Exhibits change frequently throughout the yr
Publications: Brochure, summer annually; Sunbury Notes, quarterly
Activities: Courses in fine arts & nature; lect open to pub, 10-15 vis lectr per yr; gallery talks; schols offered; mus shop sells books, original art, reproductions & prints

L **Library,** 139 Water St, Saint Andrews, NB E5B 1A7 Canada. Tel 506-529-3386; Fax 506-529-4779; Elec Mail sunshore@nbnet.nb.ca; Internet Home Page Address: www.sunburyshores.org; *Dir* Lois Fenety
Open Mon-Fri 9 AM - 4:30 PM, cl Sat & Sun; No admis fee; Circ Non-circulating; Open to pub; primarily for reference
Income: Financed by mem
Library Holdings: Book Volumes 600; Exhibition Catalogs; Periodical Subscriptions 10

SAINT JOHN

A **NEW BRUNSWICK ARTS COUNCIL INC,** Brunswick Sq 3rd level, 39 King St Saint John, NB E2L 4W3 Canada. Tel 506-635-8019; Fax 506-657-7832; Elec Mail nbac@nbnet.nb.ca; Internet Home Page Address: www.nbac.ca; *Exec Dir* Nancy Schell
Open Mon - Fri 10 AM - 6 PM; No admis fee; Estab 1979; Mem: 50; dues

$50-175 per yr; mem qualifications include artist, art organization or arts presenter based in New Brunswick
Income: Financed by mem, booking fees & grants
Exhibitions: Ann multi-disciplinary arts festival featuring visual and performing artists from New Brunswick

M **NEW BRUNSWICK MUSEUM,** 1 Market Sq, Saint John, NB E2L 4Z6 Canada. Tel 506-643-2300; Fax 506-643-6081; *Controller* Judith Brown; *Chief Cur* Gary Hughes; *Mgr Temporary Exhibits* Regina Mantin; *Mgr Pub Affairs & Acting Dir* Jane Fullerton; *Cur Zoology* Dr Donald McAlpine; *Cur Geology* Dr Randy Miller; *Cur Canada & International Art* Andrea Kirkpatrick; *Cur New Brunswick Cultural History & Art* Peter Larocque; *Cur Botany* Stephen Clayden
Open Mon - Wed & Fri 9 Am - 5 PM, Thurs 9 AM - 9 PM, Sat 10 AM - 5 PM, Sun Noon - 5 PM; Admis families $13, adults $6, seniors $4.75, students $3.25, children 3 & under free; Estab 1842 to collect, conserve, exhibit & interpret the Human & Natural history of New Brunswick in relation to itself & to the outside world; Twelve major galleries for permanent exhibits, three galleries for changing temporary exhibits; 62,000 sq ft gallery space; Average Annual Attendance: 75,000; Mem: 500; dues $16 - $500
Income: $1,600,000 (financed by municipal, federal & provincial appropriations)
Special Subjects: Painting-American, American Indian Art, African Art, Ethnology, Costumes, Crafts, Folk Art, Landscapes, Decorative Arts, Judaica, Manuscripts, Collages, Painting-Canadian, Dolls, Furniture, Glass, Painting-British, Maps, Period Rooms, Antiquities-Greek, Antiquities-Roman, Gold, Pewter, Leather
Collections: 3 galleries: Canadian Art, International Art; New Brunswick Art; Decorative Arts
Exhibitions: Various exhibitions
Publications: In Sum, quarterly newsletter
Activities: Classes for children; docent training; lect open to pub; gallery talks; tours; competitions sponsored in schools; schols & fels offered; individual paintings & original objects of art lent to museums & galleries; book traveling exhibs; originate traveling exhibs organized & circulated nationally & internationally; mus shop sells books & gifts

L **Archives & Research Library,** 277 Douglas Ave, Saint John, NB E2K 1E5 Canada. Tel 506-643-2324; Fax 506-643-2360; Elec Mail archives@nbm-mnb.ca; Internet Home Page Address: www.nbm-mnb.ca; *Coordr, Head Archives & Research Library* Felicity Osepchook; *Libr/Archives Asst* Janet Bishop; *Library & Archives Asst* Jennifer Longon; *Library & Archives Asst* Christine Little; *Library & Archives Asst* Daryl Johnson
Open Tues - Sat 10 AM - 4:30 PM (with the exception of long weekends), cl Mon; Circ Non-circulating; Open to the pub for reference only
Income: nonprofit, government funded
Library Holdings: Auction Catalogs; Book Volumes 20,000; Clipping Files; Exhibition Catalogs; Fiche; Manuscripts; Original Documents; Periodical Subscriptions 75; Photographs; Reels
Special Subjects: Art History, Decorative Arts, Photography, Calligraphy, Etchings & Engravings, Maps, Painting-American, Painting-British, Prints, Watercolors, Ceramics, Crafts, Archaeology, American Western Art, Bronzes, Printmaking, Cartoons, Art Education, Asian Art, American Indian Art, Porcelain, Anthropology, Eskimo Art, Furniture, Costume Design & Constr, Aesthetics, Afro-American Art, Bookplates & Bindings, Metalwork, Carpets & Rugs, Gold, Goldsmithing, Jewelry, Miniatures, Oriental Art, Pottery, Restoration & Conservation, Silver, Silversmithing, Textiles, Marine Painting, Antiquities-Assyrian, Scrimshaw, Painting-Canadian, Architecture, Folk Art, Portraits

NEWFOUNDLAND

CORNER BROOK

M **MEMORIAL UNIVERSITY OF NEWFOUNDLAND,** Sir Wilfred Grenfell College Art Gallery, University Dr, Corner Brook, NF A2H 6P9 Canada. Tel 709-637-6209; Fax 709-637-6383; Elec Mail gtuttle@beothuk.swgc.mun.ca; *Dir & Cur* Gail Tuttle
Open Tues - Sun 11 AM - 5 PM; No admis fee; Estab 1988; 2,000 sq ft, 170 running ft, white walls, neutral carpet; Average Annual Attendance: 6,000; Mem: 300
Income: $100,000 (financed by univ & Canada Council)
Collections: Drawings, paintings, photography & prints (mainly contemporary Canadian)
Exhibitions: Changing contemporary exhibs every 7 wks
Publications: Exhibition catalogues
Activities: Docent progs; lect open to pub, 8 vis lectr per yr; lending coll; book traveling exhibs 3 per yr; originate traveling exhibs 1 per yr; sales shop sells catalogues

SAINT JOHN'S

A **CRAFT COUNCIL OF NEWFOUNDLAND & LABRADOR,** (Newfoundland & Labrador Crafts Development Association) Devon House, 59 Duckworth St Saint John's, NF A1C 1E6 Canada. Tel 709-753-2749; Fax 709-753-2766; Elec Mail kcpfcouncil@craftcouncil.nf.ca; Internet Home Page Address: www.craftcouncil.nf.ca; *Gallery Coordr* Sharon LeRiche; *Shop Mgr* Shannon Reid; *Exec Dir* Anne Manuel
Open Mon - Sat 10 AM - 5 PM, Sun 1 PM - 5 PM; No admis fee; Estab 1991 to promote innovation & excellence in craft; The only gallery in Newfoundland & Labrador dedicated to the promotion & sale of fine craft. It encourages excellence & innovation & promotes craft as a valuable part of our cultural heritage. Maintains lending & reference library; Average Annual Attendance: 50,000; Mem: 300
Income: $80,000 (financed by federal government, foundations, fund raising & earned revenue)
Special Subjects: Embroidery, Metalwork, Textiles, Pottery, Stained Glass, Pewter, Ceramics, Crafts, Dolls, Furniture, Jewelry, Leather, Enamels, Tapestries

Collections: Craft Permanent Collection
Exhibitions: Revolving theme & solo exhibitions, 6-8 per year
Publications: Newsletter, 6 per yr
Activities: Classes for adults & children; lect open to pub; ann awards of excellence; juried; schols offered; sales shop sells high quality craft

M **MEMORIAL UNIVERSITY OF NEWFOUNDLAND,** Art Gallery of Newfoundland & Labrador, Allandale Rd & Prince Philip Dr Saint John's, NF A1C 5S7 Canada; Arts & Culture Centre, PO Box 4200 Saint John's, NF A1C 5S7 Canada. Tel 709-737-8209; Fax 709-737-2007; Elec Mail agnl@mun.ca; Internet Home Page Address: www.munica/agnl/; *Supv of Operations* Edward Cadigan; *Educ & Exhib Cur* Caroline Stone; *Registrar* Brian Murphy; *Admin Staff Specialist* Wanda Mooney; *Develop Mgr* Don Beaubier
Open Tue - Sun Noon - 5 PM, cl Mon; No admis fee; Estab 1961 to display contemporary Canadian art, with an emphasis on Newfoundland work & provide visual art educ progs; Four galleries with 130 running ft each; Average Annual Attendance: 30,000
Income: Financed through the univ, federal funding & revenue generation
Collections: Newfoundland Contemporary, Folk & Historic Art; Post 1960 Canadian Art
Exhibitions: Contemporary art rotating exhibit
Publications: Catalogs of in-house exhibitions
Activities: Educ dept; docent training; lect open to pub, 10-12 vis lectr per yr; concerts; gallery talks; tours; exten dept serves east coast of province; book traveling exhibs 8-10 per yr; originate traveling exhibs to Canadian & international pub art museums; sales shop sells books, art coll products, t-shirts, bags & cards

M **PROVINCIAL MUSEUM OF NEWFOUNDLAND & LABRADOR,** 285 Duckworth St, Saint John's, NF A1C 1G9 Canada. Tel 709-729-2329; Fax 709-729-2179; Elec Mail kwalsh@mail.gov.nf.ca; Internet Home Page Address: www.nfmuseum.ca; *Head, Pub Programming* Karen Walsh; *Dir* Penny Houlden; *Cur Archaeology/Ethnology* Elaine Anton; *Cur Military History* Dr Bernard Ransom; *Cur Natural History* John Maunder
Open Tues - Fri 9 AM - 4:45 PM, Sat 9:30 AM - 4:45 PM, cl Mon; Admis adult $3, sr citizen & post-secondary students $2.50, children under 18 free; Estab 1878 as the Athenaeum for the preservation of Provincial Heritage; The Provincial Mus houses colls & exhibs reflecting the human & natural history of Newfoundland & Labrador. Branches at The Provincial Seamen's Mus at Grand Bank & The Mary March Provincial Mus at Grand Falls; Average Annual Attendance: 60,000
Income: Financed by federal & provincial appropriations
Special Subjects: Photography, Archaeology, Ethnology, Textiles, Costumes, Ceramics, Crafts, Folk Art, Pottery, Eskimo Art, Dolls, Furniture, Glass, Jewelry, Porcelain, Marine Painting, Scrimshaw, Coins & Medals, Dioramas, Embroidery, Gold, Pewter, Leather
Collections: Beothuk, Thule, Maritime Archaic, pre-Dorset, Dorset, Innu, Inuit and Micmac artifacts; history material; maps; naval and military; 19th century Newfoundland domestic artifacts, maritime, natural history, mercantile; 18th - 20th century Newfoundland material, outport furniture, textiles, navigational instruments, ship portraits, watercolors, prints, drawings
Exhibitions: Rotating exhibits; Native Peoples gallery; Natural History Gallery-permanent
Publications: Museum Notes; exhib catalogues; technical bulletins; Archeology in Newfoundland & Labrador, Natural History Curatorial Reports
Activities: Classes for adults & children; lect open to public, 12 vis lectr per year; tours; gallery talks; concerts; book 3 traveling exhibs per yr; originate traveling exhibitions to nat and international mus

L **Library,** 285 Duckworth St, Saint John's, NF A1C 1G9 Canada; PO Box 8700 Saint John's, NF A1B 4J6 Canada. Tel 709-729-2329; Fax 709-729-2179; Elec Mail phoulden@mail.gou.nf.ca; Internet Home Page Address: www.nfmuseum.ca; *Public Programming Asst* Karen Walsh; *Chief Cur* Penny Houlden
Open Tues-Fri 9AM-4:45PM, Sat 9:30AM-4:45PM, Sun Noon-4:45PM, cl Mon & holidays; Admis Adult $3, sr citizen & students $2.50, children under 18 free; Open to researchers for reference
Special Subjects: Historical Material
Collections: Mercury Series of National Museums in Archaeology, Ethnology, Restoration; National Historic Parks & Sites Reports
Activities: Classes for children & docent training; lectr open to public; gallery talks & tours

NOVA SCOTIA

DARTMOUTH

M **DARTMOUTH HERITAGE MUSEUM,** (Regional Museum of Cultural History) 100 Wyse Rd, Dartmouth, NS B3A 1M1 Canada. Tel 902-464-2300; Fax 902-464-8210; Internet Home Page Address: www.dartmouthheritagemuseum.ns.ca; *Cur* Amita Price
Open summer Tues-Sun 10AM - 5PM, winter Wed-Sat 1:30PM - 5PM; No admis fee; Estab 1967 to collect & preserve the history & heritage of the Dartmouth & area; Average Annual Attendance: 15,000; Mem: 70 mems, $20 yr dues Aug-June
Income: Financed by city appropriation, provincial funds & fundraising
Special Subjects: Graphics, Photography, Prints, Watercolors, Textiles, Costumes, Ceramics, Pottery, Painting-European, Portraits, Posters, Painting-Canadian, Dolls, Furniture, Glass, Porcelain, Scrimshaw, Embroidery
Collections: Local history collection including art, archival, textile/costume & general social history material
Exhibitions: Twenty-four exhibitions scheduled per year
Activities: Classes for adults & children; gallery talks; tours; exten dept serves historic houses

L **SOCIETY FOR THE PROTECTION & PRESERVATION OF BLACK CULTURE IN NOVA SCOTIA,** Black Cultural Center for Nova Scotia, 1149 Main St, Dartmouth, NS B2Z 1A8 Canada. Tel 902-434-6223; Fax 902-434-2306; Elec Mail bccns@istar.ca; Internet Home Page Address: www.bccns.com; *Cur* Henry Bishop
Open Daily 9 AM - 5 PM; Admis adults $5, sr citizens & students $3, family $15,

mems free; Estab 1984; For reference only; Average Annual Attendance: 10,000; Mem: Dues $15 & up
Income: Financed by provincial & federal government
Library Holdings: Audio Tapes; Book Volumes 3000; Cassettes; Clipping Files; Framed Reproductions; Lantern Slides; Manuscripts; Memorabilia; Original Art Works; Pamphlets; Prints; Records; Reproductions; Slides; Video Tapes
Collections: African Nova Scotians
Exhibitions: African Canadians
Publications: Newsletter Preserver
Activities: Lect open to public; school tours; presentations; sales shop sells books

HALIFAX

M **ART GALLERY OF NOVA SCOTIA,** 1723 Hollis St, PO Box 2262 Halifax, NS B3J 3C8 Canada. Tel 902-424-7542; Fax 902-424-7359; Internet Home Page Address: www.ednet.ns.ca/educ/heritage/agns; *Chief Exec Officer & Dir* Bernard Riordon; *Mgr Coll & Gallery Svcs* Judy Dietz; *Fine Arts Conservator* Laurie Hamilton; *Asst Dir* Brenda Garagan; *Mgr Finance & Operations* Sue Tingley
Open Tues-Fri 10AM-6PM, Sat & Sun Noon-5PM, cl Mon; Summer hours: June - Aug Thurs 10AM-9PM; Admis adult $5, sr citizen $4, student with ID $2, children under 12 & members free, Tues free sponsored by Sprint Canada Inc; Estab 1975 to replace the Nova Scotia Mus of Fine Arts, dedicated to serving the pub by bringing the visual arts & people together in an environment which encourages exploration, dialogue & enjoyment; Seventeen galleries, for permanent collection & temporary exhibitions; Average Annual Attendance: 85,000; Mem: 2000; dues life members $2000, family $50, individual $35, senior couple $30, artist & senior individual $20, young member/student $15
Income: Financed by Nova Scotia Dept of Educ & Culture, Dept of Canadian Heritage, The Canada Council, municipal governments, private foundations & individual & corporate supporters
Special Subjects: Drawings, Prints, Watercolors, Ceramics, Crafts, Folk Art, Pottery, Woodcarvings, Eskimo Art, Painting-Canadian, Painting-British, Historical Material, Renaissance Art, Reproductions
Collections: Canadian Historical & Contemporary Art Collection drawings, paintings, prints, sculpture, ceramics & international art; Nova Scotia Folk Art Collection; Nova Scotian Collection
Exhibitions: Rotating exhibits
Activities: Classes for adults & children; docent training; lect open to public, 20 vis lectr per year; gallery talks; tours, family Sundays, family weekends; Black Tie Gala; Pick of the Month; exten dept serves Canada; artmobile; individual paintings & original objects of art lent to Province & Government House; lending collection contains original art works, framed reproductions, original prints, paintings & sculpture; book traveling exhibitions 6-8 per year; originate traveling exhibitions 10-15 per year; museum & sales shop sells books, jewelry, magazines, original art, pottery, prints, reproductions, slides, crafts & also rental service

M **DALHOUSIE UNIVERSITY,** Dalhousie Art Gallery, 6101 University Ave, Halifax, NS B3H 3J5 Canada. Tel 902-494-2403, 494-2195; Fax 902-494-2890; Elec Mail gallery@dac.cohn.dal.ca; Internet Home Page Address: www.is.dal.ca/~gallery; *Registrar & Preparator* Michele Gallant; *Dir & Cur* Susan Gibson Garvey; *Office Mgr* Sym Corrigan
Open Tues - Sun 11 AM - 5 PM, Wed 7 - 10 PM, cl Mon; No admis fee; Estab 1943 to collect, preserve, interpret & display works of art, primarily of Canadian origin; Dalhousie Art Gallery is located in the Dalhousie Arts Centre and open to university community and local area; it contains 400 running ft of wall space & 4000 sq ft floor space; Average Annual Attendance: 12,000
Income: Financed by university supplemented by government grants
Collections: Canadian works on paper; Atlantic Canadian artists all media
Exhibitions: Contemporary & historical exhibitions
Publications: Annual Report; Calendar of Events, 3 times per yr, exhibition catalogues & brochures
Activities: Classes for children; docent training; lect open to public, 12 vis lectr per year; concerts; gallery talks; tours; exten dept serves regional & national area; individual paintings & original objects of art lent to professional galleries & campus areas; book traveling exhibitions; originate traveling exhibitions; sales shop sells gallery publications

M **EYE LEVEL GALLERY,** 2128 Gottingen St, Halifax, NS B3K 3B3 Canada. Tel 902-425-6412; Fax 902-425-0019; Elec Mail director@eyelevelgallery.ca; Internet Home Page Address: www.eyelevelgallery.ca; *Dir* Eryn Foster; *Admin Dir* Christine Kleckner
Open Tues - Sat Noon - 5 PM; No admis fee; Estab 1974 to exhibit contemporary art in a non-museum setting; Ten 25 x 40 ft windows on one end; white, grey floor, 2 small pillars. Exhibiting every 4 wks (Sept-Apr) & every 2 wks during the summer; Average Annual Attendance: 10,000; Mem: 150; dues $6 & up; meetings in Feb, Mar, Apr, June, Aug & Nov
Income: $65,000 (financed by mem, Canada Council, Nova Scotia Arts Council)
Collections: Art Poster, 1974-Present; Artist Books Collection
Exhibitions: Cultural Competition; rotating exhibits
Publications: Exhibition catalogues
Activities: Lect open to public, 5 vis lectr per year; competition with awards; sales shop sells books

M **MOUNT SAINT VINCENT UNIVERSITY,** Art Gallery, 166 Bedford Hwy, Halifax, NS B3M 2J6 Canada. Tel 902-457-6788, 457-6160; Fax 902-457-2447; Elec Mail art.gallery@msvu.ca; Internet Home Page Address: www.textstyle.net/msvuart; *Office Mgr* Traci Scanlan; *Dir Art Gallery* Ingrid Jenkner
Open Tues - Fri 11 AM - 5 PM, Sat, Sun 1 - 5 PM, cl Mon & holidays; No admis fee; Estab 1970 & operating throughout the year with continuously-changing exhibitions of local, regional, national & international origin in the area of visual culture; Gallery situated on the main floor & mezzanine; Average Annual Attendance: 15,000
Income: Financed by university funds
Special Subjects: Ceramics, Pottery

Collections: The Art Gallery is custodian of a collection of pictures, ceramics & pottery of the late Alice Egan Hagen of Mahone Bay, noted Nova Scotia potter & ceramist; works by Atlantic region artists; women artists
Publications: Gallery News, 4 times per yr; exhibition catalogs
Activities: Workshops; lect open to public, 12 vis lectr per year; concerts; gallery talks; tours; competitions; individual paintings & original objects of art lent to other galleries; lending collection contains videotapes; book traveling exhibitions 6 per year; originate traveling exhibitions

A **NOVA SCOTIA ASSOCIATION OF ARCHITECTS,** 1361 Barrington St, Halifax, NS B3J 1Y9 Canada. Tel 902-423-7607; Fax 902-425-7024; Internet Home Page Address: www.nsaa.ns.ca; *Exec Dir* Diane Scott-Stewart
Open Mon - Fri 9 AM-5 PM; Estab 1932 to license & regulate architects of Nova Scotia; Mem: 200; annual meeting in Apr
Income: Financed by memberships
Publications: Newsletter, monthly

M **NOVA SCOTIA CENTRE FOR CRAFT & DESIGN,** Mary E Black Gallery, 1061 Marginal Rd, Halifax, NS B3H 4P6 Canada. Tel 902-492-2522; Fax 902-492-2526; Elec Mail susan@craft-design.ns.ca; Internet Home Page Address: www.craft-design.ns.ca; *Dir* Susan MacAlpine Foshay; *Studio Coordr* Leola Le Blanc; *Admin Asst* Erica Lowe
Open Mon - Wed, Fri - Sun 11 AM - 5 PM, Thurs 11 AM - 8 PM; No admis fee; Estab 1990; 900 sq ft in Halifax's seawall develop area near Pier 21 national site. Meets Canadian Conservation Institute Standards for temporary exhibitions; Average Annual Attendance: 15,000
Collections: Permanent collection of crafts
Exhibitions: 6 contemporary, temporary shows of craft & design annually
Publications: Exhibition catalogues
Activities: Classes for adults; lect open to the pub, 51 vis lect per yr; gallery talks; tours

M **NOVA SCOTIA COLLEGE OF ART AND DESIGN,** Anna Leonowens Gallery, 5163 Duke St, Halifax, NS B3J 3J6 Canada. Tel 902-494-8223; Fax 902-425-3997; Elec Mail peterd@nscad.ns.ca; *Dir* Peter Dykhuis; *Pres* Paul Greenhalgh
Open Tues - Fri 11 AM - 5 PM, Mon evenings 5:30 - 7:30 PM, Sat Noon - 4 PM; No admis fee; Estab 1968 for educational purposes; 3 exhibition spaces; Average Annual Attendance: 20,000
Income: Financed by state appropriations & tuition
Special Subjects: Drawings, Graphics, Prints, Sculpture, Textiles, Ceramics, Crafts, Etchings & Engravings, Collages, Jewelry, Metalwork
Collections: NSCAD permanent coll; prints from NSCAD lithography workshop
Exhibitions: 120 exhibitions per yr
Publications: Ten books; exhibition catalogs, occasionally
Activities: Lect open to public; 2 vis lectr per year; gallery talks
L **Library,** 5163 Duke St, Halifax, NS B3J 3J6 Canada. Tel 902-494-8196; Fax 902-425-2420; Elec Mail ilega@nscad.ca; Internet Home Page Address: www.nscad.ca; *Dir of Non-Print Coll* Victoria Sigurdson; *Dir* Ilga Leja
Open Mon - Fri 8:30 AM - 9 PM, Sat & Sun 1 - 5 PM; No admis fee; Estab 1887; Circ 30,000
Income: Financed by state appropriation & student fees
Purchases: $51,000
Library Holdings: Audio Tapes; Book Volumes 50,000; CD-ROMs; Cassettes; Compact Disks; DVDs; Exhibition Catalogs; Fiche; Filmstrips; Motion Pictures; Pamphlets; Periodical Subscriptions 250; Records; Reels; Slides; Video Tapes

M **NOVA SCOTIA MUSEUM,** Maritime Museum of the Atlantic, 1675 Lower Water St, Halifax, NS B3J 1S3 Canada. Tel 902-424-7490; Fax 902-424-0612; Internet Home Page Address: www.maritime.museum.gov.ns.ca; *Cur* Gerry Lunn
Open May 1 - Oct 31 daily 9:30 AM - 5:30 PM, Sun 1 - 5:30 PM, Tues 9:30 AM - 8:00 PM, Nov 1 - Apr 30 Tues - Sun 9:30 AM - 5:00 PM, Sun 1 - 5:00 PM, Tues 9:30 AM - 8:00 PM; Admis May - Oct adults $8, children 6-17, under 6 free, sr $7, family $21; Nov - Apr adults $4, children $2, under 6 free, sr $3.50, family $10; Estab 1948 to interpret maritime history of eastern coast of Canada; Gallery exhibits items from Days of Sail, Age of Steam, Navy, Small Craft, Shipwrecks & Underwater Archaeology; Average Annual Attendance: 175,000
Income: Financed by province of Nova Scotia Dept Tourism & Culture
Library Holdings: Book Volumes; Clipping Files; Photographs; Slides
Special Subjects: Crafts, Marine Painting
Collections: Halifax Explosion; Historical Marine Painting display; small craft, ship models, ship portraits, uniforms, marine artifacts; Titantic artifacts; WWII Atlantic convoys; Sable Island Canadian Navy
Exhibitions: Rotate 6-8 per yr
Activities: Classes for adults & children; school programs; interpretive programs & tours; lect open to public, 20 vis lectr per year; gallery talks; concerts; tours; individual paintings & original objects of art lent to other institutions; museum shop sells books, reproductions, clothing, marine memorabilia & toys

M **ST MARY'S UNIVERSITY,** Art Gallery, 5865 Gorsebrook Ave, Halifax, NS B3H 3C3 Canada. Tel 902-420-5445; Fax 902-420-5060; Elec Mail robert.zingone@stmarys.ca; *Dir & Cur* Gordon Laurin; *Asst Dir & Cur* Robert Zingone; *Prog Coordr* Mathew Reichertz
Open Tues - Thurs 1 - 7 PM, Fri 1 - 5 PM, Sat & Sun Noon - 5 PM, cl Mon; Estab 1970 to present a variety of exhibitions & performances of both regional & national interest & by contemporary artists; Average Annual Attendance: 12,000
Income: Financed by provincial appropriation
Collections: Works on paper by contemporary Canadian artists
Publications: Exhibit catalogues, 1-2 times per year
Activities: Adult drawing classes; lect open to public, 3-4 vis lectr per year; concerts; gallery talks; tours; individual paintings & original objects of art lent; exten dept serves university; book traveling exhibitions 1-2 per year; organize 1 traveling exhib; circulated to the Atlantic Provinces of Canada; sales shop sells catalogs

A **VISUAL ARTS NOVA SCOTIA,** 1113 Marginal Rd Halifax, NS B3H 4P7 Canada. Tel 902-423-4694; Tel 866-225-8267 (tollfree); Fax 902-422-0881; Elec Mail vans@visualarts.ns.ca; Internet Home Page Address: http://vans.ednet.ns.ca; *Exec Dir* Briony Carros; *Mem & Outreach Coordr* Dee Gibson; *Communications Coordr* Larissa Holman

Open daily 9 AM - 5 PM; No admis fee; Estab 1976 as a non-profit arts service organization to foster the development, awareness & understanding of the visual arts in Nova Scotia. Encourages the production, exhibition & appreciation of works by Nova Scotia's visual artists; 1 small gallery maintains slide registry, video library & archives & off-site exhib space - 5 small vitrines; Average Annual Attendance: 1,000; Mem: Over 600; dues corporate $65, couple/group/gallery $45, individual $35, senior $30, student $25
Income: $170,000 (financed by fund raising, mem & provincial appropriation)
Library Holdings: Audio Tapes; Exhibition Catalogs; Slides; Video Tapes
Exhibitions: Far & Wide: third biennial exhibition; biennial juried exhibitions, annual open exhibitions & occasional regional exhibitions; 2007, Undercurrents, juried exhib - 4 venues
Publications: Visual Arts News, 3 times per yr
Activities: PAINTS (Professional Artists in the Schools); classes for adults; workshop prog; mentorship prog; internships offered

LUNENBURG

M **LUNENBURG ART GALLERY SOCIETY,** 79 - 81 Pelham , PO Box 1418 Lunenburg, NS B0J 2C0 Canada. Tel 902-640-4044; Fax 902-640-3035; Elec Mail lag@eastlink.ca; Internet Home Page Address: www.lunenburgartgallery.com; *Pres* Ruth Flower; *Treas* Laird Wilton; *Secy* Mary Catharine McDonnell; *Planning & Exhib* Lynn Gillard; *VPres* Ann O'Dowd; *Publicity* Beverley Cluett; *Members' Gallery* Mary Brownless; *Webmaster* Doug Cooke

Open Tues - Sat 10 AM-5 PM, Sun 1-5 PM, cl Mon; No admis fee; Estab 1977 to provide art appreciation to community & venue for artists; 1 exhib gallery & 1 members' gallery ; Average Annual Attendance: 5,000; Mem: 180; dues $10-$15
Income: $30,000 (financed by mem, city appropriation & fundraising)
Purchases: Collection of Earl Bailly Paintings, Lunenburg Mouth Painter
Library Holdings: Cards; Clipping Files; Exhibition Catalogs; Framed Reproductions; Memorabilia; Original Art Works; Original Documents; Pamphlets; Photographs; Prints; Reproductions; Sculpture
Exhibitions: Exhibits rotate once per month with "opening receptions" last Tues - 5 PM every month
Activities: Classes for children; art workshops; competitions; sales shop sell books, original art, prints, cards & notes

WOLFVILLE

M **ACADIA UNIVERSITY ART GALLERY,** c/o Beveridge Arts Centre, Wolfville, NS B0P 1X0 Canada. Tel 902-585-1373; Fax 902-585-1070; Elec Mail fran.kruschen@acadia.u.ca; *Dir* Franziska Kruschen

No admis fee; Estab 1978, art dept 1928, to exhibit contemporary & historical art particularly from the Atlantic region; Average Annual Attendance: 15,000; Mem: $10 membership
Income: $65,000 (financed by endowment & University funds)
Purchases: $15,000 (works by Atlantic region artists)
Collections: Contemporary & Historical Paintings, Drawings & Prints
Activities: Lectures open to public; 4 vis lectr per year; book traveling exhibitions 8 per year; originate travel exhibitions 4 per year

YARMOUTH

M **YARMOUTH COUNTY HISTORICAL SOCIETY,** Yarmouth County Museum, 22 Collins St, Yarmouth, NS B5A 3C8 Canada. Tel 902-742-5539; Fax 902-749-1120; Elec Mail ycn0056@ycn.ca; Internet Home Page Address: www.ycn.ca/museum/yarcamus; *Pres* Barbara Smith; *Archivist* Laura Bradley; *Cur* Eric Ruff

Open Jun 1 - Oct 15 9 AM - 5 PM, Sun 1 - 5 PM, Oct 10 - May 31 2 - 5 PM, cl Mon; Admis adults $2.50, students $1, children $.50; Estab 1958 to display artifacts & paintings relating to Yarmouth's past; Located in former Congregational Church built in 1893; Average Annual Attendance: 14,000; Mem: 400; dues $17; meetings first Fri each month
Income: $170,000 (financed by mem, admis & state appropriation)
Purchases: $500
Special Subjects: Drawings, Graphics, Photography, Ethnology, Costumes, Crafts, Folk Art, Etchings & Engravings, Landscapes, Decorative Arts, Manuscripts, Portraits, Painting-Canadian, Dolls, Furniture, Glass, Porcelain, Marine Painting, Historical Material, Ivory, Coins & Medals, Period Rooms, Embroidery, Laces, Pewter
Collections: Gen historical coll; paintings of & by Yarmouthians; coll of ship portraits of Yarmouth vessels & vessels commanded by Yarmouthians; gen & marine artifacts; marine drawings & portraits
Exhibitions: Various local exhibits
Publications: Monthly newsletter
Activities: Lect open to public, 12 vis lectr per year; concerts; gallery talks; tours; Heritage Awards; museum shop sells books, prints, reproductions

ONTARIO

ALMONTE

M **MISSISSIPPI VALLEY CONSERVATION AUTHORITY,** R Tait McKenzie Memorial Museum, Mill of Kintail Conservation Area, 2854 Concession 8 Almonte, ON K0A 1A0 Canada; 4175 Hwy 511, Lanark, ON K0G 1K0 Canada. Tel 613-256-3610; Fax 613-256-5087; Elec Mail Kintail@trytel.com; Internet Home Page Address: www.millofkintail.com; *Site Supv* Nicole Guthrie; *Cur* Stephanie Kolsters

Open May 15 - Oct 15 daily 10:30 AM - 4:30 PM; Admis $5 per car; Estab 1952 as a private mus, publicly owned since 1973 by Mississippi Valley Conservation

Authority as a memorial to Dr R Tait McKenzie, Canadian sculptor, physical educator, surgeon & humanitarian; Average Annual Attendance: 7,500
Income: Financed by provincial government grant
Library Holdings: Exhibition Catalogs; Manuscripts; Memorabilia; Original Art Works; Original Documents; Photographs; Sculpture
Special Subjects: Sculpture
Collections: 70 Original Athletic, Memorial & Monumental Sculptures, nearly all in plaster; 600 Pioneer Artifacts, mostly collected by Dr McKenzie
Activities: Classes for children; tours; scholarships offered; sales shop sells books, reproductions, postcards & gift notes

ATIKOKAN

L **QUETICO PARK,** John B Ridley Research Library, Quetico Park, 108 Saturn Ave Atikokan, ON P0T 1C0 Canada. Tel 807-929-2571 ext 224; Fax 807-929-2123; Elec Mail andrea.allison@mnr.gov.on.ca; *Librn* Andrea Allison
Open year-round by appointment; Estab 1986; For reference only
Income: Financed by Ontario Parks
Purchases: $1500
Library Holdings: Book Volumes 4,500; Cassettes 350; Periodical Subscriptions 20; Photographs 8000; Slides 18,000; Video Tapes 100
Special Subjects: Archaeology
Collections: Natural history & cultural history displays on Quetico Park including archaeology, fur trade & voyageur history
Activities: Lect open to pub July - Aug

BANCROFT

M **ALGONQUIN ARTS COUNCIL,** Art Gallery of Bancroft, PO Box 1360, Bancroft, ON K0L 1C0 Canada. Tel 613-332-1542; Fax 613-332-2119; Elec Mail artgallerybancroftont@bellnet.ca; Internet Home Page Address: www.algonquinarts.ca; *Secy* Diana Gurley; *Cur* Wayne Link
Open Wed - Sun Noon - 5 PM (Spring/Summer), Wed - Sun Noon - 5 PM (Fall/Winter); Admis by donation; Estab 1980 to foster the fine arts in the area; Gallery & gift shop are located in an historic railway station; Average Annual Attendance: 9,000; Mem: 155; dues $20; annual meeting in Sept
Income: $25,979 (financed by corporations, donations, federal government, rent, & gallery & gift shop sales
Special Subjects: Photography, Watercolors, Textiles, Pottery, Posters, Painting-Canadian, Stained Glass
Collections: Murray Schafer: Sound Sculptures; miscellaneous glass, fabric, paintings
Exhibitions: 12 exhibitions per year
Publications: Algonquin Arts Council, newsletter
Activities: Classes for children; concerts; gallery talks; tours; competition with awards; museum shop sells books, original art, reproductions, prints, crafts of all nature, pottery, stained glass, wood carvings & photographs

BELLEVILLE

M **GLANMORE NATIONAL HISTORIC SITE OF CANADA,** 257 Bridge St E, Belleville, ON K8N 1P4 Canada. Tel 613-962-2329; Fax 613-962-6340; Elec Mail rrustige@citybelleville.com; *Educ* Melissa Wakeling; *Cur* Rona Rustige; *Secy* Darlene Rodgers; *Custodian* Mac Ellis; *Weekend Receptionist* Mary Jane Throop
Open June, July, Aug Tues - Sun 10 AM - 4:30 PM, Sept-May Tues - Sun 1 - 4:30 PM; Admis adults $3, seniors & students $1.50; children under 5 free; Estab 1973 to collect & interpret history of Hastings County & 1880s nat historic site; Historic House with extensive collection of Victorian paintings, notably Horatio Henry Couldery, Bertram & Cecelia Couldery, copies of Gainsborough, Constable, Uens & Wilkie; Average Annual Attendance: 8,000; Mem: 40; Friends of Glanmore; dues $5 per yr; meeting 1st Tues of month Sept - June
Income: Financed by corporation of City of Belliville
Library Holdings: Book Volumes; Clipping Files; Lantern Slides; Maps; Original Art Works; Original Documents; Other Holdings; Pamphlets
Special Subjects: Porcelain, Portraits, Textiles, Sculpture, Architecture, Drawings, Photography, Ceramics, Landscapes, Decorative Arts, Manuscripts, Painting-Canadian, Dolls, Furniture, Glass, Jewelry, Oriental Art, Painting-British, Painting-French, Historical Material, Ivory, Coins & Medals, Restorations, Miniatures, Period Rooms, Embroidery, Gold, Pewter, Leather, Enamels
Collections: Couldery European Art Collecion: (Cloisonne, paintings & furniture, typical of upper class turn of the century taste's) : Dr Paul Lamp Collection; Phillips-Burrows-Faulkner Collection; Regional History Collection
Activities: Classes for adults & children; docent training; internships; student placements; education kits lent to schools & groups; lect open to pub; tours; gallery talks; sponsoring of competitions; individual paintings & original objects of art lent to museums, galleries; book traveling exhibitions, annually; museum shop sells books, reproductions, artifacts, prints, & gift items related to Victoriana

BRACEBRIDGE

M **MUSKOKA ARTS & CRAFTS INC,** Chapel Gallery, 15 King St, PO Box 376 Bracebridge, ON P1L 1T7 Canada. Tel 705-645-5501; Fax 705-645-0385; Elec Mail info@muskokaartsandcrafts.com; Internet Home Page Address: www.muskokaartsandcrafts.com; *Cur* Elene J Freer
Open Tues - Sat 10 AM-1 PM & 2-5 PM; Admis donations accepted; Estab 1963, museum estab 1989; Average Annual Attendance: 10,000; Mem: 340; dues $20-$30; annual meeting in Oct
Income: Financed by mem & donations
Publications: Newsletter, 12 per year
Activities: Classes for adults & children; lect open to public, 4 vis lectr per year; scholarships offered

BRAMPTON

M **ART GALLERY OF PEEL,** Peel Heritage Complex, 9 Wellington St E, Brampton, ON L6W 1Y1 Canada. Tel 905-791-4055; Fax 905-451-4931; Internet Home Page Address: www.region.peel.on.ca/heritage; *Cur* David Somers; *Develop Officer* Valerie Dowbiggin
Open Mon - Fri 10 AM - 4:30 PM, Thurs 6 - 9 PM, Sat & Sun Noon - 4:30 PM; Admis family $7, adults $2.50, seniors $1.50, students $1; Estab 1968 to promote & collect art & artifacts on regional & provincial level; Average Annual Attendance: 20,000; Mem: 200; dues corporate $150, family $45, individual $30; annual meeting in Feb
Collections: Caroline & Frank Armington Print Collection; Permanent Collection of Canadian Artists, special focus on Peel Region; Works on paper
Exhibitions: Eight exhibits per year (all mediums); Annual Open Juried Show; Regional Artists
Publications: Carolina & Frank Armington; Canadian Painter -Etchers in Paris; exhib catalogs
Activities: Classes for adults & children; docent training; lect open to public, 2-3 vis lectr per year; gallery talks; tours, competitions with prizes; exten dept serves Southern Ontario; individual paintings & original objects of art lent to public buildings & other institutions; book traveling exhibitions 1 per year; originate traveling exhibitions to libraries & other galleries; sales shop sells books, reproductions & prints

L **Archives,** 9 Wellington St E, Brampton, ON L6W 1Y1 Canada. Tel 905-791-4055; Fax 905-451-4931; Internet Home Page Address: www.region.peel.on.ca/heritage; *Archivist* Diane Kuster; *Cur* David Somers
Open Mon-Fri 10 AM - 4:30 PM, Thurs 6 - 9 PM, Sat & Sun Noon - 4:30 PM; Circ Non-circulating; Reference only
Library Holdings: Book Volumes 550; Clipping Files; Exhibition Catalogs; Memorabilia; Periodical Subscriptions 3

BRANTFORD

M **BRANT HISTORICAL SOCIETY,** Brant County Museum & Archives, 57 Charlotte St, Brantford, ON N3T 2W6 Canada. Tel 519-752-2483; Fax 519-752-2483; Internet Home Page Address: www.efree.on.ca/comdie/musgal/bcma; *Asst Cur* Shanna Dunlop; *Dir* Stacey McKellar
Open Sept - Apr Wed - Fri 10 AM - 4 PM, Sat 1 - 4 PM, July - Aug Wed - Fri 10 AM - 4 PM, Sat & Sun 1 - 4 PM; Admis adults $2, students & seniors $1.50, children $1.25, under 6 free; Estab 1908 to preserve, interpret & display Brant County history; Average Annual Attendance: 9,200; Mem: 200; dues patron $25, family $20, single $15
Income: Financed by mem, provincial, county & city grants & fundraising
Library Holdings: Book Volumes; Clipping Files; Fiche; Filmstrips; Manuscripts; Maps; Original Art Works; Original Documents; Photographs; Prints; Slides
Special Subjects: Historical Material
Collections: Early Indian history; historical figures; portraits & paintings; Brant County history; Old maps & photographs of Brant County
Publications: Annual brochure; Brant County, the Story of its People, vol I & II; Grand River Navigation Company Newsletter, quarterly
Activities: Classes for children; docent training & Kids' camps; lect open to public; tours; museum shop sells books, reproductions & prints

L **Library,** 57 Charlotte St, Brantford, ON N3T 2W6 Canada. Tel 519-752-2483; Fax 519-752-2483; Internet Home Page Address: www.efree.on.ca/comdir/musgal/bcma
Estab for research only; Circ Non-circulating
Library Holdings: Book Volumes 500; Maps; Photographs
Special Subjects: Religious Art
Collections: First editions of history & archaeology; old Bibles available for research on premises under supervision of curator; rare books; Photographs of Brant County & old maps

M **GLENHYRST ART GALLERY OF BRANT,** 20 Ava Rd, Brantford, ON N3T 5G9 Canada. Tel 519-756-5932; Fax 519-756-5910 (alt fax) Elec Mail info@glenhyrstartgallery.ca; Internet Home Page Address: www.glenhyrst.ca; *Exec Dir* Mary-Ellen Heiman; *Cur* Kathryn Hogg
Open Tues - Fri 10 AM - 5 PM, Sat & Sun 1 - 5 PM; No admis fee; Estab 1957 as a nonprofit pub arts center serving the citizens of Brantford & Brant County; Situated on 16 picturesque acres, the gallery offers rotating exhib of contemporary art; Average Annual Attendance: 19,000; Mem: 425; dues family $40, individual $30, student & senior citizen $20; annual meeting in Mar
Income: Financed by mem, municipal, provincial & federal appropriations & local foundations
Library Holdings: Book Volumes 140; CD-ROMs; Clipping Files 200; Exhibition Catalogs 200; Periodical Subscriptions 10
Special Subjects: Prints, Painting-Canadian
Collections: Contemporary Canadian graphics/works on paper; historical works by R R Whale & descendants, outdoor sculpture
Exhibitions: Annual juried exhibition in Sept
Publications: Catalogue with each exhib
Activities: Classes for adults & children; lect open to public; tours; gallery talks; individual paintings lent to public art galleries & museums/Brantford and Brant; sales shop sells original art & giftware

BURLINGTON

M **BURLINGTON ART CENTRE,** 1333 Lakeshore Rd, Burlington, ON L7S 1A9 Canada. Tel 905-632-7796; Fax 905-632-7796; Elec Mail info@BurlingtonArtCentre.on.ca; Internet Home Page Address: www.BurlingtonArtCentre.on.ca; *Exec Dir* Ian D Ross; *Dir Programs* George Wale; *Cur Coll* Jonathan Smith; *Dir Devel* Barbara Smith
Open Mon - Fri 9 AM - 10 PM, Sat 9 AM - 5 PM, Sun Noon - 5 PM; No admis fee; Estab 1978; Maintains reference library, main gallery, F R Perry Gallery;

permanent collection corridor courtyard; Average Annual Attendance: 90,000; Mem: 1200; dues $30-$65; annual meeting in Mar
Income: $1,150,000 (financed by mem, city appropriation, province appropriation, earned revenues, fund raising, donations & sponsorship)
Purchases: $10,000
Collections: Contemporary Canadian Ceramic Art
Activities: Classes for adults & children; docent training; hands-on programs; lect open to public, 2 vis lectr per year; tours; exten dept; original objects of art lent; book traveling exhibitions 1 per year; originate traveling exhibitions 20 per year; museum shop sells original art & jewelry

CAMBRIDGE

L **CAMBRIDGE PUBLIC LIBRARY AND GALLERY,** 20 Grand Ave N, Cambridge, ON N1S 2K6 Canada. Tel 519-621-0460; Fax 519-621-2080; *Coordr Cultural Svcs* Mary Misner; *Chief Librn* Greg Hayton
Open Mon - Thurs 9:30 AM - 8:30 PM, Fri & Sat 9:30 AM - 5:30 PM; Sept - May open Sun 1 - 5 PM; No admis fee; Estab 1969; Gallery on second floor with 2000 sq ft, 250 linear ft; Average Annual Attendance: 25,000
Income: Financed by provincial appropriation, federal & private
Library Holdings: Book Volumes 150,000; Periodical Subscriptions 100
Collections: Regional Artists
Exhibitions: Rotate 6 - 8 per yr
Publications: Bi-monthly newsletter
Activities: Classes for adults & children; lect open to public, 10 vis lectr per year; concerts; gallery talks; tours; competitions with awards; individual paintings & original objects of art lent; originate traveling exhibitions
Courses: Fiber Art

CHATHAM

A **CHATHAM CULTURAL CENTRE,** Thames Art Gallery, 75 William St N, Chatham, ON N7M 4L4 Canada. Tel 519-354-8338; Fax 519-354-4170; Elec Mail ccc@city.chatham-kenton.on.ca; Internet Home Page Address: www.city.chatham-kent.on.ca; *Dir & Cur* Carl Lavoy
Open daily 1 - 5 PM; No admis fee; Estab 1963 to operate as a regional arts centre, to advance knowledge & appreciation of & to encourage, stimulate & promote interest in the study of culture & the visual arts; Gallery maintained; designated National Exhibition Centre for the presentation of visual art works & museum related works, to the public of this country; Average Annual Attendance: 15,000; Mem: 500; dues family $28, single $17, seniors & students $11.50
Income: Financed by mem, municipal, & federal governments; Ontario Arts Council, & the Canada Council for the Arts
Library Holdings: Book Volumes; CD-ROMs; Exhibition Catalogs; Original Art Works; Periodical Subscriptions; Photographs; Slides; Video Tapes
Collections: Local Artists; Historical Photographs; regional contemporary artists
Exhibitions: Ten various historical and contemporary exhbs per yr
Publications: At the Centre, 5 per year
Activities: Classes for adults & children; docent training; lect open to public, 9 vis lectr per year; concerts; gallery talks; tours; juried fine art shows; individual & original objects of art lent to accredited galleries & museums; lending collection contains 2100 slides; serves Chatham-Kent; 1-2 book traveling exhibs; originate traveling exhibitions to other accredited galleries

CORNWALL

M **CORNWALL GALLERY SOCIETY,** Cornwall Regional Art Gallery, 164 Pitt St Promenade, Cornwall, ON K6J 3P4 Canada. Tel 613-938-7387; Fax 613-938-9619; Elec Mail crag@cnwl.igs.net; Internet Home Page Address: http://www.cnwl.igs.net/~crag; *Dir* Sylvie Lizotte
Open Tues - Sat 10 AM - 5 PM; cl Sun & Mon; No admis fee; Estab 1982 to promote interest in & study of visual arts; Main gallery has 3 display walls measuring 44.5 ft, 30 ft & 10 ft 9 inches; walls 12 ft; Gallery Shoppe where local art is sold; Average Annual Attendance: 15,000; Mem: 200; dues $20 & up; annual meeting in June
Income: $90,000 - $100,000 (financed by mem & city appropriation)
Special Subjects: Drawings, Photography, Prints, Sculpture, Watercolors, Religious Art, Ceramics, Crafts, Folk Art, Pottery, Decorative Arts, Portraits, Painting-Canadian, Porcelain, Embroidery, Laces
Collections: Contemporary Canadian Art
Exhibitions: Annual Juried Exhibition; rotate exhibits from Canadian artists once per month
Publications: Newsletter, tri-annually
Activities: Classes for adults & children; individual paintings lent; museum shop sells original art

DON MILLS

C **ROTHMANS, BENSON & HEDGES,** Art Collection, 1500 Don Mills Rd, Don Mills, ON M3B 3L1 Canada. Tel 416-449-5525; Fax 416-449-4486; *Dir Corp Affairs* John MacDonald
Open to public; Estab 1967; Collection displayed at head office
Collections: Contemporary Canadian art from last decade
Activities: Awards for Toronto Outdoor Art Exhibition each year; individual objects of art lent to traveling or special exhibitions; originate traveling exhibitions to all major public galleries in Canada

DURHAM

M **DURHAM ART GALLERY,** 251 George St E, PO Box 1021 Durham, ON N0G 1R0 Canada. Tel 519-369-3692; Fax 519-369-3327; *Pres* Trevor Crilly
Open Tues - Fri Noon-6 PM, Sat 1-5 PM, Sun 1-4 PM; Estab 1978

GANANOQUE

M **GANANOQUE MUSEUM,** 10 King St E, Gananoque, ON K7G 2T8 Canada. Tel 613-382-4024; Elec Mail gregsuzz@kingston.net; *Cur* O Pritchard; *Board Dirs* C Doneuan; *Bd Dir* F Gordoon; *Board Dirs* D Richmond; *Board Dirs* G Bounds; *Bd Dirs* J Nalon; *Bd Dir* G Dobbie
Open daily 10 AM - 6 PM (May 15 - Sept 15); Admis adult $1, children under 12 free; Estab 1964 to preserve local history; Average Annual Attendance: 2,500
Special Subjects: Historical Material, Period Rooms
Collections: China Collection; Military & Indian Artifacts; glass; portraits & photographs pertaining to local history; Victorian kitchen

GUELPH

M **MACDONALD STEWART ART CENTRE,** 358 Gordon St, Guelph, ON N1G 1Y1 Canada. Tel 519-837-0010; Fax 519-767-2661; Internet Home Page Address: www.uoguelph.ca/msac;
Open Tues - Sun Noon - 5 PM; No admis fee; Estab 1978 by University of Guelph, city, county & board of educ to collect & exhibit works of art; maintain & operate a gallery & related facilities for this purpose fulfilling a pub role in city & county; 30,000 sq ft building comprising galleries, lecture room, studio, meeting rooms, resource centre, gift shop & rental service. Restored & renovated in 1980; Average Annual Attendance: 25,000; Mem: 600; dues family $30, individual $20, senior & student $10; annual meeting Sept-Oct
Income: Financed by university, city, county, board of educ, provincial & federal grants, mem & donations
Purchases: Canadian art
Special Subjects: Prints, Decorative Arts, Eskimo Art
Collections: Historical & contemporary Canadian art; historical & contemporary international prints; Inuit Collection; contemporary sculpture; outdoor sculpture (Donald Forster Sculpture Park)
Publications: Catalogue of permanent collection of University of Guelph 1980; exhibition catalogues, 6 per yr; quarterly newsletter
Activities: Classes for adults & children; docent training; parent/child workshops; lectures open to public; gallery talks; school & group tours; competitions; awards; exten dept serves Wellington County & other Canadian public galleries, also have circulated in US & Europe; individual paintings lent to institutions & public galleries; art rental to gallery members; lending collection contains 500 original paintings, 400 prints, photographs & 50 sculptures; book traveling exhibitions 4-6 per year; originate traveling exhibitions 1 -2 per year for museums in Canada & abroad; sales shop sells books, magazines, reproductions, toys, pottery, textiles, jewelry & catalogues

HAILEYBURY

M **TEMISKAMING ART GALLERY,** PO Box 1090, Haileybury, ON P0J 1K0 Canada. Tel 705-672-3706; Fax 705-672-5966; *Dir* Maureen Steward
Open Tues - Fri 2-8 PM, Sat 10 AM-2 PM; No admis fee; Estab 1980 to educate; 1 large gallery; Mem: Dues $15 & up; Annual meeting Jan
Income: Financed by mem & city appropriation
Collections: North Ontario Collection
Exhibitions: Rotating exhibits
Activities: Classes for adults & children; lect open to public, 5 vis lectr per year

HAMILTON

M **ART GALLERY OF HAMILTON,** 123 King St W, Hamilton, ON L8P 4S8 Canada. Tel 905-527-6610; Fax 416-577-6940; Elec Mail larissa@artgalleryofhamilton.com; Internet Home Page Address: www.artgalleryofhamilton; *Pres & CEO* Louis Dompierre; *Dir Programming* Kathryn Rumbold; *Educator* Laurie Kilgour; *Dir Mktg & Communications* Larissa Ciupka
Open Tues-Sun; Estab Jan 1914 to develop & maintain a centre for the study & enjoyment of the visual arts; new gallery opened Oct 1977; renovated & reopened May 2005; Building is 76,000 sq ft, 24,000 sq ft of exhibition space; Average Annual Attendance: 150,000+; Mem: 2000; dues family $60, single $35; annual meeting first Tues in June
Income: Earned revenue endowment, mem, city & provincial appropriation & federal grants
Special Subjects: Graphics, Painting-American, Photography, American Western Art, Religious Art, Woodcarvings, Etchings & Engravings, Painting-European, Eskimo Art, Painting-British, Baroque Art
Collections: Complete graphics of Karel Appel; Canadian fine arts; American, British & European fine arts; historical, modern & contemporary collection
Exhibitions: Twenty-nine exhibitions scheduled per yr
Publications: Insights, 3 times per yr
Activities: Classes for adults & children; docent training; lect open to public, 10-20 per yr; concerts; gallery talks; tours; 2000 Lieutenant Governor's award for the arts; individual paintings & original objects of art lent to other galleries & museums; lending collection contains 7800 art works; book traveling exhibitions; organize traveling exhibitions to provincial galleries & art ctrs; internat. art galleries; museum shop sells books, original art, reproductions & giftware
L **Muriel Isabel Bostwick Library,** 123 King St W, Hamilton, ON L8P 4S8 Canada. Tel 905-527-6610; Fax 905-577-6940; Internet Home Page Address: www.artgalleryofhamilton.on.ca; *Librn* Helen Hadden; *Sr Cur* Shirley Madill
Open Tues-Sun 11AM-5PM, Thurs 11AM-9PM; Open to gallery members & researchers for reference
Library Holdings: Book Volumes 4800; Clipping Files; Exhibition Catalogs; Periodical Subscriptions 14; Photographs
Special Subjects: Art History, Mixed Media, Painting-American, Prints, Sculpture, Painting-European, Portraits, Printmaking, Oriental Art, Restoration & Conservation
Collections: References on Canadian art history; exhibition catalogues

M **DUNDURN CASTLE,** 610 York Blvd Hamilton, ON L8R 3H1 Canada. Tel 905-546-2872; Fax 905-546-2875; Elec Mail ecchin@interlynx.net; Internet Home Page Address: www.city.hamilton.on.ca/culture-and-rec; *Cur Asst* Elizabeth Wakeford; *Cur* Bill Nesbitt
Open June 1 - Labor Day daily 10 AM - 4:30 PM, Labor Day - May 31, cl Mon, booked tours mornings, open to public Noon - 4 PM, cl Christmas & New Year's Day; Admis family $18, adults $7, senior citizens $6, students $5.50, children $3, children under 5 free, discounts on group rates for over 20 people; Dundurn, the home of Sir Allan Napier MacNab; Hamilton's Centennial Project was the restoration of this historic house; built in 1832-35, it was tenured by MacNab until his death in 1862. The terminal date of the furnishings is 1855; Approximately 43 rooms are shown; two-room on-site exhibit area; Average Annual Attendance: 70,000
Income: Financed by city of Hamilton, owner & operator
Special Subjects: Architecture, Photography, Prints, Watercolors, Archaeology, Textiles, Religious Art, Pottery, Woodcarvings, Etchings & Engravings, Portraits, Painting-Canadian, Furniture, Glass, Porcelain, Silver, Carpets & Rugs, Coins & Medals, Restorations, Tapestries, Calligraphy, Period Rooms, Stained Glass, Pewter, Reproductions
Collections: Regency & mid-Victorian furnishings depicting the lifestyle of an upper class gentleman living in upper Canada in the 1850s; restored servants quarters
Exhibitions: Historical Crafts Fair, Harvest Home-baking & preserving competitions; Victorian Christmas
Activities: Classes for adults & children; docent training; lect open to public; concerts; gallery talks, tours; individual paintings & original objects of art lent; museum shop sells books, reproductions, prints & slides, tea room & food service facilities

M **MCMASTER UNIVERSITY,** McMaster Museum of Art, Alvin A Lee Bldg, 1280 Main St W Hamilton, ON L8S 4L6 Canada. Tel 905-525-9140, Ext 27573; Fax 905-527-4548; Elec Mail museum@mcmail.cis.momaster.ca; Internet Home Page Address: www.mcmaster.ca/museum; *Dir & Cur* Carol Podedworny; *Preparator* Jennifer Petteplace; *Asst Cur* Ingrid Mayrhofer; *Registrar* Geraldine Loveys; *Communications Officer* Rose Anne Prevec; *Admin Asst* Judd Levett; *Information Officer* Greg Rennick; *Information Officer* Sally Frater; *Information Officer* Nicole Knibb; *Information Officer* Teresa Gregorio
Open Tues - Wed & Fri 11 AM - 5 PM, Thurs 11 AM - 7 PM, Sat Noon - 5 PM, cl Mon & Sun; Admis fee donations; Estab 1967 to provide the university & pub with exhibitions of historical & contemporary art from Canada & other countries; Five galleries incandescent lighting throughout; display cases; sculpture stands; Average Annual Attendance: 25,000
Income: $1,500,000 (financed by university & private endowment, corporate & individual support)
Purchases: $15,000
Library Holdings: Auction Catalogs; Book Volumes; CD-ROMs; Clipping Files; Exhibition Catalogs; Manuscripts; Maps; Memorabilia; Original Documents; Pamphlets; Periodical Subscriptions; Photographs; Slides; Video Tapes
Special Subjects: American Indian Art, Etchings & Engravings, Landscapes, Flasks & Bottles, Photography, Maps, Sculpture, Drawings, Painting-American, Prints, Watercolors, Bronzes, Religious Art, Woodcuts, Painting-European, Painting-Canadian, Glass, Asian Art, Painting-British, Painting-Dutch, Painting-French, Coins & Medals, Painting-Flemish, Painting-Italian, Antiquities-Egyptian, Antiquities-Roman, Painting-German, Painting-Russian
Collections: Levy Collection, impressionist & post-impressionist, paintings & early Dutch panels; American & Canadian Art; European paintings, prints & drawings; Expressionist Prints
Exhibitions: On going prog in 5 gallery spaces
Publications: The Art Collection of McMaster University; Levy legacy and various exhibition catalogues
Activities: Clases for adults & children; classroom facilities; lect open to public; concerts; gallery talks; artist talks; 15 vis lect per yr; tours; receptions; individual paintings and original objects of art lent to National Gallery of Canada, Art Gallery of Ontario & other Canadian institutions; various book traveling exhib from yr to yr; originate traveling exhibitions to other univs or public galleries; museum shop sells books, original art, pottery, jewelry, handmade cards
L **Library,** University Ave, 1280 Main St W Hamilton, ON L8S 4L6 Canada. Tel 905-525-9140, Ext 23081; Fax 905-527-4548; Elec Mail museum@mcmaster.ca; *Communications Officer* Rose Anne Prevec; *Dir & Cur* Kim G. Ness; *Operations Mgr* Gerrie Loveys
Open Tues - Fri 11 AM - 6 PM, Thurs evenings 7 - 9 PM, Sun Noon - 5 PM; Houses reference materials on art gallery management, exhibition & sales catalogues
Library Holdings: Auction Catalogs; Book Volumes 3000; Clipping Files; Exhibition Catalogs; Other Holdings Serial titles; Periodical Subscriptions
Publications: Exhibition Catalogues, artist files, auction catalogues

JORDAN

M **JORDAN HISTORICAL MUSEUM OF THE TWENTY,** 3082 Main St, Jordan, ON L0R 1S0 Canada. Tel 905-562-5242, 562-4849; Internet Home Page Address: www.tourismniagra.com/jordanmuseum; *Cur* Helen Booth
Open Thurs - Sun 1-4 PM; Admis adults $3.25, sr citizens & children $2.25, children under 10 $1.25; Estab 1953 to preserve the material & folklore of the area known as The Twenty, Mile Creek vicinity; Average Annual Attendance: 10,000; Mem: 100; dues corp with over 15 employees $50, under 15 $35, family $25, individual $15
Income: Financed by admis, provincial grants, municipal grants, internal fund raising activities & donations
Special Subjects: Historical Material, Period Rooms
Collections: Archives; furniture; historical material & textiles
Exhibitions: Special annual exhibits; Pioneer Day
Activities: Classes for children; special displays as requested by the community; Pioneer Day first Sat after Canadian Thanksgiving holiday; lect open to public, 1 vis lectr per year; individual paintings & original objects of art lent; sales shop sells books, original art, prints, pottery, textiles & local craft items

KINGSTON

M QUEEN'S UNIVERSITY, Agnes Etherington Art Centre, University Ave Kingston, ON K7L 3N6 Canada. Tel 613-533-2190; Fax 613-533-6765; Elec Mail acac@post.queensu.ca; Internet Home Page Address: www.queensu.ca/ageth; *Assoc Dir & Cur* Dorothy Farr; *Cur Contemporary Art* Jan Allen; *Admin Coordr* Annabel Hanson; *Pub Prog Officer* Pat Sullivan; *Dir* Janet M. Brooke; *Preparator* Nigel Barnett; *Financial Coordr* Barry Fagan; *Bader Cur European Art* David de Witt
Open year round Tues - Fri 10 AM - 4:30 PM, Sat & Sun 1 - 5 PM; Admis adults $4, seniors $2.50, students& children free; Estab 1957 to provide the services of a pub art gallery & mus for the community & region; Gallery has approximately 8000 sq ft of display space, in eight galleries showing a balanced program of exhibitions of contemporary & historical, national, international & regional art; Average Annual Attendance: 30,000; Mem: 900; dues $15-$200; annual meeting in Sept (Gallery Association)
Income: $1,000,000 (financed by endowment, city & provincial appropriation, University & Canada Council funds)
Purchases: $100,000
Special Subjects: Graphics, Prints, Sculpture, Ethnology, Antiquities-Greek, Antiquities-Roman
Collections: African Art; Canadian Dress Collection; Canadian Paintings; Prints, Sculpture, Historical & Contemporary; Decorative Objects; Ethnological Collection; European Graphics; European 17th Century; Old Master Paintings; Quilts; Silver
Exhibitions: About 30 exhibitions mounted each year
Publications: Currents, quarterly; annual report; exhibition publications & catalogues; studies
Activities: Docent training regarding tours for school & other groups; lect open to public, 10 vis lectr per year; gallery talks; tours; artwork rented by Gallery Association Art Rental to private individuals & businesses; originate traveling exhibitions to other cultural institutions; museum shop sells books, reproductions, prints & gift items including ceramics, jewelry, glassware

L Art Library, Ontario Hall, Kingston, ON K7L 3L6 Canada. Tel 613-533-2841; Fax 613-533-6765; Elec Mail wallsl@post.queensu.ca; *Librn* Lucinda Walls
Open to students, faculty & staff; open to public for reference only
Library Holdings: Book Volumes 50,000; Exhibition Catalogs 14,000; Fiche 1400; Other Holdings Reference bks; Periodical Subscriptions 140; Photographs; Reels 300; Video Tapes 215
Special Subjects: Art History

M ST LAWRENCE COLLEGE, Art Gallery, King & Portsmouth, PO Box 6000 Kingston, ON K7L 5A6 Canada. Tel 613-544-5400, Ext 1283; Fax 613-545-3923; Internet Home Page Address: www.sl.on.ca; *Dept Coordr* Terry Pfliger; *Gallery Coordr* Michael Shumate, BFA
Open Noon - 4 PM; No admis fee; College estab 1968, mus estab 1973 to augment the creative art program with shows, visiting artists; Average Annual Attendance: 4,000

KITCHENER

M HOMER WATSON HOUSE & GALLERY, 1754 Old Mill Rd, Kitchener, ON N2P 1H7 Canada. Tel 519-748-4377; Fax 519-748-6808; Internet Home Page Address: www.homerwatson.on.ca; *Prog Coordr* Astero Kalogeropoulos; *Cur & Adminr* Faith Hieblinger
Open Tues - Sun Noon - 4:30 PM; No admis fee, donations suggested; Estab 1981 as Homer Watson Memorial; Three studios for contemporary art - total of 155 running ft; Average Annual Attendance: 6,000; Mem: 165; dues family $25, individual $15; annual meeting 2nd Tues in June
Income: $140,000 (financed by mem, city appropriation, workshops & classes)
Purchases: $6,000
Collections: Watson Family Artifacts; Homer Watson Paintings
Exhibitions: Contemporary art-regional & provincial artists
Activities: Classes for adults & children; lect for members only, 1 vis lectr per year

M KITCHENER-WATERLOO ART GALLERY, 101 Queen St N, Kitchener, ON N2H 6P7 Canada. Tel 519-579-5860; Fax 519-578-0740; Elec Mail mail@kwag.on.ca; *Exec Dir* Alf Bogusky
Open Tues - Sat 10 AM - 5 PM, 1 hr before Center performances, Sun 1 - 5 PM, cl Mon; Admis contribution adults $2, students & senior citizens $1, members free; Estab 1956, the Kitchener-Waterloo Art Gallery is a pub institution interested in stimulating an appreciation of the visual arts & dedicated to bringing to the community exhibitions, art classes, lectures, workshops & special events; Average Annual Attendance: 75,492; Mem: 820; dues business $100, family $40, individual $30, senior citizens & students $15
Income: Financed by government grants, foundation grants, corporate & individual donations, special events, mem dues, voluntary admis & sales of publication
Special Subjects: Drawings, Prints, Painting-Canadian
Collections: Canadian; Homer Watson Collection
Publications: Calendar, quarterly; exhibition catalogs, quarterly
Activities: Art classes for adults & children; lect open to public; tours; scholarships offered; exten dept serves Waterloo region; book traveling exhibitions; sales shop sells books, original art, reproductions

L Eleanor Calvert Memorial Library, 101 Queen St N, Kitchener, ON N2H 6P7 Canada. Tel 519-579-5860; Fax 519-578-0740; *Dir* Carolyn Vesely
Cl for recataloging; call for opening hrs; Estab 1972 for pub art reference & lending to members
Library Holdings: Book Volumes 5000; Cassettes; Clipping Files; Exhibition Catalogs; Pamphlets; Periodical Subscriptions 25; Slides

KLEINBURG

M MCMICHAEL CANADIAN ART COLLECTION, 10365 Islington Ave, Kleinburg, ON L0J 1C0 Canada. Tel 905-893-1121; Fax 905-893-2588; Internet Home Page Address: www.mcmichael.com; *Chmn Bd Trustees* David Braley; *Exec Dir & CEO* Vincent V. Varga; *COO* John Ryerson; *CFO* Michael Ervin
Open Nov 1 - Mar 31 Tues - Fri 10 AM - 4 PM, Sat & Sun 11 AM - 5 PM, Apr 1 - Oct 31 daily 10 AM - 5 PM; Admis family $8, adults $4, students & senior citizens $2, children under 5 free, Wed free; Estab 1965
Collections: Focus of the collection is the works of art created by Indian, Inuit & Metis artists, the artists of the Group of Seven & their contemporaries & other artists who have made or make a contribution to the development of Canadian Art
Exhibitions: Temporary exhibitions lasting from 1 to 3 months
Publications: Permanent collection catalogue; exhibition catalogues; quarterly newsletters
Activities: Comprehensive educ programme at the elementary & secondary school levels; guided group tours by appointment; exten programme & temporary exhibition programme; programmes for kindergarten & special interest groups

L Library & Archives, Islington Ave, Kleinburg, ON L0J 1C0 Canada. Tel 905-893-1121; Fax 905-893-2588; Elec Mail library@mcmichael.com; Internet Home Page Address: www.mcmichael.com; *Librn & Archivist* Linda Morita
Open by appointment
Library Holdings: Auction Catalogs; Audio Tapes; Book Volumes 5000; Cassettes; Clipping Files; Exhibition Catalogs; Fiche; Manuscripts; Memorabilia; Original Art Works; Original Documents; Other Holdings Archival material; Pamphlets; Periodical Subscriptions 30; Photographs; Reproductions; Slides; Video Tapes
Special Subjects: Art History, Prints, Printmaking, Eskimo Art, Landscapes, Painting-Canadian

LINDSAY

M THE LINDSAY GALLERY INC, 190 Kent St W, Lindsay, ON K9V 2Y6 Canada. Tel 705-324-1780; Fax 705-324-1780; Elec Mail lind.gall@on.aibn.com; Internet Home Page Address: www.thelindsaygallery.com; *Board Chair* Janet Smith
Open Tues - Fri 10 AM - 4 PM, Sat 10 AM - 4 PM; No admis fee; Estab 1976; half of 2d floor of library, Lindsay branch; Average Annual Attendance: 3,200; Mem: 269; family $30, individual $20, senior citizens & student $15
Income: $76,000 (financed by mem, fund raising, & corporate sponsorship)
Special Subjects: Sculpture, Painting-Canadian
Collections: Historical & contemporary Canadian
Publications: Bimonthly Newsletter
Activities: Art classes for adults & children; lect open to public, 2 vis lectr per year; Awards, art student bursary, memorial award to a secondary school student at juried show; book traveling exhibitions 1-2 times per year; 12 Exhib per yr; Summer Art in the Park; sales shop sells original art, prints, original crafts & artists jewelry

LONDON

M MUSEUM LONDON, 421 Ridout St N, London, ON N6A 5H4 Canada. Tel 519-661-0333; Fax 519-661-2559; Elec Mail ramurray@city.london.on.ca; Internet Home Page Address: www.londonmuseum.on.ca; *Cur Contemporary Art* Robin Metcalfe; *Bus Mgr* Gail Roberts; *Cur Regional History* Michael Baker; *Exec Asst* Gloria Kerr; *Coordr Pub Progs* Peter Smith; *Publicity & Promotion Coordr* Ruth Anne Murray; *Graphic Designer* Robert Ballantine; *Accounts Supvr* Janice Lopez; *Tour Coordr, Sec & Visitor Servs Coordr* Bev Bourque; *Exec Dir* Brian Meehan; *Head Programs* Cydna Mercer; *Accounts Supvr* Barry Fair
Open Tues - Sun Noon - 5 PM; No admis fee; Estab 1940; New bldg open 1980 containing 26,500 sq ft of exhibition space, 150 seat auditorium; maintains reference library; Average Annual Attendance: 125,000; Mem: 2000; family $65, individual $50, senior citizens & students $20; annual meeting in Apr
Income: $1,201,900 (financed by city, province, mem & donations, community)
Collections: Permanent Collection stresses regional & local artists, who have become internationally & nationally recognized such as Jack Chambers, Greg Curnoe, F M Bell-Smith & Paul Peel; Hamilton King Meek Memorial Collection; F B Housser Memorial Collection; The Moore Collection; a collection of historical art & artifacts, primarily of London & region
Exhibitions: Works of art - international, national & regional; programs of multi-media nature, including performing arts, exhibitions of historical artifacts & art
Publications: Exhibition catalogues; Quarterly magazine
Activities: Classes for adults & children; docent training; lect open to public, some for members only; concerts; gallery talks; tours; individual paintings & original objects of art lent to other art institutions; lending collection contains 25,000 slides; book traveling exhibitions; originate traveling exhibitions; museum shop sells books, original art, reproductions, prints & jewelry

M UNIVERSITY OF WESTERN ONTARIO, McIntosh Gallery, London, ON N6A 3K7 Canada. Tel 519-661-3181; Fax 519-661-3059; Elec Mail akenned4@uwo.ca; Internet Home Page Address: www.uwo.ca/uwocom/McIntosh; *Cur* Catherine Elliot Shaw; *Installations Officer & Registrar* David Falls; *Dir* Arlene Kennedy
Open Tues - Thurs Noon - 7 PM, Fri - Sun Noon - 4 PM, cl Mon; No admis fee; Estab 1942; Three galleries with a total of 2960 sq ft; Average Annual Attendance: 14,000; Mem: 155
Income: Financed by endowment, mem, provincial appropriation, special grants & University funds
Collections: Canadian Art
Exhibitions: 12 to 14 exhibitions per year
Publications: Newsletter, 3 times a yr; exhibition catalogues
Activities: Docent training; lect open to public, 6-10 vis lectr per year; gallery talks; tours; individual paintings & original objects of art lent to galleries; lending collection contains books, cassettes, framed reproductions, original art works & prints, paintings, photographs & sculpture; book traveling exhibitions 1-3 per year; originate traveling exhibitions

L The D B Weldon Library, 1151 Richmond St, Ste 2, London, ON N6A 3K7 Canada. Tel 519-661-3162; Fax 519-661-3911; Internet Home Page Address: www.lib.uwo.ca; *Dir* Catherine Wilkins
Open Mon - Thurs 8 AM - 11:30 PM, Fri 8 AM - 9 PM, Sat 11 AM - 9 PM, Sun 11 AM - 11:30 PM; Open to all university staff, faculty & students for research & borrowing. Open to the public for in-house research; Average Annual Attendance: 1,700,000

Library Holdings: Book Volumes 1,439,855; Clipping Files; Exhibition Catalogs; Fiche; Pamphlets; Periodical Subscriptions 4,956; Reels
Special Subjects: Art History, Decorative Arts, Maps, Painting-American, History of Art & Archaeology, Archaeology, American Western Art, Eskimo Art, Metalwork, Carpets & Rugs, Antiquities-Byzantine, Antiquities-Etruscan, Antiquities-Greek, Antiquities-Roman, Painting-Canadian

MIDLAND

M HURONIA MUSEUM, Gallery of Historic Huronia, 544 Little Lake Park, PO Box 638 Midland, ON L4R 4P4 Canada. Tel 705-526-2844; Fax 705-527-6622; Elec Mail hmchin@csolve.net; Internet Home Page Address: www.georgianbaytourism.on.ca; Internet Home Page Address: www.huroniamuseum.com; *Dir* James Hunter; *Photographer & Cur* Nicole Henderson; *Educ* Dianna Moody
Open Jan - Mar Mon - Sat 9 AM-5 PM, cl Sun, summer hrs daily 9 AM-6 PM; Admis adult $6.42, sr citizens $5.89, children 6 - 17 $4.82, under 6 free; Estab 1947 to collect art of Historic Huronia; Several large galleries dealing with local contemporary artists, historical regional artists, design exhibit on Thor Hansen & other designers; Average Annual Attendance: 20,000; Mem: Dues family $25, individual $15; annual meeting last Thurs in May
Income: $400,000 (financed by endowment, mem, admis, sales, fundraising, grants)
Purchases: $10,000 (Ted Lord Art Collection)
Library Holdings: Auction Catalogs; Book Volumes; Manuscripts; Maps; Memorabilia; Original Art Works; Original Documents; Pamphlets; Periodical Subscriptions; Photographs; Records; Reproductions; Slides
Special Subjects: Drawings, American Indian Art, Archaeology, Ethnology, Costumes, Ceramics, Crafts, Folk Art, Etchings & Engravings, Decorative Arts, Eskimo Art, Dolls, Coins & Medals, Bookplates & Bindings
Collections: Mary Hallen Collection (watercolors); Franz Johnson Collection (oils, watercolors); Ted Lord Collection (paintings, prints, watercolors); Bill Wood Collection (etchings, oils, watercolors); General Collection (carvings, oil, watercolors); Lucille Oille Welk
Exhibitions: A Photographic History of the Georgian Bay Lumber Co 1871-1942; art shows once a month
Publications: Exhibition catalogues, annual
Activities: Children's classes; lect open to public, 12vis lectr per year; tours; fels; Huronia Heritage Award ann award; lending collection contains paintings to other institutions who put together exhibitions; originate traveling exhibitions 5 per year; museum shop sells books, prints, magazines, original art, reproductions

MISSISSAUGA

M ART GALLERY OF MISSISSAUGA, 300 City Centre Dr, Mississauga, ON L5B 3C1 Canada. Tel 905-896-5088; Fax 905-615-4167; Elec Mail fred.troughton@city.mississauga.on.ca; Internet Home Page Address: www.city.mississauga.on.ca/agm/; *Exec Dir* Fred Troughton; *Interim Cur* Robert Freeman; *Gallery Asst* Lucia Cecco
Open Mon-Fri 9AM-5PM, Sat & Sun Noon-4PM; No admis fee; Estab 1987; Average Annual Attendance: 20,000; Mem: 400; dues $15-$1000; annual meeting in Apr
Income: Financed by mem, city appropriation, federal & provincial government
Collections: Permanent collection
Exhibitions: 11 exhibitions per year, 6 week average per exhibition
Publications: Brush Up
Activities: Lect open to public, 3-5 vis lectr per year; individual paintings & original objects of art lent; book traveling exhibitions 1 per year

L MISSISSAUGA LIBRARY SYSTEM, 301 Burnhamthorpe Rd W, Mississauga, ON L5B 3Y3 Canada. Tel 905-615-3500; Fax 905-615-3625; Internet Home Page Address: www.city.mississauga.on.ca/library; *Dir Library Svcs* Don Mills
Open: Hours vary according to branch; No admis fee; Outlet for local artists at branch galleries; present more widely recognized artists at Central & Burnhamthorpe Galleries; Total of eleven galleries in system, 90 running ft each, often multi-purpose rooms
Collections: Permanent collection of 135 paintings and prints by Canadian artists, emphasis on prints (all framed)
Publications: Link News Tabloid Format, quarterly
Activities: Lect open to public; competitions with cash prizes; lending collection contains books & motion pictures; book traveling exhibitions
L Central Library, Arts Dept, 301 Burnhamthorpe Rd W, Mississauga, ON L5B 3Y3 Canada. Tel 905-615-3500; Fax 905-615-3625; Internet Home Page Address: www.city.mississauga.on.ca/library; *Dir Library Svcs* Don Mills
Open Mon - Fri 9 AM - 9 PM, Sat 9 AM - 5 PM, Sun 1 - 5 PM, cl Victorian Day
Income: $7,000,000 (financed by Municipal & Provincial funds)
Library Holdings: Book Volumes 38,000; Cassettes; Exhibition Catalogs; Filmstrips; Other Holdings Compact Discs; Periodical Subscriptions 29; Video Tapes

M UNIVERSITY OF TORONTO AT MISSISSAUGA, (Erindale College, University of Toronto at Mississauga) Blackwood Gallery, 3359 Mississauga Rd N, Mississauga, ON L5L 1C6 Canada. Tel 905-828-3789; Fax 905-828-5202; Elec Mail bfischer@credit.erin.utoronto.ca; Internet Home Page Address: www.erin.utoronto.ca/services/gallery/index.htm; *Cur* Barbara Fischer
Open Sun - Fri 1PM - 5PM, Thur 1PM - 9PM; No admis fee; Estab 1969 to educate the public & present contemporary art; Gallery has four walls with various dividers & floor space of 36 x 30 ft; Average Annual Attendance: 5,000
Collections: Acrylics, drawings, oils, pen sketches & prints, sculpture, water colour, multiples
Publications: exhib catalogs
Activities: Classes for children; lect open to public; presentation of 6-8 exhibs of contemporary art per year; gallery talks; tours; competitions with awards, Blackwood Gallery Award; individual paints & original objects of art lent in house

& to public art galleries; book 1 traveling exhib per year; organize traveling exhib for small to medium sized galleries & museums

OAKVILLE

CANADIAN SOCIETY FOR EDUCATION THROUGH ART
For further information, see National and Regional Organizations

OAKVILLE GALLERIES
M Centennial Square and Gairloch Gardens, Tel 905-844-4402; Fax 905-844-7968; Elec Mail oakgalleries@idirect.com; Internet Home Page Address: www.oakvillegalleries.com; *Dir* Francine Perinet; *Cur Contemporary Art* Marnie Fleming; *Installations & Registrar* Shannon Anderson; *Office Mgr* Maria Zanetti; *Develop Officer* Gail Smith; *Adjunct Cur* Su Ditta; *Pub Prog* Teresa Casas; *Communications* Gellman Jenifer Dara; *Community Liaison* Catherine Sicot
Centennial Square open Tues - Thurs Noon - 9 PM, Fri & Sat Noon - 5 PM, Sun 1 - 5 PM; Gairloch Garden open Tues - Sun 1 - 5 PM; No admis fee; Estab Centennial 1967, Gairloch 1972, to exhibit contemporary visual arts; Oakville Galleries is a not-for-profit public art gallery committed to contemporary art; Average Annual Attendance: 48,000; Mem: 500
Collections: Contemporary Canadian painting, sculpture, photographs, drawing & prints; contemporary outdoor sculpture
Exhibitions: Monthly exhibits
Publications: Exhibition catalogues
Activities: Art classes for adults & children; lect series open to public; tours; gallery talks; 12 vis lect per yr; originate various traveling exhibitions; museum shop sells original art and crafts

L SHERIDAN COLLEGE OF APPLIED ARTS AND TECHNOLOGY, Trafalgar Campus Library, 1430 Trafalgar Rd, Oakville, ON L6H 2L1 Canada. Tel 905-845-9430, Ext 2495; Fax 905-815-4123; Internet Home Page Address: www.sheridanc.on.ca; *Reference Technician* Susan Platt
Open Mon - Thurs 8:30 AM-9 PM, Fri 8:30 AM-4:30 PM, cl weekends; Estab 1970 to serve the students & faculty of School of Animation, Art & Design; Circ 23,000
Income: Financed by the college
Library Holdings: Book Volumes; Clipping Files; Exhibition Catalogs; Periodical Subscriptions 96; Slides 27,809; Video Tapes 50
Special Subjects: Art History, Illustration, Photography, Graphic Design, Crafts

OSHAWA

M THE ROBERT MCLAUGHLIN GALLERY, Civic Centre, Oshawa, ON L1H 3Z3 Canada. Tel 905-576-3000; Fax 905-576-9774; Elec Mail communications@rmg.on.ca; Internet Home Page Address: www.rmg.on.ca; *Exec Dir* David Aurandt; *Cur* Linda Jansma; *Adminr* Olinda Casimiro
Open Mon, Tues, Wed & Fri 10 AM - 5 PM, Thurs 10 AM - 9 PM, Sat & Sun Noon - 4 PM, cl Mon; No admis fee; Estab Feb 1967 as The Art Gallery of Oshawa, in May 1969 as the Robert McLaughlin Gallery; R S McLaughlin Gallery 77 x 38 x 15 ft; Isabel McLaughlin Gallery 77 x 38 x 13 ft; Alexandra Luke Gallery (no 1) 62 x 48 x 9 1/2 ft; Alexandra Luke Gallery (no 2) 46 x 27 x 13 ft; E P Taylor Gallery 23 x 37 x 9 ft; General Motors Gallery 25 x 37 x 9 ft; Corridor Ramp (Isabel McLaughlin Gallery) 48 x 8 x 10 ft; Corridor (Alexandra Luke) 68 x 5 1/2 x 8 ft with Foyer & Director's Office; Average Annual Attendance: 40,000; Mem: 500; dues family $45, single $35, student $20; annual meeting in May
Income: Financed by membership, city appropriation, Canada Council, Ministry Culture & Recreation & Ontario Arts Council
Special Subjects: Photography, Prints, Sculpture, Watercolors, Woodcuts, Portraits, Painting-Canadian
Collections: Canadian 19th & 20th century drawings, paintings, prints & sculpture; major collection of works by Painters Eleven
Publications: Annual Report; bi-monthly bulletin; Calendar of Events, annually; exhibition catalogs
Activities: Classes for adults and children; docent training; lect open to public, 6 vis lectr per year; gallery talks; tours; scholarships & fels offered; original objects of art lent to schools, institutions & industries; lending collection contains cassettes, 300 color reproductions, framed reproductions, original art works, 10,000 slides & 5100 books; sales shop sells books, reproductions, prints & local crafts
L Library, Civic Centre, 72 Queen St Oshawa, ON L1H 3Z3 Canada. Tel 905-576-3000; Fax 905-576-9774; Elec Mail bduff@rmg.on.ca; Internet Home Page Address: www.rmg.on.ca; *Coordr Library Svcs* Barb Duff; *Curatorial Asst* Olex Wlasenko
Open Mon, Tues, Wed & Fri 10 AM - 5 PM, Thurs 10 AM - 9 PM, Sat & Sun Noon - 4 PM; Admis donations accepted; Open to pub, mem available
Library Holdings: Audio Tapes; Book Volumes 6000; Cassettes; Clipping Files; Exhibition Catalogs; Manuscripts; Pamphlets; Photographs; Slides; Video Tapes
Collections: Canadian contemporary art books

OTTAWA

A CANADA COUNCIL FOR THE ARTS, Conseil des Arts du Canada, 350 Albert St, PO Box 1047 Ottawa, ON K1P 5V8 Canada. Tel 613-566-4414; Fax 613-566-4390; Internet Home Page Address: www.canadacouncil.ca; WATS 800-263-5588; *Dir* Robert Sirman; *Chmn* Karen Kain
Open daily 8:45 AM-5 PM, cl Sat & Sun; Estab 1957 to foster & promote the arts. The Council provides a wide range of grants & services to professional Canadian artists & art organizations in dance, media arts, music, opera, theatre, writing, publishing & the visual arts. Also Art Bank; Estab 1957, the Council is a national arm's-length agency which provides grants & services to professional Canadian artists & arts organizations in dance, media arts, music, theatre, writing & publishing, interdisciplinary work & performance art, & the visual arts. The Art Bank of the Canada Council rents contemporary Canadian art to the pub & private sectors across Canada. The Council also maintains the secretariat for the Canadian

Commission for UNESCO, administers the Killam Program of scholarly awards & prizes, & offers a number of other prestigious awards. The Public Lending Right (PLR) Commission, which is operated by the Canada Council, administers a program of payments to Canadian authors for their eligible books catalogued in libraries across Canada. The Canada Council for the Arts is funded by & reports to Parliament through the Minister of Canadian Heritage
Income: Financed by Parliament of Canada, endowment fund & private individuals
Activities: Prizes awarded; grants & fels offered

M **CANADA SCIENCE AND TECHNOLOGY MUSEUM,** 1867 St Laurent Blvd, PO Box 9724, Sta T Ottawa, ON K1G 5A3 Canada. Tel 613-991-3044; Fax 613-990-3654; Elec Mail cts@nmstc.ca; Internet Home Page Address: www.science-tech.nmstc.ca; *Promotion* Leeanne Akehurst; *Dir Gen* Claude Faubert; *Dir Exhibs* Ginette Beriault; *Dir Curatorial* Geoff Rider
Open Daily 9 AM - 5 PM (May - Labor Day), winter hrs Tues - Sun 9 AM - 5 PM, cl Mon; Admis adult $6, senior citizens & students $5, children 4-14 $3, under 4 free, family $14; Estab 1967 to foster scientific & technological literacy throughout Canada by establishing & maintaining a collection of scientific & technological objects; Main exhib areas showcase astronomy, Canada in space, communications, computer technology, household appliances, physics & land & marine transportation; Average Annual Attendance: 400,000; Mem: Dues $25 & up
Income: Financed by treasury board appropriations, admis fees & sales
Collections: Agriculture, Energy, Land & Marine Transportation, Physical Sciences, Printing, Space Communications
Exhibitions: Canada in Space; Connexions; Love, Leisure & Laundry; Locomotives; Canadian SC & Engineering Hall of Fame; LOG On; More Than A Machine; Rotate 2-8 exhibitions per yr
Publications: Material History Bulletin
Activities: Classes for adults & children; astronomy programs (evening); March break and summer day camps for children; originate traveling exhibitions; museum shop sells books, magazines, models, shirts, mugs, maps & educational toys

CANADIAN CONFERENCE OF THE ARTS
For further information, see National and Regional Organizations

CANADIAN CRAFTS COUNCIL
For further information, see National and Regional Organizations

M **CANADIAN HERITAGE - PARKS CANADA,** Laurier House, National Historic Site, 335 Laurier Ave E, Ottawa, ON K1N 6R4 Canada. Tel 613-992-8142; Fax 613-992-9233; *Area Mgr* Bernie Roche
Open Apr - Oct Tues - Sat 9 AM-5 PM, Sun Noon-5 PM, cl Mon, Oct 8 - Apr 1 by appt only; Admis adults $2.50, sr citizens $2, children 6 - 16 $1.25, under 6 free; Estab 1951; This is a historic house & former residence of Two Prime Ministers, Sir Wilfrid Laurier & the Rt Honorable William Lyon Mackenzie King containing furniture & memorabilia. The house is primarily furnished in the style of its last occupant, the Rt Honorable William Lyon Mackenzie King, with space given to the Laurier Collection. The Lester Pearson study was installed in 1974; Average Annual Attendance: 8,014
Income: Financed by federal government & trust fund
Special Subjects: Period Rooms
Exhibitions: Yr-end flower show
Publications: Main Park Brochure provided to visitors
Activities: Guided tours

M **CANADIAN MUSEUM OF CONTEMPORARY PHOTOGRAPHY,** One Rideau Canal, PO Box 465, Sta A Ottawa, ON K1N 9N6 Canada. Tel 613-990-8257; Fax 613-990-6542; Elec Mail cmcp@ngc.chin.gc.ca; Internet Home Page Address: www.cmcp.gallery.ca; *Nat & International Prog Mgr* Anne Jolicoeur; *Assoc Cur* Pierre Dessureault; *Prog Mgr* Maureen McEvoy; *Dir* Martha Hanna
Open Thurs 11 AM - 8 PM, Wed, Fri, Sat & Sun 11 AM - 5 PM, cl Mon, Tues & Good Friday (Labor Day - Apr 30); Mon & Tues, Fri - Sun 11 AM - 5 PM, Wed 4 - 8 PM, Thurs 11 AM - 8 PM (May 1 - Labor Day); No admis, donations accepted; Estab 1985 as an affiliate of the National Gallery of Canada; Reconstructed railway tunnel houses 354 sq metres of exhibition galleries specially lit for photography, a theatre designed for flexible programming, a boutique & a research centre; exhibitions change quarterly
Income: Financed by federal government, National Gallery of Canada (Crown Corporation)
Special Subjects: Photography, Prints, Landscapes, Portraits, Reproductions
Collections: 158,000 images by Canadian photographers
Exhibitions: Over 40 exhibitions, solo & group, are available for loan
Publications: Exhibition catalogues
Activities: Family programmes; teacher workshops; educational exhibitions; interpreter training; didactic printed materials; evaluation studies; lect open to public, 10-12 vis lectr per year; gallery talks; tours for adults & children; original objects of art lent to other museums & galleries for use in exhibitions; book traveling exhibitions 1-2 per year; originate traveling exhibitions to other museums, art galleries or spaces that meet conservation requirements across Canada & abroad; museum shop sells books, prints, photo related jewelry, children's gifts & postcards

M **CANADIAN MUSEUM OF NATURE,** Musee Canadien de la Nature, Metcalfe & McLeod Sts, PO Box 3443, Sta D Ottawa, ON K1P 6P4 Canada. Tel 613-566-4730; Fax 613-998-1065; Internet Home Page Address: www.nature.ca; *Temporary Exhib* Monique Horth; *Head Library & Archives* Arch W L Stewart
Open Sept - Apr daily 10 AM - 5 PM & Thurs 10 AM - 8 PM, May - Sept daily 9:30 AM - 5 PM & Sun, Mon & Thurs 9:30 AM - 8 PM, cl Christmas; Admis family $12, adult $4, students $3, senior citizens & children 6 - 16 $2, children under 6 free; Estab 1842 to disseminate knowledge about the natural sciences, with particular but not exclusive reference to Canada; Average Annual Attendance: 300,000
Income: Financed by donations & government

Special Subjects: Drawings, Photography, Prints, Watercolors, Ceramics, Woodcarvings, Posters, Painting-Canadian
Collections: Prints; Paintings; Sculpture
Exhibitions: Evergreen (National nature-related exhibition, annual); 15 exhibitions by various artists
Activities: Lect; film series; demonstrations & workshops dealing with natural history subjects; exten dept; individual paintings & original objects of art lent to other museums on the traveling exhibition circuit; lending collection contains 600 original prints & paintings, 150 photographs, 400 sculptures; book traveling exhibitions; originate traveling exhibitions

CANADIAN MUSEUMS ASSOCIATION
For further information, see National and Regional Organizations

M **CANADIAN WAR MUSEUM,** 330 Sussex Dr, Ottawa, ON K1A 0M8 Canada. Tel 819-776-8600; Fax 819-776-8623; Elec Mail joe.geurts@warmuseum.ca; Internet Home Page Address: www.civilization.ca/cwmeng/cwmeng.html; *Dir* Joe Geurts
Cl Mon & Christmas Day Oct 15 - Apr 30; Open 7 days per week May 1 - Oct 14; Admis family $9, adult $4, sr citizen & student $3, children 3-12 $3; Estab 1880 to collect, classify, preserve & display objects relevant to Canadian military history; Average Annual Attendance: 225,000
Income: Financed by government funds
Collections: Uniforms & accoutrements; medals & insignia; equipment; vehicles; art; archives; photographs; weapons
Activities: Educ dept; lect & film presentations open to public; tours; artwork lent to other museums & galleries, educational institutions, national exhibition centers; lending collection contains 13,000 books; sales shop sells books, reproductions, prints, slides, shirts & models

M **CANADIAN WILDLIFE & WILDERNESS ART MUSEUM,** PO Box 98, Sta B, Ottawa, ON K1P 6C3 Canada. Tel 613-237-1581; Fax 613-237-1581; Elec Mail cawa@magma.ca; Internet Home Page Address: www.magma.ca/cawa; *Co-Dir* Cody Sadler; *Dir* Gary Slimon
Open Mon - Sun 10 AM - 5 PM; Admis $3; Estab 1987; Museum exhibits paintings, sculptures & carvings of wildlife themes; Mem: Dues $50-$1000; annual meeting in Jan
Income: Financed by endowment, mem, state appropriation, mus proceeds
Special Subjects: Painting-American, Sculpture
Collections: Wildlife & wilderness paintings, sculpture, carvings & decoys
Publications: Brochure; newsletter
Activities: Classes for children; 'how-to' seminars; lect open to public, 4 vis lectr per year; individual paintings & original objects of art lent to museums with similar mandates; lending collection contains original art work paintings & sculpture; book traveling exhibitions 1 per year; originate traveling exhibitions; museum shop sells books, magazines, prints, slides

L **Library,** PO Box 98, Sta B, Ottawa, ON K1P 6C3 Canada. Tel 613-237-1581 (and fax); Elec Mail cawa@magma.ca; Internet Home Page Address: www.magma.ca/cawa/; *Co-Dir* Cody Sadler; *Dir* Gary Slimon
Library mainly for research for member artists
Library Holdings: Exhibition Catalogs; Other Holdings Magazines; Slides
Special Subjects: Commerical Art, Graphic Arts, Painting-American, Painting-French, Pre-Columbian Art, Prints, Sculpture, Painting-European, Historical Material, Watercolors, Latin American Art, Ethnology, American Western Art, Printmaking, Art Education, Video, American Indian Art, Eskimo Art, Mexican Art, Southwestern Art, Woodcarvings, Landscapes, Painting-Canadian, Portraits

A **DEPARTMENT OF CANADIAN HERITAGE,** Canadian Conservation Institute, 1030 Innes Rd, Ottawa, ON K1A 0M5 Canada. Tel 613-998-3721; Fax 613-998-4721; Elec Mail cci-icc@pch.gc.ca (English) or icc-biblio@pch.gc.ca (French); Internet Home Page Address: www.pch.gc.ca/cci-icc; *Chief Library Svcs* Joy Patel; *Client Serv* Mary Lou Simac; *Publications* Christine Bradley; *Dir* Bill Peters
Open Tues - Fri 9 AM - 4 PM; No admis fee; Estab 1972; Delivers wide range of services and products, research & preservation
Income: Financed by state appropration
Library Holdings: Audio Tapes 17; Book Volumes 10,000; Clipping Files; Fiche 139; Pamphlets; Periodical Subscriptions 300; Video Tapes 175
Collections: Conservation of cultural property; conservation research
Publications: CCI Newsletter, biannual; CCI Notes, irregular; CCI Technical Bulletins, irregular

M **MUSEUM FOR TEXTILES,** Canada Aviation Museum, PO Box 9724 STNT, Ottawa, ON K1G 5A3 Canada. Tel 613-993-2010; Fax 613-990-3655; Elec Mail aviation@nmstc.ca; Internet Home Page Address: www.aviation.nmstc.ca; *Dir* Francine Poirier; *Cur* A J (Fred) Shortt
Open May 1 - Labour Day daily 9 AM - 5 PM, Thurs 9 AM - 9 PM, after Labour Day - Apr 30 Tues - Sun 10 AM - 5 PM, Thurs 10 AM - 9 PM, cl Mon; Admis adults $6, seniors & students with ID $4, children 6-15 $2, families with children under 6 $12, children under 6, members & Thurs evenings free; Estab 1960 to illustrate the evolution of the flying machine & the important role aircraft played in Canada's development; Average Annual Attendance: 250,000; Mem: 2000; dues $20-$80
Collections: More than 120 aircraft plus thousands of aviation related artifacts
Activities: Classes for adults & children; lect open to public; tours; sales shop sells books, magazines & prints

NATIONAL ARCHIVES OF CANADA
L **Art & Photography Archives,** Tel 613-996-7766; Fax 613-995-6575; Elec Mail jburant@archives.ca; Internet Home Page Address: www.archives.ca; *National Archivist* Ian Wilson; *Dir & Custodian Holdings* Elizabeth Moxley; *Chief Coll Consultation* Robert Grandmaitre; *Documentary Art & Photo Acquisition* Jim Burant; *Descriptive Servs Section* Jennifer Svarckopf
Open daily 9 AM - 4:45 PM; No admis fee; Estab 1905 to acquire & preserve significant Canadian archival material in the area of visual media, including paintings, watercolours, drawings, prints, medals, heraldry, posters & photography

relating to all aspects of Canadian life, to the development of the country, to provide suitable research services, facilities to make this documentation available to the pub by means of exhibitions, publications & pub catalogue
Income: Financed by federal appropriation
Purchases: $80,000
Library Holdings: Auction Catalogs; Book Volumes 4000
Special Subjects: Photography, Drawings, Etchings & Engravings, Painting-British, Painting-Italian, Posters, Prints, Portraits, Watercolors, American Indian Art, Miniatures, Landscapes, Coins & Medals, Reproductions, Painting-Canadian
Collections: 1800 paintings; 22,000 watercolours & drawings; 90,000 prints; 30,000 posters; 16,000 medals; 7000 heraldic design & seals; 80,000 caricatures; 22 million photographs
Publications: Catalog of publications available on request
Activities: Lect open to pub; Tours; original art lent to mus & galleries; sales shop sells reproductions & slides

M NATIONAL GALLERY OF CANADA, 380 Sussex Dr, PO Box 427, Sta A Ottawa, ON K1N 9N4 Canada. Tel 613-990-1985; Fax 613-993-4385; Elec Mail info@gallery.ca; info@beaux-arts.ca; Internet Home Page Address: www.national.gallery.ca; *Deputy Dir Bus* Pierre Theberge; *Chief Cur* Dr Colin Bailey; *Dir Exhib & Installations* Daniel Amadei; *Dir Public Affairs* Karen Spierkel; *Cur Canadian Art* Charles Hill; *Asst Cur Later Canadian Art* Denise LeClerc; *Asst Cur Early Canadian Art* Rene Villeneuve; *Assoc Cur Canadian Prints & Drawings* Rosemarie Tovell; *Asst Cur Inuit Art* Marie Routledge; *Cur Contemporary Art* Diane Nemiroff; *Assoc Cur Film & Video* Janice Seline; *Asst Cur Contemporary Art* Shirley Proulx; *Cur European Art* Catherine Johnston; *Assoc Cur European Art* Michael Pantazzi; *Cur 20th Century Art* Brydon Smith; *Cur Prints & Drawings* David Franklin; *Acting Cur Photo Coll* Ann Thomas; *Dir* Pierre Theberge
Open Sept - May Wed - Sat 10 AM - 6 PM, Thurs 10 AM - 8 PM, May - Sept daily 10 AM - 6 PM, Thurs 10 AM - 8 PM; No admis fee to the permanent collection. Fee for special exhibitions. Parking fees $1.50-$8; Founded 1880 under the patronage of the Governor-General, the Marquess of Lorne & his wife the Princess Louise; first inc 1913 & charged with the develop & care of the nat coll & the promotion of art in Canada; On May 21 1988, the first permanent home of National Gallery of Canada opened to the pub & to critical & popular acclaim. Overlooking the Ottawa river & steps away from Parliament Hill, the gallery is a landmark in the Capital's skyline. Light, spacious galleries & quiet courtyards lead the visitors on a voyage of discovery of Canada's exceptional art coll; Average Annual Attendance: 500,000; Mem: 8,500-9,000; dues $75
Purchases: $3,000,000
Library Holdings: Audio Tapes; Book Volumes; CD-ROMs; Cards; Cassettes; Clipping Files; Exhibition Catalogs; Fiche; Filmstrips; Framed Reproductions; Kodachrome Transparencies; Manuscripts; Original Documents; Other Holdings; Periodical Subscriptions; Photographs; Prints; Records; Slides; Video Tapes
Special Subjects: Drawings, Graphics, Painting-American, Photography, Bronzes, Etchings & Engravings, Landscapes, Decorative Arts, Collages, Painting-European, Portraits, Painting-Canadian, Furniture, Asian Art, Painting-British, Painting-Dutch, Painting-French, Baroque Art, Painting-Flemish, Medieval Art, Painting-Spanish, Painting-Italian, Painting-German, Painting-Russian, Bookplates & Bindings
Collections: Over 45,000 works in entire coll, over 1200 on display in permanent coll galleries; contemporary Inuit artists work; historical & contemporary Canadian art; media arts in the world over 600 titles, totalling more than 10,000 hours of video & film; 19,000 photography works; 20th century American art; western European art 14th-20th centuries
Exhibitions: Exhibitions from permanent coll, private & pub sources are organized & circulated in Canada & abroad
Publications: Annual report (incorporating annual review, with current acquisition lists); catalogues of permanent coll; CD-Rom on the Canadian coll; documents in the history of Canadian Art; exhibition books & catalogues; masterpieces in the National Gallery of Canada
Activities: Classes for adults & children; docent training; workshops for physically & mentally challenged, teen council; lect open to public, 50 vis lectr per year; concerts; gallery talks; tours; scholarships offered; individual paintings & original objects of art lent to art museums & galleries in Canada & abroad, subject to the same environmental conditions (other conditions apply); book traveling exhibitions 1-2 per year; originate traveling exhibitions; museum shop sells books, magazines, reproductions; affiliate Canadian Museum of Contemporary Photography

L Library, 380 Sussex Dr, PO Box 427, Sta A Ottawa, ON K1N 9N4 Canada. Tel 613-998-8949; Fax 613-990-9818; Elec Mail erefel@gallery.ca; Internet Home Page Address: www.national.gallery.ca; *Chief Librn* Murray Waddington; *Head Coll & Database Management* Jonathan Franklin; *Head Archives* Cyndie Campbell; *Bibliographer* Jo Biglo; *Head Reader Serv* Peter Trepanier
Open Wed - Fri 10 AM - 5 PM, cl holidays; Estab 1918 to support the research & information requirements of gallery personnel; to make its collections of resource materials in the fine arts available to Canadian libraries & scholars; to serve as a source of information about art & art activities in Canada; Circ 35,000; For reference only; Average Annual Attendance: 9,000
Library Holdings: Audio Tapes; Book Volumes 230,000; Cards; Cassettes; Clipping Files; Exhibition Catalogs; Fiche; Filmstrips; Kodachrome Transparencies; Lantern Slides; Manuscripts; Memorabilia; Motion Pictures; Original Documents; Other Holdings Auction catalogues; Illustrated books; Rare books;; Pamphlets; Periodical Subscriptions 1100; Photographs; Records; Reels; Slides; Video Tapes
Special Subjects: Art History, Film, Drawings, Graphic Arts, Conceptual Art, Printmaking, Video, Eskimo Art, Aesthetics, Painting-Canadian, Architecture
Collections: Art Documentation; Canadiana; Art Metropole
Exhibitions: Various, see website
Publications: Artists in Canada; Reference Database (CHIN); Library and Archives, occasional paper series 1-4; library and archives, exhibition 1-8
Activities: Library tours, exhibitions

L OTTAWA PUBLIC LIBRARY, Fine Arts Dept, 120 Metcalfe St, Ottawa, ON K1P 5M2 Canada. Tel 613-236-0301; Fax 613-567-4013; Internet Home Page Address: www.opl.on.ca; *Admin Dir* Jean Martel; *Dir* Barbara Clubb
Open Mon - Thurs 10 AM - 9 PM, Fri 10 AM - 6 PM, Sat 9:30 AM - 5 PM, Sun

1 - 5 PM (winters); No admis fee; Estab 1906 to serve the community as a centre for general & reliable information; to select, preserve & administer books & related materials in organized collections; to provide opportunity for citizens of all ages to educate themselves continuously
Income: $8,808,600 (financed by city, province, other)
Library Holdings: Book Volumes 12,000; Cassettes; Clipping Files; Fiche; Filmstrips; Pamphlets; Periodical Subscriptions 85; Reels
Exhibitions: Monthly exhibits highlighting local artists, craftsmen, photographers & collectors
Activities: Lect open to public; library tours

ROYAL ARCHITECTURAL INSTITUTE OF CANADA
For further information, see National and Regional Organizations

OWEN SOUND

M OWEN SOUND HISTORICAL SOCIETY, Marine & Rail Heritage Museum, 1165 First Ave W, Owen Sound, ON N4K 4K8 Canada. Tel 519-371-3333; Internet Home Page Address: www.city.owen-sound.on.ca/marinerail; *Pres* Jim Henderson; *Cur* Neil Garneau
Open May - Oct 10 AM - 4:30 PM; Admis adults $2, children 5 - 15 $1, under 5 yrs free, family $5; Estab 1985 for the preservation of Owen Sound's marine, rail & industrial history; Mem: Dues $10 & up
Income: Financed by mem, donations & government grant
Special Subjects: Historical Material
Collections: Charts, timetables, railway artifacts & models; Corvette HMCS Owen Sound artifacts; Dug-out & Birch-bark canoes; house flags of Marine Transport Coys; lifeboat from the Paul Evans; marine & railway uniforms; patterns from local foundry in production of propellers & shipbuilding; scale models of ships that sailed the Great Lakes
Exhibitions: (2001) Permanent exhibit
Activities: Lect open to public, 6 vis lectr per year; children's competition with prizes; lending collection contains books

M TOM THOMSON MEMORIAL ART GALLERY, 840 First Ave W, Owen Sound, ON N4K 4K4 Canada. Tel 519-376-1932; Fax 519-376-3037; Internet Home Page Address: www.tomthomson.org; *Dir* Stuart Reid; *Educ* David Huff
Open Sept - June Tues - Fri 11 AM - 5 PM, Wed 11 AM - 5 PM, Sat & Sun Noon - 5 PM; July & Aug Mon - Sat 10 AM - 5 PM, Sun Noon - 5 PM; No admis fee; Estab 1967 to collect & display paintings by Tom Thomson, a native son & Canada's foremost landscape artist; to educate the public; Paintings by Tom Thomson on permanent display, plus 2 galleries of changing exhibitions; Average Annual Attendance: 30,000; Mem: 300; dues family $25, individual $15, senior citizens & students $10
Income: Financed by city appropriation & provincial grants & fundraising
Collections: Tom Thomson; Historic & Contemporary Canadian Artists; Group of Seven
Publications: Bulletin, six per year; exhibition catalogs 3 per year
Activities: Classes for adults & children; docent training; lect open to public; gallery talks; tours; films; competitions with awards; concerts; exten dept serves city buildings; museum shop sells books, reproductions, prints & postcards
L Library/Archives, 840 First Ave W, Owen Sound, ON N4K 4K4 Canada. Tel 519-376-1932; Fax 519-376-3037; Internet Home Page Address: www.tomthomson.org; *Dir* Stuart Reid; *Educ* David Huff
Open by appointment only; Circ Non-circulating; Open for reference of Tom Thomson files
Library Holdings: Book Volumes 400; Exhibition Catalogs; Periodical Subscriptions 6
Collections: Files on Tom Thomson

PETERBOROUGH

M ART GALLERY OF PETERBOROUGH, 2 Crescent St, Peterborough, ON K9J 2G1 Canada. Tel 705-743-9179; Fax 705-743-8168; Internet Home Page Address: www.agp.on.ca; *Prog Asst* Dominick Hardy; *Secy* Vera Novacek; *Dir* Illi-Maria Tamplin
Open Victoria Day-Labor Day Tues - Fri 1-5 PM, Wed 1-8 PM, Sat & Sun 1-5 PM, winter hrs Tues - Fri Noon-4 PM, Sat 10 AM-5 PM, Sun 1-5 PM; No admis fee; Estab 1973; Gallery situated along a lake & in a park; new extension added & completed June 1979; Average Annual Attendance: 18,600; Mem: 700; dues sustaining $25, family $25, individual $20, sr citizens $15, student $10; annual meeting June
Income: Financed by mem, fundraising & provincial, federal, municipal grants
Collections: European and Canadian works of art
Exhibitions: Mark Gomes, Joey Morgan, Susan Schelle, Nancy Paterson, Ron Bolt; French Photography - New Directions; Rotate 7 per yr
Publications: Catalogues on some exhibitions; Bulletin of Events, monthly; pamphlets on artists in exhibitions
Activities: Classes for adults & children; dramatic programs; docent training; workshops; art program to public schools; lect open to public; gallery talks; tours; individual paintings & original objects of art lent to other galleries; lending collection contains 250 original art works; sales shop sells books, magazines, crafts

SAINT CATHARINES

M NIAGARA ARTISTS' COMPANY, 2 Bond St, Saint Catharines, ON L2R 4Y9 Canada. Tel 905-641-0331; Fax 905-641-0331; Internet Home Page Address: www.nac.org; *Artistic Dir* Dermot Wilson
Open Tues - Fri Noon - 5 PM, Sat Noon - 4 PM; No admis fee; Estab 1969; Main gallery has 2400 sq ft, 2 gallery has 500 sq ft; Average Annual Attendance: 6,100; Mem: 135; mem open to volunteers for exhibits & fundraisers; dues $15-$50; annual meeting mid-July
Income: $120,000 (financed by mem, Ontario government, federal government & sponsorship)

Exhibitions: rotate 6-8 exhibits per yr
Publications: NAC News, monthly
Activities: Lect open to public

A **RODMAN HALL ARTS CENTRE,** 109 St Paul Crescent, Saint Catharines, ON L2S 1M3 Canada. Tel 905-684-2925; Fax 905-682-4733; *VPres* C Day; *Cur Educ* Debra Attenborough; *Dir* Terry Croft
Open Tues - Fri 11 AM - 5 PM, Sat & Sun 1 - 5 PM, cl Mon; Admis $2 donations requested; Estab 1960, art gallery, cultural centre & visual arts exhibitions; Four galleries in an 1853, 1960 & 1975 addition. 1975 - A1 - National Museums of Canada. Maintains reference library; Average Annual Attendance: 45,000; Mem: 800; dues tax receipt $75 or more, family $40, individual $25; annual meeting in Sept
Income: Financed by mem, city, province & government of Canada
Collections: American graphics & drawings; Canadian drawings, paintings, sculpture & watercolours; international graphics & sculpture
Exhibitions: Monthly exhibitions featuring painting, photographs, sculpture & other art
Publications: Catalogue - Lord and Lady Head Watercolours; monthly calendar; Rodmon Hall Arts Center (1960-1981)
Activities: Classes for adults & children; dramatic programs; docent training; workshops; films; lect open to public, 6 vis lectr per year; concerts; gallery talks; tours; individual paintings & original objects of art lent to city hall & other art galleries; book traveling exhibitions 16 per year; book traveling exhibitions 5 per year; museum shop sells books, original art, gifts, pottery, glassware & jewerly

L **Library,** 109 St Paul Crescent, Saint Catharines, ON L2S 1M3 Canada. Tel 905-684-2925; Fax 905-682-4733; *Librn* Debra Attenborough
Open Tues - Fri 9 AM - 5 PM; Estab 1960; Reference library
Library Holdings: Book Volumes 3500; Cards; Cassettes; Clipping Files; Exhibition Catalogs; Pamphlets; Periodical Subscriptions 7; Photographs; Reproductions; Slides; Video Tapes

SAINT THOMAS

M **ST THOMAS-ELGIN PUBLIC ART CENTRE,** (St Thomas Elgin Art Gallery) 301 Talbot St, Saint Thomas, ON N5P 1B5 Canada. Tel 519-631-4040; Fax 519-631-4057; Internet Home Page Address: www.stepac.ca; *Exec Dir* Lori Chamberlain; *Art Dir* Debra Seabrook; *Dir Prog* Sherri Howard
Open Tues, Wed, Sat 12 - 4PM, Thurs, Fri 1 - 9PM, Su 12 - 3PM; No admis fee; Estab 1969; Pub gallery; Average Annual Attendance: 10,000; Mem: 658; dues senior citizens $15, family $30, single $20; annual meeting in March
Income: $150,000 (financed by endowment, mem, municipality, donations, & earned revenues)
Library Holdings: Book Volumes; Exhibition Catalogs; Original Art Works; Photographs; Slides; Video Tapes
Collections: Fine Art Works by Canadian Artists
Publications: Info brochures; gallery newsletter 3 per year
Activities: Educ program in art for all adults & children; lect open to public; tours, sponsor competitions; scholarships offered; lending of original art to other galleries; originate traveling exhibitions; gift shop sells original art & promotional items

SARNIA

L **COUNTY OF LAMBTON,** Gallery Lambton, 150 N Christina St, Sarnia, ON N7T 7W5 Canada. Tel 519-336-8127; Fax 519-336-8128; Elec Mail glchin@ebtech.net; *Cur* David Taylor
Open Tues-Wed & Fri-Sat 10 AM - 5:30PM, Thurs 10AM - 9PM, cl Mon; No admis fee; Estab 1961, a collection of Canadian paintings instituted in 1919 & administered by the Women's Conservation Art Assoc of Sarnia. The Collection was turned over to the Sarnia Library Board in 1956 & additions are being made from time to time; 3500 sq ft; Average Annual Attendance: 15,000
Income: Financed by municipal appropriations, mem & donations
Purchases: Canadian works of art
Library Holdings: Exhibition Catalogs; Slides
Collections: Canadian Paintings; Canadian Sculpture; Canadian Works on paper; Eskimo carvings
Exhibitions: Twelve to fifteen shows a year, either traveling from other galleries or initiated by the Sarnia Art Gallery
Publications: Exhibition catalogues
Activities: Classes for adults & children; lect open to public; gallery talks; tours; competitions with awards; films; bus trips; workshops; individual paintings & original objects of art lent; book traveling exhibitions 6-7 per year; junior museum located at Lawrence House

SCARBOROUGH

M **CITY OF SCARBOROUGH,** Cedar Ridge Creative Centre, 225 Confederation Dr, Scarborough, ON M1G 1B2 Canada. Tel 416-396-4026; Fax 416-396-7044; *Coordr Cultural Progs* Ann Christian
Open 9 AM - 9 PM; No admis fee; Estab 1985 as a gallery & teaching studio; 3-interconnecting rooms & solarium with oak panelling, 18' x 22', 18' x 28', 16' x 26'; Average Annual Attendance: 1,300; Mem: Annual dues $10 (it entitles member to rent gallery for one week for $39)
Exhibitions: Contemporary Art Show
Activities: Classes for adults & children; one day workshops in arts & crafts; lect open to public, 2 vis lectr per year

SIMCOE

M **EVA BROOK DONLY MUSEUM,** 109 Norfolk St S, Simcoe, ON N3Y 2W3 Canada. Tel 519-426-1583; Fax 519-426-1584; Internet Home Page Address: www.norfolkore.com; *Cur* William Yeager
Open Sept - May Wed - Fri 10 - 4:30 PM, Sat & Sun 1 - 4:30 PM, June - Aug Tues - Fri 10 AM - 4:30 PM, Sat & Sun 1 - 4:30 PM; Admis general $2; Estab 1946 to display & aid research in the history of Norfolk County; Average Annual Attendance: 8,500; Mem: 700; dues $15-$25; annual meeting in Jan
Income: Financed by endowment, mem, city & provincial appropriation
Special Subjects: Historical Material
Collections: Large Collection of important Early Documents & Newspapers, 370 paintings of historic Norfolk by W E Cantelon; Displays of artifacts of the 19th century Norfolk County; historical materials
Exhibitions: Egyptian Display
Activities: Lect open to public, 15 vis lectr per year; tours; book traveling exhibitions 3 per year; museum shop sells books, crafts & candy

L **Library,** 109 Norfolk St S, Simcoe, ON N3Y 2W3 Canada. Tel 519-426-1583; Fax 519-426-1584; Internet Home Page Address: www.norfolkore.com; *Cur* William Yeager
Open Sept-May Wed-Fri 10 AM - 4:30 PM, Sat & Sun 1 - 4:30 PM, June-Aug Tues-Fri 10 AM - 4:30 PM, Sat & Sun 1 - 4:30 PM; Admis $2; Reference & a photograph collection for display
Library Holdings: Book Volumes 2000; Cassettes; Clipping Files; Fiche; Manuscripts; Memorabilia; Original Art Works; Photographs; Prints; Reels; Slides

A **LYNNWOOD ARTS CENTRE,** 21 Lynnwood Ave, PO Box 67 Simcoe, ON N3Y 4K8 Canada. Tel 519-428-0540; Fax 519-428-0549; Elec Mail lynnwood@kwic.com; *Dir* Rod Demerling; *Office Mgr* Gail Smalley; *Chmn* Hazel Andrews
Open Wed & Thurs Noon-4 PM, Fri Noon-8 PM, Sat 10 AM-4 PM, Sun Noon-4 PM; No admis fee; Estab 1973 to provide a focal point for the visual arts in the community; Built in 1851 - Greek Revival Architecture; orange brick with ionic columns & is a National Historic Site; Average Annual Attendance: 8,800; Mem: 300; dues family $30, individual $25, student & senior citizen $20; annual meeting in Mar
Income: $140,000 (financed by mem, patrons-private & commercial, Ontario Arts Council)
Collections: Contemporary Canadian Art
Exhibitions: Exhibitions of contemporary art & permanent collection works; Local artists
Publications: Quarterly newsletter
Activities: Classes for adults & children; docent training; lect open to public, 15 lectr per year; concerts; gallery talks; tours; seminars; juried art exhibitions (every two years) with purchase awards; sales shop sells books & hand-crafted items

STRATFORD

M **GALLERY STRATFORD,** 54 Romeo St S, Stratford, ON N5A 4S9 Canada. Tel 519-271-5271; Fax 519-271-1642; Elec Mail clee@gallerystratford.on.ca; Internet Home Page Address: www.gallerystratford.on.ca; *Pres* Jan Greenwood; *Exec Dir* Jennifer Rudder; *Office Mgr* Christine Lee; *Educ Coordr* Marian Doucette; *Dir Fund Develop* Zhe Gu
Open Sept - May Tues - Sun 1 PM - 4 PM; summer hrs June - Sept Tues - Sun 10 AM - 5 PM; business hrs weekdays 9 AM - 5 PM; Admis $5, senior citizens & students $4, children under 12 free; Estab 1967 as a nonprofit permanent establishment open to the pub & administered in the pub interest for the purpose of studying, interpreting, assembling & exhibiting to the pub; public art gallery; Average Annual Attendance: 25,000; Mem: 400; annual meeting in Mar
Income: $348,743 (financed by mem, city appropriation, provincial & federal grants & fundraising)
Collections: Works of art on paper
Exhibitions: Changing exhibits, geared to create interest for visitors to Stratford Shakespearean Festival; during winter months geared to local municipality
Publications: Catalogs; calendar of events
Activities: Classes for adults & children; docent training; lect open to public; gallery talks; tours; visual art award for grade 12; scholarships offered; traveling exhibitions organized & circulated; gift shop sells books, Canadian craft, glass, jewelry, pottery, silk scarves & cards

SUDBURY

LAURENTIAN UNIVERSITY
L **Art Centre Library,** Tel 705-675-4871; Fax 705-674-3065; Elec Mail gallery@artsudbury.org; Internet Home Page Address: www.artsudbury.org; *Dir & Cur* Bill Huffman; *Curatorial Asst* Leeann Lahaie
Open Tues, Wed, Sat & Sun Noon-5PM, Thurs & Fri Noon-9PM; Admis $2 donation; Estab 1977; For reference only; Average Annual Attendance: 25,000
Purchases: Contemporary Canadian, new media
Library Holdings: Book Volumes 5000; Cards; Cassettes; Clipping Files; Exhibition Catalogs; Lantern Slides; Pamphlets; Periodical Subscriptions 78; Photographs; Slides 8300; Video Tapes
Activities: Classes for adults & children; lect open to pub; concerts; gallery talks; tours; exten prog serves area schools; artmobile; lending of original objects of art; originate 2 traveling exhibitions per yr; museum shop sells books & magazines

TORONTO

M **A SPACE,** 401 Richmond St W, Ste 110, Toronto, ON M5V 3A8 Canada. Tel 416-979-9633; Fax 416-979-9683; Elec Mail aspace@interlog.com; Internet Home Page Address: www.aspacegallery.org; *Admin Dir* Bill Huffman; *Dir Prog* Ingrid Mayrhofer
Open Tues - Fri 11 AM - 6 PM, Sat Noon - 5 PM, cl Sun & Mon; No admis fee; Estab 1971; 1000 sq ft of gallery space & hardwood floors. Maintains reference library; Average Annual Attendance: 15,000; Mem: 150; dues $15; 4 meetings yearly
Income: $171,000 (financed by endowment, mem, city & state appropriation)
Exhibitions: Artists' submissions to gallery
Publications: Addendum-A Space Community Newsletter, quarterly
Activities: Lect open to public, 5 vis lectr per year; concerts; gallery talks; tours; book traveling exhibitions; originate traveling exhibitions; museum shop sells books

M ART GALLERY OF ONTARIO, 317 Dundas St W, Toronto, ON M5T 1G4 Canada. Tel 416-979-6648; Fax 416-979-6646; Internet Home Page Address: www.ago.net; *Head Develop* Sean St Michael; *Dir* Matthew Teitelbaum; *Chief Cur* Dennis Reid; *Mgr Mktg* Michelle Koerner; *Dir Marketing & Communications* Sharon Salson
Open Tues, Thurs & Fri 11 AM - 6 PM, Wed 11 AM - 8:30 PM, Sat & Sun 10 AM - 5:30 PM; Donations accepted for permanent collection; admis for special exhibitions $12 - $20; Estab 1900 to cultivate & advance the cause of the visual arts in Ontario; to conduct programmes of educ in the origin, development, appreciation & techniques of the visual arts; to collect & exhibit works of art & displays & to maintain & operate a gallery & related facilities as required for this purpose; to stimulate the interest of the pub in matters undertaken by the Gallery; Average Annual Attendance: 400,000; Mem: Student dues $40, nonres $60, individual $75, family $100, contributing $150 - $249, Supporting $250 - $499, Sustaining $400 - $999, Cur's Circle $1000+
Income: Financed by mem, provincial, city & federal appropriations & earned income
Purchases: $1,000,000
Special Subjects: Painting-American, Sculpture, Painting-European
Collections: American & European Art (16th century to present); Canadian Historical & Contemporary Art; Henry Moore Sculpture Center, Prints & Drawings
Exhibitions: Micah Lexier: A work of art in the form of a quantity of coins equal to the number of months of statistical life expectancy of a child born Jan 6, 1995; Treasures of a Collector; European Works of Art, 1100 to 1800, from the Thomson Collection
Publications: Ago News, eleven times per year; annual report; exhibition catalogs
Activities: Classes for adults & children; docent training; lect open to public; 35 vis lectr per year; concerts; gallery talks; tours; exten dept organizes traveling exhibitions, circulated throughout the Province, Canada & United States; individual paintings & original objects of art loaned; lending coll includes 60 cassettes, educational v-tapes & 100,000 slides; originate traveling exhibitions; sales shop sells books, magazines, reproductions, prints, slides & jewelry; art rental shop for members to rent original works of art
L Edward P Taylor Research Library & Archives, 317 Dundas St W, Toronto, ON M5T 1G4 Canada. Tel 416-979-6642; Fax 416-979-6602; Elec Mail library_archives@ago.net; Internet Home Page Address: www.ago.net/ago/library; *Deputy Librn* Larry Pfaff; *Chief Librn* Karen McKenzie; *Archivist Special Coll* Amy Marshall
Open Wed - Fri 1 - 4:45 PM; No admis fee; Estab 1933 to collect printed material for the documentation & interpretation of the works of art in the Gallery's collection, to provide research & informational support for the Gallery's programmes & activities; to document the art & artists of Ontario, Toronto & Canada, Includes Museum's archives and Canadian art archives
Income: Financed by parent institution, donations, grants
Library Holdings: Auction Catalogs; Audio Tapes; Book Volumes 140,000; CD-ROMs; Clipping Files; DVDs; Exhibition Catalogs; Fiche; Manuscripts; Original Documents; Other Holdings Auction catalogs; Pamphlets; Periodical Subscriptions 650; Photographs; Reels; Reproductions
Special Subjects: Art History, Decorative Arts, Mixed Media, Etchings & Engravings, Graphic Arts, Painting-American, Painting-British, Painting-Dutch, Painting-Flemish, Painting-French, Conceptual Art, Latin American Art, Eskimo Art, Marine Painting, Landscapes, Painting-Canadian
Collections: Canadian Illustrated Books; Garrow Collection of British Illustrated Books & Wood Engravings of the 1860s; Canadian Book-Plates; International Guide Books; McIntosh Collection of Books on Sepulchral Monuments; Muldoon Collection of Aesop Editions

M ART METROPOLE, 788 King St W, Toronto, ON M5V 1N6 Canada. Tel 416-703-4400; Fax 416-703-4404; Internet Home Page Address: www.artmetropole.org; *Dir* Joan Goodwin
Open Tues - Fri 11 AM - 6 PM, Sat Noon - 5 PM; No admis fee; Estab 1974 to document work by artists internationally working in non-traditional & multiple media; 900 sq ft
Income: Financed by sales & government funding
Exhibitions: Exhibits rotate every 2 months
Activities: Sales shop sells books, artists video & multiples

A ARTS AND LETTERS CLUB OF TORONTO, 14 Elm St, Toronto, ON M5G 1G7 Canada. Tel 416-597-0223; Fax 416-597-9544; Elec Mail artsletr@interlog.com; *Pres* Donald F Pounsett; *Cur* Margaret C Maloney; *Librn* Margaret Spence; *Archivist* Scott James
Admis by appointment; Estab 1908 to foster arts & letters in Toronto; Mem: 580; annual meeting May
Collections: Club Collection - art by members & others; Heritage Collection - art by members now deceased
L Library, 14 Elm St, Toronto, ON M5G 1G7 Canada. Tel 416-597-0223; *Librn* Margaret Spence; *Gen Mgr* Jason Clarke
Open by appointment; Open to club members & researchers for reference
Library Holdings: Audio Tapes; Book Volumes 2500; Cassettes; Clipping Files; Exhibition Catalogs; Kodachrome Transparencies; Manuscripts; Memorabilia; Motion Pictures; Original Art Works; Periodical Subscriptions 40; Prints; Sculpture; Slides; Video Tapes
Special Subjects: Sculpture, Theatre Arts, Architecture

M BAU-XI GALLERY, 340 Dundas St W, Toronto, ON M5T 1G5 Canada. Tel 416-977-0600; Fax 416-977-0625; Elec Mail bau-X1.toronto@sympatico.ca; Internet Home Page Address: www.bau-xi.com; *Dir* Tien Hung
Open Tues - Sat 10 AM - 5:30 PM; No admis fee; Estab 1976; Locations in Toronto & Vancouver, representing a broad spectrum of artists; upper & lower galleries
Income: Financed by pvt funding
Collections: Contemporary Canadian Art
Exhibitions: Changing exhibition schedule showcasing gallery artists including: estate of Alistair Bell, Tom Burrows, Tom Campbell, Robert Cadotte, Darlene Cole, Lynn Donoghue, Jamie Evrard, Roly Fenwick, Ted Fullerton, Max Gatta, estate of Henry de la Giroday, Ted Godwin, Fred Hagan, Don Jarvis, Brian

Kipping, Ken Lochhead, Hugh Mackenzie, Eva McCauley, Casey McGlynn, Robert McNealy, Don Maynard, Robert Marchessault, Mimi Matte, Julie Oakes, Pat O'Hara, Andre Pettersen, Joseph Plaskett, David Robinson, Jack Shadbolt, Shi, Le, Stuart Slind & David Sorensen; rotate 14 - 15 per yr

M BAYCREST CENTRE FOR GERIATRIC CARE, Silverman Heritage Museum, 3560 Bathurst St, Toronto, ON M6A 2E1 Canada. Tel 416-785-2500, Ext 2802, Ext 2645 (pub affairs); Fax 416-785-2378; Elec Mail pdickinson@baycrest.org; Internet Home Page Address: www.baycrest.org; *Coordr* Pat Dickinson
Open 9 AM - 9 PM; No admis fee; Estab 1973
Special Subjects: Judaica
Collections: Judaica: ceremonial objects, domestic artifacts, memorabilia, books, photos, documents & works on paper

CANADIAN ART FOUNDATION
For further information, see National and Regional Organizations

CANADIAN SOCIETY OF PAINTERS IN WATERCOLOUR
For further information, see National and Regional Organizations

M CITY OF TORONTO CULTURE DIVISION, The Market Gallery, 95 Front St E, Toronto, ON M5E 1C2 Canada. Tel 416-392-7604; Fax 416-392-0572; Internet Home Page Address: www.toronto.ca/culture/the_market_gallery.htm; *Cur* Pamela Wachna; *Exhit & Outreach Technician* Anne Shropshire; *Gallery Clerk* Marilyn Nicholson
Open Wed - Fri 10 AM - 4 PM, Sat 9 AM - 4 PM, Sun Noon - 4 PM, cl Mon & Tues; No admis fee; Estab 1979 to bring the art & history of Toronto to the public; Located in original 19th century Toronto City Hall; Average Annual Attendance: 25,000
Library Holdings: Exhibition Catalogs; Kodachrome Transparencies; Original Documents
Special Subjects: Prints, Watercolors, Landscapes, Portraits, Painting-Canadian, Marine Painting, Historical Material
Collections: City of Toronto Fine Art Collection (oil, watercolor, prints & sculpture)
Exhibitions: Various exhibitions on Toronto's art, culture & history presented on an on-going basis
Publications: Exhibit catalogs
Activities: Classes for adults & children; lect open to public; gallery talks; exten dept servs other institutions; paintings lent

M CONTEMPORARY ART GALLERY, (Toronto Centre for Contemporary Art) Unit 312, 1800 Sheppard Ave E Toronto, ON M2J 5B7 Canada. Tel 416-499-6034; Elec Mail contempart@compuserver.com; *Dir* Sonja Dagon; *Gallery Mgr* Zoya Boruchov
Open daily 10AM-9PM, Sat 9:30AM-6PM, Sun 11AM-6PM; No admis fee; Estab 1969
Collections: Permanent collections of contemporary art in Toronto's public schools
Exhibitions: Rotating exhibits monthly

M DELEON WHITE GALLERY, 1096 Queen St W, Toronto, ON M6J 1H9. Tel 416-597-9466; Fax 416-597-9455; Elec Mail white@eco-art.com; Internet Home Page Address: www.eco-art.com; *Cur* Virginia MacDonnell; *Dir* Stephen White
Open daily Tues & Wed Noon-6 PM, Thurs - Sun Noon-7 PM; No admis fee; Estab 1995
Special Subjects: Architecture, Drawings, Mexican Art, Painting-American, Photography, Prints, Sculpture, Watercolors, Bronzes, Woodcuts, Landscapes, Collages, Painting-Japanese, Painting-Canadian, Painting-French, Painting-German
Collections: Contemporary Ecological Art
Exhibitions: Alan Sonfist, Ian Lazarus
Publications: DeLeon White Gallery News, quarterly
Activities: Lect open to public; book traveling exhibitions 2 per year; originate traveling exhibitions 2 per year; sales shop sells books, magazines, original art, prints & slides

A FUSION: THE ONTARIO CLAY & GLASS ASSOCIATION, The Gardeners Cottage/Cedar Ridge Creative Ctr, 225 Confederation Dr Toronto, ON M1G 1B2 Canada. Tel 416-438-8946; Fax 416-438-0192; Elec Mail 2fusion@interlog.com; Internet Home Page Address: www.clayandglass.on.ca; *Pres* Anne Chambers; *Office Adminr* Jacqueline Meyer; *Office Adminr* Diane Wade; *Bd Chmn* Derek Chung; *Advocacy* Janet Hurly; *Publications* Victor Levin
Open Mon - Fri 10 AM - 5 PM, Sat 10:30 AM-Noon; No admis fee; Estab 1975; The Gardener's Cottage is located in the Cedar Ridge Creative Centre, where there is an art gallery & formal gardens; Mem: Dues $55 per yr
Income: Financed by mem
Collections: Permanent collection housed at Burlington Art Ctr
Exhibitions: Fireworks (biennial juried travelling exhibition); Silent Auction (biennial fundraiser)
Publications: Fusion Magazine, 3 per year; Fusion News Magazine, 3 per year
Activities: Workshops; lect open to public; workshops; organize traveling exhibitions to galleries within Ont

M GALLERY MOOS LTD, 622 Richmond St W, Toronto, ON M5V 1Y9 Canada. Tel 416-504-5445; Fax 416-504-5446; Elec Mail gallerymoos@rogers.com; Internet Home Page Address: www.gallerymoos.com; *Pres* Walter A Moos; *Adminr* Svetlorna Novikova
Open Tues - Sat 11 AM - 6 PM; No admis fee; Estab 1959; Maintains reference library, contemporary art gallery
Income: Financed by pvt funding
Collections: Contemporary Canadian & international art artists include: Karel Appel, Ken Danby, Sorel Etrog, Gershon Iskowitz, Jean-Paul Riopelle, Antoni Tapies, Lester Johnson, WIlliam Scott, Robert Hedrick, March Ash, Josie Demariche, Evan Levy, Dennis Geden

M GEORGE R GARDINER MUSEUM OF CERAMIC ART, 111 Queen's Park, Toronto, ON M5S 2C7 Canada. Tel 416-586-8080; Fax 416-586-8085; Internet Home Page Address: www.gardinermuseum.on.ca; *Cur* Meredith Chilton; *Exec Dir* Alexandra Montgomery
Open Mon, Wed & Fri 10 AM-6 PM, Tues & Thurs 10 AM-8 PM, Sat & Sun 10 AM-5 PM; Admis adults $10, sr citizens, students & children $6; Estab 1984 as

the only specialized museum of ceramics in North America; Museum houses one of the world's greatest collections of European ceramic art from the early 15th century to the 20th century; Average Annual Attendance: 60,000
Income: Endowment
Special Subjects: Ceramics
Collections: English delftware; European porcelain; Italian maiolica; Pre-Columbian pottery; Chinese porcelain; Minton contemporary ceramics
Activities: Classes for adults & children; docent programs; lect open to public; gallery talks; tours; book traveling exhibitions 2 per year; retail store sells books & ceramics

A **HERITAGE TORONTO,** Historic Fort York, 100 Garrison Rd, Toronto, ON M5V 3K9 Canada; 205 Yonge St, Toronto, ON M5B 1N2 Canada. Tel 416-392-6907; Fax 416-392-6917; Elec Mail fortyork@toronto.ca; *Cur* Carl Benn PhD; *Mus Adminr* Jo Ann Pynn
Open end of May - end Sept Mon - Sun 9:30 AM - 5 PM, Oct - mid May 10 AM - 4 PM, Sat & Sun 10 AM - 5 PM; Admis adults $5, senior citizens & youth 13-18 years $3.25, children $3; Estab 1934 to tell the story of the founding of Toronto & the British Army in the 19th century; All buildings have permanent or temporary exhibits & period - room settings; maintains reference library; Average Annual Attendance: 55,000
Income: Financed by city appropriation
Collections: 19th century Military; Original War of 1812 Buildings; Original War of 1812 Uniforms; Original War of 1812 Weapons
Activities: Classes for adults & children; lect open to public; sales shop sells books, prints & reproductions

INTERNATIONAL ASSOCIATION OF ART CRITICS
For further information, see National and Regional Organizations

M **JOHN B AIRD GALLERY,** MacDonald Block, 900 Bay St, Main Fl Toronto, ON M7A 1C2 Canada. Tel 416-928-6772;Dale Barrett
Open Tues - Sat 10 AM-6 PM; Nonprofit, non-collecting exhib ctr
Special Subjects: Photography, Sculpture, Watercolors, Textiles, Pottery, Woodcarvings, Woodcuts, Silver, Tapestries, Stained Glass
Exhibitions: 12 ann exhibs

M **KOFFLER CENTRE OF THE ARTS,** (Bathurst Jewish Community Centre) The Koffler Gallery, 4588 Bathurst St, Toronto, ON M2R 1W6 Canada. Tel 416-636-1880, Ext 268; Fax 416-636-5813; Elec Mail kofflergallery@bjcc.ca; Internet Home Page Address: www.kofflercentre.com; *Sr Cur* Carolyn Bell Farrell; *Educ Officer* Mona Filip; *Dir* Lori Starr
Open Tues - Fri 10 AM - 4 PM, Sun noon - 4 PM; No admis fee; Estab 1976; 2,000 sq ft, 200 running ft, contemporary program
Income: $245,000 (financed by government grants, pvt donations & various institutions)
Library Holdings: CD-ROMs; Clipping Files; DVDs; Exhibition Catalogs; Slides
Special Subjects: Manuscripts
Publications: Catalogues & exhibitions brochures
Activities: Tours; school workshops; docent training; lect open to public; 5 artist talks per year; book traveling exhibitions 1-3 per year; originate traveling exhibitions 1 per year

M **MASLAK-MCLEOD GALLERY,** 25 Prince Arthur Ave, Toronto, ON M5R 1B2 Canada. Tel 416-944-2577; Fax 416-944-2577; Internet Home Page Address: www.maslakmcleod.com; *Cur* Joseph MacLeod PhD; *Asst Cur* Kersti McLeod; *Asst Cur* Christian McLeod
Open daily 10 AM - 5 PM; No admis fee; Estab 1968; Gallery exhibits fine art, Indigenia Canada, international exhibits; Average Annual Attendance: 20,000; Mem: ADAC; recommendation from mems
Income: pvt
Purchases: Directly from artists or collections
Library Holdings: Auction Catalogs; Audio Tapes; Book Volumes; Cassettes
Special Subjects: American Indian Art, American Western Art, Anthropology
Collections: Native Art; North American Art; International
Exhibitions: Joseph Jacobs; Norval Morrisseau; Inuit Sculptures; Governors Gallery Santa Fe; Iaia Mus Santa Fe; Geronimo, Munich, Germany
Publications: catalogs
Activities: Classes for adults; lects for mems only; gallery talks; awards connected to exhibits

M **MERCER UNION,** A Centre for Contemporary Visual Art, 37 Lisgar St Toronto, ON M6J 3T3 Canada. Tel 416-536-1519; Fax 416-536-2955; Elec Mail info@mercerunion.org; Internet Home Page Address: www.mercerunion.org; *Admin Dir* Natalie DeVito; *Admin Dir & Dir Prog* Jenifer Papararo
Open Tues - Sat 11 AM - 6 PM; No admis fee; Estab 1979 is an artist-run centre committed to the presentation & examination of Canadian & international contemporary Visual art & related cultural practices; 1500 sq ft; Average Annual Attendance: 15,000; Mem: 200; dues arts supporter $500-$1000, sustaining $100, supporting $50, educational $30, associate $25, students $15; monthly board meetings
Income: $225,000 (financed by endowment, mem, city & state appropriations, Canada Council, Ontario Arts Council & Toronto Arts Council)
Library Holdings: Exhibition Catalogs
Collections: Michael Buchanan; Patricia Galimente, Gretchen Sankey
Exhibitions: rotate every 5 wks
Publications: Exhibition catalogues
Activities: Lect open to public,10 vis lectr per year; gallery talks; sales shop sells books & catalogues

METAL ARTS GUILD
For further information, See National and Regional Organizations

M **MUSEUM OF CONTEMPORARY CANADIAN ART,** (Art Gallery of North York) 5040 Yonge St, Toronto, ON M2N 6R8 Canada. Tel 416-395-7599; Fax 416-395-7598; Elec Mail dbliss@city.toronto.on.ca; Internet Home Page Address: www.agny.com; *Asst Dir* Eleanor Darke; *Dir* David Liss
Open Tues - Sun Noon - 5 PM; No admis fee; Estab 1994 to collect & exhibit Canadian contemporary art from 1985 - present; Two floors, 6000 sq ft with 6

exhibitions per year of some of the most challenging art being produced in Canada today; Average Annual Attendance: 65,000
Special Subjects: Sculpture, Painting-Canadian
Collections: Contemporary Canadian Art

A **ONTARIO ASSOCIATION OF ART GALLERIES,** 489 King St W, Ste 306, Toronto, ON M5V 1K4 Canada. Tel 416-598-0714; Fax 416-598-4128; Elec Mail oaag@interlog.com; *Exec Dir* Cheryl Smith
Open 9 AM - 5 PM; Estab in 1968 as the provincial nonprofit organization representing pub art galleries in the province of Ontario. Institutional mem includes approx 84 pub art galleries, exhibition spaces & arts related organizations. Mem is also available to individuals; Gallery not maintained; Mem: 83; annual meeting in June
Income: Financed by mem, Ontario Arts Council, Ontario Ministry of Culture, Tourism & Recreation, Department of Canadian Heritage
Publications: Context, bimonthly newsletter
Activities: Professional development seminars & workshops; awards; active job file & job hot-line

M **ONTARIO COLLEGE OF ART & DESIGN,** OCAD Gallery, 100McCaul St, Toronto, ON M5T 1W1 Canada. Tel 416-977-6000, Ext 262; Fax 416-977-4080; Elec Mail cswiderski@ocad.on.ca; Internet Home Page Address: www.ocad.on.ca; *Cur* Christine Swiderski
Open Wed - Sat Noon - 6 PM; No admis fee; Estab 1970 for faculty & student exhibitions & to exhibit outside work to benefit the college; Average Annual Attendance: 15,000
Income: Financed by College
Exhibitions: Exhibiting student works, rotate every 3 weeks
Publications: Invitations; small scale catalogs

L **Dorothy H Hoover Library,** 100 McCaul St, Toronto, ON M5T 1W1 Canada. Tel 416-977-6000; Fax 416-977-6006; Elec Mail jpatrick@ocad.on.ca; Internet Home Page Address: www.ocad.on.ca; *Dir* Jill Patrick
Open Mon - Fri 9 AM - 4:45 PM; Estab to support the curriculum
Income: Financed through the College
Purchases: $100,000
Library Holdings: Book Volumes 30,000; Cassettes 620; Clipping Files; Exhibition Catalogs; Fiche; Filmstrips; Kodachrome Transparencies; Lantern Slides; Motion Pictures 75; Other Holdings Pictures 40,000; Vertical files 43,000; Pamphlets; Periodical Subscriptions 225; Records; Reels; Slides 85,000; Video Tapes 1000
Special Subjects: Art History, Decorative Arts, Film, Illustration, Mixed Media, Commerical Art, Drawings, Graphic Arts, Graphic Design, Ceramics, Conceptual Art, Advertising Design, Industrial Design, American Indian Art, Jewelry

M **ONTARIO CRAFTS COUNCIL,** The Craft Gallery, Designers Walk, Ste 300, 170 Bedford Rd Toronto, ON M5R 2K9 Canada. Tel 416-925-4222; Fax 416-925-4223; Internet Home Page Address: www.craft.on.ca; *Pres* Pat James; *Mgr Resource Centre* Carol Ann Casselman; *Exec Dir* Rosalyn Morrison; *Outreach Coordr* Rommy Rodriguez A
Open Tues - Fri 10 AM - 5 pM, Sat 10 AM - 5 PM, Sun Noon - 5 PM, cl Mon; No admis fee; Estab 1976 to foster crafts & crafts people in Ontario & is the largest craft organization in Canada. Has over 100 affiliated groups; Maintains an art gallery; Average Annual Attendance: 8,000; Mem: 3,000; dues $50; annual meeting in June
Income: Financed by mem & provincial appropriation, The Guild Shop, fundraising & publications
Exhibitions: Ontario Crafts Regional Juried Exhibition; bimonthly exhibitions in craft gallery
Activities: Sales shop sells books, original craft, prints, Inuit art, sculpture & prints

L **Craft Resource Centre,** 170 Bedford Rd, Toronto, ON M5R 2K9 Canada. Tel 416-925-4222; Fax 416-925-4223; Internet Home Page Address: www.craft.on.ca; *Portfolio of Makers Mgr* Carol Ann Casselman; *Outreach Coordr* Rommy Rodriguez A
Open Wed - Fri Noon - 5 PM; No admis fee; Estab 1976. A comprehensive, special library devoted exclusively to the field of crafts. It is a primarily mem-funded not-for-profit organization & is available as an information service to the general pub & Ontario crafts Council members. Has an extensive portfolio registry featuring Canadian craftspeople; For reference only; Average Annual Attendance: 6,000; Mem: 3,000; dues $40; annual meeting in June
Library Holdings: Book Volumes 3000; Clipping Files; Exhibition Catalogs; Manuscripts; Other Holdings Portfolios of craftspeople 530; Periodical Subscriptions 350; Slides 100,000; Video Tapes
Special Subjects: Glass, Metalwork, Enamels, Pottery
Activities: Educ dept; tours; scholarships & fels offered; slide rental; publishing; Portfolio Makers Program; Sales shop sells books, magazines, contemporary Canadian crafts

A **Artists in Stained Glass,** 253 College St, Toronto, ON M5T 1R5 Canada. Tel 416-690-0031; *Ed* Brigitte Wolf; *Pres* Robert Browne
Estab 1974 to encourage the development of stained glass as a contemporary art form in Canada; Maintains slide file library through the Ontario Crafts Council; Mem: 130; dues $25-$70; annual meeting in Nov
Income: $6,000 (financed by mem & state appropriation)
Publications: Flat Glass Journal, quarterly; Leadline, occasionally
Activities: Classes for adults; lect open to public, 5 vis lectr per year

A **THE PHOTON LEAGUE OF HOLOGRAPHERS,** 401 Richmond St W, Ste B03, Toronto, ON M5V 3A8 Canada. Tel 416-599-9332, 203-7243; Internet Home Page Address: www.photonleague.org; *Dir* C Abrams
Open by apppointment only; Estab 1985 for holography production. The Photon League is committed to providing affordable access to a professional level holography facility, education about holography through workshops, encouragement & support of artistic production & dialogue in the field of holography. As a resource center, The Photon League organizes & curates exhibitions, maintains an archive of holographic work & fosters the exploration of relevant technologies; Holography studio includes: 50 mw Helium Neon laser, 3 mw Helium Neon laser, 2 mw Helium Neon laser, 8 x 16 ft floating table,

darkroom, computer controlled stereogram, optics & mounts; Mem: 15; dues international $75, core $60, student $20, associate $15
Income: Financed by mem
Exhibitions: Ann exhibits at local locations
Publications: Quarterly newsletter
Activities: Classes for adults & children; artist-in-residence; workshops; panel discussions; open house; discussion group; lect open to public; lending collection contains original objects of art; sales shop sells holograms & T-shirts

PROFESSIONAL ART DEALERS ASSOCIATION OF CANADA
For further information, see National and Regional Organizations

M **REDHEAD GALLERY,** 96 Spadina Ave, Toronto, ON M5V 2J6 Canada. Tel 416-504-5654; Fax 416-504-2421; Elec Mail art@redheadgallery.org; *Dir* Christy Thompson
Open Wed - Fri Noon - 5 PM, Sat Noon - 6 PM; No admis fee; Estab 1990 as an artist run culture; There are 2 exhibition spaces. One main space is primarily reserved for mem. Annual programming will include exhibitions by visiting artists. Two window spaces are rented on a monthly basis to emerging artists. Also hold poetry reading, exhibits permitting; Average Annual Attendance: 5,400; Mem: 19; dues $1,320
Income: financed by mem
Exhibitions: Contemporary Art; rotating exhibits

ROYAL CANADIAN ACADEMY OF ARTS
For further information, see National and Regional Organizations

M **ROYAL ONTARIO MUSEUM,** 100 Queen's Park, Toronto, ON M5S 2C6 Canada. Tel 416-586-5549; Fax 416-586-5863; Internet Home Page Address: www.rom.on.ca; *Chmn Bd Trustees* Jack Cockwell; *VPres Coll & Research* Hans-Dieter Sues; *Bus & Capital Development* Mike Shoreman; *Dir Human Resources* Chris Koester; *Dir Exhib Prog* Margo Welch; *Dir* William Thorsell; *Exec Dir Mkg & Comm Develop* Joel Peters; *Exec Dir Visitor Experience* Jan Howlette; *Media Relations* Jeff Kostyniuk
Open Mon-Thurs 10 AM - 6 PM, Fri 10 AM - 9:30 PM, Sat 10 AM - 6 PM, Sun 11 AM - 6 PM; Admis families $35, adults $15, senior citizens, students & children $10, children 5-14 $8; Estab 1912 & includes 20 curatorial departments in the fields of fine & decorative arts, archaeology & the natural & earth sciences; Average Annual Attendance: 1,000,000; Mem: 42,000; dues individual $65
Income: $25,000,000 (financed by federal grants, provincial grants, mus income, mem, bequests, grants & donations)
Special Subjects: Architecture, Hispanic Art, African Art, Anthropology, Archaeology, Pre-Columbian Art, Southwestern Art, Primitive art, Asian Art, Historical Material, Medieval Art
Collections: Extensive Far Eastern collection
Publications: Rotunda, quarterly magazine; numerous academic publications; gallery guides; exhibition catalogs; publications in print
Activities: Classes for adults & children; throughout the school year, prebooked classes receive lessons in the museum. Unconducted classes can also be arranged with the museum at a cost of $3 per student; lect open to public with vis lectr, special lect for members only; concerts; gallery talks; tours; competitions; outreach dept serves Ontario; individual paintings & original objects of art lent to museums & galleries; originate traveling exhibitions; museum shop sells books, magazines, reproductions prints & slides

L **Library & Archives,** 100 Queen's Park, Toronto, ON M5S 2C6 Canada. Tel 416-586-5595; Fax 416-586-5863; Elec Mail library@rom.on.ca; Internet Home Page Address: www.rom.on.ca; *Library Mgr* Arthur Smith; *Far Eastern Librarian* Jack Howard
Open to staff & pub viewing; No admis fee; Estab 1960 for curatorial research; Circ Non-circulating; Average Annual Attendance: 5,000
Income: $600,000 (operating grant)
Purchases: $110,000
Library Holdings: Book Volumes 156,769; Compact Disks 48; DVDs; Exhibition Catalogs; Fiche 531; Manuscripts; Memorabilia; Original Art Works; Original Documents; Pamphlets; Periodical Subscriptions 363; Photographs; Video Tapes 15
Special Subjects: Art History, Decorative Arts, Photography, Etchings & Engravings, Graphic Arts, Islamic Art, Painting-American, Painting-British, Pre-Columbian Art, Prints, Sculpture, Painting-European, Historical Material, History of Art & Archaeology, Judaica, Portraits, Watercolors, Ceramics, Crafts, Archaeology, Ethnology, Printmaking, Fashion Arts, Asian Art, American Indian Art, Porcelain, Primitive art, Anthropology, Eskimo Art, Furniture, Ivory, Jade, Period Rooms, Costume Design & Constr, Glass, Mosaics, Stained Glass, Metalwork, Antiquities-Oriental, Antiquities-Persian, Carpets & Rugs, Embroidery, Enamels, Gold, Goldsmithing, Handicrafts, Jewelry, Miniatures, Oriental Art, Religious Art, Restoration & Conservation, Silver, Silversmithing, Tapestries, Textiles, Woodcarvings, Woodcuts, Antiquities-Assyrian, Antiquities-Byzantine, Antiquities-Egyptian, Antiquities-Etruscan, Antiquities-Greek, Antiquities-Roman, Dioramas, Coins & Medals, Pewter, Scrimshaw, Laces, Painting-Canadian, Architecture, Pottery
Collections: Rare book coll; far eastern coll
Activities: Classes for adults; dramatic programs; lect open to the pub; concerts

M **Dept of Western Art & Culture,** 100 Queen's Park, Toronto, ON M5S 2C6 Canada. Tel 416-586-5524; *Dept Head* Paul Denis
Open Mon - Thurs & Sat 10 AM - 6 PM, Fri 9 AM - 9:30 PM, Sun 11 AM - 6 PM; No admis fee; Estab 1951 to collect, exhibit & publish material on Canadian historical paintings & Canadian decorative arts; Canadian Gallery has three galleries: first gallery has six rooms showing English Colonial, French, Maritime, Ontario & German-Ontario furniture, also silver, glass, woodenware; second gallery has ceramics, toys, weathervanes, religious carving, early 19th century Quebec panelled room; third is a picture gallery for changing exhibitions; Average Annual Attendance: 45,000; Mem: 42,000
Special Subjects: Decorative Arts, Portraits, Coins & Medals
Collections: Canadian 18th & 19th centuries decorative arts - ceramics, coins & medals books, furniture, glass, guns, silver, woodenware; 16th-18th centuries exploration; portraits of Canadians & military & administrative people connected with Canada; 18th & 19th centuries topographic & historical Canadian views; 19th century travels

Exhibitions: Various exhibitions
Publications: William Berczy; D B Webster Brantford Pottery; Canadian Watercolors & Drawings; The William Eby Pottery, Conestogo, Ontario 1855 - 1970; English Canadian Furniture of the Georgian Period; An Engraver's Pilgrimage: James Smillie Jr in Quebec, 1821-1830; Georgian Canada: Conflict & Culture, 1745 - 1820; Printmaking in Canada: The Earliest Views & Portraits

L **RYERSON UNIVERSITY,** (Ryerson Polytechnical University) Ryerson University Library, 350 Victoria St, Toronto, ON M5B 2K3 Canada. Tel 416-979-5055; Fax 416-979-5215; Elec Mail libweb@ryerson.ca; Internet Home Page Address: www.library.ryerson.ca; *Chief Librn* Cathy Matthews
Open Mon - Fri 8 AM - Midnight, Sat - Sun 10 AM - Midnight; No admis fee; Estab 1948
Income: Financed by provincial appropriation & student fees
Purchases: $2-3 million total library acquisition
Library Holdings: Audio Tapes; Book Volumes 403,897; Cassettes; Fiche; Filmstrips; Micro Print; Motion Pictures; Pamphlets; Periodical Subscriptions 3888; Records; Reels; Slides; Video Tapes
Special Subjects: Film, Photography, Graphic Arts, Theatre Arts, Fashion Arts, Interior Design, Architecture
Exhibitions: Rotate periodically

SCULPTOR'S SOCIETY OF CANADA
For further information, see National and Regional Organizations

SOCIETY OF CANADIAN ARTISTS
For further information, see National and Regional Organizations

M **STEPHEN BULGER GALLERY,** 1026 Queen St W, Toronto, ON M6J 1H6 Canada. Tel 416-504-0575; Fax 416-504-8929; Elec Mail info@bulgergallery.com; Internet Home Page Address: www.bulgergallery.com; *Dir* Stephen Bulger
Open Tues - Sat 11 AM - 6 PM; Estab 1995; Gallery displays historical & contemporary photography; Average Annual Attendance: 13,000
Income: pvt
Special Subjects: Photography
Collections: Canadian & International Photography Collection
Exhibitions: Month-long exhibitions, either solo or thematic group shows
Activities: Lect open to public; classes for adults; 6 vis lectr per year; occasional gallery talks; original objects of art lent; lending collection contains 2000 books & 5000 photographs; book traveling exhibs; organize traveling exhibs to pub and commercial galleries; sales shop sells books

M **TEXTILE MUSEUM OF CANADA,** 55 Centre Ave, Toronto, ON M5G 2H5 Canada. Tel 416-599-5321; Fax 416-599-2911; Elec Mail info@museumfortextiles.on.ca; Internet Home Page Address: www.museumfortextiles.on.ca; *Contemporary Gallery Cur* Sarah Quinton; *Cur & Colls Mgr* Marijke Kerkhoven; *Dir* Jennifer Kaye; *Cur Educ* Rebecca Duclos
Open Tues, Thurs & Fri 11 AM - 5 PM, Wed 11 AM - 8 PM, Sat & Sun Noon - 5 PM; Admis $5 adults, $4 seniors & students, children under 12 free; Estab 1975; 15,000 sq ft of gallery space where 6-8 exhibitions are mounted each yr. Maintains reference library; Average Annual Attendance: 18,000; Mem: 900; dues $40; annual meeting in May
Income: $400,000 (financed by mem, corporate & private sponsorship, fund raising, shop & attendance revenues)
Library Holdings: Exhibition Catalogs; Pamphlets; Periodical Subscriptions; Video Tapes
Special Subjects: Textiles, Carpets & Rugs, Laces
Collections: Artifacts Collection, 9000 textiles from all over the world
Exhibitions: Rotating exhibitions
Publications: Exhibition catalogues, 2-3 per year
Activities: Classes for adults & children; docent training; workshops; symposia; lect open to public, 8 vis lectr per year; concerts; gallery talks; tours; original objects of art lent; lending collections contains 9000 art objects; 2 book traveling exhibitions per yr; originate traveling exhibitions 2 per year; sales shop sells books, magazines, original art, reproductions & gifts

C **TORONTO DOMINION BANK,** Toronto Dominion Ctr, PO Box 1 Toronto, ON M5K 1A2 Canada. Tel 416-982-8473; Fax 416-982-6335; *Cur Art* Natalie Ribkoff
Contemporary Art Collection is available for viewing by appointment only. The Inuit Gallery is open Mon - Fri 8 AM - 6 PM, Sat & Sun 10 AM - 4 PM; No admis fee; The Contemporary Art Collection is shown throughout branch offices in Canada & internationally; the Inuit Art Collection has its own gallery in the Toronto-Dominion Centre
Collections: The Inuit Collection consists of a selection of prints, as well as stone, bone & ivory carvings; the Contemporary Collection is an ongoing project focusing on the art of emerging & mature Canadian artists, including original prints, paintings, sculpture & works on paper

TORONTO PUBLIC LIBRARY BOARD (Metropolitan Toronto Library Board)
L **Library,** Tel 416-393-7131; Fax 416-393-7229; Internet Home Page Address: www.tpl.toronto.on.ca; Others Virtual Library: vrl.tpl.toronto.on.ca; *City Librn* Jo Bryant; *Dir Research & Reference* Linda Mackenzie
Open Mon - Thurs 10 AM - 8 PM, Fri 10 AM - 5 PM, Sat 9 AM - 5 PM, Sun Oct 15 - end of Apr 1:30 - 5 PM; Estab 1959 for public reference
Income: Financed by city appropriation
Library Holdings: Book Volumes 50,000; Clipping Files; Exhibition Catalogs; Fiche; Periodical Subscriptions 450; Photographs; Prints; Reels; Reproductions
Special Subjects: Decorative Arts
Collections: Postcards, scenic & greeting; printed ephemera; private presses with emphasis on Canadian; 834,000 picture clippings; theatre arts & stage design

M **TORONTO SCULPTURE GARDEN,** PO Box 65, Station Q Toronto, ON M4T 2L7 Canada. Tel 416-515-9658; Fax 416-515-9655; Elec Mail info@torontosculpturegarden.com; Internet Home Page Address: www.torontosculpturegarden.com; *Dir* Rina Greer
Open 8 AM - dusk; No admis fee; Estab 1981; Outdoor park featuring exhibitions of site-specific work commissioned for the site

Exhibitions: 2-3 exhibits per yr
Publications: Toronto Sculpture Garden; exhibition brochures

M **UNIVERSITY OF TORONTO,** (University of Toronto Art Centre) University of Toronto Art Centre, 15 King's College Circle, Toronto, ON M5S 3H7 Canada. Tel 416-978-1838; Fax 416-971-2059; Elec Mail liz.wylie@utoronto.ca; Internet Home Page Address: www.utoronto.ca/artcentre; *Cur* Liz Wylie; *Dir* Niamh O'Laughaire; *Mgr Programs & Facilities* Maureen Smith; *Coll Mgr* Heather Pigat; *Malcove Cur* Dawn Cain; *Malcove Asst Cur* Elisa Coish
Open Tues - Fri Noon - 5 PM, Sat Noon-4 PM, cl Sat July & Aug; Admis adults $5, seniors $3, students, members, faculty & staff free; Estab 1996; There are nine galleries each displaying selections from the three collections. Maintains reference library; Average Annual Attendance: 15,000; Mem: 200; dues $50 & up
Income: $260,000 (financed by endowment, mem & the University
Special Subjects: Drawings, Graphics, Painting-American, Bronzes, Ceramics, Etchings & Engravings, Landscapes, Manuscripts, Collages, Eskimo Art, Furniture, Oriental Art, Asian Art, Antiquities-Byzantine, Marine Painting, Metalwork, Painting-British, Carpets & Rugs, Ivory, Embroidery, Medieval Art, Antiquities-Oriental, Antiquities-Egyptian, Antiquities-Greek, Antiquities-Roman
Collections: Malcove Collection; University College Collection; University of Toronto Collection
Exhibitions: Selections from the Malcove Collection, University College Collection & the University of Toronto Collection
Publications: Partners Newsletter, griannual
Activities: Docent training; lect open to public, 2 vis lectr per year; concerts; gallery talks; tours; individual paintings & original objects of art lent to other institutions/galleries; 2-3 book traveling exhib per yr; sales shop sells books, reproductions & cards

UNIVERSITY OF TORONTO
M **Justina M Barnicke Gallery,** Tel 416-978-8398; Fax 416-978-8387; Elec Mail judi.schwartz@utoronto.ca; Internet Home Page Address: www.utoronto.ca/gallery; *Dir* Judith Schwartz
Open Mon - Fri 11 AM - 7 PM, Sat & Sun 1 - 4 PM; No admis fee; Estab 1919 to promote young Canadian artists, as well as present a historical outlook on Canadian art; Gallery has modern setting & total wall space of 350 running ft; outdoor quadrangle is available for summer sculpture shows; Average Annual Attendance: 12,000
Income: Financed by Hart House
Purchases: Canadian art
Special Subjects: Painting-Canadian
Collections: Canadian Art (historical & contemporary)
Exhibitions: Temporary exhibitions of historical & contemporary Canadian art
Activities: Classes for adults; docent training; lect, 5 vis lectr per year; concerts; gallery talks; tours; individual paintings & original objects of art lent; originate traveling exhibitions
L **Fine Art Library,** Tel 416-978-5006; Fax 416-978-1491; Internet Home Page Address: www.library.utoronto.ca/fine_art/library/refinfo.html; *Library Asst* Catherine Spence
Open Mon, Tues, Fri 9:30 AM - 5 PM, Wed - Thurs 9:30 AM - 8 PM ; No admis fee; Estab 1936 for reference only
Income: Financed by state appropriation & Department of Fine Art
Library Holdings: Book Volumes 5,000; Exhibition Catalogs 30,000; Photographs 90,000
Special Subjects: Art History, Archaeology
Collections: Catalog materials including temporary, permanent, dealer catalogs; photographic archives in various fields of Western art
Publications: Canadian Illustrated News (Montreal); Index to Illustrations, quarterly

A **VISUAL ARTS ONTARIO,** 1153A Queens St W, Toronto, ON M6J 1J4 Canada. Tel 416-591-8883; Fax 416-591-2432; Elec Mail vao@www/online.com; Internet Home Page Address: www.vao.org; *Coordr Art Placement* Tracey Bowen; *Project Officer* David McClyment; *Bookkeeper* Frima Yolleck; *Exec Dir* Hennie L Wolff
Open Mon - Fri 9 AM - 5 PM; Estab 1974, Visual Arts Ontario is a nonprofit organization dedicated to furthering the awareness & appreciation of the visual arts; Mem: 3500; dues 2 year $40, 1 year $25
Income: Financed by mem, fundraising, municipal, provincial & federal grants, attendance at events
Collections: Resource Center; Slide Registry of Ontario artists
Publications: Agenda, quarterly newsletter; Art in Architecture; Art for the Built Environment in the Province of Ontario; The Guidebook to Competitions & Commissions; Perfect Portfolio on Your Own; Visual Arts Handbook
Activities: Workshops for professional artists; lect open to public; seminars & conferences; special projects; individual paintings & original objects of art lent to Ontario Government Ministries & corporations; originate traveling exhibitions; offers on-line course "Perfect Portfolio" a learning course in professional portfolio development

A **WOMEN'S ART ASSOCIATION OF CANADA,** 23 Prince Arthur Ave, Toronto, ON M5R 1B2 Canada. Tel 416-922-2060; Fax 416-922-4657; *Pres* Janet Newton
Open to pub for scheduled exhibitions & lectures; Estab 1886 to encourage women in the arts; branches in Ontario, Hamilton, St Thomas & Peterborough; Mem: 180; dues $125, qualifications: interest in the arts, nominated & seconded by members; annual meeting in Apr
Collections: Canadian Art Collection
Activities: Classes for adults; lect open to public, 10 vis lectr per year; concerts; competitions with awards; scholarships given to Ontario College of Art, Royal Conservatory of Music, National Ballet School, University of Toronto Faculty of Music; individual paintings & original objects of art lent
L **Library,** 23 Prince Arthur Ave, Toronto, ON M5R 1B2 Canada. Tel 416-922-2060; Fax 416-922-4657; *Librn* Isabelle Johnson
Open during exhibs & lect only; Circ Non-circulating
Library Holdings: Book Volumes 1000

M **WYNICK TUCK GALLERY,** 401 Richmond St W Toronto, ON M5V 2J3 Canada. Tel 416-504-8716; Fax 416-504-8699; Elec Mail wtg@wynicktuckgallery.ca; Internet Home Page Address: www.wynicktuckgallery.ca; *Co-Dir* David Tuck; *Asst Dir* Gina Facchini; *Co-Dir* Lynne Wynick
Open Tues - Sat 11 AM - 5 PM, cl Sun & Mon; No admis fee; Estab 1968 to represent contemporary Canadian artists as well as some international artists featuring paintings, sculptures, works on paper & photos; 4000 sq ft
Income: Financed by pvt funding
Exhibitions: Exhibitions rotate monthly
Activities: Sales shop sells original art

M **YORK UNIVERSITY,** Glendon Gallery, Glendon Col York Univ, 2275 Bayview Ave Toronto, ON M4N 3M6 Canada. Tel 416-487-6721; Fax 416-487-6779; Elec Mail gallery@glendon.yorku.ca; Internet Home Page Address: www.yorku.ca/gallery; *Admin Asst* Cristina Raimondo; *VPrin* Louise Lewin; *Dir* Martine Rheault; *Cur* Marc Audette
Open Tues - Fri Noon-3 PM, Sat 1-4 PM; No admis fee; Estab 1977, focus on contemporary visual arts; 107.2 ft of running wall space, dark hardwood flooring, natural sunlight & halogen track lighting; ground floor of Glendon Hall; Average Annual Attendance: 2,000
Income: $141,868 (financed by mem, York University & granting agencies)
Publications: Bilingual exhibition catalogue
Activities: Classes for children; lect open to public, 5 vis lectr per year; concerts; gallery talks; tours; book traveling exhibitions

M **YORK UNIVERSITY,** Art Gallery of York University, Ross Bldg N145, 4700 Keele St Toronto, ON M3J 1P3 Canada; Ross Bldg N201, 4700 Keele St Toronto, ON M3J 1P3 Canada. Tel 416-736-5169; Fax 416-736-5985; Elec Mail agyu@yorku.ca; Internet Home Page Address: www.yorku.ca/agyu; *Acting Dir* Kathleen McLean; *Admin Asst* Karen Pellegrino; *Educ Coordr & Coll Asst* Allyson Adley
Open Mon - Fri 10 AM - 4 PM, Wed 10 AM - 8 PM, Sun Noon - 5 PM, cl July & Aug; Admis donations welcomed; Estab 1970 to maintain a program of exhibitions covering a broad spectrum of the contemporary visual arts; Gallery is 3600 sq ft, exhibition space 2800 sq ft, including program space & support space 750 sq ft; Average Annual Attendance: 15,000
Income: Financed by university, federal, provincial & municipal grants & private donations
Special Subjects: Painting-American, Sculpture, Eskimo Art, Painting-Canadian
Collections: Approx 750 works including ethnographical items & artifacts, approx 550 of the works are by Canadian artists. Current emphasis & expansion of outdoor sculpture collection
Publications: Exhibit catalogs
Activities: Lect open to public, 3-4 vis lectr per year; gallery talks; tours; sponsoring of competitions; Critical Writing award; individual paintings & original objects of art lent for major shows or retrospectives to other members of the University & faculty for their offices; book traveling exhibitions; originate traveling exhibitions; museum shop sells books
L **Fine Arts Phase II Slide Library,** 4700 Keele St, Rm 274, North York, ON M3J 1P3 Canada. Tel 519-736-5534; Fax 519-736-5447; *Cur* M Metraux; *Slide Librn* Marie Holubec; *Slide Librn* Lillian Heinson
Open 8 AM - 4:30 PM daily; cl weekends; Estab for reference only, students & faculty; Circ Slides circulate for staff & faculty
Income: Financed through university
Library Holdings: Periodical Subscriptions; Slides 250,000

M **YYZ ARTISTS' OUTLET,** 401 Richmond St W, No 140, Toronto, ON M5V 3A8 Canada. Tel 416-598-4546; Elec Mail yyz@interlog.com; Internet Home Page Address: www.interlog.com/~yyz; *Co-Dir* Dionne McAffee; *Co-Dir* Lisa Deanne Smith
Open Tues-Sat 11 AM - 5 PM; No admis fee; Estab 1979; Exhibs and pubs books on contemporary art; Average Annual Attendance: 3,000
Library Holdings: Exhibition Catalogs; Memorabilia; Original Documents; Pamphlets
Activities: Lect open to public, 5 vis lect per year; sales shop sells books, magazines, original art, multiples

WATERLOO

M **CANADIAN CLAY & GLASS GALLERY,** 25 Caroline St N, Waterloo, ON N2L 2Y5 Canada. Tel 519-746-1882; Fax 519-746-6396; Elec Mail info@canadianclayandglass.ca; Internet Home Page Address: www.canadianclayandglass.ca; *Dir & Cur* Glenn Allison; *Admin Asst* Jennifer Bullock; *Gift Shop & Visitor Servs Coordr* Susan Addison; *Community Develop Coordr* Diana Lobb; *Bus Mgr* Robert Achtemichuk; *Educator* Sheila McMath
Open Tues - Sat 10 AM- 5 PM, Sun 1-5 PM; Admis by donation; Estab 1993; 4 galleries; Average Annual Attendance: 25,000; Mem: 255; dues family $45, adults $35, seniors $25, students $15
Income: Financed by mem, donations & facility rentals
Collections: Contemporary Canadian & International clay, glass, stained glass & enamel
Exhibitions: Exhibits rotate monthly
Activities: Classes for children; art talks; 4 vis lects per year; Tours; Winifred Shantz award for ceramists; retail shop sells original art

M **ENOOK GALLERIES,** 29 Young St E, PO Box 335 Waterloo, ON N2J 4A4 Canada. Tel 519-884-3221; *Cur* Laura Napran; *Dir* H Norman Socha
Open Tues - Sat 11 AM - 5 PM; No admis fee; Estab 1981 to promote awareness of Native art; 250 sq ft
Income: Financed by sales, privately owned
Special Subjects: Painting-American, American Indian Art, Southwestern Art, Crafts, Folk Art, Pottery, Primitive art, Woodcarvings, Painting-Canadian, Scrimshaw

Collections: Benjamin Chee/Chee Collection; David General Collection; Kiakshuk Collection; Doug Maracle Collection; Native American, Indian & Eskimo/Inuit Art; Papua New Guinea artifacts; graphics, paintings & sculptures
Publications: Visions of Rare Spirit
Activities: Lect open to public, 2 vis lectr per year; book traveling exhibitions 2 per year; originate exhibitions for international art galleries & universities on contemporary Native art, 4 per year; retail store sells sculpture, prints, original art & reproductions

UNIVERSITY OF WATERLOO
M **Art Gallery,** Tel 519-888-4567, Ext 3575; Fax 519-746-4982; Elec Mail cpodedwo@uwaterloo.ca; Internet Home Page Address: www.artgallery.uwaterloo.ca; *Dir/Cur* Carol Podedworny
Open Sept - June Tues, Wed & Fri Noon - 4 PM, Thurs Noon - 7 PM, Sat 1 - 4 PM, clJuly & Aug; No admis fee; Estab 1962; 4,000 sq ft, 350 running ft, concrete floors, drywell, 20 ft ceilings; Average Annual Attendance: 5,000; Mem: Alumni
Income: Financed by university & arts council grants from Canada; corporate sponsorship
Collections: Contemporary Canadian Art
Exhibitions: Changing temporary exhibits, 6-12 per yr
Publications: Exhibit catalogues
Activities: Lect open to public; in-gallery visitor-directed learning opportunities; gallery talks; tours; workshops; 7 vis lectr per yr; exten dept serves Canada and U.S.; lending collections contains original objects of art; 1-2 book traveling exhibitions per yr; organize traveling exhibitions to Canadian galleries
L **Dana Porter Library,** Tel 519-885-1211, Ext 5763; Fax 519-888-4320; Internet Home Page Address: www.uwaterloo.ca; Telex 069-5259; *Spec Coll Librn* Susan Bellingham; *Reference & Coll Develop Librn - Fine Arts & Archit* Michele Sawchuk; *Univ Librn* Murray Shepherd
Open Mon - Fri 9 AM - Noon & 1 - 4 PM; Estab 1958 to provide access to information appropriate to the needs of the academic community
Income: $244,311 (financed by mem)
Library Holdings: Book Volumes 26,770; Clipping Files; Exhibition Catalogs; Fiche; Periodical Subscriptions 160; Records; Reels
Special Subjects: Etchings & Engravings, Printmaking
Collections: The Dance Collection (monographs, periodicals & pamphlets from 1535 to date relating to the history of dance-ballet); B R Davis Southy Collection; Euclid's Elements & History of Mathematics; Eric Gill Collection; Lady Aberdeen Library of Women; George Santayana Collection; Private Press Collection; Rosa Breithaupt Clark Architectural History Collection
Publications: Library publishes four bibliographic series: Bibliography, Technical Paper, Titles & How To
Activities: Undergraduate curriculum in architecture, art history & studio

M **WILFRID LAURIER UNIVERSITY,** Robert Langen Art Gallery, 75 University Ave, Waterloo, ON N2L 3C5 Canada. Tel 519-884-0710, Ext 2714; Fax 519-886-9351; *Pres* Dr Robert Rosehart; *Cur & Mgr* Suzanne Luke
Open Tues - Fri 10 AM-5 PM, Sat Noon-5 PM; No admis fee; Estab 1969 to exhibit for the students, staff & faculty; The gallery has its own space in the John Aird Building & has 18 x 50 ft rectangular space incl various modular mounts; Average Annual Attendance: 50,000
Income: Financed by the university
Purchases: $16,000
Special Subjects: Drawings, Painting-American, Photography, Prints, Sculpture, Watercolors, Textiles, Woodcarvings, Woodcuts, Etchings & Engravings, Landscapes, Painting-European, Portraits, Eskimo Art, Painting-Canadian, Oriental Art, Marine Painting, Metalwork, Painting-British, Historical Material, Restorations, Tapestries
Collections: 2000 pieces of original art works & prints
Exhibitions: Student, staff & faculty show; the gallery mounts 10 exhibitions each year, mostly shows by artists in local area
Publications: Buried Treasure (75th Anniversary of WLU 1986)
Activities: Classes for adults; docent training; lect open to public, 1-5 vis lectr per year; gallery talks; competitions; individual paintings & original works of art lent to campus offices & public areas; originate traveling exhibitions

WINDSOR

M **ART GALLERY OF WINDSOR,** 4100 Riverside Dr West, Windsor, ON N9 A 7J1 Canada. Tel 519-977-0013; Fax 519-977-0776; Internet Home Page Address: www.artgalleryofwindsor.com; *Business Mgr* Ken Ferguson; *Cur* Robert McKaskell; *Cur* Helga Pakasaar; *Information Coordr* Otto Buj; *Registrar* Janine Butler; *Admin Asst* Diane Lane; *Pres* Stephen Marshall; *Cur Educ* Christine Goodchild; *Cur Coordr* Cassandra Getty
Open Tues - Thurs 11 AM - 7 PM, Fri 11 AM - 9 PM, Sat 11 AM - 5 PM, Sun 11 AM - 5 PM, cl Mon; No admis fee; Estab 1943 for collection & exhibition of works of art, primarily Canadian, for the study & enjoyment of the Windsor-Detroit area; Average Annual Attendance: 70,000; Mem: 2500; president's club $1000 & up, director's circle $500-$999, advocate $250-$499, supporter $100-$249, gallery friend $50-$99, family $45, single $25, student $20; annual meeting in Mar
Income: $1,300,000 (financed by mem, city appropriation & federal & provincial grants)
Collections: Primarily Canadian drawings, paintings, prints & sculpture 18th century to present; Inuit prints & sculpture; non-Canadian paintings & sculpture
Exhibitions: Approx 30 exhibitions a year, besides installation of permanent collection, of mostly Canadian historic & contemporary art works, paintings & graphics
Publications: Quarterly bulletin & catalogues for exhibitions organized by this gallery, 6 times a year
Activities: Docent training; lect open to public, 20 vis lectr per year; gallery talks; tours; book traveling exhibitions approximately 20 per year; originate traveling exhibitions; museum shop sells Canadian handicrafts, original art, reproductions & prints; Education Gallery
L **Reference Library,** 401 Riverside Dr West, Windsor, ON N9 A 7J1 Canada. Tel

519-977-0013; Fax 519-977-0776; Elec Mail agw@mnsi.net; Internet Home Page Address: www.artgalleryofwindsor.com; *Librn* Janine Butler
Open Mon-Fri 9 AM - 5 PM; Estab 1966; Circ Non-circulating; Reference for staff, members & public
Income: Financed by mem
Library Holdings: Book Volumes 2500; Clipping Files; Exhibition Catalogs; Other Holdings Catalogs & museum bulletins; Pamphlets; Periodical Subscriptions 30; Video Tapes

WOODSTOCK

M **CITY OF WOODSTOCK,** Woodstock Art Gallery, 447 Hunter St, Woodstock, ON N4S 4G7 Canada. Tel 519-539-6761; Fax 519-539-2564; Elec Mail gallery@city.woodstock.on.ca; Internet Home Page Address: www.woodstock.on.ca; *Educ Officer* Stephanie Porter; *Gallery Admin* Anne Buckrell; *Cur* Maria Ricker
Open Tues - Fri 11 AM - 5 PM, Sat 10 AM - 5 PM; No admis fee; Estab 1967 as a community art gallery; Moved into neo-Georgian building (c1913) in 1983. Four gallery spaces: Carlyle Gallery (313 sq ft); Verne T Ross Gallery (464 sq ft); Nancy Rowell Jackman Gallery (323) sq ft): East Gallery (1303.75 sq ft); Average Annual Attendance: 18,500; Mem: 400; dues, life member $300, corporate $50, family $30, individual $20, senior citizen, children & students $15
Income: Financed by City of Woodstock, Ministry of Citizenship & Culture, Ontario Arts Council, mem & donations
Collections: 290 works collection of Canadian Art, concentrating on Florence Carlyle contemporary Canadian regional artists
Publications: Newsletter 4 times per year; educational handouts on current exhibitions; monthly bulletin
Activities: Classes for adults & children; dramatic programs; lect open to public, 6-8 vis lectr per year; concerts; gallery talks; tours; competitions with awards; scholarships offered; art rental paintings are leased to residents of Oxford County & business firms; lending collection contains paintings; originate traveling exhibitions to circulate southwestern Ontario & Toronto vicinities; gift shop sells cards, wrapping & writing paper, pottery, jewelry, weaving

PRINCE EDWARD ISLAND

CHARLOTTETOWN

M **CONFEDERATION CENTRE ART GALLERY AND MUSEUM,** 145 Richmond St, Charlottetown, PE C1A 1J1 Canada. Tel 902-628-6111; Fax 902-566-4648; Elec Mail jsimpson@isn.net; Internet Home Page Address: www.confederationcentre.com; *Registrar* Kevin Rice; *Dir* Jon Tupper; *Admin Asst* Judy Simpson
Open Tues - Sat 11 AM - 5 PM, Sun 1 - 5 PM, Mid June - Oct 10 AM - 8 PM, cl Mon; Estab 1964 as a nat coll devoted to Canadian art & fine crafts; Average Annual Attendance: 90,000; Mem: 200; group $20, family $5, individual $3
Income: Financed by federal, provincial, city & private sector
Special Subjects: Painting-American, Prints, Crafts
Collections: 19th & 20th century Canadian paintings, drawings & decorative arts; paintings & drawings by Robert Harris
Exhibitions: Twenty-five exhibitions
Activities: Classes for adults & children, 6 vis lectr per year; gallery talks; tours; concerts; lect open to public; tours; concerts; originate traveling exhibitions; junior museum
L **Library,** 145 Richmond St, Charlottetown, PE C1A 1J1 Canada. Tel 902-368-4642; Fax 902-368-4652; Internet Home Page Address: www.library.pe.ca
Open Tues-Thurs 10 AM - 9 PM, Fri & Sat 10 AM - 5 PM, Sun 1 - 5 PM, cl Mon; Open for reference
Library Holdings: Audio Tapes 30; Book Volumes 3500; Filmstrips 60; Periodical Subscriptions 35; Photographs; Slides 5000; Video Tapes

A **PRINCE EDWARD ISLAND MUSEUM & HERITAGE FOUNDATION,** Beaconsfield 2 Kent St, Charlottetown, PE C1A 1M6 Canada. Tel 902-368-6600; Fax 902-368-6608; Elec Mail mhpei@gov.pe.ca; Internet Home Page Address: www.peimuseum.com
Open July - Sept, call for hrs after Aug; Admis charged; Estab 1970 for the human & natural history of Prince Edward Island; Seven sites, 3 open yr round; Average Annual Attendance: 70,000; Mem: 500, dues family $40, individual $25
Income: Financed by mem, provincial & federal appropriations
Special Subjects: Costumes, Embroidery, Etchings & Engravings, Historical Material, Decorative Arts, Crafts, Dolls, Furniture, Glass, Period Rooms, Maps, Carpets & Rugs, Coins & Medals
Collections: Provincial coll, 80,000 artifacts
Exhibitions: Rotate 4-5 exhibits per yr
Publications: The Island Magazine, semi-annual

QUEBEC

DORVAL

A **DORVAL CULTURAL CENTRE,** 1401 Lakeshore Dr, Dorval, PQ H9S 2E5 Canada. Tel 514-633-4000; Fax 514-633-4177; Elec Mail dorval@total.net; Internet Home Page Address: www.dorval.ville.montreal.qc.ca; *Coordr* Danyelle Brodeur
Open Mon - Thurs 2 - 5 PM & 7 - 9 PM, Fri, Sat & Sun 2 - 5 PM; No admis fee; Estab 1967 to promote culture and art; Maintains an art gallery
Income: Financed by city appropriation
Publications: Calendar, biannually

Activities: Classes for adults and children; dramatic programs; lect open to public; gallery talks; tours

GATINEAU

M CANADIAN MUSEUM OF CIVILIZATION, 100 Laurier St, PO Box 3100, Sta B Gatineau, PQ J8X 4H2 Canada. Tel 819-776-7000; Fax 819-776-8300; Internet Home Page Address: www.civilization.ca; *Chief Operating Officer* Joe Geurts; *Dir Exhib & Programs* Sylvie Morel; *Chief Exec Officer* Dr Victor Rabinovitch; *Dir* Michel Cheff; *VPres Development* Francine Brousseau; *VPres Pub Affairs & Publishing* Mark O'Neill; *Dir Gen Research & Coll* Dr Stephen Inglis; *Dir Canadian War Mus* Joe Guerts; *Corp Sec & Dir Gen Strategic Planning* Mark O'Neill; *Cheif Financial Officer* David Loye
Open Jan 1 - Apr 30 9 AM - 5 PM, cl Mon, May 1 - June 30 daily 9 AM - 6 PM, T July 1 - Sept 2 daily 9 AM - 6 PM, Thurs - Fri 9 AM - 9 PM, Sept 3 - Oct 7 daily 9 AM - 6 PM, Oct 9 - Dec 31 9 AM - 5 PM, cl Mon; Admis adults $10, seniors & students $8, children (3 - 12) $6, free on Thurs 4 - 9 PM; Estab 1989 to promote among all Canadians the advancement of intercultural understanding & make known the cultural legacy with special, but not exclusive, reference to Canada; The Canadian Mus of Civilization was formerly known as the National Mus of Man. It is located on a 24-acre site in Gatineau, Quebec, on the Ottawa River, directly opposite Parliament Hill. The building has 1,076,430 sq ft & designed in two distinct structures: the mus bldg, the pub exhibition wing with over 177,611 sq ft of display space & the curatorial bldg, housing the collections (3 million artifacts), plus conservation labs & administration; children's mus; Imax 295 seat theatre; Average Annual Attendance: 1,300,000; Mem: 3,500 mems; individual $75, family $90 Canadian dollars
Income: The mus generates $12,000,000 a yr & receives over $50,000,000 a yr from the federal government
Library Holdings: Audio Tapes; Book Volumes 70,000; CD-ROMs; Cards; Cassettes; Compact Disks; DVDs; Exhibition Catalogs; Fiche; Filmstrips; Manuscripts; Maps; Memorabilia; Micro Print; Motion Pictures; Original Art Works; Original Documents; Photographs; Prints; Records; Reels; Sculpture; Slides; Video Tapes
Special Subjects: Anthropology, Drawings, Etchings & Engravings, Folk Art, Historical Material, Landscapes, Marine Painting, Ceramics, Collages, Metalwork, Flasks & Bottles, Gold, Porcelain, Portraits, Prints, Period Rooms, Textiles, Sculpture, Tapestries, Graphics, Photography, Watercolors, Bronzes, Archaeology, Ethnology, Costumes, Religious Art, Folk Art, Pottery, Primitive art, Woodcarvings, Woodcuts, Decorative Arts, Manuscripts, Posters, Eskimo Art, Painting-Canadian, Dolls, Furniture, Glass, Jewelry, Silver, Carpets & Rugs, Historical Material, Ivory, Maps, Juvenile Art, Coins & Medals, Restorations, Calligraphy, Dioramas, Embroidery, Laces, Mosaics, Stained Glass, Pewter, Leather, Military Art, Reproductions, Enamels, Bookplates & Bindings
Collections: Archaeological Collection; Ethnological Collection; Folk Culture Collections; Historical Collection; Military History Collection; Canadian Children's Mus Coll; Canadian Postal Mus Coll
Exhibitions: Permanent exhibitions: Grand Hall, First Peoples Hall.
Publications: Several series of publications & periodicals, 102 titles published in-house in last six years, or 17 titles per yr
Activities: Classes for adults & children; dramatic programs; docent training; lect open to the public, several vis lectr per year; concerts; gallery talks; tours; sponsoring of competitions; exten dept; original artifacts lent to museums & other institutions meeting specifications regarding security, environment, etc in Canadian Museums; awards, the William E Taylor Research Award Fund; 10 book traveling exhibitions per yr; originate traveling exhibitions to Canadian and foreign institutions; the boutiques stock a vast range of gift & educational articles; Kidshoppe; Bookstore/Collector's shop offers selection of books & fine crafts including folk art pieces & Native artwork; Canadian Children's Museum 100 Laurier St, PO Box 3100, Sta B Gatineau, QC J8X 4H2 Canada

M GALERIE MONTCALM, 25 Laurier St, PO Box 1970, Stn Hull Gatineau, PQ J8X 3Y9 Canada. Tel 819-595-7488; Fax 819-595-7492; Elec Mail galeriemontcalm1@gatineau.ca; Internet Home Page Address: www.gatineau.ca/galerie; *Dir* Dominique Laurent; *Coordr Permanent Coll* Louise Parisien
Open Mon-Fri 9AM-4:30PM, Thurs 9AM-8PM, Sun Noon-5PM, cl Sat; No admis fee; Estab 1980, to present the art of local artists & national exhibitions, multi-disciplinary; One gallery, 2505 sq ft, three other secondary areas; Average Annual Attendance: 25,000
Income: $145,500 (financed by City of Gatineau)
Collections: City of Gatineau (permanent collection); heritage artifacts; paintings; photographs; prints; sculpture
Publications: Exhibition catalogs
Activities: Classes for children; workshops; lect open to public, 1560 vis lectr per year; concerts; gallery talks; tours of the permanent collection; competitions with awards; retail store sells books, prints, original art

JOLIETTE

M MUSEE D'ART DE JOLIETTE, 145 Wilfrid-Corbeil St, Joliette, PQ J6E 4T4 Canada. Tel 450-756-0311; Fax 450-756-6511; Elec Mail musee.joliette@citenet.net; Internet Home Page Address: www.musee.joliette.org; *Pres* Helene Masse; *VPres* Anand Swaminadhan; *Dir* France Gascon; *Gen Dir* Gaetane Verna
Open Tues - Sun Noon - 5 PM July & Aug, Wed - Sun Noon - 5 PM winter; Admis adults $8, senior citizens $6, students $4; Estab 1967 for educational purposes; preservation of the collections; save local patrimony; 3 rooms of temporary exhibitions; Sacred Art Gallery; European Medieval Renaissance Gallery; Canadian Art Gallery; Permanent Collection room tells story of the collection; Average Annual Attendance: 15,000; Mem: 500; dues family $40, individual $30; annual meeting in Sept
Income: $450,000 (financed by endowment, municipal & provincial government grants)

Library Holdings: Book Volumes; Exhibition Catalogs; Kodachrome Transparencies; Photographs; Slides
Special Subjects: Pre-Columbian Art, Religious Art, Painting-European
Collections: Canadian art; European art; sacred art of Quebec; painting & sculpture
Exhibitions: 9 exhibitions per year
Publications: Catalog & pamphlet entitled Le Musee d'Art de Joliette; catalogs of temporary exhibits
Activities: Classes for adults & children; docent training; lect open to public, 9 vis lect per yr; concerts; gallery talks; tours; films; originate traveling exhibitions 3 per year to museums & libraries; sales shop sells books, magazines, original art, postcards, reproductions & prints
L Library, 145 Wilfrid-Corbeil St, PO Box 132 Joliette, PQ J6E 4T4 Canada. Tel 450-756-0311; Fax 450-756-6511; Elec Mail musee.joliette@citenet.net; Internet Home Page Address: www.bw.qc.ca.musee.joliette; *Dir* France Gascon
Open by appointment; Estab 1976; Circ Non-circulating; Open with reservations only for art reference
Purchases: $200-$250
Library Holdings: Book Volumes 1000; Exhibition Catalogs; Periodical Subscriptions 5; Photographs; Sculpture; Slides
Collections: Art Journal; Great Masters; History of Painting; Larousse Mensuel

JONQUIERE

M INSTITUT DES ARTS AU SAGUENAY, Centre National D'Exposition a Jonquiere, 4160 du Vieux Pont, CP 605, Succursale A Jonquiere, PQ G7X 7W4 Canada. Tel 418-546-2177; Fax 418-546-2180; Elec Mail cne@videotron.ca; Internet Home Page Address: www.pages.infinit.net/cne; *Dir* Jacqueline Caron
Open daily 10 AM - 5 PM; No admis fee; Estab 1979 as an art exposition; 3 galleries; Average Annual Attendance: 20,000; Mem: 150; open to all interested in Au Milieu Des Arts; dues $25; annual meeting in June
Income: $350,000 (financed by endowment, mem, city & state appropriation)
Exhibitions: (1/20/2007-3/25/2007) Ombres En Exil Et L'Atelier Rouge - Helene Roy; (1/13/2007-4/9/2007) X15 Creations Textiles - Centre des Textiles Contemporains; (3/31/2007-6/10/2007) Jean-Paul Lemieux - Exposition Itinerante du Musee National des Beaux-Arts du Quebec; (4/5/2007-6/17/2007) Sites Intermittents - Sylvie Bouchard; (6/16/2007-9/3/2007) Legendes En Pieces Detachees - Monic Pilote; (6/23/2007-9/9/2007) Artistes Regionaux; (9/1/2007-11/11/2007) Histoires - Stephanie Morissette; (9/8/2007-11/18/2007) Trois Fois Passera - Danielle Lagacee; (9/15/2007-1/6/2008) Denis Rousseau - Exposition Itinerante du Musee Regional de Rimouski
Activities: Classes for adults & children; gallery talks; tours; fellowships offered; book traveling exhibitions 3-4 per year

KAHNAWAKE

M KATERI TEKAKWITHA SHRINE, CP 70, Kahnawake, PQ J0L 1B0 Canada. Tel 450-632-6030; Fax 450-632-6031; Elec Mail kateritekakwithasanctuary@yahoo.com; *Dir* Alvaro Salazar, FM; *Treas* Gayla Ouimet
Open Mon - Fri 9 AM - 5 PM, Sat - Sun 10 AM - 5 PM (June - Sept); No admis fee; Estab as a mission in 1667; 1 large room & 2 small rooms; Average Annual Attendance: 5,000
Income: Financed by donations
Special Subjects: American Indian Art, Period Rooms, Painting-French, Religious Art
Collections: Archives, French & Canadian church silver, historic church, rectory & fort, old paintings, religious artifacts; Shrine of Kateri Tekakwitha, mohawk woman on threshhold of becoming a saint, relics are in tomb in church, old known painting of Kateri (1690)
Publications: Kateri, quarterly
Activities: Concerts; tours; individual paintings & original objects of art lent; containing Kodachromes & sculptures; originate traveling exhibitions; sales shop sells books, reproductions, & religious & Kateri Tekakwitha articles & relic medals

LENNOXVILLE

M BISHOP'S UNIVERSITY, Art Gallery, College St, Lennoxville, PQ J1M 1Z7 Canada; PO Box 2136, Lennoxville, PQ J1M 1Z7 Canada. Tel 819-822-9600, Ext 2687; gallery ext 2260; Fax 819-822-9703; Elec Mail gverna@ubishops.ca; Internet Home Page Address: www.ubishops.ca/artgallery.htm; Telex 819-822-9703; *Dir, Cur* Gaëtane Verna; *Cur Asst* Melinda Clifford; *Pub Relations Asst* Zoë Chan
Open Sept - June Tues-Sat 12 - 5PM; No admis fee; Estab 1992 to serve the University Community & the entire Eastern Townships by displaying regional, national & international art work; 154.5 sq m/1667sq ft exhib space located adjacent to the Foyer of Centennial Theatre; Average Annual Attendance: 5,200
Income: Bishop's Univ
Collections: paintings, prints, & sculptures
Publications: catalog of exhibs, yearly
Activities: Docent training; work study program; workshops; lect open to pub, 5 vis lects per year; gallery talks, sponsoring of competitions; graduating student exhib 3 awards per year

MONTREAL

C ALCAN ALUMINIUM LTD, 1188 Sherbrooke St W, Montreal, PQ H3A 3G2 Canada. Tel 514-848-8000; Fax 514-848-8115; *Cur* JoAnn Meade
Spec times by request; Estab 1982 to enhance new offices in which they are installed to enrich the lives of those who work there and their visitors; Collection displayed in reception areas and private offices to animate Alcan's global presence
Collections: International arts & crafts from regions where Alcan operates
Publications: Artluminium catalogue; oeuvres de la collection Alcan, catalogue

Activities: Lect; individual objects of art lent for special exhibits & tours upon request

L **ARTEXTE INFORMATION CENTRE,** (Artexte Information & Documentation Centre) Documentation Centre, 460 Sainte Catherine Ouest, Rm 508, Montreal, PQ H3B 1A7 Canada. Tel 514-874-0049; Elec Mail info@artexte.ca; Internet Home Page Address: www.artexte.ca; *Dir* Francois Dion; *Information Specialist* Felicity Tayler; *Information Specialist* John Latour
Open Wed - Sat 10:30 AM - 5:30 PM, cl Sun & Mon; No admis fee; Institution estab 1980, libr estab 1982; Documentation of contemporary visual arts, from 1965 - present with particular emphasis on Canadian art, consultation only; Average Annual Attendance: 1,500
Income: $350,000 (financed by city & state grants, donations)
Purchases: $15,500
Library Holdings: Book Volumes 2000; CD-ROMs; Cassettes; Clipping Files 8700; Compact Disks; DVDs; Exhibition Catalogs 10,500; Memorabilia; Pamphlets; Periodical Subscriptions 100; Photographs; Slides; Video Tapes
Publications: Artextes editions; Artexte info

ASTED INC
For further information, see National and Regional Organizations

L **CANADIAN CENTRE FOR ARCHITECTURE,** Library, 1920 Baile St, Montreal, PQ H3H 2S6 Canada. Tel 514-939-7000; Fax 514-939-7020; Elec Mail ref@cca.qc.ca; Internet Home Page Address: www.cca.qc.ca; *Founding Dir* Phyllis Lambert; *Dir* Mirko Zardini; *Acting Head Librn* Judy Silverman
Estab 1979; Circ 15,000 vols per yr; Estab 1979; on-site & remote research; library catalog available via website; surrogates provided when possible
Library Holdings: Auction Catalogs; Audio Tapes; Book Volumes 200,400; CD-ROMs; Cards; Cassettes; Clipping Files; Compact Disks; DVDs; Exhibition Catalogs; Fiche; Filmstrips; Manuscripts; Maps; Memorabilia; Motion Pictures; Original Documents; Other Holdings 3-D Artifacts including architectural toys; Pamphlets; Periodical Subscriptions 700; Photographs; Prints; Records; Reels; Reproductions; Slides; Video Tapes
Special Subjects: Landscape Architecture, Decorative Arts, Photography, Stage Design, Archaeology, Industrial Design, Interior Design, Furniture, Architecture
Collections: 200,000 printed vols
Activities: Educ program; lect open to pub; gallery talks; tours; sponsored competitions; fel offered; museum shop sells books

M **CHATEAU RAMEZAY MUSEUM,** 280 Notre-Dame E, Montreal, PQ H2Y 1C5 Canada. Tel 514-861-7182; Fax 514-861-8317; Internet Home Page Address: www.chateauramezay.qc.ca; *Dir* Andre Delisle
Open Tues - Sun 10 AM - 4:30 PM, cl Mon, June 1 - Oct 1 daily 10 AM - 6 PM; Admis adults $6, seniors $5, students $4; Estab 1895 in residence of Claude de Ramezay (1705), governor of Montreal; Average Annual Attendance: 60,000; Mem: 200; dues life $1000, individual $40
Special Subjects: Period Rooms
Collections: Canadian drawings, furniture, paintings, prints & sculptures; 18th, 19th & 20th century collections; Indian collections; Period Rooms to Victorian Era
Activities: Classes for children; docent training; lect open to public & some for members only, 6 vis lectr per year; gallery talks; tours; sales shop sells books, reproductions, prints & slides
L **Library,** 280 Notre-Dame E, Montreal, PQ H2Y 1C5 Canada. Tel 514-861-7182; Fax 514-861-8317; Internet Home Page Address: www.chateauramezay.qc.ca; *Librn* Judith Berlyn
Open by appointment only; Estab for research & reference only; Circ Non-circulating
Library Holdings: Book Volumes 2200; Original Documents

M **CONCORDIA UNIVERSITY,** Leonard & Bina Ellen Art Gallery, 1400 de Maisonneuve Blvd W, Montreal, PQ H3G 1M8 Canada. Tel 514-848-4750; Fax 514-848-4751; *Dir & Cur* Karen Antaki; *Admin Asst* Jenny Calder-Lacroix
Open Mon - Fri 11 AM - 7 PM, Sat 1 - 5 PM; No admis fee; Estab 1962 for exhibitions of Canadian art, to provide a venue for a variety of significant touring exhibitions chosen from within the region & across Canada; to display the permanent collection, all with the idea of providing an important cultural arena both for the university & public alike; One gallery, 4111 sq ft with 328 running ft, located in University Library Pavillion; Average Annual Attendance: 66,000
Income: Financed by university & governmental funds
Purchases: Historic, modern & contemporary Canadian art
Special Subjects: Drawings, Prints, Sculpture, Pre-Columbian Art, Etchings & Engravings, Landscapes, Painting-Canadian
Collections: Modern & Contemporary Canadian art
Exhibitions: Edge & Image; ChromaZone; John MacGregor: A Survey; The Photographs of Professor Oliver Buell (1844-1910); Goodridge Roberts: The Figure Works; Figure Painting in Montreal 1935-1955; Sickert, Orpen, John & their Contemporaries at the New English Art Club; Robert Bordo: New York + Montreal; Conservation: To Care for Art; Undergraduate Student Exhibition; Recent Acquisitions to the Collection: Selections from the Concordia Collection of Art; Michael Jolliffe: Paintings; Phillip Guston: Prints; John Arthur Fraser: Watercolours; Brian Wood: Drawings & Photographs; Barbara Astman: Floor pieces; K M Graham: Paintings & Drawings 1971-1984; Robert Flaherty: Photographs; Work by Selected Fine Art Graduates: A 10th Anniversary Celebration; Joyce Wieland: A Decade of Painting; Francois Baillarge (1759-1830): A Portfolio of academic drawings; Faculty of Fine Arts Biennial; Murray MacDonald & R Holland Murray: Recent Sculptures; Jean Paul Lemieux: Honoured by the University; The Figurative Tradition In Quebec; Contemporary Works on Paper; Undergraduate Student Exhibition; Selections from the Concordia Collection of Art; Canadian Pacific Poster Art 1881-1955; Shelagh Keeley: Drawings; Bernard Gamoy: Paintings; Harold Klunder:Paintings; Marcel Bovis: Photographs; Neerland Art Quebec: an exhibition by artists of Dutch descent in Quebec; Canada in the Nineteenth Century: The Bert & Barbara Stitt Family Collection; Posters from Nicaragua; Betty Goodwin: Passages; Ron Shuebrook: Recent Work; Louis Muhlstock: New Themes & Variations 1980-1985; John Herbert Caddy 1801-1887; Expressions of Will: The Art of Prudence Heward; Riduan Tomkins: Recent Paintings; Undergraduate Student Exhibition; Selections

from the Concordia Collection of Art; Concordia: The Early Years of Loyola & Sir George Williams; Porcelain: Traditions of Excellence; Francois Houde: Glass Work; Shelley Reeves: Relics; Pre-Columbian Art from the Permanent Collection: Josef Albers: Interaction of Color; Brian McNeil: Ironworks; Robert Ayre: The Critic & the Collection; Claude-Philppe Benoit: Interieur, jour; A Decade of Collecting: A selection of Recent Acquisitions; Contemporary Montreal Sculpture & Installation from the Canada Council Art Bank: A Twentieth Anniversary Celebration; First Impressions: Views of the Natural History of Canada 1550-1850; Local Developments: 20th century Montreal Area Art from the Collection of the Universite de Montreal; Montreal Photo Album: Photographs from Montreal Archives; Joanne Tod: The (Dis) Order of Things; Undergraduate Student Exhibition; Temporal Borders: Image & Site; Faculty Exhibition; Alex Colville: Selected Drawings; Selections from the Permanent Collection; From the Permanent Collection: A Selection of Recent Acquisitions; Chris Cran; Tom Dean; Undergraduate Student Exhibition; Nina M Owens (1869-1959); In Habitable Places
Publications: Exhibition catalogues
Activities: Lect open to public, 3 vis lectr per year; originate traveling exhibitions

L **CONSEIL DES ARTS DU QUEBEC (CATQ),** (Conseil des Arts Textiles du Quebec (CATQ))Diagonale, Centre des arts et des fibres du Quebec, 5455 de Gaspe Ave, Spac 203 Montreal, PQ H2T 3B3 Canada. Tel 514-524-6645; Fax 514-524-7735; Internet Home Page Address: www.artdiagonale.org; *Pres* Natalie Rolland; *Coordr* Stephanie L'Heureux
Open Tues - Sat Noon - 5 PM; Estab 1980; Specialized in fiber art exhibits; Average Annual Attendance: 1,000
Income: $60,000 (financed by endowment & mem)
Purchases: $1100
Library Holdings: Book Volumes 800; Cassettes 10; Other Holdings Artist CV (textile); Periodical Subscriptions 17; Slides 1000; Video Tapes 13
Exhibitions: 4 - 6 exhibits a yr
Activities: Artist talks; conferences; artists residencies; Artist exchanges; Quebec Univ programs; organize traveling exhib to other nonprofit galleries across Canada, Quebec

A **GUILDE CANADIENNE DES METIERS D'ART QUEBEC,** Canadian Guild of Crafts Quebec, 1460 Sherbrooke St W, Ste B, Montreal, PQ H3G 1K4 Canada. Tel 514-849-6091; Fax 514-849-7351; Elec Mail info@canadianguild.com; Internet Home Page Address: www.canadianguild.com; Internet Home Page Address: www.canadianguildofcrafts.com; *Mng Dir* Diane Labelle
Open Tues - Fri 10 AM - 6:00 PM, Sat 10 AM - 5 PM; None; Estab 1906 to promote, encourage & preserve arts & crafts of Canada; Permanent Collection Gallery of Inuit & Indian Art; Exhibition Gallery; Average Annual Attendance: 30,000; Mem: 107; dues $30 & up; annual meeting in Mar/Apr
Income: Income from retail sales & donations
Library Holdings: Exhibition Catalogs; Periodical Subscriptions; Prints
Collections: Permanent collection of Inuit and Indian Arts and Crafts; Audio Video tapes
Exhibitions: Fine craft exhibitions every 5 weeks except Jan & Feb; Inuit & Indian Art (contemporary) twice a year
Activities: Educ dept; lect open to public, 6-8 vis lect per yr; gallery talks; tours; awards; individual paintings & original objects of art lent to accredited institutions; lending collection includes prints; sales shop sells books, original art, reproductions, prints & Canadian crafts

L **JARDIN BOTANIQUE DE MONTREAL,** Bibliotheque, 4101 Sherbrooke St E, Montreal, PQ H1X 2B2 Canada. Tel 514-872-1824; Fax 514-872-3765; Internet Home Page Address: www.montreal.qc.ca/jardin; *Botanist & Librn* Celine Arseneault
Open Mon - Sat 9 AM-4:30 PM, cl Sun; No admis fee; Estab 1931; For reference; Average Annual Attendance: 10,000
Income: Financed by city & donations
Library Holdings: Book Volumes 14,400; Cassettes 100; Other Holdings Posters 300; Periodical Subscriptions 495; Photographs; Slides 100,000; Video Tapes 200
Special Subjects: Landscape Architecture, Asian Art
Exhibitions: Rotate exhibitions once per yr

M **LA CENTRALE POWERHOUSE GALLERY,** 460 Sainte Catherine W, Rm 506, Montreal, PQ H3B 1A6 Canada. Tel 514-871-0268; Fax 514-871-9830; Elec Mail galerie@lacentrale.org; Internet Home Page Address: www.lacentrale.org; *Admin Coordr* Suzanne St. Denis; *Programming Coordr* Christine Dubois; *Communication Asst* Sandra Lynn Belanger; *Programming Asst* Jessica MacCormack
Open Tues - Sat Noon - 5 PM, cl Sun & Mon; No admis fee; Estab 1973 to promote & broadcast the work of women artists in all domains; Gallery has 1500 sq ft; Average Annual Attendance: 6,000; Mem: 35; dues subscribers $20, active $10; annual meeting in Sept
Income: $120,000 (financed by mem, grants from federal, provincial & city governments, corporate & private donations)
Exhibitions: 7 exhibitions per year; a mixture of local & other parts of the country, occasionally American
Publications: Exhibit catalogues
Activities: Lect open to public, 2-3 vis lectr per year; concerts; gallery talks; originate traveling exhibitions to Canadian Art Centers; sales shop sells catalogues & t-shirts

A **LA SOCIETE DES DESIGNERS D'INTERIOR DU QUEBEC,** Interior Designers Society of Quebec, 354 Notre Dame St W Rm 200, Montreal, PQ H2Y 1T9 Canada. Tel 514-284-6263; Fax 514-284-6112; Elec Mail sdiq@videotron.ca; *Dir* Sylvie Champeau
Open 9AM-4PM; Estab 1935 as a nonprofit professional association; Mem: 800; dues $320
Exhibitions: Traveling exhibitions in the Province of Quebec
Publications: Journal magazine, monthly; News Bulletin, 5 issues per year
Activities: Education Committee to improve the level of teaching in interior design; lect for members only, 5-8 vis lectr per year; book traveling exhibitions

M LE MUSEE MARC-AURELE FORTIN, 118 St Pierre, Montreal, PQ H2Y 2L7
Canada. Tel 514-845-6108; Fax 514-845-6100; Internet Home Page Address:
www.nafaglobetrotter.net; *Asst to Dir* Marcelle Trudeau; *Dir* Rene Buisson
Open 11 AM - 5 PM, cl Mon; Admis $4, seniors & students $2, children under 12
free; Estab 1984; Average Annual Attendance: 15,000; Mem: 400; dues individual
$30, family $50
Income: $100,000 (financed by endowment, mem & sales of reproductions)
Purchases: $45,000
Exhibitions: Marc-Aurele Fortin; Professional Book-Binding; rotate 2-4
exhibitions per yr
Activities: Lect open to public

M MAISON SAINT-GABRIEL MUSEUM, 2146 Dublin Pl, Montreal, PQ H3K
2A2 Canada. Tel 514-935-8136; Fax 514-935-5692; Elec Mail
msgrcip@globetrotter.net; Internet Home Page Address:
www.maisonsaint-gabriel.qc.ca
Group tours Tues-Sat 2:30 & 3:30PM, Sun 1:30, 2:30, 3:30 & 4PM; Admis adults
$5, students with ID $4; Estab 1966
Special Subjects: Sculpture, Crafts, Furniture, Embroidery
Collections: Antique Tools, Embroidery, Paintings & Sculpture; Furniture, Crafts
& Upholstery of 18th & 19th centuries located in a 17th century house
Exhibitions: From Root Cellar to Attic; Laces & Embroideries

M MCCORD MUSEUM OF CANADIAN HISTORY, 690 Sherbrooke St W,
Montreal, PQ H3A 1E9 Canada. Tel 514-398-7100; Elec Mail
info@mccord.lan.mcgill.ca; Internet Home Page Address:
www.mccord-museum.qc.ca; *Cur Costume* Cynthia Cooper; *Cur Costume*
Jacqueline Beaudoin-Ross; *Dir Develop* Elizabeth Kennell; *Dir Coll Management*
Nicole Vallieres; *Dir Coll & Res* Morra McCaffrey; *Cur Decorative Arts* Conrad
Graham; *Archivist* Suzanne Morin; *Exec Dir* Dr Victoria Dickenson
Open Tues - Fri 10 AM - 6 PM, Sat & Sun 10 AM - 5 PM, cl Mon; Admis family
$17, adults $8.50, sr citizens $6, students $4, children 6-12 $2, children under 6
free; Estab 1919 as a museum of Canadian Ethnology & Social History; Average
Annual Attendance: 100,000; Mem: 1400
Income: Financed by mems, government & donations
Special Subjects: Drawings, Graphics, Ethnology, Costumes, Ceramics, Folk Art,
Etchings & Engravings, Landscapes, Decorative Arts, Manuscripts, Eskimo Art,
Painting-Canadian, Dolls, Furniture, Glass, Jewelry, Metalwork, Painting-British,
Painting-French, Historical Material, Maps, Miniatures, Embroidery, Laces,
Cartoons
Publications: Exhibition catalogs & monographs; guides to collections for
children
Activities: Classes for adults & children; docent training; lect open to public, 2-3
vis lectr per year; concerts; gallery talks; tours; competitions; scholarships offered;
individual paintings & original works of art lent to other museums; book traveling
exhibitions 3 per year; originate traveling exhibitions to other museological
institutions in Canada; museum shop sells books, original art, reproductions, prints
& giftware

MCGILL UNIVERSITY
L Blackader-Lauterman Library of Architecture and Art, Tel 514-398-4743; Fax
514-398-6695; Elec Mail marilyn.berger@mcgill.ca; Internet Home Page Address:
www.mcgill.ca/blackader; *Librn* Mrs M Berger
Open winter 9 AM - 5 PM, summer 9 AM - 5 PM, Sat 12 PM - 4 PM; Estab
1922 to establish a special collection of architectural material
Library Holdings: Book Volumes 97,000; CD-ROMs 70; Exhibition Catalogs;
Other Holdings Drawings 223,241; Pamphlets; Periodical Subscriptions 317;
Photographs 25,000
Collections: Canadian Architecture Collection
Publications: The Libraries of Edward & W S Maxwell in the Collection of the
Blacker-Lauterman; Moshe Safdie: Buildings & Projects, 1967-1992; Sources in
Iconography: An Annotated Bibliography

M MONTREAL MUSEUM OF FINE ARTS, PO Box 3000, Sta H, Montreal, PQ
H3G 2T9 Canada. Tel 514-285-1600; Fax 514-844-6042 (pub relations); Elec Mail
webmaster@mbamtl.org; Internet Home Page Address: www.mmfa.qc.ca; *Cur
Contemporary Art* Stephane Aquin; *Cur Old Master, Prints & Drawings* Hilliard T
Goldfarb; *Dir Admin* Paul Lavallee; *Cur Canadian Art* Jacques Des Rochers; *Dir*
Guy Cogeval; *Chief Conservator* Natalie Bondil; *Cur Non-Canadian Decorative
Arts* Rosalynd Pepall; *Dir Communications* Danielle Champagne
Open Tues & Thurs - Sun 11 AM - 5 PM, Wed 11 AM - 9 PM, cl Mon;
Permanent collection; no admis fee; Temporary exhibits; adults $12, students &
seniors $6, children 2-12 $3; Estab 1860 as an art assoc for the exhibition of
paintings; mus estab 1916; Average Annual Attendance: 275,000; Mem: dues
$7-$50; annual meeting in Sept
Income: Financed by endowment, mem & provincial appropriation
Library Holdings: Exhibition Catalogs
Special Subjects: Drawings, American Western Art, Bronzes, African Art,
Archaeology, Ceramics, Etchings & Engravings, Decorative Arts, Eskimo Art,
Furniture, Glass, Asian Art, Antiquities-Byzantine, Carpets & Rugs, Baroque Art,
Embroidery, Antiquities-Oriental, Antiquities-Persian, Antiquities-Egyptian,
Antiquities-Greek, Antiquities-Roman, Gold, Antiquities-Etruscan, Enamels,
Antiquities-Assyrian
Collections: Collection of African art by Fr Gagnon; Chinese, Near Eastern,
Peruvian, Inuit primitive art; Saidye and Samuel Bronfman Collection of
Contemporary Canadian art; European decorative arts; French, Spanish, Dutch,
British, Canadian and other schools; Japanese incense boxes; The Parker Lace
Collection; Harry T Norton Collection of ancient glass; Lucile Pillow Collection
of porcelain; decorative arts, painting, sculpture from 3000 BC to the present
Exhibitions: Rotating exhibitions
Publications: Collage (a calendar of events)
Activities: Classes for adults & children; lect open to public; museum shop sells
books, magazines, original art, reproductions, prints
L Library, CP 3000, Succursale H, Montreal, PQ H3G 2T9 Canada. Tel
514-285-1600; Fax 514-285-5655; Elec Mail biblio@mbamtl.org; *Head Librn*
Joanne Dery; *Librn Periodicals* Therese Bourgault; *Library Technician* Diane
Fournier; *Library Technician* Anne-Marie Cinq-Mars

Open 11 AM - 4:45 PM, cl Mon; Estab 1882 for a reference & research centre for
art students, specialists & visitors; Open for reference to students, scholars,
teachers, researchers & general public
Library Holdings: Auction Catalogs 57,824; Audio Tapes; Book Volumes 77,671;
CD-ROMs; Cassettes; Clipping Files; Exhibition Catalogs; Fiche; Manuscripts;
Other Holdings Vertical files 17,069; Pamphlets; Periodical Subscriptions 875;
Photographs; Slides 40,496; Video Tapes 110
Special Subjects: Art History, Decorative Arts, Drawings, Sculpture,
Painting-Canadian
Collections: Canadiana

M MUSEE D'ART CONTEMPORAIN DE MONTREAL, 185 Saint Catherine St
W, Montreal, PQ H2X 1Z8 Canada. Tel 514-847-6226; Fax 514-847-6293;
Internet Home Page Address: www.macm.org; *Cur-in-Chief* Paulette Gagnon;
Traveling Exhib Officer E Meren Garcia; *Dir* Marcel Brisebois
Open Tues, Thurs - Sun 11 AM - 6 PM, Wed 11 AM - 9 PM; Admis adults $6;
Estab 1964. Conservation & information about contemporary art are the most
important aspects of the mus; also to present contemporary artists to the general
pub; Building is a medium-sized four-story, art mus, with an exhibition area of
2800 sq meters divided in eight galleries & a Multimedia room; Average Annual
Attendance: 150,000
Income: Financed by provincial grants
Collections: Contemporary Art - Canadian, international & Quebecois: drawings,
engravings, installations, paintings, photographs, sculptures, videos
Publications: Catalogs of exhibitions
Activities: Classes for adults & children; lect open to public, 15 vis lectr per year;
concerts; gallery talks; tours; competitions; exten dept through Quebec province;
originate traveling exhibitions; sales shop sells books & magazines
L Mediatheque, 185 Saint Catherine St W, Montreal, PQ H2X 1Z8 Canada. Tel
514-847-6906; Fax 514-864-9844; Internet Home Page Address:
www.macm.qu.ca; *Librn* Michelle Gauchier
Open Tues, Wed, Thurs & Fri 11 AM - 4:30 PM; Estab 1965; Circ
Non-circulating; For reference only
Income: Partially financed by Quebec Government
Purchases: $22,000
Library Holdings: Audio Tapes 250; Book Volumes 30,015; Cassettes; Clipping
Files 8332; Exhibition Catalogs 25,644; Framed Reproductions; Kodachrome
Transparencies; Motion Pictures; Periodical Subscriptions 359; Photographs;
Records; Slides 40,000; Video Tapes 325
Special Subjects: Art History, Mixed Media, Etchings & Engravings, Graphic
Arts
Collections: Archives of Paul-Emile Borduas (Painter 1905-1960); about 12,500
items including writings, correspondence, exhibition catalogs, etc

A SAIDYE BRONFMAN CENTRE FOR THE ARTS, Liane & Danny Taran
Gallery, 5170 Cote Sainte Catherine Rd, Montreal, PQ H3W 1M7 Canada. Tel
514-739-2301; Fax 514-739-9340; Elec Mail gallery@saidyebronfman.org; Internet
Home Page Address: www.saidyebronfman.org/gallery/g_home.html; *Asst Dir*
Katia Meir; *Exec Dir* David Moss; *Cur* Sylvie Gilbert; *Exec Dir (SBC)* John
Hobday; *Dir/Cur (gallery)* Renee Baert; *Asst to Dir/Cur* Meredith Carruthers
Open Mon - Thurs 9 AM - 9 PM, Fri 9 AM - 2 PM, Sun 10 AM - 5 PM, cl Sat;
No admis fee; Estab 1967 as a nonprofit cultural centre for the promotion &
dissemination of contemporary arts; 3000 sq ft gallery; Average Annual
Attendance: 90,000
Income: Financed by government grants
Exhibitions: Five major exhibitions per year, special interest in contemporary art,
local, national & international
Publications: Exhibition catalogs
Activities: Classes for adults & children; lect open to public, 6-12 vis lectr per
year; gallery talks; tours; originate traveling exhibitions; sales shop sells exhib
catalogues

M SAINT JOSEPH'S ORATORY, Museum, 3800 Queen Mary Rd, Montreal, PQ
H3V 1H6 Canada. Tel 514-733-8211; Fax 514-733-9735; Elec Mail
musee@saint-joseph.org; Internet Home Page Address: www.saint-joseph.org;
Artistic Cur Father Andre Bergeron, CSC; *Oratory Rector* Claude Grov, CSC
Open daily 10 AM - 5 PM (museum); Admis contributions welcomed; Shrine
founded 1904, estab 1953 as art mus; St Joseph's Oratory is also a Montreal
landmark, the highest point in this city (856 ft above sea level), a piece of art -
architecture - with a history, style, etc of its own
Library Holdings: Cards; Pamphlets
Special Subjects: Decorative Arts, Drawings, Textiles, Bronzes, Painting-French,
Sculpture, Graphics, Photography, African Art, Religious Art, Posters, Eskimo Art,
Painting-Canadian, Porcelain, Silver, Ivory, Coins & Medals, Miniatures,
Embroidery, Mosaics, Painting-German
Collections: Ancient & Contemporary Art; Nativity Scenes from around the world
Exhibitions: Christmas Exhibition; Sacred Art Exhibition; Les Creches Du Monde
Publications: 290 Nativity Scenes from 110 Countries
Activities: Concerts; films
L Library, 3800 Queen Mary Rd, Montreal, PQ H3V 1H6 Canada. Tel
514-733-8211, Ext 2341; Fax 514-733-9735; Elec Mail biblio@saint-joseph.org;
Internet Home Page Address: www.saint-joseph.org; *Librn* Annick Robert
Open Mon - Fri 8:30 AM - 4:30 PM; Open to pub for use on the premises & for
interlibrary loan
Library Holdings: Book Volumes 100,000; Photographs

A SOCIETE DES MUSEES QUEBECOIS, CP8888, Succursale Centre Ville,
UQAM, Montreal, PQ H3C 3P8 Canada. Tel 514-987-3264; Fax 514-987-3379;
Elec Mail info@smq.uqam.ca; Internet Home Page Address:
www.museumsquebec.ca; *Dir* Michel Perron
Open daily 9 AM - Noon & 1 - 5 PM; Estab 1958; Mem: Annual meeting in Oct
Income: $900,000 (financed by pub grants & sponsorships)
Publications: Musees, once a year; Bulletin, 2 times a year; Museums to
Discover, Quebec & Series of Electronic Guides / Museum Guide (2006)
Activities: Classes for museum works; lect open to public; museum shop sells
books & magazines

M **THE STEWART MUSEUM,** (David M Stewart) The Fort, St Helen's Island, PO Box 1200, Sta A Montreal, PQ H3C 2Y9 Canada. Tel 514-861-6701; Fax 514-284-0123; Elec Mail courriel@stewart-museum.org; Internet Home Page Address: www.stewart-museum.org; *Cur* Guy Vadeboncoeur; *Dir* Bruce D Bolton; *Librn* Eileen Meillan; *Dir of Communications* Sylvia Deschenes
Open summer daily 10 AM - 6 PM, off season 10 AM - 5 PM, cl Tues; Admis $7 adults, $5 children & seniors, group & family rates available; Estab 1955 to exhibit artifacts relating to Canada's history; Located in an old British Arsenal, built between 1820-24; galleries cover theme chronologically & by collection; Average Annual Attendance: 75,000; Mem: 100; dues $30; annual meeting in May
Income: $2,000,000 (financed by grants & self generated sources)
Library Holdings: Book Volumes 8156; Maps 704; Original Art Works; Original Documents 407; Pamphlets 62; Periodical Subscriptions 50; Photographs; Prints; Reproductions; Slides; Video Tapes 97
Special Subjects: Drawings, Etchings & Engravings, Marine Painting, Metalwork, Portraits, Ethnology, Decorative Arts, Glass, Historical Material, Miniatures, Pewter, Military Art
Collections: Firearms; Kitchen & Fireplace, dating from 16th century; prints; maps, navigation & scientific instruments
Exhibitions: (2001) In Search of Paradise: The South Pacific with Cook and Bongainville
Publications: Exhibition catalogs
Activities: Classes for children; during summer months 18th century military parades by La Compagnie Franche de la Marine & the 78th Fraser Highlanders; concerts; tours; originate traveling exhibitions to interested museums; Mus shop sells books, reproductions, prints & slides
L **Library,** The Fort, Ile Sainte-Helene, PO Box 1200, Sta A Montreal, PQ H3C 2Y9 Canada. Tel 514-861-6701; Fax 514-284-0123; Elec Mail ntrudel@stewart-museum.org; Internet Home Page Address: www.stewart-museum.org; *Cur, Library Coll* Normand Trudel
Open Mon - Fri 9 AM - 5 PM; Estab 1955 as an 18th century gentleman's library; Library of rare books & rare maps open to researchers & members for reference
Library Holdings: Book Volumes 8156; CD-ROMs; DVDs; Manuscripts; Maps 704; Original Art Works; Original Documents; Pamphlets; Periodical Subscriptions 50; Photographs; Prints 3501; Reproductions; Slides; Video Tapes
Special Subjects: Maps
Collections: Coll of rare books, maps, documents & prints
Publications: Exhibition catalogs
Activities: Mus shop sells books & reproductions

C **UNITED WESTURNE INC,** Art Collection, Ville Saint Laurent, 505 Locke St Montreal, PQ H4T 1X7 Canada. Tel 514-342-5181; Fax 514-342-5181; *Chmn* Herbert Chervrier; *Exec Asst Finance & Admin* Carol Valiquette
Open Mon - Fri 8 AM-5 PM; Estab 1977; Mem: 250
Collections: Sculptures, mixed media, works on canvas, works on paper
Publications: Selections from the Westburne Collection
Activities: Individual paintings & original objects of art lent

L **UNIVERSITE DE MONTREAL,** Bibliotheque d'Amenagement, 5620 Darlington, Montreal, PQ Canada; 5620 Darlington, C P 6128 Succ Centre Montreal, PQ H3C 3S9 Canada. Tel 514-343-7177; Fax 514-343-5698; Internet Home Page Address: www.umontreal.ca; *Chef de Bibliotheque* Marc Joanis; *Aggregate Prof* Esma Aimeur; *Aggregate Prof* El Mostapha Aboulhamid; *Aggregate Prof* Yoshua Bengio; *Aggregate Prof* Gregor Bochmann; *Assoc Prof* Raouf Boutaba; *Aggregate Prof* Michel Boyer; *Prof* Gilles Arm-band; *Reprocessed Prof* Paul Bratley; *Prof* Eduard Cerny; *Assoc Prof* Claude Crepeau; *Assoc Prof* Teodor Crainic; *Titular Prof* Rachida Dssouli; *Asst Prof* Nadia El Mabrouk; *Aggregate Prof* Marc Feeley; *Prof* Jacques A Ferland; *Assoc Prof* Paola Flocchini; *Prof* Michael Florian; *Prof* Claude Frasson; *Assoc Prof* Jan Gecsei; *Prof* Michel Gendreau; *Asst Prof* Bernard Gendron; *Assoc Prof* Abdelhakim Hafid; *Aggregate Prof* Gena Hahn; *Assoc Prof* Alain Hertz; *Asst Prof* Balazs Kegl; *Assoc Prof* Marc Kaltenbach; *Aggregate Prof* Rudolf K Keller; *Aggregate Prof* Peter Kropf; *Prof, Head Computational Finance* The Rider; *Prof* Guy Lapalme; *Prof* Francois Lustman; *Aggregate Prof* Francois Major; *Assoc Prof* Jacques Malenfant; *Prof* Patrice Marcotte; *Prof* Pierre Mckenzie; *Incorporated Prof* Jean Miller; *Assoc Prof* Philippe Michelon; *Asst Prof* Max Mignotte; *Prof, Dir* Blood Nguyen; *Aggregate Prof* Jian-Yun Deny; *Assoc Prof* Roger Nkambou; *Aggregate Prof* Victor Ostromoukhov; *Assoc Prof* Alexander Petrenko; *Prof* Jean-Yves Potvin; *Aggregate Prof* Pierre Poulin; *Prof* Jean-Marc Rousseau; *Asst Prof* Sebastien Roy; *Asst Prof* Houari Sahraoui; *Assoc Prof* Xiaoyu Song; *Prof* Neil F Stewart; *Aggregate Prof* Felisa J Vazques-abad; *Prof* Jean Vaucher; *Assoc Prof* Doors Zubieta
Estab 1964
Purchases: $100,000
Library Holdings: Audio Tapes; Book Volumes 46,484; Clipping Files; Exhibition Catalogs; Fiche; Filmstrips; Periodical Subscriptions 520; Photographs; Records; Slides 59,115; Video Tapes
Special Subjects: Landscape Architecture, Industrial Design, Architecture
Collections: Rare books; History of Landscape Architecture

L **UNIVERSITE DU QUEBEC,** Bibliotheque des Arts, CP 8889, Succursale Centreville, Montreal, PQ H3C 3P3 Canada. Tel 514-987-6134; Fax 514-987-0262; *Dir* Daphne Dufresne; *Reference Librn* Patricia Black
Library Holdings: Book Volumes 65,000; CD-ROMs; Clipping Files; Exhibition Catalogs; Periodical Subscriptions 500; Slides
Special Subjects: Painting-American, Pre-Columbian Art, Sculpture, Watercolors, Advertising Design, Art Education, Video, Primitive art, Eskimo Art, Religious Art, Restoration & Conservation, Silver, Woodcarvings, Woodcuts, Architecture

POINTE CLAIRE

A **POINTE CLAIRE CULTURAL CENTRE,** Stewart Hall Art Gallery, Stewart Hall, 176 Bord du Lac Pointe Claire, PQ H9S 4J7 Canada. Tel 514-630-1254; Fax 514-630-1285; Elec Mail millarj@ville.pointe-claire.qc.ca; *Dir Art Gallery* Joyce Millar; *Prog Dir* Micheline Belanger; *Gallery Asst* Amanda Johnston; *Gallery Asst* Alexandra Hofmaenner
Open Mon & Wed 1 - 5 PM & 7 - 9 PM, Tues, Thurs & Fri 1 - 5 PM, Sat & Sun 1 - 5 PM, cl Sat after June 24 & Sun after June 1 for summer; No admis fee;

Estab 1963; Gallery is 25 x 120 ft; Average Annual Attendance: 11,000; Mem: Policy & Planning Board meets 6 times per year
Income: Financed by endowment & city appropriation
Purchases: Contemporary Canadian Art for city of Pointe Claire permanent collection
Collections: Permanent collection of contemporary Canadian art
Exhibitions: Approximately ten per year, local, provincial, national and international content
Publications: Bulletins; schedules of classes, study series, social events, approximately 30 per year
Activities: Classes for children; docent training; lect open to the public, 8-10 vis lectr per year; concerts, gallery talks, tours; lending collection contains framed reproductions, original prints, paintings & crafts to pvt and corporate clients; mus shop sells original art, reproductions, objets d'art

QUEBEC

M **L'UNIVERSITE LAVAL,** Ecole des Arts Visuels, Edifice La Fabrique, Quebec, PQ G1K 7P4 Canada. Tel 418-656-7631; Fax 418-656-7678; Internet Home Page Address: www.ulaval.ca; *Dir* Claude Debe'
Open Mon - Fri 8:30 AM - 7 PM; No admis fee; Estab 1970
Special Subjects: Graphics, Sculpture, Decorative Arts, Painting-Canadian
Collections: Art color slides, decorative arts, graphics, paintings, sculpture
Exhibitions: Temporary exhibitions, changing monthly
Activities: Originate traveling exhibitions organized & circulated
L **Library,** Cite' Universitaire, Quebec, PQ G1K 7P4 Canada. Tel 418-656-2131, Ext 3451; Fax 418-656-7897; Internet Home Page Address: www.vol.laval.org; *Dir Art* Madeleine Robin; *Dir General Library System* Claude Bonnelly
Open Mon-Fri 8:30 - 11 PM; Open to the pub for use on the premises; original prints & works of art available for loan
Library Holdings: Book Volumes 25,000

M **LA CHAMBRE BLANCHE,** 185 Christophe-Colomb E, Quebec, PQ G1K 3S6 Canada. Tel 418-529-2715; Fax 418-529-0048; Elec Mail info@chambreblanche.qc.ca; Internet Home Page Address: www.chambreblanche.qc.ca; *Production Coordr* Francois Vallee; *Programming Coordr* Maude Levesque; *Technician* Christophe Viau; *Documentalist* Marie-Helene Audet; *Technician* Hugo-Lupin Catellier
Open daily 1 - 5 PM; No admis fee; Estab 1978 for diffusion of installation & in situation art, web art lab; Mem: 125
Income: Financed by Canada Art Council, Quebec Art Council & Town of Quebec City
Publications: Annual bulletin; Lani Maestro; Residence 1982-1993; Temporalité; Jamelie Hassan; Sur les taits
Activities: Lect open to public, 4-5 vis lectr per year; competitions with awards; museum shop sells books and museum publs

L **LES EDITIONS INTERVENTION, INTER-LE LIEU,** Documentation Center, 345 Du Pont, Quebec, PQ G1K 6M4 Canada. Tel 418-529-9680; Fax 418-529-6933; Elec Mail lelieu@total.net; *Coordr* Richard Martel; *Inter Mag Mgr* Nathalie Perrault
Open daily 10 AM - 4 PM, cl Sat & Sun unless exhibitions showing; Estab 1978; For reference, possible lending & magazine exchanges; Average Annual Attendance: 10,000; Mem: Dues $20 & up
Income: Financed by pub funds, donations & mem
Special Subjects: Constructions, Mixed Media, Photography, Conceptual Art, Video, American Indian Art, Architecture
Exhibitions: Rotate 8 per yr
Publications: Inter, Art Actuel, 3 per year
Activities: Lect open to public, 3 vis lectr per year

M **MUSEE DE L'AMERIQUE FRANCAISE,** 2 Cote de la Fabrique, Quebec, PQ G1R 4R7 Canada; 16 rue de la Barricade, CP 155, Succ B Quebec, PQ G1K 7A6 Canada. Tel 418-692-2843; Fax 418-692-5206; Internet Home Page Address: www.mcq.org; *Conservation & Management Dir* Danielle Poire; *Registrar* Sonia Mimeault; *Coll & Research* Andree Gendreau; *General Dir* Claire Simard
Open daily from June 24 - Labor Day 9:30 AM - 5 PM, Day after Labor Day - June 23 Tues - Sun 10 AM - 5 PM, Nov 1 -May 31 free on Tues; Admis adult $5, senior citizen $4, students $3, children 12-16 $2, under 11 free; The Musee de l'Amerique francaise has been integrated to the Musee de la civilisation since 1995. The Musee de la civilisation is subsidized by the ministere de la Culture et des Communications, Gouvernement du Quebec; Average Annual Attendance: 100,000; Mem: dues $25
Income: Financed by Ministere, Gouvernement du Quebec, Gouvernement Federal
Collections: 18th & 19th centuries Canadian paintings; 17th & 18th centuries European paintings; Ethnology; Gold & Silver Objects; Scientific Instruments; Sketches & Prints; Sculpture; Coins & Medals; Zoology
Exhibitions: Amerique francaise (The Settling of French America); Histoire des Collections du Seminaire de Quebec (The History of the Collections Seminaire de Quebec); Bringing Nature into the Future, until 3/25/2007
Activities: Lect open to public; concerts; gallery talks; tours; sales shop sells books, magazines, prints & slides

M **MUSEE DES AUGUSTINES DE L'HOTEL DIEU DE QUEBEC,** 32 rue Charlevoix, Quebec, PQ G1R 5C4 Canada. Tel 418-692-2492; *Dir Mus* Sr Nicole Perron; *Guide* Jacques St-Arnaud
Open Tues - Sat 9:30 AM - Noon & 1:30 - 5 PM, Sun 1:30 - 5 PM; No admis fee, donations appreciated; Estab 1958 in the Monastere des Augustines (1695); The Hotel Dieu relives three centuries of history of the French Canadian people; Average Annual Attendance: 11,000
Special Subjects: Drawings, Photography, American Indian Art, African Art, Religious Art, Ceramics, Pottery, Manuscripts, Painting-European, Portraits, Dolls, Furniture, Glass, Porcelain, Painting-French, Coins & Medals, Calligraphy, Painting-Flemish, Period Rooms, Embroidery, Painting-Spanish, Painting-Italian, Leather

Collections: Antique furniture; embroideries; medical instruments 17th-20th century; objects from everyday life, models & several other unique works; paintings; silver & pewter artifacts
Activities: Original objects of art lent to museums

L **Archive,** 32 rue Charlevoix, Convent Office Quebec, PQ G1R 5C4 Canada. Tel 418-692-2492, Ext 247; Fax 418-692-2668; *Archivist* Sr Marie-Paule Couchon; *Dir Mus* Sr Nicole Perron
Open by appointment only; Religious & medical books available for research upon special request
Library Holdings: Book Volumes 4000

M **MUSEE DU QUEBEC,** Parc des Champs-de-Bataille, Quebec, PQ G1R 5H3 Canada. Tel 418-643-2150; Fax 418-646-3330; Elec Mail webmdq@mdq.org; Internet Home Page Address: www.mdq.org; *Exec Dir* John R Porter; *Cur Early Quebec Art 1850-1900* Mario Beland; *Cur Contemporary Art* Michel Martin; *Dir Admin & Communication* Marc Delaunay; *Cur Modern Art* Michele Grandbois; *Dir Exhibs & Educ* Line Ouellet; *Dir Reseach & Coll* Yves LaCasse; *Cur Early Quebec Art before 1850* Daniel Drovin; *Cur Contemporary Art & Prêt doeuvres d'art Coll* Annemarie Winacs
Open (June 23 - Sept 8) daily 10 AM - 5 PM, (Sept 9 - May 31) Tues - Sun 10 AM - 5 PM, cl Mon; Admis $10; Estab 1933 under Government of Province of Quebec; 12 galleries, 1 restaurant, 1 theatre; Average Annual Attendance: 300,000
Income: Financed by Quebec government appropriation
Purchases: $60,000
Library Holdings: Auction Catalogs; Audio Tapes; Book Volumes; CD-ROMs; Cards; Cassettes; Clipping Files; Compact Disks; DVDs; Exhibition Catalogs; Fiche; Filmstrips; Framed Reproductions; Prints
Special Subjects: Drawings, Painting-American, Photography, Sculpture, Bronzes, Woodcarvings, Decorative Arts, Portraits, Painting-Canadian
Collections: Quebec art from 18th century to present; Design, drawings, goldsmith's work, paintings, photography, sculpture, tapestry works; European art
Exhibitions: Rotating exhibitions
Publications: Exhibit catalogs
Activities: Classes for adults & children; lect open to public; concerts; gallery talks; tours; schol offered; exten dept serves province of Quebec; individual paintings lent to government; organize traveling exhibs; museum shop sells books, magazines, original art, reproductions, prints & postcards; junior museum

L **Bibliotheque,** Parc des Champs-de-Bataille, Quebec, PQ G1R 5H3 Canada. Tel 418-644-6460 ext 3341; Fax 418-646-3330; Elec Mail bibliom@mdq.org; Internet Home Page Address: www.mdq.org; *Asst Librn* N Gastonguay; *Asst Librn* Lina Doyon; *Dir Research & Coll* Yves Lacasse
Open only by appointment; Estab 1933
Income: $100,000 (financed by Quebec government appropriation)
Purchases: $55,000
Library Holdings: Auction Catalogs; Audio Tapes 144; Book Volumes 28,600; CD-ROMs 52; Clipping Files 19,000; Compact Disks 23; Exhibition Catalogs; Fiche; Other Holdings CD-Rom; Periodical Subscriptions 126; Photographs; Reels; Slides 58,000; Video Tapes 423
Special Subjects: Art History, Decorative Arts, Photography, Art Education, Painting-Canadian

M **VU CENTRE D'ANIMATION ET DE DIFFUSION DE LA PHOTOGRAPHIE,** 523 Saint Zallirsaast, Quebec, PQ G1K 3A9 Canada. Tel 418-640-2585; Elec Mail vuphoto@meduse.org; Internet Home Page Address: www.meduse.org/vuphoto; *Coordr* Alain Belanger; *Dir* Marie-Lucei Creteau
Open Thurs - Sun 1 - 5 PM; Estab 1982; Gallery contains exhibition area, studio & darkroom; Average Annual Attendance: 15,000; Mem: 200
Income: $200 (financed by endowment, mem, city appropriation & special events)
Activities: Classes for adults; workshop; lect open to public, 5 vis lectr per year; book traveling exhibitions annually; originate traveling exhibitions

RIMOUSKI

M **LE MUSEE REGIONAL DE RIMOUSKI,** Centre National d'Exposition, 35 W St Germain, Rimouski, PQ G5L 4B4 Canada. Tel 418-724-2272; Fax 418-725-4433; Internet Home Page Address: www.museederimouski.qu.ca; *Conservator Contemporary Art* Jocelyn Fortin; *Dir Museum* Carl Johnson
Open Sept - June Wed - Sun Noon - 5 PM, Thurs Noon - 9 PM; Admis family $10, adults $4, students & senior citizens $3, children 5 & under free; Estab 1972 for the diffusion of contemporary art, historic & scientific exhibitions; to present local, national & international exhibitions & organize itinerant exhibitions; An old church, built in 1823, now historical monument, completely restored inside with three floors of exhibitions; Average Annual Attendance: 15,000; Mem: 400; dues $40; annual meeting in May or June
Income: $237,000 (financed by federal, provincial & municipal appropriation)
Exhibitions: Scientific Exploration of the Sea
Publications: L'Esprit des lieux; L'Artiste au jardin; Messac; Opera, Les Nuits de Vitre; Cozic; exhibit catalogs
Activities: Classes for children; school programs; lect open to public, 5 vis lectr per year; concerts; gallery talks; tours; originate traveling exhibitions; museum shop sells magazines

L **Library,** 35 W St Germain, Rimouski, PQ G5L 4B4 Canada. Tel 418-724-2272; Fax 418-725-4433; Internet Home Page Address: www.museederimouski.qu.ca; *Dir Museum* Carl Johnson
Circ Non-circulating; Open to pub for reference, call for seasonal hours, cl statutory holidays
Library Holdings: Book Volumes 2500; Exhibition Catalogs; Other Holdings Documents 800; Pamphlets; Reproductions; Sculpture

SAINT-LAURENT

M **MUSEE D'ART DE SAINT-LAURENT,** 615 Sainte Croix Ave, Saint-Laurent, PQ H4L 3X6 Canada. Tel 514-747-7367; Fax 514-747-8892; *Pres* Jean Royer; *Mus Guide* Chantal Kodoin; *Dir* Johane Canning-LaCroix
Open Tues - Sun 12:30 - 5 PM; Admis family $6, adult $3, senior citizen & student $2, under 6 free, no admis fee Wed; Estab 1962 to didactic exhibitions of

traditional arts & crafts of Quebec; Mus situated in a Gothic chapel of the Victorian period, built in 1867 in Montreal & moved to Saint-Laurent in 1930. Besides its permanent collection, the mus presents periodical exhibitions illustrating various aspects of the Quebec cultural heritage; Average Annual Attendance: 20,000
Income: Financed by memberships, provencial and municipal appropriations, fund raising
Special Subjects: American Indian Art, Textiles, Ceramics, Folk Art, Woodcarvings, Furniture, Silver, Metalwork
Collections: Traditional & folk art of French Canada from 17th - 19th century: ceramics, crafts, furniture, metalworks, paintings, sculpture, religious art, silver, textiles, tools & wood-carving
Exhibitions: Album: Email au Quebec: 1949 - 1989; La dentelle au fil des ans; Album: Un musee dans une eglise; Rotate every 3 months
Publications: Album: Images Taillees du Quebec; Album: Les eglises et le tresor de Saint Laurent; Album: Les cahiers du musee: Hommage a Jean Palardy; Les cahiers du musee: Premiere biennale de la reliure du Quebec; La main et l'outil; monthly calendar
Activities: Lect open to public; concerts; gallery talks; tours

SEPT-ILES

M **MUSEE REGIONAL DE LA COTE-NORD,** 500 boul Laure, Sept-Iles, PQ G4R 1X7 Canada. Tel 418-968-2070; Fax 418-968-8323; Elec Mail mrcn@mrcn.qc.ca; Internet Home Page Address: www.mrcn.qc.ca; *Educ* Christine Lebel; *Technician* Sophie Levesque; *Secy* Anne Lise Fillion; *Dir* Micheline Huard; *Conservateur* Steve Dubreuil
Open Tues - Fri 10 AM-5 PM, Sat & Sun 1-5 PM, cl Mon; Admis adult $5, sr citizens & students $4, children under 12 free; Estab 1975. Protects, preserves, studies & exhibits the heritage of the Cote-Nord region, with particular emphasis on fishing, hunting, mining & archaeological activity; Average Annual Attendance: 22,000; Mem: 150; annual meeting in June
Income: Financed by mem, city & state appropriation
Special Subjects: Drawings, Photography, Sculpture, Watercolors, Archaeology, Ethnology, Textiles, Ceramics, Pottery, Woodcarvings, Woodcuts, Landscapes, Portraits, Posters, Eskimo Art, Painting-Canadian, Furniture, Porcelain, Metalwork, Historical Material, Juvenile Art
Collections: Archaeology; art; ethnology; history
Activities: Classes for adults & children; docent programs; lect open to public; book traveling exhibitions 2 per year; sales shop sells books & prints

SHAWINIGAN

A **SHAWINIGAN ART CENTER,** 2100 des Hetres, CP 400 Shawinigan, PQ G9N 6V3 Canada. Tel 819-539-1888; Fax 819-539-2400; Internet Home Page Address: www.cdas.ca; *Dir* Robert Y Desjardins
Open Mon & Sun 1-5 PM, Wed & Sat 7-9 PM; No admis fee; Estab 1967; Gallery is maintained; Average Annual Attendance: 36,000
Income: Financed by city appropriation
Collections: Oils; pastels; watercolors; polyesters; reproductions; copper enameling; inks; sculpture; tapestries
Activities: Classes for adults & children; dramatic programs; concerts; lending collection contains original art works, original prints, paintings, sculpture, slides; sales shop sells original art

SHERBROOKE

M **UNIVERSITY OF SHERBROOKE,** Art Gallery, 2005 University Blvd Sherbrooke, PQ J1K 2R1 Canada. Tel 819-821-7748; Fax 819-820-1361; Elec Mail jbrouill@courrier.usherb.ca; *Dir* Johanne Brouillet
Open Mon - Fri 12:30 - 5 PM, Sat & Sun 1 - 5 PM; No admis fee; Estab 1964 to introduce pub to the best art work being done in Canada & to place this work in a historical (European) & geographical (American) context; Gallery has three exhibition areas totalling 12,800 sq ft on university campus & serves the community; Average Annual Attendance: 30,000
Income: $300,000 (financed by state & city appropriation & university funds)
Special Subjects: Graphics
Collections: 90 per cent Contemporary Graphics & Paintings Quebec & 10 per cent international
Publications: Monthly bulletin; catalogue
Activities: Lect open to public; 20 vis lectr per year; gallery talks; lending collection contains books, cassettes, color reproductions, Kodachromes, original prints, paintings, photographs, sculpture, slides & videos

SUTTON

M **COMMUNICATIONS AND HISTORY MUSEUM OF SUTTON,** (Eberdt Museum of Communications) South Sutton, PQ J0E 2K0 Canada. Tel 450-538-3222
Open Mon-Fri 9AM-5PM; Admis $2; Mem: 160; dues $10
Income: (financed by mem, city & state appropriation)
Special Subjects: Historical Material
Collections: History, art & communications collection; 2300 historic objects
Activities: Lect open to public; museum shop sells books

TROIS RIVIERES

M **FORGES DU SAINT-MAURICE NATIONAL HISTORIC SITE,** 10,000 des Forges Blvd, Trois Rivieres, PQ G9C 1B1 Canada. Tel 819-378-5116; Fax 819-378-0887; *Supt* Carmen D Le Page
Open May 8 - Oct 15 9 AM - 5 PM; Estab 1973 as the first iron & steel industry in Canada 1729-1883; 50 acres of land-2 main exhibition centers. The ironmaster's house & the blast furnace; Average Annual Attendance: 50,000

Special Subjects: Archaeology, Metalwork
Collections: Cast Iron Stoves from the 18th & 19th century; Metal objects found between 1973-1980
Exhibitions: Blast Furnace Permanent Exhibition

M **GALERIE D'ART DU PARC-MANOIR DE TONNANCOUR,** Manoir de Tonnancour, 864 rue des Ursulines, CP 871 Trois Rivieres, PQ G9A 5J9 Canada. Tel 819-374-2355; Fax 819-374-1758; Elec Mail galerie@galeriedart.duparc.qc.ca; Internet Home Page Address: www.galeriedartduparc.qc.ca; *Dir* Christiane Simoneau
Open Tues - Fri 10 AM-Noon & 1:30-5 PM, Sat & Sun 1-5 PM, cl Mon; No admis fee; Estab 1972 to promote visual arts; Nonprofit organization; 10-12 exhibitions in visual arts per year & permanent history exhibition; Average Annual Attendance: 19,000
Income: Financed by city appropriation & government
Exhibitions: Rotating exhibitions
Activities: Classes for adults & children; book traveling exhibitions 1 per year; originate traveling exhibitions; museum shop sells original art & reproductions

A **MAISON DE LA CULTURE CENTRE D'EXPOSITION RAYMOND-LASNIER,** (Centre Culturel de Trois Rivieres) 376 Ire des Soijes, CP 368 Trois Rivieres, PQ G9A 5H3 Canada. Tel 819-372-4611; Fax 819-372-4632; Elec Mail cdctr@v3r.net; Internet Home Page Address: www.v3r.net; *Dir* Michel Jutras; *Head Exhib* Louise Desaulniers
Open Thurs-Sun 12 - 17; No admis fee; Estab 1967 to promote visual art; Gallery features 1 50 x 35 ft room, 1 25 x 25 ft room; Average Annual Attendance: 12,000
Income: Financed by city appropriation & a corporation
Purchases: regular contacts with visual arts
Collections: 100 pieces
Publications: Exhib catalogues
Activities: Classes for adults & children; guided group visits; tours

VAUDREUIL

M **MUSEE REGIONAL DE VAUDREUIL-SOULANGES,** 431 Avenue St Charles, Vaudreuil, PQ J7V 2N3 Canada. Tel 450-455-2092; Fax 450-455-6782; Internet Home Page Address: www.mrds.qu.ca; *Dir* Daniel Bissonnette
Open Mon - Wed & Fri 9:30 AM - 4:30 PM, Thurs 7:30 - 9 PM, Sat & Sun 1 - 4:30 PM; Admis adults $3, children $1.50; Estab 1953, nonprofit organization subsidized by the Direction des Musees et Centres d'Exposition of the Ministere des Affaires culturelles du Quebec. The collection consists of artifacts & artists production that have & still illustrate the traditional way of life in the counties of Vaudreuil & Soulanges, the surroundings & the Province of Quebec; Mus has four rooms for permanent collection & one for temporary & traveling exhibitions. A documentation centre is open for searchers & students & an animator will receive groups on reservation for a commented tour; Average Annual Attendance: 13,000; Mem: 300; dues $20; annual meeting in Apr
Income: Financed by endowment
Special Subjects: Painting-American, Sculpture, Pottery, Portraits, Furniture
Collections: Edison Gramophone 1915; antique pottery; historic documents & material; farming; furniture, paintings, portraits, sculpture & woodworking
Exhibitions: Various exhibitions
Publications: Musee de Vaudreuil Catalog (selectif); Vaudreuil Soulanges, Western Gateway of Quebec
Activities: Classes for children; concerts; original objects of art lent
L **Centre d'Histoire d'la Presqu'ile,** 431 Avenue Chaud, Vaudreuil, PQ J7V 2N3 Canada. Tel 450-455-2092; Fax 450-455-6782; Internet Home Page Address: www.mrds.qu.ca; *Dir* Daniel Bissonnette
Open Mon-Fri 9:30 AM - 4:30 PM, cl Sat & Sun; Circ Non-circulating; Reference only
Library Holdings: Book Volumes 5200; Other Holdings AV cylinders 600; Photographs

SASKATCHEWAN

ALBERTA

M **IMHOFF ART GALLERY,** 4515 44th St Alberta, SK S9V 0T8 Canada; 4420 50th Ave Lloydminster, SK T9V 0W2 Canada. Tel 780-825-6184; Fax 306-825-9070; *Cur* Barbara McKeand
Open Wed - Fri Noon-5 PM, Sat & Sun 1-5 PM; Admis adults $4, students $3.50, children $1.50; Estab to exhibit 200 paintings done by Berthold Imhoff, who died in 1939; 1 large gallery
Income: Financed by municipal and provincial appropriations
Exhibitions: Rotating exhibits

ESTEVAN

M **ESTEVAN NATIONAL EXHIBITION CENTRE INC,** 118 Fourth St, Estevan, SK S4A 0T4 Canada. Tel 306-634-7644; Fax 306-634-2940; Elec Mail eagm@sasktel.net; Internet Home Page Address: www.eagm.ca; *Dir & Cur* Cheryl Andrist
Open Mon - Fri 8:30 AM - 4:30 PM, Sat & Sun 12:30 PM-3:30 PM; No admis fee; Estab 1978 to receive, display & interpret objects & collections, that would increase the communities access to culture; Two galleries; one 16 x 30 ft, the other 26 x 65 ft; Average Annual Attendance: 22,000; Mem: Board of Dir meet first Tues each month at 7 PM, Ann Gen meeting Feb/Mar
Income: $168,000 (financed by provincial & city appropriation & private sector fundraising)
Purchases: Andrew King Block Printing Coll valued at $80,000

Library Holdings: Audio Tapes; Exhibition Catalogs; Kodachrome Transparencies; Memorabilia; Original Art Works; Original Documents; Photographs; Prints; Sculpture; Slides; Video Tapes
Special Subjects: Prints, Painting-Canadian
Collections: Saskatchewan artists print series; Saskatchewan painting collection; Two ceramic wall murals valued at 18,000
Exhibitions: Rotating
Publications: Annual Report; newsletter, 6 times per year
Activities: Classes for adults & children; lect open to public, 1-2 vis lectr per year; gallery talks; tours; children's & regional art show competitions; awards of merit; exten dept serves area within a 30 mile radius; lending of original objects of art; book traveling exhibitions 13-18 per year; originate traveling exhibitions; sales shop sells original art & souvenirs

LLOYDMINSTER

A **BARR COLONY HERITAGE CULTURAL CENTRE,** c/o City of Lloydminster, 4515 44th St Lloydminster, SK S9V 0T8 Canada; 4420 50th Ave Lloydminster, SK T9V 0U2 Canada. Tel 780-875-6184; Fax 306-825-9070; *Cur* Barbara McKeand
Open daily May - Sept 10 AM - 8 PM, Sept - May Wed - Sun 1 - 6 PM; Admis family $5.75, adults $2.75, senior citizens & students $2, children 12 & under $1.50, school tours $.50; Estab 1963 to promote & support appreciation for & educ about local history & the arts; The center is comprised of 4 exhibit galleries (1000 sq ft), a mus bldg (24,000 sq ft) & classroom teaching space
Income: Financed by donations & city appropriations
Collections: Antique Museum; Fuchs' Wildlife; Imhoff Paintings; Berghammer Art Collection; over 5000 artifacts related to the Barr Colonists, the first settlers of the area
Exhibitions: Exhibits rotate 6-8 per yr
Activities: Gallery talks; tours; traveling exhibitions

MOOSE JAW

M **MOOSE JAW ART MUSEUM, INC,** Art & History Museum, Crescent Park, Moose Jaw, SK S6H 0X6 Canada. Tel 306-692-4471; Fax 306-694-8016; Elec Mail mjamchin@sk.sympatico.ca; Internet Home Page Address: www.moosejawartmuseum.op.nu; *Business Mgr* Nancy Dougherty; *Cur* Heather Smith
Open Tues - Sun Noon - 5 PM, Tues - Thurs 7 - 9 PM, cl Mon; No admis fee; Estab 1966 for preservation, educ, collection & exhibitions; Gallery has 4304 sq ft with movable walls, Mus has 3970 sq ft, Discovery Centre has 1010 sq ft; Average Annual Attendance: 30,000; Mem: 190; dues family $25, individual $15
Income: $260,000 (financed by city, province & national appropriations & self-generated revenues)
Purchases: $260,000
Special Subjects: American Indian Art, Ethnology, Costumes, Folk Art, Painting-Canadian
Collections: 723 Canadian Historical & Contemporary Art Collection; 4700 Human History Artifacts Collection
Exhibitions: Heritage Gallery has permanent exhibits; art gallery rotates exhibits every 6 wks
Publications: Annual catalogs; bi-annual newsletter
Activities: Classes for adults & children; docent training; school tours; Discovery Centre mini science ctr; lect open to public, 10-15 vis lectr per year; gallery talks; tours; individual paintings & original objects of art lent to other professional public institutions that meet appropriate environmental standards; book traveling exhibitions 5-10 per year; originate traveling exhibitions; museum shop sells books, original works of art, educational toys

NORTH BATTLEFORD

M **ALLEN SAPP GALLERY,** One Railway Ave, PO Box 460 North Battleford, SK S9A 2Y6 Canada. Tel 306-445-1760; Fax 306-445-1161; Elec Mail sapp@accesscomm.ca; Internet Home Page Address: www.allensapp.com; Internet Home Page Address: www.virtualmuseum.ca/Exhibitions/allensapp; *Cur* Dean Bauche
Open Wed - Sun 1 - 5 PM (winter); daily 10:30 AM - 5:30 PM (June-Sept); No admis fee; Estab 1989; 8,000 sq ft gallery built in 1916 contains state of the art equipment incl high tech audiovisual presentation equipment; Average Annual Attendance: 9,000; Mem: 200 - $10
Income: $100,000 (financed by municipal & provincial grants & gift shop revenues)
Library Holdings: Auction Catalogs; Book Volumes; CD-ROMs; Cards; Clipping Files; Compact Disks; Exhibition Catalogs; Kodachrome Transparencies; Manuscripts; Memorabilia; Motion Pictures; Original Documents; Pamphlets; Periodical Subscriptions; Photographs; Prints; Records; Slides; Video Tapes
Collections: The Gonor Collection, paintings, photos, slides of art by renowned Cree artist Allen Sapp plus the work of other Canadian 1st Nations artist
Exhibitions: Rotate 2 exhibits per yr featuring powerful and sensitive images of the Northern Plains Cree
Publications: gallery catalog, biennially
Activities: Classes for adults & children; Native studies; lect open to public, 4 vis lectr per year; 1999 & 2002 Attractions Canadian award; circulate exhibs to credited museums; mus shop sells books, reproductions, prints

PRINCE ALBERT

M **JOHN M CUELENAERE PUBLIC LIBRARY,** Grace Campbell Gallery, 125 12th St E, Prince Albert, SK S6V 1B7 Canada. Tel 306-763-8496; Fax 306-763-3816; Elec Mail library@jmcpl.ca; WATS www.jmcpl.ca; *Dir* Eleanor Acorn
Open Mon 12:30 - 9 PM, Tues - Wed 9 AM - 9 PM, Thurs - Sat 9 AM - 5:30 PM, Sun 1 PM - 5 PM, cl Sun in July & Aug; No admis fee; Estab 1973; Gallery is 100 linear ft

Income: Financed by city appropriation
Activities: Tours

REGINA

A MUSEUMS ASSOCIATION OF SASKATCHEWAN, 422 McDonald St, Regina, SK S4N GE1 Canada. Tel 306-780-9279; Fax 306-780-9463; Elec Mail mas@saskmuseums.org; Internet Home Page Address: www.saskmuseums.org; *Museum Advisor* Wendy Fitch; *Educ Mgr* Patricia Fiori; *Admin Coordr* Brenda Herman; *Exec Dir* Joan Kaniean-Fairen; *Pres Brd Dirs* Brenda Barry Byrne
Open daily 8 AM-4 PM, cl Sat & Sun; Estab 1967; Mem: 188; dues vary with budget $37 - $321
Income: Financed by lotteries & mem
Collections: Human resource & board development, museological, slides & video
Publications: Bi-monthly newsletter

ORGANIZATION OF SASKATCHEWAN ARTS COUNCILS (OSAC)
For further information, see National and Regional Organizations

L REGINA PUBLIC LIBRARY, Art Dept, PO Box 2311, Regina, SK S4P 3Z5 Canada. Tel 306-777-6070; Fax 306-949-7260; Internet Home Page Address: www.rpl.regina.sk.ca; *Acting Dir & Librn* Sandy Cameron
Open Mon - Thurs 9:30 AM - 9 PM, Fri 9:30 AM - 6 PM, Sat 9:30 AM - 5 PM, Sun 1:30 - 5 PM, cl holidays; No admis fee; Estab 1947; Also operates Sherwood Village Branch Gallery
Library Holdings: Audio Tapes; Book Volumes 10,230; Cassettes; Clipping Files; Exhibition Catalogs 4000; Fiche; Filmstrips; Motion Pictures; Original Art Works; Pamphlets; Periodical Subscriptions 60; Photographs; Prints; Slides; Video Tapes

M Dunlop Art Gallery, 2311 12th Ave, PO Box 2311 Regina, SK S4P 3Z5 Canada. Tel 306-777-6040; Fax 306-949-7264; Elec Mail dunlop@rpl.regina.sk.ca; Internet Home Page Address: www.dunlopartgallery.org; *Dir* Noreen Neu; *Preparator* John Reichert; *Cur Asst* Joyce Clark; *Secy* Bev Antal
Open Mon - Thurs 9:30 AM - 9 PM, Fri 9:30 AM - 6 PM;, Sat 9:30 AM - 5 PM, Sun 1:30 - 5 PM, cl holidays; No admis fee; Estab 1949 to research practices & histories with visual culture, with emphasis on relationships between cultural production & social context; to present results of research in an informative & publicly accessible format including exhibitions, screenings, lectures, programs, publications & extension programs; to promote the Gallery's purpose scope & programs to the public; to communicate, consult & cooperate with individuals, groups & organizations having similar objectives; to collect research catalog & preserve works of contemporary & historical significance for the people of Regina & Saskatchewan; to acquire & maintain works of contemporary art for circulation through art rental service; Circ 110,897; 122 seat film theater with stage, preview room, meeting rooms, library van, woodworking shop, collections & services of the Regina library. Maintains art research resource centre; Average Annual Attendance: 100,000
Income: Financed by city appropriation, provincial & federal grants
Purchases: $10,000
Library Holdings: Book Volumes; Exhibition Catalogs; Original Documents; Pamphlets; Periodical Subscriptions; Slides; Video Tapes
Special Subjects: Photography, Sculpture, American Indian Art, Crafts, Folk Art, Landscapes, Painting-Canadian
Collections: Permanent collection of Saskatchewan art; Inglis Sheldon-Williams Collection; 205 works of historical & contemporary art including paintings, sculpture & graphic art by Saskatchewan artists; Art Rental Collection: 226 works of historical & contemporary paintings & graphic art by Canadian artists
Exhibitions: 15 exhibitions per year
Publications: At the Dunlop Newsletter, quarterly; brochures; exhibition catalogs
Activities: Docent training; gallery facilitators available to discuss exhibitions with members of public individually; lect open to public, 6 vis lectr per year; gallery talks; tours; competitions; individual paintings & original objects of art lent to Regina Pub Library card holders through an art rental coll available to the pub & works from permanent coll lent to other galleries; lending coll contains original art works, original prints & drawings; book traveling exhibitions; originate traveling exhibitions to galleries & museums with acceptable museum standards; sales shop sells books, magazines, cards, catalogues, posters & exhibition catalogues

SASKATCHEWAN ARTS BOARD
For further information, see National and Regional Organizations

UNIVERSITY OF REGINA
M MacKenzie Art Gallery, Tel 306-584-4250; Fax 306-569-8191; Elec Mail mackenzie@uregina.ca; Internet Home Page Address: www.mackenzieartgallery.sk.ca; *Mgr Finance & Operations* Allen Lefebvre
Open Mon - Wed, Fri - Sun 10 AM - 5:30 PM, Thurs 10 AM - 10 PM; No admis fee; Estab 1953 to preserve & expand the collection left to the gallery by Norman MacKenzie & to offer exhibitions to the city of Regina; to offer works of art to rural areas through the Outreach Program; Eight discreet galleries totalling approx 1500 running ft of exhibition space; Average Annual Attendance: 100,000; Mem: 1079; dues $35; annual meeting in June
Income: $1,000,000 (financed by federal & provincial governments, University of Regina & city of Regina & private funds)
Special Subjects: Oriental Art
Collections: Contemporary Canadian & American work; contemporary Saskatchewan work; 19th & early 20th century works on paper; a part of the collection is early 20th century replicas of Eastern & Oriental artifacts & art
Exhibitions: Changing exhibitions from the permanent collection & traveling exhibitions
Publications: Exhibition catalogues; staff publications of a professional nature; Vista, quarterly
Activities: Docent training; community program of touring exhibitions in Saskatchewan; interpretive programs; school tours; lect open to public, 8-10 vis lectr per year; concerts; gallery talks; tours; films; exten dept serves entire province of Saskatchewan; originate traveling exhibitions nation-wide; gallery shop sells books, magazines, reproductions, cards & catalogues

—MacKenzie Art Gallery Resource Centre, Tel 306-522-4242; Fax 306-569-8191;
Open Mon, Tues, Fri, Sat & Sun 11 AM - 7 PM, Wed & Thurs 11 AM - 10 PM; Estab 1970 to offer the community a resource for art information, both historical & current; For reference only
Collections: Regional press clippings from 1925
Exhibitions: Between Abstraction & Representation, George Glenn; Jana Sterbak; Jan Gerrit Wyels 1888-1973; The Asymmetric Vision; Philosophical Intuition & Original Experience in the Art of Yves Gaucher; Peace Able Kingdom, Jack Severson; Artists With Their Work; Ryan Arnott; Grant McConnell; Memory in Place
Publications: Exhibition catalog
Activities: Film program, twice a month

—Visual Resource Center, Tel 306-585-5579; Fax 306-585-5744; Elec Mail finearts@max.cc.uregina.ca; *Cur* Pat Matheson
Estab for the instruction of art history
Library Holdings: Audio Tapes; Slides 90,000; Video Tapes
Collections: Prehistoric - contemporary, eastern & western art

L Education/Fine Arts Library, Tel 306-585-5123; Fax 306-585-5115; *Vis Arts Librn* Donna Bowman; *Music Librn* William Sgrazzutti; *Theatre Librn* Leanne Mitchell; *Film Librn* Linda Winkler
Open (semester) Mon - Thurs 8 AM - 9 PM, Fri 8 AM - 5 PM, Sat 1 PM - 5 PM, Sun 1 PM - 9PM; Amalgamated with Education Library in 1996. Serves the students of music & the visual arts; For both lending & reference
Library Holdings: Audio Tapes; Book Volumes 18,000; Cassettes; Clipping Files; Compact Disks; Exhibition Catalogs; Fiche; Pamphlets; Periodical Subscriptions 55; Records; Reels; Video Tapes

SASKATOON

M AKA ARTIST RUN CENTRE, 424 20th St W, Saskatoon, SK S7M OX4 Canada. Tel 306-652-0044; Fax 306-652-0534; Elec Mail aka@sasktel.net; Internet Home Page Address: www.akagallery.org; *Prog Coordr* Cindy Baker; *Administrative Coordr* Troy Gronsdhal
Open Mon - Sat Noon - 5 PM; No admis fee; Estab 1970, incorporated 1973 to encourage the development of photography as a creative visual art; Main gallery is 650 sq ft, & workshop gallery is 250 sq ft; Average Annual Attendance: 8,000; Mem: 100; dues $25; annual meeting first Sun in May
Income: $196,000 (financed by mem, province appropriation, federal grants & fundraising)
Special Subjects: Photography
Collections: Permanent Collection of 901 Contemporary Canadian photographs
Exhibitions: 7 main gallery exhibitions per year; 7 workshop gallery exhibitions per year
Publications: Backflash, quarterly magazine; members monthly newsletter
Activities: Classes for adults; lect open to pub, 12 vis lectr per yr; tours; exten dept; workshops throughout the province; portable darkrooms travel with instructors; book traveling exhibs; originate traveling exhibs to pub galleries in Canada; sales shop sells books, postcards, t-shirts

L Library, 424 20th St W, Saskatoon, SK S7M 0X4 Canada. Tel 306-244-8018; Fax 306-665-6568; *Program Coordr* Cindy Baker; *Administrative Coordr* Troy Gronsdahl
Open Mon - Sat Noon - 5 PM; No admis fee; Estab 1970; Circ Non-circulating; For references mem only
Library Holdings: Audio Tapes; Book Volumes 1500; Cassettes; Clipping Files; Exhibition Catalogs; Manuscripts; Pamphlets; Periodical Subscriptions 10; Reproductions; Slides

M MENDEL ART GALLERY & CIVIC CONSERVATORY, 950 Spadina Crescent E, PO Box 569 Saskatoon, SK S7K 3L6 Canada. Tel 306-975-7610; Fax 306-975-7670; Internet Home Page Address: www.mendel.ca; *Dir* Gilles Herbert; *Business Mgr* Richard Moldenhauer; *Admin Asst* Judy Koutecky; *Asst Cur* George Moppett; *Extension Coordr & Asst Cur* Dan Ring; *Gallery Store Supvr* Michael Gibson
Open daily 9 AM - 9 PM, cl Christmas Day; No admis fee; Estab 1964 to exhibit, preserve, collect & interpret works of art; to encourage the development of the visual arts in Saskatoon; to provide the opportunity for citizens to enjoy & understand & to gain a greater appreciation of the fine arts; Average Annual Attendance: 200,000; Mem: 700; dues $30, senior citizens & students $10
Income: $2,000,000 (financed by grants, gift shop, mem, donations & other sources)
Special Subjects: Painting-American, Photography, Prints, Religious Art, Portraits, Painting-Canadian
Collections: Regional, National and International Art
Publications: Exhibition catalogues; Folio, gallery newsmagazine
Activities: Classes for adults & children; gallery theatre; dramatic programs; lect open to public; gallery talks; tours; exten dept; individual paintings & original objects of art lent to other galleries; lending collection contains 3000 paintings, 500 photographs, 300 sculptures; originate traveling exhibitions; gallery shop sells books, magazines, original Inuit art, reproductions, prints & craft items, all with an emphasis on Canadian handcrafts

L Reference Library, 950 Spadina Crescent E, PO Box 569 Saskatoon, SK S7K 3L6 Canada. Tel 306-975-7610; Fax 306-975-7670; Elec Mail mendel@mendel.saskatoon.sk.ca
Open to public by appointment; No admis fee; Estab 1964 for art research; For staff use; open to pub by appointment; Average Annual Attendance: 175,000; Mem: 650; dues $30
Library Holdings: Audio Tapes; Book Volumes 10,057; Cassettes; Clipping Files; Exhibition Catalogs; Filmstrips; Manuscripts; Memorabilia; Pamphlets; Periodical Subscriptions 20; Photographs; Records; Slides; Video Tapes
Special Subjects: Art History, Constructions, Folk Art, Commerical Art, Graphic Arts, Painting-American, Painting-British, History of Art & Archaeology, Conceptual Art, American Western Art, Art Education, American Indian Art, Eskimo Art, Painting-Canadian, Architecture
Collections: Aboriginal/First Nation; Canadian Contemporary; Canadian Historical
Activities: Classes for adults & children; lect open to pub, 6 vis lectr per year; gallery talks; tours; individual paintings & original objects of art lent to galleries

only; lending collection contains books, phono records & slides; book traveling exhibitions 20 per year; originate traveling exhibitions; sales shop sells books, magazines, original art, reproductions, prints, ceramics & glass

L NUTANA COLLEGIATE INSTITUTE, Memorial Library and Art Gallery, 411 11th St E, Saskatoon, SK S7N 0E9 Canada. Tel 306-683-7580; Fax 306-683-7587; *VPrin* Doug Njah; *Principal* Bruce Bradshaw; *Librn* Ron Bernston
Open daily 8 AM - 4 PM, summer 9 AM - 3 PM; No admis fee; Estab 1919 to promote an appreciation for art; a memorial to students who lost their lives in the two world wars; Maintains an art gallery; Average Annual Attendance: 2,000
Income: Financed by the institute
Library Holdings: Audio Tapes; Book Volumes 8000; Cassettes; Clipping Files; Exhibition Catalogs; Filmstrips; Kodachrome Transparencies; Motion Pictures; Original Art Works; Pamphlets; Periodical Subscriptions 35; Records; Reels; Slides; Video Tapes
Collections: Paintings & wood cuts by Canadian artists

A SASKATCHEWAN ASSOCIATION OF ARCHITECTS, 200-642 Broadway Ave, Saskatoon, SK S7N 1A9 Canada. Tel 306-242-0733; Fax 306-664-2598; Elec Mail saskarchitects@sasktel.net; Internet Home Page Address: www.saskarchitects.com; *Exec Dir* John Parry; *Member Services Co-Ordinator* Natal Laycock
Estab 1911 to support member architects; Mem: 111; dues $550; annual meeting in Feb
Income: Financed by mem
Publications: Columns, quarterly newsletter
Activities: Docent training; continuing educ for members; book prize given to architectural technology student at Saskatchewan Technical Institute, Moose Jaw (4 twice a year)

M SASKATCHEWAN CRAFT COUNCIL & GALLERY, 813 Broadway Ave, Saskatoon, SK S7N 1B5 Canada. Tel 306-653-3616; Fax 306-244-2711; Elec Mail saskcraftcouncil@home.com; *Exhib Coordr* Leslie Potter; *Dir* Pat Adams
Open Mon-Sun 1 - 5 PM; No admis fee; Estab 1975 to support, promote, exhibit & develop excellence in Saskatchewan craft; 900 sq ft; Average Annual Attendance: 14,000; Mem: 385; dues $60; annual meeting in May
Income: $429,000 (financed by mem, city appropriation, provincial grants)
Exhibitions: 8 exhibitions yearly
Publications: The Craft Factor, 3 per year
Activities: Lect open to public, 8 vis lectr per year; gallery talks; tours; open juried competition with award for Saskatchewan residents; book traveling exhibitions 2 per year; originate traveling exhibitions to provincial galleries

M UNIVERSITY OF SASKATCHEWAN, Gordon Snelgrove Art Gallery, 3 Campus Dr, Saskatoon, SK S7N 5A4 Canada. Tel 306-966-4208; Fax 306-966-4266; Elec Mail gary.young@usask.ca; Internet Home Page Address: www.usask.ca/snelgrove; *Gallery Cur* Gary Young
Open Mon - Fri 9 AM - 4:30 PM, Sat 11 AM - 5 PM; No admis fee; Estab approx 1960 for the educ of students & local pub; Gallery covers approx 3000 sq ft of floor space, 300 running ft of wall space; Average Annual Attendance: 12,000
Income: Financed by provincial & federal government appropriations & university funds
Collections: Contemporary art from western & midwestern Canada
Exhibitions: Constantly changing exhibitions of art works; internationally organized & traveling shows
Publications: Show announcements, every three weeks; catalogues for selected exhibits
Activities: Lect open to public, 10 vis lectr per year; gallery talks; tours; individual paintings & original objects of art lent to recognized regional exhibition centres for one time presentation or tour; lending collection contains 150 original art works

M Diefenbaker Canada Centre, University of Saskatchewan, 101 Diefenbaker Pl Saskatoon, SK S7N 5B8 Canada. Tel 306-966-8382; Fax 306-966-6207; Elec Mail bruce.shepard@sask.usask.ca; Internet Home Page Address: www.usask.ca/diefenbaker; *Archivist* Rob Innes; *Educ Liaison* Lenora Wiebe; *Technician* G Burke; *Dir* Bruce Shepard; *Gift Shop/Reception* Pat St. Louis
Open Mon & Fri 9:30 AM - 4:30 PM, Tues, Wed & Thurs 9:30 AM - 8 PM, Sun & holidays 12:30 - 5 PM; Admis adults $2, children $1, families $5; Estab 1980 to explore Canada's evolution with its citizens & their visitors. Its focus is Canada's citizenship, leadership & the country's international role; 2,000 sq ft gallery with complete environmental controls; Average Annual Attendance: 20,000
Income: Financed by pub foundations, donations & endowments
Library Holdings: Audio Tapes; Book Volumes; Cards; Cassettes; Clipping Files; Fiche; Framed Reproductions; Manuscripts; Maps; Memorabilia; Original Art Works; Original Documents; Pamphlets; Periodical Subscriptions; Photographs; Prints; Records; Reels; Reproductions; Sculpture; Slides; Video Tapes
Special Subjects: Landscapes, Glass, Furniture, Portraits, Manuscripts, Maps, Sculpture, Drawings, Photography, Prints, Watercolors, Textiles, Costumes, Crafts, Etchings & Engravings, Decorative Arts, Posters, Eskimo Art, Painting-Canadian, Dolls, Jewelry, Silver, Historical Material, Coins & Medals, Dioramas, Period Rooms, Pewter, Leather, Reproductions
Collections: Priministal papers of the Rt Honourable J G Diefenbaker & related papers
Exhibitions: Canadian Politics focuses upon the country during the 10th decade of the Confederacy; international & national regional travel exhibits; Prime Ministers office & the Canadian Cabinet room
Publications: The Diefenbaker Legacy, 1998
Activities: Study of modern Canadian history; reference service; classes for children; curriculum-based programs on Canadian law, politics & government; Conferences; seminars; public events; 5 vis lect per yr; gallery talks; tours; book traveling exhibitions, 30 plus per year; originate traveling exhibitions provincially; retail store sells books, prints, slides, jewelry, scarfs, gifts, souvenirs

SWIFT CURRENT

M ART GALLERY OF SWIFT CURRENT NEC, 411 Herbert St E, Swift Current, SK S9H 1M5 Canada. Tel 306-778-2736; Fax 306-778-2194; Internet Home Page Address: www.city.swift-current.sk.ca/arts/nec; *Dir & Cur* Kim Houghtaling; *Educ Coordr* Laurie Wagner
Open 2 - 5 PM & 7 - 9 PM; No admis fee; Estab 1974 to exhibit temporary art exhibitions; 1876 sq ft; Average Annual Attendance: 18,000
Income: $120,000 (financed by city & state appropriation & federal grant)
Exhibitions: Nine temporary exhibitions per year featuring Provincial, national & internations artists
Activities: Classes for adults & children; docent training; film series; lect open to public, 3-6 vis lectr per year; book traveling exhibitions; originate traveling exhibitions

WEYBURN

M WEYBURN ARTS COUNCIL, Allie Griffin Art Gallery, 23 McKinnon Bay, Weyburn, SK S4H 1L8 Canada. Tel 306-848-3278; Fax 306-848-3271; *Cur* Helen Mamer
Open Mon-Thurs 10AM - 8:30PM, Fri & Sat 10AM - 6PM, Sunday 2PM - 5PM between Oct & May; No admis fee; Estab 1964 to showcase art & craft work by Weyburn artists, Saskatchewan artists from various large & small communities, nationally known artists & artisans as well as international exhibitions on tour from lending galleries; Public art gallery dislaying Saskatchewan art; Average Annual Attendance: 10,000
Collections: City of Webyrn Permanent Collection; Courtney Milne: Visions of the Goddess
Exhibitions: Exhibits works from the Weyburn permanent collection at regular intervals throughout each year; Exhibs supplied by lending galleries from across Saskatchewan
Activities: Gallery talks, tours; James Weir People's Choice Award given annually; original objects of art lent to offices in city owned buildings; lending collection contains original art works & paintings; book 8 traveling exhibitions; organize traveling exhibition to Saskatchewan OSAC mems

YUKON TERRITORY

DAWSON CITY

M DAWSON CITY MUSEUM & HISTORICAL SOCIETY, PO Box 303, Dawson City, YT Y0B 1G0 Canada. Tel 867-993-5291; Fax 867-993-5839; *Dir* Paul Thistle; *Dir Admin* Cheryl Thompson
Open 10 AM - 6 PM May - Sept, winter hrs 9 AM - 5 PM; Admis Adult $7, senior citizens & students $5; Estab 1959 to collect, preserve & interpret the history of the Dawson City area; Two long term, two changing exhibition spaces featuring Dawson & Klondike gold fields; Average Annual Attendance: 20,000; Mem: 170; dues $30-$1000; annual meeting in Apr
Income: $300,000 (financed by mem, state appropriation, grants)
Special Subjects: Ethnology, Furniture, Glass, Scrimshaw, Coins & Medals
Collections: 30,000 piece collection including archives, cultural, enthnographic, household, industrial, paleontology, photographs; Local history of Klondike region art & exhibits
Exhibitions: Gold Rush; Railway; natural history; mining; Han People
Publications: Newsletter, quarterly
Activities: Docent programs; lect open to public, 10 vis lectr per year; book traveling exhibitions; originate traveling exhibitions 2 per year; museum shop sells books, original art, jewelry & souvenirs

L Klondike History Library, PO Box 303, Dawson City, YT Y0B 1G0 Canada. Tel 867-993-5291; Fax 867-993-5839; Elec Mail dcmuseum@yknet.yk.ca; Internet Home Page Address: www.gold-rush.org; *Dir & Cur* Paul C Thistle
Open Mid-May - Mid-Sept 10 AM - 6 PM, other by appointment only; Admis adults $5; Estab 1959; Museum; Average Annual Attendance: 20,000; Mem: 145
Income: Financed by earned income & government grants
Library Holdings: Book Volumes 3500; Cassettes; Clipping Files; Lantern Slides; Photographs; Slides
Special Subjects: Mixed Media, Photography, Manuscripts, Maps, Historical Material, Industrial Design, Furniture, Glass, Gold, Restoration & Conservation, Scrimshaw
Activities: Docent training; 7 lect per yr; tours; museum shop sells books, prints, & souvenirs

WHITEHORSE

A YUKON HISTORICAL & MUSEUMS ASSOCIATION, 3126 3rd Ave, Whitehorse, YT Y1A 1E7 Canada. Tel 867-667-4704; Fax 867-667-4506; Elec Mail yhma@yknet.yk.ca; Internet Home Page Address: www.yukonalaska.com/yhma/; *Dir* Brent Slobodin
Open Mon - Fri 9AM - 5 PM; No admis fee; Estab 1977 as a national organization to preserve & interpret history; Mem: 180; dues individual $20, annual meeting in Oct
Income: Financed by mem, donations & fundraising
Publications: Newsletters, tour booklet, Yukon Exploration by G Dawson
Activities: Lect open to public, 4 or more vis lectr per year; tours; competitions with awards; lending collection contains books, photographs, audio equipment (oral history taping); originate traveling photo exhibitions to Yukon communities; sales shop sells books, t-shirts, heritage pins & reproductions of old Canadian expedition maps

II ART SCHOOLS

Arrangement and Abbreviations

Art Schools in the U.S.

Art Schools in Canada

Arrangement and Abbreviations
Key to Art Organizations

ARRANGEMENT OF DATA

Name and Address of institution; telephone number, including area code.

Names and titles of key personnel.

Hours open; admission fees; date established and purpose; average annual attendance; membership.

Annual figures on income and purchases.

Collections with enlarging collections indicated.

Exhibitions.

Activities sponsored, including classes for adults and children, dramatic programs and docent training; lectures, concerts, gallery talks and tours; competitions, awards, scholarships and fellowships; lending programs; museum or sales shops.

Libraries also list number of book volumes, periodical subscriptions, and audiovisual and micro holdings; subject covered by name of special collections.

ABBREVIATIONS AND SYMBOLS

Acad—Academic
Admin—Administration, Administrative
Adminr—Administrator
Admis—Admission
A-tapes—Audio-tapes
Adv—Advisory
AM—Morning
Ann—Annual
Approx—Approximate, Approximately
Asn—Association
Assoc—Associate
Asst—Assistant
AV—Audiovisual
Ave—Avenue
Bldg—Building
Blvd—Boulevard
Bro—Brother
C—circa
Cert—Certificate
Chap—Chapter
Chmn—Chairman
Circ—Circulation
Cl—Closed
Col—College
Coll—Collection
Comt—Committee
Coordr—Coordinator
Corresp—Corresponding
Cr—Credit
Cur—Curator
D—Day
Den—Denominational
Dept—Department
Develop—Development
Dipl—Diploma
Dir—Director
Dist—District
Div—Division
Dorm—Dormitory
Dr—Doctor, Drive
E—East, Evening
Ed—Editor

Educ—Education
Elec Mail—Electronic Mail
Enrol—Enrollment
Ent—Entrance
Ent Req—Entrance Requirements
Est, Estab—Established
Exec—Executive
Exhib—Exhibition
Exten—Extension
Fel(s)—Fellowships
Fri—Friday
Fs—Filmstrips
Ft—Feet
FT—Full Time Instructor
GC—Graduate Course
Gen—General
Grad—Graduate
Hon—Honorary
Hr—Hour
HS—High School
Hwy—Highway
Inc—Incorporated
Incl—Including
Jr—Junior
Lect—Lecture(s)
Lectr—Lecturer
Librn—Librarian
M—Men
Maj—Major in Art
Mem—Membership
Mgr—Manager
Mon—Monday
Mss—Manuscripts
Mus—Museums
N—North
Nat—National
Nonres—Nonresident
Per subs—Periodical subscriptions
PM—Afternoon
Pres—President
Prin—Principal
Prof—Professor

Prog—Program
PT—Part Time Instructor
Pts—Points
Pub—Public
Publ—Publication
Pvt—Private
Qtr—Quarter
Rd—Road
Rec—Records
Reg—Registration
Req—Requirements
Res—Residence, Resident
S—South
Sat—Saturday
Schol—Scholarship
Secy—Secretary
Sem—Semeseter
Soc—Society
Sq—Square
Sr—Senior, Sister
St—Street
Ste—Suite
Sun—Sunday
Supt—Superintendent
Supv—Supervisor
Thurs—Thursday
Treas—Treasurer
Tues—Tuesday
Tui—Tuition
TV—Television
Undergrad—Undergraduate
Univ—University
Vis—Visiting
Vol—Volunteer
Vols—Volumes
VPres—Vice President
V-tapes—Videotapes
Vols—Volumes
W—West, Women
Wed—Wednesday
Wk—Week
Yr—Year(s)

† Major offered
A Association
C Corporate Art Holding
L Library
M Museum
O Organization

ALABAMA

AUBURN

AUBURN UNIVERSITY, Dept of Art, 108 Biggin Hall, Auburn, AL 36849-5125. Tel 334-844-4373; Fax 334-844-4024; Internet Home Page Address: www.auburnuniversity.edu; *Interim Dean* Joseph P Ansell; *Interim Head* Mark M Graham
Estab 1928; Maintain nonprofit art gallery; Biggin Gallery; pub; D & E; 457 maj & non-maj
Ent Req: HS dipl, ACT, SAT
Degrees: BFA 4 yr, BA 4 yr
Tuition: Res—$750 per quarter; nonres—$2250 per quarter
Courses: †Ceramics, †Drawing, †Graphic Design, †Illustration, †Painting, †Printmaking, †Sculpture
Summer School: Complete 10 wk program

BAY MINETTE

JAMES H FAULKNER COMMUNITY COLLEGE, Art Dept, 1900 US Hwy 31 S, Bay Minette, AL 36507. Tel 334-937-9581; Internet Home Page Address: www.faulkner.cc.ai.us; *Div Chmn of Art* Walter Allen, MFA
Estab 1965; FT 2; pub; D & E; Scholarships; SC 4, LC 3; D 35, E 40, non-maj 57, maj 18
Ent Req: HS dipl
Degrees: AA 2 yrs
Tuition: Res—undergrad $63 per cr hr; nonres $115 per cr hr; campus res—room & board $1428
Courses: †Art History, †Commercial Design, †Drawing, History of Art & Architecture, †Painting, †Printmaking, †Sculpture
Summer School: Dir, Milton Jackson. Courses—Art Appreciation

BIRMINGHAM

BIRMINGHAM-SOUTHERN COLLEGE, Art Dept, 900 Arkadelphia Rd, Box 549021 Birmingham, AL 35254-9021. Tel 205-226-4928; Fax 205-226-3044; Elec Mail jpandeli@bsc.edu; Internet Home Page Address: www.bsc.edu; *Art Chair* Pamela Venz; *Prof* Steve Cole; *Asst Prof* Jim Neel; *Assoc Prof* Kathleen Spies; *Asst Prof* Timothy B Smith; *Asst Prof* Kevin Shook; *Art Instr* Cooper Spivey; *Office Mgr* Judy E Pandelis
Estab 1946; FT 5; pvt; D, E; Scholarships, Financial aid; SC 22, LC 8, interim term courses of 4 or 8 wk, 4 req of each student in 4 yr period; 500, maj 50
Ent Req: HS dipl, ACT, SAT scores, C average
Degrees: AB, BS, BFA, BM and BME 4 yr
Tuition: $15,930 per yr; room $2,830 per yr, board $2,660 per yr
Courses: Aesthetics, Art Appreciation, Art Education, Art History, Collage, Constructions, Design, Drawing, Film, Graphic Design, History of Art & Architecture, Mixed Media, Painting, Photography, Printmaking, Sculpture, Video
Adult Hobby Classes: Enrl 30; 8 wk term. Courses—Art History, Basic Drawing, Basic Painting
Children's Classes: Enrl approx 20. Laboratory for training teachers
Summer School: Enrl 100; 8 wk beginning June 11 & Aug 10. Courses—Art History, Design, Drawing, Painting, Sculpture

SAMFORD UNIVERSITY, Art Dept, 800 Lakeshore Dr, Birmingham, AL 35229. Tel 205-726-2840; Elec Mail lcvann@samford.edu; Internet Home Page Address: www.samford.edu; *Chmn* Dr Robin D Snyder
Estab 1841; maintain nonprofit art gallery; FT 4, PT 11; pvt; D; Scholarships; SC 24, LC 4
Ent Req: HS dipl, ent exam, ACT, SAT
Degrees: BA & BS 4 yrs
Tuition: $15,458 per yr incl room & board
Courses: Advertising Design, Ceramics, Commercial Art, Costume Design & Construction, Drawing, †Fine Arts, Graphic Arts, †Graphic Design, Handicrafts, History of Art & Architecture, Interior Design, Painting, Photography, Sculpture, Stage Design, Teacher Training, Theatre Arts
Summer School: Dir, Lowell Vann. Enrl 30, 2 five week terms. Courses—Appreciation, Studio Arts

UNIVERSITY OF ALABAMA AT BIRMINGHAM, Dept of Art & Art History, 113 Humanities Bldg, 900 13th St S Birmingham, AL 35294-1260; Humanities Bldg 113, 1530 3rd Ave S Birmingham, AL 35294-0006. Tel 205-934-4941; Fax 205-975-2836; Elec Mail evelee@uab.edu; Internet Home Page Address: www.uab.edu; *Prof* Sonja Rieger, MFA; *Prof* James Alexander, MFA; *Prof* Heather McPherson PhD, MFA; *Prof & Chmn* Gary Chapman, MFA; *Asst Prof* Katherine McIver PhD, MFA; Janice Klage, MFA; *Prof* Bert Brouwer, MFA; *Asst Prof* Derek Cracco, MFA; *Asst Prof* Jessica Dallow, PhD; *Assoc Prof* Erin Wright, MFA; *Instr* Doug Baulos, MFA; *Asst Prof* Audra Buck, MFA
Estab 1966, dept estab 1974; Maintain nonprofit art gallery, 1530 3rd Ave-HB113, Birmingham, AL 35294-1260; pub; D, E & weekend; Scholarships; SC 27, LC 15, GC 8; D 500, E 300, non-maj 250, maj 210, grad 12
Ent Req: HS dipl, ACT, SAT
Degrees: BA, BFA, MA Art History
Tuition: Res—undergrad $5926-$6819 incl room & board; nonres—undergrad $8746-$9639 incl room & board
Courses: Advertising Design, Art Appreciation, Art Education, Art History, †Art Studio, Ceramics, Design, Drawing, Graphic Arts, Graphic Design, Illustration, Mixed Media, Painting, Photography, Printmaking, Sculpture
Summer School: Courses—Range over all fields & are about one half regular offerings

BREWTON

JEFFERSON DAVIS COMMUNITY COLLEGE, Art Dept, PO Box 958, Brewton, AL 36427; 220 Alco Dr, Brewton, AL 36426. Tel 334-867-4832; Fax 334-867-7399; Elec Mail slaing@acet.net; Internet Home Page Address: www.jeffdavis.cc.al.us/; *Instr* Sue Laing
Estab 1965; pub; D & E; SC 10, LC 1; D 700, E 332, maj 20
Ent Req: HS dipl or equiv
Degrees: AA & AS
Tuition: Res—$300 per yr, $25 per cr hr; nonres—$600 per yr
Courses: Art Appreciation, Art History, Basic Design, Ceramics, Drawing, Introduction to Art, Painting, Photography
Summer School: Dir, Sue Laing. Enrl 200. Courses—Ceramics, Drawing, Introduction to Art, Art Appreciation

DECATUR

JOHN C CALHOUN STATE COMMUNITY COLLEGE, Department of Fine Arts, Hwy 31 N, PO Box 2216 Decatur, AL 35609-2216. Tel 256-306-2500; Fax 205-306-2925; Internet Home Page Address: www.calhoun.cc.al; *Instr* William Godsey, MA; *Instr* Jimmy Cantrell, EDS; *Instr* William Provine, MBA; *Dept Chmn* John T Colagross, MBA, EdD; *Instr* Kristine Beadle, BFA; *Instr* Stephanie Furry, DMA; *Instr* Samuel Timberlake, MM
Estab 1963; pub; D, E & Weekend; Scholarships; SC 30, LC 8; D 80, E 22, non-maj 29, maj 70, others 3
Ent Req: HS dipl, GED
Degrees: AS, AA and AAS 2 yrs
Tuition: $57 per cr hr
Courses: †Art Appreciation, Art Education, Art History, †Ceramics, †Commercial Art, †Drawing, †Film, †Graphic Design, Illustration, Lettering, †Painting, †Photography, Printmaking, †Sculpture, †Video
Summer School: Courses are selected from regular course offerings

FLORENCE

UNIVERSITY OF NORTH ALABAMA, Dept of Art, UNA Box 5006, Florence, AL 35632-0001. Tel 256-765-4384; Fax 256-765-4511; Elec Mail rlshady@una.edu; Internet Home Page Address: www.una.edu; *Prof* Fred Owen Hensley, MFA; *Asst Prof* Dr Suzanne D Zurinsky, PhD; *Assoc Prof* John D Turner, MFA; *Chair, Prof* Ronald L Shady, MFA; *Assoc Prof* Wayne Sides, MFA; *Assoc Prof* Chiong-Yiao Chen, MFA; *Asst Prof* Lisa Kirch, PhD
Estab 1830, dept estab approx 1930; Maintain nonprofit art gallery; Univ Art Gallery, Box 5006, Univ N Ala; FT 8; pub; D & E; Scholarships; SC 39, LC 10, GC 1; D 6900, non-maj 400, maj 120
Ent Req: HS dipl, or GED, ACT
Degrees: BFA, BS & BA 4 yr
Tuition: res—$1,716 per sem; nonres—$3,432; campus res—room & board $1,825
Courses: Art Appreciation, Art Education, Art History, Ceramics, Design, Drawing, Graphic Design, Illustration, Painting, Photography, Printmaking, Sculpture
Summer School: Dir, Ronald L Shady. Enrl 90; tuition $1716 for 8 wk term beginning June 8. Courses—Art Appreciation, Digital Media, Painting, Ceramics, Photography

HUNTSVILLE

UNIVERSITY OF ALABAMA IN HUNTSVILLE, Dept of Art and Art History, Roberts Hall, Rm 313, Huntsville, AL 35899. Tel 256-824-6114; Fax 256-824-6438; Elec Mail art@email.uah.edu; Internet Home Page Address:

uah.edu/html/academics/libarts/art; *Prof* David Stewart PhD, MFA; *Asst Prof* Lillian Joyce, PhD; *Asst Prof* Keith Jones, MFA; *Temp Asst Prof* Susan Truman-McGlohon, MFA; *Chmn Art & Art History Dept* Michael Crouse, MFA; *Prof* Glenn Dasher, MFA
Estab 1969 (as independent, autonomous campus), dept estab 1965; pub; D & E; Scholarships; SC 46, LC 14; D 150
Ent Req: HS dipl, ACT
Degrees: BA 4 yr
Tuition: $3,284.00 (2 semesters, tuition only)
Courses: †Art History, †Art Studio, Graphic Design, Painting, Photography, Sculpture
Adult Hobby Classes: Tuition $411 per 3 hr course. Courses—Computer Graphics, other miscellaneous workshops offered through Div of Continuing Educ
Summer School: Limited number of courses offered in a two 6 wk mini-terms

JACKSONVILLE

JACKSONVILLE STATE UNIVERSITY, Art Dept, 700 Pelham Rd N, Jacksonville, AL 36265. Tel 256-782-5626; Fax 256-782-5419; Elec Mail art@jsucc.jsu.edu; *Head* Charles Groover, MFA
Estab 1883; pub; D & E; Scholarships; SC 22, LC 8, GC 4; D 8000, E 24, non-maj 70, maj 170, grad 11, others 15
Ent Req: HS dipl, ACT
Degrees: BFA, BA 4 yr
Tuition: $1620 per sem in state, $3240 out of state
Courses: Art Appreciation, Art History, Calligraphy, Ceramics, Commercial Art, Drawing, Graphic Arts, Graphic Design, History of Art & Architecture, Painting, Photography, Printmaking, Sculpture

LIVINGSTON

UNIVERSITY OF WEST ALABAMA, Division of Fine Arts, Sta 10, Livingston, AL 35470. Tel 205-652-3400 (main), 652-3510 (arts); Fax 205-652-3405; Internet Home Page Address: www.uwa.com; *Chmn* Jason Guynes
Estab 1835; Maintain nonprofit art gallery; pub; D; Scholarships; 1800
Degrees: BA, BS, BMus, MEd, MSc
Courses: Art Appreciation, †Ceramics, Design, †Design, Drawing, †Introduction to Art
Summer School: Chmn, Jason Guynes. Courses—Introduction to Art

MARION

JUDSON COLLEGE, Division of Fine and Performing Arts, 302 Bibb St, Marion, AL 36756; PO Box 120, Marion, AL 36756. Tel 334-683-5251; Fax 334-683-5147; Elec Mail twhisenhunt@judson.edu; Internet Home Page Address: www.home.judson.edu; *Chmn* Dr Roger Walworth; *Head of Art Dept* Ted Whisenhunt
Estab 1838; Maintain nonprofit art gallery; pvt, den, W; D & E; Scholarships, Grants, Loans; SC 23, LC 6; 450
Ent Req: HS grad, adequate HS grades & ACT scores
Degrees: BA 3-4 yr
Tuition: $3500 per sem
Courses: Commercial Art, Design, Drawing, Elementary Art, Painting, Perspective Drafting, Pottery, Sculpture, Special Courses
Adult Hobby Classes: Enrl 5. Courses—Painting, Studio Drawing
Children's Classes: Drawing, Painting
Summer School: Head Art Dept, Ted Whisenhunt. Courses vary

MOBILE

SPRING HILL COLLEGE, Department of Fine & Performing Arts, 4000 Dauphin St, Mobile, AL 36608. Tel 334-380-3855; Fax 334-460-2110; Internet Home Page Address: www.shc.edu; *Chmn* Stephen Campbell, SJ; *Prof, Chmn Communications Div* Thomas Loehr, MFA; *Prof* Ruth Belasco, MFA
Estab 1830, dept estab 1965; den; D & E; SC 21, LC 3; D 163, non-maj 128, maj 35
Ent Req: HS dipl, ACT, CEEB, SAT
Degrees: BA
Tuition: Undergrad $6210 per 12-18 cr hrs; campus res—room $275-$1700 , board $650-$1200 per sem
Courses: Advertising Design, Aesthetics, Art Appreciation, †Art Business, Art Education, Art History, Ceramics, Commercial Art, Costume Design & Construction, Design, Drawing, †Studio Art, Textile Printing, †Therapy
Adult Hobby Classes: Enrl 15. Courses—wide variety
Summer School: Enrl 15. Courses—wide variety

UNIVERSITY OF SOUTH ALABAMA, Dept of Art & Art History, 172 Visual Arts Bldg, Mobile, AL 36688-0002. Tel 334-460-6335; Fax 334-414-8294; Internet Home Page Address: www.southalabama.edu/art/; *Chmn & Graphic Design* Larry Simpson; *Graphic Design* Clint Orr; *Printmaker* Sumi Putman; *Art Historian* Robert Bantens; *Art Historian* Janice Gandy; *Art Historian* Philippe Oszuscik; *Sculptor* Pieter Favier; *Graphic Design* Patrick Miller
Estab 1963, dept estab 1964; pub; D & E; SC 32, LC 25; maj & 150
Ent Req: HS dipl, ACT
Degrees: BA, BFA and BA(Art History) 4 yrs
Tuition: Res—undergrad $97 per cr hr; non res—undergrad $194 per cr hr; grad $254 per cr hr
Courses: Art Appreciation, †Art History, †Ceramics, Design, Drawing, †Graphic Design, History of Art & Architecture, Illustration, Mixed Media, †Painting, Photography, †Printmaking, †Sculpture
Summer School: Chmn, Larry Simpson. Courses—Art Appreciation, Art History, Ceramics, Drawing, Graphic Design, Painting

MONROEVILLE

ALABAMA SOUTHERN COMMUNITY COLLEGE, Art Dept, PO Box 2000, Monroeville, AL 36461. Tel 334-575-3156; Elec Mail sbrown@ascc.edu; Internet Home Page Address: www.ascc.edu; *Chmn* Dr Margaret H Murphy
Sch estab 1965, dept estab 1971; pub; D & E; SC 6, LC 1; D 25, E 8, non-maj 23, maj 3
Ent Req: HS dipl, GED
Degrees: AA & AS 2 yrs
Tuition: In state—$60 per cr; out of state—$104
Courses: Art Appreciation, Drafting, †Drawing, †Painting, Stage Design, Theatre Arts

MONTEVALLO

UNIVERSITY OF MONTEVALLO, College of Fine Arts, Department of Art, Station 6400 Montevallo, AL 35115. Tel 205-665-6400; Fax 205-665-6383; Internet Home Page Address: www.montevallo.edu; *Dean* Kenneth J Procter; *Chmn* Clifton Pearson
Estab 1896; Maintain nonprofit art gallery; Bloch Hall; art supplies available on-campus; pub; D & E; Scholarships, Work study; SC 25, LC 5, GC 7; Maj 200, others 3300
Ent Req: ACT
Degrees: BA, BS, BFA
Tuition: $1500 per sem; res $111 per cr hr; non-res $220 per cr hr
Courses: †Advertising Design, Art Education, Art History, Ceramics, Commercial Art, Design, Digital Imaging, †Drawing, †Graphic Arts, †Painting, †Photography, †Printmaking, †Sculpture
Summer School: Chmn Clifton Pearson. Enrl 1000; two 5 wk sessions beginning June 5 & July 5

MONTGOMERY

ALABAMA STATE UNIVERSITY, Dept of Visual & Theatre Arts, 915 S Jackson, Montgomery, AL 36101. Tel 334-229-4474; Fax 334-229-4920; Internet Home Page Address: www.ASU.edu; *Acting Dept Chmn* Dr William E Colvin
FT 10, PT 4; pub; D&E; Scholarships
Degrees: BA, BFA
Tuition: Res—undergrad $1260 per sem; nonres—undergrad $2520 per sem
Courses: Advertising Design, Art Appreciation, Art Education, Art History, Ceramics, †Computer Graphics, Design, Drawing, Graphics, Painting, Photography, Printmaking, Stage Design, Theatre Arts

HUNTINGDON COLLEGE, Dept of Art, 1500 E Fairview Ave, Montgomery, AL 36106-2148. Tel 334-833-4536, 4497; *Chmn* Christopher Payne, MFA
Estab 1973; E; 119
Degrees: AA
Tuition: $6720 per yr
Courses: Art Appreciation, Art Education, Art History, Art in Religion, Ceramics, Design, Drawing, Graphic Design, Painting, Photography, Printmaking, Teacher Training, Theatre Arts
Adult Hobby Classes: Enrl 119; tuition $80 per hr. Courses—Art Appreciation, Beginning Drawing, Ceramics, Painting
Summer School: Enrl 329; tuition $800 per term for 6 hrs in Art. Courses—Ceramics, Drawing, Painting, Photography

NORMAL

ALABAMA A & M UNIVERSITY, Art & Art Education Dept, PO Box 26, Normal, AL 35762. Tel 256-858-4072; Fax 256-851-5571; Internet Home Page Address: www.alabamaa&muniversity.edu; *Head Dept* William L Boyd; *Assoc Prof* Jimmie Dawkins, MFA; *Prof* William W Nance, MFA; *Asst Prof* Allen Davis, MFA; *Assoc Prof* Dr Darrell Evans; *Assoc Prof* Joe Washington
Estab 1875, dept estab 1966; pub; D & E; Scholarships; SC 18, LC 3; non-maj 430, maj 35, grad 10
Ent Req: HS dipl
Degrees: BS (Commercial Art & Art Education), MS, MEd (Art Educ)
Tuition: Res—undergrad $1388 per sem, grad $221 per sem; nonres—undergrad $2981 per sem, grad $375 per sem
Courses: †Advertising Design, Art Appreciation, †Art Education, †Commercial Art, Drawing, Fibers, Glass Blowing, Graphic Arts, Jewelry, Painting, Photography, Printmaking, Weaving
Adult Hobby Classes: Enrl 10 - 15; tuition $89 per sem. Courses offered in all areas
Children's Classes: Enrl 15 - 20; tuition $89 per sem. Courses offered in all areas
Summer School: Dir, Dr Clifton Pearson. Enrl 50; tuition $426 for 8 wk sem. Courses—Art Education, Art History, Ceramics

TROY

TROY STATE UNIVERSITY, Dept of Art & Classics, Troy, AL 36082. Tel 334-670-3391; Fax 334-670-3390; Elec Mail egreen@tsogan.troyst.edu; Internet Home Page Address: www.troyst.edu; *Asst Prof* Pamela Allen; *Asst Prof* S L Shillabeer; *Prof* Ed Noriega; *Prof* A. J. Olson; *Chmn* Jessy John
Estab 1957. University has 2 other campuses; FT 5; pub; Scholarships; SC 23, LC 11
Ent Req: HS grad, ent exam
Degrees: BA and BS (Arts & Sciences), MS
Tuition: Res—undergrad $62 per cr hr, grad $64 per cr hr; in-state $720 12-18 cr hrs; out-of-state $1500 12-18 cr hrs

Courses: Art Education, †Art History, Commercial Art, Drawing, Graphic Arts, Handicrafts, Jewelry, Lettering, Museology, Painting, Photography, Pottery, Silversmithing, Teacher Training
Adult Hobby Classes: Courses—Basketry, Crafts, Matting & Framing
Children's Classes: Enrl 30. Courses—Summer Workshop
Summer School: Dir, Robert Stampfli. Enrl 100; tuition $600 for June 12-Aug 11 term. Courses—Art Appreciation, Art Education, Art History, Drawing, Painting

TUSCALOOSA

STILLMAN COLLEGE, Stillman Art Gallery & Art Dept, 3601 15th St, PO Box 1430 Tuscaloosa, AL 35403. Tel 205-349-4240, Ext 8860; Internet Home Page Address: www.stillman.edu; *Asst Prof* Keyser Wilson, MFA; *Prof* R L Guffin, MFA
Estab 1876, dept estab 1951; pvt den; D; SC 8, LC 2; D 73, non-maj 73
Ent Req: HS dipl, ent exam
Tuition: $5200 per yr; campus res—room & board $3100 per yr
Courses: Afro-American Art History, Art Education, Art History, Ceramics, Commercial Art, Design, Drawing, Mixed Media, Painting, Sculpture

UNIVERSITY OF ALABAMA, Dept of Art & Art History, Bldg 103 Garland Hall, Tuscaloosa, AL 35487-0270; PO Box 870270, Tuscaloosa, AL 35487-0270. Tel 205-348-5967; Fax 205-348-0287; Elec Mail wbaker@woodsquad.as.ua.edu; Internet Home Page Address: www.bama.ua.edu/matildaartweb; *Chmn* William Dooley
Estab 1831, dept estab 1919; Moody Gallery of Art at University of Alabama; pub; D & E; Scholarships; SC 43, LC 12, GC 18; D 750, maj 200, grad 30
Ent Req: HS dipl, ACT
Degrees: BA and BFA 4 yr, MFA 3 yr, MA (art) 2 yr
Tuition: Res—undergrad & grad $905 per sem; nonres—undergrad & grad $2243 per sem; campus res available
Courses: Advertising Design, Aesthetics, †Art History, †Ceramics, Commercial Art, Constructions, Costume Design & Construction, Design, Display, Drafting, Drawing, Fashion Arts, Graphic Arts, †Graphic Design, History of Art & Architecture, Interior Design, Intermedia, Mixed Media, Museum Staff Training, †Painting, †Photography, †Printmaking, †Sculpture, Stage Design, Textile Design, Theatre Arts
Children's Classes: Enrl 70; tuition $65-$75 for 5 wk term.
Courses—Discoveries, Drawing, Explorations, Photography, 3-D Design
Summer School: Enrl 300; tuition $358.31 per sem. Courses—Art History, Ceramics, Drawing, Design, Foundation, Graphic Design, Painting, Photography, Printmaking, Sculpture

TUSKEGEE

TUSKEGEE UNIVERSITY, Liberal Arts & Education, Dept of Art, Tuskegee, AL 36088. Tel 334-727-8913, 8011; Fax 334-724-4196; Internet Home Page Address: www.tusk.edu; *Instr* Carla Jackson-Reese; *Head Dept Art* Uthman Abdur-Rahman; *Chmn Fine & Performing Arts* Warren Duncan; *Dean Liberal Arts* Benjamin Benford, Dr
Estab 1881; pvt
Courses: Art Appreciation, Art Education, Design Foundation

ALASKA

ANCHORAGE

UNIVERSITY OF ALASKA ANCHORAGE, Dept of Art, College of Arts and Sciences, 3211 Providence Dr Anchorage, AK 99508. Tel 907-786-1783; Fax 907-786-1799; Internet Home Page Address: www.uaa.alaska.edu; *Chmn* Sean Licka
FT 11, PT 15; Pub; D & E; Scholarships; SC 43, LC 7-9; College of Arts & Sciences FT 1310
Ent Req: open enrl
Degrees: BA in art, BFA 4 yr
Tuition: Res—$95 per cr, $900 for 12 or more cr; nonres—$80 per 3 cr, $2820, 9 or more cr
Courses: †Art Education, †Ceramics, †Drawing, Graphic Design, Illustration, †Painting, †Photography, †Printmaking, †Sculpture
Adult Hobby Classes: Same as regular prog
Summer School: Dir, Dennis Edwards. One term of 10 wks beginning May or two 5 wk sessions. Courses—Art Appreciation, Art Education, Native Art History, Photography & various studio courses

FAIRBANKS

UNIVERSITY OF ALASKA-FAIRBANKS, Dept of Art, Fine Arts Complex, Rm 310, PO Box 755640 Fairbanks, AK 99775-5640. Tel 907-474-7530; Fax 907-474-5853; Elec Mail fyart@uaf.edu; *Assoc Prof* Wendy Croskrey; *Dept Chmn* Todd Sherman Assoc Prof; *Assoc Prof* Alvin Amason; *Assoc Prof* Jim Brashear; *Asst Prof* Michael Nakoneczny; *Asst Prof* David Mollett; *Asst Prof* Mary Goodwin; *Asst Prof* Miho Aoki
Estab 1963; nonprofit gallery - UAF Art Dept Gallery, PO Box 5640, Fairbanks, AK 99775; pub; D & E; Scholarships; SC 28, LC 4; D 312, E 60, maj 45, 5 graduate students
Purchases: on-campus shop with limited amt art supplies
Ent Req: HS dipl
Degrees: BA, BFA, MFA
Tuition: Res—$112 per credit hour (lower dist); nonres $343 per credit hour; grad level $222/non-res $453

Courses: Art History, Ceramics, Computer Art, †Drawing, Metalsmithing, Native Art, †Painting, †Printmaking, †Sculpture
Children's Classes: Enrl 50. Courses—Ceramics, Drawing, Design, Metalsmithing, Painting, Sculpture. Under the direction of the downtown center
Summer School: Dir, Michelle Bartlett. Enrl 65; 6 wk term. Courses—Ceramics, Drawing, Printmaking, Sculpture, Native Art-Painting

ARIZONA

DOUGLAS

COCHISE COLLEGE, Art Dept, 4190 W Hwy 80, Douglas, AZ 85607-9724. Tel 520-364-7943, Ext 225; Internet Home Page Address: www.cochise.org; *Instr Dept Head* Monte Surratt; *Instr* Manual Martinez
Estab 1965, department estab 1965; PT 7; pub; D & E; Scholarships; SC 12, LC 2; D 280, E 225, maj 20
Ent Req: HS dipl, GED
Degrees: AA 2 yrs(Painting & Sculpture)
Tuition: Res—$26 per unit per sem; nonres—$39 per 1-6 units; $158 per over 6 units sem
Courses: Appreciation, Art, Art History, Ceramics, Color & Design, Commercial Design, Drawing, Jewelry, Painting, Photography, Printmaking, Sculpture, Special Topics in Art
Adult Hobby Classes: Courses—Painting

FLAGSTAFF

NORTHERN ARIZONA UNIVERSITY, Museum Faculty of Fine Art, 1115 S Knoles Dr Rm 211, PO Box 6020 Flagstaff, AZ 86011. Tel 520-523-4612; Fax 520-523-3333; Internet Home Page Address: www.nau.edu/finearts/; *Prof* J Cornett, MFA; *Prof* J O'Hara, MFA; *Assoc Prof* Dr Gretchen Boyer, EdD; *Instr* Dr Marianne Bruner, PhD; *Instr* Carl Clark; *Assoc Prof* Helaine McLain, MFA
Estab 1899; pub; D & E; Scholarships; SC 56, LC 19, GC 8-10; D 400, E 100, non-maj 342, maj 300, grad 30
Ent Req: HS dipl, ACT
Degrees: BA & BS 4 yr, MA(Art Educ)
Tuition: Res—undergrad $1078 per sem; nonres—undergrad $368 per cr hr, $4416 per sem (12 cr hr); campus res available
Courses: Art Education, Art History, Ceramics, Drawing, †Fine Arts, Interior Design, Jewelry, †Metalsmithing, Painting, Printmaking, Sculpture
Adult Hobby Classes: Most of the above studio areas
Children's Classes: Enrl 80; tuition $5 for 5 Sat. Courses—Ceramics, Drawing, Painting, Puppetry
Summer School: Dir, Richard Beasley. Enrl 150; tuition $46 per cr.
Courses—Most regular courses

HOLBROOK

NORTHLAND PIONEER COLLEGE, Art Dept, 993 E Hermosa Dr, PO Box 610 Holbrook, AZ 86025. Tel 520-524-6111; Fax 520-524-2772; Internet Home Page Address: www.northland.cc.az.us; *Dir* Pat Wolf, MS
Estab 1974; FT 2, PT 60; pub; D & E; SC 28, LC 2
Degrees: AA, Assoc of Applied Sci 2 yr
Tuition: Res—$20 per sem, nonres—$1125 per sem
Courses: Art Appreciation, Art History, Calligraphy, Ceramics, Commercial Art, Crafts, Design, Drawing, Graphic Arts, Lettering, Painting, Photography, Printmaking, Sculpture, Textile Design, Weaving
Adult Hobby Classes: Courses—Same as above
Summer School: 4 wk session in June

MESA

MESA COMMUNITY COLLEGE, Dept of Art, 1833 W Southern Ave, Mesa, AZ 85202. Tel 480-461-7524, 461-7000 (main); Fax 480-461-7350; Internet Home Page Address: www.mc.maricopa.edu; *Chmn Art Dept* Sarah Capawana, MFA; *Instr* Carole Drachler PhD; *Instr* Jim Garrison, MA; *Instr* Linda Speranza, MA; *Instr* Darlene Swain, MFA; *Instr* Robert Galloway, MFA; *Instr* Cynthia Greening
Estab 1965; pub; D & E; Scholarships; SC 10, LC 8; D 667, E 394
Ent Req: HS dipl or GED
Degrees: AA 2 yrs
Tuition: Res—$41 per cr hr, nonres—out of state $178 per cr hr, out of county $66 per cr hr for 1-6 cr hrs, $189 per cr hr for 7+ cr hrs, audit $25 per hr
Courses: †Advertising Design, Art Appreciation, †Art History, †Ceramics, Crafts, †Drawing, Film, Interior Design, Jewelry, †Painting, †Photography, Weaving

PHOENIX

GRAND CANYON UNIVERSITY, Art Dept, 3300 W Camelback Rd, Phoenix, AZ 85017. Tel 602-249-3300, Ext 2840; Tel 800-800-9776 Ext 2840; Fax 602-589-2459; Elec Mail imorrison@gcu.edu; Internet Home Page Address: www.grand-canyon.edu; *Asst Prof Art* Esmeralda Delaney, MFA; *Assoc Prof Art* Gaylen Stewart, MFA; *Asst Prof Art, Chair* Ian Morrison, MA; *Asst Prof Art* Sheila Schumacher, BFA; *Art Instr* Lynn Karns, MA; *Art Hist Instr* Judy Moffit, PhD
Estab 1949; maintains an on-campus gallery - A. P. Tell Gallery; prv; D & E; Scholarships; SC 52, LC 9 (Art Dept); D 106, E 25, non-maj 75, maj 30 (Art Dept)
Ent Req: HS dipl
Degrees: (art) BA & other university colleges/majors/degrees

Tuition: Commuter students $14,500 ft yr; residents $21,630 ft yr(includes room & board)
Courses: †Advertising Design, Aesthetics, †Art Appreciation, †Art Education, Art History, Ceramics, †Collage, †Commercial Art, †Conceptual Art, †Constructions, †Costume Design & Construction, †Design, †Drawing, †Goldsmithing, †Graphic Arts, †Graphic Design, †Jewelry, †Mixed Media, †Painting, †Photography, †Printmaking, Professional Artist Workshop, †Sculpture, †Silversmithing, †Stage Design, †Teacher Training, †Theatre Arts
Adult Hobby Classes: Watercolor, Printmaking
Children's Classes: Enrl 31; tuition $25. Courses—Ceramics, Composition, Drawing, Sculpture

PHOENIX COLLEGE, Dept of Art & Photography, 1202 W Thomas Rd, Phoenix, AZ 85013. Tel 602-264-2492; Fax 602-285-7276; Internet Home Page Address: www.pc.maricopa.edu; *Coordr, Photograph Dept* John Mercer; *Chmn* Roman Reyes; *Coordr Computer Graphics* Virginia Brouch, Dr; *Art History* Pamela Reed
Estab 1920; FT 5, PT 22; pub; Scholarships
Ent Req: HS dipl
Degrees: AA & AG 2 yrs
Tuition: Res—undergrad $34 per cr hr
Courses: Art Education, Basic Design, Ceramics, Commercial Art, Computer Design, Computer Graphics, Drawing, Painting, Photography, Sculpture
Adult Hobby Classes: Enrl 500; tuition $22.50 for 16 wks. Courses—Full range incl Computer Art
Summer School: Dir, John Mercer. Enrl 100; two 5 wk sessions. Courses—Intro to Art, Western Art

PRESCOTT

YAVAPAI COLLEGE, Visual & Performing Arts Div, 1100 E Sheldon, Prescott, AZ 86301. Tel 520-445-7300, 776-2035; Fax 520-776-2036; Internet Home Page Address: www.yavapai.cc.az.us; *Instr* Glen L Peterson, EdD; *Instr* Dr Will Fisher, MA; *Instr* Roy Breiling, MA; Amy Stein, MA; Laura Bloomenstein, MFA; Cynthia DeCecco, MA; Steve Mason, MA
Estab 1966, dept estab 1969; pub; D & E; Scholarships; SC 50, LC 50; D 1650, E 1563
Ent Req: HS dipl
Degrees: AA 2 yr
Tuition: Res $31 per cr hr; non-res $41 per cr hr; people over 62 $25 per cr hr; non-res over 62 $35 per cr hr
Courses: Art History, Calligraphy, Ceramics, Collage, Commercial Art, Design, Drawing, Film, Goldsmithing, †Graphic Arts, Illustration, Jewelry, Lathe Turning, Metalsmithing & Jewelry, Painting, †Papermaking, Photography, †Printmaking, Sculpture, Silversmithing, Theatre Arts, Weaving, †Web Page Design, Wood
Adult Hobby Classes: Enrl open; tuition per course. Courses offered through Retirement College
Children's Classes: Enrl open; tuition $15 per course. Courses—Ceramics, Drawing, Painting
Summer School: Dir, Donald D Hiserodt. Enrl open; tuition $12 per sem hr for term of 6 wks beginning June 4. Courses—Ceramics, Drawing, Jewelry, Painting, Photography, Printmaking

SCOTTSDALE

SCOTTSDALE ARTISTS' SCHOOL, 3720 N Marshall Way, Scottsdale, AZ 85251. Tel 480-990-1422; Fax 480-990-0652; Internet Home Page Address: www.scottsdaleartschool.org; WATS 800-333-5707; *Exec Dir* Stephanie Lynch
Estab 1983; D & E; Scholarships; 2200
Courses: Drawing, Painting, Sculpture

TEMPE

ARIZONA STATE UNIVERSITY
—School of Art, Tel 480-965-8521; Fax 480-965-8338; Internet Home Page Address: www.herbergercollege.asu.edu.art; *Dir* Julie Codell PhD
Estab 1885; maintain nonprofit art gallery; Harry Wood Gallery & Northlight Gallery for Photography; pub; D & E; Scholarships, Fellowships; SC 88, LC 70, GC 116; D 44,500, maj 960, grad 175
Ent Req: HS dipl, ACT
Degrees: BA & BFA 4 yrs, MFA 3 yrs, MA 2 yrs, EdD 3 yrs
Tuition: Res—undergrad $1136 (12 credits) per sem, grad $1136 per sem; nonres—undergrad $4864 (12 credits) per sem, grad $4864 per sem; campus res—room & board $6000
Courses: Art Appreciation, †Art Education, †Art History, †Ceramics, Computer Art, †Drawing, Fibers, †Intermedia, †Jewelry, †Painting, †Photography, †Printmaking, †Sculpture, Small Metals, †Textile Design, †Video, Video Art, †Weaving
Children's Classes: Enrl 400; tuition $35. Courses—Studio
Summer School: Asst Dir, Jon Sharer. Enrl 500; tuition $93 per sem hr. Courses—Varies
—College of Architecture & Environmental Design, Tel 480-965-8169; Fax 480-965-0894; *Dean* John Meunier, MFA; *Dir Archit* Michael Underhill, McPUD; *Dir Design* Robert L Wolf, MFA; *Chmn Planning* Frederick Steiner, MFA
Estab 1885, college estab 1949; pub; D & E; lower div 212, upper div 466, grad 135
Ent Req: HS dipl, SAT
Degrees: BA, MA
Tuition: Res—$914 per sem; nonres—$3717 per sem
Courses: Architecture, Graphics, History, Interior Design, Mixed Media, Photography, Sketching

Summer School: Courses—lower & upper div courses primarily in Design, Graphics, History, Sketching and Rendering

THATCHER

EASTERN ARIZONA COLLEGE, Art Dept, 600 Church St, Thatcher, AZ 85552. Tel 520-428-8233, 428-8460; Fax 520-428-8462; Elec Mail wilson@eac.cc.az.us; Internet Home Page Address: www.eac.cc.az.us; *Instr* Richard Green PhD; *Instr* James Gentry, MA
Estab 1888, dept estab 1946; PT 14; pub; D & E; Scholarships; SC 25, LC 3; D 105, E 202, maj 30
Ent Req: HS dipl or GED
Degrees: AA & AAS 2 yrs
Tuition: Res—$2569, non-res—$4529 (includes room & board)
Courses: Advertising Design, Airbrush, Art Appreciation, Art History, Calligraphy, Ceramics, Design, Drawing, Fibers, Gem Faceting, Lapidary, Life Drawing, Photography, Printmaking, Sculpture, Silversmithing, Stage Design, Stained Glass, Weaving, Wood Carving

TUCSON

TUCSON MUSEUM OF ART SCHOOL, 140 N Main Ave, Tucson, AZ 85701. Tel 520-624-2333; Fax 520-624-7202; Elec Mail info@tucsonarts.com; Internet Home Page Address: www.tucsonarts.com; *Dir Educ* Carolyn King, MA
Estab 1924; Maintains art library; PT 30; pvt; D & E; Scholarships; SC 25, LC 67 (children); D & E 1139
Ent Req: none
Degrees: none
Tuition: Varies per course; no campus res
Courses: Art Appreciation, Art History, Ceramics, Collage, Constructions, Design, Docent Training, Drawing, Intermedia, Mixed Media, Painting, Photography, Printmaking, Sculpture
Adult Hobby Classes: Enrl 300; tuition $120-180 for 12 wks.
Courses—Ceramics, Design, Drawing, Painting, Printmaking, Sculpture
Children's Classes: Ceramics, Drawing, Painting, Photography, Primary Art, Sculpture, Mixed Media, Puppetry
Summer School: Dir, Judith D'Agostino. Enrl 800; tuition mem $60 half day, $145 full day per wk., non-mem $65 half day, $160 full day per wk.
Courses—Ceramics, Design, Drama, Drawing, Painting, Photography, Printmaking, Puppetry, Sculpture, Mixed Media

UNIVERSITY OF ARIZONA, Dept of Art, Art Bldg # 21, Rm 108, PO Box 210002 Tucson, AZ 85721. Tel 520-621-7570; Fax 520-621-2955; Internet Home Page Address: www.arizona.edu; *Foundations, Dept Head* Andrew W Polk III; *Regents Prof* Robert Colescott, MA; *Prof Jewelry & Metalsmithing* Michael Croft, MFA; *Prof Sculpture* Moira Geoffrion, MFA; *Prof Emerita* Judith Golden, MFA; *Prof Art Educ* Dwaine Greer PhD, MFA; *Prof Painting & Drawing* Harmony Hammond, MA; *Prof Painting & Drawing* Chuck Hitner, MFA; *Prof Photography* Harold Jones, MFA; *Prof Fibers* Gayle Wimmer, MFA; *Prof Art History* Lee Parry PhD, MFA; *Prof Painting & Drawing* Barbara Rogers, MA; *Assoc Prof Art History* Keith McElroy PhD, MFA; *Prof Graphic Design-Illustration* Jackson Boelts, MFA; *Assoc Prof Graphic Illustration* Jerold Bishop, MFA; *Assoc Prof Ceramics* Aurore Chabot, MFA; *Assoc Prof Sculpture* John Heric, MFA; *Assoc Prof* Bart Morse, MFA; *Assoc Prof Painting & Drawing* Barbara Penn, MFA; *Assoc Prof Printmaking* Andrew Polk, MFA; *Assoc Prof Photography* Ken Shorr, MFA; *Assoc Prof Graphic Design-Illustration* David Christiana, MFA; *Assoc Prof Art History* Pia Cuneo PhD, MFA; *Assoc Prof Art Educ* Lynn Galbraith PhD, MFA; *Assoc Prof Art History* Paul Ivey PhD, MFA; *Asst Prof Gallery Management* Sheila Pitt, MFA; *Assoc Prof Art History* Julie Plax PhD, MFA; *Assoc Prof Painting & Drawing* Alfred Quiroz, MFA; *Assoc Prof New Genre* Joyan Saunders, MFA; *Assoc Prof Art History* Stacie Widdifield PhD, MFA; *Assoc Prof Art History* Jane Williams PhD, MFA; *Asst Prof Graphic Design-Illustration* Ellen McMahon, MFA; *Asst Prof Art History* Sarah Moore PhD, MFA; *Assoc Prof Art History* Mikelle Omari, MFA; *Assoc Prof Chair* Elizabeth Garber, MFA
Estab 1891, dept estab 1893; pub; D; Scholarships; SC 30, LC 21, GC 32; D 3094, maj 600, grad 100
Ent Req: Res—undergrad $919 per 7 units; grad $942 per 7 units per sem; campus res available
Degrees: BFA(Studio), BFA(Art Educ) and BA(Art History) 4 yrs, MFA(Studio) and MA(Art History or Art Educ) 2-3 yrs
Tuition: Res—undergrad $1174 per 7 units, grad $1132 per 7 units per yr; campus res—available
Courses: Advertising Design, †Art Education, †Art History, †Ceramics, †Drawing, Fibers, †Graphic Design, †Illustration, New Genre, †Painting, †Photography, †Printmaking, †Sculpture, Teacher Training, Video, Weaving
Summer School: Presession & two sessions offered. Request catalog (available in April) by writing to: Summer Session Office, Univ of Arizona, Tucson, AZ 85721

ARKANSAS

ARKADELPHIA

OUACHITA BAPTIST UNIVERSITY, Dept of Visual Art, OBU Box 3665, Arkadelphia, AR 71998-0001. Tel 870-245-5559; Fax 870-245-5500; Elec Mail thompsonl@obu.edu; *Dean School Fine Arts* Charles Fuller; *Prof Dr* Raouf Halaby; *Chmn* Larry Thompson; *Prof* Ted Barnes; *Instr* Stephanie Smith; *Instr* Becky Spradun
Estab 1886, dept estab 1934; Maintain nonprofit art gallery; Mabee Fine Arts Gallery, Box 3633 OBu, Arkadelphia, AR 71998; Pvt; D&E; Scholarships; SC 15, LC 2; D 72, non-maj 130, maj 72
Ent Req: HS dipl, ACT

Degrees: BA, BSE, BS and BME 4 yr
Tuition: $4200 per sem
Courses: Art Appreciation, Art Education, Art History, Ceramics, Commercial Art, Conceptual Art, Design, Drawing, Graphic Design, History of Art & Architecture, Illustration, Jewelry, Mixed Media, Painting, Photography, Public School Arts, Sculpture, Teacher Training, †Theatre Arts

CLARKSVILLE

UNIVERSITY OF THE OZARKS, Dept of Art, 415 College Ave, Clarksville, AR 72830. Tel 501-754-3839; Fax 501-979-1349; Internet Home Page Address: www.ozarks.edu; *Prof* Blaine Caldwell; *Chmn* David Strain
Estab 1836, dept estab 1952; den; D; Scholarships; SC 9, LC 2; D 83, non-maj 8, maj 17
Ent Req: HS dipl, ACT
Degrees: BA & BS 4 yr
Tuition: Res—undergrad $2500 per sem
Courses: Art Appreciation, Design, Sculpture
Summer School: Drawing, History of Contemporary Art, Sculpture, Watercolor

CONWAY

UNIVERSITY OF CENTRAL ARKANSAS, Department of Art, McAlister Hall, Rm 101, Conway, AR 72035. Tel 501-450-3113; Fax 501-450-5788; Elec Mail jyoung@uca.edu; Internet Home Page Address: www.uca.edu/academic/art; *Prof* Patrick Larsen; *Prof* Gayle Seymour; *Prof* Roger Bowman; *Prof* Bryan Massey; *Chair, Assoc Prof* Jeff Young; *Prof* Dr Kenneth Burchett; *Asst Prof* Liz Smith; *Asst Prof* Deborah Kuster; *Asst Prof* Donna Pinckley; *Lect* Barbara Satterfield; *Asst Prof* Reinaldo Morales; *Asst Prof* Jennifer Rospert; *Asst Prof* Carrie Dyer
Estab 1908; Maintain nonprofit gallery, Gaum Gallery of Fine Art, McCastlain Hall, UCA, Conway, AR 72035; FT 13, PT 6; pub; D; Scholarships; SC 26, LC 16; non-maj 200, maj 172
Ent Req: HS dipl
Degrees: BFA, BA
Tuition: Res $3,005 15 hrs & up; nonres $5,930; additional fee summer term res, nonres
Courses: Advanced Studio, Art Appreciation, †Art Education, †Art History, †Ceramics, Color, Design, Drawing, Figure, †Graphic Design, Mixed Media, †Painting, †Photography, †Printmaking, †Sculpture

FAYETTEVILLE

UNIVERSITY OF ARKANSAS, Art Dept, 116 Fine Arts Bldg Fayetteville, AR 72701. Tel 479-575-5202; Fax 479-575-2062; Elec Mail artdept@vafsysb.uark.edu; Elec Mail artinfo@www.uark.edu; Internet Home Page Address: www.uark.edu/%7Eartinfo/art.html; *Prof* Donald Harington, MA; *Prof* Myron Brody, MFA; *Prof* Ken Stout, MFA; *Assoc Prof* Lynn Jacobs PhD, MFA; *Dept Chairperson, Assoc Prof* Kristin Musgnug, MFA; *Assoc Prof* John Newman, MFA; *Prof Emeritus* Robert Ross, MFA; *Asst Prof* Angela M LaPorte, PhD; *Instr* Joanne Jones, MFA; *Assoc Prof* Marilyn Nelson, MFA; *Assoc Prof* Jaqueline Golden, MFA; *Prof* Michael Peven, MFA; *Asst Prof* Larry Swartwood, MFA; *Asst Prof* Jeannie Hulen, MFA; *Instr* Shannon Mitchell
Estab 1871; Dept maintains Fine Arts Gallery & Library; Pub; D & E; Scholarships, Fellowships; SC 34, LC 16, GC 20; Non-maj 950, maj 200, grad 15
Ent Req: HS dipl, ent exam, GED
Degrees: MFA 60 cr hours & BA & BFA 4 yrs
Tuition: Res-$4,344 per yr; non-res-$10,290; room & board $5000
Courses: Art Appreciation, †Art Education, †Art History, †Ceramics, †Design, †Drawing, †Graphic Design, †Painting, †Photography, †Printmaking, †Sculpture
Summer School: Dir, M Peven. Enrl 150; 6 wk session. Courses—Ceramics, Drawing, Painting, Photography, 2-D Design, 3-D Design

HARRISON

NORTH ARKANSAS COMMUNITY-TECHNICAL COLLEGE, Art Dept, Pioneer Ridge, Harrison, AR 72601. Tel 501-743-3000, Ext 311; Fax 501-743-3577; Elec Mail sdomino@northark.edu; Internet Home Page Address: www.northark.edu; *Chmn Div of Communications & Arts* Bill Skinner; *Dir Art Dept* Dusty Domino
Estab 1974, dept estab 1975; pub; D & E; SC 7, LC 1; in art dept D 80, E 30-40, non-maj 45, maj 35
Ent Req: HS dipl
Degrees: AA 2 yrs, AFA 2 yrs
Tuition: County res—$80 per cr hr; non-county res—$92 per cr hr; nonres—$138 per cr hr
Courses: Art Appreciation, Ceramics, Commercial Art, Costume Design & Construction, Design, Drafting, Drawing, Elementary Art Education, Graphic Design, Painting, Theatre Arts, Video
Adult Hobby Classes: Various courses offered each sem through Continuing Education Program
Summer School: Enrl 20-30; tuition $30-$35 for term of 6-8 wks beginning June 1. Courses—open; Art Workshop on Buffalo National River

HELENA

PHILLIPS COMMUNITY COLLEGE AT THE UNIVERSITY OF ARKANSAS, (Phillips County Community College) Dept of English & Fine Arts, 1000 Campus Dr, Helena, AR 72342; PO Box 785, Helena, AR 72342. Tel 870-338-6474; Fax 870-338-7542; Internet Home Page Address: www.pccua.cc.ar.us; *Art Instr* Susan Worrington; *Chmn Visual & Performing Arts* Kirk Whiteside

Estab 1966; Maintain nonprofit art gallery; pub; D & E; Scholarships; SC 8, LC 1; 55
Ent Req: HS dipl, ent exam, GED
Degrees: AA and AAS 2 yr
Tuition: Res—$38 per cr hr
Courses: Drawing, Pottery, Sculpture

LITTLE ROCK

THE ARKANSAS ARTS CENTER, Museum School, PO Box 2137, Little Rock, AR 72203. Tel 501-372-4000; Fax 501-375-8053; Internet Home Page Address: www.arkarts.com; *Dir* Brenda K Long; *Mus Educ* Michael Preble; *Dir Mktg* Heather Haywood; *Dir & Chief Cur* Townsend Wolfe; *Registrar* Thom Hall; *Business Mgr* Rocky Nickles; *Sate Svcs* Ned Metcalf; *Dir Mem* Linda Gill; *Shop Mgr* Kim White; *Cur Arts* Brian Young; *Children's Theatre* Bradley Anderson; *Cur Decorative Arts* Alan B Dubois; *Mgr (V)* Laurie Ann Ross; *Pres (9)* Doug Buford
Estab 1960, dept estab 1965; pub; D & E; Scholarships; SC 62, LC 3; D 350, E 300 children & adults
Ent Req: open to anyone age 4 through adult
Tuition: 10 wk course for adults $95-$150; 10 wk course for children $65-$90
Courses: Aesthetics, Art Appreciation, Art History, Ceramics, Drawing, Jewelry, Mixed Media, Painting, Photography, Sculpture, Teacher Training, Woodworking
Adult Hobby Classes: Enrl 1265; tuition $95-$125 for 10 wk term
Children's Classes: Enrl 1373; tuition $65-$75 for 10 wk term. Courses—Theater Arts, Visual Arts
Summer School: Same as above

UNIVERSITY OF ARKANSAS AT LITTLE ROCK, Dept of Art, 2801 S University, Little Rock, AR 72204. Tel 501-569-3182; Fax 501-569-8775; Internet Home Page Address: www.ulr.edu/artdept; *Chmn* Win Bruhl, MFA
Estab 1928; FT 12, PT 5; pub; D & E; Scholarships; SC, LC; Univ sem 10,200, dept sem 1200
Ent Req: HS grad
Degrees: BA 4 yr, MA(studio), MA(art history)
Tuition: Res—undergrad $1054, grad $1441; non-res—undergrad $2557, grad $2971
Courses: Art Appreciation, Art Education, Art History, Ceramics, Design, Drawing, Graphic Design, Illustration, Painting, Photography, Pottery, Printmaking, Sculpture
Summer School: Dean, Deborah Baldwin. Enrl 250; tuition $584 per sem. Courses—Art Appreciation, Art Education, Art History, Studio Art

MAGNOLIA

SOUTHERN ARKANSAS UNIVERSITY AT MAGNOLIA, Dept of Art, 100 E University, Magnolia, AR 71753-5000. Tel 870-235-4000; Fax 870-235-5005; Elec Mail rsstout@saumag.edu; Internet Home Page Address: www.saumag.edu/art; *Asst Prof* Steven Ochs, MFA; *Chmn* Scotland Stout, MFA; *Asst Prof* Doug Waterfield; *Asst Prof* Harlow Hodges
Estab 1909; pub; D & E; Scholarships; SC 18, LC 4; D 240, non-maj 260, maj 40
Ent Req: HS dipl
Degrees: BA & BSE 4 yr
Tuition: Res—undergrad $1152 per yr; nonres—undergrad $1776 per yr
Courses: Advertising Design, Art Appreciation, Art Education, Art History, †Ceramics, Commercial Art, Design, Drafting, Drawing, Graphic Arts, †Graphic Design, †Painting, †Printmaking, †Sculpture
Adult Hobby Classes: Classes & courses open to all at regular tuition rates
Children's Classes: Enrl 30; tuition $30. Courses—Kinder Art
Summer School: Dir, Jerry Johnson. Enrl 60. Courses—Art, Fine Arts

MONTICELLO

UNIVERSITY OF ARKANSAS AT MONTICELLO, Fine Arts Dept, PO Box 3460, Monticello, AR 71656. Tel 870-460-1078; Internet Home Page Address: www.cotton.uamont.edu/~richardt/art_index.html; *Chmn* Tom Richard
Dept estab 1909; Scholarships
Ent Req: HS dipl
Degrees: BA
Tuition: Res—undergrad $2680 per sem; waiver from MI, LA, TX
Courses: Art Appreciation, †Art Education, Ceramics, Design, Drawing, Graphic Arts, History of Art & Architecture, Mixed Media, Painting, Printmaking
Summer School: Enrl 25; tuition $65 per cr hr for June-July. Courses—Art Appreciation, Art Education

PINE BLUFF

UNIVERSITY OF ARKANSAS AT PINE BLUFF, Art Dept, N University Dr, Box 4925 Pine Bluff, AR 71611. Tel 870-575-8326, 575-8328; Elec Mail linton_h@4500.uapb.edu; Internet Home Page Address: www.uapb.edu; *Dept Chmn* Henri Linton
Leedell Morehead-Graham Gallery (nonprofit) on campus; pub; D & E; Scholarships
Ent Req: HS dipl
Degrees: BS
Tuition: Undergrad—$840 per sem nonres— $1944 per sem
Courses: Art Appreciation, Art Education, Art History, Calligraphy, Ceramics, Design, Drawing, Handicrafts, Painting, Photography, Printmaking, Sculpture, Textile Design, Weaving

RUSSELLVILLE

ARKANSAS TECH UNIVERSITY, Dept of Art, 1505 N Boulder Ave, Russellville, AR 72801. Tel 501-968-0244; Fax 501-968-0204; Elec Mail john.sullivan@mail.atu.edu; Internet Home Page Address: www.atu.edu; *Assoc Prof* John Sullivan, MFA; *Asst Prof* Ty Brunson; *Asst Prof* David Mudrinich, MFA

Estab 1909; pub; D & E; Scholarships; SC 28, LC 5, GC 1; D 200, non-maj 130, maj 88
Ent Req: ent req HS dipl, ACT, SAT
Degrees: BA 4 yr
Tuition: Res—undergrad $1008 per sem, $89 per cr hr, grad $91 per cr hr; nonres—undergrad $2016 per sem, $178 per cr hr, grad $182 per cr hr; no campus res
Courses: Advertising Design, Art Education, Art History, Ceramics, †Commercial Art, Display, Drawing, †Fine Arts, †Graphic Design, Illustration, Intro to Art, Lettering, Packaging Design, Painting, †Photography, Printmaking, †Sculpture, Teacher Training
Adult Hobby Classes: Drawing, Oil Painting, Watercolor
Summer School: Head Dept, Ron Reynolds. Enrl 30-50; tuition res $84 per cr hr, nonres $168 per cr hr; terms of 6 wks beginning June 8 & July 12. Courses—Art Education, Art History, Ceramics, Design, Drawing, Painting

SEARCY

HARDING UNIVERSITY, Dept of Art, 900 E Center St, Searcy, AR 72149-0001; PO Box 2253, Searcy, AR 72149-0001. Tel 501-279-4000, Ext 4426; Fax 501-279-4717; Internet Home Page Address: www.harding.edu; *Chmn Dept* John Keller, MA; *Prof* Faye Doran, EdD; *Prof* Paul Pitt, MFA; *Asst Prof* Daniel Adams, MFA; *Instr* Beverly Austin, MA; *Instr* Steven B Choate, MFA; *Instr* Ashley Brown; *Assoc Prof* Amy Cox
Estab 1924; pvt; D; Scholarships; SC 27, LC 9, GC 7; D 103, non-maj 25, maj 103
Ent Req: HS dipl, ACT
Degrees: BA, BS and BFA 4 yrs, MEd 5-6 yrs
Tuition: $227.50 per sem hr; campus res—room & board $3184 per yr
Courses: 2-D Design, Advertising Design, Aesthetics, Architecture, Art Appreciation, Art Education, Art History, †Art Therapy, Ceramics, Color Theory, Computer Graphics, Design, Drafting, Drawing, Graphic Arts, Graphic Design, Interior Design, Jewelry, Painting, Printmaking, Sculpture, Silversmithing, Teacher Training, Weaving
Summer School: Dir, Dr Dean Priest. Enrl 1000; tuition per sem hr for two 16 wk sessions beginning August. Courses—Vary depending upon the demand, usually Art Education, Art History, Ceramics, Drawing, Graphic Design, Interior Design, Painting

SILOAM SPRINGS

JOHN BROWN UNIVERSITY, Art Dept, 2000 W University, Siloam Springs, AR 72761. Tel 501-524-3131, Ext 182; Fax 501-524-9548; Internet Home Page Address: www.jbu.edu; *Asst Prof* Peter Pohle; *Head Dept* Charles Peer
Estab 1919; FT 2; pvt; D; Scholarships; SC 9, LC 3
Ent Req: HS grad
Degrees: AS(Art)
Tuition: $4250 yr, $2175 per sem, $138 per sem hr; campus res—room & board $3800
Courses: Art Appreciation, Art Education, Composition, Crafts (copper tooling, Design & Color, Drawing, Painting, enameling, jewelry, macrame, mosaic, pottery, weaving)

STATE UNIVERSITY

ARKANSAS STATE UNIVERSITY, Dept of Art, PO Box 1630, State University, AR 72467. Tel 870-972-3050; Fax 870-972-3932; Elec Mail csteele@aztec.astate.edu; Internet Home Page Address: www.astate.edu/; *Prof* Evan Lindquist, MFA; *Prof* William Allen PhD, MFA; *Prof* Steven L Mayes, MFA; *Prof* Tom Chaffee, MFA; *Prof* John Keech, MFA; *Assoc Prof* Roger Carlisle, MFA; *Assoc Prof* Curtis Steele, MFA; *Assoc Prof* Debra Satterfield, MFA; *Assoc Prof* John J Salvest, MFA; *Asst Prof* Dr Paul Hickman PhD, MFA; *Instr* Jean Flint; *Instr* Nadine Hawke; *Instr* Gayle Pendergrass, MFA; *Instr* William H Rowe, MFA
Estab 1909, dept estab 1938; FT 13; pub; D & E; Scholarships; SC 33, LC 10, GC 34; D 300, E 100, non-maj 800, maj 132, grad 10
Ent Req: HS dipl
Degrees: BFA, BSE 4 yr, MA
Tuition: Res—dorm $10,636, with parent $8310; non-res—dorm $10,636, off campus $13,368, with parent $8310; campus res—room & board $1270 per sem
Courses: Art Appreciation, †Art Education, †Art History, Ceramics, Drawing, †Graphic Design, Illustration, Intermedia, Painting, Photography, †Studio Art
Adult Hobby Classes: 20; tuition $82 per sem hr. Courses—Art History, Ceramics, Drawing, Painting
Summer School: Dir, Curtis Steele. Enrl 100; tuition res—$490; nonres—$1260 per 5 wk term. Courses—Art History, Drawing, Painting, Photography, Sculpture

WALNUT RIDGE

WILLIAMS BAPTIST COLLEGE, Dept of Art, 60 W Fulbright, Walnut Ridge, AR 72476. Tel 870-886-6741; Fax 870-886-3924; Internet Home Page Address: www.wbeoll.edu/infranetstart.htm; *Instr* Melissa Christiano; *Instr* Jima Mickie; *Chmn* Dr David Midkiff
den; D & E; Scholarships
Degrees: BS (Art Educ) & BA
Tuition: Res—$6900 per yr; campus res available; room & board $3500 per yr
Courses: Art Education, Ceramics, Conceptual Art, Drawing, Painting, Theatre Arts
Summer School: Dir, Dr Jerrol Swaim. Tuition $925 for 12-16 hrs, &75 per hr

CALIFORNIA

ANGWIN

PACIFIC UNION COLLEGE, Art Dept, 100 Howell Mountain Rd Angwin, CA 94508; One Angwin Ave Angwin, CA 94508. Tel 707-965-6311; Elec Mail ctturner@pcu.edu; Internet Home Page Address: puc.edu; *Chmn* Tom Turner
Dept estab 1882; pvt; D&E; Scholarships
Degrees: AS, BA, BS
Tuition: $470 per unit, $5445 per qtr
Courses: Art History, Ceramics, †Collage, Design, Drawing, Graphic Design, Illustration, Painting, Photography, Printmaking, Sculpture, Stained Glass
Summer School: Dir, Gary Gifford. Courses—Art History, Photography

APTOS

CABRILLO COLLEGE, Visual & Performing Arts Division, 6500 Soquel Dr, Aptos, CA 95003. Tel 831-479-6464; Fax 831-479-5095; Internet Home Page Address: www.cabrillo.cc.ca.us; *Chmn* Dan Martinez
Estab 1959; FT 12, PT 22; pub; D & E; Scholarships; SC 46, LC 7
Ent Req: HS dipl
Degrees: AA 2 yr
Tuition: $13 per cr
Courses: Art History, Ceramics, Color, Design, Drawing, Handicrafts, Jewelry, Painting, Photography, Printmaking, Sculpture, Textile Design

ARCATA

HUMBOLDT STATE UNIVERSITY, College of Arts & Humanities, 1 Harpst St, Arcata, CA 95521. Tel 707-826-3624; Fax 707-826-3628; Internet Home Page Address: www.humboldt.edu; *Instr* M D Benson; *Instr* M Bravo; *Instr* C DiCostanza; *Instr* M Isaacson; *Instr* R Johnson; *Instr* E Land-Weber; *Instr* D M LaPlantz; *Instr* L B Marak; *Instr* D Mitsanas; *Instr* J Crawford; *Instr* L Price; *Instr* S Ross; *Instr* M Morgan; *Instr* W Anderson; *Instr* A M Scott; *Instr* D Anton; *Instr* T Stanley; *Chmn* James Crawford
Estab 1913; pub; D & E; Scholarships; SC 35, LC 11, GC 11
Degrees: BA 4 yr, BA with credential 5 yr
Tuition: Res—$1992 per yr; campus res available
Courses: Ceramics, Drawing, Graphic Design, Jewelry, Painting, Photography, Printmaking, Sculpture, Teacher Training
Children's Classes: Children's Art Academy
Summer School: Chmn, James Crawford. Enrl 24; tuition $75 per unit for 6 weeks

AZUSA

AZUSA PACIFIC UNIVERSITY, College of Liberal Arts, Art Dept, 901 E Alosta, PO Box 7000 Azusa, CA 91702-7000. Tel 626-969-3434; Fax 818-969-7180; Internet Home Page Address: www.apu.edu; *Assoc Prof* James Thompson, EdD; *Chmn Dept* William Catling, MFA; *Asst Prof* Dave McGill, MFA; *Assoc Prof* Susan Ney, MA; *Asst Prof* Guy Kinnear; *Asst Prof* Kieran Gays; *Asst Prof* Kent Butler; *Asst Prof* David Carlson
Estab 1899, dept estab 1974; Azusa Pacific Art Gallery; den; D & E; Scholarships; SC 54, LC 7; maj 190, non-maj 250
Ent Req: HS dipl, state test
Degrees: BA(Art) 4 yrs
Tuition: $6000 per sem
Courses: Art Appreciation, Art Education, Art History, Ceramics, Drawing, Graphic Arts, Graphic Design, Painting, Photography, Printmaking, Sculpture, Textile Design, Video
Summer School: Dir, W. Catling; Enrl varies; Courses—varies

BAKERSFIELD

BAKERSFIELD COLLEGE, Fine Arts Dept, 1801 Panorama Dr, Bakersfield, CA 93305. Tel 661-395-4011; Fax 661-395-4078; Internet Home Page Address: www.bc.cc.ca.us; *Chmn* Chalita Robinson; *Dir Art Gallery* Theresia Kleeman; *Graphic Dept Dir* Nelson Richardson; *Ceramics Dept Dir* Marlene Tatsuno; *Photography* Harry Wilson
Estab 1913; pub; D & E; Scholarships, Fellowships; SC 16, LC 4; D 8000, maj 150-200
Ent Req: ent exam, open door policy
Degrees: AA 2 yr
Tuition: Calif res—$11 per unit (max 5 and a half); 6 or more units $70; nonres—$135 per unit (max 15); no charge for units in excess of maximum
Courses: Advertising Design, Art Appreciation, Art History, Ceramics, Design, Drawing, Glassblowing, Jewelry, Lettering, Painting, Photography, Printmaking, Sculpture
Adult Hobby Classes: Enrl 100-150. Various courses incl floral design
Summer School: Dir, chmn Chalita Robinson. Enrl 100; tuition $13 per unit for 6 wk term. Courses—Art Appreciation, Ceramics, Drawing

CALIFORNIA STATE UNIVERSITY, BAKERSFIELD, Dept of Performing Arts Dept of Art, 9001 Stockdale Hwy, Bakersfield, CA 93311. Tel 661-664-3031; Fax 661-665-3555; Internet Home Page Address: www.csub.edu; *Chmn* Dr Ted Kerzie
FT 5; pub; D&E; Scholarships
Ent Req: HS diploma
Degrees: BA
Tuition: Res—$396 0-6 units; $618 6 or more units per qtr; nonres $2055 per qtr

Courses: Art Education, Art History, Ceramics, Design, Drawing, Painting, Photography, Printmaking, Sculpture

BELMONT

NOTRE DAME DE NAMUR UNIVERSITY, Wiegand Gallery, 1500 Ralston Ave, Belmont, CA 94002. Tel 650-508-3595; Fax 650-508-3488; Internet Home Page Address: www.ndnu.edu; *Art Dept Chair* Betty Friedman; *Gallery Dir* Robert Poplack
Estab 1951; Maintains nonprofit art gallery; FT 2, PT 6; pvt; D & E; weekends; Scholarships; SC 20, LC 8; D 200, E 100, maj 35
Ent Req: HS dipl, ent exam
Degrees: BA 3 1/2 - 4 yrs, BFA
Courses: 2-D & 3-D Design, Advertising Design, Art Education, Art History, Color, Commercial Art, Composition, Conceptual Art, Constructions, Costume Design & Construction, Design, Display, Drawing, Etching, Film, Gallery Techniques, Graphic Arts, Graphic Design, History of Art & Architecture, Interior Design, Lettering, Lithography, Mixed Media, Museum Staff Training, Painting, Photography, Printmaking, Sculpture, Stage Design, Teacher Training, Theatre Arts

BERKELEY

UNIVERSITY OF CALIFORNIA, BERKELEY
—College of Letters & Sciences-Art Practice Dept, Tel 510-642-2582; Fax 510-643-0884; Elec Mail love2jr@uclink4.berkeley.edu; Internet Home Page Address: http://art.berkeley.edu; *Dept Mgr* Margaret Thalhuber, MFA; *Chair* Mary Lovelace O'Neil, MFA; *Chair* Shawn Brixey, MS; *Undergrad faculty adv* Squeak Carnwath, MS; *Undergrad faculty adv* Anne Healy, BA; *Grad & undergrad faculty adv* Richard Shaw, MA; *Grad & undergrad faculty adv* Katherine Sherwood, MFA; *Grad & undergrad faculty adv* Wendy Sussman, MFA; *Grad & undergrad advising asst* Delores Levister, MFA; *Admin Asst* Jude Bell
Estab 1915; pub; D; Scholarships
Degrees: BA, MFA(sculpture & painting)
Tuition: Res—undergrad $2023.25 per sem, grad $2134.25 per sem; nonres—undergrad $7330.25 per sem, grad $7351.25 per sem
Courses: Art Theory, Drawing, Painting, Sculpture
—College of Environmental Design, Tel 510-643-9335; Fax 510-643-6166; Elec Mail maclark@vclink4.berkeley.edu; Internet Home Page Address: www.laep.ced.berkeley.edu/laep/index; *Chmn City & Regional Planning* Michael Southworth PhD; *Chair* Walter J Hood, MLA & MArch; Randolph Hester, MLA; Louise MoZingo, MLA; Charles Sullivan, MLA; John Radke, PhD; Peter Walker, MLA; Peter Bosselmann, MArch; Timothy Duane, PhD; Linda Jewell, MLA; G Mathias Kondolf, PhD; Patricia Lindsey, PhD; Joe McBride, PhD
pub; D & E; Scholarships
Degrees: BA, MA, MSC, PhD
Tuition: Res—undergrad $2023.25 per sem, grad $2134.25 per sem; nonres—undergrad $7330.25 per sem, grad $7351.25 per sem
Courses: Computer-Aided Design, Drawing, Landscape Architecture

BURBANK

WOODBURY UNIVERSITY, Dept of Graphic Design, 7500 Glenoaks Blvd, Burbank, CA 91510-7846. Tel 818-767-0888; Fax 818-504-9320; Internet Home Page Address: www.woodburyu.edu; *Chmn Interior Design* Randall Stauffer; *Chmn Fashion Design* Penny Collins; *Chmn Graphic Design* Bill Keeney; *Chmn Animation* Jack Bosson; *Chmn Architecture* Norman Millar
Estab 1884; Maintain art/architecture library; art supplies available on-campus; pvt; D & E; Scholarships; SC 56, LC 18
Ent Req: HS dipl
Degrees: BFA 4 yrs, MRA 2 yrs, BArc 5 yrs
Tuition: $9557 per sem
Courses: Advertising Design, Architecture, Art History, Costume Design & Construction, Design, Display, Fashion Arts, †Fashion Design, Graphic Design, Illustration, †Interior Architecture, Photography, Textile Design
Summer School: Regular session

CANTA COLITA

COLLEGE OF THE CANYONS, Art Dept, 26455 Rockwell Canyon Rd, Canta Colita, CA 91355; 26455 Rockwell Canyon Rd, Santa Clarita, CA 91355. Tel 661-259-7800; Fax 661-259-8362; Elec Mail lorigan-j@mail.coc.cc.ca.us; Internet Home Page Address: www.coc.cc.ca.us; *Instr* Robert Walker, MFA; Joanne Julian, MFA; *Chair* Jim Lorigan, MFA; *Adjunct* Larry Arbino; *Adjunct* Denise Delavaux; *Adjunct* Rebecca Edwards; *Adjunct* Amy Green; *Adjunct* Mercedes McDonald; *Adjunct* Ron Petrosky; *Adjunct* Laura Shurley-Olivas; *Adjunct* Larry Hurst; *Adjunct* Joy Von Wolffersdorff
Estab 1970; dept estab 1974; Maintain nonprofit art gallery at Col of Canyons, Santa Clarita, CA; art supplies available on-campus; pub; D & E, Sat; Scholarships; SC 11, LC 4; D 300, E 300, maj 50
Ent Req: must be 18 yrs of age
Degrees: AA & AS 2 yrs
Tuition: Res—$26 per unit; nonres—$271 per unit; non res foreign— $271 per unit
Courses: 2-D Design, 3-D Design, Advertising Design, Art Appreciation, Art History, Computer Graphics, Drawing, Gallery Practices, Illustration, Painting, Photography, Printmaking, Sculpture, Watercolor
Adult Hobby Classes: Tuition $10 plus lab fees usually another $10 per sem
Children's Classes: Classes offered in continuing educ under child development
Summer School: Dir Carole Long

CARSON

CALIFORNIA STATE UNIVERSITY, DOMINGUEZ HILLS, Art Dept, LCH-A111 , 1000 E Victoria St Carson, CA 90747. Tel 310-243-3310; Elec Mail livers@csudh.edu; Internet Home Page Address: www.csudh.edu; *Chmn* Dr Louise Ivers; Gilah Hirsch; John Goders; Bernard Baker; *Asst Prof* Michele Allan; *Asst Prof* Jim Keville; *Instr* Patricia Gamon; *Instr* David Parsons

Estab 1960; Maintain nonprofit Univ Art Gallery; Cain Educ Resources Ctr; pub; D & E; Scholarships; SC 35, LC 25; maj 130
Ent Req: 2.0 GPA
Degrees: BA 4 yr
Tuition: Res—undergrad $700 per sem for 6.0 units or less, $900 per sem for more than 6 units; tuition includes several fees
Courses: †Advertising Design, Aesthetics, Art Appreciation, †Art History, Ceramics, Collage, Design, Drawing, †Graphic Design, History of Art & Architecture, Mixed Media, Painting, Sculpture, Studio Art
Children's Classes: Tuition $36 - $55 per unit for 4 - 8 wk term.
Courses—Crafts
Summer School: Dir, Dr Louise H Ivers. Enrl 40; tuition $36 - $55 per unit for 4 - 8 wk term. Courses—Crafts, Experiencing Creative Art, Ceramics

CHICO

CALIFORNIA STATE UNIVERSITY, CHICO, Department of Art & Art History, First & Normal, Chico, CA 95929-0820. Tel 530-898-5331; Fax 530-898-4171; Elec Mail vpatrick@oavax.csuchico.edu; Internet Home Page Address: www.csuchico.edu/art; *Chmn* Tom Patton; *Graduate Advisor, Instr & Prof* Jean Gallagher, MFA; *Prof* Sheri Simons, MFA; *Prof Emeritus* David Hoppe, MFA; *Prof* James Kuiper, MFA; *Prof Emeritus* Yoshio Kusaba PhD; *Prof Emeritus* Sharon Smith, EdD; *Instr* Jason Tannen, MFA; *Prof* Cameron Crawford, MFA; *Prof Emeritus* Michael Simmons, EdD; *Prof* Karen VanDerpool, MFA; *Assoc Prof* Nanette Wylde, MFA; *Assoc Prof* Sue Whitmore, MFA; *Asst Prof* Eileen Macdonald; *Assoc Prof* Robert Herhusky; *Assoc Prof* Matt Looper; *Asst Prof* Amy Bloch; *Assoc Prof* Kijeong Jeon; *Prof* Michael Bishop; *Asst Prof* Teresa Cotner; *Assoc Prof* Masami Toku; *Prof Emeritus* James McManus; *Prof Emeritus* Vernon Patrick; *Instr* David Thode
Estab 1887; maintains nonprofit gallery, Dept of Art, CSU, Chico, Chico, CA 95928; pub; D & E; SC 39, LC 29, GC 29; non-maj & maj 1900, grad 59
Ent Req: Ent exam and test scores
Degrees: BA 4 yr, BFA 5 yr, MFA 3 yr, MA 1 1/2 yr minimum
Tuition: Res—undergrad $715 per sem for less than 6 cr hrs, $1015 per sem for over 6 cr hrs; nonres—$246 per unit; grad $739 for less than 66 hrs, $1051 for more than 6 hrs
Courses: Aesthetics, Art Appreciation, Art Education, †Art History, †Ceramics, Design, Display, †Drawing, Glass, †History of Art & Architecture, †Interior Design, Intermedia, Mixed Media, Museum Staff Training, †Painting, Photography, †Printmaking, †Sculpture, Teacher Training, †Weaving
Summer School: Chmn, Vernon Patrick. Enrl 50. Courses—Varies

CLAREMONT

CLAREMONT GRADUATE UNIVERSITY, Dept of Fine Arts, 251 E Tenth St, Claremont, CA 91711. Tel 909-621-8071; Fax 909-607-1276; Elec Mail art@cgu.edu; Internet Home Page Address: www.cgu.edu/arts/art; *Prof* Michael Brewster, MFA; *Chair* Connie Zehr, BFA; *Vis Instr* David Amico, MFA; *Vis Instr* Ann Bray, MFA; *Vis Instr* John Millei, BA; *Prof* Shirley Kenada; *Vis Instr* Shirley Tse; *Vis Instr* Meg Cranston
Estab 1925; maintain nonprofit art gallery; Claremont Graduate University/Art Galleries & Special Exhibs Progs, 251 East Tenth St, Claremont, CA 91711-3913; FT 3 PT 13; priv; D; Scholarships; SC 43 LC 7 GC50; non-maj 1, maj 56, grad 53
Ent Req: BA, BFA or Equivalent
Degrees: MA 1 yr, MFA 2 yr
Tuition: Grad $22,984 per yr, $600 per unit fewer than 12; campus res available
Courses: Aesthetics, Art History, †Drawing, †Film, Graphic Arts, Installation, Intermedia, Mixed Media, Newmedia, †Painting, Performance, †Photography, †Printmaking, †Sculpture

PITZER COLLEGE, Dept of Art, 1050 N Mills Ave, Claremont, CA 91711. Tel 909-621-8000; Fax 909-621-8481; Internet Home Page Address: www.pitzer.edu; *Photography* Stephen Cahill; *Drawing* Kathryn Miller; *Prof Ceramics* David Furman; *Photography* Michael Honer
Estab 1963; pvt; D&E; Scholarships, Fellowships; SC 10, LC 6
Ent Req: HS dipl, various criteria, apply Dir of Admis
Degrees: BA 4 yr
Tuition: Res—$31,696 (including campus res, board & activities fees per yr)
Courses: Art History, Ceramics, Constructions, Drawing, Environments, Film, History of Art & Architecture, Mixed Media, Photography, Sculpture, Video

POMONA COLLEGE, Dept of Art & Art History, 145 E Bonita Ave, Claremont, CA 91711-6322. Tel 909-607-2221; Fax 909-621-8892; *Prof* Judson Emerick; *Prof* Enrique Martinez Celaya, MFA; *Chmn, Prof* George Gorse, PhD; *Assoc Prof* Sheila Pinkel, MFA; *Assoc Prof* Frances Pohl, PhD; *Asst Prof* Mercedes Teixido, MFA; *Asst Prof* Phyllis Jackson, PhD
Estab 1889; Maintain Montgomery Gallery at Pomona College; pvt; D; Scholarships; SC 15, LC 25; D 330 maj 37
Ent Req: HS dipl
Degrees: BA 4 yrs
Tuition: Res—undergrad $7850 per sem. $22,455 with room & board
Courses: †Art History, Art Studio, Ceramics, Drawing, Graphic Design, Painting, Photography, Sculpture

SCRIPPS COLLEGE, Millard Sheets Art Center-Williamson Gallery, 1030 Columbia Ave, Claremont, CA 91711. Tel 909-621-8000; Fax 909-607-7576; Internet Home Page Address: www.scrippscollege.edu; *Chmn Dept* Nancy Macko
Estab 1928; dept estab 1933; pub; D; Scholarships; D 580, non-maj 480, maj 100
Ent Req: HS dipl
Degrees: BA
Tuition: $2500 per unit
Courses: Architecture, Art History, Ceramics, Drawing, Fiber Arts, Film, Mixed Media, Painting, Printmaking, †Sculpture, Typography

COALINGA

WEST HILLS COMMUNITY COLLEGE, Fine Arts Dept, 300 Cherry Lane, Coalinga, CA 93210. Tel 559-935-0801, Ext 328; Fax 559-935-5655; Internet Home Page Address: www.westhillscollege.com; *Instr* Marilyn Trouse
Estab 1935; pub; D & E; SC 15, LC 2; D 625, E 1250, non-maj 25, maj 10
Ent Req: HS dipl or equivalent
Degrees: AA 2 yrs
Tuition: $11 per unit in-state; $139 out-of-state
Courses: Art History, †Ceramics, Design, †Drawing, Fashion Arts, †Illustration, Lettering, †Museum Staff Training, †Painting, Printmaking, Sculpture

COMPTON

COMPTON COMMUNITY COLLEGE, Art Dept, 1111 E Artesia Blvd, Compton, CA 90221. Tel 310-637-2660; Internet Home Page Address: www.compton.cc.ca.us; *Prof* Verneal De Silvo; *Chmn* David Cobbs
Estab 1929; FT 1; pub; D & E; Scholarships; SC 16, LC 6; D 3500, E 2000, maj 18
Ent Req: HS dipl, 18 yrs of age
Degrees: AA 2 yr
Tuition: Res—$12 per unit
Courses: Advertising Design, Afro-American Art, Art Appreciation, Drafting, Drawing, History of Art & Architecture, Lettering, Painting, Photography, Showcard Writing, Theatre Arts
Summer School: Courses—Art Appreciation

COSTA MESA

ORANGE COAST COLLEGE, Division of Fine Arts, 2701 Fairview, Costa Mesa, CA 92628. Tel 714-432-5629; Fax 714-432-5075; Internet Home Page Address: www.orangecoastcollege.com; *Div Dean* Sylvia Impert
Estab 1946; FT 35, Adjunct 80; pub; D & E; Scholarships; SC 225, LC 25; D 4500, E 3500, maj 825
Ent Req: ent exam
Degrees: AA 2 yr
Tuition: Undergrad $29 per unit, grad $75 per unit
Courses: Advertising Design, †Art, Art Appreciation, Art History, Ceramics, Commercial Art, †Computer Graphics, Design, Display, †Display & Visual Presentation, Drawing, Film, Graphic Arts, Graphic Design, Illustration, Interior Design, Jewelry, Lettering, Mixed Media, †Music, Painting, Photography, Printmaking, Sculpture, Stage Design, Theatre Arts, Video
Summer School: Dir Sylvia Imperl. Six & eight wk sessions. Courses—same as regular session

CUPERTINO

DE ANZA COLLEGE, Creative Arts Division, 21250 Stevens Creek Blvd, Cupertino, CA 95014. Tel 408-864-8832; Internet Home Page Address: www.deanza.fhda.edu; *Instr* William Geisinger; *Instr* Michael Cole; *Instr* Lee Tacang; *Instr* Michael Cooper; *Dean Creative Arts* Dr Nancy Canter
Estab 1967, dept estab 1967; pub; D & E; Scholarships
Ent Req: 16 yrs of age
Degrees: Certificates of Proficiency, AA 2 yrs
Courses: Aesthetics, Art History, Ceramics, Drafting, Drawing, Film, Graphic Arts, Graphic Design, Lettering, Painting, Photography, Printmaking, Sculpture, Stage Design, Theatre Arts, Video
Adult Hobby Classes: Tuition varies per class. Courses—Bronze Casting, Calligraphy, Museum Tours,
Children's Classes: Computer art camp
Summer School: Courses—Drawing, Painting, Printmaking

CYPRESS

CYPRESS COLLEGE, Fine Arts Division, 9200 Valley View St Cypress, CA 90630. Tel 714-484-7000, Ext. 47139; *Fine Arts Mgr* Barbara Russo; *Chairperson* Charlene Felos
Estab 1966; pub; D & E, Sat; Scholarships; SC, LC; D 13,200
Ent Req: HS dipl
Degrees: AA 2 yrs
Tuition: $13 per unit up to 5 units; nonres $114 per unit; foreign $118 per unit plus enroll fee $13
Courses: Advertising Design, Art Appreciation, Art History, Ceramics, Commercial Art, Design, †Display, Drawing, †Gallery Design, Graphic Arts, Graphic Design, †Metalsmithing, †Painting, †Printmaking
Adult Hobby Classes: Adults may take any classes offered both day & extended; also offer adult education classes
Summer School: Extended Day Coordinator, Dr Evelyn Maddox

DAVIS

UNIVERSITY OF CALIFORNIA, DAVIS, Dept of Art & Art History, One Shields Ave, Davis, CA 95616-8528. Tel 530-752-0105; Fax 530-752-0795; Elec Mail lcday@ucdavis.edu; Internet Home Page Address: www.ucdavis.edu; *Chmn Art Studio* Gina Werfel, MFA; *Dir Art History* Jeffrey Ruda; Conrad Atkinson; Mike Henderson, MFA; Lynn Hershman, MA; David Hollowell, MFA; Malaquias Montoya, BA; Pardee Hearne, MFA; Lucy Puls, MFA; Annabeth Rosen, MFA; Cornelia Schulz, MFA
Estab 1952; FT 16; pub; D; Scholarships; SC 28, LC 35; maj 130, others 900
Degrees: BA 4 yrs, MA(Art History), MFA(Art Studio)
Tuition: Res—$2714 per yr; nonres—$14,686 per yr

Courses: Art Appreciation, †Art History, Ceramic Sculpture, Ceramics, Conceptual Art, Constructions, Drawing, Graphic Arts, History of Art & Architecture, Mixed Media, Painting, Photography, Sculpture

EUREKA

COLLEGE OF THE REDWOODS, Arts & Languages Dept Division, 7351 Tompkins Hill Rd, Eureka, CA 95501-9300. Tel 707-445-6700, 476-4302 (Art Dept); Fax 707-441-5916; *Dean* Lea Mills
Estab 1964; FT 4, PT 8; pub; D & E; Scholarships; SC 15, LC 3 per sem; 8330, maj 160
Ent Req: HS grad
Degrees: AA & AS 2 yrs
Tuition: Nonres—$148 per unit plus $15 enrollment fee per unit
Courses: Art Fundamentals, Ceramics, Drawing, Fabrics, Jewelry Making, Photography, Weaving

FRESNO

CALIFORNIA STATE UNIVERSITY, FRESNO, Art & Design, 5225 N Backer Ave, Mail-Stop No 65 Fresno, CA 93740-8001. Tel 559-278-4240, 278-2516; Fax 559-278-4706; Elec Mail info@csufresno.edu; Internet Home Page Address: www.csufresno.edu/art and design; *Chmn* Nancy K Brian
Estab 1911, dept estab 1915; FT 15; pub; E; Scholarships; SC 45, LC 9, GC 4; 1000
Ent Req: HS dipl, SAT or ACT
Degrees: BA 4 yrs, MA 2 yrs
Tuition: Res—undergrad $881 per sem; res—grad $920 per sem; nonres—$3341 per sem; campus res available
Courses: Art Education, Art History, Ceramics, Crafts, Drawing, Film, †Graphic Design, †Interior Design, Metalsmithing, Painting, Photography, Printmaking, Sculpture, Teacher Training
Adult Hobby Classes: Tuition $35 unit. Courses—various
Summer School: Courses—Ceramics

FRESNO CITY COLLEGE, Art Dept, 1101 E University Ave, Fresno, CA 93741. Tel 559-442-4600; Fax 559-485-3367; Internet Home Page Address: www.fcc.cc.ca.us; *Dean* Anthony Cantu
Estab 1910, dept estab 1955; pub; D & E; SC 13, LC 3; D 14,000, E 2000
Ent Req: none, open door policy
Degrees: AA 2 yrs
Tuition: Res—$18 first unit, then $8 reg fee per unit up to maximum of $65; nonres—$108 per unit
Courses: Art Appreciation, Art History, Ceramics, Drawing, Fiber Art, Gallery Practices, Interaction of Color, Painting, Printmaking, Sculpture
Adult Hobby Classes: Ceramics, Design, Drawing, Painting, Sculpture
Summer School: Art Appreciation, Art History, Ceramics

FULLERTON

CALIFORNIA STATE UNIVERSITY, FULLERTON, Art Dept, PO Box 6850 Fullerton, CA 92834-6850. Tel 714-278-3471; Fax 714-278-2390; Internet Home Page Address: www.art.fullerton.edu; *Dean School of Arts* Jerry Samuelson, MA; *Chmn Dept* Larry Johnson, MA
Estab 1957, dept estab 1959; Art supplies available on-campus; pub; D & E; Scholarships; SC 62, LC 27, GC 12; grad 110, undergrad 1200
Ent Req: HS dipl, SAT or ACT
Degrees: BA, BFA, MA, MFA
Tuition: Res—undergrad $640.50 for 0 - 6 units, $940.50 for 7 or more units, grad $664.50 for 0 - 6 units, $979.50 for 7 or more units; nonres—undergrad & grad $246 per unit plus $640.50 or $979.50; no campus res
Courses: †Art Education, †Art History, †Ceramics, Collage, Conceptual Art, Constructions, Design, Display, †Drawing, Glass, †Graphic Design, †Illustration, Intermedia, †Jewelry, Museum Studies, †Painting, †Photography, †Printmaking, †Sculpture, Silversmithing, Video, Wood
Summer School: Enrl 100; tuition $145 per unit. Courses—Art History

FULLERTON COLLEGE, Division of Fine Arts, Art Dept, 321 E Chapman Ave Fullerton, CA 92832-2095. Tel 714-992-7000, 7298; Fax 714-447-4097; Internet Home Page Address: www.fullcoll.edu; *Dir* Kate Johnson
Estab 1913; pub; D & E; Scholarships
Ent Req: HS dipl, ent exam
Degrees: AA 2 yr
Tuition: Nonres—$130 per unit; no campus res
Courses: Art History, Ceramics, Computer Graphics, Drawing, Gallery Design & Exhibition, Graphic Arts, Graphic Design, Illustration, Jewelry, Museum Staff Training, Painting, Photography, Printmaking, Sculpture, Textile Design, Weaving

GILROY

GAVILAN COMMUNITY COLLEGE, Art Dept, 5055 Santa Teresa , Gilroy, CA 95020. Tel 408-846-4946; Fax 408-848-4801; Elec Mail jedberg@gavilan.edu; Internet Home Page Address: www.gavilan.cc.ca.us; *Adjunct Prof* Jane Rekedael; *Chmn & Prof* Jane Edberg; *Adjunct* Morrie Roizen; *Prof* Aruturo Rosette
Estab 1919; Maintain nonprofit art gallery; art supplies available on-campus; FT 2, PT 3; pub; D & E, Weekends, Long Distance Learning; SC 12, LC 2; D 450, E 75, maj 30
Ent Req: HS dipl or 18 yrs of age
Degrees: AA 2 yrs
Tuition: Res—undergrad $23 per unit

Courses: Aesthetics, Art Appreciation, Art History, Art of the Americas, Ceramics, Design, Drawing, Graphic Design, History of Art & Architecture, Painting, Sculpture, Teacher Training, Theatre Arts
Summer School: Dir Jane Edberg. Courses—Ceramics, Drawing, Painting, Photo, Art Appreciation, Art History

GLENDALE

GLENDALE COMMUNITY COLLEGE, Visual & Performing Arts Div, 1500 N Verdugo Rd, Glendale, CA 91208. Tel 818-240-1000; Fax 818-549-9436; Internet Home Page Address: www.glendale.edu; *Prof of Art* Robert Kibler, MA; *Prof of Theatre Art* Kenneth Gray, MA; *Prof of Photography* Joan Watanabe, MFA; *Instr* Susan Sing, MA; *Instr* Annabelle Aylmer, MFA; *Assoc Prof of Art* Daniel Stearns, MA; *Instr* Caryl St Ama, MFA; *MFA* Rodger Dickes; *Assoc Prof of Media Art* Michael Petros, MA; *Instr Art History* Trudi Abram, PhD; *Instr Art History* Dr Andrea Rusnock, MFA; *Art* Betsy Kenyon, MFA; *Instr Dance* Dora Krannig; *Instr Music* Peter Green, DMA; *Assoc Prof Music* Beth Pflueger, MM; *Prof Music* Ted Stern, PhD; *Prof Music* Glenn DeLange, PhD
Estab 1927; Maintain nonprofit art gallery; pub; D & E; SC 25, LC 7; D 4100, E 3900, nonmaj 800, maj 200
Ent Req: HS dipl, ent exam
Degrees: AA 2 yrs
Tuition: $26 per unit
Courses: †2-D & 3-D Art, †Advertising Design, †Art History, Ceramics, Costume Design & Construction, Design, Drawing, †Graphic Design, Illustration, Lettering, †Media Arts Animation, Painting, †Photography, Printmaking, Sculpture, Stage Design, Theatre Arts
Summer School: Superintendent, Dr John Davitt

GLENDORA

CITRUS COLLEGE, Art Dept, 1000 W Foothill, Glendora, CA 91740. Tel 626-914-8062, 914-8581; Elec Mail bbollinger@citrus.cc.ca.us; Internet Home Page Address: www.citrus.cc.ca.us; *Dean of Faculty* Ben Bollinger
Estab 1915; pub; D & E; Scholarships; SC 26, LC 7; D 400, E 175, non-maj 400, maj 175
Ent Req: HS dipl
Degrees: AA and AS 2 yrs
Tuition: Res—$11 per unit, non-res—$155 per unit
Courses: Advertising Design, Art Appreciation, Art History, Ceramics, Commercial Art, Computer Art, Design, Drafting, Drawing, Graphic Design, Illustration, Painting, Photography, Sculpture
Children's Classes: Animation, Art Appreciation, Art History, Clay Sculpture, Computer Art, Design, Figure Drawing, Graphic Design, Watercolor
Summer School: Dir, Tom Tefft. Enrl 80; 6 wk term beginning June 1. Courses—Art History, Ceramics

HAYWARD

CALIFORNIA STATE UNIVERSITY, HAYWARD, Art Dept, 25800 Carlos Bee Blvd, Hayward, CA 94542. Tel 510-885-3111; Fax 510-885-2281; Internet Home Page Address: www.csuhayward.edu; *Interim Chmn* Michael Henninger
Estab 1957; Maintain nonprofit art gallery; University Art Gallery; pub; D & E; Scholarships; SC 30, LC 12; 9900
Ent Req: HS dipl, ent exam, ACT
Degrees: BA 4 yr
Tuition: Res—undergrad $648 per qtr; nonres—undergrad $1,566 per 6 units
Courses: Art Appreciation, Art History, Ceramics, Computer Graphics, Design, Drawing, Electronic Arts, History of Art & Architecture, Intermedia, Painting, Photography, Printmaking, Sculpture
Adult Hobby Classes: Courses offered through Continuing Education Dept

CHABOT COLLEGE, Humanities Division, 25555 Hesperian Blvd, Hayward, CA 94545. Tel 510-723-6600; Internet Home Page Address: www.chabot.org; *Chmn* Dr Sally Fitzgerald
Estab 1961; FT 21, PT 50; pub; D & E; Scholarships; SC 27, LC 5
Ent Req: HS dipl
Degrees: AA 2 yr
Tuition: None to res; nonres—$128 per unit, $16 per sem unit; no campus res
Courses: Advertising Design, Cartooning, Ceramics, Costume Design & Construction, Drafting, Drawing, History of Art & Architecture, Illustration, Lettering, Painting, Sculpture, Stage Design, Theatre Arts
Summer School: Dir, Robert Hunter. Enrl 72-100; tuition $2-$100 per 6 wks. Courses—Art History, Drawing, Introduction to Art, Sculpture, Watercolor

HUNTINGTON BEACH

GOLDEN WEST COLLEGE, Visual Art Dept, 15744 Golden West St, Huntington Beach, CA 92647. Tel 714-895-8358; Fax 714-895-8784; *Dean* David Anthony; *Chmn & Instr* Roger Camp, MA, MFA; *Instr* P Donaldson, MFA; *Instr* D Ebert, MA; *Instr* C Glassford, MA; *Instr* N Tornheim, MA; *Instr* B Conley; *Instr* S Lee-Warren
Estab 1966; pub; D & E, weekends; Scholarships; SC 12, LC 6; D 13,820, E 9339
Ent Req: HS dipl
Degrees: AA 2 yrs
Tuition: Nonres—undergrad $104 per unit
Courses: †Advertising Design, Art History, Calligraphy, Ceramics, Display, †Drafting, Drawing, Illustration, Interior Design, Jewelry, Lettering, Mixed Media, Painting, Photography, Printmaking, Sculpture, Silversmithing, Stage Design, †Theatre Arts, Video
Summer School: Dir, Dave Anthony. Enrl 250-300; classes vary

IDYLLWILD

IDYLLWILD ARTS ACADEMY, 52500 Temecula Dr, Idyllwild, CA 92549. Tel 909-659-2171; Fax 909-659-5463; *Chmn Dance* Jean-Marie Martz; *Chmn Theater* William Scott; *Visual Arts Chmn* Greg Kennedy; *Humanities Chmn* Ned Barrett; *Chmn Math & Science* Jerry McCampbell; *Chmn Music* Laura Melton
Estab 1950; pvt; Idyllwild Arts Academy is a 14 wk summer program beginning in mid-June with courses in the arts for all ages; Scholarships
Degrees: not granted by the Idyllwild Campus; university credits earned through USC-LA Campus; documentation provided to high schools for credit
Tuition: Boarding students $25,000 per yr; day students $12,700 per yr
Courses: Ceramics, Fiber, Painting, Papermaking, Photography, Printmaking, Sculpture
Adult Hobby Classes: Enrl open; tuition $165 per wk
Children's Classes: Enrl open; tuition $90-$120 per wk, $65 for half day program. Day & Residential Children's Arts Program; also Youth Ceramics

IMPERIAL

IMPERIAL VALLEY COLLEGE, Art Dept, PO Box 158, Imperial, CA 92251. Tel 760-355-6206; Internet Home Page Address: www.imperialcc.ca.us; *Chmn Dept Humanities* Richard Hann; *Asst Prof Art* Nannette Kelly
Scholarships
Degrees: AA
Tuition: $13 per unit
Courses: Art Appreciation, Art History, Ceramics, Drawing, Painting

IRVINE

CITY OF IRVINE, Irvine Fine Arts Center, 14321 Yale Ave, Irvine, CA 92604. Tel 949-724-6880; Fax 949-552-2137; *Educ Coordr* Tim Jahns, MA; *Cur* Dori Rawlins, MA
Estab 1980; FT 3; pub; D & E; SC 35; D 600, E 600
Tuition: Res—undergrad $20 - $150 per course
Courses: Art Appreciation, Calligraphy, Ceramics, Drawing, Handicrafts, Jewelry, Mixed Media, Painting, Sculpture, Teacher Training
Children's Classes: Enrl 400. Tuition varies. Courses—Arts
Summer School: Enrl 40. Tuition varies. Courses—Arts

UNIVERSITY OF CALIFORNIA, IRVINE, Studio Art Dept, Clare Trevor School of The Arts, 300 Arts Irvine, CA 92697-2775. Tel 949-824-6648; Fax 949-824-5297; Internet Home Page Address: www.arts.uci.edu/studioart; *Dean* David Trend; *Chmn* Christiana Christenson
Estab 1965; pub; D; Scholarships; SC 25, LC 5, GC 4
Ent Req: HS dipl
Degrees: BA(Studio Art) 4 yr, MFA(Art)
Tuition: Res—undergrad $1351 per qtr, grad $1763 per qtr; nonres—undergrad $4888 per qtr, grad $5250 per qtr
Courses: Ceramics, Digital Imaging, Drawing, History of Art & Architecture, Installation, Painting, Photography, Sculpture, Video
Summer School: Ceramics, Drawing, Painting

KENTFIELD

COLLEGE OF MARIN, Dept of Art, 835 College Ave, Kentfield, CA 94904. Tel 415-485-9480; *Chmn* Chester Arnold
Estab 1926; pub; D & E; SC 48, LC 8; D 5000
Ent Req: HS dipl, ent exam
Degrees: AA, AS 2 yrs
Tuition: Res—undergrad $17 per unit; nonres—undergrad $148 per unit
Courses: Architectural Design, Architecture, Art Gallery Design Management, Art History, Ceramics, Color Theory, Drawing, History of Art & Architecture, Interior Design, Jewelry, Painting, Photography, Printmaking, Sculpture, Textile Design
Adult Hobby Classes: Enrl 400. Courses—Calligraphy, Drawing, Illustration, Jewelry, Painting, Printing
Children's Classes: College for Kids
Summer School: Ceramics, Drawing, Painting, Sculpture

LA JOLLA

UNIVERSITY OF CALIFORNIA, SAN DIEGO, Visual Arts Dept, 9500 Gilman Dr, La Jolla, CA 92093-0327. Tel 760-534-4831, 534-2252; *Dept Chmn* Louis Hock
Estab 1967; pub; D & E; Scholarships; SC 55, LC 30, GC 15; Maj 350, grad 40
Ent Req: HS dipl
Degrees: BA(Studio Art, Art History/Criticism, & Media) 4 yrs, MFA(Studio or Art Criticism) 2-3 yrs
Tuition: Res—undergrad $1281.50 per qtr; nonres—undergrad $4818 per qtr
Courses: Art Criticism/Film Criticism
Summer School: Dir, Mary Walshok

LA MIRADA

BIOLA UNIVERSITY, Art Dept, 13800 Biola Ave, La Mirada, CA 90639. Tel 562-903-4807; Fax 562-903-4748; Elec Mail loren.baker@biola.edu; Internet Home Page Address: www.biolart.org; *Chmn Dept & Asst Prof* Loren Baker, MFA; *Asst Prof* Murray McMillan, MFA; *Prof* Barry Krammes, MA; *Instr* Christina Valentine, MA; *Assoc Prof* Daniel Callis, MFA; *Asst Prof* Kayo Nakamura, MFA; *Instr* Patricia Riske, MFA; *Instr* Amanda Burks, BA; *Instr* Lisa Rinaldo, BS; *Instr* Dyanna Espinoza, BS; *Instr* Jenifer Hanen, BS

Estab 1908, dept estab 1971; Maintain nonprofit art gallery on-campus; art library; limited art supplies available on-campus; pvt; D & E; Scholarships; SC 28, LC 4; D 120, maj 120
Ent Req: HS dipl, SAT or ACT; portfolio
Degrees: BFA 4 yrs
Tuition: Undergrad—$17440 per yr
Courses: 2-D Design, 3-D Design, 4-D Design, Aesthetics, Animation, Art Appreciation, Art History, Ceramics, Critical Thought, Culmination, Design, Drawing, Figure Studies, Graphic Arts, Graphic Design, Illustration, Installation & Performance, Lettering, Mixed Media, Painting, Photography, Sculpture, Video
Summer School: Dir, Barry A Krammes. six week courses. Courses—vary

LA VERNE

UNIVERSITY OF LA VERNE, Dept of Art, 1950 Third St, La Verne, CA 91750. Tel 909-593-3511, Ext 4273, 4763; Elec Mail johnson@ulv.edu; Internet Home Page Address: www.ulv.edu; *Prof Photography* Gary Colby; *Asst Prof Art* Keith Lord; *Asst Prof Art History* Andres Zerreigon; *Dept Chmn, Prof Art* Ruth Trotter
Estab 1891; Maintain nonprofit art gallery; Harris Art Gallery; pvt; D & E; Scholarships; SC 12, LC 10; D 125, E 60, maj 12
Ent Req: HS dipl
Degrees: BA(Art) 4 yrs
Tuition: $8000 per sem
Courses: †Advertising Design, †Art Appreciation, †Art Education, †Art History, †Conceptual Art, Contemporary Art Seminar, Drawing, †History of Art, Painting, Photography, Sculpture, †Teacher Training, Theatre Arts
Summer School: Terms of 3 and 4 wks

LAGUNA BEACH

ART INSTITUTE OF SOUTHERN CALIFORNIA, 2222 Laguna Canyon Rd, Laguna Beach, CA 92651. Tel 949-376-6000; Fax 949-376-6009; Elec Mail admissions@aisc.edu; Internet Home Page Address: www.aisc.edu; *Dean Visual Communication* Jonathan Burke; *Dean Fine Arts* Betty Shelton; *Dean Liberal Arts* Helen Garrison; *Instr* Stephanie Taugner; *Instr* George Zebot; *Instr* Kim Owinell
Estab 1961; pvt; D & E; Scholarships; SC 81, LC 48; D 280, maj 4
Ent Req: SATI or ACT, 3.0 GPA, portfolio, letter reg, personal, state
Degrees: BFA
Tuition: $11,900 per yr
Courses: Animation, Art History, Drawing, Fine Arts, Graphic Arts, Graphic Design, Painting, Photography, Visual Communication
Adult Hobby Classes: 15 wk semesters. Courses—Studio & Lecture courses
Children's Classes: 15 wk semesters. Courses—Studio & Lecture courses
Summer School: Pres, Patricia Caldwell. Two 5 wk sessions. Courses—Studio & Lecture courses

LANCASTER

ANTELOPE VALLEY COLLEGE, Art Dept, Division of Fine Arts, 3041 W Ave K, Lancaster, CA 93536-5426. Tel 661-722-6300; Fax 661-722-6390; Internet Home Page Address: www.avc.edu; *Dean Fine & Performing Arts Div* Dr Dennis White, MFA; *Prof* Robert McMahan, MFA; *Prof* Richard Sim, MFA; *Prof* Patricia Crosby-Hinds, MFA; *Asst Prof* Cynthia Minet, MFA
Estab 1929; pub; D & E
Degrees: AA 2 yrs
Tuition: Nonres—undergrad $108 per unit
Courses: Art History, Ceramics, Color & Design, Computer Graphics, Drawing, Graphic Arts, Jewelry, Painting, Photography, Sculpture

LONG BEACH

CALIFORNIA STATE UNIVERSITY, LONG BEACH
—Art Dept, Tel 562-985-4376; Fax 562-985-1650; *Chmn* Jay Kvapil
Estab 1949; FT 40, PT 57; pub; D & E; Scholarships, Fellowships; SC 164, LC 26, GC 23, for both locations; 5356 for both locations
Ent Req: HS grad, ent exam, SAT
Degrees: BA, BFA, MA, MFA
Tuition: Res—$851 per sem; nonres—$130 per unit
Courses: Art Education, Art History, Bio Medical Art, Ceramics, †Digital Media, Drawing, †Fiber Art, Graphic Design, Illustration, †Intermedia, †Metals, Museum Studies, Painting, †Photography, Printmaking, Sculpture, †Studio Art, †Wood
Children's Classes: Ceramics, Drawing, Painting
Summer School: Dean, Dr Robert Behm. Tuition $150 per unit. Courses—Art Education, Art History, Ceramics, Drawing, Fiber, Graphic Design, Illustration, Painting, Special Topics, Photography
—Design Dept, Tel 562-985-5089; Fax 562-985-2284; *Dean* Wade Hobgood; *Chmn* Charles Leinbach
Estab 1949; FT 10, PT 9; pub; SC 164, LC 26, GC 23 for both locations; 5356 for both locations
Ent Req: HS grad, ent exam
Degrees: BF, BFA, BS, MA, MFA
Tuition: Res—$580 per sem, nonres—$246-$580 per unit, $875.50 per sem
Courses: Design, Industrial Design, Interior Design, Perspective, Rapid Visualization
Summer School: Dean, Dr Donna George

LONG BEACH CITY COLLEGE, Art & Photography Dept, 4901 E Carson St, Long Beach, CA 90808. Tel 562-938-4319; Internet Home Page Address: www.art.lbcc.edu; *Instr* Larry White; *Instr* Linda King, MFA; *Instr* Rodney Tsukashima, MA; *Instr* Mike Daniel, MFA; *Instr* Stas Orlovski; *Dept Chmn* Ann Mitchell; *Instr* Colleen Sterritt; Kristin Beeler, MFA

Pub; D, E & W; Scholarships; SC 65, LC 26
Ent Req: HS dipl, ent exam
Degrees: AA & cert 2 yrs
Tuition: $26 per unit
Courses: Art History, Ceramics, Commercial Art, Computer Art & Design, Drawing, Illustration, Jewelry, Lettering, Mixed Media, Painting, Photography, Printmaking, Sculpture, Studio Crafts
Adult Hobby Classes: Enrl 1500; tuition $13 per unit sem. Courses—Art History, Ceramics, Computer Graphics, Drawing, Jewelry, Painting, Photography, Printmaking, Sculpture
Summer School: Tuition $13 for 4-8 wk sem. Courses—same as above

LOS ALTOS HILLS

FOOTHILL COLLEGE, Fine Arts & Communications Div, 12345 El Monte Rd, Los Altos Hills, CA 94022. Tel 650-949-7325; Internet Home Page Address: www.foothillcollege.edu; *Dean* Alan Harvey
College has three campuses; D; Scholarships
Degrees: AA, cert
Tuition: Res—undergrad & grad $30 per unit; nonres—grad $102 per unit
Courses: Advertising Design, Art Appreciation, Art History, Ceramics, Computer Graphics, Design, Drawing, Film, Illustration, Painting, Photography, Printmaking, Sculpture, Stage Design, Textile Design

LOS ANGELES

ACE GALLERY, 5514 Wilshire Blvd, Los Angeles, CA 90046; 5514 Wilshire Blvd, Los Angeles, CA 90036. Tel 323-935-4411; Fax 323-202-1082; Elec Mail acelosa@aol.com; *Dir* Douglas Chrismas
Estab 1955; pvt; D; Scholarships; SC 4, LC 4, GC 4; D 6, E 7, non-maj 2, maj 8, grad 3
Ent Req: art school diploma, ent exam
Tuition: $5600 for annual nine month program
Courses: Architecture, Calligraphy, Collage, Design, Drafting, Drawing, Graphic Arts, History of Art & Architecture, †History of Art in Architecture, Intermedia, Lettering, Mixed Media, Painting, Photography, Printmaking, Sculpture, Stage Design

THE AMERICAN FILM INSTITUTE, Center for Advanced Film & Television, 2021 N Western Ave, Los Angeles, CA 90027. Tel 323-856-7600; Fax 323-467-4578; Internet Home Page Address: www.afionline.org/nft; *Dir & COO* James Hindman; *Dir & CEO* Jean Firstenberg; *Chmn Board Trustees* Howard Stringer; *Chmn (V)* Frederick S. Pierce; *Chmn. Board Dirs* John Aunet
Estab 1969 to aid in the development & collaboration of making films; Scholarships
Degrees: MFA
Tuition: $17,000
Courses: †Cinematography, Digital Media, †Directing, †Editing, Film, †Producing, †Production Design & Screen Writing, Video
Adult Hobby Classes: Non degree evening & weekend classes

BRENTWOOD ART CENTER, 13031 Montana Ave, Los Angeles, CA 90049. Tel 310-451-5657; Fax 310-395-5403; Internet Home Page Address: www.brentwoodart.com; *Dir* Edward Buttwinick, BA
Estab 1971; 25; pub & priv; D & E; SC 40; D 400, E 100
Tuition: $100-$225 per month per class
Courses: Design, Drawing, Mixed Media, Painting, Sculpture
Adult Hobby Classes: Enrl 300; tuition $175-$225 per month. Courses—Basic Drawing, Design, Life Drawing, Mixed Media, Painting, Sculpture
Children's Classes: Enrl 300; tuition $100-$180 per month. Courses—Cartooning, Drawing, Mixed Media, Painting, Sculpture
Summer School: Dir, Ed Buttwinick. Enrl 400; tuition $300-$500 for nine wk prog. Courses—Drawing, Mixed Media, Painting, Sculpture

CALIFORNIA STATE UNIVERSITY, LOS ANGELES, Art Dept, 5151 State University Dr, Los Angeles, CA 90032-8101. Tel 323-343-4010; Fax 323-343-4045; Elec Mail eforde@calstatela.edu; Internet Home Page Address: www.calstatela.edu/; *Chmn* Ed Forde, MFA
Estab 1947; Maintains fine arts gallery; art supplies available on-campus; pub; D & E; Scholarships; SC 85, LC 12, GC 9; D 2500 (Art), non-maj 150, maj 324, grad 47 (per quarter)
Ent Req: HS dipl, ent exam
Degrees: BA(Art), MA(Art), MFA(Art)
Tuition: Res—undergrad $476 per quarter, grad $502 per quarter; non-res—undergrad & grad $164 per unit; campus res available
Courses: Advertising Design, Architecture, Art Education, Art History, †Ceramics, †Commercial Art, †Computer Graphics, Costume Design, Costume Design & Construction, Design, †Design Theory, †Drawing, Fashion Illustration, Graphic Arts, History of Art & Architecture, †Illustration, Painting, †Photography, Printmaking, Sculpture, †Teacher Training, †Textile Design, Textiles

INNER-CITY ARTS, 720 Kohler St, Los Angeles, CA 90021. Tel 213-627-9621; Fax 213-627-6469; Internet Home Page Address: www.inner-cityarts.org; *Dir* Cynthia Harnisch
Estab to enrich the lives of inner city children, through a total arts program; 4; pub; D

LOS ANGELES CITY COLLEGE, Dept of Art, 855 N Vermont Ave, Los Angeles, CA 90029-9990. Tel 323-953-4000; Internet Home Page Address: www.lacc.cc.ca.us; *Chmn* Norman Schwab; *Instr* Phyllis Muldavin; *Prof* Gloria Bohanon, MFA; *Prof* Gayle Partlow; *Prof* LaMont Westmoreland; *Prof* Lee Whitton
Estab 1929; PT 9; pub; D & E; Scholarships; SC 48, LC 8; D 450, E 150, non-maj approx 2/3, maj approx 1/3

Ent Req: HS dipl & over 18 yrs of age
Degrees: AA 2 yr
Tuition: Res—undergrad $13 per unit, 10 or more units $100; nonres—$125 per unit plus $13 per sem
Courses: †Advertising Design, †Art History, Ceramics, †Commercial Art, Display, Drawing, †Graphic Design, Life Drawing, †Painting, Printmaking, Sculpture
Adult Hobby Classes: Enrl 2090; tuition approx $20 per class of 8 wks.
Courses—Ceramics, Design, Drawing, Painting, Perspective, Printmaking, Sculpture
Summer School: Chmn, Phyllis Muldavin. Enrl 250; tuition $50 for term of 6 wks beginning July. Courses—basic courses only

LOYOLA MARYMOUNT UNIVERSITY, Dept of Art & Art History, MS 8346, One LMU Dr Los Angeles, CA 90045-2659. Tel 310-338-7424, 338-5189; Fax 310-338-1948; Elec Mail mtang@imu.edu; Internet Home Page Address: www.lmu.edu/collegeslcfa/art; Internet Home Page Address: www.lmu.edu; *Prof* Rudolf Fleck, MFA; *Prof* Terresa Munoz, MFA; *Assoc Prof* Katherine Harper, PhD; *Prof* Jane Brucker, MFA; *Prof* Michael Brodsky, MFA; *Asst Prof* Dimitri Kmelitsky, MFA; *Asst Prof* Teresa Lenihan, MFA; *Asst Prof* Damon Willick, PhD; *Assoc Prof* Dr Kirstin Noreen, PhD; *Asst Prof* Garland Kirkpatrick, MFA; *Asst Prof* Diane Meyer, MFA; *Asst Prof* Han Dai-Yu, MFA
Estab as Marymount Col in 1940, merged with Loyola Univ 1968; Maintain nonprofit art gallery, Laband art gallery; FT 13, PT 24; pvt & den; D & E; Scholarships; SC 65, LC 20; Maj 200
Ent Req: HS dipl
Degrees: BA 4 yrs
Tuition: $27,162 per yr, room $6,200 - $8,400 per yr
Courses: Advertising Design, Aesthetics, Art Appreciation, †Art Education, Art History, Ceramics, Computer Animation, Computer Graphics, †Conceptual Art, Design, Drawing, Graphic Arts, Graphic Design, Illustration, Jewelry, Lettering, †Mixed Media, †Museum Staff Training, Painting, Photography, Printmaking, Sculpture, Silversmithing
Adult Hobby Classes: Ceramics, Jewelry
Summer School: Dir, Chris Chapple, PhD. Courses— Ceramics, Computer Graphics, Jewelry, Art History, Water Color

MOUNT SAINT MARY'S COLLEGE, Art Dept, 12001 Chalon Rd, Los Angeles, CA 90049-1599. Tel 310-954-4000, 954-4361 adm@mscm.la.edu; Internet Home Page Address: www.msmc.la.edu; *Chmn & Prof* Judy Baral
Estab as Chalon Campus in 1925, also maintains Doheny Campus estab 1962; den; D & E; Scholarships; D 60, non-maj 31, maj 29
Ent Req: HS dipl
Degrees: BA and BFA 4 yrs
Tuition: $14,888 per yr; campus res—room & board available
Courses: †Art Education, †Art History, Ceramics, †Collage, †Conceptual Art, †Constructions, Drawing, Fiber Design, †Graphic Arts, †Graphic Design, †Illustration, †Intermedia, †Mixed Media, Painting, Photography, †Printmaking, Sculpture, †Textile Design

OCCIDENTAL COLLEGE, Dept of Art History & Visual Arts, 1600 Campus Rd, Los Angeles, CA 90041. Tel 323-259-2749; Fax 323-259-2930; Elec Mail admissions@oxy.com; Internet Home Page Address: www.oxy.edu; *Chmn* Louise Yunas; *Prof* Eric Frank, PhD; *Prof* Amy Lyford, PhD; *Prof* Ester Yau, PhD; *Prof* Dana Plays, PhD
Estab 1887; FT 7, PT 2; pvt; D & E; Scholarships, Grants; SC 19, LC 25, GC 5; maj 40, others 300
Ent Req: HS dipl, col transcript, SAT, recommendations
Degrees: BA 4 yr
Tuition: $19,000 campus res available
Courses: †Art Education, †Art History, †Drawing, Film, †Graphics, †Painting, †Sculpture, †Theory & Criticism
Adult Hobby Classes: Fundamentals

OTIS COLLEGE OF ART & DESIGN, Fine Arts, 9045 Lincoln Blvd, Los Angeles, CA 90045. Tel 310-665-6800; Fax 310-665-6805; Internet Home Page Address: www.otis.edu; *Chmn Fine Arts* Suzanne Lacy; *Pres* Samuel Hoi
Estab 1918; Maintains nonprofit art gallery; Pvt; D & E; Scholarships; SC 276, LC 117, GC 31; D 1,043, E 550, maj 1,043, grad 46
Degrees: BFA 4 yrs, MFA 2 yrs
Tuition: $12,250 per sem
Courses: Architecture/Landscapes/Interiors, Art Education, Communication Design, Digital Media, Environmental Arts, †Fashion Design, Fine Arts, Graphic Design, Illustration, Interactive Product Design, Photography, Toy Design
Adult Hobby Classes: Enrl 2,400; tuition varies
Children's Classes: Enrl 300. Courses vary
Summer School: Coordr K-12 Prog, Rosina Catalano. Tuition & courses vary

SOUTHERN CALIFORNIA INSTITUTE OF ARCHITECTURE, 960 E Third St, Los Angeles, CA 90013; 350 Merrick St Los Angeles, CA 90013-0000. Tel 213-613-2200; Fax 213-613-2260; Elec Mail admissions@sciarc.edu; Internet Home Page Address: www.sciarc.edu; *Dir* Eric Owen Moss; *Dir Asst* Lindsay Aydelott; *Academic Prog Asst* Uyen C Tran
Estab 1972
Degrees: BArch, MArch
Tuition: Undergrad—$9188 per sem; 18,496 per year
Courses: Architecture
Adult Hobby Classes: Dir, Rose Marie Rabin. Summer term only
Summer School: Dir, Gary Paige. Enrl 30; tuition $1000 for 12-15 wk term beginning July. Courses—Foundation Program in Architecture

UNIVERSITY OF CALIFORNIA, LOS ANGELES
—Dept of Art, Tel 310-825-3281; Fax 310-206-6676; Internet Home Page Address: www.arts.ucla.edu; *Chmn* Barbara Drucker
Scholarships, Fellowships

Degrees: BA, MA, MFA
Tuition: Res—undergrad $1252 per qtr, grad $1420 per qtr; nonres—undergrad $3819.50 per qtr, grad $3987 per qtr
Courses: Ceramics, Critical & Curatorial Studies, Drawing, Interdisciplinary Studio, New Genres, Painting, Photography, Sculpture
—Dept of Design & Media Arts, Tel 310-825-9007; Fax 310-206-6676; Internet Home Page Address: www.design.ucla.edu; *Acting Chmn* Victoria Vesna
pub; D; SC, LC, GC
Ent Req: Dept and UCLA Application
Degrees: BA, MA, MFA
Tuition: Res—undergrad $1252 per quarter, grad $1420 per quarter; nonres—undergrad $3819.50 per quarter, grad $3987 per quarter
Courses: Art Education, Ceramics, Computer Imagery, Design, Fiber Textile, Graphic Design, Industrial Design, Interior Design, Video
—Dept Art History, Tel 310-206-6905; Internet Home Page Address: www.ucla.edu; *Dept Chmn* Anthony Vidler
Scholarships, Fellowships
Degrees: BA, MA, PhD
Tuition: Res—undergrad $1252 per quarter, grad $1420 per quarter; nonres—undergrad $3819.50 per quarter, grad $3987 per quarter
Courses: †Art History

UNIVERSITY OF JUDAISM, Dept of Continuing Education, 15600 Mulholland Dr, Los Angeles, CA 90077. Tel 310-476-9777; Fax 310-471-1278; Internet Home Page Address: www.uj.edu; *Dir* Gady Levy
Estab 1947; den; SC 14, LC 6
Degrees: units in continuing education only
Tuition: Varies with course; $230 & up
Courses: Art History, Book Illustration, Calligraphy, Drawing, History of Jewish Art, Interior Design, Painting, Photography, Picture Book Making for Children, Sculpture, Tile Painting
Adult Hobby Classes: Enrl 8; tuition $127 per sem
Summer School: Courses offered

MALIBU

PEPPERDINE UNIVERSITY, SEAVER COLLEGE, Dept of Art, Malibu, CA 90263. Tel 310-456-4155; Fax 310-456-4077; *Prof* Avery Falkner; *Prof* Joe Piasentin; *Instr* Michael Brummett; *Prof* Bob Privitt
Estab 1937; Maintain nonprofit art gallery, Weisman Art Museum, Cultural Arts Center, Pepperdine University, Malibu, CA 90263; Church of Christ, priv; D; Scholarships; SC & LC
Degrees: BA in Art
Tuition: Apartment $26,100; campus res—room & board $25,850 per yr
Courses: Art Appreciation, Art Education, Art History, Ceramics, Design, Drawing, Graphic Arts, Jewelry, Monotypes, Painting, Sculpture
Children's Classes: Children's classes are offered thru Weisman Museum (on campus), Dir: Dr. Michael Zahian, Cultural Arts Center, Pepperdine Univ, Malibu, CA 90263
Summer School: Enrl 20; tuition $235 per unit. Courses—Jewelry, Mixed Media, Monotypes, Painting

MARYSVILLE

YUBA COLLEGE, Fine Arts Division, 2088 N Beale Rd, Marysville, CA 95901. Tel 530-741-6700; Internet Home Page Address: www.yuba.cc.ca.us; *Assoc Dean* Michael Moyers
Estab 1927; FT 2; pub; D & E; Scholarships; SC 23, LC 2; total 1437, maj 493
Ent Req: HS grad or 18 yrs of age
Degrees: AA 2 yr
Tuition: Res—$24 per unit per sem; nonres—$198 per unit
Summer School: Dean & Assoc Dean Community Educ, Cal Gower. Courses—Ceramics, Drawing

MENDOCINO

MENDOCINO ART CENTER, 45200 Little Lake St, PO Box 765 Mendocino, CA 95460. Tel 707-937-5818; WATS 800-653-3328; *Exec Dir* Peggy Templer
Estab 1959; pvt; D & E; SC 24, LC 6; D 24
Publications: A&E Magazine, monthly
Ent Req: mutual interview, ceramics ROP 2 yr prog
Degrees: program in ceramics, sculpture, jewelry, textiles, computer arts, & fine arts
Courses: Calligraphy, †Ceramics, Drawing, Graphic Design, Jewelry, Lettering, Painting, Printmaking, Sculpture, Silkscreen, Silversmithing, Textile Design, Weaving
Summer School: Dir, Elaine Beldin-Reed. Enrl 6-15; tuition $175-$250 for 1 wk term. Courses—Acting, Ceramics, Fine Art, Jewelry, Weaving

MERCED

MERCED COLLEGE, Arts Division, 3600 M St, Merced, CA 95348. Tel 209-384-6000; Internet Home Page Address: www.merced.cc.ca.us; *Pres* Benjamin T Duran; *Chmn* Jamey Brzezinski; *Gallery Dir* Susanne French
Estab 1964; pub; D & E; Scholarships; SC 50, LC 10; D 4741, E 3187, non-maj 3700, maj 4228
Ent Req: 18 yrs & older
Degrees: AA & AS 2 yr
Tuition: Res—undergrad $11 per unit; nonres—undergrad per unit
Courses: Art History, Ceramics, Costume Design & Construction, Design, Digital Arts, Drafting, Drawing, †Fine Art, †Graphic Design, †Guitar, History of Art & Architecture, Illustration, †Music, Painting, †Photography, Printmaking, Sculpture, Stage Design, Teacher Training, †Theatre Arts

Summer School: Dir, Dr Ron Williams, Dean of Arts & Sciences. Tuition res—undergrad $13 for 7 wk term beginning June 21

MODESTO

MODESTO JUNIOR COLLEGE, Arts Humanities & Communications Division, 435 College Ave, Modesto, CA 95350. Tel 209-575-6081; Fax 209-575-6086; Internet Home Page Address: www.gomjc.org; *Dean Div* Jim Johnson; *Instr* Richard Serroes; *Instr* Doug Smith; *Instr* Terry L Hartman, MA; *Instr* Gui Todd, MA; *Instr* Jerry M Reilly, MFA
Estab 1921, div estab 1964; pub; D & E; Scholarships; 16,024 total
Ent Req: grad of accredited high school, minor with California High School Proficiency Cert & parental permission, 11th & 12th graders with principal's permission, persons 18 or older who are able to profit from the instruction
Degrees: AA and AS 2 yrs
Tuition: Res—$6 health fee; nonres—$87 per sem unit to maximum of $1044 per sem plus health fee; no campus res
Courses: Advertising Design, Architecture, Art History, Ceramics, Display, Drafting, Drawing, Enameling, Film, Jewelry, Lapidary, Lettering, Painting, †Photography, Printmaking, Sculpture, Silversmithing, Theatre Arts
Adult Hobby Classes: Courses—Arts & Crafts, Lapidary
Summer School: Dir, Dudley Roach. Tuition $6 health fee. Courses—a wide variety offered

MONTEREY

MONTEREY PENINSULA COLLEGE, Art Dept, Div of Creative Arts, 980 Fremont St Monterey, CA 93940. Tel 831-646-4200; Fax 831-646-3005; Internet Home Page Address: www.mpc.edu; *Chairperson Div Creative Arts* John Anderson; *Painting Instr* Robynn Smith; *Art Hist Instr* Richard Janick; *Jewelry & Metals Instr* Theresa Lovering-Brown; *Sculpture Instr* Gary Quinonez; *Graphics Instr* Darien Payne; *Adjunct* Skip Kadish; *Adjunct* Carol Holoday; *Graphics Instr* Jamie Dagdigian; *Ceramics Instr* Diane Eisenbach; *Photog Instr* Kevin Bransfield
Estab 1947; Monterey Peninsula College Art Gallery, nonprofit; Adjunct 20; pub; D & E; Scholarships; SC 17, LC 8; D 1,343, E 623, maj 160
Activities: Bookstore
Ent Req: HS dipl, 18 yrs or older
Degrees: AA & AS 2 yrs
Tuition: Res—$72; nonres—$48 per unit; no campus res
Courses: †Architecture, Art Appreciation, Art History, †Ceramics, Collage, †Commercial Graphics, Costume Design & Construction, Design, Drafting, †Drawing, Graphic Arts, Illustration, Intermedia, †Jewelry, Mixed Media, †Painting, †Photography, Printmaking, †Sculpture, Silversmithing, †Studio Art, Video, Weaving
Summer School: Dir, Thorne Hacker. Term of 6 wks beginning June. Courses are limited

MONTEREY PARK

EAST LOS ANGELES COLLEGE, Art Dept, 1301 Avenida Cesar Chavez, Monterey Park, CA 91754. Tel 323-265-8650; Internet Home Page Address: www.laccd.edu; *Dept Chmn* Carson Scott
Estab 1949; FT 5; pub; D & E; SC 43, LC 10; D 486, E 160, maj 646
Degrees: AA 2 yr
Tuition: $13 per unit
Courses: †Advertising Design, †Art Fundamentals, †Art Graphic Communications, †Art History, †Ceramics, †Computer Graphics, Design, Display, †Drawing, †Electronic Publishing, Graphic Arts, Graphic Design, Lettering, †Life Drawing, Mixed Media, †Painting
Children's Classes: Enrl 60. Courses—Ceramics, Direct Printing Methods, Drawing, Painting
Summer School: Dir, Carson Scott. Enrl 50; tuition $13 per unit for 6 wk term. Courses—Art 201, Beginning Drawing, Beginning 2-D Design

NAPA

NAPA VALLEY COLLEGE, Art Dept, 2277 Napa Vallejo Hwy, Napa, CA 94558. Tel 707-253-3000; Internet Home Page Address: www.nvc.cc.ca.us; *Chmn & Dir* Jan Molen; *Prof* Jay Golik; *Prof* Caroyln Broodwell
Degrees: AA & AS
Tuition: $11 per unit up to 5 units
Courses: Art Appreciation, Art History, Ceramics, Design, Drawing, Painting, Photography, Printmaking, Sculpture
Adult Hobby Classes: Courses offered
Children's Classes: Courses offered
Summer School: Courses—Painting, Ceramics, Drawing

NORTHRIDGE

CALIFORNIA STATE UNIVERSITY, NORTHRIDGE, Dept of Art, College of Arts, Media & Communication, 18111 Nordhoff St Northridge, CA 91330-8300. Tel 818-677-2242; Fax 818-677-3046; Elec Mail art.dept@csun.edu; Internet Home Page Address: www.csun.edu/artdep; *Dept Chmn* Joe Lewis
Estab 1956; 48; pub; D & E; Scholarships; SC 13, GC 5; D & E 2231, grad 101
Ent Req: HS dipl, GRE, SAT
Degrees: BA 4-5 yrs, MA
Tuition: Nonres—$246 per unit
Courses: †Animation?Wood, †Art Education, †Art History, †Ceramics, †Drawing, †Graphic Design, †Illustration, †Painting, †Photography, †Printmaking, Public Art, †Sculpture, †Textile Design, †Video

Summer School: Dir, Joe Lewis. Enrl 100; tuition $136 per unit for 6 wks beginning June 1. Courses—Art History, Graphic Design

NORWALK

CERRITOS COMMUNITY COLLEGE, Fine Arts & Communication Div, 11110 Alondra Blvd, Norwalk, CA 90650-6298. Tel 562-860-2451; Fax 562-653-7807; Elec Mail info@cerritos.edu; Internet Home Page Address: www.cerritos.edu/fac; *Instr Dean Fine Arts* Dr Barry Russell
Estab 1956; pub; D & E; SC 36, LC 12
Ent Req: HS dipl or 18 yrs of age
Degrees: AA 2 yrs
Tuition: Res—$26 per unit; nonres—$114 per unit
Courses: 2-D & 3-D Design, †Acting, Calligraphy, Ceramics, Commercial Art, †Communications, †Directing, Display, Drawing, Graphic Arts, Graphic Design, History of Art & Architecture, Jewelry, †Journalism, Museum Staff Training, †Photography, Printmaking, Sculpture, †Theater
Summer School: Dir Dr Barry Russell. 6 wks per session. Drawing, Painting, History, Design, Ceramics, Calligraphy

OAKLAND

HOLY NAMES COLLEGE, Art Dept, 3500 Mountain Blvd, Oakland, CA 94619. Tel 510-436-1000, Ext 1458; Fax 510-436-1199; Internet Home Page Address: www.hnc.edu; *Chmn Dept* Robert Simon
Estab 1917; FT 2, PT 4; pvt; D & E; Scholarships; SC 24, LC 4
Ent Req: HS dipl
Degrees: BA and BFA 4 yrs
Tuition: $620 per unit
Courses: Art History, Calligraphy, Ceramics, Drawing, Jewelry, Painting, Photography, Printmaking, Sculpture

LANEY COLLEGE, Art Dept, 900 Fallon St, Oakland, CA 94607. Tel 510-834-5740; Fax 510-464-3231; *Asst Dean* Carlos McLean; *Chmn* Carol Joy
Estab 1962; FT 8, PT 9; pub; D & E; SC 52, LC 8; D 1400, E 450
Ent Req: HS dipl
Degrees: AA 2 yrs
Tuition: Res—undergrad $17 per unit, grad $78 per unit
Courses: Advertising Design and Architectural Design Courses available through the Architectural Design Dept; Photography Courses available through the Photography Dept, Cartooning, †Ceramics, Color & Design, †Commercial Art, Design, Drawing, Etching, †Graphic Arts, Graphic Design, Handicrafts, History of Art & Architecture, Illustration, Lettering, Lithography, †Painting, Portraiture, Relief Printing, †Sculpture, Silkscreen
Summer School: Chmn, David Bradford. Enrl 250; tuition $10 per unit for 6 wk term

MERRITT COLLEGE, Art Dept, 12500 Campus Dr, Oakland, CA 94619. Tel 510-531-4911; Internet Home Page Address: www.peralta.cc.ca.us; *Dir* Helmut Schmitt
Estab 1970; FT 2 PT 8; D & E
Degrees: AA
Tuition: Undergrad—$11 per unit
Courses: Art History, Ceramics, Design, Illustration, Life Drawing, Painting, Sculpture
Adult Hobby Classes: Dir, Helmut Schmitt
Summer School: Dir, Helmut Schmitt. Enrol 120; tuition $5 per unit; six week courses. Courses—Life Drawing, Painting

MILLS COLLEGE, Art Dept, 5000 MacArthur Blvd, PO Box 9975 Oakland, CA 94613. Tel 510-430-2117; Fax 510-430-3148; *Prof* Ron Nagle, MA; *Prof Art Hist* Moira Roth PhD, MA; *Prof History* Mary-Ann Lutzker-Milford PhD, MA; *Assoc Prof* Hung Liu, MFA; *Assoc Prof* Anna Valentina Murch, MFA; *Assoc Prof* Catherine Wagner, MA; *Prof* Joanne Bernstein, PhD; *Asst Prof* Steven Matheson, MFA
Estab 1852; Maintain nonprofit art gallery, Stephen Jost Art Mus Dir, Mills College, 5000 MacArthur Blvd Oakland, CA 94613; pvt, MFA coed, BA female only; D & E; Scholarships; SC 23, LC 22, GC 20; grad 24
Ent Req: HS dipl, SAT, Advanced Placement Exam for undergrads
Degrees: BA 4 yrs, MFA 2 yrs
Tuition: $30,300 per yr; MFA $25,350 per yr; campus res—room & board $4,810 - 5,460 depending on type of room
Courses: 3-D Design, Aesthetics, †Art Education, Art History, Ceramics, †Conceptual Art, Drawing, †Electronic Arts, †History of Art & Architecture, Mixed Media, †Museum Staff Training, Painting, Photography, †Restoration & Conservation, Sculpture, Video

OCEANSIDE

MIRACOSTA COLLEGE, Art Dept, 1 Barnard Dr, Oceanside, CA 92056. Tel 760-757-2121; Fax 760-795-6817; Internet Home Page Address: www.miracosta.cc.ca.us; *Instr* Erik Growborg, MA; *Instr Digital Art* Peggy Jones; *Art History Instr* Susan Delaney
Estab 1934; pub; D & E; Scholarships; SC 12, LC 4; maj 200
Ent Req: HS dipl
Degrees: AA and AS normally 2 yrs
Tuition: $11 per unit; nonres—$130 per unit; no campus res
Courses: Aesthetics, †Architecture, Art Appreciation, Art Education, †Art History, Ceramics, Collage, Computer Art, Conceptual Art, Constructions, †Costume Design & Construction, Design, †Drafting, Drawing, Figure Drawing, Figure Painting, Figure Sculpture, Film, †Graphic Design, History of Art & Architecture, Interior Design, Landscape Architecture, Mixed Media, †Painting, †Photography, †Printmaking, †Sculpture, †Stage Design, Teacher Training, †Theatre Arts

Children's Classes: Enrl 200; tuition small fees. Courses—Art, Theater
Summer School: Enrl 2000; tuition $15. Courses—Various subjects

ORANGE

CHAPMAN UNIVERSITY, Art Dept, 333 N Glassell, Orange, CA 92666. Tel 714-997-6729; Fax 714-997-6744; Internet Home Page Address: www.chapman.edu; *Chmn* David Kiddie, MFA; *Prof* Jane Sinclair, MFA; *Prof* Richard Turner, MFA; *Prof* Sharon Corey, MFA; *Prof* Denise Weyhrich, MFA; *Prof* Stephen Berens, MFA; *Prof* Wendy Salmond PhD, MFA
Estab 1918, branch estab 1954; den; D & E; Scholarships; SC 20, LC 15; D 275, non-maj 75
Ent Req: HS dipl, ACT, SAT or CLEP
Tuition: $595 per unit; campus res—room & board $5346 per yr
Courses: Advertising Design, Art Appreciation, Art Education, Art History, Ceramics, Computer Graphics, Design, Drawing, Film, Graphic Arts, Graphic Design, Illustration, Lettering, Painting, Photography, Sculpture, Stage Design, Theatre Arts, Video
Children's Classes: Courses—workshops in connection with art education classes
Summer School: Courses—Ceramics

ORANGE CITY

NORTHWESTERN COLLEGE, Art Dept, 101 7th St SW, Orange City, CA 51041. Tel 712-737-7003, 737-7004; *Prof* Rein Vanderhill, MFA; *Chmn, Prof* John Kaericher, MFA; *Adj Instr* Sue Siemonsma; *Adj Instr* Randy Becker; *Adjunct Instr* Donald Harding
Estab 1882, dept estab 1965; pvt, affil Reformed Ch Am; D & E; Scholarships; SC 25, LC 3-4; D 200, non-maj 250, maj -25
Ent Req: HS dipl
Degrees: BA 4 yr
Tuition: Campus residency available
Courses: †Art Education, Art History, Ceramics, †Computer Design, Design, †Directed Studies, Drawing, Painting, Photography, Printmaking, Sculpture, †Student Initiated Majors

OROVILLE

BUTTE COLLEGE
—Dept of Fine Arts and Communication Tech, Tel 530-895-2404; Fax 530-895-2346; Internet Home Page Address: www.butte.cc.ca.us; *Chmn & Ceramic Coordr* Idie Adams; *Dean Instruction* Dan Walker; *Instr* Will Stull; *Instr* Geoff Fricker; *Instr* Adrian Carrasco-Zanini; *Instr* David Cooper; *Instr* Mark Hall; *Instr* Simone Senat
Estab 1968; pub; D & E; Scholarships; SC 21, LC 4; D 3988, E 4194
Ent Req: HS dipl or 18 yrs or older
Degrees: AA
Tuition: Res—$12 per unit; nonres—$208 per unit
Courses: Ceramics, Commercial Photography, Fine Arts, Graphic Arts
—Dept of Performing Arts, Tel 530-895-2581; Fax 530-895-2532; Internet Home Page Address: www.butte.cc.ca.us; *Head Dept* Margaret Hughes
Degrees: transfer major
Tuition: Res—$12 per unit; nonres—$208 per unit
Courses: Acting, Adaptive Dramatics, Set Design & Construction, Theater Arts Appreciation, Theater for Children

PALM DESERT

COLLEGE OF THE DESERT, Art Dept, 43-500 Monterey Ave, Palm Desert, CA 92260. Tel 760-773-2574; Fax 760-776-7310; Internet Home Page Address: www.collegeofthedesert.edu; *Chmn* Doug Walker
Estab 1962; College also has High Desert Campus; FT 3, PT 5; pub; D & E; Scholarships; SC 10, LC 3; D 150, E 150, maj 15
Ent Req: HS dipl, ent exam
Degrees: AA 2 yrs
Tuition: $21 per unit; no campus res
Courses: Advertising Art, Art History, Ceramics, Design, Drawing, Introduction to Art, Oriental Brush Painting, Painting, Photography, Printmaking, Sculpture
Summer School: Six wk session. Courses—Art History, Ceramics, Painting, Sculpture

PASADENA

ART CENTER COLLEGE OF DESIGN, 1700 Lida St, PO Box 7197 Pasadena, CA 91103. Tel 626-396-2200; Fax 626-405-9104; Elec Mail swing.reception@artcenter.edu; Internet Home Page Address: www.artcenter.edu; *Pres* Richard Halushak, MA; *Fine Arts Dept Chmn* Laurence Drieband, MFA; *Film Dept Chmn* Robert Peterson, BFA; *Photography Dept Chmn* Jeff Atherton, BFA; *Transportation Design Chmn* Ken Okuyama, BS; *Liberal Arts, Science, Graduate & Academic Studies Chmn* Mark Breitenberg, MArch; *Computer Graphics Chmn* Fred Fehlau, BFA; *Illustration Chmn* Philip Hays, BFA; *Product Design Chmn* C Martin Smith, BFA; *Chmn Environmental Design* Patricia Oliver, MArch; *Co-Chmn* Peter DiFabatino
Estab 1930; pvt; D & E; Scholarships; SC 168, LC 82, GC 22; D 1200, E 200, non-maj 200, maj 1200, grad 60
Library Holdings: Book Volumes 40,000
Ent Req: HS dipl, ACT, SAT if no col background, portfolio required, at least 12 samples of work in proposed maj
Degrees: BFA, BS, MFA, MS
Tuition: $9,955 per yr

Courses: †Advertising Design, †Advertising Illustration, Aesthetics, Architecture, Art History, Calligraphy, Collage, Commercial Art, Conceptual Art, †Critical Theory, Design, Drafting, Drawing, †Environmental Design, Fashion Arts, †Fashion Illustration, †Film, Graphic Arts, †Graphic Design, †Graphic Packaging, History of Art & Architecture, †Illustration, Interior Design, Intermedia, Mixed Media, New Media, †Painting, †Photography, Printmaking, †Product Design, †Transportation Design, Video
Adult Hobby Classes: Enrl 550, tuition $650 per class for 14 wk term. Courses—Advertising, Computer Graphics, Film, Fine Arts, Graphics, Illustration, Industrial Design, Liberal Arts & Sciences, Photography
Children's Classes: Enrl 230; tuition $175 per class for 10 wks; Sat classes for high school

PASADENA CITY COLLEGE, Art Dept, 1570 E Colorado Blvd, Pasadena, CA 91106. Tel 626-585-7238; Fax 626-585-7914; Elec Mail www.paccd.cc.ca.us; Internet Home Page Address: www.paccd.cc.ca.us; *Acting Area Head Design* Eric Peterson; *Acting Area Head Photography* Michael Mims, MA; *Acting Area Head History* Sandra Haynes, MA; *Acting Area Head Jewelry* Kay Yee, MA; *Acting Area Head Ceramics* Phil Cornelius, MA; *Div Dean* Dr Linda Malm
Estab 1902, dept estab 1916; pub; D & E; Scholarships; SC 50; D 2000, E 1200, non-maj 3200, maj 400
Ent Req: HS dipl
Degrees: AA 2 yrs, cert
Tuition: $13 per unit
Courses: Advertising Design, Art History, Ceramics, Commercial Art, Drawing, Film Art, Filmmaking, Graphic Arts, Graphic Design, Illustration, Jewelry, Lettering, Painting, Photography, Printmaking, Product Design, Sculpture
Adult Hobby Classes: Enrl 3000; tuition $10 per unit, BA $50 per unit
Summer School: Dir, Linda Malm. Enrl 500; tuition $13 per unit for two wk sessions. Courses—Art History, Ceramics, Cinema, Design, Jewelry, Photography, Studio Arts

POMONA

CALIFORNIA STATE POLYTECHNIC UNIVERSITY, POMONA, Art Dept, College of Environmental Design, 3801 W Temple Blvd Pomona, CA 91768. Tel 909-869-3508; Fax 909-869-4939; Elec Mail pmartinez@csupomona.edu; Internet Home Page Address: www.csupomona.edu; *Prof* Dr Maren Henderson PhD; *Prof* Stanley Wilson, MFA; *Prof* Charles Fredrick, MFA; *Prof* Joe Hannibal, MFA; *Prof* Eileen Fears, MFA; *Chair, Prof* Babette Mayor, MFA; *Assoc Prof* Sarah Meyer, MFA; *Assoc Prof* David Hylton, MA; *Lectr* Rebecca J Hamm; *Lectr* Joyce Hesselgrave; *Lectr* Yunhui Maggie Yu; *Lectr* Ann Phong; *Lectr* Rebecca J Roe; *Lectr* Wendy E Slatkin; *Lectr* Karen Sullivan; *Lectr* Deane Swick; *Lectr* Milka Broukhim; *Lectr* Hannah Chen; *Asst Prof* Yachin Crystal Lee; *Asst Prof* Alison Pearlman; *Asst Prof* Chari Pradel
Estab 1966; pub; D & E; SC 66, LC 15; enrl D 350, E 50, non-Maj 470, maj 350
Ent Req: HS dipl, plus testing
Degrees: BA & BFA, 4 yrs
Tuition: $297 per qtr 6 or more units, $187 per qtr 5 units or less; campus res $4245 per yr
Courses: †Advertising Design, †Art Appreciation, †Art Education, †Art History, †Ceramics, †Drafting, †Drawing, †Graphic Arts, Graphic Design, †History of Art & Architecture, †Illustration, †Lettering, Museum Staff Training, †Painting, Photography, †Printmaking, †Sculpture, †Studio Crafts, †Teacher Training
Adult Hobby Classes: Courses offered through Office of Continuing Education
Summer School: Tuition same as above for regular 10 wk quarter. Courses—usually lower division

PORTERVILLE

PORTERVILLE COLLEGE, Dept of Fine Arts, 100 E College, Porterville, CA 93257. Tel 559-791-2200; Fax 559-784-4779; Elec Mail Thowell@pc.cc.ca.us; Internet Home Page Address: www.pc.cc.ca.us; *Chmn* Tom Howell
Estab 1927; FT 2, PT 6; pub; D & E; SC 18, LC 3; D 300, E 78, non-maj 320, maj 58
Ent Req: HS dipl or over 18 yrs of age
Degrees: AA & AS 2 yrs
Tuition: Nonres—$160 per unit
Courses: Airbrush, Art History, Ceramics, Design, Drawing, Handicrafts, Jewelry, Painting, Photography, Sculpture, Textile Design, Theatre Arts, color, weaving
Adult Hobby Classes: Courses—Jewelry, Weaving
Summer School: Dir, Nero Pruitt. Enrl 700 Term of 6 wks beginning June 13. Courses—Ceramics, Jewelry, Weaving

QUINCY

FEATHER RIVER COMMUNITY COLLEGE, Art Dept, 570 Golden Eagle Ave., Quincy, CA 95971. Tel 530-283-0202; Internet Home Page Address: www.frcc.cc.ca.us; *Chmn* Diane Lipscomb
FT 25 PT 65; D&E; Scholarships
Degrees: AS
Tuition: Res—$22 per unit; nonres—$195 per unit
Courses: Art Appreciation, Art History, Ceramics, Design, Drawing, Painting, Sculpture, Textile Design, Weaving

RANCHO CUCAMONGA

CHAFFEY COMMUNITY COLLEGE, Art Dept, 5885 Haven Ave, Rancho Cucamonga, CA 91737. Tel 909-987-1737; Internet Home Page Address: www.chaffey.edu/; *Dept Chmn* Jan Raithel
E; Scholarships
Ent Req: HS dipl or equivalent

Degrees: AA
Tuition: Res—$11 per unit; non res— $155 per unit
Courses: Art History, Ceramics, Design, Drawing, Graphic Arts, Graphic Design, Illustration, Interior Design, Mixed Media, Museum Staff Training, Painting, Photography, Sculpture, Theatre Arts
Summer School: Dir, Byron Wilding. Enrl 200; tuition $13 for 6 wk courses. Courses—Art History, Ceramics, Design, Drawing, Graphic Computer Design

REDDING

SHASTA COLLEGE, Art Dept, Arts, Communication & Education Division, 11555 Old Oregon Trail, Redding, CA 96003; PO Box 496006, Redding, CA 96049. Tel 530-225-4761; Fax 530-225-4763; Internet Home Page Address: www.shastacollege.edu; *Dean Div Arts, Communication & Educ* Ron Johnson; *Instructor & Gallery Dir* John Harper; *Instr* David Gentry; *Instructor* Marko Marian
Estab 1950; Maintains a nonprofit art gallery on campus; 2; pub; D & E; SC 28, LC 5
Ent Req: HS dipl
Degrees: AA 2 yr
Tuition: Res—$20 per unit; nonres—$171 per unit
Courses: Art Education, Art History, Ceramics, Commercial Art, Drawing, Graphic Design, Jewelry, Painting, Photography, Printmaking, Sculpture
Summer School: Dir, Dean Summer Prog. Enrl 150; tuition same as regular sem

REDLANDS

UNIVERSITY OF REDLANDS, Dept of Art, 1200 E Colton Ave, Redlands, CA 92373-0999. Tel 909-793-2121, Ext 3663; Elec Mail brownfie@uor.edu; Internet Home Page Address: www.redlands.edu; *Chmn* John Brownfield
Estab 1909; pvt; D & E; Scholarships, Fellowships; SC 18, LC 12; 1500
Ent Req: HS grad, ent exam
Degrees: BA and BS 4 yr, MA, ME, MAT
Tuition: $21,180 per yr; room $4370 per yr, board $3470 per yr
Courses: Art History, Ceramics, Drawing, Ethnic Art, Graphic Arts, Painting, Teacher Training

RIVERSIDE

CALIFORNIA BAPTIST COLLEGE, Art Dept, 8432 Magnolia Ave, Riverside, CA 92504. Tel 909-689-5771, Ext 270; Internet Home Page Address: www.calbaptist.edu; *Chmn* Mack Branden
Scholarships
Degrees: BA
Tuition: $420 per unit
Courses: Art Appreciation, Art History, Ceramics, Design, Drawing, Painting, Printmaking, Sculpture

LA SIERRA UNIVERSITY, Art Dept, 4700 Pierce, Riverside, CA 92515. Tel 909-785-2170; Internet Home Page Address: www.lasierra.cc.ca.us; *Chmn* Prof Susan Patt; *Instr* Jan Inman; *Prof* Peter Erhard; *Prof* Beatriz Mejia-Krumbein; *Instr* Katrin Weise; *Instr* Donna Adrian; *Instr* Stephne Patt
Estab 1905; den; D & E; SC 29, LC 8, GC 1; D 2354
Ent Req: HS dipl, SAT
Degrees: BA, BS 4 yrs
Tuition: Res—$4,860 per quarter; nonres—$5,390 per quarter; campus res—room & board $2,400
Courses: Art History, Calligraphy, †Ceramics, Computer Graphics, Drawing, †Graphic Design, Illustration, Lettering, Occupational Therapy, †Painting, †Photography, †Printmaking, †Sculpture
Adult Hobby Classes: Enrl 35 per wk; tuition $330 per wk for 4 wk term. Courses—Watercolor Workshop
Summer School: Chmn, Roger Churches. 6 wk, 2-4 units. Courses—Art in the Elementary & Secondary School

RIVERSIDE COMMUNITY COLLEGE, Dept of Art & Mass Media, 4800 Magnolia Ave, Riverside, CA 92506. Tel 909-222-8000; Fax 909-222-8740; Internet Home Page Address: www.rccd.cc.ca.us; *Dance Chmn* Jo Dierdorff; *Media Chmn* Charles Richard; *Chmn Performing Arts & Media* Kevin Mayse; *Chmn Art Dept* Dayna Peterson Mason
Estab 1917; FT8; pub; D & E; 37; SC 8, LC 9; D 910, E 175
Ent Req: HS dipl or over 18 yrs of age
Degrees: AA 2 yrs & Certs
Tuition: Res—undergrad $13 per unit, nonres—$114 per unit
Courses: 3-D Design, Advertising Design, Art Appreciation, Art History, Ceramics, †Computer Art, Design, Drawing, †Gallery-Exhib Design & Animation, Painting, Printmaking, Sculpture, Teacher Training
Summer School: Dir Dayna Peterson Mason. Term of 6 wks beginning June 21. Courses—Art for Elementary Teachers, Art History, Ceramics, Drawing, Painting, Sculpture

UNIVERSITY OF CALIFORNIA, RIVERSIDE
—Dept of the History of Art, Tel 951-827-4634; Fax 909-827-2331; Elec Mail arthist@ucr.edu; Internet Home Page Address: http://arthistory.ucr.edu; *Assoc Prof* Steven F Ostrow PhD; *Prof* Jonathan W Green, MA; *Prof* Francoise Forster-Hahn PhD, MA; *Prof Emeriti* Dericksen M Brinkerhoff PhD, MA; *Prof Emeriti* Thomas O Pelzel PhD, MA; *Prof* Conrad Rudolph PhD, MA; *Asst Prof* Ginger C Hsu PhD, MA; *Prof* Amelia G Jones PhD, MA; *Chmn & Assoc Prof* Patricia M Morton PhD, MA; *Asst Prof* Eduardo de Jesus Douglas; *Assoc Prof* Caroline Murphy; *Actg Asst Prof* Kenneth Rogers
Estab 1968; pub; D; LC 18, GC 5; maj 62, grad 26
Ent Req: HS dipl, res grad-point average 3.1, nonres grade-point average 3.4
Degrees: BA, MA

Tuition: Res—undergrad $6684, grad $8145; nonres—undergrad $23,640, grad $23,085
Courses: Art History, History of Art & Architecture, History of Photography
—Dept of Art, Tel 909-787-4634; Elec Mail jdivola@earthlink.net; *Prof* John Divola; *Chmn* Erika Suderburg; *Prof* Uta Barth; *Prof* James S Strombotne, MFA; *Lectr* Gordon L Thorpe, MA
Estab 1954; maintain nonprofit art gallery, Sweeny art gallery, UC Riverside, UCR California Museum of Photography, 3824 Main St, Riverside, CA 92507; pub; D; SC 14, LC 2; maj 58
Ent Req: HS dipl
Degrees: BA
Tuition: Res—undergrad $1500 per qtr, grad $1603; nonres—undergrad $3930 per qtr, grad $4163
Courses: Drawing, Painting, Photography, Printmaking, Video

ROCKLIN

SIERRA COMMUNITY COLLEGE, Art Dept, Liberal Arts Division, 5000 Rocklin Rd Rocklin, CA 95677. Tel 916-624-3333, 789-2866 (Art Dept); Fax 916-789-2854; Internet Home Page Address: www.sierracollege.org; *Dean Humanities* Bill Tsuji; *Instr* Pam Johnson, MA; *Instr* Dottie Brown, MA; *Instr* Rebecca Gregg; *Instr* Tom Fillebrown; *Instr* Randy Snook; *Dept Tech Dir* Anthony Gilo
Estab 1914; pub; D & E; SC 18, LC 4; D & E approx 9000
Ent Req: English Placement Test
Degrees: AA
Tuition: Res—undergrad $11 per unit; non res—$125 per unit
Courses: Art Education, Art History, Ceramics, Drawing, Painting, Photography, Printmaking, Sculpture
Summer School: Ceramics, Painting

ROHNERT PARK

SONOMA STATE UNIVERSITY, Art & Art History Dept, 1801 E Cotati Ave, Rohnert Park, CA 94928. Tel 707-664-2151, 664-2365; Fax 707-664-4333; Internet Home Page Address: www.sonoma.edu/art; *Art Chmn* Michael Schwager
Estab 1961, dept estab 1961; pub; D & E; SC 38, LC 17; D 6000
Ent Req: HS dipl, SAT, eligibility req must be met
Degrees: BA & BFA
Tuition: Res—$1001 regular fee per sem; nonres—$1001 regular fee plus $246 per unit; payment plan available; regular campus res available
Courses: Art Education, Art History, Ceramics, Drawing, Painting, Papermaking, Photography, Printmaking, Sculpture, Teacher Training
Adult Hobby Classes: Various classes offered through Extended Educ
Summer School: Various classes offered through Extended Educ

SACRAMENTO

AMERICAN RIVER COLLEGE, Dept of Art/Art New Media, 4700 College Oak Dr, Sacramento, CA 95841. Tel 916-484-8433; *Instr* Ken Magri, MA; *Spokesperson* Pam Maddock, MFA; *Instr* Tom J Brozovich, MA; *Instr* Gary Pruner, MFA; *Instr* Craig Smith, MFA; *Instr* Laura Parker, MAT; *Instr* Diane Richey-Ward, MFA; *Instr* Judy Hiramoto, MFA
Estab 1954; pub; D & E; Scholarships; SC 65, LC 12; D 10,000, E 10,000, non-maj 5000, maj 5000
Ent Req: HS dipl
Degrees: AA 2 yrs or more
Tuition: Nonres—$134 per unit
Courses: Art Appreciation, Art History, Ceramics, Commercial Art, Design, Drawing, Film, Gallery Management, Graphic Arts, Graphic Design, Illustration, Interior Design, Jewelry, Lettering, Painting, Photography, Printmaking, Sculpture
Summer School: Area Dean, Sheryl Gessford. Enrl 120; tuition $11 per unit June-Aug. Courses—Ceramics, Design, Drawing, Introduction to Art, Photography

CALIFORNIA STATE UNIVERSITY, SACRAMENTO, Dept of Art, 6000 J St, Sacramento, CA 95819-6061. Tel 916-278-6166; Fax 916-278-7287; Internet Home Page Address: www.csus.edu/art; *Chmn* Catherine Turrill
Estab 1950; FT 20; pub; D; Scholarships; SC 40, LC 18, GC 12; maj 585
Ent Req: HS dipl, ent exam
Degrees: BA 4 yr, MA
Tuition: Res—$597 (0-6 units), $930 (7 plus units); nonres—$843 per unit
Courses: Art Education, Art History, Arts with Metals, Ceramics, Computer Art, Drawing, Jewelry, Painting, Printmaking, Sculpture
Summer School: Enrl 225; 3 & 6 wk sessions

SACRAMENTO CITY COLLEGE, Art Dept, 3835 Freeport Blvd, Sacramento, CA 95822. Tel 916-558-2551; Fax 916-558-2190; Internet Home Page Address: www.scc.losrios.cc.ca.us; *Dir Humanities & Fine Arts* Chris Iwata; *Instr* Laureen Landau, MFA; *Instr* F Dalkey, MFA; *Instr* Darrell Forney, MFA; *Instr* George A Esquibel, MA; *Instr* B Palisin, MA; *Instr* Mimi Fong; *Instr* Jennifer Griffin; *Instr* Robert Leach; *Instr* Christine Reading; *Instr* Teiko Sasser; *Instr* Isabel Shaskan; *Instr* Frank Zamora
Estab 1916; pub; D & E; Scholarships; SC 17, LC 9; D 880, E 389
Ent Req: HS dipl
Degrees: AA 2 yr
Tuition: Res—undergrad $11 per unit, nonres—undergrad $11 per unit
Courses: Ceramics, Commercial Art, Drawing, Jewelry, Modern Art, Painting, Photography, Sculpture, Technology, Theatre Arts
Summer School: Chmn, George A Esquibel. Courses—Art History, Design, Drawing, Oil-Acrylic, Watercolor

SALINAS

HARTNELL COLLEGE, Art & Photography Dept, 156 Homestead Ave, Salinas, CA 93901. Tel 831-755-6905; Fax 831-759-6052; Internet Home Page Address: www.hartnell.cc.ca.us; *Dean Fine Arts* Dr Daniel A Ipson

Estab 1922; FT 5, PT 18; pub; D & E; Scholarships; SC 14, LC 3; D 350 E 160, major 30
Ent Req: HS dipl
Degrees: AA 2 yr
Tuition: Res—$11 per unit; non-res $125 per unite
Courses: †Calligraphy, Ceramics, Drafting, Drawing, Foundry, Gallery Management, Graphic Arts, History of Art & Architecture, †Jewelry, Metalsmithing, Painting, Photography, Sculpture, Stage Design, Theatre Arts, Video, Weaving
Summer School: Enrl 150; tuition free; begins approx June 15. Courses—Art Appreciation, Ceramics, Drawing, Film Making, Photography

SAN BERNARDINO

CALIFORNIA STATE UNIVERSITY, SAN BERNARDINO, Dept of Art, Visual Arts Center, 5500 University Pkwy San Bernardino, CA 92407. Tel 909-880-5802; Fax 909-880-7068; Internet Home Page Address: www.csusb.edu; *Chmn Dept & Instr* Joe Moran, MFA; *Dir Mus* Eva Kirsch; *Instr* Leo Doyle, MFA; *Instr* Don Woodford, MFA; *Instr* Billie Sessions, MFA; *Instr* Julius Kaplan PhD, MFA; *Instr* George McGinnis, MFA; *Instr* Sant Khalsa, MFA; *Instr* Kurt Collins, MS; *Instr* Susan Beiner; *Instr* Thomas McGovern
Estab 1965; pub; D & E; Scholarships; D 13,500, maj 220
Ent Req: HS dipl, SAT
Degrees: BA 4 yr, MA 2 yr
Tuition: Res—undergrad $645 per 15 units; nonres—undergrad $126 per unit; campus res—room & board $3195 per yr
Courses: Advertising Design, Art Education, †Art History, Ceramics, Drawing, †Furniture Design, Glassblowing, Glasscasting, †Graphic Design, Painting, Photography, Printmaking, Sculpture, Woodworking

SAN BERNARDINO VALLEY COLLEGE, Art Dept, 701 S Mount Vernon Ave, San Bernardino, CA 92410. Tel 909-888-6511; Internet Home Page Address: www.sbccd.cc.ca.us; *Head Dept* David Lawrence
Estab 1926; FT 5, PT 7; pub; D & E; Scholarships; D 750, E 400, maj 230
Ent Req: HS dipl or 18 yrs of age
Degrees: AA and AS 2 yrs
Tuition: Res—undergrad $11 per unit; nonres—$138 per unit
Courses: Advertising Art, Architecture, Art History, Basic Design, Ceramics, Commercial Art, Computer Graphics, Designs in Glass, Drafting, Drawing, Film, Glass Blowing, Lettering, Life Drawing, Painting, Photography, Sculpture, Theatre Arts

SAN DIEGO

SAN DIEGO MESA COLLEGE, Fine Arts Dept, 7250 Mesa College Dr, San Diego, CA 92111-0103. Tel 619-388-2829; Internet Home Page Address: www.sdccd.net; *Chmn* Richard Lou; *Instr* Barbara Blackmun PhD; *Instr* Ross Stockwell, MA; *Instr* Anita Brynolf, MA; *Instr* Jeorgia Laris, MA; *Instr* John Conrad, MA
Estab 1964; pub; D & E; Scholarships; SC 20, LC 7; D 15,000, E 8,000, maj 300
Ent Req: HS dipl or age 18
Degrees: AA 2 yrs
Tuition: Res—$11 per unit; nonres—$130 per unit; no campus res
Courses: Art Appreciation, Art Education, Art History, Book Arts, Ceramics, Design, Drawing, Gallery Studies, Painting, Photography, Printmaking, Sculpture, Studio Arts
Summer School: Enrl 200; tuition & courses same as regular sem

SAN DIEGO STATE UNIVERSITY, School of Art, Design & Art History, 5500 Campanile Dr, San Diego, CA 92182-4805. Tel 619-594-6511; Fax 619-594-1217; Internet Home Page Address: www.sdsu.edu/art; *Studio Graduate Coordr* Richard Burkett, MFA; *Art History Graduate Coordr* Ida K Rigby, PhD, MFA; *Dir* Fredrick Orth, MFA
Estab 1897; pub; D & E; Scholarships; SC 140, LC 35, GC 30; maj 1109
Ent Req: HS dipl
Degrees: BA 4 yrs, MA, MFA
Tuition: $888 per unit for 6+ units, non-res— $246 per unit; grad— $927 per unit for 6+ units; campus res—room & board
Courses: Art Education, †Art History, †Ceramics, Commercial Art, Conceptual Art, †Drawing, †Environmental Design, Fashion Arts, †Furniture Design ?Gallery Design, Goldsmithing, †Graphic Design, Handicrafts, History of Art & Architecture, Illustration, †Interior Design, Intermedia, †Jewelry, Mixed Media, †Painting, Photography, †Printmaking, †Sculpture, †Silversmithing, †Textile Design, †Weaving
Summer School: Tuition $128 per cr hr June-Aug. Courses— Art History, Ceramics, Drawing, Furniture, Graphic Design, Painting, Sculpture

UNIVERSITY OF SAN DIEGO, Art Dept, 5998 Alcala Park, San Diego, CA 92110. Tel 619-260-4600; Fax 619-260-4619, Ext 4486; Internet Home Page Address: www.usd.ca.ca.us; *Chmn* Patricia Drinan
Estab 1952; pvt; D & E; Scholarships; SC 19, LC 7; univ 5300, maj 50
Ent Req: HS dipl, SAT
Degrees: BA 4 yrs
Tuition: $20,350 per yr
Courses: †Art History, †Art Management, †Art in Elementary Education, †Ceramics, †Design, †Drawing, †Enameling, †Exhibition Design, †Museum Internship, †Painting, †Photography, †Printmaking, †Sculpture, †Weaving
Summer School: Tuition $230 per unit for terms of 3 wk, 6 wk beginning June 1; 2 courses offered

SAN FRANCISCO

ACADEMY OF ART COLLEGE, Fine Arts Dept, 625 Sutter, San Francisco, CA 94108. Tel 415-274-2229; *Pres* Elisa Stephens

Estab 1929; FT 2, PT 8; pvt; D & E; Scholarships; SC 200, LC 100; D 2000, E 150, grad 20
Ent Req: HS dipl
Degrees: BFA 4 yrs, MFA 2 yrs
Tuition: Res—undergrad $12,300 per yr, grad $14,200 per yr; campus res available
Courses: Advertising Design, Aesthetics, Architecture, Art History, Ceramics, Collage, Commercial Art, Design, Drawing, Fashion Arts, Film, Graphic Arts, Graphic Design, Illustration, Industrial Design, Interior Design, Jewelry, Mixed Media, Painting, Photography, Printmaking, Sculpture, Video
Adult Hobby Classes: Enrl 75; tuition $350 per unit. Courses—Basic Painting, Ceramics, Portrait Painting, Pottery
Summer School: Term of 6 wks beginning June 23. Courses—Commercial & Fine Art

CALIFORNIA COLLEGE OF ARTS AND CRAFTS, 450 Irwin St, 16th Street at Wisconsin San Francisco, CA 94107. Tel 415-703-9500; Fax 415-703-9539; Elec Mail enroll@ccac-art.edu; Internet Home Page Address: www.ccac-art.edu; *Pres* Michael Roth
Estab 1907; pvt; D & E; Scholarships; D 1154, non-maj 60, maj 1015, grad 79
Ent Req: HS dipl, HS & col transcripts, portfolio, 2 letters recommendation, interview
Degrees: BFA 4 yrs, BArch 5 yrs, MFA 2 yrs
Tuition: Res—undergrad $10,220 per sem, $852 per unit up to 11 units
Courses: †Architecture, Art History, †Ceramics, Conceptual Art, Costume Design & Construction, †Design, †Drawing, †Fashion Arts, †Film, Glass, Graphic Arts, †Graphic Design, †Illustration, †Industrial Design, †Interior Design, †Jewelry, Mixed Media, †Painting, †Photography, †Printmaking, †Sculpture, Silversmithing, †Textile Design, †Video, Weaving, Wood/Furniture
Adult Hobby Classes: Enrl 1100; tuition $50-$3750 per class. Courses—varies
Children's Classes: Enrl 175; tuition $695 for 3 wk session

CALIFORNIA COLLEGE OF THE ARTS, (California College of Arts & Crafts) 1111 8th St, San Francisco, CA 94107. Tel 415-703-9500; Fax 415-703-9539; Elec Mail enroll@cca.edu; Internet Home Page Address: www.cca.edu; *Pres* Michael S Roth; *Provost* Stephen Beal
Estab 1907; Non-profit art gallery; Wattis Institute for Contemporary Arts, SF campus; Simpson Library, SF campus & Meyer Library, Oakland campus; 200+; pvt; D & E; Scholarships; undergrad 384; grad 110; lecture 123; Total: 1302 undergrad/311 grad
Ent Req: HS dipl, Portfolio, SAT or ACT recommended, C grade-point average, 2 letters of recommendation
Degrees: BArch 5 yrs, BFA 4 yrs, MFA 2 yrs & MArch
Tuition: UG $27,624; Grad $959 per unit
Courses: †Animation, †Architecture, †Calligraphy, †Ceramics, †Community Arts, †Curatorial Practice, †Drafting, †Fashion Arts, †Fashion Design, †Fine Arts, †Glass, †Goldsmithing, Graphic Arts, †Graphic Design, Illustration, †Industrial Design, †Interior Architectural Design, †Interior Design, †Jewelry, †Metal Arts, Mixed Media, †Painting, †Photography, †Printmaking, †Sculpture, †Textiles, †Video, †Visual Criticism, †Visual Studies, †Woodwork & Furniture Design, †Writing & Literature
Adult Hobby Classes: Enrl 1400; tuition $45-395. Courses—Vary
Children's Classes: Pre-College (students completed 10, 11 & 12th grade) Enrl 230; tuition 4 wk, 3 college credit July program; housing $795; Courses: Architecture, Community Arts, Creative Writing, Drawing, Fashion Design, Graphic Design, Illustration, Industrial Design, Jewelry/Metal Arts, Painting, Photography (Black & White, Color, Digital), Printmaking, Sculpture
Summer School: Summer Atelier (students who complt 9th gr) - enrl 32; tuition $1,050, 3 wk prog July or July/Aug, courses: Alternative photog, book arts, drawing; Young Artist Studio Prog (stud who complt 6, 7 & 8th gr) -enrl 200, tuition $575 for 2 wk prog June or Aug, Courses: Animation, Architecture, Cartoon Drawing, Computers in art, Drawing, Hat Design, Jewelry Design, Mosaic Design, Painting, Photography, Printmaking, Sculpture, Woodworking; Dir, Nina Sadek. Enrl 300; tuition $1,075 per unit. Courses—Vary

SAN FRANCISCO ART INSTITUTE, Admissions Office, 800 Chestnut St San Francisco, CA 94133. Tel 415-749-4500; Fax 415-749-4592; Elec Mail admissions@sfai.edu; Internet Home Page Address: www.sfai.edu; *Dir Admissions* Renee Talmon
Estab 1871; Maintain nonprofit art gallery; Walter & McBean Galleries, 800 Chestnut St., San Francisco, CA 94133; pvt; D & E; Scholarships; SC 80, LC 22, GC 11; maj 466 grad 208
Ent Req: HS dipl or GED
Degrees: BFA 4 yrs, MFA 2 yrs
Tuition: $22,176 per yr, $11,088 per sem; no campus res
Courses: Art History, †Ceramics, †Conceptual Art, †Digital Media, †Drawing, †Film, †Painting, †Performance/Video, †Photography, †Printmaking, †Sculpture
Adult Hobby Classes: Tuition $290 for 4-11 wk session (per course). Courses—Variety of studio courses year round
Children's Classes: Enrl 40; tuition 8 wk session. Courses—Variety of studio courses, summers only
Summer School: Dir, Kate Eilertsen. Tuition 2-8 wk sessions $1800 course. Courses—Variety of studio courses

SAN FRANCISCO STATE UNIVERSITY, Art Dept, 1600 Holloway, San Francisco, CA 94132. Tel 415-338-2176; Fax 415-338-6537; Elec Mail artdept@sfsu.edu; Internet Home Page Address: www.sfsu.edu; *Dean* Morrison Keith; *Chmn* Candace Crockett
Estab 1899; Maintains nonprofit gallery, San Francisco State Univ Art Dept Gallery, 1600 Holloway Ave, San Francisco, CA 94132; art supplies available at on-campus shop; FT 23, PT 10; pub; D & E; Scholarships; SC 80, LC 20, GC 15; D 450, maj 600, grad 30
Ent Req: HS dipl
Degrees: BA 4 yrs, MFA 3 yrs, MA 2 yrs
Tuition: Nonres—$269 per unit; campus res available

Courses: Art Education, Art History, Ceramics, Conceptual/Information Arts, Mixed Emphasis, Painting, Photography, Printmaking, Sculpture, Textile
Summer School: Not regular session. Self-supporting classes in Art History, Ceramics, Drawing & Painting, Art Educ

SAN JACINTO

MOUNT SAN JACINTO COLLEGE, Art Dept, 1499 N State St, San Jacinto, CA 92583. Tel 909-654-8011, Ext 1522; Elec Mail srobinso@msjc.cc.ca.us; Internet Home Page Address: www.msjc.cc.ca.us; *Dept Chair* Sandra Robinson
Estab 1964; pub; D & E; SC 8, LC 2; D 250, E 420, non-maj 400, maj 50
Ent Req: HS dipl
Degrees: AA & AS
Tuition: $29 per unit; res—$11 per unit; non-res—$134 per unit
Courses: Art History, Basic Design, Ceramics, Painting, Sculpture
Children's Classes: Studio courses
Summer School: Courses—Drawing

SAN JOSE

SAN JOSE CITY COLLEGE, School of Fine Arts, 2100 Moorpark Ave, San Jose, CA 95128. Tel 408-298-2181; Fax 408-298-1935; Internet Home Page Address: www.sjcc.edu; *Dean Humanities & Social Science* Dr Patrick Gierster; *Instr* Judell Bell; *Interim Pres* Chui L Tsang; *Coordr Fine Arts* Eve Page Mathias; *Instr* Ciaran Maegowan
Estab 1921; pub; D & E; SC 7, LC 2; D 320, E 65
Ent Req: HS dipl or 18 yrs of age or older
Degrees: AA 2 yrs
Tuition: Res—$11 per unit; nonres—$137 per unit
Courses: 2-D & 3-D Design, Art History, Ceramics, Color, Drawing, Expressive & Representational Drawing, Life Drawing, Painting, Photography, Theatre Arts

SAN JOSE STATE UNIVERSITY, School of Art & Design, One Washington Square, San Jose, CA 95192-0089. Tel 408-924-4320; Fax 408-924-4326; Elec Mail rwmilnes@sjsu.edu; Internet Home Page Address: www.ad.sjsu.edu; *Dir* Robert Milnes PhD; *Art Educ Coordr* Pamela Sharp PhD; *Assoc Dir, Studio* David Middlebrook, MFA; *Graduate Prog Coordr* Linda Walsh, MFA; *Assoc Dir, Design* Randall Sexton, BFA; *Prog Coordr, Art History* Anne Simonson, PhD; *Dir Gallery* Jo Farb Hernandez, MA; *Digital Media Art Prog Coordr* Joel Slayton, MA; *Photography Coordr* Robin Lasser, MFA
Estab 1857, dept estab 1911; Maintains Natalie and James Thompson Art Gallery, School of Art & Design SJSU, One Washington Square, San Jose, CA 95192-0089; pub; D & E; Scholarships, Fellowships; SC 200+, LC 30+, GC 10+; D 4529, maj 1800, grad 100
Ent Req: ACT & grade point average, SAT
Degrees: BA(Art), BA(Art History) 4 yrs, BFA(Graphic Design), BS(Industrial Design), BFA(Interior Design) & BFA(Art-Animation, Illustration, Digital Media, Pictorial Art, Spatial Art, Photography) 4 1/2 yrs, MA(Art History), 1 yr, MFA(Pictorial Arts), MFA(Photography), MFA(Spatial Arts) & MFA(Digital Media Arts) 3 yrs
Tuition: Res—(undergrad) $899 - $1328 per sem; nonres—$899 - $1328 plus $282/unit/per sem (non-res u.q.)
Courses: †Animation, †Art Education, †Art History, Ceramics, †Crafts (Jewelry, †Digital Media Art, Drawing, †Graphic Design, Illustration, †Industrial Design, †Interior Design, Jewelry, †Photography, Printmaking, †Sculpture, Teacher Training, Textiles)
Summer School: Dean Continuing Educ, Mark Novak. Tuition $160 per unit for three summer sessions of 3 & 6 wks; 3 wk Jan session. Courses—Vary according to professors available & projected demand

SAN LUIS OBISPO

CALIFORNIA POLYTECHNIC STATE UNIVERSITY AT SAN LUIS OBISPO, Dept of Art & Design, San Luis Obispo, CA 93407. Tel 805-756-1148; Fax 805-756-6321; *Prof* C W Jennings, MFA; *Prof* Robert Densham, MFA; *Prof* Clarissa Hewitt, MFA; *Prof* Mary La Porte, MFA; *Prof* George Jercich, MFA; *Assoc Prof* Sky Bergman, MFA; *Prof* Eric B Johnson, MFA; *Asst Prof* Joseph Coates; *Prof Dr* Keith Dills; *Prof* Robert Howell; *Asst Prof* Michael B Miller; *Prof* Jeanne Ruggles; *Asst Prof* Dr Jean Wetzel
Estab 1901, dept estab 1969; FT 12; pub; D & E; SC 40, LC 12; D 1000, E 100, non-maj 1100, maj 220
Ent Req: HS dipl, portfolio review
Degrees: BS (Art & Design) 4 yrs
Tuition: Res—undergrad $3640 per yr; nonres—undergrad $5893 per yr; campus res—room & board $4366 per yr
Courses: Advertising Design, Art History, Ceramics, Design History, Drawing, Glass, Graphic Arts, Graphic Design, Metalsmithing, Painting, Photography, Printmaking, Sculpture
Summer School: Chair, Chuck Jennings. Enrl 215; tuition $740 for term June 20-Sept 2. Courses—Basic b/w Photography, Ceramics, Fundamentals of Drawing, Intermediate Drawing

CUESTA COLLEGE, Art Dept, PO Box 8106, San Luis Obispo, CA 93403-8106. Tel 805-546-3201; Fax 805-546-3995; *Chmn Fine Arts Div & Instr* Bob Pelfrey; *Instr* Guyla Call Amyx; *Instr* Barry Frantz; *Instr* Marian Galczenski; *Instr* David Prochaska
Estab 1964; pub; D & E; Scholarships
Ent Req: HS dipl or Calif HS Proficiency Exam
Degrees: AA and AS
Tuition: Nonres—$115 per unit
Courses: Art Appreciation, Art History, Camera Art, Ceramics, Design, Display, Drawing, Graphic Design, Painting, Printmaking, Sculpture, Video

Summer School: Chmn Div Fine Arts, Bob Pelfrey. Courses—Drawing, Art History, Ceramics

SAN MARCOS

PALOMAR COMMUNITY COLLEGE, Art Dept, 1140 W Mission Rd, San Marcos, CA 92069. Tel 760-744-1150, Ext 2302; Fax 760-744-8123; Internet Home Page Address: www.palomar.cc.ca.us; *Assoc Prof & Dir* Harry E Bliss MFA; *Assoc Prof* Jay Shultz, MA; *Assoc Prof* James T Saw, MA; *Assoc Prof* Michael Steirnagle, MA; *Assoc Prof* Steve Miller, MA; *Chmn* Doug Durrant
Estab 1950; pub; D & E; Scholarships; SC 31, LC 4; D 775, E 200
Ent Req: ent exam
Degrees: AA 2 yr
Tuition: $11 per unit
Courses: †Animation, Art History, †Ceramics, Collage, †Commercial Art, Design Composition, †Drawing, Glassblowing, Graphic Arts, Graphic Design, Handicrafts, Illustration, †Jewelry, Lettering, Life Drawing, †Painting, †Printmaking, Sculpture, †Silversmithing, Stained Glass
Summer School: Courses—basic courses except commercial art and graphic design

SAN MATEO

COLLEGE OF SAN MATEO, Creative Arts Dept, 1700 W Hillsdale Blvd, San Mateo, CA 94402. Tel 650-574-6288; Fax 650-358-6842; Internet Home Page Address: www.gocsm.net; *Dir Fine Arts* Janis Willis; *VPres* Grace Sonner
Pub; D & E
Degrees: AA 2 yr
Tuition: Res—$11 per unit, nonres—$130 per unit; no campus res
Courses: †Architecture, Art History, Ceramics, †Commercial Art, Design, Drafting, Drawing, †Film, †General Art, Graphic Arts, Graphic Design, Painting, Photography, Printmaking, Sculpture, Video

SAN PABLO

CONTRA COSTA COMMUNITY COLLEGE, Dept of Art, 2600 Mission Bell Dr, San Pablo, CA 94806. Tel 510-235-7800, Ext 4261; Fax 510-236-6768; Internet Home Page Address: www.contracosta.cc.ca.us; *Dept Head* Rich Akers
Estab 1950; pub; D & E; SC 10, LC 16; D 468, E 200
Ent Req: HS dipl or 18 yrs old
Degrees: Cert of Achievement 1 yr, AA and AS 2 yrs
Tuition: Res—$11 per unit; nonres—$144 per unit; no campus res
Courses: Art History, Ceramics, Drawing, Painting, Photography, Sculpture, Silkscreen
Summer School: Assoc Dean Continuing Educ, William Vega. Enrl 50; tuition free for term of 8 wks beginning June 26. Courses—Art, Art Appreciation

SAN RAFAEL

DOMINICAN COLLEGE OF SAN RAFAEL, Art Dept, 50 Acacia Ave, San Rafael, CA 94901. Tel 415-457-4440; Fax 415-485-3205; Internet Home Page Address: www.dominican.edu; *Chmn* Edith Bresnahan
Estab 1890; Scholarships
Degrees: BA, MA 4 yr
Tuition: Undergrad—$8628 per sem
Courses: Advertising Design, Art Appreciation, Art Education, Art History, Calligraphy, Ceramics, Design, Drawing, Handicrafts, Painting, Photography, Pottery, Printmaking, Sculpture, Stage Design, Textile Design, Theatre Arts, Weaving

SANTA ANA

SANTA ANA COLLEGE, (Rancho Santiago College) Art Dept, 1530 W 17th St, Santa Ana, CA 92706. Tel 714-564-5600; Fax 714-564-5629; *Dean of Fine & Performing Arts* Thom Hill, MA; *Art Instr* Gene Isaacson, MA; *Instr* George E Geyer, MA; *Instr* Frank Molner, MA; *Instr* Mayde Herberg, MA; *Instr* Sharon Ford, MA
Estab 1915, dept estab 1960; pub; D & E; Scholarships; SC 21, LC 5; D 280, E 160, maj 57
Ent Req: HS dipl
Degrees: AA 2 yrs
Tuition: Res—$11 per unit; nonres—$138 per unit
Courses: Advertising Design, Architecture, Art History, Ceramics, Commercial Art, Computer Graphics, Display, Drawing, Glass Blowing, Graphic Arts, Graphic Design, Handicrafts, Interior Design, Jewelry, Museum Staff Training, Painting, Sculpture
Adult Hobby Classes: Ceramics, Stained Glass
Summer School: Dir, Dean Thom Hill. Enrl 3000; tuition free for term of 6-8 wks beginning early June. Courses—Art Concepts, Ceramics, Design, Drawing, Painting

SANTA BARBARA

SANTA BARBARA CITY COLLEGE, Fine Arts Dept, 721 Cliff Dr, Santa Barbara, CA 93109-2394. Tel 805-965-0581; Fax 805-963-7222; Internet Home Page Address: www.sbcc.net; *Chmn* Diane Handsloser
Pub; D&E; Scholarships
Degrees: AA
Tuition: In-state—$12 per unit

Courses: Advertising Design, Architecture, Art Appreciation, Art History, Calligraphy, Cartooning, Ceramics, Design, Drawing, Fashion Arts, Film, Glassblowing, Handicrafts, Industrial Design, Interior Design, Jewelry, Painting, Printmaking, Sculpture, Stage Design, Textile Design, Weaving

UNIVERSITY OF CALIFORNIA, SANTA BARBARA, Dept of Art Studio, Santa Barbara, CA 93106. Tel 805-893-3138; Fax 805-893-7206; Internet Home Page Address: www.arts.ucsb.edu; *Chmn Dept* Kim Yasuda
Estab 1868, dept estab 1950; pub; D&E; Scholarships; SC 30, LC 7, GC 7; D 479, grad 60
Ent Req: HS dipl
Degrees: BA 4 yrs, MFA 2 yrs, PhD 7 yrs
Tuition: Res—undergrad $1287 per qtr; nonres—$3415 per qtr
Courses: †Art Theory, Ceramics, Drawing, Painting, †Performance Art, Photography, Printmaking, Sculpture
Summer School: Dir Loy Lytle

SANTA CLARA

SANTA CLARA UNIVERSITY, Dept of Art & Art History, 500 El Camino Real, Santa Clara, CA 95053-0264. Tel 408-554-4594; Fax 408-554-4809; Internet Home Page Address: www.scu.edu/art; *Prof* Sam Hernandez, MFA; *Sr Lect* Gerald P Sullivan, SJ; *Chmn* Kathleen Maxwell PhD; *Assoc Prof* Brigid Barton; *Asst Prof* Andrea Pappas; *Assoc Prof* Susan Felter, MFA; *Assoc Prof* Kelly Detweiler, MFA; *Lectr* Pancho Jimenez, MFA; *Asst Prof* Blake DeMaria; *Asst Prof* Katherine Aok; *Asst Prof* Katherine Morris; *Lectr* Barbara Hoffman; *Lectr* Ryan Reynolds; *Lectr* Don Fritz
Estab 1851, dept estab 1972; Maintain a nonprofit art dept gallery; Pvt; D, E; Scholarships; SC 38, LC 32; D 700, non-maj 700, maj 100
Ent Req: HS dipl
Degrees: BA Art, Art History
Tuition: $29,000 per yr; campus res—rm & bd $10K per yr
Courses: †Art History, Ceramics, Computer Art, Drawing, †Graphic Design, Painting, Photography, Printmaking, Sculpture
Summer School: Dir, Kathleen V. Schneider. Enrl 15 per class; 5 & 10 wk terms. Courses—Ceramics, Intro to Art History, Painting, Watercolor

SANTA CRUZ

UNIVERSITY OF CALIFORNIA, SANTA CRUZ, Art Dept, E104 Baskin Visual Arts, 1156 High St Santa Cruz, CA 95064. Tel 831-459-2272; Fax 831-459-3793; Internet Home Page Address: www.arts.ucsc.edu; *Chmn* Norman Locks
Pub; D; SC per quarter 11, LC per quarter 3; D approx 7000, maj 80
Ent Req: HS dipl
Degrees: BA 4 yrs
Tuition: Res—$4263 per qtr; nonres—$8200 per qtr
Courses: Aesthetics, Book Arts, Drawing, Electronic Art, Intaglio Printmaking, Intermedia, Lithography, Metal Sculpture, Painting, Photography, Sculpture

SANTA MARIA

ALLAN HANCOCK COLLEGE, Fine Arts Dept, 800 S College Dr, Santa Maria, CA 93454. Tel 805-922-6966, Ext 3252; Fax 805-928-7905; Internet Home Page Address: www.hancock.cc.ca.us; *Head* Steve Lewis
Estab 1920. College has three other locations; FT 10, PT 20; pub; D & E; Scholarships; SC 24, LC 4; D 800, E 220, maj 115
Ent Req: HS dipl, over 18 and educable
Degrees: AA 2 yrs
Tuition: Nonres—$134 per unit; res $11 per unit only
Courses: Art Appreciation, Art History, Ceramics, Costume Design & Construction, Dance, Design, Drawing, †Film, †Graphic Arts, Graphic Design, History of Art & Architecture, Life Drawing, Music, Painting, †Photography, Sculpture, Silk Screen, †Theatre Arts, †Video, Video Production
Adult Hobby Classes: Enrl 100. Courses—Drawing, Watercolor
Children's Classes: Enrl 20. Courses—Drawing
Summer School: Enrl 230; term of 6-8 wks beginning June. Courses—Animation, Art, Computer Graphics, Dance, Drama, Electronic Music, Film, Video, Graphics, Music, Photography

SANTA ROSA

SANTA ROSA JUNIOR COLLEGE, Art Dept, 1501 Mendocino Ave, Santa Rosa, CA 95401. Tel 707-527-4259; Fax 707-527-8416; Internet Home Page Address: www.santarosa.edu; *Chmn* Deborah Kirklin
Estab 1918, dept estab 1935; pub; D & E; Scholarships; SC 40, LC 8; D approx 800, E approx 1000
Ent Req: HS dipl
Degrees: AA 2 yrs
Tuition: Res—undergrad $11 per unit; nonres—undergrad $134 per unit; campus res available
Courses: 3-D Design, Art Appreciation, Art History, Ceramics, Computer Graphics, Drawing, Etching, Graphic Design, Jewelry, Layout, Lettering, Painting, Photography, Poster Design, Pottery, Principles of Color, Printmaking, Sculpture, Silkscreen, Watercolor
Summer School: Chmn, Donna Larsen. Term of 6 wks beginning June 20. Courses—Art History, Ceramics, Design, Drawing, Jewelry, Painting, Printmaking, Sculpture, Watercolor

SARATOGA

WEST VALLEY COLLEGE, Art Dept, 14000 Fruitvale Ave, Saratoga, CA 95070. Tel 408-741-2014; Fax 408-741-2059; *Chmn* Morry Roizen

Estab 1964; Maintain nonprofit art gallery; Viking Art Gallery; FT 5, PT 8; pub; D & E; SC 51, LC 12; D 1260, E 801
Ent Req: HS dipl or 18 yrs of age
Degrees: AA, 2 yrs
Tuition: Res fee under $50; no campus res
Courses: Aesthetics, †Ceramics, Costume Design & Construction, †Design, Digital Graphics & Animation, †Drawing, †Etching, †Graphic Arts, †History of Art & Architecture, †Jewelry, †Lithography, †Metal Casting, Museum Staff Training, †Occupational Work Experience, †Painting, †Papermaking, †Sculpture, Stage Design, Stained Glass, Theatre Arts
Adult Hobby Classes: Tuition varies. Courses—many classes offered by Community Development Dept
Summer School: Dir, Moises Roizen. Enrl 200-250; tuition $35-$50. Courses—Art Appreciation, Art History, Ceramics, Drawing, Painting

SONORA

COLUMBIA COLLEGE, Fine Arts, 11600 Columbia College Dr, Sonora, CA 95370. Tel 209-588-5100, 588-5150; Fax 209-588-5104; *Instr* Li Ching Accurso; *Instr* Laurie Sylwester
Estab 1968; pub; D & E; Scholarships; SC 50, LC 4; D 100, E 75, non-maj 90, maj 10
Ent Req: HS dipl or over 18 yrs old
Degrees: AA 2 yrs
Tuition: Res—$24 per unit; nonres—$146 per unit; dorms
Courses: Art History, Ceramics, †Design, Drafting, Drawing, Film, History of Art & Architecture, Painting, Photography, Sculpture, Theatre Arts, Video
Adult Hobby Classes: Quilting; Watercolor (variable or no fee)
Summer School: Courses—Ceramics, Drawing

SOUTH LAKE TAHOE

LAKE TAHOE COMMUNITY COLLEGE, Art Dept, One College Dr South Lake Tahoe, CA 96150. Tel 530-541-4660, Ext 228; Fax 530-541-7852; Elec Mail foster@ltcc.edu; Internet Home Page Address: www.ltcc.ca.us; *Painting Instr* Phyllis Shafer, MFA; *Chmn Art Dept* David Foster, MA; *Instr* Ellen Manaffey
Estab 1975; Maintain nonprofit art galleries: Foyer Gallery, Fine Arts Bldg, Lake Tahoe Community Ctr; Main Gallery, Main Bldg; pub; D, E & weekends; Scholarships; SC 22, LC 6; D 375, E 150, non-maj 300, maj 75
Ent Req: HS dipl
Degrees: AA 2 yrs
Tuition: Undergrad $17 per unit, grad $33 per unit
Courses: Art Appreciation, Art History, Bronze Casting, Ceramics, Color, Design, Digital Art, Drawing, Painting, Photography, Printmaking, Sculpture, Theatre Arts
Summer School: Dean Humanities Mrs Diane Rosner. Enrl 100; tuition undergrad $7 per unit, grad $33 per unit. Courses—Art History, Bronze Casting, Ceramics, Design, Intro to Art, Landscape Drawing, Life Drawing, Painting, Photography, Raku Pottery, Sculpture, Watercolor

STANFORD

STANFORD UNIVERSITY, Dept of Art, Cummings Art Bldg, Stanford, CA 94305-2018. Tel 650-723-3404, 725-0142 (Chmn); Fax 650-725-0140; Internet Home Page Address: www.stanford.edu/dept/art; *Chmn Dept Art* Richard Vinograd
Estab 1891; FT 19; pvt; D; Scholarships; SC 48, LC 63, GC 37 (seminars); 3200, maj 70, grad 40
Ent Req: HS dipl
Degrees: BA 4 yrs, MA 1 yr, MFA 2 yrs, PhD 5 yrs
Tuition: $25,000 per yr; campus res—room & board $7105 per yr
Courses: Art History, Drawing, Painting, Photography, Printmaking, Sculpture
Adult Hobby Classes: Offered through Stanford Continuing Education
Children's Classes: Enrl 250. Courses—Offered through Museum
Summer School: Enrl 100; eight wk term. Courses—Art History, Drawing, Painting, Photography, Printmaking

STOCKTON

SAN JOAQUIN DELTA COLLEGE, Art Dept, 5151 Pacific Ave, Stockton, CA 95207. Tel 209-954-5209; Fax 209-954-5755; Elec Mail cjennings@deltacollege.edu; Internet Home Page Address: www.deltacollege.edu; *Chmn* Dr Charles Jennings; *Instr* Jennifer Barrows; *Instr* Ro Cheaney; *Instr* Joe Mariscol; *Instr* Mario Moreno; *Instr* Patricia Nakamura
Estab 1935; Maintains nonprofit art gallery, L H Horton, Jr. Art Gallery San Joaquin Delta College 515 Pacific Ave Stockton CA 92507; Pub; D & E; SC 12, LC 2; D 7,000, E 6,000, Maj 100
Ent Req: HS dipl
Degrees: AA 2 yrs
Tuition: Res—undergrad $26 per unit, with BA $65 per unit; nonres—$149 & $26 enollment fees per unit; no campus res
Courses: Advertising Design, †Architecture, Art Appreciation, Art History, Calligraphy, Ceramics, Collage, Commercial Art, Costume Design & Construction, Design, Drafting, Fashion Arts, Film, Graphic Arts, Graphic Design, History of Art & Architecture, Interior Design, Landscape Architecture, Lettering, Painting, Photography, Printmaking, Sculpture, Stage Design, Textile Design, Theatre Arts, Video
Summer School: Dir, Dr Charles Jennings. Enrl 8,000; Six week session. Courses—Same as regular sessions

UNIVERSITY OF THE PACIFIC, College of the Pacific, Dept of Art & Art History, 3601 Pacific Ave, Stockton, CA 95211. Tel 209-946-2241; Fax 209-946-2518; Internet Home Page Address: www.uop.edu; *Chmn* Barbara Flaherty

Estab 1851; FT 9; pvt; Scholarships; 37 (3 unit) courses & 14 (4 unit) courses available over 4 yrs, independent study; maj 55-70
Ent Req: HS grad with 20 sem grades of recommending quality earned in the 10th, 11th and 12th years in traditional subjects, twelve of these grades must be in acad subj
Degrees: BA & BFA
Tuition: $21,525 per yr; campus res—$6,750
Courses: Art Education, †Art History, †Arts Administration, Ceramics, Commercial Design, Computer Art, Design, Drawing, Graphic Arts, †Graphic Design, Illustration, Lettering, Painting, Photography, Printmaking, Sculpture, †Studio Art
Summer School: Two 5 wk sessions

SUISUN CITY

SOLANO COMMUNITY COLLEGE, Division of Fine & Applied Art & Behavioral Science, 4000 Suisun Valley Rd, Suisun City, CA 94585. Tel 707-864-7000; Internet Home Page Address: www.solano.cc.ca.us; *Instr* Jan Eldridge; *Instr* Kate Delos; *Instr* Marc Lancet; *Instr* Marilyn Tannebaum; *Instr* Ray Salmon; *Instr* Rod Guyer; *Instr* Marc Pondone; *Instr* Debra Bloomfield; *Instr* Vera Grosowsky; *Instr* Christine Rydell; *Instr* Al Zidek; *Instr* Bruce Blondin; *Div Dean* Richard Ida
Estab 1945; pub; D & E; SC 16, LC 5; D 255, E 174, maj 429
Ent Req: HS dipl
Degrees: AA 2 yrs
Tuition: Res—$11 per unit; nonres—$112 per unit
Courses: †3-D Art, Art History, Ceramics, Commercial Art, Drawing, Fashion Illustration, Form & Composition, Fundamentals of Art, Illustration, Lettering, Painting, Papermaking, Photography, Printmaking, Raku, Sculpture, Silkscreen, Survey of Modern Art
Adult Hobby Classes: Tuition varies per class. Courses—Cartooning, Jewelry Design, Stained Glass
Summer School: Dean summer session, Dr Don Kirkorian

TAFT

TAFT COLLEGE, Art Department, 29 Emmons Park Dr, Taft, CA 93268. Tel 661-763-4282; Fax 661-763-7705; Internet Home Page Address: www.tafp.cc.ca.uf; *Chmn* Sonja Swenson-Wolsey
Estab 1922; pub; D & E; Scholarships; SC 67, LC 6; 1500 total
Ent Req: HS grad or 18 yrs old
Degrees: AA 2 yrs
Tuition: $110 per unit (7-14 units), $122 per unit for out-of-state
Courses: Architecture, †Art History, Basic Design, Ceramics, Commercial Art, Conceptual Art, †Drafting, Drawing, Graphic Arts, Graphic Design, †History of Art & Architecture, Illustration, Painting, †Photography, Sculpture
Adult Hobby Classes: Courses—Ceramics, Graphic Arts, Jewelry, Painting, Photography
Summer School: Dean, Don Zumbro. Term of 6-8 wks. Courses—vary

TEMECULA

DORLAND MOUNTAIN ARTS COLONY, PO Box 6, Temecula, CA 92593. Tel 909-302-3837; Elec Mail dorland@ez2.net; Internet Home Page Address: www.ez2.net/dorland; *Dir* Karen Parrott
Estab 1979; non-profit; Grants
Tuition: $450 per month
Courses: Architecture & Design, Mixed Media, Music, Performance, Photography, Sculpture, Theatre Arts, Visual Arts, Weaving, Writing, dance

THOUSAND OAKS

CALIFORNIA LUTHERAN UNIVERSITY, Art Dept, 60 W Olson Rd, Thousand Oaks, CA 91360. Tel 805-493-3450; Fax 805-493-3479; Internet Home Page Address: www.callutheran.edu; *Prof* Larkin Higgins; *Chmn* Nathan Tierney, PhD; *Asst Prof* Christine Sellin, PhD; *Asst Prof* Michael Pearce; *Asst Prof* Barry Burns; *Asst Prof* Brian Sethem
Estab 1961; maintains a nonprofit art gallery; Kwan Fong Art Gallery, Thousand Oaks, Calif; pvt; D & E; Scholarships; SC 12, LC 7; D 110, non-maj 46, maj 40
Ent Req: HS dipl, SAT or ACT, portfolio suggested
Degrees: BA 4 yr; MA 1 - 2 yr; EdD 3 yr
Tuition: Res—undergrad $24,915 per yr
Courses: Art Education, Art History, Ceramics, †Commercial Art, Design, †Display, Drawing, †Graphic Arts, Graphic Design, Medical Illustration, †Mixed Media, Painting, Photography, Printmaking, Sculpture, Stage Design, Teacher Training, Theatre Arts
Summer School: Asst Prof, Michael Pearce. Tuition $800 per unit for term June-July, July-Aug. Courses—Art Education, Design, Drawing, Painting, Pottery, Sculpture

TORRANCE

EL CAMINO COLLEGE, Division of Fine Arts, 16007 Crenshaw Blvd, Torrance, CA 90506. Tel 310-660-3715; Fax 310-660-3792; Elec Mail rquadham@elcamino.cc.ca.us; Internet Home Page Address: www.elcamino.cc.ca.us; *Dean Div* Dr Roger Quadhamer
Estab 1947; FT 33, PT 61; pub; D & E; Scholarships; SC 46, LC 6; D 1700, E 900, non-maj 2378, maj 222
Ent Req: HS dipl
Degrees: AA 2 yrs
Tuition: None; no campus res

Courses: †Advertising Design, †Art Appreciation, †Art History, †Ceramics, Drawing, Graphic Arts, Jewelry, †Lettering, Museum Staff Training, Painting, Photography, Printmaking, Sculpture
Children's Classes: Enrl 30. Courses—Exploration of Children's Art
Summer School: Enrl 400; tuition $11 per unit. Courses—Art Appreciation, Drawing, Painting

TUJUNGA

MCGROARTY CULTURAL ART CENTER, 7570 McGroarty Terrace, Tujunga, CA 91042. Tel 818-352-5285, 352-0865; Elec Mail director@mcgroartyartscenter.org; Internet Home Page Address: www.mcgroartyartscenter.org; *Dir* Laurelle Geils
Estab 1982; PT 24; pub; D & E; Scholarships; SC 40, LC 1; D 600, E 200
Tuition: Adults $60 per 8 wk session; children & teens $45 per 8 wk session
Courses: Cartooning, Ceramics, Dance, Drawing, †Fashion Arts, Life Drawing, Painting, Piano, Tai Chi Chuan, †Violin, †Yoga
Adult Hobby Classes: Enrl 10; $100; Courses—Ceramics & Painting
Children's Classes: Enrol 14; $40 per 8 wk session; Courses—Ceramics, Creative Drama, Dance, Music for Little People, Painting, Piano, Visual Arts, Violin

TURLOCK

CALIFORNIA STATE UNIVERSITY, Art Dept, 801 W Monte Vista Ave, Turlock, CA 95382. Tel 209-667-3431; Fax 209-667-3871; Elec Mail gsenior@csustan.edu; *Chmn Dept* Gordon Senior, MFA; *Prof* John Barnett, MFA; *Prof* C Roxanne Robbin, PhD; *Prof* David Olivant, MFA; *Prof* Richard Savini, MFA; *Prof* Hope Werness, PhD; *Prof* Dean DeCoker, MFA; *Prof* Jessica Gomula, MFA
Estab 1963, dept estab 1967; Maintain nonprofit art gallery; Univ Art Gallery, 801 University Ave, Bldg D, Turlock, CA 95382; pub; D & E; Scholarships; SC 27, LC 6, GC 4; D 700, E 300, non-maj 350, maj 125, grad 20
Ent Req: HS dipl
Degrees: BA 4 yrs; Printmaking Cert Prog; BFA 5 yrs
Tuition: Res—undergrad & grad $937 per sem, $127 winter terms; nonres—undergrad & grad are same as res plus $246 per unit; limited campus res
Courses: Art History, †Drawing, †Gallery Management, Painting, †Printmaking, †Sculpture, Teacher Training
Summer School: Summer semester offered

VALENCIA

CALIFORNIA INSTITUTE OF THE ARTS, School of Art, 24700 McBean Pkwy, Valencia, CA 91355. Tel 661-255-1050; Fax 661-259-5871; *Pres* Dr Steven D Lavine; *Dean* Thomas Lawson
Estab 1970; FT 30; pvt; Scholarships; D 270
Ent Req: portfolio
Degrees: BFA 4 yrs, MFA
Tuition: $20,930 per yr; campus res available
Courses: Aesthetics, Art History, Collage, Conceptual Art, Constructions, Critical Theory, Drawing, Film, Graphic Arts, †Graphic Design, †Integrated Media, Intermedia, †Mixed Media, †Painting, †Photography, †Post Studio, †Printmaking, †Sculpture, †Video, Visual Communication

VAN NUYS

LOS ANGELES VALLEY COLLEGE, Art Dept, 5800 Fulton Ave, Van Nuys, CA 91401-4096. Tel 818-781-1200; Fax 818-785-4672; Internet Home Page Address: www.lavalleycollege.com; *Chmn* Dennis Reed
Degrees: AA, cert
Tuition: Undergrad—$13 per unit; nonres—$13 per unit
Courses: Advertising Design, Art History, Ceramics, Design, Drawing, Painting, Photography, Printmaking, Sculpture
Summer School: Beginning Design I, Drawing

VENTURA

VENTURA COLLEGE, Fine Arts Dept, 4667 Telegraph Rd, Ventura, CA 93003. Tel 805-654-6400 ext 1280; Internet Home Page Address: www.vccca.net; *Chmn* Myra Toth
Estab 1925; FT 7, PT 26; pub; D & E; Scholarships; SC 50, LC 15; D 500, E 500, maj 300
Ent Req: HS dipl or 18 yrs of age
Degrees: AA and AS
Tuition: Res—$12 per unit to 90 units; nonres—$117 per unit, foreign students $131 per unit; no campus res
Courses: Advertising Design, †Art, Art Appreciation, †Art History, †Ceramics, Collage, †Commercial Art, Costume Design & Construction, Design, Display, Drafting, Drawing, Fashion Arts, †Graphic Arts, Graphic Design, History of Art & Architecture, Illustration, Intermedia, Landscape Architecture, Mixed Media, Museum Staff Training, †Painting, †Photography, †Printmaking, †Sculpture, Stage Design, Textile Design, †Theatre Arts
Adult Hobby Classes: Enrl 500; tuition same as regular session. Courses—Art
Summer School: Dir, Gary Johnson. Enrl 325; tuition same as regular courses. 4-8 wk term. Courses—Ceramics, Color & Design, Computer Graphics, Drawing, Photography

VICTORVILLE

VICTOR VALLEY COMMUNITY COLLEGE, Art Dept, 18422 Bear Valley Rd, Victorville, CA 92392. Tel 935-245-4271; Fax 935-245-9745; Internet Home Page Address: www.vcconline.com; *Instructional Aide* Richard Ripley; *Chmn* Frank Foster

Estab 1961, dept estab 1971; pub; D & E; Scholarships; SC 20, LC 5; D 125, E 125, non-maj 200, maj 50
Ent Req: HS dipl
Degrees: AA 2 yrs
Tuition: $13 per cr hr
Courses: Art History, Commercial Art, Design, Drawing, Graphic Design, History of Art & Architecture, Painting, Photography
Adult Hobby Classes: Enrl 100; tuition $10 per 6 wks
Summer School: Dir, John F Foster. Enrl 75; tuition $13 per cr hr. Courses—Art Concepts, Art History, Design, Drawing, Photography

VISALIA

COLLEGE OF THE SEQUOIAS, Art Dept, Fine Arts Division, 915 S Mooney Blvd Visalia, CA 93277. Tel 559-730-3700; Fax 559-730-3894; Internet Home Page Address: www.sequoias.cc.ca.us; *Instr* Richard Flores; *Instr* Gene Maddox; *Instr* Barbara Strong
Estab 1925, dept estab 1940; PT 12; pub; D & E; Scholarships; SC 12, LC 4; D 60, E37, maj 10
Ent Req: HS dipl, must be 18 yr of age
Degrees: AA 2 yr
Tuition: Res—$11 per unit
Courses: Art Appreciation, Art History, Calligraphy, Ceramics, Commercial Art, Display, Drawing, Gallery Staff Training, Graphic Arts, Graphic Design, History of Art & Architecture, Illustration, Lettering, Painting, Photography, Printmaking, Sculpture, Stage Design, Textile Design, Theatre Arts, Video
Adult Hobby Classes: Ceramics, Painting, Photography
Summer School: Dir, Marlene Taber. Courses—Drawing, Painting

WALNUT

MOUNT SAN ANTONIO COLLEGE, Art Dept, 1100 N Grand Ave, Walnut, CA 91789. Tel 909-594-5611; Fax 909-468-3954; Internet Home Page Address: www.mtsac.edu; *Chmn Art* Carolyn Alexander; *Chmn Art* Craig Deines; *Chmn Art* Kirk Peterson; *Chmn Animation* Don Shore
Estab 1945; FT 14, PT 10; pub; D & E; SC 24, LC 5; D 2254, E 852, maj 500
Ent Req: over 18 yrs of age
Degrees: AA and AS 2 yrs
Tuition: Non-district res—$18 per unit; nonres—$144 per unit
Courses: Advertising Design, Art History, Ceramics, Commercial Art, Drafting, Drawing, Fibers, Graphic Arts, Illustration, Lettering, Life Drawing, Metals & Enamels, Painting, Photography, Printmaking, Sculpture, Theatre Arts, Woodworking
Summer School: Enrl art 50; term of 6 wks beginning June 16. Courses—Ceramics, Drawing

WEED

COLLEGE OF THE SISKIYOUS, Theatre Dept, 800 College Ave, Weed, CA 96094. Tel 530-938-5257; Fax 530-938-5227; Internet Home Page Address: www.siskiyous.edu; *Area Dir* Dennis Weathers
Estab 1957; pub; D & E; Scholarships; SC 15, LC 2; D 1200, maj 20
Ent Req: HS dipl
Degrees: AA 2 yrs
Tuition: $11 unit to res, $137 unit to out-of-state & foreign
Courses: Art History, Ceramics, Computer Graphics, Drafting, Drawing, Graphic Arts, History of Art & Architecture, Life Drawing, Painting, Photography, Printmaking, Sculpture

WHITTIER

RIO HONDO COLLEGE, Visual Arts Dept, 3600 Workman Mill Rd, Whittier, CA 90601-1699. Tel 562-908-3471; Fax 562-908-3446; Elec Mail jdowney@riohondo.edu; Internet Home Page Address: www.rh.riohondo.edu; *Dean* Joanna Downey; *Paintig & Drawing Instr* Ada Pullini Brown
Estab 1962; FT 8, PT 14; pub; D & E; SC 18, LC 3; D & E 19,000, non-maj 2100, maj 200
Ent Req: HS dipl
Degrees: AA 2 yrs
Tuition: $11 per cr hr, no campus residence
Courses: Advertising Design, Aesthetics, Architecture, Art Appreciation, Art History, Ceramics, Commercial Art, Conceptual Art, Design, Display, Drafting, Drawing, Graphic Arts, Graphic Design, History of Art & Architecture, Illustration, Lettering, Painting, Photography, Theatre Arts
Adult Hobby Classes: Courses—Calligraphy, Printmaking, Oriental Brush Painting, Tole & Decorative Painting
Summer School: Enrl 3468; tuition $5 per unit for term of 6 wks beginning June 23

WHITTIER COLLEGE, Dept of Art, 13406 Philadelphia St, Whittier, CA 90608. Tel 562-693-0771, ext 4686; Fax 562-698-4067; Elec Mail dsloan@whittier.edu; Internet Home Page Address: www.whittier.edu/academic/art/arthome; *Chmn* Dr David Sloan
Estab 1901; pvt; D & E; Scholarships, Fellowships; SC 12, LC 12; 552-560 per sem
Ent Req: HS dipl, accept credit by exam CLEP, CEEBA
Degrees: BA 4 yrs
Tuition: Off campus $19,869 per yr; on campus $24,886 per yr
Courses: Art Education, Art History, Ceramics, Drawing, Painting, Printmaking
Adult Hobby Classes: Tuition $5. Courses—Classes for special students
Children's Classes: Tuition $5. Courses—Classes for special students

Summer School: Dir, Robert W Speier. Enrl 25; tui $140 per credit 1-7 credits, $125 per credit 7-up credits, May 31-June 17, June 20-July 29, Aug 1-Aug 19. Courses—Water Soluble Painting, Color & Basic Drawing

WILMINGTON

LOS ANGELES HARBOR COLLEGE, Art Dept, 1111 Figueroa Pl, Wilmington, CA 90744. Tel 310-522-8200; Fax 310-834-1882; Internet Home Page Address: www.lahc.cc.ca.us; *Assoc Prof* John Cassone, MA; *Asst Prof* Nancy E Webber, MFA; *Instr* DeAnn Jennings, MA; *Instr* Jay McCafferty, MA; *Chmn* David O'Shaughnessy
Estab 1949; pub; D & E; SC 48, LC 11; D 10,000, E 4200
Ent Req: HS dipl
Degrees: AA 2 yrs
Tuition: Res—undergrad $11 per unit; nonres—$130 per unit; F1-Visa students; $137 per unit
Courses: Architecture, Art History, Ceramics, Drawing, Fashion Arts, Painting, Photography, Printmaking, Stage Design, Theatre Arts
Summer School: Art Dept Chmn, DeAnn Jennings. Courses—Art Fundamentals, Art History and Photography

WOODLAND HILLS

PIERCE COLLEGE, Art Dept, 6201 Winnetka, Woodland Hills, CA 91371. Tel 818-710-4366, 719-6475; Fax 818-710-2907; Elec Mail oshimad@pierce.laccd.edu; Internet Home Page Address: www.piercecollege.edu/usr/art/; *Art Dept Chmn* David Oshima; *Prof* Constance Moffat, PhD; *Instr* Angelo Allen; *Instr* Larissa Bank; *Instr* Amy Blount; *Instr* Joane Byce; *Instr* Alex Carrillo; *Instr* Melody Cooper; *Instr* Camille Cornelius; *Instr* Greg Gilbertson; *Instr* David Glover; *Instr* Robert Kingston; *Instr* Lori Koefoed; *Instr* Eduardo Navas; *Instr* Brian Peshek; *Instr* Howell Pinkston; *Instr* Jill Poyourow; *Instr* Nancy Rizzardi; *Instr* Gerald Vicich; *Instr* Constance Kocs
Estab 1947, dept estab 1956; Maintains nonprofit art gallery, 6201 Winnetka Ave, Woodland Hills, CA 91371; pub; D & E; SC 20, LC 8; D & E 23,000
Ent Req: HS dipl 18 yrs and over
Degrees: AA 60 units
Tuition: Res—$11 per unit; nonres—$134 plus $11 per unit plus enrl fee
Courses: Advertising Design, Architecture, Art Appreciation, Art History, Ceramics, Design, Drawing, Graphic Arts, Graphic Design, Jewelry
Adult Hobby Classes: Offered through Community Services Dept
Children's Classes: Offered through Community Services Dept
Summer School: Dir, Paul Whelan

COLORADO

ALAMOSA

ADAMS STATE COLLEGE, Dept of Visual Arts, 208 Edgemont Blvd, Alamosa, CO 81102. Tel 719-587-7823; Fax 719-587-7330; Elec Mail ascart@adams.edu; Internet Home Page Address: www.art.adams.edu; *Head Chair & Prof Art* Margaret Doell, MFA; *Prof Art* Eugene Schilling, MFA; *Asst Prof Art* Dr Joyce Centofanti, PhD; *Asst Prof Art* Dana Provence, MFA; *Asst Prof Art* Roger Eriksen, MFA; *Instr* Kris Gosar; *Instr* Laura Murphy; *Asst Prof* Nancy Anderson; *Instr* Linda McGowan; *Instr* Amy Alexander
Estab 1924; Nonprofit galleries: Cloyde Snook Gallery, Hatfield Gallery, 208 Edgemont Blvd, Alamosa, CO 81101; pub; D & E; Scholarships; SC 46, LC 6, GC 11; D 450, non-maj 200, maj 85, grad 15
Ent Req: HS dipl, ACT & SAT
Degrees: BA 4 yrs, MA 1-1/2 yrs
Tuition: Res—undergrad $899 per sem, grad $1034 per sem; nonres—$3714 per sem, grad $4048 per sem; campus res—room & board $975-$2785
Courses: Art Appreciation, Art Education, Art History, Ceramics, Design, Drawing, Graphic Design, Metalsmithing, Painting, Photography, Printmaking, Sculpture, Weaving
Summer School: Tuition res—$90 per cr hr, nonres—$371 per cr hr. Courses—Art Education, Art History, Ceramics, Design, Drawing, Metals, Painting, Photography, Sculpture

BOULDER

UNIVERSITY OF COLORADO, BOULDER, Dept of Art & Art History, Sibell-Wolle Fine Arts Bldg, N198A Boulder, CO 80309; Campus Box 318, Boulder, CO 80309. Tel 303-492-3580; Fax 303-492-4886; Elec Mail finearts@colorado.edu; Internet Home Page Address: www.colorado.edu/arts; *Chmn* James Johnson
Estab 1861; FT 32, PT 10; pub; D & E; Scholarships; SC 63, LC 44, GC 31, internships 2; D 800, grad 50, others 100
Ent Req: HS dipl
Degrees: BA or BFA (Art History & Studio Arts) 4 yrs, MA (Art History) 2 yrs, MFA (Studio Arts) 3 yrs
Tuition: Res—undergrad $3480 yr; non—res undergrad—$20,592 & board $5,488
Courses: Art History, Ceramics, †Digital Arts, Drawing, Painting, Photography, Printmaking, Sculpture, Video
Summer School: Dir, James Johnson. Enrl 20-25 per course; tuition $579 res, $2116 nonres for term of 5 weeks beginning in June. Courses—Art History, Drawing, Painting, Photography, Printmaking, Sculpture, Special Topics, Watermedia, Digital Arts, Video

COLORADO SPRINGS

COLORADO COLLEGE, Dept of Art, 14 E La Cache Poudre, Colorado Springs, CO 80903. Tel 719-389-6000; Fax 719-389-6882; Internet Home Page Address: www.coloradocollege.edu; *Chmn* Carl Reed, MFA; *Prof* James Trissel, MFA; *Assoc Prof* Gale Murray PhD, MFA; *Prof* Bougdon Swider, MFA; *Assoc Prof* Edith Kirsch PhD, MFA

Estab 1874; pvt; D; Scholarships; SC 20, LC 20; D 1800, maj 40
Ent Req: HS dipl or equivalent & selection by admis committee
Degrees: BA & MAT 4 yr
Tuition: Undergrad $20,880 per yr
Courses: 3-D Design, Art History, Art Studio, Drawing, Graphic Design, Painting, Photography, Printmaking, Sculpture
Summer School: Dean, Elmer R Peterson. Tuition $260 per unit for term of 8 wks beginning June 19. Courses—Architecture, Art Education, Photography

UNIVERSITY OF COLORADO-COLORADO SPRINGS, Visual & Performing Arts Dept, 1420 Austin Bluffs Pky, PO Box 7150 Colorado Springs, CO 80933-7150. Tel 719-262-4065; Fax 719-262-4066; Elec Mail brogacki@uccs.edu; Internet Home Page Address: http://web.uccs.edu/vapa/index.shtml; *Prof* Lin Fife, MFA; *Prof* Robert von Dassanowsky, PhD; *Assoc Prof* Teresa Meadows, PhD; *Instr* Murray Ross; *Instr* Curtis Smith; *Chair & Assoc Prof* Suzanne MacAulay, PhD; *Asst Prof* Glen Whitehead, MDA; *Asst Prof* Laura Tesman, PhD; *Asst Prof* Elissa Auther, PhD; *Assoc Prof* Valerie Brodar, MFA
Estab 1965, dept estab 1970; FT 9 PT 15; pub; D & E; SC 18 LC 16; maj 100
Ent Req: HS dipl, res-ACT 23 SAT 1000, non-res ACT 24 SAT 1050
Degrees: BA (Studio) 4 yr, BA (Art History) 4 Yr, BA (Visual & Performing Arts) 4 yr, (Concentrations in music, art history, film studies, theatre, visual art, museum & gallery practice)
Tuition: Res—undergrad $105 per credit hour; nonres—undergrad $466 per credit hr
Courses: Aesthetics, †Art, Art Appreciation, Art History, Collage, Computer Art, †Costume Design & Construction, Drawing, †Film Studies, †History of Art & Architecture, Mixed Media, †Museum Staff Training, Painting, Photography, Sculpture, †Stage Design, †Theatre Arts
Summer School: Chair & Assoc Prof, Suzanne MacAulay

DENVER

ART INSTITUTE OF COLORADO, (Colorado Institute of Art) 1200 Lincoln St, Denver, CO 80203. Tel 303-837-0825; Fax 303-860-8520; Elec Mail alcadm@aii.edu; Internet Home Page Address: www.aii.edu; *Dean Academic Affairs* Mitra Watts; *Pres* David Zorn
Estab 1952; Maintain nonprofit gallery; pvt; D & E; Scholarships; SC all; D1800
Ent Req: HS dipl
Degrees: Assoc 2 yr, BA 4 yr
Tuition: Undergrad $369 per credit
Courses: Advertising Design, Commercial Art, Computer Animation, Costume Design & Construction, Culinary Arts, Design, Drafting, Fashion Arts, Graphic Arts, Graphic Design, Industrial Design, Interior Design, Multimedia, Video, Website Administration
Adult Hobby Classes: Part time prog available, nights & weekends
Summer School: Summer studio prog for HS Srs

METROPOLITAN STATE COLLEGE OF DENVER, Art Dept, Box 59, PO Box 173362 Denver, CO 80217-3362. Tel 303-556-3090; Fax 303-556-4094; Internet Home Page Address: www.mscd.art.edu; *Chmn* Greg Watts
Estab 1963, dept estab 1963; pub; D & E & F; Scholarships; SC 52, LC 8; D 650, E 325, maj 500
Ent Req: HS dipl or GED
Degrees: BFA 4 yrs
Tuition: Res $73.65; non-res $365
Courses: †Advertising Design, Aesthetics, Art Appreciation, Art Education, †Art History, †Ceramics, †Design, †Drawing, Electronic Media, Graphic Arts, Graphic Design, Illustration, †Jewelry, †Painting, Photography, Printmaking, Sculpture
Summer School: Same as regular session

REGIS UNIVERSITY, Fine Arts Dept, 3333 Regis Blvd, Denver, CO 80221. Tel 303-458-3576, 458-4286; Internet Home Page Address: www.regis.edu; *Dept Chair* Gene Stewart
Estab 1880; FT 3, PT 6; pvt; D & E
Ent Req: HS dipl, ent exam
Degrees: BA, BS & BFA 4 yrs
Tuition: $7800 per sem
Courses: Aesthetics, Art Appreciation, Art History, Design, Drawing, Film, Graphic Arts, Graphic Design, Painting, Photography, Sculpture, †Visual Arts

UNIVERSITY OF COLORADO AT DENVER, College of Arts & Media Visual Arts Dept, Campus Box 177, PO Box 173364 Denver, CO 80217-3364. Tel 303-556-4891; Fax 303-556-2355; Internet Home Page Address: www.cudenver.edu/CAM/visual/; *Prof* Ernest O Porps, MFA; *Asst Prof* Karen Mathews PhD, MFA; *Chmn* John Hull, MFA; *Painting & Drawing* Quinton Gonzales; *Painting & Drawing* James Elhenny; *Photo* Joan Brennan; *Sculpture* Scott Massey; *Multi-Media Study* Kent Homchick
Estab 1876, dept estab 1955; pub; D & E; Scholarships; SC 21, LC 13, GC 11; maj 168
Ent Req: HS dipl, ACT or SAT, previous academic ability and accomplishment
Degrees: BA and BFA 4 yrs
Tuition: Res—undergrad $115 per sem, $116 per cr hr; nonres—undergrad $5032 per sem
Courses: †Art History, †Creative Arts, †Drawing, †Painting, †Photography, †Sculpture, †Studio Arts
Summer School: Tuition same as regular sem, term of 10 wk beginning June 12. Courses—Art History, Studio Workshops

UNIVERSITY OF DENVER, School of Art & Art History, 2121 E Asbury, Denver, CO 80208-2846. Tel 303-871-2846; Fax 303-871-4112; Elec Mail saah-interest@du.edu; Internet Home Page Address: www.du.edu/art; WATS 800-876-3323; *Dir & Assoc Prof Art History* Annette Stott; *Assoc Prof Sculpture* Lawrence Argent; *Sr Lectr Art History* Gwen Chanzit; *Asst Prof Electronic Media Arts Design* Angela Forster; *Asst Prof Art History & Gallery Dir* Shannen Hill;

Assoc Prof Drawing & Painting Deborah Howard; *Assoc Prof Drawing & Printmaking* Bethany Kriegsman; *Prof Ceramics* Maynard Tischler; *Assoc Prof Art History* M E Warlick; *Asst Prof Foundations* Sarah Gjertson; *Asst Prof Electronic Media Arts Design* Rafael Fajardo; *Asst Prof Electronic Media Arts Design* Chris St. Cyr; *Asst Prof Electronic Media Arts Design* Timothy Weaver; *Asst Prof Photography* Roddy MacInnes; *Asst Prof Art History* Scott Montgomery; *Ceramics* Mia Fetterman-Mulvey
Estab 1864; Maintain nonprofit art gallery; Victoria H Myhren Gallery, 2121 East Asbury Ave, Denver, CO 80208; Mem: Maintains a nonprofit art gallery, Victoria H. Myhren Gallery, 2121 E Ashbury Ave, Denver, CO 80208; Pvt; D&E; Scholarships; SC 44, LC 34, GC 38; D 450, non-maj 170-200, maj 193, grad 40
Ent Req: HS dipl, ent exam, portfolio
Degrees: BA & BFA 4 yrs, MA & MFA 2 yrs
Tuition: $721 per qtr hr; campus res available
Courses: Art Appreciation, Art Education, Art History, Ceramics, Design, Digital Media, Drawing, †Electronic Media Arts Design, History of Art & Architecture, Museum Studies, Painting, Photography, Printmaking, Restoration & Conservation, Sculpture, †Studio Art

DURANGO

FORT LEWIS COLLEGE, Art Dept, 1000 Rim Dr, Durango, CO 81301-3999. Tel 970-247-7243; Fax 970-247-7520; Internet Home Page Address: www.fortlewis.edu; *Chmn & Prof* Gerald Wells, MFA & MA; *Prof* Mick Reber, MFA; *Assoc Prof* Laurel Covington-Vogl, MFA; *Assoc Prof* David Hunt, MA
Estab 1956; 5 FT; pub; D & E; Scholarships; SC 30, LC 6; D 600, non-maj 450, maj 150
Ent Req: HS dipl, SAT
Degrees: BA & BS
Tuition: $1105 per sem; campus res available—$2528 room & board per sem
Courses: Aesthetics, Art History, Ceramics, Drawing, Handicrafts, Illustration, Industrial Design, Intermedia, Jewelry, Southwest Art
Summer School: Dean, Ed Angus. Enrl 1000. Courses—Art Education, Ceramics, Drawing, Mural Design, Painting

FORT COLLINS

COLORADO STATE UNIVERSITY, Dept of Art, Fort Collins, CO 80523. Tel 970-491-6774; Fax 970-491-0505; Internet Home Page Address: www.colostate.edu/depts/art; *Chmn* Phil Risbeck
Estab 1870, dept estab 1956; 34; pub; D; Scholarships; SC 55, LC 13, GC 5; D 547, non-maj 860, maj 547, grad 22
Ent Req: HS dipl, portfolio if by transfer
Degrees: BA(Art History & Art Education) and BFA 4 yr, MFA 60 hrs
Tuition: Res—undergrad $11,863 per yr, $3,283 per sem; grad $12,227 per yr, $3,647 per sem; nonres—undergrad $20,283 per yr, $11,303 per sem; grad $20,733 per yr, $11,753 per sem
Courses: Advertising Design, Aesthetics, Art Appreciation, †Art Education, †Art History, †Ceramics, †Drawing, †Fibers, Goldsmithing, Graphic Arts, †Graphic Design, History of Art & Architecture, Illustration, Jewelry, †Metalsmithing, †Painting, †Photography, †Pottery, †Printmaking, †Sculpture, Silversmithing, Teacher Training, Textile Design, Weaving
Children's Classes: Continuing education art offerings not on regular basis
Summer School: Dir, James T Dormer. Enrl 700; tuition $77 per cr. Courses—most regular session courses

GRAND JUNCTION

MESA STATE COLLEGE, Art Dept, 1100 North Avenue, Grand Junction, CO 81501. Tel 970-248-1833; Fax 970-248-1834; Elec Mail sgarner@mesastate.edu; Internet Home Page Address: mesastate.edu; *Chmn* Teresa S Garner; *Assoc Prof* Carolyn I Quinn-Hensley; *Prof* Laverne Mosher; *Prof* Charles Hardy; *Assoc Prof* Dr. W Steven Bradley; *Lecturer* Joshua Butler
Estab 1925; Maintain nonprofit art gallery, Johnson Gallery, Mesa State College, 1100 North Ave., Grand Junction, CO 81501; art supplies available on-campus; pub; D & E; Scholarships; SC 24, LC 6; D 538, E 103
Ent Req: HS dipl, GED
Degrees: BA
Tuition: Res—undergrad $1258 per sem; nonres—undergrad $4084 per sem
Courses: †Advertising Design, †Art Appreciation, †Art Education, Art History, Ceramics, Drawing, Exhibitions & Management, †Graphic Arts, †Graphic Design, Mixed Media, Painting, Printmaking, Sculpture

GREELEY

AIMS COMMUNITY COLLEGE, Visual & Performing Arts, PO Box 69, Greeley, CO 80632. Tel 970-330-8008; Fax 970-330-5705; Internet Home Page Address: www.aims.edu; *Dir Visual & Performing Arts* Alysan Broda; *Acad Dean Communications & Humanities* Susan Cribelli
Estab 1967; pub; D & E
Ent Req: HS dipl, equivalent
Degrees: AA
Tuition: Res—$28 per cr hr for in-state, out-of-district; nonres—$134 per cr hr for out-of-state
Courses: Art Appreciation, Art History, Ceramics, Design, Drawing, Fashion Arts, Interior Design, Jewelry, Painting, Photography, Sculpture, Textile Design, Weaving
Children's Classes: Courses offered
Summer School: Courses offered

UNIVERSITY OF NORTHERN COLORADO, Dept of Visual Arts, 501 20th St, Greeley, CO 80639. Tel 970-351-2143; Fax 970-351-2299; Internet Home Page Address: www.unco.edu; *Chmn* Virginia Jenkins

Estab 1889; FT 10; pub; D & E
Ent Req: HS dipl
Degrees: BA 4 yr
Tuition: Res—undergrad $957 per sem, grad $4208 per sem; nonres—undergrad $1132 per sem, grad $4479 per sem; campus—room & board available upon request
Courses: Art Education, Art History, Ceramics, †Computer Graphics, Drawing, Fiber Art, Graphic Arts, Graphic Design, Jewelry, Painting, Papermaking, Photo Communications, Photography, Printmaking, Sculpture
Summer School: Courses—Comparative Arts Program in Florence, Italy, Study of the Indian Arts of Mesa Verde, Mesa Verde workshop & on campus courses, Workshops in Weaving & Ceramics in Steamboat Springs, Colorado

GUNNISON

WESTERN STATE COLLEGE OF COLORADO, Dept of Art & Industrial Technology, 600 N Adam, Gunnison, CO 81231. Tel 970-943-0120, Ext 3090; Internet Home Page Address: www.western.edu; *Mgr* Charles Cunningham
Estab 1911; FT 40, PT 10-20; pub; D & E; Scholarships; SC 29, LC 7; 2550
Ent Req: HS dipl, special exam
Degrees: BA & BFA, 4 yr
Tuition: Res—$2290 per yr; nonres—$8093per yr
Courses: Art Appreciation, Art Education, Art History, Calligraphy, Ceramics, Commercial Art, Conceptual Art, Design, Drawing, Graphic Arts, Graphic Design, History of Art & Architecture, Indian Art, Introduction to Art, Jewelry, Mixed Media, Painting, Photography, Printmaking, Sculpture, Silversmithing, Studio Art, Textile Design, Weaving
Summer School: 4 & 8 wk courses. Courses—Drawing, Painting, Photography

LA JUNTA

OTERO JUNIOR COLLEGE, Dept of Arts, 1802 Colorado Ave, La Junta, CO 81050. Tel 719-384-8721; Fax 719-384-6880; Internet Home Page Address: www.ojc.cccoes.edu; *Head Dept* Timothy F Walsh
Estab 1941; pub; D & E; Scholarships; SC 12, LC 3; 850
Ent Req: HS grad
Degrees: AA & AAS 2 yr
Courses: Art History, Creative Design, Drawing, Painting
Adult Hobby Classes: Enrl 60; tuition $47.50 per cr, non-credit courses vary. Courses—Art, Drawing, Painting

LAKEWOOD

RED ROCKS COMMUNITY COLLEGE, Arts Dept, 13300 W Sixth Ave, Lakewood, CO 80228. Tel 303-988-6160; Fax 303-914-6666; Internet Home Page Address: www.rrcc.cccoes.edu; *Art Instr* Susan Arndt; *Instr Pottery* James Robertson
Estab 1965; pub; D & E
Ent Req: HS dipl, equivalent
Degrees: AA
Tuition: $60.05 with art fees per cr hr
Courses: Art Appreciation, Art History, Ceramics, Design, Drawing, Electronic Studio, Painting, Photography, Printmaking, Sculpture
Summer School: Enrl 80; tuition $99 per 3 cr course per 10 wks. Courses—Ceramics, Drawing, Design, Watercolor

ROCKY MOUNTAIN COLLEGE OF ART & DESIGN, 1600 Pierce St, Lakewood, CO 80214. Tel 303-753-6046; Fax 303-759-4970; Elec Mail admissions@rmcad.edu; Internet Home Page Address: www.rmcad.edu; WATS 800-888-2787; *Dir* Steve Steele; *Financial Aid* Tammy Dybdahl; *Academic Dean* Jenny Stevenson; *Admis* Angela Carlson
Estab 1963; Maintain nonprofit art gallery, Phillip J. Steele Gallery, Mary K Harris Bldg, 1600 Pierce St, Lakewood, CO 80214; FT 19, PT 41; pvt; D & E; Scholarships; SC 68%, LC 32%; D 400
Ent Req: HS grad or GED, portfolio, essay, GEST scores
Degrees: BFA
Tuition: $8400 per trimester for all full time students; $700 per cr for all part-time students; campus housing available
Courses: †Animation, †Graphic Design, †Illustration, †Interior Design, †Painting, †Sculpture
Summer School: Enrl 250; tuition $5736 for 15 wk term. Courses—Same as regular sem

PUEBLO

UNIVERSITY OF SOUTHERN COLORADO, Dept of Art, 2200 Bonforte Blvd, Pueblo, CO 81001. Tel 719-549-2835; Fax 719-549-2120; *Asst Prof* Carl Jensen, MFA; *Chmn* Roy Sonnema, PhD; *Asst Prof* Maya Avina, MFA; *Asst Prof* Dennis Dalton, MFA; *Assoc Prof* Richard Hansen, MFA; *Assoc Prof* Victoria Hansen, MFA
Estab 1933; pub; D & E; Scholarships; SC 50, LC 18; D 700, E 50, non-maj 600, maj 175
Ent Req: HS dipl, GED, Open Door Policy
Degrees: BA and BS 4 yrs
Tuition: Res—undergrad & grad $928 18 hr sem; nonres—$3760 18 hr sem; campus res—available
Courses: Art History, Ceramics, Collage, Commercial Art, Computer Animation, Computer Imaging, Drawing, Exhibition Design, Graphic Design, Illustration, Painting, Photography, Printmaking, Sculpture, Teacher Training, Video
Summer School: Dir, Ed Sajbel. Enrl 125; tuition resident $40 per cr hr, nonres $150 per cr hr. Courses—Art Education, Art History, Ceramics, Introduction to Art, Painting

SALIDA

DUNCONOR WORKSHOPS, PO Box 416, Salida, CO 81201-0416. Tel 719-539-7519; *Head* Harold O'Connor
Estab 1976; pvt; D; SC; D 34
Ent Req: professional experience
Tuition: Varies by course
Courses: Design, Goldsmithing, Jewelry, Silversmithing
Adult Hobby Classes: Enrl 24; tuition $450 per wk. Courses—Jewelry Making
Summer School: Enrl 34; tuition $450 per wk. Courses—Jewelry Making

STERLING

NORTHEASTERN JUNIOR COLLEGE, Art Department, 100 College Dr, Sterling, CO 80751. Tel 970-522-6600, Ext 6701, 521-6701; Elec Mail larry.prestwich@njc.edu; Elec Mail jaci.mathis@njc.edu; *Prof* Larry B Prestwich, MA; *Instr* Peter L Youngers; *Instr* Joyce May; *Instr* Jaci Mathis, BA
Estab 1941; Maintain nonprofit art gallery on-campus, Peter L Youngers Fine Arts Gallery; art supplies available on-campus; pub; D & E; Scholarships; SC 16, LC 2; D 100, E 24, non-maj 80, maj 20, others 10
Ent Req: HS dipl, GED
Degrees: AA 2 yr
Tuition: Res— $901 per sem; non res—$2331 per sem
Courses: Advertising Design, Art Appreciation, Art Education, Art History, Ceramics, Commercial Art, Design, Drawing, Graphic Design, Lettering, Mixed Media, Painting, Photography, Printmaking, Sculpture, Teacher Training
Adult Hobby Classes: Enrl 100; tuition $8 per cr hr. Courses—Basic Crafts, Ceramics, Drawing, Macrame, Painting, Stained Glass

CONNECTICUT

BRIDGEPORT

HOUSATONIC COMMUNITY COLLEGE, Art Dept, 900 Lafayette Blvd, Bridgeport, CT 06604. Tel 203-332-5000; Fax 203-332-5123; Internet Home Page Address: www.hcc.commnet.edu; *Faculty* Michael Stein, MFA; *Prog Coordr* Ronald Abbe, MFA; *Faculty* John Favret, MFA
Estab 1967, dept estab 1968; maintains nonprofit gallery, Burt Chernow Gallery & Housatonic Museum of Art; pub; D & E; Scholarships; SC 29, LC 4; D 200, E 170, maj 75
Ent Req: HS dipl
Degrees: AA Fine Art 2 yr, AA Graphic Design, AA Graphic Design Computer Graphic Option
Tuition: Res—$70 per cr; nonres—$218 per cr
Courses: †Art History, †Ceramics, Computer Graphics, †Constructions, †Design, †Drawing, †Film, †Graphic Arts, †Graphic Design, Mixed Media, †Painting, †Photography, †Sculpture, †Stage Design, †Theatre Arts
Summer School: Dir, William Griffin. Courses—Same as regular session

UNIVERSITY OF BRIDGEPORT, School of Arts, Humanities & Social Sciences, 600 University Ave, Bridgeport, CT 06601. Tel 203-576-4239, 576-4709; Fax 203-576-4653; *Dir* Thomas Julius Burger; *Assoc Prof* Donald McIntyre, MFA; *Assoc Prof* Jim Lesko, MFA; *Assoc Prof* Sean Nixon, MFA; *Asst Prof* Ketti Kupper, MFA
Estab 1927, dept estab 1947; pvt; D & E; Scholarships; SC 38, LC 24, GC 15; D 1150, E 200, non-maj 1070, maj 260, GS 22
Ent Req: portfolio for BFA candidates only, college boards
Degrees: BA, BS & BFA 4 yr
Tuition: Res—undergrad $6010 per sem
Courses: Advertising Design, Art History, Ceramics, †Graphic Design, †Illustration, †Industrial Design, †Interior Design, Painting, Photography, Printmaking, Sculpture, Theatre Arts, Weaving
Adult Hobby Classes: Enrl open; Courses—most crafts
Summer School: Chmn, Sean Nixon. Details from chairperson (203-576-4177)

DANBURY

WESTERN CONNECTICUT STATE UNIVERSITY, School of Visual & Performing Arts, 181 White St, Danbury, CT 06810. Tel 203-837-9401; Fax 203-837-8945; Internet Home Page Address: www.wcsu.ctstateu/artsci/homepage; *Dean* Dr Carol Hawkes; *Chmn Art Dept* Terry Wells; *MFA Coordr* Margaret Grimes
Estab 1903; Maintains nonprofit art gallery; 181 White St, White Hall, 3rd Floor; Haas Library Midtown Campus, 181 White St; art supplies available at book & art store Midtown & Westside campus; FT 7; pub; D & E; Scholarships; SC 30, LC 3-6, GC 5; D 155, grad 11
Ent Req: HS dipl
Degrees: BA (graphic communications) 4 yr, MFA (painting & illustration) 2 yr
Tuition: Res—$2142 per sem; nonres—$6934 per sem
Courses: Animation Production, Ceramics, Design, Drawing, Graphic Arts, †Graphic Design, History of Art & Architecture, †Illustration, Lettering, †Museology, Painting, †Photography, Printmaking, Sculpture, Stage Design, †Studio Art
Summer School: Dir Peter Serniak; Courses—same as regular session

FAIRFIELD

FAIRFIELD UNIVERSITY, Visual & Performing Arts, N Benson Rd, Fairfield, CT 06430-5195. Tel 203-254-4000; Fax 203-254-4119; Internet Home Page Address: www.fairfield.edu; *Prof, Chmn* Kathryn Jo Yarrington; *Acting Dean* Dr Beverly Khan

Estab 1951; Priv; D & E, summer; Scholarships
Degrees: BA, Masters
Tuition: Res—$20,000 per yr; res—room & board $7380 per yr; upperclassmen—$19,560
Courses: Art History, Art of Film, Design, Drawing, Film Production, History of Film, Painting, Photography, Printmaking, Sculpture, Video, Visual Design
Adult Hobby Classes: Enrl 2000; tuition $330 per 3 cr. Courses—Full Fine Arts curriculum
Summer School: Dir, Dr Vilma Allen. Enrl 2000. Semester June - August

SACRED HEART UNIVERSITY, Dept of Art, 5151 Park Ave, Fairfield, CT 06432-1000. Tel 203-371-7737; Internet Home Page Address: www.sacredheart.edu; *Prof* Virginia F Zic, MFA
Estab 1963, dept estab 1977; 8; pvt; D & E; Scholarships; SC 26, LC 5; D 300, E 100, non-maj 225, maj 70
Ent Req: HS dipl
Degrees: BA 4 yrs
Tuition: $6106 per sem; campus res—available
Courses: Advertising Design, Art History, Computer Design, Design, Drawing, †Graphic Design, History of Art & Architecture, †Illustration, †Painting
Summer School: Prof, Virgina Zic. Courses—Art History

FARMINGTON

TUNXIS COMMUNITY TECHNICAL COLLEGE, Graphic Design Dept, 271 Scott Swamp Rd, Farmington, CT 06032. Tel 860-677-7701; Internet Home Page Address: www.tunxis.commnet.edu; *Acad Dean* Sharon LeSuer; *Graphic Design Coordr* Stephen A Klema, MFA; *Assoc Prof* William Kluba, MFA
Estab 1970, dept estab 1973; pub; D & E; SC 15, LC 4; non-maj 40, maj 90
Ent Req: HS dipl
Degrees: AS, AA(Graphic Design, Visual Fine Arts)
Tuition: Res—$804 per sem, non-res—$2616 per sem
Courses: 2-D & 3-D Design, Color, Computer Graphics, Drawing, Graphic Design, Illustration, Painting, Photography, Typography
Summer School: Dir Community Services, Dr Kyle. Courses—Computer Graphics, Drawing, Painting, Photography

GREENWICH

CONNECTICUT INSTITUTE OF ART, 581 W Putnam Ave, Greenwich, CT 06830. Tel 203-869-4430; Fax 203-869-0521; Elec Mail info@artinstitute.com; Internet Home Page Address: www.artinstitute.com; WATS 800-278-7246; *Dir & Pres* Michael Propersi; *Chmn* August Propersi
Estab 1954; Pvt; D & E; Scholarships; SC 7, LC 2; D 150, E 90
Ent Req: HS dipl, portfolio, interview
Degrees: dipl, 2 yrs
Tuition: $10,300 per yr; no campus res
Courses: Commercial Art, Computer Graphics, Drawing, Graphic Design, Illustration, Web Design
Adult Hobby Classes: Enrl 60; tuition $715. Courses—Computer Graphics, Illustrator, Photoshop, Web Design
Summer School: Dir, Linda MacDonald. Tuition $2,700 per quarter (11 wks). Courses—Commercial Art

HAMDEN

PAIER COLLEGE OF ART, INC, 20 Gorham Ave, Hamden, CT 06514. Tel 203-287-3030; Fax 203-287-3021; Internet Home Page Address: www.paiercollegeofart.edu; *Pres* Jonathan E Paier
Estab 1946; FT 36, PT 11; pvt; D & E; Scholarships; SC 10, LC 6 GC 1; D 185, E 130
Ent Req: HS grad, presentation of portfolio, transcript of records, recommendation
Degrees: BFA & AFA programs offered
Tuition: Res—undergrad $10,500 per yr
Courses: Advertising Design, Architecture, Art Education, Art History, Calligraphy, Conceptual Art, Design, Drafting, Drawing, Fine Arts, Graphic Arts, †Graphic Design, History of Art & Architecture, †Illustration, †Interior Design, Lettering, †Painting, †Photography, Printmaking, Textile Design
Summer School: Dir, Dan Paier. Enrl 50; tuition $200 per sem hr, one 5 wk term beginning July. Courses—CADD, Fine Arts, Graphic Design, Illustration, Interior Design, Photography

HARTFORD

CAPITOL COMMUNITY TECHNICAL COLLEGE, Humanities Division & Art Dept, 61 Woodland St, Hartford, CT 06105. Tel 860-520-7800; Fax 860-520-7906; Internet Home Page Address: www.commnet.edu; *Chmn* John Christi; *Prof* Thomas Werle
Estab 1967; FT 1, PT 2; D & E
Ent Req: HS diploma or equivalent
Degrees: AA & AS 2 yr
Tuition: $70 per cr hr
Courses: Art History, Ceramics, Design, Drawing, Figure Drawing, Painting, Printmaking, Sculpture
Summer School: Courses offered

TRINITY COLLEGE, Dept of Studio Arts, 300 Summit St, Hartford, CT 06106. Tel 860-297-2208; Fax 860-297-5349; Elec Mail Joseph.Byrne@trincoll.edu; Internet Home Page Address: www.trincoll.edu/depts/star; *Prof Fine Arts* Robert Kirschbaum, MFA; *Asst Prof* Pablo Delano, MFA; *Visiting Assoc Prof* Nathan Margalit, MFA; *Asst Prof* Patricia Tillman, MFA; *Chmn, Prof Fine Arts* Joseph Byrne

Estab 1823, dept estab 1939; pvt; D; Scholarships; SC 20, LC 22; D 400, non-maj 350, major 50
Ent Req: HS dipl
Degrees: MA
Tuition: Res—undergrad $23,730 per yr; campus res—room & board $6,890
Courses: Design, Drawing, History of Art & Architecture, Painting, Photography, Printmaking, Sculpture, †Studio Arts

MANCHESTER

MANCHESTER COMMUNITY COLLEGE, Fine Arts Dept, 60 Bidwell St, Mail Sta 31, PO Box 1046 Manchester, CT 06045-1046; Fax 860-647-6214; Internet Home Page Address: www.mcc.commnet.edu; *Prof* John Stevens
Estab 1963, dept estab 1968; PT 4; pub; D & E; D & E 300, non-maj 240, maj 60
Ent Req: HS dipl, portfolio for visual fine arts prog
Degrees: AA & AS 2 yrs
Tuition: 3 cr courses $102 per cr hr
Courses: Art History, Basic Design, Calligraphy, Ceramics, Drawing, Film, Graphic Arts, History of Film, Lettering, Painting, Photography, Printmaking, Sculpture, Sign Painting

MIDDLETOWN

MIDDLESEX COMMUNITY COLLEGE, (Middlesex Community Technical College) Fine Arts Div, 100 Training Hill Rd, Middletown, CT 06457. Tel 860-343-5800; Internet Home Page Address: www.mxcc.commnet.edu; *Head Dept* Lucinda Patrick
Degrees: AS
Tuition: Res—$243 per 3 cr hr; nonres—$218 per cr hr
Courses: Art History, Ceramics, Design, Drawing, Painting, Sculpture

WESLEYAN UNIVERSITY, Dept of Art & Art History, Middletown, CT 06459-0442. Tel 860-685-2000; Fax 860-685-2061; Internet Home Page Address: www.wesleyan.edu; *Prof* John T Paoletti PhD; *Prof* David Schorr, MFA; *Prof* Jeanine Basinger, MFA; *Prof* Clark Maines PhD, MFA; *Prof* J Seeley, MFA; *Prof* Jonathan Best PhD, MFA; *Prof* John Frazer, MFA; *Prof* Peter Mark PhD, MFA; *Prof* Joseph Siry PhD, MFA; *Adjunct Prof Emerita* Helen G D'Oench PhD, MFA; *Assoc Prof* Jeffrey Schiff, MFA; *Assoc Prof* Tula Telfair, MFA; *Assoc Prof* Elizabeth Milroy PhD, MFA; *Assoc Prof* Phillip Wagoner PhD, MFA; *Adjunct Assoc Prof Emerita* Mary Risley, MFA; *Asst Prof* Martha Amez, MFA; *Adjunct Lectr* Stephanie Wiles, MFA
Estab 1831, dept estab 1928; pvt; D; SC 30, LC 25; in school D 3604, maj 94, undergrad 2667
Ent Req: HS dipl, SAT
Degrees: BA 4 yrs
Tuition: Campus res available
Courses: Architecture, Art History, Film, Film History, Film Production, Graphic Arts, History of Art & Architecture, History of Prints, Painting, Photography, Printmaking, Printroom Methods & Techniques, Sculpture, Theatre Arts, Typography
Summer School: Dir, Barbara MacEachern. Enrl 576; Term of 6 wks beginning July 5. Courses—grad courses in all areas

NEW BRITAIN

CENTRAL CONNECTICUT STATE UNIVERSITY, Dept of Art, 1615 Stanley St, New Britain, CT 06050. Tel 860-832-3200; Fax 860-832-2634; Internet Home Page Address: www.ccsu.edu; *Chmn Dept* Dr M Cipriano
Estab 1849; FT 14, PT 15; pub; D & E; SC 36, LC 8, GC 20; D 200, E 150, non-maj 1000, maj 200, grad 200
Ent Req: HS dipl
Degrees: BA(Graphic Design), BA(Fine Arts) & BS(Art Educ) 4 yrs
Courses: Art Education, Art History, Ceramic Sculpture, Ceramics, Color Theory, Curatorship, Display, Drawing, Fibre Sculpture, Fine Arts, Gallery Management, Graphic Arts, Graphic Design, Handicrafts, Jewelry, Lettering, Painting, Photography, Printmaking, Sculpture, Serigraphy (Silk Screen), Stained Glass, Teacher Training
Children's Classes: Enrl 30, 5-17 yr olds; tuition $90 per 30 wks. Courses—Crafts, Fine Arts
Summer School: Dean Continuing Educ, P Schubert. Enrl 200; tuition $150 per cr hr for term of 5 wks. Courses—Crafts, Design, Drawing, Fine Arts

NEW CANAAN

GUILD ART CENTER, Silvermine, 1037 Silvermine Rd, New Canaan, CT 06840. Tel 203-866-0411, 966-6668; Fax 203-966-2763; Internet Home Page Address: www.silvermineart.org; *Dir School* Anne Connell
Estab 1949; Maintain nonprofit art gallery, Florence Schick School Exhib Gallery, for student work & the Silvermine Guild Gallery for Silvermine Guild Artists; pvt; D & E; SC 60, LC 1; 560
Ent Req: none
Degrees: none
Tuition: $412 per sem
Courses: Advertising Design, Art History, Ceramics, Computer Graphics, Drawing, Illustration, Painting, Photography, Printmaking, Sculpture, Sogetsu Ikebana, Youth Programs in Art
Adult Hobby Classes: Enrl 550-600; tuition $6 per studio hr for sem of 14 wks. Courses offered
Children's Classes: Enrl 80-100; tuition $6 per studio hr for sem of 14 wks. Courses offered

Summer School: Dir, Anne Connell. Tuition $6 for 8 wk prog. Courses—Same as above

NEW HAVEN

ALBERTUS MAGNUS COLLEGE, Visual and Performing Arts, 700 Prospect St, New Haven, CT 06511. Tel 203-773-8546, 773-8550; Fax 203-773-3117; Internet Home Page Address: www.albertus.edu; *Prof Art* Jerome Nevins, MFA; *Chmn & Assoc Prof Art* Beverly Chieffo, MA; *Asst Prof Art Therapy* Marian Towne, MA
Estab 1925, dept estab 1970; pvt; D & E; Scholarships; SC 20, LC 9; D 120, non-maj 60, maj 40
Ent Req: HS dipl, SAT, CEEB
Degrees: BA, BFA 8 sem
Tuition: Res—undergrad $16,000 per yr; campus res available
Courses: Aesthetics, Art Education, Art History, Art Therapy, Ceramics, Collage, Design, Drawing, Fabric Design & Construction, History of Art & Architecture, Mixed Media, Painting, Photography, Printmaking, Sculpture, Teacher Training, Weaving
Adult Hobby Classes: Courses offered
Summer School: Dir, Elaine Lewis. Courses—vary

SOUTHERN CONNECTICUT STATE UNIVERSITY, Dept of Art, 501 Crescent St, New Haven, CT 06515-1355. Tel 203-392-6653; Fax 203-392-6658; Internet Home Page Address: www.southernct.edu/undergrad/schas/ART/index; *Dept Head* Cort Sierpinski
Estab 1893; pub; D & E; SC 40, LC 18, GC 20; D 315, GS 100
Ent Req: HS dipl, SAT
Degrees: BS, MS(Art Educ), BA(Art History) & BA, BS(Studio Art) 4 yrs
Tuition: Res—$2,772, non-res $7,726
Courses: Art Education, Art History, Ceramics, Graphic Design, Jewelry, Metalsmithing, Painting, Photography, Printmaking, Stained Glass, Teacher Training
Summer School: Dir, Keith Hatcher. Enrl 320; tuition undergrad $133 per cr hr, grad 144 per cr hr for 2 - 5 wk terms. Courses—Art History, Crafts, Drawing, Graphic Design, Painting, Photography, Printmaking, Sculpture, Stained Glass

YALE UNIVERSITY
—**School of Art,** Tel 203-432-2600; Fax 203-436-4947; Internet Home Page Address: www.yale.edu/art; *Dean* Richard Benson; *Prof* Rochelle Feinstein, MFA; *Prof* Tod Papageorge, MA; *Prof Emeritus* William Bailey, MFA; *Prof* Richard Lytle, MFA; *Prof* Sheila Levrant-Bretteville, MFA; *Prof* Robert Reed, MFA
Estab 1869; pvt; D; Scholarships; GC 118
Ent Req: BFA, BA, BS or dipl from four year professional art school & portfolio
Degrees: MFA 2 yrs
Tuition: $14,600 per yr
Courses: Drawing, Graphic Design, Painting, Photography, Printmaking, Sculpture
Summer School: 8 wk undergrad courses in New Haven, 3 cr each; 5 wk Graphic Design Prog in Brissago, Switzerland; 8 wk Fel Prog in Norfolk
—**Dept of the History of Art,** Tel 203-432-2667; Fax 203-432-7462; *Dir Grad Studies* Christopher Wood; *Prof* Mimi Yiengpruksawan; *Dir Undergrad Studies* Kelly Jones; *Chmn* Edward Cooke
Estab 1940; FT 27, PT 2; pvt; D; Scholarships, Fellowships, Assistantships
Ent Req: for grad prog—BA & foreign language
Degrees: PhD(Art History) 6 yr
Tuition: $26,770 per yr
Courses: †Art History
—**School of Architecture,** Tel 203-432-2296, 432-2288; Fax 203-432-7175; Internet Home Page Address: www.architecture.yale.edu; *Dean* Robert Stern
Estab 1869; pvt; Scholarships; 142 maximum
Ent Req: Bachelor's degree, grad record exam
Degrees: MEd 2 yr, MArchit 3 yr
Tuition: $24,500 per yr
Courses: Aesthetics, Architecture, Art History, Design, Drawing, Landscape Architecture, Photography

NEW LONDON

CONNECTICUT COLLEGE
—**Dept of Art,** Tel 860-439-2740; Fax 860-439-5339; Internet Home Page Address: www.conncoll.edu/ccacad/art.dept; *Prof* Peter Leibert; *Prof* David Smalley; *Prof* Barkley L Hendricks; *Prof* Maureen McCabe; *Assoc Prof* Pamela Marks; *Assoc Prof* Andrea Wollensak; *Assoc Prof* Ted Hendrickson; *Prof* Tim McDowell; *Visiting Asst Prof* Matt Harle; *Visiting Asst Prof* Denise Pelletier; *Academic Dept Asst* Heidi Shepard
Estab 1911; pvt; D & E; Scholarships; SC 25; D 1600, maj approx 20
Ent Req: HS dipl, ent exam
Degrees: BA 4 yrs
Tuition: $15,175 per yr; campus res—room & board $4800
Courses: Architecture, Arts & Technology, Ceramics, Collage, Computer Art, Design, Drawing, Graphic Arts, Graphic Design, Mixed Media, Painting, Photography, Printmaking, Sculpture, Video
Summer School: Acting Dir, Ann Whitlach. Courses—Vary
—**Dept of Art History, Architectural Studies & Museum Studies,** Tel 860-439-2729; Fax 860-4395339; Internet Home Page Address: www.conncoll.edu/academics/departments/arthistory; *Assoc Prof* Robert Baldwin; *Academic Dept Asst* Heidi Shepard; *Prof* Barbara Zabel; *Prof* Christopher Steiner; *Assoc Prof* Abigail Van Slyck; *Adjunct Prof* John Steffian; *Adjunct Asst Prof* Charles Shepard; *Visual Resources Librn* Mark Braunstein
Estab 1911, dept estab 1972; pvt; D & E; LC approx 20; D 1600, maj approx 18
Ent Req: HS dipl, SAT
Degrees: BA 4 yrs
Tuition: $17,000 per yr

Courses: Aesthetics, Architectural Studies, Architecture, Art History, Film, History of Art & Archeology, Museum Staff Training, Museum Studies

OLD LYME

LYME ACADEMY OF FINE ARTS, 84 Lyme St, Old Lyme, CT 06371. Tel 860-434-5232; Fax 860-434-8725; Elec Mail admission@lymeacademy.edu; Internet Home Page Address: www.lymeacademy.edu; *Pres* Henry E Putsch, MA; *Acad Dean* Sharon Hunter, MA; *Registrar* Jim Falconer, MA
Estab 1976; Maintain nonprofit art gallery; pvt; D & E; Scholarships, Fellowships; SC 83 LC 6; 274
Ent Req: HS dipl, portfolio
Degrees: Cert 3 yr, BFA 4 yr
Tuition: $10,200 per yr, $464 per cr
Courses: Aesthetics, Art History, Design, Drawing, †Painting, Printmaking, †Sculpture
Children's Classes: Enrl 92; tuition $80-$120 for 6 wk term
Summer School: Enrl 553; tuition $406 per cr

STORRS

UNIVERSITY OF CONNECTICUT, Dept of Art & Art History, 830 Bolton Rd, Unit 1099 Storrs, CT 06269-1099. Tel 860-486-3930; Fax 860-486-3869; Elec Mail judith.thorpe@uconn.edu; Internet Home Page Address: www.art.uconn.edu; *Head Dept* Judith Thorpe; *Assoc Head* Cora Lynn Deibler; *Assoc Head* Ray DiCapua
Estab 1882, dept estab 1950; Dept has nonprofit Atrium Gallery, professional & teaching gallery - The Contemporary Art Galleries, Barry Rosenberg, Dir of Exhib; FT 24, PT 10; pub; D; Scholarships; SC 43, LC 32, GC 15; D 1600, maj 280, grad 10
Ent Req: HS dipl, SAT, Portfolio Review
Degrees: BA(Art History), BFA(Studio) 4 yrs, MFA 2 yrs, MA Art History 2 yrs
Tuition: Res—undergrad $4282 per yr, grad $5272 per yr; nonres—undergrad $13,056 per yr, grad $13,696 per yr; campus res available
Courses: †Art History, †Communication Design, Drawing, †Illustration, †Painting, †Photography, †Printmaking, †Sculpture, †Video

VOLUNTOWN

FOSTER CADDELL'S ART SCHOOL, North Light, Northlight, 47 Pendleton Hill Rd Voluntown, CT 06384. Tel 860-376-9583; Fax 860-376-9583; Fax 860-376-9589; Elec Mail fcaddell@sbcglobal.net; Internet Home Page Address: www.pastelsocietyofamerica.org; Internet Home Page Address: www.artshow.com; Internet Home Page Address: www.ctpastelsociety.com; Internet Home Page Address: www.conneticutsocietyofportraitartist.com; *Head Dept* Foster Caddell, PSA
Estab 1958; Pub; D; SC; D 75, E 50
Ent Req: Willingness to work & study
Tuition: $750 per course; no campus res
Courses: †Conceptual Art, †Drawing, †Painting, †Pastel, †Teacher Training
Adult Hobby Classes: Enrl 40; tuition $2000. Courses—Drawing, Painting

WEST HARTFORD

SAINT JOSEPH COLLEGE, Dept of Fine Arts, 1678 Asylum Ave, West Hartford, CT 06117-2700. Tel 860-232-4571; Fax 860-233-5695; Elec Mail info@mercy.sjc.edu; Internet Home Page Address: www.sjc.edu; *Chmn Dept* Dorothy Bosch Keller
Estab 1932; FT 1, PT 2; pvt, W; D & E; weekend; summer; Scholarships; SC 5, LC 7; D 104
Ent Req: HS dipl, CEEB
Degrees: BA, BS and MA 4 yr (except for Art History or Studio Art)
Tuition: $19,000 (24-36 cr) incoming freshman
Courses: American Architecture, Architecture, Art Appreciation, †Art History, Art of Ireland, Creative Crafts, Drawing, Egyptian Art, Fundamental of Design, Greek Art, History of American Antiques, History of American Art, History of Art & Architecture, History of Women Artists, Impressionism, Painting, Renaissance, Victorian Antiques
Summer School: Chmn, D Keller. Enrl 400; tuition $250 per cr hr. Maj in art history offered

UNIVERSITY OF HARTFORD, Hartford Art School, 200 Bloomfield Ave, West Hartford, CT 06117. Tel 860-768-4393, 768-4827; Fax 860-768-5296; Elec Mail calafiore@mail.hartford.edu; Internet Home Page Address: www.hartfordartschool.org; *Assoc Dean* Thomas Bradley, MA; *Asst Dean* Robert Calafiore, MFA; *Prof* Lloyd Glasson, MFA; *Prof* Frederick Wessel, MFA; *Assoc Prof* Gilles Giuntini, MFA; *Assoc Prof* Christopher Horton, MAT; *Assoc Prof* Jim Lee, MFA; *Assoc Prof* Patricia Lipsky, MFA; *Assoc Prof* Ellen Carey, MFA; *Assoc Prof* Walter Hall, MFA; *Assoc Prof* Mary Frey, MFA; *Assoc Prof* Stephen Brown, MFA; *Asst Prof* Douglas Andersen, MA; *Asst Prof* Mark Snyder, MFA; *Asst Prof* Hirokazu Fukawa, MFA; *Asst Prof* Susan Wilmarth-Rabineau, MFA; *Asst Prof* Gene Gort, MFA; *Asst Prof* Matthew Towers, MFA; *Dean* Stuart Schar, PhD; *Asst Prof* Bill Thomson; *Asst Prof* John Nordyke; *Asst Prof* Nancy Wynn; *Asst Prof* Jeremiah Patterson
Estab 1877; pvt; D & E; Scholarships; SC 70, LC 5, GC 32; D 375, E 100, non-maj 125, maj 375, grad 20
Ent Req: HS dipl, SAT, portfolio review
Degrees: BFA 4 yr, MFA 2 yr
Tuition: undergrad $18,000 per yr, $9000 per sem, $280 per cr; campus res—room $5000, board $2770
Courses: Architecture, †Art History, †Ceramics, Glass, Illustration, Media Arts, †Painting & Drawing, †Photography, †Printmaking, †Sculpture, †Video, †Visual Communication Design

Children's Classes: Summer Place, $1400 for 6 wks, $680 for 2 wks, summer camp
Summer School: Dir, Tom Bradley. Enrl 50-75; tuition $280 per cr for 2-6 wks, $900 per 3 cr course. Courses—Ceramics, Drawing, Visual Comm Design, Photography, Printmaking, Sculpture

WEST HAVEN

UNIVERSITY OF NEW HAVEN, Dept of Visual & Performing Arts & Philosophy, 300 Orange Ave, West Haven, CT 06516. Tel 203-932-7101; Internet Home Page Address: www.newhaven.edu; *Coordr of Arts* Christie Summerville; *Chmn* Michael G Kaloyanides
Estab 1927, dept estab 1972; FT 2, PT 8; pvt; D & E; SC 30, LC 5; D 350, E 110
Ent Req: HS dipl
Degrees: BA & BS 4 yrs, AS 2 yrs
Tuition: $6100 per sem
Courses: †Advertising Design, Art History, Calligraphy, Ceramics, Commercial Art, Constructions, Dimensional Design, Drawing, Film Animation, Graphic Arts, Graphic Design, History of Art & Architecture, Illustration, Interaction of Color, Interior Design, Mixed Media, Painting, Photography, Printmaking, Sculpture
Summer School: June 12th - July 20th. Courses—Ceramics, Drawing, History of Art, Painting, Photography, Sculpture

WILLIMANTIC

EASTERN CONNECTICUT STATE UNIVERSITY, Fine Arts Dept, 83 Windham St, Willimantic, CT 06226. Tel 860-465-5000; Fax 860-456-5508; Internet Home Page Address: www.ecsu.ctstate.edu; *Chmn* Lulu Blocton
Estab 1881; FT 4, PT 4; pub; D & E; Scholarships; D 300, E 75, maj 40
Ent Req: HS dipl
Degrees: BA(Fine Arts) & BS(Art) 4 yrs
Tuition: Res—$3914 per yr; nonres—$9422 per yr
Courses: Art History, Ceramics, Drawing, Enameling, Graphic Arts, Interior Design, Jewelry, Painting, Sculpture, Weaving
Summer School: Dir, Owen Peagler. Courses—Art & Craft Workshop

WINSTED

NORTHWESTERN CONNECTICUT COMMUNITY COLLEGE, Fine Arts Dept, Park Pl E, Winsted, CT 06098. Tel 860-738-6300; Fax 860-379-4995; Internet Home Page Address: www.commnet.edu/nwctc; *Prof* Charles Dmytriw; *Prof* Janet Nesteruk; *Prof* Richard Fineman
Dept estab 1965; FT 3; D & E
Ent Req: HS dipl or equivelant
Degrees: AA (Arts)
Tuition: res $130 per cr hr
Courses: Advertising Design, Art Appreciation, Art History, Ceramics, Design, Drawing, Graphic Arts, Painting, Photography, Printmaking, Sculpture, Video

DELAWARE

DOVER

DELAWARE STATE COLLEGE, Dept of Art & Art Education, 1200 Dupont Hwy, Dover, DE 19901. Tel 302-857-6000; Tel 302-857-6290; Fax 302-739-5182; *Art Dept Chmn* Arturo Bassolos
Estab 1960; FT 4; pub; D & E; Scholarships; SC 13, LC 9; 50-60 maj
Ent Req: HS dipl or GED, SAT or ACT
Degrees: BS(Art Educ), BS(General Art) & BS(Art Business)
Tuition: Res—$1407 per sem; nonres—$3281; campus res—room & board $4052 per sem; nonres—$11,852 per sem
Courses: Art Appreciation, †Art Education, Art History, Ceramics, Commercial Art, Design, Drawing, Fibers, Independent Study, Interior Design, Jewelry, Lettering, Painting, Photography, Printmaking, Sculpture, Senior Exhibition (one man show & research), Teacher Training
Adult Hobby Classes: Courses—same as above
Summer School: Courses—same as above

NEWARK

UNIVERSITY OF DELAWARE, Dept of Art, 104 Recitation Hall, Newark, DE 19716. Tel 302-831-2244; Fax 302-831-0505; Internet Home Page Address: seurat.art.udel.edu; *Acting Chmn* Suzanne Alchon; *Coordr Sculpture* Michael Johnson, MFA; *Coordr Photography* John Weiss, MFA; *Coordr Ceramics* Victor Spinski, MFA; *Coordr Printmaking* Rosemary Lane, MFA; *Coordr Drawing, Painting & Grad* Larry Holmes, MFA; *Coordr Foundations* Rene Marquez, MFA; *Coordr Illustration* Robyn Phillips-Pendleton, MFA; *Coordr Visual Communication* Ray Nichols, MFA; *Coordr Photography* Priscilla Smith, MFA; *Coordr Drawing & Painting* Robert Straight, MFA; *Instr* Hendrik-Jan Francke, BA; *Instr* Bill Deering; *Prof Graphic Design* Martha Carothers, MFA; *Assoc Prof Foundations* Vera Kaminski, MFA
Estab 1833; Maintain nonprofit art gallery; Dept of Art Gallery, 102 Recitation Hall, University of Delaware, Newark, DE 19716; Pub & pvt; D & E; Scholarships; SC 61, LC 4, GC 25, maj 450, grad 20; D 1,110, E 150, non-maj 60, maj 1,180, grad 87
Ent Req: BFA FA & BFA VC prog (both sophomore year)
Degrees: BA, BFA FA & BFA VC 4 yrs, MFA 2 yrs

Tuition: Res—undergrad $4,510 per yr, grad $251 per cr hr, res—grad $2,255 per sem; nonres—undergrad $13,260, grad $737 per cr hr, nonres—grad $6,630 per sem; campus res—room & board $3,200, nonres—room & board $3,200
Courses: †Advertising Design, †Applied Photography, Art Education, †Ceramics, Drawing, Fibers, †Graphic Design, Illustration, †Illustration, Jewelry, †Painting, †Photography, †Printmaking, †Sculpture
Summer School: Chair Suzenne Alchon. Enrl 165; res tuition $183 credit, non-res $243 credit; 11 courses

REHOBOTH BEACH

REHOBOTH ART LEAGUE, INC, 12 Dodds Lane, Rehoboth Beach, DE 19971. Tel 302-227-8408; Fax 302-227-4121; Internet Home Page Address: www.rehobothartleague.org; *Dir* Nancy Alexander
Estab 1938; pvt; D; SC 7; D 400, others 400
Ent Req: interest in art
Courses: Calligraphy, Ceramics, Drawing, Painting, Photography
Adult Hobby Classes: Enrl 150. Courses—Ceramics, Drawing, Painting, Pottery
Children's Classes: Courses—Art Forms

DISTRICT OF COLUMBIA

WASHINGTON

AMERICAN UNIVERSITY, Dept of Art, 4400 Massachusetts Ave NW, Washington, DC 20016. Tel 202-885-1670; Fax 202-885-1132; Elec Mail dkimes@american.edu; *Chmn Dept & Prof* Don Kimes, MFA; *Prof* C Stanley Lewis, MFA; *Prof* Mary Garrard; *Prof* Norma Broude, PhD; *Prof* M Oxman, MFA; *Assoc Prof* Ron Haynie Oxman, MFA; *Assoc Prof* Deborah Kahn, MFA; *Assoc Prof* Michael Graham, MFA; *Asst Prof* Helen Langa, PhD; *Asst Prof* Luis Silva, MFA; *Prof* Barbara Rose, PhD; *Chemi Montes*, MFA; *Instr* Glenn Goldberg, MFA; *Instr* Steven Cushner, MFA; *Instr* Susan Yanero, MFA; *Instr* Sharo Fischel, MFA; *Instr* Carol Goldberg, MFA; *Instr* Jo Weiss Le, MFA; *Instr* Jeneen Piccuirro, MFA; *Instr* Guy Zoller, MFA; *Instr* Rachel Simons, PhD; *Instr* Laurie Swindull, MFA
Estab 1893, dept estab 1945; Maintain nonprofit art gallery; Watkins Gallery, Dept of Art, 4400 Massachusetts Ave NW, Washington, DC; pvt; D&E; Scholarships, Fellowships; SC 26, LC 15, GC 19 and 6 Art History courses in Italy Program; D & E 1600, maj 191, grad 70
Ent Req: HS dipl
Degrees: BA, BFA(Studio Art), BA(Design), BA(Art History) 4 yrs, MA(Art History) 18 months, MFA(Painting, Sculpture, Printmaking) 2 yrs
Tuition: Undergrad $10,572 per sem, grad $6814 per sem
Courses: Aesthetics, Art Appreciation, †Art History, Ceramics, Collage, Computer Graphics, Constructions, †Drawing, †Graphic Design, History of Art & Architecture, Lettering, Mixed Media, Multimedia, †Painting, †Printmaking, †Sculpture
Summer School: Dept Adminr, Glenna Haynie. Design, Studio & Art History

CATHOLIC UNIVERSITY OF AMERICA
Maintain nonprofit art gallery; Salve Regina Gallery-The Catholic University of America, 620 Michigan Ave, NE Washington, DC 20064
—School of Architecture & Planning, Tel 202-319-5188; Fax 202-319-5728; Elec Mail arch@cua.edu; Internet Home Page Address: architecture.cua.edu/; *Dean* Gregory K Hunt; *Prof* Stanley I Hallet FAIA; *Prof* Ernest Forest Wilson PhD, MArchit; *Prof* W Dodd Ramberg, BArchit; *Assoc Prof* Julius S Levine, MCP; *Prof* George T Marcou, MArchit; *Prof* Theodore Naos, MArchit; *Assoc Prof* Thomas Walton, PhD; *Prof* John V Yanik, MArchit; *Asst Prof* Ann Cederna, MArchit; *Asst Prof* Jill St Clair Riley RA; *Asst Prof* J Ronald Kabriel, MArchit; *Asst Prof* Lavinia Pasquina; *Assoc Prof* Terrence Williams AIA; *Asst Dean/Asst Prof* Erik Jenkins; *Assoc Prof* Vytenis A Gureckas RA; *Assoc Prof* Barry D Yatt AIA, CSI
Estab 1887, dept estab 1930; den; D & E; SC 6, LC 4 per sem, GC 15 per sem; D 240, maj 240, grad 95
Ent Req: HS dipl and SAT for undergrad, BS or BA in Archit or equivalent plus GPA of 2.5 in undergrad studies for grad
Degrees: BArchit & BS(Archit) 4 yr, MArchit 4 yr
Tuition: $10,110 per sem
Courses: Architecture, Drafting, Graphics, History and Theory of Architecture, Landscape Architecture, Photography, Planning, Practice, Technology, Urban Design
Children's Classes: Session of 3 wks. Courses—High School Program
Summer School: Dir, Richard Loosle. Enrl 100, term of 5-9 wks May-Aug. Courses—Computers, Construction & Documents, Design Studio, Environmental Systems, Graphic, History & Theory of Architecture, Photography, Structures
—Dept of Art, Tel 202-319-5282; Internet Home Page Address: arts-sciences.cua.edu/art/; *Prof* Thomas Nakashima; *Chmn Dept* John Winslow; *Asst Prof* Nora Heimann
Estab 1930; den; D & E; Scholarships; SC 19, LC 9, GC 4; D 412, E 101, non-maj 449, maj 32, grad 4
Ent Req: HS dipl and SAT for undergrad, BA-BFA; MAT, GRE for grad
Degrees: BA (Studio Art, Art History, Studio Art for Secondary Educ)
Tuition: FT $9550 per sem, PT $735 per cr hr
Courses: †Art Education, †Art History, †Ceramics, Design, †Digital Arts, †History of Art & Archeology, †Painting, Photography, Printmaking, †Sculpture
Summer School: Chmn, John Winslow. Term of 4-5 wks beginning June. Courses—Drawing, Ceramics, Painting, Special Independent Courses, Digital Arts

CORCORAN SCHOOL OF ART, 500 17th St NW, Washington, DC 20006-4804. Tel 202-639-1800; Fax 202-628-3186; Internet Home Page Address: www.corcoran.edu; *Assoc Dean Students* Susan Moran; *Chmn Fine Arts* Nancy Palmer, MFA; *Chmn Academic Studies* Martha McWilliams, MFA; *Chmn Foundation* Marie Ringwald, MFA; *Chmn Printmaking* Georgia Deal, MFA; *Chmn*

Sculpture & Ceramics F L Wall, MFA; *Chmn Photography* Claudia Smigrod, MA; *Chmn Graphic Design* Johan Severtson, BFA; *Chmn Computer Graphics* Antje Kharchi, BFA; *Chmn Drawing & Painting* Leslie Exton, BFA
Estab 1890; pvt; D & E; Scholarships; SC 84, LC 42; D 300 maj, E 750 non-maj
Ent Req: HS dipl, SAT or ACT, portfolio & interview
Degrees: BFA 4 yrs
Tuition: $16,970 per yr
Courses: Animation, Art Appreciation, Art History, Business & Law for the Artist, Ceramics, Computer Art, Design, Drawing, Fine Arts, Furniture, History of Photography, Illustration, Interior Design, Painting, Philosophy, Photography, Printmaking, Sculpture, Typography, Video
Adult Hobby Classes: Enrl 1000 per sem; tuition $380-$1060 for 13-15 wks. Courses—Art History, Ceramics, Color & Design, Computer Graphics, Drawing, Furniture, Interior Design, Landscape Design, Painting, Photography, Printmaking, Sculpture
Children's Classes: Enrl 70, tuition $127 per 5 wk session, Saturday ages 6-10; $380 per 13 wk session, Saturday ages 10-15. Courses—General Studio ages 15-18. Courses—Ceramics, Computer Art, Drawing, Painting, Photography, Portfolio Prep Workshop, Screenprinting
Summer School: Dean, Samuel Hoi. Enrl 400; Adult—tuition $350-$960 for 6 wks beginning June. Courses—Art History, Ceramics, Computer Graphics, Drawing, Illustration, Interior Design, Landscape Design, Painting, Photography, Printmaking, Sculpture, Watercolor. HS (ages 15-18)—tuition $390-$690 for 5 wks beginning June. Courses—Ceramics, Drawing, Painting, Photography, Portfolio Prep, Pre-College. Children's Workshops (ages 6-10)—tuition $10 for 5 day session beginning June

GEORGE WASHINGTON UNIVERSITY, Dept of Art, Smith Hall of Art, 801 22nd St NW Washington, DC 20052. Tel 202-994-6085; Fax 202-994-8657; Internet Home Page Address: www.gwu.edu/~art; *Chmn* David Bjelajac PhD; *Prof* Barbara Von Barghahn PhD; *Prof* W T Woodward, MFA; *Prof* J Franklin Wright Jr, MFA; *Prof* Samuel B Molina, MFA; *Prof* Constance C Costigan, MFA; *Prof* Jerry L Lake, MFA; *Prof* Turker Ozdogan, MFA; *Prof* H I Gates, MFA; *Assoc Prof* Philip Jacks PhD, MFA; *Assoc Prof* Jeffrey C Anderson PhD, MFA; *Assoc Prof* Jeffrey L Stephanic, MFA; *Assoc Prof* Kim Hartswick PhD, MFA
Estab 1821, dept estab 1893; pvt; D & E; Scholarships; SC 103, LC 74, GC 68; D 1350, GS 196
Ent Req: HS dipl, ent exam
Degrees: BA 4 yr, MA 2-2 1/2 yr, MFA 2 yr
Tuition: $23,000 per cr hr
Courses: Advertising Design, American Art, †Art History, †Ceramics, Classical Art & Archaeology, Contemporary Art, †Design, †Drawing, †Graphic Design, History of Art & Architecture, Interior Design, Jewelry, Medieval Art, Mixed Media, †Painting, †Photography, †Printmaking, Renaissance & Baroque Art, Restoration & Conservation, †Sculpture, Silversmithing, †Visual Communications
Summer School: Tuition $680 per cr hr for two 6 wk sessions. Courses—Art History, Ceramics, Drawing, Painting, Photography, Sculpture, Visual Communications

GEORGE WASHINGTON UNIVERSITY, School of Interior Design, 2100 Foxhall Rd NW, Washington, DC 20007. Tel 202-242-6700, 625-4551; Elec Mail nblossom@gwu.edu; Internet Home Page Address: www.gwu.edu/~mvc.gw; *Dept Chmn* Erin Speck
Estab 1875; maintains non profit art gallery, The Dimock Gallery, Lisner autditorium, 730 21st St NW, Washington DC; pvt; D & E; Scholarships; SC 16
Degrees: AA, BA & BFA
Tuition: FT student $34,000 per yr
Courses: Aesthetics, Art History, Arts & Humanities, Ceramics, Design, Drafting, Drawing, Graphic Arts, †Graphic Design, Historical Preservation, †History of Decorative Art, †Interior Design, Painting, Photography, Printmaking, Sculpture, †Studio Art, Textile Design, Theatre Arts
Adult Hobby Classes: Graphic Design, History of Decorative Art, Interior Design, Studio Art
Summer School: Dir, Dr Sharon Fechter. Enrl 40, 8 wks, June-July. Courses—History of Decorative Art, Interior Design, Studio Art

GEORGETOWN UNIVERSITY, Dept of Art, Music & Theatre, Walsh 102, Washington, DC 20057; 1221 36th St NW, Washington, DC 20057. Tel 202-687-7010; Fax 202-687-3048; Internet Home Page Address: www.georgetown.edu/departments/amth; *Prof* Elizabeth Prelinger PhD; *Chmn & Prof* Alison Hilton PhD; *Prof* Peter Charles, MFA; *Assoc Prof* B G Muhn, MFA; *Asst Prof* John Morrell, MFA; *Prof* Roberto Bocci; *Asst Prof* L Collier Hyams, MFA; *Asst Prof* Al Acres, PhD; *Dir Gallery* Evan Reed, MFA
Estab 1789, dept estab 1967; Maintain nonprofit art gallery, 1221 36th St, NW, Washington, DC 20057; FT 15; pvt; Jesuit/Catholic; D & E; SC 20, LC 15; D 1000 (includes non-maj), maj 20 studio & 15 art history per yr
Ent Req: HS dipl
Degrees: BA 4 yrs
Tuition: campus res available
Courses: †Art History, †Design, Digital Art, †Drawing, †Mixed Media, †Painting, †Photography, †Printmaking, †Sculpture
Adult Hobby Classes: Continuing Studies Dean Robert Manuel
Summer School: Assoc Dean, Ester Rider. Courses offered

TRINITY COLLEGE, Fine Arts Program, 125 Michigan Ave NE, Washington, DC 20017. Tel 202-884-9280, 884-9000; Fax 202-884-9229; Elec Mail easbyr@trinitydc.edu; Internet Home Page Address: www.trinitydc.edu/academics/depts/finearts/index; *Chmn & Assoc Prof* Dr Rebecca Easby; *Lectr* Eugene D Markowski; *Prof* Dr Yvonne Dixon
Estab 1897; den; D & E; Scholarships; SC 8, LC 2-3; D 120, maj 12
Ent Req: HS dipl, SAT or ACT, recommendation
Degrees: BA 4 yr
Tuition: $14,290 per yr, $475 per cr hr; campus res—room & board $6700
Courses: Art History, Design, Documentary, Drawing, Film, Graphic Design, History of Art & Architecture, Lettering, Painting, Photography, Photojournalism, Printmaking, Sculpture

Summer School: Dir, Susan Ikerd. Courses—Vary

UNIVERSITY OF THE DISTRICT OF COLUMBIA, Dept of Mass Media, Visual & Performing Arts, 4200 Connecticut Ave NW, MB46 A03 Washington, DC 20008. Tel 202-274-7402; Fax 202-274-5817; Internet Home Page Address: www.udc.edu; *Prof* Meredith Rode, PhD; *Prof* Manon Cleary, MFA; *Chairperson & Prof* Yvonne Pickering-Carter, MFA; *Asst Prof* George Smith, MS
Estab 1969; pub; D & E; SC 65, LC 21; D 616, E 99, non-maj 405, maj 112
Ent Req: HS dipl, GED
Degrees: AA(Advertising Design) 2 yrs, BA(Studio Art) and BA(Art Educ) 4 yrs
Tuition: Res—undergrad $360 per sem; non-res—undergrad $1320 per sem; no campus res
Courses: †Advertising Design, †Art Education, Art History, Ceramics, Conceptual Art, Drawing, Graphic Arts, Graphic Design, Handicrafts, Illustration, Lettering, Mixed Media, Museum Staff Training, †Painting, Photography, †Printmaking, Sculpture
Summer School: C A Young. Enrl 200. Courses—Art History, Ceramics, Drawings, Painting, Photography

FLORIDA

BOCA RATON

FLORIDA ATLANTIC UNIVERSITY, Art Dept, 777 Glades Rd, PO Box 3041 Boca Raton, FL 33431. Tel 562-297-3000, ext 73756; Elec Mail russok@fau.edu; *Chmn* Dr Kathleen Russo
Estab 1964; FT 8; pub; D & E; Scholarships; SC 25, LC 8, GC 6; D 1600, maj 220, grad 7, special students 7
Degrees: BFA & BA 4 yrs, MAT, MFA
Tuition: Res—$79.88 per cr hr; nonres—$324.47 per cr hr; grad res—$156.35 per cr hr; nonres—$535.11 per cr hr
Courses: Advertising Design, Aesthetics, Applied Art, Art Appreciation, Art Education, †Art History, Ceramics, Costume Design & Construction, Design, Drafting, Graphic Arts, Graphic Design, History of Architecture, Jewelry, Museum Staff Training, Painting, Photography, Printmaking, Sculpture, Silkscreen & Etching, Stage Design, Studio Crafts, Teacher Training, Theatre Arts, Video, Weaving
Adult Hobby Classes: Courses offered through continuing education
Summer School: Courses offered

LYNN UNIVERSITY, Art & Design Dept, 3601 N Military Trail, Boca Raton, FL 33431. Tel 561-237-7029; Internet Home Page Address: www.lynn.edu; *Prof* Ernest Ranspach, MFA; *Prof* Tuscano
Estab 1962; Scholarships
Degrees: AA, BFA, BS & Design
Tuition: $18,500 per yr
Courses: Advertising Design, Art Appreciation, Art History, Corporate Identity Rendering Techniques, Design, Drawing, Environmental Design, Graphics, Painting, Photography, Portfolio & Exhibition, Textile Design

BRADENTON

MANATEE COMMUNITY COLLEGE, Dept of Art & Humanities, PO Box 1849, Bradenton, FL 34206. Tel 941-752-5251; Fax 941-727-6088; Internet Home Page Address: www.mcc.cc.fl.us; *Prof & Chmn* Edward Camp, MFA; *Prof* Sherri Hill, MFA; *Prof* Priscilla Stewart, MA; *Prof* Joe Loccisano, MA; *Prof, Film* Del Jacobs, MA; *Prof, Photography* Drew Webster, MFA; *Prof, Theatre* Ken Erickson, MEd
Estab 1958; FT 7, PT 5; pub; D & E; Scholarships; SC 22, LC 5; D 310, E 90, maj 75
Ent Req: HS dipl, SAT
Degrees: AA & AS 2 yrs
Tuition: Res—undergrad $50 per cr hr; nonres—undergrad $180 per cr hr
Courses: 2-D & 3-D Design, Art Appreciation, Art History, Ceramics, Color Fundamentals, Costume Design & Construction, Drawing, Figure Drawing, Film, Graphic Arts, Graphic Design, †Graphic Design Technology, Interior Design, Lettering, Painting, Photography, Printmaking, Sculpture, Stage Design, Theatre Arts, Video
Adult Hobby Classes: Enrl 200; average tuition $30 per class. Courses—Ceramics, Drawing, Oil Painting, Photography, Watercolor

CLEARWATER

SAINT PETERSBURG COLLEGE, Fine & Applied Arts at Clearwater Campus, 2465 Drew St, Clearwater, FL 33765; PO Box 13489, Saint Petersburg, FL 33733-3489. Tel 727-341-3600, 341-4360, 791-2611; Fax 727-791-2605; Internet Home Page Address: www.spcollege.edu; *Prog Dir* Barbara Glowaski; *Assoc Prof* Kevin Grass; *Asst Prof* Kim Kirchman; *Instr* Marjorie Greene; *Asst Prof* Paul Miehl; *Asst Prof* Ragan Brown; *Asst Prof* Barton Gilmore
Estab 1927. College has eight campuses; Maintain nonprofit art gallery; Muse Gallery, 2465 Drew St Clearwater FL 33765; art library; FT6; pub; D & E; Scholarships; SC 125 LC 5; D 160, E 400, maj 20-25
Ent Req: HS dipl
Degrees: AA & AS 2 yr, BS 4 yr
Tuition: Res—$55 per cr; nonres—$165 per cr
Courses: †2-D & 3-D, Advertising Design, Architecture, Art Appreciation, Art History Survey, Ceramics, Design, Drawing, Graphic Arts, Graphic Design, Painting, Photography, †Printmaking, †Studio Lighting, Survey in Crafts, Theatre Arts
Summer School: Prog Dir, Barbara Glowaski. Courses—Same as regular session; 10 wk session; 55 per credit hr plus studio fees

CORAL GABLES

UNIVERSITY OF MIAMI, Dept of Art & Art History, PO Box 248106, Coral Gables, FL 33124-2618. Tel 305-284-2542; Fax 305-284-2115; Elec Mail art-arh@miami.edu; Internet Home Page Address: www.miami.edu/art; *Prof* Michael L Carlebach PhD; *Prof* Darby Bannard, BA; *Prof* Christine Federighi, MFA; *Assoc Prof* Paula Harper PhD, MFA; *Prof* Perri Lee Roberts PhD, MFA; *Assoc Prof* Carlos Aquirre, MFA; *Assoc Prof* Tom Gormley, MFA; *Prof* J Tomas Lopez, MFA; *Asst Prof* William Betsch PhD, MFA; *Asst Prof* Lise Drost, MFA; *Assoc Prof* Brian Curtis, MFA; *Assoc Prof* Kerry Coppin, MFA; *Instr* Bonnie Seeman, MFA; *Instr* Kyle Trowbridge, MFA; *Instr* Anne Lemos, MFA; *Asst Prof* Rebecca P Brienen, PhD; *Asst Prof* Margaret A Jackson, PhD; *Chair, Prof* William D Carlson, MFA; *Asst Prof* Billie G Lynn, MFA; *Vis Asst Prof* Brent Cole Ph.D, MFA; *Instr* Amber McAlister, MFA; *Instr* Leslie Speicher, MFA; *Instr* Silvia Pease, MFA; *Instr* Johathan Thomas, MFA; *Instr* Carola Dreidemie, MFA
Estab 1925, dept estab 1960; pvt; D&E; Scholarships; SC 71, LC 16, GC 50; D 1100, non-maj 870, maj 230, grad 20, other 5
Ent Req: HS dipl, SAT
Degrees: BA & BFA 4 yrs, MA(Art History) 2 yrs& MFA 3 yrs
Tuition: Res & nonres—undergrad $27,384 per yr, $13,692 per sem, $1,140 per cr hr
Courses: †Art History, †Ceramics, Design, Digital Imaging, Drawing, †Glassblowing, †Graphic Design, †Illustration, †Multimedia, †Painting, †Photography, †Printmaking, †Sculpture
Adult Hobby Classes: Tuition $250 for 8 wk term. Courses—Bronzecasting, Drawing, Glassblowing, Handbuilding, Mixed Media, Painting, Wheel Throwing
Summer School: Tuition $790 per cr for two 6 wk terms. Courses—Limited regular courses, special workshops, travel

DANIA

SOUTH FLORIDA ART INSTITUTE OF HOLLYWOOD, 233 N Federal Hwy, Ste 45 Dania, FL 33004. Tel 954-920-2961; *Dir* Elwin Porter; *Pres* Joanne Sanders; *Faculty* Ilona Hardy; *Faculty* Arlene Luckhower; *Faculty* Valerie Ambrose
Estab 1958; pvt & non_profit; D; Scholarships; SC 30, LC 2, GC 2; D 230, E 20
Ent Req: portfolio
Degrees: cert fine arts & cert 2 & 4 yrs
Tuition: $900 per yr, no campus res
Courses: Abstraction, Anatomy, Clay Modeling, Color Theory, Composition, Drawing, Life Sketching, Painting, Sculpture

DAYTONA BEACH

DAYTONA BEACH COMMUNITY COLLEGE, Dept of Fine Arts & Visual Arts, PO Box 2811, Daytona Beach, FL 32120-2811. Tel 904-255-8131; Fax 904-947-3134; *Dean* Dr Frank Wetta; *Prof* Denis Deegan, MFA; *Prof* Pamela Griesinger, MFA; *Prof* Gary Monroe, MFA; *Prof* Eric Breitenbach, MS; *Prof* Patrick Van Duesen, BS; *Prof* Dan Biferie, MFA; *Prof* Bobbie Clementi, MFA; *Prof* Jacques A Dellavalle, MFA; *Prof* John Wilton, MFA; *Prof* Patricia Thompson, MA
Estab 1958; pub; D & E; Scholarships; SC 15, LC 3; D 250, E 50, maj 30
Ent Req: HS dipl or GED
Degrees: 2 year program offered
Tuition: Res—$45 per sem hr; nonres—$143.25 per sem hr
Courses: Advertising Design, Art Appreciation, †Art Education, Art History, Ceramics, Cinematography, Constructions, Design, Digital Imaging, Drafting, Drawing, Film, Fine Arts, Graphic Arts, †Graphic Design, History of Art & Architecture, Illustration, Interior Design, Museum Staff Training, Painting, †Photography, Printmaking, Sculpture, Teacher Training, †Theatre Arts, Video
Summer School: Enrl 15; tuition $35 per cr hr for 3 cr. Courses—Painting I & II

DELAND

STETSON UNIVERSITY, Art Dept, Deland, FL 32724. Tel 386-822-7266; Elec Mail cnelson@stetson.edu; Internet Home Page Address: www.stetson.edu/departments/art; *Dept Chmn* Robert Favis; *Prof* Gary Bolding; *Prof* Dan Gunderson; *Assoc Prof* Matt Roberts; *Assoc Prof* Cyriaco Lopes
Estab 1880; Maintain nonprofit art gallery, Duncan Gallery of Art, 421 N Woodland Blvd, Unit 8252, Deland, FL 32723; FT 5; pvt; D&E; Scholarships; SC 8, LC 3; 200
Ent Req: col boards
Degrees: 4 yr
Courses: Art History, Ceramics, Design, Digital Art, Drawing, Mixed Media, Painting, Photography, Sculpture
Summer School: Courses—Drawing, Design, Ceramics

DUNEDIN

DUNEDIN FINE ARTS & CULTURAL CENTER, 1143 Michigan Blvd, Dunedin, FL 34698. Tel 727-298-3322; Fax 727-298-3326; Elec Mail info@dfac.org; *Acting Dir* Robert V Docherty; *Cur* David Shankmiller; *Dir of Youth* Todd Still; *Dir Adult Educ* Catherine Bergmann; *Admin Asst* Barbara Ferguson
Estab 1975; pub; D & E & weekends; Scholarships; SC 20-25, LC 5-10; approx 900
Tuition: Members $50 per class; nonmembers $85 per class; no campus res
Courses: Arts for the Handicapped, Batik, Calligraphy, Children's Art, Clay, Collage, Drawing, Fine Crafts, Jewelry, Painting, Pastel, Photography, Pottery, Printmaking, Sculpture
Children's Classes: Tuition $25-$35 per quarter. Courses—Fine Arts, Drama

Summer School: Dir, Carla Crook. Enrl approx 250; tuition $15-$45 for two 5 wk sessions beginning June. Courses—Visual Arts

FORT LAUDERDALE

ART INSTITUTE OF FORT LAUDERDALE, 1799 SE 17th St, Fort Lauderdale, FL 33316-3000. Tel 954-527-1799; Fax 305-728-8637; Internet Home Page Address: www.aifl.edu; WATS 800-275-7603; *Dir Admis* Eileen Northrop; *Dir Educ* Steve Schwab; *Dir Visual Communications* Rosanne Giuel; *Dir Photo* Ed Williams; *Dir Interior Design* Bill Kobrynich, AA; *Asst Chmn Advertising Design* Lorna Hernandez, AA; *Dir Music & Video Bus* Ed Galizia, AA; *Dir Fashion Design* June Fisher, AA
Estab 1968; pvt; D & E; Scholarships; D 1900, maj 1900
Ent Req: HS dipl
Degrees: AS(technology), BA
Tuition: Res—undergrad $10,000 per yr; $40,000 per yr
Courses: Advertising Design, Art History, Computer Animation, Conceptual Art, Display, Drafting, Drawing, †Fashion Arts, Fashion Design, Graphic Arts, Graphic Design, Illustration, Industrial Design, †Interior Design, Lettering, Mixed Media, Multimedia, Painting, †Photography, Video
Summer School: Same as regular semester

FORT MYERS

EDISON COMMUNITY COLLEGE, Gallery of Fine Arts, 8099 College Pkwy SW, Box 60210 Fort Myers, FL 33906-6210. Tel 941-489-9313; Internet Home Page Address: www.edison.edu; *Instr of Art* Robert York; *Instr* Dr Dennis Hill; *Music Instr* Dr Glenn Cornish; *Music Instr* Dr T Defoor; *Theatre Arts Instr* Richard Westlake; *Head Dept Fine & Performing Arts* Edith Pendleton
Estab 1962; FT 1, PT 5; pub; D & E; Scholarships
Ent Req: HS dipl
Degrees: AA & AS 2 yrs
Tuition: Res—$22 per cr hr; nonres—$49 per cr hr
Courses: 3-D Design, Art Appreciation, Art History, Ceramics, Design, Drawing, Intro to Computer Imaging, Jewelry, Painting, Photography, Printmaking, Sculpture
Adult Hobby Classes: Enrl 20. Courses—any non-cr activity of interest for which a teacher is available

FORT PIERCE

INDIAN RIVER COMMUNITY COLLEGE, Fine Arts Dept, 3209 Virginia Ave, Fort Pierce, FL 34981. Tel 772-462-7824; *Asst Dean Arts & Sciences* Raymond Considine; *Chmn Fine Arts* David Moberg; *Vis Arts Dir* Linda Waugaman; *Instr* Francis Sprout; *Instr* Cira Cosentino
Estab 1960; pub; D & E; Scholarships; SC 10, LC 4; D 45, E 18, Maj 25, Non-Maj 10, Other 10
Ent Req: HS dipl
Degrees: AA & AS 2 yrs
Tuition: Res—$48 per unit; nonres—$48 per unit
Courses: Acting, Advertising Design, Art History, Design, Drawing, General Art, Graphic Arts, Intro to Drama, Landscape, Music Theory, Painting, Portrait, Printmaking, Vocal Ensemble
Summer School: Dir, Linda Waugaman. Enrl 80. Courses—Theater & Music

GAINESVILLE

UNIVERSITY OF FLORIDA, Dept of Art, 302, FAC Complex, Gainesville, FL 32611-5800. Tel 352-392-0211; Fax 352-392-8453; Elec Mail revelle@ufl.edu; Internet Home Page Address: www.arts.ufl.edu/art; *Chmn* Barbara Jo Revelle, MFA; *Prof* Robert C Skelley, MFA; *Prof* Robert Westin, MFA; *Prof* John A O'Connor, MFA; *Prof* Evon Streetman, MFA; *Prof* John L Ward, MFA; *Prof* Marcia Isaacson, MFA; *Assoc Prof* Barbara Barletta PhD, MFA; *Assoc Prof* Jerry Cutler, MFA; *Assoc Prof* Richard Heipp, MFA; *Assoc Prof* David Kremgold, MFA; *Assoc Prof* Robin Poynor PhD, MFA; *Assoc Prof* John Scott PhD, MFA; *Assoc Prof* Nan Smith, MFA; *Assoc Prof* David Stanley PhD, MFA; *Asst Prof* Craig Roland, MFA; *Asst Prof* Robert Mueller, MFA; *Asst Prof* Brian Slawson, MFA; *Asst Prof* William Pappenheimer, MFA; *Asst Prof* Celeste Rogerge, MFA; *Asst Prof* Alexander Alberro; *Assoc Prof* Linda Arbuckle; *Asst Prof* George Ferrandi; *Prof* Melissa Hyde, PhD; *Asst Prof* Ron Janowich; *Asst Prof* Valerie Mendoza, MFA
Estab 1925; FT 22; pub; D & E; Scholarships; SC 40, LC 26, GC 11; maj 200 upper div, grad 16
Ent Req: HS dipl, SAT, ACT, TOEFL, SCAT or AA degree (transfers must have 2.0 average) GRE
Degrees: BAA & BFA 4 yrs, MA 2 yrs, MFA 3 yrs
Tuition: Res—undergrad $2300, grad $3640; nonres—undergrad $9810, grad $12,730 per cr hr; campus res—$800 per yr with air conditioning; undergrad room—$3810, grad & undergrad board—$2420
Courses: †Art Education, †Art History, †Ceramics, †Drawing, Electronic Media, †Graphic Design, Lettering, †Painting, †Photography, †Printmaking, †Sculpture
Summer School: Limited classes

JACKSONVILLE

FLORIDA COMMUNITY COLLEGE AT JACKSONVILLE, SOUTH CAMPUS, Art Dept, 11901 Beach Blvd, Jacksonville, FL 32246. Tel 904-646-2031; Fax 904-646-2396; Internet Home Page Address: www.fccj.org; *Gallery Coordr* Elizabeth Louis; *Prof* Derby Ulloa; *Prof* Mark Sablow; *Prof* Mary Joan Hinson; *Prof* Stephen Heywood; *Faculty Coordr Fine Arts* Larry Davis
Estab 1966; Maintain nonprofit art gallery; FT 5; pub; D & E; Scholarships; SC 14, LC 6; D 150, E 75

Ent Req: HS dipl
Degrees: AA & AS 2 yrs
Tuition: Res—$49.30 per cr hr; nonres—$112.55 per cr hr; no campus res
Courses: Batik, Blockprinting, Ceramics, Computer Graphics, Drawing, Experimentations, Graphic Design, History of Art & Architecture, Painting, Photography, Sculpture, Serigraphy
Adult Hobby Classes: Enrl 75-80; for term of 6 wks beginning June. Courses—Art Appreciation, Crafts, Drawing, Painting, Photography
Summer School: Courses—Ceramics, Design, Drawing, Painting, Printmaking, Sculpture

JACKSONVILLE UNIVERSITY, Dept of Art, College of Fine Arts, 2800 University Blvd N Jacksonville, FL 32211. Tel 904-744-3950; Fax 904-745-7375; Internet Home Page Address: www.ju.edu; *Dir Dance* Violet Angeles Hollis; *Art Chmn* Cheryl Sowder; *Dean* D Perence Netter; *Theater Dept Chmn* Ben Wilson
Estab 1932; pvt; D & E; Scholarships; SC 47, LC 13; D 403, maj 80
Ent Req: HS dipl, ent exam
Degrees: BFA, BA, BS & BAEd, 4 yr; MAT
Tuition: $6930 per sem 12-16 cr hrs
Courses: †Art Education, †Art History, Ceramics, †Computer Art & Design, Drawing, Hotglass, Painting, Photography, Sculpture, †Studio Art, †Visual Communication

UNIVERSITY OF NORTH FLORIDA, Dept of Communications & Visual Arts, 4567 St Johns Bluff Rd S, Jacksonville, FL 32224. Tel 904-620-2650; Tel 904-620-2624 (admissions); Internet Home Page Address: www.unf.edu; *Chmn* Oscar Patterson; *Prof* Louise Freshman Brown, MFA; *Assoc Prof* David S Porter, MFA; *Assoc Prof* Robert L Cocaougher, MFA; *Assoc Prof* Paul Ladnier, MFA; *Asst Prof* Debra E Murphy, MFA
Estab 1970; pub; D & E; Scholarships; maj 385
Ent Req: AA
Degrees: BA 2 yr, BFA
Tuition: Res—undergrad $71.89 per sem hr, grad $141.24 per qtr hr; nonres—undergrad $293.75 per qtr hr, grad $484.80 per qtr hr
Courses: Advertising Design, Aesthetics, Art Appreciation, Art History, Broadcasting, †Ceramics, Commercial Art, Computer Images, Conceptual Art, Design, Digital Photography, †Drawing, Electronic Multi-Media, Graphic Arts, Graphic Design, †History of Art & Architecture, Illustration, Lettering, Mixed Media, †Painting, †Photography, Printmaking, †Sculpture, †Video
Summer School: Various courses offered on demand

KEY WEST

FLORIDA KEYS COMMUNITY COLLEGE, Fine Arts Div, 5901 College Rd, Key West, FL 33040. Tel 305-296-9081, 296-1520 (Box Office); Fax 305-292-5155; *Chmn Fine Arts Div* G Gerald Cash
Scholarships
Degrees: AA, AS
Tuition: Res—$42 per cr hr; nonres—$158 per cr hr
Courses: Art Appreciation, Art Education, Art History, Calligraphy, †Ceramics, Commercial Art, Costume Design & Construction, Design, Display, Drafting, Drawing, Film, †Fine Arts, Graphic Arts, Graphic Design, Handicrafts, Jewelry, Jewelry Making, Mixed Media, Painting, †Photography, Printmaking, Sculpture, Stage Design, †Theatre Arts, Voice
Adult Hobby Classes: Enrl 150; Sept-Apr. Courses—Acting, Costume Design, Theatre Production (Lighting, Stagecraft, Design)

LAKE WORTH

PALM BEACH COMMUNITY COLLEGE, Dept of Art, 4200 S Congress Ave, Lake Worth, FL 33461-4796. Tel 561-439-8142; Fax 561-439-8384; Elec Mail slateryp@pbcc.cc.fl.us; Cable FLASUNCOM; *Art Dept Chmn* W Patrick Slatery; *Architecture & Interior Design Chmn* Zenida Young; *Graphic Design Chmn* Timothy Eichner
Estab 1933; Maintain nonprofit art gallery; Pub; D & E; Scholarships; SC 20, LC 5; D 15,000 maj 400
Ent Req: HS dipl or over 25
Degrees: AA and AS 2 yr, cert
Tuition: Res $46.14 per cr hr; non-res $170.49
Courses: Advertising Design, Architectural Drawing, Architecture, Art Appreciation, Art History, †Basic Design, Ceramics, Commercial Art, Design, Drawing, Enameling, †Etching, Graphic Arts, Graphic Design, Handicrafts, History of Art & Architecture, Illustration, Interior Design, Intermedia, Jewelry, Lithography, Painting, Photography, Printmaking, Screen Printing, Stage Design, Technical Photo Courses, Theatre Arts, Typography, Weaving
Summer School: Assoc Dean Humanities, Richard Holcomb. Enrl 300; tuition $36.50 per cr hr. Courses—Art Appreciation, Ceramics, Crafts, Design, Drawing, History of Art, Photography

LAKELAND

FLORIDA SOUTHERN COLLEGE, Art Dept, 111 Lake Hollingsworth Dr, Lakeland, FL 33801. Tel 863-680-4220; Fax 863-680-4147; Internet Home Page Address: www.flsouthern.edu; *Asst Prof* Eric Blackmore, BFA; *Asst Prof* Nadine Pantano, PhD; *Asst Prof* Joe Mitchell, MFA; *Chmn Dept* James Rogers, PhD; *Asst Prof* Bill Otremsky, MFA; *Asst Prof* Robert Recht, MFA; *Asst Prof* Eirka Schmidt, MFA; *Asst Prof* Alexis Serio, MFA; *Asst Prof* Zoey Stites, MFA; *Asst Prof* Ryan Bailey, MFA; *Asst Prof* Josh Hallett; *Asst Prof* Michael Barrickman, MFA
Estab 1885; den; private; D & E; Scholarships; SC 20, LC 6, maj 34
Activities: Melvin Art Gallery
Ent Req: HS dipl
Degrees: BA/BFA Studio Art, Graphic Design, Art History; BA/BS Art Ed
Tuition: $8287 board per sem; $5637 commuters per sem

Courses: Advertising Design, Ancient & Medieval Art, †Art Communication, †Art Education, Art History, Ceramics, Design (19th & 20th century art), Drawing, Graphic Arts, Graphic Illustration, Handicrafts, Lettering, Painting, Photography, Renaissance & Baroque Art, Sculpture, †Studio Art, Teacher Training, Theatre Arts, Weaving
Adult Hobby Classes: Courses—Graphics, Oil Painting
Summer School: Dean, Dr Ben F Wade. Tuition $126 per hr, two terms of 4 wks beginning June & July. Courses—Art Humanities, Drawing, Painting

LARGO

GULF COAST MUSEUM OF ART, 12211 Walsingham Rd, Largo, FL 33778. Tel 727-518-6833; Fax 727-518-1852; Internet Home Page Address: www.gulfcoastmuseum.org; *Exec Dir* Ken Rollins; *Registrar* Laurel Deloach; *Cur Educ* Patricia S Fosnaught; *Mktg & Mem* Karen Barth
Estab 1936; pvt & non_profit; D & E; D 315
Collections: Florida Contemporary Art/American Fine Crafts
Ent Req: None
Degrees: None
Courses: Ceramics, Drawing, Goldsmithing, Metalsmithing, Mixed Media, Painting, Photography, Sculpture, Silversmithing
Children's Classes: After school & summer camp 6 weeks, tui $85 per week

MADISON

NORTH FLORIDA COMMUNITY COLLEGE, Dept Humanities & Art, 100 Turner Davis Dr, Madison, FL 32340. Tel 850-973-9481; *Chmn* Dr Barbara McCauley; *Instr* Dr William F Gardner Jr
Estab 1958; pub; Scholarships
Degrees: AA
Tuition: Res—$47 per sem hr; nonres—$169.15 per sem hr
Courses: Art History, Ceramics, Design, Drawing, Painting, Sculpture

MARIANNA

CHIPOLA COLLEGE, Dept of Fine & Performing Arts, 3094 Indian Circle, Marianna, FL 32446. Tel 850-718-2301; Fax 850-718-2206; Elec Mail stadsklevj@chipola.edu; Internet Home Page Address: www.chipola.edu; *VPres Instr* Sarah Clemmons; *Dir Fine & Performing Arts* Joan Stadsklev
Estab 1947; pub; D & E; Scholarships; SC 8, LC 2; D 60
Ent Req: HS dipl
Degrees: AA 2 yr
Tuition: Res—$59 per sem hr; nonres—$180 per sem hr
Courses: 2-D & 3-D Design, Art History, Ceramics, Color Picture Comp, Crafts, Drawing, Graphic Arts, Painting, Purpose of Arts, Sculpture, Stage Design, Theatre Arts
Summer School: Courses—varied

MIAMI

FLORIDA INTERNATIONAL UNIVERSITY, School of Art & Art History, University Park Campus Bldg VH 216, Miami, FL 33199. Tel 305-348-2897, 348-2000 (main); Fax 305-348-0513; Internet Home Page Address: www.fiu.edu/~viart/; *Prof* William J Burke; *Prof* R F Buckley; *Prof* Manuel Torres; *Prof* Ed del Valle; *Prof* Mirta Gomez; *Assoc Prof* Barbara Watts; *Prof* Juan Martinez; *Prof* Carol Damian; *Assoc Prof* Dan Guernsey; *Assoc Prof* Pip Brant; *Grad Prof* Geoffrey Olsen; *Assoc Prof* Tori Arpad; *Asst Prof* Jacek Kolasinski; *Dir Museum Studies* Marta de la Torre
Estab 1972, dept estab 1972; pub; D & E; Scholarships; SC 170, LC 27, GC 14; D 900, E 150, non-maj 250, grad 25
Ent Req: 1000 on SAT, 3.0 HS grade point average
Degrees: BFA, BA, MFA, Museum Studies Grad Certificate
Tuition: Res—undergrad $94.72 per cr hr; nonres—undergrad $319.31 per cr hr; res—grad $251.19 per cr hr; nonres $529.95 per cr hr
Courses: Art Appreciation, Art History, Ceramics, Drawing, †Electronic Art, Jewelry, Painting, Photography, Printmaking, Sculpture
Summer School: Dir, Clive King. Enrl 160; tuition $55 per sem hr for term of 6.5 wks beginning May 13 & June 28

INTERNATIONAL FINE ARTS COLLEGE, 1501 Biscayne Blvd, Ste 100, Miami, FL 33132-1418. Tel 305-373-4684; Fax 305-374-7936; Internet Home Page Address: www.ifac.edu; *Pres College* Erika Fleming; *Dean Academic Affairs* Deborah Mas
Estab 1965, dept estab 1966; Maintain nonprofit art gallery; pvt; D; SC 6; D 180, maj 110
Ent Req: HS dipl
Degrees: AA
Tuition: AA degree $17,520 academic yr; BA $17,520 academic yr; MA $21,465 academic yr
Courses: Accessory Design, Computer Animation, Fashion Design and Merchandising, Film and Digital Production, Graphic Design, Interior Design, Motion Graphics, Visual Effects

MIAMI-DADE COMMUNITY COLLEGE, Arts & Philosophy Dept, 11011 SW 104th St, Miami, FL 33176. Tel 305-237-2281; Fax 305-237-2871; *Chmn* Robert Huff; *Prof* Charles Dolgos; *Prof* Charles Fink; *Prof* Robert Krantzler; *Prof* Peter Kuentzel; *Prof* Alberto Meza; *Prof* Wade Semerena; *Prof* Wickie Whalen; *Prof* Richard Williams; *Instr* Jennifer Basile; *Asso Prof Sr* Annette Wells
Estab 1960, dept estab 1967; Nonprofit - Kendall Campus Art Gallery, M123, 11011 SW 104th St, Miami, FL 33176; Pub; D & E; Scholarships; SC 14, LC 4; E 300, non-maj 150, maj 150
Ent Req: open door
Degrees: AA & AS 2 yr

Tuition: Res—$59.15 per cr; nonres—$206.95 per cr
Courses: Art Appreciation, Art History, Ceramics, Commercial Art, †Computer Art, Design, Drawing, Jewelry, Metals, Painting, Photography, Printmaking, Sculpture
Adult Hobby Classes: Courses by demand
Summer School: Dir, Robert Huff. Courses vary

NEW WORLD SCHOOL OF THE ARTS, 25 NE Second St, Miami, FL; 300 NE Second Ave, Miami, FL 33132-2297. Tel 305-237-3620; Fax 305-237-3794; Elec Mail hgershfe@mdcc.edu; Internet Home Page Address: www.mdcc.edu/nwsa/horizons; *Dean* Louise Romeo; *Asst Dean Visual Arts* Yelena Gershfeld
Estab 1987; A Cooperative venture of University of Florida & Miami-Dade Community College; pub; D; SC 43, LC 6; D 249, maj 249
Publications: Art in Ecological Perspective
Ent Req: HS dipl, entrance exam, portfolio review
Degrees: AA 2 yr, BFA 4 yr
Tuition: Lower Division; res—undergrad $50 per cr - $750 sem; non res—undergrad $175 per cr - $2700 sem
Courses: Advertising Design, Art Education, Art History, †Ceramics, Collage, Conceptual Art, Cyberarts, Design, †Drawing, †Graphic Design, †Illustration, Intermedia, Mixed Media, †Painting, †Photography, †Printmaking, Restoration & Conservation, †Sculpture, Theatre Arts
Summer School: scholarships

MIAMI SHORES

BARRY UNIVERSITY, Dept of Fine Arts, 11300 NE Second Ave, Miami Shores, FL 33161. Tel 305-899-3424 (chmn), 899-3426 (asst to chmn); Fax 305-899-2972; Internet Home Page Address: www.barry.edu; *Dean* Dr Laura Aimesto; *Chmn Fine Arts Dept* Dr Dan Ewing
Estab 1940; FT 4; pvt; D & E; Scholarships; SC 33, LC 12; D 300, E 60, maj 30
Ent Req: HS dipl, portfolio for BFA
Degrees: BA, BFA, MFA, MFA(Photo)
Tuition: Undergrad $7395; grad $450 per cr hr; PhD $555 per cr hr
Courses: Advertising Design, Art Appreciation, Art Education, Art History, Ceramics, Collage, Commercial Art, Costume Design & Construction, Design, Drawing, Graphic Design, History of Art & Architecture, Jewelry, Mixed Media, Painting, †Photography, Sculpture, Stage Design, Teacher Training, Theatre Arts, Video
Summer School: Dir, Dr Laura Aimesto. Tuition $155 per cr hr for 6 wk terms. Courses—Ceramics, Drawing, Photography, Watercolor

NICEVILLE

OKALOOSA-WALTON COMMUNITY COLLEGE, Division of Humanities, Fine & Performing Arts, 100 College Blvd, Niceville, FL 32578. Tel 850-729-5382; Fax 850-729-5286; Elec Mail herronc@owc.edu; *Chmn* Cliff Herron, PhD
Estab 1964, dept estab 1964; Maintain nonprofit art gallery & library; Pub; D & E; Scholarships; SC 26, LC 3; D 2,000, E 1,000, maj 80
Ent Req: HS dipl
Degrees: AA 2 yrs
Tuition: Res—$50.90 per sem; nonres—$196.34 per sem
Courses: 2-D & 3-D Design, Acting, Architecture, Art History, Ceramics, Costume Design & Construction, Drafting, Drawing, Ethics, Graphic Arts, Handicrafts, Humanities, Interior Design, Jewelry, Painting, Philosphy, Photography, Printmaking, Religion, Sculpture, Silversmithing, Stage Design, Teacher Training, Theatre Arts, Weaving
Adult Hobby Classes: Enrl 15 per class. Courses—Antiques, Interior Decorating, Painting, Photography, Pottery, Vase Painting, others as needed
Summer School: Dir, Dr Jill White. Term of 6 or 12 wks beginning May 2 & June 18. Courses—same as regular sessions

OCALA

CENTRAL FLORIDA COMMUNITY COLLEGE, Humanities Dept, 3001 SW College Rd, PO Box 1388 Ocala, FL 34478-1388. Tel 352-237-2111, Ext 293; Fax 352-231-0510; Internet Home Page Address: www.cfcc.cc.fl.us; *Prog Facilitator* Carolyn West
Estab 1957; pub; D & E; SC 5, LC 1; 3500, non-maj 85, maj 15
Ent Req: HS dipl
Degrees: AA & AS 2 yr
Tuition: Res—$50.85 per cr hr; nonres—$183.50 per cr hr
Courses: Art History, Ceramics, Design, Drawing, Painting, Printmaking, Sculpture
Adult Hobby Classes: Ceramics, Commercial Art; Design, Drawing, Painting
Summer School: Two 6 wk terms

ORLANDO

UNIVERSITY OF CENTRAL FLORIDA, Art Dept, 4000 Central Florida Blvd, PO Box 161342 Orlando, FL 32816-0342. Tel 407-823-2676; Fax 407-823-6470; Internet Home Page Address: www.pegasus.cc.ucs.edu/~art; *Dept Advisor* Jagdish Chauda
Estab 1963; pub; Scholarships
Degrees: BA, BFA, cert
Tuition: Res—undergrad $57 per sem hr; nonres—undergrad $221 per sem hr
Courses: Art History, Ceramics, Design, Drawing, Fibers & Fabrics, Graphic Design, Painting, Photography, Printmaking, Sculpture
Summer School: Tuition same as above. Courses—vary

VALENCIA COMMUNITY COLLEGE - EAST CAMPUS, Art Dept, 701 N Econlachachee Trail, Orlando, FL 32825. Tel 407-299-5000, Ext 2270; Fax 407-293-8839; Internet Home Page Address: www.valencia.cc.fl.us; *Chmn* Rickard Rietveld
Estab 1967, dept estab 1974; pub; D & E; Scholarships; SC 16, LC 5; D 6858
Ent Req: HS dipl
Degrees: AA and AS 2 yrs
Tuition: Res—$49.34 per cr; nonres—$179.49 per cr
Courses: Ceramics, Drafting, Drawing, Film, †Graphic Design, History of Art & Architecture, Illustration, Intermedia, Lettering, Painting, Photography, Printmaking, Sculpture, Stage Design, †Theatre Arts, Visual Arts Today
Summer School: Same as for regular academic yr

PALATKA

FLORIDA SCHOOL OF THE ARTS, Visual Arts, 5001 Saint Johns Ave, Palatka, FL 32177-3897. Tel 386-312-4300, 312-4072 (Barrineau); Internet Home Page Address: www.sjrcc.cc.fl.us/floarts; *VPres Student Servs* Annette W Barrineau, MFA; *Coordr Graphic Design* Phil Parker, BFA; *Dir Galleries* David Ouellette, MFA
Estab 1974, dept estab 1974; pub; D; Scholarships; SC 35, LC 10; D 85, maj 85
Ent Req: HS dipl, recommendation, review, interview
Degrees: AA 2 yrs, AS 2 1/2 yrs
Tuition: Res—$47.30 per hr; nonres—$178.61 per hr
Courses: Advertising Design, Art History, Commercial Art, Display, Drafting, Drawing, Graphic Arts, †Graphic Design, Illustration, Lettering, Mixed Media, †Painting, Photography, †Printmaking, †Stage Design, †Theatre Arts

PANAMA CITY

GULF COAST COMMUNITY COLLEGE, Division of Visual & Performing Arts, 5230 W Hwy 98, Panama City, FL 32401-1058. Tel 850-769-1551; Internet Home Page Address: www.gc.cc.fl.us; *Dir* Rosemarie O'Bourke, MS; *Assoc Prof* Sharron Barnes, MA; *Assoc Prof* Roland L Hockett, MS
Estab 1957; pub; D & E; SC 5, LC 2; D 300, E 70, non-maj 330, maj 40
Ent Req: HS dipl
Degrees: AA 2 yrs
Tuition: Res—undergrad $36.30 per cr hr; nonres—undergrad $144.16 per cr hr
Courses: Art History, Ceramics, Design, Drawing, Illustration, Lettering, Photography
Adult Hobby Classes: Macrame, Painting, Weaving

PENSACOLA

PENSACOLA JUNIOR COLLEGE, Dept of Visual Arts, 1000 College Blvd, Pensacola, FL 32504. Tel 850-484-2550; Fax 850-484-2564; Internet Home Page Address: www.pjc.cc.fl.us; *Head Dept* Allan Peterson
Estab 1948; FT 9, PT 5; pub; D & E; Scholarships; maj 180
Ent Req: HS dipl
Degrees: AS & AA 2 yrs
Tuition: Res—$40.20 per cr hr; nonres—$144.20 per cr hr; no campus res
Courses: Advertising Design, Art History, †Art Studio, Ceramics, Crafts, Design, Drawing, Graphic Arts, Illustration, Mixed Media, Painting, Photography, Pottery, Printmaking, Sculpture
Adult Hobby Classes: Enrl 600. Courses—Drawing, Painting
Summer School: Dir, Allan Peterson. Enrl 300; tuition $30.30 per cr. Courses—same as regular session

UNIVERSITY OF WEST FLORIDA, Dept of Art, 11000 University Pkwy, Pensacola, FL 32514. Tel 850-474-2045; Fax 850-474-3247; Elec Mail khaworth@uwf.edu; Internet Home Page Address: www.uwf.edu/art; *Prof* William A Silhan, EdD; *Assoc Prof* Robert Marshman, MFA; *Assoc Prof* Duncan E Stewart, MA; *Assoc Prof* Stephen K Haworth, MFA; *Assoc Prof* Suzette J Doyon-Bernard PhD, MFA; *Visiting Prof* John Donovan, MFA; *Chmn* Jim Jipson, MFA; *Asst Prof* Daniel Franke
Estab 1967; Maintain nonprofit art gallery; University Art Gallery, 1000 University Pkwy, Pensacola, FL 32514; Pub; D & E; Scholarships; SC 20, LC 10; D 600, E 300, non-maj 500, maj 175
Ent Req: AA degree or 60 sem hrs credit
Degrees: BA & BFA 4 yr
Tuition: Res— undergrad $79.93 per sem hr; nonres—undergrad $8,068 per sem, grad $3,003 per sem: campus res—room $4,668 two sem
Courses: Aesthetics, †Art Education, †Art History, BFA, Calligraphy, Design, Graphic Design, Handicrafts, †History of Art & Architecture, Illustration, Intermedia, †Jewelry, Mixed Media, Museum Staff Training, Painting, Photography, Printmaking, Sculpture, Studio Art, Teacher Training, Video
Summer School: Dir, Jim Jipson. Enrl 400; 2 sessions. Courses—Ceramics, Drawing, Painting, Photography, Printmaking, Sculpture

SAINT AUGUSTINE

FLAGLER COLLEGE, Visual Arts Dept, 74 King St, Saint Augustine, FL 32084. Tel 904-829-6481; Internet Home Page Address: www.flagler.edu; *Chmn* Don Martin; *Prof* Enzo Torcoletti, MFA; *Asst Prof* Kerry Tustin, MFA; *Instr* Maureen O'Neil, MFA
Estab 1968; pvt; D & E; Scholarships; SC 29, LC 7; 1000, maj 100
Ent Req: HS dipl
Degrees: BA 4 yr
Tuition: $3275 per sem
Courses: Advertising Design, Air Brush, †Art Education, Art History, Drawing, †Graphic Design, Illustration, Painting, Photography, Sculpture, Visual Arts, Visual Communications

Summer School: Academic Affairs, William Abare. Tuition $180 per hr for terms of 7 wks beginning May. Courses—Airbursh, Ceramics, Computer Illustration, Painting

SAINT PETERSBURG

ECKERD COLLEGE, Art Dept, 4200 54th Ave S, Saint Petersburg, FL 33711. Tel 727-867-1166; Fax 727-866-2304; *Prof* Kirk Wang; *Asst Prof* Arthur Skinner; *Asst Prof* Brian Ransom; *Chmn* Marion Smith
Scholarships
Degrees: BA, BF
Tuition: $20,500 per yr, room & board $5500 per yr
Courses: Art Education, Art History, Calligraphy, Ceramics, Design, Drawing, Painting, Photography, Printmaking
Adult Hobby Classes: Enrl 25. Courses—Ceramics, Drawing, Painting
Summer School: Dir, Cheryl Gold. Enrl 150

SARASOTA

ART CENTER SARASOTA, 707 N Tamiami Trail, Sarasota, FL 34236-4050. Tel 941-365-2032; Fax 941-366-0585; Elec Mail visualartcenter@aol.com; Internet Home Page Address: www.artsarasota.org; *Exec Dir* Lisa-Marie Confessore; *Educ Coordr* Jill Kowal; *Pres* William van Osnabrugge; *Instr* Barbara Nechis; *Instr* Peter Sptaro; *Instr* Edward Minchin; *Instr* Charles Meyrick; *Instr* Win Jones; *Instr* Frank Webb; *Instr* Bill Buchman; *Instr* Joseph Melancon; *Instr* Pat Deadman
Estab 1926; Maintain nonprofit art gallery & library; Art Ctr Sarasota, 707 N Tamiami Trail, Sarasota, FL 34236-4050; Not-for-profit; D&E; SC 32, LC 6, other 5, workshops; D 200, E 10
Ent Req: Varied
Degrees: Cert of Completion
Courses: Art Appreciation, Art Education, Art History, Calligraphy, Ceramics, Collage, Drawing, Mixed Media, Painting, Photography, Sculpture, Watercolor
Adult Hobby Classes: 200. Courses—Drawing, Painting
Children's Classes: 20 per class maximum
Summer School: Educ Coordr Jill Kowal. Enrl 80. Courses—Watercolor

NEW COLLEGE OF THE UNIVERSITY OF SOUTH FLORIDA, Fine Arts Dept, Humanities Division, 5700 N Tamiami Trail, Sarasota, FL 34243. Tel 941-359-4360, 359-5605; Internet Home Page Address: www.newcollege.usf.edu
Estab 1963; FT 4; pub; D; SC 6, LC 5; D 150-200, maj 15
Ent Req: ent exam, SAT
Degrees: BA(Fine Arts) 3 yrs
Tuition: Res—undergrad $52.70 per cr hr, grad $104.62 per cr hr; nonres—undergrad $216.11 per cr hr, grad $357.64 per cr hr
Courses: †Aesthetics, †Art History, Ceramics, †Color Theory, Design, †Drawing, Life Drawing, †Painting, †Printmaking, †Sculpture, Stained Glass

RINGLING SCHOOL OF ART & DESIGN, 2700 N Tamiami Trail, Sarasota, FL 34234. Tel 941-351-5100; Fax 941-359-7517; *Pres* Thomas E Linehan; *Dean Admis* Jim Dean
Estab 1931; 31; pvt; Scholarships; 830
Ent Req: HS dipl or equivalency, portfolio
Degrees: BFA, 4 yrs
Tuition: $600 per sem; campus res—room & board $3150
Courses: †Computer Animation, †Fine Arts, †Graphic Design, †Illustration, †Interior Design, Painting, †Photography, Sculpture
Adult Hobby Classes: Enrl 150; tuition $40 per 7 wk session

TALLAHASSEE

FLORIDA A & M UNIVERSITY, Dept of Visual Arts, Humanities & Theatre, 413 Tucker Hall, Tallahassee, FL 32307. Tel 850-599-3831; Fax 850-599-8417; Internet Home Page Address: www.essential_yahoo.com; *Prof* Kenneth Falana; *Prof* Ronald F Yarbedra; *Dir* Balencia Matthews; *Prof* Yvonne Tucker; *Prof* Chester Williams
Estab 1887; pub; D & E; Scholarships; D 5887, non-maj 5800, maj 87
Ent Req: HS dipl, ent exam
Degrees: BS & BA with Fine Arts Cert
Tuition: Res—$62.10 per sem hr; nonres $236.94 per sem hr
Courses: Art Education, Art History, Ceramics, Design, Drawing, Metals, Plastic, Textile Design, Wood
Summer School: Enrl 125; tuition same as regular session for term of 9 & 7 wks beginning June. Courses—Arts, Ceramics, Design, Drawing, Metal & Plastics, Textile Design, Wood

FLORIDA STATE UNIVERSITY
—**Art Dept,** Tel 850-644-6474; Fax 850-644-8977; Elec Mail hdstripl@mailer.fsu.edu; Internet Home Page Address: www.fsu.edu/~svad; *Chmn Studio Art* Roald Nasgaard; *Prof* James Roche, MFA; *Prof Emeritus* Ed Love, MFA; *Prof* George C Blakely, MFA; *Prof* Robert Fichter, MFA; *Prof Emeritus* Trevor Bell, MFA; *Prof Emeritus* William Walmsley, MFA; *Assoc Prof* George Bocz, MEd; *Assoc Prof* Janice E Hartwell, MFA; *Assoc Prof* Charles E Hook, MFA; *Prof* Mark Messersmith, MFA; *Assoc Prof* Gail Rubini, MFA; *Assoc Prof* Paul Rutkovsky, MFA; *Assoc Prof* Terri Lindbloom, MFA; *Assoc Prof* Kasuya Bowen, MFA; *Assoc Prof* Keith Roberson, MFA; *Prof & Assoc Chair* Ray Burggraf; *Assoc Prof* Donald Odita; *Prof* Pat Ward Williams; *Assoc Prof* Lilian Garcia-Roil; *Asst Prof* Scott Groeninger; *Asst Prof* Steve Jones
Estab 1857, dept estab 1911; maintains nonprofit gallery; Cate Wyatt-Magalian, Daniel Kariko & John Raulerson; pub; D & E; Scholarships; SC 45, LC 2, GC 22; non-maj 400, maj 488, grad 35
Ent Req: HS dipl, B average & test scores of at least 24 (composite) on the ACT or 1100 (verbal plus math) on the SAT I
Degrees: BA, BFA, BS, MFA

Tuition: Res--undergrad $73.19 per cr hr, grad $146.01 per cr hr; nonres--undergrad $306.14 per cr hr, grad $506.74 per cr hr
Courses: Ceramics, Digital Arts, Drawing, Graphic Design, Painting, Photography, Printmaking, Sculpture
Summer School: Term of 13 wks; two terms of six & a half wks
—**Art Education Dept,** Tel 850-644-2926; 850-644-5473; Fax 850-644-5067; Elec Mail mrosal@mailer.fsu.edu; Internet Home Page Address: http://www.fsu.edu/~are; *Prof* Tom Anderson PhD; *Prof* Charles Dorn, Ed.D; *Asst Prof* David Gussak PhD; *Asst Prof* Penny Orr PhD; *Assoc Prof* Pat Villenure PhD; *Chmn* Marcia L Rosas PhD
Estab 1857, dept estab 1948; pub; D & E; Scholarships; LC, GC
Ent Req: HS dipl
Degrees: BA(Art Educ) 4 yr, MS(Art Edu & Art Therapy) & MA(Arts Admin). 1-2 yr, EDS degree, PhD
Tuition: Res-- $2,379; non res--$9, 716
Courses: †Art Education, Art Therapy, Arts Administration, Special Population, Teacher Training
Summer School: Studio Art & Art History Emphasis
—**Art History Dept (R133B),** Tel 850-644-1250; Fax 850-644-7065; Elec Mail arh@www.fsu.edu; Internet Home Page Address: www.fsu.edu/~arh; *Dean School Visual Arts* Jerry L Draper PhD; *Prof* Robert M Neuman PhD; *Prof* Jehnne Teilhet-Fisk; *Prof* Cynthia J Hahn PhD; *Assoc Prof* Lauren Weingarden PhD; *Assoc Prof* Karen Bearor PhD; *Asst Prof* Jack Freiberg PhD; *Asst Prof* Brenda Jordan, PhD; *Chmn* Paula Gerson
Estab 1857, dept estab 1948; Maintain nonprofit art gallery, Fine Art Museum; pub; D & E; Scholarships
Ent Req: HS dipl
Degrees: MA(Art History) 2 1/2 yr, PhD(Art History) 3 yr
Tuition: Res—$59.93 per cr hr; nonres—$223.34 per cr hr
Courses: Art Appreciation, †Art History, Arts Administration, History of Art & Archeology

TALLAHASSEE COMMUNITY COLLEGE, Art Dept, 444 Appleyard Dr, Tallahassee, FL 32304. Tel 850-201-8713; Elec Mail baroodyj@tcc.cc.fl.us; Internet Home Page Address: www.tcc.cc.fl.us; *Art Coordr* Julie Baroody; *Dean* Dr Marge Banocy-Payne
Estab 1966; Maintain nonprofit art gallery; TC Art Gallery, 444 Appleyard Dr, Tallahassee FL 32304; art supplies available on-campus; PT 4; pub; D & E; Scholarships; SC 13, LC 3; D 350 per sem, E 150 per sem
Ent Req: HS dipl
Degrees: AA 2 yrs
Tuition: $48 per sem hr; out of state res $178
Courses: Art Appreciation, Art History, Color Theory, Design, Drawing, †Graphic Design, History & Appreciation of Cinema, Painting, Photography, Printmaking, Silkscreen, Silversmithing, Watercolor
Summer School: Dir, Dr Marge Benocy-Payne. Tuition $40 per sem hr for 10 wk term. Courses—Basic Photo, Methods/Concepts

TAMPA

HILLSBOROUGH COMMUNITY COLLEGE, Fine Arts Dept, PO Box 5096, Tampa, FL 33675-5096. Tel 813-253-7685 ext 7752; *Dir* Steve Holm; *Assoc Prof* David Dye; *Assoc Prof* Suzanne Crosby; *Chmn* Craig Johnson
Scholarships
Degrees: AA
Tuition: Res—$48.06 per cr hr; nonres—$177.61 per cr hr
Courses: Art Appreciation, Art History, Ceramics, Design, Drawing, Painting, Photography, Printmaking, Sculpture, Weaving

UNIVERSITY OF SOUTH FLORIDA, School of Art & Art History, College of Visual & Performing Arts, 4202 E Fowler Ave, FAH 110 Tampa, FL 33620-7350. Tel 813-974-2360; Fax 813-974-9226; Elec Mail minfanti@arts.usf.edu; Internet Home Page Address: www.art.usf.edu; *Dir* Wallace Wilson
Estab 1956; Maintain nonprofit gallery; William & Nancy Oliver Gallery, School of Art & Art History, FAH 110, University of South Florida, Tampa, FL 33620; FT 26; pub; D&E; Scholarships, Fellowships; SC 100, LC 125, GC 20, other 50; D 625, E 50, non-maj 400, maj 350, grad 75
Ent Req: HS grad, 14 units cert by HS, ent exam, portfolio for studio
Degrees: BA (Art) minimum 120 sem hrs, BFA 120 sem hrs, MFA 60 sem hrs & MA(Art History) 40 sem hrs
Tuition: Res—undergrad $75.21 per cr hr, grad $48.03 per cr hr; nonres—undergrad $308.16 per cr hr, grad $508.76 per cr hr
Courses: †Art Appreciation, Art History, Ceramics, Collage, Drawing, Electronic Media, Mixed Media, Museum Staff Training, Painting, Photography, Printmaking, Sculpture, Video
Summer School: Dir Wallace Wilson. Enrol 150

UNIVERSITY OF TAMPA, Dept of Art, 401 W Kennedy Blvd, Tampa, FL 33606. Tel 813-253-3333; Elec Mail dcowden@ut.edu; *Prof Dept Chmn* Lane Harris; *Dir Prof* Catherine Chastain; *Dir Gallery* Dorothy Cowden; *Prof* Santiago Echevery; *Prof* Doug Sutherland
Estab 1930; Maintains nonprofit art gallery, University of Tampa, Scarfone/Hartley Gallery; FT 3; pvt; D & E; Scholarships; SC 17, LC 8
Degrees: 4 yrs
Tuition: $265 per cr hr 1-8 hrs; $777 per cr hr 12, fulltime
Courses: Art Education, Art History, Arts Management, Ceramics, Computer Graphics, Design, Drawing, Graphic Design, Painting, Photography, Printmaking, Sculpture
Summer School: Art courses offered

TEMPLE TERRACE

FLORIDA COLLEGE, Division of Art, 119 N Glen Arven Ave, Temple Terrace, FL 33617. Tel 813-988-5131; Fax 813-899-6772; Internet Home Page Address: www.flcoll.edu; *Faculty* Julia Gibson

Estab 1947; FT 1; pvt; D&E; Scholarships
Degrees: AA
Tuition: $5000 per sem
Courses: †Design I, †Design II

WINTER HAVEN

POLK COMMUNITY COLLEGE, Art, Letters & Social Sciences, 999 Ave H
NE, Winter Haven, FL 33881-4299. Tel 863-297-1025; Fax 863-297-1037; Internet
Home Page Address: www.polk.cc.fl.us; *Prof* Gary Baker, MFA; *Prof* Bob
Morrisey, MFA; *Dean of Arts* Hugh B Anderson, MFA
Estab 1964; pub; D & E; Scholarships; SC 10, LC 1; D 175, E 50
Ent Req: HS dipl
Degrees: AA & AS 2 yrs
Tuition: Res—undergrad $49.41 per cr hr; nonres—undergrad $185.25 per cr hr,
no campus res
Courses: Advertising Design, Art Appreciation, Ceramics, Design, Drawing, Film,
Interior Design, Painting, Photography, Printmaking, Sculpture, Theatre Arts
Adult Hobby Classes: Enrl 60; tuition res—$36.13 per cr hr, non res—$135.46
per cr hr. Courses—Calligraphy, Ceramics, Christmas Crafts, Drawing, Interior
Design, Jewelry, Painting

WINTER PARK

ROLLINS COLLEGE, Dept of Art, Main Campus, 1000 Holt Ave, Winter Park,
FL 32789. Tel 407-646-2498; Fax 407-628-6395; Internet Home Page Address:
www.rollins.edu; *Chmn* Ron Larned
Estab 1885; pvt; D & E; Scholarships; SC 11, LC 10; D & E 250
Degrees: BA 4 yr
Tuition: Res—$23.205 per yr; $4229 room, $3112 board
Courses: Aesthetics, Art History, Art History Survey, Design, Drawing,
Humanities Foundation, Painting, Principles of Art, Sculpture
Adult Hobby Classes: Selected Studio & History courses
Summer School: Selected Art History & Appreciation courses

GEORGIA

AMERICUS

GEORGIA SOUTHWESTERN STATE UNIVERSITY, Dept of Fine Arts, 800
Wheatley St, Americus, GA 31709-4693. Tel 912-931-2204; Fax 912-931-2927;
Chmn Dr Duke Jackson
Scholarships
Degrees: BA, BSEd, BSA, cert
Tuition: Res—$1099 per sem; nonres—$2610 per sem
Courses: Ceramics, Drawing, Glassblowing, Graphic Design, Jewelry, Painting,
Photography, Printmaking, Sculpture, Textile Design

ATHENS

**UNIVERSITY OF GEORGIA, FRANKLIN COLLEGE OF ARTS &
SCIENCES,** Lamar Dodd School of Art, Visual Arts Bldg, Jackson St Athens, GA
30602-4102. Tel 706-542-1511; Fax 706-542-0226; Elec Mail
ccola@arches.uga.edu; Internet Home Page Address: www.visart.uga.edu; *Dean*
Wyatt Anderson; *Dir* Carmon Colangelo; *Assoc Dir* Richard Johnson; *Grad
Coordr* Andy Nasisse; *Assoc Dir* Shelley Zuraw; *Assoc Prof Ceramics* Ted Saupe;
Prof Drawing & Painting Judy McWillie; *Prof Fabric Design* Glen Kaufman; *Prof
Graphic Design* Lanny Webb; *Assoc Prof Interior Design* Thom Houser; *Asst Prof
Jewelry & Metalwork* Robert Jackson; *Asst Prof Scientific Illustration* Gene
Wright; *Prof Sculpture* Larry Millard; *Assoc Prof Printmaking* Melissa Harshman;
Assoc Prof Photography Stephen Scheer; *Franklin Prof Art History* Andrew Ladis;
Wheatley Prof Drawing & Painting Arthur Rosenbaum; *Distinguished Research
Prof Drawing & Painting* James Herbert; *Gallery Coordr* Robin Dana; *Assoc Prof
Art Educ* Dr Carole Henry; *Asst Prof Art Educ* Dr Pam Taylor; *Asst Prof Art Educ*
Dr Richard Siegesmund; *Franklin Fellow Asst Prof* Dr Jessie Whitehead; *Prof Art
History* Evan Firestone; *Asst Prof Art History* Asen Kirin; *Asst Prof Art History*
Alisa Luxenberg; *Assoc Prof Art History* Tom Polk; *Assoc Prof Art History* Janice
Simon; *Prof Art History* Francis Van Keuren; *Asst Prof Digital Media* Michael
Oliveri; *Asst Prof Digital Media* Laleh Mehran; *Asst Prof Drawing & Painting*
Radcliffe Bailey; *Asst Prof Drawing & Painting* Jim Barsness; *Assoc Prof
Drawing & Painting* Scott Belville; *Assoc Prof Drawing & Painting* Diane
Edison; *Assoc Prof Drawing & Painting* Stefanie Jackson; *Assoc Prof Drawing &
Painting* Bill Marriott; *Assoc Prof Drawing & Painting* Joe Norman; *Prof Fabric
Design* Ed Lambert; *Assoc Prof Foundations* Christopher Hocking; *Asst Prof
Foundations* Gretchen Hupfel; *Prof Graphic Design* Ron Arnholm; *Acad
Professional Graphic Design* Joey Hannaford; *Asst Prof Graphic Design* Alex
Murawski; *Prof Graphic Design* Susan Roberts; *Prof Graphic Design* Ken
Williams; *Asst Prof Interior Design* Jane Lily; *Asst Prof Interior Design* Welynda
Wright; *Asst Prof Photography* Michael Marshall; *Lectr Photography* Mary Ruth
Moore; *Acad Professional Photography* Ben Reynolds; *Assoc Prof Printmaking*
Joe Sanders; *Assoc Prof Sculpture* Jim Buonaccorsi; *Assoc Prof Sculpture* Imi
Hwangho; *Assoc Prof Sculpture* Rocky Sapp
Opened 1801, chartered 1875; Maintain art library & nonprofit art gallery; Pub; D;
Scholarships, Fellowships, Assistantships; SC 145, LC 60, GC 99; non-maj 50,
maj 950, grad 80
Ent Req: HS dipl, SAT
Degrees: BA, BFA, BSEd, MA, MFA, MAE, EdS, EdD, PhD
Tuition: Res—undergrad $1,517 per sem, grad $1,888 per sem;
nonres—undergrad $5,138 per sem, grad $6,397 per sem

Courses: Art Appreciation, †Art Education, †Art History, †Ceramics, Digital
Media, Drawing, †Graphic Arts, †Graphic Design, Illustration, †Interior Design,
†Jewelry, Lettering, Mixed Media, †Painting, †Photography, †Printmaking,
†Scientific Illustration, †Sculpture, Silversmithing, †Textile Design, Weaving
Summer School: Dir, Carmen Colangelo, Assoc Dir Rick Johnson; Enrl 600, 35
courses

ATLANTA

ART INSTITUTE OF ATLANTA, 6600 Peachtree-Dunwoody, 100 Embassy
Row Atlanta, GA 30328. Tel 770-394-8300; Fax 770-394-0008; Internet Home
Page Address: www.aia.artinstitute.edu; *Pres* Janet Day; *Dean* Larry Stulpz
The Institute has the following departments: Graphic Design, Photography, Interior
Design, Culinary Arts, Computer Animation, Multi Media Web Design;
Scholarships
Degrees: AA
Courses: Advertising Design, Cartooning, Commercial Art, Design, Display,
Drawing, Fashion, Graphic Arts, Interior Design, Lettering, Mixed Media,
Painting, Photo Design, Photography, Portrait, Video

ATLANTA COLLEGE OF ART, 1280 Peachtree St NE, Atlanta, GA 30309. Tel
404-733-5001; Fax 404-733-5201; Internet Home Page Address: www.aca.edu;
Painting Chmn Tom Francis, MFA; *Prof* Anthony Greco, MFA; *Assoc Prof*
Michael Brekke, MFA; *Assoc Prof* Curtis Patterson, MFA; *Assoc Prof* Marcia R Cohen,
MA; *Prof* Martin Emanuel, MFA; *Assoc Prof* Daniel Zins PhD, MFA; *Asst Prof*
Harriette Gressom PhD, MFA; *Assoc Prof* Robert Stewart, MFA; *Asst Prof of
Communication* J Mark Rokfalusi, MFA; *Vis Prof* Cynthia Graham PhD,
MFA; *Dir Student Affairs* Betty Tilley; *VPres* Stewart Mollenkamp; *Chmn (V)*
Sallie Daniel; *Dir Business Affairs* Timothy Spaeth; *Academic Dean* Kay Klein
Kallos
Estab 1928; pvt; D & E; Scholarships; SC 168, LC 46; D 422, E 450, non-maj
450, maj 422
Ent Req: HS dipl, ent exam, SAT, portfolio of art work
Degrees: BFA 4 yrs
Tuition: $14,005 per 12-18 cr hr
Courses: †Advertising Design, †Communication Designs, †Computer Arts &
Graphics, †Drawing, †Graphic Design, †Illustration, †Interior Design, †Intermedia,
Mixed Media, †Painting, †Photography, †Printmaking, †Sculpture, †Video
Adult Hobby Classes: Dir, Rick Fisher. MA. Enrl 400 - 500; tuition $130 per
course for 10 wk term
Children's Classes: Enrl 30 - 50; tuition $90 for 10 wk term. High School (15 -
18) - Enrl 40; tuition $110 for 10 wk term
Summer School: Dir, Rick Fisher. Enrl 400; tuition $130 for 2 five wk terms.
Children's Classes—Enrl 50; tuition $100 for 5 wks. Courses—Drawing, Painting,
Art & Theatre Camp. Summer Visual Studies Program for High School students
enrl 30 - 50; tuition $1175 for 3 wk term. BFA Program: Dir Xena Zed. Enrl 95;
tuition $775 per course for 7 wk term. Courses—Curriculum Courses

ATLANTA TECHNICAL INSTITUTE, Visual Communications Class, 1560
Metropolitan Pkwy, Atlanta, GA 30310. Tel 404-756-3700; Fax 404-756-0932;
Internet Home Page Address: www.atlantatech.org; *Head Dept* Eric Jefferies
Estab 1967; pub; D; SC 13; D 25, E 25
Ent Req: HS dipl, ent exam
Degrees: AA in conjunction with the Atlanta Metro Col
Tuition: $296 per quarter
Courses: Advertising Design, Commercial Art, Graphic Arts, Photography, Print
Production Art, Video

CLARK-ATLANTA UNIVERSITY, School of Arts & Sciences, 223 James P
Brawley Dr SW, Atlanta, GA 30314. Tel 404-880-8000; Internet Home Page
Address: www.cau.edu; *Assoc Prof* Christopher Hickey; *Chmn Dept* Belinda A
Peters; *Prof* Emmanuel Asihene; *Asst Prof* Dorothy Batey; *Instr* Javier Tolbert;
Instr Constance Boothe; *Instr* Norman Meyer
Estab 1869, dept estab 1964; pvt; D; Scholarships; SC 8, LC 8; D 198, non-maj
120, maj 85
Ent Req: HS dipl
Degrees: BA (Art, Fashion Design) 4 yrs, Honors Program
Tuition: $8108 per yr
Courses: Art Education, Art History, Design, Drawing, Fashion Design, Graphic
Design, Illustration, Painting, Photography, Printmaking, Sculpture
Summer School: Summer school program offered.

EMORY UNIVERSITY, Art History Dept, Carlos Hall, 571 Kilgo Cir Atlanta,
GA 30322. Tel 404-727-6282; Elec Mail grobins@emory.edu; *Chmn* Gay Robins
PhD; *Assoc Prof* Dorinda Evans PhD; *Assoc Prof* Bonna D Wescoat PhD; *Assoc
Prof* Sidney L Kasfir PhD; *Assoc Prof* Rebecca Stone-Miller PhD; *Asst Prof* Sarah
McPhee, ABD; *Asst Prof* Eric Varner PhD, ABD; *Lectr* Dorothy Fletcher, MA;
Assoc Prof Judith C Rohrer, PhD; *Assoc Prof* Jean C Campbell, PhD; *Prof* Clark
V Poling, PhD; *Asst Prof* Matthew Simms, PhD
Estab 1847; pvt; D; Scholarships; SC 27, LC 26, GC 18; non-maj 240, maj 80,
grad 41
Ent Req: HS dipl, ent exam, SAT
Degrees: BA(Art History) & PhD(Art History)
Tuition: $19,870 per yr; campus res available
Courses: †Art History, Ceramics, Drawing, Film, History of Art & Architecture,
Museum Staff Training, Painting, Photography, Sculpture, Video
Summer School: Dir, Elizabeth Pastan. Enrl 51; tuition $621 per cr hr, 2 six wk
sessions. Courses—Drawing, History of Art Abroad, Photography, Video,
Sculpture, Studio Art, Various seminars in Europe (variable 8 cr hr)

GEORGIA INSTITUTE OF TECHNOLOGY, College of Architecture, 247
Fourth St, Atlanta, GA 30332-0155. Tel 404-894-3880; Fax 404-894-2678; Elec
Mail tom.galloway@coa.gatech.edu; Internet Home Page Address: arch.gatech.edu;
Dean Thomas D Galloway PhD; *Assoc Dean* Douglas Allen; *Assoc Dean* Sabir
Khan

Estab 1885, dept estab 1908; Maintain nonprofit art gallery, Atlanta Contemporary Art Center; pub; D & E; Scholarships; SC 31, LC 86, GC 109; D 639, maj 731, grad 275
Ent Req: HS dipl, SAT
Degrees: BS(Architecture), BS(Building Construction), BS(Industrial Design) & M (Architecture) 2 yr & 3 1/2 yrs (for students w/out degree in Architecture), PhD MCRP 2 yr, PhD MS (Building Construction & Integrated Facility Management) 2 yr, MS (undesignated) 1-2 yr, MS (Advanced Architectural Design) 1yr, MID 2yr & 3yr (for students w/out degree in Industrial Design), MS (Music Technology) 2 yr
Tuition: Res - $1,946 per sem, non-res $9,619 per sem
Courses: Aesthetics, †Architecture, Art Appreciation, Art History, †Building Construction, †City & Regl Planning, Conceptual Art, Constructions, Design, Drafting, Drawing, †Facility Management, Graphic Arts, Graphic Design, History of Art & Architecture, †Industrial Design, Intermedia, Music, Painting, Photography, Printmaking, Teacher Training
Summer School: Dir, Ellen Dunham-Jones. Enrl 50; tuition same. Courses—vary

GEORGIA STATE UNIVERSITY, Ernest G Welch School of Art & Design, PO Box 4107, Atlanta, GA 30302-4107. Tel 404-651-2257; Fax 404-651-1779; Elec Mail artundergrad@gsu.edu; grad@gsu.edu; Internet Home Page Address: www.gsu.edu; *Dir* Cheryl Goldsleger
Estab 1914; FT 34; pub; Scholarships; SC 80, LC 16; maj 450, others 300
Ent Req: HS dipl, ent exam, college board, interview
Degrees: BFA, BA(Art) and BA(Art History) 4 yrs, MA(Art History), MAEd (Art Education), MFA(Studio), MFA
Tuition: Res—$36.40 per cr hr; nonres—$124.80 per cr hr
Courses: Art Education, Art History, Ceramics, Drawing, Graphic Design, Illustration, Interior Design, Jewelry, Metalsmithing, Painting, Photography, Printmaking, Sculpture, Textile Design, Weaving
Children's Classes: Enrl 10-15, 8-10 wk term
Summer School: Dir, Larry Walker. Enrl 350-400; tuition $36.40 per cr hr for 6-8 wk term. Courses—Art Education, Art History, Studio

AUGUSTA

AUGUSTA STATE UNIVERSITY, Dept of Arts, 2500 Walton Way, Augusta, GA 30904-2200. Tel 706-737-1453; Fax 706-667-4937; Elec Mail finearts@aug.edu; Internet Home Page Address: www.aug.edu; *Acting Chair* Kristin Casaletto, MFA; *Prof* Janice Williams, MFA; *Prof* Michael Schwartz, PhD; *Prof* Brian Rust, MFA; *Morris Eminent Scholar in Art* Tom Nakashima, MFA; *Prof* Priscilla Hollingsworth, MFA; *Assoc Prof* Jennifer Onofrio, MFA
Estab 1925, dept estab 1965; Maintain nonprofit art gallery; Fine Arts Center Art Gallery, Dept of Fine Arts, Augusta State University, 2500 Walton Way, Augusta, GA 30904; pub; D & E; Scholarships; SC 46, LC 4; D 300, E 45, non-maj 80, maj 100
Ent Req: HS dipl, SAT
Degrees: BA & BFA
Tuition: Res—undergrad $1161 per semester; nonres—undergrad $4645 per semester; no campus res
Courses: Aesthetics, Art History, †Ceramics, Design, †Drawing, Mixed Media, †Painting, Photography, Printmaking, †Sculpture
Adult Hobby Classes: Contact Continuing Education Dept for info

BARNESVILLE

GORDON COLLEGE, Dept of Fine Arts, 419 College Dr, Barnesville, GA 30204. Tel 770-358-5118; Fax 770-358-3031; *Instr* Marlin Adams; *Dir* Jason Horn Scholarships
Degrees: AA
Tuition: Res—$627 per sem; nonres—$2694 per sem
Courses: Art Appreciation, Ceramics, Design, Drawing, Graphic Design, Illustration, Introduction to Art, Painting, Photography, Printmaking, Survey Art History

CARROLLTON

STATE UNIVERSITY OF WEST GEORGIA, Art Dept, Carrollton, GA 30018. Tel 770-836-6521; Fax 770-836-4392; Internet Home Page Address: www.westga.edu/~artdept; *Chmn* Bruce Bobick
Estab 1906; Maintain nonprofit art gallery - Department of Art Gallery, State U of West Georgia; Pub; D&E; Scholarships; SC 39, LC 16, GC 2, Other 9; maj 230, grad 15
Ent Req: HS dipl, ent exam
Degrees: BFA, AB(Studio, Pre-Medical Illustration, Art History), MEd 1 yr full-time
Tuition: Res— $2,010 per yr, PT $84 per sem hr; nonres—$4,020 per sem, PT $335 per sem hr; campus res— $1,060-$1,170 per sem
Courses: Art Appreciation, †Art Education, Art History, †Ceramics, Design, Drawing, †Graphic Design, †Interior Design, †Painting, Papermaking, †Photography, †Printmaking, †Sculpture
Summer School: Dir, B Bobick, 8 wk sem in Carrollton, summer study abroad program in Bayeux, France. Courses—Art Appreciation, Art Education, Art History, Ceramics, Design, Drawing, Painting, Printmaking, Sculpture, Photography

CLEVELAND

TRUETT-MCCONNELL COLLEGE, Fine Arts Dept & Arts Dept, 100 Alumni Dr, Cleveland, GA 30528. Tel 706-865-2134; Fax 706-865-0975; Internet Home Page Address: www.truett.cc.ga.us; *Instr* Susan Chapman; *Prof* Dr David N George; *Chmn* Dr Edwin Calloway

Estab 1946; den; D & E; SC 10, LC 2; D 700, non-maj 98, maj 15
Ent Req: HS dipl, SAT
Degrees: AA and AS 2 yr
Tuition: Res—$6150 per yr; nonres—$6150 per yr, room & board $3150 per yr
Courses: 3-D Design, Aesthetics, Art History, Ceramics, Drawing, Graphic Design, Handicrafts, Painting, Sculpture

COCHRAN

MIDDLE GEORGIA COLLEGE, Dept of Art, Cochran, GA 31014. Tel 478-934-6221; Fax 478-934-3199; Internet Home Page Address: www.mgc.peachnet.edu; *Chmn* Dr Valerie D'ortona
Estab as Junior College Unit of University of Georgia; FT 2; Pub; D & E; SC 6; D 270, E 45
Ent Req: HS dipl, GED
Degrees: AA 2 yr
Tuition: Res—$5398 incl room & board per yr; nonres—$8938 per yr, incl room & board
Courses: Art Appreciation, Art Education, Commercial Art, Drawing, Fine Art, Hands-on Art, Lettering, Painting, Understanding Art

COLUMBUS

COLUMBUS STATE UNIVERSITY, Dept of Art, Fine Arts Hall, 4225 University Ave, Columbus, GA 31907-5645. Tel 706-568-2047; Fax 706-568-2093; Internet Home Page Address: www.colstate.edu; *Chmn* Jeff Burden
Estab 1958; pub; D & E; Scholarships; SC 30, LC 7, GC 28; D 300, E 50, maj 130, grad 20
Ent Req: HS dipl, ent exam
Degrees: BS(Art Educ), BFA(Art) & MEd(Art Educ) 4 yr
Tuition: Res—$615 per quarter; nonres—$1908 per quarter
Courses: Art Appreciation, Art Education, Art History, Ceramics, Critical Analysis, Design, Drawing, Graphic Arts, Graphic Design, Painting, Photography, Printmaking, Sculpture, Textile Design
Summer School: Enrl 200; term of one quarter. Courses—various

DAHLONEGA

NORTH GEORGIA COLLEGE & STATE UNIVERSITY, Fine Arts Dept, 322 Georgia Cir Dahlonega, GA 30597. Tel 706-864-1423; Fax 706-864-1429; Internet Home Page Address: www.ngcsu.edu; *Dept Head* Dr Lee Barrow; *Assoc Prof* CM Chastain; *Asst Prof* Hank Margeson; *Asst Prof* Michael Marling de Cuellar
Estab 1873; pub; D & E; Scholarships
Degrees: BA, BS, MEd
Tuition: Res—undergrad $2954 per yr, grad $2918 per yr; nonres—undergrad $3991per sem, grad $3200 per sem; campus res available
Courses: Art Appreciation, †Art Education, Art History, †Ceramics, Computer Graphics, Design, †Drawing, Painting, †Photography, Printmaking, Scientific Illustration, †Sculpture, Textile Design, Weaving
Children's Classes: Enrl 10; tuition $30. Courses—Children's Art
Summer School: Dir, Lee Barrow . Courses—Art Appreciation, Drawing, Painting, Photography, Pottery

DECATUR

AGNES SCOTT COLLEGE, Dept of Art, 141 E College Ave, Decatur, GA 30030-3797. Tel 404-471-6000; Fax 404-638-5369; Internet Home Page Address: www.agnesscott.edu; *Chmn* Anne Beidler
Estab 1889; pvt; D; Scholarships; SC 13, LC 15; non-maj 200, maj 23
Degrees: BA 4 yr
Tuition: Res—undergrad $15,340 yr; nonres—undergrad $15,340 yr; campus res—room & board $6440
Courses: Aesthetics, Art History, Drawing, Graphic Arts, Painting, Printmaking, Sculpture

DEMOREST

PIEDMONT COLLEGE, Art Dept, PO Box 10, Demorest, GA 30535. Tel 706-778-3000; Fax 706-778-2811; Internet Home Page Address: www.piedmont.edu; *Dept Head* Cheryl Goldsleger
Estab 1897; Pvt; Scholarships
Degrees: BA
Tuition: Res & nonres—undergrad fall & spring $437 per cr hr, summer $230 per cr hr
Courses: Art Appreciation, Art Education, Art History, Ceramics, Drawing, Graphic Design, Painting, Photography, Printmaking, Sculpture

GAINESVILLE

BRENAU UNIVERSITY, Art & Design Dept, One Centennial Circle, Gainesville, GA 30501. Tel 770-534-6240; Fax 770-538-4599; Elec Mail lmjones@lib.brenau.edu; Internet Home Page Address: www.brenau.edu; *Graphic Design Prog Dir* Mark A Taylor, MEd; *Art & Design Chair* Lynn M Jones, MHP; *Cur, Arts Management Prog Dir* Jean Westmacott, MFA; *Fashion Merchandising Prog Dir* Janet Morley; *Interior Design Prog Dir* Christopher R Sherry, ASID; *Instr* Jere Williams, MFA; *Studio Arts Prog Dir* Mary Beth Looney, MFA; *Instr* Sandra McGowen, FASID; *Instr* Michael Marling, MFA; *Asst Prof* Carol Platt, ASID; Toni Carlucci, MFA; *Instr* Frank Saggus, MFA

Estab 1878; Maintain nonprofit gallery, Breneau University Galleries, One Central Circle, Gainesville, GA 30506; W; D & E; weekends; Scholarships; 100; D, 75; E, 25
Ent Req: HS dipl
Degrees: BFA, BA, BS 4 yr
Tuition: Res—$20,100, incl room & board; nonres—$280-426 per sem
Courses: Advertising Design, Aesthetics, †Art Appreciation, †Art Education, Art History, †Art Management, †Ceramics, †Commercial Art, †Design, Drafting, †Drawing, †Fashion Design, †Fashion Merchandising, Graphic Design, History of Art & Architecture, Interior Design, †Painting, Photography, †Sculpture, †Silversmithing
Summer School: Dir, Dr John Upchurch. Enrl 300; tuition room & board $949 for 2 wks. Courses—Dance, Music, Theatre, Art & Design

LAGRANGE

LA GRANGE COLLEGE, Lamar Dodd Art Center Museum, 601 Broad St, LaGrange, GA 30240. Tel 706-812-7211; Fax 706-812-7212; Internet Home Page Address: www.lgc.peachnet.edu; *Dept Head* John D Lawrence
Estab 1831; FT 3, PT 1; pvt; D & E; Scholarships; SC 11, LC 2; maj 40
Ent Req: HS dipl, ent exam
Degrees: BA 4 yr
Tuition: Undergrad $3383 per qtr; campus res—room & board $1480 per qtr
Courses: Art Education, Art History, Art History Survey, Batik, Ceramics, Drawing, Graphic Design, Painting, Photography, Printmaking, Sculpture, Textile Design
Summer School: Dir, Luke Gill. Enrl 200; tuition $250 per course. Courses—Art History, Ceramics, Drawing, Photography

MACON

MERCER UNIVERSITY, Art Dept, 1400 Coleman Ave, Macon, GA 31207. Tel 478-301-2591; Fax 478-301-2171; *Assoc Prof* Gary L Blackburn
Estab 1945; FT 4; den; D; SC 9, LC 7, GC 2; maj 25
Ent Req: HS dipl
Degrees: BA 4 yr
Tuition: Res—$2805 per qtr; nonres—$3387 per qtr; campus res—room and board $2196
Courses: Art Education, Art History, Ceramics, Drawing, Photography, Printmaking, Sculpture
Adult Hobby Classes: Evening classes
Summer School: Dir, JoAnna Watson. 2 terms, 5 wks each beginning June 23. Courses—Art Education, Ceramics, Crafts, Drawing, Painting, Photography, Sculpture

WESLEYAN COLLEGE, Art Dept, 4760 Forsyth Rd, Macon, GA 31210-4462. Tel 478-477-1110; Fax 478-757-2469; Internet Home Page Address: www.wesleyancollege.edu; *Asst Prof* Lebe Bailey, MFA; *Asst Prof* Francise deLarosa, MFA
Estab 1836; den; D & E; Scholarships; SC 38, LC 10; D 159, non-maj 13, maj 45, others 12
Ent Req: HS dipl, SAT, GPA
Degrees: BFA 4 yrs, BA
Tuition: $8950 per yr
Courses: Advertising Design, Art Education, Art History, Ceramics, Commercial Art, Drawing, Elementary School Arts & Crafts, Graphic Arts, Graphic Design, Illustration, Painting, Photography, Printmaking, Sculpture, Special Topics in Art, Stage Design, Teacher Training, Theatre Arts, Visual Arts
Summer School: Art History Survey, Ceramics, Graphic Design, Illustration, Painting, Photography, Printmaking, Sculpture

MILLEDGEVILLE

GEORGIA COLLEGE & STATE UNIVERSITY, Art Dept, Milledgeville, GA 31061. Tel 478-445-4572; Fax 478-445-6088; *Chmn* Dorothy D Brown
Scholarships
Courses: Art Appreciation, †Art Education, Art History, Ceramics, Design, Drawing, Handicrafts, Jewelry, Painting, Printmaking, Sculpture, Textile Design, Weaving
Adult Hobby Classes: Courses offered
Summer School: Courses offered

MOUNT BERRY

BERRY COLLEGE, Art Dept, Box 580, Mount Berry, GA 30149. Tel 706-236-2219; Fax 706-238-7835; Elec Mail tmew@berry.edu; *Prof & Chmn* T J Mew PhD; *Asst Prof* Jere Lykins, MEd; *Asst Prof* V Troy PhD, MEd; *Asst Prof* Brad Adams, MFA
Estab 1902, dept estab 1942; Maintain nonprofit art gallery; Moon Gallery, Moon Bldg, Berry College Campus, Mt Berry, GA 30149; pvt; D & E; Scholarships; SC 24, LC 9; D 122, non-maj 38, maj 84, others 7
Ent Req: HS dipl, SAT, CEEB, ACT
Degrees: BA, BS 4 yrs
Tuition: Res—undergrad $6500 yr; nonres—undergrad $6600 yr; campus res—available
Courses: Aesthetics, †Art Appreciation, Art Education, Art History, Calligraphy, †Ceramics, Collage, Conceptual Art, Constructions, Design, Drawing, Ecological Art, Film, Graphic Arts, †Graphic Design, History of Art & Architecture, †Painting, †Photography, Printmaking, Sculpture, Teacher Training, Video
Summer School: Chair, Art Dept, Dr T J Mew III. Courses—Same as above

MOUNT VERNON

BREWTON-PARKER COLLEGE, Visual Arts, Hwy 280, Mount Vernon, GA 30445. Tel 912-583-2241, Ext 306; Fax 912-583-4498; Internet Home Page Address: www.bpc.edu; *Dir* E W Addison, MFA; *Pres* David Smith
Estab 1906, dept re-estab 1976; pvt, den; D & E; SC 10, LC 4; in dept D 19, non-maj 4, maj 15
Ent Req: HS dipl
Degrees: AA(Visual Arts) 2 yrs
Tuition: campus res $4380 per sem
Courses: 2-D & 3-D Design, Art History, Art Media & Theory, Art for Teachers, Drawing, Painting, Photography, Printmaking, Sculpture
Adult Hobby Classes: Same courses as above, on and off campus classes
Summer School: Same courses as above

ROME

SHORTER COLLEGE, Art Dept, 315 Shorter Ave, Rome, GA 30165. Tel 706-291-2121; Fax 706-236-1515; Internet Home Page Address: www.shorter.edu; *Co-Chair* Brian Taylor; *Prof* Christine Colley
Estab 1873, dept estab 1900; pvt; D; Scholarships; SC 40, LC 7; non-maj 15, maj 20
Ent Req: HS dipl
Degrees: BA(Art) and BFA(Art Ed) 4 yr
Tuition: Res & nonres—$4325 per sem (12-19 hr)
Courses: Art Appreciation, Art Education, Art History, †Ceramics, Color Theory, Commercial Art, Design, †Drawing, Graphic Arts, Graphic Design, Illustration, †Mixed Media, †Painting, Photography, Printmaking, †Sculpture, Theatre Arts
Children's Classes: Enrl 20; tuition varies

SAVANNAH

ARMSTRONG ATLANTIC STATE UNIVERSITY, Art & Music Dept, 11935 Abercorn St, Savannah, GA 31419-1997. Tel 912-927-5325; Fax 912-921-5492; *Chmn* Dr Jim Anderson
FT 5, PT varies per sem; pub; D&E; Scholarships
Degrees: BA
Tuition: $261 per cr hr
Courses: Art Appreciation, Art Education, Art History, Ceramics, Design, Drawing, Handicrafts, Jewelry, Painting, Photography, Printmaking, Sculpture, Weaving
Adult Hobby Classes: Courses—Ceramics, Painting, Watercolors
Children's Classes: Enrl 30. Two wk session. Courses—Computer Art, Printing, Sculpture

SAVANNAH STATE UNIVERSITY, Dept of Fine Arts, PO Box 20512, Savannah, GA 31404. Tel 912-356-2248; Fax 912-353-3159; *Dir* Dr Peggy Blood, MA; *Asst Prof* Farnese Lumpkin, MA; *Asst Prof* Clara Aguero, MA; *Asst Prof* Roland C Wolff, MA
Estab 1880s, dept estab 1950s; pub; D & E; SC 13, LC 3
Ent Req: HS dipl
Degrees: BFA
Tuition: Res—$1700 per sem, nonres—$3800 per sem; campus res available
Courses: Advertising & Editorial Illustration, Art History, Basic Design, Calligraphy, Ceramics, Color Theory, Computer Design, Graphic Design, Interior Design, Painting, Photography, Sculpture, Textile Design, Weaving
Summer School: Dir, Dr Luetta Milledge. Enrl 60; tuition $180. Courses—on demand

STATESBORO

GEORGIA SOUTHERN UNIVERSITY, Dept of Art, PO Box 8032, Statesboro, GA 30460. Tel 912-681-5918, 681-5358; *Prof* Thomas Steadman, MFA; *Assoc Prof* Jessica Hines, MFA; *Assoc Prof* Dr Jane R Hudak, MFA; *Assoc Prof* Henry Iler, MFA; *Assoc Prof* Dr Bruce Little, MFA; *Assoc Prof* Onyile B Onyile, MFA; *Assoc Prof* Elizabeth Peak, MFA; *Assoc Prof* Dr Roy B Sonnema, MFA; *Asst Prof* Patricia Walker, MFA; *Asst Prof* Marie Cochran, MFA; *Temp Asst Prof* Greg Carter, MFA; *Temp Asst Prof* Patricia Carter, MFA; *Temp Asst Prof* Micheal Obershan, MFA; *Temp Asst Prof* Iris Sandkulher, MFA; *Temp Instr* Julie McGuire, MFA; *Head Dept* Richard Tichich, MFA
pub; D & E; Scholarships; SC, LC
Ent Req: HS dipl
Degrees: BA & BSEd 4 yr
Tuition: Res—undergrad $40 per qtr hr (1-11 hrs); nonres—undergrad $120 per qtr hr (1-11 hrs); campus res—room & board $515
Courses: Art Education, Art History, Ceramics, Commercial Art, Constructions, Drawing, Graphic Arts, Graphic Design, Lettering, Mixed Media, Painting, Photography, Printmaking, Sculpture, Teacher Training
Adult Hobby Classes: Enrl 40; tuition $35 per 10 wks. Courses—Painting, Photography
Children's Classes: Offered in Laboratory School & Sat Program

THOMASVILLE

THOMAS UNIVERSITY, (Thomas College) Humanities Division, 1501 Mill Pond Rd, Thomasville, GA 31792. Tel 229-226-1621, Ext 142; Fax 229-226-1653; Internet Home Page Address: www.thomas.edu; *Asst Prof of Art* James Adams; *Div Chmn* Ann Landis
Scholarships
Degrees: AA
Tuition: $250 per cr hr
Courses: Art Appreciation, Art Education, Drawing, Painting

Adult Hobby Classes: Enrl 30; 2 terms (quarters) per yr. Courses—Art Structure
Children's Classes: Courses offered on demand
Summer School: Enrl 60; summer quarter. Courses—same as regular yr

TIFTON

ABRAHAM BALDWIN AGRICULTURAL COLLEGE, Art & Humanities
Dept, 2802 Moore Hwy, ABAC Sta Tifton, GA 31794. Tel 912-386-3236,
386-3250; Internet Home Page Address: www.abac.peachnet.edu; Pres Homer Day
Degrees: Cert AA
Tuition: Res $832 per sem; non-res $2572 per sem
Courses: Art Appreciation, Art History, Design, Drawing, Painting

VALDOSTA

VALDOSTA STATE UNIVERSITY, Dept of Art, 1500 N Patterson St, Valdosta,
GA 31698-0110. Tel 229-333-5835; Fax 229-259-5121; Elec Mail
apearce@valdosta.edu; Dept Head A Blake Pearce
Estab 1906; Maintains nonprofit gallery, Valdosta State University Art Gallery; FT
16; pub; D&E; Scholarships; SC 25, LC 10; maj 270, total 10,400
Ent Req: SAT
Degrees: BA, BFA (Int Des) & BFA (Art Ed) 4 yr
Tuition: Res- $1,745 per sem; nonres- $5,586 per sem
Courses: Advertising Design, Aesthetics, Art Appreciation, †Art Education, Art
History, Ceramics, Collage, Commercial Art, Computer Graphics, Constructions,
Design, Drawing, Graphic Arts, Graphic Design, History of Art & Architecture,
Illustration, †Interior Design, Intermedia, Lettering, Mixed Media, Painting,
Photography, Portfolio Preparation, Printmaking, Sculpture, Teacher Training
Summer School: Tuition res—$155 per qtr hr for 4 or 8 wk term. Courses—Art
Appreciation, Computer Graphics, Design, Studio

YOUNG HARRIS

YOUNG HARRIS COLLEGE, Dept of Art, One College St, PO Box 68 Young
Harris, GA 30582. Tel 706-379-3111; Fax 706-379-4306; Internet Home Page
Address: www.yhc.edu; Chmn Richard Aunspaugh
Estab 1886; Maintain nonprofit art gallery; Clegg Art Gallery, PO Box 236, Young
Harris, GA 30582; FT 2; pvt; D; Scholarships; SC 5, LC 1; D 450, maj 25
Ent Req: HS dipl
Degrees: AFA 2 yr
Tuition: $6,360 per yr; room & board $11,500 per yr
Courses: Art Appreciation, Art History, Design, Drawing, Painting, Sculpture,
Stage Design, Theatre Arts

HAWAII

HONOLULU

HONOLULU ACADEMY OF ARTS, The Art Center at Linekona, 1111 Victoria
St, Honolulu, HI 96814; 900 S Beretania St Honolulu, HI 96814. Tel
808-532-8700; Fax 808-532-8787; Elec Mail webmaster@honoluluacadmey.org;
Internet Home Page Address: www.honoluluacademy.org; Cur Art Ctr Carol
Khewhok; Mike Nevin; Head Operational Robert White; Librn Ronald F
Chapman; Keeper Lending Gwen Harada; Cur Textiles Reiko Brandon; Specail
Events Vicki Reisner; Assoc Dir David J de la Torre; Pub Relations Dir Charlene
Aldinger; Dir Develop Judy Dawson; Cur Film Ann Brandman; VChmn Samuel A
Cooke; Registrar Sanna Saks Deutsch; Annual Fund Coordr Linda Grzywaca;
Mus Shop Mgr Kathee Hoover; Cur Educ Daren Thompson; Cur Asian Art Julia
White; Cur Western Art Jennifer Saville; Dir, CEO & Pres George R Ellis; CFO
Eric Watanabe
Estab 1946; FT 3, PT 1; pvt
Ent Req: 16 yrs of age with talent
Degrees: no degrees granted
Tuition: varies
Courses: Ceramics, Drawing, Etching, Lithography, Painting, Printmaking
Adult Hobby Classes: Tuition $130 per sem. Courses—Ceramics, Drawing,
Jewelry, Painting, Printmaking, Watercolors, Weaving
Children's Classes: tuition $95 for 11 wks. Courses—Drawing, Exploring Art,
Painting

HONOLULU COMMUNITY COLLEGE, Commercial Art Dept, 874
Dillingham Blvd, Honolulu, HI 96817. Tel 808-845-9211; Fax 808-845-9173;
Internet Home Page Address: www.hcc.hawaii.edu; Dept Head Sandra Sanpei;
Instr Commercial Art Michel Kaiser; Instr Graphic Arts Romolo Valencia, BA
College maintains three art departments: Commercial Art, Art & Graphic Arts;
pub; D & E; SC 20, LC 2; D 150 majors
Ent Req: 18 yrs of age, English & math requirements, motivation, interest in
learning, willingness to work
Degrees: AS 2 yr
Tuition: Res—$502 per sem; nonres—$2890 per sem
Courses: Advertising Design, Commercial Art, Drafting, Drawing, Graphic Arts,
Graphic Design, Illustration, Lettering, Painting, Photography, Printmaking, Textile
Design

UNIVERSITY OF HAWAII, Kapiolani Community College, 4303 Diamond
Head Rd, Honolulu, HI 96816. Tel 808-734-9282; Fax 808-734-9151; Chmn
Kauka de Silva
Estab 1965; FT 8, PT 7; pub; D & E; Scholarships; SC 11, LC 5; D 4800, E 500
Ent Req: ent exam
Degrees: AA and AS 1-2 yr

Tuition: No campus res
Courses: Art Appreciation, Art History, Ceramics, Computer Graphics, Conceptual
Art, Design, Drawing, History of Art & Architecture, Painting, Photography,
Sculpture
Adult Hobby Classes: Enrl 15 per class; tuition depends on number of units.
Courses—Art Appreciation, Art History, Ceramics, Color Theory, Computer
Graphics, Conceptual Art, Design

UNIVERSITY OF HAWAII AT MANOA, Dept of Art, 2535 McCarthy Mall,
Honolulu, HI 96822. Tel 808-956-8251; Fax 808-956-9043; Elec Mail
uhart@hawaii.edu; Internet Home Page Address: www.hawaii.edu/art; Dept Chair
Gaye Chan; Assoc Chair Frank Beaver; Dir Gallery Thomas Klobe
Estab 1907; FT 26, PT 25; pub; D; Scholarships; SC 64, LC 34; maj 450, grad 40
Ent Req: HS dipl or GED and SAT or ACT
Degrees: BA(Art History), BA(Studio), BFA 4 yr, MA & MFA
Tuition: Res—undergrad $126 per cr hr; grad $168 per cr hr; nonres—undergrad
$396 per cr hr; grad $415 per cr hr; campus res limited
Courses: Aesthetics, Art Appreciation, †Art History, Calligraphy, †Ceramics,
Design, †Drawing, †Fiber Arts, †Glass, Graphic Arts, †Graphic Design,
†Intermedia, Mixed Media, Museum Staff Training, †Painting, †Photography,
†Printmaking, Sculpture, Textile Design, Video
Adult Hobby Classes: Drawing, Painting, Sculpture
Summer School: Dean, Victor Kobayashi. Tuition $123 per cr hr, non res $130
per cr hr, plus fees. Courses—Art History (Western, Asian & Pacific), Ceramics,
Drawing, Design, Fiber, Glass, Painting, Photography, Printmaking, Sculpture

KAHULUI

MAUI COMMUNITY COLLEGE, Art Program, 310 Kaahumanu Ave, Kahului,
HI 96732. Tel 808-244-9181; Internet Home Page Address: mauicc.hawaii.edu;
Div Chmn Dorothy Pyle
Estab 1967; FT 1, PT 3; pub; D & E; Scholarships; SC 8, LC 2; 2600
Ent Req: ent exam
Degrees: AA, AAF, AS, 2 yr Cert (ACH)
Tuition: Res—$501 per sem; nonres—$2889 per sem
Courses: Advertising Design, Architecture, †Batik, †Ceramics, Copper Enameling,
Display, †Drawing, Graphic Arts, Graphic Design, History of Architecture,
†History of Art & Architecture, Jewelry, †Painting, †Photography, Sculpture,
†Textile Design, †Weaving, Welding
Adult Hobby Classes: Enrl 200. Courses—Art, Art History, Ceramics, Drawing,
Intro to Visual Art, Painting

LAIE

BRIGHAM YOUNG UNIVERSITY, HAWAII CAMPUS, Division of Fine
Arts, 55-220 Kulanui St, Laie, HI 96762. Tel 808-293-3211; Fax 808-293-3645,
293-3900; Chmn Dr Jeffrey Belnap
Scholarships
Degrees: BA
Tuition: Church mem $2035 per sem; non church mem $1837 per sem
Courses: †Ceramics, †Painting, Polynesian Handicrafts, †Printmaking, †Sculpture
Summer School: Dir, V Napua Tengaio. Tuition $60 per cr, 2 four wk blocks.
Courses—Ceramics, Polynesian Handicrafts

LIHUE

KAUAI COMMUNITY COLLEGE, Dept of Art, 3-1901 Kaumualii, Lihue, HI
96766. Tel 808-245-8284, 245-8226; Fax 808-245-8220; Faculty Wayne A Miyata,
MFA; Faculty Waihang Lai, MA
Estab 1965; FT 2, PT 1; pub; D & E; Scholarships; SC 6, LC 2; D 965, E 468
Ent Req: HS dipl
Degrees: AA and AS 2 yr
Tuition: Res—$43 per cr hr; nonres—$242 per cr hr
Courses: Art History, Ceramics, Drawing, Oriental Brush Painting, Painting,
Photography
Summer School: Term of 6 wk beginning June and July

PAHOA

KALANI OCEANSIDE RETREAT, 12-6860 Kalapana-Kapoho Beach Rd
Pahoa, HI 96778-9724. Tel 808-965-7828; Fax 808-965-0527; Elec Mail
kalani@kalani.com; Internet Home Page Address: www.kalani.com; Registrar
Donna Perry, BA; Arts Instr Arthur Johnson, BA; Genl Mgr Jared Sam, BA; Exec
Dir Richard Koob, MFA; Hawaiian Arts Linda Tomga; Crafts Carrie Musgrove;
Healing Arts Michael Cerado, LMT
Open daily 8 AM - 8 PM; Estab 1980, sch estab 1982; Maintain a nonprofit art
gallery; maintain an art/architecture library; pvt; D & E; Scholarships; SC 3, LC
2, Pleine airhealing 3, yoga & dance arts 10; D 4,000, E 4,000, all non-maj
Ent Req: written application form on www.kalani.com
Tuition: $8-$15 per 1-1/2hr class; campus res $20-$240 per night, $33-$120 with
scholarship discount
Courses: †Aesthetics, Collage, Costume Design & Construction, †Dance, Design,
Drawing, Graphic Arts, Graphic Design, Handicrafts, †Healing Arts, History of Art
& Architecture, Illustration, Mixed Media, Occupational Therapy, Painting,
†Performing, Photography, Printmaking, Textile Design, Theatre Arts, Weaving,
†Yoga
Adult Hobby Classes: Enrl 3,500; tuition approx $570-840 per wk.
Courses—Dance, Drawing, Music, Yoga
Children's Classes: Enrl 500; tuition approx $200 per wk, Art in Play
Summer School: Dir, Richard Koob. Enrl 400; tuition $300-500. Dance Festivals,
Music, Arts, Yoga

PEARL CITY

LEEWARD COMMUNITY COLLEGE, Arts & Humanities Division, 96-045 Ala Ike, Pearl City, HI 96782. Tel 808-455-0228; Fax 808-455-0638; Internet Home Page Address: www.lcc.hawaii.edu; *Dean* Dr Mark Silliman
Estab 1968; pub; D & E; Scholarships; SC 11, LC 3; D 400, E 100
Ent Req: over 18 yrs of age
Degrees: AA & AS 2 yrs
Tuition: Res—$32 per cr hr; nonres—$213 per cr hr
Courses: 2-D Design, 3-D Design, Art History, Aspects of Asian Art, Ceramics, Costume Design & Construction, Drawing, Graphic Arts, Painting, Photography, Printmaking, Sculpture, Theatre Arts
Summer School: Enrl 100; Term of 7 wks beginning June 12th. Courses—vary

IDAHO

BOISE

BOISE STATE UNIVERSITY, Art Dept, 1910 University Dr, Boise, ID 83725. Tel 208-426-1230; Fax 208-426-1243; Internet Home Page Address: www.boisestate.edu/art; *Chmn* Dr Gary Rosine
Estab 1932; pub; D & E; Scholarships; SC 51, LC 8, GC 4; D 2539, maj 550, GS 14
Ent Req: HS dipl
Degrees: BA, BFA, BA(Educ), BFA(Educ), BA(Graphic Design), BA (Art History), BFA(Graphic Design) 4 yr, MA(Art Educ) 4 yr
Tuition: Res—$1322 per sem; nonres—$4262 per sem
Courses: Architecture, †Art Education, Art History, †Art Metals, Ceramics, Design, Drawing, †Graphic Design, †Illustration, Painting, Photography, Printmaking, Sculpture
Summer School: Dir, Gary Rosine. Enrl 200; tuition $112.80 per cr hr for 5 wks. Courses—Art History, Basic Design, Elementary School Art Methods, Introduction to Art, Special Topics, Watercolor

COEUR D'ALENE

NORTH IDAHO COLLEGE, Art Dept, 1000 W Garden Ave, Coeur D'Alene, ID 83814. Tel 208-769-3300; Fax 208-769-7880; Internet Home Page Address: www.nic.edu; *Dept Chmn* Allie Vogt, MA; *Instr* Lisa Lynes, MA
Degrees: BA, AA
Tuition: Res—in county $564 per sem, $79 per cr hr, $69 each additional cr hr; nonres—$1942 per sem, $251 per cr hr,$241 each additional cr hr
Courses: Art Appreciation, Art History, Ceramics, Design, Drawing, Graphic Design, Illustration, Letter Form, Life Drawing, Painting, Photography, Portfolio, Professional Advertising, Sculpture, Stage Design, Weaving

LEWISTON

LEWIS-CLARK STATE COLLEGE, Art Dept, 500 Eighth Ave, Lewiston, ID 83501-2691. Tel 208-746-2341; Internet Home Page Address: www.lcsc.edu; *Prof* Lawrence Haapanen
Estab 1893; Maintains reference library; FT 1; pub; D & E; Scholarships; SC 10, LC 1; D 89, E 43
Ent Req: HS dipl or GED, ACT
Degrees: BA and BS 4 yrs
Tuition: Res—undergrad $600 per yr; nonres—undergrad $2300 per yr; PT (up to 7 cr) $40 per cr; campus res—room and board $1870 double room, $2070 single room
Courses: Art Education, Composition, Drawing, Graphic Arts, Independent Study, Painting, Stage Design, Teacher Training, Theatre Arts, Video
Adult Hobby Classes: Discipline Coordr, Robert Almquist, MFA

MOSCOW

UNIVERSITY OF IDAHO, Dept of Art & Design, PO Box 442471, Moscow, ID 83844-2471. Tel 208-885-6851; Fax 208-885-9428; Elec Mail artdesign@uidaho.edu; Internet Home Page Address: www.uidaho.edu/artdesign/; *Prof* Frank Cronk; *Prof* Lynne Haagenson; *Assoc Prof* Delphine Keim-Campbell; *Assoc Prof* Sally Machlis; *Dept Chmn* Jill Dacey; *Asst Prof* Ivan Castaneda; *Asst Prof* Gregory Turner-Rahman; *Prof & Dean CAA* William Woolston; *Gallery Dir & Lectr* Roger Rowley
Estab 1923; Maintains a nonprofit art gallery, Prichard Art Gallery, PO Box 444405, 416 S Main, Moscow, ID 83843; Pub; D & E; Scholarships; SC 35, LC 17, GC 14
Ent Req: HS dipl or equivalent
Degrees: BA, BS, BFA, MFA, MAT, Art Educ
Tuition: Res—undergrad $2,100 per sem, grad $2,370 per sem; nonres—undergrad $6,900 per sem, grad $7,170 per sem
Courses: †Art Education, Art History, Ceramics, Graphic Design, Information Design, Interaction Design, Painting, Photography, Printmaking, Sculpture, Visual Communication, Visual Culture
Summer School: Courses—vary

NAMPA

NORTHWEST NAZARENE COLLEGE, Art Dept, 63 Holly, Nampa, ID 83686. Tel 208-467-8011; Internet Home Page Address: www.nnu.edu; *Art Head* Jim Willis
FT 3; Den; D & E; Scholarships; SC 12, LC 5; D 200, E 40, maj 24

Ent Req: HS dipl
Degrees: BA & BS 4 yr
Tuition: Undergrad $352 per cr hr; grad $352 per cr hr
Courses: Art Education, Ceramics, Crafts for Teachers, Drawing, Graphic Design, History of Art & Architecture, Illustration, Painting, Printmaking, Sculpture, Teacher Training
Adult Hobby Classes: Crafts, Painting
Summer School: Courses—Art Education

POCATELLO

IDAHO STATE UNIVERSITY, Dept of Art, 1010 S Fifth, PO Box 8004 Pocatello, ID 83209. Tel 208-282-2361, 282-2488; Fax 208-282-4741; Elec Mail kovarudo@isu.edu; Internet Home Page Address: www.isu.edu; *Chmn* Rudy Kovacs, MFA; *Faculty* Doug Warnock; *Faculty* Dr Miles E Friend PhD; *Faculty* Scott Evans, MFA; *Faculty* Tony Martin, MFA; *Faculty* Gail Dial, MFA; *Faculty* Robert Granger, MFA
Estab 1901; pub; D & E; Scholarships; SC 32, LC 6, GS 22; maj 75, GS 15, total 500
Ent Req: HS dipl, GED, ACT
Degrees: BA, BFA and MFA 4 yr
Tuition: Nonres--$230 per cr hr; res--$140 per cr hr
Courses: Art Education, Art History, Ceramics, Design, Drawing, Metals, Painting, Printmaking, Sculpture, Weaving
Adult Hobby Classes: Enrl 20; tuition $45 for 6 wk term. Courses—Drawing, Landscape Painting
Children's Classes: Enrl 20; tuition $40 for 8 wk term. Courses—Vary
Summer School: Dir/Chair, Rudy Kovacs. Enrl 75. Courses—Art History, Ceramics

REXBURG

RICKS COLLEGE, Dept of Art, 16 E Main St, Rexburg, ID 83460. Tel 208-356-2913, 356-4871; *Instr* Scott Franson; *Instr* Vince Bodily; *Instr* Gerald Griffin; *Instr* Mathew Geddes; *Instr* Leon Parson; *Instr* Gary Pearson; *Chmn* Kelly Burgner
Estab 1888; pvt; D & E; Scholarships; SC 23, LC 1; D 123, maj 123
Ent Req: HS dipl
Degrees: AAS, AAdv Design and AFA 2 yrs
Tuition: $920
Courses: Art Appreciation, Art Education, Art History, Ceramics, Drawing, †Fine Art, †Graphic Design, Illustration, Painting, †Photography, Typography
Adult Hobby Classes: Enrl 150. Courses—Art History, Introduction to Visual Arts
Summer School: Dir, Jim Gee. Enrl 370; tuition $60 per cr hr. Courses—Art History, Ceramics, Drawing, Graphic Design, Illustration, Photography

SUN VALLEY

SUN VALLEY CENTER FOR THE ARTS & HUMANITIES, Dept of Fine Art, PO Box 656, Sun Valley, ID 83353. Tel 208-726-9491; Fax 208-726-2344; Internet Home Page Address: www.sunvalleycenter.org; *Visual Arts Dir* Kristine Poole; *Dir Educ* Heather Crocker; *Exec Dir* Gay Weake
Estab 1971
Tuition: $8-$9 per class instruction; members $8-$9 per class; non members $10-$11 per class
Adult Hobby Classes: Calligraphy, Ceramics, UFE Drawing
Children's Classes: Enrl vary per sem. Courses—Ceramics, Musical Theatre Workshop
Summer School: Dir, Roberta Heinrich. Tuition $100-$200 per wk. Courses—Ceramics, Mixed Media, Painting from Nature, Photography, Watercolor

TWIN FALLS

COLLEGE OF SOUTHERN IDAHO, Art Dept, PO Box 1238, Twin Falls, ID 83303. Tel 208-733-9554, Ext 344; Fax 208-736-3014; Internet Home Page Address: www.csi.cc.id.us; WATS 800-680-0274; *Assoc Prof* Russell Hepworth, MFA; *Chmn* Mike Green, MFA
Estab 1965; pub; D & E; Scholarships; SC 26, LC 2; D 3000, E 2000, non-maj 50, maj 45
Ent Req: HS dipl, ACT
Degrees: dipl or AA
Tuition: Res—undergrad $550 per yr; nonres—undergrad $1350 per yr; campus res—room & board
Courses: Art History, Ceramics, Design, Drawing, Lettering, Mixed Media, Painting, Papermaking, Photography, Printmaking, Sculpture, Theatre Arts
Adult Hobby Classes: Enrl 100; tuition $35 per class. Courses—Photography, Pottery, Printmaking
Children's Classes: Enrl 50; tuition $20 per class. Courses—Crafts, Drawing, Photography, Pottery
Summer School: Dir Jerry Beck. Courses—Art General, Crafts, Drawing, Papermaking, Pottery

ILLINOIS

AURORA

AURORA UNIVERSITY, Art Dept, 347 S Gladstone Ave, Aurora, IL 60506. Tel 630-844-5519, 892-7431; Fax 630-844-7830; Elec Mail slowery@aurora.edu; Internet Home Page Address: www.aurora.edu; *Prof* Stephen Lowery, MFA

Estab 1893, dept estab 1979; Maintain nonprofit art gallery; Downstairs Dunham Gallery, Dunham Hall; pvt; D & E; SC 7, LC 1; D 102, E 96, non-maj 171
Ent Req: HS dipl
Degrees: BA 4 yrs
Tuition: $16,000 per yr; campus res—$5328
Courses: 2-D Design, 3-D Design, Art Appreciation, Drawing, Media Technology, Painting, Photography, Sculpture
Summer School: Courses—Photography, Media Technology

BELLEVILLE

SOUTHWESTERN ILLINOIS COLLEGE, (Belleville Area College) Art Dept, 2500 Carlyle Ave, Belleville, IL 62221. Tel 618-235-2700; Internet Home Page Address: www.southwestern.cc.il.us; *Dept Head* Jerry Bolen
Estab 1948; pub; D & E; Scholarships; SC 36, LC 9; D 4000, E 3500, maj 200
Ent Req: HS dipl
Degrees: AA and AS 2 yrs
Tuition: $48 per cr hr
Courses: Advertising Design, Art Appreciation, Art Education, Art History, Calligraphy, Ceramics, Commercial Art, Design, Drawing, Film, Graphic Arts, Graphic Design, History of Art & Architecture, Jewelry, Lettering, Painting, Photography, Printmaking, Sculpture, Theatre Arts, Video
Summer School: Dept Head, Jerry Bolen. Tuition $30 per hr for 8 wks. Courses—Art History, Ceramics, Drawing, Photography

BLOOMINGTON

ILLINOIS WESLEYAN UNIVERSITY, School of Art, PO Box 2900, Bloomington, IL 61702-2900. Tel 309-556-1000 (information), 556-3077 (school of art), 556-3134 (Dir); Internet Home Page Address: www.iwu.edu; *Instr* Connie Wells, MFA; *Instr* Therese O'Halloran, MFA; *Instr* Timothy Garvey PhD, MFA; *Instr* Kevin Strandberg, MFA; *Instr* Sherri McElroy, MS; *Dir* Miles Bair, MA
Estab 1855, school estab 1946; pvt; D; Scholarships; non-maj 150, maj 60
Ent Req: HS dipl, SAT or ACT
Degrees: BA, BFA
Tuition: $18,250, room & board & tuition $23,200
Courses: Art History, Ceramics, Drawing, Graphic Design, Painting, Photography, Printmaking, Sculpture

BOURBONNAIS

OLIVET NAZARENE UNIVERSITY, Dept of Art, One University Ave Bourbonnais, IL 60915. Tel 815-939-5229, 939-5172; Fax 815-939-5112; Elec Mail bgreiner@olivet.edu; Internet Home Page Address: www.olivet.edu; *Prof & Chair* William Greiner
Estab 1907, dept estab 1953; Maintain a nonprofit art gallery: Brandenburg Gallery, Larsen Fine Arts Bldg; FT 3, PT 3; den; D & E; Scholarships; SC 14, LC 4; D 100, non-maj 80, maj 21
Ent Req: HS dipl
Degrees: MBA, BS & BA 4 yrs, MEd & MTheol 2 yrs
Tuition: $11,780 per yr, $5,589 per sem, $310 per sem hr; campus res—room & board $2,348 per sem
Courses: †Art Education, Art History, †Ceramics, Drawing, Film, Graphic Arts, Graphic Design, Lettering, †Painting, Photography, Printmaking, Sculpture, Teacher Training, Textile Design

CANTON

SPOON RIVER COLLEGE, Art Dept, Canton, IL 61520. Tel 309-647-4645; Fax 309-647-6498; Internet Home Page Address: www.spoonrivercollege.net; *Instr* Tracy Snowman; *Dir* Dr Sue Spencer
College maintains three campuses; Scholarships
Degrees: AA
Tuition: $42 per cr hr
Courses: Ceramics, Design, Drawing, Painting, Sculpture

CARBONDALE

SOUTHERN ILLINOIS UNIVERSITY, School of Art & Design, Mail Code 4301, Carbondale, IL 62901-4301. Tel 618-453-4315; Fax 618-453-7710; Internet Home Page Address: www.artanddesign.siu.edu; *Dir & Prof* Harris Deller, MFA; *Undergrad Admissions* Valerie Brooks, MS Ed; *Prof* Edward Shay, MFA; *Assoc Prof & Studio Area Head* Jerry Monteith, MFA; *Assoc Prof* Larry S Briggs, BFA; *Asst Dir & Assoc Prof* Kay M Zivkovich, MFA; *Assoc Prof* Erin Palmer, MFA; *Assoc Prof & Studio Area Head* Richard E Smith, MFA; *Assoc Prof* Carma Gorman PhD; *Assoc Prof* Peter Chametzky, PhD; *Asst Prof* Jiyong Lee, MFA; *Asst Prof* Najjar Abdul-Musawwir, MFA; *Assoc Prof & Design Area Head* Steve Belletire, BFA; *Asst Prof* Jason Howell, MFA; *Assoc Prof* Xuhong Shang, MFA; *Asst Prof* Colleen Ludwig, MFA; *Asst Prof* Peter Storkerson, Ph.D; *Asst Prof* Chris Wildrick, MFA; *Asst Prof* Pattie Chalmers, MFA; *Asst Prof* Elina Gertsman, PhD; *Asst Prof* Stacey Sloboda, PhD; *Asst Prof* Alex Lopez, MFA; *Asst Proff & Head Undergrad Studies* Sally Gradle, PhD; *Coordr Visual Resources/Facilitator Web Enhanced Curriculum* Eric Peterson, BA; *Asst Prof* Jason Urban, MFA
Estab 1874; Maintain nonprofit art library - School of Art & Design Surplus Gallery at the Glove Factory, 432 S Washington, SIUC, Carbondale, IL 62901, School of Art Design, Vergette Gallery, located on the first floor of the Allyn Bldg, in room 107; art supplies available on-campus; pub; D & E; Scholarships; SC 100, LC 24, GC 28; D 1304, E 338, non-maj 400, maj 400, grad 60, others 400
Ent Req: HS dipl, upper 50 percent of class, ACT
Degrees: BA, BFA & BS 4 yrs, MFA 3 yrs

Tuition: Res—undergrad $3,317, grad $3906, undergrad $194 per cr hr, grad $243 per cr hr; nonres—undergrad $6,801, grad $8,280 per sem, unergrad $484 per cr hr, grad $608 per cr hr; campus res—available
Courses: Advertising Design, Aesthetics, Architecture, †Art Education, †Art History, Art for Elementary Education, †Blacksmithing, †Ceramics, Collage, Commercial Art, †Communication Design, Conceptual Art, Constructions, Drafting, †Drawing, Fashion Arts, †Foundry, †Glassblowing, Goldsmithing, Graphic Arts, †Industrial Design, †Jewelry, Lettering, Mixed Media, Museum Staff Training, †Painting, †Printmaking, †Sculpture, Silversmithing, †Teacher Training, Web Design
Adult Hobby Classes: Drawing, Jewelry, Painting
Children's Classes: Enrl 150; tuition $30 per 4-6 wk term. Courses—Ceramics, Drawing, Fibers, Jewelry, Mask-Making, Painting, Papermaking, Printing, Sculpture, 3-D Design
Summer School: 500; tuition undergrad res $177 per hr, grad res $216 for term of 2-8 wks beginning May. Courses—selection from regular courses
—Applied Arts, 250 E Park, Mail Code 6721 Carbondale, IL 62901. Tel 618-453-8863; *Prog Rep* David White
Art Dept estab 1960; 5; pub; D; D 65, maj 65
Ent Req: HS dipl, ent exam
Degrees: AAS 2 yr, BS 4 yr
Tuition: Res—undergrad $75.00 per cr hr; nonres—undergrad $225.00 per cr hr
Courses: Air Brush & Photo Retouching, Drawing, Graphic Design

CARLINVILLE

BLACKBURN COLLEGE, Dept of Art, 700 College Ave, Carlinville, IL 62626. Tel 217-854-3231, Ext 235; Fax 217-854-3713; Internet Home Page Address: www.blackburn.edu/; *Prof* James M Clark, MFA; *Chmn* Melba Buxbaum
Estab 1837; FT 2, PT 2; pvt; D & E; Scholarships; SC 14, LC 7; maj 15
Ent Req: HS grad
Degrees: BA 4 yrs
Tuition: $6500 per yr; room & board $2700
Courses: †Art History, Ceramics, Drawing, Painting, Printmaking, Sculpture, Studio Art, †Teacher Training, Theatre Arts

CHAMPAIGN

UNIVERSITY OF ILLINOIS, URBANA-CHAMPAIGN, College of Fine & Applied Arts, 608 E Lorado Taft Dr, Champaign, IL 61820. Tel 217-333-1661; *Interim Dean* Robert Graves, PhD; *Assoc Dean* Lew Hopkins; Melissa Madsen
Estab 1931; FT 268, PT 150; pub; D; Fellowships; underg 2000, grad 750
Ent Req: HS grad, ent exam
Degrees: bachelors 4 yrs, Masters, Doctorate
Adult Hobby Classes: Scheduled through University Extension
Children's Classes: Sat; summer youth classes
Summer School: courses offered
—School of Art & Design, 143 Art & Design Bldg, 408 E Peabody Dr Champaign, IL 61820. Tel 217-333-0855; Fax 217-244-7688; *Dir School* David Weightman; *In Charge Art Educ* Paul Duncum, PhD; *In Charge Art Educ* Julia Kellman, PhD; *In Charge History* David O'Brien, PhD; *In Charge Ceramics* Ron Kovatch, MFA; *In Charge Graphic Design* Jennifer Gunji, MFA; *In Charge Industrial Design* William Bullock, MFA; *In Charge Painting and Sculpture* Tim Van Laar, MFA; *In Charge Photography* Ernesto Scott, MFA; *In Charge Metals* Billie Theide, MFA
Estab 1867, dept estab 1877; pub; D & E; Scholarships; SC 119, LC 72, GC 77; maj 521, grad 100, others 10
Ent Req: HS dipl, ACT, SAT, CLEP
Degrees: BFA 4 yrs, MA 2 yrs, MFA 2-3 yrs, EdD & PhD 5 yrs
Tuition: Res—undergrad $8542 per yr, $4271 per sem; res—grad $8358 per yr, $4179 per sem; nonres—undergrad $22,628 per yr, $11,314 per sem, nonres—grad $21,168 per yr, $10,584 per sem; campus res—room & board $7716 for double
Courses: Art Education, Art History, Drawing, Graphic Design, Industrial Design, Metals, Mixed Media, Painting, Photography, Printmaking, Sculpture, †Video
Adult Hobby Classes: Enrl 150; tuition varies. Courses—Art History, Art Education, Studio
Children's Classes: 220; tuition $75 per sem. Courses—Creative Arts for Children
Summer School: Courses—foundation & lower division courses with some limited offerings & independent study at upper division & graduate levels

CHARLESTON

EASTERN ILLINOIS UNIVERSITY, Art Dept, 600 Lincoln Ave Charleston, IL 61920. Tel 217-584-6199; Internet Home Page Address: www.eiu.edu/~artdept; *Dept Chmn* Glenn Hild; *Prof* Suzan Braun, MFA; *Prof* Melinda Hegarty, PhD; *Prof* Denise Rehm-Mott, MFA; *Prof* Charles Nivens, MFA; *Prof* Janet Marquardt-Cherry MFA, PhD; *Prof* Mary Leonard-Cravens, MFA; *Prof* Jeff Boshart, MFA; *Assoc Prof* Katherine Bartel, MFA; *Assoc Prof* David Griffin MFA, MFA; *Assoc Prof* Eugene Harrison, PhD; *Assoc Prof* Dwain Naragon, MFA; *Asst Prof* Stephen Eskilson, PhD; *Asst Prof* Patricia Belleville, PhD; *Asst Prof* Chris Kahler, MFA; *Asst Prof* Ke-Hsin Chi, MFA
Estab 1895, dept estab 1930; FT 18, PT 6; pub; D & E; Scholarships; SC 60, LC 19, GC 27; non-maj 754, maj 249, grad 8
Ent Req: HS dipl, ACT, grad - MAT or GRE
Degrees: BA 4 yrs, MA 1 yr, Specialist Educ 2 yrs
Tuition: Res—undergrad $3898 per yr, grad $4034.40 per yr; nonres—undergrad $8926 per yr, grad $9328 per yr, $330.95 per sem hr; campus res—available
Courses: Art Appreciation, †Art Education, Art History, Ceramics, Drawing, †Graphic Design, Jewelry, Painting, Printmaking, Sculpture, Studio Art
Summer School: Dept Chmn, Glenn Hild, MFA. Enrl 200; tuition undergrad $1615. grad $1675 for 8 wk term beginning in June. Courses—Same as regular session

CHICAGO

AMERICAN ACADEMY OF ART, 332 S Michigan Ave, Chicago, IL 60604-4302. Tel 312-461-0600; Fax 312-294-9570; Elec Mail info@aaart.edu; Internet Home Page Address: www.aaart.edu; *Dir Educ* Duncan J Webb; *Pres* Richard H Otto
Estab 1923; Maintain nonprofit gallery, Bill L Parks Gallery, on-site; Art & Architecture Library: Irving Shapiro Library, on-site; FT 17, PT 22; pvt; D & E; Scholarships; SC 13, LC; D 396, E 3, Maj 394, Grad 5
Ent Req: HS dipl, portfolio
Degrees: BFA & MFA
Tuition: $10,340 per sem, $20,680 per yr
Courses: †Advertising Design, Art History, Commercial Art, Design, †Drawing, †Electronic Design, Graphic Arts, †Graphic Design, History of Art & Architecture, †Illustration, †Painting

CITY COLLEGES OF CHICAGO
—Daley College, Tel 773-838-7721; Internet Home Page Address: www.cc.edu/daley/; *Prof* A Lerner; *Prof* T Palazzolo; *Prof* C Grenda; *Prof* M Rosen; *Prof* D Wiedemann; *Chmn* David Riter
Estab 1960; 5500
Degrees: AA
Tuition: In-county res— $47.50 per cr hr; out-of-county res—$140.36 per cr hr; out-of-state res—$210.45 per cr hr
Courses: Architecture, Art Appreciation, Art History, Ceramics, Design, Drawing, Handicrafts, Painting, Photography, Weaving
—Kennedy-King College, Tel 773-602-5000; Internet Home Page Address: www.ccc.edu/kennedyking/; *Chmn* Dr Thomas Roby
Estab 1935; Enrl 9010
Degrees: AA, AS
Tuition: In-county res—$47.50 per cr hr; out-of-county res—$92.86 per cr hr; out-of-state res—$162.85 per cr hr
Courses: Art Appreciation, Ceramics, Humanities, Painting, Photography
—Harold Washington College, Tel 773-553-6065; 5600; Internet Home Page Address: www.ccc.edu/hwashington/; *Chmn Humanities* Paul Urbanick
Estab 1962; Enrl 8000
Degrees: AA, AS
Tuition: In-county res—$47.50 per cr hr; out-of-county res—$145.48 per cr hr; out-of-state res—$204.34 per cr hr
Courses: Art Appreciation, Ceramics, Commercial Art, Humanities, Painting, Photography, Printmaking, Sculpture
—Malcolm X College, Tel 312-850-7324; Fax 773-850-3323; Internet Home Page Address: www.cc.edu/malcolmx/; *Asst Prof* Barbara J Hogu; *Chmn Humanities* Mark Schwertley
Estab 1911; Enrl 5000
Degrees: AA
Tuition: In-county res—$47.50 per cr hr; out-of-county res—$92.86 per cr hr
Courses: Art Appreciation, Drawing, Freehand Drawing, Individual Projects
—Olive-Harvey College, Tel 773-291-6530; 6534; Internet Home Page Address: www.ccc.edu/oliveharvey/acaddep/humani/index; *Chmn Humanities* Richard Reed
Estab 1957; Enrl 4700
Degrees: AA, Liberal Arts
Tuition: In-county res—$47.50 per cr hr; out-of-county res—$98.86 per cr hr; out-of-state res—$162.85 per cr hr
Courses: Art Appreciation, Arts & Crafts, Ceramics, Color Photography, Painting, Photography, Visual Arts Photography
—Truman College, Tel 773-907-4062; Fax 773-907-4464; Internet Home Page Address: www.ccc.edu/truman; *Chmn Humanities* Dr Michael Swisher
Estab 1956; Enrl 3800
Degrees: AA, AAS
Tuition: In-county res—$47.50 per cr hr; out-of-county res—$92.86 per cr hr; out-of-state res—$162.85 per cr hr
Courses: Ceramics, Painting, Photography
—Wright College, Tel 773-481-8365; Internet Home Page Address: www.ccc.edu/wright/; *Chmn* James Mack
Estab 1934; FT 3; pub; D & E; SC 15, LC 8; D 3000, E 2500
Ent Req: HS dipl
Degrees: AA, AS
Tuition: In-county res— $47.50 per cr hr; out-of-county res—$92.86 per cr hr; out-of-state res—$162.85 per cr hr
Courses: Arts & Crafts, Ceramics, Drawing, Lettering, Painting, Photography, Sculpture, Visual Arts
Adult Hobby Classes: Enrl 400; tuition $15 per course for 6 or 7 wks. Courses—Drawing, Fashion, Painting, Watercolor
Summer School: Dir, Roy LeFevour. Enrl 24; 8 wk session. Courses—Vary

COLUMBIA COLLEGE, Art Dept, 600 S Michigan Ave, Chicago, IL 60605. Tel 312-663-1600; Fax 312-987-9893; *Coordr Graphics* Marlene Lipinski, MFA; *Architectural-Grad Studies & Coordr Interior Design* Joclyn Oats, BFA; *Coordr Fine Arts* Tom Taylor, BFA; *Coordr Illustration* Fred Nelson, BFA; *Coordr Fashion Design* Dennis Brozynski, BFA; *Coordr Pkg Designs* Kevin Henry, BFA
Estab 1893; pvt; D & E; Scholarships; SC 43, LC 17
Ent Req: HS dipl
Degrees: BA 4 yrs, MFA
Tuition: Res—undergrad $5800 per sem, $396 per cr hr; no campus res
Courses: Advertising Design, Architecture, Art Education, Art History, Calligraphy, Ceramics, Commercial Art, Drafting, Drawing, Fashion Arts, Film, Graphic Arts, Graphic Design, Handicrafts, Illustration, Industrial Design, Interior Design, Jewelry, Mixed Media, Painting, Printmaking, Sculpture, Silk Screen, Typography

CONTEMPORARY ART WORKSHOP, 542 W Grant Pl, Chicago, IL 60614. Tel 773-472-4004; Fax 773-472-4004; *Instr Apprentice Prog* John Kearney
Estab 1949. Twenty artists studios are available to artists for a modest fee on a month to month basis; Maintain nonprofit art gallery; Pub; D & E
Ent Req: none, studio artists are juried

Degrees: none, we offer an apprentice program in sculpture
Tuition: $55 per month
Courses: †Sculpture Workshop Space
Adult Hobby Classes: Tuition $110 for 10 wks. Courses—Sculpture
Summer School: Dir, Paul Zakoian. Tuition $110 for 10 wks. Summer courses—Sculpture

DEPAUL UNIVERSITY, Dept of Art, College of Liberal Arts & Sciences, 1150 W Fullerton Chicago, IL 60614. Tel 312-362-8194; Fax 312-362-5684; Internet Home Page Address: www.depaul.edu; *Gallery Dir* Robert Tavani, MFA; *Prof* Robert Donley, MFA; *Assoc Prof* Simone Zurawski PhD, MFA; *Assoc Prof* Elizabeth Lillehoj PhD, MFA; *Assoc Prof* Bibiana Swarez, MFA; *Asst Prof* Jenny Morlan, MFA; *Asst Prof* Paul Jaskot PhD, MFA; *Asst Prof* Mark Pohlad PhD, MFA; *Chmn Dept* Stephen Luecking, MFA
Estab 1897, dept estab 1965; pvt; D; Scholarships; SC 20, LC 12; D 150 art maj
Ent Req: HS dipl, SAT or ACT
Degrees: BA(Art) 4 yrs
Tuition: All tuition fees are subject to change, contact admissions office for current fees; campus res available
Courses: †Advertising Design, Aesthetics, Architecture, Art Appreciation, †Art History, Ceramics, Computer Graphics, Design, †Drawing, Film, Graphic Arts, †Graphic Design, Illustration, Intermedia, Mixed Media, †Painting, †Photography, †Printmaking, †Sculpture, Studio Art, †Video
Summer School: Chmn, Stephen Luecking

HARRINGTON INSTITUTE OF INTERIOR DESIGN, Harrington Coll Design, 200 W Madison St, 2nd Fl Chicago, IL 60606-3433. Tel 312-939-4975; Fax 312-939-8005; Internet Home Page Address: www.interiordesign.edu; *Dept Chair* Crandon Gustafson
Estab 1931; pvt; D & E; Scholarships; D 220, E 209
Ent Req: HS dipl, interview
Degrees: AA & BA(interior design)
Tuition: $9920 per yr, $4960 per sem; campus res—room & board $4420
Courses: Interior Design
Adult Hobby Classes: Enrl 209; tuition $2322 per sem, 3 yr part-time prog. Courses—Interior Design

THE ILLINOIS INSTITUTE OF ART - CHICAGO, 350 N Orleans, Ste 136-L Chicago, IL 60654. Tel 312-280-3500; Fax 312-280-8562; Internet Home Page Address: www.ilic.artinstitutes.edu; *Pres* John Jenkins; *A A to Pres* Allison Santos; *Dir Admis* Janis K Anton; *Dean Acad Affairs* Sandra Graham; *Dir Financial Services* Robert Smetak; *Dean Student Affairs* Betty Kourasis; *Dir Housing* Valerie Rand; *Librn* Juliet S Teipel; *Registrar* Luciana Stabila
Estab 1916; pvt; D & E, yr-round; Scholarships; SC 7, LC, GC; 2170 total
Ent Req: HS dipl, portfolio review
Degrees: BA, AAS, BFA
Tuition: $335 per credit
Courses: Advertising, Culinary Arts, Culinary Management, Digital Filmmaking & Video Production, Fashion Design, Fashion Marketing & Management, Fashion Merchandising, Fashion Production, Game Art & Design, General Education, Graphic Design, Interactive Media Design, Interactive Media Production, Interior Design, Media Arts & Animation, Visual Communications, Visual Effects of Motion Graphics

ILLINOIS INSTITUTE OF TECHNOLOGY
—College of Architecture, Tel 312-567-3262; Fax 312-567-8871; Elec Mail arch@iit.edu; Internet Home Page Address: www.arch.iit.edu; *Assoc Prof* Peter Beltemacchi; *Studio Prof* Dirk Denison; *Dean* Donna Robertson; *Assoc Prof* Paul Thomas; *Prof* Mahjoub Elnimeiri; *Prof* Peter Land; *Assoc Prof* David Hovey; *Assoc Prof* George Schipporeit; *Assoc Prof* David Sharpe; *Assoc Prof* Arthur Takeuchi; *Asst Dean for Student Affairs* Dr Lee W Waldrep
Estab 1895 as Armour Institute, consolidated with Lewis Institute of Arts & Sciences 1940; FT 23; pvt; 345
Degrees: BA 5 yr, MA 3 yr
Tuition: $15,000 per yr
Courses: Architecture
Summer School: Term June 15 through August 8
—Institute of Design, Tel 312-595-4900; Fax 312-595-4901; Elec Mail whitney@id.iit.edu; Internet Home Page Address: www.id.iit.edu/; *Dir* Patrick Whitney
Estab 1937; FT 10, PT 29; pvt; D; Scholarships; D 150
Degrees: BS 4 yr, MD, PhD(Design)
Tuition: Undergrad $9300per sem, grad $11,315 per sem
Courses: Industrial Design, Photography, Visual Communications

LOYOLA UNIVERSITY OF CHICAGO, Fine Arts Dept, 6525 N Sheridan Rd, Chicago, IL 60626. Tel 773-508-2820; Fax 773-508-2282; Internet Home Page Address: www.luc.edu; *Prof Emeritus* Ralph Arnold, MFA; *Prof Emeritus* Juliet Rago, MFA; *Assoc Prof* James Jensen, MFA; *Assoc Prof* Judith Dewell PhD, MFA; *Assoc Prof* Marilyn Dunn PhD, MFA; *Assoc Prof* Brian Fiorentino, MFA; *Assoc Prof* Patricia Hernes, MFA; *Assoc Prof* Eliza Kenney, MM; *Assoc Prof* Frank Voduarka, MFA; *Assoc Prof* Paula Wisotzki PhD, MFA; *Assoc Prof* Dorothy Dwight, MM; *Assoc Prof* Michel Balasis, MFA; *Assoc Prof* Nicole Ferentz, MFA; *Chmn Fine Arts Dept* Eugene Geimzer, MFA
Estab 1870, dept estab 1970; PT 25; den; D & E; Scholarships; SC 25, LC 17
Degrees: BA 4 yr
Tuition: $16,600 per yr, $8300 per sem, $336 per hr; campus res—room & board $5412-$6700 per yr
Courses: Advertising Design, Aesthetics, Art Appreciation, †Art History, †Ceramics, Commercial Art, Computer Graphics, †Design, †Drawing, Graphic Design, History of Art & Architecture, Jewelry, †Painting, †Photography, †Printmaking, Sculpture, †Visual Communications
Summer School: Dir, Dr Mark Wolff. Courses—Art Appreciation, Art History, Ceramics, Drawing, Painting, Photography

NORTH PARK UNIVERSITY, (North Park College) Art Dept, 3225 W Foster, Chicago, IL 60625. Tel 773-244-5622, 6200; Fax 773-583-0858; Internet Home

Page Address: www.campus.northpark.edu/art; *Chmn Dept* Neale Murray, MA; *Asst Prof* Kelly Vanderbrug; *Asst Prof* David Johanson
Estab 1957; PT2; den; D & E; Scholarships; SC 18, LC 5; D 40
Ent Req: HS dipl
Degrees: BA 4 yrs
Tuition: Res— & nonres—undergrad $16,910 per yr; campus res—room & board $5480 per yr
Courses: Advertising Design, Aesthetics, Art Education, Art History, Calligraphy, Ceramics, Commercial Art, Drawing, Illustration, Painting, Photography, Printmaking, Sculpture, Teacher Training
Summer School: Enrl 25; tuition $200 course for term of 8 wks beginning June 12. Courses—Ceramics, Drawing, Painting, Sculpture

NORTHEASTERN ILLINOIS UNIVERSITY, Art Dept, 5500 N St Louis, Chicago, IL 60625. Tel 773-442-4100; Fax 773-442-4920; Internet Home Page Address: www.neiu.edu; *Chmn* Mark P McKernin
Estab 1969; Maintain nonprofit art gallery, Fine Arts Gallery, 550 N St Louis Ave, Chicago, IL 60625; Pub; D & E; Scholarships; SC 44, LC 22; total 10,200, maj 175, grad 1,583, others 798
Ent Req: HS dipl, GED, upper half high school class or higher ACT
Degrees: BA 4 yrs
Courses: Art Education, Art History, Ceramics, Commercial Art, Computer Graphics, Drawing, Graphic Arts, Jewelry, Painting, Photography, Printmaking, Sculpture

SAINT XAVIER UNIVERSITY, Dept of Art & Design, 3700 W 103rd St, Chicago, IL 60655. Tel 773-779-3300; Fax 773-779-9061; Internet Home Page Address: www.sxu.edu; *Assoc Prof* Mary Ann Bergfeld, MFA; *Assoc Prof* Brent Wall, MFA; *Assoc Prof* Michael Rabe PhD, MFA; *Assoc Prof* Cathie Ruggie Saunders, MFA; *Assoc Prof* Monte Gerlach, MS; *Chmn* Jayne Hileman, MFA; *Instr* Nathan Peck
Estab 1847, dept estab 1917; Nonprofit gallery - Gallery/Art & Design, Saint Xavier Un, 3700 W 103rd St, Chicago, Il 60655; FT6; pvt; D & E; Scholarships; SC 35, LC 15; D 50, E 5, maj 75, others 250
Ent Req: HS dipl
Degrees: BA & BS 4 yrs
Tuition: $500 per cr hr; campus res availr
Courses: Art Business, Art Education, Art History, Ceramics, †Collage, Drawing, Film, Graphic Design, †History of Art & Architecture, Illustration, Painting, Photography, Printmaking, Sculpture, Teacher Training, Video
Adult Hobby Classes: Enrl 15-20; tuition $20-$40 per course.
Courses—Drawing, Calligraphy, Painting, Photography
Summer School: Dir, Richard Venneri. Tuition $242 per cr hr for term of 6 wks beginning June 1. Courses—Various studio courses

SCHOOL OF THE ART INSTITUTE OF CHICAGO, 37 S Wabash, Chicago, IL 60603. Tel 312-899-5100; Fax 312-263-0141; Internet Home Page Address: www.artic.edu; *Undergrad Div Chmn* Lisa Wainwright; *Prof* Leah Bowman; *Prof* Barbara Crane; *Prof* Richard Keane; *Prof* Robert Loescher; *Prof* Richard Loving; *Prof* Ray Martin; *Prof* Bill Farrell; *Prof* Ray Yoshida; *Prof* Frank Barsotti; *Prof* Michael Miller; *Prof* Anthony Phillips
Estab 1866; FT 80, PT 160; pvt; D 1600; E 600; Scholarships; SC 280, LC 90, GC 50; maj 1400, non-maj 800
Income: $31,558,200
Purchases: $30,211,300
Ent Req: portfolio; recommendations
Degrees: BFA 4 yrs, MFA 2 yrs, Grad Cert(Art History) 1 yr, MA(Art Therapy) 1 yr, MA(Modern Art History, Theory & Criticism) 2 yr
Tuition: BFA $9600 per term, $604 per cr hr; MFA $9900 per term, $666 per cr hr
Courses: †Art Education, †Art History, Art Therapy, Book Arts, †Ceramics, †Drawing, †Fashion Arts, †Fiber, †Film, †Graphic Arts, Interior Architecture, †Painting, †Performance, †Photography, Printmaking, †Sculpture, †Sound, †Textile Design, †Video, †Visual Communications, †Weaving
Adult Hobby Classes: Tuition $360 non cr course, $669 1 1/2 cr course.
Courses—Varies, see summer session
Children's Classes: Tuition $240 non cr course. Courses—Drawing, Exploring the Arts Workshop, Multi-Media, Open Studio
Summer School: Dir, E W Ross. Enrl 200 (degree); 121 (non-degree); tuition undergrad $1338 per 3 cr hr for 4 & 8 wk term, grad $1455 for 8 wk seminar & courses. Courses—Art Education & Therapy, Art & Technique, Art History, Ceramics, Drawing, Fashion Design, Fiber, Filmmaking, Interior Architecture, Painting, Performance, Photo, Printmaking, Theory & Criticism, Sculpture, Sound, Video & Visual Communications

UNIVERSITY OF CHICAGO, Dept of Art History & Committee on Visual Art, 5540 S Greenwood, Chicago, IL 60637. Tel 773-702-0278; Fax 773-702-5901; Elec Mail ctoakle@midway.uchicago.edu; *Prof* Joel Snyder
Estab 1892; pvt; D; Scholarships; SC, LC and GC vary; maj 11, grad 104, others 3
Ent Req: through college of admissions
Degrees: BA 4 yrs, MA 1 yr, PhD 4-6 yrs
Tuition: $8269 per quarter undergrad/res

UNIVERSITY OF ILLINOIS AT CHICAGO, College of Architecture, 929 W Harrison St, M/C 030, Rm 3100, Jefferson Hall Chicago, IL 60607-7038. Tel 312-996-3351, Art & Design 996-3337; Fax 312-996-5378; Internet Home Page Address: www.u.c.edu/depts/arch/homepage.html; *Dir School Archit* Katerina Ruedi; *Chmn Dept Art & Art History* David Sokol; *Dean* Judith Russi Kirshner
Estab 1946; FT 80, PT 28; pub; D; Scholarships; SC 79, LC 10, GC 3; D 579, non-maj 325, maj 579, grad 17
Ent Req: 3 units of English plus 13 additional units, rank in top one-half of HS class for beginning freshman, transfer students 3.25 GPA
Degrees: BA(Design), BA(Studio Arts), BA(Art Educ), BA(History of Archit & Art), BA(Music), BA(Theatre), BArchit, MFA(Studio Art or Design), MArchit, MA(Theatre)

Tuition: Res—undergrad $2546 per sem, grad $2249 per sem; nonres—undergrad $5864 per sem, grad $5295 per sem
Courses: †Architecture, †Art Education, †Art History, Ceramics, †Communications Design, †Comprehensive Design, Drawing, †Film, †Industrial Design, †Painting, †Photography, †Printmaking, †Sculpture, †Studio Arts, †Urban Planning & Policy, †Video
Children's Classes: Enrl 50; tuition $5. Courses—Saturday school in connection with art education classes
Summer School: Dir, Morris Barazani. Tuition res undergad $229, nonres undergrad $547 for term of 8 wks beginning June

UNIVERSITY OF ILLINOIS AT CHICAGO, Biomedical Visualization, College of Health & Human Development Sciences, 1919 W Taylor St, Rm 211 Chicago, IL 60612. Tel 312-996-7337; Elec Mail sbarrows@uic.edu; Internet Home Page Address: www.sbhis.uic.edu; *Clinical Asst Prof* Raymond Evenhouse; *Res Asst Prof* Mary Rasmussen; *Clinical Asst Prof* John Daugherty; *Prog Coordr* Scott Barrows CMI, FAMI; *Clin Asst Prof* Gregory Blew
Estab 1923; pub; D; Scholarships; SC, LC. GC; D 24, grad 24
Ent Req: Bachelors degree
Degrees: Master of Associated Medical Sciences in Biomedical Visualization
Tuition: Res—$2444 per sem; nonres—$5665 per sem
Courses: 3-D Modeling, †Advertising Design, Computer Animation, †Conceptual Art, Design, Drawing, Graphic Design, Illustration, Instructional, Multimedia, Prosthetics, Sculpture, Surgical Illustration

CHICAGO HEIGHTS

PRAIRIE STATE COLLEGE, Art Dept, 202 S Halsted, Chicago Heights, IL 60411. Tel 708-709-3500, 709-3671; Fax 708-755-2587; Internet Home Page Address: www.prairie.cc.il.us; *Dept Chmn* Don Kouba
Estab 1958; FT 4, PT 30; pub; D & E; SC 24, LC 6; dept 600, maj 200
Ent Req: HS dipl, ACT
Degrees: AAF 2 yrs Cert 1 yr
Tuition: $57 per cr hr, out of district $168 per cr hr, out of state $203 per cr hr
Courses: Advertising Design, Airbrush, Art Appreciation, Art Education, Commercial Art, Computer Graphics, Design, †Drawing, †Graphic Design, Illustration, †Interior Design, Jewelry, Life Drawing, Materials Workshop, Package Design, Painting, †Photography, Production Processes, Sign Painting, Stained Glass, Typography, Video Graphics
Summer School: Dir, John Bowman. Tuition $48 per cr hr for term of 8 wks. Courses—Art History, Drawing, Graphic Design, Interior Design, Painting, Photography

DE KALB

NORTHERN ILLINOIS UNIVERSITY, School of Art, De Kalb, IL 60115. Tel 815-753-1473; Fax 815-753-7701; *Chmn, School of Art* Adrian R Tio, MFA; *Asst Chmn* Jerry D Meyer PhD; *Grad Coordr* Yale Factor, MFA; *Div Coordr FA Studio* Dorothea Bilder, MFA; *Div Coordr Art History* Jeff Kowalski PhD, MA; *Div Coordr Art Educ* Stanley Madeja PhD, MA; *Div Coordr Design* Harry Wirth, BS
Estab 1895; Maintain nonprofit art gallery; Jack Olson Memorial Gallery; Pub; D & E; Scholarships, Fellowships; SC 127, LC 59, GC 98, other 15; D 3,000, maj 1,000, grad 130
Ent Req: HS dipl, ACT, SAT
Degrees: BA, BFA, BSEd 4 yrs, MA, MS 2 yrs, MFA 3 yrs, EdD 3 yrs
Tuition: Res—$4,420 per yr; nonres—$7,716 per yr; campus res available
Courses: †Advertising Design, Art Appreciation, †Art Education, Art Gallery Studies, †Art History, †Ceramics, Cinematography, †Commercial Art, Computer Animation-Web Page Design, †Computer Graphics/Design, Conceptual Art, Drafting, †Drawing, †Film, Goldsmithing, †Graphic Arts, †Graphic Design, History of Art & Architecture, †Illustration, Interior Design, †Intermedia, †Jewelry, †Jewelry/Metalwork, Mixed Media, Museum Staff Training, †On-Loom/Off-Loom Construction, †Painting, †Photography, †Printmaking, †Sculpture, Silversmithing, †Teacher Training, Television Graphics, Textile Design, Video, †Visual Communications, Weaving
Summer School: Dir, Richard M Carp. Tuition res—$115.48 per cr hr, nonres—$288.78 per cr hr. Courses—Vary

DECATUR

MILLIKIN UNIVERSITY, Art Dept, 1184 W Main St, Decatur, IL 62522. Tel 217-424-6227; Fax 217-424-3993; Elec Mail webmaster@mail.millikin.edu; Internet Home Page Address: www.millikin.edu; *Chmn Art Dept* Edwin G Walker, MFA
Estab 1901, dept estab 1904; Maintain nonprofit art gallery; Perkinson Gallery, 1184 W Main St, Decatur IL 62522; FT 5, PT 4; pvt; D & E; Scholarships; SC 47, LC 3; D 1,700, non-maj 25, maj 110
Ent Req: HS dipl, ACT
Degrees: BA & BFA 4 yrs
Tuition: $14,758 per yr; campus res—room & Board $5,271 per yr
Courses: Art Education, Art History, Ceramics, Commercial Art, Computer Graphics, Design, Drawing, Graphic Arts, Graphic Design, Illustration, Painting, Photography, Printmaking, Sculpture, Teacher Training
Summer School: Dean of Arts & Sciences. Enrl 400; tuition $225 per cr hr for 7 wk term beginning June 13. Courses—Ceramics, Drawing, Painting, Photography

DES PLAINES

OAKTON COMMUNITY COLLEGE, Language Humanities & Art Divisions, 1600 E Golf Rd, Des Plaines, IL 60016. Tel 847-635-1600; Fax 847-635-1987; Elec Mail jkrauss@oakton.edu; *Chmn & Prof* James A Krauss, MA; *Assoc Prof*

Peter Hessemer, MFA; *Assoc Prof* Bernard K Krule, MS; *Asst Prof* Dawn J Mercedes; *Cur Gallery* Nathan Harpaz; *Asst Prof* Judy Langston; *Asst Prof* Kathryn Howard-Rogers
Maintain nonprofit art gallery; Koehnline Art Gallery 1600 E Golf Rd, Des Plaines IL 60016; Pub; D & E, Weekends
Degrees: AA, AFA
Tuition: Res district—$54 per cr hr; nonres district—$102 per sem hr
Courses: Architecture, Art Appreciation, Art History, Ceramics, Design, Drawing, Graphic Design, Museum Staff Training, Painting, Photography, Printmaking, Sculpture
Summer School: Dir, Prof Art James A Krauss. Enrl 90; tuition $52 cr for 8 wk term. Courses—Design I, Photography, Ceramics, Field Study, Painting

EAST PEORIA

ILLINOIS CENTRAL COLLEGE, Dept Fine, Performing & Applied Arts, One College Dr, East Peoria, IL 61635. Tel 309-694-5113; Fax 309-694-8095; Internet Home Page Address: www.icc.edu; *Assoc Dean* Jeffrey Hoover PhD; *Asst Prof & Cur* Jennifer Costa, MFA; *Prof* Fred Hentchel, MFA; *Asst Prof & Dept Chair* John Tuccillo, MFA; *Asst Prof* Janet Newton, MFA; *Asst Prof & Dept Chair* Christie Cirone, MA; *Assoc Prof* Robert Moulton, MA; *Asst Prof* Roger Bean, MA; *Asst Prof* Stephen Knight, MFA
Estab 1967, dept estab 1967; Maintains nonprofit art gallery, Gallery 305A; art supplies available on-campus; pub; D & E; SC 27, LC 3; D 1,000, E 500, maj 322
Ent Req: HS dipl
Degrees: Assoc(Arts & Sciences) 2 yrs, Assoc(Applied Science)
Tuition: $52 per sem hr; no campus res
Courses: Advertising Design, Art Education, Art History, Ceramics, Color, Commercial Art, Design, Drawing, Graphic Design, Illustration, Interior Design, Painting, Photography, Printmaking, Sculpture, Typography
Adult Hobby Classes: Tuition $70 per cr hr. Courses—Drawing, Painting
Summer School: Chmn Fine Arts, Jeffrey Hoover. Tuition $70 per cr hr. Courses—Drawing, Introduction to Art, Photography, Sculpture

EDWARDSVILLE

SOUTHERN ILLINOIS UNIVERSITY AT EDWARDSVILLE, Dept of Art & Design, PO Box 1608, Edwardsville, IL 62026-1764. Tel 618-650-5050; Elec Mail igausep@siue.edu; Internet Home Page Address: www.siue.edu/ART/; *Chmn Dept* Ivy Schroeder, PhD; *Head Art History* Pamela Decoteau; *Head Printmaking* Robert R Malone, MFA; *Head Drawing* Dennis L Ringering, MFA; *Head Fiber & Fabric* Laura Strand, MFA; *Head Ceramic* Daniel J Anderson, MFA; *Art Educ* Joseph A Weber PhD, MFA; *Photography & Graphic Design* Steven Brown, MFA; *Head Painting* Jane Barrow, MFA; *Head Sculpture* Thomas D Gipe, MFA
Estab 1869, dept estab 1959; pub; D & E; Scholarships; SC 65, LC 26, GC 45; D 250, E 75, maj 200, grad 50
Ent Req: HS dipl, ACT, portfolio req for BFA & MFA
Degrees: BA, BS & BFA 4 yrsm NFA 3 yrs, MS 2 yrs
Tuition: Res—undergrad $1495.55, grad $1642.55 per sem; nonres—undergrad $2632.55, grad $2998.15 per sem; room $1373-$2880 per sem; board $100-$995 per sem
Courses: Aesthetics, †Art Education, Art History, †Ceramics, †Drawing, †Graphic Design, History of Art & Architecture, Jewelry, Metalsmithing, Mixed Media, †Painting, Photography, †Printmaking, †Sculpture, †Teacher Training, Textile Arts
Children's Classes: Enrl 250; Summer classes. Courses—Ceramics, Drawing, Painting, Photography
Summer School: Chmn, Joe Weber. Enrl 250; term of 8 wks beginning June 21. Courses—Ceramics, Drawing, Painting, Photography

ELGIN

ELGIN COMMUNITY COLLEGE, Fine Arts Dept, 1700 Spartan Dr, Elgin, IL 60123. Tel 847-697-1000; *Instr* Roger Gustafson; *Instr* John Grady; *Instr* Howard Russo; *Dean* Dr David Broad
Scholarships
Degrees: AA
Tuition: In district—$52.50 per cr hr; res—$230.26 per cr hr; nonres—$278.70 per cr hr
Courses: Art Appreciation, Art History, Ceramics, Design, Drawing, Jewelry, Painting, Photography, Printmaking, Sculpture

JUDSON COLLEGE, Division of Art, Design & Architecture, 1151 N State St, Elgin, IL 60123. Tel 847-628-2500, Ext 1030; Fax 847-628-2043; Elec Mail dloven@judson-il.edu; Internet Home Page Address: www.judsoncollege.edu; *Chmn Dept Art & Design* GE Colpitts; *Chmn Dept Architecture* Dr Curtis Sartor; *Gallery Dir* Jeff Carl; *Asst Prof* Faith Veenstra; *Instr* Melanie Gibb
Maintains nonprofit gallery, Draewell Gallery Fine Arts Building Jackson College 1051 N State St, Elgin, IL 60123; maintains non-profit library; Pvt; D, E; Scholarships; SC 15, LC 10; D 737, E 397, M 227 (incl arch); GS 48, O 59
Ent Req: HS dipl, ACT, or SAT
Degrees: BA 4 yrs
Tuition: $19,150 per yr; room & board $6,900 per yr
Courses: †Architecture, Art Appreciation, Art Education, Ceramics, †Commercial Art, Design, Design History, Drawing, †Fine Arts, Graphic Arts, Graphic Design, History of Art & Architecture, †Mixed Media, Painting, Photography, Printmaking, Sculpture, †Teacher Training, †Visual Communications

ELMHURST

ELMHURST COLLEGE, Art Dept, 190 Prospect, Elmhurst, IL 60126. Tel 630-617-3542; Fax 630-279-4100; Internet Home Page Address: www.elmhurst.edu; *Chmn* Richard Paulsen, MFA; *Prof* John Weber, MFA; *Asst Prof* Lynn Hill, MFA; *Asst Prof* Mary Lou Stewart, MFA

Estab 1871; Pvt; D & E; Scholarships; SC 13, LC 8; D 1927, E 1500, maj 33
Ent Req: HS dipl, ACT or SAT
Degrees: BA, BA & BM 4 yrs
Tuition: $6435 per term
Courses: †Art Education, †Artbusiness, Design, †Electronic Imaging, †Painting, †Photography, †Printmaking, †Sculpture
Summer School: Dir, Dr Marie Baehr. Enrl 1379; tuition $375 per cr hr for courses of 4, 6 & 8 wks. Courses in selected programs

EVANSTON

NORTHWESTERN UNIVERSITY, EVANSTON
Maintain nonprofit art gallery; Scholarships, Fellowships
—Dept of Art Theory & Practice, Tel 847-491-7346; Fax 847-467-1487; Elec Mail art-theory@northwestern.edu; Internet Home Page Address: www.art.northwestern.edu; *Prof* William Conger; *Prof* Ed Paschke; *Prof* James Valerio; *Assoc Prof* Judy Ledgerwood; *Lectr* James Yood; *Lectr* Charlie Cho; *Assoc Prof* Jeanne Dunning; *Asst Prof* Lane Relyea; *Lectr* William Cass; *Lectr* Dan Devening; *Lectr* Pamela Bannos
Estab 1851; FT 11, PT 3; pvt; D & E; Scholarships, Fellowships; SC 40, LC 6, GC 6, seminars; D 800, E 40, non-maj 750, maj 50, grad 12
Ent Req: requirements set by university admissions; for MFA prog a distinctive record and portfolio is required
Degrees: AB 4 yrs, MFA 2+
Tuition: $27,000
Courses: Conceptual Art, Drawing, †Painting, Photography, †Practice of Art, †Printmaking, Sculpture
Summer School: Courses—Introductory
—Dept of Art History, Tel 847-491-7077; Fax 847-467-1035; Elec Mail art-history@northwestern.edu; Internet Home Page Address: www.arthistory.northwestern.edu; *Assoc Prof* Stephen Eisenman, PhD; *Asst Prof* Lyle Massey PhD; *Prof* Hollis Clayson, PhD; *Assoc Prof* Claudia Swan, PhD; *Prof* David Van Zanten, PhD; *Chmn & Assoc Prof* Sarah E Fraser, PhD; *Asst Prof* Huey Copeland, PhD; *Asst Prof* Hannah Feldman, PhD; *Asst Prof* Cecily J Hilsdale, PhD; *Asst Prof* Christina Kiaer, PhD; *Asst Prof* Krista Thompson, PhD; *Adjunct Prof* Hamid Naficy, PhD; *Adjunct Prof* Marco Ruffini, PhD; *Adjunct Prof* James Cuno, PhD
Estab 1851; Maintains nonprofit gallery, Derring Library, Northwester U, Evanston Il, 60208; pvt; D & E; Scholarships; LC 36, GC 15; maj 60, grad 40
Ent Req: HS dipl, SAT or ACT
Degrees: PhD, MA, BA
Tuition: $5,468 per qtr
Courses: 20th Century Art, Architecture, Architecture of Ancient Rome, †Art History, †Handicrafts, History of Art & Architecture, Introduction to African Art, Medieval Art, Renaissance Art
Summer School: Dir Louise Love. Courses—vary in Western Art History

FREEPORT

HIGHLAND COMMUNITY COLLEGE, Art Dept, 2998 W Pearl City Rd, Freeport, IL 61032. Tel 815-235-6121; Fax 815-235-6130; Internet Home Page Address: www.highland.cc.il.us; *Dir* Thomas Brandt
Estab 1962; FT 1, PT 5; pub; D & E; Scholarships; SC 6, LC 1; 126
Ent Req: HS dipl, ent exam
Degrees: AS, AA, ABA, AAS 2 yrs
Tuition: In-district $43 per cr hr; out-of-district $160.26 per cr hr; out-of-state $203.20 per cr hr
Courses: Art History, Art Materials & Processes, Design, Drawing, Fabrics, Graphic Design, History of Modern Art, Introduction to Art, Metals & Jewelry, Painting, Pottery, Printmaking, Sculpture
Adult Hobby Classes: Enrl 278. Courses—Basic Drawing, Oil, Charcoal, Printmaking, Sculpture, Pottery, Handweaving & Related Crafts, Rosemaking, Macrame, Needlepoint
Children's Classes: Occasional summer workshops for high school and elementary school students
Summer School: Courses same as above

GALESBURG

KNOX COLLEGE, Dept of Art, 2 E South St, Galesburg, IL 61401. Tel 309-341-7000, 341-7423 (Art Dept Chmn); *Asst Prof* Lynette Lombard; *Chmn* Frederick Ortner
Scholarships
Degrees: BA 4yrs
Tuition: $28,230 per yr, room & board $5630 per yr
Courses: Art History, Ceramics, Design, Drawing, History of Art & Architecture, Painting, Photography, Printmaking, Sculpture

GLEN ELLYN

COLLEGE OF DUPAGE, Liberal Arts Division, 425 22nd St, Glen Ellyn, IL 60137. Tel 630-942-2047; Fax 630-942-3711; Internet Home Page Address: www.cod.edu; *Assoc Dean Liberal Arts* Ed Storke; *Prof* Richard Lund, MFA; *Assoc Prof* Deb Postlewait, MFA; *Asst Prof* Anita Dickson, AAS; *Asst Prof* Lynn Mackenzie, MA; *Asst Prof* Fred Bruney, MFA; *Asst Prof* Jennifer Hereth, MFA; *Asst Prof* Kathleen Kamal, MFA; *Asst Prof* Charles Boone, MFA; *Asst Prof* Marina Kuchinski, MFA
Estab 1966; Maintain nonprofit art gallery on-campus; pub; D & E; SC 24, LC 5
Ent Req: completion of application
Degrees: AA(Art) , AAS(Interior Design, Fashion Design, Commercial Art) 2 yrs, AFA

Tuition: DuPage County res—$43 per cr hr, other Illinois res—$83 per cr hr; nonres—$107 per cr hr; no campus res
Courses: Aesthetics, Architecture, Art History, Book Arts, Ceramics, Commercial Art, Computer Art, Costume Design & Construction, Design, Drafting, Drawing, Fashion Arts, Fiber Arts, Graphic Arts, Illustration, Interior Design, Jewelry, Landscape Architecture, Painting, Papermaking, Photography, Printmaking, Sculpture, Textile Design, Theatre Arts
Children's Classes: Ceramics, Drawing, Painting
Summer School: Tuition $43 per hr for term of 8 or 10 wks. Courses—Vary

GODFREY

LEWIS & CLARK COMMUNITY COLLEGE, Art Dept, 5800 Godfrey Rd, Godfrey, IL 62035. Tel 618-466-3411, Ext 279; *Assoc Dean* Dr Linda Chapman
Estab 1970, formerly Monticello College; FT 2, PT 3; pub; D & E; Scholarships; SC 13, LC 2; D 1800, E 600, maj 40
Ent Req: HS dipl, ent exam, open door policy
Degrees: AA 2 yrs
Tuition: $34.50 per cr hr; no campus res
Courses: Advanced Drawing, Art History, Basic Design, Ceramics, Drawing, Fibers, Painting, Printmaking, Sculpture, Weaving
Adult Hobby Classes: Enrl 30; tuition variable. Courses—Antiques, Interior Design, Introduction to Drawing & Painting
Summer School: Enrl 15; tuition $17 per sem hr for 8 wks. Courses—Introduction to Visual Arts

GRAYSLAKE

COLLEGE OF LAKE COUNTY, Art Dept, 19351 W Washington St, Grayslake, IL 60030. Tel 847-543-2040; Fax 847-543-3040; Internet Home Page Address: www.clcillinois.edu; *Dean* Jean V Kartje; *VPres Educ Affairs* DeRionne P Pollard; *Ceramics* David Bolton; *Photography* Roland Miller; *Computer Art* Terry Dixon; *Drawing & Design* Hans Habeger; *Painting & Watercolor* Robert Lossmann
Estab 1969, dept estab 1969; Maintains nonprofit art gallery, Robert T. Wright Community Gallery of Art, 19351 W Washington St, Grayslake, IL, 60030; pub; D & E; SC 22, LC 5; D 250, E 250, non-maj 500, maj 100
Ent Req: HS dipl, SAT, GED
Degrees: AA & AS 2 yrs
Tuition: in-district $71 per cr hr; out-of-district $196 per cr hr; nonres—$267 per cr hr
Courses: 2-D & 3-D Design, Art Appreciation, Art Education, Art History, Ceramics, Drawing, Graphic Arts, Graphic Design, Jewelry, Mixed Media, Painting, Photography, Sculpture, Watercolor
Adult Hobby Classes: Advertising, Ceramics, Drawing, Lettering, Mixed Media, Portrait, Stained Glass
Summer School: Courses—same as above

GREENVILLE

GREENVILLE COLLEGE, Art Dept, Dept of Art, 315 E College Ave Greenville, IL 62246. Tel 618-664-2800, 664-5518; Fax 618-664-1373; Elec Mail gchase@greenville.edu; Internet Home Page Address: www.greenville.edu/academics/departments/art; *Dept Head* Guy M Chase, MFA
Estab 1892, dept estab 1965; pvt; D & E; SC 16, LC 4; D 135, non-maj 105, maj 30
Ent Req: HS dipl
Degrees: BA 4 yrs, BS 4 1/2 yrs
Tuition: $13,490 per yr; campus—room & board $5186 per yr
Courses: †Art Education, Art History, Calligraphy, †Ceramics, †Drawing, †Graphic Arts, †Graphic Design, Handicrafts, History of Art & Architecture, Lettering, †Painting, Photography, †Sculpture, †Teacher Training
Summer School: Registrar, Tom Morgan. Tuition $424 or $848 for term of 8 wks beginning June. Courses—Introduction to Fine Arts

JACKSONVILLE

MACMURRAY COLLEGE, Art Dept, 447 E College Ave, Jacksonville, IL 62650. Tel 217-479-7000; Fax 217-479-7086; Internet Home Page Address: www.mac.edu; *Chmn Art Dept* Raymond Yeager
Estab 1846; den; Scholarships; SC 29, LC 6
Degrees: BA 4 yr
Tuition: $14,000; campus res—room $2,000-2,200; board $2,100-2,800 per yr
Courses: Advertising Design, Ceramics, Drawing, Painting, Photography, Sculpture, Teacher Training

JOLIET

JOLIET JUNIOR COLLEGE, Fine Arts Dept, 1215 Houbolt Rd, Joliet, IL 60431. Tel 815-729-9020, Ext 2232; Fax 815-744-5507; Internet Home Page Address: www.jjc.cc.il.us; *Chmn Dept* Jerry Lewis, MM; *Instr* James Dugdale, MA; *Instr* Joe Milosevich, MFA; *Instr* Steve Sherrell, MFA
Estab 1901, dept estab 1920; pub; D & E; Scholarships; SC 15, LC 4; D 10,000, maj 120
Ent Req: HS dipl, ent exam
Degrees: AA 2 yrs
Tuition: $42 per sem cr for res of Ill Dist 525; $152.63 per sem cr for the res outside Ill Dist 525; no campus res
Courses: 2-D & 3-D Design, Art Appreciation, Art History, Ceramics, Drawing, Graphic Arts, Interior Design, Jewelry, Painting, Silversmithing, Weaving
Summer School: Dir, Jerry Lewis, MM. Courses—Same as winter school

UNIVERSITY OF SAINT FRANCIS, (College of Saint Francis) Fine Arts Dept, Division of Humanities and Fine Arts, 500 N Wilcox St Joliet, IL 60435. Tel 815-740-3360; Fax 815-740-4285; Internet Home Page Address: www.stfrancis.edu; *Dept Head* Dr Patrick Brannon
Estab 1950; Maintain nonprofit art gallery; Moser Performing Arts Gallery Center; Pvt; D & E; SC 6, LC 3; D 150, maj 25
Ent Req: HS grad, ent exam
Degrees: BA(Creative Arts with Art Specialization or Art Educ)
Tuition: Full-time $18,000, part-time $354 per cr hr, campus room & board $4,960
Courses: Advanced Drawing & Painting, Applied Studio, Basic Design, Ceramics, Fabrics, Photography, Silversmithing, Special Topics, Textiles
Children's Classes: Courses—Art in variety of media
Summer School: Term of 6 wks beginning June

LAKE FOREST

BARAT COLLEGE, Dept of Art, 700 E Westleigh Rd, Lake Forest, IL 60045. Tel 847-234-3000, 604-6339; Fax 847-615-5000; Elec Mail ilagerbv@barat.edu; Internet Home Page Address: www.barat.edu; *Chmn Art Dept* Irmfriede Lagerkvist
Estab 1858; FT 4, PT 4; den, W; D; Scholarships; SC 32, LC 16; maj 58
Ent Req: HS dipl, ent exam
Degrees: BA & BFA 4 yrs
Tuition: $7315 per sem; $124,630 per yr; campus res—housing $2425 per sem, $4050 per yr
Courses: 3-D Design, Ceramics, Drawing, Fibers, History of Art & Architecture, Illustration, Painting, Photography, Printmaking, Sculpture, Theatre Arts, Weaving
Summer School: Ceramics, Fibers, History of Art, Painting, Photography, 2-D Design

LAKE FOREST COLLEGE, Dept of Art, 555 N Sheridan Rd, Lake Forest, IL 60045. Tel 847-234-3100; Fax 847-735-6291; Internet Home Page Address: www.lfc.edu; *Lectr* Mary Lawton PhD; *Chmn* Anne Roberts
Estab 1857; pvt; D & E; Scholarships; SC 8, LC 21; D 1050 (sch total), maj 38
Ent Req: HS dipl, SAT, CEEB or ACT
Degrees: BA 4 yrs
Tuition: Res—undergrad $21,896 per yr; nonres—undergrad $25,900 per yr; campus res—room & board $5194
Courses: Aesthetics, Architecture, Art Appreciation, Art Education, Art History, Computer Assisted Design, Drawing, Film, Graphic Design, History of Art & Architecture, Painting, Photography
Adult Hobby Classes: Enrl 5-15. Courses—Photography
Summer School: Dir, Arthur Zilversmit. Enrl 200; tuition $990 per 4 sem hrs for 7 wks. Courses—Photography

LINCOLN

LINCOLN COLLEGE, Art Dept, 300 Keokuk St, Lincoln, IL 62656. Tel 217-732-3155; Fax 217-732-8859; Internet Home Page Address: www.lincolncollege.com; *Assoc Prof* Bob Stefl; *Chmn* E J Miley; *Instr Painting & Design* Karen Miley
Estab 1865; pvt; D & E; Scholarships; SC 35, LC 5; maj 200
Ent Req: HS dipl
Degrees: AA
Tuition: $10,200 campus res—room & board $4600
Courses: Art Appreciation, Art History, Ceramics, Design, Drawing, Graphic Design, Illustration, Mixed Media, Painting, Photography, Stage Design, Theatre Arts
Children's Classes: Courses offered through summer
Summer School: Dir, EJ Miley Jr. Courses—Art of France & Itlay

LISLE

ILLINOIS BENEDICTINE UNIVERSITY, Fine Arts Dept, 5700 College Rd, Lisle, IL 60532. Tel 630-829-6250; Fax 630-960-4805; *Chair* Dr Alicia Tate
Estab 1887, dept estab 1978; den; D & E; Full time 1150, grad 915
Ent Req: HS dipl, ACT, SAT
Degrees: BA, BS, MS & MBA 4 yrs
Tuition: Undergrad $15,220 per yr; campus res available
Courses: Art Appreciation, Art History, Calligraphy, Design, Drawing, Lettering, Painting, Printmaking

MACOMB

WESTERN ILLINOIS UNIVERSITY, Art Dept, 1 University Cir, 32 Garwood Hall Macomb, IL 61455-1396. Tel 309-298-1549; Fax 309-298-2605; Internet Home Page Address: www.wiu.edu; *Dean College Fine Arts & Communication* Dr Paul Kreider; *Prof* Don Crouch, MFA; *Prof* Edmond Gettinger, MFA; *Prof* Julie Mahoney, MFA; *Asst Prof* Dr Ron Aman, PhD; *Asst Prof* Susan Czechowski, MFA; *Asst Prof* Dr Keith Holz, PhD; *Asst Prof* William Howard, MFA; *Assoc Prof* Jenny Knavel, MFA; *Asst Prof* Damon McArthur, MFA; *Asst Prof* Vince Palacios, MFA; *Asst Prof* Terry Rathje, MA; *Assoc Prof* Lorraine Schwartz, PhD; *Asst Prof* Tim Waldrop, MFA; *Assoc Prof* Bruce Walters, MFA; *Assoc Prof* Kat Myers, MFA; *Chair Art Dept & Prof* Jan Clough, MFA
Estab 1900, dept estab 1968; Maintains a nonprofit art gallery, Univ Art Gallery, Western Illinois Univ, Macomb, IL, 61455; Pub; D & E; Scholarships; SC 50, LC 20, GC 4; maj 200
Ent Req: HS dipl
Degrees: BA 4 yrs, BFA
Tuition: Res—undergrad $7,000 per yr

Courses: Advertising Design, Art Education, Art History, Ceramics, Commercial Art, Conceptual Art, Drawing, Foundry Casting, Graphic Design, Illustration, Jewelry, Metal Working, Painting, Printmaking, Sculpture
Children's Classes: Dir, Ron Aman, PhD. HS Summer Arts Prog
Summer School: Dir, Jan Clough. Enrl 65; 8 wk session. Courses—Art Appreciation, Studio

MOLINE

BLACK HAWK COLLEGE, Art Dept, 6600 34th Ave, Moline, IL 61265. Tel 309-796-5469; Fax 309-792-3418; Elec Mail thorsonz@bhc.edu; Internet Home Page Address: www.bhc.edu; *Assoc Prof* David Murray; *Asst Prof & Co Chair Communication & Fine Arts* Zaiga Thorson; *Instr* Melissa Hebert
Estab 1962; maintain a nonprofit art gallery, Artspace; pub; D & E; Scholarships; SC 17, LC 4; D 300, E 100, non-maj 300, maj 60
Ent Req: HS dipl
Degrees: AA & AAS(Commercial Art) 2 yrs
Tuition: Res—undergrad $55 per cr hr; nonres—undergrad $259 per cr hr; outside district res—undergrad $140 per cr hr; no campus res
Courses: Art Appreciation, Art History, Ceramics, Commercial Art, Computer Graphics, Design, Drawing, Graphic Design, Illustrator, Jewelry, Life Drawing, Painting, Photography, Photoshop
Adult Hobby Classes: Calligraphy, Drawing, Painting, Stained Glass, Photography
Summer School: Chmn, Jonathan Palumaki. Enrl 30; tuition $48 per cr hr for term of 6 wks beginning in June. Courses—Art Appreciation

MONMOUTH

MONMOUTH COLLEGE, Dept of Art, McMichael Academic Hall, Monmouth, IL 61462. Tel 309-457-2311; Fax 309-734-7500; Internet Home Page Address: www.monm.edu; *Dept Chair & Assoc Prof Art* Stacy Lotz; *Prof Art* Cheryl Meeker; *Asst Prof Art* Brian Baugh; *Lectr* Tyler Hennings
College estab 1853; Maintains nonprofit art gallery, Len G. Everett Gallery; FT 3, PT 3; pvt; D&E; Scholarships, Grants; SC 16, LC 4
Ent Req: 15 units incl English, history, social science, foreign language, mathematics & science, SAT or ACT
Degrees: BA 4 yr
Tuition: Undergrad $7,560 per sem, $15,120 per yr
Courses: Advanced Special Topics, †Art Education, Art History, Ceramics, Contemporary Art, Drawing, †Graphic Design, Independent Study, Open Studio, Painting, Photography, Printmaking, Sculpture, Secondary Art Methods, Senior Art Seminar
Adult Hobby Classes: 10; ceramics

MOUNT CARROLL

CAMPBELL CENTER FOR HISTORIC PRESERVATION STUDIES, 203 E Seminary St, PO Box 66 Mount Carroll, IL 61053. Tel 815-244-1173; Fax 815-244-1619; Elec Mail campbellcenter@internetni.com; Internet Home Page Address: www.campbellcenter.org; *Dir* Kathy A Cyr
Estab 1979; Maintains Campbell Memorial Research Library & Campbell Ctr for Historic Preservation Studies, 203 E Seminary, Mt Carroll, Ill; PT 45; pub; D May - mid-Oct; Scholarships
Tuition: $550-$1275 fee per course, 3-6 days; campus res available
Courses: Collections Care, Conservation, Historic Preservation, Museum Staff Training

NAPERVILLE

NORTH CENTRAL COLLEGE, Dept of Art, 30 N Brainard St, Naperville, IL 60566. Tel 630-637-5542; Fax 630-637-5121; *Adjunct Prof* Joan Bredendick, MFA; *Adjunct Prof* Edward Herbeck, MFA; *Assoc Prof* Barry Skurkis, MA; *Asst Prof* Gerard Ferrari, MA; *Adjunct Prof* John Slavik, MA
Estab 1861; pvt; D & E; Scholarships; SC 16, LC 6; non-maj 3000, maj 35
Ent Req: HS dipl, SAT or ACT
Degrees: BA 4 yrs
Tuition: Res & nonres—undergrad $9096 per yr, $5300 per term, $160-$2700 part time per term; non-degree—$135-$2394 per term; campus res—room & board $3528 per yr
Courses: Advanced Studio, Aesthetics, Art Education, Art History, Ceramics, Design, Drawing, Figure Drawing, Handicrafts, History of Art & Architecture, Painting, Photography, Printmaking, Sculpture, Studio Survey, Teacher Training, Theatre Arts
Adult Hobby Classes: Enrl 3800. Tuition $50 for 6 wks. Courses offered through Continuing Education
Children's Classes: Enrl 500; tuition $45-$50 per term of 6 wks. Courses—Art, Beginning Art, Ceramics, Drawing
Summer School: Dir, B Roth. Enrl 1000; tuition $1136 per course. Courses—Ceramics, Drawing, Painting

NORMAL

ILLINOIS STATE UNIVERSITY, Art Dept, Campus Box 5620, Normal, IL 61790-5620. Tel 309-438-5621; Fax 309-438-8318; Elec Mail rjmottr@ilstu.edu; *Chmn* Ron Mottram
Estab 1857; FT 40; 6 vis profs per yr; pub; D & E; Scholarships, Fellowships; SC 50, LC 35, GC 40; D 20,000, non-maj 100, maj 500, grad 40
Ent Req: HS dipl, SAT or ACT
Degrees: BA & BS 4 yrs, BFA 5 yrs, MA, MS, MFA

Tuition: Res—undergrad & grad $2430 per yr, $1215 per sem, $75 per hr; nonres—undergrad $6030 per yr, $3015 per sem, $225 per hr, grad $2454 per yr, $1227 per sem
Courses: †Art Education, Art Foundations, †Art History, †Art Therapy, †Ceramics, †Drawing, †Fibers, †Glass, †Graphic Design, †Intaglio, Jewelry Design, †Lithography, †Metalwork, Mixed Media, †Painting, †Photography, †Sculpture, Video Art
Summer School: 8 wk term beginning in June

OGLESBY

ILLINOIS VALLEY COMMUNITY COLLEGE, Division of Humanities & Fine Arts, 815 N Orlando Smith Ave, Oglesby, IL 61348-9691. Tel 815-224-2720, Ext 491; *Instr* David Bergsieker, MFA; *Instr* Dana Collins, MFA
Estab 1924; pub; D & E; Scholarships; SC 14, LC 2; D 120, E 44, non-maj 156, maj 8
Degrees: AA 2 yrs
Tuition: $50 per sem hr
Courses: Art Education, Art History, Ceramics, Drawing, Graphic Design, Painting, Photography, Sculpture, Weaving
Summer School: Tuition $50 per sem

PEORIA

BRADLEY UNIVERSITY, Dept of Art, Heuser Art Ctr, 1501 W Bradley Ave Peoria, IL 61625. Tel 309-677-2967; Fax 309-677-3642; Internet Home Page Address: www.bradley.edu; *Chair* Harold Linton
FT 10, PT 4; Pvt; Scholarships, Assistantships; maj 121, others 500
Ent Req: HS grad
Degrees: BA, BS, BFA 4 yrs, MA, MFA 3 yrs
Tuition: $7990 per yr
Courses: Art History, †Art Metal, Ceramics, Drawing, Graphic Arts, Graphic Design, Illustration, Painting, Photography, Printmaking, Sculpture
Summer School: Chair, James Hansen. Enrl 39; tuition $281 per cr hr for courses June-Aug. Courses—Ceramics, Drawing, Graphic Design, Independent Study, Painting, Printmaking

QUINCY

QUINCY UNIVERSITY, Dept of Art, 1800 College Ave, Quincy, IL 62301-2699. Tel 217-228-5200, Ext 5371; Fax 217-228-5354; Internet Home Page Address: www.quincy.edu; *Prof Art* Robert Lee Mejer
Estab 1860, dept estab 1953; FT 3, PT 2; pub; D & E; SC 21, LC 13; maj 25, total enrl 1715, E 150
Ent Req: HS grad, ACT or SAT ent exam
Degrees: BA, BS & BFA 4 yr
Tuition: $5620 per sem; campus res—$875 per sem
Courses: 2-D & 3-D Design, Aesthetics, Art Appreciation, Art Education, Art History, Art Seminars, Ceramics, Commercial Art, Design, Drawing, Illustration, Jewelry, Mixed Media, Modern Art, Non-Western Art, Painting, Photography, Printmaking, Sculpture, Teacher Training, Weaving
Summer School: Dir, Robert Lee Mejer. Tuition $190 per sem hr, optional jr yr abroad

RIVER GROVE

TRITON COLLEGE, School of Arts & Sciences, 2000 N Fifth Ave, River Grove, IL 60171. Tel 708-456-0300; Internet Home Page Address: www.triton.cc.il.us; *Chmn* Norman Weigo
Estab 1965; FT 5, PT 6; pub; D & E; SC 17, LC 3; D 650, E 150, maj 138, adults and non-cr courses
Ent Req: HS dipl, some adult students are admitted without HS dipl, but with test scores indicating promise
Degrees: AA 2 yrs
Tuition: No campus res
Courses: Advertising Design, Art History, Ceramics, Commercial Art, Drawing, Graphic Arts, Graphic Design, Illustration, Lettering, Painting, Printmaking, Recreational Arts & Crafts, Sculpture, Theatre Arts
Adult Hobby Classes: Enrl 550. Courses—Candle Making, Continuing Education Classes, Crafts, Drawing, Ceramics, Jewelry, Quilting, Painting, Plastics, Stained Glass, Sculpture, Theatre Arts
Summer School: Dir, Norm Wiegel. Enrl 100; tuition $27 per cr hr. Courses—Selection from regular classes offered

ROCK ISLAND

AUGUSTANA COLLEGE, Art Dept, 639 38th St, Rock Island, IL 61201. Tel 309-794-7729; Fax 309-794-7659; Elec Mail arschussheim@augustana.edu; Internet Home Page Address: www.augustana.edu; *Chmn Dept* Rowen Schussheim-Anderson; *Assoc Prof* Peter Xiao; *Prof* Megan Quinn; *Adjunct* Jim Konrad; *PT Prof* Bruce Walters; *PT Prof* John Deason
Estab 1860; Maintain nonprofit art gallery, Augustana Art Museum, Rock Island, IL 61201; art supplies available for purchase on campus; FT 6, PT 2; pvt; D; Scholarships, Fellowships; SC 8, LC 9, LabC 3; Enrol 2200
Ent Req: HS grad plus exam
Degrees: BA 4 yr
Tuition: Undergrad $28,173 per yr
Courses: †Art Education, Art History, Ceramics, Costume Design & Construction, Design, Drawing, Graphic Arts, History of Art & Architecture, Painting, Photography, Printmaking, Sculpture, †Studio Art, Teacher Training, Textile Design, Theatre Arts, Weaving

Children's Classes: Enrl 175; tuition $38 for 8 wk term. Courses—Calligraphy, Clay, Drawing, Mixed Media, Painting, Sculpture, Weaving
Summer School: Dean, Jeff Abernathy. Enrl 100; tuition $513 per sem hr for 5 wk term. Courses—Drawing, Fabric Design, Painting, Photography, Weaving

ROCKFORD

ROCK VALLEY COLLEGE, Humanities and Fine Arts Division, 3301 N Mulford Rd, Rockford, IL 61114-5699. Tel 815-654-4410; Fax 815-654-5359; Elec Mail faco1dr@rvc.cc.il.us; Internet Home Page Address: www.rvc.cc.il.us; *Prof* Cherri Rittenhouse; *Prof* Lester Salberg; *Prof* Lynn Fischer-Carlson; *Div Chmn* Dave Ross
Estab 1964, dept estab 1965; FT 2, PT 3; pub; D & E; SC 10, LC 4; D 158, non-maj 70, maj 27
Degrees: AA, AS & AAS 2 yrs
Tuition: Res—$190.43 per cr hr, non-res—$288.46
Courses: Art Education, Art History, Color Theory, Commercial Art, Design, Drawing, Painting, Printmaking

ROCKFORD COLLEGE, Dept of Fine Arts, Clark Arts Ctr, 5050 E State St Rockford, IL 61108. Tel 815-226-4000; Fax 815-394-5167; Internet Home Page Address: www.rockford.edu; *Chmn Dept Fine Arts* Robert N McCauley
Estab 1847, dept estab 1848; FT 4, PT 2; pvt; D & E; Scholarships; SC 20, LC 3-4; D 750, E 700, non-maj 135, maj 45
Ent Req: HS dipl, SAT or ACT
Degrees: BA, BFA and BS 4 yrs, MAT 2 yrs
Tuition: Undergrad $8,725 per sem; room & board $6,780 per sem
Courses: Art History, Ceramics, Drawing, Painting, Papermaking, Photography, Printmaking, Sculpture
Summer School: Dir, Dr Winston McKean. Courses—Art History, Fine Arts (Studio), Stage Design

SOUTH HOLLAND

SOUTH SUBURBAN COLLEGE, Art Dept, 15800 S State St, South Holland, IL 60473. Tel 708-596-2000; *Chmn* Joe Rejholec
Degrees: AA, AAS
Tuition: $53 per cr hr
Courses: †Advertising Design, Art Appreciation, Art History, Calligraphy, Ceramics, Design, Drawing, Illustration, Jewelry, Painting, Printmaking, Sculpture
Summer School: Dir, Dr Fred Hanzelin. Enrl 65. Courses - Art History, Ceramics, Design, Drawing, Nature of Art

SPRINGFIELD

SPRINGFIELD COLLEGE IN ILLINOIS, Dept of Art, 1500 N Fifth, Springfield, IL 62702. Tel 217-525-1420 ext 518; Elec Mail admissions@sci.edu; Internet Home Page Address: www.sci.edu; *Head Dept* Jeff Garland; *Instr* Marianne Stremsterfer, BA; *Instr* John Seiz, MA; *Instr* Jim Allen, MA; *Instr* Lisa Manuele, BA
Estab 1929, dept estab 1968; pvt; D & E; SC 12, LC 4; D 27, E 6, non-maj 11, maj 16
Ent Req: HS dipl, ACT
Degrees: AA 2 yrs
Tuition: $2850 per sem
Courses: 2-D & 3-D Design, Art History, Ceramics, Design, Drawing, History of Art & Architecture, Painting, Photography, Printmaking, Weaving
Adult Hobby Classes: Enrl 125; tuition $125 per cr hr. Courses—Art History, Ceramics, Design, Drawing, Photography
Children's Classes: Enrl 20; tuition $30 for 2 wks in summer. Courses—Art for Children 6 - 9 yrs, 10 - 14 yrs
Summer School: Dir, Dorothy Shiffer. Tuition $125 per cr hr

UNIVERSITY OF ILLINOIS AT SPRINGFIELD, Visual Arts Program, Shepherd Rd, Springfield, IL 62794-9243. Tel 217-206-6790; Fax 217-206-7280; Elec Mail bdixo2@uis.edu; *Assoc Prof* Bob Dixon, MFA & MS; *Asst Prof* Barbara Bolser
Estab 1969, dept estab 1974; pub; D & E; Scholarships; SC 24, LC 10
Ent Req: 2 yrs col educ
Degrees: BA(Creative Arts) 2 yrs
Tuition: Res—$85 per cr hr, $88 per cr hr PT; nonres—undergrad $255 per cr hr, grad $264 per cr hr
Courses: Aesthetics, Art History, †Ceramics, Conceptual Art, Constructions, Design, Drawing, †Graphic Arts, Graphic Design, †Mixed Media, †Painting, †Photography, †Printmaking, †Sculpture, †Video

SUGAR GROVE

WAUBONSEE COMMUNITY COLLEGE, Art Dept, Rte 47 at Harter Rd, Sugar Grove, IL 60554. Tel 630-466-4811; Fax 630-466-9102; Internet Home Page Address: www.cc.us; *Chmn* Stephanie Decicco
Estab 1967; pub; D & E; Scholarships; SC 8, LC 3; D approx 275, E approx 200, maj 25
Ent Req: HS dipl, open door policy for adults without HS dipl
Degrees: AA, AS and AAS 2 yrs
Tuition: $45 per sem hr
Courses: Art Education, Art History, Ceramics, Drawing, Painting, Teacher Training, Theatre Arts
Adult Hobby Classes: Enrl 250; Courses—ceramics, Interior Design, Painting, graphic Arts
Children's Classes: Enrl 50. Courses—Dramatics, Experience in Art.

Summer School: Enrl 50; Tuition $20.50 per sem hr for term of 8 wks beginning June 6. Courses— as per regular session

UNIVERSITY PARK

GOVERNORS STATE UNIVERSITY, College of Arts & Science, Art Dept, University Park, IL 60466. Tel 708-534-5000; Fax 708-534-7895; *Div Chmn* Dr Joyce Kennedy
Scholarships; 175
Degrees: BA, MA
Tuition: Undergrad $95 per cr hr, grad $101 per cr hr
Courses: Art History, Art Studio, Ceramics, Drawing, Electronic Arts, History of Art & Architecture, Jewelry, Mixed Media, Painting, Photography, Printmaking, Sculpture
Summer School: Dir, Mary Bookwalter. Enrl 150; tuition $79.25 per cr hr for May-Aug term. Courses—Art History, Art Studio

WHEATON

WHEATON COLLEGE, Dept of Art, 501 E College, Wheaton, IL 60187. Tel 630-752-5050, 752-5000; Internet Home Page Address: www.wheaton.edu/homeArt; *Chmn* Dr E John Walford
Estab 1861; FT 4; pvt; D & E; Scholarships; SC 32, LC 16; 2350, maj 38, grad 450
Ent Req: HS dipl
Degrees: BA 4 yrs
Tuition: $16,390 per yr; room $3240, board $2304 per yr
Courses: Aesthetics, Art Education, Ceramics, Creativity Practicum, Drawing, Film, Graphic Arts, Graphic Design, History of Art & Architecture, Painting, Philosophy of Art, Photography, Printmaking, Sculpture, Television Production, Theory & Techniques, Video

WINNETKA

NORTH SHORE ART LEAGUE, 620 Lincoln, Winnetka, IL 60093. Tel 847-446-2870; Fax 847-446-4306; Elec Mail nsal@sbcglobal.net; Internet Home Page Address: www.northshoreartleague.org; *Board Pres* Cindy Fuller
Estab 1924; pvt; D & E; Scholarships; SC 20; D 200, E 150
Ent Req: adults must be art league mem
Degrees: continuing educ credits
Tuition: Classes meet once per week for a 12-14 week period; no campus res
Courses: Ceramics, Children's Film, Costume Design & Construction, Critique, Drawing, Fashion Arts, Graphic Arts, Mixed Media, Painting, Printmaking
Children's Classes: various classes
Summer School: Arts Educ Mgr, Josh Barney & Exec Dir, Linda Nelson; six week sessions; art camp

INDIANA

ANDERSON

ANDERSON UNIVERSITY, Art Dept, 1100 E Fifth St, Anderson, IN 46012-3462. Tel 765-641-4320; Fax 765-641-4328; *Chmn* M Jason Knapp
Estab 1928; pvt; D & E; Scholarships; SC 30, LC 3; non-maj 15, maj 60
Ent Req: HS dipl, ent exam plus recommendation
Degrees: BA 4 yrs
Tuition: Undergrad $6555 per sem
Courses: Advertising Design, Art Education, †Art History, Ceramics, Commercial Art, Drawing, Glass, †Graphic Arts, Graphic Design, History of Art & Architecture, Illustration, Jewelry, Lettering, Museum Staff Training, †Painting, †Photography, Printmaking, Sculpture, †Stage Design, Teacher Training
Summer School: Dir, Robert Smith

BLOOMINGTON

INDIANA UNIVERSITY, BLOOMINGTON, Henry Radford Hope School of Fine Arts, 1201 E 7th St, Bloomington, IN 47405. Tel 812-855-7766; Fax 812-855-7498; *Chmn Art History* Bruce Cole; *Prof* Thomas Coleman; *Prof* Molly Faries; *Prof* William Itter; *Prof* Eugene Kleinbauer; *Prof* John Goodheart; *Prof* Roy Sieber; *Prof* Bonnie Sklarski; *Prof* Budd Stalnaker; *Prof* Joan Sterrenburg; *Prof* Barry Gealt; *Assoc Prof* Sarah Burns; *Assoc Prof* Randy Long; *Assoc Prof* Wendy Calman; *Assoc Prof* John Turner; *Assoc Prof* Patrick McNaughton; *Assoc Prof* Shehira Davezac; *Assoc Prof* Janet Kennedy; *Assoc Prof* Georgia Strange; *Assoc Prof* Susan Nelson; *Assoc Prof* James Reidhaar; *Assoc Prof* Ed Bernstein; *Asst Prof* Eve Mansdorf; *Asst Prof* Tim Mather; *Asst Prof* Karen Ros; *Asst Prof* Yolanda McKay; *Asst Prof* Dale Newkirk; *Asst Prof* Michelle Facos; *Dir* Jeffrey Wolin
Estab 1911; pub; D; Scholarships; SC 55, LC 100, GC 110; maj undergrad 300, grad 135 (45 Art History, 90 Studio), others 5600
Ent Req: admis to the Univ
Degrees: BA, BFA, 4 yrs, MA, MFA, PhD
Tuition: Res—undergrad $4,412 per yr, grad $168.60 per cr hr; nonres—undergrad $13,416 per yr, grad $491.15 per cr hr, room & board avg $5,608 per yr
Courses: Art History, Ceramics, Graphic Design, Jewelry, Painting & Drawing, Photography, Printed Textiles, Printmaking, Sculpture, Woven Textiles
Summer School: Dir, John Goodheart. Tuition res—undergrad $71 per cr hr, grad $93 per cr hr; nonres—undergrad $222.15 per cr hr, grad $266.60 per cr hr. Courses—Art History, Ceramics, Drawing, Painting, Photography

CRAWFORDSVILLE

WABASH COLLEGE, Art Dept, 301 W Wabash Ave, Crawfordsville, IN 47933. Tel 765-361-6386; Fax 765-361-6341; Elec Mail huebnerg@wabash.edu; Internet Home Page Address: www.wabash.edu; *Chmn* Gregory Huebner; *Prof* Doug Calisch; *Gallery Dir* Lali Hess; *Asst Prof Art History* Matt Backer
Estab 1832, dept estab 1950; Maintain nonprofit art gallery; Eric Dean Gallery, Randolph Deer Art Wing, Fine Arts Ctr, Wabash College, 301 W Wabash Ave, Crawfordsville, IN 47933; art library in Randolph Deer Art Wing; Pvt, men only; D; Scholarships, Fellowships; SC 16, LC 7; D 100, non-maj 80, maj 20
Ent Req: HS dipl, SAT
Degrees: BA 4 yrs
Tuition: $24,342 per yr; campus res—room & board $7,064
Courses: 2-D & 3-D Design, Aesthetics, Architecture, Art History, †Ceramics, Design, †Drawing, †History of Art & Architecture, †Painting, †Photography, †Sculpture

DONALDSON

ANCILLA COLLEGE, Art Dept, PO Box One, Donaldson, IN 46513. Tel 219-936-8898; Fax 219-935-1773; *Act Dept Head* Charles Duff
Estab 1936, dept estab 1965; pvt; D & E; SC 9-12, LC 2
Ent Req: HS dipl
Degrees: AA, AAA(Applied Arts) 2 yrs
Tuition: Undergrad $145 per cr hr
Courses: Aesthetics, Art Appreciation, Calligraphy, Ceramics, Design, Drawing, Enameling, Graphic Design, Lettering, Photography
Children's Classes: Enrl 12; tuition $40 for 6 sessions; Courses—Crafts for Children, Drawing and Painting for Children. Classes on Saturday

EVANSVILLE

UNIVERSITY OF EVANSVILLE, Art Dept, 1800 Lincoln Ave, Evansville, IN 47722. Tel 812-479-2043; Fax 812-479-2101; Elec Mail bb32@evansville.edu; *Dept Head, Prof* William Brown, MFA; *Instr* James Goodridge, MA; *Asst Prof* Ralph Larmann, MFA; *Instr* Stephanie Frasier, BS; *Instr* Petronella Bannien, MFA; *Instr* Pamela Combs, MFA; *Instr* Tracy Maurer, MA; *Instr* Mark Schoenbaum, MFA
Estab 1854; Maintain nonprofit art gallery; Krannert Gallery; Pvt; D & E; Scholarships; SC 20, LC 10; D 2,600, maj 70
Ent Req: HS dipl
Degrees: BA(Art History), BS(Art Educ, Art & Assoc Studies), BFA, BA(Art) 4 yrs
Tuition: $12,990
Courses: †Art & Associated Studies, Art Appreciation, †Art Education, †Art History, †Ceramics, Design, Drawing, †Graphic Design, Jewelry, Life (figure) Drawing, †Painting, Photography, Printmaking, †Sculpture, †Visual Communication
Summer School: Tuition $210 5 wk sessions. Courses—Art Appreciation, Ceramics, Photography

UNIVERSITY OF SOUTHERN INDIANA, Art Dept, 8600 University Blvd, Evansville, IN 47712. Tel 812-465-7047; Fax 812-465-1263; Elec Mail vthomas@usi.edu; Internet Home Page Address: www.usi.edu; *Assoc Prof* Hilary Braysmith; *Prof* Leonard Dowhie Jr, MFA; *Assoc Prof* Margaret Skoglund, PhD; *Prof* Kathryn Waters, MFA; *Prof* John McNaughton, MFA; *Assoc Prof* Joseph Uduehi; *Assoc Prof* Joan Kempf, MFA; *Prof* Michael Aakhus, MFA; *Instr* Chuck Armstrong; *Instr* Virginia Poston, MA; *Asst Prof* Xinran Hu, MFA; *Instr* Cathryn Roth, MFA
Estab 1969; FT 12, PT 17; pub; D & E; Scholarships, Fellowships; SC 27, LC 4; D 220, E 32, maj 208, non maj 12
Ent Req: HS dipl
Degrees: BS (Art Educ), BA & BS (Art) 4 yrs
Tuition: Res—$127.50 per cr hr; nonres—$304.25 per cr hr
Courses: Art History, Ceramics, Contemporary Art, Graphic Design, Painting, Photography, Printmaking, Sculpture
Adult Hobby Classes: Enrl 25. Courses—Silkscreen
Children's Classes: Enrl 80, Sat am, 3 age groups
Summer School: Summer sessions offered; Dir Michael Aakhus

FORT WAYNE

INDIANA-PURDUE UNIVERSITY, Dept of Fine Arts, 2101 Coliseum Blvd E, Fort Wayne, IN 46805-1499. Tel 219-481-6705; Internet Home Page Address: www.ipfw.edu; *Assoc Prof* Anne-Marie LeBlanc, MFA; *Assoc Prof* Norman Bradley, MFA; *Assoc Prof* Audrey Ushenko PhD, MFA; *Asst Prof* Dennis Krist, BFA; *Asst Prof* John Hrehov, MFA; *Asst Prof* Nancy McCroskey, MFA
Estab 1920, dept estab 1976; pub; D & E; Scholarships; SC 96, LC 5; non-maj 60, maj 235
Degrees: AB, AS, BFA 4 yrs
Tuition: Res—$122.75 per cr hr; nonres—$213.95 per cr hr; no campus res
Courses: Art History, †Ceramics, †Computer Design, †Crafts, †Drawing, †Graphic Arts, Illustration, †Metalsmithing, †Painting, †Photography, †Printmaking, †Sculpture
Children's Classes: Enrl 75; tuition $60 for 11 wks. Courses—Ceramics, Drawing, Painting, Sculpture

UNIVERSITY OF SAINT FRANCIS, School of Creative Arts, 2701 Spring St, Fort Wayne, IN 46808. Tel 260-434-7591; Fax 260-434-7604; Elec Mail rcartwright@sf.edu; Internet Home Page Address: www.sf.edu/art; *Dean* Rick Cartwright, MFA; *Assoc Prof* Mary Klopfer, MFA; *Assoc Prof* Jane Martin, MFA; *Assoc Prof* Karen McArdle, MFA; *Instr* Tom Keesee, MFA; *Instr* Alan Nauts, BA;

Prof Maurice A Papier, MS; *Asst Prof* Neal McDonald, MFA; *Asst Prof* Cara Wade, MFA; *Asst Prof* Esperanca Camara, PhD; *Asst Prof* Patricia Edwards, MA; *Asst Prof* Kristin Fedders, PhD; *Instr* Bob Mayer, MS
Estab 1890; Maintains a nonprofit art gallery, John P. Weatherhead Gallery, Rolland Art Center, 2701 Spring St, Fort Wayne, IN 46808; also maintains an art/architecture library, Lee & Jim Vann Library; Pvt; D, E, weekends & summer; Scholarships; SC 22, LC 6, GC 14, workshops; D 150, maj 150
Ent Req: HS dipl, class rank in HS, SAT
Degrees: MA (Studio Art), BA (Communication, Communication Arts & Graphic Design, Computer Art, Studio Art), BS (Education, Visual Art All Grade Major grds K-12; Education - Secondary Education Visual Arts grds 9-12); AA (Communication Arts & Graphic Design); Minors: Art, Art History, Communication, Speech
Tuition: Undergrad $560 45 per sem hr, grad $590 per sem hr; campus res—room & board $7,396 per yr
Courses: †2D Composition, †3D Composition, Advertising Design, Animation, †Art Education, Art History, Ceramics, †Commercial Art, Computer Graphics, †Design, †Desktop Publishing, Display, Drawing, Fashion Arts, Graphic Arts, Graphic Design, Painting, Photography, Printmaking, †Sculpture, †Teacher Training
Children's Classes: Enrl 60; tuition $75 per sem. Courses—General Art Instruction grades K - 8
Summer School: Dir, Dean Rick Cartwright; two 6 wk sessions. Courses—Art Appreciation, Computer Graphics, Drawing, Painting

FRANKLIN

FRANKLIN COLLEGE, Art Dept, 501 E Monroe, Franklin, IN 46131. Tel 317-738-8279; Fax 317-736-6030; Internet Home Page Address: www.franklincoll.edu; *Chmn Dept* Michael Swanson
Estab 1834; FT 2, PT 2; den; D; Scholarships; SC 9, LC 4; 900
Ent Req: HS grad
Degrees: BA 4 yrs
Tuition: $17,225 per yr; commuter $13,520 per yr
Courses: Art History, Basic Design, Design, Drawing, Painting, Sculpture

GOSHEN

GOSHEN COLLEGE, Art Dept, 1700 S Main St, Goshen, IN 46526. Tel 219-535-7595; Fax 219-535-7660; Internet Home Page Address: www.goshen.edu; WATS 800-348-7422; *Prof* Abner Hershberger, MFA; *Asst Prof* John Mishler, MFA; *Chmn* John Blosser
Estab 1950; den; D & E; Scholarships; D 145, E 25, non-maj 60, maj 50
Ent Req: HS dipl, top half of class
Degrees: BA(Art) with Indiana Teaching Cert
Tuition: Res & nonres—$11,900, room & board $4160
Courses: Aesthetics, Architectural Drawing, Architecture, Art Appreciation, †Art Education, Art History, †Ceramics, Commercial Art, Design, Drafting, Drawing, Graphic Design, †Jewelry, †Painting, Photography, †Printmaking, Sculpture, Stage Design, †Teacher Training, †Theatre Arts, Video

GREENCASTLE

DEPAUW UNIVERSITY, Art Dept, Greencastle, IN 46135. Tel 765-658-4340, 4800; Fax 765-658-6552; Internet Home Page Address: www.depauwuniversity.edu; *Prof Chmn* Mitch Murback; *Prof* David Herrold
Estab 1837, dept estab 1877; pvt den; D; SC 14, LC 9, GC 18; D 300, E 20 (Art Dept), non-maj 25%, maj 75%, grad 20
Ent Req: HS dipl, upper half of high school graduating class
Degrees: BA & BM 4 yrs
Tuition: $21,100 per yr; campus res—room & board $6,500 per yr, plus $320 various fees
Courses: Art Education, Art History, Ceramics, Drawing, Painting, Photography, Printmaking, Studio Arts

HAMMOND

PURDUE UNIVERSITY CALUMET, Dept of Communication & Creative Arts, 2200 169th St, Hammond, IN 46323. Tel 219-989-2393; Fax 219-989-2008; Internet Home Page Address: www.calumet.purdue.edu; *Head* Yahya R Kamalipour
Estab 1946; pub; D & E; Scholarships; SC 1-4, LC 1-2, GC 1
Ent Req: HS dipl
Tuition: Res—undergrad $101.45 per cr hr, grad $135.80 per cr hr; nonres—undergrad $255.10 per cr hr, grad $299.50 per cr hr
Courses: Architecture, Art Education, Ceramics, Drawing, Film, Painting, Photography, Teacher Training, Theatre Arts, Video

HANOVER

HANOVER COLLEGE, Dept of Art, 359 LeGrange Rd, Hanover, IN 47243; PO Box 108, Hanover, IN 47243. Tel 812-866-7000; Fax 812-866-7114; Internet Home Page Address: www.hanover.edu; *Interim Chmn Dept* Debbie Whistler
Estab 1827, dept estab 1967; pvt; D & E; Scholarships; SC 16, LC 4; D 1142
Ent Req: HS dipl
Degrees: BS and BA 4 yrs
Tuition: $16,700 per yr
Courses: Advertising Design, Aesthetics, Art Education, Art History, Ceramics, Collage, Commercial Art, Constructions, Drawing, Fiber, Film, Glass Blowing, Graphic Arts, Graphic Design, Jewelry, Painting, Photography, Printmaking, Sculpture, Stage Design, Stained Glass, Teacher Training, Theatre Arts, Video

HUNTINGTON

HUNTINGTON COLLEGE, Art Dept, 2303 College Ave, Huntington, IN 46750. Tel 219-356-6000; Fax 219-356-9448; *Asst Prof* W Kenneth Hopper; *Asst Prof* Rebecca L Coffman; *Dean* Ron Webb
Estab 1897; den; D & E; SC 5, LC 3
Ent Req: HS dipl, SAT & two recommendations
Degrees: BA 4 yr
Tuition: Res—$19,720, incl room & board; nonres—$14,270
Courses: Art Appreciation, †Art Education, Art History, Arts & Crafts, Ceramics, Computer Graphics, Drawing, Fine Arts, †Graphic Design, Painting, Photography
Summer School: Dean, Ron Webb. Tuition $180 per sem hr beginning May 21. Courses—same as above

INDIANAPOLIS

INDIANA UNIVERSITY-PURDUE UNIVERSITY, INDIANAPOLIS, Herron School of Art, 1701 N Pennsylvania St, Indianapolis, IN 46202. Tel 317-920-2416; Fax 317-920-2401; Elec Mail herrart@iupui.edu; Internet Home Page Address: herron.iupui.edu; *Coordr Foundation* William Potter; *Dean* Valerie Eickmeier; *Assoc Dean* Martel Plummer; *Fine Arts Dept Chair* Craig McDaniel; *Visual Comun Dept Chair* Christopher Vice
Estab 1902; Non-profit art gallery - Herron Gallery, 1701 N Pennsylvania St, Indianapolis, IN 46202 (after 5/1/2005, 735 W New York St, Indianapolis, IN 46202); Art supplies available on-campus; pub; D & E; Scholarships; SC 115, LC 14, GC 10; D 800, non-maj 400, grad 25
Degrees: BFA and BAE 4 yrs, MAE 5 yrs
Tuition: Res—undergrad $171.70 per cr hr, grad $194.10 per cr hr; nonres—undergrad $477.80 per cr hr; grad $560.15 per cr hr
Courses: †Art Education, †Art History, †Ceramics, Computer Graphics, Drawing, †Fine Arts, Furniture Design, Graphic Arts, Graphic Design, Illustration, Mixed Media, Painting, †Photography, †Printmaking, †Visual Communications
Adult Hobby Classes: Sat school $175.00
Children's Classes: Enrl 150; tuition $175 (partial scholarships) for 10 wk term, Saturday art classes for jr & sr HS students. Youth Art Day Camp $135 per wk
Summer School: Commuinity Learning Coordr annemarie Pankratz; 2 two-week sessions of Honors Art $280/ses

MARIAN COLLEGE, Art Dept, 3200 Cold Spring Rd, Indianapolis, IN 46222. Tel 317-955-6000, Ext 432; Fax 317-955-0263; Internet Home Page Address: www.marian.edu; *Instr* Roberta Williams, MA; *Chmn* Jamie Higgs, PhD; Megan Wright, MFA; Stephanie Taugner, MFA
Estab 1851, dept estab 1938; Pvt; D ; Scholarships; SC 27, LC 11; D 40, maj 40
Special Subjects: Art History, Graphic Design
Ent Req: HS dipl, SAT
Degrees: AA 2 yrs, BA 4 yrs
Tuition: Res—undergrad incl room & board $21,172 per yr; nonres—$21,720, room & board incl
Courses: †Art Education, Art History, Art Therapy, Ceramics, Crafts, Design, Drawing, Graphic Design, Interior Design, Painting, Photography, Sculpture, Stage Design, Theatre Arts

UNIVERSITY OF INDIANAPOLIS, Art Dept, 1400 E Hanna Ave, Indianapolis, IN 46227. Tel 317-788-3253; Internet Home Page Address: www.uindy.edu; *Prof* Earl Snellenberger, MFA; *Chair* Dee Schaad, MFA
Estab 1902; den; D & E; Scholarships; SC 24, LC 7, GC 7; D 400, E 160, maj 70, grad 5
Ent Req: HS dipl, SAT, upper half of HS class
Degrees: BA and BS 4 yrs
Tuition: $15,350 per yr; room & board $5490 per yr
Courses: Advertising Design, Art Appreciation, Art Education, Art History, †Art Therapy, Ceramics, Commercial Art, Design, Drawing, Graphic Arts, History of Art & Architecture, Jewelry, Lettering, Occupational Therapy, Painting, Photography, Printmaking, Sculpture, Teacher Training
Children's Classes: Enrl 20; free for 10 wk session. Courses—Drawing
Summer School: Dir, Dee Schaad. Enrl 60; $104 per cr hr. Courses—Art Appreciation, Ceramics, Computer, Photography, Printmaking

MARION

INDIANA WESLEYAN UNIVERSITY, Art Dept, 4201 S Washington St, Marion, IN 46953. Tel 765-677-2711; Fax 765-677-2794; Internet Home Page Address: www.indwes.edu; *Assoc Prof* Robert Curfman, MA; *Asst Prof* Rodney Crossman, BS Ed; *Assoc Prof* Ron Mazellen, MA; *Assoc Prof* Alan Kwok, MFA; *Assoc Prof* Dallas Walters, MFA; *Asst Prof* Dan Pocock; *Asst Prof* Daniel Hall, MA; *Asst Prof* Ana Pongracic
Estab 1890, dept estab 1969; maintains nonprofit gallery, Beards Art Center, 4201 S Washington St Marion, IN, 46953; pvt, den; D & E; Scholarships; SC 32, LC 11; D 35, non-maj 5, maj 200
Ent Req: HS dipl
Degrees: BS(Art Educ), ceramic, painting, printmaking, computer graphics, inllustration, photography, art ed
Tuition: $19,000 - $21,000 per yr; campus res—available
Courses: †Advertising Design, Art Appreciation, Art Education, Art History, Batik, Ceramics, Commercial Art, Drawing, Graphic Arts, Graphic Design, Illustration, Jewelry, Painting, Photography, Pre-Art Therapy, Printmaking, Sculpture, Silversmithing, Stained Glass, Studio Administration, Studio Practicum, †Teacher Training, †Visual Arts Education, Weaving
Summer School: Dir, Robert Curfman. Enrl 20

MUNCIE

BALL STATE UNIVERSITY, Dept of Art, 217 Riverside Ave, Muncie, IN 47306. Tel 765-285-5838; Fax 765-285-5275; Internet Home Page Address: www.bsu.edu; *Chmn* Thomas Spoerner, EdD

Estab 1918; FT 21; pub; D & E; Scholarships; SC 82, LC 25, GC 30; non-maj 386, maj 341, grad 15
Ent Req: HS dipl
Degrees: BS & BFA 4 yrs, MA 1 yr
Tuition: Res—undergrad $1981 per sem, grad $2100 per sem; nonres—undergrad $5689 per sem, grad $5341; campus res available
Courses: Art Appreciation, †Art Education, Art History, †Ceramics, †Drawing, †Graphic Design, Jewelry, †Metals, †Painting, †Photography, †Printmaking, †Sculpture, Silversmithing
Summer School: Enrl 5000; tuition $1090 for term of 5 wks beginning May

NEW ALBANY

INDIANA UNIVERSITY-SOUTHEAST, Fine Arts Dept, 4201 Grant Line Rd, New Albany, IN 47150. Tel 812-941-2342; Fax 812-941-2529; Internet Home Page Address: www.ius.edu; *Coordr of Fine Arts* Anne Allen; *Assoc Prof* John R Guenthler, MFA; *Assoc Prof* Debra Clem, MFA; *Asst Prof* Marilyn Whitesell
Estab 1945, dept estab 1966; pub; D & E; SC 25, LC 2; D 150, E 35, non-maj 100, maj 50
Ent Req: HS dipl
Degrees: BA 4 yrs
Tuition: Res—undergrad $180 per cr hr; nonres—undergrad $266.65 per cr hr
Courses: Advertising Design, Art Appreciation, Art Education, Art History, Ceramics, Drawing, Painting, Printmaking
Adult Hobby Classes: Enrl 35; tuition $25 per sem. Courses—Crafts, Watercolor
Summer School: Enrl 60; term of two 6 wk sessions beginning May 15 & July 5. Courses—Same as above

NORTH MANCHESTER

MANCHESTER COLLEGE, Art Dept, 604 College Ave, North Manchester, IN 46962. Tel 219-982-5000, Ext 5334; Fax 219-982-6868; Internet Home Page Address: www.manchester.edu.com; *Prof* Stephen Batzka, BA; *Chmn Dept* James R C Adams, MFA
Estab 1889; den; D & E; Scholarships; SC 15, LC 3; D 45, maj 15
Ent Req: HS dipl
Degrees: AA 2 yrs, BA and BS 4 yrs
Tuition: Res—undergrad $15,230 per yr, room & board $5,600 per yr
Courses: Advertising Design, Art Education, †Art History, Camera Techniques, Ceramics, Drawing, Film, Graphic Arts, Handicrafts, History of Art & Architecture, Lettering, Painting, Photography, Printmaking, Sculpture, Teacher Training, Textile Design
Adult Hobby Classes: Tuition $35 per sem hr. Courses—Camera Techniques, Sculpture

NOTRE DAME

SAINT MARY'S COLLEGE, Dept of Art, Moreau Hall, Notre Dame, IN 46556. Tel 219-284-4631; Fax 219-284-4716; Internet Home Page Address: www.stmaryscollege.edu/~art; *Chmn* Bill Sandusky
Estab 1844; Maintains nonprofit gallery, Moreau Art Galleries; Pvt, W; D & E; Scholarships, Fellowships; SC 21, LC 10; maj 50
Ent Req: CEEB, standing, recommendations, others
Degrees: BA and BFA 3 1/2-5 yrs
Tuition: $18,929 per yr
Courses: Art Appreciation, Art Education, Art History, Ceramics, Computer Media, †Costume Design & Construction, Drawing, Fibers, Holography, Mixed Media, Painting, Photo Silkscreen, Photography, Printmaking, Sculpture, Stage Design

UNIVERSITY OF NOTRE DAME, Dept of Art, Art History & Design, 132 O'Shaughnessy Hall, Notre Dame, IN 46556. Tel 219-631-7602; Fax 219-631-6312; Elec Mail art.art.l@nd.edu; *Chmn* Austin Collins, CSC; *Grad Dir* Richard Gray; *Office Coordr* Mary Foster
Estab 1855; FT 15, PT 8; pvt; D; Scholarships; SC 38, LC 8, GC 20; maj 100
Ent Req: upper third HS class, ent exam
Degrees: BA, BFA 4 yrs, MA, MFA
Tuition: Undergrad $24,500 per yr; grad $24,375 per yr; campus res—available
Courses: †Art History, †Ceramics, Drawing, Fibers, †Graphic Design, †Industrial Design, †Painting, †Photography, †Printmaking, †Sculpture
Summer School: Enrl 30-50; $93 per cr hr plus general fee for 7 wk term. Courses—Art History, Ceramics, Photography, Studio Workshops

OAKLAND CITY

OAKLAND CITY UNIVERSITY, Division of Fine Arts, 143 N Lucretia St, Oakland City, IN 47660. Tel 812-749-4781, Ext 274; Fax 812-749-1233; Elec Mail dhazelwo@oak.edu; Internet Home Page Address: www.oak.edu; *Assoc Prof* Donna Hazelwood, PhD; *Prof* Joseph E Smith, MFA; *Assoc Prof* Carol Spitler, MA; *Assoc Prof* Jean Cox, PhD
Estab 1961; Maintain nonprofit art gallery; J Michael Dunn Gallery; art supplies available on-campus; FT 4, PT 1; pvt, den; D & E; Scholarships; SC 15, LC 5; maj 35
Ent Req: HS dipl, SAT
Degrees: AA 2 yrs, BA & BS 4 yrs
Tuition: Undergrad $300 per cr hr
Courses: Advertising Design, Art Appreciation, †Art Education, Art History, Ceramics, Commercial Art, Conceptual Art, Design, Drawing, Graphic Arts, †Graphic Design, History of Art & Architecture, Painting, Photography, Printmaking, Sculpture, Teacher Training
Summer School: Courses vary

RICHMOND

EARLHAM COLLEGE, Art Dept, 801 National Rd W, Drawer 48 Richmond, IN 47374. Tel 765-983-1200, 983-1410; Fax 765-983-1247; Internet Home Page Address: www.earlham.edu; *Convener* Kristin Fedders
Estab 1847; den; D; Scholarships; SC 10, LC 7; maj 12-18
Ent Req: HS dipl
Degrees: BA 4 yrs
Tuition: $21,700 per yr; campus res—room $2500 per yr, board $2638 per yr
Courses: Art History, Ceramics, Drawing, Film, Painting, Photography, Printmaking, Theatre Arts

INDIANA UNIVERSITY-EAST, Humanities Dept, 2325 Chester Blvd, Richmond, IN 47374. Tel 765-973-8200; Fax 765-973-8485; Internet Home Page Address: www.indiana.edu; *Chmn* Dr T.J. Rivard
Tuition: Res—$108.40 per cr hr; nonres—$267.40 per cr hr
Courses: Art Appreciation, Art Education, Art History, Drawing, Handicrafts, Painting, Photography, Sculpture

SAINT MARY OF THE WOODS

SAINT MARY-OF-THE-WOODS COLLEGE, Art Dept, 3301 Saint Mary's Rd, Saint Mary of the Woods, IN 47876; PO Box 68 Saint Mary of the Woods, IN 47876. Tel 812-535-5151, 535-5141; Fax 812-535-4613; Internet Home Page Address: www.smwc.edu; *Area Coordr* Donna Dene English; *Gallery Dir* Sheila Genteman; *Assoc Prof* Thomas Swopes; *Asst Prof* Pat Jancosek
Estab 1840; FT 2, PT 1; den(W); D; Scholarships; SC 15, LC 4; maj 14
Ent Req: HS dipl, SAT or ACT
Degrees: BA & BS 4 yrs, MAAT
Tuition: $15,090, $520 fees, $2,250 room, $3,500 board
Courses: †Art Education, Art History, †Ceramics, Design, Drawing, †Graphic Design, †Painting, Photography, Teacher Training

SOUTH BEND

INDIANA UNIVERSITY SOUTH BEND, Fine Arts Dept, 1700 Mishawaka Ave, South Bend, IN 46615. Tel 219-237-4134; Fax 219-237-4317; Internet Home Page Address: www.iusb.edu; *Chmn* Thomas Miller; *Prof* Alan Larkin, MFA; *Adjunct Asst Prof* Linda Crimson, MFA; *Adjunct Asst Prof* Anthony Droega, MFA
Estab 1964; pub; D & E; SC 18, LC 6; non-maj 380, maj 48
Ent Req: HS dipl
Degrees: AA(Fine Arts) 2 yr, BA & BFA(Fine Arts) 4 yr
Tuition: Res—undergrad $99.15 per cr hr, grad $131 per cr hr; nonres—undergrad $275.30 per cr hr, grad $301.90
Courses: Art Education, Art History, Drawing, Graphic Design, Painting, Printmaking, Sculpture
Summer School: Chmn, Anthony Droege. Tuition same as regular session; two 6 wk summer sessions. Courses—Art Appreciation, Drawing, Painting

TERRE HAUTE

INDIANA STATE UNIVERSITY
—Dept of Art, Tel 812-237-3697; Fax 812-237-4369; Elec Mail artdept@ruby.indstate.edu; Internet Home Page Address: baby.indstate.edu/art_sci/art/; *Acting Chmn* Craig McDaniel
Estab 1870; pub; D & E; Scholarships; SC 66, LC 45, GC 61; D 2432, E 311, maj 180, grad 40
Ent Req: HS dipl, top 50% of class with C average
Degrees: BA(Art History), BS(Studio Art), BSed(Art Education), BFA(Studio Art) 4 yr, MA(Studio Art) 1 yr & MFA(Studio Art) 2 yr
Tuition: Res—undergrad $128 per cr hr, (18 hr) grad $154 per cr hr; nonres—undergrad $321 per cr hr (9 hr), grad $351 per cr hr
Courses: Aesthetics, Art Appreciation, †Art Education, †Art History, †Ceramics, †Drawing, †Graphic Design, History of Art & Archeology, †Painting, Papermaking, †Photography, †Printmaking, †Sculpture, Studio Furniture, Teacher Training, Wood Sculpture
Summer School: Dir, Dr Louis Jensen. Tuition res—undergrad $119, grad $137.50 per cr hr; nonres—undergrad $289, grad $311.50 per cr hr for term of two 5 wks beginning June. Courses—variety of studio & lecture courses

UPLAND

TAYLOR UNIVERSITY, Visual Art Dept, 236 W Reade Ave, Upland, IN 46989-1001. Tel 765-998-2751, Ext 5322; Fax 765-998-4680; Elec Mail visualarts@tayloru.edu; Internet Home Page Address: www.tayloru.edu; *Chmn, Assoc Prof, Gilkison Family Chair in Art History* Rachel Smith; *Asst Prof* Larry Blakely; *Assoc Prof* Craig Moore; *Asst Prof* Kathy Hermann; *Asst Prof* Matt Tailford; *Instr* Shawn Casbarro
Estab 1846; dept estab 1968; Maintain nonprofit art gallery; Metcalf Gallery; FT 7, PT 4; pvt; D ; Scholarships; SC 18, LC 7; D 200, non-maj 250, maj 94
Ent Req: HS dipl, SAT, recommendations
Degrees: BA and BS 4 yrs
Tuition: $27,000 incl tuition, room & board
Courses: Art History, †Art Studio, Ceramics, †Design, Drawing, Graphic Arts, †Graphic Design, †History of Art & Architecture, Metals, Mixed Media, †New Media, Painting, Photography, Printmaking, Sculpture, †Silversmithing, †Video

VINCENNES

VINCENNES UNIVERSITY JUNIOR COLLEGE, Humanities Art Dept, 1002 N First St, Vincennes, IN 47591. Tel 812-888-5110; Fax 812-888-5531; Elec Mail ajendrzejewski@indian.vinu.edu; Internet Home Page Address: www.vinu.edu; *Prof* Amy DeLap; *Prof* Jim Pearson; *Assoc Prof* Steve Black; *Assoc Prof* Deborah Hagedorn; *Assoc Prof* John Puffer; *Assoc Prof* Bernard Hagedorn; *Chmn* Andrew Jendrzejewski

Estab 1971; Maintain a nonprofit art gallery: Shirchift Gallery of Art, 1002 1st St, Vincennes University, Vincennes, IN 47591; Pub; D&E; Scholarships; SC 14, LC 2, Other Course 2; non-maj 80, maj 80
Ent Req: HS dipl
Degrees: AA, AS
Tuition: Res—$77.70 per cr hr; nonres—$188 per cr hr
Courses: Art Appreciation, †Art Education, Art History, Ceramics, †Commercial Art, †Design, Drawing, Fine Art, Graphic Arts, †Graphic Design, †Occupational Therapy, Painting, Photography, Printmaking, Sculpture, †Teacher Training

WEST LAFAYETTE

PURDUE UNIVERSITY, WEST LAFAYETTE, Patti and Rusty Rueff Department of Visual & Performing Arts, 552 W Wood St, West Lafayette, IN 47907-2002. Tel 765-494-3058; Fax 765-496-2076; Elec Mail artdesign@sla.purdue.edu; Internet Home Page Address: www.sla.purdue.edu/ad; *Chmn Div* Lisa Lee Peterson; *Grad Coordr* Sue Uhlig; *Intern/Co-op Coordr* Laura Bittner
Estab 1869; Maintain a nonprofit art gallery; FT 32; pub; D & E; Scholarships; SC 50, LC 22, GC 22; maj 976, other 4,237
Degrees: BA 4 yrs, M.F.A., PhD
Tuition: Res—$3,046 per sem; nonres—$9,350 per sem
Courses: †Advertising Design, Aesthetics, Art Appreciation, Art Education, Art History, Ceramics, †Conceptual Art, Costume Design & Construction, Design, †Drawing, †Graphic Arts, †Graphic Design, History of Art & Architecture, Illustration, †Industrial Design, †Interior Design, †Jewelry, †Metals, †New Media, †Painting, †Photography, †Printmaking, †Sculpture, Silversmithing, Stage Design, Teacher Training, †Textile Design, †Textiles, Theatre Arts, †Video, †Visual Communications Design, †Weaving
Summer School: Dept Head, David Sigman

WINONA LAKE

GRACE COLLEGE, Dept of Art, 200 Seminary Dr, Winona Lake, IN 46590. Tel 574-372-6021; Fax 574-372-5152; Elec Mail davisaw@grace.edu; Internet Home Page Address: www.grace.edu; *Assoc Prof* Gary Nietcr, MA; *Assoc Prof* Timothy Young, MFA; *Head Dept* Art Davis, MA
Estab 1952, dept estab 1971; maintain nonprofit art gallery, Mount Memorial Art Gallery; pvt; D & E; Scholarships; SC 12, LC 3; maj 80, non-maj 200
Activities: Schols
Ent Req: HS dipl, SAT
Degrees: 4 yr Art Major, 4 yr Educ Major, 4 yr Graphic Art, 4 yr Illustration, 4 yr Drawing/Painting
Tuition: $11,440 per yr; room $2,395, board $2,615
Courses: 2-D Design, 3-D Design, Art Appreciation, †Art Education, Art History, Ceramics, †Drawing, †Graphic Design, †Illustration, Painting, Photography, Printmaking, Teacher Training, Typography
Children's Classes: Children's Art Encounters, 6th - 12th grade, $50

IOWA

AMES

IOWA STATE UNIVERSITY, Dept of Art & Design, 158 College of Design Bldg, Ames, IA 50011-3092. Tel 515-294-6724; Fax 515-294-2725; Internet Home Page Address: www.iastate.edu; *Coordr Graphic Design* Sung Yung Kang; *Coordr Graphic Design* Debra Satterfield; *Coordr Integrated Arts* Steve Herrnstadt; *Coordr Interior Design* Fred Maluen; *Coordr Core Prog* Karen Bermann; *Coordr Core Prog* Carol Faber
Estab 1858, dept estab 1920; Maintain nonprofit art gallery, Gallery 181, 134 College of Design, Iowa State Univ, Ames IA 50011; pub; D & E; Scholarships; SC 45, LC 15, GC 6; D 1,000, maj 960, grad 40
Ent Req: HS dipl
Degrees: BA, BFA(Graphic Design, Integrated Studio Arts, Interior Design), MFA(Graphic & Interior Design, Integrated Studio Arts)
Tuition: Res—undergrad $2,291 per sem; nonres—undergrad $7,581 per sem; campus res available
Courses: Art History, Ceramics, Drawing, Graphic Design, Illustration, Interior Design, Intermedia, Jewelry, Mixed Media, Painting, Photography, Printmaking, †Surface Design, Textile Design, †Wood Design
Summer School: Dir, Chair Dept Roger Baer. Term of 8 wks. Courses—Art Education, Art History, Design, Drawing, Painting

BOONE

DES MOINES AREA COMMUNITY COLLEGE, Art Dept, Boone Campus, 1125 Hancock Dr Boone, IA 50036. Tel 515-432-7203; Fax 515-432-6311; Internet Home Page Address: www.demac.cc.ia.us; *Chmn* Pete Conis
Estab 1927, dept estab 1970; pub; D & E; SC 3, LC 2; D 100, E 60
Ent Req: HS dipl
Degrees: AA, AS 2 yrs
Tuition: Res $72.40 per cr hr; non res $136.40 per cr hr
Courses: Art Appreciation, Art History, Art in Elementary School, Drawing, Exploring Art Media, Landscaping, Life Drawing, Painting, Stage Design, Teacher Training, Theatre Arts

CEDAR FALLS

UNIVERSITY OF NORTHERN IOWA, Dept of Art, Col of Humanities and Fine Arts, Cedar Falls, IA 50614-0362. Tel 319-273-2077; Fax 319-273-7333; Internet Home Page Address: uni.edu/artdept; *Prof* Steve Bigler, MFA; *Prof* Felipe

Echeverria, MFA; *Prof* Crit Streed, MFA; *Prof* Roy Behrens, MA; *Assoc Prof* Charles Adelman PhD; *Prof* Jeffery Byrd, MFA; *Prof* JoAnn Schnabel, MFA; *Prof* Thomas Stancliffe, MFA; *Prof* Jeff Byrd, MFA; *Assoc Prof* Philip Fass, MFA; *Asst Prof* Aaron Wilson, MFA; *Prof* Richard Colburn, MFA; *Asst Prof* Tim Dooley, MFA; *Prof & Head* Mary Frisbee Johnson, MFA; *Asst Prof* Jean Petsch, PhD
Estab 1876, dept estab 1945; Maintain nonprofit art gallery; art library; pub; D & E; Scholarships; SC 65, LC 20, GC 31; 13,500, non-maj 515, maj 400, grad 5
Ent Req: HS dipl, ACT
Degrees: BA & BFA 4 yrs, MA 1 1/2 yr
Tuition: Res—undergrad $2058 per sem, grad $2406 per sem; nonres— $5212 per sem, grad $5618 per sem, campus res—room & board $4148 per yr
Courses: Art Appreciation, Art Education, Art History, Ceramics, Drawing, Graphic Design, Illustration, †Jewelry/Metals, †Painting, Performance Art, Printmaking, Sculpture
Summer School: Dir Mary Frisbee Johnson. Enrl 75

CEDAR RAPIDS

COE COLLEGE, Dept of Art, Cedar Rapids, IA 52402. Tel 319-399-8559; Fax 319-399-8557; Elec Mail pthompso@coe.edu; Internet Home Page Address: www.coe.edu/academics/art; *Chmn* Peter Thompson, MFA; *Assoc Prof* David Goodwin, MFA; *Asst Prof* Lucy Goodson, MFA; *Lectr* Kahleen Carracio, MFA; *Prof* John Beckelman, MFA; *Adjunct* Priscilla Steele
Estab 1851; Maintain nonprofit art gallery, Marvin Cone Gallery, Eaton-Buchan Gallery, 1220 1st Ave NE, Cedar Rapids IA; pvt; D & E; Scholarships; SC 15, LC 5; D 1200
Ent Req: HS dipl, SAT, ACT
Degrees: BA 4 yr
Tuition: $21,000 per yr; campus res—room & board $5700 per yr
Courses: Advertising Design, Aesthetics, Architecture, Art Appreciation, †Art Education, †Art History, †Ceramics, Collage, Costume Design & Construction, Design, Digital Art, Drafting, †Drawing, Film, Graphic Arts, Graphic Design, Mixed Media, †Painting, †Photography, †Printmaking, †Sculpture, †Teacher Training, Video

KIRKWOOD COMMUNITY COLLEGE, Dept of Arts & Humanities, 6301 Kirkwood Blvd SW, Cedar Rapids, IA 52406. Tel 319-398-5537; Fax 319-398-1021; Internet Home Page Address: ww.kcc.edu; *Head Dept* Rhonda Kekke; *Prof* Doug Hall, MFA; *Prof* Helen Gruenwald, MA
Estab 1966; pub; D & E; SC 18, LC 6; D 180, E 50
Ent Req: HS dipl
Degrees: AA 2 yr
Tuition: $65 per cr hr; no campus res
Courses: Art Appreciation, Art History, Ceramics, Design, Drawing, Graphic Arts, Photography, Printmaking, Sculpture
Summer School: Tuition $35 per cr hr. Courses—Art History, Art Appreciation, Ceramics, Design, Drawing, Lettering, Painting, Photography, Printmaking, Sculpture

MOUNT MERCY COLLEGE, Art Dept, 1330 Elmhurst Dr NE, Cedar Rapids, IA 52402. Tel 319-363-8213; Fax 319-363-5270; Internet Home Page Address: www2.mtmercy.edu; *Prof* Charles Barth PhD, MFA; *Prof* Jane Gilmor, MFA; *Asst Prof* David VanAllen, MFA; *Chmn Dept* Robert Naujoks, MFA
Estab 1928, dept estab 1960; Maintain nonprofit art gallery; Janalyn Hanson White Gallery; art library; Pvt; D & E; Scholarships; SC 12, LC 5; D 1,100, E 300, non-maj 150, maj 45
Ent Req: HS dipl, ACT
Degrees: BA 4 yr
Tuition: $145,600 per yr, $7,280 per sem, $405 per cr hr; campus res—room & board $4,980
Courses: †Art Education, Art History, Calligraphy, Ceramics, Design, Drawing, Graphic Arts, Graphic Design, Jewelry, Painting, Photography, Sculpture, Textile Design, Travel Study
Summer School: Dir, Susan Pauly, VPres Acad Affairs. Enrl 500; tuition $1,215 per 3 hr course, two 5 wk sessions. Courses—Art Appreciation, Ceramics, Graphic Design, Photography

CENTERVILLE

INDIAN HILLS COMMUNITY COLLEGE, Dept of Art, Centerville Campus, N First St Centerville, IA 52544. Tel 641-856-2143; Fax 641-856-5527; Internet Home Page Address: www.ihcc.cc.iowa.us; WATS 800-670-3641; *Head Dept* Mark McWhorter; *Instr* Enfys McMurrey, MA; *Instr* David Johnson
Estab 1932, dept estab 1967; pub; D & E; Scholarships; SC 10; D 70, E 30, non-maj 50, maj 14
Ent Req: HS dipl or equal, open door
Degrees: AA 2 yr
Tuition: Res $69 per cr hr; nonres—$89 per cr hr
Courses: Art Appreciation, Art History, Arts & Crafts, Ceramics, Design, †Design, †Drafting, Drawing, †Occupational Therapy, Painting, †Photography, Raku Pottery, †Theatre Arts
Summer School: Chmn, Mark McWhorter. Courses—Art Appreciation, Ceramics, Design, European Art Tours, Painting

CLINTON

EASTERN IOWA COMMUNITY COLLEGE, Clinton Community College, 1000 Lincoln Blvd, Clinton, IA 52732. Tel 563-244-7001; Fax 319-244-7026; Internet Home Page Address: www.eicc.edu; *Instr* Carolyn Phillips
Estab 1946; Pub; D&E; distance educ; Scholarships
Ent Req: depends on specific schlarship
Degrees: AA
Tuition: Res—$65 fees included per sem; nonres—$97.50 fees included per sem

Courses: Art Appreciation, Art History, Design, Drawing, Painting, Photography, Printmaking

MOUNT SAINT CLARE COLLEGE, Art Dept, 400 N Bluff, Clinton, IA 52732. Tel 319-242-4023; Fax 319-242-2003; Internet Home Page Address: www.clare.edu; *Prof Art* Joann Windier; *Prof Art* Robert Kennon; *Head Dept* Dr Robert Engelson
Estab 1928, dept estab 1940; den; D & E; Scholarships; SC 5, LC 1; non-maj 80, maj 8
Ent Req: HS dipl
Degrees: AA 2 yr
Tuition: Res—undergrad $10,980 per yr
Courses: 2-D & 3-D Design, Art Appreciation, Calligraphy, Ceramics, Computer Art, Computer Graphics, Design, Desktop Publishing, Drawing, Fiber Art, Fiber Sculpture
Summer School: Art Appreciation, Calligraphy, Painting

COUNCIL BLUFFS

IOWA WESTERN COMMUNITY COLLEGE, Art Dept, 2700 College Rd, PO Box 4C Council Bluffs, IA 51502. Tel 712-325-3200; Fax 712-325-3424; *Chmn* Frances Parrott
2000
Degrees: BA 4 yr
Tuition: Res—undergrad $79 per cr hr; nonres—undergrad $114
Courses: Art Appreciation, Art History, Ceramics, Design, Drawing, Painting, Photography, Sculpture

CRESTON

SOUTHWESTERN COMMUNITY COLLEGE, Art Dept, 1501 W Townline St, Creston, IA 50801. Tel 641-782-7081; Fax 641-782-3312; Internet Home Page Address: www.swcc.cc.ia.us; *Dir Art Dept* Linda Dainty
Estab 1966; pub; D & E; Scholarships; SC 6, LC 3; D 550, E 200, non-maj 40, maj 15, others 15
Ent Req: HS dipl
Degrees: AA 2 yrs
Courses: Art Appreciation, Art Education, Art History, Ceramics, Computer Graphics, Design, Drawing, Graphic Design, Painting, Photography, Teacher Training
Adult Hobby Classes: Enrl 10-30; tuition $30 per sem. Courses—Per regular session
Summer School: Workshops in arts science

DAVENPORT

SAINT AMBROSE UNIVERSITY, Art Dept, 518 W Locust St, Davenport, IA 52803. Tel 319-333-6000; Fax 319-333-6243; Internet Home Page Address: www.sau.edu; *Instr* Kristin Quinn, MFA; *Faculty* Janet Seiz, MA; *Chmn* John Schmits
Estab 1892; den; D & E; Scholarships; SC 17, LC 12; D 450, E 40, maj 55
Ent Req: HS dipl
Degrees: BA 4 yrs
Tuition: $456 per cr hr; campus res— available; room $1210-1935 per sem; board $1197-1530 per sem
Courses: Art Education, Calligraphy, Ceramics, Drawing, Graphic Design, History of Art & Architecture, Illustration, Painting, Photography, Printmaking, Teacher Training
Summer School: Tuition $400 per sem hr. Courses—vary

DECORAH

LUTHER COLLEGE, Art Dept, 700 College Dr, Decorah, IA 52101. Tel 563-387-2000, 387-1114; Fax 563-387-1391; Elec Mail martinka@luther.edu; Internet Home Page Address: www.luther.edu; *Head Dept* Kate Martinson
Estab 1861; FT 3, PT 2; den; D; Scholarships; SC 13, LC 5; D 160
Ent Req: HS dipl or ent exam
Degrees: BA 4 yr
Tuition: $21,994 per yr
Courses: †Aesthetics, †Art Education, Art Management, †Ceramics, Computer Art, †Drawing, Fibers, Graphic Arts, Hand Made Paper, †History of Art & Architecture, †Lettering, †Painting, †Printmaking, Spinning, †Stage Design, †Teacher Training, †Theatre Arts
Children's Classes: Enrl 50; Courses offered spring & fall
Summer School: Academic Dean, A Thomas Kraalsel. Enrl 200 June & July. Courses—Drawing, Invitation to Art

DES MOINES

DRAKE UNIVERSITY, Dept Art & Design, 25th & University Ave, Des Moines, IA 50311. Tel 515-271-2863; Fax 515-271-2558; Elec Mail admissions@drake.edu; Internet Home Page Address: www.drake.edu/artsci/art; *Assoc Prof Art* Robert Craig
Estab 1881; FT 10, PT 8; pvt; D & E; Scholarships; SC 64, LC 15, GC 33; D 140, maj 140
Ent Req: 2 pt average in HS or previous col
Degrees: BA, BFA
Tuition: $9095 per sem
Courses: †Art Education, Costume Design & Construction, Design, †Drawing, †Graphic Design, †History of Art & Architecture, †Interior Design, †Painting, †Printmaking, †Sculpture, Silversmithing, Stage Design, Teacher Training, Theatre Arts

GRAND VIEW COLLEGE, Art Dept, 1200 Grandview Ave, Des Moines, IA 50316. Tel 515-263-2800; Fax 515-263-2974; Internet Home Page Address: www.gvc.edu; *Dept Head* Dennis Kaven
Scholarships
Degrees: BA, cert
Tuition: Res—undergrad $6290 per sem
Courses: Art Therapy, Computer Graphics, Drawing, Jewelry, Painting, Photography, Printmaking, Textile Design, Theatre Arts

DUBUQUE

CLARKE COLLEGE, Dept of Art, 1550 Clarke Dr, Dubuque, IA 52001. Tel 563-588-6300; Fax 563-588-6789; Elec Mail joan.lingen@clarke.edu; Internet Home Page Address: www.clarke.edu; *Chmn & Prof Art* Joan Lingen PhD; *Prof Art* Douglas Schlesier, MFA; *Prof Art* Louise Kamas, MFA; *Assoc Prof* Carmelle Zserdin, MA; *Assoc Prof* Al Grivetti, MFA
Estab 1843; Maintain nonprofit art gallery; Quigley Gallery; pvt, den; D & E; Scholarships; SC 15, LC 4; maj 60, others 1200
Ent Req: HS grad, 16 units and Col Ent Board
Degrees: BFA(studio), BA(studio & art history)& BFA(graphic design)
Tuition: $12,199
Courses: Aesthetics, Art Appreciation, †Art Education, Art History, Book Arts, Calligraphy, †Ceramics, Costume Design & Construction, Design, †Drawing, †Graphic Design, History of Art & Architecture, Lettering, Mixed Media, †Painting, Photography, †Printmaking, †Sculpture, Stage Design, †Teacher Training, †Theatre Arts
Adult Hobby Classes: Enrl varies; 3, 4, 7 & 15 wk terms
Children's Classes: Enrl 15 per camp; tuition $60 per wk, summers
Summer School: Dir, Karen Adams. 3-4 wk term. Courses—Varies from yr to yr

LORAS COLLEGE, Dept of Art, PO Box 22-178, Dubuque, IA 52004-0178. Tel 563-588-7117; Fax 563-588-7292; Internet Home Page Address: www.loras.edu; *Chmn & Prof* Roy Haught; *Assoc Prof* Thomas Jewell Vitale; *Instr* Tom Gibbs
Degrees: MA (Art Educ &Studio Arts), BA
Tuition: Res & nonres—$13,645 per yr
Courses: Art Appreciation, †Art Education, †Art History, Design, Drawing, †Fibers, Painting, Printmaking, Sculpture, †Studio Art
Summer School: Dir, John Hess. Enrl $170 per course

ESTHERVILLE

IOWA LAKES COMMUNITY COLLEGE, Dept of Art, 300 S 18th St, Estherville, IA 51334. Tel 712-362-2604; Fax 712-362-8363;
Estab 1967; pub; D & E; Scholarships; SC 26, LC 1
Ent Req: HS dipl
Degrees: AA, AS(Commercial Art) 2 yrs
Tuition: Res—undergrad $917 per sem; nonres—undergrad $941 per sem
Courses: Advertising Design, Art History, Calligraphy, Ceramics, Commercial Art, Commercial Studio Portfolio Preparation, Computer Graphics, Drawing, Graphic Arts, Graphic Design, Illustration, Mixed Media, Painting, Photography
Summer School: Courses—Internships in Commercial Art

FOREST CITY

WALDORF COLLEGE, Art Dept, 106 S Sixth St Forest City, IA 50436. Tel 641-585-2450; Fax 641-582-8194; Internet Home Page Address: www.waldorf.edu; *Chair* Kristi Carlson; *Adjunct* Lori Hadacek
Estab 1903; FT 1, PT 2; den; D & E; Scholarships; SC 4; D 80, maj 15
Ent Req: HS dipl, ACT or SAT
Degrees: AA, 2 yr, BA, 3 yr
Tuition: $9790 per sem
Courses: Art Appreciation, †Art History, Design, Drawing, Painting, Photography, Printmaking

FORT DODGE

IOWA CENTRAL COMMUNITY COLLEGE, Dept of Art, 330 Ave M, Fort Dodge, IA 50501. Tel 515-576-7201; Internet Home Page Address: www.iccc.cc.ia.us; *Chmn* Rusty Farrington
Estab 1966; Pub; D & E; Scholarships; SC 4, LC 2; D 120, E 15, non-maj 153, maj 20
Ent Req: HS dipl
Degrees: AA 2 yr
Tuition: Res— 61 per cr hr; nonres—$97 per cr hr; campus res—room & board $3790 per yr
Courses: Art History, Painting, Studio Art
Summer School: Dir, Rusty Farrington. Enrl 45; tuition $53 per cr hr

GRINNELL

GRINNELL COLLEGE, Dept of Art, Fine Arts Ctr, PO Box 805 Grinnell, IA 50112-0806. Tel 641-269-3064, 269-3085; Fax 515-269-4420; Internet Home Page Address: www.grinnell.edu; *Prof* Merle W Zirkle; *Interim Dir* Bobbie McKibbin; *Chmn* Tony Crowley
Estab 1846; dept estab 1930; Maintain nonprofit art gallery; Faueconer Art Gallery-Bucksbaum Center for Arts; pvt; D; Scholarships; SC 9, LC 9; D 150, non-maj 125, maj 25
Ent Req: HS dipl, SAT or ACT
Degrees: BA 4 yrs
Tuition: Res & nonres—undergrad $21,700 per yr; campus res—room & board
Courses: Art Education, Art History, Ceramics, Design, Drawing, Jewelry, Painting, Printmaking, Sculpture

INDIANOLA

SIMPSON COLLEGE, Art Dept, 701 NC, Indianola, IA 50125. Tel 515-961-1561; Fax 515-961-1498; Internet Home Page Address: www.simpson.edu; *Chmn Dept* Janet Heinicke; *Asst Prof Photography* David Richmond
Estab 1860, dept estab 1965; pvt; D & E; Scholarships; SC 3, LC 3; D 120, maj 20
Ent Req: HS dipl, ACT or SAT
Degrees: BA and BM 4 yrs
Tuition: Res—undergrad $8815 per yr; campus res—room $1380 and board $1695
Courses: †Art Education, Art History, Art Management, Commercial Art, †Commercial Design, Design, Drawing, History of Art & Architecture, Museum Education, Photography, Teacher Training

IOWA CITY

UNIVERSITY OF IOWA, School of Art & Art History, Art Dept E 100 AB, Iowa City, IA 52242. Tel 319-335-1771; Fax 319-335-1774; Internet Home Page Address: www.uiowa.edu; *Prof Foil Stamping* Virginia Myers; *Prof Metalsmithing & Jewelry* Chunghi Choo; *Dir* Dorothy Johnson
Estab 1847, school estab 1911; FT 38, PT 3; pub; D & E; Scholarships; SC 60, LC 55, GC 55; D 681, maj 508, grad 173
Ent Req: HS dipl, ACT or SAT, upper rank in HS
Degrees: BA and BFA 4 yr, MA, MFA, PhD
Tuition: Res—undergrad $366 per 3 cr hrs; nonres—$798 per 3 cr hrs
Courses: Aesthetics, †Art Education, †Art History, †Ceramics, Conceptual Art, †Design, †Drawing, †Graphic Design, Industrial Design, Interior Design, †Intermedia, †Jewelry, †Multimedia, †Painting, †Photography, †Printmaking, †Sculpture, †Silversmithing, Teacher Training, †Video
Summer School: Dir, Dorothy Johnson. Enrl undergrad 195, grad 115; tuition res—undergrad $1030, grad $1467; nonres—undergrad $3780, grad $4726 for term of 8 wks, beginning June 10. Courses—Full range of Art Education, Art History, Studio Courses

IOWA FALLS

ELLSWORTH COMMUNITY COLLEGE, Dept of Fine Arts, 1100 College Ave, Iowa Falls, IA 50126. Tel 641-648-4611; Fax 641-648-3128; Internet Home Page Address: www.iavalley.cc.il.us/eco; *Chmn* Greg Metzen
Estab 1890; pub; D & E; SC 10, LC 1; in dept D 20-25
Ent Req: HS dipl, ACT
Degrees: AA 2 yrs
Tuition: Res $900 per yr, $55 per cr hr; nonres—undergrad $1800 per yr, $110 per cr hr; campus res—room & board $1900
Courses: †Advertising Design, Art Appreciation, Art History, Ceramics, Commercial Art, Design, Drawing, Graphic Arts, Graphic Design, Illustration, Lettering, Mixed Media, Painting, Photography, Sculpture
Adult Hobby Classes: Enrl 12; tuition $20 per 20 hrs. Courses—Pottery
Summer School: Dir, Dr Del Shepard. Enrl 14; tuition $40 per sem hr for 4 weeks. Courses—Art Interpretation

LAMONI

GRACELAND UNIVERSITY, Fine Arts Div, One University Pl, Lamoni, IA 50140. Tel 641-784-5270; Fax 641-784-5487; Elec Mail finearts@graceland.edu; Internet Home Page Address: www.graceland.edu; *Dept Coordr & Assoc Prof* Julia Franklin; *Asst Prof* Kitty Miller; *Assoc Prof* Robert Stephens; *Asst Prof* John Stanko; *Instr* Chuck Manuel; *Instr* Amber McDole
Estab 1895, dept estab 1961; Maintain nonprofit art gallery, Constance Gallery, The Helene Center Art Gallery & The Shaw Center Art Gallery, 1 University Pl, Lamoni, IA; pvt den; D; Scholarships; SC 36, LC 10; D 250, E 15, non-maj 60, maj 85, others 4
Ent Req: HS dipl
Degrees: BA and BS 4 yrs
Tuition: $16,000 per yr
Courses: Art Appreciation, †Art Education, Art History, Ceramics, Color Theory, †Commercial Design, Computer Graphic Design, Design, Drawing, †Graphic Design, Illustration, †Painting, Photography, †Printmaking, †Sculpture
Children's Classes: 138 summer art camp attendance, one week $75
Summer School: Dir, Dr Velma Ruch

MASON CITY

NORTH IOWA AREA COMMUNITY COLLEGE, Dept of Art, 500 College Dr, Mason City, IA 50401. Tel 641-423-1264, Ext 242; Tel 888-406-4222; Fax 641-423-1711; Internet Home Page Address: www.niacc.cc.ia.us; *Instr* Peggy L Bang; *Instr* Carol Faber; *Chmn* James Zirnhelt
Estab 1964; pub; D & E; Scholarships; SC 4, LC 2; D 240, E 100, maj 30
Ent Req: HS dipl
Degrees: AA 2 yr
Tuition: Res— $800 per 15 cr hrs; nonres—$1200 per 15 cr hr
Courses: 2-D Design, Art Education, Art History, Ceramics, Computer Graphic Design, Drawing, Painting, Photography
Summer School: Dir, Carol Faber. Enrl 30; tuition $46 per cr for 6 wk term. Courses—Essence of Art, Drawing

MOUNT PLEASANT

IOWA WESLEYAN COLLEGE, Art Dept, 601 N Main, Mount Pleasant, IA 52641. Tel 319-385-8021; Internet Home Page Address: www.iwc.edu; *Chmn* Don R Jones; *Chmn Fine Arts Div* Ann Kligensmith; *Design Ctr Adjunct* Mike Foley; *Ceramist Adjunct* Truly Ball; *Art Educ Adjunct* Don Kramer

Estab 1842; den; Scholarships; SC 10, LC 4; maj 32
Degrees: BA 4 yr
Tuition: Res—undergrad $6,765 per sem; room & board $2400-$2900 per sem
Courses: Art Education, Art History, Ceramics, Design, Drawing, Graphic Arts, Introduction to Art, Painting, Photography, Printmaking, Secondary Art, Special Problems, Twentieth Century Art History, †Visual Communication & Design

MOUNT VERNON

CORNELL COLLEGE, Art Dept, Armstrong Hall, Fine Arts, 600 First St W Mount Vernon, IA 52314. Tel 319-895-4000; Fax 319-895-5926; Internet Home Page Address: www.cornell-iowa.edu; *Head Dept* Tony Plaut
Estab 1853; FT 4; den; D; Scholarships; SC 30, LC 12; 890
Ent Req: HS dipl
Degrees: BA, BSS and BPhil 4 yr
Tuition: $25,200 per yr
Courses: Art History, Ceramics, Collage, Design, Drawing, Fiber Design, Painting, Photography, Sculpture, Textile Design, Weaving

OTTUMWA

INDIAN HILLS COMMUNITY COLLEGE, OTTUMWA CAMPUS, Dept of Art, 525 Grandview, Ottumwa, IA 52501. Tel 641-683-5111, 683-5149; Fax 641-683-5206; Elec Mail mmcwhort@indianhills.edu; Internet Home Page Address: www.indianhills.edu; WATS 800-726-2585; *Dean Arts & Sciences* Darlas Shockley; *Dept Head* Mark McWhorter; *Instr* Dr David D Johnson; *Instr* Lisa Fritz
Estab 1932; Maintains nonprofit art gallery, Indian Hills Art Gallery 525 Grandview Ottumwa, IA 52501; pub; D & E; Scholarships; SC 7, LC 2; D 150, E 70, maj 25
Ent Req: HS dipl, GED, ACT or SAT
Degrees: AA, AAS & AAA 2 yrs
Tuition: Res—$105 per sem cr hr; nonres—$125 per sem cr hr (res acquired after 90 days)
Courses: Advertising Design, Aesthetics, Art Appreciation, Art History, Ceramics, Crafts, Design, Drafting, Drawing, Film, †Graphic Design, Handicrafts, History of Art & Architecture, Lettering, Occupational Therapy, Painting, Photography, Sculpture
Adult Hobby Classes: Enrl 10-20; tuition $35 per sem cr hr. Courses—Ceramics, Painting, Watercolor
Children's Classes: Enrl 15-20. Courses—General Workshops, Painting, Ceramics
Summer School: Dean Arts & Sciences, Darlas Shockley. Enrl 120; 6 wk session. Courses—Liberal Arts

PELLA

CENTRAL COLLEGE, (Central University of Iowa) Art Dept, 812 University, Pella, IA 50219. Tel 641-628-5261; Internet Home Page Address: www.central.edu; *Chmn* J Vruwink, MFA
Estab 1853; pvt; D & E; Scholarships; SC 20, LC 6; D 180, non-maj 140, maj 40
Ent Req: HS dipl, ACT
Degrees: BA 4 yrs
Tuition: $21,206 per yr
Courses: Art History, Ceramics, Drawing, Glassblowing, Modern Art, Painting, Primitive Art, Studio Art

SIOUX CITY

BRIAR CLIFF UNIVERSITY, Art Dept, 3303 Rebecca St, Sioux City, IA 51104. Tel 712-279-5321 or 800-662-3303; Fax 712-279-1698; Elec Mail bill.welu@briarcliff.edu; Internet Home Page Address: www.sbc.edu/academic/arts; *Chairperson* William J Welu, MFA; *Assoc Prof* Dr Judith A Welu, MFA, EdD; *Lectr* Jeff Baldus, BA; *Lectr* Noreen Eskildsen, MA
Estab 1930; Maintain nonprofit art gallery; Clausen Art Gallery; pvt, den; D & E; Scholarships; SC 8, LC 5; D 250, non-maj 150, maj 30
Ent Req: HS dipl, ACT
Degrees: BA and BS 4 yr, MA in Educ
Tuition: $17,490 per yr; campus res—room 7 board $5600 per yr
Courses: 2, 3 & 4 (major studio areas & independent study), Art 1, Art Appreciation, Art Education, Art History, Ceramics, Collage, Critical Seminar, Design, Drawing, Intermedia, †Mixed Media, †Painting, †Sculpture, †Teacher Training
Summer School: Dr Judith Welu. Enrl 30-40; tuition $210 per cr hr for 5 wk term. Courses—Contemporary Art History, Elementary Art Education, Pottery

MORNINGSIDE COLLEGE, Art Dept, 1501 Morningside Ave, Sioux City, IA 51106. Tel 712-274-5212; Fax 712-274-5101; Elec Mail bowitz@morningside.edu; Internet Home Page Address: www.morningside.edu; *Chmn* John Bowitz; *Asst Prof* Terri McGaffin; *Instr* John Kolbo; *Instr* Shannon Sargent; *Instr* Jim Bisenivs; *Instr* Amy Foltz; *Instr* Dolly Thompson
Estab 1894; Maintain nonprofit art gallery, Helen Levitt Gallery & Eppley Gallerym 3625 Garretson Ave, Sioux City, IA 51106; FT 4; pvt; D & E; Scholarships; SC 17, LC 4; D 161, maj 90
Ent Req: HS dipl
Degrees: BA and BS (Art Educ) 4 yrs
Tuition: $11,000 per yr
Courses: Advertising Design, Art Education, Art History, Ceramics, Commercial Art, Conceptual Art, Costume Design & Construction, Design, Drawing, Film, Graphic Arts, Graphic Design, Illustration, Mixed Media, Painting, Photography, Printmaking, Sculpture, Stage Design, Studio, Teacher Training, Theatre Arts, Video

Summer School: Dir, John Bowitz. Enrl 50; tuition $120 per cr, May, June, July. Courses—Drawing, Photography, Teaching Methods

SIOUX CITY ART CENTER, 225 Nebraska St, Sioux City, IA 51101. Tel 712-279-6272; Fax 712-255-2921; Elec Mail jcollins@sioux-city.org; Internet Home Page Address: www.siouxcityartcwenter.org; *Dir* Al Harris-Fernandez; *VChmn* Pauline Sensenig; *Cur Educ* Sandi Fravel; *Cur* Christopher Cook; *Mus Shop Mgr* Marsha Newman; *Registrar* Chuck Jenkins; *VPres* Ritch Li Grand; *Secy* Jill Collins
Estab 1938; pvt; D & E; Scholarships; SC 14-20, LC 1-2; D 100, E 400
Tuition: $25-$70 members; $5-$25 workshops
Courses: †Art Education, †Art History, †Ceramics, †Drawing, †Mixed Media, †Painting, †Photography
Adult Hobby Classes: Enrl 60, tuition $25-$30 for 3-6 wk terms, $300 per yr. Courses—Drawing, Painting, Studio, Printmaking
Children's Classes: Enrl 900; tuition $25-$27 for 6 wk term, $1000 per yr. Courses—Clay, Drawing, Mixed Media, Painting, Photography

WAVERLY

WARTBURG COLLEGE, Dept of Art, 100 Wartburg Blvd, Waverly, IA 50677. Tel 319-352-8200; Internet Home Page Address: www.wartburg.edu/art; WATS 800-553-1797; *Dept Head* Thomas Payne, MFA; *Asst Prof* Barbara Fedeler, MFA
Estab 1852; Non-profit art gallery; den; D & E; Scholarships; SC 18, LC 4; D 135, non-maj 110, maj 25
Ent Req: HS dipl, PSAT, ACT & SAT, foreign students TOEFL and upper 50 percent of class
Degrees: BA(Art), BA(Art Educ) 4 yrs
Tuition: Res—undergrad $15,510 per yr, $5850 room & board
Courses: Advertising Design, Art Appreciation, Art Education, Art History, Computer Graphic Design, Design, Drawing, Graphic Design, Metal Design, Painting, Photography, Printmaking, Sculpture
Summer School: Courses—Drawing, Independent Study, Painting

KANSAS

ATCHISON

BENEDICTINE COLLEGE, Art Dept, 1020 N Second St, Atchison, KS 66002. Tel 913-367-5340; Fax 913-367-6102; Internet Home Page Address: www.benedictine.edu; *Chmn* Dan Carrell
Estab 1971; FT 1; den; D; SC 15, LC 3; D 145, non-maj 123, maj 22
Ent Req: HS dipl, ent exam
Degrees: BA 4 yr
Tuition: Campus res—undergrad $17,510, room & board $4200; nonres—undergrad $22,621
Courses: Art Education, Art History, Calligraphy, Ceramics, Drawing, Graphic Arts, Painting, Photography, Printmaking, Sculpture, Teacher Training

BALDWIN CITY

BAKER UNIVERSITY, Dept of Art, 618 Eighth St, Baldwin City, KS 66006. Tel 785-594-6451; Fax 785-594-2522; *Chmn* Inge Balch; *Assoc Prof* Jack Collins; *Assoc Prof* Heidi Strobel
Estab 1858; Holt/Russell Gallery; pvt; D; Scholarships; SC 11, LC 3; D 105, maj 28
Activities: Bookstore
Ent Req: HS dipl, provision made for entrance without HS dipl by interview & committee action
Degrees: BA (Art) 4 yrs
Tuition: $19,925 per yr
Courses: Art Education, Ceramics, Drawing, Graphic Arts, History of Art & Architecture, Painting, Printmaking, Sculpture, Teacher Training, Textile Design

COFFEYVILLE

COFFEYVILLE COMMUNITY COLLEGE, Art Dept, 400 W 11th St, Coffeyville, KS 67337. Tel 620-252-7020; Fax 620-252-7098; Elec Mail michaeld@coffeyville.edu; Internet Home Page Address: www.ccc.cc.ks.us; *Head Dept* Michael DeRosa
Estab 1923; dept estab 1969; pub; D & E; Scholarships; SC 8, LC 2; D 300, E 60, non-maj 300, maj 25
Ent Req: HS dipl
Degrees: AA
Tuition: Res—undergrad $32 per cr hr & $18 fee per cr hr; nonres—undergrad $74 per cr hr & $18 fee per cr hr; campus res—$3030 room & board per yr
Courses: Art Appreciation, Art Education, Art History, Ceramics, Constructions, Design, Drawing, Film, Handicrafts, Mixed Media, Painting, Photography, Printmaking, Sculpture, Theatre Arts, Video
Adult Hobby Classes: Enrl 15-20; 3 month sem. Courses—Crafts
Children's Classes: Enrl 15; tuition $60 for 2 wks. Courses—Clay, Sculpture
Summer School: Dir, Michael DeRosa. Enrl 25; 2 month session. Courses—Ceramics I, Drawing I

COLBY

COLBY COMMUNITY COLLEGE, Visual Arts Dept, 1255 S Range, Colby, KS 67701. Tel 785-462-3984; Fax 785-462-4600; Internet Home Page Address: www.colby.edu; *Dir* Kathy Gordon

Estab 1965, dept estab 1966; pub; D & E; Scholarships; SC 18, LC 8; D 141, E 210, maj 18
Activities: Bookstore
Ent Req: HS dipl
Degrees: AA 2 yrs
Tuition: Res—$41 per cr hr; nonres—$87 per cr hr
Courses: †Art Appreciation, †Art Education, †Art History, Color Structure & Design, †Drawing, †Graphic Design, Painting, †Printmaking
Adult Hobby Classes: Enrl 10-20; tuition $15 per hr

EL DORADO

BUTLER COUNTY COMMUNITY COLLEGE, Art Dept, 901 S Haverhill Rd, El Dorado, KS 67042. Tel 316-321-2222; Fax 316-322-3318; Internet Home Page Address: www.butlercc.edu; *Dean* Larry Patton; *Instr* Valerie Haring
Estab 1927, dept estab 1964; Maintain nonprofit art gallery; Erman B White Gallery, 901 S Haverhill, El Dorado KS 67042; pub; D & E, online courses; Scholarships; SC 13, LC 1; D 168, E 57
Ent Req: HS dipl, ACT, EED
Degrees: AA 2 yr
Tuition: Res—$44 per cr hr; nonres—$89.50 per cr hr
Courses: Art History, Ceramics, Drawing, †Glasswork, Interior Design, Painting, Printmaking, Silversmithing

EMPORIA

EMPORIA STATE UNIVERSITY, Dept of Art, 1200 Commercial, Campus Box 4015 Emporia, KS 66801. Tel 620-341-5246; Fax 620-341-6246; Internet Home Page Address: www.emporia.edu/art; *Chair* Elaine Henry; *Asst Prof* Matthew Derezinski; *Prof* Dan R Kirchhefer; *Asst Prof* Patrick Martin; *Asst Prof* Andre Piper; *Prof* Larry Schwarm; *Asst Prof* Eric Conrad; *Asst* Roberta Eichenberg; *Lectr* Deborah Maxwell; *Lectr* Susan Nakao; *Lectr* John Hasegawa; *Lectr* Lily Liu; *Asst* Monica Kjellman-Chapin
Estab 1863, dept estab early 1900s; Maintain nonprofit art gallery; Norman R Eppink Art Gallery, Johnkins Hall, Emporia State Univ, Emporia, KS 66801; art supplies available on-campus; pub; D & E; Scholarships; SC 42, LC 15, GC 30; D 920, E 60, maj 182, grad 10
Ent Req: HS dipl, HS seniors may enroll in regular classes, ACT 21
Degrees: BFA, BSE, BS(Art Therapy) 4 yr, MS(Art Therapy)
Tuition: Res—undergrad $1793 per sem; nonres—undergrad $5469 per sem; campus res available
Courses: Art Appreciation, †Art Education, Art History, †Ceramics, Design, Drawing, Engraving Arts, Fibers, Glass, †Graphic Design, Metals, Mixed Media, †Painting, †Photography, †Printmaking, †Sculpture, Teacher Training
Adult Hobby Classes: 45; $278; Metals, Ceramics & Photography
Summer School: Chair, Elaine Henry. Enrl 150; tuition res $129 per hr, nonres $374 per hr for term beginning June 11. Courses—most of the regular classes

GARDEN CITY

GARDEN CITY COMMUNITY COLLEGE, Art Dept, 801 Campus Dr, Garden City, KS 67846. Tel 316-276-7611; Fax 316-276-9630; *Chmn Human & Fine Arts* Kevin Brungrdt
Degrees: AA
Tuition: Res—undergrad $44 per cr hr; nonres—$78 per cr hr
Courses: Art Appreciation, Art History, Ceramics, Design, Drawing, Handicrafts, Interior Design, Jewelry, Painting, Photography, Printmaking, Stage Design, Stained Glass

GREAT BEND

BARTON COUNTY COMMUNITY COLLEGE, Fine Arts Dept, RR 3, Great Bend, KS 67530. Tel 316-792-9260; Internet Home Page Address: www.barton.cc.ks.us/dudekswatercolors; *Dir* Steve Dudek, MFA; *Instr* Marcia Polenberg, MFA
Estab 1965, dept estab 1969; FT 4 PT 3; pub; D & E; Scholarships
Ent Req: HS dipl or GED
Degrees: AA
Tuition: Res—undergrad $46 per cr hr; campus residence available
Courses: Advertising Design, Architecture, Art Appreciation, Art Education, Art History, Ceramics, Commercial Art, Computer Graphics, Constructions, Design, Drawing, Graphic Arts, Graphic Design, Illustration, Interior Design, Jewelry, Occupational Therapy, Painting, Photography, Sculpture, †Stained Glass, †Web Design
Adult Hobby Classes: Enrl 50-300; tuition $38 per cr hr. Courses—Ceramics, Computer Graphics, Design, Drawing, Graphic Design, Individual Art Projects, Jewelry, Painting, Photo
Summer School: Dir, Steve Dudek. Enrl 30-60; tuition $38 per hr for 8 wks. Coures—Art Education, Art Media, Ceramics, Drawing, Individual Art Projects, Painting, Photo

HAYS

FORT HAYS STATE UNIVERSITY, Dept of Art, 600 Park St, Hays, KS 67601-4099. Tel 785-628-4247; Elec Mail ctaylor@fhsu.edu; Internet Home Page Address: www.fhsu.edu/art/; *Chmn* Leland Powers; *Prof* Kathleen Kuchar, MFA; *Prof* Merlene Lyman, MFA; *Prof* Michael Jilg, MFA; *Assoc Prof* Chaiwat Thumsujarit, MFA; *Assoc Prof* Zoran Stevanov PhD, MFA; *Asst Prof* Martha Holmes, MA; *Asst Prof* Linda Ganstrom, MFA; *Instr* Adelle Rich, MA; Allen Craven, MFA; Gordon Sherman, MFA; Sondra Schwetman, MFA; Karrie Simpson Voth, MFA; *Asst Prof* Amy Schmierbach, MFA; *Asst Prof* Jayson Taylor, MFA

Estab 1902, dept estab 1930; maintains nonprofit gallery, Moss-Thorns Gallery of Art, 600 Park St Hays, KS 67619-4099; pub; D & E; Scholarships; SC 66, LC 19, GC 28; D 742, non-maj 555, maj 286, grad 36, others 7
Ent Req: HS dipl
Degrees: BA & BFA 4 yrs, AA & MFA 2 - 3 yrs
Tuition: Res—undergrad $96.70 per cr hr, grad $133.15 per cr hr; non-res—undergrad $300.85 pr cr hr, grad $349.60 per cr hr; campus res available
Courses: Advertising Design, Art Appreciation, †Art Education, †Art History, †Ceramics, Commercial Art, Design, †Drawing, †Graphic Design, †Handicrafts, Illustration, †Interior Design, Intermedia, †Jewelry, Lettering, Mixed Media, †Painting, †Photography, †Printmaking, †Sculpture, †Silversmithing, †Teacher Training, Textile Design

HESSTON

HESSTON COLLEGE, Art Dept, 325 S College Ave, PO Box 3000 Hesston, KS 67062-3000. Tel 316-327-8164; Internet Home Page Address: www.hesston.edu; *Head Dept* Lois Misegadis
Estab 1915; den; D & E; Scholarships; SC 9, SC 1; non-maj 50, maj 5
Ent Req: HS dipl
Degrees: AA 2 yr
Tuition: $8100 annual tuition; campus res available
Courses: Art Appreciation, Art History, Ceramics, Design, Drawing, Graphic Design, Painting, Photography, Printmaking, Sculpture, Theatre Arts

HUTCHINSON

HUTCHINSON COMMUNITY COLLEGE, (Hutchinson Community Junior College) Visual Arts Dept, 600 E 11th St, Hutchinson, KS 67501. Tel 620-665-3500, 665-3471; Fax 620-665-3310; Elec Mail connettd@hutchcc.edu; Internet Home Page Address: www.hutchcc.edu; *Prof* Roy Swanson; *Color & Graphic Instr* Nancy Masterson; *Ceramics & Sculpture Instr* Jerri Griffin; *Art History Instr* Teresa Preston; *Chmn* Dee Connett
Estab 1928; pub; D & E; Scholarships; SC 17, LC 4; D 215, E 41, non-maj 180, maj 81
Ent Req: HS dipl
Degrees: AA 2 yrs
Tuition: Res—$49 per cr hr
Courses: Art Appreciation, Art Education, Art History, Ceramics, Commercial Art, Computer Graphics Design, Drawing, Graphic Arts, Graphic Design, Jewelry, Painting, Printmaking, Sculpture, Silversmithing, Stage Design, Teacher Training, Theatre Arts, Video
Summer School: Dir, Dee Connett. Tuition $27 per hr for 6 wk session. Courses—Art Appreciation, Art Education

IOLA

ALLEN COUNTY COMMUNITY COLLEGE, Art Dept, 1801 N Cottonwood, Iola, KS 66749. Tel 316-365-5116; Internet Home Page Address: www.allencc.net; *Dept Head* Steven R Greenwall, MFA
Estab 1965; pub; D & E; Scholarships; SC 5, LC 2; D 700, E 1000, non-maj 40, maj 10
Ent Req: HS dipl or GED
Degrees: AA, AS & AAS 2 yr
Tuition: Res—$45 per cr hr
Courses: 2-D & 3-D Design, Art Appreciation, Art Fundamentals, Ceramics, Commercial Art, Drawing, Painting, Photography, Sculpture
Summer School: Courses—all courses

LAWRENCE

HASKELL INDIAN NATIONS UNIVERSITY, Art Dept, 155 Indian Ave, Lawrence, KS 66046. Tel 785-749-8431, Ext 252; Internet Home Page Address: www.haskell.com; *Instr* B J Wahnee, MA
Estab 1884, dept estab 1970; pub; D; SC 14, LC 1; in dept D, non-maj 90, maj 30
Ent Req: HS dipl or GED, at least 1/4 Indian, Eskimo or Aleut and receive agency approval
Degrees: AA & AAS 2 yrs, BA 4 yr
Tuition: Government funded for native Americans only; campus res available
Courses: Art Appreciation, Art History, Ceramics, Design, Drawing, Jewelry, Native American Architecture, Native American Art History, Native American Cultural/Tribal Art Forms, Native American Painting, Painting, Sculpture, Textile Design
Summer School: Enrl 150

UNIVERSITY OF KANSAS, School of Fine Arts, 1530 Naismith, Lawrence, KS 66045. Tel 785-864-3421; Fax 785-864-4404; Internet Home Page Address: www.ukans.edu; *Dean* Peter G Thompson; *Assoc Dean* Philip Hofstra; *Assoc Dean Grad Studies* Carole Ross
Pub; Scholarships, Fellowships; 1300
Degrees: BA, BAE, BFA, BS, MFA 4-5 yr
—Dept of Art, Lawrence, KS 66045. Tel 785-864-4401; Fax 785-864-4404; *Chmn* Judith McCrea
Estab 1885; FT 19; SC 50, GC 25; maj 160
Activities: Schol
Tuition: Res—undergrad $899 per sem, grad $1088 per sem; nonres— $2985 per sem
Courses: †Drawing, New Grenre, †Painting, †Printmaking, †Sculpture
Summer School: Dir, Judith McCrea. Enrl 60; tuition $57 for 8 wks. Courses—Life Drawing, Intro to Drawing I & II, Painting I-IV
—Dept of Design, Lawrence, KS 66045. Tel 785-864-4401; *Chmn* Lois Greene
Estab 1921; FT 25, PT 5; SC 83, LC 32, GC 26; maj 550, grad 30

Tuition: Res—undergrad $2041.50 per yr, $68.05 per cr hr; nonres—undergrad $8460 per yr, $282 per cr hr
Courses: †Art Education, †Ceramics, Design, †Graphic Design, †Illustration, †Industrial Design, †Interior Design, †Jewelry, Photography, †Textile Design, Textile Printing & Dyeing, Visual Communications, †Weaving
Summer School: Term of 4-8 wks beginning June
—**Kress Foundation Dept of Art History,** Spencer Museum of Art, Rm 209, Lawrence, KS 66045. Tel 785-864-4713; Fax 785-864-5091; Elec Mail arthist@lark.cc.ukans.edu; *Dept Chair* Linda Stone-Ferrier; *Prof Emeritus* Chu-tsing Li PhD; *Prof* Charles Eldredge PhD; *Prof* Marilyn Stokstad PhD; *Prof* Stephen Goddard; *Prof & Asian Grad Advisor* Marsha Weidner; *Assoc Prof* Edmund Eglinski PhD; *Assoc Prof* Amy McNair; *Assoc Prof* David Cateforts PhD; *Asst Prof* John Teramoto PhD; *Asst Prof* Patrick Frank; *Lectr* Roger Ward; *Dir Mus* Andrea Norris PhD; *Asst Prof* Patricia Darish PhD; *Assoc Prof* John Pultz
Estab 1866, dept estab 1953; pub; D & E; Scholarships; LC 30, GC 10; D 900, E 40, maj 50, grad 70
Ent Req: HS dipl
Degrees: BA, BFA, BGS, MA, PhD
Tuition: Res—undergrad $2041.50 per yr, $68.05 per cr hr; nonres—undergrad $8460 per yr, $282 per cr hr
Courses: African Art, American Art, Art History, Chinese Art, Japanese Art, Photography, Western European Art
Summer School: Enrl 80. Intro courses—Art History, Asian Art History & Modern Art History. Classes in Great Britain & Rome
—**Dept of Art & Music Education & Music Therapy,** 311 Bailey Hall, Lawrence, KS 66045. Tel 785-864-4784; Fax 785-864-5076; *Chmn Dept* Lois Greene; *Asst Prof* Denise Stone PhD; *Asst Prof* Elizabeth Kowalchek
Estab 1865, dept estab 1969; pub; D & E; Scholarships; GC 12; D 535, maj 123, grad 123, others 289
Ent Req: HS dipl, ent exam
Degrees: BAE 5 yrs, MA 1-6 yrs, PhD 3-6 yrs
Tuition: Res—undergrad $2041.50 per yr, $68.05 per cr hr; nonres—undergrad $8460 per yr, $282 per cr hr
Courses: Visual Arts Education
Summer School: Term of 8 wks beginning June

LEAVENWORTH

SAINT MARY COLLEGE, Fine Arts Dept, 4100 S Fourth St Trafficway, Leavenworth, KS 66048-5082. Tel 913-758-6151; Fax 913-758-6140; Elec Mail nelson@hub.smcks.edu; Internet Home Page Address: www.smcks.edu; *Asst Prof* Alexandra Robinson, MFA; *Assoc Prof & Dir Prog* Susan Nelson, MFA
Estab 1923; Maintains a nonprofit art gallery, Xavier Gallery; Pvt, Catholic; D & E; Scholarships; SC 20, LC 3, wkend workshops 5; non-maj 80, maj 25
Ent Req: HS dipl
Degrees: BA, BS 4 yr
Tuition: Res—$8,475 per sem
Courses: Advertising Design, Art Appreciation, Art History, Ceramics, Commercial Art, Computer Graphics, Design, Drawing, Graphic Arts, Graphic Design, Illustration, †Mixed Media, Painting, Photography, Printmaking

LIBERAL

SEWARD COUNTY COMMUNITY COLLEGE, Art Dept, 1801 N Kansas, PO Box 1137 Liberal, KS 67905. Tel 620-629-2685; Fax 620-629-2680; Elec Mail susan.copas@sccc.edu; Internet Home Page Address: www.sccc.edu; *Dept Chair* Susan Copas; *Art Instr* Dustin Farmer
Estab 1969; pub; D & E; online; Scholarships; SC 23, LC 5; D 1,000, E 700
Ent Req: HS dipl
Degrees: AA 2 yrs
Tuition: Res—$62 per cr hr; border county—$72; nonres—$85 per cr hr
Courses: Art Education, Art History, Ceramics, Design, Drawing, Graphic Design, Handicrafts, History of Art & Architecture, Painting, Photography, Sculpture, Silversmithing, Visual Communication

LINDSBORG

BETHANY COLLEGE, Art Dept, 421 N First St, Lindsborg, KS 67456. Tel 785-227-3311, Ext 8145; Fax 785-227-2860; Elec Mail kahlerc@bethanylb.edu; Internet Home Page Address: www.bethanylb.edu; *Prof* Mary Kay, MFA; *Asst Prof* Frank Shaw, MFA; *Head Art Dept* Caroline Kahler, MFA; *Asst Prof* Ed Pogue, MFA; *Dr* Bruce Kahler; *Instr* James Turner
Estab 1881; Maintain nonprofit art gallery, Mingenback Art Center Gallery, Corner of Olson & Second St., Lindsburg, KS 67456; Den, Private, Denominational, Coed, ELCA - Lutheran Church of America; D & E; Scholarships; SC 26, LC 4, GC 2; D 150, non-maj 120, maj 40
Ent Req: HS dipl
Degrees: BA 4 yr
Tuition: $14,800, with rm & brd $20,160
Courses: †Art Administration, Art Appreciation, †Art Education, Art History, Art Therapy, †Basketry-textiles, †Ceramics, Design, †Drawing, Jewelry, †Painting, Photography, Printmaking, †Sculpture, Studio Concentration, †Teacher Training, †Webpage Design
Summer School: Acad Dean, Dr Gene Bales

MANHATTAN

KANSAS STATE UNIVERSITY
—**Art Dept,** Tel 785-532-6605; Fax 785-532-0334; Elec Mail art@ksu.edu; Internet Home Page Address: www.ksu.edu/art; *Head Dept & Prof* Duane Noblett, MFA; *Prof* Yoshiro Ikeda, MFA; *Prof* Elliott Pujol, MFA; *Prof* Glen R Brown, Phd; *Prof* Anna Calluori Holcombe, MFA; *Assoc Prof* Daniel Hunt, MFA; *Assoc*

Prof Kathleen King, MFA; *Asst Prof* Barri Lester, MFA; *Asst Prof* Rachel Melis, MFA; *Asst Prof* Nancy Morrow, MFA; *Prof* Lynda Andrus, MFA; *Asst Prof* Thomas Bookwalter, BFA; *Asst Prof* Jason Scuilla, MFA; *Asst Prof* Roger Rouston, MFA; *Prof* Teresa Tempero Schmidt, MFA
Estab 1863, dept estab 1965; Non-Profit art gallery, Chapman Gallery of Art, Kansas State Univ, 116 Willard Hall, Manhattan, KS 66506; pub; D & E; Scholarships, Fellowships; SC 45, LC 19, GC 7; D 1940, E 60, non-maj 1800, maj 400, grad 15
Ent Req: HS dipl
Degrees: BS(Art Educ) jointly with Col Educ, BA & BFA 4 yrs, MFA 60 sem cr
Tuition: Res—undergrad $172.50 per cr hr, grad $239.50 per cr hr; nonres—undergrad $497 per cr hr; grad $570.50 per cr hr; campus res available, out-of-state tuition waived plus reduction of fees with GRA & GTA appointments
Courses: †Art Education, †Art History, †Ceramics, Design, †Digital Arts, †Drawing, Graphic Arts, †Graphic Design, †Illustration, †Jewelry, †Metalsmithing, †Painting, †Pre-Art Therapy, †Printmaking, †Sculpture
Summer School: Dir, Duane Noblett. Enrl 150; tuition res $172.50 per cr hr, nonres $497 per cr hr for term of 4 to 8 wks beginning June. Courses—most of above, varies from summer to summer
—**College of Architecture Planning & Design,** Tel 785-532-5950; Fax 785-532-6722; Elec Mail dela@ksu.edu; Internet Home Page Address: http://aalto.arch.ksu.edu; *Assoc Dean* Ray Weisenburger; *Dean* Dennis Law
Estab 1904; FT 53; 800
Degrees: BA, MA(Archit, Regional Planning & Interior Archit)
Tuition: Res--$75.55 per cr hr; nonres--$301.15 per cr hr
Courses: Architectural Programming, Architecture, Art History, Building Construction, Landscape Architecture, Landscape Design
Adult Hobby Classes: Dean, Lane L Marshall. Courses—Graphic Delineation, Preservation
Children's Classes: Courses—Special Design Program in June
Summer School: Dean, Lane L Marshall. 8 wks of courses beginning June 4th. Courses—Design Discovery Program, Design Studio

MCPHERSON

MCPHERSON COLLEGE, Art Dept, 1600 E Euclid, PO Box 1402 McPherson, KS 67460. Tel 316-241-0731; Internet Home Page Address: www.mcpherson.edu; *Asst Prof* Kelly Frigard; *Chmn* Wayne Conyers
Estab 1887; den; D & E; Scholarships; SC 14, LC 5; D 150, maj 10, others 140
Ent Req: HS dipl, ACT
Degrees: AB 4 yr
Tuition: Res & nonres—undergrad $16,600 per yr
Courses: †Art Education, Art History, Ceramics, Drawing, †Interior Design, Lettering, Museum Staff Training, Painting, Printmaking, Teacher Training, Textile Design

NORTH NEWTON

BETHEL COLLEGE, Dept of Art, North Newton, KS 67117. Tel 316-283-2500; Fax 316-284-5286; Internet Home Page Address: www.bethelks.edu; *Chmn* Merrill Kraball; *Assoc Prof* Gail Lutsch, MFA
Estab 1888, dept estab 1959; den; D; Scholarships; SC 11, LC 3; D 240, non-maj 215, maj 25
Ent Req: HS, ACT
Degrees: BA(Art) 4 yrs
Tuition: $5400 per sem; campus res—room & board $2540 per sem
Courses: Art Education, Art History, Ceramics, Crafts, Drawing, Graphic Arts, Graphic Design, Painting, Photography, Printmaking, Sculpture
Adult Hobby Classes: Enrl 15; tuition $40 per 6 wk session. Courses—Ceramics, Drawing, Painting
Summer School: Courses—Drawing, Painting

OTTAWA

OTTAWA UNIVERSITY, Dept of Art, 1001 S Cedar St, Ottawa, KS 66067-3399. Tel 785-242-5200; Fax 785-242-7429; Internet Home Page Address: www.ottawa.edu; *Chmn* Frank J Lemp
Estab 1865; FT 1; pvt; D; Scholarships; SC 16, LC 5; D 35, maj 5
Ent Req: HS grad, SAT, ACT
Degrees: BA 4 yrs
Tuition: Res & nonres—$11,250 and fees per yr tuition & room & board
Courses: Art Education, Art History, Arts Management, Ceramics, Drawing, Graphic Arts, Painting, Photography
Children's Classes: Outreach Progs
Summer School: Dir, Frank Lemp. Tuition $89 per cr hr for 8 wk session. Courses—Art Fundamentals

OVERLAND PARK

JOHNSON COUNTY COMMUNITY COLLEGE, Visual Arts Program, 12345 College Blvd, Overland Park, KS 66210. Tel 913-469-8500; Fax 913-469-4409; Elec Mail lthomas@jccc.net; Internet Home Page Address: www.jccc.net; *Adjunct Asst Prof Art Hist* Reed Anderson, Ma/ABD; *Adjust Asst Prof Art* Erin Arnold-Miller, MFA; *Adjunct Prof Art* Doug Baker, MFA; *Adjunct Prof Art Hist* Tracey Boswell, MA; *Adjunct Assoc Prof Art* John Carroll, MFA; *Asst Prof Art, Sculp Dept Coordr* Mark Cowardin, MFA; *Assoc Prof Art, Ceramic Dept Coordr* Laura-Harris Gascogne, MFA; *Adjunct Assoc Prof Art* Nicholas Haney, MFA; *Adjunct Assoc Prof Art* Keiko Kira, MFA; *Adjunct Asst Prof Art Hist* Alice Kuo, PhD; *Adjunct Assoc Prof Art* Derek Larson, MFA; *Adjunct Assoc Prof Art Hist* Ted Meadows, MA; *Adjunct Assoc Prof Art Hist* Rahjee Mohan, MA; *Adjunct Assoc Prof Art* Sydney Pener, MFA; *Adjunct Assoc Prof Art* Michael Pesselato, MFA; *Adjunct Asst Prof Art* Ruthanne Robertson, MFA; *Adjunct Asst Prof Art* Angelica

Sandoval, MFA; *Asst Prof Art Hist, Art Hist Coordr* Allison Smith, PhD; *Adjunct Asst Prof Art* Kent Smith, MFA; *Adjunct Asst Prof Art* Bridget Stewart, MFA; *Prof Art, Painting/Drawing/Digital Dept Coordr* Larry Thomas, MFA; *Adjunct Asst Prof Art Hist* Carla Tilghman, MA; *Adjunct Asst Prof Art* Cara Walz, MFA; *Adjunct Prof Art* Ann Wiklund, MA; *Adjunct Asst Prof Art* Gene Wineland, MFA; *Asst Dean Arts & Humanities* Michael Garrett, PhD
Estab 1969; Maintain 3 nonprofit art galleries, Nerman Museum of Contemp Art, Student Art Gallery, Faculty & Alumni Gallery, all JCCC address; on-campus shop sells art supplies; pub; D, E & weekends; Scholarships; SC 30, LC 4; D 200, E 100
Ent Req: HS dipl or equivalent
Degrees: AA 2 yr
Tuition: Res—$63.00 per sem cr hr; nonres—$144.00 per sem cr hr; no campus res
Courses: 2-D & 3-D Design, Art History, Ceramics, †Design, †Digital Imaging for Artists, Drawing, †Graphic Design, Illustration, Layout, Lettering, Life Drawing, Painting, Photography, Preparation of Portfolio, Printmaking, Sculpture, Silkscreen, Silversmithing, Visual Communications, Visual Technology, Weaving
Children's Classes: Accelerated fine arts for gifted children
Summer School: Dir, Michael Garrett. Enrl 95; tuition $63.00 per cr hr for term of 8 wks beginning June 5. Courses—Ceramics, Design, Drawing, Painting, Photogrpahy, Sculpture, Silversmithing

PITTSBURG

PITTSBURG STATE UNIVERSITY, Art Dept, 1701 S Broadway St, Pittsburg, KS 66762-7512. Tel 620-235-4302; Fax 620-235-4303; Elec Mail art@pittstate.edu; Internet Home Page Address: www.pittstate.edu/art; *Chairperson* Larrie J Moody PhD; *Prof* Marjorie K Schick, MFA; *Assoc Prof* Malcolm E Kucharski, MFA; *Asst Prof* Andree Flageolle, PhD; *Asst Prof* Stephanie K Bowman, MFA; *Asst Prof* Jr James M Oliver, MFA; *Asst Prof* Rhona E Shand, MFA
Estab 1903, dept estab 1921; Maintain nonprofit art gallery, Pittsburg State University Art Gallery, Art Dept - Porter Hall, 1701 S Broadway, Pittsburg, KS 66762-7512; pub; D & E; Scholarships; SC 50, LC 24, GC 22; D 600, E 50, non-maj 300, maj 90, grad 10
Ent Req: HS dipl
Degrees: BFA & BSed 4 yr, MA 36 hr
Tuition: Res—undergrad $1647 & grad $1864 per sem, $158 per sem hr; nonres—undergrad $4826 & grad $4578 per sem, undergrad $330 per sem hr, grad $384 per sem hr; campus res—room & board available
Courses: Art Appreciation, †Art Education, Art History, †Ceramics, †Commercial Art, Crafts, Design, Drawing, †Jewelry, †Jewelry Design, †Painting, Photography, Printmaking, Sculpture, Teacher Training
Summer School: Dir, Larrie J Moody. Enrl 100; tuition res—undergrad $105 per cr hr; grad $141 per cr hr; nonres—undergrad $299 per cr hr, grad $349 per cr hr, for term of 2 4 wk sessions (June & July). Courses—Art Education, Ceramics, Crafts, Drawing, Painting

PRATT

PRATT COMMUNITY COLLEGE, Art Dept, 348 NE SR 61, Pratt, KS 67124. Tel 620-672-5641 Ext 228, 800-794-3091; Fax 620-672-5288; Elec Mail marshas@prattcc.edu; Internet Home Page Address: www.pcc.cc.ks.us; Internet Home Page Address: www.prattcc.edu; *Art Instr* Marsha Shrack, MFA
Maintain Delmar Riney Gallery, PCC 348 NE SR 61, Pratt, 1; Pub; D & E; Scholarships; SC 6, LC; D 100, E 15, Maj 25
Ent Req: HS dipl
Degrees: AA and AS
Tuition: Res—$39 per cr hr; nonres—$68 per cr hr
Courses: Art Appreciation, Ceramics, Design, Drawing, Elementary School Arts, Graphic Design, Illustration, Introduction to Art, Painting, Photography, Printmaking
Summer School: Dir Marsha Shrack; Graphic Design, Illustration, Introduction to Art

SALINA

KANSAS WESLEYAN UNIVERSITY, Art Dept, 100 E Claflin, Salina, KS 67401. Tel 785-827-5541; Fax 785-827-0927; Internet Home Page Address: www.kwu.edu; *Instr* Brian Anderson
Estab 1886; den; Scholarships; SC 8, LC 3; maj 15, others 500 for two sem
Degrees: AB 4 yr
Tuition: Res—undergrad $17,000; fees incl room & board
Courses: †Advertising Art, †Art Education, Art History, †Art Studio, †Arts Management
Summer School: Enrl 125; for term of 8 wks beginning June

STERLING

STERLING COLLEGE, Art Dept, 125 W Cooper, PO Box 98 Sterling, KS 67579. Tel 620-278-2173; Fax 620-278-4375; Internet Home Page Address: www.sterling.edu; *Chmn* David Cook
Estab 1876; den; D & E; Scholarships; SC 16, LC 2; D 410
Ent Req: HS dipl
Degrees: BA & BS
Tuition: $12,100 per yr; room $2080-$2700, board $2680-$2940
Courses: 2-D Color Design, 3-D Design, Ceramics, Costume Design & Construction, Drawing, Fibers, Graphic Arts, Graphic Design, Painting
Adult Hobby Classes: Enrl 25; tuition $20. Courses—all areas
Children's Classes: Art Education

TOPEKA

WASHBURN UNIVERSITY OF TOPEKA, Dept of Art, 1700 SW College, Topeka, KS 66621. Tel 785-670-1125; Fax 785-670-1126; Elec Mail judy.cogswell@washburn.edu; Internet Home Page Address: www.washburn.edu/cas/art/; *Art & Theatre Arts Chmn* Glenda Taylor; *Prof* Edward Navone; *Assoc Prof* Reinhild Janzen; *Assoc Prof* Azyz Sharafy; *Catron Prof of Art* Marguerite Perret; *Lectr* Mary Dorsey Wanless
Estab 1868; Maintain nonprofit art gallery; Mulvane Art Museum, Washburn University, 1700 SW College, Topeka, KS 66621; FT 5, PT 11; pub; D&E; Scholarships; SC 23, LC 7, GC 1; non-maj 300, maj 100
Ent Req: HS dipl
Degrees: BA and BFA 4 yr
Tuition: Res—$175 per cr hr; nonres—$397 per cr hr
Courses: Art Appreciation, Art History, Art Introduction, Ceramics, Computer Graphic Design, Computer Publication, Computers, Design, Drawing, Etching, Lithography, Painting, Photography, Printmaking, Sculpture, Silkscreen, Watercolor
Children's Classes: Tuition $35 for ten 1 1/2 hr sessions
Summer School: VPres Acad Affairs, Dr Ron Wasserstein. $175 per cr hr; courses—Art history, Art studio

WICHITA

FRIENDS UNIVERSITY, Art Dept, 2100 University Ave, Wichita, KS 67213. Tel 316-295-5100; Tel 316-295-5656; Fax 316-263-1092; Fax 316-295-5656; Elec Mail maber@friends.edu; Internet Home Page Address: www.friends.edu; *Chmn* Ted Krone
Estab 1898; den; D & E; Scholarships; SC 18, LC 4; D 329, E 37
Ent Req: HS dipl
Degrees: MA 6 yrs, BA & BS 4 yrs
Tuition: $5,730 per sem, $383 per cr hr; campus res—room & board $3200
Courses: †Aesthetics, †Art Education, †Art History, †Ceramics, †Computer Graphics, †Design, †Drawing, †Fine Arts 2 & 3-D, †Graphic Design, †Painting, Photography, Printmaking, Sculpture, Silversmithing, Teacher Training
Adult Hobby Classes: Courses—Drawing, Jewelry, Painting

WICHITA CENTER FOR THE ARTS, Mary R Koch Sch of Visual Arts, 9112 E Central, Wichita, KS 67206. Tel 316-634-2787; Fax 316-634-0593; Elec Mail arts@wcfta.com; Internet Home Page Address: www.wcfta.com; *Exec Dir* Howard W Ellington; *Dir Educ* Diane Post; *Dir Gallery* David Murano; *Film & Educ Theatre Coordr* Jake Euker; *Dir Arts Based Pre-School* Julie Lawson; *Theatre Develop* John Boldenolo; *3-D Coordr* Dan Gegen; *Pub Relations* Stephanie Brock
Estab 1920; Maintain nonprofit art gallery; Hurst Sales Gallery; art library; 35; pvt; D&E; Scholarships; SC 40; D 450, E 150
Tuition: $45 - $180 per class
Courses: 3-D Design, Art Education, Art History, Ceramics, Drawing, Enameling, Mixed Media, Painting, Photography, Pottery, Printmaking, Sculpture, Teacher Training, Weaving
Adult Hobby Classes: Enrl 300; tuition $130 for 12 wk term. Courses—Performing Arts, 2-D & 3-D Design
Children's Classes: Enrl 300; tuition $70. Courses—Performing Arts, 2-D & 3-D Design
Summer School: Dir Educ, Diane Post. Enrl 300; tuition $45-$55 for 6 wk term. Courses—same as regular sessions

WICHITA STATE UNIVERSITY, School of Art & Design, 1845 Fairmount St, Box 67 Wichita, KS 67260-0067. Tel 316-978-3555; Fax 316-978-5418; Internet Home Page Address: www.finearts.twsu.edu; *Grad Coordr* Ronald Christ; *Chmn* Donald Byrum
Estab 1895, dept estab 1901; pub; D & E; Scholarships; D 1149, E 194, non-maj 78, maj 285, grad 51, others 2
Ent Req: HS dipl
Degrees: BAE, BA & BFA 4 yr, MFA 2 yr, MA 1 yr
Tuition: Res—undergrad $94.10per cr hr, grad $128.35 per cr hr; nonres—undergrad $320 per cr hr, grad $368.35 per cr hr
Courses: †Art Education, †Art History, †Ceramics, Drawing, †Graphic Design, Illustration, Lettering, †Painting, Photography, †Printmaking, †Sculpture, Teacher Training
Summer School: Tuition as above for term of 8 wks

WINFIELD

SOUTHWESTERN COLLEGE, Art Dept, 100 College St, Winfield, KS 67156-2499. Tel 620-229-6000; Internet Home Page Address: www.sckans.edu; Estab 1885; pvt & den; D & E; Scholarships; SC 12, LC 4
Ent Req: HS dipl
Degrees: BA 4 yr
Tuition: $5650 per 16 hrs
Courses: Art Education
Adult Hobby Classes: Design, History of Art, Life Drawing, Painting
Summer School: Chmn, Michael Wilder. Enrl 15-20; term May 27-June 20. Courses—Art History, Design, Drawing, Painting, Sculpture

KENTUCKY

BARBOURVILLE

UNION COLLEGE, Music and Fine Arts Dept, 310 College St, Barbourville, KY 40906. Tel 606-546-1334; Fax 606-546-1625; Internet Home Page Address: www.unionky.edu; *Chmn* Dr Thomas McFarland

Estab 1879; Den; D & E; Scholarships; LC
Ent Req: HS dipl
Degrees: BA, BS and MA (Educ) 4 yr
Tuition: $15,900 room & board & tuition
Courses: Art History

BEREA

BEREA COLLEGE, Art Dept, CPO Box 2342, Berea, KY 40404. Tel 859-985-3000, Ext 3530; Fax 859-985-3541; Internet Home Page Address: www.berea.edu; *Chmn* Robert Boyce PhD; *Prof* Neil DiTeresa, MA; *Assoc Prof* William Morningstar, MFA; *Assoc Prof* Jeannine Anderson, MFA; *Asst Prof* Christopher Pierce, MFA; *Asst Prof* Jeanette Klein, MFA
Estab 1855, dept estab 1936; pvt; D; Scholarships; SC 14, LC 8; C 1500, D 324, maj 71
Ent Req: HS dipl (preference given to students from Southern Appalachian region)
Degrees: BA 4 yr
Tuition: None; campus res—room and board $300-$1800 based on income
Courses: Art Appreciation, †Art Education, †Art History, †Ceramics, Design, †Drawing, †Painting, Photography, †Printmaking, †Sculpture, †Textile Design, Weaving

BOWLING GREEN

WESTERN KENTUCKY UNIVERSITY, Art Dept, Ivan Wilson Ctr for Fine Arts, Room 441 Bowling Green, KY 42101. Tel 270-745-3944; Fax 270-745-5932; Elec Mail art@wku.edu; Internet Home Page Address: www.wku.edu/dept/academic/ahss/art/art.html; *Dept Head* Kim Chalmers
Maintains on-campus art supply shop; FT 10, PT 9; Pub; D & E; SC 49, LC 21; maj 187
Ent Req: HS dipl
Degrees: BA & BFA 4 yrs, MA(Art Educ)
Tuition: $1267 per sem; nonres—$3417
Courses: †Art Education, Art History, †Ceramics, Design, Drawing, Graphic Design, †Painting, Photography, †Printmaking, †Sculpture, †Weaving
Summer School: Dept Head Kim Chalmers. Enrl 100; tuition res $97 per cr hr, nonres $265 per cr hr. Courses—Lecture & Studio Art Courses

CAMPBELLSVILLE

CAMPBELLSVILLE UNIVERSITY, Department of Art, One University Dr, Campbellsville, KY 42718; UPO 1324, Campbellsville, KY 42718. Tel 270-789-5268; Fax 270-789-5524; Elec Mail ljcundiff@campbellsville.edu; *Prof of Art* Tommy Clark; *Chmn Art* Linda Cundiff; *Instr* Myrtie Parsley; *Instr* Henrietta Scott; *Instr* Davie Reneav; *Instr* Joseph Andrews
Estab 1906, dept estab 1967; Non-profit art gallery - Tommy Clark, UPO, 1 University Dr, Campbellsville, KY 42718; Pvt; D & E; Scholarships; SC 26, LC 5; D 35, E 10, non-maj 12, maj 22, others 8 minors
Ent Req: HS dipl, ACT, portfolio
Degrees: BA, BS with/without teacher certification
Tuition: $9800 per yr
Courses: Art Appreciation, Art Education, Art History, Ceramics, Collage, Commercial Art, Constructions, Design, Drawing, Elementary School Art, Graphic Design, Jewelry, Lettering, Painting, Photography, Printmaking, Sculpture, Secondary School Art, Stage Design, Teacher Training, Theatre Arts
Adult Hobby Classes: Enrl 15; tuition $50 per audit hr. Courses—Understanding Art, courses above as auditors
Summer School: Term of 8 wks. Courses—Art Appreciation,

CRESTVIEW HILLS

THOMAS MORE COLLEGE, Art Dept, 333 Thomas More Pky, Crestview Hills, KY 41017. Tel 859-341-5800, Ext 3420; Fax 859-344-3345; Internet Home Page Address: www.thomasmoore.edu; *Chmn* Rebecca Bilbo; *Assoc Prof* Barbara Rauf, MFA
Estab 1921; pvt; D & E; SC 12, LC 4; D 12, E 5, maj 17
Ent Req: HS dipl
Degrees: BA, BES, BS, AA & AES
Tuition: $6,600 per sem; room & board $2,100-$2,900 per sem
Courses: Aesthetics, Anatomy, Art Education, Art History, Arts Management, Ceramics, Color, Design, Drawing, Figure Drawing, Painting, Perspective, Photography, Printmaking, Sculpture, Teacher Training, Theatre Arts
Summer School: Dir, Dr Raymond Hebert. Courses—various

HIGHLAND HEIGHTS

NORTHERN KENTUCKY UNIVERSITY, Art Dept, Nunn Dr, Highland Heights, KY 41099. Tel 859-572-5421; Fax 859-572-6501; Internet Home Page Address: www.nkul~art/; *Chmn* Thomas F McGovern
Estab 1968; Maintains nonprofit gallery, Dept of Art Galleries, Northern Kentucky University; FT 15, PT 8; pub; D & E; Scholarships; SC, LC ; Enrl 395
Ent Req: HS grad, ACT scores
Degrees: BA(Art Educ), BFA(Studio Art), BFA (Graphic Design), BA(Graphic Design), BA (Studio Art)
Tuition: Res—grad $1,521 per sem; nonres—undergrad $1,414 per sem
Courses: Advertising Design, Aesthetics, Art Appreciation, †Art Education, †Art History, †Ceramics, Design, †Drawing, †Graphic Design, History of Art & Architecture, Mixed Media, †Painting, †Photography, †Pre-Art Therapy, †Printmaking, †Sculpture, Teacher Training
Adult Hobby Classes: Enrl 350; tuition $50-$100 for a period of 5-10 wks.

Courses — Various Art & Crafts
Summer School: Chmn, Thomas McGovern. Enrl 90; tuition $47 per sem hr for sessions. Courses—Art Education, Drawing, Graphic Design, Printmaking, Ceramics

LEXINGTON

TRANSYLVANIA UNIVERSITY, Studio Arts Dept, 300 N Broadway, Lexington, KY 40508. Tel 859-233-8246, 233-8115; Internet Home Page Address: www.transy.edu; *Prog Dir* Nancy Wolsk, MFA; *Prof* Jack Girard, MFA; *Assoc Prof of Art* Kurt Gohde, MFA; *Prof of Art* Dan S Seltzer, MA; *Asst Prof* Kimberly Miller
Estab 1780; pvt; D & E; Scholarships; SC 20, LC 3; D 105, E 14, maj 18
Ent Req: HS dipl
Degrees: BA
Tuition: $16,000 per yr
Courses: Art Appreciation, Art History, Ceramics, Collage, Costume Design & Construction, Design, Drawing, Film, Graphic Arts, Mixed Media, Painting, Photography, Sculpture, Stage Design, Teacher Training, Theatre Arts

UNIVERSITY OF KENTUCKY, Dept of Art, College of Fine Arts, 207 Fine Arts Bldg Lexington, KY 40506-0022. Tel 859-257-8151; Fax 859-257-3042; Internet Home Page Address: www.edu/finearts; *Dean* Robert Shay; *Chmn* Jack Gron
Estab 1918; FT 22, PT 15; pub; D; Scholarships, Assistantships; SC 23, LC 19, GC 6; maj 200, others 1500
Degrees: BA, BFA, MA & MFA 3 yr
Tuition: Res—undergrad $1700, grad $1800per sem; nonres—undergrad $4800, grad $5300 per sem, PT res—undergrad $136 per cr hr, grad $197 per cr hr, nonres—undergrad $395 per cr hr, grad $578 per cr hr
Courses: †Art Education, †Art History, Ceramics, Drawing, Fibers, Graphic Design, Painting, Photography, Printmaking, Sculpture, †Studio Art, Video
Summer School: Dir, Jack Gron. Tuition res—$118 per cr hr, nonres—$341 per cr hr. Courses—varied

LOUISVILLE

JEFFERSON COMMUNITY COLLEGE, Fine Arts, 109 E Broadway, Louisville, KY 40202. Tel 502-213-2289; Fax 502-585-4425; *Coordr Fine Arts* J Barry Motes
Estab 1968; PT 6; pub; D & E; Scholarships; SC 11, LC 6; D 4774, E 4172
Ent Req: HS dipl
Degrees: AA & Assoc in Photography 2 yrs
Tuition: $500 per sem
Courses: †Advertising Design, Aesthetics, Art Education, Art History, †Commercial Art, Drawing, Graphic Arts, Graphic Design, Painting, †Photography, Sculpture, †Theatre Arts
Summer School: Dean, Dr Robert Deger. Tuition $45 per cr hr. Courses—Art Appreciation, Drawing, Photography

UNIVERSITY OF LOUISVILLE, Allen R Hite Art Institute, Department of Fine Arts, Belknap Campus Louisville, KY 40292. Tel 502-852-6794; Fax 502-852-6791; Internet Home Page Address: www.art.louisville.edu; *Chmn Dept Fine Arts, Dir Hite Art Institute* James T Grubola, MFA; *Assoc Prof* Moon-elu Balk, MFA; *Asst Prof* Todd Burns, MFA; *Assoc Prof* Tom Buser, PhD; *Assoc Prof* Mary Carothers, MFA; *Prof* Ying Kit Chan, MFA; *Assoc Prof* Stow Chapman, MS; *Prof* Robert Douglas, PhD; *Assoc Prof* Mitch Eckert, MFA; *Power Creative Designer-in-Residence* Leslie Friesen, BFA; *Assoc Prof* Christopher Fulton, PhD; *Assoc Prof* Linda Gigante, PhD; *Prof* Lida Gordon, MFA; *Assoc Prof* Barbara Hanger, MFA; *Assoc Prof* Ben Hufbauer, PhD; *Assoc Prof* Jay Kloner, PhD; *Asst Prof* Scott Massey, MFA; *Prof* Stephanie Maloney, PhD; *Prof* Mark Priest, MFA; *Prof* Steve Skaggs, MS; *Prof* John Whitesell, MFA; *Gallery Dir & Adjunct Assoc Prof* John Begley, MFA; *Adjunct Assoc Prof* Peter Morrin, MFA; *Prof Emeritus* Donald Anderson, MFA; *Prof Emeritus* Henry Chodkowski, MFA; *Prof Emeritus* Dario Cofi, PhD; *Prof Emeritus* Suzanne Mitchell, MFA; *Prof Emeritus* William Morgan, MFA; *Asst Prof* Che Rhodes, MFA; *Asst Prof* Susan Jarosi, PhD
Estab 1846, dept estab 1935; Maintain nonprofit art galleries; Hite Art Institute Galleries, Schneider Hall, Univ of Louisville, Louisville, KY 40292. Library: Margaret Bridwell Art Library, Scheider Hall; FT 21, PT 18; pub; D & E; Scholarships; SC 60, LC 50, GC 38; D 1,200, E 200, non-maj 50, maj 500, grad 65
Ent Req: HS dipl, CEEB
Degrees: MA 1 to 2 yrs, PhD 3 yrs, BA 4 yrs, BFA 4 yrs
Tuition: Undergrad: Res—$3,126 per sem; nonres—$8,036 per sem. Grad: Res—$3,393; Nonres—$8,674
Courses: Aesthetics, †Art Education, †Art History, †Ceramics, †Design, †Drawing, †Fiber, †Glass, †Graphic Design, †History of Art & Architecture, Interior Architecture, †Interior Design, †Jewelry, †Museum Staff Training, †Painting, †Photography, †Printmaking, †Sculpture
Summer School: Dir, James T Grubola. Enrl 100 for May-Aug. Courses—Various Art & Art History Classes

MIDWAY

MIDWAY COLLEGE, Art Dept, 512 E Stephens St, Midway, KY 40347-1120. Tel 859-846-4421, Ext 5809; Fax 859-846-5349; Internet Home Page Address: www.midway.edu; *Instr Music & Choir* Wayne Gebb; *Chmn* Steve Davis-Rosenbaum; *Instr* Kate Davis-Rosenbaum
FT 2; Den; W; D; Scholarships; SC 7, LC 3; 55
Ent Req: HS dipl, ACT
Degrees: 2 yr
Tuition: $5100 per sem; room & board $2600-$3370 per sem
Courses: Art Education, Art in the Child's World, Basic Design, Ceramics, Drawing, Historical Furniture, Painting, Sculpture, Textile Design

MOREHEAD

MOREHEAD STATE UNIVERSITY, Art Dept, Claypool-Young Art Bldg 211, Morehead, KY 40351. Tel 606-783-2771, 783-2193; Fax 606-783-5048; Elec Mail b.whitt@morehead-st.edu; Internet Home Page Address: www.moreheadstate.edu; *Chmn* Robert Franzini; *Prof* David Bartlett; *Assoc Prof* Steve Tirone; *Assoc Prof* Elisabeth Mesa-Gaido; *Assoc Prof* Deeno Golding
Estab 1922; Maintain nonprofit art gallery; pub; D & E; Scholarships; SC 45, LC 14, GC 26; D 900, E 20, non-maj 800, maj 180, GS 55, others 145
Ent Req: HS dipl, ACT
Degrees: BA 4 yr, MA 1 - 2 yr
Tuition: Res—undergrad $1135 per sem, grad $1235 per sem; nonres—undergrad $3055 per sem, grad $3355 per sem
Courses: Advertising Design, Art Education, Ceramics, Commercial Art, Computer Art, Drawing, Graphic Design, Illustration, Mixed Media, Painting, Photography, Printmaking, Sculpture
Adult Hobby Classes: Courses—Ceramics, Crafts, Oil Painting, Watercolor Painting, Weaving
Summer School: Dept chair Robert Franzini, Enrl 150, 2 - 4 week sessions, courses - Studio & Art History

MURRAY

MURRAY STATE UNIVERSITY, Dept of Art, College of Fine Arts and Communication, 604 Price Doyle Fine Arts Ctr Murray, KY 42071-0009. Tel 270-762-3741; Fax 270-762-3920; Internet Home Page Address: www.murraystate.edu; *Chmn* Richard Dougherty; *Prof* Dale Leys, MFA; *Prof* Paul Sasso, MFA; *Prof* Jerry Speight, MFA; *Assoc Prof* Michael Johnson, MFA; *Assoc Prof* Camille Sarre PhD, MFA; *Assoc Prof* Steve Bishop, MFA; *Asst Prof* Peggy Schrock PhD, MFA; *Gallery Dir* Albert Sperath, MFA; *Asst Prof* Jeanne Beaver; *Asst Prof* Sarah Guthworth; *Asst Prof* Alma Hale; *Asst Prof* Nicole Hard; *Asst Prof* Susan O'Brien; *Lectr* Zbynek Smetana
Estab 1925, dept estab 1931; pub; D & E; Scholarships; SC 117, LC 15, GS 48; non-maj 475, maj 200, grad 13
Ent Req: HS dipl, ACT, portfolio required for grad students
Degrees: BA, BS & BFA 4 yr, MA(Studio) 1 1/2 - 2 yrs
Tuition: Res—undergrad $1377 per sem, grad $1440 per sem; nonres—undergrad $3711 per sem, grad $4003 per sem; campus res—room & board $1010 per yr
Courses: Art Appreciation, Art Education, Art History, Ceramics, Drawing, Graphic Design, History of Art & Architecture, Jewelry, †Painting, †Photography, †Printmaking, †Sculpture, Silversmithing, Surface Design, Teacher Training, Textile Design, †Weaving, Wood Design
Children's Classes: Summer art workshops for HS students
Summer School: Dir, Dale Leys. Enrl 40-80; tuition res—undergrad $67 per hr, grad $99 per hr; nonres—undergrad $193 per hr, grad $282 per hr for short sessions of 5 wk 7 1/2 wk or 10 wk terms

OWENSBORO

BRESCIA UNIVERSITY, (Brescia College) Div of Fine Arts, 717 Frederica St, Owensboro, KY 42301. Tel 502-685-3131; Fax 502-686-4266; Internet Home Page Address: www.brescia.edu; *Chmn* Sr Mary Diane Taylor; Stephen Driver; David Stratton; Monty Helm
Estab 1950; Maintain nonprofit art gallery; Anna Eaton Stout Memorial Art Gallery, 717 Frederica St, Owensboro, KY 42301; on-campus shop where art supplies may be purchased; FT 4; den; D&E; Scholarships; SC 47, LC 10; 960, maj 30
Ent Req: HS dipl, placement exam, ACT, GED
Degrees: BA 4 yr
Courses: 2-D & 3-D Design, Advertising Design, Art Appreciation, †Art Education, Art History, †Black & White Photography, Calligraphy, †Ceramics, Design, Drawing, †Graphic Design, Mixed Media, Painting, Printmaking

KENTUCKY WESLEYAN COLLEGE, Dept Art, 3000 Frederica St, Owensboro, KY 42302. Tel 270-926-3111, Ext 250; Fax 270-926-3196; Internet Home Page Address: www.kwc.edu; *Acting Chmn* Monte Hamm
Dept estab 1950; den; Scholarships; SC 11, LC 4; maj 40
Degrees: BA 4 yr
Tuition: Res—$10,570 per yr
Courses: Arts & Crafts, Design, Painting
Summer School: Enrl 60. Courses—Art for the Elementary Schools, Art Survey

PIKEVILLE

PIKEVILLE COLLEGE, Humanities Division, 147 Sycamore St, Pikeville, KY 41501. Tel 606-218-5250; Fax 606-218-5269; Elec Mail webmaster@pc.edu; Internet Home Page Address: www.pc.edu; *Gallery Dir* Janice Ford; *Chmn* Dr Brigitte LaTrespo
Estab 1889; Maintain nonprofit art gallery, Weber Art Gallery, 147 Sycamore St, Pikeville, KY 41501; pvt den; D & E; SC 16, LC 5
Ent Req: SAT, ACT
Degrees: BA & BS 4 yrs
Tuition: $52.50 per sem
Courses: †Art Education, Art History, Ceramics, Drawing, History of Art & Architecture, Painting, Printmaking, Sculpture, †Teacher Training
Summer School: Courses—vary

PIPPA PASSES

ALICE LLOYD COLLEGE, Art Dept, 100 Purpose Rd, Pippa Passes, KY 41844. Tel 606-368-2101, Ext 6083; Fax 606-368-6496; Internet Home Page Address: www.alc.edu; *Instr* Mike Ware

Estab 1923; FT 1; pvt; D & E; Scholarships; SC 6, LC 1
Ent Req: HS dipl, ent exam
Degrees: BS & BA 4 yrs
Tuition: Out of state—$6360 per yr; no tuition for 108 mountain counties
Courses: Art Appreciation, Art History Survey No 2, †Art for Elementary Education, Pottery
Children's Classes: Enrl 10-20; tuition free. Courses—Drawing, Painting, Sculpture

RICHMOND

EASTERN KENTUCKY UNIVERSITY, Art Dept, Campbell 309, Richmond, KY 40475; 521 Lancaster Ave, Richmond, KY 40475-3102. Tel 859-622-1629; Fax 859-622-5904; Elec Mail artsmith@acs.eku.edu; Internet Home Page Address: www.art.eku.edu; *Chmn* Dr Gil R Smith
Estab 1906; Maintain nonprofit art gallery; Frederick Giles Gallery, Campbell Building 309, Eastern Kentucky University, Richmond, KY 40475-3102; pub; D&E; Scholarships; SC 40, LC 14, GC 12, other 5; non-maj 70, maj 251, grad 6
Ent Req: HS grad
Degrees: BA, BFA & MA(Educ) 4 yrs
Tuition: Res—undergrad $1271 per sem, $106 per cr hr, grad $1378 per sem, $153 per cr hr; nonres—undergrad $3442 per sem, $287 per cr hr; grad $3765 per sem, $418 per cr hr
Courses: Art Appreciation, †Art Education, Art History, †Ceramics, Drawing, †Graphic Design, †Interior Design, †Metals, †Painting, †Photography, †Sculpture
Adult Hobby Classes: Non-credit courses offered
Summer School: Enrl & courses vary; tuition same as regular sem

WILLIAMSBURG

CUMBERLAND COLLEGE, Dept of Art, 7523 College Station Dr, Williamsburg, KY 40769-1386. Tel 606-549-2200; Fax 606-539-4490; Internet Home Page Address: cumberlandcollege.edu; *Chmn* Kenneth R Weedman
Estab 1889; Maintains nonprofit art gallery on campus; den; D & E; Scholarships; SC 20, LC 10; D 1614, E 60, maj 30
Ent Req: HS dipl, ACT test
Degrees: BA and BS 4 yr
Tuition: $5194 per sem, room & board $2238 per sem
Courses: Aesthetics, Art Appreciation, Art Education, Art History, Computer Imaging, Design, Drawing, Film, Painting, Printmaking, Sculpture, Stage Design, Teacher Training, Theatre Arts, Video

WILMORE

ASBURY COLLEGE, Art Dept, One Macklem Dr, Wilmore, KY 40390. Tel 606-858-3511, Ext 239; Fax 606-858-3921; Elec Mail kevin.sparks@asbury.edu; *Art Dept Chmn* Prof Rudy Medlock; *Instr* Prof Kevin Sparks; *Instr* Prof Linda Stratford; *Instr* Prof Keith Barker; *Instr* Prof Joann Cullip; *Instr* Prof Allen Creech; *Instr* Prof Becky Faulkner; *Instr* Prof Ross Zirkel; *Dir Gallery* Prof Dan Garcia
Estab 1892; Maintain nonprofit art gallery, Student Center Gallery, One Macklem Dr, Wilmore, KY 40390; FT 13; pvt; D & E; Scholarships; SC 24, LC 6; D 1350, maj 45, others 250
Ent Req: HS dipl
Degrees: AB & BS 4 yr
Tuition: $18,000 per yr incl tuition, room & board
Courses: Advertising Design, Aesthetics, Animation, Art Appreciation, Art Education, Art History, Calligraphy, Ceramics, Commercial Art, Design, Drawing, †Glass, †Goldsmithing, Graphic Arts, Graphic Design, History of Art & Architecture, Lettering, Painting, Photography, Printmaking, Sculpture, Stage Design, Stained Glass, Teacher Training, Theatre Arts
Children's Classes: Enrl 12; tuition $10. Courses—Elementary Education
Summer School: Dir, Rudy Medlock. Enrl 8 - 12; tutition $650.50 for term June 9 - July 9. Courses—Art Appreciation

LOUISIANA

ALEXANDRIA

LOUISIANA STATE UNIVERSITY AT ALEXANDRIA, Dept of Fine Arts & Design, Student Ctr, Hwy 71 S Alexandria, LA 71302. Tel 318-445-3672; Internet Home Page Address: www.lsu.edu; *Prof Art* Roy V deVille, MA
Estab 1960; pub; D; Scholarships; D 200, E 50, non-maj 300, maj 15
Ent Req: HS dipl, entrance exam, state exam & ACT
Degrees: Fine Arts Assoc 2-3 yr
Tuition: Res $698.50 per sem; non-res $1928 per sem
Children's Classes: Enrl 50; tuition $189 per course. Courses—Painting, Pottery
Summer School: Enrl 150; tuition $120 per cr. Courses—Art Appreciation, Art History, Painting, Pottery

BATON ROUGE

LOUISIANA STATE UNIVERSITY, School of Art, 123 Art Bldg, Baton Rouge, LA 70803. Tel 225-388-5411; Fax 225-578-5424; Internet Home Page Address: www.lsu.edu; *Prof* Richard Cox PhD, MFA; *Prof* Mark Zucker PhD, MFA; *Prof* Patricia Lawrence PhD, MFA; *Prof* Melody Guichet, MFA; *Prof* A J Meek, MFA; *Prof* Christopher Hentz, MFA; *Prof* Kimberly Arp, MFA; *Prof* Robert Hausey, MFA; *Prof* Gerald Bower, MFA; *Assoc Prof* Michael Book, MFA; *Asst Prof* Gregory Elliot, MFA; *Asst Prof* Paul Dean, MFA; *Asst Prof* Herb Goodman, MFA;

Asst Larry Livaudais, MFA; *Asst* Lynne Baggett, MFA; *Asst* Susan Ryan, MFA; *Asst* Kirsten Noreen; *Dir* Michael Daugherty, MFA; *Asst* Edward Smith; *Asst Prof* Denyce Celentano; *Asst Prof* Cynthia Handel; *Asst Prof* Robert Silverman; *Asst Prof* Parrott Bacot
Estab 1874, dept estab 1935; pub; D & E; Scholarships
Ent Req: HS dipl, ACT scores
Degrees: BFA 4 yr, MFA 3
Tuition: Res—undergrad $1330, grad $1166 per sem; nonres—undergrad $2980 per sem, grad $2988 per sem
Courses: †Art History, †Ceramics, Drawing, †Graphic Design, †Painting, †Printmaking, †Sculpture
Summer School: Tuition res—$273, nonres—$653 for 8 wk course

SOUTHERN UNIVERSITY A & M COLLEGE, School of Architecture, Southern Branch, PO Box 11947 Baton Rouge, LA 70813. Tel 225-771-3015; Fax 225-771-4709; Internet Home Page Address: subr.edu/architecture/awotona; *Dean* Adenrele Awotona; *Instr* Jill Bambury; *Instr* John Delgado; *Instr* Charles Smith; *Instr* Randall Teal; *Instr* Archie Tiner; *Instr* Lonnie Wilkinson; *Instr* Annette Williams; *Instr* Kelley Roberts; *Instr* Henry Thurman
Estab 1956; pub; D & E; Scholarships; SC 14; D 250, non-maj 7, maj 162
Ent Req: HS dipl
Degrees: BA 5 yrs
Tuition: Res—undergrad $1114 per sem, grad $1023 per sem
Courses: Architecture, Art Education, Computer, Graphic Arts, Painting, Printmaking
Summer School: Dir, E D Van Purnell. Term of 8 wks beginning June. Courses—Architectural Design, Construction Materials & Systems, Graphic Presentation, Structures

GRAMBLING

GRAMBLING STATE UNIVERSITY, Art Dept, PO Box 1184, Grambling, LA 71245-3090. Tel 318-274-3811; Fax 318-274-3723; Internet Home Page Address: www.grambling.edu; *Chmn* Thomas O Smith
Degrees: BA 4 yr
Tuition: Res—$1044 per sem; nonres—$2019 per sem
Courses: Art Appreciation, †Art Education, Art History, Ceramics, Computer, Design, Drawing, Handicrafts, Illustration, Painting, Printmaking, Sculpture, Teacher Training

HAMMOND

SOUTHEASTERN LOUISIANA UNIVERSITY, Dept of Visual Arts, SLU 10765, Hammond, LA 70402. Tel 504-549-2193; Fax 985-549-5316; Internet Home Page Address: www.selu.edu; *Prof* Ronald Kennedy, MFA; *Assoc Prof* Gail Hood, MFA; *Asst Prof* Gary Keown, MFA; *Instr* Lynda Katz, MFA; *Prof* C Roy Blackwood, MFA; *Lectr* Susan Wingard; *Lectr* Rancy Boyd-Snee; *Asst Prof* Irene Nero; *Asst Prof* John Valentine; *Lectr* April Hammock; *Lectr* Malcolm McClay; *Interim Dept Head* David Everson; *Asst Prof* Kim Finley-Stansbury; *Asst Prof* Timothy Van Beke; *Lectr* Peggy Cogswell; *Lectr* Robert Labranche; *Lectr* Timothy Roper; *Lectr* Timothy Silva
Estab 1925; Maintain nonprofit art gallery; Clark Hall Gallery, SLU 10765, Hammond, N 70402; art supplies available on-campus; Pub; D & E; Scholarships; SC 25, LC 4, GC 2; D 121, E 75, maj 122
Ent Req: HS dipl, ACT
Degrees: BA(Educ), BA(Humanities), BA(Cultural Resource Management) 4 yrs
Tuition: $1,014 per 12 hr load
Courses: Art Education, Art History, Ceramics, Digital Design, Drawing, Painting, Photography, Printmaking, Sculpture, Teacher Training
Summer School: Dir, C Roy Blackwood. Enrl 150; 8 wk term. Courses—Art Education, Art Survey for Elementary Teachers

LAFAYETTE

UNIVERSITY OF LOUISIANA AT LAFAYETTE, College of the Arts, USL Box 43850, Lafayette, LA 70504. Tel 337-482-6224; Fax 337-482-5907; Internet Home Page Address: www.arts.louisiana.edu; *Dean* H Gordon Brooks II
Estab 1900; FT 68, PT 7; pub; D&E; Scholarships; univ 18,000
Degrees: BArchit & BFA 4-5 yrs
Tuition: $700 per sem
Courses: †Advertising Design, †Architecture, †Art Education, †Ceramics, †Choreographic Design, †Fine Arts, †Interior Architecture, †Photography
Summer School: Dir, Gordon Brooks. Enrl 300; study aboard program in Paris, France & London, England. Courses—Ceramics, Computer Art, Design, Drawing, Film & Video Animation, Painting, Photography

LAKE CHARLES

MCNEESE STATE UNIVERSITY, Dept of Visual Arts, Ryan St, MSU Box 92295 Lake Charles, LA 70609-2295. Tel 337-475-5060; Fax 337-475-5927; *Chmn* Lisa Reinauer
Estab 1950, dept estab 1953; FT 9; pub; D & E; Scholarships; SC 24, LC 4, GC 1; D 85, E 15, non-maj 215, maj 85
Ent Req: HS dipl
Degrees: BA (Art Educ) & BA (Studio Arts) 4 yrs
Tuition: $1049 per sem
Courses: †Advertising Design, Art Appreciation, †Art Education, Art History, †Ceramics, †Drawing, Graphic Arts, Graphic Design, Mixed Media, †Painting, †Photography, †Printmaking, Survey crafts course
Adult Hobby Classes: Enrl 50; tuition $254 per sem (3 hrs). Courses—Art History & Ceramics

Summer School: Dir, Bill Iles. Enrl 100; tuition $343 per 3 hrs. Courses—Basic Design, Beginning Drawing, Ceramics, Printmaking, Photography

MONROE

UNIVERSITY OF LOUISIANA AT MONROE, (Northeast Louisiana University) Dept of Art, 700 University Ave, Stubbs 141 Monroe, LA 71209. Tel 318-342-1375, 342-5252; Fax 318-342-1369; Internet Home Page Address: www.ulm.edu; *Instr* Brian Fassett, MFA; *Instr* Richard Hayes, MFA; *Instr* Gary Ratcliff, MFA; *Instr* Robert Ward, MFA; *Instr* Cynthia Kee, MFA; *Instr* James Norton, MFA; *Instr* Joni Noble, MFA; *Instr* Linda Ward, MFA; *Head Dept* Ronald J Alexander, MFA; *Asst Prof* Cliff Tresner
Estab 1931, dept estab 1956; pub; D & E; Scholarships; SC 28, LC 4, GC 9; non-maj 300, maj 125, GS 3
Ent Req: HS dipl
Degrees: BFA 4 yrs, MEd
Tuition: Res—$168 per unit
Courses: 3-D Design, Advertising Design, Analytical Perspective, Art Appreciation, Block Printing, Ceramics, Drawing, Figure Drawing, Painting, Photography, Printmaking, Sculpture, Silkscreen, Survey Class
Adult Hobby Classes: Enrl 20. May 31 - July 2. Courses—Art 411
Summer School: Dir, Ronald J Alexander. Enrl 30; tuition $168 from May 25 - July 3 & July 5 - Aug 11. Courses—Art Appreciation, Art Education, Drawing, Painting

NATCHITOCHES

NORTHWESTERN STATE UNIVERSITY OF LOUISIANA, School of Creative & Performing Arts - Dept of Fine & Graphic Arts, 140 Central Ave, Natchitoches, LA 71497. Tel 318-357-6176; Fax 318-357-5904; Elec Mail chandlerr@nsula.edu; *Prof* Michael Yankowski, MFA; *Assoc Prof & Vis Arts Chmn* Roger A Chandler, MArch, PhD; *Asst Prof* Clyde Downs, MFA; *Asst Prof* Robert Moreau, MFA; *Asst Prof* F Brooks DeFee, MA; *Asst Prof* W Anthony Watkins
Estab 1885; Maintains nonprofit gallery, Hanchey Gallery, AA Fredericks & Alice Dear Fine Art Building, NSU 71497; Watson Libr, NSU 71497; Orville J Hanchey Gallery, 140 Central Ave, Natchitoches, LA 71497; Pub; D, E & internet; Scholarships; SC 67, LC 17, GC 36; non-maj 60, maj 101, grad 16
Ent Req: Selective admis
Degrees: BFA 4 yrs, MA 2 yrs, special prog for advanced students MA in Art
Tuition: Res—undergrad $1,786.30; nonres—undergrad $3,039
Courses: †Advertising Design, Art Appreciation, †Art Education, Art History, Ceramics, Commercial Art, Design, Drawing, Graphic Arts, †Graphic Design, History of Art & Architecture, Painting, Printmaking, Professional Photography, Sculpture, Stained Glass, Stringed Instrument Construction
Adult Hobby Classes: Courses—most of above

NEW ORLEANS

DELGADO COLLEGE, Dept of Fine Arts, 501 City Park Ave, New Orleans, LA 70119. Tel 504-483-4400, 483-4069; Fax 504-483-4954; Elec Mail lcoppi@dcc.edu; Internet Home Page Address: www.dcc.edu; *Chmn Fine Arts* Lisette Copping
Dept estab 1967. College has 2 campuses; pub; D & E; Scholarships; SC 12-20, LC 12-20; D 150, E 65, maj 60
Ent Req: HS dipl, 18 yr old
Degrees: AA and AS 2 yrs
Tuition: Res—$618 per sem; nonres—$1898 per sem
Courses: Art Appreciation, Art History, Ceramics, Drawing, History of Art & Architecture, Jewelry, Painting, Sculpture

LOYOLA UNIVERSITY OF NEW ORLEANS, Dept of Visual Arts, 6363 Saint Charles Ave, New Orleans, LA 70118; Bpx 906, New Orleans, LA 70118. Tel 504-865-2011, 861-5456; Fax 504-861-5457; *Chmn* Carol Leak Den; D & E; Scholarships; SC 9, LC 3; D 150, E 45, maj 28
Ent Req: HS dipl, ent exam
Degrees: BSA 4 yrs
Tuition: $13,000 12 - 20 hrs
Courses: Art History, Ceramics, Computer Graphics, Design, Drawing, Painting, Photography, Printmaking, Sculpture, Teacher Training
Summer School: Chmn, John Sears. Enrl 40; term of 6 wks beginning in June. Courses—Drawing, Painting, Printmaking, Sculpture

SOUTHERN UNIVERSITY IN NEW ORLEANS, Fine Arts & Philosophy Dept, 6400 Press Dr, New Orleans, LA 70126. Tel 504-286-5000, 286-5267; Fax 504-286-5296; *Asst Prof* Gary Oaks, MFA; *Music* Roger Dickerson, MFA; *Music* Valeria King, MFA; *Chmn* Sara Hollis, MA; *Instr* Cynthia Ramirez; *Instr* Charlie Johnson; *Instr* Arthur Pindle; *Instr* Tommy Myrick; *Instr* Edward Jordan
Estab 1951, dept estab 1960; pub; D 21, E 26, non-maj 700, maj 47
Ent Req: HS dipl
Degrees: BA 4 yrs, BS(Art Educ) 4 yrs, BS(Music Educ) 4 yrs
Tuition: Res—undergrad $1050 per 12 cr hrs, grad $2100 per 12 cr hrs, $1525 per 9 cr hrs
Courses: African & American Art, African Art, Art Education, Art History, Ceramics, Commercial Art, Crafts, Drawing, Painting, Photography, Printmaking, Sculpture, Video
Adult Hobby Classes: Courses offered
Summer School: Courses offered

TULANE UNIVERSITY
—School of Architecture, Tel 504-865-5389; Fax 504-862-8798; Internet Home Page Address: www.tsaarch.edu; *Dean* Donald Gatzke
Estab 1907; FT 24, PT 12; pvt; 320

Degrees: BA, MA(Archit)
Tuition: $9380 per sem
Courses: Computer Graphics, Design, Frank Lloyd Wright's Architecture, History, Life Drawing, Structures, Technology, Theory
—**Sophie H Newcomb Memorial College,** Tel 504-865-5327; Fax 504-862-8710; Internet Home Page Address: www.2tulane.edu; *Assoc* Theresa Cole; *Prof* Gene H Koss; *Prof* Marilyn R Brown; *Assoc Prof* Ronna Harris; *Assoc Prof* Jeremy Jernegan; *Prof* Barry Bailey; *Prof* Elizabeth Boone; *Chmn* Arthur Okazaki; *Assoc Prof* Sandy Chism; *Asst Prof* Pamela Franco; *Assoc Prof* Michael Plante; *Prof* Bill Tronzo
Estab 1886; pvt; D & E; Scholarships; SC 33, LC 25, GC 29; D 817 per sem,E 37 per sem
Ent Req: HS dipl, CEEB, interview, review of work by chmn & or faculty (optional)
Degrees: BA, BFA, BA(Art Biology), MA, MFA
Tuition: $26,000 incl room & board per yr
Courses: American Art, Ceramics, Drawing, Glass Blowing, Painting, Photography, Pre-Columbian Art, Printmaking, Sculpture
Adult Hobby Classes: Art History, Ceramics, Drawing, Glass, Painting, Photography, Printmaking, Sculpture
Children's Classes: Offered through the Dept of Educ
Summer School: Dean, Richard Marksbury. Courses—Art History, Ceramics, Drawing, Glass, Painting, Photography, Sculpture

UNIVERSITY OF NEW ORLEANS-LAKE FRONT, Dept of Fine Arts, 2000 Lake Shore Dr, New Orleans, LA 70148. Tel 504-280-6493; Fax 504-280-7346; Elec Mail finearts@uno.edu; *Prof* Doyle J Gertjejansen, MFA; *Chmn* Richard A Johnson, MFA; *Prof* Harold James Richard, MFA; *Assoc Prof* Thomas C Whitworth, MFA; *Assoc Prof* Cheryl A Hayes Fournet, MFA; *Asst Prof* Christopher Saucedo, MFA; *Asst Lawrence* Jenkins, MFA; *Asst Prog* Jeffrey Prentice, MFA; *Prof* Peggy McDowell; *Art History* Isabelle Wallace
Estab 1958, dept estab 1968; pub; D & E; SC 29, LC 24, GC 34; D 17,900 (university), non-maj 3000, maj 150, grad 20
Ent Req: HS dipl
Degrees: BA 4 yrs, MFA 60 hrs
Tuition: Res—undergrad & grad $1356 per sem FT, nonres—undergrad $3522 per sem FT, grad $4878 per sem FT
Courses: †Art History, Drawing, Graphic Design, Hyper-Media, †Painting, †Photography, †Printmaking, †Sculpture
Summer School: Tuition $600 for term of 6 wks beginning June. Courses—Art Fundamentals, Art History, Drawing, Graphic Design, Graphics, Painting, Photography, Sculpture

XAVIER UNIVERSITY OF LOUISIANA, Dept of Fine Arts, 1 Drexel Dr New Orleans, LA 70125. Tel 504-483-7556; Internet Home Page Address: www.xula.edu; *Chmn* Ron Bechet; *Prof* John T Scott, MFA; *Asst Prof* Mrs Nelson Marsalis, MFA
Estab 1926, dept estab 1935; den; D & E; Scholarships; SC 48, LC 10; D 50, E 12, non-maj 10, maj 52
Ent Req: HS dipl, SAT or ACT, health cert, C average at least
Degrees: BA, BA (Art Ed), BFA, BS & MA
Tuition: $9300 per yr
Courses: Art Appreciation, Art History, Black & White Photography, Ceramics, Design, Graphic Ad Design, Painting, Photography, Printmaking
Adult Hobby Classes: Courses—Creative Crafts

PINEVILLE

LOUISIANA COLLEGE, Dept of Art, 1140 College Dr, Pineville, LA 71359; PO Box 561, Pineville, LA 71359. Tel 318-487-7262; Fax 318-487-7337; Internet Home Page Address: www.lacollege.edu; *Prof* Bob Howell; *Prof* Ted Barnes; *Adjunct Prof* Preston Gilchrist; *Adjunct Prof* Leslie Elliotsmith; *Adjunct Prof* Leandro Huebner
Estab 1906; Maintains nonprofit gallery, Weathersby Fine Arts Building Gallery, Art Dept Luoisiana College, Pineville, LA 71359; Den; D & E; Scholarships; SC 25, LC 6, Lab C; maj 35
Ent Req: HS grad
Degrees: BA 4 yrs, 49 hrs of art req plus 78 hrs acad for degree
Tuition: Res—$315 per sem hr plus rm & board
Courses: Advertising Design, Art Appreciation, †Art Education, Art History, Ceramics, Design, Drawing, †Graphic Design, Illustration, Painting, Photography, Printmaking, †Studio Arts

RUSTON

LOUISIANA TECH, School of Art, PO Box 3175, Tech Sta Ruston, LA 71272. Tel 318-257-3909; Fax 318-257-3909; Elec Mail ddablow@latech.edu; Internet Home Page Address: www.art.latech.edu; *Dir* Dean Dablow
Estab 1894; maintain non-profit art gallery, School of Art Gallery at same address; FT 11, PT 3; pub; D&E; Scholarships; SC 98, LC 8, GC 87; maj 380, Grad 17
Ent Req: HS dipl
Degrees: BID, BFA, MFA 3 yrs
Tuition: Res—undergrad $835 per quarter; Nonres—undergrad $1,325 per quarter
Courses: †Advertising Design, Art Appreciation, Art Education, Art History, †Ceramics, †Commercial Art, Conceptual Art, Design, †Drawing, †Graphic Arts, †Graphic Design, Illustration, †Interior Design, †Painting, †Photography, †Printmaking, †Sculpture, †Studio Art
Summer School: varies

SHREVEPORT

CENTENARY COLLEGE OF LOUISIANA, Dept of Art, 2911 Centenary Blvd, Shreveport, LA 71104. Tel 318-869-5261, 869-5011; Fax 318-869-5730; Elec Mail ballen@bata.centenary.edu; Internet Home Page Address: www.centenary.edu/department/art/; *Chmn Dept & Prof* Bruce Allen, MFA; *Lectr* Neil Johnson, BA; *Vis Asst Prof* Lisa Nicoletti, PhD; *Instr* Diane Dufilho, MA

Estab 1825, dept estab 1935; Maintain Turner Art Center Gallery; den; D & E; Scholarships; SC 22, LC 8; D 125 per sem
Ent Req: HS dipl, SAT or ACT
Degrees: BA 4 yrs
Tuition: $15,400 per yr, $7700 per sem; campus res—room & board $4800 per yr
Courses: Aesthetics, Art Education, Art History, Ceramics, Drafting, Drawing, Graphic Arts, Painting, Printmaking, Sculpture, Teacher Training

THIBODAUX

NICHOLLS STATE UNIVERSITY, Dept of Art, Thibodaux, LA 70310. Tel 985-448-4597; Fax 985-448-4596; Internet Home Page Address: www.nicholls.edu; *Art Dept Head* Dennis Sipiorski
Estab 1948; FT 8; pub; D & E; Scholarships; SC 73, LC 6; D 100, non-maj 20, maj 80, others 20
Ent Req: HS dipl, ACT
Degrees: BA 4 yrs
Tuition: Res—undergrad $1184 for 12 hrs or more per sem; nonres—grad & undergrad $3908 per sem
Courses: Applied Design, Art Appreciation, Art Education, Art History, Ceramics, Design, Drawing, Graphic Design, Illustration, Painting, Papermaking, Photography, Printmaking, Rendering, Sculpture, Water Media

MAINE

AUGUSTA

UNIVERSITY OF MAINE AT AUGUSTA, College of Arts & Humanities, 46 University Dr, University Heights Augusta, ME 04330. Tel 207-621-3000; Fax 207-621-3293; Internet Home Page Address: www.uma.maine.edu; *Prof* Philip Paratore, MFA; *Prof* Robert Katz, MFA; *Prof* Karen Gilg, MFA; *Prof* Tom Hoffman, MFA; *Prof* Lizabeth Libbey, MFA; *Prof* Bill Moseley, MFA; *Prof* Mark Polishook, MFA; *Prof* Roger Richman, MFA; *Prof* Donald Stratton, MFA; *Prof* Charles Winfield, MFA; *Assoc Prof* Brooks Stoddard, MFA; *Chmn* Joshua Nadel, MFA
Estab 1965, dept estab 1970; pub; D & E; SC 20, LC 8; D 50, E 40, non-maj 40, maj 60
Ent Req: HS dipl
Degrees: AA(Architectural Studies) 2 yrs
Tuition: Res—$3840 per yr, $94 per cr hr; nonres—$9000 per yr, $229 per cr hr
Courses: Advertising Design, Art History, Ceramics, Drawing, Graphic Arts, Mixed Media, Painting, Paper Making, Photography, Sculpture
Summer School: Provost, Richard Randall. Enrl 30-50; tuition $52 per cr hr for term of 7 wks beginning last wk in June. Courses - Drawing, Painting, Sculpture

BRUNSWICK

BOWDOIN COLLEGE, Art Dept, Visual Arts Ctr, 9300 College Station Brunswick, ME 04011. Tel 207-725-3697; Fax 207-725-3996; Internet Home Page Address: www.bowdoin.edu; *Prof* Linda Docherty PhD; *Chair* Mark Wethli, MFA; *Dir Art History* Susan Wegner, PhD; *Prof* Thomas B Cornell, AB; *Lectr* John Bisbee, BFA; *Asst Prof* Stephen Perkinson, PhD; *Asst Prof* Pamela Fletcher, PhD; *Asst Prof* Michael Kolster, MFA; *Prof* Jim Mullen, MFA; *Visiting Asst Prof* Anna Hepler, MFA; *Asst Prof* De-Nin Lee, MFA; *Prof* Clifton Olds, PhD; *Vis Asst Prof* Meghan Brady, MFA; *Vis Asst Prof* Wiebke Theodore, MArch; *Vis Asst Prof* Meggan Gould, MFA
Estab 1794; maintain a nonprofit art gallery: Bowdin College Museum of Art, Walker Art Bldg, 9400 College Station Brunsurickm ME 04011; maintain an art/architecture library: Pierce Art Library, Visual Arts Center, 9300 College Station, Brunswick ME 04096; on-campus shop where art supplies may be purchased; pvt; D & E; Scholarships; SC 12, LC 12; maj 54
Ent Req: HS dipl
Degrees: AB 4 yrs
Courses: Architecture, Art History, Digital Animation, Drawing, History of Art & Architecture, Painting, Photography, Printmaking, Sculpture, Stage Design, Visual Arts

DEER ISLE

HAYSTACK MOUNTAIN SCHOOL OF CRAFTS, PO Box 518, Deer Isle, ME 04627-0518. Tel 207-348-2306; Fax 207-348-2307; Internet Home Page Address: www.haystack-mpm.org; *Dir* Stuart J Kestenbaum
Estab 1951; on-campus shop where art supplies may be purchased.; FT 36; pvt; D, Summer school; Scholarships; SC; D 82
Tuition: $600 for 2 wk session; $800 for 3 wk session, $280-1900 rm & board
Courses: Basketry, Blacksmithing, Ceramics, Fabric, Glassblowing, Graphic Arts, Metalsmithing, Papermaking, Quiltmaking, Stained Glass, Weaving, Woodworking
Summer School: Dir, Stu Kestenbaum. Enrl 80; tuition $800 for 3 wks, $600 for 2 wks. Courses—Basketry, Blacksmith, Fabric Arts, Glassblowing, Graphics, Metalsmithing, Papermaking, Quiltmaking, Woodworking

GORHAM

UNIVERSITY OF SOUTHERN MAINE, Art Dept, 37 College Ave, Gorham, ME 04038. Tel 207-780-5460; Fax 207-780-5759; Internet Home Page Address: www.usm.maine.edu;
Estab 1878, dept estab 1956; pub; D & E; SC 9, LC 2; maj 229
Ent Req: HS dipl, portfolio
Degrees: BA, BFA
Tuition: Res—undergrad $124 per cr hr; nonres—undergrad $347 per cr hr

Courses: Art Education, Art History, Ceramics, Design, Drawing, Museum Staff Training, Painting, Philosophy of Art; Problems in Art, Photography, Printmaking, Sculpture
Children's Classes: Enrl 15; tuition $475 res $375 commuter 1 wk in the summer. Courses—Drawing, Painting, Photography & Sculpture
Summer School: Chmn, Trudy Wilson. Enrl 125; same as general tuition May 15-Aug 30. Courses—Art Education, Art History, Ceramics, Design, Drawing, Painting, Photography, Printmaking, Sculpture

LEWISTON

BATES COLLEGE, Art & Visual Culture, Olin Arts Center, Bates College Lewiston, ME 04240. Tel 207-786-8212; Fax 207-786-8335; Elec Mail aodom@bates.edu; Internet Home Page Address: www.bates.edu; *Prof, Chmn* Rebecca W Corrie; *Pres* Elaine Hansen; *Assoc Prof* Edward S Hardwood; *Prof* Erica Rand; *Asst Prod* Trian Nguyen; *Assoc Prof* Pamela Johnson
Estab 1864, dept estab 1964; Maintain nonprofit art gallery, Bates College Mus of Art; FT 5, PT 4; pvt; D; Scholarships; SC 26, LC 37; 1650 total
Degrees: BA 4 yr
Tuition: $41,000+ per yr (comprehensive fee)
Courses: Aesthetics, Art History, Ceramics, Drawing, History of Art & Architecture, Painting, Printmaking, †Studio Art

ORONO

UNIVERSITY OF MAINE, Dept of Art, 5712 Carnegie Hall, Orono, ME 04469-5712. Tel 207-581-1110; Fax 207-581-3276; Internet Home Page Address: www.maine.edu/; *Assoc Prof* Laurie E Hicks PhD; *Prof* Michael H Lewis, MFA; *Assoc Prof* David Decker, MA; *Assoc Prof* Michael Grillo PhD, MA; *Asst Prof* Brooke Knight, MFA; *Asst Prof* Jay Hanes PhD, MFA; *Asst Prof* Eleanor Weisman PhD, MFA; *Asst Prof* Cristin Millett, MFA; *Adjunct Asst Prof* Judith Sasson-Mason, MFA; *Prof Art, Chairperson* James Linehan; *Prof & Interim Chair* Susan Groce
Estab 1862, dept estab 1946; pub; D & E; Scholarships; SC 24, LC 24; D 135, maj 135
Ent Req: HS dipl, 3 CEEB tests
Degrees: BA 4 yrs
Tuition: Res—undergrad $5070; nonres—undergrad $12,810; campus res—room & board $5628 per yr
Courses: Aesthetics, Art Appreciation, †Art Education, †Art History, Computer Art, Design, Digital Art, Drawing, Graphic Design, History of Art & Architecture, Mixed Media, New Media, Painting, Photography, Printmaking, Sculpture, Teacher Training
Children's Classes: Chair, Laurie E Hicks, PhD. Enrl 110-125; tuition $25 for 8 wks during the Fall sem. Courses—Art Education
Summer School: Dir, Robert White. Tuition $105 per cr hr, 3-8 wk courses. Courses—Art Education, Art History, Basic Drawing, Basic Painting, Computer Graphics, Photography, Printmaking

PORTLAND

MAINE COLLEGE OF ART, 97 Spring St, Portland, ME 04101. Tel 207-775-3052; Fax 207-775-5087; Elec Mail info@meca.edu; Internet Home Page Address: www.meca.edu; *Pres* Christine J Vincent; *Dean* Greg Murphy; *Instr* John Eide, MFA; *Instr* Mark Jamra, BFA; *Instr* John T Ventimiglia, MFA; *Instr* Mark Johnson, MFA; *Instr* George LaRou, MFA; *Instr* Gan Xu, Ph; *Instr* Joan Uraneck, MFA; *Instr* Honour Mack, MFA; *Instr* Paul Diamato, MFA; Sean Foley, MFA; Adriane Herman, MFA; Chris Thompson, PhD
Estab 1882; pvt; D & E; Scholarships; SC 37, LC 9; D 330, E300, maj 330, others 170 HS, 75 children (4th-9th grades)
Ent Req: HS dipl, portfolio
Degrees: BFA 4 yr (under Maine law, & academically advanced HS Sr may take the freshman yr at Maine College of Art for both HS & Maine College of Art credit), MFA 2 yr
Tuition: $20,614 per yr
Courses: Art Education, Art History, Art in Service, †Ceramics, Computer Arts, Design, Drawing, †Graphic Design, Illustration, †Jewelry, †Metalsmithing, Mixed Media, New Media Illustration, †Painting, †Photography, †Printmaking, †Sculpture, †Self-Designed ?Media Arts, †Silversmithing, Video, Woodworking & Furniture Design
Adult Hobby Classes: 300; tuition 325 per 1 cr course plus lab fee $10-$25. Courses—Apparel Design, Cartooning, Ceramics, Design, Drawing, Electronic Imaging, Graphic Design, Illustration, Jewelry, Landscape Design, Metalsmithing, Painting, Photography, Printmaking, Sculpture, Textile Design
Children's Classes: $245; tuition $150 for 10 wk term. Courses—Ceramics, Computer Graphics, Drawing, Graphic Design, Metalsmithing, Photography, Printmaking, Sculpture
Summer School: Dir, Margo Halverson. Enrl $60; tuition $1800 per cr for term of 3 wks beinning June 23. Courses—Art History, Ceramics, Computer Imaging, Drawing, Graphic Design, Jewelry & Metalsmithing, Painting, Photography, Printmaking, Sculpture, Watercolor, 2 & 3-D Design

ROCKPORT

MAINE PHOTOGRAPHIC WORKSHOPS, THE INTERNATIONAL T.V. & FILM WORKSHOPS & ROCKPORT COLLEGE, 2 Central St, PO Box 200 Rockport, ME 04856. Tel 207-236-8581; Fax 207-236-2558; Elec Mail info@theworkshops.com; Internet Home Page Address: www.theworkshops.com; *Founder & Dir* David H Lyman; *Registrar* Kerry Curren; *Student Servs* Christy Smith
Estab 1973; Scholarships; 1200
Degrees: AA 2 yr, MFA

Tuition: Workshops $600
Courses: 3-D Art, Animation, Archaeology, Art History, Collage, Commercial Art, Conceptual Art, Digital Media, Drawing, Film, Graphic Arts, Graphic Design, History of Cinema, History of Photography, Illustration, Interactive Multimedia, Painting, Photography, Printmaking, Psychology of Symbols, Screen Dynamics, Teacher Training, Video
Adult Hobby Classes: Enrl 1000
Summer School: Dir, David H Lyman. Enrl 2000; tuition $250-$600 for 1 wk workshop. Courses—Directing, Editing, Film, Video, Writing

WATERVILLE

COLBY COLLEGE, Art Dept, Mayflower Hill, Waterville, ME 04901. Tel 207-872-3233; Fax 207-872-3141; *Prof* Harriett Matthews, MFA; *Prof* David Simon, PhD; *Prof* Michael Marlais, PhD; *Assoc Prof* Scott Reed, MFA; *Asst Prof* Ankeney Weitz, PhD; *Assoc Prof* Berin Engman, MFA; *Assoc Prof* Veronique Plesch, PhD; *Asst Prof* Laura Saltz, PhD; *Vis Asst Prof* Dee Peppe, MFA
Estab 1813, dept estab 1944; Maintain nonprofit art gallery; pvt; D & E; Scholarships; SC 25, LC 25; D 500, non-maj 425, maj 75
Ent Req: HS dipl
Degrees: BA 4 yrs
Tuition: $35,800 per yr incl room & board
Courses: Art History, †Art History, Ceramics, Drawing, History of Art & Architecture, Painting, †Painting, Photography, Printmaking, †Printmaking, Sculpture, †Sculpture

MARYLAND

BALTIMORE

BALTIMORE CITY COMMUNITY COLLEGE, Dept of Fine Arts, Main Bldg, Rm 243, 2901 Liberty Heights Ave Baltimore, MD 21215. Tel 410-462-7605; Internet Home Page Address: www.bccc.edu; *Chmn* Rose Monroe; *Assoc Prof* David Bahr, MFA; *Asst Prof* Sally De Marcos, MEd
Estab 1947; Harbor Campus address Lombrad St & Market Place, Baltimore, Md 21202; FT 7, PT 20; pub; D & E; Scholarships; D & E 9800, non-maj 505, maj 388
Ent Req: HS dipl or HS equivalency, ent exam
Degrees: AA 2 yrs
Tuition: Res—undergrad $60 per cr hr; nonres—undergrad $147 per cr hr
Courses: Advertising Design, Art Education, Art History, Ceramics, Commercial Art, Drawing, †Fashion Design, Fashion Illustration, †Fashion Merchandising, Graphic Arts, †Graphic Design, Jewelry, Painting, †Photography, Printmaking, Sculpture, Textile Design
Adult Hobby Classes: Tuition res $56 per cr; nonres $168 per cr. Courses—same as above
Summer School: Dir, Dr Stephen Millman. Enrl 2655. Courses - Ceramics, Crafts, Design, Drawing, Fashion Design, Painting

COLLEGE OF NOTRE DAME OF MARYLAND, Art Dept, 4701 N Charles St, Baltimore, MD 21210. Tel 410-532-5520; Fax 410-532-5795; Elec Mail dfirmani@ndm.edu; Internet Home Page Address: www.ndm.edu; WATS (Md) 800-435-0200; all other 800-435-0300; *Chmn Prof* Domenico Firmani PhD; *Prof* Kevin Raines, MFA; *Asst Prof* Geoff Delanoy, MFA
Estab 1899; Maintains nonprofit gallery, Gormley Gallery, 4701 N Charles, Baltimore, MD 21210; den, W; wkend, M; D & E, wkend; Scholarships; SC 32, LC 20, GC 5; D 680, non-maj 480, maj 45
Ent Req: HS dipl, SAT
Degrees: BA 4 yrs
Tuition: Res—undergrad $11,180 per yr, $5590 per sem; campus res—room & board $5620 per yr
Courses: Advertising Design, Art Education, †Art History, Commercial Art, Design, Drawing, †Graphic Arts, Graphic Design, Illustration, †Museum Staff Training, Painting, †Photography, Printmaking, Sculpture, †Studio, Teacher Training
Adult Hobby Classes: Enrl 55; tuition $150 per cr (1-9 cr). Courses offered in Weekend College & Continuing Education Programs
Summer School: Enrl 35; tuition $95 per cr. Courses—Drawing, History of Art Surveys, Painting, Photography, Printmaking, Sculpture, Teacher Training

COPPIN STATE COLLEGE, Dept Fine & Communication Arts, 2500 W North Ave, Baltimore, MD 21216. Tel 410-383-5400; Fax 410-383-9606; Internet Home Page Address: www.coppin.edu; *Chmn* Dr Judith Willner
FT 1, PT 2; Scholarships; SC 6, LC 7; D 350, E 45
Degrees: BS, MA & Doc in Art Education
Tuition: Res—$3477 per yr; nonres—$8604 per yr; room & board $5700-5900 per yr
Courses: Advertising Design, Art Education, Art History, Calligraphy, Ceramics, Drawing, Film, Graphic Design, Lettering, Painting, Photography, Printmaking, Sculpture, Teacher Training, Theatre Arts

GOUCHER COLLEGE, Art Dept, 1021 Dulaney Valley Rd, Baltimore, MD 21204. Tel 410-337-6000, 337-6235; Fax 410-337-6405; Internet Home Page Address: www.goucher.edu; *Chmn* Edward Worteck
Estab 1885; FT 5, PT 6-7; pvt; D; Scholarships; SC 38, LC 18; D 970, non-maj 558, maj (art) 29
Ent Req: HS dipl, SAT, achievement tests (CEEB), American College Testing Program
Degrees: MA 4 yrs, MA (Dance Movement Therapy) 2 yrs
Tuition: $22,000 per yr, room $5200, board $2600-$2750

Courses: †Art Appreciation, †Art Education, †Art History, †Ceramics, †Design, †Drawing
Summer School: Dir, Fontaine M Belford. Enrl 160; Term of 4 wks beginning June 12 and July 10. Courses—(Art) Dance, Fibers Workshop, Nature Drawing Workshop, Photography, Pottery Workshop, Theatre

JOHNS HOPKINS UNIVERSITY
—**Dept of the History of Art,** Tel 410-516-7117; Fax 410-516-5188; Elec Mail arthist@jhu.edu; Internet Home Page Address: www.jhu.edu; *Chmn* Dr Stephen Campbell
Estab 1947; FT 5, PT 3; pvt; D & E; Scholarships; LC; 10-20 in advanced courses, 80-100 in introductory courses
Degrees: scholarships & fels
Tuition: $31,620 per yr
Courses: Art History, History of Art & Archeology
Summer School: Enrl 30
—**School of Medicine, Dept of Art as Applied to Medicine,** Tel 410-955-3213; Fax 410-955-1085; Elec Mail cbreslin@medart.jhu.edu; Internet Home Page Address: www.med.jhu.edu/medart; *Dir Dept* Gary P Lees, MS; *Dir Emerita* Ranice W Crosby, MLA; *Assoc Prof* Timothy H Phelps, MS; *Assoc Prof* Howard C Bartner, MA; *Asst Prof Emerita* Elizabeth Blumenthal, MA; *Asst Prof* David Rini, MA; *Assoc Prof* Neil Hardy, BFA; *Asst Prof* Dale R Levitz, MS; *Asst Prof* Corinne Sandone, MA; *Instr* Norman Barker, MS; *Instr* Juan R Garcia, MA; *Instr* Anne R Altemus, MA; *Lectr* Joseph Dieter Jr; *Asst Prof* Miguel A Schon, PhD; *Prof Pathology* Grover M Hutchins, MD; *Lectr* Joan A Freedman, MS
Univ estab 1876, School Medicine estab 1893, dept estab 1911; pvt; D; Scholarships; SC 13, LC 5, GC 18
Ent Req: Baccalaureate degree
Degrees: MA
Tuition: $24,700 per yr
Courses: Illustration, Photography, Sculpture, Video

MARYLAND INSTITUTE, College of Art, 1300 W Mt Royal Ave, Baltimore, MD 21217. Tel 410-669-9200; *Pres* Fred Lazarus IV
Estab 1826; FT 45, PT 55; pvt; D & E; Scholarships; D 1107, E 554, Sat 280
Ent Req: HS grad, exam
Degrees: BFA & MFA 4 yrs
Tuition: $15,000 per yr; campus res—$4800
Courses: Ceramics, Computer Graphics, Drawing, Fibers & Wood, Graphic Design, Illustration, Interior Design, Painting, Photography, Printmaking, Sculpture
Adult Hobby Classes: Evenings & Saturdays, cr-non cr classes
Children's Classes: Saturdays & Summer classes
Summer School: Dir Continuing Studies, M A Marsalek. Enrl 1066; tuition $400 per sem per class for Continuing Studies
—**Hoffberger School of Painting,** 1300 W Mt Royal Ave, Baltimore, MD 21217. Tel 410-225-2255; Fax 410-225-2408; *Dir* Grace Hartigan
fel awarded annually for study at the grad level; limited to 14
Tuition: $16,500
—**Rinehart School of Sculpture,** 1300 W Mt Royal Ave, Baltimore, MD 21217. Tel 410-225-2255; Fax 410-225-2408; *Dir* Maren Hassinger
Tuition: $16,500
Adult Hobby Classes: Enrl 748; tuition $200 per cr
Children's Classes: Enrl 174; tuition $170 per class
—**Mount Royal School of Art,** 1300 Mount Royal Ave, Baltimore, MD 21217. Tel 410-225-2255; *Faculty* Babe Shapiro; *Faculty* Salvatore Scarpitta
79
Degrees: MAT 2 yrs
Tuition: $16,750
Courses: Aesthetics, Art Education, Art History, Calligraphy, †Ceramics, †Drawing, History of Art & Archeology, Intermedia, †Mixed Media, Painting, Photography, †Sculpture, Studio Art, Teacher Training, Video
—**Graduate Photography,** 1300 W Mount Royal Ave, Baltimore, MD 21217. Tel 410-225-2306; *Dir* Will Larson
Degrees: MFA 2 yrs
Tuition: Res—grad $17,000 per yr
Courses: History of Photography
—**Art Education Graduate Studies,** 1300 W Mount Royal Ave, Baltimore, MD 21217. Tel 410-225-2306; *Dir* Dr Karen Carroll
Degrees: MFA 2 yrs
Tuition: Res—grad $17,000 per yr
Courses: Art Education, Teacher Training

MORGAN STATE UNIVERSITY, Dept of Art, 1700 E Coldspring Lane, Baltimore, MD 21251. Tel 443-885-3021, 885-3333 (Main); Internet Home Page Address: www.morgan.edu; *Fine Arts Dept Chmn* Dr Nathan Carter; *Coordr Art Dept* Kenneth Royster
Estab 1867, dept estab 1950; FT 7; pub; D & E; Scholarships; SC 28, LC 11, GC 17; D 340, E 50, non-maj 250, maj 140, GS 11
Ent Req: HS dipl
Degrees: BA(Art & Music Performance) & MA(Music)
Tuition: Res—$1563 per sem; nonres—$3644 per sem
Courses: 3-D Design, Architecture, Art Education, Art History, Ceramics, Design, Drawing, †Gallery, Graphic Arts, Graphic Design, Illustration, Painting, Photography, Sculpture, †Theatre Arts

SCHULER SCHOOL OF FINE ARTS, 5 E Lafayette Ave, Baltimore, MD 21202. Tel 410-685-3568; Fax 410-783-0580; Elec Mail schulerschool@msn.com; *Dir* Francesca Schuler Guerin
Estab 1959; pvt; D & E; SC 9, GC 3; D 50, E 30, grad 2
Degrees: 4 yrs; diploma, 5 yr schedule
Tuition: $4000 per yr, part-time students pay by schedule for sem
Courses: Drawing, Painting, Sculpture
Children's Classes: Tuition $650-$960 (summer - ages 14 & over). Courses—Drawing, Painting, Sculture
Summer School: Dir, Francis S. Guerin. Enrl 30; tuition $700 for term of 6 wks beginning June, $900 for 6 hrs per day, 6 wks. Courses—Drawing, Oil Painting, Sculpture, Watercolor

UNIVERSITY OF MARYLAND, BALTIMORE COUNTY, Imaging, Digital & Visual Arts Dept, 5401 Wilkens Ave, Rm 111, Baltimore, MD 21250. Tel 410-455-2150, 455-1000; Fax 410-455-1070; Elec Mail grabill@umbc.edu; Internet Home Page Address: www.umbc.edu; *Assoc Prof* Jaromir Stephany; *Assoc Prof* Daniel Bailey; *Asst Prof* Franc Nunoo-Quarcoo; *Asst Prof* Alan Rutberg; *Asst Prof* Hollie Lavenstein; *Asst Prof* Kim Lovely; *Asst Prof* Preminda Jacob; *Interim Chmn* Vin Grabill; *Asst Prof* Kathy O'Dell; *Asst Prof* Peggy Re; *Asst Prof* Teri Rueb; *Asst Prof* Mark Street; *Asst Prof* Tim Nohe; *Prof & Dir of Gallery* David Yager; *Asst Prof* Steve Bradley; *Asst Prof* Fanky Chak; *Asst Prof* Colin Ives; *Asst Prof* Lisa Moren
Estab 1966; pub; D & E; SC 27, LC 12, GC 4; in dept D 485, non-maj 375, maj 110
Ent Req: HS dipl, SAT
Degrees: BA 4 yrs, MFA
Tuition: Res—$5490 per yr; nonres—$10,258 per yr
Courses: Advertising Design, Aesthetics, †Art History, Calligraphy, Ceramics, Collage, Commercial Art, Conceptual Art, †Drawing, †Film, Graphic Arts, †Graphic Design, †History of Art & Architecture, Intermedia, Lettering, Mixed Media, †Painting, †Photography, Printmaking, †Video
Summer School: Dir, David Yager. Six wk term. Courses—Drawing, Film, History, Photography, Video

BEL AIR

HARFORD COMMUNITY COLLEGE, Fine & Applied Arts Division, 401 Thomas Run Rd, Bel Air, MD 21015. Tel 410-836-4000; Fax 410-836-4198; Internet Home Page Address: www.harford.cc.md.us; *Chmn* Paul Labe
Estab 1957; FT 5, PT 10; pub; D & E; SC 17, LC 4; FT 1000, PT 1000
Ent Req: HS dipl
Degrees: AA 2 yrs
Tuition: Res—undergrad $65 per cr hr; nonres—undergrad $130 (out of county), $195 (out of state) per cr hr
Courses: Architecture, Art History, Ceramics, †Commercial Art, Design, Digital Imaging, Digital Media, Drawing, †Fine Art, Graphic Arts, Graphic Design, History of Art & Architecture, Illustration, †Interior Design, Mixed Media, Painting, †Photography, Printmaking, Sculpture, Video
Summer School: Div Chair, Paul Labe

BOWIE

BOWIE STATE UNIVERSITY, Fine & Performing Arts Dept, MLK Bldg, Rm 236, Jericho Park Rd Bowie, MD 20715. Tel 301-860-4000; Fax 301-860-3767; *Coordr Gallery Dir* Robert Ward; *Chmn* Clarence Knight
Estab 1865, dept estab 1968; FT 8; pub; D; SC 7, LC 3; D 1600, E 350, non-maj 180, maj 45
Ent Req: HS dipl
Degrees: BA(Art) 4 yrs
Tuition: Res—undergrad $127 per cr hr; grad $317.50 per cr hr; nonres—$2344.50 per sem
Courses: African & American History, Art History, Ceramics, Cinematography, Computer Graphics, Crafts, Design, Drawing, Graphics, Museum & Gallery Study, Painting, Photography, Sculpture
Summer School: Dir, Dr Ida Brandon. Courses—Ceramics, Media Workshop

CATONSVILLE

COMMUNITY COLLEGE OF BALTIMORE COUNTY, (Catonsville Community College) Art Dept, 800 S Rolling Rd, Catonsville, MD 21228. Tel 410-455-4429; Fax 410-455-5134; Elec Mail pglasgow@ccbc.cc.md.us; *Chmn Dept* Paul Glasgow
Estab 1957; pub; D & E; Scholarships; SC 26, LC 6; D 600, E 400, non-maj 200, maj 300, applied arts maj 350
Ent Req: HS dipl
Degrees: cert & AA 2 yrs
Tuition: County res—$60 per cr hr; non- county res—$113 per cr hr; out of state—$168 per cr hr
Courses: †Advertising Design, Art Education, Art History, Ceramics, Commercial Art, Drawing, Graphic Design, Illustration, Interior Design, Painting, †Photography, Sculpture
Adult Hobby Classes: Chmn Dept, Dr Dian Fetter
Summer School: Same as above

COLLEGE PARK

UNIVERSITY OF MARYLAND
—**Dept of Art History & Archaeology,** Tel 301-405-1479; 405-1494; Fax 301-314-9652; Elec Mail jh24@umail.umd.edu; Internet Home Page Address: www.inform.umd.edu/EdRes/colleges/ARHU/Depts/ArtHistory; *Chmn* June Hargrove
Estab 1944; FT 17, PT 2; pub; D; Scholarships; SC 39, LC 37, GC 22; 2000 per sem, maj 102, grad 77
Ent Req: 3.0 grade average
Degrees: BA, MA, PhD
Tuition: Res—$2568 per sem; nonres—$6334 per sem
Courses: Art History
Adult Hobby Classes: Enrl 500 per yr. Courses—Art History
Summer School: Dir, Dr Melvin Hall. Enrl 350; tuition res—$170; nonres—$280 per cr hr for term of 6 wks. Courses—Art History
—**Department of Art,** Tel 301-405-1442; Fax 301-314-9740; Elec Mail artdept@umail.umd.edu; Internet Home Page Address: www.inform.umd.edu/EdRes/colleges/ARHU/Depts/Art; *Chmn* John Ruppert

Estab 1944; FT 19, PT 5; pub; D; Scholarships; SC 39, LC 37, GC 22; 850 per sem, maj 170, grad 20
Ent Req: 3.0 grade average
Degrees: BA, MFA
Tuition: Res—$2568 per sem; nonres—$6334 per sem
Courses: 2-D & 3-D Drawing, Art Theory, Artist Survival, Design, Lithography, Mixed Media, Papermaking, Photography, Printmaking
Summer School: Dir, Dr Melvin Berstein. Two six-week sessions.
Courses—Design, Drawing, Painting, Printmaking, Sculpture

CUMBERLAND

ALLEGANY COMMUNITY COLLEGE, Art Dept, 12401 Willow Brook Rd SE, Cumberland, MD 21502. Tel 301-724-7700; Fax 301-724-6892; Internet Home Page Address: www.ac.cc.md.us; *Chmn* James D Zamagias
Estab 1966; FT 1 PT 3; pub; D & E; Scholarships; SC 6, LC 1; Enrl D 30, E 9
Ent Req: HS dipl
Degrees: AA 2 yrs
Tuition: Res—undergrad $85 per cr hr; nonres—undergrad $167 per cr hr
Courses: 2-D & 3-D Design, Ceramics, Drawing, Painting, Survey of Art History
Adult Hobby Classes: Courses offered
Summer School: Dir, James D Zamagias. Term of 6 wks beginning July. Courses—Painting, 2-D Design

EMMITSBURG

MOUNT SAINT MARY'S UNIVERSITY, Visual & Performing Arts Dept, 16300 Old Emmitsburg, Emmitsburg, MD 21727. Tel 301-447-6122, Ext 5308; Fax 301-447-5755; Internet Home Page Address: www.msmary.edu; *Prof* Margaret Rahaim, MFA; *Dr* Kurt Blaugher; *Prof* Elizabeth Holtry, MFA; *Prof Dr* Andrew Rosenfeld; *Prof* Barry Long, MA
Estab 1808; pvt; D & E; Scholarships; SC 13, LC 3; D 1528, maj 20
Ent Req: HS dipl, SAT
Degrees: BA and BS 4 yrs
Tuition: $15,900 per yr; campus res available $3225
Courses: Art Education, †Art History, Ceramics, Design, †Drawing, Graphic Arts, Graphic Design, Mixed Media, †Painting, Photography, Printmaking, †Sculpture, †Theatre Arts

FREDERICK

HOOD COLLEGE, Dept of Art, 401 Rosemont Ave, Frederick, MD 21701-8575. Tel 301-663-3131; Fax 301-694-7653; Internet Home Page Address: www.hood.edu; *Assoc Prof* Fred Bohrer; *Chmn* Dr Anne Derbes
Estab 1893; Varies from PT to FT; pvt, W; D; SC 18, LC 16; D 700, maj 60
Ent Req: HS dipl
Degrees: BA 4 yrs
Tuition: Res—$26,020; commuter—$19,120
Courses: Art History, Three Areas of Concentration: Studio Arts, Visual Communications
Summer School: Dir, Dr Patricia Bartlett. Tuition by course for term of 6 wks, June-Aug. Courses—Internships and Independent Studies, Photography, Watercolor and Sketching, Woodcut

FROSTBURG

FROSTBURG STATE UNIVERSITY, Dept of Visual Arts, 101 Braddock Rd, Frostburg, MD 21532. Tel 301-687-4797; Fax 301-689-4737; Elec Mail ddavis@frostburg.edu; WATS 800-687-8677; *Head Dept* Dustin P Davis
Estab 1898; FT 3; pub; D; Scholarships; SC 25, LC 5; D 230, maj 150, GS 13
Ent Req: HS dipl
Degrees: BFA(Art Educ Certification) 4 yr
Tuition: Res—$1722 per sem; out of state—$4471
Courses: 2-D & 3-D Design, Art Appreciation, Art Criticism, Art Education, Art History, Art Therapy, Ceramics, Crafts, Drawing, Graphic Design, Painting, Photography, Printmaking, Sculpture, Teacher Training, Visual Imagery

HAGERSTOWN

HAGERSTOWN JUNIOR COLLEGE, Art Dept, 11400 Robinwood Dr, Hagerstown, MD 21742. Tel 301-790-2800, Ext 221; Fax 301-739-0737; *Coordr* Ben Culbertson; *Pres* Norman Shea
Estab 1946; pub; D & E; SC 10, LC 4; D 110, E 66
Degrees: AA, 2 yrs
Tuition: Washington County res—$70 per cr hr; out-of-county—$114 per cr hr; nonres—$143per cr hr
Courses: Art Appreciation, Art History, Art Methods, Basic Design, Ceramics, Drawing, Painting, Photography, Sculpture, Video
Summer School: Courses - Art & Culture, Basic Drawing, Painting, Photography, Special Studies in Ceramics, Parent & Child Art Studio

LARGO

PRINCE GEORGE'S COMMUNITY COLLEGE, Art Dept, English & Humanities Div, 301 Largo Rd Largo, MD 20774-2199. Tel 301-322-0966; Fax 301-808-0960; Internet Home Page Address: www.pg.cc.md.us; *Chmn* Gary Kirkeby
Estab 1958, dept estab 1967; 5 FT, 16 PT; pub; D & E; Scholarships; SC 18, LC 2; D 220, E 140, maj 11
Ent Req: HS dipl, CGP test
Degrees: AA

Tuition: $75 per cr hr
Courses: Art Appreciation, Art Survey, Ceramics, Commercial Advertising, Commercial Design, Computer Graphics, Design, Drawing, Graphic Arts, Graphic Design, Illustration, Lettering, Multi Media, Painting, Photography, Sculpture
Summer School: Dean, Dr Robert Barshay. Courses—Drawing, Intro to Art, Painting, Photography

PRINCESS ANNE

UNIVERSITY OF MARYLAND EASTERN SHORE, Art & Technology Dept, 11931 Art Shell Plaza, UMES, Princess Anne, MD 21853. Tel 410-651-6488, 651-2200; Fax 410-351-7959; *Coordr Art Educ* Ernest R Satchell
Degrees: BA 4 yr
Tuition: Res—$124 per cr hr incl room & board per sem; nonres—$265
Courses: Art Appreciation, Art Education, Art History, Calligraphy, Ceramics, Drawing, Handicrafts, Jewelry, Painting, Photography, Printmaking, Sculpture

ROCKVILLE

MONTGOMERY COLLEGE, Dept of Art, 51 Manakee St, Rockville, MD 20850. Tel 301-279-5115; Fax 301-251-7642; *Chair* Kathleen McCrohan
Estab 1946, dept estab 1966; Maintain nonprofit art gallery; art supplies available on-campus; Pub; D & E & W; Scholarships; SC 25, LC 7; 1,700
Ent Req: HS dipl
Degrees: AA 2 yrs
Tuition: Res—$126 per sem hr; out-of-state—$250 per sem hr
Courses: †Advertising Design, †Architecture, Art Appreciation, †Art Education, †Art History, Ceramics, Color, †Commercial Art, Computer Graphics, Crafts, Design, Drawing, Enameling, Film, Goldsmithing, †Illustration, †Interior Design, Jewelry, Lettering, Metalsmith, Painting, †Photography, Printing, Printmaking, Sculpture, Video
Summer School: Chmn Prof James L Brown. Tuition $35 per sem hr. Courses—Ceramics, Color, Crafts, Design, Drawing, Painting, Printmaking, Sculpture, Art History

SAINT MARY'S CITY

SAINT MARY'S COLLEGE OF MARYLAND, Art & Art History Dept, 18952 East Fischer Rd Saint Mary's City, MD 20686. Tel 240-895-2000, 895-4250; Fax 240-895-4958; Elec Mail srjohnson@smcm.edu; Internet Home Page Address: www.smcm.edu; *Dept Chmn* Sue Johnson, MFA; *Prof* Jeffrey Carr, MFA; *Asst Prof* Joe Lucchesi, PhD; *Asst Prof* Rebecca Brown, PhD
Estab 1964; pub; D & E; Scholarships; SC 14, LC 16; D 155, E 43, non-maj 128, maj 70
Ent Req: HS dipl, SAT scores
Degrees: BA
Tuition: Res—undergrad $3,900 per sem; nonres—undergrad $6,750 per sem; campus res—room & board $3,300 per sem
Courses: Art History, Digital Imaging, Drawing, Graphic Arts, Mixed Media, Painting, Photography, Printmaking, Sculpture
Adult Hobby Classes: Art History, Drawing, Mixed Media, Painting, Photography, Printmaking, Sculpture
Summer School: Tuition $110 per cr

SALISBURY

SALISBURY STATE UNIVERSITY, Art Dept, 1101 Camden Ave, Salisbury, MD 21801. Tel 410-543-6270; Fax 410-548-3002; Internet Home Page Address: www.ssu.edu; *Chmn* Paul Flexner, PhD; *Assoc Prof* John R Cleary, MFA; *Asst Prof* Ursula M Ehrhardt, MA; *Asst Prof* Dean A Peterson, MA; *Assoc Prof* Marie Cavallaro
Estab 1925, dept estab 1970; Maintain nonprofit art gallery; Atrium Gallery & Fueton Gallery; Pub; D & E; Scholarships; SC 26, LC 7, GC 1; non-maj 500, maj 111, grad 2
Ent Req: HS dipl, SAT verbal & math, ACT
Degrees: BA & BFA 4 yrs,
Tuition: Res—$4,486 plus $6,100 rm & board; non-res—$16,032 total
Courses: †Advertising Design, Art Appreciation, Art Education, Art History, Ceramics, Commercial Art, Design, †European Field Study, Glassblowing, History of Art & Architecture, †Independent Study, Painting, Photography, †Principles of Color, Sculpture, †Visual Communications

SILVER SPRING

MARYLAND COLLEGE OF ART & DESIGN, 10500 Georgia Ave, Silver Spring, MD 20902. Tel 301-649-4454; Fax 301-649-2940; Internet Home Page Address: www.mcadmd.org; *Pres* Wesley E Paulson; *Dean* Don Smith; *Asst Prof* Chris Medley, MFA
Estab 1955; pvt; D & E; Scholarships; Degree Prog 83, Enrichment & Special Students 175
Ent Req: HS dipl, SAT verbal scores, letter of recommendation, portfolio interview
Degrees: AFA 2 yrs
Tuition: $9250 per yr
Courses: Advertising Design, Art History, Commercial Art, Computer Graphics, Design, Drawing, Graphic Arts, Graphic Design, Illustration, Intermedia, Lettering, Painting, Photography, Printmaking
Adult Hobby Classes: Enrl 1000; tuition $80-180 for 6-10 wks.
Courses—Computer, Design, Drawing, Painting, Photography, Printmaking, Sculpture, Watercolor
Children's Classes: Enrl 1200; tuition $80-100 for 1-8 wks.

Courses—Cartooning, Ceramics, Computer, Design, Drawing, Painting, Photography, Printmaking, Sculpture
Summer School: Dir, David Gracyalny. Enrl 1000; tuition $80-250 for 1-9 wks. Courses—Cartooning, Ceramics, Computer, Design, Drawing, Painting, Photography, Printmaking, Sculpture, Watercolor

TOWSON

TOWSON STATE UNIVERSITY, Dept of Art, 8000 York Rd, Towson, MD 21252. Tel 410-704-3682, 704-2808; Fax 410-704-2810; Elec Mail jflood@towson.edu; Internet Home Page Address: www.towson.edu/art; *Dept Chmn* James Flood
Estab 1866; FT 15, PT 9; pub; D & E
Ent Req: HS grad
Degrees: BA, BS, MEd(Art Educ) 4 yr & MFA; spring sem Florence, Italy, Feb-May
Tuition: Res—undergrad $11,802.50 per sem; nonres—undergrad $5245.50 per sem
Courses: Art Education, Art History, Ceramics, Drawing, Enameling, Graphic Arts, Jewelry, Painting, Sculpture, Textile Design, Weaving, Wood & Metal
Adult Hobby Classes: Enrl 60
Summer School: Dir, Jim Flood. Enrl 25; 2 five wk sessions. Courses—Art History, Studio

WESTMINSTER

WESTERN MARYLAND COLLEGE, Dept of Art & Art History, 2 College Hill, Westminster, MD 21157-4390. Tel 410-848-8700; Internet Home Page Address: www.wmdc.edu; *Prof* Wasyl Palijczuk; *Assoc Prof* Michael Losch; *Dept Head* Sue Bloom
Estab 1867; FT 4, PT 2; independent; D & E; Scholarships; SC 15, LC 12, GC 6; D 1213, maj 40-60, grad 15
Ent Req: HS dipl, ent exam, SAT
Degrees: BA, BS & MEd 4 yrs
Tuition: $20,550 per yr
Courses: Ceramics, Computer Graphics, Design, Drawing, Graphic Design, †History of Art & Architecture, Jewelry, Lettering, Painting, Photography, Printmaking, Sculpture, †Teacher Training
Summer School: Two 5 wk terms beginning June 21. Courses—Art History, Ceramics, Painting, Printmaking, Sculpture, Weaving

MASSACHUSETTS

AMHERST

AMHERST COLLEGE, Dept of Fine Arts, Box 2249, 107 Fayerweather Hall Amherst, MA 01002-5000. Tel 413-542-2365; Fax 413-542-7917; Elec Mail finearts@amherst.edu; Internet Home Page Address: www.amherst.edu/~finearts; *Chmn* Natasha Staller; *Head of Studio* Robert T Sweeney
Estab 1822; Maintain nonprofit art gallery, The Eli Mrsh Gallery, 105 Fayerweather Hall; FT 11; pvt; D; Scholarships; SC 15, LC 15
Ent Req: HS dipl
Degrees: BA 4 yrs
Tuition: $32,400 comprehensive fee for yr + room & board
Courses: 3-D Design, Aesthetics, Anatomy, Art History, Drawing, Painting, Photography, Printmaking, Sculpture

UNIVERSITY OF MASSACHUSETTS, AMHERST
—College of Arts & Sciences, Fine Arts Center, Tel 413-545-1902; Fax 413-545-3929; Internet Home Page Address: www.umass.edu; *Chmn Dept* Ronald Michaud
Estab 1958; FT 36; pub; SC 50, LC 19, GC 20; maj undergrad 430, grad 85
Ent Req: HS grad, portfolio & SAT required, 16 units HS
Degrees: BA, BFA, MFA
Tuition: Res—$9670 incl room & board; nonres—$11,920 tuition only
Courses: Ceramics, Computer Art, Design, Drawing, Painting, Photography, Printmaking, Sculpture
Summer School: Dir, Angel Ramirez. Enrl 150-250; tuition $175 per 3 cr course, 2 six wk sessions. Courses—Architectural Drawing, Design, Drawing, Painting, Photography
—Art History Program, Tel 413-545-3595; Fax 413-545-3880; Internet Home Page Address: www.umass.edu; *Prof* Walter B Denny PhD; *Prof* Craig Harbison PhD; *Assoc Prof* Kristine Haney PhD; *Assoc Prof* Laetitia La Follette PhD; *Prof* Bill Odel; *Dir* Ronald Michaud
Estab 1947, prog estab 1958; pub; D & E; Scholarships, Fellowships; LC 36, GC 16; D 1735, non-maj 1369, maj 105, grad 40
Ent Req: HS dipl & transcript, SAT
Degrees: BA, MA
Tuition: Res—$9670 per yr incl room & board; nonres—$11,920 tuition only
Courses: Aesthetics, American Art to 1860, Ancient Art, †Art History, Greek & Roman Art & Architecture, History of Art & Archeology, Islamic Art, Museum Staff Training, Renaissance to Modern Art, Survey
Adult Hobby Classes: All courses available through Continuing Education
Summer School: Enrl 15 per course. Tuition $30 per cr & $42 service fee for term of 6 wks beginning June 2 & July 14. Courses—Introduction to Art, Modern Art
—Dept of Landscape Architecture & Regional Planning, Tel 413-545-2255; Fax 413-545-1772; Internet Home Page Address: www.umass.edu/larp; *Asst Dept Head* Merle Willman PhD; *Dept Head* Jack Ahern
Estab 1903; pub; D; SC 6, LC 5; 35

Degrees: MA(Archit, Regional Planning & Landscape Design)
Tuition: $115.75 per cr, $1389 per sem; nonres—$357 per cr, $4283 per sem; Res-undergrad $702 per sem, graduate $73.25 pr cr hr up to $879
Courses: Aspects of Design Environment, Drafting, Drawing, Drawing & Measuring, Environmental Policy & Planning, Landscape Architecture, Site Planning, Studio Landscape
Summer School: Planning & design short courses

BEVERLY

ENDICOTT COLLEGE, School of Art & Design, 376 Hale St, Beverly, MA 01915. Tel 978-232-2250; Fax 978-232-2231; Internet Home Page Address: www.endicott.edu; *Dean* Mark Towner
Estab 1939; maintains nonprofit gallery, Broudo Gallery of Art; pvt, co-ed; D & E; Scholarships; SC 100, LC 20; 310, non-maj 40, maj 270
Ent Req: HS dipl
Degrees: BS 4 yr & BFA
Tuition: Res—$21,074 per yr, room & board $10,200
Courses: Advertising Design, Aesthetics, Art History, †Ceramics, †Commercial Art, Design, Drafting, Drawing, Graphic Arts, Graphic Design, History of Art & Architecture, Illustration, †Interior Design, Painting, †Photography, Printmaking, Sculpture, Theatre Arts

MONTSERRAT COLLEGE OF ART, 23 Essex St, Beverly, MA 01915; PO Box 26, Beverly, MA 01915. Tel 978-921-4242; Fax 978-922-4268; Elec Mail admiss@montserrat.edu; Internet Home Page Address: www.montserrat.edu; *Dean* Laura Tonelli; *Painting* Rob Roy; *Printmaking* Stacy Thomas-Vickory; *Photography* Ron DiRito; *Illustration* Fred Lynch; *Graphic Design* John Colan; *Gallery Dir* Leonie Bradbury; *Art Educ* Diane Ayott; *Pres* Stan Trecker; *Sculpture Chair* Meredith Davis; *Foundation Dept* Blyth Hazen; *Foundation Dept* Judy Brown; *Liberal Arts Chair* Marjorie Ausunbraum
Estab 1970; Maintain nonprofit art gallery on campus, Montserrat Gallery; Paul Scott Library; art supplies available on-campus; Pvt; D & weekend workshops; Scholarships; SC 150, LC 50, Cont Educ; D 270, E 150, Other 300
Ent Req: personal interview and portfolio review
Degrees: BFA 4 yr dipl granted
Tuition: $20,500 per yr, $10,250 per sem; $600 reg fee per yr/$300 reg fee per sem
Courses: Advertising Design, Art Education, Art History, Conceptual Art, Design, Drawing, Fashion Arts, Graphic Arts, †Graphic Design, †Illustration, Lettering, Mixed Media, †Painting, †Photography, †Printmaking, †Sculpture, Video
Adult Hobby Classes: Courses—Drawing, Graphic Design, Painting, Photography, Printmaking
Children's Classes: Courses—Drawing, Painting, Computer Art, Animation & Sculpture
Summer School: Dir of Cont Educ, Wendy Hubbard Enrl 60; Pre-College Prog in July & Aug. Courses—Life Drawing, Painting, Illustration, Printmaking

BOSTON

ART INSTITUTE OF BOSTON AT LESLEY UNIVERSITY, 700 Beacon St, Boston, MA 02215. Tel 617-262-1223; Fax 617-437-1226; Elec Mail admissions@aiboston.edu; Internet Home Page Address: www.aiboston.edu; *Dean* Angelo Fertitta; *Chmn Design Dept* Geoffry Fried, MFA; *Chmn Illustration Dept* Robert Kaufman, MFA; *Chmn Photography Dept* Christopher James, MFA; *Chmn Liberal Arts* Robert Wauhkonen, MA; *Chmn Fine Arts Dept & Found Dept* Joan Ryan
Estab 1912; Maintains nonprofit art gallery, art library; Art Institute of Boston Gallery & Art Institute of Boston Library, 700 Beacon St, Boston; pvt; D & E; Scholarships; SC 80, LC 20; D 535, E 200
Ent Req: HS dipl, portfolio and interview
Degrees: BFA, MFA
Tuition: Res & nonres—undergrad $15200 per yr
Courses: Animation, Art Education, Art History, Ceramics, Commercial Art, Computer Graphics, Conceptual Art, Design, Drawing, †Fine Arts, †Graphic Design, History of Art & Architecture, Illustration, †Illustration, Painting, †Photography, Printmaking, Sculpture, Typography, Video
Adult Hobby Classes: Enrl 200; tuition $300 per cr. Courses—Continuing education offers most of the above typically 2-3 cr each
Summer School: Dir Diana Arcadipone, Assoc Dean Continuing Educ. Enrl 250; tuition $180 per cr term of 8 wks beginning June 15. Courses—most of above

BOSTON CENTER FOR ADULT EDUCATION, 5 Commonwealth Ave, Boston, MA 02116. Tel 617-267-4430; Fax 617-247-3606; Internet Home Page Address: www.bcae.org; *Exec Dir* Mary McTique
Estab 1933; pvt; D & E; Scholarships; SC 26, LC 2; D 2300, E 20,000
Ent Req: open to all over 17
Tuition: $30-$200 for 1-8 wks
Courses: Architecture, Art Appreciation, Art History, Calligraphy, Ceramics, Clay Sculpture, Crafts, Drawing, Interior Design, Painting, Photography, Sculpture, Studio Crafts, Theatre Arts, Video, Weaving
Summer School: Same as winter program

BOSTON UNIVERSITY, Graduate Program - Arts Administration, 808 Commonwealth Ave, Boston, MA 02215. Tel 617-353-4064; Fax 617-353-6840; Elec Mail artsadmn@bu.edu; *Dir* Daniel Ranalli, Prof; *Prof* Richard Maloney
Estab 1992; pvt; E; GC 25
Ent Req: BA dipl
Degrees: MS (Arts Administration), 2 yr
Tuition: Res—$22,830 FT, $713 per cr hr; campus res available
Courses: Art History, Museum Staff Training

BOSTON UNIVERSITY, School for the Arts, Visual Arts Division, 855 Commonwealth Ave Boston, MA 02215. Tel 617-353-3371; Fax 617-353-7217; Elec Mail visuarts@bu.edu; Internet Home Page Address: www.bu.edu; *Dean* Walt

Meissner; *Prof* John Walker; *Prof* Hugh O'Donnell; *Prof* Nicolas Edmonds; *Assoc Prof* Janet Olson; *Assoc Prof* Richard Raiselis; *Assoc Prof* Harold Reddicliffe; *Assoc Prof* Judith Simpson; *Assoc Prof* Stuart Baron; *Visiting Prof* Alfred Leslie; *Dir* Alston Purvis
Estab 1869, sch estab 1954; Pvt; D; Scholarships; SC 38, LC 12, GC 15; 395, non-maj 75, maj 260, grad 60
Ent Req: ent req HS dipl, portfolio
Degrees: BFA 4 yrs, MFA 2 yrs
Tuition: $35,000 per yr incl room & board
Courses: †Art Education, Design, Drawing, †Graphic Design, †Painting, Photography, Printmaking, †Sculpture, Studio Teaching (grad level), Teacher Training

BUTERA SCHOOL OF ART, 111 Beacon St, Boston, MA 02116. Tel 617-536-4623; Fax 617-262-0353; Elec Mail jbutera@buteraschool.com; Internet Home Page Address: www.buteraschool.com; *Dir* John Butera, BA; *Head Commercial Art* Murray Huber; *Head Sign Painting* Jim Garballey; *Pres* Joseph L Butera, MBA
Estab 1932; pvt; D ; Enrl D 100
Ent Req: HS dipl, portfolio, teacher recommendations, transcript
Degrees: 2 yr and 3 yr dipl progs
Tuition: $10,750-$10,900 per yr; independent dormitories available
Courses: Advertising Design, Art Appreciation, Art History, Commercial Art, Computer Graphics, Design, †Drafting, Drawing, Graphic Arts, Graphic Design, Lettering, †Mixed Media, †Painting

EMMANUEL COLLEGE, Art Dept, 400 The Fenway, Boston, MA 02115. Tel 617-735-9807; Fax 617-735-9877; Internet Home Page Address: www.emmanuel.edu/; *Chmn Art Dept* Theresa Monaco, MFA; *Prof* Ellen Glavin, ShD; *Prof* C David Thomas, MFA; *Assoc Prof* Kathleen A Soles, MFA
Estab 1919, dept estab 1950; pvt; D & E; Scholarships; SC 30, LC 11; D 300, E 50, non-maj 200, maj 80
Ent Req: HS dipl, SAT
Degrees: BA & BFA 4 yrs
Tuition: $14,900 full time or $1863 per course; campus res—room & board $7025 per yr
Courses: †Art Education, †Art History, Art Therapy, Ceramics, Drawing, Graphic Arts, †Graphic Design, Mixed Media, †Painting, †Printmaking, Sculpture, †Teacher Training
Adult Hobby Classes: Enrl 300; tuition $193 per cr. Courses—Art Educ, Art History, Art Theory, In Studio Art
Summer School: Dir, Dr Jacquelyn Armitage. Enrl 230; tuition $143 per cr hr for term of 6 wks in June-Aug

MASSACHUSETTS COLLEGE OF ART, 621 Huntington Ave, Boston, MA 02115. Tel 617-879-7000; Fax 617-879-7250; Internet Home Page Address: www.massart.edu; *Dean Grad & Continuing Educ* Richard Aronowitz; *Chmn Fine Arts 2D* Roger Tibbets; *Chmn Fine Arts 3D* Joe Wood; *Chmn Media* Barbara Bosworth; *Chmn Critical Studies* John Russell; *Pres* Katherine Sloan; *Chair Environmental Design* Paul Hajian; *Chair Communication Design* Elizabeth Resnick; *Chair Art Educ* John Crowe
Estab 1873; Maintain a nonprofit art gallery: Arnhein Gallery, Bakalar Gallery, Deren Gallery, 621 Huntington Ave, Boston, MA 02115; maintain an art/architecture library: Martan R Godine Library, 621 Huntington Ave, Boston, MA 02115; on-campus shop where art supplies may be purchased; Pub; D & E; SC 400, LC 250, GC 50; D 1,100, E 1,000, grad 100
Ent Req: HS transcript, college transcript, SAT, statement of purpose, portfolio
Degrees: BFA 4 yrs, MFA 2 yrs, MSAE 2 yrs
Tuition: Res—$3,868 per yr; nonres—$10,700 per yr; New England Regional Program $4,398
Courses: Architectural Design, Art Education, Art History, Ceramics, Fashion Design, Fibers, Film, Film Making, Freshman Artistic Seminars, Glass, Graphic Design, Illustration, Industrial Design, Intermedia, Metals, Painting, Photography, Printmaking, Sculpture, Video
Adult Hobby Classes: Enrl 1,000; tuition $200 per cr hr. Courses—All areas
Children's Classes: Enrl 150; tuition $135 for 10 wks. Courses—All areas
Summer School: Assoc Dir Continuing Educ, Susan Gately. Enrl 900; tuition $200 per cr hr. Courses—all areas

MOUNT IDA COLLEGE
—**Chamberlayne School of Design & Merchandising,** Tel 617-969-7000, Ext 4655; Fax 617-928-4760, 928-4636; Internet Home Page Address: www.mountida.edu; *School Dir* Phyllis Misite; *Lectr* Rose Botti-Salitsky
Estab 1892, dept estab 1952; pvt; D & E; D 253, E 38, maj 253
Ent Req: HS dipl
Degrees: AA, BA
Tuition: $24,250 per yr incl room & board
Courses: Drawing, Fashion Arts, Graphic Arts, Illustration, Interior Design, Jewelry, Merchandising, Painting, Sculpture, Textile Design
Summer School: Dir Susan Holton. 12 wks beginning June 1. Courses—same as regular academic yr

THE NEW ENGLAND SCHOOL OF ART & DESIGN AT SUFFOLK UNIVERSITY, 81 Arlington St, Boston, MA 02116. Tel 617-536-0383; Fax 617-536-0461; Internet Home Page Address: www.suffolk.edu; *Chmn* William Davis; *Dir Admis* Anne Blevins; *Chmn Dept Graphic Design* Laura Golly; *Chmn Fine Arts* Audrey Goldstein
Estab 1923; pvt; D & E; Scholarships; D 200, E 250, maj 200
Ent Req: HS dipl, portfolio
Degrees: Certificate, Dipl, BFA
Tuition: Res & nonres—undergrad $437 per cr hr, Dipl $328 per cr, cert $397 per cr
Courses: Advertising Design, Art History, Computer Graphics, Drafting, Drawing, †Fine Arts, Graphic Arts, †Graphic Design, Illustration, †Interior Design, Painting, Photography, Printmaking
Adult Hobby Classes: Enrl 275; tuition $366 per cr for 10 wk term.

Courses—Fine Arts, Interior Design, Graphic Design, Computer Graphics
Summer School: Dir, Susan John. Enrl 275; tuition $366 per cr for 10 wk term. Courses—those above

NORTHEASTERN UNIVERSITY, Dept of Art & Architecture, 239 Ryder Hall, Boston, MA 02115. Tel 617-373-2347; Fax 617-373-8535; *Chmn* Elizabeth Cromley, PhD; *Prof* Mardges Bacon PhD; *Assoc Prof* T Neal Rantoul, MFA; *Assoc Prof* Mira Cantor, MFA; *Assoc Prof* George Thrush, MArchit; *Assoc Prof* Julie Curtis, MFA; *Assoc Prof* Edwin Andrews, MFA; *Assoc Prof* Tom Starr, MFA; *Asst Prof* Peter Wiederspahn, MArchit; *Asst Prof* Ann McDonald, MFA
Estab 1898, dept estab 1952; pvt; D & E; Scholarships; D 1200, E 1200, non-maj 1500, maj 380
Ent Req: HS dipl
Degrees: BA & BS 4 yrs
Tuition: Freshmen $4460 per acad qtr; upperclassmen $5775 per acad qtr; campus res available
Courses: Animation, Architectural Design, Architecture, Art History, Computer Aided Design, Design, Drafting, Drawing, Graphic Arts, Graphic Design, History of Art & Architecture, Illustration, Media Design, Mixed Media, Multimedia, Painting, Photography, Video
Adult Hobby Classes: Enrl 180; tuition $116 per 12 wk quarter cr.
Courses—same as full-time program
Summer School: Chmn, Peter Serenyi. Enrl 240. Tuition & courses—same as above

SCHOOL OF FASHION DESIGN, 136 Newbury St, Boston, MA 02116. Tel 617-536-9343; Elec Mail sfdboston@aol.com; Internet Home Page Address: www.schooloffashiondesign.org; *Head Art Dept* Richard Alartosky
Estab 1934; pvt; D & E; Scholarships; D approx 60, E approx 40
Ent Req: HS dipl
Degrees: no degrees, 2 yr cert or 3 yr dipl
Tuition: Res—$9000 per yr; school approved res
Courses: Costume Design & Construction, Drafting, Drawing, Fashion Arts, Illustration, Textile Design, Theatre Arts
Adult Hobby Classes: 100; tuition $900 per 3 cr course. Courses—Fashion Design
Summer School: Dir, James Hannon. Enrl 100; tuition $900 per 3 cr course of 10 wks. Courses—Fashion Design

SCHOOL OF THE MUSEUM OF FINE ARTS, 230 The Fenway, Boston, MA 02115. Tel 617-267-6100, 369-3581; Fax 617-424-6271; Elec Mail ddluhy@mfa.org; Internet Home Page Address: www.smfa.edu; *Dean* Deborah H Dluhy PhD; *Provost* Daniel Poteel II; *Dean Faculty* Lorne Falk
Estab 1876; Grossman Gallery; pvt; D & E; Scholarships; SC 190 LC 30 GC 12 CE 78 per sem; D 678 E 646, grad 100
Ent Req: HS dipl, HS and col transcripts, portfolio
Degrees: Dipl, BFA, BFA plus BA or BS, MFA, MAT, BFA-E, Post BA all degrees in affiliation with Tufts University)
Tuition: Dipl $25,280 per yr; BFA varies on ratio of academics & studies taken in any given yr; MFA $25,254 for the degree
Courses: Art Education, Art History, Ceramics, Drawing, Film, Graphic Arts, Graphic Design, Illustration, Jewelry, Mixed Media, Painting, Performance, Photography, Printmaking, Sculpture, Video
Adult Hobby Classes: E & Saturday classes; 1.5 cr or 3 cr per course.
Courses—Artists' Books, Ceramics, Drawing, Electronic Arts, Film/Animation, Graphic Design, Jewelry, Mixed Media, Painting, Papermaking, Photography, Printmaking, Sculpture, Stained Glass, Video
Summer School: Dir Continuing Educ, Debra Samdpenl

UNIVERSITY OF MASSACHUSETTS - BOSTON, Art Dept, Harbor Campus, 100 Morrissey Blvd Boston, MA 02125-3393. Tel 617-287-5730; Fax 617-287-5757; Internet Home Page Address: www.umb.edu; *Emeritus Prof* Ruth Butler PhD; *Emeritus Prof* Hal Thurman; *Prof* Paul Tucker PhD; *Assoc Prof* Ronald Polito PhD; *Prof* Wilfredo Chiesa; *Assoc Prof* Melissa Shook; *Asst Prof* Margaret Wagner, MFA; *Asst Prof* Victoria Weston PhD, MFA; *Chmn* Anne McCauley; *Assoc Prof* Ann Torke, PhD; *Assoc Prof* Pamela Jones; *Asst Prof* Elizabeth Marrin
Sch estab 1965, dept estab 1966; pub; D & E; SC 18, LC 32; D 900, E 100, maj 200
Ent Req: entrance exam
Degrees: BA
Tuition: Res—$1055 per sem; nonres—$4421 per sem (plus fees)
Courses: Aesthetics, Art History, Drawing, Film, Graphic Arts, History of Art & Architecture, Intermedia, Painting, Photography, Printmaking, Sculpture, Video
Summer School: Enrl 150; tuition $140 per cr, 2 sessions. Courses—American Art in Boston, Ancient to Medieval Art, Drawing, Photography

BRIDGEWATER

BRIDGEWATER STATE COLLEGE, Art Dept, School and Summer Sts, Bridgewater, MA 02325. Tel 508-531-1200; Fax 508-279-6128; *Prof* John Droege, MFA; *Prof* Stephen Smalley, EdD; *Chmn* Roger Dunn PhD, PhD, MFA; *Prof* Mercedes Nunez, MFA; *Assoc Prof* Dorothy Pulsifer, MA; *Assoc Prof* Rob Lorenson, MFA; *Assoc Prof* Collin Asmus, MFA; *Asst Prof* Beatrice St Laurent, PhD; *Asst Prof* Preston Saunders, MFA; *Asst Prof* Ivana George, MFA; *Asst Prof* Brenda Molife, PhD; *Asst Prof* Shanshan Cui, MFA; *Asst Prof* Magaly Ponce, MFA; *Asst Prof* Mary Dondero, MFA
Estab 1840; Maintain nonprofit art gallery; The Wallace Anderson Gallery, 40 School St., Bridgewater, MA 02325; Maintain Maxwell Library, Park Ave, Bridgewater, MA 02325; pub; D & E; SC 35, LC 10, GC 35; D 1000, E 400, non-maj 960, maj 280, grad 10
Ent Req: HS dipl, SAT
Degrees: BA 4 yrs
Tuition: Res—undergrad $146.07 per cr hr, grad $155.94 per cr hr; nonres—undergrad & grad $366.90

Courses: Art Education, Art History, Ceramics, Drawing, Goldsmithing, Graphic Arts, Graphic Design, Handicrafts, Jewelry, Painting, Printmaking, Sculpture, Silversmithing, †Studio Art, †Video, Watercolor
Adult Hobby Classes: Enrl 100. Courses—Same as day courses; rotational
Summer School: Dir, Roger Dunn. Enrl 40. Courses—Same as above

CAMBRIDGE

HARVARD UNIVERSITY, Dept of History of Art & Architecture, 485 Broadway, Cambridge, MA 02138. Tel 617-495-2377; Fax 617-495-1769; Internet Home Page Address: www.fas.harvard.edu; *Chmn Dept* Ioli Kalavrezou
Estab 1874; FT 24; pvt; Scholarships; LC 26 incl GC 12; undergrad 88, grad 100
Courses: Art History

MASSACHUSETTS INSTITUTE OF TECHNOLOGY
—School of Architecture and Planning, Tel 617-253-4401 (Dean's office); Fax 617-253-8993; Internet Home Page Address: architecture.mit.edu; *Dean* William J Mitchell; *Head Dept* Stanford Anderson; *Urban Studies & Planning* Bish Sanyal; *Assoc Dean* Bernard Frieden
Estab 1865; FT 62; pvt; Scholarships; SC, LC, GC; 600
Degrees: MA, PhD(Building Technol); Media Arts & Sciences
Tuition: $26,960 per yr
Courses: History of Art & Architecture
—Center for Advanced Visual Studies, Tel 617-253-4415; Fax 617-253-1660; Internet Home Page Address: www.mit.edu; *Dir* Steve Benton
Estab dept 1967; pvt; D & E; SC 9, LC 1, GC 5; D & E 250, non-maj 240, grad 10
Ent Req: BA degree
Degrees: MS(Visual Studies)
Tuition: $26,690 per yr
Courses: Art & Technology, Environmental Art, †Video
Summer School: Art Workshop

CHESTNUT HILL

BOSTON COLLEGE, Fine Arts Dept, Devlin Hall # 434, 140 Commonwealth Ave Chestnut Hill, MA 02467-3809. Tel 617-552-4295; Fax 617-552-0134; Internet Home Page Address: www.bostoncollege.com; *Chmn* John Michalczyk
FT 11, PT 20
Degrees: BA offered
Courses: Art History, Ceramics, Drawing, Film, Painting, Photography, Sculpture, Studio Art

PINE MANOR COLLEGE, Visual Arts Dept, 400 Heath St, Chestnut Hill, MA 02167. Tel 617-731-7157; Fax 617-731-7199; Internet Home Page Address: www.pmc.edu; *Div Chmn* Bob Owcvark; *Prog Coordr Photography Dept* Susan Butler
Estab 1911; pvt; D; SC 25, LC 25; D 80
Ent Req: HS dipl
Degrees: AA & AS 2 yrs, BA 4 yrs
Tuition: Res—undergrad $11,940 per acad yr; campus res—room & board $7450 per acad yr
Courses: Architecture, †Art History, Costume Design & Construction, Drafting, Drawing, Graphic Arts, Interior Design, Museum Staff Training, Painting, Printmaking, Sculpture, Stage Design, Theatre Arts, Visual Arts
Adult Hobby Classes: Studio courses 25, lecture courses 25
Summer School: Dir, Dr Eva I Kampits

CHICOPEE

OUR LADY OF ELMS COLLEGE, Dept of Fine Arts, 291 Springfield St, Chicopee, MA 01013. Tel 413-594-2761; Fax 413-592-4871; *Chmn Dept* Nancy Costanzo
Estab 1928, dept estab 1950; pvt; D & E; Scholarships; SC 14, LC 6; D 210, non-maj 193, maj 17
Ent Req: HS dipl, Col Ent Exam (Verbal and Math)
Degrees: BA 4 yrs
Tuition: $21,500 including room & board
Courses: Art Education, Art History, Calligraphy, Ceramics, Drawing, Painting, Photography, Printmaking, Sculpture

DOVER

CHARLES RIVER SCHOOL, Creative Arts Program, 56 Centre St, PO Box 339 Dover, MA 02030-0339. Tel 508-785-0068, 785-8250; Fax 508-785-8291; Elec Mail crcap@charlesriverschool.edu; Internet Home Page Address: www.crcap.org; *Dir* Toby Dewey
Estab 1910, program estab 1970; pvt summer school; D; Scholarships
Ent Req: Open to ages 8-15 years (as of July 1)
Tuition: $1735 per 4 wks
Courses: Art, Computer, Dance, Drama, Media, Music, Photography, Textile Design, Writing
Summer School: Dir, Toby Dewy Jr. Enrl 235; tuition $1675 per session. Courses—Computer

FRAMINGHAM

DANFORTH MUSEUM OF ART SCHOOL, 123 Union Ave, Framingham, MA 01702. Tel 508-872-5542; Internet Home Page Address: www.danforthmuseum.org; *Dir* Beverly Snow
Estab 1975; Maintain nonprofit art gallery; Round Room Gallery; pvt; D&E; Scholarships; SC

Ent Req: none
Tuition: Varies per course; museum members receive a tuition reduction
Courses: Art History, Calligraphy, Ceramics, Drawing, Graphic Arts, Interior Design, Jewelry, Painting, Photography, Printmaking, Sculpture, Weaving
Adult Hobby Classes: Enrl 100 - 200; tuition varies per 9 wk sessions. Courses—Arts, Crafts, Photography
Children's Classes: Enrl 100 - 200; tuition varies per 8 wk session. Courses—Art Multi-Media, Ceramics
Summer School: Enrl 100-150; tuition varies per 2 wk courses. Courses—Same as above

FRAMINGHAM STATE COLLEGE, Art Dept, 100 State St, Framingham, MA 01701. Tel 508-620-1220, 626-4831 (Cote); Fax 508-626-4022; Elec Mail mcote@fre.mass.edu; Internet Home Page Address: www.framingham.edu; *Prof* James Eng; *Assoc Prof* Elizabeth Perry; *Prof* Sachiko Beck; *Prof* Barbara Milot; *Chmn* Marc Cote; *Asst Prof* Brian Zugay; *Asst Prof* Timothy McDonald; *Asst Prof* Keri Straka
Estab 1839, dept estab 1920; Maintain nonprofit art gallery, Mazmarian Gallery; pub; D & E; Scholarships; SC 20, LC 10, GC 10; D 3,000, E 2500, maj 124
Ent Req: HS dipl, portfolio review
Degrees: BA 4 yrs
Tuition: Res $878 per yr nonres $2957; campus res—room & board $1,800 per yr
Courses: Art Appreciation, †Art Education, †Art History, †Ceramics, Collage, Commercial Art, †Fashion Arts, †Graphic Design, Museum Studies, †Printmaking, †Sculpture, †Studio Art
Adult Hobby Classes: Art History, Studio Art
Summer School: Dir, James Brown. Tuition $170 per course for term of 8 wks. Courses—Art History, Studio

FRANKLIN

DEAN COLLEGE, Visual Art Dept, 99 Main St, Franklin, MA 02038. Tel 508-541-1795; Fax 508-541-1953; Internet Home Page Address: www.dean.edu; *Div Chmn* Nancy Kerr; *Instr* Sarah Mott, MFA
Estab 1865, dept estab 1960; pvt; D & E; Scholarships; SC 10, LC 4; D 300, E 30, non-maj 180, maj 30
Ent Req: HS dipl
Degrees: AA, AS 2 yrs
Tuition: Res—$16,220 per yr; campus res—room & board $8000 plus $1410 fees
Courses: Art Appreciation, Art History
Adult Hobby Classes: Enrl 10-25 per class; tuition varies for 14 wk term. Courses—Ceramics, Fundamental Drawing, Introduction to Visual Art, Photography I
Summer School: Assoc Dean, Ida LaMothe. Enrl 10-25 per class; tuition varies for 4-6 wk term. Courses—Fundamental Drawing, Introduction to Visual Art, Photography I

GREAT BARRINGTON

SIMON'S ROCK COLLEGE OF BARD, Visual Arts Dept, 84 Alford Rd, Great Barrington, MA 01230. Tel 413-528-0771; Fax 413-528-7365; Elec Mail admit@simons-rock.edu; Internet Home Page Address: www.simons-rock.edu; *Prof* William D Jackson; *Prof* Arthur Hillman, MFA; *Prof Ceramics* John Kingston, MFA
Estab 1966; PT 2; pvt; D & E; Scholarships; SC 14, LC 4
Ent Req: personal interview
Degrees: AA 2-3 yrs, BA 4 yrs
Tuition: $21,740 per yr; campus res—room $3270, board $3430
Courses: 2-D Design, 3-D Design, Aesthetics, Art History, Artist & the Book, Ceramics, Drawing, Graphic Design, Illustration, Intermedia, Introduction to the Arts, Jewelry, Microcomputer Graphics, Painting, Photography, Printmaking, Sculpture

GREENFIELD

GREENFIELD COMMUNITY COLLEGE, Art, Communication Design & Media Communication Dept, One College Dr, Greenfield, MA 01301. Tel 413-774-3131; Internet Home Page Address: www.gcc.mass.edu; *Head Art Dept* Tom Boisvert, MFA; *Instr* John Bross, MFA; *Instr* Penne Krol, MFA; *Instr* Budge Hyde, MFA; *Art Historian* Eileen Claveloux; *Instr* Cecilia Hirsh; *Instr* Susan Katz; *Instr* Karl Hluska
Estab 1962; maintains a small gallery; pub; D & E; Scholarships; SC 16; in school D 1400, E 400, maj 110
Ent Req: HS dipl
Degrees: AA, AS 2 yrs
Tuition: Res—$26 per cr hr; nonres—$247 per cr, $62 per cr to VT & NH res
Courses: †Advertising Design, †Art History, †Commercial Art, Communication Design, Display, †Drawing, Graphic Arts, Illustration, Media Communication, Multi Media Design, †Painting, †Photography, †Printmaking, Video
Summer School: Elizabeth Roop. Tuition $38 per cr for a 7 wk term. Courses—Color, Design, Drawing Workshop, Multi Media Design, Photography

HOLYOKE

HOLYOKE COMMUNITY COLLEGE, Dept of Art, 303 Homestead Ave, Holyoke, MA 01040. Tel 413-538-7000; Fax 413-534-8975; Internet Home Page Address: www.hcc.mass.edu; *Dean of Humanities & Fine Arts* John Field
Estab 1946; FT2; pub; D & E; Scholarships; SC 7, LC 4; D 115, E 20, maj 50
Ent Req: HS dipl, portfolio
Degrees: AA 2 yrs
Tuition: Res—$73 per cr hr; commuter—$95.04 per cr hr; nonres—$268 per cr hr

Courses: Art Education, Drawing, Graphic Arts, Graphic Design, History of Art & Architecture, Painting, Photography
Summer School: Dir, William Murphy. Courses—Per regular session, on demand

LEXINGTON

LEXINGTON FRIENDS OF THE ARTS, INC, Monroe Center for the Arts, 1403 Massachusetts Ave, Lexington, MA 02420. Tel 781-862-6040; Fax 781-674-2787; Internet Home Page Address: www.monroecenter.org; *Exec Dir* Melinda Dietrich, MBA; *Dir Educ* Jeffrey Lipski, BA
Estab 1994; PT 16; pub; D & E; Scholarships; SC 100, LC 20; D 700, E 300
Ent Req: Registration
Degrees: Cert of Completion
Tuition: $92-$130 for 8 weeks (spring), 7 weeks (summer)
Courses: Aesthetics, Art Education, Ceramics, †Costume Design & Construction, †Fashion Arts, Illustration, Mixed Media, Painting, Printmaking, Sculpture, Theatre Arts
Adult Hobby Classes: Enrl 300; tuition $150 per class. Courses—Ceramics, Faux Art, Painting, Printmaking, Quilt Making, Sculpture, Yoga
Children's Classes: Enrl 700; tuition $120 per class. Courses—Drama, Drawing, Ceramics, Mixed Media, Painting, Woodworking
Summer School: Enrl 360; tuition $250 per wk, Integrated Creative Arts Camp (ages 6-12)

LONGMEADOW

BAY PATH COLLEGE, Dept of Art, 588 Longmeadow St, Longmeadow, MA 01106. Tel 413-567-0621; Fax 413-567-9324; Internet Home Page Address: www.baypath.edu; *Dir* Dr John Jarvis
Estab 1947; pvt, W; D & E; SC 18, LC 2; D 660, E 400, maj 10
Ent Req: HS dipl
Degrees: AFA 2 yr
Tuition: $14,754; room & board, $6,867 per yr
Courses: Ceramics, Drawing, Graphic Arts, Handicrafts, History of Art & Architecture, Painting
Adult Hobby Classes: Enrl 300; tuition $80 per 8 wk course. Courses - Drawing, Painting, Watercolor

LOWELL

UNIVERSITY OF MASSACHUSETTS LOWELL, Dept of Art, 71 Wilder St Ste 8, Lowell, MA 01854. Tel 978-934-3494; Fax 978-934-4050; Internet Home Page Address: www.uml.edu; *Chmn Dept* James Coates; *Prof* Brenda Pinardi, MFA; *Prof* Arno Minkkinen, MFA; *Assoc Prof* James Veatch, EdM; *Prof* Fred Faudie; *Assoc Prof* John C Freeman
Estab 1975 (merger of Lowell State College and Lowell Technological Institute); Maintain nonprofit art gallery; Duggan Gallery & University Gallery; Pub; D & E; D 1,200, E 25, non-maj 450, maj 150
Ent Req: HS dipl, SAT
Degrees: BFA 4 yrs
Tuition: Res—undergrad $4,255 per yr; nonres—undergrad $10,892 per yr; campus res—room & board $4,836 per yr
Courses: Graphic Design, Photography, †Studio Art, Visual Communication Design
Adult Hobby Classes: Enrl 15 - 20 per course; tuition $135. Courses—Art Appreciation, Drawing, Painting, Survey of Art
Summer School: Enrl 10-15; tuition $135 per cr for 3 weeks. Courses—Art Appreciation, Drawing, Photography, Survey of Art I & II, Seminars in Italy, Greece, Finland, France

MEDFORD

TUFTS UNIVERSITY, Dept of Art & Art History, 11 Talbot Ave, Medford, MA 02155. Tel 617-628-5000; Fax 617-627-3890; Elec Mail rosalie.bruno@tufts.edu; Internet Home Page Address: ase.tufts.edu/art/ahwelcome; *Prof* Madeline H Caviness PhD; *Prof* Judith Wechsler PhD; *Assoc Prof* Eric Rosenberg PhD; *Assoc Prof* Jodi Magness PhD; *Assoc Prof* Cristelle Baskins PhD; *Asst Prof* Ikumi Kaminishi PhD; *Asst Prof* Eva Hoffman PhD; *Asst Prof* Daniel Abramson PhD; *Adjunct Prof* Lucy Der Manuelian PhD; *Chmn Art & Art History* Andrew McClellan, PhD
Pvt; D; Scholarships
Ent Req: HS dipl
Degrees: BA, BS, BFA, MA, MFA; certificate in museum studies
Tuition: $25,062 per yr, room, board & fees
Courses: †Art History, Calligraphy, Ceramics, Design, Drawing, Film, Graphic Arts, Graphic Design, History of Architecture, Illustration, Interdisciplinary Studio Art, Jewelry, Lettering, Metal Working, Mixed Media, Museum Staff Training, Museum Studies, Studio
Adult Hobby Classes: Courses offered
Summer School: Dir, Andrew McClellan. Enrl 100; tuition $1185 per credit for 6 wks. Courses—Boston Architecture, Modern Art, Survey, Museum History

NORTH DARTMOUTH

UNIVERSITY OF MASSACHUSETTS DARTMOUTH, College of Visual & Performing Arts, 285 Old Westport Rd, North Dartmouth, MA 02747. Tel 508-999-8564; Fax 508-999-9126; Internet Home Page Address: www.umassd.edu; *Dean Col* John Laughton PhD; *Chmn Music Dept* Eleanor Carlson, DMA; *Chmn Art Educ* Arlene Mollo; *Chmn Fine Art* Anthony J Miraglia, MFA; *Chmn Design* Spencer Ladd; *Chmn Art History* Michael Taylor; *Coordr Gallery* Lasse Antonsen, MA

Estab 1895, col estab 1948; Maintain nonprofit art gallery; art supplies available on-campus; FT 46, PT 25; pub; D & E; Scholarships; SC 75, LC 41, GC 7; D 700
Ent Req: HS dipl, SAT, open admis to qualified freshmen
Degrees: BFA and BA 4 yr, MFA and MAE 2-5 yrs
Tuition: Res—undergrad $9,446 per yr, grad $2,630 per yr; nonres—undergrad $17,100 per yr, grad $9,243 per yr (all figures include room & board)
Courses: Art Education, Art History, Ceramics, Design, Electronic Imaging, Illustration, Jewelry, Painting, Photography, Printmaking, Sculpture, Textile Design
Adult Hobby Classes: Enrl 175; tuition $365 for 14 wk session. Courses—13 including Art History, Ceramics, Jewelry
Children's Classes: Enrl 35; tuition $95 for 9 wk session. Courses—Children's Theater
Summer School: Dir, Dean R Waxler. Enrl 240; tuition $365 for 5 wk session. Courses—15 including Art History, Crafts

NORTHAMPTON

SMITH COLLEGE, Art Dept, Bell Hall, 45 Round Hill Rd Northampton, MA 01063. Tel 413-584-2700; Fax 413-585-3119; *Prof* Marylin Rhei PhD; *Prof* Craig Pogue; *Prof* Chester Michalik; *Prof* Elliot Offner, MFA; *Prof* John Davis, PhD; *Assoc Prof* Roger Boyce, MFA; *Assoc Prof & Dir Archaeology* Caroline Houser, PhD; *Asst Prof* Brigitte Buettner, MFA; *Asst Prof* Barbara Kellum, PhD; *Asst Prof* Dana Leibsohn, PhD; *Asst Prof* Gary Niswonger, MFA; *Asst Prof* John Moore, PhD; *Chmn Art Dept* A Lee Burns; *Prof* Craig Felton Dr, MArchit
Estab 1875, dept estab 1877; FT 17; pvt, W; D; Scholarships; SC 24, LC 34; maj 170
Ent Req: HS dipl, col board exam
Degrees: BA 4 yrs
Tuition: $32,704 per yr incl room & board
Courses: Architecture, Art History, Calligraphy, Color, Design with Computer, Drafting, Drawing, Graphic Arts, Graphic Design, History of Art & Architecture, Landscape Architecture, Painting, Photography, Printmaking, Sculpture, Woodcut

NORTON

WHEATON COLLEGE, Art Dept, 26 E Main St, Norton, MA 02766. Tel 508-285-7722; Fax 508-286-3565; *Chmn Dept* Andrew Howard
Estab 1834; Maintain nonprofit arts gallery; Watson Fine Arts Center; FT 6, PT 3; pvt; Scholarships; SC 6, LC 18; 1,500
Degrees: BA (art history) 4 yr, BFA (Studio Art)
Tuition: $32,000 per yr, incl room & board
Courses: 2-D & 3-D Design, †Art History, Drawing, Painting, Photography, Printmaking, Sculpture

PAXTON

ANNA MARIA COLLEGE, Dept of Art, 50 Sunset Lane, PO Box 114 Paxton, MA 01612. Tel 508-849-3441; Internet Home Page Address: www.annamaria.edu; *Chmn Dept* Alice Lambert
Estab 1948; FT 2, PT 4; pvt; D & E; Scholarships; SC 15, LC 12; D 397, maj 32
Ent Req: HS dipl, ent exam
Degrees: 4 yr
Tuition: $22,950 per yr incl room & board; commuter $16,650 per yr
Courses: †Advertising Design, Aesthetics, †Art Education, Art History, †Art Therapy, Ceramics, Drawing, Enameling, Lettering, Macrame, Modeling, Painting, Photography, Rug Design, Sculpture, Silk Screen, Stitchery, †Studio Art, †Teacher Training, Weaving
Summer School: Dir, Ann McMorrow. Two sessions beginning May.

PITTSFIELD

BERKSHIRE COMMUNITY COLLEGE, Dept of Fine Arts, 1350 West St, Pittsfield, MA 01201. Tel 413-499-4660; Fax 413-447-7840; *Instr* Benigna Chilla, MFA
Estab 1960, dept estab 1961; pub; D & E; Scholarships; SC 16, LC 4; D 72, E 75, non-maj 12, maj 72
Ent Req: HS dipl
Degrees: AA 2 yrs
Tuition: Res—$83 per cr hr; nonres—$302 per cr hr; $96 per cr hr (Vermont, Connecticut, Maine)
Courses: 2-D Design, 20th Century Art, 3-D Design, Applied Graphics, Art History, Drawing, Mixed Media, Painting, Photography, Primitive Art, Printmaking
Adult Hobby Classes: Continuing education evening classes, some may be applied to degree program
Summer School: 7 wks beginning June. Courses—Design, Drawing, Painting, Photography

PROVINCETOWN

CAPE COD SCHOOL OF ART, 48 Pearl St, Provincetown, MA 02657; PO Box 948, Provincetown, MA 02657. Tel 508-487-0101; Internet Home Page Address: www.capecod.net/artschool; *Dir* Lois Griffel
Estab 1899; D (summer only)
Ent Req: none
Tuition: $350 per workshop
Courses: Drawing, Oils, Painting, Pastels, Plein Air Painting in Landscape, Portraits, Still Life, Watercolors

QUINCY

QUINCY COLLEGE, Art Dept, 34 Coddington St, Quincy, MA 02169. Tel 617-984-1600; Fax 617-984-1779; *Chmn Humanities* Sue Harris

Degrees: AA, AS and Certificate offered
Tuition: Res & non-res $1485 per sem
Courses: Development to American Film, Drawing, Painting, Photography

SALEM

SALEM STATE COLLEGE, Art Dept, 352 LaFayette St, Salem, MA 01970. Tel 978-542-6222; Fax 978-542-6597; Elec Mail richard.lewis@salemstate.edu; Internet Home Page Address: www.salem.mass.edu; *Chmn Dept* Richard Lewis, MFA; *Prof* Benjamin Gross, MFA; *Prof* John Volpacchio, MFA; *Prof* Mark Malloy, MFA; *Prof* Patricia Johnston PhD, MEd; *Prof* Mary Mellili, MFA; *Prof* Maureen Creegan-Quinquis, MFA, MEd
Estab 1854; Maintain nonprofit art gallery, Winfisky Gallery; Pub; D & E; Scholarships; SC 19, LC 8, GC 5; maj 210
Ent Req: HS dipl
Degrees: BA 4 yrs, MAT in Art
Tuition: Res—$910 per yr; nonres—$7,050 per yr; campus res available
Courses: 3-D Studio, †Art Education, †Art History, Ceramics, †Graphic Design, Illustration, Jewelry, Mixed Media, Multimedia Design, †Painting, †Photography, †Printmaking, Sculpture
Summer School: Pres, Dr Nancy D Harrington

SOUTH HADLEY

MOUNT HOLYOKE COLLEGE, Art Dept, 50 College St, South Hadley, MA 01075; 201 Art Building, Mount Holy College South Hadley, MA 01075-1499. Tel 413-538-2200; Fax 413-538-2167; Internet Home Page Address: www.mtholyoke.educ/acad.art/; *Studio Chmn* Joseph Smith; *Interim Chmn* Michael P Davis; *Art History* Ajay Sinha
Estab 1837; Maintain nonprofit art gallery; Blanchaid Campus Center; Pvt, W; D & E; Scholarships; SC 13, LC 32; D 409, maj 52
Ent Req: SAT, college boards
Degrees: BA
Tuition: Res—undergrad $11,600 per sem; campus res—room & board $3,410 per sem
Courses: †Architecture, †Art History, Drawing, †Film, †History of Art & Architecture, Painting, Photography, Printmaking, Sculpture
Adult Hobby Classes: Continuing education program leading to BA

SPRINGFIELD

SPRINGFIELD COLLEGE, Dept of Visual & Performing Arts, 263 Alden St, Springfield, MA 01109. Tel 413-748-3540; Fax 413-748-3580; *Chmn* Ronald Maggio; *Asst Prof* Martin Shell, MFA; *Asst Prof* Chris Haynes, MFA; *Asst Prof* Simone Alter-Muri, Ed; *Asst Prof* Cynthia Noble, MFA; *Asst Prof* Leslie Abrams, MA; *Instr* Charles Abel, MFA; *Instr* Holly Murray, MFA; *Instr* Ruth West, MFA; *Instr* John Moriarty, MFA; *Instr* Catherine Lydon, MFA; *Instr* Scott Redman; *Instr* Jorge Costa; *Instr* Monika Burzcyk
Estab 1885, dept estab 1971; Maintain nonprofit art gallery; Wieliam Blizard Gallery; Pvt; D & E; Scholarships; SC 30, LC 6; D 400, E 10, non-maj 300, maj 50
Ent Req: HS dipl, SAT, portfolio
Degrees: BA, BS 4 yr, MS(Art Therapy) 2 yr
Tuition: $13,500 per yr
Courses: Advertising Design, Aesthetics, Art Appreciation, Art Education, Art History, †Art Therapy, Arts Management, Ceramics, Collage, †Computer Graphics, Computer Graphics Animation, Conceptual Art, Constructions, Costume Design & Construction, Design, Drawing, Graphic Arts, Graphic Design, History of Art & Architecture, Illustration, Intermedia, Mixed Media, Museum Staff Training, Painting, Photography, Printmaking, Restoration & Conservation, Sculpture, Stage Design, Teacher Training, Theatre Arts, Video

TRURO

TRURO CENTER FOR THE ARTS AT CASTLE HILL, INC, Meetinghouse Rd & Castle Rd, PO Box 756 Truro, MA 02666. Tel 508-349-7511; Fax 508-349-7513; Elec Mail castlehilltruro@aol.com; Internet Home Page Address: www.castlehill.org; *Instr, Sculpture* Paul Bowen; *Instr, Sculpture* Anna Poor; *Instr, Poetry* Marge Piercy; *Dir* Cherie Mittental; *Instr, Memoir* Eleanor Munro; *Instr Painting* Elizabeth Pratt; *Instr Painting* Peters Jim; *Instr Drawing* Leslie Jackson; *Instr Ceramics* Keith Kreeger; *Acting Instr* Kevin Rice; *Instr Sculpture* Joyce Johnson
Estab 1972; Maintain nonprofit art gallery; over 45 other nationally known instructors; pvt summer school; D & E; Scholarships; SC 50, LC 3; studio courses; lect courses; poetry readings; 730
Ent Req: none
Tuition: $200 & up, usually one wk, no campus res
Courses: Book Arts, Ceramics, Drawing, †Illustration, Jewelry, Literature, Painting, Photography, Printmaking, Sculpture, Wood, Writing
Children's Classes: Classes in painting, printmaking, sculpture, jewelry
Summer School: Exec Dir, Cherie Mittenthal. Enrl 700-730; tuition $180-$220 per workshop. Courses—Book, Clay, Drawing, Illustration, Jewelry, Painting, Paper Arts, Photography, Printmaking, Sculpture, Woodwork, Writing

WALTHAM

BRANDEIS UNIVERSITY, Dept of Fine Arts, 415 South St Waltham, MA 02454-9110. Tel 781-736-2655; Internet Home Page Address: www.brandeis.edu; *Chmn* Graham Campbell
Estab 1948; FT 12; pvt; D; Scholarships; SC 10, LC 28; 2800
Ent Req: HS dipl, college board ent exam
Degrees: BS 4 yr
Tuition: $23,360 per yr, room & board $6970

Courses: Art History, Design, Drawing, Painting, Sculpture
Summer School: Dir, Sanford Lotlor. Enrl 10-12 per course; tuition $585 per course for 4 week term. Courses—Introduction to History of Art II, Survey of Western Architecture

WELLESLEY

WELLESLEY COLLEGE, Art Dept, Wellesley, MA 02481. Tel 781-283-2042; Fax 781-283-3647; *Chmn* Patricia Berman; *Prof* Peter J Fergusson PhD; *Prof* James W Rayen, MFA; *Prof* Richard W Wallace PhD; *Prof* Miranda Marvin PhD, MFA; *Prof* Margaret Carroll PhD; *Prof* Carlos Dorrien, MFA; *Prof* Lilian Armstrong, PhD, MA; *Prof* Bunny Harvey, MFA; *Prof* Alice T Friedman PhD; *Assoc Prof* Anne Higonnet, PhD; *Assoc Prof* Elaine Spatz-Rabinowitz, MFA; *Assoc Prof* Judy Block, MFA; *Assoc Prof* Phyllis McGibbon, MFA; *Asst Prof* Heping Liu, MA, PhD
Estab 1875, dept estab 1886; pvt; D; SC 19, LC 46; D 1233
Ent Req: HS dipl
Degrees: BA
Tuition: $22,114 per yr; campus res—room $3540 & board $3450
Courses: †Architecture, †Art History, Drawing, Graphic Arts, Painting, Photography, Printmaking, Sculpture, †Studio Art

WEST BARNSTABLE

CAPE COD COMMUNITY COLLEGE, Art Dept, Humanities Division, Route 132 West Barnstable, MA; Rte 132, 2240 Lyanough Rd West Barnstable, MA 02668. Tel 508-362-2131; Fax 508-362-8638; *Prof* Sara Ringler, MFA; *Prof* Marie Canaves, MFA; *Coordr Art* Robert McDonald, MFA
Estab 1963, dept estab 1973; pub; D & E; SC 14, LC 7; in school D 2000, E 3000, maj 100
Ent Req: HS dipl
Degrees: AA and AS 2 yrs
Tuition: Res—$950 per yr, nonres—$5052 per yr
Courses: Art History, †Digital Imaging, Drawing, †Film, Graphic Design, Illustration, Life Drawing, Mixed Media, Painting, †Papermaking/Book Arts, †Printmaking, †Quark Express, †Sculpture, Stage Design, Theatre Arts, Video, Visual Fundamentals, †Watercolor Advanced Projects
Adult Hobby Classes: Enrl 100 - 150; tuition $225 per 3 cr. Courses—Art History, Drawing, Graphic Design, Watercolor
Summer School: Assoc Dean, Humanities, Bruce Bell. Enrl 100 - 200; tuition $225 per 3 cr for 8 wk term beginning June 23. Courses—Art History, Drawing, Graphic Design, Visual Fundamentals

WESTFIELD

WESTFIELD STATE COLLEGE, Art Dept, 577 Western Ave, Westfield, MA 01086. Tel 413-572-5630; Fax 413-562-3613; *Chmn* Barbara Keim
Estab 1972; Maintain nonprofit art gallery; Arno Maris Art Gallery; Pub; D & E; Scholarships
Ent Req: HS dipl & portfolio review
Degrees: BA (Fine Arts) 4 yrs
Courses: Anatomy, Art Appreciation, Art Education, Art History, Commercial Art, Computer Graphics, Design, Drawing, Illustration, Lettering, Mixed Media, Practicum, Printmaking, Sculpture, Teacher Training
Adult Hobby Classes: Enrl 100. Courses—Design Fundamentals, Studio Courses
Summer School: Dept Chmn, P Conant. Courses—Design Fundamentals, Studio Courses

WESTON

REGIS COLLEGE, Dept of Art, 235 Wellesley St, Weston, MA 02193. Tel 781-768-7000; Fax 781-768-8339; Internet Home Page Address: www.regiscollege.edu; *Chmn* Sr Marie de Sales Dinneen
Estab 1927, dept estab 1944; den; D & E; Scholarships; SC 12, LC 12; D 250, non-maj 200, maj 50
Ent Req: HS dipl, SAT, various tests
Degrees: BA 4 yr
Tuition: Res—$26,750 incl room & board; nonres—$18,233, room & board $8,779
Courses: †Art History, Art Therapy, Ceramics, Computer Design, Coordinating Seminars, Drawing, Enameling, Etching, Graphic Techniques, Illustration, †Introduction to Art, Painting, Silk Screen, Stained Glass, Weaving, Woodcut

WILLIAMSTOWN

WILLIAMS COLLEGE, Dept of Art, Williamstown, MA 01267. Tel 413-597-2377 (Art History Office), 597-3578 (Art Studio Office); Fax 413-597-3498 (Art History Office), 597-3693 (Art Studio Office); Internet Home Page Address: www.williams.edu; *Chmn Art History* Michael Lewis PhD; *Dir Grad Prog* Charles Haxthausen PhD, MFA
Estab 1793, dept estab 1903; FT 12, PT 12; pvt; D; Scholarships; SC 14, LC 40, GC 10; 2000, maj 85, grad 29
Ent Req: HS dipl
Degrees: BA 4 yrs, MA(History of Art) 2 yrs
Tuition: $25,352 per yr; campus res—rm $3440, bd $3490
Courses: Architecture, Art History, Drawing, Painting, Photography, Printmaking, Sculpture, Video

WORCESTER

ASSUMPTION COLLEGE, Dept of Art & Music, 500 Salisbury St, PO Box 15005 Worcester, MA 01615-0005. Tel 508-767-7000; Internet Home Page Address: www.assumption.edu; *Prof* Rev Donat Lamothe, PhD; *Assoc Prof* Nancy

Flanagan, MFA; *Assoc Prof* Michelle Granelina, MFA; *Chmn* Michelle Graveline, DMA; *Asst Prof* Barbara Apelian Beall, PhD; *Asst Prof* Elizabeth Meyersohn, MFA; *Asst Prof* Judy Norms, PhD
Estab 1904, dept estab 1976; Maintain a nonprofit art gallery & library at Emmanuel d'Alzen Library; den; D & E; Scholarships; D 600, E 25
Ent Req: HS dipl
Degrees: BA 4 yr
Tuition: $17,950 per yr; campus res available
Courses: †Advertising Design, Aesthetics, Architecture, Art Education, Art History, †Commercial Art, †Design, Drawing, Graphic Arts, †Graphic Design, History of Art & Architecture, Painting, †Photography, Printmaking, †Sculpture, †Stage Design, Theatre Arts

CLARK UNIVERSITY, Dept of Visual & Performing Arts, 950 Main St, Worcester, MA 01610. Tel 508-793-7113; Fax 508-793-8844; Internet Home Page Address: www.clarku.edu; *Dir Studio Art Prog* Elli Crocker, MFA; *Dean Admissions* Harold Wingood; *Chmn* Rhys Townsend; *Prof* Sarah Bule; *Assoc Prof* Sarah Walker; *Instr* Stephen Dirado
Estab 1887; University gallery on campus; FT 4, PT 10; pvt; D & E; Scholarships; SC 50, LC 24; Maj 100, non-maj 450, other 20
Ent Req: HS dipl, CEEB, achievement tests, SAT & ACH
Degrees: BA
Tuition: BA $29,975 per yr, campus res room & board $2610 per yr
Courses: Aesthetics, Costume Design & Construction, Drawing, †Graphic Design, History of Art & Architecture, †History of Art & Architecture, †Painting, †Photography, Printmaking, Screen Studies, Sculpture, Stage Design, Theatre Arts, Video, Video Production, Visual Design, Visual Studies
Adult Hobby Classes: Offered through Clark University College of Professional and Continuing Education
Summer School: Offered through Clark University College of Professional and Continuing Education

COLLEGE OF THE HOLY CROSS, Dept of Visual Arts, One College St, Worcester, MA 01610; PO Box 60-A, Worcester, MA 01610. Tel 508-793-2011; Internet Home Page Address: www.holycross.edu; *Prof* Virginia C Raguin PhD, SJ; *Assoc Prof* Susan S Schmidt, MFA; *Assoc Prof* Robert Parke-Harrison, MFA; *Assoc Prof* Father John Reboli PhD, SJ; *Assoc Prof* Michael Beatly, MFA; *Prof* Joanna Ziegler, PhD; *Asst Prof* Alison Fleming, PhD; *Asst Prof* Cristi Rinklin, MFA; *Instr* Naomi Ribner, MFA
Estab 1843, dept estab 1954; pvt; D; SC 12, LC 15; D 485, maj 25
Ent Req: HS dipl, SAT, ATS
Degrees: BA 4 yr
Courses: Aesthetics, Architecture, †Art History, †Digital Art, Drawing, Graphic Arts, Graphic Design, History of Art & Architecture, Painting, Photography, Printmaking, Sculpture, †Studio

WORCESTER CENTER FOR CRAFTS, 25 Sagamore Rd, Worcester, MA 01605. Tel 508-753-8183; Fax 508-797-5626; Elec Mail wcc@worcestercraftcenter.org; Internet Home Page Address: www.worcestercraftcenter.org; *Exec Dir* Davie R Leach; *Gallery Store* Candace Casey; *Registrar* Bettie Carlson; *Weaving* Christine Folz; *Dept Head* Tom O'Malley; *Silversmith* Sarah Nelson; *Metals Dept Head* Linda Hansen; *Glass Dept Head* Alex Bernstein
Estab 1856; Maintain nonprofit art gallery, Krikorian Gallery; Pvt; D & E; Scholarships; varies; D & E 280
Ent Req: no req for adult educ
Tuition: adult educ $350 per 10 wk session; no campus res
Courses: Art History, Ceramics, Design, Drawing, Enameling, †Fibre, Furniture Restoration, Glass Blowing, Goldsmithing, Handicrafts, Jewelry, Lampworking, Photography, Sculpture, Silversmithing, Stained Glass, Surface Design, †Wood Working
Adult Hobby Classes: Enrl 1,500; tuition $300 Sept-July. Courses—Ceramics, Enamel, Furniture Refinishing, Photography, Stained Glass, Textiles, Weaver & Fibre, Wood Working, Metal Working, Glass Blowing
Children's Classes: Enrl 500; tuition $300 per 12 wks. Courses—Ceramics, Metals, Photography, Surface Design, Weaving
Summer School: Enrl 100 adults & children, also children's summer camp. Courses—Ceramics, Furniture Refinishing, Glass, Metal, Photography, Textile, Wood

WORCESTER STATE COLLEGE, Visual & Performing Arts Dept, 486 Chandler, Worcester, MA 01602. Tel 508-929-8824, 929-8000; Elec Mail cnigro@worcester.edu; Internet Home Page Address: www.fac.worcester.edu/visper; *Chmn* Dr Christie Nigro; *Prof* Dr Ellen Kosmere; *Assoc Prof* Michael C Hachey; *Prof* Michel D Merle; *Asst Prof* Bryce Vinokurov
Estab 1874; pub; D & E; SC 18, LC 9; D & E 725
Ent Req: HS dipl, col board exams, completion of systems application form
Degrees: BA and BS 4 yr
Tuition: Res—$1032 per sem; nonres—$7056
Courses: Art Education, Art History, Collage, Drafting, Drawing, Environmental Design, Graphic Design, Handicrafts, History of Urban Form, Intermedia, Mixed Media, Painting, Printmaking, Sculpture
Summer School: Usually 5-8 courses & workshops

MICHIGAN

ADRIAN

ADRIAN COLLEGE, Art & Design Dept, 110 S Madison St, Adrian, MI 49221. Tel 517-265-5161; Fax 517-264-3331; Elec Mail croyer@adrian.edu; Internet Home Page Address: www.adrian.edu; *Prof* Pauleve Benio, MFA; *Assoc Prof* Nancy Van Over, MA; *Instr* Jeffrey L Ball; *Chmn, Assoc Prof* Catherine M Royer, MFA; *Assoc Prof* Brian R Steele, MFA; *Instr* Nichole Havekost, MFA

Estab 1859, dept estab 1962; Maintain nonprofit art gallery; Suptnitz Gallery, Adrian Col, 110 S Madison, Adrian MI 49221; art supplies available on-campus; pvt, den; D & E; Scholarships; SC 32, LC 18; in dept D 300, E 50, non-maj 220, maj 120
Ent Req: HS dipl
Degrees: BA, BS in Interior Design & BFA with teaching certification
Tuition: Res—$15,560 per yr, commuter $15,560 per yr; campus res—room $2320, board $2460
Courses: Art Education, Art History, Arts Management, Ceramics, Design, Drafting, Drawing, Graphic Design, History of Art & Architecture, Interior Design, Mixed Media, Painting, Photography, Pre-Art Therapy, Printmaking, Sculpture, Textile Design
Summer School: Dir, Catherine Royer. Enrl 15; May term, summer term June-July. Courses—Advanced Study, Art Education, Design, Drawing

SIENA HEIGHTS UNIVERSITY, Studio Angelico-Art Dept, 1247 Siena Heights Dr, Adrian, MI 49221. Tel 517-264-7860; Fax 517-264-7739; Internet Home Page Address: www.sienahts.edu/~art; *Prof* Joseph Bergman, MFA; *Prof* John Wittershiem, MFA; *Prof & Chmn* Christine Reising, MFA; *Prof* Deborah Danielson, MFA; *Instr* Jamie Goode, MFA; *Instr* Lois DeMots, MA; *Asst Prof* Paul McMullen; *Assoc Prof Art History* Peter Barr, PhD; *Instr* Niki Havekost, MFA; *Instr* Jean Buescher, MFA; *Instr* Todd Marsee, MFA; *Instr* Robert Stranges, MArtEd; *Instr* Jean Lash, MArtEd
Estab 1919; Maintains nonprofit art gallery, Klemm Gallery, Studio Angelico; Pvt; D & E; Scholarships; SC 56; D 200, maj 96
Ent Req: HS dipl
Degrees: BA & BFA 4 yrs
Tuition: Undergrad $6,350 per sem
Courses: Aesthetics, Architecture, Art Appreciation, Art Education, Art History, †Ceramics, †Drawing, †Graphic Design, †Metalsmithing, †Painting, †Photography, †Printmaking, †Sculpture
Summer School: Courses—Bookmaking, Ceramics, Mixed Media, Portrait Painting, Watercolor

ALBION

ALBION COLLEGE, Dept of Visual Arts, 611 E Porter St, Albion, MI 49224. Tel 517-629-0246; Elec Mail rkruger@albion.edu; Internet Home Page Address: www.albion.edu; *Chmn Dept Visual Arts* Lynne Chytilo; *Asst Prof* Billie Wicker, MA; *Prof* Douglas Goering, MFA
Estab 1835; den; D & E; Scholarships; SC 32, LC 8
Ent Req: HS dipl
Degrees: BA and BFA 4 yrs
Tuition: $138 per sem; consult website for more information
Courses: Art History, Ceramics, Drawing, Film, Painting, Photography, Printmaking, Sculpture, Stage Design, Teacher Training, Theatre Arts
Summer School: Acad Dean, Dr Daniel Poteet. Tuition $131 per sem hr for term of 7 wks beginning May 15

ALLENDALE

GRAND VALLEY STATE UNIVERSITY, Art & Design Dept, Allendale, MI 49401. Tel 616-331-3486; Fax 616-331-3240; Elec Mail mcgeed@gvsu.edu; Internet Home Page Address: www.gvsu.edu; *Chmn* J David McGee PhD; *Prof* Daleene Menning; *Prof* Ed Wong-Ligda; *Prof* Beverly Seley; *Assoc Prof* Dellas Henke; *Assoc Prof* Lorelle Thomas; *Assoc Prof* Richard Weis; *Assoc Prof* Ann Keister; *Assoc Prof* Elona Van Gent; *Assoc Prof* Michelle Bowers; *Asst Prof* Paul Wittenbraker; *Asst Prof* Bill Hosterman; *Asst Prof* Yi-Chien Chen; *Asst Prof* Joyce de Vries; *Assoc Prof* Jill Eggers
Estab 1960; pub; D & E; Scholarships; SC 52, LC 12, GC 1; D 380, E 40, maj 1,400, non-maj 420
Ent Req: ACT, Entrance portfolio
Degrees: BA(Studio), BS(Studio), BFA 4 yrs, BA(Art Educ), BA(Art Educ)
Tuition: Res—undergrad $2300 per sem per cr hr; nonres—undergrad $5040 per sem; campus res—room & board $2900 per sem
Courses: Advertising Design, Art Appreciation, †Art Education, Art History, †Ceramics, Drawing, †Goldsmithing, †Graphic Design, †Illustration, †Jewelry, †Painting, †Photography, †Printmaking, †Sculpture, †Silversmithing, †Stage Design, †Theatre Arts, †Video
Summer School: Courses—Introduction to Art, Art for the Classroom Teacher, Workshops, 2-D Design, Color & Design, Intro to Drawing

ALMA

ALMA COLLEGE, Clack Art Center, Dept of Art & Design, 614 W Superior, Alma, MI 48801. Tel 517-463-7220, 463-7111; Fax 517-463-7277; Internet Home Page Address: www.alma.edu; *Assoc Prof* C Sandy Lopez-Isnardi; *Assoc Prof* Robert Rozier; *Prof, Chmn* Carrie Anne Parks-Kirby
Estab 1886; pvt; D & E; Scholarships; SC 10-20, LC 4-8; D 250, maj 45-50
Degrees: BA, BFA
Tuition: $13,690; campus res—room & board $4905
Courses: Advertising Design, Aesthetics, Art Education, Art History, Ceramics, Computer Graphics, Drawing, Foreign Study, Graphic Design, History of Art & Architecture, Illustration, Jewelry, Mixed Media, Museum Staff Training, Painting, Photography, Printmaking, Scientific Illustration, Sculpture, Weaving

ANN ARBOR

UNIVERSITY OF MICHIGAN, ANN ARBOR
—**School of Art & Design,** Tel 734-764-0397; Fax 734-615-9753; Elec Mail a+d@umich.edu; Internet Home Page Address: www.art-design.umich.edu; *Prof* Vince Castagnacci; *Prof* James Cogswell; *Prof* Julie Ellison; *Prof* Daniel Herwitz;

Prof Al Hinton; *Prof* Joanne Leonard; *Prof* Lou Marinaro; *Prof* Dwayne Overmyer; *Prof* Panos Papalambros; *Prof* Ted Ramsay; *Prof* Bryan Rogers; *Prof* Jon Rush; *Prof* Allen Samuels; *Prof* Sherri Smith; *Prof* James Steward; *Prof* Takeshi Takahara; *Prof* Edward West; Georgette Zirbes; *Assoc Prof* Larry Cressman; *Assoc Prof* Susan Crowell; *Assoc Prof* Holly Hughes; *Assoc Prof* Sadashi Inuzuka; *Assoc Prof* Shaun Jackson; *Assoc Prof* Carol Jacobsen; *Assoc Prof* Malcolm McCullough; *Assoc Prof* Dennis Miller; *Assoc Prof* Marianetta Porter; *Assoc Prof* Michael Rodemer; *Assoc Prof* Brad Smith; *Assoc Prof* Joe Trumpey; *Asst Prof* Jan-Henrik Andersen; *Asst Prof* Phoebe Gloeckner; *Asst Prof* Andy Kirshner; *Asst Prof* Heidi Kumao; *Asst Prof* Patricia Olynyk; *Asst Prof* Cynthia Pachikara; *Asst Prof* Janie Paul; *Asst Prof* Dan Price; *Asst Prof* Stephanie Rowden; *Asst Prof* Hannah Smotrich; *Asst Prof* Satoru Takahashi; *Asst Prof* Nick Tobier; *Asst Prof* Alicyn Warren; *Visiting Assoc Prof* David Chung; *Visiting Assoc Prof* Rebekah Modrak; *Visiting Assoc Prof* Elona Van Gent; *Visiting Asst Prof* Anne Mondro; *Visiting Asst Prof* Rich Pell; *FT Lectr* Doug Hesseltine; *FT Lectr* Mary Schmidt
Estab 1817, sch estab 1974; maintains nonprofit art galleries: Jean Paul Slusser Gallery & Warren M Robbins Gallery, both on-campus; Work Exhibition Space, 306 State St, Ann Arbor, MI 48104; FT 40, PT 20; pub; D & E; Scholarships; non-maj 500, maj 30
Ent Req: HS dipl, portfolio exam
Degrees: BFA, MFA
Courses: Art History, Ceramics, Collage, Conceptual Art, Constructions, Costume Design & Construction, Design, Display, Drawing, Graphic Arts, Graphic Design, Lettering, Mixed Media, Painting, Photography, Printmaking, Sculpture, Textiles, Video, Weaving
 —**Dept of History of Art,** Tel 734-764-5400; Fax 734-647-4121; Elec Mail dianek@umich.edu; Internet Home Page Address: www.umich.edu/~hartspc/histart; *Interim Chmn* Diane Krikpatrick; *Dir Kelsey Museum & Prof* Elaine K Gazda; *Dir Museum Art* James Steward; *Prof* R Ward Bissell; *Prof* Margaret Root; *Assoc Prof* Thelma Thomas; *Prof* Martin Powers; *Assoc Prof* Patricia Simons; *Prof* Celeste Brusati; *Asst Prof* Alka Patel; *Asst Prof* Qiang Wing; *Asst Prof* Robert Maxwell; *Asst Prof* Rebecca Zurier; *Asst Prof* Elizabeth Sears; *Asst Prof* Matthew Biro; *Asst Prof* Jacqueline Francis; *Asst Prof* Maria Gough; *Asst Prof* Howard Lay
Dept estab 1910; FT 16; pub; Scholarships, Fellowships; maj 75, grad 60
Degrees: BA, MA, PhD
Tuition: Res—undergrad $61,840 per yr, grad $11,654 per yr; nonres—undergrad $21,346 per yr, grad $23,132 per yr
Courses: †Art History, Museology
Summer School: Chairman, Diane Kirkpatrick. Enrl 77; tuition res $379 per cr, nonres $803 per cr

BATTLE CREEK

KELLOGG COMMUNITY COLLEGE, Arts & Communication Dept, 450 North Ave, Battle Creek, MI 49017. Tel 269-965-3931; Fax 269-965-0280; Internet Home Page Address: www.kellogg.edu; *Art Instr* Ryan Flathu; *Art Instr* Peter Williams; *Chmn* Paula Puckett
Estab 1962; Maintains nonprofit art gallery, Davidson Gallery; FT 9, PT 18; pub; D & E; occupational certificates; Scholarships; SC, LC; D 2,200, E 2,000, maj 60
Ent Req: none
Degrees: AA 2-4 yr
Tuition: res $72 per cr hr, nonres $112.50 per cr hr, international $166 per cr hr, Ind res $113 per cr hr
Courses: †Advertising Design, Animation, †Architecture, Art Appreciation, †Art Education, Art History, †Ceramics, Design, Drafting, †Drawing, †Graphic Design, †Industrial Design, †Mixed Media, †Painting, †Photography, †Sculpture, Stage Design, Teacher Training, Theatre Arts
Adult Hobby Classes: Courses—all areas
Summer School: Courses—Basic Art & Appreciation

BENTON HARBOR

LAKE MICHIGAN COLLEGE, Dept of Art & Science, 2755 E Napier Ave, Benton Harbor, MI 49022. Tel 616-927-3571, Ext 5180; *Instr* Ken Schaber, MFA
Estab 1943; pub; D & E; Scholarships; SC 10, LC 5; 3377 total
Ent Req: open door policy
Degrees: AA 2 yrs
Tuition: Res—$48 per sem hr; nonres—out of district $58 per sem hr, out of state $68 per sem hr; no campus res
Courses: 2-D & 3-D Design, Art Appreciation, Art Education, Art History, Ceramics, Design, Drawing, Occupational Therapy, Painting, Photography, Printmaking, Sculpture, Weaving

BERRIEN SPRINGS

ANDREWS UNIVERSITY, Dept of Art, Art History & Design, N US Rt 31, Berrien Springs, MI 49104. Tel 616-471-7771; Fax 616-471-3949; Internet Home Page Address: www.andrews.edu; *Chmn* Gregory Constantine; *Prof* Steve Hansen; *Instr* Robert Mason
Estab 1952; FT 4; den; D & E; SC 18, LC 5; enrl 130, maj 20
Ent Req: HS grad
Degrees: BS(Art Educ), BA 4 yrs, BFA 4 yrs
Tuition: Tuition, room & board $9,088 per yr est
Courses: Art Education, Art History, Ceramics, Drawing, European Study, Graphic Design, Painting, Photography, Printmaking, Sculpture
Summer School: Classes June 14-Aug 6

BIG RAPIDS

FERRIS STATE UNIVERSITY, Visual Communication Dept, 119 S State St, Big Rapids, MI 49307. Tel 231-592-2426; *Dept Head* Kaaren Denyes
10; Scholarships

Degrees: AAS & BS
Tuition: Res—undergrad $2142 per sem; nonres—undergrad $4838 per sem
Courses: Advertising Design, Air Brush, Art History, Concept Development, Conceptual Art, Creative Writing, Design, Drawing, Figure Drawing, Film, †Graphic Arts, †Graphic Design, Illustration, Intermedia, Lettering, Mixed Media, Painting, Photography, Printmaking, Production Art, Rendering, Typography, Video
Adult Hobby Classes: Enrl 400; tuition $180 per cr hr
Summer School: Dir, Karl Walker. Tuition $180 per qtr

BIRMINGHAM

BIRMINGHAM-BLOOMFIELD ART CENTER, 1516 S Cranbrook Rd, Birmingham, MI 48009. Tel 248-644-0866; Fax 248-644-7904; Internet Home Page Address: www.bbartcenter.org; *Exec Dir* Jane Linn; *Asst Exec Dir* Cynthia Mills; *Exhib Coordr* John Cynar; *Mem & Develop Mgr* Diane Taylor; *Festival & Art Gallery Shop Dir* Peggy Kerr
Estab 1957; Maintain nonprofit art gallery; PT 75; pub; Community School of the Arts; D & E; SC & LC 500; 3600 total
Tuition: $0-$300 per term, no campus res
Courses: Aesthetics, Architecture, Art Appreciation, Art History, Calligraphy, Ceramics, Collage, Commercial Art, Design, Drawing, Glass, Goldsmithing, Graphic Arts, Graphic Design, Illustration, Jewelry, Mixed Media, Painting, Photography, Printmaking, Sculpture, Silversmithing, Surface Design, Textile Design, Weaving
Adult Hobby Classes: Enrl 3000-3500; tuition $0-$300 for 3-39 hrs.
Courses—Art History, Calligraphy, Crafts, Design, Drawing, Fibers, Jewelry, Painting, Pottery, Printmaking, Sculpture
Children's Classes: Enrl 500; tuition $75-$100.
Summer School: Dir, J Torno. Enrl 500; 2 wk term. Children's Summer Art Camp

BLOOMFIELD HILLS

CRANBROOK ACADEMY OF ART, 39221 Woodward Ave, PO Box 801 Bloomfield Hills, MI 48303-0801. Tel 248-645-3300; Fax 248-646-0046; Elec Mail caaadmissions@cranbrook.edu; Internet Home Page Address: www.cranbrookart.edu; *Head 2-D Design Dept* Elliott Earls; *Head Fiber Dept* Jane Lackey; *Head Metalsmithing Dept* Iris Eichenberg; *Head Painting Dept* Beverly Fishman; *Head Photo Dept* Carl Toth; *Head Ceramics Dept* Tony Hepburn; *Head Archit Dept* William Massie; *Head Dept Print* Medida Randy Boltan; *Head Sculpture Dept* Heather McGill; *Head 3-D Design Dept* Scott Klinker; *Dir* Gerhardt Knodel
Estab 1932; Maintain nonprofit art gallery; Cranbrook Art Mus & Cranbrook Acad of Art Library; Pvt; Studio Prog minimum 30 hrs wk; Scholarships; SC, GC; 150
Ent Req: portfolio
Degrees: MFA & MArchit 2 yrs
Tuition: $22,800 per yr; campus res—room & board $3,700 (single), $2,050 (double)
Courses: Architecture, Ceramics, Design, Fiber, Metalsmithing, Painting, Photography, Print Media, Sculpture

DEARBORN

HENRY FORD COMMUNITY COLLEGE, McKenzie Fine Art Ctr, 5101 Evergreen Rd, Dearborn, MI 48128. Tel 313-845-9634, 9600; Fax 313-845-6321; Internet Home Page Address: www.hfcc.net; *Div Dir* Rick Goward; *Mgr Performing Arts* Dale Van Dorp; *Dept Head* Martin Anderson; *Instr Interior Design* Pamela Banduric; *Mgr Enrichment* Robert Cadez; *Ceramics* Cathy Dambach; *Drawing* Kevin Donahue; *Graphic Design* Kirk McLendon; *Dance* Diane Mancinelli; *Music* Kevin Dewey; *Philosophy* John Azar; *Speech* Stanley Moore; *Radio* Jay Kornek; *Dir Theater* George Popovich
Estab 1938; FT 6, PT 40; pub; D & E; Scholarships; SC 25, LC 9; D 3500, E 7500, maj 600
Ent Req: HS dipl
Degrees: AA 2 yrs
Tuition: Res—$55 per cr hr; nonres—$92 per cr hr, out-of-state & international $106 per cr hr, plus lab fees; drive in campus
Courses: 2-D Design, 3-D Design, Art Appreciation, Art History, †Ceramics, Drawing, †Graphic Design, †Interior Design, Jewelry, †Painting, Photography, Printmaking, Sculpture, Textile Design
Children's Classes: Ceramics, Jewelry, Painting/Drawing, Sculpture
Summer School: Dir, Martin W Anderson. Tuition res-$30 per cr hr, nonres $42.
Courses—Art Appreciation, Art History, Ceramics, Color Photography, Directed Study, Drawing, Black & White Photography, 2-D Design

DETROIT

CENTER FOR CREATIVE STUDIES, College of Art & Design, 201 E Kirby, Detroit, MI 48202. Tel 313-664-7400; Internet Home Page Address: www.ccscad.edu; *Pres* Richard L Rogers; *Acad Dean* Roger Williams; *Chmn Industrial Design* Clyde Foles Ret; *Chmn Crafts* Herb Babcock; *Chmn Liberal Arts* Dr Dorothy Kostuch; *Chmn Graphic Design* Doug Kisor; *Chmn Animation & Digital Media* Ed McDonald; *Chmn Photography* John Ganis; *Chmn Fine Arts* Patrick McCaye; *Dir Communications* Robin Terry; *Chmn Illustrations* Gil Ashby
Estab 1926; pvt; D & E; Scholarships; D 950, E 250, others 200
Ent Req: HS dipl & portfolio
Degrees: BFA 4 yrs
Tuition: $552 per cr hr
Courses: †Advertising Design, †Art History, †Ceramics, †Commercial Art, †Conceptual Art, Crafts, †Design, †Drawing, †Film, Fine Arts, Glass, †Graphic Arts, †Graphic Design, †Illustration, †Industrial Design, †Interior Design, †Jewelry, †Mixed Media, †Painting, †Photography, †Printmaking, †Sculpture, †Silversmithing, †Textile Design, †Video, †Weaving

Adult Hobby Classes: Enrl 281. Courses—Computer Technology, Crafts, Fine Arts, Graphic Communication, Industrial Design, Photography

Children's Classes: Enrl 59. Courses—Art, Music

Summer School: Dean Acad Affairs, Roger Williams. Enrl 230; tuition $476 per cr hr. Courses—Computer Technology, Crafts, Fine Arts, Industrial Design, Photography

MARYGROVE COLLEGE, Department of Art, 8425 W McNichols Rd, Detroit, MI 48221-2599. Tel 313-927-1370; Elec Mail nsmith@marygrove.edu; Internet Home Page Address: www.marygrove.edu; *Dean* Rose DeSloover, MFA; *Asst Prof* James Lutomski, MFA; *Asst Prof* Beverly Hall Smith; *Chmn & Asst Prof* Nelson Smith, MFA; *Asst Prof* Cindy Read; *Asst Prof* Diane Rieman, MFA; *Instr* Anita Ricks-Bates, MFA; *Instr* Christine Hagedorn, MFA
Estab 1910; maintains nonprofit art gallery, The Gallery Marygrove College, 8425 W McNichols, Detroit, MI 48221; pvt; D & E; SC 37, LC 20, GC 5; D 150, E 25, non-maj 60, maj 50, grad 5

Ent Req: interview with portfolio

Degrees: BA & BFA 4 yrs

Tuition: Res—undergrad $380 per cr hr, grad $390 per cr hr; campus res available

Courses: Advertising Design, Art Education, Art History, †Ceramics, Constructions, †Drawing, †Graphic Arts, Graphic Design, Mixed Media, †Painting, Photography, †Printmaking, Sculpture, †Teacher Training

Adult Hobby Classes: Enrl 65; tuition $35-$90 per course. Courses—Drawing, Painting, Photography

Children's Classes: Enrl 100; tuition $20-$50 per course. Courses—Ceramics, Painting, Photography

Summer School: Dean Continuing Educ, Sr Andrea Lee, PhD. Enrl 40, tuition $86 per cr hr for term of two 6 wk terms. Courses—Basic courses, graduate and undergraduate

UNIVERSITY OF DETROIT MERCY, School of Architecture, 4001 W McNichols, PO Box 19900 Detroit, MI 48219-0900. Tel 313-993-1532; Fax 313-993-1512; Internet Home Page Address: www.udmercy.edu; *Dean* Stephan P Vogel; *Prof* John C Mueller; *Assoc Dean* Stephan J LaGrassa
Estab 1877, school estab 1964; pvt; D & E; Scholarships; SC 14, LC 36; D 200, maj 200

Ent Req: HS dipl, B average

Degrees: MArch 5 years

Tuition: undergrad $8235 per 12-18 cr hrs per sem, $420 per 1-11 cr; grad $9075 per 12-18 cr hrs per sem, $605 per 1-11 cr

Courses: Architecture, Design

WAYNE STATE UNIVERSITY, Dept of Art & Art History, School of Fine, Performing & Communication Arts, 150 Community Arts Bldg Detroit, MI 48202. Tel 313-577-2980; Fax 313-577-3491; *Chmn* Marian Jackson; *Interim Chmn* Robert Marten
FT 25, PT 20

Tuition: Res—undergrad $1365 for 12 cr hrs, grad $1341 for 8 cr hrs; nonres—undergrad $2961 for 12 cr hrs, grad $2797 for 8 cr hrs

Courses: Art History, Ceramics, Drawing, Fibers, Graphic Design, Industrial Design, Interdisciplinary Electronic Media, Interior Design, Metals, Painting, Photography, Printmaking, Sculpture

Summer School: Tuition same as regular sem for 7 wks. Courses—Art History, Ceramics, Drawing, Fibers, Painting, Photography, Sculpture

DOWAGIAC

SOUTHWESTERN MICHIGAN COLLEGE, Fine & Performing Arts Dept, 58900 Cherry Grove Rd, Dowagiac, MI 49047. Tel 616-782-5113; Internet Home Page Address: www.swmich.edu; *Chmn & Instr* Dr John Korzon, DA; *Instr* David R Baker, MFA; *Instr* Patty Bunner, MFA
Estab 1964; pub; D & E; Scholarships; SC 13, LC 3; D 200, E 100, non-maj 200, maj 100

Ent Req: HS dipl

Degrees: AA & AS

Tuition: Res—undergrad $50 per cr hr; nonres—undergrad $85 per cr hr; foreign, in service & out of state $66 per cr hr

Courses: Advertising Design, Architecture, Ceramics, Commercial Art, Drafting, Drawing, Graphic Arts, Lettering, Painting, Photography, Printmaking

Adult Hobby Classes: Art Appreciation, Ceramics, Painting, Photography

Summer School: Dir, Marshall Bishop. Enrl 1000; 7 wk terms

EAST LANSING

MICHIGAN STATE UNIVERSITY, Dept of Art & Art History, 113 Kresge Art Ctr, East Lansing, MI 48824-1119. Tel 517-355-7610; Fax 517-432-3938; Elec Mail art@msu.edu; Internet Home Page Address: www.art.msu.edu; *Chmn* Jim Hopfensperger; *Prog Head* Dr Kenneth Haltman; *Dir Grad Prog* Dr Janice Simpson
Estab 1855; FT 30; pub; D & E; Scholarships; SC 77, LC 45, GC 25; D 2500, non-maj 1500, maj 450, grad 60

Ent Req: HS dipl

Degrees: BA & BFA 4 yrs, MA 1 yr, MFA 2 yrs

Tuition: Res—undergrad $144-$160 per cr hr, grad $222 per cr hr; nonres—undergrad $385-$399 per cr hr, grad $450 per cr hr; campus res—room & board $1984

Courses: Art Education, Art History, Ceramics, Collage, Conceptual Art, Constructions, Design, Drawing, Graphic Design, History of Art & Architecture, Mixed Media, †Museum Studies, Painting, Photography, Printmaking, Sculpture, Teacher Training, Video

Adult Hobby Classes: Tuition $10 per session. Courses—History of Art & Studio Art

Children's Classes: Enrl 150; tuition $50 for 10 wks. Courses—Computer, Drawing, Painting, Photography, Sculpture

Summer School: Dir, Jim Hopfensperger

ESCANABA

BAY DE NOC COMMUNITY COLLEGE, Art Dept, 2001 N Lincoln Rd, Escanaba, MI 49829. Tel 906-786-5802; Fax 906-789-6913;Mary Joy Johnson; *Instr Drawing & Design* Craig Seckinger; *Instr Art History* Joann Leffel; *Instr Pottery* Al Hansen
Maintain nonprofit art gallery; Scholarships; SC 6, LC 2; D 60, E 20

Degrees: AA, AS

Tuition: County res—$53.50 per cr hr; non-county res—$73.50 per cr hr; non-state res—$117.50 per cr hr

Courses: Art History, Ceramics, Design, Drawing, Painting, Sculpture

FARMINGTON HILLS

OAKLAND COMMUNITY COLLEGE, Art Dept, Orchard Ridge Campus, 27055 Orchard Lake Rd Farmington Hills, MI 48334-4579. Tel 248-522-3400; Fax 248-471-7544; Internet Home Page Address: www.oaklandcc.edu; *Chmn* Robert Piepenburg

Degrees: AA and ASA offered

Tuition: District res—$48-70 per cr hr; non-district—$82.40 per cr hr

Courses: Advertising Design, Art Appreciation, Art History, Calligraphy, Ceramics, Design, Drawing, Fashion Arts, Handicrafts, Photography, Sculpture

FLINT

MOTT COMMUNITY COLLEGE, (Charles Stewart Mott Community College) Liberal Arts & Sciences, 1401 E Court St, Flint, MI 48503. Tel 810-762-0443, 762-0200, 762-0455; Fax 810-762-5613; Elec Mail dhoppa@mcc.edu; Internet Home Page Address: www.mcc.edu; *Assoc Dean* Doug Hoppa; *Assoc Prof* Jessie Sirna, MA; *Instr* Catherine Smith, MFA; *Prof* Thomas Nuzum, MFA; *Prof* Thomas Bohnert, MAEd; *Faculty Emeritus* Bill O'Malley; *Faculty Emeritus* Sam Morello
Estab 1923; pub; D & E; D & E 250, maj 250

Ent Req: HS dipl or 19 yrs old

Degrees: AA 2 yrs

Tuition: District res—$61.15 per cr hr; state res—$88.25 per cr hr; nonres—$117.70 per cr hr; no campus res

Courses: Art Education, Art History, Ceramics, Drafting, Drawing, Film, Graphic Design, Jewelry, Painting, Printmaking, Sculpture, Teacher Training

Adult Hobby Classes: Classes offered through cont education division

Summer School: Coordr, Thomas Bohnert. Tuition same as above; 7.5 wk sessions, first May 15 - July 1, second July 1 - Aug 15. Courses—vary

GRAND RAPIDS

AQUINAS COLLEGE, Art Dept, 1607 Robinson Rd SE, Grand Rapids, MI 49506. Tel 616-459-8281, Ext 2413; Fax 616-459-2563; Elec Mail zimmekat@aquinas.edu; Internet Home Page Address: www.aquinas.edu; WATS 800-678-9593; *Chmn Dept & Prof* Ron Pederson, MFA; *Prof* Sr Marie Celeste Miller PhD, MFA; *Prof* Steve Schousen, MFA; *Assoc Prof & Dir Exhibs* Dana Freeman, MFA; *Assoc Prof* Kurt Kaiser, MFA; *Adjunct Assoc Prof Painting* Sharon Sandberg, MFA; *Prof* Joseph Becherer, PhD; *Prof Art History* Lena Meijer; *Adjunct Asst Prof Art Educ* HJ Slider, MA; *Adjunct Prof* Don Kerr, MFA; *Adjunct Assoc Prof* Chris LaPorte, MFA; *Adjunct Instr Ceramics* Madeline Kaczmarczyk
Estab 1940, dept estab 1965; maintains nonprofit art gallery, AMC Gallery, 1607 Robinson Rd SE, Grand Rapids, MI 49506; pvt; den; D & E; Scholarships; SC 30, LC 12; non-maj 80, maj 50

Ent Req: HS dipl

Degrees: BA and BFA 4 yrs

Tuition: $19,000 per yr; campus res—room & board $5,174 per yr

Courses: Art Appreciation, †Art Education, †Art History, †Ceramics, Conceptual Art, Constructions, Design, †History of Art & Architecture, Mixed Media, †Painting, †Photography, †Printmaking, †Sculpture, Stage Design, Theatre Arts

CALVIN COLLEGE, Art Dept, 3201 Burton SE, Grand Rapids, MI 49546. Tel 616-957-6271; Fax 616-957-8551; Internet Home Page Address: www.calvin.edu; *Prof* Helen Bonzelaar PhD, MFA; *Prof* Franklin Spevers, MS; *Assoc Prof* Anna Greidanus Probes, MFA; *Prof* Henry Luhikhuizen PhD, MFA; *Chmn Dept* Carl Huisman
Estab 1876, dept estab 1965; den; D & E; Scholarships; SC 16, LC 4, GC 5; maj 130, grad 4, others 4

Ent Req: HS dipl, SAT or ACT

Degrees: BA(Art, Art Educ, Art History) & BFA(Art), MAT

Tuition: $7020 per sem; campus res—room & board $4890 per yr

Courses: Advertising Design, Aesthetics, Architecture, Art Appreciation, Art Education, Art History, Art Therapy, Ceramics, Commercial Art, Conceptual Art, Constructions, Graphic Design, History of Art & Architecture, Jewelry, Painting, Photography, Printmaking, Sculpture, Silversmithing, Teacher Training

Summer School: Courses vary

GRAND RAPIDS COMMUNITY COLLEGE, Visual Art Dept, 143 Bostwick NE, Grand Rapids, MI 49503. Tel 616-234-3544; Fax 611-234-3368; Elec Mail nantonak@grcc.cc.edu; Internet Home Page Address: grcc.cc.edu; *Dept Head Visual Arts* Nick Antonakis; *Art Gallery Dir* Robin VanRooyen
Estab 1914; Maintains nonprofit art gallery, Grand Rapids Community College Art Gallery; FT 7, PT 11; pub; D, E & W; Scholarships; SC 17, LC 2; D 250, E 75, maj 60

Ent Req: HS dipl or ent exam

Degrees: AA 2 yrs & AFA 2 yrs

Tuition: Res—$61.50 per cr hr; nonres—$90 per cr hr; out-of-state—$110 per cr hr; no campus res
Courses: 20th Century Art, Art Education, Art History, Ceramics, Color & Design, Drawing, Graphic Design, History of Art & Architecture, Life Drawing, Mixed Media, Painting, Photography, Teacher Training
Summer School: Term of 7 wks beginning May. Courses—Art History, Drawing, Photography, Pottery, Outdoor Painting, Drawing

KENDALL COLLEGE OF ART & DESIGN, 17 Fountain St NW, Grand Rapids, MI 49503-3194. Tel 616-451-2787; Internet Home Page Address: www.KendallCollArtDes.edu; *Pres* Oliver H Evans PhD; *Chmn Foundation Fine Arts* Tom Gondek, MFA; *Chmn Design Studies* Bruce Mulder, MEd; *Chmn Art History & Liberal Arts* Ruth O'Keefe, MA
Estab 1928; FT 27, PT 39; pvt; D & E; Scholarships; SC 64, LC 27, AH 9; 581
Ent Req: HS dipl, ACT, SAT
Degrees: BFA & BS 4 yrs
Tuition: Res/non-res—$7750 per sem incl room and board
Courses: Advertising Design, †Art History, Design, Drafting, Drawing, †Fine Arts, †Furniture Design, Graphic Design, History of Art & Architecture, †Illustration, †Industrial Design, †Interior Design, Mixed Media, Painting, Photography, Printmaking, Sculpture, Video, †Visual Communications
Adult Hobby Classes: 524; tuition $150-$160 for 8 wk term. Courses—Ceramics, Computer Art, Drawing, Jewelry Design, Painting, Photography
Children's Classes: 826; tuition $65 & up for 6 wk term. Courses—Ceramics, Drawing, Painting, Photography, Sculpture
Summer School: Full semester, May - July; same program as regular session

HANCOCK

SUOMI INTERNATIONAL COLLEGE OF ART & DESIGN, Fine Arts Dept, 601 Quincy St, Hancock, MI 49930. Tel 906-482-5300; *Instr* Elizabeth Leifer, MA; *Instr* Patti Pawlicki, MA; *Instr* Phyllis McIntyre, MA; *Instr* Tom Gattis, MA; *Chmn Dept* Jon Brookhouse, MA
Estab 1896, dept estab 1974; pvt; D & E; SC 5; D 24, E 30, non-maj 18, maj 12
Ent Req: HS dipl, open door policy
Degrees: AA 2 yrs, BFA, BA 4 yrs
Tuition: $7000 per sem; campus res available
Courses: Ceramics, Design, Drawing, Fiber, Graphic Arts, Painting, Photography, Printmaking, Product Design, Sculpture, Visual Communications, Weaving

HILLSDALE

HILLSDALE COLLEGE, Art Dept, 33 E College St, Hillsdale, MI 49242. Tel 517-437-7341, Ext 2371; Fax 517-437-3923; Internet Home Page Address: www.hillsdale.edu; *Dir* Samuel Knecht, MFA; *Asst Prof* Tony Frudakis, MFA; *Instr* Patrick Forshay; *Instr* Will Bippes
Estab 1844; pvt; Scholarships; SC 12, LC 5; D 1000, non-maj 150, maj 15
Ent Req: HS dipl, SAT
Degrees: BA & BS 4 yrs
Tuition: $14,000 per yr; $2,880 room, $3,000 board; campus res available
Courses: Advertising Design, Art Education, Art History, Ceramics, Drawing, Film, Graphic Arts, History of Art & Architecture, Illustration, Lettering, Painting, Photography, Printmaking, Restoration & Conservation, Sculpture, Stage Design, Teacher Training, Video
Summer School: Dir, Rich Moeggenberg. Courses—Vary

HOLLAND

HOPE COLLEGE, Dept of Art & Art History, Holland, MI 49423. Tel 616-395-7500; Fax 616-395-7499; Elec Mail mahsun@hope.edu; Internet Home Page Address: www.hope.edu;William Mayer, MFA; *Prof* Katherine Sullivan, MFA; *Prof* Bruce McCombs, MFA; *Assoc Prof & Chmn* Carol Anne Mahsun PhD, MFA; *Asst Prof* Steve Nelson, MFA; *Asst Prof* Judy Hillman, BS; *Asst Prof* John Hanson, PhD
Estab 1866, dept estab 1962; Maintain nonprofit art gallery; DePree Gallery, Hope College, 275 Columbia Ave, Hooland, MI 49423; den; D & E; Scholarships; SC 18, LC 12; D 185, E 61, non-maj 488, maj 26
Ent Req: HS dipl, CEEB-SAT or ACT
Degrees: BA and BM 4 yrs
Tuition: $13,369 per sem
Courses: 2-D & 3-D Design, †Art Education, †Art History, †Ceramics, Design, †Drawing, †Painting, †Photography, †Printmaking, †Sculpture
Summer School: Registrar, John Huisken. Tuition $250 per sem hr. Courses—Vary from yr to yr

INTERLOCHEN

INTERLOCHEN CENTER FOR THE ARTS, Interlochen Arts Academy, Dept of Visual Art, 4000 M, 137 St Interlochen, MI 49643-0199; PO Box 199, Interlochen, MI 49643. Tel 231-276-7200; Internet Home Page Address: www.interlochen.k12.mi.us; *Chair* Chad Andrews
Pvt; D; Scholarships; 440, non-maj 30, maj 40
Ent Req: portfolio, HS dipl
Tuition: $24,000 per yr, includes room & board
Courses: Art History, Ceramics, Design, Drawing, Fiber Art, Jewelry, Painting, Photography, Printmaking, Sculpture, Silversmithing, Textile Design, Weaving
Summer School: Dir, Martin Drexler. Enrl 1300; tuition $6000. Interlochen Arts Camp, formerly National Music Camp Courses & same as above

IRONWOOD

GOGEBIC COMMUNITY COLLEGE, Fine Arts Dept, E 4946 Jackson Rd, Ironwood, MI 49938. Tel 906-932-4231, Ext 283; *Chmn* Jeannie Milakovich

Estab 1932; pub; D & E; Scholarships; SC 14, LC 3; D 37, E 32, non-maj 65, maj 4
Ent Req: HS dipl or equivalent
Degrees: AA 2 yrs
Tuition: In-district $43 per cr hr; out-of-district/state $60 per cr hr
Adult Hobby Classes: Courses—Painting
Summer School: Dean Instruction, Dale Johnson. Courses—Ceramics, Ceramic Sculpture, Drawing, Painting

KALAMAZOO

KALAMAZOO COLLEGE, Art Dept, 1200 Academy St, Kalamazoo, MI 49006. Tel 616-337-7047; Fax 616-337-7067; Elec Mail fischer@kzoo.edu; *Prof* Richard Koenig, MFA; *Chmn* Tom Rice, MFA
Estab 1833, dept estab approx 1940; pvt; D; Scholarships; SC 14, LC 10; (school) 1200, non-maj 250 (dept), maj 20, others 5
Ent Req: HS dipl, SAT, ACT, class rank
Degrees: BA 4 yrs
Tuition: $26,000 per yr incl room & board; campus res available
Courses: Aesthetics, Art History, Ceramics, Drawing, Painting, Photography, Printmaking, Sculpture, Teacher Training

KALAMAZOO INSTITUTE OF ARTS, KIA School, 314 S Park St, Kalamazoo, MI 49007. Tel 616-349-7775; Fax 616-349-9313; Elec Mail denise_l@kiarts.org; Internet Home Page Address: www.kiarts.org; *Dir KIA School* Denise Lisiecki, MA; *Head Photography Dept* James Riegel, MA; *Head Children's Prog* Anne Forrest, MFA; *Head Weaving Dept* Gretchen Huggett, BS; *Head Jewelry Dept* Jeannette Maxey; *Head Ceramics* Paul Flickinger, MFA; *Head Sculpture* Joshua Diedrich, MFA
Estab 1924; Maintains nonprofit art gallery & art library; Kalamazoo Institute of Arts, 314 S Park;; PT 50; pvt, nonprofit; D & E; Scholarships; SC 85 LC 1; D 530, E 490
Tuition: $178-$215 depending upon membership; no campus res
Courses: Art Appreciation, Ceramics, Computer Graphics, Courses for the Handicapped, Design, Drawing, Glass, Home School, Jewelry, Painting, Photography, Printmaking, Sculpture, Weaving
Children's Classes: Enrl 400; tuition $108-$148 for one sem; Courses—Varied
Summer School: Dir, Denise Lisiecki. Enrl 900; tuition $108-$240 June - Aug. Courses—Full schedule

KALAMAZOO VALLEY COMMUNITY COLLEGE, Center for New Media, 6767 W O Ave, PO Box 4070 Kalamazoo, MI 49003-4070. Tel 616-372-5000; Elec Mail kmatson@kvcc.edu; Internet Home Page Address: www.kvcc.edu; *Dept Chair Humanities* Martin Obed; *Coordr Technical Communications* Karen Matson; *Dir Fine Art* Arleigh Smyrnios; *Coordr Ctr for New Media* Linda Rzoska; *Instr* David Baker; *Instr* Ravi Akoor
Estab 1968; pub; D, E, & Sun; Scholarships; SC 12, LC, Post Assoc Degree Cert; D 300, E 100
Ent Req: Open Door
Degrees: AA, AS and Cert (1 yr)
Tuition: In-county—$47.50 per cr hr; out-of-county—$82.75 per cr hr; nonres—$117.25 per cr hr
Courses: 2-D Design, Advertising Design, Aesthetics, Art Appreciation, Art Education, Calligraphy, Ceramics, Commercial Art, Design, Drafting, Drawing, Electronic Publishing, Graphic Design, Illustration, Illustration Media, Illustrator, Lettering, Pagemaker, Painting, Photography, Photoshop, Teacher Training
Adult Hobby Classes: Courses—Same as regular session
Children's Classes: Courses—Ceramics
Summer School: Instr, Arleigh Smyrnios; Enrl 1125; tuition $43.25 per cr hr for 8 wk term. Courses—Ceramics, Design, Drawing, Watercolor, Electronic Publishing

WESTERN MICHIGAN UNIVERSITY, Dept of Art, 1201 Oliver St, Kalamazoo, MI 49008; 1903 West Michigan Ave Kalamazoo, MI 49008-5213. Tel 269-387-2436; Fax 269-387-2477; Internet Home Page Address: www.wmich.edu/art; *Chmn Dept* Phil Vander Weg
Estab 1904, dept estab 1939; FT 22; pub; D & E; Scholarships, Fellowships; SC 60, LC 9, GC 8; non-maj 300+, maj 600+, grad 20
Ent Req: HS dipl, ACT
Degrees: BA, BS & BFA 4 yrs, MA 1 yr, MFA 2 yrs
Tuition: Res—undergrad $104.08-159.49 per cr hr, grad $205 per cr hr; nonres—undergrad $366.90-411.37 per cr hr, grad $503.46 per cr hr; campus res—room & board $4,000
Courses: †Art Education, Art History, †Ceramics, Computer Imaging, Drawing, †Graphic Design, †Jewelry, †Painting, †Photography, †Printmaking, †Sculpture
Adult Hobby Classes: Chairperson Dept
Summer School: Chairperson dept. Enrl 250; tuition same per hr as academic yr for one 8 wk term beginning May. Courses—same as above

LANSING

LANSING COMMUNITY COLLEGE, Visual Arts & Media Dept, 315 N Grand Ave, PO Box 40010 Lansing, MI 48901-7210. Tel 517-483-1476; Fax 517-483-1050; Internet Home Page Address: www.lcc.edu; *Prof* Constance Peterson, BS; *Prof* Sharon Wood, MFA; *Prof* Ike Lea; *Prof* Fred Clark, MFA; *Prof* Brian Bishop, MFA; *Prof* Susie Stanley, BA; *Prof* Jim Redding, MA
Estab 1957; FT & PT 40; pub; D & E, weekends - online; Scholarships; SC 80, LC 10; D 758, E 506, non-maj 400, maj 560, others 304
Ent Req: HS dipl
Degrees: AA 2 yrs
Tuition: Res—$55 per cr hr; nonres—$88 per cr hr; out-of-state- $120 per cr hr; no campus res; $107 International
Courses: Advertising Design, Commercial Art, †Computer Graphics Animation, †Computer Graphics Web Design, †Conceptual Art, Design, †Digital Effects, Drawing, †Film, †Graphic Design, Illustration, †Multimedia, Painting, †Photography, Printmaking, †Sequential Art, Typography

Adult Hobby Classes: Enrl 60; duration 16 wks. Courses— Watercolor, Matting & Framing, Photography, Photoshop
Summer School: Dir, Mary Cusack. Enrl 250. Courses—Same as Fall & Spring sem

LIVONIA

MADONNA UNIVERSITY, Art Dept, 36600 Schoolcraft Rd, Livonia, MI 48150. Tel 734-432-5300; *Chmn Art Dept* Doug Semivan; *Instr* Anthony Balogh, MA; *Instr* Thos Church, MA; *Prof* Mary Francis Lewandowski Sr; *Instr* Marjorie Chellstrop, MA; *Sculptor* Donald Gheen, MA
Estab 1947; pvt; D & E; Scholarships; SC 17, LC 3; D 43, E 22, maj 17
Ent Req: HS dipl, portfolio
Degrees: AA 2 yrs, AB 4 yrs
Tuition: $250 per sem hr, 288 grad per sem hr
Courses: †Advertising Design, Architecture, Art Appreciation, Art Education, Art History, Calligraphy, Ceramics, Collage, †Commercial Art, Computer Art, Design, Display, †Fine Arts, †Graphic Arts, †Graphic Design, History of Art & Architecture, Illustration, Lettering, Mixed Media, Painting, Photography, Printmaking, Sculpture, Teacher Training, Video
Adult Hobby Classes: Enrl 25; tuition $70 per 10 wk course. Courses—Painting
Summer School: Dir, Prof R F Glenn. Enrl 25 for 6-8 wks. Courses—Art History, Printmaking, Teacher Art Education

SCHOOLCRAFT COLLEGE, Dept of Art & Design, 18600 Haggerty Rd, Livonia, MI 48152. Tel 734-462-4400; Fax 734-462-4538; *Prof* Stephen Wroble, MA; *Dean Art Dept* Jean Bonner
Estab 1964; pub; D & E; Scholarships, Fellowships; SC 13, LC 4; D 300, E 150, maj 100
Ent Req: ent exam
Degrees: AAS & AA 2 yrs
Tuition: Res—In District $54 per cr hr; nonres—$80 per cr hr; no campus res
Courses: Ceramics, Computer Aided Art & Design, Design, Drawing, Film, Graphic Arts, History of Art & Design, Jewelry, Painting, Photography, Printmaking, Sculpture
Adult Hobby Classes: Acrylic Painting, Ceramics, Drawing, Jewelry, Macrame, Photography, Stained Glass
Children's Classes: Enrl 40; tuition same as above. Courses—Talented & Gifted Program
Summer School: Design, Drawing, Printmaking, Watercolor

MARQUETTE

NORTHERN MICHIGAN UNIVERSITY, Dept of Art & Design, 1401 Presque Isle, Marquette, MI 49855. Tel 906-227-2194, 227-2279; Fax 906-227-2276; Elec Mail art@num.edu/department/ad_career.html; Internet Home Page Address: www.nmu.edu; *Prof* Thomas Cappuccio; *Prof* John D Hubbard; *Prof* William C Leete; *Prof* Diane D Kordich; *Prof* Dennis Staffne; *Prof* Dale Wedig; *Asst Prof* Jane Milkie; *Asst Prof* Sam Chung; *Head Dept* Michael J Cinelli; *Asst Prof* Derrick Christen; *Asst Prof* Steve Leuthold; *Asst Prof* Stephan Larson
Estab 1899, dept estab 1964; pub; D & E; Scholarships; SC 30, LC 20, GC 18
Ent Req: HS dipl, ACT
Degrees: BS, BFA, BA 4 yrs, MAE
Tuition: Res—undergrad $1425 12-18 cr and fees, grad $144 per cr hr; nonres—undergrad $2688 12-18 cr and fees, grad $233 per cr hr; campus res—room & board $4468 per yr
Courses: †Art Education, †Art History, †Ceramics, Computer Graphics, †Drawing, Electronic Imaging, †Film, Graphic Design, Illustration, Industrial Design, Jewelry, Painting, Photography, Printmaking, Sculpture, Silversmithing, Video
Summer School: Dir, Michael J Cinelli. Enrl 15-20; 6 wk terms

MIDLAND

ARTS MIDLAND GALLERIES & SCHOOL, 1801 W St Andrews, Midland, MI 48640. Tel 517-631-3250; Fax 517-631-7890; Elec Mail winslow@mcfta.org; Internet Home Page Address: www.mcfta.org; *Dir* B B Winslow
Estab 1971; FT 15; pvt; D & E; SC 12-20, LC 2; D & E 250
Tuition: $85-$120 member-nonmember status
Courses: Aesthetics, Art Appreciation, Art History, Calligraphy, Ceramics, Collage, Conceptual Art, Constructions, Design, Drawing, History of Art & Architecture, Metalsmithing, Mixed Media, Museum Staff Training, Painting, Papermaking, Photography, Printmaking, Sculpture, Stained Glass, Textile Design, Weaving
Adult Hobby Classes: Enrl 200; tuition $85-$120 per sem
Children's Classes: Enrl 50; tuition $50-$65 per sem
Summer School: Schoof Coordr Armin Mersmann

NORTHWOOD UNIVERSITY, Alden B Dow Creativity Center, 4000 Whiting Dr, Midland, MI 48640-2398. Tel 989-837-4478; Fax 989-837-4468; Elec Mail creativity@northwood.edu; Internet Home Page Address: www.northwood.edu/abd; *Exec Dir* Dr Grover B Proctor Jr; *Asst Dir* Christianna Schartow
Estab 1978; Pvt; Scholarships, Fellowships

MONROE

MONROE COUNTY COMMUNITY COLLEGE, Humanities Division, 1555 S Raisinville Rd, Monroe, MI 48161. Tel 734-384-4153; Fax 734-384-4160; *Secy* Peggy Faunt; *Asst Prof Art* Theodore Vassar; *Asst Prof Art* Gary Wilson
FT 2
Degrees: AFA offered
Tuition: Res—$600 per sem; nonres—$81-89 per cr hr

Courses: Art Appreciation, Art History, †Art for Elementary Teachers, Ceramics, Design, Drawing, Illustration, Painting, Printmaking

MOUNT PLEASANT

CENTRAL MICHIGAN UNIVERSITY, Dept of Art, Wightman Hall, Rm 132, Mount Pleasant, MI 48859. Tel 989-774-3025; Fax 989-774-2278; Internet Home Page Address: www.art.cmich.edu; *Chmn Dept* Al Wildey
Estab 1892; Maintain a nonprofit art gallery; FT 17, PT 2; pub; D & E; Scholarships, Fellowships; SC 81, LC 27; for univ 19,800
Ent Req: HS dipl
Degrees: BA, BFA & BAA 4 yrs, MA, MFA
Tuition: Res—undergrad $108.15 per cr hr, grad $147.90 per cr hr; nonres—undergrad $280.70 per cr hr, grad $293.80 per cr hr
Courses: Aesthetics, Art Appreciation, Art Criticism, Art Education, Art History, Ceramics, Drawing, Fiber Design, Graphic Design, Jewelry, Metalsmithing, Painting, Photography, Printmaking, Sculpture

MUSKEGON

MUSKEGON COMMUNITY COLLEGE, Dept of Creative & Performing Arts, 221 S Quarterline Rd, Muskegon, MI 49442. Tel 231-773-9131, Ext 324; Fax 231-777-0255; Elec Mail tim.norris@muskegoncc.edu; Internet Home Page Address: www.muskegoncc.edu; *Dept Chmn* Richard Oman; *Prog Coordr* Tim Norris
Estab 1926; pub; D & E; Scholarships; SC 18, LC 6; D 280, E 60
Ent Req: HS dipl
Degrees: AA 2 yrs
Tuition: County res—$49 per cr hr; state res—$71 per cr hr; nonres—$87 per cr hr
Courses: Art Education, Art History, Beginning Art, Ceramics, Design, Drawing, Painting, Printmaking, Sculpture

OLIVET

OLIVET COLLEGE, Art Dept, 320 S Main, Olivet, MI 49076. Tel 616-749-7000; *Chmn* Gary Wertheimer, MFA; *Prof* Donald Rowe; *Instr* Susan Rowe, MFA
Estab 1844, dept estab 1870; pvt; D & E; Scholarships; SC 17, LC 8, GC 10; D 610, non-maj 50, maj 20, grad 2
Ent Req: HS dipl
Degrees: BS and BM 4 yrs, MA 1 yr
Tuition: $12,948 per yr, part-time $464 per hr; campus res—room & board $4252 per yr
Courses: Art History, †Commercial Art, †Design, †Drawing, †Painting, †Printmaking, †Sculpture

PETOSKEY

NORTH CENTRAL MICHIGAN COLLEGE, Art Dept, 1515 Howard St, Petoskey, MI 49770. Tel 231-348-6651, 348-6600; Fax 231-348-6628; *Chmn* Douglas Melvin, MA
Degrees: AA offered
Tuition: Res—$42 per cr hr; nonres—$55 per cr hr; out-of-state—$68 per cr hr
Courses: Art Education, Art History, Drawing, Painting, Photography, Printmaking, Sculpture, Stained Glass
Adult Hobby Classes: Courses offered
Summer School: Courses offered

PONTIAC

CREATIVE ART CENTER-NORTH OAKLAND COUNTY, 47 Williams St, Pontiac, MI 48341. Tel 248-333-7849; Fax 248-333-7841; Elec Mail createpont@aol.com; Internet Home Page Address: www.pontiac.mi.us/cac; *Exec Dir* Carol Paster; *Educ Coordr* Brenda Clay
Open Tues - Sat 10 AM - 5 PM, cl holidays; No admis fee; Estab 1964 to present the best in exhibitions, educational activities & community art outreach; non-profit community arts center serving adults & children with ongoing exhibits; Average Annual Attendance: 10,000; Mem: 160; dues organizations $50, family $40, general $35, artists & seniors $20; ann meeting in Apr; pub; D & E; Scholarships; SC 15; 200
Income: Financed by endowment, mem, city & state appropriation, trust funds, Mich Council for the Arts
Activities: Calsses for adults & children; lect open to the pub; 6 vis lectrs per year; concerts; extension program to local schools
Ent Req: open enrollment
Tuition: Varies; no campus res
Courses: Ceramics, Drawing, Painting, Photography, Sculpture
Children's Classes: Courses—Dance, Drawing, Music, Painting, Sculpture
Summer School: Three wk session. Courses—Creative Writing, Dance, Drama, Visual Arts

PORT HURON

SAINT CLAIR COUNTY COMMUNITY COLLEGE, Jack R Hennesey Art Dept, 323 Erie St, PO Box 5015 Port Huron, MI 48061-5015. Tel 810-984-3881; *VPres Acad Svcs* Anita Gliniecki; *Dept Chmn* David Korff; *Advertising Design Faculty* John Henry; *Theater* Nancy Osborn
Estab 1923; pub; D & E; Scholarships; SC 30, LC 5; D 60
Ent Req: HS dipl
Degrees: AA and AAS 2 yrs

Tuition: In-county—$59.50 per cr hr; out-of-county $87 per cr hr; nonres—$116.50 per cr hr
Courses: †Advertising Design, Art Appreciation, Art Education, Art History, Calligraphy, †Commercial Art, Costume Design & Construction, †Drafting, Drawing, Mixed Media, Painting, Photography, †Pottery, Printmaking, Sculpture, Stage Design, †Theatre Arts, Weaving
Adult Hobby Classes: Courses—Drawing, Painting, Pottery

ROCHESTER

OAKLAND UNIVERSITY, Dept of Art & Art History, Rochester, MI 48309-4401. Tel 248-370-3375; Internet Home Page Address: www.oakland.edu/art-history; *Chmn Dept* Janice G Schimmelman PhD; *Prof* John B Cameron PhD; *Prof* Susan Wood PhD; *Assoc Prof* Bonnie Abiko PhD; *Lectr* Lisa Ngote, MA; *Lectr* Paul Webster, MFA; *Gallery Dir & Special Instr* Stephen Goody, MFA; *Lectr* Lisa Baylis Ashby, MA; *Special Instr* Andrea Eis; *Asst Prof* Tamara Machmut-Jhashi
Estab 1957, dept estab 1960; FT & PT 12; pub; D & E; Scholarships; SC 3, LC 9
Ent Req: HS dipl
Degrees: BA 4 yrs
Tuition: Res—undergrad $122 - $134.40 per cr hr, grad $227 per cr hr; nonres—undergrad $356.65-384.20 per cr hr, grad $489.10 per cr hr; campus res—room & board single with meal plan $2831.50, double $2416.50
Courses: †Art History, Studio Art

SCOTTVILLE

WEST SHORE COMMUNITY COLLEGE, Division of Humanities & Fine Arts, 3000 N Stiles Rd, Scottville, MI 49454. Tel 231-845-6211; Internet Home Page Address: www.westshore.cc.mi.us; *Chmn* Sharon Bloom; *Assoc Prof* Rebecca Mott, MA; *Instr* Teresa Soles, MA; *Instr* Judy Peters, BA
Estab 1965; PT 3, FT 7; Pub; D & E; Scholarships; SC 18, LC 10; non-maj 250, maj 10
Ent Req: HS dipl
Degrees: AA 2 yrs
Courses: †Art History, Ceramics, Drafting, Drawing, Graphic Design, Mixed Media, Painting, Photography, Printmaking, Sculpture, Stage Design, †Theatre Arts
Adult Hobby Classes: Art Workshops & Studio, Crafts, Photography
Summer School: Painting, Pottery

SOUTHFIELD

LAWRENCE TECHNOLOGICAL UNIVERSITY, College of Architecture, 21000 W Ten Mile Rd, Southfield, MI 48075-1058. Tel 248-204-2800; Fax 248-204-2900; Internet Home Page Address: www.ltu.edu; *Asst Dean* Betty Lee Seydler-Hepworth; *Dean* Neville H Clouten
Estab 1932; Pvt; D&E
Degrees: BArchit, BA(Archit Illustration), BS(Archit), BS(Interior Archit)
Tuition: $362 per sem freshmen & sophomore, $362 per sem Jr & Sr
Courses: †Architecture, †Interior Architecture
Summer School: Dir, Harold Linton. Enrl 75; tuition $250. Courses—Pre-College Architecture

SPRING ARBOR

SPRING ARBOR COLLEGE, Art Dept, 106 E Main, Sta 19 Spring Arbor, MI 49283. Tel 517-750-1200, Ext 1364; Internet Home Page Address: www.arbor.edu; *Div Dir Music Arts* Bill Bippes, MFA; *Asst Prof* Roger Valand, MFA; *Dir* Paul Wolber, MA
Estab 1873, dept estab 1971; pvt den; D & E; Scholarships; SC 17, LC 6; D 200, E 20, non-maj 20, maj 32
Ent Req: HS dipl
Degrees: AA(Commercial) 2 yrs, BA 4 yrs
Tuition: $10,630 per sem, campus res—room & board $4190
Courses: †Advertising Design, Commercial Art, †Drawing, †Graphic Arts, †Illustration, †Painting, †Printmaking, †Sculpture, †Teacher Training

TRAVERSE CITY

NORTHWESTERN MICHIGAN COLLEGE, Art Dept, 1701 E Front St, Traverse City, MI 49686. Tel 231-922-1325; Fax 231-922-1696; Internet Home Page Address: www.nmc.edu; *Chmn Dept* Doug Domine, BFA; *Instr* Mike Torre, MA; *Instr* Jill Hinds, BFA; *Art Historian* Jackie Shinners, MFA
Estab 1951, dept estab 1957; FT 4, PT 12; pub; D & E; Scholarships; SC 40, LC 4; non-maj 400, maj 75
Ent Req: HS dipl
Degrees: AA 2 yrs, AAS
Tuition: $56 per billing hr per sem in-district, $93.25 per billing per sem in state $106 per billing per sem out-of-state; campus res room & board
Courses: Advertising Design, Art Education, Art History, Commercial Art, Drawing, Goldsmithing, Graphic Arts, Graphic Design, Illustration, Jewelry, Lettering, Life Drawing, Painting, Perspective, Photography, Pottery, Printmaking, Publication Design, Reproduction Techniques, Silversmithing, Typography
Adult Hobby Classes: Enrl 50; tuition $23. Courses - Drawing, Life Drawing, Painting, Pottery, Printmaking
Summer School: Dir, Stephen Ballance. Enrl 100 tuition $53 per billing hr in-district, $87.75 per billing hr other for 8 week terms. Courses—drawing, Photography, Pottery

TWIN LAKE

BLUE LAKE FINE ARTS CAMP, Art Dept, 300 E Crystal Lake Rd, Twin Lake, MI 49457. Tel 231-894-1966; Fax 231-893-5120; Internet Home Page Address: www.bluelake.org; *Chmn* Carol Tice; *Exec Asst* Lisa Martin
Estab 1966; Pub; Summer; Scholarships; Summer prog for middle and high school students
Tuition: $935 for 12 days & camp res
Courses: 2D-3D, Ceramics, Drawing, Fibre Arts, Illustration, Painting, Sculpture, Weaving, Wheel-Work
Adult Hobby Classes: Call for information

UNIVERSITY CENTER

DELTA COLLEGE, Art Dept, 1961 Delta Rd University Center, MI 48710. Tel 517-686-9000, Ext 9101; *Chmn Dept* Randal Crawford, MFA; *Prof* Larry Butcher, MA; *Prof* Linda Menger, MA; *Assoc Prof* John McCormick, MFA
Estab 1960; pub; D & E; Scholarships; SC 21, LC 5; D 550, E 100, maj 190
Ent Req: open door policy
Degrees: AA 2 yrs
Tuition: Res—in district $61.40 per cr hr, out of district $84 per cr hr; nonres—$120 per cr hr
Courses: Art Education, Art History, Ceramics, Commercial Art, Drawing, Graphic Design, Interior Design, Painting, Photography, Printmaking, Sculpture

SAGINAW VALLEY STATE UNIVERSITY, Dept of Art & Design, 7400 Bay Rd, University Center, MI 48710. Tel 517-790-4390; Elec Mail mzivich@svsu.edu; *Prof* Matthew Zivich, MFA; *Prof* Barron Hirsch, MFA; *Chmn Dept, Prof* Hideki Kihata, MFA; *Adjunct Instr* Sara B Clark, MFA; *Assoc Prof* Rodney Nowosielski; *Asst Prof* Shaun Bangert, MFA; *Asst Prof* Mike Mosher; *Instr* David Littell; *Instr* Craig Prime; *Instr* Terry Basmadjian; *Instr* Marlene Pellcrito
Estab 1960, dept estab 1968; Maintain nonprofit art gallery; University Gallery & Marshall Fredericks Sculpture Gallery; Pub; D & E; Scholarships; SC approx 20, LC approx 15; D 200, E 50, maj 65
Ent Req: HS dipl
Degrees: BA(Art), BFA 4 yrs or less
Tuition: Res—$105.05 per cr hr; nonres—$215.50 per cr hr
Courses: Advertising Design, Art Education, Art History, Ceramics, Commercial Art, Design, Drafting, Drawing, Graphic Arts, Graphic Design, Handicrafts, Illustration, Lettering, Occupational Therapy, Painting, Photography, Printmaking, Sculpture, Teacher Training, Theatre Arts
Summer School: Courses vary

WARREN

MACOMB COMMUNITY COLLEGE, Art Dept, Division of Humanities, 14500 E Twelve Mile Rd Warren, MI 48093. Tel 810-445-7000, 445-7354; *Prof* James Pallas, MFA; *Prof* David Barr, MA
Estab 1960, dept estab 1965; pvt; D & E; Scholarships; SC 14, LC 6
Ent Req: HS dipl, ent exam
Degrees: AA 2 yrs
Tuition: Res—in county $38 per hr, in state $61 per hr; nonres—$74 per hr
Courses: Art History, Ceramics, Design, Drawing, Painting, Photography, Sculpture

YPSILANTI

EASTERN MICHIGAN UNIVERSITY, Dept of Art, 114 Ford, Ypsilanti, MI 48197. Tel 734-487-1268, 487-0192; Fax 734-481-1095; Internet Home Page Address: www.art.acad.emich.edu; *Head Dept* Tom Venner
Estab 1849, dept estab 1901; pub; D & E; Scholarships; SC 55, LC 18; undergrad maj 420, non-maj 800, grad 100
Ent Req: HS dipl
Degrees: BA(Art History), BFA(Studio Art), BS & BA(Art Educ) 4 yrs, MA(Art Educ), MA(Studio) & MFA 2 yrs
Tuition: Undergrad $99 per cr, grad $105.50 per cr
Courses: Art Education, †Art History, †Ceramics, †Drawing, †Graphic Design, †Jewelry, †Painting, †Photography, †Printmaking, †Sculpture, †Textile Design
Children's Classes: Enrl 40; tuition $35 for 8-10 classes offered on Sat for Art talented & gifted
Summer School: Term of 7 1/2 wks, major & non-major courses

MINNESOTA

BEMIDJI

BEMIDJI STATE UNIVERSITY, Visual Arts Dept, 1500 Birchmont Dr, Bemidji, MN 56601. Tel 218-755-3735; Fax 218-755-4406; Internet Home Page Address: www.bemidjistate.edu; *Chmn* MaryAnn Papanek-Miller; *Prof* Kyle Crocker PhD; *Asst Prof* John Holden, MFA; *Asst Prof* Steve Sundahl, MFA; *Asst Prof* Jaineth Skinner, MFA; *Asst Prof* Carol Struve, MFA
Estab 1918; pub; D & E; Scholarships; SC 54, LC 17, GC individual study
Ent Req: HS dipl, ACT, SAT, PSAT, or SCAT
Degrees: BA, BS(Teaching) and BS(Tech Illustration, Commercial Design), BFA
Tuition: Res—undergrad $107 per sem, grad $65.80 per quarter hr; nonres—undergrad $209.70 per cr hr, grad $85.80 per quarter hr; campus residency available
Courses: Advertising Design, Art Appreciation, Art Education, Art History, Ceramics, Crafts, Design, Drawing, Graphic Arts, Graphic Design, Jewelry, Painting, Printmaking, Sculpture, Teacher Training

Adult Hobby Classes: Tuition res—$46.70 per qtr hr. Courses—Graphic Design, Elementary Art Concepts & Methods, Secondary Art Concepts & Methods
Summer School: Dir, M Kaul. Enrl 250; tuition res—undergrad $46.70 per qtr hr, nonres—undergrad $101.40 per qtr hr. Courses—Art, Ceramics, History, Metals, Painting, Printmaking, 3-D Design

BLOOMINGTON

NORMANDALE COMMUNITY COLLEGE, Art Dept, 9700 France Ave S, Bloomington, MN 55431. Tel 952-487-8143; Fax 952-487-8230; Internet Home Page Address: www.normandale.mncu.edu; *Instr* D R Peterson, BFA; *Instr* Marilyn Wood, MFA; *Art Coordr* Martha Wittstruck
Estab 1969; Pub; D&E
Degrees: AA
Tuition: $88.75 per cr
Courses: Art Appreciation, Art History, Ceramics, Design, Drawing, Jewelry, Painting, Photography, Sculpture
Adult Hobby Classes: Courses offered
Summer School: Courses offered

BROOKLYN PARK

NORTH HENNEPIN COMMUNITY COLLEGE, Art Dept, 7411 85th Ave N, Brooklyn Park, MN 55445. Tel 763-424-0702; Fax 763-493-0568; Elec Mail lance.kiland@nhcc.edu; Internet Home Page Address: www.nhcc.edu; *Instr* Lance Kiland; *Instr* Will Agar; *Instr* David Hebb; *Instr* Susan MacDonald; *Instr* Dan Mason; *Instr* Jane Bassuk; *Instr* Jerry Mathiason; *Instr* Steve Pauley
Estab 1964; Non-profit gallery: Joseph F Gazzuolo Gallery, North Hennepin Community College, 7411 85th Ave N Brooklyn, MN 55445; Art & Architecture Library: Learning Media Center.; FT 6; pub; D, E & Wknd; Scholarships; SC 15, LC 4; Total college enrollment: 8,751
Ent Req: HS dipl. ent exam
Degrees: AA , AS & AAS 2 yr
Tuition: Res $130.80 per cr; nonres—$233.40 per cr
Courses: 2-D & 3-D Design, Art History, Contemporary Crafts, Digital Photography, Drawing, Graphic Design, Illustration, Introduction to Art, Jewelry, Metalsmithing, Painting, Photography, Printmaking, Typography, Video, Visual Communications
Adult Hobby Classes: Enrl 28. Courses—Drawing, Jewelry, Painting, Quilt Making
Children's Classes: Enrl 20. Courses—Art Theatre, Computer, Language, Photography, Sports
Summer School: Enrl 28; tuition $234. Courses—Drawing, Introduction of Art, Photography

COLLEGEVILLE

SAINT JOHN'S UNIVERSITY, Art Dept, Box 2000, Collegeville, MN 56321. Tel 320-363-2011, 363-5036; Internet Home Page Address: www.csbsju.edu/; *Assoc Prof* James Hendershot, MFA; *Assoc Prof* Bro Alan Reed, MFA; *Assoc Prof* Sr Baulu Kuan, MFA; *Asst Prof* Andrea Shaker, MFA; *Prof* Dennis Frandrup, MFA; *Lectr* Susan Hendershot, MFA; *Instr* Anne Salisbury, PhD; *Lectr* James Rolle, BFA; *Lectr* Robert Wilde, MA
Estab 1856, joint studies with College of Saint Benedict; pvt; Scholarships; SC 20, LC 15
Ent Req: HS dipl
Degrees: BA, BS
Tuition: Approx $10,000 for all 4 yrs; campus res—room & board $4000
Courses: Art History, Ceramics, Drawing, Jewelry, Painting, Photography, Printmaking, Sculpture
Adult Hobby Classes: Occasional adult education classes

COON RAPIDS

ANOKA RAMSEY COMMUNITY COLLEGE, Art Dept, 11200 Mississippi Blvd NW, Coon Rapids, MN 55433. Tel 763-427-2600; Fax 612-422-3341; Internet Home Page Address: www.an.cc.mm.us; *Dean* Brenda Robert; *Instr* Robert E Toensing, MFA
Estab 1970; Pub; D&E; Scholarships
Degrees: AA offered
Tuition: $75 per cr hr
Courses: Advertising Design, Art Appreciation, Art Education, Ceramics, Design, Drawing, Film, Glassblowing, Jewelry, Painting, Photography, Sculpture

DULUTH

UNIVERSITY OF MINNESOTA, DULUTH, Art Dept, 317 Humanities Bldg, 10 University Dr Duluth, MN 55812. Tel 218-726-8225, 800-232-1339; Fax 218-726-6532; Elec Mail art@ub.d.umn.edu; Internet Home Page Address: www.d.umn.edu/art/; *Prof* Thomas F Hedin PhD, MFA; *Prof* Dean R Lettenstrom, MFA; *Assoc Prof* Robyn Roslak PhD, MA; *Prof* James Klueg, MFA; *Asst Prof* Robert Repinski, MFA; *Assoc Prof* Janice Kmetz, MFA; *Prof, Head Dept* Gloria D Brush, MFA; *Assoc Prof* Alyce Coker; *Assoc Prof* Sarah Bauer, MFA; *Asst Prof* Stephen Hilyard, MFA; *Asst Prof* Catherine Ishino, MFA; *Asst Prof* Alison Aune, PhD; *Asst Prof* Philip Choo; *Asst Prof* Eun-Kyung Suh
B; Pub; D & E; Scholarships, Fellowships; SC 30, LC 6, GC 10; D 200, E 50, maj 414, grad 3
Ent Req: HS dipl, HS rank & ACT req, col prep req
Degrees: BFA, BA 4 yrs, MFA in Graphic Design
Tuition: Averages $50 per cr hr; campus res available

Courses: †2D & 3D Digital Studios, Art Appreciation, Art Education, Art History, †Art in Technologies, Ceramics, Design, Drawing, Fibers, Graphic Design, †History of Art, †Interactive Design, Intermedia, Jewelry, Mixed Media, †Motion Graphics, Museum Staff Training, Painting, Photography, Printmaking, Sculpture, Silversmithing, †Studio Major, Teacher Training, †Typography, Weaving
Adult Hobby Classes: 10 wk courses. Courses—Studio Arts, Graphic Design
Summer School: Dir, Haren Heikel. 5 wk summer sessions. Courses—Art Appreciation, Art Education, Ceramics, Drawing, Graphic Design, Jewelry & Metals, Painting, Photography

ELY

VERMILION COMMUNITY COLLEGE, Art Dept, 1900 E Camp St, Ely, MN 55731. Tel 218-365-7273; Internet Home Page Address: www.vcc.edu; WATS 800-657-3608; *Instr* Chris Koivisto
Estab 1922, dept estab 1964; pub; D & E; SC 13, LC 5; D 63, E 15, non-maj 65, maj 13
Ent Req: HS dipl
Degrees: AA 2 yr
Tuition: $105 per cr
Courses: Art Appreciation, Art History, Ceramics, Drawing, Painting, Sculpture
Adult Hobby Classes: $105 per cr. Courses—Drawing, Introduction, Painting, Ceramics

FERGUS FALLS

LUTHERAN BRETHREN SCHOOLS, Art Dept, 815 W Vernon Ave, Fergus Falls, MN 56537. Tel 218-739-3371, 739-3376; *Head Dept* Gaylen Peterson
Estab 1900; den; D & E; SC 1, LC 1; D 20
Ent Req: HS dipl, questionnaire
Tuition: $1900 per sem; campus res—room & board $1000 per sem
Courses: Drawing

GRAND MARAIS

GRAND MARAIS ART COLONY, Grand Marais, MN 55604. Tel 218-387-1284; Fax 218-387-1395; Elec Mail arts@boreal.org; Internet Home Page Address: grandmaraisartcolony.org; *Faculty* Kelly Dupre; *Faculty* Hazel Belvo; *Faculty* Sharon Frykman; *Faculty* Steve Frykman; *Faculty* Naomi Hart; *Faculty* Karen Knutson; *Faculty* Susan Frame; *Instr* Joann Krause; *Instr* Jeanne Larson; *Faculty* Michaelin Otis
Estab 1947; D & E; Scholarships; SC 4; D 200
Ent Req: open
Tuition: $275 per wk
Courses: Drawing, Painting, Pastels, Personal Creativity
Adult Hobby Classes: Enrl 200; tuition same as above; 15 wks of 1 - 2 wk workshops. Courses—Drawing, Painting,
Children's Classes: Enrl 50; tuition $70 for 1 full wk. Courses—Drawing, Mixed Media, Painting
Summer School: Dir, Jay Andersen. Courses—Drawing, Painting, Watercolor

HIBBING

HIBBING COMMUNITY COLLEGE, Art Dept, 1515 E 25th St, Hibbing, MN 55746. Tel 218-262-6700; Internet Home Page Address: www.hcc.mnscu.edu; *Instr* Theresa Chudzik; *Instr* Bill Goodman
Pub; D&E; Scholarships
Degrees: AA & AAS 2 yrs
Tuition: Res—undergrad $81.75 per cr hr; non-res—undergrad $139 per cr hr
Courses: Art Appreciation, Ceramics, Design, Drawing, Introduction to Theatre, Painting, Photography, Sculpture, Stage Craft

MANKATO

BETHANY LUTHERAN COLLEGE, Art Dept, 700 Luther Dr, Mankato, MN 56001-6163. Tel 507-344-7000; Fax 507-344-7376; Internet Home Page Address: www.blc.edu; *Head of Dept* William Bukowski
Estab 1927, dept estab 1960; FT 2, PT 3; den; D; Scholarships; SC 2, LC 2; D 36, non-maj 40, maj 18
Ent Req: HS dipl, ACT
Degrees: AA 2 yr, dipl
Tuition: $10,000 tuition; room & board $3780
Courses: †3-D Design, Art Appreciation, Art History, Art Structure, Ceramics, †Computer Graphics, Design, Drawing, Painting, †Web Design
Summer School: Dir, William Bukowski. Enrl 20; tuition $130 for 2 wk - 1 1/2 days

MANKATO STATE UNIVERSITY, Art Dept, PO Box 8400, MSU Box 42 Mankato, MN 56002-8400. Tel 507-389-6412; Internet Home Page Address: www.mankato.ms.edu; WATS 507-389-5887; *Chmn* Roy Strassberg
Estab 1868, dept estab 1938; FT 15; pub; D & E; Scholarships; SC 42, LC 28, GC 54; D 3000 (total), E 500, non-maj 1000, maj 200, grad 25
Ent Req: HS dipl
Degrees: BA, BFA and BS 4 yr, MA and MS 1-1 1/2 yr
Tuition: Res—$59 per quarter hr, grad $85.10 per quarter hr; nonres—$129.25 per quarter hr
Courses: Art Education, Art History, Ceramics, Drawing, Fibers, Graphic Arts, Painting, Photography, Printmaking, Sculpture
Summer School: Tuition same as above

MINNEAPOLIS

ART INSTRUCTION SCHOOLS, Education Dept, 3400 Technology Dr., Minneapolis, MN 55418. Tel 612-362-5060; Elec Mail 612-info@artists-ais.com; Internet Home Page Address: www.artists-ais.edu; *Dir* Judith Turner
Estab 1914; pvt
Courses: Fundamentals of Art and Specialized Art
Adult Hobby Classes: Enrl 5000; tuition $1495 - $2000. Courses—Fundamentals of Art, Specialized Art

AUGSBURG COLLEGE, Art Dept, 2211 Riverside Ave, Minneapolis, MN 55454. Tel 612-330-1285; Fax 612-330-1649; Elec Mail anderso3@augsburg.edu; *Chmn* Kristin Anderson
Estab 1869, dept estab 1960; FT 3, PT 4; den; D & E; Scholarships; SC 15, LC 6; D 200, maj 60, others 1500
Ent Req: HS dipl
Degrees: BA 4 yrs
Tuition: $7235 per sem; campus res—room & board $4022
Courses: Art Education, Art History, Calligraphy, Ceramics, Communications Design, Drawing, Environmental Design, Handicrafts, History of Art & Architecture, Painting, Photography, Sculpture, Stage Design, Teacher Training, Theatre Arts
Adult Hobby Classes: Enrl 1200; tuition $780 per course. Courses—Art History, Calligraphy, Ceramics, Communications Design, Drawing, Environmental Design, Painting, Publication Design
Summer School: Enrl 350; term of six or four wks beginning end of May

MINNEAPOLIS COLLEGE OF ART & DESIGN, 2501 Stevens Ave S, Minneapolis, MN 55404. Tel 612-874-3700, 874-3754; Fax 612-874-3704; Internet Home Page Address: www.mcad.edu; *Liberal Arts* Mary McDunn, MA; *Dean Studio Programs* Thomas De Biaso, MFA; *Dir Continuing Studies* Brenda Grachek, BA; *Pres* Michael O'Keefed, MS; *Acting Chair Fine Arts* Howard Quednau, MFA; *Dir Graduate & Post Baccalaureate Programs* Carole Fisher, MFA; *Chair, Media Arts* Vince Leo, MA; *Dean of Liberal Studies* Mary McDunn, MA; *Chair, Design* Kali Nikitas, MFA; *Chair, BS: Visualization* Lester Shen, PhD
Estab 1886; FT 32, PT 609; pvt; D & E; Scholarships; SC 82, LC 60, GC 3; D 670, E 325, maj 620, grad 30
Ent Req: HS dipl or GED
Degrees: BS & BFA 4 yr, MFA
Tuition: $21,300 annual tuition off campus, $25,000 annual tuition on campus
Courses: †Advertising Design, †Animation, †Art History, †Comic Art, Computer Graphics, †Critical Studies, †Design Theory & Methods, †Drawing, †Film, †Furniture Design, †Graphic Arts, †Graphic Design, †Illustration, †Interactive Media, Liberal Arts, Packaging & Product Design, †Painting, Performance Arts, †Photography, †Printmaking, Screen Printing, †Sculpture, Video, †Visualization
Adult Hobby Classes: Continuing Studies
Children's Classes: Courses offered
Summer School: Dir of Continuing Studies Brenda Grachek. Enrl 485; tuition $533 per cr; Courses—Drawing, Graphic Design, History of Art & Design, Liberal Arts, Painting, Papermaking, Photography, Printmaking, Sculpture, Video, Furniture Design, Illustration, Comic Arts, Computer Courses, Women's Art Inst

UNIVERSITY OF MINNESOTA, MINNEAPOLIS
—**Art History,** Tel 612-624-4500; Fax 612-626-8679; Elec Mail arthist@umn.edu; Internet Home Page Address: http://www.arthist.umn.edu; *Prof* Frederick Asher PhD; *Prof* Gabriel P Weisberg, PhD; *Prof* Frederick A Cooper; *Prof* Sheila J McNally; *Prof* Karal Ann Marling, PhD; *Prof* Robert Poor, PhD; *Assoc Prof* John Steyaert, PhD; *Assoc Prof* Robert Silberman, PhD; *Assoc Prof* Catherine Asher, PhD; *Asst Prof* Jane Blocker, PhD; *Asst Prof* Michael Gaudio; *Chmn* Steven Ostrow, PhD
An on-campus shop where art supplies may be purchased; Pub; D & E; Scholarships, Fellowships; LC 28, GC 59; res 108 per quarter, nonres 216 per quarter, maj 68, grad 52
Ent Req: HS dipl, ent exam, GRE required for grad school
Degrees: BA 4 yrs, MA 2 yrs, PhD
Tuition: Res—undergrad $5420 per yr, grad $6800 per yr; nonres—$15,993.98 per yr, grad $13,359 per yr
Courses: †Art History, †Film, †History of Art & Archeology
Adult Hobby Classes: Enrl 200; sem system. Courses—Ancient & Modern Art History, Asian Art History
Summer School: Dir, Steven Ostrow. Enrl 270; tuition $46 per cr for terms June 11 - July 16 & July 18 - Aug 21
—**Dept of Art,** Tel 612-625-8096; Fax 612-625-7881; Elec Mail artdept@tc.umn.edu; Internet Home Page Address: http://artdept.umn.edu; *Chmn Dept* Clarence Morgan, MFA; *Prof* Karl Bethke, MFA; *Prof* Curtis Hoard, MFA; *Prof* Thomas Rose, MA; *Prof* Mary Diane Katsiaficas, MFA; *Prof* Clarence Morgan, MFA; *Assoc Prof* Thomas Cowette, BFA; *Assoc Prof* David Feinberg, MFA; *Assoc Prof* Gary Hallman, MFA; *Assoc Prof* Lynn Gray, MFA; *Assoc Prof* James Henkel, MFA; *Assoc Prof* Guy Baldwin, MFA; *Assoc Prof* Jerald Krepps, MFA; *Assoc Prof* Thomas Lane, MFA; *Assoc Prof* Susan Lucey, MFA; *Assoc Prof* Marjorie Franklin, MFA; *Assoc Prof* Joyce Lyon, MFA; *Assoc Prof* Alexis Kuhr, MFA; *Assoc Prof* Wayne Potratz, MA; *Asst Prof* Christine Arle Baumler, MFA; *Asst Prof* Margaret Bohls, MFA; *Asst Prof* Lynn Lukkas, MFA; *Asst Prof* Ryuta Wakajima, MFA
Estab 1851, fine arts estab 1939; pub; D & E; Scholarships; SC 39, LC 7; D 1000, E 560, maj 325, grad 55
Ent Req: HS dipl, PSAT, ACT
Degrees: BA, BFA, MFA
Tuition: Res—undergrad $$256.85 per credit, grad $681.17 per credit; nonres—undergrad $704.16 per credit; grad $1272.84 per credit
Courses: Ceramics, Critical Theory, Drawing, Electronic Art, Neon, Painting, Papermaking, Photography, Printmaking, Sculpture, Silkscreening
Adult Hobby Classes: Tuition $425 for 4 cr for 10 wk term. Courses—same as above
Children's Classes: Summers Honors College for HS students

Summer School: Dir, Carol Ann Dickinson. Enrl 20; tuition $500 for June 16 - July 2 term. Courses—same as above
—**Split Rock Arts Program,** Tel 612-625-8100; 624-5314; Fax 612-624-6210; Elec Mail srap@cce.umn.edu; Internet Home Page Address: www.cce.umn.edu/splitrockarts; *Dir* Andrea Gilats; *Prog Assoc* Vivien Oja
Estab 1984; Scholarships
Publications: Split Rock Arts Program catalog, annually
Activities: Enrl 550; tuition $410 per wk. Courses_Creativity Enhancement, Creative Writing, Fine Crafts, Visual Arts
Tuition: $540 plus; campus res—$180-$516 per wk
Courses: Basketry, Beadworking, Bookmaking, †Ceramics, †Collage, Creativity Enhancement Fabric Art, †Design, †Drawing, †Fashion Arts, †Handicrafts, †Jewelry, †Mixed Media, †Painting, †Printmaking, Quiltmaking, †Sculpture, †Textile Design, †Weaving

MOORHEAD

CONCORDIA COLLEGE, Art Dept, 901 S Eighth, Moorhead, MN 56562. Tel 218-299-4623; Fax 218-299-4256, 299-3947; *Assoc Prof* David Boggs, MFA; *Asst Prof* Heidi Allen, MFA; *Asst Prof* Robert Meadows-Rogers PhD, MFA; *Asst Prof* Susan Pierson Ellingson PhD, MFA; *Instr* Barbara Anderson, MA; *Instr* John Borge, BA; *Prof* Duane Mickelson, MFA; *Asst Prof* Ross Hilgers; *Chair* Robert Meadows Rogers, PhD
Estab 1891; den; D&E; Scholarships; SC 10, LC 5; D 300, maj 80, total 2900
Ent Req: HS dipl, character references
Degrees: BA and BM 4 yrs, independent studio work, work-study prog and special studies
Tuition: $14,400 per yr, $7900 per sem, student association dues $80; campus res—room $1600 & board $2200
Courses: 2-D Foundations, 3-D Foundations, †Art Education, †Art History, Ceramics, Drawing, Figure Drawing, Graphic Design, Macintosh Computer Design Lab, Painting, Photography, Printmaking, Sculpture, Senior Project, †Studio Art
Summer School: Enrl 40; tuition $1200 for term of 4 wks beginning May 15 & June 12. Courses—Art Education, Art History, Drawing, Graphic Design, Painting, Printmaking, Travel Seminar, 2-D Foundation

MINNESOTA STATE UNIVERSITY-MOORHEAD, (Moorhead State University) Dept of Art, Dille Center for the Arts 161, 1104 Seventh Ave S Moorhead, MN 56563. Tel 218-477-2151; 477-2152; Fax 218-477-5039; Internet Home Page Address: www.mnstate.edu; *Prof* Allen Sheets, MFA; *Asst Prof* Anna Arnar, PhD; *Prof* Carl Oltvedt, MFA; *Asst Prof* Chris Walla, MFA; *Asst Prof* Jim Park, MFA; *Assoc Prof* Donald Clark, MFA; *Assoc Prof* Zhimin Guan, MFA; *Asst Prof* Maryann Hosseinnia, MFA; *Asst Prof* Sherry Short, MFA; *Assoc Prof* Wil Shynkaruk, MFA
Estab 1887; Maintian a nonprofit art gallery, Roland Dille Center for the Arts Gallery, MSUM Campus; Pub; D & E; Scholarships; SC 47, LC 20; D 7,500, maj 400
Ent Req: HS dipl
Degrees: BA, BS, BFA
Tuition: Res—undergrad—$162.94 per cr hr; nonres—uundergrad—$162.94 per cr hr
Courses: †Art Appreciation, Art Education, Art History, Ceramics, †Design, Drawing, Graphic Design, †History of Art & Architecture, Illustration, Painting, Photography, Printmaking, Sculpture, Teacher Training

MORRIS

UNIVERSITY OF MINNESOTA, MORRIS, Humanities Division, 600 E Fourth St, Morris, MN 56267. Tel 320-589-2211, 589-6251; *Chmn* Frederick Peterson PhD
Estab 1960, dept estab 1963; pub; D; Scholarships; SC 16, LC 8; D 195, non-maj 150, maj 45
Ent Req: top 50% in HS, ACT or PSAT
Degrees: BA 4 yrs
Tuition: Res—undergrad $167.75 per cr, $5000 per qtr; non res—undergrad $4000 per qtr; campus res—room & board $4000 per qtr
Courses: †Art History, †Studio Art, Teacher Training

NORTH MANKATO

SOUTH CENTRAL TECHNICAL COLLEGE, Commercial & Technical Art Dept, 1920 Lee Blvd, North Mankato, MN 56003. Tel 507-389-7200; Internet Home Page Address: www.sctc.mnscu.edu; *Instr* Kevin McLaughin; *Instr* Robert Williams
Estab 1969; FT 2; pub; D; Scholarships; D 20
Ent Req: portfolio
Degrees: AA 2 yr
Tuition: $80 per cr hr
Courses: Advertising Design, Calligraphy, Commercial Art, Conceptual Art, Desktop Publishing, Drafting, Drawing, Fashion Arts, Graphic Arts, Graphic Design, Illustration, Lettering, Mixed Media, Multi-Media, †Web Page Design

NORTHFIELD

CARLETON COLLEGE, Dept of Art & Art History, One N College St, Northfield, MN 55057. Tel 507-646-4341, 646-4000 (main); *Chmn* Alison Kettering
Estab 1921; pvt; Scholarships; SC 30, LC 20; maj 42, others 550
Degrees: 4 yr
Tuition: $29,702 (comprehensive)
Courses: †Art History, †Studio Art

SAINT OLAF COLLEGE, Art Dept, 1520 Saint Olaf Ave, Northfield, MN 55057-1098. Tel 507-646-3248, 646-3025; Fax 507-646-3332; Internet Home Page Address: www.stolaf.edu; *Chmn* Urve Dell; *Museum Dir* Jill Ewald; *Prof* Malcolm Gimse, MFA; *Assoc Prof* Jan Shoger, MFA; *Assoc Prof* Meg Ojala, MFA; *Assoc Prof* Ron Gallas, MFA; *Assoc Prof* Mary Griep, MFA; *Assoc Prof* Mathew Rohn, MFA; *Asst Prof* Steve Edwins, MFA; *Asst Prof* John Saurer, MFA; *Asst Prof* Judy Yourman, MFA; *Instr* Don Bratland, MFA
Estab 1875, dept estab 1932; den; D & E; Scholarships
Ent Req: HS dipl, SAT
Degrees: BA 4 yr
Tuition: $21,280 yr; campus res—$80 per yr
Courses: Advertising Design, Aesthetics, †Animation, †Architecture, Art Appreciation, †Art Education, †Art History, †Art Studio, Ceramics, Commercial Art, Conceptual Art, Design, Drafting, Drawing, Film, Graphic Arts, Graphic Design, History of Art & Architecture, Illustration, Interior Design, Intermedia, Landscape Architecture, Mixed Media, Painting, Photography, Printmaking, Sculpture, Stage Design, Teacher Training, Theatre Arts, Video
Adult Hobby Classes: Dir, Heidi Quiram, Acadamic Outreach. Enrl 300; two 5 wk sessions. Courses—Art History, Studio
Summer School: Dir, Susan Hammerski. Enrl 300; two 5 wk sessions. Courses—Art History, Studio

ROCHESTER

ROCHESTER COMMUNITY & TECHNICAL COLLEGE, Art Dept, 851 30th Ave SE, Rochester, MN 55904-4999. Tel 507-285-7215 (Pres), 285-7210 (main); Internet Home Page Address: www.roch.edu; *Instr* Terry Richardson, MS; *Instr* Pat Kraemer, MS; *Instr* Terry Dennis, MS
Estab 1920s; pub; D & E; Scholarships; SC 17, LC 4; D & E 4000, maj 50
Ent Req: state req
Degrees: AAS and AA
Tuition: Res—$46.95 tuition & fees; nonres—$88.55 except in reciprocal states
Courses: Advertising Design, Art Appreciation, Art History, †Ceramics, Craft Design Series, Design, †Drawing, Fibers, †Graphic Design, Interior Design, Jewelry, †Painting, Photography, Printmaking, Sculpture, Stage Design, Theatre Arts, Weaving
Adult Hobby Classes: All areas, cr & non cr for variable tuition. Courses—Cartooning, & others on less regular basis
Summer School: Dir, A Olson. Art workshops are offered for at least one session each summer

SAINT CLOUD

SAINT CLOUD STATE UNIVERSITY, Dept of Art, 720 Fourth Ave S, KVAC Rm 101 Saint Cloud, MN 56301. Tel 320-308-4283; Fax 320-308-2232; Elec Mail art@stcloudstate.edu; Internet Home Page Address: www.stcloudstate.edu/~art; *Chair* David Sebberson
Estab 1869; FT 13, PT 6; Pub; D & E; SC 65, LC 15, GC 20; maj 350, grad 5
Ent Req: HS dipl
Degrees: BA, BFA, BS, MA(Studio Art) 4 yrs
Tuition: Res—undergrad $152.55 per cr hr
Courses: Art Education, Art History, Ceramics, Design, Drawing, Graphic Design, Painting, Photography, Printmaking, Sculpture, Teacher Training
Summer School: Two terms

SAINT JOSEPH

COLLEGE OF SAINT BENEDICT, Art Dept, 37 S College Ave, Saint Joseph, MN 56374. Tel 320-363-5011; Internet Home Page Address: www.csbjsu.edu; *Assoc Prof* Sr Baulu Kuan, MA; *Assoc Prof* James Hendershot, MA; *Asst Prof* Andrea Shaker, MFA; *Instr* Robert Wilde, MFA; *Chmn* Sr Dennis Frandrup
Estab 1913; joint studies with St John's University, Collegeville, MN; pvt; D & E; Scholarships; SC 21, LC 15; D 1893, maj 70
Ent Req: HS dipl, SAT, PSAT, ACT
Degrees: BA(Art) & BA(Art History) 4 yr, internships & open studio
Tuition: $22,500 per yr
Courses: †Art History, †Ceramics, †Drawing, Jewelry, Mixed Media, †Painting, †Photography, †Printmaking, †Sculpture

SAINT PAUL

BETHEL COLLEGE, Dept of Art, 3900 Bethel Dr, Saint Paul, MN 55112. Tel 651-638-6400; Fax 651-638-6001; Internet Home Page Address: www.bethelcollege.edu; *Prof* Wayne L Roosa PhD; *Prof* Stewart Luckman, MFA; *Prof* George Robinson, BFA; *Prof* Dale R Johnson, MFA; *Assoc Prof* Karen Berg-Johnson, MFA; *Assoc Prof* Kirk Freeman, MFA
Estab 1871; FT 6; den; D & E; Scholarships; SC 30, LC 7; non-maj 100, maj 75
Ent Req: HS dipl, SAT, ACT, PSAT or NMSQT, evidence of a standard of faith & practice that is compatible to Bethel lifestyle
Degrees: BA(Art Educ), BA(Art History) & BA(Studio Arts) 4 yr
Tuition: $16,780 per sem; campus res—room $2,960; $22,740 per year
Courses: 2-D Design, 3-D Design, †Art Education, †Art History, †Ceramics, †Drawing, †Graphic Design, †Painting, †Photography, †Printmaking, †Sculpture

COLLEGE OF SAINT CATHERINE, Art & Art History Dept, 2004 Randolph, Saint Paul, MN 55105. Tel 651-690-6636, 690-6000; Internet Home Page Address: www.stkate.edu; *Chmn* Jan Czecholwski
Dept estab 1915; FT 3, PT 5; Pvt, W; D; Scholarships; 65
Ent Req: HS dipl
Degrees: BA(Art) 4 yr
Tuition: $510 per cr hr, $21,000 per yr

Courses: Art & Technology, Art Appreciation, Art Education, Art History, Ceramics, Drawing, Graphic Arts, Graphic Design, Illustration, Jewelry, Mixed Media, Museum Staff Training, Painting, Photography, Pottery, Printmaking, Publication Design, Sculpture, †Studio Art, Typography, Women in Art
Adult Hobby Classes: Special Workshops
Summer School: Enrl 30. Courses—Art Education, Art History, Art Studio

COLLEGE OF VISUAL ARTS, 344 Summit Ave, Saint Paul, MN 55102. Tel 651-224-3416; Fax 651-224-8854; Internet Home Page Address: www.cva.edu; *Prof* Maria Santiago, MFA; *Acad Dean* Karen Wirth, MFA; *Chmn Commercial Design* John DuFresne, MFA; *Asst Prof* Julie L'Enfant, MFA; *Asst Prof* Susan Short, MFA; *Chmn Fine Arts* Valerie Jenkins, MFA; *Asst Prof* Linda Rossi, MFA; *Instr* Paul Bruski, MFA; *Prof* Philip Ogle, MFA
Estab 1924; pvt; D; Scholarships; SC 30, LC 8; D 260, maj 134
Ent Req: HS dipl, portfolio, essay
Degrees: BFA 4 yr
Tuition: $9970 per yr
Courses: †Advertising Design, Aesthetics, Art Appreciation, Art History, Commercial Art, Conceptual Art, Design, †Drawing, Graphic Design, †History of Art & Architecture, Illustration, Lettering, Mixed Media, Painting, Photography, Printmaking, Sculpture, Typography
Children's Classes: Enrl 230; tuition $95-$250 for 1-2 wks. Courses—Summer Kids Art Adventure, Summer Teen Visual Arts Sampler
Summer School: Enrl 30; tuition $800. Courses—Art History, Computer Design, Fine Arts, Graphic Design, Liberal Arts, Photography

CONCORDIA COLLEGE, Art Dept, Fine Arts Division, 275 N Syndicate St Saint Paul, MN 55104. Tel 651-641-8743; Fax 651-654-0207; Internet Home Page Address: www.cst.edu; *Prof* Karla Ness; *Chmn* Keith Williams
Estab 1897, dept estab 1967; den; D & E; Scholarships; SC 14, LC 3; D 84, E 20, others 35
Ent Req: HS dipl
Degrees: BS and BA 4 yrs
Tuition: $1525 per qtr
Courses: Aesthetics, Art Education, Art History, Ceramics, Drawing, Jewelry, Painting, Photography, Printmaking, Sculpture, Teacher Training, Theatre Arts
Summer School: Courses—Art Educ Methods, Art Fundamentals

HAMLINE UNIVERSITY, Dept of Art & Art History, Saint Paul, MN 55104. Tel 651-523-2296; Fax 651-523-3066; Internet Home Page Address: www.hamline.edu/depts/art/; *Head Dept* Leonardo Lasansky, MFA; *Prof* Michael Price, MFA; *Assoc Prof* Michele Bassett PhD, MFA; *Asst Prof* Barbara Kreft, MFA; *Vis Asst Prof* Jean Noel Guermonporez, MFA; *Vis Asst Prof* Sarah Heimann, MFA; Vis Asst Prof Andrew Wykes MFA
Estab 1854; pvt; D & E; Scholarships; SC 18, LC 7; non-maj 70, maj 35
Ent Req: HS dipl
Degrees: BA 4 yrs
Tuition: $16,050 per yr; campus res—room & board $5,681 per yr
Courses: Art Education, †Art History, †Ceramics, Design, Drawing, Museum Staff Training, †Painting, †Printmaking, †Sculpture
Summer School: Dean, Garvin Davenport

MACALESTER COLLEGE, Art Dept, 1600 Grand Ave, Saint Paul, MN 55105. Tel 651-696-6279; Fax 651-696-6266; Elec Mail godollei@macalester.edu; Internet Home Page Address: www.macalester.edu; *Prof, Chair* Donald Celender; *Prof* Ruthann Godollei; *Assoc Prof* Stanton Sears; *Asst Prof* Christine Willcox; *Instr* Amy DiGennaro; *Instr* Gary Erickson; *Instr* Mary Hark
Estab 1946; Maintain nonprofit art gallery on campus; pvt; D; Scholarships; SC 16, LC 13; Maj 20
Degrees: BA(Art) 4 yrs
Tuition: Res—undergrad $23,604 per yr; campus res—room & board $6,516 per yr
Courses: 20th Century Art, American Art, Art of the Last Ten Years, Ceramics, Classical Art, Design, Drawing, Far Eastern Art, Fibers, Mural Painting, Painting, Principles Art, Printmaking, Renaissance Art, Sculpture, Senior Seminar, Tribal Art, Women in Art

UNIVERSITY OF MINNESOTA, Dept of Design, Housing & Apparel, 1985 Buford Ave, Saint Paul, MN; 240 McNeal Hall, Saint Paul, MN 55108-6136. Tel 612-624-9700; Fax 612-624-2750; Internet Home Page Address: www.umn.edu; *Head Dept* Dr Becky L Yust
Dept estab 1851; Pub; D & E; SC 57, LC 54, GC 25; D 877 (spring quarter 92), grad 75
Ent Req: HS dipl; math requirement
Degrees: BS, MS, MA & PhD 4 yr
Tuition: Res—undergrad lower division $76.45 per cr, upper division $86.65 per cr, grad $705 per 3 cr hr; nonres—undergrad lower division $1359 per 3 cr hr, upper division $255.60
Courses: †Applied Design, Art History, †Costume Design & Construction, Costume History, Decorative Arts, Drawing, Handicrafts, †Housing, †Interior Design, †Retail Merchandising, Textile Design, †Textiles Clothing, Weaving Off-Loom
Summer School: Courses—vary each yr

UNIVERSITY OF SAINT THOMAS, Dept of Art History, 2115 Summit Ave, Loras Hall, Mail 57P Saint Paul, MN 55105-1096. Tel 651-962-5560, 962-5000; Fax 651-962-5861; Elec Mail setocke@stthomas.edu; Internet Home Page Address: www.stthomas.edu; *Prof* Susan V Webster; *Prof* Mark Stansbury O'Donnell; *Prof* Victoria Young; *Prof* Craig Ellason; *Prof* Cynthia Becker; *Prof* Shelly Nordtorp-Madson
Estab 1885, dept estab 1978; FT 6 PT 2; Pvt; D & E; Scholarships; SC 25, LC 8; D 2847, E 275, maj 40
Ent Req: HS dipl
Degrees: BA 4 yrs
Tuition: $1508 full sem cr
Courses: Art Education, †Art History, Calligraphy, Ceramics, Drawing, Graphic Arts, Graphic Design, Jewelry, Painting, Photography, Printmaking, Sculpture, Teacher Training

Summer School: Dir, Dr Susan Webster

SAINT PETER

GUSTAVUS ADOLPHUS COLLEGE, Art & Art History Dept, Schaefer Fine Arts Ctr, 800 W College Ave Saint Peter, MN 56082-1498. Tel 507-933-8000, 933-7019; Internet Home Page Address: www.gustavus.edu; *Chmn* Linnea Wren
Estab 1876; FT 8, PT 2; den; D; Scholarships; SC 27; 2300 total, 750 art, maj 50
Ent Req: HS grad, ent exam
Degrees: BA 4 yr
Tuition: $18,940 per yr (comprehensive fee); PT $1400 per course; room & board $4,900
Courses: Art Appreciation, †Art Education, †Art History, Basic Design, Bronze Casting, Ceramics, Design, Drawing, Painting, Photography, Printmaking, Sculpture, †Studio Art, Teacher Training
Summer School: Independent Study prog for three 4 wk periods during June, July or Aug

WHITE BEAR LAKE

CENTURY COLLEGE, Humanities Dept, 3300 Century Ave N, White Bear Lake, MN 55110. Tel 651-779-3200; Fax 651-779-3417; Internet Home Page Address: www.cedntury.edu; *Instr* Mel Sundby; *Instr* Karin McGinness; *Chmn* Kenneth Maeckelbergh; *Instr* Dawn Saks; *Instr* Larry Vienneau; *Instr* Mary Aspness
Estab 1968; Maintains Century College Art Gallery on campus; pub; D,E & Sat; Scholarships; SC 20, LC 8; D 75, E 30
Degrees: AA
Tuition: Res—$95.76 per sem cr; nonres—$181.41 per sem cr
Courses: American Art, Art Appreciation, Art History, Art Therapy, Calligraphy, Ceramics, Design, Drawing, Film, Graphic Arts, Graphic Design, Interior Design, Lettering, Painting, Photography, Theatre Arts, Video
Adult Hobby Classes: Enrl 6000; tuition varies. 39 courses offered
Children's Classes: Enrl 500; tuition under $100 each course. 30 courses offered
Summer School: Dean Sue Ehlers. Tuition $181.41 per cr

WILLMAR

RIDGEWATER COLLEGE, Art Dept, 2101 15th Ave NW, PO Box 1097 Willmar, MN 56201. Tel 320-231-5102, 231-5132; Fax 320-231-6602; Internet Home Page Address: www.ridgewater.mnscu.edu; *Chmn Art Dept & Coordr Art Gallery* Robert Mattson
Estab 1962-63; pub; D & E; SC 8, LC 3; D 50, maj 15
Ent Req: HS dipl
Degrees: AA & AS 2 yrs
Tuition: $74.40 per sem cr
Courses: Art Education, Ceramics, Display, Drawing, Graphic Arts, Graphic Design, History of Art & Architecture, Introduction to Studio Practices, Painting, Structure, Teacher Training
Adult Hobby Classes: Courses—Ceramics, Design, History of Art, Painting

WINONA

SAINT MARY'S UNIVERSITY OF MINNESOTA, Art & Design Dept, 700 Terrace Heights, Winona, MN 55987. Tel 507-457-1593; Fax 507-457-6967; Internet Home Page Address: www.smumn.edu; WATS 800-635-5987; *Prof* Margaret Mear, MFA; *Prof* Roderick Robertson, MFA; *Chair* Preston Lawing; *Prof* Robert McCall; *Instr* Michelle Cochran; *Instr* Charles Campbell; *Instr* John Whelan
Estab 1912, dept estab 1970; Nonprofit - Lillian Davis Hogan Galleries, 700 Terrace Heights, Winona, MN 55987; Den; D; Scholarships; SC 20, LC 6; in school D 1,390
Ent Req: HS dipl
Degrees: BA 4 yrs
Tuition: $9,630 per yr; campus res—room & board $1,900 per yr
Courses: Art Appreciation, Art History, Ceramics, Computer Design, Design, Drawing, †Electronic Publishing, †Graphic Design, Illustration, Painting, Photography, Printmaking, Sculpture, †Studio Arts, Theatre Arts

WINONA STATE UNIVERSITY, Dept of Art, Winona, MN 55987. Tel 507-457-5395; Fax 507-457-5086; *Prof* Judy Schlawin, MS; *Assoc Prof* Don Schmidlapp, MFA
Estab 1860; pub; D & E; Scholarships
Degrees: BA and BS
Tuition: Res—undergrad $43 per cr hr; nonres—undergrad $95 per cr hr; plus student fees; campus res—room & board $3745 per yr single occupancy
Courses: Art Education, Art History, Ceramics, Drawing, Graphic Design, Interior Design, Lettering, Painting, Printmaking, Sculpture, Weaving
Summer School: Courses offered

MISSISSIPPI

BLUE MOUNTAIN

BLUE MOUNTAIN COLLEGE, Art Dept, Box 296, Blue Mountain, MS 38610. Tel 662-685-4771, Ext 162; Internet Home Page Address: www.bmc.edu; *Chmn Dept* William Dowdy, MA
Estab 1873, dept estab 1875; FT 2; den; D & E; Scholarships; SC 16, LC 2; D 28, E 12, non-maj 20, maj 8, others 12
Ent Req: HS dipl

Degrees: BA & BS(Educ) 4 yr
Tuition: $3050 per sem, $1450 room & board
Courses: Art History, Commercial Art, Drawing, Painting
Adult Hobby Classes: Enrl 12; tuition $42 per sem hr. Courses—Drawing, Painting
Summer School: Dir, William Dowdy. Enrl 20

BOONEVILLE

NORTHEAST MISSISSIPPI JUNIOR COLLEGE, Art Dept, 101 Cunningham, Booneville, MS 38829. Tel 662-728-7751, Ext 229; Internet Home Page Address: www.necc.cc.ms.us; *Instr* Terry Anderson; *Instr* Judy Tucci; *Chmn* Jerry Rains; *Chair Visual Arts* Marty McLendon
Estab 1948; Anderson Hall Art Gallery; FT 3, PT 1; pub; D & E; Scholarships; SC 6, LC 3; D 2800, maj 30
Ent Req: HS dipl, ent exam
Degrees: 2 yr Associate degrees in art educ, fine arts and interior design
Tuition: res—$648 per sem; nonres—$1508 per sem; foreign countries—$1608 per sem
Courses: Advertising Design, Aesthetics, Art Education, Art History, Ceramics, Design, Drafting, Drawing, Painting, Teacher Training, Theatre Arts
Adult Hobby Classes: Watercolor

CLARKSDALE

COAHOMA COMMUNITY COLLEGE, Art Education & Fine Arts Dept, 3240 Friars Pt Rd, Clarksdale, MS 38614. Tel 662-627-2571, Ext 208; *Chmn* Henry Dorsey
Degrees: AA
Tuition: In district—$700 per yr; res—$2511.70 per yr; outside district $1100 per yr; outside state $2100 per yr; out of district boarding $2911.70 per yr, out of state boarding $3911.70 per yr
Courses: Art Appreciation, Art Education, Art History, Drawing, Handicrafts, Intro to Art
Adult Hobby Classes: Enrl 15-32; tuition $27.50 per sem hr. Courses—Art & Music Appreciation

CLEVELAND

DELTA STATE UNIVERSITY, Dept of Art, PO Box D-2, Cleveland, MS 38733. Tel 662-846-4720; Internet Home Page Address: www.deltast.edu; *Chmn* Collier B Parker; *Prof* William Carey Lester Jr, MFA; *Prof* Ron Koehler, MFA; *Asst Prof* Kim Rushing, BFA; *Asst Prof* Marcella Small, BFA; *Asst Prof* Margaret Rutledge, BFA; *Asst Prof* Patricia L Brown, BFA; *Instr* Molly Rushing, BFA; *Asst Prof* Joe Abide, BFA; *Assoc Prof* Katheryn Lewis; *Instr* Allison Melton
Estab 1924; Maintain nonprofit art gallery; Fielding Wright Art Gallery; FT 10 PT 2; pub; D & E; Scholarships; SC 42, LC 10, GC 30; maj 160
Ent Req: HS dipl
Degrees: BA & BFA
Tuition: Res—$5686 per year; commuter—$2696
Courses: †Advertising Design, Aesthetics, †Art Education, Art History, Ceramics, Clay, †Commercial Art, Computer Graphics, Drawing, Fibers, Graphic Arts, †Graphic Design, Illustration, †Interior Design, Lettering, Mixed Media, †Painting, Printmaking, †Sculpture, Teacher Training, Textile Design
Summer School: Tuition & living expenses $488 per term, June 2 - July 3 or July 7 - August 8. Courses—Art for Elementary, Ceramics, Drawing, Internship in Commercial Design, Introduction to Art, Painting, Sculpture

CLINTON

MISSISSIPPI COLLEGE, Art Dept, PO Box 4020, Clinton, MS 39058. Tel 601-925-3231; Fax 601-925-3926; Internet Home Page Address: www.mc.edu/campus/academics/arts; *Head Art Dept* Randy B Miley
Estab 1825, dept estab 1950; FT 5, PT 1; den; HS grad; Scholarships, Assistantships; SC 22, LC 3; maj 80, others 300
Ent Req: HS diploma, BA, BS, BE(Art), MA(Art) and ME(Art) 4 yr, Freshman Art merit
Tuition: Undergrad $320 per cr hr, grad $330 per cr hr
Courses: †Art Education, Art History, Ceramics, Drawing, Foundry Casting, †Graphic Design, †Interior Design, †Painting, †Sculpture
Adult Hobby Classes: Enrl 50; tuition $35 for 5 weeks. Courses—Calligraphy, Drawing, Flower Arranging, Painting
Summer School: Dir, Dr Miley. Tuition $1200 for two 6-wk terms. Courses—Ceramics, Drawing, Painting, Printmaking

COLUMBUS

MISSISSIPPI UNIVERSITY FOR WOMEN, Division of Fine & Performing Arts, PO Box W-70 MUW, Columbus, MS 39701. Tel 662-329-7341; Internet Home Page Address: www.muw.edu/fine_arts/; *Head Dept* Dr Michael Garrett; *Prof* David Frank; *Prof* Thomas Nawrocki, MFA; *Prof* Lawrence Feeny, MFA; *Asst Prof* Robert Gibson, MFA; *Asst Prof* John Alford, MFA
Estab 1884; FT 8, PT 3; pub; D & E; Scholarships; SC 49, LC 8; D 263, E 39, non-maj 45, maj 72
Ent Req: HS dipl, ACT, SAT
Degrees: BA, BS and BFA 4 yrs
Tuition: Res—undergrad $1119.50 per sem; nonres—undergrad $2228 per sem
Courses: Architectual Construction & Materials, †Art Education, Art History, Calligraphy, Ceramics, Commercial Art, Conceptual Art, Graphic Design, Illustration, †Interior Design, Lettering, †Metal Art, Mixed Media, †Painting, Photography, †Printmaking, Sculpture, Stage Design, Teacher Training, †Theatre Arts, Weaving

Adult Hobby Classes: Enrl 45; tuition $25 per hr. Courses—Drawing, Painting, Weaving

Summer School: Tuition $66 per hr for term of 5 wks beginning June 1 & July 6. Courses—Vary according to demand

DECATUR

EAST CENTRAL COMMUNITY COLLEGE, Art Dept, PO Box AA, Decatur, MS 39327. Tel 601-635-2121; Elec Mail bguraedy@eccc.cc.ms.us; Internet Home Page Address: eccc.cc.ms.us; *Head Dept* J Bruce Guraedy, MEd; *Art Instr* Todd Eldridge
Estab 1928, dept estab 1965; pub; D, E & Sat; Scholarships; SC 10, LC 8; D 175, E 70, non-maj 100, maj 10
Ent Req: HS dipl, GED
Degrees: AA and AS 2 yrs
Tuition: Res—$3000 per yr, $1500 per sem; nonres—$6700 per yr, $1850 per sem; campus res available
Courses: Advertising Design, Art Appreciation, Art Education, Art History, Ceramics, Collage, Design, Drafting, Drawing, Fashion Arts, Handicrafts, Illustration, Industrial Design, Interior Design, Landscape Architecture, Mixed Media, Painting, Printmaking, Sculpture, Stage Design, Theatre Arts
Adult Hobby Classes: Enrl 15; tuition $100 per sem for 10 wks.
Courses—Beginning Painting, Drawing, Painting
Children's Classes: Kid's College & pvt lessons available
Summer School: Vice Pres of Continuing Educ, Gene Davis. Enrl 300 - 400; tuition $50 per sem hr for term of 10 wks. Courses—vary according to student demand

ELLISVILLE

JONES COUNTY JUNIOR COLLEGE, Art Dept, 900 S Court St, Ellisville, MS 39437. Tel 601-477-4148, 477-4000; Fax 601-477-4017; *Chmn Fine Arts* Jeff Brown
Estab 1927; pub; D; Scholarships; SC 12, LC 4; D 100, E 12, maj 15, others 12
Ent Req: HS dipl
Degrees: AA 2 yrs
Tuition: $60 per cr hr; $64 per cr hr
Adult Hobby Classes: Enrl 20. Courses—Painting
Summer School: Term of 4 wks beginning June. Courses—same as regular session

GAUTIER

MISSISSIPPI GULF COAST COMMUNITY COLLEGE-JACKSON COUNTY CAMPUS, Art Dept, PO Box 100, Gautier, MS 39553. Tel 228-497-9602; *Chmn Fine Arts Dept* Johnnie Gray, MA; *Instr (2-D)* Mary Hardy, MA; *Instr (3-D)* Kevin Turner
Maintains nonprofit gallery, MGCCC/Jackson County Campus Fine Arts Gallery P.O. Box 100, Gautier MS 39553; Pub; D & E; Scholarships; SC 9, LC 2; D 90, E 8, non-maj 62, maj 28
Degrees: AA, 2 yrs
Tuition: Res—$65 per credit
Courses: †3-D Design, Art Appreciation, Art Education, †Art for Elementary Teachers, Ceramics, Design, Drawing, Painting, Sculpture

HATTIESBURG

UNIVERSITY OF SOUTHERN MISSISSIPPI, Dept of Art & Design, College of the Arts, USM Hattiesburg, MS 39406. Tel 601-266-6028, 266-4972; Fax 601-266-6379; Elec Mail susan.fitzsimmons@usm.edu; Internet Home Page Address: www.arts.usm.edu; *Chair & Assoc Prof* Susan Fitzsimmons; *Prof* William Baggett Jr, MFA; *Prof* James Meade Jr, MFA; *Asst Prof* Cheryl Goggin PhD, MFA; *Asst Prof* John House, MFA; *Asst Prof* Janet Gorzegno, MFA; *Asst Prof* Deanna Douglas, MFA; *Asst Prof* Dr Carley Causey; *Asst Prof* Christopher Wubbena; *Asst Prof* Claire Hamilton
Estab 1910; Maintain a nonprofit art gallery, USM Museum of Art, also maintain an art/architecture library; on-campus shop where art supplies may be purchased and Barnes & Noble book store; FT 11, PT 3; pub; D & E; Scholarships; SC 64, LC 41, GC 34; non-maj 35, maj 120, grad 5
Ent Req: HS dipl
Degrees: BA, BFA, MAE, MFA
Tuition: Res—undergrad—$1,485 per yr full time; non—res— $1,964 per yr; campus residency available
Courses: Art Education, Ceramics, Drawing, Graphic Design, Interior Design, Mixed Media, Painting, Photography, Printmaking, Sculpture, Teacher Training
Adult Hobby Classes: Enrl 20-50; 16 wk sem. Courses—Ceramics, Drawing, Painting, Sculpture
Children's Classes: Classes offered by Office of Lifelong Learning. Courses—Painting
Summer School: Dir, Jerry Walden. Enrl 60; 5 & 10 wk sessions. Courses—as above

ITTA BENA

MISSISSIPPI VALLEY STATE UNIVERSITY, Fine Arts Dept, 14000 Hwy 82 W, Ste 7255, Itta Bena, MS 38941-1400. Tel 662-254-3482; Elec Mail lhorn@musu.edu; Internet Home Page Address: www.mvsu.edu.com; *Co-Gallery Dir* Dorothy Vaughn; *Co-Dir Gallery* Ronald Minks; *Acting Head* Lawrence Horn; *Assoc Prof Art* Frank Hardmon; *Asst Prof Art* Charles Davis
Estab 1952; SC 8, LC 2; pub; D & E
Ent Req: HS dipl

Degrees: BA & BS
Tuition: Res—undergrad $2094.50 per sem; out-of-state—$3074.50
Courses: 2 & 3-D Design, African American Art History, Art Appreciation, Art History, Arts & Crafts, Ceramics, Color Fundamentals, Commercial Art, Drawing, Graphic Arts, Illustration, Painting, Photography, Printmaking, Public School Art, Typography, Visual Communications
Summer School: Courses—Art Appreciation, Public School Art

JACKSON

BELHAVEN COLLEGE, Art Dept, 1500 Peachtree St, Jackson, MS 39202. Tel 601-968-5950; Fax 601-968-9998; Elec Mail mhause@belhaven.edu; Internet Home Page Address: belhaven.edu; *Asst Prof Art* William Morse; *Asst Prof Art History* Melissa Hause; *Asst Prof of Art* Nate Theisen; *Instr* Gretchen Haien; *Instr* Sam Beibers
Estab 1883, dept estab 1889; Maintain nonprofit art gallery, Bessie Cary Lemly Gallery, Belhaven College, 1500 Peachtree St., Jackson, MS 39202; den; D & E; Scholarships; SC 6; D 650, E 200, maj 30
Ent Req: HS dipl
Degrees: BA
Tuition: $5,790 (12 - 16 semester hours)
Courses: Aesthetics, Art Appreciation, Art Education, Art History, Design, Drawing, Graphic Design, Painting, Photography, Printmaking, Sculpture

JACKSON STATE UNIVERSITY, Dept of Art, 1400 John R Lynch St, Jackson, MS 39217-0280. Tel 601-979-2040; Fax 601-968-7010; Elec Mail liberalarts@jsums.edu; Internet Home Page Address: www.jsums.edu; *Chmn* John M Sullivan; *Assoc Prof* Hyun Chong Kim; *Assoc Prof* Charles W Carraway; *Assoc Prof* Lealan Swanson
Estab 1949; Maintain nonprofit art gallery; pub; D; Scholarships; SC 16, LC 7, GC 1; D 486, maj 57
Ent Req: HS dipl
Degrees: BA & BS(maj in Art) 4 yrs
Tuition: $118 per cr hr 1-11 hrs; $1920 per sem 12-19 hrs; campus res available
Courses: Art History, Ceramics, Commercial Art, Drawing, Graphic Arts, Painting, Studio Crafts
Adult Hobby Classes: Athenian Art Club activities
Children's Classes: Enrl 75; tuition $100. Courses—General Art
Summer School: Dir, B Graves. Enrl 3000; tuition $100. Courses—Art Education, Painting

MILLSAPS COLLEGE, Dept of Art, 1701 N State St, Jackson, MS 39210. Tel 601-974-1000, 974-1432; Internet Home Page Address: www.millsaps.edu; *Chmn* Elise Smith, MFA; *Asst Prof* Collin Asmus, MA; *Instr* Kay Holloway, MFA; *Instr* Sandra Smithson; *Instr* Steven Jones
Estab 1913, dept estab 1970; priv; D & E; Scholarships; LC 4; non maj 100, maj 20
Ent Req: HS dipl, SAT combined 1100 average
Degrees: BA 4 yr
Tuition: $6830 per sem; campus res—room & board $6000
Courses: Aesthetics, Architecture, Art History, Calligraphy, Ceramics, Design, Drawing, History of Art & Architecture, Lettering, Museum Staff Training, Painting, Photography, Printmaking, Sculpture, Stage Design, Teacher Training, Textile Design, Theatre Arts, Weaving
Adult Hobby Classes: Tuition $35 per class
Children's Classes: Limited courses

LORMAN

ALCORN STATE UNIVERSITY, Dept of Fine Arts, 1000 ASU Dr, No 29, Lorman, MS 39096-7500. Tel 601-877-6271, 877-6100; Fax 601-877-6262; *Instr* John Buchanan; *Chmn* Joyce Bolden PhD
Estab 1871, dept estab 1973; pub; D & E; SC 9, LC 3
Ent Req: HS dipl, ACT
Tuition: Res—$1194.50 per yr; nonres—$2445.50; meals—res $2309; nonres—$3560 per sem
Courses: Art Appreciation, Art Education, Ceramics, Drawing, Painting
Adult Hobby Classes: Drawing, Graduate Level Art Education, Painting
Summer School: Enrl 40 for term of 10 wks beginning May 28. Courses—Art Education, Fine Arts

MISSISSIPPI STATE

MISSISSIPPI STATE UNIVERSITY, Dept of Art, PO Box 5182, Mississippi State, MS 39762. Tel 662-325-2970, 325-2323 (main), 325-2224 (admis), 325-6900 (art dept); Fax 662-325-3850; Elec Mail da@ra.msstate.edu; Internet Home Page Address: http://www.msstate.edu/Dept/Art/index.html; *Head* Kay DeMarsche, MFA; *Prof* Brent Funderburk, MFA; *Prof* Marita Gootee, MFA; *Prof* Robert Long, MFA; *Prof* Jamie Mixon, MFA; *Prof* Linda Seckinger, MFA; *Assoc Prof* Tim McCourt, MFA; *Assoc Prof* Soon Ee Ngoh, MFA; *Assoc Prof* Jeffrey Haupt, MFA; *Assoc Prof* Patrick Miller, MFA; *Asst Prof* Jamie Runnells, MFA; *Asst Prof* Angi Bourgeois, PhD; *Asst Prof* Ben Harvey; *Asst Prof* Kate Bingaman, MFA; *Lectr* Jennifer Pagliaro, MFA; *Lectr* Marc Poole, MFA; *Instr* Marc Cowardin, MFA; *Instr* Bill Andrews, MFA
Estab 1879, dept estab 1971; aintains nonprofit art gallery, Dept of Art Gallery, PO Box 5182, MS State, MS 39762; Pub; D&E; Scholarships; SC 80, LC 30; D 750, non-maj 650, maj 250
Ent Req: HS dipl
Degrees: BFA 4-5 yrs
Tuition: In-state $3,000; out-state $7,000; campus res—room & board $2,065.50 per yr
Courses: Art History, Ceramics, Drawing, †Fine Art, †Graphic Design, Painting, Photography, Printmaking, Sculpture

Adult Hobby Classes: Enrl 40; tuition $1,700 per yr. Courses—Drawing, Fundamentals, Painting

MOORHEAD

MISSISSIPPI DELTA COMMUNITY COLLEGE, Dept of Fine Arts, Hwy 3 & Cherry St, Moorhead, MS 38761; PO Box 668, Moorhead, MS 38761. Tel 662-246-6322; Fax 662-246-6321; Internet Home Page Address: www.mdcc.cc.ms.us; *Coordr* Wallace Mallette; *Coordr* Cindy Ray; *Chmn* Simone Strawbridge; *Instr* Nancy Stone-Street
Estab 1926; pub; D & E; Scholarships; SC 11, LC 2; D 68, E 29, maj 28
Ent Req: HS dipl, ent exam
Degrees: AA 2 yrs
Tuition: Res—undergrad $3784 per yr
Courses: Advertising Design, Art Appreciation, Art Education, Art History, Ceramics, Design, Drawing, Graphic Arts, Painting, Printmaking, Sculpture, Stage Design, Theatre Arts
Adult Hobby Classes: Enrl 29. Courses—Ceramics, Painting

POPLARVILLE

PEARL RIVER COMMUNITY COLLEGE, Visual Arts, Dept of Fine Arts & Communication, Sta A, PO Box 5007, 101 Highway 11 N Poplarville, MS 39470. Tel 601-403-1000; Elec Mail cnull@prcc.edu; Internet Home Page Address: www.prcc.edu; *Chmn* James A Rawls; *Instr* Charleen A Null; *Instr* Art Anna Holsten
Estab 1921; FT 1, PT 2; pub; D & E; Scholarships; SC 4, LC 2; D 85 - 100, non-maj 65 - 75, maj 20 - 25, E 20 - 40, non-maj 20 - 30, maj 10 - 20
Ent Req: HS dipl or ACT Score & GED
Degrees: AA
Tuition: Res—$760 per sem; out of state $1345; campus res available
Courses: Art Appreciation, Art Education, Art History, Calligraphy, Design, Drafting, Drawing, Elementary Art Education, Handicrafts, Interior Design, Introduction to Art, Painting, Photography, Teacher Training

RAYMOND

HINDS COMMUNITY COLLEGE, Dept of Art, 505 E Main St, Raymond, MS 39154-1100. Tel 601-857-3275; Fax 601-857-3392; Elec Mail info@hindscc.edu; Internet Home Page Address: www.hindscc.edu; *Chmn* Gayle McCarty; *Instr* Jimmy Tillotson; *Instr* Paula Duren; *Instr* Randy Minton
Estab 1917; Maintain nonprofit art gallery; Marie Hull Gallery, Art Department, Hinds Community College, Raymond, MS 39154-1100; FT 4; pub; D & E; Scholarships; SC 6, LC 2; D 400, E 75, maj 60
Degrees: AA 2 yr
Tuition: Res—$830 per sem (12-19 hrs), nonres—$1,933 per sem (12-19 hrs); campus res available
Courses: Art Appreciation, Art Education, Art History, Ceramics, Commercial Art, †Computer Art, Design, Drawing, Graphic Arts, Graphic Design, Landscape Architecture, Painting, Photography
Adult Hobby Classes: Courses offered
Summer School: Dir, Gayle McCarty. Enrl 24; tuition $165 for 8 wk term. Courses—Art Appreciation

UNIVERSITY

UNIVERSITY OF MISSISSIPPI, Department of Art, 116 Meek Hall, University, MS 38677. Tel 662-915-7193 (art dept); Fax 662-915-5013; Elec Mail art@olemiss.edu; Internet Home Page Address: www.olemiss.edu/depts/art; *Assoc Prof* Tom Dewey II, PhD, MA; *Prof* Paula Temple, MFA; *Assoc Prof* Betty Crouther PhD, MFA; *Prof* Aileen Ajootian PhD, MA; *Chair & Prof* Nancy Wicker, PhD; *Prof* Jan Murray, MFA; *Assoc Prof* Sheri Rieth, MFA; *Asst Prof* Virginia Chavis; *Asst Prof* Matt Long; *Asst Prof* Brooke White; *Asst Prof* Durant Thompson
Dept estab 1949; Maintains a nonprofit art gallery; FT 11, PT 13; pub; D&E; online; Scholarships, Financial aid; SC 470, LC 265, GC 48; D 735, non-maj 350, maj 265, grad 13
Ent Req: HS dipl
Degrees: BA 4 yr, BFA 4 yr, MFA 2 yr
Tuition: Res—undergrad $2,302 per sem; campus res—room $800-$966
Courses: †Art History, †Ceramics, Drawing, †Graphic Design, †Painting, †Printmaking, †Sculpture
Summer School: Two 4 wk sessions beginning June. Courses—Art History, Drawing, Painting

MISSOURI

BOLIVAR

SOUTHWEST BAPTIST UNIVERSITY, Art Dept, 1600 University Dr, Bolivar, MO 65613. Tel 417-326-1651, 328-1605; *Chmn* Wesley A Gott, MFA; *Adjunct Prof* Diane Callahan, BFA; *Asst Prof* John Gruber, MFA; *Adjunct Prof* Sandra Maupin, MA
Sch estab 1879; dept estab 1974; Maintains nonprofit gallery, Driskill Art Gallery, 1600 University Ave Bolivar, MO 65613; Den; D & E; Scholarships; SC 30, LC 3; D 150, E 20, maj 35
Ent Req: HS dipl
Degrees: BS, BA, MS, MBA & MPT
Tuition: Res & nonres—undergrad $5,000 per yr; campus res—room & board $3,100 per academic yr

Courses: †Art Education, Art History, †Ceramics, †Commercial Art, Costume Design & Construction, †Drawing, †Graphic Arts, Graphic Design, †Painting, †Photography, †Printmaking, †Sculpture, Stage Design, †Teacher Training, Theatre Arts
Adult Hobby Classes: Enrl 10; per hr for 15 weeks. Courses—Drawing, Painting, Photography
Summer School: Enrl 600; Dir Dr Bill Brown, Dean of Music, Arts & Letters, 4 wk term beginning in June, also a 4 wk term beginning in July. Courses—Internships

CANTON

CULVER-STOCKTON COLLEGE, Art Dept, 1 College Hill Canton, MO 63435-1299. Tel 217-231-6367, 231-6368; Fax 217-231-6611; Elec Mail croyer@culver.edu, jjorgen@culver.edu; Internet Home Page Address: www.culver.edu/; *Assoc Prof* Joseph Jorgensen; *Prof* Gary Thomas
Estab 1853; pvt; D; Scholarships; SC 16, LC 6; 1030, maj 40
Ent Req: HS dipl, ACT or Col Board Ent Exam
Degrees: BFA & BA(Visual Arts), BS(Art Educ) & BS(Arts Management) 4 yrs
Tuition: $595 per cr hr
Courses: †Art Education, Art History, †Ceramics, Design, Drawing, †Graphic Design, Illustration, †Painting, †Photography, Printmaking, †Sculpture, Teacher Training
Summer School: Reg, Barbara Conover. Tuition $150 per cr hr. Courses—Various studio workshops

CAPE GIRARDEAU

SOUTHEAST MISSOURI STATE UNIVERSITY, Dept of Art, One University Plaza, Art Bldg 306, Mail Stop 4500 Cape Girardeau, MO 63701. Tel 573-651-2143, 651-2000; Internet Home Page Address: www.smsu.edu; *Prof & Interim Chmn* Ron Clayton; *Assoc Prof* Lane Fabrick; *Assoc Prof* Pat Reagan; *Asst Prof* Louise Bodenheimer
Estab 1873, dept estab 1920; FT11; pub; D & E; Scholarships; SC 28, LC 10, GC 18; D 1300
Ent Req: HS dipl
Degrees: BS, BS(Educ) & BA 4 yrs, MAT
Tuition: Res—undergrad $203 per cr hr
Courses: 3-D Design, Advertising Design, Art History, Ceramics, Color Composition, Commercial Art, Design Foundation, Drawing, Fiber, Graphic Design, Illustration, Lettering, Painting, Perceptive Art, Printmaking, Screen Printing, Sculpture, Silversmithing, Typography, Video Art Graphic

COLUMBIA

COLUMBIA COLLEGE, Art Dept, 1001 Rogers, Columbia, MO 65216. Tel 573-875-8700; Fax 573-875-7209; Internet Home Page Address: www.ccis.edu; *Instr* Sidney Larson, MA; *Instr* Ben Cameron, MA; *Instr* Richard Baumann, MFA; *Instr* Michael Sledd, MFA; *Chmn* Tom Watson; *Instr Painting* Jodie Garrison; *Instr Photography & Ceramics* Ed Collings
Estab 1851; FT 5, PT 2; den; D; Scholarships; SC 55, LC 13; D 180, non-maj 80, maj 115
Ent Req: HS dipl or equivalent, ACT or SAT, also accept transfer students
Degrees: AA 2 yrs, BA, BS and BFA 4 yrs
Tuition: Res—$3583 per sem; nonres—$5201
Courses: Art History, Ceramics, Drawing, Fashion Arts, Graphic Arts, Graphic Design, Illustration, Painting, Photography
Adult Hobby Classes: Enrl 15; tuition $75 per cr. Courses—Arts & Crafts, Photography
Summer School: Evening Studies Dir, Dr John Hendricks. Enrl 20; tuition $75 per cr hr

STEPHENS COLLEGE, Art Dept, 1200 E Broadway, Columbia, MO 65215. Tel 573-442-2211, Exten 4363; Elec Mail jterry@stephens.edu; Internet Home Page Address: www.stephens.edu; *Instr* Robert Friedman; *Chair* Dr James H Terry; *Instr* Lillian Sung
Estab 1833, dept estab 1850; Maintain nonprofit art gallery; Davis Art Gallery; art supplies available on-campus; Pvt; D & E; Scholarships; SC 20, LC 11; D 450, maj 5, others 10
Ent Req: SAT or ACT, recommendations, interview
Degrees: BA 3-4 yrs, BFA 3 1/2-4 yrs
Tuition: $16,715 per yr; campus res—room & board $5,540
Courses: Advertising Design, Art Education, Art History, Ceramics, Commercial Art, Costume Design & Construction, Drawing, †Fashion Arts, Film, Graphic Arts, †Graphic Design, History of Art & Architecture, Illustration, Occupational Therapy, †Painting, †Photography, †Printmaking, †Sculpture, Stage Design, Teacher Training, †Theatre Arts, †Video
Children's Classes: Tuition $900 per yr; Stephens Child Study Center, grades K-3, preschool; includes special creative arts emphasis

UNIVERSITY OF MISSOURI
—Art Dept, Tel 573-882-3555; Fax 314-884-6807; Internet Home Page Address: www.missouri.edu; *Chmn* Jean Brueggenjohann
Estab 1901, dept estab 1912; FT 13, PT 2; pub; D & E; Scholarships; SC 76, LC 1, GC 53; non-maj 1600 per sem, maj 214, grad 19
Ent Req: HS dipl
Degrees: BA, BFA, MFA, MeD, PhD, EDD
Tuition: Res—undergrad $128.50 per cr hr, grad $162.60 per cr hr; nonres—undergrad $384.10 per cr hr, grad $489.10 per cr hr
Courses: Ceramics, Design, Drawing, Fibers, Graphic Design, Introduction to Art, Painting, Photography, Printmaking, Sculpture

Summer School: Chmn, Oliver A Schuchard. Enrl 175; tuition $161 for term of 8 wks beginning June 12. Courses—Art Education, Ceramics, Design, Drawing, Fibers, Intro to Art, Jewelry, Painting, Photography, Printmaking, Sculpture, Watercolor

—**Art History & Archaeology Dept,** Tel 573-882-6711; Fax 573-884-5269; Internet Home Page Address: www.missouri.edu; *Prof Emeritus* Osmund Overby PhD; *Prof* Norman Land PhD; *Prof* William R Biers PhD; *Prof* Patricia Crown PhD; *Prof* Anne Rudloff Stanton PhD; *Asst Prof* John Klein PhD; *Chmn* Marcus Rautman
Estab 1839, dept estab 1892; pub; D; Scholarships; LC 42, GC 18; maj 48, grad 39
Ent Req: HS dipl, SAT, GRE for grad students
Degrees: BA 4 yrs, MA 2-3 yrs, PhD 4 yrs
Tuition: Res—grad $103 per cr hr; nonres—grad $288 per cr hr; campus res available
Courses: Art History, Classical Archaeology, Historic Preservation, History of Art & Archeology
Summer School: Courses offered

FERGUSON

SAINT LOUIS COMMUNITY COLLEGE AT FLORISSANT VALLEY, Liberal Arts Division, 3400 Pershall Rd, Ferguson, MO 63135. Tel 314-513-4375; Fax 314-513-2086; *(Acting) Chmn Div* Carol Berger; *Prof* Kim Mosley; *Assoc Prof* Jim Gormley; *Assoc Prof* John Ortbals; *Assoc Prof* Larry Byers; *Assoc Prof* Chris Licata; *Assoc Prof* Bob Langnas; *Assoc Prof* Eric Shultis; *Instructor II* Janice Nesser-Chu
Estab 1962; Maintains nonprofit gallery, St. Louis Community College at Florissant Valley, 3400 Pershall Rd, St Louis 63135; FT10; pub; D & E; Scholarships; SC 36, LC 4; maj 70
Activities: Art supplies available at on-campus store
Ent Req: HS dipl, ent exam
Degrees: AA, AFA 2 yr, AAS 2 yr
Tuition: District res—$72, non district res—$93, non state res—$128, instructional—$138
Courses: Advertising Design, Air Brush, Art Appreciation, Art History, Ceramics, Commercial Art, Design, Drawing, Electronic Certificate, Graphic Design, Illustration, Lettering, Painting, Photography, Printmaking, Sculpture, Silversmithing, Transfer Art, Typography, Video
Adult Hobby Classes: variable - through continuing educ div
Summer School: Enrl 270; tuition $20.50 per cr hr for term beginning June 9. Courses—Design, Drawing, Figure Drawing, Lettering, Painting

FULTON

WILLIAM WOODS-WESTMINSTER COLLEGES, Art Dept, 200 W 12th, Fulton, MO 65251. Tel 573-592-4367; Fax 573-592-1623; Internet Home Page Address: www.williamwoods.edu; *Chmn* Paul Clervi; *Instr* Terry Martin, MA; *Instr* Tina Mann, MA; *Instr* Bob Elliott, MA; *Instr* Ken Greene, BA; *Instr* Jane Mudd; *Instr* Greig Thompson; *Instr* Dr Aimee Sapp; *Instr* Joe Potter
Estab 1870; Maintain nonprofit art gallery; Mildred M Cox Gallery, One Univ Ave, Fulton, MO 65251; Pvt; D & E; Scholarships; SC 54, LC 6; maj 100
Ent Req: HS dipl, SAT or ACT
Degrees: BA, BS & BFA 4 yr
Tuition: Res—$13,500 per yr; $19,100 incl room & board
Courses: Advertising Design, Aesthetics, Art Appreciation, Art Education, Art History, Art Therapy, Ceramics, Collage, Commercial Art, Costume Design & Construction, Design, Drawing, Film, Goldsmithing, Graphic Arts, Graphic Design, Handicrafts, History of Art & Architecture, Illustration, Interior Design, Jewelry, Painting, Photography, Printmaking, Sculpture, Silversmithing, Stage Design, Teacher Training, Theatre Arts, Video, Weaving

HANNIBAL

HANNIBAL LA GRANGE COLLEGE, Art Dept, 2800 Palmyra, Hannibal, MO 63401. Tel 573-221-3675; *Instr* Bill Krehmeier; *Instr* Dorothy Hahn; *Chmn* Robin Stone
Scholarships
Degrees: AA, BA(Art)
Tuition: $4425 per sem (12-17 hrs)
Courses: Advertising Design, Art Appreciation, Art Education, Art History, Calligraphy, Cartooning, Ceramics, Commercial Art, Design, Drawing, Handicrafts, Lettering, Mixed Media, Painting, Photography, Printmaking, Sculpture, Textile Design
Summer School: Dean, Dr Woodrow Burt. Term 2-4 wk & one 8 wk. Courses—vary

JEFFERSON CITY

LINCOLN UNIVERSITY, Dept Fine Arts, 820 Chestnut St, Jefferson City, MO 65102-0029. Tel 573-681-5280; Internet Home Page Address: www.lincolnu.edu/finearts; *Asst Prof* Cheryl Unterschulz; *Prof* James Tatum; *Asst Prof* Dr. Jesse Whitehead; *Asst Prof* Cynthia Byler
Estab 1927; FT 3, PT 4; pub; D&E; Scholarships; maj 50, others 100
Ent Req: HS dipl
Degrees: BS(Art) & BS(Art Educ) 4 yr
Tuition: Res—undergrad $92 per cr hr
Courses: Applied Art, Art Education, Art History, Studio Art, Teacher Training
Summer School: Courses—same as above

JOPLIN

MISSOURI SOUTHERN STATE UNIVERSITY, Dept of Art, 3950 Newman Rd, Joplin, MO 64801. Tel 417-625-9563; Fax 417-625-3046; Elec Mail

kyle-n@mail.mssc.edu; Internet Home Page Address: www.mssu.edu; *Prof* V A Christensen; *Prof* David Noblett; *Adjunct Prof* Alice Knepper; *Dept Head* Nick Kyle; *Prof* Josie Mai; *Prof* Burt Bucher; *Prof* Frank Pishkur; *Adjunct Prof* Peggy Beckham
Estab 1937; Maintains nonprofit art gallery; on-campus art supply shop; FT 7; pub; D & E; Scholarships; SC 24, LC 2, Non-credit 4; D 500, non-maj 15 maj 125, others 10
Ent Req: HS dipl
Degrees: BA & BSE 4 yrs
Tuition: Res—undergrad $124 per cr hr; non-res—undergrad $248
Courses: Aesthetics, Art Appreciation, Art Education, Art History, Ceramics, Commercial Art, Design, Drawing, †Graphic Communications, Graphic Design, Mixed Media, Painting, Photography, Printmaking, Sculpture, Silversmithing, †Studio, Studio Crafts, Teacher Training, Typography
Adult Hobby Classes: Enrl 60; Tuition varies. Courses—Clay, Jewelry, Photographic (Digital), Watercolor
Summer School: Dir, Nick Kyle. Art Appreciation, Studio Course

KANSAS CITY

AVILA COLLEGE, Art Division, Dept of Humanities, 11901 Wornall Rd, Kansas City, MO 64145. Tel 816-942-8400, Ext 2289; Fax 816-501-2459; Internet Home Page Address: www.avila.edu; *Instr* Sharyl Wright; *Instr* Kelly Mills; *Instr* Lisa Sugimoto; *Chmn Humanities* Carol Coburn; *Chmn Art & Design* Susan Lawlor; *Instr* Marci Aylward
Estab 1948; 7 adjunct instrs; den; D & E; Scholarships; SC 35, LC 4; D 140, E 20, non-maj 120, maj 40
Ent Req: HS dipl, SAT and PSAT
Degrees: BA 4 yrs
Tuition: $2975 per sem
Courses: Art Appreciation, Art Education, Art History, Ceramics, Commercial Art, Design, Drawing, Graphic Arts, Graphic Design, Illustration, Painting, Photography, Printmaking, Sculpture, Teacher Training
Adult Hobby Classes: Courses offered

KANSAS CITY ART INSTITUTE, 4415 Warwick Blvd, Kansas City, MO 64111. Tel 816-472-3338; Fax 816-802-3309; Fax 816-802-3338; Elec Mail lstone@kcai.edu; Internet Home Page Address: www.kcai.edu; *Pres* Kathleen Collins, MFA; *Chmn Ceramics* Cary Esser, MFA; *Interim Chmn Design* Jon Kamnitzer, MFA; *Chmn Painting* Warren Rosser, MFA; *Chmn Photo* Patrick Clancy, MFA; *Interim Chmn Sculpture* Michael Wickerson, MFA; *Interim Chmn Found* Russell Ferguson, MFA; *Chmn Liberal Arts* Phyliss Moore, MFA; *Chmn Fiber* Jason Pollen, MFA; *Dean Faculty* Gary Sutton, MFA; *Chmn Interdisciplinary Arts* Julia Cole, MFA; *Prog Head, Printmaking* Laura Berman, MFA
Estab 1885; Maintain nonprofit art gallery; H & R Block Art Space at Kansas City Art Institute, 4415 Warwick Blvd, Kansas City, MO 64111; library Jannes Library & Learning Ctr; Pvt; D & E; Scholarships; maj areas 7, LC 104 in liberal arts; D 540, E 740
Activities: Book traveling exhibitions; originate traveling exhibitions
Ent Req: HS dipl, portfolio interview
Degrees: BFA 4 yrs
Tuition: $21,326 per yr, $10,663 per sem, $850 per cr hr; campus res—room $6,800 per yr (double occupancy)
Courses: Art History, †Ceramics, Commercial Art, †Design, Drawing, Fashion Arts, Film, Graphic Arts, Graphic Design, Interior Design, Mixed Media, Painting, †Photography, †Printmaking, †Sculpture, †Textile, †Video, Weaving
Adult Hobby Classes: tuition varies
Summer School: Dir, Asst Dean for Acad Affairs, Shirley O'Leary. Tuition $315 per credit hr, 2 sessions 1-3 wk, 1-2 wk; 3 wk term. Courses—Liberal Arts, Studio

MAPLE WOODS COMMUNITY COLLEGE, Dept of Art & Art History, 2601 NE Barry Rd, Kansas City, MO 64156. Tel 816-437-3000, Ext 3226; Internet Home Page Address: www.maplewoods.cc.mo.us; *Head Dept* Jennie Frederick
Estab 1969; PT 6; pub; D & E; Scholarships; SC 12, LC 2; D 125, E & Sat 80
Ent Req: HS dipl or GED
Degrees: AA 2 yrs
Tuition: District res—$156 per cr hr; non-district res—$95 per cr hr; out-of-state $132
Courses: Art Education, Art Fundamentals, Art History, Ceramics, Commercial Art, †Computer, †Design, Drawing, †Fiber, Painting, Photography, Printmaking, Sculpture
Adult Hobby Classes: Enrl 30; tuition same as above. Courses same as above
Children's Classes: Summer classes; enrl 30; tuition $30 for 6 wks
Summer School: Dir, Helen Mary Turner. Tuition same as above for 8 wks beginning June 1. Courses—Ceramics, Drawing, Painting

PENN VALLEY COMMUNITY COLLEGE, Art Dept, 3201 SW Trafficway, Kansas City, MO 64111. Tel 816-759-4000; Fax 816-759-4050; *Div Chmn Humanities* Eleanor Bowie
Scholarships
Degrees: AA
Tuition: District res—$55 per sem hr; non-district res—$95 per sem hr; non-state res—$132 per sem hr
Courses: Advertising Design, Animation, Art Fundamentals, Art History, Calligraphy, Cartooning, Ceramics, Computer Graphics, Design, Drawing, Fashion Arts, Film, Painting, Photography, Printmaking, Sculpture, Video

UNIVERSITY OF MISSOURI-KANSAS CITY, Dept of Art & Art History, 204 Fine Art Bldg, 5100 Rockhill Rd Kansas City, MO 64110-2499. Tel 816-235-1501; Fax 816-235-5507; Internet Home Page Address: www.umkc.edu/art; *Chmn* Dr Burton Dunbar
Estab 1933; Average Annual Attendance: 11,000; FT 10, PT 7; pub; D & E; Scholarships; maj 138
Income: $15,000 (financed through city and state)

Ent Req: contact Admis Office
Degrees: BA (Art), (Studio Art) & (Art History)
Tuition: Res—\$141.50 per cr hr; nonres—\$423 per cr hr, grad—\$538.70
Courses: Art Appreciation, †Art History, Computer Art, Drawing, Graphic Design, Intermedia, Painting, Photography, Printmaking
Summer School: Dir, B L Dunbar. Enrl 65; 8 wk term. Courses—Art History, Drawing, Painting, Photography, Printmaking

KIRKSVILLE

TRUMAN STATE UNIVERSITY, Art Dept, Division of Fine Arts, Kirksville, MO 63501. Tel 660-785-4417; *Head Div Fine Arts* Robert L Jones
Estab 1867; pub; D & E; Scholarships; SC 27, LC 8; D 220, non-maj 45, maj 155
Ent Req: HS dipl
Degrees: BFA(Visual Comminications, Studio) 4 yrs, BA(Liberal Arts) 4 yrs, BA(Art History) 4 yrs
Tuition: Res—undergrad \$125 per sem hr, grad \$133 per sem hr; nonres—undergrad \$225 per sem hr, grad \$241 per sem hr
Courses: †Art History, †Ceramics, Fibers, †Painting, †Photography, †Printmaking, †Sculpture, Visual Communications
Summer School: Enrl 80-100; term of two 5 wk sessions beginning June & July

LIBERTY

WILLIAM JEWELL COLLEGE, Art Dept, 500 College Hill, Liberty, MO 64068. Tel 816-781-7700, Ext 5415; Fax 816-415-5027; *Chmn* Nano Nore, MFA; *Instr* Rebecca Koop, BFA
Estab 1849, dept estab 1966; pvt (cooperates with the Missouri Baptist Convention); D & E; Scholarships; D 120, E 35-40, maj 30
Degrees: BA(Art) & BS 4 yr
Tuition: \$16,400 (incl room & board)
Courses: Art Appreciation, Art Education, Art History, Calligraphy, Ceramics, Computer Graphic, Design, Drawing, Fibers, Painting, Photography, Printmaking, Sculpture, Weaving
Adult Hobby Classes: Enrl 10 - 15; tuition \$120 per 14 wk sem.
Courses—Drawing, Illustration, Jewelry/Silversmithing, Painting, Photography
Children's Classes: Enrl 10 - 15; tuition \$30 - \$40 for a 6 wk session.
Courses—Ceramics, Drawing, Painting, Photography
Summer School: Dir, Dr Steve Schwegler; Illustration Academy, Dirs John & Mark English

MARYVILLE

NORTHWEST MISSOURI STATE UNIVERSITY, Dept of Art, 800 University Dr, Maryville, MO 64468. Tel 660-562-1212; Internet Home Page Address: www.nwmissouri.edu; *Assoc Prof* Kenneth Nelsen, MFA; *Asst Prof* Russell Schmaljohn, MS; *Asst Prof & Chmn* Kim Spradling PhD, MS; *Asst Prof* Paul Falcone, MFA; *Prof* Philip Laber, MFA; *Asst Prof* Armin Muhsam
Estab 1905, dept estab 1915; FT 7, PT 2; pub; D & E; Scholarships; SC 74, LC 19; D 475, E 25, non-maj 350, maj 150
Ent Req: HS dipl
Degrees: BA, BFA, BSE & BA 4 yrs
Tuition: Res—\$111 per hr; nonres—\$186.25 per hr; campus res— room & board \$1975-\$2075 per sem
Courses: Art Appreciation, Art Education, Art History, Ceramics, Commercial Art, Computer Graphics, Drawing, Graphic Design, Jewelry, Metalsmithing, Painting, Photography, Printmaking, Sculpture
Children's Classes: Courses—Art Educ Club workshops \$15
Summer School: Chmn Dept Art, Lee Hageman. Two wk short courses varying from summer to summer; cost is hourly rate listed above. Courses—Art Education, Ceramics, Jewelry, Painting, Photography, Watercolor

NEOSHO

CROWDER COLLEGE, Art & Design, 601 La Clede Blvd, Neosho, MO 64850. Tel 417-451-3223; Fax 417-451-4280; Internet Home Page Address: www.crowdercollege.net; *Chmn* Janie Lance; *Div Chmn* Glenna Wallace
Estab 1964; FT 1, PT 1; Pub; D & E; Scholarships; D 1000, E 300, maj 20, others 250
Ent Req: HS grad or equivalent
Degrees: AA & AAS 2 yrs
Tuition: Res \$64; non res \$87
Courses: †20-30 Design, Art Appreciation, Art History, Ceramic Design, Design, Drawing, Fibers Design, Jewelry, Painting, Sculpture
Summer School: Dean of Col, Jackie Vietti. Term of 8 wks beginning in June. Courses—Varied academic courses

NEVADA

COTTEY COLLEGE, Art Dept, 1000 W Austin, Nevada, MO 64772. Tel 417-667-8181; Internet Home Page Address: www.cottey.edu; *Dean* Mary Kitterman, PhD; *Instr* Rand Smith, MFA
Estab 1884; maintains nonprofit art gallery, PEO Foundation Gallery; FT 3; pvt, W; D & E; Scholarships; SC 15, LC 4; maj 12-15, total 369
Ent Req: HS grad, AC Board
Degrees: AA 2 yrs & AS 2 yrs
Tuition: \$13,900 (includes room & board)
Courses: Art Appreciation, Art History, Ceramics, Design, Drawing, Graphic Arts, Handicrafts, Illustration, Jewelry, Metals, Painting, Photography, Printmaking, Weaving

PARKVILLE

PARK UNIVERSITY, Dept of Art & Design, 8700 NW River Park Dr, Box 42 Parkville, MO 64152. Tel 816-741-2000, Ext 6457; Fax 816-741-4911; Elec Mail donnabach@mail.park.edu; *Chmn* Donna N Bachman; *Asst Prof* Thomas H Smith; *Asst Prof* Kay M Boehr
Estab 1875; Maintain nonprofit gallery; Campanella Gallery; Pvt; D & E; Scholarships; SC 13, LC 4; D 50, non-maj 40, maj 130
Ent Req: HS dipl, ACT
Degrees: BA, 4 yrs
Tuition: Res—undergrad \$165 per cr hr; campus res—\$2,425 room & board
Courses: 3-D Design, Advertising Design, Art Education, Art History, Ceramics, Drawing, †Fiber, Graphic Design, History of Art & Architecture, Interior Design, Painting, Photography, Sculpture, Teacher Training
Summer School: Tuition \$165 per cr hr for 8 wk term. Courses—Ceramics, Printmaking, varied curriculum

POINT LOOKOUT

COLLEGE OF THE OZARKS, Dept of Art, PO Box 17, Art Dept Point Lookout, MO 65726. Tel 417-334-6411, Ext 4255; Internet Home Page Address: www.cofo.edu; *Prof* Anne Allman PhD; *Prof* Jayme Burchett, MFA; *Prof* Jeff Johnston, MFA; *Asst Prof* Richard Cummings
Estab 1906, dept estab 1962; Maintain nonprofit art gallery; Boger Art Gallery, Art Dept, PO Box 17, Point Lookout, MO 65726; pvt; D & E; Scholarships; SC 22, LC 4; D 200, E 25, non-maj 180, maj 40
Ent Req: HS dipl, ACT
Degrees: BA & BS 4 yr
Tuition: No fees are charged; each student works 960 hrs in on-campus employment
Courses: †Art Education, †Ceramics, Computer Art, †Drawing, Fibers, Graphic Design, †Painting

SAINT CHARLES

LINDENWOOD COLLEGE, Art Dept, 209 S Kings Hwy, Saint Charles, MO 63301. Tel 636-949-4862, 949-2000; *Chmn Dept, Contact* Elaine Tillinger
Estab 1827; FT 4, PT 4; pvt; D & E; Scholarships; SC 24, LC 16; D 200, E 30, maj 40
Ent Req: HS dipl, ent exam
Degrees: BA, BS, BFA 4 yrs, MA, MFA
Tuition: Res—undergrad \$14,000 per yr
Courses: Art Education, Art History, Ceramics, Computer Art, Design, Drawing, Graphic Arts, Painting, Photography, Printmaking, Sculpture, Teacher Training

SAINT JOSEPH

MISSOURI WESTERN STATE UNIVERSITY, Art Dept, 4525 Downs Dr, Saint Joseph, MO 64507-2294. Tel 816-271-4200, Ext 4282; Fax 816-271-4181; Elec Mail sauls@missouriwestern.edu; Internet Home Page Address: www.missouriwestern.edu; *Chmn Dept* Dr Allison Sauls PhD; *Prof* Jim Estes, MFA; *Assoc Prof* Jean Harmon Miller, MFA; *Asst Prof* Geo Sipp, MFA; *Asst Prof* Teresa Harris, MFA
Estab 1969; Maintians nonprofit gallery, Gallery 206; Pub; D & E; Scholarships; SC 25, LC 8; D 355, E 100, non-maj 120, maj 130
Ent Req: HS dipl, GED, ACT
Degrees: BSE (Art Educ), BA & BS(Graphic Design) 4 yrs
Tuition: Res—\$465 per sem; nonres—\$875 per sem; campus residence available
Courses: Advertising Design, Aesthetics, Art Appreciation, Art Education, Art History, Ceramics, Commercial Art, Computer Art, Design, Drawing, Graphic Arts, Graphic Design, History of Art & Architecture, Illustration, Painting, Photography, Printmaking, Sculpture, Teacher Training, Tools & Techniques
Adult Hobby Classes: adult classes through western institute prog
Children's Classes: childrens classes through western institute prog
Summer School: Chmn, Art Dept, Dr Allison Sauls. Tuition res—\$130 for 5 or more cr hrs, nonres—\$240 for 5 or more cr hrs; term of 8 wks beginning June 1. Courses—Art Education, Ceramics, Introduction to Art, Photomedia, Painting

SAINT LOUIS

FONTBONNE UNIVERSITY, Fine Art Dept, 6800 Wydown Blvd, Saint Louis, MO 63105. Tel 314-889-1431; Fax 314-889-1451; Internet Home Page Address: www.fontbonne.edu; *Prof* Hank Knickmeyer, MFA; *Assoc Prof* Victor Wang, MFA; *Assoc Prof* Deanna Jent, MFA; *Assoc Prof* Tim Liddy, MFA; *Asst Prof* Michael Sullivan, MFA; *Chmn Dept* Catherine Connor-Talasek, MFA; *Asst Prof* Mark Douglas
Estab 1923; Maintains nonprofit gallery, Gallery of Art 6800 Wydown Blvd, St Louis, MO 63105; pvt; D & E; Scholarships; SC 10, LC 2, GC 6; non-maj 10, maj 46, grad 12, others 5
Ent Req: HS dipl, portfolio
Degrees: BA and BFA 4 yrs, MA 1 yr, MFA 2 yrs
Tuition: Res - undergrad \$5,843 per sem
Courses: Aesthetics, Art Appreciation, Art Education, Art History, †Ceramics, Commercial Art, Design, †Drawing, †Graphic Design, History of Art & Architecture, Illustration, Interior Design, †Photography, Printmaking, †Sculpture, Teacher Training, Weaving
Adult Hobby Classes: Tuition \$150 per cr. Courses—Art History
Summer School: Dir, C Connor-Talasek. Enrl 75; tuition \$780 for 6 wk term. Courses—Ceramics, Drawing, Modern Art, Painting, Printmaking

MARYVILLE UNIVERSITY OF SAINT LOUIS, Art & Design Program, 650 Maryville University Dr, Saint Louis, MO 63141-7299. Tel 314-529-9300, 529-9381 (art div); Fax 314-529-9940; Internet Home Page Address:

www.maryville.edu; *Assoc Prof Graphic Design* Cherie Fister, MFA; *Prof & Dir Art & Design Prog & Studio Art* Nancy Rice, MFA; *Prof* Les Armontrout, MBA; *Adjunct Instr* Ken Worley, IES; *Assoc Prof* John Baltrushunas, MFA; *Prof* Steven Teczar, MFA; *Adjunct* Marie Oberkirsch, MFA; *Adjunct* Renee Petty, MA; Barbara Zappulla; *Asst Prof Interior Design* Darlene Davison; *Adjunct* Sherri Jaudes, MFA; *Adjunct Instr* Clay Pursell; *Instr* Martha Whitaker, BFA; *Instr* Laurie Eisenbach-Bush, BFA; *Asst Prof* Todd Brenningmeyer, PhD; *Asst Prof* Jon Fahnestock, MFA
Estab 1872, dept estab 1961; Maintains nonprofit gallery, Morton J May Foundation Gallery; on-campus shop for purchase of art supplies; Pvt; D, E & W; Scholarships; SC 74, LC 6; D 200, E 30, non-maj 60, maj 180
Ent Req: HS dipl, ACT or SAT
Degrees: BA, BFA
Tuition: $8,200 per yr, $5,140 per sem; $293 per cr hr; campus res—room & board $2,450 per yr
Courses: †2-D & 3-D Design, Advertising Design, †Aesthetics, †Art Appreciation, †Art Education, †Art History, †Art Studio, †Auto CAD, †Calligraphy, †Ceramics, †Collage, †Color Theory, †Commercial Art, Conceptual Art, Constructions, †Design, †Display, †Drafting, Drawing, †Fibers & Soft Sculpture, †Furniture Design, †Graphic Arts, †Graphic Design, †Handmade Book, History of Art & Architecture, Illustration, †Interior Design, †Mixed Media, †Painting, †Painting the Figure, †Photography, †Printmaking, †Sculpture, †Silversmithing, †Teacher Training, †Weaving
Adult Hobby Classes: Enrl & tuition vary. Courses—Art & Architectural History, Art in St Louis, Drawing, Painting, Photography
Children's Classes: Enrl 115; tuition $150 (1 cr) & $100 (no cr) for 10 wk session. Courses—Ceramics, Cartooning, Drawing, Painting, Photography, Printmaking, Watercolor
Summer School: Dir, Dan Ray. Enrl 60; tuition same as regular year. Courses—Photography, Art Appreciation, Art History, Auto CAD, Drawing, Painting

SAINT LOUIS COMMUNITY COLLEGE AT FOREST PARK, Art Dept, 5600 Oakland Ave, Saint Louis, MO 63110-1393. Tel 314-644-9350; Fax 314-644-9752; Internet Home Page Address: www.stlcc.cc.mo.us; *Asst Prof* Evann Richards, BA; *Instr* Joe C Angert, MA; *Instr* Allen Arpadi, BA
Estab 1962, dept estab 1963. College maintains three campuses; PT 14; pub; D & E; Scholarships; SC 36, LC 6; D 200, E 100, non-maj 75, maj 75
Ent Req: HS dipl
Degrees: AA & AAS 2 yrs
Tuition: College Res—$42 per cr hr; nonres—$53 per cr hr; nonres out-of-state—$57 per cr hr
Courses: Advertising Design, Art Appreciation, Art Education, †Art History, Ceramics, Color, Commercial Art, Commercial Photography, Computer-Assisted Publishing, Design, Drawing, Film, †Graphic Design, Illustration, Lettering, †Painting, †Photography
Adult Hobby Classes: Courses—Drawing, Painting, Photography, Printmaking, Sculpture, Video
Summer School: Chmn, Leon Anderson. Enrl 100. Courses—Same as those above

SAINT LOUIS COMMUNITY COLLEGE AT MERAMEC, Art Dept, 11333 Big Bend Blvd, Saint Louis, MO 63122. Tel 314-984-7500, 984-7632; Internet Home Page Address: www.stlcc.edu/mc/dept/art; *Prof* Patrick Shuck, MFA; *Prof* Ronald Thomas, MFA; *Prof* Kay Hagan, MS; *Prof* Rena Michel-Trapaga, MFA; *Assoc Prod* Margaret Kelly, MFA; *Prof* John Wm Nagel, MFA
Estab 1964; Maintain nonprofit art gallery, Meramec Contemporary Art Gallery; Pub; D & E; Scholarships; SC 130, LC 10
Ent Req: HS dipl
Degrees: AFA 2 yr, AAS 2yr
Tuition: Res—$78 per cr hr; nonres—$138 per cr hr; non campus res
Courses: Advertising Design, Art History, Ceramics, Commercial Art, Drawing, Illustration, Interior Design, Painting, Photography, Printmaking, Sculpture
Summer School: Chmn Dept, David Hanlon. Tuition $78 per cr hr for term of wks beginning June 6. Courses—Art Appreciation, Ceramics, Design, Drawing, Photography

SAINT LOUIS UNIVERSITY, Fine & Performing Arts Dept, 221 N Grand Blvd, Saint Louis, MO 63103. Tel 314-977-3030; Fax 314-977-3447; *Chmn* Dr Cindy Stollhans
Maintains McNamee Gallery, St Louis; Scholarships
Degrees: BA
Tuition: Undergrad $6765 full-time per term, $468 part-time per hr
Courses: Approaching the Arts, Art History, Design, Drawing, Painting, Photography, Sculpture, †Studio Art
Summer School: Courses—Drawings, Painting, Studio Art

UNIVERSITY OF MISSOURI, SAINT LOUIS, Dept of Art & Art History, 8001 Natural Bridge Rd, Saint Louis, MO 63121. Tel 314-516-5975; Fax 314-516-5003; Internet Home Page Address: www.umsl.edu/~art; *Chmn* Dan Younger MFA; *Prof* Ken Anderson, MFA; *Prof* Yael Even PhD, MFA; *Prof* Jeanne Morgan Zarucchi, PhD; *Asst Prof* Terry Suhre, MFA; *Assoc Prof* Gretchen Schisla, MFA; *Sr Lectr* Juliana Yuan, MA; *Des Lee Foundation Prof Art Educ* E Louis Lankford, PhD; *Assoc Prof* Marian Amies, MFA; *Asst Prof* Phillip Robinson, MFA; *Assoc Prof* Jeffrey Sippel, MFA; *Asst Prof* Jennifer McKnight, MFA; *Instr* Luci McMichael, MAT; *Assoc Prof* Ruth Bohan, PhD; *Assoc Prof* Susan Cahan, PhD; *Asst Prof* Susan Waller, PhD
Estab 1963; Maintain nonprofit art gallery; Gallery 210; Pub; D & E; Scholarships; SC 66, LC 52, GC 7; maj 270 (50 Art History, 220 Studio Art)
Ent Req: HS dipl
Degrees: BA(Art Hist), BFA
Tuition: Res—undergrad $136.80 per cr hr; nonres—undergrad $409.10 per cr hr
Courses: Art Education, †Art History, Design, †Drawing, †General Fine Arts, †Graphic Design, Illustration, †Painting, †Photography, †Printmaking

WASHINGTON UNIVERSITY

—**School of Art,** Tel 314-935-6500; Fax 314-935-4862; Elec Mail jpike@art.wustl.edu; Internet Home Page Address: www.wustl.edu; *Dean School* Jeffrey C Pike; *Assoc Dean School* Georgia Binnington; *Assoc Dean* Michael Byron; *Dir Graduate Studies* Eric Troffkin
Estab 1853; Maintain nonprofit art gallery, The Des Lee Gallery, 1627 Washington Ave., St. Louis, MO 63104; pvt; D; Scholarships, Fellowships; SC 62, LC 10, GC 31; maj 320, grad 20
Ent Req: HS dipl, SAT or ACT, portfolio
Degrees: BFA 4 yrs, MFA 2 yrs
Tuition: $26,900 per yr, $13,450 per sem, $1,120 per cr hr; campus res—room & board available
Courses: †Advertising Design, Aesthetics, Architecture, Art Appreciation, Art Education, Art History, †Ceramics, Costume Design & Construction, Design, Drawing, †Fashion Arts, †Fashion Design, †Glass Blowing, Graphic Arts, †Graphic Design, History of Art & Archeology, †Illustration, Mixed Media, Occupational Therapy, †Painting, †Photography, †Printmaking, †Sculpture, Stage Design, Theatre Arts, Video
Summer School: Enrl 50; tuition $$4565 HS program for term beginning June 12- Jul 16. Courses—Painting, Printmaking, Photography. Drawing, Computer Graphics, Fashion, Sculpture, Ceramics, Florence, Italy, enrl 40; tuition $2850, $750 room, June 1 - June 30. Courses—On-site Drawing, Photography, Book Arts & Painting

—**School of Architecture,** Tel 314-935-6200; Fax 314-935-7656; Internet Home Page Address: www.wustl.edu; *Dean School* Cynthia Weese, FAIA
Estab 1910; pvt; D; Scholarships; SC 28, LC 58, GC 42; 300, maj 200, grad 100
Degrees: BA(Arch), March, MA(UD)
Tuition: $18,350 per yr, $765 per cr hr
Courses: †Architecture, Design, Drawing, Interior Design, Landscape Architecture, Photography
Adult Hobby Classes: Enrl 43; tuition $175 per unit. Certificate degree program, Bachelor of Technology in Architecture
Summer School: Tuition varies. Courses—Advanced Architectural Design, Fundamentals of Design, Structural Principles

SPRINGFIELD

DRURY COLLEGE, Art & Art History Dept, 900 N Benton Ave, Springfield, MO 65802. Tel 417-873-7263, 873-7879; Fax 417-873-6921; Internet Home Page Address: www.drury.edu; *Chmn* Alkis Tsolakis
Estab 1873; FT 6, PT 9; den; D; Scholarships; SC 12, LC 5; 2246
Ent Req: HS diploma
Degrees: 4 yrs
Tuition: Res—undergrad $11,160 per yr, $362 per cr hr
Courses: Architecture, Art History, Ceramics, Commercial Art, Photography, Studio Arts, Teacher Training, Weaving
Adult Hobby Classes: Enrl 25-35; tuition $125 per cr hr. Courses—Studio Art & History of Art
Children's Classes: Summer Scape, gifted children. Courses—Architecture, Design, Photography
Summer School: Dir, Sue Rollins. Enrl 292; tuition $125 per cr hr June-Aug for 9 wk term. Courses—Art History, Ceramics, Drawing, Painting, Photography

MISSOURI STATE UNIVERSITY, Dept of Art & Design, 901 S National, Springfield, MO 65897. Tel 417-836-5110; Fax 417-836-6055; Elec Mail artanddesign@missouristate.edu; Internet Home Page Address: www.art.missouristate.edu; *Head Dept* Dr Andrew Cohen
Estab 1901; Maintains nonprofit gallery, Art & Design Gallery, 333 Walnut, Springfield, MO 65806; FT 30, PT 15; pub; D & E; Scholarships; SC 54, LC 19; maj 556, others 18,930
Ent Req: HS dipl, ent exam
Degrees: BFA (Art, Design) BS (Education Comprehensive & Electronic Arts) & BA (Art History) 4 yrs
Tuition: Res—$173 per cr hr; nonres—$337
Courses: †Art Education, †Art History, †Ceramics, Computer Animation, †Digital Imaging, †Drawing, †Electronic Arts, Fibers, †Graphic Design, Illustration, †Metals/Jewelry, †Painting, †Photography, †Printmaking, †Sculpture
Adult Hobby Classes: Tuition $98 per cr hr for 1 & 2 wk sessions
Summer School: Dean, Adele S. Newson-Horst. Enrl 6,836; special workshops available during summer session; tuition $154 per cr hr & Student Services fee for 4, 5 & 8 week sessions. Courses—Selected from above curriculum

UNION

EAST CENTRAL COLLEGE, Art Dept, 1964 Prairie Dell Rd, Union, MO 63084. Tel 636-583-5195, Ext 2258; Internet Home Page Address: www.ecc.cc.mo.us/enter.html; *Dir* John Anglin; *Instr* James Crow
Estab 1968; FT 2, PT 1; pub; D & E; Scholarships; SC 8, LC 8; D 370, E 120, maj 40
Ent Req: HS dipl, ent exam
Degrees: AA & AAS 2 yrs
Tuition: In-district—$59 per cr hr; out-of-district—$85 per cr hr; nonres—$129 per cr hr
Courses: Art Appreciation, Art Education, Art History, Business of Art, Design, Drawing, Figure Drawing, Handicrafts, History of Art & Architecture, Lettering, Painting, Photography, Printmaking, Sculpture, Teacher Training
Adult Hobby Classes: Enrl 121; tuition $21-$38 per semester. Courses—Painting
Children's Classes: Tuition $25 for 4 wk summer term. Courses—Art, Drawing, Sculpture, Painting
Summer School: Tuition $21 per cr hr for 8 wk term. Courses—Art Appreciation, Art History

WARRENSBURG

CENTRAL MISSOURI STATE UNIVERSITY, Art Dept, Art Ctr 120, Warrensburg, MO 64093. Tel 660-543-4481; Fax 660-543-8006; Internet Home Page Address: www.cmsu.edu; *Chair Dept* Jerry Miller, EdD; *Prof* Kathleen

0

Desmond, EdD; *Prof* Richard D Monson, MFA; *Prof* Margaret Peterson, MFA; *Prof* John R Haydu, MFA; *Assoc Prof* Harold M Reynolds, EdD; *Assoc Prof* LeRoy McDermott PhD, EdD; *Assoc Prof* Andrew Katsourides, MFA; *Assoc Prof* Chris Willey, MFA; *Assoc Prof* John W Lynch, MFA; *Asst Prof* George Sample, MSEd; *Asst Prof* John Owens, MFA; *Asst Prof* Neva Wood, MFA
Estab 1871; pub; D & E; Scholarships; SC 40, LC 14, GC 10; D 300, maj 300
Ent Req: HS dipl, Missouri School & Col Ability Test, ACT
Degrees: BA, BSE, & BFA 4 yrs, MA 1 yr
Tuition: Res—$84 per cr hr; nonres— $168 per cr hr; campus res—room & board varies
Courses: †Art Education, Art History, †Commercial Art, Drawing, Graphic Arts, Illustration, †Interior Design, Painting, Sculpture, †Studio Art, Teacher Training
Summer School: Chair Dept, Jerry L Miller. Term of 8 wks beginning first wk in June. Courses—Ceramics, Drawing, Grad Studio Courses, Painting

WEBSTER GROVES

WEBSTER UNIVERSITY, Art Dept, 470 E Lockwood Blvd, Webster Groves, MO 63119-3194. Tel 314-968-7171 or 314-961-2660; Fax 314-968-7139; Internet Home Page Address: www.webster.edu; *Chmn* Tom Lang, MFA; *Asst Prof* Carol Hodson, MFA; *Asst Prof* Jeffrey Hughes PhD, MFA; *Asst Prof* Brad Loudenback, MFA; *Asst Prof* Jeri Au, MFA; *Asst Prof* Gary Passanise, MFA
Estab 1915, dept estab 1946; pvt; D & E; Scholarships; SC 60, LC 15; 1100, maj 100
Ent Req: HS dipl, SAT or ACT
Degrees: BA & BFA 4 yrs
Tuition: $280 per cr hr; campus res available
Courses: †Art Education, †Art History, †Ceramics, Collage, Conceptual Art, †Drawing, Film, †Graphic Design, †Painting, †Papermaking, †Photography, †Printmaking, †Sculpture, †Teacher Training
Adult Hobby Classes: Tuition $175 per cr hr for 16 wk sem. Courses—Art, Photography, Watercolor
Summer School: Assoc Dean Fine Arts, Peter Sargent. Tuition $175 per cr hr for term of 6 or 8 wks beginning June. Courses—Introductory Photography, Sculpture Workshop: Bronze

MONTANA

BILLINGS

MONTANA STATE UNIVERSITY-BILLINGS, Art Dept, 1500 N 30th St, Billings, MT 59101-0298. Tel 406-657-2324; Fax 406-657-2187; Internet Home Page Address: www.msubilling.edu/art; *Head* Connie M Landis
Estab 1927; Northcutt Steele Gallery on campus; FT 6, PT 4; pub; D; Scholarships
Ent Req: HS dipl
Degrees: AA, BS(Educ), BSEd(Art), BA(Lib Arts & Studio)
Tuition: Res—$1529.90 per sem; nonres—$4114 per sem
Courses: Art Appreciation, †Art Education, Art History, Ceramics, Display, Drawing, †Lithography, Painting, Photography, Sculpture
Summer School: Tuition res—$174.50 per cr, nonres—$323.45 per cr for two 6 wk sessions from May 13-June 17 & June 19-July 24. Courses—Art Appreciation, Ceramics, Drawing, Painting, Sculpture

ROCKY MOUNTAIN COLLEGE, Art Dept, 1511 Poly Dr, Billings, MT 59102. Tel 406-657-1094, 657-1040 (main), 657-1000 (admis); Internet Home Page Address: www.rocky.edu; *Chmn* Mark Moak
Estab 1878, dept estab 1957; pvt; D; Scholarships; SC 12, LC 5; 112, non-maj 40, maj 30, others 5
Ent Req: HS dipl, ACT
Degrees: BA & BS 4 yrs
Tuition: $10,099 per yr; campus res—room & board $3882 per yr for double
Courses: Art Education, Art History, Ceramics, Drawing, Graphic Design, Painting, Photography, Sculpture, Teacher Training
Adult Hobby Classes: Enrl 100; tuition $20 for 5 wks. Courses—Crafts, Painting, Picture Framing

BOZEMAN

MONTANA STATE UNIVERSITY
—**School of Art,** Tel 406-994-4501; Fax 406-994-3680; Elec Mail art@montana.edu; Internet Home Page Address: www.montana.edu/art; *Prof Metalsmithing & Dir School of Art* Richard Helzer; *Adjunct Instr Metalsmithing* Ken Bova; *Prof Graphic Design* Jeffrey Conger; *Prof Graphic Design* Anne Garner; *Adjunct Instr Art History & Gallery Dir* Erica Howe Dungan; *Prof Art History* Todd Larkin; *Prof Graphic Design* Stephanie Newman; *Prof Ceramics* Michael Peed; *Prof Ceramics* Rick Pope; *Prof Painting & Drawing* Harold Schlotzhauer; *Prof Sculpture* Jay Schmidt; *Asst Prof Printmaking* Gesine Janzen; *Asst Prof Painting* Sarah Mast; *Asst Prof - Painting & Drawing* Rollin Beamish; *Asst Prof - Art History* Regina Gee; *Adjunct Asst Prof - Foundation Painting & Drawing* Olga Lomshakova
Estab 1893; Maintain nonprofit art gallery; Helene E Copeland Gallery, Montana State Univ, Bozeman, MT 59717; creative arts library; art supplies available in bookstore; 14; pub; D & E; Scholarships, Fellowships; SC 43, LC 21, GC 14; maj 450, grad 15
Ent Req: HS dipl 2.5 GPA or ACT score of 20
Degrees: BFA, MFA, BA
Tuition: Res—$5,730 per yr, nonres—$15,580 per yr
Courses: †Art Education, †Art History, †Ceramics, Design, †Drawing, Graphic Arts, †Graphic Design, History of Art & Archeology, Illustration, Jewelry, Metals, †Painting, †Printmaking, †Sculpture, †Silversmithing, †Studio Arts, Teacher Training

Summer School: Dir, Richard Helzer. Enrl 65; tuition res—$284.65 per credit, nonres—$695.05 per credit for 12 wk term. Courses—Art History, Ceramics, Drawing, Graphic Design, Metals, Painting, Printmaking, Sculpture, Special Workshops
—**School of Architecture,** Tel 406-994-4255; Fax 406-994-6696; Elec Mail architecture@montana.edu; Internet Home Page Address: www.arch.montana.edu/; *Dir Archit* Clark Llewellyn
FT 13, PT 1; Pub; D & E; Scholarships; LabC 31, LC 39; maj 400
Degrees: BA(Environmental Design), MArch
Tuition: Res—$3,079 per yr; nonres—$9,075 per yr
Courses: Architectural Graphics, Architecture, Computer Applications in Architecture, Construction Drawings & Specifications, Design Fundamentals, Environmental Controls, History, Professional Practice, Structures, Theory
Summer School: Res—$171.40 undergrad per cr, $190.35 per cr, nonres—$421.25 undergrad per cr, $440.20 grad per cr

DILLON

THE UNIVERSITY MONTANA - WESTERN, (Western Montana College) Art Program, 710 S Atlantic, Dillon, MT 59725. Tel 406-683-7232; Fax 406-683-7493; Elec Mail r_horst@umwestern.edu; Internet Home Page Address: www.umwestern.edu/; *Chmn Dept* Randy Horst; *Prof* Barney Brienza; *Prof* Eva Mastandrea
Estab 1897; Maintains nonprofit gallery, The University of Montana - Western Art Gallery & Museum, 710 S Atantic, Dillion, MT 59725; FT 3; pub; 3 1/2 block sessions; Scholarships; SC 15, LC 2; maj 30
Ent Req: HS dipl
Degrees: BS & BA 4 yrs
Tuition: in-state $2,700, out-of-state $11,000
Courses: Art Education, Art History, Blacksmithing, Ceramics, Drawing, Glass Blowing, Handicrafts, Jewelry, Painting, Photography, Printmaking, Sculpture
Summer School: Dir Anneliese Ripley. Courses—Ceramics, Glassblowing, Travel Study

GREAT FALLS

UNIVERSITY OF GREAT FALLS, (College of Great Falls) Humanities Div, 1301 20th St S, Great Falls, MT 59405. Tel 406-761-8210; Fax 406-791-5394; Internet Home Page Address: www.ugf.edu; *Div Chmn* Lydon Marshall; *Asst Prof Art* Julia Becker; *Prof Music* Dr John Cubbage
Estab 1933; FT 1, PT 2; den; D & E; Scholarships; SC, Lab C, LC; approx 1250
Degrees: 4 yrs
Tuition: $3900 per yr
Courses: Art Education, Ceramics, Design, Drawing
Summer School: General art classes

HAVRE

MONTANA STATE UNIVERSITY-NORTHERN, Humanities & Social Sciences, PO Box 7751, Havre, MT 59501. Tel 406-265-3751, 265-3700; Fax 406-265-3777; Internet Home Page Address: www.montanastateuniv.edu; *Art Dept Chmn* Will Ron
Estab 1929; pub; D & E; Scholarships; SC 15, LC 5, GC 9; D 425, grad 7
Ent Req: HS dipl
Degrees: AA 2 yrs, BS(Educ) and BA 4 yrs, MSc(Educ)
Tuition: Res—$2692 per sem; nonres—$8078 per sem
Courses: Art Education, Ceramics, Commercial Art, Drafting, Drawing, Graphic Arts, Painting, Sculpture
Adult Hobby Classes: Enrl 60. Courses—Classroom and Recreational Art, Watercolor Workshop
Summer School: Dir, Dr Gus Korb. Enrl 1390; two 5 wk sessions. Courses—Art Education, Art Methods K-12, Art Therapy

MILES CITY

MILES COMMUNITY COLLEGE, Dept of Fine Arts & Humanities, 2715 Dickinson St, Miles City, MT 59301. Tel 406-234-3031; Internet Home Page Address: www.milescc.edu; *Instr* Fred McKee, MFA
Estab 1937, dept estab 1967; pub; D & E; Scholarships; SC 17, LC 1; D 36, E 23, non-maj 55, maj 4
Ent Req: HS dipl, ACT
Degrees: AA 2 yrs, cert
Tuition: Res—$1392 per yr; nonres—$1992 per yr; campus res available
Courses: Art Appreciation, Ceramics, Design, Graphic Arts, Graphic Design, Jewelry, Painting, Photography
Adult Hobby Classes: Enrl 39; tuition $58 per cr hr. Courses—Crafts, Jewelry Making, Painting, Photography, Pottery
Children's Classes: Kids Kamp-2 wks in summer

MISSOULA

UNIVERSITY OF MONTANA, Dept of Art, Campus Dr 32 Missoula, MT 59812. Tel 406-243-4181; Fax 406-243-4968; Elec Mail artdept@selway.umt.edu; Internet Home Page Address: www.umt.edu/art; *Prof* Steven Connell, MFA; *Prof* Marilyn Bruya, MFA; *Prof* Beth Lo, MFA; *Prof* David James, MFA; *Co-Chair* Barbara Tilton, MFA; *Assoc Prof* Rafael Chacon, PhD; *Assoc Prof* Mary Ann Bonjorni, MFA; *Assoc Prof* Martin Fromm, MFA; *Chmn, Assoc Prof* James Bailey, MFA; *Asst Prof* Elizabeth Dove, MFA; *Co-Chair* Cathryn Mallory
Pub; D & E; Scholarships; SC 107, LC 14, GC 38; non-maj 899, maj 1,542, grad 76
Ent Req: HS dipl

Degrees: BA & BFA 4 yrs, MA & MFA
Tuition: Res—$2,027.60 per sem (12-21 cr hrs); nonres—$5,419.4 per sem (12-21 cr hrs)
Courses: Art Appreciation, Art Criticism and Social History of Art, Art Education, †Art History, †Ceramics, †Drawing, History of Art & Architecture, Mixed Media, †Painting, †Photography, †Printmaking, †Sculpture
Summer School: Co-Chairs Bobby Tilton & Cathryn Mallory. Enrl 25 per class; Courses—Various regular & experimental classes

NEBRASKA

BELLEVUE

BELLEVUE COLLEGE, Art Dept, 1000 Galvin Rd S, Bellevue, NE 68005. Tel 402-291-8100; *Chmn* Dr Joyce Wilson PhD
Scholarships
Degrees: BA, BFA, BTS(Commercial Art)
Tuition: Undergrad—$135 per cr hr, grad $265 per cr hr
Courses: Advertising Design, Aesthetics, Art History, Art Management, Ceramics, Commercial Art, Design, Drawing, History of Art & Architecture, Life Drawing, Painting, Papermaking, Photography, Printmaking, Sculpture
Summer School: Tuition $132 per cr hr

BLAIR

DANA COLLEGE, Art Dept, 2848 College Dr, Blair, NE 68008. Tel 402-426-7206, 426-9000; *Prof* Starla Stensaas; *Chmn* Dr Milton Heinrich
Scholarships
Degrees: BA, BS
Tuition: $6700 per sem
Courses: Advertising Design, Art Appreciation, Art Education, Art History, Ceramics, Commercial Art, Drawing, Jewelry, Painting, Photography, Printmaking, Sculpture, Teacher Training, Theatre Arts

CHADRON

CHADRON STATE COLLEGE, Dept of Art, 1000 Main St, Chadron, NE 69337. Tel 308-432-6326; Fax 308-432-6464; Elec Mail rbird@asc.edu; *Chmn* Richard Bird, MFA; *Asst Prof* Mary Donahue, MFA; *Asst Prof* Laura Bentz, MFA; *Instr* Don Ruleaux, MFA; *Instr* Nancy Sharps, MA
Estab 1911, dept estab 1935; Maintain nonprofit art gallery; pub; D & E; Scholarships; SC 24, LC 4, GC 6; D 2000, off-campus 500, non-maj 40, maj 65
Ent Req: HS dipl
Degrees: BSE & BA 4 yrs
Tuition: Res—undergrad $100 per hr, grad $150 per hr; nonres—undergrad $110 per hr, grad $137.50 per hr; campus res—room & board $1491
Courses: Advertising Design, Art Appreciation, Art Education, Art History, Ceramics, Design, Drawing, Graphic Design, Jewelry, Painting, Photography, Printmaking, Sculpture
Adult Hobby Classes: Enrl 30. Tuition varies. Courses vary
Summer School: Dir, Dr Taylor. Enrl 30; tuition same as above. Courses—usually 2 - 4 courses on semi-rotation basis

COLUMBUS

CENTRAL COMMUNITY COLLEGE - COLUMBUS CAMPUS, Business & Arts Cluster, 4500 63rd St, Columbus, NE; PO Box 1027, Columbus, NE 68602-1027. Tel 402-564-7132; *Head Dept* Ellen Lake; *Instr* Richard Abraham, MA; *Instr* Kathleen Lohr, MA
Estab 1969, dept estab 1971; pub; D & E; Scholarships; SC 8, LC 1; D 100, E 20, non-maj 77, maj 43
Ent Req: HS dipl, GED
Degrees: AA 2 yrs
Tuition: Res—$49 per cr hr; nonres—$57.90 per cr hr; campus res
Courses: Air Brush, Art History, Ceramics, Color Theory, †Commercial Art, Design, Drafting, Drawing, Graphic Arts, Handicrafts, Interior Design, Life Drawing, Mixed Media, Painting, Photography, Printmaking, Stage Design, Textile Design, Theatre Arts
Summer School: Dir, Richard D Abraham. Enrl 25; tuition $41 per hr for term of 7 wks beginning June. Courses—Drawing, Painting

CRETE

DOANE COLLEGE, Dept of Art, 1014 Boswell Ave, Crete, NE 68333. Tel 402-826-2161, 826-8273; Internet Home Page Address: www.doane.edu; *Head Dept* Richard Terrell
Estab 1872, dept estab 1958; FT 3; pvt; D; Scholarships; SC 6, LC 5; 150, non-maj 140, maj 10
Ent Req: HS dipl
Degrees: BA 4 yrs
Tuition: $16,820 per yr, includes room & board
Courses: Art Education, Art History, Ceramics, Drawing, Film, Graphic Design, Painting, Printmaking, Sculpture, Stage Design

HASTINGS

HASTINGS COLLEGE, Art Dept, Seventh & Turner, Hastings, NE 68902-0269. Tel 402-461-7396; Fax 402-461-7480; Elec Mail tmcgehee@hastings.edu; Internet Home Page Address: www.hastings.edu; *Dir Pub Relations* Joyce Ore; *Chmn Dept* Turner McGehee; *Prof* Tom Kreager

Estab 1925; FT 3, PT 2; den; D & E; Scholarships; SC 16, LC 5; maj 50, others 350
Ent Req: HS grad
Degrees: BA 4 yrs
Tuition: $4688 per sem; campus res—room & board $1636 per sem
Courses: †Art Appreciation, Art Education, Art History, Ceramics, Color, †Commercial Art, Design, Drawing, Glass Blowing, †Graphic Design, Painting, †Photography, Printmaking, Sculpture

KEARNEY

UNIVERSITY OF NEBRASKA, KEARNEY, Dept of Art & Art History, 905 W 25th St, Kearney, NE 68849. Tel 308-865-8353; Fax 308-865-8806; Internet Home Page Address: www.unk.edu; *Chmn & Assoc Prof* Mark Hartman, MFA; *Prof* Gary E Zaruba, EdD; *Prof* Jack Karraker, MFA; *Assoc Prof* Jake Jacobson, MFA; *Assoc Prof* Tom Dennis, MFA; *Asst Prof* James M May, MA; *Asst Prof* Richard Schuessler, MFA; *Asst Prof* Wutcichai Choonhafakulchoke; *Asst Prof* Eliazabeth Kronfield; *Prof* Dr Christine Bueckl; *Lectr* Kristie Sumpter; *Asst Prof* Donna Alden, PhD; *Asst Prof* Victoria Goro-Rapoport; *Assistant Prof* Michelle Lang, PhD; *Lectr* Kern Harshbarger
Estab 1905; FT 13, PT 11; pub; D & E; Scholarships; SC 20, LC 12, GC 18; D 870, E 22, non-maj 1400, maj 250, grad 25
Ent Req: HS dipl, SAT or ACT recommended
Degrees: BFA, BA, BA(Art History), BA(Educ), 4 yrs, MA(Educ-Art)
Tuition: Res—$90.50 per cr hr
Courses: Aesthetics, Art Education, Art History, Ceramics, Computer Graphics, †Drawing, Fibers, Glass Blowing, †Painting, Photography, †Printmaking, †Sculpture, †Teacher Training, Visual Communication & Design
Summer School: Chmn, John Dinsmore. Enrl 250; tuition undergrad $90.75 per hr, grad $112.00 per hr. Courses—Aesthetics, Computer Graphics, Drawing, Painting, Special Problems in Art History

LINCOLN

NEBRASKA WESLEYAN UNIVERSITY, Art Dept, 5000 St Paul, Lincoln, NE 68504. Tel 402-465-2273; Fax 402-465-2179; Internet Home Page Address: www.nebrwesleyan.edu; *Assoc Prof* Lisa Lockman, MFA; *Adjunct Prof Art* Susan Horn, MFA; *Dept Chair, Prof Art History* Dr Donald Paoletta, PhD; *Asst Prof* David Gracie, MFA
Estab 1888, dept estab 1890; Maintains nonprofit gallery, Elder Gallery 50th & Huntington Sts, Lincoln, NE 68504; FT 3 PT 2; pvt; D & E; Scholarships; SC 22, LC 4; non-maj 300, maj 50
Ent Req: HS dipl, ent exam
Degrees: BA, BFA & BS 4 yrs
Tuition: $7,190 per sem
Courses: Art Education, Art History, Ceramics, Design, Drawing, Graphic Arts, Graphic Design, Jewelry, Painting, Photography, Printmaking, Sculpture, Silversmithing
Adult Hobby Classes: Enrl 30; tuition $152 per sem hr. Degree Program
Summer School: Enrl 30; tuition $152 per sem hr per 8 wks

UNIVERSITY OF NEBRASKA-LINCOLN, Dept of Art & Art History, 120 Richards Hall, Lincoln, NE 68588-0114. Tel 402-472-2631; Fax 402-472-9746; Elec Mail artdept@unl.edu; Internet Home Page Address: www.unl.edu; *Chmn Grad Comt* Gail Kendall, MFA; *Chmn Dept* Ed Forde, MFA
Estab 1869, dept 1912; Maintain nonprofit art gallery; Eisentrager/Howard Gallery, 1st Floor Richards Hall, Stadium Dr & T St, Univ Nebr, Lincoln 68588-0114; art supplies available on-campus; FT 20, PT 8; pub; D & E; Scholarships; SC 71, LC 27, GC 45; D 1950, E 175, non-maj 600, maj 400, grad 25
Ent Req: HS dipl
Degrees: BA, BFA , MFA 2-3 Yrs
Tuition: Res—undergrad $111.50 per cr hr, grad $147.50; nonres—undergrad $331.25 per cr hr, grad $297.50
Courses: †2-D & 3-D Design, Advertising Design, †Art History, Book Art, †Ceramics, †Commercial Art, †Drawing, †Graphic Arts, †Graphic Design, †Illustration, Mixed Media, †Painting, Papermaking, †Photography, †Printmaking, †Sculpture
Summer School: Dir, Nancy Stara. Enrl 250; two 5 wk sessions beginning June & Aug. Courses—Art History, Ceramics, Drawing, Painting, Photography, Printmaking, Special Problems & Topics

NORFOLK

NORTHEAST COMMUNITY COLLEGE, Dept of Liberal Arts, 801 E Benjamin Ave, PO Box 469 Norfolk, NE 68702-0469. Tel 402-371-2020, Ext 480; Fax 402-644-0650; Internet Home Page Address: www.northeastcollege.com; *Instr* Julie Noyes; *Instr* Harry Lindner, MA
Estab 1928; FT 3 PT 1; pub; D & E; Scholarships; SC 5, LC 5; D 150, E 50, non-maj 100, maj 50
Ent Req: HS dipl
Degrees: AA & AS 2 yrs
Tuition: Res—$49.25 per cr hr; nonres—$60.25 per cr hr; campus res—room & board $1044-$1332
Courses: Art Education, Art History, Drawing, Graphic Design, Painting, Photography
Adult Hobby Classes: Oil Painting
Summer School: Chmn Dept, Patrick Keating. Tuition same as regular yr. Courses—Photography

OMAHA

COLLEGE OF SAINT MARY, Art Dept, 1901 S 72nd St, Omaha, NE 68124. Tel 402-399-2400; *Chmn Dept* Tom Schlosser

Estab 1923; pvt, W; D & E; Scholarships; SC 11, LC 5; D 620, maj 18, special 2
Ent Req: HS dipl
Degrees: BA and BS 4 yrs
Tuition: $6875 per sem, full-time
Courses: Art History, Ceramics, Computer Graphics, Design, Painting, Photography, Sculpture, Teacher Training, Women in Art
Adult Hobby Classes: Enrl 587; tuition $133 per cr hr. Evening & weekend college offer full range of general education classes
Summer School: Dir, Dr Vernon Lestrud. Enrl 572; tuition $133 per cr hr. Full range of studio & history general education classes

CREIGHTON UNIVERSITY, Fine & Performing Arts Dept, 2500 California Plaza, Omaha, NE 68178. Tel 402-280-2509, 280-2700; Fax 402-280-2320; Internet Home Page Address: www.creighton.edu; *Assoc Chair* Fr Michael Flecky SJ, MFA; *Assoc Chair Performing Arts* Alan Klem, MFA; *Dance Coordr* Valerie Roche, ARAD; *Instr* John Thein, MFA; *Instr* Carole Seitz, MFA; *Instr* Bob Bosco, MFA; *Instr* Bill Hutson, MFA; *Instr* Jerry Horning, MFA; *Theater Coordr* Bill Vandest, MFA; *Instr* Don Doll SJ, MFA; *Instr Art History* Roger Aikin; *Instr Sculpture* Littleton Alston; Fr Ted Bohr SJ, Gallery Dir; *Music Coordr* Dr Fredrick Henna; *Instr Music* Fr Charles Jurgensmeier; *Instr Arts Mgmt* Mike Markey; Michael McCandaless, Theater Instr; *Instr Set Design* Mark Krejci
Estab 1878, dept estab 1966; den; D & E; Scholarships; SC 87, LC 16; 888, non-maj 850, maj 38, cert prog 24
Ent Req: HS dipl, regular col admis exam
Degrees: BA & BFA 4 yrs
Tuition: $750 average per yr; campus res available
Courses: 3-D Design, Advertising Design, Art Appreciation, Art Education, Art History, Ceramics, Color Theory, Design, Drawing, History of Art & Architecture, Intaglio, Lithography, Painting, Photography, Printmaking, Sculpture, Studio Fundamentals, Teacher Training, †Theatre Arts
Adult Hobby Classes: Advertising, Art History, Ceramics, Design, Life Drawing, Painting, Photography

UNIVERSITY OF NEBRASKA AT OMAHA, Dept of Art & Art History, 60th & Dodge Sts, Omaha, NE 68182. Tel 402-554-2420, 554-2800; Internet Home Page Address: www.unomaha.edu; *Chmn* Dr Frances Thurber; *Prof* Donalyn Heise; *Prof* Mary Caroline Simpson; *Assoc Prof* Henry Serenco, MFA; *Assoc Prof* Gary Day, MFA; *Assoc Prof* James Czarnecki, MFA; *Asst Prof* Bonnie O'Connell, MFA; *Prof* Barbara Simcoe, MFA; *Prof* Larry Brabshaw; *Prof* David Helm
Estab 1908, dept estab 1910; FT 12 PT 8; pub; D & E; Scholarships; SC 32, LC 22, GC 10; D 550, E 100
Ent Req: HS dipl
Degrees: BA & BFA 4 yrs
Tuition: Res—undergrad $85 per cr hr, grad $105 per cr hr; nonres—undergrad $225 per cr hr, grad $235 per cr hr; no campus res
Courses: †Art Education, †Art History, †Ceramics, †Drawing, †Painting, Paper Making, †Printmaking, †Sculpture
Summer School: Chmn Dept, Dr Martin Rosenberg. Tuition same as above for term of 5 wks. Courses—Vary

PERU

PERU STATE COLLEGE, Art Dept, PO Box 10, Peru, NE 68421. Tel 402-872-2271, 872-3815; Elec Mail perry@nscs.peru.edu; *Prof* Kenneth Anderson Scholarships
Degrees: BA, BAEd, BS, MA
Tuition: Res—$65.75 per sem; nonres—$131.50 per sem
Courses: Art Appreciation, Art Education, Art History, Ceramics, Design, Drawing, Figure Drawing, Independent Art Study, Lettering, Painting, Photography, Printmaking, Sculpture, Stage Design
Summer School: $65.75 credit for 5 weeks

SCOTTSBLUFF

WESTERN NEBRASKA COMMUNITY COLLEGE, Division of Language & Arts, 1601 E 27th St, Scottsbluff, NE 69361. Tel 308-635-3606; Internet Home Page Address: www.wncc.net; *Chmn Div Language* Paul Jacobson; *Chmn Art* Ziya Sever, MA
Estab 1926; FT 2; pub; D & E; Scholarships; SC 8, LC 3; D 60, E 150, non-maj 50, maj 10
Ent Req: HS dipl
Degrees: AA & AS 2 yrs
Tuition: Res—$50.50 per cr hr; nonres—$56.50 per cr hr; campus res available
Courses: Art Education, Art History, Drawing, History of Film, Music Education, Painting, Photography, Theatre Arts
Adult Hobby Classes: Enrl 150; tuition $15 per course. Courses—Carving, Drawing, Macrame, Pottery, Sculpture, Stained Glass, Watercolor & Oil Painting, Weaving

SEWARD

CONCORDIA COLLEGE, Art Dept, 800 N Columbia, Seward, NE 68434. Tel 402-643-3651; Internet Home Page Address: www.cune.edu; *Prof* Richard Wiegmann, MFA; *Prof* Lynn Soloway, MFA; *Prof* James Bockelman, MFA; *Head Dept* William R Wolfram, MFA; *Prof* Kenneth Schmidt, PhD
Estab 1894; Maintain nonprofit art gallery; Marxhausen Art Gallery, 800 N Columbia Ave, Seward, NE 68434; den; D & E; Scholarships; SC 40, LC 7; non-maj 10, maj 95
Ent Req: HS dipl
Degrees: BS, BA 4 yr, BFA 4 yr
Tuition: $13,468 per yr
Courses: Advertising Design, †Art Education, Ceramics, Collage, †Commercial Art, Design, Drawing, Graphic Arts, Graphic Design, Illustration, Mixed Media, Painting, Photography, Printmaking, Sculpture, Teacher Training

Summer School: Tuition $210 per cr hr for term of 2 1/2 wks beginning early May

WAYNE

WAYNE STATE COLLEGE, Dept Art & Design, 1111 Main St, Wayne, NE 68787. Tel 402-375-7359; Fax 402-375-7204; Internet Home Page Address: www.wsc.edu; *Prof* Steve Elliot; *Prof* Pearl Hansen; *Prof* Wayne Anderson; *Prof* Marlene Mueller; *Prof* Vic Reynolds; *Dept Chair* Pearl Hansen; *Lectr* Judith Berry
Estab 1910; Maintains nonprofit gallery, Norstrand Visual Arts Gallery, FA, 111 Main, Wayne NE 68787; 10 FT & PT; pub; D&E; Scholarships; SC 21, LC 8; maj 65, others 700, total 4,000
Ent Req: HS grad
Degrees: BA, BFA, MA & MS
Tuition: Res—$125 per cr hr; nonres—$155 per cr hr
Courses: †Advertising Design, †Art Appreciation, Art History, †Ceramics, Commercial Art, Design, Drafting, Drawing, Graphic Arts, Handicrafts, Jewelry, Painting, †Printmaking, Sculpture, †Teacher Training
Summer School: Three sessions

YORK

YORK COLLEGE, Art Dept, 1127 E 8th, York, NE 68467. Tel 402-362-4441, Ext 218; *Asst Prof* Paul M Shields
Sch estab 1956, dept estab 1962; Pvt; D; Scholarships; SC 6, LC 1; D 26, non-maj 20, maj 10
Ent Req: HS dipl, ACT
Degrees: AA 2 yrs
Tuition: Res—undergrad $5,150 per sem
Courses: 2-D & 3-D Design, Art Appreciation, Art History, Commercial Design, Drawing, Painting

NEVADA

INCLINE VILLAGE

SIERRA NEVADA COLLEGE, Fine Arts Dept, 999 Tahoe Blvd, Incline Village, NV 89451. Tel 775-831-1314; Elec Mail ashipley@sierranevada.edu; Internet Home Page Address: www.sierranevada.edu; *Dir Gallery* Russell Dudley; *Chmn* Anne Shipley; *Dir Summer Arts* Sheri Leigh
Estab 1969; Maintains Tahoe Gallery, Abernathy Hall, 800 College Dr, Incline Village, Nev; art supplies available at on-campus shop; pvt; D & E; Scholarships; SC 75, LC 8; D 260, E 40, maj 30
Collections: Contemporary ceramics; Contemporary mixed media
Ent Req: HS dipl, 2.5 grade point avg
Degrees: BA, BFA 4 yr
Tuition: res—undergrad $1950 per yr; campus—room & board; non-res—undergrad $7450 per yr
Courses: Art Appreciation, Art Education, Art History, †Ceramics, Design, Digital Arts, †Drawing, †Film, Graphic Arts, Mixed Media, Music, †Painting, †Photography, †Printmaking, Sculpture, Teacher Training, †Theatre Arts, †Video
Adult Hobby Classes: Enrl 80; tuition per cr. Courses—Ceramics
Summer School: Dir, Sheri Leigh. Enrl 200; tuition $420 per course non credit. Courses—Studio Arts

LAS VEGAS

UNIVERSITY OF NEVADA, LAS VEGAS, Dept of Art, 4505 S Maryland Pky, Box 455002 Las Vegas, NV 89154-5002. Tel 702-895-3237; Fax 702-895-4346; *Assoc Prof* Cathie Kelly; *Prof* Thomas J Holder; *Prof* Jim Pink; *Assoc Prof* Pasha Rafat; *Assoc Prof* Mary Warner; *Prof & Chmn* Mark Burns; *Prof* Catherine Angel; *Prof* Bill Leaf; *Asst Prof* Louisa McDonald; *Asst Prof* John Paul Ricco; *Prof* Bob Tracy; *Asst Prof* Stephen Hendee; *Asst Prof* Helga Watkins; *Asst Prof* Bob Wysocki
Estab 1955; Maintains nonprofit gallery, Donna Beam Fine Art Gallery, 4505 Maryland Pkwy Box 5002, Las Vegas NV 89154; Pub; D & E; Scholarships; SC 32, LC 18; all courses 551, maj 95
Ent Req: HS dipl, ACT
Degrees: BA and BFA 4 yrs, MFA
Tuition: Res—$91 per cr hr, $123 per cr hr; campus res—room & board varies per sem
Courses: Art Appreciation, Ceramics, Drawing, Graphic Design, Intermedia, Painting, Photography, Printmaking, Sculpture
Summer School: Dir, Thomas Holder. Enrl varies; 5 wk session. Courses—Ceramics, Drawing, Painting, Printmaking

RENO

UNIVERSITY OF NEVADA, RENO, Art Dept, Mail Stop 224, Reno, NV 89557-0007. Tel 775-784-1110, 784-6682; Internet Home Page Address: www.unr.edu; *Chmn Dept* Ed W Martinez
Estab 1940; FT 10; pub; D & E; Scholarships; SC 20, LC 6, GC 5; maj 120, others 800
Ent Req: HS grad and 16 units
Degrees: BA 4 yr
Tuition: Res—$80.50 per cr hr; non res—$80.00 per cr hr plus additional $3607
Courses: †Art Education, †Art History, †Ceramics, †Drawing, Graphic Design, †Painting, †Photography, †Printmaking, †Sculpture
Adult Hobby Classes: Evening division in all areas

Summer School: Courses in all studio areas

NEW HAMPSHIRE

DURHAM

UNIVERSITY OF NEW HAMPSHIRE, Dept of Arts & Art History, Paul Creative Arts Ctr, 30 College Rd Durham, NH 03824-3538. Tel 603-862-2190, 862-1234, 862-1360; Fax 603-862-2191; Internet Home Page Address: unhinfo.unh.edu; *Chmn* Scott Schneph; *Prof* David Andrew PhD; *Prof* Michael McConnell; *Assoc Prof* David Smith PhD; *Assoc Prof* Maryse Searls-McConnel, MFA; *Assoc Prof* Mara Witzling PhD, MFA; *Assoc Prof* Chris Enos, MFA; *Assoc Prof* Craig Hood, MFA; *Assoc Prof* Grant Drumheller, MFA; *Asst Prof* Jennifer Moses, MFA; *Asst Prof* Langdon Quin, MFA; *Asst Prof* Joy Stone; *Asst Prof* Brian Chu; *Assoc Prof* Elenor Hight; *Assoc Prof* Patricia Emison
Estab 1928, dept estab 1941; pub; D & E; Scholarships; SC 60, LC 20; non-maj 1000, maj 175, grad 5, others 60
Ent Req: HS dipl, portfolio
Degrees: BFA & BA(Studio Arts & Art History) 4 yrs, MAT 5 yrs
Tuition: Res—$6555; nonres—$15,275; campus res available
Courses: Architecture, Art Education, Art History, Ceramics, Drawing, Painting, Photography, Printmaking, Sculpture

HANOVER

DARTMOUTH COLLEGE, Dept of Art History, 6033 Carpenter Hall, Hanover, NH 03755-3570. Tel 603-646-2306; Fax 603-646-3428; Elec Mail art.history@dartmouth.edu; Internet Home Page Address: www.dartmouth.edu/~arthist/; *Sr Lectr* Marlene Heck; *Assoc Prof* Allen Hockley; *Chm & Assoc Prof* Kathleen Corrigan; *Prof* Adrian Randolph; *Assoc Prof* Angela Rosenthal; *Lectr* Steven Kangas; *Prof Emeritus* Robert McGrath; *Prof* Jim Jordan; *Prof* Joy Kenseth; *Assoc Prof* Ada Cohen; *Mellon Fel* Phoebe Wolfskill; *Adjunct Asst Prof* Jane Carroll; *Adjunct Asst Prof* Kristin O'Rourke
Estab 1906; Maintain nonprofit art gallery; Hood Museum of Art, Hanover, NH 03755; FT 7; pvt; D; SC 16, LC 26; in col 4000, maj 46
Degrees: AB 4 yr
Tuition: $23,790 per yr, room & board $6912
Courses: 3-D Design, †Art History

HENNIKER

NEW ENGLAND COLLEGE, Art & Art History, 24 Bridge St, Henniker, NH 03242. Tel 603-428-2211; Fax 603-428-7230; Internet Home Page Address: www.nec.edu; *Prof* Marguerite Walsh, MFA; *Prof* Farid A Haddad, MFA; *Asst Prof* Inez McDermott, MA; *Lectr* Darryl Furtkamp, MFA; *Asst Prof* Neil Rennie, MFA
Estab 1946; Maintain non-profit art gallery; New England College Gallery, Preston Barn, Henniker, NJ 03242; art supplies can be purchased on-campus; Pvt; D; Scholarships
Degrees: BA
Courses: †Art Appreciation, †Art History, Design, Drawing, Graphic Arts, Mixed Media, †Painting, †Photography, Printmaking, Sculpture

MANCHESTER

NEW HAMPSHIRE INSTITUTE OF ART, 148 Concord St, Manchester, NH 03104. Tel 603-623-0313; Internet Home Page Address: www.nhia.edu; *Interim Pres* Dr Daniel Lyman
Estab 1898; pvt; credit and adult educ courses; D & E; Scholarships; SC 16; 1000
Ent Req: none
Degrees: BFA
Tuition: $3375 per sem
Courses: Aesthetics, Art Appreciation, Art Education, Art History, Calligraphy, †Ceramics, Collage, Design, Fashion Arts, Handicrafts, History of Art & Architecture, Illustration, Jewelry, Mixed Media, †Painting, †Photography, Printmaking, Sculpture, Silversmithing, Theatre Arts, Weaving
Adult Hobby Classes: Enrl 400; tuition $150-$600 for 12-15 wks. Courses—Art History, Ceramics, Drawing, Fiber Arts, Painting, Photography, Printmaking, Sculpture
Children's Classes: Enrl 75; tuition $75-$125 for 6-12 wks. Courses—Artful Hands
Summer School: Courses—Same as in Fall & Spring

SAINT ANSELM COLLEGE, Dept of Fine Arts, Manchester, NH 03102-1310. Tel 603-641-7370; Fax 603-641-7116; Internet Home Page Address: www.anselm.edu; *Chmn* Katherine Hoffman
Estab 1889; FT 3; pvt; D & E; Scholarships; SC 2, LC 9; 1500
Ent Req: HS dipl, relative standing, SAT, interview
Degrees: BA 4 yr
Tuition: $19,400 per yr; room & board $7350
Courses: Aesthetics, Architecture, †Art History, Design, Drawing, Film, †Fine Arts, Graphic Arts, Graphic Design, Mixed Media, Painting, Photography, Printmaking, Sculpture, Teacher Training, Theatre Arts
Summer School: Dir, Dennis Sweetland. Courses—Vary

NASHUA

RIVIER COLLEGE, Art Dept, 420 Main St, Nashua, NH 03060. Tel 603-888-1311, Ext 8276;

Estab 1933, dept estab 1940; pvt; D & E; Scholarships; SC 100, LC 25; D 50,E 40, non-maj 20, maj 70
Ent Req: HS dipl, SAT, certain HS equivalencies, preliminary evidence of artistic ability, slide portfolio
Degrees: AA 2 yrs, BA, and BFA 4 yrs
Tuition: $8445 per sem, $863 per cr; part-time $339 per cr; campus res—$3325 room & board per sem
Courses: Aesthetics, Art Appreciation, Art Education, Art History, Calligraphy, Ceramics, Collage, Conceptual Art, Design, †Digital Imaging, Drawing, †Graphic Design, †Illustration, Mixed Media, †Painting, †Photography, Printmaking, Sculpture, Silversmithing, Teacher Training, Weaving
Adult Hobby Classes: Enrl 60; tuition $171 per cr for 15 wk term.
Courses—Variety of fine arts & design studio courses
Children's Classes: Enrl 24. Courses—Pre-college summer art program
Summer School: Dir, Rose Arthur, PhD. Tuition $132 per cr for 6 wks.
Courses—Master Workshops in Basic Design, Drawing, Etching, Graphic Design, Painting, Sculpture

NEW LONDON

COLBY-SAWYER COLLEGE, Dept of Fine & Performing Arts, 100 Main St, New London, NH 03257. Tel 603-526-3000, 526-3662, Ext 3666 (Chair); Fax 603-526-2135; Internet Home Page Address: www.colby-sawyer.edu; *Prof* John Bott, MFA; *Assoc Prof* Loretta Barnett, MFA; *Chair* Jon Keenan, MFA; *Asst Prof* Jane Petrillo, MFA; *Asst Prof* Jerry Bliss, MFA; *Prof* Martha Andrea, MFA
Estab 1837; FT 6; pvt; W; D; Scholarships; SC 10, LC 25; 775
Ent Req: high school diploma
Degrees: BA, BFA(Art & Graphic Design), Arts Management (student designed major)
Tuition: $20,130; room—$4300; board—$3420
Courses: Acting, Advertising Design, Aesthetics, American Art, Art Appreciation, Art History, †Ceramics, Contemporary Art since 1945, Creative Expression, Dance, †Design, †Drawing, European Trips to France & Italy, Graphic Arts, †Graphic Design, Illustration, Life Drawing, Museum Staff Training, Music, Origins of Modern Art, †Painting, †Photography, †Printmaking, †Sculpture, Stage Craft, Theatre Design, Theatre History, Women in Art
Adult Hobby Classes: Acad Dean, Dan Meerson, PhD. Continuing educ classes

PETERBOROUGH

SHARON ARTS CENTER, School Arts & Crafts, 457 Rte 123, Peterborough, NH 03458; 457 Rte 123, Sharon, NH 03458. Tel 603-924-7256; Fax 603-924-6074; Elec Mail jeb@sharonarts.org; Internet Home Page Address: www.sharonarts.org
Estab 1947; PT 30; pvt; D & E; Scholarships; SC 75; classes yr round; D 700, E 100
Ent Req: none
Tuition: $180 members, $215 non-members
Courses: Basketry, Calligraphy, Ceramics, Drawing, †Glassmaking, Jewelry, Painting, Photography, Printmaking, Sculpture, Weaving, Woodcarving
Adult Hobby Classes: Enrl 900. Courses—Visual & Tactile Arts
Children's Classes: Enrl 100. Courses—Visual & Tactile Arts
Summer School: Dir, Deb DeCicco. Courses—Visual & Tactile Arts, Drawing, Painting, Jewelry, Ceramics, Weaving & others; July Art Week for Teens

PLYMOUTH

PLYMOUTH STATE COLLEGE, Art Dept, 17 High St, Plymouth, NH 03264-1595. Tel 603-535-2201; Fax 603-535-3892; Elec Mail bhaust@mail.plymouth.edu; Internet Home Page Address: www.plymouth.edu; *Head Dept* Bill Haust
Estab 1871; FT 11; pub; D & E; Scholarships; SC 17, LC 8; D 3050, maj 90
Ent Req: HS grad, references, health record, transcript, SAT, CEEB, ACT
Degrees: BS, BFA & BA 4 yrs
Tuition: Res—$2590 per sem; nonres—$7870 per sem; room & board $4024
Courses: Architecture, Art Appreciation, †Art Education, †Art History, †Ceramics, Design, †Drawing, †Graphic Design, Illustration, Museum Staff Training, †Painting, †Photography, †Printmaking, †Sculpture, †Teacher Training
Adult Hobby Classes: Dir, Gail Carr. Enrl 50. Courses—Vary
Children's Classes: Courses available
Summer School: Courses vary

RINDGE

FRANKLIN PIERCE COLLEGE, Dept of Fine Arts & Graphic Communications, College Rd, PO Box 60 Rindge, NH 03461. Tel 603-899-4000; Fax 603-899-4308; *Co-Chmn* Robert Diercks
Estab 1962; pvt; D & E; Scholarships; SC 20, LC 2
Ent Req: HS dipl
Degrees: BA(Fine Arts), BA(Graphic Design)
Tuition: $26,375 per yr incl room & board
Courses: Art Education, Art History, Ceramics, Color Photography, Commercial Art, Design, Drawing, Graphic Design, Illustration, Painting, Photography, Printmaking, Sculpture, Stage Design, Teacher Training
Summer School: Color Photography, Landscape Painting

NEW JERSEY

BLACKWOOD

CAMDEN COUNTY COLLEGE, Visual & Performing Arts Dept, College Dr, PO Box 200 Blackwood, NJ 08012. Tel 856-227-7200; Fax 856-374-4969; *Prof* L Dell'Olio; *Dean & Prof* J Rowlands

Estab 1966; Scholarships; SC 12, LC 10; 100
Ent Req: HS dipl or equivalent
Degrees: AA 2 yrs
Tuition: In county & res—$59 per cr hr; nonres—$63 per cr hr
Courses: Art History, Art Therapy, Ceramics, Computer Graphics, Design, Drawing, Painting, Sculpture
Adult Hobby Classes: Special sessions
Children's Classes: Special sessions
Summer School: Courses available

CALDWELL

CALDWELL COLLEGE, Art Dept, 9 Ryerson Ave, Caldwell, NJ 07006-6195. Tel 973-228-4424; Fax 973-618-3915; Internet Home Page Address: www.caldwellcollege.edu; *Chmn* Lawrence Szycher
Estab 1964; FT 3, PT 6; pvt, W; D; Scholarships; SC 24, LC 12; maj 76, dept 90
Ent Req: HS grad, ent exam, art portfolio
Degrees: BA 3-4 yr, BFA 4-5 yr
Tuition: Full time $10,050 per yr, $179 per cr hr; part-time $258 per cr hr
Courses: Art Education, Art History, Art Therapy, Calligraphy, Ceramics, Drawing, Painting, Photography, Sculpture, Visual Communications

CAMDEN

RUTGERS UNIVERSITY, CAMDEN, Art Dept, Fine Arts Ctr, 311 N Fifth St Camden, NJ 08102. Tel 609-225-6176; Fax 609-225-6330; Internet Home Page Address: www.camden.rutgers.edu; *Chmn* John Giannotti
FT 5, PT 9; pub; D; SC 24, LC 13; art D 450, maj 75
Ent Req: HS dipl, must qualify for regular col admis, portfolio
Degrees: BA(Art) 4 yrs
Tuition: Res—$2281 per sem (12 cr), $147.45 per cr; nonres—$4643 per sem (12 cr), $301.05 per cr
Courses: Art History, Computer Animation, Computer Graphics, Drawing, Graphic Design, Museum Studies, Painting, Photography, Printmaking, Sculpture
Summer School: Chmn, John Giannotti. Three sessions beginning May 20. Courses—Varies

DEMAREST

THE ART SCHOOL AT OLD CHURCH, 561 Piermont Rd, Demarest, NJ 07627. Tel 201-767-7160; Fax 201-767-0497; Elec Mail info@tasoc.org; Internet Home Page Address: www.tasoc.org; *Admin Dir* Karen Shalom; *Public Progs Dir* Lorraine Zaloom; *Exec Dir* Maria Danziger; *Facilities Mgr* Peter Schmidt; *Develop Asst* Cynthia Shevelew; *Dir Gallery* Paula Madawick; *Exec Asst* Melissa Pazcoguin
Estab 1974; Maintain nonprofit art gallery; Center Gallery at Old Church, 561 Piermont Rd., Demarest, NJ 07627; Pub; D & E; Scholarships, Fellowships; SC 75; D 475, E 325
Publications: Centerling, semi-annual
Tuition: Varies per course
Courses: Art Appreciation, Ceramics, Drawing, Fiber Art, Glass Bead Making, Goldsmithing, Jewelry, Mixed Media, Painting, Photography, Printmaking, Sculpture, Silversmithing, Stained Glass
Adult Hobby Classes: Enrl 450. Courses—Ceramics, Drawing, Metals, Painting, Printmaking, Sculpture, Basketry, Glass
Children's Classes: Enrl 250. Courses—Ceramics, Drawing, Painting, Sculpture

DOVER

JOE KUBERT SCHOOL OF CARTOON & GRAPHIC ART, INC, 37 Myrtle Ave, Dover, NJ 07801. Tel 973-361-1327; Fax 973-361-1844; Internet Home Page Address: www.kubertsworld.com; *Instr* Hy Eisman; *Instr* Irwin Hasen; *Instr* Douglas Compton; *Instr* Michael Chen; *Instr* Jose Delbo; *Instr* Kim Demulder; *Instr* Jim McWeeney; *Instr* Judy Mates; *Instr* Greg Webb; *Instr* John Troy; *Pres* Joe Kubert
Estab 1976; pvt; D & E; Scholarships; SC all, LC all; D 200, E 100
Ent Req: HS dipl, interview, portfolio
Degrees: 3 yr dipl
Tuition: $11,425 per yr
Courses: Cartoon Graphics, Cinematic Animation, Commercial Art, Design, Graphic Arts, Illustration, Lettering, Painting, Video
Adult Hobby Classes: Enrl 100; tuition $200 per 12 wks. Courses—Basic & Advanced Paste-Ups & Mechanicals, Cartoon Workshop, Computer Graphic/Animation Workshop
Children's Classes: Enrl 20; tuition $15 per class. Courses—Saturday Cartoon Sketch Class
Summer School: Courses—same as regular session

EDISON

MIDDLESEX COUNTY COLLEGE, Visual Arts Dept, 155 Mill Rd, PO Box 3050 Edison, NJ 08818. Tel 732-906-2589; Fax 732-906-2510; *Chmn* Jay Siegfried
Scholarships
Degrees: AA
Tuition: County $57.50 per cr hr; out-of-county $115; out-of-state $115 per cr hr
Courses: Art Appreciation, Art Education, Art Foundation, Art Fundamentals (2-D & 3-D Design), Art History, Art Industry & Communication, Ceramics, Drawing, Painting, Printmaking, Sculpture, Stage Design
Adult Hobby Classes: Courses offered

Summer School: Dir, Warren Kelerme. Courses—Art History, Ceramics, Drawing, Painting

EWING

THE COLLEGE OF NEW JERSEY, School of Arts & Sciences, 2000 Pennington Rd, Ewing, NJ 08628; PO Box 7718, Ewing, NJ 08628-0718. Tel 609-771-2652; Fax 609-637-5134; Internet Home Page Address: www.tcnj.edu; *Chmn Dept* Lois Fichner-Rathus; *Prof* Bruce Rigby, MFA; *Assoc Prof* Kenneth Kaplowitz, MFA; *Assoc Prof* Charles Kumnick, MFA; *Assoc Prof* Marcia Taylor, PhD, MAATR; *Assoc Prof* Wendell Brooks, MFA; *Assoc Prof* Elizabeth Mackie, MFA; *Asst Prof* Philip Sanders, MA; *Asst Prof* Charles McVicker, BPA; *Asst Prof* William Nyman, MFA; Anita Allyn; Tia Brancaccio; Sarah Oppenheimer; Lee-Ann Riccardi
Estab 1855; FT 17, PT 18; pub; D & E; Scholarships; SC 40, LC 10, GC 11; non-maj 5200, maj 300
Ent Req: HS dipl
Degrees: BA & BFA 4 yr
Tuition: Res—$4446; nonres—$7032
Courses: Advertising Design, Art Appreciation, †Art Education, Art History, Ceramics, Computer Animation, Computer Graphics, Design, Display, Drafting, Drawing, †Fine Arts, †Graphic Design, History of Art & Architecture, Illustration, †Interior Design, Intermedia, Jewelry, Lettering, Mixed Media, Painting, Photography, Printmaking, Sculpture, Silversmithing, Teacher Training
Summer School: June & July five wk sessions, Governor's School of the Arts (July)

GLASSBORO

ROWAN UNIVERSITY, Dept of Art, 201 Mullica Hill Rd, Glassboro, NJ 08028-1701. Tel 856-256-4000; Fax 856-256-4814; *Chmn* Thomas Skeffington; *Asst Chair* Fred Adelson
Estab 1925; Maintain nonprofit art gallery, Westby Gallery, Westby Hall, Rowan Univ,Rt #322, Glassboro, NJ 08028; Pub; D & E; D 6,100, E 5,000, maj 300, grad 5-
Ent Req: HS dipl, ent exam, portfolio and SAT
Degrees: BA 4 yrs, BFA 4 yrs, MA
Tuition: Res—$8,606; nonres—$14,900
Courses: Advertising Design, Art Appreciation, Art Education, Art History Survey, Batik, Ceramics, Computer Art, Drawing, Enameling, Fiber Arts, Illustration, Jewelry, Metaltry, Puppetry, Sculpture, Theatrical Design
Children's Classes: Enrl 30. Courses—Crafts, Drawing, Mixed Media, Painting
Summer School: Enrl 100; Courses—Drawing, Painting, Printing,

HACKETTSTOWN

CENTENARY COLLEGE, Humanities Dept, 400 Jefferson St, Hackettstown, NJ 07840. Tel 908-852-1400, Ext 2265; *Head* Dr Robert Frail; *Assoc Prof* Richard Wood, MFA; *Asst Prof Interior Design* Elena Kays, MFA; *Instr* Elizabeth Desabritas, MFA; *Assoc Prof* Carol Yoshimine-Webster, MFA
Estab 1874; pvt; Scholarships; SC 11, LC 2; maj 70, others 367, total 678
Exhibitions: Gallery Exhibitions (BFA students) Architecture Site, Art/Design reviews, Interior Design students
Ent Req: high school diploma
Degrees: BFA(Art & Design), AA(Interior Design), BFA(Interior Design), BS(Communications)
Tuition: Res—$22,180; commuter—$15,100;
Adult Hobby Classes: Tuition $98 per cr. Courses—Graphic Arts, Interior Design
Summer School: Dir, Larry Friedman. Tuition $98 per cr. Courses—Graphic Art, Interior Design

JERSEY CITY

JERSEY CITY STATE COLLEGE, Art Dept, 2039 Kennedy Blvd, Jersey City, NJ 07305. Tel 201-200-3214, Ext 3241; Fax 201-200-3238; Internet Home Page Address: www.njcu.edu; *Prof* Dr Elaine Foster, EdD; *Prof* Harold Lemmerman, EdD; *Prof* Anneke Prins Simons PhD, EdD; *Prof* Ben Jones, MFA; *Prof* Dr Eleanor Campulli, EdD; *Assoc Prof* Marguarite LaBelle, MA; *Assoc Prof* Mary Campbell, MFA; *Assoc Prof* Jose Rodeiro PhD, MFA; *Assoc Prof* Charles Plosky, MFA; *Assoc Prof* Herbert Rosenberg, MFA; *Assoc Prof* Raymond Statlander, MFA; *Asst Prof* Sr Joan Steans, MFA; *Asst Prof* Mauro Altamura, MFA; *Asst Prof* Winifred McNeill, MFA; *Asst Prof* Tom Reiss, MFA; *Asst Prof* Ellen Quinn, MFA; *Asst Prof* Karen Santry, MFA; *Chmn* Denise Mullen, MFA
Estab 1927, dept estab 1961; FT 13 PT 15; pub; D & E; Scholarships; SC 61, LC 19, GC 31; D 350, E 60, GS 60
Ent Req: HS dipl or equivalent
Degrees: BA & BFA 128 sem hrs, MA, MFA 60 sem hrs, grad assistantship
Tuition: Res—undergrad $154 per cr; campus res available
Courses: Advertising Design, Aesthetics, Art Appreciation, Art Education, Art History, Art Therapy, Ceramics, †Communication Design, Conceptual Art, †Crafts, Design, Digital Imaging, Drawing, Fashion Illustration, †Fine Arts, Graphic Design, History of Art, Illustration, Industrial Design, Interior Design, Intermedia, Jewelry, Lettering, Metalsmithing, Mixed Media, Painting, †Photography, Printmaking, Sculpture, †Teacher Certification

SAINT PETER'S COLLEGE, Fine Arts Dept, 2641 Kennedy Blvd, Jersey City, NJ 07306. Tel 201-915-9238; Fax 201-915-9240; Internet Home Page Address: www.spc.edu; *Chmn* Jon D Boshart PhD
Estab 1872, dept estab 1963; Maintain nonprofit art gallery; St Peter's College Art Gallery; Jesuit; D & E; Scholarships; SC 8, LC 20; D 2,000, E 900, maj 15
Ent Req: HS dipl
Degrees: BA, BA in Cursu Classico, BS 4 yrs

Tuition: $508 per cr hr
Courses: Advertising Design, Aesthetics, Architecture, Art Appreciation, Art Education, †Art History, Commercial Art, †Drawing, †Graphic Arts, History of Art & Architecture, Mixed Media, †Painting, Photography, Restoration & Conservation, †Sculpture, Teacher Training
Adult Hobby Classes: Tuition $508 per sem. Courses—Art History, Studio
Summer School: Dir, Dr Boshart. Tuition $1,524 per 3 cr, one 3 wk session & two 5 wk sessions. Courses—Art History, Electives, Drawing, Film History, Introduction to Visual Arts, Painting, Photography, Graphic Arts, Museum Courses

LAKEWOOD

GEORGIAN COURT COLLEGE, Dept of Art, 900 Lakewood Ave, Lakewood, NJ 08701-2697. Tel 908-364-2200, Ext 348; Fax 908-905-8571; Internet Home Page Address: www.georgian.edu; *Head Dept* Geraldine Velasquez, EdD; *Prof* Sr M Christina Geis, MFA; *Assoc Prof* Sr Mary Phillis Breimayer, MFA; *Asst Prof* Suzanne Pilgram, MFA; *Asst Prof* Sr Joyce Jacobs, MA; *Asst Prof* Vincent Hart, MA; *Lectr* Nicholas Caivano, MFA; *Lectr* Eva Bousard-Hui, EdD
Estab 1908, dept estab 1924; pvt; D & E; Scholarships; SC 18, LC 11; 240, non-maj 150, maj 90
Ent Req: HS dipl, col board scores, portfolio
Degrees: BA 4 yr
Tuition: Undergrad $10,332, $287 per cr; campus res—room & board 7 day $4450, 5 day $4300
Courses: †Art (studio & art history), †Art Education, †Art History, Calligraphy, Ceramics, Color & Design, Commercial Art, Computer Graphics, Drafting, Drawing, Fashion Arts, Graphic Design, Handicrafts, Illustration, Jewelry, Lettering, Painting, Photography, Printmaking, Sculpture, Teacher Training, Textile Design, Weaving
Summer School: Dir, Linda Capuano. Tuition $287 per cr for term of 12 wks beginning May 17. Courses—Art History, Studio Courses, Workshops by recognized artists

LAWRENCEVILLE

RIDER UNIVERSITY, Dept of Fine Arts, 2083 Lawrenceville Rd, Lawrenceville, NJ 08648. Tel 609-896-5168; *Chmn* Richard Homan
Estab 1966; FT 5; pvt; D & E; SC 9, LC 4; D 3500, E 5169, maj 35
Ent Req: HS dipl
Degrees: BA(Fine Arts) 4 yrs
Tuition: $8925 per yr; campus res available
Courses: Drawing, Graphic Arts, Graphic Design, Painting
Summer School: Courses—Drawing, Art & Society

LINCROFT

BROOKDALE COMMUNITY COLLEGE, Center for the Visual Arts, 765 Newman Springs Rd, Lincroft, NJ 07738. Tel 732-224-2000; Fax 732-224-2060; Internet Home Page Address: www.brookdale.cc.nj.us; *Chmn* Ed o'Neill
Estab 1968; Pub; D & E
Ent Req: HS diploma
Degrees: AA
Tuition: County res—$90 per cr hr; non-county res—$165 per cr hr; non-state res—$341 per cr hr
Courses: Ceramics, Design, Drawing, Jewelry, Painting, Printmaking

LIVINGSTON

ART CENTRE OF NEW JERSEY, Riker Hill Art Pk Bldg 501, 284 Beaufort Ave Ste 3 Livingston, NJ 07039. Tel 973-227-3488 & 535-1159; Fax 973-227-3488; *Pres* Tim Maher; *First VPres* Alden Baker; *Second VPres* Salomon Kadoche; *Treas* Louis de Smet
Estab 1924 as an art school & presently is a venue for workshops, art events, lects, critiques, exhibitions etc; Mem: 250; dues $12.50; annual meeting in May; Pub; D (open studies, no classes)
Income: Financed by mem & art sales
Publications: Membership newsletter
Courses: Painting
Adult Hobby Classes: Workshops

MADISON

DREW UNIVERSITY, Art Dept, College of Liberal Arts, 36 Madison Ave Madison, NJ 07940. Tel 973-408-3553, 408-3000; Fax 973-408-3768; *Prof* Livio Saganic, MFA; *Dept Chmn* Michael Peglau, PhD; *Asst Prof* Margaret Kuntz, PhD; *Adjunct Asst Prof* William Mutter, MFA; *Adjunct Asst Prof* Raymond Stein; *Prof* Sara Henry-Corrington; *Adjunct Asst Prof* Lisa Solon, MBA; *Adjunct Asst Prof* Anne Gaines, MFA; *Adjunct Asst Prof* Tom Birkner, MFA; *Adjunct Asst Prof* Jim Jeffers, MFA
Estab 1928; Maintain nonprofit art gallery; Korn Gallery, Drew University, Madison, NJ 07940; pvt; D & E; Scholarships; SC 17, LC 10; D 275, E 12, maj 45, minors 15
Ent Req: HS dipl
Degrees: BA 4 yrs
Tuition: $29,500 per yr
Courses: Aesthetics, †Art History, Ceramics, Computer Graphics, Design, Drawing, History of Art & Architecture, Painting, Photography, Printmaking, Sculpture
Summer School: Dir, Catherine Messer. Enrl 300; tuition $1200 for 4, 5 or 6 wk term. Courses—Art History for the Blind, Ceramics, Computer Graphics, Photography

MAHWAH

RAMAPO COLLEGE OF NEW JERSEY, School of Contemporary Arts, 505 Ramapo Valley Rd, Mahwah, NJ 07430-1680. Tel 201-529-7368; Fax 201-684-7481; Internet Home Page Address: www.ramapo.edu; *Dir* Steven Perry; *Prof Art History* Carol Duncan PhD; *Prof* Judith Peck, EdD; *Prof Painting* W Wada, MFA; *Prof* Jay Wholley, MFA; *Assoc Prof Architecture* Newton LeVine, MCRP; *Assoc Prof Photo* David Freund, MFA
Estab 1968; pub; D & E; SC 53, LC 15; D 800, E 50, non-maj 750, maj 100
Ent Req: HS dipl, SAT
Degrees: BA
Tuition: Res—undergrad $32 per cr hr; nonres—undergrad $50 per cr hr; campus res available
Courses: Architecture, Art Appreciation, Art History, Commercial Art, Computer Art, Conceptual Art, Design, Drawing, Film, Graphic Arts, Graphic Design, Intermedia, Painting, Photography, Printmaking, Sculpture, Stage Design, Video
Summer School: Dir, Shalom Gorewitz. Tuition $71.50 cr hr, $91.50 out of state. Courses—Computer Graphics, Photography

MERCERVILLE

JOHNSON ATELIER TECHNICAL INSTITUTE OF SCULPTURE, 60 Ward Ave Extension, Mercerville, NJ 08619. Tel 609-890-7777; Fax 609-890-1816; Elec Mail lrn2sculpt@aol.com; Internet Home Page Address: www.gotrain.com/schools; *Pres* James Barton, MFA; *Acad Dir* James E Ulry, MFA; *Dir* Dona Warner, BFA; *Acad Asst* E Gyuri Hollosy, MFA
Open by appointment; Estab 1974; pvt; D & E; Scholarships; SC 12; apprentices 20, interns 2
Ent Req: HS dipl, portfolio review
Degrees: The Atelier is a non degree granting institution with a two year apprenticeship program in sculpture
Tuition: $4800 per academic yr, $400 monthly
Courses: Ceramic Shell, Foundry, Metal Chasing, Modeling & Enlarging, Moldmaking, Patina, Restoration & Conservation, Sand Foundry, Sculpture, Structures, Wax Working & Casting

MONTCLAIR

MONTCLAIR ART MUSEUM, Yard School of Art, Education Dept, 3 S Mountain Ave, Montclair, NJ 07042. Tel 973-746-5555; Fax 973-746-9118; Elec Mail mail@montclair-art.com; Internet Home Page Address: www.montclair-art.com; *Dir* Jacquelyn Roesch Sanchez
Art school estab 1924; FT 18; pvt; D & E; Scholarships; SC 17; D 300 per term, E 100 per term
Tuition: Children $160-$185 for 10 sessions; adults $160-$225 for 10 sessions
Courses: Art Education, Chinese Print, Collage, Drawing, Mixed Media, Painting, Portraiture, Printmaking, Sculpture
Adult Hobby Classes: Enrl 300; tuition $135-$175, duration 8 wks. Courses—Anatomy, Drawing, Painting, Pastels, Portraiture, Still Life, Watercolor
Children's Classes: Enrl 90; tuition $120-$140 per 8 wk sem. Courses—Mixed Media

MORRISTOWN

COLLEGE OF SAINT ELIZABETH, Art Dept, 2 Convent Rd, Morristown, NJ 07960-6989. Tel 973-290-4315; Elec Mail vbutera@cse.edu; Internet Home Page Address: www.cse.edu; *Chmn Dept* Dr Virginia Fabbri Butera; *Assoc Prof* Sr Anne Haarer; *Adjunct Prof* Elaine Chong; *Adjunct Prof* Raul Villarreal
Estab 1899, dept 1956; Maintain a nonprofit art gallery, Terese F Maloney Art Gallery, Annunciation Center, College of St Elizabeth, 2 Convent Rd, Morristown, NJ 07960; den, W, M & W continuing studies; D & E; Scholarships; SC 17, LC 4; D 250, maj 27
Ent Req: HS dipl, ent exam
Degrees: BA 4 yrs
Tuition: $20,000 per yr; campus res available
Courses: Advertising Design, Aesthetics, Art Appreciation, Art History, Calligraphy, Ceramics, Color and Design, Leather Work, Sand Casting, Sculpture, Stitchery, Teacher Training
Summer School: Dir, Amy Kmetz. Courses—Art Education, Painting, Photography, Drawing

NEW BRUNSWICK

INSTITUTE FOR ARTS & HUMANITIES EDUCATION, New Jersey Summer Arts Institute, 100 Jersey Ave, Ste B-104, New Brunswick, NJ 08901. Tel 732-220-1600; Fax 732-220-1515; Elec Mail ihe@ihenj.org; *Exec Dir* Maureen Heckerman
Estab 1980; Students earn HS credits; 4 FT; pvt; D & E; Scholarships; 130
Publications: Quarterly newsletter
Ent Req: audition, master class, portfolio, interview
Tuition: Campus res avail $3,000 (summer only)
Courses: Advertising Design, Aesthetics, Architecture, Art Appreciation, Art Education, Art History, Ceramics, Collage, Conceptual Art, Costume Design & Construction, Design, Display, Drawing, Fashion Arts, Film, Graphic Arts, Graphic Design, History of Art & Architecture, Illustration, Intermedia, Jewelry, Mixed Media, Painting, Photography, Printmaking, Sculpture, Stage Design, Teacher Training, Textile Design, Theatre Arts, Video, Weaving

RUTGERS, THE STATE UNIVERSITY OF NEW JERSEY
—Mason Gross School of the Arts, Tel 732-932-7711 (Grad Admissions), 445-3770 (Undergrad Admissions); Internet Home Page Address: www.gradstudy.rutgers.edu (Grad); www.mgsa.rutgers.edu/visual.htm; *Dean*

George B Stauffer; *Dir Visual Arts* Gary Kuehn; *Assoc Dean* Dennis Benson; *Prof* Lynne Allen; *Prof* Geoffrey Hendricks; *Prof* Lauren Ewing; *Prof* Raphael Ortiz; *Prof* Melvin Edwards; *Prof* Emma Amos; *Prof* Gary Kuehn; *Prof* Diane Neumaier; *Prof* Martha Rosler; *Assoc Prof* Thomas Nozkowski; *Assoc Prof* Robert T Cooke; *Assoc Prof* Phil Orenstein; *Assoc Prof* Paul Bruner; *Assoc Prof* Ardele Lister; *Assoc Prof* Toby MacLennan; *Asst Prof* Hanneline Rogeberg; *Asst Prof* Gerry Beegan; *Asst Prof* Jason Francisco; *Asst Prof* Allison Platt
Estab 1766, school estab 1976; pub; D; Scholarships; SC 50, LC 20, GC 28; MFA prog 60, BFA prog 450
Ent Req: HS dipl, portfolio
Degrees: BHA, BFA, MFA
Tuition: Res—undergrad $4762 per yr, grad $7166 per yr; nonres—undergrad $9692 per yr, grad $10,434 per yr
Courses: Ceramics, Computer Arts, Critical Studies, Event and Performance, Film, Painting, Photography, Printmaking, Sculpture, Seminars and Museum Internship, Video
Summer School: Dir, Mark Berger. 4 wk courses. Courses—Computer Art, Figure Drawing
—**Graduate Program in Art History,** Tel 732-932-7041, 932-7819; Fax 732-932-1261; Internet Home Page Address: www.arthistory.rutgers.edu; *Prof* Matthew Baigell; *Prof* Sarah McHam; *Prof* Jack J Spector PhD; *Prof* Rona Goffen; *Prof* Tod Marder; *Prof* Jocelyn Small; *Assoc Prof* John F Kenfield PhD; *Assoc Prof* Archer Harvey; *Assoc Prof* Sarah Brett-Smith; *Assoc Prof* Angela Howard; *Dir Prog & Assoc Prof* Catherine Puglisi PhD
Estab 1766, grad prog estab 1971; pub; D; Scholarships, Fellowships; grad courses 15; grad students 97
Ent Req: BA
Degrees: MA 2 yrs, PhD 4 yrs
Tuition: Res—undergrad $191 per cr hr, grad $2315 per sem; nonres—$282 per cr hr, grad $3394 per sem
Courses: Architecture, Art History, History of Art & Archeology, Museum Staff Training
Summer School: Intro to Art Hist, 19th & 20th century Art

NEWARK

RUTGERS UNIVERSITY, NEWARK, Dept of Visual & Performing Arts, University Heights, 110 Warren St Bradley Hall Newark, NJ 07102. Tel 973-353-5119; Fax 973-353-1392; Internet Home Page Address: www.rutgers.edu; WATS 800-648-5600; *Chair* Annette Juliano; *Deputy Chair* Ian Watson
FT 6; Pub; D; Scholarships; D 486, maj 100
Ent Req: HS dipl, or as specified by col and univ
Degrees: BA 4 yr, BFA(Design)
Courses: Art Appreciation, Art Education, Art History, Ceramics, Computer Graphics, Design, Drawing, Graphic Design, History of Art & Architecture, Illustration, Painting, Photography, Printmaking, Sculpture, Stage Design, Teacher Training, Theatre Arts
Summer School: Dir, Annette Juliano. Enrl 100. Courses—Art History, Ceramics, Drawing, Painting, 2-D Design, 3-D Design

OCEAN CITY

OCEAN CITY ARTS CENTER, 1735 Simpson Ave, Ocean City, NJ 08226. Tel 609-399-7628; Fax 609-399-7089; Elec Mail ocarts@pro-usa.net; Internet Home Page Address: www.oceancityartscenter.org; *Instr Guitar* Rob Gummel; *Instr Paintign* Sue Rau; *Exec Dir* Lorraine Hansen; *Instr* Annie Arena; *Marketing & Public Relations* Christine Harry; *Bookkeeper* Peg Castagna; *Instr* Lee Kuchler; *Instr* Susan Myers; *Instr* Patty Guckes; *Instr* Marie Natale; *Instr* Kim Weiland; *Instr* Sue Van Duyne
Estab 1966; Maintains nonprofit art gallery, Ocean City Arts Center Gallery; Pvt; D & E; weekends; Scholarships; SC 14, LC 1; D 1, E 8
Ent Req: none
Tuition: Varies
Courses: Ceramics, Collage, Dance, Drawing, Film, Handicrafts, Mixed Media, Painting, Photography, Pottery, Sculpture, Stained Glass, Theatre Arts, Video
Adult Hobby Classes: 50; $65 - $150
Children's Classes: 250; $65 - $350; art camp, performing arts camp, tv/media camp, guitar camp
Summer School: Exec Dir, Lorraine Hansen. Same classes offered during summer plus workshops & demonstrations

PARAMUS

BERGEN COMMUNITY COLLEGE, Visual Art Dept, 400 Paramus Rd, Rm A335, Paramus, NJ 07652. Tel 201-447-7100; Fax 201-612-8225; Internet Home Page Address: www.bergen.cc.nj.us; *Dean Art & Humanities* Michael Redmond
pub; D&E; Scholarships
Degrees: AA
Tuition: In county—$57.60 per cr; nonres—$119.70 per cr hr
Courses: Animation, Art Anatomy, Art Appreciation, Art History, Ceramics, Color Theory, Commercial Illustration, Craft Design, Design, Drawing, Fundamentals Art, Graphic Design, Handicrafts, Interior Design, Lettering, Painting, Photography, Printmaking, Sculpture

PATERSON

PASSAIC COUNTY COMMUNITY COLLEGE, Division of Humanities, One College Blvd, Paterson, NJ 07505-1179. Tel 973-684-6555; Fax 973-523-6085; Elec Mail mgillan@pccc.cc.nj.us; Internet Home Page Address: www.pccc.cc.nj.us/poetry/index.htm; *Prof* Mark G Bialy; *Prof* Steve Rose; *Cur Gallery* Jane Havv; *Exec Dir Cultural Arts* Maria Mazziotti Gillan; *Asst Dir* Aline Papazian

Estab 1969; pub; D & E; SC 4, LC 3; D 100, E 25
Ent Req: HS dipl, New Jersey basic skills exam
Degrees: AA 2 yrs
Tuition: $59.50 per cr hr
Courses: Advertising Design, Aesthetics, Art Appreciation, Art History, Commercial Art, Design, Drawing

PEMBERTON

BURLINGTON COUNTY COLLEGE, Humanities & Fine Art Div, Rte 530, Pemberton & Browns Mills Rd, Pemberton, NJ 08068. Tel 609-894-9311, Ext 7441; Internet Home Page Address: www.bcc.edu; *Art Lectr & Prog Coordr* Diane Spellman-Grimes
Estab 1969; pub; D & E; Scholarships
Ent Req: HS dipl, equivalent
Degrees: AA
Tuition: County res—$69.50 per cr hr; non-county res—$84.50 per cr hr; non-state res—$120.50 per cr hr
Courses: Art Appreciation, Art Education, Art History, Art Therapy, Calligraphy, Ceramics, Design, Drawing, Film, Handicrafts, Introduction To Teaching Art, Modernism, Painting, Photography, Sculpture, Theatre Arts, Video
Adult Hobby Classes: 10; tuition $150. Courses—Ceramics
Summer School: Dir, Diane Grimes. Courses—Ceramics, Drawing, Painting, Sculpture

PRINCETON

PRINCETON UNIVERSITY
—**Dept of Art & Archaeology,** Tel 609-258-3782; Fax 609-258-0103; Internet Home Page Address: www.princeton.edu; *Chmn* Robert Bagley MFA; *Dir Prog Chinese & Japanese Art & Archaeology* Yoshiaki Shimiza; *Chmn Prog in Classical Archaeology* William A P Childs PhD; *Prof* T Leslie Shear Jr PhD; *Prof* Thomas Leisten; *Prof* Anne-Marie Bouche; *Prof* Peter Bunnell, MFA; *Prof* Esther da Costa-Meyer, MFA; *Prof* Slobodan Curcic PhD, MFA; *Prof* Hal Foster, MFA; *Prof* John Pinto PhD, MFA; *Prof* Hugo Meyer PhD, MFA; *Prof* Thomas Kaufmann PhD, MFA; *Chmn* Patricia Fortini-Brown, MFA
Estab 1783; pvt; Scholarships; LC 16, GC 9; 761, maj 55, grad 50
Degrees: PhD
Tuition: $32,500 per yr
Courses: American Art, Archaeology, Early Chinese Art, Greek Archaeology, Islamic Art & Architecture, Italian Renaissance Art & Architecture, Later Japanese Art, Photography
—**School of Architecture,** Tel 609-258-3741; Fax 609-258-4740; Internet Home Page Address: www.princeton.edu/soa; *Dean* Ralph Lerner
Estab 1919; FT 16; pvt; D; Scholarships, Fellowships; SC 6, LC 13, GC 6, seminars 17; undergrad 120, grad 50
Ent Req: HS dipl
Degrees: BA, MA, PhD
Tuition: $32,500 per yr
Courses: Acoustics & Lighting, Building & Science Technology, Environmental Engineering, History of Architectural Theory, Modern Architecture, Urban Studies

RANDOLPH

COUNTY COLLEGE OF MORRIS, Art Dept, 214 Center Grove Rd, Randolph, NJ 07869. Tel 973-328-5000; Fax 973-328-5445; *Chmn & Prof* James Gwynn; *Asst Prof* Christine Holzer-Hunt
Estab 1970; pub; D & E; SC 15, LC 3; maj 263
Ent Req: HS dipl
Degrees: AA(Humanities/Art) 2 yrs, AAS(Photography Technology) 2 yrs
Tuition: $77 per cr; out-of-county $144; out-of-state $184
Courses: Advertising Design, Art History, Ceramics, Color & Design, Drawing, Major Styles & Historical Periods, Modern Art, Painting, Photography, Printmaking, Sculpture
Summer School: Two 5 week day sessions, one evening session

SEWELL

GLOUCESTER COUNTY COLLEGE, Liberal Arts Dept, 1400 Tanyard Rd, Sewell, NJ 08080. Tel 856-468-5000; Fax 856-488-2018; Internet Home Page Address: www.gcc.nj.edu; *Head* John Henzy
Estab 1967; Special program offered for gifted students; art gallery on campus; 130 PT & FT; pub; D & E; Scholarships; SC 6, LC 6
Ent Req: HS dipl
Degrees: AA
Tuition: Res—$79 per cr hr; nonres—$80 per cr hr
Courses: Art History, Arts & Crafts for Handicapped, Ceramics, Drawing, General Design, Graphic Arts, Jewelry, Mixed Media, Painting, Sculpture
Summer School: Dir, Dr Mossman

SHREWSBURY

GUILD OF CREATIVE ART, 620 Broad St, Rte 35 Shrewsbury, NJ 07702. Tel 732-741-1441; Elec Mail guildofcreativeart@verizon.net; Internet Home Page Address: www.guildofcreativeart.com; *Pres* Deborah Redden
Estab 1960; Maintain nonprofit art gallery; Non-profit coop; D&E; SC; D & E
Ent Req: Membership adult $25 per yr
Tuition: $150 per 10 wks
Courses: †Drawing, Painting
Adult Hobby Classes: Enrl 185; tuition $130 for 10 wk term. Courses—Design, Drawing, Painting

Children's Classes: Enrl 100; tuition $65 for 10 wk term. Courses—Design, Life Drawing, Painting
Summer School: Oil & Acrylic Painting, Watercolor

SOUTH ORANGE

SETON HALL UNIVERSITY, College of Arts & Sciences, 400 S Orange Ave, South Orange, NJ 07079. Tel 973-761-9459; Fax 973-275-2368; Internet Home Page Address: www.shu.edu; *Chmn* Charlotte Nichols PhD; *Prof* Julius Zsako PhD; *Prof* Barbara Cate; *Prof* Jeanette Hile, MA; *Assoc Prof* Alison Dale, MA; *Asst Prof* Arthur Cook, MM; *Asst Prof* Arline Lowe, MA; *Asst Prof* Joel Friedman, DMA; *Asst Prof* Deborah Gilwood, MA; *Asst Prof* K D Knittel PhD, MA; *Asst Prof* Susan Leshnoff, EdD; *Asst Prof* Ira Greenberg, MFA
Estab dept 1968; FT 10, PT 9; pvt; D & E; Scholarships, Fellowships; SC 8
Degrees: BA 4 yr, MA
Tuition: $9000 per sem, $500 per cr hr
Courses: Advertising, Art Education, Art History, Chinese Brush Painting, Commercial Art, Drawing, Fine Art, Graphic Design, Illustration, Mixed Media, Music Art, Painting, Printmaking, Sculpture
Summer School: Dir, Petra Chu. Enrl 200; May - Aug. Courses—Art, Art History, Fine Arts

TEANECK

FAIRLEIGH DICKINSON UNIVERSITY, Fine Arts Dept, University Hall, 1000 River Rd Teaneck, NJ 07666. Tel 201-692-2000; Fax 201-692-2800; Internet Home Page Address: www.fdu.edu; *Prof* David A Hanson; *Assoc Prof* Joan Taylor, MA; *Prof* Marie Roberts, MFA
Estab 1942, dept estab 1965; pvt; D & E; Scholarships; SC 37, LC 9
Ent Req: HS dipl, SAT
Degrees: degrees BA (Art & Fine Arts)
Tuition: Res—undergrad $367 per cr, room & board; nonres—undergrad $367 per cr hr; campus res available
Courses: Advertising Design, Art Appreciation, Art History, Bio & Wildlife Illustration, Calligraphy, Ceramics, Commercial Art, Computer Animation, Computer Graphics, Design, Desktop Publishing, Drawing, †Graphic Design, History of Art & Architecture, Illustration, Lettering, Mixed Media, Painting, Photography, Printmaking, Sculpture

TOMS RIVER

OCEAN COUNTY COLLEGE, Humanities Dept, College Dr, Toms River, NJ 08754-2001. Tel 732-255-0400; Fax 732-255-0444; Internet Home Page Address: www.ocean.cc.nj.us; *Coordr* Joseph Conrey; *Prof* Patricia Kennedy, MS; *Prof* Lisa Horning, MS; *Prof* Howard Unger, EdD; *Prof* John R Gowen, EdD; *Prof* Arthur Waldman, EdD; *Pres* Stephen McCleary
Estab 1964, dept estab 1964; pub; D & E; Scholarships; SC 19, LC 3; D 1500, E 1500, maj 67
Ent Req: HS dipl
Degrees: AA in Liberal Arts with concentration in Fine Art & AAS(Visual Communication Technology) 2 yrs
Tuition: Res—undergrad $1066 per yr, PT $41; nonres—undergrad $1196 per yr, PT $46; no campus res
Courses: Advertising Design, Aesthetics, Art History, Calligraphy, Ceramics, Commercial Art, Conceptual Art, Costume Design & Construction, Drawing, Film, Graphic Arts, Graphic Design, Handicrafts, Lettering, Painting, Photography, Printmaking, Sculpture, Stage Design, Theatre Arts
Summer School: Enrl 175; tuition $34 for term of 5 wks or 6 wks beginning June. Courses—Arts & Humanities, Basic Drawing, Ceramics, Computer Graphics, Crafts, Photography

TRENTON

MERCER COUNTY COMMUNITY COLLEGE, Arts, Communication & Engineering Technology, 1200 Old Trenton Rd, PO Box B Trenton, NJ 08690. Tel 609-586-4800, Ext 3348; Fax 609-586-2318; Internet Home Page Address: www.mccc.edu; *Dean* Robert A Terrano, MFA; *Cur* Tricia Fagan; *Prof* Mel Leipzig, MFA; *Prof* Frank Rivera, MFA; *Instr* Michael Welliver, MFA
Estab 1902, dept estab 1967; FT 10, PT 13; pub; D & E; Scholarships; SC 44, LC 6; E 350, maj 261
Ent Req: HS dipl
Degrees: AA & AAS 2 yrs
Tuition: Res—grad $77
Courses: †Advertising Design, †Architecture, Art Education, Art History, †Ceramics, Commercial Art, Design, Drawing, Film, Graphic Arts, Graphic Design, History of Art & Architecture, Illustration, †Painting, †Photography, Printmaking, †Sculpture, †Theatre Arts, Video
Adult Hobby Classes: Enrl 448. Tuition varies. Courses—Caligraphy, Ceramics, Drawing, Painting, Photography, Stained Glass
Children's Classes: Enrl 1000. Tuition varies. Courses—Drawing, Maskmaking, Painting, Printmaking, Soft Sculpture
Summer School: Dir, R Serofkin. Enrl 712 (camp college); 2 - 4 wk sessions. Dir, M Dietrich. Enrl 22; 4 wks. Courses—Architecture. Dir, M K Gitlick. Enrl 160; Arts Camp 2 - 4 wk sessions. Also regular cr courses

UNION

KEAN COLLEGE OF NEW JERSEY, Fine Arts Dept, Morris Ave, Union, NJ 07083. Tel 908-527-2307; Fax 908-527-2804; *Dir Gallery* Alec Nicolescu; *Coordr Interior Design* Linda Fisher; *Coordr Art Educ* Michael DeSiano; *Coordr Art History* Louis Kachur; *Chmn* Jack Cornish

Estab 1855; FT 31; pub; D & E; Scholarships; SC 58, LC 37, GC 24; FT 383, PT 236, maj 656, grad 37
Ent Req: HS dipl, portfolio interview for art maj, SAT
Degrees: BA 4 yrs, BFA 4, MA(Art Educ)
Tuition: Res—undergrad $89.65 per cr hr, grad $168.15 per cr hr; nonres—undergrad $207 per cr hr, grad $145 per cr hr
Courses: Advertising Design, Aesthetics, †Art Education, †Art History, Ceramics, †Commercial Art, Display, Drafting, Drawing, Film, Furniture Making, Graphic Arts, Graphic Design, Illustration, †Interior Design, Jewelry, Lettering, Museum Staff Training, Occupational Therapy, Painting, Photography, Printmaking, Sculpture, Textile Design
Summer School: Asst Dir, George Sisko. Tuition $43 per cr for term of 6 wks beginning June 26. Courses—Art History, Art in Education, Ceramics, Drawing, Introduction to Art, Introduction to Interior Design, Jewelry, Life Drawing, Painting, Printmaking, Sculpture, Watercolor

UPPER MONTCLAIR

MONTCLAIR STATE UNIVERSITY, Fine Arts Dept, Calcia Bldg, Rm 221, Upper Montclair, NJ 07043. Tel 973-655-7295; Internet Home Page Address: www.montclair.edu; *Dean* Geoffrey Newman; *Chmn* John Czerkowicz
Estab 1908; FT 18, PT 4; pub; Scholarships; SC 35, LC 18; maj 250, grad maj 200
Ent Req: HS grad and exam, interview, portfolio
Degrees: BA 4 yr, BFA 4 yr, MA
Tuition: Res—undergrad $94.50 per cr, grad $163.50 per cr; nonres—grad $203 per cr
Courses: Art Education, Art History, Ceramics, Drawing, Film, Graphic Design, Illustration, Jewelry, Metalwork, Painting, Photography, Printmaking, Sculpture, TV as Art, Textile Design
Summer School: Life Drawing, Painting, Photography, Sculpture

VINELAND

CUMBERLAND COUNTY COLLEGE, Humanities Div, PO Box 1500, College Drive, Vineland, NJ 08362-1500. Tel 609-691-8600; Fax 609-691-8813, Ext 314; Elec Mail art@cccnj.net; *Coordr, Asst Prof* Diane Spellman-Grimes
Maintain nonprofit gallery; pub; D&E; Scholarships; SC 24, LC 8; maj 88
Degrees: AS
Tuition: County res—$737 per sem; out-of-county res—$122.50 per cr hr; out-of-state res—$245 per cr hr
Courses: Art Appreciation, †Art Education, Art History, †Design, Drawing, †Graphic Arts, †Graphic Design, Multi-media, Painting, Photography, Video
Adult Hobby Classes: non-cr
Summer School: Computer Graphics

WAYNE

WILLIAM PATERSON UNIVERSITY, Dept Arts, College of the Arts & Communications, 300 Pompton Rd Wayne, NJ 07470. Tel 973-720-2401; Fax 973-720-3805; Elec Mail hortond@wpunj.edu; Internet Home Page Address: www.wpunj.edu; *Chmn* David Horton; *Assoc Prof* Alejandro Anreus; *Assoc Prof* James Brown; *Assoc Prof* Zhiyuan Cong; *Asst Prof* Angela DeLaura; *Assoc Prof* Leslie Farber; *Prof* Ming Fay; *Assoc Prof* David Horton; *Prof* Alan Lazarus; *Asst Prof* Elaine Lorenz; *Prof* Charles Magistro; *Asst Prof* Kristen Palana; *Asst Prof* Lily Prince; *Asst Prof* Steve Rittler; *Assoc Prof* Margaret Rothman; *Prof* David Shapiro; *Asst Prof* Joseph VanPutten; *Asst Prof* Thomas Uhlein; *Asst Prof* He Zhang; *Asst Prof* Nisha Drinkard; *Asst Prof* Jane Lloyd; *Asst Prof* Robin Schwartz
Dept estab 1958; FT 24, PT 8; pub; D, E; Scholarships; SC 135, LC 60, GC 50; maj 450, grad 30, E non-maj 170
Degrees: BA 4 yr, BFA, MFA
Tuition: Res—undergrad $73, grad $131
Courses: †Art History, †Ceramics, Computer Animation, Computer Graphics, Computer Illustration, †Design, †Drawing, †Graphic Design, †Illustration, †Painting, †Photography, †Printmaking, †Sculpture, †Textile Design
Summer School: Dir, David Horton. Enrl 150; tuition $65 per cr, $90 out of state. Courses—Art History, Drawing, Painting, Photography

WEST LONG BRANCH

MONMOUTH UNIVERSITY, Dept of Art & Design, 800 Bldg, Rm 822, 400 Cedar Ave West Long Branch, NJ 07764. Tel 732-571-3428; Fax 732-263-5273; Internet Home Page Address: www.monmouth.edu; *Chmn* Vincent Dimattio, MFA; *Prof* Pat Cresson; *Assoc Prof* Ellen Garfield, MA; *Assoc Prof* Richard Davis, MFA; *Assoc Prof* Karen Bright, MFA; *Asst Prof* Edward Jankowski, MFA
Estab 1933; pvt; D & E; Scholarships; SC 25, LC 8; in dept D 108, E 6, non-maj 80, maj 108, audits 6
Ent Req: HS dipl, portfolio for transfer students
Degrees: BA(Art), BFA & BA(Art Educ) 4 yr
Tuition: Res—$7260 per sem
Courses: Appreciation of Art, †Art Education, Art History, †Ceramics, Drawing, Graphic Arts, Handicrafts, History of Art & Architecture, Metalsmithing, †Painting, Photography, Printmaking, †Sculpture, Teacher Training
Adult Hobby Classes: Courses—Painting
Summer School: Art Appreciation, Ceramics, Independent Study, Painting, Sculpture

NEW MEXICO

ALBUQUERQUE

UNIVERSITY OF NEW MEXICO

—College of Fine Arts, Tel 505-277-2111; Fax 505-277-0708; Internet Home Page Address: www.unm.edu
Estab 1935; pub
Degrees: BFA, MA, MAFA, PhD(Art)
Tuition: $78.50 per cr hr, $35.57 (12-15 hrs) per cr hr
Courses: †Architecture, Art Appreciation, Art Education, †Art History, Ceramics, Dance, Drawing, Electronic Arts, Film, History of Art & Archeology, Jewelry, Music, Painting, Photography, Printmaking, Sculpture, Theater
Adult Hobby Classes: Wide variety of courses offered
Summer School: Arts of the Americas Program, wide variety of courses offered
—Dept of Art & Art History, Tel 505-277-5861; Fax 505-277-5955; Internet Home Page Address: www.unm.edu/~artdept2/; *Chmn* Martin Facey, PhD
Estab 1889; John Sommers Gallery; art supplies available at univ bookstore; pub; D & E; Scholarships, Fellowships; SC 190, LC 43, GC 73; E 511, non-maj 230, maj 227, grad 116
Ent Req: HS dipl
Degrees: BA & BFA 4 yrs, MA 2 yrs, MFA 3 yrs, PhD 3+ yrs
Tuition: Res—undergrad $31702 per yr, $1585 per sem, grad $2614 per yr, $1307 per sem; nonres—undergrad $11436 per yr, $5718 per sem, grad $8833 per yr, $4416 per sem
Courses: Aesthetics, Architecture, Art Appreciation, Art History, Ceramics, Conceptual Art, Design, †Digital/Electronic Art, Drawing, Film, Graphic Arts, History of Art & Architecture, Metalwork, Mixed Media, Painting, Photography, Printmaking, Sculpture, Video
Children's Classes: Offered through Art Educ Dept
Summer School: Tuition res $132 per cr hr, 6-9 hrs $792. Two 4 wk terms & one 8 wk term beginning June 9. Courses—same as above
—Tamarind Institute, Tel 505-277-3901; Fax 505-277-3920; Elec Mail tamarind@unm.edu; Internet Home Page Address: www.tamarind.unm.edu; *Tamarind Master Printer & Studio Mgr* Bill Lagattuta; *Dir* Marjorie Devon; *Edn Dir* Rodney Hamon
Maintains nonprofit art gallery; Pub; D; Fellowships
Ent Req: Extensive previous experience in lithography &/or undergrad degree in printmaking
Degrees: Cert as Tamarind Master Printer 2 yrs
Tuition: $160 per cr hr
Courses: †Lithography
Summer School: 4 wk prog; campus res available. Courses—Various lithographic techniques

VSA ARTS OF NEW MEXICO, (Very Special Arts of New Mexico) Enabled Arts Center, 4904 4th St NW, Albuquerque, NM 87107. Tel 505-345-2872; Fax 505-345-2896; Elec Mail info@vsartsnm.org; Internet Home Page Address: vsartsnm.org; *Exec Dir* Beth Rudolph; *Dir* Deborah Malshibini; *Exhib Coordr* Wendy Zollinger
Estab 1992; Center is a studio program for individuals with disabilities focusing on pre-vocational, vocational & studio skills; maintain nonprofit art gallery, Very Special Arts Gallery, 4904 Fourth St., NW, Alburquerque, NM 87107; pvt; D; D 30-40
Ent Req: 14 years or older
Courses: Art Appreciation, Ceramics, Collage, Drawing, Mixed Media, Painting, Printmaking, Sculpture, †Theatre Arts

FARMINGTON

SAN JUAN COLLEGE, Art Dept, 4601 College Blvd, Farmington, NM 87402. Tel 505-326-3311, Ext 281, 599-0281; Fax 505-599-0385; Internet Home Page Address: www.sjc.cc.nm.us; *Dept Chmn* Bill Hatch
Estab 1956; FT 1, PT 5; pub; D & E; Scholarships
Ent Req: HS diploma
Degrees: AA
Tuition: Res—$15 per cr hr; nonres—$25 per cr hr
Courses: Art Appreciation, Art Education, Art History, Calligraphy, Ceramics, Design, Drawing, Film, Graphic Design, Jewelry, Painting, Photography, Printmaking, Sculpture

HOBBS

NEW MEXICO JUNIOR COLLEGE, Arts & Sciences, 5317 Lovington Hwy, Hobbs, NM 88240. Tel 505-392-4510; Fax 505-392-1318; Internet Home Page Address: www.nmjc.cc.nm.us; *Dean* Mickey D Best, MFA; *Instr* Lawrence Wilcox, MFA; *Instr* George Biggs, MFA
Estab 1965; pub; D & E; Scholarships; SC 6, LC 1; D 100, E 30, non-maj 200, maj 20
Ent Req: HS dipl, GED or special approval
Degrees: AA 2 yrs
Courses: Advertising Design, †Animation, Ceramics, Collage, Color & Design, Drawing, Interior Design, Painting, Photography, Printmaking
Adult Hobby Classes: Drawing, Painting, Portraiture, Watercolor
Children's Classes: Drawing, Painting
Summer School: Dean, Steve McLeary. Enrl 30; term of 8 wks beginning June 10. Courses—Ceramics, Printmaking

LAS CRUCES

NEW MEXICO STATE UNIVERSITY, Art Dept, Dept 3572, PO Box 30001 Las Cruces, NM 88003. Tel 505-646-1705; Fax 505-646-8036; Elec Mail artdept@msu.edu; *Dept Head* Spencer Fidler, MFA; *Assoc Prof* William Green, MFA; *College Asst Prof* Jacklyn St Aubyn, MFA; *Assoc Prof* Julia Barello, MFA; *Assoc Prof* Rachel Stevens, MFA; *Assoc Prof* Elizabeth Zarur, PhD; *College Asst Prof* Julie Fitzsimmons, MFA; *Prof* Joshua Rose, MFA; *Dir Ceramics* Amanda Jaffe; *Photo Dir* David Taylor; *Asst Prof* Stephanie Taylor, PhD

Estab 1975; Maintains nonprofit art gallery, John Lawson Gallery, NMSU, Las Cruces, NMex; Pub; D & E; Scholarships, Fellowships; SC 52, LC 25, GC 53; maj 280, grad 31
Ent Req: HS dipl
Degrees: BA & BFA 4 yrs, MFA 3 yrs, MA(Studio) & MA(Art Hist) 2 yrs
Tuition: Res—$163.25 per cr hr; nonres—$550.25 per cr hr
Courses: Art Appreciation, Art History, Ceramics, Design, Drawing, Graphic Arts, Graphic Design, Illustration, Jewelry, †Metal Arts, Mixed Media, Painting, Photography, Printmaking, Restoration & Conservation, Sculpture, Silversmithing
Summer School: Prof, Spencer Fidler

LAS VEGAS

NEW MEXICO HIGHLANDS UNIVERSITY, Dept of Communications & Fine Arts, Music Bldg 106, Las Vegas, NM 87701. Tel 505-454-3238, 454-3573; Fax 505-454-3068; Internet Home Page Address: www.nmhu.edu/Department/commarts; *Asst Prof* Arthur Trujillo; *Chmn* Andre Garcia-Nuthmann
Estab 1898; pub; D & E; Scholarships; SC 24, LC 8, GC 12; non-maj 55, maj 51, grad 4
Ent Req: HS dipl, ACT, Early Admis Prog, GED
Degrees: BA 4 yrs, BFA, MA 1 yr
Tuition: Res—$996 per sem; nonres—$4137.60 full-time per sem; campus res available
Courses: Art Education, Art History, Calligraphy, Ceramics, Drawing, Graphic Arts, Jewelry, Lettering, Painting, Photography, Printmaking, Sculpture, Silversmithing, Stage Design, Teacher Training, Theatre Arts
Adult Hobby Classes: Courses—Ceramics, Painting, Weaving
Summer School: Mainly studio plus core curriculum, depending upon staffing

PORTALES

EASTERN NEW MEXICO UNIVERSITY, Dept of Art, Sta 19, Portales, NM 88130. Tel 505-562-2778; Internet Home Page Address: www.enmu.edu/; *Chmn* Jim Bryant; *Asst Prof* Mary Finneran, MFA; *Asst Prof* Greg Erf, MFA; *Asst Prof* Phil Geraci, MFA; *Asst Prof* Galina McGuire, MFA; *Asst Prof* Mic Muhlbauer, MFA
Estab 1932; pub; D & E; Scholarships; SC 44, LC 6, GC 25; D 507, E 150, maj 110
Ent Req: HS dipl, GED, ACT
Degrees: AA 2 yrs, BS, BA & BFA 4 yrs
Tuition: Res—$972 per sem; nonres—$3564 per sem
Courses: †Advertising Design, Art Education, Art History, Calligraphy, †Ceramics, †Commercial Art, †Drawing, †Graphic Arts, Graphic Design, Illustration, †Jewelry, Lettering, †Painting, Photography, †Sculpture, †Teacher Training, Theatre Arts, Video
Summer School: Terms of 8 & 16 wks beginning June 4. Courses—Ceramics, Commercial Art, Crafts, Drawing, Lettering, Photography

SANTA FE

COLLEGE OF SANTA FE, Art Dept, 1600 Saint Michael's Dr, Santa Fe, NM 87505. Tel 505-473-6500; Fax 505-473-6501; Elec Mail info@csf.edu; Internet Home Page Address: www.csf.edu; *Emeritus* Richard L Cook, MA; *Prof* Ronald Picco, MFA; *Asst Prof* Robert Sorrell, MFA; *Asst Prof* David Schienbaum, MFA; *Asst Prof* James Enyeart, MFA; *Asst Prof* Richard Fisher, MFA; *Asst Prof* Nancy Sutor, MFA; *Asst Prof* Khristaan Villela, PhD; *Asst Prof* Roxanne Malone, MFA; *Asst Prof* Don Messec, MA; *Adjunct Assoc* Steve Fitch, MFA; *Adjunct Assoc* Linda Swanson, MFA; *Dir Gallery* Lake McTighe, MFA; *Chmn* Gerry Snyder, MA
Estab 1947, dept estab 1986; pvt; D & E; Scholarships; SC 35, LC 10; D 350, non-maj 250, maj 95, non-degree 30
Ent Req: HS dipl or GED
Degrees: BA & BFA (Visual Arts)
Tuition: $7000 per sem, $466 per sem hr; campus res—room & board $1154 per yr
Courses: Aesthetics, Art, Art Appreciation, Art Education, †Art History, †Art Studio, Art Therapy, Ceramics, Collage, Conceptual Art, Constructions, †Drawing, Film, Intermedia, Mixed Media, Museum Staff Training, †Painting, †Photography, †Printmaking, Psychology, †Sculpture, Theatre Arts, Video
Children's Classes: Enrl 20-25; tuition $500-$750 for 3 wk term. Courses—General Studio Art
Summer School: Dir, Gerry Snyder. Tuition $372 per sem hr for term of 4-12 wks beginning May 13. Courses—Art History, Drawing, Lifecasting, Painting, Photography, Printmaking, Sculpture

INSTITUTE OF AMERICAN INDIAN ARTS, Institute of American Indian Arts Museum, 108 Cathedral Pl, Santa Fe, NM 87501. Tel 505-983-9800; Fax 505-983-1222; Elec Mail jgrimes@iaia.edu; Internet Home Page Address: www.iaiamuseum.org; *Dir* John Richard Grimes; *Cur* Joseph Sanchez; *Assoc Cur* Tatiana Lomahaftewa-Slock; *Registrar* Paula Rivera; *Admin & Finance Officer* Jary Earl; *Special Projects & Community Relations Officer* Larry Phillips; *Educational Programs Asst* Loni Manning; *Membership Officer* Heather Doherty; *Mus Shop Mgr* Maggie Ohnesorgen; *Mus Studies Dept Faculty* Barbara Lucero Sand; *Mus Studies Dept Faculty* Chuck Daily; *Mus Studies Dept Faculty* Jessie Ryker-Crawford; *Mus Studies Dept Chair* Lee Anne Wilson
Estab 1972; Maintain art gallery, 108 Cathedral Pl, Santa Fe, NM 87501; nonprofit art gallery, Primitive Edge Gallery, 83 Avan Nu Po Rd, Santa Fe, NM 87508; congressionally funded; D; Scholarships; SC, LC; D 192
Ent Req: HS dipl
Degrees: AAS, AA, AFA, BFA, BA, Cert
Tuition: $100 per cr hr

Courses: †Creative Writing, †Indigenous Liberal Arts, †Museum Studies, †Native Studies, †New Media Arts, †Studio Art
Adult Hobby Classes: Beadwork, Dancing, Exhib Techniques, Traditional Clothing, Flute Making, Fiber Arts
Summer School: Dir, Hayes Lewis. Courses—Museum Studies, Summer Film & Television Workshop

SANTA FE ARTS INSTITUTE, 1600 St Michael Dr, Santa Fe, NM 87505. Tel 505-424-5050; Fax 505-424-5051; Internet Home Page Address: www.sfai.org; *Dir* Diane R Karp, Dr; *Res Dir* Sheilah Wilson
Estab 1985; ; pvt; D & E; Scholarships; SC 12; varies
Ent Req: portfolio review
Courses: Collage, Installation, Mixed Media, Painting, Photography, Sculpture, Video, Video Art
Adult Hobby Classes: Installation & Video Art, Master classes in Printing, Mixed Media, Sculpture
Children's Classes: Summer youth workshops

SILVER CITY

WESTERN NEW MEXICO UNIVERSITY, Dept of Expressive Arts, 1000 W College Ave, Silver City, NM 88062. Tel 505-538-6614; Fax 505-538-6155; *Prof* Gloria Maya, MFA; *Prof* Claude Smith, MFA; *Co-Chmn Art* Michael Metcalf; *Co-chmn Music* Ben Tucker; *Co-Chmn Theater* Jack Ellis
Pub; D & E; Scholarships; SC 10, LC 7; D 211, non-maj 196, maj 15
Ent Req: HS dipl
Degrees: BA & MA, 4 yrs
Tuition: Res—$48 per cr hr; $743 for 12-18 cr hrs; nonres—$2727 for 12-18 cr hrs; campus res available
Courses: Advertising Design, Art Appreciation, Art Education, Art History, †Ceramics, Costume Design & Construction, Design, Drawing, Fiber Arts, Graphic Arts, Occupational Therapy, †Painting, Photography, †Printmaking, †Sculpture, Silversmithing, Stage Design, Teacher Training, Textile Design, Theatre Arts, Weaving
Adult Hobby Classes: Ceramics, Fiber, Lapidary
Summer School: Enrl 80-100; tuition $257 for 4-6 cr hr more credits from June 1-July 3 or July 5-Aug 9. Courses—Art Appreciation, Ceramics, Clay Workshop, Elementary Art Methods, Painting & Drawing Workshop, Printmaking, Special Art Tours in New Mexico & Europe

NEW YORK

ALBANY

COLLEGE OF SAINT ROSE, Art Dept, 432 Western Ave, Albany, NY 12203. Tel 518-485-3900; Fax 518-485-3920; Elec Mail faulk@mail.strose.edu; Internet Home Page Address: www.strose.edu; *Chmn* Karene Faul, MFA; *Assoc Prof* Paul Mauren, MFA; *Assoc Prof* Kristine Herrick, MFA; *Assoc Prof* Ann Breaznell, MFA; *Asst Prof* Scott Brodie, MFA; *Asst Prof* Lucy Bodwitch PhD, MFA; *Asst Prof* Jessica Loy, MFA; *Asst Prof* Deborah Zlotsky, MFA; *Asst Prof* Thomas Santelli, MFA; *Asst Prof* Jennifer Childress, MFA; *Asst Prof* Robert O'Neil, MFA; *Asst Prof* Gina Occhiogrosso; *Asst Prof* Theresa Flanigan PhD; *Instr* Lynn Allard; *Instr* Kris Tolmie
Estab 1920, dept estab 1970; Maintain nonprofit art gallery; St Rose Art Gallery 432 Western Ave, Albany NY 12203; pvt; D & E; Scholarships; SC 50, LC12, GC 20; non-maj 110, maj 225, GS 29
Ent Req: HS dipl, SAT or ACT, rank in top 2/5 of class
Degrees: BFA(Graphic Design, Studio Arts), BS(Art Educ, Studio Arts), MS(Art Educ)
Tuition: $8115 per sem undergrad (12-17 cr/sem), $540 per sem hr
Courses: Aesthetics, Art Education, Art History, Design, Drawing, Graphic Design, Painting, Photography, Printmaking, Sculpture, Studio Art, †Teacher Training, Typography
Adult Hobby Classes: Enrl 20; tuition $250 per cr hr. Courses—Some continuing education courses each sem
Summer School: Chmn Karene Faul. Enrl 80; two 5 wk courses from May 19-June 27 & June 30-Aug 8. Courses—Photoshop, History of Art, Theories of Art Educ (grad course)

SAGE JUNIOR COLLEGE OF ALBANY, Dept Visual Arts, 140 New Scotland Ave, Albany, NY 12208. Tel 518-292-1778; Fax 518-292-7758; Elec Mail aceror@sage.edu; Internet Home Page Address: www.sage.edu; *Chair Visual Arts* Raul Acero; *Admin Asst* Cathleen Breling
Estab 1957, dept estab 1970; Maintain a nonprofit art gallery - Opaika Gallery, The Sage Colleges, 140 W Scotland Ave, Albany, NY 12208; Pvt; D & E; Scholarships; SC 43, LC 16 (Art); D 700 (total), 200 (art), E 823 (total)
Ent Req: HS dipl, references, records, SAT, portfolio
Degrees: AAS 2 yrs, BA (Theatre), AS-BFA (fine arts, graphic design, interior design)
Tuition: $8,950 per yr
Courses: Art History, Ceramics, Collage, Design, Drafting, Drawing, Fine Arts, Fine Arts Illustration, Graphic Design, Illustration, Interior Design, Intermedia, Lettering, Mixed Media, Painting, Photography, Printmaking, Sculpture, Studio Studies
Children's Classes: Summer courses for High School students
Summer School: Dir, Dierdra Zarrillo. Enrl 60.

STATE UNIVERSITY OF NEW YORK AT ALBANY, Art Dept, 1400 Washington Ave, Albany, NY 12222. Tel 518-442-4020; Fax 518-442-4807; Elec Mail bh996@albany.edu; Internet Home Page Address: www.albany.edu; *Prof* Roberta Bernstein, PhD; *Prof* Edward Mayer, MFA; *Prof* Phyllis Galembo, MFA;

Assoc Prof Mark Greenwold, MFA; *Assoc Prof* Marja Vallila, MFA; *Dept Chair & Prof* JoAnne Carson, MFA; *Assoc Prof* David Carbone, MFA; *Assoc Prof* Sarah Cohen, PhD; *Asst Prof* Rachel Dressler, PhD; *Asst Prof* Daniel Goodwin, MFA; *Technician* Roger Bisbing, MFA; *Asst Prof* Leona Christie, MFA; *Asst Prof* Yvette Mattern, MFA; *Assoc Prof* Michael Werner, PhD; *Prof* John Overbeck, PhD
Estab 1848; Art library; art supplies available on-campus; pub; D & E; Scholarships; SC 43, LC 20, GC 33; D 750, E 400, non-maj 600, maj 150, grad 45
Ent Req: HS dipl
Degrees: BA 4 yr, MA 1.5 yr, MFA 2 yr
Tuition: Res—undergrad $1700 per sem, $137 per cr hr, grad $2550 per sem, $213 per cr hr; nonres—undergrad $4150 per sem; $346 per cr hr, grad $4208 per sem, $351 per cr hr; campus res—room & board $3440.50 per sem
Courses: Aesthetics, †Art History, Design, Digital Imaging, †Drawing, Mixed Media, †Painting, †Photography, †Printmaking, †Sculpture, Video
Adult Hobby Classes: Courses in all studio areas
Summer School: Dir, Michael DeRensis. Enrl 350; term of 3-6 wks beginning July 1

ALFRED

NEW YORK STATE COLLEGE OF CERAMICS AT ALFRED UNIVERSITY, School of Art & Design, 2 Pine St, Alfred, NY 14802. Tel 607-871-2412, 871-2480; Fax 607-871-2490; Internet Home Page Address: www.nyscc.alfred.edu; *Dean* Richard Thompson
Estab 1900; FT 27; D & E; Scholarships; maj undergrad 435, grad 37. Two yrs of foundation study & two yrs of upper level study
Ent Req: Portfolio, GPA, SAT, HS diploma
Degrees: BFA and MFA 2 yrs
Tuition: Res—$12,844 out-of-state $9316 in-state per yr
Courses: Art Education, Ceramics, Digital Imaging, Drawing, Electronic Integrated Arts, Glass Arts, Graphic Design, Painting, Photography, Pre-Art Therapy, Printmaking, Sculpture, Sonic Arts, Video, Wood
Summer School: Dean's Office, School Art & Design. Tuition 4 cr $840. Courses—Art History, Ceramics, Glass, Painting, Sculpture, Digital Imaging, Sonic Arts, Experimental TV

AMHERST

DAEMEN COLLEGE, Art Dept, 4380 Main St, Amherst, NY 14226-3592. Tel 716-839-8241; Fax 716-839-8516; Internet Home Page Address: www.daemen.edu; *Assoc Prof* Dennis Barraclough, MFA; *Asst Prof & Chmn* Joseph Kukella, MFA; *Instr* Jane Marinsky, BFA; *Instr* Joan Goldberg, BFA; *Instr* David Cinquino, MFA; *Instr* Dana Hatchett, MFA; *Prof* James Allen, MFA; *Asst Prof* Kevin Kegler, MAH
Estab 1947; pvt; D & E; Scholarships; SC 50; D 1800, non-maj 1740, maj 100
Ent Req: HS dipl, art portfolio
Degrees: BFA(Drawing, Graphic Design, Illustration, Painting, Printmaking, Sculpture), BS(Art), & BS(Art Educ) 4 yrs
Tuition: Undergrad—$5300 per sem, $350 per cr hr; campus res—room & board $2750
Courses: †Advertising Design, Aesthetics, Art Appreciation, †Art Education, Art History, Ceramics, Computer Art, Design, Drawing, †Graphic Design, †Illustration, †Painting, Photography, †Printmaking, †Sculpture, Stage Design, Textile Design, Theatre Arts, Weaving, †Website Design
Summer School: Dean, Charles Reedy

ANNANDALE-ON-HUDSON

BARD COLLEGE, Center for Curatorial Studies Graduate Program, PO Box 5000, Annandale-on-Hudson, NY 12504-5000. Tel 845-758-7598; Fax 845-758-2442; Elec Mail ccs@bard.edu; Internet Home Page Address: www.bard.edu/ccs/; *Dir* Norton Batkin; *Grad Comt* Lynne Cooke; *Grad Comt* Thelma Golden; *Grad Comt* Ivo Mesquita; *Grad Comt* Robert Storr; *Grad Comt* David Levi Strauss
Prog estab 1994; Maintains nonprofit art gallery, Ctr for Curatorial Studies Mus, Bard Col, Annandale-on-Hudson, NY 12504-5000; pvt; D; Scholarships, Fellowships; GC 20; grad 29
Ent Req: BA, BFA or equivalent
Degrees: Master's 2 yr
Tuition: $18,900 per yr (2005-2006)
Courses: Aesthetics, Art History, †Museum Staff Training

BARD COLLEGE, Milton Avery Graduate School of the Arts, Annandale-on-Hudson, NY 12504. Tel 845-758-7481, 758-6822; *Dir Prog* Arthur Gibbons; *Instr* Ann Lauterbach; *Instr* Alan Cote; *Instr* Peggy Ahwesh; *Instr* Richard Teitelbaum; *Instr* Charles Hagen; *Instr* Peter Hutton
Estab 1981; pvt; Scholarships; 70
Degrees: MFA
Tuition: $25,620 per yr
Courses: Film, Music, Painting, Performance, Photography, Sculpture, Video, Writing
Summer School: A student will normally be in res for three summers terms, earning 13 credits per term; eight credits are awarded for the Master's project, for a total of 60; 13 independent study credits are awarded towards a degree

AURORA

WELLS COLLEGE, Dept of Art, Rte 90, Aurora, NY 13026. Tel 315-364-3440, 364-3266; *Asst Prof* Rosemary Welsh; *Div Chmn* Susan Forbes
Estab 1868; pvt, W; D; Scholarships; SC 19, LC 20; D 500 (total), non-maj 122, maj 18
Ent Req: HS dipl, cr by exam programs

Degrees: BA 4 yrs
Tuition: Res—undergrad $12,450 per yr; campus res available
Courses: Aesthetics, †Art History, †Ceramics, †Drawing, †Painting, Photography, Printmaking, Teacher Training, †Theatre Arts

BAYSIDE

QUEENSBOROUGH COMMUNITY COLLEGE, Dept of Art & Photography, 222-05 56th Ave, Bayside, NY 11364. Tel 718-631-6395; Fax 718-631-6612; *Assoc Prof* Robert Rogers, MFA; *Asst Prof* Jules Allen, MFA; *Chmn* Dr JoAnn Wein; *Asst Prof* Javier Cambre; *Assoc Prof* Kenneth Golden; *Prof* Paul Tschinkel; *Asst Prof* Anissa Mack
Estab 1958, dept estab 1968; Maintains nonprofit art gallery, Queensborough Community College Art Gallery, Oakland Building, 222-05 56th Ave, Bayside, NY 11364; Pub; D & E; Scholarships; SC 21, LC 14; D 9,000, E 4,000
Ent Req: HS dipl, placement exams
Degrees: AA & AS
Tuition: Res—undergrad $1,050 per sem, $85 per cr; nonres—undergrad $1,338 per sem, $104 per cr; no campus res
Courses: Advertising Design, Art History, Artist Apprenticeships, Arts Internships, Arts for Teachers of Children, Ceramics, Color Theory, Design, Digital Art & Design, Drawing, Graphic Design, Illustration, Painting, †Photography, Printmaking, Sculpture, Video
Summer School: Dir, Jo Ann Wein. Courses—Drawing, Photography, Sculpture, Art History, 2-D Design

BINGHAMTON

STATE UNIVERSITY OF NEW YORK AT BINGHAMTON, Dept of Art History, PO Box 6000, Binghamton, NY 13902-6000. Tel 607-777-2111; Fax 607-777-4466; Elec Mail frames@binghamton.edu; Internet Home Page Address: www.arthist.binghamton.edu; *Chmn Dept* John Tagg; *Assoc Prof* Barbara Abou-El-Haj; *Assoc Prof* Karen Barzman; *Assoc Prof* Charles Burroughs; *Bartle Prof* Anthony King; *Asst Prof* Thomas McDonough; *Assoc Prof* NKiru Nzegwu; *Assoc Prof* Oscar Vazquez; *Assoc Prof* Jean Wilson
Estab 1950; pub; D&E; Scholarships; LC 32, GC 63; 679, non-maj 400, maj 40, grad 43
Ent Req: HS dipl, Regents Scholarship, ACT or SAT
Degrees: BA 4 yrs, MA 1-2 yrs, PhD varies
Tuition: Res—$1700 per sem, grad $2000 per sem; nonres—undergrad $4150 per sem, grad $2550 per sem; nonres—grad $4208
Courses: †Architecture, †Art History, †Cinema, Printmaking, †Studio Art, Video
Summer School: Tuition same as academic yr, 3 separate sessions during summer. Courses—Art History

BROCKPORT

STATE UNIVERSITY OF NEW YORK COLLEGE AT BROCKPORT, Dept of Art, Tower Fine Arts Bldg, Brockport, NY 14420-2985; 350 New Campus Dr, Brockport, NY 14420. Tel 716-395-2209; Fax 716-395-2588; Internet Home Page Address: www.brockport.edu; *Chmn* Debra Fisher; *Prof* Jennifer Heuker; *Asst Prof* Alisia Chase; *Asst Prof* Tim Massey; *Assoc Prof* James Morris
Maintain nonprofit art gallery; FT 3, PT 6; Pub; D; Scholarships; SC 33, LC 29; 8188, maj 100, grad 2000, grad 30
Ent Req: HS dipl, ent exam
Degrees: BA, BS & BFA 4 yrs
Tuition: Res—$2650; nonres—$3600, grad $4000
Courses: Artists Books, †Ceramics, Design, Drawing, †Jewelry, †Painting, †Photography, †Printmaking, †Sculpture, Video
Adult Hobby Classes: Tuition $105 per cr hr for 13 wk term.
Courses—Ceramics, Drawing, Methods, Museum & Gallery Studies, Painting, Photography, Sculpture, 2-D & 3-D Design
Summer School: Dir, Dr Kenneth O'Brien

BRONX

BRONX COMMUNITY COLLEGE, Music & Art Dept, 181 St & University Ave, Bronx, NY 10453. Tel 718-289-5100, 289-5889; Internet Home Page Address: www.bcc.cuny.edu; *Chmn* Dr Ruth Bass
Pub; AM, PM
Ent Req: HS dipl, equivalent
Degrees: Cert, AS, AAS
Tuition: Res—$1305 per sem; nonres—$1538 per sem
Courses: Art Appreciation, Art History, Ceramics, Commercial Art, Design, Drawing, Modern Art, Painting, Photography, Printmaking, †Sculpture
Adult Hobby Classes: Enrl 25; tuition $45 for 7 wks. Courses—Calligraphy, Drawing

HERBERT H LEHMAN COLLEGE, Art Dept, 250 Bedford Park Blvd W, Bronx, NY 10468. Tel 718-960-8256; Fax 718-960-7203; *Chmn* Herbert R Broderick, MFA; *Assoc Prof* Arvn Bose; *Asst Prof* David Gillison, MFA
Estab 1968; pub; D & E; Scholarships; SC 18, LC 29, GC 31; non-maj 100, major 50, grad 15
Ent Req: HS dipl, ent exam
Degrees: BA & BFA 4 yrs, MA, MFA & MA 2 yrs
Tuition: Res—$1100 per sem, $92 per cr, nonres—$2400 per sem, $202 per cr; no campus res available
Courses: †Art History, †Graphic Arts, †Painting, †Sculpture
Summer School: Dean, Chester Robinson. Enrl 45; tuition $35 & $40 per cr for 6 wk term beginning June 28. Courses—Art History, Drawing, Painting

BRONXVILLE

CONCORDIA COLLEGE, Art Dept, 171 White Plains Rd, Bronxville, NY 10708. Tel 914-337-9300; Fax 914-395-4500;
Estab 1881; pvt; D; Scholarships; SC 4, LC 2
Ent Req: HS dipl, SAT or ACT
Degrees: BA and BS 4 yrs
Tuition: $15,500 per yr
Courses: Art Education, Art History, Ceramics, Computer Graphics, Drawing, Handicrafts, History of Art & Architecture, Painting, Photography, Sculpture, Teacher Training
Adult Hobby Classes: Courses—Painting

SARAH LAWRENCE COLLEGE, Dept of Art History, One Meadway, Bronxville, NY 10708. Tel 914-337-0700; Internet Home Page Address: www.slc.edu; *Instr Visual Arts* Gary Burnley, MFA; *Instr* David Castriota PhD, MA; *Instr Visual Arts* U Schneider, MFA; *Instr Visual Arts* Kris Phillips, MFA; *Instr Visual Arts* Joel Sternfeld, BA; *Dean* Barbara Kaplen, BA; *Prof* Lee Edwards; *Prof* Judith Rodenbeck
Estab 1926; FT 1, PT 9; pvt; D; Scholarships
Ent Req: HS dipl
Degrees: BA 4 yrs
Tuition: $17,280 per yr
Courses: Art History, Drawing, Filmmaking, Painting, Photography, Printmaking, Sculpture, Visual Fundamentals
Summer School: Center for Continuing Education

BROOKHAVEN

INTERNATIONAL COUNCIL FOR CULTURAL EXCHANGE (ICCE), 426 South Country Rd Ste 1, Brookhaven, NY 11719. Tel 800-690-4223; Fax 212-982-4017; Elec Mail info@ICCE-Travel.org; Internet Home Page Address: www.icce-travel.org; *Prog Coordr* Stanley I Gochman PhD; *International Planning Dir* Julie Gochman
Estab 1982; pvt; SC, LC
Ent Req: Minimum age - 17
Degrees: college credits
Courses: Art Appreciation, Art History, Drawing, History of Art & Architecture, Mixed Media, Theatre Arts
Summer School: Tuition approx $3698 for 3 wk session abroad.
Courses—Landscape, Painting, Studio Art

BROOKLYN

BROOKLYN COLLEGE, Art Dept, Bedford Ave & Ave H, Brooklyn, NY 11210. Tel 718-951-5181; Fax 718-951-5670; Internet Home Page Address: www.brooklyn.cuny.edu; *Chmn* Michael Mallory
Estab 1962; Pub; AM, PM; Scholarships
Degrees: BA, BFA, MA, MFA
Tuition: Res (in state)—undergrad $1,600 per sem, grad $160 per cr hr; non res—undergrad $3,400 per sem, grad $285 per cr hr
Courses: Aesthetics, Art History, Calligraphy, Ceramics, Collage, Computer Graphics, Design, Drawing, Graphic Arts, Graphic Design, History of Art & Architecture, Intermedia, Mixed Media, Museum Staff Training, Painting, Photography, Printmaking, Sculpture
Adult Hobby Classes: Enrl 50. Courses—Studio Art
Summer School: Enrl 100-150; two summer sessions. Courses—Art History, Computer Graphics, Studio Art

KINGSBOROUGH COMMUNITY COLLEGE, Dept of Art, 2001 Oriental Blvd, Brooklyn, NY 11235. Tel 718-368-5000, 368-5718 (art); Fax 718-368-4872; Internet Home Page Address: www.kbcc.cuny.edu;
Estab 1965, dept estab 1972; pub; D & E; SC 10, LC 8; maj 135
Ent Req: HS dipl
Degrees: AS 2 yrs
Courses: Art History, Ceramics, Communication Design, Design, Drawing, Graphic Arts, Graphic Design, Illustration, Jewelry, Mixed Media, Painting, Printmaking, Sculpture
Adult Hobby Classes: Overseas travel courses
Summer School: Courses—Art

LONG ISLAND UNIVERSITY, BROOKLYN CAMPUS, Art Dept, University Plaza, Brooklyn, NY 11201. Tel 718-488-1051; *Prof* Liz Rudey; *Chm* Bob Barry; *Prof* Nancy Grove; *Prof* Cynthia Dantzic; *Prof* Hilary Lorenz
Maintain nonprofit art gallery; The Salena Gallery, The Resnick Gallery & The Kumbie Gallery; FT 5, PT 15; Pvt; D & E; Scholarships; SC 20, LC 6; maj 35
Ent Req: HS dipl, ent exam
Degrees: BA, BFA in Art Educ & Studio Art
Tuition: $408 per cr
Courses: †Art Education, Art History, Arts Management, Calligraphy, Ceramics, †Color, †Computer Graphics, Drawing, Media Arts, Medical-Scientific Illustration, Painting, †Photography, Printmaking, Sculpture, †Teacher Training, Teaching Art to Children, †Video, Visual Experience
Adult Hobby Classes: Courses—Teaching Art to Children
Summer School: Dir, Liz Rudey. Term of two 6 wk sessions. Courses—Ceramics, Drawing, Painting, Art History, Calligraphy

NEW YORK CITY TECHNICAL COLLEGE OF THE CITY UNIVERSITY OF NEW YORK, Dept of Advertising Design & Graphic Arts, 300 Jay St, Brooklyn, NY 11201. Tel 718-260-5175; Fax 718-260-5485; Elec Mail Jmason@nyctc.cuny.edu; Internet Home Page Address: www.nyctc.cuny.edu; *Chmn* Joel Mason
Estab 1949; pub; D & E; Scholarships; SC 16, LC 3; D 650, E 350

Ent Req: HS dipl
Degrees: AAS 2 yr, BTech, AAF, BComm, AAS Graphic Art, Cert. Desktop Pub
Tuition: $1475 per sem, $135 per cr hr
Courses: †Advertising Design, †Computer Graphics, †Digital Graphics, †Digital Video, †Digital Work Flow, Drawing, Graphic Design, Illustration, Lettering, †Mute-Media, Packaging, Painting, †Photography Binding Finishing, Printmaking, Type Spacing
Summer School: Computer Graphics, Design, Illustration, Lettering, Life Drawing, Paste-up, Photography, Video Design

PRATT INSTITUTE
—**School of Art & Design,** Tel 718-636-3600; Fax 718-636-3410; Internet Home Page Address: www.pratt.edu; *Dean* Frank Lind
Pub; 3700
Degrees: BFA & BID 4 yr, MA, MF, MFA & MPF 2 yr
Tuition: Undergrad $7200 per sem, grad $505 per cr hr
Courses: †Art Education, †Art History, †Ceramics, †Computer Graphics, †Drawing, †Film, †Graphic Design, †Illustration, †Industrial Design, †Interior Design, †Painting, †Photography, †Printmaking, †Sculpture, †Video
Adult Hobby Classes: Enrl 195. Various courses offered
Children's Classes: Morning classes
Summer School: Dean, Vieri Salvadori. Enrl for high school students only; tuition $400 per 4 cr. Courses—Computer Graphics, Fine Arts, Foundation Art
—**School of Architecture,** Tel 718-636-3404; Fax 718-399-4332; Internet Home Page Address: www.pratt.edu; *Dean* Thomas Hanrahan
Degrees: BArch 5 yr, MArch
Tuition: $15,800 per yr
Courses: Architecture, Art History, Construction Documents In Professional Practice, Design, History of Architecture, Landscape Architecture, Materials, Structures

PROMOTE ART WORKS INC (PAWI), Job Readiness in the Arts-Media-Communication, 123 Smith St, Brooklyn, NY. Tel 718-797-3116; Fax 718-855-1208; Elec Mail executive@micromuseum.com; Internet Home Page Address: www.micromuseum.com; *Technical Dir* William Laziza
Estab 1993; Internship; ongoing; Scholarships
Ent Req: interview process
Courses: †Conceptual Art, †Interactive Media, †Mixed Media, †Video
Adult Hobby Classes: Tuition $50 per hr. Courses—Video Editing
Children's Classes: Tuition $15 per class. Courses—Dance, Drama, Movement
Summer School: Tuition $15 per class. Courses—Art, Science

BROOKVILLE

C W POST CAMPUS OF LONG ISLAND UNIVERSITY, School of Visual & Performing Arts, 720 Northern Blvd, Brookville, NY 11548. Tel 516-299-2000, 299-2395 (visual & performing arts); Internet Home Page Address: www.cwpost.liunet.edu; *Chmn & Prof* Jerome Zimmerman; *Prof* Marilyn Goldstein; *Prof* Howard LaMarcz; *Prof* Robert Yasuda; *Assoc Prof* David Henley; *Assoc Prof* Jacqueline Frank; *Assoc Prof* Frank Olt; *Assoc Prof* Joan Powers; *Asst Prof* John Fekner; *Asst Prof* Richard Mills; *Asst Prof* Carol Huebner-Venezia; *Asst Prof* Donna Tuman; *Asst Prof* Vincent Wright; *Dean Visual & Performing Arts* Lynn Croton
Dept estab 1957; pvt; D & E; Scholarships; SC 70, LC 15, GC 40; D 2000, E 450, non-maj 2000, maj 250, grad 150, others 50
Ent Req: HS dipl, portfolio
Degrees: BA(Art Educ), BA(Art Hist), BA(Studio), BS(Art Therapy) & BFA(Graphic Design) 4 yrs, MA(Photography), MA(Studio), MS(Art Educ) & MFA(Art, Design or Photography) 2 yrs
Tuition: Full-time grad $6845 per 12 cr hrs, $427 per cr hr; part-time $408 per sem cr
Courses: †Advertising Design, Aesthetics, †Art Education, †Art History, Ceramics, Collage, Commercial Art, Computer Graphics, Conceptual Art, Constructions, Drawing, Film, Fine Arts, Graphic Arts, Graphic Design, Handicrafts, Illustration, Intermedia, Jewelry, Lettering, Mixed Media, Painting, Photography, Printmaking, Sculpture, Stage Design, Teacher Training, Theatre Arts, Video, Weaving
Adult Hobby Classes: Courses—Varied
Summer School: Prof, Howard LaMarcz. Duration 3-5 wk sessions. Courses—varied

BUFFALO

LOCUST STREET NEIGHBORHOOD ART CLASSES, INC, 138 Locust St, Buffalo, NY 14204. Tel 716-852-4562; Fax 716-852-4562; Elec Mail locustst@buffnet.et; Internet Home Page Address: www.buffnet.net/~locustst/; *Grant Writer* Stephanie Gray; *Photo & Painting Teacher* Lenore Bethel; *Clay Teacher* Sally Danforth; *Clay Teacher* Dorothy Harold; *Dir & Painting Teacher* Molly Bethel; *Photog Teacher* Kenn Morgan
Open Tues - Thurs & Sat Noon - 5 PM; Estab 1959; Inc 1971; Maintain a nonprofit art gallery: Exhibit work in Bldg, an annual art show all year long; maintain an art/architecture library: many art books that students can reference; Pvt; D & Weekend; SC 4; Non-maj 300 per yr
Collections: Permanent collection of paintings by students
Exhibitions: Annual Art Show
Tuition: No tuition fees
Courses: Clay, †Drawing, †Painting, †Photography
Adult Hobby Classes: Enrl 120. Courses—Clay, Drawing, Painting, Photography
Children's Classes: Enrl 200. Courses—Clay, Drawing, Painting
Summer School: Dir, Molly Bethel. Enrl adults and children. Course—Drawing, Painting, Photog

STATE UNIVERSITY COLLEGE AT BUFFALO, Fine Arts Dept, 1300 Elmwood Ave, Buffalo, NY 14222. Tel 716-878-6014; Fax 716-878-6697; Internet Home Page Address: www.buffalostate.edu; *Chmn* Peter Sowiski

Estab 1875, dept estab 1969; FT 16; pub; D & E; SC 34, LC 17, GC 6; maj 300 (art) 50 (BFA) 12 (art history)
Ent Req: HS dipl
Degrees: BA(Art), BA(Art History) & BFA 4 yrs
Tuition: Res—undergrad $3400 per sem, room & board $5455; nonres—undergrad $8300 per sem, room & board $5256
Courses: †Art History, †Drawing, †Painting, †Papermaking, †Photography, †Printmaking, †Sculpture
Summer School: Dir, Gerald Accurso. Tuition res—$45 per cr hr, nonres—$107 per cr hr for 10 wk term beginning June 2. Courses—Art History, Studio

UNIVERSITY AT BUFFALO, STATE UNIVERSITY OF NEW YORK, Dept of Visual Studies, 202 Center for the Arts, Buffalo, NY 14260-6010. Tel 716-645-6878 ext 1350; Fax 716-645-6970; Elec Mail uginfo@acsu.buffalo.edu; vs-gradinfo@acsu.buffalo.edu; Internet Home Page Address: www.ubart.buffalo.edu; *Chmn, Prof* David Schirm; *Distinguished Prof* Harvey Breverman; *Prof* Tyrone Georgiou; *Assoc Prof* Tony Rozak; *Assoc Prof* Millie Chen; *Assoc Prof* Jolene Rickard; *Assoc Prof* Paul Vanouse; *Asst Prof* Gary Nickard; *Asst Prof* Reinhard Reitzenstein; *Assoc Prof* Steven Kurtz; *Asst Prof* Sylvie Belanger; *Asst Prof* Joan Linder; *Distinguished Prof* John Quinan; *Prof* Adele Henderson; *Prof* Livingston Watrous; *Asst Prof* George Hughes; *Asst Prof* Nancy Anderson; *Asst Prof* Binggi Huang; *Ast Prof* Elizabeth Otto; *Asst Prof* Lori Johnson; *Assoc Prof* Charles Carman; *Vis Asst Prof* Kyle Schlesinger
Estab 1846; Maintain nonprofit art gallery, UB Dept of Visual Studies Gallery b45 Center For The Arts, North Campus, Univ at Buffalo 14260-6010; FT 14, PT 14; pub; D & E; Scholarships, Fellowships; SC 80, LC 30, GC 25; D & E 350, non-maj 50, maj 350, grad 50
Ent Req: HS dipl, portfolio
Degrees: BA, BFA & MFA, MA
Tuition: Res—undergrad $2,175 per sem, $442 per cr hr, grad $3,450 per sem, $455 per cr hr; nonres—undergrad $5,305 per sem, $540 per cr hr, grad $6,194 per sem, $514 per cr hr; campus res—$3,763 per sem, double $1,787 per sem, three-person $1,717 per sem, four-person $1,531 per sem (rates vary depending on campus location)
Courses: Aesthetics, Art History, †Communications Design, †Computer Art, Conceptual Art, Criticism & Theory, Design, Drawing, Foundations, Graphic Design, Installation, Mixed Media, †Painting, †Photography, †Printmaking, Public Art Practice, †Sculpture, Typography, Video
Summer School: Enrl 104; tuition res $180 per cr hr, nonres $389 per cr hr for 3-6 wk term. Courses—Computer Art, Drawing, Painting, Photo, Printmaking

VILLA MARIA COLLEGE OF BUFFALO, Art Dept, 240 Pine Ridge Rd, Buffalo, NY 14225. Tel 716-896-0700; Fax 716-896-0705; Internet Home Page Address: www.villa.edu; *Chmn* Brian R Duffy, MFA
Estab 1961; pvt; D & E; Scholarships; SC 27, LC 3; D 450, E 100, maj 170
Ent Req: HS dipl of equivalency
Degrees: AA, AAS & AS 2 yrs
Tuition: $4575 per sem
Courses: 3-D Design, Advertising Design, Advertising Graphics, Art History, Color Photo, Commercial Design, Computer-aided Design, Design, Drafting, Drawing, Etching, Graphic Arts, Graphic Design, History of Interior Design, History of Photography, Interior Design, Lettering, Mechanical Systems & Building Materials, Painting, Photography, Printmaking, Rendering & Presentation, Sculpture, Serigraphy, Studio Lighting, Textile Design, View Camera Techniques
Adult Hobby Classes: Courses - Drawing, Painting, Photography
Summer School: Enrl 10-20. courses—a variety of interest courses, including drawing, painting and photography

CANANDAIGUA

FINGER LAKES COMMUNITY COLLEGE, Visual & Performing Arts Dept, 4355 Lake Shore Dr, Canandaigua, NY 14424. Tel 716-394-3500, Ext 257; Fax 716-394-5005; *Prof* Wayne Williams, MFA; *Asst Prof* John Fox, MFA; *Pres* Daniel T Hayes
Estab 1966; FT 5; pub; D & E; SC 14, LC 2; D 60, non-maj 700, maj 50
Ent Req: HS dipl
Degrees: AA & AAS 2 yrs
Tuition: Res—$1260 per sem; nonres—$1520 per sem
Courses: Advertising Design, Art History, Ceramics, Commercial Art, Drawing, Graphic Arts, Graphic Design, Illustration, Painting, Photography, Printmaking, Sculpture, Stage Design, Theatre Arts
Summer School: Courses—Per regular session

CANTON

ST LAWRENCE UNIVERSITY, Dept of Fine Arts, Canton, NY 13617. Tel 315-229-5192; Internet Home Page Address: www.stlawu.edu; *Assoc Prof* Dorothy Limouze, PhD; *Assoc Prof* Faye Serio, MFA; *Asst Prof* Chandreyi Basu, PhD; *Asst Prof* Melissa Schulenberg, PhD; *Asst Prof* Amy Hauber, MFA; *Asst Prof* Mark Denaci, PhD; *Asst Prof* Kasarian Dane, MFA; *Prof* Obiora Udechukwu, MFA
Estab 1856; Non-Profit art gallery, Richard F Brush Art Gallery; pvt; D&E; SC 16, LC 13; maj 80, non-maj 300
Ent Req: HS dipl
Degrees: BA
Tuition: $33,690 per yr; room & board $8,850
Courses: Art History, Ceramics, Drawing, Painting, Photography, Printmaking, Sculpture, Teacher Training
Summer School: Dir, Donna Fish. Enrl 10-20. Courses—Art History, Studio

CAZENOVIA

CAZENOVIA COLLEGE, Center for Art & Design Studies, Studio Art, 22 Sullivan St Cazenovia, NY 13035. Tel 800-654-3210; Fax 315-655-2190; Internet Home Page Address: www.cazenovia.edu; *Pres* Mark Tierno; *Prof* Lillian

Ottaviano, MFA; *Prof* Jeanne King, MFA; *Prof* Jo Buffalo, MFA; *Prof & Chmn* Charles Goss, MFA; *Assoc Prof* Kim Waale, MFA; *Assoc Prof* Anita Welych, MFA; *Assoc Prof* Karen Steen, MFA; *Instr* Patricia Beglin, MA; *Asst Prof* Laurie Selleck, MFA; *Asst Prof* Allyn Stewart, MFA; *Asst Prof* Tod Guynn, MFA; *Asst Prof* Elizabeth Moore, MS; *Prof* Josef Ritter, MFA
Estab 1824; pvt; D & E; Scholarships; SC 21, LC 3; D 660
Ent Req: HS dipl
Degrees: AS, AAS, BS, BFA, & BPS 2 yr & 4 yr progs
Tuition: Res—$17, 885 per yr; campus res—room & board $3885
Courses: †Advanced Studio Art, †Advertising Design, Advertising Layout, Basic Design, Ceramics, Drafting, Drawing, Fashion Design, †Illustration, †Interior Design, Lettering, Office & Mercantile Interiors, Painting, Photography, Printmaking, Rendering, Residential Interiors, Typography
Adult Hobby Classes: Enrl 200; tuition $84 per cr. Courses—large variety
Summer School: Dir, Marge Pinet. Enrl 100; tuition $1650 for 5 wk term. Courses—Variety

CHAUTAUQUA

CHAUTAUQUA INSTITUTION, School of Art, 1 Ames Ave, Chautauqua, NY 14722; PO Box 1098, Chautauqua, NY 14722. Tel 716-357-6233; Fax 716-357-9014; Internet Home Page Address: www.ciweb.org; *Instr* Stanley Lewis; *Instr* Barbara Grossman; *Instr* Shari Mendelson; *Instr* David Lund; *Dir Art School* Don Kimes
Estab 1874; pub; D (summers only); Scholarships; SC 40, LC 20; D 500
Tuition: $3155 full cost for 8 wk term
Courses: Ceramics, Drawing, Painting, Printmaking, Sculpture
Adult Hobby Classes: Enrl 300; tuition $75 per wk; Courses—same as above
Children's Classes: Young artists programs, ages 6 - 17
Summer School: Dir, Don Kimes. Enrl 55; tuition $2200 beginning June 26 - Aug 18

CLAYTON

HANDWEAVING MUSEUM & ARTS CENTER, (Thousand Islands Craft School & Textile Museum) 314 John St, Clayton, NY 13624. Tel 315-686-4123; Fax 315-686-3459; Elec Mail info@hm-ac.org; Internet Home Page Address: www.hm-ac.org; *Exec Dir* Beth Conlon; *Dir of Develop* Amy Fox; *Cur* Sonja Wahl
Estab 1964; maintain a nonprofit art gallery: Catherine C. Johnson Gallery, 314 John St, Clayton, NY 13624; maintain an art/architecture library: Berta Frey Memorial Library, 314 John St, Clayton, NY 13624; PT 27; brd of trustees, non-profit; D & E (weekdays & weekends); SC 35; D 210, E 10
Degrees: no degrees but transfer credit
Courses: Basketry, Bird Carving, Ceramics, Decoy Carving, Drawing, Fashion Arts, Fiber Arts, Handicrafts, Jewelry, Mixed Media, Painting, Pottery, Quilting, Sculpture, †Sewing, Spinning, Weaving
Children's Classes: Drawing, Painting, Pottery, Weaving
Summer School: July 3-Aug 25. Courses—Country Painting, Decoy Carving, Painting on Silk, Pottery, Quilting, Sculpture, Watercolor Painting, Weaving

COBLESKILL

STATE UNIVERSITY OF NEW YORK, AGRICULTURAL & TECHNICAL COLLEGE, Art Dept, Rte 7, Cobleskill, NY 12043. Tel 518-234-5011; Fax 518-234-5333; Internet Home Page Address: www.synycobleskill.edu; Estab 1950; pub; D & E; SC 2, LC 2; D 95
Ent Req: HS dipl
Degrees: AA & AS 2 yrs, BT 4 yrs
Tuition: Res—undergrad $1700 per sem; nonres—undergrad $2250 per sem; campus res—room & board $2380-$2460 per yr
Courses: Art Education, Art History, Drawing, Painting, Sculpture, Teacher Training, Theatre Arts
Adult Hobby Classes: Enrl 4000 per yr; tuition $9 per course. Courses—large variety of mini-courses

CORNING

CORNING COMMUNITY COLLEGE, Division of Humanities, One Academic Dr, Corning, NY 14830. Tel 607-962-9271; Fax 607-962-9456; *Prof* Margaret Brill, MA; *Assoc Prof* Fred Herbst; *Prof* David Higgins, MFA
Estab 1958, dept estab 1963; FT 3; pub; D & E; SC 8, LC 6
Ent Req: HS dipl, SAT
Degrees: AA, AS, AAS 2 yrs
Tuition: $1250 per sem
Courses: Architecture, Art Appreciation, Art History, Ceramics, Design, Drawing, History of Art & Architecture, Jewelry, Painting, Photography, Silkscreen, Silversmithing
Adult Hobby Classes: Enrl 18; $73 sem
Summer School: Dir, Betsy Brune

CORTLAND

STATE UNIVERSITY OF NEW YORK, COLLEGE AT CORTLAND, Dept Art & Art History, PO Box 2000, Cortland, NY 13045. Tel 607-753-4316; Fax 607-753-5970, 753-5728; *Chmn* Charles Heasley; *Slide Cur* E Joyce; *Gallery Dir* Allison Graff; *Prof* Barbara Wisch PhD, MAT; *Prof* Libby Kowalski, MAT; *Prof* Louis Ellis, MFA; *Asst Prof* Kathryn Kramer PhD, MFA; *Asst Prof* Jeremiah Donovan, MFA; *Asst Prof* Allen Mooney, MFA; *Prof* Martien Barnaby-Sawyer
Estab 1868, dept estab 1948; pub; D & E; Scholarships; SC 40, LC 10; D 5600 (total), 1200 (art), maj 80

Ent Req: HS dipl, all college admissions standards based on high school average or scores from SAT, ACTP or Regent's tests
Degrees: BA 4 yrs
Tuition: Res—undergrad $1450 per yr; nonres—undergrad $3100 per yr; other college fee & activity assessment $87 per yr; campus res—$1400 per yr(room) and $972 per yr(board)
Courses: Art Appreciation, Art Education, †Art History, Ceramics, Computer Generated Prints, Computers in the Visual Arts, Contemporary Art, Design, Drawing, Fabric Design, †History of Art & Architecture, Lithography, Modern Art, Painting, Photography, Printmaking, Sculpture, Silkscreen, Surrealism, Weaving
Summer School: Two terms of 5 wks beginning June 26. Courses—Art History, Studio

ELMIRA

ELMIRA COLLEGE, Art Dept, One Park Pl, Elmira, NY 14901. Tel 607-735-1800, 735-1804 (Acad Affairs); Tel 607-735-1724 (Admission); Fax 607-735-1712; Internet Home Page Address: www.elmira.edu; *Chmn* Doug Holtgrewe; *Prof* James Cook; *Asst Prof* Leslie Kramer, MFA; *Asst Prof* Mac Dennis, MFA; *Asst* John Diamond-Nigh, MFA; *Asst* Jan Kather, MFA
Estab 1855; pvt; D & E; Scholarships; SC 26, LC 15, GC 8; D 250, E 125, maj 35, grad 6
Ent Req: HS dipl
Degrees: AA, AS, BA, BS & MEduc
Tuition: $22,960 per yr; $4560 for room, $2970 for board; $100 house fee
Courses: †Art Education, †Art History, †Ceramics, †Drawing, †Painting, †Photography, †Printmaking, †Sculpture, †Video
Adult Hobby Classes: Tuition $180 - $265 per cr hr. Courses—Art History, Ceramics, Drawing, Landscape Painting & Drawing, Painting, Photography, Video
Summer School: Dir, Lois Webster. Tuition undergrad $180 cr hr, grad $265 per cr hr. Courses—Art History, Ceramics, Drawing, Landscape Painting & Drawing, Painting

FARMINGDALE

STATE UNIVERSITY OF NEW YORK AT FARMINGDALE, Visual Communications, Broadhollow Rd, Rte 110, Farmingdale, NY 11735-1021. Tel 631-420-2181; Fax 631-420-2034; Internet Home Page Address: www.farmingdale.edu/art; *Dept Chmn* Wayne Krush; *Asst Prof* George Fernandez; *Assoc Prof* Thomas Germano; *Assoc Prof* Paul Gustafson; *Assoc Prof* Mark Moscarillo; *Asst Prof* Donna Proper; *Assoc Prof* Allison Puff; *Assoc Prof* Bill Steedle
Estab 1912; 10 FT, 6 PT; pub; D&E
Ent Req: portfolio, drawing test
Degrees: BT
Tuition: Res—$3,700 per yr; nonres—$8,300 per yr
Courses: Calligraphy, Computer Art, Computer Graphics, Design, Drawing, Electronic Publishing, Illustration, Layout, Multi-Media, Painting, Pastels, Photography, Printmaking, Typography, Watercolors, Web Design
Adult Hobby Classes: Tuition $45 per credit hr. Courses same as above
Summer School: Dir, Francis N Pellegrini. Tuition $45 per cr; June-Aug. Courses—Advertising, Art History, Design, Drawing, Lettering, Mechanical Art, Production

FLUSHING

QUEENS COLLEGE, Art Dept, 65-30 Kissena Blvd, Flushing, NY 11367. Tel 718-997-5770, 997-5411; Internet Home Page Address: www.qc.edu; *Chmn* James Saslow
Nonprofit art gallery on 4th fl; also a museum; 13 FT instrs
Degrees: BA, BFA, MA, MFA, MSEd
Tuition: Res—undergrad $1,600 per sem, $135 per cr hr; nonres—$3,400 per sem, $285 per cr hr
Courses: Advertising Design, Architecture, Art Appreciation, Art Education, Art History, Calligraphy, Ceramics, Design, Drawing, Illustration, Painting, Photography, Printmaking, Sculpture
Summer School: Courses held at Caumsett State Park

FOREST HILLS

FOREST HILLS ADULT AND YOUTH CENTER, 6701 110th St, Forest Hills, NY 11375. Tel 718-263-8066; *Principal High School* Elma Fleming
Degrees: Cert
Tuition: $70 plus materials for 7 wk course
Courses: Art Appreciation, Calligraphy, Drawing, Handicrafts, Painting, Quilting

FREDONIA

STATE UNIVERSITY COLLEGE OF NEW YORK AT FREDONIA, Dept of Art, Rockefeller Art Center, Rm 269, Fredonia, NY 14063. Tel 716-673-3537; Elec Mail lundem@fredonia.edu; Internet Home Page Address: www.fredonia.edu; *Prof* Marvin Bjurlin; *Prof* Robert Booth; *Prof* Paul Bowers; *Prof* John Hughson; *Prof* Daniel Reiff, PhD; *Chmn* Mary Lee Lunde; *Prof* Alberto Rey; *Prof* Liz Lee; *Asst Prof* Jan Conradi
Estab 1867, dept estab 1948; pub; D & E; Scholarships; SC 30, LC 18; D 650, E 70, non-maj 610, major 140
Ent Req: ent req HS dipl, GRE, SAT, portfolio review all students
Degrees: BA 4 yrs, BFA 4 yrs
Tuition: Res—$137 per cr hr; nonres—$346 per cr hr
Courses: Art History, †Ceramics, Drawing, †Graphic Arts, †Illustration, †Painting, †Photography, Printmaking, †Sculpture, Video

GARDEN CITY

ADELPHI UNIVERSITY, Dept of Art & Art History, Blodgett S Ave, Rm 320, Garden City, NY 11530. Tel 516-877-4460; Fax 516-877-4459; Internet Home Page Address: www.adelphi.edu; *Prof* Richard Vaux; *Assoc Prof* Thomas MacNulty; *Asst Prof* Dale Flashner; *Chmn* Harry Davies; *Asst Prof* Geoffrey Grogan; *Asst Prof* Jacob Wisse
Estab 1896; Maintain nonprofit art gallery; FT 7p, PT 18; pvt; D & E; Scholarships; SC 50, LC 10, GC 20; D 700, E 100, maj 130, grad 60
Ent Req: HS dipl; portfolio required for undergrad admission, portfolio required for grad admission
Degrees: BA 4 yrs, MA 1 1/2 yrs
Tuition: $7675 per sem; campus res available; $520 grad cr
Courses: †Advertising Design, Aesthetics, Art Education, Art History, Calligraphy, Ceramics, Design, Drawing, Graphic Arts, Graphic Design, History of Art & Architecture, Jewelry, Lettering, Mixed Media, Painting, Photography, Printmaking, Sculpture, Teacher Training
Summer School: Chmn, Harry Davies. Tuition—same as regular session; two 4 wk summer terms also 2 wk courses. Courses—Crafts, Drawing, Painting, Sculpture, Photography

NASSAU COMMUNITY COLLEGE, Art Dept, One Education Dr, Garden City, NY 11530. Tel 516-572-7162; Fax 516-572-9673; *Prof* Robert Lawn; *Prof* Edward Fox
Estab 1959, dept estab 1960; pub; D & E; Scholarships; SC 22, LC 5; D & E 20,000
Ent Req: HS dipl
Degrees: AA 2 yrs, cert in photography & advertising design 1 yr
Tuition: $92 per cr hr
Courses: Advertising Art, Art History, Arts & Crafts, Ceramics, Drawing, Fashion Arts, Painting, Photography, Printmaking, Sculpture
Summer School: Two 5 wk terms

GENESEO

STATE UNIVERSITY OF NEW YORK COLLEGE AT GENESEO, Dept of Art, One College Circle, Geneseo, NY 14454. Tel 716-245-5814, 245-5211 (main); Fax 716-245-5815; Internet Home Page Address: www.geneseo.edu; *Chmn* Carl Shanahan
Estab 1871; FT 8, PT 3; pub; D & E; Scholarships; SC 35, LC 7; D 1000, E 1150, maj 115
Ent Req: HS dipl, ent exam
Degrees: BA(Art) 3-4 yrs
Tuition: $2105 per yr
Courses: 2-D & 3-D Design, Art History, Ceramics, Computer Art, Drawing, Graphic Arts, Jewelry, Painting, Photography, Photolithography, Sculpture, Textile Design, Wood Design
Summer School: Enrl 180; tuition undergrad $45.85 per hr, grad $90.85 per hr for two 5 wk sessions & a 3 wk session. Courses vary

GENEVA

HOBART & WILLIAM SMITH COLLEGES, Art Dept, Houghton House Gallery, 1 Kings Lane Geneva, NY 14456. Tel 315-781-3487; Fax 315-781-3689; *Chmn* Phillia Yi
Estab 1822; FT 6; pvt; D; Scholarships; SC 15, LC 8; D 1,800
Ent Req: HS dipl, ent exam
Degrees: BA & BS 4 yrs
Tuition: $27,255; room & board $6,315
Courses: †Architecture, †Art History, Drawing, Mixed Media, Painting, Photography, Printmaking, Sculpture, †Studio Art

HAMILTON

COLGATE UNIVERSITY, Dept of Art & Art History, 13 Oak Dr, Hamilton, NY 13346. Tel 315-228-7633, 228-1000; Fax 315-824-7787; Internet Home Page Address: www.colgate.edu; *Chmn* John Knecht, MFA; *Prof* Eric Van Schaack PhD, MFA; *Prof* Jim Loveless, MFA; *Assoc Prof* Judith Oliver PhD, MFA; *Assoc Prof* Robert McVaugh, PhD; *Assoc Prof* Lynn Schwarzer, MFA; *Asst Prof* Padma Kaimal, MA; *Asst Prof* Mary Ann Calo, MA; *Asst Prof* Daniella Dooling, MA; *Asst Prof* Carol Kinne, MA
Estab 1819, dept estab 1905; pvt; D; Scholarships; SC 22, LC 23; D 941, maj 50
Ent Req: HS dipl, CEEB or ACT
Degrees: BA 4 yrs
Tuition: $13,595 per yr; campus res—room & board $4540
Courses: Art History, Combined Media, Drawing, Mixed Media, Motion Picture Productions, Painting, Photography, Printmaking, Sculpture

HEMPSTEAD

HOFSTRA UNIVERSITY
—Department of Fine Arts, Tel 516-463-5475; Fax 516-463-6268; Elec Mail fadmh@hofstra.edu; Internet Home Page Address: www.hofstra.edu/Academics/HCLAS/Arts/index_Arts.cfm; *Chmn* Douglasl Hilson
Estab 1935, dept estab 1945; Maintain nonprofit art gallery, Rosenberg, Calkins Hall, Hofstra Univ, Hempstead, NY 11550; FT 11; pvt; D & E; Scholarships; SC, LC 20, GC 16; D 1610, maj 100, grad 10
Ent Req: HS dipl
Degrees: BA, MA, BS
Tuition: Undergrad $7,140 per sem
Courses: Appraisal of Art and Antiques, Art History, Drawing, Graphic Arts, Jewelry, Painting, †Photography, †Sculpture

Summer School: Dean, Deanna Chitayat. Courses—Art History, Fine Arts

HERKIMER

HERKIMER COUNTY COMMUNITY COLLEGE, Humanities Social Services, 100 Reservoir Rd, Herkimer, NY 13350. Tel 315-866-0300, Ext 200; Fax 315-866-7253; Internet Home Page Address: www.hccc.ntcnct.com; *Dean* Jennifer Boulanger, MFA; *Asst Dean* Pat Haag, MFA; *Assoc Prof* James Bruce Schwabach, MFA; *Assoc Prof* Mariann Wrinn, MFA; *Asst Prof* Gale Farley
Estab 1966; pub; D & E; SC 8, LC 4; D 329 (total), maj 16
Ent Req: HS dipl, SAT or ACT; open
Degrees: AA, AS & AAS 2 yrs
Tuition: Res—grad $145 per cr hr; res—undergrad $175 per sem, $80 per cr hr; nonres—undergrad $2100 per sem; no campus res; international $175 per cr hr; international $2500 per sem
Courses: †2-D Design, †3-D Design, Art Appreciation, Art History, †Ceramics, Drawing, Painting, Photography, †Sculpture, Theatre Arts, Video
Adult Hobby Classes: Enrl 40 credit, 100 non-credit; tuition $33 per cr hr. Courses—Art Appreciation, Calligraphy, Pastels, Portraits, Photography
Children's Classes: Enrl 40; tuition varies. Courses—Cartooning Workshop, Introduction to Drawing
Summer School: Dir, John Ribnikac. Enrl 40. Courses—Same as regular session

HOUGHTON

HOUGHTON COLLEGE, Art Dept, One Willard Ave, Houghton, NY 14744. Tel 716-567-2211; *Head Art Dept* Gary Baxter
Estab 1883; den; D & E; Scholarships; SC 8, LC 6
Degrees: AA & AS 2 yrs, BA & BS 4 yrs
Tuition: $7300 per sem
Courses: Ceramics, Drawing, Graphic Design, Painting, Photography, Printmaking, Sculpture

ITHACA

CORNELL UNIVERSITY
—Dept of Art, Tel 607-255-3558; Fax 607-255-3462; Elec Mail artinfo@cornell.edu; Internet Home Page Address: www.cornell.edu; *Dean College* Porus Olpadwala; *Prof* Jack L Squier, MFA; *Assoc Prof* Jean Locey, MFA; *Assoc Prof* Greg Page, MFA; *Assoc Prof* Elisabeth Meyer, MFA; *Assoc Prof* Barry Perlus, MFA; *Asst Prof* W Stanley Taft, MFA; *Asst Prof* Kay WalkingStick, MFA; *Asst Prof* Todd McGrain, MFA; *Vis Asst Prof* Carl Ostendarp; *Prof* Victor Kord; *Assoc Prof* Roberto Bertoia, MFA; *Chair, Prof* Buzz Spector, MFA
Estab 1868, dept estab 1921; Maintain nonprofit art gallery; Olive Tjaden Gallery; Fine Arts Library, Cornell Univ; art supplies available on-campus; pvt; D; Scholarships; SC 25, LC 1, GC 4; maj 150, grad 12
Ent Req: HS dipl, HS transcript, SAT
Degrees: BFA, MFA
Tuition: $27,270
Courses: †Combined Media, Drawing, Painting, Photography, Printmaking, Sculpture
Summer School: Dir, Charles Jennyt. Tuition $375 per cr for term of 3 & 6 wks beginning May 28
—Dept of the History of Art & Archaeology, Tel 607-255-4905; Fax 607-255-0566; Internet Home Page Address: www.cornell.edu; *Prof* Andrew Ramage PhD; *Assoc Prof* Judith E Bernstock PhD; *Assoc Prof* Peter I Kuniholm PhD; *Assoc Prof* Claudia Lazzaro PhD; *Assoc Prof* Laura L Meixner PhD; *Prof* Robert G Calkins PhD
Estab 1939; pvt; D; Scholarships; LC 64, GC 12; D 1300, maj 40, grad 18, others 5
Ent Req: HS dipl, SAT, grad admission requires GRE
Degrees: BA, PhD
Tuition: R$25,970 yr
Courses: 1940-1990 Art, Art History, Classical Art & Architecture, Gothic Art & Architecture
Summer School: Dean, Glenn Altschuler. Tuition $410 per cr hr. Courses—Introductory
—New York State College of Human Ecology, Tel 607-255-2168; Fax 607-255-0305; Internet Home Page Address: www.cornell.edu; *Chmn Dept* Frank Becker
FT 12; Scholarships
Degrees: BS, MA, MS, MPF
Tuition: Res—$3870 per sem; nonres—$7450 per sem
Courses: Facilities Planning & Management, Human Factors & Management, Interior Design

ITHACA COLLEGE, Fine Art Dept, 101 Ceracche Ctr, Ithaca, NY 14850-7277. Tel 607-274-3330; Fax 607-274-1358; Internet Home Page Address: www.ithaca.edu; *Chmn* Harry McCue, MFA; *Prof* Raymond Ghirardo, MFA; *Prof* Susan Weisend, MFA; *Assoc Prof* Bruce North, MFA; *Lectr* Pat Hunsinger; *Lectr* Bill Hastings; *Lectr* Linda Price; *Asst Prof* Susan Barbehenn, MFA; *Asst Prof* Brody Burroughs, MFA
Estab 1892, dept estab 1968; Maintain nonprofit art gallery; Handwerker Gallery, 1170 Gannett Center, Ithaca, NY 14850; Pvt; D & E; Scholarships; SC 27; non-maj 300, maj 50
Ent Req: HS dipl, SAT scores
Degrees: BA and BFA 4 yrs & Teacher Education
Tuition: $21,102 per yr; campus res—available
Courses: 2-D Design, Art History, Computer Art, Drawing, Figure Drawing, Painting, Printmaking, Sculpture, Silkscreen
Summer School: Chmn, Harry McCue. Enrl 10-20. Courses—Introduction to Drawing, Computer Art

JAMAICA

SAINT JOHN'S UNIVERSITY, Dept of Fine Arts, 8000 Utopia Pky, Jamaica, NY 11439. Tel 718-990-6161; Fax 718-990-1907; *Gallery Dir* Mohammad Mohsin; *Chmn* Paul Fabozzi
Pvt; D; Scholarships; SC 24, LC 9; D 1300, maj 100
Ent Req: HS dipl, ent exam, portfolio review
Degrees: BFA & BS 4 yrs
Tuition: $425-$47 per cr hr, $8700 per sem (12-18 cr)
Courses: Advertising Design, Aesthetics, Art Appreciation, Art Education, Art History, Ceramics, Collage, Commercial Art, Conceptual Art, Design, Drawing, Film, †Fine Arts, Graphic Arts, †Graphic Design, History of Art & Architecture, †Illustration, Industrial Design, Intermedia, Jewelry, Lettering, Mixed Media, †Painting, †Photography, †Printmaking, Saturday Scholarship Program, †Sculpture, Video
Adult Hobby Classes: Courses—Drawing, Figure, Painting, Sculpture
Summer School: . Courses—Drawing, Painting

YORK COLLEGE OF THE CITY UNIVERSITY OF NEW YORK, Fine & Performing Arts, 94-20 Guy Brewer Blvd, Jamaica, NY 11451. Tel 718-262-2400; Fax 718-262-2998; *Prof* Jane Schuler PhD; *Coordr Fine Arts* Phillips Simkin; *Assoc Prof* Ernest Garthwaite, MA; *Assoc Prof* Arthur Anderson, MFA
Estab 1968; pub; D & E; 4303
Ent Req: HS dipl
Degrees: BA 4 yrs
Tuition: Res—$1050 per sem, $100 per cr; nonres—$1338 per sem, $210 per cr; no campus res
Courses: Art Education, Art History, Computer Graphics, Drawing, Graphic Arts, Painting, Photography, Printmaking, Sculpture
Summer School: Dean, Wallace Schoenberg. Enrl $20 per course; tuition $47 per cr for term of 6 wks beginning late June. Courses—Art History, Drawing, Painting

JAMESTOWN

JAMESTOWN COMMUNITY COLLEGE, Arts, Humanities & Health Sciences Division, 525 Falconer St, Jamestown, NY 14701. Tel 716-665-5220, Ext 394; Fax 716-665-9110; Elec Mail billdisbro@mail.sunyjcc.edu; Internet Home Page Address: www.sunyjcc.edu; *Art Coordr* Bill Disbro
Estab 1950, dept estab 1970; Maintain nonprofit art gallery; Week Gallery; FT 1, PT 7; pub; D & E; Scholarships; SC 11, LC 1; D 310, E 254
Ent Req: open
Degrees: AA 60 cr hrs; AS Fine Arts; Studio Art
Tuition: Res—$88 per cr hr; nonres—$154 per cr hr
Courses: Ceramics, Computer Graphics, Design, Drawing, Introduction to Visual Art, Painting, Photography, Survey of Visual Arts, Video
Summer School: Dir, Roslin Newton. Enrl 25-50; tuition res $88 per cr hr; nonres $154 per cr hr, 2 terms of 6 wks beginning in May. Courses—Ceramics, Drawing, Painting, Photography

LOCH SHELDRAKE

SULLIVAN COUNTY COMMUNITY COLLEGE, Division of Commercial Art & Photography, 112 College Rd, PO Box 4002 Loch Sheldrake, NY 12759. Tel 845-434-5750; Internet Home Page Address: www.sullivan.suny.edu; *Chmn Art Dept* Mike Fisher; *Prof* L Jack Agnew, MEd; *Prof* Thomas Ambrosino, BPS; *Instructional Asst* Charles Arice; *Assoc Prof* Mary Clare
Estab 1962, dept estab 1965; pub; D & E; SC 24; D 200, maj 180
Ent Req: HS dipl or equivalent
Degrees: AA, AS & AAS 2 yrs
Tuition: Res—undergrad $1575 per sem, $95 per cr; nonres—undergrad $2250 per sem, $225 per cr
Courses: Advertising Design, Commercial Art, Computer Graphics, Design, Drawing, Graphic Arts, Graphic Design, Photography
Summer School: Assoc Dean of Faculty for Community Services, Allan Dampman

LOUDONVILLE

SIENA COLLEGE, Dept of Creative Arts, 515 Loudon Rd, Loudonville, NY 12211. Tel 518-783-2300, 783-2301 (Dept Arts); Fax 518-783-4293; Internet Home Page Address: www.siena.edu; *Chmn* Greg Zoltowski
Estab 1937
Ent Req: HS diploma
Degrees: BA
Tuition: $1300 per year without room & board
Courses: Aesthetics, Art Appreciation, Art History, Drawing, Graphic Design, History of Art & Architecture, Mixed Media, Music, Painting, Printmaking, Theatre Arts
Adult Hobby Classes: Enrl 35; tuition $315 per cr hr for 15 wks. Courses—Introduction to Visual Arts
Summer School: Enrl 35; tuition $315 per cr hr for 7 wk term. Courses—Intro to Visual Arts

MIDDLETOWN

ORANGE COUNTY COMMUNITY COLLEGE, Arts & Communication, 115 South St, Middletown, NY 10940. Tel 845-341-4787; Fax 845-341-4775; Internet Home Page Address: www.sunyorange.edu; *Chair* Mark Strunsky; Joseph Litow; Susan Slater-Tanner
Estab 1950, dept estab 1950; Maintain a nonprofit art gallery; Pub; D & E; Scholarships; SC 16, LC 8; D 135, maj 60
Ent Req: HS dipl

Degrees: AA 2 yrs, AAS(Visual Comm Graphics)
Tuition: $1,500; no campus res
Courses: Art History, Color, Computer Graphic Design, Design, Drawing, Painting, Photography, Sculpture

NEW PALTZ

STATE UNIVERSITY OF NEW YORK COLLEGE AT NEW PALTZ
— Tel 845-257-3830; Fax 845-257-3848; Internet Home Page Address: www.newpaltz.edu; *Chmn Art Studio & Art Educ* Patricia C Phillips; *Prog Dir Art Educ* Margaret Johnson
Maintain nonprofit art gallery, Samuel Dorsky Museum of Art, SUNY New Paltz, New Paltz, NY 12561; 33; Pub; D & E; SC, LC, GC; maj 600, grad 100
Degrees: BA, BS(Visual Arts), BFA, MA, MS, MFA
Tuition: res—$1500.50 per sem; nonres—$3450 per sem
Courses: Ceramics, Graphic Design, Metal, Painting, Photography, Printmaking, Sculpture
Summer School: Dir, Patricia C Phillips. Courses—Art Education
—**Art Education Program,** Tel 914-257-3850; *Dir* Kristin Rauch
3
Degrees: BA, MA
Tuition: res—$1500.50 per sem; nonres—$3450.50 per sem
Courses: Drawing, Painting, Photography, Printmaking, Sculpture
Summer School: Dir, Robert Davidson. 8 wk sem

NEW ROCHELLE

COLLEGE OF NEW ROCHELLE SCHOOL OF ARTS & SCIENCES, Art Dept, 29 Castle Pl, New Rochelle, NY 10805. Tel 914-654-5274; Elec Mail mneuhaus@cnr.edu; Internet Home Page Address: www.cnr.edu; *Chmn* Margie Neuhaus; *Prof* William C Maxwell; *Assoc Prof* Cristina deGennaro, MFA; *Assoc Prof* Emily Stein, MFA; *Prof* Susan Canning, PhD
Estab 1904, dept estab 1929; Maintain nonprofit gallery, Castle Gallery, 29 Castle Pl, New Rochelle, NY 10805; Pvt; D&E; Scholarships; SC 52, LC 14, GC 21; D 150, non-maj 45, maj 105, grad 98
Ent Req: HS dipl, SAT or ACT scores, college preparatory program in high school
Degrees: BA, BFA and BS 4 yrs
Tuition: $9950 per yr; campus res— room and board $4320 per yr
Courses: †Art Education, †Art History, †Art Therapy, Ceramics, Collage, Computer Graphics, Design, Drawing, Fiber Arts, Film, Graphic Design, Interior Design, Jewelry, Metalwork, Mixed Media, Painting, Photography, Printmaking, Sculpture, Teacher Training, Weaving
Summer School: Painting for non-maj

NEW YORK

AESTHETIC REALISM FOUNDATION, 141 Greene St, New York, NY 10012-3201. Tel 212-777-4490; Fax 212-777-4426; Internet Home Page Address: www.aestheticrealism.org; *Class Chmn Aesthetic Realism* Ellen Reiss; *Exec Dir* Margot Carpenter
Estab 1973, as a not for profit educational foundation to teach Aesthetic Realism, the philosophy founded by American poet & critic Eli Siegel (1902-1978), based on his historic principle: "All beauty is a making one of opposites, and the making one of opposites is what we are going after in ourselves"; Maintain nonprofit art gallery; Terrain Gallery, 141 Green St, NYC, NY 10012
Publications: The Right of Aesthetic Realism to Be Known, weekly periodical
Courses: Anthropology, Art Criticism, Art History, Drawing, Education, Music, Poetry, Singing, Theatre Arts
Children's Classes: Learning to Like the World

AMERICAN ACADEMY IN ROME, 7 E 60th St, New York, NY 10022. Tel 212-751-7200; Fax 212-751-7220; Internet Home Page Address: www.aarome.org; *Pres* Adele Chatfield Taylor; *Exec VPres* Wayne Linker; *Chmn* Michael I Sovern
Estab 1894, chartered by Congress 1905; consolidated with School of Classical Studies 1913; Dept of Musical Composition estab 1921; Fellowships for independent study in Rome at the Acad in the fields of architecture, landscape architecture, design, painting, sculpture, musical composition, classical and post-classical studies, history of art, Italian studies are open to citizens of the United States. Painters and sculptors receive a supplies allowance of $600 per year. Approximately 30 fellowships are awarded each year Applicants' material is judged by independent juries of professionals in the field of award. Stipend and travel allowances total $6200, plus room, studio or study, and partial board. Application forms and information sheets are available from the New York office. Applications and supporting material and $25 application fee must be received at the Academy's New York office by November 15 of each year.; Mem: Annual meeting Oct; Board in Feb; Scholarships
Summer School: 28 fellowships

ART STUDENTS LEAGUE OF NEW YORK, 215 W 57th St, New York, NY 10019. Tel 212-247-4510; Fax 212-541-7024; Internet Home Page Address: www.theartstudentleague.org;
Estab 1875; FT 65; pvt; Scholarships; LC; D 1200, E 800, Sat 500 (adults and children)
Ent Req: none
Tuition: $155 month full-time, $80 part-time
Courses: Drawing, Graphic Arts, Illustration, Painting, †Printmaking, Sculpture
Children's Classes: Classes on Saturday
Summer School: Enrl 800, beginning June

BERNARD M BARUCH COLLEGE OF THE CITY UNIVERSITY OF NEW YORK, Art Dept, Box B7/237, 55 Lexington Ave New York, NY 10010. Tel 212-802-2287, 802-6590; Fax 212-802-6604; Internet Home Page Address: www.petersons.com; *Chmn* Virginia Smith; *Chair* Philip Lambert

Estab 1968; pub; D & E; SC 26, LC 16; D 2000, E 500
Ent Req: HS dipl
Degrees: BA, BBA & BSEd 4 yrs, MBA 5 yrs, PhD
Tuition: Res—$1100 per sem, $92 per cr hr; nonres—$2400 per sem, $202 per cr hr
Courses: Advertising Design, Art History, Ceramics, Computer Graphics, Drawing, History of Art & Architecture, Illustration, Painting, Photography, Sculpture
Summer School: Courses - Art History Survey, Ceramics, Crafts, Drawing, Painting, Photography

THE CHILDREN'S AID SOCIETY, Visual Arts Program of the Greenwich Village Center, 219 Sullivan St, New York, NY 10012. Tel 212-254-3074; Fax 212-420-9153; Internet Home Page Address: www.children'saidsociety.org; *Dir* Steve Wobido; *Dir Arts Prog* Erin McLaughlin
Estab 1854, dept estab 1968; D & E; Scholarships; SC 7; D 200, E 175
Tuition: Adults $225 per sem; children $175 per sem; no campus res
Courses: Ceramics, Collage, Comic Book Art, Drawing, Enameling, Handicrafts, Jewelry, Painting, Photography, Pottery, Puppet Making, Woodworking
Adult Hobby Classes: Enrl 95; tuition $60-$75 per sem.
Courses—Cabinetmaking, Ceramics, Drawing, Enameling, Painting, Photography, Pottery
Children's Classes: Enrl 325; tuition $32-$42 per sem. Courses—Dance, Drawing, Enameling, Mixed Media, Painting, Photography, Puppet Making, Woodwork, Theatre & Mime
Summer School: Dir, H Zaremben & Allen M Hart

CITY COLLEGE OF NEW YORK, Art Dept, 138th St & Convent Ave, New York, NY 10031. Tel 212-650-7420; Fax 212-650-7438; Elec Mail art@ccny.cuny.edu; Internet Home Page Address: www.ccny.cuny.edu; *Dir Grad Studies* Michi Itami, MFA; *Supv Art Educ* Catti James, MA; *Dir Museum Studies* Harriet F Senie, PhD; *Chmn* Ellen Handy, PhD; *Prof* Annette Weintraub; *Prof* George Preston; *Assoc Prof* Colin Chase; *Assoc Prof* Sylvia Netzer; *Assoc Prof* Ina Saltz; *Prof* Leo Fuentes; *Assoc Prof* Bruce Habegger; *Asst Prof* Kevin McCoy
Estab 1847; pub; D & E; Scholarships; SC 45, LC 29, GC 20; D 1043, E 133, maj 100, grad 40
Ent Req: HS dipl, entrance placement exams
Degrees: BA, MA, BFA, MFA
Tuition: Res—undergrad $1600 per sem, $135 per cr hr, grad $2175 per sem, $185 per cr hr; nonres—undergrad $3400 per sem, $285 per cr hr, grad $3800 per sem, $320 per cr hr
Courses: Advertising Design, Art Education, Art History, Ceramics, Design, Drawing, Graphic Arts, Graphic Design, Intermedia, †Lettering, Mixed Media, Museum Staff Training, Painting, Photography, Printmaking, Sculpture
Adult Hobby Classes: Courses—Advertising & Design, Art History, Ceramics, Drawing, Graphics, Museum Studies, Painting, Photography, Sculpture

CITY UNIVERSITY OF NEW YORK, PhD Program in Art History, The Graduate Center, 365 5th Ave New York, NY 10016. Tel 212-817-8035; Fax 212-817-1502; Elec Mail arthistory@gc.cuny.edu; Internet Home Page Address: web.gc.cuny.edu/dept/arthi; Internet Home Page Address: www.web.gc.cuny.edu/dept/arthi; *Distinguished Prof* Janet Cox-Rearick; *Distinguished Prof* Jack Flam; *Prof* Laurie Schneider Adams; *Prof* Rosemarie Haag Bletter; *Prof* Anna Chave; *Prof* George Corbin; *Prof Emeritus* William H Gerdts; *Prof* Mona Hadler; *Prof* Eloise Quinones-Keber; *Prof Emerita* Diane Kelder; *Prof* Gail Levin; *Exec Officer* Patricia Mainardi; *Prof* Michael Mallory; *Prof Emeritus* Marlene Park; *Prof Emeritus* Robert Pincus-Witten; *Prof* Sally Webster; *Prof* Jane Roos; *Prof* Geoffrey Batchen; *Assoc Prof* Romy Golan; *Prof* Barbara Lane; *Prof* Stuart Liebman; *Prof* Katherine Manthorne; *Assoc Prof* Kevin Murphy; *Prof* James M Saslow; *Prof* Harriet Senie; *Prof* Judy Sund; *Prof Emerita* H Barbara Weinberg; *Prof* Emily Braun; *Prof* Lisa Vergara
Estab 1961, prog estab 1971; Maintain nonprofit art gallery on campus; art libr within Mina Rees Libr; pub; D & E; Scholarships, Fellowships; LC 10, GC 6; D 230
Ent Req: BA or MA in Art History
Degrees: PhD
Tuition: Res—$2435 per sem, $275 per cr hr; nonres—$3800 per sem, $475 per cr hr
Courses: African, Art History, Modern and Contemporary Art & Architecture, Native American & Pre-Columbian Art & Architecture, Oceanic, Renaissance & Baroque Art & Architecture

COLUMBIA UNIVERSITY
—**Graduate School of Architecture, Planning & Preservation,** Tel 212-854-3414; Fax 212-864-0410; Internet Home Page Address: www.columbia.edu, www.arch.columbia.edu; *Dean Architectural Planning* Bernard Tschumi; *Chmn Div Urban Design* Stan Allen; *Prof* Sig Guava
Estab 1881; FT 31, PT 32; pvt; Scholarships, Fellowships; 400
Ent Req: Bachelor's degree in appropriate area of study
Degrees: MPlanning & MPreservation 2 yr, MArcht 3 yr
Tuition: $25,800
Courses: Architecture, Architecture & Urban Design, Historic Preservation, Urban Planning
—**Dept of Art History & Archaeology,** Tel 212-854-4505; Fax 212-854-7329; Internet Home Page Address: www.columbia.edu; Telex 749-0397; *Dir Grad Studies* Barry Bergboll; *Chmn* Joseph Connors
Pvt
Degrees: MA, MPhil, PhD
Tuition: $27,000 per yr
Courses: Aesthetics, Architecture, Art Appreciation, Art History, Classical Art & Archeology, Far Eastern Art & Archeology, History & Theory of Art History, History of Architecture, History of Art & Archeology, History of Western Art, Near Eastern Art & Archeology, Primitive & Pre-Columbian Art & Archeology
—**Columbia College,** Tel 212-854-2522; Internet Home Page Address: www.columbia.edu; *Dean* Austin Quigley
Pvt, M; Scholarships, Fellowships

Degrees: BA & BS 4 yr
Tuition: $27,000 per yr
Courses: Art and Archaeology of South Eastern Asia, Asian Art and Archaeology, Classical Art and Archaeology, History of Western Art, Near Eastern Art and Archaeology, Primitive and Pre-Columbian Art and Archaeology
—**School of the Arts, Division of Visual Arts,** Tel 212-854-2829, 854-4065; Fax 212-854-7708; Internet Home Page Address: www.columbia.edu/cu/arts/; *Prog Coordr* Liz Perlman; *Chmn* Ronald Jones
Estab 1754, div estab 1945; pvt; D & E; Scholarships
Ent Req: special students required to have studied at the college level in an institution of higher learning, non-degreed students are permitted to register for one or more courses in the division
Degrees: BA
Tuition: Undergrad $18,624 per yr, grad $19,000 per yr
Courses: Drawing, Graphic Arts, Mixed Media, Painting, Photography, Printmaking, Sculpture, Video
Summer School: Prof, Tomas Vu-Daniel. Tuition $2600 for 2-6 wk sessions, Courses—Digital Art, Drawing, Painting, Photography, Printmaking
—**Barnard College,** Tel 212-854-2118; *Chmn* Benjamin Buchloh
Estab 1923; pvt, W; Scholarships; maj 29, total 1930
Degrees: AB 4 yrs
Tuition: $16,228 per yr; campus res available
Courses: Art History, Drawing, Painting
—**Teachers Col Program in Art & Art Educ,** Tel 212-678-3000; Fax 212-678-4048; Internet Home Page Address: www.columbia.edu; *Dir* Judith Burton; *Interim Dean* Edmund Gordon
Estab 1888; pvt; Scholarships, Fellowships, Assistantships; GC; 225
Ent Req: Bachelor's degree & Portfolio review
Degrees: EDD, EDDCT, EDM, MA
Tuition: $705 per cr hr
Courses: Art Appreciation, Art Education, Artistic-Aesthetic Development, Ceramics, Crafts, Curriculm Design, Design, Drawing, Historical Foundations, Museum Studies, Painting, Painting Crafts, Philosophy of Art, Photography, Printmaking, Sculpture, Teacher Education
Adult Hobby Classes: Enrl 35; tuition $150 per 10 wk session

COOPER UNION, School of Art, 30 Cooper Sq, New York, NY 10003. Tel 212-353-4200; Fax 212-353-4345; Internet Home Page Address: cooper.edu; *Acting Dean* Dennis Adams
Estab 1859; Nonprofit gallery - The Arthur J. Houghton Gallery, 7 E 7th St, New York, NY 10003; FT 10, PT 60; pvt; D & E; Scholarships
Ent Req: HS dipl, ent exam
Degrees: BFA 4 yr
Tuition: Free
Courses: †Calligraphy, †Conceptual Art, †Design, †Drawing, †Film, †Graphic Design, †Painting, †Photography, †Printmaking, †Sculpture, †Video
Adult Hobby Classes: Extended Studies Prog
Children's Classes: Enrl 200. Courses—Pre College Art & Architecture for HS students
Summer School: Dir, Stephanie Hightower. Enrl 100. Courses—Same as above

EDUCATION ALLIANCE, Art School & Gallery, 197 E Broadway, New York, NY 10002. Tel 212-780-2300; Fax 212-979-1225; Internet Home Page Address: www.edalliance.org; *Dir* Walt O'Neill
Estab 1889; PT 26; priv; D & E; Scholarships
Ent Req: None
Degrees: Cert
Tuition: Varies per course
Courses: Ceramics, Drawing, Metal Sculpture, Mixed Media, Painting, Photography, Sculpture
Adult Hobby Classes: Enrl 150; 15 wk term; Courses—Painting, Drawing, Sculpture, Metal Sculpture, Ceramics, Photography, Photo Silk Screen
Children's Classes: Enrl 20; 30 wk term. Courses—Mixed Media
Summer School: Dir Clare J Kagel. Enrl 60; tuition by the course for 10 wk term. Courses—Painting, Sculpture

FASHION INSTITUTE OF TECHNOLOGY, Art & Design Division, Seventh Ave at W 27th St, New York, NY 10001-5992. Tel 212-217-7999; Fax 212-217-7160; Internet Home Page Address: www.fitnyc.suny.edu; *Chmn Interior Design* Frank Memoli; *Chmn Fashion Design* Carol Adelson; *Chmn Advertising Design* Susan Cotler Block; *Chmn Fine Arts* M Frauenglass; *Chmn Illustrations* Ed Soyka; *Chmn Photo* Manny Gonzalez; *Chmn Display Design* Anne Kong; *Chmn Jewelry Design* Michael Coan; *Dean* Joe Lewis
Estab 1951; pub; D & E; Scholarships; SC 317, LC 26; D 4011, E 7004
Ent Req: HS dipl, ent exam
Degrees: AAS 2 yr, BFA 4 yr
Tuition: Res—undergrad $1200 per sem; nonres—undergrad $2825 per sem; campus res—room & board $4412 per yr
Courses: Accessories Design, †Advertising Design, Art History, †Display, History of Art & Architecture, †Illustration, †Interior Design, †Jewelry, Painting, †Photography, Printmaking, †Restoration & Conservation, Sculpture, Silversmithing, †Textile Design, Toy Design, Weaving
Adult Hobby Classes: Part-time Studies
Summer School: VPres Student Affairs, Stayton Wood. Enrl 4589; tuition $78-$200 per course for term of 3, 5 & 7 wks beginning June. Courses—Same as above

FORDHAM UNIVERSITY, Art Dept, Arts Division, Lincoln Ctr, 113 W 60th St New York, NY 10023. Tel 212-636-6000; *Div Chmn* William Conlon
Estab 1968; FT 7; pvt; D & E; Scholarships; SC 18, LC 25; D 900, E 1750, maj 56
Ent Req: HS dipl
Degrees: BA 4 yrs
Tuition: Undergrad—$450 per cr hr, grad $565 per cr hr; campus res available

Courses: Aesthetics, Costume Design & Construction, Drawing, Graphic Arts, History of Art & Architecture, Painting, Photography, Sculpture, Stage Design, Teacher Training, Theatre Arts
Summer School: Dir, Dr Levak. Four terms per summer for 5 wks each

GREENWICH HOUSE INC, Greenwich House Pottery, 16 Jones St, New York, NY 10014. Tel 212-242-4106; Fax 212-645-5486; Elec Mail pottery@greenwichhouse.org; Internet Home Page Address: www.greenwichhousepottery.org; *Asst Dir* Lynne Lerner; *Dir* Elizabeth Zawada; *Programs Coordr* Gail Heidel; *Studio Mgr* Josephine Burr
Estab 1909, parent organization estab 1902; Maintains nonprofit art gallery, Jane Hartsook Gallery, 16 Jones Sr, New York, NY 10014; 26; pvt; D & E; Scholarships; SC 32; D 200, E 94
Ent Req: none
Degrees: none
Tuition: $310 per sem; no campus res
Courses: Art History, Ceramics, Glazing Chemistry, Sculpture
Adult Hobby Classes: Enrl 200; tuition $420 per 12 wk term. Courses—Pottery Wheel, Handbuilding, Sculpture
Children's Classes: Enrl 50; tuition $260 and $325 for 12 wk term. Creative technique instruction
Summer School: Dir, Elizabeth Zawada. Enrl 40; tuition $110-$140 for children per 4 wk term

HARRIET FEBLAND ART WORKSHOP, 245 E 63rd St, Ste 1803, New York, NY 10021. Tel 212-759-2215; Elec Mail harrietfebland@aol.com; Internet Home Page Address: www.harrietfebland.com; *Instr* Bernard Kassoy; *Instr* John Close; *Dir* Harriet FeBland
Estab 1962; pvt; D & E; SC 6, LC 1, GC 2; D 90, others 30
Income: Financed by student tuition
Ent Req: Review of previous work, paintings or sculpture
Tuition: $1,200 per 15 wk class, $500 for 5 wk 1 hr critique session
Courses: Collage, Constructions, Drawing, †Moku-Hanga woodcut block printing, Painting
Adult Hobby Classes: 70; $1,200 per sem (15 wk each sem).
Courses—Advanced Painting, Assemblage, Construction, Drawing
Summer School: Workshops for 2 to 3 wks are given at various universities in US & England

HENRY STREET SETTLEMENT ARTS FOR LIVING CENTER, 466 Grand St, New York, NY 10002. Tel 212-598-0400; Fax 212-505-8329; *Dir* Barbara Tate
Estab 1895; pvt; D; Scholarships; D 60, E 60
Ent Req: None
Tuition: $45-$250 per course
Courses: Calligraphy, Ceramics, Drawing, Graphic Arts, Mixed Media, Painting, Printmaking, Sculpture
Adult Hobby Classes: Courses—Crafts, Drawing, Painting, Pottery
Children's Classes: Courses—Arts & Crafts, Cartooning, Drawing, Experimental Art, Painting, Pottery, Printmaking

HUNTER COLLEGE, Art Dept, 695 Park Ave, New York, NY 10021. Tel 212-772-4995; Fax 212-772-4458; Internet Home Page Address: reg.hunter.edu; *Chmn Art Dept* Sanford Wurmfeld; *Head MFA Prog* Joel Carreiro; *Head MA Prog* Ulko Bates
Estab 1890, dept estab 1935; Maintain nonprofit art gallery; Leubsdorf Gallery 68th St & Lexington Ave, NYC, NY 10004; Times Square Gallery, 450 W 41st St, NYC; FT 29; pub; D & E; SC 20-25, LC 10, GC 14-20; D 250 (including evening), maj 250, GS 250
Ent Req: HS dipl
Degrees: BA & BFA 4 yrs
Tuition: Res—$135 per cr hr; nonres—$285 per cr hr
Courses: Art History, Ceramics, Drawing, Painting, Photography, Printmaking, Sculpture

JOHN JAY COLLEGE OF CRIMINAL JUSTICE, Dept of Art, Music & Philosophy, 899 Tenth Ave, New York, NY 10019-1029. Tel 212-237-8325; Internet Home Page Address: www.jjay.cuny.edu; *Chmn* John Pittman; *Prof* Laurie Schneider PhD; *Assoc Prof* Helen Ramsaran, MFA
Estab 1964, dept estab 1971; FT 4, PT 3; pub; D & E; SC 5, LC 6; D 180, E 180
Ent Req: HS dipl
Degrees: BA and BS 4 yr
Tuition: Res—undergrad $1475 per sem, $125 per cr; nonres—undergrad $3400 per sem, $285 per cr
Courses: Art History, Drawing, Painting, Sculpture

MANHATTAN GRAPHICS CENTER, 481 Washington St, New York, NY 10013. Tel 212-219-8783; Fax 212; Elec Mail manhattangraphicscenter@yahoo.com; Internet Home Page Address: www.manhattangraphicscenter.org; *VPres* Belinda Madden; *Pres* Betty Harmon
Estab 1986; Center is a nonprofit printmaking school & workshops where artists may work in a variety of media, including etching, silkscreen, lithography, woodcut, monotype & other printmaking techniques; D & E; Scholarships; SC 25 LC 3
Tuition: $85-395
Courses: Photography, Printmaking
Adult Hobby Classes: Enrl 10; tuition $30 per wk. Courses—Etching, Lithography, Monotype, Silkscreen, Woodcut

MARYMOUNT MANHATTAN COLLEGE, Fine & Performing Arts Dept, 221 E 71st St, New York, NY 10021. Tel 212-517-0400; Fax 212-517-0413; Internet Home Page Address: www.marymount.mm.edu; *Chmn* Mary Fleischer; *Prof* Bill Bordeau
Estab 1936; FT 25; Scholarships
Ent Req: HS diploma
Degrees: BA & BFA
Tuition: $14,695 per yr

Courses: Art Appreciation, Art Education, †Art History, Ceramics, †Commercial Art, Conceptual Art, Costume Design & Construction, Design, Display, Drawing, Film, Graphic Arts, Graphic Design, History of Art & Architecture, Illustration, Intermedia, Painting, Photography, Sculpture, Stage Design, Teacher Training, †Theatre Arts, Video

NATIONAL ACADEMY SCHOOL OF FINE ARTS, 5 E 89th St, New York, NY 10128. Tel 212-996-1908; Fax 212-426-1711; Elec Mail nlittle@nationalacademy.org; Internet Home Page Address: www.nationalacademy.org; *Dir School* Nancy Little
Estab 1826; Maintain nonprofit art museum, 1083 Fifth Ave, NY, NY, 10128; art & architecture library on-site; art supplies available on-campus; 39; pvt; D, E & weekends; Scholarships; SC 54, LC 3; Enrl 600, Maj, Cont Educ
Ent Req: none
Degrees: cert
Tuition: varies
Courses: Anatomy, Career Development Seminar, Collage, Composition-Portraiture, Drawing, Drawing the Classical Orders, Life Sketch Class, †Mixed Media, Painting, Printmaking, Sculpture, Workshops
Adult Hobby Classes: Enrl 550; tuition varies per class. Courses—Drawing, Painting, Printmaking, Sculpture & related subjects
Children's Classes: Enrl 25; tuition $220. Courses ages 6-16 & older—Drawing & Painting
Summer School: Dir, Nancy Little. Enrl 300.Courses—Drawing, Painting, Printmaking, Sculpture, Watercolor, Mixed Media & variety of workshops

NEW SCHOOL UNIVERSITY, Adult Education Division, 66 W 12th St, New York, NY 10011. Tel 212-229-5600; Fax 212-929-2456; *Dean* Elissa Tenny
Estab 1919
Ent Req: HS dipl; 24 or older for BA program
Degrees: BA, MA
Tuition: Varies per course
Courses: Advertising Design, Art Appreciation, Art History, Calligraphy, Cartooning, Ceramics, Design, Drawing, Fashion Arts, Film, Fine Art, Glassblowing, Jewelry, Painting, Photography, Printmaking, Sculpture, Textile Design
Adult Hobby Classes: Enrl 1500; tuition $220 per course. Courses—All fine arts
Children's Classes: Summer Program for Young Adults
Summer School: Dir, Wallis Osterholz. Enrl 500; 6 wk term. Courses—All fine arts

NEW YORK ACADEMY OF ART, Graduate School of Figurative Art, 111 Franklin St, New York, NY 10013. Tel 212-966-0300; Fax 212-966-3217; Elec Mail michael@nyaa.edu; Internet Home Page Address: www.nyaa.edu; *Instr* Randolph Melick; *Chmn* Harvey Citron; *Instr* Edward Schmidt; *Instr* Martha Mayer Erlebacher; *Instr* Vincent Desiderio; *Exec Dir* Stephen Farthing
Estab 1983; Maintain art library; NY Academy of Art Library; pvt; Scholarships
Degrees: MFA 2 yrs, part-time MFA 4 yrs
Tuition: Full-time $14,400 per yr
Courses: Anatomy, Art History, Drawing, †Figurative Art, History of Art & Architecture, Painting, Sculpture
Adult Hobby Classes: Enrl 250; tuition $350-$400 per course for 12 wk term. Courses—Anatomy, Drawing, Painting, Sculpture
Children's Classes: Enrl 60; tuition $0-350 for 8-12 weeks
Summer School: Dir, Jesse Penridge. Enrl 250; tuition $250 per course for 9 wk term. Courses—Anatomy, Drawing, Painting, Sculpture

NEW YORK INSTITUTE OF PHOTOGRAPHY, 211 E 43rd St, New York, NY 10017. Tel 212-867-8260; Fax 212-867-8122; Internet Home Page Address: www.nyip.com; *Dean* Charles DeLaney; *Dir* David Sills
Estab 1910; Correspondence course in photography approved by New York State and approved for veterans; Enrollment 10,000
Degrees: cert of graduation
Tuition: $852
Courses: Still Photography

NEW YORK SCHOOL OF INTERIOR DESIGN, 170 E 70th St, New York, NY 10021. Tel 212-472-1500; Fax 212-472-3800; Elec Mail admission@nysid.edu; Internet Home Page Address: nysid.edu; *Pres* Inge Heckel; *Dean* Scott Ageloff; *Assoc Dean* Ellen Fisher
Estab 1916; Maintain nonprofit art gallery, 161 E 69 St, New York, NY 10021; pvt; D & E & Wknds; Scholarships, Fellowships; SC, LC, GC; 750 maj & grad
Ent Req: HS dipl, application & interview
Degrees: AAS, BFA, MFA
Tuition: Undergrad tui $9300 per sem; no campus res
Courses: Art History, Color, Design Materials, Drafting, Drawing, History of Art & Architecture, †Interior Design, Space Planning
Summer School: Dean, Scott Ageloff. Enrl 275; tuition $620 per cr

NEW YORK STUDIO SCHOOL OF DRAWING, PAINTING & SCULPTURE, 8 W Eighth St, New York, NY 10011. Tel 212-673-6466; Fax 212-777-0996; *Dean* Graham Nickson; *Dir Prog* Elisa Jensen
Estab 1964; pvt; D; Scholarships; SC 13, LC 2; D100
Ent Req: HS dipl, portfolio of recent work
Tuition: $4700 per sem; campus res—available
Courses: Drawing, Drawing Marathon, Painting, Sculpture
Adult Hobby Classes: 40; tuition $375 per 13 wks. Courses—Drawing (from the model)
Summer School: Courses—Drawing, Painting, Sculpture

NEW YORK UNIVERSITY, Institute of Fine Arts, One E 78th St, New York, NY 10021. Tel 212-992-5800; Fax 212-772-5807; *Dir* James R McCredie
Pvt; D & E; Scholarships, Fellowships; grad 400
Tuition: $2988 per yr
Courses: Conservation and Technology of Works of Art; Curatorial Staff Training, History of Art & Architecture

—**Dept of Art & Art Professions,** 34 Stuyvesant St, New York, NY 10003. Tel 212-998-5700; Fax 212-995-4320; *Prof* Leonard Lehrer MFA; *Dir Undergraduate Studies* Judith S Schwartz, PhD; *Assoc Prof* John Torreano, MFA; *Artist-in-Residence* N Krishna Reddy, MFA; *Artist-in-Residence* Gerald Pryor, MA
FT 10, PT 72; Pvt; D & E; Scholarships, Fellowships; undergrad SC 26, LC 13, grad SC 40, LC 25; maj undergrad 115, grad 230
Ent Req: col board ent exam, 85 HS average, portfolio, interview
Degrees: BS, MA, EdD, DA, PhD
Tuition: $3256 per cr
Courses: †Art Education, Art Therapy, Arts Administration, Ceramics, Collage, Computer Art, Costume Studies, Dealership & Collecting Folk Art, †Drawing, †Intermedia, Jewelry, Mixed Media, †Painting, †Photography, †Printmaking, †Sculpture, Studio Art, Teacher Training, Video

PACE UNIVERSITY, Theatre & Fine Arts Dept, Pace Plaza, New York, NY 10038. Tel 212-346-1352; Fax 212-346-1424; *Chmn* Dr Lee Evans
Estab 1950; pvt; D & E; Scholarships; SC 4, LC 20; D 200, E 150, 700-800 per yr art only
Ent Req: HS dipl, ent exam
Degrees: 4 yr, Art History Major
Tuition: $8325 per sem, $520 per cr hr; campus res—available
Courses: Art History, Drawing, Graphic Design, Modern Art, Oriental Art, Studio Art
Adult Hobby Classes: Courses same as above
Summer School: Two summer sessions. Courses—Studio Art

PARSONS SCHOOL OF DESIGN, 66 Fifth Ave, 6th Fl, New York, NY 10011. Tel 212-229-8910; Internet Home Page Address: www.parsonsschl.edu; *Dean* H Randolph Swearer
Estab 1896; pvt (see also Otis Art Institute of Parsons School of Design, Los Angeles, California); D & E; Scholarships; SC 200, LC 400, GC 25; D 1800, E 4000, GS 25, other 40
Ent Req: HS dipl, portfolio
Degrees: AAS, BFA, BBA, MA, MFA & MArch
Tuition: $22,000 per yr, $734 per cr
Courses: †Advertising Design, Aesthetics, Architecture, †Art Education, Art History, Calligraphy, †Ceramics, Commercial Art, Fashion Arts, †Fine Arts, Graphic Design, History of Art & Architecture, †History of Decorative Arts, Illustration, Industrial Design, Interior Design, Jewelry, Lighting Design, Marketing & Fashion Merchandising, Painting, Photography, Product Design, Sculpture, †Textile Design
Adult Hobby Classes: Enrl 4200; tuition $374 per cr for term of 12 wks. Courses—Advertising, Computer Graphics, Fashion Design, Fine Arts, Floral Design, Illustration, Interior Design, Lighting Design, Marketing & Merchandising, Product Design, Surface Decoration, Theatre Design
Summer School: Dir, Francine Goldenhar. Tuition $4000 for term of 4-6 wks. Courses—Art, Art History, Design

PRATT INSTITUTE, Pratt Manhattan, 144 W. 14th St, New York, NY 10011. Tel 212-647-7775; Fax 212-461-6026; Internet Home Page Address: www.prattinst.edu; *Dir* David Marcincowski
Estab 1892; Maintain nonprofit art gallery, Pratt Manhattan Gallery, 144 W 14th St, 2nd Fl, New York, NY 10011; pvt; D; Scholarships
Ent Req: HS dipl, portfolio, interview
Degrees: AOS, 2 yrs
Tuition: $810 per cr; campus res available
Courses: Advertising Design, Art History, Commercial Art, Computer Graphics, Design, Graphic Design, Illustration

SCHOOL OF VISUAL ARTS, 209 E 23rd St, New York, NY 10010. Tel 212-592-2000, Div Continuing Educ 592-2050; Fax 212-725-3587; Internet Home Page Address: www.schoolofvisualart.edu; *Chmn* Silas H Rhodes; *Pres* David Rhodes; *Provost* Christopher Cyphers
Estab 1947; pvt; D, E & W; Scholarships; FT 2890, PT 2433
Publications: Art & Academe, semi-annual; Portfolio, annual; Words, semi-annual
Ent Req: HS transcript, portfolio review, SAT or ACT test results, interview, 2 letters of recommendation
Degrees: BFA, MFA, MAT (K-12) in Art Educ, MPS Art Therapy
Tuition: $14,300 plus fees per yr
Courses: †Advertising Design, †Animation, †Art Education, Art History, †Cartooning, Ceramics, Commercial Art, †Computer Art, Conceptual Art, Design, Display, Drafting, Drawing, †Film, Graphic Arts, †Graphic Design, History of Art & Architecture, †Illustration, †Interior Design, Intermedia, Mixed Media, †Painting, †Photography, †Printmaking, †Sculpture, Silversmithing, Teacher Training, †Video
Adult Hobby Classes: Enrl 2446; tuition $175 per cr for 12 wks/sem. Courses—Advertising & Graphic Design, Art Education, Art History, Art Therapy, Computer Art, Craft Arts, Film & Video, Fine Arts, Humanities Sciences, Illustration & Cartooning, Interior Design, Photography
Children's Classes: Enrl 200; tuition $200 course 8wks/sem. Courses—Cartooning, Design, Drawing, Film, Interior Design, Painting, Photography, Portfolio Preparation, Sculpture
Summer School: Dir, Christopher Cyphers. Enrl 2471; tuition $175 per cr 10 wks. Courses—Same as adult education classes, Archaeology in Greece, Painting in Barcelona

SKOWHEGAN SCHOOL OF PAINTING & SCULPTURE, 200 Park Ave S, Ste 1116, New York, NY 10003-1503. Tel 212-529-0505; Fax 212-473-1342; Elec Mail mail@skowheganart.org; Internet Home Page Address: www.skowheganart.org; *Exec Dir Prog* Linda Earle; *Exec Dir Develop & Admin* Marella Consolini
Estab 1946; Maintain art library; Robert Lehman Library; 10; pub, nine wk summer residency prog for independent work; Fellowships; 65
Ent Req: proficient in English, 21 years of age & slide portfolio or video
Degrees: credits recognized for transfer, no degrees

Tuition: $5200 includes room & board
Courses: No academic work; individual critiques only
Summer School: Enrl 65; 9 wk summer res prog in Maine for independent work. Contact admin office at 200 Park Ave S, No 1116, New York, NY 10003

WOOD TOBE-COBURN SCHOOL, 8 E 40th St, New York, NY 10016. Tel 212-686-9040; Fax 212-686-9171; Internet Home Page Address: www.woodtobecoburn.com; *Pres* Sandi Gruninger
Estab 1937; FT 7, PT 10; pvt; D; Scholarships; 2 yr course, 16 months, for HS grad; 1 yr course, 9-12 months, for those with 15 or more transferable college sem cr, classroom study alternates with periods of work in stores or projects in fashion field; 250
Degrees: AOS(Occupational Studies)
Tuition: $5060 per yr
Courses: Display, Fabrics, Fashion Arts, Fashion Design, Fashion Merchandising, Marketing & Management

NIAGARA FALLS

NIAGARA UNIVERSITY, Fine Arts Dept, De Veaux Campus, Niagara Falls, NY 14109. Tel 716-285-1212; Internet Home Page Address: www.niagara.edu; *Chmn* Sharon Watkinson
Tuition: $3750 per sem
Courses: Art Appreciation, Art History, Ceramics, Drawing, Painting
Adult Hobby Classes: Enrl 150; tuition $85 per sem. Courses—Ceramics, Painting
Summer School: Dir, L Centofanti. Enrl 25; tuition $185 per sem hr. Courses—Ceramics

OAKDALE

DOWLING COLLEGE, Dept of Visual Arts, Idle Hour Blvd, Oakdale, NY 11769. Tel 631-244-3000; Fax 631-589-6644; Internet Home Page Address: www.dowling.edu; *Asst Prof Visual Arts* Dr Mary Abell; *Dept Chair, Coordr Visual Communications Prog & Asst Prof Visual Arts* Elissa Iberti; *Assoc Prof Visual Arts* Kathy Levine; *Instr Visual Arts* Sorina Ivan; *Assoc Prof Visual Arts* Dr Stephen Lamia; *Asst Prof Visual Arts* Pam Brown; *Asst Prof Visual Arts* Betty Ann Derbentli; *Asst Prof Visual Arts* Kathy Reba; *Instr Visual Arts* Herb Reichert; *Asst Prof Visual Arts* Elvis Richardson; *Asst Prof Visual Arts* Tom Williams
maintain a nonprofit art gallery: The Anthony Giordano Gallery, Dir Pam Brown, Dowling College, Idle Hour Blvd, Oakdale, NY 11769; maintain an art/architecture library: Slide Collection-Betty ann Derbentli, Cur, Dowling College, Fortun off Hall 323, Idlehour Blvd, Oakdale , NY 11769; Pvt; D & E; Scholarships; D 1100, E 500
Ent Req: HS dipl
Degrees: BA(Visual Art), BA(Visual Communications), BS and BBA 4 yrs
Tuition: Undergrad $445 per cr hr; grad $495 per cr hr
Courses: 2-D & 3-D Design, Advertising Design, Art Criticism, Art History, Calligraphy, Ceramics, Computer Graphics, Costume Design & Construction, Design, Drawing, Graphic Arts, Graphic Design, History of Art & Architecture, Illustration, Jewelry, Lettering, Life Drawing, Painting, Photography, Printmaking, Sculpture, †Stage Design, Textile Design
Adult Hobby Classes: Software Instruction
Children's Classes: Software Instruction
Summer School: Software Instruction

OLD WESTBURY

NEW YORK INSTITUTE OF TECHNOLOGY, Fine Arts Dept, PO Box 8000, Wheatley Rd Old Westbury, NY 11568-8000. Tel 516-686-7516, 686-7542; Fax 516-686-7613; Elec Mail pvoci@nyit.edu; Internet Home Page Address: www.iris.nyit.edu/finearts; *Chmn & Assoc Prof* Peter Voci; *Prof* Faye Fayerman, MFA; *Adjunct Prof* Albert Prohaska, MA; *Assoc Prof* Nieves Micas, MA; *Asst Prof* Lev Poliakov, MA; *Adjunct Asst Prof* Steven Woodburn, MFA; *Adjunct Instr* Martin Clements, MA; *Adjunct Asst Prof* Richard Shen; *Adjunct Asst Prof* Joanne Hartman; *Asst Prof* Jane Grundy; *Adjunct Asst Prof* Charles DiDiego; *Adjunct Instr* Blase Decelestino; *Adjunct Assoc Prof* Antonio DiSpigna; *Adjunct Asst Prof* Donna Voci
Estab 1910, dept estab 1963; pvt; D; Scholarships; SC 11, LC 85; D 427, non-maj 100, maj 327
Ent Req: HS dipl, portfolio review
Degrees: BFA 4 yr
Tuition: $525 per cr; no campus res
Courses: †Advertising Design, Aesthetics, †Architecture, Art Appreciation, †Art Education, Art History, Calligraphy, Computer Graphics, Design, Drafting, Drawing, Film, †Graphic Arts, †Graphic Design, Illustration, †Interior Design, Lettering, Mixed Media, Painting, Photography, Printmaking, Sculpture
Summer School: Tuition $80 per cr for term of 8 wks. Courses—Drawing, Interior Design, Painting, Sculpture

STATE UNIVERSITY OF NEW YORK COLLEGE AT OLD WESTBURY, Visual Arts Dept, PO Box 210, Old Westbury, NY 11568. Tel 516-876-3000, 876-3056, 876-3135 (acad affairs); Internet Home Page Address: www.oldwestbury.edu; *Prof* William McGowin; *Chmn* Mac Adans
Estab 1968, Dept estab 1969; pub; D & E; SC 10, LC 10; D & E 277
Ent Req: HS dipl, skills proficiency exam, GED, special exception - inquire through admissions
Degrees: BA & BS(Visual Arts) 4 yr
Tuition: Res—$1960 per sem, $137 per cr
Courses: Collage, Conceptual Art, History of Art & Architecture, Mixed Media, Painting, Photography, Printmaking, Sculpture, TV Production/Editing, Video

ONEONTA

HARTWICK COLLEGE, Art Dept, Oneonta, NY 13820. Tel 607-431-4825; Fax 607-431-4191; *Chmn* Gloria Escobar, MFA; *Prof* Phil Young, MFA; *Prof* Roberta Griffith, MFA; *Asst Prof* Dr Elizabeth Ayer, MFA; *Asst Prof* Terry Slade, MFA; *Assoc Prof* Dr Fiona Dejardin, MFA; *Assoc Prof* Leesa Rittelmann

Estab 1797; FT 7, PT 8; pvt; D; Scholarships; 1500, non-maj 1433, maj 67
Ent Req: HS dipl, SAT or ACT, recommendation from teacher or counselor & personal essay, $35 fee
Degrees: BA 4 yr
Tuition: $14,350 per yr; campus res—$4450
Courses: †Art History, Ceramics, Drawing, Graphic Design, Painting, Photography, Printmaking, Sculpture, †Studio, Teacher Training
Summer School: High sch arts workshop, 3 wks in July

STATE UNIVERSITY OF NEW YORK COLLEGE AT ONEONTA, Dept of Art, 222 Fine Arts Ctr, Oneonta, NY 13820. Tel 607-436-3717; *Asst Prof* Sven Anderson; *Instr* Nancy Callahan; *Instr* Yolanda Sharpe; *Instr* Ellen Farber; *Instr* Thomas Sakoulas
Estab 1889; pub; D & E; SC 31, LC 22; D 660, E 35, maj 123, 25-30 at Cooperstown Center
Ent Req: ent req HS dipl, regents scholarship exam, SAT & ACT
Degrees: degrees BA(Studio Art, Art History) other programs include: one leading to MA(Museum History, Folk Art) in conjunction with the New York State Historical Association at Cooperstown, NY 13326 (Daniel R Porter III, SUNY Dir); a 3-1 program in conjunction with the Fashion Institute of Technology in New York City, with 3 years at Oneonta as a Studio Art major leading to a BS degree and/or 1 year at FIT leading to an AAS, Advertising & Communications, Advertising Design, Apparel Production & Management, Fashion Buying & Merchandising, Fashion Design, Textile Design, and/or Textile Technology
Tuition: Res—$1700 per sem; nonres—$4150 per sem
Courses: 2-D Design, 3-D Design, Art History, Ceramics, Computer Art, Drawing, Images of Women in Western Art, Painting, Visual Arts
Adult Hobby Classes: Offered only on a subscription basis at normal tuition rates through the Office of Continuing Education
Summer School: Enrl 40-50. Tuition same as in regular session for two 4 & 5 wk terms beginning June and July. Courses—Studio

ORANGEBURG

DOMINICAN COLLEGE OF BLAUVELT, Art Dept, 470 Western Hwy, Orangeburg, NY 10962. Tel 845-359-7800; Fax 845-359-2313; Internet Home Page Address: www.dc.edu; *Dir Dept Arts & Science* William Hurst
Estab 1952; Independent; D&E
Degrees: BS & BA 4 yr
Tuition: $6645 per sem, $443 per cr
Courses: Art Education, Art History, Drawing, Painting
Adult Hobby Classes: Enrl 40; tuition $117 per cr. Courses—Art History, Painting
Summer School: Dir, A M DiSiena. Enrl 35: tuition $117 per cr. Courses—History of Art, Watercolor

OSSINING

POLYADAM CONCRETE SYSTEM WORKSHOPS, 11-1 Woods Brooke Circle, Ossining, NY 10562-2070. Tel 914-941-1157; Internet Home Page Address: www.polyadam.com; *Dir* George E Adamy, MBA
Estab 1968; Art supplies available on-campus; FT 1, PT 1; pvt; D & E; SC 13, LC 2, GC 13; D 20, E 30
Tuition: From $30 per hr (open-ended sessions) to $225 for 10 sessions of advanced courses. Individual arrangements for special projects or commissions, & for lect & demonstrations at other schools, museums, art organizations; no campus res
Courses: Collage, Constructions, Museum Staff Training, †Plastics, Polyadam Concrete Casting & Construction, Restoration & Conservation, Sculpture, Teacher Training
Adult Hobby Classes: Courses offered
Children's Classes: Courses offered
Summer School: Courses offered

OSWEGO

STATE UNIVERSITY OF NEW YORK COLLEGE AT OSWEGO, Art Dept, 125 Tyler Hall, Oswego, NY 13126. Tel 315-312-3017; Fax 315-312-5642; Elec Mail oertling@oswego.edu; Internet Home Page Address: www.oswego.edu/art/; *Chmn* Sewall Oertling
Estab 1861; FT 18; pub; D & E; SC 31, LC 9; maj 150, grad 10
Ent Req: HS dipl, SAT or NYS regents scholarship exam
Degrees: BA 4 yr, BFA 4 yr, MA 2 yr, MAT 2 yr
Tuition: Res—$1,700 per sem; nonres—$4,150 per sem
Courses: Aesthetics, †Art History, †Ceramics, †Drawing, †Graphic Arts, †Graphic Design, Jewelry/Metalsmithing, Museum Staff Training, †Painting, †Photography, †Printmaking
Summer School: Dir, Lewis C Popham III. Tuition state grad res $90.85 per cr hr, non-grad res $45.85 per cr hr, grad nonres $156.85 per cr hr, non-grad nonres $107.85 per cr hr

PLATTSBURGH

CLINTON COMMUNITY COLLEGE, Art Dept, 136 Clinton Point Dr, Plattsburgh, NY 12901. Tel 518-562-4200; Fax 518-561-8261; Internet Home Page Address: www.clintoncc.suny.edu; *Chmn* Mark Davison
Estab 1966
Ent Req: HS diploma
Degrees: AS & AA 2 yr
Tuition: Res—$94 per cr hr; nonres—$188 per cr hr
Courses: Art Appreciation, Design, Drawing, Painting, Photography, Sculpture, Theatre Arts

STATE UNIVERSITY OF NEW YORK AT PLATTSBURGH, Art Dept, Myers Fine Arts Bldg, 101 Broad St Plattsburgh, NY 12901. Tel 518-564-2000; Fax 518-564-7827; Internet Home Page Address: www.plattsburgh.edu; *Chmn* Rick Mikkelson, MFA
Estab 1789, dept estab 1930; FT 9, PT 4; pub; D & E; Scholarships; SC 30, LC 10; D 700, maj 154
Ent Req: HS dipl, EOP
Degrees: BA & BS 4 yrs
Tuition: Res $9,181 per yr; non-res $11,581; campus res available
Courses: †Art History, †Ceramics, †Computer Graphics, †Drawing, †Graphic Arts, †Graphic Design, Illustration, Lettering, Mixed Media, †Painting, †Photography, †Printmaking, †Sculpture
Summer School: Dir, J Worthington. Tuition $137 for 5 wks. Courses—Ceramics, Painting, Photography, Sculpture

PLEASANTVILLE

PACE UNIVERSITY, Dyson College of Arts & Sciences, Fine Arts Dept, Bedford Rd Pleasantville, NY 10570. Tel 914-773-3675; Internet Home Page Address: www.pace.edu; *Assoc Dean Arts & Science* Joseph Franko; *Chmn* John Mulgrew, MA; *Prof* Barbara Friedman, MFA; *Prof* Janetta Benton PhD, MFA; *Prof* Linda Gottesfeld, MFA; *Prof* Roger Sayre, MFA
FT 5, PT 12; Pvt; D & E; SC 4, LC 4
Ent Req: HS dipl
Degrees: AA & BS
Tuition: Full-time—$6735 per sem; part-time $420 per cr hr; campus res available
Courses: Advertising Design, Aesthetics, Architecture, Art Appreciation, Art Education, Ceramics, Commercial Art, †Conceptual Art, Design, Drawing, Graphic Arts, Graphic Design, History of Art & Architecture, Illustration, Interior Design, Painting, Photography, Printmaking, Sculpture, Typography
Summer School: Dir, Prof John Mulgrew. Courses—Art History, Ceramics, Drawing, Painting

POTSDAM

STATE UNIVERSITY OF NEW YORK COLLEGE AT POTSDAM, Dept of Fine Arts, Brainerd Hall 219, Potsdam, NY 13676. Tel 315-267-2251; Fax 315-267-4884; Internet Home Page Address: www.potsdam.edu; *Prof* James Sutter MFA; *Asst Prof* Mary Jo McNamara; *Asst Prof* Marc Leuthold; *Asst Prof* Tracy Watts PhD; *Chmn* Mark Huff
Estab 1948; pub; D & E
Ent Req: HS dipl, SAT, portfolio review recommended
Degrees: BA 4 yrs, special program Empire State studio sem in New York City
Tuition: Res—undergrad lower div $3400 per yr, $615 per sem, $35.85 per cr hr; nonres—undergrad lower div $4900 per yr; no grad students; campus res—$675 room & $560 (10 meals per wk) per sem
Courses: †Art History, †Ceramics, Drawing, †Painting, Photography, †Printmaking, †Sculpture
Adult Hobby Classes: Enrl 15; tuition $30 for 10 weeks. Courses—Pottery
Children's Classes: Enrl 30; tuition $20 for 6 weeks. Courses—General Art Workshop
Summer School: Dir, Joe Hildreth. Enrl 50-60; tuition $180 for 4 cr class of 5 weeks. Courses—Ceramic Survey, Intro to Studio Art

POUGHKEEPSIE

DUTCHESS COMMUNITY COLLEGE, Dept of Visual Arts, 53 Pendell Rd, Poughkeepsie, NY 12601. Tel 845-431-8000; Fax 845-431-8991; *Dir* Eric Somers
Estab 1957; pub; D & E; Scholarships; SC 24, LC 22; D 660, E 340, maj 100
Ent Req: HS dipl
Degrees: AAS (Commercial Art)
Tuition: $1150 per sem, $89 per cr hr
Courses: Glass, Leather, Metal, Painting, Photography, Plastic, Weaving, Wood

VASSAR COLLEGE, Art Dept, 125 Raymond Ave, Poughkeepsie, NY 12604. Tel 845-437-5220; Fax 845-437-7187; Internet Home Page Address: www.vassun.vassar.edu/~artdept/; *Prof* Nicholas Adams; *Prof* Susan D Kuretsky; *Assoc Prof* Peter Charlap; *Assoc Prof* Peter Huenink; *Prof* Karen Lucic; *Assoc Prof* Brian Lukacher; *Prof* Molly Nesbit; *Prof* Eve D'Ambra; *Asst Prof* Andrew Watsky; *Asst Prof* Jacqueline Musacchio; *Asst Prof* Lisa Collins; *Prof* Harry Roseman
Estab 1861; FT 10, PT 7; pvt; D; Scholarships; SC 8; maj 90, others 2400
Ent Req: HS grad, ent exam
Degrees: BA(Art History) 4 yr
Tuition: $18,920 per yr; campus res—room & board $5950
Courses: Architecture, Art History, Drafting, Drawing, Painting, Printmaking, Sculpture

PURCHASE

MANHATTANVILLE COLLEGE, Art Dept, 2900 Purchase St, Purchase, NY 10577. Tel 914-323-5331; Fax 914-323-5311; *Head Dept* Ann Bavar
Estab 1841; pvt; D & E; Scholarships; SC 25, LC 10, GC 7; D 180, non-maj 90, maj 90, grad 10
Ent Req: HS dipl, portfolio, interview
Degrees: BA and BFA 4 yrs, MAT 1 yr, special prog MATA (Masters of Art in Teaching)
Tuition: $16,760 per yr; room & board $8000 per yr
Courses: Advertising Design, Art Education, Art History, Book Design, Ceramics, Commercial Art, Conceptual Art, Constructions, Design, Drawing, Graphic Arts, Graphic Design, Illustration, Lettering, Metal Sculpture, Painting, Photography, Printmaking, Sculpture, Teacher Training

Summer School: Dir, Don Richards. Two sessions June & July. Courses—Art History, Ceramics, Computer Graphics, Drawing, Painting, Sculpture

PURCHASE COLLEGE , STATE UNIVERSITY OF NEW YORK
—School of Art+Design, Tel 914-251-6750; Fax 914-251-6793; Elec Mail art+design@purchase.edu; Internet Home Page Address: www.purchase.edu/art+design; *Asst Dean* Ravi Rajan; *Dean* Denise Mullen; *Prof* Ted Devine; *Prof* Donna Dennis; *Prof* Phil Zimmermann; *Prof* Murphy Zimiles; *Prof* Nancy Davidson; *Prof Emeritus* Antonio Frasconi
Estab 1974; Maintain nonprofit art gallery, Richard & Dolly Maass Gallery; Average Annual Attendance: 50,000; Mem: 900; FT 18, PT 18; pub; D & E; Scholarships, Fellowships; SC, LC, GC; 3600, maj 500
Ent Req: HS Dipl/GED, bachelors for MFA, recommendations& test scores required
Degrees: BFA 4 yr, MFA 2 or 3 yr
Tuition: Res—undergrad $4,350 per yr; nonres—$10,610 per yr; res—grad $6,900 per yr; nonres—grad $10,610 per yr
Courses: Advertising Design, †Art History, Art of the Book, Ceramics, Collage, †Design, Drawing, Graphic Design, †Interactive Media, Mixed Media, Painting, Photography, Printmaking, Sculpture, Time-based Media, Video
Adult Hobby Classes: Enrl 450-500
Children's Classes: Enrl 50; summer session art program
Summer School: Dir, Ruth Nybro; Enrl 400; 6 wk sessions
—Art History Board of Study, Tel 914-251-6750; Fax 914-251-6793; Internet Home Page Address: www.purchase.edu; *Prof* Irving Sandler PhD; *Prof* Johanna Drucker PhD
Estab 1971, dept estab 1977; pub; D & E; Scholarships; 2500, maj 50
Ent Req: HS dipl, essay on application, grades, test scores
Degrees: BA & BALA 4 yrs
Tuition: Res—$3,400 per yr; nonres—$8,300 per yr
Courses: Art History

RIVERDALE

COLLEGE OF MOUNT SAINT VINCENT, Fine Arts Dept, 6301 Riverdale Ave, Riverdale, NY 10471-1093. Tel 718-405-3200; Fax 718-601-6392; *Prof* Richard Barnett, BFA; *Chmn & Prof* Enrico Giordana, BFA
Estab 1911; pvt; D & E; Scholarships; SC 22, LC 10; D 950, E 50
Ent Req: HS dipl and SAT
Degrees: BA, BS and BS(Art Educ) 4 yrs
Tuition: $17,030 per yr; room & board $8615
Courses: Art History, Ceramics, Design, Drawing, Painting, Photography
Summer School: Dir Continuing Education, Dr Marjorie Connelly. Courses—vary each summer

MANHATTAN COLLEGE, School of Arts, Manhattan College Pky, Riverdale, NY 10471. Tel 718-862-7346; Fax 718-862-8444; Elec Mail mdonnel@manhattan.edu; Internet Home Page Address: www.manhattan.edu/arts; *Dean of Art* Maryann O'Donnell; *Prof* Mark Pottunger; *Prof* Scott Grimaldi; *Prof* Hugh Berberich
Estab 1853; pvt den; D&E; Scholarships; LC 8, Art 4, Music 4; D 3000
Ent Req: HS dipl
Degrees: BA, BS
Tuition: Res—undergrad $8,250 per sem, $450 per cr; campus res—room & board $3,850 per sem
Courses: Art History, Ceramics, Drawing, Film, Graphic Arts, Graphic Design, History of Art & Architecture, Painting, Photography, Printmaking, Sculpture

ROCHESTER

MONROE COMMUNITY COLLEGE, Art Dept, 1000 E Henrietta Rd, Rochester, NY 14623. Tel 716-292-2000; Fax 716-427-2749; Internet Home Page Address: www.monroe.cc.edu; *Assoc Prof* Joe Hendrick, MFA; *Prof* Bruce Brown, MFA
Estab 1961; Monthly art exhibitions in school library; 3 FT, PT varies; pub; D & E; SC 16, LC 4
Ent Req: HS dipl
Degrees: Assoc in Arts 2 yrs, Assoc in Science 2 yrs, Assoc in Applied Science 2 yrs
Tuition: $1525 per nine months
Courses: Art History, Ceramics, †Commercial Art, Drafting, Drawing, Graphic Arts, Graphic Design, Handicrafts, Illustration, Jewelry, Lettering, Painting, Printmaking, Sculpture, Textile Design, Theatre Arts, Video, Weaving
Adult Hobby Classes: Tuition $36 per hr. Courses—Batik, Ceramics, Jewelry, Leatherwork, Macrame, Rugmaking, Soft Sculpture, Weaving
Summer School: Dir, George C McDade

NAZARETH COLLEGE OF ROCHESTER, Art Dept, 4245 East Ave, Rochester, NY 14618. Tel 716-389-2525; Fax 716-586-2452; *Head Dept* Ron Netsky; *Assoc Prof* Kathy Calderwood, BFA; *Prof* Karen Trickey, MSEd; *Assoc Prof* Maureen Brilla, MFA; *Prof* Lynn Duggan, MFA; *Assoc Prof* Mitchell Messina, MFA; *Asst Prof* Catherine Kirby, MFA; *Assoc Prof* Ellen Horovitz, PhD; *Dir* Dorothy Bokelman, PhD
Estab 1926, dept estab 1936; pvt; D & E; Scholarships; SC 40, LC 15, GC 6; D 180, E 74, non-maj 50, maj 200, grad 48
Ent Req: HS dipl
Degrees: BA and BS 4 yrs
Tuition: Undergrad $6810 per sem, $454 per cr hr; board $3660 per yr; board $2430 per yr
Courses: †Art Education, †Art History, Art Therapy, Ceramics, Computer Graphics, Drawing, †Graphic Arts, Jewelry, Painting, Photography, Printmaking, Sculpture, Textile Design
Summer School: 6 wks beginning July 5th. Courses—Grad & undergrad

ROBERTS WESLEYAN COLLEGE, Art Dept, 2301 Westside Dr, Rochester, NY 14624-1997. Tel 716-594-9471; Internet Home Page Address: www.roberts.edu; *Dir Art* Loren Baker; *Assoc Prof* Douglas Giebel; *Chmn Fine Arts & Music* Noel Magee
Estab 1866; pvt; D; Scholarships
Ent Req: HS dipl
Degrees: BA(Fine Art), BA(Studio Art), BS(Studio Art), BS(Art Education)
Tuition: $14,366 per yr
Courses: Art Appreciation, Art Education, Art History, Ceramics, Design, Drawing, Graphic Design, Jewelry, Lettering, Painting, Photography, Printmaking, Sculpture, Weaving

ROCHESTER INSTITUTE OF TECHNOLOGY
—College of Imaging Arts & Sciences, Tel 716-475-2646; Fax 716-475-6447; *Dean Col* Dr Joan Stone; *Assoc Dean* Nancy Stuart; *Design Chair* Nancy Cioleio; *Art Chair* Tom Lightfoot; *School for American Crafts Chair* Richard Tannen; *Foundations Chair* Joyce Hertlson
Degrees: BFA, MFA
Tuition: Undergrad $333 per cr, grad $432 per cr
Courses: Computer Graphics, Illustration, Jewelry, Metals
Adult Hobby Classes: Courses offered
Children's Classes: One wk summer workshop for juniors in HS
Summer School: 5 wk sessions, 2 1/2 wk sessions, & special one wk workshops
—School of Design, Tel 716-475-2668; Fax 716-475-6447; *Chmn Graphic Design* Mary Anne Begland; *Chmn Industrial, Interior & Packaging Design* Toby Thompson; *Chmn Foundation Studies* Joyce Hertzson; *Chmn Crafts* Michael White; *Prof* Kener E Bond Jr, BEd; *Prof* Frederick Lipp, MFA; *Prof* R Roger Remington, MS; *Prof* Joanne Szabla PhD, MS; *Prof* James E Thomas, MFA; *Prof* Lawrence Williams, MFA; *Prof* Philip W Bornarth, MFA; *Prof* Barbara Hodik PhD, MFA; *Prof* James Ver Hague, MFA; *Prof* Robert A Cole, MS; *Prof* Robert Heischman, UCFA; *Prof* Craig McArt, MFA; *Prof* William Keyser, MFA; *Prof* Doug Sigler, MFA; *Prof* Robert Schmitz, MFA; *Prof* Richard Hirsch, MFA; *Prof* Richard Tanner, MS; *Prof* Michael Taylor, MFA; *Prof* Mark Stanitz, MA; *Prof* Len Urso, MFA; *Prof* Max Lenderman, MFA; *Prof* Albert Paley, MFA; *Prof* Wendell Castle, MFA; *Prof* Robert C Morgan PhD, MFA; *Prof* James H Sias, MA; *Prof* Robert Wabnitz, Dipl & Cert; *Assoc Prof* Edward C Miller, MFA; *Assoc Prof* Bruce Sodervick, MFA; *Assoc Prof* Joseph A Watson, MFA; *Assoc Prof* Robert M Kahute, MFA; *Assoc Prof* Steve Loar, MA; *Asst Prof* Heinz Klinkon, BFA; *Asst Prof* Doug Cleminshaw, MFA; *Asst Prof* Elizabeth Fomin, MFA; *Asst Prof* Glen Hintz, MFA; *Asst Prof* Thomas Lightfoot PhD, MFA
Estab 1829; FT 47, PT 19; pvt; 1000
Ent Req: HS grad, ent exam, portfolio
Degrees: BFA, MFA
Tuition: Undergrad $333 per cr, grad $425 per cr
Courses: Computer Graphics, Drawing, Glass Blowing, History of Art & Archeology, Illustration, †Industrial Design, †Interior Design, Jewelry, Sculpture, †Silversmithing, Stained Glass, †Textile Design, †Weaving
Adult Hobby Classes: Crafts, Design, Painting
Summer School: Enrl 250; tuition undergrad $260 per cr, grad $330 per cr for 8 wk term beginning June. Courses—Ceramics, Computer Graphics, Glass, Graphic Design, Metal, Painting, Printmaking, Textiles, Wood, Industrial, Interior, Packaging Design, Art History, 2-D and 3-D Design
—School of Photographic Arts & Sciences, Tel 716-475-2716; Fax 716-475-5804; *Assoc Dir* Nancy Stuart, AB; *Chmn Imaging & Photographic Technology* Andrew Davidhazy, MEd; *Chmn Fine Arts Photo* Ken White, MEd; *Chmn Film/Video* Howard Lester, MEd; *Chmn Biomedical Photo Communications* Michael Peres, MEd; *Chmn American Video Institute* John Ciampa, JD; *Chmn Photographic Processing & Finishing Management* James Rice, BS; *Prof* John E Karpen, MFA; *Prof* Weston D Kemp, MFA; *Prof* Lothar K Engelmann PhD, MFA; *Prof* Russell C Kraus, EdD; *Prof* David J Robertson, BFA; *Assoc Prof* Owen Butler, BFA; *Assoc Prof* Kerry Coppin, BFA; *Assoc Prof* Jeff Weiss, BFA; *Assoc Prof* Patti Ambroge, BFA; *Assoc Prof* Bradley T Hindson, BFA; *Assoc Prof* Alan Vogel, BA; *Assoc Prof* Robert Kayser, BS; *Assoc Prof* James Reilly, MA; *Assoc Prof* Guenther Cartwright, BA; *Assoc Prof* Howard Lester, MFA; *Assoc Prof* Howard LeVant, BS; *Assoc Prof* Elliott Rubenstein, MA; *Assoc Prof* Erik Timmerman, BS; *Assoc Prof* Douglas F Rea, MFA; *Assoc Prof* Steve Diehl, BS; *Assoc Prof* Mark Haven, BA; *Assoc Prof* John Retallack, BA; *Assoc Prof* Nancy Stuart, MS; *Asst Prof* Tom Lopez, MS; *Asst Prof* Stephanie Maxwell, MS; *Asst Prof* Bruce Lane, MS; *Asst Prof* Adrianne Carrageorge, MS; *Asst Prof* Lorett Falkner, MS; *Asst Prof* Deni Defenbaugh, MS; *Asst Prof* Sabrine Susstrink, MS; *Asst Prof* Kaleen Moriority, MS; *Asst Prof* Jack Holm, MS; *Asst Prof* Glen Miller, MS; *Asst Prof* William Osterman, MFA; *Asst Prof* Martha Leinroth, MFA; *Lectr* Dan Larken, MFA; *Dir* William DuBois, MS
900
Degrees: AA, BA, MA
Tuition: Undergrad $333 per cr, grad $425 per cr
Courses: Advertising, Biomedical Photography, Film, Film Studies, Photographic Communications, Photographic Technology, Photography, Processing & Finishing, Video
Summer School: Courses—Photography, Film/Video, Motion Picture Workshops, Narrative/Documentary/Editorial workshop, Nature Photography
—School of Printing Management & Sciences, Tel 716-475-2728; Fax 716-475-7029; *Dir* Harold Gaffin; *Dean* Joan Stone; *Chmn Design Composition Division* Emery E Schneider, BS & MEd; *Coordr Grad Prog* Joseph L Noga, MS; *Paul & Louise Miller Prof* Robert G Hacker, BS; *Prof* Barbara Birkett, BS; *Prof* Miles F Southworth, BS; *Assoc Prof* William H Birkett, BS; *Assoc Prof* Clifton T Frazier, BS; *Assoc Prof* Herbert H Johnson, BS; *Assoc Prof* Archibald D Provan, BS; *Assoc Prof* Werner Rebsamen, dipl; *Asst Prof* Robert Y Chung, BA; *Asst Prof* Hugh R Fox, AB & JD; *Asst Prof* David P Pankow, BA & MA
School has 25 laboratories, occupying 125,000 sq ft. More than 70 courses are offered; 700
Degrees: BS, MS
Tuition: Undergrad $333 per cr, grad $425 per cr
Courses: Color Separation, Flexography, Gravure, Ink & Color, Introduction to Book Production, Newspaper Design, Printmaking, Systems Planning, Typography & Design

Summer School: Graphic Arts, Layout & Printing, Reproduction Photography, Ink & Color, Newspaper & Magazine Design, Hand Papermaking, Web Offset, Gravure, Lithography, Printing Plates, Typography, Bookbinding
—School for American Craft, Tel 716-475-5778; *Dean* Dr Joan Stone; *Dir* Thomas Morin; *Chmn* Richard Pannen
Degrees: BS, BFA, MS, MST
Tuition: Undergrad $333 per cr, grad $425 per cr
Courses: Ceramics, Furniture & Wood Working, Glass, Metals, Textiles
Adult Hobby Classes: Extensive seminar schedule
Summer School: scholarships

UNIVERSITY OF ROCHESTER, Dept of Art & Art History, 424 Morey Hall, Rochester, NY 14627. Tel 585-275-9249; Fax 585-442-1692; Elec Mail art_artist@cc.rochester.edu; Internet Home Page Address: www.rochester.edu/college/aah; *Chmn* Allen C Topolski
Estab 1902; Maintain nonprofit art gallery; Hartnett Art Gallery, Rochester NY; FT 11, PT 5; pvt; D; Scholarships; SC 25, LC 25; maj 15, others 600
Degrees: BA, MA, PhD(Visual & Cultural Studies)
Tuition: $32,650 per yr
Courses: Art History, Drawing, History of Art & Architecture, Painting, Photography, Sculpture, †Video
Summer School: Enrl 40; tuition & duration vary

SANBORN

NIAGARA COUNTY COMMUNITY COLLEGE, Fine Arts Division, 3111 Saunders Settlement Rd, Sanborn, NY 14132. Tel 716-614-6222; Fax 716-614-6700; Internet Home Page Address: www.sunyniagara.cc.ny.us; *Dept Coordr MFA* Barbara Buckman; *Prof* Bud Jacobs; *Prof* Nancy Knechtel
Estab 1965; FT 15, PT 14; pub; D & E; Scholarships; SC 12, LC 4; D 400, E 120, maj 140
Ent Req: HS dipl
Degrees: AS(Fine Arts) 2 yrs
Tuition: In state $1250 per sem; out of state $1875 per sem
Courses: Advertising Design, Aesthetics, Art Appreciation, Art History, Art Therapy, Ceramics, Commercial Art, Conceptual Art, Constructions, Design, Drafting, †Drawing, Film, Graphic Arts, †Graphic Design, Handicrafts, Illustration, Lettering, Mixed Media, Museum Staff Training, †Painting, Photography, Sculpture, Stage Design, Theatre Arts, Visual Art

SARATOGA SPRINGS

SKIDMORE COLLEGE, Dept of Art & Art History, 815 N Broadway, Saratoga Springs, NY 12866. Tel 518-580-5000, 580-5030 (Dept Art & Art History); Fax 518-580-5029; Internet Home Page Address: www.skidmore.edu; *Chmn* Peter Stake
Estab 1911; FT 20; pvt; Scholarships; SC 32, LC 18; maj 350, 2000 total
Ent Req: HS grad, 16 cr, ent exam, portfolio
Degrees: BA & BS 4 yrs
Courses: Art History, Ceramics, Computer Imaging, Design, Drawing, Graphic Design, Jewelry/Metalsmithing, Painting, Photography, Printmaking, Sculpture, Weaving
Summer School: Dir, Regis Brodie. Enrl 194 for two 6 wk sessions. Courses—Advanced Studio & Independent Study, Art History, Ceramics, Drawing, Etching, Jewelry, Lettering, Painting, Photography, Sculpture, 2-D Design, Video, Watercolor, Weaving

SCHENECTADY

UNION COLLEGE, Dept of Visual Arts, Arts Bldg, Schenectady, NY 12308. Tel 518-388-6714; Fax 518-388-6567; Internet Home Page Address: www.union.edu; *Chmn Visual Arts* Chris Duncan
Estab 1795; FT 7; pvt; D; Scholarships; SC 14, LC 4; maj 35
Ent Req: HS dipl, ent exam
Degrees: BA with emphasis in music, art or theatre arts 4 yr
Tuition: $22,929 per yr
Courses: 3-D, Art History, Drawing, Painting, Photography, Printmaking, Sculpture, Stage Design, Theatre Arts, †Visual Arts
Adult Hobby Classes: Enrl 30; tuition $1390 & lab fee for 10 wks. Courses—Drawing, Photography
Children's Classes: Enrl 15; tuition $250 wk for 3 one wk sessions
Summer School: Dean, Jane Zacek. Enrl 30; tuition $1390 & lab fee for 6 wks. Courses—Art History, Drawing, 3-D, Painting, Photography, Printmaking

SEA CLIFF

STEVENSON ACADEMY OF TRADITIONAL PAINTING, 361 Glen Ave, Sea Cliff, NY 11579. Tel 516-676-6611; *Head Dept* Alma Gallanos Stevenson; *Prof* Atila Hejja
Estab 1960; FT 2; pvt; E; SC 3, LC 5; 95
Ent Req: interview
Tuition: $350 per 12 wk sem, one evening per wk
Courses: Artistic Anatomy, Basic Form, Drawing, Illustration, Painting
Summer School: Courses—Artistic Anatomy, Drawing, Painting

SELDEN

SUFFOLK COUNTY COMMUNITY COLLEGE, Art Dept, 533 College Rd, Selden, NY 11784. Tel 631-451-4110; Internet Home Page Address: www.sunysuffolk.edu; *Dept Head* Arthur Kleinfelder
FT 6, PT 6

Ent Req: HS dipl, equivalent
Degrees: AFA
Tuition: Res $98.50 per cr hr; nonres (out of state) $198 per cr hr
Courses: Art Appreciation, Art History, Ceramics, Design, Drawing, Painting, Printmaking
Adult Hobby Classes: Enrl 200; tuition $15 per hr. Courses—Photography, Interior Design
Summer School: Dir, Maurice Flecker. Tuition res $60 per cr for 6-8 wk sessions. Courses—Painting, Sculpture, 2-D Design, Life Drawing, Printmaking & Ceramics

SPARKILL

SAINT THOMAS AQUINAS COLLEGE, Art Dept, 125 Rte 340, Sparkill, NY 10976. Tel 845-398-4000, Ext 4136; Fax 845-398-4071; *Prof* Carl Rattner, MFA, DA; *Asst Prof* Barbara Yont, MFA; *Prof* Karen Ebezmann, MFA; *Asst Prof* Annie Shieh, MFA; *Asst Prof* Carol Lagsteid, MFD, MSW
Estab 1952, dept estab 1969; Maintain nonprofit art gallery; Pvt; D & E; Scholarships; SC, LC; D 1,100, maj 50
Ent Req: HS dipl
Degrees: BA and BS 4 yrs
Tuition: $21,140 per yr, incl room & board
Courses: Art Appreciation, Art History, Art Therapy, Ceramics, Drawing, Graphic Design, Jewelry, Painting, Photography, Printmaking, Sculpture, Theatre Arts, Video
Summer School: Dir, Dr Joseph Keane. Tuition $210 for 3 cr course. Courses—Varies 3-6 art courses including Ceramics, Painting, Photography

STATEN ISLAND

COLLEGE OF STATEN ISLAND, Performing & Creative Arts Dept, 2800 Victory Blvd, Staten Island, NY 10314. Tel 718-982-2000; Fax 718-982-2537; Internet Home Page Address: www.csi.cuny.edu; *Dir* Pat Passlof maintains nonprofit gallery; Pub; D, E & W; SC & LC
Degrees: BA & MA(Cinema Studies), BS(Art), BS(Photography)
Tuition: Res—undergrad $135 per cr hr, grad $185 per cr hr
Courses: Advertising Design, †Architecture, †Art Appreciation, Art Education, †Art History, †Design, †Drawing, †Film, †History of Art & Architecture, †Museum Staff Training, †Painting, †Photography, †Printmaking, Sculpture, Video
Summer School: Courses offered

WAGNER COLLEGE, Arts Administration Dept, One Campus Rd, Staten Island, NY 10301. Tel 718-390-3271, 390-3100; Fax 718-390-3223; Elec Mail gpsull@wagner.edu; Internet Home Page Address: www.wagner.edu; *Chmn* Gary Sullivan; *Instr* Lillian Stausland; *Instr* Robert Williams
Estab 1948; Maintain nonprofit art gallery; pvt; D & E; SC 20, LC 6; maj 35, others 2000
Ent Req: HS grad
Degrees: BA(Art), BS(Art Admin)
Tuition: Res—undergrad campus res $14700 per yr; campus res—room & board $5310
Courses: 2-D Design, 3-D Design, Advertising Design, Art History, Arts Administration, Ceramics, Crafts Design, Drawing, Graphic Arts, Mixed Media, Painting, Photography, Printmaking, Sculpture
Summer School: Two sessions of 4 wks, Dir Extensions & Summer Prog, Maureen Connolly

STONE RIDGE

ULSTER COUNTY COMMUNITY COLLEGE/SUNY ULSTER, Dept of Visual & Performing Arts, Cottekill Rd, Stone Ridge, NY 12484. Tel 845-687-5066 (Art Dept); Fax 845-687-5083; Elec Mail machell@sunyulster.edu; Internet Home Page Address: www.sunyulster.edu; *Chmn* Iain Machell, MFA; *Prof* Peter Correia, MS; *Prof* Sean Nixon, MFA
Estab 1963; Maintain nonprofit art gallery, Muroff-Kotler Gallery, Suny Ulster Stone Ridge Campus, Stone Ridge, NY 12484; Maintain Library, Dewitt Library; PT 7; pub; D & E; SC 17, LC 6; D 500, E 190, non-maj 590, maj 100
Ent Req: HS dipl
Degrees: AA 2 yrs, AS 2 yrs
Tuition: Res—undergrad $2596 per yr; nonres—undergrad $5192 per yr; no campus res
Courses: 2-D Design, 3-D Design, Art History, Computer Art, Computer Assisted Graphic Design, Desk-Top Publishing, Drawing, †Graphic Design, Life Drawing, Painting, Photography, Web Page Design
Summer School: Visual Arts Coordr, Iain Machell. Enrl 30 - 50; tuition $285 per 3 sem hrs for 6 wks. Courses—Computer Art, Drawing, Painting, Photography

STONY BROOK

STATE UNIVERSITY OF NEW YORK AT STONY BROOK, Dept of College of Arts & Sciences, Art Dept, Staller Center, State University of NY at Stony Brook Stony Brook, NY 11794-5400. Tel 631-632-7250; Fax 631-632-7261; Elec Mail mvogelle@notes.cc.sunysbiedu; Internet Home Page Address: www.art.sunysb.edu; *Chmn & Prof* Melvin H Pekarshy, MA; *Dir* Beverly Rivera; *Prof* Donald B Kuspit PhD; *Prof* Howardena Pindell, MFA; *Prof* Toby Buonagurio, MA; *Prof* Michele H Bogart PhD, MA; *Prof* Anita Moskowitz PhD, MA; *Prof* Barbara Frank PhD, MA; *Asst Prof* Grady Gereracht PhD, MA; *Asst Prof* Joseph Monteyne, PhD; *Asst Prof* Martin Levine, MFA; *Assoc Prof* Stephanie Dinkins; *Assoc Prof* Christa Erickson; *Assoc Prof* Nobuho Nagasawa; *Prof* James Robin, PhD; *Lectr* Shoki Goodarzi, PhD; *Visiting Assoc Prof* Richard Leslie, PhD; *Artist in Res* Gary Schneider

Estab 1957; Maintains nonprofit gallery, Staller Center for The Arts, Stony Brook University, Stony Book, NY, 11797-5400; FT 7; pub; D, E; SC 41, LC 49, GC 47; D 1,3180, E 5,382, non-moj 228, maj 16,401, GS 3,449
Ent Req: HS dipl, SAT
Degrees: BA(Art History) & BA(Studio Art), MA(Art History & Criticism), MFA(Studio Art), PhD(Art History & Criticism)
Tuition: Undergrad $4,350 per yr, grad $6,900 per yr
Courses: †Art History, Ceramics, †Collage, Conceptual Art, †Costume Design & Construction, Design, Drawing, History of Art & Architecture, †Mixed Media, Painting, Photography, Printmaking, Sculpture, †Studio Art, †Video
Summer School: Tuition res—undergrad $18 per cr hr, grad $288 per cr hr; nonres—undergrad $442 per cr hr, grad $455 per cr hr for term of 6 wks (two sessions). Courses vary in areas of Art Education, Art History & Criticism, Studio Art

SUFFERN

ROCKLAND COMMUNITY COLLEGE, Graphic Arts & Advertising Tech Dept, 145 College Rd, Suffern, NY 10901. Tel 845-574-4251; Fax 845-356-1529; *Discipline Coordr* Emily Harvey
Estab 1965; pub; D & E; SC plus apprenticeships; D 900, E 300, maj 200
Ent Req: open
Degrees: AAS 2 yrs
Tuition: Res—$97 per sem hr; nonres—$194 per sem hr
Courses: Advertising Design, Alternative Processes in Photography, Art Appreciation, Art History, Art Therapy, Color Production, Drawing, Electric Art, Graphic Arts, Graphic Design, Lettering, Lithography, Painting, Photography, Portfolio Workshop, Sculpture, Serigraphy Printing
Adult Hobby Classes: Enrl 528; tuition varies. Courses—Ceramics, Crafts
Summer School: Dir, Emily Harvey. Enrl 180; June - Aug. Courses—Computer Graphics, Drawing, Overseas Program, Painting, Sculpture

SYRACUSE

LE MOYNE COLLEGE, Fine Arts Dept, Le Moyne Heights, Syracuse, NY 13214-1399. Tel 315-445-4100, 445-4147; Elec Mail belfortj@mail.lemoyne.edu; Internet Home Page Address: www.lemoyne.edu; *Chmn & Prof* Jacqueline Belfort-Chalat; *Adjunct Asst Prof* Barry Darling; *Adjunct Asst Prof* Charles Wollowitz; *Adjunct Prof* J Exline, MA; *Adjunct Asst Prof* William West, MA; *Adjunct Asst Prof* David G Moore
Estab 1946; Maintain nonprofit art gallery; Wilson Art Gallery, Lemoyne College, Syracuse, NY 13214; Pvt; D&E; SC 6, LC 5; non-maj 350
Ent Req: HS dipl, SAT or ACT
Degrees: BS & BA 4 yrs
Tuition: $15,370 per yr, $342 per cr hr; campus res—room & board $4,180 per yr
Courses: †Art Appreciation, Art History, Drawing, Graphic Arts, Painting, †Photography, †Printmaking, Sculpture

SYRACUSE UNIVERSITY
—College of Visual & Performing Arts, Tel 315-443-2507; Fax 315-443-1303; *Interim Dir* Barbara Walter, MFA; *Dean* Carole Brzozowski, MS
Estab 1873; Maintain nonprofit art gallery; Lowe Art Gallery, 102 Shaffer Art Bldg, Syracuse Univ, Syracuse, NY 13244; FT 60, PT 52; pvt; D & E; Scholarships; SC 200, LC 25, GC 100; D 1,200
Ent Req: HS dipl, portfolio review
Degrees: BID 5 yrs, BFA 4 yrs, MFA & MA(Museum Studies) 2 yrs
Tuition: Undergrad $13,480 per yr; grad $406 per cr; campus res available
Courses: †Advertising Design, †Art Education, †Art History, †Art Photography, †Ceramics, †Communications Design, †Computer Graphics, Drawing, Environmental Design, †Fashion Arts, Fibers, Film, †Illustration, †Industrial Design, †Interior Design, †Metalsmithing, †Museum Studies Program, †Painting, Papermaking, †Printmaking, †Sculpture, †Surface Pattern Design, †Textile Design, †Video, Weaving
Adult Hobby Classes: Enrl 155; tuition undergrad $276 per cr. Courses—same as above
Children's Classes: Enrl 80; tuition $50 per sem. Courses—general art
Summer School: Tuition undergrad $408 per cr, grad $456 per cr. Courses—same as above
—Dept of Fine Arts (Art History), Tel 315-443-4184; Fax 315-443-4186; Elec Mail ljstraub@syr.edu; Internet Home Page Address: www-hl.syr.edu/depts/fia/default.html; *Prof* Gary Radke PhD; *Prof* Meredith Lillich PhD; *Prof* Laurinda Dixon PhD; *Prof* Mary Marien PhD; *Prof* Barbara Larson PhD; *Prof* Alan Braddock
Estab 1870, dept estab 1948; Pvt; D & E; Scholarships; LC 25, GC 15; non-maj 900, maj 71, grad 46
Ent Req: HS dipl, SAT
Degrees: BA, MA
Tuition: Undergrad $15,800 per yr
Courses: American Art, Art & Music History, Art Appreciation, Art History, Arts & Ideas, Baroque, History of Art & Archeology, Italian Medieval Art, Photography

TARRYTOWN

MARYMOUNT COLLEGE OF FORDHAM UNIVERSITY, Art Dept, 100 Marymount Ave, Tarrytown, NY 10591. Tel 914-631-3200; Fax 914-631-8305; Elec Mail dholt@fordham.edu; Internet Home Page Address: www.fordham.edu; *Prof* David Holt; *Prof* Maria Chamberlin-Hellman; *Asst Prof* Gina Porcelli; *Chmn* David J Holt
Estab 1918; Maintain nonprofit gallery, Butler Gallery; pvt, coed ; D & E; Scholarships; SC 42, LC 15; D 806, Weekends 337
Ent Req: HS dipl, CEEB
Degrees: BA and BS 4 yrs

Tuition: Res—undergrad $16,680 per yr; nonres—undergrad $16,680 per yr; PT student $540 per hr; campus res—room board $6,905 per yr
Courses: Advertising Design, †Art Appreciation, †Art Education, †Art History, †Art Therapy, Ceramics, Drawing, †Fashion Arts, Film, †Historic Preservation, †Interior Design, Mixed Media, Painting, Photography, Printmaking, Sculpture, Stage Design, Stitchery, †Studio Art, Teacher Training, Textile Design, Theatre Arts, Weaving
Adult Hobby Classes: Changing lect series - continuing education
Summer School: Dir, Loretta Donovan. Tuition $165 per cr. Courses—Changing Studio & Art History courses

TROY

EMMA WILLARD SCHOOL, Arts Division, 285 Pawling Ave, Troy, NY 12180. Tel 518-274-4440, Ext 231; Fax 518-274-0923; *Div Chmn* Edward McCartan
Estab 1814, dept estab 1969; pvt; D; Scholarships
Tuition: $19,600 incl room & board
Courses: Advanced Studio Art, Art Appreciation, Art History, Ceramics, Dance, Drawing, Jewelry, Music, Photography, Printmaking, Theatre Arts, Visual Arts Foundation, Weaving

RENSSELAER POLYTECHNIC INSTITUTE
—School of Architecture, Tel 518-276-6466; Fax 518-276-3034; Internet Home Page Address: www.arch.rpi.edu; *Dean* Alan Balfour
Estab 1929; FT 18, PT 18; pvt; D; Scholarships; 275
Degrees: BA(Archit), MA(Archit), MS(Lighting)
Tuition: Undergrad $23,525 per yr
Courses: Design, History, Practice, Structure, Studio
Summer School: Architectural Design
—Eye Ear Studio Dept of Art, Tel 518-276-4778; Internet Home Page Address: www.arts.rpi.edu; *Chmn* Neil Rolnick PhD; *Asst Dir* Laura Garrison; *Prof* Larry Keegan; *Clerk Specialist* Amy Horowitz
Scholarships, Fellowships
Degrees: MFA (Electronic Arts) 2 1/2 - 3 yrs
Tuition: $15,880 annual tuition
Courses: Animation, Computer Graphics, Computer Music, Drawing, Installation, Painting, Performance, Sculpture, Video

RUSSELL SAGE COLLEGE, Visual & Performing Arts Dept, Schacht Fine Arts Ctr, Troy, NY 12180. Tel 518-244-2000; Fax 518-271-4545; *Chmn & Dir Creative Arts* Leigh Davies
Pvt, W; 20-40 per class
Ent Req: HS grad
Degrees: fine arts and divisional maj in Music, Art and Drama 4 yrs
Tuition: Res—undergrad $7200 per se; campus res—room & board $6038 per sem
Courses: 2-D Design, †Arts Management, †Creative Arts Therapy

UTICA

MOHAWK VALLEY COMMUNITY COLLEGE, 1101 Sherman Dr, Utica, NY 13510. Tel 315-792-5446; Fax 315-792-5666; Elec Mail lmigliori@mucc.edu; Internet Home Page Address: www.mvcc.edu; *Pres* Michael I Schafer PhD; *Prof* Ronald Labuz PhD; *Assoc Prof* Henry Godlewski, BS; *Head Dept* Larry Migliori, MS; *Assoc Prof* E Duane Isenberg, MA; *Assoc Prof* Jerome Lalonde, MA; *Assoc Prof* Robert Clarke, BFA; *Instr* Thomas Maneen, BFA; *Asst Prof* Alex Piejko, BFA; *Instr* James Vitale; *Assoc Prof* Christine Miller; *Instr* Scott Selden; *Assoc Prof* Wayne Freed; *Instr* Christi Harrington; *Instr* Aaron Board; *Instr* Kathleen Partridge; *Instr* David Yahnke; *Instr* Scot Connor; *Instr* Sara Demas
Estab 1947, dept estab 1955; Maintain a nonprofit art gallery: Small Works, an art/architecture library: James O'Looney and on-campus shop where art supplies may be purchased; FT 16, ADJ 14; pub; D & E; Scholarships; SC 42 (over 2 yr period), LC 10 (over 2 yr period); D 450, E varies, maj 450
Ent Req: HS dipl, GED
Degrees: AAS 2 yrs
Tuition: $2,625 per yr; campus res—available
Courses: †Advertising Design, Aesthetics, Art Appreciation, Art History, Computer Graphics, †Design, Drawing, Graphic Arts, Graphic Design, †Handicrafts, History of Art & Architecture, Illustration, Lettering, Painting, †Photography, Textile Design, Weaving
Adult Hobby Classes: Enrl 440; tuition $1,000 per 15 wks sem. Courses—Air Brush, Design, Illustration, Painting, Photography, Sketching, Watercolor
Children's Classes: Coll for child
Summer School: Dir, Larry Migliori. Enrl 40; tuition $200 per course. Courses—Drawing, Design, Photography

MUNSON-WILLIAMS-PROCTOR ARTS INSTITUTE, School of Art, 310 Genesee St, Utica, NY 13502. Tel 315-797-0000; Fax 315-797-9349; Elec Mail rbaber@mwpi.edu; Internet Home Page Address: www.mwpai.org; *Assoc Prof* Steve Arnison; *Assoc Prof* Daniel Buckingham; *Assoc Prof* Chris Irick; *Prof* Nancy Long; *Asst Prof* Ken Marchione; *Prof* Bryan McGrath; *Assoc Prof* Dorene Quinn; *Prof* Kieth Sandman; *Asst Prof* Sandra Stephens; *Prof* Lisa Gregg Wightman
Estab 1941; Maintains nonprofit gallery; pvt; d, e; Scholarships; adults 1900, children 533, pratt at mwp 130
Activities: On-campus shop sells art supplies
Tuition: $11, 645/sem
Courses: 2-D & 3-D Design, Color Theory, Dance, Drawing, Graphic Design, Humanities, Metal Arts, Painting, Photography, Pottery, Printmaking, Sculpture
Adult Hobby Classes: Enrl 805. Courses—Dance, Design, Drawing, Jewelry, Painting, Photography, Pottery, Printmaking, Sculpture
Children's Classes: Enrl 423. Courses - Dance, Drawing, Painting,
Summer School: Dir, Dean Robert E Baber. Enrl 413, tuition $65 - $110 for 4 wk term. Courses—Dance Drawing, Jewelry Making, Painting, Photography, Pottery

UTICA COLLEGE OF SYRACUSE UNIVERSITY, Division of Art & Science, 1600 Burrstone Rd, Utica, NY 13502. Tel 315-792-3092; Fax 315-792-3831; Internet Home Page Address: www.utica.edu; *Dean Arts & Sciences* Lawrence R Aaronson
Estab 1946, school of art estab 1973; pvt; D; Scholarships; SC 20, LC 7; School of Art D 94, Utica College maj 14
Degrees: BS(Fine Arts) 4 yrs
Tuition: $23,764 per yr
Courses: Art History, †Ceramics, Design, Drafting, Drawing, Film, Graphic Arts, Occupational Therapy, †Painting, Photography, †Sculpture, Stage Design, Theatre Arts, Video

WATERTOWN

JEFFERSON COMMUNITY COLLEGE, Art Dept, Coffeen St, Watertown, NY 13601. Tel 315-786-2404; Fax 315-788-0716; Elec Mail johndeans@ccmgate.sunyjefferson.edu; Internet Home Page Address: www.sunyjefferson.edu; *Pres* John Deans
Estab 1963; FT 1; pub; D & E; Scholarships; SC 2, LC 1; 850
Ent Req: HS dipl, GED
Degrees: AA, AS & AAS 2 yr
Tuition: $1,161 per sem, $74 per cr hr
Courses: 2-D Studio, Art Appreciation, Art History, Ceramics, Computer-Aided Art & Design, Film Appreciation, Photography, Sculpture, Snow Sculpture
Summer School: Pres, John T Henderson

WEST NYACK

ROCKLAND CENTER FOR THE ARTS, 27 S Greenbush Rd, West Nyack, NY 10021. Tel 845-358-0877; Fax 845-358-0971; Elec Mail info@rocklandartcenter.org; Internet Home Page Address: www.rocklandartcenter.org; *Dir School* Kristienne Coulter, MFA; *Exec Dir* Julianne Ramos, MFA
Estab 1947; pub; D & E; Scholarships; SC 100; D 1000, E 500
Collections: Contemporary painting & drawing collection
Publications: Artline newsletter; art school catalogues; exhibition catalogues
Courses: Calligraphy, Ceramics, Creative Writing, Drawing, Handicrafts, Painting, Printmaking, Tai Chi, Theatre Arts, Weaving
Adult Hobby Classes: Enrl 300; tuition $170 - $200 for twelve 3 hr sessions. Courses—Ceramics, Fine Arts & Crafts, Writing
Children's Classes: Enrl 300; tuition $110 for ten 1 1/2 hr sessions. Courses—same as above
Summer School: Dir, Lucy Brody. Enrl 100 children & 200 adults; tuition average $120 per 6 wks. Courses—same as above

WHITE PLAINS

WESTCHESTER COMMUNITY COLLEGE, Westchester Art Workshop, County Ctr, 196 Central Ave White Plains, NY 10606. Tel 914-684-0094; Fax 914-684-0608; *Prog Dir* Abre Chen
Estab 1926; 75; pub; D & E; Scholarships; SC 90 per sem, 5 sem per yr; D 650, E 550, others 700 (credits given for most courses)
Ent Req: no special req
Degrees: AA, AS & AAS
Tuition: $98 per cr; no campus res
Courses: Art Appreciation, Art Foundation, Art Therapy, Calligraphy, Ceramics, Commercial Art, Computer Art Animation, Design, Drawing, Faux Finishes, Goldsmithing, Graphic Arts, Graphic Design, Illustration, Jewelry, Lost Wax Casting, Mixed Media, Painting, Photography, Portrait Painting, Printmaking, Quilting, Sculpture, Silversmithing, Stained Glass, Video, Weaving
Adult Hobby Classes: 100; $98 per cr Sept-May
Children's Classes: Enrl 150; tuition $132 for 12 wks. Courses—Cartooning, Ceramics, Drawing, Jewelry, Mixed Media, Painting
Summer School: 700; tuition $98 per cr. Courses—same as above

WOODSTOCK

WOODSTOCK SCHOOL OF ART, INC, PO Box 338, Woodstock, NY 12498. Tel 845-679-2388; Fax 845-679-2388 *51; Elec Mail wsart@earthlink.net; Internet Home Page Address: www.woodstockschoolofart.com; *Dir* Mary Anna Goetz; *Instr* Anna Contes; *Instr* Karen O'Neil; *Instr* Kate McGloughlin; *Instr* Eric Angeloch; *Instr* Richard Segalman; *Instr* Hong Nian Zhang; *Instr* Staats Fasoldt; *Instr* Lois Woolley; *Instr* Pia Oste-Alexander; *Instr* Tricia Cline; *Instr* Mariella Bisson; *Instr* Christina Debarry; *Instr* Christine Debrosky; *Instr* Jon deMartin; *Instr* Steve Dininno; *Instr* Ron Netsky; *Instr* Joyce Washer; *Instr* Michael Peery; *Instr* Paul Abrams; *Instr* Christie Scheele; *Instr* Michael Asbill; *Pres* Paula Nelson
Estab 1968, dept estab 1981; Maintains nonprofit gallery, Woodstock School of Art Gallery; printmaking supplies can be purchased at on-campus shop; pvt nonprofit; D & E; Scholarships; SC 19, LC 8; D 400
Tuition: $120-$240 per month
Courses: Collage, Drawing, Painting, Printmaking, Sculpture
Summer School: Tuition $400 per wk. Courses—Collage, Drawing, Etching, Landscape, Lithography, Monotype, Painting, Pastel, Portrait, Sculpture, Watercolor, Figure

NORTH CAROLINA

ASHEVILLE

UNIVERSITY OF NORTH CAROLINA AT ASHEVILLE, Dept of Art, One University Heights, Asheville, NC 28804. Tel 828-251-6600, 257-6559 (Art Dept); Elec Mail tcooke@enca.edu; Internet Home Page Address: www.unca.edu/art/; *Chmn* S Tucker Cooke, MFA

Estab 1927, dept estab 1965; pub; D & E; Scholarships; SC 20, LC 5; 3277, maj 69
Ent Req: HS dipl, ent exam
Degrees: BA, BFA 4-5 yrs
Tuition: Res—$2063 per yr; non-res—$8909 per yr; campus res—room & board $4320
Courses: 2-D & 3-D Design, Art Education, Art History, Ceramics, Drawing, Intermedia, Life Drawing, Mixed Media, Painting, Photography, Printmaking, Sculpture
Adult Hobby Classes: Contact Educ Dept 704-251-6420
Summer School: Dir, S Tucker Cooke. Courses vary

BOONE

APPALACHIAN STATE UNIVERSITY, Dept of Art, Herbert Wey Hall, Rm 232, Boone, NC 28608. Tel 828-262-2000; Fax 828-262-6312; Internet Home Page Address: www.appstate.edu; *Prof* Marianne Suggs; *Prof* Glenn Phifer; *Asst Prof* Eli Bentor; *Asst Prof* Joan Durden; *Prof* Judy Humphrey; *Asst Prof* L.Kathleen Campbell; *Chmn* Laura Ives; *Prof* Robin Martindale; *Instr* Lilith Eberle-Nielander; *Instr* Tim Ford; *Instr* Henry T. Foreman; *Instr* Kyle Van Lusk; *Instr* Margaret Carter Martine; *Instr* Dr Janet Montgomery; *Instr* Mary Perry; *Instr* Mary Prather; *Instr* Nancy Sokolove; *Instr* Sonny Struss; *Instr* Vicki Clift; *Instr* Susie Winters; *Instr* Ann Thompson; *Asst Prof* Christopher Curtin; *Assoc Prof* Ed Midgett; *Assoc Prof* Gary Nemcosky; *Prof* William G. Phifer; *Assoc Prof* Eric Purves; *Prof* Marilyn Smith; *Asst Prof* Lisa Stinson; *Assoc Prof* Jim Toub; *Assoc Prof* Gayle Weitz; *Assoc Prof* Barbara Yale-Read; *Asst Prof* Margaret Yaukey
Estab 1960; pub; D; Scholarships; SC 52, LC 14; D 1000, maj 350, grad 45
Ent Req: HS dipl, ent exam
Degrees: BA, BS & BFA (graphic design, art educ, studio art, art marketing & production) 4 yrs
Tuition: Res—$1053 per sem; nonres—$4688 per sem
Courses: Art Appreciation, Art History, Fibers, Graphic Arts
Children's Classes: After sch art program enrl 40, $250 per sem
Summer School: Chmn, Laura Ives. Enrl 60; $75 per hr res, $239 per hr non-res. Courses—per regular session

BREVARD

BREVARD COLLEGE, Division of Fine Arts, 400 N Broad St, Brevard, NC 28712. Tel 828-883-8292; Fax 828-884-3790; Internet Home Page Address: www.brevard.edu; *Chair Div Fine Arts* Kay Hoke PhD; *Coordr Fine Arts & Prof* Timothy G Murray, MACA; *Asst Prof* Anne Chapin, PhD; *Assoc Prof* Bill Byers, MFA; *Assoc Prof* M Jo Pumphrey, MFA; *Asst Prof* Mollie Doctrow, MA; *Adj Prof* Dixon W Brady, MFA; *Adjunct Prof* Teri Godfrey, MFA
Estab 1853; FT 5, PT 2; den; D & E; Scholarships; SC 12, LC 2
Ent Req: HS dipl
Degrees: BA
Tuition: Res—undergrad $8050 per yr; nonres— $12,425 per yr
Courses: †Art Appreciation, Art History, Ceramics, Drawing, Film, Graphic Arts, Graphic Design, †History of Art & Architecture, †Mixed Media, Painting, Photography, Printmaking, Sculpture, Theatre Arts
Summer School: Courses vary

CHAPEL HILL

UNIVERSITY OF NORTH CAROLINA AT CHAPEL HILL, Art Dept, Hanes Art Ctr, Chapel Hill, NC 27599-3405. Tel 919-962-2015; Fax 919-962-0722; Internet Home Page Address: www.unc.edu/depts/art; *Prof* Mary C Sturgeon PhD; *Chm & Prof* Mary Sheriff PhD; *Prof* Jaroslav Folda PhD; *Asst Chm & Prof* Beth Grabowski, MFA; *Prof* Dennis Zaborowski, MFA; *Prof* Jim Hirschfield, MFA; *Prof* Elin O Slavick, MFA; *Assoc Prof* Dorothy Verkerk, MFA; *Prof* Yun-Dong Nam, MFA; *Assoc Prof* Pika Ghosh, PhD; *Prof* Carol Mavor, MFA; *Asst Prof* Carol Magee, PhD; *Asst Prof* Lyneise Williams, PhD; *Asst Prof* Jeff Whetstone, MFA; *Assoc Prof* Juan Logan, MFA; *Asst Prof* Kimowan McLain, MFA; *Assoc Prof* Mary Pardo, PhD; *Asst Prof* Glaire Anderson, PhD; *Instr* Susan Haubage-Page, MFA
Estab 1793, dept estab 1936; Maintain nonprofit art gallery; John & June Allcott Gallery, UNC-CH, Dept of Art, Chapel Hill, NC 27599; Pub; D; Scholarships; SC 15, LC 15, GC 10; D 100 undergrad, 55 grad
Ent Req: HS dipl, SAT
Degrees: BA & BFA 4 yr, MFA & MA(Art History) 2 yr, PhD(Art History) to 6 yr
Tuition: Res—undergrad $693 per sem, grad $693 per sem; nonres—undergrad $4,959 per sem, grad $4,959; campus res—available
Courses: Architecture, †Art History, Ceramics, Drawing, History of Art & Architecture, †Mixed Media, †Painting, Photography, Printmaking, Sculpture
Summer School: Dir Beth Grabowski. Courses—Various Art History & Studio Courses

CHARLOTTE

CENTRAL PIEDMONT COMMUNITY COLLEGE, Visual & Performing Arts, PO Box 35009, Charlotte, NC 28235. Tel 704-330-2722; Internet Home Page Address: www.cpcc.cc.nc.us; *Chmn* Mary Lou Paschal
Estab 1963; Scholarships
Ent Req: HS dipl, equivalent
Degrees: AS, AA & AAS 2 yrs
Tuition: Res undergrad $27.50 per cr hr; nonres $169.75 per cr hr
Courses: Advertising Design, Architecture, Art Appreciation, Art History, Artists Books (special topic), Bronze Casting, Ceramics, Computer Aided Design, Design, Drawing, Interior Design, Jewelry, Painting, Photography, Printmaking, Sculpture, Weaving

QUEENS COLLEGE, Fine Arts Dept, 1900 Selwyn Ave, Charlotte, NC 28274-0001. Tel 704-337-2212; Tel 800-849-0202; Elec Mail cas@queens.edu; Internet Home Page Address: www.queens.edu; *Fine Arts Chmn* Robert F Porter
Estab 1857; Den; Scholarships; SC 19, LC 7
Degrees: BA
Tuition: $17,250 annual tuition incl room & board
Courses: Art History, Ceramics, Commercial Art

UNIVERSITY OF NORTH CAROLINA AT CHARLOTTE, Dept Art, 9201 University City Blvd, Rm 173, Charlotte, NC 28223. Tel 704-687-2473; Fax 704-687-2591; Internet Home Page Address: www.art.uncc.edu; *Prof & Chair* Roy Strassberg; *Gallery Mgr* Dean Butckovitz; *Assoc Prof* Winston Tite; *Asst Prof* Joan Tweedy; *Assoc Prof* Eldred Hudson; *Prof Emeritus* Lili Corbus; *Assoc Prof* Susan Brenner; *Prof Emeritus* Heather Hoover; *Asst Prof* David Brodeur; *Lectr* Keith Bryant; *Assoc Prof* Jamie Franki; *Lectr* Frances Hawthorne; *Lectr* Ann Kluttz; *Assoc Prof* Jeff Murphy; *Asst Prof* Bonnie Noble; *Assoc Prof* Mary Tuma; *Prof* David Edgar; *Asst Prof* Jim Frakes; *Asst Prof* Maja Godlewska; *Lectr* Kristin Rothrock; *Coordr Undergrad Educ* Malena Bergmann; *Asst Prof* John Ford; *Asst Prof* Heather Freeman; *Asst Prof* Pamela Lawton; *Lectr* Michael Simpson; *Lectr* Deborah Wall; *Lectr* Jason Tselentis; *Asst Prof* Angela Herren
Estab 1965, dept estab 1971; Maintain nonprofit art gallery, Rowe Gallery & Cone Center Gallery, Art Dept, UNC Charlotte, NC 28223; pub; D & E; SC 96, LC 32, Other 16; maj 500
Ent Req: HS dipl, SAT, Col Boards, Portfolio Review for studio degrees
Degrees: BA (Art & Art History) & BFA 4 yrs, K - 12 Art Educ Cert 4 yrs
Tuition: Res—$1738.50; nonres—$6794.50; room & board per sem $1362 - $1892
Courses: Art Education, Art History, Ceramics, Design, Drawing, Electronic Media, Fibers, Graphic Design, Illustration, Jewelry, Painting, Photography, Printmaking, Sculpture
Summer School: Prof Roy Strassberg. Enrl 120; tuition res—$413.90, nonres—$1487.90; two 5 wk sessions, one 3 wk session. Courses—Art Appreciation, Ceramics, Design, Drawing, Painting, Photography

CULLOWHEE

WESTERN CAROLINA UNIVERSITY, Dept of Art/College of Arts & Science, Belk Bldg, Cullowhee, NC 28723. Tel 828-227-7210; Fax 828-227-7505; Elec Mail wcrawford@wcu.edu; Internet Home Page Address: www.wcu.edu/as/arts/; *Head Dept* Robert Godfrey, MFA; *Prof* James Thompson, PhD; *Prof* Jon Jicha, MFA; *Prof* James E Smythe, MFA; *Prof* Joan Byrd, MFA; *Assoc Prof* Louis Petrovich-Mwaniki, PhD; *Assoc Prof* Cathryn Griffin, MFA; *Assoc Prof* Lee P Budahl, PhD; *Asst Prof* Marya Roland, MFA; *Asst Prof* Matt Liddle, MFA
Estab 1889, dept estab 1968; pub; D & E; Scholarships; SC 51, LC 12; non-maj 1200 per sem, maj 150
Ent Req: HS dipl, SAT & C average in HS
Degrees: BFA, BA & BSE 4 yrs, MA, art honors studio
Tuition: Res—undergrad and grad $830 per yr, $425 per sem; nonres—undergrad and grad $3697 per yr, $1848.50 per sem; campus res—room & board $1600 per yr
Courses: Art Appreciation, Art Education, Art History, Book Arts, Ceramics, Conceptual Art, Drawing, Graphic Design, Intermedia, Jewelry, Painting, Photography, Printmaking, Sculpture, Silversmithing, Weaving
Summer School: Dir, Dr Oakley Winters. Course—Art History, Studio Courses in Ceramics, Design, Drawing, Experimental Studio, Fibers, Metalsmithing, Painting, Sculpture

DALLAS

GASTON COLLEGE, Art Dept, 201 Hwy 321 S, Dallas, NC 28034. Tel 704-922-6343, 922-6344; *Dept Chmn* Gary Freeman
Estab 1965; pub; D & E; Scholarships; SC 22, LC 3; D 286, E 70, maj 50
Ent Req: HS dipl
Degrees: AA & AFA 2 yrs, cert 1 yr
Tuition: Res—$27.50 per sem cr hr; nonres—$169.75 per sem cr hr
Courses: 2-D & 3D Design, Ceramics, Commercial Art Fundamentals, Computer Graphics, Drawing, Jewelry, Painting, Photography, Pottery, Printmaking, Sculpture, Wood Design
Summer School: Dir, Gary Freeman. Enrl 20; term of 11 wks beginning June. Courses—Design, Drawing, Painting, Pottery, Sculpture

DAVIDSON

DAVIDSON COLLEGE, Art Dept, 315 N Main St, PO Box 1720 Davidson, NC 28036. Tel 704-894-2344; Fax 704-894-2732; Elec Mail shsmith@davidson.edu; Internet Home Page Address: www.davidson.edu; *Prof* Larry L Ligo PhD; *Asst Prof* Nina Serebrennikov, MFA; *Chmn* C Shaw Smith Jr; *Prof* W Herbert Jackson; *Assoc Prof* Cort Savage; *Prof* Russ C Warren
Estab 1837, dept estab 1950; pvt & den; D; Scholarships; SC 12, LC 9; non-maj 300, maj 18
Ent Req: Col Boards, HS transcripts
Degrees: BA & BS 4 yrs
Tuition: $23,000 per yr (comprehensive fee); campus res—room & board fee included in tuition
Courses: Aesthetics, Art History, Collage, Conceptual Art, Drawing, Graphic Design, History of Art & Architecture, Painting, Printmaking, Sculpture, Theatre Arts

DOBSON

SURRY COMMUNITY COLLEGE, Art Dept, PO Box 304, Dobson, NC 27017. Tel 336-386-8121; Fax 336-386-8951; Internet Home Page Address: www.surry.cc.nc.us; *Instr* William Sanders; *Dean* John Collins

Estab 1966; Varies
Ent Req: HS dipl, equivalent
Degrees: AA
Tuition: Res $27.50 per cr hr; nonres $169.75 per cr hr
Courses: Art Appreciation, Art History, Commercial Art, Design, Drawing, Handicrafts, Painting, Printmaking, Sculpture

DURHAM

DUKE UNIVERSITY, Dept of Art, Art History & Visual Studies, PO Box 90764, Durham, NC 27708-0764. Tel 919-684-2224; Fax 919-684-4398; Internet Home Page Address: www.duke.edu/web/art; *Prof* Richard J Powell, PhD, MFA; *Prof* Caroline Bruzelius PhD; *Prof* Annabel Wharton PhD; *Prof* Patricia Leighten PhD; *Prof* Mark Antliff; *Prof* Kristine Stiles PhD; *Chair & Prof* Hans J Van Miegroet PhD, MFA; *Assoc Prof Practice* Merrill Shatzman, MFA; *Assoc Prof* Stanley Abe PhD, MFA; *Assoc Prof* Gennifer Weisenfeld PhD, MFA; *Adjunct Assoc Prof* Sarah Schroth PhD, MFA; *Assoc Prof Practice* William Noland, BA; *Asst Prof* Sheila Dillon, PhD; *Asst Prof Practice* Anya Belkina, MFA; *Adjunct Asst Prof* Anne Schroder, PhD; *Assoc Prof Practice* Thomas Rankin, MFA, MA; *Asst Prof* Esther Gabara; *Prof* Neil McWilliam; *Adjunct Prof* Kimberly Rorschach; *Asst Prof Practice* Pedro Lasch; *Prof Visual Studies* Tim Lenoir
Pvt; D; Scholarships; SC 36, LC 84, GC 28, Seminars 32; D 1850, maj 134
Ent Req: HS dipl & ent exam for BA
Degrees: BA, MA in History of Art, JD in law, PhD in Art History
Tuition: Campus res—available
Courses: Aesthetics, Architecture, Art History, Conceptual Art, Design, Drawing, Film, Graphic Design, History of Art & Architecture, Mixed Media, Museum Staff Training, Painting, Photography, Printmaking, Sculpture, Visual Studies & Culture
Summer School: Dir, Paula E Gilbert. Two 6 wk sessions offered

NORTH CAROLINA CENTRAL UNIVERSITY, Art Dept, 1801 Fayetteville St, PO Box 19555 Durham, NC 27707. Tel 919-560-6100; Fax 919-560-6391; Internet Home Page Address: www.nccu.edu; *Chmn* Dr Melvin Carver, MPD; *Prof* Achameleh Debela, PhD; *Prof* Rosie Thompson, PhD; *Prof* Isabell Chicquor, MFA; *Prof, Dir Art Museum* Kenneth Rodgers, MFA; *Prof* John Hughley, EDD; *Prof* Michelle Patterson, EDD
Estab 1910, dept estab 1944; pub; D & E; SC 30, LC 11; D 120, E 30, non-maj 1678, maj 120
Ent Req: HS dipl, SAT
Degrees: in Art Educ, Visual Communications & Studio Art 4 yrs
Tuition: Res—undergrad $421.50 yr; nonres—undergrad $1800 yr; campus res—$2041.50-$2854.50 per yr
Courses: †Advertising Design, †Art Education, Art History, Calligraphy, Ceramics, Commercial Art, Drawing, Engineering Graphics, Graphic Arts, Handicrafts, Illustration, Jewelry, Lettering, Painting, Printmaking, Sculpture, Stained Glass, Studio Arts, Teacher Training
Children's Classes: Saturday school

ELIZABETH CITY

ELIZABETH CITY STATE UNIVERSITY, Dept of Art, 1704 Weeksville Rd, Elizabeth City, NC 27909. Tel 252-335-3632, 335-3347 (Art Dept); *Chmn* Jenny C McIntosh PhD
Estab 1891, dept 1961; pub; D & E; Scholarships; SC 27, LC 18, advance courses in Studio and History of Art; D 2003, E 455, non-maj 1928, maj 75
Ent Req: HS dipl, portfolio
Degrees: BA 4 yrs
Tuition: Res— $668 per yr; nonres—$3740 per yr
Courses: Art History, Art Studio general, Painting, Photography, Sculpture, Teacher Training
Summer School: Dir, Floyd Robinson. Enrl 950. Courses—Same as regular session

FAYETTEVILLE

FAYETTEVILLE STATE UNIVERSITY, Performing & Fine Arts, 1200 Murchison Rd, Fayetteville, NC 28301-4298. Tel 910-672-1457, 672-1571; Fax 910-672-1572; *Head Division of Fine Arts & Humanities* Dr Robert G Owens
Estab 1877; pub; D & E; D 60, E 20
Ent Req: HS dipl, ent exam
Degrees: BA & BFA 4 yr
Tuition: Res—$2893 per sem; nonres—$6528 per sem
Courses: Advertising Design, Aesthetics, Art Education, Ceramics, Drawing, Graphic Arts, Handicrafts, History of Art & Architecture, Leather Craft, Lettering, Painting, Photography, Sculpture, Weaving
Summer School: Dir, Dr Beeman C Patterson. Courses—Art in Childhood Education, Arts & Crafts, Drawing, Photography, Survey of Art

METHODIST COLLEGE, Art Dept, 5400 Ramsey St, Fayetteville, NC 28311-1406. Tel 910-630-7107; Fax 910-630-2123; Internet Home Page Address: www.methodist.edu/; *Chmn* Silvana Foti, MFA; *Prof* Peggy S Hinson
Estab 1960; FT 2, PT 1; den; D & E; Scholarships; SC 6, LC 4; D 650, maj 22
Ent Req: HS dipl, SAT
Degrees: BA & BS 4 yrs
Tuition: Res—undergrad $13,300 per yr, $18,380 incl room & board
Courses: Art Education, Art History, Design, Drawing, Painting, Papermaking, Photography, Printmaking, Sculpture
Summer School: 3 terms, 3 wk early session, 5 wk main session, 6 wk directed study. Courses—Art Appreciation, Painting, Sculpture, others as needed

GOLDSBORO

THE ARTS COUNCIL OF WAYNE COUNTY, (Goldsboro Art Center) Community Arts Council, 2406 E Ash St Goldsboro, NC 27534. Tel 919-736-3300; Fax 919-736-3335; Internet Home Page Address: www.artscouncilofwaynecounty.org; *Exec Dir* Alice Strickland

Estab 1971; pub; D & E; Scholarships; SC 25; D 150, E 60, others 210
Tuition: $40 & up per class
Courses: Drawing, Painting, Pottery, Spinning
Adult Hobby Classes: Enrl 75; tuition $19 for 11 wk term. Courses—
Calligraphy, Oil Painting, Pottery, Watercolors
Children's Classes: Enrl 50; tuition $15 for 6 wk term. Courses—Discovering
Art, Drawing, Painting, Pottery

WAYNE COMMUNITY COLLEGE, Liberal Arts Dept, Caller Box 8002,
Goldsboro, NC 27533. Tel 919-735-5151; Fax 919-736-3204; Internet Home Page
Address: www.wayne.cc.nc.us; *Instr* Patricia Turlington; *Chmn* Ann Spicer
Estab 1957; 4 FT, PT varies
Degrees: AA, AS, AAS & AFA 2 yr
Tuition: Res $27.50 per cr hour; nonres $159.75 per cr hr
Courses: Art Appreciation, Art History, Design, Drawing
Adult Hobby Classes: Courses offered

GREENSBORO

GREENSBORO COLLEGE, Dept of Art, Division of Fine Arts, 815 W Market
St, Greensboro, NC 27401. Tel 336-272-7102, Ext 301;
Internet Home Page Address: www.gborocollege.edu; *Assoc Prof* Ray Martin,
MFA; *Prof* Robert Kowski, MFA; *Instr* James V Langer; *Instr* Ginger Williamson
Estab 1838; Maintain nonprofit art gallery; Irene Cullis Gallery, Greensboro Col;
pvt den; D & E, weekends; Scholarships; SC 15, LC 4; D 200, non-maj 50, maj
20
Ent Req: HS dipl
Degrees: BA 4 yrs
Tuition: Res & nonres—undergrad $14650 per yr; campus res—room & board
$5760 per yr
Courses: Art Appreciation, †Art Education, Art History, Ceramics, Design,
Drawing, †Painting, Photography, Printmaking, †Sculpture, Stage Design, †Theatre
Arts
Adult Hobby Classes: Enrl 40; tuition $225 per cr hr. Courses—Art History
Summer School: Dir, Dr John Drayer. Tuition $138 per cr hr for two 5 wk
sessions. Courses—Art Appreciation, Art History

GUILFORD COLLEGE, Art Dept, 5800 W Friendly Ave, Greensboro, NC
27410. Tel 336-316-2000; Fax 336-316-2299; Elec Mail glorio@guilford.edu;
Internet Home Page Address: www.guilford.edu; *Prof of Art* David Newton; *Prof
of Art* Roy Nydorf; *Prof of Art, Dept Chair* Adele Wayman
Estab 1837, dept estab 1970; Maintain nonprofit art gallery, Hege Library Art
Gallery; private; D & E; Scholarships; studio, lectrs; 40 maj
Ent Req: HS dipl, entrance examination
Degrees: BA 4 yr, BFA 4 yr
Tuition: $7090 per sem
Courses: Art History, Ceramics, Design, Drawing, History of Art & Architecture,
Painting, Photography, Printmaking, Sculpture

**NORTH CAROLINA AGRICULTURAL & TECHNICAL STATE
UNIVERSITY,** Visual Arts Dept, 312 N Dudley St, Greensboro, NC 27411. Tel
336-334-7993; *Chmn* Stephanie Santmyers
Estab 1930; FT 4, PT 1; pub; SC 29, LC 7; maj 50
Tuition: res $1122 per sem; non res $4757 per sem; campus res-room and board
$2235 per sem
Courses: 2-D Design, 3-D Design, Advertising Design, Aesthetics, Art
Appreciation, †Art Design, †Art Education, Art History, Ceramics, Crafts, Design,
Drawing, Graphic Arts, Graphic Design, Handicrafts, Illustration, †Painting,
Printmaking, Sculpture, Teacher Training, Textile Design
Summer School: Dir, Dr Ronald Smith. Courses—Crafts, Public School Art, Art
History, Art Appreciation

UNIVERSITY OF NORTH CAROLINA AT GREENSBORO, Art Dept, PO
Box 26170, 162 McIver Bldg Greensboro, NC 27402-6170. Tel 336-334-5248;
Fax 336-334-5270; Elec Mail artdept2@uncg.edu; Internet Home Page Address:
www.uncg.edu/art; *Prof* K Porter Aichele; *Prof* Michael Ananian; *Prof* George
Dimock; *Prof* Andrew Dunnill; *Head* Patricia Wasserboehr; *Prof* Billy Lee; *Prof*
John Maggio; *Prof* Carl Goldstein; *Lectr* Richard Gantt; *Prof* Cora Cohen; *Prof*
Mark Gottsegen; *Prof* Robert Gerhart; *Prof* Melissa Bell; *Prof* Amy Lixi Purcell;
Prof Mariam Stephan; *Prof* Heather Holian; *Prof* Seth Ellis; *Prof* Sharon Harper;
Lectr Janet Oliver; *Prof* Nikki Blair
Dept estab 1935; maintains nonprofit gallery, UNCG McIver Gallery, Dept Art P.O
Box 26170 Greensboro, NC 27402-6170; FT 22; pub; D&E; Scholarships,
Fellowships; SC 46, LC 12, GC 7; D 400+, Maj 400+ non-maj 750, maj 200, grad
17
Ent Req: HS grad, ent exam
Degrees: BA, BFA & MFA 2 yrs
Tuition: Res—undergrad $1025.50 per sem; nonres—$5252.50 per sem
Courses: †Art Education, †Art History, Ceramics, Conceptual Art, †Design,
Digital Design, Drawing, Graphic Design, Mixed Media, Museum Studies,
Painting, Photography, Printmaking, Sculpture, Teacher Training, Video
Summer School: Head of dept. Pat Wasserboehr. Enrl 225; beginning May - June
and July - Aug. Courses—Art Educ, Art History, Design, Drawing, Etching,
Painting, Photography, Sculpture

GREENVILLE

EAST CAROLINA UNIVERSITY, School of Art, E Fifth St, Greenville, NC
27858-4353. Tel 910-328-6665; Fax 910-328-6441; Internet Home Page Address:
www.ecu.edu; *Dir* Richard Tichich; *Assoc Dir* Art Haney; *Assoc Dir* Dr Phil
Phillips
Estab 1907; Maintain nonprofit gallery; Wellington B Gray Art Gallery, Greenville
SC; FT 43, PT 10; pub; D&E; Scholarships, Fellowships; SC 155, LC 28, GC
142; non-maj 1,500, maj 650, grad 50

Ent Req: HS dipl, 20 units, Col Board Exam
Degrees: BA, BFA, MFA, MAEd
Tuition: Campus res—available
Courses: Advertising Design, †Aesthetics, Art Appreciation, †Art Education, †Art
History, †Ceramics, Color & Design, Commercial Art, Computer-Aided Art &
Design, Design, Drawing, †Fabric Design, Goldsmithing, Graphic Arts, Graphic
Design, History of Art & Architecture, †Illustration, Independent Study,
Interdisciplinary 3-D Design, †Metal Design, Mixed Media, †Museum Staff
Training, †Painting, †Photography, †Printmaking, †Sculpture, Silversmithing,
†Textile Design, Video, †Weaving, †Wood Design, Work Experience in the Visual
Arts & Design
Summer School: Assoc Dir, Phil Phillips. Enrl 200; two 5 wk terms.
Courses—Foundation & Survey

HICKORY

LENOIR RHYNE COLLEGE, Dept of Art, Visual Arts Ctr, PO Box 7471
Hickory, NC 28603. Tel 828-328-1741; Fax 828-328-7338; Internet Home Page
Address: www.lrc.edu; *Chmn Dept* Robert Winter PhD; *Asst Prof* Douglas Burton,
MA; *Instr* Tom Perryman, MA
Estab 1892, dept estab 1976; den; D & E; Scholarships; SC 5; D 1200, E 350
Ent Req: HS dipl
Degrees: AB & BS 4 yrs
Tuition: Res—undergrad $6448 per sem; res—room & board $8823 per sem
Courses: Aesthetics, Art Appreciation, Art Education, Art History, Ceramics,
Drawing, Painting, Photography, Printmaking, Sculpture
Adult Hobby Classes: Courses on Tues & Thurs evenings
Children's Classes: Summer courses for gifted & talented
Summer School: Dir, Dr James Lichtenstein. Enrl 900; tuition $175 per sem hr
for 2-5 wk terms beginning June. Courses—Art Appreciation, Art Education,
Ceramics, Painting

HIGH POINT

HIGH POINT UNIVERSITY, Fine Arts Dept, University Sta, 932 Montlieu Ave
High Point, NC 27262-3598. Tel 336-841-9282; Fax 336-841-5123; *Asst Prof*
Alexa Schlimmer; *Chmn* Andrea Wheless
Estab 1924, dept estab 1956; pvt den; D & E; Scholarships; SC 16, LC 6;
non-maj 950, maj 10
Ent Req: HS dipl, SAT
Degrees: AB & BS 4 yrs
Tuition: Res—undergrad $19180 per yr incl room & board; non res—undergrad
$13150 per sem incl room & board
Courses: Advertising Design, Aesthetics, †Art Education, Art History, Ceramics,
Crafts, Drawing, History of Art & Architecture, Interior Design, Painting,
Printmaking, Sculpture, Stage Design, Teacher Training, †Theatre Arts
Summer School: Enrl 200; two 5 wk sessions. Courses—Art Education, Crafts,
Design, Interior Design

JAMESTOWN

GUILFORD TECHNICAL COMMUNITY COLLEGE, Commercial Art Dept,
PO Box 309, Jamestown, NC 27282. Tel 336-454-1126, Ext 2230; Fax
336-819-2022; Elec Mail reidm@gtcc.cc.nc.us; Internet Home Page Address:
www.technet.gtcc.cc.nc.us/; *Instr* Awilda Feliciano, BFA; *Instr* Frederick N Jones,
MFA; *Instr* Scott Burnette, BA; *Head* Margaret Reid, MFA; *Instr* Michael Swing;
Instr Alex Forsyth; *Instr* Julie Evans
Estab 1964; pub; D & E; Scholarships; SC 20, LC 4; D 130, E 60
Ent Req: HS dipl, English & math placement
Degrees: AAS 2 yrs
Tuition: Res—undergrad $26.75 per hr; nonres—undergrad up to $169.75 per hr
Courses: †Advertising Design, Art History, Commercial Art, Computer Graphics,
Drafting, Drawing, Graphic Arts, Illustration, Lettering, Photography
Adult Hobby Classes: Courses—Variety of subjects
Summer School: 9 wk term. Courses—Various

KINSTON

LENOIR COMMUNITY COLLEGE, Dept of Visual Art, PO Box 188, Kinston,
NC 28502-0188. Tel 252-527-6223, Ext 923; *Prof* Henry Stindt
Pub; D&E
Degrees: AA, AS & AFA
Tuition: Res—$27.50 per cr hr; nonres—$169.75 per cr hr
Courses: Ceramics, Commercial Art, Design, Drawing, Illustration, Introduction to
Art, Painting, Photography, Printmaking
Summer School: Dir, Gerald A Elliott. Enrl 32; tuition $51 for 12 cr hrs.
Courses—Lecture & Studio Art

LAURINBURG

SAINT ANDREWS PRESBYTERIAN COLLEGE, Art Program, 1700
Dogwood Mile, Laurinburg, NC 28352. Tel 910-277-5240, Ext 5264, 277-5264;
Fax 910-277-5020; Elec Mail mcdavids@sapc.edu; Internet Home Page Address:
www.sapc.edu/art; *Chmn Art Dept & Instr* Stephanie McDavid
Estab 1960; den; D; Scholarships; SC 14, LC 2; D 852, maj 20 - 30
Ent Req: HS dipl, SAT, 2.6 grade point average, 12 academic units
Degrees: BA, MS & BM 4 yrs or 32 courses
Tuition: $14,000 per yr
Courses: Art Appreciation, Art Education, Art History, Computer Graphics,
Design, Drawing, Painting, Photography, Printmaking, Sculpture, Video
Summer School: Studio courses offered

LEXINGTON

DAVIDSON COUNTY COMMUNITY COLLEGE, Humanities Div, 2997 DCCC Rd, PO Box 1287 Lexington, NC 27293-1287. Tel 336-249-8186, Ext 253 or 314; Fax 336-249-0379; Internet Home Page Address: www.davidson.cc.nc.us/; Estab 1963, dept estab 1966; FT 2, PT 3; pub; D & E; Scholarships; SC 14, LC 4; D 100, E 30, non-maj 195, maj 30
Ent Req: HS dipl
Degrees: AFA, AS & AA 2 yrs
Courses: Art Education, Art History, Design, Drafting, Handicrafts, Independent Studio, Painting, Photography, Printmaking, Sculpture
Adult Hobby Classes: Courses—Variety taught through continuing educ

MARS HILL

MARS HILL COLLEGE, Art Dept, Mars Hill, NC 28754. Tel 828-689-1396; Elec Mail rcary@mhc.edu; *Chmn* Scott Lowley
Estab 1856, dept estab 1932; pvt and den; D & E; Scholarships; SC 9, LC 6; D 120, non-maj 100, maj 20
Ent Req: HS dipl, ent exam
Degrees: BA 4 yrs
Tuition: Undergrad $10,000 per yr, $14,300 per yr incl room & board
Courses: †Advertising Design, Aesthetics, †Art Education, †Art History, Ceramics, †Graphic Arts, †Painting, Photography, †Printmaking, Sculpture, †Teacher Training, †Theatre Arts
Summer School: Enrl 450; tuition $65 per cr hr for 5 wk term.
Courses—Introduction to the Arts & Photography

MISENHEIMER

PFEIFFER UNIVERSITY, Art Program, PO Box 960 Misenheimer, NC 28109. Tel 704-463-1360, Ext 2667; Fax 704-463-1363; Internet Home Page Address: www.pfeiffer.edu/; *Dir* James Haymaker
Estab 1965; FT 1; den; D; Scholarships; SC 4, LC 4; D 100
Ent Req: HS dipl
Degrees: BA
Tuition: $5690 per sem, $2280 per sem room & board
Courses: Art Education, Art History, Ceramics, Drawing, Painting, Sculpture

MOUNT OLIVE

MOUNT OLIVE COLLEGE, Dept of Art, 634 Henderson St, Mount Olive, NC 28365. Tel 919-658-2502, 658-7181; Fax 919-658-7180; *Chmn* Larry Lean
Estab 1951; den; D & E; Scholarships; SC 5, LC 3
Degrees: BA & BS
Tuition: Res—undergrad $13910 per yr; campus res available
Courses: American Art, Art Appreciation, Art History, Design, Drawing, Painting
Summer School: Courses—Art Appreciation

MURFREESBORO

CHOWAN COLLEGE, Division of Art, 200 Jones Dr, Murfreesboro, NC 27855. Tel 252-398-6500, Ext 267; Fax 252-398-6500; Internet Home Page Address: www.chowan.edu; *Head Div* Haig David-West
Estab 1848, dept estab 1970; den; Scholarships; SC 18, LC 3; maj 64
Ent Req: HS dipl, SAT recommended
Degrees: AA 2 yrs
Tuition: Room & board $9500 per yr; commuter—$4950 per yr, $2475 per sem
Courses: Advertising Design, Art Appreciation, Art Education, Art History, Ceramics, Commercial Art, Drawing, Figure Drawing, Illustration, Lettering, Painting
Summer School: Dir, Doug Eubank. Enrl 10; tuition $165 per sem hr for term of 6 wks beginning June 8. Courses—Art Appreciation, Ceramics, Drawing, Painting

PEMBROKE

UNIVERSITY OF NORTH CAROLINA AT PEMBROKE, Art Dept, PO Box 1510, Pembroke, NC 28372-1510. Tel 910-521-6216; Fax 910-521-6639; Elec Mail art@nat.uncp.edu; Internet Home Page Address: www.uncp.edu; *Asst Prof* John Labadie; *Asst Prof* Ann Horton-Lopez; *Asst Prof* Ralph Steeds; *Chmn Dept* Paul Van Zandt
Estab 1887; Maintain nonprofit art gallery; Locklear Hall Art Gallery; FT 4, PT 3; pub; D; Scholarships; SC 30, LC 12; maj 60
Ent Req: CEEB scores, HS record, scholastic standing in HS grad class, recommendation of HS guidance counselor & principal
Degrees: BA 4 yrs
Tuition: Res—$858 per sem; nonres—$4,493 per sem
Courses: †Art Education, Art History, †Ceramics, Computer Graphics, Design, Drawing, †Painting, †Printmaking, †Sculpture
Summer School: Variety of courses

PENLAND

PENLAND SCHOOL OF CRAFTS, Penland Rd, PO Box 37 Penland, NC 28765-0037. Tel 828-765-2359; Fax 828-765-7389; Internet Home Page Address: www.penland.org
Estab 1929; Maintain nonprofit art gallery; Penland Gallery; Nonprofit org; D (summer, spring & fall classes); Scholarships; SC 112; D approx 1,200
Ent Req: age 19 and above, special fall and spring sessions require portfolio and resume

Degrees: none granted but credit may be obtained through agreement with East Tennessee State Univ & Western Carolina Univ
Tuition: $4,225 for term of 8 wks; campus res—room & board $435 per 2 wks
Courses: Basketry, Blacksmithing, Book Arts, Ceramics, †Drawing, Fibers, Glass, Jewelry, Metalsmithing, †Painting, Papermaking, Photography, Printmaking, Sculpture, †Surface Design, †Textiles, Weaving, Woodworking
Summer School: Dir, Jean McLaughlin. Tuition varies for 1, 2 & 2-1/2 wk courses between June & Sept; 8 wk concentrations-spring & fall.
Courses—Basketry, Book Arts, Clay, Drawing, Fibers, Glass, Iron, Metal, Paper, Photography, Printmaking, Sculpture, Surface Design, Wood

RALEIGH

MEREDITH COLLEGE, Art Dept, Gaddy-Hamrick Art Ctr, 3800 Hillsborough St Raleigh, NC 27607-5298. Tel 919-760-8332; Fax 919-760-2347; *Chmn* Rebecca Bailey
Estab 1898; den, W; D & E; Scholarships; SC 15, LC 5; D 490, E 130, maj 85, others 30
Ent Req: HS dipl
Degrees: AB 4 yrs
Tuition: Res—undergrad $9560 per yr, $280 per cr hr; campus res—room & board $4300 per yr
Courses: Advertising Design, Art Appreciation, Art Education, Art History, Calligraphy, Ceramics, Computer Graphics, Costume Design & Construction, Design, Drawing, Graphic Design, Handicrafts
Adult Hobby Classes: Courses—Art History, Ceramics, Drawing, Fibers, Graphic Design, Painting, Photography, Sculpture
Summer School: Dir, John Hiott. Courses—vary

NORTH CAROLINA STATE UNIVERSITY AT RALEIGH, School of Design, PO Box 7701, Raleigh, NC 27695-7701. Tel 919-515-8310, 515-8317 (School Design); Fax 919-515-7330; Internet Home Page Address: www.ncsu.edu/; *Head Design & Technology Dept* Haig Khachatoorian; *Prof* Percy Hooper; *Assoc Prof* Bryan Lafitte; *Prof* Vincent M Foote; *Prof* Glen Lewis; *Dept Secy, Grad Prog Asst* Cheryl Eatmon
Estab 1948; FT 38, PT 5; pub; Architecture 251, Art & Design 60, Graphic Design 118, Industrial Design 135, Landscape Architecture 94
Ent Req: col board, ent exam
Degrees: BEnv(Design in Architecture, Design, Graphic & Industrial Design, Landscape Architecture, March), MGraphic Design, MLandscape Arch, 4-6 yrs
Tuition: Res—$3208; nonres—$12,374
Courses: Architecture, Design, Graphic Design, Industrial Design, Landscape Architecture, Product Design, Visual Design
Summer School: Courses—Undergrad: Architecture, Graphic Design, Industrial Design, Landscape Architecture

PEACE COLLEGE, Art Dept, 15 E Peace St, Raleigh, NC 27604. Tel 919-508-2000; Fax 919-508-2326; Internet Home Page Address: www.peace.edu; *Head Dept* Carolyn Parker
Estab 1857; pvt; D & E; SC 8, LC 2; D 600
Ent Req: HS dipl, SAT
Degrees: AA & AFA 2 yrs & 4 yrs
Tuition: $12,225 per yr, incl room & board
Courses: †Liberal Arts

ROCKY MOUNT

NORTH CAROLINA WESLEYAN COLLEGE, Dept of Visual & Performing Arts, 3400 N Wesleyan Blvd, Rocky Mount, NC 27804-8630. Tel 252-985-5100, 985-5167 (Dept Visual & Art); Fax 252-977-3701; Internet Home Page Address: www.ncwc.edu; *Instr* Everett Mayo Adelman; *Instr* Michele A Cruz; *Dir Theater Dept* David Blakely
Founded 1956; opened 1960; Scholarships
Ent Req: HS diploma
Degrees: BA
Tuition: Res—$9,758 per year
Courses: Advertising Design, Architecture, Art Appreciation, Art Education, Visual Communication
Adult Hobby Classes: Enrl 1055; tuition $125 per sem hr. Courses—Art Appreciation, American Architecture

STATESVILLE

MITCHELL COMMUNITY COLLEGE, Visual Art Dept, 500 W Broad St, Statesville, NC 28677-5293. Tel 704-878-3200; Internet Home Page Address: www.mitchell.cc.nc.us; *Chmn* Donald Everett Moore, MA; *Instr* James Messer
Estab 1852, dept estab 1974; FT 2, PT 1; pub; D & E; Scholarships; SC 12-15, LC 5; D 85, E 40, non-maj 100, maj 25
Ent Req: HS dipl, HS transcripts, placement test
Degrees: AA & AFA 2 yrs
Tuition: Res—$40 per sem hr; nonres—$163 per sem hr; $2282 per sem; no campus res available
Courses: Art History, †Ceramics, Color Theory, Drawing, Intermedia, †Painting, Printmaking, †Sculpture
Adult Hobby Classes: Enrl 100; tuition $130 per 10 wks. Courses—Continuing education courses in art & crafts available

SYLVA

SOUTHWESTERN COMMUNITY COLLEGE, Advertising & Graphic Design, 447 College Dr, Sylva, NC 28779. Tel 828-586-4091, Ext 233; Fax 828-586-3129; Internet Home Page Address: www.southwest.cc.nc.us/; *Instr* Bob Clark, MS; *Instr* Bob Keeling, AAS; *Photog Instr* Matthew Turlington

Estab 1964, dept estab 1967; FT 2, PT 2; pub; D; Scholarships; SC 19, LC 14; D 50, maj 50
Ent Req: HS dipl
Degrees: AAS
Tuition: Res—undergrad $496 per sem; nonres—undergrad $2772 per sem; no campus res
Courses: Advertising Design, Art Appreciation, Computer Graphics, Conceptual Art, Design, Drafting, Drawing, Graphic Arts, Graphic Design, Illustration, Photography, Screenprinting, Technical Illustration, Typography
Adult Hobby Classes: Enrl 30, tuition $35 per class hr

WHITEVILLE

SOUTHEASTERN COMMUNITY COLLEGE, Dept of Art, PO Box 151, Whiteville, NC 28472. Tel 910-642-7141; Ext 237; Fax 910-642-5658; Elec Mail dmccormick@mail.southeast.cc.nc.us; Internet Home Page Address: www.southeastern.cc.nc.us; *Instr, Chair* David McCormick
Estab 1965; FT 1 PT 1; pub; D & E; SC 18, LC 7
Ent Req: HS dipl or 18 yrs old
Degrees: AFA 2 yrs
Tuition: Res—$27.50 per cr hour; non-res—$169.75
Courses: Art History, Ceramics, Drawing, Painting, Pottery, Printmaking, Sculpture
Adult Hobby Classes: Tuition res—$25 per course
Summer School: Dir, Christa Balogh

WILKESBORO

WILKES COMMUNITY COLLEGE, Arts & Science Division, PO Box 120, Wilkesboro, NC 28697. Tel 336-838-6100; Fax 336-838-6277; Internet Home Page Address: www.wilkes.cc.mc.us; *Instr* Dewey Mayes; *Dir* Blair Hancock
Estab 1965, dept estab 1967; pub; D & E; Scholarships; SC 2, LC 2; D 1600, E 800
Ent Req: HS dipl
Degrees: AA, AFA
Tuition: Res—$13.25 per cr hr; nonres—$107.50 per cr hr; no campus res
Courses: Art History, Art Travel Courses, Costume Design & Construction, Drafting, Drawing, Painting, Photography, Sculpture, Theatre Arts
Summer School: Dir, Bud Mayes

WILMINGTON

UNIVERSITY OF NORTH CAROLINA AT WILMINGTON, Dept of Fine Arts - Division of Art, 601 S College Rd, Wilmington, NC 28403-3297. Tel 910-962-3415 (Dept of Art); *Prof* Ann Conner, MFA; *Prof* Donald Furst, MFA; *Prof, Chmn* Kemille Moore, PhD
Estab 1789, dept estab 1952; pub; D & E
Ent Req: HS dipl, ent exam
Degrees: BCA 4 yrs
Tuition: $1200 per sem
Courses: Art Appreciation, Art History, Ceramics, Design, Drawing, Painting, Printmaking, Sculpture
Adult Hobby Classes: Courses—Drawing, Painting
Summer School: Dir, David Miller. Two 5 wk sessions. Courses—Varied

WILSON

BARTON COLLEGE, Art Dept, PO Box 5000, Wilson, NC 27893-7000. Tel 252-399-6477; Fax 252-399-6572; Elec Mail sfecho@barton.edu; Internet Home Page Address: www.barton.edu; *Asst Prof* Gerard Lange, MFA; *Prof* Chris Wilson, MFA; *Chmn* Susan C Fecho, MFA; *Assoc Prof* Mark Gordon, MFA
Estab 1903, dept estab 1950; pvt; D & E; Scholarships; SC 15, LC 8; D 68, E 5, non-maj 68, others 8 (PT)
Ent Req: HS dipl, ent exam
Degrees: BS, BA & BFA 4 yrs
Tuition: Undergrad—$11,568 per yr; $2188 campus res—room & board $2382 per yr
Courses: Advertising Design, Art Education, Art History, †Ceramics, †Commercial Art, Display, †Drawing, †Graphic Design, †Illustration, Museum Staff Training, †Painting, Photography, †Printmaking, †Sculpture, †Teacher Training, Textile Design, Theatre Arts

WINGATE

WINGATE UNIVERSITY, Art Department, PO Box 3015, Wingate, NC 28174-0159. Tel 704-233-8000; WATS 800-755-5550; *Chmn Div* Louise Napier
Estab 1896, dept estab 1958; den; D & E; Scholarships; D & E 1500
Ent Req: HS grad
Degrees: BA(Art), BA(Art Education) 4 yrs
Tuition: $12,900 per yr;campus res—available
Courses: 3-D Design, Art Appreciation, Art History, Art Methods, Ceramics, Composition, Drawing, Film, Gallery Tours, Metalsmithing, Painting, Photography, Printmaking, Sculpture, Sketching
Summer School: Pres, Dr Jerry McGee. Term of 4 wks beginning first wk in June. Courses—all regular class work available if demand warrants

WINSTON-SALEM

SALEM ACADEMY & COLLEGE, Art Dept, PO Box 10548, Winston-Salem, NC 27108. Tel 336-721-2600, 721-2683; Fax 336-721-2683; *Asst Prof* Penny Griffin; *Prof* John Hutton; *Assoc Prof* Kimberly Varnadoe

Non-profit art gallery: Salem Fine Arts Center Gallery; Den, W; D & E; Scholarships; D 642, maj 44
Ent Req: HS Dipl
Degrees: BA 4 yrs
Tuition: Res—$24000 per yr includes room & board; nonres—$13730 per yr w/o room & board
Courses: Art History, Design, Drawing, Graphic Design, Painting, Printmaking, Sculpture

SAWTOOTH CENTER FOR VISUAL ART, 226 N Marshall St, Winston-Salem, NC 27101. Tel 336-723-7395; Fax 336-773-0132; Elec Mail director@sawtooth.org; Internet Home Page Address: sawtooth.org; *Adult Prog Mgr* Benita VanWinkle; *Youth Prog Mgr* Mary Brownlee
Estab 1945 as Community School of Craft & Art; PT 75; D, E & Wknds; Scholarships; SC
Degrees: non-degree
Tuition: $25-$250 per 10 wk course
Courses: Basketry, Book Arts, Calligraphy, Ceramics, Computer Graphics, Drawing, Jewelry, Lampwork, Mixed Media, Painting, Papermaking, Photography, Printmaking, Silversmithing, Stained Glass, Teacher Training, Textile Design, Weaving, Wood Carving
Adult Hobby Classes: Enrl 2000; tuition $100-$250 for 5-10 wk term. Courses—All visual arts & craft mediums
Children's Classes: Enrl 1000; tuition $60-$100 for 5 wks. Courses—35 different media oriented courses
Summer School: Enrl 600; tuition $250 for 4 wks

WAKE FOREST UNIVERSITY, Dept of Art, 1834 Wake Forest Rd, Winston-Salem, NC 27106; PO Box 7232, Winston-Salem, NC 27109. Tel 336-758-5310; Fax 336-758-6014; Internet Home Page Address: www.wfu.edu/art; *Prof* Page Laughlin; *Prof* Harry B Titus Jr; *Prof* Robert Knott; *Assoc Prof* David Faber; *Assoc Prof* Margaret Supplee Smith, PhD; *Assoc Prof* Bernadine Barnes; *Assoc Prof* David Finn; *Assoc Prof* John Pickel; *Instr* Alix Hitchcock; *Gallery Dir* Victor Faccinto; *Asst Prof* Lynne Johnson; *Charlotte C Weber Prof Art* David M Lubin; *Reynolds Prof Film Studies* Peter Brunette
Estab 1834, dept estab 1968; Maintains nonprofit art gallery & art libr on campus; Pvt; D; Scholarships; SC 14, LC 28
Ent Req: HS dipl, SAT
Degrees: BA 4 yrs
Tuition: Undergrad—$20,450 yr, $10,225 per sem, $550 per cr; campus res—room & board $5,200
Courses: Art History, Film, Painting, Photography, Printmaking, Restoration & Conservation, †Studio Art
Summer School: Assoc Dean & Dean of Summer Session Toby Hale. Enrl 25; tuition $235 per cr. Courses—Independent Study, Intro to Visual Arts, Practicum, Printmaking Workshop

WINSTON-SALEM STATE UNIVERSITY, Art Dept, Fine Arts Bldg, FA 112, Winston-Salem, NC 27110. Tel 336-750-2520; Fax 336-750-2522; Elec Mail legettel@wssul.adp.wssu.edu; Internet Home Page Address: www.wssu.edu/academic/arts-sci/finearts.usp; *Prof* Arcenia Davis; *Asst Prof* Marvette Aldrich; *Interim Chmn* Lee David Legette
Estab, 1892, dept estab 1970; pub; D & E; SC 10, LC 7; D 65, nonmaj 275, maj 65
Ent Req: HS Dipl
Degrees: BA 4 yrs
Courses: Art Education, Art History, Drawing, Graphic Arts, Painting, Sculpture
Summer School: Courses offered

NORTH DAKOTA

BISMARCK

BISMARCK STATE COLLEGE, Fine Arts Dept, 1500 Edwards Ave, Bismarck, ND 58501. Tel 701-224-5471; Internet Home Page Address: www.bsc.edu; *Assoc Prof* Richard Sammons; *Instr* Tom Porter; *Instr* Marietta Turner; *Instr* Michelle Lindblom; *Instr* Dan Rogers; *Instr* Carol Cashman; *Instr* Barbara Cichy; *Chmn* Jonelle Masters
Estab 1961; FT 3 PT 9; pub; D & E
Degrees: AA 2 yrs
Tuition: Res—undergrad $904.32 per sem; nonres—undergrad $2200.08 per sem
Courses: Art Appreciation, Ceramics, Design, Drawing, Elementary Art, Gallery Management, Handicrafts, Introduction to Understanding Art, Jewelry, Lettering, Painting, Photography, Printmaking, Sculpture

DICKINSON

DICKINSON STATE UNIVERSITY, Dept of Art, Div of Fine Arts and Humanities, 291 Campus Dr Dickinson, ND 58601. Tel 701-483-2175; Tel 701-483-2060; Elec Mail ken_haught@eagle.asu.nodak.edu; *Chmn* Ken Haught, MFA; *Asst Prof* Sharon Linnehan, MFA
Estab 1918, dept estab 1959; pub; D & E; Scholarships; SC 36, LC 8; D approx 150 per quarter, non-maj 130, maj 20
Ent Req: HS dipl, out-of-state, ACT, minimum score 18 or upper-half of class
Degrees: BA, BS and BCS 4 yr
Tuition: Res—undergrad $2,378 per yr, nonres—undergrad $5688 per yr, $2,874 per yr for the following states MN, SD, MT, MB & SK; campus res—room & board $2716 double occupancy per yr
Courses: Advertising Design, †Art Education, Art History, †Ceramics, Color, Costume Design & Construction, Display, Drawing, Graphic Design, Handicrafts, Intermedia, Jewelry, Lettering, Painting, Photography, Printmaking, Sculpture, Stage Design, Teacher Training, Theatre Arts

Adult Hobby Classes: Enrl varies; courses - Photography

FARGO

NORTH DAKOTA STATE UNIVERSITY, Division of Fine Arts, State Univ Sta, PO Box 5691 Fargo, ND 58105. Tel 701-231-8011; Internet Home Page Address: www.ndsu.edu; *Asst Prof* Kimble Bromley, MFA; *Lectr* David Swenson, MFA; *Lectr* Jaime Penuel, BFA; *Lectr* Kent Kapplinger, BFA
Estab 1889, dept estab 1964; Maintain Memorial Union Art Gallery at the University; FT 5; pub; D & E; Scholarships; SC 21; D 225, E 60, non-maj 250, maj 30
Ent Req: HS dipl
Degrees: BA & BS 4 yr
Tuition: Res—undergrad $77.50 per cr hr; nonres—$207 per cr hr; campus res available
Courses: Architecture, Art Appreciation, Art History, Ceramics, Design, Drafting, Drawing, Fashion Arts, History of Art & Architecture, Interior Design, Landscape Architecture, Painting, Photography, Printmaking, Sculpture, Textile Design, Theatre Arts

GRAND FORKS

UNIVERSITY OF NORTH DAKOTA, Art Department, PO Box 7099, Grand Forks, ND 58202. Tel 701-777-2257; Fax 701-777-2903; Elec Mail patrick_luber@und.nodak.edu; Internet Home Page Address: www.und.edu/dept/arts2000/; *Chmn* Patrick Luber
Estab 1883; D FT 11; pub; Scholarships; SC 30, LC 4, GC 14; maj 90, others 1000
Degrees: BFA, BA, BSEd, MFA
Tuition: Campus res—available
Courses: Aesthetics, Art Appreciation, †Art Education, Art History, †Ceramics, Design, †Digital Media, Drawing, †Fibers, Goldsmithing, History of Art & Architecture, †Jewelry, Lettering, †Metalsmithing, †Painting, †Photography, †Printmaking, †Sculpture, Silversmithing, †Teacher Training, †Weaving
Adult Hobby Classes: Enrl 800-1000; tuition $2428 per yr. Courses—Various studio art & art history
Summer School: Dir, J McElroy-Edwards. Enrl 100; tuition one half cash of regular sem. Courses—Varies every summer

JAMESTOWN

JAMESTOWN COLLEGE, Art Dept, PO Box 1559, Jamestown, ND 58402. Tel 701-252-3467; Fax 701-253-4318; Internet Home Page Address: www.jc.edu; *Chmn* Sharon Cox; *Dean Students* Carol Schmeichel
Maintain nonprofit art gallery, Reiland Fine Art Center 6003 College Lane c/o Sharon Cox, Dir Jamestown College, ND 58405; art library; art supplies available on-campus; FT 21; Pvt, den; D & E; Scholarships; SC 13, LC 4; 146, maj 14
Ent Req: HS dipl
Degrees: BA and BS 4 yr, directed study and individual study in advanced studio areas, private studios
Tuition: $6,000 per yr; campus res—available
Courses: †2-D Design; Art Business; Fine Arts, Advertising Design, Art Appreciation, Art History, Ceramics, Design, Drawing, Eastern Art History, Graphic Design, History of Art & Architecture, Painting, Photography, Printmaking, Sculpture, Stage Design, Teacher Training, Textile Design, Weaving
Summer School: Prof Business Jim Dick, Enrl 20-25, 3 sessions of 6 wks beginning in May

MINOT

MINOT STATE UNIVERSITY, Dept of Art, Division of Humanities, 500 University Ave W, Minot, ND 58701. Tel 701-858-3000, 858-3171, 858-3109; Fax 701-839-6933; Elec Mail davidsoc@misu.nodak.edu; Internet Home Page Address: www.warp6.cs.misu.nodak.edu; *Chmn Div Humanities* Conrad Davidson; *Art Dept Coordr* Walter Piehl
Estab 1913; FT 4; pub; Scholarships; SC 30; per quarter 200, maj 40
Degrees: BA & BS 4 yr
Tuition: Res—undergrad $2,553.50; nonres—undergrad $6,300.50; campus res available
Courses: Advertising Design, Art History, Ceramics, Design, Drawing, Handicrafts, Jewelry, Painting, Photography, Printmaking, Sculpture, Silk Screen, Weaving
Summer School: Courses—same as above

VALLEY CITY

VALLEY CITY STATE COLLEGE, Art Dept, 101 College St SW, Valley City, ND 58072. Tel 701-845-7598, 845-0701; Internet Home Page Address: www.vcsu.edu; *Division Chair* Diana P. Skroch; *Instr* Richard Nickel; *Dept Chair* Linda Whitney
Estab 1890, dept estab 1921; pub; D & E; Scholarships; SC 20, LC 3; D 1300, E 200, non-maj 120, maj 30
Ent Req: HS dipl, ACT
Degrees: AA 2 yr, BS & BA 4 yr
Tuition: Res $1586.50 per sem; nonres - $3,241.50 per sem
Courses: †Art Appreciation, †Art Education, Art History, Ceramics, Computer Graphics, Design, Drawing, Mixed Media, Painting, Printmaking, Theatre Arts

WAHPETON

NORTH DAKOTA STATE COLLEGE OF SCIENCE, Dept of Graphic Arts, 800 N Sixth St, Wahpeton, ND 58076-0002. Tel 440-671-2401; Elec Mail wad_king@ndscs.nodak.edu; Internet Home Page Address: www.ndscs.nodak.edu; *Dept Head* Wade King

Estab 1903, dept estab 1970; pub; D & E
Degrees: AA 2 yr
Tuition: Res—$8,670 per yr; nonres—$11,400 per yr plus room and board
Courses: Drafting, Graphic Design, Layout Design & Image Assembly, Lettering, Painting
Adult Hobby Classes: Enrl 15; tuition $30. Courses—Calligraphy, Drawing, Painting
Summer School: varies

OHIO

ADA

OHIO NORTHERN UNIVERSITY, Dept of Art, 525 S Main St, Ada, OH 45810. Tel 419-772-2160; Fax 419-772-2164; Elec Mail art@onu.edu; Internet Home Page Address: www.onu.edu/arts/art; *Chmn* William Brit Rowe; *Assoc Prof Art* Melissa Eddings; *Asst Prof Art* William Mancuso; *Instr* Marty Shuter; *Instr* Bruce Chesser; *Instr* Linda Lehman; *Instr* Rhonda Grubbs; *Instr* Robert Bailey; *Instr* Luke Sheets
Estab 1871; Maintain nonprofit art gallery; Elzay Art Gallery; Stambaugh Theatre Gallery; Pvt; D; Scholarships; SC 30, LC 8; non-maj 20, maj 35
Activities: schols open to freshmen, jr, sr, duration one yr, offered ann
Ent Req: HS dipl, ent exam, portfolio
Degrees: BA and BFA 4 yrs
Tuition: Freshman $8,535 per qtr
Courses: Art Education, Art History, Ceramics, Drawing, Graphic Design, History of Art & Architecture, Jewelry, Museum Studies, Painting, Photography, Printmaking, Sculpture, Teacher Training

AKRON

UNIVERSITY OF AKRON, Myers School of Art, 150 E Exchange St, Akron, OH 44325-7801. Tel 330-972-6030; Fax 330-972-5960; Internet Home Page Address: www.uakron.edu/faa/schools/art/index; *Dept Head* Del Ray Loven
Estab 1967; Maintains nonprofit gallery, Emily Davis Gallery; Pub; D & E; Scholarships; SC 25, LC 7, GC 8; D 943, E 129, non-maj 493, maj 450
Ent Req: HS dipl
Degrees: BA, BFA 4 yr
Tuition: $8,000
Courses: Art Appreciation, Art Education, †Art History, †Art Studio, †Ceramics, Computer, †Drawing, †Graphic Design, History of Art & Architecture, Illustration, †Jewelry, †Metalsmithing, Museum Staff Training, †Painting, †Photography, †Printmaking, †Sculpture, †Silversmithing, Teacher Training, Video

ALLIANCE

MOUNT UNION COLLEGE, Dept of Art, 1972 Clark Ave, Alliance, OH 44601. Tel 330-823-2590, 823-2083 (Chmn), 823-3860 (Secy of Dept); *Chmn* Joel Collins, MFA
Estab 1846; pvt; D; Scholarships; SC 27, LC 6; D 150, non-maj 125, maj 25
Ent Req: HS dipl, SAT
Degrees: BA
Tuition: Undergrad—$12,250 per yr; campus res available
Courses: Aesthetics, Art Education, Art History, Drawing, Painting, Printmaking, Sculpture, Teacher Training

ASHLAND

ASHLAND UNIVERSITY, Art Dept, 401 College Ave, Ashland, OH 44805. Tel 419-289-4142; Internet Home Page Address: www.ashland.edu; *Chmn* David Edgar, MFA; *Prof* Carl M Allen, MA; *Assoc Prof* Charles D Caldemeyer, MFA; *Asst Prof* Keith A Dull, MA; *Asst Prof* Robert A Stanley, EdD
Estab 1878; FT 4; den; D & E; Scholarships; D 1460, maj 32, minors 12
Ent Req: HS dipl
Degrees: BA, BS 4 yr
Tuition: $15,134 per yr
Courses: †Advertising Design, Art Appreciation, Art Education, †Ceramics, †Commercial Art, Computer Art, Constructions, Costume Design & Construction, Design, Drawing, Fashion Arts, Interior Design, Photography/Multi Media, Visual Communication, available through affiliation with the Art Instititue of Pittsburgh: Fashion Illustration

ATHENS

OHIO UNIVERSITY, School of Art, College of Fine Arts, Athens, OH 45701. Tel 740-593-4288, 593-0497; Elec Mail boothe@ohio.edu; Internet Home Page Address: www.ohiou.edu/art/index; *Dir* Power Boothe
Estab 1936; 39; pub; D & E; Scholarships, Fellowships; SC 88, LC 30, LGC 29, SGC 50; maj 573, others 1718
Ent Req: secondary school dipl, portfolio
Degrees: BFA, MA & MFA 4-5 yrs
Tuition: Res—undergrad $163 per cr hr, grad $252 per cr hr; non-res—undergrad $348 per cr hr, grad $484 per cr hr
Courses: †Art Education, †Art History, †Art Therapy, †Ceramics, Drawing, Fibers, Glass, †Graphic Design, †Illustration, †Painting, †Photography, †Printmaking, †Sculpture, †Studio Arts, †Visual Communication
Summer School: Two 5 wk sessions June-July & July-Aug; 8 qtr hr maximum per session; SC, LC, GC

BEREA

BALDWIN-WALLACE COLLEGE, Dept of Art, 95 E Bagley Rd, Berea, OH 44017. Tel 440-826-2900; Internet Home Page Address: www.2.baldwinw.edu; *Prof Art History* Harold D Cole; *Chmn Div* Dr Marc Vincent
Estab 1845; den; D & E; SC 23, LC 12; 1900, maj 65
Degrees: AB 4 yrs
Tuition: $8165 per yr; campus res—available
Courses: Art Education, Art History, Ceramics, Design & Color, Drawing, Painting, Photography, Printmaking, Sculpture

BOWLING GREEN

BOWLING GREEN STATE UNIVERSITY, School of Art, 1000 Fine Arts Bldg, Bowling Green, OH 43403. Tel 419-372-2786; Fax 419-372-2544; *Dir Grad Studies* Charlie Kanwischer; *Chmn Design Studies* Mark Zust; *Chmn 3-D Studies* Kathy Hagan; *Chmn 2-D Studies* Lynn Whitney; *Chmn Art Educ* Dr Karen Kakas; *Chmn Art History* John Lavezzi PhD; *Dir Gallery* Jacqueline Nathan; *Dir* Tomas Hilty
Estab 1910, dept estab 1946; pub; D & E; Scholarships, Fellowships; SC 53, LC 14, GC 33; D 2460, E 150, non-maj 350, maj 750, grad 25, others 15
Ent Req: ACT (undergrad), GRE (grad)
Degrees: BA, BS & BFA 4 yrs, MA 1 yr, MFA 2 yrs
Tuition: Res—undergrad $2172 per sem, grad $232 per cr hr
Courses: Advertising Design, †Art Education, †Art History, †Ceramics, †Computer Art, Design, †Drawing, †Fibers, †Glass, †Graphic Design, Jewelry, †Jewelry/Metals, †Painting, †Photography, †Printmaking, †Sculpture, †Silversmithing, Weaving
Children's Classes: Enrl 100; tuition $40 per 10 wk sem of Sat mornings
Summer School: Dir, Lou Krueger. Enrl 300; tuition $1224 for 8 wk & 6 wk session. Undergrad Courses—Drawing, Photography, Printmaking, Sculpture, Special Workshops

CANTON

CANTON MUSEUM OF ART, 1001 Market Ave N, Canton, OH 44702. Tel 330-453-7666; Fax 330-453-1034; Internet Home Page Address: www.cantonart.org; *Dir* Manuel J Albacete; *Cur Exhibits & Registrar* Lynnda Arrasmith; *Bus Mgr* Kay Scarpitti; *Cur Educ* Laura Kolinski
Pub; D & E; Scholarships; SC 28; D 322, E 984, others 1306
Tuition: Call office for tuition & class schedules
Courses: †Painting, †Pottery, †Sculpture

MALONE COLLEGE, Dept of Art, Division of Fine Arts, 515 25th St NW Canton, OH 44709. Tel 330-471-8100; Fax 330-471-8478; *Assoc Prof* Clair Murray; *Asst Prof* Sam Vasbinder; *Asst Prof* Barbara Drennen; *Chmn Fine Arts* Jesse Ayers
Estab 1956; den; D & E; Scholarships; SC 20, LC 2; D 75, maj 30
Ent Req: HS dipl, ent exam
Degrees: BA & BS(Educ) 4 yrs
Tuition: $19,190 per yr, campus res—room & board $5,640
Courses: Applied Design, Art Appreciation, †Art Education, Art History, Ceramics, Commercial Art, †Drawing, Graphic Communications, History and Criticism of Art, History of Art & Architecture, Jewelry, †Painting, Printmaking, Sculpture, Stage Design, Teacher Training

CHILLICOTHE

OHIO UNIVERSITY-CHILLICOTHE CAMPUS, Fine Arts & Humanities Division, 571 W Fifth St, PO Box 629 Chillicothe, OH 45601. Tel 740-774-7200; Fax 740-774-7214; Elec Mail mcadamsm@ohio.edu; Internet Home Page Address: www.ohiou.edu; *Assoc Prof* Margaret McAdams, MFA; *Assoc Prof* Dennis Deane, MFA
Estab 1946; FT 2 PT 1; pub; D & E; Scholarships
Ent Req: HS dipl, ACT or SAT
Degrees: campus for freshman & sophomores only
Courses: Art Appreciation, Art Education, Art History, Ceramics, Design, Drawing, Film, Graphic Design, History of Art & Architecture, Painting, Photography, Teacher Training

CINCINNATI

ANTONELLI COLLEGE, 124 E Seventh St, Cincinnati, OH 45202. Tel 513-241-4338; Fax 513-241-9396; Internet Home Page Address: www.antonellic.com; *Dept Head Commercial Arts* James Slouffman; *Dept Head Photography* Chas E Martin; *Dept Head Interior Design* Kristen Courtney Altenau; *Dept Head Bus Office Tech* Pam Bingham
Estab 1947; FT 5, PT 12; pvt; D & E; D 200
Ent Req: HS dipl, review of portfolio
Degrees: AAS
Tuition: Undergrad—$250-$500 per quar depending on program
Courses: †Commercial Art, †Interior Design, †Photography
Adult Hobby Classes: Courses offered
Summer School: Courses offered

ART ACADEMY OF CINCINNATI, 1125 St Gregory St, Cincinnati, OH 45202. Tel 513-721-5205; Fax 513-562-8778; Internet Home Page Address: www.artacademy.edu; *Prof* Anthony Batchelor; *Pres* Gregory A Smith, BFA; *Prof* Mark Thomas, MFA; *Instr* Kenn Knowlton, MFA; *Instr* Calvin Kowal, MS; *Instr* Larry May, MFA; *Chmn Acad Studies Dept* Diane Smith, MA; *Instr* Jay Zumeta, MA; *Instr* April Foster, MFA; *Instr* Rebecca Seeman, MFA; *Instr* Paige Williams; *Chmn Foundation Dept* Claire Darley, MFA; *Instr* Gary Gaffney, MFA; *Instr* Kim Krause, MFA

Estab 1887; pvt; D & E; Scholarships; 220
Ent Req: HS grad, SAT
Degrees: degrees cert offered at the Academy, 4-5 yr
Tuition: $12,725 for 4 yr prog
Courses: Advertising Design, Aesthetics, Art Education, Art History, Commercial Art, †Communication Design, Conceptual Art, Constructions, Design, Drawing, Graphic Arts, Graphic Design, Illustration, Museum Staff Training, Painting, Photography, Printmaking, Sculpture
Adult Hobby Classes: Enrl 2000. Courses—Design, Drawing, Illustration, Painting, Photography, Sculpture
Children's Classes: Enrl 500; tuition $100 per class. Courses—Drawing, Painting, 3-D Design

THE ART INSTITUTE OF CINCINNATI, 1171 E Kemper Rd, Cincinnati, OH 43246. Tel 513-751-1206; Fax 513-751-1209; Elec Mail aic@theartinstituteofcincinnati.com; Internet Home Page Address: www.theartinstituteofcincinnati.com; *Design Dir* Roy Waits; *Instr Foundation Art* Cyndi Mendell; *Instr Illustration & Design* Tom Greene; *Pres & CEO* Marion Allman; *Instr Illustration & Design* Frederic Bonin Pissarro; *Instr Computer Graphics* Dan Bittman; *Instr Computer Graphics* Randy Zimmerman; *Instr Computer Graphics* David Griffin
Estab 1976; Maintain nonprofit art gallery; 5 FT, 4 PT; priv; D; Scholarships; D 80
Ent Req: HS dipl, portfolio, interview
Degrees: Design & Computer Graphics AD 2 yr
Tuition: $17,396 per yr
Courses: Advertising Design, Commercial Art, Computer Graphics, Design, Graphic Design, Illustration, Packaging Web

COLLEGE OF MOUNT SAINT JOSEPH, Art Dept, 5701 Delhi Pike, Cincinnati, OH 45233-1670. Tel 513-244-4420; Fax 513-244-4222; Elec Mail dan mader@mail.msj.edu; Internet Home Page Address: www.msj.edu; WATS 800-654-9314; *Assoc* Beth Belknap, MDES; *Asst Prof* John Griffith, MFA; *Asst Prof* Gerry Bellas, MFA; *Chmn* Daniel Mader, MA; *Asst Prof* Robert Voight, BA; *Assoc Prof* Walter Loyola, MFA; *Prof* Sharon Kesterson-Bullen, EdD; *Asst Prof* Craig Lloyd
Estab 1920; den; D & E; Scholarships; SC 35, LC 4; 203 maj
Ent Req: HS dipl, national testing scores
Degrees: AA 2 yr, BA and BFA 4 yr
Tuition: Res—undergrad $14,200 per yr;
Courses: †Art Education, Art History, †Ceramics, †Drawing, †Fabrics Design, †Graphic Design, †Interior Design, †Jewelry, Lettering, †Painting, †Photography, †Pre-Art Therapy, †Printmaking, †Sculpture

UNIVERSITY OF CINCINNATI, School of Art, PO Box 210016, 6431 Aronoff Bldg Cincinnati, OH 45221-0016. Tel 513-556-2962; Fax 513-556-2887; Elec Mail jonathan.riess@uc.edu; Internet Home Page Address: www.daap.uc.edu/art/default; *Dir, School of Art & Prof Fine Arts* Mark Harris MA; *Dir MFA Prog, Chair & Prof Fine Arts* Kimberly Burleigh, MFA; *Dir Art Hist Prog & Asst Prof Art Educ* Theresa Leininger-Miller, PhD; *Dir Art Educ Prog & Asst Prof Art Educ* Flavia Bastos, PhD; *Foundations Coordr, Undergrad Advisor & Assoc Prof Fine Arts* Denise Burge, MFA; *Assoc Prof Fine Arts* Benjamin Britton, MFA; *Prof Fine Arts* Roy Cartwright, MFA; *Assoc Prof Fine Arts* Tarrence Corbin, MFA; *Assoc Prof Fine Arts* Linda Einfalt, MFA; *Prof Fine Arts* Wayne Enstice, MA; *Prof Fine Arts* Frank Herrmann, MFA; *Asst Prof Art History* Mikiko Hirayama, PhD; *Prof Fine Arts* Don Kelley, MFA; *Assoc Prof Fine Arts* Diane Mankin, PhD; *Asst Prof Fine Arts* Matthew Lynch, MFA; *Prof Art History* Kristi Nelson, PhD; *Asst Prof Art History* Kimberly Paice, PhD; *Asst Prof Art Educ* Nancy Parks, EdD; *Prof Art History* Jonathan Riess, PhD; *Chmn & Assoc Prof Art Educ* Robert Russell, PhD; *Prof Fine Arts* Jane Alden Stevens, MFA; *Prof Fine Arts* John Stewart, MFA; *Prof Fine Arts* Jim Williams, MFA; *Assoc Prof Fine Arts* Charles Woodman, MFA
Estab 1819, dept estab 1946; Maintain nonprofit gallery; library; art supplies available for purchase on-site; Pub; D & E; Scholarships
Ent Req: HS dipl - top 3rd class rank, transfers to Fine Arts, portfolio optional & MFA, portfolio required
Degrees: BA(Art History) 4 yr, 5 yr with teaching certification, BFA(Fine Arts) 4 yr, 5 yr with teaching certification, MA(Art History) 2 yr, MA(Art Educ) 2 yr, MFA 2 yr
Tuition: Res— undergrad $1,489, grad $1,798; nonres—undergrad $4,248, grad $3,613; campus res available
Courses: Art Education, Art History, Ceramics, Conceptual Art, Contemporary Art & Theory, Digital Art, Drawing, Electronic Arts, Museum Staff Training, Painting, Photography, Printmaking, Sculpture, Teacher Training, Video
Adult Hobby Classes: Art Education, Art History
Children's Classes: Enrl 25; tuition $60 for 10 wks. Courses—Intro to Life Drawing
Summer School: Dir, Wayne Enstice. Enrl 200. Courses—Art Education, Art History, Fine Arts

XAVIER UNIVERSITY, Dept of Art, 3800 Victory Pky, Cincinnati, OH 45207-7311. Tel 513-745-3811; Fax 513-745-1098; Elec Mail karagheusianm@xavier.edu; Internet Home Page Address: www.xu.edu/art; *Prof & Chair* Marsha Karagheusian-Murphy, MFA; *Prof* Suzanne Chouteau, MFA; *Prof* Kelly Phelps, MFA; *Prof* Kim Howes, MFA
Estab 1831, dept estab 1935; Maintain nonprofit Xavier University Art Gallery, 3860 Pacific Ave., Cincinnati, OH 45207-7311; pvt; D & E; Scholarships; SC 17, LC 20; D 403, E 349, non-maj 349, maj 54
Ent Req: HS dipl, SAT or ACT
Degrees: BA 4 yr, BFA 4 yr
Tuition: Undergrad $10,050 per semester
Courses: Advertising Design, Aesthetics, Art Appreciation, Art Education, Art History, Art Therapy, Ceramics, Collage, Commercial Art, Constructions, Design, Display, Drawing, Graphic Arts, Graphic Design, History of Art, Intermedia, Mixed Media, Painting, Photography, Printmaking, Sculpture, Teacher Training, Textile Design, Weaving

Summer School: Mary Seifried, Dean; Art Appreciation, School Art

CLEVELAND

CASE WESTERN RESERVE UNIVERSITY, Dept of Art History & Art, Mather House, Cleveland, OH 44106-7110. Tel 216-368-4118; Fax 216-368-4681; Elec Mail dxt6@case.edu; Internet Home Page Address: cwru.edu/artsci/arth/arth.html; *Prof* Ellen Landau; *Prof Emeritus* Walter Gibson PhD; *Prof* Edward J Olszewski PhD; *Prof* Henry Adams; *Asst Prof* Tim Shuckerow, MA; *Assoc Prof* Catherine Scallen, MA; *Prof Emeritus* Harvey Buchunan; *Chmn* Charles Burroughs; *Prof* David Carrier; *Asst Prof* Constantine Petridis; *Assoc Prof* Anne Helmreich
Estab 1875; pvt; D & E; Scholarships; SC 24, LC 55, GC 73; D 644, grad 75
Exhibitions: Annual faculty exhibition & MA student shows
Ent Req: HS transcript, SAT or ACT, TOEFL for foreign students
Degrees: BA, BS, MA and PhD
Tuition: $15,120 per sem—undergrad; campus res available; $10,539 per sum—grad
Courses: Architecture, †Art Education, †Art History, Ceramics, Costume Design & Construction, Enameling, †History of Art & Architecture, Jewelry, Medical Illustration, †Museum Staff Training, Painting, Photography, †Teacher Training, Textile Design, Weaving
Summer School: June & July. Courses—Art Education, Art History, Art Studio, Museum Studies

CLEVELAND INSTITUTE OF ART, 11141 E Blvd, Cleveland, OH 44106. Tel 216-421-7000; Fax 216-421-7438; *Pres* David Deming; *Prof* Tina Cassara; *Prof* Michael Holihan; *Prof* Paul St Denis; *Prof* Lawrence Krause; *Prof* Carl Floyd; *Prof* Kenneth Dingwall; *Prof* Eugene Powlowski; *Assoc Prof* Robert Palmer; *Assoc Prof* Brent Young; *Assoc Prof* Richard Hall
Estab 1882; pvt; D & E; Scholarships; SC 90, LC 38; D 483, E 266, non-maj 169, maj 300, others 23
Ent Req: HS dipl SAT, ACT and transcript, portfolio
Degrees: BFA 5 yrs, BS & MEd (educ with Case Western Reserve Univ) 4 yrs
Tuition: Res $25,624 per yr, incl rm & board; non-res $23,768 per yr
Courses: Aesthetics, Art Education, Art History, †Ceramics, †Drawing, †Enameling, †Fiber, †Film, †Glass, †Graphic Arts, †Illustration, †Industrial Design, †Interior Design, †Jewelry, †Medical Illustration, †Painting, †Photography, †Printmaking, †Sculpture, †Silversmithing
Adult Hobby Classes: Enrl 266; tuition varies per course. Course—Calligraphy, Ceramic, Crafts, Design, Drawing, Fiber & Surface Design, Graphic Design, Painting, Printmaking, Sculpture, Silversmithing, Watercolor
Children's Classes: Enrl 210; tuition varies per course. Courses—Art Basics, Ceramic Sculpture, Crafts, Design, Drawing, Painting, Portfolio Preparation, Printmaking, Photography
Summer School: Dir, William Jean. Courses—Ceramics, Design, Drawing, Jewelry & Metalsmithing, Photography, Printmaking, Sculpture, Watercolor

CLEVELAND STATE UNIVERSITY, Art Dept, 2307 Chester Ave, Cleveland, OH 44114. Tel 216-687-2040; Fax 216-687-2275; Internet Home Page Address: www.csuohio.edu; *Chmn & Assoc Prof* George Mauersberger, MFA; *Prof* Thomas E Donaldson PhD; *Prof* Walter Leedy Jr PhD; *Prof* Marvin H Jones, MA; *Prof* Kenneth Nevadomi, MFA; *Prof* Masumi Hayashi, MFA; *Assoc Prof* Kathy Curnow, MFA; *Assoc Prof* Laurel Lampela PhD, MFA; *Assoc Prof* Richard Schneider, MA; *Chmn* John Hunter PhD, MA; *Asst Prof* Claudia Mesch, PhD
Estab 1972; pub; D & E; Scholarships; SC 26, LC 32
Ent Req: HS dipl
Degrees: BA 4 yr
Tuition: Res—undergrad $171 per cr hr
Courses: †Art Education, †Art History, †Ceramics, Computer Graphics, †Drawing, Introduction to Studio Art, †Painting, †Photography, †Printmaking, †Sculpture
Summer School: Chmn, John Hunter. Tuition & courses same as regular schedule

CUYAHOGA COMMUNITY COLLEGE, Dept of Art, 2900 Community College Ave, Cleveland, OH 44115. Tel 216-987-4248, 4600; Elec Mail Gerald-Kramer@tri-C.cc.oh.us; Internet Home Page Address: www.tri-c.cc.oh.us; *Coordr Fine Art Prog* Gerald Kramer, MFA; *Assoc Prof* Richard Karberg; *Assoc Prof* Jacqueline Freedman
Estab 1963. College maintains four campuses; PT 6; pub; D & E; Scholarships; SC 15, LC 4; D 1,000, E 1,000, maj 1,000
Ent Req: HS dipl/GED
Degrees: AA, AS
Tuition: County res—$58.40 per cr hr; out-of-county—$77.55 per cr hr; nonres—$83.50 per cr hr; out-of-state—$159.95
Courses: Art Appreciation, Art Education, Art History, Calligraphy, Ceramics, Graphic Design, Occupational Therapy, Painting, Photography, Printmaking, Sculpture, Stage Design, Teacher Training, Theatre Arts, Video
Summer School: Courses—various

JOHN CARROLL UNIVERSITY, Dept of Art History & Humanities, University Heights, Cleveland, OH 44118. Tel 216-397-4388 (art dept); 397-1886 (main); Internet Home Page Address: www.jcu.edu; *Chmn* Dr Robert H Getscher
Estab 1886, dept estab 1965; pvt; D & E; SC 3, LC 30; D 400, non-maj 350, maj-humanities 30, art hist 14
Ent Req: HS dipl, SAT
Degrees: BA Art History 4 yrs, BA Humanities 4 yrs
Tuition: $17,478 per year; res—MBA $533 per cr hr
Courses: Art History, Drawing, Film, History of Art & Architecture, Modern History

COLUMBUS

CAPITAL UNIVERSITY, Fine Arts Dept, Huber Hall, 2199 E Main St Columbus, OH 43209. Tel 614-236-6201; Fax 614-236-6169; *Chmn* Gary Ross, MA; *Asst Prof* Donald Duncan, MS; *Instr* Gretchen Crawford, MA, ATR, LPC

FT 3
Degrees: BA, BFA
Tuition: $15,260 per yr, grad $508 per cr hr, room & board $4400 per yr
Courses: Advertising Design, Art Education, Art History, Ceramics, Design, Drawing, Jewelry, Painting, Photography, Sculpture, Stained Glass, Theatre Arts, Weaving

COLUMBUS COLLEGE OF ART & DESIGN, Fine Arts Dept, 107 N Ninth St, Columbus, OH 43215. Tel 614-224-9101; Internet Home Page Address: www.ccad.edu; *Dean* Lowell Tolstedt
Estab 1879; 68; pvt; approved for Veterans; D & E; Scholarships
Ent Req: HS grad, art portfolio
Degrees: BFA 4 yr
Tuition: $14,520 per yr
Courses: Advertising Design, Fashion Arts, Fine Arts, Graphic Arts, Illustration, Industrial Design, Interior Design, Packaging Design, Painting, Retail Advertising, Sculpture
Children's Classes: Saturday sessions 9 - 11:30 AM

OHIO DOMINICAN COLLEGE, Art Dept, 1216 Sunbury Rd, Columbus, OH 43219. Tel 614-253-2741, 251-4580; Fax 614-252-0776; *Dept Chmn* William Vensel
Estab 1911; den; D & E; Scholarships; SC and LC 709 per sem; D 139, E 105, maj 17
Ent Req: HS dipl
Degrees: BA 4 yrs, also secondary educ cert or special training cert, K-12
Tuition: $6025 per sem, room & board $5220
Courses: Ceramics, Color & Materials, History of Art, Painting, Sculpture, Studio Humanities

OHIO STATE UNIVERSITY
—**School of Architecture,** Tel 614-292-1012; Fax 614-292-7106; Internet Home Page Address: www.osu.edu; *Dir* Robert Livesey
Estab 1899; FT 43, PT 23; pub; Scholarships; Archit 450, Landscape Archit 170, City & Regional Planning 65
Activities: Schols
Degrees: BS(Archit), MA, PhD
Tuition: Res—$5000 per yr
Courses: City Planning, Design, History of Architecture, Landscape Architecture
Adult Hobby Classes: Enrl limited; Tuition $170-$469.
Summer School: Dir, Robert Liveson. Enrl 50-70; tuition $170-$469 for 10 wks.
—**College of the Arts,** Tel 614-292-5171; Fax 614-292-5218; Internet Home Page Address: www.arts.ohio-state.edu; *Dean* Col Judith Koroscik
Univ estab 1870, col estab 1968; pub; D & E; Scholarships; SC 106, LC 192, GC 208; D 3678, E varies, non-maj 2300, maj 893, grad 150
Ent Req: HS dipl
Degrees: BA, MA, PhD
Tuition: Res—$1200 per qtr; nonres—$3000 per qtr
Courses: Art, Art History, Dance, Music, †Stage Design, †Teacher Training, †Theatre Arts, †Weaving
Adult Hobby Classes: Courses—art experiences in all media for local adults
Children's Classes: Enrl 300 per quarter; fees $36 per quarter; Saturday School. Courses—art experiences in all media for local children
Summer School: Same as regular session
—**Dept of Art,** Tel 614-292-5072; Fax 614-292-1674; Internet Home Page Address: www.osu.edu; *Chmn* Georg Heimdal
FT 36, PT 34; Scholarships; SC 56, LC 6, GC 30
Degrees: BA, BFA, MFA
Tuition: Res—undergrad $6000 per yr, grad $1824 per quarter; nonres—undergrad $3825 per quarter, grad $4724 per quarter
Courses: Art & Technology, Art Critical Practices, †Ceramics, †Drawing, †Glass, †Goldsmithing, †Painting, †Photography, †Printmaking, †Sculpture
Adult Hobby Classes: Offered through CAP (Creative Art Program) & CED (Continuing Education)
—**Dept of Art Education,** Tel 614-292-7183; Fax 614-688-4483; Internet Home Page Address: www.art.ohio-state.edu/ArtEducation; *Chmn Dept* James Hutchens PhD; *Prof* Robert Arnold PhD; *Prof* Terry Barrett PhD; *Prof* Judith Koroscik PhD; *Prof* Michael Parsons PhD; *Prof* Margaret Wyszomirski PhD; *Prof Emeritus* Arthur Efland EdD; *Prof Emeritus* Kenneth Marantz EdD; *Assoc Prof* Don Krug PhD; *Assoc Prof* Sydney Walker PhD; *Prof* Patricia Stuhr PhD; *Assoc Prof* Vesta Daniel EdD; *Asst Prof* Christine Ballangee-Morris PhD; *Asst Prof* Georgianna Short PhD
Estab 1907; pub; D & E; Scholarships, Fellowships; SC 2, LC 42, GC 48, other 14; maj 65, grad 110
Ent Req: HS dipl
Degrees: BAE, MA, PhD
Tuition: Res—$1500 per qtr; nonres—$4300 per qtr
Courses: Art Appreciation, †Art Education, †Art History, †Arts Administration, †Arts Policy, Computer Graphics, Ethnic Art, History of Art, †Industrial Design, †Teacher Training
Summer School: Chmn Dept, James Hutchens, PhD. Courses—Art Educ
—**Dept of Industrial Interior & Visual Communication Design,** Tel 614-292-6746; Fax 614-292-0217; Elec Mail design@osu.edu; Internet Home Page Address: www.arts.ohio-state.edu/design; *Chmn* Wayne E Carlson
FT 11, PT 5; Public ; Day & Evening classes; Scholarships; SC 35, LC 10, GC 10
Degrees: BS, MA, MFA
Tuition: Res—$1461 per quarter; nonres—$4244 per quarter
Courses: 3-D Computer Modeling, †Architecture, †Design, †Design Development, †Design Education, †Design Management, †Graphic Design, Manufacturing Materials & Processes, Research Problems & Design, Visual Thinking Design Methodology
Summer School: Advanced Typography
—**Dept of the History of Art,** Tel 614-292-7481; Fax 614-292-4401; Internet Home Page Address: www.history-of-art.ohio-state.edu;
Estab 1871, dept estab 1968; pub; D & E; Scholarships, Fellowships; LC 56, GC 29; D 854, non-maj 700, maj 71, grad 73

Ent Req: HS dipl
Degrees: BA, MA 2 yrs, PhD 4-6 yrs
Courses: †Art History, History of Art & Archeology
Summer School: Enrl 250; tuition same as regular session for term of ten wks beginning June. Courses—vary each yr

CUYAHOGA FALLS

CUYAHOGA VALLEY ART CENTER, 2131 Front St, Cuyahoga Falls, OH 44221. Tel 330-928-8092; Fax 330-928-8092; Elec Mail cvartcenter@sbcglobal.net; Internet Home Page Address: http://cvartcenter.org/; *Instr* Robert Putka; *Instr* Dino Massaroni; *Instr* Jack Liberman; *Instr* Beth Lindenberger; *Instr* Tony Cross; *Instr* Dave Everson; *Instr* Carolyn Lewis; *Instr* Mary Sanders; *Pres* Larry Kerr; *Instr* Jack Mulhollen; *Dir* Linda Nye; *Instr* Sally Heston; *Instr* Susan Mencini; *Instr* Tom Jones; *Instr* Linda Hutchinson; *Instr* Monalea Hutchins; *Instr* Elinore Korow
Estab 1934; maintains a nonprofit art gallery, 2131 Front St, Cuyahoga Falls, OH, 44221; Nonprofit; D & E; SC 23; 300 D&E
Exhibitions: Regional Painting; Whiskey Painters of America; Summer Painting Show; Members Show; Cuyahoga Falls High School Showing; Small Painting Show; Student Show; Akron Soc Artists; Abstract Show; Akron Camera Club
Ent Req: none, interest in art
Degrees: none
Tuition: $85 members for 10 wks, $100 nonmembers; no campus res
Courses: Ceramics, Collage, †Design, Drawing, †Mixed Media, Painting, †Pottery, †Printmaking, Special Workshops, †Textile Design, †Weaving
Adult Hobby Classes: 200; tuition $85 for members, $100 for nonmembers per 10 wks. Courses—Drawing, Painting, Pottery
Children's Classes: 100; tuition $50 for members, $60 for nonmembers per 10 wks
Summer School: Dir, Linda Nye. Enrl 20. Courses—Same as regular session, Young People's art

STUDIOS OF JACK RICHARD CREATIVE SCHOOL OF DESIGN, Professional School of Painting & Design, 2250 Front St, Cuyahoga Falls, OH 44221. Tel 330-929-1575; Fax 330-929-2285; Elec Mail jackprichard@aol.com; *Dir* Jack Richard
Estab 1960; pvt; D & E; Scholarships; SC 20, LC 10; D 50-60, E 50-60
Degrees: cert of accomplishment
Tuition: $10 - $12 per class
Courses: Aesthetics, †Art Appreciation, Art Education, Color, Design, Drawing, Illustration, Mural, Occupational Therapy, Painting, Photography, †Restoration & Conservation, Sculpture
Adult Hobby Classes: Enrl 200-300 per session; tuition $11 per class. Courses—Design, Drawing, Painting
Children's Classes: Tues morning & evening
Summer School: Dir, Jane Williams. Enrl 90; tuition $10 - $12 per class Courses—Design, Drawing, Painting

DAYTON

SINCLAIR COMMUNITY COLLEGE, Division of Fine & Performing Arts, 444 W Third St, Dayton, OH 45402. Tel 937-512-5313; Fax 937-512-2130; Elec Mail kelly.joslin@sinclair.edu; Internet Home Page Address: www.sinclair.edu; *Chair Arts & Asst Prof* Kelly Joslin; *Assoc Prof* Kevin Harris; *Prof Reach Coordr* Tess Little; *Prof* George Hageman; *Prof* Mark Echtner; *Prof* Richard Jurus; *Instr* Nancy Mitchell; *Asst Prof* Robert Coates; *Instr* Bridgett Bogle; *Asst Prof* Kay Koeninger
Estab 1973; Maintain nonprofit art gallery on-campus; Pub; D & E, wkend & web; Scholarships; SC 80, LC 8; 1,500 per qtr
Exhibitions: Rotating three week exhibitions of nationally known artists in four different galleries
Ent Req: HS dipl, ent exam
Degrees: AA 2 yrs
Tuition: County res—$45.00 per cr hr; non-county res—$73.50 per cr hr; out of state— $145.00 per cr hr; no campus res
Courses: Advertising Design, †Art Appreciation, †Art History, Ceramics, Commercial Art, Digital Photography, Drawing, Graphic Arts, Painting, Photography, Sculpture, Theatre Arts
Adult Hobby Classes: Drawing for seniors - free to those over 60
Summer School: Chair of Art, Kelly Joslin. Enrl 1,200. Courses—Art Appreciation, Ceramics, Computer Photography, Drawing, Printing, Studio Art

UNIVERSITY OF DAYTON, Visual Arts Dept, 300 College Park, Dayton, OH 45469-1690. Tel 937-229-3237; Fax 937-229-3943; Internet Home Page Address: www.as.dayton.edu/visualarts; *Prof, Chmn Dept* Fred Niles, MFA; *Assoc Prof* Mary Zahner PhD, MFA; *Assoc Prof* Tim Wilbers, MFA; *Assoc Prof* Peter Gooch, MFA; *Assoc Prof* Roger Crum PhD, MFA; *Assoc Prof* Gary Marcinowski, MFA; *Asst Prof* Jayne Whitaker, MFA; *Asst Prof* Lari Gibbons, MFA; *Asst Prof* Joel Whitaker, MFA; *Prof* Sean Wilkinson, MFA; *Asst Prof* Judith Huacuja-Person; *Asst Prof* Matt Rapporport
Estab 1850; pvt; D & E; Scholarships; SC 15, LC 8; D 275, E 75-100, non-maj 100, maj 250
Ent Req: HS dipl
Degrees: BA, BFA
Tuition: Campus res—$23,452 per yr
Courses: Animation, †Art Education, †Art History, Ceramics, Computer Modeling, Digital Imaging, Drawing, Illustration, Mixed Media, †Painting, †Photography, †Printmaking, †Sculpture, †Visual Communication Design
Summer School: Tuition $456 per cr hr

WRIGHT STATE UNIVERSITY, Dept of Art & Art History, 3640 Colonel Glenn Hwy, Dayton, OH 45435. Tel 937-775-2896; Fax 937-775-3049; Elec Mail linda.caron@wright.edu; Internet Home Page Address: www.wright.edu/dept/art/art.html; *Chmn* Linda Caron, PhD; *Prof* Thomas Macaulay, MFA; *Prof* Ron Geibert, MFA; *Assoc Prof* David Leach, MFA; *Assoc Prof* Carol Nathanson PhD, MFA; *Assoc Prof* Diane Fitch, MFA; *Assoc Prof* Kimberly Vito, MFA; *Assoc Prof* Glen Cebulash, MFA; *Asst Prof* Penny Park, MFA
Estab 1964, dept estab 1965; Maintain nonprofit art gallery; University Art Galleries, 3640 Col Glenn Hwy, Dayton, OH 45435; Pub; D & E; Scholarships; SC 67, LC 16, GC 8; D 516, E 43, non-maj 80, maj 150
Ent Req: HS dipl
Degrees: BA(Studio Art), BA(Art History), BFA 4 yr
Tuition: Res—undergrad $1,787 per quarter; nonres—undergrad $3,508 per quarter
Courses: Art Education, Art History, Drawing, Painting, Photography, Printmaking, Sculpture
Summer School: Dir, Linda Caron. Enrl 65; tuition res $166 per cr hr, nonres $326 per cr hr. Courses—Drawing, Painting, Photography, Printmaking, Sculpture

DELAWARE

OHIO WESLEYAN UNIVERSITY, Fine Arts Dept, Delaware, OH 43015. Tel 740-368-3600; Fax 740-368-3299; *Prof* Marty J Kalb, MA; *Prof* Carol Neuman de Vegvar PhD, MA; *Chmn* James Krehbiel, MFA; *Assoc Prof* Cynthia Cetlin, MFA; *Asst Prof* Jonathan Quick, MFA
Estab 1842, dept estab 1864; pvt; D & E; Scholarships, Fellowships; D 1925, non-maj 1805, maj 120
Ent Req: HS dipl, SAT or ACT
Degrees: BA and BFA 4 yrs
Tuition: Res—$21,880 per yr; Campus res—room & board $25,890 per yr
Courses: Aesthetics, Art Education, Art History, Ceramics, Computer Graphics, Drawing, Graphic Design, Jewelry, Painting, Photography, Printmaking, Sculpture, Teacher Training
Summer School: Dean, Richard Fusch. Tuition $1125 for 6 wks. Courses—Varies

ELYRIA

LORAIN COUNTY COMMUNITY COLLEGE, Art Dept, 1005 N Abbe Rd, Elyria, OH 44035. Tel 440-366-4032; Fax 440-365-6519; Internet Home Page Address: www.lorainccc.edu; *Chmn* Dr Robert Beckstrom
Estab 1966; FT 2 PT varies by sem
Ent Req: HS diploma or equiv
Degrees: AA
Tuition: County res—$72.50 per cr hr; out-of-county res—$87.50 per cr hr; out-of-state res—$178 per cr hr
Courses: Art Appreciation, Ceramics, Design, Drawing, Painting, Photography, Printmaking, Sculpture, Textile Design

FINDLAY

UNIVERSITY OF FINDLAY, Art Program, 1000 N Main St, Findlay, OH 45840. Tel 419-434-4445; Fax 419-434-4531; Internet Home Page Address: www.findlay.edu; *Dean College Liberal Arts* Dr Dennis Stevens; *Prof* Douglas Salveson; *Assoc Prof* Jack (Ed) Corle; *Asst Prof* Lansford Holness; *Asst Prof* Diane Kontar
Estab 1882; Maintain a nonprofit art gallery; Dudley & Mary Marks Lea Gallery, The Univ of Findlay; FT 4, PT 4; pvt; D & E; Scholarships; SC 21, LC 8; maj 60
Ent Req: HS dipl
Degrees: AA 2yr, BA & BS 4 yr
Tuition: $21,836 per yr
Courses: Advertising Design, Aesthetics, Art Education, Art History, Ceramics, Collage, Drawing, Graphic Design, Painting, Photography, Printmaking, Sculpture, Teacher Training
Adult Hobby Classes: Enrl 10-20. Courses—Ceramics
Children's Classes: Courses—Ceramics, Drawing

GAMBIER

KENYON COLLEGE, Art Dept, Gambier, OH 43022. Tel 740-427-5459; Fax 740-427-5230; Internet Home Page Address: www.kenyon.edu; *Prof* Martin Garhart, MFA; *Prof, Chmn* Barry Gunderson, MFA; *Prof* Eugene J Dwyer PhD, MFA; *Prof, Assoc Provost* Gregory P Spaid, MFA; *Prof* Claudia Esslinger, MFA; *Assoc Prof* Melissa Dabakis, MFA; *Gallery Dir, Vis Asst Prof* Daniel P Younger, MFA; *Vis Asst Prof* K Read Baldwin; *Asst Prof* Sarah Blick; *Vis Assoc Prof Art* Karen M Garhart; *Vis Asst Prof* Marcella M Hackbardt; *Asst Prof* Karen F Snouffer; *Vis Asst Prof* Kristen Van Ausdall
Estab 1824, dept estab 1965; Maintain nonprofit art gallery; Olin Art Gallery, Kenyon College, Gambier, OH 43022; pvt; D; Scholarships; SC 15, LC 10; D 450, non-maj 250, maj 60
Ent Req: HS dipl
Degrees: BA
Tuition: Res—undergrad $22,990 per yr; campus res required
Courses: †Art History, Installation Art, †Studio Art

GRANVILLE

DENISON UNIVERSITY, Dept of Art, 201 Mulberry St, Granville, OH 43023. Tel 614-587-0810; Fax 614-587-6417; Elec Mail green@denison.edu; Internet Home Page Address: www.denison.edu; *Prof* George Bogdanovitch, MFA; *Assoc Prof* L Joy Sperling PhD, MFA; *Dept Chmn* Karl Sandin PhD, MFA; *Assoc Prof* Ronald Abram, MFA; *Asst Prof* Alexander Mouton, MFA; *Asst Prof* Joanna Grabski, PhD; *Asst Prof* Lauren Eisen, MFA
Estab 1831, dept estab 1931; pvt; D; Scholarships; SC 24, LC 16; D 800, maj 65, double maj 35

Ent Req: HS

Degrees: BA, BFA, BS 4 yr

Tuition: Res—undergrad $21,710 per yr; campus res—room $3440, board $2860

Courses: Aesthetics, Architecture, †Art History, †Ceramics, †Drawing, Graphic Arts, Graphic Design, History of Art & Architecture, Mixed Media, Museum Staff Training, †Painting, †Photography, †Printmaking, Restoration & Conservation, †Sculpture

HAMILTON

FITTON CENTER FOR CREATIVE ARTS, 101 S Monument Ave, Hamilton, OH 45041-2833. Tel 513-863-8873; Fax 513-863-8865; Elec Mail rjatfitton@aol.com; Internet Home Page Address: www.fittoncenter.org; *Arts in Common Dir* Henry Cepluch; *Exhib* Cathy Mayhugh; *Exec Dir* Rick H Jones
Estab 1992; pub; D & E; Scholarships; SC 50, LC 2; D & E 400

Ent Req: varies by program

Degrees: MFA

Tuition: $50 & up depending on course

Courses: Aesthetics, Art Appreciation, Art Education, Art History, Drawing, Fashion Arts, Film, Graphic Arts, Graphic Design, Handicrafts, Illustration, Industrial Design, Intermedia, Painting, Photography

MIAMI UNIVERSITY, Dept Fine Arts, 1601 Peck Blvd, Hamilton, OH 45011. Tel 513-529-2900, 785-3000; Fax 513-785-3145; Internet Home Page Address: www.ham.muohio.edu; *Prof* Edward Montgomery; *Art Coordr* Phil Joseph
Date estab 1809; Pub; D; Scholarships

Ent Req: HS diploma

Degrees: BA

Tuition: Full-time $1524.45 per sem; part-time $125.85 per cr hr

Courses: Advertising Design, Art Education, Art History, Drawing, Painting, Printmaking

Summer School: Courses—Drawing, Painting

HIRAM

HIRAM COLLEGE, Art Dept, Dean St, Hiram, OH 44234. Tel 330-569-5304; Fax 330-569-5309; Elec Mail SaffordLB@Hiram.edu; Internet Home Page Address: www.hiram.edu; *Chmn* Lisa Safford; *Prof* George Schroeder; *Assoc Prof* Linda Bourassa
Estab 1850; Maintain nonprofit art gallery; Frohring Art Gallery; FT 3, PT 2; pvt; E & Weekend; Scholarships; SC 21, LC 19; D 400

Ent Req: HS dipl

Degrees: AB 4 yr

Tuition: $19,650 per acad yr

Courses: Aesthetics, Art Education, †Art History, Ceramics, Drawing, Painting, Photography, Printmaking, Sculpture, †Studio Art, Teacher Training

Summer School: Enrl 15-20 per course; 6-7 wks. Courses—Art History, Ceramics, Film Studies, Photography

HURON

BOWLING GREEN STATE UNIVERSITY, FIRELANDS COLLEGE, Humanities Dept, One University Dr, Huron, OH 44839. Tel 419-433-5560; Fax 419-433-9696; Internet Home Page Address: www.firelands.bgsu.edu/~dsapp; *Assoc Prof Art* David Sapp
Estab 1907, col estab 1966; Maintain nonprofit art gallery, Little Gallery; BGSU Firelands, One University Dr, Huron, OH 44839; FT 1, PT 3; pub; D & E Sat; Scholarships; SC 12, LC 3; D 2000

Ent Req: HS dipl, SAT

Degrees: AA 2 yr

Tuition: Res—undergrad $1593 per sem, $157 per cr hr

Courses: Art Education, Art History, Drawing, Enameling, Painting, Printmaking, Studio Foundations

Summer School: Term of 5 wks beginning July. Courses—Studio Courses

KENT

KENT STATE UNIVERSITY, School of Art, Kent, OH 44242. Tel 330-672-2192, 2444; Fax 330-672-4729; Internet Home Page Address: www.kent.edu/; *Dir* William Quinn; *Asst Dir* Joseph Fry; *Grad Coordr* Frank Susi, MFA
Estab 1910; FT 43, PT 6; pub; D & E; Scholarships, Grants; SC 105, LC 35, GC 50; non-maj 600, maj 600, grad 100

Ent Req: HS dipl, ACT

Degrees: BFA, BA 4 yrs, MA 1 - 2 yrs, MFA 2 - 3 yrs

Tuition: Res—undergrad $2643 per sem; grad $2811 per sem; nonres—undergrad $5231 per sem, grad $5399 per sem, $471 per cr hr; campus res—room $1155, board $957 per sem

Courses: Advertising Design, Art Appreciation, †Art Education, †Art History, Calligraphy, †Ceramics, Collage, Commercial Art, Conceptual Art, Constructions, Design, Display, †Drawing, Goldsmithing, Graphic Arts, †Graphic Design, †History of Art & Architecture, Hot Glass, †Illustration, Intermedia, †Jewelry, Lettering, Mixed Media, Museum Staff Training, †Painting, †Printmaking, †Sculpture, Silversmithing, Teacher Training, †Textile Design, †Weaving

Adult Hobby Classes: Tuition free to adults 50 yr & retired or 60 yr old (non-credit basis)

Children's Classes: Enrl 100; tuition $15 per 6 wk session, two 6 wk sessions, fall & spring

Summer School: Dir, William Quinn, Enrl 500; tuition $212 per cr hr, 5 or 10 wk term. Courses—Art Education, Art History, Blossom Art, Fine Arts & Crafts, Visual Communication Design

KIRTLAND

LAKELAND COMMUNITY COLLEGE, Fine Arts Department, 7700 Clock Tower Dr, Kirtland, OH 44094. Tel 440-525-7459 (Dept), 525-7000 (main); Internet Home Page Address: www.lakelandcc.edu; *Prof* Teresa Hess, MFA; *Assoc Prof* Christopher Berry, MFA; *Instr* Derek O'Brien, MFA
Estab 1967, dept estab 1968; Maintains a nonprofit art gallery, 7700 Clocktower Dr, Kirtland, OH, 44094; FT 3 PT varies; pub; D & E, weekends; Scholarships; D & E 350

Ent Req: HS dipl

Degrees: AA with concentration in Art 2 yrs, AA Technology degree in Graphic Design

Tuition: In-county res—$89.90 per cr hr; out-of-county res—$110.15 per cr hr; out-of-state—$235 per cr hr

Courses: Art Appreciation, Art History, Ceramics, Drawing, Jewelry, Painting, Sculpture

Summer School: Courses—Ceramics, Drawing, Jewelry, Painting, Sculpture

MARIETTA

MARIETTA COLLEGE, Art Dept, 215 Fifth St Marietta, OH 45750. Tel 740-376-4643; Fax 740-376-4529; Elec Mail garoza@marietta.edu; Internet Home Page Address: www.mcnet.marietta.edu; *Prof* Ron Wright; *Chmn* Valdis Garoza
Estab 1835; 4; pvt; Grants, Loans; SC 20, LC 7; total col 1600

Degrees: BA(Studio, Art History, Art Education & Graphic Design), BFA

Tuition: $24,580 per yr incl room & board

Courses: Advertising Design, Art Appreciation, Art Education, Art History, Calligraphy, Carving in Wood & Stone, Ceramics, Commercial Art, Computer Graphic, Design, Drawing, Jewelry Making, Life Drawing, Lithography & Silkscreen, Modeling & Casting, Painting, Printmaking, Stained Glass

MOUNT VERNON

MOUNT VERNON NAZARENE UNIVERSITY, (Mount Vernon Nazarene College) Art Dept, 800 Martinsburg Rd, Mount Vernon, OH 43050. Tel 740-397-9000 x 3040; Internet Home Page Address: www.mvnc.edu; *Instr* John Donnelly; *Chmn* Jim Hendrickx
Estab 1968, dept estab 1970; Maintain a nonprofit gallery & library; on-campus bookstore sells art supplies; Den; D & E; Scholarships; SC 20, LC 5; D 1,052, non-maj 1,032, maj 20

Ent Req: HS dipl & grad of upper 2/3, ACT

Degrees: BA; Sr project required for graduation

Tuition: Res, nonres, undergrad $276 per cr hr per term

Courses: Aesthetics, Art Education, Art History, Art in the Western World, Ceramics, Design Fundamentals, Drafting, Drawing, Graphic Communication, Graphic Design, Painting, Photography, Printmaking, Sculpture, Selected Topics, Senior Project

NEW CONCORD

MUSKINGUM COLLEGE, Art Department, Johnson Hall, 163 Stormont St New Concord, OH 43762. Tel 740-826-8211, 826-8310; Internet Home Page Address: www.muskingum.edu/; *Asst Prof* Ken McCollum; *Chmn* Yan John Sun; *Instr* Rhoda Van Tassel; *Instr* Amy Kennedy
Estab 1837; FT 3; pvt; D; Scholarships; SC 13, LC 6; D 300, maj 15

Ent Req: HS dipl, ent exam, specific school standards

Degrees: BA and BS 4 yr

Courses: †Art Education, Art History, Ceramics, Design, Drawing, Graphic Arts, Painting, Photography, Sculpture, Teacher Training

Adult Hobby Classes: Enrl 60. Courses—Art Educ

Children's Classes: Enrl 10. Courses—Ceramics

OBERLIN

OBERLIN COLLEGE, Dept of Art, 87 N Main St, Oberlin, OH 44074. Tel 440-775-8181; Fax 440-775-8969; Internet Home Page Address: www.oberlin.edu; *Chmn* Daniel Goulding PhD; *Prof* John Pearson, MFA; *Assoc Prof* John Kane PhD, MFA; *Assoc Prof* Patricia Mathews PhD, MFA; *Assoc Prof* Sarah Schuster, MFA; *Assoc Prof* Johnny Coleman, MFA; *Assoc Prof* Nanette Yannuzzi Macias, MFA; *Asst Prof* Paul Yanto; *Asst Prof* Pipo Nguien-Ouy; *Asst Prof* Doug Sanderson; *Asst Prof* Andy Shaken; *Asst Prof* Will Wilson; *Asst Prof* Rian Brown-Urso; *Asst Prof* Julie Davis; *Asst Prof* Erik Inglis
Estab 1833, dept estab 1917; pvt; D & E; Scholarships; SC 28, LC 38, advanced undergrad & grad courses 13; D approx 1200, non-maj 500, maj 100, grad 5

Ent Req: HS dipl, SAT

Degrees: BA 4 yr

Tuition: Undergrad $34,648 per yr; campus res—room and board $6560

Courses: Art History, Drawing, History of Art & Architecture, Interactive Media, Painting, Photography, Sculpture, Silkscreening

OXFORD

MIAMI UNIVERSITY, Art Dept, New Art Bldg, Oxford, OH 45056. Tel 513-529-2900; Fax 513-529-1532; *Dean School Fine Arts* Pamela Fox; *Chmn* Jerry W Morris
Estab 1809, dept estab 1929; pub; D & E; Scholarships; SC 49, LC 35, GC 20; D 2309, non-maj 1890, maj 419, grad 32

Ent Req: HS dipl, class rank, ACT or SAT

Degrees: BFA & BS(Art) 4 yrs, MFA 2 yrs, MA(Art or Art Educ)

Tuition: Res—$11,289 with room & board per yr; nonres—$18,435 with room & board per yr

Courses: †Advertising Design, Architecture, †Art Education, †Art History, Calligraphy, †Ceramics, Collage, Commercial Art, Display, †Drawing, Graphic Arts, †Graphic Design, †History of Art & Architecture, Illustration, †Jewelry, Lettering, Museum Staff Training, †Painting, †Photography, †Printmaking, †Sculpture, †Silversmithing, Stitchery, †Teacher Training, Weaving
Children's Classes: Enrl 70; tuition $30 per sem. Courses—General Art
Summer School: Dir, Geoff Eacker. Courses—Crafts

PAINESVILLE

LAKE ERIE COLLEGE, Fine Arts Dept, 391 W Washington St, Painesville, OH 44077. Tel 440-375-7455; Fax 440-375-7454; Internet Home Page Address: www.lakeerie.edu; *Prof* Paul Gothard; *Assoc Prof Theater* John Huston; *Asst Prof Visual Art* Nancy Prudic; *Asst Prof Dance* Lisa DeCat
Estab 1856; maintains nonprofit gallery, BK Smith Gallery; FT 4, PT 2; pvt; D & E; SC 20, LC 7; 800 total
Ent Req: col board exam
Degrees: BA & BFA 4 yrs
Tuition: Res—undergrad $450 per cr hr
Courses: Art Education, †Art History, †Ceramics, Design, Drawing, Introductory Art, †Painting, †Photography, †Printmaking, Sculpture
Summer School: Courses vary

SAINT CLAIRSVILLE

OHIO UNIVERSITY-EASTERN CAMPUS, Dept Comparative Arts, 45425 National Rd, Saint Clairsville, OH 43950. Tel 740-695-1720; Internet Home Page Address: www.eastern.ohiou.edu; *Prof* David Miles
Pub; D & E; Scholarships
Degrees: BA & BS 4 yrs
Tuition: Res—undergrad $92 pr cr hr, grad $100 per cr hr; nonres—undergrad $102 per cr hr, grad $110 per cr hr
Courses: Art Appreciation, Art Education, Design, Drawing, Photography

SPRINGFIELD

SPRINGFIELD MUSEUM OF ART, 107 Cliff Park Rd, Springfield, OH 45501. Tel 937-325-4673; Fax 937-325-4674; *Dir* Mark Chepp
Estab 1951; PT 15; pvt; D & E; Scholarships; D 600
Tuition: $15-$150 for 9 wks sessions
Courses: Ceramics, Drawing, Glass Blowing, Jewelry, Painting, Photography, Sculpture
Adult Hobby Classes: Enrl 287; tuition varies
Children's Classes: Enrl 286; tuition $39 per qtr. Courses—vary

WITTENBERG UNIVERSITY, Art Dept, Koch Hall, N Wittenberg Ave, PO Box 720 Springfield, OH 45501. Tel 937-327-6231; Fax 937-327-6349; Elec Mail jmann@wittenberg.edu; Internet Home Page Address: www.wittenberg.edu; *Prof* Jack Mann, MFA; *Asst Prof* Kevin Salzman, MFA; *Assoc Prof* Ed Charney, MFA; *Asst Prof* Scott Douley, MFA; *Instr* Amy Morris, MA
Estab 1842; maintains nonprofit gallery, Ann Miller Gallery in Koch Hall Art Dept; pvt den; D & E; Scholarships; SC 30, LC 17; D 350, non-maj 270, maj 80
Ent Req: HS dipl, class rank, transcript, SAT or ACT test results, recommendations & if possible, a personal interview
Degrees: BA & BFA 4 yr
Tuition: Nonres—undergrad $22,680 per yr; campus res—room $2984, board $2792
Courses: †Art Education, †Art History, †Ceramics, †Computer Imagaing, Drawing, †Illustration, Jewelry, †Painting, Photography, †Printmaking, †Sculpture, †Teacher Training
Summer School: Provost, William Wiebenga. Enrl 400; tuition $250 for term of 7 wks beginning June 14. Courses—Art in the Elementary School, Fundamentals of Art, Painting

SYLVANIA

LOURDES COLLEGE, Art Dept, 6832 Convent Blvd, Sylvania, OH 43560. Tel 419-885-3211; Fax 419-882-3987; Elec Mail eszavuly@lourdes.edu; Internet Home Page Address: www.lourdes.edu; *Chmn Fine Arts* Erin Palmer Szavuly
Estab 1958; Maintains nonprofit art gallery & art library; Gallery Loft & Sr. Thomas More Library; limited art supplies available on-campus; pvt, den; D & E; Scholarships; SC 12, LC 9; D 70, E 30, non-maj 60, maj 35
Ent Req: HS dipl, ACT or SAT
Degrees: AA, BA, BIS, MA
Tuition: $300 per cr hr; no campus res
Courses: Aesthetics, Art Appreciation, Art Education, Art History, Art Therapy, Calligraphy, Ceramics, Copper Enameling, Design, Drawing, Fiber Arts, Painting, Printmaking, Sculpture, Weaving
Summer School: Dir, Erin Palmer Szavuly. Enrl 30; tuition 274 per cr for 10 wk & 5 wk term. Courses—Art History, Studio Courses

TIFFIN

HEIDELBERG COLLEGE, Dept of Art, 310 E Market St, Tiffin, OH 44883. Tel 419-448-2186; *Chmn* Jim Hagemeyer
Estab 1850; FT 2, PT 3; pvt; D; Scholarships; SC 22, LC 9; 200, maj 24
Ent Req: HS dipl, each applicant's qualifications are considered individually
Degrees: AB 4 yrs, independent study, honors work available
Tuition: $17,849 per yr

Courses: Advertising Design, Aesthetics, Art Education, Ceramics, Chip Carving, Commercial Art, Copper Enameling, Display, Drawing, Graphic Arts, Graphic Design, History of Art & Architecture, Illustration, Jewelry, Lettering, Metal Tooling, Mosaic, Museum Staff Training, Painting, Sculpture, Stage Design, Teacher Training, Textile Design
Summer School: Term of 6 wks beginning June. Courses—Materials & Methods in Teaching, Practical Arts

TOLEDO

UNIVERSITY OF TOLEDO, Dept of Art, University Art Bldg, 620 Grove Place Toledo, OH 43620. Tel 419-530-8300; Fax 419-530-8337; Internet Home Page Address: www.ut.edu; *Chmn* David Guip PhD; *Prof* Diana Attie, MS; *Prof* Linda Ames-Bell, MFA; *Prof* Peter Elloian, MFA; *Assoc Prof* Carolyn Autry, MFA; *Assoc Prof* Marc Gerstein PhD, MFA; *Assoc Prof* Rex Fogt, MFA
Estab 1919; FT 13, PT 12; D & E; Scholarships
Ent Req: HS dipl
Degrees: BA, BFA, BEd 4 yr; MEd (Art Educ) 2 yr
Tuition: Res—undergrad $1913 per sem or per cr hr, grad $2741 per sem; nonres—undergrad $2882 per quarter, grad $3629 per quarter or $209 per cr hr
Courses: Advertising Design, Art Education, †Art History, †Ceramics, Design, †Drawing, †Metalsmithing, †Painting, †Photography, †Printmaking, †Sculpture
Summer School: Courses offered from those above

WESTERVILLE

OTTERBEIN COLLEGE, Art Dept, Westerville, OH 43081. Tel 614-823-1258, 823-1556 (General); Fax 614-823-1118; *Chmn* Nicholas Hill
Maintains a nonprofit art gallery, Dunlap Gallery, Batelle Fine Art Center; OC Fisher Gallery, Roush Hall, O C; Westerville, OH 43081; Pvt; D & E; Scholarships; SC 11, LC 4; maj 100
Ent Req: HS dipl
Degrees: BA 4 yrs
Tuition: Res—undergrad $21,342 per yr; campus res—room & board $6,189
Courses: Art Education, Art History, Ceramics, Computer Art, Drawing, Graphic Design, Painting, Photography, Printmaking, Sculpture

WILBERFORCE

CENTRAL STATE UNIVERSITY, Dept of Art, P.O. Box 1004, Wilberforce, OH 45384-1004. Tel 513-376-6011; Elec Mail info@csu.sec.edu; Internet Home Page Address: www.centralstate.edu/; *Assoc Prof* Abner Cope; *Assoc Prof* Larry Porter; *Assoc Prof* Ronald Claxton; *Asst Prof* Dwayne Daniel
Estab 1856; FT 6; D; SC 20, LC 8; D 175, maj 50, others 130
Ent Req: HS dipl
Degrees: BA and BS 4 yr
Tuition: Res—$3453 for 3 qtrs; non-res—$7566 for 3 qtrs
Courses: Advertising Design, Art Education, Art History, Ceramics, Drawing, Graphic Arts, Lettering, Painting, Sculpture, Studio, Teacher Training

WILBERFORCE UNIVERSITY, Art Dept, P.O. Box 1001, Wilberforce, OH 45384. Tel 937-376-2911; *Advisor* James Padgett, MFA
Estab 1856; dept estab 1973; pvt; D; Scholarships; SC 22, LC 5
Ent Req: HS dipl
Degrees: BA, BS & BA(Educ) 4 yrs
Tuition: $8860 per yr
Courses: Commercial Art, Fine Arts, Printmaking, Sculpture, Teacher Training
Summer School: Courses offered

WILLOUGHBY

WILLOUGHBY SCHOOL OF FINE ARTS, Visual Arts Dept, 38660 Mentor Ave, Willoughby, OH 44094. Tel 440-951-7500; Fax 440-975-4592; Elec Mail info@fineartsassociation.org; Internet Home Page Address: www.fineartsassociation.org/; *Dept Chair* Mary Sarns; *Dir* Charles Lawrence
Estab 1957; pvt; D & E; Scholarships; D 85, E 195
Tuition: $57-$180 per class; no campus res
Courses: Ceramics, Drawing, Intermedia, Mixed Media, Painting, Photography

WILMINGTON

WILMINGTON COLLEGE, Art Dept, 251 Ludovic St, Wilmington, OH 45177. Tel 937-382-6661, Ext 474; Internet Home Page Address: www.wchome.wilmington.edu; *Chmn* Hal Shunk; *Prof* Terry Inlow
Scholarships
Degrees: BA
Tuition: $12,790 per yr
Courses: Art Education, Art History, Ceramics, Design, Drawing, Handicrafts, Painting, Photography, Printmaking, Sculpture, Stage Design

WOOSTER

COLLEGE OF WOOSTER, Dept of Art, Ebert Art Ctr, 1220 Beall Ave Wooster, OH 44691. Tel 330-263-2388; Fax 330-263-2633; Elec Mail dwarner@wooster.edu; Internet Home Page Address: wooster.edu/art; WATS 800-321-9885; *Assoc Prof* Linda Hults PhD; *Chmn* Walter Zurko, MFA; *Slide Cur* Yan Zhou, MFA; *Admin Asst* Donna Warner, MFA; *Vis Prof* John Siewert, PhD; *Asst Prof* Marina Manguba, MFA; *Vis Prof* Daniel Connolly, PhD; *Vis Prof* Erin Sotak, MFA
Estab 1866; pvt; D & E; SC 13, LC 19; D 1800, maj 40
Ent Req: HS dipl

Degrees: BA 4 yr
Tuition: $27,200 per yr (board & room included)
Courses: Architecture, Art Education, †Art History, Ceramics, Drawing, History of Art & Architecture, Mixed Media, Painting, Photography, Printmaking, Sculpture, Studio Art
Adult Hobby Classes: Available through student activities board. Enrl 12-20; tuition varies
Summer School: Dir, Dr Charles Hampton

YELLOW SPRINGS

ANTIOCH COLLEGE, Visual Arts Dept, Yellow Springs, OH 45387. Tel 937-767-7331; Fax 937-767-6470; *Prof* Christopher Garcia, MFA; *Prof* Nevin Mercede, MFA; *Prof* David Lapalombara, MFA
Estab 1853; pvt; D & E; SC 48, LC 10; D 665 per sem, non-maj 100, maj 50
Ent Req: HS dipl
Degrees: BA
Tuition: $25,072 per yr (tuition, fees, room & board)
Courses: Ceramics, Drawing, Painting, Printmaking, Sculpture

YOUNGSTOWN

YOUNGSTOWN STATE UNIVERSITY, Dept of Art, One University Plaza, Youngstown, OH 44555. Tel 330-742-3000 (Main), 742-3627 (Dept); Fax 330-742-7183; Internet Home Page Address: www.ysu.edu; *Chmn* Susan Russo
Estab 1908, dept estab 1952; FT 15, PT 13; pub; D & E; SC 44, LC 26, GC 8; D & E 1250, maj 300, grad 15
Ent Req: HS dipl
Degrees: AB, BFA & BS 4 yrs
Tuition: Res—$134 per cr, room & board $4970; non res—$2184 per sem
Courses: Art & Technology, †Art Education, †Art History, †Ceramics, †Commercial Art, Drawing, Graphic Arts, †Graphic Design, Illustration, Jewelry, Museum Staff Training, †Painting, Photography, †Printmaking, †Sculpture, †Teacher Training
Adult Hobby Classes: Courses—Calligraphy, Ceramics, Drawing, Painting, Photography, Weaving
Summer School: Two 5 wk sessions beginning June. Courses—same as above

OKLAHOMA

ADA

EAST CENTRAL UNIVERSITY, Art Dept, 1100 E 14th St, Box L-3 ECU Ada, OK 74820. Tel 580-310-5353; Fax 580-436-4042; Elec Mail bjessop@mailclerk.ecok.edu; Internet Home Page Address: www.ecok.edu; *Chair* F Bradley Jessop, EdD; *Asst Prof* Stefan Chinov, MFA; *Asst Prof* Kathleen Rivers-Landes, MFA; *Instr* Wavneath Weddle, MEd; *Instr* Michael Hughes, PhD; *Instr* Bill Roach, MEd
Estab 1909; Maintain nonprofit art gallery; East Central Univ Gallery 1100 E 14th, Ada OK 74820; pub; D & E; Scholarships; SC 30, LC 10, GC 8; D 350, E 45, non-maj 300, maj 45, grad 2
Ent Req: HS dipl, ACT
Degrees: BA & BA(Educ) 4 yr, MEd 33 hrs, post grad work, pub service prog
Tuition: Res—undergrad $99.85, grad $121.85; nonres—undergrad $238.95, grad $287.10
Courses: Aesthetics, Art Appreciation, †Art Education, Art History, Ceramics, Design, Drawing, Graphic Design, Handicrafts, History of Art & Architecture, Painting, Photography, Printmaking, Sculpture
Adult Hobby Classes: Enrl 25 average. Courses—Drawing, Painting
Children's Classes: Drawing, painting
Summer School: Chair, Dr Bradley Jessop. Tuition undergrad $99.85, grad $121.25. Courses—Art Education, Drawing, Painting, Sculpture

ALTUS

WESTERN OKLAHOMA STATE COLLEGE, Art Dept, 2801 N Main, Altus, OK 73521. Tel 580-477-2000; Fax 580-521-6154; Internet Home Page Address: www.western.cc.uk.us; *Chmn* Jerry Bryan
Pub; D&E; Scholarships
Degrees: AA, AS, AT
Tuition: Res—undergrad $45 per hr; nonres—undergrad $67.50 per hr
Courses: Advertising Design, Art Appreciation, Art History, Ceramics, Design, Drawing, Handicrafts, Jewelry, Painting, Photography, Printmaking, Sculpture, Stage Design, Video, Weaving

BETHANY

SOUTHERN NAZARENE UNIVERSITY, Art Dept, 6729 NW 39th Expressway, Bethany, OK 73008. Tel 405-789-6400; Fax 405-491-6381; Internet Home Page Address: www.snu.edu; *Dean Arts & Sciences* Martha Banz
Estab 1920; den; D & E; Scholarships; SC 13, LC 7; D 51, E 6, non-maj 38, maj 13
Ent Req: HS dipl, ACT
Tuition: Res—undergrad $158 per hr, grad $190 per hr; campus res available
Courses: Aesthetics, Art Education, Art History, Commercial Art, Crafts, Drawing, Painting, Pottery, Printmaking, Sculpture, †Teacher Training
Children's Classes: Enrl 55; tuition $115 one wk summer art camp (grades 3 - 12). Courses—Drawing, Pottery, Watercolor & various crafts
Summer School: Dir, Nila Murrow. Same as children's classes

CHICKASHA

UNIVERSITY OF SCIENCE & ARTS OF OKLAHOMA, Arts Dept, 17th and Grand St, Chickasha, OK 73018. Tel 405-224-3140, Ext 301; Elec Mail faclamarak@usao.edu; Internet Home Page Address: www.usao.edu/usao.art; *Chmn, Prof Art* Kent Lamar, MFA; *Prof* Steven Brown, MFA; *Instr* Jaymes F Dudding, MFA; *Instr* Jacquelyn Knapp, MFA; *Instr* Holli S Howard
Estab 1909; pub; D; Scholarships; SC 26, LC 3; maj 84, others 180
Degrees: BA
Tuition: Res—undergrad $49 per hr, grad $50 per hr; nonres—undergrad $143 per hr; room and board available
Courses: Ceramics, Computer Graphics, Design, Drawing, Jewelry, Painting, Photography, Pottery & Modeling, Printmaking, Sculpture, Teacher Training
Adult Hobby Classes: Enrl 30; tuition $43 per hr. Courses—Ceramics, Drawing, Graphics Design
Summer School: Enrl 60; tuition $47 per hr for 10 wk course. Courses—Ceramics, Jewelry, Painting, Photography, Sculpture

CLAREMORE

ROGERS STATE COLLEGE, Art Dept, 1701 W Will Rogers Blvd, Claremore, OK 74017-3252. Tel 918-341-7510, 343-7744; *Dir* Gary E Moeller, MFA
Estab 1971; pub; D & E; Scholarships; SC 22, LC 3; D 126, E 60, non-maj 146, maj 82
Ent Req: HS dipl, ACT
Degrees: AA & AS 2 yr
Tuition: Res—$58.50 per hr; nonres—$185.65 per hr; Campus res—room & board available
Courses: Art History, Ceramics, Drawing, †Fine Arts, †Graphic Technology, Lettering, Painting, Photography, Printmaking, Sculpture
Children's Classes: Tuition $42 per hr. Courses—Children's Art
Summer School: Tuition $42 per hr for term of 8 wks beginning June 5th. Courses—Advanced Ceramics, Art Appreciation, Drawing, Graphic Technology, Painting

DURANT

SOUTHEASTERN OKLAHOMA STATE UNIVERSITY, Fine Arts Dept, Visual Arts Division, Box 4231, Durant, OK 74701-6069. Tel 580-745-2352; Fax 580-745-7477; Elec Mail gbeach@sosu.edu; Internet Home Page Address: www.sosu/departments/art; *Chmn* Dr Michael Miles; *Dir Art Activities* Gleny Beach; *Instr* Greg Reimen; *Instr* Jack Ousey
Estab 1909; pub; D; Scholarships
Ent Req: HS dipl, col exam
Degrees: BA & BAEduc 4-5 yrs, BS Graphic Design & Visual Communication
Tuition: Res—lower div $65 per hr, upper div $85 per hr, grad div $85 per hr; nonres—lower div $195 per hr, upper div $195 per hr, grad div $240 per hr
Courses: †Aesthetics, Applied Design, Art Appreciation, Art Education, Art History, Ceramics, †Commercial Art, Crafts, Design, Drawing, Graphic Arts, †Graphic Design, Jewelry, †Non-Western Art & Culture, Painting, †Photography, Printmaking, Sculpture
Adult Hobby Classes: Enrl 20; 12 wk term. Courses—Ceramics, Drawing, Jewelry, Painting
Summer School: Dir, Susan H Allen. Enrl 130; tuition same as above. Courses—Art Appreciation, Ceramics

EDMOND

UNIVERSITY OF CENTRAL OKLAHOMA, Dept of Art & Design, 100 N University Dr, Edmond, OK 73034-0180. Tel 405-974-5201; Fax 405-341-4964; *Chmn* Dr Bob E Palmer
Estab 1890; pub; D & E; Scholarships; maj 280, grad 20, dept 1168, school 13,086
Ent Req: HS dipl, health exams, IQ test, scholarship tests
Degrees: BA, BS and MEduc 3-4 yrs
Tuition: Res $55-65 per cr hr
Courses: Advertising Design, African Art, Art Appreciation, †Art Education, Art History, Art in America, Arts & Crafts, Ceramics, Commercial Art, Drawing, Etching & Lithography, Figure Drawing, †Graphic Arts, †Graphic Design, Illustration, Jewelry, Metal Design, Mixed Media, Museum Staff Training, Painting, †Photography, Printmaking, Sculpture, Studio Art, Teacher Training, Weaving
Summer School: Chmn, Dr Bob E Palmer. Enrl 276; tuition $60.20 per cr hr lower div, $61.20 per cr hr upper div. Courses—Art Appreciation, Art History, Ceramics, Computer Graphics, Design, Drawing, European Study Tour, Fibers, Figure Drawing, Jewelry, Painting, Sculpture

LAWTON

CAMERON UNIVERSITY, Art Dept, 2800 W Gore Blvd, Lawton, OK 73505. Tel 580-581-2450; Fax 580-581-2453; Elec Mail tammyj@cameron.edu; Internet Home Page Address: www.cameron.edu; *Chmn* Edna McMillan; *Prof* Benson Warren; *Assoc Prof* Kathy Liontas-Warren; *Asst Prof* Monika Linehan; *Asst Prof* Elizabeth Tilak
Estab 1970; FT 5; pub; D & E; Scholarships; SC 22, LC 5; D 417, E 90, maj 60
Ent Req: HS dipl
Degrees: BA & BFA 4 yrs
Tuition: Res—undergrad $67 per hr, grad $82.45 per hr; nonres—undergrad $148 per hr, grad $188.45 per hr; campus res—room & board $405 per sem
Courses: Art Appreciation, Art Education, †Art History, Ceramics, Color, Crafts, Design, Drawing, Graphic Arts, Graphic Design, †Mixed Media, Painting, Photography, †Printmaking, †Sculpture

Summer School: Courses—Art Education, Ceramics, Drawing, Graphics, Mixed Media, Painting, Photography, Printmaking

MIAMI

NORTHEASTERN OKLAHOMA A & M COLLEGE, Art Dept, 200 I St NE Miami, OK 74354. Tel 918-542-8441, 540-6354; Internet 918-542-9759; Internet Home Page Address: www.neoam.cc.ok.us/; *Instr* Kirsten Couch; *Chmn* David Froman
Estab 1919; pub; D & E; Scholarships; SC 12, LC 3
Ent Req: HS dipl
Degrees: AA 2 yr
Tuition: Res—$45.50 per hr; nonres—$113; campus res available
Courses: Advertising Design, Art Appreciation, Art Education, Calligraphy, Ceramics, Commercial Art, Costume Design & Construction, Design, Display, Drawing, Fashion Arts, Graphic Arts, Lettering, Painting, Photography, Sculpture, Stage Design, Theatre Arts, Video

NORMAN

UNIVERSITY OF OKLAHOMA, School of Art, 520 Parrington Oval, Rm 202, Norman, OK 73019. Tel 405-325-2691; Fax 405-325-1668; Internet Home Page Address: www.ou.edu/finearts/art; *Dir* Dr Andrew Phelan; *Asst Dir Undergrad* Karen Hayes-Thumann; *Asst Dir Grad* Andrew Stout
Estab 1911; pub; D&E; Scholarships; SC 65, LC 25, GC 15; maj 400, others 1200
Degrees: BFA, BA(Art History), MA(Art History) & MFA
Courses: Art Appreciation, Art Education, †Art History, †Ceramics, †Drawing, Figurative Sculpture, †Film, †Graphic Design, Jewelry, Metal Design, Museum Staff Training, †Painting, †Photography, Printmaking, Sculpture, Video

OKLAHOMA CITY

OKLAHOMA CHRISTIAN UNIVERSITY OF SCIENCE & ARTS, Dept of Art & Design, PO Box 11000, Oklahoma City, OK 73136-1100. Tel 405-425-5556; Fax 405-425-5547; Internet Home Page Address: www.ocusa.edu; *Assoc Prof* Cherry Tredway PhD, MFA; *Asst Prof* David Crismon, MFA; *Med Adjunct Prof* Annette Pate, MEd; *Adjunct Prof* Skip McKinstry, MEd; *Adjunct Prof* Donna Watson PhD, MEd; *Chmn* Michael J O'Keefe, MFA
Estab 1949; FT 2 PT 15; D; Scholarships
Ent Req: Check with admissions
Degrees: BFA
Tuition: $2125 per trimester (12-16 hrs)
Courses: †Advertising Design, Art Appreciation, †Art Education, Art History, Computer Graphics, Design, Drawing, Graphic Design, Illustration, †Interior Design, Painting, Photography, Printmaking, Stage Design

OKLAHOMA CITY UNIVERSITY, Norick Art Center, 2501 N Blackwelder, Oklahoma City, OK 73106. Tel 405-521-5226; Fax 405-557-6029; Internet Home Page Address: www.okcu.edu; *Chmn* Jack R Davis; *Prof* Bruce Macella
Estab 1904; FT 2, PT 8; den; D & E; Scholarships; SC 36, LC 6; maj 45
Ent Req: HS dipl or equivalent
Degrees: 4 yr
Tuition: $4025 per sem
Courses: Airbrush, Art History, Ceramics, Computer Graphics, Design, Drawing, †Graphic Design, History of Art & Architecture, Illustration, Mixed Media, Painting, Photography, Printmaking, Sculpture, †Studio Art, Teacher Training
Adult Hobby Classes: Summer workshops
Summer School: Chmn, Jack Davis. Enrl 15; tuition $335 per cr hr for two 6 wk sessions May to July, July to August. Courses—Ceramics, Drawing, Painting, Sculpture

OKMULGEE

OKLAHOMA STATE UNIVERSITY, Graphic Arts Dept, Visual Communications, 1801 E Fourth, Okmulgee, OK 74447. Tel 918-293-5050; Fax 918-293-4625; Elec Mail braithw@osu-okmulgee.edu; Internet Home Page Address: www.osu.okmulgee.edu; *Instr* Mark Moore; *Instr* Kurt Stenstrom; *Instr* James McCullough; *Instr* Mary Trammell; *Instr* Dennis Crouch; *Instr* Mary Dickson; *Instr* Pam Wedel; *Instr* Gary Jobe; *Instr* Becky Mounger; *Instr* Jerry Poppenhouse
Estab 1946, dept estab 1970; Maintain nonprofit art gallery, Conoco Art Gallery, Student Union, OSU-Oumulgee; FT 10, PT 1; pub; D & E; Scholarships; SC 12, LC 1; D 130, E 18
Ent Req: HS dipl or 18 yrs of age
Degrees: 2 yr Associate, degree granting technical school
Tuition: Res—$105 per hr; out-of-state $238 per cr hr
Courses: Advertising Design, †Art History, Commercial Art, Drafting, Drawing, Graphic Arts, †Graphic Design, Illustration, Lettering, †Multimedia, Photography, †Studio
Summer School: Tuition same as above per trimester beginning June 1st to last of Sept

SHAWNEE

OKLAHOMA BAPTIST UNIVERSITY, Art Dept, 500 W University, Shawnee, OK 74801. Tel 405-275-2850, Ext 2345; Fax 405-878-2069; Internet Home Page Address: www.okbu.edu; *Part-Time Instr* Gloria Duncan, MA; *Instr* Julie Blackstone, MA; *Part-Time Instr* Chris Owens, MFA; *Chmn* Prof Steve Hicks, MFA; *Asst Prof* Judi McGee
Estab 1910; Maintain nonprofit art gallery; Den; D & E; Scholarships; SC 23, LC 8, grad 1; D 216, E 17, non-maj 86, maj 48
Ent Req: HS dipl, SAT-ACT

Degrees: BA & BFA 4 yrs
Tuition: Res—undergrad $6,143 per sem, $330 per hr; nonres—undergrad $3,830; campus res—room & board $2,000 per acad yr
Courses: Art Appreciation, †Art Education, Art History, Calligraphy, Ceramics, Design, †Drawing, Fibers, Graphic Arts, Graphic Design, History of Art & Architecture, Museum Staff Training, †Painting, Photography, †Printmaking, Teacher Training, Theatre Arts, Weaving

SAINT GREGORY'S UNIVERSITY, Dept of Art, 1900 W MacArthur Dr, Shawnee, OK 74801. Tel 405-878-5100; *Chmn & Prof Emerita* Shirlie Bowers Wilcoxson, BFA; *Instr* Stephen L Mauldin, MFA
Estab 1898, dept estab 1960; den; D & E; Scholarships; SC 8, LC 4; D 750
Ent Req: HS dipl, ACT or SAT
Degrees: AA 2 yrs, 4 yrs
Tuition: $3330 per sem
Courses: †Art Appreciation, Art History, Ceramics, Commercial Art, Drawing, Mixed Media, †Museum Staff Training, †Painting, †Photography, Sculpture

STILLWATER

OKLAHOMA STATE UNIVERSITY, Art Dept, 108 Bartlett Ctr for the Visual Arts, Stillwater, OK 74078. Tel 405-744-6016; Fax 405-744-5767; Elec Mail osu-art@okstate.edu; Internet Home Page Address: www.art.okstate.edu; *Assoc Prof* Kristy Andrew; *Prof* Marty Avrett; *Assoc Prof* Dean Bloodgood; *Assoc Prof* Carey Hissey; *Prof* Bob Parks; *Assoc Prof* Jeff Price; *Prof* Chris Ramsay; *Asst Prof* Brandon Reese; *Assoc Prof* Dave Roberts; *Prof* Marcella Sirnandi; *Prof* Mark Sisson; *Assoc Prof* Jack Titus; *Asst Prof* Mark White; *Assoc Prof* Nancy Wilkinson
Estab 1890, dept estab 1928; Maintain nonprofit art gallery; Gardiner Art Gallery, 108 Bartlett Ctr for the Visual Arts, Okla State U, Stillwater, OK 74078-4085; art library, Rena Penn Brittan Reading Room; Pub; D & E; Scholarships; SC 33, LC 17; D 850, E 60, non-maj 810, maj 210
Ent Req: HS dipl
Degrees: BA, BA(Art Hist), BFA, 4 yr
Tuition: Lower div res—$97 per credit hr; non-res—$340 per credit hr; div res—$97 per credit hr
Courses: Art Appreciation, Art History, Ceramics, Computer Graphics, Design, Drawing, Graphic Arts, Graphic Design, Illustration, Jewelry, Painting, Printmaking, Sculpture, Typography
Adult Hobby Classes: Enrl 169; tuition $950 per sem. Courses—Lecture, Studio
Summer School: Dept Head, Nicholas Bormann

TAHLEQUAH

NORTHEASTERN STATE UNIVERSITY, College of Arts & Letters, 600 N Grand, Tahlequah, OK 74464. Tel 918-456-5511, Ext 2705; Fax 918-458-2348; Internet Home Page Address: www.nsuok.edu;Dr Kathryn D Robinson; *Instr* Jerry Choate, MFA; *Instr* R C Coones, MFA; *Chmn* James Terrell, EdD; *Instr* Bobby Martin; *Instr* Dawn Ward; *Instr Art History* Andrew Vassar; *Asst Dean* Paul Westbrook
Estab 1889; pub; D & E; Scholarships; non-maj 50, maj 30, grad 10
Ent Req: HS dipl
Degrees: BA & BA(Educ) 4 yr
Tuition: Res—undergrad $59.15 per hr, grad $59.96 per hr; nonres—undergrad $137.65 per hr, grad $154.44; campus res available
Courses: Art Education, Art History, Ceramics, Commercial Art, Costume Design & Construction, Drafting, Drawing, Graphic Arts, Lettering, Painting, Photography, Printmaking, Sculpture, Stage Design, Teacher Training, Theatre Arts
Adult Hobby Classes: Enrl 20; tuition $20.85 per cr hr for 1 sem.
Courses—Indian Art
Summer School: Dir, Tom Cottrill. Courses—Art Education, Fundamentals of Art

TULSA

ORAL ROBERTS UNIVERSITY, Art Dept, 7777 S Lewis, Tulsa, OK 74171. Tel 918-495-6611; Fax 918-495-6033; Elec Mail sbranston@oru.edu; Internet Home Page Address: www.oru.edu; *Chmn* Stuart Branston, MFA; *Assoc Prof* Douglas Latta, MFA; *Adjunct Prof* Dorothea Heit, MFA; *Instr* Nathan Opp, MA; *Adj Prof* Darlene Gaskil
Estab 1965; pvt; D & E; Scholarships; SC 22, LC 3; D 287, maj 100, others 87
Ent Req: HS dipl, SAT
Degrees: BA(Art Educ), BA & BS(Graphic Design Print), BA(Studio Art) & BS(Graphic Design Video) 4 yrs
Tuition: Res & nonres—undergrad $320 per hr, $3255 per sem 12 - 18.5 hrs; campus res—room & board $2500
Courses: Advertising Design, Art Appreciation, †Art Education, Art History, Calligraphy, Ceramics, Constructions, Design, Drawing, Graphic Arts, †Graphic Design, Handicrafts, Illustration, Interior Design, Intermedia, Jewelry, Lettering, Mixed Media, Painting, Photography, Printmaking, Sculpture, †Studio Art, Teacher Training

TULSA COMMUNITY COLLEGE, Art Dept, 909 S Boston Ave, Tulsa, OK 74119. Tel 918-595-7000; Fax 918-595-7295; Internet Home Page Address: www.tulsa.cc.okay.us; *Instr* Dwayne Pass, MFA; *Instr* William Derrevere, MA
Estab 1970; Maintain nonprofit art gallery; PT 8; pub; D & E; Scholarships; SC 16, LC 7; non-maj 40, maj 160
Ent Req: HS dipl
Degrees: AA 2 yrs
Tuition: Campus residency available
Courses: Art Appreciation, Art History, Commercial Art, Design, Drawing, Goldsmithing, Graphic Arts, Health & Safety for Artists & Craftsmen, Jewelry, Painting, Photography, Printmaking, Sculpture, Silversmithing
Adult Hobby Classes: Special prog of art courses & crafts courses
Summer School: Art Appreciation, Color & Design, Drawing, Painting

UNIVERSITY OF TULSA, School of Art, 600 S College Ave, Tulsa, OK 74104. Tel 918-631-2202; Fax 918-631-3423; Internet Home Page Address: www.utulsa.edu; *Asst Prof, Art Hist & Visual Cult* Michaela Merryday; *Asst Prof, Photog* Glenn Herbert Davis; *Asst Prof, Art Hist* Susan M Dixon
Estab 1898; Maintain nonprofit art gallery, Alexandre Hogue Gallery, financed by University (annual attendance 1,000); pvt; D & E; Scholarships; SC 20, LC 13, GC 22, Continuing Educ; maj 110, others 400
Degrees: BA, BFA, MA, MFA and MTA 4 yrs
Tuition: Res—$5865 per yr; campus res available
Courses: Advertising Design, Architecture, Art Appreciation, †Art Education, Ceramics, Graphic Design, †Painting, Photography, †Printmaking, †Sculpture
Adult Hobby Classes: Courses offered through Continuing Educ
Summer School: H Teresa Valero, Summer School Dir

WEATHERFORD

SOUTHWESTERN OKLAHOMA STATE UNIVERSITY, Art Dept, 100 Campus Dr, Weatherford, OK 73096. Tel 405-772-6611, Ext 3756, 774-3757; Fax 405-772-5447; Internet Home Page Address: www.swosu.edu/depts/art/index; *Chmn* Joe London; *Asst Prof* Jan Bradfield; *Asst Prof* Bob Durlac; Andrew Maruck, PhD; Norman Taber, MFA
Estab 1901, dept estab 1941; pub; D & E; Scholarships; SC 35, LC 8, GC 43; D 5000
Ent Req: HS dipl
Degrees: BA(Art), BA(Art Educ) and BA(Commercial Art) 4 yr
Tuition: Res—undergrad $64 - $81 per hr, nonres—undergrad $148 - $190 per hr; campus res available
Courses: Advertising Design, Art Education, Art History, Ceramics, Commercial Art, Drawing, Graphic Arts, Graphic Design, Illustration, Jewelry, Lettering, Mixed Media, Painting, Sculpture, Teacher Training
Adult Hobby Classes: Varies
Summer School: Varies

OREGON

ALBANY

LINN BENTON COMMUNITY COLLEGE, Fine & Applied Art Dept, 6500 SW Pacific Blvd, Albany, OR 97321. Tel 541-917-4999; Fax 541-967-6550; *Instr* John Aikman; *Instr* Rich Bergeman; *Instr* Jason Widmer; *Chmn* Doris Litzer
Estab 1968; pub; D & E; SC 14, LC 2; D 2000, E 4000
Ent Req: open entry
Degrees: AA, AS & AAS 2 yrs
Tuition: Res—$38 per cr up to a maximum of $570 per sem
Courses: †Advertising Design, Art History, Ceramics, Display, Drafting, Drawing, †Graphic Arts, †Graphic Design, Handicrafts, Illustration, Lettering, Painting, Photography, Sculpture, Textile Design, Theatre Arts
Adult Hobby Classes: Painting, Tole Painting, Watercolor

ASHLAND

SOUTHERN OREGON UNIVERSITY, Dept of Art, 1250 Siskiyou Blvd, Ashland, OR 97520. Tel 541-552-6386; Fax 541-552-6564; Internet Home Page Address: www.sou.edu; *Chmn Dept Art* Cody Bustamante, MFA
Estab 1926; Galleries at the center for visual arts, 1250 Siskiyou Blvd Ashland OR 97520; pub; D & E; Scholarships; SC 53, LC 17, GC 18; D 120, E 30, non-maj 700, maj 100
Ent Req: HS dipl, SAT or ACT
Degrees: BFA, BA or BS(Art) 4 yrs
Tuition: Res—undergrad $3147 per yr; nonres—undergrad $8847 per yr; campus res available
Courses: Art Appreciation, Art Education, Art History, Ceramics, Commercial Art, Computer Art, Conceptual Art, Design, Drawing, Graphic Arts, Graphic Design, Illustration, Intermedia, Mixed Media, Museum Staff Training, Painting, Photography, Printmaking, Sculpture
Adult Hobby Classes: Various courses
Children's Classes: Summer classes
Summer School: Dir, Claire Cross. Enrl 210; 4 - 8 wk term. Courses—various

BEND

CENTRAL OREGON COMMUNITY COLLEGE, Dept of Art, 2600 NW College Way, Bend, OR 97701. Tel 541-382-6112, 383-7510; Fax 541-385-5978; Elec Mail jhamblin@cocc.edu; Internet Home Page Address: www.cocc.edu/finearts/; *Prof* Sara Krempel, MA
Estab 1949; pub; D & E; Scholarships; in col D 2025, E 2000
Ent Req: HS dipl
Degrees: AA, AS, Cert
Tuition: In-district—$38 per cr hr; out-of-district—$49 per cr hr; out-of-state—$137 per cr hr; campus res available
Courses: Calligraphy, Ceramics, Drawing, Painting, Photography, Printmaking, Stage Design, Theatre Arts
Adult Hobby Classes: Enrl 1500-2000; tuition, duration & courses offered vary
Summer School: Dir, John Weber. Enrl 300-400; tuition $32 per course for a term of 8 wks beginning June 23. Courses—General courses

COOS BAY

COOS ART MUSEUM, 235 Anderson Ave, Coos Bay, OR 97420-1610. Tel 541-267-3901, 267-4877 (art education); Elec Mail info@coosart.org; Internet Home Page Address: www.coosart.org; *Exec Dir* M J Koreiva; *Dir Art Educ* Karen Hammer; *Dir Progs* Ciara Van Velson
Open Tues - Fri 10 AM - 4 PM, Sat 1 - 4 PM; Estab 1950; 5 separate galleries with the Art Mus, one rental/sales gallery; pvt; D & E, Weekends; SC 30, LC 10; D 25, E 15
Tuition: Varies
Courses: Art Appreciation, Art History, Ceramics, Collage, Design, Drawing, Glass Fusing, Painting, Paste Papers, Printmaking
Adult Hobby Classes: Enrl 100; tuition for 10 wks, mem $40/$45, non-mem $48/$53
Children's Classes: Tuition varies depending on courses & membership status
Summer School: Tuition same as above

SOUTHWESTERN OREGON COMMUNITY COLLEGE, Visual Arts Dept, 1988 Newmark, Coos Bay, OR 97420. Tel 541-888-7322, 888-7321; Fax 541-888-7801; Internet Home Page Address: www.socc.edu/; *Div Dir* Bob Bower; *Prof* Melanie Schwartz, MFA; *Prof* James Fritz
Estab 1962, dept estab 1964; pub; D & E; Scholarships; SC 11, LC 1; D 420, E 300, non-maj 250, maj 170
Degrees: AA 2 yrs
Tuition: Res—undergrad $540 per quarter; nonres—undergrad $540 per quarter; campus res—$295 per month
Courses: Art History, Calligraphy, Ceramics, Computer Art, Design, Drawing, Handmade Paper, Painting, Printmaking, Sculpture
Adult Hobby Classes: Tuition $396 per qtr. Courses—Art History, Calligraphy, Ceramics, Drawing, Glassworking, Handmade Paper & Prints, Painting
Children's Classes: Only as occasional workshops
Summer School: Dean Instruction, Phill Anderson. Tuition varies. Courses—Ceramics, Painting & Composition, Watercolor

CORVALLIS

OREGON STATE UNIVERSITY, Dept of Art, 106 Fairbanks Hall, Corvallis, OR 97331-3702. Tel 541-737-4745; Fax 541-737-8686; Internet Home Page Address: www.oregonstate.edu/dept/arts/; Internet Home Page Address: www.oregonstate.edu/dept/arts/gallery/index.htnl; *Chmn* James Folts, MS; *Prof* Harrison Branch, MFA; *Prof* Clinton Brown, MFA; *Prof* Thomas Morandi, MFA; *Prof* Henry Sayre PhD, MFA; *Assoc Prof* Shelley Jordon, MFA; *Assoc Prof* Barbara Loeb PhD, MFA; *Asst Prof* Andrea Marks, MFA; *Asst Prof* Yuji Hiratsuka, MFA; *Asst Prof* John Bowers, MFA; *Asst Prof* John Maul, MFA; *Sr Research Assoc* Douglas Russell, BA; *Prof* Elizabeth Pillod, MFA; *Assoc Prof* Kay Campbell; *Asst Prof* Julie Green; *Asst Prof* John Nettleton; *Asst Prof* Muneera U. Spence
Estab 1868, dept estab 1908; Maintains nonprofit art gallery, 100 Fairbanks Hall, Corvallis, OR 97331; pub; D & E; Scholarships; SC 63, LC 16, GC 271; non-maj 2000, maj 525
Ent Req: HS dipl
Degrees: BA, BS, BFA & MAIS
Tuition: Res—undergrad $1360 per quarter; res—grad $2542 per quarter; nonres—undergrad $47°0 per quarter; nonres—grad $4270 per quarter; campus res available
Courses: 2-D & 3-D Design, Art History, Drawing, Graphic Design, Painting, Photography, Printmaking, Sculpture, Visual Appreciation
Summer School: Dir, John Maul. Enrl 75; 3 wk session beginning 3rd wk in June. Jumpstart-Preschool Visual Arts Workshop for HS students

EUGENE

LANE COMMUNITY COLLEGE, Art & Applied Design Dept, 4000 E 30th Ave, Eugene, OR 97405. Tel 541-747-4501, Ext 2409; *Art Div* Mary Jo Workman
Estab 1964, dept estab 1967; FT 10; pub; D & E; Scholarships; SC 42, LC 4; D 300, E 75, non-maj 240, maj 60
Ent Req: HS dipl
Degrees: AA, AAS 2 yrs
Tuition: Res—$43 per cr hr; out-of-state $138 per cr hr; international student $138
Courses: 2-D & 3-D Design, Advertising Design, Air Brush, Art Appreciation, Art Education, Art History, Ceramics, Commercial Art, Design, Drawing, Film, †Graphic Design, History of Art & Architecture, Illustration, Intermedia, Jewelry, Lettering, Metal Casting, Painting, Photography, Printmaking, Sculpture, Silversmithing, Textile Design, Weaving
Adult Hobby Classes: 250; tuition $39 for 30 hrs & fees. Courses—Art Appreciation, Calligraphy, Ceramics, Chinese Brush Painting, Doll Making, Drawing, Jewelry, Oil Painting, Papermaking, Sculpture, Stained Glass, Watercolor
Summer School: Div Chmn, Nanci Lavelle. Enrl 205; tuition $43 per cr hr; Courses—Art Appreciation, Drawing, Independent Study, Sculpture, Watercolor

MAUDE KERNS ART CENTER, 1910 E 15th Ave, Eugene, OR 97403. Tel 541-345-1571; Fax 541-345-6248; Elec Mail mkac@efn.org; Internet Home Page Address: www.mkartcenter.org; *Exec Dir* Karen Marie Pavelec
Estab 1950; pvt; D & E; Scholarships; SC 45; D & E 450
Tuition: $20-$60 per class per quarter
Courses: Ceramics, Design, Drawing, Glass Blowing, Graphic Design, Handicrafts, Jewelry, Lampworking, Leaded Glass, †Mixed Media, †Painting, Photography, Printmaking, Sculpture, Textile Design, Weaving
Adult Hobby Classes: Enrl 100. Courses—Per regular session
Children's Classes: Enrl 200; tuition $75. Courses—Ceramics, Drawing & other special workshops
Summer School: Courses varied

UNIVERSITY OF OREGON, Dept of Fine & Applied Arts, 5232 University of Oregon, Eugene, OR 97403-5232. Tel 541-346-3610; Fax 541-346-3626; *Assoc Prof* L Alpert
FT 20, PT 10; Pub; D; Scholarships; D 1475, non-maj 350, maj 1050
Degrees: BA, BS 4 yrs, BFA 5 yrs, MFA 2 yrs minimum after BFA or equivalent

Tuition: Res—undergrad $1273 per term; grad $2450 per term; nonres—undergrad $4825 per term; grad $4166; campus res available
Courses: Ceramics, Drawing, Fibers, Jewelry, Metalsmithing, Painting, Photography, Printmaking, Sculpture, Visual Design
Summer School: Dir, Ron Trebon. 8 wks beginning June. Courses—Ceramics, Computer Graphics, Drawing, Fibers, Jewelry, Metalsmithing, Painting, Photography, Printmaking, Sculpture, Visual Design

FOREST GROVE

PACIFIC UNIVERSITY IN OREGON, Arts Div, Dept of Art, 2043 College Way, Forest Grove, OR 97116. Tel 503-359-2216; Internet Home Page Address: www.pacificu.edu; *Chmn* Jan Shield, MFA; *Prof* Patricia Cheyne, MFA; *Prof* Terry O'Day, MFA; *Instr* Ann Wetherell; *Instr* Jacqueline Ehlis, MFA; *Instr* Jim Flory; *Instr* Steve O'Day
Estab 1849; Maintain nonprofit art gallery; Cawein Gallery; Pvt; D & E; Scholarships
Ent Req: HS dipl, SAT or ACT, counselor recommendation, transcript of acad work
Degrees: BA, MA(Teaching)
Tuition: $16,000 per yr; campus res—room & board $4,433
Courses: Art Appreciation, †Art Education, Art History, Ceramics, †Communications, Computer Graphics, Design, Drawing, Goldsmithing, Graphic Design, History of Art & Architecture, Illustration, Jewelry, †Mixed Media, Painting, Photography, Printmaking, Sculpture, Silversmithing, Teacher Training, Theatre Arts
Children's Classes: Enrl 15. Courses—Children's Art (children of faculty & staff)
Summer School: Dean, Willard Kniep. Enrl 7-15; 3 terms over summer. Courses—Varies

GRESHAM

MOUNT HOOD COMMUNITY COLLEGE, Visual Arts Center, 26000 SE Stark St, Gresham, OR 97030. Tel 503-491-7309; Fax 503-491-7389; *Assoc Dean* Chris Bruya
Scholarships
Degrees: AA
Courses: Art Education, Art History, Calligraphy, Ceramics, Design, Drawing, Film, Graphic Design, Illustration, Jewelry, Painting, Printmaking, Sculpture
Adult Hobby Classes: Tuition $30 per cr. Courses—All studio courses
Summer School: Dir, Eric Sankey. Enrl 60 - 90; two 5 wk sessions. Courses—Calligraphy, Ceramics, Drawing, Watercolor

LA GRANDE

EASTERN OREGON UNIVERSITY, School of Arts & Science, Division of Arts & Letters, One University Blvd La Grande, OR 97850-2899. Tel 541-962-3672; Fax 503-962-3596; Elec Mail dimondt@eou.edu; Internet Home Page Address: www.eou.edu; *Prof Art* Thomas Dimond, MFA; *Assoc Prof* Terry Gloeckler, MFA; *Dean Arts & Scis* Denny Swonger; *Prof Art* Kat Galloway, MFA; *Prof Art* Doug Kaigler, MFA; *Assoc Prof* Jason Brown, MFA; *Instr Photography* Mel Buffington; *Instr Art Educ* Lisa Brown
Estab 1929; pub; D & E; SC 35, LC 15; Non-maj 30, maj 65
Ent Req: HS dipl
Degrees: degrees BA & BS in Art, Endorsement in Art
Tuition: Res—$1091 per term; campus res available
Courses: Aesthetics, †Art Appreciation, Art Education, Art History, †Calligraphy, Ceramics, †Conceptual Art, †Constructions, †Costume Design & Construction, Design, Drawing, †Film, Glass, †Graphic Arts, †Graphic Design, †Handicrafts, †History of Art & Architecture, Jewelry, Life Drawings, †Mixed Media, Painting, Photography, †Printmaking, Sculpture, †Silversmithing, †Stage Design, †Teacher Training, †Textile Design, †Theatre Arts, †Video
Summer School: Dir, Dr Doyle Slater. Enrl 400. Term of 4-8 wks. Courses—Two or three per summer, beginning & advanced level

MARYLHURST

MARYLHURST UNIVERSITY, Art Dept, PO Box 261, Marylhurst, OR 97036-0261; 17600 Pacific Hwy, Marylhurst, OR 97036. Tel 503-636-8141; Fax 503-636-9526; Elec Mail studentinfo@marylhurst.edu; Internet Home Page Address: www.marylhurst.edu; *Dir* Kelcey Beardsley; *Instr* Kristin Collins; *Instr* Dennis Cunningham; *Instr* Margaret Shirley; *Instr* Rich Rollins; *Instr* Terri Hopkins; *Instr* Martha Pfanschmidt; *Instr* Denise Roy; *Dir* Paul Sutinen; *Instr* Nancy Hiss; *Instr* Trude Parkinson; *Instr* Peggy Suzio; *Instr* Marlene Bauer; *Instr* Libby Farr; *Instr* Louise Farrar-Wegener; *Instr* Carole Hermanson; *Instr* Kathleen Huun; *Instr* Michele Kremers; *Instr* Paul Pavlock; *Instr* Cheryl Schneidermann; *Instr* Elizabeth Spurgeon; *Instr* William Washburn; *Instr* Nancy Wilkins; *Instr* Stephanie Robison Baggs
Estab 1980; Maintain nonprofit art gallery; The Art Gym, Marylhurst University, PO Box 261, Maryhurst, OR 97036; pvt; D&E; Scholarships; SC 35, LC 16, other 4; non-maj 50, maj 140
Ent Req: HS dipl or equivalent
Degrees: BA, BFA, MA (Art Therapy)
Courses: Art History, Art Therapy Program, Design, Drawing, History of Photography, Interior Design, Lighting, Mixed Media, Museum Staff Training, Painting, Photography, Printmaking, Sculpture, Textiles
Summer School: Dir, Paul Sutinen. Enrl 100; tuition $293 per cr for 10 wk term. Courses—Drawing, Interior Design, Painting, Photography, Printmaking, Sculpture

MCMINNVILLE

LINFIELD COLLEGE, Art Dept, 900 SE Baker, ADD-Suite A466 McMinnville, OR 97128. Tel 503-434-2275; Elec Mail mills@linfield.edu; Internet Home Page Address: www.infield.edu/art/arthome; *Chmn Dept* Ron Mills, MFA

Estab 1849, dept estab 1964; Mem: Maintains non-profit gallery, Linfield Fine Arts Gallery 900 SE Bater St Suite A466, McMinnville OR 97128; pvt; D; Scholarships; SC 16, LC 2; non-maj 250, maj 35
Activities: Art supplies available at on-campus shop
Ent Req: HS dipl
Degrees: BA 4 yr, ME 2 yr
Tuition: $19,380 per yr; room $2860, board $2770
Courses: †Aesthetics, Art Education, Art History, Ceramics, Drawing, Mixed Media, Painting, Photography, Printmaking, Sculpture, Teacher Training

MONMOUTH

WESTERN OREGON STATE COLLEGE, Creative Arts Division, Visual Arts, 345 N Monmouth Ave, Monmouth, OR 97361. Tel 503-838-8000; Fax 503-838-8995; Internet Home Page Address: www.wou.edu; *Prof* Kim Hoffman; *Chmn Creative Arts* Dr Tom Bergeron
Estab 1856; FT 8, PT 2; pub; D & E; Scholarships; SC 72, LC 21, GC 27; total 3600
Degrees: BA and BS 4 yr
Tuition: Res—undergrad $940 per term, grad $887 per term; nonres—undergrad $2603 per term, grad $2383 per term
Courses: Art Education, Art History, Art Theory, Ceramics, Design, Drawing, Graphic Design, Individual Studies, Painting, Printmaking, Sculpture

ONTARIO

TREASURE VALLEY COMMUNITY COLLEGE, Art Dept, 650 College Blvd, Ontario, OR 97914. Tel 541-881-8822; Internet Home Page Address: www.tvcc.cc.or.us; *Chmn* Robin Jackson
Estab 1961; PT 4; pub; D & E; Scholarships; SC 14, LC 1; D 50, E 35, non-maj 10, maj 15
Ent Req: Placement testing
Degrees: AS & AA 2 yrs
Tuition: Res—$40 per cr; nonres—$54 per cr; out of state—$56; international—$100; campus res available
Courses: Art History, †Ceramics, Drawing, Painting, Sculpture
Summer School: Chmn, Robert M Jackson. Tuition $190 for term of 8 wks beginning June 22. Courses—Ceramics, Drawing, Painting

OREGON CITY

CLACKAMAS COMMUNITY COLLEGE, Art Dept, 19600 S Molalla Ave, Oregon City, OR 97045. Tel 503-657-8400, Ext 2540; Internet Home Page Address: www.clackamas.cc.or.us; *Chmn* Rich True
Estab 1969; Pub; D&E
Ent Req: HS dipl
Degrees: AA
Tuition: Res—$37 per cr hr, nonres—$131 per cr hr
Courses: Advertising Design, Art History, Calligraphy, Ceramics, Design, Drawing, Jewelry, Painting, Sculpture

PENDLETON

BLUE MOUNTAIN COMMUNITY COLLEGE, Fine Arts Dept, 2411 NW Carden Ave, PO Box 100 Pendleton, OR 97801. Tel 541-276-1260; Fax 541-276-6119; Internet Home Page Address: www.bmcc.or.us; *Chmn* Michael Booth; *Chmn* Doug Radke
Estab 1962; dept estab 1964; Maintain nonprofit art gallery; Betty Fevis Memorial Art Gallery; art library; art supplies available at bookstore; pub; D & E; SC 8, LC 2 per qtr; D 255, E 72
Ent Req: HS diploma or equivalent
Degrees: AA, 2 yrs
Tuition: Res—undergrad $50 per cr hr; nonres—undergrad $100
Courses: Art History, Ceramics, Drawing, Jewelry, Lettering, Painting, Sculpture

PORTLAND

LEWIS & CLARK COLLEGE, Dept of Art, 0615 SW Palatine Hill Rd, Portland, OR 97219. Tel 503-768-7390, 768-7000; Fax 503-768-7401; Elec Mail buether@lclark.edu; Internet Home Page Address: www.lclark.edu/~art/; *Prof* Phyllis Yes; *Assoc Prof* Michael Taylor; *Asst Prof* Sherry Fowler; *Asst Prof* Theodore Vogel; *Vis Lect* Robert B Miller; *Visiting Lect* Bruce West; *Chmn Dept* Stewart Buettner; *Instr* Debra Beers
Dept estab 1946; pvt; D; Scholarships; SC 10, LC 2
Ent Req: HS dipl
Degrees: BS and BA 4 yr
Tuition: Res—undergrad $21,520 per yr; campus res—room & board $6100-$6350
Courses: Art History, Ceramics, Drawing, Graphic Arts, History of Art & Architecture, Jewelry, Painting, Printmaking, Sculpture, Weaving

OREGON COLLEGE OF ART & CRAFT, (Oregon College of Fine Arts) 8245 SW Barnes Rd, Portland, OR 97225. Tel 503-297-5544; Fax 503-297-3155; Internet Home Page Address: www.ocac.edu; *Admis Dir* Barry Beach; *Pres* Bonnie Laing-Malcolmson
Estab 1907; maintains non-prof gallery, Hoffman Gallery 8245 SW Barnes Rd Portland, OR 97225; Ft 10, PT 13; pvt; non-profit; D & E; Scholarships; SC & LC 117; D 119, E 950
Ent Req: portfolio review
Degrees: BFA 4 yrs, Cert prog 3 yrs, arbitrary prog 2 yrs
Tuition: $645 per cr hr for 1-11 cr; $7400 per semester (12+ cr hrs); no campus res

Courses: Book Arts, †Ceramics, †Drawing, †Jewelry, †Textile Design, Wood
Adult Hobby Classes: Enrl 1300; tuition $450 noncr hr $700 per cr hrs for 10 wk term. Courses—Aesthetics, Book Arts, Ceramics, Drawing, Fibers, Metals, Photography, Writing, Wood
Summer School: Exten Prog Dir Sara Black, Enrl 215; tuition $250 for 1 wk workshop. Courses—same as above

PACIFIC NORTHWEST COLLEGE OF ART, 1241 NW Johnson, Portland, OR 97209. Tel 800-818-PNCA; Fax 503-226-3587; Elec Mail pncainfo@pnca.edu; *Pres* Sally Lawrence; *Instr* William Moore; *Instr* Paul Missal; *Instr* Betsy Lindsay; *Instr* Robert Hanson; *Instr* Frank Irby; *Instr* Anne Johnson; *Instr* Chris Gander; *Instr* Tom Fawkes; *Instr* Judy Cooke; *Dir Enrol* Jennifer Satalino; *Instr* David Ritchie; *Instr* Cynthia Pachikara; *Dir* Horatio Law; *Instr* Robert Selby
Estab 1909; FT 19, PT 24; pvt; D & E; Scholarships; SC 54, LC 15; D 258, PT 47, E 249
Ent Req: HS dipl, portfolio, essay
Degrees: BFA 4 yr
Tuition: $12,420 per yr, $6,200 per sem; no campus res
Courses: Art History, †Ceramics, †Drawing, †Graphic Design, †Illustration, †Intermedia, †Painting, †Photography, †Printmaking, †Sculpture
Adult Hobby Classes: Enrl 546; tuition $250 per 12 wk term. Courses—Ceramics, Graphic Design, Illustration, Life Drawing, Painting, Photography, Printmaking, Sculpture & other art-related courses
Children's Classes: Enrl 132; tuition $125 per 12 wk term. Courses—Ceramics, Drawing, Painting, Printmaking, Sculpture
Summer School: Dean, Continuing Educ, Lennie Pitkin. Enrl 500; tuition $210 per 12 wk term. Courses—Wide range of Visual Arts

PORTLAND COMMUNITY COLLEGE, Visual & Performing Arts Division, PO Box 19000, Portland, OR 97280-0990. Tel 503-977-4264, Ext 4263; Fax 503-977-4874; *Div Dean* Steve Ward
Estab 1961, dept estab 1963; pub; D & E, Sat; SC 40, LC 5; D 864, E 282, total 1212
Ent Req: none
Degrees: AA 2 yrs
Tuition: Res—$39 per cr hr; nonres—$145 per cr hr
Courses: Art History, Calligraphy, Ceramics, Drawing, Graphic Design, Painting, Photography, Printing Tech, Sculpture, Stage Design, Theatre Arts
Adult Hobby Classes: Tuition varies per quarter. Courses—various
Children's Classes: Courses offered
Summer School: Dept Chmn, Mary Stupp-Greer. Enrl 400; Term of 8 wks beginning June. Courses—same as regular session

PORTLAND STATE UNIVERSITY, Dept of Art, PO Box 751, Portland, OR 97207. Tel 503-725-3515; Fax 503-725-4541; Internet Home Page Address: www.art.pdx.edu; *Dept Chmn, Prof* Michihiro Kosuge, MFA; *Prof* William Fosque, MFA; *Asst Prof* William LePore, MA; *Assoc Prof* Elizabeth Mead, MFA; *Assoc Prof* Sue Taylor, PhD; *Assoc Prof* Daniel Pirosky, BA; *Assoc Prof* Jane Kristof, PhD; *Assoc Prof* Susan Agre-Kippenhan, MFA; *Assoc Prof* Eleanor Erskins, MFA; *Assoc Prof* Susan Harlan, MFA; *Assoc Prof* Junghee Lee, MA; *Asst Prof* Lee Charmin, MFA; *Asst Prof* Charles Colbert, PhD; *Asst Prof* Anne McClanan, PhD
Estab 1955; pub; D & E; Scholarships; E 2000, non-maj 1300, maj 600, grad 12, others 70
Ent Req: HS dipl, SAT
Degrees: BS & BA(Art) 4 yr, MFA (Painting, Printmaking, Sculpture) 2 yr
Tuition: Res—undergrad $1175 per qtr; nonres—undergrad $4097 per qtr; campus res available
Courses: Art History, †Drawing, †Graphic Design, †Painting, Printmaking, †Sculpture
Summer School: Enrl 4-500; term of 8-12 wks beginning June 28. Courses—vary. Two centers, one in Portland and one at Cannon Beach: The Haystack Program

REED COLLEGE, Dept of Art, 3203 S E Woodstock Blvd, Portland, OR 97202-8199. Tel 503-771-1112; Fax 503-788-6691; Internet Home Page Address: www.reed.edu; *Chmn Art History & Humanities* William J Diebold; *Prof Art* Michael Knutson; *Asst Prof Art* Geraldine Ondrizek
Estab 1911; FT 5; pvt; D; Scholarships; SC 7, LC 5; D 1150, E 15
Degrees: BA 3-5 yr
Tuition: $22,960 annual tuition; campus res—available
Courses: Aesthetics, Architecture, †Art History, Ceramics, †Conceptual Art, †Drawing, Graphic Arts, History of Art & Architecture, †History of Art & Architecture, Humanities, †Painting, Photography, Printmaking, Restoration & Conservation, †Sculpture, Theory
Adult Hobby Classes: Courses offered & MA degree
Summer School: Courses offered

ROSEBURG

UMPQUA COMMUNITY COLLEGE, Fine & Performing Arts Dept, PO Box 967, Roseburg, OR 97470. Tel 541-440-4600, Ext 691; Elec Mail rochess@umpqua.edu; Internet Home Page Address: www.umpqua.edu; *Dir Fine Arts* Susan Rochester
Estab 1964; Maintain nonprofit art gallery, Umpqua Community College, 1140 College Rd, Roseburg, OR 97470; pub; D & E; Scholarships; SC 21, LC 3; D 190, E 90, maj 30
Ent Req: HS dipl
Degrees: AA 2 yr
Tuition: Res—$54 per cr; out of district $154 per cr
Courses: Art History, Basic Design, Ceramics, Drawing, Painting, Photography, Sculpture, Theatre Arts
Adult Hobby Classes: Enrl 195; tuition $45 & lab fee for 10 weeks. Courses—Ceramics, Drawing, Painting, Photography, Sculpture

SALEM

CHEMEKETA COMMUNITY COLLEGE, Dept of Humanities & Communications, 4000 Lancaster Dr NE, Salem, OR 97309; PO Box 14007 Salem, OR 97301. Tel 503-399-5184; Fax 503-399-5214; Elec Mail donb@chemeketa.edu; Internet Home Page Address: www.chemeketa.edu/exploring/areas/programs/art.html; *Dir* Don Brase; *Instr* Robert Bibler, MFA; *Instr* Lee Jacobson, MFA; *Instr* Kay Bunnenberg-Boehmer, MFA; *Instr* Carol Bibler, BFA; *Gary* Rawlins, BFA; *Deanne* Beausoleil, MA
Estab 1969, dept estab 1975; Maintain nonprofit art gallery; Chemeketa Campus Gallery; art supplies available in bookstore; pub; D & E; SC 21, LC 5; D 175, E 175
Ent Req: none
Degrees: AA 2 yr
Tuition: Res—$56 per cr hr; nonres—$192 per cr hr
Courses: Art Appreciation, Art History, Art as a Profession, Ceramics, Design, Drawing, Film, Graphic Design, Painting, Photography, Printmaking, Sculpture
Adult Hobby Classes: Enrl 150-200; tuition $56 per cr hr
Summer School: Tuition varies, 8 wk term

PENNSYLVANIA

ALLENTOWN

CEDAR CREST COLLEGE, Art Dept, 100 College Dr, Allentown, PA 18104-6196. Tel 610-606-4666; Internet Home Page Address: www.cedarcrest.edu/; *Prof* Nelson Maniscalco, MFA; *Prof* Pat Badt, MFA; *Asst Prof* William Clark, MFA; *Asst Prof* Jill Odegaard; *Asst Prof* Kim Sloane
Estab 1867; Maintain nonprofit art gallery, Tempkins Gallery; FT 3, PT 2; pvt, women only; D & E; Scholarships; SC 10, LC 6; 1000
Ent Req: HS dipl, CEEB
Degrees: BA, BS, Interdisciplinary Fine Arts Maj (art, theatre, music, dance, creative writing), 4 yr
Tuition: Undergrad in-state $15,920 per yr, out-of-state $15,920 per yr; campus res—room $3100, board $2645
Courses: Aesthetics, Art Education, Art History, Ceramics, Comparative Study of Art, Drawing, Jewelry, Metal Forming, Painting, †Printmaking, Sculpture, Theatre Arts
Summer School: Courses—Ceramics, Jewelry-Metalsmithing, Sculpture, Painting

MUHLENBERG COLLEGE, Dept of Art, 2400 Chew St, Allentown, PA 18104-5586. Tel 484-664-3100; Internet Home Page Address: www.muhlenbergcollege/artdept; Internet Home Page Address: www.muhlenberg.edu; *Chmn* Jadviga Da Costa Nunes PhD; *Assoc Prof* Scott Sherk, MFA; *Asst Prof* Raymond S Barnes, MFA; *Asst Prof* Joseph Elliott, MFA; *Instr* Kevin Tuttle; *Instr* David Haas; *Instr* Carol Heft
Estab 1848; FT 4, PT 6; pvt, pub; D & E; SC 16, LC 17; D 2000, non-maj 284, maj 60
Ent Req: HS dipl, 3 achievement tests & English Composition Achievement required
Degrees: BA 4 yrs
Tuition: Res—$26,700 per yr with room & board
Courses: Art Education, †Art History, Ceramics, †Design, Drawing, Graphic Arts, History of Art & Architecture, Museum Staff Training, Painting, Photography, Printmaking, Sculpture, †Studio Arts, †Teacher Training, †Theatre Arts
Adult Hobby Classes: Courses—Art History, Drawing, Painting, Photography, Photo-Journalism
Summer School: Dean of Evening Coll, S Laposata; Courses—same as adult educ courses

BETHLEHEM

LEHIGH UNIVERSITY, Dept of Art & Architecture, 17 Memorial Dr E, Bethlehem, PA 18015. Tel 610-758-3610; Internet Home Page Address: www.lehigh.edu; *Assoc* Bruce Thomas PhD; *Prof* Ricardo Viera, MFA; *Prof* Tom F Peters PhD, MArch; *Prof* Lucy Gans, MFA; *Prof* Ivan Zaknic, MArch; *Chmn & Assoc Prof* Anthony Viscardi, MArch; *Assoc Prof* Berrisford Boothe, MFA; *Prof Practice* Christine Ussler, MArch; *Assoc Prof* Anna Chupa, MFA; *Assoc Prof* Amy Forsyth, MArch; *Adjunct Prof* Jason Travers, MFA
Estab 1925; FT 9, PT 1; pvt; D & E; SC 22, LC 16; D & E 100
Ent Req: HS dipl, SAT, CEEB
Degrees: BA 4 yrs
Tuition: $33,470 per yr; campus res available
Courses: †Architecture, †Art, Art History, Design, Drawing, Graphic Design, Painting, Photography, Sculpture
Summer School: Courses—Architectural Design, Art History, Graphic Design Workshop, Color

MORAVIAN COLLEGE, Dept of Art, Church Street Campus, 1200 Main St Bethlehem, PA 18018. Tel 610-861-1680; Fax 610-861-1682; Elec Mail jciganick@moravian.edu; Internet Home Page Address: www.moravian.edu; *Chmn* Anne Dutlinger, MFA; *Dir of Paine Gallery* Diane Radycki, PhD; *Photographer-in-Residence* Jeffrey Hurwitz, MFA; *Ceramist-in-Residence* Renzo Faggioli, Master Craftsman; *Prof Emeritus* Rudy S Ackerman, DEd; *Prof* Krista Steinke, MFA; *2-year appt* Jason Bell, MFA
Estab 1742, dept estab 1963; Maintain nonprofit art gallery, Payne Gallery of Moravian College located at same address; art & architecture library; pvt; D & E; Scholarships; SC 15, LC 8; D 1200, E 500, non-maj 1200, maj 140
Ent Req: HS dipl
Degrees: BA and BS 4 yrs
Courses: †Advertising Design, †Art Education, †Art History, †Ceramics, Design, Digital Video, †Drawing, Graphic Arts, Graphic Design, Handicrafts, History of Art & Architecture, Jewelry, Museum Staff Training, Painting, Photography, Printmaking, Sculpture, †Teacher Training & Certification

Summer School: Dir Continuing Studies, Florence Kimball. Enrl 110.
Courses—Same as above

NORTHAMPTON COMMUNITY COLLEGE, Art Dept, 3835 Green Pond Rd,
Bethlehem, PA 18020. Tel 610-861-5300, Ext 5485; Fax 610-861-5373; Internet
Home Page Address: www.northampton.edu; *Asst Prof* Andrew Szoke; *Prog
Coordr* Gerald Rowan
Estab 1967; pub; D & E; Scholarships; SC 12, LC 8; D 100, E 350
Ent Req: HS dipl, portfolio
Degrees: AAS(Advertising), cert in photography
Tuition: Res—$76 per cr hr; nonres—$158 per cr hr; out-of-state $240 per cr hr
Courses: 3-D Materials, Advertising Design, Architecture, Art History, Ceramics,
Color & Spatial Concepts, Computer Graphics, Drafting, Drawing, Fashion Arts,
Graphic Arts, Graphic Design, Handicrafts, History of Art & Architecture,
Illustration, Interior Design, Lettering, Painting, Photography, Pottery, Printmaking,
Sculpture
Adult Hobby Classes: Courses—Art, Photography

BLOOMSBURG

BLOOMSBURG UNIVERSITY, Dept of Art & Art History, 400 E Second St,
Bloomsburg, PA 17815-1301. Tel 570-389-4646; Fax 570-389-4459; Internet
Home Page Address: www.bloomu.edu; *Chmn* Dr Christine Sperling; *Prof* Gary F
Clark, MA; *Prof* Vera Viditz-Ward, MA; *Assoc Prof* Charles Thomas Walter PhD,
MA; *Prof* Karl Beamer, MFA; *Asst Prof* Matthew Clay-Robinson, MFA; *Asst Prof*
Meredith Grimsley, MFA; *Assoc Prof* Andrea Pearson; *Assoc Prof* Vincent Hron,
MFA; *Asst Prof* Teresa Vadala, MFA
Estab 1839, dept estab 1940; maintains nonprofit gallery, Haas Center for th Arts,
400 E 2nd St, Bloomsburg PA 17815; pvt; D & E; Scholarships; SC 43, LC 17; D
1050, E 35, maj 100, non-maj 985, Grad 5
Ent Req: HS dipl
Degrees: BA(Art Studio) and BA(Art History) 4 yrs, MA(Art Studio), MA(Art
Hist)
Tuition: Res—tuition & campus res—room & board $5978; nonres—tuition &
campus res—room & board $7868
Courses: Art History, Ceramics, Computer Graphics, Crafts, General Design,
Painting, Photography, Printmaking, Sculpture, †Textile Design, Weaving
Summer School: Dean, Michael Vavrek. Enrl 200. Courses—Art History, General
Studio

BLUE BELL

MONTGOMERY COUNTY COMMUNITY COLLEGE, Art Center, 340 De
Kalb Pike, Blue Bell, PA 19422. Tel 215-641-6477, 641-6551, 641-6328; Internet
Home Page Address: www.mc.cc.pa.us; *Coordr* Frank Short; *Assoc Prof* Roger
Cairns, MFA; *Assoc Prof* Michael Smyser, MFA
FT 3, PT 14; Pub; D & E; Scholarships; SC 60, LC 3; D 250
Ent Req: HS dipl
Degrees: AA Fine Arts, AAS Commercial Art
Tuition: Count res—undergrad $76 per cr hr; nonres—$151 per cr hr
Courses: Advertising Design, Art Education, Art History, Ceramics, †Commercial
Art, Drawing, Film, †Fine Art, Graphic Design, Illustration, Painting, Photography,
Printmaking, Sculpture, Teacher Training, Theatre Arts, Typography, Video
Summer School: Dir, Michael Smyser. Enrl 66; tuition $35 per cr.
Courses—Ceramics, Drawing, Painting, Photography

BRYN MAWR

BRYN MAWR COLLEGE, Dept of the History of Art, 101 N Merion Ave, Bryn
Mawr, PA 19010. Tel 610-526-5000; Fax 610-526-7479; Elec Mail
dcast@brynmawr.edu; *Prof* Steven Levine; *Prof* Dale Kinney; *Prof* Gridley
McKim-Smith PhD; *Prof* Christiane Hertel; *Assoc Prof* Lisa Saltzman PhD; *Chmn
Dept* David Cast; *Asst Prof* Homay King
Estab 1913; maintains nonprofit gallery; pvt, W (men in grad school); D;
Scholarships, Fellowships; LC 10, GC 8; maj 15, grad 30, others 250
Degrees: BA 4 yr, MA, PhD
Tuition: $21,860 per yr; campus res—room & board $7870
Courses: †Architecture, Art History, †Graphic Arts, †History of Art &
Architecture

HARCUM COLLEGE, Fashion Design, Montgomery & Morris Ave, Bryn Mawr,
PA 19010. Tel 610-526-6050; Internet Home Page Address: www.harcum.edu; *Dir*
Winifred Curtis
Estab 1915; FT 1, PT 5; pvt, W; D & E; Scholarships; SC 7, LC 1; D 40, E 8,
maj 10
Ent Req: HS dipl
Degrees: AA 2 yr
Tuition: $9525 per yr
Courses: Commercial Art, Drawing, Fashion Arts, Graphic Design, History of Art
& Architecture, Lettering, Painting, Sculpture

CALIFORNIA

CALIFORNIA UNIVERSITY OF PENNSYLVANIA, Dept of Art, 250
University, California, PA 15419. Tel 724-938-4000, 938-4182; Fax 724-938-4256;
Internet Home Page Address: www.cup.edu; *Chmn Dept* Richard Mieczinkowski
Estab 1852, dept estab 1968; pub; D & E; SC 20, LC 5; maj 137
Ent Req: SAT
Degrees: Cert(Art Educ), BA 4 yrs
Tuition: Res—$1734 per sem, $144 per cr hr; nonres—$4412 per sem, $368 per
cr hr

Courses: Advertising Design, Aesthetics, Art Appreciation, Art Education, Art
History, Ceramics, Commercial Art, Costume Design & Construction, Design,
Drawing, Fashion Arts, Graphic Arts, Handicrafts, Illustration, Interior Design,
Jewelry, Mixed Media, Painting, Printmaking, Sculpture, Stage Design, Stained
Glass, Textile Design, Weaving
Adult Hobby Classes: Enrl 25 per class. Courses—Pottery, Stained Glass
Summer School: Chmn, Richard Grinstead. Term of 5 or 10 wks beginning June

CARLISLE

DICKINSON COLLEGE, Dept Fine Arts & History, Weiss Ctr for the Arts, PO
Box 1773 Carlisle, PA 17013-2896. Tel 717-245-1053; Fax 717-245-1937; Elec
Mail millejoa@dickinson.edu; Internet Home Page Address:
www.dickinson.edu/departments/arts/; *Prof, Chair* Barbara Diduk; *Assoc Prof*
Ward Davenny; *Prof* Melinda Schlitt, PhD; *Asst Prof* Elizabeth Lee; *Asst Prof*
Anthony Cervino; *Adjunct Faculty* Andrew Bale; *Adjunct Faculty* Todd Arsenault;
Adjunct Faculty Dee Jenkins; *Adjunct Faculty* Lisa Dorrill
Estab 1773, dept estab 1940; Maintains nonprofit art gallery, The Trout Gallery,
Weiss Center for the Arts, PO Box 1773, Carlisle, PA 17013; pvt; D; SC 10, LC
15; D 2200, non-maj 550, Maj 50
Ent Req: HS dipl, SAT
Degrees: BA and BS 4 yrs
Tuition: Res—undergrad $35,000 per yr, campus res available
Courses: Art History, Ceramics, Drawing, History of Art & Architecture, Italian
Renaissance, Painting, Photography, Printmaking, Sculpture, †Studio Major
Summer School: Dir, Diane Fleming. Term of 6 wks beginning May.
Courses—per regular session

CHELTENHAM

CHELTENHAM CENTER FOR THE ARTS, 439 Ashbourne Rd, Cheltenham,
PA 19012. Tel 215-379-4660; Fax 215-663-1946; Elec Mail
info@cheltenhamarts.org; Internet Home Page Address: www.cheltenhamarts.org;
Pres Bd Patricia Castner; *Bus Mgr & Adult Educ Coordr* Andrea Walsh; *Office
Mgr & Children's Educ Coordr* Jessica Wareheim
Estab 1940; maintain nonprofit art gallery at same address; community; D & E;
8-wk terms, 5 per yr; Scholarships; SC 50; D 875, E 200, Other 250
Ent Req: children & teens from families in need
Tuition: Course prices vary
Courses: Ceramics, Drawing, Jewelry, Painting, Pottery, Printmaking, Sculpture,
Stained Glass, Theater Classes, Theatre Arts, Video

CHEYNEY

CHEYNEY UNIVERSITY OF PENNSYLVANIA, Dept of Art, Cheyney, PA
19319. Tel 610-399-2000; *Fine Arts Dept Chmn* J Hank Hamilton Jr
Estab 1937; pub; D & E; Scholarships; SC 16, LC 4
Ent Req: HS dipl, ent exam
Degrees: BA 4 yrs
Tuition: Res—$4715 per sem; nonres—$7085 per sem
Courses: Drawing, Handicrafts, Painting, Sculpture

CLARION

CLARION UNIVERSITY OF PENNSYLVANIA, Dept of Art, Clarion, PA
16214. Tel 814-393-2000, ext 2291; Fax 814-393-2168; Elec Mail
ggreenberg@clarion.edu; Internet Home Page Address: www.clarion.edu/art; *Prof*
Catherine Joslyn; *Asst Prof* James Rose; *Asst Prof & Chmn* Gary Greenberg; *Asst
Prof* Kaersten Colvin; *Assoc Prof* Dr Joe Thomas; *Assoc Prof* Melissa Kuntz; *Asst
Prof* Mark Franchino; *Instr* Scott Turri
Estab 1867; Maintains nonprofit University Gallery; Pub; D & E; Scholarships;
SC 13, LC 10; D & E 925 per sem, day 450, eve 50, non-maj 150, maj 85
Ent Req: HS dipl
Degrees: BFA(Art), BA(Art), BA(Art History)
Tuition: Res—undergrad $2519 per sem, $210 per cr; nonres—undergrad $5039
per sem, $420 per cr
Courses: 3-D Design, Art Appreciation, †Art History, †Ceramics, Commercial
Design, Design, †Drawing, †Fabric, †Fiber, †Graphic Arts, Graphic Design,
Handicrafts, History of Art & Architecture, Jewelry, †Printmaking, †Sculpture,
Textile Design, Weaving
Adult Hobby Classes: Enrl 20; tuition $50 - $90 for 9-12 wk course.
Courses—Calligraphy, Ceramics, Drawing, Painting
Summer School: Tuition $210 per cr hr for 2-5 wk sessions. Courses—Various

EAST STROUDSBURG

EAST STROUDSBURG UNIVERSITY, Fine Arts Center, Fine Arts Bldg, 200
Prospect St East Stroudsburg, PA 18301. Tel 570-422-3759; Fax 570-422-3777;
Internet Home Page Address: www.esu.edu; *Chmn* Dr Herbert Weigand
Estab 1894; FT 3, PT 2; pub; D & E; Scholarships; SC 17, LC 6, grad 1; D 45
Ent Req: HS dipl, HS equivalency
Degrees: BA in Fine Arts
Tuition: Res—undergrad $1192 per sem, grad $1845 per sem; nonres—undergrad
$4301 per sem, grad $3074 per sem; campus res available
Courses: Aesthetics, American Art Communication Graphics, Art Education, Art
History, Calligraphy, Ceramics, Design, Drawing, Graphics, Handicrafts, Lettering,
Painting, Printmaking, Sculpture
Summer School: Tuition res—grad $89 per cr hr

EASTON

LAFAYETTE COLLEGE, Dept of Art, Williams Ctr for the Arts, Easton, PA
18042-1768. Tel 610-330-5355; Fax 610-330-5355; Elec Mail
ahldiane@lafayette.edu; *Prof Art* Ed Kerns; *Dept Head* Diane Cole Ahl

Estab 1827; FT 4, PT 4; pvt; D & E; SC 8, LC 12; D 300, E 250, non-maj 1, maj 17
Ent Req: HS dipl, ent exam, selective admis
Degrees: BS and AB 4 yr
Tuition: $24,828 per yr
Courses: 2-D & 3-D Design, Art History, Drawing, Graphic Design, History of Architecture, Painting, Photography, Printmaking, Sculpture
Summer School: Graphic Design, Painting, Photography

EDINBORO

EDINBORO UNIVERSITY OF PENNSYLVANIA, Art Dept, Doucette Hall, Edinboro, PA 16444. Tel 814-732-2406; *Chmn Crafts* Bernard Maas; *Fine Arts Representative* Ben Gibson; *Dir Gallery* William Mathie; *Chairperson* Dr Connie Mullineaux; *Asst Chmn of Art* Franz Stohn
Estab 1857; FT 34, PT 2; pub; D & E; Scholarships; SC 86, LC 30, GC 20; D 400 art maj, non-maj 6000, grad 30
Ent Req: HS dipl, SAT
Degrees: BSEd, BFA and BA 4 yrs, MA 1 yr, MFA 2 yrs
Tuition: Res—$5512, $129 per cr hr; nonres—$7546, $327 per cr hr
Courses: Advertising Design, Art Education, Art History, Ceramics, †Communications Graphics, Film, Goldsmithing, Handicrafts, History of Art & Architecture, Jewelry, Mixed Media, †Painting, †Photography, †Printmaking, †Sculpture, †Silversmithing, †Teacher Training, †Textile Design, Video, Weaving
Summer School: Chmn, Ian Short. Tuition $129 per cr for two 5 wk sessions

ELKINS PARK

TEMPLE UNIVERSITY, Tyler School of Art, 7725 Penrose Ave, Elkins Park, PA 19027. Tel 215-782-2715; Fax 215-782-2799; Elec Mail d12es@astro.temple.edu; *Chmn Painting, Drawing, & Sculpture* Stan Whitney, MFA; *Chmn Graphic Arts & Design* Hester Stinnett, MFA; *Chmn Crafts* Jon Clark, MFA; *Chmn Art History* Theresa Dolon PhD; *Chmn Univ Art & Art Educ* Richard Hricko, MFA; *Dean* Rochelle Toner, MFA; *Chmn Foundation Prog* Sharyn O'Mara, MFA; *Prog Dir Architecture* Brooke Harrington, BArch; *Sr Assoc Dean* Judith Thorpe, MFA; *Assoc Dean Main Campus Prog* Brigitte Knowles, MArch
Dept estab 1935; Maintain nonprofit art gallery; Temple Gallery, 45 N 2nd St, Philadelphia, PA 19106; Pub; D & E; Scholarships, Fellowships; maj 1,200
Ent Req: HS dipl, SAT, portfolio
Degrees: BA(Art History & Studio Art), BS(Art Educ), BFA, MA(Art History), MEd(Art Educ), MFA & PhD(Art History)
Tuition: Res—undergrad $9,194 per yr, grad $12,480 per yr; nonres—undergrad $16,442 per yr, grad $18,210 per yr
Courses: Animation, †Architecture, †Art Education, †Art History, †Ceramics, Computers, Drawing, †Fibers Fabric Design, Film, Foundry, †Glass, †Graphic Design, Handmade Cameras, †History of Art & Architecture, Illustration, Metals, †Painting, Papermaking, Performance Art, †Photography, †Printmaking, Sculpture, Video, Weaving
Children's Classes: Courses—Computer & Studio, also programs for HS students

ERDENHEIM

ANTONELLI INSTITUTE, Professional Photography & Commercial Art, 300 Montgomery Ave, Erdenheim, PA 19038. Tel 215-836-2222; Fax 215-836-2794; Elec Mail admissions@antonelli.org; Internet Home Page Address: www.antonelli.org; *Pres & Dir* Thomas D Treacy, EdD; *Instr* Joseph Wilk; *Dir Educ* Marion Freeman; *Placement, Faculty* Andrew Simcox; *Placement, Faculty* Harris Freeman; *Graphic Design* Chris Patchell; *Graphic Design* Ed Zawora; *Photography* Randy Davis; *Bus* Harris Freeman; *Photography* Robert Golding; *Photography* Vladmir Hartman; *Photography* Ed Marco; *Photography* Mimi Janosy; *Photography* Todd Murray; *Photography/Graphic Design* Troy Sayers; *Graphic Design* Larry Schafle; *Photography* Robert Wood
Estab 1938; Maintain art library; pvt; D; SC, LC; D 205, Maj 205
Ent Req: HS dipl
Degrees: A (Specialized Technology)
Tuition: $8575 per sem (photography), $7725 per sem (all others); campus res—room $3050 per sem
Courses: Advertising Design, Art History, †Commercial Art, Design, Drawing, Film, Graphic Arts, †Graphic Design, History of Art & Architecture, Illustration, †Photography, Typography
Adult Hobby Classes: Workshops as scheduled
Summer School: Workshops

ERIE

MERCYHURST COLLEGE, Dept of Art, 501 E 38th St, Erie, PA 16546. Tel 814-824-2000; Fax 814-825-2188; Elec Mail thubert@mercyhurst.edu; Internet Home Page Address: www.mercyhurst.edu; *Dept Chmn* Thomas Hubert; *Prof* Dan Burke; *Asst Prof* Gary Chardot; *Art Therapy Dir* Cathlyn Hahn; *Dir Art Educ* Richard Hanwi; *Dir Graphic Design* Jodi Staniunas Hopper
Estab 1926, dept estab 1950; FT 6, PT 4; pvt; D & E; Scholarships; SC 45, LC 12; D 80, E 20, maj 100
Ent Req: HS dipl, col boards
Degrees: BA 4 yr
Courses: 3-D Design, †Advertising Design, Aesthetics, Airbrush Painting, †Art Appreciation, Art Education, Art Foundations, Art History, Art Therapy, Ceramics, †Design, Drawing, †Graphic Arts, Graphic Design, †History of Art & Architecture, Independent Study, Individualized Studio, Internship, Painting, Photography, Printmaking, Sculpture, Senior Seminar, Teaching Internship, †Weaving

FARMINGTON

TOUCHSTONE CENTER FOR CRAFTS, 1049 Wharton Furnace Rd, Farmington, PA 15437. Tel 724-329-1370; Fax 724-329-1371; Internet Home Page Address: www.touchstonecrafts.com; *Registrar* Laura Peters
Estab 1983; 90 PT; pvt; D; Scholarships; D 500
Tuition: $175-$325 per wk; campus housing available
Courses: Ceramics, Design, Fashion Arts, Handicrafts, Illustration, Jewelry, Painting, Photography, Printmaking, Sculpture, Silversmithing, Textile Design, Video, Weaving
Adult Hobby Classes: Enrl 400; tuition $100-$250 per wk. Courses—Blacksmithing, Clay, Fibre, Glass, Metal, Painting, Photography, Printmaking, Wood
Children's Classes: Enrl 100. Courses—Art

GETTYSBURG

GETTYSBURG COLLEGE, Dept of Visual Arts, PO Box 2452, Gettysburg, PA 17325. Tel 717-337-6121; Elec Mail atrevely@gettysburg.edu; *Prof* Alan Paulson; *Assoc Prof* James Agard; *Asst Prof* Carol Small; *Instr* Lisa Dorrill; *Instr* Jim Ramos; *Instr* Brent Blair; *Instr* John Winship; *Chmn* Mark Warwick
Estab 1832, dept estab 1956; pvt; D; SC 10, LC 15; D 300
Ent Req: HS dipl, ent exam
Degrees: BA 4 yrs
Tuition: $30,717 annual tuition; room & board
Courses: 2-D & 3-D Design, American Indian Art, Architecture, †Art History, Art of Cinema, Ceramics, Design, Drawing, Film, Gallery Training, History of Art & Architecture, Museum Staff Training, Painting, Printmaking, Sculpture

GLENSIDE

BEAVER COLLEGE, Dept of Fine Arts, Easton & Church Rds, Glenside, PA 19038. Tel 215-572-2900; Internet Home Page Address: www.beaver.edu; *Asst Prof* Bonnie Hayes, MA, ABD; *Assoc Prof* Betsey Batchelor, MFA; *Asst Prof* Judith Taylor, MFA; *Asst Prof* W Scott Rawlins, MFA; *Chmn* Robert Mauro, MFA
Estab 1853; PT 7; pvt; D & E; Scholarships; SC 43, LC 14; in Col D FT 625, PT 115, non-maj in dept 30, maj in dept 140
Ent Req: HS dipl, SAT, ACT, optional portfolio review
Degrees: BA and BFA 4 yrs, MA(Educ) 1 yr
Tuition: $13,690 per yr, $6845 per sem, $1040 per 4 cr course; campus res—room & board $5750
Courses: Art Education, Art History, †Art Therapy, Ceramics, Design, Drawing, Goldsmithing, Graphic Design, History of Art & Architecture, Interior Design, Jewelry, Painting, Photography, Printmaking, Silversmithing
Summer School: Chmn, Robert Mauro. Enrl approx 30; tuition $1040 per cr hr for term of 7 wks. Courses—Drawing, Painting, Visual Fundamentals

GREENSBURG

SETON HILL UNIVERSITY, Art Program, 1 Seton Hill Dr Greensburg, PA 15601. Tel 724-834-2200, Ext 4255; Fax 724-830-1294; Elec Mail admit@setonhill.edu; Internet Home Page Address: setonhill.edu; *Asst Prof* Maureen Vissat, MA; *Prof* Stuart Thompson PhD, MFA; *Dir Gallery & Asst Prof* Carol Brode, MA; *Prog Dir & Assoc Prof* Chrissy Schaffer, MFA; *Dir Grad Adult Studies* Mary Kay Cooper; *Asst Prof* Patricia Beachley, MFA; *Asst Prof* Philip Rostek, MFA; *Assoc Prof* Nina Denninger, MA; *Instr* Richard Stoner; *Instr* Jim Andrews; *Instr* Brian McDermott, MFA
Estab 1918, dept estab 1950; Maintains nonprofit art gallery, Harlan Gallery, 1 Seton Hill Dr, Greensburg, PA 15601; pvt; D & E & Sat; Scholarships; SC 40, LC 8, GC 11; D 1,800, maj 82, minor 15, pt 10, grad 34
Ent Req: HS dipl, review portfolio
Degrees: BA, BFA 4 yr
Tuition: $17,310 per yr; campus res—room & board $7355 per yr
Courses: 3-D Design, Advanced 2-D Media, Advanced 3-D Media, †Art Education, †Art History, †Art Therapy, Calligraphy, †Ceramics, Design, Digital Imaging, †Drawing, Fabrics, †Graphic Design, Illustration, Jewelry, Metalsmithing, †Painting, Photography, †Printmaking, Professional Practice, †Sculpture, †Studio Art, Typography, †Weaving
Adult Hobby Classes: Enrl 25; tuition $425 per cr for 14 wk sem. Courses— Art History, Photography, Design
Summer School: Dir, Christine Schaffer. Enrl 20. Courses—Art in Elementary Educ, Photography, Digital Imaging

GREENVILLE

THIEL COLLEGE, Dept of Art, 75 College Ave, Greenville, PA 16125. Tel 724-589-2094, 589-2000; Internet Home Page Address: www.thiel.edu; *Chmn Dept* Ronald A Pivovar, MFA
Estab 1866, dept estab 1965; pvt; D & E; Scholarships; SC 14, LC 11; D 105, non-maj 65, maj 40
Ent Req: HS dipl, interviews
Degrees: BA 4 yrs
Tuition: $25,480 includes room & board, $432 per cr hr
Courses: Art History, Ceramics, Drawing, Graphic Arts, Jewelry, Painting, Printmaking, Sculpture, Stage Design, Theatre Arts
Adult Hobby Classes: Classes offered
Summer School: Asst Acad Dean, Richard Houpt. Term of 4 wks beginning June 3. Courses—Art History, Extended Studies, Drawing

HARRISBURG

HARRISBURG AREA COMMUNITY COLLEGE, Division of Communication & the Arts & Social Science, One HACC Dr, Harrisburg, PA 17110. Tel 717-780-2420, 780-2432; Fax 717-780-3281; Internet Home Page Address: www.hacc.edu; *Chmn* Michael Dockery PhD; *Instr* Ronald Talbott, MFA

Estab 1964; pub; D & E; SC 15, LC 5; D 500, E 100, maj 100
Ent Req: HS dipl
Degrees: AA 2 yrs
Tuition: Res—undergrad $55.25 per cr hr; out-of-district—undergrad $110.50 per cr hr; out-of-state $185.95 per cr hr; no campus res
Courses: Art History, Ceramics, Commercial Art, Drafting, Drawing, Film, Graphic Arts, Handicrafts, Jewelry, Painting, Photography, Printmaking, Sculpture, Stage Design, Theatre Arts
Adult Hobby Classes: Courses—Calligraphy, Drawing, Painting, Photography, Pottery
Children's Classes: Courses—Calligraphy, Creative Dramatics
Summer School: Dir, Michael Dockery. Courses vary

HAVERFORD

HAVERFORD COLLEGE, Fine Arts Dept, 370 Lancaster Ave, Haverford, PA 19041-1392. Tel 610-896-1267 (Art Dept); Fax 610-896-1495; *Prof* R Christopher Cairns, MFA
Estab 1833, dept estab 1969; pvt; D, M; Scholarships; maj 12
Ent Req: HS dipl, programs in cooperation with Bryn Mawr College, Fine Arts Program
Degrees: BA 4 yrs
Tuition: $25,826 annual yr; campus res—$8230 room & board
Courses: Drawing, Graphic Arts, History of Art & Architecture, Painting, Photography, Sculpture

MAIN LINE ART CENTER, Old Buck Rd & Lancaster Ave, Haverford, PA 19041. Tel 610-525-0272; Fax 610-525-5036; Internet Home Page Address: www.mainlineart.org; *Admin Exec Dir* Judy S Herman; *Instr* Carol Cole, BA; *Instr* Liz Goldberg, MFA; *Instr* Robert Finch, BFA; *Instr* Ginny Kendall, BFA; *Instr* Carol Kardon, BFA; *Instr* Bonnie Mettler, BFA; *Instr* Francine Shore, BFA; *Instr* Carson Fox, BFA; *Instr* Sallee Rush, BFA; *Instr* Moe Brooker, MFA; *Instr* Mimi Oritsky, MFA; *Instr* Val Rossman, MFA; *Instr* Scott Wheelock, MFA; *Instr* Martha Kent Martin, BFA; *Instr* Patrick Arnold, BFA; *Instr* Carol Stirton-Broad, BFA; *Instr* Lydia Lehr, MFA; *Instr* Ann Simon, MFA; *Instr* Kathie Regan-Dalzell, BA; *Instr* Nury Vicens, MFA; *Instr* Susanna T Saunders, BA
Estab 1937; pvt; D & E; Scholarships; SC 45; D 300, E 250
Courses: Art History, Batik, Calligraphy, Ceramics, Collage, Drawing, Faux Painting, Jewelry, Mixed Media, Painting, Photography, Printmaking, Sculpture, Silversmithing, Textile Design, Tie-dyeing
Children's Classes: Enrl 1500, Courses—General Arts, Pottery
Summer School: Admin Dir, Judy S Herman. Tuition varies, classes begin mid-June. Courses—same as above

HUNTINGDON

JUNIATA COLLEGE, Dept of Art, Moore St, Huntingdon, PA 16652. Tel 814-643-4310, Ext 3683; *Chmn Dept* Karen Rosell
Estab 1876; FT 3, PT 1; pvt; D; Scholarships; SC 12, LC 3; 1100, maj 40
Ent Req: HS dipl
Degrees: BA 4 yrs
Tuition: Campus res
Courses: Aesthetics, Arts Management, Ceramics, Computer Graphics, Drawing, History of Art & Architecture, Museum Studies, Painting, Photography, Theatre Arts
Summer School: Dir, Jill Pfrogner, Courses —Art History, Ceramics, Studio Art

INDIANA

INDIANA UNIVERSITY OF PENNSYLVANIA, College of Fine Arts, 115 Sprowls Hall, 470 S 11th St Indiana, PA 15705. Tel 724-357-2530; Fax 724-357-7778; Elec Mail jlstrong@grove.iup.edu; Internet Home Page Address: www.arts.iup.edu; *Art Dept Chair* Dr Vaughn H Clay; *Asst Chair, Prof* Susan Palmisano; *Assoc Prof* Ronald Ali; *Assoc Prof* Paul Ben-Zvi; *Assoc Prof* Parker Boerner; *Assoc Prof* Sandra L Burwell; *Asst Prof* Dr Richard Ciganko; *Prof* Dr Anthony C DeFurio; *Assoc Prof* Andrew Gillham; *Asst Prof* Dr John Hanson; *Prof* Donn W Hedman; *Asst Prof* Lynda LaRoche; *Assoc Prof* Dr Majrorie Mambo; *Prof* Dr James P Nestor; *Assoc Prof* Dr Brenda Mitchell; *Assoc Prof* Patricia Villalobos Echeufefa; *Prof* Christopher Weiland
Estab 1875, dept estab 1875; pub; D & E; Scholarships, Assistantships; SC 26, LC 21, GC 30; D 250, non-maj 1700, maj 270, grad 30
Ent Req: HS dipl, SAT, portfolio review
Degrees: BS(Art Educ), BA(Art History & Humanities with Art Concentration), BFA(Studio Art Concentration) 4 yr, MA 2 yr & MFA
Tuition: Res undergrad $3,792 per yr, grad $3,780 per yr; nonres—undergrad $9,480 per yr, grad $6,610 per yr; campus res—room & board
Courses: Art Appreciation, Art Education, Art History, Art Studio, Ceramics, Computer Graphics, Design, Drawing, Fiber Arts, Goldsmithing, Graphic Design, Jewelry, Painting, Papermaking, Printmaking, Sculpture, Silversmithing, Weaving, Woodworking
Adult Hobby Classes: Enrl 60; Courses—Ceramics, Drawing
Summer School: Dir, Anthony G DeFurio. Enrl 140; tuition regular acad sem cr cost. Courses—Art Appreciation, Art History, Special Workshops, Studios

JOHNSTOWN

UNIVERSITY OF PITTSBURGH AT JOHNSTOWN, Dept of Fine Arts, 450 Schoolhouse Rd, Johnstown, PA 15904. Tel 814-269-7000 (Main); Fax 814-269-2096; Elec Mail vgrash@pitt.edu; Internet Home Page Address: www.upj.pitt.edu; *Dept Head* Dr Valerie Grash; *Instr* Paul Whinney
Estab 1968; pub, pvt; D & E; SC 2, LC 15; D 160, maj 3
Ent Req: HS dipl, SAT

Degrees: BA 4 yrs
Tuition: Res—$13,000 annual; nonres—$20,000 annual
Courses: Art History, Drawing, Film, History of Art & Architecture, Painting, Photography, Stage Design, Theatre Arts
Summer School: Enrl 30. Courses—Contemporary Art

KUTZTOWN

KUTZTOWN UNIVERSITY, College of Visual & Performing Arts, PO Box 730 Kutztown, PA 19530-0000. Tel 610-683-4500; Fax 610-683-4547; *Dean* William Mowder
Institution estab 1860, art dept estab 1929; pub; D & E; Scholarships; SC 284, LC 40, GC 8; D 943, maj 10
Ent Req: HS dipl
Degrees: BFA 4 yr, BS(Art Educ) 4 yr, MA(Educ)
Tuition: Res—undergrad $158 per cr hr
Courses: Advertising Design, Art Education, Ceramics, Drawing, Fine Metals, Graphic Design, Illustration, Jewelry, Painting, Photography, Printmaking, Sculpture, Weaving, Woodworking
Children's Classes: Young at Art
Summer School: Regular sessions 5 wks. Courses—Art Ed, Studio

LAPLUME

KEYSTONE COLLEGE, Fine Arts Dept, College Ave, LaPlume, PA; One College Green, PO Box 50 LaPlume, PA 18440-0200. Tel 570-945-5141, Ext 3300, 3301; Fax 570-945-6767; Elec Mail cliff.prokop@keystone.edu; Internet Home Page Address: www.keystone.edu; *Prof* William Tersteeg, MFA; *Art Dept Coordr* Stacey Donahue-Semenza, MFA; *Assoc Prof* Ward V Roe, MFA; *Asst Prof* Sally Tosti, MFA; *Instr* Nikki Moser, BFA; *Chmn Fine Arts* Clifton Prokop, MFA; *Asst Prof* Drake Gomez, MFA; *Asst Prof* Dave Potter, MA; *Instr* Mark Cioccia, BFA; *Instr* Ronald Berniek, PhD; *Instr* Kevin O'Neil, MFA; *Prof* Karl Neuroth; *Instr* Elizabeth Burktragermed
Estab 1868, dept estab 1965; Maintains Linder Gallery at the College; pvt; D & E, weekends; Scholarships; SC 15, LC 2; D 100
Ent Req: HS dipl, SAT
Degrees: AFA 2 yrs, BS (Art Educ), BA (Fine Art)
Tuition: Res—$9848 per yr, incl rm & board
Courses: 2-D Design, 3-D Design, Advertising Design, Art History, Ceramics, Color, Commercial Art, Design, Drawing, Film, Graphic Design, Intro to Commercial Design, Life Drawing, Mixed Media, Painting, Photography, Printmaking, Sculpture, Silversmithing, †Theatre Arts

LANCASTER

FRANKLIN & MARSHALL COLLEGE, Art Dept, PO Box 3003, Lancaster, PA 17604. Tel 717-291-3951; Fax 717-291-4389; *Prof* Folke Kihlstedt; *Assoc Prof* Linda Aleci; *Assoc Prof* Richard Kent; *Assoc Prof* Jun-Cheng Liu; *Instr* Carol Hickey; *Instr* Linda Cunningham; *Chmn Dept* James Peterson
Estab 1966; pvt; D & E; Scholarships; SC 10, LC 17; in col D 1900, E 580
Ent Req: HS dipl, SAT
Degrees: BA 4 yr
Tuition: Res—$90,810 per yr
Courses: Architecture, Art History, Basic Design, Drawing, History of Art & Architecture, Painting, Printmaking, Sculpture

PENNSYLVANIA SCHOOL OF ART & DESIGN, 204 N Prince St, Lancaster, PA 17603; 204 N Prince St, PO Box 59 Lancaster, PA 17608-0059. Tel 717-396-7833; Fax 717-396-1339; Internet Home Page Address: www.psad.edu; *Pres* Mary Colleen Heil
Estab 1982; Maintain nonprofit art gallery on-campus; art library; 40 FT & PT; pvt; D & E; Scholarships; SC 160, LC 9; D 200, E 150, non-maj 60, maj 140
Ent Req: HS dipl
Degrees: BFA (Fine Art, Graphic Design, Illustration) 4 yr
Tuition: Res—undergrad $9,500 per yr
Courses: Aesthetics, Art History, †Drawing, †Fine Art, †Graphic Design, †Illustration, Interior Design, †Photography
Adult Hobby Classes: Enrl 800; tuition $380 per cr. Certificate Programs in Desktop Publishing, Interior Design. Studio credit & non-credit courses for youths & adults; web site design certificate
Children's Classes: Enrl 250; tuition $160 per cr, 20 contact hrs. Courses—Figure Drawing, Studio
Summer School: Dir, Tracy Beyl. Enrl 220; tuition youth $160 for 20 contact hrs, adult $380 per cr for 30 hrs. Courses—Computer, Interior Design, Photography, Studio

LEWISBURG

BUCKNELL UNIVERSITY, Dept of Art, Lewisburg, PA 17837. Tel 570-524-1307; Internet Home Page Address: www.bucknell.edu; *Prof* Janice Mann PhD, MFA; *Prof* Neil Anderson, MFA; *Prof* James Turnure PhD, MFA; *Prof* Christiane Andersson PhD, MFA; *Prof* Jody Blake PhD, MFA; *Head Dept* Rosalyn Richards, MFA
Estab 1846; pvt; D; Scholarships; SC 19, LC 20, GC 30; D 500, non-maj 450, maj 50, grad 2
Ent Req: HS dipl
Degrees: BA 4 yrs
Tuition: $21,870 per yr; campus res—room $2865, board $2490
Courses: Art History, Drawing, Graphic Arts, History of Art & Architecture, Painting, Photography, Printmaking, Sculpture
Summer School: Dir, Lois Huffines. Enrl 426; term of 3 or 6 wks beginning June 14. Courses—Lectures, Studio

LOCK HAVEN

LOCK HAVEN UNIVERSITY, Dept of Fine Arts, Sloan Fine Arts Ctr, Lock Haven, PA 17745. Tel 570-893-2151, 893-2011, 893-2143; Fax 570-893-2432; Internet Home Page Address: www.lhup.edu; *Chmn* Bridgett Glenn
FT 4; pvt; D; Scholarships
Degrees: BA
Tuition: Res—$3468 per 2 sem, $144 per cr hr; nonres—$6824 per 2 sem, $284 per cr hr
Courses: 2-D Design, 3-D design, Art Appreciation, Art Education, Art History, Arts & Crafts, Ceramics, Drawing, Jewelry, Painting, Photography, Printmaking, Sculpture, Stage Design, Textile Design, Weaving
Summer School: Courses offered

LORETTO

ST FRANCIS COLLEGE, Fine Arts Dept, 110 Franciscan Way, Loretto, PA 15940-0600. Tel 814-472-3216; Fax 814-472-3044, 472-3000 (main); Elec Mail colson@sfcpa.edu; Internet Home Page Address: www.sfcpa.edu; *Chmn* Charles Olsen, MFA
Scholarships
Degrees: minor in fine arts
Tuition: $463 per cr hr; campus res—room & board available
Courses: Art Appreciation, Art History, Culture & Values, Design, Drawing, Exploration of Arts, Independent Study, Modern Art, Museum Staff Training, Painting, Photography, Weaving

MANSFIELD

MANSFIELD UNIVERSITY, Art Dept, Allen Hall, Mansfield, PA 16933. Tel 570-662-4500; Fax 570-662-4114; *Assoc Prof* Tom Loomis, MA; *Asst Prof & Chmn Dept* Dr Bonnie Kutbay, MA
Estab 1857; pub; D; Scholarships; SC 26, LC 18; D 700, maj 90
Ent Req: HS dipl, SAT, portfolio & interview
Degrees: BA & BS(Studio Art), BA(Art History) & BSE(Art Educ) 4 yr, MEd(Art Educ)
Tuition: Res—$1896 per sem, $3792 per yr; non-res—$4740 per sem, $9480 per yr; campus res available
Courses: Advertising Design, Aesthetics, Art Education, Art History, Ceramics, Color & Design, Computer Art, Drawing, Fibers, History of Art & Architecture, Jewelry, Lettering, Painting, Printmaking, Sculpture, Studio Crafts, Visual Studies in Aesthetic Experiences, Weaving
Adult Hobby Classes: Enrl 10. Courses—Art History, Studio Art, Graduate Level Art Education
Children's Classes: Enrl 100, tuition $20 for 10 wks, fall sem. Courses—Elementary Art Education
Summer School: Term of 3-6 wks beginning May 17. Courses—Ceramics, Drawing, Fibers, Graduate Courses, Painting, Printmaking, Sculpture, Studio Courses

MEADVILLE

ALLEGHENY COLLEGE, Art Dept, 520 N Main St, Meadville, PA 16335. Tel 814-332-4365; Elec Mail name@allegheny.edu; Internet Home Page Address: www.allegheny.edu; *Chair Art Dept* Amara Geffen
Estab 1815, dept estab 1930; pvt; D; Scholarships; SC 10 per sem, LC 6 per sem; 550, maj 30, non-maj 250
Ent Req: HS dipl, ent exam
Degrees: BA and BS 4 yr
Tuition: Tuition $24,860 room & board incl
Courses: Art History, Ceramics, Costume Design & Construction, †Drawing, Film, Mixed Media, †Painting, †Photography, †Printmaking, †Sculpture, Stage Design, Theatre Arts, †Video

MEDIA

DELAWARE COUNTY COMMUNITY COLLEGE, Communications & Humanities House, 901 S Media Line Rd, Media, PA 19063-5382. Tel 610-359-5000, Ext 5382; Fax 610-359-5343; Elec Mail bgutman@dccc.edu; Internet Home Page Address: www.dccc.edu; *Dean* Rosina Fieno, PhD; *Prof* Bertha Gutman, MFA; *Prof* Gail Fox, MFA; *Prof* Bob Jones; *Prof* David Yox, MFA
Estab 1967; Maintain art gallery; pub; D & E; Studio & lecture courses
Degrees: AS, AA and AAS 2 yrs
Tuition: District res—$69 per cr hr; non-district res—$138 per cr hr; non-state res—$207 per cr hr; no campus res
Courses: 2-D & 3-D Design, Advertising, Advertising Design, Aesthetics, Art Education, Art History, Commercial Art, Computer Graphics, Desk Top Publishing, Drawing, Graphic Arts, Graphic Design, History of Art & Architecture, Illustration, Lettering, Mixed Media, Painting, Photography, Production Techniques, Sculpture, Teacher Training, Theatre Arts, Typography
Adult Hobby Classes: Enrl varies; tuition varies. Courses—Calligraphy, Crafts, Drawing, Graphic Design, Interior Design, Needlepoint, Photography, Stained Glass, Sketching, Woodcarving
Summer School: Tuition res $27 per cr hr, nonres $81 per cr hr for term of 6 wks. Courses—Drawing, Painting

MIDDLETOWN

PENN STATE HARRISBURG, School of Humanities, 777 W Harrisburg Pike, Middletown, PA 17057-4898. Tel 717-948-6189; Fax 717-948-6724; Internet Home Page Address: www.hbg.psu.edu/; *Prof* Irwin Richman PhD; *Assoc Prof* Troy Thomas PhD; *Dir Humanities* Simon J Bronner; *Dir Humanities* Linda Ross

Estab 1965; Maintain nonprofit art gallery; Morrison Gallery, Gallery Lounge; PT 10; pub; D & E; Scholarships; SC 7, LC 15; D & E 60, grad 40
Degrees: BHumanities, MA
Tuition: Res—undergrad 12 or more crs per sem $3,273, undergrad 11 or/fewer crs $274 per cr, grad 12 or more crs per sem $3,657, grad 11 or fewer crs $309 per cr; nonres—undergrad 12 or more crs per sem $6,280, undergrad 11 or fewer crs $523 per cr, grad 12 or more crs per sem $6,674, grad 11 or fewer crs $557 per cr
Courses: Aesthetics, Architecture, Art Education, Art History, Drawing, Folk Art & Architecture, Graphic Design, †History of Art & Architecture, Mixed Media, Museum Staff Training, Painting, Photography, Theatre Arts, Video, Visual Studies

MILLERSVILLE

MILLERSVILLE UNIVERSITY, Art Dept, PO Box 1002, Millersville, PA 17551. Tel 717-872-3298; Fax 717-871-2004; Internet Home Page Address: www.millersville.edu; *Chmn* Marianne S Kerlavage PhD
Estab 1855, dept estab 1930; pub; D & E; SC 65, LC 10, GC 64; maj 330, grad 20
Ent Req: HS dipl
Degrees: BA(Art), BS(Art Educ), BFA 4 yr, MEd(Art Educ) 1 yr
Tuition: Res—$5050.50 per yr; nonres—$8022.50 per yr
Courses: Advertising Design, Aesthetics, Art Appreciation, Art Crafts, Art Education, Art History, Calligraphy, Ceramics, Commercial Art, Computer Art, Design, Drawing, Goldsmithing, Graphic Arts, Graphic Design, Illustration, Jewelry, Lettering, Painting, Photography, Printmaking, Sculpture, Silversmithing, Teacher Training, †Visual Communication
Summer School: Dir, Marianne S Kerlavage, PhD. Enrl 200; term of 5 wks, two sessions beginning June & July. Courses—Art, Art Education, Art History

MONROEVILLE

COMMUNITY COLLEGE OF ALLEGHENY COUNTY, BOYCE CAMPUS, Art Dept, 595 Beatty Rd, Monroeville, PA 15146. Tel 724-327-1327; *Adjunct Prof* Kathy Gilbert; *Adjunct Prof* Jesse Almasi; *Adjunct Prof* Jamie Boyd
Pub; D & E; SC 13, LC 1; D 200, E 40, non-maj 140, maj 60
Ent Req: HS dipl
Degrees: AS 2 yrs
Tuition: $58 per credit
Courses: Art History, Ceramics, Collage, Color & Design, Constructions, Drawing, Graphic Arts, Mixed Media, Painting, Photography, Printmaking, Sculpture
Adult Hobby Classes: Ceramics, Color & Design, Drawing, History of Art, Mixed Media, Painting, Photography, Printmaking
Children's Classes: Enrl varies. Courses—Drawing, Painting
Summer School: Courses—Vary

NANTICOKE

LUZERNE COUNTY COMMUNITY COLLEGE, Commercial Art Dept, Prospect St & Middle Rd, Nanticoke, PA 18634. Tel 570-740-0364; Internet Home Page Address: www.luzerne.cc.pa.usa; WATS 800-377-5222; *Instr* Mike Molnar, BFA; *Instr & Coordr* Sam Cramer, BFA; *Instr* William Karlotski, BFA; *Coordr* Susan Sponenberg, BFA; *Instr* Chris Veda
Estab 1967; pub; D & E; SC 20, LC 7; D 140, E 60, non-maj 5, maj 60
Ent Req: HS dipl
Degrees: 2 year programs offered
Courses: Advertising Design, Airbrush, Art Education, Art History, Color & Design, Color Photography, †Computer Graphics, Conceptual Art, Design, Drawing, †Graphic Design, Illustration, Life Drawing, Mixed Media, Painting, Photography, Typography
Adult Hobby Classes: Enrl 350 per yr. Courses—Drawing, Graphic Design, Painting, Photography, Printmaking
Children's Classes: Enrl 500 per yr; summer sessions. Courses—Drawing, Painting
Summer School: Dir, Doug Williams, Enrl 20; Pre College Prog in July & Aug. Courses—Illustration, Life Drawing, Painting, Printmaking

NEW WILMINGTON

WESTMINSTER COLLEGE, Art Dept, Charles Freeman Hall , Rm 213 Box 162 New Wilmington, PA 16172. Tel 724-946-7239, 946-6260; Fax 724-946-7070; Elec Mail barnerdl@westminster.edu; *Chmn* Dr David L Barner
Estab 1852; 3; den; D; Scholarships; maj 30, total 1100
Degrees: BS & BA(Fine Arts, Educ) 4 yrs
Tuition: $23,320 with room & board
Courses: 2-D Design, 3-D Design, Art History, Ceramics, Computer Graphics, Drawing, Oil Painting, Photography, Printmaking, Sculpture
Children's Classes: Enrl 20

NEWTOWN

BUCKS COUNTY COMMUNITY COLLEGE, Fine Arts Dept, 275 Swamp Rd, Newtown, PA 18940. Tel 215-968-8421; Fax 215-504-8530; *Instr* Jon Alley; *Instr* Robert Dodge; *Instr* Jack Gevins; *Instr* Alan Goldstein; *Instr* Catherine Jansen; *Instr* Diane Lindenheim; *Instr* Marlene Miller; *Instr* Charlotte Schatz; *Instr* Helen Weisz; *Instr* Mark Sfirri; *Instr* Milt Sigel; *Instr* Gwen Kerber; *Instr* John Mathews; *Chmn Dept* Frank Dominguez
Estab 1965; pub; D & E; D & E 9200 (school)
Ent Req: HS dipl
Degrees: AA

Tuition: $74 per cr in county, $148 per cr out of county
Courses: Art History, Ceramics, Design, Drawing, Glass, Graphic Design, Jewelry, Painting, Photography, Printmaking, Sculpture, Woodworking

PHILADELPHIA

ART INSTITUTE OF PHILADELPHIA, 1622 Chestnut St, Philadelphia, PA 19103. Tel 215-567-7080; Fax 215-246-3358; Elec Mail pohlm@aii.edu; Internet Home Page Address: www.aiph.aii.edu; WATS 800-275-2474; *Pres* Frank Covaleskie
Estab 1966; FT 40, PT 65; pvt; D & E; Scholarships; SC 30, LC 8; D 1125, E 72
Ent Req: HS dipl, portfolio
Degrees: AST 2 yr
Tuition: $4635 per qtr
Courses: Advertising Design, Art History, Computer Graphics, Design, †Fashion Illustration, †Fashion Merchandising, Graphic Design, Illustration, †Interior Design, Lettering, Mixed Media, †Photography, Weaving

DREXEL UNIVERSITY, College of Media Arts & Design, Nesbitt Hall, 33rd & Market Sts Philadelphia, PA 19104. Tel 215-895-2386; Fax 215-895-4917; Elec Mail comad@drexel.edu; Internet Home Page Address: www.drexel.edu/academics/coda; *Dean* Jonathan Estrin; *Head Dept Interiors & Graphic Studies* Marjorie Kriebel; *Head Dept Fashion & Visual Studies* David Raizman; *Head Dept Architecture* Paul Hirschorn, MArch; *Head Dept Design* Karin Kuenstler; *Head Dept Media Arts* Yvonne Leach; *Head Dept Performing Arts* Alfred Blatter; *Head Dept Visual Studies* Nadine Heller; *Asst Prof Dramatic Writing* Ian Abrams; *Asst Prof Music* Barry Atticks; *Prof Visual Studies* Elliott Barowitz; *Assoc Prof Architecture* Judith Bing; *Asst Prof Architecture* Mark Brack; *Prof Fashion Design* Renér Chase; *Assoc Prof Graphic Design* Jack Cliggett; *Assoc Prof Design* Robert Croston; *Asst Prof Interior Design* Rena Cumby; *Asst Prof Interior Design* Eugenia Ellis; *Asst Prof Arts Adminis* Cecelia Fitzgibbon; *Assoc Prof Design & Merchandising* Roberta Gruber; *Prof Visual Studies* Joseph Grunfeld; *Assoc Prof Visual Studies* Lydia Hunn; *Prof Film & Video* Dave Jones; *Asst Prof Fashion Design* Kathi Martin; *Prof Art History* Charles Morscheck; *Asst Prof Digital Media* Glen Muschio; *Prof Visual Studies* Keith Newhouse; *Assoc Prof Music* Steven Powell; *Assoc Prof Photography* Stuart Rome; *Asst Prof Photography* Paul Runyon; *Prof Music* George Starks; *Asst Prof Graphic Design* Sandra Stewart; *Assoc Prof Photography* Blaise Tobia; *Assoc Prof Visual Studies* Brian Wagner; *Prof Visual Studies* Michael Webb; *Prof Visual Studies* Dennis Will
Estab 1891; FT 59, PT 159; pvt; D & E; Scholarships; SC 156, LC 112; undergrad 1231, grad 101
Ent Req: col board exam
Degrees: BS 4 yr (cooperative plan for BS), BArch 2 yr undergrad & 4 yr part time program, MS
Tuition: $19,686 per yr, room & board $1675-1905 per term
Courses: Advertising Design, †Architecture, Art History, †Arts Administration, Calligraphy, Commercial Art, Conceptual Art, Costume Design & Construction, Design, Design & Merchandising, †Digital Media, Display, †Dramatic writing, Drawing, †Fashion Arts, †Fashion Design, †Film, †Graphic Arts, †Graphic Design, Illustration, †Interior Design, Lettering, Mixed Media, †Music, Painting, †Photography, Printmaking, Sculpture, Stage Design, Textile Design, Theatre Arts, †Video

HUSSIAN SCHOOL OF ART, Commercial Art Dept, 1118 Market St, Philadelphia, PA 19107-3679. Tel 215-981-0900; Fax 215-864-9115; Elec Mail info@hussianart.edu; Internet Home Page Address: www.hussianart.edu; *Pres* Ronald Dove
Estab 1946; FT 1, PT 25; pvt; D; Scholarships; 120
Ent Req: HS dipl, portfolio interview
Degrees: AST
Tuition: No campus res
Courses: †Advertising Design, Airbrush, Art History, Commercial Art, Computer Graphics, Drawing, Fine Art, Graphic Arts, Graphic Design, †Illustration, Mixed Media, Painting, Photography, Printmaking
Adult Hobby Classes: Courses offered
Summer School: Dir, Wilbur Crowford. Summer workshop in Advertising Design, Computer Graphics, Drawing & Illustration

LA SALLE UNIVERSITY, Dept of Art, 20th St & Olney Ave, Philadelphia, PA 19141. Tel 215-951-1126; Internet Home Page Address: www.lasalle.edu/; *Chmn Dept Fine Arts* Dr Charles White
Estab 1865, dept estab 1972; den; D & E; SC 2; D 4, maj 2
Ent Req: HS dipl
Degrees: BA 4 yr
Tuition: $9870 per sem; campus res—room $2170 per sem, board $1335 per sem
Courses: Art History, Painting, Printmaking
Summer School: Selected courses offered

MOORE COLLEGE OF ART & DESIGN, 20th St & the Parkway, Philadelphia, PA 19103-1179. Tel 215-568-4515; Fax 215-568-8017; Elec Mail info@moore.edu; Internet Home Page Address: www.moore.edu; *Dean* Dona Lantz; *Fine Arts* Paul Hubbard; *Chmn Fashion Design* Janice Lewis; *Chmn Liberal Arts* Jonathan Wallis; *Chmn Illustration* Bill Brown; *Chmn Interior Design* Margaret Leahy; *Chmn Textile Design* Deborah Warner; *Chmn Basic Arts* Moe Brooker; *Pres* Happy Craven Fernandez; *Chmn Graphic Design* Gigi McGee; *Chmn Art Educ* Lynne Horoschak; *Chmn Photography & Digital Arts* James Johnson
Estab 1848; Maintains nonprofit art galleries: The Goldie Paley Gallery and the Levy Gallery for the Arts in Philadelphia, 20th St & The Parkway, Philadelphia, PA 19103; also maintains an art/architecture library on site; Pvt, women only; D & E; Scholarships, Fellowships; SC 119, LC 30; D 503, non-maj 1
Ent Req: HS dipl, portfolio, SAT
Degrees: BFA 4 yr
Tuition: Res—$34,134 per yr includes room & board; part-time students $994 per cr

Courses: †2-D & 3-D Design, Art Education, †Art History, Ceramics, †Curatorial Studies, Design, Display, †Drafting, Drawing, Fashion Arts, Film, Graphic Arts, †Graphic Design, History of Art & Architecture, †Illustration, †Interior Design, Jewelry, Mixed Media, †Painting, †Photography, †Photography & Digital Arts, †Printmaking, Sculpture, Teacher Training, †Textile Design, Weaving
Adult Hobby Classes: Tuition $510 per 3 hr class, 2 cr each, once per wk; 10 wk term. $870 for certificate courses. Courses—CADD, Computer Seminars, Desktop Publishing, Drawing, Fashion Design Studio, Illustration, Interior Decorating, Jewelry Making, Life Drawing, Millinery, Oil Painting, Print Design
Children's Classes: Enrl 500; tuition $280, registration $200 per class; Oct - Dec & Feb - Apr on Sat. Courses—General Art
Summer School: Dir Continuing Educ, Neil di Sabato

PENNSYLVANIA ACADEMY OF THE FINE ARTS, 118 N Broad St, Philadelphia, PA 19102. Tel 215-972-7600; Fax 215-569-0153; Elec Mail tafa@pafa.org; Internet Home Page Address: www.pafa.org; *CEO* Derek A Gillman
Estab 1805; Pvt; D & E; Scholarships; SC 15, LC 4
Publications: Newsletter/Calendar, quarterly
Ent Req: HS dipl, portfolio & recommendations
Degrees: Cert, 4 yrs; BFA Coordinated prog with Univ Pennsylvania or Univ of the Arts 5 yr, MFA(Painting), MFA(Printing) & MFA(sculpture) 2 yrs, Post-Baccalaurcate prog 1 yr
Tuition: Nonres—undergrad $10,375 per sem, MFA $16,400 per yr, Post-Baccalaurcate $13,100 per yr; no campus res
Courses: Anatomy, Drawing, Painting, Perspective, Printmaking, Sculpture
Adult Hobby Classes: Enrl 310; tuition $390 per class for 5 wk term. Courses—Drawing, Painting, Printmaking, Sculpture
Children's Classes: Enrl 200; tuition $150 one wk session. Courses—Theme Camps
Summer School: Dir, Neil di Sabato. Enrl 500-600; tuition $390 per class for 1 wk workshop 6 wk classes. Courses—Drawing, Painting, Printmaking, Sculpture

PHILADELPHIA COMMUNITY COLLEGE, Dept of Art, 1700 Spring Garden St, Philadelphia, PA 19130. Tel 215-751-8771; *Dir Div Liberal Arts* Dr Sharon Thompson; *Prof* Robert Paige, MFA; *Assoc Prof* Dan Evans, MA; *Asst Prof* Meiling Hom, MFA; *Asst Prof* Karen Aumann, BFA; *Asst Prof* Michael Saluato, MA
Estab 1967; Pub; D & E; SC 10, LC 6; D 80 art maj
Ent Req: HS dipl, portfolio
Degrees: AA 2 yr
Tuition: call for information, no campus res
Courses: 2-D Design, 3-D Design, Art History, Ceramics, Computer Graphics, Design, Drawing, Graphic Design, Painting, Photography, Transfer Foundation Program
Summer School: Dir, Bob Paige. Tuition $61 per cr Courses—Art History, Ceramics, Design, Drawing, Painting

PHILADELPHIA UNIVERSITY, School of Textiles & Materials Technology, 4201 Henry Ave, Philadelphia, PA 19144. Tel 215-951-2700; Internet Home Page Address: www.philau.edu; *Pres* Dr James Gallagher; *Dean* David S Brookstein; *Dir Global Textile Marketing* Jacob Gargir; *Prof Art History* Sigrid Weltge; *Prof Print Design* Joyce B Storey; *Dir Textile Programs* Muthu Govindaraj; *Prof Textiles* Marylyn Goutman
Estab 1884; FT 23; pvt; D&E; Scholarships; D 1600, E 1100
Degrees: BS 4 yrs, MBA, MBA, Master in Business, Master in Textiles
Tuition: $15,412 per yr
Courses: Chemistry & Dyeing, Fashion Apparel Management, Fashion Design, Fashion Merchandising, Interior Design, Knitted Design, Print Design, Textile Engineering, Textile Quality Control & Testing, Weaving Design
Summer School: Dir, Maxine Lentz

SAINT JOSEPH'S UNIVERSITY, Dept of Fine & Performing Arts, 5600 City Ave, Philadelphia, PA 19131. Tel 610-660-1000, 660-1840; Fax 610-660-2278; Elec Mail dmcnally@sju.edu; *Chmn* Dennis McNally SJ, PhD; *Assoc Head Music* Lewis Gordon, DMA; *Prof Painting* Steve Cope, MFA; *Prof Ceramics* Ron Klein, MFA; *Prof Art History* Elizabeth Anderson, MA; *Prof Film* Devon Albright; *Barnes Foundation Lectr* Mollie McNickle, PhD; *Photography* Susan Fenton, MFA; *Theatre* Celeste Walker, MFA
Estab 1851, prog estab 1975; Maintains nonprofit art gallery; St Joseph's Univ Gallery Boland Gall, 5600 City Ave, Philadelphia, PA 19131; Drexel Library at St Joseph's Univ; Den; D & E; Scholarships; SC 15, LC 4; D 600, maj 50, non-maj 550
Ent Req: HS dipl
Degrees: BA
Tuition: $14,400 per yr; campus res—room & board $6,350
Courses: Advertising Design, Aesthetics, Architecture, Art Appreciation, Art Education, Art History, Ceramics, Drawing, Film, History of Art & Architecture, Music History, Painting, Photography, Stage Design, Theatre Arts
Adult Hobby Classes: Enrl 30 per sem; tuition $175 per cr hr. Courses—same as above
Children's Classes: Chmn, Rev Dennis McNally, SJ, PhD. Enrl 60; tuition $175 per cr hr, 3 cr for 6 wk term. Courses—Art History, Drawing, Photography

SAMUEL S FLEISHER ART MEMORIAL, 719 Catharine St, Philadelphia, PA 19147. Tel 215-922-3456; Fax 215-922-5327; Elec Mail info@fleisher.org; Internet Home Page Address: www.fleisher.org; *Instr* Cathy Hopkins; *Instr* Frank Gasparro; *Instr* Louise Clement; *Dir* Thora E Jacobson
Estab 1898; administered by the Philadelphia Museum of Art; maintains nonprofit gallery, Dene M Louchheim Galleries, 719 Catharine St; Matilda Rosenbaum Memorial Library (children) 719 Catharine St; pvt; E; Scholarships; SC 80, LC 1; E 2000
Ent Req: none
Degrees: none
Tuition: $165 for 10 wk session; fall & spring free; $30 mem fee only; summer $150 pp plus lab fees

Courses: †Calligraphy, Ceramics, Drawing, Painting, Photography, Printmaking, Sculpture
Adult Hobby Classes: Enrl 850; tuition free Sept-May. Courses—Ceramics, Drawing, Painting, Photography, Printmaking, Sculpture
Children's Classes: Enrl 425; tuition free Sept-May. Courses—Drawing, Painting, Papermaking, Sculpture
Summer School: Ceramics, Drawing, Landscape Painting, Painting, Photography, Printmaking, Sculpture

UNIVERSITY OF PENNSYLVANIA, Graduate School of Fine Arts, Dept of Fine Arts, 205 S 34th St, Morgan Bldg Rm 100 Philadelphia, PA 19104-6311. Tel 215-898-8374; Fax 215-573-2459; Elec Mail fine-art@pobox.upenn.edu; Internet Home Page Address: www.upenn.edu/gsfa/ugfnar/index.htm; *Chair* John Moore; *Assoc Prof* Terry Adkins; *Prof* Robert Slutzky; *Asst Prof* Scot Kaylor; *Prof Emeritus* Robert Engman; *Sr Critic* Matthew Freedman; *Sr Critic* Claudia Gould; *Adjunct Assoc Prof* Susana Jacobson; *Sr Critic* Alfred Leslie; *Prof Emeritus* Maurice Lowe; *Asst Prof* Joshua Mosley; *Adjunct Prof* Hitoshi Nakazato; *Senior Critic* Nigel Rolfe; *Adjunct Assoc Prof* Julie Schneider; *Asst Prof* Jackie Tileston; *Prof Emeritus* Neil Welliver; *Adjunct Assoc Prof* Becky Young
Estab 1874; pvt; Scholarships, Fellowships; GC; 47
Ent Req: ent exam, portfolio
Degrees: MFA
Tuition: Grad $26,234 per yr, $13,612 per sem; campus res available
Courses: Architectural Design, Fine Arts, Painting
Summer School: Dir, Adele Santos. Tuition $2500 per 6 wks. Studio courses in Paris, Venice & India
—**Dept of Architecture,** 207 Meyerson Hall, Philadelphia, PA 19104-6311. Tel 215-898-5728; Fax 215-573-2192; *Chmn Grad Group* David Leatherbarrow; *Interim Chmn* Richard Wesley
FT 7, PT 25; 180
Degrees: MA 3 yrs, PhD 4 - 5 yrs
Tuition: Grad $24,200 per yr, $12,100 per sem; campus res available
Courses: Architectural Design and Construction
Summer School: Chmn, Adele Santos. Enrl 70; tuition $1200 per 3 cr course (4-6 wks duration). Courses—Summer studios (only upper level students)
—**Dept of Landscape Architecture & Regional Planning,** Meyerson, Rm 119, Philadelphia, PA 19104-6311. Tel 215-898-6591; Fax 215-573-3770; *Chmn* John Dixon Hunt
FT 6, PT 5; Scholarships; LC 7, Design Courses 4; 68
Degrees: MLA 2 - 3 yrs, MRP 2 yrs, Cert & joint degrees available
Tuition: Grad $24,200 per yr, $12,100 per sem; campus res available
Courses: Computation - GIS & CAD, Design Studio, Field Ecology, History & Theory, Regional Planning Studio, Workshop Series

UNIVERSITY OF THE ARTS, Philadelphia Colleges of Art & Design, Performing Arts & Media & Communication, 320 S Broad St, Philadelphia, PA 19102. Tel 215-875-4800 (Univ), 875-1100 (PCAD), 800-616-2787 (Admissions); Fax 215-875-1100 (PCAD); Internet Home Page Address: www.uarts.edu; *Pres* Peter Solmssen, JD; *Provost* Terry Applebaum; *Dean, College of Art & Design* Stephen Tarantal, MFA; *Dean, College of Performing Arts* Stephen Jay, MM; *Dir Admis* Barbara Elliot, MM; *Chmn Crafts* Roy Superior, MFA; *Chmn Graphic Design* Chris Myers, MFA; *Chmn Illustration* Mark Tocchet, BFA; *Chmn Industrial Design* Anthony Guido, BS; *Chmn Fine Arts Dept* Lois Johnson, MFA; *Chmn Photography, Media Arts, Film & Animation* Harris Fogel, MA; *Co-Chmn Foundation Prog* Robert McGovern, BFA; *Co-Chmn Foundation Prog* Michael Rossman, MFA; *Chmn Educ Art* Janis Norman PhD, MFA; *Chmn Museum Educ* Anne El-Omami PhD, MFA; *Dir Continuing Studies* Barbara Lippman, BA; *Dir Pre-College Prog* Erin Elman, MA; *Coordr Grad Prog* Carol Moore, MFA; *Grad Prog* Mary Phelan, MA; *Graduate Prog* Charles Burnette PhD, MA; *Grad Prog* Michael Blakeslee, MFA; *Dir School Dance* Susan Glazer, MFA; *Dir School Music* Marc Dicciani, MFA; *Dir School Theater Arts* Paul Berman, MFA; *Dir Writing Media* Jeffrey Ryder, MFA; *Dir Multimedia* Chris Garvin, MFA
Estab 1876; pvt; D & E; Scholarships; undergrad 760, grad 120
Ent Req: ent req HS dipl, portfolio & audition SAT
Degrees: degrees BFA 4 yrs, BS, BM, MFA, MM, Mid, Mat certificates
Tuition: $17,250 per yr
Courses: Acting, Aesthetics, Animation Business of the Arts, Art Education, Art History, Calligraphy, †Ceramics, Collage, Conceptual Art, Constructions, Dance Education, Digital Storytelling, Drawing, †Film, Goldsmithing, †Graphic Design, †Illustration, †Industrial Design, Interactive Narrative, Interface Design, Intermedia, Jazz Dance Performance, Jazz Music Theory, Jewelry, Lettering, Media Technology, Mixed Media, Multimedia, Museum Exhibition Design, †Museum Staff Training, Music Education, Music Industry: Modern Ballet, Musical Theater, †Painting, Performance & Composition, †Photography, †Printmaking, †Sculpture, Silversmithing, †Teacher Training, †Textile Design, Weaving
Adult Hobby Classes: Courses—Ceramics, Computer Graphics, Creative Writing, Design, Fine Arts, Illustration, Jewelry & Metalsmithing, Photography, Printmaking, Sculpture, Woodworking
Children's Classes: Courses—Acting, Animation, Bookmaking, Ceramics, Comix, Creative Writing, Dance, Drama, Drawing, Figure Drawing, Graphic Design, Illustration, Jewelry, Musical Theater, Painting, Photography, Sculpture
Summer School: Courses—Acting, Crafts, Design, Fine Arts, Jazz Performing, Media Arts, Musical Theater

PITTSBURGH

ART INSTITUTE OF PITTSBURGH, 420 Boulevard of the Allies Pittsburgh, PA 15219. Tel 412-263-6600, 291-6200; Fax 412-263-6667; Elec Mail admissions-aip@aii.edu; Internet Home Page Address: www.aip.aii.edu; *Pres* George Pry; *Technology* Allan Agamedia, BS; *Media Arts & Animation* James Allen, AST; *Digital Media Production/Video Production* Cy Anderson, BS; *Gen Educ* Douglas Anke, BS; *Photography* Karen Antonelli, BA; *Industrial Design Technology* Alan Assad, MEd; *Industrial Design Technology* Cyril Assad, BFA;

Media Arts & Animation Michele Bamburak, BA; *Multimedia & Web Design* David Barton, BA; *Graphic Design* Mark Bender, BFA; *Media Arts & Animation* Sean Benedict, BA; *Dir Gen Educ* Heather A Bigley, MS; *Gen Educ* Maria Boada, MS; *Gen Educ* Diane Bowser, MA; *Media Arts & Animation/Gen Educ* J Nicholas Brockmann, MFA; *Gen Educ* Chad Brown, BA; *Graphic Design* Stephen M Butler, BS; *Multimedia & Web Design* Michael Cantella, BA; *Media Arts & Animation* Richard Catizone; *Gen Educ* Alberta Patella Gross, MEd; *Industrial Design Technology* Dan-Horia Chinda, MArch; *Gen Educ, Graphic Design* Angelo L Ciotti, MA; *Digital Design* Bob Clements, BS; *Photography* Brian Colkitt, AST; *Computer Animation* Ruth Comley, BA; *Graphic Design* Jeff Davis, MFA; *Graphic Design* Frank J DeGennaro, BS; *Gen Educ* Maura Doern-Danko, MFA; *Photography* Thomas Donley, AST; *Gen Educ* Elizabeth C Dunn, MAT; *Graphic Design* Earl Easter, BS; *Photography* Anderson B English, MFA; *Industrial Design Technology* William Farrell; *Gen Educ* John C Franke, BA; *Video Production* Donald Gabany, BA; *Graphic Design* Deborah Giancola, MPA; *Interior Design* Jordene Gates, BA; *VPres, Dean Educ* Edward A Gill, MEd; *Graphic Design* David S Giuliani, BS; *Graphic Design* Albert Gotlieb, MFA; Maurice Graves; *Gen Educ* Kathy Griffin, MEd; *Industrial Design Technology* Eric Hahn, BFA; *Graphic Design* John L Hassinger; *Gen Educ* Janna L Haubach, MEd; *Prog Chmn Digital Media Production* Douglas N Heaps, BS; *Photography* Bruce Henderson, BA; Douglas Henderson; *Media Arts & Animation* Joseph Herron, BFA; *Interior Design* Margaret Herron, BA; *Video Production* James Hudson, BS; *Multimedia & Web Design* Patricia Adamcik-Huettel, AST; *Gen Educ* Jason Joy, MA; *Video Production* Douglas R Kennedy; *Graphic Design* Amy Kern, MFA; *Graphic Design* Michael W LaMark, MS; Una Charlene Langer-Holt; *Photography* Barry Lavery, MDiv; *Interior Design* Pamela A Lisak; *Graphic Design* Leslie B Lockerman, BFA; *Gen Educ* Frederick Lorini, MFA; *Media Arts & Animation* Angela Love, BS; *Video Production* Andrew Maietta, MLS; *Graphic Design* Michael Malle; *Gen Educ* Edward M Matus, MA; *Gen Educ* Richard Matvey, MEd; *Chair Multimedia & Design* Sharon McGuire, BA; *Photography* G Chris Miller, BS; *Graphic Design* Linda Miller; *Graphic Design* Ronald A Miller, BA; *Graphic Design & Digital Design* Joseph W Milne, BA; *Industrial Design Technology* William R Mitas, BS; *Graphic Design* Connie Moore, MAT; *Gen Educ* Linda Musto, BS; *Industrial Design* Lars Nyquist, BS; *Culinary Arts & Management* Shawn Oddo, AOS; *Digital Design* Shawn O'Mara, BS; *Graphic Design* Michael N Opalko, BFA; *Gen Educ* Robert Peluso, PhD; *Industrial Design Technology* David Pence, BS; *Gen Educ* Stephanie Perry, MBA; *Multimedia & Web Design* Dante Piombino, BA; *Media Arts & Animation* Francis A Pionati, MFA; *Gen Educ* Linda Rathburn, MEd; *Industrial Design Technology* Scott Ritiger, BA; *Industrial Design* Arturo Rivero; *Multimedia & Web Design* Leon L Salvayon, MEd; *Media Arts & Animation* Michael C Schwab, BFA; *Media Arts & Animation* John Simpson Jr, BA; *Interior Design* James J Smelko, BS; *Interior Design* Kelly JK Spewock, MFA; *Multimedia & Web Design* Jay W Speyerer, BS; *Graphic Design* Mary Jean Stabile, BS; *Media Arts & Animation* Jeffrey Styers, BS; *Gen Educ* Rebecca Suhoza, MA; *Graphic Design, Media Arts & Animation* Andrew Sujdak, BS; *Gen Educ* Michele M Thomas, MS; *Interior Design* John Michael Toth, BA; *Media Arts & Animation* Edward A Urian, BS; *Media Arts & Animation* David M Walters, BA; *Graphic Design, Media Arts & Animation* Helen Webster, BFA; *Media Arts & Animation* Greg Weider, BFA; *Media Arts & Animation* Hans Westman, BA; *Gen Educ* Jialu Wu, PhD; *Industrial Design* James Yedinak, BA; *Graphic Design* Shirley Yee, MFA; *Media Arts & Animation* Jeffrey Zehner, BS; *Graphic Design, Media Arts & Animation* Flavia Zortea, BFA
Estab 1921; Maintain nonprofit art gallery & art library; pvt; D & E, Sas; Scholarships; 2300
Ent Req: HS grad
Degrees: AA 2 yrs, dipl
Tuition: $334 per credit hr, AS prog 105 credits, BS prog 180 credits
Courses: Culinary Arts, Digital Design, Digital Media Production, Game Art & Design, Graphic Design, Industrial Design, Interior Design, Media Arts & Animation, Multimedia, Photography, Video, Web Site Administration
Summer School: Dir, Melinda Trempus.

CARLOW COLLEGE, Art Dept, 3333 Fifth Ave, Pittsburgh, PA 15213. Tel 412-578-6000, 578-6003; Internet Home Page Address: www.carlow.edu; *Assoc Chmn* Suzanne Steiner; *Chmn Dept of Art* Dale Hussman
Estab 1945; FT 1, PT 3; den; D & E; Scholarships; SC 17, LC 6; 800, maj 35
Ent Req: HS dipl and transcript, col boards
Degrees: BA, Certificate Art Education
Tuition: $13,468 per yr; campus res—room & board $5490
Courses: 2-D Design, American Art, Art Education, Art Therapy, Ceramics, Drawing, Fiber Arts, Painting, Printmaking, Sculpture, Survey of Art, Teacher Training, Twentieth Century Art

CARNEGIE MELLON UNIVERSITY, College of Fine Arts, 5000 Forbes Ave, Rm 100, Pittsburgh, PA 15213. Tel 412-268-2000, Ext 2349 (dean's office), Ext 2409 (art); *Assoc Dean* Barbara Anderson; *Assoc Dean* Craig Vogel; *Dean* Hilary Robinson
Estab 1905; Maintain a nonprofit art gallery, Regina Gouger Miller Gallery, 5000 Forbes Ave Pornell Center for the Arts, Pittsburgh, PA 15213; pvt; D & E; Scholarships, Fellowships
Ent Req: col board ent exam plus auditions or portfolio
Degrees: 4-5 yr, MFA in Stage Design available in Dept of Drama
Tuition: Undergrad $19,400 per yr; campus res available
Courses: Architecture, Conceptual Art, Constructions, Costume Design & Construction, Design, Graphic Arts, Graphic Design, Mixed Media, Painting, Photography, Printmaking, Restoration & Conservation, Sculpture, Stage Design, Theatre Arts, Video
Summer School: Term of 6 wks. Courses—includes some pre-college courses
—**School Architecture,** 201 College of Fine Arts, Pittsburgh, PA 15213-3890. Tel 412-268-2354; *Head* Vivian Loftness
FT 22, PT 20; 295
Degrees: BArch, MS, PhD
Tuition: Undergrad $19,400 per yr
Courses: Architecture
Summer School: Dir, John Papinchak. Tuition $2094 per 6 wks
—**School of Design,** MMCH 110, Pittsburgh, PA 15213. Tel 412-268-2828; *Head*

Richard Buchanan
FT 14, PT 4; 200
Degrees: BFA 4 yrs
Tuition: Res—undergrad $19,400 per yr
Courses: Graphic Design, Industrial Design
Adult Hobby Classes: Calligraphy
Summer School: Design Studio
—**School of Art,** Pittsburgh, PA 15213-3890. Tel 412-268-2409; Fax 412-268-7817; *Assoc Head* Mary Schmidt; *Head* Byran Rogers
FT 28, PT 2-6; Scholarships; 215
Degrees: BFA & MFA
Tuition: Undergrad & grad $21,275 per yr
Courses: †Art, Art History, Ceramic Sculpture, Computer, Conceptual Art, Constructions, Drawing, Mixed Media, Painting, Printmaking, Sculpture, Video
Children's Classes: Enrl 100: tuition $575 for 9 months. Courses—same as undergrad prog
Summer School: Dir, Janice Hart. Enrl 50; tuition $3200 for 6 wks. Courses—same as undergrad prog

CHATHAM COLLEGE, Fine & Performing Arts, Woodland Rd, Pittsburgh, PA 15232. Tel 412-365-1100; Internet Home Page Address: www.chatham.edu; *Dir* Dr Margaret Ross; *Asst Prof* Michael Pestel; *Chmn* Pat Montley
Estab 1869; FT 2, PT 2; pvt, W; SC 17, LC 7
Ent Req: HS grad
Degrees: BA 4 yrs
Tuition: $14,616 (incl res fees); campus res—room & board $5364
Courses: Aesthetics, Art Appreciation, Art Education, †Art History, Conceptual Art, Constructions, Design, Drawing, Film, History of Art & Architecture, Independent Study, Introduction to Art, Mixed Media, †Painting, Photography, Printmaking, †Sculpture, Tutorial

LA ROCHE COLLEGE, Division of Graphics, Design & Communication, 9000 Babcock Blvd, Pittsburgh, PA 15237. Tel 412-367-9300; Fax 412-536-1023; Elec Mail toriskt1@laroche.edu; *Prof* Tom Bates, MFA; *Assoc Prof* George Founds, MFA; *Instr* Grant Dismore, MFA; *Instr* Devvrat Nagar, BArchit; *Interior Design* Crispan Zuback, BArchit; *Interior Design* Carolyn Freeman, BArchit; *Graphic Design* Rosemary F Gould, MFA; *Div Chair* Wendy Beckwith, MArchit
Estab 1963, dept estab 1965; PT 15; pvt; D & E; SC 25, LC 15; D & E 200, non-maj 20, maj 180
Ent Req: HS dipl
Degrees: BA and BS 4 yr
Tuition: $5800 per sem, $420 per cr hr, grad $440 per cr hr
Courses: 3-D Design, Advertising Design, Aesthetics, Airbrush Illustration, Art History, Ceramics, Commercial Art, Communication, Computer Graphics, Display, Drawing, Fashion Design, †Graphic Arts, †Graphic Design, Illustration, Industrial Design, †Interior Design, Lettering, †Multimedia Design, Package Design, Painting, Photography, Sculpture
Summer School: Dir of Admissions, Marianne Shertzer.

POINT PARK COLLEGE, Performing Arts Dept, 201 Wood St, Pittsburgh, PA 15222. Tel 412-392-3450; Fax 412-391-1980; *Chmn* Ronald Allan Lindblom
Degrees: BA & BFA
Tuition: $4300 per sem
Courses: Architecture, Art Appreciation, Art History, †Fashion Illustration, †Film, †Interior Design, †Photography, †Stage Design, Theatre Design, †Visual Arts

UNIVERSITY OF PITTSBURGH
—**Henry Clay Frick Dept History of Art & Architecture,** Tel 412-648-2400; Fax 412-648-2792; Internet Home Page Address: www.pitt.edu; *Chmn* Kirk Savage; *Mellon Prof* Terence Smith; *Prof Emeritus* David Wilkins; *Prof Emeritus* Aaron Sheon; *Asst Prof* Kathleen Christian
Estab 1787, dept estab 1927; Maintain nonprofit, University Art Gallery; Fine Arts Library; Pvt; D & E; Scholarships, Fellowships; LC 35, GC 10; D 750, E 250, grad 30
Ent Req: HS dipl, BA, GRE for grad work
Degrees: BA 4 yrs, MA 2 yrs, PhD
Tuition: Res—grad $6,142 per sem; nonres—grad $1,1725 per sem
Courses: Art History, History of Art & Architecture
Summer School: Dir, Kirk Savage. Enrl 150; 6 wks, 2 sessions 3-4 wks, 3 sessions
—**Dept of Studio Arts,** Tel 412-648-2430; Fax 412-648-2792; Internet Home Page Address: www.pitt.edu/~studio; *Assoc Prof* Michael Morrill; *Assoc Prof* Kenneth Batista; *Assoc Prof* Paul Glabicki; *Assoc Prof* Delanie Jenkins; *Asst Prof* Bovey Lee; *Assoc Prof* Edward Powell
Estab 1968; FT 6, PT 4-7; pub; D & E; SC 29; 1,000 non-majors; 75 majors
Degrees: BA
Tuition: Res—$11,000 per yr
Courses: Design, Drawing, Graphic Design, Painting, Print Etching, Sculpture

RADNOR

CABRINI COLLEGE, Dept of Fine Arts, 610 King of Prussia Rd, Radnor, PA 19087-3699. Tel 610-902-8380; Fax 610-902-8539; *Chmn Dept* Adeline Bethany, EdD
Estab 1957; FT 2, PT 3; den; D & E; Scholarships; SC 11, LC 4
Ent Req: HS dipl, statisfactory average & rank in secondary school class, SAT, recommendations
Degrees: BA(Arts Administration, Fine Arts & Graphic Design), BS & BSED
Tuition: $24,600 per yr incl room & board, $16,900 per yr commuter
Courses: Art Education, Ceramics, Computer Publication Design, Design & Composition, Drawing, Graphic Design, History of Art & Architecture, Painting, Teacher Training
Adult Hobby Classes: Courses offered
Summer School: Dir, Dr Midge Leahy. Term of 6 wks beginning May & July. Courses—Color Theory, Drawing, Elem Art Methods, Mixed Media, Painting

READING

ALBRIGHT COLLEGE, Dept of Art, 13th & Bern Sts, PO Box 15234 Reading, PA 19612-5234. Tel 610-921-7715; Fax 610-921-7530; Internet Home Page Address: www.alb.edu; *Prof* Tom Watcke; *Chmn* Kristen Woodward; *Asst Prof* Dr Richard Hamwi; *Assoc Prof* Gary Adelstein; *Lectr* Christopher Youngs
Estab 1856, dept estab 1964; maintains nonprofit gallery, Freedman Gallery 13th & Bern St, PO Box 15234, Reading, PA 19612-5234; Pvt; D & E; Scholarships; SC 14, LC 7; D 322, E 41, non-maj 340, maj 14, others 20
Ent Req: HS dipl, SAT
Degrees: BA 4 yrs
Tuition: $17,710 per yr; campus res—room $3050, board $2400
Courses: †Art Education, Art History, Ceramics, †Commercial Art, Constructions, †Design, Drawing, Fashion Arts, Film, †Graphic Arts, History of Art & Architecture, Interior Design, Mixed Media, †Painting, Photography, Printmaking, †Sculpture, †Teacher Training, †Textile Design, Theatre Arts
Adult Hobby Classes: Enrl 40; tuition $110 per cr. Courses—Drawing, Photography
Children's Classes: Enrl 25-35; tuition $35-$50 per course. Courses—Crafts, Drawing
Summer School: Enrl 30 - 50; 2 terms of 4 wks beginning in June & July. Courses—Art History, Drawing, Painting

ROSEMONT

ROSEMONT COLLEGE, Art Program, 1400 Montgomery Ave, Rosemont, PA 19010. Tel 610-527-0200; Fax 610-526-2984; Elec Mail admissions@rosemont.edu; Internet Home Page Address: www.rosemont.edu; *Chmn Div* Tina Walduier Bizzarro, PhD; *Assoc Prof & Dir Gallery* Patricia Nugent, MFA; *Assoc Prof* Michael Willse, MFA; *Asst Prof* Amy Orr, MFA
Estab 1921; FT 6, PT 4; pvt; W (exchange with Villanova Univ, Cabrini College, Eastern College, The Design Schools); D; Scholarships; total col 600, art 200, grad approx 17
Ent Req: HS dipl, SAT
Degrees: BFA (Studio Art), BA (Art History, Studio Art), Teacher certificate in Art K-12
Tuition: $14,580 annual tuition; campus res—room & board $7,030
Courses: Aesthetics, American Indian Art, Art Criticism, Art Education, Ceramics, Creativity & the Marketplace, Drawing, Fibres History, Graphic Arts, Painting, Photography, Printmaking, Sculpture, Studio Art, Teacher Training
Summer School: Dir, Tina Walduier Bizzarro

SCRANTON

LACKAWANNA JUNIOR COLLEGE, Fine Arts Dept, 501 Vine St, Scranton, PA 18509. Tel 570-961-7827; Fax 717-961-7858; Internet Home Page Address: www.lacka.ljc.edu; *Chmn* John De Nunzio
Estab 1885
Ent Req: HS dipl or equivalent
Degrees: AA
Tuition: $795 per cr, $585 per 3 cr
Courses: Fine Arts, Survey Class

MARYWOOD UNIVERSITY, Art Dept, 2300 Adams Ave, Scranton, PA 18509. Tel 570-348-6211, 348-6278; Fax 570-Fax: 340-6023; Internet Home Page Address: www.marywood.edu; *Chmn* Matt Povse
Estab 1926; FT 12, PT 20; pvt; D & E; Scholarships; SC 28, LC 7, GC 12; maj 200, grad 100
Ent Req: HS dipl, portfolio & interview
Degrees: BA(Art Educ), BA(Architecture, Arts Admin), BFA(Drawing & Painting, Illustration, Advertising Graphics, Art Therapy, Photography, Ceramics, Sculpture, Interior Design), MA(Studio Art, Art Educ, Art Therapy), MFA (Visual Arts with concentration in Clay, Fibers, Graphic Design, Illustration, Metal, Painting, Printmaking)
Tuition: Grad MA $524, MFA $535 per cr, undergrad $520 per cr
Courses: †Advertising Design, †Art Education, Art History, †Art Therapy, †Ceramics, Contemporary Learning Theories, Drawing, Fabrics, †Graphic Arts, †Illustration, †Interior Design, Jewelry, Metalcraft, Painting, †Photography, †Printmaking, †Sculpture, Serigraphy, Textile Design, †Weaving

PENN FOSTER COLLEGE (Harcourt Learning Direct)
—**School of Interior Design,** Tel 570-342-7701, Ext 341; Fax 570-343-0560; Elec Mail harcourt@aol.com; *Dir Educ Serv* Connie Dempsey
Estab 1890, dept estab 1969; FT 1; pvt; 4200
Ent Req: HS dipl
Tuition: $689
Courses: Interior Decorating
Adult Hobby Classes: Interior Decorating
—**School of Art,** Tel 480-315-4950; Internet Home Page Address: www.pennfoster.edu; *Dir Educ Serv* Connie Dempsey
Estab 1890; FT 1, PT 2; pvt; open enrollment; Distance Learning
Ent Req: HS dipl
Degrees: Associate of Science
Tuition: $399-$499 per yr
Courses: Art Appreciation, Graphic Design
Adult Hobby Classes: Drawing, Painting

SHIPPENSBURG

SHIPPENSBURG UNIVERSITY, Art Dept, Huber Art Ctr, 1871 Old Main Dr Shippensburg, PA 17257-2299. Tel 717-477-1530; Fax 717-477-4049; Internet Home Page Address: www.shippensburg.edu; *Chmn Art Dept* William Hynes, MFA; *Assoc Prof* Janet Ruby; *Asst Prof* Bill Davis, MFA; *Asst Prof* Dr Stephen Hirshon, MFA; *Asst Prof* Michael Campbell, MFA; *Asst Prof* Steven Dolbin

Estab 1871, dept estab 1920; pub; D & E; Scholarships; SC 17, LC 6; D 400, E 100, non-maj 600, grad 15, continuing educ 20
Ent Req: HS dipl, Portfolio review
Degrees: BA(Art)
Tuition: Res—$1734 per sem, nonres—$4412 per sem, campus res—room & board $2006 per sem
Courses: Art History, Arts & Crafts, Ceramics, Drawing, Enamelling, Painting, Printmaking, Sculpture
Adult Hobby Classes: Sr citizen tuition waived in regular classes if space is available
Summer School: Dir, William Hynes. Tuition $110 per cr hr for terms of 3 - 5 wks beginning May 18. Lectr & Studio courses

SLIPPERY ROCK

SLIPPERY ROCK UNIVERSITY OF PENNSYLVANIA, Dept of Art, 14 Maltby Dr, Slippery Rock, PA 16057. Tel 724-738-2020; Fax 724-738-4485; *Prof, Chmn* Thomas Como; *Prof* J Robert Bruya, MFA; *Prof* Richard Wukich, MFA; *Asst Prof* John Shumway, MFA; *Prof* Dr Kurt Pitluga; *Prof* Katherine Mickle, MFA; *Prof* June Edwards, MFA
Maintain nonprofit art gallery, gaultgallery@maltbycenter; FT 9; Pub; D & E; SC 27, LC 3; maj 70
Ent Req: HS dipl
Degrees: BA(Art), BFA(Art) 4 yr
Tuition: In-state res—$3,792 per sem (12-18 hrs), $144 per cr; out-of-state—$9,480 per sem, $368 per cr
Courses: Art History, Art Synthesis, Ceramics, Drawing, Graphic Design, Metalsmithing, Mixed Media, Painting, Photography, Printmaking, Sculpture, Teacher Training, Textile Design
Summer School: Tuition $129 per cr hr

SWARTHMORE

SWARTHMORE COLLEGE, Dept of Art, 500 College Ave, Swarthmore, PA 19081-1397. Tel 610-328-8116, 328-8000; Fax 610-328-8086; Internet Home Page Address: www.swarthmore.edu; *Prof* T Kaori Kitao PhD, MFA; *Prof* Constance Cain Hungerford PhD, MFA; *Prof* Michael Cothren PhD, MFA; *Assoc Prof* Brian A Meunier, MFA; *Assoc Prof* Maribeth Graybill PhD, MFA; *Asst Prof* Syd Carpenter, MFA; *Asst Prof* Celia Reisman, MFA; *Chmn* Randall L Exxon, MFA
Estab 1864, dept estab 1925; pvt; D; Scholarships; SC 14, LC 33; non-maj 500, maj 25
Ent Req: HS dipl, SAT, CEEB
Degrees: BA 4 yrs
Tuition: $23,020 per yr, campus res—room & board $7500 per yr
Courses: Aesthetics, Architecture, Art, Art History, Ceramics, Drawing, History, History of Architecture, History of Art & Architecture, History of Cinema, Landscape Architecture, Mixed Media, Painting, Philosophy, Photography, Printmaking, Sculpture, Stage Design, Theatre Arts, Theatre Program, Urban History

UNIVERSITY PARK

**PENNSYLVANIA STATE UNIVERSITY, UNIVERSITY PARK
—Penn State School of Visual Arts,** Tel 814-865-0444; Fax 814-865-1158; Internet Home Page Address: www.sova.psu.edu; *Dir & Prof Art Educ* Charles Garoian; *Prof Art & Women's Studies (Drawing/Painting)* Micaela Amato; *Assoc Prof Art Educ* Patricia Amburgy; *Asst Prof Women's Studies & Art (Art Criticism)* Irina Aristarkhova; *Assoc Prof Art (Drawing/Painting)* John Bowman; *Assoc Prof Art (Core Prog & Drawing/Painting)* Paul Chidester; *Assoc Prof Art (Fayette Campus)* David DiPietro; *Prof Art Educ, Interim Dean, Col* Yvonne Gaudelius; *Assoc Prof Art (Printmaking)* Robin Gibson; *Asst Prof Art (Photography)* Lonnie Graham; *Prof Art (Photography)* Ken Graves; *Prof Art Educ & Women's Studies* Karen Keifer-Boyd; *Asst Prof Art (New Media)* Matthew Kenyon; *Asst Prof Art Educ* Wanda Knight; *Prof Art (Gen Educ)* Jerrold Maddox; *Asst Prof Art (Sculpture)* Cristin Millet; *Assoc Prof Art & Assoc Dean Research & Grad Studies, Col Arts & Architecture* Gunalan Nadarajan; *Assoc Prof Art (Drawing/Painting)* Helen O'Leary; *Asst Prof Art (Art Criticism)* Simone Osthoff; *Asst Prof Art Educ & Curriculum & Instruction* Kimberly Powell; *Assoc Prof Art (Ceramics)* Elizabeth Quackenbush; *Asst Prof Art Educ* James Rolling Jr; *Assoc Prof Art (New Media)* Carlos Rosas; *Assoc Prof Art (Printmaking & New Media)* Jean Sanders; *Asst Prof Integrative Art & Art (Photography)* Keith Shapiro; *Asst Prof Art Educ & Women's Studies* Stephanie Springgay; *Prof Art (Ceramics)* Christopher Staley; *Prof Art Educ* Mary Ann Stankiewicz; *Prof Art Educ* Christine Thompson; *Asst Prof Art (Metal Art & Technology)* James Thurman; *Distinguished Prof Art (Drawing/Painting)* Robert Yarber; *Assoc Prof Art & Art Educ* David Ebitz; *Instructor Art* Jason Ferguson; *Instructor Art Educ* Jody Guy; *Asst Prof Art* Janet Hartranft; *Instructor Art* Sarah Schwartz; *Instructor Art* Sara Young
Estab 1855, col estab 1963; Non-Profit art gallery, Zoller Gallery, 210 Patterson Bldg, Penn State Univ, University Park, PA 16802; pub; D & E; SC 282, LC 99, GC 104
Ent Req: HS dipl and GPA, SAT
Degrees: PhD, MEd, MFA, MS, BA, BFA
Tuition: Res—$6,082 per sem; nonres—$11,097 per sem
Courses: Art Education, Ceramics, Drawing, Metals, †New Media, Painting, Photography, Printmaking, Sculpture
Summer School: Courses— limited
—Dept of Art History, Tel 814-865-6326; Fax 814-865-1242; Elec Mail cxz3@psu.edu; Internet Home Page Address: www.arthistory.psu.edu; *Evan Pugh Prof Emeritus* Hellmut Hager, PhD; *Prof Emeritus* Roland E Fleischer, PhD; *Res Prof Emeritus* Heinz Henisch; *Evan Pugh Prof* Anthony Cutler, PhD; *Assoc Prof Emeritus* Jeanne Chenault Porter PhD; *Assoc Prof* Elizabeth B Smith PhD; *Assoc Prof* Elizabeth J Walters PhD; *Assoc Prof* Brian Curran, PhD; *Assoc Prof &Dept Head* Craig Zabel, PhD; *Assoc Prof* Charlotte Houghton, PhD; *Assoc Prof* Nancy Locke, PhD; *Asst Prof* Chika Okeke-Agulu, PhD; *Assoc Prof* Sarah Rich, PhD

Estab 1855, dept estab 1963; pub; D & E; Scholarships, Fellowships, Assistantships; LC 50, GC 36; maj 50, grad 35
Ent Req: HS dipl
Degrees: BA, MA, PhD
Tuition: Res—$3273 per sem; nonres—$7044 per sem
Courses: 19th & 20th century European Art & Architecture, Aesthetics, American Art & Architecture, Ancient Egyptian, †Art History, Contemporary Art, Early Christian & Byzantine Art, German Baroque & Rocco Architecture, Greek & Roman Art & Architecture, Historiography, History of Art & Archeology, History of Photography, Iconology, Italian Renaissance & Baroque Art & Architecture, Late Antique, Museum Studies, Northern Renaissance & Baroque Art, Spanish & French Baroque & Rocco Art, Western Medieval Art & Architecture, criticism
Adult Hobby Classes: Classes offered through Continuing Education
Summer School: Courses same as regular session, but limited

UPPER BURRELL

PENNSYLVANIA STATE UNIVERSITY AT NEW KENSINGTON, Depts of Art & Architecture, 3550 Seventh St Rd, Upper Burrell, PA 15068. Tel 724-339-5466, 339-5456; Internet Home Page Address: www.psu.edu/dept/arts/schools/schools; *Assoc Prof Art* Bud Gibbons
Estab 1968; pub; D; Scholarships; SC 3-4, LC 1 per sem
Ent Req: col boards
Degrees: 2 yr (option for 4 yr at main campus at University Park)
Tuition: Res—undergrad $6626; nonres—undergrad $10,098
Courses: Art Education, Art History, Ceramics, Design, Drawing, Music, Painting, Theatre Arts
Adult Hobby Classes: Courses—Ceramics, Painting, Theater for Children
Children's Classes: Courses—Art, Drama, Music Workshops
Summer School: Dir, Joseph Ferrino. Enrl 100; 8 wk term. Courses—Art, Drama, Music, Workshops

VILLANOVA

VILLANOVA UNIVERSITY, Dept of Theater, 800 Lancaster Ave, Villanova, PA 19085. Tel 610-519-4610, 519-4660 (History); Internet Home Page Address: www.villanova.edu; *Prof* George Radan; *Asst Prof* Dr Mark Sullivan; *Chmn* Bro Richard Cannuli
Estab 1842, dept estab 1971; pvt; D & E; SC 25, LC 6; D 35, maj 35
Ent Req: HS dipl, SAT
Degrees: BFA 4 yrs; courses taught in conjunction with Rosemont College
Tuition: Res—undergrad $19,110 per yr; campus res—room & board $7400 per yr
Courses: †Aesthetics, Archaeology, Art Education, Art History, Conservation, Drawing, Painting, Theatre Arts
Adult Hobby Classes: Enrl 20-30; tuition $585 per course in 14 wk sem. Courses—Calligraphy, Drawing
Summer School: Held in Siena, Italy. Courses—Art History, Language, Studio Art

WASHINGTON

WASHINGTON & JEFFERSON COLLEGE, Art Dept, Olin Art Ctr, 285 E Wheeling St Washington, PA 15301. Tel 724-222-4400, 223-6110; Internet Home Page Address: www.wj.edu; *Chmn Art Dept & Assoc Prof* John Lambertson; *Asst Prof* Patrick T Schmidt, MFA; *Adjunct Prof* James McNutt, MA
Estab 1787, dept estab 1959; Maintain nonprofit art gallery; pvt; D & E; Scholarships; SC 14, LC 8; D 162, E 18, non-maj 139, maj 23, others 15
Ent Req: HS dipl, SAT, achievement tests
Degrees: BA 4 yr
Tuition: $24,220 per yr; campus res—room & board $6710 per yr
Courses: Art Appreciation, Art Education, Art History, Ceramics, Design, Drawing, Framing & Matting, Gallery Management, Lettering, Painting, Photography, Printmaking, Restoration & Conservation, Sculpture, Teacher Training
Summer School: Dir, Dean Dlugos. Enrl 250, two 4 wk sessions, June-Aug. Courses—Drawing, Framing, Matting, Photography

WAYNE

WAYNE ART CENTER, 413 Maplewood Ave, Wayne, PA 19087. Tel 610-688-3553; Fax 610-995-0478; Elec Mail wayheart@worldnet.att.net; Internet Home Page Address: www.wayneart.com/reginfo; *Instr* Carolyn Howard; *Instr* Regina Allen, MFA; *Instr* Maevernon Varnum; *Instr* Deena Ball, BA; *Instr* Candace Stringer; *Instr* Nancy Barch; *Instr* Susan Branco; *Instr* Maggie DeBaecke, BA; *Instr* Paul DuSold; *Pres* Leslie Ehrin, BA; *Instr* Karen Carlin Fogerty; *Instr* Frances Galante, BA; *Instr* Margaret Gardner, BA; *Instr* Virginia Garwood; *Instr* Denise Gonzalez; *Instr* Mimi Green; *Instr* Mark Gruener; *Instr* Ann Howes; *Instr* Patricia Jordan; *Instr* Pat Kerr; *Instr* Andi Lieberman; *Instr* James Lloyd; *Instr* Charlotte Martin; *Instr* Cornelia Maxion; *Instr* James McFarlane; *Instr* Kathy Miller; *Instr* Lyn Mueller
Estab 1930; pvt; D & E; SC 25; D 200, E 50, others 40
Ent Req: none; free program for senior citizens
Tuition: $185-$220 for 12 wk session
Courses: Mixed Media, Painting, Pottery, Sculpture, Woodcarving
Children's Classes: Tuition $35 for 10 wk sem, yearly dues $6. Courses—Drawing, Painting, Sculpture
Summer School: Exec Dir, Meg Miller. Courses—same as above plus Landscape Painting

WAYNESBURG

WAYNESBURG COLLEGE, Dept of Fine Arts, 51 W College St, Waynesburg, PA 15370. Tel 724-627-8191, 852-3296; Fax 724-627-6416; Internet Home Page Address: www.waynesburg.edu/~art; *Prof* Susan Phillips, MFA; *Instr* Nathan Sims

Estab 1849, dept estab 1971; pvt; D & E; Scholarships; SC 25, LC 6; D 131, E 3, maj 17
Ent Req: HS dipl
Degrees: BA(Visual Communication) 4 yrs, MBA
Tuition: $11,670 per yr; room $2460, board $2160 - $2360 per yr
Courses: Art Education, Art History, Ceramics, Computer Applications for Visual Communication, Computer Graphics, Design, Desk Top Publishing, Drawing, Graphic Arts, Layout & Photography for Media, Media Presentation, Painting, Photo-Journalism, Photography, Printmaking, Sculpture, Television, Theatre Arts, Typography, †Visual Art, †Visual Communication, †Visual Communication-Print Media
Adult Hobby Classes: Courses—Art History, Graphic Design, Photography
Summer School: Dept Chmn, Daniel Morris. Tuition $270 for term of 5 wks beginning June 2 and July 7

WEST MIFFLIN

COMMUNITY COLLEGE OF ALLEGHENY COUNTY, Fine Arts Dept, South Campus, 1750 Clairton Rd West Mifflin, PA 15122. Tel 412-469-1100; Fax 412-469-6370; Internet Home Page Address: www.ccac.edu; *Chmn* George Jaber
Estab 1968; FT 2; pub; D&E
Ent Req: HS dipl
Degrees: AA, AS
Tuition: County res—$920 per yr, $68 per cr hr
Courses: Advertising Design, Art Appreciation, Calligraphy, Ceramics, Commercial Art, Computer Graphics, Design, Drawing, Handicrafts, Painting, Photography

WILKES-BARRE

WILKES UNIVERSITY, Dept of Art, Bedford Hall, Wilkes-Barre, PA 18766. Tel 570-826-1135; Internet Home Page Address: www.wilkes.edu; *Chmn* Terry Zipay, PhD; *Assoc Prof* Sharon Bowar; *Asst Prof* Sedor Sieboda PhD; *Adjunct Prof* Jan Conway, MFA; *Adjunct Prof* Jean Adams, BA
Estab 1947; pvt; D & E; Scholarships; SC 20, LC 7; D 170, E 23, non-maj 120, maj 35
Ent Req: HS dipl, SAT
Degrees: BA 4 yr
Tuition: Undergrad $16,388 per yr, $8194 per sem, PT $455 per cr hr; campus res—room & board $4956 per yr
Courses: †Art Education, †Art History, †Ceramics, †Communication Design, Drawing, Painting, †Photography, †Printmaking, †Sculpture, Surface Design, Teacher Training, Textile Design
Adult Hobby Classes: Courses variable
Summer School: Dir, Henry Steuben. Tuition $350 per cr for 5 wk day, 8 wk evening or 3 wk presession. Courses—Art Studio, Ceramics, Photography, Surface Design

WILLIAMSPORT

LYCOMING COLLEGE, Art Dept, 700 College Pl, Williamsport, PA 17701. Tel 570-321-4000, 321-4002, 321-4240; Internet Home Page Address: www.lycoming.edu/; *Chmn* B Lynn Estomin, MFA; *Assoc Prof* Amy Golahny PhD, MFA; *Asst Prof* Stafford Smith, MFA; *Prof* Roger Shipley, MFA; *Instr* Katherine Sterngold; *Asst Prof* Howard Tran, MFA; *Instr* Cathy Gorg
Estab 1812; Maintain nonprofit art gallery; Lycoming Col Art Gallery; art supplies available on-campus; pvt; D & E; Scholarships; SC 20, LC 7; College 1,500, Dept 500, maj 70
Ent Req: HS dipl, ACT or SAT
Degrees: BA 4 yr
Tuition: $23,685 per yr incl room & board
Courses: Advertising Design, †Art Education, †Art History, Ceramics, †Commercial Art, Computer Design & Animation, Computer Grapics, Costume Design & Construction, Design, Drawing, Graphic Arts, Graphic Design, †History of Art & Architecture, †Painting, †Photography, †Printmaking, †Sculpture, Stage Design, Teacher Training, Theatre Arts

PENNSYLVANIA COLLEGE OF TECHNOLOGY, Dept. of Communications, Construction and Design, 1 College Ave, Williamsport, PA 17701. Tel 570-326-3761; Fax 570-327-4503; Internet Home Page Address: www.pct.edu; *Prof* Ralph Horne, EdD; *Assoc Prof* Dale Metzker, AA; *Assoc Prof* Patrick Murphy, MSEd; *Asst Prof* William Ealer, BS; *Asst Prof* Steven Hirsch, MFA; *Instr* Kathy Y Walker, CET; *Instr* Tuna Saka, BAarch
Estab 1965; pub; D & E; Scholarships; D 2903, E 2909
Ent Req: HS dipl, placement test
Degrees: AA 2 yr
Tuition: Res—$247.40 per hr; housing - $1,650 per sem, $3,300 per yr
Courses: †Advertising Design, Art History, Design, Drawing, Graphic Arts, Graphic Design, Lettering, Mixed Media, Painting, Photography, Technical Illustration

YORK

YORK COLLEGE OF PENNSYLVANIA, Dept of Music, Art & Speech Communications, Country Club Rd, York, PA 17405. Tel 717-846-7788; Fax 717-849-1602; *Coordr Div Arts* Pamela Hemzik; *Coordr, Graphic Design* Paul Saikai, BA; *Asst Prof* Otto Tomasch, MFA; *Adjunct* Mary Todenhoff, MFA; *Adjunct* Penelope Grumbine-Hornock, MFA; *Adjunct* Marian Lorence, MPA; *Adjunct* Laure Drogoul, MA
Estab 1941; pvt; D & E; SC 17, LC 7
Ent Req: HS dipl, SAT or ACT
Degrees: BA 4 yrs & AA 2 yrs

Tuition: $7000 per yr; campus res available
Courses: Art Appreciation, Art Education, Art History, Ceramics, Commercial Art, Computer Graphics, Drawing, Graphic Design, Painting, Photography, Sculpture
Adult Hobby Classes: Enrl 40; Courses—per regular session
Summer School: Dir, Thomas Michalski. Enrl 15; Term of 3 wks beginning May 19 & two 5 wk sessions beginning June & July

RHODE ISLAND

BRISTOL

ROGER WILLIAMS UNIVERSITY, Visual Art Dept, One Old Ferry Rd, Bristol, RI 02809-2921. Tel 401-254-3617; Internet Home Page Address: www.rwuonline.cc/; *Prof* Ronald Wilczek; *Assoc Prof* Sharon Delucca; *Asst Prof* Rebecca Leuchak; *Asst Prof* Kathleen Hancock
Estab 1948, dept estab 1967; pvt; D & E; Scholarships; SC 18, LC 8; D 1800, E 1500, maj 42
Ent Req: HS dipl
Degrees: AA 2 yr, BA 4 yr, apprenticeship and senior teaching
Tuition: Full-time $17,400-$19,920; campus res—room $4280-$6360, board $3730-$3860
Courses: †Graphic Design, †Painting, †Photography, †Printmaking, Sculpture

KINGSTON

UNIVERSITY OF RHODE ISLAND, Dept of Art & Art History, Fine Arts Ctr, 105 Upper College Rd Ste 1 Kingston, RI 02881-0820. Tel 401-874-2131, 874-5821; Fax 401-874-2729; Elec Mail artdept@etal.uri.edu; *Chair* Wendy W Roworth, PhD; *Prof* William Klenk PhD; *Prof* Robert Dilworth, MFA; *Prof* Richard Calabro, MFA; *Prof* Gary Richman, MFA; *Prof* Barbara Pagh, MFA; *Assoc Prof* Mary Hollinshead, PhD; *Assoc Prof* Ronald Onorato PhD; *Assoc Prof* Sherri Wills, MFA, MA; *Asst Prof* Annu Palakunnathu Matthew, MFA; *Asst Prof* Ron Hutt, MFA
Estab 1892; Maintain nonprofit art gallery, URI Fine Arts Center Galleries, Fine Arts Center URI, Kingston, RI 02881; Ft 12, PT 6; pub; D & E; Scholarships; SC 21, studio seminars 24, LC 23; D 900, E 30, non-maj 725, maj 200, other 10 - 20
Ent Req: same as required for Col of Arts & Sciences
Degrees: BA(Studio), BA(Art History) & BFA(Art Studio) 4 yrs
Tuition: Res—$137 per cr hr; nonres—$470 per cr hr
Courses: Aesthetics, Architecture, †Art Appreciation, Art History, Collage, Conceptual Art, Digital Art, Digital Design, Drawing, Film, Graphic Arts, †Graphic Design, History of Art & Architecture, Painting, Photography, †Printmaking, Sculpture, Studio Art, †Video
Adult Hobby Classes: Art History, Drawing, Painting, Sculpture
Summer School: Enrl 45 - 50; tuition in-state—undergrad $121 per cr, out-of-state—undergrad $388 per cr for 5 wk terms beginning May 24 - June 25 & June 28 - July 30. Courses— Art History, Drawing, Photography

NEWPORT

NEWPORT ART MUSEUM SCHOOL, 76 Bellevue Ave, Newport, RI 02840. Tel 401-848-8200; Fax 401-848-8205; Elec Mail info@newportartmuseum.com; Internet Home Page Address: www.newportartmuseum.com; *Dir School* Judy Hambleton; *Dir Museum* Christine Callahen
Estab 1912; D & E; Scholarships; SC 25, LC 3; D 300 (total)
Ent Req: none
Degrees: none
Courses: Art History, Ceramics, Collage, Drawing, Etching, Jewelry, Multimedia, Painting, Pastels, Photography, Printmaking, Sculpture
Adult Hobby Classes: Enrl 200; tuition varies; 6, 8 or 10 wk courses
Children's Classes: Enrl 100 per term; tuition varies per 6, 8, or 10 wk session
Summer School: Enrl 160; tuition varies. Courses—Painting, Drawing, Workshops, Children's Multimedia

SALVE REGINA UNIVERSITY, Art Dept, Ochre Point Ave, Newport, RI 02840. Tel 401-847-6650; *Chmn* Barbara Shamblin, MFA; *Assoc Prof* Daniel Ludwig, MFA; *Asst Prof* Bert Emerson, MAT
Estab 1947; den; D & E; Scholarships; SC 28, LC 8; D 270 per sem (dept), non-maj 95, maj 72
Ent Req: HS dipl, ent exam
Degrees: BA 4 yr
Tuition: Res—undergrad $7100 per sem, $330 per sem hr, grad $150 per cr
Courses: 2 & 3-D Design, Aesthetics, Anatomy, Art History, Ceramics, Commercial Art, Design, Drawing, Environmental Design, Film, Graphic Arts, Graphic Design, History of Art & Architecture, Illustration, Painting, Photography, Sculpture, Theatre Arts
Summer School: Dir, Jay Lacouture

PROVIDENCE

BROWN UNIVERSITY
—Dept History of Art & Architecture, Tel 401-863-1174; Fax 401-863-7790; Internet Home Page Address: www.brown.edu; *Prof & Chair* Catherine W Zerner
Pvt; D; Scholarships; LC 13-15, GC 10-12; maj 59, grad 47
Degrees: BA, MA, PhD
Tuition: $33,888 per yr
Courses: 19th & 20th Century Architecture & Painting, †Art History, Chinese Art, Greek, History of Art & Archeology, Introduction to Art, Italian & Roman Art & Architecture
Summer School: Dean, Karen Sibley. Courses—limited

—**Dept of Visual Art,** Tel 401-863-2423; Fax 401-863-1680; Internet Home Page Address: www.brown.edu; *Chmn* Richard Fishman
Pvt; D; SC 19-21, LC 13-15, GC 10-12; maj 140
Degrees: BA
Tuition: $19,528 per yr
Courses: Art of the Book, Computer Art, Drawing, Painting, Printmaking, Sculpture

PROVIDENCE COLLEGE, Art & Art History Dept, 549 River Ave, Providence, RI 02918. Tel 401-865-2401, 865-2707; Fax 401-865-2410; *Chmn* Dr Ann Wood Norton; *Prof* Joan Branham; *Prof* James Baker; *Assoc Prof* Adrian G Dabash, MFA; *Assoc Prof* Richard A McAlister, MFA; *Assoc Prof* Alice Beckwith PhD, MFA; *Asst Prof* James Janecek, MFA; *Asst Prof* Richard Elkington, MFA; *Asst Prof* Deborah Johnson PhD, MFA; *Slide Librn* John DiCicco, MFA
Estab 1917, dept estab 1969; Maintain Hunt - Cavanogh Gallery in Hunt - Cavanogh Hall of Providence College; pvt; D & E; SC 49, LC 8; D 254, E 250, non-maj 209, maj 45
Ent Req: HS dipl, portfolio needed for transfer students
Degrees: BA 4 yr
Tuition: Res & nonres—undergrad $16,980 per yr; campus res—room & board $7125 per yr
Courses: †Art History, †Ceramics, †Drawing, †Painting, †Photography, †Printmaking, †Sculpture
Adult Hobby Classes: Dean, Dr O'Hara. Courses—History of Architecture, Art History, Calligraphy, Ceramics, Drafting, Drawing, Painting, Photography, Sculpture, Studio Art, Watercolor
Summer School: Dir, James M Murphy. Tuition $180 & $50 lab fee for three credit courses beginning mid-June through July. Courses—Art History, Calligraphy, Ceramics, Drawing, Painting, Photography, Printmaking, Soft and Hard Crafts. A summer program is offered at Pietrasanta, Italy: Dir, Richard A McAlister, MFA. Courses—Art History, Languages, Literature, Religious Studies, Studio Art, Drawing, Painting, Sculpture

RHODE ISLAND COLLEGE, Art Dept, 600 Mt Pleasant, Providence, RI 02908. Tel 401-456-8054; Fax 401-456-4755; Elec Mail hkim@ric.edu; Internet Home Page Address: www.ric.edu/art; *Prof* Samuel B Ames, MFA; *Prof* Krisjohn O Horvat, MFA; *Prof* Mary Ball Howkins PhD, MFA; *Asst Prof* Paola Ferrario, MFA; *Assoc Prof* Nancy Evans, MFA; *Asst Prof, Coordr Art Educ* Donna Kelly PhD, MFA; *Prof* William Martin, MFA; *Prof, Chairperson* Heemong Kim, MFA; *Prof* Stephen Fisher, MFA; *Instr* Evan H. Larson; *Asst Prof* Bret L Rothstein, PhD; *Asst Prof* Lisa Russell, MFA; *Asst Prof* Bryan E Steinberg, MFA; *Asst Prof* Sondra Sherman, MFA
Estab 1854, dept estab 1969; Maintain nonprofit gallery, Bannister Gallery, 600 Mt Pleasant Ave, Providence, RI 02908; Pub; D & E; Scholarships; SC 48, LC 10, GC 15; D 450, E approx 50, non-maj approx 100, maj 350, grad 25
Ent Req: HS dipl, CEEB and SAT
Degrees: BA(Art History), BA, BS(Art Educ) & BFA(Studio Art) 4 yr, MAT 1 yr
Tuition: Res undergrad $1,390 per sem; out of state $3,940 per sem; grad $2,375 per sem; out of state $3,650 per sem; res - room $1,400 - $1,470, board $1,350 - $1,525
Courses: Aesthetics, Art Appreciation, †Art Education, †Art History, †Ceramics, Design, Drawing, Fibers, Graphic Arts, †Graphic Design, History of Art & Architecture, †Jewelry, Metals, †Painting, †Photography, †Printmaking, †Sculpture, †Silversmithing, Teacher Training, †Weaving
Adult Hobby Classes: Visual Arts in Society, Drawing, Design, Photography
Summer School: Enrl 150; tuition $124 per cr, nonres—$330 per cr for term of 6 wks beginning June 26th. Courses—Ceramics, Drawing, Painting, Photography, Relief Printing

RHODE ISLAND SCHOOL OF DESIGN, Two College St, Providence, RI 02903. Tel 401-454-6100; Fax 401-454-6309; Elec Mail admissions@risd.edu; Internet Home Page Address: www.risd.edu; *Provost* Joe Deal; *Pres* Roger Mandle
Estab 1877; Pvt; endowed; Scholarships, Fellowships, Grants, Loans; D 2050
Publications: RISD Views, bimonthly; Catalogue of Degree Programs (annually); Annual Report; Continuing Ed Catalogues, 5 times a year
Ent Req: HS grad, SAT, visual work
Degrees: BFA, BArch, BID, BLA, BIntArch, BGD, MFA, MID, MLA, MAE, MAT
Tuition: $22,952
Courses: Animation, †Apparel Design, †Architecture, †Art History, †Ceramics, †Film, †Furniture Design, †Glass, †Graphic Design, †Illustration, †Industrial Design, †Interior Architecture, †Jewelry & Metalsmithing, †Landscape Architecture, Liberal Arts, †Painting, †Photography, †Printmaking, †Sculpture, †Teacher Training, †Textile Design, †Video
Adult Hobby Classes: Enrl 4500; tuition varies. Courses—Advertising & Print Design, Apparel Design, Ceramics, Computer Graphics, Culinary Arts, Glass, Illustration, Interior Design, Jewelry, Natural Science Illustration, New Media, Painting, Photography, Printmaking, Sculpture, Textile, Video
Summer School: Art & Design, Graphic Design

WARWICK

COMMUNITY COLLEGE OF RHODE ISLAND, Dept of Art, 400 East Ave, Warwick, RI 02886. Tel 401-825-2220; Fax 401-825-2282; *Instr* T Aitken; *Instr* R Judge; *Instr* F Robertson; *Instr* M Kelman; *Instr* C Smith; *Instr* S Hunnibell; *Instr* T Morrissey; *Chmn* Nick Sevigne; *Instr* Natalie Coletta
Estab 1964; FT 10, PT 15; pub; D & E; Scholarships; SC 16, LC 3, seminar 1; D 4600
Ent Req: HS dipl, ent exam, equivalency exam
Degrees: AA, AFA, AS & AAS 2 yr
Tuition: Res—$832 per sem, $77 per cr hr
Courses: Art Appreciation, Art Education, Art History, Ceramics, Commercial Art, Drawing, Graphic Arts, Graphic Design, History of Modern Art, Interior Design, Life Drawing, Mixed Media, Painting, Photography, Sculpture, Survey of Ancient Art

Summer School: Chmn, Rebecca Clark. Enrl 200; 7 wk term.
Courses—Ceramics, Crafts History of Modern Art, Drawing

SOUTH CAROLINA

AIKEN

UNIVERSITY OF SOUTH CAROLINA AT AIKEN, Dept of Visual & Performing Arts, 471 University Pky, Aiken, SC 29801. Tel 803-641-3305; *Chmn* Jack Benjamin; *Prof* Albin Beyer; *Asst Prof* John Elliot; *Instr* Robert McCreary, BS; *Instr* Michael Southworth, BS
Estab 1961, dept estab 1985; pub; D & E; SC 31, LC 6; D 180, E 60
Ent Req: HS dipl, GED, SAT
Degrees: BA & MFA
Tuition: Res—$1729 per sem; nonres—$3992 per sem
Courses: Advertising Design, Art History, Ceramics, Commercial Art, Drawing, Graphic Design, Illustration, Painting, Photography, Printmaking, Sculpture, Theatre Arts
Adult Hobby Classes: Tuition $1060 per sem. Courses—Vary
Summer School: Dir, A Beyer. Courses—Vary

CHARLESTON

CHARLESTON SOUTHERN UNIVERSITY, Dept of Language & Visual Art, PO Box 118087, Charleston, SC 29411. Tel 843-863-7000; *Chmn* Dr Pamela Peak
Estab 1960; den; D & E; Scholarships; SC 14, LC 2; D 80, E 71, maj 15
Ent Req: GED or HS dipl
Degrees: BA and BS 4 yrs
Tuition: $8561 per sem, incl rm & board
Courses: Art Education, Ceramics, Drawing, Graphic Arts, History of Art & Architecture, Painting, Sculpture, Teacher Training
Summer School: Enrl 1500; tui $45 per sem hr; campus res—room and board $240 per sem; two 5 wk sessions beginning June. Courses—same as regular session

COLLEGE OF CHARLESTON, School of the Arts, 44 Saint Philip St, Charleston, SC 29424. Tel 843-953-7766; Fax 843-953-4988; *Chmn Music Dept* Steve Rosenberg; *Chmn Theatre Dept* Mark Landis; *Chmn Studio Art* Michael Tyzack; *Chmn Art History* Diane Johnson; *Dir, Arts Management* Karen Chandler; *Dir, Historic Preservation* Robert Russell; *Dir, Historic Preservation* Ralph Muldrow; *Dean* Valerie B Morris
Estab 1966; Maintain nonprofit art gallery; Halsey Gallery, College of Charleston School of Arts, Charleston, SC 29424; pub; D & E; Scholarships; SC 36, LC 24
Ent Req: HS dipl
Degrees: BA(Fine Arts) 4 yrs
Tuition: Res—$1470 per yr; nonres—$2670 per yr
Courses: Art History, Arts Management, Drawing, Historic Preservation, History of Art & Architecture, Painting, Photography, Printmaking, Sculpture, Stage Design, Theatre Arts

GIBBES MUSEUM OF ART, Museum Studio, 135 Meeting St, Charleston, SC 29401. Tel 843-722-2706; Fax 843-720-1682; Elec Mail marketing@gibbes.com; Internet Home Page Address: www.gibbes.com; *Studio Admin* Noel Walker; *Staff Office Mgr* Erin Caldwell; *Dir Develop* Anne Weston; *Registrar* Stacey Brown; *Mus Shop Mgr* Sharla Helms; *VPres* Bill Medich; *Cur Educ* Amy Watson Smith; *Dir* Elizabeth A Fleming; *Operations Mgr* Sylvester Harper; *Cur Coll* Angela Mack
Estab 1969; PT 35; pub; D & E; Scholarships; SC 25; 370
Ent Req: none
Tuition: $55-$175 per course
Courses: Calligraphy, †Ceramics, †Childrens Drawing Workshops, †Paints & Drawings, Photography, Printmaking, Sculpture
Children's Classes: Enrl 10 per course; tuition $80 per course per sem. Courses—Mixed Media (ages 4-6)
Summer School: Dir, Nole Walker. Courses—Same as regular session; kids camp

CLEMSON

CLEMSON UNIVERSITY, College of Architecture, Lee Hall, Clemson, SC 29634-0509. Tel 864-656-3881; *Pres* James Bourker; *Prof* Lynn Craig; *Prof* Martin Davis; *Prof* Teoman Doruk; *Prof* John Jacques; *Prof* Richard Norman; *Assoc Prof* David Allison; *Assoc Prof* Joseph Burton; *Assoc Prof* Harry Harritos; *Assoc Prof* Robert Hogan; *Assoc Prof* Jane Hurt; *Assoc Prof* Dale Hutton; *Assoc Prof* Coleman Jordan; *Assoc Prof* Yuji Kishimoto; *Assoc Prof* Matthew Rice; *Assoc Prof* Robert Silance
Estab 1967; pub; D; GC 24, SC 40, LC 29 (undergrad courses for service to pre-architecture and other Univ requirements); approx 1500 annually, grad maj 10
Ent Req: available on request
Degrees: degress BA, BS & MFA 60 hrs
Tuition: Res—$3592 per sem; nonres—$5890 per sem
Courses: Architecture, Art History, Ceramics, Drawing, Painting, Photography, Printmaking, Sculpture

CLINTON

PRESBYTERIAN COLLEGE, Visual & Theater Arts, Harper Ctr, PO Box 975 Clinton, SC 29325. Tel 864-833-2820, 833-8316; Fax 864-833-8600; Internet Home Page Address: www.presby.edu; *Asst Prof* Lesley Preston; *Chmn* Mark R Anderson

Estab 1880, Dept estab 1966; den; D & E; Scholarships; SC 8, LC 5; D 200, non-maj 190, maj 10
Ent Req: HS dipl with C average, SAT
Degrees: BA & BS 4 yr
Tuition: $22,686 annual tuition; campus res available
Courses: 2-D & 3-D Design, Art Appreciation, Art Education, Art History, Drawing, Painting
Summer School: Dean, J W Moncrief. Enrl 150; tuition $120 per sem. Courses—Art Appreciation, Painting

COLUMBIA

BENEDICT COLLEGE, Fine Arts Dept, 1600 Harden St, Columbia, SC 29204. Tel 803-253-5290; Fax 803-253-5260; *Instr* John Wrights; *Chmn* Scott Blanks
Estab 1870; pvt; D; Scholarships; SC 11, LC 6
Ent Req: HS dipl
Degrees: BA(Teaching of Art), BA(Commercial Art)
Tuition: $13800 per yr (room & board incl)
Courses: Art Appreciation, Drawing, Teacher Training
Summer School: Term of two 5 wk sessions beginning June. Courses—Art Appreciation

COLUMBIA COLLEGE, Dept of Art, 1301 Columbia College Dr, Columbia, SC 29203. Tel 803-786-3012; Fax 803-786-3893; Internet Home Page Address: www.columbiacollegesc.edu; *Chmn* Stephen Nevitt
Estab 1854; FT 4, PT 1; pvt; D&E; Scholarships
Degrees: BA (Studio Art), BA (Studio Art with Art Educ Certification)
Tuition: $15,570 per yr; campus res—room & board $5240 per yr; additional fee $300
Courses: 3-D Design, Advertising Design, Art Appreciation, Art History, Ceramics, Design, Drawing, Life Drawing, Painting, Photography, Printmaking, †Sculpture
Adult Hobby Classes: Enrl 20 per class. Courses—Art Appreciation, Art History, Drawing, Photography
Summer School: Dir, Becky Hulion. Enrl 20 per class. Courses—Art Appreciation, Art History, Art Education, Drawing, Photography, Printmaking

UNIVERSITY OF SOUTH CAROLINA, Dept of Art, McMaster College, Columbia, SC 29208. Tel 803-777-4236, 777-0535, 777-7480; Fax 803-777-0535; Internet Home Page Address: www.cal.sc.edu/Art/index.html; *Chmn* Robert F Lyon; *Chmn Studio* Richard Rose; *Chmn Art Educ* Cynthia Colbert, EdD; *Chmn Art History* John Bryan, EdD; *Chmn Media Arts* Sandra Wertz PhD, EdD; *Asst Chmn* Harry Hansen
Estab 1801, dept estab 1924; pub; D & E; Scholarships; SC 89, LC 57, GC 73; D 1620, E 174, non-maj 1000, maj 520, grad 82
Ent Req: HS dipl
Degrees: BA, BFA & BS 4 yrs, MA & MAT 2 yr, MFA 3 yrs
Tuition: Res—undergrad $3810 pr yr; $1905 per sem, PT $127 per cr, grad $4230 per yr, $2115 per sem; nonres—undergrad $9240 per yr, $4620 per sem, PT undergrad $308 per cr, grad $282; Campus res—room $1800 per yr
Courses: †3-D Studies, †Advertising Design, †Art Education, †Art History, †Ceramics, †Commercial Art, †Drawing, †Graphic Arts, †Graphic Design, Illustration, Jewelry, Museum Staff Training, Painting, Photography, Printmaking, Restoration & Conservation
Adult Hobby Classes: Enrl 125; tuition $127 per hr for 16 wk term. Courses—Art for Elementary School, Basic Drawing, Ceramics, Fiber Arts, Fundamentals of Art, Interior Design, Intro to Art
Children's Classes: Enrl 100; tuition $30 for 9 wk term. Courses—Children's Art
Summer School: Enrl 400; tuition undergrad $127 per hr, grad $141 per hr. Courses—Same as academic yr

FLORENCE

FRANCIS MARION UNIVERSITY, Fine Arts Dept, PO Box 100547, Florence, SC 29501-0547. Tel 843-661-1385; Fax 843-661-1219; Internet Home Page Address: www.fmarion.edu/famc; *Chmn* Larry Anderson
Estab 1969; Pub; D&E; Scholarships
Degrees: BA
Tuition: Res—$1705 per yr; nonres—$3410 per yr
Courses: Art Appreciation, †Art Education, Art History, †Ceramics, Costume Design & Construction, Design, Drafting, Drawing, Film, Graphic Design, †Painting, †Photography, Sculpture, †Stage Design, †Theatre Arts, Video
Summer School: Dir, Dennis Sanderson. Enrl 50; 6 wk term. Courses—Art Appreciation, Art Education, Photography

GAFFNEY

LIMESTONE COLLEGE, Art Dept, 1115 College Dr, Gaffney, SC 29340. Tel 864-489-7151, Ext 513; *Chmn* Andy Cox
Estab 1845; pvt; D & E; Scholarships; SC 19, LC 9; D 112, maj 42, others 3
Ent Req: HS dipl, ent exam
Degrees: BS(Educ, Studio) 4 yrs
Tuition: $10,800 full-time res; rm & board $2550
Courses: 2-D & 3-D Design, Ceramics, Painting, Printmaking, Silk-Screen, Wood-Block

GREENVILLE

BOB JONES UNIVERSITY, Div of Art, Greenville, SC 29614. Tel 864-242-5100, Ext 2700; Fax 864-233-9829; *Dean* Darren Lawson, PhD; *Chmn Division of Art* David Appleman, MA; *Instr* Emery Bopp, MFA; *Instr* Kathy Bell, MA; *Instr* James Brooks, BA; *Instr* Harrell Whittington, MA; *Instr* Michael Slattery, MA; *Instr* Jay Bopp, MA; *Instr* John Roberts, MA

Estab 1927, dept estab 1945; pvt; D; Scholarships; SC 29, LC 12, GC 10; M 59, W 57
Ent Req: HS dipl, letters of recommendation
Degrees: BFA & BS 4 yrs, MA 1-2 yrs
Tuition: $4980 per yr, $2490 per sem; campus res—room & board $3900 per yr
Courses: Advertising Design, Aesthetics, Art Appreciation, †Art Education, Art History, Bronze Casting, Calligraphy, Ceramics, Costume Design & Construction, Drawing, †Film, Graphic Arts, †Graphic Design, Handicrafts, Illustration, Jewelry, Lettering, †Painting, Photography, Printmaking, Sculpture, Stage Design, Theatre Arts, Video

FURMAN UNIVERSITY, Dept of Art, Greenville, SC 29613. Tel 864-294-2074; Internet Home Page Address: www.furman.edu/academics/dept/art; *Chmn* Robert Chance
Estab 1826; pvt; D & E; Scholarships; SC 21, LC 8; D 245, non-maj 205, maj 60
Ent Req: HS dipl, SAT
Degrees: BA 4 yr
Courses: Advertising Design, Art Criticism, Art Education, Art History, Ceramics, †Crafts, Drawing, Graphic Design, †History of Art, Painting, Printmaking, Sculpture, Teacher Training, †Typography

GREENVILLE COUNTY MUSEUM SCHOOL OF ART, Museum School of Art, 420 College St, Greenville, SC 29601. Tel 864-271-7570; Fax 803-271-7579; *Coordr* Robert A Strother
Estab 1960; PT 35; pub; D & E; Scholarships; SC 12, LC 2, GC 6; D 250, E 170
Tuition: Call for brochure
Courses: Art History, Drawing, Painting, Philosophy of Art, Photography, †Pottery, †Printmaking, Sculpture, Weaving

GREENVILLE TECHNICAL COLLEGE, Visual Arts Dept, PO Box 5616, Greenville, SC 29606-5616. Tel 864-848-2024, 848-2000; Fax 864-848-2003; Internet Home Page Address: www.greenvilletech.com; *Campus Dir* Nancy Welch; *Dept Head* Blake Praytor
Degrees: AA (Fine Art, Graphic Design) Cert Program
Tuition: In-county res—$71 per cr hr, out of county $78 per cr hr, out of state $157 per cr hr
Courses: Art Appreciation, Art History, Film, Graphic Design, Photography
Adult Hobby Classes: Courses offered
Summer School: Dir, Dr David S Trask. Enrl 35. Courses—Art Appreciation

GREENWOOD

LANDER UNIVERSITY, College of Arts & Humanities, Stanley Ave, Greenwood, SC 29649. Tel 864-388-8323; Fax 864-388-8144; Elec Mail amactagg@lander.edu; Internet Home Page Address: www.lauder.edu; *Prof Art* Alan C Mactaggart; *Prof Art* Roger A Wohlford; *Assoc Prof Art* Robert H Poe; *Assoc Prof Art History* Dr Tom R Pitts; *Asst Prof Art Educ* Dr Linda Neely; *Instr Graphics* Briles Lever
Estab 1872; Maintains a nonprofit art gallery, Monsanto Art Gallery, Cultural Center, Greenwood, SC 29649; FT 6, PT 4; pub; D & E; Scholarships; SC 28, LC 7, GC 7, Study Tours 2; D 330, E 150, non-maj 250, maj 80, grad 11
Ent Req: HS dipl
Degrees: BS (Art) 4 yrs, BS (K-12 certification), MAT (Art) 14 months
Tuition: Res—$7,200; non-res—$13,520 campus res—room & board $5,600-$6,000
Courses: Advertising Design, Art Appreciation, Art Education, Art History, Ceramics, Commercial Art, Costume Design & Construction, Display, Drafting, Drawing, Film, Graphic Arts, Graphic Design, Handicrafts, Mixed Media, Painting, Photography, Printmaking, Sculpture, Stage Design, Study Tour to Europe, †Teacher Training, Theatre Arts, Video
Summer School: Dir, Dr L Lundquist. Enrl 300; tuition $173 per sem hr for 4 wks. Courses—Art Appreciation, Ceramics, Grad Art Education, Mass Media, Music Appreciation, Photography; Speech Fundamentals, Theatre & Film Appreciation, TV Production, Undergrad Art Education

HARTSVILLE

COKER COLLEGE, Art Dept, 300 E College Ave, Hartsville, SC 29550. Tel 843-383-8150; Elec Mail jgrosser@coker.edu; Internet Home Page Address: www.coker.edu/art/; *Prof Art, Chair* Jean Grosser; *Assoc Prof Design* Ken Maginnis; *Assoc Prof Painting & Drawing* Jim Boden; *Asst Prof & Gallery Dir* Larry Merriman
Estab 1908; Maintain nonprofit art gallery; Cecelia Coker Bell Gallery, 300 E College Ave, Hartsville, SC 29550; FT 3; pvt; D & E; Scholarships; SC 24, LC 12; 1000, maj 50
Ent Req: HS dipl, ent exam
Degrees: BA and BS 4 yrs
Tuition: $16,464 per yr; campus res—room & board $5586 per yr
Courses: Art Appreciation, †Art Education, Art History, Ceramics, Conceptual Art, Design, Drawing, †Fine Arts, †Graphic Design, Illustration, Painting, †Photography, Sculpture, Teacher Training, Web Design

NEWBERRY

NEWBERRY COLLEGE, Dept of Art, 2100 College St, Newberry, SC 29108. Tel 803-276-5010; Fax 803-321-5627; *Asst Prof* Elizabeth Ruff; *Head Dept* Bruce Nell-Smith
Estab 1856, dept estab 1973; den; D & E; SC 35, LC 2; D 114, non-maj 106, maj 15
Ent Req: HS dipl, SAT
Degrees: BA (Art Studio) 4 yrs, BA (Arts Mgt), two courses in independent study, financial aid available
Tuition: $19,800 per yr, incl rm & board

Courses: Art History, Drawing, Mixed Media, Painting, Printmaking, Stage Design, Theatre Arts

ORANGEBURG

CLAFLIN COLLEGE, Dept of Art, 400 College Ave, Orangeburg, SC 29115. Tel 803-535-5335 (Art Dept); Internet Home Page Address: www.claflincollege.edu; *Assoc Prof* Dr Kod Igwe; *Instr* Cecil Williams; *Chmn* Herman Keith
School estab 1869, dept estab 1888; pvt; D; Scholarships; SC 10, LC 2; D 20
Ent Req: HS dipl, SAT
Degrees: BA 4 years, BA Teacher Educ 4 years
Tuition: Res—undergrad $6510 including room & board; nonres—$4230
Courses: Advanced Studio, †Advertising Design, Afro-American Art History, †Art Education, Art History, Ceramics, Drawing, Film, Graphic Arts, Lettering, Painting, Photography, Printmaking, Sculpture, Theatre Arts, Video
Summer School: Dir, Karen Woodfaulk. Enrl 10-12, 6 wk term beginning June. Courses—Art Appreciation, Art-Elem School Crafts, Advertising Art, Textile Design

SOUTH CAROLINA STATE UNIVERSITY, Dept of Visual & Performing Arts, 300 College St NE, Orangeburg, SC 29117. Tel 803-536-7101; Fax 803-536-7192; Elec Mail jwalsh@scsu.edu; Internet Home Page Address: www.scsu.edu/; *Asst Prof* Johnathon Walsh; *Asst Prof* Kimberly Ledee; *Asst Prof* Leslie Rech; *Asst Prof* Steven Crall; *Instr* Frank Martin II
Dept estab 1972; Maintains non-profit gallery; music & fine arts libr; pub, state; D & E; SC 15, LC 7; D 73, nonmaj 8, maj 73
Ent Req: HS dipl
Degrees: BA & BS 4 yrs, MS approx 2 yrs
Courses: †Art Education, †Design, †Printmaking, †Sculpture
Adult Hobby Classes: Ceramics, Sculpture, Drawing, Painting
Summer School: Dir, Dr Leroy Davis. Tuition $90 per cr hr. Courses—Art Appreciation, Arts & Crafts for Children

ROCK HILL

WINTHROP UNIVERSITY, Dept of Art & Design, Rock Hill, SC 29733. Tel 803-323-2653; Elec Mail waldenr@winthrop.edu; Internet Home Page Address: www.winthrop.edu/vp2/artanddesign; *Prof* Mary Mintich; *Prof* John Olvera; *Prof* David Freeman; *Prof* Alf Ward; *Assoc Prof* Dr Seymour Simmons; *Assoc Prof* Alan Huston; *Assoc Prof* Paul Martyka; *Assoc Prof* Jim Connell; *Assoc Prof* Laura Dufresne; *Assoc Prof* Phil Moody; *Assoc Prof* Margaret Johnson; *Assoc Prof* David Stokes; *Assoc Prof* Dr Peg DeLamater; *Asst Prof* Chad Dresbach; *Asst Prof* Marge Moody; *Asst Prof* Dr Alice Burmeister; *Chmn* Jerry Walden
Estab 1886; pub; D & E; SC 42, LC 10; in college D 5300, non-maj 300, maj 345, grad 10
Ent Req: HS dipl, SAT, CEEB
Degrees: BA and BFA 4 yrs
Tuition: Res—undergrad $2121 per yr, non—res $3830 per sem, grad $2076; campus res available
Courses: Advertising Design, Art Appreciation, †Art Education, †Art History, Calligraphy, †Ceramics, Collage, Commercial Art, Conceptual Art, Design, Display, Drafting, †Drawing, Fashion Arts, Graphic Arts, †Graphic Design, Handicrafts, History of Art & Architecture, Illustration, Industrial Design, †Interior Design, †Jewelry, Lettering, Mixed Media, Museum Staff Training, †Painting, †Photography, †Printmaking, †Sculpture, Silversmithing, Teacher Training, Textile Design, Weaving

SPARTANBURG

CONVERSE COLLEGE, Dept of Art & Design, 580 E Main St, Spartanburg, SC 29302. Tel 864-596-9000, 596-9181, 596-9178; Fax 864-596-9606; Elec Mail art.design@converse.edu; Internet Home Page Address: www.converse.edu; *Chm of Dept & Assoc Prof* Teresa Prater; *Prof* Mayo McBoggs, MFA; *Prof* Dianne R Bagnal, MA; *Dir Art Therapy* Merilyn Field; *Coordr Interior Design* Terri Jory-Johnsen; *Assoc Prof* Frazer SM Pajak, MA Arch; *Assoc Prof* David Zacharias, MFA; *Instr CAD* Mike Parris
D & E; Col estab 1889; Maintain nonprofit gallery, Milliken Gallery, 580 E Main St, Spartanburg, SC 29302; pvt, women only; D & E; Scholarships; SC 40, LC 17; D 554, non-maj 153, maj 90, grad 897, others 12, double major available
Ent Req: HS dipl, SAT, CEEB, ACT, Advanced placement in Art & Art History
Degrees: BA & BFA 4 yrs
Tuition: $26,070 incl room & board
Courses: Advertising Design, Architecture, Art Appreciation, †Art Education, †Art History, †Art Therapy, Ceramics, Commercial Art, Design, Drafting, Drawing, Graphic Design, †History of Art & Architecture, †Interior Design, Jewelry, Mixed Media, Museum Staff Training, Occupational Therapy, Painting, Photography, Printmaking, Restoration & Conservation, Sculpture, †Studio Art
Adult Hobby Classes: Enrl 100; tuition $16,000 for 4 yrs. Courses—Art Education, Art History, Art Therapy, Interior Design, Studio Art
Summer School: Dir, Joe Dunn

SPARTANBURG COUNTY MUSEUM OF ART, The Art School, 385 S Spring St, Spartanburg, SC 29306. Tel 864-582-7616; Fax 803-948-5353; Elec Mail museum@spartanarts.org; Internet Home Page Address: www.sparklenet.com/museumofart
Estab 1962; Maintain nonprofit art gallery; Pvt; D & E; SC 25; 300-400
Ent Req: none
Tuition: $80-$130 for 8-12 wk classes & weekend workshops
Courses: Calligraphy, Cartooning, Drawing, Figure Drawing, Mixed Media, Painting, Portraiture, Pottery & Ceramic Design, Sculpture, Stained Glass
Adult Hobby Classes: $90-$135 for Art Appreciation, Fine Arts
Children's Classes: $50-$85 for 4-8 wk classes & weekend workshops

Summer School: Dir, Robert LoGrippo. Enrl 200. Art Camp, 1-6 wk sessions

SOUTH DAKOTA

ABERDEEN

NORTHERN STATE UNIVERSITY, Art Dept, 1200 S Jay St, Aberdeen, SD 57401. Tel 605-626-2514; Fax 605-626-2263; Elec Mail kilianp@northern.edu; Internet Home Page Address: www.northern.edu/artdept/index.html; *Prof* Mark McGinnis, MFA; *Prof* Bill Hoar PhD, MFA; *Prof & Coordr* Peter Kilian, MFA; *Asst Prof* Ruth McKinney; *Prof* Mark Shekore, MFA; *Asst Prof & Adjnct* Joel McKinney; *Adjunct Instr* Troy McQuillen; *Adjunct Instr* Roxanne Hinze
Maintain nonprofit art gallery, Northern Galleries, 1200 S Jay St, Aberdeen, SD 57401; Estab 1901, dept estab 1920; pub; D & E; Scholarships; SC 40, LC 14, GC 6; D 385, non-maj 300, maj 85
Ent Req: HS dipl
Degrees: AA 2 yrs, BA, BSEd 4 yrs
Tuition: Res—undergrad $74.10 per cr, grad $112.45 per cr; nonres—undergrad $235.55 per cr, grad $331.50 per cr; campus res—room $990 per sem
Courses: †Advertising Design, Aesthetics, Art Appreciation, Art Education, Art History, Ceramics, Commercial Art, †Computer Graphics, Design, Drawing, Fiber Arts, Graphic Arts, History of Art & Architecture, Mixed Media, Painting, Photography, Printmaking, Sculpture, Teacher Training, Theatre Arts, Video
Adult Hobby Classes: Enrl 30; tuition $74.10 per cr
Summer School: Prof, Peter Kilian, Dir

BROOKINGS

SOUTH DAKOTA STATE UNIVERSITY, Dept of Visual Arts, PO Box 2802, Brookings, SD 57007. Tel 605-688-4103; Fax 605-688-6769; Elec Mail Norman_Gambill@sdstate.edu; Internet Home Page Address: www3.sdstate.edu/Academics/CollegeOfArtsAndScience/VisualArts; *Head Dept* Norman Gambill PhD; *Prof* Melvin Spinar, MFA; *Prof* Tim Steele, MFA; *Assoc Prof* Gerald Kruse, MFA; *Assoc Prof* Jeannie French, MFA; *Assoc Prof* Scott Wallace, MFA; *Instr* Randy Clark, MFA
Estab 1881; Maintain nonprofit art gallery; RitzGallery, Box 2802, 111 Grove Hall, SDSU Brookings SD 57007; art supplies available on-campus; Pub; D & E; Scholarships; SC 26, LC 7
Ent Req: HS dipl, ent ACT
Degrees: BA & BS 128 sem cr
Tuition: Res—$65 per cr hr; nonres—$206.65 per cr hr; in-state tuition with Minnesota only
Courses: Advertising Design, Art Appreciation, †Art Education, Art History, †Ceramics, Design, Drawing, General Art, †Graphic Design, History of Art & Design, Intermedia, Mixed Media, †Painting, †Printmaking, †Sculpture

HURON

HURON UNIVERSITY, Arts & Sciences Division, 333 Ninth St SW, Huron, SD 57350. Tel 605-352-8721; *Dean* Gretchen Rich
Pvt; Scholarships; 510
Ent Req: HS dipl or GED
Degrees: BA & BS 4 yrs
Tuition: $200 per cr hr
Courses: Art Appreciation, Manual & Public School Art

MADISON

DAKOTA STATE UNIVERSITY, College of Liberal Arts, 114 Beadle Hall, 820 N Washington Ave Madison, SD 57042. Tel 605-256-5270; Fax 605-256-5021; Internet Home Page Address: www.dsu.edu; *Prof* John Laflin; *Prof* Roger Reed; *Assoc Prof* Alan Fisher; *Assoc Prof* James Janke; *Assoc Prof* Nancy Moose; *Assoc Prof* Louise Pope; *Assoc Prof* James Swanson; *Dean* Eric Johnson
Estab 1881; FT 1, PT 1; pub; D; Scholarships; SC 16, LC 5; D 120, maj 20
Ent Req: HS dipl, ACT
Degrees: BS 4 yrs
Tuition: Res—undergrad $1620 per yr; nonres—$5152 per yr
Courses: Art Education, Art History, Ceramics, Drawing, Jewelry, Painting, Sculpture, Teacher Training
Summer School: Term of 8 wks beginning June

SIOUX FALLS

AUGUSTANA COLLEGE, Art Dept, 2001 S Summit Ave, Sioux Falls, SD 57197. Tel 605-336-5428; WATS 800-727-2844; *Chmn* Carl A Grupp, MFA; *Asst Prof* Tom Shields, MFA; *Instr* John Peters, MFA; *Instr* Gerry Punt, BA
Estab 1860; den; D & E; Scholarships; SC 14, LC 3; total 1861
Ent Req: HS dipl, ent exam
Degrees: BA & MAT
Tuition: $13,960 annual tuition; campus res—room & board $4058
Courses: †Art Education, †Drawing, Etching, †Graphic Design, History of Art & Architecture, Lithography, Painting, Printmaking, Sculpture, Teacher Training
Children's Classes: Enrl 15; tuition $600 fall & spring. Courses—Ceramics, Drawing
Summer School: Dir, Dr Gary D Olson. Term of 7 wks beginning June. Courses—Arts, Crafts, Drawing

UNIVERSITY OF SIOUX FALLS, Dept of Art, Division of Fine Arts/Music, 1101 W 22nd St Sioux Falls, SD 57105. Tel 605-331-5000; Internet Home Page Address: www.usiouxfalls.edu; *Chmn* Nancy Olive; *Pres* Mark Benedetto

Estab 1883; pub; Scholarships; SC, LC; 1000
Degrees: BA with maj in Art or Art Educ 4 yrs
Tuition: $8990 per yr
Courses: Art Education, Art History, Ceramics, Drawing, Graphic Design, Handicrafts, Painting, Photography, Printmaking, Sculpture
Summer School: Terms one 3 wk session, two 4 wk sessions. Courses—Crafts, Design, Drawing, Education

SPEARFISH

BLACK HILLS STATE UNIVERSITY, Art Dept, Univerity Sta, Box 9003, Spearfish, SD 57799-9003. Tel 605-642-6011, 642-6420; *Prof* Steve Babbitt; *Prof* James Knutson; *Prof* Susan Hore-Pabst; *Prof* Janeen Larson; *Prof* Stephen Parker; *Prof* Randall Royer; *Instr* Abdollah Farrokhi; *Chmn* Jim Cargill
Estab 1883; FT 13; pub; D; Scholarships; SC 15, LC 4; maj 50
Ent Req: HS dipl, transcripts, ACT, physical exam
Degrees: BA 4 yrs
Tuition: Res—$1797 per sem; nonres—$5717 per sem
Courses: Art Education, Calligraphy, Ceramics, Commercial Art, Drafting, Drawing, Painting, Photography, Sculpture
Summer School: Art in our Lives, Ceramics, Drawing, Painting, School Arts & Crafts

VERMILLION

UNIVERSITY OF SOUTH DAKOTA, Department of Art, College of Fine Arts, 414 Clark St, Vermillion, SD 57069-2390. Tel 605-677-5636; 677-5011; Elec Mail jday@usd.edu; Internet Home Page Address: www.usd.edu/; *Chmn & Dean* John Day, MFA; *Prof* Lloyd Menard, MFA; *Prof* Jeff Freeman, MFA; *Prof* John Banasiak, MFA; *Assoc Prof* Martin Wanserski, MFA; *Assoc Prof* Ann Balakier PhD, MFA; *Prof* Dennis Wavrat, MFA; *Instr* Michael Hill
Estab 1862, dept estab 1887; pub; D & E; Scholarships; SC 32, LC 9, GC 9; non-maj 300, maj 80, grad 17
Ent Req: HS dipl, ACT
Degrees: BFA, BFA with Teacher Cert, MFA
Tuition: Res—undergrad room & board $7215.28; nonres— room & board $11,431.28
Courses: Advertising Design, Aesthetics, Art Appreciation, †Art Education, Art History, †Ceramics, Commercial Art, Design, Drawing, †Graphic Design, Graphics, History of Art & Architecture, Lettering, Mixed Media, Museum Staff Training, †Painting, †Photography, †Printmaking, †Sculpture, Teacher Training
Summer School: Chmn, Lawrence Anderson. Tuition per cr hr for terms of 4 wks to 15 wks. Courses—variable offerings in summer-not all disciplines are offered each summer

YANKTON

MOUNT MARTY COLLEGE, Art Dept, 1105 W Eighth St, Yankton, SD 57078. Tel 605-668-1011, 668-1574; Fax 605-668-1607; Internet Home Page Address: www.mtmc.edu; *Dept Head* David Kahle, MA
Estab 1936; den; D; SC 17, LC 5; 9
Ent Req: HS dipl
Degrees: BA 4 yrs, MA(Anesthesia)
Tuition: $5275 two sem & interim; $215 per cr hr; campus res available
Courses: 2-D & 3-D Design, Art Appreciation, Calligraphy, Ceramics, Collage, Design, Drawing, Handicrafts, Mixed Media, Printmaking, Teacher Training
Adult Hobby Classes: Enrl 100-150; tuition $283 per 11 cr hrs, $3390 full time. Courses—Art Appreciation, Calligraphy, Ceramics, Crafts, Design, Painting & Drawing, Photography, Printmaking
Summer School: Dir, Sr Pierre Roberts. Tuition $100 per cr hr for term of wks beginning June & July

TENNESSEE

CHATTANOOGA

CHATTANOOGA STATE TECHNICAL COMMUNITY COLLEGE, Advertising Arts Dept, 4501 Amnicola Hwy, Chattanooga, TN 37406. Tel 423-697-4400, 697-4441; Fax 423-697-2539; Internet Home Page Address: www.cstcc.cc.tn.us; *Dir Fine Arts* Denise Frank; *Asst Prof* Alan Wallace
FT 2; pub; D & E; Scholarships; SC 30, LC 5; D 3000, E 2000
Ent Req: HS dipl
Degrees: Certificate, AA(Advertising Art)
Tuition: Res—$56 per cr hr; nonres—$168 per cr hr
Courses: Advertising Concepts, Advertising Design, Air Brush, Art Education, Art History, Ceramics, Commercial Art, Drafting, Drawing, Graphic Arts, Graphic Design, Illustration, Internships, Painting, Photography, Production Art, Teacher Training, Typography
Adult Hobby Classes: Tuition $45 per course. Courses—Painting, Photography
Children's Classes: Tuition $20 per course. Courses—Arts & Crafts, Ceramics & Sculpture
Summer School: Tuition $140 per term of 10 wks

UNIVERSITY OF TENNESSEE AT CHATTANOOGA, Dept of Art, 615 McCallie Ave, Chattanooga, TN 37403. Tel 423-755-4178; Fax 423-785-2101; Internet Home Page Address: www.utc.edu; *Head* E Alan White; *Prof* Anne Lindsey PhD; *Prof* Maggie McMahon, MFA; *Assoc Prof* Bruce Wallace, MFA; *Assoc Prof* Gavin Townsend PhD, MFA; *Assoc Prof* Stephen S LeWinter, MA
Estab 1928; pub; D & E; Scholarships; SC 11, LC 13, GC 1; D 420, E 80, non-maj 500, maj 130, grad 6, others 14

Ent Req: HS dipl, ACT or SAT, health exam
Degrees: BA and BFA 4 yrs
Tuition: Res—undergrad $746 per sem, grad $974 per sem; nonres—undergrad $2428 per sem, grad $2656 per sem; campus res—room available
Courses: Art Education, Art History, Ceramics, Commercial Art, Drawing, Graphic Design, Painting, Printmaking, Sculpture
Summer School: Tuition $72 per sem hr

CLARKSVILLE

AUSTIN PEAY STATE UNIVERSITY, Dept of Art, 601 College St, Clarksville, TN 37044; PO Box 4677, Clarksville, TN 37044. Tel 931-648-7333; Elec Mail marsh@apsu02.apsu.edu; Internet Home Page Address: www.apsu.edu/; *Assoc Prof* Gregg Schlanger, MFA; *Assoc Prof* Kell Black, MFA; *Chair* Cindy Marsh, MFA
Estab 1927, dept estab 1930; pub; D & E; Scholarships; GC 3; D 740, E 75, non-maj 590, maj 150
Ent Req: HS dipl
Degrees: BFA, BA & BS 4 yrs
Tuition: Res—undergrad $1415.50 per sem; nonres—$4229.50 per sem; campus residence available
Courses: †Art Education, Art History, †Ceramics, Drawing, †Graphic Design, Illustration, Lettering, †Painting, †Photography, †Printmaking, †Sculpture
Summer School: tuition $192 per cr

CLEVELAND

CLEVELAND STATE COMMUNITY COLLEGE, Dept of Art, Adkisson Dr, PO Box 3570 Cleveland, TN 37320-3570. Tel 423-472-7141; Fax 423-478-6255; WATS 800-604-2722; *Head* Jere Chumley, MA
Estab 1967; pub; D & E; Scholarships; SC 6, LC 5; D 95, E 20, non-maj 60, maj 35
Ent Req: HS dipl or GED
Degrees: AA and AS 2 yrs
Tuition: Res—$647 per sem; nonres—$2585 per sem
Courses: Architecture, Art Appreciation, Art Education, Art History, Calligraphy, Ceramics, Design, Drafting, Drawing, History of Art & Architecture, Painting, Photography, Sculpture
Adult Hobby Classes: Drawing, Painting

LEE UNIVERSITY, Dept of Communication & the Arts, 1120 N Ocoee St, Cleveland, TN 37311. Tel 423-614-8240; Fax 423-614-8242; Internet Home Page Address: www.leeuniversity.edu; *Chmn* Dr Matthew Melton
Estab 1918; Priv
Ent Req: HS diploma
Degrees: BA, BS
Tuition: Res—$5500 on campus per sem
Courses: Art Appreciation, Art History, Drawing, Film, Painting, Photography

COLLEGEDALE

SOUTHERN ADVENTIST UNIVERSITY, Art Dept, PO Box 370, Collegedale, TN 37315. Tel 423-238-2732, 237-2111; *Chmn* Wayne Hazen
Estab 1969; den; D & E; Scholarships; LC 4; maj 50
Ent Req: HS dipl, ent exam
Degrees: BA(Art), BA(Art & Educ) & BA(Computer Graphic Design) 4 yr
Tuition: $10700 per yr, $16500 with dorm
Courses: Animation, Art, Art Appreciation, Art Education, Art History, Ceramics, Computer Graphic Design, Design, Drawing, Fine Art, Graphic Arts, Graphic Design, Painting, Printmaking, Sculpture

COLUMBIA

COLUMBIA STATE COMMUNITY COLLEGE, Dept of Art, 412 Hwy W, PO Box 1315 Columbia, TN 38402. Tel 931-540-2722; Internet Home Page Address: www.coscc.cc.tn.us; *Prof* Fred Behrens, MFA; *Div Chm* Marvin Austin PhD
Estab 1966; pub; D & E; Scholarships; SC 17, LC 4; D 230, non-maj 215, maj 12-15
Ent Req: open door institution
Degrees: AA & AS 2 yrs
Tuition: Res—$53 per cr hr; nonres—$210 per cr hr
Courses: Art History, †Art Studio, Design, Drawing, Film, Painting, Photography, Printmaking, Visual Arts
Children's Classes: Enrl 18-20, tuition $30 per session

GATLINBURG

ARROWMONT SCHOOL OF ARTS & CRAFTS, Arrowmont School of Arts & Crafts, 556 Parkway, PO Box 567 Gatlinburg, TN 37738. Tel 865-436-5860; Fax 865-430-4101; Internet Home Page Address: www.arrowmont.org/; *Dir* David Willard; *Asst Dir* Bill Griffith
Estab 1945; Maintians nonprofit gallery, Sandra J Blain Galleries, Arrowmont School of Arts & Crafts 556 Parkway, Gatlinburg, TN 37738; pvt; D & E (operate mostly in spring & summer with special programs for fall & winter); Scholarships; SC 44-50, GC 30; D 2000
Degrees: none granted, though credit is offered for courses through the Univ of Tennessee, Knoxville
Tuition: Tuition varies
Courses: Basketry, Bookbinding, Ceramics, Drawing, Enamel, Jewelry, Painting, Papermaking, Photography, Quilting, Stained Glass, Textile Design, Weaving, Woodturning

GOODLETTSVILLE

NOSSI COLLEGE OF ART, 907 Rivergate Pkwy, E-6, Goodlettsville, TN 37072. Tel 615-851-1088; Fax 615-851-1087; Elec Mail admissions@nossi.com; Internet Home Page Address: www.nossicollege.com; *Dept Chair, Graphic Design* Stephan LaSeurer, BA; *Co-Dept Chair, Illustration* Blake Long, BA; *Exec Dir* Cyrus Vatandoust, BA; *Dept Chair, Photog* Donnie Beauchamp, BA; *Dept Chair, Computer Graphics* Richard Schrand; *Co-Dept Chair, Illustration* Jeff Preston, BA; *Founder, CEO & Pres* Nossi Vatandoust, BA
Estab 1973; pvt; D & E; Scholarships; SC 1, LC 4
Ent Req: HS dipl or GED
Degrees: AOS degree; 2 yr Commercial Art, BA Graphic Art & Design, Photography, Commercial Illustration
Tuition: $9,300 per yr
Courses: Advertising Design, Architecture, Art Appreciation, Art Education, Art History, †Commercial Art, Conceptual Art, Design, Display, Drawing, Graphic Arts, †Graphic Design, Illustration, Lettering, Mixed Media, Painting, †Photography, Video

GREENEVILLE

TUSCULUM COLLEGE, Fine Arts Dept, Division of Arts & Humanities, 2299 Tusculum, PO Box 5084 Greeneville, TN 37743. Tel 423-636-7300; *Asst Prof Art* Tom Silva
Estab 1794; den; D; Scholarships; SC 25, LC 3; D 445, maj 18
Ent Req: HS dipl
Degrees: BA & BS 4 yrs
Tuition: $10,120 per yr
Courses: Art Education, Ceramics, Drawing, History of Art & Architecture, Painting, Printmaking, Sculpture
Adult Hobby Classes: Enrl 14. Courses—Painting

HARROGATE

LINCOLN MEMORIAL UNIVERSITY, Division of Humanities, Cumberland Gap Pky, PO Box 2019 Harrogate, TN 37752-2019. Tel 423-869-3611; Internet Home Page Address: www.lmunet.edu; *Assoc Prof Art* Betty DeBord; *Instr* Alex Buckland; *Chmn Humanities* Colun Leckey
Estab 1897, dept estab 1974; pvt; D & E; SC 30, LC 3; D 120, E 75, non-maj 97, maj 98
Ent Req: HS dipl
Degrees: BA 4 yrs
Tuition: Res—$5400 per sem; room & board $3400
Courses: Aesthetics, Art Education, Art History, Ceramics, Commercial Art, Drawing, Film, Goldsmithing, †Graphic Arts, Jewelry, Lettering, Museum Staff Training, †Painting, †Photography, †Sculpture, Silversmithing, †Teacher Training, †Textile Design, †Theatre Arts, Weaving

JACKSON

LAMBUTH UNIVERSITY, Dept of Human Ecology & Visual Arts, 705 Lambuth Blvd, PO Box 431 Jackson, TN 38301. Tel 901-425-3275, 425-2500; Fax 901-423-1990; Internet Home Page Address: www.lambuth.edu; *Chmn* Lawrence A Ray PhD; *Assoc Prof* June Creasy, MS; *Asst Prof* Lendon H Noe, MS; *Lectr* Susan Haubold, MEd; *Lectr* Belinda A Patterson, BS; *Lectr* Glynn Weatherley, BS; *Lectr* Rosemary Carroway, BA
Estab 1843, dept estab 1950; Methodist; D & E; Scholarships; SC 21, LC 10
Ent Req: HS dipl
Degrees: BA, BS, B(Mus) & B(Bus Ad) 4 yrs
Tuition: $14,354 per yr
Courses: Advertising Design, Aesthetics, †Art Education, †Art History, †Commercial Art, Crafts, †Drawing, Fiber Crafts, †Graphic Design, Human Ecology, †Interior Design, †Painting, †Photography, †Printmaking, †Sculpture, Stage Design, †Stained Glass, Visual Art
Adult Hobby Classes: Adult Evening Prog. $1800 per term
Children's Classes: Enrl 45-50; tuition $50 for 5 wk term. Courses—Elementary art classes
Summer School: Dir, William Shutowski. Courses—Art Appreciation, Art Education, Basic ID, Painting, Printmaking

UNION UNIVERSITY, Dept of Art, 1050 Union University Dr, Jackson, TN 38305. Tel 901-668-1818; Fax 901-661-5175; Elec Mail lbenson@uu.edu; Internet Home Page Address: www.uu.edu; *Prof* Chris Nadaskay; *Chmn* Aaron Lee Benson; *Instr* Jonathan Gillette; *Instr* Lori Nolen
Estab 1824, dept estab 1958; Maintain nonprofit art gallery; Union Univ Gallery of Art, Jackson TN; Pvt; D & E; Scholarships; SC 20, LC 5; D 200, E 40, maj 28
Ent Req: HS dipl, portfolio, ACT
Degrees: BA and BS 4 yrs
Tuition: $2,125 per sem; 12 hrs $4,920
Courses: Art Appreciation, Art Education, Ceramics, Design, †Drafting, Drawing, Graphic Design, Painting, Photography, Printmaking, Sculpture, Teacher Training
Children's Classes: Enrl 6-8 $185
Summer School: Dir Debra Tayloe

JEFFERSON CITY

CARSON-NEWMAN COLLEGE, Art Dept, PO Box 71995, Jefferson City, TN 37760. Tel 865-475-9061; Fax 865-471-3502; Elec Mail sgray@cn.edu; Internet Home Page Address: www.cn.edu; *Assoc Prof & Second Dept Chmn* David Underwood; *Artist-in-Residence* William Houston; *Chmn Dept* H T Niceley; *Asst Prof* Julie Rabun; *Assoc Prof* John Alford

Col estab 1851; maintain a nonprofit art gallery: The Omega Gallery, Warren Art Bldg, 2130 Branner Ave, Jefferson City, TN 37760; FT 3; pvt; D & E; Scholarships; SC 32, LC 16; maj 85
Ent Req: HS dipl
Degrees: BA(Art & Photography) 4 yrs
Tuition: $12,200
Courses: Aesthetics, Art Education, Art History, Computer Graphics, Drawing, Graphic Design, Painting, Photography, Printmaking, Senior Seminar, Support Systems

JOHNSON CITY

EAST TENNESSEE STATE UNIVERSITY, College of Arts and Sciences, Dept of Art & Design, PO Box 70708, Johnson City, TN 37614-1708. Tel 423-439-4247; Fax 423-439-4393; Internet Home Page Address: http://art.etsu.edu; *Chmn, Dept of Art & Design & Prof* M Wayne Dyer; *Prof* Michael Smith, MFA; *Prof* Vida Hull, PhD; *Prof* Ralph Slatton, MFA; *Assoc Prof* David Dixon, MFA; *Assoc Prof* Don Davis, MFA; *Asst Prof* Mira Gerard, MFA; *Assoc Prof* Anita DeAngelis, MFA; *Assoc Prof* Peter Pawlowicz, PhD; *Assoc Prof* Catherine Murray, MFA; *Assoc Prof* Scott Koterbay, PhD; *Asst Prof* Pat Mink; *Asst Prof* Travis Graves; *Gallery Dir* Karluta Contreras-Koterbay
Estab 1911, dept estab 1949; Maintain nonprofit gallery, Slocumb Galleries & Carroll Reece Museum on ETSU campus; pub; D & E; Scholarships; SC 102, LC 30, GC 46; maj 225
Ent Req: HS dipl, ACT or SAT
Degrees: BA & BFA 4 yrs, MA, MFA
Tuition: Res—undergrad $146 per sem hr, $1676 per sem, grad $238 per sem hr, $2250 per sem; nonres—undergrad $340 per sem hr, $3925 per sem
Courses: †Aesthetics, †Art History, †Ceramics, Commercial Art, Conceptual Art, Design, Drawing, Film, Goldsmithing, †Graphic Design, History of Art & Architecture, Illustration, †Jewelry, †Metalsmithing, Mixed Media, †Painting, †Photography, Printmaking, †Sculpture, Silversmithing, Teacher Training, Video, Weaving, †Weaving/Fibers
Adult Hobby Classes: Credit/no credit classes at night. Courses—Art History, Drawing, Photography, painting
Summer School: Dir, M Wayne Dyer. Term for 2-5 wks. Courses—Book Arts, Ceramics, Computer Art, Stone Carving

KNOXVILLE

UNIVERSITY OF TENNESSEE, KNOXVILLE, School of Art, 1715 Volunteer Blvd, Ste. 213, Knoxville, TN 37996-2410. Tel 865-974-3407; Fax 865-974-3198; Internet Home Page Address: www.web.utk.edu/~art; *Dir School of Art* Paul Lee; *Assoc Dir* Tim Hiles
Estab 1794, dept estab 1951; Maintain nonprofit art gallery; Ewing Gallery; art supplies available on campus; FT 27, PT 15; pub; D & E; Scholarships; SC 51, LC 23, GC 50; D 1,600, E 250, non-maj 300, maj 400, grad 40
Ent Req: HS dipl
Degrees: BA & BFA, MFA; both undergraduate & graduate credit may be earned through the affiliated program at Arrowmont School of Arts & Crafts, Gatlinburg, TN
Tuition: Res—undergrate $1,302 per sem, grad $1,653 per sem; nonres—undergrad $3,034 per sem, campus res—room & board $3,166 per yr
Courses: †Art History, †Ceramics, †Drawing, †Graphic Design, Media Arts, †Painting, †Printmaking, †Sculpture, †Watercolors
Summer School: Dir, Norman Magden. Enrl 400; term of 2 sessions beginning June & Aug. Courses—Art History, Design, Drawing, Media Arts

MARYVILLE

MARYVILLE COLLEGE, Dept of Fine Arts, 502 East Lamar Alexander Pkwy, Maryville, TN 37804. Tel 865-981-8000; Internet Home Page Address: www.maryvillecollege.edu; *Asst Prof* Carl Gombert; *Asst prof* Jeff Turner; *Chmn* Dan Taddie
Estab 1937; FT 2, PT 1; den; D&E; Scholarships; SC 10, LC 6
Degrees: 4 yr
Tuition: $2275 per term
Courses: Art Education, Art History, Ceramics, Computer Graphics, Drawing, Fabric Design, Graphic Design, Painting, Photography, Printmaking, Visual Theory & Design, Weaving
Adult Hobby Classes: Courses offered
Children's Classes: Art Education, Crafts

MEMPHIS

MEMPHIS COLLEGE OF ART, Overton Park, 1930 Poplar Ave Memphis, TN 38104-2764. Tel 901-272-5100; Fax 901-272-5158; Elec Mail info@mca.edu; Internet Home Page Address: www.mca.edu; *Pres* Jeffrey Nesin; *VPres for Acad Affairs/Dean* Ken Strickland, MFA; *Div Chair Fine Arts* Howard Paine, MFA; *Div Chair Design Arts* David Chioffi, MFA; *Div Chair Foundations* Remy Miller, MFA; *Div Chair Liberal Studies* Betty Spence, MA; *Cur Galleries* Jennifer Sargent; *Dir Grad Studies* Sanjit Sethi, MFA; *Dir Grad Studies* Dr Cathy Wilson, MA
Estab 1936; maintain art libr & nonprofit art gallery on campus; FT 21, PT 22; pvt; D & E; Scholarships; SC 132, LC 73, GC 20; D 300, E 300, GS 19
Ent Req: HS dipl
Degrees: BFA 4 yrs, MFA 2 yrs, MA 1 yr
Tuition: $19,200 per yr
Courses: Advertising Design, Aesthetics, Architecture, Art Appreciation, †Art Education, Art History, †Book Arts, Calligraphy, †Ceramics, Collage, †Commercial Art, †Computer Arts, Conceptual Art, Constructions, †Design, Digital Media Animation, †Drawing, Goldsmithing, †Graphic Arts, †Graphic

Design, History of Art & Architecture, †Illustration, Intermedia, †Jewelry, Lettering, Mixed Media, †Painting, †Papermaking, †Photography, †Printmaking, †Sculpture, †Silversmithing, Stage Design, †Textile Design, Video
Adult Hobby Classes: Classes vary
Children's Classes: Classes vary
Summer School: Dir, Mary Beth Haas

RHODES COLLEGE, Dept of Art, 2000 N Pky, Memphis, TN 38112. Tel 901-843-3000, 3442; Fax 901-843-3727; Internet Home Page Address: www.rhodes.edu; *Chmn, Asst Prof* Victor Coonin, MFA; *Assoc Prof* David McCarthy; *Assoc Prof* Diane Hoffman, MFA; *Instr* Hallie Charney, MFA; *Asst Prof* Val Vaigardson; *Prof* Jim Lutz; *Asst Prof* Margaret Woodhull
Estab 1848, dept estab 1940; pvt; D & E; SC 17, LC 12; D 250, non-maj 240, maj 10
Ent Req: SAT or ACT, 13 acad credits, 16 overall
Degrees: BA 4 yrs
Tuition: campus res—room & board
Courses: Aesthetics, Architecture, Art History, Drawing, History of Art & Architecture, Museum Staff Training, Painting, Photography, Printmaking, Sculpture

UNIVERSITY OF MEMPHIS, Art Dept, Campus Box 526715, Memphis, TN 38152-6715. Tel 901-678-2216; Fax 901-678-2735; *Chmn Asst* Wayne Simpkins; *Chmn Asst* Brenda Landman; *Acting Chmn* Sandy Lowrance
Estab 1912; pub; D & E; Scholarships; SC 100, LC 40, GC 30; D 2200, maj 467, grad 80
Ent Req: HS dipl, SAT
Degrees: BA & BFA 4 yrs, MA 1 yr, MFA 2 yrs
Tuition: Campus residence available
Courses: Art Education, Ceramics, Drawing, Graphic Design, History of Art & Architecture, Illustration, Interior Design, Museum Staff Training, Painting, Photography, Printmaking, Teacher Training
Adult Hobby Classes: Courses offered
Summer School: Dir, Robert E Lewis

MURFREESBORO

MIDDLE TENNESSEE STATE UNIVERSITY, Art Dept, 1301 E Main, Murfreesboro, TN 37132. Tel 615-898-2300; Fax 615-898-2254; Internet Home Page Address: www.mtsu.edu; *Instr* Jean Nagy; *Instr* Ollie Fancher; *Instr* Pati Beachley; *Instr* Klaus Kallenberger; *Instr* Janet Higgins; *Instr* Christie Nuell; *Instr* Lon Nuell; *Instr* Marissa Recchia; *Instr* Charles Jansen; *Instr* Tanya Tewell; *Instr* Nancy Kelker; *Instr* John O'Connell; *Instr* Doug Schatz; *Instr* David Shaul; *Instr* Shirley Yokley; *Chmn Art Dept* Mark Price; *Instr* Carlyle Johnson
Estab 1911, dept estab 1952; pub; D & E; Scholarships; SC 62, LC 10, GC 35; non-maj 900, maj 200, grad 5
Ent Req: HS dipl
Degrees: BS(Art Educ), & BFA 4 yrs
Tuition: Res—$953 per sem; non-res—$3366 per sem
Courses: †Art Education, †Ceramics, †Commercial Art, Drawing, Goldsmithing, Graphic Design, †Jewelry, †Painting, †Printmaking, †Sculpture, †Silversmithing, Textile Design
Adult Hobby Classes: Courses Offered
Children's Classes: Creative Art Clinic for Children; enrl 45; tuition $25 per term
Summer School: Courses Offered

NASHVILLE

CHEEKWOOD NASHVILLE'S HOME OF ART & GARDENS, Education Dept, 1200 Forrest Park Dr, Nashville, TN 37205. Tel 615-353-9827; Fax 615-353-2162; *Pres* Jane Jerry; *Dir Museum* John Wentenhall; *Cur Coll* Celia Walker; *Dir Botanical Gardens* Bob Brackman; *Dir Educ* Mary Grissim
Estab 1960; pvt; D & E; Scholarships; SC 10-15, LC 5-10
Tuition: $90-$137 for 8 wk term
Courses: Art Appreciation, Art History, Ceramics, Drawing, Jewelry, Landscape Design, Painting, Papermaking, Sculpture, Weaving
Adult Hobby Classes: Enrl 750; tuition $110-137. Courses—Clay on Wheel, Drawing, Horticulture, Landscape Design, Painting, Photography, Sculpture
Children's Classes: Enrl 200; tuition $90-110. Courses—Clay Jewelry, Drawing, Environmental Science, Film Making, Gardening, Painting, Photography, Sculpture
Summer School: Enrl 900; tuition $90-$110. Courses—Clay Jewelry, Drawing, Environmental Science, Film Making, Gardening, Painting, Photography, Sculpture

FISK UNIVERSITY, Art Dept, 1000 17th Ave N, Nashville, TN 37208-3051. Tel 615-329-8674, 329-8500; Fax 615-329-8551; Internet Home Page Address: www.fisk.edu; *Asst Prof* Alicia Henry, MA; *Chmn & Instr* Lifran Fort, MA
Estab 1867, dept estab 1937; pvt; D; Scholarships; SC 10, LC 3; 65, non-maj 40, maj 15
Ent Req: HS dipl, SAT
Degrees: BS & BA 4 yrs
Tuition: $6585 per sem; room & board $2325
Courses: Aesthetics, African Art, Afro-American Art, Art History, Drawing, Painting, Sculpture

VANDERBILT UNIVERSITY, Dept of Art, Box 351660-B, 2301 Vanderbilt Pl Nashville, TN 37235. Tel 615-343-7241; Fax 615-322-3467; Internet Home Page Address: www.vanderbilt.edu/arts; *Emeritus Prof* Donald H Evans, MFA; *Prof* Michael Aurbach, MFA; *Sr Lectr* Susan DeMay, MFA; *Sr Lectr* Carlton Wilkinson, MFA; *Chair* Marilyn Murphy, MFA; *Sr Lectr* Ron Porter, MFA; *Sr Lectr* Libby Rowe; *Lectr* Robert Durham
Estab 1873, dept estab 1944; Maintain nonprofit gallery; Fine Arts Gallery, Nashville, TN; maintain arts section in gen library; Jean & Alexander Heard Library; Pvt; D; Scholarships, Fellowships; SC 19, LC 29, GC 2; D, non-maj 367, maj 9

Ent Req: HS dipl, ent exam
Degrees: BA 4 yrs
Tuition: $25,190 per yr; campus res—room & board combined $8,500
Courses: Art Appreciation, Art History, Ceramics, Drawing, Multimedia Design, Painting, Photography, Printmaking, Sculpture, Video
Summer School: Dean, Richard McCarty. Tuition $840 per cr hr for two 4 wk terms beginning early June. Courses—Vary

WATKINS INSTITUTE, College of Art & Design, 2298 Metro Center Blvd, Nashville, TN 37228. Tel 615-383-4848; Elec Mail tgray@watkins.edu; Internet Home Page Address: www.watkins.edu; *Dir Fine Arts* Terry Glispin
Estab 1885; Maintain non profit gallery; 50; pvt; D & E; SC 30, LC 5; D 1000, E 1000
Ent Req: noncredit adult educ program, must be 17 yrs of age or older
Degrees: AA in Art, approved by Tennessee Higher Education Commission, 2 yr
Tuition: Film: $10,080 per yr; Part time $420 per credit
Courses: †Film, †Fine Art, †Graphic Design, †Interior Design, †Photography
Children's Classes: Enrl 500; tuition $150-$200 for 12 wks. Courses—Fine Arts
Summer School: Enrl 400; tuition $90 - $135 per course for 10 wks. Summer Art Camp for children, 2 wk sessions. Courses—Commercial Art, Fine Arts, Interior Design

SEWANEE

UNIVERSITY OF THE SOUTH, Dept of Fine Arts, Carnegie Hall, Sewanee, TN 37383. Tel 913-598-1201; Elec Mail pmalde@seraph1.sewaner.edu; Internet Home Page Address: www.sewanee.edu; *Chmn Dept* Gregory Clark
FT 6; Pvt, den; D; SC 20, LC 20; D 250, non-maj 225, maj 30
Degrees: BS & BA, MDivinity
Tuition: $9100 per yr
Courses: Art History, Drawing, Painting, Photography, Printmaking, Sculpture, Video
Summer School: Dir, Dr John Reishman. Enrl 150 for term of 6 wks beginning June; tuition $400 per cr. Courses—History of Western Art II, Painting, Photography

TULLAHOMA

MOTLOW STATE COMMUNITY COLLEGE, Art Dept, 6015 Ledford Mill Rd, Tullahoma, TN 37388; PO Box 88100, Tullahoma, TN 37388-8100; Dept 210, PO Box 8500 Lynchburg, TN 37352-8500. Tel 931-393-1500; Fax 931-393-1681; Internet Home Page Address: www.mscc.cc.tn.us; *Art Teacher* Ann Smotherman; *Dean* Dr Mary McLemore; *Art Teacher* Brian Robinson
Estab 1969; Pub; D & E; Scholarships
Ent Req: HS diploma or equivalent
Tuition: In state—$2199 per yr; out of state—$4022.50 per yr
Courses: Art Appreciation, Arts & Crafts, Ceramics, Commercial Art, Design, Drawing, Painting, Photography
Adult Hobby Classes: Enrl 200
Children's Classes: Enrl 40

TEXAS

ABILENE

ABILENE CHRISTIAN UNIVERSITY, Dept of Art & Design, ACU Box 27987, Abilene, TX 79699-7987. Tel 915-674-2085; Fax 915-674-2051; Elec Mail maxwellj@acu.edu; Internet Home Page Address: www.acu.edu/academics/cas/art.html; *Head Dept & Chmn* Jack Maxwell; *Prof* Robert Green; *Prof* Ginna Sadler; *Prof* Nil Santana; *Prof* Geoff Broderick; *Prof* Dan McGregor; *Prof* Ronnie Rama; *Prof* Kitty Wasemiller; *Prof* Mike Wiggins
Estab 1906; Maintain nonprofit art gallery, Clover Virginia Shore Art Gallery, 142 Don Morris Center, Box 27987, Abilene, TX 79699-7987; FT 8, PT 2; pvt; D & E; Scholarships; SC 31, LC 8; maj 130
Ent Req: upper 3/4 HS grad class or at 19 standard score ACT composite
Degrees: BA, BA(Educ) & BFA 4 yrs
Tuition: $347 per sem hr
Courses: Advertising Design, Architecture, Art Appreciation, Art Education, Art History, Ceramics, Design, Drawing, Graphic Design, History of Art & Architecture, †Illustration, Jewelry, Painting, Photography, Pottery, Printmaking, Sculpture
Summer School: Chmn, Jack Maxwell, Enrl 10; tuition $347 per sem hour. Courses— Drawing, Introduction to Art History, Sculpture, Graphic Design

HARDIN-SIMMONS UNIVERSITY, Art Dept, Hickory at Ambler St, PO Box 16085 Abilene, TX 79698. Tel 915-670-1246, 670-1247; *Prof, Chmn* Martha Kiel, MEd; *Prof* Carrie Tucker, MFA
Univ estab 1891; den; D & E; Scholarships; SC 27, LC 5; D 60, E 25, non-maj 35, maj 35
Ent Req: HS dipl, SAT, ACT
Degrees: BA & BBS 4 yrs
Tuition: $330 per cr hr; campus res—room $790-$865, board $434.60-$927.50
Courses: Art Education, Art History, †Ceramics, †Drawing, †Graphic Design, †Painting, †Photography, †Printmaking, Sculpture, †Teacher Training, †Theatre Arts
Children's Classes: Enrl summer only 110; tuition $160 per wk full day, $85 per wk half day. Courses—Art History, Ceramics, Drawing, Painting, Papermaking, Photography, Printmaking, Sculpture
Summer School: Dir, Linda D Fawcett. Enrl 30; tuition $230 per cr hr for term of 6 wks beginning June 2. Courses—Art Appreciation, Ceramics, Drawing, Photography

MCMURRY UNIVERSITY, Art Dept, McMurry Sta, PO Box 308 Abilene, TX 79697. Tel 915-793-4888; Fax 915-793-4662; Internet Home Page Address: www.mcm.edu; *Head Dept* Kathy Walker-Millar, BS; *Prof* J Robert Miller, BS; *Asst Prof* Linda Stricklin, BS; *Instr* Judy Deaton
Estab 1923; pvt; D & E; Scholarships; SC 19, LC 1; D 80, E 8, non-maj 18, maj 15
Ent Req: HS dipl
Degrees: BA, BFA & BS 4 yrs
Tuition: Res—undergrad $9255 per sem; (incl room); nonres—same as res fees
Courses: Art Education, Art History, Assemblage Sculpture, Ceramics, Design, Drawing, Jewelry, Painting, Teacher Training
Adult Hobby Classes: Enrl 24; tuition $360 fall, spring & summer terms. Courses—Art Education I & II
Summer School: Dir, Bob Maniss. Two summer terms. Courses—Art Education I, Exploring the Visual Arts

ALPINE

SUL ROSS STATE UNIVERSITY, Dept of Fine Arts & Communications, C-43, Alpine, TX 79832. Tel 915-837-8130; Fax 915-837-8046; *Prof* Charles R Hext, MFA; *Asst Prof* Carol Fairlie, MFA; *Asst Prof* Jim Bob Salazar, MFA
Estab 1920, dept estab 1922; pub; D & E; Scholarships; SC 21, LC 3, GC 19; D 183, E 32, non-maj 170, maj 25-30, GS 15
Ent Req: HS dipl, ACT or SAT
Degrees: BFA 4 yrs, MEd(Art) 1 1/2 yrs
Tuition: Res—12 hr $615 pr sem, nonres—12 hr $3812 per sem
Courses: Advertising Art, †Advertising Design, †Art Appreciation, †Art Education, †Art History, †Ceramics, Collage, †Commercial Art, Conceptual Art, Constructions, Costume Design & Construction, Design, Drafting, Drawing, †Graphic Arts, †Graphic Design, Handicrafts, †History of Art & Architecture, Illustration, Industrial Design, Interior Design, Jewelry, Landscape Architecture, †Mixed Media, †Painting, Photography, †Printmaking, Restoration & Conservation, †Sculpture, Stage Design, †Teacher Training

ALVIN

ALVIN COMMUNITY COLLEGE, Art Dept, 3110 Mustang Rd, Alvin, TX 77511. Tel 281-756-3752; Fax 281-388-4903; Elec Mail dlavalley@alvin.cc.tx.us; *Chmn* Dennis LaValley
Estab 1949; D & E
Ent Req: HS dipl
Degrees: AA 2 yrs
Tuition: Res—$419 per cr
Courses: Art Appreciation, Art History, †Art Metals, Ceramics, Design Communication, Drawing, Graphic Design, Graphic Media, Painting, †Photography, Sculpture
Summer School: Dir, Bruce Turner. 6-12 wk term. Courses—Vary

AMARILLO

AMARILLO COLLEGE, Visual Art Dept, PO Box 447, Amarillo, TX 79178. Tel 806-371-5000, Ext 5084; Internet Home Page Address: www.actx.edu/~visual_arts/; *Prof* William Burrell, MFA; *Asst Prof* Dennis Olson, MFA; *Asst Prof* Steven Cost, MFA; *Instr* Pedro Gonzalez, MFA; *Assoc Prof* Joseph Walsh, MA; *Instr* Alix Christian; *Instr* Victoria Taylor-Gore; *Dept Head* Kenneth Pirtle, BFA
Estab 1926; pub; D & E; Scholarships; SC 18, LC 2; D 142, E 60
Ent Req: HS dipl, CEEB
Degrees: AA 2 yrs
Tuition: Res—undergrad $19 per cr hr, FT $309, lab fee $8; nonres—$47.50 per cr hr, FT $759, no campus res
Courses: Art History, Ceramics, Drawing, †Fine Art, †Graphic Design, Illustration, Jewelry, Layout, †Painting, †Sculpture, Typographics

ARLINGTON

UNIVERSITY OF TEXAS AT ARLINGTON, Dept of Art & Art History, 335 Fine Arts Bldg, PO Box 19089 Arlington, TX 76019. Tel 817-272-2891; Fax 817-273-2805; Internet Home Page Address: www.uta.edu; *Chmn* Kenda North
Estab 1895, dept estab 1937; pub; D & E; Scholarships; SC 46, LC 39, maj 400
Ent Req: HS dipl, SAT of ACT
Degrees: BFA 4 yrs
Tuition: Res—$14,905 per yr; nonres—$21,935 per yr
Courses: Advertising Design, Art Appreciation, †Art History, †Ceramics, Commercial Art, Conceptual Art, Constructions, Design, Display, †Drawing, Film, Glass Blowing, Goldsmithing, Graphic Arts, †Graphic Design, History of Art & Architecture, Illustration, Intermedia, †Jewelry, †Metalsmithing, Mixed Media, Museum Staff Training, †Painting, †Photography, †Printmaking, †Sculpture, Silversmithing, Teacher Training, †Video

AUSTIN

AUSTIN COMMUNITY COLLEGE, Dept of Commercial Art, North Ridge Campus, 11928 Stonehollow Dr, Austin, TX 78758. Tel 512-223-7000 (Main), 223-4830 (Dept); Fax 512-223-4444; Internet Home Page Address: www.austin.cc.tx.us/; *Head Dept South Campus* Steve Kramer
Estab 1974; FT 3, PT 30; pub; D & E; 386 per sem
Ent Req: HS dipl or GED
Degrees: AAS 2 yr, Multi Media Cert
Tuition: Res—undergrad $46 per cr hr; nonres—undergrad $214 per cr hr

Courses: Advertising, Animation, Art History, Calligraphy, Ceramics, Commercial Art, Commercial Art History, Computer Layout & Design, Desktop Publishing, Drawing, Environmental Graphics, Figure Drawing, Graphic Arts, Graphic Design, Graphics Practicum, Illustration, Illustrative Techniques, Metalsmithing, Painting, Photography, †Printmaking, Production Art, †Sculpture, Silkscreening, Typography Design, †Video

CONCORDIA UNIVERSITY, Dept of Fine Arts, 3400 H-35 N, Austin, TX 78705. Tel 512-452-7661; Fax 512-459-8517; *Chmn* Dr David Kroft
Estab 1925; FT 1; den; D; Scholarships; SC 1, LC 1; D 350
Ent Req: HS dipl
Degrees: AA 2 yrs
Tuition: $5345 per sem; campus res available
Courses: Art Fundamentals, Ceramics, Design, Drawing, Drawing Media, Relief Printing

UNIVERSITY OF TEXAS
—**School of Architecture,** Tel 512-471-1922; Fax 512-471-0716; Elec Mail lwspeck@mail.utexas.edu; Internet Home Page Address: www.ar.utexas.edu; *Dean* Lawrence Speck
Estab 1909; FT 38, PT 9; pub; Scholarships; undergrad 450, grad 210
Ent Req: reasonable HS scholastic achievement, SAT, ACT
Degrees: BA, MA, PhD
Tuition: Res—$80 per cr hr, grad $120 per cr hr; nonres—$295 per cr hr, grad $335 per cr hr
Courses: †Architecture, Community & Regional Planning
Adult Hobby Classes: Courses through Division of Continuing Education
Children's Classes: Six week summer program for high school
Summer School: Dir, Harold Box
—**Dept of Art & Art History,** Tel 512-471-3382; Fax 512-471-7801; Elec Mail carolynp@mail.utexas.edu; Internet Home Page address: www.finearts.utexas.edu/aah/; *Chair* John Yancey; *Assoc. Chair* Lee Chesney; *Asst. Dir. Devel.* Carolyn Porter; *Asst Chair - Art History* Michael Charlesworth; *Asst Chair - Design* Kate Cattevall; *Asst Chair - Studio Art* Janet Kastner; *Asst Chair - Visual Art Studies* Christopher Adejumo
Estab 1938; Maintain nonprofit art gallery; Creative Research Laboratory, 2832 E Martin Luther King Jr Blvd, Austin TX 78705; art library; FT & PT 80; pub; D & E; Scholarships, Fellowships; SC 20, LC 15, GC 20; enrl grad 150, 700 undergrad maj
Ent Req: academic & portfolio application
Degrees: BA 4yrs, BFA 4 yrs, MA 2 yrs, MFA 2 yrs, PhD & MFA 3yrs
Tuition: Res—undergrad $1484 & fees per sem, grad $1950 & fees per sem; nonres—undergrad $4064 & fees per sem, grad $4537 & fees per sem
Courses: Aesthetics, Art Appreciation, Art Education, Art History, Ceramics, Conceptual Art, Design, Digital-Time Arts, Drawing, Graphic Arts, Graphic Design, History of Art & Archeology, Metals, Mixed Media, Painting, Performance Art, Photography, Printmaking, Sculpture, Teacher Training, Video
Summer School: Two 6 wk terms

BEAUMONT

LAMAR UNIVERSITY, Art Dept, PO Box 10027, LU Sta, Beaumont, TX 77710. Tel 409-880-8141; Fax 409-880-1799; Elec Mail donna.meeks@lamar.edu; Internet Home Page Address: www.lamar.edu; *Prof* Lynne Lokensgard, PhD; *Prof* Meredith M Jack, MFA; *Prof* Keith Carter, BS; *Assoc Prof* Prince Thomas, MFA; *Chmn & Prof* Donna M Meeks, MFA; *Assoc Prof* Kurt Dyrhaug, MFA; *Assoc Prof* Ann Matlock, MFA; *Asst Prof* Xenia Fedorchenko, MFA; *Instr* Linnis Blanton, BFA; *Instr* Rose Matthis, MFA
Estab 1923, dept estab 1951; Maintains nonprofit art gallery, Dishman Art Museum, Lamar Univ, PO Box 10027, Beaumont, TX, 77710; pub; D & E; Scholarships; SC 60, LC 76; D 547, E 111, non-maj 300, maj 190
Ent Req: HS dipl, SAT/ACT
Degrees: BFA, BS & MA, 4 yr
Tuition: Res—undergrad $186 for 3 sem hrs; nonres—undergrad $813 for 3 sem hrs; campus res available
Courses: Advertising Design, Aesthetics, Art Appreciation, †Art Education, †Art History, †Ceramics, †Commercial Art, †Computer Graphics, Design, †Drawing, †Graphic Arts, †Graphic Design, †Illustration, Jewelry, Museum Staff Training, †Painting, †Photography, †Printmaking, †Sculpture, †Teacher Training, Textile Design, Weaving
Summer School: Dir, Donna M Meeks. Enrl 125; tuition res $174, nonres $813 per 3 sem hrs for 5 wk sessions. Courses—Art Appreciation, Computers in Art, Drawing, Watercolor & Illustration

BELTON

UNIVERSITY OF MARY HARDIN-BAYLOR, School of Fine Arts, 900 College St, UMHB Box 8012 Belton, TX 76513. Tel 254-295-4678, 295-8642; Fax 254-295-4675; Elec Mail hseals@umhb.edu; Internet Home Page Address: www.umhb.edu; *Chmn* Hershall Seals; *Prof* Philip Dunham; *Dean* George Stansbury; *Asst Prof* John Hancock; *Asst Prof* Helen Kwiatkowski; *Asst Prof* Barbar Fontaine-White
Estab 1845; Art supplies available on-campus; PT 3; pvt; D & E; Scholarships; SC 6, LC 1 and one independent learning course per sem; D 300, E 50, non-maj 250, maj 55
Ent Req: upper half of HS grad class
Degrees: BA, BFA & BS 4 yrs
Tuition: $240 per sem hr
Courses: Advertising Design, Art Appreciation, Art Education, Art History, Calligraphy, Ceramics, Design, Drawing, Graphic Arts, Graphic Design, Jewelry, Painting, Photography, Printmaking, Sculpture, Silversmithing, Teacher Training
Children's Classes: Summer Art Camp
Summer School: Sem of 5 wks, from 1 to 4 cr hrs. Courses—Crafts, Independent Learning

BIG SPRING

HOWARD COLLEGE, Art Dept, Division of Fine Arts, 1001 Birdwell Lane Big Spring, TX 79720. Tel 915-264-5000; Fax 915-264-5082; *Prof* Mary Dudley; *Dept Chair* Liz Lowery
Estab 1948, dept estab 1972; pub; D & E; Scholarships; SC 5, LC 1; D 70, E 20, non-maj 60, maj 10
Ent Req: HS dipl, ACT
Degrees: AA
Tuition: Res—$447 per sem; non res—$565 per sem
Courses: Art Appreciation, Art Education, Art History, Ceramics, Drawing, Painting, Watercolors

BROWNSVILLE

UNIVERSITY OF TEXAS AT BROWNSVILLE & TEXAS SOUTHMOST COLLEGE, Fine Arts Dept, 80 Fort Brown, Brownsville, TX 78520. Tel 956-544-8200; *Chmn Fine Arts* Terry Tomlin
Estab 1973; pub; D & E; Scholarships; SC 10, LC 10; D 300, E 100
Ent Req: HS dipl
Degrees: AA (Fine Arts) 2-3 yrs, BA 4 yr
Tuition: Res—undergrad $590, grad $648 for 12 hrs or more; nonres—undergrad $1550, grad $2304 for 12 hrs or more
Courses: Art Education, Ceramics, Design I and II, Drawing, Graphic Design, History of Art & Architecture, Painting, Photography, Sculpture
Adult Hobby Classes: Courses—Ceramics, Drawing
Summer School: Dir, Terry Tomlin. Courses—Art Appreciation, Art History

BROWNWOOD

HOWARD PAYNE UNIVERSITY, Dept of Art, School of Fine & Applied Arts, PO Box 839, HPU Sta Brownwood, TX 76801. Tel 915-646-2502; *Dean* Donal Bird PhD; *Chmn Dept Art* Ann Smith, MA
Estab 1889; FT 2, PT 2; den; D & E; Scholarships; SC 18, LC 8; D 120, E 25, maj 2
Ent Req: HS dipl, ent exam
Degrees: BA & BS 4 yrs
Tuition: $260 per sem hr
Courses: Art Appreciation, Art Education, Art History, Ceramics, Computer Graphics, Design, Drawing, Graphic Arts, Graphic Design, Handicrafts, Painting, Photography
Adult Hobby Classes: Enrl 30; tuition $50 per course. Courses—Travel Seminars
Summer School: Enrl 75; tuition term of 4 wks beginning June. Courses—Art Educ, Crafts, Drawing, Painting

CANYON

WEST TEXAS A&M UNIVERSITY, Art, Communication & Theatre Dept, PO Box 60747, Canyon, TX 79016. Tel 806-651-2799; Fax 806-651-2818; Elec Mail rbrantley@mail.wtamu.edu; Internet Home Page Address: www.wtamu.edu; *Head Dept* Royal Brantley, MFA; *Prof* Robert Caruthers, MFA; *Prof* Darold Smith, MFA; *Assoc Prof* David Rindlisbacher, MFA; *Asst Prof* Scott Frish, MFA; Instr Barbara Lines, MA; *Asst Prof* Harold LenFestey PhD
Estab 1910; Maintain nonprofit art gallery, Mary Moody Northern Art Gallery; Pub; D & E; Scholarships; SC 70, LC 23, GC 50; maj 62, non-maj 15, grad 21
Ent Req: HS dipl
Degrees: BA, BS, BFA, MA & MFA
Courses: Aesthetics, †Art Education, Art History, †Ceramics, Computer Art, †Drawing, †Glassblowing, Graphic Arts, †Graphic Design, Illustration, †Jewelry, †Painting, †Printmaking, †Sculpture, †Silversmithing, Teacher Training

COLLEGE STATION

TEXAS A&M UNIVERSITY, College of Architecture, College Station, TX 77843-3137. Tel 979-845-1221; Fax 979-845-4491; Elec Mail reganjt@archone.tamu.edu; Internet Home Page Address: www.tamu.edu; *Dean* Tom Regan
Estab 1905; FT 92; pub; D; Scholarships; maj Ed 800, total 1750
Ent Req: SAT; Achievement, HS rank
Degrees: BEenviron Design, BS(Building Construction), BLandscape Arch, March, MLandscape, MUrban Planning, PhD(Urban Science) 4 yr, MS(Construction Mgmt), MS(Land Development), MS(Architecture), PhD(Architecture), MS(Visualization) (Computer Animation)
Tuition: Res—$40 per sem cr hr
Courses: Architecture, Art History, Computer Animation, Constructions, Design, Drafting, Drawing, History of Art & Architecture, Illustration, Landscape Architecture, Photography, Restoration & Conservation, Video
Summer School: Dir, Rodney Hill. Enrl 1000; Courses—Arch Design, Arch History, Construction Science, Drawing, Planning

COMMERCE

TEXAS A&M UNIVERSITY COMMERCE, Dept of Art, PO Box 3011, Commerce, TX 75429. Tel 903-886-5208; Fax 903-886-5987; Internet Home Page Address: www.tamu-commerce.edu; *Head* William Wadley; *Instr Ceramics* Barbara Frey, MFA; *Instr Printmaking* Lee Baxter Davis, MFA; *Instr Sculpture* Jerry Dodd, MFA; *Coordr Grad Progs & Instr Painting* Michael Miller, MFA; *Instr Art History* Ivana Spalatin, MFA; *Asst Prof* Stan Godwin, MFA; *Prof Photography* Bill McDowell; *Coordr New Media* Lee Whitmarsh; *Gallery Coordr* Brenda Feher-Simonelli
Pub; D & E; Scholarships; SC 64, LC 29, GC 19; maj 300, GS 30

Ent Req: HS dipl, ACT or SAT
Degrees: BA, BS & BFA 4 yr, MFA 2 yr, MA & MS 1 1/2 yr. There is a special prog called the Post Masters-MFA which is worked out on an individual basis
Courses: †Advertising Design, Aesthetics, †Art Education, Art History, †Ceramics, Collage, †Commercial Art, Constructions, Drafting, †Drawing, †Graphic Arts, †Graphic Design, History of Art & Architecture, †Illustration, Industrial Design, †Intermedia, †Jewelry, Lettering, Lithography, †Mixed Media, †Painting, Papermaking & Casting, †Photography, †Printmaking, †Sculpture, Silversmithing, †Teacher Training, Video
Adult Hobby Classes: Enrl 15; tuition $77 per sem. Courses—Bonzai, Ceramics, Drawing, Painting, Watercolor
Summer School: Enrl 15; tuition res—$64.75-$393; nonres—$134.75-$2121, for 2 terms of 2 to 6 wks beginning June. Courses—Art Education, Ceramics, Design, Drawing, Painting, Printmaking

CORPUS CHRISTI

DEL MAR COLLEGE, Art Dept, 101 Baldwin Blvd, Corpus Christi, TX 78404-3897. Tel 361-698-1216, 1200; Fax 361-698-1511; Internet Home Page Address: www.delmar.edu; *Prof* Jan R Ward, MFA; *Prof* Ronald Dee Sullivan, MA; *Prof* Randolph Flowers, MS; *Prof* Kitty Dudics, MFA; *Assoc Prof* Ken Rosier, MFA
Estab 1941, dept estab 1965; pub; D & E; Scholarships; SC 21, LC 3; D 500, E 100, non-maj 400, maj 139
Ent Req: HS dipl, SAT score or any accepted test including GED
Degrees: AA 2 yr in studio, art educ
Tuition: Res—$118 per 3 sem hrs, $50; nonres—$261 per 3 sem hrs
Courses: Ceramics, Drawing, Graphic Design, History of Art & Architecture, Painting, Photography, Printmaking, Sculpture
Adult Hobby Classes: Tuition varies according to classes. Courses—same as above

CORSICANA

NAVARRO COLLEGE, Art Dept, 3200 W Seventh Ave, Corsicana, TX 75110. Tel 903-874-6501; Fax 903-874-4636; Elec Mail tsale@nav.cc.tx.us; WATS 800-NAVARRO; *Dir* Tom Sale
Estab 1946; FT2, PT2; pub; D & E; Scholarships; SC 6, LC 2; D 300, maj 30
Ent Req: HS dipl, ent exam, special permission
Degrees: AA, AS, A Gen Educ & A Appl Sci 60 sem hr
Tuition: $450 per sem
Courses: 2-D & 3-D Design, Advertising Design, Art Appreciation, Ceramics, Commercial Art, †Computer Art, Design, Drafting, Drawing, Graphic Arts, Illustration, Multi-Media, Painting, Photography, Sculpture, Video
Adult Hobby Classes: Enrl 200; tuition $30-$150 for sem of 6-12 wks. Courses—Art Appreciation, Crafts, Design, Drawing, Painting, Photography, Sculpture
Summer School: Enrl 30; Courses—Art Appreciation

DALLAS

THE ART INSTITUTE OF DALLAS, 2 N Park East, 8080 Park Lane Dallas, TX 75231-9959. Tel 214-692-8080; Fax 214-692-6541; Internet Home Page Address: www.aid.edu; WATS 800-275-4243; *Registrar* Mary Chris Sayre
Estab 1998; pvt; D & E; Scholarships
Ent Req: HS dipl, equivalent
Degrees: AA
Tuition: $299 per cr hr
Courses: Computer Animation Multimedia, Fashion Design, Fashion Marketing, Interior Design, Music & Video Business, Photography, Visual Communication
Adult Hobby Classes: Enrl 850; tuition $2050 per quarter. Courses—Commercial Art, Fashion Merchandising, Interior Design, Music Business, Photography, Video

DALLAS BAPTIST UNIVERSITY, Dept of Art, 3000 Mountain Creek Pky, Dallas, TX 75211-9299. Tel 214-333-5316, 333-5300; Fax 214-333-6804; Internet Home Page Address: www.dbu.edu; *Head Art Dept* Dawna Hamm Walsh PhD; *Asst Prof* Jim Colley, MFA; *Dean Fine Arts* Dr Edward Spann
Estab 1965; Learning Center Gallery, Dept of Art, Dallas Baptist Univer, 3000 Creek Pkwy, Dallas, TX 75244-9299; PT 18; pvt den; D & E; Scholarships; D 75, E 25, non-maj 75, maj 25
Ent Req: HS dipl
Degrees: BA & BS 4 yrs, Bachelor of Applied Studies 2-4 yrs, Grad Art Degree: MLA
Tuition: $315 per sem hr
Courses: Advertising Design, Aesthetics, Art Education, Art History, Ceramics, Commercial Art, Crafts, Design, Drawing, Fine Arts, Graphic Arts, Graphic Design, Handicrafts, History of Art & Architecture, Interior Design, Painting, Photography, Religious & Christian Art, Sculpture, Teacher Training, Theatre Arts
Adult Hobby Classes: Art Education, Art History, Ceramics, Commercial Art, Crafts, Drawing, Fine Arts, Graphic Design, Interior Design, Painting, Photography, Sculpture, Teacher Training
Children's Classes: Contact PBU Lab School
Summer School: Dir, Dr Dawna Walsh. Tuition $200 per cr hr. Courses—Ceramics, Drawing, Painting. Art Travel Program for cr available

SOUTHERN METHODIST UNIVERSITY, Division of Art, PO Box 750356, Dallas, TX 75275-0356. Tel 214-768-2489; Fax 214-768-4257; Elec Mail jsulliva@mail.smu.edu; Internet Home Page Address: www.smu.edu/~art; *Dir* Philip VanKeuren; *Prof* Laurence Scholder; *Prof* Bill Komodore; *Asst Prof* Peter Beasecker; *Asst Prof* Charles DeBus; *Prof* Barnaby Fitzgerald; *Asst Prof* Debora Hunter; *Asst Prof* Cynthia Lin; *Asst Prof* Mary Vernon; *Chair* Jay Sullivan; *Asst Prof* Karen Kittelson; *Assoc Prof* Arthur Koch

Estab 1911, Meadows School of Arts estab 1964; pvt; D & E; Scholarships; SC 43; maj 40, grad 9
Ent Req: selective admis
Degrees: BFA(Art), BFA(Art Histroy), BA(Art History) 4 yr, MFA(Art) 2 yr, MA(Art History) 1 1/2 yr
Tuition: $18,513 per yr; campus res—room & board $7345
Courses: †Art History, †Ceramics, †Color and Composition, Bronze Casting, †Drawing, †Painting, †Photography, †Printmaking, †Sculpture
Adult Hobby Classes: Ceramics, Color and Composition
Summer School: Tuition $1100 per course for term of 5 wks beginning June 4. Selected courses in art & art history at Taos, NM

DENISON

GRAYSON COUNTY COLLEGE, Art Dept, 6101 Grayson Dr, Denison, TX 75020. Tel 903-463-8662; Fax 903-463-5284; Internet Home Page Address: www.gcc.edu; *Inst* Evette Moorman; *Instr* Terri Blair; *Dept Head* Steve O Black
Estab 1965; PT 2; pub; D & E; Scholarships; LC 3; D 63, E 35
Ent Req: HS dipl
Degrees: AA 2 yrs
Tuition: In dist $31 per cr hr, out of dist $37 per cr hr, out of state $73 per cr hr
Courses: 3-D Design, Art Appreciation, Art Education, Art History, Color & Design, Drawing, Foundations of Art, Painting
Adult Hobby Classes: Ceramics, Drawing, Painting
Summer School: Dir, Steve O Black. Courses—Art Appreciation, Foundations of Art, Drawing, Painting

DENTON

TEXAS WOMAN'S UNIVERSITY, School of the Arts, Dept of Visual Arts, PO Box 425469, Denton, TX 76204. Tel 940-898-2530; Fax 940-898-2496; Elec Mail visualarts@twu.edu; Internet Home Page Address: www.twu.edu/as/va; *Dir School of the Arts* John Weinkein, MFA; *Prof* Linda Stuckenbruck, MFA; *Prof* Dr John A Calabrese PhD, MFA; *Prof* Susan Kae Grant, MFA; *Adjunct Assoc Prof* Don Radke, MFA; *Adjunct Assoc Prof* Laurie Weller, MFA; *Asst Prof* Colby Parsons-O'Keefe, MFA; *Instr* David Bieloh, MA
Estab 1901; pub; D & E; Scholarships; SC 21, LC 34, GC 17; non-maj 400, maj 110, undergrad 150, total 750
Ent Req: HS dipl, MA and MFA portfolio review required
Degrees: BA and BFA 4 yrs, MA 1 yr, MFA 2 yrs
Tuition: Res—$63 per hr; nonres—$279 per sem hr; meal plan available at extra charge
Courses: Art Education, Art History, Bookmaking-Topography, Clay, †Graphic Design, Handmade Paper, Painting, Photography, Sculpture
Summer School: tuition same as above for 2 5-wk sessions. Courses—Art Design, Art Education, Art History, Clay, Drawing, Fibers, Painting, Photography

UNIVERSITY OF NORTH TEXAS, School of Visual Arts, PO Box 305100, Denton, TX 76203. Tel 940-565-4003; Fax 940-565-4717; Internet Home Page Address: www.art.unt.edu; *Asst Prof Painting* Michael Drought, PhD & MEd; *Assoc Dean* Don R Schol, MFA; *Chair, Div Art Educ* Jacqueline Chanda, PhD; *Chair, Div Studio* Jerry Austin, MFA; *Asst Prof Sculpture* Andy Holtin, MFA; *Asst Prof Art History* Denise Baxter, PhD; *Asst Prof Art History* Mickey Abel, PhD; *Asst Prof Interior Design* Sam Miranda, MFA; *Assoc Prof Interior Design* Cynthia Mohr, MFA; *Asst Prof Communication Design* Keith Owens, MFA
Estab 1890, dept estab 1901; Maintain nonprofit art gallery, University Art Gallery, 1201 W Mulberry, Denton, TX 76201; pub; D & E; Scholarships; SC 83, LC 42, GC 41; non-maj 500, maj 2000, grad 150, others 25
Ent Req: HS dipl, SAT, GRE, portfolio for MFA, letters of recommendation for PhD
Degrees: BFA 4 yrs, MFA, MA, PhD
Tuition: Res—undergrad $123 per hr, grad $401.15 per hr; nonres—undergrad $381 per hr, grad $659.15 per sem hr; room & board $4096.260 per sem
Courses: Art Appreciation, †Art Education, †Art History, †Ceramics, Communication Design, Conceptual Art, Design, Drawing, †Fashion Arts, Graphic Design, Illustration, †Interior Design, †Jewelry, †Painting, †Photography, †Printmaking, †Sculpture, Silversmithing, Teacher Training, Textile Design, †Weaving
Adult Hobby Classes: Tuition determined by class. Courses—Mini-classes in arts and craft related areas. Offered by Mini Course Office.
Children's Classes: Courses—Mini-classes in arts and crafts related areas; special prog for advanced students. Offered by Mini-Course Office
Summer School: Dir, Michael Drought. Enrl 700-900 per session; tuition res—undergrad & grad $99 per sem hr for term of 5 wks; nonres—undergrad $335 per sem hr, grad $531.90 per sem hr for term of 5 wks; 2 summer sessions. Courses—Art Appreciation, Art Education, Art History, Design, Drawing, Fashion, Interior Design, Painting, Photography

EDINBURG

UNIVERSITY OF TEXAS PAN AMERICAN, Art Dept, 1201 W University Dr, Edinburg, TX 78539-2999. Tel 956-381-2011; Fax 210-384-5072; Elec Mail nmoyer@panam.edu; Internet Home Page Address: www.panam.edu/dept/art/; *Prof Sculpture* Richard P Hyslin; *Prof Painting* Philip S Field; *Prof Printmaking & Drawing* Wilbert R Martin; *Chmn Dept* Nancy Moyer PhD; *Asst Prof Ceramics* Charles Wissinger; *Asst Prof Painting & Printmaking* Lenard Brown; *Asst Prof Art History* Richard Phillips; *Gallery Dir* Dindy Reich; *Art Educ* James Dutremaine
Estab 1927, dept estab 1972; maintain nonprofit art gallery, Charles and Dorothy Clark Gallery, FIAB, Art Dept. UT-PA, Edinburg, TX 78539; University Gallery, CAS, Art Dept. UT-PA, Edinburg, TX 78539; pub; D & E; Scholarships; SC 43, LC 14; D 1200, E 150, non-maj 650, maj 209
Ent Req: immunization, top 50%, GED
Degrees: BA and BFA 4 yrs

Tuition: Res—$288.75 per 3 cr hr, $1,181.73 per 15 cr hr; nonres—$933.75 per 3 cr hr, $4,406.76 per 15 cr hr
Courses: Advertising Design, Aesthetics, Art Appreciation, †Art Education, Art History, †Ceramics, Collage, Computer Graphic, Design, Drawing, †Graphic Design, Illustration, †Jewelry, Lettering, †Painting, Photography, †Printmaking, †Sculpture, Silversmithing
Summer School: Dir, Nancy Moyer. Enrl 20 per class; tuition $31-$78 for term of 5 wks beginning June 2 & July 9. Courses—Art Appreciation, Art Education, Basic Design, Beginning & Advanced Painting, Ceramics, Drawing, Elementary Art Educ, Printing

EL PASO

UNIVERSITY OF TEXAS AT EL PASO, Dept of Art, Fox Fine Arts Bldg, 500 W University El Paso, TX 79968. Tel 915-747-5181, 747-5000; Fax 915-747-6749; Elec Mail artdept@utep.edu; Internet Home Page Address: www.utep.edu/arts; *Head Dept* Albert Wong
Estab 1939; FT 12, PT 9; pub; D & E; Scholarships; SC 24, GC 8; 200
Degrees: BA & BFA 4 yrs, MA (Studio & Art Ed)
Tuition: Res—$74 per cr hr; non-res—$289 per cr hr
Courses: Art Education, Art History, Ceramics, Design, Drawing, Graphic Design, Metals, Painting, Printmaking, Sculpture
Adult Hobby Classes: Enrl 9; tuition varies from class to class. Courses—offered through Extension Division
Children's Classes: Enrl 25; tuition $25 for 6 week class. Courses—Kidzart

FORT WORTH

SAGER STUDIOS, 320 N Bailey Ave, Fort Worth, TX 76107. Tel 817-626-3105; *Owner* Judy Sager
Estab 1964; pvt; D & E; D 8, E 16
Ent Req: entrance exam, portfolio preparation stressed
Degrees: BFA 4 yr
Tuition: $35 per month
Courses: Ceramics, Collage, Design, Drawing, Lettering, Mixed Media, Painting, Photography, Printmaking, Sculpture, Teacher Training
Children's Classes: Special classes for gifted students ages 10-24

TEXAS CHRISTIAN UNIVERSITY, Dept of Art & Art History, College of Fine Arts, PO Box 298000 Fort Worth, TX 76129. Tel 817-257-7643; Fax 817-257-7399; Elec Mail art@tcu.edu; Internet Home Page Address: www.tcu.edu; *Dean of Fine Arts* Scott Sullivan; *Chmn of Art & Art History* Ronald Watson; *Prof* Anne Helmreich PhD; *Prof* David Conn, MFA; *Prof* Babette Bohn PhD, MFA; *Prof* Linda Guy, MFA; *Prof* Lewis Glaser, MFA; *Prof* Susan Harrington, MFA; *Prof* Jim Woodson, MFA; *Prof* Mark Thistlethwaite PhD, MFA; *Prof* Luther Smith, MFA; *Prof* Michael Niblett, MFA; *Prof* Lori Diel, PhD
Estab 1909; Maintain nonprofit art gallery; Pvt; D & E; Scholarships, Fellowships; SC 35, LC 10, GC; maj 170, others 450
Degrees: BA, BFA & BFA Art Ed, MFA, MA
Tuition: $450 per sem hr
Courses: Advertising Design, †Art Education, †Art History, Ceramics, Drawing, †Graphic Design, †Painting, †Photography, †Printmaking, †Sculpture, Teacher Training
Summer School: Dir, Terri Cummings. Enrl 200; tuition $200 per sem hr. Courses-ARA Camp

TEXAS WESLEYAN UNIVERSITY, Dept of Art, 1201 Wesleyan St, Fort Worth, TX 76105-1536. Tel 817-531-4444; Fax 817-531-4814; *Dean, Theater Arts* Joe Brown; *Dean Art Dept* Kit Hall; *Dir Art Dept* Bob Pevitts
Den; D & E; Scholarships; SC, LC
Ent Req: HS dipl
Degrees: BA 4 yrs
Tuition: $305 per cr
Courses: Art Education, Ceramics, Drawing, History of Art & Architecture, Painting, Printmaking, Teacher Training

GAINESVILLE

NORTH CENTRAL TEXAS COLLEGE, Division of Communications & Fine Arts, 1525 W California St, Gainesville, TX 76240. Tel 940-668-7731; Fax 940-668-6049; Internet Home Page Address: www.nctc.cc.tx.us; *Chmn* Mary Dell Heathington; *Prof* Scott Robinson
Estab 1924; pub; D & E; Scholarships; SC 14, LC 1; D 50
Ent Req: HS dipl, SAT or ACT, individual approval
Degrees: AA and AFA 2 yrs
Courses: Art Appreciation, Art History, Ceramics, Drawing, Figure Drawing, Jewelry, Painting, Sculpture
Adult Hobby Classes: Enrl 120; tuition in county $28 per cr hr, out of county $40 per cr hr, out of state $64 per cr hr; Courses—Basketry, Country Art, Drawing, Flower Arrangement, Painting, Weaving
Children's Classes: Enrl 20; tuition $15. Courses - Art

GEORGETOWN

SOUTHWESTERN UNIVERSITY, Sarofim School of Fine Art, Dept of Art & Art History, PO Box 770, Georgetown, TX 78627. Tel 512-863-1504; Fax 512-863-1422; Elec Mail vainl@southwestern.edu; Internet Home Page Address: www.southwestern.edu; *Prof* Thomas Howe PhD; *Prof* Patrick Veerkamp, MFA; *Prof* Mary Visser, MFA; *Chmn Prof* Victoria Star Varner, MFA; *Assoc Prof* Kimberly Smith, PhD; *Asst Prof* Diana Tenckhoff, PhD
Estab 1840, dept estab 1940; Non-Profit art gallery, Sarofim School of Fine Art, Fine Art Gallery; pvt; D; Scholarships; SC 28, LC 9; D 160, maj 43

Ent Req: HS dipl, SAT, portfolio
Degrees: BA 4 yrs
Tuition: $23,650 per yr
Courses: Architecture, Art Education, Art History, Ceramics, †Computer Imaging, †Costume Design & Construction, Design, Drawing, Painting, Photography, Printmaking, Sculpture, †Stage Design, †Theatre Arts
Summer School: Courses—various

HILLSBORO

HILL COLLEGE, Fine Arts Dept, 112 Lamar Dr, PO Box 619 Hillsboro, TX 76645. Tel 254-582-2555; Fax 254-582-5791; Elec Mail dotallen@hillcollege.hill-college.cc.tx.us; Internet Home Page Address: www.hill-college.cc.tx.us; *Coordr Music Prog* Phillip Lowe; *Art Prog Coordr* Dottie Allen
Scholarships
Degrees: AA, cert
Tuition: In district—$30.50 per sem hr; res—$33 per sem hr; nonres—$76 per sem hr
Courses: †Advertising Design, Art History, Computer Graphics, Digital Imaging, Drafting, Drawing, †Graphic Design, Painting, Photography, Stage Design, Theatre Arts

HOUSTON

ART INSTITUTE OF HOUSTON, 1900 Yorktown, Houston, TX 77056. Tel 713-623-2040; Fax 713-966-2700; Internet Home Page Address: www.aih.aii.edu; WATS 800-275-4244; *School of Design* John Luukkonen; *Dir Educ* Joe Orlando
Estab 1964; FT 25, PT 15; pvt; D & E; Scholarships; D 800, E 145
Ent Req: ent req HS transcripts & graduation or GED, interview
Degrees: AA
Tuition: $4515 for 7 qtrs
Courses: Fashion Merchandising, Graphic Design, Illustration, Interior Design, Photography
Adult Hobby Classes: Applied Photography, Interior Planning, Layout & Production

GLASSELL SCHOOL OF ART, The Museum of Fine Arts, 1001 Bissonnet St Houston, TX 77006. Tel 713-639-7500; Fax 713-639-7709; Internet Home Page Address: www.mfah.org; *Assoc Dir* Valerie L Olsen; *Dean Jr School & Community Outreach Prog* Norma Jane Dolcater; *Dir* Joseph Havel; *Dean Studio School* Suzanne Manns
Estab 1979. Under the auspices of the Museum of Fine Arts; Maintain nonprofit art gallery, Laura Lee Blanton Gallery; pvt; D & E; Fellowships; SC 34, LC 5; studio 1552, Jr 2597
Ent Req: ent req portfolio review, transfer students
Degrees: 4 yr cert
Tuition: FT $935, SC $325 each, Art History $210 each; no campus res
Courses: Art History, Ceramics, Drawing, Jewelry, Painting, Photography, †Printmaking, †Sculpture, Visual Fundamentals
Children's Classes: 2597; tuition $85-$105 per class (4-17 yrs)

HOUSTON BAPTIST UNIVERSITY, Dept of Art, 7502 Fondren Rd, Houston, TX 77074. Tel 281-649-3000; *Chmn* James Busby
Estab 1963; den; D & E; Scholarships; SC 7, LC 9; D 2500, maj 35
Ent Req: HS dipl, ent exam
Degrees: BA & BS
Tuition: $325 per sem hr
Courses: Art Appreciation, Art Education, Ceramics, Design, Drawing, Elementary Art with Teacher Certification, History of Art & Architecture, Painting, Printmaking, Sculpture

RICE UNIVERSITY, Dept of Art & Art History, 6100 Main St, MS 549, Houston, TX 77005-1892; PO Box 1892, MS 549 Houston, TX 77251-1892. Tel 713-348-4882; Fax 713-348-5910; Elec Mail arts@rice.edu; Internet Home Page Address: http://arts.rice.edu; *Dir Art Gallery* Kimberly Davenport; *Prof* Basilios N Poulos, MA; *Prof* Karin Broker, MFA; *Prof* George Smith, MFA; *Prof* Geoffrey Winningham, MFA; *Assoc Prof* Brian Huberman, MFA; *Assoc Prof* John Sparagana, MFA; *Assoc Prof* Darra Keeton, MFA; *Assoc* Linda Neagley PhD, MFA; *Asst Prof* Marcia Brennan, PhD; *Asst Prof* Shirine Hamadeh, PhD; *Assoc Prof* Joseph Manca, PhD; *Chair* Hamid Naficy, PhD; *Asst Prof* Hajame Nakatani, PhD; *Lectr* Charles Dove, PhD; *Adjunct Lectr* Heather Logan; *Distinguished Lectr* Thomas McEvilley, PhD; *Lectr* Prince Thomas; *Lectr* Gary Fuege; *Lectr* Paul Hester
Estab 1912, dept estab 1966-67; Maintain nonprofit art gallery; Rice University Art Gallery, PO Box 1892, MS-53, Houston, TX 77251-1892; pvt; D & E; Scholarships, Fellowships; D 125, non-maj 75, maj 50, grad 2 (BFA)
Ent Req: HS dipl, CEEB, evaluations of HS counselors and teachers, interview
Degrees: BA 4 yrs, BFA 5 yrs
Tuition: $12,800 per yr, $6,400 per sem, grad $13,300 per yr, $6,650 per sem; PT $740 per yr, $370 per sem; campus res—room & board $6,000 per yr
Courses: †Art History, Design, Drawing, Film, Painting, Photography, Printmaking, Sculpture, Video
Adult Hobby Classes: Classes offered for adults & children at university

SAN JACINTO COLLEGE-NORTH, Art Dept, 5800 Uvalde, Houston, TX 77049. Tel 281-459-7119; Internet Home Page Address: www.sjcd.cc.tx.us; *Instr* Ken Luce; *Chmn Fine Arts Dept* Randy Snyder
Estab 1972; pub; D & E; Scholarships; SC 16, LC 3; D 56, E 21, non-maj 50, maj 27
Ent Req: HS dipl
Degrees: AA 2 yrs
Tuition: Res—undergrad $318 per yr, $136 per 12 hrs, $80 for 6 hrs; nonres—undergrad $1286 per yr, $643 per sem, $270 per 6 hrs; no campus res

Courses: Art Appreciation, Art History, Drawing, Painting, Sculpture
Adult Hobby Classes: Enrl 50; tuition $15 - $40 per 6-18 hrs.
Courses—Calligraphy, Ceramics, Origami, Pastel Art, Photography, Stained Glass
Children's Classes: Enrl 15, tuition $30 per 6 wks. Courses—Pastel Art
Summer School: Dir, Kenneth A Luce. Enrl 10 - 25; tuition $78 - $96.
Courses—vary beginning May

TEXAS SOUTHERN UNIVERSITY, College of Liberal Arts & Behavorial Sciences, 3100 Cleburne Ave, Houston, TX 77004. Tel 713-313-7337; Fax 713-313-1869; *Assoc Prof* Alvia Wardlaw; *Art Coordr & Assoc Prof* Harvey Johnson; *Chmn* Dianne Jemmson-Pollard; *Assoc Prof* Dr Sarah Trotty; *Assoc Prof* Leamon Green; *Instr* Maya Watson
Estab 1949; Nonprofit art gallery: University Museum & Lobby of Biggers Center; Pub; D & E; Scholarships; SC 31, LC 12, GC 4; maj 50, other 100
Ent Req: HS dipl
Degrees: BA in Art
Tuition: $2,225 per sem
Courses: Art Education, Ceramics, Design, Drawing, Hot Print Making, Painting, Sculpture, Silk Screen Painting, Weaving

UNIVERSITY OF HOUSTON, Dept of Art, 4800 Calhoun Rd, Houston, TX 77004-4893. Tel 713-743-3001; Fax 713-743-2823; *Chmn* Dr W Jackson Rushing
Estab 1927; FT 29, PT 7; pub; D & E; Scholarships; D 600 maj
Ent Req: HS dipl, SAT
Degrees: BA, BFA, MFA
Tuition: Res—$4 per sem cr hr; nonres—$40 per sem cr hr; campus res available
Courses: Art History, Ceramics, †Graphic Communications, Interior Design, Jewelry/Metals, †Paint/Drawing, Painting, Photography, †Photography/Video, Printmaking, †Sculpture, Silversmithing, Video

UNIVERSITY OF SAINT THOMAS, Art Dept, 3800 Montrose Blvd, Houston, TX 77006. Tel 713-522-7911; Internet Home Page Address: www.stthom.edu; *Dept Chmn* Claire McDonald; *Chmn Art History* Nancy L Jircik MA
Den; D & E; Scholarships; SC 15, LC 7; E 30, maj 44
Ent Req: HS dipl
Degrees: BA (Liberal Arts), BA (Fine Arts-Drama & Music), BFA Art History
Tuition: $450 per cr hr; campus res available; room & board, $2600 per sem
Courses: Art History, Survey of Art, Visual Arts

HUNTSVILLE

SAM HOUSTON STATE UNIVERSITY, Art Dept, Box 2089, Huntsville, TX 77341. Tel 936-294-1315; Fax 936-294-1251; Internet Home Page Address: www.shsu.edu; *Prof* Jimmy Barker, MFA; *Assoc Prof* Kenneth L Zonker, MFA; *Asst Prof* Patric K Lawler, MFA; *Asst Prof* Kate Borcherbing, MFA; *Dept Head* Martin Amorous, MFA; *Prof* Sharon King; *Ceramics* Matt Wilt; *Prof* Tony Shipp; *Asst Prof* Charlotte Drumm
Estab 1879, dept estab 1936; pub; D; SC 26, LC 7, GC 12; D 844, non-maj 100, maj 170, grad 15
Ent Req: HS dipl, ACT or SAT
Degrees: BA, BFA 4 yrs, MFA 2 yrs, MA 1 1/2 yrs
Tuition: Res—$1082 per 12 sem hrs; nonres—$4277 per 12 sem hrs; Campus res—room & board $3620 per yr
Courses: 2-D & 3-D Design, Advertising Design, Art History, Ceramics, Drawing, Illustration, Jewelry, Life Drawing, Painting, Printmaking, Sculpture, Studio Art
Summer School: Chmn, Jimmy H Barker. Enrl 100; tuition 232 per term of 6 wks beginning June 5 & July 11. Courses—Art History, Crafts, Drawing, Watercolor, 2-D Design

HURST

TARRANT COUNTY JUNIOR COLLEGE, Art Dept, 828 Harwood Rd, Northeast Campus, Hurst, TX 76054. Tel 817-515-6100; Internet Home Page Address: www.tccd.net; *Chair* Martha Gordon, MFA; *Asst Prof* Richard Hlad, MA; *Assoc Prof* Karmien Bowman, MA
Estab 1967, dept estab 1968; pub; D & E; SC 19, LC 3; D 200, E 150, non-maj 150, maj 200
Ent Req: HS dipl, GED, admission by individual approval
Degrees: AA and AAS 2 yrs
Tuition: Res—$14 per hr, minimum $70 per sem; nonres—of county $8 per sem hr added to res fee, others $120 per sem hr with $200 minimum fee, aliens $120 per sem hr with $200 minimum fee; no campus res
Courses: Advertising Design, Art Appreciation, Art Education, Art History, Ceramics, Collage, Constructions, Drawing, Jewelry, Mixed Media, Painting, Photography, Printmaking, Sculpture
Adult Hobby Classes: Enrl 50; for 7 wks. Courses—Drawing, Oil-Acrylic, Tole Painting, Ceramics
Children's Classes: Enrl 100; 7 wks. Courses—Cartooning, Ceramics, College for Kids, Drawing, Painting
Summer School: Dir, Dr Jane Harper. Enrl 100; tuition as above for term of 6 wks beginning June. Courses—Art Appreciation

KILGORE

KILGORE COLLEGE, Visual Arts Dept, Fine Arts, 1100 Broadway Kilgore, TX 75662-3299. Tel 903-984-8531; Fax 903-983-8600; Internet Home Page Address: www.kilgore.edu; *Instr* Larry Kitchen; *Instr* O Rufus Lovett; *Chmn* John Hillier
Estab 1935; D & E; Scholarships; SC 11, LC 3; D 75, E 25, non-maj 25, maj 50
Ent Req: HS dipl
Degrees: AAAS & AA
Tuition: District res—$31 per sem hr; non-district res—$53 per sem hr; non-state res—$239 per sem hr

Courses: †Art Education, †Art History, Commercial Art, †Drawing, Painting, Photography, Printmaking, Sculpture

KINGSVILLE

TEXAS A&M UNIVERSITY-KINGSVILLE, Art Dept, Box 157, Station 1, Kingsville, TX 78363. Tel 361-593-2619; Fax 361-593-2662; Internet Home Page Address: www.tamuk.edu; *Prof* William Renfro; *Prof* Richard Scherpereel; *Prof* Maurice Schmidt; *Lectr* Peggy Wilkes; *Chmn* Santa Barraza
Estab 1925, dept estab 1930; pub; D & E; SC 21, LC 5, GC 2; D 700, non-maj 300, maj 400, art maj 150, grad 20
Ent Req: HS dipl
Degrees: BFA & BA 4 yr
Tuition: Res—$60 per cr hr; nonres—$246 per cr hr
Courses: Advertising Design, Art Education, Art History, Ceramics, Design, Drawing, Graphic Arts, History of Art & Architecture, Painting, Principles of Art, Printmaking, Sculpture, Teacher Training
Adult Hobby Classes: Courses offered
Summer School: Courses—full schedule

LAKE JACKSON

BRAZOSPORT COLLEGE, Art Dept, 500 College Dr, Lake Jackson, TX 77566. Tel 979-230-3000; Fax 979-230-3465; Elec Mail kfunkhou@brazosport.edu; Internet Home Page Address: www.brazosport.edu; *Fine Arts Dept Chmn* Kate Funkhouser; *Asst Prof* Sandra Baker; *Instr* Eric Schnell
Estab 1968; Maintains Brazosport Col Art Gallery, 500 Col Dr, Lake Jackson; pub; D & E; Scholarships; SC 10, LC 4; D 220 Maj 30
Ent Req: HS dipl or GED
Degrees: AA 2 yrs
Tuition: 12 cr hr $411; out-of-district—12 cr hr $615; nonres—$299 per 3 cr hr
Courses: Art Appreciation, Art History, Ceramics, Design, Drawing, Mixed Media, Painting, Sculpture, Theatre Arts
Adult Hobby Classes: Ceramics, China Painting, Painting

LEVELLAND

SOUTH PLAINS COLLEGE, Fine Arts Dept, 1401 College Ave, Levelland, TX 79336. Tel 806-894-9611, Ext 2261; Elec Mail dgomez@spc.cc.tx.us; Internet Home Page Address: www.spc.cc.tx.us; *Chmn* Jon Johnson; *Asst Prof Art* Drake Gomez; *Asst Prof* Lynette Watkins; *Instr* Cary Loving
Estab 1958; FT 3, PT 1; pub; D & E; Scholarships; SC 13, LC 3; D 252, E 76, maj 52
Ent Req: HS dipl
Degrees: AA 2 yrs
Tuition: Res—$16 per sem hr; nonres—$32 per sem hr
Courses: 2-D Design, 3-D Design, Advertising Design, Art Appreciation, Art History, Ceramics, Commercial Art, Drafting, Drawing, Life Drawing, Painting, Photography, Teacher Training
Adult Hobby Classes: Enrl 62; tuition & duration vary. Courses—Drawing, Painting, Photography
Children's Classes: Enrl 116; tuition & duration vary. Courses—Crafts, Drawing, Painting
Summer School: Dir, Drake Gomez. Enrl 66; tuition same as regular sem for 6 wk term. Courses—Art History, Life Drawing, Photography

LUBBOCK

LUBBOCK CHRISTIAN UNIVERSITY, Dept of Communication & Fine Art, 5601 19th St, Lubbock, TX 79407-2099. Tel 806-796-8800; Fax 806-796-8917; Internet Home Page Address: www.lcu.edu; *Chmn & Instr* Dr Michelle Kraft, MA; *Prof* Karen Randolph, MFA
Estab 1956; Scholarships
Degrees: BA & BSID
Tuition: $3200 annual tuition
Courses: Advertising Design, †Animation, Art Appreciation, Art Education, Art History, Design, †Digital Imaging, Drawing, Fine Arts, Graphic Arts, Graphic Design, Handicrafts, Painting, Sculpture
Summer School: Dir, K Randolph. Tuition $310 per course for 3-4 wk session. Courses—Art, Art & Children, Art History, Desktop Publishing, 2-D Design

TEXAS TECH UNIVERSITY, Dept of Art, 18th Flint Ave, Lubbock, TX 79409-2081. Tel 806-742-3825; Fax 806-742-1971; *Prof* Ken Dixon, MFA; *Prof* Rick Dingus, MFA; *Prof* Hugh Gibbons, MA; *Prof* Terry Morrow, MS; *Prof* Lynwood Kreneck, MFA; *Prof* Sara Waters, MFA; *Assoc Prof* Rob Glover, MFA; *Assoc Prof* Tina Fuentes, MFA; *Assoc Prof* John Stinespring PhD, MFA; *Asst Prof* Robin Germany, MFA; *Asst Prof* Karen Keifer-Boyd PhD, MFA; *Assoc Prof* Nancy Reed PhD, MFA; *Assoc Prof* Juan Granados, MFA; *Assoc Prof* Brian Steele PhD, MFA; *Asst Prof* Nancy Slagle, MFA; *Asst Prof* Carolyn Tate PhD, MFA; *Asst Prof* Andrew Martin, MFA; *Asst Prof* Phoebe Lloyd PhD, MFA
Estab 1925, dept estab 1967; pub; D & E; Scholarships; SC 60 undergrad, 20 grad, LC 20 undergrad, 15 grad; D 1400, non-maj 950, maj 400, grad 50
Ent Req: HS dipl, SAT or ACT test
Degrees: BFA & BA(Art History), MAE 36 hrs, MFA 60 hrs minimum, PhD 54 hrs beyond MA minimum
Tuition: Variable for res and nonres; campus residence available
Courses: Aesthetics, Art Appreciation, †Art Education, †Art History, Ceramics, Computer-Aided Design, Design, †Design Communication, Digital Imaging, Drawing, Graphic Design, Illustration, Installation, Intermedia, Jewelry, Lettering, Mixed Media, Painting, Photography, Printmaking, Sculpture, Silversmithing, †Studio Art, Teacher Training, Weaving
Adult Hobby Classes: Computer-Aided Design, Photography, Studio Art

Children's Classes: Art Project for talented high school students, Artery; classes in art for elementary & middle school students
Summer School: Dir, Betty Street. Courses—Art Education, Ceramics, Drawing, Glassblowing, Jewelry & Metalsmithing, Painting, Papermaking, Photography, Printmaking, Sculpture, Textile Design, Weaving

MESQUITE

EASTFIELD COLLEGE, Humanities Division, Art Dept, 3737 Motley Dr, Mesquite, TX 75150. Tel 972-860-7100; Internet Home Page Address: www.efc.dccd.edu; *Dean* Enric Madriguera
Degrees: AA
Tuition: $79 per 3 cr hr
Courses: Art Appreciation, Art History, Ceramics, Design, Drawing, Jewelry, Painting, Sculpture

MIDLAND

MIDLAND COLLEGE, Art Dept, 3600 N Garfield, Midland, TX 79705. Tel 915-685-4500; Fax 915-685-4769; Internet Home Page Address: www.midland.cc.tx.us; *Instr* Warren Taylor, MFA; *Instr* Carol Bailey, MA; *Instr* Kent Moss, MFA; *Chmn* William Feeler; *Instr* Susan Randall
Estab 1972; pub; D & E; Scholarships; SC 28, LC 4; D 70, E 80, non-maj 125, maj 25
Ent Req: HS dipl
Degrees: AA and AAA 2 yrs
Tuition: Res—undergrad $327 per 12 hrs plus $40 fee; nonres—undergrad $351 per 12 hrs plus $40 fee; no campus res
Courses: Art History, Collage, Drawing, Illustration, †Jewelry, Mixed Media, †Painting, †Photography, †Sculpture, Teacher Training
Adult Hobby Classes: Ceramics, Painting, Photography
Children's Classes: Kid's College
Summer School: Dir, Larry D Griffin. Enrl 40. Courses—varied

NACOGDOCHES

STEPHEN F AUSTIN STATE UNIVERSITY, Art Dept, PO Box 13001, Nacogdoches, TX 75962. Tel 409-468-4804, 2011; Fax 409-468-4041; Internet Home Page Address: www.sfasu.edu; *Chmn* Jon D Wink, MFA
Estab 1923; pub; D & E; Scholarships; SC 28, LC 11, GC 11; D 461, non-maj 150, maj 200, grad 20
Ent Req: HS dipl, ACT score 18
Degrees: BA & BFA 4 yrs, MFA 2 yrs, MA 1 yr
Tuition: Res—$10,937 per yr, non-resident—$16,929; campus res available
Courses: †Advertising Design, Art Appreciation, †Art Education, Art History, †Ceramics, Cinematography, Design, †Drawing, Film, Illustration, †Interior Design, †Jewelry, †Painting, †Photography, †Printmaking, †Sculpture, Silversmithing, Stage Design, Teacher Training, Theatre Arts, Video
Summer School: Dir, Jon D Wink. Beginning & advanced art classes. Courses—Varies summer to summer

ODESSA

UNIVERSITY OF TEXAS OF PERMIAN BASIN, Dept of Art, 4901 E University Blvd, Odessa, TX 79762. Tel 432-552-2286; Fax 432-552-3285; Elec Mail price_p@utpb.edu; Internet Home Page Address: utpb.edu; *Chmn* Pam Price, MFA; *Assoc Prof* Chris Stanley, MFA; *Asst Prof* Marianne Berger Woods, PhD; *Asst Prof* David Poindexter, MFA; *Lectr* Dan Askew, MFA
Estab 1972; Maintain nonprofit art gallery, Nancy Fyfe Cardozier Art Gallery, Art Dept., UTPB, 4901 E. University, Odessa, TX 79762; art supplies available on-campus; pub; D & E; Scholarships; SC 48, LC 13; non-maj 10, maj 83
Degrees: BA, BFA
Tuition: Campus residency available
Courses: Art Education, Ceramics, Commercial Art, Drawing, Graphic Design, Painting, Photography, Printmaking, Sculpture
Summer School: Courses—varied

PARIS

PARIS JUNIOR COLLEGE, Art Dept, 2400 Clarksville St, Paris, TX 75460. Tel 913-785-7661 Ext. 460, 800-441-1398 (TX), 800-232-5804 (US); Fax 913-784-9370; Elec Mail ctyler@paris.cc.tx.us; Internet Home Page Address: www.paris.cc.tx.us; *Gallery & Exhib Dir & Instr* Susan Moore; *Chm Div Fine Art & Instr* Cathie Tyler
Estab 1924; Maintain nonprofit art gallery, art dept-Foyer Gallery, Attn Susan Moore, Paris Junior College, 2400 Clarksville, Paris, TX 75460; pub; D & E; Scholarships; SC 11, LC 2; D 30-60, E 50-70, non-maj 60-65, maj 15-20
Ent Req: none
Degrees: AA & AS in Art 2 yrs
Tuition: $42-$89 per hr & lab fees
Courses: Art Appreciation, Art History, Art Metals (General Art Preparatory Program), Ceramics, Design, Foundation Graphic Technologies, Painting, Photography, Sculpture
Adult Hobby Classes: Enrl 20. Courses—Art Appreciation, Art Metals, Ceramics, Design, Drawing, Graphic Art, Painting, Photography, Sculpture
Summer School: Dir, Cathie Tyler. 2-5 wk sessions June-Aug. Courses—Art Appreciation, Ceramics, Painting, Photography

PASADENA

SAN JACINTO JUNIOR COLLEGE, Division of Fine Arts, 8060 Spencer Hwy, Pasadena, TX 77501. Tel 281-476-1501; Fax 281-478-2711; Internet Home Page Address: www.sjcd.cc.tx.us; *Acting Div Chmn & Dean Fine Arts* Dr Jerry Ivins

Estab 1961; pub; D & E; SC 5, LC 1; D 230, E 45, non-maj 120, maj 155
Ent Req: HS dipl, GED or individual approval
Degrees: AA and AS 2 yrs
Tuition: In district—$96 per 6 hr; out of district—$180 per 6 hr; out of state & non-citizens—$360 per 6 hr
Courses: Advertising Design, Advertising Design, Art Appreciation, Art History, Ceramics, Commercial Art, Design, Drawing, Free Illustration, Lettering, Painting, Photography, Sculpture
Summer School: Enrl 25; tuition $25 for term of 6 wks beginning June 5th. Courses—Design, Painting Workshop

PLAINVIEW

WAYLAND BAPTIST UNIVERSITY, Dept of Art, Division of Fine Arts, Plainview, TX 79072; WBU #249, 1900 West Seventh Plainview, TX 79073. Tel 806-291-1083; Fax 806-291-1980; Elec Mail kellerc@wbu.edu; Internet Home Page Address: www.wbu.edu; *Prof* Candace Keller, PhD; *Asst Prof* Mark Hilliard; *Prof* Harold Temple, PhD
Estab 1916; Non-Profit art gallery; Abraham Art Gallery; 2; Pvt & Den; D & E; Scholarships; SC 15, LC 2; D 150, E 50, non-maj, maj 30
Ent Req: HS dipl, ent exam
Degrees: BA and BS 4 yrs
Tuition: $250 per sem hr
Courses: Advertising Design, †Art Appreciation, Art Education, Art History, Ceramics, Commercial Art, Design, Drawing, Graphic Arts, Graphic Design, Painting, Photography, Printmaking, Sculpture, Silversmithing, Theatre Arts
Adult Hobby Classes: Enrl 90 - 100; 16 wk term. Courses—Art Appreciation, Ceramics, Design, Drawing, Painting, Watercolor
Children's Classes: Enrl 25-35; tuition $60 for 2 wk term. Courses offered through Academy of fine Art on Campus
Summer School: Art Cur, Candace Keller. Enrl 30-40; 3 wk term. Courses—Ceramics, Teacher Art Education, Watercolor

ROCKPORT

SIMON MICHAEL SCHOOL OF FINE ARTS, 510 E King St, PO Box 1283 Rockport, TX 78382. Tel 361-729-6233; *Head Dept* Simon Michael
Estab 1947; FT 1; pvt; professionals & intermediates
Courses: Drawing, Landscape Architecture, Mixed Media, Painting, Sculpture
Summer School: Enrl varies; tuition varies for each 1 wk workshop. Courses—Travel Art Workshop in USA and Europe

SAN ANGELO

ANGELO STATE UNIVERSITY, Art & Music Dept, 2601 W Ave N San Angelo, TX 76909. Tel 325-942-2085; Fax 325-942-2152; Elec Mail david.scott@angelo.edu; Internet Home Page Address: www.angelo.edu/; *Interim Head* David Scott, PhD
Estab 1963, dept estab 1976; pub; D & E; Scholarships; SC 20, LC 9; D 400 (art), E 50, non-maj 320, maj 80
Ent Req: HS dipl
Degrees: BA(Art) &Teaching Certification, BFA
Tuition: Res—$1301 per 15 cr hr; nonres—$4496 per 15 cr hr
Courses: Art Education, Art History, Ceramics, Creative Design, Drawing, Etchings, †Graphic Illustration, Greek & Roman Art, History of Contemporary Art, History of Italian Renaissance, Intaglio Processes, Introduction to Art, Jewelry, Painting, Primary Art Theory, †Printmaking, †Sculpture
Summer School: Tuition as above for term of 10 wks beginning June 1. Courses—Art Education, Art History, Ceramics, Introduction to Art, Sculpture, Studio Courses incl Design & Drawing

SAN ANTONIO

OUR LADY OF THE LAKE UNIVERSITY, Dept of Art, 411 SW 24 St, San Antonio, TX 78207-4689. Tel 210-434-6711, Ext 435; Internet Home Page Address: www.ollusa.edu/; *Chmn* Alfredo Cruz; *Assoc Prof* Sr Jule Adele Espey PhD; *Assoc Prof* Jody Cariolano; *Dean* Sr Isabel Ball PhD
Estab 1911, dept estab 1920; FT 2, PT 1; den; D & E; Scholarships; SC 12, LC 3; non-maj 62, maj 8
Ent Req: HS dipl, completion of GED tests, 35 on each test or average of 45 on tests
Degrees: BA(Art)
Tuition: Res—undergrad $6264 per sem; campus res—room $1555 per sem, board $825 per sem
Courses: Art Appreciation, Art Education, Art History, Ceramics, Computer Design, Design, Drawing, Graphic Arts, Painting, Photography, Printmaking, Sculpture
Adult Hobby Classes: Courses offered

SAINT MARY'S UNIVERSITY, Dept of Fine Arts, One Camino Santa Maria, San Antonio, TX 78228. Tel 210-436-3797, 436-3011; *Chmn* Sharon McMahon
Estab 1852; FT 8, PT 12; pvt; D & E; SC 10, LC 20; D 60, maj 58
Ent Req: HS dipl or GED, ent exam
Degrees: BA 4-5 yrs
Tuition: Res $4548, incl rm & board; $365 per cr hr
Courses: 3-D Design, Art Education, Drawing, Graphic Design, History of Art & Architecture, Painting, Photography, Printmaking, Sculpture, Teacher Training, Theatre Arts
Adult Hobby Classes: Enrl 75-100; tuition $25. Courses—vary
Summer School: Courses—vary

SAN ANTONIO COLLEGE, Visual Arts & Technology, 1300 San Pedro Ave, San Antonio, TX 78212. Tel 210-733-2894, 733-2000; Fax 210-733-2338; Internet Home Page Address: www.accd.edu/sac; *Chmn* Richard Arredondo; *Fine Arts Program Dir* Mark Pritchett
Estab 1955; FT 17, PT 20; pub; D & E; SC 75, LC 4; D 1000-1300, E 250-450
Ent Req: Ent req HS dipl, GED, TASP, ent exam
Degrees: AA & AS 2 yrs
Tuition: $360 per 12 sem hrs; no campus res
Courses: Art Appreciation, Art History, Art Metals, Ceramics, Design, Drawing, Electronic Graphics, †Graphic Arts, Graphic Design, Illustration, Painting, Photography, Printmaking, Sculpture
Summer School: Dir, Richard Arredondo. Enrl 500; Courses—Same as for regular school yr

TRINITY UNIVERSITY, Dept of Art, 715 Stadium Dr, San Antonio, TX 78212-7200. Tel 210-736-7216, 736-7011; Internet Home Page Address: www.trinity.edu; *Chmn & Prof* Kate Ritson, MFA; *Asst Prof* Elizabeth Ward, MFA
Estab 1869; pvt; D & E; SC 39, LC 20; D 144, E 30, non-maj 50, maj 90
Ent Req: HS dipl, CEEB, SAT, 3 achievement tests
Degrees: BA 4 yrs
Tuition: $16,410 per yr; campus res—room $4,220 per yr; board $2,530 per yr
Courses: Art Education, Drawing, Graphic Arts, Painting, Photography, Printmaking, Sculpture, †Studio Art
Adult Hobby Classes: Courses offered by Department of Continuing Educ
Summer School: Dir, Dept of Continuing Educ. Courses vary

UNIVERSITY OF TEXAS AT SAN ANTONIO, Dept of Art & Art History, 6900 N Loop 1604 W, San Antonio, TX 78249-0642. Tel 210-458-4352; Fax 210-458-4356; Elec Mail artinfo@utsa.edu; *Prof* James Broderick, MA; *Prof* Ronald Binks, MFA; *Prof Emeritus* Charles Field, MFA; *Prof Emeritus* Jacinto Quirarte PhD; *Prof* Stephen Reynolds, MFA; *Prof* Judith Sobre PhD; *Prof* Ken Little, MFA; *Prof* Kent Rush, MFA; *Prof* Dennis Olsen, MA; *Assoc Prof* Neil Maurer, MFA; *Assoc Prof* Frances Colpitt; *Assoc Prof* Constance Lowe, MFA; *Asst Prof* Kellen McIntyre PhD; *Asst Prof* Ruben Cordova, PhD; *Dept Chair* Frances Colpitt, PhD
Maintains Univ Tex Art Gallery, 6900 N Loop 1604W, San Antonio; Pub; D & E; Scholarships; SC 31, LC 25, GC 17; maj 200, grad 35
Ent Req: HS dipl, ACT, grad
Degrees: BFA 4 yrs, MFA 2 yrs, MA 1 yr
Tuition: $1056 per sem (12 hrs or under)
Courses: Art History, †Ceramics, †Drawing, †Painting, †Photography, †Printmaking, †Sculpture
Summer School: Tuition $264 per sem. Courses—Art History, Ceramics, Drawing, Painting, Photography, Printmaking, Sculpture

UNIVERSITY OF THE INCARNATE WORD, Art Dept, 4301 Broadway, San Antonio, TX 78209. Tel 210-829-6000; Internet Home Page Address: www.uiw.edu; *Prof* E Stoker, MA; *Lectr* Don Ewers, MA; *Chmn* Kathy Vargas, MFA; *Asst Prof* Miguel Cortinas, MFA; *Asst Prof* John Dawes, MFA
Estab 1881, dept estab 1948; Maintains nonprofit gallery, Semmes Gallery, 4301 Broadway, San Antonio, TX 78209; Den; D & E; Scholarships; SC 14, LC 9; D 195, non-maj 120, maj 30
Ent Req: HS dipl, ent exam
Degrees: BA 4 yrs
Courses: Advertising Design, Art Education, Art History, Ceramics, Costume Design & Construction, Design, Drawing, Fashion Arts, Graphic Arts, Graphic Design, Museum Staff Training, Painting, Photography, Printmaking, Sculpture, Stage Design, Textile Design, Theatre Arts, Weaving

SAN MARCOS

TEXAS STATE UNIVERSITY - SAN MARCOS, (Southwest Texas State University) Dept of Art and Design, 601 University Dr, San Marcos, TX 78666. Tel 512-245-2611; Fax 512-245-7969; Elec Mail en04@tx.state.edu; Internet Home Page Address: www.swt.edu; *Dean* Richard Cheatham; *Chmn* Dr Erik Nielsen; *Prof* Mark Todd; *Prof* Jean Laman, MFA; *Prof* Neal Wilson; *Prof* Roger Bruce Colombik; *Assoc Dean* Steven Beebe, PhD; *Prof* David Shields; *Prof* Beverley Penn; *Prof* Michel Conroy; *Prof* Brian Row; *Prof* Eric Weller; *Prof* Randal Reid; *Prof* William Meek
Estab 1903, dept estab 1916; pub; D & E; Scholarships; SC 31, LC 7, GC 6; D 1600, E 150, non-maj 1350, maj 1100
Ent Req: HS dipl, ACT, SAT
Degrees: BFA(Communication Design & Studio), BFA Art Ed all-level & BA(Art History), BA 4 yr
Tuition: Undergrad res - $2,098 per sem; undergrad out-of-state $6,398 per sem; grad res $1,898 per sem; grad out-of-state $6,178 per sem
Courses: Advertising Design, Art Appreciation, Art Education, Art History, Communication Design, Computer Graphics, Design, Digital Images, Drawing, Fibers, Graphic Arts, Graphic Design, Illustration, Metals, Multi-Media, Painting, Photography, Printmaking, Sculpture, Teacher Training, Watercolor
Children's Classes: summers only; one week; $15
Summer School: Chmn, Eric Nielson. Two 6 week terms

SEGUIN

TEXAS LUTHERAN UNIVERSITY, Dept of Visual Arts, 1000 W Court St, Seguin, TX 78155. Tel 830-372-8000, Ext 6017; Internet Home Page Address: www.tlu.edu; *Chmn* J Nellermoe, MA; *Assoc Prof* T Paul Hernandez; *Asst Prof* Landa King
Estab 1923; FT 2; D; SC 18, LC 3; 1000, maj 10
Ent Req: HS dipl
Degrees: BA(Art) 4 yrs
Tuition: $12,500, room $1840, board $2280

Courses: Advertising Design, Art Appreciation, Art Concepts, Art Education, Art History, Ceramics, Design, Drawing, Independent Study, Painting, Printmaking, Sculpture
Adult Hobby Classes: Enrl 12; tuition $72 for 6 wk term. Courses—Art Appreciation, Sketching
Summer School: Instr, John Nellermoe. Enrl 12; tuition $75 for 6 wk term. Courses—Ceramics, Painting

SHERMAN

AUSTIN COLLEGE, Art Dept, 900 N Grande, Ste 61587, Sherman, TX 75090-4440. Tel 903-813-2000; Elec Mail mmonroe@austinc.edu; Internet Home Page Address: www.austinc.edu/; *Prof* Mark Smith; *Chmn* Tim Tracz; *Prof* Mark Monroe, MFA; *Prof* Jeffrey Fontana; *Studio Mgr* Joseph Allison
Estab 1848; Maintains a nonprofit art gallery, Ida Green Gallery, Austin College, 900 N Grand Ave Sherman, TX 75090-4440; pvt; D; Scholarships; SC 9, LC 5, GC 8; D 350, maj 55, grad 2
Ent Req: ent exam plus acceptance by admission committee
Degrees: BA 4 yrs, MA 5 yrs
Tuition: $18,000 per yr, campus res—room $2811, board $3126
Courses: Art History, Ceramics, Drawing, History of Art & Architecture, Painting, Photography, Printmaking, Sculpture, Silversmithing, Theatre Arts, Video

TEMPLE

TEMPLE COLLEGE, Art Dept, 2600 S First St, Temple, TX 76504. Tel 254-298-8282; Internet Home Page Address: www.templejc.edu; *Chmn* Michael Donahue, MFA
Estab 1926; 43; pub; D & E; Scholarships; SC 4, LC 2; D 100, E 15, non-maj 85, maj 15
Ent Req: HS dipl, ACT or SAT
Degrees: AA 2 yrs
Tuition: District res—$43 per sem hr; non-district res—$65 per sem hr; non-state res—$124 per sem hr; campus res available Aug, $1525 per sem
Courses: Art Appreciation, Art History, Ceramics, Communications, Design, Drawing, Figure Drawing, Painting, Printmaking, Sculpture
Adult Hobby Classes: Enrl 15 per class; tuition $19 per 8 sessions. Courses—Arts & Crafts, Calligraphy, Drawing

TEXARKANA

TEXARKANA COLLEGE, Art Dept, 2500 N Robison Rd, Texarkana, TX 75599. Tel 903-838-4541; Fax 903-832-5030; *Prof* Valerie Owens
Estab 1927; D & E; Scholarships
Ent Req: HS dipl
Tuition: District res—$375 for 15 cr hrs; out of district res—$570 for 15 cr hrs
Courses: Art Appreciation, Ceramics, Drawing, Painting, Sculpture, Weaving
Summer School: Enrl 20; tuition $300. Courses—Drawing & Ceramics

TYLER

TYLER JUNIOR COLLEGE, Art Program, PO Box 9020, Tyler, TX 75711. Tel 903-510-2200, 510-2234; Internet Home Page Address: www.tyler.cc.tx.us; Internet Home Page Address: www.tjc.edu; *Dept Dir* Chris Stewart; *Art Instr* CJ Cavanaugh; *Art Instr* Barbara Holland; *Art Instr* Derrick White
Estab 1925; Maintain nonprofit art gallery; art supplies available on-campus; Pub; D & E; Scholarships; SC 13, LC 3; 600+
Degrees: AA
Tuition: Res—undergrad $578 per yr
Courses: Art Appreciation, Art Education, Art History, Ceramics, Design, Drawing, Painting, Sculpture, Weaving
Adult Hobby Classes: Courses—Offered
Children's Classes: Courses—Offered for ages 5-8 & 9-12
Summer School: Courses—Offered

UNIVERSITY OF TEXAS AT TYLER, Deptartment of Art, School of Visual & Performing Arts, 3900 University Blvd, Tyler, TX 75799. Tel 903-566-7250; Fax 903-566-7062; Internet Home Page Address: uttgler.edu/arts/studioarts; *Assoc Prof & Chmn* Gary C Hatcher, MFA; *Prof* James R Pace, MFA; *Asst Prof* Jill Blondin, PhD; *Asst Prof* Alexis Serio; *Asst Prof* Dewane Hughes; *Asst Prof* Dr Barbara Airulla; *Asst Prof* Sally Campbell
Estab 1973; Maintain nonprofit art gallery, The Meadowlands Gallery, 3900 University Blvd., Tyler, TX 75799; pub; D & E; Scholarships; SC 32, LC 18, GC 12
Ent Req: AA degree or 60 hrs of college study
Degrees: BA, BFA, MAT, MAIS, MFA
Tuition: Res—$432 per sem; nonres—$2988 per sem
Courses: Aesthetics, †Art Education, †Art History, Ceramics, Drawing, Graphic Arts, Graphic Design, History of Art & Architecture, Interior Design, Mixed Media, Painting, Photography, Printmaking, Sculpture, †Silversmithing, †Studio Art, Teacher Training
Summer School: Dir, Gary C. Hatcher, Courses—vary

VICTORIA

VICTORIA COLLEGE, Fine Arts Dept, 2200 E Red River, Victoria, TX 77901. Tel 361-573-3291; Fax 361-572-3850; Internet Home Page Address: www.vc.cc.tx.us/; *Prof* Fred Spaulding; *Head Dept* Dr Marylynn Fletcher
Estab 1925; pub; D & E; SC 9, LC 3; D 100, E 40, non-maj 40, maj 100
Ent Req: HS dipl
Degrees: AA
Tuition: Res—$60 per cr hr; nonres—$500 per cr hr; no campus res

Courses: Art Appreciation, Art Education, Art Fundamentals, Art History, Ceramics, Design, Drafting, Drawing, Graphic Arts, Graphic Design, †Occupational Therapy, Painting, Sculpture, Stage Design, †Teacher Training, Theatre Arts
Summer School: Courses—as above

WACO

BAYLOR UNIVERSITY, Dept of Art, Waco, TX 76798-7263. Tel 254-710-1867; Fax 254-710-1566; *Chmn* John D McClanahan; *Prof & Artist in Res* Karl Umlauf, MFA; *Prof* William M Jensen PhD; *Prof* Berry J Klingman, MFA; *Prof* Terry M Roller, MFA; *Prof & Ceramic in Res* Paul A McCoy, MFA; *Prof* Heidi J Hornik PhD, MFA; *Assoc Prof* Robbie Barber, MFA; *Assoc Prof* Susan Dunkerley, MFA; *Prof* Mary Ruth Smith PhD, MFA; *Assoc Prof* Julia Hitchcock, MFA; *Lectr* Karen Pope, PhD; *Lectr* Denny Pickett, MFA; *Asst Prof* Virginia Green, MFA; *Vis Asst Prof* Todd Turek, MFA; *Vis Asst Prof* Kate Edwards, PhD
Estab 1845, dept estab 1870; den; D & E; Scholarships; SC 65, LC 24, GC 12; D 1600, E60, non-maj 1300, maj 200
Ent Req: HS dipl, ent exam, SAT/ACT tests
Degrees: BA & BFA(Studio) 4 yrs
Courses: 2-D Design, 3-D Design, †Art History, †Ceramics, Drawing, †Fibers, †Graphic Design, †Painting, †Photography, †Printmaking, †Sculpture
Summer School: Prof, John McClanahan

MCLENNAN COMMUNITY COLLEGE, Visual Arts Dept, 1400 College Dr, Waco, TX 76708. Tel 254-299-8000, 299-8791 (art dept); Fax 254-299-8778; Elec Mail amurad@mclennan.edu; Internet Home Page Address: www.mclennan.edu; *Dir* Donald C Blamos; *Coordr* Andrew Murad
Estab 1965; Maintain nonprofit art gallery; 3 located on campus; Pub; D & E; SC 8, LC 3; D 35, non-maj 20, maj 40
Ent Req: HS dipl
Degrees: AA 2 yrs
Tuition: Res—$34 per sem hr; nonres—$39 per sem hr, out-of-state & international $94; no campus res
Courses: Art Appreciation, Art History, Ceramics, Design, Design Communication, Drafting, Oil Painting, Painting, Photography, Problems in Contemporary Art, Sculpture, Watercolor
Adult Hobby Classes: Tuition depends on the class. Courses—Ceramics, Drawing, Jewelry, Painting, Sculpture, Stained Glass
Summer School: Dir, Andrew Murad. Tuition $55. Courses—Design, Drawing, Watercolor, Art Appreciation

WEATHERFORD

WEATHERFORD COLLEGE, Dept of Speech Fine Arts, 225 College Park Dr, Weatherford, TX 76086. Tel 817-594-5471, Ext 211; Elec Mail endy@wc.edu; Internet Home Page Address: www.wc.edu/; *Head Dept Art* Mike Endy
Estab 1856, dept estab 1959; pub; D & E; SC 10, LC 4; D 58, non-maj 30, maj 16, others 12
Ent Req: HS dipl
Degrees: AA
Tuition: In-district—$75 per cr hr; out-of-district—$83 per cr hr
Courses: Art History, Intermedia, Mixed Media, Painting
Summer School: Term May 24 & July 10

WHARTON

WHARTON COUNTY JUNIOR COLLEGE, Art Dept, 911 Boling Hwy, Wharton, TX 77488. Tel 979-532-4560; Internet Home Page Address: www.wcjc.cc.tx.us;Jess Coleman, MFA
Maintain nonprofit art gallery; pub; D & E; Scholarships; SC 8, LC 2; D 140, E 100
Ent Req: HS dipl, GED
Degrees: 2 yrs
Tuition: District res—$28.50 per sem hr; non-district—$47.50 per sem hr; non-state res—$86.50 per sem hr
Courses: Art Education, Art Fundamentals, Art History, Calligraphy, Ceramics, Design, Drawing, History of Art & Architecture, Painting, Sculpture, Teacher Training
Summer School: Dir Jess Coleman. Enrl 36; 6 wk term. Courses—Foundation of Art, Drawing

WICHITA FALLS

MIDWESTERN STATE UNIVERSITY, Lamar D. Fain College of Fine Arts, Dept of Art, 3410 Taft Blvd Wichita Falls, TX 76308. Tel 940-397-4264; Fax 940-397-4369; Elec Mail art@mwsu.edu; Internet Home Page Address: http://finearts.mwsu.edu/art/; *Chair* Nancy Steele-Hamme; Dr Ron Fischli
Estab 1926; Maintain a nonprofit art gallery, Midwestern State Univ Art Gallery, 3140 Taft Blvd, Wichita Falls, TX 76308; Average Annual Attendance: G; Pub; D & E; Scholarships
Ent Req: HS dipl, ACT, SAT
Degrees: BA, BFA & BFA with Teacher Cert 4 yrs
Tuition: refer to website
Courses: Art Appreciation, Art Education, Art History, †Ceramics, †Commercial Art, Design, Drawing, †Metals, †Painting, †Photography, †Printmaking, †Sculpture, †Teacher Training
Summer School: Dir, Dr. Nancy Steele-Hamme. Courses—Commercial Art

UTAH

CEDAR CITY

SOUTHERN UTAH STATE UNIVERSITY, Dept of Art, 351 W Center, Cedar City, UT 84720. Tel 435-586-7962, 586-5426; Elec Mail felstead@suu.edu; Internet Home Page Address: www.suu.edu; *Chmn* Brian P Hoover
Estab 1897; FT 4, PT 2; pub; D & E; Scholarships; SC 29, LC 6; D 300, E 80, maj 60, minors 45
Ent Req: HS dipl ent exam
Degrees: BA and BS 4 yrs
Tuition: Res—$866 per sem; nonres—$3157 per sem
Courses: Ceramics, Commercial Art, Drawing, Graphic Arts, Graphic Design, History of Art & Architecture, Illustration, Painting, Sculpture, Teacher Training
Summer School: Dir, Arlene Braithwaite. Tuition same as regular school. Courses—Drawing, Ceramics, Art Methods for Elementary School, Art Appreciation

EPHRAIM

SNOW COLLEGE, Art Dept, 150 E College Ave, Ephraim, UT 84627. Tel 435-283-7039, 283,7414; Internet Home Page Address: www.snow.edu; *Chmn* Carl Purcell
Estab 1888; Pub; D&E; Scholarships
Ent Req: HS dipl
Degrees: AA, AAS
Tuition: Res—$707 per yr; nonres— $2942 per yr
Courses: Art Appreciation, Ceramics, Design, Drawing, Interior Design, Jewelry, Painting, Photography, Printmaking, Sculpture

LOGAN

UTAH STATE UNIVERSITY
—Dept of Landscape Architecture Environmental Planning, Tel 435-797-0500; Fax 435-797-0503; Elec Mail cjohnson@hass.usu.edu; Internet Home Page Address: www.usu.edu/~laep/; *Acting Head* Craig Johnson
FT 6, PT 3
Degrees: BA, BLA & MLA 4 yr
Tuition: Res—$309 per cr hr; nonres—$736 per cr hr
Courses: Landscape Architecture, †Town & Regional Planning
—Dept of Art, Tel 435-797-3460 3; Fax 435-797-3412; *Prof* Glen Edwards; *Prof* Craig Law; *Prof* Jon Anderson; *Prof* Adrian Van Suchtelen; *Assoc Prof* Thomas Toone; *Assoc Prof* John Neely; *Assoc Prof* Marion Hyde; *Assoc Prof* Christopher Terry; *Assoc Prof* Sara Northerner; *Assoc Prof* Greg Schulte; *Assoc Prof* Janet Shapero; *Asst Prof* Jane Catlin; *Asst Prof* Lauren Schiller; *Asst Prof* Alan Hashimoto; *Asst Prof* Julie Johnson; *Asst Prof* Koichi Yamamoto
Estab 1890; D & E; D 500, maj 500, grad 37
Ent Req: HS dipl, HS transcript, ACT
Degrees: BA, BS & BFA 4 yr, MA 2 yr, MFA 3 yr
Tuition: Res—undergrad $1060, grad $935; nonres—undergrad $3182, grad $2751
Courses: †Art Education, †Art History, †Ceramics, †Drawing, †Graphic Arts, †Illustration, †Painting, †Photography, †Printmaking, †Sculpture
Summer School: Head, Prof Craig Shaw. 4 wk session. Courses—Basic Drawing, Ceramics, Exploring Art, Individual Projects, Photography, 3-D Design, 2-D Design, Various Summer Workshops

OGDEN

WEBER STATE UNIVERSITY, Dept of Visual Arts, 1904 University Circle, Ogden, UT 84408-2001. Tel 801-626-6762, 6000; Internet Home Page Address: www.weber.edu/; *Prof* David N Cox, MFA; *Prof* Mark Biddle, MFA; *Prof* Susan Makov, MFA; *Assoc Prof* Angelika Pagel PhD, MFA; *Prof* Drex Brooks, MFA; *Asst Prof* Scott Betz, MFA; *Asst Prof* Naseem Banerji PhD, MFA; Henry Barendse, MFA; Susan Kanatsiz, MFA
Estab 1933; dept estab 1937; pub; D & E; Scholarships; SC 66, LC 17; D 2464, E 694, non-maj 700, maj 200
Ent Req: HS dipl, ACT
Degrees: BA, BS 4 yr
Tuition: Res—$1533 per sem; nonres—$4783 per sem; campus res available
Courses: †2-D, †3-D, Advertising Design, Art Appreciation, Art Education, Art History, Calligraphy, Commercial Art, Conceptual Art, Design, Drawing, Graphic Arts, History of Art & Architecture, Illustration, Painting, Photography, Printmaking, Sculpture, Silversmithing, Textile Design, Weaving

PROVO

BRIGHAM YOUNG UNIVERSITY, Dept of Visual Arts, E-509 HFAC, Provo, UT 84602. Tel 801-422-4266; Fax 801-422-0695; Elec Mail aliesha_cook@byu.edu; Internet Home Page Address: cfac.byu.edu/va/; *Chmn* John Telford; *Assoc Chmn* Gary Barton
Estab 1875, dept estab 1893; Gallery 303, F-303 HFAC, Provo, UT 84602; FT 33, PT 50; den; D & E; Scholarships; SC 50, LC 40, Grad 15; E 1975, maj 908, pre-maj 335, grad 45
Ent Req: HS dipl or ACT
Degrees: BA and BFA 4 yrs, MFA 2 yrs and MA 1 1/2 yrs
Tuition: Undergrad full-time LDS $1640, non-LDS $2460; grad full-time LDS $2070, non-LDS $3105; campus res—room & board $2420
Courses: †Art Education, †Art History, Calligraphy, †Ceramics, †Drawing, Graphic Design, Illustration, †Painting, Photography, †Printmaking, †Sculpture, †Teacher Training
Summer School: Courses same as regular session

SAINT GEORGE

DIXIE COLLEGE, Art Dept, 225 South & 700 East, Saint George, UT 84770. Tel 435-652-7700, 652-7792; Elec Mail hanson@dixie.edu; Internet Home Page Address: www.dixie.edu; *Prof* Glen Blakely; *Asst Prof* Del Parson; *Chmn* Brent Hanson; *Asst Prof* Dennis Martinez
Estab 1911; pub; D & E; Scholarships; SC 24, LC 7, GC 1; D 400, maj 30
Ent Req: HS dipl, ACT
Degrees: AA and AS 2 yrs
Tuition: Res—$739.80 per sem; nonres—$2737.80 per sem full-time
Courses: 3-D Design, Advertising Design, Art Education, Art History, Ceramics, Commercial Art, Costume Design & Construction, Drafting, Drawing, Film, Illustration, Interior Design, Life Drawing, Painting, Photography, Portrait Drawing, Printmaking, Sculpture, Teacher Training, Textile Design, Theatre Arts, Video, Weaving
Adult Hobby Classes: Weaving
Children's Classes: 10 wk session
Summer School: Varies

SALT LAKE CITY

SALT LAKE COMMUNITY COLLEGE, Graphic Design Dept, 4600 S Redwood Rd, PO Box 30808 Salt Lake City, UT 84130. Tel 801-957-4630, 957-4072; Internet Home Page Address: www.slcc.edu; *Div & Dept Chair* Steve Mansfield, BA; *Dean* Elwood Zaugg; *Prof* Rob Adamson; *Prof* Rodayne Esmaye; *Prof* Neal Reiland; *Prof* Fred VanDyke, BA; *Prof* Sheila Chambers, BA; *Instr* Richard Graham, BA; *Instr* Terry Martin, BA; *Instr* Lana Gruendell, BA
FT 3, PT 3; Pub; D & E; Scholarships; SC 44, LC 7; D 123, E 10, non-maj 81, maj 42
Ent Req: HS dipl or equivalent, aptitude test
Degrees: Dipl, AAS(Design), AAS(Animation), AAS(Illustration), AAS (Photography), AAS (Multimedia)
Tuition: Res—$880 per sem; nonres—$2725 per sem
Courses: Advertising Design, Art Principles, Computer Graphics, Drawing, †Graphic Design, Illustration, †Lettering, Photography
Summer School: Dean, James Schnirel. Enrl 30; tuition $145 for term of 10 wks beginning June. Courses—Aesthetics, Drawing, Lettering, Media & Techniques

UNIVERSITY OF UTAH, Dept of Art & Art History, 375 South 1530 East, Rm 161, Salt Lake City, UT 84112-0380. Tel 801-581-7200 (Main), 581-8677 (Dept); Fax 801-585-6171; Elec Mail info@art.utah.edu; Internet Home Page Address: www.art.utah.edu; *Dean* Raymond Tymas-Jones; *Prof* Joseph Marotta, MFA; *Asst Prof Lectr* Laurel Caryn, MFA; *Prof* McRay Magleby, BA; *Prof* Sheila Muller, PhD; *Prof* David Pendell, MFA; *Prof* Raymond Morales, BA; *Prof* Roger D (Sam) Wilson, MFA; *Chair & Assoc Prof* Elizabeth Peterson, PhD; *Assoc Prof* Kaiti Slater, MFA; *Assoc Prof* Justin Diggle, MFA; *Asst Prof Lectr* Dave Eddy, MFA; *Asst Prof* Paul Stout, MFA; *Asst Prof Lectr* John Erickson, MFA; *Asst Prof* Beth Krensky, PhD; *Asst Prof* Boreth Ly, PhD; *Asst Prof* Kim Martinez, MFA; *Asst Prof* John O'Connell, MFA; *Asst Prof Lectr* Maureen O'Hara Ure, MFA; *Asst Prof* Paul Paet, PhD; *Assoc Prof* Brian Snapp, MFA; *Assoc Prof* Carol Sogard, MFA; *Instr* Stephen Furches; *Instr* Sandy Brunvand; *Instr* Elizabeth DeWitte; *Instr* Lance Duffin; *Instr* Chris Gochnair; *Instr* Elaine Harding; *Instr* Tom Hoffman; *Instr* Alexandra Karl; *Instr* Kristina Lenzi; *Instr* Diane Shaw; *Instr* Maryann Webster
Estab 1850, dept estab 1888; Maintain nonprofit art gallery, Gittens Gallery, 375 S, 1530 E, Rm. 161, Salt Lake City, UT 84112-0380, also mainta ins art/architecture library, D Ray Owen Jr Reading Room; on-campus shop sells art supplies; pub; D & E; Scholarships; SC 148, LC 47, GC 38/semester; D 1736, E 403, non-maj 1043, maj 1428, grad 51
Ent Req: HS dipl
Degrees: degrees BA (Art History) & BFA 4 yrs (Art), MA (Art History) and MFA (Art) 2 yrs
Tuition: Res—$1964 for 12 semester hrs; nonres—$6113 for 12 semester hrs; campus res available
Courses: †Art Appreciation, Art Education, †Art History, †Ceramics, †Conceptual Art, †Design, †Drawing, †Goldsmithing, †Graphic Design, †Illustration, †Lettering, †Mixed Media, †Painting/Drawing, †Photography/Digital Imaging, †Printmaking, †Sculpture/Intermedia, †Silversmithing, Teacher Training, †Transmedia, †Video

WESTMINSTER COLLEGE OF SALT LAKE CITY, Dept of Arts, 1840 S 1300 E, Salt Lake City, UT 84105. Tel 801-484-7651; Fax 801-484-5579; Internet Home Page Address: www.wcslc.edu; *Chmn Fine Arts Prog* Craig Glidden
Estab 1875; FT 2, PT 5; pvt; D; Scholarships; SC 25, LC 2; D 900-1000, maj 25
Ent Req: HS dipl, ent exam acceptable, HS grade point average
Degrees: BA & BS 4 yrs
Tuition: $13,450, room & board $4570-$5190
Courses: Art Education, Art History, Ceramics, Drawing, Painting, Photography, Sculpture, Teacher Training, Weaving

VERMONT

BENNINGTON

BENNINGTON COLLEGE, Visual Arts Division, Bennington, VT 05201. Tel 802-442-5401; Fax 802-440-4350; Internet Home Page Address: www.bennington.edu/; *Pres* Elizabeth Coleman
Estab 1932; FT E 70; pvt; Scholarships
Degrees: AB 4 yrs & MA 2 yrs
Tuition: $28,150 per yr; campus res
Courses: 3-D Modeling, Animation Lithography, Architecture, Art History, CAD, Ceramics, Cultural Studies, Drawing, Etching Studio, Graphics, Painting, Photography, Printmaking, Sculpture, Visual Arts

BURLINGTON

UNIVERSITY OF VERMONT, Dept of Art, 304 Williams Hall, Burlington, VT 05405. Tel 802-656-2014; Fax 802-656-8429; Internet Home Page Address: www.uvm.edu; *Chmn* William E Mierse
24; Pub; D & E; D 25
Degrees: BA 4 yrs
Tuition: Res—$176 per cr hr; nonres—$536 per cr hr
Courses: Art Education, Art History, Ceramics, Clay Silkscreen, Computer Art, Design, Drawing, Fine Metals, Lithography, Painting, Photography, Printmaking, Sculpture, Teacher Training, Video, Visual Art
Adult Hobby Classes: College of Continuing Education
Summer School: Dir, Lynne Ballard. Two 9 wk sessions beginning in May

CASTLETON

CASTLETON STATE COLLEGE, Art Dept, Castleton, VT 05735. Tel 802-468-5611; Fax 802-468-5237; Elec Mail information@castleton.edu; Internet Home Page Address: www.csc.vsc.edu; *Head Dept* Jonathon Scott; *Prof* William Ramage; *Coordr* Mariko Hancock
Estab 1787; Pub; D & E; Scholarships; SC 31, LC 3, GC varies; D 1900, E 1000, non-maj 300, maj 52, grad 5
Ent Req: HS dipl, ACT, SAT, CEEB
Degrees: BA(Art) & BA Art(2nd major Education) 4 yrs
Courses: Advertising Design, Art History, Calligraphy, Computer Graphics, Drawing, Education, Graphic Design, Lettering, Painting, Photography, Printmaking, Professional Studio Arts, Sculpture, Typography, Video
Summer School: Enrl 24. Courses—Introduction to Art History, Introduction to Studio Art

COLCHESTER

ST MICHAEL'S COLLEGE, Fine Arts Dept, Winooski Park, Colchester, VT 05439. Tel 802-654-2000; Internet Home Page Address: www.smcvt.edu; *Chmn* Paul LeClair, MFA; *Assoc Prof* Lance Richbourg, MFA; *Asst Prof* Gregg Blasdel, MFA; *Asst Prof* Amy Werbel, MFA
Estab 1903, dept estab 1965; den; D & E; SC 8, LC 3
Ent Req: HS dipl
Degrees: BA 4 yrs
Tuition: Res—undergrad $18,615 per yr, campus res—available
Courses: Art Education, Art History, Art Theory, Calligraphy, Costume Design & Construction, Drawing, Graphic Arts, History of Art & Architecture, Painting, Photography, Printmaking, Sculpture, Stage Design, Teacher Training, Theatre Arts
Summer School: Dir, Dr Art Hessler. Session 1, 5 wks beginning mid May, session 2, 6 wks beginning last wk in June. Courses—Calligraphy, Drawing, Painting

JOHNSON

JOHNSON STATE COLLEGE, Dept Fine & Performing Arts, Dibden Center for the Arts, 337 College Hill, Johnson, VT 05656. Tel 802-635-1310; Fax 802-635-1248; Elec Mail parizom@badger.jsc.vsc.edu; Internet Home Page Address: www.jsc.vsc.edu; *Gallery Dir* Suzanne Ritger; *Photography Dept Head* Scott Johnson; *Assoc Prof* Lisa Jablow; *Prof Sculpture* Susan Calza; *Head Dept Painting* Ken Leslie; *Asst Prof Art History* Marie Shurkus; *Asst Prof Music-Jazz* Steve Blair
Estab 1828; Maintain nonprofit art gallery; Julian Scott Memorial Gallery, Johnson State Col, Johnson VT 05656; art library; art supplies available at Vt Studio Ctr; pub; D & E; Scholarships; SC 30, LC 10, GC 20; D 325, non-maj 200, maj 140
Ent Req: HS dipl
Degrees: BA & BFA 4 yrs, MFA 3 yrs
Tuition: Res—undergrad $177 per cr; nonres—undergrad $400 per cr; campus res—room & board $5,000 per yr
Courses: Art Education, Art History, Ceramics, Design, Drawing, Painting, Photography, Printmaking, Sculpture, Studio Art
Children's Classes: Gifted & talented prog for high school students
Summer School: Ddir, Mary Pariyo. Courses—Mixed Media, Painting, Sculpture

MIDDLEBURY

MIDDLEBURY COLLEGE, History of Art & Architecture Dept, Johnson Memorial Bldg, Middlebury, VT 05753. Tel 802-443-5234; Fax 802-443-2250; Elec Mail midd@middlebury.edu; Internet Home Page Address: www.middlebury.edu; *Chmn* Peter Broucke; *Coordr* Mary Lousplain; *Prof* John Hunisak; *Prof* Kristen Hovins; *Prof* Glenn Andres; *Visiting Asst Prof* Katherine Smith-Abbott; *Prof* Cynthia Atheron; *Visitng Asst Prof* Parker Croft; *Robert P Youngman Cur Asian Art* Colin Mackenzie; *Dir College Museum* Richard Saunders
Estab 1800; pvt; D; SC 7, LC 30; maj 77, others 500 per term
Ent Req: exam and cert
Degrees: BA
Courses: Art History, Design, Drawing, Painting, Photography, Printmaking, Sculpture

NORTHFIELD

NORWICH UNIVERSITY, Dept of Architecture and Art, 158 Harmon Dr, Northfield, VT 05663. Tel 802-485-2000; Fax 802-485-2580; Elec Mail ddoz@norwich.edu; Internet Home Page Address: www.norwich.edu/acad; *Div*

Head & Assoc Prof Michael Hoffman, MFA; *Prof* Earl Fechter, MFA; *Asst Prof* Arthur Schaller; *Asst Prof* Kirsten van Aalst; *Prof* Robert Schmidd, MFA; *Assoc Prof* David Woolf, MFA; *Prof* Arnold Aho, MFA; *Architectural History* Dr Lisa Shrenk
Maintains Kreitzberg Library; art supplies can be purchased at on-campus shop; Pvt; D; SC, LC; D 65 (studio art), E 8, non-maj 126
Ent Req: HS dipl
Degrees: BA
Tuition: Campus residency available
Courses: Architecture, Art History, Design, Drawing, Painting, Photography, Printmaking

PLAINFIELD

GODDARD COLLEGE, Dept of Art, 123 Pitkin Rd Plainfield, VT 05667. Tel 802-454-8311; Internet Home Page Address: www.goddard.edu; *Instr* Cynthia Ross; *Instr* David Hale; *Head* Jon Batdorff
Estab 1938; pvt; D & E
Degrees: BA 4 yr, MA 1-2 yr
Tuition: Res—undergrad $16,528 (comprehensive) per sem, $8,920 (tuition only) per sem; nonres—undergrad $9,163 per sem, grad $5,105 per sem; campus res available
Courses: Art Education, Art History, Ceramics, Drawing, Holography, Painting, Photography, Printmaking, Sculpture, Video, Weaving

POULTNEY

GREEN MOUNTAIN COLLEGE, Dept of Art, 1 College Circle Poultney, VT 05764. Tel 802-287-8000; Fax 802-287-8099; *Chmn* Susan Smith-Hunter; *Prof* Dick Weis; *Prof* Richard Weinstein
Estab 1834; maj 60
Ent Req: scholarships
Degrees: BFA 4 yrs
Tuition: Res and non-res $17000 per sem
Courses: Art History, Ceramics, Design, Drawing, Fine Art Studio, Graphic Design, Graphic Design Studio, Illustration, Painting, Photography, Printmaking, Sculpture

VIRGINIA

ANNANDALE

NORTHERN VIRGINIA COMMUNITY COLLEGE, Art Dept, 8333 Little River Turnpike, Annandale, VA 22003. Tel 703-323-3107; Fax 703-323-4248; Internet Home Page Address: www.nv.cc.va.us; *Chmn* Dr Duncan Tebow; *Admin & Prog Specialist* Barbara Divers
Estab 1960s; Maintain nonprofit art gallery; Pub; D & E; Scholarships; D 589, E 200
Ent Req: open admis
Degrees: degrees AA(Art Educ), AA(Art History) AAS(Commercial Art), AA(Fine Arts) & AA(Photography) 2 yrs
Tuition: Res—undergrad $39.45 per cr hr; nonres—undergrad $177.33 per cr hr; no campus res
Courses: Art History, Ceramics, Computer Graphics, Design, Drawing, †Fine Arts, Painting, Sculpture
Summer School: Chmn Humanities Div, Dr Duncan Tebow. Tuition same as regular session; 2 five wk D sessions and 1 ten wk E session during Summer. Courses—varied, incl study abroad

ARLINGTON

MARYMOUNT UNIVERSITY, School of Arts & Sciences Div, 2807 N Glebe Rd, Arlington, VA 22207. Tel 703-522-5600; Fax 703-284-3859; *Dean* Rosemary Hubbard; *Prof* Pamela Stoessell, MFA; *Prof* Janice McCoart, MFA; *Prof* Christine Haggerty, MFA; *Prof* Judy Bass, MFA; *Asst Prof* Selly Garen, PhD
Estab 1950; Maintain nonprofit art gallery; Barry Gallery; pvt; D & E; SC 20, LC 12
Ent Req: HS dipl, SAT results, letter of recommendation
Degrees: BA 4 yrs
Tuition: Res—undergrad $7,800 per sem, grad $530 per cr hr; campus res available
Courses: Advertising Design, Art History, †Art of the Book, Ceramics, Clothing Design & Construction, Design, Drafting, Drawing, Fashion Arts, †Figure Drawing, Graphic Design, Handicrafts, †Jewelry Design, Painting, Sculpture, †Studio Arts, Textile Design
Adult Hobby Classes: Courses—any course in fine arts
Summer School: Dir, Rosemary Hubbard. Tuition $1,600 per summer 3 cr course, for term of 6 wks beginning May

ASHLAND

RANDOLPH-MACON COLLEGE, Dept of the Arts, Ashland, VA 23005-1698. Tel 804-798-8375, 798-8372; Fax 804-752-7231; Internet Home Page Address: www.rmc.edu; *Prof* R D Ward; *Assoc Prof* Joe Mattys; *Lectr* Evie Terrono; *Chmn* E Raymond Berry; *Instr Music* James Doering; *Dir Coral Act* Dave Greennagle
Estab 1830, dept estab 1953; FT 5, PT 2; pvt; D; SC 4, LC 4; D 200, non-maj 200
Degrees: BA & BS 4 yrs
Tuition: Res—undergrad $9905 per yr; campus res available

Courses: †Art History, †Art Management, †Drama, Drawing, †Music, Painting, †Studio Art

BLACKSBURG

VIRGINIA POLYTECHNIC INSTITUTE & STATE UNIVERSITY, Dept of Art & Art History, 201 Draper Rd, Blacksburg, VA 24061-0103. Tel 540-231-5547; Fax 540-231-5761; Elec Mail dmyers@vt.edu; Internet Home Page Address: www.art.vt.edu; *Prof Emerita* Jane Aiken PhD; *Prof* Steve Bickley, MFA; *Prof* Derek Myers, MFA; *Prof* Ann-Marie Knoblauch, PhD; *Prof* Robert Fields, MFA; *Prof* Alison Slein, MFA; *Prof* Gregg Bryson, MFA; *Prof* Robert Graham, MFA; *Prof* Ray Kass, MFA; *Prof* Janet Niewald, MFA; *Head Dept* L Bailey Van Hook PhD; *Prof* David Crane, MFA; *Prof* Truman Capone, MFA; *Prof* Sally Cornelius, PhD
Estab 1969; FT 13; pub; D&E; Scholarships; SC 25, LC 12; Maj 300
Degrees: BA 4 yrs, BFA 5 yrs
Tuition: In state N/A; out of state N/A
Courses: Advertising Design, Art Appreciation, Art History, Ceramics, Commercial Art, Computer Art, Design, Drawing, Graphic Arts, Graphic Design, Illustration, Mixed Media, Painting, Sculpture
Summer School: Dir, Derek Myers. Enrl 150; tuition proportional to acad yr for two 5 wk sessions. Courses—Advertising Design, Art History, Ceramics, Computer Art, Design, Drawing, Graphic Design, Illustration, Painting, Sculpture, Watercolor

BRIDGEWATER

BRIDGEWATER COLLEGE, Art Dept, 402 E College St, Bridgewater, VA 22812. Tel 540-828-5396; Fax 540-828-2160; Internet Home Page Address: www.bridgewater.edu; *Dept Head* Nan Covert, MFA
FT 2; Scholarships
Ent Req: HS dipl, sophomore review portfolio
Degrees: BA 4 yr
Tuition: $20,000 per yr undergrad
Courses: Art History, †Computer Graphics, Design, Drawing, Painting, Photography, Printmaking, Sculpture

BRISTOL

VIRGINIA INTERMONT COLLEGE, Fine Arts Div, 1013 Moore St, Bristol, VA 24201. Tel 540-669-6101; Fax 540-669-5763; *Chmn* Dr Jon Mehlferber; *Instr* Tedd Blevins, MFA
Estab 1884; den; D & E; Scholarships; SC 15, LC 4; D 35, non-maj 110
Ent Req: HS dipl, review of work
Degrees: BA(Art) & BA(Art Educ) 4 yrs, AA 2 yrs
Tuition: $17510 per yr (incl board)

BUENA VISTA

SOUTHERN VIRGINIA COLLEGE, Division of Arts and Humanities, One College Hill Dr, Buena Vista, VA 24416. Tel 540-261-8471; Fax 540-261-8451; Elec Mail bcrawford@southvirginia.edu; Internet Home Page Address: www.southernvirginia.edu; *Head Dept* Barbara Crawford
Estab 1867; pvt; D; SC 10, LC 5; D 185, non-maj 175, maj 2
Ent Req: HS dipl, SAT or ACT
Degrees: AA & BA 2 yrs
Tuition: Full time $5,350; part-time $425 per credit hr; room and board $2,200
Courses: Art Education, Art History, Design, Italian Renaissance, Painting, Photography, Study Abroad, Teacher Training

CHARLOTTESVILLE

UNIVERSITY OF VIRGINIA, McIntire Dept of Art, Fayerweather Hall, Charlottesville, VA 22904; PO Box 400130, Charlottesville, VA 22904. Tel 804-924-6123; Fax 804-924-3647; Elec Mail mwd2f@virginia.edu; Internet Home Page Address: minerva.acc.virginia.edu/finearts; *Chmn & Art History Instr* Lawrence Goedde; *Dir of Grad Studies & Art History Instr* Marion Roberts; *Art History Instr* Matthew Affron; *Art History Instr* Paul Barolsky; *Art History Instr* Malcolm Bell; *Art History Instr* John Dobbins; *Art History Instr* Daniel Ehnbom; *Art History Instr* Francesca Fiorani; *Art History Instr* Christopher James; *Art History Instr* Maurie McInnis; *Art History Instr* Howard Singerman; *Art History Instr* David Summers; *Art History Instr* Dorothy Wong; *Studio Faculty* William Bennett; *Studio Faculty* Nina Bovasso; *Studio Faculty* Richard Crozier; *Studio Faculty* Dean Dass; *Studio Faculty* Kevin Everson; *Studio Faculty* Suzi Fox; *Studio Faculty* Philip Geiger; *Studio Faculty* Jim Hagan; *Studio Faculty* Sandra Iliescu; *Studio Faculty* Megan Marlatt; *Studio Faculty* Akemi Ohira; *Studio Faculty* Elizabeth Schoyer; *Studio Faculty* William Wylie; Sylvia Newstrawn
Estab 1819, dept estab 1951; Maintain nonprofit art gallery, Fayerweather Gallery, Fayerweather Hall, University of Virginia, Charlottesville, VA 22903; FT 21; D; Scholarships; SC 21, LC 21, GC 14; D 1500, maj 150, grad 40 res, 18 nonres
Ent Req: HS dipl
Degrees: BA(Studio and Art History), MA(Art History) and PhD(Art History)
Tuition: In state $5,000; out of state $17,400
Courses: Art History, Computer Graphics, Drawing, Painting, Photography, Printmaking, Sculpture
Summer School: Enrl 15; tuition varies. Courses—Art History, Studio Art

DANVILLE

AVERETT COLLEGE, Art Dept, 420 W Main St, Danville, VA 24541. Tel 804-791-5600, 791-5797; Fax 804-791-5647; *Coordr* Diane Kendrick, MFA; *Prof* Robert Marsh, MFA

Estab 1859, dept estab 1930; pvt; D & E; Scholarships; SC 13, LC 5; D 1000, non-maj 250, maj 25
Ent Req: HS dipl
Degrees: AB
Tuition: $10128 per yr
Courses: Advertising Design, Art Education, Art History, Ceramics, Commercial Art, Drawing, Fashion Arts, History of Art & Architecture, Illustration, Jewelry, Lettering, Painting, Printmaking, Sculpture, Teacher Training, Textile Design
Summer School: Two 4 wk sessions

FAIRFAX

GEORGE MASON UNIVERSITY, Dept of Art & Art History, 4400 University Dr, Fairfax, VA 22030. Tel 703-993-1010; Fax 703-323-3849; Internet Home Page Address: www.gmu.edu/; *Prof* M Kravitz; *Dir Institute of the Arts* Betsy Brininger
Estab 1948, dept estab 1981; pub; D & E; SC 16, LC 15; non-maj 200, maj 130
Ent Req: HS dipl, SAT or CEEB
Degrees: BA
Tuition: Res—$1884 per 12-17 sem hrs; nonres—$6306 per 12-17 sem hrs
Courses: †Art History, Computer Graphics, Drawing, Graphic Arts, Painting, Photography, Printmaking, Sculpture, †Studio Art
Summer School: Courses—Art Appreciation, Art Education, Studio Arts

FARMVILLE

LONGWOOD UNIVERSITY, Dept of Art, 201 High St Farmville, VA 23901; 201 High St Farmville, VA 23909. Tel 434-395-2284; Fax 434-395-2775; Elec Mail mcqueenjg@longwood.edu; Internet Home Page Address: www.lwc.edu/; *Assoc Prof* Christopher M Register; *Prof* Randall W Edmonson; *Asst Prof* SJ Burke; *Asst Prof* Claire B McCoy; *Prof* Mark Baldridge; *Asst Prof* Kelly Nelson; *Asst Prof* Martin Brief; *Asst Prof* Johnson Bowles; *Asst Prof* Anna Cox; *Lectr* John Williams
Estab 1839, dept estab 1932; Maintains nonprofit gallery, Longwood Center for the Visual Arts, Main Street, Farmville, VA 23901; pub; D & E; Scholarships; SC 59, LC 15; non-maj 450 per sem maj 225 per sem
Ent Req: HS dipl
Degrees: BFA (Art Educ, Art History, Studio) 4 yr
Courses: 3-D Design, Art Appreciation, Art Education, Art History, Basic Design, Ceramics, Crafts, Design, Drawing, Fibers, Graphic Design, Illustration, Jewelry, Metalsmithing, Painting, Photography, Printmaking, Sculpture, Stained Glass, Teacher Training, Typography, Wood Design
Summer School: Dir, Randall W Edmonson. Tuition varies for one 3-wk & two 4-wk sessions. Courses—Varied

FREDERICKSBURG

MARY WASHINGTON COLLEGE, Dept of Art & Art History, Fredericksburg, VA 22401. Tel 540-654-2038; Fax 540-654-1952; Internet Home Page Address: www.mwc.edu; Others TTY 540-654-1104; *Chair & Assoc Prof* Jean Ann Dabb; *Prof* Joseph Dreiss; *Prof* Lorene Nickel; *Assoc Prof* Steve Griffin; *Asst Prof* Marjorie Och; *Sr Lectr* Carole Garmon
Estab 1904; pub; D & E; Scholarships; SC 18, LC 20; Maj 100
Ent Req: HS dipl, ent exam
Degrees: BA, BS & BLS 4 yr
Tuition: Res—undergrad $116 per cr hr, grad $114 per cr hr; nonres—undergrad $282 per cr hr, grad $283 per cr hr; campus res available
Courses: Art History, Ceramics, Drawing, Painting, Photography, Printmaking, Sculpture, †Studio Art

HAMPTON

HAMPTON UNIVERSITY, Dept of Fine & Performing Arts, Hampton, VA 23668. Tel 757-727-5416, 727-5402; Internet Home Page Address: www.hamptonu.edu/academics; *Chmn* Dr Karen Ward
Estab 1869; pvt; D; Scholarships; SC 22, LC 7, GC 9; maj 80, others 300, grad 7
Ent Req: HS grad
Degrees: BA, BS
Tuition: $9490 annual tuition; campus res—room & board $4754
Courses: Ceramics, Interior Design, Painting, Photography
Summer School: Dir, Sheila May. Courses—Advanced Workshop in Ceramics, Art Educ Methods, Art Methods for the Elementary School, Basic Design, Ceramics, Commercial Art, Design, Drawing & Composition, Graphics, Metalwork & Jewelry, Painting, Understanding the Arts

HARRISONBURG

JAMES MADISON UNIVERSITY, School of Art & Art History, MSC 7101, James Madison U Harrisonburg, VA 22807. Tel 540-568-6216; Fax 540-568-6598; *Dir* Dr Cole H Welter; *Prof* James Crable, MFA; *Prof* Steve Zapton, MFA; *Prof* Barbara Lewis, MFA; *Prof* Kathleen Arthur PhD, MFA; *Prof* Gary Chatelain, MFA; *Prof* Jack McCaslin, MFA; *Prof* Masako Miyata, MFA; *Prof* Kenneth Szmagaj, MFA; *Assoc Prof* Sang Yoon, MFA; *Assoc Prof* Trudy Cole-Zielanski, MFA; *Asst Prof* William Tate, MArch; *Asst Prof* Peter Ratner, MFA; *Asst Prof* Corinne Deiope, MFA; *Instr* Stuart Downs, MA
Estab 1908; pub; D & E; Scholarships; SC 31, LC 21, GC 22; D & E 1254, maj 184, GS 12
Ent Req: HS dipl, grads must submit portfolio, undergrads selected on portfolio & acad merit
Degrees: BA(Art History), BS & BFA(Studio) 4 yrs, MA(Studio, Art History, Art Educ) 1 1/2 to 2 yrs, MFA 60 cr hrs
Tuition: Res—undergrad $56 per credit; undergrad $252 per credit; room & board available

Courses: Advertising Design, Aesthetics, †Art Education, †Art History, Art Therapy, †Ceramics, Computer Graphics, Drafting, †Drawing, Goldsmithing, †Graphic Design, Interior Design, †Jewelry, Museum Staff Training, Painting, Papermaking, Photography, Printmaking, Sculpture, Silversmithing, Stained Glass, Textile Design, Typography, Weaving
Adult Hobby Classes: Tuition res—$250, nonres—$658 for 1-3 cr hr.
Courses—Summer workshop, all beginning courses
Children's Classes: Enrl 260; tuition $40 for 8 sessions

LEXINGTON

WASHINGTON AND LEE UNIVERSITY, Div of Art, Dupont Hall, Lexington, VA 24450. Tel 540-458-8857, 463-8861 (Art Dept); Fax 540-458-8104; Elec Mail psimpson@wlu.edu; *Prof* Pamela H Simpson PhD, MFA; *Prof* Larry M Stene, MFA; *Assoc Prof* Kathleen Olson-Janjic, MFA; *Assoc Prof* Joan O'Mara PhD, MFA; *Head* George Bent, MFA, PhD
Estab 1749, dept 1949; pvt; D; Scholarships; SC 14, LC 26; D 1700 (in col) non-maj 200, maj 20
Ent Req: HS dipl, SAT, 3 CEEB, one English CEEB plus essay on skills in English, English composition test; entrance requirements most rigorous in English; required of all, including art majors
Degrees: BA 4 yrs
Tuition: Res—undergrad $21,000 per yr, grad $21,300 per yr; campus res—room & board available
Courses: Art History, Drawing, Graphic Arts, Greece), History of Art & Architecture, Museum Staff Training, Painting, Printmaking, Sculpture, Stage Design, Study Art Abroad (Italy, Theatre Arts

LYNCHBURG

LYNCHBURG COLLEGE, Art Dept, 1501 Lakeside Dr, Lynchburg, VA 24501. Tel 804-544-8349; Fax 804-544-8277; Internet Home Page Address: www.lynchburg.edu/academic/art; *Prof* Richard Pumphrey, MFA; *Prof* Beverly Rhoads, MFA; *Lectr* Barbara Rothermel, MLA
Estab 1903, dept estab 1948; Maintains nonprofit art gallery, The Davra Gallery, Dillard Fine Arts Building, 1501 Lakeside Dr, Lynchburg, VA 24501; pvt; D & E; SC 26, LC 16, GC 2; D 400, E 50, non-maj 410, maj 45
Ent Req: HS dipl
Degrees: BA & BS 4 yrs
Tuition: Res—undergrad $22600 per yr, grad $290 per sem hr, $5000 - $7000 per yr room & board
Courses: Art Appreciation, Art History, Ceramics, Design, Drawing, Figure Drawing, Graphic Arts, Graphic Design, Painting, Photography, Sculpture
Summer School: Art Education, Art History & Studio

RANDOLPH-MACON WOMAN'S COLLEGE, Dept of Art, 2500 Rivermont Ave, Lynchburg, VA 24503. Tel 804-947-8486; Fax 804-947-8138; Internet Home Page Address: www.rmwc.edu; *Acting Chmn* Kathy Muehlemann
Estab 1891; FT 4; pvt, W; D; Scholarships; SC 18, LC 15; maj 35, others 305
Degrees: BA 4 yrs
Tuition: $17,950 incl room & board
Courses: American Art, Art History, Art Survey, Ceramics, Drawing, Painting, Printmaking, Sculpture
Summer School: Dir, Dr John Justice. Enrl 30; 4 wk term. Courses—various

MCLEAN

MAGNUM OPUS, 6803 Whittier Ave McLean VA 22101. Tel 703-790-0861; *Head Dept* John Fettes
Estab 1955; pvt; D & E; SC 1; D 63, E 12
Tuition: Adults $170 for 10 lessons; children $140 for 10 lessons
Courses: Drawing, Painting
Summer School: Dir, John Fettes.

NEWPORT NEWS

CHRISTOPHER NEWPORT UNIVERSITY, Dept of Fine Performing Arts, One University Pl, Newport News, VA 23606. Tel 757-594-7089, 594-7000; Fax 757-594-7389; *Chmn* Lawrence Wood, MA; *Asst Prof* B Anglin, BA; *Prof* David Alexick PhD, MA; *Prof* Belle Pendleton, MA, PhD; *Assoc Prof* Greg Henry, BFA, MFA
Estab 1974; Maintain nonprofit art gallery; pub; D & E; Scholarships; SC 18, LC 9; D 250, E 60, non-maj 200, maj 100
Ent Req: HS dipl, admis committee approval
Degrees: BA & BS 4 yrs
Tuition: Res—undergrad $3326 per yr, $139 per cr hr; nonres—undergrad $7946 per yr, $331 per cr hr
Courses: †Art, †Art Appreciation, Art Education, Art History, Ceramics, Collage, Costume Design & Construction, Drawing, Graphic Arts, †Music (BM), Painting, Photography, †Printmaking, Sculpture, Stage Design, Theatre Arts
Adult Hobby Classes: 100 variable
Summer School: Dir, Dr Barry Woods. Enrl 25; tuition $300. Courses—Ceramics, Drawing, Painting

NORFOLK

NORFOLK STATE UNIVERSITY, Fine Arts Dept, 700 Park Ave Norfolk, VA 23504. Tel 757-823-8844; Elec Mail webmaster@nsu.edu; Internet Home Page Address: www.nsu.edu/; *Head Dept* Rod A Taylor PhD
Estab 1935; pub; D & E; SC 50, LC 7; D 355, E 18, non-maj 200, maj 155
Ent Req: HS dipl

Degrees: BA(Art Educ), BA(Fine Arts) and BA(Graphic Design) 4 yrs, MA and MFA in Visual Studies
Tuition: Res—undergrad $8586 per yr incl room & board; non-res—$5396 per yr incl room & board
Courses: Advertising Design, Aesthetics, Art Appreciation, †Art Education, Art History, Calligraphy, Ceramics, Commercial Art, †Costume Design & Construction, Design, Drawing, †Fashion Arts, Graphic Arts, †Graphic Design, †Handicrafts, Illustration, Lettering, Mixed Media, Painting, Photography, Printmaking, Sculpture, †Teacher Training
Adult Hobby Classes: Enrl 30. Courses—Ceramics, Crafts
Children's Classes: Enrl 45; tuition none. Courses—all areas

OLD DOMINION UNIVERSITY, Art Dept, Visual Arts Bldg, Rm 203, Norfolk, VA 23529. Tel 757-683-4047, 683-3000; Fax 757-683-5923; Elec Mail rrlove@odu.edu; Internet Home Page Address: www.odu.edu/al/art; *Grad Prog Dir* Elliott Jones; *Dir Gallery* Katherine Huntoon; *Prof* Ken Daley; *Prof* Linda McGreevy; *Assoc Prof* Ronald Snapp; *Assoc Prof* Robert Wojtowicz; *Assoc Prof* Elizabeth Lipsmeyer; *Assoc Prof* Elliott Jones; *Assoc Prof* David Johnson; *Assoc Prof* Robert McCullough; *Asst Prof* Richard Nickel; *Asst Prof* John Roth; *Assoc Prof* Dianne deBeixedon; *Lect* Patricia Edwards; *Lect* Peter Eudenbach; *Assoc Prof* Kenneth Fitzgerald; *Instr* Agnieszka Whelan
Maintain a nonprofit art gallery, Old Dominion Univ Gallery, 350 W 21st St, Norfolk, VA 23517; maintain an art library, Elise N. Hofheimer Art Libr, Diehn Fine & Performing Arts Ctr, Rm 109, Norfolk, VA 23529; Pub, Commonwealth of Virginia; D, E, weekend (Sat); Scholarships, Fellowships, Assistantships; SC, LC, GC; 1,244 day; 296 evening; 300 majors; 17 grad stud
Ent Req: HS, dipl, SAT
Degrees: BA(Art History, Art Education or Studio Art), BFA, MA & MFA
Tuition: Res—$127 per cr hr; nonres—$398 per cr hr
Courses: Aesthetics, Art Appreciation, †Art Education, †Art History, Ceramics, Clay, Computer Imaging, Crafts, Design, †Drawing, †Goldsmithing, Graphic Arts, †Graphic Design, History of Art & Architecture, Illustration, †Jewelry, Metals, Mixed Media, Museum Staff Training, †Painting, †Photography, †Printmaking, †Sculpture, †Silversmithing, †Studio Art, Teacher Training, Textile Design, Weaving
Adult Hobby Classes: Enrl 18; tuition $60-$90 per 8 wk course. Courses—Painting
Children's Classes: Enrl 25. Courses—2 semesters, Governor's Magnet School classes
Summer School: Dir, Prof Ken Daley. Enrl 125; tuition res $126 per cr hr; nonres $313 per cr hr

VIRGINIA WESLEYAN COLLEGE, Art Dept of the Humanities Div, 1584 Wesleyan Dr, Norfolk, VA 23502. Tel 757-455-3200; Fax 757-461-5025; *Assoc Prof* Barclay Sheaks; *Assoc Prof* Joyce B Howell PhD, MFA; *Adjunct Instr* Ken Bowen, MA
Pvt, den; D & E; Scholarships; SC 21, LC 8; E 20
Ent Req: HS dipl, SAT
Degrees: BA(Liberal Arts) 4 yrs
Tuition: $16,500 per yr; campus res available
Courses: Aesthetics, Art Appreciation, Art Education, Art History, Ceramics, Computer Art, Drawing, Fabric Enrichment, Graphic Arts, Graphic Design, Handicrafts, History of Art & Architecture, Jewelry, Mixed Media, Painting, Photography, Printmaking, Sculpture, Silversmithing, Stage Design, Teacher Training, Theatre Arts, Weaving
Adult Hobby Classes: Enrl 20

PETERSBURG

RICHARD BLAND COLLEGE, Art Dept, 11301 Johnson Rd, Petersburg, VA 23805. Tel 804-862-6272, 862-6100; *Pres* James B McNeer; *Chmn* David Majewski
Estab 1960, dept estab 1963; pub; D & E; SC 3, LC 3; D 73
Ent Req: HS dipl, SAT, recommendation of HS counselor
Degrees: AA(Fine Arts) 2 yrs
Tuition: Res—undergrad $1140 per sem; nonres—$3125 per sem
Courses: Art Appreciation, Art History, Basic Design, Drawing, Painting, Sculpture
Adult Hobby Classes: Courses—Interior Design, Yoga

VIRGINIA STATE UNIVERSITY, Arts & Design, PO Box 9026, Petersburg, VA 23806. Tel 804-524-5944; Fax 804-524-5472; Elec Mail rjknight@vsu.edu; Internet Home Page Address: www.vsu.edu; *Chmn & Dir* Thomas Larose; *Assoc Prof* Brenda Mary Whitted; *Asst Prof* Lawrence Hawthorne; *Asst Prof* Shirley Dort
Estab 1882, dept estab 1935; Maintains nonprofit art gallery, Meredith Art Gallery; Pub; D & E; SC 16, LC 6, GC 2; D 400, E 60, non-maj 302, maj 98
Ent Req: HS dipl
Degrees: degrees BFA(Visual Commercial Art & Design) 4 yrs
Tuition: Res—undergrad $1,614 per sem, res grad—$4,600 room & board; nonres undergrad—$1,996 per sem, nonres grad—$4,967
Courses: †Animation, Art Appreciation, Art History, Ceramics, Computer Graphics, Drawing, †Illustration, Internship, Lettering, Photography, Printmaking, Sculpture, †Senior Thesis, Silkscreen, Typography
Summer School: Dir, Dr V Thota, Art Appreciation. Courses—Drawing, Art Crafts

PORTSMOUTH

TIDEWATER COMMUNITY COLLEGE, Visual Arts Center, 340 High St, Portsmouth, VA 23704. Tel 757-822-6999; Fax 757-822-6800; Internet Home Page Address: www.tc.cc.va.us; *Prof* Ed Gibbs; *Prof* Rob Hawkes; *Prof* Craig Nilson; *Prof* George Tussing; *Dir* Anne Iott; *Dir Pub Relations* Janet Sydenstricker
Estab 1968; pub; D & E; SC 12, LC 3; D 120, E 180, non-maj 190, maj 110

Ent Req: HS dipl
Degrees: AA(Fine Arts), AAS(Graphic Arts) 2 yrs
Tuition: Res—$43.97 per cr hr; nonres—$117.85 per cr hr; no campus res
Courses: †Advertising Design, Art Appreciation, Art History, Ceramics, Computer Graphics, Design, Drawing, Illustration, Lettering, Painting, Photography, Sculpture
Adult Hobby Classes: Offered through Continuing Educ Div
Summer School: Dir Anne Iott. Enrl 15 per course; tuition per course beginning May. Courses—Art History, Ceramics, Design, Drawing, Painting

RADFORD

RADFORD UNIVERSITY, Art Dept, E. Main St., PO Box 6965 Radford, VA 24142. Tel 540-831-5754; Elec Mail sarbury@radford.edu; Internet Home Page Address: www.radford.edu; *Chmn* Dr Steve Arbury, PhD; *Prof* Halide Salam; *Asst Prof* Ed LeShock, MFA; *Assoc Prof* Jennifer Spoon, MFA; *Prof* Charles Brouwer, MFA; *Asst Prof* Dr Eloise Philpot, PhD; *Asst Prof* Matthew Johnston, PhD; *MFA* Z.L. Feng; *Asst Prof* Richard Bay, EdD; *Asst Prof* Drew Dodson, MFA; *Asst Prof* John O'Connor, MA
Estab 1910, dept estab 1936; Maintains nonprofit art gallery, Radfor University Art Museum; Pub; D & E; Scholarships; D 1,250, E 80, non-maj 1,086, maj 202, grad 32
Activities: Limited art supplies sold in campus bookstore
Ent Req: HS dipl, SAT
Degrees: BA, BFA, BS & BS (teaching) 4 yrs, MFA 2 yrs, MS 1 yr
Tuition: In-state undergrad $4,762 per yr, out-of-state undergrad $11,762 per yr; campus res—room & board $5,886 per yr
Courses: Animation, Art Appreciation, Art Education, Art Foundations, Art History, Baroque & Rococo Art, Ceramics, Contemporary Art, Drawing, Graphic Design, Jewelry, Lettering, †Museum Staff Training, Painting, Photography, Sculpture, Teacher Training, Visual Arts

RICHMOND

J SARGEANT REYNOLDS COMMUNITY COLLEGE, Humanities & Social Science Division, PO Box 85622, Richmond, VA 23285-5622. Tel 804-371-3263; Internet Home Page Address: www.jsr.cc.va.us; *Assoc Div Chmn* Patricia Johnson; *Head Art Prog* Barbara Glenn
Estab 1972
Ent Req: HS diploma or equivalent
Degrees: AA
Tuition: Res—$4.52 per cr hr; nonres—$175.40 per cr hr
Courses: Art Appreciation, Art History, Design, Drawing, Graphic Design, Handicrafts, Interior Design, Painting, Photography, Sculpture

UNIVERSITY OF RICHMOND, Dept of Art and Art History, Richmond, VA 23173. Tel 804-289-8272, 289-8276; Fax 804-287-6006; *Chmn* Charles W Johnson Jr PhD; *Prof* Stephen Addiss, PhD; *Assoc Prof* Margaret Denton, PhD; *Assoc Prof* Mark Rhodes; *Assoc Prof* Tanja Softie; *Asst Prof* Erling Sjovold; *Exec Dir Univ Mus* Richard Waller
Estab 1840; Maintains nonprofit art gallery; Pvt; D & E; Scholarships; SC 29, LC 15
Ent Req: HS dipl, CEEB
Degrees: BA and BS 4 yrs
Tuition: Res—&14,000 per yr
Courses: †Architecture, †Art History, Ceramics, Color & Design, Design, Drawing, History of Art & Architecture, †Mixed Media, Museum Staff Training, Museum Studies, Painting, Photography, Printmaking, Sculpture, †Studio Art

VIRGINIA COMMONWEALTH UNIVERSITY
—Art History Dept, Tel 804-828-2784; Fax 804-828-7468; Internet Home Page Address: www.vcu.edu; *Prof* Dr Baba Tunde Lawal; *Prof* Robert Hobbs; *Prof* Howard Risatti; *Assoc Prof* Dr Charles Brownell; *Assoc Prof* Fredrika H Jacobs; *Asst Prof* Dr Ann G Crowe; *Asst Prof* Dr James Farmer; *Chmn* Bruce M Koplin
Degrees: BA, MA, PhD
Tuition: Nonres—$6,285 per yr
Courses: Motion Pictures Western Survey, Pre-Columbian Art & Architectures
—School of the Arts, Tel 804-828-2787; Fax 804-828-6469; Elec Mail arts@vcu.edu; Internet Home Page Address: www.vcu.edu/arts; *Dir Summer School* Sue F Munro; *Dean* Richard Toscan
Estab 1838; Maintains a nonprofit gallery, Anderson Gallery, 907 1/2 West Franklin St, Richmond, VA 23284; FT 155, PT 153; pub; D & E; Scholarships, Fellowships, Assistantships; 2,984
Ent Req: ent req portfolio or audition
Degrees: BA, BFA, MFA, MAE, BM
Courses: 2-D Art, Art Education, Art Experience, Art History, Ceramics, Costume Design & Construction, Design, Exceptional Art, Fashion Arts, †Film, Fine Art, Graphic Arts, Graphic Design, Interior Design, Jewelry, Painting, Photography, Print, Printmaking, Sculpture, Theatre Arts
Summer School: Dir, Sue F Munro. Courses 3 - 8 wks, most art disciplines

ROANOKE

VIRGINIA WESTERN COMMUNITY COLLEGE, Communication Design, Fine Art & Photography, 3095 Colonial Ave SW, Roanoke, VA 24038; PO Box 14007 Roanoke, VA 24038. Tel 540-857-7385, 857-7255 (Dept Head); Fax 540-857-6096; Elec Mail dcurtis@vw.cc.va.us; Internet Home Page Address: www.vw.cc.va.us; *Interim Chmn Div Human* Dr John Capps, EdD; *Dept Head* Elizabeth Bailey
PT 10; Pub; D & E; Scholarships; SC 11, LC 2
Ent Req: HS dipl
Degrees: AA(Fine Art), AAS(Communication Design)
Tuition: Res—$39 per cr hr; nonres—$170.88 per cr hr & svc fees

Adult Hobby Classes: Oil Painting, Papermaking, Watercolor

SALEM

ROANOKE COLLEGE, Fine Arts Dept-Art, Olin Hall, 221 College Ln Salem, VA 24153. Tel 540-375-2354; Fax 540-375-2559; Elec Mail partin@roanoke.edu; Internet Home Page Address: www.roanoke.edu; *Chmn* Bruce Partin, PhD; *Prof* Scott Hardwig, MFA; *Assoc Prof* Elizabeth Heil, MFA; *Assoc Prof* Dr Jane Long, MFA; *Asst Prof* Katherine Shortridge; *Asst Prof* Justin Wolff
Estab 1842, dept estab 1930; Maintain nonprofit art gallery, Olin Galleries; pvt; D&E; Scholarships; SC 16, LC 8; D 130, non-maj 120, maj 40
Ent Req: HS dipl, SAT or ACT, 13 academic credits - 2 English, 2 Social Sciences, 5 Arts & Humanities, 2 Math, 2 Science
Degrees: BA 4 yrs
Tuition: Res—$21,000 per yr incl room & board; nonres—$15,000 per yr
Courses: Advertising Design, Art Education, †Art History, Ceramics, Drawing, Graphic Design, Painting, Photography, Printmaking, Sculpture, Stage Design, †Studio Arts
Children's Classes: Ceramics
Summer School: Dir, Ms Leah Russell. Courses—Art History, Studio

STAUNTON

MARY BALDWIN COLLEGE, Dept of Art & Art History, Frederick and New Sts, Staunton, VA 24401. Tel 540-887-7196; Fax 540-887-7139; Internet Home Page Address: www.mbc.edu; *Assoc Prof* Paul Ryan; *Assoc Prof* Dr Sara N James; *Asst Prof* Jim Sconyers; *Instr* Nancy Ross; *Visiting Artist* Anne Hanger; *Adjunct Instr* Beth Young
Estab 1842; Maintain nonprofit gallery, Hunt Gallery at Mary Baldwin College, Staunton, VA 24401; pvt; D & E; Scholarships; SC 40, LC 30; D 173, E 32, non-maj 172, maj 45, others 4 non-credit
Ent Req: HS dipl
Degrees: BA & BS 4 yrs
Tuition: $25,680 annual tuition incl room & board
Courses: Art Appreciation, Art Criticism, Art History, Ceramics, Drawing, Film, Graphic Design, Historical Preservation, Interior Design, Museum Staff Training, Painting, Photography, Printmaking, Teacher Training, Typography, Video

SWEET BRIAR

SWEET BRIAR COLLEGE, Art History Dept, Sweet Briar, VA 24595. Tel 804-381-6125 (Art History Dept), 381-6100; Fax 804-381-6152; Elec Mail witcombe@sbc.edu; Internet Home Page Address: www.sbc.edu/academics/arth/; *Prof* Aileen H Laing PhD; *Chmn* Christopher Witcombe; *Prof* Diane D Moran, PhD
Estab 1901, dept estab 1930; pvt; D; Scholarships; SC 19, LC 19; D 375 per term, maj 32
Ent Req: HS dipl, col boards
Degrees: BA 4 yrs
Tuition: $25,310 incl room & board
Courses: †Art History, Drawing, Graphic Arts, History of Art & Architecture
Adult Hobby Classes: Fibre Art History, Graphic Design, Modern Art

WILLIAMSBURG

COLLEGE OF WILLIAM & MARY, Dept of Fine Arts, PO Box 8795, Williamsburg, VA 23187. Tel 757-221-2530 (Dept of Arts);Dr Alan Wallach, MFA; Miles Chappell PhD; *Assoc Prof* Marlene Jack, MFA; *Assoc Prof* William Barnes, MFA; *Asst Prof* Lewis Choen, MFA; *Lectr* Joseph Dye, MFA
Estab 1693, dept estab 1936; pub; D; SC 20, LC 22; D 5000, non-maj 825, maj 64
Ent Req: HS dipl
Degrees: BA 4 yrs
Tuition: Res—$1560 per sem; nonres—$4500 per sem; campus res available
Courses: †Architecture, †Art History, †Ceramics, †Drawing, †Painting, †Printmaking, †Sculpture
Summer School: Dir, Nell Jones. Courses—Art History, Design, Painting, Drawing

WISE

CLINCH VALLEY COLLEGE OF THE UNIVERSITY OF VIRGINIA, Visual & Performing Arts Dept, One College Ave, Wise, VA 24293. Tel 540-328-0100; Fax 540-328-0115; *Chmn* Susan Adams Ramsey
Estab 1954, dept estab 1980; pub; D & E; Scholarships; SC 9, LC 4
Ent Req: HS dipl, SAT or ACT
Degrees: BA & BS 4 yrs
Tuition: Res/non-res—$77 per credit; res/non-res—12-18 credits $1,735
Courses: Applied Music, Art Education, Art History, Ceramics, Costume Design & Construction, Drawing, Film, History of Art & Architecture, Music History & Literature, Music Theory, Painting, Performance, Sculpture, Stage Design, Teacher Training, Theatre Arts
Adult Hobby Classes: Dir, Dr Winston Ely
Summer School: Courses—Same as above

WASHINGTON

AUBURN

GREEN RIVER COMMUNITY COLLEGE, Art Dept, 12401 SE 320th St, Auburn, WA 98092-3699. Tel 253-833-9111; Fax 253-288-3465; Internet Home Page Address: www.greenriver.ctc.edu; *Chmn* Dr Bernie Bleha, MFA & EdD; *Instr* Ed Brannan, MFA; *Instr* Elayne Levensky-Vogel, MFA; *Instr* Patrick Navin, MFA

Estab 1965; pub; D & E; SC 31, LC 4; D 330, E 120
Ent Req: HS dipl or 18 yrs old
Degrees: AA 2 yr
Tuition: Living with parents $7380, other housing $11,052
Courses: Art History, Ceramics, Computer Enhanced Design, Craft, Design, Drawing, Painting, Papermaking, Photography, Weaving
Summer School: Dir, Bruce Haulman. Tuition $193.66. Courses—Ceramics, Drawing, Painting, Photography

BELLEVUE

BELLEVUE COMMUNITY COLLEGE, Art Dept, 3000 Landerholm Circle SE, Bellevue, WA 98007-6484. Tel 206-641-2341; Fax 425-643-2690; *Dept Chmn* Carolyn Luark; *Photo Instr* John Wesley; *Art History Instr* Vicki Artimovich
Estab 1966; pub; D & E; SC 15, LC 5; 600, maj 50
Ent Req: no ent req
Degrees: AA 2 yrs
Tuition: Varies according to courses taken
Courses: Art History, Design, Drawing, Interior Design, Painting, Photography, Sculpture, Textile Design
Adult Hobby Classes: Enrl 600. Courses—Ceramics, Design, Drawing, Jewelry, Painting, Photography, Sculpture

BELLINGHAM

WESTERN WASHINGTON UNIVERSITY, Art Dept, Fine Arts Complex, Rm 116, Bellingham, WA 98225-9068. Tel 360-650-3660; Fax 360-647-6878; Internet Home Page Address: www.wwu.edu; *Chmn Dept Art* Thomas Johnston
Estab 1899; FT 15, PT 6; pub; D & E; Scholarships; D 1500, E 200
Ent Req: HS dipl, ent exam
Degrees: BA 4 yr, BA(Educ) 4 yr, BFA 5 yr, MEd 6 yr
Tuition: Res—undergrad $752 per quarter; nonres—undergrad $2658 per quarter
Courses: †Art History, †Ceramics, †Drawing, †Fibers, †Graphic Design, †Metals, †Painting, †Sculpture
Adult Hobby Classes: Enrl 200; tuition $43 per cr continuing educ; Courses—Ceramics, Drawing, Fibers, Paintings, Sculpture
Children's Classes: Enrl 100; tuition $125 one wk session; Courses—Adventures in Science/Arts
Summer School: Dir, Shirley Ennons. Tuition $404, six & nine week sessions; Courses—Art Education, Art History, Ceramics, Drawing, Fibers, Painting, Sculpture

BREMERTON

OLYMPIC COLLEGE, Social Sciences & Humanities Di, 1600 Chester Ave, Bremerton, WA 98337. Tel 360-792-6050, 7767; Fax 360-792-7689; Elec Mail rlawrence@oc.ctc.edu; Internet Home Page Address: www.oc.ctc.edu/; *Dir* Randy Lawrence; *Instr* Ina Wu, MFA; Matt Bockner, MA
Estab 1946; Olympic College Art Gallery; pub; D & E; Scholarships; LC 3; D 125, E 75
Ent Req: HS dipl
Degrees: AA, AS & ATA 2 yrs, cert
Tuition: Res—undergrad $54.70 per cr hr; nonres—undergrad $215.30 per cr hr; no campus res
Courses: Art Appreciation, Art History, Ceramics, Drawing, Jewelry, Life Drawing, Native American Art History, Painting, Papermaking, Photography, Printmaking, Sculpture, Stained Glass
Adult Hobby Classes: Calligraphy, Painting

CHENEY

EASTERN WASHINGTON UNIVERSITY, Dept of Art, 526 Fifth St, Art 1400 Cheney, WA 99004. Tel 509-359-2493; Fax 509-359-7028; Internet Home Page Address: www.ewu.edu; Internet Home Page Address: www.visual.arts.ewu.edu; *Chmn* Lanny Devono; Dr Barbara Miller
Estab 1886; pub; D; Scholarships; SC 58, LC 21, GC 18; D 600, non-maj 200, maj 200, GS 20
Degrees: BA, BEd and BFA 4 yrs, MA and MEd 1 to 2 yrs
Tuition: Res—undergrad $81 per cr hr, grad $130 per cr hr; nonres—undergrad $287 per cr hr, grad $394 per cr hr
Courses: Aesthetics, Art Appreciation, Art Education, Art History, Ceramics, Design, Drawing, Graphic Design, Mixed Media, Painting, Photography, Printmaking, Sculpture, Teacher Training
Summer School: Dir, Richard L Twedt. Enrl 200; tuition $120 per cr undergrad, $190 per cr grad for 8 wk term. Courses—Art History, Art in Humanities, Drawing, Painting, Photography

ELLENSBURG

CENTRAL WASHINGTON UNIVERSITY, Dept of Art, 400 University Way, MS 7564 Ellensburg, WA 98926. Tel 509-963-2665; Elec Mail chinm@cwu.edu; Internet Home Page Address: www.cwu.edu/~art; *Chmn* William Folkestad
Estab 1891; Maintains nonprofit gallery, Sarah Spurgeon Gallery, Dept Art, 400 E University Way MS 7564 Ellensburg WA 98926; 12; pub; D; maj 150, others 7134
Ent Req: GPA 2
Degrees: BA, BFA, MA & MFA 4-5 yrs
Tuition: Res—undergrad $2838 per yr, grad $4548 per yr; nonres—undergrad $10,089 per yr, grad $13,848 per yr; campus res available
Courses: Art Appreciation, †Art Education, Art History, †Ceramics, †Computer Art, Design, †Drawing, †Graphic Design, Illustration, †Jewelry, †Painting, Papermaking, †Photography, Printmaking, †Sculpture, †Wood Design

Adult Hobby Classes: Art in Elementary School, Art in Secondary School
Summer School: Dir, Dr William Folkestad. Tuition $80 per cr for 4, 6, 8 wk sessions. Courses—Art Appreciation, Ceramics, Computer Art, Drawing, Painting

EVERETT

EVERETT COMMUNITY COLLEGE, Art Dept, 2000 Tower St, Everett, WA 98201. Tel 425-388-9378 (Art Dept), 388-9100; Fax 425-388-9129; Elec Mail hvitous@evcc.ctc.edu; Internet Home Page Address: www.evcc.ctc.edu; *Instr Art* Lowell Hanson; *Instr Art* Thom Lee; *Instr Art* Sandra Lepper
Maintain nonprofit art gallery, Northern Gallery; Pub; D&E; Scholarships; SC, LC, Online/Distance Learning
Degrees: AA, AFA & ATA 2 yr
Tuition: $56 per cr hr
Courses: †Aesthetics, Graphic Arts, Media Production, Multimedia, Photography, †Studio Arts, †Written Arts

LACEY

ST MARTINS COLLEGE, Humanities Dept, 5300 Pacific Ave SE, Lacey, WA 98503-1297. Tel 360-491-4700; Fax 360-459-4124; Internet Home Page Address: www.stmartin.edu; *Pres* David R Spangler, PhD
Dept estab 1895; pvt; D & E
Ent Req: HS dipl
Degrees: BA
Tuition: FT $7780 per sem
Courses: Art Appreciation, Art History, Ceramics, Design, Drawing, Painting, Printmaking

LAKEWOOD

FORT STEILACOOM COMMUNITY COLLEGE, Fine Arts Dept, 9401 Farwest Dr SW, Lakewood, WA 98498. Tel 253-964-6500, 964-6655; Fax 253-964-6318; Elec Mail mpederse@pierce.ctc.edu; Internet Home Page Address: www.pierce.ctc.edu/; *Chmn* Morrie Pedersen
Estab 1966, dept estab 1972; FT 2, PT 2; pub; D & E; SC 20, LC 5; D 3500
Ent Req: ent exam
Degrees: AA 2yrs
Tuition: $793 per term; nonres—$3042 per term; no campus res
Courses: Drawing, Figure Drawing, Painting, Photography, Printmaking
Adult Hobby Classes: Courses vary
Summer School: Dir, Walt Boyden. Tuition $19 per cr hr. Courses—Ceramics, Drawing, Painting.

LONGVIEW

LOWER COLUMBIA COLLEGE, Art Dept, 1600 Maple, PO Box 3010 Longview, WA 98632. Tel 360-577-2300, Ext 3414 (Art Dept); Fax 360-577-3400; Internet Home Page Address: lcc.ctc.edu/; *Instr* Yvette O'Neill, MA; *Chmn* Rosemary Powelson, MFA
Estab 1934; pub; D & E; Scholarships; SC 36, LC 8; D 200, E 100
Ent Req: open admis
Degrees: AAS 2 yrs
Tuition: Res—undergrad $57.50 per cr; nonres—undergrad $218.10 per cr; no campus res
Courses: Art History, Calligraphy, Ceramics, Design, Drawing, Graphic Arts, Painting, Photography, Printmaking, Sculpture
Adult Hobby Classes: Courses—Matting & Framing, Relief Woodcuts, Recreational Photography

MOSES LAKE

BIG BEND COMMUNITY COLLEGE, Art Dept, 7662 Chanute St, Moses Lake, WA 98837. Tel 509-762-5351 ext 269; Internet Home Page Address: www.bbcc.ctc.edu; *Dir* Rie Palkovic; *Art Instr* Francis Palkovic; *Art Instr* Betty Johanssen
Estab 1962; Art supplies can be purchased at on-campus shop; pub; D & E; SC 8, LC 2; D 325, E 60, maj 10-15
Ent Req: HS dipl
Degrees: AA 2 yrs
Tuition: Res—undergrad $1641 per yr; nonres—undergrad $6459 per yr; campus res available
Courses: Art Appreciation, Basic Design, Ceramics, Drawing, History of Art & Architecture, Lettering, Painting, Photography, Poster Art, Pottery, Sculpture
Adult Hobby Classes: Enrl 15. Courses—Drawing

MOUNT VERNON

SKAGIT VALLEY COLLEGE, Dept of Art, 2405 E College Way, Mount Vernon, WA 98273. Tel 360-416-7724 (Dept Art), 428-1261; Fax 360-416-7690; *Chmn* Ann Chadwick-Reid
Estab 1926; FT 2, PT 6; pub; D & E; Scholarships; SC 32, LC 1; D 2500, E 3500
Ent Req: open
Tuition: Res—$562 per quarter full-time; nonres—$2168 per quarter full-time
Courses: Art Appreciation, Art History, Ceramics, Design, Drawing, Figure Drawing, Jewelry, Painting, Photography, Printmaking, Sculpture
Adult Hobby Classes: Four nights a week
Summer School: Dir, Bert Williamson

PASCO

COLUMBIA BASIN COLLEGE, Esvelt Gallery, 2600 N 20th Ave, Pasco, WA 99301. Tel 509-547-0511 ext 2374; Fax 509-546-0401; Elec Mail kpierce@columbiabasin.edu; Internet Home Page Address: www.cbc2.org/arts/arts_center; *Art Dept Lead & Instr* James Craig, MFA; *Dean Arts & Humanities* Bill McKay; *Dir Gallery & Instr* Karin Pierce; *Instr* Tracy Petre; *Instr* Greg Pierce
Estab 1955; FT 3, PT 15; D & E, wkends; Scholarships; SC 12, LC 3
Degrees: AA & AS
Tuition: Res—$178.50; nonres—$684.50
Courses: Art Appreciation, Art History, Calligraphy, Ceramics, Design, Drawing, Graphic Design, Interior Design, Jewelry, Metal Casting & Foundary, Photography, Printmaking, Sculpture, Stage Design, Video
Adult Hobby Classes: Enrl 5000; tuition $400 per qtr. Courses—Art Appreciation, Fine Arts, Graphic Design
Summer School: Dir, Bill McKay. Enrl 1500; tuition $400 for 8 wks. Courses—Ceramics, Drawing, Illustration, Introduction to Art

PULLMAN

WASHINGTON STATE UNIVERSITY, Fine Arts Dept, Pullman, WA 99164-7450. Tel 509-335-8686; Fax 509-335-7742; *Chmn* Paul Lee
Estab 1890, dept estab 1925; FT 12; pub; D & E; Scholarships; SC 29, LC 13, GC 25; D 1593, E 131, maj 220, GS 25
Ent Req: HS dipl
Degrees: BA(Fine Arts) 4 yrs, BFA 4 yrs, MFA 2 yrs
Tuition: Res—$1829; nonres—$5272
Courses: Ceramics, Drawing, Electronic Imaging, Painting, Photography, Printmaking, Sculpture

SEATTLE

THE ART INSTITUTES, The Art Institute of Seattle, 2323 Elliott Ave, Seattle, WA 98121-1622. Tel 206-448-0900; Fax 206-448-2501; Elec Mail aisadm@aii.edu; Internet Home Page Address: www.ais.edu; *Pres* Tim Schutz; *VPres & Dean Educ* Daniel Lafferty, MS; *Exec VPres, Dir Admin & Financial Servs* Shelly DuBois
Estab 1946; pvt; D&E; Scholarships; SC 60%, LC 40%; D 2000, E 350
Ent Req: HS dipl, portfolio approval recommended but not required
Degrees: prof dipl, AA 2 yr
Tuition: $13,365 per yr for 3 qtrs
Courses: Advertising Design, †Audio Production, Animation, Culinary Arts, Multimedia, Fashion Marketing, Industrial Design, Commercial Art, Commercial Art Technician, †Costume Design & Construction, †Design, Fashion Arts, Fashion Merchandising, Film, Graphic Arts, Graphic Design, Illustration, Interior Design, Layout & Production, Lettering, Photography, †Textile Design, Video

CITY ART WORKS, Pratt Fine Arts Center, 1902 S Main St, Seattle, WA 98144-2206. Tel 206-328-2200; Fax 206-328-1260; Internet Home Page Address: www.pratt.org; *Development Dir* Patience Allen, MRP; *Exec Dir* Gregory Robinson, MPA
Open daily 9 AM - 9 PM; Estab 1979; pvt; D & E; Scholarships, Fellowships; SC 300; D 1000, E 1000
Ent Req: open enrollment
Degrees: no degree prog
Tuition: $55 - $500 per class
Courses: Collage, Drawing, Glass blowing & casting, Goldsmithing, Illustration, Jewelry, Mixed Media, Painting, Printmaking, Sculpture, Silversmithing
Adult Hobby Classes: Enrl 2000; tuition $100-$500 for 8 wk class. Classes—Drawing, Glass, Jewelry, Painting, Printmaking, Sculpture
Children's Classes: Drawing, Glass, Printmaking, Sculpture
Summer School: Educ Dir, Janet Berkow. Enrl 50; tuition $400-$650 per wk-long class. Classes—Glassblowing, Jewelry, Printmaking, Sculpture

NORTH SEATTLE COMMUNITY COLLEGE, Art Dept, Humanities Division, 9600 College Way N Seattle, WA 98103. Tel 206-527-3709; Fax 206-527-3784; Elec Mail echriste@sccd.ctc.edu; Internet Home Page Address: northseattle.edu/humanities/art/; *Dean* Edigh Wollin, MFA; *Instr* David J Harris, MFA; *Instr* Joan Stuart Ross, MFA; *Head Dept* Elroy Christenson, MFA
Estab 1970; pub; D & E; Scholarships; SC 27, LC 7; D 150, E 65
Income: $State funded, foundation endowments, grants
Ent Req: HS dipl
Degrees: AA 2 yr, AFA, CFA 2 yr
Tuition: Res—undergrad $657.75 per quarter, $62.752 per cr, nonres—$2,393.75 per quarter; no campus res
Courses: Art History, Drawing, History of Art & Architecture, Jewelry, Painting, Sculpture
Adult Hobby Classes: Enrl 6600; tuition $657.75 per quarter for res, $2,393.75 per quarter for nonres. Courses—Art History, Basic Drawing, Ceramics, 2-D & 3-D Design, Intro to Art, Jewelry Design, Painting, Sculptures, Water Solvable Media

PILCHUCK GLASS SCHOOL, 430 Yale Ave North, Seattle, WA 98109. Tel 206-621-8422; Fax 206-621-0713; Elec Mail info@pilchuck.com; Internet Home Page Address: www.pilchuck.com; *Exec Dir* Patricia Wilkinson
Estab 1971; summer location: 1201 316th St NW, Stanwood, WA 98292-9600, Tel: 206-445-3111, Fax: 206-445-5515; FT & PT 50; pvt; D & E; Scholarships; SC 25; D & E 250
Ent Req: 18 years or older
Tuition: $2675-$3250 per class; campus res available
Courses: Constructions, Glass, Sculpture
Summer School: Exec Dir, Marjorie Levy. Enrl 250; tuition approx $2200 for 2 1/2 wk course. Courses—Casting, Cold Working, Flamework, Fusing, Glassblowing, Mosaic, Stained Glass

SEATTLE CENTRAL COMMUNITY COLLEGE, Humanities - Social Sciences Division, 1701 Broadway, Seattle, WA 98122. Tel 206-587-3800; Fax 206-344-4390; Internet Home Page Address: www.seattlecentral.org; *Prof* Ileana Leavens; *Chmn* Audrey Wright; *Prof* Tatiana Garmendia; *Asst Prof* Don Barrie; *Asst Prof* Don Tanze; *Instr* Royal Alley-Bavaes
Estab 1970; pub; D & E; Scholarships; SC 15, LC 5; D 70, E 50
Ent Req: HS dipl, ent exam
Degrees: AA 2 yrs
Tuition: Res—$426 per qtr; nonres—$1692 per qtr; no campus res
Courses: †Aesthetics, †Art Appreciation, Art History, †Design, †Drawing, †History of Art & Architecture, †Mixed Media, Painting, †Printmaking
Summer School: Dir, Ileana Leavens. Courses—Art History, Painting, Sculpture

SEATTLE PACIFIC UNIVERSITY, Art Dept, 3307 Third Ave W, Seattle, WA 98119. Tel 206-281-2079; Fax 206-281-2500; *Prof* Michael Caldwell; *Dean Col Arts & Sciences* Joyce Erickson
Scholarships, Fellowships
Tuition: $4223 per qtr for 12-17 cr; campus res—$1620 room, board & meals
Courses: Art Appreciation, †Art Education, Ceramics, Design, Drawing, Fashion Arts, Handicrafts, Industrial Design, Interior Design, Jewelry, Painting, Printmaking, Sculpture, Textile Design, Weaving
Children's Classes: Tuition $23 for 8 wk session. Courses - General Art for Children
Summer School: Dir, Larry Metcalf. Two 4 wk sessions. Courses - Elementary Art Education Workshops, Fabrics, Monoprinting, Painting, Papermaking, Silkscreening

SEATTLE UNIVERSITY, Fine Arts Dept, Division of Art, Broadway & Madison, Seattle, WA 98122-4460. Tel 206-296-5356 (Fine Arts Dept), 296-6000; Elec Mail cwclay@seattleu.edu; Internet Home Page Address: www.seattleu.edu/artsci; *Prof* William Dore; *Assoc Prof Art* Michael Holloman; *Chmn* Carol Wolfe Clay; *Asst Prof Art* Karen Ann Gottberg; *Assoc Prof Art* Andrew P Schulz; *Dir Choral Activities* Joy L Sherman; *Asst Prof Art* Father Josef V Venker
D; Scholarships
Ent Req: HS dipl and entrance exam
Degrees: BA prog offered
Tuition: $397 per cr hr
Courses: Art History, Design, Drama, Drawing, Painting, Printmaking, Sculpture, Studio Art
Summer School: Chmn, Kate Duncan. Courses—same as regular session

SHORELINE COMMUNITY COLLEGE, Humanities Division, 16101 Greenwood Ave N, Seattle, WA 98133. Tel 206-546-4741; Fax 206-546-5869; Elec Mail shart@ctc.edu; Internet Home Page Address: www.shoreline.com; *Chmn* Sara Hart, MFA; *Acting Dir Writing* Chris Fisher; *Prof* Mike Larson, MA; *Prof* Chris Simons, MFA; *Prof* Bruce Armstutz, MFA; *Prof* K C Maxwell, MFA
Estab 1964; pub; D & E; Scholarships; SC 9, LC Art History Survey; D 5500
Publications: EBBTIDE, biweekly; Spindrift, annual art & literary publication
Ent Req: HS dipl, col ent exam
Degrees: AA & AFA
Tuition: On-campus $10,809, off-campus $7,491
Courses: †Advertising Design, Aesthetics, Art Appreciation, Art History, Ceramics, †Commercial Art, Conceptual Art, Constructions, †Costume Design & Construction, Design, †Drafting, Drawing, †Fashion Arts, Film, †Graphic Arts, †Graphic Design, History of Art & Architecture, Mixed Media, Multimedia, Painting, †Photography, Sculpture, Stage Design, †Textile Design, †Video
Summer School: Dir, Marie Rosenwasser. Enrl 45 maximum; two 4 wk terms. Courses—Ceramics, Design, Design Appreciation, Drawing, Electronic Design, Graphic Design, Painting, Photography, Sculpture

UNIVERSITY OF WASHINGTON, School of Art, PO Box 353440, Seattle, WA 98195-3440. Tel 206-543-0970 (Admin), 543-0646; Fax 206-685-1657; Internet Home Page Address: www.washington.edu; *Dir* Christopher Ozubko
Estab 1878; pub; D & E; Scholarships; SC 113, LC 84, GC 30; Maj 1100, grad 125
Ent Req: must meet university admission req, must be matriculated to enroll in art classes in academic year
Degrees: BFA 5 yrs, BA 4 yrs, MA, PhD and MFA
Tuition: Res—undergrad $1300, grad $1850, nonres—undergrad $3500, grad $4405
Courses: †Art History, †Ceramics, Drawing, Fibers, †Graphic Design, †Industrial Design, Interdisciplinery Visual Arts, Metals, †Painting, †Photography, †Printmaking, †Sculpture, Textile Design, Video, Weaving
Summer School: Dir, C Ozubko. Enrl 830; 2-month term. Various courses offered through UW Extension, open to community

SPOKANE

GONZAGA UNIVERSITY, Dept of Art, College of Arts & Sciences, 502 E Boone Spokane, WA 99258-0001. Tel 509-328-4220, Ext 6686; *Prof* J Scott Patnode; *Prof* R Gilmore; *Prof* Mary Farrell; *Chmn* Terry Gieber; *Asst Prof* Shalon Parker
Estab 1962; Maintains a nonprofit art gallery, The Jundt Gallery - art mus consists of a 2,800 sq ft gallery, the Gonzaga Art Dept is loated within the Jundt Art Center & mus; FT 4, PT 2; pvt; D & E; SC 20, LC 5, GC 12; D 250 incl maj 40, others 80
Ent Req: HS dipl
Degrees: BA 4 yrs
Tuition: $8,730 per sem; campus res available
Courses: 2-D Design, Art Education, Ceramics, Drawing, †History of Art, Painting, Printmaking, Sculpture, Teacher Training
Summer School: Dean, Mary McFarland. Term of 8 wks beginning June. Courses—Ceramics, Drawing, Painting, Printmaking

SPOKANE FALLS COMMUNITY COLLEGE, Fine Arts Dept, W 3410 Fort George Wright Dr, Spokane, WA 99204. Tel 509-533-3500; 533-3710 (Art Dept); Fax 509-533-3484; Elec Mail jof@sfcc.spokane.cc.wa.us; Internet Home Page Address: www.stcc.spokane.cc.wa.us; *Dean* Jim Minkler; *Asst Prof* Tom O'Day; *Asst Prof* Carolyn Stephens; *Asst Prof* Dick Ibach; *Asst Prof* Jeanette Kirishian; *Asst Prof* Patty Haag; *Asst Prof* Carl Richardson; *Asst Prof* Mardis Nenno; *Dept Chmn & Asst Prof* Jo Fyfe; *Adjunct Asst Prof* Linda Kraus-Perez; *Adjunct Asst Prof* Peter Jagoda; *Adjunct Asst Prof* Ann Lauderbaugh; *Adjunct Asst Prof* Bob Evans; *Adjunct Asst Prof* Richard Schindler; *Adjunct Asst Prof* Karen Kaiser; *Adjunct Asst Prof* Roger Ralston; *Adjunct Asst Prof* Ken Speiring; *Adjunct Asst Prof* Lee Ayars; *Adjunct Asst Prof* Cindy Wilson
Estab 1963; pub; D & E & Sat; Scholarships; SC 41, LC 5, workshops; D 600, E 200
Ent Req: HS dipl, GED
Degrees: AAA 3 yr, AA, AFA & CFA 2 yr
Tuition: Res—$467 per quarter; nonres—$1837 per quarter; no campus res
Courses: African, Art Education, Art History, †Bronze Casting, Calligraphy, Ceramics, Computer Arts, Design 2D & 3D Advanced, Digital Paint, Drawing, Exhibit, Fiber Arts, Handicrafts, Health/Safety in Art, Illustration, Intro to Art, Jewelry, Lettering, Mixed Media, †Mold Making, Native & Hispanic Arts, Painting, Photography, Portfolio, Printmaking, Sculpture, Weaving
Adult Hobby Classes: Enrl 10-20; tuition $25.60 for 6 week term. Courses—Art History, Calligraphy, Ceramics, Drawing, Watercolor, Weaving
Children's Classes: Enrl 20-22; tuition $30 for 4 wks. Art Experiences, Courses—Ceramics, Drawing
Summer School: Dir, Stan Lauderbaugh. Enrl 100; tuition $50.30 per cr or $503 per 10-18 cr; 6-8 wk term. Courses—Art Workshops, Ceramics, Color & Design, Drawing, Intro to Art, Watercolor

WHITWORTH COLLEGE, Art Dept, 300 W Hawthorne Ave, Spokane, WA 99251. Tel 509-777-1000, 777-3258 (Art Dept); Fax 509-466-3781; Internet Home Page Address: www.whitworth.edu; *Fine Arts Dept Chmn & Asst Prof* Barbara Filo, MA & MFA; *Assoc Prof* Gordon Wilson, MFA; *Instr* Jeff Harris, MFA; *Instr* Carl Stejer; *Assoc Prof* Scott Kolbo, MFA
Pvt; D & E; Scholarships; SC 18, LC 6
Ent Req: HS dipl
Degrees: BA 4 yrs, MA, MAT & MEd 2 yrs
Courses: Art Administration, Art Education, Art History, Ceramics, Drawing, Graphic Design, Leaded Glass, Mixed Media, Painting, Printmaking

TACOMA

PACIFIC LUTHERAN UNIVERSITY, Dept of Art, Dept Art, Tacoma, WA 98447. Tel 253-535-7573; Fax 253-536-5063; Internet Home Page Address: www.plu.eduartd; *Chmn* John Hallam PhD; *Prof* David Keyes; *Assoc Prof* Dennis Cox, MFA; *Assoc Prof* Beatrice Geller, MFA; *Assoc Prof* Lawrence Gold, MFA; *Assoc Prof* Walt Tomsic, MFA
Estab 1890, dept estab 1960; Maintain nonprofit art gallery on-campus; Den; D & E; Scholarships; SC 29, LC 8; D 800, E 75, maj 60
Ent Req: HS dipl, SAT
Degrees: BA, BAEd & BFA 4 yrs
Tuition: $19,000 per yr
Courses: Art Appreciation, Art Education, Art History, †Ceramics, †Drawing, Electronic Imaging, †Graphic Arts, †Graphic Design, Illustration, †Mixed Media, †Painting, †Photography, †Printmaking, †Sculpture

TACOMA COMMUNITY COLLEGE, Art Dept, 6501 S 19th St, Tacoma, WA 98466-6139. Tel 253-566-5000, 566-5260 (Art Dept); Fax 253-566-6070; Internet Home Page Address: www.tacoma.ctc.edu; *Art Dept Chmn* Richard Mahaffey
Estab 1965; FT 5; pub; D & E; Scholarships; SC 35, LC 1; D & E 1500
Degrees: AAS & Assoc in Liberal Arts 2 yrs
Tuition: Res—$58.01 per cr hr; nonres—$218.65 per cr hr
Courses: 2-D & 3-D Design, Art History, Figure Drawing, Jewelry, Painting, Photography, Pottery, Printmaking, Sculpture

UNIVERSITY OF PUGET SOUND, Art Dept, 1500 N Warner St, Campus Mailbox 1072 Tacoma, WA 98416. Tel 253-879-3348; Fax 253-879-3500; Elec Mail sgervais@ups.edu; Internet Home Page Address: www.ups.edu/; *Chmn* Helen Nagy
Estab 1935; FT 7, PT 2; den; D & E; Scholarships; SC 17, LC 15; maj 119, undergrad 455
Ent Req: HS grad
Degrees: BA 4 yrs
Tuition: $22,350 per yr; campus res—room & board $5780 per yr; student fee $155
Courses: Art History, Ceramics, Design, Drawing, Oriental Art, Painting, Photography, Printmaking, Sculpture, Studio Art, Studio Design
Summer School: Courses—Art Education, Art History, Ceramics, Drawing, Painting, Watercolor

VANCOUVER

CLARK COLLEGE, Art Dept, 1800 E McLoughlin Blvd, Vancouver, WA 98663. Tel 360-694-6521; Fax 360-992-2828; Internet Home Page Address: www.clark.edu; *Coordr* Chuck Ramsey
Estab 1933, dept estab 1947; pub; D & E; Scholarships; SC 87, LC 3; D 400, E 500
Ent Req: open door
Degrees: Assoc of Arts & Science, Assoc of Applied Science, & Assoc of General Studies 2 yrs
Tuition: Res—$27.50 per cr hr, $247.50 (9 cr), $315 (10 cr); nonres—$104 per cr, $936 (9 cr), $1040 (10 cr)
Courses: Art History, Calligraphy, Ceramics, Drawing, Graphic Design, Handicrafts, Jewelry, Lettering, Painting, Photography

Summer School: Dir Chuck Ramsey. Enrl 40 FTE; tuition $27.50 per cr. Courses—Art Appreciation, Art History, Calligraphy, Ceramics, Drawing, Photography, Watercolor

WALLA WALLA

WALLA WALLA COMMUNITY COLLEGE, Art Dept, 500 Tausick Way, Walla Walla, WA 99362. Tel 509-527-4212, 527-4600; *Instr* Melissa Webster; *Instr* Jim Fritz; *Instr* Bill Piper
Estab 1967; pub; D & E; Scholarships
Ent Req: HS dipl, equivalent
Degrees: AA 2 yr
Tuition: Res (in state) $587 per qtr; nonres $893 per qtr
Courses: Art Appreciation, Ceramics, Design, Drawing, Handicrafts, Photography, Pottery, Printmaking, Sculpture
Summer School: Dir, Don Adams. Tuition same as regular quarter

WHITMAN COLLEGE, Art Dept, Olin Hall, 345 Boyer Ave Walla Walla, WA 99362. Tel 509-527-5248, 527-5111; Fax 509-527-5039; *Co-Chmn* Charles Timm-Ballard; *Vis Asst Prof Art* Mathew Kelly; *Instr* Charly Bloomquist; *Vis Asst Prof Art* Ruth Lingen; *Vis Asst Prof Art* Trygve Faste; *Vis Asst Prof Art* Jessica Swanson; *Vis Asst Prof Art* Kevin Johnson
Estab 1883; Maintains nonprofit gallery, Sheehan Gallery & Bleesway Student Gallery; Pvt; D & E; Scholarships; SC 31, LC 3; D 320, E 30, non-maj 200, maj 150
Ent Req: HS dipl, ent exam
Degrees: BA 4 yrs
Tuition: $26,870 per yr
Courses: Aesthetics, Art History, Book Arts, Ceramics, Design, Drawing, History of Art & Architecture, Painting, Photography, Printmaking, Sculpture

WENATCHEE

WENATCHEE VALLEY COLLEGE, Art Dept, 1300 Fifth St, Wenatchee, WA 98801. Tel 509-662-1651; Fax 504-664-2538; Elec Mail shenderson@wvcmail.ctc.edu; Internet Home Page Address: wvc.ctc.edu/; *Prof* Stephen Henderson
Estab 1939; pub; D & E; Scholarships; LC 6; D 550, E 200, maj 45
Ent Req: HS dipl, open door policy
Degrees: AA 2 yrs
Tuition: Res—54.70 per cr hr; nonres—undergrad $67.10 per cr; campus res available
Courses: Aesthetics, Art Appreciation, Art History, Ceramics, Color Theory, Design, Drawing, Painting, Printmaking
Summer School: Dir, Dr Joann Schoen

YAKIMA

YAKIMA VALLEY COMMUNITY COLLEGE, Dept of Visual Arts, S 16th Ave & Nob Hill Blvd, PO Box 22520 Yakima, WA 98907-2520. Tel 509-574-4846 (Chair), 574-4844 (E Hayes), 574-4845 (Assoc faculty), 574-4600 (Main); Elec Mail rfisher@yvcc.cc.wa.us; Internet Home Page Address: www.yvcc.cc.wa.us; *Dir* Robert A Fisher; *Faculty* Herb Blisard; *Faculty* Erin Hayes
Estab 1928; Maintain nonprofit art gallery; Larson Gallery; art supplies available on-campus; PT 5; pub; D&E; Scholarships; SC 9, LC 2; D 250, E 100, non-maj 320, maj 30
Ent Req: HS dipl
Degrees: AA & AS offered
Tuition: Res—$66.55 per cr hr; nonres—$79.74 per cr hr with waiver; international $238.25
Courses: Art Appreciation, Art History, Ceramics, Design, Drawing, Graphic Design, Jewelry, Painting, Photography, Sculpture, Silversmithing
Summer School: Dir, Robert A Fisher. Tuition $530 per quarter, FT

WEST VIRGINIA

ATHENS

CONCORD COLLEGE, Fine Art Division, PO Box 1000, Athens, WV 24712-1000. Tel 304-384-3115; Fax 304-384-9044; *Prof* Gerald C Arrington, MFA; *Asst Prof* Sheila M Chipley, EdD; *Asst Prof* Steve Glazer, EdD
Estab 1872, dept estab 1925; pub; D & E; Scholarships; SC 32, LC 3; non-maj 200, maj 75, D 75
Ent Req: HS dipl
Degrees: BA & BS 4 yrs
Tuition: Res—$1223 per sem; nonres—$2488 per sem; campus res—room & board available
Courses: †Advertising, Advertising Design, Art Education, Art History, Ceramics, Collage, Commercial Art, Drawing, Graphic Arts, Graphic Design, Handicrafts, Illustration, Painting, Printmaking, Sculpture, Teacher Training
Adult Hobby Classes: Enrl varies; tuition based on part-time rates. Courses—Vary
Children's Classes: Enrl varies; tuition none for 4 wk sessions. Courses vary
Summer School: Term of 5 wks beginning June. Courses—varied

BETHANY

BETHANY COLLEGE, Dept of Fine Arts, 1 Main St, Bethany, WV 26032. Tel 304-829-7000; Fax 304-829-7312; Internet Home Page Address: www.bethanywv.edu; *Assoc Prof Studio Art* Kenneth Morgan; *Head Dept* Herb Weaver

Estab 1840, dept estab 1958; den; D; Scholarships; SC 27, LC 7; D 136, non-maj 106, maj 30
Ent Req: HS dipl
Degrees: BA & BS 4 yrs
Tuition: $14,752 per yr; campus res available
Courses: Art History, Calligraphy, Ceramics, Drawing, Graphic Design, Illustration, Painting, Photography, Sculpture

BLUEFIELD

BLUEFIELD STATE COLLEGE, Division of Arts & Sciences, Bluefield, WV 24701. Tel 304-327-4000; Fax 304-325-7747; Internet Home Page Address: www.bluefield.wvnet.edu; *Prof* Joyhce Shamro; *Head Dept* Jim Voelker
Estab 1895; pub; D & E; Scholarships, Fellowships; SC 14, LC 4; D 125, E 40, non-maj 150, minor 10, other 5
Ent Req: HS dipl, 18 yrs old
Degrees: BA, BA(Humanities), BS, BS(Educ) & BS(Engineering Technology) 4 yrs
Tuition: Res—$3000 per sem; nonres—$6432 per sem
Courses: Art Education, Art History, Ceramics, Computer Art, Drawing, Painting, Photography, Printmaking, Sculpture
Adult Hobby Classes: Enrl 10-15. Courses—Art in Western World, Photography, Television, Woodcarving
Children's Classes: Enrl varies. Courses—Ceramics, Drawing
Summer School: Dir, Dwight Moore. Enrl 15-20; term of 5 wks beginning June/July. Courses—Art Educ & Appreciation (workshops on occasion)

BUCKHANNON

WEST VIRGINIA WESLEYAN COLLEGE, Art Dept, 59 College Ave, Buckhannon, WV 26201. Tel 304-473-8000, 473-8433; Elec Mail mason_k@wvwc.edu; Internet Home Page Address: www.wvwc.edu/aca/art/artfront; *Assoc* Margo Davis; *Chmn & Assoc Prof* Kelvin Mason; *Assoc Prof* Carol Pelletier; *Asst Prof* Brent Patterson
Estab 1890; Maintains nonprofit art gallery; Den; D & E; SC 16, LC 6; non-maj 120, maj 20, grad 2
Ent Req: HS dipl, ent exam
Degrees: BA
Tuition: $17,300 per yr; campus res—room & board $4,500
Courses: Art Education, Art History, Ceramics, Computer Graphics, Computer Illustration, Design, Drawing, Graphic Design, Painting, Printmaking, Sculpture, Theatre Arts

CHARLESTON

UNIVERSITY OF CHARLESTON, Carleton Varney Dept of Art & Design, 2300 MacCorkle Ave SE, Charleston, WV 25304. Tel 304-357-4725; Fax 304-357-4175; Elec Mail swatts@ucwv.edu; *Coordr* Steve Watts; *Dir* Joellen Kerr; *Instr* Tracy Wasinger, BS
Estab 1888; FT 3, PT 3; pvt; D & E; Scholarships; maj 55
Ent Req: usual col req
Degrees: 4 yr
Tuition: Full time $6,600 per sem; room $935 - $1,590; board $1,175 - $1,305
Courses: Advanced Studio, Art Administration, Art Appreciation, †Art Education, Art History, Color Theory, Design, Drafting, Drawing, †Interior Design, Painting, Photography, Printmaking, Teacher Training
Children's Classes: Enrl 30; tuition by the wk. Courses—Summer Art Camp Program
Summer School: Dir, Joellen Kerr. Tuition $60 per wk. Courses—Summer Colors

ELKINS

DAVIS & ELKINS COLLEGE, Dept of Art, 100 Campus Dr, Elkins, WV 26241. Tel 304-637-1212; Fax 304-637-1287; Elec Mail larosem@DnE.edu; *Head, Assoc Prof* Matthew LaRose; *Adjunct Instr* Holly Adams; *Adjunct Instr* Mary Rayme; *Adjunct Instr* Donna Morgan
Estab 1904; FT 1, PT 3; pvt, den; D & E; Scholarships; SC 18, LC 4; non-maj 30, maj 10
Ent Req: HS dipl
Degrees: BA, BS
Tuition: $5290 per sem; campus res available
Courses: †Art Education, Art History, Ceramics, Costume Design & Construction, Drawing, Graphic Arts, Painting, Pottery, †Printmaking, Sculpture, Stage Design, †Theatre Arts, Weaving
Adult Hobby Classes: Enrl 90
Summer School: Dir Margo Blevin. Augusta Heritage Arts Workshop. Courses—Appalachian Crafts, Basketry, Bushcraft, Calligraphy, Chairbottoming, Dance, Folkcarving, Folklore Musical Instrument Construction & Repair, Papermaking, Pottery, Stained Glass, Woodworking

FAIRMONT

FAIRMONT STATE COLLEGE, Div of Fine Arts, Fairmont, WV 26554. Tel 304-367-4000; Internet Home Page Address: www.fscwv.edu; *Prof* John Clovis, MFA; *Prof Dr* Stephen Smigocki PhD, MFA; *Prof* Barry Snyder, MFA; *Prof* Lynn Boggess, MFA
Pub; D & E; Scholarships; D maj 35, non-maj 15
Ent Req: HS dipl
Degrees: BA(Art Educ) and BS(Graphics, Fine Arts) 4 yrs
Tuition: Living with relative $6234; res—in-state $8016, out-of-state $11,250; non-res—in-state $10,280, out-of-state $13,514

Courses: †Art Education, Art History, Ceramics, Commercial Design, Design, Drawing, Graphic Arts, Painting, Photography, Printmaking, Sculpture
Adult Hobby Classes: Two - three times a wk for 16 wks. Courses—same as above
Children's Classes: Enrl 20; tuition $25 per 6 wk term. Courses—Art for children ages 5 - 12, 2 - D & 3 - D Design
Summer School: Dir Dr S Snyder. Enrl 50; 4 wks per sessions. Courses—Art Education, Drawing, Design, Painting, Art Appreciation

GLENVILLE

GLENVILLE STATE COLLEGE, Dept of Fine Arts, 200 High St, Glenville, WV 26351. Tel 304-462-7361, Ext 215, 462-4130; Fax 304-462-8619; Elec Mail mckinneyj@glenville.wvnet.edu; Internet Home Page Address: www.glenville.wvnet.edu/academic; *Chmn* John McKinney; *Assoc Prof* Deanna Foxworthy, BFA
Estab 1872, dept estab 1952; pub; D & E; Scholarships; SC 25, LC 3; D 128, E 42, non-maj 14, maj 55
Ent Req: HS dipl
Degrees: BA 4 yrs
Courses: †Art Education, Art History, †Ceramics, Drawing, Graphic Arts, Jewelry, Lettering, †Painting, Photography, Printmaking, Sculpture, Textile Design, Weaving

HUNTINGTON

MARSHALL UNIVERSITY, Dept of Art, 400 Hal Greer Blvd, Huntington, WV 25755. Tel 304-696-6760, 696-5451; Fax 304-696-6505, 696-6760; Elec Mail lemon@marshall.edu; Internet Home Page Address: www.marshall.edu/art/; *Chmn* Robert Lemon; *Dean* Donald Van Horn; *Prof* Earlene Allen; *Prof* Mary Grassell; *Prof* Susan Jackson; *Prof* Peter Massing; *Prof* Stan Sporny; *Prof Dr* Beverly Marchant; *Prof Dr* Susan Power; *Asst Prof* Jonathan Cox; *Prof* Michael Cornfeld; *Prof* Robert Rowe
Estab 1903; FT 10; pub; maj incl grad 108
Ent Req: HS grad
Degrees: BFA & MA in art educ & studio 4 yrs
Tuition: Res—$1310 per sem; nonres—$3412 per sem; campus res available
Courses: Art Education, Ceramics, Graphic Design, Painting, Photography, Printmaking, Sculpture, Weaving
Summer School: Tuition $427.10 for 6 sem hrs, nonres $1247.10 for 5 wk terms

INSTITUTE

WEST VIRGINIA STATE COLLEGE, Art Dept, Campus Box 4, Institute, WV 25112-1000. Tel 304-766-3196, 766-3198; Fax 304-768-9842; *Chair* Reidun Ovrebo PhD; *Asst Prof* Molly Erlandson; *Asst Prof* Paula Clendenin
D & E; Scholarships; SC 26, LC 11
Ent Req: HS dipl
Degrees: AB(Art) and BSEd(Art) 4 yrs
Tuition: Res—$1282 per sem; nonres—$2946 per sem
Courses: Appalachian Art & Crafts, Art Education, Art History, Ceramics, Computer Graphics, Design, Drawing, Figure Drawing, Graphic Design, Painting, Photography, Printmaking, Sculpture, Teacher Training
Summer School: Dir, R Ovrebo. Enrl 75.; 3 or 6 wk session. Courses—Art Appreciation, Basic Studio

KEYSER

POTOMAC STATE COLLEGE, Dept of Art, Mineral St & Fort Ave, Keyser, WV 26726. Tel 304-788-6800; Internet Home Page Address: www.wvu.edu; *Pres* Anthony Whitmore, MA; *Chmn* Richard Davis
College estab 1953, dept estab 1974; FT 2; pub; D & E; SC 8, LC 2; D 160, non-maj 150, others 10
Ent Req: HS dipl
Degrees: AA 2 yrs, AAS 2 yrs
Tuition: In state—$10.50 per cr hr; out of state—$33.50 per cr
Courses: Drawing, Painting, Sculpture, Visual Foundation
Summer School: Dir, Edward Wade. Enrl 10-20; tuition res—undergrad $77.25 per 3 hrs, nonres—undergrad $236.25 per 3 hrs for 5 wk term beginning June 1. Courses—Art Appreciation, Drawing, Painting

MONTGOMERY

WEST VIRGINIA INSTITUTE OF TECHNOLOGY, Creative Arts Dept, 405 Fayette Pike, Montgomery, WV 25136. Tel 304-442-3192 (Dept), 442-3071; Elec Mail rsimile@wvutech.edu; Internet Home Page Address: www2.wvutech.edu; *Head Dept* Robert Simile
Estab 1896; pub; Scholarships; 3500 (total)
Ent Req: HS grad
Degrees: AS, BA and BS 2-4 yrs
Tuition: Res—$1323 per sem; nonres—$3229 per sem
Courses: Art Appreciation, Ceramics, Design, Graphic Design, Painting

MORGANTOWN

WEST VIRGINIA UNIVERSITY, College of Creative Arts, Division of Art, PO Box 6111 Morgantown, WV 26506-6111. Tel 304-293-4841; Fax 304-293-5731; Elec Mail sergio.soave@mail.wvu.edu; Internet Home Page Address: www.wvu.edu; *Prof* Robert Anderson, MFA; *Prof* Janet Snyder, PhD; *Prof* Victoria Fergus PhD, MFA; *Prof* Nagun Zhang, MFA; *Prof* Kristina Olson, MA; *Prof* Clifford Harvey, BFA; *Prof* Alison Helm, MFA; *Prof* Shaila Christofferson, MFA;

Prof Young Kim, MFA; *Prof* Eve Faulkes, MFA; *Prof* William Thomas PhD, MFA; *Prof* Paul Krainak, MFA; *Chmn Div of Art* Sergio Soave, MFA; *Prof* Joseph Lupo, MFA; *Prof* Robert Bridges, MFA; *Prof* Robert Hopson, PhD; *Prof* Ann Hoffman, MFA; Juan Girardo
Estab 1867, div estab 1897; Maintain nonprofit art gallery; Mesaros Gallery; Evansdale Library; Pub; D & E; Scholarships; D 250, maj 330, grad 28
Ent Req: HS dipl
Degrees: BA(Art Educ) and BFA 4 yrs, MA(Art) and MFA(Art) 2-4 yrs; grad degrees
Tuition: Res—undergrad $7,988 per yr, grad $3,004 per yr; nonres—undergrad $13,514 per yr, grad $8,640 per yr; campus residency available
Courses: †Art Education, Art History, Basic Design, †Ceramics, Drawing, †Graphic Design, †Painting, †Printmaking, †Sculpture

PARKERSBURG

WEST VIRGINIA UNIVERSITY AT PARKERSBURG, Art Dept, 300 Campus Dr, Parkersburg, WV 26101-9577. Tel 304-424-8000; Fax 304-424-8354; Internet Home Page Address: www.wvup.wvnet.edu; *Chmn* Dr Nancy Nanney; *Asst Prof* Henry Aglio, MFA; *Instr* Sarah Beth Cox
Estab 1961, dept estab 1973; pub; D & E; Scholarships; SC 25, LC 5; D 120, E 80, non-maj 125, maj 8
Ent Req: HS dipl plus diagnostic tests in Reading, Math & English
Degrees: AA 2 yrs, BA
Tuition: Res—undergrad $65 per cr hr; nonres—$147 per cr hr
Courses: Art History, Bronze Castings, Ceramics, Drawing, Painting, Photography, Printmaking, Wood Carvings
Summer School: Chmn, Dr Nancy Nanney. Tuition $49.50 per cr hr

SHEPHERDSTOWN

SHEPHERD UNIVERSITY, (Shepherd College) Art Dept, A02 Frank Ctr, Shepherdstown, WV 25443; A02 Frank Center, P.O. Box 3210 Shepherdstown, WV 25443. Tel 304-876-5254; Fax 304-876-0955; Elec Mail sevanisk@shepherd.edu; Internet Home Page Address: www.shepherd.edu; WATS 800-826-6807; *Dean* Dow Benedict; *Coordr Photography* Rich Bruner; *Coordr Design* Stephanie Engle; *Coordr Painting & Drawing* Sonya Evanisko; *Coordr Printmaking & Mixed Media* Rhonda Smith; *Chair* Sonya Evanisko; *Coordr Art Educ* Dahn Hiuini; *Dir Exhib* Benita Keller
Estab 1872; Maintain a nonprofit art gallery - Frank Center Gallery, Frank Arts Center, West Campus Dr, Shepherdstown, WV 25443; FT 10, PT 15; pub; D & E; Scholarships; SC 75, LC 15, GC 5; maj 250; grad stu 10
Ent Req: HS dipl
Degrees: AA and BFA, BA(Educ)
Tuition: $1,635 per sem; campus res-$2,614 per yr; nonres-$4,015 per sem
Courses: Advertising Design, Aesthetic Criticism, Aesthetics, Art Appreciation, †Art Education, Art History, Art Therapy, Conceptual Art, Constructions, Design, Drawing, Film, †Graphic Design, History of Art & Architecture, Interior Design, Intermedia, Mixed Media, †Painting, †Photography, †Printmaking, †Sculpture, Stage Design, Teacher Training, Theatre Arts, Video
Summer School: Dir, Dow Benedict; Chair, Sonya Evanisko. Enrl 60; tuition $85 per cr hr, 2-5 wk sessions. Courses—Art Appreciation, Studio, Photo

WEST LIBERTY

WEST LIBERTY STATE COLLEGE, Div Art, 125 Campus Service Center, PO Box 295 West Liberty, WV 26074. Tel 304-336-8096; Fax 304-336-8056; Elec Mail dejaager@wlsc.edu; Internet Home Page Address: www.wlsc.edu; *Chmn* Mark Williams, MFA; *Assoc Prof* Robert Villmagna, MFA; *Asst Prof* Brian Fencl; *Assoc Prof* Jim Haizlett; *Instr* Brad Johnson; *Instr* Paula Lucas
Estab 1836; pub; D & E; Scholarships; SC 40, LC 6; D 855, E 140, non-maj 900, maj 90, others 12
Ent Req: HS dipl, score of 17 or higher on ACT test or cumulative HS GPA of at least 2.0 or a combined verbal/math score of 680 on the SAT
Degrees: BA and BS 4 yrs
Tuition: Res—undergrad $3138 per yr, $1569 per sem, $139.17 per cr hr; nonres—undergrad $7790 per yr, $3895 per sem, $346.42 per cr hr; campus res—available
Courses: Advertising Design, Art Appreciation, †Art Education, Art History, Ceramics, Computer Graphics, Costume Design & Construction, Drawing, Film, Graphic Arts, †Graphic Design, History of Art & Architecture, Illustration, Jewelry, Lettering, Painting, Photography, Printmaking, Sculpture, Stage Design, Studio Crafts, Theatre Arts, Weaving
Summer School: Dir, David T Jauersak. Tuition res $100 per sem hr, nonres $190 per sem hr. Courses—Art Education, Special Education

WISCONSIN

APPLETON

LAWRENCE UNIVERSITY, Dept of Art, Wriston Art Ctr, 613 E College Ave Appleton, WI 54911. Tel 920-832-6621; Fax 920-832-6606; Internet Home Page Address: www.lawrence.edu/dept/art; *Chmn* Carol Lawton; *Prof* Michael Orr; *Asst Prof* Alexis Boylan; *Asst Prof* Joseph D'uva
Estab 1847; Maintain nonprofit art gallery; FT 6; pvt; D; Scholarships; SC 21, LC 21
Ent Req: HS performance, CEEB scores, recommendation
Degrees: BA 4 yrs
Tuition: $23,000 includes room & board per 3 term yr

Courses: 3-D Design, Art Education, †Art History, Ceramics, Drawing, Metalwork, Painting, Photography, Printmaking, Sculpture, †Studio Art, Studio Ceramics

DE PERE

SAINT NORBERT COLLEGE, Div of Humanities & Fine Arts, 100 Grant St, De Pere, WI 54115. Tel 920-337-3181, 403-3119 (Dir of Humanities); Fax 920-403-4086; Internet Home Page Address: www.snc.edu/; *Dir* Dr John Neary
Estab 1898; FT 6; pvt den; D; SC 19, LC 5; D 60, maj 60
Ent Req: HS dipl, ent exam
Degrees: BA 4 yrs
Tuition: $17,758 per yr; campus housing available
Courses: Aesthetics, Art Education, Art History, Ceramics, Drawing, Graphic Arts, Graphic Design, Illustration, Jewelry, Painting, Photography, Sculpture, Teacher Training
Summer School: Terms of 3 or 5 wks beginning June. Courses—Art Education, Ceramics, Drawing, History of Art, Painting, Sculpture

EAU CLAIRE

UNIVERSITY OF WISCONSIN-EAU CLAIRE, Dept of Art, Box 4004, 105 Garfield Ave Eau Claire, WI 54702-4004. Tel 715-836-3277, 836-2637; Fax 715-836-4882; Internet Home Page Address: www.uwec.edu/; *Chmn* Stephen Katrosits; Li-ying Bao; Michael Christopherson; Jeanine Hegge; Eugene Hood; Karen Horah; Deidre Monk; Greta Murphy; Bobby Pitts; Tiit Raid; Scott Robertson; Anders Shafer; Sandra Stark; Steven Terwilliger; Christos Thew; Tom Wagener; Mike Weber
Estab 1916; pub; D & E; Scholarships; SC 31, LC 12; maj 260
Ent Req: HS dipl, ent exam
Degrees: BA, BS & BFA 4 yrs
Tuition: Res—$3252 per yr; nonres—$10,780 per yr
Courses: Advertising Design, Art Education, Art History, Ceramics, Drawing, Fibers, Illustration, Metalsmithing, Painting, Photography, Printmaking, Sculpture
Adult Hobby Classes: Ceramics, Painting
Summer School: Chmn, Scott Roertson. Enrl 100; tuition res—$1165, nonres—$3550 for 8 wk, 8 cr term. Courses—Art Methods for Teachers, Drawing Painting

FOND DU LAC

MARIAN COLLEGE, Art Dept, 45 S National Ave, Fond Du Lac, WI 54935. Tel 920-923-7612; Fax 920-923-7154; Elec Mail streis@MarianCollege.edu; Internet Home Page Address: www.mariancoll.edu/; *Chmn Arts & Humanities* Sr Susan Treis, MA; *Mary Carihi; Dir Art Prog* Kristine S. Krumenauer PhD
Estab 1936; pvt; E; Scholarships; SC 20, LC 12; D 107, E 35, maj 6
Ent Req: HS dipl, ACT or SAT
Degrees: BA and BA(Art Educ) 4 yrs
Tuition: $10,560 per yr, $230 per cr; campus res available
Courses: Aesthetics, Art Appreciation, Art Education, Art History, Calligraphy, Ceramics, Design, Drawing, Fiber Arts, Graphic Arts, Graphic Design, Handicrafts, Illustration, Jewelry, Lettering, Mixed Media, Painting, Photography, Printmaking, Puppetry, Restoration & Conservation, Sculpture, Teacher Training, Weaving
Adult Hobby Classes: Workshops, summer sessions, continuing education
Children's Classes: In Relationship with Art Education
Summer School: Workshops, credit art courses

GREEN BAY

UNIVERSITY OF WISCONSIN-GREEN BAY, Arts Dept, 2420 Nicolet, Green Bay, WI 54311-7001. Tel 920-465-2348, 465-2310; Fax 920-465-2890; Internet Home Page Address: www.uwgb.edu; *Assoc Prof* Ronald Baba; *Prof* David Damkoehler; *Chmn* Curt Heuer; *Assoc Prof* Jeff Benzow; *Assoc Prof* Christine Style; *Asst Prof* Jan Bradfield; *Asst Prof* Jennifer Mokren; *Asst Prof* Elizabeth Ament; *Prof* Jery Dell; *Prof* Carol Emmons; *Prof* Karon Winzenz
Estab 1970; FT 3; pub; D & E; SC 29, LC 3; D 5500
Ent Req: HS dipl, ent exam
Degrees: BA and BS 4 yrs
Tuition: Res—$1652.75 per sem; nonres—$5416.75 per sem
Courses: Acting & Directing, Aesthetics, Art Education, Ceramics, Costume & Makeup Design, Drawing, Environmental Design, Graphic Communications, Graphic Design, Intermedia, Jewelry, Mixed Media, Painting, Photography, Printmaking, Sculpture, Stage Design, Styles, Textile Design, Theatre Arts
Children's Classes: Varies
Summer School: Courses—vary

KENOSHA

CARTHAGE COLLEGE, Art Dept, 2001 Alfred Dr, Kenosha, WI 53140-1994. Tel 262-551-5859; Fax 262-551-6208; Internet Home Page Address: www.carthage.edu; *Chmn* Ed Kalke
Estab 1963; Priv, den; D & E; Scholarships
Degrees: BA
Tuition: Res—$18,205 per term; campus res—room & board $5465
Courses: Advertising Design, Art Education, Art History, Basic Photography, Ceramics, Design, Drawing, Graphic Design

UNIVERSITY OF WISCONSIN-PARKSIDE, Art Dept, 900 Wood Rd, PO Box 2000 Kenosha, WI 53141. Tel 414-595-2581; Fax 414-595-2271; *Prof* Douglas DeVinny, MFA; *Assoc Prof* Dennis Bayuzick, MFA; *Assoc Prof* Alan Goldsmith, MFA; *Prof* David Holmes, MFA; *Asst Prof* Trenton Baylor, MFA; *Asst Prof* Susan Funkenstein, PhD; *Lectr* Rob Miller, MA; *Asst Prof* Lisa Barber; *Asst Prof* Tao Chen

Estab 1965; Maintain nonprofit art gallery; Communication Arts Gallery, Kenosha, WI; art supplies available on-campus; Pub; D & E; Scholarships; SC 25, LC 6
Ent Req: ent req HS dipl, upper 50%
Degrees: BA and BS 4 yrs
Tuition: Res— undergrad $2,500 per sem; nonres—undergrad $7,523 per sem; campus res—available
Courses: Advertising Design, Aesthetics, †Animation, Art Appreciation, †Art Education, Art History, Art Metals, †Ceramics, †Design, †Drawing, †Graphic Arts, †Graphic Design, History of Art & Architecture, Illustration, †Illustration, Jewelry, Life Drawing, †Painting, †Printmaking, †Sculpture, Silversmithing, Teacher Training, Textile Design, Weaving, †Web Design
Summer School: Tuition $210 res hr for term of 8 wks beginning mid June. Courses—Vary from summer to summer

LA CROSSE

UNIVERSITY OF WISCONSIN-LA CROSSE, Center for the Arts, 1725 State St, La Crosse, WI 54601. Tel 608-785-8230; Fax 608-785-6719; *Chmn* Cam Choy
Estab 1905; FT 8; pub; D & E; Scholarships; SC 25, LC 5; (univ) 7600
Ent Req: HS dipl
Degrees: BA and BS 4 yrs
Tuition: Res—$155.90 per cr hr; nonres—$468.90 per cr hr
Courses: 2-D & 3-D Design, Aesthetics in Art Criticism in the Visual Arts, Ancient Art of the Western World, Art Appreciation, Art Education, Art Metals, Blacksmithing, Ceramics, Computer Art, Drawing, Figure Drawing, Graphic Arts, History of American Art, Medieval Art of the Western World, Modern Art of the Western World, Multi-Cultural Art Survey, Painting, Printmaking, Renaissance Art of the Western World, Sculpture
Adult Hobby Classes: Courses—Blacksmithing, Ceramics, Outreach Jewelry
Summer School: Courses—vary

VITERBO COLLEGE, Art Dept, 815 S Ninth, La Crosse, WI 54601. Tel 608-796-3000, 796-3755; Fax 608-791-0367; Elec Mail lschoenfielder@viterbo.edu; Internet Home Page Address: www.viterbo.edu/; *Asst Prof* Edward Rushton; *Instr* Diane Crane; *Chmn* Lisa Schoenfielder; *Prof* Peter Fletcher; *Asst Prof* Tom Bartel; *Asst Prof* Ed Rushton
Estab 1890; pvt; D & E; Scholarships; SC 10-12, LC 6; D 55, maj 55
Degrees: BA, BAEd & BS 4 yrs
Tuition: $18,340 incl room & board
Courses: Advertising Design, Art Education, Art History, Ceramics, Commercial Art, Drawing, Fibers, Graphic Arts, Illustration, Painting, Photography, Printmaking, Sculpture, Teacher Training, Weaving

WESTERN WISCONSIN TECHNICAL COLLEGE, Graphics Division, 304 N Sixth St, PO Box 0908 La Crosse, WI 54602-0908. Tel 608-785-9200; Fax 608-785-9473; Elec Mail west@fahlr.wwtc.edu; Internet Home Page Address: wwtc.edu; *Chmn* Richard Westpfahl; *Program Head* Philip Brochhauren; *Instr* Barb Fischer; *Instr* Craig Kunce; *Instr* Lane Butz; *Instr* Eddie Hale; *Instr* Ken Hey; *Instr* Chris Bucheit; *Visual Com Instr* Mark Davini; *Visual Com Instr* Jacob Griggs; *Electronic Imaging & Print Instr* Janet Olgesby; *Electronic Imag & Print Instr* Eugene Van Roy
Estab 1911, dept estab 1964; pub; D & E; Scholarships; SC & LC 16; D 130, E 145, non-maj 132, maj 143
Ent Req: HS dipl or GED
Degrees: AAS 2 yrs
Tuition: $76 in state per cr hr; $488.10 out of state per cr hr
Courses: Advertising Design, †Commercial Art, Computer Graphics, Display, Film, †Graphic Arts, Graphic Design, Illustration, Lettering, Media, Mixed Media, Painting, Photography, Printing & Publishing, Stage Design, Video, Visual Communications
Adult Hobby Classes: Enrl 264. Courses—Color Photo Printing, Painting, Photography, Computer Graphics
Summer School: Dir, Richard Westpfahl. Courses—varied

MADISON

EDGEWOOD COLLEGE, Art Dept, 1000 Edgewood College Dr, Madison, WI 53711. Tel 608-663-2307; Fax 608-663-3291; Elec Mail rtarrell@edgewood.edu; Internet Home Page Address: www.edgewood.edu/; *Assoc Prof* David Smith; *Assoc Prof* Melanie Herzog; *Instr* Ellen Meyer; *Instr* Mary Lybarger; *Asst Prof* Randy Feig; *Asst Prof* Janice M Havlena; *Prof* Robert Tarrell; *Asst Prof* Alan Luft; *Instr* Tracy Dietzel; *Instr* Jane Fasse
Estab 1941; Maintain nonprofit art gallery; DeRicci Gallery; den; D & E; Grants
Ent Req: HS dipl, ACT
Degrees: BA or BS 4 yrs
Tuition: $7100 per sem; campus res available
Courses: †Art Education, Art History, Art Therapy, Calligraphy, Ceramics, Design, Drawing, Graphic Design, Painting, Photography, †Printmaking, Sculpture, †Teacher Training, Textile Design, Video
Summer School: Dir, Dr Joseph Schmiedicke. Tuition $110 per cr. Courses—vary

MADISON AREA TECHNICAL COLLEGE, Art Dept, 3550 Anderson St, Madison, WI 53704. Tel 608-246-6058, 246-6100, 246-6002; Fax 608-246-6880; *Chmn* Jerry E Butler PhD
Estab 1911; Pub; D & E; Scholarships; SC 45, LC 12; D 5,300, E 23,000 (part-time)
Ent Req: HS dipl
Degrees: AA 2 yrs(Commercial Art, Interior Designing, Photography & Visual Communications)
Tuition: $64 per cr
Courses: Advertising Design, Art History, Calligraphy, Ceramics, †Commercial Art, Design, Display, Drawing, Handicrafts, Illustration, Jewelry, Lettering, Painting, †Photography, Printmaking, Visual Communications

Adult Hobby Classes: Enrl 1,000. Courses—same as regular session

UNIVERSITY OF WISCONSIN, MADISON
—Dept of Art, Tel 608-262-1660; Fax 608-265-4593; Internet Home Page Address: www.soemadison.wisc.edu/art; *Prof* Jim Escalante; *Prof* Jack Damer; *Prof* Leslee Nelson; *Prof* Bruce Breckenridge; *Prof* Cavaliere Ketchum; *Prof* Richard Long; *Prof* Truman Lowe; *Prof* George Cramer; *Prof* Doug Marschalek; *Prof* Frances Myers; *Prof* Carol Pylant; *Prof* Steve Feren; *Prof* David Becker; *Prof* Elaine Scheer; *Prof* John Rieben; *Prof* Tom Loeser; *Assoc Prof* Derrick Buisch; *Assoc Prof* Michael Connors; *Assoc Prof* Michelle Grabner; *Assoc Prof* Theresa Marche; *Assoc Prof* T L Solien; *Prof* Laurie Beth Clark; *Prof* Patricia Fennell; *Prof* Fred Fenster; *Assoc Prof* Aristotle Georgiades; *Asst Prof* Nancy Mladenoff; *Asst Prof* Gail Simpson; *Assoc Prof* Lisa Gralnick; *Asst Prof* John Hitchcock; *Assoc Prof* Gelsy Verna; *Asst Prof* Stephen Hilyard
Estab 1911; Maintains nonprofit art gallery; FT 32; pub; Scholarships, Fellowships; SC 68, LC 2, GC 19; maj 500, grad 100
Degrees: BS, BFA, MA, MFA
Tuition: Res—undergrad $2,930 per sem, grad $4,160 per sem; nonres—undergrad $9,930 per sem, grad $11,795 per sem
Courses: Art Education, Book Making, Ceramics, Design, Drawing, Etching, Glass, Graphic Design, Illustration, Intermedia, Jewelry, Lettering, Lithography, Mixed Media, Painting, Papermaking, Performance, Photography, Printmaking, Sculpture, Serigraphy, Stage Design & Lighting, Typography, Video, Wood, Woodworking
Summer School: Three wk early session, 8 wk session, 4 wk session
—Dept of Art History, Tel 608-263-2340; Fax 608-265-6425; Elec Mail arthistory@ls.wisc.edu; Internet Home Page Address: www.wisc.edu/arth; *Prof Art History* Barbara C Buenger; *Prof* Henry J Drewal; *Prof* Narcisco G Menocal; *Prof, Dept Chmn* Gail L Geiger; *Prof* Jane C Hutchison; *Prof* Julia K Murray; *Prof* Quitman E Phililips; *Dept Adminr* Sandra Russell; *Prof* Nicholas D Cahill; *Prof* Thomas E A Dale; *Asst Prof* Anna V Andrzejewski; *Asst Prof* Jill H Casid; *Assoc Prof* Nancy R Marshall; *Assoc Prof* Ann Smart Martin; *Instr* Dan Fuller; *Instr* Gautama Vajracharya
Estab 1848, dept estab 1925; Art supplies available at univ bookstore; Pub; D & E; Scholarships, Fellowships; LC 15, GC 18-20; D 1,200, maj 250, non-maj 1,100, grad 150, continuing educ 100
Activities: $30,000
Ent Req: BA, BS, BFMA
Degrees: MA, PhD
Tuition: Res—$4,160 per sem; nonres—$11,796 per sem
Courses: 20th Century Photography, African Art, American Art, †Art History, Asian Art, Ceramics, Dutch Painting, Greek Art & Society, Material Culture, Modern Art, Printmaking, Sculpture, Venetian Painting, Visual Culture, Western Architecture, Women's Art
—Graduate School of Business, Bolz Center for Arts Administration, Tel 608-263-4161; Fax 608-265-2739; Elec Mail ataylor@bus.wisc.edu; Internet Home Page Address: www.bolzcenter.org/; *Dir* Andrew Taylor
Estab 1969
Degrees: MA
Tuition: Res bus MA $1,777.35 per sem, non-res $4,985.35 per sem
Courses: Arts Administration Seminars, Colloquium in Arts Administration

MANITOWOC

SILVER LAKE COLLEGE, Art Dept, 2406 S Alverno Rd, Manitowoc, WI 54220. Tel 920-684-6691, 686-6181; Fax 920-684-7082; Elec Mail merdmann@silver.sl.edu; Internet Home Page Address: www.sl.edu/art; *Asst Prof* Mona Massaro, MFA; *Assoc Prof* Sr Andree DuCharme, MFA; *Chmn* Sr Mariella Erdmann, MFA; *Instr* Jo Woodcock, MS
Estab 1936, dept estab 1959; pvt; D & E; SC 21, LC 6; D 50, E 10, non-maj 25, maj 25
Ent Req: HS dipl, ACT or SAT
Degrees: AA(Commercial Art) 2 yrs, BA(Studio Art) or BA(Art Educ) 4 yrs
Tuition: Res & nonres—undergrad $12,050 per yr
Courses: †Art Education, Art History, Calligraphy, Ceramics, †Commercial Art, Computer Graphics, Drawing, Graphic Arts, Graphic Design, Jewelry, Lettering, Mixed Media, Painting, Photography, Printmaking, Sculpture, †Studio Art, Teacher Training, Textile Design
Adult Hobby Classes: Tuition $50 (Life-Long Learners-sr citizens 55 or over). Courses—Vary
Children's Classes: Enrl 100; tuition $30-$40 per week, 3-6 wk term. Courses—Clay, Drawing, Fibers, Graphics, Painting, Sculpture
Summer School: Dir, Sr Lorita Gaffney. Enrl 350; tuition $195 per cr 6 wk terms beginning June 18. Courses—Vary

MARINETTE

UNIVERSITY OF WISCONSIN COLLEGE - MARINETTE, Art Dept, 750 W Bay Shore St, Marinette, WI 54143. Tel 715-735-4301; Fax 715-735-4307; Elec Mail ssinfo@wuc.edu; Internet Home Page Address: www.uwc.edu/mnt/; *Prof* Don Ruedy, MFA; *Prof* John Whitney; *Prof* Judith Baker; *Prof* Frank Zetzman; *Prof* Heidi Jensen; *Prof* Diana Budde; *Prof* Tom Fleming; *Prof & Chmn* Kitty Kingston; *Prof* Mary Alice Wimmer; *Prof* Stephanie Coupolos-Selle; *Prof* James LaMalfa; *Digital Design* Angelo Osterlund
Estab 1850, dept estab 1946; Maintains nonprofit art gallery; Theater on the Bay Gallery; Pub; D & E; Scholarships; SC, LC; D 525, E 150, non-maj 150, maj 15
Ent Req: HS dipl or GED
Degrees: AAS 2 yrs
Tuition: Res—undergrad $1,201 per sem; nonres—undergrad $4,203 per sem
Courses: 2-D Design, Art History, †Digital Cinema, †Digital Design, Drawing, Painting, Photography, Sculpture, Survey of Art
Summer School: Dir, Sidney Bremer. Tuition $70 per cr. Courses—Art Appreciation, Art History

MENOMONIE

UNIVERSITY OF WISCONSIN-STOUT, Dept of Art & Design, Applied Arts Bldg, Menomonie, WI 54751. Tel 715-232-1141; Fax 715-232-1669; Elec Mail jacksonm@uwstout.edu; Internet Home Page Address: www.uwstout.edu/cas/; *Head Dept* Ron Verdon, MFA; *Prof* Todd Boppel, MFA; *Prof* Doug Cumming, MFA; *Prof* Eddie Wong, MFA; *Prof* Dr Claudia Smith PhD, MFA; *Prof* Susan Hunt, MFA; *Prof* Rob Price, MFA; *Prof* Paul De Long, MFA; *Asst Prof* William De Hoff, MFA; *Asst Prof* Mark Kallsen, MFA; *Asst Prof* Kate Maury, MFA; *Asst Prof* Maureen Mitton, MFA; *Asst Prof* Timothy O'Keeffe, MFA; *Asst Prof* Benjamin Pratt, MFA; *Asst Prof* David Gariff, MFA; *Asst Prof* David Morgan, MFA; *Lectr* Nancy Blum-Cumming, MFA
Estab 1893, dept estab 1965; pub; E; SC 60, LC 6; D 24, non-maj 1200, maj 630
Ent Req: HS dipl
Degrees: BS(Art), BFA(Art) 4 yrs
Tuition: Res—undergrad $2938.14 per sem; nonres—undergrad $9220.14 per yr; campus res—room & board $3254 per yr
Courses: †Art Education, Art History, Art Metals, Art Period Courses, Blacksmithing, Ceramics, Design, Drawing, Fashion Illustration, †Graphic Design, †Industrial Design, †Interior Design, Painting, Printmaking, Sculpture, Silversmithing
Children's Classes: Sat classes in Art Design, Art History, Fine Arts, Graphic Arts
Summer School: Dir, Gene Bloedorn. Enrl varies with class; tuition res—undergrad $452, grad $587; nonres—undergrad $1303, grad $1717 for term of 8 wks beginning June 1 - Aug 6. Courses—Advanced Graphic Design, Ceramics, Drawing, Design, Life Drawing, Painting, Printmaking

MEQUON

CONCORDIA UNIVERSITY, Division of Performing & Visual Arts, 12800 N Lake Shore Dr, 9 W, Mequon, WI 53097. Tel 262-243-4242; Fax 262-243-4459; Elec Mail gayland.store@con.edu; Internet Home Page Address: con.edu; *Dir* Dr Gene Edward Veith; *Prof* Maaji Bell; *Prof* Jeff Shaarhan; *Prof* Terry Valentine; *Prof* Dean Graf
Estab 1881, dept estab 1971; Maintain nonprofit art gallery, Concordia University Art Gallery; den; D & E; SC 25, LC 4; non-maj 100, maj 60
Ent Req: HS dipl
Degrees: BA
Tuition: $13,550 per sem
Courses: †Aesthetics, †Art Education, †Art History, †Calligraphy, †Ceramics, Design, †Design, †Drawing, †Graphic Arts, †Graphic Design, †History of Art & Architecture, †Mixed Media, †Painting, †Photography, †Printmaking, †Sculpture, †Teacher Training, †Weaving
Summer School: Dr. William Cario, Assistant Vice President of Academics, Terms of 6 wks. Courses—Drawing & Painting (outdoors)

MILWAUKEE

ALVERNO COLLEGE, Art Dept, 3400 S 43rd St, PO Box 343922 Milwaukee, WI 53234-3922. Tel 414-382-6000, 382-6148; Fax 414-382-6354; *Chmn* Nancy Lamers
Estab 1948; pvt, W only in degree program; D & E; Scholarships; SC 20, LC 5; D 2300, E 2300, maj 60
Ent Req: GPA, class rank and ACT or SAT
Degrees: BA 4 yrs (or 128 cr)
Tuition: $6000 per sem; campus res—room & board available, $1900 per sem
Courses: Art Education, Art History, Art Therapy, Ceramics, Computer Graphics, Drawing, Enameling (Cloisonne), Fibers, General Crafts, Introduction to Visual Art, Metal Working, Painting, Printmaking, Sculpture, Teacher Training
Summer School: Term June to August. Courses—Art Education, Studio Art

CARDINAL STRITCH UNIVERSITY, Art Dept, 6801 N Yates Rd, Milwaukee, WI 53217-3985. Tel 414-410-4100; Fax 414-351-7516; Elec Mail tbernie@stritch.edu; Internet Home Page Address: www.stritch.edu/; *Asst Prof* Peter Galante; *Asst Prof* Teri Wagner; *Instr* Michal Ann Carley; *Asst Prof* Steven Sellars; *Asst Prof* Timothy Abler; *Dean Arts & Scis* Dr Dickson K Smith
Estab 1937; den; D & E; Scholarships; SC 29, LC 17; maj 98
Ent Req: HS dipl, ent exam
Degrees: AA, BA, BFA
Tuition: Undergrad $6240 per sem, $390 per cr hr; campus—room & board $2435-$2470
Courses: †Art Education, †Art History, †Ceramics, Computer Graphics, †Drawing, †Fibers, †Film, †Graphic Design, Illustration, †Jewelry, †Metalsmithing, †Painting, †Photography, †Printmaking, †Sculpture, †Textile Design, †Video
Adult Hobby Classes: Enrl 200; tuition $40-$100 per 8-12 wk sessions. Courses—Basic, Ceramics, Drawing, Mixed Media, Painting, Watercolor
Children's Classes: Enrl 100; tuition $60 per child per 12 classes. Courses—traditional media plus various crafts

MILWAUKEE AREA TECHNICAL COLLEGE, Graphic Arts Div, 700 W State St, Milwaukee, WI 53233. Tel 414-297-6433; Fax 414-271-2195; Elec Mail macdonaj@mate.edu; *Assoc Dean* James MacDonald, BA & MS; *Instr* Howard Austin, MS; *Instr* Joseph D'Lugosz, BFA; *Instr* Geraldine Geischer, MFA; *Instr* Edward Adams, MFA; *Instr* Corrine Kraus, BFA; *Instr* Janice Mahlberg, BS; *Instr* Patrick Mitten, BS; *Instr* Mark Saxon, AAS; *Instr* Elliot Schnackenberg, BFA; *Instr* Robert Stocki, BFA; *Instr* James Surges, AAS; *Instr* Ted Joyce, BA; *Instr* Thomas Kusz, BA; *Instr* Leonard McGhee, MS; *Instr* Walter Royek, AAS; *Instr* Olga Horton, AAS; *Instr* Anne Steinberg, BS; *Instr* Alain DeMars, MS
Estab 1912, dept estab 1958; pub; D & E; Financial aid; D 240, E 150
Ent Req: HS dipl
Degrees: AA 2 yrs

Tuition: res—$35.25 per cr hr; $564 per sem; $1128 per yr; nonres—$235.80 per cr hr; no campus res
Courses: 3-D Modeling & Animation, Advertising Design, Commercial Art, Computer Graphics, Design, Display, Drawing, Graphic Arts, Graphic Design, Illustration, Interior Design, Jewelry, Lettering, Mixed Media, Multimedia, Photography, Teacher Training, Video, Visual Communications
Adult Hobby Classes: Tuition $46.10 per cr

MILWAUKEE INSTITUTE OF ART & DESIGN, 273 E Erie St, Milwaukee, WI 53202. Tel 414-276-7889; Fax 414-291-8077; Elec Mail miadadm@miad.edu; Internet Home Page Address: www.miad.edu; *Dean Fine Arts* Al Balinsky; *Dean Design* Becky Balistreri, BFA; *Dean Foundations* Jan Feldhausen, BFA; *Provost* Richard Higgs; *Dean Liberal Studies* Barbara McLaughlin, PhD
Estab 1974; FT 100, PT 60; pvt; D&E; Scholarships; SC, LC; D 400, maj 472
Ent Req: HS dipl, portfolio
Degrees: BFA 4 yrs
Tuition: $21,000 per yr
Courses: Advertising Design, Aesthetics, Art History, Conceptual Art, Constructions, Design, Display, Drafting, Drawing, Graphic Design, History of Art & Architecture, Illustration, Industrial Design, Interior Design, Painting, Photography, Printmaking, Sculpture

MOUNT MARY COLLEGE, Art & Design Division, 2900 N Menomonee River Pky, Milwaukee, WI 53222. Tel 414-258-4810; Fax 414-256-1224; Elec Mail huebner@mtmary.edu; Internet Home Page Address: www.mtmary.edu; *Prof* Angelee Fuchs, MA; *Prof* Charles Kaiser, MFA; *Prof* Joseph Rozman, MFA; *Assoc Prof* Sandra Keiser, MA; *Assoc Prof* Sr Aloyse Hessburg, MA; *Assoc Prof* Pamela Steffen, MBS; *Chmn* Lynn Kapitan, PhD; *Assoc Prof* Sr Carla Huebner, MS, MA; *Asst Prof* Dennis Klopfer, MS; *Asst Prof* Melody Todd, MS; *Asst Prof* Greg Miller, MS; *Asst Prof* Karen McCormick, MA; *Asst Prof* Troy Gerth, MFA; *Instr* Patty Rass, MA; *Instr* Sue Loesl, MA; *Instr* Luanne Alberts, MA; *Asst Prof* Nancy Lohmiller, BA; *Prof* Sr Rosemarita Huebner, MA; *Asst Prof* Kenneth Miller, BA; *Instr* Janice Stewart, MA; *Instr* Dianne Atkinson, MA; *Instr* Mary Bartling, BA; *Prof* Bruce Moon, PhD; *Asst Prof* Leona Nelson, MA; *Asst Prof* Dympna Rochford, MA; *Asst Prof* Elizabeth Gaston, PhD; *Instr* Barbara Chappell, MA; *Instr* Sandra Tonz; *Instr* Joan Kadow; *Instr* Marie Perloneo
Estab 1913, dept estab 1929; Maintains Marian Gallery, 2900 Menomonee River Pky, Milwaukee, WI 53222; art supplies available at on-campus shop; pvt, W only; D & E; Scholarships; SC 22, LC 12, GC12; D 200, E 30, non-maj 50, maj 300, grad 50
Ent Req: HS dipl
Degrees: BA 4 yrs, MA(Art Therapy)
Tuition: $11,380 per yr, $5660 per sem; campus res—available; board $750 - $1000 per sem
Courses: †Advertising Design, Aesthetics, Architecture, Art Appreciation, †Art Education, Art History, †Art Therapy, Calligraphy, Ceramics, †Commercial Art, Constructions, †Costume Design & Construction, Design, Display, Drawing, †Fashion Arts, †Graphic Arts, †Graphic Design, Handicrafts, †History of Art & Architecture, †Interior Design, †Lettering, †Mixed Media, †Occupational Therapy, †Painting, †Photography, †Printmaking, †Sculpture, Silversmithing, †Teacher Training, †Textile Design, Video
Adult Hobby Classes: Enrl 1300; tuition variable, on going year round. Courses—Varied, self-interest
Children's Classes: Enrl 125; tuition $65 for 1-6 wk term, summer only. Courses—Arts & Crafts
Summer School: Dir, Toni Wulff

UNIVERSITY OF WISCONSIN-MILWAUKEE, Dept of Art, School of the Arts, PO Box 413 Milwaukee, WI 53201. Tel 414-229-4428, 229-6052; Fax 414-229-2973; Elec Mail lanehall@uwm.edu; Internet Home Page Address: www.uwm.edu/soa//; *Chair* Lane Hall; *Asst Chair* Brigitte Taylor
FT 30, PT 29; Scholarships; maj 860
Degrees: BFA(Art), BFA with teachers cert, BA(Art), MA(Art), MS(Art Educ), MFA(Art), MFA with teachers cert
Tuition: Res—undergrad $9087 per yr incl room & board, grad $13,905; non-res—$21,048 per yr, grad $21,256 per yr
Courses: Art Education, Ceramics, Drawing, Graphic Design, Metals, Painting, Photography, Printmaking, Sculpture
Children's Classes: Enrl 100; tuition for 1 month term. Courses—Clay, Drawing, Mixed Media, Painting
Summer School: Enrl 250. Courses—Vary

OSHKOSH

UNIVERSITY OF WISCONSIN-OSHKOSH, Dept of Art, 800 Algoma Blvd, Oshkosh, WI 54901. Tel 920-424-2222; Fax 920-424-1738; *Chmn* Jeff Lipschutz
Estab 1871; Maintain nonprofit art gallery, Priebe Gallery, Dept. of Art, University of Wisconsin, Oshkosh, WI 54901; FT 18; pub; D & E; Scholarships; SC 56, LC 14, GC 31; D 10,5000, E 2500, maj 350, minors 50
Ent Req: HS dipl
Degrees: BA, BAE and BS(Art) 4 yrs, BFA 82 cr
Tuition: Res—$2606.90; non-res—$8548.90; campus res—room & board $2658
Courses: Advertising Design, Art Education, Art History, Ceramics, Commercial Art, Drawing, Graphic Arts, Jewelry, Lettering, Painting, Photography, Printmaking, Sculpture, Teacher Training, Textile Design, Woodcraft

PLATTEVILLE

UNIVERSITY OF WISCONSIN-PLATTEVILLE, Dept of Fine Art, Art Bldg 212B, Platteville, WI 53818. Tel 608-342-1781; Fax 608-342-1491; *Instr* Steve Vance; *Instr* Kaye Winder; *Chmn* David Van Buren
Estab 1866; FT 8; pub; D & E; SC 30, LC 5, GC 3; maj 105
Ent Req: HS dipl, ent exam
Degrees: BA and BS 4 yrs

Tuition: Res—undergrad $3520; nonres—undergrad $12,300; campus res—room & board $1295 per sem
Courses: Art Survey, Art in Elementary Education, Ceramics, Drawing, Ethnic Art, Fiber & Fabrics, Graphic Design, Illustration, Lettering & Typographic, Painting, Photography, Printmaking
Summer School: Enrl 2200; term of 8 wks beginning June. Courses—same as regular session

RICE LAKE

UNIVERSITY OF WISCONSIN, Center-Barron County, Dept of Art, 1800 College Dr, Rice Lake, WI 54868. Tel 715-234-8176, Ext 5408; Fax 715-234-1975; Internet Home Page Address: www.uwc.edu; *Prof* Don Ruedy, MFA
Estab1968; FT 1 PT 1; pub; D & E; Scholarships; SC 8, LC 2; D 63, E 10, non-maj 57, maj 16
Ent Req: HS dipl
Degrees: AA
Tuition: In-state—$1280
Courses: Art History, Calligraphy, Design, Drawing, Jewelry, Lettering, Painting, Printmaking, Theatre Arts
Children's Classes: Enrl 30; tuition $40 for 2 wks in summer. Courses—Art

RIPON

RIPON COLLEGE, Art Dept, 300 Seward St, PO Box 248 Ripon, WI 54971. Tel 920-748-8110; Elec Mail kainee@ripon.edu; Internet Home Page Address: www.ripon.edu/academics/; *Chmn* Evelyn Kain; *Assoc Prof & Dir Gallery* Eugene Kain; *Asst Prof* Kevin Brady; *Art Dept Asst* Lee Shippey
Estab 1851; Pvt; D; Scholarships, Financial aid; SC 13, LC 8; maj 20
Ent Req: grad from accredited secondary school, SAT or ACT is recommended, but not required
Degrees: BA
Tuition: $18,000 per yr
Courses: †Art History, Design, Drawing, Mixed Media, Painting

RIVER FALLS

UNIVERSITY OF WISCONSIN-RIVER FALLS, Art Dept, 410 S Third St River Falls, WI 54022-5001. Tel 715-425-3266; Fax 715-425-0657; Elec Mail michael.a.padgett@uwrf.edu; Internet Home Page Address: www.uwrf.edu/art/welcome; *Chmn* Michael Padgett
Estab 1874, major estab 1958; pub; D; Scholarships; SC 26, LC 18; non-maj 400, maj 170
Ent Req: HS dipl
Degrees: BA, BS(Educ), BFA and BS(Liberal Arts) 4 yrs
Tuition: Res—$3322 per yr; non-res—$10,850 per yr; room & board $1580-$1932 per yr
Courses: Aesthetics, †Art Education, Art History, Ceramics, Costume Design & Construction, Drawing, Fibers, Film, Glass Blowing, Graphic Design, History of Art & Architecture, Jewelry, Painting, Photography, Printmaking, Silversmithing, Stained Glass, Textile Design
Summer School: Dir, Dr Lynn Jermal. Enrl 1600; 4 wk sessions. Courses—Clay, Fibers, Glass, Painting, Printmaking, Sculpture

STEVENS POINT

UNIVERSITY OF WISCONSIN-STEVENS POINT, Dept of Art & Design, College of Fine Arts, 1800 Portage St Stevens Point, WI 54481. Tel 715-346-2669, 346-4066; Fax 715-346-4072; Elec Mail rstolzer@uwsp.edu; Internet Home Page Address: www.uwsp.edu/acad/cofa/index.htm; Internet Home Page Address: www.uwsp.edu/art-design/; *Prof* Rex Dorethy, MFA; *Prof* Robert Stowers, MFA; *Prof* Diane Bywaters, MFA; *Prof* Anne-Bridget Gary, MFA; *Prof* Robert Erickson, MFA; *Prof* Larry Ball, MFA; *Prof* Rob Stolzer, MFA; *Prof* Guillermo Penafiel, MFA; *Prof* John O. Smith, MFA; *Lect* Mark Pohlkamp, MFA; *Prof* Susan Morrison, MFA; *Assoc Lectr* Sheila Sullivan; *Acad Dept Assoc* Mimi Johnson; *Dir Gallery* Caren Heft; *Sr Lectr* Mark Brueggeman; *Assoc Lectr* William McKee; *Asst Prof* Diana Black; *Asst Prof* Stuart Morris; *Asst Prof* Kristin Theilking; *Assoc Lect* Mary Rosek; *Assoc Lect* Keven Brunett; *Art Hist Librn* Matthew Sackel
Estab 1894; Maintain a nonprofit art gallery, Edna Carlsten Art Gallery; Pub; D & E; Scholarships; SC 47, LC 8, GC 7; D 866, non-maj 666, maj 325
Ent Req: HS dipl
Degrees: BA(Fine Arts) & BFA(Art-Professional)
Tuition: Res $5,000.51 per semester; non-res $8,737.37 per semester incl room & board
Courses: †Advertising Design, †Art Appreciation, †Art Education, †Art History, Ceramics, †Commercial Art, Computer Graphics, †Design, Drawing, †Graphic Arts, Graphic Design, †History of Art & Architecture, †Landscape Architecture, Painting, Photography, Printmaking, Sculpture, †Studio Art
Children's Classes: Art Workshop

SUPERIOR

UNIVERSITY OF WISCONSIN-SUPERIOR, Programs in the Visual Arts, 1800 Grand Ave, Superior, WI 54880; Holden Fine Arts Ctr 3101, Belknap & Catlin PO Box 2000 Superior, WI 54880. Tel 715-394-8391, 394-8101; Elec Mail lgrittne@staff.uwsuper.edu; Internet Home Page Address: www.uwsuper.edu; *Prof* Mel Olsen, MFA; *Prof* William Morgan, MFA; *Assoc Prof* Laurel Scott PhD, MFA; *Assoc Prof* Susan Loonsk, MFA; *Lectr* Kim Borst, MFA; *Lectr* Pope Wright, MA; *Chmn* James Grittner, MFA; *Lectr* Tim Cleary

Estab 1896, dept estab 1930; Maintain nonprofit art gallery; Pub; D & E; Scholarships; SC 7, LC 3, GC 8; D 250, E 100-125, non-maj 250, maj 100, grad 30
Ent Req: HS dipl
Degrees: BS, BS(Photography), BS(Art Therapy), BFA & BFA(Photography) 4 yrs, BFA with cert 5 yrs, MA 5 - 6 yrs
Tuition: Res—undergrad $1,300 per sem; nonres—undergrad $4,922 per sem; campus res available
Courses: †Art Education, †Art History, †Art Therapy, †Ceramics, Collage, Design, Drawing, †Jewelry, †Painting, †Photography, †Printmaking, †Sculpture, †Silversmithing, †Teacher Training, †Weaving
Adult Hobby Classes: Ceramics, Crafts, Drawing, Fibers, Metalwork, Painting, Photography
Children's Classes: Summer session only
Summer School: Dir, Mel Olsen. Enrl 100; tuition varies for term of 3 & 4 wks beginning June 12th. Courses—Art History, Ceramics, Drawing, Painting, Photography

WAUKESHA

CARROLL COLLEGE, Art Dept, 100 N East Ave, Waukesha, WI 53186. Tel 262-547-1211, 524-7191; Internet Home Page Address: www.cc.edu; *Co-Chmn* Thomas Selle; *Assoc Prof* Philip Krejcarek, MFA
Estab 1846; pvt; D & E; Scholarships; SC 21, LC 4; D 1100, E 350
Ent Req: HS dipl, SAT or ACT
Degrees: BA
Tuition: $15,860 annual full-time tuition, room & board $4,970
Courses: Museum Staff Training, †Pre-Architecture; ?Commercial Art; Weaving, Sculpture, †Stage Design, †Teacher Training, Textile Design, †Theatre Arts, †Video
Adult Hobby Classes: Enrl 20 per sess. Courses—Photographing Your Own Work
Children's Classes: New program
Summer School: Asst Prof, Thomas Selle. Enrl varies; tuition varies for term of 6 wks. Courses—Drawing, Graphics, Photography

WHITEWATER

UNIVERSITY OF WISCONSIN-WHITEWATER, Dept of Art, Ctr of the Arts 2073, Whitewater, WI 53190. Tel 262-472-1324; Fax 262-472-2808; Internet Home Page Address: www.uvw.edu; *Chmn* Robert Mertens
Estab 1868; FT 16, PT 1; pub; D & E; Scholarships; SC 41, LC 18; D 270, maj 200
Ent Req: HS dipl
Degrees: BA & BS(Art, Art Educ, Art History, Graphic Design), BFA 4 yrs
Tuition: Res—$1293.63 per sem; nonres—$4025.62 per sem; campus res—$3250 per year
Courses: Art Appreciation, Art Education, Ceramics, Commercial Art, Drawing, †Graphic Design, Illustration, Jewelry, Painting, Photography, Printmaking, Sculpture, Teacher Training
Adult Hobby Classes: Enrl 240; tuition non res—undergrad $296.40 per cr, res undergrad—$96.90 per cr
Summer School: Dir, Richard Lee. Enrl 80; 3 & 6 wk terms, May-Aug. Courses—Art History, Ceramics, Drawing

WYOMING

CASPER

CASPER COLLEGE, Dept of Visual Arts, 125 College Dr, Casper, WY 82601. Tel 307-268-2110, 268-2509; Fax 307-268-2224; Elec Mail lmunns@acad.cc.whecn.edu; *Div Head* Lynn R Munns, MFA; *Instr* Richard Jacobi, MFA; *Instr* Linda Lee Ryan, MFA; *Instr* Nancy Madura, MFA; *Instr* Laura Guinan, BFA; *Instr* Michael Keogh, MFA
Pub; D & E; Scholarships; LC 2; D 3870
Ent Req: HS dipl
Degrees: AA 2 yrs
Tuition: Res—undergrad $53 per cr hr, $660 per sem nonres—undergrad $153 per cr hr, $1836 per sem; campus res—room & board $1075-$1275
Courses: Advertising Design, Art History, Ceramics, Collage, Commercial Art, Drafting, Drawing, Handicrafts, Illustration, Jewelry, Painting, Photography, Sculpture, Silversmithing, Textile Design, Theatre Arts
Summer School: Tuition $624 for summer sem or $52 per hr. Courses—Air Brush, Ceramics, Drawing, Jewelry, Painting, Photography

CHEYENNE

LARAMIE COUNTY COMMUNITY COLLEGE, Division of Arts & Humanities, 1400 E College Dr, Cheyenne, WY 82007. Tel 307-778-1158; Fax 307-778-1399; Elec Mail kerryhart@lccc.wy.edu; *Dean* Kerry Hart, MA; *Instr* Matt West, MFA; *Instr* Ron Medina, MFA
Estab 1969; maintains nonprofit gallery; pub; D & E; Scholarships; SC 19, LC 3; D 125, E 100, non-maj 150, maj 20
Ent Req: HS dipl
Degrees: AA
Tuition: Res—$714 per sem; nonres—$1842 per sem
Courses: Ceramics, Computer Graphics, Designs & Welded Sculpture, Drawing, Metals, Painting, Photography, Sculpture, Theatre Arts
Summer School: Dean, Chuck Thompson. Enrl 40; tuition $50 per cr hr for 8 wk term. Courses—Ceramics, Computer Graphics, Drawing, Metals, Watercolor

LARAMIE

UNIVERSITY OF WYOMING, Dept of Art, Dept 3138, 1000 E University Ave Laramie, WY 82071. Tel 307-766-3269; Fax 307-766-5468; Elec Mail kwold@uwyo.edu; rik@uwyo.edu; *Head Dept* Ricki Klages
Estab 1886, dept estab 1946; FT 9; pub; D; Scholarships; SC 23, LC 6, GC 13; D 80, non-maj 600, maj 120, grad 16
Ent Req: HS dipl
Degrees: BA, BS and BFA 4 yrs
Tuition: Res—$1505 per sem; nonres—$4121 per sem
Courses: Art Appreciation, †Art Education, Art History, †Ceramics, †Design, †Drawing, †Graphic Design, †Painting, †Printmaking, †Sculpture
Adult Hobby Classes: Courses offered through University of Wyoming Art Museum
Summer School: Dir, Ricki Klages. Enrl 140; tuition res—undergrad $83.50 per cr hr 1-12, grad $102.50 per cr hr 1-12; non res—undergrad $231.50 per cr hr 1-12, grad $250.50 per cr hr 1-12, 4 & 8 wk sessions. Courses—Art Appreciation, Art History, Ceramics, Drawing, Graphic Design, Painting, Printmaking, Sculpture

POWELL

NORTHWEST COMMUNITY COLLEGE, Dept of Art, 231 W Sixth St, Powell, WY 82435. Tel 307-754-6111, 754-6201; Elec Mail mastersm@nwc.cc.wy.us; *Instr & Asst Prof* Lynn Thorpe; *Assoc Prof* John Giarrizzo; *Asst Prof* Morgan Tyree; *Chmn* Mike Masterson; *Asst Prof* Peder Gjovick; *Assoc Prof* Craig Satterlee
Estab 1946, dept estab 1952; pub; D & E; Scholarships; SC 12, LC 4; D 130, E 222, non-maj 317, maj 35
Ent Req: HS dipl, nonres ACT
Degrees: AA 2 yrs
Tuition: Res—undergrad $1610 per sem; nonres—undergrad $3866 per sem, WUE 5892 room & board $3058
Courses: Advertising Design, Art Education, Ceramics, Commercial Art, Drawing, Graphic Arts, Graphic Design, Handicrafts, History of Graphic Design, Lettering, Painting, Photography, Printmaking
Adult Hobby Classes: Enrl 100. Courses—Vary each sem

RIVERTON

CENTRAL WYOMING COLLEGE, Art Center, 2660 Peck Ave, Riverton, WY 82501. Tel 307-855-2216, 855-2211; Fax 307-855-2090; Elec Mail nkehoe@csc.edu; Internet Home Page Address: www.cwc.edu; *Chair Dept* Nita Kehoe; *Prof Photography* Lonnie Slorck; *Ceramics* Markus Urbanik; *Prof 2-D* Matt Flint
Estab 1966; Maintain nonprofit art gallery; Robert A Peck Gallery; pub7; D & E; Scholarships; SC 30, LC 2; D 1500, E 500, non-maj 200, maj 100, others 20
Ent Req: HS dipl, GED
Degrees: AA 2 yrs
Tuition: Res—$900 per sem; nonres—$1980 per sem; sr citizen free of charge; campus res—room & board $1138
Courses: Art Appreciation, Art Education, Art History, Bronze Casting, Ceramics, Design, Drawing, Fiber Arts, Graphic Design, Mixed Media, Moldmaking, Painting, Photography, Printmaking, Sculpture, Textile Design, Video
Adult Hobby Classes: Enrl 30 plus; tuition $15-$50. Courses—Varied Art & General Curriculum
Children's Classes: Enrl 200; classes for a day, wk or sem. Courses—varied
Summer School: Dir, Nita Kehoe; Limited Art offerings

ROCK SPRINGS

WESTERN WYOMING COMMUNITY COLLEGE, Art Dept, PO Box 428, Rock Springs, WY 82902-0428. Tel 307-382-1600, Ext 723; Elec Mail fmcewin@uucc.cc.uy.us; *Head Dept* Dr Florence McEwin
Estab 1959; pub; D & E; Scholarships; SC 12, LC 1; D 675, E 600, maj 20
Ent Req: HS dipl
Degrees: AA 2 yrs
Tuition: resident—$672, non-resident—$1800; room $ 613, board $701
Courses: Advertising Design, Art Appreciation, Art History, Ceramics, Collage, Design, Drafting, Drawing, Film, Graphic Design, History of Art & Architecture, Life Drawing, Mixed Media, Museum Staff Training, Painting, Photography, Printmaking, Sculpture, Stage Design, Theatre Arts, Video
Adult Hobby Classes: Enrl 100. Courses—Crafts, Drawing, Painting, Pottery
Children's Classes: Dance
Summer School: Dir, Florence McEwin. Courses—Ceramics, Photography

SHERIDAN

SHERIDAN COLLEGE, Art Dept, 3059 Coffeen Ave, PO Box 1500 Sheridan, WY 82801-1500. Tel 307-674-6446, ext 6123; Fax 307-674-4293; Elec Mail jlawson@sc.cc.wy.us; *Head Dept* Jim Lawson; *Instr* Danna Hildebrand
Estab 1951; PT 3; pub; D & E; Scholarships; maj 10
Ent Req: HS grad
Degrees: AA, AS & AAS 2 yrs
Tuition: In-state res—$729.50 per sem; out-of-state res—$1857.50 per sem
Courses: Art Appreciation, Ceramics, Design, Drawing, Etching, Jewelry, Lithography, Painting, Photography, Pottery, Sculpture, Silk Screen
Adult Hobby Classes: Enrl 40-60; tuition varies. Courses—Drawing, Painting, Pottery, Stained Glass
Children's Classes: Enrl 10-15; tuition varies. Courses—Pottery
Summer School: Enrl 10-15; tuition varies. Courses—Painting, Pottery

TORRINGTON

EASTERN WYOMING COLLEGE, Art Dept, 3200 W C St, Torrington, WY 82240. Tel 307-532-8291; Fax 307-532-8225; Elec Mail cphillip@ewc.wy.edu; *Head Dept* Carolyn Phillips
Estab 1948; PT 2; pub; D & E; Scholarships; SC 9, LC 1; D 50, maj 4, non-maj 46
Ent Req: varied
Degrees: AA and AAS 2 yrs
Tuition: Res—$312 per sem; nonres—$936 per sem
Courses: Ceramics, Commercial Art, Design I, Drawing, General Art, Graphic Arts, History of Art & Architecture, Painting, Sculpture
Adult Hobby Classes: Painting Workshops
Summer School: No summer school offered

PUERTO RICO

MAYAGUEZ

UNIVERSITY OF PUERTO RICO, MAYAGUEZ, Dept of Humanities, College of Arts & Sciences, PO Box 5000, Mayaguez, PR 00681. Tel 787-832-4040, Ext 3160, 265-3846; Fax 809-265-1225; *Gallery Dir* Felix Zupata; *Dir* Frances Santiago
Estab 1970; FT 40; pub; D; SC 20, LC 15; 402, maj 115
Ent Req: HS dipl
Degrees: BA(Art Theory) and BA(Plastic Arts) 4 yrs
Courses: Aesthetics, Art Appreciation, Art Education, Art History, Calligraphy, Ceramics, Commercial Art, Design, Drawing, Graphic Arts, Illustration, Painting, Photography, Printmaking, Restoration & Conservation, Sculpture, Stage Design, Teacher Training, Theatre Arts
Adult Hobby Classes: Enrl 40

PONCE

CATHOLIC UNIVERSITY OF PUERTO RICO, Dept of Fine Arts, 2250 Las Americas Ave, Ste 563, Ponce, PR 00717-0777. Tel 787-841-2000; Fax 787-840-9595; *Head Dept* Alfonso Santiago
Estab 1948, dept estab 1964; den; D; Scholarships; SC 22, LC 4; D 50 maj
Ent Req: HS dipl
Degrees: BA 4 yrs
Tuition: Res—undergrad $105 per cr hr, grad $152 per cr hr
Courses: Advertising Design, Aesthetics, Art Appreciation, Art Education, Art History, Ceramics, Conceptual Art, Constructions, Contemporary Form, Design, Drawing, Graphic Design, History in Art in Puerto Rico, Painting, Photography, Printmaking, Sculpture

RIO PIEDRAS

UNIVERSITY OF PUERTO RICO, Dept of Fine Arts, Ponce de Leon Ave, Rio Piedras, PR; UPR Sta, PO Box 21849 San Juan, PR 00931-1849. Tel 787-764-0000 Ext 3611; Fax 787-773-1721; Elec Mail departmentodebellasartes@yahoo.com; *Dir* Guy Paizy; *Prof* Arturo Davila PhD, MA; *Prof* Susana Herrero, MA; *Prof* Pablo Rubio, MA; *Prof* Jaime Romano, MA; *Prof* Nelson Millan, MFA; *Prof* Maria Del Pilar Gonzalez, PhD; *Assoc Prof* Alejandro Quinteros, MFA; *Auxiliary Prof* Roberto Barrera, MFA; *Prof* Teresa Tio, PhD; *Assoc Prof* Martin Garcia, MFA; *Prof* Brenda Alejandro, PhD; *Assoc Prof* Ingrid Jimenez PhD, MFA; *Auxiliary Prof* Nilsevady Fussa PhD; *Instr* Nathan Budoff, MFA
Estab 1902, dept estab 1950; pub; D & E & Sat; Scholarships; SC 25, LC 15; D 200, maj 45
Ent Req: HS dipl
Degrees: BA 4 yrs
Tuition: Res—undergrad $35 per cr; grad $45 per cr; campus res available
Courses: Art Appreciation, Art History, †Art Theory, Art in Puerto Rico, Color Theory, †Conceptual Art, Design, †Digital Images, Drawing, †Graphic Arts, †History of Art & Architecture, †Mixed Media, †Museum Staff Training, Painting, Photography, Pre-Hispanic Art of Antilles, Printmaking, Sculpture, Video

SAN GERMAN

INTER AMERICAN UNIVERSITY OF PUERTO RICO, Dept of Art, Call Box 5100, San German, PR 00683. Tel 787-264-1912, Ext 7552; *Auxiliary Prof* Fernando Santiago, MA; *Auxiliary Prof* Maria Garcia Vera, MFA; *Instr* Jose B Alvarez, BA
Estab 1912, dept estab 1947; pvt; D; SC 20, LC 12; D 135, maj 135
Ent Req: HS dipl, college board, presentation of portfolio
Degrees: BA 4 yrs
Tuition: Res—undergrad $98 per cr, grad $145 per cr; campus res available
Courses: †Art Education, Art History, Calligraphy, †Ceramics, Drawing, Experimental Design in Native Media, †Graphic Arts, Handicrafts, Leather, Macrame, Metals, †Painting, †Photography, †Sculpture
Summer School: Dir, Jaime Carrero. Enrl 10; tuition $75 per cr hr for 5 wk term. Courses—Art Appreciation

SAN JUAN

INSTITUTE OF PUERTO RICAN CULTURE, Escuela de Artes Plasticas, Escuela de Artes Plasticas, PO Box 9021112 San Juan, PR 00902-1112; School of Fine Arts, El Morro Grounds San Juan, PR 00901. Tel 787-725-1522; Fax 787-725-8111; Elec Mail info@eap.edu; Internet Home Page Address: eap.edu.pr; *Chancellor* Marimar Benitez; *Student Aid Coordr* Alfred Diaz

Estab 1971; Maintains nonprofit art gallery on campus. Francisco Oller Library; Pub; D&E; Scholarships; SC 38, LC 12; D 377, E 107
Ent Req: HS dipl, ent exam
Degrees: BA 4 yrs
Tuition: In-state or out-of-state $2225 per yr, $70 per cr
Courses: †Art Education, Art History, Ceramics, Drawing, Graphic Arts, †Graphic Design, †Industrial Design, †Painting, †Printmaking, †Sculpture, Teacher Training

Adult Hobby Classes: Enrl 250; tuition $50 per cr. Courses—Graphic, Painting, Sculpture
Summer School: Basic Drawing, Painting, Sculpture

ALBERTA

BANFF

BANFF CENTRE, PO Box 1020, Sta 28, 107 Tunnel Mountain Dr Banff, AB
T1L 1H5 Canada. Tel 403-762-6180; Fax 403-762-6345; Elec Mail
arts_info@banffcentre.ca; Internet Home Page Address: www.banffcentre.ab; Cable
ARTSBANFF; *Exec Producer* Sara Diamond; *Assoc Dir Creative Residences*
Anthony Kiendl
Estab 1933 for summer study, winter cycle prog began 1979; Pub; Day - Mostly
Independent Study; Scholarships
Ent Req: Resume, slides of work, post-secondary art training at a university or art
school and/or professional experience in field
Tuition: Tuition depends on Prog
Courses: Art Studio, Ceramics, Media Arts, Photography, †Theatre Arts, †Video
Adult Hobby Classes: Courses - Art Studio, Ceramics Studio, Photography
Studio, Visual Community
Summer School: Courses - Art Studio, Ceramics Studio, Photography Studio,
Visual Community

CALGARY

ALBERTA COLLEGE OF ART & DESIGN, 1407 14th Ave NW, Calgary, AB
T2N 4R3 Canada. Tel 403-284-7600; Fax 403-289-6682; Elec Mail
admissions@acad.ab.ca; Internet Home Page Address: www.acad.ab.ca; *Painting
Dept* Jim Ulrich; *Pres* Desmond Rochfort; *VPres External Affairs & Develop*
Colleen Evans; *VPres Finance* Eric Fecter; *Acad Head Media Arts* Alan Dunning;
Acad Head Design Eugene Ouchi; *Acad Head Fine Arts* Stuart Parker; *Acad Head
Liberal Studies* Mireille Perron
Estab 1926; Maintain nonprofit art gallery; The Illingworth Kerr Gallery; pub; D
& E; Scholarships; SC 250, LC 14; D 1000, E 500, non-maj 60, maj 850, others
60
Ent Req: HS dipl, portfolio
Degrees: BFA; BDes
Tuition: $9108 per yr plus course costs (Canadian funds)
Courses: Ceramics, Drawing, †Fibre, Glass, †Interdisciplinary, Jewelry, †Media &
Digital Technology, Painting, Photographic Arts, Photography, Printmaking,
Sculpture, Visual Communications
Adult Hobby Classes: Enrl 1500; tuition varies per course. Courses—Ceramics,
Art Fundamentals, Drawing, Jewelry, Painting, Printmaking, Sculpture, Glass,
Textiles, Watercolor, Photography
Children's Classes: Enrl 560; tuition $110 per course; Pre-College Studio $135
for 18 hrs. Courses—Ceramics, Jewelry, Mixed Media, Painting, Painting for
Teenagers, Puppetry, Sculpture
Summer School: Dir Continuing Educ, David Casey, Enrl varies 100 approx

MOUNT ROYAL COLLEGE, Dept of Interior Design, 4825 Richard Rd SW,
Calgary, AB T3E 6K6 Canada. Tel 403-240-6100; Fax 403-240-6939; Elec Mail
fharks@mtroyal.ab.ca; Internet Home Page Address: www.mtroyal.ab.ca; *Chmn*
Frank Harks; *Admin Support* Sarah Block
Estab 1910; FT 5, PT 10; pub; D & E; Scholarships; SC 12, LC 17
Ent Req: HS dipl
Degrees: 2 yr dipl
Tuition: $3857 per sem
Courses: Business Principles & Practices, Design, Graphic Presentation, History
of Art & Architecture, History of Furniture, †Interior Design, Sculpture, Stage
Design, Technical Design & Drafting
Adult Hobby Classes: Enrl 50. Courses—Interior Design Program

UNIVERSITY OF CALGARY, Dept of Art, 2500 University Dr NW, AB605
Calgary, AB T2N 1N4 Canada. Tel 403-220-5251; Fax 403-289-7333; Internet
Home Page Address: www.ucalgary.cal; *Dean, Faculty Fine Arts* Dr Ann Calvert
Estab 1965; FT 21, PT 6; pub; D & E; SC 56, LC 19, GC 8; D 263, E 31, all maj
Ent Req: HS dipl
Degrees: BA(Art History), BFA(School Art, Art), MFA(Studio)
Tuition: $2513 per session
Courses: †Architecture, †Art Education, Art Fundamentals, †Art History, Art
Theory, Conceptual Art, Costume Design & Construction, Drawing, Film, Graphic
Arts, History of Art & Architecture, Intermedia, Mixed Media, Museum Staff
Training, †Painting, †Photography, †Printmaking, †Sculpture, Stage Design,
†Theatre Arts, Video
Summer School: Two terms of 6 wks, May-July. Courses—Art History, Drawing,
Printmaking, Painting, Art Fundamentals, Art Education, Sculpture

EDMONTON

UNIVERSITY OF ALBERTA, Dept of Art & Design, 398 Fine Arts Bldg,
Edmonton, AB T6G 2C9 Canada. Tel 780-492-3261; Fax 780-492-7870; Elec Mail

artdes@gpu.srv.ualberta.ca; Internet Home Page Address:
www.ualberta.ca/ARTDESIGN; *Chair* M Elizabeth (Betsy) Boone; *Acad Advisor*
Dawn McLean; *APO* Stan Szynkowski; *Admin Clerk* Sharon Orescan; *Secy*
Deanna Ashton; *Coordr Grad Programs* Prof Joan Greer; *Coordr Industrial
Design* Prof. Cezary Gajewski; *Coordr Visual Communications Design* Prof Sue
Colberg; *Coordr History of Art, Design & Visual Culture* Dr Steven Harris;
Coordr Printmaking & Drawing Prof Sean Caulfield
Estab 1908, dept estab 1946; Maintains a nonprofit art gallery, FAB Gallery &
Design Gallery; Pub; D & E; Scholarships; SC 51, LC 42, grad 23; D 151, grad
20-30
Ent Req: HS dipl, portfolio
Degrees: BFA 4 yrs, MFA, MA , M Des 2 yrs
Tuition: Res—undergrad $3,770-40 per yr, grad $3,699-36 per yr; international;
campus res available
Courses: Design & Visual Culture, History of Art, †Industrial Design, †Painting,
†Printmaking, †Sculpture, †Visual Communication Design
Summer School: Dir, Dr. E Boone Enrl 150; tuition $420 per course.
Courses—Art History, Drawing, Painting, Printmaking, Sculpture, Visual
Communication Design

LETHBRIDGE

UNIVERSITY OF LETHBRIDGE, Div of Art, 4401 University Dr, Lethbridge,
AB T1K 3M4 Canada. Tel 403-329-2691; Fax 403-382-7127; Internet Home Page
Address: www.uleth.ca; *Assoc Prof* Carl Granzow, MFA; *Asst Prof* Leslie Dawn,
MFA; *Asst Dean* Jennifer Gordon
Estab 1967; pub; D & E; Scholarships; SC 26, LC 9
Ent Req: HS dipl
Degrees: BA & BFA 4 yrs
Tuition: Res—undergrad $5184 per sem; nonres—undergrad $10,320 per sem
Courses: Aesthetics, Art Appreciation, Art Education, Art History, Conceptual Art,
Costume Design & Construction, Design, Drawing, History of Art & Architecture,
Intermedia, Mixed Media, Museum Staff Training, Painting, Photography,
Printmaking, Sculpture, Stage Design, Teacher Training, Theatre Arts, Video

RED DEER

RED DEER COLLEGE, Dept of Visual Arts, 56th Ave & 32nd St, Box 5005
Red Deer, AB T4N 5H5 Canada. Tel 403-342-3300; Fax 403-347-0399; Internet
Home Page Address: www.rdc.ab.cal; *Chmn Visual Arts* Graham Page
Estab 1973; FT 6, PT 2; pub; D & E; Scholarships; max 50 first yr students, 30
second yr
Ent Req: HS dipl, portfolio
Degrees: dipl, BFA 2 yrs
Tuition: undergrad—$77-80 per cr
Courses: Art History, Ceramics, Drawing, Fundamentals of Visual
Communication, Painting, Printmaking, Sculpture
Adult Hobby Classes: Enrl 300; tuition $74 - $100 per course.
Courses—Ceramics, Drawing, Glass Blowing
Children's Classes: Enrl 80; tuition $350 per wk. Courses—Drawing, Painting,
Sculpture
Summer School: Dir, Ann Brodie. Enrl 500; tuition $200 per wk.
Courses—Applied Arts, Drawing, Glass Blowing, Painting, Printmaking

BRITISH COLUMBIA

KELOWNA

UNIVERSITY OF BRITISH COLUMBIA OKANAGAN, (Okanagan
University College) Dept of Creative Studies, 3333 University Way, Kelowna, BC
V1V 1V7 Canada. Tel 250-807-9761; Fax 250-807-8027; Elec Mail
w.briar.craig@ubc.ca; Internet Home Page Address:
www.ubc.ca/okanagan/creative/welcome.html; *Dept Head & Assoc Prof (Visual
Art)* Briar Craig; *Assoc Prof (Visual Art)* Doug Biden; *Assoc Prof (Performance -
Theater)* Neil Cadger; *Assoc Prof (Visual Art)* Renay Egami; *Assoc Prof (Visual
Art)* Johann Feught; *Assoc Prof (Creative Writing)* Anne Fleming; *Assoc Prof
(Visual Art)* Stephen Foster; *Assoc Prof (Visual Art)* Fern Helfand; *Assoc Prof
(Creative Writing)* Nancy Holmes; *Assoc Prof (Visual Art)* Byron Johnston; *Assoc
Prof (Visual Art)* Jim Kalnin; *Assoc Prof (Visual Art)* Ruth MacLaurin; *Asst Prof
(Performance - Theater)* Virginie Magnat; *Assoc Prof (Visual Art)* Gary Pearson;
Assoc Prof (Visual Art) Bryan Ryley; *Assoc Prof (Visual Art)* Jim Tanner; *Assoc
Prof (Creative Writing)* Sharon Thesen

Estab 2005; Maintains a nonprofit art gallery, Fina Gallery; 17; pub; D & E; Scholarships; SC 75, LC 18; D 200, E 20
Ent Req: HS dipl
Degrees: BFA 4 yr, BA Creative Writing, BA Performance (theatre)
Tuition: res—undergrad $4,600 per year
Courses: Aesthetics, †Art History, Collage, Conceptual Art, Constructions, Creative Writing, †Drawing, Graphic Arts, †Intermedia, Mixed Media, †Painting, †Photography, †Printmaking, †Sculpture, Theater Arts, Video
Summer School: 40 $300 per course, painting, drawing, aramids

VANCOUVER

EMILY CARR INSTITUTE OF ART & DESIGN, 1399 Johnston St, Vancouver, BC V6H 3R9 Canada. Tel 604-844-3800; Fax 604-844-3801; Elec Mail amcmilan@eciad.bc.ca; Internet Home Page Address: www.eciad.bc.ca/eriadmain; *Dir Student Svcs* Alan C McMillan; *Pres* Dr Ronald Burnett; *VPres Acad* Monique Fouquet
Estab 1925; pub; D & E; Scholarships; SC 20, LC 8; 1200
Ent Req: HS dipl plus presentation of folio of art work
Degrees: 4 yr dipl, 4 yr degree
Tuition: res—$2500 per yr; non-res—$10,2000 per yr
Courses: Animation, Art History, Ceramics, Design, Drawing, Film, Graphic Design, Intermedia Studies, Photography, Printmaking, Sculpture, Video
Adult Hobby Classes: Enrl 2000; tuition $250 per course. Courses—Design, Fine Arts
Summer School: Dir, Isabel Scott. Enrl 700; tuition $250. Courses—Design, Fine Arts

LANGARA COLLEGE, Dept of Display & Design, 100 W 49th Ave, Vancouver, BC V5Y 2Z6 Canada. Tel 604-323-5995; Fax 604-323-5555; Elec Mail gKennedy@langara.bc.ca; Internet Home Page Address: www.langara.bc.ca/displaydesign/index; *Chmn Dept* Daryl Plater, MFA, MArch; *Div Chmn* Scott Plear, BFA
Estab 1970; pub; D & E; SC 7, LC 1; D 160
Ent Req: HS dipl, portfolio
Degrees: 2 yr Fine Arts Dipl
Tuition: $704.60 per sem
Courses: Ceramics, Design, Drawing, Painting, Printmaking, Sculpture
Adult Hobby Classes: Enrl 20 per class; tuition $100 per sem. Courses—Design, Drawing

UNIVERSITY OF BRITISH COLUMBIA
—School of Architecture, Tel 604-822-2779; Fax 604-822-3808; Internet Home Page Address: www.arch.ubc.ca; *Dir* Christopher Macdonald
Estab 1946; For reference only; maintain nonprofit art gallery, Downtown Gallery & Studio, UBC School of Architecture, 319 West Hastings, Vancouver, BC; FT 14; pub; Scholarships, Fellowships
Library Holdings: Book Volumes 3500; Clipping Files; Other Holdings Architectural plans; Pamphlets; Periodical Subscriptions 17; Slides
Degrees: MArch & MASA
Tuition: $2,500 per yr for Canadian students; MArch $10,000 per yr for International students, MASA $7,200 per yr for International students
Courses: Architectural History, Architecture, Computational Design, Design Studios, Environmental Design, Structures, Urban Design
Adult Hobby Classes: Enrl 170; tuition $2,448 per yr for 3 yr program
Summer School: Dir, Christopher Macdonald. Courses—vary

VICTORIA

UNIVERSITY OF VICTORIA
—Dept of Visual Arts, Tel 250-721-8011; Fax 250-721-6595; Elec Mail ntrembla@finearts.uvic.ca; *Chmn & Assoc Prof* Lynda Gammon; *Assoc Prof* Vikky Alexander, BFA; *Prof* Robert Youds, MFA; *Asst Prof* Steve Gibson, PhD; *Asst Prof* Daniel Naskarin, MFA
Estab 1963; pub; D & E; Scholarships, Fellowships; 50
Ent Req: HS dipl
Degrees: BFA, MFA
Tuition: Undergrad $2000 per yr
Courses: †Digital Multimedia, †Drawing, †Painting, †Photography, †Printmaking, †Sculpture
Summer School: Drawing, Painting, Printmaking
—Dept of History in Art, Tel 250-721-7942; Fax 250-721-7941; Elec Mail cgibson@finearts.uvic.ca; Internet Home Page Address: www.finearts.uvic.ca/historyinart/; *Dean* G Hogya PhD; *Prof* John L Osborne PhD; *Prof* S Anthony Welch PhD; *Assoc Prof* Kathlyn Liscomb PhD; *Assoc Prof* Victoria Wyatt PhD; *Assoc Prof* Astri Wright PhD; *Assoc Prof* Lianne McLarty PhD; *Asst Prof* Catherine Harding PhD; *Asst Prof* Christopher Thomas PhD; *Chair* Carol Gibson-Wood; *Prof* Nancy Micklewright, PhD
LC 52, grad 20
Degrees: BA, MA, PhD
Tuition: $2,265 per yr, rm & board $4,600-$5,224
Courses: Asian, Canadian, European, Islamic & Native American Art
Summer School: May-Aug

MANITOBA

WINNIPEG

UNIVERSITY OF MANITOBA
—School of Art, Tel 204-474-9303; Fax 204-275-3148; *Dir* Dale Amundson, MFA; Sharon Alward, MFA; Marilyn Baker, PhD; Oliver Botar, PhD; James

Bugslag, PhD; Cliff Eyland, MFA; Robert Flynn, MFA; Jeff Funnell, MFA; Steve Higgins, MFA; Ted Howorth, MFA; David McMillan, MFA; Alexander Poruchnyk, MFA; Bill Pura, MFA; Gordon Reeve, MFA; Robert Sakowski, MFA; Charlie Scott, MFA; Mary Ann Steggles, MFA; Charlotte Werner, PhD
Estab 1950; Maintain nonprofit art gallery; Pub; D&E; Scholarships; SC 35, LC 16; D 440
Ent Req: HS dipl and portfolio
Degrees: BFA
Tuition: $4,200 per yr
Courses: †Art History, †Ceramics, †Drawing, †Foundations, †Graphic Design, †Painting, †Photography, †Printmaking, †Sculpture
Summer School: Courses—Studio & Art History
—Faculty of Architecture, Tel 204-474-6433; Fax 204-474-7532; Internet Home Page Address: www.umanitoba.ca; *Dean* Michael Cox; *Assoc Dean, Head Environmental Design* Charles Thomsen; *Head Landscape Archit* Alan Tate; *Acting Head Dept City Planning* Ian Whight; *Head Dept Architecture* Ian MacDonald; *Head Dept Interior Design* Lynn Chalmers
Estab 1913; Pub; Scholarships; Environmental Studies 218, Archit 110, Interior Design 284, City Planning 72, Landscape 60
Ent Req: Senior matriculation or Bachelor for particular subject
Degrees: BED, BID, MArchit, MCP, MID, M(Land Arch)
Tuition: $1,900 per yr
Courses: Architecture, Environmental Design, Interior Design, Landscape, Landscape Architecture

NEW BRUNSWICK

EDMUNDSTON

UNIVERSITE DE MONCTON, CAMPUS D'EDMUNDSTON, Dept of Visual Arts Arts & Lettres, 165 Blvd Hebert, Edmundston, NB E3V 2S8 Canada. Tel 506-737-5050; *Chief* Roger Jurvais
Estab 1946, dept estab 1968; pub; D & E; Scholarships; SC 12, LC 1; D 20, E 11, non-maj 25, maj 6
Ent Req: HS dipl
Degrees: BA(Fine Arts) 4 yrs
Tuition: $2430; campus res—room & board $1545 per yr
Courses: Art History, Drawing, Painting, Sculpture

FREDERICTON

NEW BRUNSWICK COLLEGE OF CRAFT & DESIGN, 457 Queen St, PO Box 6000 Fredericton, NB E3B 5H1 Canada. Tel 506-453-2305; Fax 506-457-7352; *Dir Craft School* Luc Paulin
Estab 1946; pub; D& E; Workshops; 70 plus PT
Ent Req: HS dipl, transcript, questionnaire and interview
Degrees: 3 yr dipl
Tuition: $2040
Courses: Advertising Design, Art History, Ceramics, †Clothing Design & Construction, Colour, †Creative Graphics, Design, Drawing, Fashion Arts, Graphic Arts, Illustration, Jewelry, †Native Arts Studies, Photography, Silversmithing, Textile Design, Weaving
Adult Hobby Classes: Courses—Weekend workshops

UNIVERSITY OF NEW BRUNSWICK, Art Education Section, Faculty of Education, PO Box 4400 Fredericton, NB E3B 5A3 Canada; 5 Macqulay Ln, Fredericton, NB E3B 5H5 Canada. Tel 506-453-4623; Fax 506-453-3569; *Science Librn* Francesca Holyoke
Tuition: Res—$1975 per yr
Courses: Art Education for Elementary Teachers, Art History, Art Media for Schools, Art Seminar, Children's Art for Teachers
Children's Classes: 70; tuition $15 for 6 weeks, one afternoon per wk

MONCTON

UNIVERSITE DE MONCTON, Dept of Visual Arts, Moncton, NB E1A 3E9 Canada. Tel 506-858-4033; Fax 506-858-4166; Elec Mail savoieda@umoncton.ca; Internet Home Page Address: www.umoncton.ca/facartslartsvisuels/; *Chmn Photography Dept* Francis Coutellier; *Prof Printmaking* Jacques Arseneault; *Prof Painting* Claude Gauvin; *Prof Sculpture* André Lapointe; *Prof Ceramics* Marie-Rene Ulmer; *Prof History of Art* Herménégilde Chiasson
Estab 1967; Maintain nonprofit art gallery; Galerie d'art Clement-Cormier, Universite de Moncton, NB, Canada, E1A 3E9; 6; pub; D & E; Scholarships; SC 7, LC 3; D 45, E 75,
Ent Req: HS dipl
Degrees: BA(Fine Arts) 4 yrs; BA (Fine Arts Educ) 6 yrs
Tuition: $3,245
Courses: Art Education, Art History, †Ceramics, Drawing, †Painting, †Photography, †Printmaking, †Sculpture, †Teacher Training

SACKVILLE

MOUNT ALLISON UNIVERSITY, Dept of Fine Arts, Att: Ms Edna Boland, Sec., 53 York St Sackville, NB E4L 1C9 Canada. Tel 506-364-2490; Fax 506-364-2606; Elec Mail finearts@mta.ca; Internet Home Page Address: www.mta.ca/finearts; *Head Prof* Thaddeus Holownia, BA; *Prof* Rebecca Burke, MFA; *Assoc Prof* Jennifer MacKlem, MFA; *Assoc Prof* Jeffrey Burns, MFA; *Assoc Prof* Erik Edson, MFA; *Dr* Anne Koval; *Adjunct Prof* Gemey Kelly, BFA; *Lectr* Dan Steeves, BFA; *Asst Prof* Leah Garnett, MFA; *Lectr* Karen Stentaford, BFA, BEd; *Lectr* Kip Jones

Estab 1854; Maintain nonprofit art gallery; Owens Art Gallery, Mount Allison University, 61 York St, Sackville, NB E4L IEI; Pub; D & E 20; Scholarships; SC 34, LC 19; 13,475 Maj, 59 non Maj
Ent Req: HS dipl
Degrees: BFA 4 yrs
Tuition: Tuition $6,405 (Canadian), $12,810 (non-Canadian) plus meals Various plans from $2,965 to $3,265, residence single $4,140, supersingle $4,370, double $3,530
Courses: †Art History, †Drawing, Open Media, †Painting, †Photography, †Printmaking, †Sculpture

SUPERIOR

LOVEWELL STUDIOS, 354 N Commercial Ave, Superior, NB 68978 Canada. Tel 402-879-3054; Elec Mail lovewell2@americaonline.com; *Dir* Rich Thibodeau, BFA
Estab 1982; pvt; D; Scholarships; SC 26; D 140
Tuition: Campus res available
Courses: Art Appreciation, Drawing, Encaustic, Mixed Media, Painting, Printmaking, Woodblock Printing
Adult Hobby Classes: Enrl 120. Courses—same as above
Children's Classes: Enrl 120. Courses—same as above
Summer School: Dir, Rich Thibodeau. Tuition $300 for 1 wk, $100-$150 weekend. Courses—same as above

NEWFOUNDLAND

CORNER BROOK

MEMORIAL UNIVERSITY OF NEWFOUNDLAND, Division of Fine Arts, Visual Arts Program, Sir Wilfred Grenfell College, University Dr Corner Brook, NF A2H 6P9 Canada. Tel 709-637-6333; Fax 709-637-6383; Internet Home Page Address: swgc.mun.ca/visual/index/html; *Head Fine Arts* Roy Hostetter; *Chair Visual Arts* Les Sasaki
Estab 1975, dept estab 1988; Maintain nonprofit art gallery; Sir Wilfred Grenfell College, Corner Brook, NF A2H6P9; pub; D & E; Scholarships; Studio & lect courses; D 50
Degrees: BFA
Tuition: Res—undergrad $3300 yr; non-res—undergrad $3300 yr; campus res—room & board $2740 yr
Courses: Aesthetics, Art Appreciation, Art History, Design, Digital Imaging, Drawing, Mixed Media, Painting, Photography, Printmaking, Sculpture
Adult Hobby Classes: Drawing, Studio Areas
Children's Classes: Art

NOVA SCOTIA

ANTIGONISH

ST FRANCIS XAVIER UNIVERSITY, Fine Arts Dept, PO Box 5000, Antigonish, NS B2G 2W5 Canada. Tel 902-867-2417, 863-3300; Fax 902-867-5153; Elec Mail iroach@stfx.ca; Internet Home Page Address: www.stfx.ca; *Chmn* Iris Delgado
PT 4; Scholarships
Degrees: BA
Tuition: undergrad—$4370, room & board—$5190-$6270
Courses: Art History, Design, Drawing, Painting, Printmaking, Stained Glass
Adult Hobby Classes: Courses - Drawing, General Studio, Painting
Children's Classes: Courses - Drawing, Painting, Printmaking
Summer School: Dir, Angus Braid. Enrl 15; 5 wk sem beginning July-Aug. Courses—General Studio

HALIFAX

NOVA SCOTIA COLLEGE OF ART & DESIGN, 5163 Duke St, Halifax, NS B3J 3J6 Canada. Tel 902-422-7381; Fax 902-425-2420; Internet Home Page Address: www.nscad.ns.ca; *Dean* Dr Jill Grant; *Assoc Dean* Dr Harold Pearse; *Dir Foundation Studies* Bryan Maycock; *Pres* Paul Greenhaigh; *VPres* Ronald Hobbs; *Dir MFA Program* Bruce Barber
Estab 1887; pvt; D & E; Scholarships, Fellowships; SC 67, LC 31, GC 8 each sem; 600, grad 17
Activities: schols
Ent Req: HS dipl, portfolio or project
Degrees: BFA, BD(Environmental Planning or Graphic Design), BA, MFA & MA(Art Educ)
Tuition: $22980 per sem; visa students $4560 per sem; no campus res
Courses: Art Education, Art History, Ceramics, Computer Art, Design, Drawing, Graphic Arts, Graphic Design, Jewelry, Mixed Media, Painting, Photography, Printmaking, Sculpture, Textile Design, Video

TECHNICAL UNIVERSITY OF NOVA SCOTIA, Faculty of Architecture, 5410 Spring Garden Rd, PO Box 1000 Halifax, NS B3J 2X4 Canada. Tel 902-494-3971; Fax 902-423-6672; Elec Mail arch.office@dal.ca; Internet Home Page Address: www.dal.ca/~arch/architecture/index; *Dean* T Emodi; *Prof* J Grant Wanzel; *Prof* D Procos; *Prof* Michael Poulton; *Assoc Prof* S Parcell; *Assoc Prof* T Cavanagh; *Assoc Prof* B MacKay-Lyons; *Asst Prof* Susan Guppy; *Assoc Prof* Richard Kroeker; *Assoc Prof* Christine Macy; *Asst Prof* Steven Mannell; *Dir* Jaques Rousseau; *Prof* Essy Baniassad; *Prof* Frank Palermo; *Asst Prof* Austin Parsons

Estab 1911, faculty estab 1961; pvt; D; Scholarships; approx 200, maj 200, grad 2
Ent Req: previous 2 yrs at univ
Degrees: MArchit 4 yrs, Post-professional MArchit 1 yr minimum
Tuition: $2200 per academic term; differential for foreign students
Courses: Architecture, Art History, Constructions, Drafting, Environmental Studies, Photography, Urban & Rural Planning
Summer School: Three terms per yr

WOLFVILLE

ACADIA UNIVERSITY, Art Dept, Wolfville, NS B0P 1X0 Canada. Tel 902-542-2200; Fax 902-542-4727; Internet Home Page Address: www.acadian.ca; *Chmn & Prof* Wayne Staples; *Dean of Arts* Thomas Regan; *Asst Dean of Arts* Maurice Tugwell; *Admin Secy* Audrey Dorey
Scholarships
Degrees: BA, BAM, BM, MA
Tuition: $3850 per yr
Courses: Art History, Drawing, Painting
Summer School: Dir, Prof Wayne Stapler. Enrl 30

ONTARIO

DUNDAS

DUNDAS VALLEY SCHOOL OF ART, Dofasco Gallery, 21 Ogilvie St, Dundas, ON L9H 2S1 Canada. Tel 905-628-6357; Fax 905-628-1087; Elec Mail dvsa@cogeco.net; Internet Home Page Address: www.dvsa.ca; *Registrar* Bonnie Wheeler; *Dir* Arthur Greenblatt
Estab 1964; Msintain nonprofit art gallery; pvt; D & E; Scholarships; SC 65, LC 2, GC 1; D 1,500, E 1,500, maj 10, grad 2
Ent Req: part time no-req, full time interview with portfolio
Tuition: $3,000 per yr
Courses: Art Appreciation, Art History, Ceramics, Collage, Conceptual Art, Constructions, Design, Drawing, Mixed Media, Painting, Photography, Printmaking, Sculpture
Adult Hobby Classes: Enrl 1500; tuition $165 for 10 wk term. Courses—Ceramics, Drawing, Painting, Photography, Printmaking, Sculpture
Children's Classes: Enrl 1200; tuition $110 for 10 wk term. Courses—Drawing, Painting, Pottery
Summer School: Dir Marla Panko. Enrl 1800; tuition starting from $94 per 1/2 week session

ETOBICOKE

HUMBER COLLEGE OF APPLIED ARTS & TECHNOLOGY, The School of Media Studies, 205 Humber College Blvd, Etobicoke, ON M9W 5L7 Canada. Tel 416-675-3111, Ext 4111; Fax 416-675-9730; Internet Home Page Address: www.sms.humberc.on.ca; *Dean* William Hanna
Estab 1967; pub; D & E; SC 300, LC 75, GC 6; grad 50, PT 25
Ent Req: HS dipl, mature student status, one yr of employment plus 19 yrs of age
Degrees: none, 2 & 3 yr dipl courses
Tuition: Canadian res—$1703 per yr; international—$10,200 per year
Courses: Art History, Drafting, Drawing, Film, Furniture Design, Graphic Arts, †Graphic Design, †Industrial Design, †Interior Design, †Landscape Technology, †Packaging Design, Photography, TV Production
Adult Hobby Classes: Enrl 4042; tuition & duration vary. Beginning classes in most regular courses
Children's Classes: Nature studies

GUELPH

UNIVERSITY OF GUELPH SCHOOL OF FINE ARTS OF MUSIC, Fine Art Dept, Zavitz Hall, Guelph, ON N1G 2W1 Canada. Tel 519-824-4120, Ext 8452; Fax 519-821-5482; Elec Mail fineart@uoguelph.ca; Internet Home Page Address: www.uoguelph.ca/fineart; *Acting Dir* Dr Edward Phillips
Estab 1966; FT 12, PT 20; pub; D; Scholarships; SC 30, LC 30 Grad 9; 959, maj 300
Ent Req: HS dipl
Degrees: BA 3 yrs, BA (Hons) 4 yrs
Tuition: Res—undergrad $2014.50 per sem; part-time $403 per course; campus res available
Courses: Aesthetics, Alternative Media, †Art History, Collage, †Conceptual Art, †Drawing, History of Art & Architecture, †Intermedia, †Painting, †Photography, †Printmaking, †Sculpture, Video
Summer School: Chair, Thomas Tritschler. Courses—Vary

HAMILTON

MCMASTER UNIVERSITY, School of Art, Drama & Music, 1280 Main St W, 4M1 Commons Bldg Rm 105 Hamilton, ON L8S 4M2 Canada. Tel 905-525-9140, Ext 24655; Fax 905-527-3731; Elec Mail ryank@mcmaster.ca; *Prog Dir* Dr G Warner; *Prog Coordr* Kathy Ryan
Estab 1934; FT 21; SC 12, LC 29; 85
Degrees: BA(Art History), Hons BA(Studio & Art History) 3-4 yrs
Tuition: $127.69 per unit; international $415 per unit; campus res available
Courses: †Art History, Music Drama, †Studio Art Program

KINGSTON

QUEEN'S UNIVERSITY, Dept of Art, MacKintosch-Corry Hall, Kingston, ON K7L 3N6 Canada. Tel 613-533-6166, 2448, 2446; Elec Mail macdnld@post.queensu.ca; Internet Home Page Address: www.queensuca/artsci; *Dean* Robert Silverman

Estab 1932; pub; D & E; SC 16, LC 25
Ent Req: Grade XIII
Degrees: BA 3 yrs, BA(hons) & BFA 4 yrs, MA(Conservation), MA(Art History), PhD(Art History)
Tuition: $4430 per year, campus res available; non-res—$11,220 per year
Courses—Art Conservation, Art History, Drawing, Painting, Printmaking, Restoration & Conservation, Sculpture
Summer School: Drawing, Painting, Sculpture

ST LAWRENCE COLLEGE, Dept of Graphic Design, King & Portsmouth Ave, PO Box 6000 Kingston, ON K7L 5A6 Canada. Tel 613-545-3910, 544-5400 ext 1140; Fax 613-545-3923; Elec Mail liaison@sl.on.ca; Internet Home Page Address: www.sl.on.ca; *Chmn* Don Niven
Estab 1967, dept estab 1969; pub; D & E
Ent Req: Hs dipl & portfolio
Degrees: Diploma (Visual & Graphic Design) 3 yrs, Certificate (Basic Photography, Certificate Graphic Design)
Tuition: Res $2117.66 per yr
Courses—Art History, Commercial Art, Communications, Computer Graphics, Drawing, †Graphic Design, Illustration, Marketing, Mixed Media, Painting, Photography, Printmaking

LONDON

UNIVERSITY OF WESTERN ONTARIO, John Labatt Visual Arts Centre, 1151 Richmond St, London, ON N6A 5B7 Canada. Tel 519-661-3440; Fax 519-661-3442; Elec Mail mlennon@uwo.ca; Internet Home Page Address: www.uwo.ca/visarts/; *Chmn* Madeline Lennon
Estab 1967; pub; D & E; SC 23, LC 31; maj 235
Ent Req: HS dipl, portfolio and/or interview
Degrees: BA 3 yrs, BA(Hons) and BFA 4 yrs
Tuition: res—$4701.01 per year; non-res—$10,483.79 per year
Courses—Drawing, †History of Art & Architecture, Museum Staff Training, †Painting, †Photography, †Printmaking, †Sculpture
Summer School: Enrl limited; term of 6 wks beginning July. Courses—Visual Arts

OAKVILLE

SHERIDAN COLLEGE, School of Animation, Arts & Design, 1430 Trafalgar Rd, Oakville, ON L6H 2L1 Canada. Tel 905-845-9430; Fax 905-815-4041; Internet Home Page Address: www.sheridaninstitute.ca; *Dean* Michael Collins, PhD; *Assoc Dean Design* Michael Large, PhD; *Assoc Dean Visual Arts* Michael Maynard, MFA; *Assoc Dean Animation* Angela Stukator, PhD
Estab 1967; FT 109; pub; D & E; SC 80%, LC 20%; D 4200
Income: Financed by Ontario Government
Ent Req: HS dipl
Degrees: BAA 4 yr
Tuition: $2645 to $6375 per yr (dom); $11,275 to $18305 (int'l)
Courses—Advanced Illustration, †Advanced Television & Film, †Applied Photography, †Art Fundamentals, †Bachelor of Applied Arts in Animation (Degree), †Bachelor of Applied Arts in Illustration (Degree), †Bachelor of Arts in Art & Art History (Degree), †Bachelor of Arts in Theatre & Drama Studies (Degree), †Bachelor of Design (Honours) (Degree), Broadcast Journalism, †Communication, Culture & Information Technology (Degree), †Computer Animation, †Computer Animation-Digital Character Animation, †Corporate Communications, †Crafts & Design, †Interior Design, †Journalism-New Media, †Journalism-Print, †Media Arts, †Music Theatre-Performance, New Media Design, †Performing Arts-Preparation, †Theatre Arts-Technical Production
Adult Hobby Classes: Enrl 2800; tuition varies
Summer School: Enrl 600. Programs-various Visual & Performing Arts

OTTAWA

CARLETON UNIVERSITY, Dept of Art History, 1125 Colonel By Dr, Ottawa, ON K1S 5B6 Canada. Tel 613-520-2342, 520-3993; Fax 613-520-3575; Internet Home Page Address: www.carleton.ca/artandculture/art_history; *Dir* Michael Bell
Estab 1964; FT 8, PT 2; D & E; Scholarships; SC 2, LC 25, GC 3; D over 700, maj 135
Ent Req: HS dipl
Degrees: BA 6 Hons 3-4 yrs
Tuition: Res—$1353.19 per sem
Courses—Art History

SOUTHAMPTON

SOUTHAMPTON ART SOCIETY, Southampton Art School, 20 Albert St S, Southampton, ON N0H 2L0 Canada. Tel 519-797-5068; Elec Mail info@theartschool.org; Internet Home Page Address: www.theartsschool.org; *Dir* Carole Cleary
Estab 1958 as a summer school; pub; D, July and Aug; Scholarships
Tuition: Adults $180 per wk; students (14-18) $85 per wk; children (10-13) $70 per wk, half days only; no campus res
Courses—Art Appreciation, Art History, Calligraphy, Collage, Design, Drawing, Handicrafts, Jewelry, Mixed Media, Painting, Photography, Printmaking, Sculpture, Textile Design
Adult Hobby Classes: Enrl 100; tuition varies. Courses—Culinary, Ferro-Cement Sculpture, Knitting, Photography, Quilting, Rug Hooking
Children's Classes: Enrl 175; tuition $60 per wk. Courses—Crafts, Drawing, Painting, Sculpture

Summer School: Dir, Carole Cleary. Enrl 250; tuition $70-$180 per wk. Courses—Acrylic, Collage, Drawing, Figures, Mixed Media, Oil, Printmaking, Portraits, Watercolor

THUNDER BAY

LAKEHEAD UNIVERSITY, Dept of Visual Arts, 955 Oliver Rd, Thunder Bay, ON P7B 5E1 Canada. Tel 807-343-8787; Fax 807-345-2394; Elec Mail mark.wisenholt@lakeheadu.ca; Internet Home Page Address: www.lakeheadu.ca/~vartswww/visualarts; Telex 073-4594; *Chmn Visual Arts Dept* Mark Nissenhold, MFA; *Prof* Patricia Vervoort, MA; *Prof* Ann Clarke, MFA; *Instr* Janet Clark; *Instr* Roly Martin; *Instr* Alison Kendall; *Instr* Sarah Link; *Instr* Mavourneen Trainor-Bruzzese
Div estab 1976, dept estab 1988; pub; D & E; Scholarships
Ent Req: HS dipl, portfolio
Degrees: HBFA, Dipl in Arts Administration
Tuition: Res—undergrad $3100-4158 per yr, non-res—$6000-8500; campus res—rooms & board $5170- $5938
Courses—Art History, †Ceramics, Drawing, †Painting, †Printmaking, †Sculpture
Adult Hobby Classes: Studio and art history courses
Summer School: Dir, Dan Pakulak. Tuition $390 per course for 6 wks

TORONTO

GEORGE BROWN COLLEGE OF APPLIED ARTS & TECHNOLOGY, Dept of Graphics, PO Box 1015, Sta B, Toronto, ON M5T 2T9 Canada. Tel 416-415-2000, 415-2165; Fax 416-415-2600; Elec Mail mmaynard@gbrown.on.ca; *Chmn* Michael Maynard
Estab 1970; FT 30, PT 60; D & E; D 900, E 2000
Ent Req: HS grade 12 dipl, entr exam
Degrees: 3 yr dipl, 1 yr cert
Courses—†Advertising Design, Air Brush Techniques, Calligraphy, Cartooning, †Commercial Art, Computer Graphics, Graphic Arts, Graphic Design, Illustration, †Lettering, Marker Rendering Techniques, Painting, Photography, Video

KOFFLER CENTER OF THE ARTS, School of Visual Art, 4588 Bathurst St, Toronto, ON M2R 1W6 Canada. Tel 416-636-1880, Ext 270; Fax 416-636-5813; Elec Mail Koffler@bjcc.ca; Internet Home Page Address: www.bjcc.ca; *Dir Cultural Programming ,Marketing & Develop* Diane Uslaner
Estab 1977; Estab 1975; pub; D & E; Scholarships; D 400, E 98; SC 35
Courses—Ceramics, Clay, Drawing, Mixed Media, Painting, Sculpture, Stone Sculpture, †Theater Arts
Adult Hobby Classes: Enrl 350-400. Courses—Drawing, Painting, Sculpture
Children's Classes: 50 Drawing, Painting, Ceramics

ONTARIO COLLEGE OF ART & DESIGN, 100 McCaul St, Toronto, ON M5T 1W1 Canada. Tel 416-977-6000; Fax 416-977-6006; Internet Home Page Address: www.ocad.on.ca; *Pres* Sara Diamond; *VPres Administration* Peter Caldwell; *Dir Library Servs* Jill Patrick; *Dir Student Servs* Josephine Polera; *VPres Acad* Sarah McKinnon; *Dean Art* Blake Fitzpatrick; *Dean Design* Anthony Cahalan; *Dean Liberal Studies* Kathryn Shailer; *Registrar* Elisabeth Paradis
Estab 1876; pub; D & E; Scholarships; SC 296 LC 53; D 2144, E 2000, grad summer 900
Ent Req: HS dipl, English requirement, interview
Degrees: Diploma AOCA 4 yrs, BFA, BDes
Tuition: $836 per cr, $418 per half-cr; international students $2600 per cr, $1300 per half-cr; no campus res
Courses—†Advertising Design, Anthropology, Art History, Arts of Latin American & Asia, †Ceramics, Collage, †Commercial Art, Communication studies, Conceptual Art, Contemporary Theory & Criticism, Creative Writing, †Criticism & Sutatorial Practice, Cultural Studies, Display, †Drawing, English, English Literature & Composition, Film, Film Studies, †Graphic Arts, †Graphic Design, History of Art & Architecture, History of Design, Humanities, †Illustration, †Industrial Design, †Integrated Media, †Jewelry, Linguistics, †Material Art & Design, Fiber, Mixed Media, Native Studies, †Painting, Philosophy, †Photography, †Printmaking, Science/Technology/Mathematics, †Sculpture/Installation, Silversmithing, Social Sciences, Sociology, Stage Design, Video, Visual Culture, †Weaving, Women's Studies
Summer School: Registrar, Elisabeth Paradis. Summer courses run for three, six or twelve week periods. Classes take place form one to four days per week and may be scheduled mornings, afternoons and/or evenings. tuition $836 per credit, $418 per half-credit. Courses—Drawing & Painting, General Art, Photography, Printmaking, General Design, Material Art & Design (Fibre, Jewellery/Metalsmithing, Ceramics) English, History & Theory of Visual Culture, Humanities, Social Sciences, Science/Technology/Mathematics

TORONTO ART THERAPY INSTITUTE, 216 St Clair Ave W, Toronto, ON M4V 1R2 Canada. Tel 416-924-6221; Fax 416-924-0156; Elec Mail info@tati.on.ca; Internet Home Page Address: www.tati.on.ca; *Dir Acad Prog & Internships* Gilda S Grossman, MSW & EdD; *Psychiatric Consultant to Training Prog* Dr Jodi Lofchy, MD; *Supv* Nell Bateman, MA; *Instr & Supv* Jacqueline Fehlner, BA; *Instr & Supervisor* Kathryn Hubner Kozman, BA; *Instr & Supv* Barbara Merkur, MA; *Instr* Ellen Bateman, BA; *Instr* Helen Burt, BA; *Instr* Mercedes Chacin De Fuchs, MEd; *Instr* Temmi Ungerman, MA; *Instr* Lyn Westwood, BA; *Instr* Val Zoulalian, BA; *Thesis Advisor* O Robert Bosso PhD, BA; *Thesis Advisor* Ruth Epstein, EdD; *Thesis Advisor* Vince Murphy PhD, EdD; *Thesis Advisor* Ken Morrison PhD, EdD
Estab 1968; D & E
Degrees: Dipl, BA and MA(Art Therapy) through affiliation with other US colleges; graduate level certificate program in art therapy
Tuition: $6750
Adult Hobby Classes: Enrl 6-12; fee $40 per session. Courses—workshops
Children's Classes: Enrl 6-12; fee $20 per session. Courses—workshops

TORONTO SCHOOL OF ART, 410 Adelaide St W, 3rd Floor Toronto, ON M5V 1S8 Canada. Tel 416-504-7910; Fax 416-504-8171; Elec Mail info-tsoa@on.aibn.com; Internet Home Page Address: www.tsa-art.ca; *Instr* Susan Beniston; *Instr & Dir* Brian Burnett; *Instr* Moira Clark; *Instr* Denis Cliff; *Instr* Andy Fabo; *Instr* Simon Glass; *Instr* Megan Williams; *Instr* Tobi Asmoucha; *Instr* Tom Campbell; *Instr* Trish Delaney; *Instr* Sharon Epstein; *Instr* Eric Glavin; *Instr* Sandra Gregson; *Instr* Janice Gurney; *Instr* Catherine Heard; *Instr* Thomas Hendry; *Instr* Maria Hlady; *Instr* Marie Lehman; *Instr* John Leonard; *Instr* Tina Poplawski; *Instr* Gretchen Sankey; *Instr* Donnely Smallwood; *Instr* Erica Shuttleworth; *Instr* Janet Morton; Andy Patton; *Instr* Joe Fleming; *Instr* Kate Brown; *Admin Mgr* Sharon Shields
Estab 1969; pvt; D & E; Scholarships; D 300 E 200 Majs10 Grads 5
Ent Req: portfolio
Degrees: 3 yr diploma, 1 yr portfolio develop, 1 yr independent studio program
Tuition: $3,100 full-time, $5.500 foreign students; no campus res
Courses: Drawing, Mixed Media, Painting, Photography, Printmaking, Sculpture
Summer School: Dir Brian Burnett

UNIVERSITY OF TORONTO
—**Dept of Fine Art,** Tel 416-946-7624; Fax 416-946-7627; Elec Mail chairfa@chass.utoronto.ca; Internet Home Page Address: www.library.utoronto.ca/fineart; *Chmn* Marc Gotlieb; *Assoc Chmn Grad Studies* Mark Cheetham; *Assoc Chair Visual Studies* Lisa Steele; *Undergrad Coordr Art History* Alexander Nagel; *Undergrad Coordr Visual Studies* George Hawken
Estab 1934; FT 21, PT 13; pub; Scholarships, Fellowships; LC, GC
Degrees: BA 4 yrs, MA 2 yrs, PhD 5 yrs
Tuition: Nonres—undergrad $12,024; campus res available
Courses: Aesthetics, Architecture, Art History, Art Studio, Conceptual Art, Drawing, Graphic Arts, History of Art & Archeology, Painting, Photography, Printmaking, Sculpture, Video
Adult Hobby Classes: Enrl 250
—**Faculty of Architecture, Landscape & Design,** Tel 416-978-5038; Fax 416-971-2094; Internet Home Page Address: www.ald.utoronto.ca; *Dean* Larry W Richars
Estab 1948; pub; D; Scholarships; SC 5, LC 33, GC 11; 299, non-maj 6, maj 293, grad 13
Ent Req: HS dipl, portfolio of work & interview
Degrees: BArchit
Tuition: Domestic students $2970 per sem; foreign students $14,250 per sem
Courses: Construction Management, Design, History & Theory Building Science, Professional Practice, Structural Design
—**Programme in Landscape Architecture,** Tel 416-978-2011; Fax 416-971-2094; Internet Home Page Address: www.ald.utoronto.ca; *Assoc Prof* John Danahy, BLA; *Assoc Dean, Dir Prog in Landscape Architecture* Robert Wright
Estab 1827, dept estab 1965; pub; D; Scholarships; maj 100
Ent Req: grad 13 dipl
Degrees: MA(Land Archit)
Tuition: Canadian Students $2970 per sem; foreign students $14,250 per sem
Courses: Computer Art, Computer Modeling, Design, Drawing, Environment, Research & Writing Studio
Summer School: Contact, Prof Gerald Englar. Enrl 20; tuition $1200 for 4 wks non-degree. Courses—Career initiation program for Architecture & Landscape Artthiture

YORK UNIVERSITY, Dept of Visual Arts, Ctr for Fine Arts, Rm 232, 4700 Keele St Toronto, ON M3J 1P3 Canada. Tel 416-736-5187; Fax 416-736-5875; Elec Mail gfwhiten@yorku.ca; Internet Home Page Address: www.yorku.ca/finearts.visa; *Chmn Prof* Tim Whiten
Estab 1969; FT 26, PT 8; pub; D & E; Scholarships; SC 53, LC 17; D over 400, maj 400, others 120
Ent Req: HS dipl, interview and portfolio evaluation for studio statement for art history
Degrees: BA(Hons), BFA(Hons) 4 yrs, MA in Art History, MFA in Visual Arts
Tuition: Res—$3951 per year; nonres—$10,381 per year (prices quoted are Canadian dollars)
Courses: Art History, Criticism, Design, Drawing, Graphic Arts, Interdisciplinary Studio, Painting, Photography, Sculpture, Theory

WATERLOO

UNIVERSITY OF WATERLOO, Fine Arts Dept, 200 University Ave W, Waterloo, ON N2L 3G1 Canada. Tel 519-885-1211, Ext 2442; Fax 519-888-4521; *Dean* R Kerton; *Prof* Jan Uhde PhD, BFA; *Prof* Art Green, BFA; *Prof & Chmn* Jane Buyers, BA; *Assoc Prof* Bruce Taylor, MFA; *Assoc Prof* Joan Coutu, PhD, MA; *Asst Prof* Robert Linsley, MFA, BA; *Asst Prof* Doug Kirton, MFA, BFA; *Asst Prof* Cora Cluett, MFA, BFA
Estab 1958, dept estab 1968; Maintains nonprofit gallery, University of Waterloo Art Gallery 200 University Ave W, Waterloo Ont N2L3G1; Pub; D & E; Scholarships; SC 32, LC 27; maj 100
Ent Req: HS dipl
Degrees: BA 3 yrs, BA(Hons) 4 yrs
Tuition: $4,476 per yr; $3,510-$4,150 room & board; campus res available
Courses: †Art History, Ceramic Sculpture, Computer Animation, Computer Imaging, †Drawing, †Film Theory & History, Illustration, †Painting, Photography, †Printmaking, †Sculpture
Summer School: Enrl 30. Courses—Drawing

WINDSOR

UNIVERSITY OF WINDSOR, Visual Arts, Huron Church Rd at College, Windsor, ON N9B 3P4 Canada. Tel 519-253-3000, Ext 2829; Fax 519-971-3647; Elec Mail art@uwindsor.ca; Internet Home Page Address: www.cronus.ca/unit/visualarts/visualartsasf; *Prof Emeritus* Iain Baxter; *Prof* Brian E Brown; *Prof* Daniel W Dingler; *Prof* Adele Duck; *Prof* Michael J Farrell; *Prof*

Susan Gold-Smith; *Prof* William C Law; *Prof* Cyndra MacDowall; *Instr* Rod Strickland; *Prof* Sigi Torinus; *Dr* Lee Rodney; *Prof* David Blatherwick; *Dir & Prof* Brenda Francis Pelkey
Estab 1960; Maintains a nonprofit art gallery, LeBel Gallery, School of Visual Arts, Univ of Windsor, Windsor, Ontario N9B 3P4; FT 10, PT 3; pub; D & E; Scholarships, Assistantships; SC 32, LC 10, GC 6; D 250, maj 300, G students 10
Ent Req: Ontario Secondary School Graduation Dipl (OSSD) plus 6 Ontario Academic Courses (OAC) or equivalent
Degrees: BA in Visual Arts or Art History3 yrs, BA(Hons) in Visual Arts or Art History, Combined honors degree program and BFA 4 yrs, MFA 2 yrs
Tuition: Undergrad $2,620 per sem, grad $1,704 per sem
Courses: †Art History, †Drawing, †Integrated Media, Multi Media, †Painting, Photography, †Printmaking, †Sculpture

PRINCE EDWARD ISLAND

CHARLOTTETOWN

HOLLAND COLLEGE, Media & Communications Dept, 140 Weymouth St, Charlottetown, PE C1A 4Z1 Canada. Tel 902-566-9551; Fax 902-566-9505; Elec Mail nroe@holland.pe.ca; Internet Home Page Address: www.holland.pe.ca/media/programareas/index; *Prog Unit Coordr* Alex Murchinson
Estab 1977; Pub; Day; Scholarships; D 100
Degrees: Diploma
Tuition: $3250 per yr
Courses: †Graphic Design, Photography, Woodworking

QUEBEC

MONTREAL

CONCORDIA UNIVERSITY, Faculty of Fine Arts, 1395 Rene Levesque Blvd, Montreal, PQ H3G 2M5 Canada. Tel 514-848-2424; Fax 514-848-4599; *Dean* Christopher Jackson
D & E; Scholarships
Ent Req: HS dipl, CEGEP dipl Prov of Quebec
Degrees: BFA, post-BFA Dipl in Art Educ & Art Therapy, full-time leading to teaching cert, MA(Art Educ), MA(Art History), MA(Art Therapy), PhD(Art Educ)
Courses: †Art Education, †Art History, †Art Therapy, †Ceramics, Cinema, †Contemporary Dance, †Design Art, †Drawing, †Fibres, Interdisciplinary Studies, †Music, †Painting, †Photography, †Printmaking, †Sculpture, †Theatre Arts, Women & the Fine Arts
Adult Hobby Classes: Courses offered
Children's Classes: Enrl 75; tuition $75 for 8 wk term, $125 for 2 terms
Summer School: Courses offered

MCGILL UNIVERSITY
—**Dept of Art History,** Tel 514-398-6541; Fax 514-398-7247; *Chmn* Christine Ross, PhD; *Assoc Prof* T Glenn, PhD; *Faculty Lectr* R Meyer, PhD; *Asst Prof* C Solomon-Kiefer, PhD
Pvt; D; Assistantships; SC 2, LC 7, GC 12
Ent Req: HS dipl or CEGEP Dipl
Degrees: BA(Art History), 3 & 4 yr, MA(Art History) 2 yr, PhD(Art History)
Tuition: Res—$1,500 per yr, nonres—$7,000 per yr
Courses: Ancient Greek Art, Baroque Art, †History of Art & Archeology, Medieval Art, Modern Art, Renaissance Art
—**School of Architecture,** Tel 514-398-6704; Fax 514-398-7372; Internet Home Page Address: www.mcgill.ca/architecture; *Prof* Ricardo Castro; *Prof* David Covo; *Prof* Annmarie Adams; *Prof* Vikram Bhatt; *Prof* Martin Bressani; *Prof (Emeritus)* Derek Drummond; *Prof* Avi Friedman; *Prof* Robert Mellin; *Prof* Alberto Perez-Gomez; *Prof* Adrian Sheppard; *Prof* Pieter Sijpkes; *Prof (Emeritus)* Radoslav Zuk; *Prof* Nik Luka
Estab 1896; Maintains a nonprofit art gallery (exhib room); FT 10, PT 36, FTE 18; Semi-Public; D; Scholarships; SC 10, LC 35, GC 45; D 200, GS 110
Ent Req: ent exam
Degrees: B.Sc.(Arch); MArch I (Professional); MArch II (Post-Professional); PhD
Tuition: Res—$1,700 per yr; nonres—$4,900 per yr; Qubec res—$1,700; Canadian res—$4,900; International res—$14,000
Courses: Architectural Design, Architecture, History of Architecture

UNIVERSITE DE MONTREAL, Dept of Art History, PO Box 6128, Succursale Centre Ville Montreal, PQ H3C 3J7 Canada. Tel 514-343-6184; Fax 514-343-2393; Elec Mail larouchm@ere.umontreal.ca; Internet Home Page Address: www.umontreal.ca; *Instr* Yves Deschamps; *Instr* Nicole Dubreuil; *Instr* Francois Marc Gagnon; *Instr* Chantal Hardy; *Instr* Alain Laframboise; *Instr* Lise Lamarche; *Instr* Johanne Lamoureux; *Instr* Luis de Moura Sobral; *Instr* Gilles Marsolais; *Instr* Constance Naubert-Riser; *Instr* Serge Tousignant; *Instr* Jean Trudel; *Instr* Peter Krausz; *Instr* David W Booth; *Instr* Andre Gaudreault; *Dir* Michel Larouche
Dept estab 1961; pvt; D & E; SC 20, LC 70, GC 10; D 270, non-maj 113, maj 106, grad 80, others 151
Ent Req: HS dipl
Degrees: BA & MA
Tuition: Campus res available
Courses: Art History, Film, Fine Arts

UNIVERSITE DU QUEBEC A MONTREAL, Famille des Arts, CP 8888, Succursale Center Ville, Montreal, PQ H3C 3P8 Canada. Tel 514-987-4545; Tel 514-987-3000, ext 3956; *Dept Head* Louise Dusseault Letocha; *Head Art History* Nycole Paquin

Estab 1969
Ent Req: 2 yrs after HS
Degrees: Baccalaureat specialize 3 yrs; Master Degrees in Visual Arts; programs in Environmental Design, Graphic Design, History of Art, Visual Arts (engraving, sculpture, painting); MA(Musicology)
Tuition: $166.50 per cr
Courses: Architectural Drafting, Ceramic Sculpture, Design, Drawing, Etching and Engraving, Graphic Techniques, Modeling, Mural Painting, Museum Staff Training, Painting, Scenography, Teacher Training
Adult Hobby Classes: Certificate in visual arts available

QUEBEC

UNIVERSITE QUEBEC CITE UNIVERSITAIRE, School of Visual Arts, Laval University, Edifice La Fabrique, Quebec, PQ G1K 7P4 Canada. Tel 418-656-3333; Fax 418-656-7678; Elec Mail arv@arv.ulaval.ca; *Faculty Dean Arts, Architecture & Amenagement* Takashi Nakajima; *Dir Visual Arts* Marie Andree Doran
Estab 1970; pub; D; 550
Ent Req: 2 yrs col
Degrees: BA(Arts Plastiques, Communication Graphique, Enseignement des Arts Plastiques); cert(arts plastiques), MA(Visual Arts)
Tuition: Res—undergrad $1952 per yr, $558 per qtr
Courses: Computer Graphic, Drawing, Engraving, Graphic Arts, Graphic Design, Illustration, Lithography, Painting, Photography, Sculpture, Silk Screen, Video

TROIS RIVIERES

UNIVERSITY OF QUEBEC, TROIS RIVIERES, Fine Arts Section, Department des arts, 3351 boul des Forges, PO Box 500 Trois Rivieres, PQ G9A 5H7 Canada. Tel 819-376-5136, 5011; Fax 819-376-5226; Elec Mail Peirre-Simon_Doyon@utqr.uquebec.ca; Internet Home Page Address: www.uqtr.uquebec.ca/arts; *Prof* Graham Cantieni; *Dir Dept Arts* Pierre-Simon Doyon, PhD
Estab 1969; pub; D & E; SC 12, LC 8, GC 28; D 150, E 100
Activities: r3 Galerie d'art
Ent Req: ent exam or DEC
Degrees: BA(Fine Arts) & BA(Art Education)
Tuition: $50 per course
Courses: Art Education, Art History, †Drawing, †Glass, †Painting, †Paper, †Printmaking, †Sculpture
Adult Hobby Classes: Enrl 100. Courses—Art History, Painting, Printmaking

SASKATCHEWAN

REGINA

UNIVERSITY OF REGINA ARTS EDUCATION PROGRAM

—**Visual Arts Dept,** Tel 306-585-5872; Fax 306-779-4744; *Acting Head* Ruth Chambers; *Head* Leesa Streifler
Maintain nonprofit art gallery; FT 9; Pub; D&E; Scholarships; SC, LC, GC; 650
Ent Req: HS grad
Degrees: 2 yr cert, BA 3 yrs, BA 4 yrs, BFA 4 yrs, MFA 2 yrs
Tuition: $284 per class
Courses: †Art Appreciation, †Art History, †Ceramics, †Drawing, Intermedia, Painting, †Printmaking, †Sculpture
Summer School: Introductory courses offered
—**Art Education Program,** Tel 306-585-4546; Fax 306-585-4880; Elec Mail norm.yakel@uregina.ca; Internet Home Page Address: www.uregina.ca/arts; *Dean Faculty Fine Arts* Katherine Laurin; *Dean Educ* Margaret McKinnon; *Chair Arts Educ Prog* Norm Yakel
Estab 1965; FT 9; pub; D & E; Scholarships; LC 6; D 160, E 20, maj 10
Ent Req: HS dipl, matriculation or degree for maj in art
Degrees: BA 3 & 4 yr, BEduc 3 yr
Tuition: Res—$2,490 per sem, visa students $4,110 per sem
Courses: Aesthetics, Art Education, †Dept offers courses in all the arts including performing arts
Children's Classes: Sat
Summer School: Exten Courses, H Kindred; Dean Educ, Dr Toombs. Term of 3 to 6 wks beginning May

SASKATOON

UNIVERSITY OF SASKATCHEWAN, Dept of Art & Art History, 3 Campus Dr, Murray Bldg 181 Saskatoon, SK S7N 5A4 Canada. Tel 306-966-4196; Fax 306-966-4266; Elec Mail mcleanj@abyss.usask.ca; Internet Home Page Address: www.usask.ca/art/index; *Head* Lynne Bell
Estab 1936; FT 13, PT 4; pub; D; Scholarships; SC, LC, GC; approx 880, BFA prog 130, grad 9
Ent Req: HS grad
Degrees: BA 3 yrs, BAHons(Art History), BA(Advanced) 4 yrs, BFA 4 yrs, MFA(Studio Art), BEd(Art)
Tuition: $117.20 per cr unit; $351.60 per 3 cr units; $703.20 per 6 cr units
Courses: Art Education, Art History, Drawing, History of Art & Architecture, Mixed Media, Painting, Photography, Printmaking, Sculpture
Summer School: Dir, Bob Cram, Extension Credit Studies. Enrl 200; tuition $366 per 6 wk term. Courses—Art Educ, Art History, Drawing, Painting, Photography, Printmaking, Sculpture

III ART INFORMATION

Major Museums Abroad

Major Art Schools Abroad

State Arts Councils

State Directors and Supervisors of Art Education

Art Magazines

Newspaper Art Editors and Critics

Scholarships and Fellowships

Open Exhibitions

Traveling Exhibition Booking Agencies

AFGHANISTAN

KABUL

M **NATIONAL MUSEUM OF AFGHANISTAN,** Darul Aman, Kabul, Afghanistan.
Tel 42656; *Dir* Ahamad Ali Motamedi
Collections: Kushan art; archaeology of prehistoric, Greco-Roman, Islamic
periods; ethnological collections

ALGERIA

ALGIERS

M **MUSEE NATIONAL DES ANTIQUITES,** Parc de la Liberte, Algiers, Algeria.
Tel 74-66-86; Fax 74-74-71; *Dir* Drias Lakhdar; *Cur* Mohammed Temmam
Collections: Algerian antiquities & Islamic art

M **MUSEE NATIONAL DES BEAUX ARTS D'ALGER,** National Museum of
Algiers, Place Dar-el Salem, El Hamma, Algiers, Algeria. Tel 664916; Fax
662054; *Dir* Dalila Orfali
Sat - Thurs 9 AM - 12 PM & 1 PM - 5 PM; 20 DA (Algerian dinars); 1930; art
gallery; Ground floor & two floors & two major entrances
Purchases: Annual commission of acquisitions
Collections: Contemporary Algerian art; paintings; drawings; bronze reliefs;
ancient paintings 14th - 19th century (European)
Publications: Guides; exhibition catalogues; collections catalogues
Activities: Exhibitions; commemorations; conferences; concerts; tours

ARGENTINA

BUENOS AIRES

M **MUSEO DE ARTE MODERNO,** Museum of Modern Art, Avda San Juan 350,
Buenos Aires, 1147 Argentina. Tel (11) 4361-1121; *Dir* Raul Santana
Collections: Latin American paintings, especially Argentine, and contemporary
schools

M **MUSEO DE BELLAS ARTES DE LA BOCA,** Fine Arts Museum, Pedro
Mendoza 1835, Buenos Aires, 1169 Argentina. Tel 4-21-1080; *Dir* Dr Guillermo C
De La Canal
Collections: Paintings, sculptures, engravings & maritime museum

M **MUSEO MUNICIPAL DE ARTE ESPANOL ENRIQUE LARRETA,**
Municipal Museum of Spanish Art, Juramento 2291 y Obligado 2139, Buenos
Aires, 1428 Argentina. Tel (11) 4784-4040; Fax (11) 4783-2640; *Dir* Mercedes di
Paola de Picot
Collections: 13th - 16th century wood carvings, gilt objects and painted panels,
paintings of Spanish School of 16th and 17th centuries, tapestries, furniture

M **MUSEO NACIONAL DE ARTE DECORATIVO,** National Museum of
Decorative Art, Avda del Libertador 1902, Buenos Aires, 1425 Argentina. Tel
11-4801-8248; Fax 11-4802-6606; Elec Mail museo@mnad.org; Internet Home
Page Address: www.mnad.org; *Dir* Alberto Guillermo Bellucci
Open 2 to 7 PM
Collections: European works; furniture, sculptures and tapestries; glasses,
porcelains, hardstones, Oriental lacquers

M **MUSEO NACIONAL DE BELLAS ARTES,** National Museum of Fine Arts,
Avda del Libertador 1473, Buenos Aires, 1425 Argentina. Tel 11-4803-0714; Fax
11-4803-4062; *Dir* Alberto G Bellucci
Collections: Argentine, American and European art, both modern and classical

CORDOBA

M **MUSEO PROVINCIAL DE BELLAS ARTES EMILIO A CARAFFA,**
Provincial Museum of Fine Arts, Avenida Hipolito Irigoyen 651, Cordoba, 5000
Argentina. Tel (351) 469-0786; *Dir Lic* Graciela Elizabeth Palella
Collections: Provincial art center, including art library and archives; Argentine and
foreign paintings, sculptures, drawings and engravings

ROSARIO

M **MUSEO MUNICIPAL DE ARTE DECORATIVO FIRMA Y ODILO
ESTEVEZ,** Municipal Decorative Arts Museum, Santa Fe 748, Rosario, 2000
Argentina. Tel (031) 480-2547; Elec Mail museoestevez@rosario.gov.ar; Internet
Home Page Address: www.rosario.gov.ar/museoestevez; *Cur* P A Sinopoli
Collections: Antique glass; paintings by Van Utrecht, Antolinez, De Hondecoeter,
Gerard, Lucas; 16th - 18th centuries furniture & silver; ceramics; antique glass;
ivories; silver

M **MUSEO MUNICIPAL DE BELLAS ARTES JUAN B CASTAGNINO,**
Municipal Museum of Fine Arts, Pellegrini 2202, Rosario, 2000 Argentina. Tel
341-421-7310; Fax 341-421-7310; *Dir* Prof Miguel Ballesteros
Library with 3000 vols
Collections: Works by Jose de Ribera, Goya, Valdes Leal & a complete collection
of Argentine art from 19th century to present

SANTA FE

M **MUSEO DE BELLAS ARTES ROSA GALISTEO DE RODRIGUEZ,**
Museum of Fine Arts, 4 de Enero 1510, Santa Fe, 3000 Argentina. Tel (342)
459-6142; Fax (342) 459-6142; *Dir* Nydia Pereyra Salva de Impini
Library with 4000 vols
Collections: Contemporary Argentine & modern art

TANDIL

M **MUSEO MUNICIPAL DE BELLAS ARTES DE TANDIL,** Municipal Museum
of Fine Arts, Chacabuco 357, Tandil, 7000 Argentina. Tel 2293-42000; *Dir* E
Valor
Collections: Paintings of classical, impressionist, cubist and modern schools

AUSTRALIA

ADELAIDE

M **ART GALLERY OF SOUTH AUSTRALIA,** North Terrace, Adelaide, SA 5000
Australia. Tel (+61 8) 8207-7000; Fax (+61 8) 8207-7070; Internet Home Page
Address: www.artgallery.sa.gov.au; *Dir* Christopher Menz; *Cur of European Art*
Jane Messenger; *Cur of Australian Art* Tracy Lock-Weir; *Cur of Australian Art*
Rebecca Andrews; *Cur of Prints, Drawings & Photographs* Julie Robinson; *Cur of
Prints, Drawings & Photographs* Maria Zagala; *Cur of Asian Art* James Bennett;
Cur of Decorative Arts Robert Reason
10 AM - 5 PM daily, cl Dec 25; No admis fee; charges for some exhibs; Estab
1881; Main art gallery of the state of South Australia; Average Annual Attendance:
600,000
Income: Financed by South Australian state government
Purchases: Continually adding to the permanent collection
Library Holdings: Auction Catalogs; Book Volumes; CD-ROMs; Cards; Clipping
Files; Exhibition Catalogs; Fiche; Original Documents; Pamphlets; Periodical
Subscriptions; Records
Special Subjects: Decorative Arts, Drawings, Etchings & Engravings, Ceramics,
Furniture, Painting-British, Photography, Prints, Sculpture, Watercolors, Textiles,
Pottery, Woodcuts, Porcelain, Asian Art, Silver, Painting-Australian
Collections: Representative selection of Australian, British and European
paintings, prints, drawings and sculpture; large collection of ceramics, glass and
silver; extensive Australian Colonial Collection; Asian Arts; SE Asian ceramics;
furniture; photography
Exhibitions: Several temporary exhibitions per year
Publications: Exhibition catalogues, collection catalogues, newsletter, ann report
Activities: Classes for children; docent training; lectrs open to the public, lectrs
for mems only; concerts; gallery talks; tours; traveling exhibs to Australian &
New Zealand galleries; mus shop sells books, magazines, reproductions; prints,
gifts, postcards & posters

CANBERRA

M **NATIONAL GALLERY OF AUSTRALIA,** PO Box 1150, Canberra, ACT 2601
Australia. Tel (02) 6240 6411; Fax 26240-6529; Elec Mail
webmanager@nga.gov.au; Internet Home Page Address: www.nga.gov.au; Telex
6-1500; *Dir* Brian Kennedy
Collections: Extensive Australian collection includes fine and decorative arts, folk
art, commercial art, architecture and design; International collection contains arts
from Asia, Southeast Asia, Oceania, Africa, Pre-Columbian America and Europe

L **Riesilarch Library,** PO Box 1150, Canberra, ACT 2601 Australia. Tel 62-1111
Library Holdings: Exhibition Catalogs 12,000; Fiche 35,000; Other Holdings
Monographs 70,000; Serials 3000; Other materials 200,000

HOBART

M **TASMANIAN MUSEUM AND ART GALLERY,** 40 Macquarie St, GPO Box
1164M Hobart, 7001 Australia. Tel (03) 62114177; Fax (03) 62114112; Elec Mail
emagmail@kmag.tas.gov.au; Internet Home Page Address: www.tmag.tas.gov.au;
Dir Patricia Sabine
Open 10AM-5PM; No admis fee; Estab 1840 by Royal Society of Tasmania;
Gallery contains art, science, humanities
Library Holdings: Auction Catalogs; Book Volumes; Clipping Files; Exhibition
Catalogs; Kodachrome Transparencies; Pamphlets; Periodical Subscriptions
Collections: Australian and Tasmanian art
Activities: Classes for children; lect open to the public; concerts; gallery talks;
tours; museum shop sells books, magazines, reproductions, prints

LAUNCESTON

M **QUEEN VICTORIA MUSEUM AND ART GALLERY,** Wellington St,
Launceston, 7250 Australia. Tel (03) 63316777; Fax (03) 63345230; *Dir* C B
Tassell
Collections: Pure & applied art; Tasmanian history: Tasmanian & general
anthropology; Tasmanian botany, geology, paleontology & zoology

MELBOURNE

M **NATIONAL GALLERY OF VICTORIA,** 180 St Kilda Rd, Melbourne, VIC
3004 Australia. Tel (03) 92080222; Fax (03) 9 2080245; *Dir* Dr Timothy Potts
Library with 20,000 vols
Collections: Asian art; Australian art; pre-Columbian art; modern European art;
antiquities, costumes, textiles, old master and modern drawings, paintings,
photography, prints and sculpture

PERTH

M **ART GALLERY OF WESTERN AUSTRALIA,** 47 James St, Perth Cultural
Centre Perth, WA 6000 Australia. Tel (08) 94926600; Fax (08) 94926655; Elec
Mail admin@artgallery.wa.gov.au; Internet Home Page Address:
www.artgallery.wa.gov.au; *Dir* Alan Dodge
Library with 14,000 vols
Collections: Australian aboriginal artifacts; British, European & Australian
paintings, prints, drawings, sculptures & crafts

SOUTH BRISBANE

M **QUEENSLAND ART GALLERY,** PO Box 3686, South Brisbane, QLD 4101
Australia. Tel (07) 3840 7303; Fax (07) 3844 8865; *Dir* Douglas Hall
Collections: Predominantly Australian art, ceramics, decorative arts, paintings and
drawings; British and European paintings and sculpture

SYDNEY

M **ART GALLERY OF NEW SOUTH WALES,** Domain, Sydney, 2000 Australia.
Tel 02-9225-1700; Fax 02-9221-6226; *Dir* Edmund Capon
Collections: Australian Aboriginal and Melanesian art; Australian art; collections
of British and European painting and sculpture; Asian art, including Japanese
ceramics and painting and Chinese ceramics

M **MUSEUM OF APPLIED ARTS & SCIENCES,** 500 Harris St, Ultimo, Sydney,
2007 Australia. Tel 612-9217-0111; Internet Home Page Address:
www.powerhousemuseum.com; *Dir* Dr Kevin Fewster AM
10:00AM to 5:00PM; Adults $10. Child/Conc $3 Family $25; Additional fees
apply for temporary exhibitions; Estab 1879; Library with 20,000 vols; Average
Annual Attendance: 600,000; Mem: 30,000
Collections: Scientific Instruments; Numismatics; Philately; Astronomy; Design;
History
Activities: Classes for adults & children; lects open to public & mems only; 5-10;
books, magazines, reproductions, prints, gifts

M **THE UNIVERSITY OF SYDNEY,** The Nicholson Museum, University of
Sydney, Sydney, 2006 Australia. Tel +61-2 93512812; Fax +61-2 93517305; Elec
Mail michael.turner@arts.usyd.edu.au; Internet Home Page Address:
www.usyd.edu.au/museums/; *Sr Cur* Michael C Turner; *Pub Programs Mgr* Craig
Barker; *Conservator* Ms Jo Atkinson; *Coll Mgr* Maree Darrell
Open Mon - Sat 10 AM - 4:30 PM; No admis fee; Estab 1860; Antiquities from
the Mediterranean; Average Annual Attendance: 45,000; Mem: 450 Mems Friends
Nicholson Museum Dues $50 Aus yr
Income: Financed through university grant
Collections: Antiquities of Egypt, Near East, Europe, Greece, Italy
Activities: Classes for adults & children; school educ program; lect for members
only, 6 vis lectrs per year, gallery talks, tours; sales shop sells books,
reproductions, greeting cards, mugs, cards, bookmats, mousemats, key rings

AUSTRIA

LINZ

M **NEUE GALERIE DER STADT LINZ-WOLFGANG GURLITT MUSEUM,**
Lentia 2000, Blutenstrasse 15 Linz, 4040 Austria. Tel (0732) 7070 3600; Fax
(0732) 736190; Elec Mail neue.galerie@mag.linz.at; Internet Home Page Address:
neuegalerie.linz.at; *Dir* Peter Baum
Collections: 19th & 20th century paintings, drawings, sculptures & prints

SALZBURG

M **RESIDENZGALERIE SALZBURG,** Residenzplatz 1, Salzburg, A-5010 Austria.
Tel (0662) 84 04 51; Fax (0662) 84 04 51-16; Elec Mail
residenzgalerie@salzburg.gv.at; Internet Home Page Address:
www.residenzgalerie.at; *Dir* Dr Roswitha Juffinger; *Educ Cur* Dr Gabriele
Groschner; *Pub Relations* Dr Erika Mayr-Oehring; *Archiving/Internet* Dr Thomas
Habersatter
Open 10 AM - 5 PM, cl Mon; Admis 5 Euro (reduced 4,-); European paintings of
the 16th - 19th centuries; Average Annual Attendance: 60,000
Income: Income from public collection of the govt of Salzburg
Collections: European paintings, 16th - 19th centuries
Publications: Exhibition catalogues
Activities: Classes for adults & children; lect open to public; 200 vis lectrs per yr;
concerts; gallery talks; tours; literature, cinema, modern art lent to museums,
official collections; museum shops sells books, magazines, reproductions,
postcards, souvenirs

M **SALZBURGER MUSEUM CAROLINO AUGUSTEUM,** Salzburg Museum,
Museumsplatz 1, Salzburg, A-5020 Austria. Tel 0043(0)662/620808-0; Fax
0043(0)662/620808-120; Elec Mail office@smca.at; Internet Home Page Address:
www.smca.at; *Dir* Dr Erich Marx
Open daily 9 AM - 5 PM, Thurs 9 AM - 8 PM; Admis 3.50 Euros; Estab 1834;
Library with 100,000 vols
Collections: Art, coins, musical instruments, costumes, peasant art; Prehistoric &
Roman archaeology; Toy, fortress, folk and excavation museums
Activities: Classes for adults & children

VIENNA

M **AKADEMIE DER BILDENDEN KUNSTE IN WIEN,** Gemaldegalerie der
Akademie der bildenden Kunste in Wien, Schillerplatz 3, Vienna, 1010 Austria.
Tel 58816228; Fax 586 3346; Elec Mail gemgal@akbild.ac.at; Internet Home Page
Address: akademiegalerie.at; *Dir* Dr Renate Trnek; *Asst* Dr Martina Fleischer; Dr
Bettina Hagen; Mag Claudia Koch; *Mag* Andrea Domanig; *Mag Dipl Rest* Astrid
Lehner
Tues - Sun 10 a.m. - 4 p.m., cl Mon; 7 Euro; Estab 1822; old masters 15 - 19th
century
Collections: European Paintings of the 14th - 20th centuries - Hieronymus Bosch,
Hans Baldung Grien; 17th century Dutch (Rembrandt, Ruisdael, van Goyen, Jan
Both & others); Flemish, (Rubens, Jordaens, van Dyck), Guardi, Magnasco,
Tiepolo, bequests by Count Lamberg, Prince Liechtenstein, Wolfgang von
Wurzbach
Activities: Lects open to public; gallery talks; books, slides, postcards

M **GRAPHISCHE SAMMLUNG ALBERTINA,** Albertina Graphic Art Collection,
Albertinaplatz 1, Vienna, 1010 Austria. Tel 43-1-534-830; Fax 43-1-533-7697;
Elec Mail info@albertina.at; Internet Home Page Address: www.albertina.at; *Dir*
Klaus Albrecht Schroder; *Deputy Dir* Alfred Weidinger
Estab 1796; Average Annual Attendance: 40,000
Special Subjects: Drawings, Prints, Watercolors, Posters, Miniatures
Collections: Drawings 44,000; sketchbooks, miniatures & posters. This is one of
the largest (over one million) and best print collections in Europe

M **KUNSTHISTORISCHES MUSEUM,** Museum of Fine Arts, Burgring 5 ,
Vienna, 1010 Austria. Tel 43 1-525240; Fax (43) 1-5232770; *Chief Dir* Dr
Wilfried Seipel
Collections: Egyptian collection; antiquities, ceramics, historical carriages &
costumes, jewelry, old musical instruments, paintings, tapestries, weapons;
collection of secular & ecclesiastical treasures of Holy Roman Empire &
Hapsburg dynasty

MUSEUM MODERNER KUNST STIFUNG LUDWIG Ludwig Foundation
Museum of Art,
M **Palais Liechtenstein,** Tel (01) 317 6900; Fax 3176901; *Dir* Dr Lorand Hegyi
Collections: Modern classics & modern art
M **Museum des 20 Jahrhunderts,** Tel +43-1-52500; Fax +43-1-52500-1300; Elec
Mail info@mumok.at; Internet Home Page Address: www.mumok.at; *Dir* Edelberk
Köb; *Vice Dir* Rainer Fuchs
Open to public Tues - Sun 10 AM - 6 PM, Thurs 10 AM - 9 PM; Admis E 8,
reduced fee E 6,5; Estab 1962; Museum modern art
Library Holdings: Book Volumes; Exhibition Catalogs; Filmstrips; Pamphlets
Collections: Works of the 20th century & a sculpture garden; artists represented
include: Archipenko, Arp, Barlach, Beckman, Boeckl, Bonnard, Delaunay, Ernst,
Gleizes, Hofer, Hoflehner, Jawlensky, Kandinsky, Kirchner, Klee, Kokoschka,
Laurens, Leger, Marc, Matisse, Miro, Moore, Munch, Nolde, Picasso, Rodin,
Rosso, Wotruba & others
Exhibitions: spec exhibs
Publications: exhib guides
Activities: Classes for adults, classes for children; lects open to public, gallery
talks, tour; schol available; lending of origional objects of art; mus shop sells
books, magazines, reproductions, prints, slides

M **OSTERREICHISCHE GALERIE,** Austrian Gallery, Oberes & Unteres
Belvedere, Prinz Eugenstrasse 27, Postfach 134 Vienna, A 1037 Austria. Tel
79557; Fax 798 43 37; *Dir* Dr Gerbert Frodl
Austrian Gallery library contains 210,000 vols; branches of the gallery include the
Austrian Gallery of 19th & 20th Century Art, the Museum of Austrian Baroque
Art, the Museum of Austrian Medieval Art, the Ambrosi Museum, and the Gallery
at Schloss Halburn
M **Museum mittelalterlicher Kunst,** Orangerie des Belvedere, Rennweg 6A Vienna,
Austria.
Collections: Austrian medieval paintings & sculptures, especially 14th - 16th
century
M **Osterreichisches Barockmuseum,** Unteres Belvedere, Rennweg 6A Vienna,
Austria.

Collections: Austrian Baroque art (paintings and sculptures)
M **Osterreichische Galerie und Internationale Kunst des XIX - Jahrhunderts,** Oberes Belvedere, Prinz Eugenstr 27 Vienna, Austria.
Collections: 19th - 20th century Austrian paintings & sculptures
M **Gustinus Ambrosi-Museum,** Scherzergasse 1A, Vienna, Austria.
Collections: Sculpture by G Ambrosi (1893-1975)
M **Expositur der Osterreichischen Galerie auf Schloss Halbturn,** Burgenland, Halbturn, A-7131 Austria. Tel (02172) 3307
Collections: 20th century Austrian paintings & sculptures
M **Osterreichische Galerie und Internationale Kunst des XX - Jahrhunderts,** Stallburg, Vienna, Austria.
Collections: International painting & sculpture

BELGIUM

ANTWERP

M **CITY OF ANTWERP,** Kunsthistorische Musea, Museum Mayer van den Bergh, Lange Gasthuisstraat 19 Antwerp, 2000 Belgium. Tel (03) 232-42-37; Fax (03) 231 73 35; Elec Mail museum.mayervandenbergh@stadt.antwerpen.be; Internet Home Page Address: http://museum.antwerpen.be/mayervandenbergh; *Dir* Hans Nieuwdorp; *Cur* Rita Van Doozen
Tues-Sun, 10AM-5PM; Admis 6c and 2f; Estab 1904
Collections: Painting 13th-18th century; sculpture 14th-16th century; all decorative arts, mainly late medieval
M **Rubenshuis,** Wapper 9-11, Antwerp, 2000 Belgium. Tel (03) 201-15-64; Fax (03) 227-36-92; *Dir* Carl DePauw; *Asst Dir* Veronique Van de Kerckhof
Collections: Reconstruction of Rubens' house & studio; paintings by P P Rubens, his collaborators & pupils
L **Rubenianum,** Kolveniersstraat 20, Antwerp, 2000 Belgium. Tel (03) 201-15-77; Fax (03) 201-15-87; Elec Mail rubenianum@rubenianum.be; Internet Home Page Address: www.rubenianum.be; *Cur* Nora de Poorter
Open 8:30 - 12:00; 13:00 - 16:30; No admis fee; Center for the study of 16th & 17th century Flemish art; library & photo archives
Library Holdings: Auction Catalogs 18,500; Book Volumes 40,000; Exhibition Catalogs; Periodical Subscriptions 127; Photographs 110,000
Special Subjects: Painting-Dutch, Painting-Flemish
Publications: Corpus Rubenianum Ludwig Burchard
M **Openluchtmuseum voor Beeldhowwkunst Middleheim,** Middelheimlaan 61, Antwerp, 2020 Belgium. Tel (03) 827-15-34; Fax (03) 227-2000; *Cur* M Meewis; *Asst Dir* R Jalon
Collections: Contemporary sculpture of Rodin, Maillol, Zadkine, Marini, Manzu, Gargallo, Moore, biennial exhibitions of modern sculpture
M **Museum Smidt van Gelder,** Belgielei 91, Antwerp, 2000 Belgium. Tel (03) 239-06-52; Fax (03) 230-22-81; *Asst Keeper* Clara Vanderhenst
Collections: Collections of Chinese & European porcelains, 17th century Dutch paintings, 18th century French furniture
M **Museum Mayer van den Bergh,** Lange Gasthuisstraat 19, Antwerp, 2000 Belgium. Tel (03) 232-42-37; *Cur* Hans Nieuwdorp
Collections: Collection of paintings, including Breughel, Metsys, Aertsen, Mostaert, Bronzino, Heda, de Vos, & medieval sculpture

M **INTERNATIONAAL CULTUREEL CENTTRUM,** International Cultural Centre, Meir 50, Antwerp, 2000 Belgium. Tel 03-226-03-06; *Dir* Willy Juwet

M **KONINKLIJK MUSEUM VOOR SCHONE KUNSTEN ANTWERPEN,** Royal Museum of Fine Arts, Leopold de Waelplaats, Antwerp, 2000 Belgium; Plaatsnyderstraat 2, Antwerp, 2000 Belgium. Tel (03) 238-78-09; Fax (03) 248-08-10; Elec Mail info@kmska.be; Internet Home Page Address: www.kmska.be; *Dir* Paul Huvenne
Open Tues - Sat 10 AM - 5 PM, Sun 10 AM - 6 PM, cl Mondays; Admis 6euros/4euros/free; Estab 1890; Library with 35,000 vols; Average Annual Attendance: 100,000+
Library Holdings: Auction Catalogs; Book Volumes; CD-ROMs; Exhibition Catalogs; Fiche; Periodical Subscriptions
Special Subjects: Drawings, Sculpture, Painting-European
Collections: Five Centuries of Flemish Painting: Flemish Primitifs, early foreign schools, 16th-17th century Antwerp School, 17th century Dutch School, 19th and 20th century Belgian artists; works of De Braekeleer, Ensor, Leys, Permeke, Smits and Wouters
Exhibitions: (3/3/2007-5/27/2007) Early Netherlandish Painters, the First Diptychs
Publications: Yearbook
Activities: Classes for adults & children; dramatic programs; docent training; lect open to public; concerts; gallery talks; tours; lending of original objects of art; museum shop sells books, magazines & reproductions

M **MUSEUM PLANTIN-MORETUS,** Plantin-Moretus Museum, Vrijdagmarkt 22, Antwerp, 2000 Belgium. Tel (03) 2330294; Fax (03) 2262516; *Dir* Dr Francine de Nave
Library of 30,000 books of 15th - 18th centuries
Collections: Designs, copper and wood engravings, printing presses, typography

M **STEDELIJK PRENTENKABINET,** Municipal Gallery of Graphic Arts, Vrijdagmarkt 23, Antwerp, 2000 Belgium. Tel +32 3 221 1450; Fax +32 3 221 1460; Elec Mail prentenkabinet@stad.artwerpen.be; Internet Home Page Address: www.antwerpen.be/cultuur/stedelijk_prentenkabinet; *Keeper* Dr Francine de Nave
Reading room: Mon - Fri 10 AM - 4PM; No admis fee for the reading room
Library Holdings: Auction Catalogs; Book Volumes; Exhibition Catalogs; Periodical Subscriptions
Collections: Antwerp iconographic collection; modern drawings: J Ensor, F Jespers, H Leys, W Vaes, Rik Wouters; modern engravings: Cantre, Ensor, Masereel, J Minne, W Vaes; old drawings: Jordaens, E and A Quellin, Rubens, Schut, Van Dyck; old engravings: Galle, Goltzius, Hogenbergh, W Hollar, Jegher, Wiericx, etc

Activities: Mus shop sells books, reproductions, postcards

BRUGES

M **GROENINGEMUSEM,** Municipal Art Gallery, Dijver, 12, Bruges, 8000 Belgium. Tel (050) 44-87-11; Fax (050) 44-87-78; *Chief Cur* Dr Valentin Vermeersch
Collections: Ancient & modern paintings, including works by Hieronymus Bosch, Gerard David, Hugo vanderGoes, Jan van Eyck, R van de Weyden & Hans Memling

M **STEDELIJK MUSEUM VOOR VOLKSKUNDE,** Municipal Museum of Folklore, Rolweg 40, Bruges, 8000 Belgium. Tel 050-33-00-44; Fax 050-335489; Elec Mail musea.reservatie@brugge.be; Internet Home Page Address: www.museabrugge.be; *Cur* W P Dezutter; *Asst Cur* Sibylla Goegebier; *Cur* Willie Le Loup
Open 9:30 AM - 5 PM, closed on Mon; Admis 3E/pp, 2E
Publications: Brief guide
Activities: Sales of books, reproductions, slides

BRUSSELS

L **BIBLIOTHEQUE ROYALE DE BELIQUE/KONINKLIJKE BIBLIOTHEEK VAN BELGIE,** (Bibliotheque Royale Albert I) The Belgian National Library, 4 blvd de l'Empereur, Brussels, 1000 Belgium. Tel (02) 519-53-11; Internet Home Page Address: www.kbr.be; *Dir* Pierre Cockshaw
Collections: Coins, medals, maps, manuscripts, prints, rare printed books housed in Belgian National Library

M **MUSEE HORTA,** 25 rue Americaine, Brussels, 1060 Belgium. Tel 02-5430490; Fax 02-5387631; Elec Mail info@hortamuseum.be; Internet Home Page Address: www.hortamuseum.be; *Dir* Francoise Aubry
14 - 17.30 groups or appt only in the morning; 5 E 3, 70 E (student, sr) 3, 50 E; Library with 2500 vols
Library Holdings: Exhibition Catalogs; Manuscripts; Original Documents; Photographs; Slides
Collections: Works of art by V Horta; architecture & furniture
Activities: Mus shop sells books & prints

M **MUSEES ROYAUX D'ART ET D'HISTOIRE,** Royal Museums of Art and History, 10 Parc du Cinquantenaire, Brussels, 1000 Belgium. Tel 02-741-72-11; *Dir* F Van Noten
Collections: Pre-Columbian art; Belgian, Egyptian, Japanese, Greek, Roman and classical art; Medieval, Renaissance and modern art - ceramics, furniture, glass, lace, silver, tapestries, textiles; ethnography; folklore

M **MUSEES ROYAUX DES BEAUX-ARTS DE BELGIQUE,** Royal Museums of Fine Arts of Belgium, 9 rue de Musee, Brussels, 1000 Belgium. Tel 32.2.508.32.11; Fax 32.2.508.32.32; Elec Mail info@fine-arts-mseum.be; Internet Home Page Address: www.fine-arts-museum.be; *Dir* Eliane De Wilde
Collections: Baroque paintings 15th, 16th, 17th & 18th centuries & sculptures
Activities: Classes for adults & children; lects open to public, gallery talks, tours; scholarships, fellowships; books, magazines, reproductions, prints, slides
M **Musee d'Art Ancien,** 3 rue de la Regence, Brussels, 1000 Belgium; 9 Rue de Musée Brussels, 1000 Belgium. Tel 32.2.508.32.11; Fax 32.2.508.32.32; Elec Mail info@fine.arts.museum.be; Internet Home Page Address: www.fine-arts.museum.be; *Dept Head* Helena Bussers
Collections: Paintings & drawings (15th - 19th centuries) & old & 19th century sculptures
M **Musee d'Art Moderne,** 1-2 Place Royale, Brussels, 1000 Belgium; 9 Rue de Musée Brussels, 1000 Belgium. Tel 32.2.508.32.11; Fax 32.2.508.32.32; Elec Mail info@fine.arts.museum.be; Internet Home Page Address: www.fine-arts.museum.be; *Dept Head* Frederik Leen; *Dir* Eliane De Wilde
Collections: Temporary exhibitions; 20th & 19th century paintings, drawings & sculptures
Activities: Classes for adults & children; lects open to public, gallery talks, tours; scholarships, fellowships; books, magazines, reproductions, prints & slides
M **Musee Constantin Meunier,** 59 rue de l'Abbaye, Brussels, 1000 Belgium; 9 rue de Musée Brussels, 1000 Belgium. Tel 02-648-44-49; Internet Home Page Address: www.fine-arts-museum.be
No admis fee
Collections: Paintings, drawings and sculptures by Constantin Meunier, the artist's house and studio
M **Musee Wiertz,** 62 rue Vautier, Brussels, 1000 Belgium. Tel 02-648-17-18; Internet Home Page Address: www.fine-arts-museum.be; *Head Cur* Philippe Roberts-Jones
Collections: Paintings by Antoine Wiertz

M **MUSEUM ERASMUS,** 31 Rue du Chapitre, Brussels, 1070 Belgium. Tel 2-521-13-83; Fax 2-527-12-69; *Cur* Alexandre Vanautgaerden
Library with 4000 vols
Collections: Documents, paintings, manuscripts relating to Erasmus & other humanists of the 16th century

LIEGE

M **MUSEES D'ARCHEOLOGIE ET DES ARTS DECORATIFS,** Musee d'Ansembourg, Feronstree 114, Liege, 4000 Belgium. Tel 32-4-221.94.02; Fax 32-4-221.94.32; *Cur* Ann Chevalier; *Librn* Monique Merland
Tues. to Sun., 1pm-5pm; FB 100/FB 50; Estab 1905
Collections: 18th century decorative arts of Liege, housed in a mansion of the same period

MARIEMONT

M **MUSEE ROYAL ET DOMAINE DE MARIEMONT,** Morlanwelz, Mariemont, 7140 Belgium. Tel (64) 21-21-93; Fax (64) 26-29-24; *Cur* Patrice Dartevelle
Maintains library with 70,000 volumes
Collections: Belgian archaeology; porcelain from Tournai; Egyptian, Grecian, Roman, Chinese & Japanese antiquities

VERVIERS

M **MUSEES COMMUNAUX DE VERVIERS: BEAUX-ARTS,** Community Museum of Fine Arts, Rue Renier 17, Verviers, 4800 Belgium. Tel 087-33-16-95; Internet Home Page Address: www.verviers.be; *Cur* Marie-Paule Deblanc
Collections: European & Asian painting and sculpture, ceramics, & folk arts

BOLIVIA

CASILLA

M **MINISTERIO DE EDUCACION, CULTURA Y DEPORTES,** Museo Nacional de Arte, Calle Comercio , esq Socabaya Casilla, 11390 Bolivia. Tel 591-2-408600; Fax 591-2-408542; Elec Mail mma@mma.org.bo; Internet Home Page Address: www.mma.org.bo; *Dir* Teresa Villegas de Aneiva; *Coordr* Teresa Adriázola; *Documentation, Archivist & Bibliologist* Reynaldo Gutierrez; *Prensa* Oscar R Mattos
9 AM to 12:30 PM and 3 PM to 7 PM; Bs 10 (Extranjeros); Circ 150 pers/mes; Colonial, Contemporary and Escultura y Huebles Galleries; Average Annual Attendance: 65,000
Library Holdings: Audio Tapes; Book Volumes; CD-ROMs; Cards; Cassettes; Clipping Files; Compact Disks; Exhibition Catalogs; Fiche; Framed Reproductions; Memorabilia; Original Art Works; Original Documents; Other Holdings; Pamphlets; Periodical Subscriptions; Photographs; Prints; Records; Reels; Sculpture; Slides; Video Tapes
Collections: Colonial & local modern art; pictura Latinoamericana
Publications: Hemoria 1990-2002. Postales, Catalogs
Activities: Lect open to public, concerts, gallery talks, tours; lending original objects of art; books, magazines

LA PAZ

M **MUSEO NACIONAL DE ARQUEOLOGIA,** National Museum, Calle Tihuanaco 93, Casilla Oficial 64 La Paz, Bolivia. Tel 29624; *Dir* Max Portugal Ortiz
Collections: Anthropology, archaeology, ethnology, folklore, Lake Titicaca district exhibitions, traditional native arts and crafts

BOTSWANA

GABORONE

M **NATIONAL MUSEUM, MONUMENTS AND ART GALLERY,** (National Museum and Art Gallery) 331 Independence Ave, Private Bag 00114 Gaborone, Botswana. Tel 697-4616; Fax 390-2797; Elec Mail national.museum@gov.bw; Internet Home Page Address: www.botswana-museum.gov.bw; *Dir* Ms Tickey Pule; *Head of Art Division* Lesiga Phillip Segola; *Head of Archeology* Phillip Segadika; *Head of Educ* Ms Phodiso Tube; *Head Tech Support* Stephen Mogotsi; *Head of Ethnology* Rudolf Mojalemotho; *Head of Natural History* Bruce Hargreaves; *Head of IT* Keletso Setlhabi; *Head of Admin* Rosinah Setshwaelo
open 9 AM - 5 PM; no admis fee; Estab 1968; art
Income: financed by govt
Library Holdings: Auction Catalogs; Book Volumes; Cards; Periodical Subscriptions; Slides; Video Tapes
Special Subjects: Decorative Arts, Photography, Pottery, Textiles, Drawings, Graphics, Sculpture, Watercolors, Bronzes, African Art, Anthropology, Archaeology, Ethnology, Costumes, Ceramics, Crafts, Folk Art, Primitive art, Portraits, Posters, Porcelain, Coins & Medals, Tapestries, Dioramas, Reproductions
Collections: Art of all races of Africa south of the Sahara; scientific collections relating to Botswana
Exhibitions: Artists in Botswana (annual); HIV/AIDS (annual); Basket & Craft Exhibition (annual); Photographic (annual)
Publications: Zebra's Voice (quarterly); annual report; exhib catalogue
Activities: Classes for children; tours; sponsoring of competition; annual visual arts awards; lending of objects of art to other ministries; originate traveling exhibitions to other countries; museum shop sells books, magazines, original art

BRAZIL

OURO PRETO

M **MUSEU DA INCONFIDENCIA,** History of Democratic Ideals and Culture, Praca Tiradentes, 139, Ouro Preto, 35400 Brazil. Tel 031-551-1121; *Dir* Rui Mourao
Collections: Objects & documents related to the 1789 Revolutionaries of Minas Gerais (the Inconfidentes)

RIO DE JANEIRO

M **MUSEU DE ARTE MODERNA DE RIO DE JANIERO,** Museum of Modern Art, Av Infante Dom Henrique 85, CP 44 Rio de Janeiro, 20021 Brazil. Tel 021-240-6351; *Pres* M F Nascimento Brito; *Exec Dir* Gustavo A Capanema
Collections: Collections representing different countries

M **MUSEU NACIONAL DE BELAS ARTES,** National Museum of Fine Arts, Ave Rio Branco 199, Rio de Janeiro, 20040 Brazil. Tel 240-9869; *Dir* Prof Heloisa A Lustosa
Library with 12,000 vols
Collections: 19th & 20th century Brazilian art, works by outstanding painters; European paintings & sculptures - works by Dutch, English, French, German, Italian, Portuguese & Spanish masters; masterpieces of foreign collection: Dutch school - eight Brazilian landscapes by Frans Post; French school - 20 Paintings by Eugene Boudin; Ventania (Storm) by Alfred Sisley; Italian School Portrait of the Cardinal Amadei by Giovanni Battista Gaulli, Baciccia; Sao Caetano (circa 1730) by Giambattista Tiepolo. Graphic art department: Prints & drawings by Annibale Carracci, Chagall, Daumier, Durer, Toulouse Lautrec, Picasso, Guido Reni, Renoir, Tiepolo, etc

SALVADOR

M **FUNDACAO INSTITUTO FEMININO DA BAHIA,** Early Art Museum: Bahia Women's College, Rua Monsenhor Flaviano 2, Salvador, Brazil. Tel (071) 321 7522; Fax (071) 3329 5681; Elec Mail museu@institutofeminino.org.br; Internet Home Page Address: www.institutofeminino.org.br; *Dir* Ana Uchoa Peixotu
Open Tues - Fri 10 AM - Noon, 1 PM - 6 PM, Sat 2 PM - 6 PM; Admis fee adults R$5, students & seniors R$3; Estab 1923; Circ 20,000; Average Annual Attendance: 4000
Income: Property investments & rent
Collections: Religious art; Brazilian art; women's apparel, jewelry, gold, silver; Costumes & Textiles
Publications: Catalogue, Costume and Textile Museum
Activities: Classes for children; concerts; gallery talks; mus shop sells books

SAO PAULO

M **MUSEU DE ARTE CONTEMPORANEA DA UNIVERSIDADE DE SAO PAULO,** Contemporary Art Museum of Sao Paulo University, Rua de Reitoria 160, Sao Paulo, 05508-900 Brazil. Tel (011) 3091 3039; Fax (011) 3812 0218; Elec Mail infomac@edu.usp.br; Internet Home Page Address: www.mac.usp.br; *Dir* Dr Elza Ajzenberg
Collections: Painting, sculptures, prints & drawings by masters of the international school & Brazillian Art

M **MUSEU DE ARTE DE SAO PAULO,** Sao Paulo Art Museum, Ave Paulista 1578, Sao Paulo, 01310-200 Brazil. Tel 251-5644; Fax 284-0574; *Dir* Julio Neves
Collections: Representative works by Portinari & Lasar Segall; ancient & modern paintings & sculptures: American, 19th - 20th Centuries; Brazilian, 17th - 20th Centuries; British, 18th - 20th Centuries; Dutch, Flemish & German, 15th - 20th Centuries; French, 16th - 20th Centuries; Italian, 13th - 20th Centuries; Spanish & Portuguese, 16th - 19th Centuries

BULGARIA

PAZARDZHIK

M **STANISLAV DOSPEVSKY MUSEUM,** Maria-Luisa 54, Pazardzhik, 4400 Bulgaria. Tel 2-71-52; *Dir* Ganka Radulova
Collections: House where the painter lived & worked; exhibition of paintings, icons, personal effects & documents

PLOVDIV

M **REGIONAL MUSEUM OF ARCHAEOLOGY,** Pl Saedinenie 1, Plovdiv, 4000 Bulgaria. Tel 22-43-39, 23-17-60; *Dir* A Peykov
Library with 15,000 vols
Collections: Prehistory; classical & medieval archaeology; epigraphic monuments, jewelry, numismatics, toreutics & vessels

SOFIA

M **NATSIONALNA HUDOZHESTVENA GALERIJA,** National Art Gallery, Moskovska 6, Sofia, 1000 Bulgaria; 1 Prince Alexander Battenberg Square, Sofia, 1000 Bulgaria. Tel 00359-2-9800071; Fax 00359-2-9803320; Elec Mail europaliabg@hotmail.com; Internet Home Page Address: www.nationalartgallery-bg.org; *Dir* S Stoyanov; *Dir* B Danailov; *Deputy Dir* B Yossitova; *Deputy Dir* B Klimentiev
Open Tues - Sun 10 AM - 6 PM, cl Mon; Admis fee adults 4 BGN leva, students 2 BGN leva; National Museum for Bulgarian Visual Arts
Income: Ministry of Culture
Library Holdings: CD-ROMs; Compact Disks; DVDs; Exhibition Catalogs; Framed Reproductions; Kodachrome Transparencies; Original Art Works; Original Documents; Photographs; Prints; Reproductions; Sculpture; Slides
Collections: National & foreign art; Permanent expositions of paintings & sculpture
Exhibitions: Temporary exhibitions of Bulgarian & foreign art

Activities: Classes for children; Concerts, gallery talks, tours; Lending of original art objects to galleries within the country; Organize traveling exhibitions to municpality & private galleries; Mus shop sells books, magazines, orginal art, reproductions

CHILE

SANTIAGO

M **MUSEO DE ARTE POPULAR AMERICANO,** Museum of American Folk Art, Parque Forestal S/N, Casilla 2100, Univ of Chile Santiago, Chile. Tel 2-682-1450; Fax 2-682-1481; *Dir* Sylvia Rios Montero
Collections: Araucanian silver; American folk arts of pottery, basketware, metal & wood

M **MUSEO NACIONAL DE BELLAS ARTES,** National Museum of Fine Arts, Parque Forestal, Casilla 3209 Santiago, Chile. Tel (2) 6330655; Fax (2) 6393297; Internet Home Page Address: www.dibam.renib.cl; *Dir* Milan Ivelic
Collections: Baroque, Chilean & Spanish paintings; sculpture; engravings

M **ORDEN FRANCISCANA DE CHILE,** Museo Colonial de San Francisco, Alameda Bernardo O'Higgins 834, PO Box 122D Santiago, Chile. Tel (2) 639 8737; Fax (02) 639 8737; Internet Home Page Address: www.sanfrancisco.cl; *Dir* Rosa Puga
Open 10 AM to 1 PM and 3 PM - 6 PM; Admis $750 niños $250
Income: Income from pvt support
Collections: 16th - 19th century art; important collection of 17th century paintings in Chile; the life of St Francis depicted in 53 pictures; other religious works of art, furniture
Exhibitions: Arte religioso de la Escuela quiteña
Publications: Pinturas de la Serie de San Francisco Edic Morgan Antártica; Catÿlogo del Museo de San Francisco
Activities: Mus shop sells books, original art, reproductions, prints, handicrafts, ceramics, oil paintings & religious articles

CHINA, REPUBLIC OF

TAIPEI

M **NATIONAL PALACE MUSEUM,** Wai-Shuang-Hsi, Shih-Lin, Taipei, China, Republic of. Tel 886-2-2881-2021; Fax 886-2-2882-1440; Elec Mail service01@pm.gov.tw; Internet Home Page Address: www.npm.gov.tw; *Dir* Tu Cheng-sheng; *Dep Dir* Shih Shou-chien; *Dep Dir* Lin Po-ting
Open daily 9 AM - 5 PM; Admis fee NT$100 adults, NT$50 students (with ID); Estab 1925 in Peking, 1965 in Wai-Shuang-hsi, Taipei; Circ Libr non-ciculating; Average Annual Attendance: 2,100,000
Income: Income: NT$106, 360. 000
Library Holdings: Auction Catalogs; Audio Tapes; Book Volumes; CD-ROMs; Cassettes; Clipping Files; Compact Disks; DVDs; Exhibition Catalogs; Fiche; Maps; Original Documents; Periodical Subscriptions; Photographs; Slides; Video Tapes
Special Subjects: Ceramics, Pottery, Manuscripts, Bronzes, Religious Art, Crafts, Woodcarvings, Portraits, Jade, Jewelry, Porcelain, Oriental Art, Ivory, Tapestries, Calligraphy, Miniatures, Embroidery, Enamels
Collections: Bronzes, calligraphy, carved lacquer, embroidery, enamelware, jades, miniature crafts, oracle bones, paintings, porcelain, pottery, rare and old books & documents from Shang Dynasty to Ch'ing Dynasty, tapestry, writing implements
Exhibitions: Ming Dynasty Masters of Painting and Calligraphy: The Art of Lu Chih (1496-1576); Annual Events of the Chinese Lunar Calendar: Paintings of Festivals and Holidays Throughout the Ages; The Calligraphy and Seal Carving of Wang Chuang-wei; Dali, a genius of the 20th Century; Taoism and the Arts of China; Fine Examples of Ming Dynasty Calligraphy; The Theme of Poetry and Literature in Chinese Art; Neolithic Jade Artifacts from the Yellow River Valley; A Special Exhibition Commemorating the Work of Li Mei-shu; Three Hundred Years of French Painting; Ancient Bronze Inscriptions from the Western Chou Period
Publications: The Elegance and Elements of Chinese Architecture; The National Palace Museum Entering the New Millennium; China at the Inception of the Second Millennium Art and Culture of the Sung Dynasty; Panorama of Ceramics in the Collection of National Palace Museum Hsuan-te Ware II; Figure Painting of the Middle Ming Dynasty; Visions of Compassion: Images of Kuan-yin in Chinese Art; Nat Palace Mus Bulletin; Ancient Chinese Writing Oracle Bone Inscriptions from the Ruins of Yin; Aesthetic Beauty of a Universal Nature: A Survey of the National Palace Museum; Japanese Lacquerware from the Ch'ing Imperial Collection; Emporer Ch'ien -lung's Grand Enterprise; Empty Vessels, Replenished Minds; The Culture, Practice and Art of Tea; Elephant Ear Vase Replica of Sung Dynasty Lung-ch'uan Ware; Han Dynasty Stoneware Owl Containers
Activities: Docent training, classes for children & adults; lectures open to public; 150 per yr; school principles throughout Republic of China; originate traveling exhibitions; shop sells books, reproductions, prints
L **Library,** Wai-shuang-hsi, Shih-Lin, Taipei, China, Republic of. Tel 886-2-2881-2021; Fax 886-2-2882-1440; Elec Mail service@npm.gov.tw; Internet Home Page Address: www.npm.gov.tw; *Dep Dir* Shih Shou-Chien; *Dep Dir* Lin Po-Ting
Library Holdings: Book Volumes 48,000; Other Holdings Documents 395,000; Rare books 191,000; Periodical Subscriptions 683

COLOMBIA

BOGOTA

M **MUSEO COLONIAL,** Museum of the Colonial Period, Carrera 6, No 9-77, Bogota, Colombia. Tel (1) 6352418-2866768.3416017; Elec Mail teramo@cable.net.co; *Dir* Teresa Morales de Gomez; Patricia Garcia
9 AM - 5 PM; $.50; Estab Aug 6, 1942
Collections: Spanish colonial period art work: paintings, sculpture, furniture, gold and silver work, drawing

COSTA RICA

SAN JOSE

M **MUSEO DE ARTE COSTARRICENSE,** Apdo 378, Fe cosa, San Jose, 1009 Costa Rica. Tel 222-71-55; Fax 222-72-47; *Dir* Amalia Chaverri Fonseca
Collections: Representative Costa Rican art

M **MUSEO NACIONAL DE COSTA RICA,** Calle 17, Avda Central y 2, Apdo 749 San Jose, 1000 Costa Rica. Tel 221-44-29; Fax 233-74-27; *Dir* Melania Ortiz Volio
Collections: Pre-Columbian & colonial religious art; natural history

CROATIA

RIJEKA

M **MODERNA GALERIJA,** Museum of Modern and Contemporary Art, Dolac 1, Rijeka, 51000 Croatia. Tel 334280; Fax 330-982; Elec Mail mmsu-rijeka@ri.t-com.hr; Internet Home Page Address: www.mmsu.hr; *Dir* Branno Franceschi
Open Tues - Sun 10 AM - 1 PM, 5 PM - 8 PM, cl Mon; Admis fee 10 eu; Estab 1948
Library Holdings: Book Volumes; DVDs; Exhibition Catalogs; Video Tapes
Special Subjects: Drawings, Photography, Graphics, Prints, Sculpture, Posters
Collections: Paintings, sculptures & graphics, drawings, photographs, mixed media, video
Publications: Catalogues of temporary exhibitions
Activities: Classes for adults & children; Lectrs open to the public, tours

SPLIT

M **ARCHEOLOSKI MUZEJ U SPLITU,** Archaeological Museum, Zrinjsko-Frankopanska 25, Split, 21000 Croatia. Tel (21) 44 574; Fax (21) 44 685; *Dir* Emilio Marin
Library with 30,000 vols
Collections: Relics from the Greek colonies; prehistoric & numismatic collection; medieval monuments from the 9th to the 13th century

M **GALERIJA UMJETNINA,** Art Gallery, Lovretska 11, Split, 21000 Croatia. *Dir* Milan Ivanisevic
Library with 10,000 vols
Collections: Paintings & sculptures; ancient & modern art

ZAGREB

M **ARHEOLOSKI MUZEJ,** Archaeological Museum, Zrinski trg 19, Zagreb, 10000 Croatia. Tel 1-421-420; Fax 1-427-724; *Dir* Ante Rendic-Miocevic
Collections: Neolithic 13th century

M **MODERNA GALERIJA,** Gallery of Modern Art, Andrije Hebranga 1, Zagreb, 10000 Croatia. Tel 433802; Tel 00385 1 49 22 368; Fax 00385 1 49 22 368; Elec Mail moderna-galerija@zg.hinet.hr; *Dir* Igor Zidic
Open Tues-Sat 10AM-6PM, Sun 10AM-1PM, cl Mon & holidays; Admis 20 kn, students/groups 10 kn; Estab 1905; Circ 1,500; Library with 3500 vols; Average Annual Attendance: 25,000
Income: $1,300,000 kn (financed by state treasury)
Library Holdings: Cards 2,000; Exhibition Catalogs 1,500; Video Tapes 200
Special Subjects: Woodcuts, Sculpture, Tapestries, Watercolors, Primitive art, Woodcarvings
Collections: Collection of sculptures, graphic arts & paintings; medals
Exhibitions: Landscape 19th Century (May 2001); Murtic's Retrospective (Autumn 2001); B Senoa (Dec 2001); Studio Josip Racic young artists exhibitions (10 per yr)
Publications: Dossier
Activities: Original objects of art lent to other museums & galleries; sales shop sells reproductions

M **MUNZEJ SUVREMENE UMJETNOSTI,** Habdeliceva 2, Zagreb, 10000 Croatia. Tel 1-431-343; Fax 1-431-404; *Dir* Snjezanda Pintaric
Collections: Five galleries exhibiting contemporary art, antique & Renaissance works, primitive art, Ivan Mestrovic's sculpture & photography
M **Galerija Benko Horvat,** Habdeliceva 2, Zagreb, 10000 Croatia. *Cur* Zelimir Koscevic; *Chief Cur* Mladen Lucic
Collections: Antique & renaissance art

M **Galerija Primitivne Umjetnosti, Gallery of Naive Art,** Cirilometodska 3, Zagreb, 41000 Croatia. Tel 041 423 669; *Cur* Mrzljak Franjo

M **Galerija Suvremene Umjetnosti, Gallery of Contemporary Art,** Katarinin trg 2, Zagreb, 10000 Croatia. Tel 1 425-227; Fax 1-273-469; *Cur* Marijan Susovski

M **MUZEJ ZA UMJETNOST I OBRT,** Museum of Arts & Crafts, Trg Marsala Tita 10, Zagreb, 10000 Croatia. Tel 385 1 4826 922; Fax 385 1 4828 088; Elec Mail muo@muo.hr; Internet Home Page Address: www.muo.hr; *Dir* Vladimir Malekovic; *Asst Dir* Vesna Lovric Plantic; *Chief Librn* Andelka Galic
Open Tues - Fri 10 AM - 6 PM, Sat & Sun 10 AM - 1 PM; 20 kn ($2.50), 10 kn ($1.25) for groups, students, retired; Estab 1880, collecting art and decorative arts from 13th - 20th century; Library with 36,000 vols; Average Annual Attendance: 40,000
Library Holdings: Auction Catalogs; Book Volumes; CD-ROMs; Exhibition Catalogs; Fiche; Framed Reproductions; Manuscripts; Maps; Original Art Works; Original Documents; Pamphlets; Periodical Subscriptions; Photographs; Prints; Reproductions
Special Subjects: Etchings & Engravings, Architecture, Flasks & Bottles, Portraits, Pottery, Bronzes, Manuscripts, Painting-British, Tapestries, Drawings, Graphics, Photography, Sculpture, Watercolors, Textiles, Costumes, Religious Art, Ceramics, Crafts, Landscapes, Decorative Arts, Judaica, Painting-European, Posters, Dolls, Furniture, Glass, Jewelry, Porcelain, Silver, Metalwork, Painting-French, Carpets & Rugs, Ivory, Coins & Medals, Restorations, Baroque Art, Miniatures, Painting-Flemish, Renaissance Art, Embroidery, Laces, Painting-Spanish, Painting-Italian, Gold, Stained Glass, Painting-German, Pewter, Leather, Bookplates & Bindings
Collections: Applied arts from the 14th to the 20th century; ceramics, glass, tapestries, textiles, paintings & sculptures, furniture, clocks & watches, metal, photography, design architecture
Activities: Children's workshops; lect open to public; 10 vis lect per yr; concerts; tours; lending of original objects of art to other museums in Croatia; museum shop sells books, reproductions

M **STROSSMAYEROVA GALERIJA STARIH MAJSTORA,** Strossmayer's Gallery of Old Masters, Trg Nikole Subica Zrinskog 11, Zagreb, 10000 Croatia. Tel 1-481-3344; Fax 1-4895-115/116-119; Elec Mail sgallery@hazu.hr; Internet Home Page Address: www.hazu.hr/strossmayeroug-galerija-starih-m.html; Internet Home Page Address: www.mdc.hr/strossmayer; *Dir* Prof Borivoj Popovcak
Open Wed - Sun 10 AM - 1 PM, Tues 10 AM 1 PM plus 5 PM - 7 PM; Students 5,000 kn, other 10,000 kn; Estab 1884
Library Holdings: Book Volumes 10,000; Exhibition Catalogs 2,000
Collections: Dutch 15th-18th century; French collection mostly 18th & 19th century; Italian collection, Fra Angelico - Piazzetta, nine rooms, paintings & sculpture, 13th to 19th century

CUBA

HAVANA

M **MUSEO DE ARTES DECORATIVAS,** Calle 17, No 502 Vedado, Havana, 10100 Cuba. Tel 320924; Fax 613857; *Dir* Maria Heidy Lopez Moyael Castillo
Library with 2500 vols
Collections: Porcelain, bronzes, gold & silver work & tapestries

M **MUSEO NACIONAL DE BELLAS ARTES,** National Museum, Animas entre Zulueta y Monserate, Havana, CP 10200 Cuba. Tel (537) 639 042; *Dir* Pilar Fernandez Priesto
Collections: Renaissance and other European art; Cuban art from colonial times to the present

CYPRUS

NICOSIA

M **CYPRUS MUSEUM,** PO Box 22024, Nicosia, Cyprus. Tel (02) 865888; Fax (02) 303148; Elec Mail antiquitiesdept@da.mcw.gov.cy; *Dir of Antiquities* Dr Pavlos Flourentzos
Open 9 AM - 5 PM weekdays, Sun 10 AM - 1 PM; Admis 1.50 Euro; Estab 1935; 14 exhibition galleries from the Nealithic to the Roman period; Average Annual Attendance: 150,000; Mem: ICOM
Income: 235,000
Library Holdings: Auction Catalogs; Book Volumes; CD-ROMs; Compact Disks; DVDs; Exhibition Catalogs; Fiche; Filmstrips; Framed Reproductions; Manuscripts; Maps; Memorabilia; Motion Pictures; Original Documents; Pamphlets; Periodical Subscriptions; Photographs; Prints; Reproductions; Sculpture; Slides; Video Tapes
Collections: Bronze cauldron from Salamis; middle and late Bronze-age Geometric, Archaic, Classical, Hellenistic and Graeco-Roman pottery; Mycenaean vases; Neolithic stone tools and vessels; sculpture from Archaic to Greco-Roman Age, including the Fine Arsos Head, the Aphrodite of Soli, and the bronze statue of Septimus Severus; silver trays from Lambousa
Exhibitions: (2006) History Lost
Publications: RDAC, annual
Activities: Originate traveling exhibitions to Europe and America; museum shop sells books, reproductions, prints, slides, postcards

CZECH REPUBLIC

BRNO

M **MORAVSKA GALERIE V BRNE,** Moravian Gallery in Brno, Husova 18, Brno, 662 26 Czech Republic. Tel ++420 532 169 181; Fax ++420 532 169 131; Elec Mail info@moravska-galerie.cz; Internet Home Page Address: www.moravska-galerie.cz; *Dir* Marek Pokorny; *Head Coll* Filip Suchomel; *Gen Secy* Katerina Tlachova
Open Wed, Fri - Sun 10 AM - 6 PM, Thur 10 AM - 7 PM, cl Mon & Tues; Estab 1873; Library with 120,000 vols; Average Annual Attendance: 100,000
Income: National Institution, main source of financing is the state budget
Library Holdings: Auction Catalogs; Book Volumes; CD-ROMs; Compact Disks; DVDs; Exhibition Catalogs; Manuscripts
Special Subjects: Decorative Arts, Etchings & Engravings, Architecture, Ceramics, Glass, Metalwork, Photography, Porcelain, Textiles, Painting-European, Sculpture, Tapestries, Drawings, Graphics, Prints, Costumes, Crafts, Pottery, Posters, Furniture, Jewelry, Painting-Dutch, Restorations, Baroque Art, Painting-Flemish, Renaissance Art, Embroidery, Medieval Art, Stained Glass, Painting-German, Enamels
Collections: European Art Collection - ceramics, furniture, glass, graphic design, jewelry, photography, textiles; Fine Art Collection - graphic art, painting, sculpture, 14th century to present; Oriental Art Collection
Exhibitions: Ca 30 per yr
Publications: Ca 6 per yr
Activities: Classes for adults & children; art workshops; lect open to the pub; concerts; gallery talks; tours; awards, Michal Rauuy Prize; mus shop sells books, magazines, reproductions & prints

JABLONEC NAD NISOU

M **MUZEUM SKLA A BIZUTERIE,** Museum of Glass & Jewelry, Jiraskova 4, Jablonec nad Nisou, 46600 Czech Republic. Tel 31 16 81; Fax 31 17 04; *Dir* Jaroslava Slaba
Library with 11,500 vols
Collections: Bohemian glass making & jewelry; exhibitions

LITOMERICE

M **GALERIE VYTVARNEHO UMENI,** Gallery of Fine Arts, Michalska 7, Litomerice, 412-01 Czech Republic. Tel 416-73-23-82; Fax 416-73-23-83; *Dir* Jan Stibr
Collections: Art of the 19th century; Baroque Art of the 17th - 18th centuries; contemporary art; Gothic art of the 13th - 16th centuries; special collections of native paintings and sculpture; Renaissance paintings and sculptures of the 15th - 16th centuries

PRAGUE

M **GALERIE HLAVNIHO MESTA PRAHY,** Prague City Gallery, Mickiewiczova 3, Prague, 16000 Czech Republic. Tel (02) 33 32 12 00; Fax (02) 33 32 36 64; Internet Home Page Address: www.citygalleryprague.cz; *Dir* Jaroslav Fatka
Collections: Pragensia work; 19th & 20th centuries Czech artists

M **NARODNI GALERIE V PRAZE,** National Gallery in Prague, Staromestske nam, Prague, 110 00 Czech Republic. Tel (02) 534457; *Dir* Dr Lubomir Slavicek
Open Tues - Sun 10 AM - 6 PM; Admis from 20Ki to 250 Ki; Estab 1796; Library with 75,000 vols
Collections: Architecture; Czech sculpture of the 19th and 20th century; French and European art of the 19th and 20th century; Old Czech art; Old European Art; graphic art, modern art; Oriental art; European Old Masters; Bohemian Art from the Era of Emperor Rudolf II to the Close of the Baroque; Medieval Art in Bohemia and Central Europe (1200 - 1550); 19th and 20th Century Art; Asian Art
Activities: Classes for adults & children; lectr open to public; lect for mems only; 85 vis lect per yr; concerts; gallery talks; fellowships offered; museum shop sells books, prints, reproductions, slides

M **UMELECKOPRUMYSLOVE MUZEUM V PRAZE,** Ulice 17 listopadu 2, Prague, 110 00 Czech Republic. Tel 2481 1241; Fax 2481 1666; *Dir* Dr Helena Koenigsmarkova
Library with 150,000 vols
Collections: European applied art from 16th to 19th century; collections of glass, ceramics, china, furniture, textiles, tapestries, gold & silver work, iron, ivory, clocks, prints, posters, photography, contemporary design

M **ZIDOVSKE MUZEUM,** Jewish Museum, Jachymova 3, Prague, 110 01 Czech Republic. Tel 24 81 00 99; Fax 23 10 681; *Dir* Dr Leo Pavlat
Library with 100,000 vols
Collections: Historical archival materials of Bohemian & Moravian Jewish religious communities; library of ancient books with a collection of Hebrew manuscripts; children's drawings & works of painters from the Terezin concentration camp; silver from Czech synagogues; textiles from synagogues of historic interest; Holocaust memorial

DENMARK

AALBORG

M **NORDJYLLANDS KUNSTMUSEUM,** Nordjyllands Kunstmuseum and Nordjyllands Kunstmuseum's Library & Archives, Kong Christians Alle 50, Aalborg, DK-9000 Denmark. Tel (+45) 98 13 80 88; Fax (+45) 98 16 28 20; Elec Mail nordjyllandskunstmuseum@aalborg.dk; Internet Home Page Address: www.nordjyllandskunstmuseum.dk; *Dir* Nina Hobolth; *Cur* Aase Bak; *Cur* Brigit Hesselluud
Library open Tues-Fri 10AM-3PM; museum open Tues-Sun 10AM-5PM, cl Mon; No admis fee to library; admis to museum adults dkr 40, discounts for students,

seniors, groups, children free; Estab 1879, building inaugurated 1972; Museum contains 3,000 art works; library contains 10,000 vols; Average Annual Attendance: 60,000

Income: Self-governing institution with state, county & municipal funding

Purchases: Modern & contemporary art

Library Holdings: Auction Catalogs; Audio Tapes; Book Volumes 10,000; Clipping Files 20,000; DVDs; Exhibition Catalogs; Kodachrome Transparencies; Manuscripts; Original Art Works 3,000; Original Documents; Pamphlets; Periodical Subscriptions; Photographs; Prints; Reproductions; Sculpture; Slides; Video Tapes

Collections: Collection of graphics, painting & sculpture from 1900 to the present, Danish and international

Exhibitions: 8-10 spec exhibitions annually

Publications: Approx 4 exhibition catalogs annually

Activities: Concerts; gallery talks; tours; exten progam to school district of Nordjylland County; traveling exhibition within school district of Nordjylland County; sales shop sells books, reproductions, scarfs, T-shirts; occasional exhibitions for children; occasional workshops for children

AARHUS C

M AARHUS KUNSTMUSEUM, Aros Aarus Kunstmuseum, Aros Alle 2, Aarhus C, 8000 Denmark. Tel 86-13-52-55, 87-30-6600; Fax 86-13-3351, 87-30-6601; Elec Mail info@aros.dk; Internet Home Page Address: www.aarhuskunstmuseum.dk, www.aros.dk; *Dir* Jens Erik Sorensen

Open Tues, Thurs-Sun 10 AM - 6 PM, Wed 10 AM - 10 PM, cl Mon; Admis adults Dkk 76, seniors & students Dkk 61; groups of 20+ Dkk 61 per head; children under 18 free admis; Library with 1000 vols

Collections: Danish & European art, Danish Golden ages, Danish modernism-Asger Jorn, Richard Mortensen, contemporay Danish & international, Jeff Koons, Gilbert & George

CHARLOTTENLUND

M ORDRUPGAARDSAMLINGEN, Vilvordevej 110, Charlottenlund, 2920 Denmark. Tel 39-64-11-83; Fax 39-64-10-05; Elec Mail ordrupgaard@ordrupgaard.dk; Internet Home Page Address: www.ordrupgaard.dk; *Dir* Anne-Birgitte Fonsmark

Open Tues - Sun 1 PM - 5 PM, clo Mon; Admis 35 Dkr adults, children free; special fees & hours during temporary exhibitions; Masterpieces by French impressionists; Danish art from the 19th and 20th centuries; art museum set in a large, lovely park

Collections: Wilhelm Hansen Collection; paintings by Cezanne, Corot, Courbet, Degas, Delacroix, Gauguin, Manet, Pissarro, Renoir, Sisley & other French & Danish artists from the 19th century & the beginning of the century

Activities: Sales of books, magazines, reproductions & prints

COPENHAGEN

L DANMARKS KUNSTBIBLIOTEK, (Kunstakademiets Bibliotek) Danish National Art Library, One Kongens Nytorv, Copenhagen, 1053 K Denmark. Tel 45 3374 4800; Fax 45 3374 4888; Elec Mail dkb@kunstbib.dk; Internet Home Page Address: www.kunstbib.dk; *Dir* Patrick Kragelund, PhD

No admis fee; Estab 1754 (National Research Library); Circ 80,000

Income: Government financed palannum c 12,000,000 DKR, per annum c 1,000,000 (not including donations)

Library Holdings: Book Volumes 175,000; Other Holdings Architectural Drawings 350,000; Photographs 350,000; Slides 170,000

Activities: Classes adults; docent training; lect open to the pub, 3 vis lect per yr; lending of original objects of art of exhib on architecture

M KOEBENHAVNS BYMUSEUM, Copenhagen City Museum, Vesterbrogade 59, DK - 1620 Copenhagen, Denmark; Absalonsgade 3, DK - 1658 Copenhagen, Denmark. Tel 45-33-21-07-72; Fax 45-33-25-07-72; Elec Mail seler@lebhbymuseum.dse; Internet Home Page Address: www.bymuseum.dk; *Dir* J Selmer

Open Mon, Thurs - Sun 10 AM - 4 PM, Wed 10 AM - 9 PM, cl Tues; Admis adults 20 dkk, children free, Fri free admis; Estab 1901; Copenhagen's more than 800 yrs long history, The Soeren Kierleegaard room

Collections: Objects, paintings and models from the history of Copenhagen

M KUNSTINDUSTRIMUSEET, The Danish Museum of Art & Design, Bredgade 68, Copenhagen, 1260 Denmark. Tel 33-18-5656; Fax 33-18-5666; Elec Mail info@kunstindustrimuseet.dk; Internet Home Page Address: www.kunstindustrimuseet.dk; *Dir* Bodil Busk Laursen; *Chieb Librn* Mirjam Gelter Jorgensen; *Cur* Ulla Houkjaer; *Cur* Christian H Olesen

Open Tues-Fri 10 AM - 6 PM, Wed 10 AM - 8 PM, Sat & Sun 12 - 6; Admis Adults 40 DKK, under 18 free; Library with 60,000 vols

Special Subjects: Interior Design, Architecture, Art Education, Art History, Ceramics, Glass, Silver, Textiles, Tapestries, Graphics, Costumes, Pottery, Decorative Arts, Posters, Furniture, Porcelain, Oriental Art, Asian Art, Carpets & Rugs, Baroque Art, Renaissance Art, Embroidery, Laces

Collections: Chinese and Japanese art and handicrafts; European decorative and applied art from the Middle Ages to present - bookbindings, carpets and tapestries, furniture, jewelry, porcelain and pottery, silverware and textiles

M NATIONALMUSEET, National Museum, Prinsens Palae, Ny Vestergade 10 Copenhagen, 1220 Denmark; Frederiksholms Kanal 12, Copenhagen, DK 1220 Denmark. Tel 33-13-44-11; Internet Home Page Address: www.natmus.dk; *Dir* Carsten U Larsen

Open 10 AM - 5 PM; Admis 50 DKK Adults; children under 16 free; Wed - free; Museum of Cultural History; Average Annual Attendance: 400,000

Collections: Museum has 5 divisions, including Danish historical collection, folk museum, ethnographic collection, classical antiquities collection, royal coin &

medal collection; Danish Prehistory (13000 BC - 1050 AD; Middle Ages and Renaissance Denmark (1050-1660); Eighteenth Century Denmark; Stories of Denmark; 1660-2000; The Royal Collection of Coins and Medals; The Collection of Egyptian and Classical Antiquities; Ethnographic Collection; The Children's Museum; The National Museum's Victorian Home

Activities: Classes for children; museum shop sells books, reproductions, prints

M NY CARLSBERG GLYPTOTEK, Ny Carlsberg Glyptotek, Dantes Plads 7, Copenhagen, 1556 Denmark. Tel 33-41-81-41; Fax 33-91-20-58; Internet Home Page Address: www.glyptoteket.dk; *Dir* Flemming Friborg; *Pres* Hans Edvard Norregard-Nielsen

Open Tues - Sun 10 AM - 4 PM, cl Mon; Admis DDK 30, Sun & Wed free; Art museum

Collections: Danish & French paintings & sculptures from 19th & 20th centuries; Egyptian, Etruscan, Greek & Roman sculpture

M ROSENBORG SLOT, Rosenborg Castle, Oster Voldgade 4A, Copenhagen, 1350K Denmark. Tel (+45) 33 15 32 86; Fax (+45) 33 15 20 46; Elec Mail museum@dkks.dk; Internet Home Page Address: www.rosenborg-slot/dk; *Dir* Niels-Knud Liebgott; *Dir Chamberlain* Niels Eilschou Holm

Open Jan - Apr & Nov - mid-Dec 11 AM - 2 PM, cl Mon; May 10 AM - 4 PM, June - Aug 10 AM - 5 PM, Sept 10 AM - 4 PM, Oct 11 AM - 3 PM; No admis fee; Estab 1833

Collections: Crown Jewels; arms, apparel, jewelry & furniture from period 1470-1863

Activities: Mus shop sells books, prints & slides

M STATENS MUSEUM FOR KUNST, Royal Museum of Fine Arts, Solvgade 48-50, Copenhagen, DK 1307 Denmark. Tel 33-74-84-94; Fax 33-74-84-04; Elec Mail smk@smk.dk; Internet Home Page Address: www.smk.dk; *Dir* Allis Helleland; *Press Coordr* Jacob Fibiger Andersen; *Const Chief Marketing & Communications* Katja Marcuslund

Exhib: admis 75 KR, Collections: No admis fee; Estab 1896/National Gallery; The Danish National Gallery; Average Annual Attendance: 350,000

Collections: Danish paintings and sculpture; various other works by 19th and 20th century Scandinavian artists; old masters of Italian, Flemish, Dutch and German Schools; modern French art; 700 years of art history, from 1300-today

Exhibitions: LA Ring on the Edge of the World; Andre Derain

Publications: Publications for each exhib

Activities: Classes for adults & children; lect open to pub; concerts; gallery talks; tours; lending of original objects of art to domestic & foriegn museums; book traveling exhib; organize traveling exhib; mus shop sells books, magazines & prints; junior mus

M THORVALDSENS MUSEUM, BertelThorvaldsens Plads 2, Copenhagen, 1213 Denmark. Tel 33-32-15-32; Fax 33-32-17-71; Elec Mail thm@thorvaldsensmuseum.dk; Internet Home Page Address: www.thorvaldsensmuseum.dk; *Dir* Stig Miss; *Cur* William Gelius; *Cur* Margrethe Floryan; *Cur* Torben Melander

Admis adults Dkk 20, seniors Dkk10, Children ages 17 & under free; Wed free admis

Special Subjects: Drawings, Sculpture

Collections: 19th century European paintings & drawings; sculpture & drawings by Bertel Thorvaldsen (1770 - 1844) & his collections of contemporary paintings, drawings & prints; Painting coll containing works by leading European & Scandinavian painters from Thorvaldsen's own time

Activities: Classes for children; lect open to the pub; tours; mus shop sells books, reproductions, prints, slides

HUMLEBAEK

M LOUISIANA MUSEUM OF MODERN ART, Gammel Strandvej 13, Humlebaek, 3050 Denmark. Tel +45 49190719; Fax +45 49193505; Elec Mail curatorial@louisiana.dk; Internet Home Page Address: www.louisiana.dk; *Dir* Poul Erik Toejner; *Cur* Kjeld Kieldsen; *Cur* Anders Kold; *Cur* Helle Crenzien; *Cur* Mette Marcus; *Cur* Kirsten Degel; *Publ* Michael Juulholm

Open 10 AM - 5 PM, Wed until 10 PM; Dkk 80; Estab 1958; Average Annual Attendance: 500,000

Collections: Danish, International & Modern art from 1950, including sculpture & paintings

Activities: Classes for children; concerts; cinema; theatre; lect for members only

DOMINICAN REPUBLIC

SANTO DOMINGO

M GALERIA NACIONAL DE BELLAS ARTES, National Fine Arts Gallery, Avenida Independencia esq Maximo Gomez, Santo Domingo, Dominican Republic. Tel 687-3300; *Dir* Dr Jose de J Alvarez Valverde

Collections: Paintings and sculptures previously exhibited in the Museo Nacional

ECUADOR

QUITO

M MUSEO MUNICIPAL DE ARTE E HISTORIA ALBERTO MENA CAAMANO, Civic Museum of Arts and History, Calle Espejo 1147 y Benalcazar, Apdo 17-01-3346 Quito, Ecuador. Tel 584-326; Fax 584 362; *Dir* Alfonso Ortiz Crespo

Collections: Sculptures; paintings; documents

M **MUSEO NACIONAL DE ARTE COLONIAL,** Cuenca St & Mejia St, Quito, Apdo 2555 Ecuador. Tel 212-297; *Dir* Carlos A Rodriguez
Collections: Art from the Escuela Quitena of the Colonial epoch - 17th, 18th and 19th century art and some contemporary art

EGYPT

ALEXANDRIA

M **GRECO-ROMAN MUSEUM,** 51 Museum St, Alexandria, Egypt. Tel (3) 4825820; *Dir* Doreya Said
Library with 15,000 vols
Collections: Exhibits from the Byzantine, Greek and Roman eras

CAIRO

M **COPTIC MUSEUM,** Old Cairo, Cairo, Egypt. Tel (2) 775-133; *Dir* Mahar Salib
Library with 6500 vols
Collections: Architecture, bone, ebony, frescos, glass, icons, ivory, manuscripts, metalwork, pottery, sculpture, textiles, woodcarvings

M **EGYPTIAN NATIONAL MUSEUM,** Midan-el-Tahrir Kasr El-Nil, Cairo, Egypt. Tel (2) 775-133; *Dir* Mohammed Saleh
Library with 39,000 vols
Collections: Ancient Egyptian art from prehistoric times through 6th century AD (excluding Coptic & Islamic periods); houses the Department of Antiquities

M **MUSEUM OF ISLAMIC ART,** Ahmed Maher Sq, Bab al-Khalq Cairo, 11638 Egypt. Tel 90-19-30-3901520; *Dir-Gen* Farouk S Asker
open 9 AM - 4 PM; Estab 1881; Museum maintains library with 14,000 volumes; Average Annual Attendance: 31,000
Income: government
Collections: Works of art showing evolution of Islamic art up to 1879
Publications: Islamic Archaeological studies, 5 vols

ENGLAND

BATH

M **HOLBURNE MUSEUM OF ART,** Great Pulteney St, Bath, BA2 4DB England. Tel (1225) 466669; Fax (1225) 333121; Elec Mail holburne@bath.ac.uk; Internet Home Page Address: www.bath.ac.uk/Holburne; *Dir* Dr Alexander Sturgis; *Cur* Amina Wright; *Educ Officer* Cleo Witt; *Cur Decorative Art* Matthew Winterbottom
Open Tues-Sat 10 AM-5 PM, Sun 2:30 PM-5:30 PM, cl mid Dec-mid Feb; Admis varies; Estab 1916
Collections: Paintings by 17th & 18th century masters, including Gainsborough, Turner, British & Continental; fine art, porcelain & silver
Activities: Educ program; classes for adults & children; docent training; lect open to public; 30 vis lect per yr; gallery talks; tours; concerts; organize traveling exhib; museum shop sells books, reproductions, prints

M **VICTORIA ART GALLERY,** Bridge St, Bath, BA2 4AT England. Tel (1225) 477233; Fax (1225) 477231; Elec Mail victoria_enquiries@bathnes.gov.uk; Internet Home Page Address: www.victoriagal.org.uk; *Cur* Stephen Bird; *Arts Officer* Victoria Barwell
Open Tues-Sat 10 AM-5:30 PM, Sun 2 PM-5 PM, cl Mon; No admis fee
Collections: British & European paintings from 17th to 20th century; English pottery, porcelain, antique glass

BIRMINGHAM

M **BIRMINGHAM MUSEUMS AND ART GALLERY,** Chamberlain Square, Birmingham, B3 3DH England. Tel (121) 303-2834; Fax (121) 303 1394; Elec Mail bmagenquirdes@bcc.com; Internet Home Page Address: www.bmag.org.uk; *Sr Asst Dir Museums & Montage Projects* Graham Allen; *head of Curatorial Servs* Jane Arthur; *Head of Community Mus* Rita McLean; *Head of Museum Servs* Isabel Churche
Open Mon - Thurs & Sat 10 AM - 5 PM, Fri 10:30 AM - 5 PM, Sun 12:30 - 5 PM; No admis fee; Estab 1867 Museum & Art Gallery; Average Annual Attendance: 570,000
Income: Birmingham City Council 6M pa
Purchases: Purchases made according to published collecting policy
Collections: Fine and applied art, including English works since 17th century, foreign schools from Renaissance, Pre-Raphaelite works; silver, ceramics, coin, textile collections; Old and New World archeology, ethnography and local history collections; branch museums house furniture, machinery and applied arts; Pinto Collection of Treen
Exhibitions: ongoing programe of temporary exhibitions
Publications: world Art from Birmingham Museums & Art Gallery
Activities: Classes for children in school parties; family activities; gallery talks; tours; museum shop sells books, prints

BRIGHTON

M **ROYAL PAVILION, AND MUSEUMS,** (Royal Pavilion, Art Gallery and Museums) Brighton Museum & Art Gallery, Royal Pavilion Gardens, Brighton, BN1 1EE England; 4/5 Pavilion Bldg, Brighton, BN1 1EE England. Tel (1273) 290900; Fax 01273 292871; Elec Mail museums@brighton-hove.gov.uk; Internet Home Page Address: www.brighton.virtualmuseum.info; *Head Museums & Royal Pavilion* Janita Bagshawe
Open Tues 10 AM - 7 PM, Wed-Sat 10 AM - 5 PM, Sun 2 PM - 5 PM, Bank Holidays 10 AM - 5 PM, cl Mon; No admis fee; Estab 1873 - mus, art gallery, library

Income: Brighton & City Council; owned by local authority, grants & funding
Collections: Fashion & Style, World Art, 20th Century Art & Design; Mr Willett's Popular Pottery & Local History
Exhibitions: Ongoing temporary exhib programming
Activities: Classes for adults & children; lects open to public; Gallery talks; mus shop sells books, reproductions, gen gifts & souvenirs

BRISTOL

M **BRISTOL MUSEUMS AND ART GALLERY,** Queen's Rd, Bristol, BS8 1RL England. Tel (0117) 922 3571; Fax (0117) 922 2047; Elec Mail general_museum@bristol-city.gov.uk; Internet Home Page Address: www.bristol-city.gov.uk/museums; *Divisional Dir, Museums & Heritage* Hilary McGowan
Collections: Fine and applied arts of Great Britain; archaeological and ethnological collection; Oriental Art

CAMBRIDGE

M **UNIVERSITY OF CAMBRIDGE,** The Fitzwilliam Museum, Trumpington St, Cambridge, CB2 1RB England. Tel (01223) 332900; Fax (01223) 332923; Elec Mail fitzmuseum-enquiries@lists.cam.ac.uk; Internet Home Page Address: www.fitzmuseum.cam.ac.uk;Duncan Robinson; *Keeper of Applied Art* Dr Julia Poole; *Sr Asst Keeper, Applied Art* Dr James Lin; *Keeper of Antiquities* Dr Lucilla Burn; *Sr Asst Keeper Antiquities* Julie Dawson; *Keeper of Coins and Medals* Dr Mark Blackburn; *Asst Keeper Coins and Medals* Dr Adrian Popescu; *Asst Dir & Keeper of Paintings, Drawings & Prints* David Scrase; *Sr Asst Keeper Paintings, Drawings & Prints* Jane Munro; *Sr Asst Keeper Prints* Craig Hartley; *Asst Keeper of Manuscripts & Printed Books* Dr Stella Panayotova; *Asst Dir* Margaret Greeves; *Asst Keeper Admin* Thyrza Smith; *Head of Educ* Julia Tozer; *Sr Asst Keeper Antiquities* Dr Sally Ann Ashton; *Asst Keeper Coins & Medals* Dr Martin Allen; *Asst Dir Conservation* Ian P McClure
Open Tues - Sat 10 AM - 5 PM, Sun - Mon & Bank Holidays Noon - 5 PM, cl Dec 24 - Dec 26 & Dec 31 - Jan 1; No admis fee; Estab 1848; Library with 300,000 vols; Average Annual Attendance: 300,000
Collections: European ceramics; Greek, Roman, western Asiatic & Egyptian antiquities; arms & armor, coins, drawings, furniture, illuminated manuscripts, manuscripts, paintings, prints, sculpture, textiles
Exhibitions: To 3/11/2007, Rembrandt & Saskia; (2/2/2007-4/29/2007) Treasures of Today - Modern Silver; (2/1/2007-4/29/2007) Maggi Hambling Drawings; (6/5/2007-9/23/2007) Paul Mellon: Cambridge Tribute; (10/23/2007-1/7/2008) Private Pleasures: Illuminated Manuscripts from Persia to Paris; (5/24/2007-9/23/2007) Howard Hodgkin 1993-2007; (6/19/2007-9/16/2007) The Book of the Dead of Ramose: a Passport to the Egyptian After-Life
Activities: Classes for adults & children; dramatic programs; lect open to the public; concerts; gallery talks; tours; lending of original objects of art; museum shop sells books, reproductions, stationery goods & jewelry

DONCASTER

M **DONCASTER MUSEUM AND ART GALLERY,** Chequer Rd, Doncaster, DN1 2AE England. Tel 1302-734293; Fax 1302 73 5409; Elec Mail museum@doncaster.gov.uk; Internet Home Page Address: www.doncaster.gov.uk/museums; *Head of Mus & Galleries* G Preece; *Coll Officer* C Dalton; *Visitor Services Officer* F Spiers; *Mus Officer Art & Exhib* Neil McGregor
Mon - Sat 10 a.m. - 5 p.m.; Sun 2 p.m. - 5 p.m.; No admis fee; Estab 1909; 7 gallery areas with permanent and temporary exhibs; Average Annual Attendance: 78,000
Income: By local authority
Special Subjects: Archaeology, Etchings & Engravings, Ceramics, Photography, Porcelain, Pottery, Painting-British, Watercolors, Glass, Jewelry, Coins & Medals, Antiquities-Roman
Collections: European painting, ceramics and glass, silver and jewelry; The King's Own Yorkshire Light Infantry Regimental Collection; Archaeology & Natural History
Publications: The Don Pottery, 1801-1893 (March 2001)
Activities: Classes for children; lect open to the pub; 20 vis lect per yr; concerts; gallery talks; mus shop sells books, prints

EAST MOLESEY

M **HISTORIC ROYAL PALACES,** Hampton Court Palace, East Molesey, KT8 9AU England. Tel (081) 7819500; *Palace Dir* Hugh Player; *Supt Royal Coll* Chris Stevens
Mid Oct - Mid March: Mon 10:15 AM - 4:30 PM; Tues - Sun 9:30 AM - 4:30 PM; Mid March - Mid Oct: Mon 10:15 AM - 6 PM, Tues - Sun 9:30 AM - 6 PM; £10.80; OAP, student £8.20, child £7.20; Represents art, architecture & gardens from the Tudor Period to Georgian Period
Special Subjects: Woodcarvings
Collections: Paintings & tapestries, including Andrea Mantegna's 9 paintings of The Triumphs of Caesar
Activities: Classes for adults & children; dramatic programs; lect open to public; tours; sales of books

KENDAL

M **ABBOT HALL ART GALLERY & MUSEUM OF LAKELAND LIFE & INDUSTRY,** Kendal, LA9 5AL England. Tel (01539) 722464; Fax (01539) 722494; Elec Mail info@abbothall.org.uk; Internet Home Page Address: www.abbothall.org.uk; *Dir* Edward King; *Deputy Dir* Cherrie Trelogan; *Head of Publicity & Marketing* Sandy Kitching; *Head of Finance & Admin* Beryl Tulley
10:30 a.m. - 4 p.m., Feb - March, Nov - Dec, otherwise 10:30 a.m. - 5 p.m.; adults 3.75 pounds, concessions; Estab 1962; 18th house beside the river bank, 18

rms plus active modern and contemporary exhib prgm; Average Annual Attendance: 35,000
Library Holdings: Cards; Exhibition Catalogs; Pamphlets; Photographs; Sculpture
Collections: Gallery provides changing exhibitions of local and international interest; houses permanent collections of 18th century furniture, paintings and objects d'art; modern paintings; sculpture; drawings; museum features working and social life of the area; 18th century potraits, Esp Romney; watercolors & drawings, including Ruskin, Constable, Turner; lake district landscapes; modern British art; Post-Lucian Freud, Bridget Riley; Paula Rego; Post Lucian Freud; Bridget Riley
Publications: Exhibition Catalogues
Activities: Classes for children; lects open to public; books

LEEDS

M **LEEDS MUSEUMS & GALLERIES,** Temple Newsam Rd, Off Selby Rd Leeds, LS15 0AE England. Tel (113) 264 7321; Internet Home Page Address: www.leeds.gov.uk/templenewsom; *Dir* Evelyn Silber
1 November - 31 December, March Tues-Sat 10AM to 4PM (last admission 3:15PM) Sunday 12 noon to 4PM (last admission 3:15PM) Closed Mondays except Bank Holidays, January and February. Start of open season varies. Please ring to check. 1 April-31 October Tues-Sat 10 AM to 5 PM; Sunday 1PM to 5PM; Admis 2 pounds adults 1 pound concessions; 50p children (accompanied by an adult; Car parking 5 pounds valid for one year, one of the party also gains free admission for 1 year from date of issue.
Collections: Decorative arts; old master and Ingram family paintings
M **Leeds City Art Gallery,** Municipal Bldg, The Headrow, Leeds, LS1 3AA England. Tel (113) 247-8248; Fax (113) 244 9689; Elec Mail leedscityart.gallery@virgin.net; Internet Home Page Address: leeds.gov.ukartgallery; *Cur* Corinne Miller; *Exhibitions Officer* Nigel Walsh; *Educ Officer* Amanda Phillips
Open Mon - Sat 10 AM - 5 PM, Wed 10 AM - 8 PM, Sun 1 - 5 PM; No admis fee; Estab 1888; Gallery with outstanding collections of British 19th & 20th centuries; Average Annual Attendance: 250,000
Collections: Early English Watercolors; English & European paintings of 19th century; modern British paintings & sculpture; Henry Moore Centre for the Study of Sculpture
Exhibitions: Temporary exhibition programme
Activities: Educ program; lect open to public; concerts; gallery talks; 2 book traveling exhibitions per yr; originate traveling exhibitions; museum shop sells book, magazines, reproductions, prints, slides, postcards, souvenirs
M **Lotherton Hall,** Leeds, LS253EB, Aberford, England. Tel (113) 281-3259; Fax (113) 281-2100; Internet Home Page Address: www.leeds.gov.uk; *Cur* Adam White
Historic house open as mus with gardens; Gascoigne family coll; special costume & Oriental art; Average Annual Attendance: 19,900
Collections: Gascoigne Collection of 17th to 19th century paintings, ceramics, silver, furniture; Oriental gallery; modern crafts

LEICESTER

M **LEICESTERSHIRE HERITAGE SERVICES,** Environment & Heritage Services, Leicestershire County Council, County Hall, Glenfield Leicester, LE3 8TD England. Tel (0116) 265-6781; Fax (0116) 265-6844; Elec Mail museums@leics.gov.uk; Internet Home Page Address: www.leics.gov.uk/index/community/museums.htm; *Head, Heritage Svcs* Heather Broughton
Open 10 AM - 4:40 PM Mon - Sat, 2 - PM - 5 PM Sun
Collections: Major special collections include 18th, 19th and 20th century British Art, German Expressionists (largest public collection in Britain); European Art from Renaissance to present; contemporary art

LINCOLN

M **LINCOLNSHIRE MUSEUMS,** Lincolnshire Heritage Services, County Offices, Newland Lincoln, LN1 1YQ England. Tel 1522-552806; *Head of Heritage* Joanna Milford
Oversees 7 museums
M **Lincoln City and County Museum,** Friar's Lane, Lincoln, England. Tel (1522) 530401; *Principal Keeper* Antony Page
Collections: Natural history, archaeological & historical collections relating to Lincolnshire; large collection of Roman antiquities from Lincoln
M **Museum of Lincolnshire Life,** Burton Rd, Lincoln, LN1 3LY England. Tel (1522) 528448; *Principal Keeper* J Finch; *Keeper Collections Mgmt* A Martin; *Keeper Visitor & Community Serv* K Howard
Collections: Displays illustrating the social, agricultural & industrial history of Lincolnshire over the last three centuries
M **Usher Gallery,** Lindum Rd, Lincoln, England. Tel (1522) 527980
Collections: Exhibits the Usher collection of watches, miniatures, porcelain; special collection of works by Peter De Wint; a general collection of paintings, sculpture & decorative art; collection of coins & tokens from Lincolnshire

LIVERPOOL

M **WALKER ART GALLERY,** William Brown St, Liverpool, L3 8EL England. Tel (151) 478-4199; Fax (151) 478-4190; *Head* Julian Treuherz
Collections: English and European drawings, paintings, prints, sculpture, watercolors, including notable collections of Italian and Netherlandish primitives; pop art

LONDON

M **BRITISH MUSEUM,** Great Russell St, London, WC1B 3DG England. Tel 020 7323 8000; Elec Mail info@thebritishmuseum.ac.uk; Internet Home Page Address: www.thebritishmuseum.ac.uk; *Dir* Neil MacGregor
Open Mon-Sun10AM-5:30PM, Thurs, Fri selected galleries open to 8:30PM; No admis fee; fee for spec exhibitions; Estab 1753

Collections: Ancient Egypt & The Sudan; Ancient Near East; Greek & Roman; Prehistory & Europe; Asia; Africa, Oceania & the Americas; coins & medals, prints & drawings
Activities: Educ prog; lect open to the public; mus shop

M **COURTAULD INSTITUTE OF ART,** Courtauld Institute Gallery, Somerset House, Strand London, WC2R 0RN England. Tel (020) 78482538; Fax (020) 7848 2589; Elec Mail galleryinfo@courtauld.ac.uk; Internet Home Page Address: www.courtauld.ac.uk; *Dir* Deborah Swallow; *Head of Gallery* Ernst Vegelin; *Cur Paintings* Caroline Campbell; *Cur Drawings* Stephanie Buck; *Cur Prints* Joanna Selborne; *Cur Decorative Arts* Alexandra Gerstein; *Cur Hermitage Rooms* Barnaby Wright; *Registrar* Julia Blanks; *Paper Conservator* William Clarke; *Paintings Conservator* Graeme Barraclough
Open Mon - Sun 10 AM - 6 PM; Admis £5, concessions £4; Estab 1932; Collection of paintings, prints, drawings & decorative arts 14th - 20th century; Average Annual Attendance: 250,000
Special Subjects: Decorative Arts, Landscapes, Silver
Collections: Samuel Courtauld Collection of French Impressionist and Post-Impressionist Paintings; other collections include old masters, early 20th century French and English paintings, modern British art, English landscape paintings and drawings; 550 paintings, ranging from 1300-1950; Samuel Courtauld's coll of Impressionist & Post-Impressionist art; 500 items of sculpture, furniture & decorative art; 7000 drawings, principally Old Masters; 15,000 prints
Exhibitions: Programme of temporary exhibitions including works from prints & drawings collections; 3 exhibs per yr
Activities: Classes for adults & children; lect open to public; gallery talks; tours; junction outreach to schools & hospitals; organize traveling exhibs; mus shop

M **DULWICH PICTURE GALLERY,** A/B, Gallery Rd, London, SE21 7AD England. Tel (0208) 693-5254; Fax (0208) 299-8700; Elec Mail info@dulwichpicturegallery.org.uk; Internet Home Page Address: www.dulwichpicturegallery.org.uk; *Dir* Ian Dejardin; *Head of Communications* Kate Knowles; *Head of Educ* Gillian Wolfe; *Head of Develop* Dida Tait; *Head of Finance* Rosamunel Sykes
Open Tues - Fri 10 AM - 5 PM, Sat & Sun 11 AM - 5 PM; Admis Gallery only £4 Adults, £ 3 Srs, concessions fee; Estab 1811; 17th & 18th century European Old Master paintings in oldest public gallery in England; Average Annual Attendance: 100,000; Mem: Friends of Dulwich Picture Gallery
Library Holdings: Book Volumes; Clipping Files; Exhibition Catalogs; Original Documents; Pamphlets; Photographs; Prints; Slides
Collections: Collections of Old Masters from 1626 onwards, including Claude, Cuyp, Gainsborough, Murillo, Poussin, Raphael, Rembrandt, Rubens, Teniers, Tiepolo, Van Dyck, Watteau & others
Publications: catalogues
Activities: Classes for adults; small visitor attraction of the yr 2005; Sandford Award for Heritage Educ 2006

M **NATIONAL GALLERY,** Trafalgar Square, London, WC2N 5DN England. Tel (02) 7747-2885; Fax (02) 7930-4764; *Dir* Neil MacGregor; *Chair* Philip Hughes
Collections: Principal schools, British, Dutch, Early Netherlandish, French, German, Italian; Western European painting up to early 20th century

M **NATIONAL PORTRAIT GALLERY,** St Martin's Place, London, WC2H 0HE England. Tel 207-306-0055; Fax 207-306-0056; Internet Home Page Address: www.npg.org.uk; *Chmn Trustees* Prof David Cannadine; *Dir* Sandy Nairne
Open daily 10 - 6, Thurs & Fri 10 - 8; No admis fee; Estab 1856; home to the largest Collection of portraiture in the world featuring famous British men & women who have created history from the Middle Ages until the present day; Average Annual Attendance: 2,000,000; Mem: Membership scheme
Collections: National Collection of portraits spanning last 500 years, including sculpture and photographs
Activities: Educ program; classes for adults & children; school groups/workshops; lect open to public; concerts; gallery talks; tours; competitions; lending of original objects of art to touring exhibitions; museum shop sells book, magazines, reproductions, prints, slides

M **QUEEN'S GALLERY,** Buckingham Palace Rd, London, SW1A 1AA England. Tel (20) 7839-1377; Internet Home Page Address: www.royal.gov.uk

M **ROYAL ACADEMY OF ARTS,** Burlington House, Piccadilly London, W1J 0BD England. Tel 20-7439-7438 or 20-7300-8001; Fax 20-7434-0837; Elec Mail webmaster@royalacademy.org.uk; Internet Home Page Address: www.royalacademy.org.uk; *Pres* Sir Nicholas Grimshaw, CBE
Open Sat - Thurs 10 AM - 6 PM, Fri 10 AM - 10 PM; Admis Varied; Estab 1768
Income: Exhib ticket sales & pvt corporate sponsors
Library Holdings: Book Volumes; Exhibition Catalogs; Original Documents
Collections: Paintings, prints, architectural collection
Exhibitions: (2/2007-4/2007) Citizens & Kings; (6/2007-8/2007) Summer Exhib; (11/11/2006-2/25/2007) Chola: Sacred Bronzes of Southern India; (3/2007-6/2007) The Unknown Money: Pastels & Drawings; (7/2007-9/2007) Impressionist by the Sea
Publications: Exhib Catalogues for exhib listed
Activities: Classes for adults & children; lect op to the pub; gallery talks; lend original objects of ar to other galleries for exhib; sales shop sells books, magazines, cards, jewelry & clothing
L **Library,** Burlington House, Piccadilly London, W1J 0BD England. Tel 020-7300-5737; Fax 020-7300-5650; Elec Mail library@royalacademy.org.wk; Internet Home Page Address: www.royalacademy.org.wk; *Librarian* Adam Waterton; *Asst Librn* Linda MacPherjon
Open Tues - Fri 10 AM - 1 PM & 2 PM - 5 PM; No admis fee; Estab 1768
Library Holdings: Book Volumes 40,000; Clipping Files 500; Exhibition Catalogs 8,000; Manuscripts; Other Holdings Engravings; Fine arts books 20,000; Manuscripts; Original drawings

M **SOUTH LONDON GALLERY,** 65 Peckham Rd, London, SE5 8UH England. Tel +44(0) 20 7703 6120; Fax +44(0) 20 7252 4730; Elec Mail mail@southlondongallery.org; Internet Home Page Address: www.southlondongallery.org; *Gallery Dir* Margot Heller; *Press & Mktg* Nicola Morgan; *Cur* Kit Hanimonds
Open Tues - Sun noon - 6 PM, cl Mon; No admis fee; Estab 1891; Since 1993 the gallery has staged ground-breaking solo & group exhibitions of works by artists

such as Gilbert & George, Tracey Emin, Gavin Turk, Mona Hatoum, Bill Viola, Barbara Kruger; Average Annual Attendance: 30,000
Collections: Contemporary British art; 20th century original prints; paintings of the Victorian period; topographical paintings & drawings of local subjects permanent collection exhibited periodically
Exhibitions: Exhibitions from permanent collection
Activities: Educ program; classes for adults & children; lect open to public; concerts; gallery talks; tours; museum shop sells books

M **TATE GALLERY,** Millbank, London, SW1P 4RG England. Tel (207) 887-8000; *Dir* Nicholas Serota
Collections: Works of Blake, Constable, Hogarth, Turner and the Pre-Raphaelites; British painting from the 16th century to present; modern foreign painting from Impressionism onward; modern sculpture; collection totals 12,000, including 5500 prints; Largest public collection of British Art of 20th Century

M **VICTORIA & ALBERT MUSEUM,** Cromwell Rd, South Kensington London, SW7 2RL England. Tel 207942-2000; Fax 207942-2162; Elec Mail vanda@vam.ac.uk; Internet Home Page Address: www.vam.ac.uk; *Dir* Mark Jones
Open daily 10 AM - 5:45 PM; No admis feeto the mus, some exhib & events carry a separate charge; Estab 1857, to enable everyone to enjoy its coll & explore the cultures that created them, and to inspire those who shape contemporary design; Average Annual Attendance: 2,000,000
Income: Grant-in-aid from government plus fundraising
Collections: Fine and applied arts of all countries, periods and styles, including Oriental art. European collections are mostly post-classical, architectural details, art of the book, bronzes, calligraphs, carpets, ceramics, clocks, costumes, cutlery, drawings, embroider, enamels, engravings, fabrics, furniture, glass, gold and silversmiths' work, ironwork, ivories, jewelry, lace, lithographs, manuscripts, metalwork, miniatures, musical instruments, oil paintings, posters, pottery and porcelain, prints, sculpture, stained glass, tapestries, theatre art, vestments, watches, watercolors, woodwork
Activities: Classes for adults & children; lect open to the pub; concerts; gallery talks; tours; fellowships; organize traveling exhibs to mus & galleries in UK & internationally; mus shop sells books, magazines, original art; reproductions & prints

M **Apsley House (Wellington Museum),** Hyde Park Corner, London, W1J 7NT England. Tel (171) 499-5676; Fax (171) 493 6576; *Cur* Alicia Roberson
Open Tues-Sun 11 AM - 5 PM; Fee £4.50, concessions £3.00, over 60 and under 18 free; Opened to the public 1952; Old Masters, silver, sculpture & porcelain; Average Annual Attendance: 50,000
Income: Income from govt grants
Special Subjects: Architecture, Ceramics, Furniture, Porcelain, Portraits, Period Rooms, Silver, Painting-British, Painting-European, Painting-French, Sculpture, Decorative Arts, Metalwork, Painting-Dutch, Coins & Medals, Painting-Flemish, Painting-Spanish, Gold
Collections: Paintings, silver, porcelain, sculpture, orders and decorations, and personal relics of the first Duke of Wellington
Activities: Classes for children; shop sells books, reproductions, slides

M **Bethnal Green Museum of Childhood,** Cambridge Heath Rd, London, E2 9PA England. Tel 020-8980-2415; Fax 020-8983-5225; Elec Mail bgmc@vam.ac.uk; Internet Home Page Address: www.museumofchildhood.org.uk; *Dir* Diane Lees
Open 10 - 17:30 except Fri, cl; No admis fee; Estab 1972; Average Annual Attendance: 190,000
Collections: Dolls, ceramics, costumes, textiles, furniture & toys; articles related to childhood
Activities: Art activities and spec events on school holidays & weekends; mus shop

M **WALLACE COLLECTION,** Hertford House, Manchester Square London, W1U 3BN England. Tel (20) 7563-9500; Fax (20) 7224-2155; *Dir* Rosalind Savill
Open daily 10 AM - 5 PM; No admis fee; Estab 1900
Income: Government of UK plus 30% generated income
Purchases: Closed coll, purchases not permitted
Special Subjects: Decorative Arts, Ceramics, Glass, Silver, Painting-British, Painting-French, Watercolors, Porcelain, Painting-Dutch, Ivory, Miniatures, Painting-Flemish
Collections: Arms & Armour; French Furniture; Sevres Porcelain; paintings & works of art of all European schools; miniatures; sculpture

M **WHITECHAPEL ART GALLERY,** 80-82 Whitechapel High St, London, E1 7QX England. Tel (020) 7522 7888; Fax (020) 7377 1685; Elec Mail info@whitechapel.org; Internet Home Page Address: www.whitechapel.org; *Dir* Iwona Blazwick; *Press Officer* David Gleeson; *Head Admin* Alison Digance; *Finance Officer* Raksha Patel
Open Tues - Sun 11 AM - 6 PM; Thurs till 9 PM; No admis fee except one spec exhib per year; Estab 1901; Established & emerging contemporary artists; Mem: Membership fees start at £ 40
Collections: Changing exhibitions, primarily of modern & contemporary art
Activities: Classes for adults, classes for children; lects for members only, gallery talks, tours; mus shop sells books, magazines, prints

M **WILLIAM MORRIS GALLERY,** William Morris Gallery, Lloyd Park, Forest Rd London, E17 4PP England. Tel (20) 8527 3782; Fax (20) 8527 7070; Elec Mail wmg.enquiries@walthamforest.gov.uk; Internet Home Page Address: www.walthamforest.gov.uk; *Dep Keeper* Peter Cormack; *Deputy Keeper* Amy Gaimster
Open Tues - Sat & 1st Sun ea month 10 AM - 1 PM & 2 PM - 5 PM; No admis fee; Estab 1950; Museum of the life & work of William Morris (1834-1896); Average Annual Attendance: 35,000
Library Holdings: Auction Catalogs; Book Volumes; Manuscripts; Original Art Works; Original Documents
Collections: Works of William Morris, pre-Raphaelites & the Arts & Crafts movement; sculpture by late 19th century artists; works by Frank Brangwyn
Publications: Works of William Morris, pre-Raphaelites & the Arts & Crafts movement; sculpture by late 19th century artists; works by Frank Brangwyn

Activities: Lects open to public; lending of original objects of art to Nat mus; museum shop sells books, reproductions

MANCHESTER

M **UNIVERSITY OF MANCHESTER,** Whitworth Art Gallery, Oxford Rd, Manchester, M15 6ER England. Tel 0161-275-7450; Fax 0161-275-7451; Elec Mail whitworth@man.ac.uk; Internet Home Page Address: www.whitwork.man.ac.uk; *Dir* Dr Maria Balshaw
Mon - Sat 10 AM - 5 PM; Sun 2 PM - 5 PM; No admis fee; Estab 1889; Internationally renowed collections of fine art & design; Average Annual Attendance: 87,000
Income: 130,000
Library Holdings: Exhibition Catalogs
Collections: British drawings and watercolors; contemporary British paintings and sculpture; Old Master and modern prints; textiles, wallpapers
Exhibitions: Programs change regularly
Activities: Classes for adults & children; lectrs open to the public; concerts; gallery talks; tours; mus shop sells books, magazines, reproductions, prints

M **WYTHENSHAWE HALL, CITY ART GALLERIES,** Corner of Mosley & Princess Sts, Manchester, M23 OAB England. Tel (0161) 236-5244; *Dir* Richard Gray
Collections: British art; English costume, enamels, silver and decorative arts; Old Master and Dutch 17th century painting; pre-Raphaelite painting

NEWCASTLE-UPON-TYNE

M **TYNE AND WEAR MUSEUMS,** Laing Art Gallery, Newcastle Discovery, New Bridge St Newcastle-upon-Tyne, NE1 8AG England. Tel (0191) 2327734; Fax (0191)222 0952; Elec Mail laing@twmmuseums.org.uk; Internet Home Page Address: www.twmuseums.org.uk; *Dir Tyne & Wear Museums* Alec Coles; *Cur Laing Art Gallery* Julie Milne
Open Mon - Sat 10 AM - 5 PM, Sun 2 - 5 PM; No admis fee; Estab 1904; The Laing Art Gallery is the premier art gallery in Newcastle. Show exhibitions of contemporary and historical art; Average Annual Attendance: 295,000
Collections: British oil paintings since 1700 (with works by Burne-Jones, Gainsborough, Landsear, Reynolds, Turner); British prints & watercolors; British (especially local) ceramics, costume, glass, pewter, silver of all periods; modern works by Ben Nicholson, Henry Moore & Stanley Spencer
Exhibitions: (2007) Wacle Rest & Play National Gallery Touring Exhib
Publications: Artists of the Cullercoats Colony
Activities: Educ program; classes for adults & children; 40 vis lectrs per yr; tours; lending of original objects of art to various galleries; museum shop sells books, magazines, original art, reproductions, prints, original craft & design

M **Sunderland Museum & Art Gallery,** Borough Rd, Newcastle, SR1 1PP England. Tel 191-5650723
Collections: Local history, pottery, paintings & glass

M **Shipley Art Gallery,** Prince Consort Rd, Newcastle, England. Tel 191-477-1495
Collections: Contemporary craft & paintings from the old masters

M **South Shields Museum & Art Gallery,** Ocean Rd, Newcastle, England. Tel 191-456-8740
Collections: Local art history

NEWPORT

M **BOROUGH OF NEWPORT MUSEUM AND ART GALLERY,** John Frost Square, Newport, NP9 1HZ England. Tel (1633) 840064; Fax (1633) 222615; *Cur* Robert Trett
Collections: Early English watercolors; oil paintings by British artists; local archeology (especially Roman); natural & social history

OXFORD

M **MUSEUM OF MODERN ART OXFORD,** 30 Pembroke St, Oxford, 0X1 1BP England. Tel (01865) 722733; Fax (01865) 722573; Elec Mail info@modernartoxford.org.uk; Internet Home Page Address: www.modernartoxford.org.uk; *Dir* Andrew Nairne; *Cur* Suzanne Cotter; *Community & Educ Manager* Sarah Mossop
Tues - Sat 10 AM - 5 PM, Sun 12 - 5 PM; No admis fee; Library with 15,000 vols; Average Annual Attendance: 200,000; Mem: 570 mems; 20 pounds (8 pounds concessions)
Library Holdings: Exhibition Catalogs; Periodical Subscriptions
Exhibitions: Features changing international exhibitions of 20th century painting, photography, prints, sculpture, drawing, film & video
Activities: Classes for adults & children; lect open to public; 10 vis lectrs per yr; concerts; gallery talks; tours; museum shop sells books, magazines, prints

M **OXFORD UNIVERSITY,** Ashmolean Museum, Beaumont St, Oxford, OX1 2PH England. Tel (01865) 278000; Fax (01865) 278018; Internet Home Page Address: www.ashmol.ox.ac.uk; *Dir* Dr Christopher Brown
Open Tues - Sat 10 AM - 5 PM, Sun 2 - 5 PM, cl Mon; No admis fee; Estab 1683
Collections: British, European, Egyptian, Mediterranean & Near Eastern archaeology; Chinese Bronzes; Chinese & Japanese porcelain, painting & lacquer; Dutch, English, Flemish, French & Italian oil paintings; Indian sculpture & painting; Hope Collection of engraved portraits; Tibetan, Indian and Islamic art objects; Extensive collection of coins from various countries and times; Old Master and modern drawings, prints and watercolors

PLYMOUTH

M **PLYMOUTH CITY MUSEUM AND ART GALLERY,** Drake Circus, Plymouth, PL4 8AJ England. Tel (01752) 304774; Fax (01752) 304775; Elec Mail plymouth.museum@plymouth.gov.uk; Internet Home Page Address: www.plymouthmuseum.gov.ui; *Cur* Nicola Moyle
Tues-Fri 10AM to 5:30PM Sat and Bank Holiday Mons 10AM to 5 PM; No admis fee; Estab 1838 to illustrate arts of the West Country; Average Annual Attendance: 70,000
Collections: The Clarendon Collection of Portraits of 16th & 17th Century English worthies; Collection of Cookworthy's Plymouth & Bristol Porcelain; The Cottonian Collection of early printed & illuminated books
Activities: Classes for adults & childen, dramatic programs, concerts & gallery talks; lects open to public; books, magazines, reproductions, prints, gifts & souvenirs

SHEFFIELD

M **SHEFFIELD CITY MUSEUM & MAPPIN ART,** (Sheffield City Museum) Weston Park, Sheffield, S10 2TP England. Tel (114) 2768588; Fax 114-275-0957; Elec Mail info@sheffieldgalleries.co.uk; *Dir* K Streets; *Sr Principal* Janet Barnes
Estab 1875
Collections: Sheffield silver, Old Sheffield Plate, British and European cutlery, coins and medals, ceramics
M **Abbeydale Hamlet,** Abbeydale Rd S, Sheffield, S7 2QW England. Tel (114) 2367731; *Dir* K Streets
Collections: An 18th century scytheworks with Huntsman type crucible steel furnace, tilt-hammers, grinding-shop and hand forges
M **Bishop's House,** Meersbrook Park, Sheffield, S8 9BE England. Tel (114) 2557701; *Dir* K Streets
Collections: A late 15th century timber-framed domestic building with 16th - 17th century additions

SOUTHAMPTON

M **SOUTHAMPTON CITY ART GALLERY,** Civic Centre, Southampton, S014 7LP England. Tel (23) 8063-2601; *Cur* Adrian B Rance; *Principal Officer Arts* Elizabeth Goodall; *Head* Margaret Heller
Collections: Continental Old Masters; French 19th & 20th centuries schools; British painting from the 18th century to present; contemporary sculpture & painting

SOUTHPORT

M **ATKINSON ART GALLERY,** Lord St, Southport, PR8 No 1DH England. Tel (1704) 533133.Ext. 2110; Fax (151) 934-2109; *Keeper of Art Galleries & Museums* Stephen P Forshaw
Collections: British art - local, contemporary & historic; British 18th, 19th & 20th centuries oils; drawings, prints, sculptures & watercolors

STOKE ON TRENT

M **THE POTTERIES MUSEUM & ART GALLERY,** Bethesda St, Stoke On Trent, ST1 3DW England. Tel 01782-232323; Fax 01782-232500; Elec Mail museums@stoke.gov.uk; Internet Home Page Address: www.stoke.gov.uk/museums; *Mgr* Pamela Mallalieu; *Head of Mus* Ian Lawley
Open Mar - Oct Mon-Sat 10 AM - 5 PM, Nov - Feb - 10 AM - 4 PM, Sun 2 - 4 PM; No admis fee; Average Annual Attendance: 170,000
Collections: One of the finest collections of English ceramics in the world, pre-eminent in Staffordshire ware; fine & decorative arts; 20th Century British Art
Activities: Educ program; classes for adults; drop-in art craft for children; lect open to public; gallery talks; tours; concerts; sponsoring of competitions; 2 book traveling exhibitions; originate traveling exhibitions; museum shop sells books, magazines

WOLVERHAMPTON

M **WOLVERHAMPTON ART GALLERY AND MUSEUM,** Lichfield St, Wolverhampton, WV1 1DU England. Tel (1902) 552055; Fax (1902) 552053; *Art Galleries & Museums Officer* Nicholas Dodd
Collections: Contemporary British art; 18th century British paintings; 19th & 20th centuries British painting & watercolors; branch museums have English enamels, japanning & porcelain

YORK

M **YORK CITY ART GALLERY,** Exhibition Square, York, Y01 7EW England. Tel (01904) 551861; Fax (01904) 551866; Elec Mail art.gallery@york.gov.uk; Internet Home Page Address: www.york.gov.uk; *Cur* Richard Green; *Exhibition & Publicition Officer* Lara Goodband; *Art Asst* Victoria Osborne; *Sec* Alison Atkinson
Open 10 AM - 5 PM; Admis ƒ2.00 adults ƒ1.50 children/concessions; Estab 2000
Collections: British and European paintings, including the Lycett Green Collection of Old Masters; modern stoneware pottery; paintings and drawings by York artists, notably William Etty; watercolors, drawings and prints, mostly local topography
Activities: Gallery talks; museum shop sells books, original art, prints, slides, cards

ETHIOPIA

ADDIS ABABA

M **MUSEUM OF THE INSTITUTE OF ETHIOPIAN STUDIES,** University of Addis Ababa, PO Box 1176 Addis Ababa, Ethiopia. Tel 550844; Fax 552-688; *Head* Ahmed Zekaria
Collections: Ethiopian cultural artifacts, ethnology collections, cultural history documents; religious art from 14th century to present

FINLAND

HELSINKI

M **SUOMEN KANSALLISMUSEO,** National Museum of Finland, Mannerheimintie 34, Helsinki, 00100 Finland; PO Box 913, Helsinki, FI-00101 Finland. Tel (09) 40501; Fax (09) 40509400; Elec Mail kansallismuseo@nba.fi; Internet Home Page Address: www.nba.fi; *Dir* Ritva Ware, PhD
Open Tues & Wed 11 AM - 8 PM, Thurs - Sun 11 AM - 6 PM, cl Mon; Admis adults 6 Euro, under 18 yrs old free; Estab 1893; Numerous branch galleries throughout Finland
Collections: Ethnographical Collections with Finnish, Finno-Ugrian & Comparative Ethnographical Collections; Finnish Historical Collections with a collection of coins & medals; Archaeological Collections with Finnish & Comparative Collections
Activities: Lect open to public; tours; museum shop sells books, gifts

M **SUOMEN RAKENNUSTAITEEN MUSEO,** Museum of Finnish Architecture, Kasarmikatu 24, Helsinki, 00130 Finland. Tel +358-9-85675101; Fax +358-9-85675100; Elec Mail mfa@mfa.fi; Internet Home Page Address: www.mfa.fi; *Dir* Severi Blomstedt
OPen Tues, Thurs - Sun 10 AM - 4 PM, Wed 10 AM - 8 PM; Admis adults 3.50/5 euro, Wed free; Estab 1956; Library with 30,000 vols
Collections: Finnish architecture collection includes 70,000 photographs, 32,000 slides, 300,000 original drawings
Activities: Lect open to the pub; gallery talks; tours; organize traveling exhib; mus shop sells books & magazines

TURKU

M **TURUN TAIDEMUSEO,** Turku Art Museum, Puolalanpuisto, Turku, 20100 Finland. Tel (02) 274 7570; Fax (02) 274 7599; *Dir* Berndt Arell
Collections: 19th & 20th centuries Finnish & Scandinavian art, drawings, paintings, prints & sculpture; 19th & 20th centuries international print collection

FRANCE

ALENCON

M **MUSEE DES BEAUX-ARTS ET DE LA DENTELLE,** rue Charles Aveline, Alencon, 61000 France. Tel 2-33-32-40-07; Fax 2-33-26-51-66; *Dir* Aude Pessey-Lux
Collections: 17th - 19th century French, Dutch & Flemish paintings; 16th - 19th century French, Italian & Dutch drawings; 16th - 20th century Alencon, Flemish, Italian & Eastern European lace

ANGERS

M **MUSEE DES BEAUX-ARTS,** Museum of Fine Arts, 10 rue du Musee, Angers, 49100 France. Tel 02-41-18-24-40; Fax 02-41-18-24-41; Elec Mail patrick.lenouene@ville-angers.fr; Internet Home Page Address: www.ville-angers.fr; *Dir* Patrick Le Nouëne; *Cur* Christine Besson; *Cur* Catherine Lesoeur
Library Holdings: CD-ROMs; Cards; Photographs
Collections: Paintings of the 17th & 18th centuries; Dutch, Flemish & French schools; sculpture, including busts by Houdon
Activities: Education prog; mus shop

ANTIBES

M **MUSEE PICASSO,** Chateau Grimaldi, Antibes, 06600 France. Tel 04-92-90-54-20; Fax 04-92-90-54-21; Elec Mail musee.picasso@antibes-juanlespins.com; Internet Home Page Address: www.antibes-juanlespins.com/fr/avet_culture; *Dir, Conservateur* Maurice Frechuret; *Attache de Conservation* Thierry Davila
Open June 1-Sept 30 10 AM - 6 PM, Oct 1 - May 31 10 AM -12 Noon and 2 PM - 6 PM; Admis 30 francs
Income: Income from Assn des Amis du musee Picasso
Collections: Modern and contemporary art; 230 works by Picasso

AVIGNON

M **MUSEE DU PETIT PALAIS,** Place du Palais des Papes, Avignon, 84000 France. Tel 4-90-86-44-58; Fax 4-90-82-18-72; Elec Mail musee.petitpalais@wamadso.fr
Open Oct-May Wed - Mon 9:30 - 1 & 2 - 5:30, cl Tues. June - Sept Wed - Mon 10 - 1 & 2 -6, cl Tues; Admis 6 Euro, groups of 10 persons 3 Euro

Library Holdings: Cards; Exhibition Catalogs; Reproductions
Collections: Italian paintings covering the period from 14th - 16th century; Medieval sculpture from Avignon from 12th - 15th century; paintings of the Avignon School of 14th - 15th centuries
Activities: Mus shop sells books, reproductions, slides

CHANTILLY

M **MUSEE ET CHATEAU DE CHANTILLY (MUSEE CONDE),** POB 70243, Cedex 60631 Chantilly , France. Tel 03 44 626262; Fax 03 44 626261; Internet Home Page Address: www.chateaudechantilly.com; *Cur* Nicole Garnier; *Cur Libr* Emmanuelle Toulet
Admis Adults 8 Euro, adolescents (12 - 17) 7 Euro children (4 - 11) 3.50 Euro; visite du panc et du Musée; painting galleries, grand apartments, private apartments of the Duke Aumale, the libr
Library Holdings: Book Volumes; Exhibition Catalogs; Manuscripts; Maps; Original Documents; Periodical Subscriptions; Photographs; Prints
Special Subjects: Decorative Arts, Woodcarvings, Manuscripts
Collections: Ceramics, manuscripts & paintings
Activities: Classes for adults & children; lectr for members only; concerts; sales of books, magazines, original art, prints, slides, porcelain, tapestries, etc

DIJON

M **MUSEE DES BEAUX-ARTS DE DIJON,** Museum of Fine Arts, Palais des Etats Cour de Bour, Dijon, 21000 France. Tel 3-80-74-52-70; Fax 3-80-74-53-44; *Chief Cur* Emmanuel Starcky
Collections: Furniture, objects of art, paintings of French & foreign schools, sculpture; Granville Collection

FONTAINEBLEAU

M **DOMAINE ET MUSÉE NATIONAUX DU CHÂTEAU DE FONTAINEBLEAU,** National Museum of Fontainebleau, Chateau de Fontainebleau, Fontainebleau, 77300 France. Tel (01) 60715070; Fax (01) 60-71-50-71; Elec Mail contact.chateau-de-fontainebleau@culture.fr; Internet Home Page Address: www.musee-chateau-fontainebleau.fr; *Dir* Bernard Notari; *Cur* Yves Carlier; *Cur* Daniele Denise; *Cur* Nicole Barbier; *Cur* Vincent Droguet; *Cur* Christopher Beyeler; *Dir Adjoint* Annick Nolter
Open 9:30 AM - 6 PM June - Sept, 9:30 AM - 5 PM Oct - May,; Admis 6.5 Euros, 4.5 Euros discount price, children under 18 free; Estab to show 8 centuries of history; State appartments, small appartments, Chinese Museum, Napoleon I's Museum
Collections: Paintings, furniture and interiors of 1st Empire and 17th, 18th and 19th centuries
Publications: Visitor's guide (French, English, German, Russian, Italian, Spanish, Japanese, Chinese edits); many other publs of the curators of the castle
Activities: Education prog; classes for children; lect open to public; 20-30 vis lectrs per yr; concerts; theater

GRENOBLE

M **MUSEE DES BEAUX-ARTS,** Place de Verdun, Grenoble, 38000 France. Tel 76-54-09-82; *Chief Cur* Serge Lemoine
Collections: 16th, 17th and 18th century paintings; French, Italian, Spanish, Flemish schools; modern collection; Egyptology collection

LILLE

M **MUSEE DES BEAUX-ARTS DE LILLE,** Museum of Fine Arts, 18 bis rue de Valmy, Lille, 59800 France. Tel 3-20-06-78-00; Fax 3-20-06-78-15; *Chief Cur* Arnauld Brejon de Lavergnee
Collections: Western European paintings from 15th - 20th centuries; collection of ceramics, objects of art and sculptures

LYON

M **MUSEE DES BEAUX-ARTS,** Museum of Fine Arts, 20 Place des Terreaux, Lyon, 69001 France. Tel 04 72 101740; Fax 04 78 281245; Elec Mail conservation@mba_lyon.fr; Internet Home Page Address: www.mairie-lyon.fr; *Chief Cur* Vincent Pomarede
Open Wed - Mon 10:00 - 18:00, Fri 10:30 - 20:00, cl Tues; Plein Tarif 3.80 E, Tarif reduit 2.oo E
Library Holdings: Cards; Exhibition Catalogs
Collections: Ancient, Medieval & Modern sculpture; Egyptian, Greek & Roman antiquities; French art since the Middle Ages; French, Hispano-Moorish, Italian & Oriental ceramics; Gothic & Renaissance art; Islamic art; modern art & murals by Purvis de Chavannes; painting of the French, Flemish, Dutch, Italian & Spanish schools
Activities: Classes for adults & children; lect open to public; concerts; gallery talks; mus shop sells books

M **MUSEE DES TISSUS, MUSEE DES ARTS DECORATIFS,** 30-34 rue de la Charite, Lyon, 69002 France. Tel 04-78-3842-00; Fax 0472402512; Elec Mail musee@lyon.cciofr; Internet Home Page Address: lyon.cciofromussee-les-tissus; *Cur* Guy Blazy; *Librn* Pascale Le Cacheux
Collections: Re-created French 18th century salons with furniture, objects d'art & decorative pieces; 15th & 16th centuries Italian majolicas; tapestries of Middle Ages & Renaissance; European drawings from 16th to 19th century

ORLEANS

M **MUSEE DES BEAUX-ARTS D'ORLEANS,** Museum of Fine Arts, 1 Rue Fernand Rabier, Orleans, 45000 France. Tel 2 38 79 2155; Fax 2 38 79 2008; Elec Mail musee_ba@ville_orleans.fr; Internet Home Page Address: www.musees-centre.com; *Cur* A Motter; *Cur* I Klinka; *Cur* E Pagliano
Open 10 AM - 12:15/ 1:30 to 5 PM, cl Sun and Mon morning; Admis 3 Euro, exhibition & museum 4 Euro; Estab 1797; The museum ranks among France's richest and oldest museums; artwork from European artistic creation from the 16th to the 20th century; Average Annual Attendance: 40,000
Library Holdings: Book Volumes; Cards; Exhibition Catalogs; Framed Reproductions; Memorabilia; Other Holdings; Reproductions
Collections: Dutch, French, Flemish, German, Italian & Spanish paintings & drawings, primarily from 17th & 18th centuries; sculpture; 19th & 20th century art works
Publications: Catalogue XVII francais
Activities: Classes for children; lect open to public; lect for mems only; 190 vis lectrs per yr; concerts; gallery talks; museum shop sells book, magazines, reproductions, prints, art fashion articles

PARIS

M **CENTRE NATIONAL D'ART ET DE CULTURE GEORGES POMPIDOU,** Musee National d'Art Moderne, 19 Rue Beaubourg, Cedex 04 Paris, 75191 France. Tel 44-78-12-33; Fax 01-44-78-12-07; Elec Mail info@cnac-gp.fr; Internet Home Page Address: www.centrepompidou.fr; Telex 21-2726; *Pres* Jean-Jacques Aillagon; *Dir* Guillaume Cerutti
Collections: 20th century paintings, prints, drawings & sculpture; art films & photographs

L **ECOLE NATIONALE SUPERIEURE DES BEAUX-ARTS,** La Bibliotheque, 14 rue Bonaparte, Paris, 75272 France. Tel (1) 47-03-50-00; Fax (1) 47-03-50-80; *Dir of School* Alfred Pacqument
120,000 vol library for school with 600 students & 75 instructors

M **MUSEE CARNAVALET-HISTOIR DE PARIS,** 23 rue de Sevigne, Paris, 75003 France. Tel (1) 01 44 59 58 58; Fax 01 44 59 58 11; Internet Home Page Address: www.paris-france.org/musee; *Head* Bernard de Montgolfier
Open daily 10AM-5:40PM; Admis adult 30 F, student 20 F; Estab 1880; Average Annual Attendance: 250,000
Special Subjects: Drawings, Architecture, Ceramics, Photography, Period Rooms, Sculpture, Graphics, Prints, Archaeology, Decorative Arts, Portraits, Painting-French
Collections: History and archaeology of Paris; prints and drawings; photography, sculpture
Activities: Classes for adults & children; lect open to the pub; concerts; museum shop sells books, magazines, reproductions, slides

M **MUSEE COGNACQ-JAY,** Cognacq-Jay Museum, 8 rue Elzevir, Paris, 75003 France. Tel 01 40 27 07 21; Fax 01 40 27 89 44; Internet Home Page Address: www.paris.fr/musees/cognacq_jay; *Conservateur Gen* Georges Brunel; *Asst* Christiane Gregoire; *Serv* Nathalie Flom
Open 10AM - 6 PM; No admis fee; Estab 1930; Gallery contains art of the XVIIIth Century
Special Subjects: Drawings, Painting-British, Painting-French, Sculpture, Watercolors, Decorative Arts, Portraits, Furniture, Jewelry, Porcelain, Tapestries, Miniatures, Painting-Italian
Collections: 18th century works of art; English and French furniture, pastels, paintings, porcelain, sculpture; miniatures, drawings
Publications: Catalogue of furniture; Catalogue of miniatures; Catalogue of paintings
Activities: Classes for children; lect open to the pub; gallery talks; tours; museum shop sells books, reproductions; catalogues & mus collections

M **MUSEE D'ART MODERNE DE LA VILLE DE PARIS,** 11 ave du President Wilson, Post 9 rue Gaston de St Paul Paris, 75116 France. Tel 1-53-67-40-00; Fax 1-47-23-35-98; *Cur* Suzanne Page
Collections: Modern painting and sculpture

M **MUSEE DU LOUVRE,** Louvre Museum, Paris Cedex 01, Paris, 75058 France. Tel 1-40-20-50-50; Fax 1-40-20-54-42; Elec Mail info@louvre.fr; Internet Home Page Address: www.louvre.fr; Telex 21-4670; *Pres & Dir* Henri Loyrette
Open Thurs - Sun 9 AM - 6 PM, Mon & Wed 9 AM - 10 PM, cl Tues; 8.50E, 6E; Average Annual Attendance: 7,500,000
Collections: Islamic art; The Edmond de Rothschild Collection; Oriental, Greek, Roman Etruscan and Egyptian antiquities; decorative arts, drawings, paintings; Medieval & Renaissance sculpture
Activities: Classes for adults & children; lects open to public, 10 lects. from Sept to May, 2002, concerts, gallery talks, tours; Awards - Les Affichades, Prix au meilleur accueil du pub; mus shop sells books, magazines, reproductions, prints, slides, jewels, post cards

M **Musee du Jeu de Paume,** Place de la Concorde, Paris, 75058 France. Tel 1-40-20-50-50; Elec Mail info@louvre.fr; Internet Home Page Address: www.louvre.fr; *Chief Cur* Daniel Abadie

M **MUSEE DU PETIT PALAIS,** Municipal Museum, Ave Winston Churchill, Paris, 75008 France. Tel 42-65-12-73; Fax 42-65-24-60; Internet Home Page Address: www.petitpalais.paris.fr; *Cur* Gilles Chazel
Open Tues 10 AM - 8 PM, Wed - Sun 10 AM - 6 PM, cl Mon & pub holidays; No admis fee to permanent coll & interior garden; Estab 1900
Collections: Egyptian, Etruscan and Greek antiquities; paintings, sculpture and other works of art to 19th century

M MUSEE GUIMET, 6 place d'Ilena, 19 Ave d'Iena Paris, 75116 France. Tel 1-56 52 53 39; Fax 1 56 52 53 54; Elec Mail resa@museeguimet.fr; Internet Home Page Address: www.museeguimet.fr; *Chief Cur* Jean-Francois Jarrige
Admis adults 6 Euro, concessions 4 Euro, children under 18 free; Estab 1889; Maintains library with 100,000 vols. Main exhib contains 4,000+ works on 5,500 Sq m; Average Annual Attendance: 300,000
Income: Admis fees & state funds
Special Subjects: Archaeology, Drawings, Ceramics, Glass, Furniture, Gold, Pottery, Textiles, Bronzes, Manuscripts, Sculpture, Photography, Costumes, Jade, Jewelry, Porcelain, Asian Art, Carpets & Rugs, Ivory, Calligraphy, Antiquities-Oriental
Collections: Art, archaeology, religions, history of India, Afghanistan, Central Asia, China, Korea, Japan, Khmer, Tibet, Thailand and Indonesia
Exhibitions: Afghanistan, the Found Treasures, 12/06-4/07; Bengladesh Masterpieces (temporary title), 10/07-3/08
Activities: Classes for adults & children; lects open to pub; concerts; mus shop sells books, reproductions, prints

M MUSEE MARMOTTAN MONET, 2 rue Louis Boilly, Paris, 75016 France. Tel 1-44-96-50-33; Fax 1-40-50-65-84; Elec Mail marmottan@marmottan.com; Internet Home Page Address: www.marmottan.com; *Dir* Jean-Marie Granier; *Conservateur* Marianne Delaford
Open 10 AM - 6 PM; Admis 6 Euros 50
Collections: Collection of Primitives, Renaissance, Empire and Impressionist works; medieval miniatures in Wildenstein collection
Activities: Educ program; classes for children; museum shop sells books, magazines, original art, reproductions, prints

M MUSEE NATIONAL DES MONUMENTS FRANCAIS, Palais de Chaillot, Place du Trocadero Paris, 75116 France. Tel (01) 4405 3910; Fax (01) 4755 4013; *Cur* Guy Cogeual
Library with 10,000 works on art history
Collections: Full scale casts of the principal French monuments and sculpture from the beginning of Christianity to the 19th century; full scale reproductions of Medieval murals

M MUSEE NATIONAL DU MOYEN AGE THERMES & HOTEL DE CLUNY, (Musee National Du Moyen Age Thermes De Cluny) 6 Place Paul Painleve, Paris, 75005 France. Tel 0153737800; Fax 0143258527; Elec Mail contact.musee-moyenage@culture.gouv.fr; Internet Home Page Address: www.musee-moyenage.fr; *Dir, Conservateur* Elisabeth Taburet Delahaye
Open 9:15 AM to 5:45 PM; Admis under 18
Collections: Enamels, furniture, goldsmithery, ivories, paintings, sculptures & tapestries of the Middle Ages-from the 10th to the beginning of the 16th centuries
Activities: Classes for children; concerts; museum shop sells books, reproductions

M UNION CENTRALE DES ARTS DECORATIFS, Central Union of Decorative Arts, 107 rue de Rivoli, Paris, 75001 France. Tel 01 44-55-57-50; Fax 01 814555784; Internet Home Page Address: www.ucad.fr; *Pres* Hélène David Weill; *Mus Dir* Béatrice Salmon; *Dir gen* Sophie Durrleman
Open Tues, Thurs, Fri 11 AM - 6 PM, Wed 11 AM - 9 PM, Sat & Sun 10 AM - 6 PM, closed Mon
Library Holdings: Auction Catalogs; Book Volumes; Exhibition Catalogs; Original Art Works
Collections: Housed in four museums: Musee des Arts Decoratifs - decorative arts collection from Middle Ages to present; library with 100,000 vols; Musee Nissim de Camondo - unique 18th century objects bequeathed by Count Moise de Camondo; Musee de la Mode et du textile; Musee de la publicité
Activities: Classes for adults and children; lects open to public; mus shop sells original art, reproductions, design and decorative arts

RENNES

M MUSEE DES BEAUX-ARTS, 20, quai Emile Zola, Rennes, 35000 France. Tel 02-23-62-17-45; Fax 02-23-62-17-49; Elec Mail museebeauxarts@utle-rennes.fr; Internet Home Page Address: www.mbar.org; *Cur* Patrick Daum; *Dir* Francis Ribemont; *Cur* Francois Coulon; *Cur* Lawrence Imbernon
10 a.m. - 12 p.m. & 2 p.m. - 6 p.m.; Mem: mem fee 100 FF
Library Holdings: Cards; Exhibition Catalogs
Collections: Egyptian, Greek and Roman archeology; drawings, paintings and sculptures from 15th - 20th centuries
Activities: Classes for children; lectrs for mems only; 6 vis lectrs per yr; concerts; mus shop sells books

STRASBOURG

M MUSEE DES BEAUX-ARTS, Museum of Fine Arts, Chateau des Rohan, 2 Place du Chateau Strasbourg, 67000 France. Tel 88-52-50-00; *Cur* Jean-Louis Faure
Collections: Old Masters; 17th to 19th century French schools; Italian schools

TOULOUSE

M MUSEE DES AUGUSTINS, 21 rue de Metz, Toulouse, 31000 France. Tel 33 (0) 5 61 22 21 82; Fax 33 (0) 5 61 22 34 69; Elec Mail augustins@mairie-toulouse.fr; Internet Home Page Address: www.augustins.org; *Cur* Alain Daguerre de Hureaux; *Cur* Axel Hemery; *Cur* Charlotte Riou; *Registrar* Berne Caroline
Open Sun - Tues & Thurs - Sat 10 AM -6 PM, Wed 10 AM-9 PM, cl Jan 1, Dec 25; Admis 3 euro, no admis fee to organ concert; Estab 1795
Library Holdings: Book Volumes; Cards; Exhibition Catalogs; Kodachrome Transparencies; Periodical Subscriptions; Photographs; Slides
Collections: The museum houses a collection of paintings and sculptures dating from the early Middle Ages to the beginning of the 20th Century
Exhibitions: (3/2007-6/2007) Stella 1596-1637
Publications: Guides to collection

Activities: Classes for children; lectrs open to the public, 6 vis lectrs per year, concerts, gallery talks, tours; mus shop sells books

TOURS

M MUSEE DES BEAUX-ARTS, Museum of Fine Arts, 18 Place Francois Sicard, Tours, 37000 France. Tel 02-47-05-68-73; Fax 02-47-05-38-31; *Cur* Phillippe Le Leyzour
Collections: Ancient and Modern Tapestries; Furniture; French School of 18th Century, including Boucher and Lancret; Italian Paintings of 13th to 16th Century, including Mantegna and primitives; 17th Century Paintings, including Rembrandt and Rubens; 19th Century Paintings, including Degas, Delacroix and Monet; Sculptures: Bourdelle, Houdon, Lemoyne
Activities: Classes for children; concerts; mus shop

VERSAILLES

M MUSEE NATIONAL DU CHATEAU DE VERSAILLES, National Museum of the Chateau of Versailles, Chateau de Versailles, Versailles, 78000 France. Tel 0130837800; Internet Home Page Address: www.chateauversailles.fr; *Pres* Hubert Astier; *Chief Cur* Pierre Arizzoli-Clémentel
Open May 2 - Sept 30, 9 AM - 6:30 PM, Oct 1 - April 30 - 9 AM - 5:30 PM; Admis 46 *f*; reducted rate: 35 *f* - free admission under 18
Special Subjects: Architecture, Tapestries
Collections: Furniture from 17th to 19th centuries; painting and sculpture from 17th to 19th centuries
Activities: Sales of books, reproductions, prints, slides, souvenirs

GERMANY

AACHEN

M SUERMONDT-LUDWIG-MUSEUM, Wilhelmstrasse 18, Aachen, 52070 Germany. Tel (0241) 47980-0; Fax (0241) 37075; Telex 2-9166; *Dir* Dr Ulrich Schneider
Collections: Paintings from the Middle Ages to the Baroque; portraits from Middle Ages to present; sculpture from the Middle Ages; graphic art (ceramics, textiles)

BERLIN

M BRUCKE MUSEUM, Bussardsteig 9, Berlin, 14195 Germany. Tel 49-30-831-20-29; Fax 49-30-831-5961; Elec Mail Bruecke-Museum@t-online.de; Internet Home Page Address: www.Bruecke-Museum.de; *Dir & Prof* Dr Magdalena Moeller
Open Sun, Mon, Wed-Sat 11:00 AM - 5: 00 PM, cl Tues; Estab 1967 upon the donation of Karl Schmidt-Rottluff; Dedicated to the works of the mems of the artist's group Brucke.; Mem: 850; dues 25 Euro; meetings throughout yr
Library Holdings: Other Holdings publs on the Brucke group, Expressionism &
Collections: German expressionism, paintings, sculptures & graphic art of the Brucke group
Publications: Brucke Archiv-Meft, appears at irregular intervals
Activities: Tours; organize traveling exhibitions; museum shop sells catalogues accompanying exhibitions

M STAATLICHE MUSEEN ZU BERLIN-PREUSSISCHER KULTURBESITZ, State Museums, Foundation for Prussian Cultural Treasures, Stauffenbergstrasse 41, Berlin, 10785 Germany. Tel 0049 30-266-3231; Fax 0049 30 266 3254; Elec Mail presse@smb.spk-berlin.de; Internet Home Page Address: www.smb.museum; *Gen Dir* Prof Dr Peter-Klaus Schuster; *Head Dept Presse Kommunikation Sponsoring* Dr Matthias Henkel
Collections: Supervises 17 museums and departments, in addition to an art library and a museum library
—Agyptisches Museum and Papyrussammlung, Egyptian Museum, Bodestrabe 1-3, Berlin, 10178 Germany. Tel 0049 30 2090 5544; Fax 0049 30 2090 5109; Elec Mail aemp@smb.spk-berlin.de; Internet Home Page Address: www.smb.museum/aemp; *Dir* Prof Dr Dietrich Wildung
Open Fri - Wed 10 AM - 6 PM, Thurs 10 AM - 10 PM; Library with 15,000 vols
Collections: Art & cultural history of ancient egypt
—Antikensammlung, Collection of Classical Antiquities, Bodestrabe 1-3, Berlin, 10178 Germany. Tel 0049 30 2090 5577; Fax 0049 30 2090 5202; Elec Mail ant@amb.spk-berlin.de; Internet Home Page Address: www.smb.museum/ant; *Dir* Dr Andreas Scholl; *Deputy Dir* Dr Gertrud Platz
Open Fri-Wed 10 AM - 6 PM, Thurs 10 AM - 10 PM
Collections: Greek & Roman antiquities
—Gemaldegalerie, Stauffenbergstrasse 40, Berlin, 10785 Germany. Tel 0049 30 266 2951; Fax 0049 30 266 2103; Elec Mail gg@smb-berlin.de; Internet Home Page Address: www.smb.museum/gg; *Dir* Dr Bernd Lindemann; *Deputy Dir* Dr Rainald Grosshans
Open Fri-Wed 10 AM - 6 PM, Thurs 10 AM - 10 PM
—Kunstgewerbemuseum, Museum of Decorative Arts, Tiergartenstrasse 6, Berlin, 10785 Germany. Tel 0049 30 266 2951; Fax 0049 30 266 2947; Elec Mail kgm@smb.spk-berlin.de; Internet Home Page Address: www.smb.museum/kgm; *Dir* Dr Angela Schonberger; *Deputy Dir* Lothar Lambacher
Tues-Fri 10 AM - 6 PM, Sat-Sun 11 AM - 6 PM
Collections: Arts & crafts
—Kupferstichkabinett-Sammlung der Zeichnungen und Druckgraphik, Museum of Prints and Drawings, Matthaikirchplatz 8, Berlin, 10785 Germany. Tel 0049 30 266 2951; Fax 0049 30 266 2959; Elec Mail kk@smb.spk-berlin.de; Internet Home Page Address: www.smb.museum/kk; *Dir* Dr Hein-Th Schulze Altcappenberg; *Deputy Dir* Dr Holm Bevers

Open Tues-Wed & Fri 10 AM - 6 PM, Thurs 10 AM - 10 PM, Sat-Sun 11 AM - 6 PM; study room Tues - Fri 9 AM - 4 PM; Library with 40,000 vols
Collections: Drawings, prints & illustrated books of all European art
—**Museum fur Indische Kunst, Museum of Indian Art,** Takustrabe 40, Berlin, 14195 Germany. Tel 0049 30 8301 361; Fax 0049 30 8301 502; Elec Mail mik@smb.spk-berlin.de; Internet Home Page Address: www.smb.museum/mik; *Dir* Prof Dr Marianne Yaldiz; *Deputy Dir* Raffael Gadebusch
—**Museum fur Islamische Kunst, Museum of Islamic Art,** Bodestrabe 1-3, Berlin, 10178 Germany. Tel 0049 30 2090 5401; Fax 0049 30 2090 5402; Elec Mail isl@smb.spk-berlin.de; Internet Home Page Address: www.smb.museum/isl; *Dir* Prof Dr Claus-Peter Haase; *Deputy Dir* Dr Jens Kroger
Open Fri-Wed 10 AM - 6 PM, Thurs 10 AM - 10 PM; Library with 25,000 vols
—**Museum fur Ostasiatische Kunst, Museum of East Asian Art,** Takustrabe 40, Berlin, 14195 Germany. Tel 0049 30 8301 382; Fax 0049 30 8301 501; Elec Mail oak@smb.spk-berlin.de; Internet Home Page Address: www.smb.museum/oak; *Dir* Prof Dr Willibald Veit; *Deputy Dir* Dr Herbert Butz
Open Tues 10 AM - 6 PM, Sat-Sun 11 AM - 6 PM
Collections: Paintings & ceramics of China & Japan
—**Ethnologisches Museum-Ethnological Museum,** Arnimallee 27, Berlin, 14195 Germany. Tel 0049 30 80 30 14 38; Fax 0049 30 8301 500; Elec Mail md@smb.spk-berlin.de; Internet Home Page Address: www.smb.museum/em; *Dir* Prof Dr Viola Konig; *Deputy Dir* Dr Richard Haas
Open Tues-Fri 10 AM - 6 PM, Sat-Sun 11 AM - 6 PM
Collections: Items of different cultures: Africa, East Asia (China & Tibet), Europe & North America
—**Museum fur Volkskunde, Museum of German Ethnology,** Im Winkel 6/8, Berlin, D-14195 Germany. Tel 83901-01; Fax 030/83901283; *Dir* Dr Erika Karasek
Library with 25,000 vols
Collections: Folklore objects from German speaking population in Europe
—**Museum fur Vor- und Fruhgeschichte, Museum of Pre- & Early History,** Schloss Charlottenburg, Langhansbau Berlin, 14059 Germany. Tel 0049 30 3267 4811; Fax 0049 30 3267 4812; Elec Mail mvf@smb.spk-berlin.de; Internet Home Page Address: www.smb.museum/mvf; *Dir* Prof Wilfried Menghin; *Deputy Dir* Dr Alix Hansel
Open Fri-Wed 9 AM - 5 PM, Sat-Sun 10 AM - 5 PM
—**Alte Nationalgalerie, Old National Gallery,** Bodestrabe 1-3, Berlin, 10178 Germany. Tel 0049 30 2090 5801; Fax 0049 30 2090 5802; Elec Mail ang@smb.spk-berlin.de; Internet Home Page Address: www.smb.museum/ang; *Dir* Prof Dr Peter-Klaus Schuster; *Leiter der Alten* Dr Bernhard Maaz
Open Fri-Wed 10 AM - 6 PM, Thurs 10 AM - 10 PM
Collections: 19th & 20th centuries works
—**Skulpturensammlung und Museum fur Byzantinische Kunst-Sculture Collection and Museum of Byzantine Art,** Bodestrabe 1-3, Berlin, 10178 Germany. Tel 0049 30 2090 5601; Fax 0049 30 2090 5602; Elec Mail sbm@smb.spk-berlin.de; Internet Home Page Address: www.smb.museum/sbm; *Dir* Prof Dr Arne Effenberger
Open Fri-Wed 10 AM - 6 PM, Thurs 10 AM - 10 PM

BIELEFELD

M **KUNSTHALLE BIELEFELD,** Artur-Ladebeck-Strasse 5, Bielefeld, 33602 Germany. Tel + 49 (0) 521329 99 50-10; Fax +49 (0)521 32 999 50-50; Elec Mail info@kunsthalle-bielefeld.de; Internet Home Page Address: www.kunsthalle-bielefeld.de; *Dir* Dr Thomas Kellein; *Pres, Officer* Christiane Heuwinkel
Open daily 11 AM - 6 PM, Wed 11 AM - 9 PM; Admis adult 7 Euro; discounts 4 Euro - 2 Euro
Library Holdings: Auction Catalogs; Book Volumes; CD-ROMs; Compact Disks; DVDs; Maps; Prints; Video Tapes
Collections: Expressionist painting, Bauhaus art, American painting after 1945, Cubistic sculpture, graphics-library, children's atelier
Activities: Classes for adults & children; dramatic progs; docent training; lects open to pub; 5 vis lects per yr; concerts; tours; artmobil; mus shop sells books, original art & prints

BONN

M **KUNSTMUSEUM BONN,** Art Museum of Bonn, Friedrich-Ebert-Allee 2, Bonn, 53113 Germany. Tel (0228) 776260; Fax (0228) 776220; Elec Mail kunstmuseum@bonn.de; Internet Home Page Address: www.kunstmuseum-bonn.de; *Dir* Dieter Ronte; *Deputy Dir* Dr Christoph Schreier; *Cur & Head Exhib* Dr Volker Adolphs; *Cur Graphic Dept* Dr Stefan Gronert
Open Sun, Tues & Thurs - Sat 10 AM - 6 PM, Wed 10 AM - 9 PM, cl Mon; Admis 5-Euro for adults, 2.50 Euro for students; Estab 1948; Average Annual Attendance: 100,000
Library Holdings: Auction Catalogs; Book Volumes; Exhibition Catalogs
Collections: Art of the 20th century, especially August Macke & the Rhenish expressionists; German Art since 1945; contemporary international graphic arts
Activities: Classes for adults & children; lect open to the pub; concerts; gallery talks; tours; organize traveling exhib to art mus in Europe & USA; Kunstladen sells books, original art, reproductions, prints & t-shirts, wine-bottles, etc

M **LANDSCHAFTS VERBAND RHEINLAND,** Rheinisches Landesmuseum Bonn, Colmanstr, Bonn, 53115 Germany; Fraunhoferstr 8, Bonn, D 53121 Germany. Tel (02 21) 98810; Fax (02 21) 9881299; Elec Mail info@lvr.de; Internet Home Page Address: www.lvr.de; *Dir* Dr Frank Gunter Zehnder
Library with 130,000 vols
Library Holdings: Auction Catalogs; Book Volumes; Exhibition Catalogs; Fiche; Maps; Pamphlets; Periodical Subscriptions; Photographs; Prints; Slides
Collections: Rhenish sculpture, painting & applied arts from the Middle Ages up to the present; finds from the Stone Age, Roman times till the Middle Ages; During closing time, small exhibitions of contemporary Rhenish art (Szene Rheinland) in the Alte Rotation (Bonn-Dransdorf)

Publications: Das Rhein Landesmuseum Bonn, Bonner Jahrbucher; Jule im Museum; several series of research reports & catalogs
Activities: Educ program; classes for children; docent training; holiday activities for children; lects open to public; gallery talks; Ceram-Preis fur das archaol. Sachbuch (every 5 years), Leo Breur-Förderpreis (every 2 years); mus shop sells books

BREMEN

M **KUNSTHALLE BREMEN,** Bremen Art Gallery, Am Wall 195, Bremen, 28195 Germany. Tel 0421-32-90-80; Fax 0421-32-90-847; Elec Mail office@kunsthalle-bremen.de; Internet Home Page Address: www.kunsthalle-bremen.de; *Dir* Dr Wulf Herzogenrath; *Cur* Dr Andreas Kreul; *Cur* Dr Dorothee Hansen; *Cur* Dr Anne Rover-Kann; *Cur* Dr Anne Buschhoff; *Pub Relations* Verena Munsberg
Open Tues 10 AM - 9 PM, Wed - Sun 10 AM - 5 PM, cl Mon; Admis Adults 9/7 Euro, members 5 Euro, children 6 - 12 4 Euro, groups 7 Euro per person; Estab 1823; Art museum; Mem: 6000
Library Holdings: Auction Catalogs; Book Volumes; Exhibition Catalogs
Collections: Japanese drawings and prints; European paintings, Middle Ages to modern, especially French and German Art of the 19th century; 17th - 20th century sculpture; illustrated books
Activities: Educ program; classes for adults & children; concerts; Kunstpreis de Bottdiestrepe in Bremen; museum shop sells books, magazines, gifts, reproductions

BRUNSWICK

M **HERZOG ANTON ULRICH-MUSEUM-KUNSTMUSEUM DES LANDES NIEDERSACHSEN,** Museumstrasse 1, Brunswick, 38100 Germany. Tel 0531-1225-0; Fax 0531-1225-2408; Elec Mail info@museum-braunschweig.de; Internet Home Page Address: www.museum-braunschweig.de; *Dir* Dr J Luckhardt; *Paintings* Dr Silhe Jatebrocke; *Sculptures* Dr Regina Marth; *Decorative Arts* Dr Alfred Walz; *Prints & Drawings* Dr Thomas Doring; *Communication* Dr Suen Nommenen
Open Tues, Thurs - Sun 10 AM - 5 PM, Wed 1 PM - 8 PM, cl Mon; Admis 2.50 Euros, reduced 1.30 Euros; Estab 1754; Library with 60,000 vols, 170,000 objects of art in the collection; Average Annual Attendance: 60,000
Library Holdings: Auction Catalogs; Book Volumes; Exhibition Catalogs
Collections: European Paintings - Renaissance & Baroque; European Renaissance & Baroque decorative art, including bronzes, clocks, French 16th century enamels, Italian maiolika, furniture, glass, ivory & wood carvings, laces; Medieval art; prints & drawings from the 15th century to present; East Asian decorative art
Activities: Educ program; classes for adults & children; docent training; lect open to public; lect for members only; concerts; gallery talks; tours; lending of original objects of art internationally; museum shop sells books, prints, slides, postcards

COLOGNE

M **MUSEEN DER STADT KOELN,** Cologne City Museums, Saint Apernstrasse 17-21, Cologne, 5000 Germany. Tel 221-22122304; Fax 221-22124030; *Dir* Prof Dr Hiltrud Kier
M **Josef-Haubrich-Kunsthalle,** Josef-Haubrich-Hof, Cologne, 50676 Germany. Tel 221-221-23-35; Fax 221-221-4552
M **Koelnisches Stadtmuseum,** Zeughausstrasse 1-3, Cologne, 50667 Germany. Tel 221-221-25789; Fax 221-221-24154; Elec Mail ksm@museenkoeln.de; Internet Home Page Address: www.museenkoeln.de/ksm; *Dir* Dr Werner Schaefke; Dr Michael Fultr-Schmidt; Dr Reiner Dieckhoff; Rita Wagner, MA
Tues 10 - 20, Wed-Sun 10 - 17, cl Mon; Admis Euro 3.60/2.00; Estab 1888 Historical Mus Cologne; Average Annual Attendance: 80,000
Income: Municipal Mus, City of Cologne subsidized
Library Holdings: Auction Catalogs; Book Volumes; CD-ROMs; Exhibition Catalogs; Manuscripts; Maps; Memorabilia; Original Documents; Pamphlets; Periodical Subscriptions
Collections: Graphic Arts of Cologne and the Rhineland; photograph collection of the Rhineland; industrial arts of Cologne; religious and rural art and culture; Paintings - local art; Local history; Ceramics; Musical instruments
Activities: Classes for children; docent training; lects open ot public, 6 vis lects per year; lending of original objects of art to gen public; mus shop sells books, reproductions, prints
M **Museum fur Ostasiatische Kunst,** Universitatsstr 100, Cologne, 50674 Germany. Tel 221-94-0 5180; Fax 221-407-290; *Dir* Adele Schlombs
Library with 18,000 vols
Library Holdings: Book Volumes 11,000
Collections: Art of China, Korea and Japan
M **Museum Ludwig,** Bischofsgartenstrass1, Cologne, 50667 Germany. Tel 0049-221-221-26165; Fax 221-221-24114; Elec Mail info@museum-ludwg.de; Internet Home Page Address: www.museum.ludwig.de; *Prof* Kasper Köuig
Open Tues - Sun 10 AM - 8 PM; 7.50 euro, reduced 5.50 euro
Library Holdings: Auction Catalogs; Exhibition Catalogs; Fiche
Collections: Painting & sculpture from 1900 to present; 20th century art/contemporary art/ expressionism/Picasso
Publications: Regular exhibition catalogues
Activities: Classes for adults & children, docent training; lects; mus shop sells books, magazines, reproductions & prints
M **Rautenstrauch-Joest-Museum,** Ubierring 45, Cologne, 50678 Germany. Tel 0221-33694-13; Fax 0221-33694-10; Elec Mail rjm@rjm.museenkoeln.de; Internet Home Page Address: www.museenkoeln.de/rjm; *Dir* Prof Dr Klaus Schneider; *Deputy Dir Indonesia, Historical Ethnographic Photographs* Dr Jutta Engelhard; *Deputy Dir South Pacific* Dr Burkhard Fenner; *Deputy Dir Asia* Dr Ulrich Wiesner; *Deputy Dir Africa* Dr Clara Himmelheber; *Deputy Dir Textile Collection* Brigitte Mojlis
Open Tues - Fri 10 AM - 4 PM, Sat & Sun 11 AM - 4 PM ; Vary depending on exhib; Estab 1901
Collections: Ethnological museum; folk culture (non European)

M **Romisch-Germanisches Museum,** Roncalliplatz 4, Cologne, D-50667 Germany. Tel 221-22305; Fax 221 24030; *Dir* Prof Dr Hansgerd Hellenkemper; *Dep Dir* Dr Friederike Naumann-Steckner
Open Tues - Sun 10 AM - 5 PM; Admis Adults 7 DM/3.58 EUR; students 4 DM/2.05 EUR; Estab 1946; archaeological collections; Roman art, migration period collection; Average Annual Attendance: 430,000; Mem: 750; Archaeological Society
Special Subjects: Archaeology, Crafts, Jewelry, Metalwork, Medieval Art, Antiquities-Roman, Mosaics, Gold
Collections: Early and pre-historic discoveries; gold ornaments; glass and industrial arts
Activities: Classes for children; docent training; lect open to pub; 8-12 vis lect per yr; gallery talks; shop sells books, magazines, reproductions, prints, slides

L **Romisch-Germanisches Museum Bibliothek,** Roncalliplatz 4, Cologne, 50667 Germany. Tel 221-22122304; Fax 221-22124030; *Dir* Dr Hansgerd Hellenkemper
Library Holdings: Book Volumes 11,000

M **Schnutgen-Museum,** Cacilienstrasse 29, Cologne, 50667 Germany. Tel 221 221-22310; Fax 221 221-28489; Elec Mail schnutgen@netcologne.de; Internet Home Page Address: www.museenkoeln.de; *Dir* Dr Hiltrud Westermann-Angerhausen
Collections: Art of the early Middle Ages to Baroque

M **Wallraf-Richartz-Museum,** Martinstraße 39, Cologne, 50677 Germany. Tel 0221-221-21119; Fax 0221-221-22629; Elec Mail wrm@wrm.museenkoeln.de; Internet Home Page Address: www.museenkoeln.de; *Dir* Dr Rainer Budde; *Dep Dir* Dr Ekkehard Mai
Open Tues 10 AM - 8 PM, Wed-Fri 10 AM - 6 PM, Sat & Sun 11 AM - 6 PM; cl Mon; Fee 10 DM; concessions 5 DM; Picture gallery
Special Subjects: Drawings, Portraits, Sculpture, Graphics, Watercolors, Religious Art, Etchings & Engravings, Painting-European, Painting-Dutch, Painting-French, Baroque Art, Painting-Flemish, Renaissance Art, Medieval Art, Painting-Spanish, Painting-Italian, Painting-German
Collections: Painting from 13th century to 1900; 19th century sculpture
Activities: Shop sells books, reproductions, slides

DRESDEN

M **STAATLICHE KUNSTSAMMLUNGEN DRESDEN,** Staatliche Kunstsammlungen, Dresden Albertinum Bruhlsche Terrasse Dresden, 01067 Germany; Staatliche Kunstsammlungen, Dresden, Postfach 120 551 Dresden, 01006 Germany. Tel (351) 4 9146 22 (public relations dept); Fax (351) 4 91 46 16; Elec Mail info@staatl-kunstsammlungen-dresden.de; Internet Home Page Address: www.staatl-kunstsammlungen-dresden.de; *Gen Dir* Dr Sybille Ebert-Schifferer
Collections: Consists of 12 galleries & museums; Mathematical-Physical Salon; The Dresden Armoury; Sculpture Collection; Museum of Saxon Folk Art; Puppet Theatre Collection; Coin Cabinet; Cabinet of Prints and Drawings; Porcelain Collection; Museum of Arts and Crafts; The Green Vault; Palace Exhibition and Hausmann Tower; Old Masters Picture Gallery; Modern Masters Picture Gallery; The Art Library

M **Gemaldegalerie Alte Meister,** Zwinger Theaterpl 1, Dresden, 8010 Germany. Tel (351) 4914620; Fax (351) 4914694; Elec Mail info@staatl-kunstsammlungen-dresden.de; Internet Home Page Address: www.staatl-kunstsammlungen-dresden.de; *Dir* Dr Harald Marx

M **Galerie Neue Meister,** Posfach 120551, Dresden, 01006 Germany. Tel (0351) 4914 9731; Fax (0351) 4914 9732; Elec Mail besucherservice@skd-dresden.de; Elec Mail gnm@skd-dresden.de; Internet Home Page Address: www.skd-dresden.de; *Dir* Dr Ulrich Bischoff
Cl until 2009 because of construction

M **Historisches Museum,** Sophienstrasse, Dresden, 8010 Germany. *Dir* Dr Dieter Schaal

M **Skulpturensammlung,** Georg-Treu-Platz Z, Albertinum, Dresden, 8010 Germany; Postfach 120551, Dresden, 01006 Germany. Tel (351) 4914740; Fax (351) 4914350; Elec Mail Gisela.Sussek@skd.smwk.sachsen.de; Internet Home Page Address: www.staatl-kunstsammlungen-dresden.de; *Dir* Dr Moritz Woelk; *Cur* Dr Kordelia Knoll; Astrid Nielsen, MA; *Conservator* Ursula Kral; *Cur* Dr Barbel Stephan
Open 10 AM - 6 PM, cl Thurs; Estab 1728
Library Holdings: Auction Catalogs; Book Volumes; Exhibition Catalogs; Kodachrome Transparencies; Original Documents; Periodical Subscriptions; Photographs; Records
Collections: Greco-roman Antiquity (Sculpture, Vases, Bronzes); Medieval Sculpture; Bronzes (Renaissance, Baroque); German, French and Italian Sculpture (Late 12th Century to Present); Cast-coll
Publications: Antike Terrakotten (1979); Agyptische Kunst (1989); Griechische Skulpturen und Fragmente (1989); Verborgene Schatze (1992); Die Antiken im Albertinum (1993); Klassizistische Bildwerke (1993); Das Albertinum vor 100 Jahren; Die Skulpturensammlung Georg Treus (1994); Alltag und Mythos (1998); Gotter und Menschen (2000); Balthasar Permoser Hats Gemacht (2001); Hauptsache Koepfe (2001); Nach der Flut - Die Dresdener Skulpturensammlung in Berlin (2002)
Activities: Sales shop sells books

DUSSELDORF

L **KUNSTAKADEMIE DUSSELDORF, HOCHSCHULE FUR BILDENDE KUNSTE - BIBLIOTHEK,** State Academy of Art - Library, Eiskellerstrasse 1, Dusseldorf, 40213 Germany. Tel (0211) 1396-461; Fax (0211) 1396-225; Elec Mail helmut.kleinenbroich@kunstakademie-duesseldorf.de; *Librn* Helmut Kleinenbroich; *Librn Asst* Klaus Saturiann
Open Mon - Thurs 9 AM - 5; holidays 10 AM - 5 PM, Fri 9 AM - 2 PM; Estab 1774; Library with 120,000 vols
Purchases: DEM 36,000 p.a.
Library Holdings: Auction Catalogs; CD-ROMs; DVDs; Exhibition Catalogs; Manuscripts 13; Periodical Subscriptions 110; Slides 50,000

M **KUNSTHALLE DUSSELDORF,** (Stadtische Kunsthalle Dusseldorf) Grabbeplatz 4, Dusseldorf, 40213 Germany. Tel (0211) 899-6243; Fax (0211) 892-9168; Elec Mail mail@kunsthalle-duesseldorf.de; Internet Home Page Address: www.kunsthalle-duesseldorf.de; *Dir* Dr Ulrike Groos; *Cur* Peter Gorschluter; *Secy* Claudia Paulus; *Cur* Thomas W Rieger
Open Tues - Sat 12 - 7 PM, Sun 11 AM - 6 PM; Admis Euro 5, 50, / 3, 50; Estab 1967; Modern art, contemporary
Exhibitions: Contemporary art exhibitions
Activities: Classes for adults & children; docent training; lect open to the pub; concerts; gallery talks; organize traveling exhibitions to museums in Europe; sales shops sell books, magazines, reproductions, prints

M **MUSEUM KUNST PALAST,** (Kunstmuseum Dusseldorf) Ehrenhof 5, Dusseldorf, 40479 Germany. Tel (0211) 899-2460; *Dir* Dr Helmut Ricke; *Genl Dir* Jean-Hubert Martin; *Head of Admn* Angela Eckert-Schweizer; *Head of Publ Rel* Bert-Antonis Kaufmann; *Head of Modern Dept* Stephan von Wiese Dr; *Head of Painting Gallery* Bettina Baumgartel, Dr; *19th Cen, Head of Libr* Anne-Marie Katins
11 a.m. - 7 p.m., cl Mon
Collections: Collections of European & applied art from middle ages to 1800, prints & drawings & contemporary art at 5 museum locations

FRANKFURT

M **LIEBIEGHAUS, MUSEUM ALTER PLASTIK,** Museum of Sculpture, Schaumainkai 71, Frankfurt, 60596 Germany. Tel 212-38615; Fax 212-30701; Elec Mail liebieghaus.amt45d@stadt-frankfurt.de; Internet Home Page Address: www.liegieghaus.de; *Dir* Dr Peter Bol; Dr Marraike Buckling
Open Sun, Tues, Thurs, Fri & Sat 10 AM - 5 PM, Mon 10 AM - 8 PM; 4 - E (reduced: 2.50 E)
Library Holdings: Book Volumes; Cards; Exhibition Catalogs; Lantern Slides
Collections: Sculpture of Egypt, Greece, Rome Medieval period, East Asia, Rococco style & Baroque period
Activities: Lect open to the public; museum shop sells books, slides

M **MUSEUM FUR KUNSTHANDWERK,** Museum of Arts and Crafts, Schaumainkai 17, Frankfurt, 60594 Germany. Tel (069) 2123-40-37
Collections: European applied art, from Gothic to art nouveau; Far Eastern & Islamic works of art

M **STADELSCHES KUNSTINSTITUT UND STADTISCHE GALERIE,** Das Stadel, Schaumainkai 63, Frankfurt, 60596 Germany; Durerstrasse 2, Frankfurt, 60596 Germany. Tel (069) 605098-0; Fax (069) 610163; Elec Mail staedel@t-online.com; Internet Home Page Address: www.staedelmuseum.de; *Dir* Prof Herbert Beck; Dr. Jochen Sander; Dr Bodo Brinkman; Dr Michael Maek-Gerard; Dr Sabine Schulze; Dr Ursula Grzechca-Mohr; Susanne Kujer; Stephen Knobloch; Dr Jutta Schutt; Ruth Schmutzler; Dr Melanne Damm
Tues, Fri - Sun 10 AM to 5 PM, Wed & Thurs 10 AM to 8 PM, cl Mon; Library with 100,000 vols
Library Holdings: Auction Catalogs; Audio Tapes; Book Volumes; Cards; Exhibition Catalogs; Reproductions; Slides
Collections: Paintings, sculptures, prints, drawings
Publications: exhibition catalog
Activities: Classes for adults & children; dramatic programs; lectrs for mems only; concerts; gallery talks; tours; mus shop sells books; magazines; reproductions; prints; slidesposters, toys

HAMBURG

M **HAMBURGER KUNSTHALLE,** Glockengieberwall, Hamburg, 20095 Germany. Tel (040) 428131200; Fax (040) 428543409; Elec Mail info@hamburger-kunsthalle.de; Internet Home Page Address: www.hamburger-kunsthalle.de; *Dir* Prof Dr Hubertus Gabner; *Bus Mgr* Tim Kistenmacher; *Dir* Andreas Stolzenburg; *Old Masters Paintings* Martina Sitt; *19th Century Paintings* Jenns Howoldt; *Early 20th Century Painting* Ulrich Luchhardt; *Contemporary Art* Christopher Heinrich
Open Tues - Sun 10 AM - 6 PM, Thurs until 9 PM; Admis Euro 8.50, Concessions Euro 5; Estab 1869; Library with 70,000 vols; Average Annual Attendance: 300,000; Mem: 13,000
Library Holdings: Auction Catalogs; Book Volumes; Exhibition Catalogs; Maps; Original Documents; Pamphlets; Periodical Subscriptions; Sculpture
Collections: Drawings, engravings & masterworks of painting from 14th century to present; sculpture from 19th and 20th centuries
Publications: catalogues
Activities: Classes for children; lect open to public; 15 vis lect per year; concerts; gallery talks; tours; sponsoring of competitions; sales of books, magazines, reproductions, prints, slides

M **MUSEUM FUR KUNST UND GEWERBE HAMBURG,** Steintorplatz 1, Hamburg, 20099 Germany. Tel (040) 42854 2732; Fax (040) 4 2854 2834; Elec Mail service@mkg-hamburg.de; Internet Home Page Address: www.mkg-hamburg.de; *Dir* Dr Wilhelm Hornbostel; *Mng Dir* Helmut Sander; *Marketing Publications* Dr Christine Maiwald
Open Tues - Sun 10 Am - 6 PM, Thurs 10 AM - 9 PM; Admis 8.20 Euro, concessions 4.10 Euro; Estab 1877; Average Annual Attendance: 300,000; Mem: Justus Brinckmann Gesellschaft 60 Euro
Collections: European art & sculpture from Middle Ages to present; Near & Far East art; European popular art
Activities: Lect open to public; concerts; gallery talks; tours; museum shop sells books, magazines, prints

HANOVER

M **KESTNER-MUSEUM,** Trammplatz 3, Hanover, 30159 Germany. Tel (0511) 1682120; Fax 16846530; Elec Mail Kestner-Museum@Hannover-Stadt.de; Internet Home Page Address: www.hannover.de;Dr Wolfgang Schepers; *Prof* Dr Rosemarie Drenkhahn; Dr Anne Viola Siebert; Pia Drake
Open Tues - Sun 11 AM - 6 PM, Wed 11 AM - 8 PM; Admis 3,00 DM, 1,53 Euro; Estab 1889; Neorenaissance building/enlarged 1960; Mem: Membership 100 DM per year

Library Holdings: Auction Catalogs; Book Volumes; Exhibition Catalogs; Kodachrome Transparencies; Periodical Subscriptions; Photographs; Prints
Collections: Ancient, medieval & modern coins & medals; Egyptian, Greek, Etruscan & Roman art objects & medieval art; illuminated manuscripts & incunabula of the 15th - 20th centuries; product design 1900-2000
Activities: Classes for adults & children; lect open to the public; 2-3 traveling exhibitions per year; organize traveling exhibitions; museum shop sells books, reproductions, prints, slides

KARLSRUHE

M **BADISCHES LANDESMUSEUM,** Schlossplatz 1, Karlsruhe, 76131 Germany. Tel 0721-926-6514; Fax 721-926-6537; Elec Mail info@landesmuseum.de; Internet Home Page Address: www.landesmuseum.de; *Dir & Prof* Dr Harald Siebenmorgen
Open Tues - Thurs 10 AM - 5 PM, Fri - Sun 10 AM - 6 PM; Admis 4, reduced 3; Estab 1921; Maintains library with 70,000 vols
Library Holdings: Auction Catalogs; Book Volumes; Exhibition Catalogs; Periodical Subscriptions
Collections: Antiquities of Egypt, Greece & Rome; art from middle ages to present; medieval, Renaissance & baroque sculpture; coins, weapons & folklore
Activities: Classes for adults & children; lect open to public; concerts; tours; originate diverse traveling exhibitions; sales of books, reproductions

M **STAATLICHE KUNSTHALLE,** State Art Gallery, Hans-Thoma-Strasse 2-6, Karlsruhe, 76133 Germany. Tel ++49-721-926-6788; Fax ++49-721-926-3359; Elec Mail info@kunsthalle-karlsruhe.de; Internet Home Page Address: www.kunsthalle-karlsruhe.de; *Head* Dr Klaus Schrenk; *Deputy Dir* Dr Siegmar Holsten; *Sr Cur* Dr Dietmar Ludke; *Cur Prints & Drawings* Dr Dorit Schafer
Open Tues - Fri 10 AM - 5 PM, Sat - Sun & pub holidays 10 AM - 6 PM; Admis 8 Euros; Estab 1846; Library with 110,000 vols; Average Annual Attendance: 140,000
Library Holdings: Auction Catalogs; Audio Tapes; Book Volumes; CD-ROMs; Exhibition Catalogs; Fiche; Periodical Subscriptions
Collections: 15th - 20th century German painting & graphics; 16th - 20th century Dutch, Flemish & French paintings & graphics; 50,000 prints & drawings, sculptures, 19th - 20th century
Activities: Classes for adults & children; docent training; training for adults; lect open to the pub; gallery talks; mus shop sells books, reproductions, prints & slides; Kindermuseum Staatliche Kunsthalle Karlsruhe

KASSEL

M **STAATLICHE MUSEEN KASSEL,** State Museums of Kassel, Schloss Wilhelmshohe, Kassel, 34131 Germany; Post Box 410420, Kassel, 34066 Germany. Tel (0561) 31680-0; Fax (0561) 31680-111; Elec Mail info@museum-kassel.de; Internet Home Page Address: www.museum-kassel.de; *Dir* Dr Michael Eissenhauer
Open Thurs - Sun 10 AM - 5 PM; Admis 3.50 Euros; Library with 60,000 vols; collection of paintings, antiquities, graphics
Library Holdings: Auction Catalogs; Exhibition Catalogs
Collections: Department of classical antiquities gallery of 15th - 18th century old master paintings, collection of drawings & engravings
Activities: Educ program; classes for adults & children; concerts; mus shop sells books

MUNICH

A **BAYERISCHE STAATSGEMALDESAMMLUNGEN,** Bavarian State Art Galleries, Barerstrasse 29, Munich, 80799 Germany. Tel (089) 238050; Fax (089) 23805221; Elec Mail in/o@pinakothek.de; Internet Home Page Address: www.inahotheh.der.moderne.de; *Head* Dr Prof Dr Reinhold Baumstark
Consists of 5 galleries
Collections: Flemish, Spanish, Italian, German & other European paintings & sculpture; 20th century sculpture & art

M **BAYERISCHES NATIONALMUSEUM,** Bavarian National Museum, Prinzregentenstrasse 3, Munich, 80538 Germany. Tel (089) 21-12-41; Fax (089) 21124201; Elec Mail bay.nationalmuseum@extern.lrz-muenchen.de; Internet Home Page Address: www.bayerisches-nationalmuseum.de; *Gen Dir* Dr Renate Eikelmann
Tues - Sat 10 AM - 5 PM, Thurs 10 AM - 8 PM; adults 3 Euro, reduced 2 Euro; 1855 (founded), 1862 (opened), 1900 (opening of the present building); One of Europe's major art and cultural history museums
Collections: European fine arts: decorative arts, paintings, folk art, sculpture; most valuable and extensive crib collection in the world
Activities: Classes for children; lect open to public; concerts; gallery talks; sales shop sells books, magazines, reproductions

M **STAATLICHE GRAPHISCHE SAMMLUNG,** Meiserstrasse 10, Munich, D-80333 Germany. Tel (089) 289 27650; Fax (089) 289 27653; Elec Mail direkton@graphische-sammlung.mwn.de; Internet Home Page Address: www.sgsm.eu; www.stmwfk.bayern.de/kunst.museen/graphische_sammlung.html; *Dir* Dr Michael Semff; *Cur* Dr Achim Riether; *Cur* Dr Andreas Strobl; *Cur* Dr Kurt Zeitler
Study Hall open Tues - Wed 10 AM - 1 PM, 2 PM - 4:30 PM, Thurs 10 AM - 1 PM, 2 PM - 6 PM, Fri 10 AM - 12:30 PM; exhibs: see Pinakothek der Moderne; No admis fee for study hall; for exhibs see Pinakothek der Moderne; Estab 1758; Library with 45,000 vols; Average Annual Attendance: 1000 (Study Hall)
Collections: French, 15th to 20th century German, Italian & Dutch prints & drawings; international prints & drawings; Portraits (prints); views of different places (prints)
Exhibitions: See website

Activities: Lectrs for members & different unions only; 350 vis lectrs per year; organize traveling exhibs to other graphic departments

M **STAATLICHE MUNZSAMMLUNG,** State Coin Collection, Residenzstrasse 1, Munich, 80333 Germany. Tel (089) 227221; Fax 089-2998859; Elec Mail smm.muenchen@t-online.de; Internet Home Page Address: www.staatliche-muenzsammlung.de; *Dir* Dr Dietrich Klose; *Cur* Gerd Stumpf, Dr; *Cur* Dr Kay Ehling
Open Tues - Sun 10 AM - 5 PM,; Admis adults 2.50 Euro , children & Sun 2 Euro; Estab 1565; Library with 14,000 vols; Average Annual Attendance: 8,000; Mem: 50 Euro (friends of the mus)
Income: mostly by state
Special Subjects: Metalwork, Coins & Medals
Collections: Coins from different countries & centuries; medals; precious stones from antiquity, Middle Ages & Renaissance; Banknotes, shares
Exhibitions: Special exhibs every year
Publications: Sylloge Nummorum Graecorum, exhibition catalogues
Activities: Lects open to the public; mus, high schools, univs; mus shop sells books & reproductions

M **STAATLICHE SAMMLUNG AEGYPTISCHER KUNST,** State Museum of Egyptian Art, Hofgartenstrasse 1, Meisev straj3e 10 Munich, 80333 Germany. Tel (089) 289 27 630; Fax (089) 289 27 638; ; *Dir* Dr Sylvia Schoske
Open Tues-Fri 9AM-5PM; Sat-Sun 10AM-5PM, Clo Mon; Estab 1970; Average Annual Attendance: 80,000
Collections: Permanent Exhibitions
Activities: Classes for children; open to the public; gallery talks; mus & exhibition halls; books & various items

M **STADTISCHE GALERIE IM LENBACHHAUS,** Luisenstrasse 33, Munich, 80333 Germany. Tel (089) 233-32000; Fax (089) 233-32003; *Dir* Dr Helmut Friedel
Collections: Art Nouveau; The Blue Rider and Kandinsky and Klee; paintings by Munich artists

NUREMBERG

M **GERMANISCHES NATIONALMUSEUM,** Kartausergasse 1, Postf 11 95 80 Nuremberg, D 90402 Germany. Tel ++49-(0)911-1331-0; Fax ++49-(0)911-1331-200; Elec Mail info@gnm.de; Internet Home Page Address: www.gnm.de; *Head* Prof Dr. G. Ulrich Grossmann; *Dir. Prints & Drawings* Dr. Rainer Schoch; *Dir. Folk toys* Dr Adelheid Mueller; *Dir Archives* Dr Irmtraud Frfr.v. Andrian-Werburg; *Dir Management* Franz Bezold; *Dir Mktg & Communications* Dr Matthias Hamann; *Dir Library* Dr Eberhard Slenczka
Open Tue - Sun 10 AM - 6 PM, Wed 10 AM - 9 PM; Admis 5 Euro and reduced rates; Estab 1852; mus archive, library for art and culture of the German speaking world; Library with 500,000 vols. Largest mus of German art & culture from the stone age to present; Average Annual Attendance: 350,000; Mem: 6.500/E 25
Income: 14.5 mio Euro; state 30%, land 60%, town 10%
Purchases: 400.000 Euro
Library Holdings: Auction Catalogs; Book Volumes; CD-ROMs; Exhibition Catalogs; Fiche; Manuscripts; Maps; Original Art Works; Original Documents; Pamphlets; Periodical Subscriptions; Photographs; Prints
Special Subjects: Archaeology, Drawings, Etchings & Engravings, Historical Material, Glass, Furniture, Gold, Porcelain, Pottery, Silver, Textiles, Maps, Painting-European, Sculpture, Tapestries, Graphics, Watercolors, Folk Art, Woodcarvings, Woodcuts, Landscapes, Decorative Arts, Manuscripts, Dolls, Metalwork, Carpets & Rugs, Ivory, Coins & Medals, Baroque Art, Renaissance Art, Medieval Art, Stained Glass, Painting-German, Military Art
Collections: Ancient historical objects, archives, books, folk art, furniture, manuscripts, musical instruments, paintings, sculpture, textiles, toys, weapons
Exhibitions: (9/20/2007-1/1/2008) The Art of the Nurenberg Goldsmiths; The Allure of the Masterpiece, Durer Rembrandt Reimerschueides, through 2009
Publications: Museum yearbook, catalogues of exhibitions and permanent collections, museum guides, popular books on the museum's collections
Activities: Classes for adults and children at Art Educ Center; docent training; lects open to public, concerts, gallery talks, tours; lending of original object of art to scientifically relevant exhibs; one book traveling exhibs per year; 1-2 traveling exhibs; museum shop sells books, magazines, reproductions, prints

RECKLINGHAUSEN

M **MUSEEN DER STADT RECKLINGHAUSEN,** Recklinghausen City Museums, Grosse Perdekamp Str 25-27, Recklinghausen, 45657 Germany. Tel (02361) 501935; Fax (02361) 501932; Elec Mail info@kunst-re.de; Internet Home Page Address: www.kunst-re.de; *Dir* Dr Ferdinand Ullrich; *Dir* Dr Hans-Jurgen Schwalm; Dr Eva Haustein-Bartsch
Open Tues - Sun 10 AM - 6 PM; Admis C 75 - 2.50 Euro; Estab 1950-1988; contemporary art, outsider art, icons; Average Annual Attendance: 20,000
Library Holdings: Auction Catalogs; Book Volumes; Exhibition Catalogs
Collections: Paintings, sculpture, drawings & prints by contemporary artists; outsider art; icons
Activities: Award, Kunstpreis: Junger westen; since 1948 for artists younger than 35; lending of original objects of art to Artothek; mus shop sells books, original art, reproductions & slides

STUTTGART

M **STAATSGALERIE STUTTGART,** Konrad-Adenauer-Strasse 30-32, Stuttgart, 70182 Germany; PO Box 104342, Stuttgart, 70038 Germany. Tel +49-711-47040-0; Fax +49-711-236 9983 (Dept Painting & Sculpture); +49-711-212-4111 (Dept Prints & Drawings); Elec Mail info@staatsgalerie.de; Internet Home Page Address: www.staatsgalerie.de; Others +49-711-47040-249; *Dir* Sean Rainbird; *Dep Dir* Cudron Luboden; *head comm* Beate Wolf
Open 10 AM - 6 PM, Thurs 10 AM - 9 PM, closed Mon; Admis (coll) E 4.50/ E 3(reduced); Wed - free; (spl exhib) E 8/E6 (reduced); built between 1838-1843;

Old German Masters 14th - 16th centuries, Dutch paintings 16th - 18th centuries, Italian paintings 14th - 18th centuries, Baroque paintings, 19th century paintings & 20th century paintings & sculptures
Library Holdings: Auction Catalogs; Book Volumes; Clipping Files; Exhibition Catalogs
Special Subjects: Drawings, Etchings & Engravings, Photography, Painting-European, Sculpture, Graphics, Prints, Posters, Painting-Dutch, Period Rooms, Medieval Art, Painting-Italian, Painting-German
Collections: European art, 14th - 20th centuries; international art of the 20th century; graphic art
Activities: Classes for adults; lect open to public; tours for children & handicapped persons; mus shop sells books, reproductions, prints & slides

WITTEN

M **MARKISCHES MUSEUM DER STADT WITTEN,** Husemannstrasse 12, Witten, 58452 Germany. Tel (02302) 5812550; *Dir* Dr Wolfgang Zemter
Collections: 20th century German paintings, drawings & graphics

GHANA

ACCRA

M **GHANA NATIONAL MUSEUM,** Barnes Rd, PO Box 3343 Accra, Ghana. Tel 221633; *Head* E A Asante
Collections: Art, archeological and ethnological collections for Ghana and West Africa

GREECE

ANCIENT OLYMPIA

M **ARCHAEOLOGICAL MUSEUM OF OLYMPIA,** Ancient Olympia, 27065 Greece. Tel 2624022529; Fax 2624022529; Elec Mail protocol@zepka.culture.gr; Internet Home Page Address: www.culture.gr; *Head* Georgia Chatzi-spieiopoulou; *Archaeologist* Vikatou Olympia; *Archaeologist* Matzanas Christos; *Archaeologist* Liaggouras Christos
Open winter 8 AM - 5 PM, summer 8 AM - 7 PM; Admis adults 19 - 65 yrs mus or site 6 euro, site & museum (joint) 9 euro, over 65 mus or site 3 euro, joint 5 euro; children free; Estab 1982 as an archaeological mus; Prehistoric, classical and Roman antiquities; Average Annual Attendance: 440,000
Library Holdings: Book Volumes; Exhibition Catalogs; Maps; Pamphlets; Periodical Subscriptions
Collections: Ancient Greek sculpture, bronzes, ceramics & glass
Publications: Arapayianni Xeni, Olympia; Viatou Olympia, olympia.archaeological site and museums
Activities: Classes for children; lening educational material for school classes; family trail for the Bronzes Gallery of the mus; museum shop sells books, prints, slides, postcards

ATHENS

M **ARCHAEOLOGICAL MUSEUM OF CORINTH,** c/o Am Sch of Classical Studies, 54 Souideas Athens, Greece. Tel 0741 31207; *Dir* Phani Pachiyanni

M **ATHENS BYZANTINE & CHRISTIAN MUSEUM,** (Byzantine Museum) 22 Vasilissis Sophias Ave, Athens, 10675 Greece. Tel 7211027, 7232178; Fax 7231883; Elec Mail protocol@bma.culture.gr; *Dir* Dimitrios Konstantios
Open summer: 8 AM - 7:30 PM, winter: 8 AM - 3 PM; Admis full: 4E, reduced: 2E; Founded 1914; Library & photo archives are maintained; Average Annual Attendance: 80,00; Mem: 250; dues 40 E once a month
Income: Auto financed & Ministry of Culture
Purchases: Publication (diaries & other) $ works of art
Library Holdings: Fiche; Periodical Subscriptions; Reproductions
Special Subjects: Archaeology, Decorative Arts, Architecture, Ceramics, Metalwork, Textiles, Manuscripts, Painting-European, Tapestries, Costumes, Religious Art, Jewelry, Antiquities-Byzantine, Coins & Medals, Embroidery, Medieval Art, Islamic Art, Antiquities-Greek, Mosaics, Painting-Russian
Collections: Byzantine & Post-Byzantine icons, ceramics, marbles, metalwork; Christian & Byzantine sculpture & pottery; liturgical items; Greek manuscripts; historic photographs
Exhibitions: Permanent exhib (Byzantine coll); periodical (2006: China under the Tangs)
Publications: European & Hellenic Ceramic of 18th century
Activities: Classes for adults & children; disabilfer group; lect open to the pub; concerts; gallery talks; artmobile; lending of original objects of art to museums & institutions; 1 book traveling exhib per yer; mus shop sells books, reproductions, prints, slides & replicas

M **BENAKI MUSEUM,** Odos Koumbari 1, Athens, 10674 Greece. Tel 36 11 617; Fax 36 22 547; *Dir* Dr Angelos Delivorrias
Library, historical archives and photographic archives are maintained
Collections: Ancient Greek art, chiefly jewelry; Byzantine and post-Byzantine art, icons and crafts; collections of Islamic art and Chinese porcelain; Greek popular art and historical relics; textiles from Far East and Western Europe

M **NATIONAL ARCHAEOLOGICAL MUSEUM,** 1 Tositsa St, Athens, 10682 Greece. Tel 8217717; Fax 8213573; 8230800; Elec Mail protocal@eam.culture.gt; Internet Home Page Address: www.culture.gt; *Dir* Ioannis Touzatsoglou, Dr; *Head of Sculpture* N Koltses, Dr
Admis adult 2,000 GRD, student 1,000 GRD; Estab 1889; Average Annual Attendance: 312,000
Income: Financed by the state
Library Holdings: Auction Catalogs; Book Volumes; CD-ROMs; DVDs; Exhibition Catalogs; Periodical Subscriptions; Photographs; Prints; Reproductions; Slides; Video Tapes
Collections: Original Greek sculptures; Roman period sculptures; Bronze Age relics; Mycenaean treasures; Greek vases, terracottas, jewels; Egyptian antiquities; neolithic collection, cyclodic collection, Stathetes jewelry collection
Activities: Classes for deaf children; lending of original objects of art to scientific archaeological exhibitions; sales shop sells books, reproductions, prints, slides

M **NATIONAL ART GALLERY & ALEXANDER SOUTZOS MUSEUM,** 50 Vassileos Konstantinou Ave, Athens, 11610 Greece. Tel 7235857; *Dir* Marina Lambraki-Plaka
Collections: Engravings; 14th - 20th century European painting; 17th - 20th century Greek engravings, paintings & sculpture; impressionist, post-impressionist & contemporary drawings

ATTICA

M **VORRES MUSEUM OF CONTEMPORARY GREEK ART AND FOLK ART,** Paiania , Attica, GR 190 02 Greece. Tel (210) 664-2520/664-4771; Fax 66 45 77 5; Elec Mail vores@otenet.gr; *Pres* Ian Vorres; *Dir* George Vorres
Open Mon - Fri for groups by appointment only, Sat & Sun 10 AM - 2 PM; Admis adults 4.40 Euros, children 2.10 Euros; Estab 1983; New 2000 sq met4er wing to the Museum of Contemporary Greek Art; Average Annual Attendance: 70,000 - 80,000
Income: Sale of tickets & catalogues, rental of space for receptions
Library Holdings: Book Volumes; Exhibition Catalogs; Reproductions
Collections: Contemporary Greek art; Greek Folk art
Publications: Catalogues & volumes for each part of the museum in Greek & English
Activities: Special guided tours

DELPHI

M **MINISTRY OF CULTURE,** (The Delphi Museum) The Delphi Museum, I Ephorate of Prehistoric & Classical Antiquities, Delphi, 33054 Greece. Tel (0265) 82 313; Fax (0265) 82 966; Elec Mail protocol@iepka.culture.gr; *Archaeologist* Photis Desios; *Archaeologist* Desp Skorda; *Archaeologist* Sotiris Raptopoulos; *Archaeologist* Dr Elena C Partida, MA, PhD; *Archaeologist* Anthoula Tsaroucha
Open daily 8:30 AM - 3 PM (winter schedule), Tues - Sun 7:30 AM - 7:30 PM, Mon Noon - 6:30 PM (summer); Admis 6 Euros, concessionary 3 Euros; Estab 1903; Library with 4800 vols; Average Annual Attendance: 350,000
Library Holdings: Book Volumes; CD-ROMs; Cards; Exhibition Catalogs; Maps; Periodical Subscriptions; Photographs; Slides
Special Subjects: History of Art & Archaeology, Architecture, Ceramics, Metalwork, Silver, Sculpture, Bronzes, Archaeology, Crafts, Landscapes, Glass, Jewelry, Asian Art, Historical Material, Ivory, Coins & Medals, Antiquities-Egyptian, Antiquities-Greek, Antiquities-Roman, Mosaics, Gold
Collections: Permanent exhibition of ancient sculpture, vases, inscriptions, statuettes, bronze weapons, tools of different periods
Activities: Mus shop sells books, reproductions, prints & slides

HERAKLION

M **ARCHAEOLOGICAL MUSEUM,** 2 Xanthoudidou St, Heraklion, 71202 Greece. Tel 2810-224630; Fax 2810-332610; Elec Mail protocol@amh.culture.gr; Internet Home Page Address: www.culture.gr; *Dir* Nota Dimopoulou
Open Summer: 8 AM - 7:30 PM, Winter: 8 AM - 3 PM; Admis 6 E
Income: Pub sector
Collections: Development of Cretan & Minoan art
Activities: Classes for children; lending of original objects of art to Greece & other countries; mus shop sells books, prints & slides

RHODES

M **ARCHAEOLOGICAL MUSEUM,** Rhodes, Greece. Tel 02 41 75674; *Dir* John Papachristodoulou
Library with 22,000 vols
Collections: Mycenean through to late Roman times

THESSALONIKI

M **ARCHAEOLOGICAL MUSEUM OF THESSALONIKI,** 6 Manolis Andronikos St, Thessaloniki, 54621 Greece. Tel 830538; Fax 861306; Elec Mail Protocol@istepka.culture.gr; Internet Home Page Address: alexander.macedonia.culture.gr; *Dir* Dr D Grammenos
Open Winter 8:30 - 15:00, Summer 8:00 - 19:00; Adults - 4E, sr citizens 2E; Estab 10-27-1962; Average Annual Attendance: 100,000
Library Holdings: Book Volumes; Exhibition Catalogs; Filmstrips; Photographs; Slides
Collections: Macedonian archaeology, mainly from Thessaloniki, Chalkidiki and Kilkis
Activities: Classes for children, hands-on activities; lects open to public; concerts; lending original objects of art to museums in Europe and elsewhere; travel exhibs

to several museums around world; mus shop sells books, reproductions, prints, slides, puzzles, scarves, ties

GUATEMALA

GUATEMALA CITY

M **MUSEO NACIONAL DE ARQUEOLOGIA Y ETNOLOGIA,** Archaeological & Ethnographical Museum, Edif No 5, La Aurora Guatemala City, Zona 13 Guatemala. Tel 472-0489; Fax 472-0489; *Dir* Patricia del Aguila Flores
Open Tues - Fri 9 AM - 4 PM, Sat & Sun 9 AM - Noon & 1:30 - 4 PM; Admis Guatemalans Q3.00, foreigners Q30.00; Estab 1931; Average Annual Attendance: 85,000
Collections: Mayan art
Publications: Simposio de Investigaciones Arqueologicas en Guatemala
Activities: Sales shop sells books, magazines, slides

M **MUSEO NACIONAL DE ARTE MODERNO,** Edificio No 6, Finca La Aurora Guatemala City, Zona 13 Guatemala. Tel 310-403; *Dir* J Oscar Barrientos
Collections: Paintings, sculpture, engravings, drawings

HAITI

PORT AU PRINCE

M **CENTRE D'ART,** 58 rue Roy, Port au Prince, Haiti. Tel 2-2018; *Dir* Francine Murat
Collections: Haitian art

HONDURAS

COMAYAGUA

M **MUSEO ARQUEOLOGIA DE COMAYAGUA,** Ciudad de Comayagua, Comayagua, Honduras. Tel 72-03-86; *Dir* Salvador Turcios
Collections: Archaeology dating back to 1000 BC; colonial collections

HONG KONG

KOWLOON

M **HONG KONG MUSEUM OF ART,** 10 Salisbury Rd, Tsimshatsui Kowloon, Hong Kong. Tel 852 2721 0116; Fax 852 2723 7666; Elec Mail museumofart@lcsd.gov.hk; Internet Home Page Address: hk.art.museum; *Chief Cur* Tang Hoi-Chiu
Open Fri - Wed 10 AM - 6 PM, cl Thurs except pub holidays, cl 5 PM on Christmas Eve; Admis standard HK$10, consessionary HK$ 5, Wed no admis fee
Collections: Chinese antiquities; Chinese paintings & calligraphy with a specialization of Cantonese artists; historical collection of paintings, prints & drawings of Hong Kong, Macau & China; local & contemporary art

HUNGARY

BUDAPEST

M **MAGYAR NEMZETI GALERIA,** Hungarian National Gallery, Budavari Palota PF 31, Budapest, 1250 Hungary. Tel 375 7533; Fax 375 8898; *Dir* Dr Lorand Bereczky
Open 10 - 18; closed on Mon; Admis: adults 500 HUE; Estab 1957; collects Hungarian art from the 11th century to date; Average Annual Attendance: 300,000
Income: financed by the state
Collections: Ancient & modern Hungarian paintings & sculpture; medal cabinet; panel paintings
Activities: Classes for children; lect open to public; concerts; sales of books, reproductions, slides

M **MUCSARNOK,** Palace of Art, Dozsa Gyorgy, UT 37 Budapest, 1146 Hungary. Tel 1 343 7401; Fax 1 343 5202; Elec Mail info@mucsarnok.hu; Internet Home Page Address: www.mucsarnok.hu
Library with 15,000 vols
Collections: Hungarian & foreign art

M **SZEPMUVESZETI MUZEUM,** Museum of Fine Arts, Dozsa Gyorgy ut 41, Budapest, 1146 Hungary. Tel (01) 343 9759; Fax (01) 343 8298; *Dir* Dr Miklos Mojzer
Library with 100,000 vols
Collections: Egyptian, Greek & Roman antiquities; paintings & sculpture; Old Masters, Egyptian, 19th century art, 20th century art, sculpture collection

ESZTERGOM

M **KERESZTENY MUZEUM,** Christian Museum, Mindszenty ter 2, Esztergom, H-2500 Hungary; Pf 25, Esztergom, H-2500 Hungary. Tel +36 33 413880; Fax +36 33 413880; Elec Mail keresztenymuzeum@vnet.hu; Internet Home Page Address: www.christianmuseum.hu; *Pres* Pal Csefalvay; Ildiko Kontsek; Dora Sallay
See the website for hours; 500 Huf per person; Estab 1875; Old Hungarian and European Painting; Average Annual Attendance: 20,000
Library Holdings: Book Volumes; Exhibition Catalogs; Periodical Subscriptions
Special Subjects: Decorative Arts, Ceramics, Silver, Textiles, Painting-European, Sculpture, Tapestries, Religious Art, Woodcarvings, Porcelain, Metalwork, Painting-Dutch, Carpets & Rugs, Ivory, Baroque Art, Painting-Flemish, Renaissance Art, Medieval Art, Painting-Spanish, Painting-Italian, Stained Glass, Painting-German
Collections: Hungarian, Austrian, Dutch, French, German & Italian medieval paintings and silver artwork, minatures, porcelain, statues & tapestries
Publications: Catalogues of temporary exhib
Activities: Lects open to public; concerts; gallery talks; mus shop sells books, reproductions & CD-ROMs

KECSKEMET

M **MAGYAR NAIV MUVESZEK MUZEUMA,** Museum of Hungarian Native Art, Gaspar A U 11, Kecskemet, 6000 Hungary. Tel (076) 324767; *Dir* Dr Pal Banszky
Collections: Works of Hungarian primitive painters and sculptors

PECS

M **JANUS PANNONIUS MUZEUM,** Pf 158, Pecs, 7601 Hungary. Tel (072) 310172; Fax 72/315-694; Elec Mail jpm@jpm.hu; *Head* Dr Huszár Zolán; *Head Art History Dept* Mr József Sárkány; *Cur* Mrs Orsolya Kovács; *Mus Educ* Mr Gábor Iillai
Open 10 AM - 6 PM, closed Mon; Admis 350 HUF adults; 150 HUF seniors/students; Estab 1904; Library with 20,000 vols
Library Holdings: Auction Catalogs; Book Volumes; Cassettes; Exhibition Catalogs; Manuscripts; Memorabilia; Periodical Subscriptions
Special Subjects: Watercolors, Antiquities-Byzantine, Antiquities-Roman
Collections: Modern Hungarian art; archaeology, ethnology, local history
Exhibitions: Zsolnay Ceramics (1955); Vasarely (1973); Csoniváry (1983)
Publications: catalogs of exhibs
Activities: Classes for children; lect open to public; 2.5 vis lects peryear; concerts; gallery talks; tours; sales of books, prints

SOPRON

M **SOPRONI MUZEUM,** Foter 8, Sopron, 9400 Hungary. Tel 99 311-327; Fax 99 311 347; *Dir* Dr Attila Kornyei
Library with 20,000 vols
Collections: Folk & local Baroque art

SZENTENDRE

M **FERENCZY MUZEUM,** Foter 6, PF 49 Szentendre, 2000 Hungary. Tel (26) 310244; Fax (26) 310790; Elec Mail kozmuvelodes@pmmi.hu; Internet Home Page Address: www.pmmi.hu; *Dir* Laszlo Simon, PhD; *Deputy Dir* Feno Darko, PhD
Open daily 9 AM - 5 PM; Admis fee 400 HUF; Estab 1951; Library with 22,000 vols; Average Annual Attendance: 1700
Income: supported by county govt
Library Holdings: Book Volumes; Exhibition Catalogs
Special Subjects: Archaeology, Drawings, Folk Art, Ceramics, Pottery, Sculpture, Tapestries, Graphics, Dolls, Carpets & Rugs
Collections: Paintings, sculptures, drawings; archaeological, ethnographic & local history collections; Gobelin tapestries
Exhibitions: Roman lapidarium, dolls & toy soldiers exhibition
Activities: Classes for adults, excavations in Pest County, scientific researches, temporary exhibs; concerts; lending of original art objects to fellow institutions & other museums; mus shop sells books, reproductions, stamps & dvds

ZALAEGERSZEG

M **GOCSEJI MUZEUM,** Batthyanyi U2, PO Box 176 Zalaegerszeg, 8900 Hungary. Tel (092) 311 455; *Dir* Dr Laszlo Vandor
Library with 12,000 vols
Collections: Regional paintings & sculptures

ICELAND

REYKJAVIK

M **LISTASAFN EINARS JONSSONAR,** National Einar Jonsson Art Gallery, PO Box 1051, Reykjavik, Iceland. Tel (55) 13797; Fax 562 3909; *Dir* Dr Hrafnhildur Schram
Collections: Sculpture and paintings by Einar Jonsson

M **THJODMINJASAFN,** National Museum Library, Sudurgata 41, PO Box 1489 Reykjavik, 121 Iceland; Lynghals 7, 210 Gardabaer Reykjavik, 121 Iceland. Tel 354-530-2200; Fax 354-530-2201; Internet Home Page Address: www.natmus.is; *Dir* Thor Magnusson; *Head Librn* Groa Finnsdottir
Library with 9000 vols
Collections: Archaeological & ethnological artifacts, Icelandic antiquities, portraits, folk art

INDIA

BARODA

M **BARODA MUSEUM AND PICTURE GALLERY,** Sayaji Park, Baroda, 390005 India. Tel 0265-2793801, 2793589; Fax 0265-2791959; *Dir* Dr S N Pandey
Open 10:30 AM - 5:30 PM; Estab 1894; Library with 19,000 vols
Collections: Indian archeology & art, numismatic collections; Asiatic & Egyptian Collections; Greek, Roman, European civilizations & art; European paintings

BOMBAY

M **HERAS INSTITUTE OF INDIAN HISTORY AND CULTURE,** Heras Institute Museum, St Xavier's College, 5, Mahapalika Marg Bombay, 400001 India. Tel 262-0665; *Head* Dr Aubrey Mascarenhas
Library with 30,000 vols
Collections: Indian stone sculptures, woodwork, paintings; old rare maps, books, metal artifacts, coins, ivories, manuscripts, weapons, seals & amulets

M **PRINCE OF WALES MUSEUM OF WESTERN INDIA,** 159-61 Mahatma Gandhi Rd, Fort Bombay, 400023 India. Tel 2844484; *Dir* K Desai, Dr
Library with 11,000 vols
Collections: Paintings; archaeology; natural history

CALCUTTA

M **INDIAN MUSEUM,** 27 Jawaharlal Nehru Rd, Calcutta, 700016 India. Tel 33 249 5699; Fax 33 249 5696; *Dir* S K Chakraverti
Collections: Bronzes and bronze figures, ceramic, coins, copper and stone implements of prehistoric and proto-historic origin; geology, botany and zoology collections

CHENNAI

M **GOVERNMENT MUSEUM & NATIONAL ART GALLERY,** Pantheon Rd, Egmore Chennai, 600008 India. Tel 869638; *Dir* M Raman
Collections: Ancient & modern Indian art; Buddhist sculptures; bronzes; archaeology; natural sciences collection

JUNAGADH

M **JUNAGADH MUSEUM,** Sakkar Bag, Junagadh, 362001 India. Tel 21685; *Dir* P V Dholakia
Collections: Archaeology, miniature paintings, manuscripts, sculptures, decorative & applied arts

NEW DELHI

M **CRAFTS MUSEUM,** All India Handicrafts Board, Bhairon Rd, Pragati Maidan New Delhi, 110001 India; 11458 N Laguna Dr 21W Mequon, WI 53092. Tel 337-1571; Fax 337 1515; *Dir & CEO* Bob Siegel
Collections: Indian traditional crafts, folk & tribal arts; folk crafts

M **NATIONAL GALLERY OF MODERN ART,** Jaipur House India Gate, Sher Shah Rd New Delhi, 110003 India. Tel 382835; *Dir* Dr Anis Farooqi
Collections: Indian contemporary paintings, sculptures, graphics, drawings, architecture, industrial design, prints and minor arts

M **NATIONAL MUSEUM OF INDIA,** Janpath, New Delhi, 110011 India. Tel 301 8159; Fax 301 9821; *Dir Gen* Dr R C Sharma
Library with 30,000 vols
Collections: Arabic, Indian, Persian, Sanskrit language manuscripts; Central Asian antiquities and murals; decorative arts

M **RABINDRA BHAVAN ART GALLERY,** Lalit Kala Akademi (National Academy of Art), 35 Ferozeshah Rd, New Delhi, India. Tel 91-11-3387241/42/43; Fax 91-11-3782485; Elec Mail ika@bol.net.in; Internet Home Page Address: www.lalitkala.org.in; *Chmn* Prof R B Bhaskaran; *Secy* Dr Sudhakar Sharma; *Deputy Secy* M Ramachandran
Income: Govt of India funding
Library Holdings: Book Volumes; Clipping Files; Exhibition Catalogs; Original Art Works; Pamphlets; Periodical Subscriptions; Photographs; Reels; Reproductions; Sculpture; Slides; Video Tapes
Collections: Permanent collection of graphics, paintings and sculpture
Exhibitions: Triennale India; National Exhibition of Art
Activities: Gallery talks; National Academy award; Triennale award; scholarships and fels offered; sales shop sells books, reproductions, slides

IRAN

ISFAHAN

M **ARMENIAN ALL SAVIOUR'S CATHEDRAL MUSEUM,** Julfa, PO Box 81735-115 Isfahan, Iran. Tel 243471; *Dir* Levon Minassian
Collections: 450 paintings, miniatures & tomb portraits; 700 ancient books

TEHERAN

M **TEHERAN MUSEUM OF MODERN ART,** Karegar Ave, Laleh Park, PO Box 41-3669 Teheran, Iran. *Dir* Ali Reza Semiazar
Museum maintains library
Collections: Modern Western art works

IRAQ

BAGHDAD

M **DIRECTORATE - GENERAL OF ANTIQUITIES AND HERITAGE,** Sahat Al-Risafi, Baghdad, Iraq. Tel 4165317; *Dir* Alae Al-Shibli
M **Babylon Museum,** Sahat Al-Risafi, Babylon, Iraq. Tel 4165317; *Dir* Alae Al-Shibli
Collections: Models, pictures & paintings of the remains at Babylon

M **IRAQI MUSEUM,** Salhiya Quarter, Baghdad, Iraq. Tel 36121-5; *Dir* Hana' Abdul Khaleq, Dr
Collections: Antiquities from the Stone Age to the 17th century, including Islamic objects

IRELAND

DUBLIN

M **HUGH LANE MUNICIPAL GALLERY OF MODERN ART,** Charlemont House, Parnell Square N Dublin, 1 Ireland. Tel (01) 8741 903; Fax (01) 8722 182; *Head* Ethna Waldron
Collections: Works of Irish, English & European artists; sculptures; Sir Hugh Lane collection

M **NATIONAL GALLERY OF IRELAND,** Merrion Square W, Clare St Dublin, 2 Ireland. Tel 6615133; Fax 6615372; Elec Mail artgall@eircom.net; Internet Home Page Address: nationalgallery.ie; *Dir* Raymond Keaveney
Mon - Sat 9:30 a.m. - 5:30 p.m.; Thurs 9:30 a.m. - 5:30 p.m.; Sun 12 p.m. - 5:30 p.m.; No admis fee; Estab 1854; Library with 30,000 vols, painting, sculpture, and the fine arts in Dublin; Average Annual Attendance: 800,000; Mem: The friends of the NGI
Library Holdings: Auction Catalogs; Book Volumes; Exhibition Catalogs; Original Documents; Other Holdings; Pamphlets
Collections: British, Dutch, Flemish, French, German, Italian, Irish, Russian & Spanish masters since 1250; drawings, prints, oil paintings, sculptures, watercolors; The Yeats Museum (works by Jack B. Yeats (1871 - 1957)
Activities: Classes for adults & children; family programs; worships; tours; lectrs; lectrs open to the public; gallery talks; tours; Guiness Living Dublin Award; Interpret Ireland Award; AIB Better Ireland Award; Sun Independent Business of the Month (gallery shop); mus shop sells books; magazines; reproductions; prints & slides

M **NATIONAL MUSEUM OF IRELAND,** Kildare St, Dublin, 2 Ireland. Tel 6 777 444; Fax 6 766 116; *Dir* Patrick F Wallace
Collections: Art and Industrial Division; Irish Antiquities Division; Irish Folklife Division; Natural History Division

ISRAEL

HAIFA

M **HAIFA MUSEUM OF MODERN ART,** 26 Shabbetai Levi St, Haifa, Israel. Tel (04) 855 3255; Fax (04) 855 2714; *Cur* Tal Nissim
Library with 10,000 vols
Collections: Israeli paintings, sculpture, drawings & prints; modern American, French, German & English paintings; art posters

M **HAIFA MUSEUMS NATIONAL MARITIME MUSEUM,** 26 Shabbetai Levi St, Haifa, Israel. Tel (04) 8536622; Fax (04) 8539286; Elec Mail nautic@netvision.net.il; *Chief Cur* Zemer Avshalom; *Cur* Merav Bonai; *Asst Cur* Orit Rotgaizer; *Sec* Rachel Tapiro; *Librn* Rena Mirkoff
Open Mon, Wed, Thurs 10 - 17; Tues 10 - 14, 17 - 20; Fri & Holidays 10 - 13, Sat 10 - 14; Admis Adults NIS 22, children/students/soldiers NIS 16, concessions NIS 4.00; Estab 1953; Includes Archaeological collection; Circ Reference only
Library Holdings: Book Volumes approx 5,000; Exhibition Catalogs; Maps; Original Art Works; Periodical Subscriptions 35
Collections: Ancient Haifa; ancient coins from Israel; antiquities from the excavations of Shikmona from the Bronze Age to Byzantine period; Biblical,

Cypriot and Greek pottery and sculpture; Near Eastern figurines; Ship models; Maps; Maritime artifacts and gear
Exhibitions: Pirates - the Skull & Crossbones; Maritime paintings by Moshe Rosenthalis
Publications: exhib catalogues; postcards
Activities: Classes for adults, classes for children; prog school classes; lects open to public, gallery talks, tours

M **HAIFA MUSEUMS TIKOTIN MUSEUM OF JAPANESE ART,** 89 Hanassi Ave, Haifa, 34-642 Israel. Tel (04) 8383554; Fax (04) 8379824; Elec Mail curator@tmja.org.il; Internet Home Page Address: www.haifamuseums.org.il; *Chief Cur* Dr Ilana Singer; *Asst Cur* Galit De Vries; *Secy* Dr Atalya Karni; *Youth Activity Organizer* Nirit Yardeni; *Librn* Rena Minkoff
Open Mon, Wed - Thurs 10 AM - 4 PM, Tues 4 PM - 8 PM, Fri 10 AM - 1 PM, Sat 10 AM - 3 PM; Estab May 1960
Library Holdings: Auction Catalogs; Book Volumes; Exhibition Catalogs; Periodical Subscriptions
Collections: Ceramics, folk art, drawings, metalwork, netsuke, prints, paintings
Publications: Catalogs
Activities: Classes for adults & childen; lects open to public, concerts, gallery talks, tours; mus shop sells books, reproductions, slides, posters & Japanese handicrafts

JERUSALEM

M **BEIT HA'OMANIM,** Jerusalem Artists' House, 12 Shmuel Hanagid St, Jerusalem, 94592 Israel. Tel (972-2) 6253653; Fax (972-2) 6258594; Elec Mail artists@internet-zahav.net; Internet Home Page Address: www.art.org.il; *Dir* Ruth Zadka; *Asst Cur* Shosh Auerbukh
Open Sun - Thurs 10 AM - 1 PM, 4 - 7 PM, Fri 10 AM - 1 PM, Sat 11 AM - 2 PM; No admis fee
Collections: Artwork of Israeli & Jerusalemite artists
Exhibitions: International Exhibitions
Publications: Research catalogues following exhibitions
Activities: Lect open to public; gallery shop sells original art

M **ISRAEL MUSEUM,** PO Box 71117, Jerusalem, 91 710 Israel. Tel (02) 670-8811; Internet Home Page Address: www.imj.org.il; *Dir* Mr James Snyder; *Chief Cur at large* Yigal Zalmona; *Spokesperson* Rachel Schechter; *Head of Mktg* Dor Lin
open Mon, Wed & Sat 10 AM - 4 PM, Tues 4 PM - 9 PM, Thurs 10 AM - 9 PM; clo Sun; Estab 1965
Collections: Consists of 6 collections: Jewish ceremonial art, ethnological objects, paintings, sculptures, drawings & prints
Publications: Catalogues, IM Journal: Mishkafayim, art quarterly
M **Billy Rose Art Garden,** PO Box 71117, Jerusalem, 91 710 Israel. Tel 2-670881; Fax 2-5631833; *Cur* Dr Martin Weyl
Collections: Modern European, American & Israeli sculpture & Reuven Lipchitz collection of Jacques Lipchitz's bronze sketches
M **Bronfman Biblical and Archaeological Museum,** PO Box 71117, Jerusalem, 91 710 Israel. Tel 972-2-6708812; Fax 972-2-6708906; Elec Mail silvario@imj.org.il; Internet Home Page Address: www.imj.org.il; *Chief Cur* Dr Silvia Rozenburg
Mon - Wed 10 AM - 4 PM; Thurs 10 AM - 9 PM, Fri and Holiday Eves 10 AM - 2 PM Tues 4 PM - 9 PM Museum, 10 AM - 9 PM Shrine; Adult $8; Child $4; Estab 1965; Mem: 10,900 local mems and patrons
Collections: Collection of archaeology of Israel from earliest times to Islamic & Crusader periods; material found in excavations since 1948
Activities: Classes for children
L **Library,** PO Box 71117, Jerusalem, 91 710 Israel. Tel 02-6771306, 02 6708886; Fax 02-6771375; *Nina Abrams Chief Librn* Yaffa Weingarten; *Sr Librn* Yaffa Szereszewski; *Librn* Jana Bloch
Open Mon, Wed, Thurs 10 AM - 4 PM, Tues 4 AM - 9 PM; Admis fee; Estab 1965; Serves mus staff; mus mem, teachers, students, scholars & visitors from all parts of the country; Circ No circ
Library Holdings: Auction Catalogs; Book Volumes 65,000; Exhibition Catalogs; Periodical Subscriptions 150 current, 250 titles
Collections: European, Modern & Contemporary art; Israeli art & art history, archaeology, Judaica, Jewish Ethnography
Activities: Classes for adults
L **Shrine of the Book,** PO Box 71117, Jerusalem, 91 710 Israel. Tel 26708811; Fax 25631833; *Cur* Dr Adolfo Roitman
D Samuel & Jeanne H Gottesman Center for Biblical MSS
Collections: Houses the Dead Sea Scrolls (discovered in Qumran) & manuscripts from adjacent sites on western shore of the Dead Sea, Masada & Nahal Hever

M **THE ROCKEFELLER MUSEUM,** Rockefeller Bldg, Sultan St, c/o Israel Mus PO Box 71117 Jerusalem, 91710 Israel. Tel (2) 6282251; Fax (2) 6271926; Elec Mail sylviaro@imj.org.il; Internet Home Page Address: http://www.imj.org.il; *Cur (Acting)* Dr Silvia Rozenberg
Open Sun, Mon, Wed & Thurs 10 AM - 3 PM, Sat 10 AM - 2 PM; No admis fee (could change in future); Estab 1938; Archaeological finds from Prehistory to Ottoman Empire
Collections: Archaeology of the Land of Israel; Islamic period; Prehistory to Ottoman periods - all periods covering 2 million years
Exhibitions: Image and Artifact: Treasures of the Rockefeller Museum and Aerial Photographs
Publications: Image and Artifact: Treasures of the Rockefeller Museum with Aerial Photographs by Duby Tal and Mata Haramari, 2000

POST KEFAR-MENAHEM

M **SHEPHELA MUSEUM,** Kibbutz Kefar-Menahem, Post Kefar-Menahem, 79875 Israel. Tel (08) 850 1827; Fax 08 8508486; Elec Mail museum_hash@kfar-menachem.org.11; Internet Home Page Address: www.touryoav.org.11/museums; *Dir* Ora Dvir; *Cur* Lea Fait; *Cur* Moshe Saidi
Open daily 8:30 AM - 12:30 PM; Sat 11 AM - 4 PM; Admis $2.50; Estab 1975; archaeology; Average Annual Attendance: 10,000

Income: $100,000
Special Subjects: Historical Material, Painting-Israeli
Collections: Collections of fine arts, children's art & antiquities; New Hebrew Settlement (1930s)
Exhibitions: 4 art exhibitions per year of Israeli contemp art
Activities: Educ programs for classes and kindergartens in the various exhibitions

TEL AVIV

M **ERETZ-ISRAEL MUSEUM,** 2 Chaim Levanon St, Tel Aviv, 61 170 Israel; PO Box 17068, Ramat Aviv Tel Aviv, 61 170 Israel. Tel (972) 3 6415244; Fax (972) 36412408; Internet Home Page Address: www.eimuseun.co.il
Open Sun - Thurs 9 AM - 5 PM
Collections: Consists of 15 museums & collections; ancient glass; historical documents of Tel Aviv-Yafo; Jewish ritual & secular art objects; ceramics, coins, prehistoric finds, scientific & technical apparatus, traditional work tools & methods
M **Ceramics Museum,** PO Box 17068, Ramat Aviv Tel Aviv, 61 170 Israel. Tel 6415244; Fax 6412408; *Cur* Dr Ir It Ziffer
Openn Sun - Thurs 9 AM to 3 PM; Admis adults 33, students 25, retired seniors 17; Estab 1958
Collections: Pottery throughout history; Reconstruction of a Biblical Dwelling from the Time of the Monarchy
Activities: Educ program; classes for children; museum shop sells books, original art
M **Museum of Antiquities of Tel-Aviv-Jaffa,** 10 Mifratz Shlomo St, Jaffa, 680 38 Israel; PO Box 8406, Jaffa, 61083 Israel. Tel 972 3 6825375; Fax 972 3 6813624; Internet Home Page Address: www.eimuseum.co.il; *Dir* Dr Tzvi Shacham
Open Sun - Thurs 9 AM - 1 PM ; Admis fee Adults 10 NIS, students 5 NIS
Special Subjects: Archaeology, Glass, Ceramics, Coins & Medals
Collections: Archaeological findings from Tel Aviv-Yafo area, covering Neolithic to Byzantine periods
M **Museum of Ethnography and Folklore,** PO Box 17068 , Ramat Aviv Tel Aviv, 61 170 Israel. *Dir* D Davidowitz
Collections: Jewish popular art & costumes

M **TEL AVIV MUSEUM OF ART,** 27 Shaul Hamelech Blvd, POB 33288 Tel Aviv, 61332 Israel. Tel (03) 607 7020; Fax (03) 6958099; Internet Home Page Address: www.tamuseum.com; *Head* Prof Mordechai Omer
Open Mon & Wed 10 AM - 4 PM, Tues & Thurs 10 AM - 10 PM; Fri 10 AM - 2 PM; Sat 10 AM - 4 PM; cl Sun; Library with 50,000 vols
Collections: Works from 17th century to present; Israeli art
Activities: Classes for adults & children; lectrs open to the public, concerts, gallery talks, tours; mus shop sells books, magazines & reproductions

ITALY

BARI

M **PINACOTECA PROVINCIALE,** Via Spalato 19, Bari, 70121 Italy. Tel (080) 5412421/22/25; Fax 080/5583401; Elec Mail pinacotecaprov.bari@tin.it; *Dir* Dr Clara Gelao; Dr Christine Farese Sperken; Anna Martucci, Acad Diploma in Fine Arts
Open Tues - Sat 9:30 AM - 1 PM, Sun 9 AM - 1 PM, cl Mon; Admis adult 2.58 pounds, student 0.52 pounds; Estab 1928; The gallery is located in the Palazzo della Privince, a building constructed in the 1930s
Special Subjects: Drawings, Etchings & Engravings, Landscapes, Photography, Sculpture, Watercolors, Bronzes, Religious Art, Ceramics, Folk Art, Pottery, Painting-European, Portraits, Furniture, Baroque Art, Renaissance Art, Medieval Art, Painting-Italian
Collections: Apulian, Venetian and Neapolitan paintings and sculpture from 11th - 19th century; Grieco collection-50 paintings from Fattom to Morandi; 23 paintings from the Banco di Napoli collection
Publications: Catalogues of all the collections
Activities: Classes for adults & children; concerts; gallery talks; museum shop sells books, reproductions

BERGAMO

M **GALLERIA DELL' ACCADEMIA CARRARA,** Piazza Giacomo Carrara 82/A, Bergamo, 24100 Italy. Tel (035) 399643; Fax (035) 224510; *Dir* Dr F Rossi
Collections: Paintings by: Bellini, Raffaello, Pisanello, Mantegna, Botticelli, Beato Angelico, Previtali, Tiepolo, Durer, Brueghel, Van Dyck

BOLOGNA

M **PINACOTECA NAZIONALE,** Via Belle Arti 56, Bologna, 40126 Italy. Tel (051) 243222; Fax 051 251368; Elec Mail sbas-bo@iperbolt.bologna.it; *Dir* Dr Marzia Faictti; *Consultant to Pub* Carla Pirani; *Consultant to Pub* Luigi Chieppa
Open Mon - Fri 9 AM - 1:30 PM; Estab 1882; Gallery contains dept of prints and drawings; Average Annual Attendance: 150,000
Library Holdings: Book Volumes; CD-ROMs; Cards; Exhibition Catalogs; Photographs; Slides
Collections: 14th - 18th centuries Bolognese paintings; German & Italian engravings
Activities: Classes for adults & children; concerts; gallery talks; tours; lending or original objects of art to museums in different countries; museum shop sells books, reproductions

FLORENCE

M GALLERIA D'ARTE MODERNA DI PALAZZO PITTI, Piazza Pitti 1, Florence, 50125 Italy. Tel (055) 238 8601; *Dir* Carlo Sisi
Collections: Paintings and sculptures of the 19th and 20th centuries

M GALLERIA DEGLI UFFIZI, Uffizi Gallery, Piazzale degli Uffizi, Florence, 50122 Italy. Tel (055) 238 8651; Fax (055) 238 8694; Elec Mail direzione.uffiz@tin.it; Internet Home Page Address: HTTP://musa.uffizi.firenze.it; *Dir* Annamaria Petrioli Tofani; *Dir Dept Dal Duecento Al Primo Cinsciemento* Alessandro Cecchi; *Dir Dept Dal Secondo Rinas Al Seicento & l' arte Contemporanca* Antonio Natali; *Dir Dip dal Settecento All' Ottocenty* Carlo Sisi; *Dir Dip Anyichita Classica* Antonella Romaldi; *Dir Architettura Eprogettazione* Antonio Godoci
8 AM to 6:30 PM; Vedi depliant; Vedi depliant
Collections: Florentine Renaissance painting
Activities: Classes for children; sells books, magazines, reproductions, prints & slides

M GALLERIA DELL' ACCADEMIA, Via Ricasoli 58-60, Florence, 50122 Italy. Tel (055) 2388609; Fax (055) 2388764; Elec Mail GalleriaAccademia@polomuseale.firenze.it; Internet Home Page Address: www.polomuseale.firenze.it; *Dir* Franca Falletti; *Vice Dir* Angelo Tartuferi
Open Tues - Sun 8:15 AM - 6:50 PM, cl Mon; Admis 6.50 euro; Estab 1784; Gallery includes 2 floors, 2 bookshops; Average Annual Attendance: 1,000,000
Collections: Michelangelo's statues in Florence & works of art of 13th - 19th centuries masters, mostly Tuscan; 19th Century plaster models, 18th-19th Century Russian icons, ancient musical instruments
Activities: Classes for children; concerts; Mus shop sells books, reproductions, prints, slides

M GALLERIA PALATINA, Palazzo Pitti, Piazza Pitti Florence, 50125 Italy. Tel (055) 238-8611; *Dir* Dr Marco Chiarini
Collections: Paintings from 16th and 17th centuries

M MUSEO DEGLI ARGENTI E MUSEO DELLE PORCELLANE, Palazzo Pitti, Florence, 50125 Italy. Tel 055/23-88-709; 055/23-88-761; Fax 055/23-88-710; Elec Mail argenti@sbas.firenze.it; Internet Home Page Address: www.sbas.firenze.it; *Dir* Marilena Mosco; *Vice Dir* Ornella Casazza
Open Mar 8:15 AM - 4:30 PM, Apr - May 8:15 AM - 5:30 PM, June - August 8:15 AM - 6:30 PM; Admis adult 4 Euro, children under 18 & seniors over 65 free; Gallery is a treasury of rare quality that houses a collection belonging to the Medici, Lorena and Savoia. It is located in the historical Palazzo Pimi in Florence Sec XVI
Library Holdings: Auction Catalogs; Book Volumes; CD-ROMs; Cards; Cassettes; Kodachrome Transparencies; Maps
Collections: Summer state apartments of the Medici Grand Dukes; gold, silver, enamel, objets d'art, hardstones, ivory, amber, cameos and jewels, principally from the 15th to the 18th centuries; period costumes exhibited in Galleria del Costume on premises
Activities: Mus shop sells books, reproductions, prints, slides

M MUSEO DELLA CASA BUONARROTI, Via Ghibellina 70, Florence, 50122 Italy. Tel (055) 241-752; Fax (055) 241-698; Elec Mail ente@casabuonarroti.it; Internet Home Page Address: www.casabuonarroti.it; *Dir* Pina Ragionieri; *Pres* Luciano Besti
Open 9:30 AM - 2 PM tutti i giorni escluso marledi; Admis intero 6.50 Euros, ridotes 4 Euros
Collections: Works by Michelangelo & others; items from the Buonarroti family collections
Exhibitions: Daniele de Volterro amios di Michelangelo
Activities: Mus shop sells books, reproductions, prints, slides

M MUSEO DI SAN MARCO, (Museo di San Marco o Dell' Angelico) Piazza San Marco 3, Florence, 50121 Italy. Tel (055) 2388608; Fax (055) 2388704; Elec Mail museosanmarco@polomuseale.firenze.it; *Dir* Magnolia Scudieri
Open Mon - Fri 8:15 AM - 1:50 PM, Sat 8:15 AM - 6:50 PM, Sun 8:15 AM - 7 PM, cl Jan 10, May 10 & Dec 25; Admis 4Euro, free for Italian citizens under the 18 yr & over 65 yr; Estab 1869
Collections: Fra Angelico frescoes, paintings & panels

GENOA

M SERVIZIO BENI CULTURALI MUSEO DI ARTE ORIENTALE EDOARDO CHIOSSONE, Via Garibaldi 18, Genoa, 16124 Italy. Tel 010-2476368; *Dir* Laura Tagliaferro
M Galleria di Arte Moderna con Opere Della Collezione Wolfson, Villa Serra, Via Capolungo 3, Nervi, Genoa, 16167 Italy; Largo Pertine 4, Genova, I - 16121 Italy. Tel (010) 3726025; Tel (010) 5574739; Fax (010) 5574701; Elec Mail gam@comune.genova.it; Internet Home Page Address: www.gamgenova.it; *Cur* Maria Flora Giubilei
Open Tues - Sun 10 AM - 7 PM, cl Mon ; A coll of modern art
Library Holdings: Book Volumes; Cards; Exhibition Catalogs; Memorabilia
Collections: 19th & 20th centuries paintings
Publications: General Catalogue & a Little Guide both in Italian & English
Activities: Classes for adults & children; docent training; lect for mem only; concerts; gallery talks; conferences; musical events; theatral events; lending of original objects of art to other museums & pub scientfic institutions for temporary exhib; organize traveling exhib to other museums; mus shop sells books
M Museo d'Arte Orientale Edoardo Chiossone, Viletta di Negro, Piazzale Mazzini 4N Genoa, 16122 Italy. Tel (010) 542285; Fax 010 564567; Elec Mail museicinci@comune.genova.it; Internet Home Page Address: www.comune.genova.it/twismo/musei/chiossone/welcome.htm; *Cur* Donatella Failla, Dr

Open to pub Tues - Fri 9:00 - 13:00, Sat & Sun 10:00 - 19:00, cl Mon; E 3.10; Estab 1971
Collections: Japanese works of art from 11th to 19th century (about 20,000 pieces) collected in Japan during the Meiji period by Edoardo Chissone
Exhibitions: Kodomono Hi; Tanabata Matsuri
Activities: Concerts, tours; mus shop sells books

M Museo di Palazzo Rosso, Via Garibaldi 18, Genoa, 16124 Italy. Tel (010) 2476351; Fax (010) 2425357; Elec Mail museicinci@comune.Genova.it; *Cur* Dr Piero Boccardo
Collections: 10,000 drawings of Italian schools and 6,000 fruits

M Museo Giannettino Luxoro, Via Aurelia 29, Nervi, Genoa, 16167 Italy. Tel 322673
Collections: Flemish & Genoese 17th & 18th centuries paintings, ceramics

M Raccolte Frugone in Villa Grimaldi, Villa Grimaldi, Via Capolungo 9, Nervi, Genoa, 16167 Italy. Tel (010) 322 396; Fax 010 5574701; Elec Mail museicinci@comune.genova.it; Internet Home Page Address: www.comune.genova.it/tarismo/musei/frugone/welcome.htm; *Cur* Dr Maria Flora Giubilei
Open Tues - Fri 9:00 - 19:00, Sat & Sun 10:00 - 19:00, cl Mon
Collections: 19th & 20th centuries Italian artists; Sculpture and paintings by 19th and 20th century Italian artists

LUCCA

M MUSEO E PINACOTECA NAZIONALE DI PALAZZO MANSI, National Museum and Picture Gallery of the Palazzo Mansi, Via Galli Tassi 43, Lucca, 55100 Italy. Tel (0583) 55570; *Dir* Dr Maria Teresa Filieri
Collections: Works of Tuscan, Venetian, French & Flemish Schools; paintings by such masters as Titian & Tintoretto

M SOPRIUTEUDEUZA DI PISA E MASSA CARRARA, Museo Nazionale Di Villa Guinigi, Villa Guinigi, Via della Quarquonia Lucca, 55100 Italy. Tel (0583) 496033; Fax (0583) 496033; Elec Mail luccamuseinazionali@libero.it; *Dir* Maria Teresa Filieri; *Dir Labor Restauro* Antonia d'Andello; *Dir Sezione Architectomica* Glauco Borella
Open Tues - Sat 8:30 AM - 7:30 PM, Sun 8:30 AM - 1:30 PM; Admis 4 euro; Estab 1924; 15th century historical bldg
Income: Ministero Beui Culturali
Collections: Roman and late Roman sculptures and mosaics; Romanesque, Gothic and Renaissance Sculpture; paintings from 12th to 18th century; Ancient coins, medals, Italian ceramics, & silverware
Publications: Matteo Civitali
Activities: Classes for adults & children; docent training; lectrs open to the public; 350 vis lectrs per year; concerts

MANTUA

M GALLERIA E MUSEO DI PALAZZO DUCALE, Gallery and Museum of the Palazzo Ducale, Piazza Sordello 39, Mantua, 46100 Italy. Tel (0376) 352111; Fax (0376) 366274; *Dir* Dr Aldo Cicinelli
Collections: Classical Antiquities & Sculpture; picture gallery

MILAN

M DIREZIONE CIVICHE RACCOLTE D'ARTE APPLICATA ED INCISIONI, Museo DeGli Strumenti Musicali, Castello Sforzesco, Milan, 20121 Italy. Tel 02-884 63730, 63742; Fax 02-884-63818; Internet Home Page Address: www.comune.milano.it/craai; *Dir* Claudio Salsi; *Cur* Dr Francesca Tasso
Open Tues - Sun 9 AM - 5:30 PM; Admis 3 euro, reduced 1,50 euro; Musical instruments
Collections: Musical instruments from XVI-XX century
Activities: Classes for adults & children; concerts; mus shop sells books & reproductions
M Civiche Raccolte di Arte Applicata ed lucisiani, Castello Sforzesco, Milan, 20121 Italy. Tel Fax 0039 02 8693071; *Dir* Dr Claudio Salsi; *Cur Mus Applied Arts* Dr Francesca Tasso
Open Tues - Sun 9:30 AM - 5 PM, cl Mon
Collections: Armor, bronzes, ceramics, coins, ironworks, ivories, porcelains, sculpture, textiles
M Raccolta delle Stampe Achille Bertarelli, Castello Sforzesco, Milan, 20121 Italy. Tel 0039 02 884-63835; Fax 0039-02-884-63812; Elec Mail craai.bertarelli@comune.milano.it; Internet Home Page Address: www.comune.milano.it/craai; *Dir* Dr Claudio Salsi; *Cur* Giovanna Mori
Open Mon - Fri 9 AM - 2 PM; No admis fee; Di Stampe collection by appointmet
Activities: Conferences; Mus shop sells books
M Civiche Raccolte Archeologiche e Numismatiche, Via B Luini 2, Milan, 20123 Italy. Tel 02 805-3972; Fax 02 86452796; *Dir* Dr Ermanno Arslan
Collections: Ancient Egyptian, antique & modern coins; Etruscan, Greek & Roman Collections
M Museo d'Arte Applicata, Castello Sforzesco, Milan, 20121 Italy. Tel 02-884-63730, 63742; Fax 02-884-63818; Elec Mail craai.applicata@comune.milano.it; Internet Home Page Address: www.comune.milano.it/craai; *Dir* Dr Claudio Salsi; *Cur* Dr Francesca Tasso
Open Tues - Sun 9:30 AM - 5:30 PM; Admis fee 3 euro, reduced 1,50 euro
Collections: Furniture, Lignee sculpture, armi, arazzi, glasses, maioliche, porcelain, bronzes, oreficerie, ivory, irons
Activities: Conferences; gallery talks; mus shop sells books & reproductions
M Galleria d'Arte Moderna, Villa Reale, Via Palestro 16 Milan, 20121 Italy. Tel 02-86463054; Fax 02 864-63054; *Dir* Dr Maria Teresa Fiorio
Collections: Painting & sculpture from Neo-Classical period to present day; includes the Grassi Collection & Museo Marino Marini (approx 200 sculptures, portraits, paintings, drawings & etchings by Marini)

M **MUSEO POLDI PEZZOLI,** Via A Manzoni 12, Milan, 20121 Italy. Tel (02) 796-334; Fax (02) 869-0788; *Dir* Dr Alessandra Mottola Molfino
Collections: Paintings from 14th - 18th centuries; armor, tapestries, rugs, jewelry, porcelain, glass, textiles, furniture, clocks and watches

M **PINACOTECA AMBROSIANA,** Piazza Pio XI, 2, Milan, 20123 Italy. Tel (02) 806-921; Fax (02) 806-92210; *Dir* Dr Gianfranco Ravasi
Collections: Botticelli, Caravaggio, Luini, Raphael, Titian; drawings, miniatures, ceramics and enamels

M **PINACOTECA DI BRERA,** Via Brera 28, Milan, 20121 Italy. Tel 722631; Fax 72001140; *Dir* Dr Luisa Arrigoni
Open Tues - Sun 8:30 AM - 7:30 PM, cl Mon; The gallery is located in the 17th century Palazz di Brera
Collections: Pictures of all schools, especially Lombard and Venetian; paintings by Mantegna, Bellini, Crivelli, Lotto, Titian, Veronese, Tintoretto, Tiepolo, Foppa, Bergognone, Luini, Piero della Francesca, Bramante, Raphael, Caravaggio, Rembrandt, Van Dyck, Rubens; also Italian 20th century works
Activities: Mus shop sells books, original art, slides

MODENA

M **GALLERIA, MEDAGLIERE E LAPIDARIO ESTENSE,** Este Gallery, Museum and Coin Collection, Palazzo dei Musei, Piazza S Agostino 109 Modena, 41100 Italy. Tel 059-22-21-45; Fax 059-23-01-96; Fax 059-23-01-96; *Dir* Jadranka Bentini
Collections: Bronzes, coins, drawings, medals, minor arts, paintings, prints & sculptures, most from the Este family

NAPLES

M **MUSEO CIVICO GAETANO FILANGIERI,** Via Duomo 288, Naples, 80138 Italy. Tel (081) 203175; *Dir* Antonio Buccino Grimaldi
Collections: Paintings, furniture, archives, photographs

M **MUSEO E GALLERIE NAZIONALI DI CAPODIMONTE,** Palazzodi Capodimonte, Naples, 80100 Italy. Tel (081) 7441307; *Dir* Dr Nicola Spinosa
Library with 50,000 vols
Collections: Paintings from 13th to 18th centuries; paintings and sculptures of 19th century; arms and armor; medals and bronzes of the Renaissance; porcelain

M **MUSEO NAZIONALE DI SAN MARTINO,** National Museum of San Martino, Largo San Martino 5, Naples, 80129 Italy. Tel 081-578 1769; *Dir* Dr Ossa Rossana Muzii
Collections: 16th - 18th century pictures & paintings; 13th - 19th century sculpture, majolicas & porcelains; section of modern prints, paintings & engravings; Neapolitan historical collection

PADUA

M **MUSEI CIVICI DI PADOVA,** Musei Civici Agli Eremitani (Civic Museum), Piazza Eremitani 8, Padua, 35121 Italy. Tel 049-8204550/51; Fax 049-8204566; Elec Mail musei.comune@padovanet.it; Internet Home Page Address: www.padovanet.it/museicivici; *Dir* Davide Banzato; *Conservatore Archeological* M. Girolamo Zampieri; *Conservatore Art Mus* Franca Pellegrini; *Conservatore Numismatic* M. Bruno Callegher; *V. Conservatore Biblioteca* Giorgio Smojver
Open Feb - Oct 9 AM - 7 PM, Nov - Jan 9 AM - 6 PM; Admis 12,000 Lire regular, 9,000 Lire reduced with reservation for the Scrovegni Ch.; Estab 1825
Library Holdings: Book Volumes; Exhibition Catalogs
Collections: Archaeological Museum; Art Gallery - bronzes, ceramics, industrial arts, painting, sculpture; Bottacin Museum - Greco-Roman, Italian, Paduan, Venetian, Napoleonic coins and medals; Renaissance gallery; Medieval and Modern Art; Archeological Collection; Numismatic Collection
Publications: Bollettino del Museo Civico
Activities: Mus shop sells books, reproductions, prints, slides

PARMA

M **GALLERIA NAZIONALE,** Palazzo Pilotta 15, Parma, 43100 Italy. Tel (0521) 233309; Fax (0521) 206336; *Dir* Lucia Fornari Schianchi
Collections: Paintings from 13th to 19th centuries, including works by Correggio, Parmigianino, Cima, El Greco, Piazzetta, Tiepolo, Holbein, Van Dyck, Mor, Nattier & several painters of the school of Parma; modern art

PERUGIA

M **GALLERIA NAZIONALE DELL'UMBRIA,** Umbrian National Gallery, Corso Vannucci, Palazzo dei Priori Perugia, 06100 Italy. Tel 075-574-1257; Fax 075-572-0316; *Dir* Vittoria Garibaldi
Collections: Jewels; paintings from the Umbrian School from the 13th - 18th centuries; 13th, 14th and 15th century sculpture

PISA

M **MUSEO NAZIONALE DI SAN MATTEO,** Convento di San Matteo, Lungarno Mediceo Pisa, 56100 Italy. Tel (050) 23750; *Dir* Dr Mariagiulia Burresi
Collections: Sculptures by the Pisanos and their school; important collection of the Pisan school of the 13th and 14th centuries, and paintings of the 15th, 16th, and 17th centuries; ceramics; important collection of coins and medals

ROME

M **GALLERIA BORGHESE,** Borghese Gallery, Villa Borghese, Rome, 00197 Italy. Tel 06-85-85-77; *Dir* Dr Alba Costamagna
Collections: Baroque & Classical; 580 paintings about XV-XVII-XVIII, 450 sculptures

M **GALLERIA DORIA PAMPHILJ,** Piazza del Collegio Romano 2, Rome, 00186 Italy; Piazza Grazioli 5, Rome, 00186 Italy. Tel (06) 679-73-23; Fax (06) 6780939; Elec Mail arti.rm@doniapamphilj.it; Internet Home Page Address: www.doriapomphilj.it; *Dir* Jonathan Doria Pamphilj; *Scientific Cur* Andrea G de Marchi
Open Sun - Wed & Fri - Sat 10 AM - 5 PM; Admis 14,000 lire, reduced 11,000 lire
Special Subjects: Porcelain, Pottery, Bronzes, Painting-European, Painting-Flemish, Painting-Italian, Antiquities-Roman, Bookplates & Bindings
Collections: Paintings by Caravaggio, Carracci, Correggio, Filippo Lippi, Lorrain, del Piombo, Titian, Velazquez
Activities: Mus shop sells books, prints, slides, jewelry & other items

M **GALLERIA NAZIONALE PALAZZO BERBERNI,** National Gallery of Rome, Via Quattro Fontane 13, Rome, 00184 Italy. Tel (06) 4824184; *Dir* Dr Sivigliano Alloisi
Collections: Italian & European paintings from 12th - 18th century; Baroque architecture

M **ISTITUTO NAZIONALE PER LA GRAFICA,** National Institute for Graphic Arts, Calcografia, Via della Stamperia 6 Rome, 00187 Italy. Tel (06) 699 801; Fax (06) 699 21454; Internet Home Page Address: www.grafica.arti.beniculturali.it; *Dir* Doff Serenita Papaldo
Collections: Italian & foreign prints & drawings from the 14th century to the present

M **MUSEI CAPITOLINI,** Via Delle Trepice 1, Rome, 00186 Italy. Tel (06) 6710 2475; Fax (06) 67 85844; Elec Mail musei.orteoutica@couruue.coua.it; *Dir* Anna Mura Sommella
Open 9:30 AM - 7 PM, Sabato 9:30 AM - 11 PM
Library Holdings: Auction Catalogs; Book Volumes; CD-ROMs; Cards; Exhibition Catalogs; Reproductions
Special Subjects: Ceramics, Furniture, Sculpture, Bronzes, Archaeology, Decorative Arts, Painting-European, Porcelain, Carpets & Rugs, Coins & Medals, Tapestries, Baroque Art, Medieval Art, Painting-Italian, Antiquities-Egyptian, Antiquities-Greek, Mosaics, Antiquities-Etruscan
Collections: Ancient sculptures, Art History
Publications: Guide Musei Capitoum, Electa, 2000
Activities: Visiteguidate per adulti E nagazu; 5 vis lect per yr; concerts; lending of original objects of art to international exhibitions; museum shop sells books, postcards, reproductions

M **MUSEO NAZIONALE ROMANO,** National Museum of Rome, Piazza dei Cinquecento 79, Rome, 00185 Italy. Tel 06-48 3617; Fax 06-48 14125; *Dir* Prof Adriano La Regina
Collections: Archaeological collection; Roman bronzes and sculpture; numismatics

ROVIGO

M **PINACOTECA DELL'ACADEMIA DEI CONCORDI,** Piazza V Emanuele II 14, Rovigo, 45100 Italy. Tel (0425) 21654; Fax (0425) 27 993
Collections: Venetian paintings from the 14th to the 18th century

SASSARI

M **MUSEO NAZIONALE G A SANNA,** G A Sanna National Museum, Via Roma 64, Sassari, 07100 Italy. Tel 272-203; *Dir* Dr F Lo Schiavo
Collections: Archeological Collections; Picture Gallery with Medieval and Modern Art; Collection of Sardinian Ethnography

TURIN

M **ARMERIA REALE,** Royal Armory, Piazza Castello 191, Turin, 10122 Italy. Tel (011) 543889; *Dir* Paolo Venturoli
Collections: Archaeological Arms; Arms and Armours from 13th - 18th Century; Arms of the 19th and 20th Century; Oriental Arms; equestrian arms; engravings of Monaco de Baviera School

M **GALLERIA SABAUDA,** Via Accademia delle Scienze 6, Turin, 10123 Italy. Tel 56 41 755; Fax 54 95 47; *Dir* Paola Astrua
Library with 100 vols
Collections: Flemish Masters; French Masters; Italian Masters; Dutch & early Italian collections; Piedmontese Masters; furniture, sculpture, jewelry

M **MUSEI CIVICI DI TORINO,** Galleria d'Arte Moderna e Contemporanea, Via Magenta 31, Turin, 10128 Italy. Tel (011) 4429518; Fax (011) 4429550; Elec Mail gam@comune.torino.it; Internet Home Page Address: www.gamtori.it; *Dir* Pier Giovanni Castagnoli; *Pres* Giovanna Cattaneo Incisa; *Vice Dir* Riccardo Passoni; *Conservatore* Virginia Bertone
Open 9 AM - 7 PM, cl Mon; Admis 5.50 Euro, 3 Euro reduction, 6.50 Europ special; Estab 1860; Library with more than 90,000 vols
Library Holdings: Auction Catalogs; Book Volumes; CD-ROMs; Exhibition Catalogs; Framed Reproductions; Kodachrome Transparencies; Manuscripts; Maps; Original Documents; Pamphlets; Periodical Subscriptions; Prints; Reproductions; Sculpture; Slides; Video Tapes

Collections: Antique & modern art; paintings; sculpture; installations from 1800 - 1900 & contemporary art
Publications: Catalogs for each exhibition
Activities: Classes for children; museum shop sells books, magazines, photographic archive

VATICAN CITY

M **MONUMENTI, MUSEI E GALLERIE PONTIFICIE,** Vatican Museums and Galleries, Vatican City, 00120 Italy. Tel (06) 69883333; *Acting Dir Gen* Dr Francesco Buranelli; *Secy* Dr Edith Cicerchia; *Adminr* Dr Francesco Riccardi; *Head of Scientific Research Cabinet* Dr Nazzareno Gabrielli; *Chief Paintings Restorer* Maurizio De Luca; *Cur Photographic Archive* Dr Guido Comini; *Press Ofc* Dr Lucina Vattuone; *Press Ofc* Dr Cristina Gennaccari
Open from Jan 8 - Mar 3 Mon - Fri 8:45 AM - 1:45 PM (last entry 12:30 PM), from Mar 5 - Nov 2 Mon - Fri 8:45 AM - 4:45 PM (last entry 3:30 PM), from Nov 3 - Dec 31 Mon - Fri 8:45 AM - 1:45 PM (last entry 12:30 PM), Sat and last Sun of each month (except holidays) 8:45 AM -1:45 PM (last entry 12:30 PM); cl Jan 1 & 6, Feb 11, Mar 19, Apr 15 & 16, May 1 & 24, June 14 & 29, Aug 15 & 16, Nov 1, Dec 8, 25 & 26; Admis Lit 18.000, Eu 9,30; reduced fee for pilgrimages and sch groups upon request Lit 12.000, Eu 6,20; free last Sun of each month and Sept 27; Estab 1506 by Pope Julius II
Collections: Twelve museum sections with Byzantine, medieval & modern art; classical sculpture; liturgical art; minor arts
Publications: For all except Missionary Museum: Bollettino dei Monumenti, Musei, Gallerie Pontificie

M **Museo Pio Clementino,** Citta del Vaticano, Vatican City, 00120 Italy. Tel (06) 6988-3333; Fax (06) 6988-5061; *Cur* Paolo Liverani
Founded by Pope Clement XIV (1770-74) & enlarged by his successor, Pius VI; exhibits include the Apollo of Belvedere, the Apoxyomenos by Lysippus, the Laocoon Group, the Meleager of Skopas, the Apollo Sauroktonous by Praxiteles

M **Museo Sacro,** Citta del Vaticano, Vatican City, 00120 Italy. Tel (06) 6988-3333; Fax (06) 6988-5061; *Cur* Dr Giovanni Morello
Founded in 1756 by Pope Benedict XIV; administered by the Apostolic Vatican Library
Collections: Objects of liturgical art, historical relics & curios from the Lateran, objects of palaeolithic, medieval & Renaissance minor arts, paintings of the Roman era

M **Museo Profano,** Citta del Vaticano, Vatican City, 00120 Italy. Tel 06-6988-3333; Fax 06-6988-5061; *Cur* Dr Giovanni Morello
Founded in 1767 by Pope Clement XIII; administered by the Vatican Apostolic Library
Collections: Bronze sculpture & minor art of the classical era

M **Museo Chiaramonti e Braccio Nuovo,** Citta del Vaticano, Vatican City, 00120 Italy. Tel 06-6988-3333; Fax 06-6988-5061; *Cur* Paolo Liverani
Founded by Pope Pius VII at the beginning of the 19th century, to house the many new findings excavated in that period
Collections: Statues of the Nile, of Demosthenes & of the Augustus of Prima Porta

M **Museo Gregoriano Etrusco,** Citta del Vaticano, Vatican City, 00120 Italy. Tel 06-6988-3333; Fax 06-6988-5061; *Cur* Maurizio Sannibale
Founded by Pope Gregory XVI in 1837
Collections: Objects from the Tomba Regolini Galassi of Cerveteri, the bronzes, terracottas & jewelry, & Greek vases from Etruscan tombs

M **Museo Gregoriano Egizio,** Citta del Vaticano, Vatican City, 00120 Italy. Tel 06-6988-3333; Fax 06-6988-5061; *Consultant* Prof Jean-Claude Grenier
Inaugurated by Pope Gregory XVI in 1839
Collections: Egyptian papyri, mummies, sarcophagi & statues, including statue of Queen Tuia (1300 BC)

M **Museo Gregoriano Profano,** Citta del Vaticano, Vatican City, 00120 Italy. Tel 06-6988-3333; Fax 06-6988-5061; *Cur* Paolo Liverani
Founded by Gregory XVI in 1844 & housed in the Lateran Palace, it was transferred to a new building in the Vatican & opened to the public in 1970
Collections: Roman sculptures from the Pontifical States; Portrait-statue of Sophocles, the Marsyas of the Myronian group of Athena & Marsyas, the Flavian reliefs from the Palace of the Apostolic Chancery

M **Museo Pio Cristiano,** Citta del Vaticano, Vatican City, 00120 Italy. Tel 06-6988-3333; Fax 06-6988-5061; *Cur* Giandomenico Spinola
Founded by Pius IX in 1854 & housed in the Lateran Palace; transferred to a new building in the Vatican & opened to the public in 1970
Collections: Sarcophagi; Latin & Greek inscriptions from Christian cemeteries & basilicas; the Good Shepherd

M **Museo Missionario Etnologico,** Citta del Vaticano, Vatican City, 00120 Italy. Tel 06-6988-3333; Fax 06-6988-5061; *Cur* Rev Roberto Zagnoli
Founded by Pius XI in 1926 & housed in the Lateran Palace; transferred to a new building in the Vatican & opened to the public in 1973
Collections: Ethnographical collections from all over the world
Publications: Annali

M **Pinacoteca Vaticana,** Citta del Vaticano, Vatican City, 00120 Italy. Tel 06-6988-3333; Fax 06-6988-5061; *Cur* Arnold Nesselrath
Inaugurated by Pope Pius XI in 1932
Collections: Paintings by Fra Angelico, Raphael, Leonardo da Vinci, Titian & Caravaggio, & the Raphael Tapestries

M **Collezione d'Arte Religiosa Moderna,** Citta del Vaticano, Vatican City, 00120 Italy. Tel 06-6988-3333; Fax 06-6988-5061; *Cur* Dr Mario Ferrazza
Founded in 1973 by Pope Paul VI; paintings, sculptures & drawings offered to the Pope by artists & donors

M **Vatican Palaces,** Citta del Vaticano, Vatican City, 00120 Italy. Tel 06-6988-3333; Fax 06-6988-5061; *Cur* Dr Arnold Nesserath
Chapel of Beato Angelico (or Niccolo V, 1448-1450); Sistine Chapel constructed for Sixtus IV (1471-1484); Borgia Apartment decorated by Pinturicchio; Chapel of Urbano VIII (1631-1635); rooms & loggias decorated by Raphael; Gallery of the Maps (1580-83)

VENICE

M **BIENNALE DI VENEZIA,** S Marco, Ca' Giustinian Venice, 30124 Italy. Tel 5218711; Fax 52 36 374; *Pres* Gian Luigi Rondi
Collections: Visual arts, architecture, cinema, theatre, music. Owns historical archives of contemporary art

M **GALLERIA DELL'ACCADEMIA,** Campo della Carita 1059A, Venice, 30100 Italy. Tel (041) 5222247; *Dir* Giovanna Scire Nepi
Collections: Venetian painting, 1310-1700

M **GALLERIA G FRANCHETTI,** Calle Ca d'Oro, Canal Grande Venice, 30100 Italy. Tel (041) 522349; *Dir* Dr Adriana Augusti
Collections: Sculpture & paintings

M **MUSEI CIVICI VENEZIANI,** (Civici Musei Veneziani d'Arte e di Storia) S Marco 52, Venice, 30100 Italy. Tel (041) 5225625; Fax 0415200935; *Dir* Prof Giandomenico Romanelli

M **Museo Correr,** San Marco 52, Venice, 30124 Italy. Tel 39041 2405211; Fax 39041 5200935; Elec Mail mkt.musei@comune.venezia.it; Internet Home Page Address: www.museicivicieneziani.it; *Dir* Giandomenico Romanelli
1.XI-31.III 9-17; 1.IV-31.X 9-19 The ticket office closes an hour before; cl Dec 25 & Jan 1 ; Admis fee 12 euro, reduced 6.50 euro
Library Holdings: Auction Catalogs; Book Volumes; CD-ROMs; Cards; Cassettes; DVDs; Exhibition Catalogs; Micro Print; Photographs; Prints; Reproductions
Special Subjects: Decorative Arts, Etchings & Engravings, Landscapes, Architecture, Ceramics, Glass, Furniture, Portraits, Prints, Period Rooms, Silver, Textiles, Bronzes, Manuscripts, Maps, Painting-British, Painting-European, Sculpture, Tapestries, Graphics, Religious Art, Porcelain, Coins & Medals, Miniatures, Painting-Flemish, Renaissance Art, Medieval Art, Painting-German, Military Art
Collections: Comprises various area of interest: neoclassical rooms, historical collections throwing light on city's institutions, urban affairs & everday life; Picture gallery collections of Venitian painting from early 16th century
Activities: Classes for adults & children; docent training; lect open to pub; conferences; concerts; gallery talks; tours; scholarships & fellowships; lending original object of art for international exhibs; organize traveling exhibs; mus shop sells books, magazines, original art, reproductions, prints, slides & merchandising

M **Ca'Rezzonico,** S Barnaba-Fondamenta Rezzonico, Canal Grande/Dorsoduro 3136 Venice, 30123 Italy. Tel 39041 241 0100; Fax 39041 241 0100; Elec Mail mkt.musei@comune.venezia.it; Internet Home Page Address: www.museicivicineziani.it; *Dir* Giandomenico Romanelli; *Cur* Filippo Pedrocco
1.XI-31.III 10-17 1.IV-31.X 10-18 The ticket office closes an hour before; cl Tues and Jan 1, Dec 25 & May 1 ; Full price: 6.50 euro, reduced: 4.50 euro; Mus contains important 18th century Venetian paintings amid furnishings of the age
Library Holdings: Auction Catalogs; Book Volumes; CD-ROMs; Cards; Cassettes; DVDs; Exhibition Catalogs; Micro Print; Photographs; Prints; Reproductions
Special Subjects: Drawings, Etchings & Engravings, Ceramics, Glass, Furniture, Portraits, Textiles, Bronzes, Tapestries, Architecture, Porcelain, Baroque Art, Painting-Italian
Collections: 18th century Venetian art, sculpture, etc; Egidio Martini Picture Gallery; Mestorovich Collection
Publications: Museum Guide; Martini's Collection Guide; Mestrovich's Collection Guide
Activities: Educ prog for adults & children; docent training; lect open to pub; concerts; gallery talks; tours; conferences; theatre lects; scholarships & fellowships; lend original art objects for international exhibs; mus sells books, magazines, original art, reproductions, prints, slides & merchandising

M **Museo Vetario di Murano,** Fondamenta Giustiniani 8, Murano, 30121 Italy.
Collections: Venetian glass from middle ages to the present

M **Palazzo Mocenigo,** Santa Croce 1992, Venice, 30125 Italy. Tel 041 721798; Fax 041 5241614; Elec Mail mkt.musei@comune.venezia.it; Internet Home Page Address: www.museicivicineziani.it; *Dir* Giandomenico Romanelli
Open XI - 31.III 10 AM - 4 PM, IV - 31.X 10 AM - 5 PM, cl Mon, New Year's Day, Christmas Day & May 1; Admis fee 4 euro, full price, 2,50 euro, reduced
Collections: Palace of the Doges; collection of fabrics & costumes; library on history of fashion
Publications: Museum Guide
Activities: Education program for schools & families; docent training; conferences; concerts; theatrical lects

M **Galleria Internazionale d'Arte Moderna di Ca'Pesaro,** Santa Croce, 2070, Venice, 30125 Italy. Tel 39 041721127; Fax 39 0415241075; Elec Mail mkt.musei@comune.venezia.it; Internet Home Page Address: www.museicivicineziani.it; *Dir* Giandomenico Romanelli; *Cur* Flavia Scotton
Open XI - 31.III 10 AM - 5 PM, IV - 31.X 10 AM - 6 PM, cl Mon, New Year's Day, Christmas Day, May 1; Admis fee 5,50 euro full price, 3 euro reduced
Collections: 19th & 20th centuries works of art
Publications: Museum Guide
Activities: Education program for schools & families; docent training; conferences

M **Doge's Palace,** San Marco 1, Venice, 30124 Italy. Tel 39 041712715911; Fax 39 0415285028; Elec Mail mkt.musei@comune.venezia.it; Internet Home Page Address: www.museicivicineziani.it; *Dir* Giandomenico Romanelli
Open XI - 31.III 9 AM - 5 PM, IV - 31.X 9 AM - 7 PM, cl New Year's Day, Christmas Day; Admis fee Nazionale and Monumental Rooms of Biblioteca Marciana, 12 euro full price, 6,50 euro reduced price
Publications: Museum Guide
Activities: Education programs for schools & families; docent training; conferences, conventions

M **Clock Tower,** Tel 39041 2715911; Elec Mail mkt.musei@comune.venezia.it; Internet Home Page Address: www.museicivicineziani.it
Visits with specialized guide, only upon prior booking; Admis fee 12 euro, holders of the ticket for the Clock Tower get free admis to the Museo Correr & a reduction on the museums of St. Mark's Square ticket which gives access to Doge's Palace

M **Carlo Goldoni's House,** San Polo 2794, Venice, 30125 Italy. Tel 39041 2759325;

Fax 39041 2440081; Elec Mail mkt.musei@comune.venezia.it; Internet Home Page Address: www.museicivicivenezia.it; *Dir* Giandomenico Romanelli; *Cur* Paola Chiapperino
Open Xi - 31.III 10 AM - 4 PM, IV - 31.X 10 AM - 5 PM, cl Sun, New Year's Day, Christmas Day, May 1; Admis fee 2,50 euro full price, 1,50 euro reduced price

M **Museo Fortuny,** San Marco 3780, Venice, 30124 Italy. Elec Mail mkt.musei@comune.venezia.it; Internet Home Page Address: www.museicivicivenezia.it;Giandomenico Romanelli; *Cur* Silvio Fuso
Thematic or temporary exhibs on installation, ticket office 10 AM - 5:30 PM, cl Mon, New Year's Day, Christmas Day, May 1; Admis fee 4 euro full price, 2,50 euro reduced price

M **Glass Museum,** Fondamenta Giustinian 8, Murano, 30121 Italy. Tel 39041 739586; Fax 39041 739586; Elec Mail mkt.musei@comune.venezia.it; Internet Home Page Address: www.museicivicivenezia.it; *Dir* Giandomenico Romanelli; *Cur* Silvio Fuso
Open XI - 31.III 10 AM - 5 PM, IV - 31.X 10 AM - 6 PM, cl Wed, New Year's Day, Christmas Day, May 1; Admis fee 5,50 euro full price, 3 euro reduced price
Publications: Museum Guide
Activities: Education program for schools & families; docent training

M **Lace Museum,** Piazza Galuppi 187, Burano, 30012 Italy. Tel 39041 730034; Fax 39041 735471; Elec Mail mkt.musei@comune.venezia.it; Internet Home Page Address: www.museicivicivenezia.it; *Dir* Giandomenico Romanelli; *Cur* Paola Chiapperino
Open XI - 31.III 10 AM - 4 PM, IV - 31.X 10 AM - 5 PM, cl Tues, New Year's Day, Christmas Day, May 1; Admis fee 4 euro full price, 2,50 euro reduced price

M **Museum of Natural History,** Santa Croce 1730, Venice, 30135 Italy. Tel 39041 2750206; Fax 39041 721000; Elec Mail mkt.musei@comune.venezia.it; Internet Home Page Address: www.museicivicivenezia.it
Open Tues - Fri 9 AM - 1 PM, Sat & Sun 9 AM - 4 PM, Ligabue Expedition Room & the Tegnue Aquarium, cl Mon New Year's Day, Christmas Day, May 1; No admis fee
Activities: Education program for schools & families; docent training

M **MUSEO ARCHEOLOGICO,** Piazza S Marco 17, Venice, 30122 Italy. Tel (041) 5225978; *Dir* Dr Giovanna Luisa Ravagnan
Collections: Greek & Roman sculpture, jewels, coins

M **MUSEO D'ARTE MODERNA,** Ca' Pesaro, Canal Grande Venice, 30100 Italy. Tel (041) 24127; *Dir* Prof Giandomenico Romanelli
Collections: 19th & 20th century works of art

M **MUSEO D'ARTE ORIENTALE,** Ca' Pesaro, Canal Grande Venice, 30100 Italy. Tel 27681; *Dir* Dr Adriana Ruggeri

M **MUSEODELLA FONDAZIONE QUERINI,** Palazzo Querini-Stampalia, Castello 5252 Venice, 30122 Italy. Tel 041 2711411; Fax 041 2711445; *Dir* Dr Giorgio Busetto
Collections: 14th - 19th century Italian paintings

M **PINACOTECA MANFREDINIANA,** Campo della Salute 1, Venice, 30123 Italy. Tel 041 522 5558; Fax 041 523 7951; *Dir* Lucio Cilia
Collections: Paintings & sculptures of the Roman, Gothic, Renaissance & Neo-classical period

VERONA

M **MUSEI CIVICI D' ARTE DI VERONA,** Museo Di Castelvecchio, Castelvecchio 2, Verona, 37121 Italy. Tel (045) 594734; Fax 0039 045 8010729; Elec Mail castelvecchio@comune.verona.it; Internet Home Page Address: www.comune.verona.it/castelvecchio/cvsito; *Dir* Dr Paola Marini; Dr Margherita Bolla; Dr Giorgio Marini
Open Tues - Sun 9 AM - 7 PM; Admis 8,000 ITL; Paintings and sculptures XIII-XVIII C mainly from Northern Italy; Average Annual Attendance: 150,000
—**Galleria Comunale d' Arte Moderna e Contemporanea,** Vla Forti 1, Verona, 37121 Italy. Tel (045) 8001903; *Sr Dir Dotl* Grossi Cortenova
—**Museo Archaeologico al Teatro Romano,** Regaste Redentore, Verona, 37129 Italy. Tel (045) 8000360; *S Dir Dssa* Margherita Bolla
—**Museo di Castelvecchio,** Corso Castelvecchio 3, Verona, 37121 Italy. Tel 594734; *S Dir Dssa* Paola Marini
—**Museo Lapidario Maffeiano,** Piazza Bra, Verona, 37121 Italy. Tel (045) 590087
—**Museo degli Affreschi e Tomba di Giulietta,** Via del Pontiere, Verona, 37122 Italy. Tel (045) 8000361

IVORY COAST

ABIDJAN

M **MUSEE DE LA COTE D'IVOIRE,** BP 1600, Abidjan, Ivory Coast. Tel 22-20-56; *Dir* Dr B Holas
Collections: Art, ethnographic, scientific & sociological exhibits

JAPAN

ATAMI

M **MOA BIJUTSUKAN,** MOA Museum of Art, 26-2 Momoyama-Cho, Atami, 413 Japan. Tel 84-2511; Fax 84-2570; *Dir* Yoji Yoshioka
Library with 20,000 vols
Collections: Oriental fine arts; paintings, ceramics, lacquers and sculptures

IKARUGA

M **HORYUJI,** Horyuji Temple, Aza Horyuji, Ikaruga-cho, Ikoma-gun Ikaruga, Japan.
Collections: Buddhist images and paintings; the buildings date from the Asuka, Nara, Heian, Kamakura, Ashikaga, Tokugawa periods

ITSUKUSHIMA

M **ITSUKUSHIMA JINJA HOMOTSUKAN,** Treasure Hall of the Isukushima Shinto Shrine, Miyajima-cho, Saeki-gun Itsukushima, Japan. *Cur & Chief Priest* Motoyoshi Nozaka
Collections: Paintings, calligraphy, sutras, swords, and other ancient weapons

KURASHIKI

M **OHARA BIJITSUKAN,** Ohara Museum of Art, 1-1-15 Chuo, Kurashiki, 710 Japan. Tel 86-422-0005; Fax 86-427-3677; Elec Mail info@ohara.or.jp; Internet Home Page Address: www.ohara.or.jp; *Dir* Shuji Takashina
Open 9 - 17; Gen [00a5]1.000-; Estab 11-6-1930; Library with 30,000 vols
Collections: Ancient Egyptian, Persian & Turkish ceramics & sculpture; 19th & 20th century European paintings & sculpture; modern Japanese oil paintings, pottery, sculpture & textiles; Asiatic Art
Activities: Classes for adults; classes for children; lects open to public; gallery talks; mus shop sells books, reproductions, prints, accessories, stationery

KYOTO

M **KYOTO KOKURITSU HAKUBUTSUKAN,** Kyoto National Museum, 527 Chayamachi, Higashiyama-ku Kyoto, 605 Japan. Tel (075) 541-1151; *Dir* Norio Fujisawa
Collections: Fine art; handicrafts & historical collections of Asia, chiefly Japan; over 65,000 research photographs

M **KYOTO KOKURITSU KINDAI BIJUTSUKAN,** The National Museum of Modern Art, Kyoto, Okazaki Enshoji-cho, Sakyo-ku, Kyoto, 606 - 8344 Japan. Tel (075) 761-4111; Fax (075) 771-5792; Elec Mail info@momak.go.jp; Internet Home Page Address: www.momak.go.jp; *Dir* Ken'ichi Waki; *Chief Cur* Shinji Kohmoto; *Cur* Yuko Keda; *Cur* Hidetsugu Yamano; *Cur* Ryuichi Matsubara
Tues - Sun 9:30 AM - 5 PM, every Fri from April - Oct 9:30 AM - 8 PM, cl Mon & Tues next to Mon of the natl holidays, and Dec 28 - Jan 4; Admis Adults 420 yen, students over 15 130 yen, under 15 free; Estab 1962; Mem: 400
Library Holdings: Audio Tapes; Book Volumes; CD-ROMs; Cards; Exhibition Catalogs; Fiche; Kodachrome Transparencies; Lantern Slides; Manuscripts; Micro Print; Motion Pictures; Original Art Works
Collections: painting (Japanese style, oil, watercolor), drawing, print, photography, sculpture, craft, and new Modern Contemporary media
Publications: Book on the complete collection of Japanese paintin,g, collection of oil on canvas, collection of prints, & collection of photography
Activities: Classes for adults & children; docent traing; lects open to public, 80-90 per yr; concerts; gallery talks; lending of original objects of art to pub museums in Japan; Japanese painting, Oil painting; 7-8 book traveling exhib per yr; organize traveling exhib to the National Museum of Modern Art, Tokyo & to museums in Japan (50 in 2002, 6 in 2003); books, magazines, reproductions, postcards, calendars, designer goods, accessories & tableware

M **KYOTO-SHI BIJUTSUKAN,** Kyoto City Art Museum, Okazaki Park, Sakyo-ku Kyoto, Japan. Tel (075) 771-4107; Fax (075) 761-0444; *Dir* Mitsugu Uehira
Collections: Contemporary fine arts objects, including Japanese pictures, sculptures, decorative arts exhibits and prints

NAGOYA

M **THE TOKUGAWA REIMEIKAI FOUNDATION,** The Tokugawa Art Museum, 1017 Tokugawa-cho, Higashi-ku Nagoya, 461-0023 Japan. Tel (052) 935-6262; Elec Mail info@tokugawa.or.jp; Internet Home Page Address: www.tokugawa-art-museum.jp/; *Dir* Yoshitaka Tokugawa
10 AM - 5 PM; Estab 10/11/1935; Mem: approx 1,000 people, 3,150-26,250 yen
Collections: Tokugawa family collection of 12,000 treasures, including scrolls, swords, calligraphy & pottery
Publications: "Kinko Sosho Bulletin of The Tokugawa Reimeikai foundation The Tokugawa Institute for The History of Forestry"

NARA

M **NARA KOKURITSU HAKUBUTSU-KAN,** Nara National Museum, 50 Nabori-oji-Cho, Nara, 630-8213 Japan. Tel (0742) 22-7771; Fax (0742) 26-7218; Internet Home Page Address: www.narahaku.go.jp; *Dir* Kenichi Yuyama
Collections: Art objects of Buddhist art, mainly of Japan, including applied arts and archaeological relics, calligraphy, paintings, sculptures

OSAKA

M **FUJITA BIJUTSUKAN,** Fujita Museum of Art, 10-32 Amijima-cho, Miyakojima-ku Osaka, Japan. Tel (06) 6351-05582; Fax 6351-0583; *Dir* Chikako Fujita
10 AM - 4:30 PM; adults 700 yen, student/high school student 400 yen; Estab 1951
Collections: Scroll paintings; Ceramics, Japenese Paintings, Calligraphy, Buddhist Art

Activities: Mus shop sells books & prints

M **OSAKA-SHIRITSU HAKUBUTSUKAN,** Osaka Municipal Museum of Art, 1-82 Chausuyama-Cho, Tennoji-ku Osaka, 543-0063 Japan. Tel (06) 6771-4874; Fax (06) 6771-4856; *Dir* Yutaka Mino
Collections: Art of China, Korea & Japan

TOKYO

M **BRIDGESTONE BIJUTSUKAN,** Bridgestone Museum of Art, 10-1, Kyobashi 1-chome, Chuo-ku Tokyo, 104 Japan. Tel (03) 3563-0241; *Executive Dir* Kazuo Ishi Kure
Collections: Foreign paintings, mainly Impressionism and after; western style paintings late 19th century to present

M **IDEMITSU MUSEUM OF ARTS,** 3-1-1 Marunouchi, Chiyoda-ku Tokyo, 100-0005 Japan. Tel 03-3213-9402; Fax 03-3213-8473; Internet Home Page Address: www.idemitsu.co.jp/museum; *Dir* Shosuke Idemitsu; *Deputy Dir* Tsunehiko Wada
Open Tues - Sun 10 AM - 5 PM, cl Mon; Admis adult F1000, student (over 15 yrs old) F700; Estab 1966; Average Annual Attendance: 150,000; Mem: 700 mems; ann dues F8,000
Income: Financed by donations
Collections: Oriental art & ceramics; Japanese paintings; calligraphy; Chinese bronzes; lacquer wares & paintings by Georges Rouault, Sam Francis

M **KOKURITSU SEIYO BIJUTSUKAN NATIONAL MUSEUM OF WESTERN ART,** National Museum of Western Art, Ueno-Koen 7-7, Taito-ku, Tokyo, 110-0007 Japan. Tel 81-3-3828-5131; Fax 81-3-3828-5135; Elec Mail wwwadmin@nmwa.go.jp; Internet Home Page Address: www.nmwa.go.jp; *Dir* Masanori Aoyagi
Open 9:30 - 17:00, Fri 9:30 - 20:00; Admis 420 yen Adults, 130 yen Student, under 15 & over 65 free; Estab 4/1/1959
Library Holdings: Auction Catalogs; Audio Tapes; Book Volumes; CD-ROMs; Cassettes; Compact Disks; DVDs; Exhibition Catalogs; Fiche; Filmstrips; Kodachrome Transparencies; Lantern Slides; Pamphlets; Reproductions; Video Tapes
Collections: Western paintings from late Medieval period through the Early 20th Century; French Modern Sculpture
Exhibitions: (3/6/2007-5/6/2007) Italian Renaissance Prints from the Swiss Federal Institute of Technology Zurich
Activities: Classes for adults, classes for children; lects open to pub, concerts, gallery talks; mus shop sells books, magazines, reproductions, others

M **NEZU BIJUSUKAN,** Nezu Institute of Fine Arts, 6-5 Minami-aoyama, Minato-ku Tokyo, 107 Japan. Tel (3) 3400 2536; Fax (3) 3400 2436; *Dir* Hisao Sugahara
Collections: Kaichiro Nezu's private collection, including 7,195 paintings, calligraphy, sculpture, swords, ceramics, lacquer-ware, archeological exhibits; 184 items designated as national treasures

M **NIHON MINGEIKAN,** Japan Folk Crafts Museum, 4-3-33 Komaba, Meguro-ku, Tokyo, 153-0041 Japan. Tel (03) 34674527; Fax (03) 3467-4537; *Dir* Sori Yanagi
Open 10 AM - 5 PM, cl Mon; Admis 1000 yen, students 500 yen, elementary & jr high students 200 yen; Estab 1936; to introduce Mingei (the arts of the people); 4 large exhibits per yr; two-story building of stone and stucco with black tile roof, designed after traditional Japanese architecture by Sietsu Yan (1889-1961) founder of the Inugeu
Income: nonprofit orgn
Special Subjects: Watercolors, African Art
Collections: Folk-craft art objects from all parts of the world; works by Shoji Hamada, Kanjiro Kami, Shiko Munakota, Keisuke, Seuzawa, Bernard Leach, other Mingei Movement advocators
Activities: Lect open to public; 5-6 vis lect per year; annual New Works competition; Japan Folk Crafts Mus Encouragement prizes; lending of original objects of art to other high quality mus; sales of books, prints, pottery, textiles, lacquered woodwork

M **TOKYO KOKURITSU HAKUBUTSUKAN,** Tokyo National Museum, 13-9 Ueno Park, Taito-ku Tokyo, 110 Japan. Tel (03) 3822-1111; *Dir Gen* Bunichiro Sano
Collections: Largest art museum in Japan; Eastern fine arts, including paintings, calligraphy, sculpture, metal work, ceramic art, textiles, lacquer ware, archaeological exhibits

M **TOKYO KOKURITSU KINDAI BUJUTSUKAN,** The National Museum of Modern Art, Tokyo, 3-1 Kitanomaru Koen, Chiyoda-ku Tokyo, 102-8322 Japan. Tel (03) 3214-2561; Fax (03) 3214-2577; Internet Home Page Address: www.momat.go.jp; *Dir* Tetsuo Tsujimura; *Deputy Dir* Masaaki Ozaki; *Chief Cur* Tahru Matsumoto; *Chief Cur* Kazuo Nakabayashi
Open Tues - Thurs & Sat - Sun10 AM - 5 PM, Fri 10 AM - 8 PM, cl Mon (except when Mon is a holiday, the mus is open a & cl on Tues) yr-end of New Year holidays and during change of exhib; Admis adults [00a5]420, col students [00a5]130, high school students [00a5]70, seniors over 65 & children under 15 free; Estab 1952; Circ 99,816; Average Annual Attendance: 931,852
Library Holdings: Auction Catalogs; Book Volumes; Compact Disks; DVDs; Exhibition Catalogs; Micro Print; Other Holdings; Pamphlets; Periodical Subscriptions; Photographs; Reels; Video Tapes
Special Subjects: Painting-Japanese, Drawings, Photography, Prints, Sculpture, Watercolors
Collections: Drawings, paintings, photographs, prints, sculptures, watercolors
Publications: Mus Newsletter, Gendai no Me (Japanese); Catalogue (Bilingual); Annual Report (Bilingual)
Activities: Classes for adults & children offered in Japanese only; lect open to pub; concerts; gallery talks; tours; lending of original objects of art to museums (world); organize traveling exhib to museums mainly in Japan; mus shop sells books, magazines, reproductions & prints

M **Crafts Gallery,** Japan; 1 Kitanomaru Koen, Chiyoda-ku Tokyo, Japan. *Chief Cur* Mitsuhiki Hasebe
Collections: Ceramics, lacquer ware, metalworks

M **TOKYO NATIONAL UNIVERSITY OF FINE ARTS & MUSIC ART,** University Art Museum, 12-8 Ueno Park, Taito-ku Tokyo, 110-8714 Japan. Tel +81-3-5685-7755; Fax +81-3-5685-7805; Internet Home Page Address: www.geidai.ac.jp
Open 10 AM - 5 PM; Admis adult F300; Estab 1970
Special Subjects: Ceramics, Metalwork, Pottery, Painting-Japanese, Architecture, Drawings, Sculpture, Bronzes, Archaeology, Textiles, Crafts, Woodcuts, Porcelain, Asian Art, Calligraphy
Collections: Paintings, sculptures & crafts of Japan, China & Korea
Publications: Tokyo Geijutsu Daigaku Daigaku Bijutsukan Nenpo

M **TOKYO-TO BIJUTSUKAN,** Tokyo Metropolitan Art Museum, Ueno Koen 8-36, Taito-Ku Tokyo, 110-007 Japan. Tel (03) 3823-6921; Fax (03) 3823-6920; Internet Home Page Address: www.tob.kan.jp/eng; *Dir* Yoshitake Mamuro; *Deputy Dir* Yoshitake Mamuro
9 AM - 5 PM; closed 3rd Mon of each month; Estab 1926
Collections: Sculptures

WAKAYAMA

M **KOYASAN REIHOKAN,** Museum of Buddhist Art on Mount Koya, Koyasan, Koya-cho, Ito-gun Wakayama, Japan. Tel 0736 562254; *Cur* Dr Chikyo Yamamoto
Collections: Buddhist paintings and images, sutras and old documents, some of them registered National Treasures and Important Cultural Properties

KOREA, REPUBLIC OF

SEOUL

M **NATIONAL MUSEUM OF KOREA,** Sejong-ro, Chongno-gu, Seoul, Korea, Republic of. Tel (02) 720-2714; Fax (02) 734-7255; *Dir Gen* Yang-Mo Chung
Seven branch museums & library with 20,000 vols
Collections: Korean archaeology, culture & folklore

LEBANON

BEIRUT

M **ARCHAELOGICAL MUSEUM OF THE AMERICAN UNIVERSITY OF BEIRUT,** Bliss St, Beirut, Lebanon; PO Box 11-0236/9, Beirut, Lebanon. Tel (961) 340549; Fax 961-1-363235; Elec Mail museum@aub.edu.lb; Internet Home Page Address: http://ddc.aub.edu.lb/projects/museum; *Dir* Dr Leila Badre
Mon - Fri 9 AM - 5 PM; No admis fee
Library Holdings: Cards; Maps; Pamphlets; Photographs
Collections: Bronze and Iron Age Near Eastern pottery collections; bronze figurines, weapons and implements of the Bronze Age Near East; Graeco-Roman imports of pottery from Near East sites; Palaeolithic-Neolithic flint collection; Phoenician glass collection; pottery collection of Islamic periods; substantial coin collection
Activities: Lects for members only: Gallery Talks and Tours; mus shop sells books, original art and reproductions

M **DAHESHITE MUSEUM AND LIBRARY,** PO Box 202, Beirut, Lebanon. *Dir* Dr A S M Dahesh
Library with 30,000 vols
Collections: Aquarelles, gouaches, original paintings, engravings, sculptures in marble, bronze, ivory and wood carvings

M **MUSEE NATIONAL,** National Museum of Lebanon, Rue de Damas, Beirut, Lebanon. Tel 4-01-00/4-40; *Dir* Dr Camille Asmar
Collections: Anthropological sarcophagi of the Greco-Persian period; Byzantine mosaics; royal arms, jewels and statues of the Phoenician epoch; Dr C Ford Collection of 25 sarcophagi of the Greek and Helenistic epoch; goblets, mosaics, relief and sarcophagi of the Greco-Roman period; Arabic woods and ceramics

LIBERIA

MONROVIA

M **NATIONAL MUSEUM,** Broad & Buchanan Sts, PO Box 3223 Monrovia, Liberia. *Dir* Burdie Urey-Weeks
Collections: Liberian history & art

LIBYA

TRIPOLI

M **ARCHAEOLOGICAL, NATURAL HISTORY, EPIGRAPHY, PREHISTORY AND ETHNOGRAPHY MUSEUMS,** Assarai al-Hamra, Tripoli, Libya. Tel 38116/7; *Pres* Dr Abdullah Shaiboub
Administered by Department of Antiquities
Collections: Archaeology from Libyan sites

LIECHTENSTEIN

VADUZ

M **KUNSTMUSEUM LIECHTENSTEIN,** Stadtle 32 Vaduz, 9490 Liechtenstein.
Tel (+423) 235 03 00; Fax (+423) 235 03 29; Elec Mail mail@kunstmuseum.li;
Internet Home Page Address: www.kunstmuseum.li; *Dir* Dr Friedemann Malsch;
Cur Christiane Meyer-Stoll; *Press Officer* Rene Schierscher
Open Tues - Sun 10 AM - 5 PM; Admis 5 Euros
Activities: Educ program; lect open to public

LITHUANIA

KAUNAS

M **M K CIURLIONIS STATE MUSEUM OF ART,** Vlado Putvinskio 55, Kaunas,
LT-3000 Lithuania. Tel 22-97-38; Fax (370-7) 204612; *Dir* Osvaldas Daugelis
Collections: Lithuanian, European & Oriental art; 5 related galleries & museums
in Kaunas & Druskininkai

VILNIUS

M **LITHUANIAN ART MUSEUM,** Didzioji, Vilnius, 2001 Lithuania. Tel
2-628-030; Fax 2-226-006; Elec Mail ldm@aiva.lt; Internet Home Page Address:
www.ldm.lt; *Dir* Romualdas Budrys
Estab 1907
Collections: Folk Art; Lithuanian & foreign fine & decorative arts from 14th
century to present

MALAYSIA

KUALA LUMPUR

M **MUZIUM NEGARA,** National Museum of Malaysia, Jln Damansara, Kuala
Lumpur, 50566 Malaysia. Tel (03) 2826255; Fax (02) 2827294; *Dir-Gen* Dr
Kamarul Baharin bin-Buyong
Collections: Oriental & Islamic arts, ethnographical, archaeological & zoological
collections

MALTA

VALLETTA

M **HERITAGE MALTA,** (National Museum of Fine Arts) National Museum of Fine
Arts, South St Valletta, Malta. Tel 356 21233034; Elec Mail
theresa.m.vella@gov.nt; Internet Home Page Address: www.heritagemalta.org;
Senior Cur Fine Arts Theresa Vella, MA; *Cur Modern Art* Dennis Vella, MA
Open daily 9 AM - 5 PM, cl Dec 24, 25, 31 & Jan 1; Admis 1LM, seniors over
65 & children under 18 .50; Estab 1975; Contains fine arts from the 14th century
to present day
Library Holdings: Cards; Exhibition Catalogs; Original Documents; Pamphlets;
Photographs
Special Subjects: Drawings, Etchings & Engravings, Ceramics, Furniture,
Bronzes, Painting-European, Painting-French, Prints, Sculpture, Watercolors,
Religious Art, Silver, Painting-Dutch, Baroque Art, Painting-Flemish, Medieval
Art, Painting-Spanish, Painting-Italian
Collections: Fine arts; maiolica & pharmacy jars of 16th-19th centuries
Exhibitions: Changing exhibitions of contemporary art & historical themes
Publications: Exhibitions catalogues & postcards

MEXICO

GUADALAJARA

M **MUSEO DEL ESTADO DE JALISCO,** Liceo 60 S H, Guadalajara, 44100
Mexico. Tel (3) 613-27-03; Fax (3) 614-52-57; *Dir* Dr Carlos R Beltran Briseno
Collections: Archaeological discoveries; early Mexican objects; folk art &
costumes

M **MUSEO-TALLER JOSE CLEMENTE OROZCO,** Calle Aurelio Aceves 27,
Sector Juarez Guadalajara, 44100 Mexico. *Mgr* Gutierre Aceves Piña
Open Mon - Fri 10 AM - 5 PM; No admis fee; The last studio J Corozco that
shows contemporary art; Average Annual Attendance: 20,000
Collections: Paintings and sketches by the artist

MEXICO CITY

M **MUSEO DE ARTE MODERNO,** Museum of Modern Art, Bosque de
Chapultepec, Paseo de la Reforma y Gandhi Mexico City, 11560 Mexico. Tel (5)
553-63-33; Fax (5) 553-62-11; *Dir* Del Conde Teresa
Collections: International and Mexican collection of modern art

M **MUSEO DE SAN CARLOS,** Puente de Alvarado 50, Mexico City, 06030
Mexico. Tel 5-592-37-21; Fax 5-535-12-56; Elec Mail
mnsancarlos@compuserve.com.mx; *Dir* Roxana Velasquez
Collections: English, Flemish, French, German, Hungarian, Italian, Polish,
Netherlandish and Spanish paintings from 14th - 19th centuries
L **Library,** Puente de Alvarado No 50, Mexico City, 06030 Mexico. Tel
5-592-37-21; Fax 5-535-12-56; Elec Mail mnsancarlos@compuserve.com.mx; *Dir*
Roxana Velasquez
Library Holdings: Book Volumes 2000

M **MUSEO NACIONAL DE ANTROPOLOGIA,** National Museum of
Anthropology, Paseo de la Reforma y Calz, Gandhi Mexico City, 11560 Mexico.
Tel (5) 553-19-02; Fax (5) 286-17-91; *Dir* Mari Carmen Serra Puche
Collections: Anthropological, archaeological & ethnographical collections

M **MUSEO NACIONAL DE ARTES E INDUSTRIAS POPULARES DEL
INSTITUTO NACIONAL INDIGENISTA,** National Museum of Popular Arts
and Crafts, Avda Juarez 44, Mexico City, 06050 Mexico. Tel 510-34-04; *Dir*
Maria Teresa Pomar
Collections: Major permanent collections of Mexican popular arts and crafts

M **MUSEO NACIONAL DE HISTORIA,** National Historical Museum, Castillo de
Chapultepec, Mexico City, 5 Mexico. Tel 553-62-02; *Dir* Lara T Amelia
Tamburrino
Collections: The history of Mexico from the Spanish Conquest to the 1917
Constitution, through collections of ceramics, costumes, documents, flags and
banners, furniture, jewelry & personal objects

M **PINACOTECA VIRREINAL DE SAN DIEGO,** San Diego Viceregal Art
Gallery, Dr Mora 7, Alameda Central Mexico City, 06050 Mexico. Tel 5-10-27-93;
Fax 5-12-20-79; *Dir* Virginia Armella de Aspe
Collections: Under auspices of Instituto Nacional de Bellas Artes; paintings of the
colonial era in Mexico

PUEBLA

M **MUSEO DE ARTE JOSE LUIS BELLO Y GONZALEZ,** Poninento No 302,
Puebla, Mexico. Tel 32-94-75; *Dir* Alicia Torres de Araujo
Collections: Ivories; porcelain; wrought iron; furniture; clocks; watches; musical
instruments; Mexican, Chinese and European paintings, sculptures, pottery,
vestments, tapestries, ceramics, miniatures

TOLUCA

M **MUSEO DE LAS BELLAS ARTES,** Museum of Fine Arts, Calle de Santos
Degollado 102, Toluca, Mexico. *Dir* Prof Jose M Caballero-Barnard
Collections: Paintings; sculptures; Mexican colonial art

MYANMAR

YANGON

M **NATIONAL MUSEUM OF ART AND ARCHAEOLOGY,** Jubilee Hall, 26/42
Pagoda Rd Yangon, Myanmar. Tel (01) 73706; *Chief Cur* U Kyaw Win
Collections: Regalia of King Thibaw of Mandalay

NEPAL

KATHMANDU

M **NATIONAL MUSEUM OF NEPAL,** Museum Rd, Chhauni Kathmandu, Nepal.
Tel 211504; *Chief* Sanu Nani Kansakar
Collections: Art, history, culture, ethnology & natural history collections

NETHERLANDS

AMSTERDAM

M **MUSEUM HET REMBRANDTHUIS,** The Rembrandt House Museum,
Jodenbreestraat 4, Amsterdam, 1011 NK Netherlands. Tel 020-5200400; Fax
020-5200401; Elec Mail museum@rembrandthuis.nl; Internet Home Page Address:
www.rembrandthuis.nl or www.rembrandtheus.com; *Dir* E de Heer
Mon - Sat 10 AM - 5 PM, Sun 1 PM - 5 PM; Admis 7; The house where
Rembrandt lived for nearly 20 years; Average Annual Attendance: 150,000
Collections: Rembrandt's etchings and drawings; drawings and paintings by
Rembrandt's pupils; contemporary artists influenced by Rembrandt
Activities: Educ program; classes for children; tours; originate traveling
exhibitions; mus shop sells books, prints, & reproductions

M **RIJKSMUSEUM,** State Museum, Stadhouderskade 42, PO Box 74888
Amsterdam, 1071 Netherlands. Tel 020-673-2121; Fax 020-6798 146; Elec Mail
info@rykmuseum.nl; Internet Home Page Address: www.rykesmuseum.nl; *Dir*
Gen Dr R de Leeuw
daily from 10 a.m. - 5 p.m.; Library with 200,000 vols

Library Holdings: Exhibition Catalogs; Framed Reproductions; Memorabilia; Photographs; Reproductions
Collections: Asiatic art; Dutch history & paintings; prints & drawings from all parts of the world; sculpture & applied art
Activities: Classes for adults; lectrs open to the public; tours; mus shop sells books, reproductions, prints & slides

M **STEDELIJK MUSEUM,** (Stedljk Museum) Municipal Museum, Paulus Potterstraat 13, PO Box 5082 Amsterdam, 1071 Netherlands. Tel (020) 573 2911; Fax (020) 675 2716; *Dir* R H Fuchs
Library with 20,000 vols & 90,000 catalogs
Collections: Applied art & design; European & American trends after 1960 in paintings & sculptures

M **VAN GOGH MUSEUM,** Paulus Potterstraat 7, PO Box 75366 Amsterdam, 1070 AJ Netherlands. Tel +31 (0)20 570 52 00; Fax +31 (0)20 673 50 53; Elec Mail info@vangoghmuseum.nl; Internet Home Page Address: www.vangoghmuseum.nl; *Dir* John Leighton
Open daily 10 AM - 6 PM; Admis f 15.50, under 12 yrs free, 13-17 yrs f 5; Estab 1973; Average Annual Attendance: 1,300,000
Library Holdings: Auction Catalogs; Audio Tapes; Book Volumes; CD-ROMs; Cassettes; Clipping Files; Exhibition Catalogs; Fiche; Filmstrips; Memorabilia; Motion Pictures; Original Art Works; Original Documents; Periodical Subscriptions; Photographs; Prints; Reproductions; Slides; Video Tapes
Special Subjects: Prints, Woodcuts, Sculpture, Watercolors, Manuscripts, Painting-Dutch
Collections: Some 550 drawings, 200 paintings & 700 letters by Vincent Van Gogh; Van Gogh's personal collection of English & French prints & Japanese woodcuts
Activities: Lect open to public; vis lectrs 8-10 per yr; guided tours; audio tours; group visits; organize traveling exhibition to Art Institute of Chicago; museum shop sells books, magazines, reproductions, prints & slides

ARNHEM

M **MUSEUM VOOR MODERNE KUNST ARNHEM,** Municipal Museum of Arnhem, Utrechtseweg 87, Arnhem, 6812 AA Netherlands. Tel (026) 3512431; Fax (026) 4435148; Internet Home Page Address: www.mmkarnhem.nl; *Deputy Dir* Dr M.G. Westen; *Head of Coll* Ype Koopmans; *Cur Applied Art* Hedewych Martens; *Press Officer* Petra Versluis
Tues - Sat 10 AM - 5 PM, Sun & holidays 11 AM - 5 PM, cl Mon; admis 4.50 euro; Library with 18,000 vols; Average Annual Attendance: 50,000
Income: 3 million guilders (financed by the city of Arnhem), 200.000 guilders (additional funding)
Library Holdings: Auction Catalogs; Book Volumes; Exhibition Catalogs; Kodachrome Transparencies; Manuscripts; Original Documents; Periodical Subscriptions; Slides; Video Tapes
Collections: Design; Dutch and international paintings, drawings and prints; Dutch contemporary applied art; sculpture gardens; video; on design; realism; contemporary art
Activities: Classes for adults & children; docent training; six visting lect per year; concerts; tours; lending of original objects of art to other art institutions; books, magazines, original applied art & design, reproductions

DELFT

M **STEDELIJK MUSEUM HET PRINSENHOF,** Het Prinsenhof State Museum, St Agathaplein 1, Delft, 2611 HR Netherlands. Tel (015) 260 2358; Fax (015) 213 8744; *Dir* Dr D H A C Lokin
Library with 6000 vols
Collections: Delft silver, tapestries and ware; paintings of the Delft School; modern art

DORDRECHT

M **DORDRECHTS MUSEUM,** Museumstraat 40, Dordrecht, 3311 XP Netherlands. Tel 078 6482148; Fax 078-6141766; Elec Mail museum@dordt.nl; Internet Home Page Address: www.museum.dordt.nl; *Dir* Dr S J M De Groot
Collections: Dutch paintings, prints, drawings & sculpture, 17th to 20th century drawings, paintings & prints

EINDHOVEN

M **VAN ABBEMUSEUM,** Eindhoven Municipal Museum, Vonderweg, PO Box 235 Eindhoven, 5600 AE Netherlands. Tel 0031-40-2755275; Fax 0031-40-2460680; Elec Mail secretary@vanabbemuseum.nl; Internet Home Page Address: www.vanabbcmuseum.nl; *Dir* J Debbaut; *Dep Dir* F Lubbers
Cl until end of 2002; Library with 120,000 vols
Collections: Modern and contemporary art; Lissitzky Collection

ENSCHEDE

M **RIJKSMUSEUM TWENTHE TE ENSCHEDE,** Lasondersingel 129, Enschede, 7514 BP Netherlands. Tel (053) 4358675; Fax (053) 4359002; Elec Mail info@njksmuseum-twenthe.nl; Internet Home Page Address: www.ryksmuseum-twenthe.nl; *Dir* Dr D A S Cannegieter
Open Tues - Sun 11 AM - 5 PM; Library with 24,000 vols
Collections: Collection of paintings & sculptures from middle ages up until present
Activities: Mus shop sells books, magazines, original art, reproductions

GRONINGEN

M **GRONINGER MUSEUM,** Museumeiland 1, Groningen, 9711ME Netherlands. Tel (050) 366 6555; Fax (050) 312 0815; Elec Mail info@groninger.museum.nl; Internet Home Page Address: www.groninger-museum.nl; *Dir* Kees Van Twist
Tues to Sun 10 AM - 5PM (closed on Mon); Library with 35,000 vols
Collections: Paintings & drawings from the 16th - 20th Century, mainly Dutch, including Averkamp, Cuyp, Fabritius, Jordaens, Rembrandt, Rubens, Teniers; Oriental ceramics; local archaeology & history

HAARLEM

M **FRANS HALS MUSEUM,** Groot Heiligland 62, Haarlem, 2011 ES Netherlands; PO Box 3365, Haarlem, 2001 DJ Netherlands. Tel 5115775; Fax 5115776; Elec Mail franshalsmuseum@haarlem.nl; Internet Home Page Address: www.franshalsmuseum.com; *Dir* K Schampers
Open Mon - Sat 11 AM - 5 PM, Sun Noon - 5 PM; Admis f7 per person; groups f5.25 per person; 16th & 17th century art, that focused on Haarlem painters from that period; Average Annual Attendance: 80,000
Collections: Works by Frans Hals & Haarlem school; antique furniture; modern art collection

M **TEYLERS MUSEUM,** Spaarne 16, Haarlem, 2011 CH Netherlands. Tel (023) 531 9010; Fax (023) 531 2004; *Dir* E Ebbinge
Library with 150,000 vols
Collections: Coins, drawings, fossils, historical physical instruments, medals, minerals & paintings

HERTOGENBOSCH

M **NOORDBRABANTS MUSEUM,** Verwersstraat 41, PO Box 1004 Hertogenbosch, 5200 BA Netherlands. Tel (73) 6877877; Fax 073 877 899; Elec Mail info@noordbrabantsmuseum.nl; *Dir* J. van Laarhoven; *Dir* Ch. de Moog; *Dir* R. Vercauteren
Open Tues - Fri 10 AM - 7 PM, Sat & Sun Noon - 7 PM; Average Annual Attendance: 85,000
Library Holdings: Auction Catalogs; Book Volumes; Exhibition Catalogs; Pamphlets; Periodical Subscriptions; Photographs; Slides
Special Subjects: Tapestries, Baroque Art
Collections: All collections have an emphasis on local history: archaeology, arts & crafts, coins & medals, painting & sculpture
Activities: Classes for adults & children; lect for mem only; 4 vis lect per year; gallery talks; organize to other museums; sales of books, magazines, reproductions

HOORN

M **WESTFRIES MUSEUM,** Rode Steen 1, Acherom 2 Hoorn, 1621 KV Netherlands. Tel (229) 280028; Fax (229) 280029; *Dir* R J Spruit
Collections: 17th & 18th century paintings, prints, oak panelling, glass, pottery, furniture, costumes, interiors; folk art; historical objects from Hoorn & West Friesland; West Friesland native painting; prehistoric finds

ISIIKE ALKMAAR

M **STEDELIJK MUSEUM ALKMAAR,** Alkmaar Municipal Museum, Nieuwe Doelen, Canadaplein 1 Isiike Alkmaar, 1811 KX Netherlands. Tel (072) 5110737; Fax 072-5151476; Elec Mail museum@alkmaar.nl; Internet Home Page Address: www.stedelykmuseumalkmaar.nl; *Dir* M E A de Vries
Open Tues - Fri 10 AM - 7 PM, Sat & Sun 1 - 7 PM; Admis Adults Dfl *f* 7.50, children, seniors and students Dfl *f*3.75
Income: Financed by city
Collections: Collection from Alkmaar region, including archaeological items, dolls and other toys, modern sculpture, paintings, silver tiles; works by Honthorst, van Everdingen, van de Velde the Elder
Activities: Sales of books, original art, reproductions, prints, other merchandise.

LEERDAM

M **STICHTING NATIONAAL GLASMUSEUM,** National Glass Museum, Lingedijk 28, Leerdam, 4142 LD Netherlands. Tel (03451) 13662; Fax (03451) 13662; *Cur* Dr T G Te Dhits
Collections: Antique, machine-made & packaging glass; art glass; unique pieces; contemporary Dutch collection & works from America & Europe

LEEUWARDEN

M **FRIES MUSEUM,** Turfmarkt 11, Leeuwarden, 8900 CE Netherlands. Tel 58 212 3001; Fax 58 213 2271
Collections: Archaeology, ceramics, costumes, folk art, historical items, painting, prints and drawings, sculpture

LEIDEN

M **MUNICIPAL MUSEUM DE LAKENHAL,** Stedelisk Museum De Lakenhal, Oude Singel 28-32, PO Box 2044 Leiden, 2312 Netherlands. Tel 31-0-71-5165360; Fax 31-0-71-5134489; Elec Mail postbus@lakenhal.nl; Internet Home Page Address: www.lakenhal.nl; *Dir* Dr H Bolten-Rempt; *Publ Rel Off* M E V Iterson; *Cur Old Master Paintings* Dr C Y Y Vogelaar; *Cur Modern Art* Dr R Wolthoorn; *Cur Modern Art* Dr D Wintgenshotte; *Cur History Dept* Dr Y Zijlmans
Open Tues - Fri 10 AM - 5 PM, Sat - Sun & Holidays 12 PM - 5 PM; Admis f5; History & Art of Leiden from the Middle Ages until today; Average Annual Attendance: 40,000

Special Subjects: Decorative Arts, Etchings & Engravings, Landscapes, Glass, Furniture, Gold, Portraits, Silver, Textiles, Tapestries, Drawings, Sculpture, Ceramics, Crafts, Porcelain, Painting-Dutch, Carpets & Rugs, Renaissance Art, Period Rooms, Medieval Art, Stained Glass
Collections: Altar pieces by Lucas van Leyden; paintings by Rembrandt, Steen, van Goyen; pictures of Leiden School & modern Leiden School; arms, ceramics, furniture, glass, period rooms, pewter, silver
Activities: Lect open to the public; 4 vis lectrs per yr; mus shop sells books, magazines, original art, reproductions & slides

MUIDEN

M MUIDERSLOT RIJKSMUSEUM, State Museum at Muiden, Muiden, 1398 AA Netherlands. Tel (0294) 256262; Fax (0294) 261056; Elec Mail info@muiderslot.nl; Internet Home Page Address: www.muiderslot.nl; *Dir* Hilgers Michiels van Kesrenich; *Cur* Dr Y Molenaar
Collections: 13th century castle furnished in early Dutch Renaissance 17th century style; paintings, tapestries, furniture & armory; sculptures, modern; reconstructed Dutch herb & vegetable gardens
Activities: Classes for adults & children; special evenings with candlelight visits and historical flower arrangements; concerts

NIJMEGEN

M NIJMEEGS MUSEUM COMMANDERIE VAN ST JAN, Franse Plaats 3, Nijmegen, 6511 VS Netherlands. Tel 080-22-91-93; *Dir* Dr G T M Lemmens
Collections: Art and history of Nijmegen and region: Middle Ages - 20th Century; modern international art

OTTERLO

M KROLLER-MULLER MUSEUM, (Rijksmuseum Kroller-Muller Museum) Foundation Kroller-Muller Museum, Nationale Park de Hoge Veluwe, Houtkampweg 6 Otterlo, Netherlands; Box nr 1, Otterlo, 6730 AA Netherlands. Tel (0318) 591241; Fax 591515; Elec Mail info@kmm.nl; Internet Home Page Address: www.kmm.nl; *Dir* Dr E J van Straaten; *Deputy Dir* M J Vonhof; *Head of Collections & Presentations* Drs L Kreyn; *Cur* Drs T van Kooten; *Marketing* Drs L van Valkenhoef; *Press* Drs W Vermeulen; *Educ* Drs H Tibosch
Tues - Sun 10 AM - 5 PM; Combined ticket park & mus Euro 10 (7-14 Euro); Estab 1938; Library with 35,000 vols; Average Annual Attendance: 300,000
Collections: Van Gogh Collection; 19th and 20th century art - drawings, paintings, sculpture garden, ceramics, graphic arts, sculpture and sculpture drawings; Contemporary Art
Publications: Sculpture Garden - Van Gogh Drawings
Activities: Educ Prog; lect open to the pub; concerts; mus shop sells books, magazines, original art, reproductions, prints & gifts

ROTTERDAM

M MUSEUM BOYMANS-VAN BEUNINGEN, Museum Park 18-20, POB 2277 Rotterdam, 3000 Netherlands. Tel 010-441-9400; Fax 31(0) 10 43 60 500; Elec Mail info@boijmans.rotterdam.nl; Internet Home Page Address: www.boijmans.rotterdam.nl; *Managing Dir* Hugo Bongers; *Presentations* Rein Wolfe; *Publicity & Marketing* Angela Riddering
Open Tues - Sat 10 AM - 5 PM, Sun 11 AM - 5 PM; Admis adults 6 Euro, seniors over 65 3 Euro, children under 13 free, group reservations 3 Euro
Collections: Dutch school paintings including Bosch, Hals, Rembrandt, Van Eyck; 15th-20th centuries Dutch, Flemish, French, German, Italian & Spanish works; Baroque School; Impressionists; old, modern & contemporary sculpture; Dutch, Italian, Persian & Spanish pottery & tiles
Activities: Classes for children; lect open to public; museum shop sells books; Art & Pleasure, Museumpark 18-20 POB 2277 3000 CG Rotterdam

THE HAGUE

M HAAGS GEMEENTEMUSEUM, Municipal Museum of The Hague, Stadhouderslaan 41, The Hague, 2517 HV Netherlands. Tel (070) 338 1111; Fax (070) 355 7360; Telex 3-6990; *Dir* Dr J L Locher
Collections: Decorative Arts Collection includes ceramics, furniture, glass, silver; modern art of 19th & 20th centuries; musical instruments; history of The Hague

M KONINKLIJK KABINET VAN SCHILDERIJEN MAURITSHUIS, Royal Picture Gallery, Korte Vijverberg 8, The Hague, 2513 AB Netherlands. Tel (070) 3023456; Fax (070) 3653819; *Dir* F J Duparc
Collections: Paintings of the Dutch and Flemish Masters of the 15th, 16th, 17th and 18th centuries, including G David, Holbein, Hals, Rembrandt, Van Dyck, Vermeer

NEW ZEALAND

AUCKLAND

M AUCKLAND CITY ART GALLERY, 5 Kitchener St, PO Box 5449 Auckland, 1 New Zealand. Tel (09) 307-7700; Fax (09) 302-1096; *Dir* Chris Saines
Library with 33,000 vols
Collections: American & Australian paintings; general collection of European paintings & sculpture from 12th century on; historical & contemporary New Zealand painting, sculpture & prints

AUCKLAND CENTRAL

L UNIVERSITY OF AUCKLAND, Elam School of Fine Arts Library, School of Fine Arts, Pvt Bag 92019 Auckland Central, New Zealand. Tel 0064 09 373 7599; Fax 0064 09 308 2302; Elec Mail elam-enquiries@auckland.ac.nz; Internet Home Page Address: www.auckland.ac.nz; *Dean of Elam School of Fine Arts* Jolyon D Saunders
Library with 30,000 vols

DUNEDIN

M DUNEDIN PUBLIC ART GALLERY, The Octagon, Dunedin, New Zealand; PO Box 566, Dunedin, New Zealand. Tel (+643) 474 3240; Fax (+643) 474 3250; Elec Mail dpagmail@dcc.govt.nz; Internet Home Page Address: dunedin.art.museum; *Dir* Priscilla Pitts
Open daily 10 AM - 5 PM, cl Good Fri & Christmas Day; No admis fee, except for special exhibs; Estab 1884; Average Annual Attendance: 180,000
Income: Local authority supplemented with grants, sponsorship, retail, hire of commercial spaces
Collections: 15th - 19th century European paintings; New Zealand paintings since 1876; Australian paintings 1900-60; British watercolors, portraits and landscapes; ancillary collections of furniture, ceramics, glass, silver, oriental rugs; De Beer collection of Old Masters, including Monet; Contemporary New Zealand Art
Activities: Classes for children; lectrs open to the public; concerts; gallery talks; tours; film screenings; 3 - 4 book traveling exhibs; New Zealand Art Mus; mus shop sells books, magazines & reproductions

INVERCARGILL

M ANDERSON PARK ART GALLERY, Art Gallery, PO Box 5095, Invercargill, New Zealand. Tel 03-215-7432; Fax 03-215-7472; Elec Mail andersonparkgallery@xtra.co.nz; *Dir* John Husband; *Dep Dir* Helen Nicoll
Open 10:30 AM - 5 PM daily; Donation; Estab 1951; Historic house & pub gallery; Average Annual Attendance: Under 20,000; Mem: 254 mems, $20 double
Income: Grant from Invercargill City Council
Collections: Contemporary New Zealand art
Exhibitions: Annual spring Exhib (Oct)
Publications: Catalogue Permant Collection; "50th Anniversary Book Release"
Activities: Tours; extension program to other galleries; sales shop sells prints, 50th Jubilee booklet

NAPIER

M HAWKES BAY ART GALLERY AND MUSEUM, 9 Herschell St, PO Box 248 Napier, New Zealand. Tel (6) 835-7781; Fax (6) 835-3984; *Dir* Lynne Trafford
Collections: Antiques; Maori & Pacific artifacts; New Zealand painting & sculpture

WANGANUI

M SARJEANT GALLERY, Queen's Park, PO Box 998 Wanganui, New Zealand. Tel (06) 349 0506; Fax (06) 349 0507; Elec Mail art@sarjeant.queenspark.org.nz; Internet Home Page Address: www.sarjeant.org.nz; *Dir* Bill Milbank; *Cur/Pub Prog Mgr* Paul Rayner; *Pub Prog Asst* Greg Donson; *Coll/Bldg Mgr* Denis Rainforth; *Admin Off* Teresa Duxfield; *Events/Communications Off* Raewyne Johnson; *Technician* Garry George; *Educ Off* Rose Stobie; *Visitor Services Off* Catherine Macdonald; *Visitor Services Off* Gillian Wilkshire; *Visitor Services Off* Nicky Hatch; *Cleaner* Dalwyne Wotton; *Photographer/Designer* Richard Wotton; *Vis Serv Officer* Jane Moore
Open Mon - Sat 10:30 AM - 4:30 PM, Sun & Pub Holidays 1 - 4:30 PM; Admis by donation; Estab 1919; built as Art Gallery
Income: financed by Wanganie Dist Council
Library Holdings: Auction Catalogs; Book Volumes; Clipping Files; Exhibition Catalogs; Periodical Subscriptions
Collections: New Zealand art with a strong photographic focus & regional art; First World War cartoons & posters; 19th & early 20th Century British & European art
Exhibitions: approx 22 per year
Publications: guide to exhibs
Activities: Classes for children; gallery talks; mus shop sells exhib catalogues, posters & cards

WELLINGTON

M NATIONAL ART GALLERY OF NEW ZEALAND, Buckle St, Wellington, New Zealand. Tel (04) 859-703; *Dir* Jenny Harper
Library with 20,000 vols
Collections: Australian, British, European & New Zealand art; Sir Harold Beauchamp Collection of early English drawings, illustrations & watercolors; Sir John Ilott Collection of prints; Nan Kivell Collection of British original prints; Monrad Collection of early European graphics; collection of Old Master drawings

NIGERIA

IFE

M MUSEUM OF THE IFE ANTIQUITIES, National Museum, Enuwa Sq, Ife, Nigeria; PMB 5515, Ile Ife, Nigeria. Tel 21-50-036-230150; Elec Mail marqadeshina@yahoo.com; *Dir* M O Adesina; *Sr Ethnographer* D N Ogunmola; *Prin Documentation* S Adedoyin; *Sr Education Officer* M B Alesinloye
Open dauly 8 AM - 6 PM; Admis fee 20 N; Estab 1954; Average Annual Attendance: 4800

Income: govt financed
Library Holdings: Book Volumes
Collections: Western Nigeria Archeology; Archeological Materials
Publications: Prominent Sons and Daughters of Ife
Activities: Educ programs; archeological excavation; art & batik classes; training of handicaps; lending of original art objects to international exhibs; organize traveling exhibitions to schools; mus shop sells books & reproductions

NORWAY

BERGEN

M **VESTLANDSKE KUNSTINDUSTRIMUSEUM,** West Norway Museum of Decorative Art, Nordahl Brunsgate 9, Bergen, 5014 Norway. Tel (55) 32-51-08; Fax (55) 31 74 55; *Museum Dir* Jorunn Haakestad
Library with 20,000 vols
Collections: Contemporary Norwegian and European ceramics, furniture, textiles; The General Munthe Collection of Chinese Art; collections of old European arts and crafts; The Anna B and William H Singer Collection of art and antiquities

LILLEHAMMER

M **LILLEHAMMER KUNSTMUSEUM,** Lillehammer Municipal Art Gallery, Stortorget 2, PO Box 264 Lillehammer, 2601 Norway. Tel 61269444; Fax 61251944; *Dir* Svein Olav Hoff
Collections: Norwegian paintings, sculpture and graphic art from 19th and 20th centuries

OSLO

M **KUNSTINDUSTRIMUSEET I OSLO,** Museum of Decorative Arts & Design, Oslo, St Olavs Gate 1, Oslo, 0165 Norway. Tel 22 203578; Fax 22 11 39 71; Elec Mail museum@kunstindustrimuseet.no; Internet Home Page Address: http://www.kunstindustrimuseet.no
11 a.m. - 3 p.m., Mon cl; Estab 1876; Library with 52,000 vols
Collections: Collection from the 600s to the present of applied arts, fashion & design with ceramics, furniture, glass, silver, textiles from Norway, Europe & Far East

M **NASJONALGALLERIET,** Universitetsgaten 13, Post Box 7014, St. Olavs plass Oslo, 0130 Norway. Tel (47) 22200404; Fax (47) 22261132; Elec Mail nga@nasjonalgalleriet.ho; Internet Home Page Address: www.nasjonalgalleriet.no; *Dir* Annichen Thue; *Chief Rest* Françoise Hanssen-Bauer; *Deputy Dir* Sitsel Hethedser; *Chief Cur Painting & Sculpture* Marit J Lange; *Cur of Prints & Drawings* Nils Hessel
Open Mon, Wed & Fri 10 AM - 6 PM, Thurs 10 AM - 8 PM, Sat 10 AM - 3 PM, Sun 11 AM - 3 PM, cl Tues; No admis fee; Library with 80,000 vols; Average Annual Attendance: 350,000
Income: Government grant; NSK 43,878,000
Library Holdings: Auction Catalogs; Book Volumes; Exhibition Catalogs; Pamphlets; Periodical Subscriptions; Slides
Collections: Norwegian paintings & sculpture; Old European paintings; icon collection; especially of modern French, Danish & Swedish art; a collection of prints & drawings; a small collection of Greek & Roman sculptures; the collections of paintings & sculpture up to 1945
Activities: Educ program; lect open to public; concerts; gallery talks

M **NORSK FOLKEMUSEUM,** Norwegian Folk Museum, Bygdoy, Museum Veien 10 Oslo, 0287 Norway. Tel 22123700; Fax 22 12 37 77; *Dir* Erik Rudeng
Collections: The Lappish section provides an insight into the ancient culture of the Lapps. The Open Air Museum totals about 170 old buildings, all original. Among them are the 13th century Gol stave church; farmsteads from different districts of the country; single buildings of particular interest; The Old Town - 17th, 18th & 19th centuries town houses. Urban Collections; Henrik Ibsen's study; other collections include peasant art & church history

M **NORSK SJOFARTSMUSEUM,** Norwegian Maritime Museum, Bygdoynesveien 37, Oslo, N-0286 Norway. Tel 4724114151; Fax 4724114150; Elec Mail fellespost@norsk-sjofartsmuseum.no; Internet Home Page Address: www.norsk-sjofartsmuseum.no; *Dir* Jan-Börge Tjäder; *Librn* Helen Furu; *Research Cur* Bärd Kolltveit
May 16 - Sept 30, 10 AM - 6 PM, Oct 1 - May 15, 10:30 AM - 4 PM; adults NOK 40; children NOK 20; family NOK 90; Estab 1914; Library with 30,000 vols; Mem: Friends of Norsk Sjofartsmuseum
Library Holdings: Clipping Files; Manuscripts; Maps; Original Documents; Pamphlets; Periodical Subscriptions; Photographs; Prints
Collections: Amundsen's Gjoa; archives pertaining to maritime history; instruments, paintings, photographs of ships, ship models, tools & other items pertaining to maritime collections, shop and boat plans
Publications: Yearbook
Activities: Classes for adults; panoramic movies of the Coast of Norway and Oslo; lectrs open to the public; mus shop sells books, reproductions, prints, maritime objects

M **OSLO KOMMUNES KUNSTSAMLINGER,** Munch museet, Toyengata 53, Post Box 1453 Vika, 0116 Oslo, 0578 Norway. Tel 22673774; Fax 22 67 33 41; *Dir* Alf Boe; *Chief Cur* Arne Eggum
Collections: Paintings, sculptures, graphic works, prints and drawings of: Edvard Munch, Gustav Vigeland, Ludvig Ravensburg, Rolf E Stenersens

L **STATENS KUNSTAKADEMI BIBLIOTEKET,** National Academy of Fine Arts Library, St Olavs Gate 32, Oslo, 0166 Norway; St Olavs Gate 32 Oslo 1, 0166 Norway. Tel 22-99-55-30; Fax 22-99-55-33; *Rector of Academy* Jan Ake Petterson
Library with 6000 volumes to support training by 14 teachers of 130 students

M **UNIVERSITETETS OLDSAKSAMLING,** University Museum of National Antiquities, Frederiksgate 2, Oslo, 0164 Norway. Tel 22416300; *Dir* Egil Mikkelsen
Collections: Archaeological finds from Norwegian Stone, Bronze & Iron Ages, also Medieval age, including religious art, 70,000 exhibits from prehistoric & Viking times, including Middle Ages

PAKISTAN

KARACHI

M **NATIONAL MUSEUM OF PAKISTAN,** Burns Garden, Karachi, 74200 Pakistan. Tel (021)-2633881-2628280-2639930; *Supt* Mohammad Arif
Open daily 10 AM - 5 PM, cl Wed; Admis PK.RS. 4, students free; Estab 1971 as archaeological & history mus for preservation of cultural heritage & educ; Average Annual Attendance: 150,000
Collections: Antiquities dating from 7000 BC to modern times, large collection of coins and miniature paintings spreading from 6th century BC to present; ethnological material from the various regions of Pakistan; Buddhist and Hindu sculptures; paleolithic implements; handicrafts and manuscripts of the Muslim period; collection of defunct Victoria Museum
Activities: Organize traveling exhibitions to USA, Germany, Japan, Korea & various other countries

LAHORE

M **LAHORE FORT MUSEUM,** Lahore, 54000 Pakistan. Tel 56747; *Dir Archaeology* Masud-ul Hasan
Collections: Mughal Gallery: Mughal paintings, coins, calligraphy, manuscripts, faience, carving, Sikh Gallery: arms and armor, paintings and art of Sikh period; Sikh Painting Gallery: oil paintings from the Princess Bamba Collection

M **LAHORE MUSEUM,** Shahrah-i-Quaid-i-Azam, Lahore, Pakistan. Tel 042-9210804-5; Fax 042-9210810; Elec Mail 1hrmuseum@wol.net.pk; *Dir* Ms Naheed Rizvi; *Deputy Dir & Cur* Miss Humera Alam; *Sr Librn* Mr Bashir Ahmed Bhatti; *Sr Chemist* Mr Waseem Ahmed
Library Holdings: Book Volumes 30,000
Special Subjects: Archaeology, Decorative Arts, Historical Material, Architecture, Ceramics, Furniture, Textiles, Bronzes, Manuscripts, Watercolors, Costumes, Crafts, Asian Art, Carpets & Rugs, Coins & Medals, Restorations, Baroque Art, Miniatures, Renaissance Art, Embroidery, Antiquities-Persian, Islamic Art, Leather, Reproductions
Collections: Greco-Buddhist sculpture; Indo-Pakistan coins; miniature paintings; local arts; armor; stamps; Oriental porcelain & manuscripts; Islamic calligraphy
Activities: Mus shop sells books & magazines

PESHAWAR

M **PESHAWAR MUSEUM,** Peshawar, Pakistan. Tel 7-44-52; *Dir* Aurangzeb Khan
Collections: Architectural pieces and minor Antiquities; mainly sculptures of the Gandhara School containing images of Buddha, Bodhisattvas, Buddhist deities, reliefs illustrating the life of the Buddha and Jataka stories; Koranic manuscripts

TAXILA

M **ARCHAEOLOGICAL MUSEUM,** Rawalpindi, Taxila, Pakistan. *Custodian* Gulzar Mohammed Khan
Collections: Antiquities from Taxila Sites ranging from 6th Century BC to 5th Century AD; gold and silver ornaments; pottery; sculptures of stone and stucco of Gandhara School

PAPUA NEW GUINEA

BOROKO

M **PAPUA NEW GUINEA NATIONAL MUSEUM & ART GALLERY,** PO Box 5560, Boroko, Papua New Guinea. Tel 252405; Fax 259 447; *Dir* Soroi Marepo Eoe
Library with 4500 vols

PARAGUAY

ASUNCION

M **MUSEO DE CERAMICA Y BELLAS ARTES JULIAN DE LA HERRERIA,** Estados Unidos, Asuncion, 1120 Paraguay. *Dir* Josefina Pla
Library with 6000 vols
Collections: Modern works of Paraguayan artists; Paraguayan folk art

M MUSEO NACIONAL DE BELLAS ARTES, Mariscal Estigarriba y Iturbe, Asuncion, Paraguay. *Dir* Jose Laterza Parodi
Collections: Paintings and sculptures

PERU

LIMA

M MUSEO DE ARTE DE LIMA, Lima Museum of Art, Paseo Colon 125, Lima, Peru. Tel (51-1) 42 34 732; Fax (51-1) 42 36 332; *Dir* Pedro Pablo Alayza
Collections: Peruvian art throughout history; Colonial painting; carvings, ceramics, furniture, metals, modern paintings, religious art, sculpture, textiles

M MUSEO NACIONAL DE LA CULTURA PERUANA, National Museum of Peruvian Culture, Avenida Alfonso Ugarte 650, Apdo 3048 Lima, 100 Peru. Tel 4235892; *Dir* Sara Acevedo Basurto
Collections: Ethnology, folklore, popular art

PHILIPPINES

MANILA

M METROPOLITAN MUSEUM OF MANILA, Bangko Sentral, ng Pilipinas Complex/Roxas Blvd Manila, Philippines. Tel (632) 536-1566; Fax (632) 528-0613; Elec Mail art4all@info.com.ph; *Pres, CEO* Corazón S. Alvina
Open 10 AM to 6 PM Mon - Sat; Admis P50.00/P30.00; Estab 1976; initially to show foreign art; Average Annual Attendance: 240,000
Income: Financed from found
Library Holdings: Audio Tapes; Book Volumes; Cassettes; Exhibition Catalogs; Kodachrome Transparencies; Manuscripts; Pamphlets; Periodical Subscriptions; Photographs; Prints; Slides
Special Subjects: Pottery, Asian Art
Collections: Fine arts museum; paintings, graphic arts, sculptures & decorative arts
Publications: catalogues, books on Filipino art & artists
Activities: Classes for adults & children; docent training; lect open to public; 4 vis lect per year; gallery talks; provincial capitals; originate non-traditional rural traveling exhibs; sales of books

M NATIONAL MUSEUM OF THE PHILIPPINES, POB 2659, Padre Burgos St Manila, 1000 Philippines. Tel (632) 5271215; Internet Home Page Address: www.skyboom.com/nationalmuseumphils; *Dir* Corazon S. Alvina; *OIC - Asst Dir* Cecilio G Salcedo; *Cur II, Med* Elenita D V Alba; *Cur II, Arch* Wilfredo Ronquillo
10:00 AM - 4:30 PM; Adults 100.00 each; students 30.00 each upon presentation of ID; Estab October 29, 1901 - to protect, preserve & disseminate the heritage of the Filipino people; Arts/Anthropological/Archaeological/Zoological/Botanical & Geological; Average Annual Attendance: 201,383
Income: varies yrly/financed by Philippine goverment paintings, specimens
Purchases: paintings, specimens
Library Holdings: Audio Tapes; Book Volumes; CD-ROMs; Cassettes; Clipping Files; Kodachrome Transparencies; Manuscripts; Original Art Works; Original Documents; Pamphlets; Periodical Subscriptions; Photographs; Prints; Reproductions; Sculpture; Slides; Video Tapes
Collections: Fine arts, cultural, archaeological, sciences collections; Textile, arts & crafts, paintings
Exhibitions: Best of Philippine Art; San Diego Exhibits; Cloth Traditions; Juan Luna Exhibs; 5 Centuries of Maritime Trade before the Coming of the West
Publications: Nat Museum Papers; Ann Reports; A Voyage of 100 Years; Art-i-facts (newsletter)
Activities: Docent training; gallery talks; tours; sponsoring of competitions; lects for staff only; lectrs minimum one per month, concerts; Metro Manila & suburbs; schools, universities & other institutions; nationwide; schools, universities & other institutions; sales shop sells books, magazines

M SANTO TOMAS MUSEUM, Museum of Arts & Sciences, Main Bldg, University of Santo Tomas, Calle Espana Manila, 1008 Philippines. Tel 7313101; Fax (602) 740-9718; Elec Mail museum@ustcg.ust.edu.ph; *Dir* Isidro Abaño; *Asst Dir* Arch Clarissa L Avendaño
Open Tues - Fri 10 AM to 4 PM; Estab 1682 as Gabinete de Figica
Income: University subsidy & funding
Library Holdings: Book Volumes; Memorabilia; Original Documents; Pamphlets; Periodical Subscriptions; Records
Special Subjects: Archaeology, Watercolors
Collections: Archaeology, cultural & historical items; Chinese trade pottery; ethnology of the Philippines; medals; Philippine art; popular Philippines religious art; stamps; Oriental arts collection; university memorabilia
Publications: quarterly museum newsletter
Activities: Classes for children; art & culture summer workshop; kids stuff workshop; lect open to public; grad school diploma course in cultural heritage studies; sales of books, magazines, original art, souvenir items

POLAND

CRAKOW

M MUZEUM NARODOWE W KRAKOWIE, National Museum in Cracow, 3 Maja 1, Crakow, 30-062 Poland. Tel (012) 335331; *Dir* Tadeusz Chruscicki
Collections: National Museum in Cracow consists of several departments with various collections: 3 galleries exhibit Polish painting and sculpture from 14th to 20th centuries; Emeryk Hutten-Czapski Dept has graphic, numismatic and old book collection; Jan Matejko's House exhibits relics and paintings of the eminent Polish painter; Czartoryski Collection contains national relics, armory, Polish and foreign crafts and paintings, archaeology; Czartoryski Library and Archives holds collections of documents, codices, books and incunabula; Stanislaw Wyspianski Museum exhibits works by the Polish Modernist artist, handicrafts, architecture and town planning; Karol Szymanowski Museum contains exhibits relating to the life of the eminent composer

KIELCE

M MUZEUM NARODOWE W KIELCACH, National Museum in Kielce, Pl Zamkowy 1, Kielce, 25-010 Poland. Tel (041)3446764, 3442559; Fax (041)3448261; Elec Mail poczta@muzeumkielce.net; Internet Home Page Address: www.muzeumkielce.net; *Dir & Prof* Kizysztof Urbaniski; *Deputy Dir* Ryszard De Latour; Yolanta Gagorowska, PhD; Anna Myslinska, PhD
Open Tues 10 AM - 6 PM, Wed -Sun 9 AM - 4 PM, cl Mon; Admis adult 10 PLN, children 5 PLN; Estab 1908; Circ Circulation: 1100; Library with 31,500 vols; Average Annual Attendance: 92,970
Library Holdings: Book Volumes 33,300; Exhibition Catalogs 2760; Periodical Subscriptions 3315
Special Subjects: Drawings, Folk Art, Historical Material, Ceramics, Glass, Metalwork, Portraits, Pottery, Maps, Sculpture, Graphics, Photography, Prints, Watercolors, Archaeology, Landscapes, Manuscripts, Painting-European, Posters, Furniture, Porcelain, Oriental Art, Silver, Painting-Dutch, Coins & Medals, Tapestries, Baroque Art, Painting-Flemish, Painting-Polish, Painting-Italian, Islamic Art, Cartoons, Stained Glass, Military Art
Collections: Polish paintings from 17th to 20th century; Polish baroque interiors; European-paintings, graphics, glass, pottery, gold, silver, furniture, arms & armour, coins, medals; historical and biographical materials, archaeology, natural history, folk art, car models
Exhibitions: Historic interiors of 17th and 18th centuries; Gallery of Polish Painting and Decorative Arts; Old European and Oriental Arms and Armour; Sanctuary of Marshal Jozef Pilsudski; Paintings by Piotr Michatowski, Henryk Czarnecki, Jozef Deskur, Jozef Czapski
Publications: The Ann of Nat Mus in Kielce; Corpus Inscriptionum Poloniae, vol 1-5; exhibit catalogs
Activities: Classes for adults & children; lectrs open to the public; 2000 vis lectrs per year; concerts; gallery talks; sponsoring of competitions; mus shop sells books & reproductions

KRAKOW

L BIBLIOTEKA GLOWNA AKADEMII SZTUK PIEKNYCH, Central Library of the Academy of Fine Arts, ul Smolensk 9, KraKow, 31-108 Poland. Tel 422-15-46 w 54; Fax (012)431-15-73; Elec Mail zewarcha@cyf-kr.edu.pl; *Dir* Elzbieta Warchalowska; *Cur* Janusz Antos; *Cur* Anna Szpor-Weglarska
Open Mon & Fri 9 AM - 2:30 PM, Tues, Wed & Thurs 9 AM - 7 PM, Sat 9 AM - 1 PM; Admis for our professors & students is free; Estab 1869, mus of Technology and Industry; Average Annual Attendance: 39,500
Library Holdings: Auction Catalogs; Book Volumes; CD-ROMs; Cards; Cassettes; Compact Disks; Exhibition Catalogs; Manuscripts; Maps; Original Art Works; Periodical Subscriptions; Photographs; Prints; Reproductions; Sculpture; Slides
Collections: Over 75,000 vols, 30,000 other items in collection; poster room, print room

KRAKOW

M ZAMEK KROLEWSKI NA WAWELU, Wawel Royal Castle, Wawel 5, Krakow, 31-001 Poland. Tel 422-51-55; Fax 422-19-50; *Dir* Prof Jan Ostrowski; *Mgr* Jerzy T Petrus; *Dir* Dr Marcin Fabianski; *Dir* Dr Maria Hennel-Barnasikowa; Dr. Kazimierz Kuczman; Dr Ryszard Skowron; Dr Kryszyna Mamajko; *Dir* Magdalena Piwocka
9 AM - 3 PM; Library with 14,900 vols; Average Annual Attendance: 791,000
Collections: Italian Renaissance furniture; King Sigismund Augustus 16th Century Collection of Flemish Tapestries; Oriental art objects; Polish, Western-European Oriental weapons; Western-European & Oriental pottery; Western European painting; royal treasury of crown jewels, gold objects, historical relics; Western European furniture; Western European Oriental textiles
Publications: Sudia Wawellana (annual)
Activities: Books, prints, slides

M ZAMEK KROLEWSKI NA WAWELU-PANSTWOWE ZBIORY SZTU, (Panstwowe Zbiory Sztuki na Wawelu) Wawel Royal Castle - State Art Collections, Wawel 5, Krakow, 31001 Poland. Tel 422-51-55; Fax 422-51-50; *Prof, Dir* Jan Ostrowski; *Deputy Dir* Jerzy T Petrus; *Asst Prof* Maria Hennel-Bernasikowa; *Asst Prof* Zbigniew Pianowski; *Asst Prof* Piotr Szlezynger
Open Sun 10 AM - 3 PM, Fri 9:30 AM - 4 PM, Wed, Thurs, Sat 9:30 AM - 3 PM, cl Mon; Admis 51,00 zl; Estab 1930; Library with 13,828 vols; Average Annual Attendance: 900,000
Income: Financed by Ministry of Culture & Nat Heritage
Purchases: Polish regalia & items linked with the castle & royal court
Collections: Collections of art in the royal castle; 16th century collection of Flemish tapestries; Italian & Dutch paintings; Oriental objects of art
Publications: Studia Waweliana; Acta Archaeological Waweliana; catalogues of collections & temporary exhibitions
Activities: Works lent to Polish & foreign museums; museum shop sells books, reproductions & slides

LODZ

M MUZEUM SZTUKI W LODZI, Art Museum, Ul Wieckowskiego 36, Lodz, 90-734 Poland. Tel (42) 633-97-90; Fax (42) 632-99-41; Elec Mail muzeum@muzeumsztuki.lodz.pl; Internet Home Page Address: www.muzeumsztuki.lodz.pl; *Dir* Jaroslaw Suchan
Open Tues 10 AM - 5 PM, Wed & Fri 11 AM - 5 PM, Thurs Noon - 6 PM, Sat - Sun 10 AM - 4 PM; No admis fee on Thurs; Estab 1931; 20th Century Art (International)

Library Holdings: Auction Catalogs; Book Volumes; Exhibition Catalogs; Original Documents; Pamphlets; Periodical Subscriptions; Prints
Collections: Gothic art; 15th to 19th century foreign paintings; 18th to 20th century Polish paintings; international modern art; Polish photography and multimedia collections
Publications: 111 Works from the Collection of Museum Sztuki in Lodzi
Activities: Classes for adults and children; music programs; lect open to public; concerts; gallery talks; tours; scholarships and fellowships offered; museum shop sells books, reproductions, prints, slides

POZNAN

M **MUZEUM NARODOWE,** National Museum, Al Marcinkowskiego 9, Poznan, 61-745 Poland. Tel 852-80-11; Fax 851-58-98; Elec Mail mnoffice@man.poznan.pl; *Dir* Wojciech Suchocki; *Vice Dir* Jerzy Nowakowski
Open 10 AM - 4 PM; 8 PLN; Library has 85,000 vols; 8 branch museums; Average Annual Attendance: 191,329
Library Holdings: Auction Catalogs; Book Volumes; Cards; Exhibition Catalogs; Periodical Subscriptions; Photographs; Slides
Special Subjects: Decorative Arts, Drawings, Folk Art, Ceramics, Glass, Photography, Portraits, Prints, Silver, Painting-British, Graphics, Sculpture, Bronzes, Ethnology, Costumes, Religious Art, Crafts, Pottery, Landscapes, Collages, Painting-European, Posters, Furniture, Jewelry, Painting-Dutch, Painting-French, Coins & Medals, Restorations, Baroque Art, Miniatures, Painting-Flemish, Painting-Polish, Renaissance Art, Medieval Art, Painting-Spanish, Painting-Italian, Antiquities-Greek, Gold, Painting-German, Military Art, Reproductions
Collections: Polish paintings from 15th to 20th century; prints, drawings, sculpture; medieval art; European paintings from 14th to 19th century; modern art; numismatics
Activities: Classes for adults & children; lect open to public; concerts; gallery talks; original art lent to other museums; museum shop sells books, magazines, reproductions & posters

WARSAW

L **BIBLIOTEKA UNIWERSYTECKA W WARSZAWIE,** Library of the University of Warsaw, Ul Krakowskie Przedmiescie 32, Warsaw, 00-927 Poland. Tel 826-41-55; *Dir* Dr Henryk Hollender
Collections: Prints & drawings from 15th - 20th centuries; various memorial collections

M **MUZEUM NARODOWE W WARSZAWIE,** National Museum in Warsaw, Al Jerozolimskie 3, Warsaw, 00495 Poland. Tel +48 (022) 6211031or +48 (022) 6225665; Fax (22) 6228559; Elec Mail muzeum@mnw.art.pl; Internet Home Page Address: www.mnw.art.pl; *Dir* Ferdynand Ruszczyc; Dorota Folfa-Januszewska, Dir for Collection & Rsrch Prgm
Tues, Wed, Fri, Sat & Sun 10 AM - 4 PM, Thurs 11 AM - 5 PM, cl Mon; No admis fee on Sat; Estab 1862
Library Holdings: Auction Catalogs; Audio Tapes; Book Volumes; CD-ROMs; Exhibition Catalogs; Fiche; Manuscripts; Maps; Memorabilia; Original Documents; Periodical Subscriptions; Prints
Collections: Paintings, sculptures & drawings; Medieval & modern Polish 12th century art; European Painting Collection; Ancient Art Collection; Eastern Christian Art Collection; Oriental Art Collection; Coin & Medal Room; Decorative Art Collection; Miniature Room
Publications: Bulletin du Musee National de Varsouie, quarterly
Activities: Educ program; classes for children; lects open to the public; concerts; gallery tallkstours; lending of original objects of art to museums and galleries all over the world; originate traveling exhibitions to museums in Europe and US; mus shop sells books, magazines, reproductions, prints

M **PANSTWOWE MUZEUM ETNOGRAFICZNE W WARSZAWIE,** State Ethnographic Museum in Warsaw, Ul Kredytowa 1, Warsaw, 00-056 Poland. Tel (22) 827-76-41; Fax (22) 827-66-69; *Dir* Dr Jan Witold Suliga
Library has 23,000 vols
Collections: Polish & non-European ethnography collection

M **ZAMEK KROLEWSKI W WARSZAWIE POMNIK HISTORII I KULTRY NARODWEJ,** Royal Castle in Warsaw, National History & Culture Memorial, Zamkowy 4, Warsaw, 00-277 Poland. Tel (022) 65-7 2-1 70; Fax (022) 635 72 60; Elec Mail zamek@zamek-krolewski.com.pl; Internet Home Page Address: www.zamek-krolewski.com.pl; *Dir* Dr Andrzej Rottermund; *Deputy Dir* Danuta Kuniewicz-koper
Open Oct - April 15: 10 AM - 4 PM, April 16 - Sept 30 10 AM - 6 PM; Library with 25,000 vols
Special Subjects: Decorative Arts, Porcelain, Portraits, Silver, Tapestries, Sculpture, Ceramics, Painting-Dutch, Carpets & Rugs, Coins & Medals, Restorations, Baroque Art, Painting-Flemish, Painting-Polish, Painting-Italian, Painting-German
Collections: Prints, paintings, sculptures, applied arts & furniture
Exhibitions: (12/15/2006-03/25/2007) At the Throne of the Queen of Polan - Jasne fore in the history of Polish culture; (10/2007-12/2007) Jon Cuther Zum Bauhaus - Nationalschatze Aus Deutschland
Activities: Classes for children; lect open to the pub; concerts; tours; mus shop sells books, magazines & reproductions

WROCLAW

M **MUZEUM ARCHITEKTURY,** Museum of Architecture, Ul Bernardynska 5, Wroclaw, 50-156 Poland. Tel (+48) (071) 343-36-75; Fax (071) 344-65-77; Elec Mail muzeum@ma.wroc.pl; Internet Home Page Address: www.ma.wroc.pl; *Dir* Jerzy Ilkosz, MA; *Deputy Mgr* Ewa Jasienko; *Deputy Mgr* Michal Kaczmarek
Open 10 PM - 4 AM, Sun 11 PM - 5 AM, cl Mon; 2 Euro Adults; 1 Euro Children; Estab 1965; Museum housed in beautiful former Bernardine 14th Century Cloister Complex

Income: State budget, City of Wroclaw, Sponsors
Purchases: Architectual books and catalogues from other museums and institutions
Library Holdings: Audio Tapes; Book Volumes; CD-ROMs; Cassettes; Compact Disks; Exhibition Catalogs; Maps; Original Documents; Photographs; Reproductions; Sculpture; Slides; Video Tapes
Collections: Polish & other architecture; modern art; Individual architecture, documents, photographs, projects
Publications: Books about architecture, art - Polish and foreign
Activities: Classes for adults & children; seminars for students; research conferences; lects open to public, concerts, gallery talks; lending original objects of art to other museums; co-operation with traveling exhibs; mus shop sells books

M **MUZEUM NARODOWE WE WROCLAWIU,** National Museum in Wroclaw, Pl Powstancow Warszawy 5, Wroclaw, 50-153 Poland. Tel (71) 372-51-50; Fax (71) 343-56-43; Elec Mail muzeumnarodowe@wr.onet.pl; Internet Home Page Address: www.mnwr.art.pl; *Dir* Mariusz Hermansdorfer
Open 10 AM - 4 PM; Library with 91,000 vols; 102,000 mus objects
Collections: Medieval art; Polish paintings of the 17th, 18th, 19th & 20th centuries, European paintings; decorative arts, prints, ethnography & history relating to Silesia; numismatics
Publications: Exhibition catalogs
Activities: Classes for adults & children; books & magazines

PORTUGAL

EVORA

M **MUSEU DE EVORA,** Largo do Conde de Vila Flor, Evora, 7000-804 Portugal. Tel 266702604; Fax 266708094; Elec Mail mevora@ipmuseus.pt; Internet Home Page Address: www.museudevona.ipmuseus.pt; *Dir* Joaquim Oliveira Caetano
Collections: Paintings: 16th century Flemish & Portuguese works; local prehistoric tools & Roman art & archaeology; sculpture from middle ages to the 19th century; 18th century Portuguese furniture & silver

LAMEGO

M **MUSEU DE LAMEGO,** Lamego, 5100 Portugal. Tel (054) 612008; Fax (054) 655264; *Dir* Dr Agostinlto Riberio
Collections: 16th century Brussels tapestries; Portuguese painting of 16th and 18th centuries; sculpture; religious ornaments

LISBON

M **MUSEU CALOUSTE GULBENKIAN,** Av de Berne 45 A, Lisbon, 1067-001 Portugal. Tel 7935131; Fax 7955249; Elec Mail info@gulbenkian.pt; Internet Home Page Address: www.bulbenkian.pt; *Dir* Joao Castel-Branco Pereira
Collections: Gulbenkian art collection covering the period 2800 BC to present; classical, Oriental, European art; manuscripts, furniture, gold and silver; medals; tapestries

M **MUSEU NACIONAL DE ARTE ANTIGA,** National Museum of Ancient Art, Rua das Janelas Verdes, Lisbon, 1293 Portugal; Rua das Janelas Verdes, Lisbon, 1249-017 Portugal. Tel 21.3912800; Fax 213973703; Elec Mail mnarteantiga@ipmuseus.pt; Internet Home Page Address: www.mnarteantiga-ipmuseus.pt; *Dir* Prof Dalila Rodrigues; *Cur* Teresa Schneider, ARG; *Cur* Dr Leonor d'Orey; *Cur* Maria da Conceicao Borges de Sousa; *Cur* Dr José Alberto Seabra; *Cur* Dra Maria Antónia Matos; *Cur* Dra Alexandra Markl
Tues 2 PM - 6 PM; Wed - Sun 10 AM - 6 PM; 3 Euros; Estab 1884; Library with 36,000 vols; Average Annual Attendance: 120,000; Mem: 650; 25 euros
Library Holdings: Auction Catalogs; Book Volumes; Exhibition Catalogs; Periodical Subscriptions
Collections: Portuguese and foreign plastic and ornamental art from 12th to 19th centuries
Activities: Docent training; Sales shop has books, reproductions, prints & educational materials

M **MUSEU NACIONAL DE ARTE CONTEMPORANEA,** National Museum of Contemporary Art, Museu Do Chiado, Rua de Serpa Pinto 4, Lisbon, Portugal. Tel 213432148; Fax 213432151; *Dir* Pedro Lapa; Maria Jesus Avila, Dr; Nuno Ferreira De Carvalho, Dr; Maria Aires Silveira, Dr
Open Tues 2 PM - 6 PM, Wed, Thurs, Fri, Sat & Sun 10 AM - 6 PM, cl Mon; Admis 600 (PTE); Estab 1911; Nat Museum of Contemporary Art; Gallery includes 5 rooms with total area of 1200M
Special Subjects: Drawings, Period Rooms, Sculpture, Portraits
Collections: Contemporary painting and sculpture
Activities: Classes for children; workshops for children; traveling exhibitions to Spain

PORTO

M **MUSEU NACIONAL DE SOARES DOS REIS,** National Museum of Soares Dos Reis, Palacio dos Carrancas, Rua de D Manuel II Porto, 4000 Portugal. Tel (02) 2081956; Fax (02) 2082851; *Dir* Dr Monica Baldaque
Collections: Furniture, glass, jewelry, old and modern paintings, porcelain, pottery, sculpture

VISEU

M **MUSEU DE GRAO VASCO,** Adro d SE, Viseu, Portugal. Tel 422049; Fax 232 421241; Elec Mail mgv@ip.museu.pt; *Dir* Dr Alberto Correia
Cl to the public until 2003
Collections: Flemish & Portuguese paintings; furniture, tapestries, ceramics & glassware; drawings, paintings

ROMANIA

BUCHAREST

L **BIBLIOTECA ACADEMIEI ROMANE,** Library of the Romanian Academy, Calea Victoriei 125, Bucharest, 71102 Romania. Tel (1) 650-30-43; Fax (1) 650-74-78; *Dir* Gabriel Strempel
Library Holdings: Other Holdings Items over 9 million
Collections: National depository for Romanian & United Nations publications; Romania, Latin, Greek, Oriental & Slavonic manuscripts, engravings, documents, maps, medals & coins

M **MUZEUL NATIONAL DE ARTA AL ROMANIEI,** National Museum of Art of Romania, Calea Victoriei 49-53, Bucharest, 70101 Romania. Tel 315-51-93; Fax 312-43-27; Elec Mail national.art@art.museum.ro; Internet Home Page Address: art.museum.ro; *Gen Dir* Roxana Theodorescu; *Deputy Dir* Rodica Matei; Mrs Anca Lazaresco; *Head Universal Gallery* Mrs Carmen Brad; *Head Educ & Pub Relations* Mrs Raluca Benz
Open May - Sept Wed - Sun 11 AM - 7 PM, Oct - Apr 10 AM - 6 PM; The Gallery of European Art 40.000 lei, The Nat Gallery 70.000 lei, Treasure 50.000 lei Combined tickets: The Gallery of European Art * The Nat Gallery 89.000 lei, The Gallery of European Art + The Nat Gallery +Treasure 120.000 lei; Average Annual Attendance: 70,000
Income: $127, 536 USA generated by visiting fees, subsidy of Ministry of Culture and Religious Affairs and from Friends of the Nat Mus of Art of Romania
Collections: Medieval Romanian art (9th - 18th centuries); National Gallery: national, old Romanian, modern & contemporary works of art; Universal Gallery: paintings, sculptures, European decorative arts & Oriental art; graphic art & prints
Activities: Classes for adults & children, workshops; Margareta Sterian awards for museology and contemporary art; lending of original objects of art; books, magazines, original art, reproductions, prints, puzzles, promotional objects
M **Ansamblul Brincovenesc Mogosoaia,** Str Donca Simo 18, Mogosoaia, 78911 Romania. Tel 667-02-40; *Dir* Alexandru Cebuc
Collections: Old Romanian art
M **Muzeul Colectiilor de Arta,** Calea Victoriei 111, Bucharest, 71102 Romania. Tel 659-66-93
Collections: Romanian folk art; decorative arts; paintings, sculpture, graphic arts

CLUJ-NAPOCA

M **MUZEUL ETNOGRAFIC AL TRANSILVANIEI,** Transylvanian Museum of Ethnography, Str Memorandumului, Cluj-Napoca, 3400 Romania. Tel (64) 192344; Fax (64) 192148; *Dir* Tiberiu Graur
Collections: Exhibits of Transylvanian traditional occupations; primitive people; Ethnographical Park, the first open-air museum in Romania

M **MUZEUL NATIONAL DE ARTA CLUJ,** National Museum of Art Cluj, Piata Libertatii 30, Cluj-Napoca, 6400 Romania. Tel 40/064/116952; *Dir* Dr Livia Dragoi
Library with 80,475 vols
Collections: Decorative arts; European and Romanian art, including graphics, paintings and sculpture of the 16th - 20th centuries

CONSTANTA

M **MUZEUL DE ARTA CONSTANTA,** Str Muzeelor 12, Constanta, 8700 Romania. Tel (41) 61-70-12; *Dir* Doina Pauleanu
Collections: Modern & contemporary Romanian art

M **MUZEUL DE ISTORIE NATIONALA SI ARHEOLOGIE DIN CONSTANTA,** National History & Archaeology Museum, Piata Ovidiu 12, Constanta, 8700 Romania. Tel (041) 613925; *Dir* Dr A Radulesu
Library with 22,000 vols
Collections: Prehistory, history & archaeology of the region; statues, coins, neolithic vessels

RUSSIA

KAZAN

M **TATAR STATE MUSEUM OF FINE ARTS,** Ul K Marska 64, Kazan, 420015 Russia. Tel 366921
Library with 10,000 exhibits
Collections: West European & Soviet paintings

MOSCOW

M **KREMLIN MUSEUMS,** Kremlin, Moscow, 103073 Russia. Tel 928-44-56; *Dir* I A Rodimtseva
Collections: Collections housed in Armoury & various Kremlin cathedrals

M **Kremlin Cathedrals,** Cathedral Sq, Moscow, 103073 Russia.
Collections: Icons, tombs & applied arts found in Cathedral of the Assumption, Cathedral of the Annunciation, Archangel Cathedral, Rizpolozhensky Cathedral & Cathedral of the Twelve Apostles

M **STATE MUSEUM OF CERAMICS,** Moscow, 111402 Russia. Tel 370-01-60; *Dir* E S Eritsan
Collections: Russian art; paintings, pottery, porcelain & tapestries

M **STATE MUSEUM OF ORIENTAL ART,** Suvorouskii bul, Moscow, 107120 Russia. Tel (095) 2919614; *Dir* V A Nabachikov
Collections: Art of the Republics of Soviet Central Asia; Chinese art; monuments of art of Japan, India, Vietnam, Korea, Mongolia, Iran and other countries of the Middle and Far East

M **STATE PUSHKIN MUSEUM OF FINE ARTS,** Volkhonka 12, Moscow, 121019 Russia. Tel 203-69-74; Fax 203-46-74; *Dir* I A Antonova
Collections: Ancient Byzantine, Greek, Roman and European art; American art

M **STATE TRETYAKOV GALLERY,** Krymskii val 10-14, Moscow, 117049 Russia. Tel 095-230-77-88; *Dir* P I Lebedev
Collections: 40,000 Russian icons; Russian & Soviet paintings, sculpture & graphic arts from 11th century to present

ROSTOV-ON-DON

M **REGIONAL MUSEUM OF FINE ARTS,** Ul Pushkinskaya 115, Rostov-on-Don, 344007 Russia. Tel 665907; *Dir* Galina Sergeevna Alimurzaeua
Collections: Old Russian, Soviet art

SAINT PETERSBURG

M **MUSEUM OF SCULPTURE,** Pl A Nevskogo 1, Saint Petersburg, Russia. *Dir* N H Belova
Collections: Collection of Russian sculpture; architectural drawings

M **MUSEUM PALACES AND PARKS IN PAVLOVSK,** Revolyutsii 20, Saint Petersburg, 189623 Russia. Tel 470-2155; Fax 465-1104; *Dir* N S Tretyakov
Collections: Russian garden architecture; 18th century sculptures & paintings by the Italian & French masters

M **STATE HERMITAGE MUSEUM,** M Dvortsovaya naberezhnaya 34, Saint Petersburg, Russia. Tel (812) 1103420; Internet Home Page Address: www.hermitagemuseum.org; *Dir* Dr Mikhail Borisovich Piotrovski
Collections: Collection of the arts of prehistoric, ancient Eastern, Graeco - Roman and medieval times; preserves over 2,600,000 objects d'art, including 40,000 drawings, 500,000 engravings; works by Leonardo da Vinci, Raphael, Titian, Rubens and Rembrandt; coins; weapons; applied art

M **STATE RUSSIAN MUSEUM,** Inzhenernaya Str 2, Saint Petersburg, 191011 Russia. Tel (812) 318 1608; Elec Mail info@rusmuseum.ru; Internet Home Page Address: www.rusmuseum.ru/eng/; *Dir* V A Gusev
Open Mon 10 AM - 4 PM, Wed - Sun 10 AM - 5 PM, cl Tues
Collections: Collection of Russian icons; paintings, sculptures & drawings from the 11th to the 19th centuries

M **SUMMER GARDEN AND MUSEUM PALACE OF PETER THE GREAT,** Saint Petersburg, 191186 Russia. Tel 812-312-96-66; *Dir* T D Kozlova
Collections: 18th century sculpture & architecture

SARATOV

M **SAROTOV A N RADISHCHEV ART MUSEUM,** Ul Radishcheva 39, Saratov, 410600 Russia. Tel 241918, 734726; Elec Mail radmuseum@renet.ru; *Dir* T V Grodskova
Open Tues - Fri & Sun 10 AM - 6 PM; Museum admis adults 5 roubles, pensioners 3 roubles, students 2 roubles, children 1 rouble; library admis is free; Estab 1885; Circ Library circulation: 8,400; Library with 34,000 vols & 20,000 exhibitions; Average Annual Attendance: Library attendance: 2,500
Library Holdings: Book Volumes 34,000; Manuscripts 7; Periodical Subscriptions 26
Collections: The Books from Bogoleubov A.P.; Russian Books XVIII-XXc; Foreign Books XVIII-XXc; Miniature Books; The History of Library
Publications: Russian Books XVIIIc

TVER

M **TVER ART GALLERY,** Sovetskaya 3, Tver, 170640 Russia. Tel 32561; Internet Home Page Address: www.gallery.tversu.ru; *Dir* Tatyana S Kuyukina
Library with 25,000 vols; 12,000 exhibits

VORONEZH

M **VORONEZH ART MUSEUM,** Pr Revolyutsii 18, Voronezh, Russia. Tel 552843; *Dir* Vladimir Y Ustinov
Library with 18,000 vols; 22,000 exhibits

YAKUTSK

M **YAKUTSK MUSEUM OF FINE ARTS,** Ul Khabarova 27, Yakutsk, 677000
Russia. Tel 27798; *Dir* N M Vasileva
Collections: 17th to 20th century folk art

SCOTLAND

ABERDEEN

M **ABERDEEN ART GALLERY & MUSEUMS,** Schoolhill, Aberdeen, AB10 1FQ
Scotland. Tel 01224 523700; Fax 01224 632133; Elec Mail info@aagm.co.uk;
Internet Home Page Address: www.aagm.co.uk; Telex 7-3366; *Principal Off*
Ciaran Monaghan; *Registrar* Jonathan Wilson
Open Mon - Sat 10 AM - 5 PM, Sun 2 PM - 5 PM; No admis fee
Collections: 20th century British art; fine & decorative arts; James McBey print
room
Activities: Classes for children; lectr open to public; concerts; gallery talks; sales
of books

DUNDEE

M **DUNDEE ARTS & HERITAGE,** (Dundee Art Galleries & Museums) McManus
Galleries, Albert Sq, Dundee, DD1 1DA Scotland. Tel 01382432020; Fax
01382-432052; *Dir* S Grimmond
Mon - Wed & Fri - Sat 10 AM - 5 PM Thurs until 7 PM, Sun 12:30 PM - 4 PM;
No admis fee; Estab 1872; Large regl mus with colls of art, history & natural
history; Average Annual Attendance: 100,000
Collections: 18th, 19th and 20th Century Scottish and English paintings; 17th
Century Venetian and Flemish works; varied selection of watercolors and prints
from the 18th - 20th Century; regional archaeology

EDINBURGH

M **NATIONAL GALLERIES OF SCOTLAND,** The Mound, Edinburgh, EH2 2EL
Scotland. Tel (0131) 6246200; Fax 131-343-3250; Elec Mail
enquiries@natgalscot.ac.uk; Internet Home Page Address: www.natgalscot.ac.uk;
Dir Timothy Clifford; *Keeper* Michael Clarke
Collections: European & Scottish drawings, paintings, prints & sculpture, 14th -
19th centuries

M **Scottish National Gallery of Modern Art,** Belford Rd, Edinburgh, EH4 3DR
Scotland. Tel (0131) 6246200; Fax 0131 343 2802; Elec Mail
enquiries@nationalgalleries.org; Internet Home Page Address:
www.nationalgalleries.org; *Dir-Gen* John Leighton; *Dir* Richard Calvocoressi;
Chief Cur Keith Hartley
Open Mon - Sun 10 AM - 5 PM; No admis fee to permanent coll; admis fee to
some exhibs; Estab 1959; Two separate gallery bldgs set in extensive grounds and
holding an Outstanding Coll of 20th & 21st Century Art; Average Annual
Attendance: 300,000
Library Holdings: Auction Catalogs; Audio Tapes; Book Volumes; CD-ROMs;
Cards; Cassettes; Clipping Files; Compact Disks; DVDs; Exhibition Catalogs;
Manuscripts; Original Documents; Pamphlets; Periodical Subscriptions;
Photographs; Prints; Records; Reels; Slides; Video Tapes
Collections: Western art from 20th & 21st centuries including painting, sculpture
and graphic art; incl Matisse, Picasso, Dali & Scottish Art from Peploe to Douglas
Gordon
Activities: Classes for adults & children; art clubs; lects open to public; gallery
talks; tours; travel exhibs circulated within the UK & internationally; mus shop
sells books, magazines, reproductions, prints, slides & gifts

M **NATIONAL MUSEUMS OF SCOTLAND,** Royal Museum/Museum of
Scotland, Chambers St, Edinburgh, EH1 1JF Scotland. Tel 0131 225 4422; Fax
0131 220 4819; Elec Mail info@nms.ac.uk; Internet Home Page Address:
www.nms.ac.uk; *Dir* M E P Jones
Open Mon & Wed - Sat 10 AM - 5 PM, Tues 10 AM - 8 PM, Sun Noon - 5 PM;
No admis fee; Average Annual Attendance: 650,000
Library Holdings: Book Volumes; Exhibition Catalogs
Collections: Collections of the Decorative Arts of the World; archaeology and
ethnography
Activities: Classes for adults & children; lect open to public; lect for mems only;
approx 20 vis lect per year; concerts; gallery talks; tours; sponsoring of
competitions; sales of books, magazines, reproductions, prints

GLASGOW

M **GLASGOW MUSEUMS AND ART GALLERIES,** Kelvingrove, Glasgow, G3
8AG Scotland. Tel (141) 287-2000; Fax (141) 287-2690; *Dir* Julian Spalding
Library with 50,000 vols
Collections: Archaeology; British and Scottish art; Decorative Art Collection of
ceramics, glass, jewelry, silver (especially Scottish); ethnography; Fine Art
Collection representing the Dutch, Flemish, French and Italian schools; history;
natural history

M **GLASGOW UNIVERSITY,** Hunterian Museum, University Ave, Glasgow, Gl2
8QQ Scotland. Tel (0141) 330 4221; Fax (0141) 330 3617; Elec Mail
hpalton@museum.gla.ac.uk; Internet Home Page Address:
www.hunterian.gla.ac.uk; *Cur Palaeontology* Dr N Clark; *Cur Mineralogy* Dr J
Faithfull; *Cur Archaeology* Dr L Keppie; *Cur Geology, Dep Dir* Dr G Durant; *Cur
Numismatics* Dr D Bateson; *Dep Dir Adminstr* Mr E Smith
Open 9:30 AM - 5:00 PM; No admis fee; Estab 1807 to serve the university and
public; Two large galleries with two levels; Average Annual Attendance: 60,000

Income: Income from the university
Purchases: Purchases in areas of expertise of curators
Special Subjects: Anthropology, Archaeology, Historical Material, Ceramics,
Porcelain, Pottery, Ethnology, Costumes, Furniture, Jade, Silver,
Antiquities-Byzantine, Ivory, Coins & Medals, Antiquities-Egyptian,
Antiquities-Greek, Antiquities-Roman, Gold
Collections: Prehistoric, Roman, ethnographical & coin collections; Paleontology,
rocks & minerals
Activities: Classes for adults & children; lect open to pub; gallery talks; extension
program serves scientific community, public, students, mus; shop sells books,
reproductions, slides, toys

M **Hunterian Art Gallery,** 82 Hillhead St, Glasgow, G12 8QQ Scotland. Tel
141-330-5431; Fax 141-330-3618; Elec Mail jbarrie@museumigla.ac.uk; Internet
Home Page Address: www.gla.ac.uk/museum; *Dir* Alfred Hatton
Collections: J M Whistler & C R Mackintosh collections; Scottish painting from
the 18th century to the present; Old Master & modern prints

SENEGAL

DAKAR

M **MUSEES DEL'INSTITUT FONDAMENTAL D'AFRIQUE NOIRE,** Musee
D'art Africain de Dakar, BP 6167, Dakar, Senegal. *Cur* amadou Tahirou Diaw
Collections: African art; ethnography

SINGAPORE, REPUBLIC OF

SINGAPORE

M **NATIONAL MUSEUM OF SINGAPORE,** Stamford Rd, Singapore, 0617
Singapore, Republic of. Tel (65) 3323575; *Chief Exec Officer* Lim How Seng
Houses the National Museum Art Gallery & the Children's Discovery Gallery;
Library with 15,000 vols
Collections: Paintings & sculpture by artists of Singapore & Southeast Asia;
ethnology & history collections

SLOVAK, REPUBLIC OF

BRATISLAVA

M **GALERIA MESTA BRATISLAVY,** City Gallery of Bratislava, Mirbachov
Palac, Frantiskanske Nam 11 Bratislava, 81535 Slovak, Republic of. Tel
00421-7-54435102; Fax 00421-7-54432611; Elec Mail gmb@nextra.sk; Internet
Home Page Address: www.gmb.sk; *Dir* PhDr Ivan Jancar; *Deputy Dir* Mzana
Jakabovā
Open 10 AM - 7 PM except Mon; 40 sk adults; 20 sk seniors and youth; Estab
1960; Public, owned by Town of Bratislava; Average Annual Attendance: 35,000
Income: Financed partially by town
Library Holdings: Auction Catalogs; Book Volumes; Exhibition Catalogs; Video
Tapes
Special Subjects: Art History, Restorations
Collections: 18th-20th centuries art; Gothic painting & sculpture; permanent
Baroque art exhibition
Activities: Lect open to the public; concerts; gallery talks

M **SLOVENSKA NARODNA GALERIA,** Slovak National Gallery, Riecna 1,
Bratislava, 815 13 Slovak, Republic of. Tel +421 2 54432081; Fax +421 2
54433971; Elec Mail gr@sng.sk; Internet Home Page Address: www.sng.sk; *Dir
Gen* Katarina Bajcurova, PhD; *Dir of Art Collections, Deputy Dir* Alexandra
Homolova
Open 10 AM - 5:30 PM; Admis 80 SK; Estab 1948; Circ Circulation 5,500;
Gallery contains art history, art collections, scientific research, culture & educ;
Average Annual Attendance: 110,000
Library Holdings: Auction Catalogs; Book Volumes; CD-ROMs; Clipping Files;
Compact Disks; Exhibition Catalogs; Fiche; Filmstrips; Manuscripts; Maps;
Memorabilia; Micro Print; Original Documents; Periodical Subscriptions;
Photographs; Reproductions; Slides; Video Tapes
Collections: Applied arts; European & Slovak paintings; Dutch, Flemish and
Italian works of art; graphics and drawings; sculpture
Activities: Classes for adults; classes for children; dramatic programs; lect open to
the public; 10 vis lectrs per year; concerts; gallery talks; museum shop sells
books, magazines, original art, reproductions, prints

SLOVENIA

LJUBLJANA

M **MODERNA GALERIJA,** Museum of Modern Art, Tomsiceva 14, Ljubljana,
61000 Slovenia. Tel 1-214-106; Fax 1-214-120; *Dir* Zdenka Badovinac
Library with 45,000 vols
Collections: Slovene art from Impressionists to present; international collection
containing works of major artists of contemporary world art

M **NARODNA GALERIJA,** National Gallery of Slovenia, Puharjeva 9, Ljubljana, 1000 Slovenia. Tel 00386-(0) 1 24 15 400; Fax 00386-(0) 1-24 15 403; Elec Mail info@ng-slo.si; Internet Home Page Address: www.ng-slo.si; *Cur* Dr Andrej Smrekar; *Dir* Barbara Jaki, PhD; *Cur* Ferdinand Serbelj, PhD; *Head Educ* Dr Lidija Tavcar, PhD; *Head Conservation* Tamara Trcek Pecak, MA; *Head Documentation* Mojca Jenko, MA; *Cur* Matcja Brescak; *Cur* Marja Lorencak; *Cur* Alenka Simoncic
Tues - Sun 10 AM - 6 PM; admis 5E, 3E (reduced); Estab 1918 for the purpose of collection of art in Slovenia; Library with 34,000 vols; Average Annual Attendance: 100,000
Income: Government
Library Holdings: Auction Catalogs; CD-ROMs; Clipping Files; DVDs; Exhibition Catalogs; Framed Reproductions; Manuscripts; Maps; Original Documents; Pamphlets; Periodical Subscriptions; Records; Reproductions; Video Tapes
Special Subjects: Drawings, Etchings & Engravings, Portraits, Prints, Painting-French, Sculpture, Graphics, Photography, Watercolors, Bronzes, Religious Art, Woodcarvings, Woodcuts, Landscapes, Painting-European, Painting-Dutch, Coins & Medals, Baroque Art, Painting-Flemish, Renaissance Art, Medieval Art, Painting-Spanish, Painting-Italian, Painting-German
Collections: Copies of medieval frescoes; European Masters from the 14th Century to the beginning of the 20th Century; Slovenian sculptures and paintings from the 13th to the beginning of the 20th Century; Slovenian graphic arts; Coll of posters; Archival-documentary collection; Photo-Library
Publications: Exhib Catalogues
Activities: Classes for adults & children, dramatic programs, docent training, workshops; 6 vis lects per yr, concerts, gallery talks, tours; lending of original objects of art to European museums; organize traveling exhibitions to Slovenian museums; museum shop sells books, magazines, reproductions & slides

SOUTH AFRICA, REPUBLIC OF

CAPE TOWN

M **MICHAELIS COLLECTION,** Old Town House, Greenmarket Square Cape Town, South Africa, Republic of. Tel (021) 246 367; Fax (021) 461 9592; *Dir* Dr H Fransen
Collections: Dutch and Flemish graphic art and paintings of the 16th - 18th centuries

M **SOUTH AFRICAN NATIONAL GALLERY,** Government Ave, Gardens, PO Box 2420 Cape Town, 8000 South Africa, Republic of. Tel (021) 45-1628; Fax (021) 461-0045; *Dir* M Martin
Collections: 19th and 20th century South African art; 15th - 20th century, European art, including drawings, paintings, prints, sculptures and watercolors; traditional African art; 20th century American Art

DURBAN

M **DURBAN MUSEUMS,** City Hall, Smith St, PO Box 4085 Durban, 4000 South Africa, Republic of. Tel (031) 311 2264; Fax (031) 311 2273; Internet Home Page Address: www.durban.gov.za/museums; *Dir* R Omar
Open 8:30 AM - 4:00 PM; No admis fee; Estab 1910/Educ
Library Holdings: Auction Catalogs; Audio Tapes; CD-ROMs; Cassettes; Clipping Files; Compact Disks; Exhibition Catalogs; Slides; Video Tapes
Collections: Archaeology, paintings, graphic art, porcelain, sculptures, local history
Activities: Classes for adults & children; lects open to public

JOHANNESBURG

M **CITY OF JOHANNESBURG ART GALLERY,** Johannesburg Art Gallery, Joubert Park, PO Box 23561 Johannesburg, 2044 South Africa, Republic of. Tel (011) 725-3130; Fax (011) 720 6000; Elec Mail job@joburg.org.za; *Dir* R Keene
Open Tues - Sunday 10 AM - 7 PM; No admis fee; Estab 1910; Art
Library Holdings: Auction Catalogs; Book Volumes; CD-ROMs; Clipping Files; Compact Disks; Exhibition Catalogs; Original Documents; Other Holdings archives; Pamphlets; Periodical Subscriptions; Slides; Video Tapes
Collections: South African & international painting & sculpture; print collection; small collection of ceramics , textiles & fans
Activities: Classes for adults & children; lect open to public; museum shop sells books

KIMBERLEY

M **WILLIAM HUMPHREYS ART GALLERY,** Civic Centre, PO Box 885 Kimberley, 8300 South Africa, Republic of. Tel (053) 83 11 724; Fax (053) 83 22 221; *Dir* Mrs Ann Pretorius; *Educ Off* Mrs Ann Bazzard; *Libr* Mrs Nellie Spangenberg; *Clerical Asst* Mrs Shirley Kidson
Open Mon - Sat 10 AM - 5 PM, Sun & pub holidays 2 PM - 5 PM; R2.00 adults, R1.00 children; Estab 1952; Circ 100; art gallery; Average Annual Attendance: 22,000
Library Holdings: Auction Catalogs; Audio Tapes; Book Volumes; Cassettes; Pamphlets; Periodical Subscriptions; Video Tapes
Special Subjects: African Art, Woodcuts
Collections: Representative collection of Old Masters; collection of South African works of art; traditional and contemp SA ceramics; traditional SA artifacts; European & Cape furniture
Exhibitions: traveling temporary exhibs
Publications: newsletter; Carter, ACR The Work of War Artists in S.A. (reprints of the London Art Jour 1900)

Activities: Classes for adults & children; lect open to public; 10 vis lect per year; concerts; gallery talks; tours; sponsoring of competitions; awards include Accredited Mus Grade I; Medal winner 1999; Heritage; lending of original objects of art; sales of books, original art

PIETERMARITZBURG

M **TATHAM ART GALLERY,** Old Supreme Court Bldg, Commercial Rd Pietermaritzburg, South Africa, Republic of. Tel (0331) 421804; Fax (0331) 949831; *Dir* Brendan Bell
Collections: 19th & 20th centuries English & French paintings & sculpture; 19th & 20th centuries English graphics; modern European graphics; South African painting & sculpture

PORT ELIZABETH

M **KING GEORGE VI ART GALLERY,** One Park Dr, Port Elizabeth, 6001 South Africa, Republic of. Tel 27 (041) 5861030; Fax 27 (041) 5863234; Elec Mail kgg@kgg.gov.za; Internet Home Page Address: www.kgg.gov.za; *Dir* Melanie Hillebrand
Open Mon & Wed - Fri 9 AM - 5 PM, Tues Noon - 5 PM, Sat, Sun & pub holidays 2 PM - 5 PM, 1st Sun of month 9 AM - 2 PM; No admis fee
Collections: English painting; international graphics; Oriental ceramics and miniatures; South African art

PRETORIA

M **PRETORIA ART MUSEUM,** Municipal Art Gallery, Arcadia Park, Pretoria, 0083 South Africa, Republic of. Tel (012) 344-1807; Fax (012) 344-1809; *Dir* Dr L M De Waal
Collections: European graphics; 17th century Dutch art; 19th & 20th centuries South African art

SPAIN

BARCELONA

M **MUSEU D'ART MODERN DE BARCELONA,** Museum of Modern Art, Parc de la Ciutadella, Barcelona, 08003 Spain. Tel 93-319-5728; *Dir* Cristina Mendoza Garriga
Library with 50,000 vols
Collections: Modern art

M **MUSEU NACIONAL D'ART DE CATALUNYA,** National Art Museum, Parc de Montjuic, Palau Nacional Barcelona, 08038 Spain. Tel (00 34) 93 622 03 60 (office); 93 622 03 75 (information); Fax (00 34) 93 622 03 74; Elec Mail mnac@mnac.es; Internet Home Page Address: www.mnac.es; *Dir* Eduard Carbonell Esteller; *Head of Dept of Cur* M Rosa Manote
Open Tues - Sat 10 AM - 7 PM, Sun & holidays 10 AM - 2:30 PM, cl Jan 1, May 1 & Dec 25; Admis permanent coll 4.80 Euros, temporary exhib 4.20 Euros, permanent and temporary exhibs 6 Euros; Medieval, Romanesque, Gothic, Renaissance & Baroque art collections; Average Annual Attendance: 500,000
Library Holdings: Book Volumes; Cards; Exhibition Catalogs; Manuscripts; Original Documents; Pamphlets; Photographs; Prints; Slides
Special Subjects: Drawings, Photography, Sculpture, Religious Art, Woodcarvings, Etchings & Engravings, Decorative Arts, Painting-European, Coins & Medals, Baroque Art, Renaissance Art, Medieval Art, Painting-Spanish, Enamels
Collections: Baroque & Renaissance paintings; Catalan Gothic & Romanesque paintings & sculpture
Publications: publications on temperary and permanent collections
Activities: Classes for adults & children; docent training; lect open to public; concerts; gallery talks; scholarships offered; lending of original objects of art; museum shop sells books, reproductions, slides, gifts

M **MUSEU PICASSO,** Calle Montcada 15-19, Barcelona, 08003 Spain. Tel 3196310; Fax 3150102; *Dir* Maria Teresa Ocana
Collections: Pablo Picasso, 1890-1972: paintings, sculpture, drawings and engravings, including the series Las Meninas and the artist's donation, in 1970, of 940 works of art

BILBAO

M **MUSEO DE BELLAS DE BILBAO,** Museum of Fine Arts, Plaza del Museo 2, Bilbao, 48011 Spain. Tel (94) 4396060; Fax (94) 439-61-45; *Dir* Miguel Zugaza Miranda
Collections: Paintings, sculpture; famous works by El Greco, Goya, Gauguin, Velazquez; general contemporary art; early Spanish paintings

MADRID

M **MUSEO CERRALBO,** Ventura Rodriguez 17, Madrid, 28008 Spain. Tel (91) 547 36 46; Fax (91) 559 11 71; *Dir* Pilar de Novascues Benlioch
Library with 12,000 vols
Collections: Paintings; drawings; engravings; porcelain arms; carpets; coins; furniture; includes paintings by: El Greco, Ribera, Titian, Van Dyck & Tintoretto

M MUSEO LAZARO GALDIANO, Calle Serrano 122, Madrid, 28006 Spain. Tel (91) 561 6084; Fax (91) 561 7793; *Dir* Araceli Pereda Alonso
Collections: Italian, Spanish and Flemish Renaissance paintings; primitives; Golden Age 18th - 19th century Spanish paintings; 17th century Dutch paintings; English 18th century collection; ivories, enamels, furniture, manuscripts, tapestries

M MUSEO NACIONAL DEL PRADO, National Museum of Paintings and Sculpture, Paseo del Prado, 28014 Spain. Tel (91) 330 2800; Fax (91) 330 2856; *Dir* Fernando Checa Cremades
Collections: Paintings by: Botticelli, Rembrandt, Velazquez, El Greco, Goya, Murillo, Raphael, Bosch, Van der Weyden, Zurbaran, Van Dyck, Tiepolo, Ribalta, Rubens, Titian, Veronese, Tintoretto, Moro, Juanes, Menendez, Poussin, Ribera; classical and Renaissance sculpture; jewels and medals

M MUSEO ROMANTICO, Museum of the Romantic Period, Calle de San Mateo 13, Madrid, 28004 Spain. Tel 448-10-45; Fax 594-28-93; *Dir* Maria Rosa Donoso Guerrero
Collections: Books, decorations, furniture and paintings of the Spanish Romantic period

M PATRIMONIO NACIONAL, Calle de Bailen s/n, Madrid, 28071 Spain. Tel 91-542-87-00; Fax 91-542-69-47; Internet Home Page Address: www.patrimonionacional.es; *Dir* Miguel Angel Recio Crespo
visit web site (for admis fee & Hours); Estab 1940 to administer former Crown property; it is responsible for all the museums situated in Royal Palaces & properties & is governed by an administrative council; Average Annual Attendance: 829,604
Income: 3,855,768.23 Euros
Library Holdings: Book Volumes; Cards; Exhibition Catalogs; Maps; Reels; Reproductions
Publications: Guides to all the Museums
Activities: Concerts; mus shop sells books, reproductions
M Palacio Real de Madrid, Calle Bailen s/n, Madrid, 28071 Spain. Tel (91) 542-00-59
Also maintains armoury and coach museum; Library with 350,000 vols
Collections: Special room devoted to 16th-18th century tapestries, clocks, paintings & porcelain from the Royal Palaces & Pharmacy
M Palacio Real de Aranjuez, Aranjuez, 28300 Spain. Tel 91-891-13-44
Collections: Royal Palace of 18th century art
M Monasterio de San Lorenzo de El Escorial, Palacio Monasterio, San Lorenzo De El Escorial, 28200 Spain. Tel (91) 8905903; Fax (91) 8907818; Internet Home Page Address: www.patrimonionacional.es; *Consejero Gerente* O Jose Antonio Bordallo Huidobro; *Head Delegation in Saint Lawrence* D Pablo Larrea Villanian
Open April - Sept 10 AM - 5 PM, Oct - March 10 AM - 6 PM; Please visit the website; Built by Juan B de Toledo & Juan de Herrera & contains many famous works by international artists of the 16th & 18th centuries from royal residences; Average Annual Attendance: 635,062
Income: 2.891.904, 52 Euro
Library Holdings: Book Volumes; Cards; Exhibition Catalogs; Reproductions
Collections: Royal Collection of famous international work by artists of 16th & 18th centuries; paintings, sculptures, tapestries, mobiliary, clocks, lamps, porcelains, maps & prints
Activities: Concerts; mus shop sells books, reproductions
M Real Monasterio de las Huelgas, Calle Campas de Adentro s/n, Burgos, 09001 Spain. Tel (947) 20-16-30; Fax (947) 27-9729; Internet Home Page Address: www.patrimonionacional.es
Founded by Alfonso VIII in the ninth century
M Real Monasterio de Santa Clara, 47100 , Tordesillas (Valla dolid), Spain. Tel 983-77-00-71
Collections: 14th century art
M Museo de la Encarnacion, Plaza de la Encarnacion 1, Madrid, 28013 Spain. Tel 91-542-00-59
Collections: Monastic life in the 16th & 17th centuries
M Museo de las Descalzas Reales, Plaza de las Descalzas s/n, Madrid, 28013 Spain. Tel 91-542-00-59
Collections: Showing monastic life in the 16th & 17th centuries
M Palacios de la Granja y Riofrio, Plaza de Espana 17, La Granja de San Ildefonso Segovia, 40100 Spain. Tel 921-47-0019, 921-48-01-42
Collections: Gardens & fountains in imitation of Versailles, tapestry museum
M Museo de Ceramica, Palacio de Pedralbes-Diagonal N 686, Barcelona, 08034 Spain. Tel (93) 2801621; Fax (93) 2054518; *Dir* Maria Antonia Casanovas
Open Tues - Sat 10 AM - 6 PM, Sun 10 AM - 3 PM; Library with 1920 vols
Library Holdings: Book Volumes; Cards; Exhibition Catalogs
Collections: Spanish ceramics, 19th & 20th century
Publications: mus guide - Ceramics of Accra, Ceramics de Talavera, Ceramica de Reflejon Metalicos
Activities: Guided tours by appointment; mus shop sells books, reproductions, souvenirs
M Palacio de la Almudaina, Calle Palau Reial S/N, Palma de Mallorca Balearic Is, 07001 Spain. Tel (971) 72-71-45
Arab-Gothic palace

TOLEDO

M CASA Y MUSEO DEL GRECO: FUNDACIONES VEGA INCLAN, El Greco's House, Calle Samuel Levi, Toledo, Spain. Tel (925) 22-40-46; *Dir* Ma Elena Gomez-Moreno
Collections: Artist's paintings and those of his followers; 16th century furniture
M Museo del Greco, Calle Samuel Levi, Toledo, Spain.
Collections: El Greco's paintings, including portraits of Christ and the apostles and other 16th and 17th century paintings

SRI LANKA

ANURADHAPURA

M ARCHAEOLOGICAL MUSEUM, Anuradhapura, Sri Lanka. Tel 411; *Keeper* J S A Uduwara
Collections: Stone sculptures, mural paintings & frescoes, coins, bronzes, pottery

COLOMBO

M NATIONAL MUSEUMS OF SRI LANKA, Sir Marcus Fernando Mawatha, PO Box 845 Colombo, 7 Sri Lanka. Tel 94767; *Dir* W Thelma T P Gunawardane
Collections: Art, folk culture and antiquities of Sri Lanka

SWEDEN

GOTEBORG

M GOTEBORGS KONSTMUSEUM, Goteborg Art Gallery, Gotaplatsen, Goteborg, 41256 Sweden. Tel (031) 612980; Fax (031) 18-41-19; *Dir* Bjorn Fredlund
Collections: French art from 1820 to present; Old Masters, especially Dutch and Flemish; Scandinavian art

M ROHSSKA KONSTSLOJDMUSEET, Rohss Museum of Arts and Crafts, 37-39 Vasagatan, PO Box 53178 Goteborg, 400 15 Sweden. Tel (031) 613850; Fax 031-184692; *Dir-Pro-Tem* Helena Dahlback Lutteman
The arts and crafts section of the Goteborgs Museer (Museums of the City of Gothenburg); Library with 33,000 vols

LANDSKRONA

M LANDSKRONA MUSEUM, Slottsgatan, Landskrona, 26131 Sweden. Tel 0418-470569; Fax 0148-473110; Elec Mail birthe.wibrand@kn.landskrona.de; Internet Home Page Address: www.landskrona.se/kommun/kultlur; *Dir* Christin Nielsen; *Art Secy* Birthe Wibrand
12 p.m. - 5 p.m.; No admis fee
Collections: Swedish paintings since 1900; modern Swiss art; Nell Walden collection of paintings & ethnology; Local history
Exhibitions: Temporary exhibs
Activities: Classes for children; lects open to public, concerts; mus shop sells books, reproductions, crafts

LINKOPING

M OSTERGOTLANDS LANSMUSEUM, Raoul Walleberg Pl, Vasaagen 16, PO Box 232 Linkoping, 58102 Sweden. Tel (46) 13-23-03-00; Fax (46) 13-230300; Elec Mail lansmuseum@lansmus.linkoping.se; Internet Home Page Address: www.linkoping.se/lansmuseum; *Dir* Pär Hallinder
Open Tues 10 AM - 8 PM, Wed - Fri 10 AM - 5 PM, Sat - Sun 11 AM - 4 PM
Collections: Dutch, Flemish & Swedish art; Swedish archaeology; furniture, tapestries; Egyptian collection; Medical history

STOCKHOLM

M THE NATIONAL MUSEUM OF FINE ARTS, Sodra Blasieholmshamnen, Stockholm, Sweden; PO Box 16176, Stockholm, 103 24 Sweden. Tel (08) 51954300; Fax (08) 51954450; Elec Mail info@nationalmuseum.se; Internet Home Page Address: www.nationalmuseum.se; *Dir Prof* Solfrid Soderlind
Tues 11 a.m. - 8 p.m., Wed - Sun 11 a.m. - 5 p.m., cl Mon; Admis fee for special exhib, discounts for seniors, students, consripts & groups of minimum 15 people, no admis fee to the collections & children under 16 years; Estab 1792; Florentine and Venetian Renaissanse building, 1866; Average Annual Attendance: 500,000; Mem: 5,900 mems of friends of The National Museum
Library Holdings: Book Volumes; Exhibition Catalogs; Original Documents
Special Subjects: Decorative Arts, Drawings, Etchings & Engravings, Glass, Porcelain, Portraits, Prints, Textiles, Painting-European, Painting-French, Sculpture, Crafts, Furniture, Painting-Dutch, Miniatures, Painting-Flemish, Painting-Spanish, Painting-Italian, Painting-German, Painting-Scandinavian
Collections: 16,000 works of paintings, icons & miniatures; sculptures, including antiquities; 500,000 drawings & prints; 30,000 items of applied art; collections of several royal castles with 7500 works of art from the middle ages to early 20th century applied arts also contemporary
Activities: Classes for adults & children; lectrs open to the public; lectrs for mems only; gallery talks; tours; traveling exhibs to regl Swedish museums; mus shop sells books, reproductions, prints, jewelry, applied arts, glass & furniture

M NORDISKA MUSEET, Scandinavian Museum, Djurgardsvagen 6-16, Box 27820, Stockholm, S-115 93 Sweden. Tel (8) 51-95-60-00; Fax (8) 51-95-45-80; Internet Home Page Address: www.nordm.se; *Dir* Lars Lofgren
Collections: Costumes, industrial art, handcrafts, period furnishings; over one million exhibits

M OSTASIATISKA MUSEET, Museum of Far Eastern Antiquities, Skeppsholmen, PO Box 16176 Stockholm, S-10324 Sweden. Tel (08) 51955750; Fax (08) 51955755; Elec Mail info@ostasiatiska.se; Internet Home Page Address: www.ostasiatiska.se; Cable Far Eastern; *Dir* Dr Magnus Fiskesjo
Open Tues 12 Noon- 8 PM, Wed - Sun 12 Noon-5 PM; Estab 1926

Collections: Chinese archaeology, Buddhist sculpture, bronzes, painting & porcelain, Stone-age pottery; Indian, Japanese & Korean art; Southeast Asian art and archaeology
Publications: Bulletin of Museum of Far Eastern Antiquities; Exhib catalogues; Monographs
Activities: Lect open to the public; concerts; gallery talks; tours; organize traveling exhibitions; museum shop sells books, magazines, reproductions, prints, slides, ikebana tools, and souvenirs

M **STOCKHOLMS STADSMUSEUM,** City Museum, Ryssgarden Slussen Box 15025, Stockholm, 10465 Sweden. Tel (08) 50831600; Fax (08) 50831699; Elec Mail stadsmuseum@smf.stockholm.se; Internet Home Page Address: www.smf.stockholm.se; *Dir* Berit Svedberg
Collections: The Lohe Treasure, naive 19th century paintings of Josabeth Sjoberg & armed 15th century vessel; photographs; paintings; drawings, sketches & engravings
Activities: Classes for children; lects open to public, tours; mus shop sells books

SWITZERLAND

AARAU

M **AARGAUER KUNSTHAUS,** Aargauer Platz, Aarau, CH-5001 Switzerland. Tel (062) 8352330; Fax (062) 8352329; Elec Mail kunsthaus@ag.ch; Internet Home Page Address: www.aargauerkunsthaus.ch; *Dir* Beat Wismer
Tues - Sun 10 AM - 5 PM; Thurs 10 AM - 8 PM; Mus for contemporary art
Collections: Swiss painting and sculpture from 1750 to the present day; Caspar Wolf paintings (1735-1783) - art of the first painter of the Alps; landscape painter Adolf Staebli and Auberjonois, Bruhlmann, Amiet, G Giacometti, Hodler, Meyer-Amden, Louis Soutter, Vallotton
Activities: Classes for children; concerts; gallery talks; tours; mus shop sells books

BASEL

M **HISTORISCHES MUSEUM BASEL,** Verwaltung, Steinenberg 4 Basel, 4051 Switzerland. Tel (061) 205 86 00; Fax (061) 205 86 01; Elec Mail historisches.museum@bs.ch; Internet Home Page Address: www.hmb.ch; *Dir* Dr Burkard von Roda
Open Mon, Wed-Sun 10 AM - 5 PM; Admis Adults 7 swiss francs, children under 13 free; Estab 1894; Historical mus with special exhib
Collections: Collection of objects from prehistory to 19th century contained in 4 branches: Barfusserkirche, Haus zum Kirschgarten, Musikmuseum, Kutschenmuseum
Activities: Educ program; classes for adults & children; tours; mus shop sells books, reproductions, prints, postcards

M **NATURHISTORISCHES MUSEUM BASER,** Augustinergasse 2, PO Box 1048 Basel, 4001 Switzerland. Tel (061) 266-55-00; Fax (061) 266-55-46; Elec Mail nmb@bs.ch; Internet Home Page Address: www.nmb.bs.ch; *Dir* Dr Christian Meyer
Open 10 AM - 5 PM; cl Mon; Admis 7 - CHF, reduced; 5 - CHF; Estab 1821; Library with 58,000 vols
Collections: Anthropology, Entomology, mineralogy, fossils, animals, zoology, Western European Centor for Ocean Drulling Prog, micropaleontological reference coll
Activities: Classes for adults; classes for children; docent training; mus shop sells books, magazines, other objects

M **OEFFENTLICHE KUNSTSAMMLUNG BASEL KUNSTMUSEUM,** St Alben-Graben 16, Basel, 4010 Switzerland. Tel (061) 206 62 62; Fax (061) 206 62 52; Elec Mail pressoffice@kunstmuseumbasel.ch; Internet Home Page Address: www.kunstmuseumbasel.ch; *Dir* Dr Bernhard Mendes Bürgi
Open Tues - Sun 10 AM - 5 PM; Admis 10-/8 - CHT; Library with 100,000 vols
Collections: Pictures from 15th century to present day, notably by Witz, Holbein & contemporary painters; collection includes Grunewald, Cranach the Elder, Rembrandt; 16th - 17th century Netherlandish painting, Cezanne, Gauguin & Van Gogh Impressionists; large collection of cubist art; sculptures by Rodin & 20th century artists; American art since 1945; German & Swiss masters, Klee, Matisse
Activities: Educ program; classes for adults & children; lect open to public; concerts; museum shop sells reproductions, prints & slides

BERN

M **KUNSTMUSEUM BERN,** Musee des Beaux-Arts de Berne, Hodlerstrasse 8-12, Bern, CH-3007 Switzerland. Tel 0041 313280944; Fax 0041 313280955; Elec Mail admin@kmb.unibe.ch; Internet Home Page Address: www.kunstmuseumbern.ch; *Dir* Dr Matthias Frehner
Open Tues 9:00 - 12:00, Wed - Sun 9:00 - 17:00, cl Mon; Admis Coll Sat - Fri 7.00, Exhibs Sat - Fri 8.00-16.00
Collections: Dutch & contemporary artists; French & other European Masters of the 19th & 20th centuries; Italian Masters; collection of Paul Klee works of 2600 items; Niklaus Manuel; Hermann & Margrit Rupf Foundation, Adolf Wolfli Foundation; Swiss Baroque Masters; Swiss 19th & 20th Century Masters; 38,000 drawings & engravings; illustrations; works by Sophie Taeuber-Arp
Activities: Classes for adults and children; guided tours; mus shop or sales shop sells books, magazines, reproductions, prints

CHUR

M **BUNDNER KUNSTMUSEUM,** Postfach 107, Chur, 7002 Switzerland. Tel (081) 2572868; Fax (081) 257 21 72; Elec Mail info@bkm.gr.ch; Internet Home Page Address: www.buendnes-kunstmuseum.ch; *Dir* Dr Beat Stutzer; *Conservator* Dr Kathleen Buehles
Admis adults 8. Fr seniors, apprentices, students, & groups 6. Fr; Library with 3000 vols

Library Holdings: Auction Catalogs; Book Volumes; CD-ROMs; Photographs
Collections: Augusto, Alberto, Augusto & Giovanni Giacometti, Angelika Kauffmann, E L Kirchner; Swiss painting
Activities: Classes for adults & children; gallery talks; mus shop sells books, prints

GENEVA

M **MUSEE D'ART ET D'HISTOIRE,** 2 rue Charles Galland, CH-1206 Geneva, Switzerland. Tel 41 (0) 22 418 26 00; Fax 41 (0) 22 418 26 01; Elec Mail mah@ville-ge.ch; Internet Home Page Address: www.ville-ge.ch/musinfo/mahg/; *Dir* Casar Menz; *Cur Fine Arts* Paul Lang; *Cur Fine Arts 20th Century* Claude Ritschard; *Cur Archaeology* Marc-Andre Haldimann; *Cur Applied Art & Textile* Marielle Martiniani-Reber; *Cur Numismatic Coll* Matteo Campagnolo
Open Tues 10 AM - 5 PM, cl Mon; No admis fee until age 18 and to the collections, CHF 5 to all temporary exhibitions, group 15 pers, CHF 3/free for the guide and the bus driver; 1903; an encyclopedic museum, it houses colls in such diverse fields as archaeology, the fine arts and applied arts; largest Swiss coll of Egyptian antiques; also Near-East, Greek, Etruscan and Roman colls.; Average Annual Attendance: 400,000 for the 7 museums
Collections: Swiss art works; primitive Italian, French, German & Flemish art; modern art; archaeology; European sculpture & decorative arts; six attached museums
Exhibitions: (11/23/2006-2/18/2007) Art, Knowledge, Memory: Treasures of the Geneva Library; (4/4/2007-8/12/2007) A Dance Legacy: The Roland Petit - Zizi Jeanmaire Collection; (9/20/2007-1/13/2008) Philippe de Champaigne, 1602-1674: Politics & Faith in the Grand Siecle; (10/5/2006-3/25/2007) Cyprus, from Aphrodite to Melusine: From the Ancient Kingdoms to the Lusignans; (12/7/2006-3/4/2007) Choices of a Vision: Drawings from the Jean Bonna Collection; (4/26/2007-10/7/2007) Gaza at the Crossroads of Civilasations; Early June 2007, Ancient Jewels & Precious Trinkets of the Musee de l'Horlogerie et de l'Emaillerie; (11/30/2007-3/30/2008) A Look at Labyrinthe, Journal by Albert Skira, 1944-1946; (2/23/2007-5/20/2007) Plastic: On a Proposal by John Tremblay; (6/8/2007-9/2/2007) Francois-Gedeon Reverdin (1772-1828) & Neoclassical Engraving; (10/18/2007-1/27/2008) Around Minotaure: Surrealist Engravings in the Collections of French-speaking Switzerland; (12/1/2006-3/4/2007) The Engineer Nicolas Ceard & the Simplon Route; (5/4/2007-9/2/2007) Vertigo in the Storerooms, a Photographic & Whimsical Voyage Inside the Mysteries of the Public Collections; 10/18/2007-3/2008, Photographers' Visions, Max Kettel & Joseph Zimmer-Meylan; (12/1/2006-3/31/2007) Pictures in Embroidery & Paint; 5/4/2007-Spring 2008, Under the Sign of the Eagle & the Key Objects with the Geneva Coat of Arms; (11/16/2006-03/12/2007) The Ariana Museum Lets go of its Reserves 1: Italian Faience; (4/18/2007-7/15/2007) Carmen Dionyse; (5/31/2007-1/28/2008) Marcoville: The Glass Forest; (9/5/2007-2/11/2008) Jean-Claude de Crousaz; (11/6/2006-5/5/2007) Fasion Magazines: A Look Behind the Seams; (11/26/2007-5/31/2008) A Childish Art: Children's Books Illustrated by Artist
Activities: Mus shop sells books, magazines & reproductions

LA CHAUX DE FONDS

M **MUSEE DES BEAUX-ARTS,** Museum of Fine Arts, 33 rue des Musees, La Chaux de Fonds, 2300 Switzerland. Tel (032) 9130444; Fax (032) 913-61-93; Elec Mail mba.yeh@ne.ch; Internet Home Page Address: www.chaux -de-fonds.ch; *Dir* Edmond Charriere
Collections: Works of local artists; Swiss works of the 19th & 20th centuries; modern European painting, sculpture & tapestries
Activities: Lects open to public; concerts, gallery talks; scholarships; books, reproductions

LAUSANNE

M **ARCHAEOLOGICAL ROCKEFELLER MUSEUM,** Palais de Rumine, Case postale 403 Lausanne, 1000 Switzerland. Tel (021) 316 34 45; Fax (021) 316 34 46; Elec Mail musee.beaux-arts@serac.vd.ch; Internet Home Page Address: www.lausanne.ch/beaux-arts; *Dir* Yves Aupetitallot; *Cur* Catherine Lepdor
Open Tues & Wed 11 AM - 6 PM, Thurs 11 AM - 8 PM, Fri - Sun 11 AM to 5 PM; closed Mon; Frs 6
Library Holdings: Exhibition Catalogs
Collections: Works by Swiss artists & artists of other European countries; works of Vaudois artists from 18th century to present; works of A.L.R. Ducros; works of Charles Gleyre; works of Ferdinand Hodler; works of Albert Anker; works of Felix Vallotton; works of Louis Soutter
Exhibitions: 4 temporary exhibitions per yr
Publications: Catalogues for each exhib
Activities: Classes for adults and children; books, magazines

LIGORNETTO

M **FEDERAL OFFICE OF CULTURE,** Museo Vela, Ligornetto, 6853 Switzerland. Tel (091) 6473268; Fax (091) 6407040; *Cur* Dr Gianna A Mina
Collections: Works of art by Vela family; paintings from eighteenth & nineteenth centuries Italian schools; original monument plasters by Vinceno Vela (1820-1891); plasters by Lorenzo Vela (1812-1897); Pictures by Spartaco; Lombard & Piemontese paintings from the eighteenth & nineteenth centuries

LUCERN

M **KUNSTMUSEUM LUZERN,** Europaplatz 1, Lucern, CH-6002 Switzerland. Tel (041) 226 78 00; Fax (041) 226 78 01; Elec Mail kml@kunstmuseumluzern.ch; Internet Home Page Address: www.kunstmuseumluzern.ch; *Dir* Peter Fischer
Open Tues - Sun 10 AM - 5 PM, Wed 10 AM - 8 PM, cl Mon; Admis adult CHF 10, groups of 10 or more CHF 8

Library Holdings: Book Volumes; Cards; Exhibition Catalogs
Collections: Swiss art from ancient times to 20th century; European expressionism and contemporary works
Activities: Classes for children; lect open to the pub; 2-4 vis lect per yr; gallery talks; tours; mus shop sells books, magazines, original art, reproductions

SANKT GALLEN

M **HISTORISCHES UND VOLKERKUNDEMUSEUM,** (Historisches Museum) Historical Museum, Museumstrasse 50, Sankt Gallen, CH-9000 Switzerland. Tel (071) 242-06-42; Fax (071) 242-06-44; Elec Mail info@hmsg.ch; Internet Home Page Address: www.hmsg.ch; *Cur* Dr Daniel Studer
Open Tues - Sun 10 AM - 5 PM
Special Subjects: American Indian Art, Glass, Pre-Columbian Art, Prints, Textiles, Graphics, Sculpture, African Art, Archaeology, Costumes, Religious Art, Ceramics, Eskimo Art, Porcelain, Asian Art, Period Rooms, Embroidery
Collections: Furniture, glass & glass painting, graphics, period rooms, pewter, porcelain, stoves, weapons; archeology; artifacts of different people from Egypt, Africa, N & S America & Asia
Activities: Mus shop sells books, magazines & original art

SCHAFFHAUSEN

M **MUSEUM ZU ALLERHEILIGEN,** Klostergasse, Schaffhausen, CH-8200 Switzerland. Tel (052) 6330777; Fax (052) 6330788; Internet Home Page Address: www.allerheiligen.ch; *Dir* Dr Gerard Seiterle
Collections: Prehistory, history and art of the region

SOLOTHURN

M **KUNSTMUSEUM SOLOTHURN,** Solothurn Art Museum, Werkhofstrasse 30, Solothurn, 4500 Switzerland. Tel (032) 6222307; Fax (032) 6225001; *Cur* Dr Christoph Vogele
Collections: Swiss art from 1850 to 1980, including Amiet, Berger, Buscher, Frolicher, Hodler, Trachsel; small old master collection; private art section

WINTERTHUR

M **KUNSTMUSEUM WINTERTHUR,** Museumstrasse 52, PO Box 378 Winterthur, 8402 Switzerland. Tel (052) 2675162; Fax (052) 2675317; *Cur* Dr Dieter Schwartz
Collections: Swiss painting and sculpture from 18th century to present day; French, Italian and German painting and sculpture of 19th and 20th centuries, including Monet, Degas, Picasso, Gris, Leger, Klee, Schlemmer, Schwitters, Arp, Kandinsky, Renoir, Bonnard, Maillol, Van Gogh, Rodin, Brancusi, Morandi, Giacometti, de Stael; drawings and prints

M **MUSEUM OSKAR REINHART AM STADTGARTEN,** Stadthausstrasse 6, Winterthur, 8400 Switzerland. Tel (052) 267-51-72; Fax (052) 267 6228; Elec Mail museum.oskarreinhart@win.ch; Internet Home Page Address: www.museumoskarreinhart.ch; *Cur* Dr Peter Wegmann
Tues 10 AM - 10 PM, Wed - Sun 10 AM - 5 PM; CHF 8, 6 reduced
Collections: Pictures & drawings by German, Swiss & Austrian Masters of the 18th to 20th centuries; Collections of drawings & prints
Publications: Catalogues of paintings on permanent display
Activities: Classes for children; concerts; mus shop sells books, reproductions & slides

ZURICH

M **MUSEUM RIETBERG ZURICH,** Gablerstrasse 15, Zurich, 8002 Switzerland. Tel (01) 206-31-31; Fax (01) 206-31-32; Elec Mail museum@rietb.stzh.ch; Internet Home Page Address: www.rietberg.ch; *Sr Dir* Eberhard Fischer, Dr; *Dir* Albert Lutz, Dr; *Deputy Dir* Lorenz Homberger; *Cur* Judith Rickenbach; *Cur* Katharina Epprecht, Dr
Open Tues - Sun 10 AM - 5 PM, Wed 10 AM - 8 PM; Admis sfr 12.00; Estab 1952, mus for non-European art; Gallery contains art from India, China, Japan,Africa, Ancient Americas; Average Annual Attendance: 80,000
Library Holdings: Auction Catalogs; Book Volumes; Exhibition Catalogs
Collections: Asian, Oceanic and African art; Chinese bronzes; Baron von der Heydt Collection; The Berti Aschmann Foundation of Tibetan bronzes
Activities: Classes for children; lect open to the public, 12 vis lectrs per year; concerts; tours; museum shop sells books, posters, jewelry, stationery

M **SCHWEIZERISCHES LANDESMUSEUM,** Swiss National Museum, Museumstrasse 2, Zurich, CH-8023 Switzerland. Tel (01) 2186511; Fax (01) 211 29 49; Elec Mail kanzlei@sim.admin.ch; Internet Home Page Address: www.musee-suisse.ch; *Dir* Dr Andres Fuger
Open Tues - Sun 10:30 AM - 5 PM; Library with 85,000 vols
Collections: History & cultural development of Switzerland since prehistoric times
Activities: Sales of books, prints, souvenirs

M **ZUERCHER KUNSTGESELLSCHAFT,** Kunsthaus Zurich, Heimplatz 1, Zurich, 8007 Switzerland; Winkelwiese 4, Zurich, CH-8024 Switzerland. Tel +41(0)1 253 84 84; Fax +41(0)1 253 84 33; Elec Mail info@kunsthaus.ch; Internet Home Page Address: www.kunsthaus.ch; *Dir* Dr Christoph Becker; Dr Christian Klemm; *Cur* Dr Tobia Bezzola; *Cur* Bice Curiger; *Cur* Mirjam Varadinis; *Cur* Bernhard Von Waldkirch
Open Tues - Thurs 10 AM - 9 PM, Fri - Sun 10 AM - 5 PM; Admis CHF 7 - 20; Estab 1910 for exhibs; Average Annual Attendance: 300,000; Mem: 17,000
Income: CHF 15 million budget

Library Holdings: Auction Catalogs; Book Volumes; CD-ROMs; DVDs; Exhibition Catalogs; Original Documents; Pamphlets; Periodical Subscriptions; Photographs; Prints; Video Tapes
Collections: Alberto Giacometti works; medieval and modern sculptures; paintings; graphic arts, 16th - 20th centuries, mainly 19th and 20th; photo and video collection
Activities: Educ program; classes for adults & children; docent training; 4500 vis lectrs per yr; concerts; gallery talks; museum shop sells books, reproductions, prints & gifts

SYRIA

DAMASCUS

M **NATIONAL MUSEUM OF DAMASCUS,** National Museum, Syrian University St, Damascus, 4 Syria. Tel 214-854; *General Dir* Dr Jawdat Chahade
Collections: Ancient, Byzantine, Greek, Islamic, Modern, Oriental, Prehistoric and Roman art

TANZANIA

DAR ES SALAAM

M **DAR-ES-SALAAM NATIONAL MUSEUM,** PO Box 511, Dar es Salaam, Tanzania. Tel (51) 22030; *Dir* M L Mbago
Collections: Archaeology from Stone Age sites; ethnography & history collections

THAILAND

BANGKOK

M **NATIONAL MUSEUM,** Na Phra-that Rd, Amphoe Phda Nakhon Bangkok, 10200 Thailand. Tel 2241396; *Dir* Mrs Chira Chongkol
Collections: Bronze & stone sculptures, prehistoric artifacts, textiles, weapons, wood-carvings, royal regalia, theatrical masks, marionettes, shadow-play figures

TRINIDAD AND TOBAGO

PORT OF SPAIN

M **NATIONAL MUSEUM AND ART GALLERY,** 117 Frederick St, Port of Spain, Trinidad and Tobago. Tel 62-35941; Fax 62-37116; *Cur* Vel A Lewis
Collections: Fine art, archaeology, history & natural history collections

TUNISIA

TUNIS

M **MUSEE NATIONAL DU BARDO,** Bardo National Museum, 2000 Le Bardo, Tunis, Tunisia. Tel 513650; Fax 514050; *Dir* Habib Ben Younes
Collections: Ancient & modern Islamic art; Greek & Roman antiquities; Roman mosaics

TURKEY

ISTANBUL

M **ISTANBUL ARKEOLOJI MUZELERI,** The Library of Archaeological Museums of Istanbul, Gulhane, Istanbul, 34400 Turkey. Tel 0 212 520 77 40; 520 77 41; Fax 0 212 527 43 00; *Act Dir* Halil OZEK; *Librn* Havva KOC
open 9:30 AM - 1:30 PM, 2:30 PM - 6:30 PM; No admis fee with permission from Dir of Museum; Estab 1902; Library with 80,000 plus vols; Average Annual Attendance: 400-500
Purchases: donation library
Special Subjects: Archaeology, American Western Art
Collections: Architectural pieces; Turkish tiles; Akkadian, Assyrian, Byzantine, Egyptian, Greek, Hittite, Roman, Sumerian and Urartu works of art
Publications: The Annual of the Istanbul Archaeological Museum
Activities: Concerts, shows & painting exhibitions; lectrs in all topics (archaeology, philology & numismatics)

M **TOPKAPI PALACE MUSEUM,** Sultanahmed, Istanbul, Turkey. Tel 28-35-47; *Dir* Turkoglu Sabahattin
Library with 18,000 manuscripts and 23,000 archival documents

Collections: Chinese & Japanese porcelains; miniatures & portraits of Sultans; private collections of Kenan Ozbel; Sami Ozgiritli's collection of furniture; Islamic relics; Sultan's costumes; Turkish embroideries; armor; tiles; applied arts; paintings

M **TURK VE ISLAM ESERLERI MUZESI,** Museum of Turkish and Islamic Art, Ibrahim Pasa Sarayi, Sultanahmet Istanbul, Turkey. Tel 5181805-06; Fax 5181807-06; Elec Mail tiemist@superonline.com; Internet Home Page Address: www.tiem.org; *Dir* Nazan Olcer; *Vice Dir* Cavit Avol; *Cur* Sula Ahboy
Open 9 AM - 4:30 PM; 1.250.000 Turkish Lira
Special Subjects: Woodcuts, Antiquities-Oriental
Collections: Illuminated manuscripts; monuments of Islamic art; metalwork and ceramics; Turkish and Islamic carpets; sculpture in stone and stucco; wood carvings; traditional crafts gathered from Turkish mosques and tombs
Activities: Sales of books, magazines, original art, reproductions, prints, slides

UKRAINE

KYIV

M **KYIV MUSEUM OF RUSSIAN ART,** Tereshchenkovska vul 9, Kyiv, 01004 Ukraine. Tel (044) 224-82-88, 224-62-18; Tel (044) 451-40-27, 234-82-88, 234-62-18; Fax (044) 224-61-07; Fax (044) 451-40-27; Elec Mail museumru@ukr.net; Internet Home Page Address: www.museumru.kiev.ua; *Dir* Iurii Vakulenko; *Deputy Dir* Kateryna Ladyzenska; *Head Cur* Alla Iling; *Science Secy* Alexandra Shpetnaya
Open Mon - Tues, Fri - Sun 10 AM - 5 PM; Admis f1; Estab 1922; Average Annual Attendance: 70,000
Special Subjects: Decorative Arts, Drawings, Etchings & Engravings, Landscapes, Ceramics, Glass, Furniture, Porcelain, Portraits, Bronzes, Sculpture, Graphics, Watercolors, Religious Art, Folk Art, Marine Painting, Metalwork, Coins & Medals, Baroque Art, Miniatures, Medieval Art, Painting-Russian
Collections: 11,000 art objects
Activities: Lect open to pub, 720 vis lect per yr; mus shop sells reproductions

M **KYIV MUSEUM OF WESTERN & ORIENTAL ART,** The Bohdan and Vervara Khanenko Museum of Arts, Tereshchenkivska 15-17, Kyiv, Ukraine. Tel (+38044) 2350225; Fax (+38044) 2350206; Elec Mail khanenkomuseum@ukr.net; Internet Home Page Address: www.khanenkomuseum.kiev.ua; *Dir* E N Roslavets
Open Wed - Sun 10:30 AM - 5:30 PM, cl Mon & Tues; Admis 10 Ukrainian hryunas; Estab 1919; European art (14-19 cent) Byzantine icons, Asian art; Average Annual Attendance, 45,000
Income: State-run
Collections: 20,000 items
Exhibitions: 5 - 8 temporary exhib per yr
Publications: Oriental Collection
Activities: Mus shop sells books, reproductions, prints, souvenirs, cards & bookmarks

M **KYIV STATE MUSEUM OF UKRAINIAN ART,** National Art Museum of Ukraine, Ul Kirova 6, Kyiv, 252004 Ukraine; Grushevsky st 6, Kyiv, 01001 Ukraine. Tel 2286482; Fax 2286429; *Dir* Anatoly Melnik; *Develop Dir* Irina Alekseva; *Head of Information Dept* Tania Grustchenko; *Head of Marketing and Pub Relations Dept* Mary Zadorozhnaya
Open Mon - Thurs & Sat - Sun 10 AM - 6 PM; Admis adult $1, student $.50, children $.25; Average Annual Attendance: 60,000
Income: Financed by state budget
Collections: Portraits, icons, wood carvings & paintings from the Middle Ages; exhibits covering 8 centuries; modern art, Soviet art, Avant-Garde
Activities: Classes for adults & children; concerts; gallery talks; original objects of art lent to state museums in other countries; organize traveling exhibitions to Tretiakov Gallery, Guggenheim Mus, Winnipeg Art Gallery

M **STATE MUSEUM OF UKRAINIAN DECORATIVE FOLK ART,** Ul Yanvarskogo Vosstaniya 21, Kyiv, Ukraine. *Dir* V G Nagai
Collections: Wood carvings, ceramics, weaving & applied arts from 16th century to present

ODESSA

M **ODESSA STATE MUSEUM OF EUROPEAN AND ORIENTAL ART,** Ul Pushkinshaya 9, Odessa, 270026 Ukraine. Tel 22-48-15; *Dir* N G Lutzkevich
Collections: Over 8000 art objects

UNITED KINGDOM

BATH

M **AMERICAN MUSEUM IN BRITAIN,** Claverton Manor, Bath, BA2 7BD United Kingdom. Tel (1225) 460503; Fax (1225) 469160; Elec Mail info@americanmuseum.org; Internet Home Page Address: www.americanmuseum.org; *Dir* Sandra Barghini; *Cur* Laura Beresford; *Librn* Anne Armitage
Open daily noon - 5 PM; Estab 1961; Average Annual Attendance: 40,000
Library Holdings: Auction Catalogs 400; Audio Tapes 60; Book Volumes approx 10,000; Exhibition Catalogs; Photographs 500; Records 80; Slides 400; Video Tapes 20
Collections: American decorative arts from 17th to 19th centuries; Early printed maps

Publications: America in Britain jour yearly, newsletter biannually
Activities: Classes for adults & children; lect open to public; gallery talks; original objects of art lent to other museums; organize traveling exhibitions regional; museum shop sells books

CARDIFF

M **NATIONAL MUSEUM AND GALLERY OF WALES,** Amgueddfa ac Oriel Genedlaethol Caerdydd, National Museum & Gallery, Cathays Park Cardiff, CF10 3NP United Kingdom. Tel 029 20 397951; Fax 029 20 373219; Internet Home Page Address: www.nmgw.ac.uk; *Dir* Michael Tooby; *Keeper of Art* Oliver Fairbough; *Pres.* Paul Loveluck; *Dir.* Michael Houlihan
Open 10 AM - 5 PM Tues - Sun; Estab 1907; Average Annual Attendance: 350,000
Income: Sponsored by the Nat Assembly for Wales
Purchases: Include Thomas Girtin, Near Beddgelet, Leon Kossott From Wilksden Gieln, Autumn
Collections: Art, natural sciences, archaeology & industry of Wales; British and European fine and applied art
Activities: Classes for adults & children, dramatic programs; lect open to public, 30 vis lectr per year; concerts; gallery talks; tours; originate traveling exhibs; UK mus & galleries; museum shop sells books, magazines, reproductions, prints, slides

URUGUAY

MONTEVIDEO

M **MUSEO MUNICIPAL DE BELLAS ARTES,** Avda Millan 4015, Montevideo, Uruguay. Tel 38-54-20; *Dir* Mario C Tempone
Collections: Paintings, sculptures, drawings, wood-carvings

M **MUSEO NACIONAL DE BELLAS ARTES,** National Museum of Fine Arts, Tomas Giribaldi 2283, Parque Rodo Montevideo, Uruguay. Tel 438-00; *Dir* Angel Kalenberg
Collections: 4217 ceramics, drawings, engravings, paintings & sculptures

VENEZUELA

CARACAS

M **GALERIA DE ARTE NACIONAL,** Plaza Morelos-Los Caobos, Apartado 6729 Caracas, 1010 Venezuela. Tel 578-18-18; Fax 578-16-61; *Dir* Rafael A Romero Diaz
Collections: Visual arts of Venezuela throughout history

M **MUSEO DE BELLAS ARTES DE CARACAS,** Museum of Fine Arts, Plaza Morelos, Los Caobos Caracas, 1010 Venezuela. Tel (2) 571-01-69; Fax 058212-571 0169; Elec Mail fmba@reacciun.ve; Internet Home Page Address: www.museodebellasartes.org; *Dir* Maria Elena Huizi; *Exec Dir* Marisela Montes; *Chief Cur* Michaelle Ascencio
Open Mon - Fri 9 AM - 5 PM, weekends and holidays 10 AM - 5 PM; No admis fee; Estab 1917; museum of fine arts and study of the arts; Average Annual Attendance: 40,000
Income: Private and public funds
Purchases: Installation by Bernardi Roig
Library Holdings: Auction Catalogs; Audio Tapes; Book Volumes; CD-ROMs; Clipping Files; Exhibition Catalogs; Pamphlets
Special Subjects: Watercolors, Antiquities-Egyptian
Collections: Latin American & foreign paintings & sculpture; Cubism (old masters); Egyptian collection; Chinese ceramics; prints, drawings and photographs cabinet
Exhibitions: Gego: 1955-1990; Perú Milenario: 3,000 years of ancestral art; IV Bienal del Barro de América Roberto Guevara; Chema Madoz: Objetos 1990-1999; Sobre la Marcha: Dibujos de Pablo Benavides; Del Cuerpo a la Imagen; 150 Años de Fotografia en España; Chinese ceramics, Egyptian art, Cubism, drawings, prints and photographs cabinet, sculpture garden
Publications: Exhibition catalogs
Activities: Classes for children; dramatic programs; docent training; lect open to public; concerts; gallery talks; tours; Daniela Chappard juried exhibition; Josune Dorronsoro contest; originate traveling exhibs to museums internaitonally; museum shop sells books, magazines, original art, reproductions, prints, slides, cartisan crafts from Venezuela

VIETNAM

HANOI

M **VIETNAM MUSEUM OF FINE ARTS,** 66 Nguyen Thai Hoc St, Hanoi, Vietnam. Tel (84-4) 8233084; Fax (84-4) 7341427; Elec Mail binhtruong451@hn.vnn.vn; Internet Home Page Address: www.vnfineartsmuseum.org.vn; *Dir* Truong Quoc Binh; *Deputy Dir* Phan Van Tien; *Deputy Dir* Nguyen Xuan Tiep; *Deputy Dir* Nguyen Binh Minh
Open Tues, Thurs & Fri 8:30 AM - 5 PM, Wed & Sat 8:30 AM - 9 PM, cl Sun & Mon; Admis adults 20,000 VND, children 7,000 VND; Estab 26 June 1966; preserving and highlighting the nation's characteristic aesthetic values, the essence

of Vietnamese plastic art from ancient times up to now; The nation's characteristic aesthetic values the essence of Vietnamese plastic art from ancient times up to present

Purchases: Artwork and art books

Library Holdings: Book Volumes; Clipping Files; Fiche; Filmstrips; Manuscripts; Original Documents; Photographs; Records

Collections: Ancient & modern ceramics, fine arts & handicrafts; Vietnamese cultural heritage; specialized library of over 1100 vols

Exhibitions: Ceramics & porcelain, excavations from wrecks in Vietnamese waters

Publications: Nguyen Phan Chanh's silk paintings, Vietnam Fine Arts Museum Guidebook of Vietnam Fine Arts Museum, VCD on Vietnamese Fine Arts Museum

Activities: Extension program includes lending of original objects of art to art museums of Finland, Japan, Belgium; sales of books, magazines, original art, prints, reproductions

ZIMBABWE

CAUSEWAY HARARE

M **NATIONAL GALLERY OF ZIMBABWE,** 20 Julius Nyerere Way, PO Box CY 848 Causeway Harare, Zimbabwe. Tel 704 666; Fax 704 668; Elec Mail ngallery@harare.africa.com; *Dir* George P Kahari; *Cur* Mrs Pip Curling; *Librn* Mrs Luness Mpunwa; *Conservation officer* Mrs Lilian Chaonwa
open 9 AM - 5 PM; admis adult 20 zimdollar, student 5 zimdollar; Estab 1957; Mem: 400

Income: commission on sales & government grant

Collections: African traditional & local contemporary sculpture & paintings; ancient & modern European paintings & sculpture, including works by Bellini, Caracciolo, Gainsborough, Murillo, Reynolds, Rodin; Showa sculpture

Activities: Classes for adults & children, dramatic programs; lectrs open to the public; museum shop sells books, magazines & original art

Art Schools Abroad

ARGENTINA

BUENOS AIRES

ESCUELA SUPERIOR DE BELLAS ARTES DE LA NACION ERNESTO DE LA CARCOVA, Tristan Achavel Rodriguez 1701, Buenos Aires, 1107 Argentina. Tel 4361 5144; *Rector Prof* Eduardo A Audivert

AUSTRALIA

CANBERRA

ROYAL AUSTRALIAN INSTITUTE OF ARCHITECTS, 2A Mugga Way, Canberra, ACT 2603 Australia. Tel 2 6273 1548; Fax 2 6273 1953; Telex 6-2428; *Chief Exec* Michael Peck

DARLINGHURST

NATIONAL ART SCHOOL, (School of Art and Design) Forbes St, Darlinghurst, NSW 2010 Australia. Tel 02 9339 8744; Fax 02 9339 8740; Elec Mail sally.marwood@det.nsw.edu.au; Internet Home Page Address: www.nas.edu.au; *Head* Ted Binder
Approximately 1850; Maintains a nonprofit art gallery; Pub, NSN Dept of Education & Training; D & E; Scholarships, Fellowships
Ent Req: Portfolio of usual artwork
Degrees: Bachelor of Fine Art, BFA (Honours); Master of Fine Art
Courses: Art History, Ceramics, Drawing, Painting, Photography, Printmaking, Sculpture
Adult Hobby Classes: Pub Programs
Summer School: Dir Jayne Dyer

GLEBE

SYDNEY COLLEGE OF THE ARTS, Balmain Rozelle Locked Bag 15, PO Box 226 Glebe, 2039 Australia. Tel (2) 9351-1000; Fax (2) 9351-1199; Elec Mail enquiries@sca.usyd.edu.au; Internet Home Page Address: www.usyd.edu.au; *Dir* R Dunn; *Lect Photomedia* Judith Ahern; *Sr Lect Sculpture* Tom Arthur; *Lect Theories of Art Practice* Eril Bailey; *Assoc Prof Painting* Brad Buckley; *Sr Lect Glass* Maureen Cahill; *Lect Electronic Art* John Conomos; *Lect Photomedia* Rebecca Cummins; *Lect Theories of Art Practice* Christina Davidson; Simone Douglas; *Dir of SCA* Richard Dunn; *Lect Jewelery & Metal* Mark Edgoose; *Sr Lect Theories of Art Practice* Ann Elias

HOBART

UNIVERSITY OF TASMANIA, Tasmanian School of Art, GPO Box 252-57, Hobart, 7000 Australia. Tel 03 62 2643-0; Fax 03 62 264 308; Elec Mail enquiries@www.artschool.utas.edu.au; Internet Home Page Address: www.artschool.utas.edu.au; *Faculty of Arts* Prof J Pakulski; *Head* Prof N Frankham; *Dep Head & Postgrad Coordr* Prof Jonathan Holmes; *Honours Coordr* P Zika; J Smith, MFAD

MELBOURNE

VICTORIAN COLLEGE OF THE ARTS, School of Art, 234 St Kilda Rd, Melbourne, 3004 Australia. Tel (03) 9616 9300; *Dir* Dr Alwynne Mackie

SYDNEY

UNIVERSITY OF SYDNEY, School of Philosophical and Historical Inquiry, Sydney, NSW 2006 Australia. Tel 61-2-9351-2222; Fax 61-2-9351-3918; Internet Home Page Address: www.usyd.edu.au.; *Prof* Dan Potts; *Prof* Margaret C Miller; *Assoc Prof* Alison Betts
Estab 1850; Maintains a nonprofit art gallery, Nicholson Museum, Main Quadrance A-14, Univ Sydney; 4; pub; D; LC, GC, LAB

AUSTRIA

SALZBURG

INTERNATIONALE SOMMERAKADEMIE FUR BILDENDE KUNST, International Summer Academy of Fine Arts, PO Box 18, Salzburg, 5010 Austria. Tel 84-21-13, 84-37-27; Fax 84-96-38; Elec Mail soak.salzburg@nextra.at; Internet Home Page Address: www.land-sbg.gv.at/sommerakademie; *Dir* Dr Barbara Wally; Gabriele Winter; Martina Rothschaedl

Estab 1953; D
Ent Req: Over 17 yrs of age
Courses: †Architecture, †Conceptual Art, †Display, †Drawing, †Fashion Arts, †Film, †Goldsmithing, †Graphic Arts, †Mixed Media, †Painting, †Photography, †Sculpture, †Silversmithing, †Textile Design, †Video

VIENNA

UNIVERSITÂT FUR ANGEWANDTE KUNST WIEN UNIVERSITY OF APPLIED ARTS VIENNA, University of Applied Arts in Vienna, Oskar Kokoschka platz 2, Vienna, A-1010 Austria. Tel (01) 71133; Fax (01) 71133-2089; Elec Mail pr@uni.ak.ac.at; Internet Home Page Address: www.angewandte.at; *Rector* Dr Gerald Bast; *Chmn Univ Collegium* Prof Sigbert Schenk; *Dean Studies Mag Art* Prof Gerda Fassel; *Dean Studies Dipl Inf* Prof Wolf D Prix; *Univ Dir* Heinz Adamek, Dr jur; *Registrar* Scenta Scwanda; *Head Librarian* Gabriele Koller, PhD; *Art Collection Kokosch Center* Dr Erika Patka; *Pub Rels* Anja Siepenbusch, MPh; *Events Organizer* Alexandra Goldbacher, MA
Estab 1868; Pub; D; 1300 total, GS 1000, other 300
Ent Req: Austrian Maturazeugnis or equivalent; entrance exam; for foreigners proof of admission to a univ in home country
Degrees: MArch, MA, PhD, ScD
Tuition: 363 for EU mems, 726 for fgn students
Courses: †Advertising Design, †Aesthetics, †Architecture, †Art Appreciation, †Art Education, †Art History, †Calligraphy, †Ceramics, †Collage, †Commercial Art, †Conceptual Art, †Constructions, †Costume Design & Construction, †Crafts, †Design, †Drawing, †Fashion Arts, †Film, †Fine Arts, †Graphic Arts, †Graphic Design, †History of Art & Architecture, †Industrial Design, †Landscape Design, †Lettering, †Mixed Media, †Painting, †Photography, Printmaking, †Restoration & Conservation, †Sculpture, †Stage Design, Teacher Training, †Textile Design, †Theatre Arts, †Video, †Weaving

BELGIUM

ANTWERP

NATIONAAL HOGER INSTITUUT EN KONINKLIJKE ACADEMIE VOOR SCHONE KUNSTEN, National Higher Institute and Royal Academy of Fine Arts, 31 Mutsaertstraat, Antwerp, 2000 Belgium. Tel 03-232-41-61; *Dir* Garard Gaudaen

NATIONAL HOGER INSTITUUT VOOR BOUWKUNST EN STEDEBOUW, National Higher Institute of Architecture of the State, Mutsaertstraat 31, Antwerp, 2000 Belgium. Tel 31-70-84; *Dir* W Toubhans

BRUSSELS

ACADEMIE ROYALE DES BEAUX-ARTS DE BRUXELLES, ANTWERPEN, Brussels Royal Academy of Fine Arts, Antwerp, 144 rue du Midi, Brussels, B-1000 Belgium. Tel 02-511-04-91; Fax 02-513-27-54; *Dir* P Ermans

ECOLE NATIONALE SUPERIEURE DES ARTS VISUELS DE LA CAMBRE, 21 Abbaye de la Cambre, Brussels, 1050 Belgium. Tel 02-648-96-19; *Dir* France Borel
Estab 1926

BRAZIL

RIO DE JANEIRO

ESCOLA DE ARTES VISUAIS, School of Visual Arts, 414 Rua Jardim Botanico, Parque Lage Rio de Janeiro, 22461-000 Brazil. Tel 55-21-2538-1091; 1879; Fax 55-21-2537-7878; Elec Mail eav@eavparquelage.org.br; Internet Home Page Address: www.eavparquelage.org.br; *Dir* Reynoldo Roels Jr
Estab 1975; maintain nonprofit art gallery, Cavalaricas; maintain art/architecture library; pub; D & E, Mon - Sat; SC 39, LC 19; 457
Ent Req: free courses
Tuition: $70-$110
Courses: Aesthetics, Art Appreciation, Art Education, Art History, Drawing, Film, Graphic Arts, Mixed Media, Painting, Photography, Sculpture, Video

Summer School: Dir, Reynaldo Roels, Jr

BULGARIA

SOFIA

NIKOLAJ PAVLOVIC HIGHER INSTITUTE OF FINE ARTS, National Academy of Arts, Shipka 1, Sofia, 1000 Bulgaria. Tel 88-17-01; Fax 87-33-28; *Rector Prof* O Shoshev

CHINA, REPUBLIC OF

TAIPEI

NATIONAL TAIWAN ACADEMY OF ARTS, Pan-chiao Park, Taipei, 22055 China, Republic of. Tel 967-6414; *Pres* S L Ling

COLOMBIA

BOGOTA

PONTIFICIA UNIVERSIDAD JAVERIANA, Carrera 7, No 40-76, Apdo Aereo 56710 Bogota, Colombia. Tel 320 8320; Fax 571-288-23-35; Elec Mail Puj@javercol.javeriana.edu.co; Internet Home Page Address: www.javeriana.edu.co; *Dean Faculty of Architecture* Andres Gaviria
Estab 1622

CROATIA

ZAGREB

AKADEMIJA IIKOVNIJ UMJETNOSTI, Academy of Fine Arts, Ilica 85, Zagreb, 41000 Croatia. Tel 137 77300; *Dean* Dubravka/Babiae

CZECH REPUBLIC

PRAGUE

AKADEMIE VYTVARNYCH UMENI, Academy of Fine Arts, U Akademie 4, Prague 7 Prague, 17022 Czech Republic. Tel 420 2 20 408 217; Fax 420 2 375781; Elec Mail Kratka@avu.cz; Internet Home Page Address: www.avu.cz; *Dir* Jiri T Kotalik
Estab 1799

VYSOKA SKOLA UMELECKOPRUMYSLOVA, Academy of Applied Arts, Nam Jana Palacha 80, Prague, 116 93 Czech Republic. Tel 21 70 81 11; Fax 21 70 82 40; *Rector* Dr Josef Hlavacek

DENMARK

AARHUS C

ARKITEKTSKOLEN AARHUS, Aarhus School of Architecture, Norreport 20, Aarhus C, 8000 Denmark. Tel 89-36-00-00; Fax 86 13 0645; Elec Mail a@aarch.dk; Internet Home Page Address: www.aarch.dk; *Rector* Staffan Henricksson
1965; Maintain an art/architecture library, Norreport 20, DK-8000 Aarhus C; on-campus shop where art supplies can be purchased; pub; D
Degrees: BA (Architecture), MA (Architecture)
Courses: †Architecture, †Design

COPENHAGEN

KONGELIGE DANSKE KUNSTAKADEMI, The Royal Danish Academy of Fine Arts, Charlottenborg, Kongens Nytorv 1, Copenhagen, 1050 Denmark. Tel 33-74-45-00; Fax 33-74-45-55; *Rector School of Fine Arts* Rene Larsen
Estab 1754

DOMINICAN REPUBLIC

SANTO DOMINGO

DIRECCION GENERAL DE BELLAS ARTES, Fine Arts Council, Santo Domingo, Dominican Republic. *Dir* Jose Delmonte Peguero

ENGLAND

BIRMINGHAM

BIRMINGHAM POLYTECHNIC, Faculty of Art & Design, Perry Barr, Birmingham, B42 2SU England. Tel (44 121) 331 5140; *Dean Art & Design* J E C Price

BRIGHTON

UNIVERSITY OF BRIGHTON, Faculty of Arts & Architecture, Grand Parade, Brighton, BN2 0JY England. Tel (1273) 600 900; Elec Mail a.boddington@brighton.ac.uk; Internet Home Page Address: www.brighton.ac.uk/arts; *Dean Art & Architecture* Bruce Brown; *Dir Centre for Research & Develop* Prof Jonathan Woodham; *Head Historical & Critical Studies* Dr Patrick Maguire; *Head Arts & Communications* Karen Norguay; *Head Architecture & Design & Dir for the Centre for Excellence in Teaching & Learning through Design* Anne Boddington
Maintains a nonprofit art gallery, Grand Parade; Pub; D & E; Scholarships; SC, LC, GC, Dr Philosophy
Ent Req: Various as applicable
Degrees: PhD, MPhil, MA, MDes, MFA, BA, FDA
Tuition: see website
Courses: Architecture, Ceramics, Design, Fashion Arts, Graphic Arts, Graphic Design, History of Art & Architecture, Painting, Photography, Printmaking, Sculpture, Teacher Training, Textile Design, Theatre Arts, Weaving
Adult Hobby Classes: see website

EXETER

EXETER COLLEGE OF ART & DESIGN, Earl Richards Rd N, Exeter, EX2 6AS England. Tel (392) 77977; *Head Prof* M Newby

FARNHAM

WEST SURREY COLLEGE OF ART & DESIGN, Falkner Rd, Surrey Farnham, GU9 7DS England. Tel 0252-722441; Elec Mail SURR@ART.AC.UR; *Dir* N J Taylor

GLOUCESTER

GLOUCESTERSHIRE COLLEGE OF ARTS & TECHNOLOGY, Brunswick Rd, Gloucester, GL1 1HU England. Tel 44 1452 426505; Fax 1452 426 531; Elec Mail info@gloscat.ac.uk; Internet Home Page Address: www.gloscat.ac.uk

IPSWICH

SUFFOLK COLLEGE, Department of Art & Design, Suffolk, Ipswich, IP4 1LT England. Tel 01473-255885; Fax 1473 230054; Internet Home Page Address: www.suffolk.ac.uk; *Prog Dir* Brian Holder

LEICESTER

DE MONTFORT UNIVERSITY, Faculty of Art and Design, The Gateway, Leicester, LE1 9BH England. Tel 116-255-1551; Fax 116 257 7533; Elec Mail enquiry@dmu.ac.uk; Internet Home Page Address: www.dmu.ac.uk; *Dean Art & Design* N Witts

LIVERPOOL

LIVERPOOL JOHN MOORES UNIVERSITY, Aldham Robarts Learning Resource Centre, 70 Mount Pleasant, Liverpool, L3 5UX England. Tel (151) 231 21 21; Fax 151 231 3194; Internet Home Page Address: www.livjm.ac.uk

LONDON

CAMBERWELL COLLEGE OF ARTS, Peckham Rd, London, SE5 8UF England. Tel (020) 7514-6302; Fax (020) 7514-6310; Internet Home Page Address: www.camb.linst.ac.uk; *Head Prof* Roger Breakwell
Degrees: BA, MA
Courses: †Ceramics, †Drawing, †Graphic Design, †Illustration, †Metalwork, †Painting, †Photography, †Restoration & Conservation, †Sculpture, †Silversmithing

CHELSEA COLLEGE OF ART & DESIGN, Manresa Rd, London, SW3 6LS England. Tel 207 514 7751; Fax (0171) 514 7777; *Principal* Bridget Jackson

CITY AND GUILDS OF LONDON ART SCHOOL, 124 Kennington Park Rd, London, SE11 4DJ England. Tel 020 7735 2306/5210; Fax 020 7582 5361; Elec Mail info@cityandguildsartschool.ac.uk; Internet Home Page Address: www.cityandguildsartschool.ac.uk; *Prin & Head of Fine Art* Tony Carter
Estab 1879; Independent; D & E; Degree & Grad Courses, Other
Degrees: BA Hons & MA
Courses: Art Education, Art History, Painting, Printmaking, Restoration & Conservation, Sculpture, Stone carving, Wood carving

LONDON INSTITUTE, Lethaby Gallery, Central Saint Martins College of Art & Design, London Institute Gallery, 65 Davies St, London, W1Y 2DA England. Tel (071) 514 6000; *Rector* Sir William Stubbs

ROYAL ACADEMY SCHOOLS, Fine Art, Burlington House, Piccadilly, London, W1V 0DS England. Tel 020 7300 5650; Fax 020 7300 5856; Elec Mail schools@royalacademy.org.uk; Internet Home Page Address: www.royalacademy.org.uk; *Keeper Prof* Maurice Cockrill RA; *School Adminr* Irina Zaraisky
Estab 1768; Maintains a nonprofit art gallery; Independent Royal Instn; D; Grad Course in Fine Arts, 3 yr Post Grad Course in Fine Art
Ent Req: University Honours Degree, Bachelor's Degree in Fine Art
Degrees: Postgrad Diploma

ROYAL COLLEGE OF ART, Kensington Gore, London, SW7 2EU England. Tel 0207 590 4444; Fax 0207 590 4500; Internet Home Page Address: www.rca.ac.uk; *Rector Prof* Sir Christopher Frayling
Estab 1837; Pub; D; SC 19
Ent Req: Undergrad degree
Degrees: MA, MPM, PhD
Courses: †Architecture, †Ceramics, †Design, †Drawing, †Fashion Arts, †Goldsmithing, †Graphic Arts, †Graphic Design, †History of Art & Architecture, †Painting, †Photography, †Printmaking, †Restoration & Conservation, †Sculpture, †Silversmithing, †Textile Design

SAINT MARTIN'S SCHOOL OF ART, 107 Charing Cross Rd, London, WC2H 0DU England. Tel 437-0611; 7539090; *Principal* Ian Simpson

SLADE SCHOOL OF FINE ART, University College, Gower St London, WC1E 6BT England. Tel 20-7679-2313; Fax 20-7679-7801; Elec Mail b.cohen@ucl.ac.uk; Internet Home Page Address: www.ucl.ac.uk; *Dir* Bernard Cohen
Estab in 1871

UNIVERSITY OF LONDON, Goldsmiths' College, Lewisham Way, New Cross London, SE14 6NW England. Tel 207 919 7171; Internet Home Page Address: 2ww.goldstr.ths.wc.uk; *Warden Prof* Kenneth Gregory

WIMBLEDON SCHOOL OF ART, Merton Hall Rd, London, SW19 3QA England. Tel 181-540-0231; Fax 181-543-1750; Elec Mail hinsley@wimbledon.ac.uk; Internet Home Page Address: www.wimbledon.ac.uk; *Prin* Colin Painter
—**Dept of Foundation Studies,** Palmerston Rd, London, SW19 1PB England. Tel 181-540-0231; Student Tel 181-540-7504; Fax 181-543-1750; *Dept Head* Yvonne Crossley
—**Dept of Theatre,** London, SW19 3QA England. Tel 181-540-0231; Fax 181-543-1750; *Dept Head* Malcolm Pride
—**Dept of Fine Arts,** London, SW19 3QA England. Tel 181-540-0231; Fax 181-543-1750; *Dept Head* Michael Ginsborg
—**Department of History of Art & Contextual Studies,** London, SW19 3QA England. Tel 181-540-0231; Fax 181-543-1750; *Dept Head* Dr Melissa McQuillan

MANCHESTER

MANCHESTER METROPOLITAN UNIVERSITY, Faculty of Art and Design, All Saints Bldg, Manchester, M15 6BH England. Tel (161) 247-2000; Fax (161) 247-6390; Elec Mail enquiries@mmu.ac.uk; Internet Home Page Address: www.mmu.ac.uk; *Dean Art & Design* R Wilson

NOTTINGHAM

NOTTINGHAM TRENT UNIVERSITY, School of Art and Design, Burton St, Nottingham, NG1 4BU England. Tel 115-941-8418; Internet Home Page Address: www.ntu.ac.uk; Telex 37-7534; *Dean* J P Lesquereux

OXFORD

UNIVERSITY OF OXFORD, Ruskin School of Drawing and Fine Art, 74 High St, Oxford, OX1 4BG England. Tel +44 (0) 1865 276 940; Fax +44 (0) 1865 276 949; Elec Mail anne.gregory@ruskin-sch.oxac.uk; Internet Home Page Address: www.ruskin-sch.ox.ac.uk; *Head School* Michael Archer; *Tutor Wolfson Col* Malcolm Bull, MA; *Tutor Brasenose Col* Maria Chevska, MA; *Tutor Linacre Col* Brian Catling, MA; *Tutor St Hildas Col* Sera Furneaux, MA; *Tutor* Gudrun Bielz; *Tutor* Daniel Coombs; *Tutor* Joby Williamson; *Tutor* Oona Grimes; *Tutor* Katja Kerstin Hock; *Sr Res Fellow in Fin Art* Paul Bonaventura, MA; *Ruskin Master Drawing* Richard Wentworth; *Sec* Anne Gregory; *Tutor* Simon Lewis; *Tutor* Daria Martin; *Tutor* Abigail Reynolds; *Tutor* Jon Roome; *Tutor* Sarah Simblet; *Tutor* Mathew Tickle; *Tutor* David Tolley; David Hyland; Sarah Wilkinson
Degrees: BFA, D Phil in Fine Art

ESTONIA

TALLINN

ESTONIAN ACADEMY OF ARTS, Tartu Maantee 1, Tallinn, 10145 Estonia. Tel (372) 626 7309; Fax 372 626 7350; Elec Mail public@artun.ee; Internet Home Page Address: www.artun.ee; *Rector* Ando Keskküla; *Prof Fine Arts* Kaisa Puustak; *Prof Applied Arts* Vilve Unt; *Prof Architecture* Veljo Kaasik; *Prof Institute of Design* Molit Summatavet; *Prof Institute of Art History* Mowt Kalm
Estab 1914; Pub; D & E; SC 20, LC 2, Postgrad 10; D 800, E 80, GS 140
Ent Req: Secondary educ, passing of entry exam
Degrees: Bachelor, Master, Doctor, diploma
Tuition: BA (general) 2051 Eur, Masters 2051 Eur in a study yr
Courses: †Architecture, †Art History, †Ceramics, †Design, †Fashion Arts, †Glass Art, †Goldsmithing, †Graphic Arts, †Graphic Design, †Interior Architecture, †Mixed Media, †Photography, †Restoration & Conservation, †Sculpture, †Stage Design, †Textile Design

Adult Hobby Classes: Open acad, diploma level educ

FINLAND

HELSINKI

KUVATAIDEAKATEMIA, Academy of Fine Arts, Yrjonkatu 18, Helsinki, 00120 Finland. Tel 358-(9)-680 3320; Fax 358-(9)-680 33260; Elec Mail kans.ia@KUVA.fi; Internet Home Page Address: http://www.kuva.fi; *Rector* Mika Hannula

FRANCE

PARIS

ECOLE DU LOUVRE, School of the Louvre, 34 quai du Louvre, Paris, 75001 France. Tel 40-20-56-14; Fax 42-60-40-36; *Principal* D Ponnau

ECOLE NATIONALE SUPERIEURE DES ARTS DECORATIFS, National College of Decorative Arts, 31 rue d'Ulm, Paris, 75005 France. Tel 1-42-34-97-00; Fax 1-42-34-87-95; *Dir* Richard Peduzzi

ECOLE NATIONALE SUPERIEURE DES BEAUX-ARTS, National College of Fine Arts, 14 rue Bonaparte, Cedex 06 Paris, 75272 France. Tel (1)47-03-50-00; Fax (1)47-03-50-80; *Dir* Alfred Pacquement
Estab 1648

ECOLE SPECIALE D'ARCHITECTURE, 254 blvd Raspail, Paris, 75014 France. Tel 1-40-47-40-47; Fax 1-43-22-81-16; *Dir* Olivier Leblois

PARIS CEDEX 05

UNIVERSITE DE PARIS I, PANTHEON-SORBONNE, UFR d'Art et d'Archeologie, 12 Place du Pantheon, Paris Cedex 05, 75231 France. Tel 1-46-34-97-00; *Actg Dir Art & Archaeology* L Pressouyre
Estab 1971

VILLENEUVE D'ASCQ

ECOLE D'ARCHITECTURE DE LILLE ET DES REGIONS NORD, rue Verte, Quartier de l'Hotel de Ville Villeneuve d'Ascq, 59650 France. Tel 20 61 95 50; Fax 20 61 95 51; Internet Home Page Address: www.lille.archi.fr; *Dir* Bernard Welcomme

GERMANY

BERLIN

UNIVERSITAT DER KUNSTE BERLIN, Postfach 12 05 44, Berlin, 10595 Germany; Einsteinufer 43-53, Berlin, 10587 Germany. Tel 030-31-85-0; Fax 0301 3185 2635; Elec Mail presse@udk-berlin.de; Internet Home Page Address: www.udk-berlin.de; *Pres & Dir Prof* Lothar Romain; *First VPres & Permanent Rep of Pres Prof* Peter Bayerer; *Dean Sch of Fine Art Prof* Burkhard Hold; *Dean Sch of Architecture & Design Prof* Kirsten Langkilde; *Dean Sch of Music Dr* Patrick Dinslage; *Dean Sch of Performing Arts Dr* Andreas Wirth; *Chancellor* Jürgen Schleicher; *Communication & Marketing Press & Publicity Dr* Jorg Kirchhoff; *Events and Alumni* Susanne S. Reich; *Marketing* Christine Faber; *Internat Relations* Angelika Theuss; *Rep for Women's Affairs Dr* Sigrid Haase; *Marketing* Regina Dehning
Estab 1975
Exhibitions: Design Transfers
Activities: Classes held days; studio course, lect courses, grad courses; schols available

BRUNSWICK

HOCHSCHULE FUR BILDENDE KUNSTE, Johannes-Selenka-Platz 1, Brunswick, 38118 Germany. Tel 391-9122; Fax 391 9292; Elec Mail hbk@hbk-bs.de; *Rector* Dr Michael Schwarz

DRESDEN

HOCHSCHULE FUR BILDENDE KUNSTE, Guntzstrasse 34, Dresden, 01307 Germany. Tel (351)4402-0; Fax (351) 459 0025; Elec Mail presse@serv1.hsbk.dresden.de; Internet Home Page Address: www.hfbk-dresden.de; *Rector Prof Dr* Ulrich Schlessel; *Dean Prof Dr* Gregor Hemmnili; *Dean Prof* Jens Bültries
Pub; D; Scholarships; S, L, G
Ent Req: abitur or equivalant, portfolio and entry exam

DUSSELDORF

KUNSTAKADEMIE DUSSELDORF, Hochschule fur Bildende Kunste, State Academy of Art, Eiskellerstrasse 1, Dusseldorf, 40213 Germany. Tel (0211) 1396-0; Fax 0211 1396 225; *Dir* Markus Lupertz

FRANKFURT

STAATLICHE HOCHSCHULE FUR BILDENDE KUENSTE - STAEDELSCHULE, Durerstr 10, Frankfurt, 60596 Germany. Tel 069-605-008-0; Fax 069 605 008 66; *Rector Prof* Kasper Koenig

HAMBURG

HOCHSCHULE FUR BILDENDE KUNSTE, College of Fine Arts, Lerchenfeld 2, Hamburg, 22081 Germany. Tel 040-29188; *Pres* Adrienne Goehler

KARLSRUHE

STAATLICHE AKADEMIE DER BILDENDEN KUNSTE KARLSRUHE STATE ACASEMY OF FINE ARTS UALRSRUHE, State Academy of Fine Arts, Reinhold-Frank-Strasse 81-83, Karlsruhe, 76042 Germany. Tel 0721-85018-0; Fax 0721-84815-0; Elec Mail mail2@kunstakademie.karlsruhe.de; Internet Home Page Address: www.kunstakademie.karlsruhe.de; *Rector* Prof Erwin Gross
Estab 1854; pub

LEIPZIG

HOCHSCHULE FUR GRAFIK UND BUCHKUNST, State Academy of Graphic Arts and Book Production, Wachterstrasse 11, Leipzig, 04107 Germany. Tel (341) 2135-0; Fax 341 2135-166; Elec Mail hgb@hgb-leipzig.de; Internet Home Page Address: www.hgb-leipzig.de; *Rector* Prof Ruedi Baur

MUNICH

AKADEMIE DER BILDENDEN KUNST, Academy of Fine Arts, Akademiestr 2, Munich, 80799 Germany. Tel 89-3852-0; Fax 89-3852-206; Elec Mail post@adbk.mhn.de; Internet Home Page Address: www.adbk.mhn.de; *Pres* Dr Otto Steidle
Estab 1770

NUREMBERG

AKADEMIE DER BILDENDEN KUNSTE IN NURNBERG, Academy of Fine Arts in Nuremberg, Bingstrasse 60, Nuremberg, 90480 Germany. Tel 0911-94040; Fax 0911 940 4150; Elec Mail info@adbk-nuernberg.de; Internet Home Page Address: www.adbk-nuernberg.de; *Prof* Peter Angermann; *Prof* Arno Brandlhuber; *Prof* Claus Bury; *Prof* Dr Christian Demand; *Prof* Rolf-Gunter Dienst; *Prof* Holger Felton; *Prof* Ralph Fleck; *Prof* Friederike Girst; *Prof* Thomas Hartmann; *Prof* Ottmar Horl; *Prof* Marko Lehanka; *Prof* Ulla Mayer; *Prof* Michael Munding; *Prof* Eva von Platen; *Prof* Hans Peter Reuter; *Prof* Georg Winter
Estab 1662; Pub; D
Ent Req: Qualifying examination, aptitude test
Degrees: State exam, diploma, certificate, master schiler, diploma postgrad, master of architecture
Courses: Advertising Design, Architecture, Art Education, Art History, Conceptual Art, Design, Goldsmithing, Graphic Arts, Graphic Design, History of Art & Architecture, Mixed Media, Painting, Photography, Printmaking, Sculpture, Silversmithing, Teacher Training, Video

STUTTGART

STAATLICHE AKADEMIE DER BILDENDEN KUNSTE, State Academy of Fine Arts, Am Weissenhof 1, Stuttgart, 70191 Germany. Tel 0711-2575-0; Fax 711-2575-225; *Rector* Prof Klaus Leehmann

GREECE

ATHENS

ECOLE FRANCAISE D'ATHENES, French School of Athens, Odos Didotou, 6 Rue Didotou Athens, 10680 Greece. Tel (0030) 210 36 79 900; Fax (0030) 210 36 32 101; Elec Mail efa@efa.gr; Internet Home Page Address: www.efa.gr; *Dir* Prof D Mulliez
Estab 1846; Pub

HUNGARY

BUDAPEST

MAGYAR KEPZOMUVESZETI EGYETEM, Hungarian Academy of Fine Arts, Andrassy vt 69-71, Budapest, 1062 Hungary. Tel 3421-738; Fax +361 3427563; Elec Mail foreign@voyager.arts7.hu; Internet Home Page Address: www.arts7.hu; *Rector* Szabados Arpad
Estab 1871; Pub; D; SC, LC, GC, Postgrad
Ent Req: Final exam at secondary sch, entrance exam
Degrees: MA
Courses: †Art Education, †Art History, †Costume Design & Construction, †Drawing, †Graphic Arts, †Graphic Design, †Mixed Media, †Painting, †Photography, †Printmaking, †Restoration & Conservation, †Sculpture, †Stage Design, †Teacher Training, †Video

INDIA

BARODA

MAHARAJA SAYAJIRAO UNIVERSITY OF BARODA, Faculty of Fine Arts, University Rd, Baroda, 390002 India. Tel 795 600; *Dean Faculty Fine Arts* P D Dhuhal
Estab 1949

LUCKNOW

UNIVERSITY OF LUCKNOW, College of Arts and Crafts, Faculty of Fine Arts, Badshah Bagh, Lucknow, UP 226007 India. Tel 43138; Fax 522 330065; *Dean* B N Arya

MUMBAI

ACADEMY OF ARCHITECTURE, Plot 278, Shankar Ghaneker Marg, Prabhadevi Mumbai, 400025 India. Tel (022) 2430 1024; Fax (022) 2430 1724; Elec Mail aoarchitecture@yahoo.co.uk; *Principal* Suresh M Singh; *Sr Lectr* Arvind Khanolkar; *Sr Lectr* Arlin Narwekar; *Sr Lectr* Milind Amle
Estab 1955; Maintains a nonprofit art gallery, Rachana Sansad's Art Gallery, 278, Shankar Ghaneker Marg, Prabhadevi, Mumbai, 400 025, India; C; SC, LC; 240 students
Ent Req: 10+2 course
Degrees: B Architecture of Univ of Mumbai
Tuition: As per government norms
Courses: Architecture

IRELAND

COUNTY CLARE

BURREN COLLEGE OF ART, Newtown Castle, Ballyvaughan County Clare, Ireland. Tel 353-65-7077200; Fax 353-65-7077201; Elec Mail admin@burrencollege.ie; Internet Home Page Address: www.burrencollege.ie; *Pres* Mary Hawkes-Greene; *Dean* Prof Timothy Emlyn Jones; *Head Painting* Tom Molloy; *Head Photography & Instr History Art* Martina Cleary; *Head Sculpture* Aine Phillips
Estab 1993; Pvt; D Weekends during summer; SC, LC, GC 2
Ent Req: GPA 3 on Scale 4 per sem or yr (undergrad) BFA degree for MFA
Degrees: MFA
Courses: Art History, Drawing, Painting, †Photography, Sculpture
Adult Hobby Classes: Enrl 10-20 Summer Costs Vary
Summer School: Enrl 20-30 6 weeks, Tui $3,300, 4 weeks, $2,500

DUBLIN

COLAISTE NAISIUNTA EALAINE IS DEARTHA, National College of Art & Design, 100 Thomas St, Dublin, 8 Ireland. Tel 353 1 6364 207; Fax 353 1 6364 200; Elec Mail fios@ncad.ie; Internet Home Page Address: www.ncad.ie; *Dir* Prof Colm O'Briain; *Head Design* Prof Angela Woods; *Head Educ* Prof Gary Granville; *Head Fine Art* Prof Brian Maguire; *Head Visual Culture* Prof Niamh O'Sullivan
Estab 1746; Pub; D, E & Easter & Summer periods; SC 12, LC 2 GC 5, Art, Design & Teacher Educ
Degrees: BA, BDes, MA, MFA, MLitt, PhD
Courses: Aesthetics, †Art Education, Art History, †Ceramics, Conceptual Art, †Design, Drawing, †Fashion Arts, †Goldsmithing, Graphic Design, Handicrafts, †Mixed Media, †Painting, Photography, †Printmaking, †Sculpture, Silversmithing, †Textile Design, Video, Weaving

ISRAEL

JERUSALEM

BEZALEL ACADEMY OF ARTS & DESIGN, Mount Scopus, PO Box 24046 Jerusalem, 91240 Israel. Tel (2) 5893333; Fax (2) 582-3094; Elec Mail liv@bezalel.ac.il;Dr Ran Sapoznik
Estab 1906
Degrees: BArch, B.DES, BFA

ITALY

BOLOGNA

ACCADEMIA DI BELLE ARTI, Academy of Fine Arts, Via delle di Belle Arti 54, Bologna, 40126 Italy. Tel 051-243 064; Elec Mail dicezione@accademiabelleartibologna.it; Internet Home Page Address: www.accademiabelleartibologna.it; *Dir* A Baccilieri

CARRARA

ACCADEMIA DI BELLE ARTI E LICEO ARTISTICO, Academy of Fine Arts, via Roma 1, Carrara, 54033 Italy. Tel 0585-71658; *Dir* Constanza Lorenzetti

FLORENCE

ACCADEMIA DI BELLE ARTI, Academy of Fine Arts, via Ricasoli 66, Florence, 50122 Italy. Tel 055-215-449; *Dir* D Viggiano

MILAN

ACCADEMIA DI BELLE ARTI DI BRERA, Academy of Fine Arts, Palazzo di Brera, via Brera 28 Milan, 20121 Italy. Tel 02-86-46-19-29; Fax 02-86-40-36-43; *Pres* Walter Fontana

PERUGIA

ACCADEMIA DI BELLE ARTI PIETRO VANNUCCI, Academy of Fine Arts, Piazza San Francesco al Prato 5, Perugia, 06123 Italy. Tel 075-5730631; *Dir* Edgardo Abbozzo

RAVENNA

ACCADEMIA DI BELLE ARTI, Academy of Fine Arts, Loggetta Lombardesca, Via di Roma 13 Ravenna, 48100 Italy. Tel 0544 482874; Fax 0544 213641; *Dir* Vittorio D'Augusta

ROME

ACCADEMIA DI BELLE ARTI DI ROMA, Academy of Fine Arts, via di Ripetta 222, Rome, 00186 Italy. Tel 06-322-70-25; Fax 06 3218007; *Dir* Antonio Passa
Estab 1873

AMERICAN ACADEMY IN ROME, Via Angelo Masina 5, Rome, 00153 Italy. Tel 06-58461; Fax 06 581 0788; Elec Mail info@aarome.org; Internet Home Page Address: www.aarome.org; *Dir* Caroline Bruzelius

BRITISH SCHOOL AT ROME, via Gramsci 61, Rome, 00197 Italy. Tel +39 06 326 4939; Internet Home Page Address: www.britac.ac.uk; *Dir* Andrew Wallace-Hadrill; *Asst Dir* Susan Russell; *Asst Dir* Jacopo Benci; *Registrar & Publs Mgr* Gillian Clark; *Gallery Cur* Cristiana Perrella; *Librn* Valerie Scott; *Bursar* Alvise Di Giulio; *Dir's Asst* Eleanor Murkett; *Hostel Supv* Geraldine Wellington; *School Sec* Maria Pia Malvezzi; *Subscriptions Sec* Jo Wallace-Hadrill; *Accounts Clerk* Isabella Gelosia; *Domestic Bursar* Renato Parente; *Archaeology Research Prof* Simon Keay; *Modern Studies Research Prof* David Forgacs
Estab 1901

ISTITUTO CENTRALE DEL RESTAURO, Central Institute for the Restoration of Works of Art, Piazza San Francesco di Paola 9, Rome, 00184 Italy. Tel 6488961; Fax 6 481 57 04; *Dir* Dott M d'Elia
Estab 1939

TURIN

ACCADEMIA ALBERTINA DI BELLE ARTI, via Accademia Albertina 6, Turin, 10123 Italy. Tel 011-889020; Fax 011 812 5688; *Pres* P Delle Roncole

VENICE

ACCADEMIA DI BELLE ARTI, Academy of Fine Arts, Campo della Carita 1050, Venice, 30123 Italy. Tel (041) 5225396; Fax 041 5230 129; *Dir* Antonio Toniato

JAMAICA

KINGSTON

EDNA MANLEY COLLEGE OF VISUAL & PERFORMING ARTS, School of Visual Arts, One Arthur Wint Dr, Kingston 5 Kingston, Jamaica. Tel 876-929-2352; Fax 876-968-0779; Internet Home Page Address: www.ednamanleycollege.edu.jm; *Dean* Hope Brooks; *Dir Studies-Degree* Annie Hamilton; *Dir Studies-Diploma* Hope Wheeler; *Libr Asst* Pamela James
Estab 1950; SC, LC
Ent Req: 5 CXC, portfolio review, drawing exam
Degrees: UWI/EMCUDA, BA, Diploma Studio Art, JBTE
Courses: †Advertising Design, †Aesthetics, †Art Education, †Art History, †Ceramics, †Design, †Display, †Drawing, †Goldsmithing, †Graphic Arts, †Graphic Design, †History of Art & Architecture, †Painting, †Photography, †Printmaking, †Sculpture, †Silversmithing, †Stage Design, †Teacher Training, †Textile Design, †Theatre Arts, †Weaving

JAPAN

KANAZAWA CITY

KANAZAWA COLLEGE OF ART, 5-11-1 Kodatsuno, Kanazawa-shi, Ishikawa 920 Kanazawa City, 920 Japan. Tel (0762) 62-3531; Fax 76 262 6594; Elec Mail admin@kanazawa-bidai.ac.jp; Internet Home Page Address: www.kanazawa-bidai.ac.jp; *Pres* Yoshiaki Inui

KYOTO

KYOTO CITY UNIVERSITY OF ARTS, 13-6 Kutsukake-Cho, Oheda, Nishikyo-Ku Kyoto, 610-11 Japan. Tel 075-332-0701; Fax 078-332-0709; Elec Mail admin@kcua.ac.jp; Internet Home Page Address: www.kcua.ac.jp; *Pres* Shumpei Ueyama

TOKYO

TAMA ART UNIVERSITY, 3-15-34 Kaminoge, Setagaya-Ku Tokyo, 158 Japan. Tel (03) 3702-1141; Elec Mail pro@tamabi.ac.jp; Internet Home Page Address: www.tamabi.ac.jp; *Pres* Nobuo Tsuji
Pvt; D & E; D 3159, E 849, GS 206
Courses: †Art Science, †Ceramics, †Design, †Environmental Design, †Glass, †Graphic Arts, †Graphic Design, †Information Design, †Japanese Painting, †Metal Design, †Oil Painting, †Painting, †Printmaking, †Product Design, †Sculpture, †Teacher Training, †Textile Design, †Theatre Arts

TOKYO GEIJUTSU DAIGAKU TOSHOKAN, Tokyo National University of Fine Arts & Music, 12-8 Ueno Park, Taito-Ku, Tokyo, 110 Japan. Tel 3828-7745; *Pres* Masao Yamamoto

KOREA

SEOUL

SEOUL NATIONAL UNIVERSITY, College of Fine Arts, Sinlim-dong, Kwanak-gu Seoul, 151 Korea. Tel 877-1601; *Dean* Se-ok Suh
Estab 1946

LATVIA

RIGA

VALST MAKSLAS AKADEMIJA, Latvian Academy of Arts, Kalpaka blvd 13, Riga, LV 186 Latvia. Tel 33-22-02; *Rector* Janis Andris Osis

LEBANON

BEIRUT

ACADEMIE LIBANAISE DES BEAUX-ARTS, PO Box 55251, Sin-El-Fil Beirut, Lebanon. Tel 480-056; *Chair* Georges Khodr

MEXICO

MEXICO CITY

ESCUELA NACIONAL DE ARTES PLASTICAS, National School of Plastic Arts, Ave Constitution 600, BO La Concha, Xochimilco, DF Mexico City, Mexico. Tel 52-5-06-30; *Dir* Jose De Santiago
Courses: Engraving

INSTITUTO NACIONAL DE BELLAS ARTES, Instituto Nacional de Bellas Artes y Literatura, Paseo Reforma y Campo Marte, Mexico City, Mexico; Paseo de la Reforma y Campo, Marte s/n, Modula A, Piso 1, Col Chapultepec Polanco Mexico City, 11560 Mexico. Tel (55) 52 80 77 27; Fax (55) 52 80 47 39; Elec Mail amaldo@correo.inba.gob.mx; lvelarde@correo.inba.gob.mx; Internet Home Page Address: www.bellasartes.gob.mx; *Dir* Vicgor Sandoval de Leon

PUEBLA

UNIVERSIDAD DE LAS AMERICAS, Artes Graficas y Diseno, Apartado Postal 100, Santa Catarina Martir Puebla, 72820 Mexico. Tel 29 20 00; *Rector* Dr Enrique Cardenas Sanchez

MOROCCO

TETOUAN

ECOLE NATIONALE DES BEAUX ARTS, Ave Mohamed V, Cite Scolaire BP 89 Tetouan, Morocco. *Dir* Mohammed M Serghini

NETHERLANDS

AMSTERDAM

ACADEMIE VAN BOUWKUNST, Academy of Architecture, Waterlooplein 211, Amsterdam, 1011 PG Netherlands. Tel 020-531-8218; Fax 020 623 2519; *Dir* A Oxenaar

RIJKSAKADEMIE VAN BEELDENDE KUNSTEN, State Academy of Fine Arts, Sarphatistraat 470, Amsterdam, 1018 GM Netherlands. Tel (20) 5270300; Fax 20 527 0301; Elec Mail info@rijksakademie.nl; Internet Home Page Address: www.rijksakademie.nl; *Pres* Prof J W Schrofer; *Dir* Dr Els M W A Vam Odyk
Estab 1970 for research in visual arts
Activities: Open to young artists from all over the world

BREDA

HOGESCHOOL WEST-BRABANT, FACULTIET VOOR BEEDENDE KUNSTEN ST JOOST, St Joost Academy of Art and Design, 18 St Janstraat, Breda, POB 90116 Netherlands. Tel (76) 5250302; Fax (76) 5250305; *Dir* H J H M Van De Vijven

GRONINGEN

AKADEMIE VOOR BEELDENDE KUNSTEN BOUWKUNST AKADEMIE MINERVA, School of Visual Arts and Architecture, Gedempte Zuiderdiep 158, Groningen, 9711 HN Netherlands. Tel (050) 3185454; *Dir* A van Hijum

HERTOGENBOSCH

AKADEMIE VOOR KUNST EN VORMGEVING HOGESCHOOLS - HERTOGENBOSCH, Academy of Art and Design, PO Box 732, Hertogenbosch, 5201 AS Netherlands. Tel (73) 6295460; Fax (73) 6214725; *Dir* Alex De Vries

ROTTERDAM

ACADEMIE VAN BEELDENDE KUNSTEN ROTTERDAM, Rotterdam Academy of Art, Blaak 10, Rotterdam, 3011 TA Netherlands. Tel 010-241-4750; Fax 010-241-4751; *Pres* Richard E Ouwerkerk

S GRAVENHAGE

STICHTING DE VRIJE ACADEMIE VOOR BEELDENDE KUNSTEN, Paviljoensgracht 2024, S Gravenhage, Netherlands; Postbus 36, S Gravenhage, 2501 CA Netherlands. Tel 363 8968; *Dir* Frans A M Zwartjes

THE HAGUE

KONINKLIJKE ACADEMIE VAN BEELDENDE KUNSTEN, Royal Academy of Fine and Applied Arts, Prinsessegracht 4, The Hague, 2514 AN Netherlands. Tel 070-364-3835; Fax 070 356 1124; *Dir* C M Rehorst
Estab 1682

NEW ZEALAND

AUCKLAND

UNIVERSITY OF AUCKLAND, Elam School of Fine Arts, Whitaker Pl, Private Bag 92019 Auckland, 1 New Zealand. Tel 64 09 373 7599; Fax 64 09 308 2302; Elec Mail elam.enquiries@auckland.ac.nz; *Head of Dept* Derrick Cherrle

NORWAY

OSLO

KUNSTHOGSKOLEN I OSLO, (Statens Kunstakademi) Oslo National Academy of the Arts, Fossveien 24, Oslo, 0551 Norway; PO Box 6853 St. Olavs plass , Oslo, 0130 Norway. Tel 22 99 55 00; Fax 22 99 55 02; Elec Mail khio@khio.no; Internet Home Page Address: www.khio.no; *Fac of Visual Arts Dean* Stale Stenslie; *Fac of Design Dean* Halldor Gislason; *Fac of Performing Arts Dean* Harry Guttormsen
Estab Aug 1996; Maintains a nonprofit art gallery; Pub; D & E; D 550
Ent Req: General univ admission certificate & entrance examination
Degrees: BA, MA
Courses: Advertising Design, Ceramics, Costume Design & Construction, Fashion Arts, Goldsmithing, Graphic Arts, Graphic Design, Opera, Painting, Printmaking, Sculpture, Silversmithing

STATENS HANDVERKS-OG KUNSTINDUSTRISKOLE, National College of Art, Crafts and Design, Ullevalsveien 5, Oslo, 0165 Norway. Tel 22-99-55-80; Fax 22-99-55-85; *Rector* Dag Hofseth

PERU

LIMA

ESCUELA NACIONAL SUPERIOR DE BELLAS ARTES, National School of Fine Arts, 681 Jiron Ancash, Lima, Peru. Tel 427-2200; Fax 427-0799; Elec Mail ccbellasartes@yahoo.es; Internet Home Page Address: www.ensabap.edu.pe; *Dir Gen* Leslie Lee Crosby; *Dir Academico* Luis Tokuda Fujita
D, E & N
Ent Req: seundaria completa, examen de admision, documentas personales (test)

Degrees: titulo de artista plastico y docente anombre de la nacion
Adult Hobby Classes: enrl 600; couses—painting & drawing
Children's Classes: enrl 600; courses—painting & drawing
Summer School: enrl 1200; courses— painting, drawing & graphic design; *Dir* Luis Tokuda

POLAND

CRACOW

AKADEMIA SZTUK PIEKNYCH IM JANA MATEJKI W KRAKOWIE, Academy of Fine Arts in Cracow, Pl Matekji 13, Cracow, 31-157 Poland. Tel 0048 12 422 24 50; Fax 0048 12 422 65 66; Elec Mail zebulano@cyf-kr.edu.pl; *Rector* Prof Stanislaw Rodzinski
Estab 1818; Pub; D & E
Degrees: BA, MA

GDANSK

PANSTWOWA WYZSZA SZKOLA SZTUK PLASTYCZNYCH, Higher School of Fine Arts, Ul Targ Weglowy 6, Gdansk, 80-836 Poland. Tel 31-28-01; Fax 31-22-00; *Rector* Stanislaw Radwanski

LODZ

PANSTWOWA WYZSZA SZKOLA SZTUK PLASTYCZNYCH, Strzeminski Academy of Fne Arts & Design, Ul Wojska Polskiego 121, Lodz, 91-726 Poland. Tel 56-10-56; *Rector* Jerzy Trelinski

WARSAW

AKADEMIA SZTUK PIEKNYCH, Academy of Fine Arts, Ul Krakowskie Przedmiescie 5, Warsaw, 00-068 Poland. Tel 26-19-72; Fax 26 21 14
Estab 1904

WROCLAW

AKADEMIA SZTUK PIEKNYCH, (Panstwowa Wyzsza Szkola Sztuk Plastyczynch) Academy of Fine Arts, Pl Polski 3/4, Wroclaw, 50-156 Poland. Tel 315-58; *Rector* Konrad Jarodzki

PORTUGAL

LISBON

ESCOLA SUPERIOR DE BELAS ARTES, Faculdade De Belas Artes Da Universidade De Lisboa, Largo da Academia Nacional de Belas-Artes 2, Lisbon, 1249-058 Portugal. Tel 34-66-148; Fax 213487635; Elec Mail biblioteca@fba.ul.pt; Internet Home Page Address: www.fba.ul.pt; *Pres* Miguel Arruda; *Secy* Ana Paula Carreira
Pub; D; Scholarships; SC 5, LC, GC 4
Degrees: Licenciatura, Mestrado, Douturamento
Courses: Advertising Design, Art Education, Art History, Ceramics, Design, Drawing, Graphic Arts, Graphic Design, Museum Staff Training, Painting, Photography, Sculpture

OPORTO

ESCOLA SUPERIOR DE BELAS ARTES, School of Fine Arts, Av Rodrigues de Freitas 265, Oporto, Portugal. Tel 228-77; *Dir* Carlos Ramos

RUSSIA

MOSCOW

MOSCOW V I SURIKOV STATE ART INSTITUTE, 30 Tovarishcheskii Pereulok, Moscow, 109004 Russia. Tel (095)912-39-32; Fax (095)912-18-75; *Dir* L V Shepelev

SAINT PETERSBURG

ST PETERSBURG REPIN INSTITUTE OF PAINTING, SCULPTURE & ARCHITECTURE, Universitetskaya Nab 17, Saint Petersburg, 199034 Russia. Tel 213-61-89; Fax 213-65-48; *Rector* O A Yeremeyev

SCOTLAND

DUNDEE

UNIVERSITY OF DUNDEE, Faculty of Duncan of Jordanstone College of Art & Design, 13 Perth Rd, Dundee, DD1 4HN Scotland. Tel 1382-345212; Fax 1382-227304; Elec Mail jordanstone@dundee.ac.uk; Internet Home Page Address:

www.dundee.ac.uk; *Principal of the Univ* Sir Alan Langlands; *Dean of Faculty* Prof G Follett; *Head Sch of Fine Art* E.C. McArthur; *Head Sch of TV & Imaging* S. R. Flack; *Sch of Design* Prof T.G. Inns
Pub; D & E; Scholarships; S 14, GC 5; D 1426, Maj 1426, GS 52
Ent Req: 3 Scottish Highers (including Art & English) or 2 A Levels plus portfolio or equivalent
Degrees: BDesign, BA Fine Art, BSc Architecture,BA in Art, Philosopy, Contemporary Studies, BSc i Interactive Media Design, Innovative Product Design MArch, MSc Electronic Imaging, MFA, M Design, MPhil, PhD
Courses: †Animation & Electronic Imaging, †Architecture, †Art History, †Design, †Drawing, †Goldsmithing, †Graphic Design, †History of Art & Architecture, †Illustration, Innovative Product Design, †Interactive Media Design, †Interior Design, †Jewelry & Metalwork, †Painting, †Printmaking, †Sculpture, †Textile Design, †Video, †Weaving
Adult Hobby Classes: Embroidery, Pressmaking, Making Soft Furnishings, Printing for Pleasure & Life Drawing
Children's Classes: Children's Creative Textile Design, Young Adults Creative Textile Design
Summer School: Dir Dr John Blicharski, Various subjects available

EDINBURGH

EDINBURGH COLLEGE OF ART, Lauriston Pl, Edinburgh, EH3 9DF Scotland. Tel 131-221 6000; Fax 131-221 6001; Internet Home Page Address: www.eca.ac.uk; *Principal* Alistair Rowan

GLASGOW

GLASGOW SCHOOL OF ART, 167 Renfrew St, Glasgow, G3 6RQ Scotland. Tel 0141-353-4500; Fax 0161-353-4408; Elec Mail info@gsa.ac.uk; Internet Home Page Address: www.gsa.ac.uk; *Prof, Dir* S Reid
Estab 1845; Pub; D & E; Scholarships; SC 10, GC 5
Ent Req: portfolio
Degrees: BA, MPhil, PhD, MFA
Courses: †Architecture, †Art Education, †Conceptual Art, †Design, †Graphic Arts, †Graphic Design, †Painting, †Photography, †Printmaking, †Textile Design

SLOVAK, REPUBLIC OF

BRATISLAVA

VYSOKA SKOLA VYTVARNYCH UMENI, Academy of Fine Arts, Hviezdoslavovo 18, Bratislava, 814 37 Slovak, Republic of. Tel (7) 54 43 24 31; Fax (7) 54 43 23 40; Internet Home Page Address: www.afad.sk; *Rector* Jan Hoffstadter
Estab 1949

SOUTH AFRICA, REPUBLIC OF

CAPE TOWN

UNIVERSITY OF CAPE TOWN, Michaelis School of Fine Art, Private Bag, Rondebosch 7701 Cape Town, South Africa, Republic of. Tel (21) 650911; Fax 21 650 213814 040; Elec Mail webmaster@uct.ac.za; Internet Home Page Address: www.uct.ac.za; *Dean* J W Rabie

DOORNFONTEIN

TECHNIKON WITWATERSRAND, Faculty of Art, Design & Architecture, PO Box 17011 Doornfontein, 2028 South Africa, Republic of. Tel (11) 406-2911; Fax (11) 402-0475; Elec Mail eugeneh@mail.twr.ac.za; Internet Home Page Address: www.twr.ac.za; www.twr.ac.za/fada; *Fine Art* M Edwards; *Industrial Design* P Oosthuizen; *Architecture* E Landzaad; *Graphic Design* E Blake
Estab 1930; pub; D; 950
Degrees: B Tech, M Tech, D Tech
Courses: Architecture, Art Appreciation, Art History, Ceramics, Design, Drawing, Fashion Arts, Goldsmithing, History of Art & Architecture, Painting, Printmaking, Sculpture, Silversmithing, Teacher Training

SPAIN

BARCELONA

REAL ACADEMIA CATALANA DE BELLAS ARTES DE SAN JORGE ROYAL ACADEMY OF FINE ARTS (MUSEUM), Royal Academy of Fine Arts, Casa Lonja, Paseo de Isabel II Barcelona, 08003 Spain. Tel (93) 319-24-32;

Fax (93) 319-02-16; Elec Mail secetavia@racba.org; Internet Home Page Address: www.racba.org; *Pres & Exec Sr Dir* Jordi Bouet Armeugol; *Sec Gen & Exec Sr Dir* Leopoldo Gil Nebot; *Conservador Mus & Ilmo Sr* Josep Bracons Clapes; *Treas & II Liu Sr Dir* Joan Uriach Marsal; *Librarian* Ilma Sra Dra Pilar Velez Vicente
Estab 1849; Private collection

MADRID

CENTRO DE ESTUDIOS HISTORICOS, Departamento de Historia del Arte Diego Velazquez, CSIC, Duque de Medinaceli 6, Madrid, 28014 Spain. Tel (1) 429-06-26; Fax 91 3690940; Elec Mail mcabamas@ceh.csic.es; *Chief of Dept* Enrique Arias Angles
Pub

SEVILLE

REAL ACADEMIA DE BELLAS ARTES DE SANTA ISABEL DE HUNGRIA DE SEVILLE, Abades 14, Seville, 41004 Spain. Tel 22-11-98; *Pres* Antona dela Banda y Vargas

VALENCIA

ESCUELA SUPERIOR DE BELLAS ARTES DE SAN CARLOS, Valencia School of Fine Arts, San Pio 9, Valencia, 46010 Spain. *Dir* Daniel de Nueda Llisiona
Estab 1756

SWEDEN

STOCKHOLM

KONSTFACK, University College of Arts, Crafts and Design, Valhallavagen 191, PO Box 24115 Stockholm, 104 51 Sweden. Tel 08-450-41-00; Fax 08 450 41 90; Elec Mail jbp@konstfach.se; *Principal* Inez Svensson
Estab 1844

KONSTHOGSKOLAN, College of Fine Arts, Flaggmansvagen 1, PO Box 16 315 Stockholm, 103 26 Sweden. Tel (08) 6144000; Fax (08) 6798626; Elec Mail info@kxh.se; Internet Home Page Address: www.kkh.se; *Principal* Olle Kaks; *Rector* Marie-Louise Ekman; *Prof* Fredric Bedoire; *Prof* Peter Cornell; *Prof* Erik Dietman; *Prof* Peter Hagdahl; *Prof* Eberhard Holl; *Prof* Jan Lisinski; *Prof* Mari Rantanen; *Prof* Johan Scott; *Prof* Annette Senneby; *Prof* Johan Widen; *Prof* Anders Wilhelmsson

SWITZERLAND

GENEVA

ECOLES D'ART DE GENEVE, Geneva Schools of Art, 9 blvd Helvetique, Geneva, 1205 Switzerland. Tel 22-311-05-10; Fax 22-310-13-63; *Dir* Bernard Zumthor
—**Ecole Superieure D'Art Visuel,** Higher School of Visual Arts, 9 blvd Helvetique Geneva, Switzerland. Tel 22-311-05-10; Fax 22-310-13-63; *Dir* Bernard Zumthor
Library with 6000 vols
—**Ecole des Arts Decoratifs,** School of Decorative Arts, rue Jacques-Necker 2 Geneva, 1201 Switzerland. Tel 22-732-04-39; Fax 22-731-87-34; *Dir* Roger Fallet

LAUSANNE

ECOLE CANTONALE D'ART DE LAUSANNE, Lausanne College of Art, Ave de l'Elysee 4, Lausanne, 1006 Switzerland. Tel 021-617-75-23; Fax 021-616-39-91; *Dir* P Keller

VENEZUELA

CARACAS

ESCUELA DE ARTES VISUALES CRISTOBAL ROJAS, Cristobal Rojas School of Visual Arts, Avda Lecund-Este 10 bis, El Conde Caracas, Venezuela. *Dir* Carmen Julia Negron de Valery

State Arts Councils

NATIONAL ENDOWMENT FOR THE ARTS

Dana Gioia, Chmn
1100 Pennsylvania Ave NW
Washington, DC 20506-0001
Tel 202-682-5400
E-mail: webmgr@arts.endow.gov
Web Site: http://arts.endow.gov

REGIONAL ORGANIZATIONS

Arts Midwest

David Fraher, Exec Dir
2908 Hennepin Ave, Ste 200
Minneapolis, MN 55408-1954
Tel 612-341-0755; Fax 612-341-0902
TDD: 612-822-2956
(IA, IL, IN, MI, MN, OH, ND, SD, WI)
E-mail: general@artsmidwest.org
Web Site: www.artsmidwest.org

Mid-America Arts Alliance/ExhibitsUSA

Mary Kennedy McCabe, Exec Dir
2018 Baltimore Ave
Kansas City, MO 64108
Tel 816-421-1388; Fax 816-421-3918
TDD: 800-735-2966
(AR, KS, MO, NE, OK, TX)
E-mail: info@maaa.org
Web Site: www.maaa.org

Mid-Atlantic Arts Foundation

Alan Cooper, Exec Dir
201 North Charles St, #401
Baltimore, MD 21202
Tel 410-539-6656; Fax 410-837-5517
TDD: 410-779-1593
(DC, DE, MD, NJ, NY, PA, VA, VI, WV)
E-mail: maas@midatlanticarts.org
Web Site: www.midatlanticarts.org

New England Foundation for the Arts

Rebecca Blunk, Exec Dir
145 Tremont St, 7th floor
Boston, MA 02111
Tel 617-951-0010; Fax 617-951-0016
(CT, MA, ME, NH, RI, VT)
E-mail: info@nefa.org
Web Site: www.nefa.org

Southern Arts Federation

Gerri Combs, Exec Dir
1800 Peachtree St NW, Ste 808
Atlanta, GA 30309
Tel 404-874-7244; Fax 404-873-2148
TTD: 404-876-6240
(AL, FL, GA, KY, LA, MS, NC, SC, TN)
E-mail: saf@southarts.org
Website: www.southarts.org

Western States Arts Federation

Anthony Radich, Exec Dir
1743 Wazee St, Ste 300
Denver, CO 80202
Tel 303-629-1166; Fax 303-629-9717
(AK,AZ,CA,CO,ID,MT,NV,NM,OR,UT,WA,WY)
E-mail: staff@westaf.org
Website: www.westaf.org

STATE ART AGENCIES

Alabama State Council on the Arts

Albert B Head, Exec Dir
201 Monroe St
Montgomery, AL 36130-1800
Tel 334-242-4076; Fax 334-240-3269
E-mail: staff@arts.state.al.us
Web Site: www.arts.state.al.us

Alaska State Council on the Arts

Charlotte Fox, Exec Dir
411 W Fourth Ave, Ste 1 E
Anchorage, AK 99501-2343
Tel 907-269-6610; Fax 907-269-6601
E-mail: aksca_info.eed.state.ak.us
Web Site: www.eed.state.ak.us/aksca

Arizona Commission on the Arts

Robert C Booker, Exec Dir
417 W Roosevelt St
Phoenix, AZ 85003-1326
Tel 602-255-5882; Fax 602-256-0282
E-mail: info@azarts.gov
Web Site: www.azarts.gov

Arkansas Arts Council

Barbara Dodge, Chmn
Joy Pennington, Exec Dir
1500 Tower Bldg
323 Center St
Little Rock, AR 72201
Tel 501-324-9766; Fax 501-324-9207
E-mail: info@arkansasarts.com
Web Site: www.arkansasarts.com

California Arts Council

Marcy Friedman, Chmn
Muriel Johnson, Dir
1300 I St, Ste 930
Sacramento, CA 95814
Tel 916-322-6555; Fax 916-322-6575
E-mail: agottlieb@caartscouncil.com
Web Site: www.cac.ca.gov

Colorado Council on the Arts

Chris Castilian, Chmn
Elaine Mariner, Exec Dir
1625 Broadway, Ste 2700
Denver, CO 80202
Tel 303-892-3802; Fax 303-892-3848
E-mail: coloarts@state.co.us
Web Site: www.coloarts.state.co.us

Connecticut Commission on the Arts
Michael Price, Chmn
Jennifer Aniskovich, Exec Dir
One Financial Plaza, 755 Main St
Hartford, CT 06103
Tel 860-566-4770; Fax 860-566-6462
E-mail: artsinfo@ctarts.org
Web Site: www.ctarts.org

Delaware Division of the Arts
Julia M McCabe, Chmn
Laura A Scanlan, Dir
Carvel State Office Bldg, 4th floor
820 N French St
Wilmington, DE 19801
Tel 302-577-8278; Fax 302-577-6561
E-mail: delarts@state.de.us
Web Site: www.artsdel.org

DC Commission on the Arts and Humanities
Dorothy McSweeny, Chmn
Anthony Gittens, Exec Dir
410 Eighth St NW, 5th Flr
Washington, DC 20004
Tel 202-724-5613; Fax 202-727-4135
E-mail: cah@dc.gov
Web Site: http://dcarts.dc.gov

Florida Division of Cultural Affairs
Sibille Hart Pritchard, Chair
Sandy Shaughnessy, Dir
R A Gray Bldg, 3rd Fl, 500 S. Bronough St
Tallahassee, FL 32399-0250
E-mail: info@florida-arts.org
Web Site: www.florida-arts.org

Georgia Council for the Arts
Kathleen G Williams, Chmn
Susan S Weiner, Exec Dir
260 14th St NW, Ste 401
Atlanta, GA 30318
Tel 404-685-2788; Fax 404-685-2788
Web Site: www.gaarts.org

Hawaii State Foundation on Culture and the Arts
Gae Bergquist Trommald, Chmn
Ronald Yamakawa, Exec Dir
250 South Hotel St, 2nd Fl
Honolulu, HI 96813
Tel 808-586-0300; Fax 808-586-0308
Web Site: www.state.hi.us/sfca

Idaho Commission on the Arts
Mark Hofflund, Chmn
Dan Harpole, Exec Dir
2410 North Old Penitentiary Rd
Boise, ID 83712
Tel 208-334-2119; Fax 208-334-2488
E-mail: info@artsidaho.com
Web Site: www.arts.idaho.com

Illinois Arts Council
Shirley Madigan, Chmn
Terry Scrogum, Exec Dir
100 W Randolph, Ste 10-500
Chicago, IL 60601-3298
Tel 312-814-6750; Fax 312-814-1471
E-mail: info@arts.state.il.us
Web Site: www.state.il.us/agency/iac

Indiana Arts Commission
Ronald J Stratten, Chmn
Dorothy Ilgen, Dir
150 W Market St, #618
Indianapolis, IN 46204
Tel 317-232-1268; Fax 317-232-5595
E-mail: IndianaArtsCommision@iac.in.gov
Website: www.in.gov/arts

Iowa Arts Council
Brad Long, Chmn
Anita Walker, Exec Dir
Capitol Complex, 600 E Locust
Des Moines, IA 50319-0290
Tel 515-281-6412; Fax 515-242-6498
Web Site: www.iowaartscouncil.org

Kansas Arts Commission
Anita Wolgast, Chmn
Llewellyn Crain, Exec Dir
700 SW Jackson, Ste 1004
Topeka, KS 66603-3761
Tel 785-296-3335; Fax 785-296-4989
E-mail: kac@arts.state.ks.us
Web Site: www.arts.state.ks.us

Kentucky Arts Council
Todd Lowe, Chmn
Lori Meadows, Exec Dir
21st Fl, Capital Tower Plaza, 500 Mero St
Frankfort, KY 40601-1987
Tel 502-564-3757; Fax 502-564-2839
E-mail: kyarts@ky.gov
Web Site: www.artscouncil.ky.gov

Louisiana Division of the Arts
Christine Weeks, Chmn
Veronique LeMelle, Exec Dir
Louisiana Division of the Arts
PO Box 44247-4247
Baton Rouge, LA 70804-4247
Tel 225-342-8180; Fax 225-342-8173
E-mail: arts@crt.state.la.us
Web Site: www.crt.state.la.us/arts

Maine Arts Commission
John M Rohman, Chmn
Alden C Wilson, Dir
25 State House Station, 193 State St
Augusta, ME 04333-0025
Tel 207-287-2724; Fax 207-287-2725
E-mail: MaineArts.info@maine.gov
Web Site: www.mainearts.gov

Maryland State Arts Council
David Phillips, Chmn
Theresa Colvin, Exec Dir
175 W Ostend St, Ste E
Baltimore, MD 21230
Tel 410-767-6555; Fax 410-333-1062
E-mail: imsac@msac.org
Web Site: www.msac.org

Massachusetts Cultural Council
Peter Nessen, Chmn
Mary Kelley, Exec Dir
10 Saint James Ave, 3rd Fl
Boston, MA 02116
Tel 617-727-3668; Fax: 617-727-0044
E-mail: web@art.state.me.us
Web Site: www.massculturalcouncil.org

Michigan Council for Arts and Cultural Affairs
Craig Ruff, Chmn
John Bracey, Exec Dir
702 W Kalamazoo, PO Box 30705
Lansing, MI 48909-8205
Tel 517-241-4011; Fax 517-241-3979
E-mail: artsinfo@michigan.gov
Web Site: www.michigan.gov

Minnesota State Arts Board
Matthew Anderson, Chmn
James Dusso, Exec Dir (Interim)
Park Square Ct
400 Sibley St, Ste 200
Saint Paul, MN 55101-1928
Tel 651-215-1600; Fax 651-215-1602
E-mail: msab@state.mn.us
Web Site: www.arts.state.mn.us

Mississippi Arts Commission
Melody Herring Maxey
Malcolm White, Exec Dir
501 N West St, Ste 701 B, Woolfork Bldg
Jackson, MS 39201
Tel 601-359-6030; Fax 601-359-6008
Web Site: www.arts.state.ms.us

Missouri Arts Council
Michael T Vangel, Chmn
Beverly Strohmeyer, Exec Dir
111 N Seventh St, Ste 105
Saint Louis, MO 63101-2188
Tel 314-340-6845; Fax 314-340-7215
E-mail: moarts@ded.mo.gov
Web Site: www.missouriartscouncil.org

Montana Arts Council
Jackie Parsons, Chmn
Arlynn Fishbaugh, Exec Dir
316 N Park Ave, Room 252, PO Box 202201
Helena, MT 59620
Tel 406-444-6430; Fax 406-444-6548
E-mail: mac@state.mt.us
Web Site: www.art.state.mt.us

Nebraska Arts Council
Frederick Simon, Chmn
Suzanne T Wise, Exec Dir (Interim)
1004 Farnam State, Plaza Level
Omaha, NE 68102
Tel 402-595-2122; Fax 402-595-2334
Web Site: www.nebraskaartscouncil.org

Nevada Arts Council
Tim Jones, Chmn
Susan Boskoff, Exec Dir
716 N Carson St, Ste A
Carson City, NV 89701
Tel 775-687-6680; Fax 775-687-6688
E-mail: jcounsil@clan.lib.nv.us
Web Site: www.dmla.clan.lib.nv.us

New Hampshire State Council on the Arts
James Patrick Kelly, Chmn
Rebecca L Lawrence, Dir
2 1/2 Beacon St, 2nd floor
Concord, NH 03301-4974
Tel 603-271-2789; Fax 603-271-3584
Web Site: www.state.nh.us/nharts

New Jersey State Council on the Arts
CarolAnn Herbert, Chmn
David A Miller, Exec Dir
225 W State St
PO Box 306
Trenton, NJ 08625
Tel 609-292-6130; Fax 609-989-1440
Web Site: www.njartscouncil.org

New Mexico Arts Division
Janice Spence, Chmn
Loie Fecteau, Exec Dir
228 E Palace Ave
Santa Fe, NM 87501
Tel 505-827-6490; Fax 505-827-6043
Web Site: www.nmarts.org

New York State Council on the Arts
Richard J Schwartz, Chmn & Acting Dir
175 Varick St
New York, NY 10014
Tel 212-627-4455; Fax 212-387-7164
E-mail: nysca@artswire.org
Web Site: www.nysca.org

North Carolina Arts Council
Bobby Kadis, Chmn
Mary Regan, Exec Dir
Dept of Cultural Resources

109 E Jones St
Raleigh, NC 27601
Tel 919-733-2111; Fax 919-733-4834
E-mail: ncarts@ncmail.net
Web Site: www.ncarts.org

North Dakota Council on the Arts
David Trottier, Chmn
Jan Webb, Exec Dir
1600 E Century Ave, Ste 6
Bismarck, ND 58503
Tel 701-328-7590; Fax 701-328-7595
E-mail: comserv@state.nd.us
Website: www.state.nd.us/arts

Ohio Arts Council
Susan Sofia, Chmn
Julie S Henahan, Exec Dir (Interim)
727 E Main St
Columbus, OH 43205-1796
Tel 614-466-2613; Fax 614-466-4494
WebSite: www.oac.state.oh.us

Oklahoma Arts Council
Jim Tolbert, Chmn
Betty Price, Exec Dir
2101 N Lincoln Blvd, Rm 640
PO Box 52001-2001
Oklahoma City, OK 73152-2001
Tel 405-521-2931; Fax 405-521-6418
E-mail: okarts@arts.ok.gov
Web Site: www.state.ok.us/~arts

Oregon Arts Commission
Cynthia Addams, Chmn
Christine T D'Arcy, Exec Dir
775 Summer St NE, Ste 200
Salem, OR 97310-1284
Tel 503-986-0082; Fax 503-986-0260
E-mail: oregon.artscomm@state.or.us
Web Site: www.oregonartscommission.org

Pennsylvania Council on the Arts
Diane Dalto, Chmn
Philip Horn, Exec Dir
216 Finance Bldg
Harrisburg, PA 17120
Tel 717-787-6883; Fax 717-783-2538
Web Site: www.pacouncilonthearts.org

Rhode Island State Council on the Arts
Christopher McMahon, Chmn
Randall Rosenbaum, Exec Dir
One Capitol Hill, 3rd Fl
Providence, RI 02908
Tel 401-222-3880; Fax 401-222-3018
E-mail: info@arts.ri.gov
Web Site: www.risca.state.ri.us

South Carolina Arts Commission
Linda C Stern, Chmn
Suzette M Surkamer, Exec Dir
1800 Gervais St
Columbia, SC 29201
Tel 803-734-8696; Fax 803-734-8526
Web Site: www.state.sc.us/arts

South Dakota Arts Council
Mickey Miller, Chmn
Dennis Holub, Exec Dir
800 Governors Dr
Pierre, SD 57501
Tel 605-773-3131; Fax 605-773-6962
E-mail:sdac@state.sd.us
Web Site: www.artscouncil.sd.gov

Tennessee Arts Commission
Stephanie Barger Conner, Chmn
Rich Boyd, Exec Dir
401 Charlotte Ave
Nashville, TN 37243-0780
Tel 615-741-1701; Fax 615-741-8559
Web Site: www.arts.state.tn.us

Texas Commission on the Arts
Victoria Hodge Lightman, Chmn
Ricardo Hernandez, Exec Dir
E O Thompson Office Bldg
920 Colorado, Ste 501
Austin, TX 78701
Tel 512-463-5535; Fax 512-475-2699
E-mail: front.desk@arts.state.tx.us
Web Site: www.arts.state.tx.us

Utah Arts Council
Anne Cullimore Decker, Chmn
Margaret Hunt, Dir
617 E South Temple
Salt Lake City, UT 84102-1177
Tel 801-236-7555; Fax 801-236-7556
Web Site: www.arts.utah.gov

Vermont Arts Council
Peggy Kannenstine, Chmn
Alexander L Aldrich, Exec Dir
136 State St, Drawer 33
Montpelier, VT 05633-6001
Tel 802-828-3291; Fax 802-828-3363
E-mail: info@vermontartscouncil.org
Web Site: www.vermontartscouncil.org

Virginia Commission for the Arts
Dr Lucius F Ellsworth, Chmn
Peggy Baggett, Exec Dir
Lewis House, 2nd Fl
223 Governor St
Richmond, VA 23219
Tel 804-225-3132; Fax 804-225-4327
E-mail: arts@arts.virginia.gov
Web Site: www.arts.state.va.us

Washington State Arts Commission
Joan Penny, Chmn
Kristin Tucker, Exec Dir
234 Eighth Ave SE
PO Box 42675
Olympia, WA 98504-2675
Tel 360-753-3860; Fax 360-586-5351
Web Site: www.arts.wa.gov

West Virginia Commission on the Arts
Susan Landis, Chmn
Richard Ressmeyer, Exec Dir
Arts & Humanities Section
West Virginia Div of Culture & History
1900 Kanawha Blvd E
Charleston, WV 25305-0300
Tel 304-558-0220; Fax 304-558-2779
Web Site: www.wvculture.org/arts

Wisconsin Arts Board
Lt Gov Barbara Lawton, Chmn
George Tzougros, Exec Dir
101 E Wilson St, First Fl
Madison, WI 53702
Tel 608-266-0190; Fax 608-267-0380
E-mail: artsboard@arts.state.wi.us
Web Site: www.arts.state.wi.us

Wyoming Arts Council
Nancy Schiffer, Chmn
Rita Basom, Exec Dir
2320 Capitol Ave
Cheyenne, WY 82002
Tel 307-777-7742; Fax 307-777-5499
Web Site: www.wyoarts.state.wy.us

American Samoa Council on Culture, Arts and Humanities
Simone Lauti, Chmn
Le'ala E Pili, Exec Dir
Territory of American Samoa
PO Box 1540
Pago Pago, AS 96799
Tel 684-633-4347; Fax 684-633-2059
Web Site: www.nasaa-arts.org/aoa/as.shtml

Guam Council on the Arts and Humanities Agency
Flora Baza Quan, Chmn
Sylvia M Flores, Exec Dir
PO Box 2950
Hagatna, GU 96932
Tel 671-475-2242; Fax 671-472-2781
Web Site: www.guam.net/gov/kaha

Commonwealth Council for Arts and Culture (Northern Mariana Islands)
Esco T Iguel, Chmn
Cecilia T Celes, Exec Dir
Dept of Community & Cultural Affairs
PO Box 5553, CHRB
Saipan, MP 96950
Tel 670-322-9982; Fax 670-322-9028
E-mail: galaidi@vzpacifica.net
Web Site: www.geocities.com/ccaarts/ccawebsite.html

Institute of Puerto Rican Culture
Teresa Tio, Exec Dir
Manuel Martinez Maldonado, Pres
PO Box 9024184
San Juan, PR 00902-4184
Tel 787-725-0700; Fax 787-724-8393
Web Site: www.icp.gobierno.pr

Virgin Islands Council on the Arts
Rosary Harper, Acting Chir
Betty Mahoney, Exec Dir
41-42 Norre Gade, PO Box 103
Saint Thomas, VI 00802
Tel 340-774-5984; Fax 340-774-6206
E-mail: vicouncil@islands.vi
Web Site: www.vicouncilonarts.org

State Directors and Supervisors of Art Education

ALABAMA

Sara Strange, Arts in Education Specialist
State Department of Education
50 N Ripley St, Rm 3345
PO Box 302101
Montgomery, AL 36130-2101
Tel 334-242-8059; Fax 334-242-0482
E-mail: sstrange@alsde.edu

ALASKA

Sandy Gillespie
Fine Arts Administrator
Alaska Department of Education
411 W 4th Ave, Ste 1E
Anchorage, AK 99501
Tel 907-269-6605
E-mail: sandy_gillespie@eed.state.ak.us

ARIZONA

Lynn Tuttle, Coord
Arizona Department of Education
Special Projects & Constituents Services
1535 W Jefferson St
Phoenix, AZ 85007
Tel 602-364-1534; Fax 602-542-5440
E-mail: ltuttle@ade.az.gov

ARKANSAS

Brenda Turner, Specialist, Art Education
State Department of Education
Education Bldg, Rm 107A
Little Rock, AR 72201
Tel 501-682-4397; Fax 501-682-4886
E-mail: brenda.turner@arkansas.gov

CALIFORNIA

Tom Adams, Administrator
California Department of Education
Curriculum Frameworks & Instructional Resources Office
1430 N St, #3207
Sacramento, CA 95814
Tel 916-319-0881(office); 319-0663(direct); Fax 916-319-0172
E-mail: tadams@cde.ca.gov

Don Doyle, Consultant of Visual & Performing Arts
California Department of Education
660 Jay Street
Sacramento, CA 95814
Tel 916-323-2469; Fax 916-324-4848
E-mail: ddoyle@cde.ca.gov

COLORADO

Susan Schafer, Fine Arts & Physical Education Consultant
Colorado Department of Education
201 E Colfax Ave, Rm 201
Denver, CO 80203
Tel 303-866-6748; Fax 303-866-6944
E-mail: schafer_s@cde.state.co.us

CONNECTICUT

Dr Scott C Shuler, Arts Education Specialist
Connecticut State Department of Education
165 Capitol Ave
Hartford, CT 06106-1630
Tel 860-713-6746; Fax 860-713-7018
E-mail: scott.shuler@po.state.ct.us

DELAWARE

Debora Hansen, Education Associate Visual & Performing Arts
Department of Education
Townsend Bldg, PO Box 1402
Dover, DE 19903
Tel 302-739-4885; Fax 302-739-7645
E-mail: dhansen@doe.k12.de.us

DISTRICT OF COLUMBIA

Paula Sanderlin, Director of Art
Division of Standards & Curriculum
825 North Capital St NE
Washington, DC 20002
Tel 202-442-5639
E-mail: paula.sanderlin@k12.dc.us

FLORIDA

June Hinckley, Music & Fine Arts Specialist
Bureau of Curriculum, Instruction & Assessment
Florida Department of Education
Turlington Bldg, 325 Gaines St
Tallahassee, FL 32399-0400
Tel 850-245-0762; Fax 850-921-0367
E-mail: june.hinkley@fldoe.org

GEORGIA

Kathy Cox, State Superintendent of Schools
2066 Twin Towers East; 205 Jesse Hill Jr Dr, SE
Atlanta, GA 30334
Tel 404-656-2800; Fax 404-651-8737
E-mail: state.superintendent@doe.k12.ga.us

HAWAII

Neal Tomita, Educational Specialist, Hawaii State Department of Education
PO Box 2360
Honolulu, HI 96804
Tel 808-394-1353; Fax 808-394-1304

IDAHO

Dr Peggy Wenner, Fine Arts & Humanities Specialist
State Department of Education
Bureau of Curriculum & Accountability
PO Box 83720-0027
Boise, ID 83720-0027
Tel 208-332-6949; Fax 208-334-4664
E-mail: pjwenner@sde.idaho.gov

ILLINOIS

Cornelia Powell, Education Consultant of Fine Arts
Professional Preparation & Certification (Arts Consultant)
Illinois State Board of Education
100 N First St, C-215
Springfield, IL 62777
Tel 217-557-7323; Fax 217-782-7937
E-mail: cpowell@isbe.net

INDIANA

Sarah Fronczek, Fine Arts Consultant
Center for School Improvement
Indiana Department of Education
State House, Rm 229
Indianapolis, IN 46204-2798
Tel 317-234-1751; Fax 317-232-9121
E-mail: fronczek@doe.state.in.us

IOWA

Roseanne Malek, Fine Arts Consultant
Department of Education
Grimes State Office Building
Des Moines, IA 50319-0146
Tel 515-281-3199
E-mail: rosanne.malek@iowa.gov

KANSAS

Joyce Huser, Education Program Consultant-Fine Arts
State Department of Education
120 Tenth Ave, SE
Topeka, KS 66612-1182
Tel 785-296-4932; Fax 913-296-7933
E-mail: jhuser@ksde.org

KENTUCKY

Phil Shepherd, Arts & Humanities Consultant
Kentucky Department of Education
Rm 1810 A
500 Mero St
Frankfort, KY 40601
Tel 502-564-2106; Fax 502-564-9848
E-mail: philip.shepherd@education.ky.gov

LOUISIANA

Richard Baker, Fine Arts Coordinator
Louisiana Department of Education
120 N 3rd St, 4th Fl
Baton Rouge, LA 70803
Tel 225-342-8993; Fax 225-342-9891
E-mail: richard.baker@la.gov

MAINE

Susan A Gendron, Comissioner
Maine Department of Education
23 State House Station
Augusta, ME 04333
Tel 207-624-6620; Fax 207-624-6601
E-mail: susan.gendron@maine.gov

MARYLAND

James L Tucker, Jr, Fine Arts Coordinator
Maryland State Department of Education
Division of Instruction
200 W Baltimore St
Baltimore, MD 21201
Tel 410-767-0352
E-mail: jtucker@msde.state.md.us

MASSACHUSETTS

Susan Wheltle, Director Office of Humanities
Massachusetts Department of Education
350 Main St
Malden, MA 02148
Tel 781-338-6239
E-mail: swheltle@doe.mass.edu

MICHIGAN

Ana Luisa Cardona, Fine Arts Education Consultant
Michigan Department of Education
Curriculum Development Department
608 W Allegan St, Box 30008
Lansing, MI 48909
Tel 517-335-0466; Fax 517-335-2473
E-mail: cardona@michigan.gov

MINNESOTA

Dr Pam Paulson, Arts Education Specialist
Minnesota Center for Arts Education
6125 Olson Memorial Hwy
Golden Valley, MN 55422
Tel 763-591-4708; Fax: 763-591-4772
E-mail: pam.paulson@pcae.k12.mn.us

MISSISSIPPI

Sally Edwards, Visual & Performing Arts Specialist
Mississippi Department of Education
PO Box 771
Jackson, MS 39205-2586
Tel 601-359-2586; Fax 601-359-2040
E-mail: sedwards@mde.k12.ms.us

MISSOURI

Deborah Fisher, Consultant, Fine Arts
Missouri State Department of Elementary & Secondary Education
PO Box 480
Jefferson City, MO 65102-0480
Tel 573-751-2625
E-mail: dfisher3@mail.dese.state.mo.us

MONTANA

Jan Clinard, Director Academic Initiatives
Office of the Commissioner of Higher Education
2500 Broadway
PO Box 203101
Helena, MT 59620-3101
Tel 406-444-0652
E-mail: jclinard@ache.montana.edu

NEBRASKA

Douglas D Christensen, Commissioner
Department of Education
301 Centennial Mall South
Lincoln, NE 68509-4987
Tel 402-471-5020
E-mail: doug-ch@nde.state.ne.us

NEVADA

Keith Rheault, Superintendent Public Instruction
Nevada Department of Education
700 E Fifth St
Carson City, NV 89701-9101
Tel 775-687-9200; Fax 775-687-9101
E-mail: krheault@doe.nv.gov

NEW HAMPSHIRE

Marcia McCaffrey, Art Consultant
New Hampshire Department of Education
101 Pleasant St
Concord, NH 03301
Tel 603-271-3193; Fax 603-271-1953
E-mail: mmccaffrey@ed.state.nh.us

NEW JERSEY

Dale Schmid, Visual & Performing Arts Coordinator
New Jersey Department of Education, Office of Standards
100 Riverview Plaza, PO Box 500
Trenton, NJ 08625
Tel 609-984-6308; Fax: 609-292-7276
Web Site: www.state.nj.us/education

NEW MEXICO

Vicki Breen, Director of the Arts
New Mexico State Department of Education
Education Building, 300 Don Gasper
Santa Fe, NM 87501
Tel 505-827-6559; Fax 505-476-0329
E-mail: vbreen@ped.state.nm.us

NEW YORK

Edward Marschilok
Associate in Music Education Curriculum Instruction & Instructional
Technology
New York State Department of Education, 89 Washington Ave, Rm 319EB
Albany, NY 12234
Tel 518-474-5932; Fax 518-473-4884
E-mail: emarschi@mail.nysed.gov

NORTH CAROLINA

Bryar Cougle, Consultant, Theatre & Visual Arts K-12
North Carolina Department of Public Instruction
301 N Wilmington St
Raleigh, NC 27601-28215
Tel 919-807-3855
E-mail: tcougle@dpi.state.nc.uc

NORTH DAKOTA

Jon Skaare, State Director
Division of Independent Study
1510 12th Ave, N
Fargo, ND 58105
Tel 701-231-6000
E-mail: jon.skaare@sendit.nodak.edu
Website: www.ndisonline.org

OHIO

Nancy Pistone, Art Consultant
Office of Curriculum & Instruction
Ohio Department of Education
25 S Front St, MS 509
Columbus, OH 43215-4104
Tel 614-466-7908
E-mail: nancy.pistone@ode.state.oh.us

OKLAHOMA

Glen Henry, Director
Arts in Education Program
State Department of Education
2500 N Lincoln Blvd
Oklahoma City, OK 73105
Tel 405-521-3034; Fax 405-521-2971
E-mail: glen_henry@mail.sde.state.ok.us

OREGON

Michael Fridley, Arts Curriculum Specialist
Oregon Department of Education
255 Capitol St NE
Salem, OR 97310-0203
Tel 503-947-5660
E-mail: michael.fridley@state.or.us

PENNSYLVANIA

Beth Cornell, Fine Arts & Humanities Advisor
Division of Arts and Sciences
Department of Education, 333 Market St
Harrisburg, PA 17126-0333
Tel 717-787-5317; Fax 717-783-3946
E-mail: bcornell@state.pa.us

RHODE ISLAND

Richard Latham, Consultant
Rhode Island Department of Education
Shepard Bldg, 255 Westminster St
Providence, RI 02903
Tel 401-222-4600 Ext 2371; Fax 401-277-4979
E-mail: ride0036@ride.ri.net

SOUTH CAROLINA

R Scot Hockman, Visual & Performing Arts
Office of Curriculum & Standards
State Department of Education
1429 Senate St, Ste 802-A
Columbia, SC 29201
Tel 803-734-0323; Fax 803-734-3927
E-mail: shockman@ed.sc.gov

SOUTH DAKOTA

Michael Pangburn, Arts Education Coordinator
South Dakota Arts Council
800 Governors Drive
Pierre, SD 57501
Tel 605-773-3131; Fax 605-773-3782
E-mail: sdac@state.sd.us
Web Site: www.artscouncil.gov

TENNESSEE

Jeanette Crosswhite, Director, Arts Education
Tennessee Department of Education
710 James Robertson Pkwy
Andrew Johnson Tower, 5th Flr
Nashville, TN 37243-0379
Tel 615-532-6278; Fax 615-532-8536
E-mail: jeanette.crosswhite@state.tn.us

TEXAS

Tom Waggoner, Director of Fine Arts Programs
Curriculum and Professional Development
Texas Education Agency
1701 N Congress Ave
Austin, TX 78701-1494
Tel 512-463-4341
E-mail: thomas.wagganer@tea.state.tx.us

UTAH

Carol Ann Goodson, State Specialist in Fine Arts Education
Utah State Office of Education
250 East 500 S
Salt Lake City, UT 84114
Tel 801-538-7892; Fax 801-538-7769
E-mail: cgoodson@usoe.kl2.ut.us

VERMONT

Kerry Garber, Dir School Quality
Department of Education
120 State St
Montpelier, VT 05620
Tel 802-828-5411; Fax 802-828-3146
E-mail: kgarber@doe.state.vt.us

VIRGINIA

Cheryle C Gardner, Principal Specialist of Fine Arts
Virginia Department of Education
PO Box 2120
Richmond, VA 23218-2120
Tel 804-225-2881; Fax 804-786-5466
E-mail: cgardner@pen.kl2.va.us

WASHINGTON

AnneRene Joseph-Art Program Supervisor
Office Superintendent of Public Information
Old Capitol Bldg
PO Box 47200
Olympia, WA 98504-7200
Tel 360-725-6365; Fax 360-664-0494
E-mail: ajoseph@ospi.wednet.edu

WEST VIRGINIA

Julia Lee, Coordinator of Fine Arts
West Virginia Department of Education
Capitol Complex, Bldg 6, Rm 330
1900 Kanawha Blvd E
Charleston, WV 25305
Tel 304-558-7805; Fax 304-558-0459
E-mail: jrlee@access.k12.wv.us

WISCONSIN

Dr Martin Rayala, Art & Design Education Consultant
Wisconsin Department of Public Instruction
125 S Webster St, PO Box 7841
Madison, WI 53707-7841
Tel 608-267-7461; Fax 608-266-1965
E-mail: martin.rayala@dpi.state.wi.us

WYOMING

Dr James M McBride, Superintendent, Public Instruction
Department of Education
Hathaway Bldg, 2300 Capitol, 2nd Fl
Cheyenne, WY 82002
Tel 307-777-7673; Fax 307-777-6234
Website www.k12.wy.us

Art Magazines

A for Annuals; Bi-M for Bimonthlies; Bi-W for Biweeklies;
M for Monthlies; Q for Quarterlies; Semi-A for Semiannually; W for Weeklies

African Arts (Q)—Don Consentino & Doran H. Ross, Eds; James S Coleman African Studies Center, University of California, 10244 Bunche Hall, PO Box 951310, Los Angeles, CA 90095. Tel 310-825-1218; Fax 310-206-2250; E-mail: Africa@international.ucla.edu. Yearly $72.00 (domestic)

Afterimage (Bi-M)—Karen vanMeenen, Ed; Visual Studies Workshop Inc, 31 Prince St, Rochester, NY 14607. Tel 585-442-8676; Fax 585-442-1992; Web Site: www.vsw.org/afterimage. Yearly $33.00

American Art (Q)—Cynthia Mills, Exec Ed; Smithsonian American Art Museum, 750 9th St NW, Washington, DC 20001. Tel 202-275-1628; Fax 202-275-1439; Web Site http://americanart.si.edu/education/art_journal.cfm. Yearly $45.00 individuals; $162.00 to institutions

American Artist (M)—M Stephen Doherty, Ed in Chf; VPI Communications Inc, 770 Broadway, New York, NY 10003. Tel 646-654-7224; Fax: 646-654-5514; Web Site http://myamericanartist.com. Yearly $29.95

American Craft (Bi-M)—Lois Moran, Ed; American Craft Council, 72 Spring St, 6th Flr, New York, NY 10012. Tel 212-274-0630; Fax 212-274-0649; Web Site: www.craftcouncil.org. $50.00 professionals

American Indian Art Magazine (Q)—Roanne Goldfein, Ed; American Indian Art Inc, 7314 E Osborn Dr, Scottsdale, AZ 85251. Tel 480-994-5445; Fax 480-945-9533; E-mail: aiamagazine@qwest.net; Web Site: www.aiamagazine.com. Yearly $20.00

American Journal of Archaeology (Q)—Naomi Norman, Ed; 656 Beacon St, Boston, MA 02215. Tel 617-353-9364; Fax 617-353-6550; E-mail aja@bu.edu; Website www.ajaonline.org. Yearly $47.00 Students; $75.00 individuals; $250.00 institutions

American Watercolor Society Newsletter (2 Issues)—American Watercolor Society, 47 Fifth Ave, New York, NY 10003. Tel 212-206-8986. Membership

Antiquarian (A)—David K Martin, Ed; Clinton County Historical Association, 3 Cumberland Ave, Plattsburgh, NY 12901. Tel 518-561-0340. Membership fee $20.00

Aperture (Q)—Melissa Harris; Aperture Foundation, 547 W 27th St, New York, NY 10001. Tel 212-505-5555; Fax 212-979-7759; Website www.aperture.org. Yearly $40.00 domestic; $65.00 foreign

Archaeology (Bi-M)—Peter Young, Ed; Archaeological Institute of America, 36-36 33rd St, Long Island City, NY 11106. Tel 718-472-3050; Fax 718-472-3051. Yearly $21.95

Architectural Digest (M)—Paige Rense, Ed; Conde-Nast Publications Inc, 6300 Wilshire Blvd, 11th Fl, Los Angeles, CA 90048. Tel 323-965-3700; Fax 323-937-1458. Yearly $40.00

Archives of American Art Journal (Q)—Darcy Tell, Ed; 1285 Avenue of the Americas, 2nd Fl, New York, NY 10019. Tel 212-399-5030. Yearly $50.00, Students $25.00

Art & Antiques (M)—Barbara S Tapp, Ed; 1177 Avenue of the Americas, 10th Fl, New York, NY 10036. Tel 212-230-0200; Fax 212-230-0201; Web Site: www.artandantiquesmag.com. Yearly $24.00, Two Years $44.95

Art & Auction (11 Issues)—Bruce Wolmer, Ed; Art Auction Guild, 111 8th Ave, Suite 302, New York, NY 10011. Tel 212-447-9555; Fax 212-447-5221; E-mail: editorial@artandauction.com. Yearly $80.00; Two years $120.00; For subscriptions call 800-777-8718

Art & Understanding (M)—David Waggoner, Ed; Art & Understanding Inc, 25 Monroe St, Ste 205, Albany, NY 12210. Tel 518-426-9010; Website www.aumag.org. Yearly $9.95

Art Brief (Bi-W) E-mail newsletter—S R Howarth, Ed; Humanities Exchange Inc, PO Box 1608 , Largo, FL 33779. Tel 727-581-7328; Fax 727-585-6398; E-mail the-iaa@ix.netcom.com. Yearly $60.00

Art Bulletin (Q)—Mark Gotlieb, Ed in Chf; College Art Association of America Inc, 275 Seventh Ave, 18th Fl, New York, NY 10001-6708. Tel 212-691-1051; Fax 212-627-2381; E-mail nyofficeoffice@collegeart.org; Website www.collegeart.org. Individual membership based on income; Institutions: Basic: $275.00 Domestic, $300.00 Foreign; Premium: $325 Domestic, $350 Foreign

Art Business News (M)—Susanne Casgar, Ed Dir; 6000 Lombardo Center Dr, Ste 420, Cleveland, OH 44131. Tel 216-328-8926; Fax 216-328-9452; Web Site: www.artbusinessnews.com Yearly $55.00; Free to art dealers

Art Calendar (M)—Carolyn Proeber, Ed; Art Calendar, PO Box 2675, Salisbury, MD 21802. Tel 866-427-8225; E-mail: info@artcalendar.com; Website www.artcalendar.com. Yearly $37.00; Two years $62.00

Art Documentation (Semi-A)—Cathy Zedimon & Judy Dyky, Ed; Art Libraries Society of North America, 329 March Rd, Ste 232, Ottawa, Ontario, K2K 2E1, Canada. Tel 800-817-0621; Fax: 613-599-7027. Web Site: www.arlisna.org Yearly $65.00 individuals; $80.00 institutions

Art Education (Q)—Lynne Ezell, Periodical Mgr; National Art Education Association, 1916 Association Dr, Reston, VA 20191-1590. Tel 703-860-8000; Fax 703-860-2960; Website www.naea-reston.org. Yearly $50.00 non-members

Art Focus (3 Issues)—Pat Fleisher, Ed; 15 McMurrich St, Ste 706, Toronto, ON M5R 3M6 Canada. Tel 416-925-5564; Fax 416-925-2972; E-mail info@artfocus.com; Web Site www.artfocus.com. Yearly $20.00 (US)

Artforum (10 Issues)—Jack Bankowsky, Ed at large; Artforum International Magazine Inc, 350 7th Ave, New York, NY 10001. Tel 212-475-4000; Fax 212-529-1257; Website www.artforum.com. Yearly $46.00; Two years $86

Art in America (M)—Elizabeth C Baker, Ed; Brant Publications, 575 Broadway, 5th Fl, New York, NY 10012. Tel 212-941-2800; Fax 212-941-2819; Website www.artinamericamagazine.com. Yearly $29.95; For subscriptions call 800-925-8059

Artist's Magazine (M)—Sandy Carpenter, Ed; F & W Publications Inc, 4700 E Galbraith Rd, Cincinnati, OH 45236. Tel 513-531-2690, Ext 1257; Website www.artistsmagazine.com. Yearly $19.96

Art Journal (Q)—Patricia C. Phillips, Ed; College Art Association of America Inc, 275 Seventh Ave, 18th Fl, New York, NY 10001-6708. Tel 212-691-1051; Fax 212-627-2381; Website www.collegeart.org. Individual membership based on income; Yearly $50, $75 institutions (add $10 for foreign shipping)

Art New England (6 Issues)—Portia Belz, Ed; 425 Washington St, Brighton, MA 02135. Tel 617-782-3008; Fax 617-782-4218; Website www.artnewengland.com. Yearly $28.00

Artnews (11 Issues)—Milton Esterow, Ed & Pub; Artnews Associates, 48 W 38th St, 9th Fl, New York, NY 10018. Tel 212-398-1690; Fax 212-768-4002; Website www.artnewsonline.com. Yearly $39.95

Artnewsletter (Bi-M)—Artnews Associates, 48 W 38th St, New York, NY 10018. Tel 212-398-1690; Website www.artnewsonline.com. Yearly $279.00

Art of the West (Bi-M)—Vicki Stavig, Ed; Duerr and Tierney Ltd,15612 Hwy 7, Ste 235, Minnetonka, MN 55345. Tel 952-935-5850; Fax 952-935-6546; E-mail: Aotw@aotw.com; Web Site: www.aotw.com. Yearly $25.00; Two Years $44.00

Art On Paper (Bi-M)—Peter Nesbitt, Publisher & Ed-in-Chief; Sarah Andress, Ed; 150 W 28th St, New York, NY 10001. Tel 212-675-1968; Fax: 212-675-2038. Web Site: www.artonpaper.com. Yearly $54.00; Two Years, $99.00

Art Papers (6 Issues)—Sylvia Fortin, Ed; Atlanta Art Papers Inc, 1083 Austin Ave NE, Rm 206, PO Box 5748, Atlanta, GA 31107. Tel 404-588-1837; Fax 404-588-1836; Website www.artpapers.org. Yearly $35.00, 2 years $65

Arts (M)—Jodie Ahern, Ed; Minneapolis Institute of Arts, 2400 Third Ave S, Minneapolis, MN 55404. Tel 612-870-3046; Fax 612-870-3004; Website www.artsmia.org. Yearly $1.00 monthly (non-members); free (members)

Artslink Newsletter (M)—Americans for the Arts, 1000 Vermont Ave, NW 6th Flr Washington, DC 20005. Tel 202-371-2830; Fax 203-271-0424; Website www.americansforthearts.org. Membership minimum $50.00

Arts Quarterly (Q)—Wanda O'Shello, Ed; New Orleans Museum of Art, PO Box 19123, New Orleans, LA 70179. Tel 504-488-2631; Fax 504-484-6662; E-mail: info@noma.org; Website www.noma.org. Yearly $10.00

Art Therapy (Q)—Lynn Kapitan, Ed; American Art Therapy Association Inc, 5999 Stevenson Ave, Alexandria, VA 22304. Tel 703-212-2238; E-mail: info@arttherapy.org; Website www.arttherapy.org. Yearly $125 (Domestic), $200 (Foreign) individuals; $200.00 (Domestic), $225 (Foreign) institutions; (Students) $60

Art Times (11 Issues)—Raymond J Steiner, Ed; PO Box 730, Mount Marion, NY 12456. Tel 845-246-6944 E-mail info@arttimesjournal.com; Web site www.arttimesjournal.com Yearly $18.00; foreign subscriptions available, call for rates

Artweek (M)—Laura Richard Janku, Ed; Artweek, PO Box 52100 Palo Alto, CA 94303-0751. Tel 800-733-2916; Fax 262-495-8703; E-mail: info@artweek.com; Website www.artweek.com. Yearly $34.00; $60.00 foreign

Artworld Europe (Bi-M)—S R Howarth, Ed; Humanities Exchange Inc, PO Box 1608, Largo, FL 33779. Tel 813-581-7328; Fax 813-585-6398. Yearly $69.00

Aviso (M)—Leah Arroyo, Ed; American Association of Museums, 1575 Eye St NW, Ste 400, Washington, DC 20005. Tel 202-289-1818; Fax 202-289-6578; E-mail: aviso@aam-us.org; Website www.aam-us.org. Yearly $40.00

Bomb (4 Issues)—Betsy Sussler, Ed; 80 Hanson Pl, Ste 703, Brooklyn, NY 11217. Tel 718-636-9100; Fax 212-636-9200; E-mail: info@bombsite.com; Website www.bombsite.com. Yearly $25.00

Bulletin of the Detroit Institute of Arts (2 Issues)—Susan Higman, Ed; 5200 Woodward Ave, Detroit, MI 48202. Tel 313-833-4838; Fax 313-833-6409; Website www.dia.org. Yearly $20.00(non members) $12.00 (members)

Canadian Art (Q)—Richard Rhodes, Ed; Canadian Art Foundation, 51 Front St E, Ste 210, Toronto, ON M5E 1B3, Canada. Tel 416-368-8854; Fax 416-368-6135; Web Site www.canadianart.ca. Yearly $24.00 (CN), $32.00 (US)

Ceramics Monthly (M)—Sherman Hall, Ed; Ceramics Monthly, 735 Ceramic Pl, Ste 100, Westerville, OH 43081. Tel 614-794-5890; Fax 614-891-8960; Website www.ceramicsmonthly.org. Yearly $34.95 (US); $40.00 (CN); $66.00 (International)

C Magazine (Q)—Rosemary Heather, Ed; PO Box 5, Sta B, Toronto, ON M5T 2T2, Canada. Tel 416-539-9495; Fax 416-539-9903; E-mail general@cmagazine.com Website www.cmagazine.com. Yearly $25.00 Canadian individuals; $35.00 Canadian institutions; $27.00 U.S. individuals; $37.00 U.S. institutions

Cleveland Museum of Art Members Magazine (10 Issues)—Laurence Channing, Ed; Publications Dept, 11150 East Blvd, Cleveland, OH 44106. Tel 216-421-7340; Email info@clevelandart.org Website www.clevelandart.org. Yearly $25.00 non-members; min. membership $50.00

Columbia-VLA Journal of Law & the Arts (Q)—Cason Moore, Ed; Editorial Board - Columbia University School of Law, 435 W 116th St, New York, NY 10027. Tel 212-854-1607; Email columbiajla@gmail.com. Yearly $45.00; $53.00 foreign

Communication Arts (8 Issues)—Patrick S Coyne, Ed; Communication Arts, 110 Constitution Dr., Menlo Park, CA 94025. Tel 650-326-6040; Fax 650-326-1648 Yearly $53.00

Evaluator (Q)—Elizabeth Carr, Ed; International Society of Fine Arts Appraisers, Beverly Hills, CA 90210. Tel 310-271-8141. Membership

Fiberarts (5 Issues)—Liz Good, Ed; Fiber Arts Mag, 201 E Fourth St Loveland, CO 80537. Tel 970-613-4769; Fax 970-613-4569; E-mail info@fiberartsmagazine.com; Website www.fiberartsmagazine.com. Yearly $19.95; Two Years $36.95

Folk Art (Q)—Tanya Heinrich, Ed; American Folk Art Museum, 45 W 53rd St, New York, NY 10019. Tel 212-265-1040; Fax 212-265-2350; E-mail info@folkartmuseum.org; Web Site www.folkartmuseum.org. Membership $50.00 students and senior citizens; $65.00 individuals; $85.00 dual (two adults in one home)

Gesta (2 Issues)—Anne D. Hedeman, Ed; International Center of Medieval Art, The Cloisters, Fort Tryon Park, New York, NY 10040. Tel 212-928-1146; Fax 212-428-9946; E-mail Imca@medievalart.org Yearly $20.00 students; $55.00 individuals; $75.00 institutions; $60.00 individuals overseas

ID: International Design (12 Issues)—Julie Lasky, Ed; Magazine Publication's LP, 38 E 29th St, 3rd Fl, New York, NY, 10016. Tel 212-447-1400; Fax 212-447-5231; Web Site www.idonline.com. Yearly $30.00

IFAR Journal (Q)—Sharon Flescher, Ed; International Foundation for Art Research, 500 Fifth Ave, Ste 935, New York, NY 10110. Tel 212-391-6234; Fax 212-391-8794; Website www.ifar.org. Membership minimum $65.00

Illustrator (A)—Steve Unverzagt, Ed; Art Instruction Schools, 3400 Technology Dr, Minneapolis, MN 55418. Tel 612-362-5060; Fax 612-362-5260; E-mail: ima@ima-art.org; Website www.artists-ais.com. Yearly $2.50, 5 years $10

Indianapolis Museum of Art Previews Magazine (Bi-M)—Anne Robinson, Ed; 4000 Michigan Rd, Indianapolis, IN 46208. Tel 317-923-1331; E-mail: ima@ima-art.org. Membership $40.00 individuals; $60.00 family/dual

International Directory of Corporate Art Collections (Bi-A)—S R Howarth, Ed; Humanities Exchange Inc, PO Box 1608, Largo, FL 33779. Tel 514-935-1228; Fax 514-935-1229. Yearly $109.95

Journal of Aesthetics & Art Criticism (Q)—Susan L. Feagan, Ed; Temple University, Department of Philosophy, 718 Anderson Hall, Philadelphia, PA 19122. Tel 215-204-8294; E-mail Jaac@blue.temple.edu; Web Site www.temple.edu/jaac. Individuals $70.00; Student $35.00

Journal of Canadian Art History (Semi-A)—Sandra Paikowsky, Ed; Concordia University, 1455 blvd de Maissoneuve Ouest, S-VA 432, Montreal, PQ H3G 1M8, Canada. Tel 514-848-4699; Fax 514-848-4584; E-mail JCAH@vax2.concordia.ca; Web Site http://art-history.concordia.ca/JCAH. Yearly $28.00 (CN); $40.00 (US)

Leonardo: Art, Science & Technology (5 Issues)—Roger Malina, Ed; MIT Press Journals, 238 Main St, Ste 500, Cambridge, MA 02142-1046. Tel 617-253-2889; Fax 617-577-1545; E-mail journals-orders@mit.edu; Website www.mitpress.mit.edu. Yearly $77.00 individuals, $432 institutions

Letter Arts Review (Q)—Rose Folsom, Ed; PO Box 9986, Greensboro, NC 27429. Tel 800-369-9598; Fax 336-272-9015; E-mail lara@johnnealbooks.com; Website www.johnnealbooks.com. Yearly $45.00

Lightworks Magazine (Irregular)—Andrea D Martin, Ed; PO Box 1202, Birmingham, MI 48012-1203. Tel 248-626-8026; E-mail lightworks_mag@hotmail.com. Sold individually (price varies $5.00-$10.00

Linea (Bi-A)—The Art Students League of New York 215 W 57th St, New York, NY 10019. Tel 212-247-4510; Fax 212-541-7024 Membership Yearly $35.00

MFAH Today (6 Issues)—Diane Lovejoy, Ed; Museum of Fine Arts, Houston, PO Box 6826, Houston, TX 77265. Tel 713-639-7300; Fax 713-639-7708. Individual Membership $50.00, Student $40.00

Master Drawings (Q)—Jane Turner, Ed; Master Drawings Association Inc, 225 Madison Ave, New York, NY 10016. Tel 212-590-0369; Fax 212-685-4740; E-mail administrator@masterdrawings.org; Website www.masterdrawings.org. Yearly $95.00 domestic; $115.00 intl

Metropolitan Museum of Art Bulletin (Q)—John P O'Neill, Ed; 1000 Fifth Ave, New York, NY 10028. Tel 212-535-7710 (distribution office); Fax 212-570-3965. Yearly $25.00, Members Free

Museum News (Bi-M)—Jane Lusaka, Ed; American Association of Museums, 1575 Eye St NW, Ste 400, Washington, DC 20005. Tel 202-289-1818; Fax 202-289-6578; Website www.aam-us.org. Yearly $38.00 non-members

Museum Studies (Semi-A)—Gregory Nosan, Ed; Art Institute of Chicago, Publications Dept, 111 S Michigan Ave, Chicago, IL 60603-6111. Tel 312-443-3540; Fax 312-443-1334. Individuals $25.00, institutions $50.00

October (Q)—Annette Michelson & Rosalyn Krauss, Eds; MIT Press Journals, 238 Main Street, Ste 500, Cambridge, MA 02142-1046. Tel 617-253-2889; Fax 617-577-1545; E-mail journals-orders@mit.edu. Yearly $46.00 individuals; $166.00 institutions

Ornament (Q)—Robert Liu and Carolyn Benesh, Ed; Ornament Inc, PO Box 2349, San Marcos, CA 92079-2349. Tel 760-599-0222; Fax 760-599-0228; Email ornament@sbcglobal.net; Website www.ornamentmagazine.com. Yearly $26.00

Parachute (Q)—Chantal Pontbriand, Ed; Editions Parachute, 4060 Blvd St Laurent, Ste 501, Montreal, PQ H2W 1Y9, Canada. Tel 514-842-9805; Fax 514-842-9319; Email info@parachute.ca; Website www.parachute.ca. Yearly $57.00 (CN) individuals; $125.00 (CN) institutions; $84.00 foreign individuals; $149.00 foreign institutions

Print (Bi-M)—Joyce Rutter, Ed; Print Mag, 38 E 29th St, 3rd Fl, New York, NY 10016; Tel 212-447-1430; Fax 212-447-5231; E-mail info@printmag.com; Website www.printmag.com; Membership US yearly $39.00, Canada $54.00, International $80.00

Record of the Art Museum Princeton University (1 Issue)—Jill Guthrie, Ed; Princeton University Art Museum, Princeton, NJ 08544. Tel 609-258-4341; Fax 609-258-5949. Yearly $18.00

SchoolArts (9 Issues)—Nancy Walkup, Ed; Davis Publications Inc, 50 Portland St, Worcester, MA 01608. Tel 508-754-7201; Fax 508-753-3834; Website www.davis-art.com. Yearly $24.95, $37.95 2 years (domestic)

Sculpture (10 Issues)—Glenn Harper, Ed; International Sculpture Center, 1529 18th St NW, Washington, DC 20036. Tel 202-234-0555; Fax 202-234-2663; Website www.sculpture.org. Yearly $50.00

Sculpture Review (Q)—Giarcarlo Biagi, Ed; National Sculpture Society, 56 Ludlow St, 5th Flr, New York, NY 10002. Tel 212-529-1763; Fax 212-260-1732; E-mail gp@sculpturereview.com; Website www.sculpturereview.com. Yearly $24.00

Society of Architectural Historians Newsletter (Bi-M)—Julie Taylor, Ed; Society of Architectural Historians-Southern Californian Chapter, PO Box 56478, Sherman Oaks, CA 91413. Tel 310-247-1099; Fax 310-247-8147. Web Site www.sahscc.org. Membership Yearly $115.00, Student $45.00

Southwest Art (M)—Kristin Bucher, Ed; 5444 Westheimer, Ste 1440, Houston, TX 77056-8535. Tel 713-296-7900, Ext 7907; Fax 713-850-1314; Email southwestart@southwestart.com; Website www.southwestart.com. $27.00 US, $39.00 International

Stained Glass (Q)—Richard Gross, Ed; Stained Glass Association of America, 10009 E 62nd St, Raytown, MO 64133. 800-438-9581; Fax 816-737-2801; Website www.stainedglass.org. Yearly $36.00, 2 Years $64.00

Studio Potter (Semi-A)—Mary Barringer, Ed; PO Box 352, Manchester, NH 03105-0322. Tel 603-774-3582; Fax 603-774-6313; Email subscription@studiopotter.org Website www.studiopotter.org. Yearly $30.00 U.S. $32.00 Canadian & Foreign $35.00

Sunshine Artist (M)—Cameron Meier, Ed; Palm House Publishing, 4075 LB McLeod Rd, Ste E, Orlando, FL 32811. Tel 407-648-7479; Fax 407-228-9862; Email business@sunshineartist.com; Website www.sunshineartist.com. Yearly $34.95

Tole World (Bi-M)—Judy Swager, Ed; EGW Publishing Co, 1041 Shary Circle, Concord, CA 94518. Tel 925-671-9852. U.S. $19.97, International $31.97

Vie des Arts (Q)—Bernard Levy, Ed; 486 Saint Catherine St W, Ste 400, Montreal, PQ H3B 1B6, Canada. Tel 514-282-0205; Fax 514-282-0235; www.viedesarts.com; Yearly $39.00 Canadian dollars for U.S.; $24.00 Canadian dollars for Canada

Walters Magzine (Q)—Gregory Rago, Ed; The Walters Art Museum, 600 N Charles St, Baltimore, MD 21201. Tel 410-547-9000; Fax 410-727-7591. Yearly $35.00 domestic, Free to Members

Woman's Art Journal (2 Issues)—Joan Marter & Margaret Barlow, Eds; Old City Publishing, 628 N 2nd St, Philadelphia, PA 19123. Tel 215-925-4390; Fax 215-925-4371. Website http://womansartjournal.org; Yearly $24.00 individuals; $52.00 institutions

Newspaper Art Editors and Critics
Cities for newspapers that do not start with city name
will have city name in parentheses as part of the listing

ALABAMA

Birmingham News—James R. Nelson & Alec Harvey
Birmingham Post-Herald—Wade Kwon
Gadsden Times—Cyndi Nelson
Huntsville Times—Howard Miller
Mobile Register—Thomas Harrison
Times Daily—Vicky Pounders
The Valley Times-News—Wayne Clark

ALASKA

Anchorage Daily News—George Bryson

ARIZONA

Bisbee Daily Review—Kelly Figula
(Flagstaff) Arizona Daily Sun—Amy Outekhine
The Tribune—Cheryl Kushner
(Phoenix) Arizona Republic—Richard Nilsen
(Tucson) Arizona Daily Star—Gerald M. Gay
Tucson Citizen—T.J. Buck

ARKANSAS

Batesville Guard—Andrea Bruner
Fort Smith Southwest Times-Record—Tina Dale
(Little Rock) Arkansas Democratic Gazette—Eric Harrison
Paragould Daily Press—Hannah Keller
(Rogers) Northwest Arkansas Morning News—Laurinda Joenks

CALIFORNIA

(Bakersfield) Californian—Steve Mullen
Beverly Hills Courier—Norma Weitz Zager
Chico News & Review—Chris Baldwin & Shannon Rooney
Contra Costa Times--Karen Hershenson
(Covina) San Gabriel Valley Tribune—Katherine Gaugh
Davis Enterprise—Derrick Bang
(El Centro) Imperial Valley Press—Stefanie Campos
Fairfield Daily Republic—Patty Amador
Fresno Bee—Alison Lucian
Hanford Sentinel—No One in Position
(Long Beach) Press-Telegram—Marlene Greer
Los Angeles Daily News—Rob Lowman
(Los Angeles) La Opinion—Antonio Mejihs
Los Angeles Times—Christopher Knight
Madera Tribune—Tammy Nix
Modesto Bee—Al Golub
(Monterey) Herald—Kathy Nichols
Napa Valley Register—L. Pierce Carson & Sasha Paulsen
Oakland Tribune—Monique Beeler
(Palm Springs) Desert Sun—Bruce Fessier
Porterville Recorder—Darla Welles
(Riverside) Press-Enterprise—Rich Deatley
Sacramento Bee—Bruce Dancis
San Bernardino Sun—John Weeks

San Diego Daily Transcript—Jennifer Chung
San Diego Union Tribune—Robert L. Pincus
San Francisco Chronicle—Kenneth Baker
San Francisco Examiner—Sonia Mansfield
(San Jose) Mercury News—Jeff Thomas
San Mateo Times—Monique Beeler
(Santa Ana) Orange County Register—Scott Duncan
Santa Barbara News-Press—Gary Robb
Torrence Daily Breeze—Andria Hayashi
Santa Rosa Press Democrat—Dan Taylor
Turlock Journal—Brandon Bowers
Vallejo Times-Herald—Richard Freedman
Ventura County Star-Free Press—Rick Welch

COLORADO

Boulder Daily Camera—Erika Stutzman & J. Gluckstern
Colorado Springs Gazette Telegraph—Mark Arnest
Denver Post—Kyle MacMillan
(Denver) Rocky Mountain News—Voelz Chandler
Pueblo Chieftain—Marvin Read

CONNECTICUT

(Bridgeport) Connecticut Post—Patrick Quinn
Bristol Press—Steve Collins
Danbury News-Times—Linda Tuccio-Koonz
Greenwich Time—Barbara A. Heins
Hartford Courant—Frank Rizzo
New Britain Herald—Lin Noble
New Haven Register—Laura Collins-Hughes
Stamford Advocate—Thomas Mellana
Waterbury Republican-American—Debra Aleksinas

DELAWARE

Wilmington News-Journal—Gary Mullinay

DISTRICT OF COLUMBIA

Washington Post—Blake Gopnik
Washington Times—Daniel Wattenberg

FLORIDA

Daytona Beach News Journal—Jeff Farence, Dave Hunter & Judy Liberi
Fort Lauderdale Sun-Sentinel—Gretchen Day Bryant
Fort Myers News-Press—Amy Bennett
Fort Walton Northwest Florida Daily News—Craig Terry
Gainesville Sun—Darrell Hartman & Dave Schlenker
(Jacksonville) Florida Times-Union—Roger Bull
Lakeland Ledger—Lyle McBride
(Melbourne) Florida Today—Pam Harbaugh
Miami Herald—Elisa Turner
Ocala Star Banner—Christopoher Lloyd
Orlando Sentinel—Mary-Frances Emmons
Palatka Daily News—Trish Murphy

Palm Beach Daily News—Jan Sjostrom
Pensacola News-Journal—Lesley Conn
Saint Augustine Record—Anne Heymen
Saint Petersburg Times—Lennie Bennett
Tallahassee Democrat—Mark Hinson & Kate Schardl
Tampa Tribune—Joanne Milani
West Palm Beach Post—Gary Schwan

GEORGIA

Albany Herald—Ethan Fowler
Atlanta Journal & Constitution—Valerie Boyd; Jerry Cullum
Augusta Herald & Chronicle—Steven Uhles
Cartersville Daily Tribune News—Nobody in Position
Columbus Ledger-Enquirer—Don Coker, Richard Hodges
Macon Telegraph—Joe Kovac Jr.
Savannah Morning News—Arlinda Broady

HAWAII

Honolulu Advertiser—Michael Tsai
(Honolulu) Star Bulletin—Nadine Kam

IDAHO

(Boise) Idaho Statesman—Julie Sarasqueta
Coeur d'Alene Press—Joe Butler
(Idaho Falls) Post-Register—Nobody in Position
Lewiston Morning Tribune—Jennifer K. Bauer
(Pocatello) Idaho State Journal—Joy Morrison
(Twin Falls) Times-News—Steve Crump

ILLINOIS

Arlington Heights Daily Herald—Diane Dungey
Belleville News-Democrat—Patrick Kuhl
Bloomington Daily Pantagraph—Dan Craft
(Centralia) Morning Sentinel—Luanne Droege
(Champaign) News-Gazette—John Foreman
Chicago Sun-Times—Margaret Hawkins
Chicago Tribune—Chris Jones
Decatur Herald-Review—Tim Cain
DeKalb Daily Chronicle—Cindy DiDonna & Rob Carroll
Dixon Telegraph—Andrea Mills
(Galesburg) Register-Mail—Janet Klockenga
Moline Daily Dispatch—Shawn Leary
Peoria Journal-Star—Gary Panetta
(Rockford) Register-Star—Georgette Braun
(Springfield) State Journal-Register—Nick Rogers, Erin Orr
Watseka Times Republic—Carla Waters, Erin Rumbley

INDIANA

(Bedford) Times-Mail—Susan Hayes
Connersville News-Examiner—Connie Gribbins
Crawfordsville Journal-Review—Wade Coggeshall
Evansville Courier and Press—-Linda Negro & Roger McBain
Fort Wayne News Sentinel—Dave Frank & Ashley Smith
Gary Post-Tribune—Carolina Procter
Huntington Herald-Press—Cindy Klepper
Indianapolis News—Zach Dunkin
Indianapolis Star—Shelby Roby-Terry & Rita Rose
Muncie Star Press—Michelle Kinsey
Shelbyville News—Bill Walsh & Judy Sprengelmeyer
South Bend Tribune—Deanna Francis
(Spencer) Evening World—Tom Douglas
Washington Times-Herald—Brandy Melton

IOWA

(Burlington) Hawk Eye—Criss Roberts
Cedar Rapids Gazette—Joe Jennison
Des Moines Register—Amanda Pierre
(Iowa City) Daily Iowan—Beth Herzinger
Muscatine Journal—Jeff Tecklemburg
Newton Daily News—Pete Hussman
Oelwein Daily Register—Deb Conkel
Sioux City Journal—Bruce Miller & Tim Gallagher
Washington Evening Journal—Josh O'Leary
Waterloo Courier—Melody Parker

KANSAS

Concordia Blade-Empire—Sharon Coy
Hutchinson News—Joyce Hall
(Independence) Daily Report—Nobody in Position
Lawrence Journal World—Mindie Paget
(Liberal) Southwest Times—Larry Phillips
Newton Kansan—Wendy Nugent
Norton Daily Telegram—Carolyn Plotts
Pratt Tribune—Carol Bronson
Russell Daily News—Pam Sotaert
Salina Journal—Gary Demuth
Topeka Capital-Journal—Bill Blankenship
Wichita Eagle—Lori Linenberger & Bud Norman

KENTUCKY

(Ashland) Daily Independent—Lee Ward
(Covington) Kentucky Post—Jerry Stein & Wayne Perry
(Elizabethtown) News-Enterprise—Casey Ehmsen
(Hopkinsville) Kentucky New Era—Jennifer Shemwell
Lexington Herald-Leader—Todd Wethall
Louisville Courier-Journal—Greg Johnson
Paducah Sun—Leigh Landini
Winchester Sun—Betty Ratliff Smith

LOUISIANA

Alexandria Daily Town Talk—Cynthia Jordon
Bastrop Daily Enterprise—Dee Tubbs
Crowley Post-Signal—Crystal Istra
Hammond Daily Star—Heather Crain
Minden Press-Herald—Theresa Gardner
(New Orleans) Times Picayune—Douglas MacCash
Shreveport Times—Kathie Rowell
Slidell Sentry-News—Betsy Swenson

MAINE

Bangor Daily News—Kristen Andreson
(Lewiston) Sun-Journal—Ursula Albert
Portland Press Herald—Linda Fullerton, Bob Keyes

MARYLAND

(Annapolis) Capital—Kathy Flynn
Baltimore Sun—Glenn McNatt
Columbia Flier—John Harding
(Hagerstown) Herald-Mail—Jake Womer
Salisbury Daily Times—Brice Stump & Mary Bargion

MASSACHUSETTS

(Boston) Christian Science Monitor—Yvonne Zipp
Boston Globe—Ken Johnson
Boston Herald—Joanne Silver
Boston Phoenix—Christopher Millis
(Brockton) Enterprise—John Murphy
The Sun Chronicle—James Merolla

(East Boston) Post-Gazette—Pamela Donnaiuma
(Framingham) Metro West Daily News—Chris Bergeron
Haverhill Gazette—Marcia Stanley
Lowell Sun—Austin O'Connor & Nancye Tuttle
(North Andover) Eagle Tribune—Will Courtney & Rosemary Ford
(Pittsfield) Berkshire Eagle—Charles Bonenti
(Quincy) Patriot Ledger—Lisa McManus
The Republican—Marion Murphy
Taunton Daily Gazette—Claudia Simpson
Worcester Telegram & Gazette—Nancy Sheehan & Karen Webber

MICHIGAN

Alpena News—Diane Speer
Ann Arbor News—Bob Needham
Battle Creek Enquirer—Dana Carter
Bay City Times—Jaylene Jamison
(Benson Harbor-St Joseph) Herald-Palladium—San Dee Wallace
Big Rapids Pioneer—Lea Nixon
Detroit Free Press—Tina Croley
Detroit News—Joy Hakanson Colby
Flint Journal—Cookie Wascha
Grand Rapids Press—John Gonzalez
Jackson Citizen Patriot—Mary Barber
Kalamazoo Gazette—Margaret DeRitter
Lansing State Journal—Tim Makinen
Ludington Daily News—Sara Jensen
(Mount Clemens) Macomb Daily—Debbie Komar
Muskegon Chronicle—Jeff Alexander
(Pontiac) Oakland Press—Tracy Ward
Saginaw News—Janet Martineau

MINNESOTA

Austin Daily Herald—Matt Merritt
Duluth News Tribune & Herald—Connie Wirta
Minneapolis Star & Tribune—Kent Gardner & Mary Abbe
(Red Wing) Republican Eagle—Ruth Nerbaugen
(Rochester) Post-Bulletin—Janice McFarland
Saint Cloud Times—Linda Taylor
Saint Paul Pioneer Press—Heidi Raschke
(Wilmar) West Central Tribune—Donna Middleton
Worthington Daily Globe—Beth Rickers

MISSISSIPPI

(Biloxi) Sun Herald—Pam Firmin
(Greenville) Delta Democrat-Times—Keri Holt
(Jackson) Clarion-Ledger—Nobody in Position
(McComb) Enterprise-Journal—Vicky Conn
Meridian Star—Ida Brown
(Pascagoula) Mississippi Press—Lindsay O'Quin
(Tupelo) Northeast Mississippi Daily Journal—Scott Morris

MISSOURI

Independence Examiner—Bonnie Horner
Jefferson City News Tribune—Richard McGonegal
Kansas City Star—Alice Thorson
Neosha Daily News—Buzz Ball
Saint Joseph News-Press—Jess DeHaven
Saint Louis Post-Dispatch—Cliff Froehlich & David Bonetti
Springfield News-Leader—Elizabeth Klay
West Plains Daily Quill—Carol Bruce

MONTANA

Billings Gazette—Chris Rubich
(Butte) Montana Standard—Carmen Winslow
(Missoula) Missoulian—Sherry Jones & Joe Nickell

NEBRASKA

Kearny Hub—Carol Fettin
Lincoln Journal—Kent Wolgamott
McCook Daily Gazette—Connie Discoe
Omaha World-Herald—Ashley Hassebroek

NEVADA

(Carson City) Nevada Appeal—Kelli DuFresne
Las Vegas Review-Journal—Frank Fertado
Las Vegas Sun—John Katsilometes & Kristen Peterson
Reno Gazette-Journal—Forrest Hartman

NEW HAMPSHIRE

Manchester Union Leader—Julie Weeks

NEW JERSEY

Atlantic City Press—Alice Cranston
Bridgeton Evening News—Kay Rudderow
The (Bridgewater) Courier News—Paul Grzella
(Cherry Hill) Courier-Post—Tammy Paolino
The (Bergen) Record—John Zeaman
(Jersey City) Jersey Journal—Craig Garretson
(Morristown) Daily Record—Jim Bohen
(Neptune) Asbury Park Press—Kathy Dzielak
Newark Star Ledger—Linda Fowler; Dan Bischoff
(East Brunswick) Home News Tribune— Bill Canacci
(Passaic) North Jersey Herald & News—Mary Jane Fine
(Trenton) Trentonian—Judy Mauro
(Woodbury) Gloucester County Times—John Barna

NEW MEXICO

Albuquerque Journal—Rene Kimball
Albuquerque Tribune—Jennifer Barol
Carlsbad Cunrent-Argus—Leanda Staebner
Clovis News-Journal—David Stevens
(Farmington) Daily Times—Debra Mayeux
(Grants) Cibola County Beacon—Editorial Dept
Hobbs News-Sun—Marie Wadsworth
Roswell Daily Record—Melissa Heilgeman
(Santa Fe) New Mexican—Kristina Melcher

NEW YORK

Albany Times Union—Timothy Cahill
Art Times—Raymond J. Steiners
Batavia Daily News—Ben Beagle
(Binghamton) Press & Sun-Bulletin—Diane Bean
Buffalo News—Elizebeth Barr
Corning Leader—Jessica Ponden
(Herkimer) Evening Telegram—Donna Thompson
(Melville) Newsday—Judy Raya
Middletown Times Herald-Record—Germain Lussier
New York Daily News—Howard Kissel
New York Post—Faye Penn
New York Times—Ben Sisario; Michael Kimmelman
(New York) Wall Street Journal—Eric Gibson
(Nyack) Rockland Journal-News—Kathy McClusky
Poughkeepsie Journal—Ray Fashona
Rochester Democrat & Chronicle—Stuart Low
(Saratoga Springs) Saratogian—Jill Wing
Schenectady Gazette—Karen Bjornland
(Southold) Long Island Traveler/Watchman—Toni Robertson
Staten Island Advance—Michael Fressola
Syracuse Herald-Journal—Mary Fran Devendorf
Syracuse Post-Standard—Melinda Johnson
(Troy) Record—Doug DeLisle
(Yorktown Heights) North County News—Florence Hutton

NORTH CAROLINA

Asheville Citizen Times—Tony Kiss
Charlotte Observer—Nicole McGill
Durham Herald-Sun—Jim Wise & Cynthia Greenlee
Elizabeth City Daily Advance—Nobody in Position
Goldsboro News-Argus—Winkie Lee
Greensboro News & Record—Dawn Kane
Greenville Daily Reflector—Kelley Kirk-Swindell & Amy Royster
Hendersonville Times-News—Kitty Turner
(Lumberton) Robesonian—Michael Jaenicke
(Raleigh) News & Observer—Suzanne Brown
Shelby Star—Jackie Bridges
Washington Daily News—Jonathon Clayborne
Wilmington Star-News—Amanda Greene & Amber Nimocks
Wilson Daily Times—Lisa Boykin Batts

NORTH DAKOTA

Bismarck Tribune—Tony Spilde
Dickinson Press—Linda Sailer
Fargo Forum—Tammy Swift
Minot Daily News—Ceecy Nucker

OHIO

Akron Beacon Journal—Kathy Fraze
Athens Messenger—Sara Fillpiak
Canton Repository—Dan Kane
Cincinnati Enquirer—Gil Kaufman
Cincinnati Post—Rick Bird, Wayne Perry & Jerry Stein
Cleveland Plain Dealer—Elizabeth McIntyre
Columbus Dispatch—Michele Toney, Bill Mayr & Barbara Zuck
Dayton Daily News & Journal Herald—Jana Collier
(Mansfield) News-Journal—Nobody in Position
Portsmouth Daily Times—Editorial Staff
Sandusky Register—Beth Naser
Sidney Daily News—Michell Perry
Toledo Blade—Tahree Lane
(Willoughby) News Herald—Jim Murphy
(Youngstown) Vindicator—Mike McGowan

OKLAHOMA

Blackwell Journal-Tribune—Helene Seubert
Claremore Progress—Rebecca Hattaway
Elk City Daily News—Cheryl Overstreet
Lawton Constitution—Charles Clark
Muskogee Daily Phoenix & Times-Democrat—Leilani Ott
(Oklahoma City) Daily Oklahoman—Bryan Painter
Pryor Daily Times—Clarice Doyle
Seminole Producer—Karen Anson
Tulsa World—Debbie Jackson & Cathy Logan

OREGON

(Coos Bay) World—Nancy Luzovich
(Eugene) Register-Guard—Bob Keefer & Margaret Haberman
(Grants Pass) Daily Courier—Edith Decker
(Medford) Mail Tribune—Bill Varble
(Ontario) Argus Observer—Christen McCurdy
(Portland) Oregonian—Nathan Skidmore & Rosemarie Stein
(Salem) Statesman-Journal—Michelle Maxwell

PENNSYLVANIA

Allentown Morning Call—Jodi Duckett & Geoff Gehman
Bradford Era—Marti Wilder
(Doylestown) Intelligencer—Stacy Briggs
(DuBois) Courier-Express—Barbara Azzato
Greensburg Tribune-Review—Phyllis Pack

(Harrisburg) Patriot-News—Arti Subramaniam
(Huntingdon) Daily News—Polly McMullin
Johnstown Tribune Democrat—Renee Carthew
(Lancaster) Sunday News—J.M. Ruth
(Levittown) Bucks County Courier Times—Tom Haines
(Lewistown) Sentinel—Suzi Kozar
(Lock Haven) Express—Wendy Stiver
(New Kensington-Tarentum) Valley News-Dispatch—Rebecca Killians
Philadelphia Daily News—Herb Denenberg
Philadelphia Inquirer—Edward J. Sozanski
Philadelphia New Observer—Yanina Carter
Pittsburgh Post-Gazette—Marylynne Pitz
Reading Eagle—Christine Burger
Scranton Times—Faith Golay
(Towanda) Daily Review—Brian Schlosser
(Wilkes-Barre) Times Leader—Mary Therese Biebel

RHODE ISLAND

Providence Journal-Bulletin—Phil Kukielski
(South Kingstown) Narragansett Times—Matt Wunsch

SOUTH CAROLINA

Aiken Standard—Jeremy Schoolfield
Anderson Independent-Mail—Leah Daniels
Beaufort Gazette—Debbie Radford
Charleston Post & Courier—Dottie Ashley
Columbia Black News—Jack Humphrey
(Columbia) State—Mark Layman
Florence Morning News—Justin Bailey
Greenville News—Ann Hicks
Myrtle Beach Sun News—Kent Kimes
Orangeburg Times & Democrat—Nancy Wooten
(Spartanburg) Herald-Journal—Jose Franco

SOUTH DAKOTA

(Mitchell) Republic—Kim Galliano
(Sioux Falls) Argus Leader—Robert Morast

TENNESSEE

Chattanooga Times-Free Press—Mark Kennedy
(Clarksville) Leaf Chronicle—Maria McClure
(Columbia) Daily Herald—Marvine Sugg
Elizabethton Starr—Rozella Hardin & Jennifer Lassiter
Jackson Sun—Brian Goins & Jacque Hillman
Johnson City Press—Keisha Bratton
Kingsport Times-News—Becky Whitlock
Knoxville News-Sentinel—Bobbie Wilson & Susan Alexander
Lebanon Democrat—Sherry Phillips
(Memphis) Commercial Appeal—Peggy Burch
(Morristown) Citizen Tribune—Diane Barnes
(Murfreesboro) Daily News Journal—Sandy Suitt
Nashville Banner—Sandy Smith
Nashville Tennessean—Alan Bostick
(Oak Ridge) Oak Ridger—Ben Greene

TEXAS

Abilene Reporter-News—Brien Murphy
Amarillo Global News—Chip Chandler
Austin American-Statesman—Jeff Salamon
Beaumont Enterprise—Brent Snyder
(Corpus Christi) Caller-Times—James Simmons
Dallas Morning News—Janet Kutner
Fort Worth Star-Telegram—Gaile Robinson
Houston Chronicle—Lindsay Heinsen & Patricia Johnson
(Lubbock) Avalanche Journal—Bill Kerns & Shelly Funsch

Midland Reporter-Telegram—Georgia Temple
(Nacogdoches) Daily Sentinel—Judy Morgan
Odessa American—Jennifer Edwards
Orange Leader—Gary Perilloux
Pecos Enterprise—Rosie Flores
Plainview Daily Herald—Nicki Logan
Port Arthur News—Darragh Doiron
San Antonio Express-News—Dan Goddard & Jim Kiest
(Tyler) Morning Telegraph—Jon Perry
Waco Tribune Herald—Carl Hoover
Waxahachie Daily Light—Amy Davis
Wichita Falls Times Record News—Bridget Knight

UTAH

Logan Herald Journal—Cindy Yurth
Ogden Standard-Examiner—Vanessa Zimmer
Provo Daily Herald—Elyssa Andrus
(Salt Lake City) Deseret News—Dave Gagon
Salt Lake Tribune—Anne Wilson

VERMONT

Burlington Free Press—Rebecca Holt

VIRGINIA

(Arlington) USA Today—Kim Willis
Bristol Herald Courier—Jan Patrick
(Charlottesville) Daily Progress—Mary Alice Blackwell
Northern Virginian Journal—Brian Truitt
Fairfax Journal—Mary Ellen Webb
(Fredericksburg) Free Lance-Star—Laura Moyer & Amy Flowers Umble
Hopewell News—Adrian Fredenberg
(Lynchburg) News & Advance—Jesse Thompson
Newport News Daily Press—Mark St. John Erickson
(Norfolk) Virginian-Pilot—Robert Borof
Richmond Times-Dispatch—Robert Walsh
Roanoke Times & World News—Tonia Moxley
(Waynesboro) News-Virginian—Courtney Hucklebee

WASHINGTON

(Aberdeen) Daily World—Jeff Burlingame
Ellensburg Daily Record—Sharla Sikes
(Everett) Herald—Mike Murray & Kathleen Tussing
(Moses Lake) Columbia Basin Herald—Carin Powell
Seattle Times—Doug Kim & Sheila Farr
Spokane Spokesman-Review—Rick Bonino
Tacoma News Tribune—Jennifer Graves
(Vancouver) Columbian—Barbara Samuels
Wenatchee World—Jefferson Robbins

WEST VIRGINIA

Bluefield Daily Telegraph—Kathy Kish
Charleston Daily Mail—Monica Orosz
Charleston Gazette—Doug Imbrogno
Huntington Herald-Dispatch—Andrea Copley
(Martinsburg) Journal—Peggy Swisher & Crystal Schelle
(Wheeling) News-Register—Lynda Comins

WISCONSIN

(Appleton) Post-Crescent—Ed Berthiaume
(Eau Claire) Leader-Telegram—Ann Barsness
Green Bay Press-Gazette—Warren Gerds

Kenosha News—Elizabeth Snyder
(Madison) Capital Times—Kevin Lynch
(Madison) Wisconsin State Journal—Amanda Henry
Milwaukee Journal & Sentinel—James Auer
(Racine) Journal Times—Sirena Mankins
Wausau Daily Herald—Amy Kimmes & David Paulsen

WYOMING

(Casper) Star-Tribune—Clay Anthony
(Cheyenne) Wyoming Tribune Eagle—C. J. Putname
Riverton Ranger—Steven Peck

PUERTO RICO

(San Juan) El Nuevo Dia—Iris Landron
(San Juan) El Vocero de Puerto Rico—German Martin-Negroni

CANADA

ALBERTA

Calgary Herald—Lisa Monforton
Calgary Sun—Kevin Franchuck
Edmonton Journal—Shawn Ohler
Edmonton Sun—Neal Watson

BRITISH COLUMBIA

Vancouver Province—Jonathan McDonald
Vancouver Sun—Michael Scott
Victoria Times-Colonist—Gavin Fletcher

MANITOBA

Winnipeg Free Press—Margo Goodhand & Boris Hrybinsky

NOVA SCOTIA

Halifax Chronicle Herald—Margaret McKay & Elissa Barnard

ONTARIO

Hamilton Spectator—Tom Hogue
(Kitchener) Waterloo Record—Robert Reid & Phil Bast
London Free Press—Barbara Taylor
Ottawa Citizen—Peter Simpson
Toronto Globe & Mail—Kate Taylor; Sarah Milroy
Toronto Star—Linwood Barclay
Windsor Star—Ted Shaw

QUEBEC

Montreal Gazette—Lucinda Chodan
(Montreal) La Presse Ltee—Jerome Delgato
(Montreal) Le Journal de Montreal—Suzanne Colpron
(Quebec) Le Journal de Quebec—Serge St-Hilaire
(Quebec) Le Soleil—Magelle Soucy

SASKATCHEWAN

Regina Leader-Post—Andy Cooper
(Saskatoon) Star Phoenix—Pat Macsymic

Abilene Christian University Dept. of Art Don H. Morris Center Rm 142 Abilene, TX 79699-7987. **Amount:** $500-$1,000 **Open to:** All art majors **Duration:** One year **When offered:** Annually

Academy of Motion Picture Arts and Sciences *Nicholl Fellowships in Screenwriting*, 1313 N. Vine St. Hollywood, CA 90228 Tel: 310-247-3000; Fax: 310-247-3610; E-mail: gallery@oscars.org; Website: www.oscars.org/Nicholl. **Amount:** $30,000 **Duration:** One year **When offered:** Annually; visit website for submission requirements

Adams State College 208 Edgemont Blvd. Alamosa, CO 81101 Tel: 719-587-7823; Fax: 719-587-7330; E-mail: ascart@adams.edu; Website: www.art.adams.edu. **Amount:** $1,000-$2,000 **Open to:** Undergraduate & graduate full time art students **Duration:** One year **When offered:** Annually

ADC National Scholarships 106 W. 29th St. New York, NY 10001 Tel: 212-643-1440; Fax: 212-643-4266; E-mail: kate@adcglobal.org. **Amount:** Varies **Open to:** Students **Duration:** One Year **When offered:** Annually

Adelphi University P.O. Box 701 Garden City, NY 11530-0701. **Amount:** $2,000-$5,000 **Open to:** All **Duration:** Four years **When offered:** Annually

Alabama State University Dept. of Visual & Theatre Arts 915 S. Jackson St. Montgomery, AL 36101. **Amount:** $500 **Open to:** Art & theatre majors **Duration:** One year **When offered:** Annually

Albion College 611 E. Porter St. Albion, MI 49224 Tel: 517-629-0249; Fax: 517-629-0752; E-mail: lchytilo@albion.edu. **Amount:** up to $10,000 **Open to:** Incoming students **Duration:** Eight semesters **When offered:** Annually

Albright College Dept. of Art 13th & Bern Sts. P.O. Box 15234 Reading, PA 19612-5234 **Amount:** Varies **Open to:** First year students **Duration:** Renewable each year **When offered:** Annually

Alice Curtis Desmond & Hamilton Fish Library Routes 9D & 403, P.O. Box 265 Garrison, NY 10524. **Amount:** Varies **Duration:** Varies **When offered:** Annually

Allan Hancock College Fine Arts Dept. 800 S. College Dr. Dept F. Santa Maria, CA 93454. **Amount:** $100-$500 **Open to:** Enrolled students **Duration:** One year **When offered:** Annually

Allegheny College *Art Dept.*, 520 N. Main St. Meadville, PA 16335. **Amount:** Varies **Open to:** All matriculated students **Duration:** One year **When offered:** Annually

The Alliance for Young Artists & Writers, The Scholastic Art & Writing Awards 557 Broadway New York, NY 10012 Website: www.artandwriting.org Or www.scholastic.com/artandwritingawards. **Amount:** Varies - scholarship nominations to participating colleges & art institutions **Open to:** Students graduating high school who submit outstanding portfolios of art and/or photography **Duration:** Varies **When offered:** Annually

Alma College, Dept. of Art & Design 614 W. Superior St. Alma, MI 48877. **Amount:** $500-$10,000 **Open to:** Entering art students **Duration:** May be renewable for four years **When offered:** Annually

American Academy of Art 332 S. Michigan Ave. Chicago, IL 60604-4302. **Open to:** High school seniors **Duration:** Varies **When offered:** Annually

American Antiquarian Society *Fellowships*, 185 Salisbury St. Worcester, MA 01609-1634 Tel: 508-755-5221; Fax: 508-753-3311; E-mail: csloat@mwa.org. **Amount:** $1,000/month **Open to:** Scholars, Visual artists **Duration:** 1-12 months **When offered:** Annually

American Artists Fund (Sub of American Artists Professional League, Inc) Sonja Weir, Pres. 47 Fifth Ave. New York, NY 10003. **Amount:** $1,000 **Open to:** American Art students at accredited institutions; must be 17 years of age or older, must demonstrate student's competence & understanding of the fundamentals of drawing and painting and/or three-dimensional design in a representational and preferably realistic manner; should have projected concentration in specialized area of painting, drawing, sculpture or printmaking; must have demonstrated financial need **Duration:** One year **When offered:** Annually

American Artists Professional League, Inc. 47 Fifth Ave. New York, NY 10033. **Amount:** $1,000 **Open to:** Students of accredited art schools **When offered:** Annually

American Film Institute Conservatory 2021 N. Western Ave. Los Angeles, CA 90027. **Amount:** Varies **Open to:** All **Duration:** One year **When offered:** Annually

American Institute of Architects 1735 New York Ave., N.W. Washington, DC 20006-5292. **Open to:** AIA membership **Duration: When offered:** Annually

American Numismatic Society 96 Fulton St. New York, NY 10038. **Amount:** $4,000 stipend in support of summer study **Open to:** Students who have completed one year graduate study in classics, archeology, history, art history, economics & related fields and to junior faculty members with an advanced desire in one these fields **Duration:** Summer **When offered:** Application deadline Feb 15 **Amount:** $5,000 Frances M. Fellowship **Open to:** Individuals who have completed the BA or equivalent **Duration:** Academic Year

American Scandinavian Foundation 58 Park Ave. New York, NY 10021 Tel: 212-879-9779; Website: www.amscan.org. **Amount:** Varies **Open to:** Varies **Duration:** Varies **When offered:** Annually

American University, Dept. of Art 4400 Massachusetts Ave., N.W. Washington, DC 20016. **Amount:** Up to full tuition **Open to:** Full-time BA, BFA & MFA students **Duration:** One year; renewable **When offered:** Annually

American Watercolor Society 47 Fifth Ave. New York, NY 10003. **Amount:** $1,000 **Open to:** Teachers of Water Color **When offered:** Annually

Anderson Ranch Arts Center P.O. Box 5598, 5263 Owl Creek Rd. Snowmass Village, CO 81615. **Amount:** Varies **Open to:** Emerging or nationally acclaimed artists; anyone based on merit & need **Duration:** One week-six months **When offered:** Annually

Appaloosa Museum *Fellowships*, 2720 W. Pullman Rd. Moscow, ID 83843 Tel: 208-882-5578, x 279; Fax: 208-882-8150; E-mail: museum@appaloosa.com. **Amount:** $500.00 **Open to:** University of Idaho and Washington State University students **Duration:** Semester **When offered:** Semi-annually

Aquinas College, Art Dept. 1607 Robinson Rd., S.E. Grand Rapids, MI 49506-1799 Tel: 616-459-8281, ext. 2413; Fax: 616-459-2563; E-mail: zimmekat@aquinas.edu; Website: www.aquinas.edu. **Open to:** Sophomores, juniors & seniors **When offered:** Annually

Arc Gallery 734 N. Milwaukee Ave. Chicago, IL 60622. **Open to:** Female art student pursuing BFA or MFA for membership & exhibition **Duration:** One year **When offered:** Annually

Archaeological Institute of America *Helen M. Woodruff Fellowship of the Aia & the American Academy in Rome,* 656 Beacon St. Boston, MA 02215-2010. **Open to:** Citizens or permanent residents of the United States

Olivia James Traveling Fellowship **Amount:** $22,000 **Open to:** For study of classics, sculpture, architecture, archaeology or history in Greece, the Aegean Islands, Sicily, Southern Italy, Asia Minor or Mesopotamia **Duration:** One year

The Archaeology of Portugal Fellowship **Amount:** $4,000 (award may vary) **Open to:** Portuguese, American and other international scholars

Publications Grant **Amount:** $5,000 **Open to:** Graduate students and postdoctoral professionals **Duration:** Distributed over the course of two years in annual installments of $2,500 **When offered:** Annually

Anna C. & Oliver C. Colburn Fellowship **Amount:** Stipend of $11,000 (awarded for the academic year 2006-2007) **Open to:** Applicant contingent upon his or her acceptance as an incoming Associate Member or Student Associate Member of the American School of Classical Studies at Athens **Duration:** One year

Harriet & Leon Pomerance Fellowship **Amount:** Stipend of $4,000 (awarded for the academic year 2005-2006) **Open to:** Person working on an individual project of a scholarly nature related to Aegean Bronze Age Archaeology. Preference will be given to candidates whose project requires travel to the Mediterranean **Duration:** One year

Architectural League of New York *The Urban Center*, 457 Madison Ave. New York, NY 10022. **Amount:** Up to $5,000 **Open to:** Recent graduates & students of architecture, architectural history & urbanism **When offered:** Annually

Arizona Artists Guild 8912 N. Fourth St. Phoenix, AZ 85020 Tel: 602-944-9713. **Amount:** $10,000 **Open to:** Undergraduates & graduates; fine arts public & private colleges & universities **Duration:** One year **When offered:** Annually

Arizona Commission on the Arts 417 W. Roosevelt St. Phoenix, AZ 85003. **Amount:** $500-$7,500 **Open to:** Residents of Arizona, over 18, students are not eligible **Duration:** One year **When offered:** Annually **Amount:** Performing Arts Fellowship; Writers Fellowship; Visual Arts Fellowship **Open to:** Same as above **Duration:** One year **When offered:** Annually

Arizona State University *Herberger College of Fine Arts*, P.O. Box 871505 Tempe, AZ 85287-1505 Website: http://art.asu.edu/scholarships/index.htm. **Duration:** One year **When offered:** Annually

The Arkansas Art Center Museum School P.O. Box 2137 Little Rock, AR 72203-2137. **Amount:** $75 & up **Open to:** Children & adults **Duration:** Per quarter **When offered:** Quarterly

Arkansas State University *Dept. of Art*, P.O. Box 1920 State University, AR 72467-1920. **Amount:** $100-$800 range, full or partial tuition grants up to four each semester **Open to:** Entering

& current undergraduates **Duration:** One-eight semesters **When offered:** Reviewed each semester

Armstrong Browning Library, Baylor University *Baylor Univerity*, P.O. Box 97152 Waco, TX 76798-7152 Tel: 254-710-3566; Fax: 254-710-3552. **Amount:** $1500 per month **Open to:** Scholars & doctoral students researching Robert or Elizabeth Barrett Browning or the literature of the Victorian period **Duration:** One-two months **When offered:** Annually

Arnold Mikelson Mind and Matter Gallery *Arnold Mikelson Scholarship*, 13743-16 Ave. White Rock, BC V4A 1P7 Canada. **Amount:** $500 **Open to:** all students **Duration:** 5 years **When offered:** Annually

Arrowmont School of Arts & Crafts 556 Pkwy. Gatlinburg, TN 37738 Tel: 865-436-5860; Fax: 865-430-4101; E-mail: info@arrowmont.org. **Amount:** $200-$400 **Open to:** Eighteen plus **Duration:** One or two week classes **When offered:** Spring, Summer, Fall

Art Academy of Cincinnati 1125 Saint Gregory St. Cincinnati, OH 45202. **Amount:** $1,000-$15,000 **Open to:** All entering, degree-seeking students to the Art Academy of Cincinnati **Duration:** Renewable **When offered:** Annually

Art and Culture Center of Hollywood 1650 Harrison St. Hollywood, FL 33020 Tel: 954-921-3274; Fax: 954-921-3273; E-mail: info@artandculturecenter.org. **Amount:** Varies **Open to:** Qualified spring & summer applicants **Duration:** Various time periods **When offered:** Various time periods

Art Center College of Design 1700 Lida St. Pasadena, CA 91109 Website: www.artcenter.edu. **Amount:** Varies **Open to:** All students **Duration:** One or two semesters at a time **When offered:** Every semester

Art Center Sarasota 707 N. Tamiami Trail Sarasota, FL 34236 Tel: 941-365-2032; Fax: 941-366-0585; E-mail: visualartcenter@aol.com; Website: www.artsarasota.org. **Amount:** $125-$325 **Open to:** All **When offered:** Seasonally **Amount:** Varies **Open to:** Children and adults **Duration:** Six week sessions & master workshops **When offered:** Oct-July

Art Dealers Association of Canada ADAC *Art Foundation Scholarships*, 111 Peter St., Ste. 501 Toronto, ON M5V 2H1 Canada Tel: 416-934-1583; Fax: 416-967-6320; E-mail: info@ad-ac.ca. **Amount:** $1,000 **Open to:** Selected Canadian University Students (1 per year; different universities) **Duration:** One year **When offered:** Annually

Art Department *Boise State University*, 1910 University Dr. Boise, ID 83725-1510. **Amount:** Varies **Open to:** All art majors **Duration:** One year **When offered:** Annually, apply by Feb. 15

Art Forms Gallery Manayunk 106 Levering St. Philadelphia, PA 19127 Tel: 215-483-3030; Fax: 215-483-8308; E-mail: artformsgallery@mac.com. **Amount:** Annual dues **Open to:** Participant in emerging artists exhibition. **Duration:** One year **When offered:** Annually

Art Guild of Burlington *Len Everett Scholarship*, Box 5 Burlington, IA 52601 Tel: 319-754-8069; Fax: 319-754-4731; E-mail: arts4living@aol.com. **Amount:** $2,000 (Varies) **Open to:** Art majors attending University of Iowa (one hundred mile radius of Burlington) **Duration:** One year **When offered:** Annually

Art Guild of Burlington Arts for Living Center Seventh & Washington Sts. *Len Everett Scholarship*, P.O. Box Five Burlington, IA 52601. **Amount:** $1,000-$2,000 **Open to:** University of Iowa students **Duration:** One year **When offered:** Annually, Portfolio review in March for Fall semester

Art Institute of Boston at Lesley University 700 Beacon St. Boston, MA 02215. **Amount:** Dupont Fellowship $15,000 **Open to:** Minority photographers **Duration:** One semester

Art Institute of Colorado 1200 Lincoln St. Denver, CO 80203-2172. **Amount:** Varies **Open to:** High school seniors **When offered:** Annually

Art Institute of Dallas Two Northpark East, 8080 Park Lane, Ste. 100 Dallas, TX 75231-5993. **Amount:** 1/2 tuition only in each major **Open to:** High school seniors **Duration:** 18-24 months **When offered:** Annually **Amount:** Full tuition only **Open to:** High school seniors with best overall portfolio **Duration:** 18-24 months **When offered:** Annually

Art Institute of Philadelphia 1622 Chestnut St. Philadelphia, PA 19103-5198. **Amount:** Varies **Open to:** Eligible students **Duration:** One year **When offered:** Annually

Art Institute of Pittsburgh *The Evelyn Keedy Memorial Scholarship*, 420 Boulervard of the Allies Pittsburgh, PA 15219 Tel: 1-800-275-2470. **Open to:** High school students **Duration:** Two years. (six quarters) For more Information call 1-800-275-2470 **When offered:** Annually

The Art Institute of Pittsburgh John T. Barclay Memorial Scholarship **Open to:** Enrolled full-time students who are in their second through fifth quarter **Duration:** First place award: $10,000; second place award: $5,000; third place award: $2,000. **When offered:** Annually

The Art Instututes International Merit Award **Open to:** New and continuing students enrolled at the Art Institute of Pittsburgh, based on academic merit & need **Duration:** Varies. For more Information call 1-800-275-2470 **When offered:** Annually

Art Institutes International 1122 N.W. Davis St Portland, OR 97209. **Amount:** $75,000 (The total represents the combined

amounts for one first & second year student) **Open to:** AIPD College students **Duration:** One financial aid year **When offered:** Quarterly

Art Museum of Greater Lafayette 102 S Tenth St. Lafayette, IN 47905. **Amount:** Full or partial tuition **Open to:** Citizens of Indiana **Duration:** Per term **When offered:** Semi-annually

Art Students League of New York 215 W. 57 St. New York, NY 10019. **Amount:** Varies **Open to:** Art students **Duration:** One year **When offered:** Annually

Artexte Information & Documentation Centre 460 Sainte Catherine Quest, Rm. 508 Montreal, PQ H3b 1A7. **Amount:** Variable **Open to:** Contemporary art educator, art critic, art scholar **Duration:** Variable **When offered:** Annually

Artists Space 38 Greene St. 3rd Fl. New York, NY 10013 Tel: 212-226-3970; Website: www.artistsspace.org. **Amount:** Up to $500 **Open to:** Artists living & working in the five boroughs of New York City. Please visit website for guidelines and application form. **Duration:** One-time grant **When offered:** Three times a year

Arts & Crafts Association of Meriden, Inc. 53 Colony St., P.O. Box 348 Meriden, CT 06451 Tel: 203-235-5347; Fax: 203-886-0015. **Amount:** Varies **Open to:** One high school graduate of Meriden, CT pursuing higher education in arts **Duration:** One year **When offered:** Annually

Arts Council of The Blue Ridge 20 Church Ave., S.E. Roanoke, VA 24011 Tel: 540-342-5790; Fax: 540-342-5720; E-mail: info@theartscouncil.org. **Amount:** $100-$500 **Open to:** High school students **Duration:** One year **When offered:** Annually **Amount:** Laban Johnson Arts Scholarship, amount $50-$250 **Open to:** High schoool students in the Blue Ridge region to pursue visual, performing or literary arts experiences **Duration:** One year **When offered:** Annually

Arts Extension Service Div of CE UMASS-100 Venture Way Ste. 201 Hadley, MA 01035 Tel: 413-545-2360; Fax: 413-577-3838; E-mail: aes@contined.umass.edu. **Amount:** $300 **Open to:** College students & emerging leaders who are employed or volunteer at non-profit arts orgs, or are enrolled in arts , arts management or arts related progs at accredited institutions **When offered:** Annually

The Arts Partnership of Greater Spartanburg *Mary Wheeler Davis Scholarship*, 385 S. Spring St. Spartanburg, SC 29306 Tel: 864-542-2787; Fax: 864-948-5353. **Amount:** $1,000 **Open to:** Spartanburg County students seeking career in performing or visual arts **Duration:** One year **When offered:** Annually

Arts United for Davidson County 220 S. Main St. Lexington, NC 27292. **Amount:** $1,000 **Open to:** Davidson Co. HS Seniors to major in the arts or college students already majoring in the arts **Duration:** One year **When offered:** Annually

Artworks 19 Everett Alley Trenton, NJ 08611. **Amount:** $50-$200 **Open to:** Students enrolled in Artworks classes **Duration:** One year **When offered:** Biannually

Asbury College Art Dept., Fine Arts Bldg. One Macklem Dr. Wilmore, KY 40390 Tel: 859-858-4348; E-mail: rudymedlock@asburycollege.com. **Amount:** (8) $500 **Open to:** All students **Duration:** One year **When offered:** Annually

Ashland University *Dept. of Art*, 401 College Ave. Ashland, OH 44805. **Amount:** $2,500 **Open to:** Entering freshmen & transfers **Duration:** One year; renewable **When offered:** Annually

Asia Society 725 Park Ave. New York, NY 10021 Tel: 212-288-6400; Fax: 212-517-8315; E-mail: info@asiasoc.org. **Amount:** $30,000 **Open to:** PhDs in Art **Duration:** One Year **When offered:** Annually

The Athenaeum of Philadelphia *Charles E. Peterson Fellowship*, 219 S. 6th St. Philadelphia, PA 19106-3794 Tel: 215-925-2688; Fax: 215-925-3755; E-mail: athena@philaathenaeum.org. **Amount:** Up to $30,000; usually $5,000 **Open to:** Senior scholars **Duration:** One year **When offered:** Annually

Atlanta College of Art 1280 Peachtree St., N.E. Atlanta, GA 30309. **Amount:** $1,625 - Full tuition **Open to:** Prospective students **Duration:** Four years **When offered:** Annually

Auburn University Montgomery Dept. of Fine Arts P.O. Box 2444023 Montgomery, AL 36124-4023. **Amount:** Full tuition **Open to:** Incoming freshmen **Duration:** One year **When offered:** Annually

Augusta State University Dept. of Fine Arts 2500 Walton Way Augusta, GA 30904-2200 Tel: 706-737-1453; Fax: 706-667-4937. **Amount:** $3,000 **Open to:** Art majors **Duration:** One year **When offered:** Annually **Amount:** Varies **Open to:** Freshmen, sophomores & juniors **Duration:** One year **When offered:** Annually

Augustana College 2001 S. Summit Ave. Sioux Falls, SD 57197. **Amount:** Varies; several thousand in scholarships available **Open to:** Deserving sophomore & junior students

Augustana College Art Dept. 639 38th St. Rock Island, IL 61201-2296. **Amount:** $1,000-$2,000 **Open to:** Incoming students **Duration:** One year; renewable **When offered:** Annually

Austin College Art Dept. 900 N. Grand Ave. Sherman, TX 75090-4400 Tel: 903-813-2188; E-mail: ttracz@austincollege.edu. **Amount:** $1,000-$3,000 **Open to:** Incoming freshmen **Duration:** One year **When offered:** Annually **Amount:** Up to $1,000 **Open to:** Continuing students **Duration:** Reviewed annually

Austin Museum of Art 823 Congress Ave. Austin, TX 78701. **Amount:** Varies **Open to:** Art school students; both adults & young people **Duration:** Semester **When offered:** Each semester

Austin Peay State University Dept. of Art, 601 College St. Clarksville, TN 37044. **Amount:** $500-$1,000 **Open to:** Current full-time undergraduates **Duration:** One year **When offered:** Annually

Avila College, Art Division 11901 Wornall Rd. Kansas City, MO 64145. **Amount:** $2,000 **Open to:** Art majors **Duration:** One year; renewable **When offered:** Annually

Bakersfield Art Foundation 1930 R St., Bakersfield, CA 93301. **Amount:** $500 **Open to:** All art students

Ball State University 2000 W. University Ave. Muncie, IN 47306. **Amount:** $5,000 graduate assistantship academic year (tuition waived) **Open to:** Masters level art students **Duration:** One year **When offered:** Annually **Amount:** Varies **Open to:** Freshmen-seniors **Duration:** One year **When offered:** Annually

Baltimore Watercolor Society 713 Stoney Spring Dr. Baltimore, MD 21210. **Amount:** $100 **Open to:** High school student in the Baltimore area **Duration:** One year **When offered:** Annually

The Banff Centre Office of the Registrar, 107 Tunnel Mtn. Dr., Box 1020 Banff, AB TIL 1H5 Canada Tel: 403-762-6180; Fax: 403-762-6345. **Amount:** Contact sponsor **Open to:** Accepted applicants of applicable Banff Centre programs **Duration:** Length of program (residency) accepted into **When offered:** On acceptance

Bard College, Center for Curatorial Studies P.O. Box 5000 Annandale-on-Hudson, NY 12504-5000 Tel: 845-758-7598; Fax: 845-758-2442; E-mail: ccs@bard.edu. **Amount:** Varies **Open to:** Students demonstrating financial need **Duration:** One year **When offered:** Annually

Barnsdall Art Center & Junior Arts Center 4814 Hollywood Blvd. Los Angeles, CA 90027 Tel: 323-644-6275; Fax: 323-644-6277; E-mail: jacbac@sbcglobal.net. **Open to:** Children & adults **Duration:** Four classes **When offered:** Quarterly

Barton College ACC Drive, Box 5000 Wilson, NC 27893 Tel: 252-399-6300; Fax: 252-399-6571. **Open to:** Students **Duration:** One year **When offered:** Annually

Barton College Art Dept. Art Dept. Box 5000 Wilson, NC 27893. **Amount:** $1,000 Triangle East Advertising/marketing **Open to:** Juniors & seniors **Duration:** One year **Amount:** $700 Bessie Massengill Scholarship **Open to:** Juniors & seniors **Duration:** One year **Amount:** Varies **Open to:** All art majors **Duration:** Determined by Art Faculty

Barton County Community College Fine Arts Department, 245 NE 30th Rd. Great Bend, KS 67530. **Amount:** $300-$400 **Open to:** All qualified students majoring in art **Duration:** One year **When offered:** Annually

Battleship North Carolina P.O. Box 480 Wilmington, NC 28402-0480. **Amount:** $3,000 **Open to:** Graduate or undergraduate history major, with interest in the museum profession **Duration:** Ten weeks, summer **When offered:** Annually

Baylor University Dept. of Art Waco, TX 76798. **Amount:** Varies **Duration:** One year **When offered:** Annually

Beinecke Rare Book & Manuscript Library P.O. Box 208240 New Haven, CT 06520-8240 Tel: 203-432-2977; Fax: 203-432-4047; E-mail: beinecke.fellowships@yale.edu. **Amount:** $3,800, plus travel expenses **Open to:** Scholars engaged in postdoctoral research at the Beinecke Library **Duration:** Sept.-May **When offered:** Annually; Application deadline, Dec. 15, 2006

Belhaven College 1500 Peachtree St. Jackson, MS 39202. **Amount:** Varies **Open to:** Art majors & minors **Duration:** One year **When offered:** Annually

Bemidji State University 1500 Birchmont Dr. Bemidji, MN 56601. **Amount:** Varies **Open to:** Incoming freshmen **When offered:** Annually

Bemis Center for Contemporary Arts 724 S. 12th St. Omaha, NE 68102 Website: www.bemiscenter.org. **Amount:** $500-$1,000 per month **Open to:** Professional artists **Duration:** Two-six months **When offered:** Annually

Amount: $750 monthly stipends **Open to:** Applicants who are accepted for residency program (applications process & jurying, please send SASE) **Duration:** Two-Four months **When offered:** Semi-annually

Bennington Museum 75 Main St. Bennington, VT 05201 Tel: 802-447-1571; Fax: 802-442-5305; E-mail: sperkins@benningtonmuseum.org. **Amount:** Varies **Open to:** Graduate students **Duration:** Six months **When offered:** Annually

Berkshire Artisans 28 Renne Ave. Pittsfield, MA 01201 Tel: 413-499-9348; Website: www.berkshireweb.com/artisans. **Amount:** $500 **Open to:** Massachusetts high school students only **Duration:** One year **When offered:** Semi-annually

Amount: (2) $1000 **Open to:** Massachusetts college students only

Amount: (3) $500 to art students only **Open to:** College students from Berkshire county, Mass. Who go to school outside Berkshire county and students living outside Berkshire county who go to school in Berkshire county **When offered:** May of each year

Berry College 2277 Martha Berry Hwy, NW Mt. Berry, GA 30149 Tel: 706-236-2219; Fax: 706-238-7835; E-mail: tmew@berry.edu. **Amount:** $2,000-$8,000 **Open to:** Qualified applicants **Duration:** One year **When offered:** Annually

Bethany College 421 N. First St. Lindsborg, KS 67456-1897 Tel: 785-227-3311; E-mail: kahler@bethanylb.edu. **Amount:** $3,000-$4,000 Art Performance awards **Open to:** Persons who submit art portfolios-GPA 2.5 or ACT 19 or top half of the graduating class **Duration:** Renewable with 2.5 GPA **When offered:** Upon review of portfolio anytime

Bethel College Dept. of Art 300 E. 27th St. North Newton, KS 67117. **Amount:** (16) $1,000 **Open to:** Freshmen-seniors **Duration:** One year; renewable **When offered:** Annually

Binghamton University, SUNY Department of Art History, P.O. Box 6000 Binghamton, NY 13901-6000. **Amount:** Varies **Open to:** Art history graduate students only; with additional fellowships open to minorities **Duration:** One year with option for additional **When offered:** Annually

Biola University Dept. of Art 13800 Biola Ave. La Miranda, CA 90639-0001 Tel: 562-903-4807; Fax: 562-903-4748; E-mail: becky.eisemann@biola.edu. **Amount:** $500-$2,500 **Open to:** Current & new students at Biola; art majors only **Duration:** One year **When offered:** Annually

Birmingham Bloomfield Art Center 1516 Cranbrook Rd. Birmingham, MI 48009. **When offered:** By semester

Black Hawk College Art Dept. 6600 34th Ave. Moline, IL 61265 Tel: 309-796-5469; Fax: 309-792-3418. **Amount:** Full tuition **Open to:** Anyone, portfolio required **Duration:** One year **When offered:** Annually

Blackburn College Art Dept. 700 College Ave. Carlinville, IL 62626. **Amount:** $2,000-$4,000 **Open to:** All who are strong academically **Duration:** Usually four years, but varies

Amount: Varies **Open to:** Need-based (generally) **Duration:** Four years, must maintain GPA

Blaffer Gallery, The Art Museum of the University of Houston 120 Fine Arts Building Houston, TX 77009 Tel: 713-743-9521; Fax: 713-743-9525; Website: www.blaffergallery.org. **Amount:** $40,000 **Open to:** Post doc art historians or curatorial studies **Duration:** 2 years with potential for 1 year extension **When offered:** Beginning 2007

Bloomsburg University Dept. of Art, Blakeless Center for the Humanities, Old Science Hall Bloomsburg, PA 17815 **Amount:** John Cook award; $500 **Open to:** Freshmen **Duration:** One year **When offered:** Annually

bn 110 S. Madison Adrian, MI 49221 Tel: 517-265-5161; Fax:

517-264-3331; E-mail: eroyer@adrian.edu. **Amount:** $1,500 & up **Open to:** By portfolio review **Duration:** Renewable up to four years **When offered:** Annually

Bob Jones University School of Fine Arts 1700 Wade Hampton Blvd. Greenville, SC 29614. **Amount:** $182-$425 per month **Open to:** Undergraduate students with demonstrated financial need & satisfactory school record, campus work assignment required **Duration:** One semester; renewable **When offered:** Semi-annually

Boston College Museum of Art 140 Commonwealth Chestnut Hill, MA 02467. **Open to:** Undergraduates studying Art & Art History **When offered:** Annually

Boston University One Sherborn St. Boston, MA 02215. **Amount:** Varies **Open to:** Graduate & undergraduate students **Duration:** One year; renewable based on need and/or merit **When offered:** Annually

Boston University Graduate Program 725 Commonwealth Ave. Boston, MA 02215. **Amount:** Fellowships $4,500/semester **Open to:** Graduate students (M.S. in Arts Administration) **Duration:** Per semester **When offered:** Semi-annually

Bowling Green State University School of Art, Fine Arts Bldg. Bowling Green, OH 43403-0211. **Amount:** Varies **Open to:** BGSU art students **Duration:** Per semester **When offered:** Annually

Brandywine Workshop 730 S. Broad St. Philadelphia, PA 19146. **Amount:** Up to $5,000 in fees, services & supplies **Open to:** Applicants must pass a peer review panel of professional artists **Duration:** One-two years **When offered:** Annually

Brazosport College Art Dept. 500 College Dr. Lake Jackson, TX 77566. **Amount:** $1000 **Open to:** Art majors **Duration:** One year **When offered:** Annually

Brenau University 500 Washington St. S.E. Gainesville, GA 30501. **Amount:** Varies **Open to:** All **Duration:** One-four years **When offered:** Semi-annually

Brevard College 400 N. Broad St. Brevard, NC 28712. **Amount:** Varies **Open to:** All art majors **Duration:** One year **When offered:** Annually

Brevard Museum of Art and Science 1463 Highland Ave. Melbourne FL 32935 Tel: 321-242-0737; Fax: 321-242-0798; E-mail: info@artandscience.org. **Amount:** Varies **Open to:** Qualifying students **Duration:** Class or summer camp **When offered:** Annually

Briar Cliff University c/o Bill Welu, 3303 Rebecca St. Sioux City, IA 51104. **Amount:** $500-$1,000 **Open to:** Freshmen **Duration:** Four years; renewable **When offered:** Annually **Amount:** $600, $1000, $2,500 **Open to:** Juniors & seniors **Duration:** Renewable **When offered:** Annually

Bridgewater State College 131 Summer St. Bridgewater, MA 02325 Tel: 508-531-1359. **Amount:** Varies **Open to:** Different scholarships available **Duration:** Varies **When offered:** Semi-annually

Brigham Young University Dept. of Visual Arts E-509 HFAC, Provo, UT 84602-2500. **Amount:** Full & half tuition **Open to:** Qualified freshmen applicants, transfer students & continuing students **Duration:** One year **When offered:** Annually

Brooklyn College, Art Dept. 299 Bedford Ave. Brooklyn, NY 11210. **Amount:** Varies **Open to:** Painters **Duration:** One year **When offered:** Annually

Brooks Institute of Photography 801 Alston Rd. Santa Barbara, CA 93108. **Amount:** Varies **Open to:** Enrolled students **Duration:** One year & two months **When offered:** Varies

Bunnell Street Gallery 106 W. Bunnell St., Ste. A Homer, AK 99603. **Amount:** $100 **Open to:** Artists **Duration:** Weekend workshops **When offered:** Semi-annually

Burke Arts Council 115 Meeting St. Morganton, NC 28655 Tel: 828-433-7282; Fax: 828-433-7282; E-mail: director@burkearts.org. **Amount:** $300 **Open to:** High school seniors of Burke County becoming art majors **Duration:** One year **When offered:** Annually
Amount: $300 **Open to:** High school seniors of Burke County becoming music majors **Duration:** One year **When offered:** Annually
Amount: $300 **Open to:** High school seniors of Freedom High School becoming art majors **Duration:** One year **When offered:** Annually

BYU-Idaho, Art Dept. 316 Spori Rexburg, ID 83460-0130. **Amount:** $200-$800 **Open to:** Art majors **Duration:** One year **When offered:** Feb. 1

Cabrillo College Visual & Performing Arts Division Aptos Campus Rm. 301 Aptos, CA 95003. **Amount:** Varies **Open to:** Artists **Duration:** One year **When offered:** Annually

California College of Arts 1111 Eighth St. San Francisco, CA 94107-2247. **Amount:** Varies **Open to:** Grants & loans, open to all CCAC students, based on need & merit **Duration:** Varies, semester or annual **When offered:** Annually

California Institute of the Arts School of Art 24700 McBean Pkwy. Valencia, CA 91355-2397. **Amount:** Varies **Open to:** Matriculated students **Duration:** One year **When offered:** Annually

California Lutheran University, Art Dept. 60 W. Olson Rd. Thousand Oaks, CA 91360 Tel: 805-493-3450; Fax: 805-493-3479. **Amount:** Varies **Open to:** Freshmen **Duration:** One year **When offered:** Annually

California State University Art Dept. 6000 J St. Sacramento, CA 95819-6049. **Amount:** $7,000-$9,000 **Open to:** Art majors **Duration:** One year **When offered:** Annually

Amount: Jam Inc. $1,000 **Open to:** Art majors **Duration:** One year **When offered:** Annually
Amount: Peyser $400 **Open to:** Art majors **Duration:** One year **When offered:** Annually
Amount: R. Witt $200, $300, $500 **Open to:** Art majors **Duration:** One year **When offered:** Annually
Amount: Robinson $4,000-$7,000 **Open to:** Art majors **Duration:** One year **When offered:** Annually
Amount: Varies **Open to:** Art majors **Duration:** One year **When offered:** Annually

California State University at Dominguez Hills 1000 E. Victoria Carson, CA 90747 Tel: 310-243-3310. **Amount:** $500 **Open to:** Minority art students **Duration:** One year **When offered:** Annually

California State University, Art Dept. 801 W. Monte Vista Ave. Turlock, CA 95382. **Amount:** Varies **Open to:** Art majors only **Duration:** One year **When offered:** Annually

California State University, Bakersfield Art Dept. 9001 Stockdale Hwy. Bakersfield, CA 93311-1099. **Amount:** $300 **Open to:** Art majors **Duration:** One year **When offered:** Annually

California State University, Chico Dept. of Art & Art History, First & Normal Chico, CA 95929-0820 Tel: 530-898-5331; Fax: 530-898-4171. **Amount:** Varies **Open to:** Art studio, art history, interior design & art education majors **Duration:** One year **When offered:** Annually

California State University, Dominguez Hills, Art Dept. 1000 E. Victoria St., LCH E 303, LCH A349, Carson, CA 90747. **Amount:** $500 **Open to:** Minority artists **Duration:** One year **When offered:** Annually

California State University, Los Angeles, Art Dept. 5151 State Univ. Dr., Fine Arts 326, Los Angeles, CA 90032. **Amount:** Varies **Open to:** Undergraduates & graduates **Duration:** One year **When offered:** Annually

California State University, Northridge 18111 Nordhoff St. Northridge, CA 91330-8300. **Amount:** $500 each **Open to:** Art majors, nominated by faculty **When offered:** Annually

California State University, San Bernadino, Visual Arts Dept. 5500 University Pkwy. San Bernadino, CA 92407. **Amount:** Arlene Roberts Memorial Scholarship, amount $600 **Open to:** Art student with 3.0 GPA **Duration:** One year **When offered:** Annually
Amount: Friends of the museum Award, amount $500 **Open to:** Senior or junior class art student with a 3.0 GPA & above in Art & Art History **Duration:** One year **When offered:** Annually

California State University, Stanislaus 801 W. Monte Vista Ave. Turlock, CA 95382 Tel: 209-667-3431; Fax: 209-667-3871; E-mail: tcody@csustan.edu. **Amount:** $300-$850 **Open to:** Juniors & seniors **Duration:** One year **When offered:** Annually

California State University-Janet Turner Print Museum 400 W. First St Chico, CA 95929-0820 Tel: 530-898-4476; Fax: 530-898-5581; E-mail: csullivan@exchange.csuchico.edu. **Amount:** $1,000 **Open to:** qualified art students **Duration:** One year **When offered:** Annually

California Watercolor Association P.O. Box 4631 Walnut Creek, CA 94596. **Amount:** Up to $2,500 **Open to:** Students at high school level **Duration:** One year **When offered:** Annually

Cameron University, Art Dept. 124 D. Art Building 2800 W. Gore Blvd. Lawton, OK 73505. **Amount:** Varies **Open to:** Qualified students **Duration:** One year **When offered:** Annually

Campbell Center Pomerantz Scholarships 203 E. Seminary Mount Carroll, IL 61053. **Open to:** Conservators in private practice **Duration:** Refesher course series **When offered:** Annually

Campbell Center *Friends Scholarship*, 203 E. Seminary Mount Carroll, IL 61053. **Amount:** Up to $300 **Open to:** Friends of Campbell Center members to be used for any of the Center's courses **Duration:** Duration of course **When offered:** Annually

Campbell Center for Historic Preservation Studies *National Endowment for the Humanities Scholarship (NEH)*, 203 E. Seminary St. Mt. Carroll, IL 61053 Tel: 815-244-1173; Fax: 815-244-1619; E-mail: campbellcenter@internetni.com. **Amount:** $100-$800 **Open to:** Individuals enrolling for Campbell Center Workshops who work for non-profit and or pursueing a career change to work for non-profit organization **Duration:** For prevention collection care courses **When offered:** Annually

Pomerantz Scholarships **Amount:** $200 **Open to:** Conservators in private practice enrolling for Campbell Center workshops **Duration:** Historic preservation, care of collections & conservator refresher cources **When offered:** Annually

Foundation of the American Institute for Conservation (FAIC) **Amount:** $200 **Open to:** Current AIC members **Duration:** For refresher course series **When offered:** Annually

Campbellsville University, Dept. of Art One University Dr. Campbellsville, KY 42718. **Amount:** (2) $6,000 High school seniors **Open to:** Others for returning students **When offered:** Annually

Canadian Centre for Architecture 1920 Rue Baile Montreal, QC H3H 2S6 Tel: 514-939-7000; Fax: 514-939-7020; E-mail: ref@cca.qc.ca. **Amount:** $3,500-$5,000 Cdn dollars **Open to:** Scholars & architects at post-doctoral or equivalent level **Duration:** Three-eight months **When offered:** Sept., Jan., May

Canadian Scandinavian Foundation, McGill Univ. 805 Sherbrook St. W. Montreal, PQ H3G 3G1 Canada. **Amount:** Brucebo Scholarship, $5,000 SEK for travel, food stipend & cottage use **Open to:** Talented, young Canadian artist-painter **Duration:** Three months in Gotland **When offered:** Annually

Canton Museum of Art 1001 Market Ave. N. Canton, OH 44702. **Amount:** $1,000 **Open to:** Stark County, OH high school seniors for college tuition **Duration:** One **When offered:** Annually

Cape Cod Community College 2240 Iyanough Rd. West Barnstable, MA 02668. **Amount:** Varies **Open to:** College graduates **Duration:** Varies **When offered:** Annually

Cardinal Stritch College, Art Dept. 6801 N. Yates Rd. Milwaukee, WI 53217-3985. **Amount:** Varies **Open to:** Incoming freshmen **Duration:** Four years **When offered:** Annually

Carnegie Mellon College of Fine Arts 5000 Forbes Ave., Ste. 100 Pittsburgh, PA 15213 Tel: 412-268-5765; Fax: 412-268-4810; E-mail: ecs@andrew.cmu.edu. **Open to:** Various students & artists **Duration:** One year **When offered:** Annually

Carson-Newman College, Art Dept. P.O. Box 71995 Jefferson City, TN 37760 . **Amount:** Varies **Duration:** By semester **When offered:** Annually

Case Western Reserve University Dept. of Art History & Art 11201 Euclid Ave. Cleveland, OH 44106-7110. **Amount:** Full tuition - $21,078 plus $6,000 stipend **Open to:** MA & PhD candidates **Duration:** Two years **When offered:** Annually

Cazenovia College 22 Sullivan St. Cazenovia, NY 13035. **Amount:** $1,000 to $13,000 **Open to:** All college applicants **When offered:** Annually

Cedar Crest College, Art Dept. 100 College Dr. Allentown, PA 18104 Tel: 610-606-4666. **Amount:** $1,500 **Open to:** Incoming freshmen **Duration:** Four years **When offered:** Annually

Center for Creative Studies Art & Design Library 201 E. Kirby Detroit, MI 48202. **Amount:** Varies **Open to:** Students with academic merit; students in need of financial assistance **Duration:** Varies **When offered:** Varies

Central Michigan University Dept. of Art, Wightman Hall 132 Pleasant, MI 48859 Tel: 989-774-3025; Fax: 989-774-2278; E-mail: al.wildey@cmich.edu. **Amount:** $2,000 **Open to:** Native American students **Duration:** One year **When offered:** Annually

Central Piedmont Community College Visual & Performing Arts 1201 Elizabeth Ave. & Kings Dr. Charlotte, NC 28235. **Open to:** Anyone over 18 **Duration:** One year **When offered:** Annually

Central Wyoming College Art Dept. 2660 Peck Ave. Riverton, WY 82501 Tel: 307-855-2211; Fax: 307-855-2090; E-mail: nkehoe@cwc.edu. **Amount:** $12,000 **Open to:** Art majors **Duration:** One year; renewable **When offered:** Annually

Amount: $500-$5,000 **Open to:** Art majors **Duration:** One year, renewable for 2nd & 3rd year sophomores **When offered:** Annually-March 1, deadline

Centre National d'Exposition 4160 du Vieux Pont c.p. 605 (Mount Jacob) Jonquiere, PQ G7X 7W4 Canada. **Amount:** $25 **Open to:** Everybody interested in art **Duration:** One year **When offered:** Annually

Century College, Humanities Dept. 3300 Century Ave. N. White Bear Lake, MN 55110. **Open to:** Art students, need not be an art major **Duration:** One year **When offered:** Annually

Chadron State College, Dept. of Art 1000 Main St. Chadron, NE 69337 Tel: 308-432-6326; Fax: 308-432-6464. **Amount:** Tuition waivers & cash scholarships **Open to:** All **Duration:** One year **When offered:** Annually

Chaffey College 5885 Haven Ave. Rancho Cumcamonga, CA 91737-3002. **Amount:** Varies **Open to:** Qualified Chaffey students only; must have 24 units with a 2.75 cumulative GPA **Duration:** One year **When offered:** Annually

Charles River School Creative Arts Program 56 Centre St., P.O. Box 339 Dover, MA 02030-0339. **Amount:** Varies **Open to:** Sliding scale according to need of any applicant **Duration:** One or two months **When offered:** Varies

Chatham Historical Society 347 Stage Harbor Rd. Chatham, MA 02633. **Amount:** $2,000 **Open to:** College juniors & seniors with history or related majors **Duration:** One year **When offered:** Annually

Chautauqua Institute/ The Art School Box 1098 Chautauqua, NY 14722. **Amount:** $27,000 **Open to:** Full term students **Duration:** Eight weeks **When offered:** Annually

Cheekwood Botanical Garden & Museum of Art 1200 Forrest Park Dr. Nashville, TN 37205. **Amount:** $110 **Open to:** Children ages 4-18 **Duration:** Per class **When offered:** Annually

Chesapeake Bay Maritime Museum Navy Point P.O. Box 636 Saint Michaels, MD 21663. **Amount:** $1,625 **Open to:** Undergraduate & graduate students in history, art history, folklore & museum studies **Duration:** 13 weeks

Chipola College 3094 Indian Circle Marianna, FL 32446. **Amount:** Varies **Open to:** Freshmen & sophomore art majors **Duration:** One year; renewable **When offered:** Annually

Christopher Newport University 1 University Place Newport News, VA 23606. **Amount:** Scholarships, $500-$2,000 **Open to:** Majors **Duration:** One year **When offered:** Annually

City College of New York, Art Dept. 138th St. @ Convent Ave. New York, NY 10031. **Amount:** Up to $1,000 **Open to:** All majors **Duration:** Varies **When offered:** Semi-annually

City College of San Francisco, Art Dept. 118 Visual Arts Bldg. San Francisco, CA 94112. **Amount:** Varies **Open to:** All parties **When offered:** Annually

City University of New York, PhD Program in Art History The Graduate Center, CUNY, 365 5th Ave. New York, NY 10016-4309 Website: www.gc.cuny.edu. **Amount:** Varies **Open to:** All eligible students **Duration:** One-Five years **When offered:** Annually

Claremont Graduate University, Art Dept. 251 E. Tenth St., Claremont, CA 91711. **Amount:** Matching **Open to:** Minority students **Duration:** One year **When offered:** Annually **Amount:** Varies **Open to:** All **Duration:** One year **When offered:** Annually

Clarion University of Pennsylvania, Dept. of Art *Janet Lesser Scholarship*, 840 Wood St. Clarion, PA 16214. **Amount:** $500 **Open to:** Incoming freshman art majors & current majors **Duration:** One year **When offered:** Annually

Clark Atlanta University 223 James P. Brawley Dr., S.W. Atlanta, GA 30314 **Amount:** Varies **Open to:** All **Duration:** One year **When offered:** Annually

Clark College, Art Dept. 1800 E. McLoughlin Blvd. Vancouver, WA 98663. **Amount:** Tuition waiver up to $275 per term **Open to:** All new or returning students who enroll for at least 6 credits **Duration:** One year **When offered:** Annually

Clarke College 1550 Clarke Dr. Dubuque, IA 52001 Tel: 563-588-6300; Fax: 563-588-6789. **Amount:** $2,500 **Open to:** Art majors **Duration:** Renewable for 4 years **When offered:** Annually

Clay Studio 139 N. Second St. Philadelphia, PA 19106 Website: www.theclaystudio.org. **Amount:** $500 stipend; free studio & materials **Open to:** Ceramic artists **Duration:** One year **When offered:** Sept.-Aug. annually; application available deadline 3/31

Cleveland State Community College, Dept. of Art 3535 Adkisson Dr. Cleveland, TN 37320. **Amount:** Varies **Open to:** All qualified applicants **Duration:** One year **When offered:** Annually

Cleveland State University 2121 Euclid Ave. Cleveland, OH 44115-2214. **Amount:** Up to full tuition **Open to:** Declared art majors **Duration:** One year; renewable **When offered:** Annually

Coe College, Art Dept. 1220 First Ave. N.E. Cedar Rapids, IA 52402 Tel: 319-399-8564; Fax: 319-399-8557. **Amount:** Up to $14,000 **Open to:** All students **Duration:** Each year at college **When offered:** Annually

Amount: Up to $16,000 **Open to:** All students **Duration:** Four years **When offered:** Annually

Coffeyville Community College Art Dept., 400 W. 11th St. Coffeyville, KS 67337 Tel: 620-252-7020; Fax: 620-252-7098; E-mail: michaeld@coffeyville.edu. **Amount:** Full tuition, loan of books **Open to:** High school graduate **Duration:** 64 credit hours **When offered:** Semi-annually

Cohasset Historical Society 14 Summer St., P.O. Box 627 Cohasset, MA 02025 Tel: 781-383-6413. **Amount:** $200 **Open to:** Senior student at Cohasset High School who has volunteered at the Cohasset Historical Society **Duration:** One year **When offered:** Annually

Coker College, Art Dept. 300 E. College Ave. Hartsville, SC 29550 Tel: 843-383-8150; E-mail: jgrosser@coker.edu. **Amount:** Up to $2,000 **Open to:** Students planning to major in art **Duration:** Renewable up to four years **When offered:** Annually (Many other scholarships & merit awards available)

Colby-Sawyer College, Dept. of Fine & Performing Arts 541 Main St. New London, NH 03257. **Amount:** $2,500 or (2) $1,250 - Charlotte Cobb Stahl Scholarship in art **Open to:** Returning students **Duration:** One year **When offered:** Annually
Amount: (10-12) $5,000 -Dean's Scholarship for Creativity **Open to:** Incoming freshmen **Duration:** One year; renewable for four years **When offered:** Annually
Amount: (5) $500 - Edith B. Long Scholarships in art **Open to:** Returning students **Duration:** One year; student may reapply for following years **When offered:** Annually

College Art Association 275 Seventh Ave. New York, NY 10001. **Amount:** $5,000/$10,000 matching **Open to:** Students completing PhD or MFA **Duration:** Two years **When offered:** Annually

College of Architecture Georgia Institute of Technology 247 Fourth St. Atlanta, GA 30332-0155 Tel: 404-894-3880; Fax: 404-894-2678; E-mail: tom.galloway@coa.gatech.edu. **Amount:** $140,000 (currently available for awards) **Open to:** Students **Duration:** One year **When offered:** Annually

College of Eastern Utah, Gallery East 451 E. Fourth St. N. Price, UT 84501. **Amount:** Full tuition - $514.20 per semester **Open to:** Portfolio review **Duration:** One year **When offered:** Annually

College of Lake County, Art Dept. 19351 W. Washington St. Grayslake, IL 60030 Tel: 847-543-2040; Fax: 847-543-3040. **Open to:** Enrolled students with demonstrated talent **Duration:** Per semester **When offered:** Annually

College of Mount St. Joseph, Art Dept. *Sr. Augusta Zimmer Scholarship*, 5701 Delhi Rd. Cincinnati, OH 45233-1670. **Amount:** $1,000 **Open to:** High school graduates **Duration:** One year renewable **When offered:** As available

John Nartker Scholarship **Amount:** $1,000 **Open to:** High school graduates **Duration:** One year renewable **When offered:** As available

Fine Arts Scholarships (2) 5701 **Amount:** $1,500 each **Open to:** High school graduates **Duration:** One year; renewable **When offered:** Annually

Moore-Eckel Scholarship **Amount:** $2,000 **Open to:** High school graduates **Duration:** One year; renewable **When offered:** Annually

Fine Arts Scholarships (2) **Amount:** $2,000 each **Open to:** High school graduates **Duration:** One year; renewable **When offered:** Annually

College of New Rochelle School of Arts & Sciences *Art Scholarship*, 29 Castle Pl. New Rochelle, NY 10805. **Amount:** $3,000-$5,000 **Open to:** Student majoring in Art; based on artistic ability and academic promise; must submit a portfolio **Duration:** One year **When offered:** Annually

Many other Scholarship and merit awards available **Amount:** Ranging from full tuition & resident grants to $2,000 **Open to:** General student population, criteria varies on academics, leadership & rank **Duration:** One year **When offered:** Annually

College of Notre Dame at Maryland, Art Dept. 4701 N. Charles St. Baltimore, MD 21210. **Amount:** Varies **Open to:** High school seniors **Duration:** Varies **When offered:** Annually

College of Saint Benedict Admissions Office 37 S. College Ave. Saint Joseph, MN 56374. **Amount:** Up to $2,000 per year **Open to:** Art majors & intended majors **Duration:** Four years **When offered:** Before enrolling; renewed annually for an additional three years

College of Saint Catherine Art & Art History Dept. 2004 Randolph Ave. Saint Paul, MN 55105. **Amount:** $100, $1,500 **Open to:** Outstanding junior or senior art majors **Duration:** One year or upon graduation **When offered:** Annually

College of Saint Elizabeth, Art Dept. 2 Convent Rd. Morristown, NJ 07960-6989 Tel: 973-290-4315; E-mail: vbutera@cse.edu. **Amount:** $1,000-$1,200 **Open to:** Sophmores & juniors **Duration:** One year **When offered:** Annually

The College of Saint Rose 432 Western Ave. Albany, NY 12203 Tel: 518-485-3900; Fax: 518-485-3920. **Amount:** $3,000-$10,000 **Open to:** Incoming students only **Duration:** Until graduation **When offered:** Only when applying

College of the Canyons 26455 Rockwell Canyon Rd. Canta Colita, CA 91355 Tel: 661-259-7800. **Amount:** Varies **Open to:** Varies **Duration:** Varies **When offered:** Annually

The College of the Ozarks, Dept. of Art P.O. Box 17 Point Lookout, MO 65726. **Amount:** Full tuition Work/study grant **Open to:** Preference to scholarships, financial need, geographic location **Duration:** Four years **When offered:** Each semester

College of the Sequoias Art Dept., Fine Arts Division 915 S. Mooney Blvd. Visalia, CA 93277. **Amount:** $500 **Open to:** Art majors transferring to four year institutions **Duration:** One year **When offered:** Annually

Colonial Williamsburg Foundation *Fellowships John D. Rockefeller Jr. Library*, CWF, P.O. Box 1776 Williamsburg, VA 23187-1776 Tel: 757-565-8500; Fax: 757-565-8505. **Amount:** $2,000 per month **Open to:** American or foreign nationals; pre- or post-doctoral or independent research **Duration:** One-three months **When offered:** Semi-annually, April 1; Nov 1

Colorado State University Dept. of Art Fort Collins, CO 80523. **Amount:** Varies **Open to:** All undergraduate art majors **Duration:** One year **When offered:** Annually

Columbia Basin College, Esvelt Gallery 2600 N. 20th Ave. Pasco, WA 99301. **Amount:** $1,500 **Open to:** Two for entering art majors (freshmen); Two for continuing art majors (sophomores) **Duration:** One year **When offered:** Annually

Columbia College, Fine Arts 11600 Columbia College Dr. Sonora, CA 95370 Tel: 209-585-5100; Fax: 209-588-5104. **Amount:** Varies **Open to:** All **Duration:** Varies **When offered:** Annually

Columbia University School of the Arts 305 Dodge Hall Mail Code 1808, 2960 Broadway New York, NY 10027. **Amount:** Varies **Open to:** All registered students in competition **When offered:** Annually

Columbia University Visual Arts Division 415 Dodge Hall, 2960 Broadway New York, NY 10027. **Open to:** Graduate students enrolled in full-time two-year program **Duration:** One year **When offered:** Annually

Columbus University Department of Art 4225 University Ave. Columbus, GA 31907. **Amount:** $10,000 **Open to:** Art majors **Duration:** One year **When offered:** Spring quarter **Amount:** Varies **Open to:** Art majors; transfer students & entering freshman

Community Colleges of Spokane 1810 N. Greene St. Spokane, WA 99217-5399. **Amount:** Varies; $50 quarterly tuition **Open to:** Art students

Concordia College Art Dept. 901 S. Eighth Moorhead, MN 56562. **Amount:** $1,000-$2,500 **Open to:** Portfolio review **Duration:** Four years **When offered:** Annually

Concordia University Art Dept. 800 N. Columbia Ave. Seward, NE 68434. **Amount:** Varies **Open to:** Entering freshmen & upperclassmen **Duration:** Four years **When offered:** Annually

Contemporary Crafts Museum & Gallery 3934 S.W. Corbett Ave. Portland, OR 97239 Tel: 503-223-2654; Website: www.contemporarycrafts.org. **Amount:** $300 per month, plus use of studio for 6-12 months **Open to:** Emerging ceramic artists **Duration:** 6-12 months **When offered:** Annually

Converse College Dept. of Art and Design, 580 E. Main St. Spartanburg, SC 29302 Website: www.converse.gov. **Amount:** Varies **Open to:** Female art students **Duration:** Four years **When offered:** Annually

The Cooper Union School of Art Cooper Square New York, NY 10003-7120. **Amount:** Full tuition **Open to:** Entering freshmen accepted into a four-year undergraduate BFA program **Duration:** Four years **When offered:** Annually

Coos Art Museum 235 Anderson Ave. Coos Bay, OR 97420 Tel: 541-267-3901; E-mail: info@coosart.org; Website: www.coosart.org. **Amount:** up to 30% **Open to:** Anyone who qualifies **Duration:** Per course **When offered:** Quarterly

Coppini Academy of Fine Arts 115 Melrose Pl. San Antonio, TX 78212. **Amount:** $3,000 **Open to:** Area high school art majors **Duration:** One year **When offered:** Annually

Corcoron College of Art & Design 500 17th St., N.W. Washington, DC 20006-4808. **Amount:** Varies ($1,000-$90,000) **Open to:** BFA degree, full-time students only **Duration:** One-four years **When offered:** Annually (March)

CORE: New Art Space 900 Santa Fe Dr. Denver, CO 80205 Website: www.corenewartspace.com. **Amount:** Gallery space for shows **Open to:** Students or schools **Duration:** Three week shows **When offered:** Annually

Cornell College 600 First St. W. Mount Vernon, IA 52314. **Amount:** $8,000-$10,000 **Open to:** First-year students **Duration:** Four years **When offered:** Annually

The Corning Museum of Glass One Museum Way Corning, NY 14830-2253. **Amount:** $10,000 Rakow Grant for Glass Research **Open to:** Scholars & researchers - by competition **Duration:** One year **When offered:** Annually

Cornish College of the Arts 1000 Lenora St. Seattle, WA 98121 Tel: 800-720-ARTS; Website: www.cornish.edu. **Amount:** Merit scholarships: 20% - 40% of tuition **Open to:** All applicants admitted before March 1 **Duration:** One year **When offered:** Annually; deadline Feb. 1

Cosanti Foundation, Arcosanti HC 74, Box 4136 Mayer, AZ 86333. **Amount:** $425 is covered by scholarship; total workshop fee is $800; student is responsible for $375 for seminar/ workshop $750 **Open to:** Applicants over 18 years old - contact workshop coordinator for application **Duration:** Five weeks **When offered:** 10 times a year - one per seminar/workshop

Cottey College, Art Dept. 1000 W. Austin Nevada, MO 64772 Tel: 417-867-8181. **Amount:** Varies **Open to:** Qualified women students **Duration:** One & two years **When offered:** Annually

Craft Council of Newfoundland and Labrador Devon House,Craft Centre, 59 Duckworth St. Saint John's, NL A1C 1E6 Canada. **Amount:** $2,000 (maximum) **Open to:** Residents of Newfoundland & Labrador **Duration:** Varies **When offered:** Three times a year

Cranbrook Academy of Art 39221 Woodward Ave., P.O. Box 801 Bloomfield Hills, MI 48303 Tel: 248-645-3330; Fax: 248-646-0046. **Open to:** Demonstrated financial need **Duration:** One year **When offered:** Annually

Crazy Horse Memorial Avenue of the Chiefs Crazy Horse, SD 57730. **Amount:** $80,000 **Open to:** Native American students attending tribal and state colleges, universities, nursing schools and vocational technical schools in South Dakota **When offered:** Annually

Creative Art Center 47 Williams St. Pontiac, MI 48341. **Amount:** $500-$1,000 **Open to:** Students **Duration:** Year round **When offered:** Annually

Creative Photographic Art Center of Maine 59 Canal St., Box 9 Lewiston, ME 04240. **Amount:** Full tuition **Open to:** Any photographic students **Duration:** Two years **When offered:** Semi-annually

Crowder College 601 Laclede Neosho, MO 64850. **Amount:** Trustee Scholarship $600 per semester **Open to:** All students **Duration:** Five semesters **When offered:** Annually

Culver-Stockton College One College Hill Canton, MO 63435. **Amount:** Varies; based upon quality of student portfolio **Open to:** All art department applicants who arrange for a portfolio review **Duration:** Renewable through end of senior year **When offered:** Annually

Cumberland College, Art Dept. 6191 College Station Dr. Williamsburg, KY 40769. **Amount:** $1,200 **Open to:** All **Duration:** One year; renewable **When offered:** Annually

Cumberland County College P.O. 1500, College Dr. Vineland, NJ 08362-1500. **Amount:** $500-$1,000 **Open to:** Art Majors **Duration:** One year **When offered:** Annually

Daemen College Art Dept. 4380 Main St. Amherst, NY 14226. **Amount:** $1,000-full tuition **Open to:** Students with outstanding high school academic record and/or superior admissions portfolio evaluation **Duration:** Renewable each year if specified cumulative academic average is maintained **When offered:** Annually

Dallas Baptist University Dept. of Art 3000 Mountain Creek Pkwy. Dallas, TX 75211. **Amount:** $600-$1,500 **Open to:** All art major students **Duration:** One year **When offered:** Annually

Dana College 2848 College Dr. Blair, NE 68008. **Amount:** $500-$2,000 **Open to:** Entering art & graphic design majors or Education majors with art emphasis **Duration:** Four years with annual review **When offered:** Annually

Danville Museum of Fine Arts & History 975 Main St. Danville, VA 24541 Tel: 434-793-5644; Fax: 434-799-6145; E-mail: dmfah@gamewood.net. **Open to:** Children to take museum classes & workshops

Davidson College, Art Dept. P.O. Box 1719 Davidson, NC 28035. **Amount:** $10,000/year - Bearden Scholarship **Open to:** Incoming first-year student at Davidson College, with preference for African Americans **Duration:** One year; renewable up to four years **When offered:** Every year, through nomination by high school art teacher or administrator in fall of senior year in high school. Awarded in the spring of 2008 to a first year student in the class of 2012

Amount: $5,000/year - Pepper Scholarship **Open to:** Incoming first-year student at Davidson College **Duration:** One year; renewable up to four years **When offered:** Every year, through submission of slide portfolio in fall of senior year of high school

Daytona Beach Community College Dept of Visual Arts 1200 W. International Speedway Blvd. Daytona Beach, FL 32114. **Amount:** Varies **Open to:** All students **Duration:** One year **When offered:** Annually

De Anza College Creative Arts 21250 Stevens Creek Blvd. Cupertino, CA 95014. **Amount:** Varies **Open to:** Students attending De Anza College **Duration:** One year **When offered:** Annually

Del Mar College Art Dept. 101 Baldwin Blvd. Corpus Christi, TX 78404-3897. **Amount:** Varies **Open to:** Art majors enrolled at Del Mar College **Duration:** One year **When offered:** Annually

Delta College 1961 Delta Rd. University Center, MI 48710. **Amount:** $350 **Open to:** Fall term: incoming high school art students, juried; Winter term: full-time current art major, juried **When offered:** Semi-annually

Delta State University Wright Art Center Gallery, Box D-2 Cleveland, MS 38733 **Amount:** Varies **Open to:** Incoming freshmen art majors **Duration:** One-four years **When offered:** Annually

DePaul University Dept. of Art & Art History 1 E. Jackson Chicago, IL 60604. **Amount:** $1,000-$4,000 **Open to:** Incoming freshmen **Duration:** One year; renewable up to four years **When offered:** Annually

The Detroit Institute of Arts 5200 Woodward Ave. Detroit, MI 48202. **Amount:** Curatorial & Education Internships & Conservation Fellowships **Open to:** Minority graduate students; all other students

Dickinson State University Dept. of Fine Arts & Humanities 291 Campus Dr., Klinefelter Hall Dickinson, ND 58601. **Amount:** $500 **Open to:** Enrolled art students **Duration:** One year **When offered:** Annually

Dillman's Creative Arts Foundation Tom Lynch Resource Center P.O. Box 98 Lac Du Flambeau, WI 54538 Tel: 715-588-3143; E-mail: frontdesk@dillmans.com; Website: www.dillmans.com. **Amount:** Scholarships $100+ **Open to:** All **Duration:** May-Oct. **When offered:** Annually

Dorot Foundation through Harvard University Semitic Museum 6 Divinity Ave. Cambridge, MA 02138. **Amount:** Up to $1,000 **Open to:** First priority to Harvard undergraduates, then to all students **Duration:** One year **When offered:** Annually

Douglas County Historical Society 1101 John Ave. Superior, WI 54880. **Amount:** $500 **Open to:** University Wisconsin - Douglas County history students **Duration:** One year **When offered:** Annually

Dowling College, Dept. of Visual Arts Idle Hour Blvd. Oakdale NY 11769. **Amount:** Varies **Open to:** Varies **Duration:** Varies **When offered:** Varies

Drake University 2507 University Ave. Des Moines, IA 50311. **Amount:** $500-$5,500 **Open to:** All art students **Duration:** One year; renewable for four years **When offered:** Annually

Drew University Art Dept. 36 Madison Ave. Madison, NJ 07940. **Amount:** $10,000 per year **Open to:** First year students **Duration:** Four-years **When offered:** Annually

Dupage Art League 218 W. Front St. Wheaton, IL 60187 Tel: 630-653-7090; Website: www.dupageartleague.org. **Amount:** $200 **Open to:** Dupage College art student **Duration:** June **Amount:** Class fee **Open to:** Three children & one adult each six week session

Dyson College of Arts & Sciences Pace University 861 Bedford Rd. Pleasantville, NY 10570. **Amount:** Varies **Open to:** All students **Duration:** Length of study **When offered:** Annually

e Media Loft 55 Bethune St. # A-629 New York, NY 10014-2035 E-mail: tyz@emedialoft.org; Website: www.emedialoft.org. **Amount:** Fifty hours of equipment use in studio **Open to:** Artist who use videos **Duration:** One year **When offered:** Ongoing

East Carolina University School of Art *Michael Bunting*, East Fifth St. Greenville, NC 27858-4353 Tel: 252-328-1282; Fax: 252-328-6441; E-mail: haneya@mail.ecu.edu. **Amount:** $1,000 **Open to:** Incoming art student **Duration:** One available/not renewable

Claire E. Armstrong **Amount:** $1,500 **Open to:** Graduate art major **Duration:** Two available/not renewable; min. GPA 3.0

VAF **Amount:** $200 **Open to:** Junior & senior art major **Duration:** One available/not renewable; min. GPA 2.5

Ed Reep **Amount:** $200 **Open to:** Junior & senior painting major **Duration:** One available/renewable; min. GPA 3.0

Taeylor **Amount:** $250 **Open to:** Undergraduate & graduate art major **Duration:** 20 available/not renewable; min. GPA 3.0

Amount: $250 - $1,800 **Open to:** New & returning students **Duration:** One year **When offered:** Annually

DeElla Wade Willis **Amount:** $500 **Open to:** Undergraduate & graduate textile major **Duration:** Two available/renewable once; min. GPA 3.0

Tran and Marilyn Gordely **Amount:** $500 **Open to:** Junior & senior painting major **Duration:** Two available/renewable once; min. GPA 2.5

UBE **Amount:** $500 **Open to:** Undergraduate & gradutate art major **Duration:** Two available/renewable; min. GPA 3.0

Wellington B. Gray East **Amount:** $500 **Open to:** Undergraduate art education major **Duration:** One available/not renewable

John Satterfield and Jenni K. **Amount:** $500 **Open to:** Undergraduate & graduate metals major **Duration:** Two available/renewable once; min. GPA 3.0

Richard Steven Bean **Amount:** $500 **Open to:** Undergraduate & graduate CA major **Duration:** One available/renewable; min. GPA 2.5

Gravely **Amount:** $500 **Open to:** Junior, senior & graduate art major **Duration:** Two available/renewable 3 sem.; min. GPA 2.5

MJS **Amount:** $500 **Open to:** Incoming art student **Duration:** One available/not renewable

Hanna and Jodi Jubran **Amount:** $500 **Open to:** Undergradute & graduate sculpture major **Duration:** Two available/not renewable; min. GPA 3.0

Kirk and Dasha Little **Amount:** $500 **Open to:** Incoming art student **Duration:** One available/not renewable

Art Enthusiasts **Amount:** $500 **Open to:** Incoming art student **Duration:** One available/not renewable

Penland **Amount:** Program tuition **Open to:** Undergradute & graduate art major **Duration:** One available/not renewable

Arrowmont **Amount:** Program tuition **Open to:** Undergraduate & graduate art major **Duration:** One available/not renewable

East Central College 1964 Pairie Dell Rd. Union, MO 63084. **Amount:** $1,200 **Open to:** High school seniors or older who display artistic ability & discipline **Duration:** One semester **When offered:** Semi-annually

East Central University, Art Dept. *Scholarships (7),* 1100 E. 14th St. Ada, OK 74820-6999 Tel: 580-310-5353; Fax: 580-436-4042; E-mail: bjessop@mailclerk.ecok.edu. **Amount:** $200-$500 **Open to:** Art students **Duration:** One year **When offered:** Annually

East Tennessee State University, Dept of Art Design *Ruth Adams Scholarship,* P.O. Box 70708 Johnson City, TN 37614-1710 Website: art.etsu.edu. **Amount:** $1,000

Hay's Freshman Art Scholarship **Amount:** $500

Lynn Whitehead Scholarship **Amount:** $500

Holly Adams Scholarship **Amount:** $500

Joy Fox Memorial Scholarship **Amount:** Amount varies

Performance Scholarship **Amount:** In state tuition for out of state students

Jane Dove Cox Scholarship **Amount:** TBA

Eastern Illinois University Art Deptment, 600 Lincoln Ave. Charleston, IL 61920-3099. **Amount:** $100-$2,700 **Open to:** Art majors **Duration:** One year **When offered:** Annually

Eastern Iowa Community College-Clinton Community College 1000 Lincoln Blvd, Clinton, IA 52732 Tel: 563-244-7001; Fax: 319-244-7026. **Duration:** One year **When offered:** Annually

Eastern Washington University Dept. of Art 140 Art Building 5th St. Cheney, WA 99004. **Amount:** Varies **Open to:** Art majors only; scholarships to undergraduates; fellowships to graduates **Duration:** One year **When offered:** Annually

Eastern Wyoming College Art Dept. 3200 W. C St. Torrington, WY 82240. **Amount:** Tuition **Open to:** Art majors, freshmen, sophomores **Duration:** Four semesters **When offered:** Annually

Edgewood College, Art Dept. 1000 Edgewood College Dr. Madison, WI 53711. **Amount:** $500-$1,500 **Open to:** Entering freshmen or transfer students **Duration:** One year; renewable for four years **When offered:** Annually

Edinboro University of Pennsylvania Dept. of Art Edinboro, PA 16444. **Amount:** Graduate assistantships which include tuition waiver plus stipend **Open to:** MFA students-graduates, undergraduates, BFA - fine arts, BA - art history, art education **Duration:** One year; renewable **When offered:** Annually

Eiteljorg Museum of American Indians and Western Art Fellowships White River State Park, 500 W. Washington St. Indianapolis, IN 46204 Tel: 317-636-9378; Fax: 317-264-1724; E-mail: museum@eiteljorg.com. **Amount:** $20,000 **Open to:** Native American Artists **Duration:** One-time award **When offered:** Bi-annually

Emmanuel College 400 The Fenway Boston, MA 02115. **Amount:** $4,500 **Open to:** Accepted incoming freshmen **Duration:** Four years **When offered:** Annually

Emory University Art History Dept. 581 S. Kilgo Cir. 133 Carlos Hall Atlanta, GA 30322. **Amount:** Competitive **Open to:** PhD candidates **Duration:** At least four years **When offered:** Annually

Emporia State University 1200 Commericial St., Campus Box 4015 Emporia, KS 66801 Tel: 620-341-5246; Fax: 620-341-6246. **Amount:** $250-$1,000 **Open to:** Incoming freshman & transfers **Duration:** One year **When offered:** Annually

Esquela de Artes Plasticcs de Puerto Rico P.O. Box 9021112 San Juan, PR 00902-1112 Tel: 787-725-8120; Fax: 787-725-8111; E-mail: info@eap.edu. **Amount:** $4,050 **Open to:** Low income students **Duration:** One year **When offered:** Annually

Eye Level Gallery 2128 Gottinger St. Halifax, NS B3K 3B3. **Amount:** $500 & $1,000 **Open to:** All artists (Canadian & International) **Duration:** Length of exhibition

F. Lammot Belin Arts Scholarship, Attn. Donna McLaughlin Attn: Donna McLaughlin Waverly Community House, Inc., 115 N. Abington Rd. Waverly, PA 18471. **Amount:** $10,000 **Open to:** Exceptional ability in fine arts. Must be a U.S. citizen. Must have been or presently be a resident of the Abingtons or Pocono Northeast of PA **Duration:** One year **When offered:** Annually; deadline Dec. 15

Fairbanks Arts Association P.O. Box 72786 Fairbanks, AK 99707. **Amount:** $400 **Open to:** Junior high students attending the University of Alaska summer fine arts camp **Duration:** One year **When offered:** Annually

Fallingwater P.O. Box R Mill Run, PA 15464. **Amount:** $600 **Open to:** Participants in summer teacher & student residencies **Duration:** Week-long residencies in the summer **When offered:** Annually

Farmington Valley Arts Center 25 Arts Center Lane Avon, CT 06001. **Amount:** Scholarships $30-$300 **Open to:** Students demonstrating financial need **Duration:** Scholarships assigned to specific class **When offered:** Quarterly

Fashion Institute of Technology Seventh Ave @ 27th St. New York, NY 10001. **Amount:** Varies **Open to:** All students who qualify **Duration:** Renewable **When offered:** Annually

Figge Art Museum 225 W. 2nd St. Davenport, IA 52801 Tel: 563-326-7804; Fax: 563-326-7876. **Amount:** $12, 000 for 4 years scholarship **Open to:** Graduating high school seniors who plan to study art or art education in college **Duration:** $12,000 over 4 years ($3,000 per year) **When offered:** Annually

Film Arts Foundation 145 Ninth St. #101 San Francisco, CA 94103. **Amount:** $2,000-$4,000 **Open to:** Northern California media makers (film & video) **When offered:** Annually

The Filson Historical Society 1310 S. Third St. Louisville, KY 40208. **Amount:** $500+ **Open to:** M.A. students; Doctoral students; Post-doctoral students in History **Duration:** One week to 2 months **When offered:** Annually, deadlines Feb.15, Oct 15

Amount: Internships $1,200 per month (summer) $1,000 per semester **Open to:** Graduate students who are currently enrolled in or have recently completed a graduate program in history or a related field **Duration:** One to two (summer) months/or two semesters **When offered:** Annually, deadlines Feb. 15, Oct, 15

Fine Arts Association 38660 Mentor Ave. Willoughby, OH 44094. **Amount:** Varies **Open to:** Those in need, achievement & minority **Duration:** Per season **When offered:** 3 times a year; Fall, Spring and Summer

Fine Arts Center of Hot Springs 405 Park Ave. Hot Springs AR 71913. **Amount:** Based on gifts received **Open to:** Children **Duration:** Workshops **When offered:** Based on scheduled

First Street Gallery 526 W. 26th St. Ste. 915 New York, NY 10012. **Amount:** Up to $4,000 **Open to:** All **Duration:** One month **When offered:** Semi-annually

Fitton Center for Creative Arts 101 S. Monument Ave. Hamilton, OH 45011. **Amount:** Class fees **Open to:** Those in need; accepting all ages & abilities **Duration:** Six-eight weeks **When offered:** Each session

Flagler Museum One Whitehall Way, P.O. Box 969 Palm Beach, FL 33480. **Amount:** TBD **Open to:** Museum Professionals **Duration:** One-two week fellowships **When offered:** Annually

Flint Institute of Arts 1120 E. Kearsley St. Flint, MI 48503. **Amount:** Tuition reimbursement **Open to:** Based on financial need **Duration:** Per class; per quarter **When offered:** Quarterly

Florida Community College at Jacksonville, South Campus, Art Dept. 11901 Beach Blvd. Jacksonville, FL 32246. **Open to:** Art Students **Duration:** One year **When offered:** Semi-annually

Florida International University, School of Art & Art History University Park Campus Bldg., VH 216 Miami, FL 33199 Tel: 305-348-2897; Fax: 305-348-0513. **Amount:** Varies **Open to:** All **Duration:** One year **When offered:** Annually

Florida State University, Dept. of Art 220 A. Fine Arts Bldg. Tallahassee, FL 32306 Tel: 850-644-6474. **Amount:** Varies (see website) stipend & tuition waiver **Open to:** Graduate students in MFA prog **Duration:** One year **When offered:** Annually

Fort Hays State University, Visual Arts Center 600 Park St. Hays, KS 67601-4099. **Amount:** $3,500 **Open to:** Freshmen **Duration:** One year **When offered:** Semi-annually

Foster Caddell's Art School 47 Pendleton Hill Rd Voluntown, CT 06384. **Open to:** All willing to work **Duration:** On going **When offered:** Annually

Franklin and Marshall College Art Dept. P.O. Box 3003 Lancaster, PA 17604-3003. **Amount:** Varies **Open to:** Advanced students with experience **Duration:** Summer **When offered:** At request of professors

Franklin College, Art Dept. 101 Branigin Blvd. Franklin, IN 46131. **Amount:** $500 **Open to:** Art minor **Duration:** One year **When offered:** Annually

Friends University Art Dept. 2100 University St. Wichita, KS 67213. **Amount:** $400 & up **Open to:** All art majors **Duration:** One-four years if grades and work standards are maintained **When offered:** Annually

Frog Hollow Vermont State Craft Center 1 Mill St. Middlebury, VT 05753. **Amount:** Open **Open to:** Applicants who demonstrate a need **Duration:** One class session **When offered:** Three sessions annually

Frostburg State University Dept of Visual Arts, 101 Braddock Rd. Frostburg, MD 21532-1099. **Amount:** $1,000; $2,000; $3,000 towards costs **Open to:** Awarded to freshmen or transfer art students pursuing a BFA at FSU for talent in the visual arts; portfolio review required **Duration:** Up to eight semesters; freshmen up to four semesters; transfer students **When offered:** Deadline: April 1

Fulton County Historical Society, Inc. 37 E. (just off N. US 31) 375 N. Rochester, IN 46975 Tel: 574-223-4436; E-mail: fchs@rtcol.com. **Amount:** $3,000 to three college students **Open to:** Indiana residents attending college, majoring in history **Duration:** June-Aug. **When offered:** Annually

Furman University Art Dept. 3300 Poinsett Hwy. Greenville, SC 29613. **Amount:** Scholarships Varies **Open to:** All applicants **Duration:** One year **When offered:** Annually

Gallery Worth 90 N. Cowboy Rd. Setauket, NY 11780. **Amount:** (10) $500 **Open to:** Students of SUNY at Stonybrook **Duration:** Semester **When offered:** By semester (short term emergency funds) through Chairman of Art Dept.

Gaston College, Arts Dept. 201 Hwy. 321 S. Dallas, NC 28034-1499. **Amount:** Varies **Open to:** Anyone **Duration:** Two years **When offered:** Annually

The George Washington University, Smith Hall of Art, A101 801 22nd St., N.W. Washington, DC 20016. **Amount:** Varies **Open to:** Undergraduate & graduate students **Duration:** Varies **When offered:** Annually

Georgetown College, Art Dept. Fine Arts Bldg., 400 E. College St. Georgetown, KY 40324. **Amount:** $250-$4,000 **Open to:** Art majors **Duration:** Four years with 2.0 GPA for grants; Four years with 3.1 GPA for scholarships **When offered:** Annually

Georgia College & State University Dept. of Art Campus Box 94 Milledgeville, GA 31061. **Amount:** Varies **Open to:** Rising juniors & seniors; some freshmen & sophomores **Duration:** One year **When offered:** Annually

Georgia Institute of Technology College of Architecture 247 Fourth St. Atlanta, GA 30332-0155 Tel: 404-894-3880; Fax: 404-894-2678; E-mail: thomas.galloway@coa.gatech.edu. **Amount:** $140,000 **Open to:** Students **Duration:** One year **When offered:** Annually

Georgian Court University 900 Lakewood Ave. Lakewood, NJ 08701. **Amount:** $750-$3,200 per year **Open to:** High school graduates who plan to major in art, based on portfolio **Duration:** Renewable for four years **When offered:** Annually

Glass Art Society 3131 Weston Ave., Ste. 414 Seattle, WA 98121 Tel: 206-382-7305; Fax: 206-382-2630; E-mail: info@glassart.org. **Amount:** $500-$1,000 **Open to:** Students **When offered:** Annually

The Glassell School of Art The Museum of Fine Arts, Houston 5101 Montrose Blvd. Houston, TX 77006. **Amount:** Tuition only **Open to:** One studio class; portfolio renew **Duration:** One semester **When offered:** Semi-annually

Golden West College 15744 Golden West St. Huntington Beach, CA 92647-2748. **Amount:** Varies **Open to:** Registered students; various requirements **Duration:** One year **When offered:** Annually

Grace College, Department of Art 200 Seminary Dr. Winona Lake, IN 46590. **Amount:** $2,600 **Open to:** All undergraduate art majors **Duration:** One year **When offered:** Annually

Graceland University, Department of Art 1 University Pl. Lamoni, IA 50140 Tel: 641-784-5270; Fax: 641-784-5487; E-mail: finearts@graceland.edu. **Amount:** up to $2,500 **Open to:** Art majors based on portfolio reviews **Duration:** One year; renewable **When offered:** Annually

Grand Canyon University 3300 W. Camelback Rd. Phoenix, AZ 85017 Tel: 800-800-9776; 602-589-2840; Fax: 602-589-2459; E-mail: imorrison@grand-canyon.edu. **Amount:** $200-$2,000 **Open to:** Art majors/minors **Duration:** One year **When offered:** Annually

Grand Rapids Community College 143 Bostwick Ave. N.E. Grand Rapids, MI 49503. **Amount:** Varies **Open to:** New students **Duration:** Semester **When offered:** Annually

Grand Valley State University 1 Campus Drive Allendale, MI 49401. **Amount:** Varies **Open to:** People in the arts may apply for any of these awards (Fulbright-Hayes & Foreign Governments, Lusk Memorial Fellowships **Duration:** One academic year **When offered:** Annually-May

Grand Valley State University Art & Design Dept. 1 Campus Drive Allendale, MI 49401. **Amount:** $1,000 **Open to:** All students **Duration:** Renewable to four years **When offered:** Annually

Grants for Graduate Study Abroad Write: US Fulbright Student Programs Institute of International *Education*, 809 United Nations Plaza New York, NY 10017-3580. **Amount:** Varies **Open to:** People in the arts may apply for any of these awards (Fulbright-Hays & Foreign Governments, Lusk Memorial Fellowships) **Duration:** One academic year **When offered:** Annually-May 1

Grayson County College, Art Dept. 6101 Grayson Dr. Hwy. 691 Denison, TX 75020. **Amount:** Varies **Open to:** Visual Arts full-time students **Duration:** By semester **When offered:** Semi-annually

Green Mountain College Dept. of Visual & Performing Art One College Circle Poultney, VT 05764. **Amount:** $3,000 **Open to:** Art applicants; freshmen **Duration:** Four years **When offered:** Annually
Amount: $500-$1,000 **Open to:** Art majors **When offered:** Annually

Greensboro Artists League 200 N. Davie St. Greensboro, NC 27401. **Amount:** (4) $250 **Open to:** Guilford County high school seniors pursuing art as a career **When offered:** Annually

Grossmont College 8800 Grossmont College Dr. El Cajon, CA 92020 Tel: 619-644-7155. **Amount:** $250-$500 **Open to:** Grossmont College Art Students **Duration:** Varies **When offered:** Annually

Guadalupe Cultural Arts Center 1300 Guadalupe St. San Antonio, TX 78207. **Amount:** Fellowships $22,000 **Open to:** US/Mexican citizens **Duration:** Nine months **When offered:** Annually

Guild of Creative Art *Mary Sheean Scholarship for high school seniors*, 620 Broad St., Rte. 35 Shrewsbury, NJ 07702 Tel: 732-741-1441; E-mail: guildofcreativeart@verizon.net. **Amount:** $150 (10 lessons) & $10 jr membership **Open to:** High school students of New Jersey **Duration:** One year **When offered:** Annually

Gulf Coast Community College P.O. Box 100 Gautier, MS 39553. **Amount:** Varies **Open to:** All **Duration:** One year **When offered:** Annually

Gustavus Adolphus College Art Dept., Schaefer Fine Arts Center, 800 W. College Ave. Saint Peter, MN 56082. **Amount:** $300-$850 **Open to:** Forty studio & art history students **Duration:** One year **When offered:** Annually

Hamline University College of Liberal Arts, 1536 Hewit Ave. Saint Paul, MN 55104-1284. **Amount:** $10,000 **Open to:** All students **Duration:** One year **When offered:** Annually

Hampton University Dept. of Fine & Performing Arts Hampton, VA 23668. **Amount:** Varies **Open to:** Fine & performing arts majors **Duration:** One year **When offered:** Annually

Hannibal-LaGrange College 2800 Palmyra Rd. Hannibal, MO 63401. **Amount:** $2,000, $250 per semester - divisional scholarship **Open to:** Beginning freshmen **Duration:** Per semester **When offered:** Annually

Amount: $2,000, $250 per semester - performance **Open to:** Art majors **Duration:** Per semester **When offered:** Annually

Amount: $2,400, $300 per semester - performance **Open to:** Art majors **Duration:** Per semester **When offered:** Annually

Harding University Department of Art and Design 900 E. Center, Box 2253 Searcy, AR 72149. **Amount:** $250-$1,000 **Open to:** Art majors, selection by portfolio, high school transcript & reference letters from art teachers **Duration:** One year; renewable **When offered:** Annually

Hardin-Simmons University, Art Dept. Hickory at Ambler St. P.O. Box 16085, Univ. Sta. Abilene, TX 79698. **Amount:** Up to $500 per semester **Open to:** Art majors, full-time students; based on financial need, then merit **Duration:** One year **When offered:** Annually

Harry Ransom Humanities Research Center 21st. & Guadalupe, P.O. Box 7219 Austin, TX 78713-7219. **Amount:** $2,500 per month **Open to:** Scholars pursuing post-doctoral research **Duration:** One-four months **When offered:** Annually

Hartford Art School University of Hartford 200 Bloomfield Ave. West Hartford, CT 06117. **Amount:** $3,000-$12,000 **Open to:** Merit scholarships available to those excelling in portfolio, academics or athletics as determined by the university **Duration:** Four years; renewable based on 3.0 cumulative GPA and full-time status (24 credits per year) **When offered:** Annually to incoming freshmen

Hartnell College Art & Photography Dept. 156 Homestead Ave. Salinas, CA 93901 **Amount:** Varies **Open to:** California residents **Duration:** Semester **When offered:** Annually

Haystack Mountain School of Crafts P.O. Box 518 Deer Isle, ME 04627 Tel: 207-348-2306; Fax: 207-348-2307; E-mail: haystack@haystack-mtn.org. **Amount:** Free tuition, room and board **Duration:** One session **When offered:** Annually

Headlands Center for the Arts 944 Fort Barry Sausalito, CA 94965. **Amount:** Artists' Residencies- studio space, housing, meals & monthly stipend **Open to:** Artists nationally & internationally **Duration:** Three month stays on average **When offered:** March-Nov.

Helene Wurlitzer Foundation of New Mexico P.O. Box 1891 Taos, NM 87571 Tel: 505-758-2413; Fax: 505-758-2559; E-mail: hwf@taosnet.com. **Amount:** Free rent & utilities - limited number of residencies available **Open to:** Artists in all media & allied fields, creative, non interpretive art performance **Duration:** April-Sept, full capacity; Oct.-March limited basis **When offered:** Annually; deadline Jan. 18 for grant the following year

Henry County Museum & Cultural Arts Center of Henry County Historical Society 203 W. Franklin St. Clinton, MO 64735 Tel: 660-885-8414; Fax: 660-890-2228; E-mail: hcmus@midamerica.net. **Amount:** $500 **Open to:** Henry County student **When offered:** Annually

Herron School of Art and Design, Indiana Univ.-Purdue Univ. Indianapolis (IUPUI) 735 W. New York St. Indianapolis, IN 46202 Tel: 317-920-2416; Fax: 317-929-2401; E-mail: herrart@iupui.edu. **Amount:** Varies **Open to:** All Students **Duration:** One Year (travel grants) **When offered:** Annually

Hesston College, Art Dept. Box 3000 Hesston, KS 67062. **Amount:** $3,000; varies by academic prowess **Open to:** Any student (not art specific) **Duration:** Two years, contingent on maintaining standards **When offered:** Biannually

Higgins Armory Museum 100 Barber Ave. Worcester, MA 01606. **Amount:** Approx. $100 scholarship grant based on need **Open to:** Students attending museum programs **Duration:** Per program

Hill College, Fine Arts Dept. P.O. Box 619 Hillsboro, TX 76645. **Amount:** Varies **Open to:** Anyone **Duration:** Semester **When offered:** Semi-annually

Hill Country Arts Foundation Duncan-McAshan Visual Arts Center 120 Point Theatre Rd. S. Ingram, TX 78025. **Amount:** $150-$200 **Open to:** Youth aged 8-18 & adults limited to funding **Duration:** Per 3-5 day workshop **When offered:** Annually

Hillsdale College 33 E. College St. Hillsdale, MI 49242. **Amount:** $1,500 **Open to:** Full-time art majors; based on need & merit **Duration:** One year **When offered:** Annually

Hinds Community College Art Dept. P. O. Box 1100 Raymond, MS 39154-1100. **Amount:** Full & partial tuition **Open to:** Full-time entering freshmen **Duration:** One year; renewable **When offered:** Annually

Hiram Blauvelt Art Museum *Artists-in-residence program*, 705 Kinderkamack Rd. Oradell, NJ 07649 Tel: 201-261-0012; Fax: 201-391-6418. **Open to:** Society of Animal Artists members **Duration:** One year **When offered:** Annually

Amount: Cottage & stipend **Open to:** Members of the Society of Animal Artists **Duration:** One year **When offered:** Annually

Historic Deerfield, Inc The Street, P.O. 321 Deerfield, MA 01342 Website: www.deerfield-fellowship.org. **Amount:** Fully funded Historic Deerfield Fellowship; financial aid available to offset lost income **Open to:** College undergraduates who have completed 2 years **Duration:** Nine weeks, from mid-June to mid-Aug. **When offered:** Annually

Historical Museum at Fort Missoula Bldg. 322, Fort Missoula Missoula, MT 59804 Tel: 406-728-3476; Fax: 406-543-6277; E-mail: fmslamuseum@montana.com. **Amount:** $450 **Open to:** College/university student **Duration:** Semester **When offered:** Semi-annually

Historical Society of Kent County, Inc. 101 Church Alley, P.O. Box 665 Chestertown, MD 21620. **Amount:** $500 book scholarship **Open to:** Kent County High School seniors **Duration:** One year **When offered:** Annually

History of Art & Architecture College of Letters & Science, 2217 Cheadle Hall Santa Barbara, CA 93106-7080. **Amount:** Varies **Open to:** Graduate students approved by art history department. MA & PhD candidates are also eligible for consideration for departmental fellowships. Museum internships are also available. **Duration:** Academic year

Hofstra University 1000 Fulton Ave. Hempstead, NY 11550. **Amount:** $20,872 **Open to:** Undergraduates **Duration:** Varies **When offered:** Annually

Hollins University Roanoke, VA 24020. **Amount:** Varies **Open to:** Undergraduates; adult students, based on both need & merit **Duration:** Varies **When offered:** Annually

Holter Museum of Art 12 E. Lawrence Helena, MT 59601. **Amount:** Varies **Open to:** Interested education/art applicants (adults & children) for art classes **Duration:** Length of class **When offered:** Upon request by applicant

Hope College, Art Department De Pree Art Center 160 E. 12th St. Holland, MI 49422. **Amount:** $2,500 **Open to:** Incoming freshmen & transfer students **Duration:** Four years; renewable **When offered:** Annually

Houston Center for Photography 1441 W. Alabama Houston, TX 77006 Tel: 713-529-4755; Fax: 713-529-9248; E-mail: info@hcponline.org. **Amount:** $1,000 **Open to:** US artists **Duration:** Completion of project **When offered:** Annually

Howard Payne University Dept of Art School of Fine & Applied Arts 1000 Fisk St. P.O. Box 839 Brownwood, TX 76801. **Amount:** Varies **Open to:** Students **Duration:** One year **When offered:** Annually

Huguenot Historical Society 18 Broadhead Ave. New Paltz, NY 12561 E-mail: hhsoffice@hhs-newpaltz.org. **Amount:** (3) $2,000 **Open to:** Graduate & undergraduate students in the museum & library fields, summer internships **Duration:** Summer **When offered:** Annually

Hui No'eau Visual Arts Center 2841 Baldwin Ave. Makawao HI 96768. **Amount:** Varies **Open to:** The public **Duration:** Class; lectures; workshops exhibit opportunities **When offered:** All year

Huntingdon College 1500 E. Fairview Ave. Montgomery, AL 36106. **Amount:** One full tuition & numerous partial tuitions **Open to:** Any incoming art students **Duration:** Four years **When offered:** Annually

Idaho State University Art Dept. Rm. 58 Design Center, Fifth & Dillion, P.O. Box 8004 Pocatello, ID 83209. **Amount:** Varies **Open to:** Declared art undergraduates & graduate students **Duration:** One semester **When offered:** Spring semester for the next academic year

Illinois Central College, Dept. Fine, Performing & Applied Arts One College Dr. East Peoria, IL 61635 Tel: 309-694-5113; Fax: 309-694-8505; Website: www.icc.edu. **Amount:** Varies according to scholarship **Open to:** Students **Duration:** Depends on scholarship **When offered:** Annually

Illinois State University College of Fine Arts Normal, IL 61790-5620. **Amount:** Varies **Open to:** All undergraduate & graduate students, including graduate assistantships with monthly stipend and full tuition waiver **Duration:** One year; some are renewable **When offered:** Annually

Illinois Wesleyan University School of Art Bloomington, IL 61702-2900. **Amount:** $3,000-$8,500 **Open to:** Alumni talent scholarship in art to deserving students based on portfolio review & academic background **Duration:** One year; renewable **When offered:** Annually

Indian Arts Research Center/ School of Research *Sallie R. Wagner Indigenous Artist Fellowship*, P.O. Box 2188 Santa Fe, NM 87504-2188

Ronald & Susan Dubin Native American Artist Fellowship

Rollin & Mary Ella King Native American Artist Fellowship **Open to:** Native American students **Duration:** Three months **When offered:** Annually

Eric & Barbara Dobkin Native American Artist Fellowship **Open to:** Native American students **Duration:** Three months **When offered:** Annually

Indian Hills Community College Centerville Campus N. First St. Centerville, IA 52544. **Amount:** Varies **Open to:** Students; based on portfolio review **Duration:** One year **When offered:** Annually

Indian Hills Community College Ottumwa Campus, Dept. of Art 525 Grandview at Elm Ottumwa, IA 52501 Tel: 641-683-5111; Fax: 641-683-5206; Website: www.indianhills.edu. **Amount:** $100-$600 per term **Open to:** Students who pass a portfolio review **Duration:** One year **When offered:** Annually

Indiana Purdue University Dept. of Fine Arts Heron School of Art., 735 W. New York St. Indianapolis, IN 46202. **Amount:** Varies **Open to:** Full-time degree students **Duration:** One year **When offered:** Annually

Indiana State University Dept. of Art, FA 108 Terre Haute, IN 47809. **Amount:** $1,200-$3,600 **Open to:** Undergraduate (freshmen) **Duration:** Four years **When offered:** Annually

Amount: $5,000 **Open to:** Graduate assistantships, with fee waiver **Duration:** Two Years **When offered:** Annually

Indiana University of Pennsylvania Dept of Arts & Art Education 115 Sprowls Hall, 470 S. 11th St. Indiana, PA 15705. **Amount:** $100-$4,500 **Open to:** Graduate students **Duration:** One year **When offered:** Annually

Indiana University-Purdue University, Indianapolis Herron School of Art, 735 W. New York St Indianapolis, IN 46202. **Amount:** Varies **Open to:** Entering Freshmen, through seniors **Duration:** One year **When offered:** Annually

Indiana Wesleyan University, Division of Art 4201 S. Washington St. Marion, IN 46953. **Amount:** $1,000 **Open to:** Any art major with 3.5 GPA **Duration:** One year **When offered:** Annually; deadline March 15

Industrial Designers Society of America 45195 Business Ct., Ste. 250 Dulles, VA 20166-6717 Tel: 703-707-6000; Fax: 703-787-8501; E-mail: idsa@idsa.org; Website: www.idsa.org. **Amount:** Varies **Open to:** Graduate & undergraduate students **Duration:** One year **When offered:** Annually

Institut des arts au Saguenay 4106 du Vieus Pont, C.P. 605 Jonquiere, QC G7X 7W4 Canada Tel: 418-546-2177; Fax: 418-546-2180; E-mail: cne@videotron.ca. **Amount:** $25 **Open to:** All people interested by art **Duration:** One year **When offered:** Annually

Institute of Arts & Sciences Gallery 148 Concord St. Manchester, NH 03104. **Amount:** Tuition **Open to:** All applicants **When offered:** Each semester

Institute of Contemporary Art (ICA) 118 S. 36th St. Philadelphia, PA 19104 Tel: 215-898-5911; Fax: 215-898-5050; E-mail: info@icaphila.org. **Open to:** Curators **Duration:** One year **When offered:** Annually

Institute of Puerto Rican Culture Escuela de Artes Plasticas, Apartado 9024184, San Juan, PR 00902-4184. **Open to:** Low-income students **Duration:** One year **When offered:** Two payments each semester

Instutute of American Indian Arts Museum 108 Cathedral Pl. Santa Fe, NM 87501 Tel: 505-983-8900; Fax: 505-983-1222; E-mail: jgrimes@iaia.edu. **Amount:** Funding provided to students at the IAIA is determined by the Development office **Open to:** IAIA is a four-year Bechelors program accredited by the NCA & NASAD **Duration:** One year **When offered:** Annually

Interlochen Arts Academy Dept. of Visual Arts P.O. Box 199 Interlochen, MI 49643-0199. **Amount:** Varies **Open to:** Talented students **Duration:** One year or more **When offered:** Annually

International Council for Cultural Exchange (ICCE) 426 S. Country Rd., Ste. 1 Brookhaven, NY 11719 Tel: 800-690-ICCE; E-mail: icceinfo@earthlink.net. **Amount:** $100 **Open to:** Artists **Duration:** ICCE art trips abroad **When offered:** TBA

Ithaca College, Art Dept. 101 Ceracche Center, 953 Danby Rd. Ithaca, NY 14850-7277 Tel: 607-274-3330; Fax: 607-274-1358; E-mail: bferguson@ithaca.edu. **Amount:** Varies **Open to:** Senior with financial need **Duration:** One year **When offered:** Annually

Jackson State University Department of Art P.O. Box 17064, 1400 John R. Lynch St. Jackson, MS 39217. **Amount:** Full tuition **Open to:** High school student with 3.5 GPA; 26 on ACT **Duration:** One year; renewable **When offered:** Annually

Jacksonville State University Department of Art 700 Pellham Rd. N. Jacksonville, AL 36265. **Amount:** $970 **Open to:** Art majors **Duration:** One year **When offered:** Annually

James A. Michener Art Museum 138 S. Pine St. Doylestown, PA 18901. **Amount:** Unpaid, can be credit or non-credit **Open to:** Summer internship stipend open to college students pursuing a credit internship **Duration:** Summer **When offered:** Summer 2005 & 2006

James Madison University School of Art & Art History, MSC 7101 Harrisonburg, VA 22807. **Amount:** $4,000-$20,000 **Open to:** Undergraduate & graduate art & art history majors **Duration:** Four years **When offered:** Annually

John C. Calhoun State Community College 6250 U. S. Hwy. 31 N. Tanner, AL 35671. **Amount:** Varies **Open to:** Art, graphic design & photography majors **Duration:** Two semesters (nine month period) **When offered:** Annually

John Simon Guggenheim Memorial Foundation 90 Park Ave. New York, NY 10016. **Amount:** $32,000 (average grant) **Open to:** Citizens & permanent residents of the U.S. & Canada **Duration:** Six months-one year **When offered:** Annually

Amount: Adjusted to need of fellows. Average award $28,000 **Open to:** Advanced professionals, citizens or permanent residents of U.S., Canada, Latin America & the Caribbean **Duration:** Six months-one year **When offered:** Annually

Johnson County Community College 12345 College Blvd. Overland Park, KS 66210 Tel: 913-469-8500; E-mail: lthomas@jccc.edu. **Amount:** $1,000 **Duration:** One semester **When offered:** Semi-annually

Judson College Dept. of Art & Design 1151 N. State St. Elgin, IL 60123. **Amount:** Variable based on review of portfolio **Open to:** New students **Duration:** Four years **When offered:** Annually

Judson College, Division of Fine & Performing Arts 302 Bibb, P.O. Box 120 Marion, AL 36756. **When offered:** Annually

Kala Art Institute 1060 Heinz Ave. Berkeley, CA 94710. **Amount:** Six months of free studio access **Open to:** Anyone in print-making, mutlimedia **Duration:** Six months **When offered:** Annually

Kalamazoo College 1200 Academy St. Kalamazoo, MI 49006. **Amount:** $2,000-$3,000 Art scholarship **Open to:** Accepted applicants **Duration:** One year; renewable **When offered:** Annually
Amount: $3,000-$10,000 Honors scholarship **Open to:** Accepted applicants **Duration:** One year; renewable **When offered:** Annually

Kalamazoo Institute of Arts *Three merit scholarships*, 314 South Park St. Kalamazoo, MI 49007. **When offered:** Annually **Amount:** Full or half tuition for one class **Open to:** Students with financial need **Duration:** Per semester **When offered:** Fall, winter & summer semesters

Kalani Oceanside Retreat 12-6860 Kalapana-Kapoho Beach Rd. Pahoa, HI 96778 Website: www.kalani.com. **Amount:** 25% lodging discount **Open to:** Professional artists **Duration:** 1 month-6 months **When offered:** May-Nov.

Kansas City Art Institute 4415 Warwick Blvd. Kansas City, MO 64111 Tel: 800-522-5224; Fax: 816-802-3309; E-mail: 1stone@kcai.edu; Website: www.kcai.edu. **Amount:** Varies **Open to:** All qualified students **Duration:** One year provided academic guidelines are maintained **When offered:** Annually

Kansas State University Dept. of Art, 322 Willard Hall Manhattan, KS 66506 Tel: 785-532-6605; Fax: 785-532-0334; E-mail: art@ksu.edu. **Amount:** Various cash, art supply & tuition awards **Open to:** New freshman, transfer & returning students **Duration:** One year **When offered:** Annually

Kapioliani Community College Art Program John Chin Young Foundation 4303 Diamond Head Rd. Honolulu, HI 96816. **Amount:** (3) $1,000 **Open to:** Art majors & art students **Duration:** One year **When offered:** Annually

Kappa Pi International International Honorary Art Fraternity 400 S. Bolivar Ave. Cleveland, MS 38732-3745. **Amount:** $100-$500 **Open to:** Current Kappa Pi Art Fraternity Members **Duration:** One year **When offered:** Annually

Kellogg Community College Visual & Performing Arts Dept. 450 North Ave. Battle Creek, MI 49017 Tel: 269-965-3931; Fax: 269-965-0280; Website: www.kellogg.edu. **Amount:** Varies **Duration:** One year **When offered:** Annually

Kendall College of Art & Design Ferris State University, 17 Fountain St. Grand Rapids, MI 49503-3102. **Amount:** $1,000-$5,000 per year **Open to:** Incoming freshmen & transfer students **Duration:** One year; renewable up to four years with maintenance of 3.0 GPA **When offered:** Annually

Kent State University School of Art Kent, OH 44242. **Amount:** $500-$1,000 **Open to:** All majors in the school (fine arts, crafts, education & history) **Duration:** Per semester **When offered:** Every semester

Keystone College One College Green LaPlume, PA 18440. **Amount:** $500 to full tuition **Open to:** All full-time students **Duration:** One year **When offered:** Annually

Kilgore College Visual Arts Dept. 1100 Broadway Kilgore, TX 75662. **Amount:** $2,400 **Open to:** All students **Duration:** Two years **When offered:** Annually

Krasl Art Center 707 Lake Blvd. St. Joseph, MI 49085 Tel: 269-983-0271; Fax: 269-983-0275; E-mail: info@krasl.org. **Amount:** Varies depending on class **Open to:** General public **Duration:** Length of class **When offered:** Year round

Kresge Art Museum, Michigan State University East Lansing, MI 48824. **Amount:** $16,500 & benefits **Open to:** Internship open to people with masters in art history or some graduate work; museum course or some museum experience **Duration:** 9 months **When offered:** Annually

Kutztown University College of Visual & Performing Arts, P.O. Box 730 Kutztown, PA 19530. **Amount:** Varies **Open to:** Talented student with financial need **Duration:** One year; renewable **When offered:** Annually

La Napoule Art Foundation 799 South St. Portsmouth, NH 03801 Tel: 603-436-3040; Fax: 603-436-0025; E-mail: lnaf@clews.org. **Amount:** Room, board & studio space at the Chateau de la Napoule artist residencies **Open to:** Accomplished and emerging artists **Duration:** Six to eight weeks **When offered:** Semi-annually

Laguna College of Art & Design 2222 Laguna Canyon Rd. Laguna Beach, CA 92651. **Amount:** $2,500-$8,300 **Open to:** Incoming freshmen & transfer students **Duration:** One-four years **When offered:** Annnually & semi-annually

Lahaina Arts Society 648 Wharf St., Ste. 103 Lahaina, HI 96761 Tel: 808-661-0111. **Amount:** $500 **Open to:** High school seniors **Duration:** One year **When offered:** Annually

Lake Forest College 555 N. Sheridan Rd. Lake Forest, IL 60045. **Amount:** Varies **Open to:** All students **Duration:** One year-four full years **When offered:** Annually

Lamar Dodd School of Art University of Georgia 101 Visual Arts Athens, GA 30602-4102. **Amount:** $500 **Open to:** Undergraduates & graduates **Duration:** One year **When offered:** Annually

Lamar University Department of Art Box 10027 Beaumont, TX 77710. **Amount:** Varies **Open to:** Undergraduates & graduates majoring in art **Duration:** Semesterly, renewable **When offered:** Semi-annually

Lander University, Div. of Fine Arts 320 Stanley Ave. Greenwood, SC 29649 Tel: 864-388-8323; Fax: 864-388-8144; E-mail: rwohlfor@lander.edu. **Amount:** $500-$1,000 (multiple awards each year) **Open to:** Art majors **Duration:** One year; renewable with 2.5 GPA **When offered:** Annually

Lane Community College 4000 E. 30th Ave. Eugene, OR 97405. **Amount:** $500 **Open to:** Graphic design students **Duration:** One year **When offered:** Annually
Amount: $500 - Wayne Shields Foundation **Open to:** All art majors **Duration:** One year **When offered:** Annually

Laramie County Community College 1400 E. College Dr. Cheyenne, WY 82007. **Amount:** Full tuition **Open to:** All students **Duration:** Per semester **When offered:** Semi-annually

Lawrence University, Dept. of Art and Art History Wriston Art Center, P.O. Box 599 Appleton, WI 54912. **Amount:** Varies **Open to:** Students of academic merit & particular talent **When offered:** Annually

Leo Baeck Institute Center for Jewish History 15 W. 16th St. New York, NY 10011. **Amount:** David Baumgardt Memorial Fellowship **Open to:** Academic affiliated with an accredited institution of higher education **Duration:** One year; monthly installments **When offered:** Annually; application deadline Nov 1.
Amount: Fritz Halbers Fellowship; up to $3,000 **Open to:** Students Enrolled in a PhD program in an accredited institute of higher education **Duration:** One year **When offered:** Annually; application deadline Nov 1.
Amount: LBI/DAAD Fellowship stipend of $2,000 **Open to:** Doctoral students or recent PhDs affiliated with an accredited American instiue of higher education; must be a U.S. citizen & no older than 35 years old **Duration:** One year; paid in two installments **When offered:** Annually; application deadline Nov 1.

Amount: LBI/DAAD Fellowship; stipend of EUR $975 monthly **Open to:** Doctoral students or academics affiliated with an accredited institute of higher education that will do research in the Federal Republic of Germany; must be U.S. citizen and no older than 35 years old **Duration:** Six months; monthly installments **When offered:** Annually; application deadline Nov 1.

Lewis-Clark State College Division of Humanities, 500 8th Ave. Lewiston, ID 83501. **Amount:** Varies **Open to:** All students **Duration:** Six months **When offered:** Annually

Library Company of Philadelphia/ Historical Society of Pennsylvania 1314 Locust St. Philadelphia, PA 19107 Tel: 215-546-3181; E-mail: jgreen@librarycompany.org; Website: www.librarycompany.org. **Amount:** $1,800 **Open to:** Those involved in both post-doctoral & dissertation research **Duration:** (30) One month **When offered:** Annually

Fellowship **Amount:** $8,100-$20,000 **Open to:** Those involved in both post-doctoral & disseration research **Duration:** One semester

Limestone College 1115 College Dr. Gaffney, SC 29340. **Amount:** $2,500 **Open to:** Majors - students & art education **Duration:** One year; renewable **When offered:** Annually

Lincoln University Dept. of Fine Arts 820 Chestnut St. Jefferson City, MO 65101. **Amount:** Half tuition **Open to:** Art majors **Duration:** One year **When offered:** Annually

Lindenwood University, Art Dept. 209 S. Kings Hwy. Saint Charles, MO 63301. **Amount:** Varies **Open to:** Basis of merit, talent & financial need **Duration:** One year; renewable **When offered:** Annually & semi-annually

Lock Haven University Art Dept., 107 Sloan Art Center, 401 N. Fairview St. Lock Haven, PA 17745. **Amount:** Varies **Open to:** Varies **Duration:** One year

Long Island University Brooklyn Center, Art Dept. 1 University Plaza Brooklyn, NY 11201. **Amount:** $5,000 **Open to:** Art majors **Duration:** One year **When offered:** Annually

Long Island University C. W. Post Campus, Art Dept. 720 Northern Blvd. Brookville, NY 11548. **Amount:** $1,000 - O'Malley Research Travel Fellowship **Open to:** Undergraduates & graduates attending LIU **Duration:** One year **When offered:** Annually

Amount: $1,500-$4,000 - Portfolio award **Open to:** Undergraduates & incoming freshman & transfer students **Duration:** Four years **When offered:** Annually in Nov.
Amount: $250-$500 - O'Malley Awards **Open to:** Undergraduates & graduates attending LIU **When offered:** By application; six times annually
Amount: Ponser Fund - $1,000 **Open to:** Incoming freshman **Duration:** Four years **When offered:** Annually

Longwood University Dept of Art, 201 High St. Farmville, VA 23909. **Amount:** $500-$1,000 **Open to:** Current students only **Duration:** One year **When offered:** Annually

Louisiana College, Dept. of Art *Excellence in the Arts*, 1140 College Dr. Pineville, LA 71359 Tel: 318-487-7262; Fax: 318-487-7337; E-mail: barnes@lacollege.edu. **Amount:** $10,400-$20,800 to be used over four years of study **Open to:** Five outstanding incoming freshman art majors **When offered:** Annually in spring semester (March) through a portfolio review process

Grady Harper **Amount:** $500 **Open to:** Junior & senior art majors **Duration:** One year **When offered:** Annually

Academic Achievement Award (Art) **Amount:** $600 **Open to:** Junior & senior art majors **Duration:** One year **When offered:** Annually

Steinschulte Scholarship **Amount:** $800 **Open to:** Junior & senior studio art majors **Duration:** One year **When offered:** Annually

Central Louisiana Ad Club **Amount:** $900 **Open to:** Junior & senior graphic design majors **Duration:** One year **When offered:** Annually

Louisiana State University 123 Art Bldg., School of Art Baton Rouge, LA 70803-0001. **Amount:** Varies **Open to:** Undergraduates & graduates; GPA above 2.7 preferred **Duration:** Varies **When offered:** Annually

Louisiana Tech University School of Art, P.O. Box 3175 W. Ruston, LA 71272. **Amount:** Varies ($1,000-$2,500) **Open to:** High school seniors (as college freshmen) art majors **Duration:** Initial year; can be extended **When offered:** Annually

Lourdes College *Hill Award*, 6832 Convent Blvd., MAH Rm. 204 A. Sylvania, OH 43560. **Amount:** $200 **When offered:** Annually

Agenta-Gorman Award **Amount:** $500 **When offered:** Annually

L.A.M.B. Award **Amount:** $500 **Open to:** First or second semester art major **Duration:** One year **When offered:** Annually

Lower East Side Printshop, Inc. 306 W. 37th St., 6th Fl. New York, NY 10018 Website: http://printshop.org. **Amount:** $1,500 & travel stipend if outside of New York **Open to:** Emerging artists of all disciplines **Duration:** 3-6 months **When offered:** Annually-deadline12/2/06

Loyola Marymount University, Dept. of Art & Art History 7900 Loyola Blvd. Los Angeles, CA 90045 **Amount:** Varies **Open to:** Enrolled art majors **Duration:** One year **When offered:** Annually

Loyola University Chicago Fine Arts Dept. 6525 N. Sheridan Rd. Chicago, IL 60626. **Amount:** $1,000 **Open to:** Sophomores & juniors **Duration:** One year **When offered:** Annually **Amount:** $3,000 **Open to:** Majors & minors (course specific) **Duration:** By semester **When offered:** Annually

Lubbock Christian University 5601 W. 19th St. Lubbock, TX 79407-2099. **Amount:** $500 **Open to:** All applicants with portfolios **Duration:** Semester **When offered:** Annually

Lycoming College, Art Dept. 700 College Pl., Fine Arts Bldg. Williamsport, PA 17701 Tel: 570-321-4002; Fax: 570-321-4090; E-mail: golahny@lycoming.edu. **Amount:** $1,000-$5,000 **Open to:** All art majors with talent who have a portfolio review **Duration:** Renewable for four years **When offered:** Annually

Amount: Varies **Open to:** Incoming freshman art majors by portfolio review **Duration:** Four years **When offered:** Annually

Lyme Academy College of Fine Arts 84 Lyme St. Old Lyme, CT 06371. **Amount:** $500-$6,000 **Open to:** Matriculated students **Duration:** One year **When offered:** Annually

Lyndhurst 635 S. Broadway Tarrytown, NY 10591, **Amount:** Varies **Open to:** Preservation/restoration students **Duration:** Varies **When offered:** Annually

Macalester College 1600 Grand Ave. Saint Paul, MN 55105. **Open to:** Enrolled Manchester students

Madonna University Art Dept. 36600 Schoolcraft Rd. Livonia, MI 48150. **Amount:** $200-$500 **Open to:** Anyone **Duration:** One year **When offered:** Annually

Main Line Art Center Old Buck Rd. - Lancaster Ave. Haverford, PA 19041. **Amount:** $50-$250 **Open to:** Students **Duration:** Semester **When offered:** Per semester

Maine College of Art 97 Spring St. Portland, ME 04101. **Amount:** Varies **Open to:** Matriculating BFA & MFA students **Duration:** Renewable based on financial need & current GPA **When offered:** Semi-annually

Malone College Dept. of Fine Arts 515 25th St., N.W. Canton, OH 44709. **Amount:** Varies **Open to:** Academic scholarships available to qualifying students **Duration:** Varies **When offered:** Applications due by April 1

Manchester College, Art Dept. 604 College Ave. North Manchester, IN 46962 **Amount:** $1,000-$4,000 **Open to:** Anyone **Duration:** One year; renewable **When offered:** Annually

Manhattan Graphics Center 481 Washington St. New York, NY 10013 Tel: 212-219-8783; Fax: 212-219-8783; E-mail: manhattangraphicscenter@yahoo.com. **Amount:** Free tuition & $100 stipend **Open to:** All interested artists who have not previously worked at MGC **Duration:** Term **When offered:** Three times a year

Mansfield University Art Dept., Allen Hall Mansfield, PA 16933. **Amount:** Varies **Open to:** Freshmen **Duration:** One year **When offered:** Annually

Marblehead Arts Association, Inc. King Hooper Mansion 8 Hooper St. Marblehead, MA 01945. **Amount:** $1,000 **Open to:** Graduating Marblehead High School art major pursuing a formal art education **Duration:** One year **When offered:** Annually

The Mariners' Museum 100 Museum Dr. Newport News, VA 23606. **Amount:** $750 **Open to:** All researchers interested in the holdings of the museum's collection, library & archives **Duration:** Varies **When offered:** Annually

Marion Art Center 80 Pleasant, Box 602 Marion, MA 02738. **Amount:** $500 **Open to:** In-house students (piano, voice, flute, violin, theater arts, dance, drawing & painting) **Duration:** One year **When offered:** Annually

Marion College, Art Dept. 3200 Cold Spring Rd. Indianapolis, IN 46222-1997. **Amount:** One quarter tuition **Open to:** First-time freshmen/art major **Duration:** Renewable for four years **When offered:** Annually

Mary Washington College Art Dept., 1301 College Ave. Fredericksburg, VA 22401. **Amount:** Varies **Open to:** Varies **Duration:** Varies **When offered:** Varies

Marygrove College, Dept. of Art 8425 W. McNichols Rd. Detroit, MI 48221-2599 Tel: 313-927-1370; Fax: www.marygrove.edu. **Amount:** $3,000 **Duration:** One year **When offered:** Annually

Marylhurst University Art Dept., 17600 Pacific Hwy., (Hwy 43), P.O. Box 261 Marylhurst, OR 97036-0261 Tel: 503-699-6242; Fax: 503-636-9526; E-mail: kheinrich@maryhurst.edu. **Amount:** Varies **Open to:** Art Students **Duration:** One year **When offered:** Annually

Marymount College of Fordham University, Art Dept. 100 Tarrytown Ave. Tarrytown, NY 10591. **Amount:** Variable **Open to:** Full-time students registered at the College **Duration:** Variable **When offered:** Annually

Marymount Manhattan College Fine & Performing Arts Dept. 221 E. 71st St. New York, NY 10021. **Amount:** Varies **Open to:** Student who auditions or submits portfolio **Duration:** Four years **When offered:** Annually

Maryville University of Saint Louis, Art & Design Program 650 Maryville University Dr. Saint Louis, MO 63141-7299 Tel: 314-529-9300; Fax: 314-529-9940. **Amount:** $2,500 **Open to:** Merit **Duration:** Four years **When offered:** Annually

Marywood University, Art Dept. 2300 Adams Ave. Scranton, PA 18509. **Amount:** Varies **Open to:** All students; undergraduate & graduate **Duration:** Undergraduate, four years; graduate, one year renewable **When offered:** Annually

Massachusetts Historical Society 1154 Boylston St. Boston, MA 02215. **Amount:** Fellowships $5,000 **Open to:** Scholars **Duration:** Forty Days **When offered:** Annually; deadline Mar. 1

Maude I Kems, Art Center 1910 E. 15th Ave. Eugene, OR 97403. **Amount:** $1,000 per year **Open to:** Children through adults exhibiting motivation and/or financial need **Duration:** One year for MKAC classes **When offered:** Quarterly

McGill University, School of Architecture 815 Sherbrooke St., W. Montreal, PQ H3A 2K6 Canada Tel: 514-398-6704; Fax: 514-398-7372. **Amount:** $110,000 **When offered:** Annually

McGroarty Cultural Art Center 7570 McGroarty Terrace Tujunga, CA 91042. **Amount:** Half the cost of class **Open to:** Anyone in need **Duration:** 8 wks **When offered:** Four times per yr

McIntire Department of Art *Jefferson Scholars Graduate Fellowships University of Virginia*, Fayerveather Hall, P.O. Box 400130 Charlottesville, VA 22904. **Amount:** Stipend begins at $16,500 rising over 5 years to $18,500, plus tuition, fees and health insurance **Open to:** PhD candidates in Art and Architectural History. Students beginning at MA level but committed to the PhD may apply **Duration:** Renewable for 5 years **When offered:** Annually

Presidents Fellowship University of Virginia **Amount:** Stipend of 15,000 plus tuition, fees and health insurance **Open to:** PhD candidates in Art and Architectural History. Students beginning a MA level but committed to the PhD may apply. **Duration:** Renewable for 3 years **When offered:** Annually

McLean County Arts Center 601 N. East St. Bloomington, IL 61701 E-mail: info@mcac.org. **Amount:** $1,500 **Open to:** High school seniors pursuing arts **Duration:** One year **When offered:** Annually

McMurry University Art Dept. 1642 Sayles Blvd. Box 8 Abilene, TX 79697. **Amount:** $3,000-$4,500 **Open to:** Perry Bentley Art Scholarship (based on portfolio judging from regional high schools) **Duration:** Four years **When offered:** Annually

Amount: $500-$2,500 **Open to:** Transfer & entering art students who show special ability **Duration:** One year **When offered:** Annually

McNeese State University Department of Visual Arts 4205 Ryan St., Box 92295 Lake Charles, LA 70601. **Amount:** $500 to full tuition **Open to:** Beginning freshmen **Duration:** One year; renewable **When offered:** Annually

Memorial University of Newfoundland Fine Arts Division Sir Wilfred Grenfell College University Dr. Corner Brook, NL A2H 6P9 Canada. **Amount:** Varies **Open to:** Varies **Duration:** One year **When offered:** Annually

Memphis College of Art 1930 Poplar Ave., Overton Pk. Memphis, TN 38104-2764. **Amount:** $500,000 total **Open to:** High school & transfer students **Duration:** Renewable **When offered:** Annually

Amount: Varies **Open to:** All MCA enrolled students **Duration:** One year **When offered:** Annually

Amount: Varies **Open to:** Any applicant **Duration:** Spring, summer & fall sessions **When offered:** Spring, summer & fall sessions

Mercer University, Art Dept. College of Liberal Arts 1400 Coleman Ave. Macon, GA 31207-0001. **Amount:** $750-$1,000 **Open to:** Two scholarships to rising seniors, have scholarships for continuing sophomores & juniors **Duration:** One year **When offered:** Annually

Mercyhurst College 501 E. 38th St., Erie, PA 16546. **Amount:** $10,000 **Open to:** Incoming freshmen art majors **Duration:** Per year over four years **When offered:** Annually

Mercyhurst College, Dept. of Art 501 E. 38th St., Erie, PA 15546. **Amount:** $6,000 1st place; $4,500 2nd place; $3,300 3rd place **Open to:** All freshmen art applicants, recent high school graduates, portfolio competition **Duration:** One year; renewable **When offered:** Annually

Mesa State College 1100 North Ave. Grand Junction, CO 81501. **Amount:** Varies **Open to:** Continuing art majors **Duration:** One year **When offered:** Annually

Metropolitan Museum of Art Fellowship Program Education Department 1000 Fifth Ave. New York, NY 10028-0198. **Amount:** Varies **Open to:** Scholars researching art historical fields relating to Metropolitan Museum of Art Collections **Duration:** One year **When offered:** Annually

Metropolitan State College of Denver Art Department Campus Box 59, P.O. Box 173362 Denver, CO 80217-3362. **Amount:** Full year tuition **Open to:** All majors, after one year **Duration:** One year **When offered:** Annually

Miami University Art Dept. 124 Art Bldg. Oxford, OH 45056. **Amount:** Varies **Open to:** Anyone **Duration:** One semester & one year **When offered:** Annually

Miami Watercolor Society P.O. Box 561953 Miami, FL 33256-1953. **Amount:** Three day workshop for a student & his/her teacher **Open to:** Local students **Duration:** Three days **When offered:** Annually

Miami-Dade Community College Visual Arts Dept. 11011 S.W. 104th St. Miami, FL 33176. **Amount:** $700 **Open to:** Art majors **Duration:** Varies **When offered:** Semi-annually

Michigan State University Dept. of Art & Art History 113 Kresge Art Center East Lansing, MI 48824-1119 Tel: 517-355-

7610. **Amount:** Varies (creative art scholarships) **Open to:** Incoming freshman who have graduated from a Michigan high school **Duration:** Varies **When offered:** Annually

Midwestern State University Art Dept. 3410 Taft Blvd. Wichita Falls, TX 76308. **Amount:** $100-$1,500 **Open to:** Art majors **Duration:** Per semester **When offered:** Semi-annually

Miles Community College Art Dept. 2715 Dickinson St. Miles City, MT 59301. **Amount:** Based on need **Open to:** Art students **Duration:** One year **When offered:** Annually

Millikin University Art Dept. 1184 W. Main Decatur, IL 62522. **Amount:** $500-$3,000 **Open to:** Art majors who present portfolios prior to entrance **Duration:** Renewable yearly **When offered:** Call for portfolio review dates

Mills College, Art Dept. 5000 MacArthur Blvd., P.O. Box 9975 Oakland, CA 94613. **Amount:** Varies **Open to:** All **Duration:** One-four years **When offered:** Annually & Semi-annually

Milwaukee Institute of Art & Design 273 E. Erie St. Milwaukee, WI 53202. **Amount:** $2,000 to full tuition **Open to:** All applicants **Duration:** One year; renewable for four years **When offered:** Annually

Minneapolis College of Art & Design 2501 Stevens Ave., S. Minneapolis MN 55404 Website: www.mcad.edu. **Amount:** Varies **Open to:** Undergraduates & graduates **Duration:** Up to four years **When offered:** Annually

Minnesota State Arts Board Park Square Court Ste. 200, 400 Sibley St. Saint Paul, MN 55101-1928. **Amount:** $8,000 (fellowships only) **Open to:** Professional artists in all disciplines who are residents of the state of Minnesota. Restriction: cannot be used for tuition, fees or work towards any degree **Duration:** One year **When offered:** Annually

Minnesota State University, Mankato, Dept. of Art 136 Nelson Hall Mankato, MN 56002-8400. **Amount:** Varies **Open to:** Recommended by faculty **Duration:** One year **When offered:** Annually

Miracosta College 1831 Mission Ave. Oceanside, CA 92056. **Amount:** $100-$500 **Open to:** All students **Duration:** One year **When offered:** Annually

Mississippi Delta Community College Dept. of Fine Arts Hwy. 3 & Cherry St., P.O. Box 668 Moorhead, MS 38761. **Amount:** Varies **Open to:** Students **Duration:** One year **When offered:** Annually

Mississippi University for Women Div. of Fine & Performing Arts 1100 College St. MUW-70 Columbus, MS 39701. **Amount:** $200-$1,600 **Open to:** Art majors **Duration:** One year; renewable **When offered:** Annually

Missouri Southern State College Art Dept. 3950 E. Newman Rd. Joplin, MO 64801-1595 Tel: 417-625-9563; Fax: 417-625-3046. **Amount:** $250-$2,000 **Open to:** All art majors **Duration:** One year **When offered:** Annually

Missouri Western State University Art Dept. 4525 Downs Dr. Saint Joseph, MO 64507. **Amount:** Varies **Open to:** Any qualifying student majoring in art **Duration:** By semester **When offered:** By semester

Monmouth College, Dept. of Art McMichael Academic Hall Monmouth, IL 61462 Tel: 309-457-2311; Fax: 309-734-7500. **Open to:** Transfer & incoming freshman **When offered:** Annually

Montana State University - Billings Art Dept. 1500 University Dr. Billings, MT 59101-0298. **Open to:** Full time art majors **Duration:** One semester-one year **When offered:** Annually

Montana State University School of Art 213 Haynes Hall, P.O. Box 173680 Bozeman, MT 59717-3680. **Amount:** $1,000 & up **Open to:** High school seniors **Duration:** One year **When offered:** Annually

Monterey Museum of Art 559 Pacific St. Monterey, CA 93940. **Amount:** $100 monthly **Open to:** All students **Duration:** One year **When offered:** Annually; deadline for application Nov 15.

Montgomery Museum of Fine Arts One Museum Dr. Montgomery, AL 36117 **Amount:** $3,200 stipend **Open to:** Currently enrolled or recent graduates of a Masters program in studio art, art history, art education or museum education **Duration:** Full-time, 15-week period **When offered:** Annually

Montserrat College of Art 23 Essex St., Box 26 Beverly, MA 01915 Tel: 978-921-4242; Fax: 978-922-4268; E-mail: admiss@montserrat.edu; Website: www.montserrat.edu. **Amount:** Varying amounts **Open to:** All **Duration:** Up to four years **When offered:** Annually

Moore College of Art and Design 20th Street & the Parkway Philadelphia, PA 19103 Tel: 215-568-4515; Fax: 215-568-8017; E-mail: info@moore.edu. Website: www.moore.edu. **Amount:** $35,000 **Open to:** Moore College students, junior-year **Duration:** One year **When offered:** Annually

Four Fellowships **Amount:** $75,000 (total) **Open to:** Moore College students, junior-year **Duration:** One year **When offered:** Annually

Moravian College, Dept. of Art 1200 Main St., Church St. Campus Bethlehem, PA 18018. **Amount:** $1,000-$8,000 **Open to:** Meritorious students in financial need **Duration:** One year **When offered:** Annually

The Morikami Museum & Japanese Gardens 4000 Morikami Park Rd. Delray Beach, FL 33446 Tel: 561-495-0233; Fax: 561-499-2557; E-mail: morikami@co.palm-beach.fl.us. **Amount:**

Scholarships $2,500 **Open to:** High school seniors in Palm Beach County **Duration:** One Year **When offered:** Annually

Morningside College 1501 Morningside Ave. Sioux City, IA 51106 Tel: 712-274-5219; E-mail: bowitz@morningside.edu. **Amount:** $1,000-$10,000 **Open to:** All **Duration:** Renewable every year **When offered:** Semi-annually

Morningside College, Art Dept. 1501 Morningside Ave. Sioux City, IA 51106. **Amount:** $1,000-$10,000 **Open to:** Incoming freshmen & transfer students **Duration:** Four years **When offered:** Semi-annually

Mount Allison University Dept. of Fine Arts, 53 York St. Sackville, NB E4L 1C9 Canada. **Amount:** Varies **Open to:** All students **Duration:** One year **When offered:** Annually

Mount Holyoke College Art Dept, 201 Art Building South Hadley, MA 01075-1499 Tel: 413-538-2200; Fax: 413-538-2167. **Amount:** Varies **Open to:** MHC graduates **Duration:** One year **When offered:** Annually

Mount Hood Community College Visual Arts Center 26000 S.E. Stark St. Breshum, OR 97030. **Amount:** Varies **Open to:** Varies **Duration:** Quarterly; annually **When offered:** Annually; semi-annually; quarterly

Mount Mary College 2900 N. Menomonee River Pkwy. Milwaukee, WI 53222 Tel: 414-258-2980; Fax: 414-256-1224; Website: www.mtmary.edu. **Amount:** $500 to full tuition **Open to:** Freshman to graduate students **Duration:** One year-four years **When offered:** Annually

Mount Mercy College, Art Dept. 1330 Elmhurst Dr., N.E. Cedar Rapids, IA 52402-4797 Tel: 319-363-4740; Fax: 319-363-5270. **Amount:** $500-$2,000 **Open to:** Art majors **Duration:** One year; renewable **When offered:** Annually

Mount Saint Mary's University, Visual & Performing Arts Dept. 16300 Old Emmitsburg Emmitsburg, MD 21727 Tel: 301-447-6122, ext. 5308; Fax: 301-447-5755. **Open to:** Incoming freshmen & rising sophomores **Duration:** Three to four years **When offered:** Annually

Mount Union College, Dept. of Art 1972 Clark Dr. Alliance, OH 44601. **Amount:** $6,000 per year **Open to:** Incoming freshmen **When offered:** Annually

Mount Vernon Hotel Museum & Garden 421 E. 61st St. New York, NY 10021 **Amount:** $2,750 **Open to:** Undergraduate & graduate students in related courses of study - by open application **Duration:** Eight weeks **When offered:** Summer

Munson-Williams-Proctor Institute School of Art 310 Genesee St. Utica, NY 13502. **Open to:** College credit students **Duration:** One year **When offered:** Semi-annually

Murray State University Dept. of Art 604 Fine Arts Bldg. Murray, KY 42071-3342. **Amount:** $500-$2,000 departmental/collegiate scholarships **Open to:** Incoming freshmen & students majoring in art at Murray State University (portfolio required) **Duration:** One year **When offered:** Annually

Amount: Varies **Open to:** All **Duration:** Varies **When offered:** Annually

Amount: Varies (Presidential University Scholars & Academic Scholarships) **Open to:** Graduating high school seniors **Duration:** One-four years **When offered:** Annually

Muscarelle Museum of Art College of William and Mary Lamberson Hall, P.O. Box 8795 Williamsburg, VA 23187-8795. **Amount:** College credit only **Open to:** Students from College of William and Mary **Duration:** Semester **When offered:** Semi-annually

The Museum of Arts and Sciences Inc. 352 S. Nova Road Daytona Beach, FL 32114 **Amount:** Varies **Open to:** Interns with college training **Duration:** One year **When offered:** Annually

Museum of Early Southern Decorative Arts Summer Institute P.O. Box 10310 Winston-Salem, NC 27108-0310. **Amount:** $300-$350 fellowship for partial summer institute tuition **Open to:** Graduate students in history, art history, preservation, museum studies; museum personnel **Duration:** June-July (four weeks) **When offered:** Annually

Museum of Fine Arts, Houston 1001 Bissonnett Houston, TX 77265. **Amount:** Varies **Open to:** Post-graduate artists, writers **Duration:** One year **When offered:** Annually

Museum of the American Quilter's Society 215 Jefferson St., P.O. Box 1540 Paducah, KY 42002-1540. **Amount:** $400 **Open to:** Workshop participants & students **Duration:** Per class **When offered:** Semi-annually

Museum of the American Quilter's Society 215 Jefferson Paducah, KY 42002-1540 Tel: 270-442-8856; Fax: 270-442-5448; E-mail: info@quiltmuseum.org. **Amount:** $200-$400 **Open to:** General public quilters **When offered:** Annually

Muskegon Community College, Dept. of Creative & Performing Arts 221 S. Quarterline Rd. Muskegon, MI 49442 Tel: 231-773-9131, ext. 324; Fax: 231-777-0255. **When offered:** Semi-annually

Muskoka Arts and Crafts, Inc. Box 376 Bracebridge, ON P1L 1T7 Canada. **Amount:** $1,200 **Open to:** Graduating high school student from Muskoka pursuing a post-secondary education in the visual arts **Duration:** One year **When offered:** Annually

Mystic Arts Center 9 Water St. Mystic, CO 06355 Tel: 860-536-7601; Fax: 860-536-0610; E-mail: maa@mystic-art.org. **Amount:** Varies **Open to:** All in need **Duration:** For individual classes **When offered:** Upon request

National Academy of Design School of Fine Arts 5 E. 89th St. New York, NY 10128 Tel: 212-996-1908; Fax: 212-426-1711. **Amount:** Total $80,000 per year **Open to:** All need & merit based applicants **Duration:** One year **When offered:** Semi-annually

National Gallery of Art 3rd & 9th @ Constitution Ave., N.W. Washington, DC 20565 Tel: 202-737-4215 **Amount:** Varies **Open to:** pre-doctoral students **Duration:** One-three years **When offered:** Annually

National Gallery of Canada 380 Sussex Dr. Ottawa, ON K1N 9N4 Canada. **Amount:** $3,000-$15,000 **Open to:** Teachers, artists, art historians, curators, conservators & other scholars **Duration:** Three-five months **When offered:** Annually

National Institute of Art & Disabilities 551 23rd St. Richmond, CA 94804. **Amount:** Free or discounted attendance **Open to:** Adults with developmental disabilities

National League of American Pen Women 1300 17th St., N.W. Washington, DC 20036 Email: NLAPW1@verizon.net. **Amount:** $1,000 (one in each Letters, Music & Art) **Open to:** Non Pen Women (35 & over) **Duration:** Varies **When offered:** Every 2 years

National Sculpture Society 237 Park Ave. New York, NY 10017 Tel: 212-764-5645; Website: www.nationalsculpture.org. **Amount:** $2,000 **Open to:** Figurative or realist sculpture students preferred **Duration:** One academic year **When offered:** Annually

Navarro College Art Dept Computer Art Multimedia Technology, 3200 W. 7th Corsicana, TX 75110. **Amount:** (20) $200-$600 each **Open to:** Art majors or any art field, granted based on a portfolio review & interview **Duration:** One year **When offered:** Annually

Nazareth College of Rochester Art Dept., 4245 East Ave. Rochester, NY 14618. **Amount:** $2,000-$5,000 **Open to:** Qualified high school graduates **Duration:** Four years **When offered:** Annually

Nebraska Wesleyan University Art Department 5000 St. Paul Lincoln, NE 68504-2794. **Amount:** $1,250 per year **Open to:** Incoming first year students **Duration:** Four years through graduation, depending on progress **When offered:** Annually

New England College 24 Bridge St. Henniker, NH 03242. **Amount:** $1,500 **Open to:** Art Majors **Duration:** One Year **When offered:** Annually

New Hampshire Institute of Art 148 Concord St. Manchester, NH 03104-4858. **Amount:** Varies **Open to:** All students **Duration:** Semester course **When offered:** Three semesters per year

New Haven Paint & Clay Club, Inc The John Slade Ely House, 51 Trumbull St. New Haven, CT 06511. **Amount:** $750 Awards total **Open to:** Local high school students who exhibit their artwork & submit a portfolio **When offered:** Annually

New Jersey City University, Art Dept. 2039 Kennedy Blvd. Jersey City, NJ 07305. **Amount:** Varies **Open to:** Applicants with appropriate SAT scores, recommendations **Duration:** Varies **When offered:** Annually

New Mexico State University, Art Dept. Dept. 3572, P.O. Box 30001 Las Cruces, NM 88003 Tel: 505-646-1705; Fax: 505-646-8036; E-mail: artdept@msu.edu. **Open to:** Enrolled art students **Duration:** One year **When offered:** Annually

New Orleans School of Glassworks Gallery & Printmaking Studio, 727 Magazine St. New Orleans, LA 70130. **Amount:** Based on funding available **Open to:** Faculty & students **Duration:** Summer or fall through spring semester **When offered:** Annually

New World School of Arts 300 N.E. Second Ave. Miami, FL 33132. **Amount:** 25%, 50% & full merit scholarships **Open to:** All U.S. & foreign students **Duration:** One-four years **When offered:** Annually

New York Academy of Art 111 Franklin St. New York, NY 10013 E-mail: info@nyaa.edu. **Amount:** $500-$5,000 **Open to:** MFA students **Duration:** Two years **When offered:** Annually

New York Historical Society 170 Central Park West New York, NY 10024 **Amount:** Varies **Open to:** Historians, Ph.D. & post doctoral **Duration:** Varies **When offered:** Semi-annually, summer

New York Institute of Technology Fine Arts Dept., Wheatley Rd., Northern Blvd. Old Westbury, NY 11568-8000. **Amount:** Varies **When offered:** Semi-annually

New York School of Interior Design 170 E. 70th St. New York, NY 10021 Tel: 212-472-1500; Fax: 212-472-3800; E-mail: admission@nysid.edu. **Amount:** up to $10,000 for MFA **Open to:** Full-time matriculated students **Duration:** One year; two years for the MFA fellowships **When offered:** Annually

Niagara County Community College 3111 Saunders Settlement Rd. Sanborn, NY 14132. **Amount:** Varies **Open to:** Residents of Niagara County **When offered:** Annually

Norman Rockwell Museum 9 Glendale Rd., Rte. 183 Stockbridge, MA 01262 Tel: 413-298-4100; Fax: 413-298-4142; E-mail: inforequest@nrm.org. **Amount:** $1,000 **Open to:** Local high school **Duration:** One year **When offered:** Annually

North Carolina State University P.O. Box 7306 Raleigh, NC 27695-7306. **Amount:** $1,000 **Open to:** NCSU students for study abroad **Duration:** One year **When offered:** Annually

North Central College Art Dept. 30 N. Brainard Naperville, IL 60566. **Amount:** Varies **Open to:** Art majors & minors **Duration:** One year **When offered:** Annually

North Dakota State University 1301 North University Fargo, ND 58105. **Amount:** $1,000 **Open to:** Freshman **Duration:** One year **When offered:** Annually

North Georgia College & State University Dahlonega, GA 30597. **Amount:** $1,500 per semester **Open to:** Undergraduate art majors **Duration:** Up to four years **When offered:** Annually

North Hennepin Community College 7411 85th Ave. N. Brooklyn Park, MN 55445. **Amount:** Varies (over 100 scholarships ranging from $100-$5,000) **Open to:** Various **Duration:** One-two years **When offered:** Annually

North Iowa Area Community College Dept. of Art 500 College Dr. Mason City, IA 50401. **Amount:** $4,000 total; range from $500-$1,000 **Open to:** Art majors **Duration:** One year **When offered:** Annually

North Shore Art League *Paul Weigner Memorial Scholarship and The Meta Fleisher Scholarship*, 620 Lincoln Ave. Winnetka, IL 60093 Tel: 847-446-2870; Fax: 847-446-4306; E-mail: nsal@sbcglobal.net. **Amount:** $750-$1,000 **Open to:** New Trier High School students **Duration:** One year **When offered:** Annually

Northeast Louisiana University Dept. of Art 700 University Ave., Stubbs 141 Monroe, LA 71209. **Amount:** $200 **Open to:** Top five full-time art students with portfolio **Duration:** One year **When offered:** Annually

Northeastern Illinois University Art Dept. 5500 N. St. Louis Chicago, IL 60625-4699. **Amount:** Full tuition **Open to:** Art majors **Duration:** One semester **When offered:** Semi-annually

Northern Illinois University School of Art DeKalb, IL 60115. **Amount:** Caroline Allrutz Scholarship - approx. $400 **Open to:** Art education majors in School of Arts with junior standing 3.0 GPA **Duration:** One year **When offered:** Annually
Amount: Chicago Book Clinic Award - approx. $1,000 **Open to:** Visual communication major with junior standing 3.0 GPA **Duration:** One year **When offered:** Annually
Amount: Cora B. Miner Scholarship - approx. $300 **Open to:** Preferably to NIU student from DeKalb County with interest in realistic art **Duration:** One year **When offered:** Annually
Amount: Dimitri Liakos endowment in art history - approx. $400 **Open to:** Art history major with junior standing 3.0 GPA **Duration:** One year **When offered:** Annually
Amount: Frances E. Gates Memorial Scholarship - approx. $400 **Open to:** Preferably an NIU graduate student specializing in watercolor **Duration:** One year **When offered:** Annually
Amount: Helen Merrit Arts Scholarship - approx. $450 **Open to:** Undergraduate or graduate student majoring in art or art history with preference to female students; 3.0 GPA **Duration:** One year **When offered:** Annually
Amount: Jack and Eleanor Olson Art Scholarships $2,000-$3,500 (2-3 generally awarded) **Open to:** Undergraduate or graduate students majoring in 2-D fine arts with preference for undergraduate in painting or drawing; 3.25 GPA **Duration:** One year **When offered:** Annually

Amount: Jack Arends Scholarship - approx. $800 **Open to:** Art majors with 3.0 overall GPA, one year residence at NIU, portfolio & degree recommendations (two from NIU School of Art) **Duration:** One year **When offered:** Annually

Amount: James Asbury Memorial Art Scholarship - approx. $450 **Open to:** Undergraduate & graduate students majoring in time arts or art history with 3.0 GPA **Duration:** One year **When offered:** Annually

Amount: James P. Bates Memorial Scholarship - approx. $500 **Open to:** Rotated among NIU majors in the area of School of Art **Duration:** One year **When offered:** Annually

Amount: John X. Koznarek Memorial Scholarship - approx. $1,000 **Open to:** Enrolled majors in studio art; portfolio & three recommendations **Duration:** One year **When offered:** Annually

Amount: NIU Tuition Waiver-tuition fee for Illinois residents or out-of-state award equal to in-state amount **Open to:** Incoming freshmen art majors; must maintain 2.5 overall GPA & 3.0 art GPA; awarded by Portfolio Competition **Duration:** Two years **When offered:** Annually

Amount: Peg Bond Scholarship - approx. $1,000 **Open to:** Awarded to an undergraduate art education major, minimum 3.0 GPA overall, art portfolio & brief paper on subject of the teaching of art as a profession must be submitted **Duration:** One year **When offered:** Annually

Amount: Richard Keefer Scholarship - approx. $350 **Open to:** Art majors-rotated among four areas-art history & art education; drawing, printing & printmaking; crafts & sculpture; design & photography **Duration:** One year **When offered:** Annually

Northern Kentucky University, Art Dept. Nunn Dr. Highland Heights, KY 41099 Tel: 859-572-5421; Fax: 859-572-6501. **Amount:** Full & partial tuition **Open to:** Declared art majors **Duration:** One year **When offered:** Annually

Northern Michigan University Dept of Art & Design, 1401 Presque Isle Ave. Marquette, MI 49855. **Amount:** $1,000 **Open to:** Entering freshmen **Duration:** One year **When offered:** Annually
Amount: $800 **Open to:** Continuing Students **Duration:** One year **When offered:** Annually

Northern State University Dept. of Art, 1200 S. Jay St. Aberdeen, SD 57401-7198. **Amount:** $200-$1,000 **Open to:** All students **Duration:** One year **When offered:** Annually

Northern Virginia Fine Arts Association at the Athenaeum 201 Prince St. Alexandria, VA 22314 Tel: 703-548-0035; Website: www.nvfaa.org. **Amount:** Varies **Open to:** Talented dancers for NVFAA's Alexandria Ballet **Duration:** Semester **When offered:** Annually

Northwest College 231 West 6th St. Powell, WY 82435. **Amount:** Maximum $1,000 per person per year; (3) $2,000 scholarships at $1,000 per year for two years **Open to:** All students, portfolio required **When offered:** Annually

Amount: One $350 scholarship **Open to:** All students, portfolio required Powell High School Grad; need is a factor **Duration:** One year **When offered:** Annually

Amount: One scholarship-amount varies **Open to:** All students, portfolio required Powell High School Grad; need is a factor **Duration:** One year **When offered:** Annually

Northwest Missouri State University Dept. of Art, 800 University Dr. Maryville, MO 64468. **Amount:** 25-50% tuition **Open to:** Freshmen & upperclassmen **Duration:** One year **When offered:** Annually

Northwestern College Art Dept., 101 7th S.W. Orange City, IA 51041. **Amount:** $300-$2,000 **Open to:** Varies **Duration:** One year **When offered:** Annually

Northwestern State University Natchitoches LA 71497. **Amount:** $9,000 **Open to:** Full-time NSU students in art programs **Duration:** One year **When offered:** Annually

Northwood University Alden B. Dow Creativity Center *Fellowships*, 4000 Whiting Dr. Midland, MI 48640-2398 Tel: 989-837-4478; Fax: 989-837-4468; E-mail: creativity@northwood.edu; Website: www.northwood.edu/abd. **Open to:** Anyone who has a creative and innovative idea to pursue **Duration:** Mid-June to mid-August **When offered:** Annually

Amount: $750 stipend room & board, per diem **Open to:** Individuals with creative projects **Duration:** Ten weeks, mid-June to mid-August **When offered:** Annually

Nossi College of Art 907 Rivergate Pkwy. Goodlettsville, TN 37072. **Amount:** $2,400 per student **Open to:** Applicants of NCA **Duration:** Two years **When offered:** Per semester

Notre Dame de Namur University, Dept. of Art 1500 Ralston Ave. Belmont, CA 94002 Tel: 650-508-3595; Fax: 650-508-3488. **Open to:** Emerging artists **When offered:** Annually

Nova Scotia College of Art & Design 5163 Duke St. Halifax, NS B3J 3J6 Canada **Amount:** $500-$1,500 (CN) **Open to:** Students at NSCAD **Duration:** One year **When offered:** Annually

Noyes Art Gallery 119 S. 9th Ave. Lincoln, NE 68508. **Amount:** Tuition of an art class **Open to:** Nebraska artist **Duration:** Length of class **When offered:** Annually

Oakland City University 139 N. Lucretia St. Oakland City, IN 47660 Tel: 812-749-4781, ext. 274; E-mail: dhazelwo@oak.edu. Website: www.oak.edu. **Amount:** 1/2 & 3/4 tuition **Open to:** Students with strong portfolios & solid academics **Duration:** Four years based on 'B' average in art **When offered:** Annually

Ocean City Arts Center 1735 Simpson Ave. Ocean City, NJ 08226 Tel: 609-399-7628; Fax: 609-399-7089; E-mail: ocarts@pro-usa.net. **Amount:** $1,500 **Open to:** Ocean City high school graduates majoring in arts university **Duration:** One year **When offered:** Annually

Ocean County College Humanities Department College Dr., P.O. Box 2001 Toms River, NJ 08754-2001. **Amount:** Varies **Open to:** Any applicant **Duration:** One year **When offered:** Annually

Ohio Northern University, Dept. of Art Wilson Art Center, 525 S. Main St. Ada, OH 45810 Tel: 419-772-2160; Fax: 419-772-2164. **Amount:** Petrillo Award $700-$1,000 **Open to:** One junior & one senior **Duration:** One year **When offered:** Annually

Amount: Talent awards - varies based upon review of portfolio **Open to:** Freshman **Duration:** One year **When offered:** Annually

Ohio State University 154 W. 12th Ave. Columbus, OH 43214. **Amount:** $1,500/yr **Open to:** Graduate & undergraduate art majors **When offered:** Annually

Amount: Barnett Fellowship-$1,000 per month **Open to:** Newly admitted graduate students in Arts Policy & Admin. Program **Duration:** One year **When offered:** Annually

The Ohio State University Dept. of Art Education 128 N. Oval Mall, 258 Hopkins Hall, Columbus, OH 43210. **Amount:** $12,000 **Open to:** Incoming graduate students in Arts Policy & Admin. Program **Duration:** Two years **When offered:** Annually

Ohio State University Graduate School 250 & 247 University Hall, 230 N. Oval Mall Columbus, OH 43210-1366. **Amount:** (1) Graduate associates; Starts at $9,027, plus tuition waivers; (2) Fellowships -Start at $12,006 plus tuition waivers plus tuition waivers **Open to:** All MA & PhD candidates **Duration:** 9-12 months **When offered:** Annually

Ohio University - Eastern Campus 45425 National Rd. W. Saint Clairsville, OH 43950. **Open to:** Varies **Duration:** One year **When offered:** Annually

Ohio University, School of Art College of Fine Arts Athens, OH 45701. **Amount:** Tuition scholarships, graduate teaching assistantships **Open to:** Undergraduate & graduate students **Duration:** One year; renewable **When offered:** Annually

Okanagan University College 1000 K.L.O. Rd. Kelowna, BC V1Y 4X8 Canada. **Amount:** A number of scholarships available; 20 Fine Arts specific scholarships with additional institutional open scholarships available **Open to:** Varies **Duration:** One year **When offered:** Annually

Oklahoma Baptist University 500 W. University Shawnee, OK 74804. **Amount:** $1,000 **Open to:** Art majors **Duration:** One year **When offered:** Annually

Oklahoma Christian University P.O. Box 11000 Oklahoma City, OK 73136-1100. **Amount:** $1,000 **Open to:** Entering freshmen **Duration:** Five years **When offered:** Annually

Oklahoma City University 2501 N. Blackwelder Oklahoma City, OK 73106. **Amount:** Varies **Open to:** Art majors attending Oklahoma City University **Duration:** Continuing based on specific criteria **When offered:** Annually

Oklahoma State University Dept. of Art 108 Bartlett Center Stillwater, OK 74078-4085. **Amount:** $29,000 ($10,000 to fresh., $19,000 soph-junior-senior) **Open to:** Incoming freshmen & continuing art majors **Duration:** One year **When offered:** Annually

Oklahoma State University, Graphic Arts Dept. 1801 E. Fourth Okmulgee, OK 74447. **Amount:** $1,000 **Open to:** All students **Duration:** Nine semesters **When offered:** Semi-annually

Old Dominion University Visual Arts Bldg., Rm. 203 Norfolk, VA 23529 Tel: 757-683-4047; Fax: 757-683-5923; E-mail: rrlove@odu.edu. **Amount:** $8,588 **Open to:** All undergraduates & graduate students **Duration:** One year **When offered:** Annually

Old York Historical Society P.O. Box 312, 207 York St. York, ME 03909 Tel: 201-363-4974; Fax: 207-363-4021. **Amount:** $2,400 (summer internship housing offered with stipend) **Open to:** Graduate students & senior level undergraduates **Duration:** Twelve weeks, summer **When offered:** Annually

Olive Hyde Art Gallery P.O. Box 5006, 123 Washington Blvd. Fremont, CA 94537. **Amount:** $500-$1,000 **Open to:** College entry students **Duration:** One year **When offered:** Annually

Ontario College of Art & Design 100 McCaul St. Toronto, ON M5T 1W1 Canada. **Amount:** Varies **Open to:** All students **When offered:** Annually

Oregon College of Art & Craft 8245 S.W. Barnes Rd. Portland OR 97225 Tel: 503-297-5544; Fax: 503-297-3155; E-mail: jcreasman@ocac.edu. **Amount:** $11,500 **Open to:** New & current students **Duration:** One year; $5,000 merit scholarship runs for four years **When offered:** Annually

Amount: $97,000 **Open to:** BFA students **Duration:** One year; four years **When offered:** Annually

Oregon Historical Society Library 1200 S.W. Park Ave. Portland, OR 97205 Tel: 503-222-1741. **Amount:** $3,000 plus tuition remission **Open to:** Portland State University graduate history students **Duration:** One year **When offered:** Annually

Amount: Tuition remission equaling $350 **Open to:** Students of annual summer course in oral history held at Portland State University **Duration:** Summer **When offered:** Annually

Oregon State University, Dept. of Art 101 Waldo Hall Corvallis, OR 97331-3702 Website: http://oregonstate.edu/dept/arts.

Amount: $100-$1,500 **Open to:** Anyone **Duration:** One year; renewable **When offered:** Annually

Osoyoos & District Arts Council P.O. Box 256 Osoyoos, BC V0H 1V0 Canada. **Amount:** 1) Fine Arts Scholarship-$500 **Open to:** Osoyoos Secondary School **When offered:** Annually

Amount: 2) Dorothy Fraser Award for Piano-perpetual trophy & $50 monetary award **Open to:** Student who obtains the highest mark in any Canadian Board Exam for the current year in Osoyoos & District Area **When offered:** Annually

Amount: 3) Arts & Business Award **Open to:** Local Business or group that has given considerable assistance to the Osoyoos & District Arts Council for the past year

Amount: 4) Music & Voice Scholarship **Open to:** Voice or music students who obtain the highest marks in grades one to seven & up; must be in membership area of Osoyoos & District Arts Council **When offered:** Annually

Otis College of Art and Design 9045 Lincoln Blvd. Los Angeles, CA 90045 Tel: 800-527-0775; 6847. E-mail: otisinfo@otis.edu; Website: www.otis.edu. **Amount:** $25,100 tuition and fees for 2004-05 (subject to change) **Duration:** Four years-undergraduate program **When offered:** Semester system, terms beginning Fall and Spring

Otterbein College One Otterbein College Westerville, OH 43081 Tel: 800-488-8144; E-mail: uotterb@otterbein.edu. **Amount:** $500-$4,000 **Open to:** New, incoming student **Duration:** Renewable for four years **When offered:** Annually

Ouachita Baptist University 410 Ouachita St. Arkadelphia, AR 71998. **Amount:** Varies **Open to:** Anyone

Our Lady of the Lake University 411 S.W. 24th St. San Antonio, TX 78207. **Amount:** Varies **Open to:** All undergraduate applicants based on ACT/SAT scores & high school GPA **Duration:** Up to eight semesters **When offered:** Annually

Pacific Lutheran University Art Dept., 1241 N.W. Johnson St. Tacoma, WA 98447. **Amount:** $1,000-$3,000 **Open to:** All enrolled students **Duration:** One year **When offered:** Annually

Pacific Northwest College of Art 1241 N.W. Johnson St. Portland, OR 97209. **Amount:** Varies **Open to:** Incoming & enrolled students **Duration:** One year **When offered:** Annually

Pacific Union College, Art Dept. 1 Angwin Ave. Angwin, CA 94508. **Amount:** $1,000 **Open to:** New students **Duration:** One year **When offered:** Annually

Pacific University in Oregon Arts Division, Dept. of Art 2043 College Way Forest Grove, OR 97116. **Amount:** Varies **Open to:** Sophomores through seniors **Duration:** One year; can be extended **When offered:** Annually

Palm Beach Community College Division of Fine Arts 4200 Congress Ave. Central Campus Lake Worth, FL 33461. **Amount:** $5,000 art scholarship **Open to:** Entering freshmen; beginning sophomores; merit based on GPA **Duration:** One year **When offered:** Annually & semi-annually

Palomar College *Lake San Marcos Art League Award*, 1140 W. Mission Rd. San Marcos, CA 92069. **Amount:** $100 **Open to:** Returning sophomores majoring in art
Ivie Frances Wickam Scholarships **Amount:** $500-$5,000 **Open to:** Current women graduates of palomar College who are evident of financial need, evidence of scholastic record; preference is given to art music & education students

Palos Verdes Art Center 5504 W. Crestridge Rd. Rancho Palos Verdes, CA 90275 Tel: 310-541-2479; Fax: 310-541-9520; E-mail: info@pvartcenter.org. **Amount:** Varies, up to $3,000 **Open to:** Residents of Southwestern Los Angeles County, CA **Duration:** Varies **When offered:** Applications due Feb 28 each year

Paris Junior College, Art Dept. 2400 Clarksville St. Paris, TX 75460. **Open to:** Full-time students enrolled at PJC **Duration:** Two semesters (fall-spring) **When offered:** Annually

Pasadena City College Art Dept. 1570 E. Colorado Ave. Pasadena, CA 91107. **Amount:** Various scholarships from $500-$2,500 **Open to:** Students with 3.5 GPA in art & have completed 12 units **Duration:** One year **When offered:** Annually

Pastel Society of the West Coast Roseville Arts Center 424 Oak St. Roseville, CA 95789. **Amount:** $500 **Open to:** Graduating high school seniors pursuing art: Contact Carryl Brown, P.O. Box 777, Magalia, CA 95954-0777 **When offered:** Annually; qualifying counties/school districts rotate

Peabody Essex Museum E. India Sq. Salem, MA 01970. **Amount:** Varies **Open to:** Graduate students in American Studies at Boston University **Duration:** One year **When offered:** Annually

Pearl River Community College 101 Highway 11 N. Poplarville, MS 39470 Tel: 601-403-6801; Fax: 601-403-1138; Website: www.prcc.edu. **Amount:** Half tuition **Open to:** Entering freshmen art majors **Duration:** Four semesters **When offered:** Annually

Pemaquid Group of Artists P.O. Box 105 South Bristol, ME 04568-0105. **Amount:** $1,000 & up **Open to:** designated art-related organizations **When offered:** Annually

The Pen and Brush, Inc. 16 E. Tenth St. New York, NY 10003-5958. **Amount:** $1,000 **Open to:** Chosen by governing board, open to women only - submissions through educational facility or with sponsorship institution/professor directly to Pen and Brush **Duration:** One year **When offered:** Annually

Pence Gallery Brunelle Curatorial Fellowship 212 D St., P.O. Box 73583 Davis, CA 95616 Tel: 530-758-3370; Fax: 530-758-4670; E-mail: pencegallery@davis.com. **Amount:** $200 **Open to:** Qualified

university students seeking a career in museums **Duration:** One semester; one quarter **When offered:** Annually

Penland School of Crafts P.O. Box 37 (67 Doras Trail) Penland, NC 28765. **Amount:** Varies **Open to:** All students over 19 years old, all levels of experience **Duration:** One-eight weeks; March-Nov. **When offered:** Annually

Pennsylvania Academy of the Fine Arts 128 N. Broad St. Philadelphia, PA 19102 Website: www.pafa.org. **Amount:** Based on need & ranking **Open to:** Full-time students **Duration:** One year **When offered:** Semi-annually

Pennsylvania School of Art & Design 204 N. Prince St., P.O. Box 59 Lancaster, PA 17608-0059. **Amount:** 1/2 year's tuition **Open to:** Freshmen **Duration:** Through graduation if 3.0 GPA is maintained **When offered:** Annually

Pensacola Junior College Visual Arts Dept. 1000 College Blvd. Pensacola, FL 32504-8998. **Amount:** $1,200 **Open to:** Incoming freshmen by portfolio review **Duration:** One year **When offered:** Annually

Peru State College Art Dept. P.O. Box 10, 600 Hoyt St. Peru, NE 68421. **Amount:** $300 **Open to:** All art majors, freshmen to seniors **Duration:** One year; renewable based on performance **When offered:** Annually

Peters Valley Craft Center 19 Kuhn Rd. Layton, NJ 07851. **Amount:** Up to $425, also work exchange possibilities **Open to:** Art teachers, college students & a limited number of high school students **Duration:** Five-day workshop **When offered:** Annually

Peters Valley Craft Education Center 19 Kuhn Rd. Layton, NJ 07851 Tel: 973-948-5200; Fax: 973-948-0011. **Amount:** Full & 1/2 tuition (scholarships on work exchange basis) **Open to:** College students/art teachers/high school student (17 & up) **When offered:** Annually

Phillips Exeter Academy, Mayer Art Center & Lamont Gallery, Tan Lane @ Front St. Exeter, NH 03833. **Amount:** Varies **Open to:** Students with financial need **When offered:** Annually

Piedmont Arts Association 215 Starling Ave. Martinsville, VA 24112. **Amount:** $3,000 **Open to:** High school graduates from Martinsville & Henry County pursuing visual or performing arts in college **Duration:** One year **When offered:** Annually

Pittsburg State University Art Dept. 1701 S. Broadway St. Pittsburg, KS 66762-7512. **Amount:** Varies **Open to:** Art majors **Duration:** One semester **When offered:** Annually

Plastic Club Art Club 247 S. Camac St. Philadelphia, PA 19107. **Amount:** Free membership **Open to:** Graduating seniors from Pennsylvania Academy of the Fine Arts, Temple University Tyler School of Art, Moore College of Art, University of the

Arts - two students from each school, chosen by faculty **Duration:** Two years **When offered:** Annually

Plum Tree Fine Arts Program, P.O. Box 1-A Pilar, NM 97531. **Amount:** 50% of tuition **Open to:** Residents of New Mexico **Duration:** Workshop session **When offered:** Annually

Plymouth State University 17 High St. Plymouth, NH 03264. **Amount:** $1,000-$2,000 **Open to:** Various criteria, including high scholarship & achievement **Duration:** Scholarships one year, fellowships one semester **When offered:** Annually

Polk Community College Arts, Letters & Social Sciences 999 Ave. H N.E. Winter Haven, FL 33881. **Amount:** Varies **Open to:** Working students **Duration:** One year **When offered:** Semi-annually

Pomona College Dept of Art & Art History 145 E. Bonita Ave. Claremont, CA 91711. **Amount:** Based on need **Open to:** Enrolled students **Duration:** Academic period **When offered:** Annually

The Ponca City Art Association 819 E. Central Ponca City, OK 74602. **Amount:** $250 **Open to:** Local art student **Duration:** One year **When offered:** Annually

Portland Community College P.O. Box 19000 Portland, OR 97280-0990. **Amount:** Tuition grants **Open to:** Art majors **Duration:** One year **When offered:** Annually

Portland State University Dept. of Art P.O. Box 751 Portland, OR 97207. **Amount:** Varies **Open to:** Art major currently enrolled at PSU with 20 hrs in art at time of application. Good cumulative GPA & portfolio also required **Duration:** Academic year **When offered:** Annually-spring

Pratt Community College 348 NE SR 61 Pratt KS 67124 Tel: 620-672-5641; Fax: 620-672-5288. **Amount:** $250-full tuition & books **Open to:** Any KS resident **Duration:** One year, renewable **When offered:** Annually, Jan. 1st for next fall

Pratt Community College Art Dept. 348 N.E. SR61 Pratt, KS 67124. **Amount:** Varies; from $250 to full in-state tuition & books **Open to:** All **Duration:** One year **When offered:** Annually

Pratt Fine Arts Center 1902 S. Main St. Seattle, WA 98144-2206. **Amount:** $11,500 **Open to:** Emerging artists; glass & sculptural artists **When offered:** Annually

Pratt Manhattan 295 Lafayette St. New York, NY 10012. **Open to:** All students **Duration:** One year **When offered:** Annually

Prince George's Community College 301 Largo Rd Largo, MD 20774-2199. **Amount:** $300-$500 **Open to:** All students **Duration:** One year **When offered:** Annually

Pyramid Atlantic 6001 66th Ave. Riverdale, MD 20737. **Amount:** Internship for credit **Open to:** Undergraduates & graduates **Duration:** Negotiable **When offered:** All year
Amount: Residency program **Open to:** Artists **Duration:** One-four weeks **When offered:** All year

The Ramsay Foundation 1128 Smith St. Honolulu, HI 96817. **Amount:** $1,000 **Open to:** 501(c)(3) organizations for distribution to worthy art organizations of Hawaii **Duration:** One year **When offered:** Annually

Randall Museum 199 Museum Way San Francisco, CA 94114. **Amount:** Up to half of class fee ($30 maximum) **Open to:** Families & persons under 18 years of age **Duration:** Per course **When offered:** Five times per year

Redlands Art Assoc. 215 E. State St. Redlands, CA 92373 Tel: 909-792-8435. **Amount:** $250 **Open to:** High school seniors **Duration:** One year **When offered:** Annually

Regional Arts & Cultural Council 108 N.W. 9th Ave., Ste. 300 Portland, OR 97209. **Amount:** Up to $5,000 **Open to:** Professional artists & non-profits in Washington, Clackamas & Multnomah counties **Duration:** One year **When offered:** Annually

Rensselaer Community Historical Society 57 Second St. Troy, NY 12180. **Amount: Open to:** High school & graduate students with art history & history of American studies majors **Duration:** Ongoing

Rhode Island College 600 Mount Pleasant Ave. Providence, RI 02908. **Amount:** $600 **Open to:** Art majors **Duration:** One year **When offered:** Annually

Rhode Island School of Design Two College St. Providence, RI 02903. **Amount:** Varies **Open to:** Full-time students & graduate students **Duration:** One year **When offered:** Semi-annually

Rhodes College 2000 N. Pkwy. Memphis, TN 38112-1690. **Amount:** $10,000 **Open to:** High school seniors **Duration:** Four years **When offered:** Annually

Rice University 6100 Main St. Houston, TX 77005 Tel: 713-348-4815; Fax: 713-348-4039; E-mail: arts@rice.edu. **Amount:** Varies **Open to:** Majors

Rice University Dept. of Art & Art History P.O. Box 1892 Houston, TX 77251. **Amount:** Varies **Open to:** Art majors

Richmond Art Museum 350 Hub Etchison Pkwy. Richmond, IN 47374. **Open to:** Richmond High School graduates **When offered:** Annually

Ringling School of Art & Design 2700 N. Tamiami Trail Sarasota, FL 34234-5895. **Amount:** $500-$2,500 **Open to:** All full-time Ringling students **Duration:** One year, some semester grants, renewable **When offered:** Annually

Robert Blackburn Printmaking Workshop *Elizabeth Foundation for the Arts, Studio Center*, 323 W. 39th St., 2nd Fl. New York, NY 10018 Tel: 646-416-6226 E-mail: rbpmw@efa1.org; Website: http://efa1.org/RBPW **Amount:** Varies: scholarships, fellowships & guest residencies **Duration:** Based on scholarship, fellowship and/or residency **When offered:** Annually

Roberts Wesleyan College Art Dept. 2301 Westside Dr. Rochester, NY 14624-1997. **Amount:** $500-$1,500 **Open to:** Incoming new students, based on portfolio review **When offered:** Annually; renewable

Rochester Art Center 320 E. Center St. Rochester, MN 55904. **Amount:** Varies **Open to:** Low income families & individuals **Duration:** Length of workshop or class **When offered:** Ongoing

Rocky Mountain College of Art and Design 1600 Pierce St. Lakewood, CO 80214. **Amount:** Varies **Open to:** Full-time students **Duration:** One semester non-renewable **When offered:** Three times annually

Roger Williams University One Old Ferry Rd. Bristol, RI 02809. **Amount:** $750 **Open to:** Art majors concentrating in Fine Arts of freshman, sophomore & junior standing **Duration:** One year **When offered:** Annually

Roswell Museum & Art Center 100 W. 11th St. Roswell, NM 88201 Tel: 505-624-6744; Fax: 505-624-6765; E-mail: rufe@roswellmuseum.org. **Amount:** $9,000 **Open to:** Museum internship program **Duration:** Nine months **When offered:** Annually

Rutgers University Camden Fine Arts Ctr. 314 Linden St. Camden, NJ 08102. **Amount:** $1,500 **Open to:** Honor students **When offered:** Annually

Rutgers University, Newark Dept. of Visual & Performing Arts University Heights, 110 Warren St. Bradley Hall Rm. 254 Newark, NJ 07102. **Amount:** $5,000 **Duration:** Four year **When offered:** Once every four years

Sacred Heart University Dept. of Art 5151 Park Ave. Fairfield, CT 06432-1000. **Amount:** $500-$2,000 **Open to:** Full-time art majors **Duration:** One year **When offered:** Annually

Sage College of Albany, Dept. of Visual Arts 140 New Scotland Ave. Albany, NY 12208 Website: www.sage.edu. **Amount:** $2,000-$4,500 **Open to:** First year & transfer students **Duration:** Renewable up to 3 years **When offered:** Fall & Spring semesters

Saginaw Valley State University 7400 Bay Rd. University Center, MI 48710. **Amount:** $1,500-$2,500 **Open to:** Portfolio applicants **Duration:** Renewable each year attending **When offered:** By appointment

Amount: Fine Arts Awards - full tuition & fees **Open to:** High school seniors with 3.0 GPA; portfolio required **Duration:** One year; renewable up to three years **When offered:** Annually

Saint Ambrose University 518 W. Locust St. Davenport, IA 52803. **Amount:** $1,500-$2,500 **Open to:** Portfolio applicants **Duration:** Renewable each year attending **When offered:** By appointment

Saint Andrews Presbyterian College *Art Program*, 1700 Dogwood Mile Laurinburg, NC 28352. **Amount:** Up to $2,500 **Open to:** First year & transfer students **Duration:** Renewable for four years total **When offered:** Annually

Saint Anselm College 100 Saint Anselm Dr. Manchester, NH 03102. **Amount:** Varies **Open to:** Full-time students **Duration:** One year **When offered:** Annually

Saint Clair County Community College 323 Erie St., P.O. Box 5015 Port Huron, MI 48061-5015. **Amount:** Partial-full tuition **Open to:** Full and part-time students **Duration:** One year **When offered:** Annually

Saint Cloud State University, Dept. of Art 720 Fourth Ave. S. Saint Cloud, MN 56301. **Amount:** $300-$400 **Open to:** Undergraduate art majors **Duration:** One year **When offered:** Annually

Saint John's University 8000 Utopia Pkwy. Jamaica, NY 11439. **Amount:** Full tuition **Open to:** All senior high school students **Duration:** Four years **When offered:** Annually

Saint Joseph's University 5600 City Ave. Philadelphia, PA 19131 Tel: 610-660-1840; Fax: 610-660-2278; E-mail: dmcnally@sju.edu. **Amount:** Varies **Open to:** Economically challenged but gifted minority fine arts students **When offered:** Annually

Saint Louis Community College Florissant Valley 3400 Pershall Rd. Saint Louis, MO 63135-1499. **Amount:** Varies **Open to:** Full time students **Duration:** One year **When offered:** Annually

Saint Louis University Studio Art Dept. of Fine and Performing Arts 221 N. Grand Saint Louis, MO 63103 **Amount:** $1,000-$2,000 **Open to: Duration:** One year **When offered:** Annually

Saint Mary College 4100 S. 4th St. Leavenworth KS 66048 Tel: 913-758-6151; Fax: 913-758-6140; E-mail: nelsons@hub.smcks.edu. **Amount:** $500-$3,000 **Open to:** All new students **Duration:** Renewable for four years **When offered:** Annually

Saint Mary College, Art Program 4100 S. Fourth St. Leavenworth, KS 66048-5082. **Amount:** $500-$3,000 **Open to:** Any new student **Duration:** Four years; renewable **When offered:** Annually

Saint Mary's College, Dept. of Art Notre Dame, IN 46556. **Amount:** $500; $1,000; $2,500 **Open to:** Freshmen; upperclassmen **Duration:** One year **When offered:** Annually

Saint Mary's University of Minnesota, Art & Design Dept. 700 Terrace Heights Winona, MN 55987. **Amount:** Saint Miguel Art & Design Awards up to $1,000 **Open to:** Portfolio review **Duration:** One year; renewable **When offered:** Annually

Amount: Undergraduate studio assistantships up to $2,000 **Open to:** All (portfolio review) **Duration:** Four years **When offered:** Annually

Saint Olaf College, Dept. of Art & Art History 1520 Saint Olaf Ave. Northfield, MN 55057-1098. **Amount:** $1,000 & up **Open to:** Students based on need; competitive scholarship by portfolio **Duration:** One year **When offered:** Annually

Saint Petersburg College, Fine & Applied Arts at Clearwater Campus 2465 Drew St. Clearwater, FL 33765 Tel: 727-341-3600; 341-4360; 791-2611; Fax: 727-791-2605; Website: www.spcollege.edu. **Amount:** $1,500 **Open to:** Students who submit exceptional portfolios, to be determined by art faculty **Duration:** One year **When offered:** Varies

Saint Xavier University, Dept. of Art & Design 3700 W. 103rd St. Chicago, IL 60655. **Open to:** Keane Art/Music Scholarship **Duration:** Four years; renewable **When offered:** Biannually

S. Paul Keefe Scholarship **Amount:** Varies **When offered:** Annually

Amount: Varies; covers course tuition **Open to:** Smith Scholarship to School of Art of Chicago open to Saint Xavier art majors for courses not offered at SXU **Duration:** Per course **When offered:** Each semester

Saint-Gaudens National Historic Site *Trustees of Saint-Gaudens Memorial*, 17 E. 47th St. New York City, NY 10017-1920. **Amount:** $10,000 **Open to:** All practicing sculpture **Duration:** One year **When offered:** Annually

Salem State College Art Dept. 352 Lafayette St. Salem, MA 01970. **Amount:** Varies **Open to:** Art majors with a 3.0 GPA & who exhibit creativity, minorities also **Duration:** One year **When offered:** Annually

Salisbury State University Art Dept. 1101 Camden Ave. Salisbury, MD 21801 **Amount:** BFA $300-$500 each **Open to:** First-year students **Duration:** One year; renewable **When offered:** Annually

Salve Regina University Art Dept. 100 Ochre Point Ave. Newport, RI 02840-4192. **Amount:** Varies **Open to:** Based on financial need **Duration:** One-four years **When offered:** Annually

San Diego State University College of Professional Studies & Fine Arts, School of Art Design & Art History, 5500 Campanile Dr. San Diego, CA 92182-4805. **Amount:** Darryl Groover Memorial Scholarship, $500 **Open to:** Painting major **Duration:** Spring **When offered:** Annually

Amount: Ellamarie Wooley Art Student Assistance Scholarship, amount varies **Open to:** Art majors with completion of 45 units toward undergraduate degree **Duration:** Fall **When offered:** Annually

Amount: Haystack Mountain School of Crafts Scholarship **Open to:** Applied design undergraduates & graduates **Duration:** Summer **When offered:** Annually

Amount: Isabel Kraft Sculpture Scholarship, amount varies **Open to:** Undergraduate & graduate sculpture majors **Duration:** Fall **When offered:** Annually

Amount: John Rogers Scholarship **Open to:** Undergraduate & graduate sculpture majors **Duration:** Spring **When offered:** Annually

Amount: Patricia Clapp Scholarship, $500 **Open to:** Advanced undergraduate & graduate art majors enrolled in spring semester **Duration:** Fall **When offered:** Annually

Amount: Paul Lingren Memorial Scholarship, amounts vary **Open to:** Advanced undergraduate & graduate students **Duration:** Spring **When offered:** Annually

Amount: Robert D. Wallace History of Art Endowed Scholarship $1,300 **Open to:** Graduate art/history majors whose area of study is history of art to the 1900's **Duration:** Fall **When offered:** Annually

Amount: Sarah Warren San Diego Creative Weavers' Guild Scholarship, amount varies **Open to:** Weaving students **Duration:** Spring **When offered:** Annually

Amount: SDSU Art Council Scholarships, $450 **Open to:** Art majors with completion of 30 units of art **Duration:** Spring **When offered:** Annually

Amount: University Scholarship $1,000 **Open to:** Art major **Duration:** Fall & spring **When offered:** Annually

San Francisco State University 1600 Holloway San Francisco, CA 94132 Tel: 415-338-2176; E-mail: artdept@sfsu.edu. **Amount:** Varies **Open to:** BA & MFA 3rd year students **Duration:** One year **When offered:** Annually

San Joaquin Delta College, Delta Center for the Arts/Horton Gallery 5151 Pacific Ave. Stockton, CA 95207. **Amount:** Varies **Open to:** Varies **When offered:** Annually through exhibitions

San Jose State University School of Art & Design One Washington Square San Jose, CA 95192-0089 Tel: 408-924-4320; Fax: 408-924-4326; Website: www.sjsu.edu/depts/art_design. **Amount:** $2,000-$4,000 (tuition waiver for TA) **Open to:** TA/GA appointments **When offered:** Semester

Amount: $30,000-$40,000 **Open to:** Undergraduate & graduate students in art & design **Duration:** Variable **When offered:** Annually

Santa Ana College Art Gallery 1530 W. 17th St. Santa Ana, CA 92706. **Amount:** $50-$500 **Open to:** Students only **Duration:** Semester **When offered:** Annually

Santa Clara University 500 El Camino Real Santa Clara, CA 95053-0264 Tel: 408-554-4594; Fax: 408-554-4809. **Amount:** $2,000-$2,500 **Open to:** Junior studio majors **When offered:** Annually

Santa Fe Arts Institute 1600 St. Michael Dr. Santa Fe, NM 87505 Tel: 505-424-5050; Fax: 505-424-5051. **Open to:** Educators & students

Sawtooth School for Visual Art 226 N. Marshall St., Ste. D Winston-Salem, NC 27101. **Amount:** Up to half tuition **Open to:** All students **Duration:** Semester; renewable quarterly **When offered:** Quarterly

The School of Fashion Design 136 Newbury St. Boston, MA 02116. **Amount:** $300-$1,000 **Open to:** All currently enrolled full-time students returning for second/third year **Duration:** One year **When offered:** Annually

School of Fine Arts 38660 Mentor Ave. Willoughby, OH 44094. **Amount:** Varies **Open to:** Need, achievement & minority **Duration:** Per session **When offered:** 3 times a year; Fall, Spring & Summer

School of the Museum of Fine Arts 230 The Fenway Boston, MA 02115 Tel: 617-267-6100; Fax: 617-424-6271. **Amount:** Varies **Open to:** All applicants **Duration:** Length of program **When offered:** Annually

Scottsdale Artists' School 3720 N. Marshall Way Scottsdale, AZ 85251. **Amount:** Based on workshop or class tuition **Open to:** All students **Duration:** Based on length of workshop/class **When offered:** Annually

Sculpture Space Inc. 12 Gates St. Utica, NY 13502 Tel: 315-724-8381; Fax: 315-797-6639; E-mail: info@sculpture. **Amount:** $2,000 **Open to:** Professional artists **Duration:** Two months **When offered:** Annually

Seton Hall University College of Arts and Sciences 400 South Orange Ave. South Orange, NJ 07079. **Amount:** $500-$1,000 **Open to:** Art & art history majors **Duration:** One year **When offered:** Annually

Seton Hill University *Hensler-Irvin Scholarship*, One Seton Hill Dr. Greensburg, PA 15601 Tel: 800-826-6234. **Amount:** $3,000-$4,000 **Open to:** Incoming freshmen art majors **Duration:** Renewable **When offered:** Annually

Hensler-Irvin Art Scholarship **Amount:** $750 **Open to:** Incoming freshman art majors **Duration:** One year **When offered:** Annually

Josefa Filkosky Scholarship **Amount:** Varies **Open to:** Seton Hill University junior art majors **Duration:** One year **When offered:** Annually

Seward County Community College 1801 N. Kansas Ave., P.O. Box 1137 Liberal, KS 67905. **Amount:** $1,000 **Open to:** Art majors **Duration:** One year **When offered:** Annually

Sharon Arts Center 457 Rte. 123, RR2, Box 361 Sharon, NH 03458. **Amount:** Half the tuition of one class **Open to:** All **When offered:** Each term

Shepherd University, Art Dept. A02 Frank Ctr., P.O. Box 3210 Shepherdstown, WV 25443 Tel: 304-876-5254; Fax: 304-876-0955; E-mail: sevanisk@shepherd.edu. **Amount:** Varies **Open to:** All **Duration:** One year **When offered:** Annually

Amount: Varies (total $30,000) **Duration:** One year **When offered:** Annually

Sheridan College, School of Animation of Arts & Design *CBC English TV Scholarship*, 1430 Trafalgar Rd. Oakville, ON L6H 2L1 Canada.

Robert Munroe-Premier's Award

Second Chance Scholarship (OSOTF)
Much More Music Access Ability Scholarship
Glenna Carr Sheridan National Academic Scholarship
Amount: 3 scholarships of tuition subsidy of up to $5,000 each plus guarantee of a space in the Sheridan residence **Duration:** renewable for up to three years

Shoreline Community College Humanities Division 16101 Greenwood Ave. N. Seattle, WA 98133. **Amount:** $100-$1,000 **Open to:** Art majors **Duration:** One year **When offered:** Semi-annually

Siena Heights University Studio Angelico-Art Dept. 1247 E. Siena Heights Dr. Adrian, MI 49221. **Amount:** Varies **Open to:** Undergraduates **Duration:** One year **When offered:** Annually

Sierra Arts Foundation 17 S. Virginia St. Suite 120 Reno, NV 89501 Tel: 775-329-2787; Fax: 775-329-1328; E-mail: ill@sierra-arts.org. **Amount:** $500, $1,000, & $5,000 **Open to:** Anyone within a 100 mile radius of Reno **Duration:** One year **When offered:** Annually

Silvermine Guild Arts Center 1037 Silvermine Rd New Canaan, CT 06840 Tel: 203-966-6668, ext 2; Fax: 203-966-8570; E-mail: school@silvermineart.org. **Open to:** K-12, need based, ages 13-16: Toland talent-based scholarship **Duration:** for one course or camp session **When offered:** Annually

Simpson College 701 North C St. Indianola, IA 50125. **Open to:** Incoming students majoring in art **When offered:** Annually

Sinclair Community College 444 W. Third St. Dayton, OH 45402. **Amount:** Varies ($300-$1,000 **Open to:** Continuing art & design majors **Duration:** Quarterly **When offered:** Semi-annually

Sioux City Art Center 225 Nebraska St. Sioux City, IA 51101. **Open to:** Children upon recommendation of teacher **Duration:** Per class **When offered:** Quarterly

Skowhegan School of Painting and Sculpture 200 Park Ave. S., Ste. 1116 New York, NY 10003-1503. **Amount:** (9) Full scholarships $5,200 **Open to:** Adults 19 years of age & over (average age 27); slide review **Duration:** Nine weeks June-Aug. **When offered:** Annually
Amount: Assorted full & partial scholarships **Open to:** Artists 21 years of age & over (average age 28); slide & video review **Duration:** Nine weeks June-Aug. **When offered:** Annually

Smithsonian Institute Office of Fellowships 750 9th St., N.W., Suite 9300, MRC 902, P.O. Box 37017 Washington, DC 20013-7012 Tel: 202-275-0655; Website: www.si.edu/research. **Amount:** $15,000 **Open to:** Dissertation research for doctoral candidates in American art history, Oriental art history & African art **Duration:** 3-12 months **When offered:** Annually

Amount: $30,000 **Open to:** Post-doctoral scholars in American art history, Oriental art history & African art **Duration:** 3-12 months **When offered:** Annually; deadline Jan. 15

Amount: Freer Gallery Internship **Open to:** Interns must have working knowledge of one or more of the pertinent Oriental languages & submit a proposal relevant to the Freer collections

Amount: Harold P. Stern Memorial Fund at Freer Gallery **Open to:** Selection of recipients is by invitation only & is based upon outstanding scholarly achievements in the field of Japanese art

Amount: Hirshhorn Museum & Sculpture Garden Internship **Open to:** College juniors & seniors who have completed at least 12 semester hours in art history; graduate student internships are available for students in accredited art history graduate programs **Duration:** One semester **When offered:** Annually

Amount: National Museum of African Art Internship **Open to:** People enrolled in undergraduate & graduate programs of study & for people interested in exploring museum professions related to African art & museum work **Duration:** Ten weeks minimum **When offered:** Annually

Amount: National Museum of American Art Internship **Open to:** Museum training for college senior graduate students in art history, studio art & American studies **Duration:** Eight weeks, commences in June, Grad program during year **When offered:** Annually

Amount: National Portrait Internship **Duration:** Three months

Amount: Sidney & Celia Siegel Fellowship Program at Cooper-Hewitt **Open to:** Applicants with two years of college education, preference given to those with previous museum experience **Duration:** Ten weeks **When offered:** Annually

Smithsonian Institution Archives of American Art Office of Fellowships and Grants 750 9th St., N.W., Ste. 9300 Washington DC 20560-0902. **Amount:** Varies **Open to:** Guidelines for fellowships & paid internships available through Smithsonian Institution, Office of Fellowship & Grants **Duration:** Varies **When offered:** Outlined in Smithsonian opportunities

Society for Photographic Education 126 Peabody Hall, School of Interdisciplinary Studies, Miami University Oxford, OH 45056 Tel: 513-529-8328; Fax: 513-529-9301. **Amount:** $500 & 1 year student membership & national conference fee waiver **Open to:** Atudents & members **When offered:** Annually

The Society of Arts & Crafts 175 Newbury St. Boston, MA 02116. **Amount:** Artist Awards, amount $2,000 each (total 4 awards) **Open to:** New England craft artists, juried by an outside panel **When offered:** Semi-annually

Society of Decorative Painters 393 N. McLean Blvd Wichita, KS 67203. **Open to:** SDP members & chapters **When offered:** Annually

Socratees Sculpture Park P.O. Box 6259, Broadway @ Vernon Blvd. Long Island City, NY 11106 Tel: 718-956-1819; Fax: 718-626-1533; E-mail: info@socratessculpturepark.org. **Amount:** $4,000 **Open to:** Emerging artists **Duration:** One year **When offered:** Annually

South Carolina Arts Commission 1800 Gervais St. Columbia, SC 29201. Website: www.state.sc.us/arts. **Amount:** (6) $7,500 **Open to:** SC professional artists: visual arts, various categories **Duration:** One year **When offered:** Annually on a rotating basis

South Dakota Art Museum Medary Ave. at Harvey Dunn St., Box 2250 SDSU Brookings, SD 57007. **Amount:** $500 **Open to:** Art students of South Dakota State Univ. **Duration:** One year **When offered:** Annually

South Plains College Fine Arts Dept. - Art Program 1401 S. College Ave. Levelland, TX 79336. **Amount:** Varies **Open to:** Full-time students **Duration:** One year, renewable **When offered:** Annually

Southampton Art Society Box 115, Southampton, ON N0H 2L0 Canada. **Open to:** Area public school students **When offered:** Annually

Southampton College Long Island University 239 Montauk Hwy. Southampton, NY 11968-4196. **Amount:** $1,000-$6,000 **Open to:** Freshmen & transfer students who have applied for admission **Duration:** Up to four years **When offered:** Annually

Southern Adventist University Box 370 Collegedale, TN 37315. **Amount:** $200-$6,500 over four years **Open to:** Students with 3.5 GPA **Duration:** One-four years **When offered:** Annually

Southern Alberta Art Gallery 601 Third Ave. S. Lethbridge, AB T1J 0H4 Canada **Amount:** Varies **Open to:** Visual arts students at University of Lethbridge **When offered:** Annually

Southern Arkansas University 100 E. University Magnolia, AR 71753. **Amount:** $7,000-$8,000 **Open to:** Beginning freshmen & resuming students - performance based **Duration:** One year; renewable **When offered:** Semi-annually

Southern Illinois University Carbondale *Rickert Ziebold Trust award Competition*, School of Art and Design, Allyn 113-MC4301 Carbondale, IL 62901. **Amount:** $20,000 **Open to:** Graduating seniors **When offered:** Annually (one or more winners)
Talent Scholarship & Minority talent scholarship **Amount:** $500-$1,000 **Open to:** Incoming undergraduate students **Duration:** One year with possible renewal **When offered:** Annually

Southern Oregon University Dept. of Art 1250 Siskiyou Blvd. Ashland, OR 97520. **Amount:** $50-$2,000 **Open to:** Enrolled art students **When offered:** Annually

Southern Utah State University Dept. of Art, 351 West University Blvd. Cedar City, UT 84720. **Amount:** $700 up **Open to:** Freshmen-seniors **Duration:** One year **When offered:** Annually
Amount: Partial tuition **Open to:** Residents of Utah & nonresidents **Duration:** One year **When offered:** Annually & quarterly

Southwest Baptist University Art Dept. 1600 University Ave. Bolivar, MO 65613. **Amount:** $600 **Open to:** Freshmen & transfer students **Duration:** Four years **When offered:** Annually

Southwest Missouri State University 901 S. National Ave. Springfield, MO 65897. **Amount:** Varies **Open to:** Art & Design majors **Duration:** One year **When offered:** Annually

Southwestern Oklahoma State University Art Dept. 100 Campus Dr. Weatherford, OK 73096. **Amount:** $5,000 (approx.) **Open to:** Art majors both lower & upperclassmen **Duration:** One year **When offered:** Annually

Southwestern Oregon Community College 1988 Newmark Coos Bay, OR 97420. **Amount:** Full tuition **Open to:** Full-time degree students **Duration:** One year **When offered:** Annually

Southwestern University P.O. Box 770 Georgetown, TX 78627 Tel: 512-863-1504; Fax: 512-863-1422; E-mail: fannina@southwestern.edu. **Amount:** $3,000-$5,000 **Open to:** Southwestern art majors **Duration:** One year **When offered:** Annually

Springfield College 263 Alden St. Springfield, MA 01109. **Amount:** Varies **Open to:** All students **Duration:** One year **When offered:** Annually

Springfield Museum of Art 107 Cliff Park Rd. Springfield, OH 45501. **Amount:** $25-$100 **Open to:** Children & some adults **Duration:** Nine weeks **When offered:** Each quarter

St. Petersburg College P.O. Box 13489 St. Petersburg, FL 33733-3489 Tel: 727-791-2548; Fax: 727-791-2605. **Amount:** $1,400 **Open to:** Awarded to student based on portfolio **Duration:** One year

Stained Glass Association of America 10009 E. 62nd St. Raytown, MO 64133-4003 Tel: 1-800-888-7422; E-mail: sgaa@stainedglass.org; Website: www.stainedglass.org. **Amount:** $1,000-$2,000 **Open to:** Students & adult stained glass practitioners **Duration:** One-two week workshops **When offered:** Annually

State University of New York at Albany 1400 Washington Ave. Albany, NY 12222. **Amount:** $4,800 **Open to:** MFA students **Duration:** One and a half to two years **When offered:** Annually

State University of New York at Brockport 204 Tower Fine Arts Brockport, NY 14420-2985. **Amount:** Jack Wolsky Art Scholarship, amount varies **Open to:** Monroe County, NY resident art major **When offered:** Annually
Amount: Maurice J. Moss Fine Arts Scholarship; amount varies **Open to:** Any art major **When offered:** Annually
Amount: William P. Manitsas Memorial Scholarship in Art; amount varies **Open to:** Sophomore & junior art majors **When offered:** Annually
Amount: William Stewart Award in Visual Arts, amount varies **Open to:** Any art major **When offered:** Annually

State University of New York at Plattsburgh, Art Dept. 101 Broad St. Plattsburgh, NY 12901. **Amount:** Varies **Open to:** All art majors & one to two scholarships offered to art minors **Duration:** One year **When offered:** Spring

State University of New York at Stoney Brook, Dept. of College of Arts & Sciences A number of graduate scholarships, fellowships, teaching assistantships, graduate assistantships & undergraduate scholarships Staller Center Stoney Brook, NY 11794-5400 Tel: 631-632-7250; Fax: 631-632-7261. **Amount:** Varies **Open to:** All graduate and undergraduate students **Duration:** One year or duration of residency **When offered:** Annually

State University of New York College at Geneseo, Schools of the Arts, 1 College Circle Geneseo, NY 14454. **Amount:** $400-$500 **Open to:** Art studio & art history majors, minors, freshmen, sophomores & juniors **Duration:** One year **When offered:** Annually

The State University of West Georgia, Dept. of Art, 1601 Maple St. Carrollton, GA 30118. **Amount:** $6,000 plus waiver of tuition **Open to:** Graduate assistantship in art education **Duration:** One year **When offered:** Annually

Amount: $8,000 **Open to:** Enrolled undergraduate art majors **Duration:** One year **When offered:** Annually

Stauth Memorial Museum P.O. Box 396, 111 N. Aztec Montezuma, KS 67867 Tel: 620-846-2527; Fax: 620-846-2810; E-mail: stauth@ucom.net. **Amount:** $800 **Open to:** South Gray High School seniors **Duration:** One year **When offered:** Annually

Stephen F. Austin State University Art Dept., Box 13042 Nacogdoches, TX 75962. **Amount:** $5,200 **Open to:** Graduates, portfolio review **Duration:** Six semesters for MFA candidates, four semesters for MA candidates **When offered:** Annually

Sterling & Francine Clark Art Institute 225 South St. Williamstown, MA 01267 Tel: 413-458-9545; Fax: 413-458-2324; E-mail: info@clarkart.edu. **Amount:** Varies **Open to:** Art historians, humanists in acadamia, museum, or independent **Duration:** One month-one year **When offered:** Annually

Stetson University, Art Dept. Deland, FL 32724 Tel: 386-822-7266. **Amount:** $1,000-$4,000 per year **Open to:** Art majors **Duration:** One year **When offered:** Annually

Sul Ross State University Dept. of Art, P.O. Box C-114 Alpine, TX 79832. **Amount:** $150 per semester **Open to:** All art majors **Duration:** One year; some one semester **When offered:** Annually

Sullivan County Community College 112 College Rd. Loch Sheldrake, NY 12759-5151. **Amount:** Varies **Open to:** Students in commercial art or photography **Duration:** Varies **When offered:** Annually

Sun Gallery 1015 E. St. Hayward, CA 94541. **Amount:** $500 **Open to:** Hayward High School students **When offered:** Semi-annually

Sunbury Shores Arts and Nature Centre, Inc. 139 Water St., Saint Andrews, NB E5B 1A7 Canada. **Amount:** Approx. $400 each; all costs covered **Open to:** New Brunswick residents ages 12-21 inclusive **Duration:** One-three weeks varying with art course **When offered:** Annually; for July & Aug submit application by Mar 31

SUNY Plattsburgh Myers Fine Arts Bldg. 101 Broad St. Plattsburgh, NY 12901. **Amount:** $10,000 total **Open to:** Art majors **Duration:** One year **When offered:** Annually

Swarthmore College 500 College Ave. Swarthmore, PA 19081. **Amount:** As much as student needs **Open to:** All students in financial need **Duration:** As long as student demonstrates financial need **When offered:** Annually

Syracuse University Dept. of Fine Arts *Fellowship*, 308 Bowne Hall Syracuse, NY 13244-1200. **Amount:** $15,900 **Open to:** Art History M.A. **Duration:** 1-3 years **When offered:** Annually

Syracuse University School of Art & Design Shaffer Art Bldg. Syracuse, NY 13244. **Amount:** $1,000-$2,000 art merit

scholarships plus academic merit scholarship - amounts vary for undergraduates **Open to:** Freshmen **Duration:** Four years **When offered:** Annually

Amount: $13,000; scholarships vary **Open to:** Graduate & Undergraduate **Duration:** Three-year fellowships awarded

Amount: $9,970 university fellowships (African-American) for graduates, half & full assistantships for graduate students **Open to:** Graduate-30 credit hours of tuition per year **Duration:** Up to three years **When offered:** Annually

Amount: Partial & full tuition scholarships **Open to:** Graduate students **When offered:** Annually

Tallahassee Community College 444 Appleyard Dr. Tallahassee, FL 32304 **Amount:** Tuition for previous semester's art courses **Open to:** Art students **When offered:** Annually

Amount: Two scholarships for $250 for a course to visit art collections in Washington, DC or New York, NY **Open to:** Art students **When offered:** Semi-Annually

Taylor University, Art Dept. 236 W. Read Ave. Upland, IN 46989. **Amount:** $500-$1,500 **Open to:** Art majors **Duration:** One year **When offered:** Annually

Temple College, Art Dept. 2600 S. First St. Temple, TX 76504. **Amount:** $50-$500 **Open to:** Art majors **Duration:** Per semester **When offered:** Semi-annually

Tennessee Arts Commission 401 Charlotte Ave. Nashville, TN 37243-0780. **Amount:** $5,000 **Open to:** Fellowship for professional artists who are residents of Tennessee; students not eligible **Duration:** One year **When offered:** Annually

Texas Southern University, Dept. of Fine Arts 3100 Cleburne Ave. Houston, TX 77004. **Amount:** $500-1,000 per semester **Open to:** AM talent based **Duration:** One year **When offered:** Semi-annually

Texas State University-San Marcos, Dept. of Art and Design 601 University Dr. San Marcos, TX 78666 Tel: 512-245-2611; Fax: 512-245-7969. **Amount:** $10,000-$20,000 **Open to:** Majors **Duration:** One year **When offered:** Annually

Texas Tech University School of Art, Box 42081 Lubbock, TX 79409-2081. **Amount:** Fellowships: $3,000-$5,000 **Open to:** Graduate art majors **Duration:** One-three years **When offered:** Annually

Amount: Scholarships: $500-$2,500 **Open to:** Undergraduate & graduate art majors **Duration:** One-four years **When offered:** Annually

Texas Woman's University Dept. of Visual Arts P.O. Box 425469 Denton, TX 76204. **Amount:** Varies **Open to:** All qualified students **When offered:** Annually

Textile Conservation Center/American Textile History Museum 491 Dutton St. Lowell, MA 01854 Tel: 978-441-1198; Fax: 978-441-1412; E-mail: vkruckeberg@athm.org. **Amount:** TBD **Open to:** Textile conservators **Duration:** One year **When offered:** Annually

The American Swedish Institute Lilly Lorenzen Scholarship Institute 2600 Park Ave. Minneapolis, MN 55407 Tel: 612-871-4907; Fax: 612-871-8682; E-mail: info@americanswedishinst.org. **Amount:** Up to $2,500 **Open to:** MN residents for study in Sweden **Duration:** One time; not renewable **When offered:** Annually

The American-Scandinavian Foundation Fellowships 58 Park Ave. New York, NY 10016 Tel: 212-879-9779; Fax: 212-686-2115; E-mail: info@amscan.org. **Amount:** $4,000-$20,000 **Open to:** Applicants who have completed their bachelors degree for exchange program in Scandinavian Countries **Duration:** Varies **When offered:** Annually

The Art Institute of Boston at Lesley University 700 Beacon St. Boston, MA 02215 Tel: 800-773-0494, ext. 6710; Website: www.aiboston.edu. **Amount:** DuPont Fellowship $15,000 **Open to:** Minority photographers **Duration:** One semester **Amount:** Merit scholarships **Open to:** Incoming students **Duration:** Four years **When offered:** Each semester

The Art Institute of Cincinnati *Ron Long Memorial Scholarship*, 1171 E. Kemper Rd. Cincinnati, OH 45246. **Amount:** $2,000 **Open to:** Second year
Faculty Scholarships (3) **Amount:** $2,500 **Open to:** New students

ICDS Scholarship **Amount:** $3,000 **Open to:** New students

Roy Waits Scholarship **Amount:** $5,000 **Open to:** New students

Jane Walter-Knaber-Baker Memorial Scholarship **Amount:** $5,000 **Open to:** Single parent

John Harris Memorial Scholarship **Amount:** $5,000 **Open to:** New or second year students

President's Scholarship **Amount:** $5,000 **Open to:** New students

The Art School at Old Church 561 Piermont Rd. Demarest, NJ 07627 Tel: 201-767-7160; Fax: 201-767-0497; E-mail: info@tasoc.org; Website: www.tasoc.org. **Amount:** 1/2 tuition **Open to:** All **Duration:** Per semester **When offered:** All year

The Clay Studio *Fellowships*, 139 N. 2nd St. Philadelphia, PA 19106 Tel: 215-925-3453; Fax: 215-925-7774; E-mail: info@theclaystudio.org. **Amount:** $6,000 per year & $1,200 material stipend **Open to:** Ceramics Artists **Duration:** One year **When offered:** Annually

The College of Saint Rose 432 Western Ave. Albany, NY 12203 Tel: 518-485-3900; Fax: 518-485-3920. **Amount:** $2,000-$6,000 yearly

Open to: Incoming students only **Duration:** Until graduation **When offered:** Semi-annually

The Embroiderers' Guild of America 426 W. Jefferson St. Louisville, KY 40202 Tel: 502-589-6956; Fax: 502-584-7900; E-mail: egahq@egausa.org. **Amount:** $1,000 & up **Open to:** Public (one $1,000 scholarship); others to members **Duration:** One year **When offered:** Annually

The Goldstein Museum of Design 364 McNeil Hall. 1985 Buford Ave. Saint Paul, MN 55708 Tel: 612-624-3474; Fax: 612-624-2750; E-mail: gmd@umn.edu. **Amount:** $1,000 **Open to:** University of Minnesota College of Design students **Duration:** 63 hours **When offered:** Annually

The Hambridge Center for Creative Arts and Sciences *Fellowships*, P.O. Box 339 Rabun Gap, GA 30568 Tel: 706-746-5718; Fax: 706-746-9933; E-mail: center@hambridge.org. **Amount:** $125-$250 **Duration:** One-two weeks **When offered:** Semi-annually

The Huntington Library, Art Collections & Botanical Gardens 1151 Oxford Rd. San Marino, CA 91108 Tel: 626-405-2194; Fax: 626-449-5703; E-mail: cpowell@huntington.org; Website: www.huntington.org. **Amount:** Over one million dollars **Open to:** Scholars **Duration:** Varies **When offered:** Varies

The Illinois Institute of Art-Chicago 350 N. Orleans, Ste. 136-L Chicago, IL 60654 Tel: 312-777-8502; Fax: 312-777-8787. **Amount:** Seven half-tuition scholarships **Open to:** High school seniors who demonstrate ability and commitment in one of The Illinois Institute of Art-Chicago programs of study

The Palette & Chisel Academy of Fine Arts 1012 N. Dearborn St. Chicago, IL 60610 Tel: 312-642-4400; Fax: 312-642-4317; E-mail: fineart@paletteandchisel.org. **Amount:** One year membership **Open to:** Non-members **Duration:** One year **When offered:** Annually

The School of Fashion Design 136 Newbury St. Boston, MA 02116 Tel: 617-536-9343; E-mail: sfdboston@aol.com. **Amount:** $300-$1,000 **Open to:** Currently enrolled students returning for a second year **Duration:** One year **When offered:** Annually

The Society for Contemporary Craft 2100 Smallman St. Pittsburgh, PA 15222 Tel: 412-261-7003; Fax: 412-261-1941; E-mail: info@contemporarycraft.org. **Amount:** $2,500 **Open to:** Graduate students **Duration:** Summer **When offered:** Annually

The Society for Photographic Education 110 Art Building, Miami University Oxford, OH 45056 Tel: 513-529-8328; Fax: 513-529-1532; E-mail: socphotoed@aol.com. **Amount:** $500 & one year student membership & national conference fee waiver **Open to:** Student members **When offered:** Annually

The University of Montana-Western Art Program 710 S. Atlantic St. Dillon, MT 59725 Tel: 406-683-7232; E-mail: r_horst@umwestern.edu. **Amount:** $1,000-$4,000 **Open to:** Students majoring in art **Duration:** One year; renewable up to four years **When offered:** Annually

The Wolfsonian-FIU *Fellowship*, 1001 Washington Ave. Miami Beach, FL 33139 Tel: 305-531-1001; Fax: 305-531-2133. **Amount:** Approx. $ 1,600 per fellow, plus travel & accomodations **Open to:** Holders of Master's & Doctoral Degrees, & Doctoral Candidates **Duration:** Three-five weeks **When offered:** Annually

The Wolfsonian-Florida International University 1001 Washington Ave. Miami Beach, FL 33139 Tel: 305-531-1001; Fax: 305-531-2133; E-mail: research@thewolf.fiu.edu. **Amount:** $425/week plus travel and housing **Open to:** Doctoral candidates and holders of master's or doctoral degrees, from US and foreign countries **Duration:** 3 to 5 weeks **When offered:** Annually

Toledo Artists' Club Toledo Botanical Garden 5403 Elmer Dr. Toledo, OH 43615. **Amount:** $1,000 **Open to:** University of Toledo art student **Duration:** One Year **When offered:** Annually

Touchstone Center for Crafts Rd. #1, Box 60, Wharton 1049 Furnace Rd. Farmington, PA 15437. **Amount:** Varies **Open to:** Any individual; based on merit & financial need **Duration:** Varies **When offered:** Annually

Truman State University Division of Fine Arts, 100 E. Normal Kirksville, MO 63501-4221. **Amount:** Varies **Open to:** High school seniors, other awards available to junior college graduates **Duration:** One year; renewable **When offered:** Annually

Truro Center for the Arts at Castle Hill 10 Meetinghouse Rd., P.O. Box 756 Truro, MA 02666. **Amount:** $100 **Open to:** High school students; Individuals with AIDS

Tucson Museum of Art 140 N. Main Tucson, AZ 85701 E-mail: cking@tucsonarts.com; Website: www.tucsonarts.com. **Amount:** Varies **Open to:** Talented, needy & minority students for TMA school classes only **Duration:** Each session **When offered:** All year

Amount: Varies **Open to:** All students **Duration:** Per semester **When offered:** All year

Tufts University Fine Arts Dept. 11 Talbot Ave. Medford, MA 02155. **Amount:** Varies **Open to:** Candidates for MA in Art History **Duration:** One year **When offered:** Annually

Turtle Bay Exploration Park P.O. Box 992360 Redding, CA 96099-2360 Tel: 530-243-8850; Fax: 530-243-8929; E-mail: info@turtlebay.org. **Amount:** $200 **Open to:** Shasta College art students **Duration:** One year **When offered:** Annually

Tyler Junior College, Art Program P.O. Box 9020 Tyler, TX 75711 Website: www.tjc.edu. **Amount:** Varies **Open to:** All **Duration:** One year **When offered:** Annually

UCLA Fowler Museum of Cultural History W. Medal Bldg., P.O. Box 951549 Los Angeles, CA 90095-1549. **Amount:** The Ralph C. Altman Award & the Arnold Rubin Award-$3,000 each **Open to:** UCLA graduate students planning a career in a field related to the goals of the awards **When offered:** Spring quarter of academic year

UCR/California Museum of Photography 3824 Main St. Riverside, CA 92501 Tel: 909-787-4787; Fax: 909-787-4797. **Amount:** To be determined **Open to:** UC Riverside undergraduate & graduate students **Duration:** One year **When offered:** Varies

UNC Pembroke Art Dept. P.O. Box 1510 Pembroke, NC 28372-1510. **Amount:** Varies **Open to:** Talented and/or academic gifted students **Duration:** One year; renewable **When offered:** Annually

Union University 1050 Union University Dr. Jackson, TN 38305. **Amount:** $100-$3,000 **Open to:** Students/art majors **Duration:** One year **When offered:** Annually

Universal Technical Institute Commercial Art Div. 11818 I St. Omaha, NE 68137. **Amount:** Varies **Open to:** High school graduates **Duration:** One year **When offered:** Annually

University at Buffalo, Department of Visual Studies 202 Center for the Arts, Buffalo, NY 14260-6010. **Amount:** $1,200 **Open to:** Junior level art majors **Duration:** Summer **When offered:** Annually

University at Buffalo, State University of New York *Sally Hoskins Potenza Award*, 103 Center for the Arts Buffalo, NY 14260. **Amount:** $1,000 **Open to:** Junior level majors **Duration:** One year **When offered:** Annually

Honors Talent Award **Amount:** $1,000/year **Open to:** Undergraduate freshman with outstanding portfolios **Duration:** Four years **When offered:** Annually

Rumsey Summer Scholarship **Amount:** $1,500-2,500 **Open to:** Junior level art majors **Duration:** One year **When offered:** Annually

Honors Creative and Performing Arts Scholarship **Amount:** $2,000/year **Open to:** Undergraduate freshman with outstanding academic credentials **Duration:** Four years **When offered:** Annually

Dennis Domkowshi Memorial Scholarship **Amount:** $400 **Open to:** Junior level communication design majors **Duration:** One year **When offered:** Annually

Julius Bloom Memorial Scholarship **Amount:** $500 **Open to:** Junior level communication design majors **Duration:** One year **When offered:** Annually

Carl E. and Virginia W. Sentz Award **Amount:** $500 **Duration:** One year **When offered:** Annually

Philip Elliott and Virginia Cuthbert Elliott Painting Scholarship **Amount:** $600 **Open to:** Junior level painting majors **Duration:** One year **When offered:** Annually

Frances R. and Louis B. Morrison Scholarship **Amount:** $600-2,000 **Open to:** Undergraduate art majors **Duration:** One year **When offered:** Annually

Amount: Honors Program, $2,500-4000/year **Open to:** Undergraduate freshmen with outstanding academic credentials. Must maintain 3.0 GPA. **Duration:** Four years **When offered:** Annually

Amount: Teaching assistantship/ Graduate assistantship **Open to:** Graduate students-accepted MFA candidates **Duration:** One year; renewable for a second year **When offered:** Annually

Amount: Varies-up to $8,400 plus tuition waiver **Open to:** BA, BFA & MFA students **Duration:** One year; four-year honors scholarships **When offered:** Annually & Semi-annually

University of Akron-Myers School of Art 150 E Exchange St Akron, OH 44325-7801 Tel: 330-972-6030; Fax: 330-972-5960; E-mail: susan27@uakron.edu. **Amount:** Up to $3,000 **Open to:** New freshman **Duration:** One year **When offered:** Annually, renewable

The University of Alabama at Birmingham Dept. of Art and Art History 900 13th St., 113 Humanities Bldg Birmingham, AL 35294-1260. **Amount:** $2,000 **Open to:** Senior art majors **Duration:** One year **When offered:** Annually

Amount: $3,000 **Open to:** Art students **Duration:** One year **When offered:** Annually

University of Alabama Dept. of Art 103 Garland Hall, P.O. 870270 Tuscaloosa, AL 35487-0270. **Amount:** Varies **Open to:** Incoming freshmen **Duration:** One year **When offered:** Annually

University of Alaska, Fairbanks 310 Fine Art Complex, P.O. Box 755640 Fairbanks, AK 99775 Tel: 907-474-7530; E-mail: fyart@vaf.edu. **Amount:** $10,000 **Open to:** MFA graduate students in UAF MFA program **Duration:** One year **When offered:** Annually

Amount: Bebe Helen Kneece Woodward Scholarship **Open to:** Sophomore registered in art class **Duration:** One year **When offered:** Annually

Amount: Tuition **Open to:** Entering students **Duration:** One year **When offered:** Annually

University of Alberta Dept. of Art & Design 3-98 Fine Arts Bldg. Edmonton, AB T6G 2C9 Canada. **Amount:** $15,000 **Open to:** Incoming graduate students in MFA & MDes program **Duration:** One year; renewable for an additional year **When offered:** Annually

Amount: Alberta Foundation for the Arts Graduate Scholarship, amount $7,500 **Open to:** Students entering the second year of MFA program in painting, printmaking, drawing or sculpture **Duration:** One year **When offered:** Annually

University of Arizona College of Fine Arts PO Box 210004, 1017 N. Olive Rd., Music Bldg. Rm. 111 Tucson, AZ 85721-0004. **Amount:** Varies **Open to:** Students enrolled in art program at UA **Duration:** One year **When offered:** Annually

University of Arkansas Art Department Fayetteville, AR 72701. **Amount:** $500 **Open to:** Undergraduate & Graduate Students **Duration:** One year **When offered:** Annually

University of Arkansas at Little Rock 2801 S. University Ave. Little Rock, AR 72204. **Amount:** Up to $1,000 **Open to:** Qualified applicants **Duration:** Semester **When offered:** Semi-annually

University of Arkansas at Monticello, Fine Arts Dept. P.O. Box 3460 Monticello, AR 71656. **Amount:** Tuition waiver **Open to:** Talented art students; 3.0 GPA or better to continue **Duration:** One year **When offered:** Annually

University of Buffalo, State University of New York Fine Arts Dept., 202 Center for the Arts Buffalo, NY 14260-6010 Tel: 716-645-6878, ext. 1350; Fax: 716-645-6970. **Open to:** Six students **When offered:** Semi-annually

University of California Dept of Art & Art History, One Shields Ave. Davis, CA 95616-8528. **Amount:** Varies **Open to:** All students **Duration:** Quarterly **When offered:** Annually

University of Central Arkansas Dept. of Art, 201 Donaghey Ave. Conway, AR 72032. **Amount:** $5,000 per semester **Open to:** High school seniors **Duration:** Four years **When offered:** Annually

University of Central Oklahoma Dept. of Art & Design Box 84 100 N. University Dr. Edmond, OK 73034-0180. **Open to:** Qualifying students **Duration:** One semester **When offered:** Semi-annually

University of Charleston Dept. of Art and Design 2300 MacCorkle Ave., S.E. Charleston, WV 25304. **Amount:** Varies **Open to:** Students with talent but of financial need **Duration:** One year **When offered:** Annually

University of Chicago 5801 Ellis Ave. Chicago, IL 60637. **Amount:** Varies **Open to:** MA & PhD candidates

University of Chicago Lorado Taft Midway Studios 6016 Ingleside Ave. Chicago, IL 60637. **Amount:** Up to full tuition & stipend **Open to:** Anyone with an undergraduate degree & portfolio **Duration:** Two years **When offered:** Semi-annually

University of Cincinnati School of Art 6431 Aronoff, ML 16 Cincinnati, OH 45221. **Amount:** Undergraduate, $500-$1,000; Graduate, stipend & full tuition $2,500 Traveling Fellowships, graduates & undergraduates **Open to:** Fine arts freshmen; SOA freshmen; University Graduate Scholarships & Minority Fellowships **Duration:** One year **When offered:** Annually

University of Colorado, Dept. of Fine Arts Boulder Sibell-Wolle Fine Arts Bldg. N196A, Campus Box 318 Boulder, CO 80309. **Amount:** Varies **Open to:** Undergraduates & graduates **Duration:** One year **When offered:** Annually

University of Connecticut Dept. of Art & Art History, 830 Bolton Rd., U-1099 Storrs, CT 06269-1099. **Amount:** $1,000-$2,000 **Open to:** BFA & BA Art History students **Duration:** One year, may be renewed **When offered:** Annually

University of Delaware Dept. of Art 104 Recitation Hall Newark, DE 19716. **Amount:** $10,000, plus tuition **Open to:** All **Duration:** One year **When offered:** Annually
Amount: Varies **Open to:** Undergraduate & Graduate students **Duration:** Renewable up to four years **When offered:** Annually

University of Denver School of Art & Art History *Harrison Merit Scholarship,* **Amount:** $5,000-$2,000 **Open to:** Sophomores, juniors & seniors **Duration:** One year **When offered:** Annually

Art Scholarship **Amount:** $500-$5,000 **Open to:** Based on admission portfolio **Duration:** Four years **When offered:** Upon acceptance to Denver University

University of Evansville, Dept. of Art 1800 Lincoln Ave. Evansville, IN 47722. **Amount:** Varies **Open to:** Incoming freshmen **Duration:** Four years **When offered:** Annually

University of Georgia School of Art Lamar Dodd Visual Arts Bldg. Athens, GA 30602-4102. **Amount:** $500-$1,500 **Open to:** Undergraduate & graduate students **Duration:** One year **When offered:** Annually

University of Hartford, Hartford Art School 200 Bloomfield Ave. West Hartford, CT 06117. **Amount:** Varies **Duration:** Renewable up to four years **When offered:** Annually

University of Hawaii at Manoa Dept. of Art 2535 McCarthy Mall Honolulu, HI 96822 Tel: 808-956-8251; Fax: 808-956-9043. **Amount:** Varies **Open to:** Varies **Duration:** One year **When offered:** Annually

University of Hawaii, Kapiolani Community College 4303 Diamond Head Rd. Honolulu, HI 96816. **Amount:** $500 **Open to:** Art majors **Duration:** One year **When offered:** Annually

University of Houston School of Art 100 Fine Arts Bldg., (FA) Houston, TX 77204-4019. **Open to:** Current students & incoming graduate students **Duration:** One year **When offered:** Annually

University of Idaho Department of Art & Design, P.O. Box 442471 Moscow, ID 83844-2471 Tel: 208-885-6851; Fax: 208-885-9428; E-mail: artdesign@uidaho.edu. **Amount:** $12,500 **Open to:** Art & design majors per scholarship criteria **Duration:** One year **When offered:** Annually

University of Illinois at Springfield One University Plaza Springfield, IL 62794-9243. **Amount:** $300 & up **Open to:** Art majors **Duration:** One year **When offered:** Annually

University of Illinois Urbana-Champaign College of Fine and Applied Arts 143 Art & Design Bldg., 408 E. Peabody Dr. Champaign, IL 61820. **Amount:** Kate Neal Kinley Memorial Fellowship **Open to:** Graduates of the College of Fine and Applied Arts of the University of Illinois, Urbana-Champaign & to graduates of similar institutions of equal educational funding. Preference is given to applicants under 25 years of age **Duration:** One academic year **When offered:** Annually

University of Indianapolis Art Dept. 1400 E. Hanna Ave. Indianapolis, IN 46227. **Amount:** Scholarships $40,000 total **Open to:** Undergraduates **Duration:** Maintained until graduation **When offered:** Annually

University of Iowa School of Art and Art History 120 N. Riverside Dr., E. 100 Art Bldg. Iowa City, IA 52242. **Amount:** Varies **Open to:** Undergraduates & graduate students enrolled at the University of Iowa School of Art & Art History **Duration:** One year **When offered:** Annually

University of Louisville Allen R. Hite Art Institute Dept. of Fine Arts, Belknap Campus Louisville, KY 40292 Tel: 502-852-6794; Fax: 502-852-6791. **Amount:** Full or partial tuition **Open to:** Majors in department **Duration:** One year **When offered:** Annually

University of Maine Wingate Hall Orono, ME 04469. **Amount:** Up to $2,000 **Open to:** First time, first-year students **Duration:** Four years **When offered:** Annually

University of Mary Hardin-Baylor 900 College St. Belton, TX 76513 Tel: 254-295-4675; E-mail: hseals@umhb.edu. **Amount:** $2,000 **Open to:** Art Majors **Duration:** One year **When offered:** Annually

University of Memphis 108 Jones Hall, Art Dept. Memphis, TN 38152 Tel: 901-678-2216; Fax: 901-678-2735. E-mail: jjacksn2@memphis.edu. **Open to:** Graduate students, Freshmen, Returning students competetive scholarships **Duration:** One year **When offered:** Annually

University of Miami Dept. of Art and Art History P.O. Box 248106 Coral Gables, FL 33124-4410. **Amount:** $3,000-$6,000, tuition plus stipend **Open to:** Undergraduate & graduate students **Duration:** Renewable **When offered:** Annually

University of Michigan, Ann Arbor History of Art Department Ann Arbor, MI 48109-1357. **Amount:** Charles L. Freer Fellowships in Oriental Art; amounts vary **Open to:** Advanced graduate students in non-western art, residence at Freer Gallery, Washington, DC **Duration:** Half year **When offered:** Annually

Amount: Graduate Fellowships offered by Horace H. Rackhum School of Graduate Studies; amounts vary **Open to:** Graduate students **Duration:** One year **When offered:** Annually

Amount: Michigan Merit Fellowship for historically under-represented groups. Tuition, health insurance, $1,000 per month offered by Horace H. Rackham School of Graduate Studies, tuition plus up to $10,000 **Open to:** Beginning graduate students, historically under-represented racial or ethnic groups **Duration:** Up to five years **When offered:** Annually

Amount: Rackhum Predoctoral Fellowship; health insurance & $14,400 stipend for two & a half terms **Open to:** Predoctoral students **Duration:** One year **When offered:** Annually

Amount: Regents Fellowship, minimum three years at $10,000 plus tuition, fees & health insurance **Open to:** Beginning graduate students **Duration:** Three years **When offered:** Annually

Amount: Teaching fellowship up to $8,000 plus full tuition waiver **Open to:** Graduate students of the second year & beyond **Duration:** One year **When offered:** Annually

University of Minnesota Duluth 1049 University Dr. Duluth, MN 55812 Tel: 218-525-8225; Fax: 218-726-6532; E-mail: art@d.umn.edu. **Amount:** $1,000 **Open to:** Sophomores, juniors & seniors **Duration:** One year **When offered:** Annually

University of Minnesota Split Rock Arts Program 360 Coffey Hall, 1420 Eckles Ave. St. Paul, MN 55108. **Amount:** $550 & up **Open to:** Anyone; scholarship awards based on artistic merit & financial need **Duration:** Week-long workshop only **When offered:** Program runs annually; July & Aug; scholarship deadline, May

University of Minnesota, Duluth Dept. of Art 317 Humanities Bldg., 1201 Ordean Ct. Duluth, MN 55812. **Amount:** (4) $250 Scholarships **Open to:** Undergraduates, who are in at least their second semester of study as an art major at UMD & who meet eligibility requirements **Duration:** One year **When offered:** Annually; spring

Amount: (4-6) $5,000 Grad teaching assistantships **Open to:** Graduate students **Duration:** One year **When offered:** Annually; spring

Amount: (5) $600 scholarships **Open to:** Undergrad/graduates, who are in at least their second semester of study as an art major at UMD & who meet eligibility requirements **Duration:** One year **When offered:** Annually; spring

Amount: (6) $1,000 awards **Open to:** Undergrad/graduates, who are in at least their second semester of study as an art major at UMD & who meet eligibility requirements **Duration:** One year **When offered:** Annually; spring

University of Minnesota, Minneapolis Department of Art, 405 21st Ave. S. Minneapolis, MN 55455. **Amount:** $1,000-$21,000 **Open to:** Undergraduate and/or graduate **Duration:** One year **When offered:** Annually

University of Mississippi Art Dept. P.O. Box 1848 Vertress Hall University, MS 38677. **Amount:** $100-$500 plus $1000 partial non-resident fee waiver **Open to:** Qualified students **Duration:** Four years; renewable **When offered:** Annually

University of Missouri Art Dept., A 126 Fine Arts Columbia, MO 65211. **Amount:** $250-$3,000 **Open to:** One scholarship for undergraduates & three or four for graduates **Duration:** One year **When offered:** Annually

University of Missouri, Kansas City Art & Art History Dept. 5100 Rockhill Rd. Kansas City, MO 64110. **Open to:** Incoming freshmen **Duration:** One year **When offered:** Annually

University of Missouri, Saint Louis Dept. of Art & Art History One University Blvd. Saint Louis, MO 63121. **Amount:** Varies-Barbara St. Cyr Scholarship **Open to:** Art history, education, or studio art majors **Duration:** One year **When offered:** Annually **Amount:** Varies-William T. Isbell II Art Scholarship **Open to:** Art history majors **Duration:** One year **When offered:** Annually

University of Montana Campus Dr. 32 Missoula, MT 59812 Tel: 406-243-4181; Fax: 406-243-4968; E-mail: artdepartment@umontana.edu. **Amount:** Varies **Open to:** Sophmore-graduate **Duration:** One semester or one year **When offered:** Annually

University of Nebraska Lincoln Dept. of Art & Art History *Mundy*, 120 Richards Lincoln, NE 68588-0114. **Open to:** Regularly enrolled undergraduate students in the Dept of Art & Art History worthy of financial assistance
Sack **Open to:** Juniors & seniors with consideration given to artistic talent & financial need

Hills **Open to:** Based on Scholastic achievement, financial need & professional potential

Riordan-Morey **Open to:** Upon recommendation of the Dept of Art & Art History to undergraduate or graduate students

Oldfield **Open to:** Junior or senior regularly enrolled at UNL who is successfully pursuing a course of study leading to a degree in the fine arts field who shows potential & is worthy of financial assistance

LaBounty **Open to:** Regularly enrolled students in the Dept of Art & Art History

Peterson **Open to:** Students with talent & need who have achieved at least sophomore standing

Ronald N. Scheerer Endowed Scholarship 120 **Amount:** $1,500 **Open to:** Based on need, scholastic, graphic design emphasis **Duration:** One year **When offered:** Annually

Faulkner Freshman **Amount:** $200 (3 awards) **Open to:** Students must have completed at least one semester in the studio foundation program with no more than 21 one credit hrs; portfolio of six works of art is required

Nellie May Schlee Vance Memorial Fund **Amount:** $250 **Open to:** Regularly enrolled undergraduate art students. **Duration:** One year **When offered:** Annually

Jeanne L. Trabold Scholarship **Amount:** $500 **Open to:** Art history major with need. **Duration:** One year **When offered:** Annually

Waggoner **Amount:** $700 **Open to:** Juniors or seniors who are US citizens & preferably a Nebraskan

Margaret Forman Woodbridge Erny Scholarship **Amount:** $900 **Open to:** Emphasis on painting or sculpture with financial need. Graduate of Nebraska high school. **Duration:** One year **When offered:** Annually

E. Evelyn Peterson Memorial Fine Arts Scholarship **Amount:** $1,000 **Open to:** Outstanding students, sophomore & above, with high potential in art **Duration:** One year **When offered:** Annually

Amount: Louise Esterday Mundy Fine Arts Scholarship $300 **Open to:** Determined by financial need **Duration:** One year **When offered:** Annually

Amount: Nellis Polly Hills & John Hills Scholarship $1,000 **Open to:** Based on scholastic achievement, Willard professional potential & financial need **Duration:** One year **When offered:** Annually

Amount: Ruth Ann Sack Memorial Scholarship in Photography & Painting, five at $300 **Open to:** Outstanding upper division students in photography & painting **Duration:** One year **When offered:** Annually

Amount: Shelly Arnold Waggoner Memorial Scholarship Fund, 3 awards of $700 each **Open to:** Based on exceptional talent **Duration:** One year **When offered:** Annually

Amount: Thomas Coleman Memorial Scholarship in Printmaking; awards of $500 each **Open to:** Outstanding graduate & undergraduate student in prints **Duration:** One year **When offered:** Annually

University of Nebraska, Kearney Dept. of Art & Art History, 213 Mitchell Hall Kearney, NE 68849. **Amount:** $200-$300-other scholarships available **Open to:** Any level **Duration:** One year **When offered:** Annually

Amount: (8) $1,000 tuition waiver in art **Open to:** Freshmen & upperclassmen **Duration:** One year **When offered:** Annually

University of Nevada Las Vegas, Dept. of Art 4505 Maryland Pkwy., Box 5002 Las Vegas, NV 89154 Tel: 702-895-3237; Fax: 702-895-4346. **Amount:** $400-$1,600 **Open to:** Full-time undergraduate students **Duration:** One year **When offered:** Annually

University of New Mexico Dept. of Art & Art History Albuquerque, NM 87131-1401. **Amount:** $200-$2,500 **Open to:** All students **Duration:** Varies **When offered:** Annually

University of New Mexico Tamarind Institute 110 Cornell Dr., S.E. Albuquerque, NM 87106. **Amount:** $500-$1,000 **Open to:** Students based on financial need **When offered:** Semi-annually

University of North Alabama Dept. of Art, UNA Box 5006 Florence, AL 35632-0001 Tel: 256-765-4384; Fax: 256-765-4511; E-mail: rlshady@una.edu. **Amount:** $500-$2,000 ($2,000 total) **Open to:** Entering freshmen, sophomores, juniors, seniors & transfers with art majors **Duration:** One year **When offered:** Annually

University of North Carolina-Chapel Hill, Dept. of Art 115 South Columbia St., Hanes Art Center, CB# 3405 Chapel Hill, NC 27599-3405. **Amount:** Anderson studio prize-$500 **Open to:** Junior & senior studio art majors **Duration:** Two-year eligibility **When offered:** Annually

Amount: Emily Pollard Fellowships, $2,000-$3,000 **Open to:** Graduate students only **Duration:** One year **When offered:** Annually

Amount: John and Vivian Dixon award in art & religion-$2,500 **Open to:** Graduate students **Duration:** One year **When offered:** Annually

Amount: Minority presence awards $9,000-$11,000 **Open to:** Students **Duration:** One year **When offered:** Annually

Amount: The Alexander Julian Prize-$500 **Open to:** Junior & senior studio art majors **Duration:** Two-year eligibility **When offered:** Annually

Amount: The George Kachergis Memorial Scholarship-$400-$700 **Open to:** Junior & senior studio art majors **Duration:** Two-year eligibility **When offered:** Annually

Amount: The Jonathan E. Sharpe Scholarship $400-$700 **Open to:** Junior & senior studio art majors **Duration:** Two-year eligibility **When offered:** Annually

Amount: UNC-CH Merit Assistantship $9,000-$11,000 **Open to:** Incoming graduate students only **Duration:** One year **When offered:** Annually

Amount: Undergraduate prize in art history-$100 **Open to:** All students **Duration:** One year **When offered:** Annually

University of North Dakota Dept. of Visual Arts P.O. Box 7099 Grand Forks, ND 58202. **Amount:** Varies **Open to:** Art majors **Duration:** One year **When offered:** Annually

University of North Texas School of Visual Arts., P.O. Box 305100 Denton, TX 76203-5100. **Amount:** $500-$15,000 **Open to:** Qualified **Duration:** One year **When offered:** Annually

University of Northern Iowa Dept. of Art Cedar Falls, IA 50614-0362. **Amount:** $1,000-$3,500 **Open to:** Incoming freshmen art majors **Duration:** One year **When offered:** Annually

University of Notre Dame Art, Art History & Design 306 Riley Hall Notre Dame, IN 46556. **Amount:** Tuition $32,550; stipend $9,800 **Open to:** Graduate students only **Duration:** Up to three years **When offered:** Annually

University of Oklahoma, School of Art 520 Parrington Oval, Rm. 202 Norman, OK 73019. **Amount:** $200- $8,000 **Open to:** Varies: some open; some restricted **Duration:** One year; renewable **When offered:** Annually

University of Oregon Dept. of Art 198 Lawrence Hall Eugene, OR 97403-5232. **Amount:** Partial & full tuition plus stipend **Open to:** Returning students **Duration:** Term

University of Pennsylvania 3451 Walnut St. Philadelphia, PA 19104-6311. **Amount:** Partial tuition

University of Pittsburgh Henry Clay Frick Dept. of History of Art & Architecture, 104 Frick Fine Arts Bldg. Pittsburgh, PA 15260 Tel: 412-648-2400; Fax: 412-648-2792. **Amount:** $13,690 **Open to:** Graduate students **Duration:** One year **When offered:** Annually

University of Puget Sound 1500 N. Warner St. Tacoma, WA 98416. **Amount:** $1,000-$2,500 **Open to:** Freshmen, art majors **Duration:** Renewable **When offered:** Annually

University of Regina Department of Visual Arts, 3737 Wascana Pkwy. Regina, SK S4S 0A2 Canada. **Amount:** $100-$2,000 **Open to:** Visual arts & art history students **Duration:** One year **When offered:** Annually

University of Rochester Dept. of Art & Art History 424 Morey Hall Rochester, NY 14627 Tel: 585-275-9249; Fax: 585-442-1692; E-mail: art_arthist@cc.rochester.edu. **Amount:** $15,000/yr. **Open to:** Visual & cultural studies graduate students **Duration:** Supported for four years **When offered:** Annually

Amount: $15,000 **Open to:** PhD candidates in visual & cultural studies program **Duration:** Seven years **When offered:** Annually

University of Saint Francis, School of Creative Arts 2701 Spring St. Fort Wayne, IN 46808 Tel: 260-434-7591; Fax: 260-434-7604; E-mail: jljohnson@sf.edu. **Open to:** Incoming students **Duration:** Four years contingent on certain criteria

University of San Diego Art History Area, Fine Arts Dept. 5998 Alcala Park San Diego, CA 92123. **Amount:** Varies **Duration:** One year **When offered:** Annually; semi-annually

University of Saskatchewan Dept. of Art & Art History, Murray Bldg. 3 Campus Dr. Saskatoon, SK S7N 5A4 Canada. **Amount:** $100-$1,000 **Open to:** Second, third & fourth year students **When offered:** Annually

University of Science and Arts of Oklahoma 1727 West Alabama Chickasha, OK 73018-5322. **Open to:** Students **Duration:** One year **When offered:** Annually

University of South Carolina Dept. of Art, McMaster College Columbia, SC 29208 **Amount:** $80 granted per semester ($1,600 per year) **Open to:** Freshmen, continuing & transfer students **Duration:** One year **When offered:** June 1

University of South Dakota Dept. of Art, CFA 414 E. Clark St. Vermillion, SD 57069. **Amount:** $7,000 total, range from $100-$750 each **Open to:** Varies **Duration:** One year **When offered:** Annually

University of South Florida, School of Art and Art History 4202 East Fowler Ave., FAH 110 Tampa, FL 33620 Tel: 813-974-2360; Fax: 813-974-9226; E-mail: minfanti@arts.usf.edu. **Amount:** $ 75,000 **Open to:** All **Duration:** One year plus one semester **When offered:** Annually & Semi-annually

University of Southern California School of Fine Arts Watt Hall 104, University Park Los Angeles, CA 90089-0292. **Amount:** Graduate teaching assistantships & readerships (tuition credit & stipend)-contact School of Fine Arts **Open to:** MFA graduate students **Duration:** One year **When offered:** Annually

Amount: Varies **Open to:** Fine arts undergraduate majors **Duration:** One year **When offered:** Annually

University of Southern Indiana 8600 University Blvd. Evansville, IN 47714. **Amount:** $500-$1,500 **Open to:** Art majors and art education majors entering as Freshmen **Duration:** Four years if 3.0 GPA is maintained **When offered:** Annually

University of Southwestern Louisiana, College of the Arts USL 104 University Circle Lafayette, LA 70504. **Amount:** $600 **Open to:** Juniors & seniors in visual arts **Duration:** One year **When offered:** Annually

University of Tampa, Dept. of Art 401 W. Kennedy Blvd. Tampa, FL 33606. **Amount:** Varies **Open to:** Registered students **Duration:** Continues with enrollment when student enrolls **When offered:** Annually

University of Tennessee at Chattanooga Dept. of Art 615 McCallie Ave. Chattanooga, TN 37403. **Amount:** Tuition scholarships **Open to:** Freshmen-seniors **Duration:** One year **When offered:** Annually

University of Tennessee School of Art 1715 Volunteer Blvd. Knoxville, TN 37996-2410. **Amount:** $2,000 **Open to:** Freshmen art majors **Duration:** One year **When offered:** Annually **Amount:** $8,000 (total) **Open to:** Currently enrolled art majors **Duration:** One year **When offered:** Annually

University of Texas at Arlington Department of Art & Art History 502 South Cooper St., Fine Arts Bldg. Rm 335 Arlington, TX 76019. **Amount:** Varies **Open to:** Art majors **When offered:** Annually

University of Texas at San Antonio Dept. of Art and Art History, 6900 N. Loop 1604 W. San Antonio, TX 78249. **Amount:** $500-$1,000 **Duration:** One year **When offered:** Annually

University of Texas at Tyler 3900 University Blvd. Tyler, TX 75799. **Amount:** $250-$2,000 **Open to:** Art majors **Duration:** One year **When offered:** Semi-annually

University of Texas of the Permian Basin Dept. of Art, 4901 E. University Odessa, TX 79762 Tel: 915-552-2286; Fax: 915-552-3285; E-mail: price_p@utpb.edu. **Amount:** Varies **Open to:** Entering freshmen & currently enrolled art majors **Duration:** Varies **When offered:** Annually

University of Texas, Dept. of Art & Art History 1 University Station D 1300 Austin, TX 78712 Tel: 512-471-3382; Fax: 512-471-7801. **Open to:** All students **Duration:** One year **When offered:** Annually

University of Texas-Pan American Communications Arts & Science Bldg. Rm. 334, 1201 W. University Dr. Edinburg, TX 78539-2999. **Amount:** $2,000 **Open to:** Art major **Duration:** One year **When offered:** Annually

Amount: $7,000 (Assistantship) **Open to:** Graduate student **Duration:** One year **When offered:** Annually

Amount: $800 **Open to:** Freshmen **Duration:** One year **When offered:** Annually

The University of the Arts 320 S. Broad & Pine Sts. Philadelphia, PA 19102. **Open to:** All matriculated students **Duration:** One year **When offered:** Annually

University of the Pacific Dept. of Art & Art History 601 Pacific Ave. Stockton, CA 95211. **Amount:** $18,000 **Open to:** Sophomore - senior art, art history or graphic design major **Duration:** One year **When offered:** Annually

The University of the South 735 University Ave. Sewanee, TN 37383. **Amount:** Browns Fellowship, approx. $20,000 **Open to:** Artists & art historians **Duration:** Semester **When offered:** Every few years

University of Tulsa School of Art 600 S. College Ave. Tulsa, OK 74104. **Duration:** One year **When offered:** Annually

University of Utah Dept. of Art & Art History, 375 S. 1530 E. Rm. 161 Salt Lake City, UT 84112-0380. **Amount:** 50 scholarships with varying amounts for undergraduate majors and Taships and fellowships for graduate students **Open to:** Currently enrolled students in art history, studio art or art education **Duration:** One year, with possibility of renewal **When offered:** Annually

University of Virginia Art Museum Thomas W. Bayly Bldg., 155 Rugby Rd. PO. Box 400119 Charlottesville, VA 22904-4119. **Amount:** $5,000 **Open to:** Graduate students in the Department of Art (2 positions) **Duration:** One year (10 hrs/week) **When offered:** Annually

University of Washington School of Art Box 353440 Seattle, WA 98195-3440. **Amount:** Varies **Open to:** Currently enrolled art & art history majors **Duration:** One year **When offered:** Annually

University of West Florida Dept. of Art Bldg. 82 Rm. 253, 11000 University Pkwy. Pensacola, FL 32514. **Amount:** Six scholarships, $1,000 each **Open to:** Incoming freshmen & junior transfers (art majors) **Duration:** Freshmen (4 years), junior (2 years) if GPA maintained **When offered:** Annually

University of Windsor School of Visual Arts Windsor, ON N9B 3P4 Canada. **Amount:** Varies **Open to:** Students **Duration:** One year **When offered:** Annually and semi-annually

University of Wisconsin, Whitewater 800 W. Main St. CA 2073 Whitewater, WI 53190. **Amount:** Varies **Open to:** Returning students **Duration:** One year **When offered:** Annually

University of Wisconsin-Madison, Dept. of Art History *Fellowships*, 232 Conrad A. Elvehjem Bldg., 800 University Ave. Madison, WI 53706 Tel: 608-263-2341; Fax: 608-265-6425; E-mail: arthistory@ls.wisc.edu. **Amount:** $30,000 (includes tuition health insurance, a monthly stipend & flexible funds) **Open to:** Incoming & continuing grad students **Duration:** One year, possible extension

University of Wisconsin-Milwaukee Art History Dept., P.O. Box 413 P.O. Box 413 Milwaukee, WI 53201. **Amount:** Varies **Open to:** Students **Duration:** One year **When offered:** Annually

University of Wisconsin-Parkside Art Dept., 900 Wood Rd., P.O. Box 2000 Kenosha, WI 53141. **Amount:** Varies **When offered:** Annually

University of Wisconsin-Stevens Point College of Fine Arts, 1800 Portage St. Stevens Point, WI 54481 Tel: 715-346-2669; Fax: 715-346-4072. **Amount:** $10,000 **Open to:** Art & design majors **Duration:** One year **When offered:** Annually

University of Wisconsin-Superior, Programs in the Visual Arts 1800 Grand Ave. Superior, WI 54880 Tel: 715-394-8391; 394-8101; E-mail: Igrittne@staff.uwsuper.edu; Website: www.uwsuper.edu. **Amount:** $500 **Open to:** Varies **Duration:** One year **When offered:** Annually

University of Wyoming Art Dept., Dept. 3138, 1000 E. University Ave. Laramie, WY 82071-3138. **Amount:** $1,000-$4,000 **Open to:** Undergraduate students, in state & out of state **Duration:** One year; renewable **When offered:** Annually
Amount: $1,000-$4,000 **Open to:** Freshmen, transfer & continuing art majors (studio) **Duration:** One year **When offered:** Annually

Urbanglass 647 Fulton St. Brooklyn, NY 11217-1112 Tel: 718-625-3685; Fax: 718-625-3889; E-mail: info@urbanglass.org. **Amount:** Variable **Open to:** Established and emerging artists **Duration:** 8 weeks **When offered:** Annually

Utica College of Syracuse University Division of Humanities 1600 Burrstone Rd. Utica, NY 13502. **Amount:** $100-$870 **Open to:** Full-time students **Duration:** One year **When offered:** Annually

Valdosta State University Dept. of Art 1500 N. Patterson St. Valdosta, GA 31698. **Amount:** $500 per semester **Open to:** Art majors **Duration:** Until graduation; recipients must maintain scholarship criteria **When offered:** As current recipients graduate or reach 129 cr hrs
Amount: Up to $500 **Open to:** Art majors **Duration:** Freshmen year **When offered:** Annually
Amount: Varies **Open to:** Art majors, freshman, transfers & department discretionary **Duration:** Until graduation; recipients must maintain scholarship criteria for endowed scholarships; freshman/transfer/discretionary scholarships one year **When offered:** Annually; as current recipients graduate or reach 129 cr hrs for endowed scholarships. Spring semester application for next academic year

Valencia Community College East Campus 701 N. Econlachachee Trail Orlando, FL 32825. **Amount:** Full & half tuition **Open to:** Art students **Duration:** One year **When offered:** Annually

Valentine Richmond History Center 1015 E. Clay St. Richmond, VA 23219-15990. **Amount:** $500 **Open to:** Undergraduate & graduate students **Duration:** Summer internship **When offered:** Annually

Valley City State University Art Department, 101 College St. S.W. Valley City, ND 58072. **Amount:** Varies **Open to:** All students, freshmen-seniors **Duration:** Varies **When offered:** Annually & semi-annually

Ventura College 4667 Telegraph Rd. Ventura, CA 93003. **Amount:** $8,000 **Open to:** Qualified applicants **Duration:** Varies **When offered:** Annually & semi-annually

Vermont Studio Center P.O. Box 613 Johnson, VT 05656. **Amount:** Up to $2,700 per month **Open to:** Painters, sculptors & writers **Duration:** One month residency with access to visiting artists and writers **When offered:** Ongoing

The Viking Union Gallery 507 507 Western Washington University, VU Rm. 422, MSI-4 Bellingham, WA 98225-9106 Tel: 360-650-6534; E-mail: asp.vu.gallery@wwn.edu; Website: www.as.wwu.edu/programs/asp/gallery/beyond.html. **Amount:** (3) prizes amount not yet decided **Open to:** All currently enrolled undergraduate students on the west coast **Duration:** Not yet decided **When offered:** Annually

Vincennes University Art Dept. 1002 N. First St. Vincennes, IN 47591. **Amount:** Varies **Open to:** Any transfer visual art student **Duration:** One year **When offered:** Annually

Vincennes University, Humanities Art Dept. 1002 N. First St. Vincennes, IN 47591. **Amount:** Varies **Open to:** All students from Knox County, IN **Duration:** One year **When offered:** Annually

Virginia Center for the Creative Arts 154 San Angelo Dr. Sweet Briar, VA 24595. **Amount:** Varies **Open to:** Professional writers, composers & visual artists **Duration:** Average residency is one month

Virginia Commonwealth University-Schools of the Arts 325 N Harrison St., P.O. Box 842519 Richmond, VA 23284 Tel: 804-828-2787; Fax: 804-828-6469; E-mail: arts@vcu.edu. **Amount:** Varies **Open to:** Applicants and current students **Duration:** Varies **When offered:** Varies

Virginia Museum of Fine Arts 200 N. Blvd. Richmond, VA 23221-2466. **Amount:** $4,000 (Undergraduate); $6,000 (Graduate); $8,000 (Professional) **Open to:** Virginia professional visual artists & art students **Duration:** One year **When offered:** Annually

Virginia Polytechnic Institute & State University, Dept. of Art Art History, 201 Draper Rd. Blacksburg, VA 24061. **Open to:** Freshmen & special students **Duration:** Varies **When offered:** Annually

Virginia Western Community College P.O. Box 14007 Roanoke, VA 24038. **Amount:** $300-$400 **Open to:** Design majors **Duration:** One year **When offered:** Annually

Wabash College, Art Dept. 301 W. Wabash Ave. Crawfordsville, IN 47933 Tel: 265-361-6386. **Amount:** $5,000-$12,500 **Open to:** High school seniors **Duration:** Four years **When offered:** Annually

Wake Forest University, Dept. of Art 1834 Wake Forest Rd., Reynolda Sta. Winston Salem, NC 27109. **When offered:** Annually

Washburn University of Topeka, Dept. of Art 1700 S.W. College Topeka, KS 66621 Website: www.washburn.edu/cas/art. **Amount:** $1,000-$1,800 **Open to:** Full-time art majors **Duration:** One year **When offered:** Annually

Washington University One Brookings Dr., Campus Box 1031 Saint Louis, MO 63130. **Amount:** Full & partial tuition **Open to:** First year undergrads & grads **Duration:** Four or two years **When offered:** Annually

Wayland Baptist University, Dept. of Art 1900 W. 7th, WBU #249 Plainview, TX 79072. **Amount:** Up to $1,000 per semester **Open to:** Art majors & minors **Duration:** One year **When offered:** Annually

West Texas A&M University, Art, Communication & Theatre Dept. Royal Brantley, Box 60747, 103 Fine Arts Complex Canyon, TX 79016 Website: www.wtamu.edu. **Amount:** Varies **Open to:** Varies **Duration:** One year **When offered:** Annually

West Virginia University, Division of Art P.O. Box 6111 Morgantown, WV 26506-6111. **Duration:** One year **When offered:** Annually

Western Art Association 416 N. Pearl St. Ellensburg, WA 98926 E-mail: waa@alltel.net. **Amount:** $1,000 **Open to:** Local high school students **Duration:** One year **When offered:** Annually

Western Illinois University 1 University Cir, 32 Garwood Hall Macomb, IL 61455-1396 Tel: 309-298-1549; Fax: 309-298-2605; Website: www.wiu.edu. **Amount:** Various amounts **Open to:** Majors **Duration:** One year and per semester **When offered:** Annually; semi-annually

Western Kentucky University WKU Art Dept., 1906 College Heights Blvd. Bowling Green, KY 42101 Tel: 270-745-6566; Fax: 270-745-5932; Website: www.wku.edu. **Amount:** $1,000 **Open to:** Full-time students **Duration:** One year **When offered:** Annually

Wharton County Junior College 911 Boling Hwy. Wharton, TX 77488. **Amount:** $750/semester **Open to:** Full-time Art Students **Duration:** Two years **When offered:** Annually

Whitman College, Art Dept. 345 Boyer Ave. Walla Walla, WA 99362 Tel: 509-527-5248; Fax: 509-527-5039. **Amount:** $2.500-$3,200 **Open to:** Freshmen or new transfer student **Duration:** Four years renewable **When offered:** Annually

Wichita State University, Ulrich Museum of Art 1845 Fairmount St. Wichita, KS 67260-0046 Tel: 316-978-3664; Fax: 316-978-3998; E-mail: ulrich@wichita.edu. **Amount:** $500 **Open to:** Graduate students-WSU School of Art & Design **Duration:** One semester (Spring) **When offered:** Annually

Amount: $500 **Open to:** Undergraduate students enrolled in 9 or more credit hours- WSU School of Art & Design **Duration:** One semester (Spring) **When offered:** Annually

William A. Farnsworth Library and Art Museum 16 Museum St. Rockland, ME 04841 Tel: 207-596-6457; Fax: 207-596-0509; E-mail: farnsworth@midcoast.com. **Open to:** Children wishing to take art classes **Duration:** Term of class - usually six weeks **When offered:** Throughout the year

William Paterson University, Department of Art, College of the Arts & Communications 300 Pompton Rd Wayne, NJ 07470 **When offered:** Annually

William Woods University One University Ave. Fulton, MO 65251. **Amount:** $500-$5,000 per year **Open to:** Students who are majoring in the arts, based on portfolio performance review **Duration:** One year (renewable) **When offered:** Annually

Winterthur, An American Country Estate Rt. 52 Kennett Pike Winterthur, DE 19735 Tel: 800-448-3883; Fax: 302-888-4820; E-mail: webmaster@winterthur.org. **Amount:** Varies **Open to:** Varies **Duration:** Varies **When offered:** Annually

Women's Caucus for Art P.O. Box 1498, Canal St. Station New York, NY 10013 E-mail: info@nationalwca.org. **Amount:** $100 **Open to:** WCA Members **When offered:** Annually

Woodstock School of Art, Inc. P.O. Box 338 Woodstock, NY 12498-2112 Tel: 845-679-2388; Fax: 845-679-2388 *51; E-mail: wsart@earthlunk.net. **Amount:** Varies **Open to:** All **Duration:** Up to 6 months **When offered:** Quarterly

Xavier University 3800 Victory Pkwy. Cincinnati, OH 45207-7311 Tel: 513-745-3811; Fax: 513-745-1098; E-mail: karagheusianm@xavier.edu. **Amount:** $10,050-$20,100 **Open to:** High school seniors **Duration:** 4 years **When offered:** Annually

ALABAMA

WATERCOLOR SOCIETY OF ALABAMA ANNUAL NATIONAL EXHIBITION Annual, May. Open to watercolor artists residing in the U.S. $6,000 in awards. For further information write Watercolor Society of Alabama, 3640 Stratford Way, Birmingham, AL 35242. Tel: 205-923-9790; E-mail: manetteljones@bellsouth.net.

ARIZONA

MESA ARTS CENTER EXHIBITS Mesa. Annual. Present up to six national juried exhibits in all media. For further information write Mesa Arts Center/Mesa Contemporary Arts, 1 E. Main St., P.O. Box 1466, Mesa, AZ 85211-1466. Tel: 602-644-2056; Fax: 602-644-2901.

SCOTTSDALE ARTS FESTIVAL Scottsdale. Annual, mid-March. Any media. Juried. Entry slides due Oct. 16 - prospectus mailed out in Aug. For further information write Scottsdale Center for the Arts, 7380 E. Second St., Scottsdale, AZ 85251. Tel: 480-874-4686. Artists can download an application at www.scottsdaleperformingarts.org.

CALIFORNIA

THE ARTISTS COUNCIL 32nd Annual Juried Exhibition. Palm Springs. Annual. All fine art media. No crafts or functional art. Artwork must not exceed 50" width x 96" height; sculpture weight not to exceed 50 lbs. Open to all residents of the U.S. Fee $30 for 1 or 2 slides for non-members. Awards: $3,500 plus honorable mentions. For prospectus send a #10 SASE to Artists Council, Palm Springs Desert Museum, P.O. Box 2310, Palm Springs, CA 92263-2310. Tel: 760-325-7186, Ext. 150.

FEATS OF CLAY Lincoln. Annual national juried ceramic competition and exhibition. Juror: Rodney Mott. Purchase and cash merit awards. For prospectus send legal sized SASE to Lincoln Arts, 580 6th St, Lincoln, CA 95648. Tel: 916-645-9713. Website: www.lincolnarts.org.

MASKIBITION 14 Eureka. Handmade masks. Juried, prizes. For further information write The Ink People Center for the Arts, 411 12th St., Eureka, CA 95501. Tel: 707-442-8413; Fax: 707-444-8722; E-mail: inkers@northcoast.com; Website: www.inkpeople.org.

OLIVE HYDE ART GALLERY ANNUAL TEXTILE COMPETITION Annual. Textiles. Open to any artist working in predominantly fiber media. Juried, awards. Fee $7 per item, limit three. Work must be hand delivered. For further information write Olive Hyde Art Gallery, City of Fremont, Recreation Services Department, P.O. Box 5006, Fremont, CA 94537-5006.

WATERCOLOR WEST ANNUAL NATIONAL JURIED EXHIBITION XXXVIII Riverside. Annual, held at the Riverside Art Museum. Transparent water media. Open to all artists. Juror for selection and awards. Fee members $25 for one or two slides; non-members $30 For further information write Watercolor West, P.O.Box 213, Redlands, CA 92373.

COLORADO

ANNUAL WATERMEDIA EXHIBIT Denver. Annual, Apr.-May, Watermedia. Statewide. Juried. Deadline, Jan.-Feb. For further information write Colorado Watercolor Society, P.O. Box 100003, Denver, CO 80250-0003.

COLORED PENCIL IN COLORADO Craig. Oct. 6-25. Juried. For further information write to Frances Williams-Reust, 615 Legion St., Craig, CO 81625. Tel: 970-824-7643.

CONNECTICUT

CELEBRATION OF AMERICAN CRAFTS New Haven. Annual, Nov.-Dec. Crafts. Open to U.S. artists. Juried. Deadline for slides June 15. For prospectus send SASE to Creative Arts Workshop, 80 Audubon St., New Haven, CT 06510.

NEW HAVEN PAINT & CLAY CLUB Annual, Mar. Oil, watercolor, acrylic, graphics, mixed media and sculpture. Open to artists from the New England states & NY. $4,000 in prizes and purchase awards. Fee $17 for first entry, $8 for second, 20% commission. Entry forms mailed out in Jan.-Feb. For further information write NHP & C Club President, 51 Trumbull St., New Haven, CT 06510.

FLORIDA

36TH ANNUAL RIVERSIDE ARTS FESTIVAL Jacksonville. Sept. 8-9. 150 artists and craftsmen. $10,000 in awards. For application and further information write Riverside Avondale Preservation, Inc., 2623 Herschel St., Jacksonville, FL 32204. Tel: 904-389-2449; Fax: 904-389-0431; E-mail: rap@fdn.com; Website: www.Riverside-Avondale.com.

ANNUAL SMALL WORKS SHOW West Palm Beach. Annual, Subject: Human form. Juried by slides, artists may submit up to three entries. $5,000 in prizes. Fee $25. Entry deadline Mar. 10. Send SASE to Small Works, Armory Art Center, 1703 S. Lake Ave. West Palm Beach, FL 33401. Tel: 561-832-1776, Ext. 33; Fax: 561-832-0191.

COMBINED TALENTS: THE FLORIDA INTERNATIONAL Tallahassee. Annual, fall. Open to artists over 18, students and faculty of FSU are ineligible. Juried by digital images (preferred) & slides (accepted). Entrants may submit up to two works. $1,500 in monetary awards. Fee $20. Deadline Feb. 14. For further information and/or prospectus write The Florida International, FSU Museum of Fine Arts, 250 Fine Arts Bldg., Tallahassee, FL 32306-1140. Tel: 850-644-3906.

MIAMI BEACH COLDWELL BANKER FESTIVAL OF THE ARTS Miami Beach. Annual, All media Fine Arts. $11,000 in awards. Entry slides due Oct. 1. Fee $295. For further information write to Fine Arts Board, c/o North Beach Development Corp., 210 71st St., Ste. 310 Miami Beach, FL 33141.

TENTH ANNUAL ART OF PHOTOGRAPHY Traditional and non-traditional categories. Juried by slides, postmark. Deadline Aug. 22. $2,500 in awards. For prospectus send SASE to Armory Art Center, 1703 Lake Ave., West Palm Beach, FL 33401. Tel: 561-832-1776, Ext. 33.

HAWAII

PACIFIC STATES BIENNIAL NATIONAL PRINT EXHIBITION Hilo. Biennial, All printmaking media including monoprints (no photographs). Open to all artists 18 years or older residing in the U.S. and territories. National juried print exhibition. Entry fee for all original work. For exhibition prospectus send SASE to Art Dept, Attn: Professor W. Miyamoto, University of Hawaii at Hilo, 200 W. Kawli St., Hilo, HI 96720-4091. Fax: 808-974-7712; E-mail: wmiyamot@hawaii.edu; Website: www.uhh.hawaii.edu/~art/ or www.uhh.hawaii.edu/~art/exhibitions.php.

IDAHO

ART ON THE GREEN Coeur d'Alene. Annual, Aug. Arts and crafts, all media. Juried show. Displayed and sold. $5,000 cash prizes. For further information write Citizens' Council for the Arts, P.O. Box 901, Coeur d'Alene, ID 83816-0901. Tel: 208-667-9346.

ILLINOIS

ANNUAL FOUNTAIN SQUARE ARTS FESTIVAL Evanston. Annual, Fine Arts & Crafts displayed and sold in 13 different media. Over $3,000 available in cash awards. For applications and festival information write the Evanston Chamber of Commerce, 1560 Sherman Ave., Ste. 860, Evanston, IL 60201. Tel: 847-328-1500; Fax: 847-328-1510.

ANNUAL NATIONAL EXHIBITION OF TRANSPARENT WATERCOLORS Annual, show will travel to different museums each year. Transparent watercolors. Open to all artists 18 years or older and living in the U.S. and Canada. Open juried. Fee $20 for non-members, free for members, one painting per entrant. $7,800 and up in awards. For further information write Transpartent Watercolor Society of America 738 E. Dundee Rd., Box 111, Palatine, IL 60074.

CHICAGO'S NEW EAST SIDE ARTWORKS Chicago. Arts and Crafts. Open to all artists throughout the U.S. and Canada. Juried show, outdoor. For further information write Chicago's New Eastside Artworks, 200 N. Michigan Ave, Ste. 300, Chicago, IL 60601. Tel: 312-551-9290; Fax: 312-541-0253.

INDIANA

EVANSVILLE MUSEUM OF ARTS AND SCIENCE ANNUAL MID-STATES CRAFT EXHIBITION Evansville. Biennial, Ceramic, textile, metalwork, glass, wood, enamel and handcrafted materials. Open to residents of Indiana, Illinois, Kentucky, Missouri, Ohio, and Tennessee. Juried awards. Fee $15. Write or call for application in May-July. For further information write Art Committee, Evansville Museum of Arts & Science, 411 S.E. Riverside Dr., Evansville, IN 47713-1098. Tel: 812-425-2406.

IOWA

45ᵀᴴ ANNUAL ART IN THE PARK Riverview Park in Clinton, along the Mississippi River. June 16, 2007. Fine arts and fine crafts only. Juried by 4 slides or digital images (1 of display). Application fee $5. Space fee $70 (12x12). No commission. Cash awards. Application deadline Apr 15. Send SASE to Art in the Park, P.O. Box 2164, Clinton, IA 52733-2164. or call Stacy Kinkaid, 563-242-5120; E-mail: directors@clintonartinthepark.com.

ANNUAL OCTAGON COMMUNITY OF ARTISTS EXHIBITION Ames. Annual, Nov. 24 - Jan. 5. Open to artists in the Octagon Community. Juried exhibition. For further information write Octagon Center for the Arts, 427 Douglas Ave., Ames, IA 50010. Tel: 515-232-5331; Fax: 515-232-5088.

IOWA CRAFTS EXHIBITION Mason City. Biennial, Nov. - Jan. Open to any and all fine craft media, such as clay, fiber, wood, metals and others. Open to all artists residing within the State of Iowa. Juried by submission of slides or jpegs, up to $2,500 in cash awards. No fee. Entry deadline four weeks prior to opening of show. Slide deadline: Oct 4 at 5 pm. For further information write the Assoc. Curator, Charles H. MacNider Art Museum, 303 Second St., S.E., Mason City, IA 50401. Tel: 641-421-3666.

OCTAGON'S CLAY FIBER PAPER GLASS METAL AND WOOD EXHIBITION Ames. Annual, Mar. - Apr. Fine Arts. Open to established and emerging artists from around the U.S. Premier. juried national exhibition. For further information write Octagon Center for the Arts, 427 Douglas Ave., Ames, IA 50010. Tel: 515-232-5331; Fax: 515-232-5088.

KANSAS

SMOKY HILL RIVER FESTIVAL Salina. Annual, June 7 - 10, 2007. Juried. Art displayed and sold. $7,900 in Merit awards; $1,500 in Public Art Purchases; $95,000 Art Patron Program. For further information write Salina Arts & Humanities Commission, P.O. Box 2181, Salina, KS 67402-2181. Tel: 785-309-5770; Fax: 913-826-7444; E-mail: sahc@salina.org; Website: www.riverfestival.com.

MAINE

MAINE OPEN JURIED ART SHOW Waterville. Annual, March-April. Open to Maine artists only. Fee $25 for two entries. Over $2,000 in cash prizes. For further information write Waterville Area Art Society, P.O. Box 2703 Waterville, ME 04901. Tel: 207-873-7404.

MARYLAND

MID-ATLANTIC REGIONAL WATERCOLOR EXHIBITION Baltimore. Original aquamedia works on paper. Juried competition, over $4,000 in prizes, juror: Judy Wagner, author of The Watercolor Fixit Book and Painting with the White of the paper. For prospectus send SASE to Liz Donovan, 4035 Roxmill Ct., Glenwood, MD 21738.

MICHIGAN

THE GREAT LAKES REGIONAL EXHIBITION Midland. Annual, fall, All media and mixed media (painting, drawing, print-making, sculpture, ceramics, fiber art, photography, jewelry and new forms). Open to artists 18 years or older residing in Michigan. Only original work completed within past three years. Juried, prizes and awards. Fee $25 per artist, maximum three entries, $20 fee for members. Preliminary jurying from

slides. Final jurying from actual works. For further information and prospectus write Arts Midland: Galleries and School, Midland Center for the Arts, 1801 W. Saint Andrews Rd., Midland, MI 48640-2695.

MICHIGAN FINE ARTS COMPETITION Birmingham. Annual, Michigan statewide all-media, Juried competition. Juror - nationally renowned artist. Cash awards. For further information write Birmingham Bloomfield Art Center, 1516 S. Cranbrook Rd., Birmingham, MI 48009. Tel: 248-644-0866, Ext. 103; Fax: 248-644-7904.

MINNESOTA

SISTER KENNY ANNUAL INTERNATIONAL ART SHOW BY ARTISTS WITH DISABILITIES Minneapolis. Annual, Fine art only. Open to all disabled artists worldwide. Two pieces per entrant; artwork sold at exhibit, profits returned to participating artists. Deadline Mar. 22nd. For further information write Kathy Schultz, Abbott Northwestern Hospital, Sister Kenny Institute, 800 E. 28th St., Minneapolis, MN 55407. Tel: 612-863-4463; Fax: 612-863-8942.

MISSOURI

BEST OF AMERICA 11th Annual Juried Exhibition and sale, sponsored by the National Oil and Acrylic Painters' Society, at the prestigious Ella Carothers Dunnegan Gallery, and Columbia College, Lake Campus. Open to all artists, styles of oil and acrylic painting. Juror: Artist, Kevin Warren Smith, Curator, Gilcrease Museum, Tulsa. There will be $5,000 in awards. Slide deadline is July 30. $25 for up to 3 slides; free to N.O.A.P.S. members. For prospectus SASE to P.O. Box 676, Osage Beach, MO 65065-0676.

GREATER MIDWEST INTERNATIONAL EXHIBITION Warrensburg. No media restriction. Open to artists 21 years or older. Work must be original, completed within the last 3 years and not previously exhibited at CMSU Art Center Gallery. Juried. $1,600 in cash awards. Fee for one to three slides, $25. For further information and prospectus send SASE to Central Missouri State University, Art Center Gallery—GMI XV, c/o Dir. Morgan Gallatin, 217 Clark St., Warrensburg, MO 64093-5246.

PHOTOSPIVA Joplin. Apr.-May (deadline Feb.), All photography processes. Open to U.S. artists Juried. $2,000 in cash awards. Fee $40, limit five. For further information write to Spiva Center for the Arts, 222 W. Third St., Joplin, MO 64801. E-mail: spiva@spivaarts.org.

NEBRASKA

PHI-THETA-KAPPA SIX-STATE COMPETITIVE McCook. Annual, Feb.-Mar. All two-dimensional art except computer-generated and photography. Open to all artists 18 years and older living in Nebraska, Colorado, Iowa, Kansas, South Dakota and Wyoming. Juried by slides. $1,200 and up in purchase and cash awards, 20% commission in all art work sold. For prospectus write Don Dernovich, Art Dept., McCook Community College, 1205 E. Third, McCook, NE 69001. Tel: 308-345-6303; Fax: 308-345-3305.

NEW MEXICO

PSNM NATIONAL ART EXHIBITION Albuquerque. Awards in excess of $3,000. For 2001 prospectus (SASE) write Pastel Society of New Mexico, P.O. Box 3571, Albuquerque, NM 87190-3571.

SOUTHWEST ARTS FESTIVAL Albuquerque. Annual. Nov. Open to artists and craftspeople. Juried. Admis. $5. For further information write Southwest Arts Festival, 4519 Martinsburg Rd. N.W., Albuquerque, NM 87120. Tel: 505-875-1748; Fax: 505-875-1749.

NEW YORK

COOPERSTOWN ANNUAL NATIONAL SUMMER EXHIBITION Cooperstown. Annual, All media. Prizes. Catalog. For further information write Janet G. Erway, Dir. Cooperstown Art Association, 22 Main St., Cooperstown, NY 13326.

EVERSON MUSEUM OF ART EVERSON BIENNIAL Syracuse. Biennial, held during even years, Painting, prints, drawing, collage, photographs, sculpture, fiber. Features works by artists living within 100 miles of Syracuse. Fee for non-members. For further information write Everson Museum of Art, Public Information Dept., 401 Harrison St., Syracuse, NY 13202.

THE MINI PRINT INTERNATIONAL EXHIBITION Binghamton. Print-making, contemporary and traditional methods acceptable. Images submitted no larger then 4" x 4". For prospectus and further information write B. McLean, Studio School & Art Gallery, 3 Chestnut St., Binghamton, NY 13905. Tel: 607-772-6867.

SALMAGUNDI CLUB ANNUAL NON-MEMBERS EXHIBITION New York. June 1-18, Oil, watercolor, pastel, acrylic, mixed media and graphics. Juried by slides. Cash and material awards. Entry fee $25 for one slide, $35 for 2 slides, $45 for 3 slides. Slides due March 13. 25% commission. Send a SASE to Non-Members Exhibition, Salmagundi Club, 47 Fifth Ave., New York, NY 10003.

OHIO

COLUMBUS ARTS FESTIVAL Columbus. Annual, June, Fine arts and crafts. Juried. Information and applications can be obtained on the internet or write Columbus Arts Festival, 100 E. Broad St. Ste. 2250 Columbus, OH 43215. Tel: 614-224-2606. Website: www.gcac.org/artsfest.

SUMMERFAIR Cincinnati. Annual. June 1-3 2007, All fine arts and crafts. Juried Exhibition. Sale. Processing fee $25. $10,000 and up in cash awards. $325 for 10'x10' booth. Application deadline Feb 7, 2007. For further information write Summerfair Cincinnati, 2515 Essex Pl., Studio 243, Cincinnati, OH 45206. Tel: 513-531-0050; Fax: 513-731-0280; E-mail: summerfair@fuse.net.

OKLAHOMA

OKLAHOMA ART WORKSHOPS NATIONAL JURIED EXHIBITION Tulsa. Multi-media. Open to all artists nationwide. Juror: Carole Katchen. $5,000 in prizes. For further information send SASE Attn: Joy Beller, Show Chmn., Oklahoma Art Workshops, 6953 S. 66th E. Ave., Tulsa, OK 74133-1747. Tel: 918-627-1825.

PENNSYLVANIA

ANNUAL JURIED EXHIBITION OF THE ART ASSOCIATION OF HARRISBURG Harrisburg. Annual. May 12 - Jun. 14, 2007, Media categories include: oil and acrylic, sculpture and ceramics, photography, watercolor, prints and graphics, etc. Open to all artists in the U.S. and abroad. Juried by slides. Fee $12.50 per slide, two slides per entrant. Deadline Feb. 28, 2007. Send SASE to Art Association of Harrisburg, 21 N. Front St., Harrisburg, PA 17101. Tel: 717-236-1432; Fax: 717-236-6631.

CENTRAL PENNSYLVANIA FESTIVAL OF THE ARTS CRAFTS NATIONAL EXHIBITION State College. Annual. June-July. Juried. Fine craft gallery exhibition open to American artists, $3,500 in awards. $25/three entries. For prospectus and further information contact the Director

of Visual Arts, Central Pennsylvania Festival of the Arts, P.O. Box 1023, State College, PA 16804-1023. Tel: 814-237-3682; Fax: 814-237-0708; Website: www.arts-festival.com.

CENTRAL PENNSYLVANIA FESTIVAL OF THE ARTS IMAGES EXHIBITION State College. Annual. June-July. Juried fine art gallery exhibition open to artists living in mid-Atlantic region. Juried. $3,500 in awards. $25/three entries. Fine Arts Exhibition. For prospectus and further information contact the Director of Visual Arts, Central Pennsylvania Festival of the Arts, P.O. Box 1023, State College, PA 16804-1023. Tel: 814-237-3682; Fax: 814-237-0708; Website: www.arts-festival.com.

CENTRAL PENNSYLVANIA FESTIVAL OF THE ARTS SIDEWALK SALE & EXHIBITION State College. Annual. July 11 - 15, 2007, Media categories: basketry, ceramics, drawing, fiber, glass, jewelry, leather, metal, mixed media (2D & 3D), musical instruments, painting, paper, photography, printmaking, sculpture, watercolor, wood and other. Juried. $17,325 in awards. $25 application fee, five slides submitted with fee. For entry and further information Director of Visual Arts, Central Pennsylvania Festival of the Arts, P.O. Box 1023, State College, PA 16804-1023. Tel: 814-237-3682; Fax: 814-237-0708; Website: www.arts-festival.com.

WASHINGTON & JEFFERSON COLLEGE NATIONAL PAINTING SHOW Washington. Annual, Mar.-Apr. All painting. Open to any U.S. artists, 18 years old. Prizes and purchase awards. Fee $10 for each slide entry. Entry cards and slides due Jan., work due Mar. For further information write Paul B. Edwards, Olin Art Center, Washington & Jefferson College, 60 S. Lincoln St., Washington, PA 15301.

RHODE ISLAND

PROVIDENCE ART CLUB Annual. Three open. Juried Shows every year scheduled at various times. Usually open to artists nationwide. Shows are either media-specific (prints, sculpture, etc.) or theme-based. For further information write Providence Art Club, 11 Thomas St., Providence, RI 02903. Tel: 401-331-1114.

SOUTH CAROLINA

WACCAMAW ARTS AND CRAFTS GUILD Myrtle Beach. ART-IN-THE-PARK, Chapin Park-16th Ave. N. and King's Highway (Bus 17), Myrtle Beach, SC 29577. Contact Bruce Smith, 843-249-4937.

SOUTH DAKOTA

RED CLOUD INDIAN ART SHOW Pine Ridge. June-Aug, Paintings, graphics, mixed media, 3-D work. Open to any tribal member of the native people of North America. Juried. $5,500 in merit and purchase awards. Entries due May 22. For further information write Red Cloud Indian Art Show, Red Cloud Indian School, 100 Mission Dr., Pine Ridge, SD 57770-2100.

TENNESSEE

CENTRAL SOUTH ART EXHIBITION Nashville. Annual, spring, All media recognized for artists residing in Tennessee, each adjoining state within a 300-mile radius and/or a league member. Juried competition and exhibition. Over $7,000 in awards. To receive prospectus send #10 SASE to Tennessee Art League, 808 Broadway, Nashville, TN 37203. Tel: 615-298-4072.

TEXAS

THE GRACE MUSEUM Abilene. Exhibition and competition of contemporary two- and three- dimensional art. Open to Texas artists. Juried. Cash prizes. Solo exhibition awarded. For Information write MOA Annual Art Competition Museums of Abilene 102 Cypress, Abilene, TX 79601. Tel: 325-673-4587.

UTAH

UTAH STATEWIDE ANNUAL COMPETITION AND EXHIBITION Salt Lake City. This juried exhibit sponsored by the Utah Arts Council has a tradition spanning more than 100 years. Open to Utah artists only, at no charge, this exhibition is selected by at least one out-of-state juror. The annual format rotating disciplines. Up to $3,000 is allocated for cash awards. For further information write Utah Arts Council, Visual Arts Dir. 617 E. South Temple, Salt Lake City, UT 84102-1177. Tel: 801-533-3581.

VIRGINIA

NATIONAL JURIED SHOW Richmond. Annual. All contemporary media will be considered except traditional craft. Open to all artists residing in the U.S. Juried. Entry fee, entry deadline Apr. 1. For prospectus send SASE to 1708 Gallery, Annual National Juried Exhibition, 319 W. Broad St., P.O. Box 12520, Richmond, VA 23241. Tel: 804-643-7829.

STOCKLEY GARDENS ARTS FESTIVALS Norfolk. Held twice a year, May 19-20 and Oct. 21-22. For further information write Hope House Foundation, 801 Boush St., 3rd Fl, Norfolk, VA 23510. Tel: 757-625-6161; Fax: 757-625-7775.

WISCONSIN

LAKEFRONT FESTIVAL OF ARTS Milwaukee. Annual, June, Multi-media. Open to professional artists and fine craftsmen from across the country. Juried. $10,000 in prizes. Fee $25. For further information write Milwaukee Art Museum, 700 N. Art Museum Dr. Milwaukee, WI 53202. Tel: 414-224-3200; Fax: 414-271-7588.

ACADEMY OF MOTION PICTURE ARTS AND SCIENCES, 8949 Wiltshire Blvd, Beverly Hills, CA 90211. Tel: 310-247-3000; Fax: 310-247-3610; E-mail: gallery@oscars.org. *Exhib Cur* Ellen Harrington. **Exhibits—** Unseen Hurrell: Reds and Blacklists in Hollywood, Oscars in Animation, Hirschfeld's Hollywood. Shipping fee to be decided.

ADAMS COUNTY MUSEUM, 9601 Henderson Rd, Brighton, CO 80601-8127. Tel: 303-659-7103. *Pres* Rosemary Fischer; *Adminr* Dixie Pierce; *Treas* Rich Hoffman. **Exhibits—** Traveling "Heritage Suitcases" that contain study guides and hands-on items from the early 1900s for: cowboys, mining, Earth Sciences and Hispanic culture. Rental fee $5 per suitcase to schools.

AKRON ART MUSEUM, One South High, Akron, OH 44308. Tel: 330-376-9185; Fax: 330-376-1180; E-mail: mail@akronartmuseum.org. *Chief Cur & Head Public Programs* Barbara Tannenbaum; *Cur Exhibitions* Katie Wat. Please call 330-376-9185 for more information.

AKRON UNIVERSITY, Myers School of Art, 150 E Exchange St, Akron, OH 44325-7801. Tel: 330-972-6030; Fax: 330-972-5960; E-mail: susan27@uakron.edu. *Dir University Galleries* Rod Bengston.

ALABAMA STATE UNIVERSITY, Dept of Visual & Theater Arts, 915 S Jackson St, Montgomery, AL 36101. *Chmn Dir* William E.Colvin. **Exhibits—** Faculty, Mixed Media, Ceramics, Prints, Painting, Drawing and Graphics. Rental fee $1,500 (depends on distance).

ALASKA DEPARTMENT OF EDUCATION, DIVISION OF LIBRARIES, ARCHIVES & MUSEUMS, Stratton Library, 801 Lincoln St, Sitka, AK 99835. Tel: 907-787-5217; Fax: 907-747-5237; E-mail: jdegnan@sj-alaska.edu. *Archivist* Jane I Degnan. **Exhibits—** A Place in Time: 1899-1929, The Photography Collection of E.W. Merrill. Rental and Shipping fees negotiable.

ALBERTA FOUNDATION FOR THE ARTS, 10708-105th Ave, Edmonton, T5H 0A1 AB Canada. *Exec Dir* Jeffrey Anderson; *Arts Devel Consultant* Sheelagh Dunlap. **Exhibits—** Exhibitions are currently provided through a consortium of Alberta public art galleries/arts organization. The programs vary from year to year and from region to region. Fees may vary and are subject to negotiation with participating galleries.

ALBRIGHT-KNOX ART GALLERY, 1285 Elmwood Ave, Buffalo, NY 14222-1096. *Dir* Louis Grachos *Sr; Cur* Douglas Dreishpoon; *Assoc Cur* Claire Schneider. **Exhibits—** Petah Coyne: Above and Beneath the Skin; Karin Davie: Dangerous Curves; The Wall: Reshaping Contemporary Chinese Art; Extreme Abstration; The Natalie and Irving Forman Collection.

ALLEN SAPP GALLERY - THE GONOR COLLECTION #1 Railway Ave. E., Box 460 North Baltleford, Saskatoon, S9A 2Y6 SK Canada. Tel: 306-445-1760; Fax: 306-445-1694; E-mail: sapp@accesscomm.ca; Web Site: www.allensapp.com *Dir* Dean Baudie. **Exhibits—** Through The Eyes of the Cree; Rental Fees are based on venue location and availability of public funding support.

ALLIE GRIFFIN ART GALLERY, Weyburn Arts Council, 45 Bison Ave, Weyburn, S4H 0H9, SK Canada. *Cur* Helen Mamer. **Exhibits—** City of Weyburn Permanent Collection: For Every Season; Saskatchewan Lotteries from 1994-1997. Rental fee $75; Shipping fee covered by OSAC.

ALMA COLLEGE, CLACK ART CENTER, 614 W. Superior St., Alma, MI 48801. Tel: 517-463-7220; Fax: 517-463-7277. *Gallery Dir* Sandy Lopez-Isnardi. **Exhibits—** Alma College annual statewide print competition. Shipping fees vary; it costs to ship to the next site. Originates at Alma College in Nov., then tours 4-5 sites in Michigan Jan. to Sept. (Since 1981).

ALVA deMARS MEGAN CHAPEL ART CENTER, Saint Anselm College, 100 Saint Anselm Dr, Manchester, NH 03102. Tel: 603-641-7470; Fax: 603-641-7116. *Dir* Iain MacLellan, O.S.B.; *Cur* Martha Sawyer. **Exhibits—** Guatemala: Holy Week (with catalogue). Colony Printmakers: MacDowell Colony Printmakers from 1925-1995 (co-sponsored & coordinated by Sharon Arts Center, Peterborough, NH, with catalogue); Family Pictures: Reconstructing the Family Album (with catalogue); Carl Barnes 1879-1953; Crossing Continents, An Artist at Home and in Exile (with catalogue); Abstraction on the Line; Defining New Realities; Color, Shape, & Form (Jan-Feb); May You Find Beauty; The Paintings of John C. Traynor (Sept-Oct ; Devotions Eternal & Temporal; The Icon Collection of Louis & Carole Mc Millen; Designs for the Church of the Transfiguration (Oct-Dec); The Body Broken; The Art of Bruce Herman (Jan-Mar).

AMERICAN JEWISH ART CLUB, 6301 N Sheridan Rd, Apt 8E, Chicago, IL 60660. *Pres* Mrs. Irmgard Hess Rosenberger. **Exhibits—** One and two group exhibitions per year-one is an annual exhibition at which awards are given to five artists. Membership is $35 annually.

AMERICAN MUSEUM OF CARTOON ART, INC, 2930 Colorado Ave, Ste A-14, Santa Monica, CA 90404. Tel: 310-828-2919; Web Site: www.cartoonmuseum.com. *Cur Dir* Jeremy Kay. **Exhibits—** The History of Cartoon Art (1640's to present), A History of American Cartoons.

AMERICAN PRINT ALLIANCE, 302 Larkspur Turn, Peachtree City, GA 30269-2210. Tel: 770-486-6680. *Dir* Carol Pulin. **Exhibits—** On/Off/Over the Edge: 48 prints, paperworks, and artists' books. Rental fee $385; Shipping fees included.

AMERICAN SOCIETY OF BOTANICAL ARTISTS, 47 Fifth Ave, New York, NY 10003. Tel: 212-691-9080; Fax: 212-691-9130. *Pres* Michele Meyer. **Exhibits—** Botanical Art & Illustration.

AMERICAN WATERCOLOR SOCIETY, 47 Fifth Ave, New York, NY 10003. *Chmn* Helen Napoli. **Exhibits—** Traveling Show.

AMERICAS SOCIETY, INC, 680 Park Ave, New York, NY 10021. Tel: 212-249-8950; Fax: 212-249-5868; E-mail: exhibitions@as-coa.org; Web Site: www.americas-society.org. *Dir Visual Arts* Marysol Nieves; *Assoc Cur* Sofia Hernandez Chong Cuy; *Exhib Coordr* Cecilia Bruson. **Exhibits—** Latin American, Caribbean and Canadian art from pre-Columbian to contemporary times. Details of programs available from Visual Arts Department. Rental fees are dependent on the nature of the exhibition.

ANCHORAGE MUSEUM OF HISTORY AND ART, 121 West Seventh Ave, Anchorage, AK 99501. *Registrar* Sharla Blanche. **Exhibits—** Arctic Transformations: The Jewelry of Denise and Samuel Wallace (travels 2005-2006); Yungnaqpiallerput: The Way We Genuinely Live (Yupik Science exhibit tentatively set for 2006-2007).

ANSEL ADAMS CENTER FOR PHOTOGRAPHY, The Friends of Photography, 250 Fourth St, San Francisco, CA 94103. *Dir* Deborah Klochko; *Cur* Nora Kabat; *Exhibs Coordr* Sharon Bliss. **Exhibits—** Ansel Adams, A Legacy: Masterworks from The Friends of Photography Collection; Innovation/Imagination: 50 Years of Polaroid Photography; Capturing Eden: A Photographic Study of Gardens. Rental fees $5,000-$20,000; Shipping fees incoming shipping from previous venue.

ARAB AMERICAN NATIONAL MUSEUM, 13624 Michigan Ave, Detroit, MI 48126. *Cur Research* Devon Akmon. **Exhibits—** In Times of War-Her Untold Story Rental fee $1,000 Shipping fee & insurance.

ARC GALLERY, 734 N Milwaukee, Chicago, IL 60622, Tel: 312-733-2787. *Pres* Aviva Kramer; *Pres* Carolyne King; *VPres* Kristina Gosh; *Secy* Arlene Levey. **Exhibits—** Gallerie der Gedok, Hamburg, Germany (exchange exhibition) A.R.C. in Japan- artist residency and cultural exchange at Matsu Gaoka Gallery in Haguro-Machi Yamagata. Exchange exhibition with Red Head Gallery, Toronto, Canada Capital Commuti-A.R.C. at Gallery 10, Washington D.C.

ARCHITECTURAL LEAGUE OF NEW YORK, 457 Madison Ave, New York, NY 10022. *Program Dir* Anne Rieselbach.

ARROWMONT SCHOOL OF ARTS & CRAFTS, 556 Parkway, PO Box 567, Gatlinburg, TN 37738. Tel: 865-436-5860; Fax: 865-430-4101; E-mail: info@arrowmont.org. *Gallery Coordr* Karen Green. **Exhibits—** Arrowmont permanent collection.

ART DIRECTORS CLUB, 106 W 29th St, New York, NY 10001. Tel: 212-643-1440; Fax: 212-643-4266; E-mail: info@adcglobal.org. *Awards Prog Assoc* Glenn Kubata. **Exhibits—** Annual awards; Young Guns.

ART FROM DETRITUS, Box 1149, New York, NY 10013. Tel: 212-925-4419; Fax: 212-925-4419; E-mail: ncognita@earthfire.org. *Dir & Cur* Vernita Nemec. **Exhibits—** Art from Detritus: General exhib of art made from recycled materials & to save the planet: Art from Detritus/Rocus: Recycled Paper; Art from Detritus/Rocus: Found Objects Rental fees $2,000; Shipping fees depend on size of show & number of works exhibit can be adapted to accommodate showing space & to include 2-D and/or 3-D works, as well as small works intended for closed cases.

ART GALLERY OF NEWFOUNDLAND AND LABRADOR, Arts & Culture Centre, PO Box 4200, St John's, AIC 5S7, NF Canada. *Dir* Patricia Grattan. **Exhibits—** Contemporary art; folk art; traditional craft of Newfoundland & Labrador. Rental & shipping fees vary.

ART GALLERY OF YORK UNIVERSITY, 4700 Keele St, N. Ross Bldg, Ste. 145, Toronto, M3J IP3, ON Canada. *Dir* Philip Monk; *Asst Cur* Kathleen McLean; *Asst Cur* Emelie Chhangur. **Exhibits—** Diana Thater; Robin Collyer; Becky Singleton; Moira Dryer; Christine Borland; Mark Manders; Walid Raad and the Atlas Group.

Art House, 700 Congress Ave, Austin, TX 78701. Tel: 512-453-5312; Fax: 512-459-4830; Web Site: www.arthousetexas.org. *Exec Dir* Sue Graze; *Art-on-Tour Coordr* Virginia Jones; *Adjunct Cur* Regine Basha; *Dir Develop* Melissa Berry. **Exhibits—** New American Talent, Going West, Texas Abstract and Pulp Fictions. Rental fees $800-$2,000; Shipping fee $120. Currently touring in Texas only.

ART IN ARCHITECTURE, 5514 Wilshire Blvd, Los Angeles, CA 90036-3829. Tel: 213-654-0990. *Dir* Joseph Young; *Assoc* Millicent E. Young. **Exhibits—** Art in Architecture.

ART WITHOUT WALLS, INC, PO Box 341, Sayville, NY 11782. Tel & Fax: 631-567-9418; E-mail: artwithoutwalls@webtv.net; Web Site: www.artwithoutwalls.net. *Exec Dir* Sharon Lippman. **Exhibits—** Holocaust: The Polish Experience; Images of Home—European Experience; Traditional, Holocaust, Contemporary art. Rental fees $3,000-$5,000. P.O. Box 2066, NY, NY 10185-2066.

ARTHUR GRIFFIN CENTER FOR PHOTOGRAPHIC ART, 67 Shore Rd, Winchester, MA 01890. Tel: 617-729-1158; Fax: 617-721-2765. *Dir* Katherine Cordova. **Exhibits**—Arthur Griffin: The Boston Globe Years, 1929-46; Arthur Griffin: A Life in Photography.

ASIA SOCIETY AND MUSEUM, 725 Park Ave @ 70th St, New York, NY 10021. *Pres* Vishakha Desai; *Dir Mus & Cur Contemporary Asian and Asian American Art* Melissa Chiu. **Exhibits**— Asian art, usually on closely focused topics. Rental and shipping fees vary.

ASIAN AMERICAN ARTS CENTRE, 26 Bowery, New York, NY 10013. *Dir* Robert Lee; *Program Mgr* Chee Wang Ng. **Exhibits**— (Nov 19-Dec 31, 2004) The Topography of Absence (Landscape Painting): Amy Kao, Shin-il Kim, Cynthia Lin, Steve Kwon, and Lisa Young. Curated by Katarina Wong.

ASTED, INC, 3414 Ave Du Parc, Bureau 202, Montreal, H2X 2H5. PQ Canada. Tel: 514-738-6391; Email: info@asted.org; Web Site: www.asted.org. *Contact* Colette Rivet. **Exhibits**— offered annually.

ATLANTA INTERNATIONAL MUSEUM OF ART AND DESIGN, 285 Peachtree Center Ave, Marquis II Tower, Atlanta, GA 30303-1229. *Exec Dir* Angelyn S. Chandler; *Dir of Devel* John Jones. **Exhibits**— Art of the Ndebele; Mandela's Cell; Tartan: Cultural Fabric of a Nation. Rental fees $800-$5,000 for 3 months plus shipping fees one way.

ATLATL, INC, National Service Organization for Native American Arts, 49 E. Thomas Rd. Suite 105, PO Box 34090, Phoenix, AZ 85012. Tel: 602-277-371; Fax: 602-277-3690. *Exec Dir* Fred Nahwooksy. **Exhibits**— Native Women of Hope, Hiapsi Wami Seewam: Flowers of Life. Rental fees $350-$800.

AUGUSTANA COLLEGE ART MUSEUM, Art & Art History Dept, 639 38th St, Rock Island, IL 61201. Tel: 309-794-7231; Fax: 309-794-7678; E-mail: armaurer@augustana.edu. *Dir* Sherry C Maurer. **Exhibits**— Swedish-American Artists; Changing exhibitions; College art collection. Rental fee $2,000. Shipping fee $1,500.

AUSTIN MUSEUM OF ART, 823 Congress Ave, Austin, TX 78701. *Museum Dir* Elizabeth Ferrer. **Exhibits**— Salomon Huerta. (Rental fee: $10,000); Common Objects/Uncommon Meetings: Sometimes a Cigar is Just a Cigar (Rental fee: $30,000).

BALTIMORE MUSEUM OF ART, 10 Art Museum Dr, Baltimore, MD 21218-3898. Tel: 443-573-1700; Fax: 443-573-1582; E-mail: amannix@artbma.org; Web Site: www.artbma.org. *Dir Communcations* Anne Mannix. **Exhibits**— Pissarro: Creating the Impressionist Landscape, Feb. 11-May 13, 2007; Matisse: Painter As Sculptor, Oct. 28, 2007-Feb. 3, 2008.

BALZEKAS MUSEUM OF LITHUANIAN CULTURE, 6500 S Pulaski Rd, Chicago, IL 60629. *Pres* Stanley Balzekas, Jr. **Exhibits**— Lithuanian Folk Art; Lithuanian Towns & Villages-photo exhibit of early 20th century black & white prints and antique cards; Contemporary Lithuanian Print-art exhibit featuring best graphic artists from Lithuania. Rental fee $150 plus transportation. Contact Karile Vaitkute at 773-582-6500.

BATON ROUGE GALLERY, CENTER FOR CONTEMPORARY ART, 1442 City Park Ave, Baton Rouge, LA 70808. Tel: 504-383-1470. *Exec Dir* Amelia Cox; *Asst Dir* Anna Roberts; *Spec Events Coordr* Janet Lurudawsky. **Exhibits**— Twelve contemporary art exhibitions each year featuring regionally- and nationally-recognized artists' works in all types of media; Outdoor film series; Spoken word series; Special performance art; Concert & theater presentations; artist cooperative, nonprofit.

BELLEVUE ART MUSEUM, 510 Bellevue Way NE, Bellevue, WA 98004. Tel: 425-519-0770; Fax: 425-637-1799; E-mail: bamc@bellevueart.org. *Cur* Ginger Duggan; *Registrar* Polly Meyer; *Assoc Cur* Mirian Sternberg. **Exhibits**— Alfredo Arreguin, Houses x Artists, OH Boy! A sideshow of design, Fashion: The Greatest show on Earth. Rental Fees $ 5,000-$15,000 Shipping fee protated.

BERKSHIRE MUSEUM, 39 South St (Rte 7), Pittsfield, MA 01201. *Exec Dir* Stuart A. Chase; *Deputy Dir & Dir Finance* Michael W. Willson. **Exhibits**— Kidstuff: Great Toys for our Childhood; Enchanted Museum: Exploring the Science of Art. Rental fee $50,000; Shipping fees vary.

BERRY COLLEGE Art Department, P.O. Box 580 Mount Berry, GA 30149-0580. Tel: 706-236-2219; Fax: 706-238-7835; E-mail: tmew@berry.edu. *Dir* Dr. Thomas J. Mew, III.

BIRGER SANDZEN MEMORIAL GALLERY, 401 N First St, PO Box 348 Lindsborg, KS 67456-0348. Tel: 785-227-2220; Fax: 785-227-4170; Email: fineart@sandzen.org. *Dir* Larry Griffis; *Cur* Ron Michael; *Secy* Muriel Gentine. **Exhibits**— Birger Sandzen and the New Land (rental fees $7,000-$10,000); Sandzen In the Smoky Valley, Kansas (rental fees $300-$400); Sandzen In the Mountains (rental fees $300-$400); Nailcuts by Birger Sandzen (rental fees $300-$400); The John P. Harris Collection: Prints Collected by a Noted Hutchinson Journalist; Hershel C. Logan, The Prairie Woodcutter; Etchings by John Taylor Arms, Prints by Arms from Travels in Europe. Shipping fees included within 500 miles.

BLACK AMERICAN WEST MUSEUM & HERITAGE CENTER, 3091 California St, Denver, CO 80205. *Exec Dir* Wallace Yvonne Tollette. **Exhibits**— Jazz, Cowboys, Buffalo Soldiers, Pioneers, Political Firsts, Negro Baseball Leagues. Rental and shipping fees vary. For information call 303-292-2566 or fax 303-382-1981.

BLACKWOOD GALLERY, UNIVERSITY OF TORONTO AT MISSISSAUGA, 3359 Mississauga Rd N, Mississauga, L5L IC6 ON Canada. Tel: 905-828-3789; Fax: 905-828-5202. *Cur* Barbara Fischer. **Exhibits—** General Idea Editions: 1967-1995. This retrospective exhibition of edition-based works by the artists' collective general idea is available for travel in 2005. The exhibition is accompanied by a 320-page catalogue raisonné. Rental fees tba; Prorated shipping.

BLAFFER GALLERY, THE ART MUSEUM OF THE UNIVERSITY OF HOUSTON, 120 Fine Arts Bldg, Houston, TX 77009. Tel: 713-743-952; Fax: 713-743-9525; Web Site: www.blaffergallery.org. *Dir* Terrie Sultan. **Exhibits—** Miguel Angel Rios: New Work; Multi Channel Video, Aug 2007; Katrina Moorehead: Sculpture, Aug 2007; Jean Luc Mylayne-Photographs, Jan 2008 Rental fees $10,000-$20,000 $10,000-$15,000. Contact Terrie Sultan at tsultan@uh.edu.

BOCA RATON MUSEUM OF ART, 501 Plaza Real Mizner Park, Boca Raton, FL 33432. Tel: 561-392-2500; Web Site: www.bocamuseum.org. *Exec Dir* George S. Bolge; *Senior Cur* Wendy Blazier; *Pres* Joseph Borrow. **Exhibits—** Contact for current exhibition list. Rental fees vary.

BOSTON PRINTMAKERS c/o Emmanuel College, 400 The Fenway, Boston, MA 02115. *Dir Traveling Exhib* Malgorzata Zurakowska. **Exhibits—** Rental fees waived for non-profit & educational organizations.

BRANDYWINE WORKSHOP, 730 S Broad St, Philadelphia, PA 19146. *Pres & Exec Dir* Allan L. Edmunds. **Exhibits—** Thematic exhibits on various ethnic artists, process of printmaking and innovations, subject matter (social narrative), abstraction. Rental fees $3,000-$8,000; Shipping fees $1,500-$2,500.

BREVARD MUSEUM OF ART AND SCIENCE, 1463 Highland Ave, Melbourne, FL 32935. Tel: 321-242-0737; Fax: 321-242-0798; E-mail: info@artandscience.org. *Cur* Jackie Borsanyi; *Registrar* Jose Marquez. **Exhibits—** Clyde Butcher; Shared Vision: Photographs of Baracoa, Cuba; Americans in Space. Rental fees vary Shipping fees paid by borrowing institution.

BROOKLYN MUSEUM, 200 Eastern Pkwy, Brooklyn, NY 11238-6052. Tel: 718-501-6380; Fax: 718-501-6131. *Chief Cur* Kevin Stayton; *Vice-Dir for Collections & Chief Conservator* Ken Moser; *Exhib Mgr* Megan Doyle Carmody; *Deputy Dir for Art* Charles Desmarais. **Exhibits—** Tour offerings are changing; please call for available exhibitions. Rental and shipping fees vary.

BRUCE MUSEUM OF ARTS & SCIENCES, One Museum Dr, Greenwich, CT 06890-7100. *Exec Dir* Peter C Sutton. **Exhibits—** Black and White Since 1960, Dec 2006-Feb 28, 2007; In Response to Place: Photographs from the Nature Conservancy's Last Great Places, Dec 2006-Jan 28, 2007; Zip, Bop and Whir: Toys of the 20th Century, Dec 9, 2006-July 8, 2007; Fakes and Forgeries, May 12, 2007-Sept 2, 2007; Chocolate Unwrapped, July 21, 2007-Feb 24, 2007.

BUNNELL STREET GALLERY, 106 W Bunnell, Ste A, Homer, AK 99603. *Dir* Asia Freeman. **Exhibits—** 2001: National Book Art Exhibition; International Mail Art Show of Valentines; Statewide (AK) Juried Sculpture Show; Various solo shows of Alaskan, National & International Artists.

BURCHFIELD-PENNEY ART CENTER, Buffalo State College, Rockwell Hall, Third Floor, 1300 Elmwood Ave, Buffalo, NY 14222. Web Site: www.burchfield-penney.org. *Dir* Ted Pietrzak; *Head Colls & Programming* Nancy Weekly. **Exhibits—** The Filmic Art of Paul Sharits; Theme and Variations: The Art of Catherine Parker; Frank Lloyd Wright: Windows from the Darwin D. Martin Complex; The Poetics of Place: Charles Burchfield and the Cleveland Connection; The Pan-American Exposition Centennial: Images of the American Indian.

BURLINGTON ART CENTRE, 1333 Lakeshore Rd, Burlington, L7S 1A9, ON Canada. Tel: 905-632-7796; Fax: 905-632-0278; Web Site: www.burlingtonartcentre.on.ca. *Exec Dir* Ian D Ross; *Dir of Progs* George Wale. **Exhibits—** Earth and Fire: Contemporary Canadian Ceramic Art; Canada's Own Captain Canuck: Inked Drawings by Richard Comely; Imagining an Other Canada: Images of Nationalism in the Canadian Landscape. Call for further information.

C M RUSSELL MUSEUM, 400 13th St N, Great Falls, MT 59401-1498. Tel: 406-727-8787; Fax: 406-727-2402; E-mail: amorand@cmrussell.org. *Exec Dir & Cur* Anne Morand.

CALIFORNIA SCIENCE CENTER, 700 State Dr, Los Angeles, CA 90037. Tel: 213-744-7400. *Mgr Special Exhibits* Shirley Radcliff. **Exhibits—** Science in Toyland; Magic: The Science of an Illusion.

CALIFORNIA WATERCOLOR ASSOCIATION, PO Box 4631, Walnut Creek, CA 94596. *Pres* Sue Johnston; *VPres* David Savellano; *Dir Communications* Lin Teichman & Pablo Villenueva-Lara. **Exhibits—** Throughout the state of California including State Capitol & National Exhibition in San Francisco. National Exhibition: Apr 1-28, 2005, Academy of Art University Gallery, 410 Bush St, San Francisco. Juror: Catherine Anderson.

CANADIAN MUSEUM OF CIVILIZATION, 100 Laurier St, PO Box 3100, Station B, Gatineau, J8X 4H2 PQ Canada. Tel 819-776-7000; Fax 819-776-8300. *Mgr Trvlg Exhibs* Helene Arsenault. **Exhibits—** Contact museum for current exhibition information. Rental and shipping fees vary. Additional cost if preparator from the museum is needed.

CAPE COD MUSEUM OF ART, 60 Hope Ln., PO Box 2034 Dennis, MA 02638. *Cur* Michael Giaguinto *Registrar* Angela Belsky *Exec Dir* Elizabeth Ives Hunter. **Exhibits—** A. Laselle Ripley Rental fees TBA Shipping fees TBA Traveling in 2008-2009.

CARNEGIE MELLON UNIVERSITY, College of Fine Arts, 5000 Forbes Ave., Ste 100 Pittsburgh, PA 15213. Tel: 412-268-5765; Fax: 412-268-4810; E-mail: ecs@andrew.cmu.edu. *Dir* Jenny Strayer. **Exhibits**— The Regina Gouger Miller Gallery hosts a variety of exhibitions, call 412-268-3877. Rental fee varie. Shipping fee varies.

CAROLINA ART ASSOCIATION, Gibbes Museum of Art, 135 Meeting St, Charleston, SC 29401. Tel: 843-722-2706 Ext 40; E-mail: pwall@gibbesmuseum.org. *Chief Cur* Angela Mack; *Coll Mgr* Zinnia Willets; *Asst Cur Exhib* Pam Wall. **Exhibits**— Call for current list of available exhibitions.

CAZENOVIA COLLEGE, Chapman Cultural Center, South Campus Building A, Cazenovia College, Cazenovia, NY 13035. *Dir, Art Gallery* John Aistars; *Dir, Cultural Center* Corky Goss. **Exhibits**— Variety of media and stylistic approaches.

CENTER FOR THE ARTS AT YERBA BUENA GARDENS, 701 Mission St, San Francisco, CA 94103-3138. *Visual Arts Cur* Rene de Guzman. **Exhibits**— German Indians by Becher & Robbins; New Portuguese Art Survey. Rental fee $5,000-$10,000, plus cost of shipping.

CENTRAL MICHIGAN UNIVERSITY University Art Gallery, Wightman 132, Mount Pleasant, MI 48859. Tel: 989-774-3974; Fax: 989-774-2278 E-mail: julia.morrisroe@cmich.edu. *Dir* Pamela Ayres. **Exhibits**— Painting: Sari Khoury Retrospective. Rental fees vary. Shipping fees vary.

CENTRAL WYOMING COLLEGE Robert A Peck Gallery, 2660 Peck Ave, Riverton, WY 82501. Tel: 307-855-2211; Fax: 307-855-2090; E-mail: nkehoe@cwc.edu. *Gallery Dir* Nita Kehoe-Gadway. **Exhibits**— Exhibits 8-10 shows per year on a variety of themes, all by contemporary artists.

CHADRON STATE COLLEGE Main Gallery, 1000 Main St, Chadron, ME 69337. Tel: 308-432-6452; Fax: 308-432-6396; E-mail: kkorte@csc.edu. *Exhibit & Design Coordr* Ken Korte. **Exhibits**— Solo and group exhibits; installations. Rental fees $4,000; Shipping fees $3,000.

CHATHAM CULTURAL CENTRE, Thames Art Gallery, 75 William St N, Chatham, N7M 4L4 ON Canada. Tel: 519-354-8338; Fax: 519-354-4170. *Dir & Cur* Carl Lavoy. **Exhibits**— Various contemporary Canadian artists. Rental fees vary.

CHATTAHOOCHEE VALLEY ART MUSEUM, 112 LaFayette Pkwy, La Grange, GA 30240. Te:1 706-882-3267. **Exhibits**— Bronislaw Bak: Graphic Works 1953-73 Rental fee $800, not including shipping.

CHILDRENS MUSEUM OF MANHATTAN The Tisch Building, 212 W. 83rd St, New York, NY 10024. Tel: 212-721-1223; Fax: 212-721-1127; Web Site: www.cmom.org. *Prod Coordr* Emily Farmer. **Exhibits**— Good Grief: Peanuts; Monkey King; Oh, Seuss!; Off to Great Places. Rental fees vary. Shipping fees vary.

CHINA INSTITUTE GALLERY, 125 E 65th St, New York, NY 10021. Tel: 212-744-8181; Fax: 212-628-4159; Email: gallery@chinainstitute.org. *Gallery Dir* Willow Hai Chang; *Gallery Registrar* Wendy Sung; *Mgr Art Educ* Pao Yu Cheng. **Exhibits**— Photography of Chinese Gardens; Chinese Shadow Puppets; The Emperors Collection: Paintings & Calligraphy from Liaoning; Ma Wang Dui: Art of Han Dynasty: Shu: Reinventing Books in Contemporary Chinese Art. Rental fees $3,500-$5,000; Shipping fees additional. Call for details.

CITY GALLERY AT CHASTAIN, 135 W Wieuca Rd, NW, Atlanta, GA 30342-3221. *Gallery Dir* Erin Bailey. **Exhibits**— Allan Wexler & Thomas Woodruff. Rental fees $15,000-$25,000.

CITY OF EL PASO ARTS & CULTURE DEPT, 2 Civic Ctr. Plaza 6th Fl, El Paso, TX 79901. Tel: 915-541-4481; Fax: 915-541-4902; Web Site: www.elpasoartsandculture.org. *Dir* Yolanda Alameda.

CLARKE COLLEGE 1550 Clarke Dr, Dubuque, IA 52001. Tel: 563-588-6300; Fax: 563-588-6789. *Dir* Douglas Schlesier. **Exhibits**— Student Work

COLBY COLLEGE Museum of Art, 5600 Mayflower Hill, Waterville, ME 04901-5600. *Cur* Sharon Corwin. **Exhibits**— Alex Katz: Linocuts and Woodcuts Rental fees $5,000 Shipping fees prorated.

COLLEGE OF THE CANYONS, 26455 Rockwell Canyon Rd, Santa Clarita, CA 91355. Tel: 661-259-7800. *Gallery Dir* Joanne Julian; *Gallery Asst* Janice Neenan; *Gallery Preparator* Larry Hurst. **Exhibits**— Four annual curriculum-enhancing exhibitions that include both student and faculty shows.

COLLEGE OF WILLIAM & MARY, MUSCARELLE MUSEUM OF ART, PO Box 8795, Williamsburg, VA 23187-8795. *Dir* Aaron H. DeGroft, Ph.D; *Exhibitions, Operations & Security* John McIntyre; *Special Projects* Ursula McLaughlin. **Exhibits**— Tenth Annual William and Mary Faculty Show, Dec 2006-Jan 7, 2007; Medici in America, Natura Morta: Still-Life Painting and the Medici Collections, Dec 2006-Jan 7, 2007; Jaune Quick-To-See Smith, Contemporary Native American Paintings; The Faithful Samurai; A 19th Century Englishman in the Middle East: David Roberts and Views of the Holy Land from Friends of the Reves Center, Feb 10-April8, 2007; Something Waits Beneathh It: Early Works by Andrew Wyeth: Master Drawings from the Artist's Collection, and Joan Miro: Dutch Interiors and Imaginary Portraits, 1928 and 1929, May 5-July 29, 2007; Clyde Butcher: America the Beautiful and Building a College: The Colonial Revival Campus at the College of William and Mary, Sept 1-Nov 4, 2007; Jonathan Green, African American Paintings, Nov 16, 2007-Jan 13, 2008.

COLORADO SPRINGS FINE ARTS CENTER, 30 W Dale St, Colorado Springs, CO 80903. Tel: 719-634-5581; Fax: 719-634-0570. *Dir* David G. Turner; *Chief Cur* Cathy Wright; *Registrar & Trav Exhib Coordr* Susan Conley. **Exhibits**— Walt Kuhn's

Imaginary History of the West; Living the Tradition: Contemporary Hispanic Crafts. Call or write for a full brochure. Rental fees $2,500-$12,500; Shipping fees vary.

COLUMBUS MUSEUM OF ART, 480 E Broad St, Columbus, OH 43215. Tel: 614-221-6801; Fax: 614-221-0226. *Head Exhib* John Owens.

CONNECTICUT HISTORICAL SOCIETY MUSEUM, 1 Elizabeth St, Hartford, CT 06105. Tel: 860-236-5621; Fax: 860-236-2664; E-mail: susan_schoelwer@chs.org. *Dir Museum Collections* Dr Susan Schoelwer. **Exhibits**— Contact Dr. Schoelwer for details.

CONTEMPORARY CRAFTS ASSOCIATION, 3934 SW Corbett Ave, Portland, OR 97239. Tel: 503-223-2654; Fax: 503-223-0910; Web Site: www.contemporarycrafts.org. *Exhib Coordr* Lisa Conte; *Exec Dir* David Cohen; *Cur Coll* Bill Henning. **Exhibits**— 100 Universes: An Accordion Book of Prints From Around the World. Touring 2003-2005.

COOS ART MUSEUM, 235 Anderson Ave, Coos Bay, OR 97420. Tel: 541-267-3901; E-mail: info@coosart.org. *Exec Dir* M J Korena. **Exhibits**— Speaking in Cloth-Art Quilts by 6 Pacific Northwest fiber art prints from the permanent collection of Coos Art Museum. Rental fees $5,000-$7,000. Shipping fees $500-$750.

CORNELL FINE ARTS MUSEUM, Rollins College, 1000 Holt Ave, Winter Park, FL 32789-4499. Tel: 407-646-2526; Fax: 407-646-2524; E-mail: ablumenthal@rollins.edu; Web Site: www.rollins.edu/cfam. *Dir* Dr. Arthur R. Blumenthal. **Exhibits**— Winslow Homer: American Illustrator. Rental $6,100, Shipping (prorated) included.

CUMBERLAND COUNTY COLLEGE, College Dr, PO Box 1500, Vineland, NJ 08362-1500. Tel: 856-691-8600, Ext. 314; Fax: 856-691-8813. *Gallery Dir* Greg Hamilton. **Exhibits**— Paintings, drawings, 3D art.

CUYAHOGA VALLEY ART CENTER, 2131 Front St, Cuyahoga Falls, OH 44221. Tel: 330-928-8092; Fax: 330-928-8092. *Dir* Linda Nye; *Pres* Larry Kerr. **Exhibits**— Whiskey Painters of America. Rental fee $500; Shipping fee paid by artist.

DALHOUSIE ART GALLERY, Dalhousie University, 6101 University Ave, Halifax, B3H 3J5 NS Canada. *Dir & Cur* Susan Gibson Garvey. **Exhibits**— Contemporary Canadian Artists. Rental fees $2,000-$5,000; Shipping fees are prorated.

DANE G HANSEN MEMORIAL MUSEUM, 110 W Main, Logan, KS 67646. Tel: 785-689-4846; Fax: 785-689-4892 . *Dir* Lee M Favre.

DECORATIVE ARTS COLLECTION MUSEUM, 393 N McLean Blvd, Wichita, KS 67203. *DAC Coordr* Jan Vavra. **Exhibits**— Exhibit of Permanent Collection of Decorative Painting. Exhibit currently scheduled for Indy, Wichita and Providence.

DENNOS MUSEUM CENTER, Northwestern Michigan College, 1701 E Front St, Traverse City, MI 49686. Tel: 231-995-1055; Fax: 231-995-1597. *Dir* Eugene A. Jenneman; *Cur Educ & Interpretation* Diana Bolander; *Registrar* Kim Hanninen; *Asst to the Dir* Judith Albers. **Exhibits**— Cultural Reflections: Inuit Art from the Dennos Museum Center Collection (consists of approximately 30 prints & 20 stone sculptures). Rental fees $2,500; Shipping is at cost.

DETROIT INSTITUTE OF ARTS, 5200 Woodward Ave, Detroit, MI 48202. *Exhibition Coordr* Amy Hamilton Foley. **Exhibits**— Rental fee varies Shipping fee varies.

DICKINSON STATE UNIVERSITY, Klinefelter Hall, 291 Campus Dr, Dickinson, ND. 58601. *Dir* Marilyn Lee; *Assoc Dir* Benni Privratsky. **Exhibits**— Prints II: Sharon Linnehan, contains non-objective monotypes or screen prints. Rental fee $100.

DIEFENBAKER CANADA CENTRE, University of Saskatchewan, 101 Diefenbaker Pl, Saskatoon, S7N 5B8 SK Canada. Tel: 306-966-8384; Fax: 306-966-6207. *Dir* R. Bruce Shepard; *Technician* Greg Burke. **Exhibits**— Avro Arrow; The Prairie Lawyer; The Three Mrs. Diefenbaker. Rental fees negotiable depending on length of rental; Shipping fees also negotiable.

DOWNEY MUSEUM OF ART, 10419 Rives Ave, Downey, CA 90241. Tel: 562-861-0419. *Prog Dir* Sachia Long; *Exec Dir* Kate Davies. **Exhibits**— "Witness" Contemporary Photographic Portraits of Armenian genocide survivors by contemporary photographers Levon Parian and Ara Oshagan. Lectures and special event for Witness available. Rental fees $ 2,500 Shipping fees To be decided. Scholars and Artists Speaker program available in support of exhibit; artists cultural figures available for programming; catalog available.

DUKE UNIVERSITY, Nasher Museum of Art at Duke University, 2001 Campus Dr, Durham, NC 27705. Tel: 919-684-5135; Fax: 919-681-8624. *Dir* Dr. Michael P. Mezzatesta; *Cur* Dr. Sarah Schroth. **Exhibits**— Russian Collection Re-Installation, 'Shroud' from Anya Belkina, "Pedro Figari (1861-1938): Lines of Uruguayan Life, A Student Curated Exhibition," "North Carolina School: The Art of Architecture." Collections-African; American 19th and 20th century; Greek and Roman; Old master paintings, drawings and sculpture; one of the largest holdings of pre-Columbian art in any university art museum; a comprehensive collection of Russian art covering the period from 1812 to the present; and the renowned Brumme Collection of Medieval and Renaissance Art, one of the finest university medieval collections in the United States. Rental Fees $1,500-$25,000.

DUNLOP ART GALLERY, Regina Public Library, PO Box 2311, Regina, S4P 3Z5 SK Canada. Tel: 306-777-6040; Fax: 306-949-7264. *Dir & Cur* Helen Marzolf; *Cur* Anthony Kiendl. **Exhibits—** Canada's Most Wanted and Unwanted Paintings; Verdure.

EAST CAROLINA UNIVERSITY, School of Art, Wellington B Gray Art Gallery, 5th St, Greenville, NC 27858. Tel: 252-328-6336; Fax: 252-328-6441. *Gallery Dir* Gil Leebrick. **Exhibits—** Baltic States Ceramics. Rental and shipping fees vary.

EAST TENNESSEE STATE UNIVERSITY, Dept of Art & Design, PO Box 70708, Johnson City, TN 37614-1710. Tel: 423-439-4247. *Chmn* M. Wayne Dyer; *Cur (Reece Museum)* Blair H. White; *Slocum Gallery Dir* Mindy Herrin. **Exhibits—** Contemporary fine arts & crafts (Slocumb), contemporary & historical exhibits (Reece). Rental and shipping fees vary.

EASTERN ILLINOIS UNIVERSITY, Tarble Arts Center, 600 Lincoln Ave, Charleston, IL 61920-3099. *Dir* Michael Watts; *Reg* David Pooley. **Exhibits—** Amish of Illinois (photo documentary). Rental and shipping fees are negotiable. This is a free-standing exhibit that includes didactic materials and some folk arts & artifacts.

EASTERN OREGON UNIVERSITY, School of Arts & Science, 1 Univ Blvd, La Grande, OR 97850-2899. Tel: 541-962-3541. *Dir* Jason Brown; *Prof of Art* Tom Dimond. **Exhibits—** Shows by students, alumni, art faculty and visiting artists. Rental and shipping fees vary.

ELK RIVER AREA ARTS COUNCIL, 400 Jackson Ave, Ste 205, Elk River, MN 55330. Tel: 612-441-4725. *Exec Dir* Sharon Tracy. **Exhibits—** A Day in the Life of Elk River, consist of thirty-six 20"x 24" & 25"x 29" mounted photographs selected from 1446 photographs taken by twenty-eight photographers on June 8, 1996. Rental fee $100; Shipping fee $60 (return shipping paid by exhibitor).

eMEDIA LOFT, 55 Bethune St #A-629, New York, NY 10014-2035. Tel: 212-924-4893; E-mail: xyz@emedialoft.org. *Co Dir & Cur* Barbara Rosenthal; *Co Dir* Bill Creston; *Asst* Sena Clara Creston. **Exhibits—** Old & New Masters of Super-86 Traveling Exhibits 1989-1996; Six years of biennials, European Venues; artist's books by 5-6 artists; NYFA Film Grant Winner's Festival Tour 2004. Rental fees $30 per film per screening ($60 plus shipping minimum). Periodic traveling show of video work that originated on super-8 film 12 years past, the film prints traveled. For additional info, refer to website.

EN FOCO, INC, 32 E Kingsbridge Rd, Bronx, NY 10468. Tel: 718-584-7718; Email: info@enfoco.org; Web Site: www.enfoco.org. *Exec Dir* Charles Biasiny-Rivera; *Managing Dir* Miriam Romais. **Exhibits—** Island Journey: Ten Puerto Rican Photographers (catalogue provided). En Foco Collection: 25 Years; New Works by Photographers of Color. Rental fee $700 and up.

ERIE ART MUSEUM, 411 State St, Erie, PA 16501. Tel: 814-459-5477; Fax: 814-452-1744. *Dir* John Vanco; *Registrar* Vance Lupher; *Asst Cur* Abigail Watson. **Exhibits—** Marc Brown—A Retrospective; Archaeology at the Dawn of History: The Khirbet Iskander Collection; Eva Zeisel: The Shape of Life. Exhibitions include press kits, brochures, children's activities. Rental fees $5,000-$10,000; Shipping fees vary.

EVANSTON HISTORICAL SOCIETY, 225 Greenwood St, Evanston, IL 60201. **Exhibits—** The Sick Can't Wait: The story of Evanston Community Hospital, founded by African-Americans. Your Presence is Requested: The Story of African-American social activities in Evanston, including debutante balls, clubs and social organizations from the 1930s through 1970s. Evanston Tackles the Woman Question: Displays the role of Evanston women in the women's movement; Evanston's Changing Lakefront; Who Knew…The Evanston Historical Society's Best Kept Secret: Paintings from the Permanent Collection. Rental fees are to be determined. Shipping fees are as required. Please contact Eden Juron Pearlman, Tel 847-475-3410.

EVERSON MUSEUM OF ART, 401 Harrison St, Syracuse, NY 13202. Tel: 315-474-6064; Fax: 315-474-6943; E-mail: eversonadmin@everson.org. *Sr Cur* Thomas Piche, Jr.; *Asst Cur* Debora Ryan; *Asst Cur* Kathryn Martini. **Exhibits—** Ceramic National, Duck Stamps and prints and various ceramic exhibitions. Call for rental and shipping information.

EXPLORATORIUM, 3601 Lyon St, San Francisco, CA 94123. E-mail: donnad@exploratorium.edu. *Traveling Exhibs* Donna DeBartolomeo; *Exhibit Sales* Kva Patten; *Exhibit Sales* Inga Peterson. **Exhibits—** Individual & Exhibition collections available for rental; traveling special exhibitions such as Memory and ExNET exhibitions.

FAULCONER GALLERY Grinnell College, 1108 Park St, Grinnell, IA 50112. Tel: 641-269-4660; Fax: 641-269-4626; Web Site: www.grinnell.edu/faulconergallery. *Dir* Lesley Wright; *Assoc Dir & Cur Exhib* Daniel Strong; *Cur Coll* Kay Wilson. **Exhibits—** Contemporary Brazilian Art; William Kentridge Prints; Scandinavian Photography 1 & 2; Sweden & Denmark; Hin: The Quiet Beauty of Japanese Bamboo Art; I Saw It: The Imagined Reality of Francisco Goya's Disasters of War.

FIGGE ART MUSEUM, FORMERLY DAVENPORT MUSEUM OF ART, 225 W. 2nd St, Davenport, IA 52801. Tel: 563-326-7804; Fax: 563-326-7876. *Cur* Ann Marie Hayes; *Cur Collections and Exhibition* Michelle Robinson. **Exhibits—** Passionate Observer: Eudora Welty among Artists of the Thirties, 2006; Edouard Duval-Carrie: Migration of the Spirit, 2006.

FINE ARTS MUSEUMS OF SAN FRANCISCO de Young Museum & Legion of Honor, 233 Post St. 6th Fl, San Francisco, CA 94108. *Exhib Coordr & Cur* Krista Davis.

FLINT INSTITUTE OF ARTS, 1120 E Kearsely St, Flint, MI 48503. Tel: 810-234-1695; Fax: 810-234-1692; E-mail: info@flintarts.org; Web Site: www.flintarts.org. *Cur Exhibs* Lisa Baylis Ashby; *Dir* John B. Henry III. **Exhibits—** prints, photographs, paintings & sculptures. Rental and shipping fees vary.

FLORIDA ATLANTIC UNIVERSITY, Schmidt Center Gallery & Ritter Art Gallery, 777 Glades Rd, Boca Raton, FL 33431. *Dir* W. Rod Faulds. **Exhibits—** Never Never Land: contemporary artists reflecting on Disney and other commercialized fantasy; Marks of the Soul: contemporary Caribbean art-8 artists from the Caribbean and U.S. reflect African philosophies and religion in their art. Rental fees $5,000-$7,500; Shipping fees $3,000-$5,000 (one way).

FLORIDA STATE UNIVERSITY, Museum of Fine Arts, 250 Fine Arts Bldg, Tallahassee, FL 32306-1140. Tel: 850-644-1254; Fax: 850-644-7229; E-mail: apcraig@mailer.fsm.edu. *Dir* A. Palladino-Craig, Ph.D. **Exhibits—** The Abridged Walmsley: Selections from the Career of William Aubrey Walmsley; Trevor Bell: British Painter in America. For information Tel: 850-644-1254. Rental fee $1,000-$4,500 Shipping fees $1,000-$3,000, 500 running wall feet.

FORT MORGAN HERITAGE FOUNDATION, 414 Main St, PO Box 184, Fort Morgan, CO 80701. *Dir* Marne Jungemeyer; *Cur* Nikki Cooper. **Exhibits—** Hogsett Navaho Rug Collection; Howard Rollin, water color bird paintings. Rental fee $1,000.

FREDERIC REMINGTON ART MUSEUM, 303 Washington St, Ogdensburg, NY 13669. *Proj Coordr* Wendy Flood. **Exhibits—** Traveling exhibit of Remington prints and recast sculptures. Rental fee $1,900; Shipping fee $600. Nine week exhibition. Contact the museum at 315-393-2425 for more information.

FUDAN MUSEUM FOUNDATION, 4206 73rd Terr E, Sarasota, FL 34043. Tel: 941-351-8208; E-mail: fmfsafsa@juno.com. *Pres* Dr. Alfonz Lengyel, RPA. **Exhibits—** We are helping the following institutions: Fudan University Museum; Institute of Archaeology of Shaanxi Province, China; Xi'an Tiaotong Univ; The Dr. Helga Wall-Apelt Gallery of Asian Art.

GALERIE RESTIGOUCHE GALLERY, 39 rue Andrew St, CP/ PO Box 674, Campbellton, E3N 3H1, NB Canada. *Dir* Valerie Gilker. **Exhibits—** Couleurs d'Acadie: Color photographs of brightly painted houses phenomena. 120 running feet. No rental fee. Borrower pays cost of transportation both ways. Catalogue available.

GENESEE COUNTRY MUSEUM, John L Wehle Art Gallery, 1410 Flint Hill Rd, Mumford, NY 14511. Tel: 716-538-6822. *Cur* Patricia M. Tice. **Exhibits—** Visions of India: The Watercolor Travels of David Rankin, John L. Wehle: The Collector's Eye.

GEORGE EASTMAN HOUSE, Attn: Jeanne Verhulst, 900 East Ave, Rochester, NY 14607. Tel: 716-271-3361; Fax: 716-271-3970; E-mail: travex@geh.org; Web Site: www.eastman.org. *Assoc Cur* Jeanne Verhulst. **Exhibits—** From 1952 as a means of sharing the Museum's renowned photographic collections with other institutions and their public. Rental Fee booking periods are eight or 12 weeks. Domestic exhibitors are responsible for outgoing shipping arrangements and costs.

GEORGIA MUSEUM OF ART, 90 Carlton St, University of Georgia, Athens, GA 30602-6719. *Dir* William U. Eiland; *Asst Registrar* Christy Sinksen. **Exhibits—** Hiroshige and the Tokaido Road: Selected Views; Animals in Bronze: The Michael and Mary Erlanger Collection; A Delicate Bouquet: French Floral Studies; Impressions of the Georgia Coast: From the Georgia Sea Grant College Collection; The Disasters of War by Goya: Selections; Passport to Paris: Nineteenth-Century French Prints; Visions of Nature: English Romantic Prints; Prints by Women: Selected Works; Travels Abroad: Paintings by Anna Richards Brewster; Lamar Dodd: Artist of Georgia; Manhattan: Images of NYC; Techniques and Styles: A Sampling of Paintings, Drawings, and Prints.

GETTYSBURG COLLEGE, Art Dept, Box 2452, Gettysburg, PA 17325. *Gallery Dir* Norman Annis. **Exhibits—** Steven H. Warner, 1946-71: Words and Pictures from the Vietnam War; Seeing a New World: The Works of Carl Beam and Frederic Remington. No rental fees. Shipping fees to cover shipping and insurance.

GRACELAND UNIVERSITY Dept of Art, 1 University Pl, Lamoni, IA 50140. Tel: 641-784-5270; Fax: 641-784-5487; E-mail: finearts@graceland.edu. *Gallery Dir* Katie.

HALLIE FORD MUSEUM OF ART, WILLAMETTE UNIVERSITY, 900 State St, Salem, OR 97301. Tel: 503-370-6855; Fax: 503-375-5458; E-mail: museum-art@willamette.edu. *Dir* John Olbrantz; *Educ Cur* Elizabeth Garrison; *Cur Coll* Jonathan Bucci; *Exhibition Designer & Chief Preparator* Keith Lachowicz. **Exhibits—** From time to time, the Hallie Ford Museum of Art circulates exhibitions of historical and contemporary art.

HALSEY GALLERY, College of Charleston, Simons Center for the Arts, 54 St. Philip Street, Charleston, SC 29424. Tel: 843-953-5680. *Dir* Mark Sloan; *Cur* Lori Kornegay. **Exhibits—** Black Boiled Coffee and the Cacophony of Frogs: Evon Streetman in Retrospect; Memory Speaks: The Art of Tiebena Dagnogo from Cote d'Ivoire. Rental fee $2,500; Shipping fee $1,500.

HAMPTON UNIVERSITY, University Museum, Hampton, VA 23668. *Cur Coll* Mary Lou Hultgren. **Exhibits—** Elizabeth Catlett: Works on Paper 1944-1992. Jacob Lawrence: The Frederick Douglass and Harriet Tubman Series of 1938-1940. Rental fees vary.

HAND WORKSHOP ART CENTER, 1812 W Main St, Richmond, VA 23220. Tel: 804-353-0094; Fax: 804-353-8018; E-mail: jokennedy@handworkshop.org. *Cur* Ashley Leistler. **Exhibits**— Shipping fees vary with project.

HANDWEAVING MUSEUM & ARTS CENTER, 314 John St, Clayton, NY 13624. Tel: 315-686-4123; Fax: 315-686-3459; E-mail: info@hm-ac.org; Web Site: www.hm-ac.org. *Exec Dir* Beth Conlon; *Cur* Sonja Wahl; *Dir of Devel* Amy Fox. **Exhibits**— Drafts and notes by Mary Meigs Atwater with hand-woven samples and slides of Patterns designed by John Landes Landes. Rental fee $35; Shipping fees vary.

HARCOURT HOUSE ARTS CENTRE, Third Fl, 10215-112 St, Edmonton, T5K-1M7, AB, Canada. *Adminr* Cindy Baker; *Prog Coordr* Christal Pshyk; *Exec Dir* Allen Ball. **Exhibits**— SNAPshots, Representation, AFA collects painting, Postoids, Double Vision, Flying Colors, Flora and Fauna, Caught in the Headlights, Fine Lines, Prairie Icon, AFA Collects Sculpture, Badlands, The Great Wall, Taylor's Planes, AFA 25th Anniversary, SNAP Portfolio, U of A Collections, Brian Injury Society; Rental fee $50 each; open to Alberta, Canada venues only.

HEARST ART GALLERY, Saint Mary's College of California, PO Box 5110, Moraga, CA 94575-5110. Tel: 510-631-4379. *Dir* Carrie Brewster; *Coll Mgr* Julie Armistead; *Educ Mgr* Heidi Donner. **Exhibits**— William Keith: California Poet-Printer. Stanley Truman: Fifty Years of Photography. Rental fees $1,000-$5,000.

HECKSCHER MUSEUM OF ART, Two Prime Ave, Huntington, NY 11743-7702. Tel: 631-351-3250; Fax: 631-423-2145. *Chief Cur* Anne Cohen DePietro; *Exec Dir* Beth E. Levinthal; *Chief Cur* Anne Cohen DePietro. **Exhibits**— Living with Art: Early American Modernism from the Baker/Pisano Collection of the Heckscher Museum of Art. Rental fee $ 20,000 Shipping fee one way 51 modernist works (Joseph Cornell, Arthur Dove, Abraham Walkowitz, Florine Stettheimer, Louis Bouché and so on.

HENRY ART GALLERY University of Washington, 15th Ave NE & NE 41st, Box 351410, Seattle, WA 98195-1410. Tel: 206-543-2281; Fax: 206-685-3123; Email: hartg@u.washington.edu. *Assoc Cur* Robin Held; *Chief Cur* Elizabeth Brown; *Dir* Richard Andrews. **Exhibits**— Gene(sis): Contemporary Art Explorers, Human Genomics; Lynn Hershman: Hershmanlandia.

HIBEL MUSEUM OF ART, 5353 Parkside Dr, Jupiter, FL 33458. Tel: 561-622-5560; Fax: 561-622-4881; E-mail: info@hibelmuseum.org. *Exec Trustee* Nancy Walls; *Prog Dir* Kathy Glover; *Museum Gallery Dir* Lynne Zuback. **Exhibits**— Edna Hibel Art focusing on a variety of media: paintings, original stone lithography, drawings, serigraphy, multimedia, porcelain art; Rental fee depends on event.

HIGGINS ARMORY MUSEUM, 100 Barber Ave, Worcester, MA 01606-2444. Tel: 508-853-6015; Fax: 508-852-7697; E-mail: higgins@higgins.org. *Sr Cur of Arms & Armor* Walter J. Karcheski, Jr.; *Cur* Paul S. Morgan, Jefferey Singman; *Conservator* William MacMillan. **Exhibits**— Road Warriors; Double-Edged Weapon.

HILLWOOD MUSEUM & GARDENS FOUNDATION, 4155 Linnean Ave., NW Washington, DC 20008. Tel: 202-686-8500; Fax: 202-966-7846; E-mail: djohnson@hillwoodmuseum.org. *Deputy Dir Collections & Chief Cur* Davd T. Johnson; *Preservation & Exhibitions Mgr* Scott Brouard. **Exhibits**— Tradition in Transition: Russian Icons in the Age of the Romanovs (through 2009); Fragile Persuasion: Late Russian and Soviet Porcelain from the Traisman Collection (2008); Sevres Then and Now: Tradition and Innovation in Porcelain, 1750-2000 (2009) All exhibitions available through Reid Buckley, International Arts and Artists, Washington, DC.

HISTORICAL MUSEUM AT FORT MISSOULA, Bldg 322, Fort Missoula, Missoula, MT 59804. Tel: 406-728-3476; Fax: 406-543-6277; E-mail: ftmslamuseum@montana.com. *Sr Cur* L. Jane Richards. **Exhibits**— Victory at Home: World War II Posters; Uniforms of the U.S. Army (1880-1910; Paintings by H.A. Ogden.

HOLLAND TUNNEL, 61 S 3rd St, Brooklyn, NY 11211. Tel: 718-384-5738; Fax: 718-384-5738; E-mail: hollandtunnel@hotmail.com. Paulien Lethen; *Graphics Designer* Roy Lethen; *Public Rels* Fran Kornfeld. **Exhibits**— Double Feature, by Jane Mulder and sculptures by Bix Lye in a collaboration of two Williamsburg Galleries; Holland Tunnel Sideshow & Slideshow, Oct.-Nov. 2006

HOLLINS UNIVERSITY, Art Dept, 7916 Williamson Rd, Roanoke, VA 24020. *Gallery Dir* Janet Carty; *Faculty* Jan Knipe, Bill White, Bob Sulkin, Kathleen Nolan, Kim Rhodes, Nancy Dahlstrom. **Exhibits**— Invites nationally known artists to exhibit on a monthly basis during both the fall and spring semesters; Artist-in-Residence Program: Invites a nationally known artist for a semester long residency to work, have a solo show & teach one class each year.

HOLTER MUSEUM OF ART, 12 E Lawrence, Helena, MT 59601. *Co-Dir* Marcia Fide;l *Co-Dir* Liz Gans; *Cur Educ* Katie Knight; *Bus Mgr* Kelly Bourgeois. **Exhibits**— Nick Cave: Soundsuits; Rudy Autio: The Infinite Figure; Michael Haykin: Intimate Terrain; Frances Senska: A Life in Art.

HUNT INSTITUTE FOR BOTANICAL DOCUMENTATION, Carnegie Mellon Univ, 5000 Forbes Ave, Pittsburgh, PA 15213-3890. Tel: 412-268-2434; Fax: 412-268-5677; E-mail: huntinst@andrew.cmu.edu. *Cur Art* James J. White; *Asst Cur of Art* Lugene B. Bruno. **Exhibits**— International Exhibition of Botanical Art & Illustration; Poisons in our Path: Watercolors by Anne Ophelia Dowden; John Wilkinson: Trees; Yuuga: Contemporary Botanical Watercolors from Japan. Rental fees $950. Shipping fees vary.

HUNTSVILLE MUSEUM OF ART, 300 Church St, S, Huntsville, AL 35801. Tel: 256-535-4350; Fax: 256-532-1743; E-mail: info@hsvmuseum.org; Web Site: www.hsvmuseum.org. *Curatorial Affairs Dir* Peter Baldaia; *Cur Exhibitions* David Reyes; *Cur Collections* Colin Thompson. **Exhibits—** A Silver Menagerie: The Betty Grisham Collection of Buccellati Silver Animals. Rental fees $20,000 per 10 weeks. Shipping fees TBD.

ILLINOIS CENTRAL COLLEGE, Dept of Fine, Performing & Applied Arts, One College Dr, East Peoria, IL 61635. Tel: 309-694-5113; Fax: 309-694-8505; Website: www.icc.edu *Cur* Jennifer Costa. **Exhibits—** Shipping fees are 1/2 paid by artist.

INDEPENDENT CURATORS INTERNATIONAL, 799 Broadway, 205, New York, NY 10003. *Exec Dir* Judith Richards; *Dir of Develop* Hedy Roma; *Dir of Exhib* Susan Hapgood; *Registrar* Susan Callanan. **Exhibits—** 100 Artists See God; After Perestroika; American Experience; At the Threshold of the Visible; Beyond Preconception: The Sixties Experiment; Dark Décor; Departures; Do It; Drawn in the 90s; Embedded Metaphor; Empty Dress; Everything Can be Different; Eye for an I: Video Self-Portraits; First Generation: Women and Video; From Media to Metaphor; Irish Art Now: From the Poetic to the Political; Lee Krasner; Likeness; Making it Real; Mark Lombardi: Global Networks; Monumental Propaganda; Beyond Green: Towards a Sustainable Art; High Times, Hard Times: New York Paintings 1967-1975; Multiple Exposure; My Reality; New Spanish Visions; Meret Oppenheim: Beyond the Teacup; No Laughing Matter; Pictures, Patents, Monkeys and More…; Painting Zero Degree; Paper Sculpture Book; Power of the Word; David Smith: Medals for Dishonor; Telematic Connections; Thin Skin; Transformers; UnNaturally; Walk Way; Words of Wisdom. Rental fees $2,000-$35,000.

INSTITUTE OF AMERICAN INDIAN ARTS MUSEUM, 108 Cathedral Pl, Santa Fe, NM 87501. Tel: 505-983-8900; Fax: 505-983-1222; E-mail: jgrimes@iaia.edu. *Dir* John Richard Grimes; *Cur* Joseph Sanchez; *Registrar* Paula Rivera. **Exhibits—** Our Land: Contemporary Art from the Arctic-12/06-2/4/07; Unraveled Secrets by Sonya Kelliher-Combs, 12/06-3/4/07; Indigenous Women of the West, 2/23/07-5/25/07; Norval Morrisseau: Shaman Artist, 6/11/07-9/3/07; Choctaw Contemporary, 9/28/07-mid Jan. 2008. The IAIA is developing Traveling Exhibitions from the Permanent Collection at this time. Rental fees are to be determined. Shipping fees TBD.

INSTITUTE OF CONTEMPORARY ART, Maine College of Art, 522 Congress St, Portland, ME 04101. Tel: 207-897-5742; Fax: 207-780-0816; E-mail: ica@meca.edu. *Dir* Toby Kamps; *Dir Educ & Asst Cur* Cindy M. Foley. **Exhibits—** Eracism: William Pope L., Wenda Gu: from Middle Kingdom to Biological Millennium. The Sportsman Redux Mar - Apr.

INSTITUTE OF CONTEMPORARY, ART, 118 S. 36th St, Philadelphia, PA 19104. Tel: 215-898-5911; Fax: 215-898-5050; E-mail: info @icaphila.org. *Exhibition Coordr & Registrar* Robert Chaney. **Exhibits—** Make Your Own Life: Artists In & Out of Cologne; Karen Kilimnik; Puppets. Fees are determined on a per show basis.

INTERNATIONAL MUSEUM OF ART AND SCIENCE, FORMERLY KNOWN AS MCALLEN INTERNATIONAL MUSEUM, 900 Nolana Ave, McAllen, TX 78501. Tel: 956-682-1564; Fax: 956-686-1813. *Dir Educ* Serena Rosenkrantz; *Dir Curriculum* Daniel Tyx; *Educ Coordr* Evana Vleck. **Exhibits—** "Our Watershed." This is an outreach science exhibit that travels in the museum track to various venues in the region only. No fine art traveling exhibits are currently being offered. Rental fees vary.

INTERNATIONAL MUSEUM OF CARTOON ART, 5788 Notre Dame de Grace, Montreal, H4A IM4, PQ Canada. Tel: 514-489-0527. *VPres* Mark Scott. **Exhibits—** Animation-Cartoon Film Exhibits: The Hollywood Cartoon; A History & Development of Animation; Homage to Walt Disney. Rental & Shipping fees vary.

INTERNATIONAL SOCIETY OF COPIER ARTISTS (ISCA), 759 President St, Ste 2H, Brooklyn, NY 11215. Tel: 718-638-3264. *Dir* Louise Neaderland. **Exhibits—** ISCAGraphics: A selection of xerographic prints and artist's books created by contributing artist members of the Society and selected guest contributors. This is a low security installation, and both workshops and lectures are available in conjunction with the exhibit. Rental fees $200/month; Shipping fees vary (but sent 4th class mail or UPS household goods).

JACQUES MARCHAIS MUSEUM OF TIBETAN ART, 338 Lighthouse Ave, Staten Island, NY 10306. Tel: 718-987-3500; Fax: 718-351-0402; E-mail: mventrudo@tibetanmuseum.org. *Cur* Sarah Johnson; *Exec Dir* Meg Ventrudo. **Exhibits—** Various exhibitions of art & photography from Tibet, Mongolia, and Northern China.

JAMES A MICHENER ART MUSEUM, 138 S Pine St, Doylestown, PA 18901. Tel: 215-340-9800; Fax: 215-340-9807. *Senior Cur* Brian Peterson; *Cur of Public Progs* Zoriana Siokalo; *Dir* Bruce Katsiff. **Exhibits—** Earth, River and Light: Masterworks of Pennsylvania Impressionism. Rental fee $25,000.

JAMES FORD BELL MUSEUM OF NATURAL HISTORY, Univ of Minnesota, 10 Church St, Minneapolis, MN 55455. Tel: 612-624-4112; Fax: 612-626-7704; E-mail: bellmuse@umm.edu. *Touring Exhibits Coordr* Ian Dudley; *Coordr* Ian Dudley. **Exhibits—** The museum offers 18 exhibits, mixing art and natural science. Topics include: The Lions's Mane, Hidden World of Bears, The Photography of Jim Brandenburg, Art of Francis Lee Jaques, paintings from the Birds of Minnesota, The Return of the Peregrine Falcon, Saving Endangered Species. Rental fees range from $1,000-$8,000. Shipping fees paid by renter For other exhibits contact Ian Dudley at 612-624-2357 or dudleoo2@umn.edu.

JAPANESE AMERICAN NATIONAL MUSEUM, 369 E First St, Los Angeles, CA 90012. Tel: 213-625-0414; Fax: 231-625-1770. *Dir Natl Progs* Cayleen Nakamura. **Exhibits**— From Bento to Mixed Plate: Americans of Japanese Ancestry in Multicultural Hawaii; America's Concentration Camps.

JILL THAYER GALLERIES AT THE FOX, 1700 20th St, Bakersfield, CA 93301-4329. Tel: 661-328-9880; Fax: 661-631-9772. *Dir/Artist* Jill Thayer. **Exhibits**— Exhibits of selected artists, represented by the gallery upon arrangement. A wide range of works available for group and solo exhibition by represented artist. Gallery provides promotional mailers and other materials on request. Recipient pays shipping charges. Rental fees Bid per show content; Shipping fees Cost billed by gallery.

JOHN WEAVER SCULPTURE MUSEUM, 19255 Silverhope Rd, PO Box 1723, Hope, V0X 1L0 BC Canada. *Sculptor* John Barney Weaver; *Gen Mgr & Cur* Henry Weaver; *Secy & Treas* Sara M. Lesztak; *Pres, Sculptor & Cur* Henry C. Weaver. **Exhibits**— Bronze sculptures, by request. The collection to serve the active collector, the charity or ethnic group in fundraising, schools & community interests.

JUNIATA COLLEGE MUSEUM OF ART, 17th & Moore Sts, Huntington, PA 16652. Tel: 814-641-3505; Fax: 814-641-3695. *Cur* Nancy Siegel. **Exhibits**— Along the Juaniata: Thomas Cole and the Dissemination of American Landscape Imagery. Rental fees negotiable.

KALA ART INSTITUTE, 1060 Heinz Ave, Berkeley, CA 94710. *Exec Dir* Archana Horsting; *Artistic Dir* Yuzo Nakano; *Prog Dir* Kevin Chen. **Exhibits**— Annual fellowship shows, Kala Institute Artists' Annual, James D. Phelan Art Awards in Printmaking. Rental fees $125-$340 per month.

KANSAS CITY ART INSTITUTE, 4415 Warwick Blvd, Kansas City, MO 64111. Tel: 816-802-3300; Fax 816-802-3309; E-mail: 1stone@kcai.edu . *VP Enrl Mgr* Larry Stone. **Exhibits**— 35 Piece student drwing show Rental fee None Shipping fee Depend upon location.

KENTUCKY ART & CRAFT GALLERY, Kentucky Art & Craft Foundation, 715 W Main, Louisville, KY 40202. Tel: 502-589-0102; Fax: 502-589-0154; E-mail: kacf@age.net. *Deputy Dir* Brion Ccinkingbeard; *Assoc Cur* Mary Ellen Furlong. **Exhibits**— Ironwirks: Contemporary Forgen Iron Rental fee $ 6,000 Shipping feeto be decided. Available through Dec 2006.

KENTUCKY GUILD OF ARTISTS & CRAFTSMEN INC, 103 Parkway, Berea, KY 40403-9114. Tel: 859-986-3192; Fax: 859-985-9114; E-mail: info@kyguild.org. *Dir* Allison Kaiseor; *Prog Mgr* Pam Bischoff. **Exhibits**— "Spirited Vessels"- 2D & 3D original art work."Samething in the water…"-Collection of works in all medium representing Kentucky Visual Art & Craft Haditions. Rental fees vary; Shipping fees vary.

KINGS COUNTY HISTORICAL SOCIETY AND MUSEUM, 7 Centennial Rd, Hampton, E5N 6N3 NB Canada. Tel: 506-832-6009; Fax: 506-832-6007. *Mus Dir & Cur* A. Faye Pearson; *Soc Pres* Richard Throrne; *Soc VPres* John R. Elliot. **Exhibits**— Beulah Camp 1894-1994.

KITCHENER-WATERLOO ART GALLERY, 101 Queen St N, Kitchener, N2H 6P7, N Canada. *Exten Cur & Educ Officer* Paul Blain. **Exhibits**— Animal Images-Part II; Art: A Study of Realism; Canadian Landscape; Inuit Art; Face to Face; From Pen to Paper; Printmaking; Silkscreening; Watercolour and Waterloo County 1930-1960.

KNOXVILLE MUSEUM OF ART, 1050 World's Fair Park Dr, Knoxville, TN 37916-1653. Tel: 865-525-6101; Fax: 865-546-3635; E-mail: info@kmaonline.org. *Cur* Dana Self. **Exhibits**— Eva Zeisel: The Playful Search for Beauty Rental fee $5,000 Shippings fees to be determined.

KOSHARE INDIAN MUSEUM, 115 W 18th St, PO Box 580, La Junta, CO 81050. *Exec Dir* Linda Powers; *Coll Mgr* JoAnn Kent. **Exhibits**— Plains & Pueblo Indian Art & Artifacts. Guided tours & rental fees negotiable.

KRESGE ART MUSEUM, Michigan State Univ, East Lansing, MI 48824 -1119. *Registrar* Rachel Vargas. **Exhibits**— Paradise Lost: John Marin's Sublime Universe, (24 Mezzotints); A Sense of Place: Photographs from the Kresge Art Museum Collection, (50 images); Manual Alvarez Bravo's Mexico, (15 photographs); Elliot Erwitt, (25 photographs), all available through 2008, Rental fees: $500-$1,500 plus shipping and insurance; Art in the 'Toon Age: (50+ paintings, drawings, & prints including cartoon documentation from the Kresge Art Museum Collection & MSU Library's Popular Culture Collection), available through 2008, Rental fee: $10,000 plus shipping and insurance. Medium security for all exhibitions.

LEATHERSTOCKING BRUSH & PALETTE CLUB INC, Pioneer Alley, PO Box 446, Cooperstown, NY 13326. *Pres* Donna Wells; *Show Chmn* Marjorie Harris. **Exhibits**— Fine Art in all media.

LEIGH YAWKEY WOODSON ART MUSEUM, INC, 700 N 12th St, Wausau, WI 54403-5007. Tel: 715-845-7010; Fax: 715-845-7103; E-mail: museum@lywam.org. *Registrar & Cur Coll* Jane M Weinke; *Assoc Dir* Marcia M Theel. **Exhibits**— Birds in Art; A Reflective Nature; Fowl Play; Natural Wonders; Wild Things; Electric Paint: The Computer as 21st Century Canvas; Only Owls; Visual Poetry: Pattern and Texture through the Lens. Rental fees $2,000-$7,500; Shipping fees $2,000-$4,000. 8-week booking periods (can be modified).

LLEGE, 1550 Clarke Dr, Dubuque, IA 52001. Tel: 563-588-6300; Fax: 563-588-6789. *Dir* Douglas Schlesier. **Exhibits**— Student Work

LOCUST STREET NEIGHBORHOOD ART CLASSES, INC, 138 Locust St, Buffalo, NY 14204. *Founder/Dir* Molly Bethel. **Exhibits**— numerous exhibits; topics available upon request; Rental fees a painting rental brochure is available upon request.

LOS ANGELES ART ASSOCIATION, Gallery 825, 825 N La Cienega Blvd, Los Angeles, CA 90069. Web Site: www.laaa.org. *Artistic Dir* Sinéad Finnerty; *Admin Dir* Garrison Smith. **Exhibits**— 17 shows annually exhibiting work of all media and style by Southern Californian artists both mid-career and emerging.

LOUISIANA STATE MUSEUM, 751 Chartres St., New Orleans, LA 70116. Tel: 504-568-6968; Fax: 504-568-6969. *Cur* Michael Hummel. **Exhibits**— Rental fee Free.

LOUISIANA STATE UNIVERSITY, 123 Art Bldg, School of Art, LSU, Baton Rouge, LA 70803-0001. *Dir* Michael Daugherty. **Exhibits**— Robert Indiana, Art and Science, Brazilian Prints.

LYME ART ASSOCIATION, 90 Lyme St, PO Box 222, Old Lyme, CT 06371. Tel: 860-434-7802; Fax: 860-434-7461; E-mail lymeart@sbcglobal.net. *Mgr* Anna Swain. **Exhibits**— 2005 Exhibition Catalog not yet finalized. 8-9 exhibits per year, including Charles A. Platt exhibition, Plein Air Painters of America. Rental fees vary.

MADISON MUSEUM OF CONTEMPORARY ART, 227 State St, Madison, WI 53703. Tel: 608-257-0158; Fax: 608-257-5722; E-mail: info@mmoca.org. *Dir* Stephen Fleischman; *Cur Exhibitions* Jane Simon. **Exhibits**— Lewitt x 2, a two-part exhibition featuring works by Sol LeWitt and works from the art collection that Sol and Carol LeWitt have established; Alyson Shotz: Topologies. Please contact museum for more information.

MAINE COLLEGE OF ART, The Institute of Contemporary Art, 522 Congress St, Portland, ME 04101. *Dir* Toby Kamps; *Dir Educ & Asst Cur* Cindy M. Foley; *Gallery Mgr & Cur Asst* Sage Lewis. **Exhibits**— Beyond Decorum: The Photography of Ike Ube; Eracism: William L. Pope; Wendy Gu, Living Green: Ten Shades of Green; The Sportsman Redux.

MAITLAND ART CENTER TRAVELING EXHIBITION SERVICE (MACTES), 231 W Packwood Ave, Maitland, FL 32751-5596. Tel: 407-539-2181; Fax: 407-539-1198; E-mail: Rcolvin@itsmymaitland.com; Web Site: www.maitlandartcenter.org. *Exec Dir* James G. Shepp; *Cur of Coll* Richard D. Colvin.

MARQUETTE UNIVERSITY, Haggerty Museum of Art, P.O. Box 1881, Milwaukee, WI 53201-1881. *Dir* Curtis L. Carter; *Registrar* James Kieselburg. **Exhibits**— Barbara Morgan Photographs; Joe Jones/J.B. Turnbull; Marc Chagall: Bible Series; Georges Rouault's: Miserere Series. Rental and shipping fees vary.

MARTHA'S VINEYARD CENTER FOR VISUAL ARTS, 134 South Rd, Chilmark, MA 02535. *Pres* Chris Dreyer. **Exhibits**— Rotating weekly 3 artist member exhibits in July & August; other exhibitions throughout the year.

MARYLHURST UNIVERSITY, Mayer Building, 17600 Pacific Hwy. (Hwy. 43), PO Box 261, Marylhurst, OR 97036. *Dir & Cur, The Art Gym* Terri M. Hopkins. **Exhibits**— Ken Butler: Hybrid Instruments; Dianne Kornberg: Photography. Rental fees $1,000-$3,000. Shipping fees $1,000-$3,000.

MASLAK-MCLEOD GALLERY, 118 Scollard St, Toronto, M5R1 1G2 ON Canada. Tel: 416-944-2577; Fax: 416-944-2577; Web Site: www.maslakmcleod.com. *Cur* Joseph McLeod. **Exhibits**— "Canadian Native Art". Rental fee arranged.

MASSACHUSETTS COLLEGE OF ART, Sandra & David Bakalar Gallery & Stephen D. Paine Gallery, 621 Hantington Ave, Boston, MA 02115. Tel: 617-879-7000. *Dir* Jeffrey Kecugh; *Cur* Lisa Tung. **Exhibits**— William Wegman: Strange But True; Sam Durant: Plymouth Rock; Shintaro Miyake Presents: Beaver No Seikastu; Polly Apfelbaum: What Does Love Have To Do With It; Anne Wilson: Unfoldings.

MASSACHUSETTS INSTITUTE OF TECHNOLOGY, School of Architecture and Planning, 77 Massachusetts Ave, Rm 7-231, Cambridge, MA 02139. Tel: 617-253-4401; Fax: 617-253-9417. **Exhibits**— Unfolding Light-The Evolution of Ten Nolographers.

MERIDIAN INTERNATIONAL CENTER, 1630 Crescent Pl NW, Washington, DC 20009. Tel: 202-939-5568; Fax: 202-319-1306; E-mail: meridian@dgs.dgsys.com. *Dir Exhib* Curtis Sandburg; *Registrar & Asst* Ellen Martin. **Exhibits**— A Winding River: The Journey of Contemporary Art in Vietnam; Imagining the World: Naive Art from Ibero-America; Once Upon a Page: The art of Children's Books; Sing Me A Rainbow: An Artistic Medley from Trinidad. Rental fees $6,000-$20,000.

MESA CONTEMPORARY ARTS, Mesa Arts Center, 1 E. Main St., PO Box 1466, Mesa, AZ 85211-1466. *Arts Adminr* Robert Schultz; *Cur* Patty Haberman; *Asst Cur* Kim Cridler & Carolyn Zarr; *Gallery Asst* Carolyn Zarr. **Exhibits**— Contemporary Realism; Steeped in Tradition: The Contemporary Art of Tea; New Works in Paint, 2002; 25th Annual Contemporary Crafts; Arizona Room; Therman Staton: Glass Installation; Two Person Regional Exhibition.

MEXIC-ARTE MUSEUM, 419 Congress Ave, PO Box 2273, Austin, TX 78768. *Exec Dir* Sylvia Orozco. **Exhibits**— Jean Charlot: Prints on Mexico; Masks from Guerrero. Rental fees $2,500, plus shipping to and from Austin.

MICHELSON MUSEUM OF ART, 216 N Bolivar, PO Box 8290, Marshall, TX 75670. *Dir* Susan Spears; *Educ Dir* Bonnie Spangler. **Exhibits**— Ongoing: Life works of Russian-American artist Leo Michelson (1887-1978); the Kronenberg Collection of New York based post-impressionist artists.

MIDWEST MUSEUM OF AMERICAN ART, 429 S Main, PO Box 1812, Elkhan, IN 46516. Tel: 574-293-6660; Fax: 574-293-6660; E-mail: mdwstmsmam@aol.com. *Dir* Jane Burns; *Cur Exhib & Educ* Brian D. Byrn; *Admin Asst* Joan Grimes. **Exhibits**— Fritz Scholder: American Indian; Roy Rogers & Dale Evans Memorabilia; Pioneer Printmakers of the 20th Century, 1930-1975; John L. Doyle: Prints of Social Satire; William Gropper: Fantasy & Folk Heroes; Viktoras Petravicius: Master of the Monoprint; Jim Huntington: An Artists Dialogue in Stone, Steel, and on Paper; Norman Rockwell: America's Illustrator. Rental fees vary. Shipping fees vary. Send for brochure.

MINNESOTA MUSEUM OF AMERICAN ART, 50 W. Kellogg Blvd., Ste 341, Saint Paul, MN 55102. Tel: 651-292-4370; Fax: 651-292-4340. *Exhib Coordr* Eunice Haugen. **Exhibits**— Speak Softly and Carry a Beagle: The Art of Charles Schulz. Rental fee $35,000. Shipping fee $2,500.

MINOT STATE UNIVERSITY, 500 University Ave W, Minot, ND 58707. Tel: 701-858-3264; E-mail nac@minostateu.edu. *Dir* Avis Veikley. **Exhibits**— Americas 2000: The Best of the Best. For booking information contact Avis Veikley.

MISSISSIPPI UNIVERSITY FOR WOMEN, Div of Fine and Performing Arts, 1100 College St. MUW-70, Columbus, MS 39701. Tel: 662-329-7341. *Head of Div of Fine & Performing Arts* Dr. Sue S Coates; *Gallery Dir & Recorder* Prof Alex Stelioes-Wills. **Exhibits**— Many forms of visual arts. Minimal shipping fees only.

MISSOULA ART MUSEUM, 335 N Pattee, Missoula, MT 59802. Tel: 406-728-0447; Fax: 406-543-8691; E-mail: museum@missoulaartmuseum.org. *Cur* Stephen Glueckert; *Registrar* Jennifer Reifsneider; *Dir* Laura J. Millin. **Exhibits**— Native Perspectives on the Trail: A Contemporary American Indian Portfolio.

MOBILE MUSEUM OF ART, 4850 Museum Dr., Langan Park, Mobile, AL 36608-1917. Tel: 251-208-5200; Fax: 251-208-5201; E-mail: dklooz@mobilemuseumofart.com. *Cur Exhib* Donan Klooz.

MONTANA HISTORICAL SOCIETY, 225 N Roberts, PO Box 201201, Helena, MT 59620-1201. Tel: 406-444-4789; Fax: 406-444-2696; Web Site: www.montanahistoricalsociety.org. *Educ Outreach Coord* Julie Saylor. **Exhibits**— Photographing Montana 1894-1928: The Life and Work of Evelyn Cameron; A Capital Capitol; F. Jay Haynes: Fifty Views; Hope in Hard Times: New Deal Photographs of Montana, 1936-1942; The World of Evelyn Cameron; Montana By Food: A Taste of the Past; Photographing Montana 1894-1928. Out-of-state fee $1,000. Shipping fee both ways actual.

MONTANA HISTORICAL SOCIETY, 225 N Roberts, PO Box 201201 Helena, MT 59620. *Educ Outreach Coordr* Julie Saylor.

MONTEREY MUSEUM OF ART, 559 Pacific St, Monterey, CA 93940. Tel: 831-372-5477; Web Site: www.montereyart.org. *Dir* Richard W. Gadd. **Exhibits**— Qualities of Light: Photographs from the Permanent Collection (Ansel Adams, Wynn Bullock, Imogen Cunningham, Edward Weston); Behind the Mask: The Textures, Shapes and Colors of Folk Art; Silent Poetry: Traditional Arts and Crafts from China; Monterey Through Artists' Eyes 1910-1950 (E. Charlton Fortune, Armin Hansen, M. Evelyn McCormick, William Ritschell); Charles M. Russll Bronzes.

MONTGOMERY MUSEUM OF FINE ARTS, One Museum Dr, Montgomery, AL 36117. Tel: 334-244-5700; Fax: 334-244-5774. *Cur Painting and Sculpture* Margaret Lynne Ausfeld; *Cur* Michael Panhorst. **Exhibits**— Icons of the Twentieth Century: Portraits by Yousuf Karsh; Just How I Picture it in My Mind: Contemporary African American Quilts from the Montgomery Museum of Fine Arts; An Ecstatic Vision: Watercolors by Hans Grohs. Rental fee $750.

MONTSERRAT COLLEGE OF ART, 23 Essex St., P.O. Box 26, Beverly, MA 01915. Tel: 978-921-4242; Fax: 978-922-4268. *Dir Exhib* Katherine French. **Exhibits**— All Media. Renting & Shipping fees vary.

MOORE COLLEGE OF ART AND DESIGN, 20th St & The Parkway, Philadelphia, PA 19103. Tel: 215-568-4515; Fax: 215-568-8017; Web Site: www.moore.edu. *Exec Dir* Molly Dougherty; *Dir Exhib* Brian Wallace. **Exhibits**— Moore International Discovery Series 6: Arthur Barrio (2006-08); Barnaby Furnas (2005-07). Rental fees $5,000-$15,000; Shipping fees $5,000-$15,000. Exhibitions of local, national, and international contemporary artists.

MOOSE JAW MUSEUM & ART GALLERY, 461 Langden Crescent, Moose Jaw, S6H 0X6 SK Canada. Tel: 306-692-4471; Fax: 306-694-8016; E-mail: mjamchin@sasktel.net. *Cur* Heather Smith. **Exhibits**— Everett Baker: Color photographs of Cooperative Movement in Saskatchewan during the 1940s & 50s. Rental fee: $1,000, Shipping fees vary. Vaughan Grayson at the Top of the World: A Woman Artist in the Canadian Rockies - Silkscreen prints produced in the mid-century period. Rental fee $1,500, Shipping fees vary. Dana Claxton: Sitting Bull and the Moose Jaw Sioux, a new commissioned 4-channel video installation. Joan Rankin: 1960s abstract paintings and prints influenced by Clement Greenberg and Jules Olitski while participating at Emma Lake Artist Workshops in Saskatchewan. Rental fees vary Shipping fees vary. Contact curator for exhibit details.

MORAVIAN HISTORICAL SOCIETY, 214 E Center St, Nazareth, PA 18064. Tel: 610-759-5070; Fax: 610-759-0787; E-mail: info@moravianhistoricalsociety.org. *Exec Dir* Susan M. Dreydoppel. **Exhibits**— "The Many Faces of Zinzendorf," about Count Nicholas Ludwig von Zinzendorf; "John Valentine Haidt: Life of Christ." Rental fee $50-$100; Shipping fees vary. Other information: photographs and labels; exhibits designed to be hung in small places.

MORRIS AND HELEN BELKIN ART GALLERY, University of British Columbia, 1825 Main Mall, Vancouver, V6T 1Z2, BC, Canada. Tel: 604-822-2759; Fax: 604-822-6689. *Registrar* Siobhan Smith. **Exhibits—** Please contact galllery for info on current touring exhibitions. Rental fees vary; Shipping fees vary.

MOUNT HOLYOKE COLLEGE ART MUSEUM, Lower Lake Rd, South Hadley, MA 01075-1499. Tel: 413-538-2245; Fax: 413-538-2144; E-mail: artmuseum@mtholyoke.edu. *Dir* Marianne Doezema *Cur* Wendy Watson. **Exhibits—** Jane Hammond: Paper Work (Dec 2006-Jan 2009); Two by Two: Line, Rhymes and Riddles (Sept 2007-TBA). Exhibition starts at Mount Holyoke College Art Museum. Please contact the museum for more information regarding specific venues on the tour.

MUNICIPAL ART COMMISSION, City Hall, 414 E 12th St, Kansas City, MO 64106. *Pub Art Admin* Blair S. Sands. **Exhibits—** Winning entries of the annual Kansas City photography contest-shown at various public locations for one month at each site, for a period of one year.

MUNSON-WILLIAMS-PROCTOR ARTS INSTITUTE, MUSEUM OF ART, 310 Genesee St, Utica, NY 13502. *Dir & Chief Cur* Paul D. Schweizer; *Cur (Modern & Contemporary Art)* Mary Murray; *Cur Decorative Arts* Anna T. D'Ambrosio. **Exhibits—** Jewels of Time: Watches from the Munson-Williams-Proctor Arts Institute.

MUSEE D'ART DE JOILETTE, 145 Wilfrid-Corbell St, Joilette, J6E 4T4. PQ Canada. *Dir* Gaetane Verna. **Exhibits—** Temporary contemporary exhibitions Rental fees $8,000-$10,000. Shipping fees vary.

MUSEE DU LOUVRE, Louvre Museum, Paris Cedex 01, Pl du Carrousel, Paris, 75058 France. Tel: 33-1-40-20-50-50; Fax: 33-1-40-20-54-42; E-mail: info@louvre.fr; Web Site: www.amus-du-louvre.org.

MUSEUM OF ART, FORT LAUDERDALE, One E Las Olas Blvd, Fort Lauderdale, FL 33301. Tel: 954-525-5500; Fax: 954-524-6011. *Cur of Coll* Jorge Santis; *Registrar* Shauntelle Millman. **Exhibits—** Selections from the permanent collection of Picasso ceramics; William Glackens; Breaking Barriers: Contemporary Cuban Art. Call for rental and shipping information.

MUSEUM OF CONTEMPORARY ART San Diego, 700 Prospect St, LaJolla, CA 92037; 1001 Kettner Blvd, San Diego, CA 92101. Tel: 858-454-3541 (24-hour recorded information); Web Site: www.mcasd.org. *Dir Dr* Hugh M. Davies; *Deputy Dir* Charles Castle; *Dir External Affairs* Anne Farrell; *Dir Institutional Advancement* Jane Rice. **Exhibits—** Christo and Jeanne Claude in the Vogel Collection; Roger Ballen: Photographs; Eusworth Kelly: Red Green Blue; Andy Goldsworthy; Manny Farber: Termite Paths; Cerca Series. Rental spaces available; fees vary.

MUSEUM OF FINE ARTS, 255 Beach Dr, NE, Saint Petersburg, FL 33701. Tel: 727-896-2667; Fax: 727-894-4638. *Dir* Dr. John E. Schloder; *Cur Colls & Exhibs* Dr. Jennifer Hardin. **Exhibits—** Call for information. Rental fees vary.

MUSEUM OF MODERN ART, 11 W 53rd St, New York, NY 10019. *Coordr of Exhibs* Maria DeMarco. **Exhibits—** A number of exhibitions directed by members of the Museum's curatorial staff are offered to other qualified museums on a participating basis. These exhibitions are generally full-scale projects or reduced versions of shows initially presented at The Museum of Modern Art. Although exhibitions are not necessarily available at all times in all media, the traveling program does cover the entire range of the Museum's New York program-painting, sculpture, drawings, prints, photography, architecture and design. Participating fees usually begin at $3,500 for smaller exhibitions and range up to several thousand dollars for major exhibitions. Tour participants are also asked to cover prorated transport costs.

MUSEUM OF NORTHERN ARIZONA, 3101 N Fort Valley Rd, Flagstaff, AZ 86001. Tel: 928-774-5211; Fax: 928-779-1527. *Dir* Dr Robert Breunig; *Deputy Dir* Dr Stefan Sommer; *Cur of Paleontology* Dr David Gillette. **Exhibits—** Native American Anthropology and Art.

MUSEUM OF SOUTHERN HISTORY, 7502 Fondren Rd, Houston TX 77074. *Cur* Dr Danny Sessums; *Asst Cur* Erin Price; *Admin Asst* Suzie Snoddy. **Exhibits—** Fancy Fashions: Fancy Furnishings, through Jan 2007.

MUSEUM OF THE AMERICAN QUILTER'S SOCIETY, 215 Jefferson St, Paducah, KY 42001. Tel: 270-442-8856; E-mail: info@quiltmuseum.org. *Cur & Registrar* Judy Schwender; *Cur Educ* Carrie Cox. **Exhibits—** Various traveling exhibits of quilts; slide presentation about the museum.

MUSEUM OF THE CITY OF NEW YORK, 1220 Fifth Ave, New York, NY 10029. *Deputy Dir* Dr Sarah Henry. **Exhibits—** Contact Dr Henry for titles & fees.

NASSAU COUNTY MUSEUM OF ART, One Museum Dr, Roslyn Harbor, NY 11576. Tel: 516-484-9337; Fax: 516-484-0710. *Dir* Canstance Schwarts. **Exhibits—** Post war Russian posters (40). Rental fees $15,000. Contemporary Latin masters Rental fee: $35,000.

NATALIE & JAMES THOMPSON ART GALLERY, School of Art & Design, San Jose State University, One Washington Square, Art Building 116, San Jose, CA 95192. *Dir* Jo Farb Hernandez. **Exhibits—** Misch Kohn: Beyond the Tradition; Irvin Tepper: When Cups Speak, My Life With the Cup; Holly Lane: Small Miracles; Jon Seri. Rental fees vary. Shipping fees prorated by institution. Please contact gallery for current information.

NATIONAL INSTITUTE OF ART AND DISABILITIES, 551 23rd St, Richmond, CA 94804. Tel: 510-620-0290; Fax: 510-620-0326. *Cur* Rose Kelly. **Exhibits—** The Creative Spirit: This NEA-funded exhibit features the best piece of art by each artist at NIAD. There is an accompanying CD-Rom with digital story about NIAD, and images from "The Creative Spirit". Rental fee $500. Shipping fees vary.

NATIONAL SOCIETY OF MURAL PAINTERS, 498 Broome St, New York, NY 10013. E-mail: reginas@anny.org; Web Site: www.anny.org.nsmp. *Pres* Jack Stewart, Ph.D., NA; *First VPres* Peter Arguimbau. **Exhibits—** NSMP Fin de Siecle Exhibition, at the Art Students League Gallery, 215 W. 57th St, New York, NY 10019. Traveling shows may be arranged by contacting the President at 212-777-8570.

NATIONAL WATERCOLOR SOCIETY, 915 South Pacific Ave, San Pedro, CA 90731. *President* Donna Watson; *Travel Show Dir* Julian Bloom. **Exhibits—** Travel shows are juried from the annual exhibitions and the all membership shows. Works are aquamedia on paper under plexi. The approximate number of works in each show is 30. NWS travel shows are available only to museums and galleries with adequate security and supervision. Commercial galleries are not eligible. National Watercolor Society requires that exhibiting galleries provide insurance during the exhibit and pay transportation and in-transit insurance one way. No other fee is charged. Past and current exhibition catalogs are available for a nominal fee.

NEW MEXICO STATE UNIVERSITY, Art Gallery, PO Box 30001, Dept 3572, Las Cruces, NM 88001-8003. *Dir* Mary Anne Redding; *Conservator* Silvia Marinas. **Exhibits—** Rental fees $6,500-$20,000; Shipping fees $4,500-$10,000.

NEW ORLEANS MUSEUM OF ART, One Collins Diboll Circle, PO Box 19123, New Orleans, LA 70129-0123. Tel: 504-658-4100; Fax: 504-658-4199. *Registrar* Paul Tarver; *Registrar's Asst* Jennifer Ickes. **Exhibits—** Blue Winds Dancing: The Whitecloud Collection of Native American Art; Magnificent Marteke: American Art Noveau Silver from the Robert and Jolie Shelton Collection; 5,000 Years of Chinese Ceramics from the R. Randolph Richmond, Jr. Collection.

NEW YORK STATE HISTORICAL ASSOCIATION, The Farmers' Museum, Inc, PO Box 800, Cooperstown, NY 13326. Tel ; 1-888-547-1500; Web Site www.nysha.org. *Chief Cur* Paul D'Ambrosio. **Exhibits—** Ralph Fasanella's America; Drawn Home: Fritz Vogt's Rural America.

NEW YORK STATE HISTORICAL SOCIETY, 2 W 77th St, New York, NY 10024-5194. *Dir Museum* Linda S Ferber; *Dir Musum Admin* Roy R Eddey. **Exhibits—** From the Permanent Collection: Paintings, Hudson River, Portraits, Narrative, Drawings.

NEXUS CONTEMPORARY ART CENTER, 535 Means St, Atlanta, GA 30318. *Gallery Dir* Teresa Bramlene. **Exhibits—** Atlanta Biennial; Boy Toys; Petscape.

NICOLAYSEN ART MUSEUM AND DISCOVERY CENTER, 400 E Collins Dr, Casper, WY 82601. Tel: 307-235-5247; Fax: 307-235-0923. *Exec Dir* Holly Turner; *Develop Dir* Carol Plummer; *Educ Dir* Linda Lyman; *Registrar* Jillian Allison. **Exhibits—** Call for information.

NORMAN ROCKWELL MUSEUM AT STOCKBRIDGE, 9 Glendale Rd, Rte 183, PO Box 308, Stockbridge, MA 01262. Tel: 413-298-4100; Fax: 413-298-4142; E-mail: inforequest@nrm.org. Web Site: www.nrm.org. *Mgr Traveling Exhib* Mary Melius Dawson. **Exhibits—** A variety of topics include Norman Rockwell's 322 Saturday Evening Post covers, family life series, Tom Sawyer and Huckleberry Finn, 1940's American Home Front, Home for the Holidays as well as exhibitions of other artists. Rental fee varies; Shipping fee varies; Please call for details.

NORTH CENTRAL COLLEGE, Art Dept, 30 N Brainard St, Naperville, IL 60540. *Assoc Prof of Art* Barry Skurkis; *Asst Gallery Dir* Brian Lynch. **Exhibits—** Block Print Exhibit; Printmaking Exhibit. Rental fee $100. Shipping fee $65.

NORTHERN KENTUCKY UNIVERSITY, Dept of Art, Fine Arts Building 312, Highland Heights, KY 41099. Tel: 859-572-5421; Fax: 859-572-6501. *Dir Exhib* David Knight.

NORTHWEST ART CENTER, 500 University Ave, West Minot, ND 58707. Tel: 701-858-3264; E-mail nac@minotstateu.edu. *Dir* Avis Veikley. **Exhibits—** Various visual art collections. Please call for more information.

NORTHWEST FILM CENTER, 1219 SW Park Ave, Portland, OR 97205. Web Site: www.nwfilm.org. *Dir* Bill Foster; *Educ Dir* Ellen Thomas; *Regn Svcs Mgr* Thomas Phillipson. **Exhibits—** Best of the Northwest: New work by film and video artists in Oregon, Alaska, Idaho, Montana, Washington and British Columbia; Animated Worlds: Two Decades of Portland Animation.

OAKVILLE GALLERIES, 1306 Lakeshore Rd E, Oakville, L6J 1L6 ON Canada. Tel: 905-844-4402; Fax: 905-844-7968; E-mail: info@oakvillegalleries.com. *Dir* Francine Perinet; *Cur Contemporary Art* Marnie Fleming; *Curatorial Asst & Registrar* Shannon Anderson. **Exhibits—** Various - contact Oakville Galleries for details.

OGUNQUIT MUSEUM OF AMERICAN ART, 543 Shore Rd, Ogunquit, ME 03907. *Dir & Cur* Dr Michael Culver. **Exhibits—** American Art: a variety of subjects. Rental and shipping fees vary.

OHIO HISTORICAL SOCIETY, 1982 Velma Ave, Columbus, OH 43211. Tel: 614-297-2300; Fax: 614-297-2411. *Traveling Exhibs Coordr* Edna Diggs. **Exhibits—** Jacob Lawrence: The John Brown Serigraphs; Allan Rogan Crite: Were You There When They Crucified My Lord? Rental fees $400-$2,000.

OHIO STATE UNIVERSITY, Wexner Center for the Arts, 1871 N High St, Columbus, OH 43210-1393. Tel: 614-292-0665. *Chief Cur Exhib* Helen Molesworth. **Exhibits—** Rental & Shipping fees vary.

OKLAHOMA CITY MUSEUM OF ART, 415 Couch Dr, Oklahoma, OK 73102. *Chief Cur* Hardy George, PhD; *Assoc Cur* Allison Anlick. **Exhibits—** Breaking the Mold: Selections from the Washington Gallery of Modern Art, 1961-1968; Shining Spirit: Westheimer Family Collection.

OLD JAIL ART CENTER, 201 S 2nd St, Albany, TX 76430. Tel: 325-762-2269; Fax: 325-762-2260; E-mail: info@theoldjailartcenter.org. Web Site: www.theoldjailartcenter.org. *Registrar* Elizabeth Weinman; *Exec Dir* Margaret Blagg. **Exhibits—** Grit and Glory: Laura Wilson's Photographs of Six-Man Football. Rental fees $5,000.

OLD SLATER MILL ASSOCIATION, Slater Mill Historic Site, 67 Roosevelt Ave, PO Box 696, Pawtucket, Rhode Island 02862-0696. Tel: 401-725-8638; Fax: 401-722-3040; E-mail: samslater@aol.com; Web Site: www.slatermill.org. *CEO* Jeanne Zavada; *Cur* Andrian Paquette. **Exhibits—** Museum on Wheels Exhibits: Things to be Corrected, Things to be Appreciated: Photographs by Lewis Hine; The Hardest Working River: 30 ready to hang framed panels with text examining the textile industry along the banks of the Blackstone River; Vanishing Rhode Island: 40 black and white framed images with interpretive text by Paul Buhle; Nature to Profit: The Transformation of Rhode Island Waterways: 90 black and white images with interpretive labeling by Robert Macieski and Richard Greenwood. Rental fees $100-$240.

OLIVE HYDE ART GALLERY, 123 Washington Blvd, PO Box 5006, Fremont, CA 94537-5006. *Gallery Dir* Kim Bach. **Exhibits—** Traveling Smithsonian Exhibits, Sister City Exhibits.

ORGANIZATION OF SASKATCHEWAN ARTS COUNCILS, 2135 Broad St, Regina, S4P 1Y6 SK, Canada. *Vis Arts Coordr* Donna Kriekle; *Vis & Media Arts Coordr* Jennifer Schell McRorie. **Exhibits—** Visual arts touring exhibitions, 5 touring shows per year. Work is by Saskatchewan artists.

PALM SPRINGS ART MUSEUM, 101 Museum Dr Palm Springs, CA 92262. Tel: 760-325-7186; Fax: 760-327-5069; E-mail: jlyle@psmuseum.org; Web Site: www.psmuseum.org. *Chief Cur* Katherine Hough; *Assoc Cur* Marilyn Cooper. **Exhibits—** Contemporary Desert Photography organized for travel through 2009.

PALMER MUSEUM OF ART, The Pennsylvania State University, Curtin Rd., University Park, PA 16802-2507. Tel: 814-865-7672; Fax: 814-863-8608. *Cur* Joyce Robinson; *Registrar* Beverly Sutley; *Dir* Jan Keene Muhlert. **Exhibits—** Family Legacies: The Art of Betye, Lezley and Alison Saar, Jan 30-April 22, 2007; Early Soviet Photography, Feb 6-May 6, 2007; Ansel Adams & Edwin Land: Art, Science and Invention, Photographs from the Polaroid Collection, July 12-Sept 9, 2007; Thomas Hart Benton's Shallow Creek (1939): A Focus Exhibition, Sept 4-Dec 2, 2007. Rental and shipping fees vary.

PALO ALTO ART CENTER, 1313 Newell Rd, Palo Alto, CA 94303. *Dir* Linda Craighead; *Cur* Signe Mayfield; *Registrar* Mark Ellen Daly. **Exhibits—** Robert Brady: In the Wing of Grace Rental fee $6,000; Shipping fees prorated among venues.

PARKS AND CULTURAL RESOURCES, Wyoming Arts Council Gallery, 2320 Capitol Ave, Cheyenne, WY 82002. **Exhibits—** 4-5 annual gallery exhibits featuring Wyoming artists in all media.

PASTEL SOCIETY OF AMERICA, 15 Gramercy Park S, New York, NY 10003. *Chmn* Flora B. Giffuni; *Pres* Sidney Hermel. **Exhibits—** National Arts Club at Roundabout Theater- 45th St. and Broadway, New York, NY.

PENNSYLVANIA ACADEMY OF THE FINE ARTS, Museum of American Art, 118-128 N Broad St, Phildaelphia, PA 19102. Tel: 215-972-7600; Fax: 215-972-5564. *Cur of Colls* Sylvia Yount, Ph.D.; *Dir* Janice Rosenfeld, Ph.D.; *Dir of Museum Educ* Glenn Tomlinson, MA. **Exhibits—** Maxfield Paresh, 1870-1966; Ida Applebroog: Nothing Personal; Judith Schaecter; William Christianbury; To Be Modern: American Encounters with Cezanne and Company.

PENSACOLA JUNIOR COLLEGE, Anna Lamar Switzer for Visual Arts, 1000 College Blvd, Pensacola, FL 32504. *Dir* Allan Peterson. **Exhibits—** Regional exhibits loaned to museums and sister institutions. No rental fees. Borrower pays shipping fees and insurance.

PHILLIPS ACADEMY, ADDISON GALLERY OF AMERICAN ART, Chapel Ave, Andover, MA 01810. *Dir* Brian T. Allen; *Cur* Allison Kemmerer; *Cur* Susan Faxon. **Exhibits—** William Wegman/Funney Strange; Carrol Dunham; Maverick Modernists; Sheila Hicks; Whistlers Bridges; American Photography; Mark Tobey. Rental fee varies. Shipping fee varies.

POLK MUSEUM OF ART, 800 E Palmetto St Lakeland, FL 33801-5529. Tel: 863-688-7743; Fax: 863-688-2611; E-mail: info@polkmuseumofart.org. *Exec Dir* Daniel E. Stetson; *Cur* Todd Behrens. **Exhibits—** Titles are available as exhibits are organized. Rental fees vary. Shipping fees vary. Contact Cur of Art Todd Bechrens for information.

PORTER THERMOMETER MUSEUM, 49 Zarahemla Rd, Box 944, Onset, MA 02558-0944. Tel: 508-295-5504; Fax: 508-295-8323; E-mail: thermometerman@aol.com; Web Site: www.members.aol.com/thermometerman/index.html. *Cur* Richard T. Porter; *Asst Cur* Barbara A. Porter. **Exhibits—** Thermometermania; The History of Galileo's Bulb; Traveling Enrichment Presentation and/or Interactive Display Table (50-75 thermometers). Listed in Guinness World Records, 2004. No rental or shipping fees.

PRAIRIE ART GALLERY, 10209 99th St, Grande Prairie, T8V 2H3, AB Canada. Tel: 403-532-8111; Fax: 403-539-1991. *Dir & Cur* Laura Van Haven. **Exhibits**— Barbara Roe Hicklin, Terry Greguroschon, Katie One, Bill Morton: Between 4; Janet Mitchell, Marcia Perkins, Wendy Toogood, Don Mabie, Robert Char Michael, The Artists Guild, Franklin Heisler and William McDonnell. Some forty exhibitions are produced by the Prarie Art Gallery.

PRATT COMMUNITY COLLEGE, Art Dept, 348 NE SR 61, Pratt, KS 67124. *Art Instructor* Gene Wineland. **Exhibits**— Evolutions: Lithographs by Gene Wineland. Rental fees $500 plus shipping.

PRINT CLUB OF ALBANY, PO Box 6578, Albany, NY 12206. Tel: 518-449-4756; E-mail: semowich@att.net. *Cur* Dr. Charile Semowich. **Exhibits**— The Presention Prints (68).

PROMOTE ART WORKS, INC, AKA MICRO MUSEUM, 123 Smith St, Brooklyn, NY 11201. Tel: 718-797-3116; Web Site: www.micromuseum.com. *Exec Dir* Kathleen Laziza. **Exhibits**— Video art, installation & interactive art. Rental and shipping fees negotiable.

PUBLIC MUSEUM OF GRAND RAPIDS, Van Andel Museum Center, 272 Pearl St NW, Grand Rapids, MI 49504. Tel: 616-456-3977; Fax: 616-456-3873; E-mail: staff@grmuseum.org. *Dir* Timothy Chester; *Cur Exhib* Tom Bantle; *Registrar* Marilyn Merdzinski. **Exhibits**— The Dead Sea Scrolls: exhibits to accompany & interpretively display DSS fragments from the collections of the Israel Antiquities Authority. Rental fees $150,000 Shipping fees negotiable Requires site approval from the IAA first.

PUTNAM MUSEUM OF HISTORY & NATURAL SCIENCE, 1717 W 12th St, Davenport, IA 52804. Tel:563-324-1054; Fax: 563-324-6638; E-mail: museum@putnam.org. *Cur Natural Science* Christine Chandler. **Exhibits**— Wild Orchids: A Photographic and Artistic Exploration of Native Orchids of North America. Rental fee $3,200. Shipping fees vary.

QCC ART GALLERY, 222-05 56th Ave, Bayside, NY 11364. *Dir* Faustino Ouintanilla; *Admin Asst* Deanne DeNyse; *Conservator* Oscar Sossa. **Exhibits**— Hats & Hats Not: Photographs by Jules Allen. Rental fee $1,500. Borrowing institutions must provide shipping and insurance.

QUEENS COLLEGE, CITY UNIVERSITY OF NEW YORK, Godwin-Ternbach Museum, 65-30 Kissena Blvd., 405 Klapper Hall, Flushing, NY 11367. Tel: 718-997-4747; Fax: 718-997-4734; E-mail: nicole-jannotte@qc1qc.edu. *Dir & Cur* Amy Winter; *Asst Dir* Nicole Jannotte; *Registrar* Nancy Williams.

QUEENS HISTORICAL SOCIETY, 143-35 37th Ave, Flushing, NY 11354-5729. Tel: 718-939-0647 Ext. 17; Fax: 718-539-9885; E-mail: nfo@queenshistoricalsociety.org. *Exec Dir* Mitchell Grubler; *Coll Mgr* Richard Hourahan; *Programs Coordr*

Katrina Raben. **Exhibits**— Angels of Deliverence: The Struggle Against Slavery in Queens and Long Island. Rental fees negotiable. Shipping fees to be determined.

QUEENSBOROUGH COMMUNITY COLLEGE, Dept of Art & Photography, 222-05 56th Ave, Bayside, NY 11364. *Dir Art Gallery* Faustino Quintanilla. **Exhibits**— Varies, please contact dir for more information.

RADFORD UNIVERSITY ART MUSEUM, Box 6965, Radford University, Radford, VA 24142. Tel: 540-831-5754; E-mail: rumuseum@radford.edu. *Dir* Preston Thayer. **Exhibits**— Art of Dorothy Gillespie. Rental fees none; Shipping fees Exhibitor pays.

RAMAPO COLLEGE GALLERY, 505 Ramapo Valley Rd, Mahwah, NJ 07430. Tel: 201-529-7587. *Dir* Shalom Gorewitz. **Exhibits**— Passing the Torch: Paintings on the Holocaust by David Boscovitch. Shipping fees assumed by borrower.

RED ROCK STATE PARK MUSEUM, PO Box 10, Church Rock, NM 87311. Tel: 505-863-1337. **Exhibits**— Anasazi artifacts; Pueblo and Navajo culture; Southwestern Native American fine art and crafts (jewelry, baskets, pottery, rugs and Kachina carvings). Art shows, featuring artwork by Native American artists and local artists, change monthly. Call for information.

RINGLING SCHOOL OF ART AND DESIGN/SELBY GALLERY, 2700 N Tamiami Trail, Sarasota, FL 34234. *Dir* Kevin Dean; *Asst Dir* Laura Avery. **Exhibits**— Math Art/Art Math; Light & Texture: The Monochromatic Paintings of David B.; The Third Eye: Heinz Lechner's Photo-Collage Portrait. Rental fees $2,000-$7,500; Shipping fees prorated. Call for more information and catalogue.

ROLLINS COLLEGE, Cornell Fine Arts Museum, 1000 Holt Ave, Winter Park, FL 32789-4499. *Dir* Dr. Arther Bluorenthal; *Cur* Theo Lotz. **Exhibits**— Winslow Homer Prints; Bloomsbury Collection, FSA File photos collection, Treasures of the Cornell Fine Arts Museum; Smith Watch Keys Rental fees $ 5,000-$10,000; Shipping fees $500-$2,500.

SAINT-GAUDENS NATIONAL HISTORIC SITE US Dept of Interior National Park Service, 139 Saint-Gaudens Rd, Cornish, NH 03745. *Supt* BJ Dunn; *Chief Cultural Resources* Henry Duffy PhD; *Chief Interpretation* Gregory C. Schwarz; *Chief Natural Resources* Steven Walasewicz. **Exhibits**— Augustus Saint-Gaudens: Sculpture of the gilded age. See Trust for Museum Exhibition.

SALEM ART ASSOCIATION, 600 Mission St SE, Salem, OR 97302. Tel: 503-581-2228. *Exhibs Dir* Saralyn Hilde. **Exhibits**— Paintings & Parfleches. Under consideration is a show of abstract calligraphy. Rental fees under $1,000.

SAMEK ART GALLERY OF BUCKNELL UNIVERSITY, Elaine Langone Center, Moore Ave, Lewisburg, PA 17837. Tel: 570-577-3792; Fax: 570-577-3215. *Asst Dir & Operations Mgr* Cynthia Peltier; *Dir* Dan Mills; *Asst Registrar* Jeffery Brunner. **Exhibits**— Regeneration: Contemporary Chinese Art from China and the US Rental fees $7,000. Shipping fees prorated.

SAN FRANCISCO STATE UNIVERSITY, Art Dept, 1600 Holloway Ave, San Francisco, CA 94132. Tel: 415-338-2176; E-mail: artdept@sfsu.edu. *Dir* Mark Johnson. **Exhibits**— Varies. Rental fees vary. Shipping fees vary.

SAN JOSE STATE UNIVERSITY, School of Art & Design, One Washington Sq, Art Building 116, San Jose, CA 95192. Tel: 408-924-4320; Fax: 408-924-4326; Web Site: www.sjsu.edu/depts/art-design. *Dir* JoFarb Hearnandet; *Gallery* Nablie Thompson; *Gallery* James Thomapson. **Exhibits**— Iru Tepper, Holly Lane. Information available from Gallery (408-924-4328). See School WebSite at www.sjsu.edu/depts/art-design.

SANTA ANA COLLEGE ART GALLERY, 11530 W 17th St, Santa Ana, CA 92706. Tel: 714-564-5615; Fax: 714-564-5629. *Gallery Dir* Mayde Herberg; *Asst Dir* Loren Sandvik; *Gallery Coordr* Caroline McCabe. **Exhibits**— Fine Art; Modern Art; Ethnic Art; Social Issues.

SCHWEINFURTH ART CENTER, 205 Genesee St, Auburn, NY 13021. Tel: 315-255-1553; E-mail: smac@relex.com. *Dir* David Kwasigroh; *Educ Coordr* Jude Valentine; *Admin Asst* Mary Ellen Kliss. **Exhibits**— Quilts=Art=Quilts; Upstate Invitational; Both Ends of the Rainbow; The Gardens of Ellen Shippman; Women's Installations; and Made in New York (juried).

SCOTTSDALE MUSEUM OF CONTEMPORARY ART, 7374 E 2nd St, Scottsdale, AZ 85251. Tel: 480-994-2787; Fax: 480-874-4655; E-mail: smoca@sccarts.org. *Dir* Susan Krane; *Sr Cur* Marilu Knode; *Asst Cur* Erin Kane. **Exhibits**— Hair Stories; Let's Talk West: Brad Kahlhamer. For further information, contact the museum's Curatorial Dept at 480-874-4630.

SEATTLE ART MUSEUM, PO Box 22000, Seattle, WA 98122-9700. Web Site: www.seattleartmuseum.org. *Mgr Exhib & Publ* Zora Hutlora Foy. **Exhibits**— Reinventing Books in Contemporary Chinese Art, Aug 23-Dec 2, 2007; Japan Envisions the West: 16th-19th Century Japanese Art from Kobe City Museum, Oct 11, 2007-Jan 6, 2008; Roman Art from the Louvre, Feb 21-May 11, 2008. Rental fees vary. Shipping fees vary.

SHELBURNE MUSEUM, 5555 Shelburne Rd., PO Box 10, Shelburne, VT 05482. Tel: 802-985-3346; Fax: 802-985-2331. *Pres* Hope Alswang. **Exhibits**— Art of the Needle: Masterpiece Quilts from the Shelburne Museum. Rental fee $25,000 - 40 masterpiece American quilts from the 18th, 19th & 20th century.

SHEPHERD UNIVERSITY, Dept of Art, PO Box 3210, Shepherdstown, WV 25443-3210. Tel: 304-876-5254; Fax: 304-876-0955; E-mail: sevanisk@shepherd.edu. *Exhibs Dir* Benita Keller. **Exhibits**— Theme Exhibits; Painting; Printmaking; Drawing; Photography; Graphic Design; Sculpture; Mixed Media; Group. Rental and shipping fees vary.

SIERRA ARTS FOUNDATION, 17 S Virginia St., Ste. 120, Reno, NV 89501. Tel: 775-329-2787; Fax: 775-329-1328; E-mail: jill@sierra-arts.org; Web Site: www.sierra-arts.org. *Program Dir* Chad Cornwell.

SILVERMINE GUILD ARTS CENTER, 1037 Silvermine Rd, New Canaan, CT 06840. Tel: 203-966-9700; Fax: 203-966-2763; E-mail: sgac@silvermineart.org. *Dir* Helen Klisser During.

SIOUX CITY ART CENTER, 225 Nebraska St, Sioux City, IA 51101-1712. *Dir* Al Harris-Fernandez; *Cur* Christopher Cook; *Educ Spec* Nan Wilson. **Exhibits**— Exhibitions focus on Upper Midwest contemporary artists.

SLATER MILL HISTORIC SITE, 67 Roosevelt Ave., PO Box 696, Pawtucket, RI 02862-0696. *Dir Programs & Mktg* Francine Murphy-Brillon; *Cur* Andrian Paquette. **Exhibits**— Vanishing Rhode Island (rental fee: $100 monthly). Nature to Profit: The Transformation of RI Waterways (rental fee: $200 for 6 week period). The Hardest Working River (rental fee: $100 monthly). Things to be Corrected, Things to be Appreciated: Photographs of Lewis Hine (rental fee $100 monthly). Industrial Revolution: Pawtucket and the Creative Economy (rental fee $150/month). Shipping fees paid by borrowing agency.

SMITHSONIAN TRAVELING EXHIBITION SERVICE, P.O. Box 37012, MRC 941, Washington, DC 20013-7012. Tel: 202-633-3168. *Dir Scheduling & Exhib* Michelle Torres-Carmona; *Scheduling & Exhibits Assoc* Minnie Micu. **Exhibits**— For more Information Call: 202-633-3168. This is not a National Museum of American History bureau, but is part of the Smithsonian Institution.

SOUTH CAROLINA ARTS COMMISSION MEDIA ARTS CENTER, 1800 Gervais St, Columbia, SC 29201. Tel: 803-734-8681; Fax: 803-734-8526; E-mail: sleonard@arts.state.sc.us; Web Site: www.southcarolinaarts.com. *Dir* Susan Leonard. **Exhibits**— Southern Circuit (film/video artist tour).

SOUTHEASTERN CENTER FOR CONTEMPORARY ART, 750 Marguerite Dr, Winston-Salem, NC 27106. Tel: 336-725-1904; Fax: 336-722-6059; E-mail: general@secca.org. *Chief Cur* David J. Brown; *Exec Dir* Vicki Kopf. **Exhibits**— The Home House Project: The Future of Affordable Housing; Edward Burtynsky: The China Series. Rental fees HHP $5,000; Burtynsky $10,000. Shipping fees HHP prorated, not to exceed $3,000; Burtynsky prorated, not to exceed $4,000. For more information contact David J. Brown at dbrown@secca.org.

SOUTHERN ALBERTA ART GALLERY, 601 Third Ave, S, Lethbridge, T1J OH4, AB Canada. *Dir* Marilyn Smith; *Cur* Joan Stebbins. **Exhibits**— Ian Carr-Harris; Janet Werner; Eric

Metcalfe, The Attic Project; Harmish Fulton, David Hoffos, Janet Cardiff George Bures Miller, Monica Tap, Angela Leach, David Kramer.

SOUTHERN OHIO MUSEUM & CULTURAL CENTER, Southern Ohio Museum Corporation, 825 Gallia St, PO Box 990, Portsmouth, OH 45662. Tel: 740-354-5629; Fax: 740-354-4090; E-mail: beth@somacc.com. *Museum Dir* Sara Johnson. **Exhibits—** Future shows curated by museum staff Rental and shipping fees to be determined.

ST JOHN'S UNIVERSITY, 8000 Utopia Pkwy, Queens, NY 11439. Tel:718-990-1526; Fax: 718-990-1881. *Chairperson* Paul F. Fabozzi; *Cur Asst* Suzanne Guarnieri. **Exhibits—** Annual calendar available by contacting The Department of Fine Arts.

ST LAWRENCE UNIVERSITY, Richard F Brush Art Gallery, 23 Romoda Dr, Canton, NY 13617. Tel: 315-229-5174; Fax: 315-229-7445; E-mail: ctedford@stlawu.edu. *Dir* Catherine L. Tedford; *Asst Dir* Carole Mathey. **Exhibits—** The Spirit of Tibet: Portrait of a Culture in Exile. Rental fee $2,500. Shipping fee $1,500. Other Information—55 framed color photographs by award-winning Alison Wright.

STANFORD UNIVERSITY, IRIS & B GERALD CANTOR CENTER FOR VISUAL ARTS, Stanford, CA 94305-5060. *Chief Cur* Bernard Barryte. **Exhibits—** The Virgin, Saints and Angels: South American Paintings 1600-1825 from the Thoma Collection; Bare Witness, Photographs by Gordon Parks; Art of Tuareg, Sahara Nomads in a Modern World.

STATE UNIVERSITY OF NEW YORK COLLEGE AT CORTLAND, Dowd Fine Arts Gallery, PO Box 2000, Cortland, NY 13045. Tel: 607-753-4316; Fax: 607-753-5999. *Dir* Allison Graff. **Exhibits—** Parodic Narratives in Recent African-American Art. Rental fee $2,500; Shipping fees paid by lender.

STEPHEN BULGER GALLERY, 1026 Queen St.West, Toronto, M6J 1H6 ON Canada. Tel: 416-504-0575; Fax: 416-504-8929; E-mail: info@bulgergallery.com. *Pres* Stephen Bulger. **Exhibits—** Phil Bergerson: Extracts of America; Canadian Press: National Treasures. Rental fee $1,500. Shipping fees one way.

STERLING & FRANCINE CLARK ART INSTITUTE, 225 South St, Williamstown, MA 01267. Tel: 413-458-9545; Fax: 413-458-2324; E-mail: info@clarkart.edu. *Sr Cur* Richard Rand; *Dir Curatorial Admin* Brian Allen.

STUDIOS OF JACK RICHARD & ALMOND TEA GALLERIES, 2250 Front St, Cuyahoga Falls, OH 44221. Tel: 330-929-1575; E-mail jackrichard@aol.com. *Dir* Jane Williams. **Exhibits—** 2000 faces and 2300 laser prints of art work in many media and subjects. Rental fee $350; Shipping fee varies.

SWISS INSTITUTE, 495 Broadway, 3rd Fl, New York, NY 10012. *Dir* Annette Schindler; *Exhibs Coordr* Michele Faguet.

Exhibits— Independing Loop/Especes D'Espaus; Rita Ackermann/Anc Axpe.

SYRACUSE UNIVERSITY ART COLLECTION, Sims Hall, Syracuse, NY 13244. Tel: 315-443-4097; Fax: 315-443-9225. *Assoc Dir* Domenic Iacono; *Cur* David Prince. **Exhibits—** Milton Avery, Rembrandt Prints, Art Nouveau Glass & Pottery, German Expressionist Prints, Photography exhibits: Berenice Abbott, Eugene Atget, Japanese photos. Rental fees $2,000-$9,000.

TAMARIND INSTITUTE, 108-110 Cornell Dr SE, Albuquerque, NM 87106. *Dir* Marjorie Devon; *Educ Dir* Rodney Hamon; *Master Printer/Studio Mgr* Bill Lagattuta; *Gallery Mgr* Arif Khan. **Exhibits—** Lithographs by various contemporary artists published by Tamarind Institute.

TELFAIR MUSEUM OF ART, 121 Barnard St., PO Box 10081, Savannah, GA 31412. Tel: 912-232-1177; Fax: 912-232-6954. *Asst Cur* Beth Moore; *Exec Dir* Diane Lesko, PhD; *Cur Fine Arts & Exhib* Holly Koons McCullough; *Cur (Owens-Thomas House)* Carol Chamberlain. **Exhibits—** Three American Printmakers: John Taylor Arms, Childe Hassam, Joseph Pennell; Watercolors & Pastels from the Permanent Collection of the Telfair Museum of Art, Savannah, Georgia; Selections from Piranesi's Views of Rome, Triumphal Arches & Other Monuments and Imaginary Prisons; The Magical Self: African American Hairdos in Savannah; Artful Persuasion: Posters & Illustrations from the Collection of Rita Trotz (Rental fee: $1,000 plus shipping); To Discover Beauty: The Art of Kahill Gibran from the Telfair Museun of Art (Rental fee: $1,500 plus shipping); Jack Leigh: The Land I'm Bound To (Rental fee: $5,000 plus shipping); Ray Ellish in Retrospect: A Painter's Journey (Rental fee: $15,000 plus proated shipping and insurance for qualified sites).

TEXAS FINE ARTS ASSOCIATION, 3809-B W 35th St, Austin, TX 78703. Tel: 512-453-5312; Fax: 512-459-4830. *Exec Dir* Sandra Gregor; *Art-on-Tour Coordr* Kelly Tankersley. **Exhibits—** New American Talent, Texas Abstract and Pulp Fictions. Rental fees $800-$2000. Shipping fee $120. Currently touring in Texas only.

TEXTILE MUSEUM OF CANADA, 55 Centre Ave, Toronto, M5G 2H5 ON, Canada. *Exec Dir & Cur Oriental Textiles* Nataley Nagy; *Contemporary Cur & Exhib Mgr* Sarah Quinton; *Contemporary Gallery Cur & Exhibs Mgr* Sarah Quinton. **Exhibits—** Exhibitions feature artifacts from the Museum's permanent collection of historic and ethnographic textiles, as well as contemporary works by Canadian and international textile artists.

THE ALBUQUERQUE MUSEUM OF ART & HISTORY, 2000 Mountain Rd NW, Albuquerque, NM 87104. Tel: 505-243-7255; Fax: 505-764-6546; Web Site: www.cabq.gov/museum. *Dir* James Moore; *Cur History* Deb Slaney; *Cur Art* Doug Fairfield. **Exhibits—** Featuring art of the Southwest and 400 years of Albuquerque history through permanent displays and temporary exhibitions.

THE AMERICAN ADVERTISING MUSEUM, 211 NW Fifth Ave, Portland, OR 97209. Tel: 503-226-0000; Fax: 503-274-2576; E-mail: info@admuseum.org. *Admin* Catherine Coleman. **Exhibits—** Dream Girls: Images of Women in Advertising, 1890s to 1990s; Advertising Comes of Age: The History of American Advertising, 1920-1969. Rental fees $2,000-$10,000. Shipping fees $500-$3,000.

THE AMERICAN SWEDISH INSTITUTE, Lilly lorenzen Scholarship, 2600 Park Ave S, Minneapolis, MN 55407. Tel: 612-871-4907; Fax: 612-871-8682; E-mail: info@americanswedishinst.org. *Cur* Curt Pederson; *Exec Dir* Bruce Karstadt. **Exhibits—** Woodcarvings, Glass, and Some individual Paintings. Rental fees paid by requestor. Shipping fees paid by requestor.

THE ARKANSAS ARTS CENTER, STATE SERVICES DEPARTMENT, PO Box 2137, Little Rock, AR 72203. Tel:501-396-0350; 800-264-2787; Fax: 501-375-8053; E-mail: nmetcalf@arkarts.com. *State Serv Mgr* Ned Metcalf. **Exhibits—** Thematically organized exhibitions from the permanent collection which includes the 2000-2004 Artmobile exhibition, Images & Stories of the South; traveling exhibitions include Arthur Dove & Seymour Lipton: The designs of Abstraction; Central High 1957 & 1997: Photographs by Will Counts; Disfarmer Photographs: Heber Springs Portraits circa 1945; Drawings & Prints of American Regionalism; Fifty Years of the American Landscape; From Abstraction to Minimalism; George Fisher Presidential Cartoons; Louis & Elsie Freund: A Lifetime Creating; Mid-Southern Watercolors; Mysterious Images: Contemporary Prints; The Surreal Drawings of Arnold Bittleman; Portraits of African Americans; Watercolors by Regional Artists. Rental fees $1,200+ per month, outside Arkansas plus shipping. Detailed information available upon request. Special offering: Peter Takal on Paper (contact for fee & related information).

THE ART CENTER AT FULLER LODGE, 2132 Central Ave, Los Alamos, NM 87544. *Dir* John Werienko; *Asst Dir* JJ Maier; *Board Chmn* Mary Carol Williams. **Exhibits—** Rotating juried art exhibits and gallery shop featuring local & regional artists.

THE ASPEN ART MUSEUM, 590 N Mill St, Aspen, CO 81611. *Cur* Heidi Zuckerman Jacobso;, *Asst Cur* Matthew Thompson; *Curatorial Assoc* Nicole Kinsler. **Exhibits—** Rental fees vary. Shipping fees vary.

THE CASEMATE MUSEUM, PO Box 51341, Fort Monroe, VA 23651-0341. Tel: 757-788-3935; Fax 757-788-3886. *Museum Dir* Dennis P. Mroczkowski; *Mus Specialist* Kathy A. Rothrock; *Museum Technician* David J. Johnson.

THE CITY COLLEGE OF NEW YORK, MORRIS RAPHAEL/ COHEN LIBRARY, 160 Convent Ave, New York, NY 10031. Tel: 212-650-7271; Fax: 212-650-7604; E-mail: prgcc@sci.ccny.cwny.edu. *Chief Librarian* Pamela Gillespie; *Head, Reference Division* Robert Laurich; *Archivist* Sydney van Nort. **Exhibits—** CCNY in Lincoln Brigade; Morris Raphael Cohen: The Golden Age of Philosophy at CCNY 1906-1938; The Artistry of Dominican Carnival; Looking at Lincoln: Political Cartoons from the Civil War Era.

THE COLLEGE OF SANTA FE, Art & Art History Dept, 1600 Saint Michaels Dr, Santa Fe, NM 87505. *Dir* Don Messec. **Exhibits—** Monoprints. Rental fees $2 per monoprint, $50 minimum. Shipping fees cost only. They are shipped with foamcore backing and plastic glazing, unframed ready for L-nails, screws or exhibitor's frames. 25% sales discount to exhibitors.

THE CONTEMPORARY MUSEUM, 241 Makiki Heights Dr, Honolulu, HI 96822. Tel: 808-526-1322; Fax: 808-536-5973; Web Site: www.tcmhi.org. *Dir* Georgianna M. Lagoria; *Assoc Dir & Chief Cur* James Jenson; *Assoc Curs* Allison Wong & Michael Rooks. **Exhibits—** Enrique Martinez Celaya, 1992-2000.

THE CORNING MUSEUM OF GLASS, One Museum Way, Corning, NY 14830-2253. Tel: 607-937-5371. *Public Rels* Beth Duane; *Exec Dir* David B. Whitehouse; *Dir Finance* Nancy Earley; *Human Resource Mgr* Ellen Corradini. **Exhibits—** Glass of the Sultans.

THE DELAND MUSEUM OF ART, 600 N. Woodland Blvd, Deland, FL 32720. Tel: 386-734-4371; E-mail: coolidge@delandmuseum.edu. *Exec Dir* Jennifer McInnes Coolidge; *Exhibitions Coordr* David Fithian. **Exhibits—** It's a Dogs Life: Photographs by William Wegman from the Polaroid Collection. Rental fees $3,500. Shipping fees according to venue and distance.

THE EMBROIDERS' GUILD OF AMERICA, 426 W Jefferson St, Louisville, KY 40202. Tel: 502-589-6956; Fax: 502-584-7900; E-mail: egahge@egausa.org. *Gallery Cur & Educ Coordr* Laura Olah; *Exec Dir* Anita Streeter; *Pres* Karen Wojahn. **Exhibits—** Through the Needle's Eye-a traveling juried embroidery exhibit. Please contact us for rental & shipping fees.

THE GOLDSTEIN MUSEUM OF DESIGN, 364 McNeil Hall, 1985 Buford Ave, Saint Paul, MN 55708. Tel: 612-624-3474; Fax: 612-624-2750; E-mail: gmd@umn.edu. *Dir* Un Nelson-Mayson. **Exhibits—** Cloth is the Center of the World: Nigerian Textiles. Rental fees $1,500. Shipping fees TBD.

THE GREAT LAKES HISTORICAL SOCIETY, 480 Main St, PO Box 435, Vermilion, OH 44089-0435. Tel: 800-893-1485; Fax: 216-967-1519; E-mail: glhs1@aol.com. *Exec Dir* William A. O'Brien; *Bus Mgr* William Stark. **Exhibits—** Great Lakes Ship Models; Steam and Out Board Engines; Fine Art. Rental and shipping fees vary with size and number of artifacts.

THE HARWOOD MUSEUM OF ART OF THE UNIVERSITY OF NEW MEXICO, 238 Ledoux St, Taos, NM 87571. Tel: 505-758-9826; Fax: 505-758-1475; E-mail: harwoodunm.edu. *Dir* Charles Lovell; *Cur* David Witt. **Exhibits**— Bidstrue/Mahaffey Collection of Taos Moderns: David Witt, Jayne Hammond: works on paper 1992-2002. Rental fees est. $6,000-$9,000. Shipping fees est. $2,500-$3,500.

THE HERITAGE CENTER, INC, 100 Mission Dr, Pine Ridge, SD 57770-2100. *Pres* Peter J. Klint; *Dir* Bro C. M. Simon. **Exhibits**— Ongoing exhibits from permanent collection; Summer: Red Cloud Indian Art Show. Contact center for shipping fees.

THE HIGH DESERT MUSEUM, 59800 S Hwy 97, Bend, OR 97702-7963. Tel: 541-382-4754; Fax: 541-382-5256; E-mail: breynolds@highdesert.org. *Exhib Coordr* Barbara Reynolds. **Exhibits**— Gum San: Land of the Golden Mountain; Amerikanuaki Basques in the High Desen. Call or write for information.

THE INSTITUTE OF CONTEMPORARY ART, 955 Boylston St, Boston, MA 02115. Tel: 617-266-5152; Fax: 617-266-4021; E-mail: info@icaboston.org. *Asst Cur* Gilbert Vicario. **Exhibits**— Call for information. Rental fees negotiable.

THE KURDISH MUSEUM, 144 Underhill Ave, Brooklyn, NY 11238. Tel: 718-783-7930; Fax: 718-398-4365. *Dir* Vera Beaudin Sacedpour. **Exhibits**— Jews of Kurdistan, largely textual with accompanying photos mounted on text boards which also includes a video. Rental fee $250; Shipping $100.

THE LEMMERMAN & COURTNEY GALLERIES, New Jersey City University, 2039 Kennedy Blvd, Jersey City NJ 07305. Tel: 201-200-3246; Fax: 201-200-3224. *Gallery Dir* Hugo X. Bastidas; *Dept Chairperson* Winifred McNiell. **Exhibits**— Historical, individual emerging or established artists. Rental and shipping fees negotiable.

THE LIGHT FACTORY, Spirit Square, Ste 21, 345 N College St, Charlotte, NC 28202. *Exec Dir* Mary Anne Redding; *Exhib Coordr* Tuyet Linh Tran. **Exhibits**— Cuban Allure: photography and video; John Pickel: A Man's World; Humanature: Photographs by Peter Goin; Photographs by Rob Amberg.

THE METROPOLITAN MUSEUM OF ART, 1000 Fifth Ave, New York, NY 10028-0198. Tel: 212-650-2390; Fax: 212-396-5040; Web Site: www.metmuseum.org. *Deputy Dir & Devel Officer* Andrea Kann. **Exhibits**— The staff of the museum selects and organizes exhibitions from the Metropolitan's extensive collections for travel to venues outside New York City.

THE MORIKAMI MUSEUM & JAPANESE GARDENS, Palm Beach County Parks and Recreations Dept, 4000 Morikami Park Rd, Delray Beach, FL 33446. Tel: 561-495-0233; Fax: 561-499-2557; E-mail: morikami@co.palm-beach.fl.us. *Sr Cur* Tom Gregersen; *Dir* Larry Rosensweig. **Exhibits**— "Florigami: Folded Images of Florida's Hidden Nature" by Michael LaFosse, available 2006-2007. Rental fees $2,500 for 8 weeks. Shipping fees prorated.

THE MUSEUM OF ARTS AND SCIENCES, INC, 352 S. Nova Rd, Daytona Beach, FL 32114. *Dir* Wayne D. Atherholt; *Cur Traveling Exhibitions* Richard Lussky. **Exhibits**— Indian and Persian Miniature Paintings; Pacific Exotics: The Woodblock Prints of Paul Jacoulet; Thomas Edison: A History of Sound Reproduction; The New World in the Eyes of Explorers; An American Portrait; Awash: Watercolors from the Museum of Arts and Sciences Permanent Collection; The Cuba and Florida History Connection; Ken and Thelma: The Story of A Confederacy of Dunces; A Century of Jewelry & Gems; The Nancy and Gilbert Levine Collection; Moses Soyer: Social Realism Romantic Realism; Napolean: Espirit de Corps; The Daytona Beach Suite: Drawings and Photographs by Norman Rockwell. Rental and shipping fees vary.

THE NEW YORK HISTORICAL SOCIETY, 170 Central Park W, New York, NY 10024. Tel: 212-873-3400; Fax: 212-874-8706. *Dir, Museum Division* Jan Ramirez. **Exhibits**— Elder Grace: The Nobility of Aging; Without Sanctuary: Lynching Photography in America. Rental and shipping fees vary. Inquiries welcome.

THE NEW YORK PUBLIC LIBRARY FOR THE PERFORMING ARTS, 40 Lincoln Center Plaza, New York, NY 10023-7498. Tel: 212-870-1830; Fax: 212-870-1870. *Cur Exhibs* Barbara Stratyner; *Exec Dir* Jacqueline Z. Davis; *Designer* Donald J. Vlack. **Exhibits**— Swing; Mozart; Balanchine at Work; Classic Black. Exhibitions travel with posters, audio/video components, brochures bibliographies and more. Rental fee $5,000 (max.); Shipping fees vary.

THE NICKLE ARTS MUSEUM, 2500 University Dr NW Calgary, T2N 1N4 AB Canada. Tel: 403-220-7234; Fax: 403-282-4742; Web Site: www.ucalgary.ca/~nickle. *Dir* Ann Davis; *Cur* Christine Sowiak; *Cur Numismatics* Geraldine Chinirri-Russell. **Exhibits**— Art and Numismatics. Rental Fees vary.

THE PHOTOGRAPHERS GALLERY, 12-23rd St E, 2nd Fl, Saskatoon, S7K OH5, SK Canada. Tel: 306-244-8018; Fax: 306-665-6568; E-mail: donna@pavedarts.ca. *Dir* Donna Jones. **Exhibits**— Contemporary photographic and photo-based art. Rental and shipping fees available on request.

THE PRINT CENTER, 1614 Latimer St, Philadelphia, PA 19103. Tel: 215-735-6090; Fax: 215-735-5511. *Interim Dir* Elizabeth Spungen; *Asst Dir* Ashley Peel Pinkham; *Cur* Jacqueline van Rhyn. **Exhibits**— Annual International Competition. Please call for further information.

THE PRINT CONSORTIUM, 6121 NW 77th St, Kansas City, MO 64151. Tel: 816-587-1986; E-mail: eickhors@mwsc.edu. *Exec Dir* Dr. William S. Eickhorst. **Exhibits**— Museum quality

exhibits of works by established American & European printmakers. Rental fees $300-$800 Shipping paid by exhibitor. Can supply quality exhibits on short term notice. Catalogue available.

THE RAMSAY MUSEUM, 1128 Smith St, Honolulu, HI 96817. *Dir* Dr. Norman Goldstein. **Exhibits**— Original quill and ink drawings of historic Hawaiian landmark architecture by Ramsay, as shown at the nation's capitol and the Museum of American Illustration with catalogues. Rental fees for traveling exhibitions of reproductions $1,500 per month; Shipping fees at cost.

THE ROCKWELL MUSEUM OF WESTERN ART, 111 Cedar St, Coming, NY 14830-2694. Tel:607-937-5386; Fax: 607-974-4536. *Dir* Kristin A. Swain; *Cur Collections* Sheila Hoffman; *Controller* Andrew Braman; *Dir Visitor Svcs* Cindy Weakland. **Exhibits**— Please call for availability of traveling Western & Native American Art exhibits.

THE ROOMS PROVINCIAL MUSEUM, 9 Bonaventure Ave., PO Box 1800, Station C, St John's, A1C 5P9 NL Canada. Tel: 709-729-2329; Fax: 709-729-2179; E-mail: aclarke@mail.gov.rf.ca. *Dir* Penny Houlden.

THE SOCIETY FOR CONTEMPORARY CRAFT, 2100 Smallman St Pittsburgh, PA 15222. Tel: 412-261-7003; Fax: 412-261-1941; E-mail: info@contemporarycraft.org. *Dir Exhibitions* Kate Lydon. **Exhibits**— Color: Five African-American Artists; Transformations 5: Works in Recycled Materials; Cat Chow; Nature/Culture: Artists Respond to Their Environments. Rental fees vary. Shipping fee one way.

THE SOLOMON R GUGGENHEIM MUSEUM, 1071 Fifth Ave @ 89th St, New York, NY 10128-0173. *Deputy Dir & Chief Cur* Lisa Dennison. **Exhibits**— Concentrations of individual artists; European painting & sculpture; modern sculpture; European sources of American abstraction; American abstract painting and works on paper from the 1930s & 1940s; postwar American painting; postwar European painting, postwar art, Latin American art; works on paper. Borrowing institutions will remain responsible for shipping, insurance costs, packing & other charges. In addition, some loan exhibitions organized by the museum are available for travel tours.

THE UKRAINIAN MUSEUM, 222 E. 6th St, New York, NY 10003. Tel :212-228-0110; Web Site: www.ukrainianmuseum.org. *Dir* Maria Shust. **Exhibits**— Introduction to Ukrainian Folk Art, featuring examples of folk costumes, textiles, kilims, ritual cloths, ceramics, woodwork & metal work objects; Masterpieces in Wood: Houses of Worship in Ukraine, 82 blown-up photographs of wooden churches in Ukraine. Rental fees $1,000-$2,000 plus shipping fees. Catalogues & packets of information on particular traveling exhibitions are available.

THE UNIVERSITY OF ALABAMA, Dept of Art, 103 Garland Hall, Box 870270, Tuscaloosa, AL 35487-0270. Tel: 205-348-5967. *Dir* Sarah Moody; *Gallery of Art* William Dooley. **Exhibits**— contact Gallery Director for further information.

THE UNIVERSITY OF THE ARTS, 320 S Broad St, Philadelphia, PA 19102. *Gallery Dir* Sid Sachs. **Exhibits**— Thomas Nozkowski; Yvonne Rainer Retrospective. Rental and shipping fees vary.

THE WINNIPEG ART GALLERY, 300 Memorial Blvd, Winnipeg, R3C 1V1, MB Canada. Tel: 204-786-6641; Fax: 204-788-4998; E-mail: Jasmina@wag.mb.ca. *Head, Museum Svcs* Jasmina Jovanovic-Vlaovic. **Exhibits**— Several exhibitions of contemporary, Canadian historical collection and international art organized each year by The Winnipeg Art Gallery are offered to other qualified galleries and museums in Canada, The United States and abroad, on a participating basis. Borrowing fees and loan terms vary.

TUCSON MUSEUM OF ART AND HISTORIC BLOCK, 140 N Main Ave, Tucson, AZ 85701. Tel: 520-624-2333; Fax: 520-624-7202; E-mail: info@tucsonarts.com; Web Site: www.tucsonarts.com. *Exec Dir* Laurie J. Rufe; *Cur: Art of the Americas* Stephen Vollmer; *Cur of Modern and Contemporary Art* Julie Sasse. **Exhibits**— Painted Essays: William Keith's Landscapes of the West; Directions: Kate Breakey; Poetic Vistas; Artist of the Year: Terri Kelly Moyers; Texas Rangeland: The Photographs of Burton Pritzker; Contemporary Southwest Images XIX: The Stonewall Foundation Series: Jaune Quick-To-See Smith; Directions: Hirotsune Tashima: "What Do You Want to Eat in Your Life?"; El Nacimiento; Paint on Metal: Modern and Contemporary Explorations and Discoveries; The Tucson Seven Rides Again!; Arizona Biennial '05.

TULANE UNIVERSITY, Newcomb Art Gallery, Woldenberg Art Center, New Orleans, LA 70118. Tel: 504-865-5328; Fax: 504-865-5329. *Dir* Erik Neil; *Cur* Sally Main. **Exhibits**— Ida Kohlmeyer. Rental fee $5,000; Shipping fees vary.

TURTLE BAY EXPLORATION PARK, PO Box 992360 Redding, CA 96099-2360. Tel: 530-243-8850; Fax: 530-243-8929; E-mail: info@turtlebay.org. *Dir Coll* Robyn G Peterson; *Coll Mgr* Julia Pennington. **Exhibits**— Ansel Adams: Masterworks. Rental fees $15,000. Shipping fees actual Illustrated brochure with show.

TWEED MUSEUM OF ART, 1201 Ordean Court, Duluth, MN 55812. Tel: 218-725-7056; Fax: 218-762-8503; E-mail pspooner@d.umn.edu. *Dir* Ken Bloom; *Cur/Registrar* Peter Spooner. **Exhibits**— The Richard and Dorothy Nelson Collection of American Indian Art; Narrative Migrations: Themes in Recent Narrative Art and Graphic Novels; Frank Big Bear: Dreams and Legends of an Urban Indian; Knute Heldner: A People's Painter Rental fees $5,000-$15,000. Please call or e-mail for more information.

UCLA DEPARTMENT OF ART, 11000 Kinross Ave. Suite 245, Los Angeles, CA 90095. Tel: 310-825-3281. **Exhibits**— Full exhibition schedule highlighting the departments of art & design/media student work.

UCLA FOWLER MUSEUM OF CULTURAL HISTORY, PO Box 951549, Los Angeles, CA 90095-1549. Tel: 310-825-9672; Fax: 310-206-7007. *Dir Tvlg Exhibs* Karyn Zarubica; *Dir* Doran Ross; *Exhib Designer* David Mayo; *Chief Cur* Polly Roberts. **Exhibits—** Include: Wrapped in Pride: Ghanaian Kente and African American Identity; The Art of Being Kuna: Layers of Meaning Among the Kuna of Panama; Beads, Body and Soul: Art and Light in the Yoruba Universe; From the Rainbow's Varied Hue: Textiles of the Southern Philippines; Sacred Arts of Haitian Voudou; Royal Tombs of Sipan; Containing Beauty: Japanese Bamboo Flower Baskets. Rental fees $9,000-$80,000 (avg. $25,000); Shipping fees are prorated amongst the venues. Space requirements range from 1,500 square feet to 10,000 square feet. For further details contact Karyn Zarubica at 310-825-6067.

UCR/CALIFORNIA MUSEUM OF PHOTOGRAPHY, Univ of California, 3824 Main St, Riverside, CA 92521-3624. Web Site: www.cmp.ucr.edu. *Dir* Jonathan Green.

ULRICH MUSEUM OF ART, 1845 Fairmount, Wichita, KS 67260-0046. Tel: 316-978-3664; Fax: 316-978-3898; E-mail: ulrich@wichita.edu. *Cur Modern & Contemporary Art* Katie Geha. **Exhibits—** Poets on Painters-Available to travel from fall 2007-summer 2008. Rental fees $5,000. Shipping fees incoming. Contact Katie Geha at 316-978-6857 or katie.geha@wichita.edu for more information.

UNIVERSITY ART MUSEUM, University of California, Santa Barbara, CA 93106-7130. Tel: 805-893-2951; Fax: 805-893-3013; E-mail: uam@uam.ucsb.edu. Web Site: www.csulb.edu/uam. *Dir* Kathryn Kanjo; *Cur* Natalie Sanderson; *Registrar* Susan Lucke. **Exhibits—** Representing America: The Ken Trevey Collection of American Realist Prints. Rental fees $6,000. Shipping fee $2,000. Fee includes 25 catalogs, 250 brochures, label copy on disk/electronic transfer.

UNIVERSITY ART MUSEUM, California State Univ, Long Beach, 1250 Bellflower Blvd, Long Beach, CA 90840. Tel: 562-985-5761; Fax: 562-985-7602; E-mail: uam@csulb.edu; Web Site: www.csulb.edu/~uam. *Dir* Christopher Scoates; *Assoc Dir* Ilee Kaplan. **Exhibits—** Contemporary art, including photography.

UNIVERSITY MUSEUM, SOUTHERN ILLINOIS UNIVERSITY, 1000 Faner Dr, Carbondale, IL 62901. *Dir* Dona R. Bachman; *Educ Program Dir* Robert De Hoet; *Cur of Coll* Lorilee Hoffman. *Exhibits Designer* Nate Steinbrink. **Exhibits—** Digging Into the Past. Contact Exhibits Designer for rental and shipping fees information.

UNIVERSITY MUSEUMS, Univ of Delaware, 208 Mechanical Hall, Newark, DE 19716. *Dir* Janis Tomlinson; *Cur* Janet Gardner Broske; *Exhibits Designer* Tim Goecke.

UNIVERSITY MUSEUMS, The Univ of Mississippi, PO Box 1848 University, MS 38677. *Dir* Bonnie J Krause; *Coll Mgr*

William Griffith. **Exhibits—** Olynthus 348 BC: The Destruction and Resurrection of a Greek City (photographic). Rental fee $100; Shipping one way.

UNIVERSITY OF CALIFORNIA, University Art Museum, Santa Barbara, CA 93106-7130. Tel: 805-893-2951; Fax: 805-893-3013; E-mail: uam@uam.ucsb.edu. *Mus Dir* Kathryn Kanjo; *Cur* Natalie Sanderson; *Registrar* Susan Lucke. **Exhibits—** Representing America: Trevey Collection of American Realist Prints. Rental fees $6,000; Shipping fees are prorated or one-way, capped at $2,000. Fee includes 25 catalogs, 250 brochures, label copy on disk & electronic transfer.

UNIVERSITY OF COLORADO, Art Galleries, UCB 204, Boulder, CO 80309-0204. Tel: 303-492-8300; Fax: 303-735-4197. *Collects Mgr* Bridget Carlin. **Exhibits—** Over 20 thematic exhibitions. Rental and shipping fees vary.

UNIVERSITY OF HAWAII ART GALLERY, Dept of Art, 2535 The Mall, Honolulu, HI 96822. Tel: 808-956-6888; Fax: 808-956-9659; E-mail: gallery@hawaii.edu. *Dir* Tom Klobe; *Assoc Dir* Sharon Tasaka; *Design Asst* Wayne Kawamoto. **Exhibits—** Jose Guadalupe Posada: My Mexico; The 9th International Shoebox Sculpture Exhibition. Rental fees $1,500. Shipping fees outgoing.

UNIVERSITY OF ILLINOIS, Krannert Art Museum and Kincaid Pavillion, 500 E Peabody Dr, Champaign, IL 61820. Tel: 217-244-0516; Fax: 217-333-0883; E-mail: kam@uiuc.edu. *Dir* Kathleen Harleman; *Registrar* Kathleen Jones; *Dir Mktg* Diane Schumacher; *Dir Develop* Carrie Turner. **Exhibits—** Balance and Power; Branded and On Display. Rental & Shipping fees vary. Contact harleman@uiuc.edu for more information.

UNIVERSITY OF MARYLAND AT COLLEGE PARK, The Art Gallery, 1202 Art/Sociology Bldg, College Park, MD 20742. *Dir* Scott Habes; *Asst Dir* Jennie Fleming *Exhib Designer* John Shipman.

UNIVERSITY OF MEMPHIS, Art Department, 108 Jones Hall, Memphis, TN 38152-3088. Tel: 901-678-2216; Fax: 901-678-2735; E-mail: jjacksn2@memphis.edu. *Chmn Art Dept* Jed Jackson; *Dir Art Museum of Memphis* Dr. Leslie Luebbers; *Cur The Egyptian Museum* Dr. Patricia Podorski; *Dir The Institute of Egyptian Art and Archeology* Dr. Lorilei Corcoran. **Exhibits—** Student Exhibitions, Juried Exhibitions. Contact the museum for more information.

UNIVERSITY OF MIAMI, Dept of Art & Art History, PO Box 248106, Coral Gables, FL 33124-2618. Tel: 305-284-2542; Fax: 305-284-2115. *Dir (New Gallery)* Lise Drost. **Exhibits—** Florida Craftsmen Annual Exhibition, 3 Generations of Swedish Photography; Art by the Mentally Ill; Denis Defibaugh. Rental and shipping fees vary.

UNIVERSITY OF MICHIGAN MUSEUM OF ART, 525 S State St, Ann Arbor, MI 48109. Tel: 734-764-0395; Fax: 734-764-3731.

Exhibitions Coordr Katie Derosier. **Exhibits**— Orchid Pavilion Gathering: Chinese Paintings from the University of Michigan Museum of Art; Nature Transformed: Wood Art from the Bohlen Collection; Silk Road to Clipper Ship: Trade, Changing Markets and East Asian Ceramics. Please call exhibitions coordr at 734-615-8186 for more information.

UNIVERSITY OF NEVADA, LAS VEGAS, Donna Beam Fine Art Gallery, 4505 Maryland Pkw, Box 455002, Las Vegas, NV 89154-5002. *Dir* Jerry A Schefcik. **Exhibits**—Adjunct Faculty; Gift to the Gallery; England's Dreaming; Midas Drowned: Installation by Stephen Hendee.

UNIVERSITY OF NORTH CAROLINA AT GREENSBORO, Weatherspoon Art Museum, PO Box 26170, Greensboro, NC 27402-6170. *Dir* Nancy M Doll; *Cur Coll* Will South; *Cur Exhibitions* Xandra Eden; *Registrar* Maggie Gregory. **Exhibits**— Loans from the permanent collection of modern and contemporary art; special traveling exhibitions. Rental & Shipping fees.

UNIVERSITY OF PITTSBURGH, History of Art & Architecture Dept, 104 Frick Fine Arts Bldg, Pittsburgh, PA 15260. Tel 412-648-2400 Fax 412-648-2792. *Dir* Josie Piller. **Exhibits**— Rental & Shipping fees are based on exhibition.

UNIVERSITY OF TAMPA, Scarfone/Hartley Gallery, 401 W Kennedy Blvd, Tampa, FL 33606. Tel: 813-253-6217; E-mail: dcowden@ut.edu. *Dir* Dorothy Cowden. **Exhibits**—Original monotypes created at the University of Tampa by Louisa Chase, Sam Gilliam, Stephen Greene, Tom Lieber, Komar and Melamid, James McGarrell, Sam Messer, Larry Poons, Katherine Porter, Hollis Sigler, John Walker, Robert Rahway Zakanitch; Willy Heeks, and Ed Paschke. Rental fee $1000; Shipping is prorated.

UNIVERSITY OF TENNESSEE, Ewing Gallery, 1715 Volunteer Blvd, Knoxville, TN 37996-2410. Tel: 865-974-3200; Fax: 865-974-3198; E-mail: ewing@utk.edu. *Dir* Sam Yeates; *Coll Mgr* Cindy Spangler. **Exhibits**— Life in the City: The Art of Joseph Delaney; Through the Lens of Ed Westcott: A Photographic History of World War II's Secret City; Ecuador: African Diaspora; Let Us Now Praise Famous Men: Words by Agee, Photographs by Evans. Rental fees $1,500-$3,000. Shipping fees $500-$1,000.

UNIVERSITY OF THE SOUTH, 735 University Ave, Sewanee, TN 37383. *Dir* Cheryl Pfeiffer. **Exhibits**— 49 etchings of Nahum Tschacbasov; 40 paintings of Johannes Oertel (1823-1909); 57 prints of Georges Rovalt (1871-1958).

UNIVERSITY OF VIRGINIA ART MUSEUM, PO Box 400119, Charlottesville, VA 22904-4119. *Cur Exhibits & Collections* Andrea Douglas. **Exhibits**— Sam Abell photographs; Japanese woodblock prints. Rental fees $5,000 & up Shipping fees $5,000 & up.

UNIVERSITY OF WATERLOO ART GALLERY, 200 University Ave W, Waterloo, N2L 3G1, ON Canada. Tel: 519-888-4567 Ext. 3575; Fax: 519-746-4982; E-mail: cpodedwo@uwaterloo.ca. *Dir & Cur* Carol Podedworny. **Exhibits**— Jane Buyers: Book Works, $4000 Cdn plus one-way shipping; Robert Houle: Abstract Paintings, $7000 Cdn plus one-way shipping. Shipping fees $400 Includes catalogs.

UNIVERSITY OF WYOMING ART MUSEUM, 2111 Willett Dr, PO Box 3807, Laramie, WY 82071-3807. *Dir & Chief Cur* Susan Moldenhawer; *Coll Mgr* E.K. Kim. **Exhibits**— Digital Photography: Selections from the Digital Studio, Penn State University; Scott Peterman: Photographs; A Wyoming Journey: Photographs of Stuart Klipper; People of the Plateau: Selections from the North American Indians, by Edward S. Curtis; In the Days of Yesteryear: Prints by Hans Kluber. Rental fees $250. Shipping fees round trip. Small exhibitions for traditional and non-traditional venues.

UTAH ARTS COUNCIL, 617 E South Temple, Salt Lake City, UT 84102-1177. Tel: 801-533-5757. **Exhibits**—The exhibition program is designed to provide traveling exhibitions to a statewide audience. Approximately twenty exhibitions are available which vary in size and subject matter. They include works from the permanent collections of the Utah Arts Council, Utah Museums and from special collections contributed by organizations and individuals. Exhibitions are scheduled for one month at $100 per exhibit. They may be booked by museums, college and public galleries, community groups or institutions such libraries, schools, or other nonprofit organizations. The Visual Arts staff transports the exhibitions and supervises installation.

VALDOSTA STATE UNIVERSITY, Art Dept, 111 Moore St, Valdosta, GA 31698. *Acting Head* A. Blake Pearce; *Gallery Dir* Julie Bowaland. **Exhibits**— Nine exhibits annually. Rental and shipping fees vary.

VANDERBILT UNIVERSITY, Fine Arts Gallery, 23rd and West End Ave, Nashville, TN 37235. Tel: 615-322-0605; Fax: 615-343-3786. *Cur* Joseph Mella; *Asst Cur* Amy Pottier.

VENTURA COUNTY MARITIME MUSEUM, INC, 2731 S Victoria Ave, Oxnard, CA 93035. Tel: 805-984-6260; Fax: 805-984-5970; E-mail: vcmm@aol.com. *Cur* Jackie Cavish; *Exec Dir* Mark Bacin; *Cur Art* Jacquelyn Cavish. **Exhibits**— None planned at present, open to requests.

VESTERHEIM NORWEGIAN-AMERICAN MUSEUM, 523 W Water St., PO Box 379, Decorah, IA 52101. *Registrar* Jennifer Johnston Kovarik. **Exhibits**— Contents of An Immigrant's Trunk. Rental fees $50. Shipping fees vary.

VIRGINIA HISTORICAL SOCIETY, 428 North Blvd, PO Box 7311, Richmond, VA 23220. Tel: 800-342-9600; Fax: 804-342-8697; E-mail: jkelly@vahistorical.org. *Dir* James C. Kelly. **Exhibits**— Various small exhibits: "Lee and Grant"; "Jamestown, Quebec, Sante Fe". Please inquire.

VIRGINIA MUSEUM OF FINE ARTS, 200 North Blvd., Richmond, VA, 23220-4007. Public Affairs: 804-204-2708; Fax: 804-204-2707; Web Site: www.vmfa.state.va.us. *Coordr Statewide Exhib* Eileen B. Mot; *Coordr Media Resources* Trent Nicholas. **Exhibits**— We offer 58 traveling exhibitions, the collection at High Security; Work by contemporary artists at Moderate security; Posters & reproducible photos for use in schools at Limited Security. Rental fees $0-$100 Shippings fees borrower pays for commercial shipping Over 100 Museum partners throughout Virginia can borrow these exhibitions. Borrowers include other museums, art centers, libraries, University galleries, and schools.

VIRIDIAN ARTISTS, INC, 530 West 25th St #407, New York, NY 10001. Tel/Fax: 212-414-4040. *Dir* Vernita Nemec. **Exhibits**— Inner Muse: Finding the Source: a group exhibit of 30 artists in a variety of media. Rental fee $2,000; Shipping fees vary.

WALKER ART CENTER, 1750 Hennepin Ave, Minneapolis, MN 55403. *Dir* Kathy Halbreich. **Exhibits**— Consult Walker Web: www.walkerart.org.

WALTER ANDERSON MUSEUM OF ART, 510 Washington Ave, Ocean Springs, MS 39564. Tel: 228-872-3164; Fax: 228-875-4494; E-mail: wama@walterandersonmuseum.org; Web Site: www.walterandersonmuseum.org. *Exec Dir* Marilyn Lyons; *Cur Coll* Dr. Patricia Pinson; *Registrar* Dennis Walker; *Educ* Cindy Quay. **Exhibits**— "Friends" from the Ogden Museum in New Orleans, LA, Dec 2004-Jan 15, 2005.

WALTERS ART MUSEUM, 600 N Charles St, Baltimore, MD 21201. *Dir Exhibs* Nancy Zinn. **Exhibits**— Bedazzled: 5,000 Years of Jewelry (2006-2008); Barye (2007-2008); Realms of Faith (2008-2009); Road to Impression (2008-2009).

WASHBURN UNIVERSITY, 1700 S.W. College Ave, Topeka, KS 66621. Tel: 785-670-1125. *Dir & Chief Cur* Gordon Fuglie. **Exhibits**— vary. Rental and shipping fees vary.

WASHINGTON COUNTY MUSEUM OF FINE ARTS, PO Box 423, City Park, 91 Key St, Hagerstown, MD 21741. Tel: 301-739-5727; Fax: 301-745-3741. *Dir* Jean Woods; *Acting Cur* Amy Metzger; *Assoc Cur* Sandra Strong; *Admin Asst* Christine Shives. **Exhibits**— Prints of Salvador Dali: Watercolors by Edmund Darch Lewis; Paperweights from the Bryden Collection; Art of the 60s and 70s; The Photographs of Mathew Brady (Civil War); Korean Watercolors; WPA Collection. Rental fees $500-$1500 monthly, plus shipping charges.

WAYLAND BAPTIST UNIVERSITY, Dept of Art, 1900 W 7th, WBU #249, Plainview, TX 79072. Tel: 806-291-1083. *Prof/Cur Art* Candace Keller, PhD; *Asst. Prof, 3-D* Mark Hilliard. **Exhibits**— The Abraham Art Gallery has 3-4 art exhibitions per year. Rental fees up to $6,000. Shipping fees up to $1,800.

WESTERN RESERVE HISTORICAL SOCIETY, 10825 East Blvd, Cleveland, OH 44106. Tel: 216-721-5722; Fax: 216-721-8934. *Dir* Dana Thorpe; *Coordr* Susan Augustine. **Exhibits**— Ice Cream: The whole scoop; Animals Among us; A Century of Amusement Parks; Pirates; Swashbucklers, and Adventurers; Fiendish Fashions; Jefferson in Paris. Rental fees $ 35,000-$ 50,000. Shipping fees in bound cost vary.

WESTERN WASHINGTON UNIVERSITY, The VU Gallery 507, c/o Heidi Norgaard & Hana Kato, Western Washington University VU Room 422, MS I-4, Bellingham, WA 98225-9106. Tel: 360-650-6534 Ext 6534; E-mail: asp.vu@gallery@wwn.edu. *Coordr* Inna Peck; *Asst Coordr* Jamey Braden.

WHARTON ESHERICK MUSEUM, PO Box 595, Paoli, PA 19301. Tel: 610-644-5822. *Dir* Robert Leonard; *Cur* Mansfield Bascom; *Dir Prog* Paul Eisenhauer. **Exhibits**— Half a Century in Wood: 1920-1970—a photographic exhibition of furniture created by Wharton Esherick, including a catalogue. Rental fee $600. Shipping fees $50-$100. Contact Program Director.

WICHITA FALLS MUSEUM & ART CENTER, Two Eureka Cir, Wichita Falls, TX 76308. Tel: 940-692-0923; Fax: 940-696-5358; E-mail: contact@wfmac.org. *Cur Coll & Exhib* Danny Bills; *Interim Dir* Jeff Desborough. **Exhibits**— Art & Science; Children's Gallery; Discovery Center, Laser light show; Planetarium; Young at Art: The Caldecott Collection of Children's Book Illustrations. Rental fee $2,000. Shipping fee actual.

WILL ROGERS MEMORIAL MUSEUMS, 1720 W Will Rogers Blvd, PO Box 157, Claremore, OK 74018. Tel: 918-341-0719; Fax: 918-343-8119. *Dir* Michelle Lefebure-Carter. **Exhibits**— framed collection of 80 movie posters, original antiques of the 1920's-1930's each starring Will Rogers. Rental fee $10,000; Shipping fee $2,000.

WILLIAM A FARNSWORTH LIBRARY & ART MUSEUM, 16 Museum St, Rockland, ME 04841. Tel: 207-596-6457; Fax: 207-596-0509; E-mail: farnsworth@midcoast.com. *Dir* Chris Crossman; *Assoc Dir* Victoria Woodhull; *Exhibition Cur* Helen Fisher; *Registrar* Angela Waldron. **Exhibits**— Varies Rental and shipping fees vary.

WILLIAMS COLLEGE, Dept of Art, Lawrence Hall, 15 Lawrence Hall Dr, Williamstown, MA 01267. Tel: 413-597-2429; Fax: 413-458-9017; E-mail: wcma@williams.edu. **Exhibits**— Tony Oursler: Mid-Career Survey (co-curated by Deborah Rothschild & Linda Shearer); Graphic Design in the Mechanical Age: Selections from the Merrill C. Berman Collection (co-created by Deborah Rothschild & Darra Goldstein); Maurice Prendergast: The State of Estate (curated by Nancy Mowll Matthews). Rental fee $20,000.

WINTERTHUR, AN AMERICAN COUNTRY ESTATE, Winterthur, DE 19735. Tel: 800-448-3883; Fax: 302-888-4820; E-mail: webmaster@winterthur.org. *Dir Exhib* Felice Lamden.

WIREGRASS MUSEUM OF ART, PO Box 1624, Dothan, AL 36302. Tel: 334-794-3871; Fax: 334-615-2217; E-mail: wmuseum@snowhill.com; Web Site: www.wiregrassmuseum.org. *Dir* Sam W. Kates; *Cur* Karen McInnis. **Exhibits—** Contemporary Masterworks on Paper (prints by Frank Stella, Ellsworth Kelly, Jim Dine, Robert Motherwell & others); Russian Children's Paintings (25 framed works from Kiev). Rental fees negotiable; Shipping fees to & from borrower. WMA would be interested in loans in return for exhibits.

WOLFSONIAN FOUNDATION, The Wolfsonian-FIU, 1001 Washington Ave, Miami Beach, FL 33139. Tel :305-531-1001; Fax: 305-531-2133; E-mail: research@thewolf.fiu.edu. *Asst Dir, Exhib & Cur Affairs* Marianne Lamonaca; *Cur Asst* Lisa Li. **Exhibits—** Weapons of Mass Dissemination: The Propaganda of War; Tokyo: The Imperial Capital. Rental fees vary; Shipping fees vary.

WOMEN AND THEIR WORK, 1710 Lavaca St, Austin, TX 78701. Tel: 512-477-1064; Fax: 512-477-1090. *Exec Dir* Chris Cowden; *Program Dir* Katherine McQueen.

WOMEN IN THE ARTS FOUNDATION, INC, 1175 York Ave, No 2G, New York, NY 10021. *Pres* Roberta Crown. **Exhibits—** Work of the members with various themes. Rental fees are open; Shipping fees depend upon exhibit.

WOODSTOCK ARTISTS ASSOCIATION, 28 Tinker St, Woodstock, NY 12498. *Dir, Permanent Coll* Linda A. Freaney; *Gallery Mgr* Lisa Williams; *Asst Gallery Mgr* Prudence See.

Exhibits— No Traveling exhibitions currently. Exhibits in the galleries for 2003 include juried group shows by contemporary regional artists, solo exhibitions by contemporary area artists, & solo & group historic exhibitions from the permanent collection in the Towbin Wing.

WYOMING ARTS COUNCIL GALLERY, Department of Commerce, 2320 Capitol Ave, Cheyenne, WY 82002. *Vis Arts Prog Mgr* Liliane Francyz. **Exhibits—** One exhibit per year from The Council Gallery exhibit schedule. Four to five sites receive the exhibit each year, from libraries, art centers to college galleries. No rental or shipping fees.

YEISER ART CENTER, INC, 200 Broadway, Paducah, KY 42001-0732. *Dir* Dan Caruer. **Exhibits—** National Fibers Exhibit: Fantastic Fibers. Rental & Shipping fees vary.

YELLOWSTONE ART MUSEUM, 401 N 27th St, Billings, MT 59101. *Sr Cur* Robert Manchester. **Exhibits—** Deborah Butterfield; The Most Difficult Journey; The Poindexter Collection of American Modernist Paintings. Rental fees starting at $5,000. Shipping fees actual costs.

YESHIVA UNIVERSITY MUSEUM, 2520 Amsterdam Ave, New York, NY 10033. Tel: 212-960-5390; Fax: 212-294-8335. *Collections Cur* Bonnie-Dara Michaels. **Exhibits—** Jewish Traders of the Silk Route; Sir Moses' Coach: The Life and Times of Sir Moses Montefiore; Birobidjan: A Soviet Jewish Agricultural Community. Rental fees $200-$300; Shipping fees variable.

IV INDEXES

Subject

Personnel

Organizational

Subject Index

Major Subjects are listed first, followed by named collections.

AFRICAN ART

Academy of the New Church, Glencairn Museum, Bryn Athyn PA
African Art Museum of Maryland, Columbia MD
Albany Museum of Art, Albany GA
Albion College, Bobbitt Visual Arts Center, Albion MI
Anchorage Museum at Rasmuson Center, Anchorage AK
Art & Culture Center of Hollywood, Art Gallery, Hollywood FL
Arts Council of Fayetteville-Cumberland County, The Arts Center, Fayetteville NC
Atlanta International Museum of Art & Design, Atlanta GA
Augustana College, Augustana College Art Museum, Rock Island IL
Ball State University, Museum of Art, Muncie IN
The Baltimore Museum of Art, Baltimore MD
Barnes Foundation, Merion PA
Beck Cultural Exchange Center, Inc, Knoxville TN
Berea College, Doris Ulmann Galleries, Berea KY
Blanden Memorial Art Museum, Fort Dodge IA
Blauvelt Demarest Foundation, Hiram Blauvelt Art Museum, Oradell NJ
Bowers Museum of Cultural Art, Bowers Museum, Santa Ana CA
Brandeis University, Rose Art Museum, Waltham MA
Brown University, Haffenreffer Museum of Anthropology, Providence RI
The Buffalo Fine Arts Academy, Albright-Knox Art Gallery, Buffalo NY
C W Post Campus of Long Island University, Hillwood Art Museum, Brookville NY
California State University Stanislaus, University Art Gallery, Turlock CA
California State University, East Bay, C E Smith Museum of Anthropology, Hayward CA
California State University, Northridge, Art Galleries, Northridge CA
Center for Puppetry Arts, Atlanta GA
Cincinnati Museum Association and Art Academy of Cincinnati, Cincinnati Art Museum, Cincinnati OH
City of El Paso Museum and Cultural Affairs, People's Gallery, El Paso TX
City of Fayette, Alabama, Fayette Art Museum, Fayette AL
College of William & Mary, Muscarelle Museum of Art, Williamsburg VA
The College of Wooster, The College of Wooster Art Museum, Wooster OH
Columbus Museum, Columbus GA
Concordia Historical Institute, Saint Louis MO
Cornell Museum of Art & History, Delray Beach FL
Cornell University, Herbert F Johnson Museum of Art, Ithaca NY
Craft and Folk Art Museum (CAFAM), Los Angeles CA
The Currier Museum of Art, Currier Museum of Art, Manchester NH
Dallas Museum of Art, Dallas TX
Denison University, Art Gallery, Granville OH
Denver Art Museum, Denver CO
Detroit Institute of Arts, Detroit MI
Detroit Zoological Institute, Wildlife Interpretive Gallery, Royal Oak MI
Dickinson College, The Trout Gallery, Carlisle PA
Duke University, Duke University Museum of Art, Durham NC
East Carolina University, Wellington B Gray Gallery, Greenville NC

East Los Angeles College, Vincent Price Gallery, Monterey Park CA
Edmundson Art Foundation, Inc, Des Moines Art Center, Des Moines IA
Emory University, Michael C Carlos Museum, Atlanta GA
Evansville Museum of Arts, History & Science, Evansville IN
Everhart Museum, Scranton PA
Everson Museum of Art, Syracuse NY
Fairbanks Museum & Planetarium, Saint Johnsbury VT
Fine Arts Museums of San Francisco, Legion of Honor, San Francisco CA
Fisk University, Fisk University Galleries, Nashville TN
Fitton Center for Creative Arts, Hamilton OH
Flint Institute of Arts, Flint MI
Florence Museum of Art, Science & History, Florence SC
Florida State University and Central Florida Community College, The Appleton Museum of Art, Ocala FL
Freeport Arts Center, Freeport IL
Fuller Museum of Art, Brockton MA
General Board of Discipleship, The United Methodist Church, The Upper Room Chapel & Museum, Nashville TN
Grand Rapids Art Museum, Grand Rapids MI
Grinnell College, Art Gallery, Grinnell IA
Guilford College, Art Gallery, Greensboro NC
Hampton University, University Museum, Hampton VA
Heard Museum, Phoenix AZ
Higgins Armory Museum, Worcester MA
Historisches und Volkerkundemuseum, Historical Museum, Sankt Gallen
Hofstra University, Hofstra Museum, Hempstead NY
Honolulu Academy of Arts, Honolulu HI
Howard University, Gallery of Art, Washington DC
William Humphreys, Kimberley
The Interchurch Center, Galleries at the Interchurch Center, New York NY
Jacksonville University, Alexander Brest Museum & Gallery, Jacksonville FL
Joslyn Art Museum, Omaha NE
Kalamazoo Institute of Arts, Kalamazoo MI
Kansas City Art Institute, Kansas City MO
Keene State College, Thorne-Sagendorph Art Gallery, Keene NH
Kelowna Museum, Kelowna BC
Kimbell Art Museum, Fort Worth TX
Lafayette Natural History Museum & Planetarium, Lafayette LA
Las Vegas Natural History Museum, Las Vegas NV
Lehigh University Art Galleries, Museum Operation, Bethlehem PA
Lehman College Art Gallery, Bronx NY
Macalester College, Macalester College Art Gallery, Saint Paul MN
Maine College of Art, The Institute of Contemporary Art, Portland ME
Marietta College, Grover M Hermann Fine Arts Center, Marietta OH
Marquette University, Haggerty Museum of Art, Milwaukee WI
McPherson Museum, McPherson KS
Menil Foundation, Inc, Houston TX
Meredith College, Frankie G Weems Gallery & Rotunda Gallery, Raleigh NC
Miami-Dade College, Kendal Campus, Art Gallery, Miami FL

Michigan State University, Kresge Art Museum, East Lansing MI
Mingei International, Inc, Mingei International Museum, San Diego CA
Minneapolis Institute of Arts, Minneapolis MN
Mint Museum of Art, Charlotte NC
Missoula Art Museum, Missoula MT
Mobile Museum of Art, Mobile AL
Modern Art Museum, Fort Worth TX
Montreal Museum of Fine Arts, Montreal PQ
Morris Museum, Morristown NJ
The Museum, Greenwood SC
Museum for African Art, Long Island City NY
Museum of African American Art, Los Angeles CA
Museum of Contemporary Art, North Miami FL
Museum of Fine Arts, Saint Petersburg, Florida, Inc, Saint Petersburg FL
Museum of York County, Rock Hill SC
National Conference of Artists, Michigan Chapter Gallery, Detroit MI
National Museum, Monuments and Art Gallery, Gaborone
Nelson-Atkins Museum of Art, Kansas City MO
New Brunswick Museum, Saint John NB
New Orleans Museum of Art, New Orleans LA
New Visions Gallery, Inc, Marshfield WI
New World Art Center, T F Chen Cultural Center, New York NY
Nihon Mingeikan, Japan Folk Crafts Museum, Tokyo
North Carolina Central University, NCCU Art Museum, Durham NC
North Carolina Museum of Art, Raleigh NC
North Country Museum of Arts, Park Rapids MN
Oakland University, Oakland University Art Gallery, Rochester MI
Ohio University, Kennedy Museum of Art, Athens OH
Omniplex, Oklahoma City OK
Orlando Museum of Art, Orlando FL
Owensboro Museum of Fine Art, Owensboro KY
Page-Walker Arts & History Center, Cary NC
Palm Springs Art Museum, Palm Springs CA
Peabody Essex Museum, Salem MA
The Pennsylvania State University, Palmer Museum of Art, University Park PA
Pensacola Museum of Art, Pensacola FL
Philbrook Museum of Art, Tulsa OK
Piedmont Arts Association, Martinsville VA
Porter Thermometer Museum, Onset MA
Portland Art Museum, Portland OR
Princeton University, Princeton University Art Museum, Princeton NJ
Queens College, City University of New York, Godwin-Ternbach Museum, Flushing NY
Royal Ontario Museum, Toronto ON
Saint Joseph's Oratory, Museum, Montreal PQ
Saint Mary's College of California, Hearst Art Gallery, Moraga CA
Salisbury House Foundation, Des Moines IA
Santa Barbara Museum of Art, Santa Barbara CA
Santa Clara University, de Saisset Museum, Santa Clara CA
Schenectady Museum Planetarium & Visitors Center, Schenectady NY
Scripps College, Ruth Chandler Williamson Gallery, Claremont CA
The Slater Memorial Museum, Slater Memorial Museum, Norwich CT
Smithsonian Institution, National Museum of African Art, Washington DC
Smithsonian Institution, Washington DC

AFRO-AMERICAN ART

AMERICAN INDIAN ART

Academy of the New Church, Glencairn Museum, Bryn Athyn PA

Adams County Historical Society, Gettysburg PA

Alabama Department of Archives & History, Museum Galleries, Montgomery AL

Alaska Department of Education, Division of Libraries, Archives & Museums, Sheldon Jackson Museum, Sitka AK

Albuquerque Museum of Art & History, Albuquerque NM

Anchorage Museum at Rasmuson Center, Anchorage AK

Appaloosa Museum and Heritage Center, Moscow ID

Archaeological Society of Ohio, Indian Museum of Lake County, Ohio, Willoughby OH

Art Museum of Greater Lafayette, Lafayette IN

Art Without Walls Inc, Art Without Walls Inc, Sayville NY

Arts Council of Fayetteville-Cumberland County, The Arts Center, Fayetteville NC

ArtSpace-Lima, Lima OH

Asheville Art Museum, Asheville NC

Ataloa Lodge Museum, Muskogee OK

Atlanta International Museum of Art & Design, Atlanta GA

Aurora University, Schingoethe Center for Native American Cultures, Aurora IL

Ball State University, Museum of Art, Muncie IN

The Baltimore Museum of Art, Baltimore MD

Bay County Historical Society, Historical Museum of Bay County, Bay City MI

Bent Museum & Gallery, Taos NM

Berea College, Doris Ulmann Galleries, Berea KY

Berkshire Museum, Pittsfield MA

Berman Museum, Anniston AL

Jesse Besser, Alpena MI

Bowers Museum of Cultural Art, Bowers Museum, Santa Ana CA

Brandeis University, Rose Art Museum, Waltham MA

L D Brinkman, Kerrville TX

Brown University, Haffenreffer Museum of Anthropology, Providence RI

Bruce Museum, Inc, Bruce Museum, Greenwich CT

Butler Institute of American Art, Art Museum, Youngstown OH

C W Post Campus of Long Island University, Hillwood Art Museum, Brookville NY

Cabot's Old Indian Pueblo Museum, Cabot's Old Indian Pueblo Museum, Desert Hot Springs CA

California Department of Parks & Recreation, California State Indian Museum, Sacramento CA

California State University, Northridge, Art Galleries, Northridge CA

Carson County Square House Museum, Panhandle TX

Cayuga Museum of History & Art, Auburn NY

Central United Methodist Church, Swords Into Plowshares Peace Center & Gallery, Detroit MI

Chattahoochee Valley Art Museum, LaGrange GA

Chelan County Public Utility District, Rocky Reach Dam, Wenatchee WA

Chief Plenty Coups Museum State Park, Pryor MT

Church of Jesus Christ of Latter-Day Saints, Museum of Church History & Art, Salt Lake City UT

Cincinnati Museum Association and Art Academy of Cincinnati, Cincinnati Art Museum, Cincinnati OH

City of El Paso, El Paso Museum of Archaeology, El Paso TX

City of El Paso Museum and Cultural Affairs, People's Gallery, El Paso TX

City of Grand Rapids Michigan, Public Museum of Grand Rapids, Grand Rapids MI

City of Ukiah, Grace Hudson Museum & The Sun House, Ukiah CA

Clark County Historical Society, Pioneer - Krier Museum, Ashland KS

College of William & Mary, Muscarelle Museum of Art, Williamsburg VA

The College of Wooster, The College of Wooster Art Museum, Wooster OH

Colorado Historical Society, Colorado History Museum, Denver CO

Colorado Springs Fine Arts Center, Colorado Springs CO

Columbus Museum, Columbus GA

Cornell College, Peter Paul Luce Gallery, Mount Vernon IA

Cornell Museum of Art & History, Delray Beach FL

Coutts Memorial Museum of Art, Inc, El Dorado KS

Craftsmen's Guild of Mississippi, Inc, Agriculture & Forestry Museum, Jackson MS

Craftsmen's Guild of Mississippi, Inc, Mississippi Crafts Center, Ridgeland MS

The Currier Museum of Art, Currier Museum of Art, Manchester NH

Dacotah Prairie Museum, Lamont Art Gallery, Aberdeen SD

Dallas Museum of Art, Dallas TX

Deming-Luna Mimbres Museum, Deming NM

Denison University, Art Gallery, Granville OH

Denver Art Museum, Denver CO

Detroit Institute of Arts, Detroit MI

DeWitt Historical Society of Tompkins County, The History Center in Tompkins Co, Ithaca NY

Dickinson College, The Trout Gallery, Carlisle PA

Dixie State College, Robert N & Peggy Sears Gallery, Saint George UT

Downey Museum of Art, Downey CA

East Carolina University, Wellington B Gray Gallery, Greenville NC

East Los Angeles College, Vincent Price Gallery, Monterey Park CA

Eastern Washington State Historical Society, Northwest Museum of Arts & Culture, Spokane WA

Eiteljorg Museum of American Indians & Western Art, Indianapolis IN

Enook Galleries, Waterloo ON

Erie Art Museum, Erie PA

Erie County Historical Society, Erie PA

Evanston Historical Society, Charles Gates Dawes House, Evanston IL

Evergreen State College, Evergreen Galleries, Olympia WA

Everhart Museum, Scranton PA

Fairbanks Museum & Planetarium, Saint Johnsbury VT

Favell Museum of Western Art & Indian Artifacts, Klamath Falls OR

Fine Arts Museums of San Francisco, Legion of Honor, San Francisco CA

Five Civilized Tribes Museum, Muskogee OK

Florence Museum of Art, Science & History, Florence SC

Freeport Arts Center, Freeport IL

Frontier Times Museum, Bandera TX

Fruitlands Museum, Inc, Harvard MA

General Board of Discipleship, The United Methodist Church, The Upper Room Chapel & Museum, Nashville TN

Thomas Gilcrease, Gilcrease Museum, Tulsa OK

Goshen Historical Society, Goshen CT

Grand Rapids Art Museum, Grand Rapids MI

Hamilton College, Emerson Gallery, Clinton NY

Hampton University, University Museum, Hampton VA

Hartwick College, The Yager Museum, Oneonta NY

Heard Museum, Phoenix AZ

Heritage Center, Inc, Pine Ridge SD

Heritage Museum Association, Inc, The Heritage Museum of Northwest Florida, Valparaiso FL

Heritage Museums & Gardens, Sandwich MA

Herrett Center for Arts & Sciences, Jean B King Art Gallery, Twin Falls ID

Hershey Museum, Hershey PA

Hidalgo County Historical Museum, Edinburg TX

High Desert Museum, Bend OR

Historic Arkansas Museum, Little Rock AR

Historisches und Volkerkundemuseum, Historical Museum, Sankt Gallen

Holter Museum of Art, Helena MT

Honolulu Academy of Arts, Honolulu HI

Huronia Museum, Gallery of Historic Huronia, Midland ON

Imperial Calcasieu Museum, Gibson-Barham Gallery, Lake Charles LA

Indian Arts & Crafts Board, US Dept of the Interior, Sioux Indian Museum, Rapid City SD

Indian Pueblo Cultural Center, Albuquerque NM

Institute of American Indian Arts Museum, Museum, Santa Fe NM

Intar Latin American Gallery, New York NY

The Interchurch Center, Galleries at the Interchurch Center, New York NY

Iowa State University, Brunnier Art Museum, Ames IA

Iroquois Indian Museum, Howes Cave NY

Jefferson County Open Space, Hiwan Homestead Museum, Evergreen CO

Johnson-Humrickhouse Museum, Coshocton OH

Joslyn Art Museum, Omaha NE

Juniata College Museum of Art, Huntingdon PA

Kansas City Art Institute, Kansas City MO

Kateri Tekakwitha Shrine, Kahnawake PQ

Kelly-Griggs House Museum, Red Bluff CA

Kelowna Museum, Kelowna BC

Klein Museum, Mobridge SD

Knoxville Museum of Art, Knoxville TN

Koshare Indian Museum, Inc, La Junta CO

Lac du Flambeau Band of Lake Superior Chippewa Indians, George W Brown Jr Ojibwe Museum & Cultural Center, Lac du Flambeau WI

Leanin' Tree Museum of Western Art, Boulder CO

Leelanau Historical Museum, Leland MI

Lightner Museum, Saint Augustine FL

Lincoln County Historical Association, Inc, 1811 Old Lincoln County Jail & Lincoln County Museum, Wiscasset ME

Loveland Museum Gallery, Loveland CO

Marquette University, Haggerty Museum of Art, Milwaukee WI

Maryhill Museum of Art, Goldendale WA

Maslak-McLeod Gallery, Toronto ON

McMaster University, McMaster Museum of Art, Hamilton ON

Mennello Museum of American Art, Orlando FL

Meredith College, Frankie G Weems Gallery & Rotunda Gallery, Raleigh NC

Metropolitan State College of Denver, Center for Visual Art, Denver CO

Mid-America All-Indian Center, Indian Center Museum, Wichita KS

Middle Border Museum & Oscar Howe Art Center, Mitchell SD

Mingei International, Inc, Mingei International Museum, San Diego CA

Minneapolis Institute of Arts, Minneapolis MN

Mint Museum of Art, Charlotte NC

Mission San Luis Rey de Francia, Mission San Luis Rey Museum, Oceanside CA

Mission San Miguel Museum, San Miguel CA

Mississippi Department of Archives & History, Old Capitol Museum of Mississippi History, Jackson MS

Mississippi River Museum at Mud-Island River Park, Memphis TN

Missoula Art Museum, Missoula MT

Missouri Historical Society, Missouri History Museum, Saint Louis MO

Arthur Roy Mitchell, Museum of Western Art, Trinidad CO

Mohave Museum of History & Arts, Kingman AZ

Montclair Art Museum, Montclair NJ

Moose Jaw Art Museum, Inc, Art & History Museum, Moose Jaw SK

Morris Museum, Morristown NJ

Musee d'Art de Saint-Laurent, Saint-Laurent PQ

Museum of Fine Arts, Houston, Houston TX

Museum of Fine Arts, Saint Petersburg, Florida, Inc, Saint Petersburg FL

Museum of New Mexico, Museum of Fine Arts, Unit of NM Dept of Cultural Affairs, Santa Fe NM

Museum of Northern Arizona, Flagstaff AZ

Museum of the Plains Indian & Crafts Center, Browning MT

National Cowboy & Western Heritage Museum, Oklahoma City OK

National Hall of Fame for Famous American Indians, Anadarko OK

National Museum of the American Indian, George Gustav Heye Center, New York NY

National Museum of Wildlife Art, Jackson WY

National Museum of Women in the Arts, Washington DC

National Park Service, Hubbell Trading Post National Historic Site, Ganado AZ

Navajo Nation, Navajo Nation Museum, Window Rock AZ

Nelson-Atkins Museum of Art, Kansas City MO

Nevada Museum of Art, Reno NV

New Brunswick Museum, Saint John NB

New Orleans Museum of Art, New Orleans LA

New Visions Gallery, Inc, Marshfield WI

New World Art Center, T F Chen Cultural Center, New York NY

New York State Historical Association, Fenimore Art Museum, Cooperstown NY

No Man's Land Historical Society Museum, Goodwell OK

Northern Illinois University, NIU Art Museum, De Kalb IL

Ohio Historical Society, National Road-Zane Grey Museum, Columbus OH

The Ohio Historical Society, Inc, Campus Martius Museum & Ohio River Museum, Marietta OH

AMERICAN WESTERN ART

National Park Service, Hubbell Trading Post National Historic Site, Ganado AZ

Natural History Museum of Los Angeles County, Los Angeles CA

Nelson-Atkins Museum of Art, Kansas City MO

Nemours Mansion & Gardens, Wilmington DE

Nevada Museum of Art, Reno NV

New World Art Center, T F Chen Cultural Center, New York NY

Elisabet Ney, Austin TX

No Man's Land Historical Society Museum, Goodwell OK

Ohio Historical Society, National Road-Zane Grey Museum, Columbus OH

Old West Museum, Sunset TX

Opelousas Museum of Art, Inc (OMA), Opelousas LA

Orlando Museum of Art, Orlando FL

Page-Walker Arts & History Center, Cary NC

Palm Springs Art Museum, Palm Springs CA

Panhandle-Plains Historical Society Museum, Canyon TX

The Frank Phillips, Woolaroc Museum, Bartlesville OK

George Phippen, Phippen Art Museum, Prescott AZ

Piedmont Arts Association, Martinsville VA

Pioneer Town, Pioneer Museum of Western Art, Wimberley TX

Porter Thermometer Museum, Onset MA

Princeton University, Princeton University Art Museum, Princeton NJ

R W Norton Art Foundation, Shreveport LA

Red Rock State Park, Red Rock Museum, Church Rock NM

Frederic Remington, Ogdensburg NY

Sid W Richardson, Sid Richardson Museum, Fort Worth TX

The Rockwell Museum of Western Art, Corning NY

Millicent Rogers, Taos NM

Ross Memorial Museum, Saint Andrews NB

C M Russell, Great Falls MT

Saginaw Art Museum, Saginaw MI

San Bernardino County Museum, Fine Arts Institute, Redlands CA

Smithsonian Institution, Freer Gallery of Art, Washington DC

Sonoma State University, University Art Gallery, Rohnert Park CA

South Dakota State University, South Dakota Art Museum, Brookings SD

Southwest Museum, Los Angeles CA

Springfield Art Museum, Springfield MO

Nelda C & H J Lutcher Stark, Stark Museum of Art, Orange TX

Swope Art Museum, Terre Haute IN

Taos, Ernest Blumenschein Home & Studio, Taos NM

Texas Tech University, Museum of Texas Tech University, Lubbock TX

Topeka & Shawnee County Public Library, Alice C Sabatini Gallery, Topeka KS

Tubac Center of the Arts, Tubac AZ

Turtle Bay Exploration Park, Redding CA

United States Military Academy, West Point Museum, West Point NY

University of British Columbia, Museum of Anthropology, Vancouver BC

University of California, Berkeley, Phoebe Apperson Hearst Museum of Anthropology, Berkeley CA

University of Colorado at Colorado Springs, Gallery of Contemporary Art, Colorado Springs CO

University of Illinois, Krannert Art Museum and Kinkead Pavillion, Champaign IL

University of Michigan, Museum of Art, Ann Arbor MI

University of New Mexico, The Harwood Museum of Art, Taos NM

University of Rhode Island, Fine Arts Center Galleries, Kingston RI

University of Victoria, Maltwood Art Museum and Gallery, Victoria BC

USS Constitution Museum, Boston MA

Utah State University, Nora Eccles Harrison Museum of Art, Logan UT

Washington University, Mildred Lane Kemper Art Museum, Saint Louis MO

Wisconsin Historical Society, State Historical Museum, Madison WI

Wyoming State Museum, Cheyenne WY

ANTHROPOLOGY

Alaska Department of Education, Division of Libraries, Archives & Museums, Sheldon Jackson Museum, Sitka AK

Anchorage Museum at Rasmuson Center, Anchorage AK

Art Without Walls Inc, Art Without Walls Inc, Sayville NY

ArtSpace-Lima, Lima OH

Bay County Historical Society, Historical Museum of Bay County, Bay City MI

Beloit College, Wright Museum of Art, Beloit WI

Berkshire Museum, Pittsfield MA

Brown University, Haffenreffer Museum of Anthropology, Providence RI

Buena Vista Museum of Natural History, Bakersfield CA

California Department of Parks & Recreation, California State Indian Museum, Sacramento CA

California State University, East Bay, C E Smith Museum of Anthropology, Hayward CA

Canadian Museum of Civilization, Gatineau PQ

Carson County Square House Museum, Panhandle TX

Chelan County Public Utility District, Rocky Reach Dam, Wenatchee WA

City of Grand Rapids Michigan, Public Museum of Grand Rapids, Grand Rapids MI

City of Providence Parks Department, Roger Williams Park Museum of Natural History, Providence RI

City of Ukiah, Grace Hudson Museum & The Sun House, Ukiah CA

Colorado Historical Society, Colorado History Museum, Denver CO

Colorado Springs Fine Arts Center, Colorado Springs CO

Deer Valley Rock Art Center, Glendale AZ

Delaware Archaeology Museum, Dover DE

Deming-Luna Mimbres Museum, Deming NM

Detroit Institute of Arts, Detroit MI

DeWitt Historical Society of Tompkins County, The History Center in Tompkins Co, Ithaca NY

East Carolina University, Wellington B Gray Gallery, Greenville NC

Evansville Museum of Arts, History & Science, Evansville IN

Fort Morgan Heritage Foundation, Fort Morgan CO

Frontier Times Museum, Bandera TX

Thomas Gilcrease, Gilcrease Museum, Tulsa OK

Hampton University, University Museum, Hampton VA

Hartwick College, The Yager Museum, Oneonta NY

Heritage Hjemkomst Interpretive Center, Moorhead MN

Heritage Museum Association, Inc, The Heritage Museum of Northwest Florida, Valparaiso FL

Herrett Center for Arts & Sciences, Jean B King Art Gallery, Twin Falls ID

Hidalgo County Historical Museum, Edinburg TX

High Desert Museum, Bend OR

Indiana State Museum, Indianapolis IN

Institute of Puerto Rican Culture, Museo Fuerte Conde de Mirasol, Vieques PR

Iredell Museum of Arts & Heritage, Statesville NC

Iroquois Indian Museum, Howes Cave NY

Lafayette Natural History Museum & Planetarium, Lafayette LA

Lehigh County Historical Society, Allentown PA

Loveland Museum Gallery, Loveland CO

Jacques Marchais, Staten Island NY

The Mariners' Museum, Newport News VA

Maryhill Museum of Art, Goldendale WA

Maslak-McLeod Gallery, Toronto ON

McAllen International Museum, McAllen TX

Milwaukee Public Museum, Milwaukee WI

Mississippi Department of Archives & History, Old Capitol Museum of Mississippi History, Jackson MS

Mississippi River Museum at Mud-Island River Park, Memphis TN

Missouri Department of Natural Resources, Missouri State Museum, Jefferson City MO

Missouri Historical Society, Missouri History Museum, Saint Louis MO

Mohave Museum of History & Arts, Kingman AZ

Morris Museum, Morristown NJ

Museo De Las Americas, Denver CO

The Museum, Greenwood SC

Museum of Northern Arizona, Flagstaff AZ

Museum of the City of New York, New York NY

Museum of York County, Rock Hill SC

National Museum of the American Indian, George Gustav Heye Center, New York NY

National Museum of Wildlife Art, Jackson WY

National Museum, Monuments and Art Gallery, Gaborone

National Park Service, Hubbell Trading Post National Historic Site, Ganado AZ

Natural History Museum of Los Angeles County, Los Angeles CA

Navajo Nation, Navajo Nation Museum, Window Rock AZ

New Jersey State Museum, Fine Art Bureau, Trenton NJ

No Man's Land Historical Society Museum, Goodwell OK

Northern Maine Museum of Science, Presque Isle ME

Palm Beach County Parks & Recreation Department, Morikami Museum & Japanese Gardens, Delray Beach FL

Palm Springs Art Museum, Palm Springs CA

Panhandle-Plains Historical Society Museum, Canyon TX

Pennsylvania Historical & Museum Commission, The State Museum of Pennsylvania, Harrisburg PA

The Frank Phillips, Woolaroc Museum, Bartlesville OK

Plumas County Museum, Quincy CA

Port Huron Museum, Port Huron MI

Red Rock State Park, Red Rock Museum, Church Rock NM

Riverside Municipal Museum, Riverside CA

Roberts County Museum, Miami TX

Rollins College, George D & Harriet W Cornell Fine Arts Museum, Winter Park FL

Royal Ontario Museum, Toronto ON

C M Russell, Great Falls MT

Saint Joseph Museum, Saint Joseph MO

Santa Monica Museum of Art, Santa Monica CA

Shirley Plantation, Charles City VA

Abigail Adams Smith, New York NY

Smithsonian Institution, Arthur M Sackler Gallery, Washington DC

Southern Illinois University Carbondale, University Museum, Carbondale IL

Texas Tech University, Museum of Texas Tech University, Lubbock TX

United Society of Shakers, Shaker Museum, New Glocester ME

University of British Columbia, Museum of Anthropology, Vancouver BC

University of California, Berkeley, Phoebe Apperson Hearst Museum of Anthropology, Berkeley CA

University of Memphis, Art Museum, Memphis TN

University of Mississippi, University Museum, Oxford MS

University of Pennsylvania, Museum of Archaeology & Anthropology, Philadelphia PA

University of Tennessee, Frank H McClung Museum, Knoxville TN

The University of Texas at San Antonio, UTSA's Institute of Texan Cultures, San Antonio TX

University of Victoria, Maltwood Art Museum and Gallery, Victoria BC

Vancouver Museum, Vancouver BC

Wake Forest University, Museum of Anthropology, Winston-Salem NC

Wayne County Historical Society, Honesdale PA

Whalers Village Museum, Lahaina HI

Wheelwright Museum of the American Indian, Santa Fe NM

Wisconsin Historical Society, State Historical Museum, Madison WI

Witte Museum, San Antonio TX

Xavier University, Art Gallery, Cincinnati OH

ANTIQUITIES-ASSYRIAN

Academy of the New Church, Glencairn Museum, Bryn Athyn PA

BJU Museum & Gallery, Bob Jones University Museum & Gallery Inc, Greenville SC

Cincinnati Museum Association and Art Academy of Cincinnati, Cincinnati Art Museum, Cincinnati OH

Dallas Museum of Art, Dallas TX

Detroit Institute of Arts, Detroit MI

Fine Arts Museums of San Francisco, Legion of Honor, San Francisco CA

Hermitage Foundation Museum, Norfolk VA

Huntington Museum of Art, Huntington WV

Kimbell Art Museum, Fort Worth TX

Menil Foundation, Inc, Houston TX

ANTIQUITIES-BYZANTINE

ANTIQUITIES-EGYPTIAN

ANTIQUITIES-ETRUSCAN

ANTIQUITIES-GREEK

Academy of the New Church, Glencairn Museum, Bryn Athyn PA
Albany Museum of Art, Albany GA
Art & Culture Center of Hollywood, Art Gallery, Hollywood FL
Art Without Walls Inc, Art Without Walls Inc, Sayville NY
Athens Byzantine & Christian Museum, Athens
Atlanta International Museum of Art & Design, Atlanta GA
Ball State University, Museum of Art, Muncie IN
Beloit College, Wright Museum of Art, Beloit WI
Berea College, Doris Ulmann Galleries, Berea KY
Berkshire Museum, Pittsfield MA
BJU Museum & Gallery, Bob Jones University Museum & Gallery Inc, Greenville SC
The Buffalo Fine Arts Academy, Albright-Knox Art Gallery, Buffalo NY
C W Post Campus of Long Island University, Hillwood Art Museum, Brookville NY
Carleton College, Art Gallery, Northfield MN
Chrysler Museum of Art, Norfolk VA
Cincinnati Museum Association and Art Academy of Cincinnati, Cincinnati Art Museum, Cincinnati OH
Cleveland Museum of Art, Cleveland OH
The College of Wooster, The College of Wooster Art Museum, Wooster OH
Dallas Museum of Art, Dallas TX
Detroit Institute of Arts, Detroit MI
Emory University, Michael C Carlos Museum, Atlanta GA
Fine Arts Museums of San Francisco, Legion of Honor, San Francisco CA
Florida State University and Central Florida Community College, The Appleton Museum of Art, Ocala FL
Forest Lawn Museum, Glendale CA
Freeport Arts Center, Freeport IL
Isabella Stewart Gardner, Boston MA
Hamilton College, Emerson Gallery, Clinton NY
Harvard University, Semitic Museum, Cambridge MA
Henry County Museum & Cultural Arts Center, Clinton MO
Hispanic Society of America, Museum & Library, New York NY
James Madison University, Sawhill Gallery, Harrisonburg VA
Kelowna Museum, Kelowna BC
Kimbell Art Museum, Fort Worth TX
Luther College, Fine Arts Collection, Decorah IA
Maryhill Museum of Art, Goldendale WA
Menil Foundation, Inc, Houston TX
The Metropolitan Museum of Art, New York NY
Michigan State University, Kresge Art Museum, East Lansing MI
Middlebury College, Museum of Art, Middlebury VT
Milwaukee Art Museum, Milwaukee WI
Ministry of Culture, The Delphi Museum, I Ephorate of Prehistoric & Classical Antiquities, Delphi
Minneapolis Institute of Arts, Minneapolis MN
Montreal Museum of Fine Arts, Montreal PQ
Mount Holyoke College, Art Museum, South Hadley MA
Musei Capitolini, Rome
The Museum, Greenwood SC
Museum of Fine Arts, Boston MA
Museum of Fine Arts, Houston, Houston TX
Muzeum Narodowe, National Museum, Poznan
New Brunswick Museum, Saint John NB
North Carolina Museum of Art, Raleigh NC
Portland Art Museum, Portland OR
Princeton University, Princeton University Art Museum, Princeton NJ
Putnam Museum of History and Natural Science, Davenport IA
Queen's University, Agnes Etherington Art Centre, Kingston ON
Queens College, City University of New York, Godwin-Ternbach Museum, Flushing NY
Saint Bonaventure University, Regina A Quick Center for the Arts, Saint Bonaventure NY
Saint Gregory's Abbey & University, Mabee-Gerrer Museum of Art, Shawnee OK
San Antonio Museum of Art, San Antonio TX
Santa Barbara Museum of Art, Santa Barbara CA
Seattle Art Museum, Seattle WA
The Slater Memorial Museum, Slater Memorial Museum, Norwich CT
Stanford University, Iris & B Gerald Cantor Center for Visual Arts, Stanford CA
Staten Island Institute of Arts & Sciences, Staten Island NY
Tampa Museum of Art, Tampa FL
Tufts University, Tufts University Art Gallery, Medford MA
University of British Columbia, Museum of Anthropology, Vancouver BC
University of Chicago, Smart Museum of Art, Chicago IL
University of Cincinnati, DAAP Galleries-College of Design Architecture, Art & Planning, Cincinnati OH
University of Delaware, University Gallery, Newark DE
University of Illinois, Krannert Art Museum and Kinkead Pavillion, Champaign IL
University of Illinois, Spurlock Museum, Champaign IL
University of Manitoba, Faculty of Architecture Exhibition Centre, Winnipeg MB
University of Michigan, Kelsey Museum of Archaeology, Ann Arbor MI
University of Mississippi, University Museum, Oxford MS
University of Missouri, Museum of Art & Archaeology, Columbia MO
University of North Carolina at Chapel Hill, Ackland Art Museum, Chapel Hill NC
University of Toronto, University of Toronto Art Centre, Toronto ON
University of Utah, Utah Museum of Fine Arts, Salt Lake City UT
University of Wisconsin-Madison, Chazen Museum of Art, Madison WI
Vancouver Museum, Vancouver BC
Vassar College, The Frances Lehman Loeb Art Center, Poughkeepsie NY
Virginia Museum of Fine Arts, Richmond VA
Walters Art Museum, Baltimore MD
Washington University, Mildred Lane Kemper Art Museum, Saint Louis MO
Wellesley College, Davis Museum & Cultural Center, Wellesley MA
Wheaton College, Watson Gallery, Norton MA

ANTIQUITIES-ORIENTAL

Academy of the New Church, Glencairn Museum, Bryn Athyn PA
Arnot Art Museum, Elmira NY
Art & Culture Center of Hollywood, Art Gallery, Hollywood FL
Art Without Walls Inc, Art Without Walls Inc, Sayville NY
Asian Art Museum of San Francisco, Chong-Moon Lee Ctr for Asian Art and Culture, San Francisco CA
Ball State University, Museum of Art, Muncie IN
Barnes Foundation, Merion PA
Bass Museum of Art, Miami Beach FL
Beloit College, Wright Museum of Art, Beloit WI
Berman Museum, Anniston AL
The Buffalo Fine Arts Academy, Albright-Knox Art Gallery, Buffalo NY
Billie Trimble Chandler, Asian Cultures Museum & Educational Center, Corpus Christi TX
Cincinnati Museum Association and Art Academy of Cincinnati, Cincinnati Art Museum, Cincinnati OH
The College of Wooster, The College of Wooster Art Museum, Wooster OH
Dallas Museum of Art, Dallas TX
Denver Art Museum, Denver CO
Detroit Institute of Arts, Detroit MI
Erie Art Museum, Erie PA
Hancock County Trustees of Public Reservations, Woodlawn Museum, Ellsworth ME
Henry County Museum & Cultural Arts Center, Clinton MO
Hermitage Foundation Museum, Norfolk VA
Kelly-Griggs House Museum, Red Bluff CA
Lehigh University Art Galleries, Museum Operation, Bethlehem PA
McPherson Museum, McPherson KS
Menil Foundation, Inc, Houston TX
Michigan State University, Kresge Art Museum, East Lansing MI
Middlebury College, Museum of Art, Middlebury VT
Mint Museum of Art, Charlotte NC
Montreal Museum of Fine Arts, Montreal PQ
Musee Guimet, Paris

The Museum, Greenwood SC
New World Art Center, T F Chen Cultural Center, New York NY
The Old Jail Art Center, Albany TX
Panhandle-Plains Historical Society Museum, Canyon TX
Portland Art Museum, Portland OR
Princeton University, Princeton University Art Museum, Princeton NJ
Putnam Museum of History and Natural Science, Davenport IA
Queens College, City University of New York, Godwin-Ternbach Museum, Flushing NY
Rosicrucian Egyptian Museum & Planetarium, Rosicrucian Order, A.M.O.R.C., San Jose CA
Royal Arts Foundation, Belcourt Castle, Newport RI
Saginaw Art Museum, Saginaw MI
Salisbury House Foundation, Des Moines IA
San Antonio Museum of Art, San Antonio TX
Shirley Plantation, Charles City VA
The Slater Memorial Museum, Slater Memorial Museum, Norwich CT
Smithsonian Institution, Arthur M Sackler Gallery, Washington DC
Staten Island Institute of Arts & Sciences, Staten Island NY
Towson University Center for the Arts Gallery, Asian Arts & Culture Center, Towson MD
Turk ve Islam Eserleri Muzesi, Museum of Turkish and Islamic Art, Istanbul
University of British Columbia, Museum of Anthropology, Vancouver BC
University of Illinois, Krannert Art Museum and Kinkead Pavillion, Champaign IL
University of North Carolina at Chapel Hill, Ackland Art Museum, Chapel Hill NC
University of Toronto, University of Toronto Art Centre, Toronto ON
Vancouver Museum, Vancouver BC
Vizcaya Museum & Gardens, Miami FL
Walters Art Museum, Baltimore MD
Woodmere Art Museum, Philadelphia PA
Worcester Art Museum, Worcester MA

ANTIQUITIES-PERSIAN

Art & Culture Center of Hollywood, Art Gallery, Hollywood FL
Asian Art Museum of San Francisco, Chong-Moon Lee Ctr for Asian Art and Culture, San Francisco CA
BJU Museum & Gallery, Bob Jones University Museum & Gallery Inc, Greenville SC
The Buffalo Fine Arts Academy, Albright-Knox Art Gallery, Buffalo NY
C W Post Campus of Long Island University, Hillwood Art Museum, Brookville NY
Cincinnati Museum Association and Art Academy of Cincinnati, Cincinnati Art Museum, Cincinnati OH
Dallas Museum of Art, Dallas TX
Detroit Institute of Arts, Detroit MI
Detroit Zoological Institute, Wildlife Interpretive Gallery, Royal Oak MI
Florida State University and Central Florida Community College, The Appleton Museum of Art, Ocala FL
Edsel & Eleanor Ford, Grosse Pointe Shores MI
Harvard University, Semitic Museum, Cambridge MA
Henry County Museum & Cultural Arts Center, Clinton MO
Hermitage Foundation Museum, Norfolk VA
Huntington Museum of Art, Huntington WV
Jacksonville University, Alexander Brest Museum & Gallery, Jacksonville FL
Johns Hopkins University, Evergreen House, Baltimore MD
Lahore Museum, Lahore
Menil Foundation, Inc, Houston TX
The Metropolitan Museum of Art, New York NY
Michigan State University, Kresge Art Museum, East Lansing MI
Mint Museum of Art, Charlotte NC
Montreal Museum of Fine Arts, Montreal PQ
Panhandle-Plains Historical Society Museum, Canyon TX
Princeton University, Princeton University Art Museum, Princeton NJ
Putnam Museum of History and Natural Science, Davenport IA
Royal Arts Foundation, Belcourt Castle, Newport RI
Salisbury House Foundation, Des Moines IA

The Slater Memorial Museum, Slater Memorial
Museum, Norwich CT
Smithsonian Institution, Arthur M Sackler Gallery,
Washington DC
University of Chicago, Oriental Institute Museum,
Chicago IL
University of Missouri, Museum of Art & Archaeology,
Columbia MO
Walters Art Museum, Baltimore MD
Woodmere Art Museum, Philadelphia PA

ANTIQUITIES-ROMAN

Academy of the New Church, Glencairn Museum, Bryn
Athyn PA
Albany Museum of Art, Albany GA
Art & Culture Center of Hollywood, Art Gallery,
Hollywood FL
Art Without Walls Inc, Art Without Walls Inc, Sayville
NY
Ball State University, Museum of Art, Muncie IN
Beloit College, Wright Museum of Art, Beloit WI
BJU Museum & Gallery, Bob Jones University
Museum & Gallery Inc, Greenville SC
The Buffalo Fine Arts Academy, Albright-Knox Art
Gallery, Buffalo NY
C W Post Campus of Long Island University, Hillwood
Art Museum, Brookville NY
Carleton College, Art Gallery, Northfield MN
Chrysler Museum of Art, Norfolk VA
Cincinnati Museum Association and Art Academy of
Cincinnati, Cincinnati Art Museum, Cincinnati OH
Cleveland Museum of Art, Cleveland OH
Dallas Museum of Art, Dallas TX
Detroit Institute of Arts, Detroit MI
Dickinson College, The Trout Gallery, Carlisle PA
Doncaster Museum and Art Gallery, Doncaster
Emory University, Michael C Carlos Museum, Atlanta
GA
Fine Arts Museums of San Francisco, Legion of Honor,
San Francisco CA
Florida State University and Central Florida
Community College, The Appleton Museum of Art,
Ocala FL
Forest Lawn Museum, Glendale CA
Freeport Arts Center, Freeport IL
Galleria Doria Pamphilj, Rome
Isabella Stewart Gardner, Boston MA
Harvard University, Semitic Museum, Cambridge MA
Hebrew Union College - Jewish Institute of Religion,
Skirball Museum Cincinnati, Cincinnati OH
Hermitage Foundation Museum, Norfolk VA
Iredell Museum of Arts & Heritage, Statesville NC
James Madison University, Sawhill Gallery,
Harrisonburg VA
Janus Pannonius Muzeum, Pecs
Johns Hopkins University, Archaeological Collection,
Baltimore MD
Kelowna Museum, Kelowna BC
Kimbell Art Museum, Fort Worth TX
Lehigh University Art Galleries, Museum Operation,
Bethlehem PA
Luther College, Fine Arts Collection, Decorah IA
McMaster University, McMaster Museum of Art,
Hamilton ON
Menil Foundation, Inc, Houston TX
The Metropolitan Museum of Art, New York NY
Michigan State University, Kresge Art Museum, East
Lansing MI
Middlebury College, Museum of Art, Middlebury VT
Milwaukee Art Museum, Milwaukee WI
Ministry of Culture, The Delphi Museum, I Ephorate of
Prehistoric & Classical Antiquities, Delphi
Minneapolis Institute of Arts, Minneapolis MN
Mint Museum of Art, Charlotte NC
Montreal Museum of Fine Arts, Montreal PQ
Mount Holyoke College, Art Museum, South Hadley
MA
The Museum, Greenwood SC
Museum of Fine Arts, Boston MA
Museum of Fine Arts, Houston, Houston TX
New Brunswick Museum, Saint John NB
North Carolina Museum of Art, Raleigh NC
Putnam Museum of History and Natural Science,
Davenport IA
Queen's University, Agnes Etherington Art Centre,
Kingston ON
Queens College, City University of New York,
Godwin-Ternbach Museum, Flushing NY

Rollins College, George D & Harriet W Cornell Fine
Arts Museum, Winter Park FL
Saint Gregory's Abbey & University, Mabee-Gerrer
Museum of Art, Shawnee OK
Santa Barbara Museum of Art, Santa Barbara CA
Seattle Art Museum, Seattle WA
The Slater Memorial Museum, Slater Memorial
Museum, Norwich CT
Smithsonian Institution, Arthur M Sackler Gallery,
Washington DC
Society of the Cincinnati, Museum & Library at
Anderson House, Washington DC
Stanford University, Iris & B Gerald Cantor Center for
Visual Arts, Stanford CA
Staten Island Institute of Arts & Sciences, Staten Island
NY
Tampa Museum of Art, Tampa FL
Tufts University, Tufts University Art Gallery, Medford
MA
University of Chicago, Smart Museum of Art, Chicago
IL
University of Delaware, University Gallery, Newark
DE
University of Illinois, Krannert Art Museum and
Kinkead Pavillion, Champaign IL
University of Illinois, Spurlock Museum, Champaign
IL
University of Manitoba, Faculty of Architecture
Exhibition Centre, Winnipeg MB
University of Michigan, Kelsey Museum of
Archaeology, Ann Arbor MI
University of Mississippi, University Museum, Oxford
MS
University of Missouri, Museum of Art & Archaeology,
Columbia MO
University of Toronto, University of Toronto Art
Centre, Toronto ON
Vancouver Museum, Vancouver BC
Vassar College, The Frances Lehman Loeb Art Center,
Poughkeepsie NY
Vizcaya Museum & Gardens, Miami FL
Walters Art Museum, Baltimore MD
Wellesley College, Davis Museum & Cultural Center,
Wellesley MA
Wheaton College, Watson Gallery, Norton MA
Worcester Art Museum, Worcester MA

ARCHAEOLOGY

Academy of the New Church, Glencairn Museum, Bryn
Athyn PA
African American Museum in Philadelphia,
Philadelphia PA
African Art Museum of Maryland, Columbia MD
Alaska Museum of Natural History, Anchorage AK
Anchorage Museum at Rasmuson Center, Anchorage
AK
Archaeological Society of Ohio, Indian Museum of
Lake County, Ohio, Willoughby OH
ArtSpace-Lima, Lima OH
Association for the Preservation of Virginia Antiquities,
John Marshall House, Richmond VA
Athens Byzantine & Christian Museum, Athens
Aurora University, Schingoethe Center for Native
American Cultures, Aurora IL
Balzekas Museum of Lithuanian Culture, Chicago IL
Bay County Historical Society, Historical Museum of
Bay County, Bay City MI
Beloit College, Wright Museum of Art, Beloit WI
Berman Museum, Anniston AL
Jesse Besser, Alpena MI
BJU Museum & Gallery, Bob Jones University
Museum & Gallery Inc, Greenville SC
Bronx Community College (CUNY), Hall of Fame for
Great Americans, Bronx NY
California State University, East Bay, C E Smith
Museum of Anthropology, Hayward CA
Cambridge Museum, Cambridge NE
Canadian Museum of Civilization, Gatineau PQ
Carson County Square House Museum, Panhandle TX
Carteret County Historical Society, Museum of History
& Art, Morehead City NC
Charleston Museum, Joseph Manigault House,
Charleston SC
Chelan County Public Utility District, Rocky Reach
Dam, Wenatchee WA
City of El Paso, El Paso Museum of Archaeology, El
Paso TX

City of Grand Rapids Michigan, Public Museum of
Grand Rapids, Grand Rapids MI
City of Providence Parks Department, Roger Williams
Park Museum of Natural History, Providence RI
Clark County Historical Society, Pioneer - Krier
Museum, Ashland KS
Colorado Historical Society, Colorado History Museum,
Denver CO
Columbus Museum, Columbus GA
Concord Museum, Concord MA
County of Henrico, Meadow Farm Museum, Glen
Allen VA
Crow Wing County Historical Society, Brainerd MN
Culberson County Historical Museum, Van Horn TX
Dallas Museum of Art, Dallas TX
Deer Valley Rock Art Center, Glendale AZ
Delaware Archaeology Museum, Dover DE
Delaware Division of Historical & Cultural Affairs,
Dover DE
Department of Community Development, Provincial
Museum of Alberta, Edmonton AB
Detroit Institute of Arts, Detroit MI
DeWitt Historical Society of Tompkins County, The
History Center in Tompkins Co, Ithaca NY
Doncaster Museum and Art Gallery, Doncaster
Dundurn Castle, Hamilton ON
Edgecombe County Cultural Arts Council, Inc,
Blount-Bridgers House, Hobson Pittman Memorial
Gallery, Tarboro NC
Emory University, Michael C Carlos Museum, Atlanta
GA
Eretz-Israel Museum, Museum of Antiquities of
Tel-Aviv-Jaffa, Tel Aviv
Essex Historical Society, Essex Shipbuilding Museum,
Essex MA
Fairbanks Museum & Planetarium, Saint Johnsbury VT
Fairfield University, Thomas J Walsh Art Gallery,
Fairfield CT
Farmington Village Green & Library Association,
Stanley-Whitman House, Farmington CT
Ferenczy Muzeum, Szentendre
Fishkill Historical Society, Van Wyck Homestead
Museum, Fishkill NY
Florida State University, John & Mable Ringling
Museum of Art, Sarasota FL
Forges du Saint-Maurice National Historic Site, Trois
Rivieres PQ
Fort Morgan Heritage Foundation, Fort Morgan CO
Fort Ticonderoga Association, Ticonderoga NY
Germanisches Nationalmuseum, Nuremberg
Hampton University, University Museum, Hampton VA
Hartwick College, The Yager Museum, Oneonta NY
Harvard University, Semitic Museum, Cambridge MA
Heard Museum, Phoenix AZ
Hebrew Union College, Jewish Institute of Religion
Museum, New York NY
Hebrew Union College, Skirball Cultural Center, Los
Angeles CA
Hebrew Union College - Jewish Institute of Religion,
Skirball Museum Cincinnati, Cincinnati OH
Henry County Museum & Cultural Arts Center, Clinton
MO
Heritage Museum Association, Inc, The Heritage
Museum of Northwest Florida, Valparaiso FL
Herrett Center for Arts & Sciences, Jean B King Art
Gallery, Twin Falls ID
Higgins Armory Museum, Worcester MA
High Desert Museum, Bend OR
Hispanic Society of America, Museum & Library, New
York NY
Historic Arkansas Museum, Little Rock AR
Historical Museum at Fort Missoula, Missoula MT
Historical Society of Rockland County, New City NY
Historisches und Volkerkundemuseum, Historical
Museum, Sankt Gallen
Huguenot Historical Society of New Paltz Galleries,
New Paltz NY
Huronia Museum, Gallery of Historic Huronia, Midland
ON
Idaho Historical Museum, Boise ID
Illinois Historic Preservation Agency, Bishop Hill State
Historic Site, Bishop Hill IL
Independence National Historical Park, Philadelphia PA
Indiana State Museum, Indianapolis IN
Institute of Puerto Rican Culture, Museo Fuerte Conde
de Mirasol, Vieques PR
Iroquois Indian Museum, Howes Cave NY
Istanbul Arkeoloji Muzeleri, The Library of
Archaeological Museums of Istanbul, Istanbul
The Jewish Museum, New York NY

Johns Hopkins University, Homewood House Museum, Baltimore MD
Kelly-Griggs House Museum, Red Bluff CA
Kelowna Museum, Kelowna BC
Kern County Museum, Bakersfield CA
Klein Museum, Mobridge SD
Koshare Indian Museum, Inc, La Junta CO
Lac du Flambeau Band of Lake Superior Chippewa Indians, George W Brown Jr Ojibwe Museum & Cultural Center, Lac du Flambeau WI
Lafayette Natural History Museum & Planetarium, Lafayette LA
Lahore Museum, Lahore
Lakeview Museum of Arts & Sciences, Peoria IL
Lehigh County Historical Society, Allentown PA
Lincoln County Historical Association, Inc, 1811 Old Lincoln County Jail & Lincoln County Museum, Wiscasset ME
Louisiana State Exhibit Museum, Shreveport LA
Loveland Museum Gallery, Loveland CO
Maine Historical Society, MHS Museum, Portland ME
Maryhill Museum of Art, Goldendale WA
McPherson Museum, McPherson KS
Ministry of Culture, The Delphi Museum, I Ephorate of Prehistoric & Classical Antiquities, Delphi
Mission San Miguel Museum, San Miguel CA
Mississippi Department of Archives & History, Old Capitol Museum of Mississippi History, Jackson MS
Mississippi River Museum at Mud-Island River Park, Memphis TN
Missouri Historical Society, Missouri History Museum, Saint Louis MO
Mohave Museum of History & Arts, Kingman AZ
Moncur Gallery, Boissevain MB
Montreal Museum of Fine Arts, Montreal PQ
Morris Museum, Morristown NJ
Musee Carnavalet-Histoir de Paris, Paris
Musee Guimet, Paris
Musee Regional de la Cote-Nord, Sept-Iles PQ
Musei Capitolini, Rome
Museo de Arte de Ponce, Ponce Art Museum, Ponce PR
Museo De Las Americas, Denver CO
The Museum, Greenwood SC
Museum of Mobile, Mobile AL
Museum of Northern Arizona, Flagstaff AZ
Museum of the City of New York, New York NY
Museum of West Louisiana, Leesville LA
Museum of York County, Rock Hill SC
Muzeum Narodowe W Kielcach, National Museum in Kielce, Kielce
National Museum of the American Indian, George Gustav Heye Center, New York NY
National Museum, Monuments and Art Gallery, Gaborone
National Park Service, Hubbell Trading Post National Historic Site, Ganado AZ
The National Park Service, United States Department of the Interior, Statue of Liberty National Monument & The Ellis Island Immigration Museum, New York NY
Natural History Museum of Los Angeles County, Los Angeles CA
Naval Historical Center, The Navy Museum, Washington DC
New Jersey Historical Society, Newark NJ
New Jersey State Museum, Fine Art Bureau, Trenton NJ
Newton History Museum at the Jackson Homestead, Newton MA
No Man's Land Historical Society Museum, Goodwell OK
Northern Maine Museum of Science, Presque Isle ME
The Ohio Historical Society, Inc, Campus Martius Museum & Ohio River Museum, Marietta OH
Old Slater Mill Association, Slater Mill Historic Site, Pawtucket RI
Oshkosh Public Museum, Oshkosh WI
Panhandle-Plains Historical Society Museum, Canyon TX
Pennsylvania Historical & Museum Commission, The State Museum of Pennsylvania, Harrisburg PA
The Frank Phillips, Woolaroc Museum, Bartlesville OK
Ponca City Cultural Center & Museum, Ponca City OK
Port Huron Museum, Port Huron MI
Princeton University, Princeton University Art Museum, Princeton NJ
Putnam Museum of History and Natural Science, Davenport IA

Red Rock State Park, Red Rock Museum, Church Rock NM
Riverside Municipal Museum, Riverside CA
Roberts County Museum, Miami TX
Rollins College, George D & Harriet W Cornell Fine Arts Museum, Winter Park FL
Rome Historical Society, Museum & Archives, Rome NY
Royal Ontario Museum, Toronto ON
C M Russell, Great Falls MT
Saco Museum, Saco ME
Safety Harbor Museum of Regional History, Safety Harbor FL
St Genevieve Museum, Sainte Genevieve MO
Saint Joseph Museum, Saint Joseph MO
Saint Peter's College, Art Gallery, Jersey City NJ
San Bernardino County Museum, Fine Arts Institute, Redlands CA
Santo Tomas Museum, Museum of Arts & Sciences, Manila
Seneca-Iroquois National Museum, Salamanca NY
Shaker Village of Pleasant Hill, Harrodsburg KY
Shirley Plantation, Charles City VA
Abigail Adams Smith, New York NY
Smithsonian Institution, Arthur M Sackler Gallery, Washington DC
Sooke Region Museum & Art Gallery, Sooke BC
Southern Baptist Theological Seminary, Joseph A Callaway Archaeological Museum, Louisville KY
Southern Illinois University Carbondale, University Museum, Carbondale IL
Southern Oregon Historical Society, Jacksonville Museum of Southern Oregon History, Medford OR
Spertus Institute of Jewish Studies, Spertus Museum, Chicago IL
Switzerland County Historical Society Inc, Switzerland County Historical Museum, Vevay IN
Tallahassee Museum of History & Natural Science, Tallahassee FL
The Temple-Tifereth Israel, The Temple Museum of Religious Art, Beachwood OH
Texas Tech University, Museum of Texas Tech University, Lubbock TX
Tokyo National University of Fine Arts & Music Art, University Art Museum, Tokyo
Tryon Palace Historic Sites & Gardens, New Bern NC
Turtle Bay Exploration Park, Redding CA
Turtle Mountain Chippewa Historical Society, Turtle Mountain Heritage Center, Belcourt ND
United Society of Shakers, Shaker Museum, New Glocester ME
University of British Columbia, Museum of Anthropology, Vancouver BC
University of California, San Diego, Stuart Collection, La Jolla CA
University of Chicago, Oriental Institute Museum, Chicago IL
University of Manitoba, Faculty of Architecture Exhibition Centre, Winnipeg MB
University of Memphis, Art Museum, Memphis TN
University of Pennsylvania, Museum of Archaeology & Anthropology, Philadelphia PA
University of Puerto Rico, Museum of Anthropology, History & Art, Rio Piedras PR
University of Tennessee, Frank H McClung Museum, Knoxville TN
University of Victoria, Maltwood Art Museum and Gallery, Victoria BC
Vancouver Museum, Vancouver BC
Vassar College, The Frances Lehman Loeb Art Center, Poughkeepsie NY
Wade House & Wesley W Jung Carriage Museum, Historic House & Carriage Museum, Greenbush WI
Wadsworth Atheneum Museum of Art, Hartford CT
Warner House Association, MacPheadris-Warner House, Portsmouth NH
Wayne County Historical Society, Museum, Honesdale PA
Wayne County Historical Society, Honesdale PA
West Florida Historic Preservation, Inc, T T Wentworth, Jr Florida State Museum & Historic Pensacola Village, Pensacola FL
Wethersfield Historical Society Inc, Museum, Wethersfield CT
Whalers Village Museum, Lahaina HI
Wisconsin Historical Society, State Historical Museum, Madison WI
Woodlawn/The Pope-Leighey, Mount Vernon VA

ARCHITECTURE

Academy of the New Church, Glencairn Museum, Bryn Athyn PA
African Art Museum of Maryland, Columbia MD
Agecroft Association, Museum, Richmond VA
Allentown Art Museum, Allentown PA
Alton Museum of History & Art, Inc, Alton IL
American Swedish Historical Foundation & Museum, Philadelphia PA
Art & Culture Center of Hollywood, Art Gallery, Hollywood FL
Art Without Walls Inc, Art Without Walls, Sayville NY
Artesia Historical Museum & Art Center, Artesia NM
Arts Council of Fayetteville-Cumberland County, The Arts Center, Fayetteville NC
ArtSpace-Lima, Lima OH
Asheville Art Museum, Asheville NC
Association for the Preservation of Virginia Antiquities, John Marshall House, Richmond VA
Athenaeum of Philadelphia, Philadelphia PA
Athens Byzantine & Christian Museum, Athens
Atlanta Historical Society Inc, Atlanta History Center, Atlanta GA
Atlanta International Museum of Art & Design, Atlanta GA
Ball State University, Museum of Art, Muncie IN
The Baltimore Museum of Art, Baltimore MD
The Bartlett Museum, Amesbury MA
Beloit College, Wright Museum of Art, Beloit WI
Boston Public Library, Albert H Wiggin Gallery & Print Department, Boston MA
Brick Store Museum & Library, Kennebunk ME
Bronx Community College (CUNY), Hall of Fame for Great Americans, Bronx NY
Burchfield-Penney Art Center, Buffalo NY
Cabot's Old Indian Pueblo Museum, Cabot's Old Indian Pueblo Museum, Desert Hot Springs CA
Central United Methodist Church, Swords Into Plowshares Peace Center & Gallery, Detroit MI
Charleston Museum, Joseph Manigault House, Charleston SC
Chatillon-DeMenil House Foundation, DeMenil Mansion, Saint Louis MO
Chicago Architecture Foundation, Chicago IL
Chicago Athenaeum, Museum of Architecture & Design, Galena IL
Chinati Foundation, Marfa TX
Church of Jesus Christ of Latter-Day Saints, Museum of Church History & Art, Salt Lake City UT
Cincinnati Institute of Fine Arts, Taft Museum of Art, Cincinnati OH
The City of Petersburg Museums, Petersburg VA
City of Springdale, Shiloh Museum of Ozark History, Springdale AR
Cohasset Historical Society, Cohasset Maritime Museum, Cohasset MA
Columbus Museum, Columbus GA
Cooper-Hewitt, National Design Museum, Smithsonian Institution, New York NY
County of Henrico, Meadow Farm Museum, Glen Allen VA
Craigdarroch Castle Historical Museum Society, Victoria BC
Cranbrook Art Museum, Cranbrook Art Museum, Bloomfield Hills MI
Crow Wing County Historical Society, Brainerd MN
The Currier Museum of Art, Currier Museum of Art, Manchester NH
Dallas Museum of Art, Dallas TX
Danville Museum of Fine Arts & History, Danville VA
Delaware Division of Historical & Cultural Affairs, Dover DE
DeLeon White Gallery, Toronto ON
Denver Art Museum, Denver CO
Detroit Institute of Arts, Detroit MI
DeWitt Historical Society of Tompkins County, The History Center in Tompkins Co, Ithaca NY
Dundurn Castle, Hamilton ON
Eastern Washington State Historical Society, Northwest Museum of Arts & Culture, Spokane WA
Edgecombe County Cultural Arts Council, Inc, Blount-Bridgers House, Hobson Pittman Memorial Gallery, Tarboro NC
Egan Institute of Maritime Studies, Nantucket MA
Elmhurst Art Museum, Elmhurst IL
Elverhoj Museum of History and Art, Solvang CA
Wharton Esherick, Paoli PA
Evanston Historical Society, Charles Gates Dawes House, Evanston IL

ART EDUCATION

Walter Anderson, Ocean Springs MS
Art & Culture Center of Hollywood, Art Gallery, Hollywood FL
Burke Arts Council, Jailhouse Galleries, Morganton NC
Craft and Folk Art Museum (CAFAM), Los Angeles CA
Elverhoj Museum of History and Art, Solvang CA
Kunstindustrimuseet, The Danish Museum of Art & Design, Copenhagen
Saint Peter's College, Art Gallery, Jersey City NJ

ART HISTORY

Walter Anderson, Ocean Springs MS
Art & Culture Center of Hollywood, Art Gallery, Hollywood FL
Belskie Museum, Closter NJ
Birger Sandzen Memorial Gallery, Lindsborg KS
Elverhoj Museum of History and Art, Solvang CA
Galeria Mesta Bratislavy, City Gallery of Bratislava, Bratislava
James Dick Foundation, Festival - Institute, Round Top TX
Kunstindustrimuseet, The Danish Museum of Art & Design, Copenhagen
Judah L Magnes, Berkeley CA
Saint Peter's College, Art Gallery, Jersey City NJ
Springfield Art Museum, Springfield MO
University Art Gallery at California State University, Dominguez Hills, Carson CA
The Woman's Exchange, Gallier House Museum, New Orleans LA

ASIAN ART

Academy of the New Church, Glencairn Museum, Bryn Athyn PA
Arnot Art Museum, Elmira NY
Art & Culture Center of Hollywood, Art Gallery, Hollywood FL
Art Complex Museum, Carl A. Weyerhaeuser Library, Duxbury MA
Art Gallery of Greater Victoria, Victoria BC
Art Gallery of South Australia, Adelaide
Art Museum of the University of Houston, Blaffer Gallery, Houston TX
Art Without Walls Inc, Art Without Walls Inc, Sayville NY
ArtSpace-Lima, Lima OH
The Asia Society Museum, New York NY
Asian Art Museum of San Francisco, Chong-Moon Lee Ctr for Asian Art and Culture, San Francisco CA
Atlanta International Museum of Art & Design, Atlanta GA
Ball State University, Museum of Art, Muncie IN
The Baltimore Museum of Art, Baltimore MD
Barnes Foundation, Merion PA
Beloit College, Wright Museum of Art, Beloit WI
Berea College, Doris Ulmann Galleries, Berea KY
Birger Sandzen Memorial Gallery, Lindsborg KS
Birmingham Museum of Art, Birmingham AL
Bowers Museum of Cultural Art, Bowers Museum, Santa Ana CA
The Buffalo Fine Arts Academy, Albright-Knox Art Gallery, Buffalo NY
C W Post Campus of Long Island University, Hillwood Art Museum, Brookville NY
California State University Stanislaus, University Art Gallery, Turlock CA
California State University, Northridge, Art Galleries, Northridge CA
Cameron Art Museum, Wilmington NC
Caramoor Center for Music & the Arts, Inc, Caramoor House Museum, Katonah NY
Carleton College, Art Gallery, Northfield MN
Center for Puppetry Arts, Atlanta GA
Billie Trimble Chandler, Asian Cultures Museum & Educational Center, Corpus Christi TX
Chinese Culture Foundation, Center Gallery, San Francisco CA
Chinese Culture Institute of the International Society, Tremont Theatre & Gallery, Boston MA
Cincinnati Institute of Fine Arts, Taft Museum of Art, Cincinnati OH
Cincinnati Museum Association and Art Academy of Cincinnati, Cincinnati Art Museum, Cincinnati OH
City of El Paso Museum and Cultural Affairs, People's Gallery, El Paso TX

City of Grand Rapids Michigan, Public Museum of Grand Rapids, Grand Rapids MI
College of William & Mary, Muscarelle Museum of Art, Williamsburg VA
Columbus Museum, Columbus GA
Concordia Historical Institute, Saint Louis MO
Cornell University, Herbert F Johnson Museum of Art, Ithaca NY
Coutts Memorial Museum of Art, Inc, El Dorado KS
Craft and Folk Art Museum (CAFAM), Los Angeles CA
The Currier Museum of Art, Currier Museum of Art, Manchester NH
Dallas Museum of Art, Dallas TX
Denison University, Art Gallery, Granville OH
Detroit Institute of Arts, Detroit MI
Detroit Zoological Institute, Wildlife Interpretive Gallery, Royal Oak MI
Dickinson College, The Trout Gallery, Carlisle PA
Elmhurst Art Museum, Elmhurst IL
Emory University, Michael C Carlos Museum, Atlanta GA
Erie Art Museum, Erie PA
Erie County Historical Society, Erie PA
Fairbanks Museum & Planetarium, Saint Johnsbury VT
Fine Arts Center for the New River Valley, Pulaski VA
Fitton Center for Creative Arts, Hamilton OH
Florida State University and Central Florida Community College, The Appleton Museum of Art, Ocala FL
Edsel & Eleanor Ford, Grosse Pointe Shores MI
Freeport Arts Center, Freeport IL
Hammond Museum & Japanese Stroll Garden, Cross-Cultural Center, North Salem NY
Hampton University, University Museum, Hampton VA
Headley-Whitney Museum, Lexington KY
Henry County Museum & Cultural Arts Center, Clinton MO
Higgins Armory Museum, Worcester MA
Hillwood Museum & Gardens Foundation, Hillwood Museum & Gardens, Washington DC
Historisches und Volkerkundemuseum, Historical Museum, Sankt Gallen
Honolulu Academy of Arts, Honolulu HI
The Interchurch Center, Galleries at the Interchurch Center, New York NY
Jacksonville University, Alexander Brest Museum & Gallery, Jacksonville FL
James Madison University, Sawhill Gallery, Harrisonburg VA
Japan Society, Inc, Japan Society Gallery, New York NY
Johns Hopkins University, Evergreen House, Baltimore MD
Kelowna Museum, Kelowna BC
Kentucky Museum of Art & Craft, Louisville KY
Kimbell Art Museum, Fort Worth TX
Kunstindustrimuseet, The Danish Museum of Art & Design, Copenhagen
L A County Museum of Art, Los Angeles CA
Lahore Museum, Lahore
Lizzadro Museum of Lapidary Art, Elmhurst IL
Los Angeles County Museum of Art, Los Angeles CA
Macalester College, Macalester College Art Gallery, Saint Paul MN
Jacques Marchais, Staten Island NY
McMaster University, McMaster Museum of Art, Hamilton ON
Metropolitan Museum of Manila, Manila
Michigan State University, Kresge Art Museum, East Lansing MI
Middlebury College, Museum of Art, Middlebury VT
Mingei International, Inc, Mingei International Museum, San Diego CA
Ministry of Culture, The Delphi Museum, I Ephorate of Prehistoric & Classical Antiquities, Delphi
Mint Museum of Art, Charlotte NC
Montreal Museum of Fine Arts, Montreal PQ
Morris Museum, Morristown NJ
Mount Holyoke College, Art Museum, South Hadley MA
Musee Guimet, Paris
The Museum, Greenwood SC
The Museum at Drexel University, Philadelphia PA
Museum of Contemporary Art, Chicago IL
National Gallery of Canada, Ottawa ON
National Museum of Women in the Arts, Washington DC
Naval Historical Center, The Navy Museum, Washington DC
Nelson-Atkins Museum of Art, Kansas City MO

New Orleans Museum of Art, New Orleans LA
New Visions Gallery, Inc, Marshfield WI
New World Art Center, T F Chen Cultural Center, New York NY
New York University, Grey Art Gallery, New York NY
Northern Illinois University, NIU Art Museum, De Kalb IL
Noyes Art Gallery, Lincoln NE
Oklahoma City Museum of Art, Oklahoma City OK
Owensboro Museum of Fine Art, Owensboro KY
Pacific - Asia Museum, Pasadena CA
Palm Beach County Parks & Recreation Department, Morikami Museum & Japanese Gardens, Delray Beach FL
Peabody Essex Museum, Salem MA
The Pennsylvania State University, Palmer Museum of Art, University Park PA
Philadelphia Museum of Art, Philadelphia PA
Philbrook Museum of Art, Tulsa OK
Phoenix Art Museum, Phoenix AZ
Polk Museum of Art, Lakeland FL
The Pomona College, Montgomery Gallery, Claremont CA
Portland Art Museum, Portland OR
Princeton University, Princeton University Art Museum, Princeton NJ
Principia College, School of Nations Museum, Elsah IL
Putnam Museum of History and Natural Science, Davenport IA
Queens College, City University of New York, Godwin-Ternbach Museum, Flushing NY
Rollins College, George D & Harriet W Cornell Fine Arts Museum, Winter Park FL
Royal Arts Foundation, Belcourt Castle, Newport RI
Royal Ontario Museum, Toronto ON
Saginaw Art Museum, Saginaw MI
San Antonio Museum of Art, San Antonio TX
Santa Barbara Museum of Art, Santa Barbara CA
Scripps College, Ruth Chandler Williamson Gallery, Claremont CA
Seattle Art Museum, Seattle WA
Smithsonian Institution, Arthur M Sackler Gallery, Washington DC
Smithsonian Institution, Washington DC
Society of the Cincinnati, Museum & Library at Anderson House, Washington DC
Springfield Art Museum, Springfield MO
State University of New York at Binghamton, University Art Museum, Binghamton NY
State University of New York at New Paltz, Samuel Dorsky Museum of Art, New Paltz NY
Stauth Foundation & Museum, Stauth Memorial Museum, Montezuma KS
Tacoma Art Museum, Tacoma WA
Tokyo National University of Fine Arts & Music Art, University Art Museum, Tokyo
Topeka & Shawnee County Public Library, Alice C Sabatini Gallery, Topeka KS
Towson University Center for the Arts Gallery, Asian Arts & Culture Center, Towson MD
University of Akron, University Art Galleries, Akron OH
University of Alabama at Birmingham, Visual Arts Gallery, Birmingham AL
University of British Columbia, Museum of Anthropology, Vancouver BC
University of California, Richard L Nelson Gallery & Fine Arts Collection, Davis CA
University of California, Berkeley, Berkeley Art Museum & Pacific Film Archive, Berkeley CA
University of Cincinnati, DAAP Galleries-College of Design Architecture, Art & Planning, Cincinnati OH
University of Colorado at Colorado Springs, Gallery of Contemporary Art, Colorado Springs CO
University of Illinois, Krannert Art Museum and Kinkead Pavillion, Champaign IL
University of Illinois, Spurlock Museum, Champaign IL
University of Iowa, Museum of Art, Iowa City IA
University of Kansas, Spencer Museum of Art, Lawrence KS
University of Mary Washington, University of Mary Washington Galleries, Fredericksburg VA
University of Michigan, Museum of Art, Ann Arbor MI
University of Mississippi, University Museum, Oxford MS
University of Missouri, Museum of Art & Archaeology, Columbia MO
University of North Carolina at Chapel Hill, Ackland Art Museum, Chapel Hill NC

University of North Carolina at Greensboro,
 Weatherspoon Art Museum, Greensboro NC
University of Oregon, Museum of Art, Eugene OR
University of San Diego, Founders' Gallery, San Diego
 CA
University of Toronto, University of Toronto Art
 Centre, Toronto ON
University of Utah, Utah Museum of Fine Arts, Salt
 Lake City UT
University of Victoria, Maltwood Art Museum and
 Gallery, Victoria BC
Vancouver Museum, Vancouver BC
Virginia Museum of Fine Arts, Richmond VA
Wake Forest University, Museum of Anthropology,
 Winston-Salem NC
Walters Art Museum, Baltimore MD
Washburn University, Mulvane Art Museum, Topeka
 KS
Washington University, Mildred Lane Kemper Art
 Museum, Saint Louis MO
Wheaton College, Watson Gallery, Norton MA
Wing Luke Asian Museum, Seattle WA
Woodmere Art Museum, Philadelphia PA
Worcester Art Museum, Worcester MA

BAROQUE ART

Allentown Art Museum, Allentown PA
Art Gallery of Hamilton, Hamilton ON
Art Without Walls Inc, Art Without Walls Inc, Sayville
 NY
Ball State University, Museum of Art, Muncie IN
Bass Museum of Art, Miami Beach FL
Beloit College, Wright Museum of Art, Beloit WI
BJU Museum & Gallery, Bob Jones University
 Museum & Gallery Inc, Greenville SC
The Buffalo Fine Arts Academy, Albright-Knox Art
 Gallery, Buffalo NY
Cincinnati Museum Association and Art Academy of
 Cincinnati, Cincinnati Art Museum, Cincinnati OH
City of El Paso, El Paso TX
College of William & Mary, Muscarelle Museum of
 Art, Williamsburg VA
Cornell College, Peter Paul Luce Gallery, Mount
 Vernon IA
The Currier Museum of Art, Currier Museum of Art,
 Manchester NH
Dallas Museum of Art, Dallas TX
Denison University, Art Gallery, Granville OH
Detroit Institute of Arts, Detroit MI
Dickinson College, The Trout Gallery, Carlisle PA
Fairfield University, Thomas J Walsh Art Gallery,
 Fairfield CT
Fine Arts Center for the New River Valley, Pulaski VA
Florida State University, John & Mable Ringling
 Museum of Art, Sarasota FL
Germanisches Nationalmuseum, Nuremberg
Guilford College, Art Gallery, Greensboro NC
Hartwick College, Foreman Gallery, Oneonta NY
Heritage Malta, National Museum of Fine Arts, Valletta
Hillwood Museum & Gardens Foundation, Hillwood
 Museum & Gardens, Washington DC
Hispanic Society of America, Museum & Library, New
 York NY
The Huntington Library, Art Collections & Botanical
 Gardens, San Marino CA
Kereszteny Muzeum, Christian Museum, Esztergom
Knights of Columbus Supreme Council, Knights of
 Columbus Museum, New Haven CT
Kunstindustrimuseet, The Danish Museum of Art &
 Design, Copenhagen
Kyiv Museum of Russian Art, Kyiv
Lahore Museum, Lahore
Michigan State University, Kresge Art Museum, East
 Lansing MI
Mint Museum of Art, Charlotte NC
Montreal Museum of Fine Arts, Montreal PQ
Moravska Galerie v Brne, Moravian Gallery in Brno,
 Brno
Musei Capitolini, Rome
Museo De Las Americas, Denver CO
Museu Nacional d'Art de Catalunya, National Art
 Museum, Barcelona
Muzej za Umjetnost i Obrt, Museum of Arts & Crafts,
 Zagreb
Muzeum Narodowe, National Museum, Poznan
Muzeum Narodowe W Kielcach, National Museum in
 Kielce, Kielce
Narodna Galerija, National Gallery of Slovenia,
 Ljubljana

National Gallery of Canada, Ottawa ON
Nelson-Atkins Museum of Art, Kansas City MO
Noordbrabants Museum, Hertogenbosch
North Carolina Museum of Art, Raleigh NC
The Pennsylvania State University, Palmer Museum of
 Art, University Park PA
Phoenix Art Museum, Phoenix AZ
Pinacoteca Provinciale, Bari
Princeton University, Princeton University Art Museum,
 Princeton NJ
Queens College, City University of New York,
 Godwin-Ternbach Museum, Flushing NY
Rollins College, George D & Harriet W Cornell Fine
 Arts Museum, Winter Park FL
San Diego Museum of Art, San Diego CA
Society of the Cincinnati, Museum & Library at
 Anderson House, Washington DC
Stanford University, Iris & B Gerald Cantor Center for
 Visual Arts, Stanford CA
Staten Island Institute of Arts & Sciences, Staten Island
 NY
University of Illinois, Krannert Art Museum and
 Kinkead Pavillion, Champaign IL
University of Kansas, Spencer Museum of Art,
 Lawrence KS
University of Miami, Lowe Art Museum, Coral Gables
 FL
University of Michigan, Museum of Art, Ann Arbor MI
University of North Carolina at Chapel Hill, Ackland
 Art Museum, Chapel Hill NC
University of Utah, Utah Museum of Fine Arts, Salt
 Lake City UT
Wadsworth Atheneum Museum of Art, Hartford CT
Walters Art Museum, Baltimore MD
Washington University, Mildred Lane Kemper Art
 Museum, Saint Louis MO
Wellesley College, Davis Museum & Cultural Center,
 Wellesley MA
Worcester Art Museum, Worcester MA
Zamek Krolewski w Warszawie Pomnik Historii i
 Kultry Narodwej, Royal Castle in Warsaw, National
 History & Culture Memorial, Warsaw

BOOKPLATES & BINDINGS

Adams National Historic Park, Quincy MA
Agecroft Association, Museum, Richmond VA
Artspace, Richmond VA
Beloit College, Wright Museum of Art, Beloit WI
Brick Store Museum & Library, Kennebunk ME
C W Post Campus of Long Island University, Hillwood
 Art Museum, Brookville NY
Cameron Art Museum, Wilmington NC
The Canadian Craft Museum, Vancouver BC
Canadian Museum of Civilization, Gatineau PQ
Center for Book Arts, New York NY
Cooper-Hewitt, National Design Museum, Smithsonian
 Institution, New York NY
The Currier Museum of Art, Currier Museum of Art,
 Manchester NH
Farmington Village Green & Library Association,
 Stanley-Whitman House, Farmington CT
Fort Ticonderoga Association, Ticonderoga NY
Galleria Doria Pamphilj, Rome
Hebrew Union College, Jewish Institute of Religion
 Museum, New York NY
Hispanic Society of America, Museum & Library, New
 York NY
Huronia Museum, Gallery of Historic Huronia, Midland
 ON
The Interchurch Center, Galleries at the Interchurch
 Center, New York NY
Johns Hopkins University, Evergreen House, Baltimore
 MD
La Casa del Libro Museum, San Juan PR
Lafayette Natural History Museum & Planetarium,
 Lafayette LA
The Mariners' Museum, Newport News VA
Minnesota State University, Mankato, Mankato MN
Muzej za Umjetnost i Obrt, Museum of Arts & Crafts,
 Zagreb
National Gallery of Canada, Ottawa ON
Natural History Museum of Los Angeles County, Los
 Angeles CA
Panhandle-Plains Historical Society Museum, Canyon
 TX
Lauren Rogers, Laurel MS
Salisbury House Foundation, Des Moines IA
Shirley Plantation, Charles City VA

Smithsonian Institution, Arthur M Sackler Gallery,
 Washington DC
Society of the Cincinnati, Museum & Library at
 Anderson House, Washington DC
South Carolina Artisans Center, Walterboro SC

BRONZES

African Art Museum of Maryland, Columbia MD
Albuquerque Museum of Art & History, Albuquerque
 NM
Allentown Art Museum, Allentown PA
Appaloosa Museum and Heritage Center, Moscow ID
Arnot Art Museum, Elmira NY
Art & Culture Center of Hollywood, Art Gallery,
 Hollywood FL
ArtSpace-Lima, Lima OH
Asian Art Museum of San Francisco, Chong-Moon Lee
 Ctr for Asian Art and Culture, San Francisco CA
Berman Museum, Anniston AL
BJU Museum & Gallery, Bob Jones University
 Museum & Gallery Inc, Greenville SC
Blanden Memorial Art Museum, Fort Dodge IA
Blauvelt Demarest Foundation, Hiram Blauvelt Art
 Museum, Oradell NJ
Roy Boyd, Chicago IL
Brigham Young University, Museum of Art, Provo UT
L D Brinkman, Kerrville TX
Bronx Community College (CUNY), Hall of Fame for
 Great Americans, Bronx NY
Brookgreen Gardens, Murrells Inlet SC
Canadian Museum of Civilization, Gatineau PQ
Canajoharie Library & Art Gallery, Arkell Museum of
 Canajoharie, Canajoharie NY
Cape Cod Museum of Art Inc, Dennis MA
Caramoor Center for Music & the Arts, Inc, Caramoor
 House Museum, Katonah NY
Carson County Square House Museum, Panhandle TX
Amon Carter, Fort Worth TX
Billie Trimble Chandler, Asian Cultures Museum &
 Educational Center, Corpus Christi TX
Church of Jesus Christ of Latter-Day Saints, Museum
 of Church History & Art, Salt Lake City UT
Cincinnati Museum Association and Art Academy of
 Cincinnati, Cincinnati Art Museum, Cincinnati OH
College of William & Mary, Muscarelle Museum of
 Art, Williamsburg VA
The College of Wooster, The College of Wooster Art
 Museum, Wooster OH
Colorado Springs Fine Arts Center, Colorado Springs
 CO
Columbus Museum of Art and Design, Indianapolis IN
Concordia University Wisconsin, Fine Art Gallery,
 Mequon WI
Cornell Museum of Art & History, Delray Beach FL
Coutts Memorial Museum of Art, Inc, El Dorado KS
Dahesh Museum of Art, New York NY
Dallas Museum of Art, Dallas TX
DeLeon White Gallery, Toronto ON
Detroit Institute of Arts, Detroit MI
Dixie State College, Robert N & Peggy Sears Gallery,
 Saint George UT
Eiteljorg Museum of American Indians & Western Art,
 Indianapolis IN
Ellen Noel Art Museum of the Permian Basin, Odessa
 TX
Erie Art Museum, Erie PA
Erie County Historical Society, Erie PA
Fine Arts Museums of San Francisco, Legion of Honor,
 San Francisco CA
Five Civilized Tribes Museum, Muskogee OK
Florida State University and Central Florida
 Community College, The Appleton Museum of Art,
 Ocala FL
Forest Lawn Museum, Glendale CA
Frankfort Community Public Library, Anna & Harlan
 Hubbard Gallery, Frankfort IN
Franklin Mint Museum, Franklin Center PA
The Frick Art & Historical Center, Frick Art Museum,
 Pittsburgh PA
Frick Collection, New York NY
Galleria Doria Pamphilj, Rome
Gallery One, Ellensburg WA
General Board of Discipleship, The United Methodist
 Church, The Upper Room Chapel & Museum,
 Nashville TN
Thomas Gilcrease, Gilcrease Museum, Tulsa OK
Gonzaga University, Art Gallery, Spokane WA
Robert Gumbiner, Museum of Latin American Art,
 Long Beach CA

Headquarters Fort Monroe, Dept of Army, Casemate Museum, Fort Monroe VA
Heard Museum, Phoenix AZ
Hebrew Union College, Jewish Institute of Religion Museum, New York NY
Heritage Malta, National Museum of Fine Arts, Valletta
Hermitage Foundation Museum, Norfolk VA
Hillwood Museum & Gardens Foundation, Hillwood Museum & Gardens, Washington DC
Honolulu Academy of Arts, Honolulu HI
The Huntington Library, Art Collections & Botanical Gardens, San Marino CA
Jacksonville University, Alexander Brest Museum & Gallery, Jacksonville FL
John Weaver Sculpture Collection, Hope BC
Johns Hopkins University, Evergreen House, Baltimore MD
Jule Collins Smith Museum of Art, Auburn AL
Kalamazoo Institute of Arts, Kalamazoo MI
Kelowna Museum, Kelowna BC
Kentucky Derby Museum, Louisville KY
Kirkland Museum of Fine & Decorative Art, Denver CO
Knights of Columbus Supreme Council, Knights of Columbus Museum, New Haven CT
Knoxville Museum of Art, Knoxville TN
Koshare Indian Museum, Inc, La Junta CO
Kyiv Museum of Russian Art, Kyiv
Lahore Museum, Lahore
Leanin' Tree Museum of Western Art, Boulder CO
Lehigh University Art Galleries, Museum Operation, Bethlehem PA
Los Angeles County Museum of Natural History, William S Hart Museum, Newhall CA
Loveland Museum Gallery, Loveland CO
Loyola University of Chicago, Martin D'Arcy Museum of Art, Chicago IL
Luther College, Fine Arts Collection, Decorah IA
Jacques Marchais, Staten Island NY
Maricopa County Historical Society, Desert Caballeros Western Museum, Wickenburg AZ
Maryhill Museum of Art, Goldendale WA
McMaster University, McMaster Museum of Art, Hamilton ON
Mennello Museum of American Art, Orlando FL
Michigan State University, Kresge Art Museum, East Lansing MI
Middle Border Museum & Oscar Howe Art Center, Mitchell SD
Middlebury College, Museum of Art, Middlebury VT
Midwest Museum of American Art, Elkhart IN
Mingei International, Inc, Mingei International Museum, San Diego CA
Ministry of Culture, The Delphi Museum, I Ephorate of Prehistoric & Classical Antiquities, Delphi
Minnesota Museum of American Art, Saint Paul MN
Missoula Art Museum, Missoula MT
Mobile Museum of Art, Mobile AL
Montreal Museum of Fine Arts, Montreal PQ
Morris Museum, Morristown NJ
Musee du Quebec, Quebec PQ
Musee Guimet, Paris
Musei Capitolini, Rome
Museo De Las Americas, Denver CO
Museum for African Art, Long Island City NY
Muzej za Umjetnost i Obrt, Museum of Arts & Crafts, Zagreb
Muzeum Narodowe, National Museum, Poznan
Napoleonic Society of America, Museum & Library, Clearwater FL
Narodna Galerija, National Gallery of Slovenia, Ljubljana
National Art Museum of Sport, Indianapolis IN
National Gallery of Canada, Ottawa ON
National Hall of Fame for Famous American Indians, Anadarko OK
National Museum of Racing, National Museum of Racing & Hall of Fame, Saratoga Springs NY
National Museum, Monuments and Art Gallery, Gaborone
National Palace Museum, Taipei
National Trust for Historic Preservation, Chesterwood Estate & Museum, Stockbridge MA
Naval Historical Center, The Navy Museum, Washington DC
Nemours Mansion & Gardens, Wilmington DE
Nevada Museum of Art, Reno NV
New Jersey State Museum, Fine Art Bureau, Trenton NJ
New Orleans Museum of Art, New Orleans LA
Norton Museum of Art, West Palm Beach FL

Ohrmann Museum and Gallery, Drummond MT
The Old Jail Art Center, Albany TX
Order Sons of Italy in America, Garibaldi & Meucci Museum, Staten Island NY
Owensboro Museum of Fine Art, Owensboro KY
Pacific - Asia Museum, Pasadena CA
Palm Springs Art Museum, Palm Springs CA
The Frank Phillips, Woolaroc Museum, Bartlesville OK
George Phippen, Phippen Art Museum, Prescott AZ
Pinacoteca Provinciale, Bari
Pioneer Town, Pioneer Museum of Western Art, Wimberley TX
Queens College, City University of New York, Godwin-Ternbach Museum, Flushing NY
Frederic Remington, Ogdensburg NY
Sid W Richardson, Sid Richardson Museum, Fort Worth TX
The Rockwell Museum of Western Art, Corning NY
Rollins College, George D & Harriet W Cornell Fine Arts Museum, Winter Park FL
Ross Memorial Museum, Saint Andrews NB
Roswell Museum & Art Center, Roswell NM
C M Russell, Great Falls MT
Saginaw Art Museum, Saginaw MI
Saint Joseph's Oratory, Museum, Montreal PQ
Saint Olaf College, Flaten Art Museum, Northfield MN
Saint Peter's College, Art Gallery, Jersey City NJ
Santarella Museum & Gardens, Tyringham MA
Shoshone Bannock Tribes, Shoshone Bannock Tribal Museum, Fort Hall ID
Smithsonian Institution, Arthur M Sackler Gallery, Washington DC
Society of the Cincinnati, Museum & Library at Anderson House, Washington DC
Springfield Art Museum, Springfield MO
Springville Museum of Art, Springville UT
Stanford University, Iris & B Gerald Cantor Center for Visual Arts, Stanford CA
Nelda C & H J Lutcher Stark, Stark Museum of Art, Orange TX
Staten Island Institute of Arts & Sciences, Staten Island NY
Syracuse University, Art Collection, Syracuse NY
Syracuse University, SUArt Galleries, Syracuse NY
Tampa Museum of Art, Tampa FL
Texas Tech University, Museum of Texas Tech University, Lubbock TX
Three Forks Area Historical Society, Headwaters Heritage Museum, Three Forks MT
Tokyo National University of Fine Arts & Music Art, University Art Museum, Tokyo
Topeka & Shawnee County Public Library, Alice C Sabatini Gallery, Topeka KS
Towson University Center for the Arts Gallery, Asian Arts & Culture Center, Towson MD
UMLAUF Sculpture Garden & Museum, Austin TX
United States Capitol, Architect of the Capitol, Washington DC
United States Figure Skating Association, World Figure Skating Museum & Hall of Fame, Colorado Springs CO
United States Military Academy, West Point Museum, West Point NY
University of Chicago, Oriental Institute Museum, Chicago IL
University of Cincinnati, DAAP Galleries-College of Design Architecture, Art & Planning, Cincinnati OH
University of Illinois, Krannert Art Museum and Kinkead Pavillion, Champaign IL
University of Kansas, Spencer Museum of Art, Lawrence KS
University of Michigan, Kelsey Museum of Archaeology, Ann Arbor MI
University of Nebraska, Lincoln, Sheldon Memorial Art Gallery & Sculpture Garden, Lincoln NE
University of North Carolina at Chapel Hill, Ackland Art Museum, Chapel Hill NC
University of North Carolina at Greensboro, Weatherspoon Art Museum, Greensboro NC
University of Toronto, University of Toronto Art Centre, Toronto ON
Virginia Museum of Fine Arts, Richmond VA
Vizcaya Museum & Gardens, Miami FL
Waterworks Visual Arts Center, Salisbury NC
Wayne Center for the Arts, Wooster OH
Wheaton College, Watson Gallery, Norton MA

CALLIGRAPHY

Academy of the New Church, Glencairn Museum, Bryn Athyn PA
Arab American National Museum, Dearborn MI
Art & Culture Center of Hollywood, Art Gallery, Hollywood FL
ArtSpace-Lima, Lima OH
Asian Art Museum of San Francisco, Chong-Moon Lee Ctr for Asian Art and Culture, San Francisco CA
Atlanta International Museum of Art & Design, Atlanta GA
Beloit College, Wright Museum of Art, Beloit WI
The Canadian Craft Museum, Vancouver BC
Canadian Museum of Civilization, Gatineau PQ
Central United Methodist Church, Swords Into Plowshares Peace Center & Gallery, Detroit MI
Billie Trimble Chandler, Asian Cultures Museum & Educational Center, Corpus Christi TX
Chinese Culture Foundation, Center Gallery, San Francisco CA
Chinese Culture Institute of the International Society, Tremont Theatre & Gallery, Boston MA
Cincinnati Museum Association and Art Academy of Cincinnati, Cincinnati Art Museum, Cincinnati OH
Cooper-Hewitt, National Design Museum, Smithsonian Institution, New York NY
Dallas Museum of Art, Dallas TX
Detroit Institute of Arts, Detroit MI
Dickinson College, The Trout Gallery, Carlisle PA
Dundurn Castle, Hamilton ON
Fine Arts Center for the New River Valley, Pulaski VA
Georgian Court College, M Christina Geis Gallery, Lakewood NJ
Guilford College, Art Gallery, Greensboro NC
Hebrew Union College, Jewish Institute of Religion Museum, New York NY
Heritage Center of Lancaster County Museum, Lancaster PA
Hispanic Society of America, Museum & Library, New York NY
The Interchurch Center, Galleries at the Interchurch Center, New York NY
Landis Valley Museum, Lancaster PA
Judah L Magnes, Berkeley CA
Jacques Marchais, Staten Island NY
Michigan State University, Kresge Art Museum, East Lansing MI
Middlebury College, Museum of Art, Middlebury VT
Mingei International, Inc, Mingei International Museum, San Diego CA
Mint Museum of Art, Charlotte NC
Missoula Art Museum, Missoula MT
Musee Guimet, Paris
National Museum of Women in the Arts, Washington DC
National Palace Museum, Taipei
Naval Historical Center, The Navy Museum, Washington DC
Nelson-Atkins Museum of Art, Kansas City MO
New World Art Center, T F Chen Cultural Center, New York NY
Pacific - Asia Museum, Pasadena CA
Phoenix Art Museum, Phoenix AZ
Portland Art Museum, Portland OR
Princeton University, Princeton University Art Museum, Princeton NJ
Saint John's University, Chung-Cheng Art Gallery, Jamaica NY
Salisbury House Foundation, Des Moines IA
Smithsonian Institution, Arthur M Sackler Gallery, Washington DC
Springfield Museums Association, George Walter Vincent Smith Art Museum, Springfield MA
State University of New York at New Paltz, Samuel Dorsky Museum of Art, New Paltz NY
Tokyo National University of Fine Arts & Music Art, University Art Museum, Tokyo
University of Illinois, Krannert Art Museum and Kinkead Pavillion, Champaign IL
University of Kansas, Spencer Museum of Art, Lawrence KS
University of North Dakota, Hughes Fine Arts Center-Col Eugene Myers Art Gallery, Grand Forks ND
Willard House & Clock Museum, Inc, North Grafton MA

CARPETS & RUGS

Academy of the New Church, Glencairn Museum, Bryn Athyn PA
Agecroft Association, Museum, Richmond VA
Amherst Museum, Amherst NY
Anchorage Museum at Rasmuson Center, Anchorage AK
Asian Art Museum of San Francisco, Chong-Moon Lee Ctr for Asian Art and Culture, San Francisco CA
Atlanta International Museum of Art & Design, Atlanta GA
Barnes Foundation, Merion PA
Bayou Bend Collection & Gardens, Houston TX
Brigham Young University, Museum of Art, Provo UT
Canadian Museum of Civilization, Gatineau PQ
Caramoor Center for Music & the Arts, Inc, Caramoor House Museum, Katonah NY
Carson County Square House Museum, Panhandle TX
Chattahoochee Valley Art Museum, LaGrange GA
Cincinnati Museum Association and Art Academy of Cincinnati, Cincinnati Art Museum, Cincinnati OH
City of Grand Rapids Michigan, Public Museum of Grand Rapids, Grand Rapids MI
Clark County Historical Society, Pioneer - Krier Museum, Ashland KS
The College of Wooster, The College of Wooster Art Museum, Wooster OH
Colorado Historical Society, Colorado History Museum, Denver CO
Cooper-Hewitt, National Design Museum, Smithsonian Institution, New York NY
Cornell College, Peter Paul Luce Gallery, Mount Vernon IA
County of Henrico, Meadow Farm Museum, Glen Allen VA
Coutts Memorial Museum of Art, Inc, El Dorado KS
Craigdarroch Castle Historical Museum Society, Victoria BC
Crow Wing County Historical Society, Brainerd MN
Dallas Museum of Art, Dallas TX
DAR Museum, National Society Daughters of the American Revolution, Washington DC
Detroit Institute of Arts, Detroit MI
Dixie State College, Robert N & Peggy Sears Gallery, Saint George UT
Dundurn Castle, Hamilton ON
Erie County Historical Society, Erie PA
Evanston Historical Society, Charles Gates Dawes House, Evanston IL
Ferenczy Muzeum, Szentendre
Fetherston Foundation, Packwood House Museum, Lewisburg PA
Fine Arts Museums of San Francisco, Legion of Honor, San Francisco CA
Flagler Museum, Palm Beach FL
Florida State University and Central Florida Community College, The Appleton Museum of Art, Ocala FL
Edsel & Eleanor Ford, Grosse Pointe Shores MI
General Board of Discipleship, The United Methodist Church, The Upper Room Chapel & Museum, Nashville TN
Germanisches Nationalmuseum, Nuremberg
Greene County Historical Society, Bronck Museum, Coxsackie NY
Hancock County Trustees of Public Reservations, Woodlawn Museum, Ellsworth ME
Henry County Museum & Cultural Arts Center, Clinton MO
Hermitage Foundation Museum, Norfolk VA
Higgins Armory Museum, Worcester MA
Hillwood Museum & Gardens Foundation, Hillwood Museum & Gardens, Washington DC
Hispanic Society of America, Museum & Library, New York NY
Historic Arkansas Museum, Little Rock AR
Historic Bethlehem Partnership, Kemerer Museum of Decorative Arts, Bethlehem PA
Historic Landmarks Foundation of Indiana, Morris-Butler House, Indianapolis IN
Huguenot Historical Society of New Paltz Galleries, New Paltz NY
The Huntington Library, Art Collections & Botanical Gardens, San Marino CA
Huntington Museum of Art, Huntington WV
Imperial Calcasieu Museum, Gibson-Barham Gallery, Lake Charles LA
Institute of American Indian Arts Museum, Museum, Santa Fe NM
Iredell Museum of Arts & Heritage, Statesville NC

Jacksonville University, Alexander Brest Museum & Gallery, Jacksonville FL
James Dick Foundation, Festival - Institute, Round Top TX
The Jewish Museum, New York NY
Johns Hopkins University, Evergreen House, Baltimore MD
Kereszteny Muzeum, Christian Museum, Esztergom
Kirkland Museum of Fine & Decorative Art, Denver CO
Koshare Indian Museum, Inc, La Junta CO
Kunstindustrimuseet, The Danish Museum of Art & Design, Copenhagen
Lac du Flambeau Band of Lake Superior Chippewa Indians, George W Brown Jr Ojibwe Museum & Cultural Center, Lac du Flambeau WI
Lahore Museum, Lahore
LeSueur County Historical Society, Chapter One, Elysian MN
Los Angeles County Museum of Natural History, William S Hart Museum, Newhall CA
Luther College, Fine Arts Collection, Decorah IA
Judah L Magnes, Berkeley CA
Jacques Marchais, Staten Island NY
Marquette University, Haggerty Museum of Art, Milwaukee WI
McDowell House & Apothecary Shop, Danville KY
Meredith College, Frankie G Weems Gallery & Rotunda Gallery, Raleigh NC
Mingei International, Inc, Mingei International Museum, San Diego CA
Mississippi River Museum at Mud-Island River Park, Memphis TN
Arthur Roy Mitchell, Museum of Western Art, Trinidad CO
Montreal Museum of Fine Arts, Montreal PQ
Morris Museum, Morristown NJ
Municipal Museum De Lakenhal, Stedelisk Museum De Lakenhal, Leiden
Munson-Williams-Proctor Arts Institute, Museum of Art, Utica NY
Muscatine Art Center, Museum, Muscatine IA
Musee Guimet, Paris
Musei Capitolini, Rome
The Museum, Greenwood SC
Muttart Public Art Gallery, Calgary AB
Muzej za Umjetnost i Obrt, Museum of Arts & Crafts, Zagreb
Nelson-Atkins Museum of Art, Kansas City MO
Nemours Mansion & Gardens, Wilmington DE
New Jersey State Museum, Fine Art Bureau, Trenton NJ
New Visions Gallery, Inc, Marshfield WI
Nichols House Museum, Inc, Boston MA
North Carolina State University, Visual Arts Center, Raleigh NC
The Old Jail Art Center, Albany TX
Panhandle-Plains Historical Society Museum, Canyon TX
Pasadena Historical Museum, Pasadena CA
Plumas County Museum, Quincy CA
Polk Museum of Art, Lakeland FL
Port Huron Museum, Port Huron MI
Portland Art Museum, Portland OR
Putnam Museum of History and Natural Science, Davenport IA
Queens College, City University of New York, Godwin-Ternbach Museum, Flushing NY
Riverside Municipal Museum, Riverside CA
The Rosenbach Museum & Library, Philadelphia PA
Ross Memorial Museum, Saint Andrews NB
Saginaw Art Museum, Saginaw MI
Salisbury House Foundation, Des Moines IA
The Slater Memorial Museum, Slater Memorial Museum, Norwich CT
Abigail Adams Smith, New York NY
Society of the Cincinnati, Museum & Library at Anderson House, Washington DC
South Carolina Artisans Center, Walterboro SC
South Dakota State University, South Dakota Art Museum, Brookings SD
Southern Illinois University Carbondale, University Museum, Carbondale IL
Springfield Museums Association, George Walter Vincent Smith Art Museum, Springfield MA
Nelda C & H J Lutcher Stark, Stark Museum of Art, Orange TX
State University of New York at Binghamton, University Art Museum, Binghamton NY
Summit County Historical Society, Akron OH

Swedish-American Museum Association of Chicago, Chicago IL
Taos, Ernest Blumenschein Home & Studio, Taos NM
The Textile Museum, Washington DC
Textile Museum of Canada, Toronto ON
Topeka & Shawnee County Public Library, Alice C Sabatini Gallery, Topeka KS
Tryon Palace Historic Sites & Gardens, New Bern NC
United Society of Shakers, Shaker Museum, New Glocester ME
US Department of State, Diplomatic Reception Rooms, Washington DC
University of Kansas, Spencer Museum of Art, Lawrence KS
University of Pennsylvania, Arthur Ross Gallery, Philadelphia PA
University of Toronto, University of Toronto Art Centre, Toronto ON
Vesterheim Norwegian-American Museum, Decorah IA
Victoria Mansion - Morse Libby House, Portland ME
Vizcaya Museum & Gardens, Miami FL
George Washington, Alexandria VA
Willard House & Clock Museum, Inc, North Grafton MA
Wisconsin Historical Society, State Historical Museum, Madison WI
Woodlawn/The Pope-Leighey, Mount Vernon VA
Woodmere Art Museum, Philadelphia PA
Zamek Krolewski w Warszawie Pomnik Historii i Kultry Narodwej, Royal Castle in Warsaw, National History & Culture Memorial, Warsaw

CARTOONS

American Kennel Club, Museum of the Dog, Saint Louis MO
American Museum of Cartoon Art, Inc, Santa Monica CA
American Museum of the Moving Image, Astoria NY
Art & Culture Center of Hollywood, Art Gallery, Hollywood FL
Art Without Walls Inc, Art Without Walls Inc, Sayville NY
ArtSpace-Lima, Lima OH
Barker Character, Comic and Cartoon Museum, Cheshire CT
Beck Cultural Exchange Center, Inc, Knoxville TN
Brigham Young University, Museum of Art, Provo UT
California State University, Northridge, Art Galleries, Northridge CA
Cartoon Art Museum, San Francisco CA
Central United Methodist Church, Swords Into Plowshares Peace Center & Gallery, Detroit MI
City of El Paso Museum and Cultural Affairs, People's Gallery, El Paso TX
Cooper-Hewitt, National Design Museum, Smithsonian Institution, New York NY
Coutts Memorial Museum of Art, Inc, El Dorado KS
Denison University, Art Gallery, Granville OH
Erie Art Museum, Erie PA
Fort George G Meade Museum, Fort Meade MD
Hartwick College, Foreman Gallery, Oneonta NY
Hartwick College, The Yager Museum, Oneonta NY
Headquarters Fort Monroe, Dept of Army, Casemate Museum, Fort Monroe VA
Hoyt Institute of Fine Arts, New Castle PA
The Jewish Museum, New York NY
Kansas State Historical Society, Kansas Museum of History, Topeka KS
Kelly-Griggs House Museum, Red Bluff CA
Lafayette College, Williams Center Gallery, Easton PA
Marylhurst University, The Art Gym, Marylhurst OR
McCord Museum of Canadian History, Montreal PQ
Museum of the City of New York, New York NY
Muzeum Narodowe W Kielcach, National Museum in Kielce, Kielce
National Art Museum of Sport, Indianapolis IN
The National Park Service, United States Department of the Interior, Statue of Liberty National Monument & The Ellis Island Immigration Museum, New York NY
Naval Historical Center, The Navy Museum, Washington DC
Panhandle-Plains Historical Society Museum, Canyon TX
George Phippen, Phippen Art Museum, Prescott AZ
Port Huron Museum, Port Huron MI
Prairie Art Gallery, Grande Prairie AB
Queens College, City University of New York, Godwin-Ternbach Museum, Flushing NY

Rollins College, George D & Harriet W Cornell Fine
 Arts Museum, Winter Park FL
C M Russell, Great Falls MT
School of Visual Arts, Visual Arts Museum, New York
 NY
Sonoma State University, University Art Gallery,
 Rohnert Park CA
Syracuse University, Art Collection, Syracuse NY
Syracuse University, SUArt Galleries, Syracuse NY
United States Military Academy, West Point Museum,
 West Point NY
United States Navy, Art Gallery, Washington DC
Wisconsin Historical Society, State Historical Museum,
 Madison WI

CERAMICS

Academy of the New Church, Glencairn Museum, Bryn
 Athyn PA
Adams National Historic Park, Quincy MA
Agecroft Association, Museum, Richmond VA
Albany Institute of History & Art, Albany NY
Albion College, Bobbitt Visual Arts Center, Albion MI
Albuquerque Museum of Art & History, Albuquerque
 NM
Allentown Art Museum, Allentown PA
Charles Allis, Milwaukee WI
American Kennel Club, Museum of the Dog, Saint
 Louis MO
American Swedish Institute, Minneapolis MN
Arab American National Museum, Dearborn MI
Arizona State University, ASU Art Museum, Tempe AZ
Arnot Art Museum, Elmira NY
Art & Culture Center of Hollywood, Art Gallery,
 Hollywood FL
Art Community Center, Art Center of Corpus Christi,
 Corpus Christi TX
Art Gallery of Nova Scotia, Halifax NS
Art Gallery of South Australia, Adelaide
Art Museum of Greater Lafayette, Lafayette IN
ArtSpace-Lima, Lima OH
Asbury College, Student Center Gallery, Wilmore KY
Asheville Art Museum, Asheville NC
Asian Art Museum of San Francisco, Chong-Moon Lee
 Ctr for Asian Art and Culture, San Francisco CA
Association for the Preservation of Virginia Antiquities,
 John Marshall House, Richmond VA
Athens Byzantine & Christian Museum, Athens
Atlanta International Museum of Art & Design, Atlanta
 GA
Augustana College, Augustana College Art Museum,
 Rock Island IL
Baldwin Historical Society Museum, Baldwin NY
Ball State University, Museum of Art, Muncie IN
The Baltimore Museum of Art, Baltimore MD
Barnes Foundation, Merion PA
Bass Museum of Art, Miami Beach FL
Bemis Center for Contemporary Arts, Omaha NE
Berea College, Doris Ulmann Galleries, Berea KY
Berkshire Museum, Pittsfield MA
Berman Museum, Anniston AL
Jesse Besser, Alpena MI
Bethany College, Mingenback Art Center, Lindsborg
 KS
Biggs Museum of American Art, Dover DE
Birger Sandzen Memorial Gallery, Lindsborg KS
BJU Museum & Gallery, Bob Jones University
 Museum & Gallery Inc, Greenville SC
Blanden Memorial Art Museum, Fort Dodge IA
Brandeis University, Rose Art Museum, Waltham MA
Brigham City Corporation, Brigham City Museum &
 Gallery, Brigham City UT
Brigham Young University, Museum of Art, Provo UT
Bradford Brinton, Big Horn WY
Burke Arts Council, Jailhouse Galleries, Morganton NC
Butler Institute of American Art, Art Museum,
 Youngstown OH
California State University, Northridge, Art Galleries,
 Northridge CA
Calvin College, Center Art Gallery, Grand Rapids MI
Cameron Art Museum, Wilmington NC
The Canadian Craft Museum, Vancouver BC
Canadian Museum of Civilization, Gatineau PQ
Canadian Museum of Nature, Musee Canadien de la
 Nature, Ottawa ON
Cape Cod Museum of Art Inc, Dennis MA
Caramoor Center for Music & the Arts, Inc, Caramoor
 House Museum, Katonah NY
Central United Methodist Church, Swords Into
 Plowshares Peace Center & Gallery, Detroit MI

Charleston Museum, Charleston SC
Chattahoochee Valley Art Museum, LaGrange GA
Chinese Culture Institute of the International Society,
 Tremont Theatre & Gallery, Boston MA
Cincinnati Institute of Fine Arts, Taft Museum of Art,
 Cincinnati OH
Cincinnati Museum Association and Art Academy of
 Cincinnati, Cincinnati Art Museum, Cincinnati OH
City of Austin Parks & Recreation, O Henry Museum,
 Austin TX
City of Grand Rapids Michigan, Public Museum of
 Grand Rapids, Grand Rapids MI
Clay Studio, Philadelphia PA
Cleveland Museum of Art, Cleveland OH
College of Saint Benedict, Art Gallery, Saint Joseph
 MN
College of William & Mary, Muscarelle Museum of
 Art, Williamsburg VA
The College of Wooster, The College of Wooster Art
 Museum, Wooster OH
Colorado Historical Society, Colorado History Museum,
 Denver CO
Colorado Springs Fine Arts Center, Colorado Springs
 CO
Columbus Museum, Columbus GA
Columbus Museum of Art, Columbus OH
Columbus Museum of Art and Design, Indianapolis IN
Concord Museum, Concord MA
Concordia University, Marx Hausen Art Gallery,
 Seward NE
Cooper-Hewitt, National Design Museum, Smithsonian
 Institution, New York NY
Cornwall Gallery Society, Cornwall Regional Art
 Gallery, Cornwall ON
County of Henrico, Meadow Farm Museum, Glen
 Allen VA
Coutts Memorial Museum of Art, Inc, El Dorado KS
Craft and Folk Art Museum (CAFAM), Los Angeles
 CA
Craigdarroch Castle Historical Museum Society,
 Victoria BC
Cranbrook Art Museum, Cranbrook Art Museum,
 Bloomfield Hills MI
Creighton University, Lied Art Gallery, Omaha NE
The Currier Museum of Art, Currier Museum of Art,
 Manchester NH
Dallas Museum of Art, Dallas TX
Danforth Museum Corporation, Danforth Museum of
 Art, Framingham MA
DAR Museum, National Society Daughters of the
 American Revolution, Washington DC
Dartmouth Heritage Museum, Dartmouth NS
Delaware Archaeology Museum, Dover DE
Delaware Division of Historical & Cultural Affairs,
 Dover DE
Denison University, Art Gallery, Granville OH
Detroit Institute of Arts, Detroit MI
Detroit Zoological Institute, Wildlife Interpretive
 Gallery, Royal Oak MI
Dickinson College, The Trout Gallery, Carlisle PA
Dickinson State University, Art Gallery, Dickinson ND
Dixie State College, Robert N & Peggy Sears Gallery,
 Saint George UT
Doncaster Museum and Art Gallery, Doncaster
East Baton Rouge Parks & Recreation Commission,
 Baton Rouge Gallery Inc, Baton Rouge LA
Edgecombe County Cultural Arts Council, Inc,
 Blount-Bridgers House, Hobson Pittman Memorial
 Gallery, Tarboro NC
Ellen Noel Art Museum of the Permian Basin, Odessa
 TX
Elmhurst Art Museum, Elmhurst IL
Emory University, Michael C Carlos Museum, Atlanta
 GA
Eretz-Israel Museum, Museum of Antiquities of
 Tel-Aviv-Jaffa, Tel Aviv
Erie Art Museum, Erie PA
Erie County Historical Society, Erie PA
Wharton Esherick, Paoli PA
Evanston Historical Society, Charles Gates Dawes
 House, Evanston IL
Everson Museum of Art, Syracuse NY
Farmington Village Green & Library Association,
 Stanley-Whitman House, Farmington CT
Ferenczy Muzeum, Szentendre
Fine Arts Center for the New River Valley, Pulaski VA
Fine Arts Museums of San Francisco, Legion of Honor,
 San Francisco CA
Florence Museum of Art, Science & History, Florence
 SC

Fondo del Sol, Visual Art & Media Center, Washington
 DC
Forest Lawn Museum, Glendale CA
Fort Collins Museum of Contemporary Art, Fort
 Collins CO
Friends of Historic Kingston, Fred J Johnston House
 Museum, Kingston NY
Fuller Museum of Art, Brockton MA
Gallery One, Ellensburg WA
George R Gardiner, Toronto ON
General Board of Discipleship, The United Methodist
 Church, The Upper Room Chapel & Museum,
 Nashville TN
Georgian Court College, M Christina Geis Gallery,
 Lakewood NJ
Glanmore National Historic Site of Canada, Belleville
 ON
Gonzaga University, Art Gallery, Spokane WA
Goucher College, Rosenberg Gallery, Baltimore MD
Grand Rapids Art Museum, Grand Rapids MI
Guilford College, Art Gallery, Greensboro NC
Robert Gumbiner, Museum of Latin American Art,
 Long Beach CA
Hancock County Trustees of Public Reservations,
 Woodlawn Museum, Ellsworth ME
Harrison County Historical Museum, Marshall TX
Haystack Mountain School of Crafts, Deer Isle ME
Headley-Whitney Museum, Lexington KY
Headquarters Fort Monroe, Dept of Army, Casemate
 Museum, Fort Monroe VA
Heard Museum, Phoenix AZ
Hebrew Union College, Jewish Institute of Religion
 Museum, New York NY
Henry Sheldon Museum of Vermont History and
 Research Center, Middlebury VT
Heritage Malta, National Museum of Fine Arts, Valletta
Hermitage Foundation Museum, Norfolk VA
Hershey Museum, Hershey PA
Higgins Armory Museum, Worcester MA
Hillwood Museum & Gardens Foundation, Hillwood
 Museum & Gardens, Washington DC
Hispanic Society of America, Museum & Library, New
 York NY
Historic Arkansas Museum, Little Rock AR
Historic Bethlehem Partnership, Kemerer Museum of
 Decorative Arts, Bethlehem PA
Historic Cherry Hill, Albany NY
Historic Deerfield, Deerfield MA
Historic Landmarks Foundation of Indiana,
 Morris-Butler House, Indianapolis IN
Historical Society of Bloomfield, Bloomfield NJ
Historical Society of Cheshire County, Keene NH
Historisches und Volkerkundemuseum, Historical
 Museum, Sankt Gallen
Holter Museum of Art, Helena MT
Honolulu Academy of Arts, Honolulu HI
Hoyt Institute of Fine Arts, New Castle PA
Huguenot Historical Society of New Paltz Galleries,
 New Paltz NY
Hui No eau Visual Arts Center, Gallery and Gift Shop,
 Makawao Maui HI
The Huntington Library, Art Collections & Botanical
 Gardens, San Marino CA
Huntington Museum of Art, Huntington WV
Huronia Museum, Gallery of Historic Huronia, Midland
 ON
Hyde Park Art Center, Chicago IL
Illinois State University, University Galleries, Normal
 IL
Imperial Calcasieu Museum, Gibson-Barham Gallery,
 Lake Charles LA
Indiana State Museum, Indianapolis IN
Institute of American Indian Arts Museum, Museum,
 Santa Fe NM
Institute of Puerto Rican Culture, Museo Fuerte Conde
 de Mirasol, Vieques PR
The Interchurch Center, Galleries at the Interchurch
 Center, New York NY
Iowa State University, Brunnier Art Museum, Ames IA
Iredell Museum of Arts & Heritage, Statesville NC
James Dick Foundation, Festival - Institute, Round Top
 TX
Jersey City Museum, Jersey City NJ
The Jewish Museum, New York NY
Johns Hopkins University, Evergreen House, Baltimore
 MD
Johns Hopkins University, Homewood House Museum,
 Baltimore MD
Joslyn Art Museum, Omaha NE
Kalamazoo Institute of Arts, Kalamazoo MI
Kansas City Art Institute, Kansas City MO

Kelly-Griggs House Museum, Red Bluff CA
Kelowna Museum, Kelowna BC
Kentucky Museum of Art & Craft, Louisville KY
Kereszteny Muzeum, Christian Museum, Esztergom
Kings County Historical Society & Museum, Hampton NB
Kirkland Museum of Fine & Decorative Art, Denver CO
Knights of Columbus Supreme Council, Knights of Columbus Museum, New Haven CT
Kunstindustrimuseet, The Danish Museum of Art & Design, Copenhagen
Kyiv Museum of Russian Art, Kyiv
Lafayette College, Williams Center Gallery, Easton PA
Lahore Museum, Lahore
LeMoyne Art Foundation, Inc, Tallahassee FL
LeSueur County Historical Society, Chapter One, Elysian MN
Lightner Museum, Saint Augustine FL
Lincoln County Historical Association, Inc, 1811 Old Lincoln County Jail & Lincoln County Museum, Wiscasset ME
Long Beach Museum of Art Foundation, Long Beach CA
The Long Island Museum of American Art, History & Carriages, Stony Brook NY
Longfellow-Evangeline State Commemorative Area, Saint Martinville LA
Longue Vue House & Gardens, New Orleans LA
Longview Museum of Fine Art, Longview TX
Loyola Marymount University, Laband Art Gallery, Los Angeles CA
Luther College, Fine Arts Collection, Decorah IA
Macalester College, Macalester College Art Gallery, Saint Paul MN
Charles H MacNider, Mason City IA
Judah L Magnes, Berkeley CA
Maine Historical Society, Wadsworth-Longfellow House, Portland ME
The Mariners' Museum, Newport News VA
Maryland Art Place, Baltimore MD
Marylhurst University, The Art Gym, Marylhurst OR
Mattatuck Historical Society, Mattatuck Museum, Waterbury CT
Maude Kerns Art Center, Eugene OR
McCord Museum of Canadian History, Montreal PQ
Mennello Museum of American Art, Orlando FL
Mercer County Community College, The Gallery, West Windsor NJ
Meredith College, Frankie G Weems Gallery & Rotunda Gallery, Raleigh NC
Mexican Museum, San Francisco CA
Michigan State University, Kresge Art Museum, East Lansing MI
Midwest Museum of American Art, Elkhart IN
Mingei International, Inc, Mingei International Museum, San Diego CA
Ministry of Culture, The Delphi Museum, I Ephorate of Prehistoric & Classical Antiquities, Delphi
Minnesota Museum of American Art, Saint Paul MN
Mint Museum of Art, Mint Museum of Craft & Design, Charlotte NC
Mint Museum of Art, Charlotte NC
Mississippi Department of Archives & History, Old Capitol Museum of Mississippi History, Jackson MS
Missoula Art Museum, Missoula MT
Arthur Roy Mitchell, Museum of Western Art, Trinidad CO
Mobile Museum of Art, Mobile AL
Modern Art Museum, Fort Worth TX
James Monroe, Fredericksburg VA
Montreal Museum of Fine Arts, Montreal PQ
Moore College of Art & Design, The Galleries at Moore, Philadelphia PA
Moravska Galerie v Brne, Moravian Gallery in Brno, Brno
Morris Museum, Morristown NJ
Morris-Jumel Mansion, Inc, New York NY
Mount Saint Vincent University, Art Gallery, Halifax NS
Municipal Museum De Lakenhal, Stedelisk Museum De Lakenhal, Leiden
Muscatine Art Center, Museum, Muscatine IA
Musee Carnavalet-Histoir de Paris, Paris
Musee d'Art de Saint-Laurent, Saint-Laurent PQ
Musee Guimet, Paris
Musee Regional de la Cote-Nord, Sept-Iles PQ
Musei Capitolini, Rome
The Museum, Greenwood SC
The Museum at Drexel University, Philadelphia PA

Museum for African Art, Long Island City NY
Museum of Art & History, Santa Cruz, Santa Cruz CA
Museum of Art, Fort Lauderdale, Fort Lauderdale FL
Museum of Contemporary Art, North Miami FL
Museum of Mobile, Mobile AL
Museum of New Mexico, Museum of Fine Arts, Unit of NM Dept of Cultural Affairs, Santa Fe NM
Museum of Northern Arizona, Flagstaff AZ
Museum of the City of New York, New York NY
Museum of York County, Rock Hill SC
Muttart Public Art Gallery, Calgary AB
Muzej za Umjetnost i Obrt, Museum of Arts & Crafts, Zagreb
Muzeum Narodowe, National Museum, Poznan
Muzeum Narodowe W Kielcach, National Museum in Kielce, Kielce
National Museum of Ceramic Art & Glass, Baltimore MD
National Museum of the American Indian, George Gustav Heye Center, New York NY
National Museum of Women in the Arts, Washington DC
National Museum, Monuments and Art Gallery, Gaborone
National Palace Museum, Taipei
The National Park Service, United States Department of the Interior, Statue of Liberty National Monument & The Ellis Island Immigration Museum, New York NY
National Society of Colonial Dames of America in the State of Maryland, Mount Clare Museum House, Baltimore MD
National Society of the Colonial Dames of America in The Commonwealth of Virginia, Wilton House Museum, Richmond VA
Naval Historical Center, The Navy Museum, Washington DC
Nelson-Atkins Museum of Art, Kansas City MO
Nemours Mansion & Gardens, Wilmington DE
Nevada Museum of Art, Reno NV
New Jersey State Museum, Fine Art Bureau, Trenton NJ
New Mexico State University, Art Gallery, Las Cruces NM
New Visions Gallery, Inc, Marshfield WI
New World Art Center, T F Chen Cultural Center, New York NY
New York State Historical Association, Fenimore Art Museum, Cooperstown NY
Newton History Museum at the Jackson Homestead, Newton MA
North Carolina State University, Visual Arts Center, Raleigh NC
North Central Washington Museum, Wenatchee Valley Museum & Cultural Center, Wenatchee WA
North Dakota State University, Memorial Union Gallery, Fargo ND
Nova Scotia College of Art and Design, Anna Leonowens Gallery, Halifax NS
Noyes Art Gallery, Lincoln NE
Oglebay Institute, Mansion Museum, Wheeling WV
Ohio Historical Society, National Road-Zane Grey Museum, Columbus OH
Olana State Historic Site, Hudson NY
The Old Jail Art Center, Albany TX
Orange County Museum of Art, Orange County Museum of Art, Newport Beach CA
Owensboro Museum of Fine Art, Owensboro KY
Pacific - Asia Museum, Pasadena CA
Palm Springs Art Museum, Palm Springs CA
Panhandle-Plains Historical Society Museum, Canyon TX
Paris Gibson Square, Museum of Art, Great Falls MT
Pasadena Historical Museum, Pasadena CA
Peabody Essex Museum, Salem MA
The Pennsylvania State University, Palmer Museum of Art, University Park PA
Pewabic Society Inc, Pewabic Pottery, Detroit MI
Philbrook Museum of Art, Tulsa OK
Phillips County Museum, Holyoke CO
George Phippen, Phippen Art Museum, Prescott AZ
Pinacoteca Provinciale, Bari
Plumas County Museum, Quincy CA
Porter Thermometer Museum, Onset MA
Portland Art Museum, Portland OR
Portsmouth Historical Society, John Paul Jones House, Portsmouth NH
Princeton University, Princeton University Art Museum, Princeton NJ
Principia College, School of Nations Museum, Elsah IL
Purdue University Galleries, West Lafayette IN

Putnam Museum of History and Natural Science, Davenport IA
Queens College, City University of New York, Godwin-Ternbach Museum, Flushing NY
Randall Junior Museum, San Francisco CA
Randolph-Macon Woman's College, Maier Museum of Art, Lynchburg VA
Millicent Rogers, Taos NM
Rollins College, George D & Harriet W Cornell Fine Arts Museum, Winter Park FL
Ross Memorial Museum, Saint Andrews NB
Roswell Museum & Art Center, Roswell NM
Royal Arts Foundation, Belcourt Castle, Newport RI
Saco Museum, Saco ME
Saginaw Art Museum, Saginaw MI
Saint Bonaventure University, Regina A Quick Center for the Arts, Saint Bonaventure NY
Saint Peter's College, Art Gallery, Jersey City NJ
The Sandwich Historical Society, Inc, Sandwich Glass Museum, Sandwich MA
Santa Clara University, de Saisset Museum, Santa Clara CA
Santa Monica Museum of Art, Santa Monica CA
Seneca-Iroquois National Museum, Salamanca NY
Shelburne Museum, Museum, Shelburne VT
Shirley Plantation, Charles City VA
The Slater Memorial Museum, Slater Memorial Museum, Norwich CT
Abigail Adams Smith, New York NY
Smithsonian Institution, Freer Gallery of Art, Washington DC
Smithsonian Institution, Arthur M Sackler Gallery, Washington DC
Smithsonian Institution, Washington DC
The Society for Contemporary Crafts, Pittsburgh PA
Society of the Cincinnati, Museum & Library at Anderson House, Washington DC
Sonoma State University, University Art Gallery, Rohnert Park CA
South Carolina Artisans Center, Walterboro SC
South Dakota State University, South Dakota Art Museum, Brookings SD
Southeastern Center for Contemporary Art, Winston-Salem NC
Southern Illinois University Carbondale, University Museum, Carbondale IL
Spartanburg County Museum of Art, Spartanburg SC
Spertus Institute of Jewish Studies, Spertus Museum, Chicago IL
Springfield Art Museum, Springfield MO
Springfield Museums Association, George Walter Vincent Smith Art Museum, Springfield MA
State University of New York at Binghamton, University Art Museum, Binghamton NY
State University of New York at Geneseo, Bertha V B Lederer Gallery, Geneseo NY
State University of New York at New Paltz, Samuel Dorsky Museum of Art, New Paltz NY
State University of New York College at Cortland, Dowd Fine Arts Gallery, Cortland NY
Staten Island Institute of Arts & Sciences, Staten Island NY
Stetson University, Duncan Gallery of Art, Deland FL
Stratford Historical Society, Catharine B Mitchell Museum, Stratford CT
Summit County Historical Society, Akron OH
Swedish-American Museum Association of Chicago, Chicago IL
Switzerland County Historical Society Inc, Switzerland County Historical Museum, Vevay IN
Syracuse University, Art Collection, Syracuse NY
Syracuse University, SUArt Galleries, Syracuse NY
Tampa Museum of Art, Tampa FL
Taos, Ernest Blumenschein Home & Studio, Taos NM
Texas Tech University, Museum of Texas Tech University, Lubbock TX
Thomas More College, TM Gallery, Crestview KY
Tokyo National University of Fine Arts & Music Art, University Art Museum, Tokyo
Topeka & Shawnee County Public Library, Alice C Sabatini Gallery, Topeka KS
Towson University Center for the Arts Gallery, Asian Arts & Culture Center, Towson MD
Trenton City Museum, Trenton NJ
Triton Museum of Art, Santa Clara CA
Tryon Palace Historic Sites & Gardens, New Bern NC
Tubac Center of the Arts, Tubac AZ
Mark Twain, Hartford CT
The Ukrainian Museum, New York NY
UMLAUF Sculpture Garden & Museum, Austin TX

COINS & MEDALS

United Society of Shakers, Shaker Museum, New Glocester ME
US Coast Guard Museum, New London CT
United States Figure Skating Association, World Figure Skating Museum & Hall of Fame, Colorado Springs CO
United States Naval Academy, USNA Museum, Annapolis MD
University of Akron, University Art Galleries, Akron OH
University of Alabama at Birmingham, Visual Arts Gallery, Birmingham AL
University of British Columbia, Museum of Anthropology, Vancouver BC
University of California, Richard L Nelson Gallery & Fine Arts Collection, Davis CA
University of Chicago, Oriental Institute Museum, Chicago IL
University of Colorado, CU Art Galleries, Boulder CO
University of Illinois, Krannert Art Museum and Kinkead Pavillion, Champaign IL
University of Illinois, Spurlock Museum, Champaign IL
University of Iowa, Museum of Art, Iowa City IA
University of Louisiana at Lafayette, University Art Museum, Lafayette LA
University of Manitoba, Faculty of Architecture Exhibition Centre, Winnipeg MB
University of Minnesota, Katherine E Nash Gallery, Minneapolis MN
University of Montana, Paxson Gallery, Missoula MT
University of Nebraska, Lincoln, Sheldon Memorial Art Gallery & Sculpture Garden, Lincoln NE
University of Nevada, Reno, Sheppard Fine Arts Gallery, Reno NV
University of New Mexico, The Harwood Museum of Art, Taos NM
University of North Carolina at Chapel Hill, Ackland Art Museum, Chapel Hill NC
University of North Dakota, Hughes Fine Arts Center-Col Eugene Myers Art Gallery, Grand Forks ND
University of Texas Pan American, Charles & Dorothy Clark Gallery; University Gallery, Edinburg TX
University of Texas Pan American, UTPA Art Galleries, Edinburg TX
University of Toronto, University of Toronto Art Centre, Toronto ON
University of Victoria, Maltwood Art Museum and Gallery, Victoria BC
USS Constitution Museum, Boston MA
Utah State University, Nora Eccles Harrison Museum of Art, Logan UT
Vancouver Museum, Vancouver BC
Vassar College, The Frances Lehman Loeb Art Center, Poughkeepsie NY
Very Special Arts New Mexico, Very Special Arts Gallery, Albuquerque NM
Vizcaya Museum & Gardens, Miami FL
Wade House & Wesley W Jung Carriage Museum, Historic House & Carriage Museum, Greenbush WI
Wadsworth Atheneum Museum of Art, Hartford CT
Wallace Collection, London
Warner House Association, MacPheadris-Warner House, Portsmouth NH
Washburn University, Mulvane Art Museum, Topeka KS
Washington University, Mildred Lane Kemper Art Museum, Saint Louis MO
Waterworks Visual Arts Center, Salisbury NC
Wayne Center for the Arts, Wooster OH
Wayne County Historical Society, Honesdale PA
West Florida Historic Preservation, Inc, T T Wentworth, Jr Florida State Museum & Historic Pensacola Village, Pensacola FL
Western Illinois University, Western Illinos University Art Gallery, Macomb IL
Wheaton College, Watson Gallery, Norton MA
Wheelwright Museum of the American Indian, Santa Fe NM
Wiregrass Museum of Art, Dothan AL
Wisconsin Historical Society, State Historical Museum, Madison WI
Woodlawn/The Pope-Leighey, Mount Vernon VA
Woodmere Art Museum, Philadelphia PA
Worcester Art Museum, Worcester MA
Xavier University, Art Gallery, Cincinnati OH
Zamek Krolewski w Warszawie Pomnik Historii i Kultry Narodwej, Royal Castle in Warsaw, National History & Culture Memorial, Warsaw

Academy of the New Church, Glencairn Museum, Bryn Athyn PA
Adams County Historical Society, Gettysburg PA
African American Museum in Philadelphia, Philadelphia PA
Albuquerque Museum of Art & History, Albuquerque NM
Alton Museum of History & Art, Inc, Alton IL
American Swedish Historical Foundation & Museum, Philadelphia PA
Art & Culture Center of Hollywood, Art Gallery, Hollywood FL
ArtSpace-Lima, Lima OH
Athens Byzantine & Christian Museum, Athens
Ball State University, Museum of Art, Muncie IN
Balzekas Museum of Lithuanian Culture, Chicago IL
Berea College, Doris Ulmann Galleries, Berea KY
Berkshire Museum, Pittsfield MA
BJU Museum & Gallery, Bob Jones University Museum & Gallery Inc, Greenville SC
Bronx Community College (CUNY), Hall of Fame for Great Americans, Bronx NY
Brookgreen Gardens, Murrells Inlet SC
Cambridge Museum, Cambridge NE
Canadian Museum of Civilization, Gatineau PQ
Cape Ann Historical Association, Gloucester MA
Cincinnati Museum Association and Art Academy of Cincinnati, Cincinnati Art Museum, Cincinnati OH
City of Grand Rapids Michigan, Public Museum of Grand Rapids, Grand Rapids MI
Clark County Historical Society, Pioneer - Krier Museum, Ashland KS
College of William & Mary, Muscarelle Museum of Art, Williamsburg VA
The College of Wooster, The College of Wooster Art Museum, Wooster OH
Colorado Historical Society, Colorado History Museum, Denver CO
Concordia Historical Institute, Saint Louis MO
Cornell University, Herbert F Johnson Museum of Art, Ithaca NY
Craft and Folk Art Museum (CAFAM), Los Angeles CA
Dallas Museum of Art, Dallas TX
DAR Museum, National Society Daughters of the American Revolution, Washington DC
Dawson City Museum & Historical Society, Dawson City YT
Department of Community Development, Provincial Museum of Alberta, Edmonton AB
Detroit Institute of Arts, Detroit MI
Doncaster Museum and Art Gallery, Doncaster
Dundurn Castle, Hamilton ON
Eretz-Israel Museum, Museum of Antiquities of Tel-Aviv-Jaffa, Tel Aviv
Fairbanks Museum & Planetarium, Saint Johnsbury VT
Farmington Village Green & Library Association, Stanley-Whitman House, Farmington CT
Florida State University, John & Mable Ringling Museum of Art, Sarasota FL
Forest Lawn Museum, Glendale CA
Franklin Mint Museum, Franklin Center PA
Frontier Times Museum, Bandera TX
General Board of Discipleship, The United Methodist Church, The Upper Room Chapel & Museum, Nashville TN
Germanisches Nationalmuseum, Nuremberg
Glanmore National Historic Site of Canada, Belleville ON
Grand Rapids Art Museum, Grand Rapids MI
Guilford College, Art Gallery, Greensboro NC
Harvard University, Semitic Museum, Cambridge MA
Hastings Museum of Natural & Cultural History, Hastings NE
Headquarters Fort Monroe, Dept of Army, Casemate Museum, Fort Monroe VA
Hebrew Union College, Skirball Cultural Center, Los Angeles CA
Heritage Museum & Cultural Center, Baker LA
Hermitage Foundation Museum, Norfolk VA
Hillwood Museum & Gardens Foundation, Hillwood Museum & Gardens, Washington DC
Hispanic Society of America, Museum & Library, New York NY
Huguenot Historical Society of New Paltz Galleries, New Paltz NY
Huntington Museum of Art, Huntington WV
Huronia Museum, Gallery of Historic Huronia, Midland ON

Imperial Calcasieu Museum, Gibson-Barham Gallery, Lake Charles LA
Institute of Puerto Rican Culture, Museo Fuerte Conde de Mirasol, Vieques PR
Iroquois County Historical Society Museum, Old Courthouse Museum, Watseka IL
Iroquois Indian Museum, Howes Cave NY
Jacksonville University, Alexander Brest Museum & Gallery, Jacksonville FL
James Dick Foundation, Festival - Institute, Round Top TX
Jersey City Museum, Jersey City NJ
The Jewish Museum, New York NY
Kings County Historical Society & Museum, Hampton NB
Knights of Columbus Supreme Council, Knights of Columbus Museum, New Haven CT
Koochiching Museums, International Falls MN
Kyiv Museum of Russian Art, Kyiv
Lahore Museum, Lahore
Lehigh University Art Galleries, Museum Operation, Bethlehem PA
Liberty Memorial Museum & Archives, The National Museum of World War I, Kansas City MO
The Long Island Museum of American Art, History & Carriages, Stony Brook NY
Longfellow-Evangeline State Commemorative Area, Saint Martinville LA
Judah L Magnes, Berkeley CA
The Mariners' Museum, Newport News VA
Maryhill Museum of Art, Goldendale WA
Mattatuck Historical Society, Mattatuck Museum, Waterbury CT
McDowell House & Apothecary Shop, Danville KY
McMaster University, McMaster Museum of Art, Hamilton ON
McPherson Museum, McPherson KS
Michigan State University, Kresge Art Museum, East Lansing MI
Middlebury College, Museum of Art, Middlebury VT
Ministry of Culture, The Delphi Museum, I Ephorate of Prehistoric & Classical Antiquities, Delphi
Mississippi Department of Archives & History, Old Capitol Museum of Mississippi History, Jackson MS
Mississippi River Museum at Mud-Island River Park, Memphis TN
Musei Capitolini, Rome
Museu Nacional d'Art de Catalunya, National Art Museum, Barcelona
The Museum, Greenwood SC
Museum of Mobile, Mobile AL
Museum of the City of New York, New York NY
Muzej za Umjetnost i Obrt, Museum of Arts & Crafts, Zagreb
Muzeum Narodowe, National Museum, Poznan
Muzeum Narodowe W Kielcach, National Museum in Kielce, Kielce
Narodna Galerija, National Gallery of Slovenia, Ljubljana
National Museum of the American Indian, George Gustav Heye Center, New York NY
National Museum, Monuments and Art Gallery, Gaborone
The National Park Service, United States Department of the Interior, Statue of Liberty National Monument & The Ellis Island Immigration Museum, New York NY
Naval Historical Center, The Navy Museum, Washington DC
New Jersey Historical Society, Newark NJ
Northern Arizona University, Art Museum & Galleries, Flagstaff AZ
Ohio Historical Society, National Afro American Museum & Cultural Center, Wilberforce OH
Order Sons of Italy in America, Garibaldi & Meucci Museum, Staten Island NY
Pacific - Asia Museum, Pasadena CA
The Pennsylvania State University, Palmer Museum of Art, University Park PA
Plainsman Museum, Aurora NE
Plumas County Museum, Quincy CA
Polish Museum of America, Chicago IL
Portland Art Museum, Portland OR
Putnam Museum of History and Natural Science, Davenport IA
Queens College, City University of New York, Godwin-Ternbach Museum, Flushing NY
Rollins College, George D & Harriet W Cornell Fine Arts Museum, Winter Park FL

Royal Ontario Museum, Dept of Western Art & Culture, Toronto ON
Saco Museum, Saco ME
St Genevieve Museum, Sainte Genevieve MO
Saint Joseph's Oratory, Museum, Montreal PQ
Saint Mary's College of California, Hearst Art Gallery, Moraga CA
Saint Peter's College, Art Gallery, Jersey City NJ
Shirley Plantation, Charles City VA
Smithsonian Institution, Arthur M Sackler Gallery, Washington DC
Society of the Cincinnati, Museum & Library at Anderson House, Washington DC
Spertus Institute of Jewish Studies, Spertus Museum, Chicago IL
Staatliche Munzsammlung, State Coin Collection, Munich
State University of New York at Binghamton, University Art Museum, Binghamton NY
Staten Island Institute of Arts & Sciences, Staten Island NY
Stauth Foundation & Museum, Stauth Memorial Museum, Montezuma KS
Swedish-American Museum Association of Chicago, Chicago IL
Syracuse University, SUArt Galleries, Syracuse NY
Tampa Museum of Art, Tampa FL
The Ukrainian Museum, New York NY
US Coast Guard Museum, New London CT
United States Figure Skating Association, World Figure Skating Museum & Hall of Fame, Colorado Springs CO
United States Military Academy, West Point Museum, West Point NY
University of British Columbia, Museum of Anthropology, Vancouver BC
University of California, Santa Barbara, University Art Museum, Santa Barbara CA
University of Illinois, Spurlock Museum, Champaign IL
University of Louisiana at Lafayette, University Art Museum, Lafayette LA
University of Saskatchewan, Diefenbaker Canada Centre, Saskatoon SK
USS Constitution Museum, Boston MA
Vancouver Museum, Vancouver BC
George Washington, Alexandria VA
Washington University, Mildred Lane Kemper Art Museum, Saint Louis MO
West Florida Historic Preservation, Inc, T T Wentworth, Jr Florida State Museum & Historic Pensacola Village, Pensacola FL
Wheaton College, Watson Gallery, Norton MA
Willard House & Clock Museum, Inc, North Grafton MA
Wisconsin Historical Society, State Historical Museum, Madison WI
Woodlawn/The Pope-Leighey, Mount Vernon VA
Worcester Art Museum, Worcester MA
Yarmouth County Historical Society, Yarmouth County Museum, Yarmouth NS
Zamek Krolewski w Warszawie Pomnik Historii i Kultry Narodwej, Royal Castle in Warsaw, National History & Culture Memorial, Warsaw

COLLAGES

African American Museum in Philadelphia, Philadelphia PA
Albany Institute of History & Art, Albany NY
Albuquerque Museum of Art & History, Albuquerque NM
Art & Culture Center of Hollywood, Art Gallery, Hollywood FL
Art Without Walls Inc, Art Without Walls Inc, Sayville NY
Arts Council of Fayetteville-Cumberland County, The Arts Center, Fayetteville NC
ArtSpace-Lima, Lima OH
Beaumont Art League, Beaumont TX
Roy Boyd, Chicago IL
California State University, Northridge, Art Galleries, Northridge CA
Cameron Art Museum, Wilmington NC
Canadian Museum of Civilization, Gatineau PQ
Chinese Culture Institute of the International Society, Tremont Theatre & Gallery, Boston MA
College of William & Mary, Muscarelle Museum of Art, Williamsburg VA

The College of Wooster, The College of Wooster Art Museum, Wooster OH
Columbus Museum, Columbus GA
Coutts Memorial Museum of Art, Inc, El Dorado KS
Dallas Museum of Art, Dallas TX
DeLeon White Gallery, Toronto ON
Detroit Institute of Arts, Detroit MI
Detroit Repertory Theatre Gallery, Detroit MI
Downey Museum of Art, Downey CA
Ellen Noel Art Museum of the Permian Basin, Odessa TX
Erie Art Museum, Erie PA
Federal Reserve Board, Art Gallery, Washington DC
Fine Arts Center for the New River Valley, Pulaski VA
Florence Museum of Art, Science & History, Florence SC
Gallery One, Ellensburg WA
Grand Rapids Art Museum, Grand Rapids MI
Robert Gumbiner, Museum of Latin American Art, Long Beach CA
Hebrew Union College, Jewish Institute of Religion Museum, New York NY
Hebrew Union College, Skirball Cultural Center, Los Angeles CA
Hickory Museum of Art, Inc, Hickory NC
Hirshhorn Museum & Sculpture Garden, Smithsonian Institution, Washington DC
Huntington Museum of Art, Huntington WV
Illinois State University, University Galleries, Normal IL
The Interchurch Center, Galleries at the Interchurch Center, New York NY
Kansas City Art Institute, Kansas City MO
The Long Island Museum of American Art, History & Carriages, Stony Brook NY
Longview Museum of Fine Art, Longview TX
Judah L Magnes, Berkeley CA
Maitland Art Center, Maitland FL
Maryhill Museum of Art, Goldendale WA
Maryland Art Place, Baltimore MD
Marylhurst University, The Art Gym, Marylhurst OR
Meredith College, Frankie G Weems Gallery & Rotunda Gallery, Raleigh NC
Michigan State University, Kresge Art Museum, East Lansing MI
Midwest Museum of American Art, Elkhart IN
Minnesota Museum of American Art, Saint Paul MN
Mint Museum of Art, Charlotte NC
Missoula Art Museum, Missoula MT
Modern Art Museum, Fort Worth TX
Monroe County Historical Association, Elizabeth D Walters Library, Stroudsburg PA
Morris Museum, Morristown NJ
Museum of Contemporary Art, Chicago IL
Museum of Contemporary Art, North Miami FL
Museum of Northwest Art, La Conner WA
Muttart Public Art Gallery, Calgary AB
Muzeum Narodowe, National Museum, Poznan
Nassau County Museum of Fine Art, Roslyn Harbor NY
National Gallery of Canada, Ottawa ON
New Brunswick Museum, Saint John NB
New Jersey State Museum, Fine Art Bureau, Trenton NJ
Niagara University, Castellani Art Museum, Niagara NY
North Dakota State University, Memorial Union Gallery, Fargo ND
Nova Scotia College of Art and Design, Anna Leonowens Gallery, Halifax NS
Noyes Art Gallery, Lincoln NE
Opelousas Museum of Art, Inc (OMA), Opelousas LA
Owensboro Museum of Fine Art, Owensboro KY
Palm Springs Art Museum, Palm Springs CA
The Pennsylvania State University, Palmer Museum of Art, University Park PA
Princeton University, Princeton University Art Museum, Princeton NJ
PS1 Contemporary Art Center, Long Island City NY
Randolph-Macon Woman's College, Maier Museum of Art, Lynchburg VA
Rollins College, George D & Harriet W Cornell Fine Arts Museum, Winter Park FL
Saginaw Art Museum, Saginaw MI
Saint Peter's College, Art Gallery, Jersey City NJ
San Bernardino County Museum, Fine Arts Institute, Redlands CA
School of Visual Arts, Visual Arts Museum, New York NY
Smithsonian Institution, Arthur M Sackler Gallery, Washington DC

Sonoma State University, University Art Gallery, Rohnert Park CA
South Carolina Artisans Center, Walterboro SC
Southeastern Center for Contemporary Art, Winston-Salem NC
Springfield Art Museum, Springfield MO
State University of New York College at Cortland, Dowd Fine Arts Gallery, Cortland NY
University of Alabama at Birmingham, Visual Arts Gallery, Birmingham AL
University of Illinois, Krannert Art Museum and Kinkead Pavillion, Champaign IL
University of Louisiana at Lafayette, University Art Museum, Lafayette LA
University of New Mexico, University Art Museum, Albuquerque NM
University of North Carolina at Greensboro, Weatherspoon Art Museum, Greensboro NC
University of Rhode Island, Fine Arts Center Galleries, Kingston RI
University of Toronto, University of Toronto Art Centre, Toronto ON
Viridian Artists Inc, New York NY
Washington University, Mildred Lane Kemper Art Museum, Saint Louis MO

CONCEPTUAL ART

Art & Culture Center of Hollywood, Art Gallery, Hollywood FL
Burke Arts Council, Jailhouse Galleries, Morganton NC
eMediaLoft.org, New York NY
Maine College of Art, The Institute of Contemporary Art, Portland ME

COSTUMES

Academy of the New Church, Glencairn Museum, Bryn Athyn PA
Adams County Historical Society, Gettysburg PA
African American Museum in Philadelphia, Philadelphia PA
African Art Museum of Maryland, Columbia MD
Agecroft Association, Museum, Richmond VA
Albany Institute of History & Art, Albany NY
Albuquerque Museum of Art & History, Albuquerque NM
American Museum of the Moving Image, Astoria NY
American Swedish Historical Foundation & Museum, Philadelphia PA
Amherst Museum, Amherst NY
Anchorage Museum at Rasmuson Center, Anchorage AK
Appaloosa Museum and Heritage Center, Moscow ID
Arab American National Museum, Dearborn MI
Arapahoe Community College, Colorado Gallery of the Arts, Littleton CO
Art Without Walls Inc, Art Without Walls Inc, Sayville NY
ArtSpace-Lima, Lima OH
Association for the Preservation of Virginia Antiquities, John Marshall House, Richmond VA
Athens Byzantine & Christian Museum, Athens
Atlanta Historical Society Inc, Atlanta History Center, Atlanta GA
Atlanta International Museum of Art & Design, Atlanta GA
Baldwin Historical Society Museum, Baldwin NY
The Bartlett Museum, Amesbury MA
Berea College, Doris Ulmann Galleries, Berea KY
Berkshire Museum, Pittsfield MA
Jesse Besser, Alpena MI
Brick Store Museum & Library, Kennebunk ME
Bruce Museum, Inc, Bruce Museum, Greenwich CT
Cabot's Old Indian Pueblo Museum, Cabot's Old Indian Pueblo Museum, Desert Hot Springs CA
Cambridge Museum, Cambridge NE
The Canadian Craft Museum, Vancouver BC
Canadian Museum of Civilization, Gatineau PQ
Canton Museum of Art, Canton OH
Caramoor Center for Music & the Arts, Inc, Caramoor House Museum, Katonah NY
Carson County Square House Museum, Panhandle TX
Center for Puppetry Arts, Atlanta GA
Billie Trimble Chandler, Asian Cultures Museum & Educational Center, Corpus Christi TX
Chinese Culture Institute of the International Society, Tremont Theatre & Gallery, Boston MA
Church of Jesus Christ of Latter-Day Saints, Museum of Church History & Art, Salt Lake City UT

Cincinnati Museum Association and Art Academy of Cincinnati, Cincinnati Art Museum, Cincinnati OH

City of Atlanta, Atlanta Cyclorama, Atlanta GA

City of Grand Rapids Michigan, Public Museum of Grand Rapids, Grand Rapids MI

The City of Petersburg Museums, Petersburg VA

Cohasset Historical Society, Cohasset Maritime Museum, Cohasset MA

Cohasset Historical Society, Pratt Building (Society Headquarters), Cohasset MA

Colorado Historical Society, Colorado History Museum, Denver CO

Columbus Museum, Columbus GA

Concord Museum, Concord MA

Concordia Historical Institute, Saint Louis MO

Craft and Folk Art Museum (CAFAM), Los Angeles CA

Cranford Historical Society, Cranford NJ

Crow Wing County Historical Society, Brainerd MN

Culberson County Historical Museum, Van Horn TX

Danville Museum of Fine Arts & History, Danville VA

DAR Museum, National Society Daughters of the American Revolution, Washington DC

Dartmouth Heritage Museum, Dartmouth NS

Detroit Institute of Arts, Detroit MI

DeWitt Historical Society of Tompkins County, The History Center in Tompkins Co, Ithaca NY

Erie County Historical Society, Erie PA

Evanston Historical Society, Charles Gates Dawes House, Evanston IL

Fairbanks Museum & Planetarium, Saint Johnsbury VT

Fall River Historical Society, Fall River MA

Farmington Village Green & Library Association, Stanley-Whitman House, Farmington CT

Fashion Institute of Technology, Museum at FIT, New York NY

Fine Arts Museums of San Francisco, Legion of Honor, San Francisco CA

Fishkill Historical Society, Van Wyck Homestead Museum, Fishkill NY

Edsel & Eleanor Ford, Grosse Pointe Shores MI

Fort George G Meade Museum, Fort Meade MD

Fort Morgan Heritage Foundation, Fort Morgan CO

Fort Ticonderoga Association, Ticonderoga NY

Germantown Historical Society, Philadelphia PA

Grand Rapids Art Museum, Grand Rapids MI

Greene County Historical Society, Bronck Museum, Coxsackie NY

Hammond Museum & Japanese Stroll Garden, Cross-Cultural Center, North Salem NY

Harvard University, Semitic Museum, Cambridge MA

Hebrew Union College, Skirball Cultural Center, Los Angeles CA

Henry County Museum & Cultural Arts Center, Clinton MO

Henry Gallery Association, Henry Art Gallery, Seattle WA

Henry Sheldon Museum of Vermont History and Research Center, Middlebury VT

Heritage Museum & Cultural Center, Baker LA

Hermitage Foundation Museum, Norfolk VA

Hillwood Museum & Gardens Foundation, Hillwood Museum & Gardens, Washington DC

Hispanic Society of America, Museum & Library, New York NY

Historic Arkansas Museum, Little Rock AR

Historic Bethlehem Partnership, Kemerer Museum of Decorative Arts, Bethlehem PA

Historic Cherry Hill, Albany NY

Historic Northampton Museum & Education Center, Northampton MA

Historic Paris - Bourbon County, Inc, Hopewell Museum, Paris KY

Historical Society of Bloomfield, Bloomfield NJ

Historisches und Volkerkundemuseum, Historical Museum, Sankt Gallen

Honolulu Academy of Arts, Honolulu HI

Huguenot Historical Society of New Paltz Galleries, New Paltz NY

Huronia Museum, Gallery of Historic Huronia, Midland ON

Idaho Historical Museum, Boise ID

Imperial Calcasieu Museum, Gibson-Barham Gallery, Lake Charles LA

Indiana State Museum, Indianapolis IN

International Clown Hall of Fame & Research Center, Inc, West Allis WI

Iredell Museum of Arts & Heritage, Statesville NC

Iroquois County Historical Society Museum, Old Courthouse Museum, Watseka IL

Iroquois Indian Museum, Howes Cave NY

James Dick Foundation, Festival - Institute, Round Top TX

Jefferson County Historical Society, Watertown NY

Jefferson County Open Space, Hiwan Homestead Museum, Evergreen CO

Jersey City Museum, Jersey City NJ

Kelly-Griggs House Museum, Red Bluff CA

Kelowna Museum, Kelowna BC

Kentucky Derby Museum, Louisville KY

Kentucky Museum of Art & Craft, Louisville KY

Kern County Museum, Bakersfield CA

Knights of Columbus Supreme Council, Knights of Columbus Museum, New Haven CT

Kunstindustrimuseet, The Danish Museum of Art & Design, Copenhagen

Kurdish Museum, Brooklyn NY

L A County Museum of Art, Los Angeles CA

Lac du Flambeau Band of Lake Superior Chippewa Indians, George W Brown Jr Ojibwe Museum & Cultural Center, Lac du Flambeau WI

Lafayette Museum Association, Lafayette Museum-Alexandre Mouton House, Lafayette LA

Lafayette Natural History Museum & Planetarium, Lafayette LA

Lahore Museum, Lahore

Lehigh County Historical Society, Allentown PA

LeSueur County Historical Society, Chapter One, Elysian MN

Liberty Memorial Museum & Archives, The National Museum of World War I, Kansas City MO

Lightner Museum, Saint Augustine FL

Lincoln County Historical Association, Inc, 1811 Old Lincoln County Jail & Lincoln County Museum, Wiscasset ME

Lockwood-Mathews Mansion Museum, Norwalk CT

The Long Island Museum of American Art, History & Carriages, Stony Brook NY

Los Angeles County Museum of Art, Los Angeles CA

Loveland Museum Gallery, Loveland CO

Judah L Magnes, Berkeley CA

Maine Historical Society, MHS Museum, Portland ME

Maine Historical Society, Wadsworth-Longfellow House, Portland ME

Maricopa County Historical Society, Desert Caballeros Western Museum, Wickenburg AZ

Maryhill Museum of Art, Goldendale WA

Mason County Museum, Maysville KY

Mattatuck Historical Society, Mattatuck Museum, Waterbury CT

McCord Museum of Canadian History, Montreal PQ

McPherson Museum, McPherson KS

Meredith College, Frankie G Weems Gallery & Rotunda Gallery, Raleigh NC

The Metropolitan Museum of Art, New York NY

Mingei International, Inc, Mingei International Museum, San Diego CA

Mint Museum of Art, Charlotte NC

Mississippi Department of Archives & History, Old Capitol Museum of Mississippi History, Jackson MS

Mississippi River Museum at Mud-Island River Park, Memphis TN

Missouri Department of Natural Resources, Missouri State Museum, Jefferson City MO

Montclair Art Museum, Montclair NJ

Moose Jaw Art Museum, Inc, Art & History Museum, Moose Jaw SK

Moravska Galerie v Brne, Moravian Gallery in Brno, Brno

Morris Museum, Morristown NJ

Morris-Jumel Mansion, Inc, New York NY

Mount Mary College, Marian Gallery, Milwaukee WI

Muscatine Art Center, Museum, Muscatine IA

Musee Guimet, Paris

The Museum, Greenwood SC

Museum of Art & History, Santa Cruz, Santa Cruz CA

Museum of New Mexico, Museum of International Folk Art, Santa Fe NM

Museum of Ossining Historical Society, Ossining NY

Museum of Southern History, Sugarland TX

Museum of the City of New York, New York NY

Museum of York County, Rock Hill SC

Muzej za Umjetnost i Obrt, Museum of Arts & Crafts, Zagreb

Muzeum Narodowe, National Museum, Poznan

Nanticoke Indian Museum, Millsboro DE

National Museum of the American Indian, George Gustav Heye Center, New York NY

National Museum of Women in the Arts, Washington DC

National Museum, Monuments and Art Gallery, Gaborone

The National Park Service, United States Department of the Interior, Statue of Liberty National Monument & The Ellis Island Immigration Museum, New York NY

Naval Historical Center, The Navy Museum, Washington DC

Naval War College Museum, Newport RI

Nelson-Atkins Museum of Art, Kansas City MO

Neville Public Museum, Green Bay WI

New Brunswick Museum, Saint John NB

New Canaan Historical Society, New Canaan CT

New Jersey Historical Society, Newark NJ

New York State Historical Association, Fenimore Art Museum, Cooperstown NY

New York State Military Museum and Veterans Research Center, Saratoga Springs NY

Newton History Museum at the Jackson Homestead, Newton MA

Norfolk Historical Society Inc, Museum, Norfolk CT

North Carolina State University, Visual Arts Center, Raleigh NC

The Ohio Historical Society, Inc, Campus Martius Museum & Ohio River Museum, Marietta OH

Old Dartmouth Historical Society, New Bedford Whaling Museum, New Bedford MA

Old Slater Mill Association, Slater Mill Historic Site, Pawtucket RI

Old West Museum, Sunset TX

Old York Historical Society, Old School House, York ME

Oshkosh Public Museum, Oshkosh WI

Palm Beach County Parks & Recreation Department, Morikami Museum & Japanese Gardens, Delray Beach FL

Panhandle-Plains Historical Society Museum, Canyon TX

Pasadena Historical Museum, Pasadena CA

Philadelphia University, Paley Design Center, Philadelphia PA

Phoenix Art Museum, Phoenix AZ

Please Touch Museum, Philadelphia PA

Plumas County Museum, Quincy CA

Polish Museum of America, Chicago IL

Pope County Historical Society, Pope County Museum, Glenwood MN

Port Huron Museum, Port Huron MI

Porter-Phelps-Huntington Foundation, Inc, Historic House Museum, Hadley MA

Portsmouth Historical Society, John Paul Jones House, Portsmouth NH

Potsdam Public Museum, Potsdam NY

Putnam Museum of History and Natural Science, Davenport IA

Red Rock State Park, Red Rock Museum, Church Rock NM

Reynolda House Museum of American Art, Winston Salem NC

Millicent Rogers, Taos NM

Rollins College, George D & Harriet W Cornell Fine Arts Museum, Winter Park FL

Rome Historical Society, Museum & Archives, Rome NY

Royal Arts Foundation, Belcourt Castle, Newport RI

Saco Museum, Saco ME

Saginaw Art Museum, Saginaw MI

Saint Joseph Museum, Saint Joseph MO

San Francisco Maritime National Historical Park, Maritime Museum, San Francisco CA

Seneca-Iroquois National Museum, Salamanca NY

Shaker Museum & Library, Old Chatham NY

Shaker Village of Pleasant Hill, Harrodsburg KY

Shores Memorial Museum and Victoriana, Lyndon Center VT

The Slater Memorial Museum, Slater Memorial Museum, Norwich CT

Smithsonian Institution, Arthur M Sackler Gallery, Washington DC

Society of the Cincinnati, Museum & Library at Anderson House, Washington DC

Sooke Region Museum & Art Gallery, Sooke BC

Southern Illinois University Carbondale, University Museum, Carbondale IL

Southern Lorain County Historical Society, Spirit of '76 Museum, Elyria OH

Southern Oregon Historical Society, Jacksonville Museum of Southern Oregon History, Medford OR

Spertus Institute of Jewish Studies, Spertus Museum, Chicago IL

CRAFTS

New Jersey State Museum, Fine Art Bureau, Trenton NJ

New Mexico State University, Art Gallery, Las Cruces NM

New Visions Gallery, Inc, Marshfield WI

New York State Historical Association, Fenimore Art Museum, Cooperstown NY

The Nippon Club, the Nippon Gallery, New York NY

North Carolina State University, Visual Arts Center, Raleigh NC

Nova Scotia College of Art and Design, Anna Leonowens Gallery, Halifax NS

Nova Scotia Museum, Maritime Museum of the Atlantic, Halifax NS

Noyes Art Gallery, Lincoln NE

The Noyes Museum of Art, Oceanville NJ

Oakland Museum of California, Art Dept, Oakland CA

The Ogden Museum of Southern Art, University of New Orleans, New Orleans LA

Ohio Historical Society, National Afro American Museum & Cultural Center, Wilberforce OH

The Ohio Historical Society, Inc, Campus Martius Museum & Ohio River Museum, Marietta OH

Okefenokee Heritage Center, Inc, Waycross GA

Old Dartmouth Historical Society, New Bedford Whaling Museum, New Bedford MA

Oshkosh Public Museum, Oshkosh WI

Owensboro Museum of Fine Art, Owensboro KY

Palm Beach County Parks & Recreation Department, Morikami Museum & Japanese Gardens, Delray Beach FL

Panhandle-Plains Historical Society Museum, Canyon TX

Pasadena Historical Museum, Pasadena CA

George Phippen, Phippen Art Museum, Prescott AZ

Pioneer Town, Pioneer Museum of Western Art, Wimberley TX

Plumas County Museum, Quincy CA

Pope County Historical Society, Pope County Museum, Glenwood MN

Porter Thermometer Museum, Onset MA

Principia College, School of Nations Museum, Elsah IL

Randall Junior Museum, San Francisco CA

Rawls Museum Arts, Courtland VA

Red Rock State Park, Red Rock Museum, Church Rock NM

Regina Public Library, Dunlop Art Gallery, Regina SK

Millicent Rogers, Taos NM

Rollins College, George D & Harriet W Cornell Fine Arts Museum, Winter Park FL

Rome Historical Society, Museum & Archives, Rome NY

Roswell Museum & Art Center, Roswell NM

Saginaw Art Museum, Saginaw MI

Saint Anselm College, Chapel Art Center, Manchester NH

San Diego State University, University Art Gallery, San Diego CA

San Francisco Maritime National Historical Park, Maritime Museum, San Francisco CA

Seneca-Iroquois National Museum, Salamanca NY

Shaker Village of Pleasant Hill, Harrodsburg KY

Shoshone Bannock Tribes, Shoshone Bannock Tribal Museum, Fort Hall ID

The Slater Memorial Museum, Slater Memorial Museum, Norwich CT

Smithsonian Institution, Arthur M Sackler Gallery, Washington DC

Smithsonian Institution, Washington DC

The Society for Contemporary Crafts, Pittsburgh PA

Sooke Region Museum & Art Gallery, Sooke BC

South Carolina Artisans Center, Walterboro SC

South Carolina State Museum, Columbia SC

Southeastern Center for Contemporary Art, Winston-Salem NC

Southern Illinois University Carbondale, University Museum, Carbondale IL

Southern Plains Indian Museum, Anadarko OK

Southwest Museum, Los Angeles CA

Stamford Museum & Nature Center, Stamford CT

Staten Island Institute of Arts & Sciences, Staten Island NY

Swedish-American Museum Association of Chicago, Chicago IL

Tallahassee Museum of History & Natural Science, Tallahassee FL

Tampa Museum of Art, Tampa FL

Texas Tech University, Museum of Texas Tech University, Lubbock TX

Tokyo National University of Fine Arts & Music Art, University Art Museum, Tokyo

Tubac Center of the Arts, Tubac AZ

Tubman African American Museum, Macon GA

Ukrainian Canadian Archives & Museum of Alberta, Edmonton AB

The Ukrainian Museum, New York NY

United Society of Shakers, Shaker Museum, New Glocester ME

University of British Columbia, Museum of Anthropology, Vancouver BC

University of Colorado at Colorado Springs, Gallery of Contemporary Art, Colorado Springs CO

University of Saskatchewan, Diefenbaker Canada Centre, Saskatoon SK

University of Texas at El Paso, Glass Gallery and Main Gallery, El Paso TX

University of Victoria, Maltwood Art Museum and Gallery, Victoria BC

Utah Arts Council, Chase Home Museum of Utah Folk Arts, Salt Lake City UT

Vermont State Craft Center at Frog Hollow, Middlebury VT

Very Special Arts New Mexico, Very Special Arts Gallery, Albuquerque NM

Vesterheim Norwegian-American Museum, Decorah IA

Wade House & Wesley W Jung Carriage Museum, Historic House & Carriage Museum, Greenbush WI

Wadsworth Atheneum Museum of Art, Hartford CT

Waterworks Visual Arts Center, Salisbury NC

West Baton Rouge Parish, West Baton Rouge Museum, Port Allen LA

West Florida Historic Preservation, Inc, T T Wentworth, Jr Florida State Museum & Historic Pensacola Village, Pensacola FL

Whatcom Museum of History and Art, Bellingham WA

Wheelwright Museum of the American Indian, Santa Fe NM

Wiregrass Museum of Art, Dothan AL

Wisconsin Historical Society, State Historical Museum, Madison WI

Worcester Center for Crafts, Krikorian Gallery, Worcester MA

Xavier University, Art Gallery, Cincinnati OH

Yarmouth County Historical Society, Yarmouth County Museum, Yarmouth NS

DECORATIVE ARTS

Academy of the New Church, Glencairn Museum, Bryn Athyn PA

Adams National Historic Park, Quincy MA

Akron Art Museum, Akron OH

Alabama Department of Archives & History, Museum Galleries, Montgomery AL

Albany Institute of History & Art, Albany NY

Albuquerque Museum of Art & History, Albuquerque NM

Allentown Art Museum, Allentown PA

Lyman Allyn, New London CT

American Swedish Historical Foundation & Museum, Philadelphia PA

Americas Society Art Gallery, New York NY

Amherst Museum, Amherst NY

Arab American National Museum, Dearborn MI

Art & Culture Center of Hollywood, Art Gallery, Hollywood FL

Art Gallery of Greater Victoria, Victoria BC

Art Gallery of South Australia, Adelaide

Art Museum of Greater Lafayette, Lafayette IN

Art Museum of the University of Houston, Blaffer Gallery, Houston TX

Art Museum of Western Virginia, Roanoke VA

Arts Council of Fayetteville-Cumberland County, The Arts Center, Fayetteville NC

ArtSpace-Lima, Lima OH

Asian Art Museum of San Francisco, Chong-Moon Lee Ctr for Asian Art and Culture, San Francisco CA

Association for the Preservation of Virginia Antiquities, John Marshall House, Richmond VA

Athenaeum of Philadelphia, Philadelphia PA

Athens Byzantine & Christian Museum, Athens

Atlanta Historical Society Inc, Atlanta History Center, Atlanta GA

Atlanta International Museum of Art & Design, Atlanta GA

Avampato Discovery Museum, The Clay Center for Arts & Sciences, Charleston WV

Ball State University, Museum of Art, Muncie IN

The Baltimore Museum of Art, Baltimore MD

Barnes Foundation, Merion PA

Bass Museum of Art, Miami Beach FL

Bay County Historical Society, Historical Museum of Bay County, Bay City MI

Bayou Bend Collection & Gardens, Houston TX

Beaverbrook Art Gallery, Fredericton NB

Berkshire Museum, Pittsfield MA

Jesse Besser, Alpena MI

Birmingham Museum of Art, Birmingham AL

BJU Museum & Gallery, Bob Jones University Museum & Gallery Inc, Greenville SC

Bowers Museum of Cultural Art, Bowers Museum, Santa Ana CA

Brick Store Museum & Library, Kennebunk ME

Bradford Brinton, Big Horn WY

Burchfield-Penney Art Center, Buffalo NY

Thornton W Burgess, Museum, Sandwich MA

Cameron Art Museum, Wilmington NC

The Canadian Craft Museum, Vancouver BC

Canadian Museum of Civilization, Gatineau PQ

Canton Museum of Art, Canton OH

Cape Ann Historical Association, Gloucester MA

Captain Forbes House Mus, Milton MA

Caramoor Center for Music & the Arts, Inc, Caramoor House Museum, Katonah NY

Carnegie Museums of Pittsburgh, Carnegie Museum of Art, Pittsburgh PA

Carson County Square House Museum, Panhandle TX

Carteret County Historical Society, Museum of History & Art, Morehead City NC

Charleston Museum, Joseph Manigault House, Charleston SC

Charleston Museum, Charleston SC

Chatillon-DeMenil House Foundation, DeMenil Mansion, Saint Louis MO

Cheekwood-Tennessee Botanical Garden & Museum of Art, Nashville TN

Chicago Athenaeum, Museum of Architecture & Design, Galena IL

Chinese Culture Foundation, Center Gallery, San Francisco CA

Chinese Culture Institute of the International Society, Tremont Theatre & Gallery, Boston MA

Church of Jesus Christ of Latter-Day Saints, Museum of Church History & Art, Salt Lake City UT

Cincinnati Institute of Fine Arts, Taft Museum of Art, Cincinnati OH

Cincinnati Museum Association and Art Academy of Cincinnati, Cincinnati Art Museum, Cincinnati OH

City of Austin Parks & Recreation, O Henry Museum, Austin TX

City of Grand Rapids Michigan, Public Museum of Grand Rapids, Grand Rapids MI

The City of Petersburg Museums, Petersburg VA

Cleveland Museum of Art, Cleveland OH

Cohasset Historical Society, Pratt Building (Society Headquarters), Cohasset MA

Colonial Williamsburg Foundation, DeWitt Wallace Gallery, Williamsburg VA

Colorado Historical Society, Colorado History Museum, Denver CO

Columbia Museum of Art, Columbia SC

Columbus Museum, Columbus GA

Columbus Museum of Art, Columbus OH

Columbus Museum of Art and Design, Indianapolis IN

Concord Museum, Concord MA

Cooper-Hewitt, National Design Museum, Smithsonian Institution, New York NY

Cornwall Gallery Society, Cornwall Regional Art Gallery, Cornwall ON

County of Henrico, Meadow Farm Museum, Glen Allen VA

Courtauld Institute of Art, Courtauld Institute Gallery, London

Coutts Memorial Museum of Art, Inc, El Dorado KS

Craft and Folk Art Museum (CAFAM), Los Angeles CA

Cranbrook Art Museum, Cranbrook Art Museum, Bloomfield Hills MI

Crocker Art Museum, Sacramento CA

Cummer Museum of Art & Gardens, DeEtte Holden Cummer Museum Foundation, Jacksonville FL

Cuneo Foundation, Museum & Gardens, Vernon Hills IL

Dallas Museum of Art, Dallas TX

Danville Museum of Fine Arts & History, Danville VA

DAR Museum, National Society Daughters of the American Revolution, Washington DC

Delaware Art Museum, Wilmington DE

Deming-Luna Mimbres Museum, Deming NM

Detroit Institute of Arts, Detroit MI

Detroit Repertory Theatre Gallery, Detroit MI

Museum of West Louisiana, Leesville LA

Museum of Wisconsin Art, West Bend Art Museum, West Bend WI

Museum of York County, Rock Hill SC

Muzej za Umjetnost i Obrt, Museum of Arts & Crafts, Zagreb

Muzeum Narodowe, National Museum, Poznan

National Gallery of Canada, Ottawa ON

National Heritage Museum, Lexington MA

The National Museum of Fine Arts, Stockholm

National Museum of the American Indian, George Gustav Heye Center, New York NY

National Museum of Women in the Arts, Washington DC

National Museum, Monuments and Art Gallery, Gaborone

National Park Service, Weir Farm National Historic Site, Wilton CT

The National Park Service, United States Department of the Interior, Statue of Liberty National Monument & The Ellis Island Immigration Museum, New York NY

National Society of Colonial Dames of America in the State of Maryland, Mount Clare Museum House, Baltimore MD

National Society of the Colonial Dames of America in The Commonwealth of Virginia, Wilton House Museum, Richmond VA

National Trust for Historic Preservation, Chesterwood Estate & Museum, Stockbridge MA

National Trust for Historic Preservation, Washington DC

Naval Historical Center, The Navy Museum, Washington DC

Nebraska State Capitol, Lincoln NE

Nelson-Atkins Museum of Art, Kansas City MO

Nemours Mansion & Gardens, Wilmington DE

New Brunswick Museum, Saint John NB

New Jersey State Museum, Fine Art Bureau, Trenton NJ

New Orleans GlassWorks Gallery & Printmaking Studio, New Orleans ArtWorks Gallery, New Orleans LA

New Orleans Museum of Art, New Orleans LA

New Visions Gallery, Inc, Marshfield WI

New World Art Center, T F Chen Cultural Center, New York NY

New York State Historical Association, Fenimore Art Museum, Cooperstown NY

New York State Museum, Albany NY

Newburyport Maritime Society, Custom House Maritime Museum, Newburyport MA

Nichols House Museum, Inc, Boston MA

North Carolina State University, Visual Arts Center, Raleigh NC

Noyes Art Gallery, Lincoln NE

The Ogden Museum of Southern Art, University of New Orleans, New Orleans LA

The Ohio Historical Society, Inc, Campus Martius Museum & Ohio River Museum, Marietta OH

Old Barracks Museum, Trenton NJ

Old Dartmouth Historical Society, New Bedford Whaling Museum, New Bedford MA

Old Slater Mill Association, Slater Mill Historic Site, Pawtucket RI

Old York Historical Society, Old Gaol Museum, York ME

Opelousas Museum of Art, Inc (OMA), Opelousas LA

Order Sons of Italy in America, Garibaldi & Meucci Museum, Staten Island NY

Oshkosh Public Museum, Oshkosh WI

Owensboro Museum of Fine Art, Owensboro KY

Oysterponds Historical Society, Museum, Orient NY

Pacific - Asia Museum, Pasadena CA

Palisades Interstate Park Commission, Senate House State Historic Site, Kingston NY

Palm Beach County Parks & Recreation Department, Morikami Museum & Japanese Gardens, Delray Beach FL

Panhandle-Plains Historical Society Museum, Canyon TX

Pasadena Historical Museum, Pasadena CA

Peabody Essex Museum, Salem MA

Pennsylvania Historical & Museum Commission, The State Museum of Pennsylvania, Harrisburg PA

The Pennsylvania State University, Palmer Museum of Art, University Park PA

Pensacola Museum of Art, Pensacola FL

Phoenix Art Museum, Phoenix AZ

Piatt Castles, West Liberty OH

Pilgrim Society, Pilgrim Hall Museum, Plymouth MA

Pioneer Town, Pioneer Museum of Western Art, Wimberley TX

Plumas County Museum, Quincy CA

Polish Museum of America, Chicago IL

Polk Museum of Art, Lakeland FL

The Pomona College, Montgomery Gallery, Claremont CA

Pope County Historical Society, Pope County Museum, Glenwood MN

Port Huron Museum, Port Huron MI

Porter Thermometer Museum, Onset MA

Porter-Phelps-Huntington Foundation, Inc, Historic House Museum, Hadley MA

Portland Art Museum, Portland OR

Portland Museum of Art, Portland ME

Prairie Art Gallery, Grande Prairie AB

Princeton University, Princeton University Art Museum, Princeton NJ

Principia College, School of Nations Museum, Elsah IL

Putnam Museum of History and Natural Science, Davenport IA

Quapaw Quarter Association, Inc, Villa Marre, Little Rock AR

Queens College, City University of New York, Godwin-Ternbach Museum, Flushing NY

Riley County Historical Society, Riley County Historical Museum, Manhattan KS

Ringwood Manor House Museum, Ringwood NJ

Riverside County Museum, Edward-Dean Museum & Gardens, Cherry Valley CA

Roberson Museum & Science Center, Binghamton NY

Rock Ford Foundation, Inc, Historic Rock Ford & Kauffman Museum, Lancaster PA

Millicent Rogers, Taos NM

Rollins College, George D & Harriet W Cornell Fine Arts Museum, Winter Park FL

Rome Historical Society, Museum & Archives, Rome NY

Roosevelt-Vanderbilt National Historic Sites, Hyde Park NY

Ross Memorial Museum, Saint Andrews NB

Royal Ontario Museum, Dept of Western Art & Culture, Toronto ON

C M Russell, Great Falls MT

Saco Museum, Saco ME

Saginaw Art Museum, Saginaw MI

Saint Anselm College, Chapel Art Center, Manchester NH

Saint Bonaventure University, Regina A Quick Center for the Arts, Saint Bonaventure NY

Saint Joseph's Oratory, Museum, Montreal PQ

Saint Peter's College, Art Gallery, Jersey City NJ

Salem Art Association, Bush House Museum, Salem OR

Salisbury House Foundation, Des Moines IA

San Diego Museum of Art, San Diego CA

The Sandwich Historical Society, Inc, Sandwich Glass Museum, Sandwich MA

Santarella Museum & Gardens, Tyringham MA

Schuyler-Hamilton House, Morristown NJ

Seneca Falls Historical Society Museum, Seneca Falls NY

Seneca-Iroquois National Museum, Salamanca NY

Shaker Museum & Library, Old Chatham NY

Shaker Village of Pleasant Hill, Harrodsburg KY

Shelburne Museum, Museum, Shelburne VT

Shirley Plantation, Charles City VA

Siena Heights College, Klemm Gallery, Studio Angelico, Adrian MI

The Slater Memorial Museum, Slater Memorial Museum, Norwich CT

Smith College, Museum of Art, Northampton MA

Smithsonian Institution, Arthur M Sackler Gallery, Washington DC

Smithsonian Institution, Washington DC

Society of the Cincinnati, Museum & Library at Anderson House, Washington DC

South Carolina Artisans Center, Walterboro SC

South Carolina State Museum, Columbia SC

Southern Illinois University Carbondale, University Museum, Carbondale IL

Southern Oregon Historical Society, Jacksonville Museum of Southern Oregon History, Medford OR

Spertus Institute of Jewish Studies, Spertus Museum, Chicago IL

Springfield Art Museum, Springfield MO

Stanford University, Iris & B Gerald Cantor Center for Visual Arts, Stanford CA

Nelda C & H J Lutcher Stark, Stark Museum of Art, Orange TX

Staten Island Institute of Arts & Sciences, Staten Island NY

Stauth Foundation & Museum, Stauth Memorial Museum, Montezuma KS

Susquehanna University, Lore Degenstein Gallery, Selinsgrove PA

Swedish-American Museum Association of Chicago, Chicago IL

Switzerland County Historical Society Inc, Switzerland County Historical Museum, Vevay IN

Syracuse University, Art Collection, Syracuse NY

Syracuse University, SUArt Galleries, Syracuse NY

Tampa Museum of Art, Tampa FL

Telfair Museum of Art, Savannah GA

The Temple-Tifereth Israel, The Temple Museum of Religious Art, Beachwood OH

Towson University Center for the Arts Gallery, Asian Arts & Culture Center, Towson MD

Tubac Center of the Arts, Tubac AZ

Mark Twain, Hartford CT

The Ukrainian Museum, New York NY

United Society of Shakers, Shaker Museum, New Glocester ME

United States Capitol, Architect of the Capitol, Washington DC

US Coast Guard Museum, New London CT

United States Figure Skating Association, World Figure Skating Museum & Hall of Fame, Colorado Springs CO

University of Alabama at Birmingham, Visual Arts Gallery, Birmingham AL

University of British Columbia, Museum of Anthropology, Vancouver BC

University of Chicago, Smart Museum of Art, Chicago IL

University of Illinois, Krannert Art Museum and Kinkead Pavillion, Champaign IL

University of Iowa, Museum of Art, Iowa City IA

University of Louisiana at Lafayette, University Art Museum, Lafayette LA

University of Manitoba, Faculty of Architecture Exhibition Centre, Winnipeg MB

University of Miami, Lowe Art Museum, Coral Gables FL

University of Mississippi, University Museum, Oxford MS

University of Nebraska, Lincoln, Sheldon Memorial Art Gallery & Sculpture Garden, Lincoln NE

University of New Mexico, The Harwood Museum of Art, Taos NM

University of North Carolina at Greensboro, Weatherspoon Art Museum, Greensboro NC

University of Saskatchewan, Diefenbaker Canada Centre, Saskatoon SK

University of Tennessee, Frank H McClung Museum, Knoxville TN

University of Victoria, Maltwood Art Museum and Gallery, Victoria BC

University of Wisconsin-Madison, Chazen Museum of Art, Madison WI

Valentine Richmond History Center, Richmond VA

Vancouver Museum, Vancouver BC

Vancouver Public Library, Fine Arts & Music Div, Vancouver BC

Vermilion County Museum Society, Danville IL

Vesterheim Norwegian-American Museum, Decorah IA

Victoria Mansion - Morse Libby House, Portland ME

Villa Terrace Decorative Art Museum, Milwaukee WI

Virginia Museum of Fine Arts, Richmond VA

Vizcaya Museum & Gardens, Miami FL

Wade House & Wesley W Jung Carriage Museum, Historic House & Carriage Museum, Greenbush WI

Wadsworth Atheneum Museum of Art, Hartford CT

The Walker African American Museum & Research Center, Las Vegas NV

Wallace Collection, London

Walters Art Museum, Baltimore MD

Mamie McFaddin Ward, Beaumont TX

Warner House Association, MacPheadris-Warner House, Portsmouth NH

Waterloo Center of the Arts, Waterloo IA

Waterville Historical Society, Redington Museum, Waterville ME

Waterworks Visual Arts Center, Salisbury NC

West Florida Historic Preservation, Inc, T T Wentworth, Jr Florida State Museum & Historic Pensacola Village, Pensacola FL

Whalers Village Museum, Lahaina HI

Wheaton College, Watson Gallery, Norton MA

White House, Washington DC

Willard House & Clock Museum, Inc, North Grafton MA
Woodrow Wilson, Staunton VA
Woodrow Wilson, Washington DC
Wiregrass Museum of Art, Dothan AL
Witte Museum, San Antonio TX
The Woman's Exchange, Gallier House Museum, New Orleans LA
The Woman's Exchange, Newcomb Art Gallery-Carroll Gallery, New Orleans LA
The Woman's Exchange, University Art Collection, New Orleans LA
Woodlawn/The Pope-Leighey, Mount Vernon VA
Woodmere Art Museum, Philadelphia PA
Worcester Art Museum, Worcester MA
Workman & Temple Family Homestead Museum, City of Industry CA
Wyoming State Museum, Cheyenne WY
Yarmouth County Historical Society, Yarmouth County Museum, Yarmouth NS
Yeshiva University Museum, New York NY
Zamek Krolewski w Warszawie Pomnik Historii i Kultry Narodwej, Royal Castle in Warsaw, National History & Culture Memorial, Warsaw

DIORAMAS

Academy of the New Church, Glencairn Museum, Bryn Athyn PA
Alton Museum of History & Art, Inc, Alton IL
Amherst Museum, Amherst NY
Atlanta Historical Society Inc, Atlanta History Center, Atlanta GA
The Bartlett Museum, Amesbury MA
Berkshire Museum, Pittsfield MA
Jesse Besser, Alpena MI
Blauvelt Demarest Foundation, Hiram Blauvelt Art Museum, Oradell NJ
Brick Store Museum & Library, Kennebunk ME
Bruce Museum, Inc, Bruce Museum, Greenwich CT
Canadian Museum of Civilization, Gatineau PQ
Cape Ann Historical Association, Gloucester MA
Carson County Square House Museum, Panhandle TX
City of Grand Rapids Michigan, Public Museum of Grand Rapids, Grand Rapids MI
Clark County Historical Society, Pioneer - Krier Museum, Ashland KS
Colorado Historical Society, Colorado History Museum, Denver CO
Concord Museum, Concord MA
Craft and Folk Art Museum (CAFAM), Los Angeles CA
Detroit Institute of Arts, Detroit MI
Evanston Historical Society, Charles Gates Dawes House, Evanston IL
Fairbanks Museum & Planetarium, Saint Johnsbury VT
Fetherston Foundation, Packwood House Museum, Lewisburg PA
Florida Department of Environmental Protection, Stephen Foster State Folk Culture Center, White Springs FL
Great Lakes Historical Society, Inland Seas Maritime Museum, Vermilion OH
Hastings Museum of Natural & Cultural History, Hastings NE
Historical Society of Bloomfield, Bloomfield NJ
Iroquois County Historical Society Museum, Old Courthouse Museum, Watseka IL
Lac du Flambeau Band of Lake Superior Chippewa Indians, George W Brown Jr Ojibwe Museum & Cultural Center, Lac du Flambeau WI
Lehigh County Historical Society, Allentown PA
Lizzadro Museum of Lapidary Art, Elmhurst IL
Loveland Museum Gallery, Loveland CO
Maricopa County Historical Society, Desert Caballeros Western Museum, Wickenburg AZ
The Mariners' Museum, Newport News VA
Mason County Museum, Maysville KY
Mission San Miguel Museum, San Miguel CA
Mississippi Department of Archives & History, Old Capitol Museum of Mississippi History, Jackson MS
Mississippi River Museum at Mud-Island River Park, Memphis TN
The Museum, Greenwood SC
Museum for African Art, Long Island City NY
Museum of the City of New York, New York NY
Museum of York County, Rock Hill SC
National Museum, Monuments and Art Gallery, Gaborone

Naval Historical Center, The Navy Museum, Washington DC
New Jersey State Museum, Fine Art Bureau, Trenton NJ
Ohio Historical Society, National Road-Zane Grey Museum, Columbus OH
Panhandle-Plains Historical Society Museum, Canyon TX
Pennsylvania Historical & Museum Commission, Railroad Museum of Pennsylvania, Harrisburg PA
Plumas County Museum, Quincy CA
Safety Harbor Museum of Regional History, Safety Harbor FL
Saint Joseph Museum, Saint Joseph MO
Seneca-Iroquois National Museum, Salamanca NY
Shoshone Bannock Tribes, Shoshone Bannock Tribal Museum, Fort Hall ID
Society of the Cincinnati, Museum & Library at Anderson House, Washington DC
Southern Illinois University Carbondale, University Museum, Carbondale IL
Tinkertown Museum, Sandia Park NM
United States Military Academy, West Point Museum, West Point NY
University of Chicago, Oriental Institute Museum, Chicago IL
University of Minnesota, The Bell Museum of Natural History, Minneapolis MN
University of Saskatchewan, Diefenbaker Canada Centre, Saskatoon SK
George Washington, Alexandria VA
Whatcom Museum of History and Art, Bellingham WA
Zigler Museum, Jennings LA

DOLLS

Adams County Historical Society, Gettysburg PA
African American Museum in Philadelphia, Philadelphia PA
Albany Institute of History & Art, Albany NY
Lyman Allyn, New London CT
Alton Museum of History & Art, Inc, Alton IL
Anchorage Museum at Rasmuson Center, Anchorage AK
Art Without Walls Inc, Art Without Walls Inc, Sayville NY
Arts Council of Fayetteville-Cumberland County, The Arts Center, Fayetteville NC
ArtSpace-Lima, Lima OH
Atlanta Historical Society Inc, Atlanta History Center, Atlanta GA
Berea College, Doris Ulmann Galleries, Berea KY
Berkshire Museum, Pittsfield MA
Jesse Besser, Alpena MI
Brooklyn Historical Society, Brooklyn OH
Thornton W Burgess, Museum, Sandwich MA
Cambria Historical Society, New Providence NJ
The Canadian Craft Museum, Vancouver BC
Canadian Museum of Civilization, Gatineau PQ
Carnegie Museums of Pittsburgh, Carnegie Museum of Art, Pittsburgh PA
Carson County Square House Museum, Panhandle TX
Billie Trimble Chandler, Asian Cultures Museum & Educational Center, Corpus Christi TX
Charleston Museum, Joseph Manigault House, Charleston SC
City of Grand Rapids Michigan, Public Museum of Grand Rapids, Grand Rapids MI
City of Springdale, Shiloh Museum of Ozark History, Springdale AR
Clark County Historical Society, Pioneer - Krier Museum, Ashland KS
Cohasset Historical Society, Pratt Building (Society Headquarters), Cohasset MA
Colorado Historical Society, Colorado History Museum, Denver CO
Columbus Museum, Columbus GA
Craigdarroch Castle Historical Museum Society, Victoria BC
Crow Wing County Historical Society, Brainerd MN
Culberson County Historical Museum, Van Horn TX
DAR Museum, National Society Daughters of the American Revolution, Washington DC
Dartmouth Heritage Museum, Dartmouth NS
Deming-Luna Mimbres Museum, Deming NM
Detroit Institute of Arts, Detroit MI
Erie Art Museum, Erie PA
Erie County Historical Society, Erie PA
Evanston Historical Society, Charles Gates Dawes House, Evanston IL

Evansville Museum of Arts, History & Science, Evansville IN
Fairbanks Museum & Planetarium, Saint Johnsbury VT
Farmington Village Green & Library Association, Stanley-Whitman House, Farmington CT
Ferenczy Muzeum, Szentendre
Fishkill Historical Society, Van Wyck Homestead Museum, Fishkill NY
Franklin Mint Museum, Franklin Center PA
Frontier Times Museum, Bandera TX
Gallery One, Ellensburg WA
Germanisches Nationalmuseum, Nuremberg
Germantown Historical Society, Philadelphia PA
Glanmore National Historic Site of Canada, Belleville ON
Hancock County Trustees of Public Reservations, Woodlawn Museum, Ellsworth ME
Heard Museum, Phoenix AZ
Hebrew Union College, Skirball Cultural Center, Los Angeles CA
Henry County Museum & Cultural Arts Center, Clinton MO
Heritage Museum Association, Inc, The Heritage Museum of Northwest Florida, Valparaiso FL
Edna Hibel, Hibel Museum of Art, Jupiter FL
Historic Bethlehem Partnership, Kemerer Museum of Decorative Arts, Bethlehem PA
Historic Cherry Hill, Albany NY
Houston Baptist University, Museum of American Architecture and Decorative Arts, Houston TX
Houston Museum of Decorative Arts, Chattanooga TN
Huguenot Historical Society of New Paltz Galleries, New Paltz NY
Huronia Museum, Gallery of Historic Huronia, Midland ON
Imperial Calcasieu Museum, Gibson-Barham Gallery, Lake Charles LA
Indiana State Museum, Indianapolis IN
The Interchurch Center, Galleries at the Interchurch Center, New York NY
International Clown Hall of Fame & Research Center, Inc, West Allis WI
Iowa State University, Brunnier Art Museum, Ames IA
Iredell Museum of Arts & Heritage, Statesville NC
Iroquois County Historical Society Museum, Old Courthouse Museum, Watseka IL
Jefferson County Open Space, Hiwan Homestead Museum, Evergreen CO
Jersey City Museum, Jersey City NJ
Kelly-Griggs House Museum, Red Bluff CA
Kings County Historical Society & Museum, Hampton NB
Klein Museum, Mobridge SD
Koochiching Museums, International Falls MN
L A County Museum of Art, Los Angeles CA
Lac du Flambeau Band of Lake Superior Chippewa Indians, George W Brown Jr Ojibwe Museum & Cultural Center, Lac du Flambeau WI
LeSueur County Historical Society, Chapter One, Elysian MN
Livingston County Historical Society, Cobblestone Museum, Geneseo NY
The Long Island Museum of American Art, History & Carriages, Stony Brook NY
Longfellow-Evangeline State Commemorative Area, Saint Martinville LA
Loveland Museum Gallery, Loveland CO
Maricopa County Historical Society, Desert Caballeros Western Museum, Wickenburg AZ
Marquette University, Haggerty Museum of Art, Milwaukee WI
McCord Museum of Canadian History, Montreal PQ
McDowell House & Apothecary Shop, Danville KY
Carrie M McLain, Nome AK
Meredith College, Frankie G Weems Gallery & Rotunda Gallery, Raleigh NC
Mexican Museum, San Francisco CA
Middle Border Museum & Oscar Howe Art Center, Mitchell SD
Mingei International, Inc, Mingei International Museum, San Diego CA
Mississippi Department of Archives & History, Old Capitol Museum of Mississippi History, Jackson MS
The Museum, Greenwood SC
Museum for African Art, Long Island City NY
Museum of Art & History, Santa Cruz, Santa Cruz CA
Museum of the City of New York, New York NY
Museum of West Louisiana, Leesville LA
Muzej za Umjetnost i Obrt, Museum of Arts & Crafts, Zagreb

Neville Public Museum, Green Bay WI
New Brunswick Museum, Saint John NB
New Jersey Historical Society, Newark NJ
Newton History Museum at the Jackson Homestead, Newton MA
Ohio Historical Society, National Afro American Museum & Cultural Center, Wilberforce OH
The Ohio Historical Society, Inc, Campus Martius Museum & Ohio River Museum, Marietta OH
Old Dartmouth Historical Society, New Bedford Whaling Museum, New Bedford MA
Palm Beach County Parks & Recreation Department, Morikami Museum & Japanese Gardens, Delray Beach FL
Panhandle-Plains Historical Society Museum, Canyon TX
Pasadena Historical Museum, Pasadena CA
The Frank Phillips, Woolaroc Museum, Bartlesville OK
Plainsman Museum, Aurora NE
Pope County Historical Society, Pope County Museum, Glenwood MN
Port Huron Museum, Port Huron MI
Presidential Museum, Odessa TX
Principia College, School of Nations Museum, Elsah IL
Putnam Museum of History and Natural Science, Davenport IA
Riley County Historical Society, Riley County Historical Museum, Manhattan KS
Riverside Municipal Museum, Riverside CA
Saco Museum, Saco ME
St Genevieve Museum, Sainte Genevieve MO
Saint Joseph Museum, Saint Joseph MO
Saint Peter's College, Art Gallery, Jersey City NJ
Seneca-Iroquois National Museum, Salamanca NY
Shaker Museum & Library, Old Chatham NY
Shelburne Museum, Museum, Shelburne VT
Shores Memorial Museum and Victoriana, Lyndon Center VT
The Slater Memorial Museum, Slater Memorial Museum, Norwich CT
Sooke Region Museum & Art Gallery, Sooke BC
South Carolina Artisans Center, Walterboro SC
Southern Illinois University Carbondale, University Museum, Carbondale IL
Southern Oregon Historical Society, Jacksonville Museum of Southern Oregon History, Medford OR
Stauth Foundation & Museum, Stauth Memorial Museum, Montezuma KS
Stratford Historical Society, Catharine B Mitchell Museum, Stratford CT
Summit County Historical Society, Akron OH
Texas Tech University, Museum of Texas Tech University, Lubbock TX
Tinkertown Museum, Sandia Park NM
United Society of Shakers, Shaker Museum, New Glocester ME
University of Chicago, Oriental Institute Museum, Chicago IL
University of Mississippi, University Museum, Oxford MS
University of Saskatchewan, Diefenbaker Canada Centre, Saskatoon SK
Vancouver Museum, Vancouver BC
Waterville Historical Society, Redington Museum, Waterville ME
Wayne County Historical Society, Honesdale PA
Wellfleet Historical Society Museum, Wellfleet MA
West Florida Historic Preservation, Inc, T T Wentworth, Jr Florida State Museum & Historic Pensacola Village, Pensacola FL
Whatcom Museum of History and Art, Bellingham WA
Wheelwright Museum of the American Indian, Santa Fe NM
Willard House & Clock Museum, Inc, North Grafton MA
Wistariahurst Museum, Holyoke MA
Witte Museum, San Antonio TX
Yarmouth County Historical Society, Yarmouth County Museum, Yarmouth NS

DRAWINGS

Academy of the New Church, Glencairn Museum, Bryn Athyn PA
African American Museum in Philadelphia, Philadelphia PA
Albany Institute of History & Art, Albany NY
Albuquerque Museum of Art & History, Albuquerque NM
Allentown Art Museum, Allentown PA

Alton Museum of History & Art, Inc, Alton IL
American Kennel Club, Museum of the Dog, Saint Louis MO
American Swedish Historical Foundation & Museum, Philadelphia PA
American University, Katzen Art Center Gallery, Washington DC
Anchorage Museum at Rasmuson Center, Anchorage AK
Walter Anderson, Ocean Springs MS
Appaloosa Museum and Heritage Center, Moscow ID
Arab American National Museum, Dearborn MI
Art & Culture Center of Hollywood, Art Gallery, Hollywood FL
Art Community Center, Art Center of Corpus Christi, Corpus Christi TX
Art Gallery of Nova Scotia, Halifax NS
Art Gallery of South Australia, Adelaide
Art Museum of Greater Lafayette, Lafayette IN
Art Without Walls Inc, Art Without Walls Inc, Sayville NY
Artesia Historical Museum & Art Center, Artesia NM
Arts Council of Fayetteville-Cumberland County, The Arts Center, Fayetteville NC
Artspace, Richmond VA
ArtSpace-Lima, Lima OH
Asbury College, Student Center Gallery, Wilmore KY
Augustana College, Augustana College Art Museum, Rock Island IL
Baldwin-Wallace College, Fawick Art Gallery, Berea OH
Ball State University, Museum of Art, Muncie IN
The Baltimore Museum of Art, Baltimore MD
Bard College, Center for Curatorial Studies, Annandale-on-Hudson NY
Barnes Foundation, Merion PA
Baruch College of the City University of New York, Sidney Mishkin Gallery, New York NY
Berea College, Doris Ulmann Galleries, Berea KY
Berkshire Museum, Pittsfield MA
Jesse Besser, Alpena MI
Blauvelt Demarest Foundation, Hiram Blauvelt Art Museum, Oradell NJ
Boston Public Library, Albert H Wiggin Gallery & Print Department, Boston MA
Roy Boyd, Chicago IL
Brandywine River Museum, Chadds Ford PA
Brigham Young University, B F Larsen Gallery, Provo UT
Brigham Young University, Museum of Art, Provo UT
Bruce Museum, Inc, Bruce Museum, Greenwich CT
Burke Arts Council, Jailhouse Galleries, Morganton NC
Butler Institute of American Art, Art Museum, Youngstown OH
C W Post Campus of Long Island University, Hillwood Art Museum, Brookville NY
Cabot's Old Indian Pueblo Museum, Cabot's Old Indian Pueblo Museum, Desert Hot Springs CA
California State University Stanislaus, University Art Gallery, Turlock CA
California State University, Northridge, Art Galleries, Northridge CA
Calvin College, Center Art Gallery, Grand Rapids MI
Cameron Art Museum, Wilmington NC
Canadian Museum of Civilization, Gatineau PQ
Canadian Museum of Nature, Musee Canadien de la Nature, Ottawa ON
Carnegie Mellon University, Hunt Institute for Botanical Documentation, Pittsburgh PA
Carnegie Museums of Pittsburgh, Carnegie Museum of Art, Pittsburgh PA
Carson County Square House Museum, Panhandle TX
Amon Carter, Fort Worth TX
Cartoon Art Museum, San Francisco CA
Cedar Rapids Museum of Art, Cedar Rapids IA
Chattahoochee Valley Art Museum, LaGrange GA
Cincinnati Institute of Fine Arts, Taft Museum of Art, Cincinnati OH
City of Cedar Falls, Iowa, James & Meryl Hearst Center for the Arts, Cedar Falls IA
City of Fayette, Alabama, Fayette Art Museum, Fayette AL
City of Fremont, Olive Hyde Art Gallery, Fremont CA
City of Grand Rapids Michigan, Public Museum of Grand Rapids, Grand Rapids MI
City of Pittsfield, Berkshire Artisans, Pittsfield MA
Sterling & Francine Clark, Williamstown MA
College of New Jersey, Art Gallery, Trenton NJ
College of Saint Benedict, Art Gallery, Saint Joseph MN

College of William & Mary, Muscarelle Museum of Art, Williamsburg VA
Colorado Springs Fine Arts Center, Colorado Springs CO
Columbus Museum, Columbus GA
Columbus Museum of Art, Columbus OH
Columbus Museum of Art and Design, Indianapolis IN
Concordia University, Leonard & Bina Ellen Art Gallery, Montreal PQ
Cooper-Hewitt, National Design Museum, Smithsonian Institution, New York NY
Cornell Museum of Art & History, Delray Beach FL
Cornell University, Herbert F Johnson Museum of Art, Ithaca NY
Cornwall Gallery Society, Cornwall Regional Art Gallery, Cornwall ON
Cranbrook Art Museum, Cranbrook Art Museum, Bloomfield Hills MI
Creighton University, Lied Art Gallery, Omaha NE
Crow Wing County Historical Society, Brainerd MN
Culberson County Historical Museum, Van Horn TX
The Currier Museum of Art, Currier Museum of Art, Manchester NH
Dahesh Museum of Art, New York NY
Dallas Museum of Art, Dallas TX
Danforth Museum Corporation, Danforth Museum of Art, Framingham MA
Danville Museum of Fine Arts & History, Danville VA
Del Mar College, Joseph A Cain Memorial Art Gallery, Corpus Christi TX
DeLeon White Gallery, Toronto ON
Detroit Institute of Arts, Detroit MI
Detroit Repertory Theatre Gallery, Detroit MI
Dickinson College, The Trout Gallery, Carlisle PA
Dixie State College, Robert N & Peggy Sears Gallery, Saint George UT
Door County, Miller Art Museum, Sturgeon Bay WI
Eiteljorg Museum of American Indians & Western Art, Indianapolis IN
Ellen Noel Art Museum of the Permian Basin, Odessa TX
Elmhurst Art Museum, Elmhurst IL
eMediaLoft.org, New York NY
Erie County Historical Society, Erie PA
Essex Historical Society, Essex Shipbuilding Museum, Essex MA
Evergreen State College, Evergreen Galleries, Olympia WA
Farmington Village Green & Library Association, Stanley-Whitman House, Farmington CT
Federal Reserve Board, Art Gallery, Washington DC
Ferenczy Muzeum, Szentendre
Fine Arts Museums of San Francisco, Legion of Honor, San Francisco CA
Fishkill Historical Society, Van Wyck Homestead Museum, Fishkill NY
Fisk University, Fisk University Galleries, Nashville TN
Fitchburg Art Museum, Fitchburg MA
Florence Museum of Art, Science & History, Florence SC
Florida State University, John & Mable Ringling Museum of Art, Sarasota FL
Edsel & Eleanor Ford, Grosse Pointe Shores MI
Forest Lawn Museum, Glendale CA
Fort Collins Museum of Contemporary Art, Fort Collins CO
Fort Hays State University, Moss-Thorns Gallery of Arts, Hays KS
Fort Smith Art Center, Fort Smith AR
Frick Collection, New York NY
Friends of Historic Kingston, Fred J Johnston House Museum, Kingston NY
Frontier Times Museum, Bandera TX
Frye Art Museum, Seattle WA
Fuller Museum of Art, Brockton MA
Gallery One, Ellensburg WA
Georgian Court College, M Christina Geis Gallery, Lakewood NJ
Germanisches Nationalmuseum, Nuremberg
Germantown Historical Society, Philadelphia PA
Thomas Gilcrease, Gilcrease Museum, Tulsa OK
Glanmore National Historic Site of Canada, Belleville ON
Goethe Institute New York, German Cultural Center, New York NY
Gonzaga University, Art Gallery, Spokane WA
Goucher College, Rosenberg Gallery, Baltimore MD
Graphische Sammlung Albertina, Albertina Graphic Art Collection, Vienna

Phillips Academy, Addison Gallery of American Art, Andover MA
The Frank Phillips, Woolaroc Museum, Bartlesville OK
George Phippen, Phippen Art Museum, Prescott AZ
Pinacoteca Provinciale, Bari
The Pomona College, Montgomery Gallery, Claremont CA
Pope County Historical Society, Pope County Museum, Glenwood MN
Porter-Phelps-Huntington Foundation, Inc, Historic House Museum, Hadley MA
Portland Art Museum, Portland OR
Potsdam College of the State University of New York, Roland Gibson Gallery, Potsdam NY
Princeton University, Princeton University Art Museum, Princeton NJ
PS1 Contemporary Art Center, Long Island City NY
Purdue University Galleries, West Lafayette IN
Putnam Museum of History and Natural Science, Davenport IA
Queens College, City University of New York, Godwin-Ternbach Museum, Flushing NY
Quincy University, The Gray Gallery, Quincy IL
Rahr-West Art Museum, Manitowoc WI
Ramsay Museum, Honolulu HI
Randall Junior Museum, San Francisco CA
Randolph-Macon Woman's College, Maier Museum of Art, Lynchburg VA
Rawls Museum Arts, Courtland VA
Roberson Museum & Science Center, Binghamton NY
Millicent Rogers, Taos NM
The Rosenbach Museum & Library, Philadelphia PA
Roswell Museum & Art Center, Roswell NM
C M Russell, Great Falls MT
Saginaw Art Museum, Saginaw MI
Saint Anselm College, Chapel Art Center, Manchester NH
Saint Bonaventure University, Regina A Quick Center for the Arts, Saint Bonaventure NY
Saint Joseph's Oratory, Museum, Montreal PQ
Saint Mary's College of California, Hearst Art Gallery, Moraga CA
San Francisco Maritime National Historical Park, Maritime Museum, San Francisco CA
San Jose Museum of Art, San Jose CA
Santa Barbara Museum of Art, Santa Barbara CA
Santa Monica Museum of Art, Santa Monica CA
School of Visual Arts, Visual Arts Museum, New York NY
Scottsdale Cultural Council, Scottsdale AZ
Seneca-Iroquois National Museum, Salamanca NY
1708 Gallery, Richmond VA
Shaker Museum & Library, Old Chatham NY
Shirley Plantation, Charles City VA
R L S Silverado Museum, Saint Helena CA
The Slater Memorial Museum, Slater Memorial Museum, Norwich CT
Smith College, Museum of Art, Northampton MA
Smithsonian Institution, Arthur M Sackler Gallery, Washington DC
Society of the Cincinnati, Museum & Library at Anderson House, Washington DC
Sonoma State University, University Art Gallery, Rohnert Park CA
South Carolina Artisans Center, Walterboro SC
South Dakota State University, South Dakota Art Museum, Brookings SD
Southeastern Center for Contemporary Art, Winston-Salem NC
Southern Illinois University Carbondale, University Museum, Carbondale IL
Southern Oregon Historical Society, Jacksonville Museum of Southern Oregon History, Medford OR
Southern Oregon University, Schneider Museum of Art, Ashland OR
Spertus Institute of Jewish Studies, Spertus Museum, Chicago IL
Springfield Art Museum, Springfield MO
Staatsgalerie Stuttgart, Stuttgart
Stamford Museum & Nature Center, Stamford CT
Stanley Museum, Inc, Kingfield ME
Nelda C & H J Lutcher Stark, Stark Museum of Art, Orange TX
State University of New York at Binghamton, University Art Museum, Binghamton NY
State University of New York at Purchase, Neuberger Museum of Art, Purchase NY
State University of New York College at Cortland, Dowd Fine Arts Gallery, Cortland NY
Stetson University, Duncan Gallery of Art, Deland FL

Stratford Historical Society, Catharine B Mitchell Museum, Stratford CT
Susquehanna University, Lore Degenstein Gallery, Selinsgrove PA
Syracuse University, Art Collection, Syracuse NY
Syracuse University, SUArt Galleries, Syracuse NY
Tampa Museum of Art, Tampa FL
Taos, Ernest Blumenschein Home & Studio, Taos NM
Terra Museum of American Art, Chicago IL
Texas Tech University, Museum of Texas Tech University, Lubbock TX
Thomas More College, TM Gallery, Crestview KY
Thorvaldsens Museum, Copenhagen
Tinkertown Museum, Sandia Park NM
Tokyo Kokuritsu Kindai Bujutsukan, The National Museum of Modern Art, Tokyo, Tokyo
Tokyo National University of Fine Arts & Music Art, University Art Museum, Tokyo
Topeka & Shawnee County Public Library, Alice C Sabatini Gallery, Topeka KS
The Ukrainian Museum, New York NY
Ulster County Community College, Muroff-Kotler Visual Arts Gallery, Stone Ridge NY
UMLAUF Sculpture Garden & Museum, Austin TX
United Society of Shakers, Shaker Museum, New Glocester ME
US Coast Guard Museum, New London CT
United States Figure Skating Association, World Figure Skating Museum & Hall of Fame, Colorado Springs CO
United States Military Academy, West Point Museum, West Point NY
United States Naval Academy, USNA Museum, Annapolis MD
University at Albany, State University of New York, University Art Museum, Albany NY
University of Alabama at Birmingham, Visual Arts Gallery, Birmingham AL
University of Alabama at Huntsville, Union Grove Gallery & University Center Gallery, Huntsville AL
University of California, California Museum of Photography, Riverside CA
University of California, Richard L Nelson Gallery & Fine Arts Collection, Davis CA
University of California, Berkeley, Berkeley Art Museum & Pacific Film Archive, Berkeley CA
University of California, San Diego, Stuart Collection, La Jolla CA
University of California, Santa Barbara, University Art Museum, Santa Barbara CA
University of Chicago, Smart Museum of Art, Chicago IL
University of Cincinnati, DAAP Galleries-College of Design Architecture, Art & Planning, Cincinnati OH
University of Colorado, CU Art Galleries, Boulder CO
University of Colorado at Colorado Springs, Gallery of Contemporary Art, Colorado Springs CO
University of Delaware, University Gallery, Newark DE
University of Georgia, Georgia Museum of Art, Athens GA
University of Illinois, Krannert Art Museum and Kinkead Pavillion, Champaign IL
University of Iowa, Museum of Art, Iowa City IA
University of Kansas, Spencer Museum of Art, Lawrence KS
University of Louisiana at Lafayette, University Art Museum, Lafayette LA
University of Louisville, Hite Art Institute, Louisville KY
University of Maine, Museum of Art, Bangor ME
University of Manitoba, Faculty of Architecture Exhibition Centre, Winnipeg MB
University of Massachusetts, Amherst, University Gallery, Amherst MA
University of Memphis, Art Museum, Memphis TN
University of Michigan, Museum of Art, Ann Arbor MI
University of Minnesota, The Bell Museum of Natural History, Minneapolis MN
University of Minnesota, Frederick R Weisman Art Museum, Minneapolis MN
University of Mississippi, University Museum, Oxford MS
University of Missouri, Museum of Art & Archaeology, Columbia MO
University of Nebraska, Lincoln, Sheldon Memorial Art Gallery & Sculpture Garden, Lincoln NE
University of Nevada, Reno, Sheppard Fine Arts Gallery, Reno NV
University of New Hampshire, The Art Gallery, Durham NH

University of New Mexico, The Harwood Museum of Art, Taos NM
University of New Mexico, University Art Museum, Albuquerque NM
University of North Carolina at Chapel Hill, Ackland Art Museum, Chapel Hill NC
University of North Carolina at Greensboro, Weatherspoon Art Museum, Greensboro NC
University of North Dakota, Hughes Fine Arts Center-Col Eugene Myers Art Gallery, Grand Forks ND
University of Pennsylvania, Arthur Ross Gallery, Philadelphia PA
University of Pittsburgh, University Art Gallery, Pittsburgh PA
University of Rhode Island, Fine Arts Center Galleries, Kingston RI
University of Saskatchewan, Diefenbaker Canada Centre, Saskatoon SK
University of Southern Colorado, College of Liberal & Fine Arts, Pueblo CO
University of the South, University Art Gallery, Sewanee TN
University of Toronto, University of Toronto Art Centre, Toronto ON
University of Victoria, Maltwood Art Museum and Gallery, Victoria BC
University of Wisconsin Oshkosh, Allen R Priebe Gallery, Oshkosh WI
University of Wisconsin-Stout, J Furlong Gallery, Menomonie WI
Upstairs Gallery, Winnipeg MB
Ursinus College, Philip & Muriel Berman Museum of Art, Collegeville PA
Valparaiso University, Brauer Museum of Art, Valparaiso IN
Vancouver Museum, Vancouver BC
Vassar College, The Frances Lehman Loeb Art Center, Poughkeepsie NY
Very Special Arts New Mexico, Very Special Arts Gallery, Albuquerque NM
Virginia Museum of Fine Arts, Richmond VA
Viridian Artists Inc, New York NY
The Walker African American Museum & Research Center, Las Vegas NV
Washington County Museum of Fine Arts, Hagerstown MD
Washington University, Mildred Lane Kemper Art Museum, Saint Louis MO
Waterworks Visual Arts Center, Salisbury NC
Wellesley College, Davis Museum & Cultural Center, Wellesley MA
Wesleyan University, Davison Art Center, Middletown CT
West Florida Historic Preservation, Inc, T T Wentworth, Jr Florida State Museum & Historic Pensacola Village, Pensacola FL
Western Illinois University, Western Illinos University Art Gallery, Macomb IL
Westminster College, Art Gallery, New Wilmington PA
Whatcom Museum of History and Art, Bellingham WA
Wheaton College, Watson Gallery, Norton MA
Wheelwright Museum of the American Indian, Santa Fe NM
Whitney Museum of American Art, New York NY
Wichita Art Museum, Wichita KS
Wichita State University, Ulrich Museum of Art & Martin H Bush Outdoor Sculpture Collection, Wichita KS
Wilfrid Laurier University, Robert Langen Art Gallery, Waterloo ON
Wisconsin Historical Society, State Historical Museum, Madison WI
The Woman's Exchange, University Art Collection, New Orleans LA
Woodlawn/The Pope-Leighey, Mount Vernon VA
Woodmere Art Museum, Philadelphia PA
Worcester Art Museum, Worcester MA
Xavier University, Art Gallery, Cincinnati OH
Yarmouth County Historical Society, Yarmouth County Museum, Yarmouth NS
Yerba Buena Center for the Arts, San Francisco CA

EMBROIDERY

Academy of the New Church, Glencairn Museum, Bryn Athyn PA
Albany Institute of History & Art, Albany NY
Albuquerque Museum of Art & History, Albuquerque NM

Allentown Art Museum, Allentown PA
American Swedish Historical Foundation & Museum, Philadelphia PA
Amherst Museum, Amherst NY
Artesia Historical Museum & Art Center, Artesia NM
Asian Art Museum of San Francisco, Chong-Moon Lee Ctr for Asian Art and Culture, San Francisco CA
Association for the Preservation of Virginia Antiquities, John Marshall House, Richmond VA
Athens Byzantine & Christian Museum, Athens
Bayou Bend Collection & Gardens, Houston TX
BJU Museum & Gallery, Bob Jones University Museum & Gallery Inc, Greenville SC
The Canadian Craft Museum, Vancouver BC
Canadian Museum of Civilization, Gatineau PQ
Cape Ann Historical Association, Gloucester MA
Caramoor Center for Music & the Arts, Inc, Caramoor House Museum, Katonah NY
Central United Methodist Church, Swords Into Plowshares Peace Center & Gallery, Detroit MI
Concord Museum, Concord MA
Cooper-Hewitt, National Design Museum, Smithsonian Institution, New York NY
Cornwall Gallery Society, Cornwall Regional Art Gallery, Cornwall ON
County of Henrico, Meadow Farm Museum, Glen Allen VA
Craft and Folk Art Museum (CAFAM), Los Angeles CA
Craigdarroch Castle Historical Museum Society, Victoria BC
Crow Wing County Historical Society, Brainerd MN
The Currier Museum of Art, Currier Museum of Art, Manchester NH
DAR Museum, National Society Daughters of the American Revolution, Washington DC
Dartmouth Heritage Museum, Dartmouth NS
Detroit Institute of Arts, Detroit MI
Detroit Zoological Institute, Wildlife Interpretive Gallery, Royal Oak MI
Ellen Noel Art Museum of the Permian Basin, Odessa TX
Erie Art Museum, Erie PA
Erie County Historical Society, Erie PA
Farmington Village Green & Library Association, Stanley-Whitman House, Farmington CT
Fashion Institute of Technology, Museum at FIT, New York NY
Fine Arts Museums of San Francisco, Legion of Honor, San Francisco CA
Fishkill Historical Society, Van Wyck Homestead Museum, Fishkill NY
Frontier Times Museum, Bandera TX
General Board of Discipleship, The United Methodist Church, The Upper Room Chapel & Museum, Nashville TN
Glanmore National Historic Site of Canada, Belleville ON
Hancock County Trustees of Public Reservations, Woodlawn Museum, Ellsworth ME
Haystack Mountain School of Crafts, Deer Isle ME
Hebrew Union College, Skirball Cultural Center, Los Angeles CA
Heritage Museum Association, Inc, The Heritage Museum of Northwest Florida, Valparaiso FL
Hermitage Foundation Museum, Norfolk VA
Hillwood Museum & Gardens Foundation, Hillwood Museum & Gardens, Washington DC
Historic Arkansas Museum, Little Rock AR
Historic Bethlehem Partnership, Kemerer Museum of Decorative Arts, Bethlehem PA
Historic Deerfield, Deerfield MA
Historical Society of Old Newbury, Cushing House Museum, Newburyport MA
Historisches und Volkerkundemuseum, Historical Museum, Sankt Gallen
Huguenot Historical Society of New Paltz Galleries, New Paltz NY
Imperial Calcasieu Museum, Gibson-Barham Gallery, Lake Charles LA
The Interchurch Center, Galleries at the Interchurch Center, New York NY
Iredell Museum of Arts & Heritage, Statesville NC
The Jewish Museum, New York NY
Kelly-Griggs House Museum, Red Bluff CA
Kings County Historical Society & Museum, Hampton NB
Klein Museum, Mobridge SD
Koochiching Museums, International Falls MN
Kunstindustrimuseet, The Danish Museum of Art & Design, Copenhagen

L A County Museum of Art, Los Angeles CA
Lac du Flambeau Band of Lake Superior Chippewa Indians, George W Brown Jr Ojibwe Museum & Cultural Center, Lac du Flambeau WI
Lafayette Natural History Museum & Planetarium, Lafayette LA
Lahore Museum, Lahore
Lehigh County Historical Society, Allentown PA
Lincoln County Historical Association, Inc, 1811 Old Lincoln County Jail & Lincoln County Museum, Wiscasset ME
The Long Island Museum of American Art, History & Carriages, Stony Brook NY
Longfellow-Evangeline State Commemorative Area, Saint Martinville LA
Loveland Museum Gallery, Loveland CO
Judah L Magnes, Berkeley CA
Maine Historical Society, Wadsworth-Longfellow House, Portland ME
Maison Saint-Gabriel Museum, Montreal PQ
McCord Museum of Canadian History, Montreal PQ
McDowell House & Apothecary Shop, Danville KY
Mexican Museum, San Francisco CA
Middle Border Museum & Oscar Howe Art Center, Mitchell SD
Mingei International, Inc, Mingei International Museum, San Diego CA
Mississippi Department of Archives & History, Old Capitol Museum of Mississippi History, Jackson MS
Missoula Art Museum, Missoula MT
Monroe County Historical Association, Elizabeth D Walters Library, Stroudsburg PA
Montreal Museum of Fine Arts, Montreal PQ
Moravska Galerie v Brne, Moravian Gallery in Brno, Brno
The Museum, Greenwood SC
Museum of Art & History, Santa Cruz, Santa Cruz CA
Museum of the American Quilter's Society, Paducah KY
Museum of the City of New York, New York NY
Muzej za Umjetnost i Obrt, Museum of Arts & Crafts, Zagreb
National Palace Museum, Taipei
The National Park Service, United States Department of the Interior, Statue of Liberty National Monument & The Ellis Island Immigration Museum, New York NY
Naval Historical Center, The Navy Museum, Washington DC
Neville Public Museum, Green Bay WI
New Jersey Historical Society, Newark NJ
New Jersey State Museum, Fine Art Bureau, Trenton NJ
Newton History Museum at the Jackson Homestead, Newton MA
No Man's Land Historical Society Museum, Goodwell OK
North Carolina State University, Visual Arts Center, Raleigh NC
Old Dartmouth Historical Society, New Bedford Whaling Museum, New Bedford MA
Old York Historical Society, Old Gaol Museum, York ME
Oshkosh Public Museum, Oshkosh WI
Panhandle-Plains Historical Society Museum, Canyon TX
Pasadena Historical Museum, Pasadena CA
Plainsman Museum, Aurora NE
Plumas County Museum, Quincy CA
Pope County Historical Society, Pope County Museum, Glenwood MN
Port Huron Museum, Port Huron MI
Portsmouth Historical Society, John Paul Jones House, Portsmouth NH
Putnam Museum of History and Natural Science, Davenport IA
Queens College, City University of New York, Godwin-Ternbach Museum, Flushing NY
Millicent Rogers, Taos NM
Royal Arts Foundation, Belcourt Castle, Newport RI
Saginaw Art Museum, Saginaw MI
St Genevieve Museum, Sainte Genevieve MO
Saint Joseph's Oratory, Museum, Montreal PQ
The Sandwich Historical Society, Inc, Sandwich Glass Museum, Sandwich MA
Shaker Museum & Library, Old Chatham NY
The Slater Memorial Museum, Slater Memorial Museum, Norwich CT
Smithsonian Institution, Arthur M Sackler Gallery, Washington DC

Southern Oregon Historical Society, Jacksonville Museum of Southern Oregon History, Medford OR
State University of New York at Binghamton, University Art Museum, Binghamton NY
Staten Island Institute of Arts & Sciences, Staten Island NY
Stratford Historical Society, Catharine B Mitchell Museum, Stratford CT
Summit County Historical Society, Akron OH
Swedish-American Museum Association of Chicago, Chicago IL
Taos, La Hacienda de Los Martinez, Taos NM
The Temple-Tifereth Israel, The Temple Museum of Religious Art, Beachwood OH
Texas Tech University, Museum of Texas Tech University, Lubbock TX
The Ukrainian Museum, New York NY
United Society of Shakers, Shaker Museum, New Glocester ME
University of Illinois, Krannert Art Museum and Kinkead Pavillion, Champaign IL
University of Kansas, Spencer Museum of Art, Lawrence KS
University of Toronto, University of Toronto Art Centre, Toronto ON
Wadsworth Atheneum Museum of Art, Hartford CT
West Florida Historic Preservation, Inc, T T Wentworth, Jr Florida State Museum & Historic Pensacola Village, Pensacola FL
Wheelwright Museum of the American Indian, Santa Fe NM
Willard House & Clock Museum, Inc, North Grafton MA
Wistariahurst Museum, Holyoke MA
Witte Museum, San Antonio TX
Woodlawn/The Pope-Leighey, Mount Vernon VA
Woodmere Art Museum, Philadelphia PA
Xavier University, Art Gallery, Cincinnati OH
Yarmouth County Historical Society, Yarmouth County Museum, Yarmouth NS

ENAMELS

Academy of the New Church, Glencairn Museum, Bryn Athyn PA
Art & Culture Center of Hollywood, Art Gallery, Hollywood FL
ArtSpace-Lima, Lima OH
BJU Museum & Gallery, Bob Jones University Museum & Gallery Inc, Greenville SC
The Canadian Craft Museum, Vancouver BC
Canadian Museum of Civilization, Gatineau PQ
Caramoor Center for Music & the Arts, Inc, Caramoor House Museum, Katonah NY
Cincinnati Institute of Fine Arts, Taft Museum of Art, Cincinnati OH
The Currier Museum of Art, Currier Museum of Art, Manchester NH
Detroit Institute of Arts, Detroit MI
Fine Arts Museums of San Francisco, Legion of Honor, San Francisco CA
Forest Lawn Museum, Glendale CA
Gallery One, Ellensburg WA
Glanmore National Historic Site of Canada, Belleville ON
Hermitage Foundation Museum, Norfolk VA
Hillwood Museum & Gardens Foundation, Hillwood Museum & Gardens, Washington DC
Hispanic Society of America, Museum & Library, New York NY
Hoyt Institute of Fine Arts, New Castle PA
The Interchurch Center, Galleries at the Interchurch Center, New York NY
Iowa State University, Brunnier Art Museum, Ames IA
Johns Hopkins University, Evergreen House, Baltimore MD
LeSueur County Historical Society, Chapter One, Elysian MN
Loyola University of Chicago, Martin D'Arcy Museum of Art, Chicago IL
Luther College, Fine Arts Collection, Decorah IA
Meredith College, Frankie G Weems Gallery & Rotunda Gallery, Raleigh NC
Michigan State University, Kresge Art Museum, East Lansing MI
Mingei International, Inc, Mingei International Museum, San Diego CA
Mint Museum of Art, Charlotte NC
Montreal Museum of Fine Arts, Montreal PQ

Moravska Galerie v Brne, Moravian Gallery in Brno, Brno

Museu Nacional d'Art de Catalunya, National Art Museum, Barcelona

National Museum of Ceramic Art & Glass, Baltimore MD

National Palace Museum, Taipei

Nemours Mansion & Gardens, Wilmington DE

New Orleans GlassWorks Gallery & Printmaking Studio, New Orleans ArtWorks Gallery, New Orleans LA

Noyes Art Gallery, Lincoln NE

Saint Peter's College, Art Gallery, Jersey City NJ

Smithsonian Institution, Arthur M Sackler Gallery, Washington DC

Southern Illinois University Carbondale, University Museum, Carbondale IL

Stauth Foundation & Museum, Stauth Memorial Museum, Montezuma KS

Topeka & Shawnee County Public Library, Alice C Sabatini Gallery, Topeka KS

University of Illinois, Krannert Art Museum and Kinkead Pavillion, Champaign IL

Virginia Museum of Fine Arts, Richmond VA

ESKIMO ART

Anchorage Museum at Rasmuson Center, Anchorage AK

Archaeological Society of Ohio, Indian Museum of Lake County, Ohio, Willoughby OH

Art Gallery of Hamilton, Hamilton ON

Art Gallery of Nova Scotia, Halifax NS

Art Without Walls Inc, Art Without Walls Inc, Sayville NY

Aurora University, Schingoethe Center for Native American Cultures, Aurora IL

Blauvelt Demarest Foundation, Hiram Blauvelt Art Museum, Oradell NJ

Cabot's Old Indian Pueblo Museum, Cabot's Old Indian Pueblo Museum, Desert Hot Springs CA

Canadian Museum of Civilization, Gatineau PQ

College of William & Mary, Muscarelle Museum of Art, Williamsburg VA

Columbus Museum, Columbus GA

Columbus Museum of Art, Columbus OH

Deming-Luna Mimbres Museum, Deming NM

Denver Art Museum, Denver CO

Detroit Institute of Arts, Detroit MI

Detroit Zoological Institute, Wildlife Interpretive Gallery, Royal Oak MI

Discovery Place Inc, Nature Museum, Charlotte NC

Downey Museum of Art, Downey CA

Eiteljorg Museum of American Indians & Western Art, Indianapolis IN

Eskimo Museum, Churchill MB

Fairbanks Museum & Planetarium, Saint Johnsbury VT

Fine Arts Museums of San Francisco, Legion of Honor, San Francisco CA

Folk Art Society of America, Richmond VA

Genesee Country Village & Museum, John L Wehle Gallery of Wildlife & Sporting Art, Mumford NY

Thomas Gilcrease, Gilcrease Museum, Tulsa OK

Henry County Museum & Cultural Arts Center, Clinton MO

Heritage Center, Inc, Pine Ridge SD

Herrett Center for Arts & Sciences, Jean B King Art Gallery, Twin Falls ID

Historisches und Volkerkundemuseum, Historical Museum, Sankt Gallen

Huronia Museum, Gallery of Historic Huronia, Midland ON

Institute of American Indian Arts Museum, Museum, Santa Fe NM

The Interchurch Center, Galleries at the Interchurch Center, New York NY

Kelowna Museum, Kelowna BC

Koshare Indian Museum, Inc, La Junta CO

Luther College, Fine Arts Collection, Decorah IA

Macdonald Stewart Art Centre, Guelph ON

Maitland Art Center, Maitland FL

Maryhill Museum of Art, Goldendale WA

McCord Museum of Canadian History, Montreal PQ

Michigan State University, Kresge Art Museum, East Lansing MI

Mingei International, Inc, Mingei International Museum, San Diego CA

Missoula Art Museum, Missoula MT

Montreal Museum of Fine Arts, Montreal PQ

Moravian Historical Society, Whitefield House Museum, Nazareth PA

Musee Regional de la Cote-Nord, Sept-Iles PQ

National Art Museum of Sport, Indianapolis IN

National Museum of the American Indian, George Gustav Heye Center, New York NY

Panhandle-Plains Historical Society Museum, Canyon TX

Pope County Historical Society, Pope County Museum, Glenwood MN

Portland Art Museum, Portland OR

Queens College, City University of New York, Godwin-Ternbach Museum, Flushing NY

Riverside Municipal Museum, Riverside CA

Saint Joseph Museum, Saint Joseph MO

Saint Joseph's Oratory, Museum, Montreal PQ

San Francisco Maritime National Historical Park, Maritime Museum, San Francisco CA

Sheldon Museum & Cultural Center, Inc, Sheldon Museum & Cultural Center, Haines AK

The Slater Memorial Museum, Slater Memorial Museum, Norwich CT

South Dakota State University, South Dakota Art Museum, Brookings SD

US Coast Guard Museum, New London CT

United States Department of the Interior Museum, Washington DC

University of Alabama at Birmingham, Visual Arts Gallery, Birmingham AL

University of Delaware, University Gallery, Newark DE

University of North Carolina at Chapel Hill, Ackland Art Museum, Chapel Hill NC

University of Saskatchewan, Diefenbaker Canada Centre, Saskatoon SK

University of Toronto, University of Toronto Art Centre, Toronto ON

Upstairs Gallery, Winnipeg MB

Vancouver Museum, Vancouver BC

Wake Forest University, Museum of Anthropology, Winston-Salem NC

Peter & Catharine Whyte Foundation, Whyte Museum of the Canadian Rockies, Banff AB

Wilfrid Laurier University, Robert Langen Art Gallery, Waterloo ON

The Winnipeg Art Gallery, Winnipeg MB

Wistariahurst Museum, Holyoke MA

York University, Art Gallery of York University, Toronto ON

Yugtarvik Regional Museum & Bethel Visitors Center, Bethel AK

ETCHINGS & ENGRAVINGS

African American Museum in Philadelphia, Philadelphia PA

Albany Institute of History & Art, Albany NY

Albuquerque Museum of Art & History, Albuquerque NM

Allentown Art Museum, Allentown PA

American Kennel Club, Museum of the Dog, Saint Louis MO

American Swedish Historical Foundation & Museum, Philadelphia PA

American University, Katzen Art Center Gallery, Washington DC

Anchorage Museum at Rasmuson Center, Anchorage AK

Arnot Art Museum, Elmira NY

Art & Culture Center of Hollywood, Art Gallery, Hollywood FL

Art Community Center, Art Center of Corpus Christi, Corpus Christi TX

Art Gallery of Hamilton, Hamilton ON

Art Gallery of South Australia, Adelaide

Art Museum of Greater Lafayette, Lafayette IN

Artspace, Richmond VA

ArtSpace-Lima, Lima OH

Asbury College, Student Center Gallery, Wilmore KY

Augustana College, Augustana College Art Museum, Rock Island IL

Baldwin Historical Society Museum, Baldwin NY

Ball State University, Museum of Art, Muncie IN

Baruch College of the City University of New York, Sidney Mishkin Gallery, New York NY

Bayou Bend Collection & Gardens, Houston TX

Berea College, Doris Ulmann Galleries, Berea KY

Berkshire Museum, Pittsfield MA

Jesse Besser, Alpena MI

BJU Museum & Gallery, Bob Jones University Museum & Gallery Inc, Greenville SC

Blanden Memorial Art Museum, Fort Dodge IA

Boston Public Library, Albert H Wiggin Gallery & Print Department, Boston MA

Brandywine River Museum, Chadds Ford PA

Brigham Young University, Museum of Art, Provo UT

Bruce Museum, Inc, Bruce Museum, Greenwich CT

The Buffalo Fine Arts Academy, Albright-Knox Art Gallery, Buffalo NY

Cabot's Old Indian Pueblo Museum, Cabot's Old Indian Pueblo Museum, Desert Hot Springs CA

California State University, Northridge, Art Galleries, Northridge CA

Cameron Art Museum, Wilmington NC

Canadian Museum of Civilization, Gatineau PQ

Cape Ann Historical Association, Gloucester MA

Cape Cod Museum of Art Inc, Dennis MA

Carnegie Mellon University, Hunt Institute for Botanical Documentation, Pittsburgh PA

Carson County Square House Museum, Panhandle TX

Amon Carter, Fort Worth TX

Cartoon Art Museum, San Francisco CA

Center for Book Arts, New York NY

Central United Methodist Church, Swords Into Plowshares Peace Center & Gallery, Detroit MI

Chattahoochee Valley Art Museum, LaGrange GA

City of Grand Rapids Michigan, Public Museum of Grand Rapids, Grand Rapids MI

Clark County Historical Society, Pioneer - Krier Museum, Ashland KS

Clinton Art Association, River Arts Center, Clinton IA

College of William & Mary, Muscarelle Museum of Art, Williamsburg VA

Columbus Museum, Columbus GA

Columbus Museum of Art, Columbus OH

Concord Museum, Concord MA

Concordia Historical Institute, Saint Louis MO

Concordia University, Leonard & Bina Ellen Art Gallery, Montreal PQ

Cooper-Hewitt, National Design Museum, Smithsonian Institution, New York NY

Cornell Museum of Art & History, Delray Beach FL

Coutts Memorial Museum of Art, Inc, El Dorado KS

Craft and Folk Art Museum (CAFAM), Los Angeles CA

Cranbrook Art Museum, Cranbrook Art Museum, Bloomfield Hills MI

Crow Wing County Historical Society, Brainerd MN

The Currier Museum of Art, Currier Museum of Art, Manchester NH

Dahesh Museum of Art, New York NY

Danville Museum of Fine Arts & History, Danville VA

Delaware Art Museum, Wilmington DE

Denison University, Art Gallery, Granville OH

Detroit Institute of Arts, Detroit MI

Detroit Repertory Theatre Gallery, Detroit MI

Dickinson College, The Trout Gallery, Carlisle PA

Dixie State College, Robert N & Peggy Sears Gallery, Saint George UT

Doncaster Museum and Art Gallery, Doncaster

Door County, Miller Art Museum, Sturgeon Bay WI

Downey Museum of Art, Downey CA

Duke University, Duke University Museum of Art, Durham NC

Dundurn Castle, Hamilton ON

Durham Art Guild Inc, Durham NC

East Baton Rouge Parks & Recreation Commission, Baton Rouge Gallery Inc, Baton Rouge LA

Eastern Illinois University, Tarble Arts Center, Charleston IL

Egan Institute of Maritime Studies, Nantucket MA

Eiteljorg Museum of American Indians & Western Art, Indianapolis IN

Ellen Noel Art Museum of the Permian Basin, Odessa TX

Elmhurst Art Museum, Elmhurst IL

Emory University, Michael C Carlos Museum, Atlanta GA

Erie Art Museum, Erie PA

Evansville Museum of Arts, History & Science, Evansville IN

Evergreen State College, Evergreen Galleries, Olympia WA

Farmington Village Green & Library Association, Stanley-Whitman House, Farmington CT

Federal Reserve Board, Art Gallery, Washington DC

Fine Arts Center for the New River Valley, Pulaski VA

Fine Arts Museums of San Francisco, Legion of Honor, San Francisco CA

United States Figure Skating Association, World Figure Skating Museum & Hall of Fame, Colorado Springs CO
United States Military Academy, West Point Museum, West Point NY
United States Navy, Art Gallery, Washington DC
University of Alabama at Birmingham, Visual Arts Gallery, Birmingham AL
University of Arkansas at Little Rock, Art Galleries, Little Rock AR
University of California, Richard L Nelson Gallery & Fine Arts Collection, Davis CA
University of California, Santa Barbara, University Art Museum, Santa Barbara CA
University of Cincinnati, DAAP Galleries-College of Design Architecture, Art & Planning, Cincinnati OH
University of Colorado at Colorado Springs, Gallery of Contemporary Art, Colorado Springs CO
University of Delaware, University Gallery, Newark DE
University of Illinois, Krannert Art Museum and Kinkead Pavillion, Champaign IL
University of Iowa, Museum of Art, Iowa City IA
University of Kansas, Spencer Museum of Art, Lawrence KS
University of Louisiana at Lafayette, University Art Museum, Lafayette LA
University of Maine, Museum of Art, Bangor ME
University of Manitoba, Faculty of Architecture Exhibition Centre, Winnipeg MB
University of Mary Washington, Belmont, The Gari Melchers, Fredericksburg VA
University of Massachusetts, Amherst, University Gallery, Amherst MA
University of Memphis, Art Museum, Memphis TN
University of Michigan, Museum of Art, Ann Arbor MI
University of Minnesota, The Bell Museum of Natural History, Minneapolis MN
University of Mississippi, University Museum, Oxford MS
University of New Hampshire, The Art Gallery, Durham NH
University of New Mexico, The Harwood Museum of Art, Taos NM
University of New Mexico, University Art Museum, Albuquerque NM
University of North Carolina at Chapel Hill, Ackland Art Museum, Chapel Hill NC
University of North Carolina at Greensboro, Weatherspoon Art Museum, Greensboro NC
University of Pennsylvania, Arthur Ross Gallery, Philadelphia PA
University of Saskatchewan, Diefenbaker Canada Centre, Saskatoon SK
University of the South, University Art Gallery, Sewanee TN
University of Toronto, University of Toronto Art Centre, Toronto ON
University of Victoria, Maltwood Art Museum and Gallery, Victoria BC
Upstairs Gallery, Winnipeg MB
Ursinus College, Philip & Muriel Berman Museum of Art, Collegeville PA
Vancouver Museum, Vancouver BC
Vassar College, The Frances Lehman Loeb Art Center, Poughkeepsie NY
Ventura County Maritime Museum, Inc, Oxnard CA
Virginia Museum of Fine Arts, Richmond VA
Washburn University, Mulvane Art Museum, Topeka KS
Washington University, Mildred Lane Kemper Art Museum, Saint Louis MO
Waterworks Visual Arts Center, Salisbury NC
Wellesley College, Davis Museum & Cultural Center, Wellesley MA
Wesleyan University, Davison Art Center, Middletown CT
West Florida Historic Preservation, Inc, T T Wentworth, Jr Florida State Museum & Historic Pensacola Village, Pensacola FL
Wheaton College, Watson Gallery, Norton MA
Peter & Catharine Whyte Foundation, Whyte Museum of the Canadian Rockies, Banff AB
Wilfrid Laurier University, Robert Langen Art Gallery, Waterloo ON
Wisconsin Historical Society, State Historical Museum, Madison WI
Woodlawn/The Pope-Leighey, Mount Vernon VA
Woodmere Art Museum, Philadelphia PA
Worcester Art Museum, Worcester MA
Xavier University, Art Gallery, Cincinnati OH

Yarmouth County Historical Society, Yarmouth County Museum, Yarmouth NS

ETHNOLOGY

African Art Museum of Maryland, Columbia MD
Alaska Department of Education, Division of Libraries, Archives & Museums, Sheldon Jackson Museum, Sitka AK
Anchorage Museum at Rasmuson Center, Anchorage AK
Arab American National Museum, Dearborn MI
Art Without Walls Inc, Art Without Walls Inc, Sayville NY
ArtSpace-Lima, Lima OH
Atlanta International Museum of Art & Design, Atlanta GA
Aurora University, Schingoethe Center for Native American Cultures, Aurora IL
Ball State University, Museum of Art, Muncie IN
Berkshire Museum, Pittsfield MA
Bruce Museum, Inc, Bruce Museum, Greenwich CT
California State University, East Bay, C E Smith Museum of Anthropology, Hayward CA
Canadian Museum of Civilization, Gatineau PQ
Carson County Square House Museum, Panhandle TX
Centenary College of Louisiana, Meadows Museum of Art, Shreveport LA
Chief Plenty Coups Museum State Park, Pryor MT
City of Grand Rapids Michigan, Public Museum of Grand Rapids, Grand Rapids MI
City of Providence Parks Department, Roger Williams Park Museum of Natural History, Providence RI
City of Ukiah, Grace Hudson Museum & The Sun House, Ukiah CA
The College of Wooster, The College of Wooster Art Museum, Wooster OH
Colorado Historical Society, Colorado History Museum, Denver CO
Columbus Museum, Columbus GA
Cornell University, Herbert F Johnson Museum of Art, Ithaca NY
Dawson City Museum & Historical Society, Dawson City YT
Department of Community Development, Provincial Museum of Alberta, Edmonton AB
Detroit Institute of Arts, Detroit MI
DeWitt Historical Society of Tompkins County, The History Center in Tompkins Co, Ithaca NY
Eskimo Museum, Churchill MB
Evansville Museum of Arts, History & Science, Evansville IN
Fairbanks Museum & Planetarium, Saint Johnsbury VT
Freeport Arts Center, Freeport IL
Thomas Gilcrease, Gilcrease Museum, Tulsa OK
Grand River Museum, Lemmon SD
Hammond Museum & Japanese Stroll Garden, Cross-Cultural Center, North Salem NY
Hartwick College, The Yager Museum, Oneonta NY
Hebrew Union College, Skirball Cultural Center, Los Angeles CA
Henry County Museum & Cultural Arts Center, Clinton MO
Higgins Armory Museum, Worcester MA
Historic Arkansas Museum, Little Rock AR
Huntington Museum of Art, Huntington WV
Huronia Museum, Gallery of Historic Huronia, Midland ON
Iroquois Indian Museum, Howes Cave NY
Kelowna Museum, Kelowna BC
Kenosha Public Museum, Kenosha WI
Kern County Museum, Bakersfield CA
L A County Museum of Art, Los Angeles CA
Lac du Flambeau Band of Lake Superior Chippewa Indians, George W Brown Jr Ojibwe Museum & Cultural Center, Lac du Flambeau WI
Lafayette Natural History Museum & Planetarium, Lafayette LA
Leelanau Historical Museum, Leland MI
Lehigh County Historical Society, Allentown PA
Loyola Marymount University, Laband Art Gallery, Los Angeles CA
Jacques Marchais, Staten Island NY
The Mariners' Museum, Newport News VA
Maryhill Museum of Art, Goldendale WA
McCord Museum of Canadian History, Montreal PQ
Carrie M McLain, Nome AK
Michigan State University, Kresge Art Museum, East Lansing MI
Missoula Art Museum, Missoula MT

Mohave Museum of History & Arts, Kingman AZ
Moose Jaw Art Museum, Inc, Art & History Museum, Moose Jaw SK
Musee Regional de la Cote-Nord, Sept-Iles PQ
Museo De Las Americas, Denver CO
The Museum, Greenwood SC
Museum for African Art, Long Island City NY
Museum of Northern Arizona, Flagstaff AZ
Museum of York County, Rock Hill SC
Muzeum Narodowe, National Museum, Poznan
National Museum of the American Indian, George Gustav Heye Center, New York NY
National Museum, Monuments and Art Gallery, Gaborone
New Brunswick Museum, Saint John NB
New Jersey State Museum, Fine Art Bureau, Trenton NJ
New World Art Center, T F Chen Cultural Center, New York NY
New York State Museum, Albany NY
Newburyport Maritime Society, Custom House Maritime Museum, Newburyport MA
No Man's Land Historical Society Museum, Goodwell OK
Ohio Historical Society, National Afro American Museum & Cultural Center, Wilberforce OH
Old Dartmouth Historical Society, New Bedford Whaling Museum, New Bedford MA
Palm Beach County Parks & Recreation Department, Morikami Museum & Japanese Gardens, Delray Beach FL
Panhandle-Plains Historical Society Museum, Canyon TX
The Frank Phillips, Woolaroc Museum, Bartlesville OK
Queen's University, Agnes Etherington Art Centre, Kingston ON
Red Rock State Park, Red Rock Museum, Church Rock NM
Riverside Municipal Museum, Riverside CA
Roswell Museum & Art Center, Roswell NM
C M Russell, Great Falls MT
Saint Joseph Museum, Saint Joseph MO
Saint Mary's College of California, Hearst Art Gallery, Moraga CA
Seneca-Iroquois National Museum, Salamanca NY
Shelburne Museum, Museum, Shelburne VT
Sheldon Museum & Cultural Center, Inc, Sheldon Museum & Cultural Center, Haines AK
Sooke Region Museum & Art Gallery, Sooke BC
Southern Illinois University Carbondale, University Museum, Carbondale IL
Spertus Institute of Jewish Studies, Spertus Museum, Chicago IL
Staten Island Institute of Arts & Sciences, Staten Island NY
The Temple-Tifereth Israel, The Temple Museum of Religious Art, Beachwood OH
Texas Tech University, Museum of Texas Tech University, Lubbock TX
Turtle Bay Exploration Park, Redding CA
The Ukrainian Museum, New York NY
University of British Columbia, Museum of Anthropology, Vancouver BC
University of California, Santa Barbara, University Art Museum, Santa Barbara CA
University of Pennsylvania, Museum of Archaeology & Anthropology, Philadelphia PA
The University of Texas at San Antonio, UTSA's Institute of Texan Cultures, San Antonio TX
University of Victoria, Maltwood Art Museum and Gallery, Victoria BC
Vancouver Museum, Vancouver BC
Wake Forest University, Museum of Anthropology, Winston-Salem NC
Whatcom Museum of History and Art, Bellingham WA
Wheelwright Museum of the American Indian, Santa Fe NM
Wistariahurst Museum, Holyoke MA
Yarmouth County Historical Society, Yarmouth County Museum, Yarmouth NS

FLASKS & BOTTLES

Adams County Historical Society, Gettysburg PA
Art & Culture Center of Hollywood, Art Gallery, Hollywood FL
Bayou Bend Collection & Gardens, Houston TX
Berman Museum, Anniston AL
Canadian Museum of Civilization, Gatineau PQ

City of Grand Rapids Michigan, Public Museum of Grand Rapids, Grand Rapids MI

Detroit Institute of Arts, Detroit MI

Frontier Times Museum, Bandera TX

Glassboro Heritage Glass Museum, Glassboro NJ

Iredell Museum of Arts & Heritage, Statesville NC

Iroquois County Historical Society Museum, Old Courthouse Museum, Watseka IL

McMaster University, McMaster Museum of Art, Hamilton ON

Muzej za Umjetnost i Obrt, Museum of Arts & Crafts, Zagreb

New Jersey Historical Society, Newark NJ

New Jersey State Museum, Fine Art Bureau, Trenton NJ

Saint Peter's College, Art Gallery, Jersey City NJ

Staten Island Institute of Arts & Sciences, Staten Island NY

Switzerland County Historical Society Inc, Switzerland County Historical Museum, Vevay IN

Texas Tech University, Museum of Texas Tech University, Lubbock TX

Three Forks Area Historical Society, Headwaters Heritage Museum, Three Forks MT

University of California, Berkeley, Phoebe Apperson Hearst Museum of Anthropology, Berkeley CA

University of Utah, Utah Museum of Fine Arts, Salt Lake City UT

Waterville Historical Society, Redington Museum, Waterville ME

West Florida Historic Preservation, Inc, T T Wentworth, Jr Florida State Museum & Historic Pensacola Village, Pensacola FL

Wheaton College, Watson Gallery, Norton MA

FOLK ART

Adams County Historical Society, Gettysburg PA

Albany Institute of History & Art, Albany NY

Albuquerque Museum of Art & History, Albuquerque NM

Alexandria Museum of Art, Alexandria LA

Allentown Art Museum, Allentown PA

Alton Museum of History & Art, Inc, Alton IL

American Folk Art Museum, New York NY

American Kennel Club, Museum of the Dog, Saint Louis MO

American Swedish Historical Foundation & Museum, Philadelphia PA

Amherst Museum, Amherst NY

Arizona Historical Society-Yuma, Sanguinetti House Museum & Garden, Yuma AZ

Art & Culture Center of Hollywood, Art Gallery, Hollywood FL

Art Gallery of Nova Scotia, Halifax NS

Art Museum of Greater Lafayette, Lafayette IN

Art Museum of Western Virginia, Roanoke VA

Art Without Walls Inc, Art Without Walls Inc, Sayville NY

ArtSpace-Lima, Lima OH

Asheville Art Museum, Asheville NC

Atlanta International Museum of Art & Design, Atlanta GA

Aurora University, Schingoethe Center for Native American Cultures, Aurora IL

Balzekas Museum of Lithuanian Culture, Chicago IL

Bayou Bend Collection & Gardens, Houston TX

Berkshire Museum, Pittsfield MA

Jesse Besser, Alpena MI

Brigham City Corporation, Brigham City Museum & Gallery, Brigham City UT

Bruce Museum, Inc, Bruce Museum, Greenwich CT

Bucks County Historical Society, Mercer Museum, Doylestown PA

Cahoon Museum of American Art, Cotuit MA

California State University, Northridge, Art Galleries, Northridge CA

Cameron Art Museum, Wilmington NC

The Canadian Craft Museum, Vancouver BC

Canadian Museum of Civilization, Gatineau PQ

Cardinal Stritch University, Art Gallery, Milwaukee WI

Miles B Carpenter, Waverly VA

Carson County Square House Museum, Panhandle TX

Cartoon Art Museum, San Francisco CA

Center for Puppetry Arts, Atlanta GA

Central United Methodist Church, Swords Into Plowshares Peace Center & Gallery, Detroit MI

Chattahoochee Valley Art Museum, LaGrange GA

Chesapeake Bay Maritime Museum, Saint Michaels MD

Chinese Culture Foundation, Center Gallery, San Francisco CA

Chinese Culture Institute of the International Society, Tremont Theatre & Gallery, Boston MA

Church of Jesus Christ of Latter-Day Saints, Museum of Church History & Art, Salt Lake City UT

City of El Paso Museum and Cultural Affairs, People's Gallery, El Paso TX

City of Fayette, Alabama, Fayette Art Museum, Fayette AL

City of Gainesville, Thomas Center Galleries - Cultural Affairs, Gainesville FL

City of Providence Parks Department, Roger Williams Park Museum of Natural History, Providence RI

City of Springdale, Shiloh Museum of Ozark History, Springdale AR

Colonial Williamsburg Foundation, Abby Aldrich Rockefeller Folk Art Center, Williamsburg VA

Colorado Springs Fine Arts Center, Colorado Springs CO

Columbus Museum, Columbus GA

Cornell Museum of Art & History, Delray Beach FL

Cornwall Gallery Society, Cornwall Regional Art Gallery, Cornwall ON

Cortland County Historical Society, Suggett House Museum, Cortland NY

County of Henrico, Meadow Farm Museum, Glen Allen VA

Coutts Memorial Museum of Art, Inc, El Dorado KS

Craft and Folk Art Museum (CAFAM), Los Angeles CA

Craftsmen's Guild of Mississippi, Inc, Agriculture & Forestry Museum, Jackson MS

Craftsmen's Guild of Mississippi, Inc, Mississippi Crafts Center, Ridgeland MS

Culberson County Historical Museum, Van Horn TX

The Currier Museum of Art, Currier Museum of Art, Manchester NH

Danville Museum of Fine Arts & History, Danville VA

Deming-Luna Mimbres Museum, Deming NM

Denison University, Art Gallery, Granville OH

Denver Art Museum, Denver CO

Detroit Institute of Arts, Detroit MI

Detroit Repertory Theatre Gallery, Detroit MI

Downey Museum of Art, Downey CA

East Carolina University, Wellington B Gray Gallery, Greenville NC

Eastern Illinois University, Tarble Arts Center, Charleston IL

Ellen Noel Art Museum of the Permian Basin, Odessa TX

Elmhurst Art Museum, Elmhurst IL

Enook Galleries, Waterloo ON

Erie County Historical Society, Erie PA

Evansville Museum of Arts, History & Science, Evansville IN

Everhart Museum, Scranton PA

Fairbanks Museum & Planetarium, Saint Johnsbury VT

Farmington Village Green & Library Association, Stanley-Whitman House, Farmington CT

Ferenczy Muzeum, Szentendre

Fine Arts Center for the New River Valley, Pulaski VA

Fishkill Historical Society, Van Wyck Homestead Museum, Fishkill NY

Fisk University, Fisk University Galleries, Nashville TN

Folk Art Society of America, Richmond VA

Frankfort Community Public Library, Anna & Harlan Hubbard Gallery, Frankfort IN

Frostburg State University, The Stephanie Ann Roper Gallery, Frostburg MD

Gadsden Museum of Fine Arts, Inc, Gadsden Museum of Art and History, Gadsden AL

Galeria de la Raza, Studio 24, San Francisco CA

General Board of Discipleship, The United Methodist Church, The Upper Room Chapel & Museum, Nashville TN

Genesee Country Village & Museum, John L Wehle Gallery of Wildlife & Sporting Art, Mumford NY

Germanisches Nationalmuseum, Nuremberg

Thomas Gilcrease, Gilcrease Museum, Tulsa OK

Wendell Gilley, Southwest Harbor ME

Grand Rapids Art Museum, Grand Rapids MI

Greene County Historical Society, Bronck Museum, Coxsackie NY

Halifax Historical Society, Inc, Halifax Historical Museum, Daytona Beach FL

Hambidge Center for the Creative Arts & Sciences, Rabun Gap GA

Hebrew Union College, Jewish Institute of Religion Museum, New York NY

Hebrew Union College, Skirball Cultural Center, Los Angeles CA

Hebrew Union College - Jewish Institute of Religion, Skirball Museum Cincinnati, Cincinnati OH

Heritage Center of Lancaster County Museum, Lancaster PA

Heritage Center, Inc, Pine Ridge SD

Heritage Hjemkomst Interpretive Center, Moorhead MN

Heritage Museum Association, Inc, The Heritage Museum of Northwest Florida, Valparaiso FL

Heritage Museums & Gardens, Sandwich MA

Hershey Museum, Hershey PA

Hickory Museum of Art, Inc, Hickory NC

High Point Historical Society Inc, Museum, High Point NC

Hillwood Museum & Gardens Foundation, Hillwood Museum & Gardens, Washington DC

Hinckley Foundation Museum, Ithaca NY

Hispanic Society of America, Museum & Library, New York NY

Historic Arkansas Museum, Little Rock AR

Historic Bethlehem Partnership, Kemerer Museum of Decorative Arts, Bethlehem PA

Holter Museum of Art, Helena MT

Huguenot Historical Society of New Paltz Galleries, New Paltz NY

Huntington Museum of Art, Huntington WV

Huronia Museum, Gallery of Historic Huronia, Midland ON

Hyde Park Art Center, Chicago IL

Illinois Historic Preservation Agency, Bishop Hill State Historic Site, Bishop Hill IL

Imperial Calcasieu Museum, Gibson-Barham Gallery, Lake Charles LA

Institute of Puerto Rican Culture, Museo Fuerte Conde de Mirasol, Vieques PR

Intuit: The Center for Intuitive & Outsider Art, Chicago IL

Iredell Museum of Arts & Heritage, Statesville NC

James Dick Foundation, Festival - Institute, Round Top TX

Jamestown-Yorktown Foundation, Williamsburg VA

Jefferson County Open Space, Hiwan Homestead Museum, Evergreen CO

Jersey City Museum, Jersey City NJ

Kelowna Museum, Kelowna BC

Kentucky Museum of Art & Craft, Louisville KY

Key West Art & Historical Society, East Martello Museum & Gallery, Key West FL

Knoxville Museum of Art, Knoxville TN

Koshare Indian Museum, Inc, La Junta CO

Kyiv Museum of Russian Art, Kyiv

L A County Museum of Art, Los Angeles CA

Lac du Flambeau Band of Lake Superior Chippewa Indians, George W Brown Jr Ojibwe Museum & Cultural Center, Lac du Flambeau WI

Lafayette Natural History Museum & Planetarium, Lafayette LA

Landis Valley Museum, Lancaster PA

Leelanau Historical Museum, Leland MI

Lehigh County Historical Society, Allentown PA

Lehigh University Art Galleries, Museum Operation, Bethlehem PA

LeSueur County Historical Society, Chapter One, Elysian MN

Lincoln County Historical Association, Inc, 1811 Old Lincoln County Jail & Lincoln County Museum, Wiscasset ME

The Long Island Museum of American Art, History & Carriages, Stony Brook NY

Longfellow-Evangeline State Commemorative Area, Saint Martinville LA

Loveland Museum Gallery, Loveland CO

Loyola Marymount University, Laband Art Gallery, Los Angeles CA

Judah L Magnes, Berkeley CA

Maine Historical Society, MHS Museum, Portland ME

Manhattan Psychiatric Center, East River Gallery, New York NY

Maricopa County Historical Society, Desert Caballeros Western Museum, Wickenburg AZ

The Mariners' Museum, Newport News VA

Maryland Art Place, Baltimore MD

Marylhurst University, The Art Gym, Marylhurst OR

McAllen International Museum, McAllen TX

McCord Museum of Canadian History, Montreal PQ

Mennello Museum of American Art, Orlando FL

Mercer County Community College, The Gallery, West Windsor NJ

Mexican Fine Arts Center Museum, Chicago IL

Mexican Museum, San Francisco CA
Miami University, Art Museum, Oxford OH
Miami-Dade College, Kendal Campus, Art Gallery, Miami FL
Midwest Museum of American Art, Elkhart IN
Milwaukee Public Museum, Milwaukee WI
Mingei International, Inc, Mingei International Museum, San Diego CA
Minot Art Association, Lillian & Coleman Taube Museum of Art, Minot ND
Mississippi Department of Archives & History, Old Capitol Museum of Mississippi History, Jackson MS
Mississippi River Museum at Mud-Island River Park, Memphis TN
Arthur Roy Mitchell, Museum of Western Art, Trinidad CO
Mobile Museum of Art, Mobile AL
Montgomery Museum of Fine Arts, Montgomery AL
Moore College of Art & Design, The Galleries at Moore, Philadelphia PA
Moose Jaw Art Museum, Inc, Art & History Museum, Moose Jaw SK
Moravian Historical Society, Whitefield House Museum, Nazareth PA
Morehead State University, Kentucky Folk Art Center, Morehead KY
Morris Museum of Art, Augusta GA
Musee d'Art de Saint-Laurent, Saint-Laurent PQ
Museo De Las Americas, Denver CO
The Museum, Greenwood SC
Museum of Art & History, Santa Cruz, Santa Cruz CA
Museum of New Mexico, Museum of International Folk Art, Santa Fe NM
Museum of Northern Arizona, Flagstaff AZ
Museum of the American Quilter's Society, Paducah KY
Museum of the City of New York, New York NY
Museum of West Louisiana, Leesville LA
Muttart Public Art Gallery, Calgary AB
Muzeum Narodowe, National Museum, Poznan
Muzeum Narodowe W Kielcach, National Museum in Kielce, Kielce
National Museum, Monuments and Art Gallery, Gaborone
The National Park Service, United States Department of the Interior, Statue of Liberty National Monument & The Ellis Island Immigration Museum, New York NY
Naval Historical Center, The Navy Museum, Washington DC
Neville Public Museum, Green Bay WI
New Brunswick Museum, Saint John NB
New Jersey State Museum, Fine Art Bureau, Trenton NJ
New Mexico State University, Art Gallery, Las Cruces NM
New Orleans Museum of Art, New Orleans LA
New World Art Center, T F Chen Cultural Center, New York NY
New York State Historical Association, Fenimore Art Museum, Cooperstown NY
No Man's Land Historical Society Museum, Goodwell OK
Norman Rockwell Museum, Rutland VT
North Carolina State University, Visual Arts Center, Raleigh NC
Northern Kentucky University, Highland Heights KY
Noyes Art Gallery, Lincoln NE
The Noyes Museum of Art, Oceanville NJ
Ohio Historical Society, National Afro American Museum & Cultural Center, Wilberforce OH
The Ohio Historical Society, Inc, Campus Martius Museum & Ohio River Museum, Marietta OH
Old Dartmouth Historical Society, New Bedford Whaling Museum, New Bedford MA
Opelousas Museum of Art, Inc (OMA), Opelousas LA
Oshkosh Public Museum, Oshkosh WI
Owensboro Museum of Fine Art, Owensboro KY
Pacific - Asia Museum, Pasadena CA
Page-Walker Arts & History Center, Cary NC
Palm Beach County Parks & Recreation Department, Morikami Museum & Japanese Gardens, Delray Beach FL
Panhandle-Plains Historical Society Museum, Canyon TX
Paris Gibson Square, Museum of Art, Great Falls MT
Pasadena Historical Museum, Pasadena CA
Pensacola Museum of Art, Pensacola FL
Philadelphia Museum of Art, Philadelphia PA
Pinacoteca Provinciale, Bari

Plainsman Museum, Aurora NE
Polish Museum of America, Chicago IL
Port Huron Museum, Port Huron MI
Prairie Art Gallery, Grande Prairie AB
Princeton University, Princeton University Art Museum, Princeton NJ
Queens College, City University of New York, Godwin-Ternbach Museum, Flushing NY
Randolph-Macon Woman's College, Maier Museum of Art, Lynchburg VA
Rangeley Lakes Region Logging Museum, Rangeley ME
Reading Public Museum, Reading PA
Regina Public Library, Dunlop Art Gallery, Regina SK
Riverside Municipal Museum, Riverside CA
Rock Ford Foundation, Inc, Historic Rock Ford & Kauffman Museum, Lancaster PA
Millicent Rogers, Taos NM
Rollins College, George D & Harriet W Cornell Fine Arts Museum, Winter Park FL
Roswell Museum & Art Center, Roswell NM
C M Russell, Great Falls MT
Saco Museum, Saco ME
Saginaw Art Museum, Saginaw MI
Saint Mary's Romanian Orthodox Cathedral, Romanian Ethnic Museum, Cleveland OH
Saint Peter's College, Art Gallery, Jersey City NJ
San Antonio Museum of Art, San Antonio TX
San Francisco Maritime National Historical Park, Maritime Museum, San Francisco CA
Shaker Village of Pleasant Hill, Harrodsburg KY
Shelburne Museum, Museum, Shelburne VT
South Carolina Artisans Center, Walterboro SC
South Carolina State Museum, Columbia SC
Southeastern Center for Contemporary Art, Winston-Salem NC
Southern Illinois University Carbondale, University Museum, Carbondale IL
Southern Oregon Historical Society, Jacksonville Museum of Southern Oregon History, Medford OR
Spartanburg County Museum of Art, Spartanburg SC
Spertus Institute of Jewish Studies, Spertus Museum, Chicago IL
Springfield Art Museum, Springfield MO
State of North Carolina, Battleship North Carolina, Wilmington NC
Stratford Historical Society, Catharine B Mitchell Museum, Stratford CT
Summit County Historical Society, Akron OH
Swedish-American Museum Association of Chicago, Chicago IL
Switzerland County Historical Society Inc, Switzerland County Historical Museum, Vevay IN
Syracuse University, SUArt Galleries, Syracuse NY
Tallahassee Museum of History & Natural Science, Tallahassee FL
Tampa Museum of Art, Tampa FL
Texas Tech University, Museum of Texas Tech University, Lubbock TX
Tinkertown Museum, Sandia Park NM
Towson University Center for the Arts Gallery, Asian Arts & Culture Center, Towson MD
Tubman African American Museum, Macon GA
The Ukrainian Museum, New York NY
United Society of Shakers, Shaker Museum, New Glocester ME
United States Military Academy, West Point Museum, West Point NY
University of British Columbia, Museum of Anthropology, Vancouver BC
University of California, Berkeley, Berkeley Art Museum & Pacific Film Archive, Berkeley CA
University of California, Berkeley, Phoebe Apperson Hearst Museum of Anthropology, Berkeley CA
University of Colorado at Colorado Springs, Gallery of Contemporary Art, Colorado Springs CO
University of Illinois, Krannert Art Museum and Kinkead Pavillion, Champaign IL
University of Louisiana at Lafayette, University Art Museum, Lafayette LA
University of Memphis, Art Museum, Memphis TN
University of Mississippi, University Museum, Oxford MS
University of Nebraska, Lincoln, Sheldon Memorial Art Gallery & Sculpture Garden, Lincoln NE
University of North Carolina at Chapel Hill, Ackland Art Museum, Chapel Hill NC
The University of Texas at San Antonio, UTSA's Institute of Texan Cultures, San Antonio TX
University of Victoria, Maltwood Art Museum and Gallery, Victoria BC

Upstairs Gallery, Winnipeg MB
Ursinus College, Philip & Muriel Berman Museum of Art, Collegeville PA
Utah Arts Council, Chase Home Museum of Utah Folk Arts, Salt Lake City UT
Vancouver Museum, Vancouver BC
Very Special Arts New Mexico, Very Special Arts Gallery, Albuquerque NM
Waterworks Visual Arts Center, Salisbury NC
West Florida Historic Preservation, Inc, T T Wentworth, Jr Florida State Museum & Historic Pensacola Village, Pensacola FL
Wethersfield Historical Society Inc, Museum, Wethersfield CT
Whalers Village Museum, Lahaina HI
Whatcom Museum of History and Art, Bellingham WA
Wheelwright Museum of the American Indian, Santa Fe NM
Willard House & Clock Museum, Inc, North Grafton MA
Wisconsin Historical Society, State Historical Museum, Madison WI
Witte Museum, San Antonio TX
Woodmere Art Museum, Philadelphia PA
Yarmouth County Historical Society, Yarmouth County Museum, Yarmouth NS

FURNITURE

Academy of the New Church, Glencairn Museum, Bryn Athyn PA
Adams County Historical Society, Gettysburg PA
Adams National Historic Park, Quincy MA
African American Museum in Philadelphia, Philadelphia PA
Albany Institute of History & Art, Albany NY
Albuquerque Museum of Art & History, Albuquerque NM
Allentown Art Museum, Allentown PA
Lyman Allyn, New London CT
Alton Museum of History & Art, Inc, Alton IL
American Folk Art Museum, New York NY
American Swedish Historical Foundation & Museum, Philadelphia PA
Americas Society Art Gallery, New York NY
Amherst Museum, Amherst NY
Anna Maria College, Saint Luke's Gallery, Paxton MA
Anson County Historical Society, Inc, Wadesboro NC
Arab American National Museum, Dearborn MI
Arizona Historical Society-Yuma, Sanguinetti House Museum & Garden, Yuma AZ
Art & Culture Center of Hollywood, Art Gallery, Hollywood FL
Art Gallery of South Australia, Adelaide
Artesia Historical Museum & Art Center, Artesia NM
ArtSpace-Lima, Lima OH
Asheville Art Museum, Asheville NC
Association for the Preservation of Virginia Antiquities, John Marshall House, Richmond VA
Baldwin Historical Society Museum, Baldwin NY
Ball State University, Museum of Art, Muncie IN
The Baltimore Museum of Art, Baltimore MD
Barnes Foundation, Merion PA
The Bartlett Museum, Amesbury MA
Bass Museum of Art, Miami Beach FL
Bayou Bend Collection & Gardens, Houston TX
Beaverbrook Art Gallery, Fredericton NB
Berkshire Museum, Pittsfield MA
Jesse Besser, Alpena MI
Biggs Museum of American Art, Dover DE
BJU Museum & Gallery, Bob Jones University Museum & Gallery Inc, Greenville SC
Bodley-Bullock House Museum, Lexington KY
Brick Store Museum & Library, Kennebunk ME
Bradford Brinton, Big Horn WY
Brooklyn Historical Society, Brooklyn OH
Cabot's Old Indian Pueblo Museum, Cabot's Old Indian Pueblo Museum, Desert Hot Springs CA
Cambria Historical Society, New Providence NJ
Cambridge Museum, Cambridge NE
Cameron Art Museum, Wilmington NC
The Canadian Craft Museum, Vancouver BC
Canadian Museum of Civilization, Gatineau PQ
Cape Ann Historical Association, Gloucester MA
Caramoor Center for Music & the Arts, Inc, Caramoor House Museum, Katonah NY
Carnegie Museums of Pittsburgh, Carnegie Museum of Art, Pittsburgh PA
Carson County Square House Museum, Panhandle TX

Mingei International, Inc, Mingei International Museum, San Diego CA

Mint Museum of Art, Mint Museum of Craft & Design, Charlotte NC

Mississippi Department of Archives & History, Old Capitol Museum of Mississippi History, Jackson MS

Mississippi River Museum at Mud-Island River Park, Memphis TN

Missouri Historical Society, Missouri History Museum, Saint Louis MO

Mobile Museum of Art, Mobile AL

Modern Art Museum, Fort Worth TX

Monroe County Historical Association, Elizabeth D Walters Library, Stroudsburg PA

James Monroe, Fredericksburg VA

Montreal Museum of Fine Arts, Montreal PQ

Moravian Historical Society, Whitefield House Museum, Nazareth PA

Moravska Galerie v Brne, Moravian Gallery in Brno, Brno

Morris-Jumel Mansion, Inc, New York NY

Mount Mary College, Marian Gallery, Milwaukee WI

Mount Vernon Ladies' Association of the Union, Mount Vernon VA

Municipal Museum De Lakenhal, Stedelisk Museum De Lakenhal, Leiden

Munson-Williams-Proctor Arts Institute, Museum of Art, Utica NY

Murray State University, Art Galleries, Murray KY

Muscatine Art Center, Museum, Muscatine IA

Musee Cognacq-Jay, Cognacq-Jay Museum, Paris

Musee d'Art de Saint-Laurent, Saint-Laurent PQ

Musee Guimet, Paris

Musee Regional de la Cote-Nord, Sept-Iles PQ

Musee Regional de Vaudreuil-Soulanges, Vaudreuil PQ

Musei Capitolini, Rome

Museo De Las Americas, Denver CO

The Museum, Greenwood SC

Museum for African Art, Long Island City NY

Museum of Art & History, Santa Cruz, Santa Cruz CA

Museum of Contemporary Art, North Miami FL

Museum of Southern History, Sugarland TX

Museum of the City of New York, New York NY

Museum of West Louisiana, Leesville LA

Museum of Wisconsin Art, West Bend Art Museum, West Bend WI

Muttart Public Art Gallery, Calgary AB

Muzej za Umjetnost i Obrt, Museum of Arts & Crafts, Zagreb

Muzeum Narodowe, National Museum, Poznan

Muzeum Narodowe W Kielcach, National Museum in Kielce, Kielce

National Gallery of Canada, Ottawa ON

The National Museum of Fine Arts, Stockholm

National Park Service, Weir Farm National Historic Site, Wilton CT

The National Park Service, United States Department of the Interior, Statue of Liberty National Monument & The Ellis Island Immigration Museum, New York NY

National Society of Colonial Dames of America in the State of Maryland, Mount Clare Museum House, Baltimore MD

National Society of the Colonial Dames of America in The Commonwealth of Virginia, Wilton House Museum, Richmond VA

National Trust for Historic Preservation, Chesterwood Estate & Museum, Stockbridge MA

National Trust for Historic Preservation, Decatur House, Washington DC

The National Trust for Historic Preservation, Lyndhurst, Tarrytown NY

National Trust for Historic Preservation, Washington DC

Naval Historical Center, The Navy Museum, Washington DC

Nebraska State Capitol, Lincoln NE

Nemours Mansion & Gardens, Wilmington DE

Neville Public Museum, Green Bay WI

New Brunswick Museum, Saint John NB

New Hampshire Antiquarian Society, Hopkinton NH

New Jersey Historical Society, Newark NJ

New Jersey State Museum, Fine Art Bureau, Trenton NJ

New Orleans GlassWorks Gallery & Printmaking Studio, New Orleans ArtWorks Gallery, New Orleans LA

New Orleans Museum of Art, New Orleans LA

New World Art Center, T F Chen Cultural Center, New York NY

New York State Historical Association, Fenimore Art Museum, Cooperstown NY

New York State Military Museum and Veterans Research Center, Saratoga Springs NY

New York State Office of Parks Recreation & Historic Preservation, John Jay Homestead State Historic Site, Katonah NY

Newton History Museum at the Jackson Homestead, Newton MA

Nichols House Museum, Inc, Boston MA

Norfolk Historical Society Inc, Museum, Norfolk CT

North Carolina State University, Visual Arts Center, Raleigh NC

Noyes Art Gallery, Lincoln NE

Oakland University, Oakland University Art Gallery, Rochester MI

Oatlands Plantation, Leesburg VA

The Ohio Historical Society, Inc, Campus Martius Museum & Ohio River Museum, Marietta OH

Olana State Historic Site, Hudson NY

Old Colony Historical Society, Museum, Taunton MA

Old Dartmouth Historical Society, New Bedford Whaling Museum, New Bedford MA

The Old Jail Art Center, Albany TX

Old Slater Mill Association, Slater Mill Historic Site, Pawtucket RI

Old York Historical Society, Old Gaol Museum, York ME

Osborne Homestead Museum, Derby CT

Owensboro Museum of Fine Art, Owensboro KY

Oysterponds Historical Society, Museum, Orient NY

Pacific - Asia Museum, Pasadena CA

Page-Walker Arts & History Center, Cary NC

Palm Springs Art Museum, Palm Springs CA

Panhandle-Plains Historical Society Museum, Canyon TX

Pasadena Historical Museum, Pasadena CA

Patterson Homestead, Dayton OH

Peabody Essex Museum, Salem MA

The Pennsylvania State University, Palmer Museum of Art, University Park PA

Philadelphia Museum of Art, Philadelphia PA

Philbrook Museum of Art, Tulsa OK

Piatt Castles, West Liberty OH

Pilgrim Society, Pilgrim Hall Museum, Plymouth MA

Pinacoteca Provinciale, Bari

Pioneer Historical Museum of South Dakota, Hot Springs SD

Plainsman Museum, Aurora NE

Plumas County Museum, Quincy CA

Pope County Historical Society, Pope County Museum, Glenwood MN

Port Huron Museum, Port Huron MI

Porter-Phelps-Huntington Foundation, Inc, Historic House Museum, Hadley MA

Portsmouth Athenaeum, Joseph Copley Research Library, Portsmouth NH

Portsmouth Historical Society, John Paul Jones House, Portsmouth NH

Princeton University, Princeton University Art Museum, Princeton NJ

Putnam County Historical Society, Foundry School Museum, Cold Spring NY

Putnam Museum of History and Natural Science, Davenport IA

Quapaw Quarter Association, Inc, Villa Marre, Little Rock AR

Queens College, City University of New York, Godwin-Ternbach Museum, Flushing NY

Rahr-West Art Museum, Manitowoc WI

Frederic Remington, Ogdensburg NY

Riley County Historical Society, Riley County Historical Museum, Manhattan KS

Riverside Municipal Museum, Riverside CA

Roberson Museum & Science Center, Binghamton NY

Roberts County Museum, Miami TX

Rock Ford Foundation, Inc, Historic Rock Ford & Kauffman Museum, Lancaster PA

Millicent Rogers, Taos NM

Rome Historical Society, Museum & Archives, Rome NY

Ross Memorial Museum, Saint Andrews NB

Royal Arts Foundation, Belcourt Castle, Newport RI

Saco Museum, Saco ME

Saint Joseph Museum, Saint Joseph MO

Saint Louis County Historical Society, Duluth MN

Saint Peter's College, Art Gallery, Jersey City NJ

Saint-Gaudens National Historic Site, Cornish NH

Salem Art Association, Bush House Museum, Salem OR

Salisbury House Foundation, Des Moines IA

San Diego Museum of Art, San Diego CA

The Sandwich Historical Society, Inc, Sandwich Glass Museum, Sandwich MA

Santa Clara University, de Saisset Museum, Santa Clara CA

Scottsdale Cultural Council, Scottsdale AZ

Seneca-Iroquois National Museum, Salamanca NY

Shaker Museum & Library, Old Chatham NY

Shaker Village of Pleasant Hill, Harrodsburg KY

Shirley Plantation, Charles City VA

Shores Memorial Museum and Victoriana, Lyndon Center VT

R L S Silverado Museum, Saint Helena CA

The Slater Memorial Museum, Slater Memorial Museum, Norwich CT

Smithsonian Institution, Arthur M Sackler Gallery, Washington DC

The Society for Contemporary Crafts, Pittsburgh PA

Society of the Cincinnati, Museum & Library at Anderson House, Washington DC

South Carolina Artisans Center, Walterboro SC

Southern Illinois University Carbondale, University Museum, Carbondale IL

Southern Lorain County Historical Society, Spirit of '76 Museum, Elyria OH

Southern Oregon Historical Society, Jacksonville Museum of Southern Oregon History, Medford OR

Springfield Art Museum, Springfield MO

Stanford University, Iris & B Gerald Cantor Center for Visual Arts, Stanford CA

Nelda C & H J Lutcher Stark, Stark Museum of Art, Orange TX

State University of New York at Binghamton, University Art Museum, Binghamton NY

Staten Island Institute of Arts & Sciences, Staten Island NY

Stauth Foundation & Museum, Stauth Memorial Museum, Montezuma KS

T C Steele, Nashville IN

Stratford Historical Society, Catharine B Mitchell Museum, Stratford CT

Summit County Historical Society, Akron OH

Susquehanna University, Lore Degenstein Gallery, Selinsgrove PA

Swedish-American Museum Association of Chicago, Chicago IL

Switzerland County Historical Society Inc, Switzerland County Historical Museum, Vevay IN

Taos, Ernest Blumenschein Home & Studio, Taos NM

Taos, La Hacienda de Los Martinez, Taos NM

Taos, Taos NM

Texas Tech University, Museum of Texas Tech University, Lubbock TX

Towson University Center for the Arts Gallery, Asian Arts & Culture Center, Towson MD

Tryon Palace Historic Sites & Gardens, New Bern NC

Mark Twain, State Historic Site Museum, Florida MO

Mark Twain, Hartford CT

United Society of Shakers, Shaker Museum, New Glocester ME

US Department of State, Diplomatic Reception Rooms, Washington DC

University of Alabama at Birmingham, Visual Arts Gallery, Birmingham AL

University of California, Berkeley, Phoebe Apperson Hearst Museum of Anthropology, Berkeley CA

University of Chicago, Oriental Institute Museum, Chicago IL

University of Illinois, Krannert Art Museum and Kinkead Pavillion, Champaign IL

University of Louisiana at Lafayette, University Art Museum, Lafayette LA

University of Manitoba, Faculty of Architecture Exhibition Centre, Winnipeg MB

University of Mississippi, University Museum, Oxford MS

University of Montana, Paxson Gallery, Missoula MT

University of New Mexico, The Harwood Museum of Art, Taos NM

University of San Diego, Founders' Gallery, San Diego CA

University of Saskatchewan, Diefenbaker Canada Centre, Saskatoon SK

University of Tampa, Henry B Plant Museum, Tampa FL

University of the South, University Art Gallery, Sewanee TN

University of Toronto, University of Toronto Art Centre, Toronto ON

University of Utah, Utah Museum of Fine Arts, Salt Lake City UT

University of Wisconsin-Madison, Chazen Museum of Art, Madison WI
Ursinus College, Philip & Muriel Berman Museum of Art, Collegeville PA
USS Constitution Museum, Boston MA
Van Cortlandt House Museum, Bronx NY
Vancouver Museum, Vancouver BC
Vancouver Public Library, Fine Arts & Music Div, Vancouver BC
Vermilion County Museum Society, Danville IL
Victoria Mansion - Morse Libby House, Portland ME
Villa Terrace Decorative Art Museum, Milwaukee WI
Virginia Museum of Fine Arts, Richmond VA
Vizcaya Museum & Gardens, Miami FL
Wade House & Wesley W Jung Carriage Museum, Historic House & Carriage Museum, Greenbush WI
Warner House Association, MacPheadris-Warner House, Portsmouth NH
George Washington, Alexandria VA
Waterville Historical Society, Redington Museum, Waterville ME
Wayne County Historical Society, Museum, Honesdale PA
Wayne County Historical Society, Honesdale PA
West Baton Rouge Parish, West Baton Rouge Museum, Port Allen LA
West Florida Historic Preservation, Inc, T T Wentworth, Jr Florida State Museum & Historic Pensacola Village, Pensacola FL
Wethersfield Historical Society Inc, Museum, Wethersfield CT
White House, Washington DC
Willard House & Clock Museum, Inc, North Grafton MA
Woodrow Wilson, Washington DC
Wisconsin Historical Society, State Historical Museum, Madison WI
Wistariahurst Museum, Holyoke MA
Witte Museum, San Antonio TX
The Woman's Exchange, Gallier House Museum, New Orleans LA
Woodlawn/The Pope-Leighey, Mount Vernon VA
Woodmere Art Museum, Philadelphia PA
Workman & Temple Family Homestead Museum, City of Industry CA
Yarmouth County Historical Society, Yarmouth County Museum, Yarmouth NS

GLASS

Academy of the New Church, Glencairn Museum, Bryn Athyn PA
Adams County Historical Society, Gettysburg PA
Albany Institute of History & Art, Albany NY
Albion College, Bobbitt Visual Arts Center, Albion MI
Albuquerque Museum of Art & History, Albuquerque NM
Alton Museum of History & Art, Inc, Alton IL
The American Ceramic Society, Ross C Purdy Museum of Ceramics, Westerville OH
American Swedish Historical Foundation & Museum, Philadelphia PA
American Swedish Institute, Minneapolis MN
Amherst Museum, Amherst NY
Arab American National Museum, Dearborn MI
Arizona Historical Society-Yuma, Sanguinetti House Museum & Garden, Yuma AZ
Arizona State University, ASU Art Museum, Tempe AZ
Art & Culture Center of Hollywood, Art Gallery, Hollywood FL
Art Community Center, Art Center of Corpus Christi, Corpus Christi TX
Arts Council of Fayetteville-Cumberland County, The Arts Center, Fayetteville NC
ArtSpace-Lima, Lima OH
Asbury College, Student Center Gallery, Wilmore KY
Asheville Art Museum, Asheville NC
Association for the Preservation of Virginia Antiquities, John Marshall House, Richmond VA
Atlanta International Museum of Art & Design, Atlanta GA
Baldwin Historical Society Museum, Baldwin NY
Ball State University, Museum of Art, Muncie IN
Bayou Bend Collection & Gardens, Houston TX
Berea College, Doris Ulmann Galleries, Berea KY
Bergstrom-Mahler Museum, Neenah WI
Berkshire Museum, Pittsfield MA
Jesse Besser, Alpena MI
Brick Store Museum & Library, Kennebunk ME

Brigham City Corporation, Brigham City Museum & Gallery, Brigham City UT
Brooklyn Historical Society, Brooklyn OH
The Buffalo Fine Arts Academy, Albright-Knox Art Gallery, Buffalo NY
Thornton W Burgess, Museum, Sandwich MA
Cambria Historical Society, New Providence NJ
Cameron Art Museum, Wilmington NC
The Canadian Craft Museum, Vancouver BC
Canadian Museum of Civilization, Gatineau PQ
Cape Cod Museum of Art Inc, Dennis MA
Charleston Museum, Joseph Manigault House, Charleston SC
Charleston Museum, Charleston SC
Chicago Athenaeum, Museum of Architecture & Design, Galena IL
Chrysler Museum of Art, Norfolk VA
City of Austin Parks & Recreation, O Henry Museum, Austin TX
City of Gainesville, Thomas Center Galleries - Cultural Affairs, Gainesville FL
City of Grand Rapids Michigan, Public Museum of Grand Rapids, Grand Rapids MI
City of Pittsfield, Berkshire Artisans, Pittsfield MA
Clark County Historical Society, Pioneer - Krier Museum, Ashland KS
Clinton Art Association, River Arts Center, Clinton IA
The College of Wooster, The College of Wooster Art Museum, Wooster OH
Colorado Springs Fine Arts Center, Colorado Springs CO
Columbus Chapel & Boal Mansion Museum, Boalsburg PA
Columbus Museum, Columbus GA
Columbus Museum of Art, Columbus OH
Concord Museum, Concord MA
Cooper-Hewitt, National Design Museum, Smithsonian Institution, New York NY
Coutts Memorial Museum of Art, Inc, El Dorado KS
Craftsmen's Guild of Mississippi, Inc, Agriculture & Forestry Museum, Jackson MS
Crow Wing County Historical Society, Brainerd MN
The Currier Museum of Art, Currier Museum of Art, Manchester NH
Danforth Museum Corporation, Danforth Museum of Art, Framingham MA
DAR Museum, National Society Daughters of the American Revolution, Washington DC
Dartmouth Heritage Museum, Dartmouth NS
Dawson City Museum & Historical Society, Dawson City YT
Delaware Archaeology Museum, Dover DE
Delaware Division of Historical & Cultural Affairs, Dover DE
Deming-Luna Mimbres Museum, Deming NM
Denver Art Museum, Denver CO
Detroit Institute of Arts, Detroit MI
DeWitt Historical Society of Tompkins County, The History Center in Tompkins Co, Ithaca NY
Doncaster Museum and Art Gallery, Doncaster
Downey Museum of Art, Downey CA
Dundurn Castle, Hamilton ON
Emory University, Michael C Carlos Museum, Atlanta GA
Eretz-Israel Museum, Museum of Antiquities of Tel-Aviv-Jaffa, Tel Aviv
Evanston Historical Society, Charles Gates Dawes House, Evanston IL
Evansville Museum of Arts, History & Science, Evansville IN
Farmington Village Green & Library Association, Stanley-Whitman House, Farmington CT
Fetherston Foundation, Packwood House Museum, Lewisburg PA
Fine Arts Center for the New River Valley, Pulaski VA
Fine Arts Museums of San Francisco, Legion of Honor, San Francisco CA
Flagler Museum, Palm Beach FL
Flint Institute of Arts, Flint MI
Florence Museum of Art, Science & History, Florence SC
Florida State University and Central Florida Community College, The Appleton Museum of Art, Ocala FL
Edsel & Eleanor Ford, Grosse Pointe Shores MI
Forest Lawn Museum, Glendale CA
Fort Collins Museum of Contemporary Art, Fort Collins CO
Fuller Museum of Art, Brockton MA
Gadsden Museum of Fine Arts, Inc, Gadsden Museum of Art and History, Gadsden AL

Gallery One, Ellensburg WA
Germanisches Nationalmuseum, Nuremberg
Girard College, Stephen Girard Collection, Philadelphia PA
Glanmore National Historic Site of Canada, Belleville ON
Glassboro Heritage Glass Museum, Glassboro NJ
Gonzaga University, Art Gallery, Spokane WA
Grand Rapids Art Museum, Grand Rapids MI
Greene County Historical Society, Bronck Museum, Coxsackie NY
Guilford College, Art Gallery, Greensboro NC
Robert Gumbiner, Museum of Latin American Art, Long Beach CA
Hancock County Trustees of Public Reservations, Woodlawn Museum, Ellsworth ME
Hastings Museum of Natural & Cultural History, Hastings NE
Haystack Mountain School of Crafts, Deer Isle ME
Headley-Whitney Museum, Lexington KY
Headquarters Fort Monroe, Dept of Army, Casemate Museum, Fort Monroe VA
Heard Museum, Phoenix AZ
Hebrew Union College, Skirball Cultural Center, Los Angeles CA
Henry County Museum & Cultural Arts Center, Clinton MO
Henry Sheldon Museum of Vermont History and Research Center, Middlebury VT
Heritage Museum Association, Inc, The Heritage Museum of Northwest Florida, Valparaiso FL
Hermitage Foundation Museum, Norfolk VA
Hershey Museum, Hershey PA
Edna Hibel, Hibel Museum of Art, Jupiter FL
Hickory Museum of Art, Inc, Hickory NC
Higgins Armory Museum, Worcester MA
Hillwood Museum & Gardens Foundation, Hillwood Museum & Gardens, Washington DC
Historic Arkansas Museum, Little Rock AR
Historic Landmarks Foundation of Indiana, Morris-Butler House, Indianapolis IN
Historic Paris - Bourbon County, Inc, Hopewell Museum, Paris KY
Historical Society of Bloomfield, Bloomfield NJ
Historical Society of Cheshire County, Keene NH
Historisches und Volkerkundemuseum, Historical Museum, Sankt Gallen
Holter Museum of Art, Helena MT
Houston Museum of Decorative Arts, Chattanooga TN
Huguenot Historical Society of New Paltz Galleries, New Paltz NY
Hunter Museum of American Art, Chattanooga TN
Huntington Museum of Art, Huntington WV
Iowa State University, Brunnier Art Museum, Ames IA
Iredell Museum of Arts & Heritage, Statesville NC
Iroquois County Historical Society Museum, Old Courthouse Museum, Watseka IL
Jacksonville University, Alexander Brest Museum & Gallery, Jacksonville FL
James Dick Foundation, Festival - Institute, Round Top TX
Jefferson County Historical Society, Watertown NY
Johns Hopkins University, Evergreen House, Baltimore MD
Kansas City Art Institute, Kansas City MO
Kelly-Griggs House Museum, Red Bluff CA
Kelowna Museum, Kelowna BC
Kentucky Museum of Art & Craft, Louisville KY
Kings County Historical Society & Museum, Hampton NB
Klein Museum, Mobridge SD
Knights of Columbus Supreme Council, Knights of Columbus Museum, New Haven CT
Koochiching Museums, International Falls MN
Kunstindustrimuseet, The Danish Museum of Art & Design, Copenhagen
Kyiv Museum of Russian Art, Kyiv
L A County Museum of Art, Los Angeles CA
Landis Valley Museum, Lancaster PA
Lehigh County Historical Society, Allentown PA
LeSueur County Historical Society, Chapter One, Elysian MN
Lincoln County Historical Association, Inc, 1811 Old Lincoln County Jail & Lincoln County Museum, Wiscasset ME
Livingston County Historical Society, Cobblestone Museum, Geneseo NY
Lockwood-Mathews Mansion Museum, Norwalk CT
The Long Island Museum of American Art, History & Carriages, Stony Brook NY

Longfellow-Evangeline State Commemorative Area, Saint Martinville LA

Los Angeles County Museum of Natural History, William S Hart Museum, Newhall CA

Loveland Museum Gallery, Loveland CO

Maine Historical Society, MHS Museum, Portland ME

Maitland Art Center, Maitland FL

Maricopa County Historical Society, Desert Caballeros Western Museum, Wickenburg AZ

Marquette University, Haggerty Museum of Art, Milwaukee WI

Maryhill Museum of Art, Goldendale WA

Maryland Historical Society, Museum of Maryland History, Baltimore MD

Mattatuck Historical Society, Mattatuck Museum, Waterbury CT

Maude Kerns Art Center, Eugene OR

McCord Museum of Canadian History, Montreal PQ

McMaster University, McMaster Museum of Art, Hamilton ON

Michigan State University, Kresge Art Museum, East Lansing MI

Middle Border Museum & Oscar Howe Art Center, Mitchell SD

Midwest Museum of American Art, Elkhart IN

Mingei International, Inc, Mingei International Museum, San Diego CA

Ministry of Culture, The Delphi Museum, I Ephorate of Prehistoric & Classical Antiquities, Delphi

Minnesota Museum of American Art, Saint Paul MN

Mint Museum of Art, Mint Museum of Craft & Design, Charlotte NC

Mississippi Department of Archives & History, Old Capitol Museum of Mississippi History, Jackson MS

Mississippi River Museum at Mud-Island River Park, Memphis TN

Mobile Museum of Art, Mobile AL

Modern Art Museum, Fort Worth TX

Montgomery Museum of Fine Arts, Montgomery AL

Montreal Museum of Fine Arts, Montreal PQ

Moravska Galerie v Brne, Moravian Gallery in Brno, Brno

Morris Museum, Morristown NJ

Morris-Jumel Mansion, Inc, New York NY

Municipal Museum De Lakenhal, Stedelisk Museum De Lakenhal, Leiden

Muscatine Art Center, Museum, Muscatine IA

Musee Guimet, Paris

The Museum, Greenwood SC

Museum of Contemporary Art, North Miami FL

Museum of Northwest Art, La Conner WA

Museum of the City of New York, New York NY

Muttart Public Art Gallery, Calgary AB

Muzej za Umjetnost i Obrt, Museum of Arts & Crafts, Zagreb

Muzeum Narodowe, National Museum, Poznan

Muzeum Narodowe W Kielcach, National Museum in Kielce, Kielce

National Museum of Ceramic Art & Glass, Baltimore MD

The National Museum of Fine Arts, Stockholm

National Society of Colonial Dames of America in the State of Maryland, Mount Clare Museum House, Baltimore MD

National Society of the Colonial Dames of America in The Commonwealth of Virginia, Wilton House Museum, Richmond VA

Naval Historical Center, The Navy Museum, Washington DC

Nelson-Atkins Museum of Art, Kansas City MO

Nemours Mansion & Gardens, Wilmington DE

Nevada Museum of Art, Reno NV

Neville Public Museum, Green Bay WI

New Brunswick Museum, Saint John NB

New Jersey Historical Society, Newark NJ

New Jersey State Museum, Fine Art Bureau, Trenton NJ

New Orleans GlassWorks Gallery & Printmaking Studio, New Orleans ArtWorks Gallery, New Orleans LA

New Orleans Museum of Art, New Orleans LA

New Visions Gallery, Inc, Marshfield WI

New York State Historical Association, Fenimore Art Museum, Cooperstown NY

North Carolina State University, Visual Arts Center, Raleigh NC

Noyes Art Gallery, Lincoln NE

The Ogden Museum of Southern Art, University of New Orleans, New Orleans LA

Oglebay Institute, Mansion Museum, Wheeling WV

The Ohio Historical Society, Inc, Campus Martius Museum & Ohio River Museum, Marietta OH

Oklahoma City Museum of Art, Oklahoma City OK

Old Dartmouth Historical Society, New Bedford Whaling Museum, New Bedford MA

Old York Historical Society, Old Gaol Museum, York ME

Orange County Museum of Art, Orange County Museum of Art, Newport Beach CA

Oshkosh Public Museum, Oshkosh WI

Owensboro Museum of Fine Art, Owensboro KY

Page-Walker Arts & History Center, Cary NC

Palm Springs Art Museum, Palm Springs CA

Panhandle-Plains Historical Society Museum, Canyon TX

Pasadena Historical Museum, Pasadena CA

The Pennsylvania State University, Palmer Museum of Art, University Park PA

Pensacola Museum of Art, Pensacola FL

Philadelphia Museum of Art, Philadelphia PA

Philbrook Museum of Art, Tulsa OK

Phillips County Museum, Holyoke CO

Plainsman Museum, Aurora NE

Plumas County Museum, Quincy CA

Pope County Historical Society, Pope County Museum, Glenwood MN

Port Huron Museum, Port Huron MI

Porter-Phelps-Huntington Foundation, Inc, Historic House Museum, Hadley MA

Portland Museum of Art, Portland ME

Portsmouth Historical Society, John Paul Jones House, Portsmouth NH

Potsdam Public Museum, Potsdam NY

Princeton University, Princeton University Art Museum, Princeton NJ

Principia College, School of Nations Museum, Elsah IL

Putnam Museum of History and Natural Science, Davenport IA

Queens College, City University of New York, Godwin-Ternbach Museum, Flushing NY

Rahr-West Art Museum, Manitowoc WI

Rawls Museum Arts, Courtland VA

Frederic Remington, Ogdensburg NY

Riley County Historical Society, Riley County Historical Museum, Manhattan KS

Rome Historical Society, Museum & Archives, Rome NY

Saco Museum, Saco ME

Saginaw Art Museum, Saginaw MI

Saint Joseph Museum, Saint Joseph MO

Saint Peter's College, Art Gallery, Jersey City NJ

Salisbury House Foundation, Des Moines IA

The Sandwich Historical Society, Inc, Sandwich Glass Museum, Sandwich MA

Scottsdale Cultural Council, Scottsdale AZ

Shaker Museum & Library, Old Chatham NY

Shirley Plantation, Charles City VA

The Slater Memorial Museum, Slater Memorial Museum, Norwich CT

Abigail Adams Smith, New York NY

Smithsonian Institution, Arthur M Sackler Gallery, Washington DC

The Society for Contemporary Crafts, Pittsburgh PA

Society of the Cincinnati, Museum & Library at Anderson House, Washington DC

South Carolina Artisans Center, Walterboro SC

Southeastern Center for Contemporary Art, Winston-Salem NC

Southern Illinois University Carbondale, University Museum, Carbondale IL

Southern Oregon Historical Society, Jacksonville Museum of Southern Oregon History, Medford OR

Springfield Art Museum, Springfield MO

Nelda C & H J Lutcher Stark, Stark Museum of Art, Orange TX

State University of New York at Binghamton, University Art Museum, Binghamton NY

State University of New York at Geneseo, Bertha V B Lederer Gallery, Geneseo NY

Staten Island Institute of Arts & Sciences, Staten Island NY

Stauth Foundation & Museum, Stauth Memorial Museum, Montezuma KS

Stratford Historical Society, Catharine B Mitchell Museum, Stratford CT

Summit County Historical Society, Akron OH

Susquehanna University, Lore Degenstein Gallery, Selinsgrove PA

Swedish-American Museum Association of Chicago, Chicago IL

Switzerland County Historical Society Inc, Switzerland County Historical Museum, Vevay IN

Syracuse University, Art Collection, Syracuse NY

Syracuse University, SUArt Galleries, Syracuse NY

Tacoma Art Museum, Tacoma WA

Tampa Museum of Art, Tampa FL

The Temple-Tifereth Israel, The Temple Museum of Religious Art, Beachwood OH

Texas Tech University, Museum of Texas Tech University, Lubbock TX

Topeka & Shawnee County Public Library, Alice C Sabatini Gallery, Topeka KS

Triton Museum of Art, Santa Clara CA

Tryon Palace Historic Sites & Gardens, New Bern NC

Mark Twain, Hartford CT

United Society of Shakers, Shaker Museum, New Glocester ME

University of California, Berkeley, Phoebe Apperson Hearst Museum of Anthropology, Berkeley CA

University of Chicago, Oriental Institute Museum, Chicago IL

University of Colorado at Colorado Springs, Gallery of Contemporary Art, Colorado Springs CO

University of Illinois, Krannert Art Museum and Kinkead Pavillion, Champaign IL

University of Illinois, Spurlock Museum, Champaign IL

University of Kansas, Spencer Museum of Art, Lawrence KS

University of Louisiana at Lafayette, University Art Museum, Lafayette LA

University of Mississippi, University Museum, Oxford MS

University of North Carolina at Chapel Hill, Ackland Art Museum, Chapel Hill NC

University of Saskatchewan, Diefenbaker Canada Centre, Saskatoon SK

Valentine Richmond History Center, Richmond VA

Vancouver Museum, Vancouver BC

Vesterheim Norwegian-American Museum, Decorah IA

Virginia Museum of Fine Arts, Richmond VA

Wallace Collection, London

Washburn University, Mulvane Art Museum, Topeka KS

Washington County Museum of Fine Arts, Hagerstown MD

Waterville Historical Society, Redington Museum, Waterville ME

Waterworks Visual Arts Center, Salisbury NC

Wayne County Historical Society, Museum, Honesdale PA

Wayne County Historical Society, Honesdale PA

West Florida Historic Preservation, Inc, T T Wentworth, Jr Florida State Museum & Historic Pensacola Village, Pensacola FL

Wheaton College, Watson Gallery, Norton MA

White House, Washington DC

Willard House & Clock Museum, Inc, North Grafton MA

Wiregrass Museum of Art, Dothan AL

Wistariahurst Museum, Holyoke MA

The Woman's Exchange, Newcomb Art Gallery-Carroll Gallery, New Orleans LA

Woodlawn/The Pope-Leighey, Mount Vernon VA

WV Museum of American Glass, Weston WV

Yarmouth County Historical Society, Yarmouth County Museum, Yarmouth NS

GOLD

Albany Institute of History & Art, Albany NY

Art & Culture Center of Hollywood, Art Gallery, Hollywood FL

The Baltimore Museum of Art, Baltimore MD

Beloit College, Wright Museum of Art, Beloit WI

Berman Museum, Anniston AL

The Canadian Craft Museum, Vancouver BC

Canadian Museum of Civilization, Gatineau PQ

Cincinnati Institute of Fine Arts, Taft Museum of Art, Cincinnati OH

Cooper-Hewitt, National Design Museum, Smithsonian Institution, New York NY

Denver Art Museum, Denver CO

Detroit Institute of Arts, Detroit MI

Forest Lawn Museum, Glendale CA

Germanisches Nationalmuseum, Nuremberg

Thomas Gilcrease, Gilcrease Museum, Tulsa OK

Glanmore National Historic Site of Canada, Belleville ON

Haystack Mountain School of Crafts, Deer Isle ME

GRAPHICS

The Pomona College, Montgomery Gallery, Claremont CA

Portland Art Museum, Portland OR

Princeton University, Princeton University Art Museum, Princeton NJ

Queen's University, Agnes Etherington Art Centre, Kingston ON

Queens College, City University of New York, Godwin-Ternbach Museum, Flushing NY

Rahr-West Art Museum, Manitowoc WI

Saginaw Art Museum, Saginaw MI

Saint Joseph's Oratory, Museum, Montreal PQ

Saint Mary's College of California, Hearst Art Gallery, Moraga CA

Saint Olaf College, Flaten Art Museum, Northfield MN

Saint Peter's College, Art Gallery, Jersey City NJ

San Francisco Maritime National Historical Park, Maritime Museum, San Francisco CA

Santa Clara University, de Saisset Museum, Santa Clara CA

School of Visual Arts, Visual Arts Museum, New York NY

Siena Heights College, Klemm Gallery, Studio Angelico, Adrian MI

Simon Fraser University, Simon Fraser Gallery, Burnaby BC

Norton Simon, Pasadena CA

The Slater Memorial Museum, Slater Memorial Museum, Norwich CT

Society of the Cincinnati, Museum & Library at Anderson House, Washington DC

Spertus Institute of Jewish Studies, Spertus Museum, Chicago IL

Staatsgalerie Stuttgart, Stuttgart

State University of New York at Binghamton, University Art Museum, Binghamton NY

State University of New York at Geneseo, Bertha V B Lederer Gallery, Geneseo NY

State University of New York at New Paltz, Samuel Dorsky Museum of Art, New Paltz NY

State University of New York College at Cortland, Dowd Fine Arts Gallery, Cortland NY

Staten Island Institute of Arts & Sciences, Staten Island NY

Stephens College, Lewis James & Nellie Stratton Davis Art Gallery, Columbia MO

Syracuse University, Art Collection, Syracuse NY

The Temple-Tifereth Israel, The Temple Museum of Religious Art, Beachwood OH

Thomas More College, TM Gallery, Crestview KY

The Turner Museum, Sarasota FL

The Ukrainian Museum, New York NY

United States Military Academy, West Point Museum, West Point NY

University of Alabama at Birmingham, Visual Arts Gallery, Birmingham AL

University of California, Richard L Nelson Gallery & Fine Arts Collection, Davis CA

University of California, Santa Barbara, University Art Museum, Santa Barbara CA

University of Cincinnati, DAAP Galleries-College of Design Architecture, Art & Planning, Cincinnati OH

University of Delaware, University Gallery, Newark DE

University of Georgia, Georgia Museum of Art, Athens GA

University of Illinois, Krannert Art Museum and Kinkead Pavillion, Champaign IL

University of Iowa, Museum of Art, Iowa City IA

University of Kansas, Spencer Museum of Art, Lawrence KS

University of Kentucky, Art Museum, Lexington KY

University of Louisiana at Lafayette, University Art Museum, Lafayette LA

University of Mary Washington, University of Mary Washington Galleries, Fredericksburg VA

University of Memphis, Art Museum, Memphis TN

University of Nebraska, Lincoln, Sheldon Memorial Art Gallery & Sculpture Garden, Lincoln NE

University of New Mexico, University Art Museum, Albuquerque NM

University of North Carolina at Greensboro, Weatherspoon Art Museum, Greensboro NC

University of Sherbrooke, Art Gallery, Sherbrooke PQ

University of the South, University Art Gallery, Sewanee TN

University of Toronto, University of Toronto Art Centre, Toronto ON

University of Utah, Utah Museum of Fine Arts, Salt Lake City UT

University of Victoria, Maltwood Art Museum and Gallery, Victoria BC

USS Constitution Museum, Boston MA

Ventura County Maritime Museum, Inc, Oxnard CA

Virginia Museum of Fine Arts, Richmond VA

The Walker African American Museum & Research Center, Las Vegas NV

Washburn University, Mulvane Art Museum, Topeka KS

Waterworks Visual Arts Center, Salisbury NC

West Florida Historic Preservation, Inc, T T Wentworth, Jr Florida State Museum & Historic Pensacola Village, Pensacola FL

Western Illinois University, Western Illinos University Art Gallery, Macomb IL

Western Washington University, Western Gallery, Bellingham WA

Wilkes Art Gallery, North Wilkesboro NC

William F Eisner Museum of Advertising & Design, Milwaukee WI

Wisconsin Historical Society, State Historical Museum, Madison WI

The Woman's Exchange, University Art Collection, New Orleans LA

Woodmere Art Museum, Philadelphia PA

Xavier University, Art Gallery, Cincinnati OH

Yarmouth County Historical Society, Yarmouth County Museum, Yarmouth NS

HISPANIC ART

Albuquerque Museum of Art & History, Albuquerque NM

Art Community Center, Art Center of Corpus Christi, Corpus Christi TX

Art Museum of Greater Lafayette, Lafayette IN

Art Without Walls Inc, Art Without Walls Inc, Sayville NY

Arts Council of Fayetteville-Cumberland County, The Arts Center, Fayetteville NC

Atlanta International Museum of Art & Design, Atlanta GA

Bradford Brinton, Big Horn WY

California State University, Northridge, Art Galleries, Northridge CA

Cartoon Art Museum, San Francisco CA

City of El Paso, El Paso TX

City of El Paso Museum and Cultural Affairs, People's Gallery, El Paso TX

City of Pittsfield, Berkshire Artisans, Pittsfield MA

Colorado Historical Society, Colorado History Museum, Denver CO

Colorado Springs Fine Arts Center, Colorado Springs CO

Concordia Historical Institute, Saint Louis MO

Detroit Institute of Arts, Detroit MI

East Baton Rouge Parks & Recreation Commission, Baton Rouge Gallery Inc, Baton Rouge LA

East Carolina University, Wellington B Gray Gallery, Greenville NC

Ellen Noel Art Museum of the Permian Basin, Odessa TX

Federal Reserve Board, Art Gallery, Washington DC

Fitton Center for Creative Arts, Hamilton OH

General Board of Discipleship, The United Methodist Church, The Upper Room Chapel & Museum, Nashville TN

Thomas Gilcrease, Gilcrease Museum, Tulsa OK

Robert Gumbiner, Museum of Latin American Art, Long Beach CA

Hartwick College, The Yager Museum, Oneonta NY

Heard Museum, Phoenix AZ

Hidalgo County Historical Museum, Edinburg TX

Institute of Puerto Rican Culture, Museo Fuerte Conde de Mirasol, Vieques PR

The Interchurch Center, Galleries at the Interchurch Center, New York NY

Johns Hopkins University, Evergreen House, Baltimore MD

Kalamazoo Institute of Arts, Kalamazoo MI

Kansas City Art Institute, Kansas City MO

Kelly-Griggs House Museum, Red Bluff CA

Knoxville Museum of Art, Knoxville TN

Koshare Indian Museum, Inc, La Junta CO

L A County Museum of Art, Los Angeles CA

La Raza-Galeria Posada, Sacramento CA

Lehigh University Art Galleries, Museum Operation, Bethlehem PA

Loyola Marymount University, Laband Art Gallery, Los Angeles CA

Maryland Art Place, Baltimore MD

Mennello Museum of American Art, Orlando FL

Metropolitan State College of Denver, Center for Visual Art, Denver CO

Mexican Museum, San Francisco CA

Mingei International, Inc, Mingei International Museum, San Diego CA

Arthur Roy Mitchell, Museum of Western Art, Trinidad CO

Modern Art Museum, Fort Worth TX

Museo De Las Americas, Denver CO

Museum of Contemporary Art, North Miami FL

The Museum of Contemporary Art (MOCA), Los Angeles CA

Museum of Fine Arts, Saint Petersburg, Florida, Inc, Saint Petersburg FL

Museum of New Mexico, Museum of International Folk Art, Santa Fe NM

Nelson-Atkins Museum of Art, Kansas City MO

New Mexico State University, Art Gallery, Las Cruces NM

New World Art Center, T F Chen Cultural Center, New York NY

Opelousas Museum of Art, Inc (OMA), Opelousas LA

Palm Springs Art Museum, Palm Springs CA

Panhandle-Plains Historical Society Museum, Canyon TX

Phoenix Art Museum, Phoenix AZ

Princeton University, Princeton University Art Museum, Princeton NJ

Queens College, City University of New York, Godwin-Ternbach Museum, Flushing NY

Millicent Rogers, Taos NM

Roswell Museum & Art Center, Roswell NM

Royal Ontario Museum, Toronto ON

Saginaw Art Museum, Saginaw MI

Saint Mary's College of California, Hearst Art Gallery, Moraga CA

San Antonio Museum of Art, San Antonio TX

Santa Monica Museum of Art, Santa Monica CA

South Carolina State Museum, Columbia SC

Southeastern Center for Contemporary Art, Winston-Salem NC

Taos, La Hacienda de Los Martinez, Taos NM

Texas Tech University, Museum of Texas Tech University, Lubbock TX

University of Illinois, Krannert Art Museum and Kinkead Pavillion, Champaign IL

University of New Mexico, The Harwood Museum of Art, Taos NM

University of Puerto Rico, Museum of Anthropology, History & Art, Rio Piedras PR

Wellesley College, Davis Museum & Cultural Center, Wellesley MA

Yerba Buena Center for the Arts, San Francisco CA

HISTORICAL MATERIAL

Academy of the New Church, Glencairn Museum, Bryn Athyn PA

Adams County Historical Society, Gettysburg PA

Adams National Historic Park, Quincy MA

African American Museum in Philadelphia, Philadelphia PA

African Art Museum of Maryland, Columbia MD

Agecroft Association, Museum, Richmond VA

Alabama Department of Archives & History, Museum Galleries, Montgomery AL

Alaska Museum of Natural History, Anchorage AK

Albuquerque Museum of Art & History, Albuquerque NM

Allentown Art Museum, Allentown PA

Alton Museum of History & Art, Inc, Alton IL

American Kennel Club, Museum of the Dog, Saint Louis MO

Americas Society Art Gallery, New York NY

Amherst Museum, Amherst NY

Anchorage Museum at Rasmuson Center, Anchorage AK

Arab American National Museum, Dearborn MI

Archives & History Center of the United Methodist Church, Madison NJ

Arizona Historical Society-Yuma, Sanguinetti House Museum & Garden, Yuma AZ

Art Gallery of Nova Scotia, Halifax NS

Art Without Walls Inc, Art Without Walls Inc, Sayville NY

Artesia Historical Museum & Art Center, Artesia NM

Ashland Historical Society, Ashland MA

Meredith College, Frankie G Weems Gallery & Rotunda Gallery, Raleigh NC

Miami-Dade College, Kendal Campus, Art Gallery, Miami FL

Middle Border Museum & Oscar Howe Art Center, Mitchell SD

Ministry of Culture, The Delphi Museum, I Ephorate of Prehistoric & Classical Antiquities, Delphi

Mint Museum of Art, Mint Museum of Craft & Design, Charlotte NC

Mission San Luis Rey de Francia, Mission San Luis Rey Museum, Oceanside CA

Mission San Miguel Museum, San Miguel CA

Mississippi Department of Archives & History, Old Capitol Museum of Mississippi History, Jackson MS

Mississippi River Museum at Mud-Island River Park, Memphis TN

Missouri Department of Natural Resources, Missouri State Museum, Jefferson City MO

Missouri Department of Natural Resources, Elizabeth Rozier Gallery, Jefferson City MO

Missouri Historical Society, Missouri History Museum, Saint Louis MO

Missouri Historical Society, Saint Louis MO

Arthur Roy Mitchell, Museum of Western Art, Trinidad CO

Mohave Museum of History & Arts, Kingman AZ

Monhegan Museum, Monhegan ME

Monroe County Historical Association, Elizabeth D Walters Library, Stroudsburg PA

Moravian Historical Society, Whitefield House Museum, Nazareth PA

Morris-Jumel Mansion, Inc, New York NY

Multicultural Heritage Centre, Stony Plain AB

Muscatine Art Center, Muscatine IA

Musee Regional de la Cote-Nord, Sept-Iles PQ

Museo De Las Americas, Denver CO

The Museum, Greenwood SC

Museum of Art & History, Santa Cruz, Santa Cruz CA

Museum of Chinese in the Americas, New York NY

Museum of Fine Arts, Saint Petersburg, Florida, Inc, Saint Petersburg FL

Museum of Mobile, Mobile AL

Museum of Northern Arizona, Flagstaff AZ

Museum of Southern History, Sugarland TX

Museum of the City of New York, New York NY

Museum of York County, Rock Hill SC

Museum Science & History, Jacksonville FL

Muzeum Narodowe W Kielcach, National Museum in Kielce, Kielce

Nanticoke Indian Museum, Millsboro DE

Napoleonic Society of America, Museum & Library, Clearwater FL

Nathan Hale Homestead Museum, Coventry CT

National Archives & Records Administration, John F Kennedy Presidential Library & Museum, Boston MA

National Cowboy & Western Heritage Museum, Oklahoma City OK

National Heritage Museum, Lexington MA

National Museum of the American Indian, George Gustav Heye Center, New York NY

National Museum of Wildlife Art, Jackson WY

National Park Service, Weir Farm National Historic Site, Wilton CT

The National Park Service, United States Department of the Interior, Statue of Liberty National Monument & The Ellis Island Immigration Museum, New York NY

Navajo Nation, Navajo Nation Museum, Window Rock AZ

Naval War College Museum, Newport RI

Nebraska Game and Parks Commission, Arbor Lodge State Historical Park & Morton Mansion, Nebraska City NE

Nebraska State Capitol, Lincoln NE

New Hampshire Antiquarian Society, Hopkinton NH

New Jersey Historical Society, Newark NJ

New Jersey State Museum, Fine Art Bureau, Trenton NJ

New York State Historical Association, Fenimore Art Museum, Cooperstown NY

New York State Office of Parks Recreation & Historic Preservation, John Jay Homestead State Historic Site, Katonah NY

Newburyport Maritime Society, Custom House Maritime Museum, Newburyport MA

Newton History Museum at the Jackson Homestead, Newton MA

Elisabet Ney, Austin TX

No Man's Land Historical Society Museum, Goodwell OK

The John A Noble, Staten Island NY

Norfolk Historical Society Inc, Museum, Norfolk CT

North Central Washington Museum, Wenatchee Valley Museum & Cultural Center, Wenatchee WA

Northeastern Nevada Museum, Elko NV

Ohio Historical Society, National Afro American Museum & Cultural Center, Wilberforce OH

The Ohio Historical Society, Inc, Campus Martius Museum & Ohio River Museum, Marietta OH

Old Barracks Museum, Trenton NJ

Old Dartmouth Historical Society, New Bedford Whaling Museum, New Bedford MA

The Old Jail Art Center, Albany TX

Old York Historical Society, Old Gaol Museum, York ME

Opelousas Museum of Art, Inc (OMA), Opelousas LA

Osborne Homestead Museum, Derby CT

Oshkosh Public Museum, Oshkosh WI

Owen Sound Historical Society, Marine & Rail Heritage Museum, Owen Sound ON

Page-Walker Arts & History Center, Cary NC

Palm Beach County Parks & Recreation Department, Morikami Museum & Japanese Gardens, Delray Beach FL

Pennsylvania Historical & Museum Commission, Railroad Museum of Pennsylvania, Harrisburg PA

Pennsylvania Historical & Museum Commission, The State Museum of Pennsylvania, Harrisburg PA

The Pennsylvania State University, Palmer Museum of Art, University Park PA

Philipse Manor Hall State Historic Site, Yonkers NY

The Frank Phillips, Woolaroc Museum, Bartlesville OK

George Phippen, Phippen Art Museum, Prescott AZ

Photographic Resource Center, Boston MA

Pine Bluff/Jefferson County Historical Museum, Pine Bluff AR

Pioneer Historical Museum of South Dakota, Hot Springs SD

Plainsman Museum, Aurora NE

Plumas County Museum, Quincy CA

Polish Museum of America, Chicago IL

Pope County Historical Society, Pope County Museum, Glenwood MN

Porter-Phelps-Huntington Foundation, Inc, Historic House Museum, Hadley MA

Portsmouth Athenaeum, Joseph Copley Research Library, Portsmouth NH

Portsmouth Historical Society, John Paul Jones House, Portsmouth NH

Prairie Art Gallery, Grande Prairie AB

Putnam County Historical Society, Foundry School Museum, Cold Spring NY

Putnam Museum of History and Natural Science, Davenport IA

Queens College, City University of New York, Godwin-Ternbach Museum, Flushing NY

Rangeley Lakes Region Logging Museum, Rangeley ME

Red Rock State Park, Red Rock Museum, Church Rock NM

Riley County Historical Society, Riley County Historical Museum, Manhattan KS

Ringwood Manor House Museum, Ringwood NJ

Millicent Rogers, Taos NM

Roswell Museum & Art Center, Roswell NM

Royal Arts Foundation, Belcourt Castle, Newport RI

Royal Ontario Museum, Toronto ON

C M Russell, Great Falls MT

Safety Harbor Museum of Regional History, Safety Harbor FL

Saginaw Art Museum, Saginaw MI

Saint Bernard Foundation & Monastery, North Miami Beach FL

St Genevieve Museum, Sainte Genevieve MO

Saint Louis County Historical Society, Duluth MN

Saint Mary's College of California, Hearst Art Gallery, Moraga CA

Salisbury House Foundation, Des Moines IA

San Bernardino County Museum, Fine Arts Institute, Redlands CA

San Francisco Maritime National Historical Park, Maritime Museum, San Francisco CA

The Sandwich Historical Society, Inc, Sandwich Glass Museum, Sandwich MA

Schuyler Mansion State Historic Site, Albany NY

Seneca Falls Historical Society Museum, Seneca Falls NY

Seneca-Iroquois National Museum, Salamanca NY

Shaker Museum & Library, Old Chatham NY

Shaker Village of Pleasant Hill, Harrodsburg KY

Shephela Museum, Post Kefar-Menahem

Ships of the Sea Maritime Museum, Savannah GA

Shirley Plantation, Charles City VA

Shoreline Historical Museum, Shoreline WA

Shores Memorial Museum and Victoriana, Lyndon Center VT

Shoshone Bannock Tribes, Shoshone Bannock Tribal Museum, Fort Hall ID

R L S Silverado Museum, Saint Helena CA

Abigail Adams Smith, New York NY

Society of the Cincinnati, Museum & Library at Anderson House, Washington DC

Southern Lorain County Historical Society, Spirit of '76 Museum, Elyria OH

Southern Oregon Historical Society, Jacksonville Museum of Southern Oregon History, Medford OR

Spertus Institute of Jewish Studies, Spertus Museum, Chicago IL

St George Art Museum, Saint George UT

State of North Carolina, Battleship North Carolina, Wilmington NC

State University of New York College at Cortland, Dowd Fine Arts Gallery, Cortland NY

Staten Island Institute of Arts & Sciences, Staten Island NY

Summit County Historical Society, Akron OH

Susquehanna University, Lore Degenstein Gallery, Selinsgrove PA

Swedish-American Museum Association of Chicago, Chicago IL

Switzerland County Historical Society Inc, Switzerland County Historical Museum, Vevay IN

Tallahassee Museum of History & Natural Science, Tallahassee FL

Taos, Ernest Blumenschein Home & Studio, Taos NM

Taos, La Hacienda de Los Martinez, Taos NM

The Temple-Tifereth Israel, The Temple Museum of Religious Art, Beachwood OH

Tennessee State Museum, Nashville TN

Texas Tech University, Museum of Texas Tech University, Lubbock TX

Three Forks Area Historical Society, Headwaters Heritage Museum, Three Forks MT

Towson University Center for the Arts Gallery, The Holtzman MFA Gallery, Towson MD

Transylvania University, Morlan Gallery, Lexington KY

Tryon Palace Historic Sites & Gardens, New Bern NC

Tubac Center of the Arts, Tubac AZ

Turtle Bay Exploration Park, Redding CA

Turtle Mountain Chippewa Historical Society, Turtle Mountain Heritage Center, Belcourt ND

Mark Twain, State Historic Site Museum, Florida MO

Ukrainian Canadian Archives & Museum of Alberta, Edmonton AB

The Ukrainian Museum, New York NY

United Society of Shakers, Shaker Museum, New Glocester ME

US Navy Supply Corps School, US Navy Supply Corps Museum, Athens GA

University of Alabama at Birmingham, Visual Arts Gallery, Birmingham AL

University of British Columbia, Museum of Anthropology, Vancouver BC

University of California, Richard L Nelson Gallery & Fine Arts Collection, Davis CA

University of Chicago, Oriental Institute Museum, Chicago IL

University of Illinois, Spurlock Museum, Champaign IL

University of Manitoba, Faculty of Architecture Exhibition Centre, Winnipeg MB

University of Mississippi, University Museum, Oxford MS

University of New Mexico, The Harwood Museum of Art, Taos NM

University of New Mexico, University Art Museum, Albuquerque NM

University of Saskatchewan, Diefenbaker Canada Centre, Saskatoon SK

University of the South, University Art Gallery, Sewanee TN

Van Cortlandt House Museum, Bronx NY

Vancouver Museum, Vancouver BC

Ventura County Historical Society, Museum of History & Art, Ventura CA

Ventura County Maritime Museum, Inc, Oxnard CA

Vermilion County Museum Society, Danville IL

Victoria Mansion - Morse Libby House, Portland ME

Wade House & Wesley W Jung Carriage Museum, Historic House & Carriage Museum, Greenbush WI

HISTORY OF ART & ARCHAEOLOGY

ILLUSTRATION

INTERIOR DESIGN

ISLAMIC ART

IVORY

JADE

Cincinnati Institute of Fine Arts, Taft Museum of Art, Cincinnati OH
Columbus Museum, Columbus GA
Columbus Museum of Art and Design, Indianapolis IN
Denver Art Museum, Denver CO
Detroit Institute of Arts, Detroit MI
Emory University, Michael C Carlos Museum, Atlanta GA
Erie Art Museum, Erie PA
Florida State University and Central Florida Community College, The Appleton Museum of Art, Ocala FL
Forest Lawn Museum, Glendale CA
Freeport Arts Center, Freeport IL
Hermitage Foundation Museum, Norfolk VA
Edna Hibel, Hibel Museum of Art, Jupiter FL
Hillwood Museum & Gardens Foundation, Hillwood Museum & Gardens, Washington DC
Honolulu Academy of Arts, Honolulu HI
Iowa State University, Brunnier Art Museum, Ames IA
Jacksonville University, Alexander Brest Museum & Gallery, Jacksonville FL
Johns Hopkins University, Evergreen House, Baltimore MD
Lizzadro Museum of Lapidary Art, Elmhurst IL
Mingei International, Inc, Mingei International Museum, San Diego CA
Musee Guimet, Paris
Museo De Las Americas, Denver CO
National Palace Museum, Taipei
Norton Museum of Art, West Palm Beach FL
Pacific - Asia Museum, Pasadena CA
Panhandle-Plains Historical Society Museum, Canyon TX
The Pennsylvania State University, Palmer Museum of Art, University Park PA
Princeton University, Princeton University Art Museum, Princeton NJ
Queens College, City University of New York, Godwin-Ternbach Museum, Flushing NY
Saint Bonaventure University, Regina A Quick Center for the Arts, Saint Bonaventure NY
Saint John's University, Chung-Cheng Art Gallery, Jamaica NY
Santa Barbara Museum of Art, Santa Barbara CA
Seattle Art Museum, Seattle WA
Society of the Cincinnati, Museum & Library at Anderson House, Washington DC
State University of New York at Binghamton, University Art Museum, Binghamton NY
Staten Island Institute of Arts & Sciences, Staten Island NY
Texas Tech University, Museum of Texas Tech University, Lubbock TX
University of Alabama at Birmingham, Visual Arts Gallery, Birmingham AL
University of Illinois, Krannert Art Museum and Kinkead Pavillion, Champaign IL
University of Iowa, Museum of Art, Iowa City IA
University of Utah, Utah Museum of Fine Arts, Salt Lake City UT
Vancouver Museum, Vancouver BC
Virginia Museum of Fine Arts, Richmond VA
Washington County Museum of Fine Arts, Hagerstown MD
Worcester Art Museum, Worcester MA

JEWELRY

Academy of the New Church, Glencairn Museum, Bryn Athyn PA
African Art Museum of Maryland, Columbia MD
Allentown Art Museum, Allentown PA
Arab American National Museum, Dearborn MI
Art & Culture Center of Hollywood, Art Gallery, Hollywood FL
Art Without Walls Inc, Art Without Walls Inc, Sayville NY
Asian Art Museum of San Francisco, Chong-Moon Lee Ctr for Asian Art and Culture, San Francisco CA
Athens Byzantine & Christian Museum, Athens
Atlanta International Museum of Art & Design, Atlanta GA
Baldwin Historical Society Museum, Baldwin NY
The Baltimore Museum of Art, Baltimore MD
Beloit College, Wright Museum of Art, Beloit WI
Berea College, Doris Ulmann Galleries, Berea KY
Berkshire Museum, Pittsfield MA
Bradford Brinton, Big Horn WY
The Canadian Craft Museum, Vancouver BC

Canadian Museum of Civilization, Gatineau PQ
Billie Trimble Chandler, Asian Cultures Museum & Educational Center, Corpus Christi TX
Chinese Culture Foundation, Center Gallery, San Francisco CA
Columbus Museum, Columbus GA
Cooper-Hewitt, National Design Museum, Smithsonian Institution, New York NY
Craft and Folk Art Museum (CAFAM), Los Angeles CA
Craftsmen's Guild of Mississippi, Inc, Agriculture & Forestry Museum, Jackson MS
Craftsmen's Guild of Mississippi, Inc, Mississippi Crafts Center, Ridgeland MS
Crow Wing County Historical Society, Brainerd MN
DAR Museum, National Society Daughters of the American Revolution, Washington DC
Denver Art Museum, Denver CO
Detroit Institute of Arts, Detroit MI
Doncaster Museum and Art Gallery, Doncaster
Eiteljorg Museum of American Indians & Western Art, Indianapolis IN
Ellen Noel Art Museum of the Permian Basin, Odessa TX
Emory University, Michael C Carlos Museum, Atlanta GA
Erie County Historical Society, Erie PA
Evanston Historical Society, Charles Gates Dawes House, Evanston IL
Fine Arts Center for the New River Valley, Pulaski VA
Fishkill Historical Society, Van Wyck Homestead Museum, Fishkill NY
Fitton Center for Creative Arts, Hamilton OH
Forest Lawn Museum, Glendale CA
Frontier Times Museum, Bandera TX
Fuller Museum of Art, Brockton MA
Gallery One, Ellensburg WA
Glanmore National Historic Site of Canada, Belleville ON
Hancock County Trustees of Public Reservations, Woodlawn Museum, Ellsworth ME
Harvard University, Dumbarton Oaks Research Library & Collections, Washington DC
Haystack Mountain School of Crafts, Deer Isle ME
Headley-Whitney Museum, Lexington KY
Heard Museum, Phoenix AZ
Hebrew Union College, Skirball Cultural Center, Los Angeles CA
Edna Hibel, Hibel Museum of Art, Jupiter FL
Hillwood Museum & Gardens Foundation, Hillwood Museum & Gardens, Washington DC
Hispanic Society of America, Museum & Library, New York NY
Holter Museum of Art, Helena MT
Hoyt Institute of Fine Arts, New Castle PA
Hui No eau Visual Arts Center, Gallery and Gift Shop, Makawao Maui HI
Imperial Calcasieu Museum, Gibson-Barham Gallery, Lake Charles LA
Institute of American Indian Arts Museum, Museum, Santa Fe NM
The Interchurch Center, Galleries at the Interchurch Center, New York NY
Iroquois Indian Museum, Howes Cave NY
James Dick Foundation, Festival - Institute, Round Top TX
Kansas City Art Institute, Kansas City MO
Kelly-Griggs House Museum, Red Bluff CA
Kelowna Museum, Kelowna BC
Kentucky Museum of Art & Craft, Louisville KY
Kings County Historical Society & Museum, Hampton NB
Koochiching Museums, International Falls MN
Koshare Indian Museum, Inc, La Junta CO
Kurdish Museum, Brooklyn NY
La Raza-Galeria Posada, Sacramento CA
Lac du Flambeau Band of Lake Superior Chippewa Indians, George W Brown Jr Ojibwe Museum & Cultural Center, Lac du Flambeau WI
Louisiana State University, School of Art Gallery, Baton Rouge LA
Loveland Museum Gallery, Loveland CO
Maricopa County Historical Society, Desert Caballeros Western Museum, Wickenburg AZ
Maude Kerns Art Center, Eugene OR
McCord Museum of Canadian History, Montreal PQ
McDowell House & Apothecary Shop, Danville KY
Meredith College, Frankie G Weems Gallery & Rotunda Gallery, Raleigh NC
Mexican Museum, San Francisco CA

Mingei International, Inc, Mingei International Museum, San Diego CA
Ministry of Culture, The Delphi Museum, I Ephorate of Prehistoric & Classical Antiquities, Delphi
Mint Museum of Art, Mint Museum of Craft & Design, Charlotte NC
Mississippi Department of Archives & History, Old Capitol Museum of Mississippi History, Jackson MS
Mississippi River Museum at Mud-Island River Park, Memphis TN
Missoula Art Museum, Missoula MT
Arthur Roy Mitchell, Museum of Western Art, Trinidad CO
James Monroe, Fredericksburg VA
Moravska Galerie v Brne, Moravian Gallery in Brno, Brno
Musee Cognacq-Jay, Cognacq-Jay Museum, Paris
Musee Guimet, Paris
Museum for African Art, Long Island City NY
Museum of Contemporary Art, North Miami FL
Museum of the City of New York, New York NY
Muttart Public Art Gallery, Calgary AB
Muzej za Umjetnost i Obrt, Museum of Arts & Crafts, Zagreb
Muzeum Narodowe, National Museum, Poznan
National Museum of Women in the Arts, Washington DC
National Palace Museum, Taipei
Navajo Nation, Navajo Nation Museum, Window Rock AZ
Nelson-Atkins Museum of Art, Kansas City MO
Nova Scotia College of Art and Design, Anna Leonowens Gallery, Halifax NS
The Ohio Historical Society, Inc, Campus Martius Museum & Ohio River Museum, Marietta OH
Ohio University, Kennedy Museum of Art, Athens OH
Page-Walker Arts & History Center, Cary NC
Panhandle-Plains Historical Society Museum, Canyon TX
Plainsman Museum, Aurora NE
Port Huron Museum, Port Huron MI
Porter-Phelps-Huntington Foundation, Inc, Historic House Museum, Hadley MA
Princeton University, Princeton University Art Museum, Princeton NJ
Queens College, City University of New York, Godwin-Ternbach Museum, Flushing NY
Randall Junior Museum, San Francisco CA
Millicent Rogers, Taos NM
Royal Arts Foundation, Belcourt Castle, Newport RI
St Genevieve Museum, Sainte Genevieve MO
Saint Peter's College, Art Gallery, Jersey City NJ
Seneca-Iroquois National Museum, Salamanca NY
Shoshone Bannock Tribes, Shoshone Bannock Tribal Museum, Fort Hall ID
The Slater Memorial Museum, Slater Memorial Museum, Norwich CT
The Society for Contemporary Crafts, Pittsburgh PA
Society of the Cincinnati, Museum & Library at Anderson House, Washington DC
South Carolina Artisans Center, Walterboro SC
Spertus Institute of Jewish Studies, Spertus Museum, Chicago IL
State University of New York at Binghamton, University Art Museum, Binghamton NY
Staten Island Institute of Arts & Sciences, Staten Island NY
Stauth Foundation & Museum, Stauth Memorial Museum, Montezuma KS
Swedish-American Museum Association of Chicago, Chicago IL
Tampa Museum of Art, Tampa FL
Topeka & Shawnee County Public Library, Alice C Sabatini Gallery, Topeka KS
The Ukrainian Museum, New York NY
United States Figure Skating Association, World Figure Skating Museum & Hall of Fame, Colorado Springs CO
University of Chicago, Oriental Institute Museum, Chicago IL
University of Illinois, Krannert Art Museum and Kinkead Pavillion, Champaign IL
University of Mississippi, University Museum, Oxford MS
University of North Dakota, Hughes Fine Arts Center-Col Eugene Myers Art Gallery, Grand Forks ND
University of Saskatchewan, Diefenbaker Canada Centre, Saskatoon SK

University of Victoria, Maltwood Art Museum and Gallery, Victoria BC
Valentine Richmond History Center, Richmond VA
Vancouver Museum, Vancouver BC
Vancouver Public Library, Fine Arts & Music Div, Vancouver BC
Vesterheim Norwegian-American Museum, Decorah IA
Virginia Museum of Fine Arts, Richmond VA
Wadsworth Atheneum Museum of Art, Hartford CT
Walters Art Museum, Baltimore MD
Waterworks Visual Arts Center, Salisbury NC
Wheelwright Museum of the American Indian, Santa Fe NM
Willard House & Clock Museum, Inc, North Grafton MA
Wisconsin Historical Society, State Historical Museum, Madison WI
Woodlawn/The Pope-Leighey, Mount Vernon VA

JUDAICA

Alpert Jewish Community Center, Gatov Gallery, Long Beach CA
Art & Culture Center of Hollywood, Art Gallery, Hollywood FL
Art Without Walls Inc, Art Without Walls Inc, Sayville NY
Arts Council of Fayetteville-Cumberland County, The Arts Center, Fayetteville NC
B'nai B'rith International, B'nai B'rith Klutznick National Jewish Museum, Washington DC
Baycrest Centre for Geriatric Care, Silverman Heritage Museum, Toronto ON
Craft and Folk Art Museum (CAFAM), Los Angeles CA
Denver Art Museum, Denver CO
Detroit Institute of Arts, Detroit MI
General Board of Discipleship, The United Methodist Church, The Upper Room Chapel & Museum, Nashville TN
Hebrew Union College, Jewish Institute of Religion Museum, New York NY
Hebrew Union College, Skirball Cultural Center, Los Angeles CA
Hillel Foundation, Hillel Jewish Student Center Gallery, Cincinnati OH
Hillwood Museum & Gardens Foundation, Hillwood Museum & Gardens, Washington DC
Joslyn Art Museum, Omaha NE
Lightner Museum, Saint Augustine FL
Judah L Magnes, Berkeley CA
Museum of Fine Arts, Saint Petersburg, Florida, Inc, Saint Petersburg FL
Muzej za Umjetnost i Obrt, Museum of Arts & Crafts, Zagreb
The National Park Service, United States Department of the Interior, Statue of Liberty National Monument & The Ellis Island Immigration Museum, New York NY
New Brunswick Museum, Saint John NB
Sherwin Miller Museum of Jewish Art, Tulsa OK
Spertus Institute of Jewish Studies, Spertus Museum, Chicago IL
Sylvia Plotkin Museum of Temple Beth Israel, Scottsdale AZ
The Temple-Tifereth Israel, The Temple Museum of Religious Art, Beachwood OH
University of Illinois, Spurlock Museum, Champaign IL
Waterworks Visual Arts Center, Salisbury NC
Yeshiva University Museum, New York NY

JUVENILE ART

Art Community Center, Art Center of Corpus Christi, Corpus Christi TX
Art Without Walls Inc, Art Without Walls Inc, Sayville NY
Arts Council of Fayetteville-Cumberland County, The Arts Center, Fayetteville NC
Canadian Museum of Civilization, Gatineau PQ
Cartoon Art Museum, San Francisco CA
Chattahoochee Valley Art Museum, LaGrange GA
Ellen Noel Art Museum of the Permian Basin, Odessa TX
Elmhurst Art Museum, Elmhurst IL
Erie Art Museum, Erie PA
Hebrew Union College, Jewish Institute of Religion Museum, New York NY

Hebrew Union College, Skirball Cultural Center, Los Angeles CA
Higgins Armory Museum, Worcester MA
Iroquois Indian Museum, Howes Cave NY
Kentucky Museum of Art & Craft, Louisville KY
LeSueur County Historical Society, Chapter One, Elysian MN
The Long Island Museum of American Art, History & Carriages, Stony Brook NY
Meredith College, Frankie G Weems Gallery & Rotunda Gallery, Raleigh NC
Montgomery Museum of Fine Arts, Montgomery AL
Murray State University, Art Galleries, Murray KY
Musee Regional de la Cote-Nord, Sept-Iles PQ
Museum of Northern Arizona, Flagstaff AZ
Muttart Public Art Gallery, Calgary AB
New Visions Gallery, Inc, Marshfield WI
Opelousas Museum of Art, Inc (OMA), Opelousas LA
Owensboro Museum of Fine Art, Owensboro KY
Polk Museum of Art, Lakeland FL
School of Visual Arts, Visual Arts Museum, New York NY
South Carolina State Museum, Columbia SC
Southeastern Center for Contemporary Art, Winston-Salem NC
Spartanburg County Museum of Art, Spartanburg SC
Spertus Institute of Jewish Studies, Spertus Museum, Chicago IL
Tampa Museum of Art, Tampa FL
University of North Carolina at Chapel Hill, Ackland Art Museum, Chapel Hill NC
Waterworks Visual Arts Center, Salisbury NC
Wiregrass Museum of Art, Dothan AL
Woodmere Art Museum, Philadelphia PA
Yerba Buena Center for the Arts, San Francisco CA

LACES

Albany Institute of History & Art, Albany NY
Allentown Art Museum, Allentown PA
Art Without Walls Inc, Art Without Walls Inc, Sayville NY
Artesia Historical Museum & Art Center, Artesia NM
Association for the Preservation of Virginia Antiquities, John Marshall House, Richmond VA
Jesse Besser, Alpena MI
Brick Store Museum & Library, Kennebunk ME
Brooklyn Historical Society, Brooklyn OH
Canadian Museum of Civilization, Gatineau PQ
Carson County Square House Museum, Panhandle TX
City of Grand Rapids Michigan, Public Museum of Grand Rapids, Grand Rapids MI
Clark County Historical Society, Pioneer - Krier Museum, Ashland KS
Cornwall Gallery Society, Cornwall Regional Art Gallery, Cornwall ON
Danville Museum of Fine Arts & History, Danville VA
Detroit Institute of Arts, Detroit MI
Evanston Historical Society, Charles Gates Dawes House, Evanston IL
Fashion Institute of Technology, Museum at FIT, New York NY
Fine Arts Museums of San Francisco, Legion of Honor, San Francisco CA
Fishkill Historical Society, Van Wyck Homestead Museum, Fishkill NY
Flagler Museum, Palm Beach FL
Freeport Arts Center, Freeport IL
Hebrew Union College, Skirball Cultural Center, Los Angeles CA
Heritage Museum Association, Inc, The Heritage Museum of Northwest Florida, Valparaiso FL
Hillwood Museum & Gardens Foundation, Hillwood Museum & Gardens, Washington DC
Historic Arkansas Museum, Little Rock AR
Historic Landmarks Foundation of Indiana, Morris-Butler House, Indianapolis IN
Imperial Calcasieu Museum, Gibson-Barham Gallery, Lake Charles LA
James Dick Foundation, Festival - Institute, Round Top TX
Kelly-Griggs House Museum, Red Bluff CA
Kern County Museum, Bakersfield CA
Koochiching Museums, International Falls MN
Kunstindustrimuseet, The Danish Museum of Art & Design, Copenhagen
Leelanau Historical Museum, Leland MI
Longfellow-Evangeline State Commemorative Area, Saint Martinville LA
Loveland Museum Gallery, Loveland CO

Judah L Magnes, Berkeley CA
McCord Museum of Canadian History, Montreal PQ
Mississippi Department of Archives & History, Old Capitol Museum of Mississippi History, Jackson MS
Mississippi River Museum at Mud-Island River Park, Memphis TN
Morris-Jumel Mansion, Inc, New York NY
The Museum, Greenwood SC
Muzej za Umjetnost i Obrt, Museum of Arts & Crafts, Zagreb
Old Dartmouth Historical Society, New Bedford Whaling Museum, New Bedford MA
Old Slater Mill Association, Slater Mill Historic Site, Pawtucket RI
Plainsman Museum, Aurora NE
Portland Art Museum, Portland OR
Saginaw Art Museum, Saginaw MI
St Genevieve Museum, Sainte Genevieve MO
The Slater Memorial Museum, Slater Memorial Museum, Norwich CT
Staten Island Institute of Arts & Sciences, Staten Island NY
Syracuse University, Art Collection, Syracuse NY
Syracuse University, SUArt Galleries, Syracuse NY
Texas Tech University, Museum of Texas Tech University, Lubbock TX
Textile Museum of Canada, Toronto ON
Vesterheim Norwegian-American Museum, Decorah IA
Wadsworth Atheneum Museum of Art, Hartford CT
Washington County Museum of Fine Arts, Hagerstown MD
West Florida Historic Preservation, Inc, T T Wentworth, Jr Florida State Museum & Historic Pensacola Village, Pensacola FL
Witte Museum, San Antonio TX
Woodmere Art Museum, Philadelphia PA
Yarmouth County Historical Society, Yarmouth County Museum, Yarmouth NS

LANDSCAPE ARCHITECTURE

Patrick Henry, Red Hill National Memorial, Brookneal VA
James Dick Foundation, Festival - Institute, Round Top TX
Saint Peter's College, Art Gallery, Jersey City NJ

LANDSCAPES

Academy of the New Church, Glencairn Museum, Bryn Athyn PA
Albany Institute of History & Art, Albany NY
Albuquerque Museum of Art & History, Albuquerque NM
Allentown Art Museum, Allentown PA
Alton Museum of History & Art, Inc, Alton IL
Anchorage Museum at Rasmuson Center, Anchorage AK
Appaloosa Museum and Heritage Center, Moscow ID
Art & Culture Center of Hollywood, Art Gallery, Hollywood FL
Art Community Center, Art Center of Corpus Christi, Corpus Christi TX
Art Without Walls Inc, Art Without Walls Inc, Sayville NY
Artesia Historical Museum & Art Center, Artesia NM
Arts Council of Fayetteville-Cumberland County, The Arts Center, Fayetteville NC
Asbury College, Student Center Gallery, Wilmore KY
Bay County Historical Society, Historical Museum of Bay County, Bay City MI
Berkshire Museum, Pittsfield MA
Jesse Besser, Alpena MI
Brandywine River Museum, Chadds Ford PA
Brick Store Museum & Library, Kennebunk ME
Brigham Young University, Museum of Art, Provo UT
Brooklyn Botanic Garden, Steinhardt Conservatory Gallery, Brooklyn NY
Cahoon Museum of American Art, Cotuit MA
California Center for the Arts, Escondido Museum, Escondido CA
Canadian Museum of Civilization, Gatineau PQ
Canadian Museum of Contemporary Photography, Ottawa ON
Cape Ann Historical Association, Gloucester MA
Amon Carter, Fort Worth TX
Cedar Rapids Museum of Art, Cedar Rapids IA
Central United Methodist Church, Swords Into Plowshares Peace Center & Gallery, Detroit MI

Church of Jesus Christ of Latter-Day Saints, Museum of Church History & Art, Salt Lake City UT

Cincinnati Museum Association and Art Academy of Cincinnati, Cincinnati Art Museum, Cincinnati OH

City of Fayette, Alabama, Fayette Art Museum, Fayette AL

City of Gainesville, Thomas Center Galleries - Cultural Affairs, Gainesville FL

City of Pittsfield, Berkshire Artisans, Pittsfield MA

City of Toronto Culture Division, The Market Gallery, Toronto ON

College of William & Mary, Muscarelle Museum of Art, Williamsburg VA

Colorado Springs Fine Arts Center, Colorado Springs CO

Columbus Museum, Columbus GA

Columbus Museum of Art, Columbus OH

Concord Museum, Concord MA

Concordia University, Leonard & Bina Ellen Art Gallery, Montreal PQ

Courtauld Institute of Art, Courtauld Institute Gallery, London

Coutts Memorial Museum of Art, Inc, El Dorado KS

CT Commission on Culture & Tourism, Sloane-Stanley Museum, Kent CT

The Currier Museum of Art, Currier Museum of Art, Manchester NH

Dahesh Museum of Art, New York NY

Delaware Art Museum, Wilmington DE

DeLeon White Gallery, Toronto ON

Denver Art Museum, Denver CO

Detroit Institute of Arts, Detroit MI

DeWitt Historical Society of Tompkins County, The History Center in Tompkins Co, Ithaca NY

Dickinson College, The Trout Gallery, Carlisle PA

Dixie State College, Robert N & Peggy Sears Gallery, Saint George UT

Door County, Miller Art Museum, Sturgeon Bay WI

Durham Art Guild Inc, Durham NC

East Baton Rouge Parks & Recreation Commission, Baton Rouge Gallery Inc, Baton Rouge LA

George Eastman, Rochester NY

Egan Institute of Maritime Studies, Nantucket MA

Eiteljorg Museum of American Indians & Western Art, Indianapolis IN

Ellen Noel Art Museum of the Permian Basin, Odessa TX

Erie Art Museum, Erie PA

Essex Historical Society, Essex Shipbuilding Museum, Essex MA

Evanston Historical Society, Charles Gates Dawes House, Evanston IL

Federal Reserve Board, Art Gallery, Washington DC

Fine Arts Center for the New River Valley, Pulaski VA

Fitton Center for Creative Arts, Hamilton OH

Florence Museum of Art, Science & History, Florence SC

Florida State University and Central Florida Community College, The Appleton Museum of Art, Ocala FL

Forest Lawn Museum, Glendale CA

Fort Collins Museum of Contemporary Art, Fort Collins CO

Fort Ticonderoga Association, Ticonderoga NY

Gadsden Museum of Fine Arts, Inc, Gadsden Museum of Art and History, Gadsden AL

Gallery One, Ellensburg WA

Germanisches Nationalmuseum, Nuremberg

Thomas Gilcrease, Gilcrease Museum, Tulsa OK

Glanmore National Historic Site of Canada, Belleville ON

Greene County Historical Society, Bronck Museum, Coxsackie NY

Guilford College, Art Gallery, Greensboro NC

Hartwick College, The Yager Museum, Oneonta NY

Hebrew Union College, Skirball Cultural Center, Los Angeles CA

Henry Gallery Association, Henry Art Gallery, Seattle WA

Hermitage Foundation Museum, Norfolk VA

Edna Hibel, Hibel Museum of Art, Jupiter FL

Hickory Museum of Art, Inc, Hickory NC

Hillwood Museum & Gardens Foundation, Hillwood Museum & Gardens, Washington DC

Hispanic Society of America, Museum & Library, New York NY

Historic Cherry Hill, Albany NY

Historic Landmarks Foundation of Indiana, Morris-Butler House, Indianapolis IN

Holter Museum of Art, Helena MT

Honolulu Academy of Arts, Honolulu HI

Hoyt Institute of Fine Arts, New Castle PA

Hui No eau Visual Arts Center, Gallery and Gift Shop, Makawao Maui HI

The Interchurch Center, Galleries at the Interchurch Center, New York NY

Iredell Museum of Arts & Heritage, Statesville NC

Iroquois Indian Museum, Howes Cave NY

James Dick Foundation, Festival - Institute, Round Top TX

Johns Hopkins University, Evergreen House, Baltimore MD

Joslyn Art Museum, Omaha NE

Juniata College Museum of Art, Huntingdon PA

Kalamazoo Institute of Arts, Kalamazoo MI

Kansas City Art Institute, Kansas City MO

Kirkland Museum of Fine & Decorative Art, Denver CO

Knoxville Museum of Art, Knoxville TN

Koochiching Museums, International Falls MN

Kyiv Museum of Russian Art, Kyiv

Lafayette College, Williams Center Gallery, Easton PA

Lafayette Natural History Museum & Planetarium, Lafayette LA

Landmark Society of Western New York, Inc, The Campbell-Whittlesey House Museum, Rochester NY

Lehigh University Art Galleries, Museum Operation, Bethlehem PA

LeSueur County Historical Society, Chapter One, Elysian MN

Longfellow-Evangeline State Commemorative Area, Saint Martinville LA

Longview Museum of Fine Art, Longview TX

Luther College, Fine Arts Collection, Decorah IA

Charles H MacNider, Mason City IA

Maine Historical Society, Wadsworth-Longfellow House, Portland ME

Maitland Art Center, Maitland FL

Maricopa County Historical Society, Desert Caballeros Western Museum, Wickenburg AZ

Marquette University, Haggerty Museum of Art, Milwaukee WI

Maryhill Museum of Art, Goldendale WA

Maryland Art Place, Baltimore MD

Marylhurst University, The Art Gym, Marylhurst OR

Mason County Museum, Maysville KY

Mattatuck Historical Society, Mattatuck Museum, Waterbury CT

Maui Historical Society, Bailey House, Wailuku HI

McCord Museum of Canadian History, Montreal PQ

McMaster University, McMaster Museum of Art, Hamilton ON

Mennello Museum of American Art, Orlando FL

Midwest Museum of American Art, Elkhart IN

Ministry of Culture, The Delphi Museum, I Ephorate of Prehistoric & Classical Antiquities, Delphi

Missoula Art Museum, Missoula MT

Arthur Roy Mitchell, Museum of Western Art, Trinidad CO

Mobile Museum of Art, Mobile AL

Modern Art Museum, Fort Worth TX

Monhegan Museum, Monhegan ME

Montgomery Museum of Fine Arts, Montgomery AL

Morris Museum of Art, Augusta GA

Municipal Museum De Lakenhal, Stedelisk Museum De Lakenhal, Leiden

Munson-Williams-Proctor Arts Institute, Museum of Art, Utica NY

Muscatine Art Center, Museum, Muscatine IA

Musee Regional de la Cote-Nord, Sept-Iles PQ

Museum of Art & History, Santa Cruz, Santa Cruz CA

Museum of Contemporary Art, North Miami FL

Museum of Northwest Art, La Conner WA

Museum of the City of New York, New York NY

Muttart Public Art Gallery, Calgary AB

Muzej za Umjetnost i Obrt, Museum of Arts & Crafts, Zagreb

Muzeum Narodowe, National Museum, Poznan

Muzeum Narodowe W Kielcach, National Museum in Kielce, Kielce

Narodna Galerija, National Gallery of Slovenia, Ljubljana

National Cowboy & Western Heritage Museum, Oklahoma City OK

National Gallery of Canada, Ottawa ON

National Museum of Wildlife Art, Jackson WY

National Museum of Women in the Arts, Washington DC

National Park Service, Weir Farm National Historic Site, Wilton CT

National Trust for Historic Preservation, Chesterwood Estate & Museum, Stockbridge MA

Nelson-Atkins Museum of Art, Kansas City MO

Nemours Mansion & Gardens, Wilmington DE

Nevada Museum of Art, Reno NV

New Brunswick Museum, Saint John NB

New Jersey Historical Society, Newark NJ

New Jersey State Museum, Fine Art Bureau, Trenton NJ

New Mexico State University, Art Gallery, Las Cruces NM

New York State Historical Association, Fenimore Art Museum, Cooperstown NY

Newton History Museum at the Jackson Homestead, Newton MA

North Dakota State University, Memorial Union Gallery, Fargo ND

Noyes Art Gallery, Lincoln NE

The Ohio Historical Society, Inc, Campus Martius Museum & Ohio River Museum, Marietta OH

Oklahoma City Museum of Art, Oklahoma City OK

Opelousas Museum of Art, Inc (OMA), Opelousas LA

Oshkosh Public Museum, Oshkosh WI

Owensboro Museum of Fine Art, Owensboro KY

Palm Springs Art Museum, Palm Springs CA

Panhandle-Plains Historical Society Museum, Canyon TX

The Pennsylvania State University, Palmer Museum of Art, University Park PA

George Phippen, Phippen Art Museum, Prescott AZ

Pinacoteca Provinciale, Bari

Pope County Historical Society, Pope County Museum, Glenwood MN

Port Huron Museum, Port Huron MI

Princeton University, Princeton University Art Museum, Princeton NJ

Queens College, City University of New York, Godwin-Ternbach Museum, Flushing NY

Regina Public Library, Dunlop Art Gallery, Regina SK

Ross Memorial Museum, Saint Andrews NB

Roswell Museum & Art Center, Roswell NM

Saco Museum, Saco ME

Saginaw Art Museum, Saginaw MI

Saint Bonaventure University, Regina A Quick Center for the Arts, Saint Bonaventure NY

Saint Mary's College of California, Hearst Art Gallery, Moraga CA

Saint Olaf College, Flaten Art Museum, Northfield MN

Shirley Plantation, Charles City VA

The Slater Memorial Museum, Slater Memorial Museum, Norwich CT

Abigail Adams Smith, New York NY

South Dakota State University, South Dakota Art Museum, Brookings SD

Southeastern Center for Contemporary Art, Winston-Salem NC

Southern Oregon University, Schneider Museum of Art, Ashland OR

Spartanburg County Museum of Art, Spartanburg SC

Springfield Art Museum, Springfield MO

State University of New York at New Paltz, Samuel Dorsky Museum of Art, New Paltz NY

State University of New York College at Cortland, Dowd Fine Arts Gallery, Cortland NY

Staten Island Institute of Arts & Sciences, Staten Island NY

Susquehanna University, Lore Degenstein Gallery, Selinsgrove PA

Switzerland County Historical Society Inc, Life on the Ohio: River History Museum, Vevay IN

Syracuse University, Art Collection, Syracuse NY

The Temple-Tifereth Israel, The Temple Museum of Religious Art, Beachwood OH

Texas Tech University, Museum of Texas Tech University, Lubbock TX

Topeka & Shawnee County Public Library, Alice C Sabatini Gallery, Topeka KS

Tubac Center of the Arts, Tubac AZ

Tucson Museum of Artand Historic Block, Tucson AZ

Turtle Bay Exploration Park, Redding CA

The Ukrainian Museum, New York NY

United Society of Shakers, Shaker Museum, New Glocester ME

United States Capitol, Architect of the Capitol, Washington DC

University of Alabama at Birmingham, Visual Arts Gallery, Birmingham AL

University of Cincinnati, DAAP Galleries-College of Design Architecture, Art & Planning, Cincinnati OH

University of Colorado at Colorado Springs, Gallery of Contemporary Art, Colorado Springs CO

University of Delaware, University Gallery, Newark DE

University of Illinois, Krannert Art Museum and Kinkead Pavillion, Champaign IL

University of Louisiana at Lafayette, University Art Museum, Lafayette LA

University of Michigan, Museum of Art, Ann Arbor MI

University of New Hampshire, The Art Gallery, Durham NH

University of New Mexico, The Harwood Museum of Art, Taos NM

University of North Carolina at Chapel Hill, Ackland Art Museum, Chapel Hill NC

University of Saskatchewan, Diefenbaker Canada Centre, Saskatoon SK

University of Toronto, University of Toronto Art Centre, Toronto ON

Upstairs Gallery, Winnipeg MB

Ursinus College, Philip & Muriel Berman Museum of Art, Collegeville PA

Vesterheim Norwegian-American Museum, Decorah IA

Viridian Artists Inc, New York NY

Washington University, Mildred Lane Kemper Art Museum, Saint Louis MO

Waterworks Visual Arts Center, Salisbury NC

Wellesley College, Davis Museum & Cultural Center, Wellesley MA

West Florida Historic Preservation, Inc, T T Wentworth, Jr Florida State Museum & Historic Pensacola Village, Pensacola FL

Whatcom Museum of History and Art, Bellingham WA

Wheaton College, Watson Gallery, Norton MA

Peter & Catharine Whyte Foundation, Whyte Museum of the Canadian Rockies, Banff AB

Wilfrid Laurier University, Robert Langen Art Gallery, Waterloo ON

Wistariahurst Museum, Holyoke MA

Woodmere Art Museum, Philadelphia PA

Worcester Art Museum, Worcester MA

Yarmouth County Historical Society, Yarmouth County Museum, Yarmouth NS

LATIN AMERICAN ART

Americas Society Art Gallery, New York NY

Arizona State University, ASU Art Museum, Tempe AZ

Art & Culture Center of Hollywood, Art Gallery, Hollywood FL

Art Community Center, Art Center of Corpus Christi, Corpus Christi TX

Art Museum of the University of Houston, Blaffer Gallery, Houston TX

Art Without Walls Inc, Art Without Walls Inc, Sayville NY

Atlanta International Museum of Art & Design, Atlanta GA

Aurora University, Schingoethe Center for Native American Cultures, Aurora IL

Austin Museum of Art, Austin TX

The Baltimore Museum of Art, Baltimore MD

Beloit College, Wright Museum of Art, Beloit WI

California State University Stanislaus, University Art Gallery, Turlock CA

California State University, Northridge, Art Galleries, Northridge CA

Cartoon Art Museum, San Francisco CA

Center for Puppetry Arts, Atlanta GA

City of El Paso, El Paso TX

City of Gainesville, Thomas Center Galleries - Cultural Affairs, Gainesville FL

Colorado Springs Fine Arts Center, Colorado Springs CO

Cooper-Hewitt, National Design Museum, Smithsonian Institution, New York NY

Coutts Memorial Museum of Art, Inc, El Dorado KS

Craft and Folk Art Museum (CAFAM), Los Angeles CA

Denver Art Museum, Denver CO

Detroit Institute of Arts, Detroit MI

East Carolina University, Wellington B Gray Gallery, Greenville NC

Emory University, Michael C Carlos Museum, Atlanta GA

Federal Reserve Board, Art Gallery, Washington DC

Fitton Center for Creative Arts, Hamilton OH

Folk Art Society of America, Richmond VA

Forest Lawn Museum, Glendale CA

Thomas Gilcrease, Gilcrease Museum, Tulsa OK

Robert Gumbiner, Museum of Latin American Art, Long Beach CA

Hidalgo County Historical Museum, Edinburg TX

Hirshhorn Museum & Sculpture Garden, Smithsonian Institution, Washington DC

Institute of Puerto Rican Culture, Museo Fuerte Conde de Mirasol, Vieques PR

Intar Latin American Gallery, New York NY

The Interchurch Center, Galleries at the Interchurch Center, New York NY

Kalamazoo Institute of Arts, Kalamazoo MI

Kansas City Art Institute, Kansas City MO

Kelowna Museum, Kelowna BC

Knights of Columbus Supreme Council, Knights of Columbus Museum, New Haven CT

Knoxville Museum of Art, Knoxville TN

L A County Museum of Art, Los Angeles CA

Lehigh University Art Galleries, Museum Operation, Bethlehem PA

Lehman College Art Gallery, Bronx NY

Loyola Marymount University, Laband Art Gallery, Los Angeles CA

Marquette University, Haggerty Museum of Art, Milwaukee WI

McAllen International Museum, McAllen TX

Mexican Fine Arts Center Museum, Chicago IL

Mexican Museum, San Francisco CA

Miami-Dade College, Kendal Campus, Art Gallery, Miami FL

Midwest Museum of American Art, Elkhart IN

Modern Art Museum, Fort Worth TX

Museum of Art, Fort Lauderdale, Fort Lauderdale FL

Museum of Contemporary Art, North Miami FL

The Museum of Contemporary Art (MOCA), Los Angeles CA

National Museum of the American Indian, George Gustav Heye Center, New York NY

National Museum of Women in the Arts, Washington DC

New World Art Center, T F Chen Cultural Center, New York NY

Oklahoma City Museum of Art, Oklahoma City OK

Opelousas Museum of Art, Inc (OMA), Opelousas LA

Page-Walker Arts & History Center, Cary NC

Palm Springs Art Museum, Palm Springs CA

Panhandle-Plains Historical Society Museum, Canyon TX

Phoenix Art Museum, Phoenix AZ

Princeton University, Princeton University Art Museum, Princeton NJ

Queens College, City University of New York, Godwin-Ternbach Museum, Flushing NY

C M Russell, Great Falls MT

Saint Mary's College of California, Hearst Art Gallery, Moraga CA

Saint Peter's College, Art Gallery, Jersey City NJ

San Antonio Museum of Art, San Antonio TX

Santa Barbara Museum of Art, Santa Barbara CA

Santa Monica Museum of Art, Santa Monica CA

Southeastern Center for Contemporary Art, Winston-Salem NC

Southern Oregon University, Schneider Museum of Art, Ashland OR

State University of New York College at Cortland, Dowd Fine Arts Gallery, Cortland NY

Stauth Foundation & Museum, Stauth Memorial Museum, Montezuma KS

Tampa Museum of Art, Tampa FL

Texas Tech University, Museum of Texas Tech University, Lubbock TX

Topeka & Shawnee County Public Library, Alice C Sabatini Gallery, Topeka KS

Tucson Museum of Artand Historic Block, Tucson AZ

University of California, Berkeley, Berkeley Art Museum & Pacific Film Archive, Berkeley CA

University of Colorado at Colorado Springs, Gallery of Contemporary Art, Colorado Springs CO

University of North Carolina at Greensboro, Weatherspoon Art Museum, Greensboro NC

University of Utah, Utah Museum of Fine Arts, Salt Lake City UT

Ursinus College, Philip & Muriel Berman Museum of Art, Collegeville PA

Wadsworth Atheneum Museum of Art, Hartford CT

Wellesley College, Davis Museum & Cultural Center, Wellesley MA

Yerba Buena Center for the Arts, San Francisco CA

LEATHER

Agecroft Association, Museum, Richmond VA

Appaloosa Museum and Heritage Center, Moscow ID

Art Without Walls Inc, Art Without Walls Inc, Sayville NY

Artesia Historical Museum & Art Center, Artesia NM

Arts Council of Fayetteville-Cumberland County, The Arts Center, Fayetteville NC

The Canadian Craft Museum, Vancouver BC

Canadian Museum of Civilization, Gatineau PQ

Carson County Square House Museum, Panhandle TX

Cooper-Hewitt, National Design Museum, Smithsonian Institution, New York NY

Craftsmen's Guild of Mississippi, Inc, Agriculture & Forestry Museum, Jackson MS

Craftsmen's Guild of Mississippi, Inc, Mississippi Crafts Center, Ridgeland MS

Culberson County Historical Museum, Van Horn TX

Deming-Luna Mimbres Museum, Deming NM

Detroit Institute of Arts, Detroit MI

Fitton Center for Creative Arts, Hamilton OH

Thomas Gilcrease, Gilcrease Museum, Tulsa OK

Glanmore National Historic Site of Canada, Belleville ON

Headquarters Fort Monroe, Dept of Army, Casemate Museum, Fort Monroe VA

Iroquois Indian Museum, Howes Cave NY

Kelly-Griggs House Museum, Red Bluff CA

Koshare Indian Museum, Inc, La Junta CO

Lac du Flambeau Band of Lake Superior Chippewa Indians, George W Brown Jr Ojibwe Museum & Cultural Center, Lac du Flambeau WI

Lahore Museum, Lahore

Lehigh County Historical Society, Allentown PA

LeSueur County Historical Society, Chapter One, Elysian MN

Mexican Museum, San Francisco CA

Mississippi Department of Archives & History, Old Capitol Museum of Mississippi History, Jackson MS

Muzej za Umjetnost i Obrt, Museum of Arts & Crafts, Zagreb

Naval Historical Center, The Navy Museum, Washington DC

Nebraska State Capitol, Lincoln NE

Nevada Museum of Art, Reno NV

New Brunswick Museum, Saint John NB

New York State Military Museum and Veterans Research Center, Saratoga Springs NY

Plainsman Museum, Aurora NE

Queens College, City University of New York, Godwin-Ternbach Museum, Flushing NY

Roswell Museum & Art Center, Roswell NM

Seneca-Iroquois National Museum, Salamanca NY

South Carolina Artisans Center, Walterboro SC

The Temple-Tifereth Israel, The Temple Museum of Religious Art, Beachwood OH

Texas Tech University, Museum of Texas Tech University, Lubbock TX

United Society of Shakers, Shaker Museum, New Glocester ME

University of Chicago, Oriental Institute Museum, Chicago IL

University of Saskatchewan, Diefenbaker Canada Centre, Saskatoon SK

Vesterheim Norwegian-American Museum, Decorah IA

Wheelwright Museum of the American Indian, Santa Fe NM

Wisconsin Historical Society, State Historical Museum, Madison WI

Woodlawn/The Pope-Leighey, Mount Vernon VA

MANUSCRIPTS

Academy of the New Church, Glencairn Museum, Bryn Athyn PA

Adams County Historical Society, Gettysburg PA

Agecroft Association, Museum, Richmond VA

Alton Museum of History & Art, Inc, Alton IL

Appaloosa Museum and Heritage Center, Moscow ID

Arab American National Museum, Dearborn MI

Archives of American Art, Smithsonian Institution, Washington DC

Arizona Historical Society-Yuma, Sanguinetti House Museum & Garden, Yuma AZ

Art Without Walls Inc, Art Without Walls Inc, Sayville NY

Artesia Historical Museum & Art Center, Artesia NM

Arts Council of Fayetteville-Cumberland County, The Arts Center, Fayetteville NC

Association for the Preservation of Virginia Antiquities, John Marshall House, Richmond VA

Athens Byzantine & Christian Museum, Athens

Atlanta Historical Society Inc, Atlanta History Center, Atlanta GA
Baldwin Historical Society Museum, Baldwin NY
The Bartlett Museum, Amesbury MA
Jesse Besser, Alpena MI
Brigham Young University, B F Larsen Gallery, Provo UT
Canadian Museum of Civilization, Gatineau PQ
Caramoor Center for Music & the Arts, Inc, Caramoor House Museum, Katonah NY
Carson County Square House Museum, Panhandle TX
Cartoon Art Museum, San Francisco CA
Chesapeake Bay Maritime Museum, Saint Michaels MD
City of Austin Parks & Recreation, O Henry Museum, Austin TX
City of Grand Rapids Michigan, Public Museum of Grand Rapids, Grand Rapids MI
City of Springdale, Shiloh Museum of Ozark History, Springdale AR
City of Ukiah, Grace Hudson Museum & The Sun House, Ukiah CA
Clark County Historical Society, Pioneer - Krier Museum, Ashland KS
Cohasset Historical Society, Pratt Building (Society Headquarters), Cohasset MA
Colorado Historical Society, Colorado History Museum, Denver CO
Concordia Historical Institute, Saint Louis MO
Cooper-Hewitt, National Design Museum, Smithsonian Institution, New York NY
Crow Wing County Historical Society, Brainerd MN
Culberson County Historical Museum, Van Horn TX
The Currier Museum of Art, Currier Museum of Art, Manchester NH
Detroit Institute of Arts, Detroit MI
Eastern Washington State Historical Society, Northwest Museum of Arts & Culture, Spokane WA
Edgecombe County Cultural Arts Council, Inc, Blount-Bridgers House, Hobson Pittman Memorial Gallery, Tarboro NC
Egan Institute of Maritime Studies, Nantucket MA
Emory University, Michael C Carlos Museum, Atlanta GA
Erie County Historical Society, Erie PA
Evanston Historical Society, Charles Gates Dawes House, Evanston IL
Evansville Museum of Arts, History & Science, Evansville IN
Fitton Center for Creative Arts, Hamilton OH
Forest Lawn Museum, Glendale CA
Fort George G Meade Museum, Fort Meade MD
Fort Morgan Heritage Foundation, Fort Morgan CO
Fort Ticonderoga Association, Ticonderoga NY
General Board of Discipleship, The United Methodist Church, The Upper Room Chapel & Museum, Nashville TN
Germanisches Nationalmuseum, Nuremberg
Thomas Gilcrease, Gilcrease Museum, Tulsa OK
Glanmore National Historic Site of Canada, Belleville ON
Hancock County Trustees of Public Reservations, Woodlawn Museum, Ellsworth ME
Headquarters Fort Monroe, Dept of Army, Casemate Museum, Fort Monroe VA
Hebrew Union College, Jewish Institute of Religion Museum, New York NY
Hebrew Union College, Skirball Cultural Center, Los Angeles CA
Hebrew Union College - Jewish Institute of Religion, Skirball Museum Cincinnati, Cincinnati OH
Henry Sheldon Museum of Vermont History and Research Center, Middlebury VT
Hidalgo County Historical Museum, Edinburg TX
Higgins Armory Museum, Worcester MA
High Desert Museum, Bend OR
Hillwood Museum & Gardens Foundation, Hillwood Museum & Gardens, Washington DC
Hispanic Society of America, Museum & Library, New York NY
Historic Arkansas Museum, Little Rock AR
Historic Cherry Hill, Albany NY
Historical Society of Cheshire County, Keene NH
Historical Society of Old Newbury, Cushing House Museum, Newburyport MA
Huguenot Historical Society of New Paltz Galleries, New Paltz NY
Imperial Calcasieu Museum, Gibson-Barham Gallery, Lake Charles LA
Independence Seaport Museum, Philadelphia PA
Indiana State Museum, Indianapolis IN

Institute of Puerto Rican Culture, Museo Fuerte Conde de Mirasol, Vieques PR
Iredell Museum of Arts & Heritage, Statesville NC
Iroquois County Historical Society Museum, Old Courthouse Museum, Watseka IL
James Dick Foundation, Festival - Institute, Round Top TX
Johns Hopkins University, Evergreen House, Baltimore MD
Kentucky Derby Museum, Louisville KY
Knights of Columbus Supreme Council, Knights of Columbus Museum, New Haven CT
Koffler Centre of the Arts, The Koffler Gallery, Toronto ON
Koochiching Museums, International Falls MN
La Casa del Libro Museum, San Juan PR
Lac du Flambeau Band of Lake Superior Chippewa Indians, George W Brown Jr Ojibwe Museum & Cultural Center, Lac du Flambeau WI
Lafayette Natural History Museum & Planetarium, Lafayette LA
Lahore Museum, Lahore
Leelanau Historical Museum, Leland MI
Lehigh County Historical Society, Allentown PA
LeSueur County Historical Society, Chapter One, Elysian MN
Liberty Memorial Museum & Archives, The National Museum of World War I, Kansas City MO
Loveland Museum Gallery, Loveland CO
Judah L Magnes, Berkeley CA
Maine Historical Society, Wadsworth-Longfellow House, Portland ME
Maricopa County Historical Society, Desert Caballeros Western Museum, Wickenburg AZ
The Mariners' Museum, Newport News VA
Mattatuck Historical Society, Mattatuck Museum, Waterbury CT
McCord Museum of Canadian History, Montreal PQ
Mexican Museum, San Francisco CA
Mission San Miguel Museum, San Miguel CA
Mississippi Department of Archives & History, Old Capitol Museum of Mississippi History, Jackson MS
Mississippi River Museum at Mud-Island River Park, Memphis TN
Missouri Historical Society, Missouri History Museum, Saint Louis MO
Mohave Museum of History & Arts, Kingman AZ
Moravian Historical Society, Whitefield House Museum, Nazareth PA
Musee et Chateau de Chantilly (MUSEE CONDE), Chantilly
Musee Guimet, Paris
Museum for African Art, Long Island City NY
Museum of Art & History, Santa Cruz, Santa Cruz CA
Museum of Mobile, Mobile AL
Museum of the City of New York, New York NY
Muzej za Umjetnost i Obrt, Museum of Arts & Crafts, Zagreb
Muzeum Narodowe W Kielcach, National Museum in Kielce, Kielce
National Museum of the American Indian, George Gustav Heye Center, New York NY
National Palace Museum, Taipei
The National Park Service, United States Department of the Interior, Statue of Liberty National Monument & The Ellis Island Immigration Museum, New York NY
Naval Historical Center, The Navy Museum, Washington DC
Naval War College Museum, Newport RI
Nevada Museum of Art, Reno NV
New Brunswick Museum, Saint John NB
New York State Historical Association, Fenimore Art Museum, Cooperstown NY
New York State Office of Parks Recreation & Historic Preservation, John Jay Homestead State Historic Site, Katonah NY
Newburyport Maritime Society, Custom House Maritime Museum, Newburyport MA
Newton History Museum at the Jackson Homestead, Newton MA
The John A Noble, Staten Island NY
Ohio Historical Society, National Afro American Museum & Cultural Center, Wilberforce OH
Old Dartmouth Historical Society, New Bedford Whaling Museum, New Bedford MA
The Old Jail Art Center, Albany TX
Old Slater Mill Association, Slater Mill Historic Site, Pawtucket RI

Old York Historical Society, Old Gaol Museum, York ME
Oshkosh Public Museum, Oshkosh WI
Page-Walker Arts & History Center, Cary NC
Pennsylvania Historical & Museum Commission, Railroad Museum of Pennsylvania, Harrisburg PA
Pope County Historical Society, Pope County Museum, Glenwood MN
Porter-Phelps-Huntington Foundation, Inc, Historic House Museum, Hadley MA
Portsmouth Athenaeum, Joseph Copley Research Library, Portsmouth NH
Putnam Museum of History and Natural Science, Davenport IA
Queens College, City University of New York, Godwin-Ternbach Museum, Flushing NY
Riley County Historical Society, Riley County Historical Museum, Manhattan KS
The Rosenbach Museum & Library, Philadelphia PA
C M Russell, Great Falls MT
Saco Museum, Saco ME
Saint Joseph Museum, Saint Joseph MO
Salisbury House Foundation, Des Moines IA
San Francisco Maritime National Historical Park, Maritime Museum, San Francisco CA
Shaker Village of Pleasant Hill, Harrodsburg KY
Shirley Plantation, Charles City VA
R L S Silverado Museum, Saint Helena CA
Abigail Adams Smith, New York NY
Smithsonian Institution, Freer Gallery of Art, Washington DC
Society of the Cincinnati, Museum & Library at Anderson House, Washington DC
Spertus Institute of Jewish Studies, Spertus Museum, Chicago IL
Nelda C & H J Lutcher Stark, Stark Museum of Art, Orange TX
State of North Carolina, Battleship North Carolina, Wilmington NC
State University of New York at Binghamton, University Art Museum, Binghamton NY
State University of New York College at Cortland, Dowd Fine Arts Gallery, Cortland NY
Staten Island Institute of Arts & Sciences, Staten Island NY
Stratford Historical Society, Catharine B Mitchell Museum, Stratford CT
Susquehanna University, Lore Degenstein Gallery, Selinsgrove PA
Swedish-American Museum Association of Chicago, Chicago IL
Switzerland County Historical Society Inc, Life on the Ohio: River History Museum, Vevay IN
Switzerland County Historical Society Inc, Switzerland County Historical Museum, Vevay IN
The Temple-Tifereth Israel, The Temple Museum of Religious Art, Beachwood OH
Tryon Palace Historic Sites & Gardens, New Bern NC
Turtle Bay Exploration Park, Redding CA
Turtle Mountain Chippewa Historical Society, Turtle Mountain Heritage Center, Belcourt ND
Mark Twain, State Historic Site Museum, Florida MO
United Society of Shakers, Shaker Museum, New Glocester ME
United States Capitol, Architect of the Capitol, Washington DC
United States Figure Skating Association, World Figure Skating Museum & Hall of Fame, Colorado Springs CO
United States Naval Academy, USNA Museum, Annapolis MD
University of Chicago, Oriental Institute Museum, Chicago IL
University of Illinois, Krannert Art Museum and Kinkead Pavillion, Champaign IL
University of Manitoba, Faculty of Architecture Exhibition Centre, Winnipeg MB
University of North Carolina at Chapel Hill, Ackland Art Museum, Chapel Hill NC
University of Saskatchewan, Diefenbaker Canada Centre, Saskatoon SK
University of the South, University Art Gallery, Sewanee TN
University of Toronto, University of Toronto Art Centre, Toronto ON
USS Constitution Museum, Boston MA
Van Gogh Museum, Amsterdam
Ventura County Maritime Museum, Inc, Oxnard CA
Vermilion County Museum Society, Danville IL
Waterville Historical Society, Redington Museum, Waterville ME

MAPS

The Woman's Exchange, University Art Collection, New Orleans LA
Woodlawn/The Pope-Leighey, Mount Vernon VA

MARINE PAINTING

Albany Institute of History & Art, Albany NY
Art Community Center, Art Center of Corpus Christi, Corpus Christi TX
Art Without Walls Inc, Art Without Walls Inc, Sayville NY
Jesse Besser, Alpena MI
Brick Store Museum & Library, Kennebunk ME
Brigham Young University, Museum of Art, Provo UT
Butler Institute of American Art, Art Museum, Youngstown OH
Cahoon Museum of American Art, Cotuit MA
Canadian Museum of Civilization, Gatineau PQ
Cape Ann Historical Association, Gloucester MA
Chatham Historical Society, The Atwood House Museum, Chatham MA
Chattahoochee Valley Art Museum, LaGrange GA
Chesapeake Bay Maritime Museum, Saint Michaels MD
City of Toronto Culture Division, The Market Gallery, Toronto ON
Columbia River Maritime Museum, Astoria OR
Columbus Museum, Columbus GA
Detroit Institute of Arts, Detroit MI
Egan Institute of Maritime Studies, Nantucket MA
Erie County Historical Society, Erie PA
Essex Historical Society, Essex Shipbuilding Museum, Essex MA
Federal Reserve Board, Art Gallery, Washington DC
Florida State University and Central Florida Community College, The Appleton Museum of Art, Ocala FL
Gallery One, Ellensburg WA
Great Lakes Historical Society, Inland Seas Maritime Museum, Vermilion OH
Headquarters Fort Monroe, Dept of Army, Casemate Museum, Fort Monroe VA
Heckscher Museum of Art, Huntington NY
Hickory Museum of Art, Inc, Hickory NC
Hillwood Museum & Gardens Foundation, Hillwood Museum & Gardens, Washington DC
Hui No eau Visual Arts Center, Gallery and Gift Shop, Makawao Maui HI
Independence Seaport Museum, Philadelphia PA
The Interchurch Center, Galleries at the Interchurch Center, New York NY
Kyiv Museum of Russian Art, Kyiv
Maine Maritime Museum, Bath ME
The Mariners' Museum, Newport News VA
Maritime Museum of San Diego, San Diego CA
Mason County Museum, Maysville KY
Mobile Museum of Art, Mobile AL
Monhegan Museum, Monhegan ME
Monterey History & Art Association, Maritime Museum of Monterey, Monterey CA
Munson-Williams-Proctor Arts Institute, Museum of Art, Utica NY
Museum of the City of New York, New York NY
Naval Historical Center, The Navy Museum, Washington DC
Naval War College Museum, Newport RI
Nemours Mansion & Gardens, Wilmington DE
Nevada Museum of Art, Reno NV
New Jersey State Museum, Fine Art Bureau, Trenton NJ
Newburyport Maritime Society, Custom House Maritime Museum, Newburyport MA
The John A Noble, Staten Island NY
Nova Scotia Museum, Maritime Museum of the Atlantic, Halifax NS
The Ohio Historical Society, Inc, Campus Martius Museum & Ohio River Museum, Marietta OH
Old Dartmouth Historical Society, New Bedford Whaling Museum, New Bedford MA
Opelousas Museum of Art, Inc (OMA), Opelousas LA
Oysterponds Historical Society, Museum, Orient NY
Peabody Essex Museum, Salem MA
The Pennsylvania State University, Palmer Museum of Art, University Park PA
Port Huron Museum, Port Huron MI
Portsmouth Athenaeum, Joseph Copley Research Library, Portsmouth NH
Princeton University, Princeton University Art Museum, Princeton NJ

Queens College, City University of New York, Godwin-Ternbach Museum, Flushing NY
Saginaw Art Museum, Saginaw MI
San Francisco Maritime National Historical Park, Maritime Museum, San Francisco CA
Ships of the Sea Maritime Museum, Savannah GA
The Slater Memorial Museum, Slater Memorial Museum, Norwich CT
State of North Carolina, Battleship North Carolina, Wilmington NC
Staten Island Institute of Arts & Sciences, Staten Island NY
Stratford Historical Society, Catharine B Mitchell Museum, Stratford CT
Switzerland County Historical Society Inc, Life on the Ohio: River History Museum, Vevay IN
Towson University Center for the Arts Gallery, The Holtzman MFA Gallery, Towson MD
United States Navy, Art Gallery, Washington DC
University of Illinois, Krannert Art Museum and Kinkead Pavillion, Champaign IL
University of Toronto, University of Toronto Art Centre, Toronto ON
Upstairs Gallery, Winnipeg MB
Ursinus College, Philip & Muriel Berman Museum of Art, Collegeville PA
USS Constitution Museum, Boston MA
Ventura County Maritime Museum, Inc, Oxnard CA
West Florida Historic Preservation, Inc, T T Wentworth, Jr Florida State Museum & Historic Pensacola Village, Pensacola FL
Wheaton College, Watson Gallery, Norton MA
Wilfrid Laurier University, Robert Langen Art Gallery, Waterloo ON
Yarmouth County Historical Society, Yarmouth County Museum, Yarmouth NS

MEDIEVAL ART

Academy of the New Church, Glencairn Museum, Bryn Athyn PA
Art Without Walls Inc, Art Without Walls Inc, Sayville NY
Athens Byzantine & Christian Museum, Athens
Beaverbrook Art Gallery, Fredericton NB
Beloit College, Wright Museum of Art, Beloit WI
BJU Museum & Gallery, Bob Jones University Museum & Gallery Inc, Greenville SC
Caramoor Center for Music & the Arts, Inc, Caramoor House Museum, Katonah NY
Cincinnati Institute of Fine Arts, Taft Museum of Art, Cincinnati OH
Cincinnati Museum Association and Art Academy of Cincinnati, Cincinnati Art Museum, Cincinnati OH
College of William & Mary, Muscarelle Museum of Art, Williamsburg VA
The Currier Museum of Art, Currier Museum of Art, Manchester NH
Detroit Institute of Arts, Detroit MI
Duke University, Duke University Museum of Art, Durham NC
Florida State University and Central Florida Community College, The Appleton Museum of Art, Ocala FL
Forest Lawn Museum, Glendale CA
Germanisches Nationalmuseum, Nuremberg
Hebrew Union College, Jewish Institute of Religion Museum, New York NY
Hebrew Union College, Skirball Cultural Center, Los Angeles CA
Heritage Malta, National Museum of Fine Arts, Valletta
Honolulu Academy of Arts, Honolulu HI
Joslyn Art Museum, Omaha NE
Keresmeny Muzeum, Christian Museum, Esztergom
Knoxville Museum of Art, Knoxville TN
Kyiv Museum of Russian Art, Kyiv
McNay, San Antonio TX
Menil Foundation, Inc, Houston TX
The Metropolitan Museum of Art, New York NY
Moravska Galerie v Brne, Moravian Gallery in Brno, Brno
Municipal Museum De Lakenhal, Stedelisk Museum De Lakenhal, Leiden
Musei Capitolini, Rome
Museu Nacional d'Art de Catalunya, National Art Museum, Barcelona
Museum of Fine Arts, Houston, Houston TX
Muzeum Narodowe, National Museum, Poznan
Narodna Galerija, National Gallery of Slovenia, Ljubljana

National Gallery of Canada, Ottawa ON
Nelson-Atkins Museum of Art, Kansas City MO
Opelousas Museum of Art, Inc (OMA), Opelousas LA
Pinacoteca Provinciale, Bari
Princeton University, Princeton University Art Museum, Princeton NJ
Queens College, City University of New York, Godwin-Ternbach Museum, Flushing NY
Rensselaer Newman Foundation Chapel & Cultural Center, The Gallery, Troy NY
Royal Ontario Museum, Toronto ON
Saginaw Art Museum, Saginaw MI
Saint Mary's College of California, Hearst Art Gallery, Moraga CA
Salisbury House Foundation, Des Moines IA
Staatsgalerie Stuttgart, Stuttgart
Stanford University, Iris & B Gerald Cantor Center for Visual Arts, Stanford CA
State University of New York at Binghamton, University Art Museum, Binghamton NY
Staten Island Institute of Arts & Sciences, Staten Island NY
University of Chicago, Oriental Institute Museum, Chicago IL
University of Illinois, Krannert Art Museum and Kinkead Pavillion, Champaign IL
University of Kansas, Spencer Museum of Art, Lawrence KS
University of Michigan, Museum of Art, Ann Arbor MI
University of Toronto, University of Toronto Art Centre, Toronto ON
University of Utah, Utah Museum of Fine Arts, Salt Lake City UT
University of Victoria, Maltwood Art Museum and Gallery, Victoria BC
University of Wisconsin-Madison, Chazen Museum of Art, Madison WI
Vassar College, The Frances Lehman Loeb Art Center, Poughkeepsie NY
Walters Art Museum, Baltimore MD
Wellesley College, Davis Museum & Cultural Center, Wellesley MA
Worcester Art Museum, Worcester MA

METALWORK

Academy of the New Church, Glencairn Museum, Bryn Athyn PA
Agecroft Association, Museum, Richmond VA
Arab American National Museum, Dearborn MI
Art & Culture Center of Hollywood, Art Gallery, Hollywood FL
Art Community Center, Art Center of Corpus Christi, Corpus Christi TX
Art Without Walls Inc, Art Without Walls Inc, Sayville NY
Asheville Art Museum, Asheville NC
Asian Art Museum of San Francisco, Chong-Moon Lee Ctr for Asian Art and Culture, San Francisco CA
Athens Byzantine & Christian Museum, Athens
Beloit College, Wright Museum of Art, Beloit WI
Belskie Museum, Closter NJ
The Canadian Craft Museum, Vancouver BC
Canadian Museum of Civilization, Gatineau PQ
City of El Paso Museum and Cultural Affairs, People's Gallery, El Paso TX
City of Fayette, Alabama, Fayette Art Museum, Fayette AL
Clark County Historical Society, Pioneer - Krier Museum, Ashland KS
College of William & Mary, Muscarelle Museum of Art, Williamsburg VA
Columbus Museum, Columbus GA
Concord Museum, Concord MA
Cooper-Hewitt, National Design Museum, Smithsonian Institution, New York NY
Craft and Folk Art Museum (CAFAM), Los Angeles CA
Craftsmen's Guild of Mississippi, Inc, Agriculture & Forestry Museum, Jackson MS
Craftsmen's Guild of Mississippi, Inc, Mississippi Crafts Center, Ridgeland MS
Cranbrook Art Museum, Cranbrook Art Museum, Bloomfield Hills MI
Detroit Institute of Arts, Detroit MI
Detroit Zoological Institute, Wildlife Interpretive Gallery, Royal Oak MI
Durham Art Guild Inc, Durham NC
Evanston Historical Society, Charles Gates Dawes House, Evanston IL

MEXICAN ART

MILITARY ART

Naval Historical Center, The Navy Museum, Washington DC
Naval War College Museum, Newport RI
New York State Military Museum and Veterans Research Center, Saratoga Springs NY
Opelousas Museum of Art, Inc (OMA), Opelousas LA
Polish Museum of America, Chicago IL
Saginaw Art Museum, Saginaw MI
Society of the Cincinnati, Museum & Library at Anderson House, Washington DC
State of North Carolina, Battleship North Carolina, Wilmington NC
Summit County Historical Society, Akron OH
United States Navy, Art Gallery, Washington DC
US Navy Supply Corps School, US Navy Supply Corps Museum, Athens GA
USS Constitution Museum, Boston MA
Wayne County Historical Society, Honesdale PA
Wisconsin Historical Society, State Historical Museum, Madison WI

MINIATURES

Art & Culture Center of Hollywood, Art Gallery, Hollywood FL
Barker Character, Comic and Cartoon Museum, Cheshire CT
Bronx Community College (CUNY), Hall of Fame for Great Americans, Bronx NY
Carolina Art Association, Gibbes Museum of Art, Charleston SC
Cincinnati Institute of Fine Arts, Taft Museum of Art, Cincinnati OH
Cincinnati Museum Association and Art Academy of Cincinnati, Cincinnati Art Museum, Cincinnati OH
City of Fayette, Alabama, Fayette Art Museum, Fayette AL
Coutts Memorial Museum of Art, Inc, El Dorado KS
DAR Museum, National Society Daughters of the American Revolution, Washington DC
Detroit Institute of Arts, Detroit MI
Favell Museum of Western Art & Indian Artifacts, Klamath Falls OR
Fine Arts Center for the New River Valley, Pulaski VA
Fishkill Historical Society, Van Wyck Homestead Museum, Fishkill NY
Glanmore National Historic Site of Canada, Belleville ON
Grand Rapids Art Museum, Grand Rapids MI
Graphische Sammlung Albertina, Albertina Graphic Art Collection, Vienna
Hancock County Trustees of Public Reservations, Woodlawn Museum, Ellsworth ME
Hebrew Union College, Jewish Institute of Religion Museum, New York NY
Henry County Museum & Cultural Arts Center, Clinton MO
Higgins Armory Museum, Worcester MA
Hillwood Museum & Gardens Foundation, Hillwood Museum & Gardens, Washington DC
Houston Baptist University, Museum of American Architecture and Decorative Arts, Houston TX
International Clown Hall of Fame & Research Center, Inc, West Allis WI
Iredell Museum of Arts & Heritage, Statesville NC
Kelowna Museum, Kelowna BC
Knoxville Museum of Art, Knoxville TN
Kyiv Museum of Russian Art, Kyiv
Lahore Museum, Lahore
LeSueur County Historical Society, Chapter One, Elysian MN
Maine Historical Society, Wadsworth-Longfellow House, Portland ME
Jacques Marchais, Staten Island NY
Maryhill Museum of Art, Goldendale WA
McCord Museum of Canadian History, Montreal PQ
McDowell House & Apothecary Shop, Danville KY
Munson-Williams-Proctor Arts Institute, Museum of Art, Utica NY
Musee Cognacq-Jay, Cognacq-Jay Museum, Paris
Muzej za Umjetnost i Obrt, Museum of Arts & Crafts, Zagreb
Muzeum Narodowe, National Museum, Poznan
Napoleonic Society of America, Museum & Library, Clearwater FL
The National Museum of Fine Arts, Stockholm
National Museum of Wildlife Art, Jackson WY
National Palace Museum, Taipei
Navajo Nation, Navajo Nation Museum, Window Rock AZ

Naval Historical Center, The Navy Museum, Washington DC
Naval War College Museum, Newport RI
New Jersey Historical Society, Newark NJ
Noyes Art Gallery, Lincoln NE
Old Dartmouth Historical Society, New Bedford Whaling Museum, New Bedford MA
Pacific - Asia Museum, Pasadena CA
Phoenix Art Museum, Phoenix AZ
Porter-Phelps-Huntington Foundation, Inc, Historic House Museum, Hadley MA
Princeton University, Princeton University Art Museum, Princeton NJ
R W Norton Art Foundation, Shreveport LA
Saco Museum, Saco ME
Saint Joseph's Oratory, Museum, Montreal PQ
Saint Peter's College, Art Gallery, Jersey City NJ
Society of the Cincinnati, Museum & Library at Anderson House, Washington DC
South Carolina State Museum, Columbia SC
Staten Island Institute of Arts & Sciences, Staten Island NY
Tinkertown Museum, Sandia Park NM
United Society of Shakers, Shaker Museum, New Glocester ME
University of Illinois, Krannert Art Museum and Kinkead Pavillion, Champaign IL
University of Louisiana at Lafayette, University Art Museum, Lafayette LA
Wallace Collection, London
Wheelwright Museum of the American Indian, Santa Fe NM
Wistariahurst Museum, Holyoke MA
Woodlawn/The Pope-Leighey, Mount Vernon VA

MIXED MEDIA

Art & Culture Center of Hollywood, Art Gallery, Hollywood FL
Artspace, Richmond VA
Haystack Mountain School of Crafts, Deer Isle ME
Springfield Art Museum, Springfield MO

MOSAICS

Academy of the New Church, Glencairn Museum, Bryn Athyn PA
Arab American National Museum, Dearborn MI
Art & Culture Center of Hollywood, Art Gallery, Hollywood FL
Art Community Center, Art Center of Corpus Christi, Corpus Christi TX
Art Without Walls Inc, Art Without Walls Inc, Sayville NY
Athens Byzantine & Christian Museum, Athens
The Baltimore Museum of Art, Baltimore MD
BJU Museum & Gallery, Bob Jones University Museum & Gallery Inc, Greenville SC
Cameron Art Museum, Wilmington NC
Canadian Museum of Civilization, Gatineau PQ
Craft and Folk Art Museum (CAFAM), Los Angeles CA
Craftsmen's Guild of Mississippi, Inc, Agriculture & Forestry Museum, Jackson MS
Detroit Institute of Arts, Detroit MI
Forest Lawn Museum, Glendale CA
Harvard University, Dumbarton Oaks Research Library & Collections, Washington DC
Henry County Museum & Cultural Arts Center, Clinton MO
Higgins Armory Museum, Worcester MA
The Interchurch Center, Galleries at the Interchurch Center, New York NY
Johns Hopkins University, Evergreen House, Baltimore MD
Kentucky Museum of Art & Craft, Louisville KY
Knights of Columbus Supreme Council, Knights of Columbus Museum, New Haven CT
Lizzadro Museum of Lapidary Art, Elmhurst IL
Ministry of Culture, The Delphi Museum, I Ephorate of Prehistoric & Classical Antiquities, Delphi
Musei Capitolini, Rome
National Museum of Ceramic Art & Glass, Baltimore MD
Noyes Art Gallery, Lincoln NE
The Frank Phillips, Woolaroc Museum, Bartlesville OK
Plainsman Museum, Aurora NE
Princeton University, Princeton University Art Museum, Princeton NJ

Queens College, City University of New York, Godwin-Ternbach Museum, Flushing NY
Saint Joseph's Oratory, Museum, Montreal PQ
Saint Peter's College, Art Gallery, Jersey City NJ
Stanford University, Iris & B Gerald Cantor Center for Visual Arts, Stanford CA
University of Manitoba, Faculty of Architecture Exhibition Centre, Winnipeg MB
Wadsworth Atheneum Museum of Art, Hartford CT
Waterworks Visual Arts Center, Salisbury NC
Wheaton College, Watson Gallery, Norton MA
Worcester Art Museum, Worcester MA

ORIENTAL ART

Academy of the New Church, Glencairn Museum, Bryn Athyn PA
Allentown Art Museum, Allentown PA
Lyman Allyn, New London CT
Amherst College, Mead Art Museum, Amherst MA
Arab American National Museum, Dearborn MI
Art & Culture Center of Hollywood, Art Gallery, Hollywood FL
Art Gallery of Greater Victoria, Victoria BC
Art Museum of Western Virginia, Roanoke VA
Art Without Walls Inc, Art Without Walls Inc, Sayville NY
Arts Council of Fayetteville-Cumberland County, The Arts Center, Fayetteville NC
Asian Art Museum of San Francisco, Chong-Moon Lee Ctr for Asian Art and Culture, San Francisco CA
Bates College, Museum of Art, Lewiston ME
Beloit College, Wright Museum of Art, Beloit WI
Birger Sandzen Memorial Gallery, Lindsborg KS
BJU Museum & Gallery, Bob Jones University Museum & Gallery Inc, Greenville SC
Blanden Memorial Art Museum, Fort Dodge IA
Boise Art Museum, Boise ID
The Buffalo Fine Arts Academy, Albright-Knox Art Gallery, Buffalo NY
California State University Stanislaus, University Art Gallery, Turlock CA
California State University, Northridge, Art Galleries, Northridge CA
Carnegie Museums of Pittsburgh, Carnegie Museum of Art, Pittsburgh PA
Carolina Art Association, Gibbes Museum of Art, Charleston SC
Billie Trimble Chandler, Asian Cultures Museum & Educational Center, Corpus Christi TX
Chinese Culture Foundation, Center Gallery, San Francisco CA
Chrysler Museum of Art, Norfolk VA
Cincinnati Institute of Fine Arts, Taft Museum of Art, Cincinnati OH
Cincinnati Museum Association and Art Academy of Cincinnati, Cincinnati Art Museum, Cincinnati OH
City of Gainesville, Thomas Center Galleries - Cultural Affairs, Gainesville FL
City of Grand Rapids Michigan, Public Museum of Grand Rapids, Grand Rapids MI
Cleveland Museum of Art, Cleveland OH
College of William & Mary, Muscarelle Museum of Art, Williamsburg VA
The College of Wooster, The College of Wooster Art Museum, Wooster OH
Columbus Museum, Columbus GA
Columbus Museum of Art, Columbus OH
Columbus Museum of Art and Design, Indianapolis IN
Coutts Memorial Museum of Art, Inc, El Dorado KS
Craft and Folk Art Museum (CAFAM), Los Angeles CA
Cummer Museum of Art & Gardens, DeEtte Holden Cummer Museum Foundation, Jacksonville FL
The Currier Museum of Art, Currier Museum of Art, Manchester NH
Davenport Museum of Art, Davenport IA
Dayton Art Institute, Dayton OH
Detroit Institute of Arts, Detroit MI
Dickinson College, The Trout Gallery, Carlisle PA
Emory University, Michael C Carlos Museum, Atlanta GA
Erie Art Museum, Erie PA
Evansville Museum of Arts, History & Science, Evansville IN
Everhart Museum, Scranton PA
Everson Museum of Art, Syracuse NY
Fairbanks Museum & Planetarium, Saint Johnsbury VT
Flint Institute of Arts, Flint MI

PAINTING-AMERICAN

C W Post Campus of Long Island University, Hillwood Art Museum, Brookville NY

Cabot's Old Indian Pueblo Museum, Cabot's Old Indian Pueblo Museum, Desert Hot Springs CA

California Center for the Arts, Escondido Museum, Escondido CA

California State University Stanislaus, University Art Gallery, Turlock CA

California State University, Northridge, Art Galleries, Northridge CA

Cameron Art Museum, Wilmington NC

Canadian Wildlife & Wilderness Art Museum, Ottawa ON

Canajoharie Library & Art Gallery, Arkell Museum of Canajoharie, Canajoharie NY

Canton Museum of Art, Canton OH

Cape Ann Historical Association, Gloucester MA

Cape Cod Museum of Art Inc, Dennis MA

Cardinal Stritch University, Art Gallery, Milwaukee WI

Carleton College, Art Gallery, Northfield MN

Carnegie Museums of Pittsburgh, Carnegie Museum of Art, Pittsburgh PA

Carolina Art Association, Gibbes Museum of Art, Charleston SC

Carson County Square House Museum, Panhandle TX

Amon Carter, Fort Worth TX

Cartoon Art Museum, San Francisco CA

Radio-Canada SRC CBC, Georges Goguen CBC Art Gallery, Moncton NB

Cedar Rapids Museum of Art, Cedar Rapids IA

Central Methodist University, Ashby-Hodge Gallery of American Art, Fayette MO

Central United Methodist Church, Swords Into Plowshares Peace Center & Gallery, Detroit MI

Chatillon-DeMenil House Foundation, DeMenil Mansion, Saint Louis MO

Chattahoochee Valley Art Museum, LaGrange GA

Cheekwood-Tennessee Botanical Garden & Museum of Art, Nashville TN

Chinese Culture Institute of the International Society, Tremont Theatre & Gallery, Boston MA

Chrysler Museum of Art, Norfolk VA

Church of Jesus Christ of Latter-Day Saints, Museum of Church History & Art, Salt Lake City UT

Cincinnati Institute of Fine Arts, Taft Museum of Art, Cincinnati OH

City of Atlanta, Atlanta Cyclorama, Atlanta GA

City of Cedar Falls, Iowa, James & Meryl Hearst Center for the Arts, Cedar Falls IA

City of El Paso, El Paso TX

City of El Paso Museum and Cultural Affairs, People's Gallery, El Paso TX

City of Fayette, Alabama, Fayette Art Museum, Fayette AL

City of Fremont, Olive Hyde Art Gallery, Fremont CA

City of Gainesville, Thomas Center Galleries - Cultural Affairs, Gainesville FL

City of Grand Rapids Michigan, Public Museum of Grand Rapids, Grand Rapids MI

The City of Petersburg Museums, Petersburg VA

City of Pittsfield, Berkshire Artisans, Pittsfield MA

City of Ukiah, Grace Hudson Museum & The Sun House, Ukiah CA

Clark County Historical Society, Pioneer - Krier Museum, Ashland KS

Cleveland Museum of Art, Cleveland OH

Clinton Art Association, River Arts Center, Clinton IA

Cohasset Historical Society, Pratt Building (Society Headquarters), Cohasset MA

College of Saint Benedict, Art Gallery, Saint Joseph MN

College of Saint Rose, Art Gallery, Albany NY

College of William & Mary, Muscarelle Museum of Art, Williamsburg VA

The College of Wooster, The College of Wooster Art Museum, Wooster OH

Colorado Historical Society, Colorado History Museum, Denver CO

Colorado Springs Fine Arts Center, Colorado Springs CO

Columbia Museum of Art, Columbia SC

Columbus Chapel & Boal Mansion Museum, Boalsburg PA

Columbus Museum, Columbus GA

Columbus Museum of Art, Columbus OH

Columbus Museum of Art and Design, Indianapolis IN

Concord Museum, Concord MA

Concordia Historical Institute, Saint Louis MO

Confederation Centre Art Gallery and Museum, Charlottetown PE

Coos Art Museum, Coos Bay OR

Cornell College, Peter Paul Luce Gallery, Mount Vernon IA

Cornell Museum of Art & History, Delray Beach FL

Cornell University, Herbert F Johnson Museum of Art, Ithaca NY

Coutts Memorial Museum of Art, Inc, El Dorado KS

Craigdarroch Castle Historical Museum Society, Victoria BC

Cranbrook Art Museum, Cranbrook Art Museum, Bloomfield Hills MI

Crane Collection, Gallery of American Painting and Sculpture, Wellesley MA

Crazy Horse Memorial, Indian Museum of North America, Native American Educational & Cultural Center & Crazy Horse Memorial Library (Reference), Crazy Horse SD

Creighton University, Lied Art Gallery, Omaha NE

Cripple Creek District Museum, Cripple Creek CO

Crocker Art Museum, Sacramento CA

Crow Wing County Historical Society, Brainerd MN

CT Commission on Culture & Tourism, Sloane-Stanley Museum, Kent CT

Cummer Museum of Art & Gardens, DeEtte Holden Cummer Museum Foundation, Jacksonville FL

The Currier Museum of Art, Currier Museum of Art, Manchester NH

Danforth Museum Corporation, Danforth Museum of Art, Framingham MA

Danville Museum of Fine Arts & History, Danville VA

DAR Museum, National Society Daughters of the American Revolution, Washington DC

Davenport Museum of Art, Davenport IA

Dayton Art Institute, Dayton OH

Deines Cultural Center, Russell KS

Delaware Art Museum, Wilmington DE

Delaware Division of Historical & Cultural Affairs, Dover DE

DeLeon White Gallery, Toronto ON

Denison University, Art Gallery, Granville OH

Detroit Institute of Arts, Detroit MI

Detroit Zoological Institute, Wildlife Interpretive Gallery, Royal Oak MI

DeWitt Historical Society of Tompkins County, The History Center in Tompkins Co, Ithaca NY

Dickinson College, The Trout Gallery, Carlisle PA

Dickinson State University, Art Gallery, Dickinson ND

Discovery Museum, Bridgeport CT

Dixie State College, Robert N & Peggy Sears Gallery, Saint George UT

The Dixon Gallery & Gardens, Memphis TN

Door County, Miller Art Museum, Sturgeon Bay WI

Eagle Rock Art Museum and Education Center, Inc, Idaho Falls ID

East Baton Rouge Parks & Recreation Commission, Baton Rouge Gallery Inc, Baton Rouge LA

East Carolina University, Wellington B Gray Gallery, Greenville NC

Eastern Washington State Historical Society, Northwest Museum of Arts & Culture, Spokane WA

Edmundson Art Foundation, Inc, Des Moines Art Center, Des Moines IA

Egan Institute of Maritime Studies, Nantucket MA

Eiteljorg Museum of American Indians & Western Art, Indianapolis IN

Elmhurst Art Museum, Elmhurst IL

Enook Galleries, Waterloo ON

Erie Art Museum, Erie PA

Wharton Esherick, Paoli PA

Evanston Historical Society, Charles Gates Dawes House, Evanston IL

Evansville Museum of Arts, History & Science, Evansville IN

Evergreen State College, Evergreen Galleries, Olympia WA

Everhart Museum, Scranton PA

Everson Museum of Art, Syracuse NY

Fairfield University, Thomas J Walsh Art Gallery, Fairfield CT

Fall River Historical Society, Fall River MA

Federal Reserve Board, Art Gallery, Washington DC

Fetherston Foundation, Packwood House Museum, Lewisburg PA

Fine Arts Center for the New River Valley, Pulaski VA

Fishkill Historical Society, Van Wyck Homestead Museum, Fishkill NY

Fisk University, Fisk University Galleries, Nashville TN

Fitchburg Art Museum, Fitchburg MA

Fitton Center for Creative Arts, Hamilton OH

Flagler Museum, Palm Beach FL

Flint Institute of Arts, Flint MI

Florence Museum of Art, Science & History, Florence SC

Florida State University, Museum of Fine Arts, Tallahassee FL

Florida State University and Central Florida Community College, The Appleton Museum of Art, Ocala FL

Folk Art Society of America, Richmond VA

Edsel & Eleanor Ford, Grosse Pointe Shores MI

Fort Collins Museum of Contemporary Art, Fort Collins CO

Fort Hays State University, Moss-Thorns Gallery of Arts, Hays KS

Fort Morgan Heritage Foundation, Fort Morgan CO

Fort Smith Art Center, Fort Smith AR

Fort Ticonderoga Association, Ticonderoga NY

Fort Wayne Museum of Art, Inc, Fort Wayne IN

Frankfort Community Public Library, Anna & Harlan Hubbard Gallery, Frankfort IN

Freeport Arts Center, Freeport IL

Friends of Historic Kingston, Fred J Johnston House Museum, Kingston NY

Frontier Times Museum, Bandera TX

Frye Art Museum, Seattle WA

Fuller Museum of Art, Brockton MA

Gallery One, Ellensburg WA

Isabella Stewart Gardner, Boston MA

Gaston County Museum of Art & History, Dallas NC

General Board of Discipleship, The United Methodist Church, The Upper Room Chapel & Museum, Nashville TN

George Washington University, The Dimock Gallery, Washington DC

Georgetown University, Art Collection, Washington DC

Georgia O'Keeffe Museum, Santa Fe NM

Thomas Gilcrease, Gilcrease Museum, Tulsa OK

Girard College, Stephen Girard Collection, Philadelphia PA

Gonzaga University, Art Gallery, Spokane WA

Goucher College, Rosenberg Gallery, Baltimore MD

Grace Museum, Inc, Abilene TX

Grand Rapids Art Museum, Grand Rapids MI

Greene County Historical Society, Bronck Museum, Coxsackie NY

Greenville College, Richard W Bock Sculpture Collection, Almira College House, Greenville IL

Greenville County Museum of Art, Greenville SC

Grevemberg House Museum, Franklin LA

Guggenheim Museum Soho, New York NY

Solomon R Guggenheim, New York NY

Guild Hall of East Hampton, Inc, Guild Hall Museum, East Hampton NY

Guilford College, Art Gallery, Greensboro NC

Gunston Hall Plantation, Mason Neck VA

The Haggin Museum, Stockton CA

Hamilton College, Emerson Gallery, Clinton NY

Hammond-Harwood House Association, Inc, Hammond-Harwood House, Annapolis MD

Hampton University, University Museum, Hampton VA

Hancock County Trustees of Public Reservations, Woodlawn Museum, Ellsworth ME

Hartwick College, Foreman Gallery, Oneonta NY

Hartwick College, The Yager Museum, Oneonta NY

Headquarters Fort Monroe, Dept of Army, Casemate Museum, Fort Monroe VA

Heard Museum, Phoenix AZ

Hebrew Union College, Jewish Institute of Religion Museum, New York NY

Hebrew Union College - Jewish Institute of Religion, Skirball Museum Cincinnati, Cincinnati OH

Heckscher Museum of Art, Huntington NY

Henry County Museum & Cultural Arts Center, Clinton MO

Henry Gallery Association, Henry Art Gallery, Seattle WA

Henry Sheldon Museum of Vermont History and Research Center, Middlebury VT

Heritage Center of Lancaster County Museum, Lancaster PA

Heritage Center, Inc, Pine Ridge SD

Hermitage Foundation Museum, Norfolk VA

Hershey Museum, Hershey PA

Edna Hibel, Hibel Museum of Art, Jupiter FL

Hickory Museum of Art, Inc, Hickory NC

High Desert Museum, Bend OR

Hillwood Museum & Gardens Foundation, Hillwood Museum & Gardens, Washington DC

Hirshhorn Museum & Sculpture Garden, Smithsonian Institution, Washington DC

Hispanic Society of America, Museum & Library, New York NY

New Brunswick Museum, Saint John NB
New England Maple Museum, Pittsford VT
New Jersey Historical Society, Newark NJ
New Jersey State Museum, Fine Art Bureau, Trenton NJ
New Mexico State University, Art Gallery, Las Cruces NM
New Orleans Museum of Art, New Orleans LA
New Visions Gallery, Inc, Marshfield WI
New World Art Center, T F Chen Cultural Center, New York NY
New York State Historical Association, Fenimore Art Museum, Cooperstown NY
New York State Military Museum and Veterans Research Center, Saratoga Springs NY
New York State Office of Parks Recreation & Historic Preservation, John Jay Homestead State Historic Site, Katonah NY
New York Studio School of Drawing, Painting & Sculpture, Gallery, New York NY
New York University, Grey Art Gallery, New York NY
Newburyport Maritime Society, Custom House Maritime Museum, Newburyport MA
Newport Art Museum, Newport RI
Newton History Museum at the Jackson Homestead, Newton MA
Niagara University, Castellani Art Museum, Niagara NY
No Man's Land Historical Society Museum, Goodwell OK
Norman Rockwell Museum, Rutland VT
Norman Rockwell Museum, Stockbridge MA
North Carolina Central University, NCCU Art Museum, Durham NC
North Carolina Museum of Art, Raleigh NC
Northern Illinois University, NIU Art Museum, De Kalb IL
Norton Museum of Art, West Palm Beach FL
Noyes Art Gallery, Lincoln NE
The Noyes Museum of Art, Oceanville NJ
Oakland Museum of California, Art Dept, Oakland CA
Oberlin College, Allen Memorial Art Museum, Oberlin OH
The Ogden Museum of Southern Art, University of New Orleans, New Orleans LA
Ogunquit Museum of American Art, Ogunquit ME
Ohio Historical Society, National Afro American Museum & Cultural Center, Wilberforce OH
The Ohio Historical Society, Inc, Campus Martius Museum & Ohio River Museum, Marietta OH
Ohio State University, Wexner Center for the Arts, Columbus OH
Ohio University, Kennedy Museum of Art, Athens OH
Ohrmann Museum and Gallery, Drummond MT
Okefenokee Heritage Center, Inc, Waycross GA
Oklahoma City Museum of Art, Oklahoma City OK
Olana State Historic Site, Hudson NY
Old Dartmouth Historical Society, New Bedford Whaling Museum, New Bedford MA
The Old Jail Art Center, Albany TX
Old Slater Mill Association, Slater Mill Historic Site, Pawtucket RI
Old West Museum, Sunset TX
Old York Historical Society, Old Gaol Museum, York ME
Omniplex, Oklahoma City OK
Opelousas Museum of Art, Inc (OMA), Opelousas LA
Orange County Museum of Art, Orange County Museum of Art, Newport Beach CA
Orlando Museum of Art, Orlando FL
Oshkosh Public Museum, Oshkosh WI
Owensboro Museum of Fine Art, Owensboro KY
Page-Walker Arts & History Center, Cary NC
Palm Springs Art Museum, Palm Springs CA
Panhandle-Plains Historical Society Museum, Canyon TX
Paris Gibson Square, Museum of Art, Great Falls MT
The Parrish Art Museum, Southampton NY
Passaic County Community College, Broadway, LRC, and Hamilton Club Galleries, Paterson NJ
Peabody Essex Museum, Salem MA
Pennsylvania Historical & Museum Commission, Railroad Museum of Pennsylvania, Harrisburg PA
The Pennsylvania State University, Palmer Museum of Art, University Park PA
Pensacola Museum of Art, Pensacola FL
Philadelphia Museum of Art, Philadelphia PA
Philbrook Museum of Art, Tulsa OK
Phillips Academy, Addison Gallery of American Art, Andover MA
The Phillips Collection, Washington DC

Phillips County Museum, Holyoke CO
The Frank Phillips, Woolaroc Museum, Bartlesville OK
George Phippen, Phippen Art Museum, Prescott AZ
Phoenix Art Museum, Phoenix AZ
Piedmont Arts Association, Martinsville VA
Plainsman Museum, Aurora NE
Plumas County Museum, Quincy CA
Polk Museum of Art, Lakeland FL
The Pomona College, Montgomery Gallery, Claremont CA
Pope County Historical Society, Pope County Museum, Glenwood MN
Port Huron Museum, Port Huron MI
Porter-Phelps-Huntington Foundation, Inc, Historic House Museum, Hadley MA
Portland Art Museum, Portland OR
Portland Museum of Art, Portland ME
Portsmouth Athenaeum, Joseph Copley Research Library, Portsmouth NH
Portsmouth Historical Society, John Paul Jones House, Portsmouth NH
Portsmouth Museums, Courthouse Galleries, Portsmouth VA
Potsdam College of the State University of New York, Roland Gibson Gallery, Potsdam NY
Prairie Art Gallery, Grande Prairie AB
Princeton University, Princeton University Art Museum, Princeton NJ
PS1 Contemporary Art Center, Long Island City NY
Pump House Center for the Arts, Chillicothe OH
Putnam County Historical Society, Foundry School Museum, Cold Spring NY
Queens College, City University of New York, Godwin-Ternbach Museum, Flushing NY
Queensborough Community College, Art Gallery, Bayside NY
R W Norton Art Foundation, Shreveport LA
Rahr-West Art Museum, Manitowoc WI
Ramsay Museum, Honolulu HI
Rapid City Arts Council, Dahl Arts Center, Rapid City SD
Rawls Museum Arts, Courtland VA
Reading Public Museum, Reading PA
Red Rock State Park, Red Rock Museum, Church Rock NM
Frederic Remington, Ogdensburg NY
Reynolda House Museum of American Art, Winston Salem NC
Sid W Richardson, Sid Richardson Museum, Fort Worth TX
Roberson Museum & Science Center, Binghamton NY
The Rockwell Museum of Western Art, Corning NY
Lauren Rogers, Laurel MS
Rogue Community College, Wiseman Gallery - FireHouse Gallery, Grants Pass OR
Rollins College, George D & Harriet W Cornell Fine Arts Museum, Winter Park FL
Ross Memorial Museum, Saint Andrews NB
Roswell Museum & Art Center, Roswell NM
Round Top Center for the Arts Inc, Arts Gallery, Damariscotta ME
Royal Arts Foundation, Belcourt Castle, Newport RI
C M Russell, Great Falls MT
Rutgers University, Stedman Art Gallery, Camden NJ
Ryerss Victorian Museum & Library, Philadelphia PA
Saco Museum, Saco ME
Saginaw Art Museum, Saginaw MI
Saint Anselm College, Chapel Art Center, Manchester NH
Saint Bonaventure University, Regina A Quick Center for the Arts, Saint Bonaventure NY
Saint Clair County Community College, Jack R Hennesey Art Galleries, Port Huron MI
Saint Gregory's Abbey & University, Mabee-Gerrer Museum of Art, Shawnee OK
Saint Joseph College, Saint Joseph College Art Gallery, West Hartford CT
Saint Mary's College of California, Hearst Art Gallery, Moraga CA
Saint Olaf College, Flaten Art Museum, Northfield MN
Saint Peter's College, Art Gallery, Jersey City NJ
Salisbury House Foundation, Des Moines IA
San Antonio Museum of Art, San Antonio TX
San Bernardino County Museum, Fine Arts Institute, Redlands CA
San Diego Museum of Art, San Diego CA
San Diego State University, University Art Gallery, San Diego CA
San Francisco Maritime National Historical Park, Maritime Museum, San Francisco CA

San Francisco Museum of Modern Art, San Francisco CA
The Sandwich Historical Society, Inc, Sandwich Glass Museum, Sandwich MA
Santa Barbara Museum of Art, Santa Barbara CA
Santa Clara University, de Saisset Museum, Santa Clara CA
Santa Monica Museum of Art, Santa Monica CA
Schenectady Museum Planetarium & Visitors Center, Schenectady NY
School of Visual Arts, Visual Arts Museum, New York NY
Scripps College, Ruth Chandler Williamson Gallery, Claremont CA
Seattle Art Museum, Seattle WA
Seneca-Iroquois National Museum, Salamanca NY
1708 Gallery, Richmond VA
Shelburne Museum, Museum, Shelburne VT
Ships of the Sea Maritime Museum, Savannah GA
Shirley Plantation, Charles City VA
Smith College, Museum of Art, Northampton MA
Society of the Cincinnati, Museum & Library at Anderson House, Washington DC
Sonoma State University, University Art Gallery, Rohnert Park CA
South Carolina Artisans Center, Walterboro SC
South Carolina State Museum, Columbia SC
South Dakota State University, South Dakota Art Museum, Brookings SD
Southeastern Center for Contemporary Art, Winston-Salem NC
Southern Lorain County Historical Society, Spirit of '76 Museum, Elyria OH
Southern Oregon Historical Society, Jacksonville Museum of Southern Oregon History, Medford OR
Southern Oregon University, Schneider Museum of Art, Ashland OR
Southern Utah University, Braithwaite Fine Arts Gallery, Cedar City UT
Spartanburg County Museum of Art, Spartanburg SC
Spertus Institute of Jewish Studies, Spertus Museum, Chicago IL
Springfield Art Museum, Springfield MO
Springfield Museums Association, George Walter Vincent Smith Art Museum, Springfield MA
Springville Museum of Art, Springville UT
St George Art Museum, Saint George UT
Stamford Museum & Nature Center, Stamford CT
Stanford University, Iris & B Gerald Cantor Center for Visual Arts, Stanford CA
Stanley Museum, Inc, Kingfield ME
Nelda C & H J Lutcher Stark, Stark Museum of Art, Orange TX
State of North Carolina, Battleship North Carolina, Wilmington NC
State University of New York at Geneseo, Bertha V B Lederer Gallery, Geneseo NY
State University of New York at New Paltz, Samuel Dorsky Museum of Art, New Paltz NY
State University of New York at Oswego, Tyler Art Gallery, Oswego NY
State University of New York at Purchase, Neuberger Museum of Art, Purchase NY
State University of New York College at Cortland, Dowd Fine Arts Gallery, Cortland NY
Staten Island Institute of Arts & Sciences, Staten Island NY
T C Steele, Nashville IN
Stephens College, Lewis James & Nellie Stratton Davis Art Gallery, Columbia MO
Stetson University, Duncan Gallery of Art, Deland FL
Stratford Historical Society, Catharine B Mitchell Museum, Stratford CT
Summit County Historical Society, Akron OH
Susquehanna University, Lore Degenstein Gallery, Selinsgrove PA
SVACA - Sheyenne Valley Arts & Crafts Association, Bjarne Ness Gallery at Bear Creek Hall, Fort Ransom ND
Switzerland County Historical Society Inc, Life on the Ohio: River History Museum, Vevay IN
Switzerland County Historical Society Inc, Switzerland County Historical Museum, Vevay IN
Swope Art Museum, Terre Haute IN
Syracuse University, Art Collection, Syracuse NY
Syracuse University, SUArt Galleries, Syracuse NY
Tacoma Art Museum, Tacoma WA
Tampa Museum of Art, Tampa FL
Taos, Ernest Blumenschein Home & Studio, Taos NM
Terra Museum of American Art, Chicago IL

Texas Tech University, Museum of Texas Tech University, Lubbock TX
Timken Museum of Art, San Diego CA
Tinkertown Museum, Sandia Park NM
Topeka & Shawnee County Public Library, Alice C Sabatini Gallery, Topeka KS
Triton Museum of Art, Santa Clara CA
Tubac Center of the Arts, Tubac AZ
Tucson Museum of Artand Historic Block, Tucson AZ
Tufts University, Tufts University Art Gallery, Medford MA
Turtle Bay Exploration Park, Redding CA
Mark Twain, State Historic Site Museum, Florida MO
Mark Twain, Hartford CT
Twin City Art Foundation, Masur Museum of Art, Monroe LA
U Gallery, New York NY
Ucross Foundation, Big Red Barn Gallery, Clearmont WY
Ulster County Community College, Muroff-Kotler Visual Arts Gallery, Stone Ridge NY
UMLAUF Sculpture Garden & Museum, Austin TX
United States Capitol, Architect of the Capitol, Washington DC
US Department of State, Diplomatic Reception Rooms, Washington DC
United States Department of the Interior Museum, Washington DC
United States Naval Academy, USNA Museum, Annapolis MD
United States Navy, Art Gallery, Washington DC
University at Albany, State University of New York, University Art Museum, Albany NY
University of Alabama at Birmingham, Visual Arts Gallery, Birmingham AL
University of Alabama at Huntsville, Union Grove Gallery & University Center Gallery, Huntsville AL
University of Arkansas at Little Rock, Art Galleries, Little Rock AR
University of California, Richard L Nelson Gallery & Fine Arts Collection, Davis CA
University of California, Berkeley, Berkeley Art Museum & Pacific Film Archive, Berkeley CA
University of California, Santa Barbara, University Art Museum, Santa Barbara CA
University of Chicago, Smart Museum of Art, Chicago IL
University of Cincinnati, DAAP Galleries-College of Design Architecture, Art & Planning, Cincinnati OH
University of Colorado, CU Art Galleries, Boulder CO
University of Delaware, University Gallery, Newark DE
University of Georgia, Georgia Museum of Art, Athens GA
University of Illinois, Krannert Art Museum and Kinkead Pavillion, Champaign IL
University of Iowa, Museum of Art, Iowa City IA
University of Kansas, Spencer Museum of Art, Lawrence KS
University of Kentucky, Art Museum, Lexington KY
University of Louisiana at Lafayette, University Art Museum, Lafayette LA
University of Maine, Museum of Art, Bangor ME
University of Manitoba, Faculty of Architecture Exhibition Centre, Winnipeg MB
University of Mary Washington, Belmont, The Gari Melchers, Fredericksburg VA
University of Mary Washington, University of Mary Washington Galleries, Fredericksburg VA
University of Maryland, College Park, The Art Gallery, College Park MD
University of Massachusetts, Amherst, University Gallery, Amherst MA
University of Memphis, Art Museum, Memphis TN
University of Michigan, Museum of Art, Ann Arbor MI
University of Minnesota, Katherine E Nash Gallery, Minneapolis MN
University of Minnesota, The Bell Museum of Natural History, Minneapolis MN
University of Minnesota, Frederick R Weisman Art Museum, Minneapolis MN
University of Mississippi, University Museum, Oxford MS
University of Montana, Paxson Gallery, Missoula MT
University of Nebraska, Lincoln, Sheldon Memorial Art Gallery & Sculpture Garden, Lincoln NE
University of Nevada, Las Vegas, Donna Beam Fine Art Gallery, Las Vegas NV
University of New Hampshire, The Art Gallery, Durham NH

University of New Mexico, The Harwood Museum of Art, Taos NM
University of New Mexico, University Art Museum, Albuquerque NM
University of North Carolina at Chapel Hill, Ackland Art Museum, Chapel Hill NC
University of North Carolina at Greensboro, Weatherspoon Art Museum, Greensboro NC
University of Northern Iowa, UNI Gallery of Art, Cedar Falls IA
University of Oregon, Museum of Art, Eugene OR
University of Pennsylvania, Arthur Ross Gallery, Philadelphia PA
University of Pittsburgh, University Art Gallery, Pittsburgh PA
University of Rhode Island, Fine Arts Center Galleries, Kingston RI
University of Southern California, Fisher Gallery, Los Angeles CA
University of Texas at Arlington, Gallery at UTA, Arlington TX
University of Texas at El Paso, Glass Gallery and Main Gallery, El Paso TX
University of the South, University Art Gallery, Sewanee TN
University of Toronto, University of Toronto Art Centre, Toronto ON
University of Utah, Utah Museum of Fine Arts, Salt Lake City UT
University of Wisconsin-Madison, Chazen Museum of Art, Madison WI
University of Wisconsin-Madison, Wisconsin Union Galleries, Madison WI
University of Wisconsin-Stout, J Furlong Gallery, Menomonie WI
University of Wyoming, University of Wyoming Art Museum, Laramie WY
Ursinus College, Philip & Muriel Berman Museum of Art, Collegeville PA
Valentine Richmond History Center, Richmond VA
Valparaiso University, Brauer Museum of Art, Valparaiso IN
Vassar College, The Frances Lehman Loeb Art Center, Poughkeepsie NY
Ventura County Maritime Museum, Inc, Oxnard CA
Very Special Arts New Mexico, Very Special Arts Gallery, Albuquerque NM
Virginia Commonwealth University, Anderson Gallery, Richmond VA
Viridian Artists Inc, New York NY
Wadsworth Atheneum Museum of Art, Hartford CT
Walters Art Museum, Baltimore MD
Washburn University, Mulvane Art Museum, Topeka KS
Washington & Lee University, Lee Chapel & Museum, Lexington VA
Washington County Museum of Fine Arts, Hagerstown MD
George Washington, Alexandria VA
Washington State University, Museum of Art, Pullman WA
Washington University, Mildred Lane Kemper Art Museum, Saint Louis MO
Waterloo Center of the Arts, Waterloo IA
Waterworks Visual Arts Center, Salisbury NC
Wayne Center for the Arts, Wooster OH
Wayne County Historical Society, Museum, Honesdale PA
Wayne County Historical Society, Honesdale PA
Wellesley College, Davis Museum & Cultural Center, Wellesley MA
West Florida Historic Preservation, Inc, T T Wentworth, Jr Florida State Museum & Historic Pensacola Village, Pensacola FL
Western Illinois University, Western Illinos University Art Gallery, Macomb IL
Western State College of Colorado, Quigley Hall Art Gallery, Gunnison CO
Westminster College, Art Gallery, New Wilmington PA
Wethersfield Historical Society Inc, Museum, Wethersfield CT
Whatcom Museum of History and Art, Bellingham WA
Wheaton College, Watson Gallery, Norton MA
White House, Washington DC
Whitney Museum of American Art, New York NY
Wichita Art Museum, Wichita KS
Wichita State University, Ulrich Museum of Art & Martin H Bush Outdoor Sculpture Collection, Wichita KS
Widener University, Art Collection & Gallery, Chester PA

Wilfrid Laurier University, Robert Langen Art Gallery, Waterloo ON
Wilkes Art Gallery, North Wilkesboro NC
Wilkes University, Sordoni Art Gallery, Wilkes-Barre PA
Woodrow Wilson, Staunton VA
Woodrow Wilson, Washington DC
The Winnipeg Art Gallery, Winnipeg MB
Winston-Salem State University, Diggs Gallery, Winston-Salem NC
Wiregrass Museum of Art, Dothan AL
Wisconsin Historical Society, State Historical Museum, Madison WI
Witte Museum, San Antonio TX
The Woman's Exchange, Newcomb Art Gallery-Carroll Gallery, New Orleans LA
T W Wood, Montpelier VT
Woodlawn/The Pope-Leighey, Mount Vernon VA
Woodmere Art Museum, Philadelphia PA
Worcester Art Museum, Worcester MA
Yerba Buena Center for the Arts, San Francisco CA
York University, Art Gallery of York University, Toronto ON
Zigler Museum, Jennings LA

PAINTING-AUSTRALIAN

Art & Culture Center of Hollywood, Art Gallery, Hollywood FL
Art Gallery of South Australia, Adelaide
Art Museum of the University of Houston, Blaffer Gallery, Houston TX
Art Without Walls Inc, Art Without Walls Inc, Sayville NY
Bakehouse Art Complex, Inc, Miami FL
California State University, Northridge, Art Galleries, Northridge CA
Central United Methodist Church, Swords Into Plowshares Peace Center & Gallery, Detroit MI
City of Fayette, Alabama, Fayette Art Museum, Fayette AL
Federal Reserve Board, Art Gallery, Washington DC
Fine Arts Center for the New River Valley, Pulaski VA
Iredell Museum of Arts & Heritage, Statesville NC
Kansas City Art Institute, Kansas City MO
Longview Museum of Fine Art, Longview TX
Modern Art Museum, Fort Worth TX
New Visions Gallery, Inc, Marshfield WI
New York Studio School of Drawing, Painting & Sculpture, Gallery, New York NY
PS1 Contemporary Art Center, Long Island City NY
Wadsworth Atheneum Museum of Art, Hartford CT

PAINTING-BRITISH

Agecroft Association, Museum, Richmond VA
American Kennel Club, Museum of the Dog, Saint Louis MO
Arnot Art Museum, Elmira NY
Art & Culture Center of Hollywood, Art Gallery, Hollywood FL
Art Gallery of Greater Victoria, Victoria BC
Art Gallery of Hamilton, Hamilton ON
Art Gallery of Nova Scotia, Halifax NS
Art Gallery of South Australia, Adelaide
Art Museum of the University of Houston, Blaffer Gallery, Houston TX
Art Without Walls Inc, Art Without Walls Inc, Sayville NY
Bard College, Center for Curatorial Studies, Annandale-on-Hudson NY
Bass Museum of Art, Miami Beach FL
Bates College, Museum of Art, Lewiston ME
Beaverbrook Art Gallery, Fredericton NB
Beloit College, Wright Museum of Art, Beloit WI
Berkshire Museum, Pittsfield MA
BJU Museum & Gallery, Bob Jones University Museum & Gallery Inc, Greenville SC
Blauvelt Demarest Foundation, Hiram Blauvelt Art Museum, Oradell NJ
Bradford Brinton, Big Horn WY
The Buffalo Fine Arts Academy, Albright-Knox Art Gallery, Buffalo NY
Cincinnati Institute of Fine Arts, Taft Museum of Art, Cincinnati OH
College of William & Mary, Muscarelle Museum of Art, Williamsburg VA
Columbus Museum, Columbus GA
Columbus Museum of Art, Columbus OH
Cornell Museum of Art & History, Delray Beach FL

Coutts Memorial Museum of Art, Inc, El Dorado KS
The Currier Museum of Art, Currier Museum of Art, Manchester NH
Dahesh Museum of Art, New York NY
Davenport Museum of Art, Davenport IA
Delaware Art Museum, Wilmington DE
Denver Art Museum, Denver CO
Detroit Institute of Arts, Detroit MI
Doncaster Museum and Art Gallery, Doncaster
Egan Institute of Maritime Studies, Nantucket MA
Evansville Museum of Arts, History & Science, Evansville IN
Fine Arts Center for the New River Valley, Pulaski VA
Glanmore National Historic Site of Canada, Belleville ON
Heckscher Museum of Art, Huntington NY
Hillwood Museum & Gardens Foundation, Hillwood Museum & Gardens, Washington DC
Huntington Museum of Art, Huntington WV
Iredell Museum of Arts & Heritage, Statesville NC
Joslyn Art Museum, Omaha NE
Juniata College Museum of Art, Huntingdon PA
Lafayette College, Williams Center Gallery, Easton PA
Lehigh University Art Galleries, Museum Operation, Bethlehem PA
Louisiana State University, Museum of Art, Baton Rouge LA
Marquette University, Haggerty Museum of Art, Milwaukee WI
Maryhill Museum of Art, Goldendale WA
McCord Museum of Canadian History, Montreal PQ
McMaster University, McMaster Museum of Art, Hamilton ON
Mobile Museum of Art, Mobile AL
Modern Art Museum, Fort Worth TX
Musee Cognacq-Jay, Cognacq-Jay Museum, Paris
Museo de Arte de Ponce, Ponce Art Museum, Ponce PR
Muzej za Umjetnost i Obrt, Museum of Arts & Crafts, Zagreb
Muzeum Narodowe, National Museum, Poznan
National Gallery of Canada, Ottawa ON
Nemours Mansion & Gardens, Wilmington DE
New Brunswick Museum, Saint John NB
New Jersey State Museum, Fine Art Bureau, Trenton NJ
New York Studio School of Drawing, Painting & Sculpture, Gallery, New York NY
Niagara University, Castellani Art Museum, Niagara NY
North Carolina Museum of Art, Raleigh NC
Oklahoma City Museum of Art, Oklahoma City OK
Panhandle-Plains Historical Society Museum, Canyon TX
Passaic County Community College, Broadway, LRC, and Hamilton Club Galleries, Paterson NJ
Phoenix Art Museum, Phoenix AZ
Piedmont Arts Association, Martinsville VA
Princeton University, Princeton University Art Museum, Princeton NJ
Queens College, City University of New York, Godwin-Ternbach Museum, Flushing NY
The Rosenbach Museum & Library, Philadelphia PA
Royal Arts Foundation, Belcourt Castle, Newport RI
Saginaw Art Museum, Saginaw MI
Saint Olaf College, Flaten Art Museum, Northfield MN
Salisbury House Foundation, Des Moines IA
San Diego Museum of Art, San Diego CA
Shirley Plantation, Charles City VA
Society of the Cincinnati, Museum & Library at Anderson House, Washington DC
Springfield Art Museum, Springfield MO
Stanford University, Iris & B Gerald Cantor Center for Visual Arts, Stanford CA
State University of New York at Binghamton, University Art Museum, Binghamton NY
State University of New York at Oswego, Tyler Art Gallery, Oswego NY
The Turner Museum, Sarasota FL
University of California, Berkeley, Berkeley Art Museum & Pacific Film Archive, Berkeley CA
University of Illinois, Krannert Art Museum and Kinkead Pavillion, Champaign IL
University of Kansas, Spencer Museum of Art, Lawrence KS
University of North Carolina at Chapel Hill, Ackland Art Museum, Chapel Hill NC
University of Southern California, Fisher Gallery, Los Angeles CA
University of Toronto, University of Toronto Art Centre, Toronto ON

University of Utah, Utah Museum of Fine Arts, Salt Lake City UT
Ursinus College, Philip & Muriel Berman Museum of Art, Collegeville PA
Ventura County Maritime Museum, Inc, Oxnard CA
Wadsworth Atheneum Museum of Art, Hartford CT
Wallace Collection, London
Walters Art Museum, Baltimore MD
Washington University, Mildred Lane Kemper Art Museum, Saint Louis MO
Waterworks Visual Arts Center, Salisbury NC
Wellesley College, Davis Museum & Cultural Center, Wellesley MA
Wheaton College, Watson Gallery, Norton MA
Wilfrid Laurier University, Robert Langen Art Gallery, Waterloo ON
Woodlawn/The Pope-Leighey, Mount Vernon VA
Worcester Art Museum, Worcester MA

PAINTING-CANADIAN

Algonquin Arts Council, Art Gallery of Bancroft, Bancroft ON
Art Gallery of Greater Victoria, Victoria BC
Art Gallery of Nova Scotia, Halifax NS
Art Without Walls Inc, Art Without Walls, Sayville NY
Beaverbrook Art Gallery, Fredericton NB
Blauvelt Demarest Foundation, Hiram Blauvelt Art Museum, Oradell NJ
Canadian Museum of Civilization, Gatineau PQ
Canadian Museum of Nature, Musee Canadien de la Nature, Ottawa ON
Cartoon Art Museum, San Francisco CA
Radio-Canada SRC CBC, Georges Goguen CBC Art Gallery, Moncton NB
Central United Methodist Church, Swords Into Plowshares Peace Center & Gallery, Detroit MI
City of Fayette, Alabama, Fayette Art Museum, Fayette AL
City of Toronto Culture Division, The Market Gallery, Toronto ON
Concordia University, Leonard & Bina Ellen Art Gallery, Montreal PQ
Cornwall Gallery Society, Cornwall Regional Art Gallery, Cornwall ON
Craigdarroch Castle Historical Museum Society, Victoria BC
Dartmouth Heritage Museum, Dartmouth NS
DeLeon White Gallery, Toronto ON
Dundurn Castle, Hamilton ON
Enook Galleries, Waterloo ON
Estevan National Exhibition Centre Inc, Estevan SK
Glanmore National Historic Site of Canada, Belleville ON
Glenhyrst Art Gallery of Brant, Brantford ON
Heritage Center, Inc, Pine Ridge SD
Huntington Museum of Art, Huntington WV
Kamloops Art Gallery, Kamloops BC
Kansas City Art Institute, Kansas City MO
Kings County Historical Society & Museum, Hampton NB
Kitchener-Waterloo Art Gallery, Kitchener ON
L'Universite Laval, Ecole des Arts Visuels, Quebec PQ
The Lindsay Gallery Inc, Lindsay ON
McCord Museum of Canadian History, Montreal PQ
McMaster University, McMaster Museum of Art, Hamilton ON
Mendel Art Gallery & Civic Conservatory, Saskatoon SK
Modern Art Museum, Fort Worth TX
Moose Jaw Art Museum, Inc, Art & History Museum, Moose Jaw SK
Musee du Quebec, Quebec PQ
Musee Regional de la Cote-Nord, Sept-Iles PQ
Museum of Contemporary Canadian Art, Toronto ON
National Gallery of Canada, Ottawa ON
New Brunswick Museum, Saint John NB
Niagara University, Castellani Art Museum, Niagara NY
Opelousas Museum of Art, Inc (OMA), Opelousas LA
Port Huron Museum, Port Huron MI
Prairie Art Gallery, Grande Prairie AB
Prince George Art Gallery, Prince George BC
PS1 Contemporary Art Center, Long Island City NY
Red Deer & District Museum & Archives, Red Deer AB
Regina Public Library, Dunlop Art Gallery, Regina SK
Ross Memorial Museum, Saint Andrews NB
Saint Joseph's Oratory, Museum, Montreal PQ

Surrey Art Gallery, Surrey BC
University of Manitoba, Faculty of Architecture Exhibition Centre, Winnipeg MB
University of Saskatchewan, Diefenbaker Canada Centre, Saskatoon SK
University of Toronto, Justina M Barnicke Gallery, Toronto ON
Upstairs Gallery, Winnipeg MB
Vancouver Public Library, Fine Arts & Music Div, Vancouver BC
Wadsworth Atheneum Museum of Art, Hartford CT
Peter & Catharine Whyte Foundation, Whyte Museum of the Canadian Rockies, Banff AB
Wilfrid Laurier University, Robert Langen Art Gallery, Waterloo ON
The Winnipeg Art Gallery, Winnipeg MB
Yarmouth County Historical Society, Yarmouth County Museum, Yarmouth NS
York University, Art Gallery of York University, Toronto ON

PAINTING-DUTCH

Allentown Art Museum, Allentown PA
Arnot Art Museum, Elmira NY
Art & Culture Center of Hollywood, Art Gallery, Hollywood FL
Art Without Walls Inc, Art Without Walls Inc, Sayville NY
Barnes Foundation, Merion PA
Bass Museum of Art, Miami Beach FL
Berkshire Museum, Pittsfield MA
BJU Museum & Gallery, Bob Jones University Museum & Gallery Inc, Greenville SC
Bruce Museum, Inc, Bruce Museum, Greenwich CT
Chrysler Museum of Art, Norfolk VA
Cincinnati Institute of Fine Arts, Taft Museum of Art, Cincinnati OH
Sterling & Francine Clark, Williamstown MA
College of William & Mary, Muscarelle Museum of Art, Williamsburg VA
Columbus Museum of Art, Columbus OH
The Currier Museum of Art, Currier Museum of Art, Manchester NH
Detroit Institute of Arts, Detroit MI
Elmhurst Art Museum, Elmhurst IL
Evansville Museum of Arts, History & Science, Evansville IN
Fine Arts Center for the New River Valley, Pulaski VA
Isabella Stewart Gardner, Boston MA
Grand Rapids Art Museum, Grand Rapids MI
Heckscher Museum of Art, Huntington NY
Heritage Malta, National Museum of Fine Arts, Valletta
Huguenot Historical Society of New Paltz Galleries, New Paltz NY
Huntington Museum of Art, Huntington WV
Juniata College Museum of Art, Huntingdon PA
Kansas City Art Institute, Kansas City MO
Kereszteny Muzeum, Christian Museum, Esztergom
Knights of Columbus Supreme Council, Knights of Columbus Museum, New Haven CT
The Mariners' Museum, Newport News VA
Marquette University, Haggerty Museum of Art, Milwaukee WI
McMaster University, McMaster Museum of Art, Hamilton ON
Mobile Museum of Art, Mobile AL
Modern Art Museum, Fort Worth TX
Moravska Galerie v Brne, Moravian Gallery in Brno, Brno
Municipal Museum De Lakenhal, Stedelisk Museum De Lakenhal, Leiden
Museo de Arte de Ponce, Ponce Art Museum, Ponce PR
Museum of Art, Fort Lauderdale, Fort Lauderdale FL
Muzeum Narodowe, National Museum, Poznan
Muzeum Narodowe W Kielcach, National Museum in Kielce, Kielce
Narodna Galerija, National Gallery of Slovenia, Ljubljana
National Gallery of Canada, Ottawa ON
The National Museum of Fine Arts, Stockholm
Nemours Mansion & Gardens, Wilmington DE
New Orleans Museum of Art, New Orleans LA
North Carolina Museum of Art, Raleigh NC
Oberlin College, Allen Memorial Art Museum, Oberlin OH
Panhandle-Plains Historical Society Museum, Canyon TX
Phoenix Art Museum, Phoenix AZ

PAINTING-EUROPEAN

University of Illinois, Krannert Art Museum and
 Kinkead Pavillion, Champaign IL
University of Kansas, Spencer Museum of Art,
 Lawrence KS
University of Kentucky, Art Museum, Lexington KY
University of Michigan, Museum of Art, Ann Arbor MI
University of Missouri, Museum of Art & Archaeology,
 Columbia MO
University of North Carolina at Chapel Hill, Ackland
 Art Museum, Chapel Hill NC
University of Northern Iowa, UNI Gallery of Art,
 Cedar Falls IA
University of Oklahoma, Fred Jones Jr Museum of Art,
 Norman OK
University of Utah, Utah Museum of Fine Arts, Salt
 Lake City UT
University of Wisconsin-Madison, Chazen Museum of
 Art, Madison WI
University of Wyoming, University of Wyoming Art
 Museum, Laramie WY
Ursinus College, Philip & Muriel Berman Museum of
 Art, Collegeville PA
Vanderbilt University, Fine Arts Gallery, Nashville TN
Vassar College, The Frances Lehman Loeb Art Center,
 Poughkeepsie NY
Ventura County Maritime Museum, Inc, Oxnard CA
Virginia Museum of Fine Arts, Richmond VA
Wadsworth Atheneum Museum of Art, Hartford CT
Walters Art Museum, Baltimore MD
Washington University, Mildred Lane Kemper Art
 Museum, Saint Louis MO
Waterworks Visual Arts Center, Salisbury NC
Wellesley College, Davis Museum & Cultural Center,
 Wellesley MA
Widener University, Art Collection & Gallery, Chester
 PA
Wilfrid Laurier University, Robert Langen Art Gallery,
 Waterloo ON
Wilkes University, Sordoni Art Gallery, Wilkes-Barre
 PA
Woodmere Art Museum, Philadelphia PA
Zigler Museum, Jennings LA

PAINTING-FLEMISH

Agecroft Association, Museum, Richmond VA
Allentown Art Museum, Allentown PA
Arnot Art Museum, Elmira NY
Art & Culture Center of Hollywood, Art Gallery,
 Hollywood FL
Art Without Walls Inc, Art Without Walls Inc, Sayville
 NY
Barnes Foundation, Merion PA
Bass Museum of Art, Miami Beach FL
Beaverbrook Art Gallery, Fredericton NB
Berkshire Museum, Pittsfield MA
BJU Museum & Gallery, Bob Jones University
 Museum & Gallery Inc, Greenville SC
Chrysler Museum of Art, Norfolk VA
Cincinnati Institute of Fine Arts, Taft Museum of Art,
 Cincinnati OH
Cincinnati Museum Association and Art Academy of
 Cincinnati, Cincinnati Art Museum, Cincinnati OH
City of El Paso, El Paso TX
Sterling & Francine Clark, Williamstown MA
College of William & Mary, Muscarelle Museum of
 Art, Williamsburg VA
Columbus Chapel & Boal Mansion Museum, Boalsburg
 PA
Columbus Museum of Art, Columbus OH
The Currier Museum of Art, Currier Museum of Art,
 Manchester NH
Detroit Institute of Arts, Detroit MI
Evansville Museum of Arts, History & Science,
 Evansville IN
Fine Arts Center for the New River Valley, Pulaski VA
Freeport Arts Center, Freeport IL
The Frick Art & Historical Center, Frick Art Museum,
 Pittsburgh PA
Galleria Doria Pamphilj, Rome
Isabella Stewart Gardner, Boston MA
General Board of Discipleship, The United Methodist
 Church, The Upper Room Chapel & Museum,
 Nashville TN
Heckscher Museum of Art, Huntington NY
Heritage Malta, National Museum of Fine Arts, Valletta
Hillwood Museum & Gardens Foundation, Hillwood
 Museum & Gardens, Washington DC
Honolulu Academy of Arts, Honolulu HI
Keresztny Muzeum, Christian Museum, Esztergom

Marquette University, Haggerty Museum of Art,
 Milwaukee WI
McMaster University, McMaster Museum of Art,
 Hamilton ON
Modern Art Museum, Fort Worth TX
Moravska Galerie v Brne, Moravian Gallery in Brno,
 Brno
Museo de Arte de Ponce, Ponce Art Museum, Ponce
 PR
Muzej za Umjetnost i Obrt, Museum of Arts & Crafts,
 Zagreb
Muzeum Narodowe, National Museum, Poznan
Muzeum Narodowe W Kielcach, National Museum in
 Kielce, Kielce
Narodna Galerija, National Gallery of Slovenia,
 Ljubljana
National Gallery of Canada, Ottawa ON
The National Museum of Fine Arts, Stockholm
Nemours Mansion & Gardens, Wilmington DE
New Orleans Museum of Art, New Orleans LA
North Carolina Museum of Art, Raleigh NC
Oberlin College, Allen Memorial Art Museum, Oberlin
 OH
Passaic County Community College, Broadway, LRC,
 and Hamilton Club Galleries, Paterson NJ
Phoenix Art Museum, Phoenix AZ
Piedmont Arts Association, Martinsville VA
Prairie Art Gallery, Grande Prairie AB
Princeton University, Princeton University Art Museum,
 Princeton NJ
Queens College, City University of New York,
 Godwin-Ternbach Museum, Flushing NY
Saint Bonaventure University, Regina A Quick Center
 for the Arts, Saint Bonaventure NY
Saint Peter's College, Art Gallery, Jersey City NJ
San Diego Museum of Art, San Diego CA
Shirley Plantation, Charles City VA
State University of New York at Binghamton,
 University Art Museum, Binghamton NY
Tampa Museum of Art, Tampa FL
University of Illinois, Krannert Art Museum and
 Kinkead Pavillion, Champaign IL
University of Michigan, Museum of Art, Ann Arbor MI
University of North Carolina at Chapel Hill, Ackland
 Art Museum, Chapel Hill NC
University of Southern California, Fisher Gallery, Los
 Angeles CA
University of Utah, Utah Museum of Fine Arts, Salt
 Lake City UT
Ursinus College, Philip & Muriel Berman Museum of
 Art, Collegeville PA
Ventura County Maritime Museum, Inc, Oxnard CA
Virginia Museum of Fine Arts, Richmond VA
Wadsworth Atheneum Museum of Art, Hartford CT
Wallace Collection, London
Wellesley College, Davis Museum & Cultural Center,
 Wellesley MA
Worcester Art Museum, Worcester MA
Zamek Krolewski w Warszawie Pomnik Historii i
 Kultry Narodwej, Royal Castle in Warsaw, National
 History & Culture Memorial, Warsaw

PAINTING-FRENCH

Charles Allis, Milwaukee WI
Arnot Art Museum, Elmira NY
Art & Culture Center of Hollywood, Art Gallery,
 Hollywood FL
Art Museum of the University of Houston, Blaffer
 Gallery, Houston TX
Art Without Walls Inc, Art Without Walls Inc, Sayville
 NY
Barnes Foundation, Merion PA
Bates College, Museum of Art, Lewiston ME
BJU Museum & Gallery, Bob Jones University
 Museum & Gallery Inc, Greenville SC
Brigham Young University, Museum of Art, Provo UT
The Buffalo Fine Arts Academy, Albright-Knox Art
 Gallery, Buffalo NY
Cartoon Art Museum, San Francisco CA
Radio-Canada SRC CBC, Georges Goguen CBC Art
 Gallery, Moncton NB
Centenary College of Louisiana, Meadows Museum of
 Art, Shreveport LA
Central United Methodist Church, Swords Into
 Plowshares Peace Center & Gallery, Detroit MI
Chrysler Museum of Art, Norfolk VA
Cincinnati Institute of Fine Arts, Taft Museum of Art,
 Cincinnati OH

Cincinnati Museum Association and Art Academy of
 Cincinnati, Cincinnati Art Museum, Cincinnati OH
City of El Paso, El Paso TX
Sterling & Francine Clark, Williamstown MA
College of William & Mary, Muscarelle Museum of
 Art, Williamsburg VA
The College of Wooster, The College of Wooster Art
 Museum, Wooster OH
Columbus Museum of Art, Columbus OH
The Currier Museum of Art, Currier Museum of Art,
 Manchester NH
Dahesh Museum of Art, New York NY
Davenport Museum of Art, Davenport IA
DeLeon White Gallery, Toronto ON
Denver Art Museum, Denver CO
Dickinson College, The Trout Gallery, Carlisle PA
The Dixon Gallery & Gardens, Memphis TN
Elmhurst Art Museum, Elmhurst IL
Fine Arts Center for the New River Valley, Pulaski VA
Fisk University, Fisk University Galleries, Nashville
 TN
Florida State University and Central Florida
 Community College, The Appleton Museum of Art,
 Ocala FL
Edsel & Eleanor Ford, Grosse Pointe Shores MI
The Frick Art & Historical Center, Frick Art Museum,
 Pittsburgh PA
Frye Art Museum, Seattle WA
Isabella Stewart Gardner, Boston MA
Glanmore National Historic Site of Canada, Belleville
 ON
Guggenheim Museum Soho, New York NY
Solomon R Guggenheim, New York NY
The Haggin Museum, Stockton CA
Heckscher Museum of Art, Huntington NY
Henry County Museum & Cultural Arts Center, Clinton
 MO
Henry Gallery Association, Henry Art Gallery, Seattle
 WA
Heritage Malta, National Museum of Fine Arts, Valletta
Hermitage Foundation Museum, Norfolk VA
Hill-Stead Museum, Farmington CT
Hillwood Museum & Gardens Foundation, Hillwood
 Museum & Gardens, Washington DC
Honolulu Academy of Arts, Honolulu HI
Johns Hopkins University, Evergreen House, Baltimore
 MD
Juniata College Museum of Art, Huntingdon PA
Kansas City Art Institute, Kansas City MO
Kateri Tekakwitha Shrine, Kahnawake PQ
Lafayette College, Williams Center Gallery, Easton PA
Lehigh University Art Galleries, Museum Operation,
 Bethlehem PA
Liberty Memorial Museum & Archives, The National
 Museum of World War I, Kansas City MO
Lockwood-Mathews Mansion Museum, Norwalk CT
Longfellow-Evangeline State Commemorative Area,
 Saint Martinville LA
The Mariners' Museum, Newport News VA
Marquette University, Haggerty Museum of Art,
 Milwaukee WI
McCord Museum of Canadian History, Montreal PQ
McMaster University, McMaster Museum of Art,
 Hamilton ON
Michelson Museum of Art, Marshall TX
Mint Museum of Art, Charlotte NC
Mobile Museum of Art, Mobile AL
Modern Art Museum, Fort Worth TX
Muscatine Art Center, Museum, Muscatine IA
Musee Carnavalet-Histoir de Paris, Paris
Musee Cognacq-Jay, Cognacq-Jay Museum, Paris
Museo de Arte de Ponce, Ponce Art Museum, Ponce
 PR
The Museum at Drexel University, Philadelphia PA
Muzej za Umjetnost i Obrt, Museum of Arts & Crafts,
 Zagreb
Muzeum Narodowe, National Museum, Poznan
Napoleonic Society of America, Museum & Library,
 Clearwater FL
Narodna Galerija, National Gallery of Slovenia,
 Ljubljana
Nassau County Museum of Fine Art, Roslyn Harbor
 NY
National Gallery of Canada, Ottawa ON
The National Museum of Fine Arts, Stockholm
Nemours Mansion & Gardens, Wilmington DE
New Jersey State Museum, Fine Art Bureau, Trenton
 NJ
New Orleans Museum of Art, New Orleans LA
New York Studio School of Drawing, Painting &
 Sculpture, Gallery, New York NY

PAINTING-GERMAN

PAINTING-ISRAELI

PAINTING-ITALIAN

McMaster University, McMaster Museum of Art, Hamilton ON
Meredith College, Frankie G Weems Gallery & Rotunda Gallery, Raleigh NC
Mint Museum of Art, Charlotte NC
Modern Art Museum, Fort Worth TX
Morris-Jumel Mansion, Inc, New York NY
Musee Cognacq-Jay, Cognacq-Jay Museum, Paris
Musei Capitolini, Rome
Museo de Arte de Ponce, Ponce Art Museum, Ponce PR
Museum of Contemporary Art, Chicago IL
Muzej za Umjetnost i Obrt, Museum of Arts & Crafts, Zagreb
Muzeum Narodowe, National Museum, Poznan
Muzeum Narodowe W Kielcach, National Museum in Kielce, Kielce
Narodna Galerija, National Gallery of Slovenia, Ljubljana
National Gallery of Canada, Ottawa ON
The National Museum of Fine Arts, Stockholm
National Trust for Historic Preservation, Chesterwood Estate & Museum, Stockbridge MA
Nemours Mansion & Gardens, Wilmington DE
New World Art Center, T F Chen Cultural Center, New York NY
North Carolina Museum of Art, Raleigh NC
Oklahoma City Museum of Art, Oklahoma City OK
The Old Jail Art Center, Albany TX
Opelousas Museum of Art, Inc (OMA), Opelousas LA
Order Sons of Italy in America, Garibaldi & Meucci Museum, Staten Island NY
Panhandle-Plains Historical Society Museum, Canyon TX
The Pennsylvania State University, Palmer Museum of Art, University Park PA
Philbrook Museum of Art, Tulsa OK
Pinacoteca Provinciale, Bari
The Pomona College, Montgomery Gallery, Claremont CA
Potsdam College of the State University of New York, Roland Gibson Gallery, Potsdam NY
Princeton University, Princeton University Art Museum, Princeton NJ
PS1 Contemporary Art Center, Long Island City NY
Queens College, City University of New York, Godwin-Ternbach Museum, Flushing NY
Saint Peter's College, Art Gallery, Jersey City NJ
San Diego Museum of Art, San Diego CA
Staatsgalerie Stuttgart, Stuttgart
State University of New York at Binghamton, University Art Museum, Binghamton NY
Timken Museum of Art, San Diego CA
University of Illinois, Krannert Art Museum and Kinkead Pavillion, Champaign IL
University of Kansas, Spencer Museum of Art, Lawrence KS
University of Michigan, Museum of Art, Ann Arbor MI
University of Southern California, Fisher Gallery, Los Angeles CA
University of Utah, Utah Museum of Fine Arts, Salt Lake City UT
Ursinus College, Philip & Muriel Berman Museum of Art, Collegeville PA
Vanderbilt University, Fine Arts Gallery, Nashville TN
Vassar College, The Frances Lehman Loeb Art Center, Poughkeepsie NY
Virginia Museum of Fine Arts, Richmond VA
Wadsworth Atheneum Museum of Art, Hartford CT
Washington University, Mildred Lane Kemper Art Museum, Saint Louis MO
Wellesley College, Davis Museum & Cultural Center, Wellesley MA
Zamek Krolewski w Warszawie Pomnik Historii i Kultry Narodwej, Royal Castle in Warsaw, National History & Culture Memorial, Warsaw

PAINTING-JAPANESE

Art & Culture Center of Hollywood, Art Gallery, Hollywood FL
Art Museum of the University of Houston, Blaffer Gallery, Houston TX
Art Without Walls Inc, Art Without Walls Inc, Sayville NY
Asian Art Museum of San Francisco, Chong-Moon Lee Ctr for Asian Art and Culture, San Francisco CA
California State University, Northridge, Art Galleries, Northridge CA

Central United Methodist Church, Swords Into Plowshares Peace Center & Gallery, Detroit MI
Billie Trimble Chandler, Asian Cultures Museum & Educational Center, Corpus Christi TX
Cleveland Museum of Art, Cleveland OH
Columbus Museum of Art, Columbus OH
DeLeon White Gallery, Toronto ON
Denver Art Museum, Denver CO
Detroit Institute of Arts, Detroit MI
Fine Arts Center for the New River Valley, Pulaski VA
Fitton Center for Creative Arts, Hamilton OH
General Board of Discipleship, The United Methodist Church, The Upper Room Chapel & Museum, Nashville TN
Grand Rapids Art Museum, Grand Rapids MI
Henry County Museum & Cultural Arts Center, Clinton MO
Hofstra University, Hofstra Museum, Hempstead NY
Honolulu Academy of Arts, Honolulu HI
Japan Society, Inc, Japan Society Gallery, New York NY
Kansas City Art Institute, Kansas City MO
Lehigh University Art Galleries, Museum Operation, Bethlehem PA
The Mariners' Museum, Newport News VA
Mint Museum of Art, Charlotte NC
Modern Art Museum, Fort Worth TX
New Visions Gallery, Inc, Marshfield WI
New World Art Center, T F Chen Cultural Center, New York NY
North Dakota State University, Memorial Union Gallery, Fargo ND
Noyes Art Gallery, Lincoln NE
Pacific - Asia Museum, Pasadena CA
Palm Beach County Parks & Recreation Department, Morikami Museum & Japanese Gardens, Delray Beach FL
Panhandle-Plains Historical Society Museum, Canyon TX
Potsdam College of the State University of New York, Roland Gibson Gallery, Potsdam NY
Princeton University, Princeton University Art Museum, Princeton NJ
PS1 Contemporary Art Center, Long Island City NY
Saginaw Art Museum, Saginaw MI
Saint John's University, Chung-Cheng Art Gallery, Jamaica NY
Saint Olaf College, Flaten Art Museum, Northfield MN
Saint Peter's College, Art Gallery, Jersey City NJ
Santa Barbara Museum of Art, Santa Barbara CA
Seattle Art Museum, Seattle WA
Society of the Cincinnati, Museum & Library at Anderson House, Washington DC
Springfield Art Museum, Springfield MO
State University of New York at New Paltz, Samuel Dorsky Museum of Art, New Paltz NY
Tokyo Kokuritsu Kindai Bujutsukan, The National Museum of Modern Art, Tokyo, Tokyo
Tokyo National University of Fine Arts & Music Art, University Art Museum, Tokyo
Towson University Center for the Arts Gallery, Asian Arts & Culture Center, Towson MD
University of Illinois, Krannert Art Museum and Kinkead Pavillion, Champaign IL
University of Kansas, Spencer Museum of Art, Lawrence KS
University of Michigan, Museum of Art, Ann Arbor MI
University of Utah, Utah Museum of Fine Arts, Salt Lake City UT
Ursinus College, Philip & Muriel Berman Museum of Art, Collegeville PA
Viridian Artists Inc, New York NY
Washington University, Mildred Lane Kemper Art Museum, Saint Louis MO

PAINTING-NEW ZEALANDER

Art Without Walls Inc, Art Without Walls Inc, Sayville NY
Detroit Institute of Arts, Detroit MI
Kansas City Art Institute, Kansas City MO
Modern Art Museum, Fort Worth TX
Prairie Art Gallery, Grande Prairie AB
PS1 Contemporary Art Center, Long Island City NY
University of Illinois, Krannert Art Museum and Kinkead Pavillion, Champaign IL

PAINTING-POLISH

Art & Culture Center of Hollywood, Art Gallery, Hollywood FL
Art Without Walls Inc, Art Without Walls Inc, Sayville NY
Detroit Institute of Arts, Detroit MI
Fine Arts Center for the New River Valley, Pulaski VA
Forest Lawn Museum, Glendale CA
Grand Rapids Art Museum, Grand Rapids MI
Hillwood Museum & Gardens Foundation, Hillwood Museum & Gardens, Washington DC
Kansas City Art Institute, Kansas City MO
Judah L Magnes, Berkeley CA
Muzeum Narodowe, National Museum, Poznan
Muzeum Narodowe W Kielcach, National Museum in Kielce, Kielce
Phoenix Art Museum, Phoenix AZ
Polish Museum of America, Chicago IL
PS1 Contemporary Art Center, Long Island City NY
Saginaw Art Museum, Saginaw MI
St Mary's Galeria, Orchard Lake MI
Zamek Krolewski w Warszawie Pomnik Historii i Kultry Narodwej, Royal Castle in Warsaw, National History & Culture Memorial, Warsaw

PAINTING-RUSSIAN

Art & Culture Center of Hollywood, Art Gallery, Hollywood FL
Art Without Walls Inc, Art Without Walls Inc, Sayville NY
Athens Byzantine & Christian Museum, Athens
BJU Museum & Gallery, Bob Jones University Museum & Gallery Inc, Greenville SC
College of William & Mary, Muscarelle Museum of Art, Williamsburg VA
Concordia University Wisconsin, Fine Art Gallery, Mequon WI
The Currier Museum of Art, Currier Museum of Art, Manchester NH
Detroit Institute of Arts, Detroit MI
Duke University, Duke University Museum of Art, Durham NC
Fine Arts Center for the New River Valley, Pulaski VA
Grand Rapids Art Museum, Grand Rapids MI
Guggenheim Museum Soho, New York NY
Solomon R Guggenheim, New York NY
Hebrew Union College, Jewish Institute of Religion Museum, New York NY
Hillwood Museum & Gardens Foundation, Hillwood Museum & Gardens, Washington DC
Huntington Museum of Art, Huntington WV
Johns Hopkins University, Evergreen House, Baltimore MD
Kansas City Art Institute, Kansas City MO
Kyiv Museum of Russian Art, Kyiv
Judah L Magnes, Berkeley CA
McMaster University, McMaster Museum of Art, Hamilton ON
Meredith College, Frankie G Weems Gallery & Rotunda Gallery, Raleigh NC
Michelson Museum of Art, Marshall TX
Mint Museum of Art, Charlotte NC
Nassau County Museum of Fine Art, Roslyn Harbor NY
National Gallery of Canada, Ottawa ON
Noyes Art Gallery, Lincoln NE
Panhandle-Plains Historical Society Museum, Canyon TX
Princeton University, Princeton University Art Museum, Princeton NJ
PS1 Contemporary Art Center, Long Island City NY
Queens College, City University of New York, Godwin-Ternbach Museum, Flushing NY
Rollins College, George D & Harriet W Cornell Fine Arts Museum, Winter Park FL
Saginaw Art Museum, Saginaw MI
Saint Peter's College, Art Gallery, Jersey City NJ
University of Cincinnati, DAAP Galleries-College of Design Architecture, Art & Planning, Cincinnati OH
University of Wisconsin-Madison, Chazen Museum of Art, Madison WI
Ursinus College, Philip & Muriel Berman Museum of Art, Collegeville PA

PAINTING-SCANDINAVIAN

American Swedish Institute, Minneapolis MN

Art & Culture Center of Hollywood, Art Gallery, Hollywood FL
Art Without Walls Inc, Art Without Walls Inc, Sayville NY
Augustana College, Augustana College Art Museum, Rock Island IL
Blauvelt Demarest Foundation, Hiram Blauvelt Art Museum, Oradell NJ
California State University, Northridge, Art Galleries, Northridge CA
Detroit Institute of Arts, Detroit MI
Fine Arts Center for the New River Valley, Pulaski VA
Grand Rapids Art Museum, Grand Rapids MI
Huntington Museum of Art, Huntington WV
James Dick Foundation, Festival - Institute, Round Top TX
Kansas City Art Institute, Kansas City MO
Luther College, Fine Arts Collection, Decorah IA
The National Museum of Fine Arts, Stockholm
Passaic County Community College, Broadway, LRC, and Hamilton Club Galleries, Paterson NJ
Pope County Historical Society, Pope County Museum, Glenwood MN
Princeton University, Princeton University Art Museum, Princeton NJ
PS1 Contemporary Art Center, Long Island City NY
Swedish-American Museum Association of Chicago, Chicago IL
University of Cincinnati, DAAP Galleries-College of Design Architecture, Art & Planning, Cincinnati OH

PAINTING-SPANISH

Art & Culture Center of Hollywood, Art Gallery, Hollywood FL
Art Museum of the University of Houston, Blaffer Gallery, Houston TX
Art Without Walls Inc, Art Without Walls Inc, Sayville NY
Bakehouse Art Complex, Inc, Miami FL
The Baltimore Museum of Art, Baltimore MD
Beaverbrook Art Gallery, Fredericton NB
California State University, Northridge, Art Galleries, Northridge CA
Canton Museum of Art, Canton OH
Cincinnati Institute of Fine Arts, Taft Museum of Art, Cincinnati OH
Cincinnati Museum Association and Art Academy of Cincinnati, Cincinnati Art Museum, Cincinnati OH
City of El Paso, El Paso TX
City of El Paso Museum and Cultural Affairs, People's Gallery, El Paso TX
Columbus Chapel & Boal Mansion Museum, Boalsburg PA
Cornell Museum of Art & History, Delray Beach FL
The Currier Museum of Art, Currier Museum of Art, Manchester NH
Detroit Institute of Arts, Detroit MI
Dickinson College, The Trout Gallery, Carlisle PA
Grand Rapids Art Museum, Grand Rapids MI
Guggenheim Museum Soho, New York NY
Solomon R Guggenheim, New York NY
Heritage Malta, National Museum of Fine Arts, Valletta
High Desert Museum, Bend OR
Huntington Museum of Art, Huntington WV
Johns Hopkins University, Evergreen House, Baltimore MD
Kansas City Art Institute, Kansas City MO
Kereszteny Muzeum, Christian Museum, Esztergom
Lynchburg College, Daura Gallery, Lynchburg VA
Marquette University, Haggerty Museum of Art, Milwaukee WI
Miami-Dade College, Kendal Campus, Art Gallery, Miami FL
Mint Museum of Art, Charlotte NC
Mission San Luis Rey de Francia, Mission San Luis Rey Museum, Oceanside CA
Mission San Miguel Museum, San Miguel CA
Museo de Arte de Ponce, Ponce Art Museum, Ponce PR
Museo De Las Americas, Denver CO
Museu Nacional d'Art de Catalunya, National Art Museum, Barcelona
Muzej za Umjetnost i Obrt, Museum of Arts & Crafts, Zagreb
Muzeum Narodowe, National Museum, Poznan
Narodna Galerija, National Gallery of Slovenia, Ljubljana
National Gallery of Canada, Ottawa ON
The National Museum of Fine Arts, Stockholm

Nemours Mansion & Gardens, Wilmington DE
North Carolina Museum of Art, Raleigh NC
The Old Jail Art Center, Albany TX
Opelousas Museum of Art, Inc (OMA), Opelousas LA
Panhandle-Plains Historical Society Museum, Canyon TX
Prairie Art Gallery, Grande Prairie AB
Princeton University, Princeton University Art Museum, Princeton NJ
PS1 Contemporary Art Center, Long Island City NY
Queens College, City University of New York, Godwin-Ternbach Museum, Flushing NY
Saint Peter's College, Art Gallery, Jersey City NJ
San Diego Museum of Art, San Diego CA
Santa Barbara Museum of Art, Santa Barbara CA
Springfield Art Museum, Springfield MO
Stanford University, Iris & B Gerald Cantor Center for Visual Arts, Stanford CA
State University of New York at Binghamton, University Art Museum, Binghamton NY
Timken Museum of Art, San Diego CA
University of Illinois, Krannert Art Museum and Kinkead Pavillion, Champaign IL
University of Utah, Utah Museum of Fine Arts, Salt Lake City UT
Ursinus College, Philip & Muriel Berman Museum of Art, Collegeville PA
Washington University, Mildred Lane Kemper Art Museum, Saint Louis MO
Wellesley College, Davis Museum & Cultural Center, Wellesley MA

PERIOD ROOMS

Academy of the New Church, Glencairn Museum, Bryn Athyn PA
Adams County Historical Society, Gettysburg PA
Adams National Historic Park, Quincy MA
Agecroft Association, Museum, Richmond VA
Albany Institute of History & Art, Albany NY
Allentown Art Museum, Allentown PA
American Kennel Club, Museum of the Dog, Saint Louis MO
Amherst Museum, Amherst NY
Arizona Historical Society-Yuma, Sanguinetti House Museum & Garden, Yuma AZ
Art Without Walls Inc, Art Without Walls Inc, Sayville NY
Artesia Historical Museum & Art Center, Artesia NM
Ashland Historical Society, Ashland MA
Association for the Preservation of Virginia Antiquities, John Marshall House, Richmond VA
Atlanta Historical Society Inc, Atlanta History Center, Atlanta GA
The Bartlett Museum, Amesbury MA
Bartow-Pell Mansion Museum & Gardens, Bronx NY
Bay County Historical Society, Historical Museum of Bay County, Bay City MI
Bayou Bend Collection & Gardens, Houston TX
BJU Museum & Gallery, Bob Jones University Museum & Gallery Inc, Greenville SC
Bradford Brinton, Big Horn WY
Brooklyn Historical Society, Brooklyn OH
Cabot's Old Indian Pueblo Museum, Cabot's Old Indian Pueblo Museum, Desert Hot Springs CA
Cambridge Museum, Cambridge NE
Canadian Heritage - Parks Canada, Laurier House, National Historic Site, Ottawa ON
Canadian Museum of Civilization, Gatineau PQ
Cape Ann Historical Association, Gloucester MA
Captain Forbes House Mus, Milton MA
Caramoor Center for Music & the Arts, Inc, Caramoor House Museum, Katonah NY
Carson County Square House Museum, Panhandle TX
Chateau Ramezay Museum, Montreal PQ
Chatillon-DeMenil House Foundation, DeMenil Mansion, Saint Louis MO
City of Austin Parks & Recreation, O Henry Museum, Austin TX
City of Gainesville, Thomas Center Galleries - Cultural Affairs, Gainesville FL
City of Grand Rapids Michigan, Public Museum of Grand Rapids, Grand Rapids MI
The City of Petersburg Museums, Petersburg VA
City of Springdale, Shiloh Museum of Ozark History, Springdale AR
Clark County Historical Society, Pioneer - Krier Museum, Ashland KS
Cliveden, Philadelphia PA
Columbus Museum, Columbus GA

Columbus Museum of Art and Design, Indianapolis IN
Concord Museum, Concord MA
Conrad-Caldwell House Museum, Louisville KY
Craigdarroch Castle Historical Museum Society, Victoria BC
Crane Collection, Gallery of American Painting and Sculpture, Wellesley MA
Creek Council House Museum, Okmulgee OK
Culberson County Historical Museum, Van Horn TX
Cuneo Foundation, Museum & Gardens, Vernon Hills IL
Danville Museum of Fine Arts & History, Danville VA
DAR Museum, National Society Daughters of the American Revolution, Washington DC
Delaware Division of Historical & Cultural Affairs, Dover DE
Detroit Institute of Arts, Detroit MI
Dundurn Castle, Hamilton ON
Edgecombe County Cultural Arts Council, Inc, Blount-Bridgers House, Hobson Pittman Memorial Gallery, Tarboro NC
Erie County Historical Society, Erie PA
Evanston Historical Society, Charles Gates Dawes House, Evanston IL
Evansville Museum of Arts, History & Science, Evansville IN
Fetherston Foundation, Packwood House Museum, Lewisburg PA
Flagler Museum, Palm Beach FL
Edsel & Eleanor Ford, Grosse Pointe Shores MI
The Frick Art & Historical Center, Frick Art Museum, Pittsburgh PA
Friends of Historic Kingston, Fred J Johnston House Museum, Kingston NY
Gananoque Museum, Gananoque ON
Gem County Historical Society and Museum, Emmett ID
Gibson Society, Inc, Gibson House Museum, Boston MA
Girard College, Stephen Girard Collection, Philadelphia PA
Glanmore National Historic Site of Canada, Belleville ON
Greene County Historical Society, Bronck Museum, Coxsackie NY
Hancock County Trustees of Public Reservations, Woodlawn Museum, Ellsworth ME
Hancock Shaker Village, Inc, Pittsfield MA
Headquarters Fort Monroe, Dept of Army, Casemate Museum, Fort Monroe VA
Henry County Museum & Cultural Arts Center, Clinton MO
Henry Sheldon Museum of Vermont History and Research Center, Middlebury VT
Heritage House Museum and Robert Frost Cottage, Key West FL
Hillwood Museum & Gardens Foundation, Hillwood Museum & Gardens, Washington DC
Historic Arkansas Museum, Little Rock AR
Historic Cherry Hill, Albany NY
Historic Landmarks Foundation of Indiana, Morris-Butler House, Indianapolis IN
Historical Society of Cheshire County, Keene NH
Historical Society of Old Newbury, Cushing House Museum, Newburyport MA
Historical Society of the Town of Greenwich, Inc, Bush-Holley House Museum, Cos Cob CT
Historisches und Volkerkundemuseum, Historical Museum, Sankt Gallen
Hopewell Museum, Hopewell NJ
Hoyt Institute of Fine Arts, New Castle PA
Huguenot Historical Society of New Paltz Galleries, New Paltz NY
Huntington Museum of Art, Huntington WV
Stan Hywet, Akron OH
Idaho Historical Museum, Boise ID
Imperial Calcasieu Museum, Lake Charles LA
Imperial Calcasieu Museum, Gibson-Barham Gallery, Lake Charles LA
Independence Historical Museum, Independence KS
Independence National Historical Park, Philadelphia PA
Jackson County Historical Society, The 1859 Jail, Marshal's Home & Museum, Independence MO
James Dick Foundation, Festival - Institute, Round Top TX
Johns Hopkins University, Homewood House Museum, Baltimore MD
Jordan Historical Museum of The Twenty, Jordan ON
Kateri Tekakwitha Shrine, Kahnawake PQ
Kelly-Griggs House Museum, Red Bluff CA

Kentucky Historical Society, Old State Capitol & Annex, Frankfort KY
Kern County Museum, Bakersfield CA
Knoxville Museum of Art, Knoxville TN
Koochiching Museums, International Falls MN
Landmark Society of Western New York, Inc, The Campbell-Whittlesey House Museum, Rochester NY
Lehigh County Historical Society, Allentown PA
LeSueur County Historical Society, Chapter One, Elysian MN
Liberty Hall Historic Site, Liberty Hall Museum, Frankfort KY
Lincoln County Historical Association, Inc, 1811 Old Lincoln County Jail & Lincoln County Museum, Wiscasset ME
Lockwood-Mathews Mansion Museum, Norwalk CT
Longfellow National Historic Site, Cambridge MA
Longfellow's Wayside Inn Museum, South Sudbury MA
Longfellow-Evangeline State Commemorative Area, Saint Martinville LA
Los Angeles County Museum of Natural History, William S Hart Museum, Newhall CA
Loveland Museum Gallery, Loveland CO
Maine Historical Society, Wadsworth-Longfellow House, Portland ME
Manitoba Historical Society, Dalnavert Museum, Winnipeg MB
Jacques Marchais, Staten Island NY
Maricopa County Historical Society, Desert Caballeros Western Museum, Wickenburg AZ
Mattatuck Historical Society, Mattatuck Museum, Waterbury CT
McDowell House & Apothecary Shop, Danville KY
McPherson Museum, McPherson KS
Middle Border Museum & Oscar Howe Art Center, Mitchell SD
Middlebury College, Museum of Art, Middlebury VT
Minneapolis Institute of Arts, Minneapolis MN
Mint Museum of Art, Charlotte NC
Mission San Miguel Museum, San Miguel CA
Mississippi River Museum at Mud-Island River Park, Memphis TN
Monhegan Museum, Monhegan ME
Monroe County Historical Association, Elizabeth D Walters Library, Stroudsburg PA
Morris Museum, Morristown NJ
Morris-Jumel Mansion, Inc, New York NY
Mount Vernon Ladies' Association of the Union, Mount Vernon VA
Muchnic Foundation & Atchison Art Association, Muchnic Gallery, Atchison KS
Municipal Museum De Lakenhal, Stedelisk Museum De Lakenhal, Leiden
Munson-Williams-Proctor Arts Institute, Museum of Art, Utica NY
Muscatine Art Center, Museum, Muscatine IA
Musee Carnavalet-Histoir de Paris, Paris
Museu Nacional de Arte Contemporanea, National Museum of Contemporary Art, Museu Do Chiado, Lisbon
The Museum, Greenwood SC
Museum of Art, Fort Lauderdale, Fort Lauderdale FL
Museum of Fine Arts, Boston MA
Museum of Fine Arts, Saint Petersburg, Florida, Inc, Saint Petersburg FL
Museum of Southern History, Sugarland TX
National Audubon Society, John James Audubon Center at Mill Grove, Audubon PA
National Cowboy & Western Heritage Museum, Oklahoma City OK
National Park Service, Hubbell Trading Post National Historic Site, Ganado AZ
National Society of Colonial Dames of America in the State of Maryland, Mount Clare Museum House, Baltimore MD
National Society of the Colonial Dames of America in The Commonwealth of Virginia, Wilton House Museum, Richmond VA
National Trust for Historic Preservation, Decatur House, Washington DC
Nelson-Atkins Museum of Art, Kansas City MO
New Brunswick Museum, Saint John NB
New Orleans Museum of Art, New Orleans LA
New York State Office of Parks Recreation & Historic Preservation, John Jay Homestead State Historic Site, Katonah NY
New York State Office of Parks, Recreation & Historical Preservation, Mills Mansion State Historical Site, Staatsburg NY

Newport Art Museum, Newport RI
Nichols House Museum, Inc, Boston MA
North Country Museum of Arts, Park Rapids MN
Oatlands Plantation, Leesburg VA
Oglebay Institute, Mansion Museum, Wheeling WV
The Ohio Historical Society, Inc, Campus Martius Museum & Ohio River Museum, Marietta OH
Old Barracks Museum, Trenton NJ
Old Fort Harrod State Park Mansion Museum, Harrodsburg KY
Old York Historical Society, Old Gaol Museum, York ME
Old York Historical Society, Elizabeth Perkins House, York ME
Owensboro Museum of Fine Art, Owensboro KY
Panhandle-Plains Historical Society Museum, Canyon TX
Passaic County Community College, Broadway, LRC, and Hamilton Club Galleries, Paterson NJ
Penobscot Marine Museum, Searsport ME
Peoria Historical Society, Peoria IL
Philadelphia Museum of Art, Philadelphia PA
Piatt Castles, West Liberty OH
Pioneer Historical Museum of South Dakota, Hot Springs SD
Plainsman Museum, Aurora NE
Pope County Historical Society, Pope County Museum, Glenwood MN
Portsmouth Historical Society, John Paul Jones House, Portsmouth NH
Putnam County Historical Society, Foundry School Museum, Cold Spring NY
Rahr-West Art Museum, Manitowoc WI
Red Deer & District Museum & Archives, Red Deer AB
Riley County Historical Society, Riley County Historical Museum, Manhattan KS
Rock Ford Foundation, Inc, Historic Rock Ford & Kauffman Museum, Lancaster PA
Lauren Rogers, Laurel MS
Royal Arts Foundation, Belcourt Castle, Newport RI
C M Russell, Great Falls MT
Ryerss Victorian Museum & Library, Philadelphia PA
Saco Museum, Saco ME
Saint-Gaudens National Historic Site, Cornish NH
Salisbury House Foundation, Des Moines IA
Schuyler-Hamilton House, Morristown NJ
Seneca Falls Historical Society Museum, Seneca Falls NY
Shelburne Museum, Museum, Shelburne VT
Shirley Plantation, Charles City VA
Shoreline Historical Museum, Shoreline WA
Shores Memorial Museum and Victoriana, Lyndon Center VT
Society of the Cincinnati, Museum & Library at Anderson House, Washington DC
Sooke Region Museum & Art Gallery, Sooke BC
Southern Oregon Historical Society, Jacksonville Museum of Southern Oregon History, Medford OR
Staatsgalerie Stuttgart, Stuttgart
Nelda C & H J Lutcher Stark, Stark Museum of Art, Orange TX
State of North Carolina, Battleship North Carolina, Wilmington NC
Stratford Historical Society, Catharine B Mitchell Museum, Stratford CT
Sturdivant Hall, Selma AL
Summit County Historical Society, Akron OH
Sylvia Plotkin Museum of Temple Beth Israel, Scottsdale AZ
Tallahassee Museum of History & Natural Science, Tallahassee FL
Taos, Ernest Blumenschein Home & Studio, Taos NM
Taos, La Hacienda de Los Martinez, Taos NM
Taos, Taos NM
Telfair Museum of Art, Savannah GA
The Trustees of Reservations, The Mission House, Ipswich MA
Tryon Palace Historic Sites & Gardens, New Bern NC
Tucson Museum of Artand Historic Block, Tucson AZ
Mark Twain, Hartford CT
United States Capitol, Architect of the Capitol, Washington DC
University of Memphis, Art Museum, Memphis TN
University of Saskatchewan, Diefenbaker Canada Centre, Saskatoon SK
Utah Department of Natural Resources, Division of Parks & Recreation, Territorial Statehouse, Salt Lake City UT
Vermilion County Museum Society, Danville IL
Vesterheim Norwegian-American Museum, Decorah IA

Victoria Mansion - Morse Libby House, Portland ME
Vizcaya Museum & Gardens, Miami FL
Wade House & Wesley W Jung Carriage Museum, Historic House & Carriage Museum, Greenbush WI
Mamie McFaddin Ward, Beaumont TX
Washington & Lee University, Lee Chapel & Museum, Lexington VA
Wayne County Historical Society, Honesdale PA
West Baton Rouge Parish, West Baton Rouge Museum, Port Allen LA
West Florida Historic Preservation, Inc, T T Wentworth, Jr Florida State Museum & Historic Pensacola Village, Pensacola FL
Wethersfield Historical Society Inc, Museum, Wethersfield CT
Whatcom Museum of History and Art, Bellingham WA
White House, Washington DC
Willard House & Clock Museum, Inc, North Grafton MA
Woodrow Wilson, Staunton VA
Woodrow Wilson, Washington DC
Wistariahurst Museum, Holyoke MA
The Woman's Exchange, Gallier House Museum, New Orleans LA
Woodlawn/The Pope-Leighey, Mount Vernon VA
Woodmere Art Museum, Philadelphia PA
Yarmouth County Historical Society, Yarmouth County Museum, Yarmouth NS

PEWTER

Agecroft Association, Museum, Richmond VA
Albany Institute of History & Art, Albany NY
Allentown Art Museum, Allentown PA
Baker University, Old Castle Museum, Baldwin City KS
Bayou Bend Collection & Gardens, Houston TX
Cameron Art Museum, Wilmington NC
Canadian Museum of Civilization, Gatineau PQ
Cape Ann Historical Association, Gloucester MA
City of Grand Rapids Michigan, Public Museum of Grand Rapids, Grand Rapids MI
Concord Museum, Concord MA
Cooper-Hewitt, National Design Museum, Smithsonian Institution, New York NY
Craftsmen's Guild of Mississippi, Inc, Mississippi Crafts Center, Ridgeland MS
The Currier Museum of Art, Currier Museum of Art, Manchester NH
DAR Museum, National Society Daughters of the American Revolution, Washington DC
Detroit Institute of Arts, Detroit MI
The Dixon Gallery & Gardens, Memphis TN
Dundurn Castle, Hamilton ON
Fetherston Foundation, Packwood House Museum, Lewisburg PA
Franklin Mint Museum, Franklin Center PA
Gallery One, Ellensburg WA
Glanmore National Historic Site of Canada, Belleville ON
Henry Sheldon Museum of Vermont History and Research Center, Middlebury VT
Heritage Center of Lancaster County Museum, Lancaster PA
Historic Deerfield, Deerfield MA
Hoyt Institute of Fine Arts, New Castle PA
Huguenot Historical Society of New Paltz Galleries, New Paltz NY
Imperial Calcasieu Museum, Gibson-Barham Gallery, Lake Charles LA
James Dick Foundation, Festival - Institute, Round Top TX
Johns Hopkins University, Homewood House Museum, Baltimore MD
Lehigh County Historical Society, Allentown PA
Lincoln County Historical Association, Inc, 1811 Old Lincoln County Jail & Lincoln County Museum, Wiscasset ME
Livingston County Historical Society, Cobblestone Museum, Geneseo NY
Longfellow-Evangeline State Commemorative Area, Saint Martinville LA
Mattatuck Historical Society, Mattatuck Museum, Waterbury CT
McDowell House & Apothecary Shop, Danville KY
Mexican Museum, San Francisco CA
The Museum, Greenwood SC
Muzej za Umjetnost i Obrt, Museum of Arts & Crafts, Zagreb

National Society of Colonial Dames of America in the State of Maryland, Mount Clare Museum House, Baltimore MD

New Brunswick Museum, Saint John NB

New Canaan Historical Society, New Canaan CT

New Jersey State Museum, Fine Art Bureau, Trenton NJ

Newton History Museum at the Jackson Homestead, Newton MA

Oglebay Institute, Mansion Museum, Wheeling WV

The Ohio Historical Society, Inc, Campus Martius Museum & Ohio River Museum, Marietta OH

Old York Historical Society, Old Gaol Museum, York ME

Porter Thermometer Museum, Onset MA

Porter-Phelps-Huntington Foundation, Inc, Historic House Museum, Hadley MA

Pump House Center for the Arts, Chillicothe OH

Rollins College, George D & Harriet W Cornell Fine Arts Museum, Winter Park FL

Saco Museum, Saco ME

Shirley Plantation, Charles City VA

The Society for Contemporary Crafts, Pittsburgh PA

South Carolina Artisans Center, Walterboro SC

Spertus Institute of Jewish Studies, Spertus Museum, Chicago IL

Stratford Historical Society, Catharine B Mitchell Museum, Stratford CT

Tryon Palace Historic Sites & Gardens, New Bern NC

University of Illinois, Krannert Art Museum and Kinkead Pavillion, Champaign IL

University of Saskatchewan, Diefenbaker Canada Centre, Saskatoon SK

Vesterheim Norwegian-American Museum, Decorah IA

Willard House & Clock Museum, Inc, North Grafton MA

Wisconsin Historical Society, State Historical Museum, Madison WI

Woodlawn/The Pope-Leighey, Mount Vernon VA

Yarmouth County Historical Society, Yarmouth County Museum, Yarmouth NS

PHOTOGRAPHY

A I R Gallery, New York NY

Academy of the New Church, Glencairn Museum, Bryn Athyn PA

The Adirondack Historical Association, The Adirondack Museum, Blue Mountain Lake NY

African American Museum in Philadelphia, Philadelphia PA

African Art Museum of Maryland, Columbia MD

AKA Artist Run Centre, Saskatoon SK

Akron Art Museum, Akron OH

Alberta College of Art & Design, Illingworth Kerr Gallery, Calgary AB

Albright College, Freedman Gallery, Reading PA

Albuquerque Museum of Art & History, Albuquerque NM

Alexandria Museum of Art, Alexandria LA

Algonquin Arts Council, Art Gallery of Bancroft, Bancroft ON

Allentown Art Museum, Allentown PA

American Textile History Museum, Lowell MA

Anchorage Museum at Rasmuson Center, Anchorage AK

Walter Anderson, Ocean Springs MS

Appaloosa Museum and Heritage Center, Moscow ID

Arab American National Museum, Dearborn MI

Art & Culture Center of Hollywood, Art Gallery, Hollywood FL

Art Community Center, Art Center of Corpus Christi, Corpus Christi TX

Art Gallery of Hamilton, Hamilton ON

Art Gallery of South Australia, Adelaide

Art Museum of Greater Lafayette, Lafayette IN

Art Museum of Southeast Texas, Beaumont TX

Art Museum of the University of Houston, Blaffer Gallery, Houston TX

Art Without Walls Inc, Art Without Walls Inc, Sayville NY

Artesia Historical Museum & Art Center, Artesia NM

Arts Council of Fayetteville-Cumberland County, The Arts Center, Fayetteville NC

Artspace, Richmond VA

Asbury College, Student Center Gallery, Wilmore KY

Asheville Art Museum, Asheville NC

Associates for Community Development, Boarman Arts Center, Martinsburg WV

Association for the Preservation of Virginia Antiquities, John Marshall House, Richmond VA

Atlanta Historical Society Inc, Atlanta History Center, Atlanta GA

Austin Museum of Art, Austin TX

Baldwin Historical Society Museum, Baldwin NY

The Baltimore Museum of Art, Baltimore MD

Balzekas Museum of Lithuanian Culture, Chicago IL

Bard College, Center for Curatorial Studies, Annandale-on-Hudson NY

Bay County Historical Society, Historical Museum of Bay County, Bay City MI

Beloit College, Wright Museum of Art, Beloit WI

Belskie Museum, Closter NJ

Berea College, Doris Ulmann Galleries, Berea KY

Jesse Besser, Alpena MI

Birger Sandzen Memorial Gallery, Lindsborg KS

Blauvelt Demarest Foundation, Hiram Blauvelt Art Museum, Oradell NJ

Boise Art Museum, Boise ID

Boston Public Library, Albert H Wiggin Gallery & Print Department, Boston MA

Bowers Museum of Cultural Art, Bowers Museum, Santa Ana CA

Roy Boyd, Chicago IL

Brown University, David Winton Bell Gallery, Providence RI

Bruce Museum, Inc, Bruce Museum, Greenwich CT

The Buffalo Fine Arts Academy, Albright-Knox Art Gallery, Buffalo NY

C W Post Campus of Long Island University, Hillwood Art Museum, Brookville NY

Cabot's Old Indian Pueblo Museum, Cabot's Old Indian Pueblo Museum, Desert Hot Springs CA

California State University Stanislaus, University Art Gallery, Turlock CA

California State University, Northridge, Art Galleries, Northridge CA

Cameron Art Museum, Wilmington NC

Canadian Museum of Civilization, Gatineau PQ

Canadian Museum of Contemporary Photography, Ottawa ON

Canadian Museum of Nature, Musee Canadien de la Nature, Ottawa ON

Canajoharie Library & Art Gallery, Arkell Museum of Canajoharie, Canajoharie NY

Cape Ann Historical Association, Gloucester MA

Caramoor Center for Music & the Arts, Inc, Caramoor House Museum, Katonah NY

Carleton College, Art Gallery, Northfield MN

Carnegie Museums of Pittsburgh, Carnegie Museum of Art, Pittsburgh PA

Carson County Square House Museum, Panhandle TX

Amon Carter, Fort Worth TX

Cartoon Art Museum, San Francisco CA

Radio-Canada SRC CBC, Georges Goguen CBC Art Gallery, Moncton NB

Center for Puppetry Arts, Atlanta GA

Central Methodist University, Ashby-Hodge Gallery of American Art, Fayette MO

Chattahoochee Valley Art Museum, LaGrange GA

Chesapeake Bay Maritime Museum, Saint Michaels MD

Chicago Athenaeum, Museum of Architecture & Design, Galena IL

Chinese Culture Foundation, Center Gallery, San Francisco CA

Church of Jesus Christ of Latter-Day Saints, Museum of Church History & Art, Salt Lake City UT

City of Cedar Falls, Iowa, James & Meryl Hearst Center for the Arts, Cedar Falls IA

City of El Paso, El Paso TX

City of El Paso Museum and Cultural Affairs, People's Gallery, El Paso TX

City of Fremont, Olive Hyde Art Gallery, Fremont CA

City of Gainesville, Thomas Center Galleries - Cultural Affairs, Gainesville FL

City of Grand Rapids Michigan, Public Museum of Grand Rapids, Grand Rapids MI

The City of Petersburg Museums, Petersburg VA

City of Pittsfield, Berkshire Artisans, Pittsfield MA

City of Springdale, Shiloh Museum of Ozark History, Springdale AR

Clark County Historical Society, Pioneer - Krier Museum, Ashland KS

Clinton Art Association, River Arts Center, Clinton IA

College of William & Mary, Muscarelle Museum of Art, Williamsburg VA

Colorado Photographic Arts Center, Denver CO

Colorado Springs Fine Arts Center, Colorado Springs CO

Columbia College Chicago, The Museum of Contemporary Photography, Chicago IL

Columbus Museum, Columbus GA

Columbus Museum of Art, Columbus OH

Cornell Museum of Art & History, Delray Beach FL

Cornell University, Herbert F Johnson Museum of Art, Ithaca NY

Cornwall Gallery Society, Cornwall Regional Art Gallery, Cornwall ON

Cranbrook Art Museum, Cranbrook Art Museum, Bloomfield Hills MI

Cranford Historical Society, Cranford NJ

Creative Photographic Arts Center of Maine, Dorthea C Witham Gallery, Lewiston ME

Creighton University, Lied Art Gallery, Omaha NE

Crocker Art Museum, Sacramento CA

Crow Wing County Historical Society, Brainerd MN

The Currier Museum of Art, Currier Museum of Art, Manchester NH

Danforth Museum Corporation, Danforth Museum of Art, Framingham MA

Dartmouth Heritage Museum, Dartmouth NS

Davistown Museum, Liberty Location, Liberty ME

Daytona Beach Community College, Southeast Museum of Photography, Daytona Beach FL

Deines Cultural Center, Russell KS

Delaware Art Museum, Wilmington DE

DeLeon White Gallery, Toronto ON

Denison University, Art Gallery, Granville OH

Detroit Institute of Arts, Detroit MI

Detroit Repertory Theatre Gallery, Detroit MI

Detroit Zoological Institute, Wildlife Interpretive Gallery, Royal Oak MI

DeWitt Historical Society of Tompkins County, The History Center in Tompkins Co, Ithaca NY

Dickinson College, The Trout Gallery, Carlisle PA

Dixie State College, Robert N & Peggy Sears Gallery, Saint George UT

Doncaster Museum and Art Gallery, Doncaster

Dundurn Castle, Hamilton ON

Durham Art Guild Inc, Durham NC

DuSable Museum of African American History, Chicago IL

East Baton Rouge Parks & Recreation Commission, Baton Rouge Gallery Inc, Baton Rouge LA

East Bay Asian Local Development Corp, Asian Resource Gallery, Oakland CA

Eastern Washington State Historical Society, Northwest Museum of Arts & Culture, Spokane WA

Egan Institute of Maritime Studies, Nantucket MA

Eiteljorg Museum of American Indians & Western Art, Indianapolis IN

Ellen Noel Art Museum of the Permian Basin, Odessa TX

eMediaLoft.org, New York NY

Emory University, Michael C Carlos Museum, Atlanta GA

Erie Art Museum, Erie PA

Erie County Historical Society, Erie PA

Essex Historical Society, Essex Shipbuilding Museum, Essex MA

Evanston Historical Society, Charles Gates Dawes House, Evanston IL

Evergreen State College, Evergreen Galleries, Olympia WA

Fairbanks Museum & Planetarium, Saint Johnsbury VT

Federal Reserve Board, Art Gallery, Washington DC

Fetherston Foundation, Packwood House Museum, Lewisburg PA

Fishkill Historical Society, Van Wyck Homestead Museum, Fishkill NY

Fisk University, Fisk University Galleries, Nashville TN

Fitton Center for Creative Arts, Hamilton OH

Five Civilized Tribes Museum, Muskogee OK

Forest Lawn Museum, Glendale CA

Fort Collins Museum of Contemporary Art, Fort Collins CO

Fort George G Meade Museum, Fort Meade MD

Fort Smith Art Center, Fort Smith AR

Fort Ticonderoga Association, Fort Ticonderoga NY

Frontier Times Museum, Bandera TX

Fuller Museum of Art, Brockton MA

Gadsden Museum of Fine Arts, Inc, Gadsden Museum of Art and History, Gadsden AL

Gallery One, Ellensburg WA

Gem County Historical Society and Museum, Emmett ID

George Washington University, The Dimock Gallery, Washington DC

Georgia O'Keeffe Museum, Santa Fe NM

Georgian Court College, M Christina Geis Gallery, Lakewood NJ

Thomas Gilcrease, Gilcrease Museum, Tulsa OK

Glanmore National Historic Site of Canada, Belleville ON

Goethe Institute New York, German Cultural Center, New York NY

Goshen Historical Society, Goshen CT

Goucher College, Rosenberg Gallery, Baltimore MD

Great Lakes Historical Society, Inland Seas Maritime Museum, Vermilion OH

Arthur Griffin, Winchester MA

Grinnell College, Art Gallery, Grinnell IA

Grossmont Community College, Hyde Art Gallery, El Cajon CA

Guggenheim Museum Soho, New York NY

Solomon R Guggenheim, New York NY

Guild Hall of East Hampton, Inc, Guild Hall Museum, East Hampton NY

Guilford College, Art Gallery, Greensboro NC

Hamilton College, Emerson Gallery, Clinton NY

Hammond Museum & Japanese Stroll Garden, Cross-Cultural Center, North Salem NY

Hancock County Trustees of Public Reservations, Woodlawn Museum, Ellsworth ME

Headquarters Fort Monroe, Dept of Army, Casemate Museum, Fort Monroe VA

Heard Museum, Phoenix AZ

Hebrew Union College, Jewish Institute of Religion Museum, New York NY

Heckscher Museum of Art, Huntington NY

Henry Gallery Association, Henry Art Gallery, Seattle WA

Patrick Henry, Red Hill National Memorial, Brookneal VA

Hermitage Foundation Museum, Norfolk VA

Hickory Museum of Art, Inc, Hickory NC

Hidalgo County Historical Museum, Edinburg TX

Higgins Armory Museum, Worcester MA

Hillwood Museum & Gardens Foundation, Hillwood Museum & Gardens, Washington DC

Hispanic Society of America, Museum & Library, New York NY

The Historic New Orleans Collection, New Orleans LA

Historic Northampton Museum & Education Center, Northampton MA

Hofstra University, Hofstra Museum, Hempstead NY

Holter Museum of Art, Helena MT

Honolulu Academy of Arts, Honolulu HI

Edward Hopper, Nyack NY

Hoyt Institute of Fine Arts, New Castle PA

The Hudson River Museum, Yonkers NY

Huguenot Historical Society of New Paltz Galleries, New Paltz NY

Hui No eau Visual Arts Center, Gallery and Gift Shop, Makawao Maui HI

Hunter Museum of American Art, Chattanooga TN

Huntington Museum of Art, Huntington WV

Huntsville Museum of Art, Huntsville AL

Hyde Park Art Center, Chicago IL

Illinois State University, University Galleries, Normal IL

Imperial Calcasieu Museum, Gibson-Barham Gallery, Lake Charles LA

Indiana State Museum, Indianapolis IN

Institute of American Indian Arts Museum, Museum, Santa Fe NM

Institute of Puerto Rican Culture, Museo Fuerte Conde de Mirasol, Vieques PR

Intar Latin American Gallery, New York NY

International Center of Photography, New York NY

Iredell Museum of Arts & Heritage, Statesville NC

Irving Arts Center, Main Gallery & Focus Gallery, Irving TX

James Dick Foundation, Festival - Institute, Round Top TX

John B Aird Gallery, Toronto ON

Joslyn Art Museum, Omaha NE

Juniata College Museum of Art, Huntingdon PA

Kalamazoo Institute of Arts, Kalamazoo MI

Kamloops Art Gallery, Kamloops BC

Kansas City Art Institute, Kansas City MO

Kentucky Derby Museum, Louisville KY

Kentucky Museum of Art & Craft, Louisville KY

Kern County Museum, Bakersfield CA

Kings County Historical Society & Museum, Hampton NB

Knoxville Museum of Art, Knoxville TN

Koochiching Museums, International Falls MN

Lac du Flambeau Band of Lake Superior Chippewa Indians, George W Brown Jr Ojibwe Museum & Cultural Center, Lac du Flambeau WI

Lafayette College, Williams Center Gallery, Easton PA

Lafayette Natural History Museum & Planetarium, Lafayette LA

Lehigh County Historical Society, Allentown PA

Lehigh University Art Galleries, Museum Operation, Bethlehem PA

LeSueur County Historical Society, Chapter One, Elysian MN

Liberty Memorial Museum & Archives, The National Museum of World War I, Kansas City MO

Lincoln County Historical Association, Inc, 1811 Old Lincoln County Jail & Lincoln County Museum, Wiscasset ME

Longfellow-Evangeline State Commemorative Area, Saint Martinville LA

Longview Museum of Fine Art, Longview TX

Louisiana Department of Culture, Recreation & Tourism, Louisiana State Museum, New Orleans LA

Louisiana State University, School of Art Gallery, Baton Rouge LA

Loveland Museum Gallery, Loveland CO

Loyola Marymount University, Laband Art Gallery, Los Angeles CA

Luther College, Fine Arts Collection, Decorah IA

Macalester College, Macalester College Art Gallery, Saint Paul MN

Charles H MacNider, Mason City IA

Madison Museum of Contemporary Art, Madison WI

Judah L Magnes, Berkeley CA

Maitland Art Center, Maitland FL

Jacques Marchais, Staten Island NY

Maricopa County Historical Society, Desert Caballeros Western Museum, Wickenburg AZ

The Mariners' Museum, Newport News VA

Maryland Hall for the Creative Arts, Chaney Gallery, Annapolis MD

Marylhurst University, The Art Gym, Marylhurst OR

Mason County Museum, Maysville KY

Mattatuck Historical Society, Mattatuck Museum, Waterbury CT

McLean County Historical Society, McLean County Museum of History, Bloomington IL

McMaster University, McMaster Museum of Art, Hamilton ON

Mendel Art Gallery & Civic Conservatory, Saskatoon SK

Menil Foundation, Inc, Houston TX

Mennello Museum of American Art, Orlando FL

Meredith College, Frankie G Weems Gallery & Rotunda Gallery, Raleigh NC

Meridian Museum of Art, Meridian MS

Mesa Arts Center, Mesa Contemporary Arts , Mesa AZ

The Metropolitan Museum of Art, New York NY

Mexican Fine Arts Center Museum, Chicago IL

Mexican Museum, San Francisco CA

Miami University, Art Museum, Oxford OH

Miami-Dade College, Kendal Campus, Art Gallery, Miami FL

James A Michener, Doylestown PA

Middle Border Museum & Oscar Howe Art Center, Mitchell SD

Middle Tennessee State University, Baldwin Photographic Gallery, Murfreesboro TN

Middlebury College, Museum of Art, Middlebury VT

Midwest Museum of American Art, Elkhart IN

Mills College, Art Museum, Oakland CA

Milwaukee Public Museum, Milwaukee WI

Minneapolis Institute of Arts, Minneapolis MN

Minnesota Museum of American Art, Saint Paul MN

Mint Museum of Art, Charlotte NC

Missoula Art Museum, Missoula MT

Arthur Roy Mitchell, Museum of Western Art, Trinidad CO

Moderna Galerija, Museum of Modern and Contemporary Art, Rijeka

Monhegan Museum, Monhegan ME

Montgomery Museum of Fine Arts, Montgomery AL

Moore College of Art & Design, The Galleries at Moore, Philadelphia PA

Moravian College, Payne Gallery, Bethlehem PA

Moravska Galerie v Brne, Moravian Gallery in Brno, Brno

Murray State University, Art Galleries, Murray KY

Muscatine Art Center, Museum, Muscatine IA

Musee Carnavalet-Histoir de Paris, Paris

Musee du Quebec, Quebec PQ

Musee Guimet, Paris

Musee Regional de la Cote-Nord, Sept-Iles PQ

Museo de Arte de Ponce, Ponce Art Museum, Ponce PR

Museo De Las Americas, Denver CO

Museu Nacional d'Art de Catalunya, National Art Museum, Barcelona

The Museum, Greenwood SC

Museum for African Art, Long Island City NY

Museum of Art & History, Santa Cruz, Santa Cruz CA

Museum of Contemporary Art, Chicago IL

The Museum of Contemporary Art (MOCA), Los Angeles CA

Museum of Contemporary Art, San Diego-Downtown, La Jolla CA

Museum of Fine Arts, Houston, Houston TX

Museum of Modern Art, New York NY

Museum of New Mexico, Museum of Fine Arts, Unit of NM Dept of Cultural Affairs, Santa Fe NM

Museum of Northern Arizona, Flagstaff AZ

Museum of Northwest Art, La Conner WA

Muzej za Umjetnost i Obrt, Museum of Arts & Crafts, Zagreb

Muzeum Narodowe, National Museum, Poznan

Muzeum Narodowe W Kielcach, National Museum in Kielce, Kielce

Nanticoke Indian Museum, Millsboro DE

Napa Valley Museum, Yountville CA

Narodna Galerija, National Gallery of Slovenia, Ljubljana

National Cowboy & Western Heritage Museum, Oklahoma City OK

National Gallery of Canada, Ottawa ON

National Museum of the American Indian, George Gustav Heye Center, New York NY

National Museum of Wildlife Art, Jackson WY

National Museum of Women in the Arts, Washington DC

National Museum, Monuments and Art Gallery, Gaborone

National Park Service, Hubbell Trading Post National Historic Site, Ganado AZ

The National Park Service, United States Department of the Interior, Statue of Liberty National Monument & The Ellis Island Immigration Museum, New York NY

Naval Historical Center, The Navy Museum, Washington DC

Nelson-Atkins Museum of Art, Kansas City MO

Nevada Museum of Art, Reno NV

Neville Public Museum, Green Bay WI

New Jersey Historical Society, Newark NJ

New Jersey State Museum, Fine Art Bureau, Trenton NJ

New Orleans Museum of Art, New Orleans LA

New Visions Gallery, Inc, Marshfield WI

New World Art Center, T F Chen Cultural Center, New York NY

New York State Historical Association, Fenimore Art Museum, Cooperstown NY

New York State Military Museum and Veterans Research Center, Saratoga Springs NY

New York State Office of Parks Recreation & Historic Preservation, John Jay Homestead State Historic Site, Katonah NY

Newburyport Maritime Society, Custom House Maritime Museum, Newburyport MA

Newport Art Museum, Newport RI

Newton History Museum at the Jackson Homestead, Newton MA

Niagara University, Castellani Art Museum, Niagara NY

Norfolk Historical Society Inc, Museum, Norfolk CT

Norman Rockwell Museum, Stockbridge MA

North Carolina State University, Visual Arts Center, Raleigh NC

North Dakota State University, Memorial Union Gallery, Fargo ND

Northern Kentucky University, Highland Heights KY

Noyes Art Gallery, Lincoln NE

Oakland Museum of California, Art Dept, Oakland CA

The Ogden Museum of Southern Art, University of New Orleans, New Orleans LA

Ohio Historical Society, National Afro American Museum & Cultural Center, Wilberforce OH

The Ohio Historical Society, Inc, Campus Martius Museum & Ohio River Museum, Marietta OH

Ohio University, Kennedy Museum of Art, Athens OH

Oklahoma City Museum of Art, Oklahoma City OK

Old Dartmouth Historical Society, New Bedford Whaling Museum, New Bedford MA

The Old Jail Art Center, Albany TX

Wichita State University, Ulrich Museum of Art & Martin H Bush Outdoor Sculpture Collection, Wichita KS

Wilfrid Laurier University, Robert Langen Art Gallery, Waterloo ON

Winston-Salem State University, Diggs Gallery, Winston-Salem NC

Wiregrass Museum of Art, Dothan AL

The Woman's Exchange, University Art Collection, New Orleans LA

Woodmere Art Museum, Philadelphia PA

Wounded Knee Museum, Wall SD

Yarmouth County Historical Society, Yarmouth County Museum, Yarmouth NS

Peter Yegen, Billings MT

Yeshiva University Museum, New York NY

Yosemite Museum, Yosemite National Park CA

PORCELAIN

Agecroft Association, Museum, Richmond VA

The American Ceramic Society, Ross C Purdy Museum of Ceramics, Westerville OH

American Kennel Club, Museum of the Dog, Saint Louis MO

American Swedish Institute, Minneapolis MN

Arizona Historical Society-Yuma, Sanguinetti House Museum & Garden, Yuma AZ

Art & Culture Center of Hollywood, Art Gallery, Hollywood FL

Art Community Center, Art Center of Corpus Christi, Corpus Christi TX

Art Gallery of South Australia, Adelaide

Art Museum of Greater Lafayette, Lafayette IN

Art Without Walls Inc, Art Without Walls Inc, Sayville NY

Asian Art Museum of San Francisco, Chong-Moon Lee Ctr for Asian Art and Culture, San Francisco CA

Association for the Preservation of Virginia Antiquities, John Marshall House, Richmond VA

Bayou Bend Collection & Gardens, Houston TX

Beaverbrook Art Gallery, Fredericton NB

Bellingrath Gardens & Home, Theodore AL

Beloit College, Wright Museum of Art, Beloit WI

Jesse Besser, Alpena MI

BJU Museum & Gallery, Bob Jones University Museum & Gallery Inc, Greenville SC

The Bradford Group, Niles IL

Brick Store Museum & Library, Kennebunk ME

Bruce Museum, Inc, Bruce Museum, Greenwich CT

Canadian Museum of Civilization, Gatineau PQ

Cape Ann Historical Association, Gloucester MA

Captain Forbes House Mus, Milton MA

Caramoor Center for Music & the Arts, Inc, Caramoor House Museum, Katonah NY

Chatillon-DeMenil House Foundation, DeMenil Mansion, Saint Louis MO

Cheekwood-Tennessee Botanical Garden & Museum of Art, Nashville TN

Cincinnati Institute of Fine Arts, Taft Museum of Art, Cincinnati OH

City of El Paso Museum and Cultural Affairs, People's Gallery, El Paso TX

City of Grand Rapids Michigan, Public Museum of Grand Rapids, Grand Rapids MI

Clark County Historical Society, Pioneer - Krier Museum, Ashland KS

Sterling & Francine Clark, Williamstown MA

College of William & Mary, Muscarelle Museum of Art, Williamsburg VA

The College of Wooster, The College of Wooster Art Museum, Wooster OH

Columbus Museum, Columbus GA

Columbus Museum of Art, Columbus OH

Columbus Museum of Art and Design, Indianapolis IN

Concord Museum, Concord MA

Cooper-Hewitt, National Design Museum, Smithsonian Institution, New York NY

Cornwall Gallery Society, Cornwall Regional Art Gallery, Cornwall ON

Craft and Folk Art Museum (CAFAM), Los Angeles CA

Cranbrook Art Museum, Cranbrook Art Museum, Bloomfield Hills MI

Cummer Museum of Art & Gardens, DeEtte Holden Cummer Museum Foundation, Jacksonville FL

The Currier Museum of Art, Currier Museum of Art, Manchester NH

DAR Museum, National Society Daughters of the American Revolution, Washington DC

Dartmouth Heritage Museum, Dartmouth NS

Detroit Institute of Arts, Detroit MI

The Dixon Gallery & Gardens, Memphis TN

Doncaster Museum and Art Gallery, Doncaster

Dundurn Castle, Hamilton ON

Ellen Noel Art Museum of the Permian Basin, Odessa TX

Elverhoj Museum of History and Art, Solvang CA

Erie Art Museum, Erie PA

Evanston Historical Society, Charles Gates Dawes House, Evanston IL

Everson Museum of Art, Syracuse NY

Fetherston Foundation, Packwood House Museum, Lewisburg PA

Fishkill Historical Society, Van Wyck Homestead Museum, Fishkill NY

Florida State University and Central Florida Community College, The Appleton Museum of Art, Ocala FL

Edsel & Eleanor Ford, Grosse Pointe Shores MI

Fort Smith Art Center, Fort Smith AR

Franklin Mint Museum, Franklin Center PA

The Frick Art & Historical Center, Frick Art Museum, Pittsburgh PA

Frick Collection, New York NY

Frontier Times Museum, Bandera TX

Gadsden Museum of Fine Arts, Inc, Gadsden Museum of Art and History, Gadsden AL

Galleria Doria Pamphilj, Rome

Gallery One, Ellensburg WA

General Board of Discipleship, The United Methodist Church, The Upper Room Chapel & Museum, Nashville TN

Germanisches Nationalmuseum, Nuremberg

Girard College, Stephen Girard Collection, Philadelphia PA

Glanmore National Historic Site of Canada, Belleville ON

Hammond-Harwood House Association, Inc, Hammond-Harwood House, Annapolis MD

Haystack Mountain School of Crafts, Deer Isle ME

Headley-Whitney Museum, Lexington KY

Headquarters Fort Monroe, Dept of Army, Casemate Museum, Fort Monroe VA

Henry County Museum & Cultural Arts Center, Clinton MO

Henry Sheldon Museum of Vermont History and Research Center, Middlebury VT

Hershey Museum, Hershey PA

Edna Hibel, Hibel Museum of Art, Jupiter FL

Hill-Stead Museum, Farmington CT

Hillwood Museum & Gardens Foundation, Hillwood Museum & Gardens, Washington DC

Historic Arkansas Museum, Little Rock AR

Historic Cherry Hill, Albany NY

Historic Landmarks Foundation of Indiana, Morris-Butler House, Indianapolis IN

Historisches und Volkerkundemuseum, Historical Museum, Sankt Gallen

Holter Museum of Art, Helena MT

Honolulu Academy of Arts, Honolulu HI

Huguenot Historical Society of New Paltz Galleries, New Paltz NY

Hui No eau Visual Arts Center, Gallery and Gift Shop, Makawao Maui HI

Iowa State University, Brunnier Art Museum, Ames IA

Jacksonville University, Alexander Brest Museum & Gallery, Jacksonville FL

James Dick Foundation, Festival - Institute, Round Top TX

Johns Hopkins University, Homewood House Museum, Baltimore MD

Kelly-Griggs House Museum, Red Bluff CA

Kereszteny Muzeum, Christian Museum, Esztergom

Knights of Columbus Supreme Council, Knights of Columbus Museum, New Haven CT

Knoxville Museum of Art, Knoxville TN

Koochiching Museums, International Falls MN

Kunstindustrimuseet, The Danish Museum of Art & Design, Copenhagen

Kyiv Museum of Russian Art, Kyiv

Lehigh County Historical Society, Allentown PA

Lehigh University Art Galleries, Museum Operation, Bethlehem PA

Lincoln County Historical Association, Inc, 1811 Old Lincoln County Jail & Lincoln County Museum, Wiscasset ME

Longfellow-Evangeline State Commemorative Area, Saint Martinville LA

Macalester College, Macalester College Art Gallery, Saint Paul MN

Maitland Art Center, Maitland FL

Marquette University, Haggerty Museum of Art, Milwaukee WI

Maryland Historical Society, Museum of Maryland History, Baltimore MD

Middle Border Museum & Oscar Howe Art Center, Mitchell SD

Mint Museum of Art, Mint Museum of Craft & Design, Charlotte NC

Mint Museum of Art, Charlotte NC

Montgomery Museum of Fine Arts, Montgomery AL

Moravska Galerie v Brne, Moravian Gallery in Brno, Brno

Municipal Museum De Lakenhal, Stedelisk Museum De Lakenhal, Leiden

Musee Cognacq-Jay, Cognacq-Jay Museum, Paris

Musee Guimet, Paris

Musee Regional de la Cote-Nord, Sept-Iles PQ

Musei Capitolini, Rome

Museo De Las Americas, Denver CO

The Museum, Greenwood SC

Museum of Fine Arts, Boston MA

Muzej za Umjetnost i Obrt, Museum of Arts & Crafts, Zagreb

Muzeum Narodowe W Kielcach, National Museum in Kielce, Kielce

Napoleonic Society of America, Museum & Library, Clearwater FL

National Museum of Ceramic Art & Glass, Baltimore MD

The National Museum of Fine Arts, Stockholm

National Museum, Monuments and Art Gallery, Gaborone

National Palace Museum, Taipei

National Society of Colonial Dames of America in the State of Maryland, Mount Clare Museum House, Baltimore MD

Naval Historical Center, The Navy Museum, Washington DC

Nemours Mansion & Gardens, Wilmington DE

Neville Public Museum, Green Bay WI

New Jersey State Museum, Fine Art Bureau, Trenton NJ

New Orleans Museum of Art, New Orleans LA

New Visions Gallery, Inc, Marshfield WI

North Carolina State University, Visual Arts Center, Raleigh NC

The Ohio Historical Society, Inc, Campus Martius Museum & Ohio River Museum, Marietta OH

Old York Historical Society, Old Gaol Museum, York ME

Pacific - Asia Museum, Pasadena CA

Palm Beach County Parks & Recreation Department, Morikami Museum & Japanese Gardens, Delray Beach FL

Panhandle-Plains Historical Society Museum, Canyon TX

Peabody Essex Museum, Salem MA

The Pennsylvania State University, Palmer Museum of Art, University Park PA

Penobscot Marine Museum, Searsport ME

Philadelphia Museum of Art, Philadelphia PA

Piedmont Arts Association, Martinsville VA

Porter-Phelps-Huntington Foundation, Inc, Historic House Museum, Hadley MA

Princeton University, Princeton University Art Museum, Princeton NJ

Pump House Center for the Arts, Chillicothe OH

Queens College, City University of New York, Godwin-Ternbach Museum, Flushing NY

Red Deer & District Museum & Archives, Red Deer AB

Frederic Remington, Ogdensburg NY

The Rosenbach Museum & Library, Philadelphia PA

Royal Arts Foundation, Belcourt Castle, Newport RI

Ryerss Victorian Museum & Library, Philadelphia PA

Saco Museum, Saco ME

Saginaw Art Museum, Saginaw MI

Saint Bonaventure University, Regina A Quick Center for the Arts, Saint Bonaventure NY

Saint John's University, Chung-Cheng Art Gallery, Jamaica NY

Saint Joseph's Oratory, Museum, Montreal PQ

Saint Peter's College, Art Gallery, Jersey City NJ

Seattle Art Museum, Seattle WA

Shirley Plantation, Charles City VA

Society of the Cincinnati, Museum & Library at Anderson House, Washington DC

South Carolina Artisans Center, Walterboro SC

Star-Spangled Banner Flag House Association, Museum, Baltimore MD

Nelda C & H J Lutcher Stark, Stark Museum of Art, Orange TX

State University of New York at Binghamton, University Art Museum, Binghamton NY

Staten Island Institute of Arts & Sciences, Staten Island NY

Stratford Historical Society, Catharine B Mitchell Museum, Stratford CT

Swedish-American Museum Association of Chicago, Chicago IL

Switzerland County Historical Society Inc, Switzerland County Historical Museum, Vevay IN

Tokyo National University of Fine Arts & Music Art, University Art Museum, Tokyo

Towson University Center for the Arts Gallery, Asian Arts & Culture Center, Towson MD

Trenton City Museum, Trenton NJ

Tryon Palace Historic Sites & Gardens, New Bern NC

US Department of State, Diplomatic Reception Rooms, Washington DC

United States Figure Skating Association, World Figure Skating Museum & Hall of Fame, Colorado Springs CO

University of California, Berkeley, Phoebe Apperson Hearst Museum of Anthropology, Berkeley CA

University of Illinois, Krannert Art Museum and Kinkead Pavillion, Champaign IL

University of Michigan, Museum of Art, Ann Arbor MI

University of Mississippi, University Museum, Oxford MS

University of Tampa, Henry B Plant Museum, Tampa FL

University of Victoria, Maltwood Art Museum and Gallery, Victoria BC

Vancouver Public Library, Fine Arts & Music Div, Vancouver BC

Vesterheim Norwegian-American Museum, Decorah IA

Victoria Mansion - Morse Libby House, Portland ME

Virginia Museum of Fine Arts, Richmond VA

Wallace Collection, London

Wayne Center for the Arts, Wooster OH

West Florida Historic Preservation, Inc, T T Wentworth, Jr Florida State Museum & Historic Pensacola Village, Pensacola FL

White House, Washington DC

Wichita Art Museum, Wichita KS

The Woman's Exchange, Gallier House Museum, New Orleans LA

Woodlawn/The Pope-Leighey, Mount Vernon VA

Woodmere Art Museum, Philadelphia PA

Yarmouth County Historical Society, Yarmouth County Museum, Yarmouth NS

Zamek Krolewski w Warszawie Pomnik Historii i Kultry Narodwej, Royal Castle in Warsaw, National History & Culture Memorial, Warsaw

PORTRAITS

Academy of the New Church, Glencairn Museum, Bryn Athyn PA

Adams County Historical Society, Gettysburg PA

Adams National Historic Park, Quincy MA

African American Museum in Philadelphia, Philadelphia PA

Agecroft Association, Museum, Richmond VA

Albany Institute of History & Art, Albany NY

American Kennel Club, Museum of the Dog, Saint Louis MO

Arizona Historical Society-Yuma, Sanguinetti House Museum & Garden, Yuma AZ

Art & Culture Center of Hollywood, Art Gallery, Hollywood FL

Art Community Center, Art Center of Corpus Christi, Corpus Christi TX

Art Museum of Greater Lafayette, Lafayette IN

Art Without Walls Inc, Art Without Walls Inc, Sayville NY

Arts Council of Fayetteville-Cumberland County, The Arts Center, Fayetteville NC

Asbury College, Student Center Gallery, Wilmore KY

Asheville Art Museum, Asheville NC

Ashland Historical Society, Ashland MA

Asian Art Museum of San Francisco, Chong-Moon Lee Ctr for Asian Art and Culture, San Francisco CA

Association for the Preservation of Virginia Antiquities, John Marshall House, Richmond VA

Bakehouse Art Complex, Inc, Miami FL

The Baltimore Museum of Art, Baltimore MD

The Bartlett Museum, Amesbury MA

Bayou Bend Collection & Gardens, Houston TX

Beaverbrook Art Gallery, Fredericton NB

Beloit College, Wright Museum of Art, Beloit WI

Biggs Museum of American Art, Dover DE

BJU Museum & Gallery, Bob Jones University Museum & Gallery Inc, Greenville SC

Blauvelt Demarest Foundation, Hiram Blauvelt Art Museum, Oradell NJ

Boston Public Library, Albert H Wiggin Gallery & Print Department, Boston MA

Brick Store Museum & Library, Kennebunk ME

Brigham Young University, Museum of Art, Provo UT

Bruce Museum, Inc, Bruce Museum, Greenwich CT

Cabot's Old Indian Pueblo Museum, Cabot's Old Indian Pueblo Museum, Desert Hot Springs CA

Cahoon Museum of American Art, Cotuit MA

Cameron Art Museum, Wilmington NC

Canadian Museum of Civilization, Gatineau PQ

Canadian Museum of Contemporary Photography, Ottawa ON

Canajoharie Library & Art Gallery, Arkell Museum of Canajoharie, Canajoharie NY

Canton Museum of Art, Canton OH

Cape Ann Historical Association, Gloucester MA

Caramoor Center for Music & the Arts, Inc, Caramoor House Museum, Katonah NY

Carolina Art Association, Gibbes Museum of Art, Charleston SC

Cartoon Art Museum, San Francisco CA

Cedar Rapids Museum of Art, Cedar Rapids IA

Chatillon-DeMenil House Foundation, DeMenil Mansion, Saint Louis MO

Chelan County Public Utility District, Rocky Reach Dam, Wenatchee WA

Church of Jesus Christ of Latter-Day Saints, Mormon Visitors' Center, Independence MO

Church of Jesus Christ of Latter-Day Saints, Museum of Church History & Art, Salt Lake City UT

Cincinnati Institute of Fine Arts, Taft Museum of Art, Cincinnati OH

City of Cedar Falls, Iowa, James & Meryl Hearst Center for the Arts, Cedar Falls IA

City of Fayette, Alabama, Fayette Art Museum, Fayette AL

City of Gainesville, Thomas Center Galleries - Cultural Affairs, Gainesville FL

City of Grand Rapids Michigan, Public Museum of Grand Rapids, Grand Rapids MI

The City of Petersburg Museums, Petersburg VA

City of Toronto Culture Division, The Market Gallery, Toronto ON

Clark County Historical Society, Pioneer - Krier Museum, Ashland KS

Cohasset Historical Society, Cohasset Maritime Museum, Cohasset MA

College of William & Mary, Muscarelle Museum of Art, Williamsburg VA

The College of Wooster, The College of Wooster Art Museum, Wooster OH

Colorado Springs Fine Arts Center, Colorado Springs CO

Columbus Museum, Columbus GA

Columbus Museum of Art, Columbus OH

Columbus Museum of Art and Design, Indianapolis IN

Concord Museum, Concord MA

Cornwall Gallery Society, Cornwall Regional Art Gallery, Cornwall ON

Crow Wing County Historical Society, Brainerd MN

The Currier Museum of Art, Currier Museum of Art, Manchester NH

Danville Museum of Fine Arts & History, Danville VA

DAR Museum, National Society Daughters of the American Revolution, Washington DC

Dartmouth Heritage Museum, Dartmouth NS

Delaware Art Museum, Wilmington DE

Delaware Division of Historical & Cultural Affairs, Dover DE

Detroit Institute of Arts, Detroit MI

Detroit Repertory Theatre Gallery, Detroit MI

DeWitt Historical Society of Tompkins County, The History Center in Tompkins Co, Ithaca NY

Dickinson College, The Trout Gallery, Carlisle PA

Dixie State College, Robert N & Peggy Sears Gallery, Saint George UT

Dundurn Castle, Hamilton ON

Durham Art Guild Inc, Durham NC

Egan Institute of Maritime Studies, Nantucket MA

Eiteljorg Museum of American Indians & Western Art, Indianapolis IN

Ellen Noel Art Museum of the Permian Basin, Odessa TX

Elmhurst Art Museum, Elmhurst IL

Erie County Historical Society, Erie PA

Evanston Historical Society, Charles Gates Dawes House, Evanston IL

Everson Museum of Art, Syracuse NY

Fetherston Foundation, Packwood House Museum, Lewisburg PA

Fishkill Historical Society, Van Wyck Homestead Museum, Fishkill NY

Fitton Center for Creative Arts, Hamilton OH

Florida State University and Central Florida Community College, The Appleton Museum of Art, Ocala FL

Fort Ticonderoga Association, Ticonderoga NY

Frontier Times Museum, Bandera TX

Fuller Museum of Art, Brockton MA

Gadsden Museum of Fine Arts, Inc, Gadsden Museum of Art and History, Gadsden AL

Thomas Gilcrease, Gilcrease Museum, Tulsa OK

Glanmore National Historic Site of Canada, Belleville ON

Greene County Historical Society, Bronck Museum, Coxsackie NY

Greenville County Museum of Art, Greenville SC

Grevemberg House Museum, Franklin LA

Robert Gumbiner, Museum of Latin American Art, Long Beach CA

Hancock County Trustees of Public Reservations, Woodlawn Museum, Ellsworth ME

Headquarters Fort Monroe, Dept of Army, Casemate Museum, Fort Monroe VA

Henry County Museum & Cultural Arts Center, Clinton MO

Patrick Henry, Red Hill National Memorial, Brookneal VA

Henry Sheldon Museum of Vermont History and Research Center, Middlebury VT

Heritage Center of Lancaster County Museum, Lancaster PA

Hidalgo County Historical Museum, Edinburg TX

Hillwood Museum & Gardens Foundation, Hillwood Museum & Gardens, Washington DC

Historic Arkansas Museum, Little Rock AR

Historic Cherry Hill, Albany NY

Historic Landmarks Foundation of Indiana, Morris-Butler House, Indianapolis IN

Huguenot Historical Society of New Paltz Galleries, New Paltz NY

Illinois Historic Preservation Agency, Bishop Hill State Historic Site, Bishop Hill IL

Independence National Historical Park, Philadelphia PA

Iredell Museum of Arts & Heritage, Statesville NC

Jekyll Island Museum, Jekyll Island GA

John Weaver Sculpture Collection, Hope BC

Joslyn Art Museum, Omaha NE

Kalamazoo Institute of Arts, Kalamazoo MI

Kansas City Art Institute, Kansas City MO

Kentucky Museum of Art & Craft, Louisville KY

Knights of Columbus Supreme Council, Knights of Columbus Museum, New Haven CT

Knoxville Museum of Art, Knoxville TN

Koochiching Museums, International Falls MN

Koshare Indian Museum, Inc, La Junta CO

Kyiv Museum of Russian Art, Kyiv

Lafayette College, Williams Center Gallery, Easton PA

Lehigh County Historical Society, Allentown PA

Lehigh University Art Galleries, Museum Operation, Bethlehem PA

LeSueur County Historical Society, Chapter One, Elysian MN

Lincoln County Historical Association, Inc, 1811 Old Lincoln County Jail & Lincoln County Museum, Wiscasset ME

Livingston County Historical Society, Cobblestone Museum, Geneseo NY

Longfellow-Evangeline State Commemorative Area, Saint Martinville LA

Longview Museum of Fine Art, Longview TX

Luther College, Fine Arts Collection, Decorah IA

Charles H MacNider, Mason City IA

Jacques Marchais, Staten Island NY

The Mariners' Museum, Newport News VA

Marylhurst University, The Art Gym, Marylhurst OR

Mason County Museum, Maysville KY

Mattatuck Historical Society, Mattatuck Museum, Waterbury CT

McDowell House & Apothecary Shop, Danville KY

Mendel Art Gallery & Civic Conservatory, Saskatoon SK

Mexican Museum, San Francisco CA

Middlebury College, Museum of Art, Middlebury VT

Midwest Museum of American Art, Elkhart IN

Minnesota Museum of American Art, Saint Paul MN
Mint Museum of Art, Charlotte NC
Arthur Roy Mitchell, Museum of Western Art, Trinidad CO
James Monroe, Fredericksburg VA
Montgomery Museum of Fine Arts, Montgomery AL
Moore College of Art & Design, The Galleries at Moore, Philadelphia PA
Moravian Historical Society, Whitefield House Museum, Nazareth PA
Morris Museum of Art, Augusta GA
Morris-Jumel Mansion, Inc, New York NY
Municipal Museum De Lakenhal, Stedelisk Museum De Lakenhal, Leiden
Munson-Williams-Proctor Arts Institute, Museum of Art, Utica NY
Murray State University, Art Galleries, Murray KY
Muscatine Art Center, Museum, Muscatine IA
Musee Carnavalet-Histoir de Paris, Paris
Musee Cognacq-Jay, Cognacq-Jay Museum, Paris
Musee du Quebec, Quebec PQ
Musee Regional de la Cote-Nord, Sept-Iles PQ
Musee Regional de Vaudreuil-Soulanges, Vaudreuil PQ
Museo De Las Americas, Denver CO
Museu Nacional de Arte Contemporanea, National Museum of Contemporary Art, Museu Do Chiado, Lisbon
Muzej za Umjetnost i Obrt, Museum of Arts & Crafts, Zagreb
Muzeum Narodowe, National Museum, Poznan
Muzeum Narodowe W Kielcach, National Museum in Kielce, Kielce
Narodna Galerija, National Gallery of Slovenia, Ljubljana
National Cowboy & Western Heritage Museum, Oklahoma City OK
National Gallery of Canada, Ottawa ON
The National Museum of Fine Arts, Stockholm
National Museum, Monuments and Art Gallery, Gaborone
National Palace Museum, Taipei
National Society of the Colonial Dames of America in The Commonwealth of Virginia, Wilton House Museum, Richmond VA
National Trust for Historic Preservation, Chesterwood Estate & Museum, Stockbridge MA
Naval Historical Center, The Navy Museum, Washington DC
Nemours Mansion & Gardens, Wilmington DE
Nevada Museum of Art, Reno NV
New Jersey Historical Society, Newark NJ
New Jersey State Museum, Fine Art Bureau, Trenton NJ
New Orleans Museum of Art, New Orleans LA
New World Art Center, T F Chen Cultural Center, New York NY
New York State Historical Association, Fenimore Art Museum, Cooperstown NY
New York State Military Museum and Veterans Research Center, Saratoga Springs NY
New York State Office of Parks Recreation & Historic Preservation, John Jay Homestead State Historic Site, Katonah NY
Newburyport Maritime Society, Custom House Maritime Museum, Newburyport MA
Newton History Museum at the Jackson Homestead, Newton MA
Elisabet Ney, Austin TX
Norfolk Historical Society Inc, Museum, Norfolk CT
Norman Rockwell Museum, Stockbridge MA
North Dakota State University, Memorial Union Gallery, Fargo ND
Noyes Art Gallery, Lincoln NE
The Ohio Historical Society, Inc, Campus Martius Museum & Ohio River Museum, Marietta OH
Oklahoma City Museum of Art, Oklahoma City OK
Old Dartmouth Historical Society, New Bedford Whaling Museum, New Bedford MA
Old York Historical Society, Old Gaol Museum, York ME
Oshkosh Public Museum, Oshkosh WI
Owensboro Museum of Fine Art, Owensboro KY
Panhandle-Plains Historical Society Museum, Canyon TX
The Pennsylvania State University, Palmer Museum of Art, University Park PA
Pensacola Museum of Art, Pensacola FL
Philipse Manor Hall State Historic Site, Yonkers NY
Phoenix Art Museum, Phoenix AZ
Piedmont Arts Association, Martinsville VA
Pinacoteca Provinciale, Bari

Plainsman Museum, Aurora NE
Pope County Historical Society, Pope County Museum, Glenwood MN
Port Huron Museum, Port Huron MI
Porter-Phelps-Huntington Foundation, Inc, Historic House Museum, Hadley MA
Presidential Museum, Odessa TX
Princeton University, Princeton University Art Museum, Princeton NJ
Pump House Center for the Arts, Chillicothe OH
Queens College, City University of New York, Godwin-Ternbach Museum, Flushing NY
R W Norton Art Foundation, Shreveport LA
Rawls Museum Arts, Courtland VA
Riley County Historical Society, Riley County Historical Museum, Manhattan KS
Ross Memorial Museum, Saint Andrews NB
Royal Ontario Museum, Dept of Western Art & Culture, Toronto ON
C M Russell, Great Falls MT
Saco Museum, Saco ME
Saginaw Art Museum, Saginaw MI
Saint Peter's College, Art Gallery, Jersey City NJ
Shirley Plantation, Charles City VA
R L S Silverado Museum, Saint Helena CA
Abigail Adams Smith, New York NY
Smithsonian Institution, Washington DC
Society of the Cincinnati, Museum & Library at Anderson House, Washington DC
Sonoma State University, University Art Gallery, Rohnert Park CA
Southern Lorain County Historical Society, Spirit of '76 Museum, Elyria OH
Spartanburg County Museum of Art, Spartanburg SC
Springfield Art Museum, Springfield MO
Stanford University, Iris & B Gerald Cantor Center for Visual Arts, Stanford CA
State University of New York College at Cortland, Dowd Fine Arts Gallery, Cortland NY
Staten Island Institute of Arts & Sciences, Staten Island NY
Stratford Historical Society, Catharine B Mitchell Museum, Stratford CT
Gilbert Stuart, Museum, Saunderstown RI
Summit County Historical Society, Akron OH
Swedish-American Museum Association of Chicago, Chicago IL
Switzerland County Historical Society Inc, Switzerland County Historical Museum, Vevay IN
Tampa Museum of Art, Tampa FL
Taos, Ernest Blumenschein Home & Studio, Taos NM
Telfair Museum of Art, Savannah GA
The Temple-Tifereth Israel, The Temple Museum of Religious Art, Beachwood OH
Terra Museum of American Art, Chicago IL
Texas Tech University, Museum of Texas Tech University, Lubbock TX
Transylvania University, Morlan Gallery, Lexington KY
Tryon Palace Historic Sites & Gardens, New Bern NC
Tubac Center of the Arts, Tubac AZ
Tucson Museum of Artand Historic Block, Tucson AZ
Mark Twain, State Historic Site Museum, Florida MO
United States Capitol, Architect of the Capitol, Washington DC
University of Alabama at Birmingham, Visual Arts Gallery, Birmingham AL
University of California, Berkeley, Phoebe Apperson Hearst Museum of Anthropology, Berkeley CA
University of Cincinnati, DAAP Galleries-College of Design Architecture, Art & Planning, Cincinnati OH
University of Illinois, Krannert Art Museum and Kinkead Pavillion, Champaign IL
University of Louisiana at Lafayette, University Art Museum, Lafayette LA
University of Maine, Museum of Art, Bangor ME
University of Manitoba, Faculty of Architecture Exhibition Centre, Winnipeg MB
University of Michigan, Museum of Art, Ann Arbor MI
University of Mississippi, University Museum, Oxford MS
University of Nebraska, Lincoln, Sheldon Memorial Art Gallery & Sculpture Garden, Lincoln NE
University of New Mexico, The Harwood Museum of Art, Taos NM
University of Saskatchewan, Diefenbaker Canada Centre, Saskatoon SK
University of Southern California, Fisher Gallery, Los Angeles CA
University of Utah, Utah Museum of Fine Arts, Salt Lake City UT

University of Victoria, Maltwood Art Museum and Gallery, Victoria BC
Ursinus College, Philip & Muriel Berman Museum of Art, Collegeville PA
USS Constitution Museum, Boston MA
Vesterheim Norwegian-American Museum, Decorah IA
Viridian Artists Inc, New York NY
Warner House Association, MacPheadris-Warner House, Portsmouth NH
Washington & Lee University, Lee Chapel & Museum, Lexington VA
George Washington, Alexandria VA
Washington University, Mildred Lane Kemper Art Museum, Saint Louis MO
Waterworks Visual Arts Center, Salisbury NC
Wayne County Historical Society, Museum, Honesdale PA
Wayne County Historical Society, Honesdale PA
Wellesley College, Davis Museum & Cultural Center, Wellesley MA
West Florida Historic Preservation, Inc, T T Wentworth, Jr Florida State Museum & Historic Pensacola Village, Pensacola FL
Whatcom Museum of History and Art, Bellingham WA
White House, Washington DC
Wilfrid Laurier University, Robert Langen Art Gallery, Waterloo ON
Willard House & Clock Museum, Inc, North Grafton MA
Wisconsin Historical Society, State Historical Museum, Madison WI
Wistariahurst Museum, Holyoke MA
Woodlawn/The Pope-Leighey, Mount Vernon VA
Woodmere Art Museum, Philadelphia PA
Yarmouth County Historical Society, Yarmouth County Museum, Yarmouth NS
Zamek Krolewski w Warszawie Pomnik Historii i Kultry Narodwej, Royal Castle in Warsaw, National History & Culture Memorial, Warsaw

POSTERS

African American Museum in Philadelphia, Philadelphia PA
Algonquin Arts Council, Art Gallery of Bancroft, Bancroft ON
American Kennel Club, Museum of the Dog, Saint Louis MO
American University, Katzen Art Center Gallery, Washington DC
Arab American National Museum, Dearborn MI
Art & Culture Center of Hollywood, Art Gallery, Hollywood FL
Art Without Walls Inc, Art Without Walls Inc, Sayville NY
Arts Council of Fayetteville-Cumberland County, The Arts Center, Fayetteville NC
Asheville Art Museum, Asheville NC
Jesse Besser, Alpena MI
Boston Public Library, Albert H Wiggin Gallery & Print Department, Boston MA
Brigham Young University, Museum of Art, Provo UT
Bruce Museum, Inc, Bruce Museum, Greenwich CT
The Buffalo Fine Arts Academy, Albright-Knox Art Gallery, Buffalo NY
C W Post Campus of Long Island University, Hillwood Art Museum, Brookville NY
Canadian Museum of Civilization, Gatineau PQ
Canadian Museum of Nature, Musee Canadien de la Nature, Ottawa ON
Cartoon Art Museum, San Francisco CA
Radio-Canada SRC CBC, Georges Goguen CBC Art Gallery, Moncton NB
Center for Puppetry Arts, Atlanta GA
Central United Methodist Church, Swords Into Plowshares Peace Center & Gallery, Detroit MI
Chicago Athenaeum, Museum of Architecture & Design, Galena IL
City of Cedar Falls, Iowa, James & Meryl Hearst Center for the Arts, Cedar Falls IA
Columbus Museum, Columbus GA
Cooper-Hewitt, National Design Museum, Smithsonian Institution, New York NY
Craft and Folk Art Museum (CAFAM), Los Angeles CA
Dartmouth Heritage Museum, Dartmouth NS
Delaware Art Museum, Wilmington DE
Delaware Division of Historical & Cultural Affairs, Dover DE
Detroit Institute of Arts, Detroit MI

POTTERY

Galleria Doria Pamphilj, Rome
Gallery One, Ellensburg WA
Germanisches Nationalmuseum, Nuremberg
Thomas Gilcrease, Gilcrease Museum, Tulsa OK
Gonzaga University, Art Gallery, Spokane WA
Greene County Historical Society, Bronck Museum, Coxsackie NY
Grossmont Community College, Hyde Art Gallery, El Cajon CA
Halifax Historical Society, Inc, Halifax Historical Museum, Daytona Beach FL
Harvard University, Dumbarton Oaks Research Library & Collections, Washington DC
Heard Museum, Phoenix AZ
Henry County Museum & Cultural Arts Center, Clinton MO
Henry Sheldon Museum of Vermont History and Research Center, Middlebury VT
Heritage Museum Association, Inc, The Heritage Museum of Northwest Florida, Valparaiso FL
Hermitage Foundation Museum, Norfolk VA
Hershey Museum, Hershey PA
Hickory Museum of Art, Inc, Hickory NC
High Point Historical Society Inc, Museum, High Point NC
Hillwood Museum & Gardens Foundation, Hillwood Museum & Gardens, Washington DC
Hispanic Society of America, Museum & Library, New York NY
Historic Cherry Hill, Albany NY
Historical Society of Cheshire County, Keene NH
Historical Society of the Town of Greenwich, Inc, Bush-Holley House Museum, Cos Cob CT
Holter Museum of Art, Helena MT
Hoyt Institute of Fine Arts, New Castle PA
Huguenot Historical Society of New Paltz Galleries, New Paltz NY
Hui No eau Visual Arts Center, Gallery and Gift Shop, Makawao Maui HI
Imperial Calcasieu Museum, Gibson-Barham Gallery, Lake Charles LA
Institute of American Indian Arts Museum, Museum, Santa Fe NM
Iowa State University, Brunnier Art Museum, Ames IA
Iredell Museum of Arts & Heritage, Statesville NC
Iroquois Indian Museum, Howes Cave NY
Irving Arts Center, Main Gallery & Focus Gallery, Irving TX
John B Aird Gallery, Toronto ON
Johnson-Humrickhouse Museum, Coshocton OH
Joslyn Art Museum, Omaha NE
Kenosha Public Museum, Kenosha WI
Kentucky Museum of Art & Craft, Louisville KY
Koochiching Museums, International Falls MN
Koshare Indian Museum, Inc, La Junta CO
Kunstindustrimuseet, The Danish Museum of Art & Design, Copenhagen
L A County Museum of Art, Los Angeles CA
Lafayette College, Williams Center Gallery, Easton PA
LeSueur County Historical Society, Chapter One, Elysian MN
Livingston County Historical Society, Cobblestone Museum, Geneseo NY
Longfellow-Evangeline State Commemorative Area, Saint Martinville LA
Luther College, Fine Arts Collection, Decorah IA
Macalester College, Macalester College Art Gallery, Saint Paul MN
Charles H MacNider, Mason City IA
Maitland Art Center, Maitland FL
The Mariners' Museum, Newport News VA
Maryland Historical Society, Museum of Maryland History, Baltimore MD
Mason County Museum, Maysville KY
McDowell House & Apothecary Shop, Danville KY
Meridian Museum of Art, Meridian MS
Mesa Arts Center, Mesa Contemporary Arts , Mesa AZ
Metropolitan Museum of Manila, Manila
Mexican Museum, San Francisco CA
Middle Border Museum & Oscar Howe Art Center, Mitchell SD
Midwest Museum of American Art, Elkhart IN
Mills College, Art Museum, Oakland CA
Minnesota Museum of American Art, Saint Paul MN
Mint Museum of Art, Mint Museum of Craft & Design, Charlotte NC
Mississippi River Museum at Mud-Island River Park, Memphis TN
Arthur Roy Mitchell, Museum of Western Art, Trinidad CO

Moravska Galerie v Brne, Moravian Gallery in Brno, Brno
Morehead State University, Kentucky Folk Art Center, Morehead KY
Morris Museum, Morristown NJ
Mount Saint Vincent University, Art Gallery, Halifax NS
Munson-Williams-Proctor Arts Institute, Museum of Art, Utica NY
Muscatine Art Center, Museum, Muscatine IA
Musee Guimet, Paris
Musee Regional de la Cote-Nord, Sept-Iles PQ
Musee Regional de Vaudreuil-Soulanges, Vaudreuil PQ
The Museum, Greenwood SC
Museum for African Art, Long Island City NY
Museum of Art & History, Santa Cruz, Santa Cruz CA
Museum of Northern Arizona, Flagstaff AZ
Muzej za Umjetnost i Obrt, Museum of Arts & Crafts, Zagreb
Muzeum Narodowe, National Museum, Poznan
Muzeum Narodowe W Kielcach, National Museum in Kielce, Kielce
Nanticoke Indian Museum, Millsboro DE
National Cowboy & Western Heritage Museum, Oklahoma City OK
National Museum of Ceramic Art & Glass, Baltimore MD
National Museum of the American Indian, George Gustav Heye Center, New York NY
National Museum, Monuments and Art Gallery, Gaborone
National Palace Museum, Taipei
Navajo Nation, Navajo Nation Museum, Window Rock AZ
Nemours Mansion & Gardens, Wilmington DE
New Jersey State Museum, Fine Art Bureau, Trenton NJ
New Visions Gallery, Inc, Marshfield WI
North Carolina State University, Visual Arts Center, Raleigh NC
North Dakota State University, Memorial Union Gallery, Fargo ND
Noyes Art Gallery, Lincoln NE
The Noyes Museum of Art, Oceanville NJ
Ohio Historical Society, National Road-Zane Grey Museum, Columbus OH
The Ohio Historical Society, Inc, Campus Martius Museum & Ohio River Museum, Marietta OH
Ohio University, Kennedy Museum of Art, Athens OH
Olana State Historic Site, Hudson NY
Oshkosh Public Museum, Oshkosh WI
Pacific - Asia Museum, Pasadena CA
Palm Beach County Parks & Recreation Department, Morikami Museum & Japanese Gardens, Delray Beach FL
Palm Springs Art Museum, Palm Springs CA
Paris Gibson Square, Museum of Art, Great Falls MT
Peoria Historical Society, Peoria IL
The Frank Phillips, Woolaroc Museum, Bartlesville OK
George Phippen, Phippen Art Museum, Prescott AZ
Piedmont Arts Association, Martinsville VA
Pinacoteca Provinciale, Bari
Potsdam Public Museum, Potsdam NY
Princeton University, Princeton University Art Museum, Princeton NJ
Pump House Center for the Arts, Chillicothe OH
Queens College, City University of New York, Godwin-Ternbach Museum, Flushing NY
R W Norton Art Foundation, Shreveport LA
Rawls Museum Arts, Courtland VA
Millicent Rogers, Taos NM
Roswell Museum & Art Center, Roswell NM
C M Russell, Great Falls MT
Saginaw Art Museum, Saginaw MI
Saint Bonaventure University, Regina A Quick Center for the Arts, Saint Bonaventure NY
Seneca-Iroquois National Museum, Salamanca NY
Shirley Plantation, Charles City VA
Abigail Adams Smith, New York NY
South Carolina Artisans Center, Walterboro SC
South Dakota State University, South Dakota Art Museum, Brookings SD
Southern Baptist Theological Seminary, Joseph A Callaway Archaeological Museum, Louisville KY
Spartanburg County Museum of Art, Spartanburg SC
Springfield Art Museum, Springfield MO
Stanford University, Iris & B Gerald Cantor Center for Visual Arts, Stanford CA
State University of New York at New Paltz, Samuel Dorsky Museum of Art, New Paltz NY

State University of New York at Oswego, Tyler Art Gallery, Oswego NY
Staten Island Institute of Arts & Sciences, Staten Island NY
Summit County Historical Society, Akron OH
Swedish-American Museum Association of Chicago, Chicago IL
Switzerland County Historical Society Inc, Switzerland County Historical Museum, Vevay IN
Tallahassee Museum of History & Natural Science, Tallahassee FL
Tampa Museum of Art, Tampa FL
Taos, Ernest Blumenschein Home & Studio, Taos NM
The Temple-Tifereth Israel, The Temple Museum of Religious Art, Beachwood OH
Texas Tech University, Museum of Texas Tech University, Lubbock TX
Tokyo National University of Fine Arts & Music Art, University Art Museum, Tokyo
Topeka & Shawnee County Public Library, Alice C Sabatini Gallery, Topeka KS
Towson University Center for the Arts Gallery, Asian Arts & Culture Center, Towson MD
Tucson Museum of Artand Historic Block, Tucson AZ
The Ukrainian Museum, New York NY
United Society of Shakers, Shaker Museum, New Glocester ME
University of California, Berkeley, Phoebe Apperson Hearst Museum of Anthropology, Berkeley CA
University of Chicago, Oriental Institute Museum, Chicago IL
University of Delaware, University Gallery, Newark DE
University of Illinois, Krannert Art Museum and Kinkead Pavillion, Champaign IL
University of Iowa, Museum of Art, Iowa City IA
University of Louisiana at Lafayette, University Art Museum, Lafayette LA
University of Manitoba, Faculty of Architecture Exhibition Centre, Winnipeg MB
University of Massachusetts, Amherst, University Gallery, Amherst MA
University of Michigan, Kelsey Museum of Archaeology, Ann Arbor MI
Ursinus College, Philip & Muriel Berman Museum of Art, Collegeville PA
Vesterheim Norwegian-American Museum, Decorah IA
Virginia Museum of Fine Arts, Richmond VA
Wake Forest University, Museum of Anthropology, Winston-Salem NC
Waterworks Visual Arts Center, Salisbury NC
West Florida Historic Preservation, Inc, T T Wentworth, Jr Florida State Museum & Historic Pensacola Village, Pensacola FL
Wheelwright Museum of the American Indian, Santa Fe NM
Winston-Salem State University, Diggs Gallery, Winston-Salem NC
The Woman's Exchange, Newcomb Art Gallery-Carroll Gallery, New Orleans LA
The Woman's Exchange, University Art Collection, New Orleans LA

PRE-COLUMBIAN ART

Americas Society Art Gallery, New York NY
Anchorage Museum at Rasmuson Center, Anchorage AK
Art & Culture Center of Hollywood, Art Gallery, Hollywood FL
Art Association of Jacksonville, David Strawn Art Gallery, Jacksonville IL
Art Without Walls Inc, Art Without Walls Inc, Sayville NY
Aurora University, Schingoethe Center for Native American Cultures, Aurora IL
The Baltimore Museum of Art, Baltimore MD
Birmingham Museum of Art, Birmingham AL
Bowers Museum of Cultural Art, Bowers Museum, Santa Ana CA
Brandeis University, Rose Art Museum, Waltham MA
C W Post Campus of Long Island University, Hillwood Art Museum, Brookville NY
California State University Stanislaus, University Art Gallery, Turlock CA
California State University, East Bay, C E Smith Museum of Anthropology, Hayward CA
California State University, Northridge, Art Galleries, Northridge CA
Center for Puppetry Arts, Atlanta GA

PRIMITIVE ART

PRINTS

Appaloosa Museum and Heritage Center, Moscow ID
Arizona State University, ASU Art Museum, Tempe AZ
Art Complex Museum, Carl A. Weyerhaeuser Library, Duxbury MA
The Art Galleries of Ramapo College, Mahwah NJ
Art Gallery of Nova Scotia, Halifax NS
Art Gallery of South Australia, Adelaide
Art Museum of Greater Lafayette, Lafayette IN
Art Museum of Western Virginia, Roanoke VA
Art Without Walls Inc, Art Without Walls Inc, Sayville NY
Artspace, Richmond VA
Asbury College, Student Center Gallery, Wilmore KY
Asheville Art Museum, Asheville NC
Attleboro Museum, Center for the Arts, Attleboro MA
Augustana College, Augustana College Art Museum, Rock Island IL
Austin College, Ida Green Gallery, Sherman TX
Baldwin-Wallace College, Fawick Art Gallery, Berea OH
The Baltimore Museum of Art, Baltimore MD
Bates College, Museum of Art, Lewiston ME
Bayou Bend Collection & Gardens, Houston TX
Jesse Besser, Alpena MI
Birger Sandzen Memorial Gallery, Lindsborg KS
Blauvelt Demarest Foundation, Hiram Blauvelt Art Museum, Oradell NJ
Boston Public Library, Albert H Wiggin Gallery & Print Department, Boston MA
Roy Boyd, Chicago IL
Brandeis University, Rose Art Museum, Waltham MA
Brandywine River Museum, Chadds Ford PA
Brigham City Corporation, Brigham City Museum & Gallery, Brigham City UT
Brigham Young University, B F Larsen Gallery, Provo UT
Brigham Young University, Museum of Art, Provo UT
Bradford Brinton, Big Horn WY
Brown University, David Winton Bell Gallery, Providence RI
Bruce Museum, Inc, Bruce Museum, Greenwich CT
Burke Arts Council, Jailhouse Galleries, Morganton NC
Burnaby Art Gallery, Burnaby BC
Butler Institute of American Art, Art Museum, Youngstown OH
C W Post Campus of Long Island University, Hillwood Art Museum, Brookville NY
California State University, Northridge, Art Galleries, Northridge CA
Calvin College, Center Art Gallery, Grand Rapids MI
Cameron Art Museum, Wilmington NC
Canadian Museum of Civilization, Gatineau PQ
Canadian Museum of Contemporary Photography, Ottawa ON
Canadian Museum of Nature, Musee Canadien de la Nature, Ottawa ON
Canajoharie Library & Art Gallery, Arkell Museum of Canajoharie, Canajoharie NY
Cape Cod Museum of Art Inc, Dennis MA
Carleton College, Art Gallery, Northfield MN
Carnegie Mellon University, Hunt Institute for Botanical Documentation, Pittsburgh PA
Carnegie Museums of Pittsburgh, Carnegie Museum of Art, Pittsburgh PA
Carolina Art Association, Gibbes Museum of Art, Charleston SC
Carson County Square House Museum, Panhandle TX
Amon Carter, Fort Worth TX
Cartoon Art Museum, San Francisco CA
Radio-Canada SRC CBC, Georges Goguen CBC Art Gallery, Moncton NB
Cedar Rapids Museum of Art, Cedar Rapids IA
Central United Methodist Church, Swords Into Plowshares Peace Center & Gallery, Detroit MI
Chattahoochee Valley Art Museum, LaGrange GA
Chesapeake Bay Maritime Museum, Saint Michaels MD
Chinese Culture Foundation, Center Gallery, San Francisco CA
Cincinnati Museum Association and Art Academy of Cincinnati, Cincinnati Art Museum, Cincinnati OH
City of Cedar Falls, Iowa, James & Meryl Hearst Center for the Arts, Cedar Falls IA
City of Fremont, Olive Hyde Art Gallery, Fremont CA
City of Grand Rapids Michigan, Public Museum of Grand Rapids, Grand Rapids MI
The City of Petersburg Museums, Petersburg VA
City of Pittsfield, Berkshire Artisans, Pittsfield MA
City of Toronto Culture Division, The Market Gallery, Toronto ON
Clinton Art Association, River Arts Center, Clinton IA

College of Eastern Utah, Gallery East, Price UT
College of New Jersey, Art Gallery, Trenton NJ
College of Saint Benedict, Art Gallery, Saint Joseph MN
College of Saint Rose, Art Gallery, Albany NY
College of William & Mary, Muscarelle Museum of Art, Williamsburg VA
The College of Wooster, The College of Wooster Art Museum, Wooster OH
Colorado Historical Society, Colorado History Museum, Denver CO
Colorado Springs Fine Arts Center, Colorado Springs CO
Columbus Museum, Columbus GA
Columbus Museum of Art, Columbus OH
Columbus Museum of Art and Design, Indianapolis IN
Concordia University, Leonard & Bina Ellen Art Gallery, Montreal PQ
Concordia University, Marx Hausen Art Gallery, Seward NE
Confederation Centre Art Gallery and Museum, Charlottetown PE
Coos Art Museum, Coos Bay OR
Cornell University, Herbert F Johnson Museum of Art, Ithaca NY
Cornwall Gallery Society, Cornwall Regional Art Gallery, Cornwall ON
Cranbrook Art Museum, Cranbrook Art Museum, Bloomfield Hills MI
Creighton University, Lied Art Gallery, Omaha NE
Crocker Art Museum, Sacramento CA
The Currier Museum of Art, Currier Museum of Art, Manchester NH
Danforth Museum Corporation, Danforth Museum of Art, Framingham MA
Dartmouth Heritage Museum, Dartmouth NS
Deines Cultural Center, Russell KS
Delaware Art Museum, Wilmington DE
DeLeon White Gallery, Toronto ON
Denison University, Art Gallery, Granville OH
Detroit Institute of Arts, Detroit MI
Detroit Repertory Theatre Gallery, Detroit MI
Detroit Zoological Institute, Wildlife Interpretive Gallery, Royal Oak MI
Dickinson College, The Trout Gallery, Carlisle PA
Dixie State College, Robert N & Peggy Sears Gallery, Saint George UT
The Dixon Gallery & Gardens, Memphis TN
Door County, Miller Art Museum, Sturgeon Bay WI
Dundurn Castle, Hamilton ON
Durham Art Guild Inc, Durham NC
DuSable Museum of African American History, Chicago IL
Eastern Washington State Historical Society, Northwest Museum of Arts & Culture, Spokane WA
Eiteljorg Museum of American Indians & Western Art, Indianapolis IN
El Camino College Art Gallery, Torrance CA
Ellen Noel Art Museum of the Permian Basin, Odessa TX
Elmhurst Art Museum, Elmhurst IL
Erie Art Museum, Erie PA
Essex Historical Society, Essex Shipbuilding Museum, Essex MA
Estevan National Exhibition Centre Inc, Estevan SK
Evergreen State College, Evergreen Galleries, Olympia WA
Everhart Museum, Scranton PA
Fairfield University, Thomas J Walsh Art Gallery, Fairfield CT
Federal Reserve Board, Art Gallery, Washington DC
Fisk University, Fisk University Galleries, Nashville TN
Fitchburg Art Museum, Fitchburg MA
Fitton Center for Creative Arts, Hamilton OH
Florida State University, John & Mable Ringling Museum of Art, Sarasota FL
Fort Collins Museum of Contemporary Art, Fort Collins CO
Fort Hays State University, Moss-Thorns Gallery of Arts, Hays KS
Fort Smith Art Center, Fort Smith AR
Fort Ticonderoga Association, Ticonderoga NY
Fort Wayne Museum of Art, Inc, Fort Wayne IN
Frankfort Community Public Library, Anna & Harlan Hubbard Gallery, Frankfort IN
Freeport Arts Center, Freeport IL
Frick Collection, New York NY
Frostburg State University, The Stephanie Ann Roper Gallery, Frostburg MD
Fuller Museum of Art, Brockton MA

Gadsden Museum of Fine Arts, Inc, Gadsden Museum of Art and History, Gadsden AL
Gallery One, Ellensburg WA
George Washington University, The Dimock Gallery, Washington DC
Wendell Gilley, Southwest Harbor ME
Glenhyrst Art Gallery of Brant, Brantford ON
Gonzaga University, Art Gallery, Spokane WA
Goucher College, Rosenberg Gallery, Baltimore MD
Grace Museum, Inc, Abilene TX
Graphische Sammlung Albertina, Albertina Graphic Art Collection, Vienna
Great Lakes Historical Society, Inland Seas Maritime Museum, Vermilion OH
Grinnell College, Art Gallery, Grinnell IA
Grossmont Community College, Hyde Art Gallery, El Cajon CA
Guild Hall of East Hampton, Inc, Guild Hall Museum, East Hampton NY
Guilford College, Art Gallery, Greensboro NC
Robert Gumbiner, Museum of Latin American Art, Long Beach CA
Hamilton College, Emerson Gallery, Clinton NY
Hammond-Harwood House Association, Inc, Hammond-Harwood House, Annapolis MD
Hancock County Trustees of Public Reservations, Woodlawn Museum, Ellsworth ME
Hartwick College, Foreman Gallery, Oneonta NY
Hartwick College, The Yager Museum, Oneonta NY
Headquarters Fort Monroe, Dept of Army, Casemate Museum, Fort Monroe VA
Heard Museum, Phoenix AZ
Hebrew Union College, Jewish Institute of Religion Museum, New York NY
Heckscher Museum of Art, Huntington NY
Henry County Museum & Cultural Arts Center, Clinton MO
Heritage Malta, National Museum of Fine Arts, Valletta
Hermitage Foundation Museum, Norfolk VA
Edna Hibel, Hibel Museum of Art, Jupiter FL
Hickory Museum of Art, Inc, Hickory NC
High Desert Museum, Bend OR
Hill-Stead Museum, Farmington CT
Hillwood Museum & Gardens Foundation, Hillwood Museum & Gardens, Washington DC
Historic Landmarks Foundation of Indiana, Morris-Butler House, Indianapolis IN
The Historic New Orleans Collection, New Orleans LA
Historisches und Volkerkundemuseum, Historical Museum, Sankt Gallen
Honolulu Academy of Arts, Honolulu HI
Howard University, Gallery of Art, Washington DC
Hui No eau Visual Arts Center, Gallery and Gift Shop, Makawao Maui HI
Hunter Museum of American Art, Chattanooga TN
Huntsville Museum of Art, Huntsville AL
Hus Var Fine Art, Buffalo NY
Hyde Collection Trust, Glens Falls NY
Illinois State University, University Galleries, Normal IL
Illinois Wesleyan University, Merwin & Wakeley Galleries, Bloomington IL
Imperial Calcasieu Museum, Gibson-Barham Gallery, Lake Charles LA
Institute of American Indian Arts Museum, Museum, Santa Fe NM
Institute of Puerto Rican Culture, Museo Fuerte Conde de Mirasol, Vieques PR
International Clown Hall of Fame & Research Center, Inc, West Allis WI
Iowa State University, Brunnier Art Museum, Ames IA
Iredell Museum of Arts & Heritage, Statesville NC
Jacksonville Museum of Modern Art, Jacksonville FL
Jamestown-Yorktown Foundation, Williamsburg VA
Johnson-Humrickhouse Museum, Coshocton OH
Joslyn Art Museum, Omaha NE
Jule Collins Smith Museum of Art, Auburn AL
Juniata College Museum of Art, Huntingdon PA
Kalamazoo Institute of Arts, Kalamazoo MI
Kamloops Art Gallery, Kamloops BC
Kansas City Art Institute, Kansas City MO
Keene State College, Thorne-Sagendorph Art Gallery, Keene NH
Kent State University, School of Art Gallery, Kent OH
Kentucky Museum of Art & Craft, Louisville KY
Kirkland Museum of Fine & Decorative Art, Denver CO
Kitchener-Waterloo Art Gallery, Kitchener ON
Knights of Columbus Supreme Council, Knights of Columbus Museum, New Haven CT
Knoxville Museum of Art, Knoxville TN

Koshare Indian Museum, Inc, La Junta CO
La Salle University, Art Museum, Philadelphia PA
Lafayette College, Williams Center Gallery, Easton PA
Lafayette Natural History Museum & Planetarium, Lafayette LA
Lehigh University Art Galleries, Museum Operation, Bethlehem PA
Liberty Memorial Museum & Archives, The National Museum of World War I, Kansas City MO
Lincoln County Historical Association, Inc, 1811 Old Lincoln County Jail & Lincoln County Museum, Wiscasset ME
Lindenwood University, Harry D Hendren Gallery, Saint Charles MO
Long Beach Museum of Art Foundation, Long Beach CA
Long Island Graphic Eye Gallery, Bellmore NY
The Long Island Museum of American Art, History & Carriages, Stony Brook NY
Longfellow's Wayside Inn Museum, South Sudbury MA
Longfellow-Evangeline State Commemorative Area, Saint Martinville LA
Longview Museum of Fine Art, Longview TX
Los Angeles County Museum of Art, Los Angeles CA
Luther College, Fine Arts Collection, Decorah IA
Lycoming College Gallery, Williamsport PA
Macalester College, Macalester College Art Gallery, Saint Paul MN
Macdonald Stewart Art Centre, Guelph ON
Charles H MacNider, Mason City IA
Madison Museum of Contemporary Art, Madison WI
Judah L Magnes, Berkeley CA
Maitland Art Center, Maitland FL
Marietta-Cobb Museum of Art, Marietta GA
The Mariners' Museum, Newport News VA
Marquette University, Haggerty Museum of Art, Milwaukee WI
Marylhurst University, The Art Gym, Marylhurst OR
Mattatuck Historical Society, Mattatuck Museum, Waterbury CT
McAllen International Museum, McAllen TX
McMaster University, McMaster Museum of Art, Hamilton ON
McPherson College Gallery, McPherson KS
Mendel Art Gallery & Civic Conservatory, Saskatoon SK
Menil Foundation, Inc, Houston TX
Mennello Museum of American Art, Orlando FL
Meridian Museum of Art, Meridian MS
Mexican Fine Arts Center Museum, Chicago IL
Mexican Museum, San Francisco CA
Miami University, Art Museum, Oxford OH
Miami-Dade College, Kendal Campus, Art Gallery, Miami FL
Michelson Museum of Art, Marshall TX
James A Michener, Doylestown PA
Middle Border Museum & Oscar Howe Art Center, Mitchell SD
Middlebury College, Museum of Art, Middlebury VT
Midwest Museum of American Art, Elkhart IN
Millikin University, Perkinson Gallery, Decatur IL
Mills College, Art Museum, Oakland CA
Minneapolis Institute of Arts, Minneapolis MN
Minnesota Museum of American Art, Saint Paul MN
Minnesota State University, Mankato, Mankato MN
Mississippi University for Women, Fine Arts Gallery, Columbus MS
Moderna Galerija, Museum of Modern and Contemporary Art, Rijeka
Monhegan Museum, Monhegan ME
Montclair Art Museum, Montclair NJ
Montgomery Museum of Fine Arts, Montgomery AL
Moravian College, Payne Gallery, Bethlehem PA
Moravska Galerie v Brne, Moravian Gallery in Brno, Brno
Morehead State University, Claypool-Young Art Gallery, Morehead KY
Mount Holyoke College, Art Museum, South Hadley MA
Mount Mary College, Marian Gallery, Milwaukee WI
Murray State University, Art Galleries, Murray KY
Muscatine Art Center, Museum, Muscatine IA
Musee Carnavalet-Histoir de Paris, Paris
Museo de Arte de Ponce, Ponce Art Museum, Ponce PR
Museum of Art & History, Santa Cruz, Santa Cruz CA
Museum of Arts & Sciences, Inc, Macon GA
Museum of Contemporary Art, Chicago IL
The Museum of Contemporary Art (MOCA), Los Angeles CA

Museum of Contemporary Art, San Diego-Downtown, La Jolla CA
Museum of Discovery & Science, Fort Lauderdale FL
Museum of Fine Arts, Boston MA
Museum of Modern Art, New York NY
Museum of Movie Art, Calgary AB
Museum of Northwest Art, La Conner WA
Muzeum Narodowe, National Museum, Poznan
Muzeum Narodowe W Kielcach, National Museum in Kielce, Kielce
Napoleonic Society of America, Museum & Library, Clearwater FL
Narodna Galerija, National Gallery of Slovenia, Ljubljana
Nassau Community College, Firehouse Art Gallery, Garden City NY
National Air and Space Museum, Washington DC
National Audubon Society, John James Audubon Center at Mill Grove, Audubon PA
The National Museum of Fine Arts, Stockholm
National Museum of Racing, National Museum of Racing & Hall of Fame, Saratoga Springs NY
The National Park Service, United States Department of the Interior, Statue of Liberty National Monument & The Ellis Island Immigration Museum, New York NY
Naval Historical Center, The Navy Museum, Washington DC
Nebraska Wesleyan University, Elder Gallery, Lincoln NE
Nelson-Atkins Museum of Art, Kansas City MO
Nemours Mansion & Gardens, Wilmington DE
Nevada Museum of Art, Reno NV
Neville Public Museum, Green Bay WI
New Jersey State Museum, Fine Art Bureau, Trenton NJ
New Mexico State University, Art Gallery, Las Cruces NM
New Orleans GlassWorks Gallery & Printmaking Studio, New Orleans ArtWorks Gallery, New Orleans LA
New Visions Gallery, Inc, Marshfield WI
New York State Military Museum and Veterans Research Center, Saratoga Springs NY
New York University, Grey Art Gallery, New York NY
Newport Art Museum, Newport RI
Niagara University, Castellani Art Museum, Niagara NY
Nichols House Museum, Inc, Boston MA
The John A Noble, Staten Island NY
Norman Rockwell Museum, Rutland VT
North Central Washington Museum, Wenatchee Valley Museum & Cultural Center, Wenatchee WA
North Dakota State University, Memorial Union Gallery, Fargo ND
Northern Kentucky University, Highland Heights KY
Nova Scotia College of Art and Design, Anna Leonowens Gallery, Halifax NS
Oakland Museum of California, Art Dept, Oakland CA
The Ogden Museum of Southern Art, University of New Orleans, New Orleans LA
Ohio University, Kennedy Museum of Art, Athens OH
Okefenokee Heritage Center, Inc, Waycross GA
Oklahoma City Museum of Art, Oklahoma City OK
Olana State Historic Site, Hudson NY
Old Dartmouth Historical Society, New Bedford Whaling Museum, New Bedford MA
The Old Jail Art Center, Albany TX
Old West Museum, Sunset TX
Olivet College, Armstrong Collection, Olivet MI
Omniplex, Oklahoma City OK
Order Sons of Italy in America, Garibaldi & Meucci Museum, Staten Island NY
Orlando Museum of Art, Orlando FL
Owensboro Museum of Fine Art, Owensboro KY
Pacific - Asia Museum, Pasadena CA
Palm Springs Art Museum, Palm Springs CA
Paris Gibson Square, Museum of Art, Great Falls MT
Passaic County Community College, Broadway, LRC, and Hamilton Club Galleries, Paterson NJ
Pennsylvania Historical & Museum Commission, Railroad Museum of Pennsylvania, Harrisburg PA
Pensacola Museum of Art, Pensacola FL
Philbrook Museum of Art, Tulsa OK
Phillips Academy, Addison Gallery of American Art, Andover MA
The Frank Phillips, Woolaroc Museum, Bartlesville OK
Phoenix Art Museum, Phoenix AZ
Piedmont Arts Association, Martinsville VA
Polk Museum of Art, Lakeland FL

The Pomona College, Montgomery Gallery, Claremont CA
Port Huron Museum, Port Huron MI
Porter-Phelps-Huntington Foundation, Inc, Historic House Museum, Hadley MA
Portland Art Museum, Portland OR
Portland Museum of Art, Portland ME
Portsmouth Museums, Courthouse Galleries, Portsmouth VA
Potsdam College of the State University of New York, Roland Gibson Gallery, Potsdam NY
Princeton University, Princeton University Art Museum, Princeton NJ
Pump House Center for the Arts, Chillicothe OH
Purdue University Galleries, West Lafayette IN
Putnam Museum of History and Natural Science, Davenport IA
Queen's University, Agnes Etherington Art Centre, Kingston ON
Queens College, City University of New York, Godwin-Ternbach Museum, Flushing NY
Queensborough Community College, Art Gallery, Bayside NY
Quincy University, The Gray Gallery, Quincy IL
Rahr-West Art Museum, Manitowoc WI
Ramsay Museum, Honolulu HI
Rapid City Arts Council, Dahl Arts Center, Rapid City SD
Real Art Ways (RAW), Hartford CT
Reed College, Douglas F Cooley Memorial Art Gallery, Portland OR
Reynolda House Museum of American Art, Winston Salem NC
Roberson Museum & Science Center, Binghamton NY
The Rockwell Museum of Western Art, Corning NY
Lauren Rogers, Laurel MS
Rogue Community College, Wiseman Gallery - FireHouse Gallery, Grants Pass OR
The Rosenbach Museum & Library, Philadelphia PA
Roswell Museum & Art Center, Roswell NM
C M Russell, Great Falls MT
Rutgers University, Stedman Art Gallery, Camden NJ
Ryerss Victorian Museum & Library, Philadelphia PA
Saginaw Art Museum, Saginaw MI
Saint Anselm College, Chapel Art Center, Manchester NH
Saint Bonaventure University, Regina A Quick Center for the Arts, Saint Bonaventure NY
Saint Clair County Community College, Jack R Hennesey Art Galleries, Port Huron MI
Saint Gregory's Abbey & University, Mabee-Gerrer Museum of Art, Shawnee OK
Saint Joseph College, Saint Joseph College Art Gallery, West Hartford CT
Saint Mary's College, Moreau Galleries, Notre Dame IN
Saint Mary's College of California, Hearst Art Gallery, Moraga CA
Saint Olaf College, Flaten Art Museum, Northfield MN
Saint Peter's College, Art Gallery, Jersey City NJ
Salisbury University, University Gallery, Salisbury MD
San Antonio Museum of Art, San Antonio TX
San Diego Museum of Art, San Diego CA
San Diego State University, University Art Gallery, San Diego CA
San Jose Museum of Art, San Jose CA
Santa Barbara Museum of Art, Santa Barbara CA
Santa Monica Museum of Art, Santa Monica CA
School of Visual Arts, Visual Arts Museum, New York NY
Scottsdale Cultural Council, Scottsdale AZ
Seattle Art Museum, Seattle WA
1708 Gallery, Richmond VA
Shoshone Bannock Tribes, Shoshone Bannock Tribal Museum, Fort Hall ID
Smith College, Museum of Art, Northampton MA
Society of the Cincinnati, Museum & Library at Anderson House, Washington DC
Sonoma State University, University Art Gallery, Rohnert Park CA
South Carolina Artisans Center, Walterboro SC
South Texas Institute for the Arts, Art Museum of South Texas, Corpus Christi TX
Southeastern Center for Contemporary Art, Winston-Salem NC
Southern Arkansas University, Art Dept Gallery & Magale Art Gallery, Magnolia AR
Southern Oregon University, Schneider Museum of Art, Ashland OR
Spartanburg County Museum of Art, Spartanburg SC
Springfield Art Museum, Springfield MO

Staatsgalerie Stuttgart, Stuttgart

Stamford Museum & Nature Center, Stamford CT

Nelda C & H J Lutcher Stark, Stark Museum of Art, Orange TX

State University of New York at New Paltz, Samuel Dorsky Museum of Art, New Paltz NY

State University of New York at Purchase, Neuberger Museum of Art, Purchase NY

State University of New York College at Cortland, Dowd Fine Arts Gallery, Cortland NY

State University of New York College at Fredonia, M C Rockefeller Arts Center Gallery, Fredonia NY

Staten Island Institute of Arts & Sciences, Staten Island NY

Stetson University, Duncan Gallery of Art, Deland FL

Stratford Historical Society, Catharine B Mitchell Museum, Stratford CT

Summit County Historical Society, Akron OH

Surrey Art Gallery, Surrey BC

Swedish-American Museum Association of Chicago, Chicago IL

Swope Art Museum, Terre Haute IN

Syracuse University, SUArt Galleries, Syracuse NY

Tacoma Art Museum, Tacoma WA

Tampa Museum of Art, Tampa FL

Terra Museum of American Art, Chicago IL

Texas Tech University, Museum of Texas Tech University, Lubbock TX

Tokyo Kokuritsu Kindai Bujutsukan, The National Museum of Modern Art, Tokyo, Tokyo

Topeka & Shawnee County Public Library, Alice C Sabatini Gallery, Topeka KS

Towson University Center for the Arts Gallery, The Holtzman MFA Gallery, Towson MD

Tryon Palace Historic Sites & Gardens, New Bern NC

Tucson Museum of Artand Historic Block, Tucson AZ

Tufts University, Tufts University Art Gallery, Medford MA

The Turner Museum, Sarasota FL

Turtle Bay Exploration Park, Redding CA

Twin City Art Foundation, Masur Museum of Art, Monroe LA

Ulster County Community College, Muroff-Kotler Visual Arts Gallery, Stone Ridge NY

United States Capitol, Architect of the Capitol, Washington DC

United States Figure Skating Association, World Figure Skating Museum & Hall of Fame, Colorado Springs CO

United States Naval Academy, USNA Museum, Annapolis MD

United States Navy, Art Gallery, Washington DC

University at Albany, State University of New York, University Art Museum, Albany NY

University of Alabama at Birmingham, Visual Arts Gallery, Birmingham AL

University of Alabama at Huntsville, Union Grove Gallery & University Center Gallery, Huntsville AL

University of Arkansas at Little Rock, Art Galleries, Little Rock AR

University of California, Richard L Nelson Gallery & Fine Arts Collection, Davis CA

University of California, Berkeley, Berkeley Art Museum & Pacific Film Archive, Berkeley CA

University of Chicago, Smart Museum of Art, Chicago IL

University of Cincinnati, DAAP Galleries-College of Design Architecture, Art & Planning, Cincinnati OH

University of Colorado, CU Art Galleries, Boulder CO

University of Colorado at Colorado Springs, Gallery of Contemporary Art, Colorado Springs CO

University of Delaware, University Gallery, Newark DE

University of Findlay, Dudley & Mary Marks Lea Gallery, Findlay OH

University of Illinois, Krannert Art Museum and Kinkead Pavillion, Champaign IL

University of Illinois at Chicago, Gallery 400, Chicago IL

University of Iowa, Museum of Art, Iowa City IA

University of Kansas, Spencer Museum of Art, Lawrence KS

University of Louisiana at Lafayette, University Art Museum, Lafayette LA

University of Louisville, Hite Art Institute, Louisville KY

University of Maine, Museum of Art, Bangor ME

University of Manitoba, Faculty of Architecture Exhibition Centre, Winnipeg MB

University of Mary Washington, Belmont, The Gari Melchers, Fredericksburg VA

University of Maryland, College Park, The Art Gallery, College Park MD

University of Massachusetts, Amherst, University Gallery, Amherst MA

University of Memphis, Art Museum, Memphis TN

University of Michigan, Museum of Art, Ann Arbor MI

University of Minnesota, Katherine E Nash Gallery, Minneapolis MN

University of Minnesota, The Bell Museum of Natural History, Minneapolis MN

University of Minnesota, Frederick R Weisman Art Museum, Minneapolis MN

University of Mississippi, University Museum, Oxford MS

University of Missouri, Museum of Art & Archaeology, Columbia MO

University of Nebraska at Omaha, Art Gallery, Omaha NE

University of Nebraska, Lincoln, Sheldon Memorial Art Gallery & Sculpture Garden, Lincoln NE

University of Nevada, Las Vegas, Donna Beam Fine Art Gallery, Las Vegas NV

University of New Brunswick, Art Centre, Fredericton NB

University of New Hampshire, The Art Gallery, Durham NH

University of New Mexico, The Harwood Museum of Art, Taos NM

University of New Mexico, University Art Museum, Albuquerque NM

University of North Carolina at Greensboro, Weatherspoon Art Museum, Greensboro NC

University of Pennsylvania, Arthur Ross Gallery, Philadelphia PA

University of Pittsburgh, University Art Gallery, Pittsburgh PA

University of Rhode Island, Fine Arts Center Galleries, Kingston RI

University of Saskatchewan, Diefenbaker Canada Centre, Saskatoon SK

University of Southern Colorado, College of Liberal & Fine Arts, Pueblo CO

University of Texas at El Paso, Glass Gallery and Main Gallery, El Paso TX

University of Texas Pan American, Charles & Dorothy Clark Gallery; University Gallery, Edinburg TX

University of Texas Pan American, UTPA Art Galleries, Edinburg TX

University of the South, University Art Gallery, Sewanee TN

University of West Florida, Art Gallery, Pensacola FL

University of Wisconsin Oshkosh, Allen R Priebe Gallery, Oshkosh WI

University of Wisconsin-Madison, Wisconsin Union Galleries, Madison WI

University of Wisconsin-Stout, J Furlong Gallery, Menomonie WI

University of Wyoming, University of Wyoming Art Museum, Laramie WY

Upstairs Gallery, Winnipeg MB

Ursinus College, Philip & Muriel Berman Museum of Art, Collegeville PA

Utah Department of Natural Resources, Division of Parks & Recreation, Territorial Statehouse, Salt Lake City UT

Valentine Richmond History Center, Richmond VA

Valparaiso University, Brauer Museum of Art, Valparaiso IN

Van Gogh Museum, Amsterdam

Vanderbilt University, Fine Arts Gallery, Nashville TN

Ventura County Maritime Museum, Inc, Oxnard CA

Virginia Commonwealth University, Anderson Gallery, Richmond VA

Viridian Artists Inc, New York NY

The Walker African American Museum & Research Center, Las Vegas NV

Washburn University, Mulvane Art Museum, Topeka KS

Washington County Museum of Fine Arts, Hagerstown MD

Washington State University, Museum of Art, Pullman WA

Washington University, Mildred Lane Kemper Art Museum, Saint Louis MO

Waterloo Center of the Arts, Waterloo IA

Waterworks Visual Arts Center, Salisbury NC

Wayne Center for the Arts, Wooster OH

Wayne State College, Nordstrand Visual Arts Gallery, Wayne NE

Wellesley College, Davis Museum & Cultural Center, Wellesley MA

Wesleyan University, Davison Art Center, Middletown CT

West Florida Historic Preservation, Inc, T T Wentworth, Jr Florida State Museum & Historic Pensacola Village, Pensacola FL

Western Illinois University, Western Illinos University Art Gallery, Macomb IL

Western Michigan University, School of Art, Kalamazoo MI

Western State College of Colorado, Quigley Hall Art Gallery, Gunnison CO

Westminster College, Art Gallery, New Wilmington PA

Wheaton College, Watson Gallery, Norton MA

Wheelwright Museum of the American Indian, Santa Fe NM

White House, Washington DC

Whitney Museum of American Art, New York NY

Peter & Catharine Whyte Foundation, Whyte Museum of the Canadian Rockies, Banff AB

Wichita Falls Museum & Art Center, Wichita Falls TX

Wichita State University, Ulrich Museum of Art & Martin H Bush Outdoor Sculpture Collection, Wichita KS

Wilfrid Laurier University, Robert Langen Art Gallery, Waterloo ON

Winston-Salem State University, Diggs Gallery, Winston-Salem NC

Wiregrass Museum of Art, Dothan AL

Wisconsin Historical Society, State Historical Museum, Madison WI

Witter Gallery, Storm Lake IA

The Woman's Exchange, University Art Collection, New Orleans LA

Woodmere Art Museum, Philadelphia PA

Worcester Art Museum, Worcester MA

WV Museum of American Glass, Weston WV

RELIGIOUS ART

Academy of the New Church, Glencairn Museum, Bryn Athyn PA

Adams County Historical Society, Gettysburg PA

African American Museum in Philadelphia, Philadelphia PA

Albany Institute of History & Art, Albany NY

Anchorage Museum at Rasmuson Center, Anchorage AK

Arab American National Museum, Dearborn MI

Archives & History Center of the United Methodist Church, Madison NJ

Archives of the Archdiocese of St Paul & Minneapolis, Saint Paul MN

Art & Culture Center of Hollywood, Art Gallery, Hollywood FL

Art Gallery of Hamilton, Hamilton ON

Art Museum of Greater Lafayette, Lafayette IN

Asbury College, Student Center Gallery, Wilmore KY

Asian Art Museum of San Francisco, Chong-Moon Lee Ctr for Asian Art and Culture, San Francisco CA

Athens Byzantine & Christian Museum, Athens

Beaverbrook Art Gallery, Fredericton NB

Berman Museum, Anniston AL

BJU Museum & Gallery, Bob Jones University Museum & Gallery Inc, Greenville SC

Brigham Young University, Museum of Art, Provo UT

The Buffalo Fine Arts Academy, Albright-Knox Art Gallery, Buffalo NY

Burke Arts Council, Jailhouse Galleries, Morganton NC

Canadian Museum of Civilization, Gatineau PQ

Caramoor Center for Music & the Arts, Inc, Caramoor House Museum, Katonah NY

Cathedral of Saint John the Divine, New York NY

Radio-Canada SRC CBC, Georges Goguen CBC Art Gallery, Moncton NB

Center for Puppetry Arts, Atlanta GA

Central United Methodist Church, Swords Into Plowshares Peace Center & Gallery, Detroit MI

Church of Jesus Christ of Latter-Day Saints, Mormon Visitors' Center, Independence MO

Church of Jesus Christ of Latter-Day Saints, Museum of Church History & Art, Salt Lake City UT

Cincinnati Institute of Fine Arts, Taft Museum of Art, Cincinnati OH

Cincinnati Museum Association and Art Academy of Cincinnati, Cincinnati Art Museum, Cincinnati OH

College of William & Mary, Muscarelle Museum of Art, Williamsburg VA

Colorado Springs Fine Arts Center, Colorado Springs CO

Columbus Museum of Art, Columbus OH

RENAISSANCE ART

Stanford University, Iris & B Gerald Cantor Center for Visual Arts, Stanford CA
State University of New York at Binghamton, University Art Museum, Binghamton NY
Staten Island Institute of Arts & Sciences, Staten Island NY
University of California, Santa Barbara, University Art Museum, Santa Barbara CA
University of Illinois, Krannert Art Museum and Kinkead Pavillion, Champaign IL
University of Kansas, Spencer Museum of Art, Lawrence KS
University of Michigan, Museum of Art, Ann Arbor MI
University of Utah, Utah Museum of Fine Arts, Salt Lake City UT
University of Victoria, Maltwood Art Museum and Gallery, Victoria BC
University of Wisconsin-Madison, Chazen Museum of Art, Madison WI
Vanderbilt University, Fine Arts Gallery, Nashville TN
Virginia Museum of Fine Arts, Richmond VA
Vizcaya Museum & Gardens, Miami FL
Walters Art Museum, Baltimore MD
Washington University, Mildred Lane Kemper Art Museum, Saint Louis MO
Wellesley College, Davis Museum & Cultural Center, Wellesley MA
Woodmere Art Museum, Philadelphia PA
Worcester Art Museum, Worcester MA

REPRODUCTIONS

American Kennel Club, Museum of the Dog, Saint Louis MO
Walter Anderson, Ocean Springs MS
Appaloosa Museum and Heritage Center, Moscow ID
Arab American National Museum, Dearborn MI
Art & Culture Center of Hollywood, Art Gallery, Hollywood FL
Art Gallery of Nova Scotia, Halifax NS
Art Without Walls Inc, Art Without Walls Inc, Sayville NY
Canadian Museum of Civilization, Gatineau PQ
Canadian Museum of Contemporary Photography, Ottawa ON
Cartoon Art Museum, San Francisco CA
Central United Methodist Church, Swords Into Plowshares Peace Center & Gallery, Detroit MI
City of Cedar Falls, Iowa, James & Meryl Hearst Center for the Arts, Cedar Falls IA
Clark County Historical Society, Pioneer - Krier Museum, Ashland KS
Detroit Institute of Arts, Detroit MI
Detroit Repertory Theatre Gallery, Detroit MI
Dundurn Castle, Hamilton ON
Fitton Center for Creative Arts, Hamilton OH
Flagler Museum, Palm Beach FL
Forest Lawn Museum, Glendale CA
Franklin Mint Museum, Franklin Center PA
Frontier Times Museum, Bandera TX
General Board of Discipleship, The United Methodist Church, The Upper Room Chapel & Museum, Nashville TN
Great Lakes Historical Society, Inland Seas Maritime Museum, Vermilion OH
Headquarters Fort Monroe, Dept of Army, Casemate Museum, Fort Monroe VA
Hermitage Foundation Museum, Norfolk VA
Higgins Armory Museum, Worcester MA
Edward Hopper, Nyack NY
Lahore Museum, Lahore
Lincoln County Historical Association, Inc, 1811 Old Lincoln County Jail & Lincoln County Museum, Wiscasset ME
Longfellow-Evangeline State Commemorative Area, Saint Martinville LA
Jacques Marchais, Staten Island NY
Mexican Museum, San Francisco CA
Mission San Miguel Museum, San Miguel CA
Museum of Movie Art, Calgary AB
Muzeum Narodowe, National Museum, Poznan
National Museum, Monuments and Art Gallery, Gaborone
New York State Office of Parks Recreation & Historic Preservation, John Jay Homestead State Historic Site, Katonah NY
The Parrish Art Museum, Southampton NY
Piedmont Arts Association, Martinsville VA
Porter Thermometer Museum, Onset MA
Pump House Center for the Arts, Chillicothe OH

Queens College, City University of New York, Godwin-Ternbach Museum, Flushing NY
C M Russell, Great Falls MT
Saint Peter's College, Art Gallery, Jersey City NJ
The Sandwich Historical Society, Inc, Sandwich Glass Museum, Sandwich MA
Seneca-Iroquois National Museum, Salamanca NY
Abigail Adams Smith, New York NY
South Carolina Artisans Center, Walterboro SC
Staten Island Institute of Arts & Sciences, Staten Island NY
Tallahassee Museum of History & Natural Science, Tallahassee FL
Turtle Bay Exploration Park, Redding CA
University of Manitoba, Faculty of Architecture Exhibition Centre, Winnipeg MB
University of Saskatchewan, Diefenbaker Canada Centre, Saskatoon SK

RESTORATIONS

4D Basement, New York NY
Agecroft Association, Museum, Richmond VA
Art & Culture Center of Hollywood, Art Gallery, Hollywood FL
Art Without Walls Inc, Art Without Walls Inc, Sayville NY
Association for the Preservation of Virginia Antiquities, John Marshall House, Richmond VA
Bakehouse Art Complex, Inc, Miami FL
Bard College, Center for Curatorial Studies, Annandale-on-Hudson NY
Canadian Museum of Civilization, Gatineau PQ
Center for Puppetry Arts, Atlanta GA
City of San Rafael, Falkirk Cultural Center, San Rafael CA
Craigdarroch Castle Historical Museum Society, Victoria BC
Cranford Historical Society, Cranford NJ
Culberson County Historical Museum, Van Horn TX
Denver Art Museum, Denver CO
Detroit Institute of Arts, Detroit MI
Dundurn Castle, Hamilton ON
Galeria Mesta Bratislavy, City Gallery of Bratislava, Bratislava
Glanmore National Historic Site of Canada, Belleville ON
Gunston Hall Plantation, Mason Neck VA
Heard Museum, Phoenix AZ
Heritage Museum & Cultural Center, Baker LA
Historic Landmarks Foundation of Indiana, Morris-Butler House, Indianapolis IN
Huguenot Historical Society of New Paltz Galleries, New Paltz NY
Illinois Historic Preservation Agency, Bishop Hill State Historic Site, Bishop Hill IL
Johns Hopkins University, Homewood House Museum, Baltimore MD
Lafayette Natural History Museum & Planetarium, Lafayette LA
Lahore Museum, Lahore
Landmark Society of Western New York, Inc, The Campbell-Whittlesey House Museum, Rochester NY
Lincoln County Historical Association, Inc, 1811 Old Lincoln County Jail & Lincoln County Museum, Wiscasset ME
Lockwood-Mathews Mansion Museum, Norwalk CT
Mission San Luis Rey de Francia, Mission San Luis Rey Museum, Oceanside CA
Mission San Miguel Museum, San Miguel CA
Mohave Museum of History & Arts, Kingman AZ
Moravska Galerie v Brne, Moravian Gallery in Brno, Brno
Muzej za Umjetnost i Obrt, Museum of Arts & Crafts, Zagreb
Muzeum Narodowe, National Museum, Poznan
The National Park Service, United States Department of the Interior, Statue of Liberty National Monument & The Ellis Island Immigration Museum, New York NY
Nebraska State Capitol, Lincoln NE
Nelson-Atkins Museum of Art, Kansas City MO
New York State Office of Parks Recreation & Historic Preservation, John Jay Homestead State Historic Site, Katonah NY
Elisabet Ney, Austin TX
The Ohio Historical Society, Inc, Campus Martius Museum & Ohio River Museum, Marietta OH

Old Dartmouth Historical Society, New Bedford Whaling Museum, New Bedford MA
Old West Museum, Sunset TX
Page-Walker Arts & History Center, Cary NC
Pennsylvania Historical & Museum Commission, Railroad Museum of Pennsylvania, Harrisburg PA
Piatt Castles, West Liberty OH
Queens College, City University of New York, Godwin-Ternbach Museum, Flushing NY
Red Deer & District Museum & Archives, Red Deer AB
Abigail Adams Smith, New York NY
Nelda C & H J Lutcher Stark, Stark Museum of Art, Orange TX
State University of New York at Binghamton, University Art Museum, Binghamton NY
Switzerland County Historical Society Inc, Switzerland County Historical Museum, Vevay IN
U Gallery, New York NY
United States Capitol, Architect of the Capitol, Washington DC
University of Michigan, Museum of Art, Ann Arbor MI
Vermilion County Museum Society, Danville IL
Victoria Mansion - Morse Libby House, Portland ME
West Baton Rouge Parish, West Baton Rouge Museum, Port Allen LA
Wilfrid Laurier University, Robert Langen Art Gallery, Waterloo ON
Willard House & Clock Museum, Inc, North Grafton MA
Woodlawn/The Pope-Leighey, Mount Vernon VA
Zamek Krolewski w Warszawie Pomnik Historii i Kultry Narodwej, Royal Castle in Warsaw, National History & Culture Memorial, Warsaw

SCRIMSHAW

Academy of the New Church, Glencairn Museum, Bryn Athyn PA
Alaska Department of Education, Division of Libraries, Archives & Museums, Sheldon Jackson Museum, Sitka AK
Blauvelt Demarest Foundation, Hiram Blauvelt Art Museum, Oradell NJ
Craftsmen's Guild of Mississippi, Inc, Mississippi Crafts Center, Ridgeland MS
Dartmouth Heritage Museum, Dartmouth NS
Dawson City Museum & Historical Society, Dawson City YT
Denver Art Museum, Denver CO
Detroit Institute of Arts, Detroit MI
Eiteljorg Museum of American Indians & Western Art, Indianapolis IN
Enook Galleries, Waterloo ON
Gallery One, Ellensburg WA
Heritage Museums & Gardens, Sandwich MA
Independence Seaport Museum, Philadelphia PA
Iroquois Indian Museum, Howes Cave NY
Koshare Indian Museum, Inc, La Junta CO
Lincoln County Historical Association, Inc, 1811 Old Lincoln County Jail & Lincoln County Museum, Wiscasset ME
The Mariners' Museum, Newport News VA
Mennello Museum of American Art, Orlando FL
The Museum, Greenwood SC
Naval Historical Center, The Navy Museum, Washington DC
Old Dartmouth Historical Society, New Bedford Whaling Museum, New Bedford MA
Old York Historical Society, Old Gaol Museum, York ME
Peabody Essex Museum, Salem MA
Penobscot Marine Museum, Searsport ME
Porter-Phelps-Huntington Foundation, Inc, Historic House Museum, Hadley MA
Princeton University, Princeton University Art Museum, Princeton NJ
Pump House Center for the Arts, Chillicothe OH
Saint Joseph Museum, Saint Joseph MO
San Francisco Maritime National Historical Park, Maritime Museum, San Francisco CA
Sheldon Museum & Cultural Center, Inc, Sheldon Museum & Cultural Center, Haines AK
Ships of the Sea Maritime Museum, Savannah GA
Staten Island Institute of Arts & Sciences, Staten Island NY
Stauth Foundation & Museum, Stauth Memorial Museum, Montezuma KS
Ventura County Maritime Museum, Inc, Oxnard CA

Whalers Village Museum, Lahaina HI

SCULPTURE

A I R Gallery, New York NY
Academy of the New Church, Glencairn Museum, Bryn Athyn PA
African American Museum in Philadelphia, Philadelphia PA
Albany Institute of History & Art, Albany NY
Albin Polasek Museum & Sculpture Gardens, Winter Park FL
Albright College, Freedman Gallery, Reading PA
Albuquerque Museum of Art & History, Albuquerque NM
Alexandria Museum of Art, Alexandria LA
American Kennel Club, Museum of the Dog, Saint Louis MO
American Swedish Institute, Minneapolis MN
American University, Katzen Art Center Gallery, Washington DC
Anchorage Museum at Rasmuson Center, Anchorage AK
Walter Anderson, Ocean Springs MS
Anna Maria College, Saint Luke's Gallery, Paxton MA
Arab American National Museum, Dearborn MI
ARC Gallery, Chicago IL
Arizona State University, ASU Art Museum, Tempe AZ
Art & Culture Center of Hollywood, Art Gallery, Hollywood FL
Art Community Center, Art Center of Corpus Christi, Corpus Christi TX
Art Gallery of Ontario, Toronto ON
Art Gallery of South Australia, Adelaide
Art Museum of Greater Lafayette, Lafayette IN
Art Museum of Southeast Texas, Beaumont TX
Art Without Walls Inc, Art Without Walls Inc, Sayville NY
Arts Council of Fayetteville-Cumberland County, The Arts Center, Fayetteville NC
Asbury College, Student Center Gallery, Wilmore KY
Asian Art Museum of San Francisco, Chong-Moon Lee Ctr for Asian Art and Culture, San Francisco CA
The Aspen Art Museum, Aspen CO
Associates for Community Development, Boarman Arts Center, Martinsburg WV
Association for the Preservation of Virginia Antiquities, John Marshall House, Richmond VA
Augustana College, Augustana College Art Museum, Rock Island IL
Avampato Discovery Museum, The Clay Center for Arts & Sciences, Charleston WV
Baldwin-Wallace College, Fawick Art Gallery, Berea OH
The Baltimore Museum of Art, Baltimore MD
The Bartlett Museum, Amesbury MA
Beaumont Art League, Beaumont TX
Belskie Museum, Closter NJ
Bemis Center for Contemporary Arts, Omaha NE
The Benini Foundation & Sculpture Ranch, Johnson City TX
Bergstrom-Mahler Museum, Neenah WI
Berman Museum, Anniston AL
Bethany College, Mingenback Art Center, Lindsborg KS
Biggs Museum of American Art, Dover DE
Birger Sandzen Memorial Gallery, Lindsborg KS
Birmingham Museum of Art, Birmingham AL
BJU Museum & Gallery, Bob Jones University Museum & Gallery Inc, Greenville SC
Blanden Memorial Art Museum, Fort Dodge IA
Blauvelt Demarest Foundation, Hiram Blauvelt Art Museum, Oradell NJ
Boise Art Museum, Boise ID
Roy Boyd, Chicago IL
Brandywine River Museum, Chadds Ford PA
Brigham Young University, B F Larsen Gallery, Provo UT
Brigham Young University, Museum of Art, Provo UT
Bradford Brinton, Big Horn WY
Bronx Community College (CUNY), Hall of Fame for Great Americans, Bronx NY
Brookgreen Gardens, Murrells Inlet SC
Bruce Museum, Inc, Bruce Museum, Greenwich CT
Burke Arts Council, Jailhouse Galleries, Morganton NC
Butler Institute of American Art, Art Museum, Youngstown OH
Cabot's Old Indian Pueblo Museum, Cabot's Old Indian Pueblo Museum, Desert Hot Springs CA

California Center for the Arts, Escondido Museum, Escondido CA
California State University Stanislaus, University Art Gallery, Turlock CA
California State University, Northridge, Art Galleries, Northridge CA
Calvin College, Center Art Gallery, Grand Rapids MI
Cameron Art Museum, Wilmington NC
Canadian Museum of Civilization, Gatineau PQ
Canadian Wildlife & Wilderness Art Museum, Ottawa ON
Canajoharie Library & Art Gallery, Arkell Museum of Canajoharie, Canajoharie NY
Canton Museum of Art, Canton OH
Cape Ann Historical Association, Gloucester MA
Cape Cod Museum of Art Inc, Dennis MA
Caramoor Center for Music & the Arts, Inc, Caramoor House Museum, Katonah NY
Carnegie Museums of Pittsburgh, Carnegie Museum of Art, Pittsburgh PA
Miles B Carpenter, Waverly VA
Amon Carter, Fort Worth TX
Radio-Canada SRC CBC, Georges Goguen CBC Art Gallery, Moncton NB
Cedar Rapids Museum of Art, Cedar Rapids IA
Central Methodist University, Ashby-Hodge Gallery of American Art, Fayette MO
Chinati Foundation, Marfa TX
Chinese Culture Foundation, Center Gallery, San Francisco CA
Chinese Culture Institute of the International Society, Tremont Theatre & Gallery, Boston MA
Church of Jesus Christ of Latter-Day Saints, Museum of Church History & Art, Salt Lake City UT
Cincinnati Museum Association and Art Academy of Cincinnati, Cincinnati Art Museum, Cincinnati OH
City of Cedar Falls, Iowa, James & Meryl Hearst Center for the Arts, Cedar Falls IA
City of Fayette, Alabama, Fayette Art Museum, Fayette AL
City of Fremont, Olive Hyde Art Gallery, Fremont CA
City of Ketchikan Museum Dept, Ketchikan AK
The City of Petersburg Museums, Petersburg VA
City of Pittsfield, Berkshire Artisans, Pittsfield MA
Sterling & Francine Clark, Williamstown MA
Cleveland Museum of Art, Cleveland OH
Clinton Art Association, River Arts Center, Clinton IA
College of Saint Benedict, Art Gallery, Saint Joseph MN
College of Saint Rose, Art Gallery, Albany NY
College of William & Mary, Muscarelle Museum of Art, Williamsburg VA
Colorado Historical Society, Colorado History Museum, Denver CO
Colorado Springs Fine Arts Center, Colorado Springs CO
Columbus Museum, Columbus GA
Concordia University, Leonard & Bina Ellen Art Gallery, Montreal PQ
Coos Art Museum, Coos Bay OR
Cornell Museum of Art & History, Delray Beach FL
Cornell University, Herbert F Johnson Museum of Art, Ithaca NY
Cornwall Gallery Society, Cornwall Regional Art Gallery, Cornwall ON
Craft and Folk Art Museum (CAFAM), Los Angeles CA
Craftsmen's Guild of Mississippi, Inc, Mississippi Crafts Center, Ridgeland MS
Cranbrook Art Museum, Cranbrook Art Museum, Bloomfield Hills MI
Crazy Horse Memorial, Indian Museum of North America, Native American Educational & Cultural Center & Crazy Horse Memorial Library (Reference), Crazy Horse SD
Creighton University, Lied Art Gallery, Omaha NE
Crocker Art Museum, Sacramento CA
Cummer Museum of Art & Gardens, DeEtte Holden Cummer Museum Foundation, Jacksonville FL
The Currier Museum of Art, Currier Museum of Art, Manchester NH
Dahesh Museum of Art, New York NY
Danville Museum of Fine Arts & History, Danville VA
Deines Cultural Center, Russell KS
Del Mar College, Joseph A Cain Memorial Art Gallery, Corpus Christi TX
Delaware Art Museum, Wilmington DE
DeLeon White Gallery, Toronto ON
Denison University, Art Gallery, Granville OH
Detroit Institute of Arts, Detroit MI

Detroit Zoological Institute, Wildlife Interpretive Gallery, Royal Oak MI
The Dinosaur Museum, Blanding UT
Dixie State College, Robert N & Peggy Sears Gallery, Saint George UT
Durham Art Guild Inc, Durham NC
DuSable Museum of African American History, Chicago IL
East Baton Rouge Parks & Recreation Commission, Baton Rouge Gallery Inc, Baton Rouge LA
Edmundson Art Foundation, Inc, Des Moines Art Center, Des Moines IA
Eiteljorg Museum of American Indians & Western Art, Indianapolis IN
El Camino College Art Gallery, Torrance CA
Ellen Noel Art Museum of the Permian Basin, Odessa TX
Elmhurst Art Museum, Elmhurst IL
Emory University, Michael C Carlos Museum, Atlanta GA
Erie Art Museum, Erie PA
Wharton Esherick, Paoli PA
Eskimo Museum, Churchill MB
Evanston Historical Society, Charles Gates Dawes House, Evanston IL
Evansville Museum of Arts, History & Science, Evansville IN
Evergreen State College, Evergreen Galleries, Olympia WA
Everhart Museum, Scranton PA
Everson Museum of Art, Syracuse NY
Federal Reserve Board, Art Gallery, Washington DC
Ferenczy Muzeum, Szentendre
Fetherston Foundation, Packwood House Museum, Lewisburg PA
Fitton Center for Creative Arts, Hamilton OH
Five Civilized Tribes Museum, Muskogee OK
Flagler Museum, Palm Beach FL
Flint Institute of Arts, Flint MI
Florida International University, The Art Museum at FIU, Miami FL
Florida State University, Museum of Fine Arts, Tallahassee FL
Florida State University, John & Mable Ringling Museum of Art, Sarasota FL
Florida State University and Central Florida Community College, The Appleton Museum of Art, Ocala FL
Fondo del Sol, Visual Art & Media Center, Washington DC
Edsel & Eleanor Ford, Grosse Pointe Shores MI
Forest Lawn Museum, Glendale CA
Fort Collins Museum of Contemporary Art, Fort Collins CO
Fort Smith Art Center, Fort Smith AR
Fort Wayne Museum of Art, Inc, Fort Wayne IN
Freeport Arts Center, Freeport IL
Frick Collection, New York NY
Fruitlands Museum, Inc, Harvard MA
Fuller Museum of Art, Brockton MA
Gadsden Museum of Fine Arts, Inc, Gadsden Museum of Art and History, Gadsden AL
Gallery One, Ellensburg WA
Gaston County Museum of Art & History, Dallas NC
General Board of Discipleship, The United Methodist Church, The Upper Room Chapel & Museum, Nashville TN
George Washington University, The Dimock Gallery, Washington DC
Georgetown University, Art Collection, Washington DC
Georgia O'Keeffe Museum, Santa Fe NM
Georgian Court College, M Christina Geis Gallery, Lakewood NJ
Germanisches Nationalmuseum, Nuremberg
Thomas Gilcrease, Gilcrease Museum, Tulsa OK
Girard College, Stephen Girard Collection, Philadelphia PA
Glanmore National Historic Site of Canada, Belleville ON
Gonzaga University, Art Gallery, Spokane WA
Goucher College, Rosenberg Gallery, Baltimore MD
Greenville College, Richard W Bock Sculpture Collection, Almira College House, Greenville IL
Grounds for Sculpture, Hamilton NJ
Guggenheim Museum Soho, New York NY
Solomon R Guggenheim, New York NY
Guild Hall of East Hampton, Inc, Guild Hall Museum, East Hampton NY
Guilford College, Art Gallery, Greensboro NC
Robert Gumbiner, Museum of Latin American Art, Long Beach CA

Hartwick College, Foreman Gallery, Oneonta NY

Hartwick College, The Yager Museum, Oneonta NY

Harvard University, Dumbarton Oaks Research Library & Collections, Washington DC

Heard Museum, Phoenix AZ

Hebrew Union College, Jewish Institute of Religion Museum, New York NY

Henry County Museum & Cultural Arts Center, Clinton MO

Henry Gallery Association, Henry Art Gallery, Seattle WA

Patrick Henry, Red Hill National Memorial, Brookneal VA

Gertrude Herbert, Augusta GA

Heritage Center of Lancaster County Museum, Lancaster PA

Heritage Malta, National Museum of Fine Arts, Valletta

Hermitage Foundation Museum, Norfolk VA

Edna Hibel, Hibel Museum of Art, Jupiter FL

Hickory Museum of Art, Inc, Hickory NC

Higgins Armory Museum, Worcester MA

Hillwood Museum & Gardens Foundation, Hillwood Museum & Gardens, Washington DC

Hirshhorn Museum & Sculpture Garden, Smithsonian Institution, Washington DC

Hispanic Society of America, Museum & Library, New York NY

Historic Landmarks Foundation of Indiana, Morris-Butler House, Indianapolis IN

Historisches und Volkerkundemuseum, Historical Museum, Sankt Gallen

Holter Museum of Art, Helena MT

Housatonic Community College, Housatonic Museum of Art, Bridgeport CT

Howard University, Gallery of Art, Washington DC

Hoyt Institute of Fine Arts, New Castle PA

The Hudson River Museum, Yonkers NY

Hunter Museum of American Art, Chattanooga TN

Huntsville Museum of Art, Huntsville AL

Hus Var Fine Art, Buffalo NY

Hyde Collection Trust, Glens Falls NY

Hyde Park Art Center, Chicago IL

Illinois State University, University Galleries, Normal IL

Indiana State Museum, Indianapolis IN

Institute of American Indian Arts Museum, Museum, Santa Fe NM

Institute of Puerto Rican Culture, Museo Fuerte Conde de Mirasol, Vieques PR

Intar Latin American Gallery, New York NY

Iredell Museum of Arts & Heritage, Statesville NC

Iroquois Indian Museum, Howes Cave NY

Irving Arts Center, Main Gallery & Focus Gallery, Irving TX

Jacksonville University, Alexander Brest Museum & Gallery, Jacksonville FL

Japan Society, Inc, Japan Society Gallery, New York NY

John B Aird Gallery, Toronto ON

John Weaver Sculpture Collection, Hope BC

Joslyn Art Museum, Omaha NE

Jule Collins Smith Museum of Art, Auburn AL

Kamloops Art Gallery, Kamloops BC

Kansas City Art Institute, Kansas City MO

Kent State University, School of Art Gallery, Kent OH

Kentucky Museum of Art & Craft, Louisville KY

Kereszteny Muzeum, Christian Museum, Esztergom

Kimbell Art Museum, Fort Worth TX

Kirkland Museum of Fine & Decorative Art, Denver CO

Knights of Columbus Supreme Council, Knights of Columbus Museum, New Haven CT

Knoxville Museum of Art, Knoxville TN

Koninklijk Museum voor Schone Kunsten Antwerpen, Royal Museum of Fine Arts, Antwerp

Kyiv Museum of Russian Art, Kyiv

L'Universite Laval, Ecole des Arts Visuels, Quebec PQ

Lafayette College, Williams Center Gallery, Easton PA

Lafayette Natural History Museum & Planetarium, Lafayette LA

Laumeier Sculpture Park, Saint Louis MO

Leanin' Tree Museum of Western Art, Boulder CO

Lehigh University Art Galleries, Museum Operation, Bethlehem PA

The Lindsay Gallery Inc, Lindsay ON

Long Beach Museum of Art Foundation, Long Beach CA

Longview Museum of Fine Art, Longview TX

Los Angeles County Museum of Art, Los Angeles CA

Louisiana State University, School of Art Gallery, Baton Rouge LA

Loveland Museum Gallery, Loveland CO

Loyola University of Chicago, Martin D'Arcy Museum of Art, Chicago IL

Luther College, Fine Arts Collection, Decorah IA

Lynchburg College, Daura Gallery, Lynchburg VA

Macalester College, Macalester College Art Gallery, Saint Paul MN

Charles H MacNider, Mason City IA

Judah L Magnes, Berkeley CA

Maison Saint-Gabriel Museum, Montreal PQ

Maitland Art Center, Maitland FL

Manhattan Psychiatric Center, Sculpture Garden, New York NY

Jacques Marchais, Staten Island NY

Maricopa County Historical Society, Desert Caballeros Western Museum, Wickenburg AZ

Marietta College, Grover M Hermann Fine Arts Center, Marietta OH

Marietta-Cobb Museum of Art, Marietta GA

The Mariners' Museum, Newport News VA

Maryland Hall for the Creative Arts, Chaney Gallery, Annapolis MD

Marylhurst University, The Art Gym, Marylhurst OR

Mason County Museum, Maysville KY

Mattatuck Historical Society, Mattatuck Museum, Waterbury CT

McMaster University, McMaster Museum of Art, Hamilton ON

McNay, San Antonio TX

Mennello Museum of American Art, Orlando FL

Meredith College, Frankie G Weems Gallery & Rotunda Gallery, Raleigh NC

Meridian Museum of Art, Meridian MS

Mesa Arts Center, Mesa Contemporary Arts , Mesa AZ

The Metropolitan Museum of Art, New York NY

Mexican Museum, San Francisco CA

Miami University, Art Museum, Oxford OH

Miami-Dade College, Kendal Campus, Art Gallery, Miami FL

James A Michener, Doylestown PA

Middle Border Museum & Oscar Howe Art Center, Mitchell SD

Middlebury College, Museum of Art, Middlebury VT

Midwest Museum of American Art, Elkhart IN

Millikin University, Perkinson Gallery, Decatur IL

Ministry of Culture, The Delphi Museum, I Ephorate of Prehistoric & Classical Antiquities, Delphi

Minneapolis Institute of Arts, Minneapolis MN

Minnesota Museum of American Art, Saint Paul MN

Mint Museum of Art, Mint Museum of Craft & Design, Charlotte NC

Mississippi Valley Conservation Authority, R Tait McKenzie Memorial Museum, Almonte ON

Arthur Roy Mitchell, Museum of Western Art, Trinidad CO

Moderna Galerija, Gallery of Modern Art, Zagreb

Moderna Galerija, Museum of Modern and Contemporary Art, Rijeka

James Monroe, Fredericksburg VA

Montgomery Museum of Fine Arts, Montgomery AL

Moore College of Art & Design, The Galleries at Moore, Philadelphia PA

Moravska Galerie v Brne, Moravian Gallery in Brno, Brno

Morehead State University, Kentucky Folk Art Center, Morehead KY

Morris Museum, Morristown NJ

Mount Allison University, Owens Art Gallery, Sackville NB

Mount Holyoke College, Art Museum, South Hadley MA

Municipal Museum De Lakenhal, Stedelisk Museum De Lakenhal, Leiden

Munson-Williams-Proctor Arts Institute, Museum of Art, Utica NY

Murray State University, Art Galleries, Murray KY

Muscatine Art Center, Museum, Muscatine IA

Musee Carnavalet-Histoir de Paris, Paris

Musee Cognacq-Jay, Cognacq-Jay Museum, Paris

Musee du Quebec, Quebec PQ

Musee Guimet, Paris

Musee Regional de la Cote-Nord, Sept-Iles PQ

Musee Regional de Vaudreuil-Soulanges, Vaudreuil PQ

Musei Capitolini, Rome

Museo de Arte de Ponce, Ponce Art Museum, Ponce PR

Museo De Las Americas, Denver CO

Museu Nacional d'Art de Catalunya, National Art Museum, Barcelona

Museu Nacional de Arte Contemporanea, National Museum of Contemporary Art, Museu Do Chiado, Lisbon

The Museum, Greenwood SC

The Museum at Drexel University, Philadelphia PA

Museum for African Art, Long Island City NY

Museum of Art & History, Santa Cruz, Santa Cruz CA

Museum of Art, Fort Lauderdale, Fort Lauderdale FL

Museum of Arts & Sciences, Inc, Macon GA

Museum of Contemporary Art, Chicago IL

The Museum of Contemporary Art (MOCA), Los Angeles CA

Museum of Contemporary Art, San Diego, La Jolla CA

Museum of Contemporary Art, San Diego-Downtown, La Jolla CA

Museum of Contemporary Canadian Art, Toronto ON

Museum of Fine Arts, Boston MA

Museum of Fine Arts, Houston, Houston TX

Museum of Modern Art, New York NY

Museum of New Mexico, Museum of Fine Arts, Unit of NM Dept of Cultural Affairs, Santa Fe NM

Museum of Northwest Art, La Conner WA

Museum of Wisconsin Art, West Bend Art Museum, West Bend WI

Museum of York County, Rock Hill SC

Muzej za Umjetnost i Obrt, Museum of Arts & Crafts, Zagreb

Muzeum Narodowe, National Museum, Poznan

Muzeum Narodowe W Kielcach, National Museum in Kielce, Kielce

Narodna Galerija, National Gallery of Slovenia, Ljubljana

Nassau Community College, Firehouse Art Gallery, Garden City NY

Nassau County Museum of Fine Art, Roslyn Harbor NY

National Air and Space Museum, Washington DC

National Cowboy & Western Heritage Museum, Oklahoma City OK

National Museum of Ceramic Art & Glass, Baltimore MD

The National Museum of Fine Arts, Stockholm

National Museum of the American Indian, George Gustav Heye Center, New York NY

National Museum of Wildlife Art, Jackson WY

National Museum, Monuments and Art Gallery, Gaborone

The National Park Service, United States Department of the Interior, Statue of Liberty National Monument & The Ellis Island Immigration Museum, New York NY

National Trust for Historic Preservation, Chesterwood Estate & Museum, Stockbridge MA

Navajo Nation, Navajo Nation Museum, Window Rock AZ

Naval Historical Center, The Navy Museum, Washington DC

Nebraska State Capitol, Lincoln NE

Nebraska Wesleyan University, Elder Gallery, Lincoln NE

Nemours Mansion & Gardens, Wilmington DE

Nevada Museum of Art, Reno NV

Neville Public Museum, Green Bay WI

New Canaan Historical Society, New Canaan CT

New Jersey State Museum, Fine Art Bureau, Trenton NJ

New Orleans GlassWorks Gallery & Printmaking Studio, New Orleans ArtWorks Gallery, New Orleans LA

New Orleans Museum of Art, New Orleans LA

New Visions Gallery, Inc, Marshfield WI

New York State Military Museum and Veterans Research Center, Saratoga Springs NY

New York Studio School of Drawing, Painting & Sculpture, Gallery, New York NY

Newport Art Museum, Newport RI

Elisabet Ney, Austin TX

Niagara University, Castellani Art Museum, Niagara NY

Isamu Noguchi, Isamu Noguchi Garden Museum, Long Island City NY

North Carolina Central University, NCCU Art Museum, Durham NC

North Carolina Museum of Art, Raleigh NC

North Dakota State University, Memorial Union Gallery, Fargo ND

Northern Kentucky University, Highland Heights KY

Norton Museum of Art, West Palm Beach FL

Nova Scotia College of Art and Design, Anna Leonowens Gallery, Halifax NS

Noyes Art Gallery, Lincoln NE

University of Wisconsin-Madison, Wisconsin Union Galleries, Madison WI

University of Wisconsin-Stout, J Furlong Gallery, Menomonie WI

University of Wyoming, University of Wyoming Art Museum, Laramie WY

Upstairs Gallery, Winnipeg MB

Ursinus College, Philip & Muriel Berman Museum of Art, Collegeville PA

Utah Arts Council, Chase Home Museum of Utah Folk Arts, Salt Lake City UT

Valentine Richmond History Center, Richmond VA

Van Gogh Museum, Amsterdam

Vassar College, The Frances Lehman Loeb Art Center, Poughkeepsie NY

Virginia Museum of Fine Arts, Richmond VA

Viridian Artists Inc, New York NY

Vizcaya Museum & Gardens, Miami FL

Wadsworth Atheneum Museum of Art, Hartford CT

Washburn University, Mulvane Art Museum, Topeka KS

Washington County Museum of Fine Arts, Hagerstown MD

Washington University, Mildred Lane Kemper Art Museum, Saint Louis MO

Waterloo Center of the Arts, Waterloo IA

Waterworks Visual Arts Center, Salisbury NC

Wellesley College, Davis Museum & Cultural Center, Wellesley MA

Western Illinois University, Western Illinos University Art Gallery, Macomb IL

Western Washington University, Western Gallery, Bellingham WA

Whalers Village Museum, Lahaina HI

Whatcom Museum of History and Art, Bellingham WA

Wheaton College, Watson Gallery, Norton MA

Wheelwright Museum of the American Indian, Santa Fe NM

White House, Washington DC

Whitney Museum of American Art, New York NY

Wichita Art Museum, Wichita KS

Wichita State University, Ulrich Museum of Art & Martin H Bush Outdoor Sculpture Collection, Wichita KS

Widener University, Art Collection & Gallery, Chester PA

Wilfrid Laurier University, Robert Langen Art Gallery, Waterloo ON

Wilkes Art Gallery, North Wilkesboro NC

Wilkes University, Sordoni Art Gallery, Wilkes-Barre PA

The Winnipeg Art Gallery, Winnipeg MB

Winston-Salem State University, Diggs Gallery, Winston-Salem NC

Wiregrass Museum of Art, Dothan AL

The Woman's Exchange, University Art Collection, New Orleans LA

Woodlawn/The Pope-Leighey, Mount Vernon VA

Woodmere Art Museum, Philadelphia PA

Worcester Art Museum, Worcester MA

Yerba Buena Center for the Arts, San Francisco CA

Yeshiva University Museum, New York NY

York University, Art Gallery of York University, Toronto ON

Zamek Krolewski w Warszawie Pomnik Historii i Kultry Narodwej, Royal Castle in Warsaw, National History & Culture Memorial, Warsaw

Zigler Museum, Jennings LA

SILVER

Adams County Historical Society, Gettysburg PA

Agecroft Association, Museum, Richmond VA

Lyman Allyn, New London CT

American Kennel Club, Museum of the Dog, Saint Louis MO

Art & Culture Center of Hollywood, Art Gallery, Hollywood FL

Art Gallery of South Australia, Adelaide

Art Without Walls Inc, Art Without Walls Inc, Sayville NY

Atlanta International Museum of Art & Design, Atlanta GA

The Bartlett Museum, Amesbury MA

Bayou Bend Collection & Gardens, Houston TX

Biggs Museum of American Art, Dover DE

Birmingham Museum of Art, Birmingham AL

BJU Museum & Gallery, Bob Jones University Museum & Gallery Inc, Greenville SC

The Canadian Craft Museum, Vancouver BC

Canadian Museum of Civilization, Gatineau PQ

Cape Ann Historical Association, Gloucester MA

Chatillon-DeMenil House Foundation, DeMenil Mansion, Saint Louis MO

Cincinnati Museum Association and Art Academy of Cincinnati, Cincinnati Art Museum, Cincinnati OH

The City of Petersburg Museums, Petersburg VA

Sterling & Francine Clark, Williamstown MA

College of William & Mary, Muscarelle Museum of Art, Williamsburg VA

Colorado Historical Society, Colorado History Museum, Denver CO

Colorado Springs Fine Arts Center, Colorado Springs CO

Columbus Museum, Columbus GA

Concord Museum, Concord MA

Courtauld Institute of Art, Courtauld Institute Gallery, London

Cranbrook Art Museum, Cranbrook Art Museum, Bloomfield Hills MI

The Currier Museum of Art, Currier Museum of Art, Manchester NH

DAR Museum, National Society Daughters of the American Revolution, Washington DC

Delaware Division of Historical & Cultural Affairs, Dover DE

Detroit Institute of Arts, Detroit MI

Dundurn Castle, Hamilton ON

Ellen Noel Art Museum of the Permian Basin, Odessa TX

Elverhoj Museum of History and Art, Solvang CA

Erie Art Museum, Erie PA

Erie County Historical Society, Erie PA

Evanston Historical Society, Charles Gates Dawes House, Evanston IL

Fetherston Foundation, Packwood House Museum, Lewisburg PA

Fishkill Historical Society, Van Wyck Homestead Museum, Fishkill NY

Fitton Center for Creative Arts, Hamilton OH

Flagler Museum, Palm Beach FL

Forest Lawn Museum, Glendale CA

The Frick Art & Historical Center, Frick Art Museum, Pittsburgh PA

Fuller Museum of Art, Brockton MA

Gadsden Museum of Fine Arts, Inc, Gadsden Museum of Art and History, Gadsden AL

Gallery One, Ellensburg WA

Germanisches Nationalmuseum, Nuremberg

Girard College, Stephen Girard Collection, Philadelphia PA

Hammond-Harwood House Association, Inc, Hammond-Harwood House, Annapolis MD

Hancock County Trustees of Public Reservations, Woodlawn Museum, Ellsworth ME

Haystack Mountain School of Crafts, Deer Isle ME

Headquarters Fort Monroe, Dept of Army, Casemate Museum, Fort Monroe VA

Heard Museum, Phoenix AZ

Patrick Henry, Red Hill National Memorial, Brookneal VA

Heritage Center of Lancaster County Museum, Lancaster PA

Heritage Malta, National Museum of Fine Arts, Valletta

Heritage Museum Association, Inc, The Heritage Museum of Northwest Florida, Valparaiso FL

Hill-Stead Museum, Farmington CT

Hillwood Museum & Gardens Foundation, Hillwood Museum & Gardens, Washington DC

Historic Cherry Hill, Albany NY

Historic Deerfield, Deerfield MA

Historic Landmarks Foundation of Indiana, Morris-Butler House, Indianapolis IN

Historical Society of Cheshire County, Keene NH

Indiana State Museum, Indianapolis IN

Institute of American Indian Arts Museum, Museum, Santa Fe NM

Iroquois Indian Museum, Howes Cave NY

John B Aird Gallery, Toronto ON

Johns Hopkins University, Homewood House Museum, Baltimore MD

Kelowna Museum, Kelowna BC

Kentucky Museum of Art & Craft, Louisville KY

Kereszteny Muzeum, Christian Museum, Esztergom

Kings County Historical Society & Museum, Hampton NB

Knights of Columbus Supreme Council, Knights of Columbus Museum, New Haven CT

Kunstindustrimuseet, The Danish Museum of Art & Design, Copenhagen

Lincoln County Historical Association, Inc, 1811 Old Lincoln County Jail & Lincoln County Museum, Wiscasset ME

Livingston County Historical Society, Cobblestone Museum, Geneseo NY

Los Angeles County Museum of Natural History, William S Hart Museum, Newhall CA

Louisiana State University, Museum of Art, Baton Rouge LA

Loyola University of Chicago, Martin D'Arcy Museum of Art, Chicago IL

Jacques Marchais, Staten Island NY

Maryland Historical Society, Museum of Maryland History, Baltimore MD

Mason County Museum, Maysville KY

Mattatuck Historical Society, Mattatuck Museum, Waterbury CT

McDowell House & Apothecary Shop, Danville KY

Mennello Museum of American Art, Orlando FL

Ministry of Culture, The Delphi Museum, I Ephorate of Prehistoric & Classical Antiquities, Delphi

James Monroe, Fredericksburg VA

Montclair Art Museum, Montclair NJ

Municipal Museum De Lakenhal, Stedelisk Museum De Lakenhal, Leiden

Munson-Williams-Proctor Arts Institute, Museum of Art, Utica NY

Musee d'Art de Saint-Laurent, Saint-Laurent PQ

Museo De Las Americas, Denver CO

Museum of Fine Arts, Boston MA

Museum of Mobile, Mobile AL

Museum of Northern Arizona, Flagstaff AZ

Muzej za Umjetnost i Obrt, Museum of Arts & Crafts, Zagreb

Muzeum Narodowe, National Museum, Poznan

Muzeum Narodowe W Kielcach, National Museum in Kielce, Kielce

National Society of Colonial Dames of America in the State of Maryland, Mount Clare Museum House, Baltimore MD

National Society of the Colonial Dames of America in The Commonwealth of Virginia, Wilton House Museum, Richmond VA

Navajo Nation, Navajo Nation Museum, Window Rock AZ

Naval Historical Center, The Navy Museum, Washington DC

Nemours Mansion & Gardens, Wilmington DE

New Jersey State Museum, Fine Art Bureau, Trenton NJ

New Orleans Museum of Art, New Orleans LA

New York State Military Museum and Veterans Research Center, Saratoga Springs NY

New York State Office of Parks Recreation & Historic Preservation, John Jay Homestead State Historic Site, Katonah NY

Newton History Museum at the Jackson Homestead, Newton MA

Noyes Art Gallery, Lincoln NE

The Ohio Historical Society, Inc, Campus Martius Museum & Ohio River Museum, Marietta OH

Olana State Historic Site, Hudson NY

Old Colony Historical Society, Museum, Taunton MA

Phoenix Art Museum, Phoenix AZ

Piedmont Arts Association, Martinsville VA

Plumas County Museum, Quincy CA

Port Huron Museum, Port Huron MI

Porter-Phelps-Huntington Foundation, Inc, Historic House Museum, Hadley MA

Portland Art Museum, Portland OR

Princeton University, Princeton University Art Museum, Princeton NJ

Pump House Center for the Arts, Chillicothe OH

Putnam Museum of History and Natural Science, Davenport IA

R W Norton Art Foundation, Shreveport LA

Rawls Museum Arts, Courtland VA

Frederic Remington, Ogdensburg NY

Lauren Rogers, Laurel MS

Millicent Rogers, Taos NM

The Rosenbach Museum & Library, Philadelphia PA

Royal Arts Foundation, Belcourt Castle, Newport RI

Saco Museum, Saco ME

Saint Joseph's Oratory, Museum, Montreal PQ

San Antonio Museum of Art, San Antonio TX

San Diego Museum of Art, San Diego CA

Santa Clara University, de Saisset Museum, Santa Clara CA

Seneca-Iroquois National Museum, Salamanca NY

Abigail Adams Smith, New York NY

SILVERSMITHING

SOUTHWESTERN ART

STAINED GLASS

New Jersey State Museum, Fine Art Bureau, Trenton NJ
Noyes Art Gallery, Lincoln NE
Owensboro Museum of Fine Art, Owensboro KY
Piedmont Arts Association, Martinsville VA
Princeton University, Princeton University Art Museum, Princeton NJ
Pump House Center for the Arts, Chillicothe OH
Queens College, City University of New York, Godwin-Ternbach Museum, Flushing NY
Royal Arts Foundation, Belcourt Castle, Newport RI
Saint Peter's College, Art Gallery, Jersey City NJ
South Carolina Artisans Center, Walterboro SC
Swedish-American Museum Association of Chicago, Chicago IL
Switzerland County Historical Society Inc, Switzerland County Historical Museum, Vevay IN
The Temple-Tifereth Israel, The Temple Museum of Religious Art, Beachwood OH
Mark Twain, Hartford CT
United States Capitol, Architect of the Capitol, Washington DC
University of Illinois, Krannert Art Museum and Kinkead Pavillion, Champaign IL
University of Michigan, Museum of Art, Ann Arbor MI
University of Pennsylvania, Arthur Ross Gallery, Philadelphia PA
University of the South, University Art Gallery, Sewanee TN
Victoria Mansion - Morse Libby House, Portland ME
Wadsworth Atheneum Museum of Art, Hartford CT
George Washington, Alexandria VA
Waterworks Visual Arts Center, Salisbury NC
Wheaton College, Watson Gallery, Norton MA
The Woman's Exchange, Newcomb Art Gallery-Carroll Gallery, New Orleans LA
Workman & Temple Family Homestead Museum, City of Industry CA

TAPESTRIES

Academy of the New Church, Glencairn Museum, Bryn Athyn PA
Agecroft Association, Museum, Richmond VA
American Swedish Institute, Minneapolis MN
Art & Culture Center of Hollywood, Art Gallery, Hollywood FL
Art Without Walls Inc, Art Without Walls Inc, Sayville NY
Athens Byzantine & Christian Museum, Athens
Barnes Foundation, Merion PA
Beaverbrook Art Gallery, Fredericton NB
BJU Museum & Gallery, Bob Jones University Museum & Gallery Inc, Greenville SC
Cameron Art Museum, Wilmington NC
The Canadian Craft Museum, Vancouver BC
Canadian Museum of Civilization, Gatineau PQ
Caramoor Center for Music & the Arts, Inc, Caramoor House Museum, Katonah NY
Chinese Culture Institute of the International Society, Tremont Theatre & Gallery, Boston MA
City of Pittsfield, Berkshire Artisans, Pittsfield MA
Clark County Historical Society, Pioneer - Krier Museum, Ashland KS
The College of Wooster, The College of Wooster Art Museum, Wooster OH
Columbus Museum, Columbus GA
Craft and Folk Art Museum (CAFAM), Los Angeles CA
Cranbrook Art Museum, Cranbrook Art Museum, Bloomfield Hills MI
Cummer Museum of Art & Gardens, DeEtte Holden Cummer Museum Foundation, Jacksonville FL
Cuneo Foundation, Museum & Gardens, Vernon Hills IL
The Currier Museum of Art, Currier Museum of Art, Manchester NH
Danville Museum of Fine Arts & History, Danville VA
Detroit Institute of Arts, Detroit MI
Detroit Zoological Institute, Wildlife Interpretive Gallery, Royal Oak MI
Dundurn Castle, Hamilton ON
The Ethel Wright Mohamed Stitchery Museum, Belzoni MS
Evansville Museum of Arts, History & Science, Evansville IN
Ferenczy Muzeum, Szentendre
The Frick Art & Historical Center, Frick Art Museum, Pittsburgh PA

General Board of Discipleship, The United Methodist Church, The Upper Room Chapel & Museum, Nashville TN
Germanisches Nationalmuseum, Nuremberg
Gonzaga University, Art Gallery, Spokane WA
Heard Museum, Phoenix AZ
Hermitage Foundation Museum, Norfolk VA
Higgins Armory Museum, Worcester MA
Hillwood Museum & Gardens Foundation, Hillwood Museum & Gardens, Washington DC
Hyde Collection Trust, Glens Falls NY
Iredell Museum of Arts & Heritage, Statesville NC
John B Aird Gallery, Toronto ON
Kentucky Museum of Art & Craft, Louisville KY
Kereszteny Muzeum, Christian Museum, Esztergom
Kunstindustrimuseet, The Danish Museum of Art & Design, Copenhagen
Lafayette Natural History Museum & Planetarium, Lafayette LA
Macalester College, Macalester College Art Gallery, Saint Paul MN
Moderna Galerija, Gallery of Modern Art, Zagreb
Moravska Galerie v Brne, Moravian Gallery in Brno, Brno
Municipal Museum De Lakenhal, Stedelisk Museum De Lakenhal, Leiden
Musee Cognacq-Jay, Cognacq-Jay Museum, Paris
Musee National du Chateau de Versailles, National Museum of the Chateau de Versailles, Versailles
Musei Capitolini, Rome
Muzej za Umjetnost i Obrt, Museum of Arts & Crafts, Zagreb
Muzeum Narodowe W Kielcach, National Museum in Kielce, Kielce
National Museum, Monuments and Art Gallery, Gaborone
National Palace Museum, Taipei
National Society of Colonial Dames of America in the State of Maryland, Mount Clare Museum House, Baltimore MD
Nebraska State Capitol, Lincoln NE
Nemours Mansion & Gardens, Wilmington DE
Nichols House Museum, Inc, Boston MA
Noordbrabants Museum, Hertogenbosch
North Carolina State University, Visual Arts Center, Raleigh NC
Pacific - Asia Museum, Pasadena CA
R W Norton Art Foundation, Shreveport LA
Royal Arts Foundation, Belcourt Castle, Newport RI
Saginaw Art Museum, Saginaw MI
Salisbury House Foundation, Des Moines IA
Santa Barbara Museum of Art, Santa Barbara CA
Santa Clara University, de Saisset Museum, Santa Clara CA
Scripps College, Ruth Chandler Williamson Gallery, Claremont CA
Norton Simon, Pasadena CA
Society of the Cincinnati, Museum & Library at Anderson House, Washington DC
Staten Island Institute of Arts & Sciences, Staten Island NY
Stauth Foundation & Museum, Stauth Memorial Museum, Montezuma KS
Sylvia Plotkin Museum of Temple Beth Israel, Scottsdale AZ
Taos, Ernest Blumenschein Home & Studio, Taos NM
University of Illinois, Krannert Art Museum and Kinkead Pavillion, Champaign IL
University of Manitoba, Faculty of Architecture Exhibition Centre, Winnipeg MB
University of Michigan, Museum of Art, Ann Arbor MI
University of San Diego, Founders' Gallery, San Diego CA
University of Utah, Utah Museum of Fine Arts, Salt Lake City UT
Ursinus College, Philip & Muriel Berman Museum of Art, Collegeville PA
Virginia Museum of Fine Arts, Richmond VA
Vizcaya Museum & Gardens, Miami FL
Wayne Center for the Arts, Wooster OH
Wilfrid Laurier University, Robert Langen Art Gallery, Waterloo ON
Zamek Krolewski w Warszawie Pomnik Historii i Kultry Narodwej, Royal Castle in Warsaw, National History & Culture Memorial, Warsaw

TEXTILES

Academy of the New Church, Glencairn Museum, Bryn Athyn PA

Adams County Historical Society, Gettysburg PA
African American Museum in Philadelphia, Philadelphia PA
African Art Museum of Maryland, Columbia MD
Agecroft Association, Museum, Richmond VA
Albany Institute of History & Art, Albany NY
Albuquerque Museum of Art & History, Albuquerque NM
Algonquin Arts Council, Art Gallery of Bancroft, Bancroft ON
American Textile History Museum, Lowell MA
Anchorage Museum at Rasmuson Center, Anchorage AK
Arab American National Museum, Dearborn MI
Art & Culture Center of Hollywood, Art Gallery, Hollywood FL
Art Gallery of South Australia, Adelaide
Art Museum of Greater Lafayette, Lafayette IN
Art Without Walls Inc, Art Without Walls Inc, Sayville NY
Artesia Historical Museum & Art Center, Artesia NM
Asian Art Museum of San Francisco, Chong-Moon Lee Ctr for Asian Art and Culture, San Francisco CA
Association for the Preservation of Virginia Antiquities, John Marshall House, Richmond VA
Athens Byzantine & Christian Museum, Athens
Atlanta Historical Society Inc, Atlanta History Center, Atlanta GA
Atlanta International Museum of Art & Design, Atlanta GA
Augustana College, Augustana College Art Museum, Rock Island IL
Aurora University, Schingoethe Center for Native American Cultures, Aurora IL
Balzekas Museum of Lithuanian Culture, Chicago IL
Barnes Foundation, Merion PA
Bay County Historical Society, Historical Museum of Bay County, Bay City MI
Bayou Bend Collection & Gardens, Houston TX
Berea College, Doris Ulmann Galleries, Berea KY
Biggs Museum of American Art, Dover DE
BJU Museum & Gallery, Bob Jones University Museum & Gallery Inc, Greenville SC
Brick Store Museum & Library, Kennebunk ME
Brooklyn Historical Society, Brooklyn OH
Bruce Museum, Inc, Bruce Museum, Greenwich CT
Burke Arts Council, Jailhouse Galleries, Morganton NC
C W Post Campus of Long Island University, Hillwood Art Museum, Brookville NY
Cabot's Old Indian Pueblo Museum, Cabot's Old Indian Pueblo Museum, Desert Hot Springs CA
California State University, East Bay, C E Smith Museum of Anthropology, Hayward CA
California State University, Northridge, Art Galleries, Northridge CA
Calvin College, Center Art Gallery, Grand Rapids MI
Cameron Art Museum, Wilmington NC
The Canadian Craft Museum, Vancouver BC
Canadian Museum of Civilization, Gatineau PQ
Caramoor Center for Music & the Arts, Inc, Caramoor House Museum, Katonah NY
Charleston Museum, Charleston SC
Chattahoochee Valley Art Museum, LaGrange GA
Chicago Athenaeum, Museum of Architecture & Design, Galena IL
Chinese Culture Foundation, Center Gallery, San Francisco CA
Chinese Culture Institute of the International Society, Tremont Theatre & Gallery, Boston MA
Church of Jesus Christ of Latter-Day Saints, Museum of Church History & Art, Salt Lake City UT
Cincinnati Museum Association and Art Academy of Cincinnati, Cincinnati Art Museum, Cincinnati OH
City of Fayette, Alabama, Fayette Art Museum, Fayette AL
City of Fremont, Olive Hyde Art Gallery, Fremont CA
City of Gainesville, Thomas Center Galleries - Cultural Affairs, Gainesville FL
City of Grand Rapids Michigan, Public Museum of Grand Rapids, Grand Rapids MI
City of Pittsfield, Berkshire Artisans, Pittsfield MA
Clark County Historical Society, Pioneer - Krier Museum, Ashland KS
Cleveland Museum of Art, Cleveland OH
Cohasset Historical Society, Pratt Building (Society Headquarters), Cohasset MA
The College of Wooster, The College of Wooster Art Museum, Wooster OH
Colorado Historical Society, Colorado History Museum, Denver CO

The Frank Phillips, Woolaroc Museum, Bartlesville OK
Phoenix Art Museum, Phoenix AZ
Piedmont Arts Association, Martinsville VA
Plainsman Museum, Aurora NE
Pope County Historical Society, Pope County Museum, Glenwood MN
Port Huron Museum, Port Huron MI
Porter-Phelps-Huntington Foundation, Inc, Historic House Museum, Hadley MA
Principia College, School of Nations Museum, Elsah IL
Putnam Museum of History and Natural Science, Davenport IA
Quapaw Quarter Association, Inc, Villa Marre, Little Rock AR
Queens College, City University of New York, Godwin-Ternbach Museum, Flushing NY
Red Deer & District Museum & Archives, Red Deer AB
Rhodes College, Clough-Hanson Gallery, Memphis TN
Riley County Historical Society, Riley County Historical Museum, Manhattan KS
Riverside Municipal Museum, Riverside CA
Millicent Rogers, Taos NM
Rollins College, George D & Harriet W Cornell Fine Arts Museum, Winter Park FL
Roswell Museum & Art Center, Roswell NM
Royal Arts Foundation, Belcourt Castle, Newport RI
Saco Museum, Saco ME
Saginaw Art Museum, Saginaw MI
Saint Joseph's Oratory, Museum, Montreal PQ
Saint Olaf College, Flaten Art Museum, Northfield MN
Saint Peter's College, Art Gallery, Jersey City NJ
Salisbury House Foundation, Des Moines IA
Santa Monica Museum of Art, Santa Monica CA
Schenectady Museum Planetarium & Visitors Center, Schenectady NY
Scripps College, Clark Humanities Museum, Claremont CA
Scripps College, Ruth Chandler Williamson Gallery, Claremont CA
Shaker Museum & Library, Old Chatham NY
Shaker Village of Pleasant Hill, Harrodsburg KY
Shelburne Museum, Museum, Shelburne VT
The Society for Contemporary Crafts, Pittsburgh PA
Society of the Cincinnati, Museum & Library at Anderson House, Washington DC
South Carolina Artisans Center, Walterboro SC
South Carolina State Museum, Columbia SC
South Dakota State University, South Dakota Art Museum, Brookings SD
Southern Baptist Theological Seminary, Joseph A Callaway Archaeological Museum, Louisville KY
Southern Oregon Historical Society, Jacksonville Museum of Southern Oregon History, Medford OR
Spartanburg County Museum of Art, Spartanburg SC
State of North Carolina, Battleship North Carolina, Wilmington NC
State University of New York at Binghamton, University Art Museum, Binghamton NY
State University of New York College at Cortland, Dowd Fine Arts Gallery, Cortland NY
Staten Island Institute of Arts & Sciences, Staten Island NY
T C Steele, Nashville IN
Stratford Historical Society, Catharine B Mitchell Museum, Stratford CT
Summit County Historical Society, Akron OH
Swedish-American Museum Association of Chicago, Chicago IL
Sylvia Plotkin Museum of Temple Beth Israel, Scottsdale AZ
Syracuse University, SUArt Galleries, Syracuse NY
Tampa Museum of Art, Tampa FL
Taos, Ernest Blumenschein Home & Studio, Taos NM
Taos, La Hacienda de Los Martinez, Taos NM
The Temple-Tifereth Israel, The Temple Museum of Religious Art, Beachwood OH
Texas Tech University, Museum of Texas Tech University, Lubbock TX
The Textile Museum, Washington DC
Textile Museum of Canada, Toronto ON
Tokyo National University of Fine Arts & Music Art, University Art Museum, Tokyo
Towson University Center for the Arts Gallery, Asian Arts & Culture Center, Towson MD
Tubac Center of the Arts, Tubac AZ
Tucson Museum of Artand Historic Block, Tucson AZ
Turtle Bay Exploration Park, Redding CA
Mark Twain, Hartford CT
Ucross Foundation, Big Red Barn Gallery, Clearmont WY

The Ukrainian Museum, New York NY
United Society of Shakers, Shaker Museum, New Glocester ME
University of British Columbia, Museum of Anthropology, Vancouver BC
University of Chicago, Oriental Institute Museum, Chicago IL
University of Colorado at Colorado Springs, Gallery of Contemporary Art, Colorado Springs CO
University of Delaware, University Gallery, Newark DE
University of Illinois, Krannert Art Museum and Kinkead Pavillion, Champaign IL
University of Iowa, Museum of Art, Iowa City IA
University of Kansas, Spencer Museum of Art, Lawrence KS
University of Manitoba, Faculty of Architecture Exhibition Centre, Winnipeg MB
University of Miami, Lowe Art Museum, Coral Gables FL
University of Michigan, Kelsey Museum of Archaeology, Ann Arbor MI
University of Mississippi, University Museum, Oxford MS
University of New Mexico, The Harwood Museum of Art, Taos NM
University of New Mexico, University Art Museum, Albuquerque NM
University of North Dakota, Hughes Fine Arts Center-Col Eugene Myers Art Gallery, Grand Forks ND
University of Oregon, Museum of Art, Eugene OR
University of San Diego, Founders' Gallery, San Diego CA
University of Saskatchewan, Diefenbaker Canada Centre, Saskatoon SK
University of Utah, Utah Museum of Fine Arts, Salt Lake City UT
Ursinus College, Philip & Muriel Berman Museum of Art, Collegeville PA
Vancouver Public Library, Fine Arts & Music Div, Vancouver BC
Victoria Mansion - Morse Libby House, Portland ME
Vizcaya Museum & Gardens, Miami FL
Wadsworth Atheneum Museum of Art, Hartford CT
Waterworks Visual Arts Center, Salisbury NC
Wayne County Historical Society, Honesdale PA
West Florida Historic Preservation, Inc, T T Wentworth, Jr Florida State Museum & Historic Pensacola Village, Pensacola FL
Wethersfield Historical Society Inc, Museum, Wethersfield CT
Whatcom Museum of History and Art, Bellingham WA
Wheaton College, Watson Gallery, Norton MA
Wheelwright Museum of the American Indian, Santa Fe NM
Wichita Art Museum, Wichita KS
Wilfrid Laurier University, Robert Langen Art Gallery, Waterloo ON
Willard House & Clock Museum, Inc, North Grafton MA
Winston-Salem State University, Diggs Gallery, Winston-Salem NC
Witte Museum, San Antonio TX
The Woman's Exchange, Gallier House Museum, New Orleans LA
Woodlawn/The Pope-Leighey, Mount Vernon VA
Yeshiva University Museum, New York NY

WATERCOLORS

Academy of the New Church, Glencairn Museum, Bryn Athyn PA
African American Museum in Philadelphia, Philadelphia PA
Albuquerque Museum of Art & History, Albuquerque NM
Alexandria Museum of Art, Alexandria LA
Algonquin Arts Council, Art Gallery of Bancroft, Bancroft ON
American Kennel Club, Museum of the Dog, Saint Louis MO
American University, Katzen Art Center Gallery, Washington DC
Anchorage Museum at Rasmuson Center, Anchorage AK
Walter Anderson, Ocean Springs MS
Art & Culture Center of Hollywood, Art Gallery, Hollywood FL

Art Community Center, Art Center of Corpus Christi, Corpus Christi TX
Art Gallery of Nova Scotia, Halifax NS
Art Gallery of South Australia, Adelaide
Art Museum of Greater Lafayette, Lafayette IN
Art Without Walls Inc, Art Without Walls Inc, Sayville NY
Artesia Historical Museum & Art Center, Artesia NM
Asbury College, Student Center Gallery, Wilmore KY
Asheville Art Museum, Asheville NC
Augustana College, Augustana College Art Museum, Rock Island IL
Barnes Foundation, Merion PA
Bethany College, Mingenback Art Center, Lindsborg KS
Biggs Museum of American Art, Dover DE
Birger Sandzen Memorial Gallery, Lindsborg KS
Blauvelt Demarest Foundation, Hiram Blauvelt Art Museum, Oradell NJ
Boston Public Library, Albert H Wiggin Gallery & Print Department, Boston MA
Roy Boyd, Chicago IL
Brandywine River Museum, Chadds Ford PA
Brigham Young University, Museum of Art, Provo UT
L D Brinkman, Kerrville TX
Burke Arts Council, Jailhouse Galleries, Morganton NC
Butler Institute of American Art, Art Museum, Youngstown OH
Cameron Art Museum, Wilmington NC
Canadian Museum of Civilization, Gatineau PQ
Canadian Museum of Nature, Musee Canadien de la Nature, Ottawa ON
Canajoharie Library & Art Gallery, Arkell Museum of Canajoharie, Canajoharie NY
Cape Ann Historical Association, Gloucester MA
Cape Cod Museum of Art Inc, Dennis MA
Carnegie Mellon University, Hunt Institute for Botanical Documentation, Pittsburgh PA
Amon Carter, Fort Worth TX
Cartoon Art Museum, San Francisco CA
Radio-Canada SRC CBC, Georges Goguen CBC Art Gallery, Moncton NB
Central Methodist University, Ashby-Hodge Gallery of American Art, Fayette MO
Chattahoochee Valley Art Museum, LaGrange GA
Chesapeake Bay Maritime Museum, Saint Michaels MD
Chinese Culture Foundation, Center Gallery, San Francisco CA
Chinese Culture Institute of the International Society, Tremont Theatre & Gallery, Boston MA
Church of Jesus Christ of Latter-Day Saints, Museum of Church History & Art, Salt Lake City UT
Cincinnati Museum Association and Art Academy of Cincinnati, Cincinnati Art Museum, Cincinnati OH
City of El Paso, El Paso TX
City of El Paso Museum and Cultural Affairs, People's Gallery, El Paso TX
City of Fayette, Alabama, Fayette Art Museum, Fayette AL
City of Fremont, Olive Hyde Art Gallery, Fremont CA
City of Gainesville, Thomas Center Galleries - Cultural Affairs, Gainesville FL
The City of Petersburg Museums, Petersburg VA
City of Pittsfield, Berkshire Artisans, Pittsfield MA
City of Toronto Culture Division, The Market Gallery, Toronto ON
Colorado Springs Fine Arts Center, Colorado Springs CO
Columbus Museum, Columbus GA
Columbus Museum of Art and Design, Indianapolis IN
Cornell University, Herbert F Johnson Museum of Art, Ithaca NY
Cornwall Gallery Society, Cornwall Regional Art Gallery, Cornwall ON
The Currier Museum of Art, Currier Museum of Art, Manchester NH
Dahesh Museum of Art, New York NY
Danforth Museum Corporation, Danforth Museum of Art, Framingham MA
Danville Museum of Fine Arts & History, Danville VA
Dartmouth Heritage Museum, Dartmouth NS
Deines Cultural Center, Russell KS
DeLeon White Gallery, Toronto ON
Detroit Institute of Arts, Detroit MI
Detroit Repertory Theatre Gallery, Detroit MI
DeWitt Historical Society of Tompkins County, The History Center in Tompkins Co, Ithaca NY
Dixie State College, Robert N & Peggy Sears Gallery, Saint George UT
The Dixon Gallery & Gardens, Memphis TN

The Temple-Tifereth Israel, The Temple Museum of Religious Art, Beachwood OH
Texas Tech University, Museum of Texas Tech University, Lubbock TX
Tokyo Kokuritsu Kindai Bujutsukan, The National Museum of Modern Art, Tokyo, Tokyo
Topeka & Shawnee County Public Library, Alice C Sabatini Gallery, Topeka KS
Tubac Center of the Arts, Tubac AZ
Tucson Museum of Artand Historic Block, Tucson AZ
Turtle Bay Exploration Park, Redding CA
Twin City Art Foundation, Masur Museum of Art, Monroe LA
Ucross Foundation, Big Red Barn Gallery, Clearmont WY
The Ukrainian Museum, New York NY
UMLAUF Sculpture Garden & Museum, Austin TX
United Society of Shakers, Shaker Museum, New Glocester ME
United States Capitol, Architect of the Capitol, Washington DC
United States Department of the Interior Museum, Washington DC
United States Figure Skating Association, World Figure Skating Museum & Hall of Fame, Colorado Springs CO
United States Navy, Art Gallery, Washington DC
University of California, Richard L Nelson Gallery & Fine Arts Collection, Davis CA
University of California, Santa Barbara, University Art Museum, Santa Barbara CA
University of Chicago, Oriental Institute Museum, Chicago IL
University of Cincinnati, DAAP Galleries-College of Design Architecture, Art & Planning, Cincinnati OH
University of Colorado, CU Art Galleries, Boulder CO
University of Colorado at Colorado Springs, Gallery of Contemporary Art, Colorado Springs CO
University of Illinois, Krannert Art Museum and Kinkead Pavillion, Champaign IL
University of Iowa, Museum of Art, Iowa City IA
University of Kansas, Spencer Museum of Art, Lawrence KS
University of Louisiana at Lafayette, University Art Museum, Lafayette LA
University of Maine, Museum of Art, Bangor ME
University of Manitoba, Faculty of Architecture Exhibition Centre, Winnipeg MB
University of Mary Washington, University of Mary Washington Galleries, Fredericksburg VA
University of Michigan, Museum of Art, Ann Arbor MI
University of Minnesota, The Bell Museum of Natural History, Minneapolis MN
University of Mississippi, University Museum, Oxford MS
University of Nebraska, Lincoln, Sheldon Memorial Art Gallery & Sculpture Garden, Lincoln NE
University of New Mexico, The Harwood Museum of Art, Taos NM
University of North Carolina at Greensboro, Weatherspoon Art Museum, Greensboro NC
University of Saskatchewan, Diefenbaker Canada Centre, Saskatoon SK
University of the South, University Art Gallery, Sewanee TN
University of Utah, Utah Museum of Fine Arts, Salt Lake City UT
University of Wisconsin-Madison, Wisconsin Union Galleries, Madison WI
Ursinus College, Philip & Muriel Berman Museum of Art, Collegeville PA
Valentine Richmond History Center, Richmond VA
Van Gogh Museum, Amsterdam
Vassar College, The Frances Lehman Loeb Art Center, Poughkeepsie NY
Ventura County Maritime Museum, Inc, Oxnard CA
Very Special Arts New Mexico, Very Special Arts Gallery, Albuquerque NM
Vesterheim Norwegian-American Museum, Decorah IA
Wallace Collection, London
Washburn University, Mulvane Art Museum, Topeka KS
Washington University, Mildred Lane Kemper Art Museum, Saint Louis MO
Waterworks Visual Arts Center, Salisbury NC
Wellesley College, Davis Museum & Cultural Center, Wellesley MA
West Florida Historic Preservation, Inc, T T Wentworth, Jr Florida State Museum & Historic Pensacola Village, Pensacola FL

Western Illinois University, Western Illinos University Art Gallery, Macomb IL
Whatcom Museum of History and Art, Bellingham WA
Wheaton College, Watson Gallery, Norton MA
Peter & Catharine Whyte Foundation, Whyte Museum of the Canadian Rockies, Banff AB
Wichita Art Museum, Wichita KS
Wilfrid Laurier University, Robert Langen Art Gallery, Waterloo ON
Winston-Salem State University, Diggs Gallery, Winston-Salem NC
The Woman's Exchange, University Art Collection, New Orleans LA
Woodlawn/The Pope-Leighey, Mount Vernon VA
Worcester Art Museum, Worcester MA

WOODCARVINGS

A I R Gallery, New York NY
Academy of the New Church, Glencairn Museum, Bryn Athyn PA
African American Museum in Philadelphia, Philadelphia PA
Agecroft Association, Museum, Richmond VA
Alaska Department of Education, Division of Libraries, Archives & Museums, Sheldon Jackson Museum, Sitka AK
Albuquerque Museum of Art & History, Albuquerque NM
American Kennel Club, Museum of the Dog, Saint Louis MO
American Swedish Institute, Minneapolis MN
Walter Anderson, Ocean Springs MS
Arab American National Museum, Dearborn MI
Arnold Mikelson Mind & Matter Gallery, White Rock BC
Art & Culture Center of Hollywood, Art Gallery, Hollywood FL
Art Gallery of Hamilton, Hamilton ON
Art Gallery of Nova Scotia, Halifax NS
Art Museum of Greater Lafayette, Lafayette IN
Art Without Walls Inc, Art Without Walls Inc, Sayville NY
Asian Art Museum of San Francisco, Chong-Moon Lee Ctr for Asian Art and Culture, San Francisco CA
Atlanta International Museum of Art & Design, Atlanta GA
Beaumont Art League, Beaumont TX
BJU Museum & Gallery, Bob Jones University Museum & Gallery Inc, Greenville SC
Blauvelt Demarest Foundation, Hiram Blauvelt Art Museum, Oradell NJ
Brigham Young University, Museum of Art, Provo UT
Cabot's Old Indian Pueblo Museum, Cabot's Old Indian Pueblo Museum, Desert Hot Springs CA
The Canadian Craft Museum, Vancouver BC
Canadian Museum of Civilization, Gatineau PQ
Canadian Museum of Nature, Musee Canadien de la Nature, Ottawa ON
Cape Cod Museum of Art Inc, Dennis MA
Miles B Carpenter, Waverly VA
Radio-Canada SRC CBC, Georges Goguen CBC Art Gallery, Moncton NB
Center for Puppetry Arts, Atlanta GA
Central United Methodist Church, Swords Into Plowshares Peace Center & Gallery, Detroit MI
Chattahoochee Valley Art Museum, LaGrange GA
Chesapeake Bay Maritime Museum, Saint Michaels MD
Chinese Culture Foundation, Center Gallery, San Francisco CA
Church of Jesus Christ of Latter-Day Saints, Museum of Church History & Art, Salt Lake City UT
Cincinnati Museum Association and Art Academy of Cincinnati, Cincinnati Art Museum, Cincinnati OH
City of Fayette, Alabama, Fayette Art Museum, Fayette AL
City of Gainesville, Thomas Center Galleries - Cultural Affairs, Gainesville FL
Clark County Historical Society, Pioneer - Krier Museum, Ashland KS
Clinton Art Association, River Arts Center, Clinton IA
Colorado Springs Fine Arts Center, Colorado Springs CO
Columbus Museum, Columbus GA
Craft and Folk Art Museum (CAFAM), Los Angeles CA
Craftsmen's Guild of Mississippi, Inc, Mississippi Crafts Center, Ridgeland MS

The Currier Museum of Art, Currier Museum of Art, Manchester NH
Danville Museum of Fine Arts & History, Danville VA
Delaware Archaeology Museum, Dover DE
Denison University, Art Gallery, Granville OH
Detroit Institute of Arts, Detroit MI
Detroit Repertory Theatre Gallery, Detroit MI
Dundurn Castle, Hamilton ON
Eastern Washington State Historical Society, Northwest Museum of Arts & Culture, Spokane WA
Ellen Noel Art Museum of the Permian Basin, Odessa TX
Elmhurst Art Museum, Elmhurst IL
Emory University, Michael C Carlos Museum, Atlanta GA
Enook Galleries, Waterloo ON
Wharton Esherick, Paoli PA
Essex Historical Society, Essex Shipbuilding Museum, Essex MA
Five Civilized Tribes Museum, Muskogee OK
Folk Art Society of America, Richmond VA
Gadsden Museum of Fine Arts, Inc, Gadsden Museum of Art and History, Gadsden AL
General Board of Discipleship, The United Methodist Church, The Upper Room Chapel & Museum, Nashville TN
Germanisches Nationalmuseum, Nuremberg
Wendell Gilley, Southwest Harbor ME
Gloridale Partnership, National Museum of Woodcarving, Custer SD
Robert Gumbiner, Museum of Latin American Art, Long Beach CA
Hancock County Trustees of Public Reservations, Woodlawn Museum, Ellsworth ME
Haystack Mountain School of Crafts, Deer Isle ME
Heard Museum, Phoenix AZ
Henry County Museum & Cultural Arts Center, Clinton MO
Hermitage Foundation Museum, Norfolk VA
Hershey Museum, Hershey PA
Higgins Armory Museum, Worcester MA
High Desert Museum, Bend OR
Hillwood Museum & Gardens Foundation, Hillwood Museum & Gardens, Washington DC
Historic Royal Palaces, Hampton Court Palace, East Molesey
Holter Museum of Art, Helena MT
Iredell Museum of Arts & Heritage, Statesville NC
Iroquois Indian Museum, Howes Cave NY
Jacksonville University, Alexander Brest Museum & Gallery, Jacksonville FL
John B Aird Gallery, Toronto ON
John Weaver Sculpture Collection, Hope BC
Kalamazoo Institute of Arts, Kalamazoo MI
Kentucky Museum of Art & Craft, Louisville KY
Kereszteny Muzeum, Christian Museum, Esztergom
Kirkland Museum of Fine & Decorative Art, Denver CO
Knights of Columbus Supreme Council, Knights of Columbus Museum, New Haven CT
Koshare Indian Museum, Inc, La Junta CO
Lac du Flambeau Band of Lake Superior Chippewa Indians, George W Brown Jr Ojibwe Museum & Cultural Center, Lac du Flambeau WI
Lincoln County Historical Association, Inc, 1811 Old Lincoln County Jail & Lincoln County Museum, Wiscasset ME
Los Angeles County Museum of Natural History, William S Hart Museum, Newhall CA
Luther College, Fine Arts Collection, Decorah IA
Maitland Art Center, Maitland FL
The Mariners' Museum, Newport News VA
Maryland Hall for the Creative Arts, Chaney Gallery, Annapolis MD
Mennello Museum of American Art, Orlando FL
Meredith College, Frankie G Weems Gallery & Rotunda Gallery, Raleigh NC
Middlebury College, Museum of Art, Middlebury VT
Mills College, Art Museum, Oakland CA
Mint Museum of Art, Mint Museum of Craft & Design, Charlotte NC
Moderna Galerija, Gallery of Modern Art, Zagreb
Morehead State University, Kentucky Folk Art Center, Morehead KY
Muscatine Art Center, Museum, Muscatine IA
Musee d'Art de Saint-Laurent, Saint-Laurent PQ
Musee du Quebec, Quebec PQ
Musee et Chateau de Chantilly (MUSEE CONDE), Chantilly
Musee Regional de la Cote-Nord, Sept-Iles PQ

Museu Nacional d'Art de Catalunya, National Art Museum, Barcelona
The Museum, Greenwood SC
Museum for African Art, Long Island City NY
Museum of Northwest Art, La Conner WA
Museum of York County, Rock Hill SC
Nanticoke Indian Museum, Millsboro DE
Narodna Galerija, National Gallery of Slovenia, Ljubljana
National Palace Museum, Taipei
Nebraska State Capitol, Lincoln NE
Nevada Museum of Art, Reno NV
New Jersey State Museum, Fine Art Bureau, Trenton NJ
North Dakota State University, Memorial Union Gallery, Fargo ND
Noyes Art Gallery, Lincoln NE
The Noyes Museum of Art, Oceanville NJ
Ohio University, Kennedy Museum of Art, Athens OH
Ohrmann Museum and Gallery, Drummond MT
Olana State Historic Site, Hudson NY
Owensboro Museum of Fine Art, Owensboro KY
Pacific - Asia Museum, Pasadena CA
Paris Gibson Square, Museum of Art, Great Falls MT
Plainsman Museum, Aurora NE
Pope County Historical Society, Pope County Museum, Glenwood MN
Porter Thermometer Museum, Onset MA
Princeton University, Princeton University Art Museum, Princeton NJ
Pump House Center for the Arts, Chillicothe OH
Queens College, City University of New York, Godwin-Ternbach Museum, Flushing NY
Rhodes College, Clough-Hanson Gallery, Memphis TN
Roswell Museum & Art Center, Roswell NM
Saginaw Art Museum, Saginaw MI
Saint Clair County Community College, Jack R Hennesey Art Galleries, Port Huron MI
Salisbury House Foundation, Des Moines IA
Seneca-Iroquois National Museum, Salamanca NY
Sheldon Museum & Cultural Center, Inc, Sheldon Museum & Cultural Center, Haines AK
South Carolina Artisans Center, Walterboro SC
South Dakota State University, South Dakota Art Museum, Brookings SD
Spartanburg County Museum of Art, Spartanburg SC
Springfield Art Museum, Springfield MO
Stauth Foundation & Museum, Stauth Memorial Museum, Montezuma KS
SVACA - Sheyenne Valley Arts & Crafts Association, Bjarne Ness Gallery at Bear Creek Hall, Fort Ransom ND
Swedish-American Museum Association of Chicago, Chicago IL
Tampa Museum of Art, Tampa FL
Taos, La Hacienda de Los Martinez, Taos NM
Texas Tech University, Museum of Texas Tech University, Lubbock TX
Tinkertown Museum, Sandia Park NM
Topeka & Shawnee County Public Library, Alice C Sabatini Gallery, Topeka KS
Mark Twain, Hartford CT
The Ukrainian Museum, New York NY
UMLAUF Sculpture Garden & Museum, Austin TX
University of British Columbia, Museum of Anthropology, Vancouver BC
University of California, Richard L Nelson Gallery & Fine Arts Collection, Davis CA
University of Illinois, Krannert Art Museum and Kinkead Pavillion, Champaign IL
University of Iowa, Museum of Art, Iowa City IA
University of Memphis, Art Museum, Memphis TN
University of Mississippi, University Museum, Oxford MS
University of New Mexico, The Harwood Museum of Art, Taos NM
University of Utah, Utah Museum of Fine Arts, Salt Lake City UT
Vesterheim Norwegian-American Museum, Decorah IA
Wadsworth Atheneum Museum of Art, Hartford CT
Warther Museum Inc, Dover OH
Washington University, Mildred Lane Kemper Art Museum, Saint Louis MO
Waterworks Visual Arts Center, Salisbury NC
West Florida Historic Preservation, Inc, T T Wentworth, Jr Florida State Museum & Historic Pensacola Village, Pensacola FL
Whatcom Museum of History and Art, Bellingham WA
Wheaton College, Watson Gallery, Norton MA
Peter & Catharine Whyte Foundation, Whyte Museum of the Canadian Rockies, Banff AB

Wichita Art Museum, Wichita KS
Wilfrid Laurier University, Robert Langen Art Gallery, Waterloo ON
Winston-Salem State University, Diggs Gallery, Winston-Salem NC
Wisconsin Historical Society, State Historical Museum, Madison WI

WOODCUTS

A I R Gallery, New York NY
African American Museum in Philadelphia, Philadelphia PA
Albuquerque Museum of Art & History, Albuquerque NM
American Kennel Club, Museum of the Dog, Saint Louis MO
American University, Katzen Art Center Gallery, Washington DC
Walter Anderson, Ocean Springs MS
Art & Culture Center of Hollywood, Art Gallery, Hollywood FL
Art Gallery of South Australia, Adelaide
Art Museum of Greater Lafayette, Lafayette IN
Art Without Walls Inc, Art Without Walls Inc, Sayville NY
ArtSpace-Lima, Lima OH
Asbury College, Student Center Gallery, Wilmore KY
Augustana College, Augustana College Art Museum, Rock Island IL
Berea College, Doris Ulmann Galleries, Berea KY
Birger Sandzen Memorial Gallery, Lindsborg KS
Blanden Memorial Art Museum, Fort Dodge IA
Boston Public Library, Albert H Wiggin Gallery & Print Department, Boston MA
Brigham Young University, Museum of Art, Provo UT
Brown University, David Winton Bell Gallery, Providence RI
California State University, Northridge, Art Galleries, Northridge CA
Canadian Museum of Civilization, Gatineau PQ
Cape Cod Museum of Art Inc, Dennis MA
Carleton College, Art Gallery, Northfield MN
Carnegie Mellon University, Hunt Institute for Botanical Documentation, Pittsburgh PA
Carnegie Museums of Pittsburgh, Carnegie Museum of Art, Pittsburgh PA
Carolina Art Association, Gibbes Museum of Art, Charleston SC
Radio-Canada SRC CBC, Georges Goguen CBC Art Gallery, Moncton NB
Chattahoochee Valley Art Museum, LaGrange GA
Chinese Culture Institute of the International Society, Tremont Theatre & Gallery, Boston MA
Church of Jesus Christ of Latter-Day Saints, Mormon Visitors' Center, Independence MO
Cincinnati Museum Association and Art Academy of Cincinnati, Cincinnati Art Museum, Cincinnati OH
City of El Paso, El Paso TX
City of Fayette, Alabama, Fayette Art Museum, Fayette AL
City of Gainesville, Thomas Center Galleries - Cultural Affairs, Gainesville FL
City of Pittsfield, Berkshire Artisans, Pittsfield MA
Clinton Art Association, River Arts Center, Clinton IA
Colgate University, Picker Art Gallery, Hamilton NY
College of William & Mary, Muscarelle Museum of Art, Williamsburg VA
The College of Wooster, The College of Wooster Art Museum, Wooster OH
Columbus Museum, Columbus GA
Coos Art Museum, Coos Bay OR
Cornell University, Herbert F Johnson Museum of Art, Ithaca NY
Craft and Folk Art Museum (CAFAM), Los Angeles CA
Danville Museum of Fine Arts & History, Danville VA
Deines Cultural Center, Russell KS
DeLeon White Gallery, Toronto ON
Denison University, Art Gallery, Granville OH
Detroit Institute of Arts, Detroit MI
Detroit Repertory Theatre Gallery, Detroit MI
Dickinson College, The Trout Gallery, Carlisle PA
Dixie State College, Robert N & Peggy Sears Gallery, Saint George UT
Door County, Miller Art Museum, Sturgeon Bay WI
Eastern Illinois University, Tarble Arts Center, Charleston IL
Elmhurst Art Museum, Elmhurst IL
Wharton Esherick, Paoli PA

Evansville Museum of Arts, History & Science, Evansville IN
Evergreen State College, Evergreen Galleries, Olympia WA
Fort Ticonderoga Association, Ticonderoga NY
Fuller Museum of Art, Brockton MA
Gadsden Museum of Fine Arts, Inc, Gadsden Museum of Art and History, Gadsden AL
Germanisches Nationalmuseum, Nuremberg
Gonzaga University, Art Gallery, Spokane WA
Grinnell College, Art Gallery, Grinnell IA
Guilford College, Art Gallery, Greensboro NC
Robert Gumbiner, Museum of Latin American Art, Long Beach CA
Hartwick College, The Yager Museum, Oneonta NY
Haystack Mountain School of Crafts, Deer Isle ME
Henry Gallery Association, Henry Art Gallery, Seattle WA
Hickory Museum of Art, Inc, Hickory NC
William Humphreys, Kimberley
Iredell Museum of Arts & Heritage, Statesville NC
Irving Arts Center, Main Gallery & Focus Gallery, Irving TX
John B Aird Gallery, Toronto ON
John Weaver Sculpture Collection, Hope BC
Joslyn Art Museum, Omaha NE
Juniata College Museum of Art, Huntingdon PA
Kalamazoo Institute of Arts, Kalamazoo MI
Kansas City Art Institute, Kansas City MO
Knoxville Museum of Art, Knoxville TN
Lafayette College, Williams Center Gallery, Easton PA
Lehigh University Art Galleries, Museum Operation, Bethlehem PA
Longview Museum of Fine Art, Longview TX
Luther College, Fine Arts Collection, Decorah IA
Charles H MacNider, Mason City IA
The Mariners' Museum, Newport News VA
Maryland Hall for the Creative Arts, Chaney Gallery, Annapolis MD
Mattatuck Historical Society, Mattatuck Museum, Waterbury CT
McMaster University, McMaster Museum of Art, Hamilton ON
Mennello Museum of American Art, Orlando FL
Miami-Dade College, Kendal Campus, Art Gallery, Miami FL
Michelson Museum of Art, Marshall TX
Midwest Museum of American Art, Elkhart IN
Mills College, Art Museum, Oakland CA
Moderna Galerija, Gallery of Modern Art, Zagreb
Montgomery Museum of Fine Arts, Montgomery AL
Moravian College, Payne Gallery, Bethlehem PA
Musee Regional de la Cote-Nord, Sept-Iles PQ
Museum of Northwest Art, La Conner WA
Narodna Galerija, National Gallery of Slovenia, Ljubljana
Naval Historical Center, The Navy Museum, Washington DC
Nelson-Atkins Museum of Art, Kansas City MO
Nevada Museum of Art, Reno NV
New Jersey State Museum, Fine Art Bureau, Trenton NJ
New Mexico State University, Art Gallery, Las Cruces NM
New Visions Gallery, Inc, Marshfield WI
Newport Art Museum, Newport RI
Niagara University, Castellani Art Museum, Niagara NY
North Dakota State University, Memorial Union Gallery, Fargo ND
Northern Illinois University, NIU Art Museum, De Kalb IL
Ohio University, Kennedy Museum of Art, Athens OH
Oklahoma City Museum of Art, Oklahoma City OK
The Old Jail Art Center, Albany TX
Palm Beach County Parks & Recreation Department, Morikami Museum & Japanese Gardens, Delray Beach FL
Palm Springs Art Museum, Palm Springs CA
Paris Gibson Square, Museum of Art, Great Falls MT
Pensacola Museum of Art, Pensacola FL
Phoenix Art Museum, Phoenix AZ
The Pomona College, Montgomery Gallery, Claremont CA
Porter Thermometer Museum, Onset MA
Pump House Center for the Arts, Chillicothe OH
Purdue University Galleries, West Lafayette IN
Queens College, City University of New York, Godwin-Ternbach Museum, Flushing NY
Roswell Museum & Art Center, Roswell NM

Saginaw Art Museum, Saginaw MI
Saint Bonaventure University, Regina A Quick Center for the Arts, Saint Bonaventure NY
Saint Joseph College, Saint Joseph College Art Gallery, West Hartford CT
Saint Olaf College, Flaten Art Museum, Northfield MN
Santa Barbara Museum of Art, Santa Barbara CA
South Carolina Artisans Center, Walterboro SC
Springfield Art Museum, Springfield MO
Stanford University, Iris & B Gerald Cantor Center for Visual Arts, Stanford CA
State Capital Museum, Olympia WA
State University of New York at Binghamton, University Art Museum, Binghamton NY
State University of New York College at Cortland, Dowd Fine Arts Gallery, Cortland NY
Staten Island Institute of Arts & Sciences, Staten Island NY
Switzerland County Historical Society Inc, Life on the Ohio: River History Museum, Vevay IN
Switzerland County Historical Society Inc, Switzerland County Historical Museum, Vevay IN
Syracuse University, SUArt Galleries, Syracuse NY
Tampa Museum of Art, Tampa FL
Tokyo National University of Fine Arts & Music Art, University Art Museum, Tokyo
Towson University Center for the Arts Gallery, Asian Arts & Culture Center, Towson MD
Turk ve Islam Eserleri Muzesi, Museum of Turkish and Islamic Art, Istanbul
Twin City Art Foundation, Masur Museum of Art, Monroe LA
The Ukrainian Museum, New York NY
United States Figure Skating Association, World Figure Skating Museum & Hall of Fame, Colorado Springs CO
United States Navy, Art Gallery, Washington DC
University of Alabama at Birmingham, Visual Arts Gallery, Birmingham AL
University of Arkansas at Little Rock, Art Galleries, Little Rock AR
University of California, Richard L Nelson Gallery & Fine Arts Collection, Davis CA
University of Colorado at Colorado Springs, Gallery of Contemporary Art, Colorado Springs CO
University of Illinois, Krannert Art Museum and Kinkead Pavillion, Champaign IL
University of Iowa, Museum of Art, Iowa City IA
University of Kansas, Spencer Museum of Art, Lawrence KS
University of Louisiana at Lafayette, University Art Museum, Lafayette LA
University of Maine, Museum of Art, Bangor ME
University of Memphis, Art Museum, Memphis TN
University of North Carolina at Greensboro, Weatherspoon Art Museum, Greensboro NC
University of Utah, Utah Museum of Fine Arts, Salt Lake City UT
Upstairs Gallery, Winnipeg MB
Ursinus College, Philip & Muriel Berman Museum of Art, Collegeville PA
Van Gogh Museum, Amsterdam
Vesterheim Norwegian-American Museum, Decorah IA
Wadsworth Atheneum Museum of Art, Hartford CT
Washburn University, Mulvane Art Museum, Topeka KS
Washington University, Mildred Lane Kemper Art Museum, Saint Louis MO
Waterworks Visual Arts Center, Salisbury NC
Wellesley College, Davis Museum & Cultural Center, Wellesley MA
Wesleyan University, Davison Art Center, Middletown CT
West Florida Historic Preservation, Inc, T T Wentworth, Jr Florida State Museum & Historic Pensacola Village, Pensacola FL
Western Illinois University, Western Illinos University Art Gallery, Macomb IL
Wheaton College, Watson Gallery, Norton MA
Peter & Catharine Whyte Foundation, Whyte Museum of the Canadian Rockies, Banff AB
Wilfrid Laurier University, Robert Langen Art Gallery, Waterloo ON
Winston-Salem State University, Diggs Gallery, Winston-Salem NC
Worcester Art Museum, Worcester MA

Collections

18th, 19th & 20th Century American paintings, drawings, prints
Kennedy Galleries, Kennedy Talkies, Inc, New York NY

19th Century African-American Arts
Museum of Afro-American History, Boston MA

19th, 20th & 21st Century art, primarily American
Rahr-West Art Museum, Manitowoc WI

Virginia & George Ablah Collection of British Watercolors
Wichita Art Museum, Wichita KS

Aboriginal Artifacts
Moncur Gallery, Boissevain MB

Acadian Artifacts
Lafayette Natural History Museum & Planetarium, Lafayette LA

Adolf Austrian Academic Painting Collection
The Pennsylvania State University, Palmer Museum of Art, University Park PA

Advertising Design
Georgian Court College, M Christina Geis Gallery, Lakewood NJ

Aesthetics
Bemis Center for Contemporary Arts, Omaha NE

African Art
College of William & Mary, Muscarelle Museum of Art, Williamsburg VA
The Slater Memorial Museum, Slater Memorial Museum, Norwich CT

African Collection
Albany Museum of Art, Albany GA

African-American Art Collection
Winston-Salem State University, Diggs Gallery, Winston-Salem NC

Agricultural Artifacts
Napa Valley Museum, Yountville CA

Agricultural Equipment
Dawson County Historical Society, Museum, Lexington NE

Agriculture
Adams County Historical Society, Gettysburg PA

Ala Story Print Collection
University of California, Santa Barbara, University Art Museum, Santa Barbara CA

Josef Albers Collection
University of Texas Pan American, Charles & Dorothy Clark Gallery; University Gallery, Edinburg TX

Joseph Albers Collection
University of Texas Pan American, UTPA Art Galleries, Edinburg TX

Washington Allston Trust Collection
University of Miami, Lowe Art Museum, Coral Gables FL

American Art
Saint Mary's College of California, Hearst Art Gallery, Moraga CA

American Art & Furniture from the Seventeenth - Twentieth Centuries
The Slater Memorial Museum, Slater Memorial Museum, Norwich CT

American Art Collection
James A Michener, Doylestown PA

American Art; Conceptual Art; Contemporary Art
University of California, Berkeley, Berkeley Art Museum & Pacific Film Archive, Berkeley CA

American Contemporary Art
Art Without Walls Inc, Art Without Walls Inc, Sayville NY

American Craft Collection
San Angelo Museum of Fine Arts, San Angelo TX

American Decorative Arts, 19th-20th Centuries
Birmingham Museum of Art, Birmingham AL

American Fine Arts
Fetherston Foundation, Packwood House Museum, Lewisburg PA

American Folk Art Collection
University of Wisconsin-Whitewater, Crossman Gallery, Whitewater WI

American Furniture
US Department of State, Diplomatic Reception Rooms, Washington DC

American Historical Artifacts
The Long Island Museum of American Art, History & Carriages, Stony Brook NY

American Illustration
Brandywine River Museum, Chadds Ford PA

American Impressionism
Historical Society of the Town of Greenwich, Inc, Bush-Holley House Museum, Cos Cob CT

American Impressionist Paintings
National Park Service, Weir Farm National Historic Site, Wilton CT

American Indian Artifacts
Napa Valley Museum, Yountville CA

American Indian Crafts
Tohono Chul Park, Tucson AZ

American Jewish Ethnographic Collection
Hebrew Union College, Skirball Cultural Center, Los Angeles CA

American Painting & Sculpture Collection
San Angelo Museum of Fine Arts, San Angelo TX

American Portraits & Paintings
US Department of State, Diplomatic Reception Rooms, Washington DC

American Renaissance
National Trust for Historic Preservation, Chesterwood Estate & Museum, Stockbridge MA

American Silver
US Department of State, Diplomatic Reception Rooms, Washington DC

Ancient Art
Albany Museum of Art, Albany GA

Inglis Anderson Collection
Walter Anderson, Ocean Springs MS

Carl Andre Collection
Chinati Foundation, Marfa TX

Animal Art & Wildlife Art
Blauvelt Demarest Foundation, Hiram Blauvelt Art Museum, Oradell NJ

Ann Louise Stanton Antique Dollhead Collection
Southern Ohio Museum Corporation, Southern Ohio Museum, Portsmouth OH

Antique Electrical Signs
Museum of Neon Art, Los Angeles CA

Antique Furniture Collection
Willard House & Clock Museum, Inc, North Grafton MA

Antiquities - Cycladic
Kimbell Art Museum, Fort Worth TX

Karel Appel Graphics Collection
Art Gallery of Hamilton, Hamilton ON

Archdiocese Santa Fe Collection
Guadalupe Historic Foundation, Santuario de Guadalupe, Santa Fe NM

Archeological Collection
Clark County Historical Society, Pioneer - Krier Museum, Ashland KS

Archives of Catalan-American Artist Pierre Daura
Lynchburg College, Daura Gallery, Lynchburg VA

Archives; Photos & Maps; Trade & Business Items
Arizona Historical Society-Yuma, Sanguinetti House Museum & Garden, Yuma AZ

Arensberg Collection
Philadelphia Museum of Art, Philadelphia PA

Caroline & Frank Armington Collection
Art Gallery of Peel, Peel Heritage Complex, Brampton ON

Arms & Armor
Higgins Armory Museum, Worcester MA

J Chester Armstrong Collection
Zigler Museum, Jennings LA

Grant Arnold Fine Print Collection
State University of New York at Oswego, Tyler Art Gallery, Oswego NY

Matthias H Arnot Collection
Arnot Art Museum, Elmira NY

Art
Carteret County Historical Society, Museum of History & Art, Morehead City NC

Art Appreciation
University of North Dakota, Hughes Fine Arts Center-Col Eugene Myers Art Gallery, Grand Forks ND

Art Deco; Victorian
Porter Thermometer Museum, Onset MA

Art Education
Brookgreen Gardens, Murrells Inlet SC
University of North Dakota, Hughes Fine Arts Center-Col Eugene Myers Art Gallery, Grand Forks ND

Art History
Adams County Historical Society, Gettysburg PA
Bemis Center for Contemporary Arts, Omaha NE
Brookgreen Gardens, Murrells Inlet SC
Georgian Court College, M Christina Geis Gallery, Lakewood NJ
University of North Dakota, Hughes Fine Arts Center-Col Eugene Myers Art Gallery, Grand Forks ND
Yeshiva University Museum, New York NY

Art History, Flasks & Bottles, Handicrafts
Heritage Museum Association, Inc, The Heritage Museum of Northwest Florida, Valparaiso FL

Art Mouveau Glass-Nineteenth Century Chinese Decorative Arts
Topeka & Shawnee County Public Library, Alice C Sabatini Gallery, Topeka KS

Art Preservation
The Bartlett Museum, Amesbury MA

Art Therapy
Art Without Walls Inc, Art Without Walls Inc, Sayville NY

Artifacts
Gilbert Stuart, Museum, Saunderstown RI

Ashby Collection of American Art
Central Methodist University, Ashby-Hodge Gallery of American Art, Fayette MO

Asian & Guatemalan Collection
Mills College, Art Museum, Oakland CA

Asian Art
College of William & Mary, Muscarelle Museum of Art, Williamsburg VA

Asnis Collection
Sonoma State University, University Art Gallery, Rohnert Park CA

Lady Nancy Astor Collection of English China
Virginia Museum of Fine Arts, Richmond VA

Eleanor Deane Audigier Art Collection
University of Tennessee, Frank H McClung Museum, Knoxville TN

Audio-Visual Installations
Dallas Museum of Art, Dallas TX

Audubon Prints
Lafayette Natural History Museum & Planetarium, Lafayette LA

Aultman Collection
Arthur Roy Mitchell, Museum of Western Art, Trinidad CO

Autio Ceramics Collection
University of Montana, Paxson Gallery, Missoula MT

Aviation
Carteret County Historical Society, Museum of History & Art, Morehead City NC

Australian Aboriginal Art Collection
New Visions Gallery, Inc, Marshfield WI

Alice Baber Midwest Collection
Art Museum of Greater Lafayette, Lafayette IN

Manson F Backus Print Collection
Seattle Art Museum, Seattle WA

Baker Collection of Porcelain
Lehigh University Art Galleries, Museum Operation, Bethlehem PA

Bryant Baker Sculpture Collection
Ponca City Cultural Center & Museum, Ponca City OK

Cyrus Baldridge Drawings
Fisk University, Fisk University Galleries, Nashville TN

Ball-Kraft Collection of Roman & Syrian Glass
Ball State University, Museum of Art, Muncie IN

Dr & Mrs William E Ballard Japanese Print Collection
Scripps College, Ruth Chandler Williamson Gallery, Claremont CA

Ballroom Dance
Hoyt Institute of Fine Arts, New Castle PA

Bancroft Collection
Delaware Art Museum, Wilmington DE

John Chandler Bancroft Collection of Japanese Prints
Worcester Art Museum, Worcester MA

Barbed Wire Collection
Clark County Historical Society, Pioneer - Krier Museum, Ashland KS

Barberini-Kress Foundation Collection
Philadelphia Museum of Art, Philadelphia PA

Virgil Barker Collection
University of Miami, Lowe Art Museum, Coral Gables FL

John Barrow Collection
John D Barrow, Skaneateles NY

Alfred I Barton Collection
University of Miami, Lowe Art Museum, Coral Gables FL

Bernard Baruch Silver Collection
University of South Carolina, McKissick Museum, Columbia SC

Zoe Beiler Paintings Collection
Dickinson State University, Art Gallery, Dickinson ND

David Belasco Collection
Neville Public Museum, Green Bay WI

Bemis Collection
Bemis Center for Contemporary Arts, Omaha NE

Bering Strait Eskimo
Carrie M McLain, Nome AK

Berman Collection
Lehigh University Art Galleries, Museum Operation, Bethlehem PA

Philip & Muriel Berman Collection
Ursinus College, Philip & Muriel Berman Museum of Art, Collegeville PA

Bernat Oriental Collection
Colby College, Museum of Art, Waterville ME

Sydney and Walda Besthoff Sculpture Garden
New Orleans Museum of Art, New Orleans LA

Biblical Archaeology
Hebrew Union College, Skirball Cultural Center, Los Angeles CA

Biblical Archaeology Collection
Hebrew Union College, Jewish Institute of Religion Museum, New York NY

Biggs Collection
Biggs Museum of American Art, Dover DE

Biggs Sculpture Collection
Red River Valley Museum, Vernon TX

Birds of America
National Audubon Society, John James Audubon Center at Mill Grove, Audubon PA

Black Diaspora Exhibits & Artifacts
Anacostia Museum, Washington DC

Wendel Black Print Collection
Oregon State University, Fairbanks Gallery, Corvallis OR

Joseph Blackburn Collection
Warner House Association, MacPheadris-Warner House, Portsmouth NH

Vyvyan Blackford Collection
Fort Hays State University, Moss-Thorns Gallery of Arts, Hays KS

Blacksmithing
Taos, La Hacienda de Los Martinez, Taos NM

Eubie Blake Collection
Eubie Blake, Baltimore MD

Edwin M Blake Memorial Collection
Trinity College, Austin Arts Center, Widener Gallery, Hartford CT

R A Blakelock
Heckscher Museum of Art, Huntington NY

Ernest L Blumenschein & Family Collection
Taos, Ernest Blumenschein Home & Studio, Taos NM

Bodmer Collection
Joslyn Art Museum, Omaha NE

Boehm Collection
Bellingrath Gardens & Home, Theodore AL

Bone & Ivory
Agecroft Association, Museum, Richmond VA

Frederick T Bonham Collection
University of Tennessee, Frank H McClung Museum, Knoxville TN

Botanical Art
Brooklyn Botanic Garden, Steinhardt Conservatory Gallery, Brooklyn NY

Henry Botkin Collection
University of Louisiana at Lafayette, University Art Museum, Lafayette LA

Bourbon County History
Historic Paris - Bourbon County, Inc, Hopewell Museum, Paris KY

Bowen Collection
BJU Museum & Gallery, Bob Jones University Museum & Gallery Inc, Greenville SC

Bower Collection
Red Deer & District Museum & Archives, Red Deer AB

Bradley Collection
Milwaukee Art Museum, Milwaukee WI

Branch Collection of Renaissance Art
Virginia Museum of Fine Arts, Richmond VA

Brancusi
Hirshhorn Museum & Sculpture Garden, Smithsonian Institution, Washington DC

Constantin Brancusi Sculpture Collection
Guggenheim Museum Soho, New York NY
Solomon R Guggenheim, New York NY

Brass Measures (1854)
Kings County Historical Society & Museum, Hampton NB

British Contemporary Paintings
The Old Jail Art Center, Albany TX

Saidye & Samuel Bronfman Collection of Canadian Art
Montreal Museum of Fine Arts, Montreal PQ

Ailsa Mellon Bruce Collection of Decorative Arts
Virginia Museum of Fine Arts, Richmond VA

Buchanan Collection of City of Lethbridge
Southern Alberta Art Gallery, Lethbridge AB

Ottilia Buerger Collection of Ancient Coins
Lawrence University, Wriston Art Center Galleries, Appleton WI

George Burchett Collection
Tattoo Art Museum, San Francisco CA

Charles E Burchfield
Burchfield-Penney Art Center, Buffalo NY

Burgeois
Hirshhorn Museum & Sculpture Garden, Smithsonian Institution, Washington DC

Charles Grove Burgoyne
Halifax Historical Society, Inc, Halifax Historical Museum, Daytona Beach FL

Burnap Collection
Nelson-Atkins Museum of Art, Kansas City MO

Burnap English Pottery Collection
Potsdam Public Museum, Potsdam NY

Burrison Folklife Collection
Atlanta Historical Society Inc, Atlanta History Center, Atlanta GA

Elizabeth Cole Butler Collection of Native American Art
Portland Art Museum, Portland OR

James E Buttersworth Collection
Cahoon Museum of American Art, Cotuit MA

James F Byrnes Collection
University of South Carolina, McKissick Museum, Columbia SC

Bertha Jacques Print Collection
Cornell College, Peter Paul Luce Gallery, Mount Vernon IA

Caballeria Collection of Oils
Southwest Museum, Los Angeles CA

Calder
Hirshhorn Museum & Sculpture Garden, Smithsonian Institution, Washington DC

California Art
Laguna Art Museum, Laguna Beach CA

California Impressionist paintings
Irvine Museum, Irvine CA

Contemporary Art

Alternative Museum, New York NY
ArtForms Gallery Manayunk, Philadelphia PA
Bard College, Center for Curatorial Studies,
 Annandale-on-Hudson NY
Burnaby Art Gallery, Burnaby BC
Contemporary Art Gallery, Toronto ON
The Contemporary Museum at First Hawaiian Center,
 Honolulu HI
Dayton Visual Arts Center, Dayton OH
Downey Museum of Art, Downey CA
Greenville County Museum of Art, Greenville SC
Hirshhorn Museum & Sculpture Garden, Smithsonian
 Institution, Washington DC
The Interchurch Center, Galleries at the Interchurch
 Center, New York NY
Kansas City Artists Coalition, Kansas City MO
Lane Community College, Art Dept Gallery, Eugene
 OR
Los Angeles Contemporary Exhibitions, Los Angeles
 CA
Malaspina College, Nanaimo Art Gallery, Nanaimo BC
Mercer Union, A Centre for Contemporary Visual Art,
 Toronto ON
Museum of Art & History, Santa Cruz, Santa Cruz CA
Museum of Contemporary Art, North Miami FL
Museum of Contemporary Art, San Diego-Downtown,
 La Jolla CA
North Dakota State University, Memorial Union
 Gallery, Fargo ND
Painted Bride Art Center Gallery, Philadelphia PA
Pasadena City College, Art Gallery, Pasadena CA
Phoenix Gallery, New York NY
Rapid City Arts Council, Dahl Arts Center, Rapid City
 SD
Real Art Ways (RAW), Hartford CT
Redhead Gallery, Toronto ON
Saint Olaf College, Flaten Art Museum, Northfield MN
San Antonio Museum of Art, San Antonio TX
Santa Fe, Santa Fe NM
Southeastern Center for Contemporary Art,
 Winston-Salem NC
Williamsburg Art & Historical Center, Brooklyn NY
Yakima Valley Community College, Larson Gallery,
 Yakima WA
Yeshiva University Museum, New York NY
Youngstown State University, The John J McDonough
 Museum of Art, Youngstown OH
YYZ Artists' Outlet, Toronto ON

Contemporary Art Collection

Passaic County Community College, Broadway, LRC,
 and Hamilton Club Galleries, Paterson NJ

Contemporary Art of Western Montana

Missoula Art Museum, Missoula MT

Contemporary Art-National & International

Maine College of Art, The Institute of Contemporary
 Art, Portland ME

Contemporary Canadian Art

Bau-Xi Gallery, Toronto ON
Museum of Contemporary Canadian Art, Toronto ON

Contemporary Canadian Art Collection

Kamloops Art Gallery, Kamloops BC

Contemporary Canadian Ceramic Art

Burlington Art Centre, Burlington ON

Contemporary Design

Cooper-Hewitt, National Design Museum, Smithsonian
 Institution, New York NY
L A County Museum of Art, Los Angeles CA

Contemporary Ecological Art

DeLeon White Gallery, Toronto ON

Contemporary German Art

Goethe Institute New York, German Cultural Center,
 New York NY

Contemporary Latin American Fine Art

Robert Gumbiner, Museum of Latin American Art,
 Long Beach CA

Contemporary Native American Art

California Department of Parks & Recreation,
 California State Indian Museum, Sacramento CA

Contemporary Native American Arts

Jesse Besser, Alpena MI

Contemporary Neon Art

Museum of Neon Art, Los Angeles CA

Contemporary Northwest Art

Marylhurst University, The Art Gym, Marylhurst OR

Contemporary Northwest Collection

University of Oregon, Museum of Art, Eugene OR

Contemporary Painting

Otis College of Art & Design, Ben Maltz Gallery,
 Westchester CA

Contemporary Painting, Native American, West African Art

Plains Art Museum, Fargo ND

Contemporary Paintings & Sculpture

Sacred Heart University, Gallery of Contemporary Art,
 Fairfield CT

Contemporary Polish Etchings & Engravings

Guilford College, Art Gallery, Greensboro NC

Contemporary Visual Art

A Space, Toronto ON

Contemporary Western Artists

Pioneer Town, Pioneer Museum of Western Art,
 Wimberley TX

Contemporay Art

City of Lubbock, Buddy Holly Center, Lubbock TX

Coons Collection

Carrie M McLain, Nome AK

Copeland Collection

Delaware Art Museum, Wilmington DE

Cosla Collection

Saint Mary's Romanian Orthodox Cathedral, Romanian
 Ethnic Museum, Cleveland OH

Cosla Collection of Renaissance Art

Montclair State University, Art Galleries, Upper
 Montclair NJ

Costume Collection

Willard House & Clock Museum, Inc, North Grafton
 MA

Cotter Collection

Saint Mary's College, Moreau Galleries, Notre Dame
 IN

Couldery European Art Collection

Glanmore National Historic Site of Canada, Belleville
 ON

Coverlet Collection

Houston Museum of Decorative Arts, Chattanooga TN

Cowan Collection

Board of Parks & Recreation, The Parthenon, Nashville
 TN

Craft Art

Burchfield-Penney Art Center, Buffalo NY

Cragg

Hirshhorn Museum & Sculpture Garden, Smithsonian
 Institution, Washington DC

Craig Collection of Edna Hibel

Edna Hibel, Hibel Museum of Art, Jupiter FL

Alexander M Craighead Collection of European & American Military Art

United States Military Academy, West Point Museum,
 West Point NY

Lucas Cranach

Heckscher Museum of Art, Huntington NY

Charles Cristadoro Sculptures

Los Angeles County Museum of Natural History,
 William S Hart Museum, Newhall CA

Crozier Collection of Chinese Art

Philadelphia Museum of Art, Philadelphia PA

Cummings Collection

Colby College, Museum of Art, Waterville ME

EE Cummings Collection of Paintings & Drawings

State University of New York, College at Brockport,
 Tower Fine Arts Gallery, Brockport NY

Custis-Washington-Lee Art Collection

Washington & Lee University, Lee Chapel & Museum,
 Lexington VA

Charles Cutts Collection

Nevada Museum of Art, Reno NV

Cybis Collection

Mercer County Community College, The Gallery, West
 Windsor NJ

Chase Collection

Brevard Museum of Art & Science, Melbourne FL

D'Berger Collection

Santa Clara University, de Saisset Museum, Santa Clara
 CA

Chester Dale Collection

National Gallery of Art, Washington DC

Salvador Dali Collection

University of Texas Pan American, Charles & Dorothy
 Clark Gallery; University Gallery, Edinburg TX
University of Texas Pan American, UTPA Art Galleries,
 Edinburg TX

Cyrus Dallin Bronze Collection

Springville Museum of Art, Springville UT

Dana Collection

University of Montana, Paxson Gallery, Missoula MT

Robert Darby Collection
Creative Photographic Arts Center of Maine, Dorthea C Witham Gallery, Lewiston ME

Honore Daumier Collection
University of Texas Pan American, Charles & Dorothy Clark Gallery; University Gallery, Edinburg TX

Honore Daumier Collection Francisco Goya Collection
University of Texas Pan American, UTPA Art Galleries, Edinburg TX

David T Owskley Collection of Ethnographic Art
Ball State University, Museum of Art, Muncie IN

Jacqueline Davis China Collection
Ross Memorial Museum, Saint Andrews NB

Norman Davis Collection of Classical Art
Seattle Art Museum, Seattle WA

Decorative Arts
National Park Service, Weir Farm National Historic Site, Wilton CT

E Hubert Deines Wood Engravings
Deines Cultural Center, Russell KS

Agness Delano Watercolor & Print Collection
Howard University, Gallery of Art, Washington DC

Oscar DeMejo Paintings
Jamestown-Yorktown Foundation, Williamsburg VA

William DeMorgan Ceramics
Glessner House Museum, Chicago IL

Bob Devine Collection
New Zone Virtual Gallery, Eugene OR

Joe DeYong Paintings
Los Angeles County Museum of Natural History, William S Hart Museum, Newhall CA

Thomas S Dickey Civil War Ordiance Collection
Atlanta Historical Society Inc, Atlanta History Center, Atlanta GA

Dickinson Collection
Delaware Division of Historical & Cultural Affairs, Dover DE

John G Diefenbaker Memorabilia & Archives
University of Saskatchewan, Diefenbaker Canada Centre, Saskatoon SK

Frank & Mary Alice Diener Collection of Ancient Snuff Bottles
Fresno Metropolitan Museum, Fresno CA

The Models of Lawson Diggett
Halifax Historical Society, Inc, Halifax Historical Museum, Daytona Beach FL

Maynard Dixon Collection
Brigham Young University, B F Larsen Gallery, Provo UT

F B Doane Collection of Western American Art
Frontier Times Museum, Bandera TX

Domestic Arts
Hinckley Foundation Museum, Ithaca NY

Herman D Doochin Collection
Vanderbilt University, Fine Arts Gallery, Nashville TN

Dorflinger Glass Collection
Everhart Museum, Scranton PA

Dorsky & Tannenbaum Collection
Fort Wayne Museum of Art, Inc, Fort Wayne IN

Doughty Bird Collection
Reynolda House Museum of American Art, Winston Salem NC

Arthur Dove
Heckscher Museum of Art, Huntington NY

Drafting
Georgian Court College, M Christina Geis Gallery, Lakewood NJ

Anthony J Drexel Collection of 19th Century Paintings & Sculptures
The Museum at Drexel University, Philadelphia PA

Grace H Dreyfus Ancient Peruvian & Middle Eastern Art Collection
University of California, Santa Barbara, University Art Museum, Santa Barbara CA

Dreyfus Collection of Paintings
Lehigh University Art Galleries, Museum Operation, Bethlehem PA

Jose Drudis-Blada Collection
Mount Saint Mary's College, Jose Drudis-Biada Art Gallery, Los Angeles CA

DuBose Civil War Collection
Atlanta Historical Society Inc, Atlanta History Center, Atlanta GA

Dunbarton Print Collection
Saint Mary's College, Moreau Galleries, Notre Dame IN

Duncan Collection
University of Montana, Paxson Gallery, Missoula MT

Harvey Dunn Paintings Collection
South Dakota State University, South Dakota Art Museum, Brookings SD

Dunnigan Collection of 19th Century Etchings
The Parrish Art Museum, Southampton NY

Asher B Durand
Heckscher Museum of Art, Huntington NY

Decorative Arts
Museum of Applied Arts & Sciences, Sydney

Thomas Eakins
Heckscher Museum of Art, Huntington NY

James Earle Studio Collection of Western Art
National Cowboy & Western Heritage Museum, Oklahoma City OK

Early American Family Furnishings
Piatt Castles, West Liberty OH

Early American Furniture
Houston Museum of Decorative Arts, Chattanooga TN

Early Americana
Johnson-Humrickhouse Museum, Coshocton OH

Early French Modern Art
Barnes Foundation, Merion PA

Early Indian Art
Appaloosa Museum and Heritage Center, Moscow ID

Early Settlers Collection
Clark County Historical Society, Pioneer - Krier Museum, Ashland KS

Eau Claire Art Collection
University of Wisconsin-Eau Claire, Foster Gallery, Eau Claire WI

Thomas Edison Collection
Port Huron Museum, Port Huron MI

Henry Eichheim Collection
Santa Barbara Museum of Art, Santa Barbara CA

Elephant Collection
Clark County Historical Society, Pioneer - Krier Museum, Ashland KS

Elisabet Ney Sculpture Collection
Elisabet Ney, Austin TX

Eliot Elisofon Photographic Archives
Smithsonian Institution, National Museum of African Art, Washington DC

Elkins Collection of Old Masters
Philadelphia Museum of Art, Philadelphia PA

Elliott Collection of 20th Century European Art
University of Iowa, Museum of Art, Iowa City IA

Lincoln Ellsworth Collection
Mid-America All-Indian Center, Indian Center Museum, Wichita KS

Clarence Ellsworth Paintings
Los Angeles County Museum of Natural History, William S Hart Museum, Newhall CA

Embroidery Collection
Willard House & Clock Museum, Inc, North Grafton MA

English Silver
Agecroft Association, Museum, Richmond VA

Esso Collection
University of Miami, Lowe Art Museum, Coral Gables FL

Eteljorg Collection of African Art
Columbus Museum of Art and Design, Indianapolis IN

Ethnographic Arts
Cornell University, Herbert F Johnson Museum of Art, Ithaca NY

Ethnographic Collection
Birmingham Museum of Art, Birmingham AL

Ethnographic Objects
Saint Mary's College of California, Hearst Art Gallery, Moraga CA

European & American Collection
Mills College, Art Museum, Oakland CA

European & American Posters
United States Military Academy, West Point Museum, West Point NY

European & Asian Furnishings
Piatt Castles, West Liberty OH

Florence Naftzger Evans Collection of Porcelain
Wichita Art Museum, Wichita KS

Mrs Arthur Kelly Evans Collection of Pottery & Porcelain
Virginia Museum of Fine Arts, Richmond VA

Henry Evans Linocuts
Napa Valley Museum, Yountville CA

Experimental Art
New Zone Virtual Gallery, Eugene OR

Edward Burr Van Vleck Collection of Japenese Prints
University of Wisconsin-Madison, Chazen Museum of Art, Madison WI

Peter Carl Faberge Collection of Czarist Jewels
Virginia Museum of Fine Arts, Richmond VA

Fairbanks Collection
Fort Wayne Museum of Art, Inc, Fort Wayne IN

Fashion Arts
Georgian Court College, M Christina Geis Gallery, Lakewood NJ

Edith H K Featherston Collection
Fetherston Foundation, Packwood House Museum, Lewisburg PA

Feminism & Contemporary Visual Art
Regina Public Library, Dunlop Art Gallery, Regina SK

Dexter M Ferry Collection
Vassar College, The Frances Lehman Loeb Art Center, Poughkeepsie NY

Fiber Art
Hui No eau Visual Arts Center, Gallery and Gift Shop, Makawao Maui HI

Clark Field Collection of American Indian Crafts
Philbrook Museum of Art, Tulsa OK

Fifteenth-Nineteenth Century European Ceramic Collection
Polk Museum of Art, Lakeland FL

Film
Bemis Center for Contemporary Arts, Omaha NE

Fine Art Permanent Collection of Northwestern College (Iowa)
Northwestern College, Te Paske Gallery, Orange City IA

Fine Arts
Knights of Columbus Supreme Council, Knights of Columbus Museum, New Haven CT

Firearms
Colorado Historical Society, Colorado History Museum, Denver CO

Elizabeth Holmes Fisher Collection
University of Southern California, Fisher Gallery, Los Angeles CA

Fisher Memorial Collection
Beloit College, Wright Museum of Art, Beloit WI

Fitzgerald Study Collection
University of Manitoba, Gallery One One One, Winnipeg MB

Flagg Collection
Milwaukee Art Museum, Milwaukee WI

James M Flagg Paintings
Los Angeles County Museum of Natural History, William S Hart Museum, Newhall CA

Julius Fleischman Collection
University of Cincinnati, DAAP Galleries-College of Design Architecture, Art & Planning, Cincinnati OH

Floral Art
Brooklyn Botanic Garden, Steinhardt Conservatory Gallery, Brooklyn NY

Focus Gallery Collection
Santa Clara University, de Saisset Museum, Santa Clara CA

Fowler Collection
Gadsden Museum of Fine Arts, Inc, Gadsden Museum of Art and History, Gadsden AL

Charles L Franck Photograph Collection
The Historic New Orleans Collection, New Orleans LA

Anne Frank Letters
Simon Wiesenthal Center Inc, Museum of Tolerance, Los Angeles CA

Robert Frank Photography Collection
Stanford University, Iris & B Gerald Cantor Center for Visual Arts, Stanford CA

Jack T Franklin Photographic Collection
African American Museum in Philadelphia, Philadelphia PA

Simon Fraser Collection
Simon Fraser University, Simon Fraser Gallery, Burnaby BC

Laura G Fraser Studio Collection of Western Art
National Cowboy & Western Heritage Museum, Oklahoma City OK

Rod Frederick Collection of Prints
High Desert Museum, Bend OR

Daniel Chester French Collection
National Trust for Historic Preservation, Chesterwood Estate & Museum, Stockbridge MA

Grace & Abigail French Collection
Rapid City Arts Council, Dahl Arts Center, Rapid City SD

Samuel Friedenberg Collection of Plaques & Medals
The Jewish Museum, New York NY

Laura Anne Fry American Art Pottery & Art Glass
Art Museum of Greater Lafayette, Lafayette IN

Eugene Fuller Memorial Collection of Chinese Jades
Seattle Art Museum, Seattle WA

Fulton-Meyer Collection of African Art
University of Mississippi, University Museum, Oxford MS

Diane F Furbush Collection
Creative Photographic Arts Center of Maine, Dorthea C Witham Gallery, Lewiston ME

Gallatin Collection
Philadelphia Museum of Art, Philadelphia PA

Emile Galle Glass
Glessner House Museum, Chicago IL

Gallier Architectural Drawings Collection
The Historic New Orleans Collection, New Orleans LA

Gardens & Gardening
The Dixon Gallery & Gardens, Memphis TN

Garfield Collection
Sonoma State University, University Art Gallery, Rohnert Park CA

Geesey Collection of Pennsylvania Dutch Folk Art
Philadelphia Museum of Art, Philadelphia PA

Genealogy
Artesia Historical Museum & Art Center, Artesia NM
The Bartlett Museum, Amesbury MA
Carteret County Historical Society, Museum of History
 & Art, Morehead City NC
Vermont Historical Society, Museum, Montpelier VT

David General Collection
Enook Galleries, Waterloo ON

General Collection
Wake Forest University, Charlotte & Philip Hanes Art
 Gallery, Winston-Salem NC

**General Edward Young Collection of
American Paintings**
Scripps College, Ruth Chandler Williamson Gallery,
 Claremont CA

**Harry L George Collection of Native
American Art**
Saint Joseph Museum, Saint Joseph MO

Georgian Silver Collection
Huntington Museum of Art, Huntington WV

Gerbaur Collection of Cameroon Art
Portland Art Museum, Portland OR

Georgia Gerber Sculpture Collection
High Desert Museum, Bend OR

Gerofsky Collection of African Art
Dickinson College, The Trout Gallery, Carlisle PA

Giacometti
Hirshhorn Museum & Sculpture Garden, Smithsonian
 Institution, Washington DC

Gibson Collection of Indian Materials
United States Department of the Interior Museum,
 Washington DC

**Gordon & Vivian Gilkey Graphic Art
Collection**
Portland Art Museum, Portland OR

Gillert Collection of Ceramics
Philbrook Museum of Art, Tulsa OK

**Arthur & Margaret Glasgow Collection of
Renaissance Art**
Virginia Museum of Fine Arts, Richmond VA

Glassware
Dawson County Historical Society, Museum, Lexington
 NE
Villa Terrace Decorative Art Museum, Milwaukee WI

Robert H Goddard Collection
Roswell Museum & Art Center, Roswell NM

Harry C Goebel Collection
Saint John's University, Chung-Cheng Art Gallery,
 Jamaica NY

Barry Goldwater Collection
Heard Museum, Phoenix AZ

The Lee Goodman Collection
Texas A&M University-Corpus Christi, Weil Art
 Gallery, Corpus Christi TX

Louisa Gordon Collection of Antiques
Frontier Times Museum, Bandera TX

Gothic Collection
The National Trust for Historic Preservation, Lyndhurst,
 Tarrytown NY

Gould Ivory Collection
University of the Ozarks, Stephens Gallery, Clarksville
 AR

Francisco Goya Collection
University of Texas Pan American, Charles & Dorothy
 Clark Gallery; University Gallery, Edinburg TX

Grace Collection of Paintings
Lehigh University Art Galleries, Museum Operation,
 Bethlehem PA

U S Grant Collection
George Washington University, The Dimock Gallery,
 Washington DC

J Jeffery Grant Permanent Collection
Palette & Chisel Academy of Fine Arts, Chicago IL

Graphic Design
Georgian Court College, M Christina Geis Gallery,
 Lakewood NJ

Graphoanalysis
Hoyt Institute of Fine Arts, New Castle PA

Great Western Performers Portrait Collection
National Cowboy & Western Heritage Museum,
 Oklahoma City OK

Greater Pacific Basin Collection
University of Oregon, Museum of Art, Eugene OR

**Greek, Roman & Renaissance Plaster Cast
Collection**
The Slater Memorial Museum, Slater Memorial
 Museum, Norwich CT

Charles A Greenfield Collection
The Metropolitan Museum of Art, New York NY

**Ben & Abby Grey Foundation Collection of
Asian & Middle Eastern Art**
New York University, Grey Art Gallery, New York NY

Owen T Gromme Collection
University of Minnesota, The Bell Museum of Natural
 History, Minneapolis MN

George Grosz
Heckscher Museum of Art, Huntington NY

Irving R Gumbel Collection of Prints
Howard University, Gallery of Art, Washington DC

Robert Gumbiner Foundation Collection
Robert Gumbiner, Museum of Latin American Art,
 Long Beach CA

Gun Collection
Clark County Historical Society, Pioneer - Krier
 Museum, Ashland KS

Gunther Collection
Saint Mary's Romanian Orthodox Cathedral, Romanian
 Ethnic Museum, Cleveland OH

Gurley Korean Pottery Collection
Beloit College, Wright Museum of Art, Beloit WI

Gussman Collection of African Sculpture
Philbrook Museum of Art, Tulsa OK

Paul M Hahn Silver Collection
Berkshire Museum, Pittsfield MA

Virginia Bacher Haichol Artifact Collection
Hartnell College Gallery, Salinas CA

**John Valentine Haidt Collection of Religious
Paintings**
Moravian Historical Society, Whitefield House
 Museum, Nazareth PA

Joe Halco Sculpture Collection
High Desert Museum, Bend OR

Hall Collection
Milwaukee Art Museum, Milwaukee WI

Frank M Hall Collection
University of Nebraska, Lincoln, Sheldon Memorial Art
 Gallery & Sculpture Garden, Lincoln NE

Theora Hamblett Collection
University of Mississippi, University Museum, Oxford
 MS

Hamilton Collection
Fort Wayne Museum of Art, Inc, Fort Wayne IN

Armand Hammer Collection
University of Southern California, Fisher Gallery, Los
 Angeles CA

Thomas Handforth Etching Collection
State Capital Museum, Olympia WA

Handicrafts
Folk Art Society of America, Richmond VA

H C Hanson Naval Architecture Collection
Whatcom Museum of History and Art, Bellingham WA

Hardstone Carving Collection
Lizzadro Museum of Lapidary Art, Elmhurst IL

Robert Harris Collection
Confederation Centre Art Gallery and Museum,
 Charlottetown PE

James M & William Hart
Heckscher Museum of Art, Huntington NY

Marsden Hartley Memorial Collection
Bates College, Museum of Art, Lewiston ME

Fred Harvey Collection
Heard Museum, Phoenix AZ

Olga Hasbrouck Collection of Chinese Ceramics
Vassar College, The Frances Lehman Loeb Art Center, Poughkeepsie NY

Hastings County Collection
Glanmore National Historic Site of Canada, Belleville ON

J David Hathaway Collection
Creative Photographic Arts Center of Maine, Dorthea C Witham Gallery, Lewiston ME

Rudolf Hausner Collection
University of Texas Pan American, Charles & Dorothy Clark Gallery; University Gallery, Edinburg TX
University of Texas Pan American, UTPA Art Galleries, Edinburg TX

Dr Ruth Wright Hayre Collection
African American Museum in Philadelphia, Philadelphia PA

Heeramaneck Collection of Asian Art
Virginia Museum of Fine Arts, Richmond VA

Heeramaneck Collection of Primitive Art
Seattle Art Museum, Seattle WA

Heritage Buildings
Peter & Catharine Whyte Foundation, Whyte Museum of the Canadian Rockies, Banff AB

Marieluise Hessel Collection
Bard College, Center for Curatorial Studies, Annandale-on-Hudson NY

Hessi
Hirshhorn Museum & Sculpture Garden, Smithsonian Institution, Washington DC

Abby Williams Hill Collection
University of Puget Sound, Kittredge Art Gallery, Tacoma WA

Lida Hilton Print Collection
Montclair State University, Art Galleries, Upper Montclair NJ

Hinkhouse Contemporary Art Collection
Coe College, Eaton-Buchan Gallery & Marvin Cone Gallery, Cedar Rapids IA

Hirschberg West African Arts Collection
Topeka & Shawnee County Public Library, Alice C Sabatini Gallery, Topeka KS

Hirsh Collection of Oriental Rugs
Portland Art Museum, Portland OR

Hispanic Collection
Hispanic Society of America, Museum & Library, New York NY

Historic Naval Uniforms
USS Constitution Museum, Boston MA

Historic Southern Plains Indian Arts
Southern Plains Indian Museum, Anadarko OK

Historical Louisiana Maps
Lafayette Natural History Museum & Planetarium, Lafayette LA

History of Art & Archaeology
Yeshiva University Museum, New York NY

History of Holyoke 1850-1930
Wistariahurst Museum, Holyoke MA

HMS Debraak, 18th century British Warship
Delaware Division of Historical & Cultural Affairs, Dover DE

Gene Hoback woodcarvings
Los Angeles County Museum of Natural History, William S Hart Museum, Newhall CA

Morris Henry Hobbs Print Collection
The Historic New Orleans Collection, New Orleans LA

Hans Hoffman Collection of Paintings
University of California, Berkeley, Berkeley Art Museum & Pacific Film Archive, Berkeley CA

Hogarth & Caroline Durieux Graphics Collection
Louisiana State University, Museum of Art, Baton Rouge LA

Albert Gallatin Hoit Paintings
Sandwich Historical Society, Center Sandwich NH

Alfred H & Eva Underhill Holbrook Collection of American Art
University of Georgia, Georgia Museum of Art, Athens GA

Mary Hollen Collection
Huronia Museum, Gallery of Historic Huronia, Midland ON

W J Holliday Collection of Neo-Impressionist Paintings
Columbus Museum of Art and Design, Indianapolis IN

Buddy Holly Memorabilla
City of Lubbock, Buddy Holly Center, Lubbock TX

Holocaust Artifacts
Simon Wiesenthal Center Inc, Museum of Tolerance, Los Angeles CA

Winslow Homer Collection
Colby College, Museum of Art, Waterville ME

Winslow Homer Woodcut Collection
State Capital Museum, Olympia WA

Samuel Houghton Great Basin Collection
Nevada Museum of Art, Reno NV

F B Housser Memorial Collection
Museum London, London ON

J Harry Howard Gemstone Collection
University of South Carolina, McKissick Museum, Columbia SC

Oscar Howe Collection
University of South Dakota Art Galleries, Vermillion SD

Oscar Howe Paintings
South Dakota State University, South Dakota Art Museum, Brookings SD

Anna C Hoyt Collection of Old Masters
Vanderbilt University, Fine Arts Gallery, Nashville TN

William J Hubbard Drawings & Oils
Valentine Richmond History Center, Richmond VA

Winifred Kimball Hudnut Collection
University of Utah, Utah Museum of Fine Arts, Salt Lake City UT

Hudson River Paintings
Putnam County Historical Society, Foundry School Museum, Cold Spring NY

Hudson Valley Portraits
Fishkill Historical Society, Van Wyck Homestead Museum, Fishkill NY

Human History Artifacts Collection
Moose Jaw Art Museum, Inc, Art & History Museum, Moose Jaw SK

J Marvin Hunter Western Americana Collection
Frontier Times Museum, Bandera TX

Philip Hyde Photography Collection
High Desert Museum, Bend OR

Haitian Painting Collection
New Visions Gallery, Inc, Marshfield WI

Hamilton Club Art Collections, Federici Studio Collection (sculpture)
Passaic County Community College, Broadway, LRC, and Hamilton Club Galleries, Paterson NJ

Hartford steam boiler collection of America
Lyme Historical Society, Florence Griswold Museum, Old Lyme CT

Harvey Dunn Collection
Arthur Roy Mitchell, Museum of Western Art, Trinidad CO

Illustration
Georgian Court College, M Christina Geis Gallery, Lakewood NJ

Implement Seat Collection
Clark County Historical Society, Pioneer - Krier Museum, Ashland KS

Incunabula
La Casa del Libro Museum, San Juan PR

Indian Artifacts
Drew County Historical Society, Museum, Monticello AR

Industrial & Domestic Artifacts
Dawson City Museum & Historical Society, Dawson City YT

Industrial Design
Chicago Athenaeum, Museum of Architecture & Design, Galena IL

Cooper-Hewitt, National Design Museum, Smithsonian Institution, New York NY
L A County Museum of Art, Los Angeles CA

William Inge Memorabilia Collection
Independence Historical Museum, Independence KS

Installation Art
Capp Street Project, San Francisco CA
Marylhurst University, The Art Gym, Marylhurst OR

Installation-Site Specific
ARC Gallery, Chicago IL

International Art
Art Without Walls Inc, Art Without Walls Inc, Sayville NY
Bard College, Center for Curatorial Studies, Annandale-on-Hudson NY

International Folk Art
L A County Museum of Art, Los Angeles CA

Inuit Art
Aurora University, Schingoethe Center for Native American Cultures, Aurora IL
National Gallery of Canada, Ottawa ON

Inuit Eskimo Collection
Upstairs Gallery, Winnipeg MB

Inuit Sculpture
Luther College, Fine Arts Collection, Decorah IA

Irish Paintings
University of Pennsylvania, Arthur Ross Gallery, Philadelphia PA

Jene Isaacson Collection
California State University, Fullerton, Art Gallery, Visual Arts Center, Fullerton CA

Isaacson Porcelain Collection
Seattle Art Museum, Seattle WA

Italian Art & Architecture
Museum of Ossining Historical Society, Ossining NY

Ike Parker, Coll: Hart
Henry County Museum & Cultural Arts Center, Clinton MO

Andrew Grayson Jackson Lithos
Napa Valley Museum, Yountville CA

William Henry Jackson Oil Paintings
United States Department of the Interior Museum, Washington DC

Harry L Jackson Print Collection
Murray State University, Art Galleries, Murray KY

James McNeill Whistler Collection
University of Michigan, Museum of Art, Ann Arbor MI

Chris Janer Prints & Paintings
Saint Olaf College, Flaten Art Museum, Northfield MN

Japan Society Collection
Japan Society, Inc, Japan Society Gallery, New York NY

Japanese Graphic Design
Chicago Athenaeum, Museum of Architecture & Design, Galena IL

Japanese Print Collection
Oregon State University, Fairbanks Gallery, Corvallis OR

Japanese Prints
Pacific - Asia Museum, Pasadena CA

Francis Lee Jaques Collection
University of Minnesota, The Bell Museum of Natural History, Minneapolis MN

Jeffersonian Collection
Thomas Jefferson, Monticello, Charlottesville VA

C Paul Jennewein Collection
Tampa Museum of Art, Tampa FL

Jens Jensen Landscape Design
Edsel & Eleanor Ford, Grosse Pointe Shores MI

Jette American Painting Collection
Colby College, Museum of Art, Waterville ME

Jewish Ceremonial Art
Judah L Magnes, Berkeley CA

Jewish Ritual Art Collection
Hebrew Union College, Jewish Institute of Religion Museum, New York NY

Franz Johnson Collection
Huronia Museum, Gallery of Historic Huronia, Midland ON

E Johnson Collection
Saint Louis County Historical Society, Duluth MN

Johnson Collection
Topeka & Shawnee County Public Library, Alice C Sabatini Gallery, Topeka KS

John G Johnson Collection of Old Masters
Philadelphia Museum of Art, Philadelphia PA

Mrs James Johnson Japanese Print Collection
Scripps College, Ruth Chandler Williamson Gallery, Claremont CA

Barbara Johnson Whaling Collection
San Francisco Maritime National Historical Park, Maritime Museum, San Francisco CA

Anna Russell Jones Collection
African American Museum in Philadelphia, Philadelphia PA

T Catesby Jones Collection of 20th Century European Art
Virginia Museum of Fine Arts, Richmond VA

Raymond Jonson Reserved Retrospective Collection of Paintings
University of New Mexico, Jonson Gallery, Albuquerque NM

Judaica Collection
Hebrew Union College, Skirball Cultural Center, Los Angeles CA

Donald Judd Collection
Chinati Foundation, Marfa TX

John Doyle Lithographs
Concordia University Wisconsin, Fine Art Gallery, Mequon WI

Joseph Delaney
University of Tennessee, Ewing Gallery of Art and Architecture, Knoxville TN

Joseph E Davies Collection of Russian Icons & Paintings
University of Wisconsin-Madison, Chazen Museum of Art, Madison WI

Ilya Kabakov Collection
Chinati Foundation, Marfa TX

Vasily Kandinsky Collection
Guggenheim Museum Soho, New York NY
Solomon R Guggenheim, New York NY

William Keith Paintings Collection
Saint Mary's College of California, Hearst Art Gallery, Moraga CA

Mary Theodore Kelleher Collection
Saint Joseph College, Saint Joseph College Art Gallery, West Hartford CT

Bebe & Crosby Kemper Collection
Kansas City Art Institute, Kansas City MO

Marie Kendall Photography Collection
Norfolk Historical Society Inc, Museum, Norfolk CT

Edwin L & Ruth E Kennedy Soutwest Native American Collection
Ohio University, Kennedy Museum of Art, Athens OH

Kentucky Fine Art
Historic Paris - Bourbon County, Inc, Hopewell Museum, Paris KY

Kentucky Self-Taught Art
Morehead State University, Kentucky Folk Art Center, Morehead KY

Maude I Kerns Collection
Maude Kerns Art Center, Eugene OR

Kiakshuk Collection
Enook Galleries, Waterloo ON

Victor Kiam Painting Collection
New Orleans Museum of Art, New Orleans LA

Kienbusch Collection of Arms & Armor
Philadelphia Museum of Art, Philadelphia PA

Darius Kinsey Photograph Collection
Whatcom Museum of History and Art, Bellingham WA

Paul Klee Collection
Guggenheim Museum Soho, New York NY
Solomon R Guggenheim, New York NY

Kolb Graphics Collection
Santa Clara University, de Saisset Museum, Santa Clara CA

Kovoes Margil Ceramic Collection, Barcsay Collection, Vajda Collection, Anna-Ames Collection, Kmetty-Kerenyi Collection
Ferenczy Muzeum, Szentendre

Krannert Memorial Collection
University of Indianapolis, Christel DeHaan Fine Arts
 Gallery, Indianapolis IN

Samuel H Kress Collection
Allentown Art Museum, Allentown PA
City of El Paso, El Paso TX
Columbia Museum of Art, Columbia SC
Howard University, Gallery of Art, Washington DC
National Gallery of Art, Washington DC
North Carolina Museum of Art, Raleigh NC
Philbrook Museum of Art, Tulsa OK
Trinity College, Austin Arts Center, Widener Gallery,
 Hartford CT
University of Miami, Lowe Art Museum, Coral Gables
 FL
Vanderbilt University, Fine Arts Gallery, Nashville TN

H Kress Collection of European Paintings
Seattle Art Museum, Seattle WA

Samuel H Kress Collection of Renaissance Art
Berea College, Doris Ulmann Galleries, Berea KY
Honolulu Academy of Arts, Honolulu HI
New Orleans Museum of Art, New Orleans LA

Samual H Kress Collection of Renaissance Paintings & Sculptures
Portland Art Museum, Portland OR

Samuel H Kress Study Collection
University of Georgia, Georgia Museum of Art, Athens
 GA

Irma Kruse Collection
Hastings Museum of Natural & Cultural History,
 Hastings NE

Kurdian Collection of Pre-Columbian & Mexican Art
Wichita Art Museum, Wichita KS

Katzen Collection of 20th century painting, prints, drawings & sculpture
American University, Katzen Art Center Gallery,
 Washington DC

John J Kelley Collection
Saint Joseph College, Saint Joseph College Art Gallery,
 West Hartford CT

Mary Andrews Ladd Collection of Japanese Prints
Portland Art Museum, Portland OR

B Lafon Drawing Collection
The Historic New Orleans Collection, New Orleans LA

Lake Superior Ojobwes Collection
Lac du Flambeau Band of Lake Superior Chippewa
 Indians, George W Brown Jr Ojibwe Museum &
 Cultural Center, Lac du Flambeau WI

Norman LaLiberte Collection
Saint Mary's College, Moreau Galleries, Notre Dame
 IN

Robert L Lambdin Paintings
Los Angeles County Museum of Natural History,
 William S Hart Museum, Newhall CA

Dr Paul Lamp Collection
Glanmore National Historic Site of Canada, Belleville
 ON

Landscape Architecture
Brookgreen Gardens, Murrells Inlet SC

Languages-Italian, French, German
Hoyt Institute of Fine Arts, New Castle PA

John D Lankenau Collection of 19th Century Paintings & Sculptures
The Museum at Drexel University, Philadelphia PA

Mauricio Lasansky Print Collection
University of Iowa, Museum of Art, Iowa City IA

Samuel K Lathrop Collection
University of Miami, Lowe Art Museum, Coral Gables
 FL

Latin America
Mission Cultural Center for Latino Arts, San Francisco
 CA

Latter-Schlesinger Miniature Collection
New Orleans Museum of Art, New Orleans LA

Clarence Laughlin Photograph Collection
The Historic New Orleans Collection, New Orleans LA

Roberta Campbell Lawson Collection of Indian Artifacts; Tabor Collection of Oriental Art
Philbrook Museum of Art, Tulsa OK

Lawther Collection of Ethiopian Crosses
Portland Art Museum, Portland OR

Layton Collection
Milwaukee Art Museum, Milwaukee WI

Robert Lehman Collection
The Metropolitan Museum of Art, New York NY

Lettering
Georgian Court College, M Christina Geis Gallery,
 Lakewood NJ
University of North Dakota, Hughes Fine Arts
 Center-Col Eugene Myers Art Gallery, Grand Forks
 ND

Roy C Leventritt Collection
Asian Art Museum of San Francisco, Chong-Moon Lee
 Ctr for Asian Art and Culture, San Francisco CA

Levy Collection
McMaster University, McMaster Museum of Art,
 Hamilton ON

Lewis Collection of Classical Antiquities
Portland Art Museum, Portland OR

Lewis-Kneberg Collection
University of Tennessee, Frank H McClung Museum,
 Knoxville TN

Lewisohn Collection of Caribbean Art
University of Mississippi, University Museum, Oxford
 MS

Dan Leyrer Photograph Collection
The Historic New Orleans Collection, New Orleans LA

Roy Lichtenstein Collection
University of Texas Pan American, Charles & Dorothy
 Clark Gallery; University Gallery, Edinburg TX
University of Texas Pan American, UTPA Art Galleries,
 Edinburg TX

Joans Lie Collection of Panama Canal Oils
United States Military Academy, West Point Museum,
 West Point NY

Eli Lilly Collection of Chinese Art
Columbus Museum of Art and Design, Indianapolis IN

Linoleum Blocks & Prints
Walter Anderson, Ocean Springs MS

Linton-Surget Collection
The Woman's Exchange, University Art Collection,
 New Orleans LA

Locke Collection
Roberts County Museum, Miami TX

Alain Locke Collection of African Art
Howard University, Gallery of Art, Washington DC

Lockwood-deForest Collection
Mark Twain, Hartford CT

Long Island Landscapes
Gallery North, Setauket NY

Loomis Wildlife Collection
Roberson Museum & Science Center, Binghamton NY

Ted Lord Collection
Huronia Museum, Gallery of Historic Huronia, Midland
 ON

Lorimar Glass Collection
Philadelphia Museum of Art, Philadelphia PA

Louisiana Collection - 19th & 20th Century Art
University of Louisiana at Lafayette, University Art
 Museum, Lafayette LA

Louisiana Indian Artifacts
Lafayette Natural History Museum & Planetarium,
 Lafayette LA

Lowe Collection - Outsider Art
University of Louisiana at Lafayette, University Art
 Museum, Lafayette LA

Barry Lowen Collection
The Museum of Contemporary Art (MOCA), Los
 Angeles CA

George A Lucas Collection
The Baltimore Museum of Art, Baltimore MD

Stephen Livingstone
New Zone Virtual Gallery, Eugene OR

Ernst Mahler Collection of Germanic Glass
Bergstrom-Mahler Museum, Neenah WI

Malacology Collection
University of Tennessee, Frank H McClung Museum, Knoxville TN

Richard Mandell Collection
University of South Carolina, McKissick Museum, Columbia SC

Maness Collection of West and Central African Art
Guilford College, Art Gallery, Greensboro NC

Mildren Many Memorial Collection
Mid-America All-Indian Center, Indian Center Museum, Wichita KS

Doug Maracie Collection
Enook Galleries, Waterloo ON

Gerhard Marcks Collection
Luther College, Fine Arts Collection, Decorah IA

Fred & Estelle Marer Contemporary Ceramics Collection
Scripps College, Ruth Chandler Williamson Gallery, Claremont CA

Marghab Linens Collection
South Dakota State University, South Dakota Art Museum, Brookings SD

Marianne Moore Papers Collection
The Rosenbach Museum & Library, Philadelphia PA

John Marin Collection
Colby College, Museum of Art, Waterville ME

Marine Artifacts
Port Huron Museum, Port Huron MI

Maritime Antiques; Ship Models
Ships of the Sea Maritime Museum, Savannah GA

Maritime Archaeology
Delaware Division of Historical & Cultural Affairs, Dover DE

Maritime History
San Francisco Maritime National Historical Park, Maritime Museum, San Francisco CA

Markley Ancient Peruvian Ceramic Collection
The Pennsylvania State University, Palmer Museum of Art, University Park PA

Masonic Collection
National Heritage Museum, Lexington MA

Material Culture
American Museum of the Moving Image, Astoria NY

A W Mauach Permanent Collection
Palette & Chisel Academy of Fine Arts, Chicago IL

McClelland Collection
Rosemount Museum, Inc, Pueblo CO

Bill McCoy Collection
Halifax Historical Society, Inc, Halifax Historical Museum, Daytona Beach FL

Evelyn McCurdy Salisbury Ceramic Collection
Lyme Historical Society, Florence Griswold Museum, Old Lyme CT

Beverley McDonald Originals
Glanmore National Historic Site of Canada, Belleville ON

McFadden Collection of Old Masters
Philadelphia Museum of Art, Philadelphia PA

McGill Collection
University of Montana, Paxson Gallery, Missoula MT

McLain Collection
Carrie M McLain, Nome AK

George F McMurray Collection
Trinity College, Austin Arts Center, Widener Gallery, Hartford CT

James McNeill Whistler Collection
Smithsonian Institution, Freer Gallery of Art, Washington DC

Mead Collection
Roberts County Museum, Miami TX

Ray Meadows Collection
Mid-America All-Indian Center, Indian Center Museum, Wichita KS

Medicine
Carteret County Historical Society, Museum of History & Art, Morehead City NC

Hamilton King Meek Memorial Collection
Museum London, London ON

Meissen Porcelain Collection
Cummer Museum of Art & Gardens, DeEtte Holden Cummer Museum Foundation, Jacksonville FL
Virginia Museum of Fine Arts, Richmond VA

Andrew W Mellon Collection
National Gallery of Art, Washington DC

Merz
Hirshhorn Museum & Sculpture Garden, Smithsonian Institution, Washington DC

Conger Metcalf Collection
Coe College, Eaton-Buchan Gallery & Marvin Cone Gallery, Cedar Rapids IA

Mexican & Mexsican-American Art Collection
San Angelo Museum of Fine Arts, San Angelo TX

Mexican American Art
City of El Paso Museum and Cultural Affairs, People's Gallery, El Paso TX

Michael Silver Collection
University of Utah, Utah Museum of Fine Arts, Salt Lake City UT

Mielke Collection
Carrie M McLain, Nome AK

Arnold Mikelson Wood Sculpture
Arnold Mikelson Mind & Matter Gallery, White Rock BC

Military Art Collection
Fort George G Meade Museum, Fort Meade MD
National Infantry Museum, Fort Benning GA

Military Artifacts
United States Military Academy, West Point Museum, West Point NY

Military Equipment Relating to Mech Cavalry & Armor
Cavalry-Armor Foundation, Patton Museum of Cavalry & Armor, Fort Knox KY

Anna L Miller Paintings
Viterbo University, Art Gallery, La Crosse WI

Millington-Barnard Collection
University of Mississippi, University Museum, Oxford MS

Mimbres Indian Artifacts
Deming-Luna Mimbres Museum, Deming NM

Minerals & Fossil
Napa Valley Museum, Yountville CA

Rose & Benjamin Mintz Collection of Eastern European Art
The Jewish Museum, New York NY

A R Mitchell Collection
Arthur Roy Mitchell, Museum of Western Art, Trinidad CO

Albert K Mitchell Russell-Remington Collection
National Cowboy & Western Heritage Museum, Oklahoma City OK

Sophie Alstrom Mitchell Watercolors
Napa Valley Museum, Yountville CA

Mixed Media
University of North Dakota, Hughes Fine Arts Center-Col Eugene Myers Art Gallery, Grand Forks ND

Modern Art
New Zone Virtual Gallery, Eugene OR

Andrew Molles Collection
Riverside Art Museum, Riverside CA

James Montgomery Ward Permanent Collection
Palette & Chisel Academy of Fine Arts, Chicago IL

Moore
Hirshhorn Museum & Sculpture Garden, Smithsonian Institution, Washington DC

Moore Collection
Museum London, London ON
University of Illinois, Krannert Art Museum and Kinkead Pavillion, Champaign IL

Grace Moore Collection
University of Tennessee, Frank H McClung Museum, Knoxville TN

Henry Moore Sculpture Collection
Art Gallery of Ontario, Toronto ON

Moran
Heckscher Museum of Art, Huntington NY

Morgenroth Renaissance Medals & Plaquettes Collection
University of California, Santa Barbara, University Art Museum, Santa Barbara CA

Mormon Collection
Church of Jesus Christ of Latter-Day Saints, Museum of Church History & Art, Salt Lake City UT

Morris & Co Textiles
Glessner House Museum, Chicago IL

George Morrison
Minnesota Museum of American Art, Saint Paul MN

Morse Collection
Beloit College, Wright Museum of Art, Beloit WI

Preston Morton Collection of American Art
Santa Barbara Museum of Art, Santa Barbara CA

Pfeffer Moser Glass Collection
University of the Ozarks, Stephens Gallery, Clarksville AR

William Sidney Mount Collection
The Long Island Museum of American Art, History & Carriages, Stony Brook NY

Mountain Sculpture-Carving
Crazy Horse Memorial, Indian Museum of North America, Native American Educational & Cultural Center & Crazy Horse Memorial Library (Reference), Crazy Horse SD

Arnold Mountfort Collection
Santa Clara University, de Saisset Museum, Santa Clara CA

Mourot Collection of Meissen Porcelain
Virginia Museum of Fine Arts, Richmond VA

Mowat Loyalist Collection
Ross Memorial Museum, Saint Andrews NB

Munich School Paintings
Frye Art Museum, Seattle WA

Murals of Wildlife & Habitats
Las Vegas Natural History Museum, Las Vegas NV

Roland P Murdock Collection of American Art
Wichita Art Museum, Wichita KS

Musical Instruments
The Metropolitan Museum of Art, New York NY
Stauth Foundation & Museum, Stauth Memorial Museum, Montezuma KS

Eadwaerd Muybridge Photography Collection
Stanford University, Iris & B Gerald Cantor Center for Visual Arts, Stanford CA

Mythology
John Weaver Sculpture Collection, Hope BC

Michener Coll of Prints & Paintings
Kent State University, School of Art Gallery, Kent OH

M C Naftzger Collection of Charles M Russell Paintings
Wichita Art Museum, Wichita KS

Nagel Collection of Chinese & Tibetan Sculpture & Textiles
Scripps College, Clark Humanities Museum, Claremont CA

Thomas Nast Collection
Cornell College, Peter Paul Luce Gallery, Mount Vernon IA

Native America
North Dakota State University, Memorial Union Gallery, Fargo ND

Native American Art
Carson County Square House Museum, Panhandle TX
College of William & Mary, Muscarelle Museum of Art, Williamsburg VA
Florence Museum of Art, Science & History, Florence SC

Native American Artifacts
Artesia Historical Museum & Art Center, Artesia NM
Coos County Historical Society Museum, North Bend OR
Klein Museum, Mobridge SD
Piatt Castles, West Liberty OH

Native American Artifacts Collection
Willard House & Clock Museum, Inc, North Grafton MA

Native American Artifacts; Egyptian Art Objects & Textiles
The Slater Memorial Museum, Slater Memorial Museum, Norwich CT

Native American Basketry
Turtle Bay Exploration Park, Redding CA

Native American Baskets
Lauren Rogers, Laurel MS

Native American Collection
Cayuga Museum of History & Art, Auburn NY

Native American Ethnographic Material
Wistariahurst Museum, Holyoke MA

Native American Fine Art
Heard Museum, Phoenix AZ

Native American Studies
Carteret County Historical Society, Museum of History & Art, Morehead City NC

Native American, Indian & Eskimo Inuit Art
Enook Galleries, Waterloo ON

Natural History
Monhegan Museum, Monhegan ME

Natural History & Science
Tallahassee Museum of History & Natural Science, Tallahassee FL

Natural History Art (Wildlife)
University of Minnesota, The Bell Museum of Natural History, Minneapolis MN

Natural Science, History & Anthropology Collections
Fairbanks Museum & Planetarium, Saint Johnsbury VT

Naval Weapons
USS Constitution Museum, Boston MA

Neese Collection of Contemporary Art
Beloit College, Wright Museum of Art, Beloit WI

Negro Baseball Leagues Collection
African American Museum in Philadelphia, Philadelphia PA

Bjarne Ness Painting Collection
SVACA - Sheyenne Valley Arts & Crafts Association, Bjarne Ness Gallery at Bear Creek Hall, Fort Ransom ND

Leslie Fenton Netsuke Collection
Hartnell College Gallery, Salinas CA

Otto Neumann Collection
Tampa Museum of Art, Tampa FL

New Brunswick Furniture Collection
Ross Memorial Museum, Saint Andrews NB

New Orleans Silver
Louisiana State University, Museum of Art, Baton Rouge LA

New York State Material & Genealogy
Roswell P Flower, Watertown NY

Newcomb Pottery Collection
West Baton Rouge Parish, West Baton Rouge Museum, Port Allen LA

Almeron Newman Collection
Arthur Roy Mitchell, Museum of Western Art, Trinidad CO

Nineteenth & Twentieth Century American & European Collection
Bates College, Museum of Art, Lewiston ME

Nineteenth & Twentieth Century American Landscape Art
Moravian College, Payne Gallery, Bethlehem PA

Nineteenth & Twentieth Century American Painting, Prints & Photographs Collection
Lafayette College, Williams Center Gallery, Easton PA

Nineteenth & Twentieth Century American, German & French Paintings
Frye Art Museum, Seattle WA

Pioneer Memorabilia
Crazy Horse Memorial, Indian Museum of North America, Native American Educational & Cultural Center & Crazy Horse Memorial Library (Reference), Crazy Horse SD

Pitkin Asian Art Collection
Beloit College, Wright Museum of Art, Beloit WI

Pohl Collection - German Expressionism
Lawrence University, Wriston Art Center Galleries, Appleton WI

William J Pollock Collection of American Indian Art
Colby College, Museum of Art, Waterville ME

H V Poor
Birger Sandzen Memorial Gallery, Lindsborg KS

Popular Culture & Contemporary Visual Art
Regina Public Library, Dunlop Art Gallery, Regina SK

Fairfield Porter Collection
The Parrish Art Museum, Southampton NY

Porter-Phelps-Huntington Family Collection
Porter-Phelps-Huntington Foundation, Inc, Historic House Museum, Hadley MA

Portrait Collection
Wake Forest University, Charlotte & Philip Hanes Art Gallery, Winston-Salem NC

Portsmouth Furniture Collection
Warner House Association, MacPheadris-Warner House, Portsmouth NH

Post-195 Art
Museum of Contemporary Art, San Diego-Downtown, La Jolla CA

Post-Impressionism
Barnes Foundation, Merion PA

Potamkin Collection of 19th & 20th Century Work
Dickinson College, The Trout Gallery, Carlisle PA

Potlatch Collection of Royal Canadian Mounted Police Illustrations
University of Minnesota, Duluth, Tweed Museum of Art, Duluth MN

Charles Pratt Collection of Chinese Jades
Vassar College, The Frances Lehman Loeb Art Center, Poughkeepsie NY

Lillian Thomas Pratt Collection of Czarist Jewels
Virginia Museum of Fine Arts, Richmond VA

Pre World War II Southern Art
Greenville County Museum of Art, Greenville SC

Pre-Columbian Art
Blanden Memorial Art Museum, Fort Dodge IA

Pre-Columbian Artifacts
University of Texas Pan American, Charles & Dorothy Clark Gallery; University Gallery, Edinburg TX

University of Texas Pan American, UTPA Art Galleries, Edinburg TX

Pre-Columbian Collection
Polk Museum of Art, Lakeland FL
Worcester Art Museum, Worcester MA

Pre-Columbian Pottery
Luther College, Fine Arts Collection, Decorah IA

William Henry Price Memorial Collection of Oil Paintings
Oregon State University, Memorial Union Art Gallery, Corvallis OR

Print Collection
Wake Forest University, Charlotte & Philip Hanes Art Gallery, Winston-Salem NC

Printmaking
Georgian Court College, M Christina Geis Gallery, Lakewood NJ
John B Aird Gallery, Toronto ON
University of North Dakota, Hughes Fine Arts Center-Col Eugene Myers Art Gallery, Grand Forks ND

Prints
Gilbert Stuart, Museum, Saunderstown RI

William Matthew Prior Collection
Cahoon Museum of American Art, Cotuit MA

Public Art
Capp Street Project, San Francisco CA

Puppetry
Center for Puppetry Arts, Atlanta GA

Putnam Collection
Timken Museum of Art, San Diego CA

Permanent collection
Contemporary Crafts Museum & Gallery, Contemporary Crafts Gallery, Portland OR

Peter Whitebird Collection of WPA Project Paintings
Viterbo University, Art Gallery, La Crosse WI

Powers Ceramics Collection
Cornell College, Peter Paul Luce Gallery, Mount Vernon IA

Quadrupeds of North America Collection
National Audubon Society, John James Audubon Center at Mill Grove, Audubon PA

R J Reynolds Collection
Wake Forest University, Charlotte & Philip Hanes Art Gallery, Winston-Salem NC

Natacha Rambova Egyptian Collection
University of Utah, Utah Museum of Fine Arts, Salt Lake City UT

Rand Collection of American Indian Art
Montclair Art Museum, Montclair NJ

Mike Randalls Collection
New Zone Virtual Gallery, Eugene OR

Rasmussen Collection of Eskimo Art
Portland Art Museum, Portland OR

Ray American Indian Collection
Red River Valley Museum, Vernon TX

Lester Raymer
Birger Sandzen Memorial Gallery, Lindsborg KS

Regional California Collection
Mills College, Art Museum, Oakland CA

Remington Bronze Collection
Pioneer Town, Pioneer Museum of Western Art, Wimberley TX

Frederic Remington Collection
Bradford Brinton, Big Horn WY
R W Norton Art Foundation, Shreveport LA
Frederic Remington, Ogdensburg NY

Frederic Remington Collection of Western Art Paintings
Sid W Richardson, Sid Richardson Museum, Fort Worth TX

Remington Drawings
Headquarters Fort Monroe, Dept of Army, Casemate Museum, Fort Monroe VA

Frederic Remington Paintings
Los Angeles County Museum of Natural History, William S Hart Museum, Newhall CA

Fredrick Remington Sculpture Collection
Coutts Memorial Museum of Art, Inc, El Dorado KS

Renaissance & Baroque Period Collection
Guilford College, Art Gallery, Greensboro NC

Renaissance 20th Century Art
Birmingham Museum of Art, Birmingham AL

Renaissance Sculpture-German Gothic Wood
Saint Mary's College of California, Hearst Art Gallery, Moraga CA

Restoration & Conservation
Folk Art Society of America, Richmond VA

Richards Coin Collection
Hastings Museum of Natural & Cultural History, Hastings NE

Rindisbacher Watercolors
United States Military Academy, West Point Museum, West Point NY

David Roberts Collection
Riverside County Museum, Edward-Dean Museum & Gardens, Cherry Valley CA

Evan H Roberts Sculpture Collection
Portland Art Museum, Portland OR

Marion Sharp Robinson Collection
University of Utah, Utah Museum of Fine Arts, Salt Lake City UT

David Robinson Collection of Antiquities
University of Mississippi, University Museum, Oxford MS

Mr & Mrs John D Rockefeller 3D Collection of Asian Art
The Asia Society Museum, New York NY

Norman Rockwell Collection
Norman Rockwell Museum, Stockbridge MA

Robert F Rockwell Foundation Collection
The Rockwell Museum of Western Art, Corning NY

Rodeo Portrait Collection
National Cowboy & Western Heritage Museum, Oklahoma City OK

Auguste Rodin Collection
Stanford University, Iris & B Gerald Cantor Center for Visual Arts, Stanford CA

Rodin Sculpture Collection
Gonzaga University, Art Gallery, Spokane WA

Rodman Collection of Popular Art
The Art Galleries of Ramapo College, Mahwah NJ

Nicholas Roerich Collection
Nicholas Roerich, New York NY

Edward Rose Collection of Ceramics
Brandeis University, Rose Art Museum, Waltham MA

Jerry Ross Collection
New Zone Virtual Gallery, Eugene OR

Ross Decorative Art Collection
Ross Memorial Museum, Saint Andrews NB

Georges Rouault Collection
University of Texas Pan American, Charles & Dorothy Clark Gallery; University Gallery, Edinburg TX
University of Texas Pan American, UTPA Art Galleries, Edinburg TX

Dorothy Adler Routh Cloissonne Collection
Scripps College, Ruth Chandler Williamson Gallery, Claremont CA

Guy Rowe Wax Drawings Collection
Angelo State University, Houston Harte University Center, San Angelo TX

Roycroft Objects
Burchfield-Penney Art Center, Buffalo NY

Peter Paul Rubens Collection
Florida State University, John & Mable Ringling Museum of Art, Sarasota FL

Charles M Russell Collection
Bradford Brinton, Big Horn WY
R W Norton Art Foundation, Shreveport LA
C M Russell, Great Falls MT

Charles M Russell Collection of Western Art Paintings
Sid W Richardson, Sid Richardson Museum, Fort Worth TX

Charles M Russell Paintings
Los Angeles County Museum of Natural History, William S Hart Museum, Newhall CA

Russian & Baltic Photography
Roy Boyd, Chicago IL

Sackler Collection
The Metropolitan Museum of Art, New York NY

Arthur M Sackler Collection
Smithsonian Institution, Arthur M Sackler Gallery, Washington DC

Oscar & Maria Salzer Collection of 16th & 17th Century Dutch & Flemish Paintings
Fresno Metropolitan Museum, Fresno CA

Sherry Sander Scupture Collection
High Desert Museum, Bend OR

Wilbur Sandison Photography Collection
Whatcom Museum of History and Art, Bellingham WA

Sandwich Glass Collection
Fuller Museum of Art, Brockton MA

Birger Sandzen
Birger Sandzen Memorial Gallery, Lindsborg KS

John Singer Sargent Collection
Isabella Stewart Gardner, Boston MA

Sargent Collection of American Indian Art
Montclair Art Museum, Montclair NJ

Sawhill Artifact Collection
James Madison University, Sawhill Gallery, Harrisonburg VA

Jonathan Sax Print Collection
University of Minnesota, Duluth, Tweed Museum of Art, Duluth MN

Scandinavian Immigrant Painting
Luther College, Fine Arts Collection, Decorah IA

Richard Schmid Permanent Collection
Palette & Chisel Academy of Fine Arts, Chicago IL

Alice F Schott Doll Collection
Santa Barbara Museum of Art, Santa Barbara CA

Rita & Taft Schreiber Collection
The Museum of Contemporary Art (MOCA), Los Angeles CA

Schreyvogel Collection
National Cowboy & Western Heritage Museum, Oklahoma City OK

Charles Schreyvogel Paintings
Los Angeles County Museum of Natural History, William S Hart Museum, Newhall CA

Hazel Schwentker Collection
Rapid City Arts Council, Dahl Arts Center, Rapid City SD

Science & Technology
Canada Science and Technology Museum, Ottawa ON

Scotese Collection of Graphics
Columbia Museum of Art, Columbia SC

Isaac Scott Collection
Glessner House Museum, Chicago IL

Philip Sears Sculpture Collection
Fruitlands Museum, Inc, Harvard MA

Seibels Collection of Renaissance Art
Columbia Museum of Art, Columbia SC

Shaker Collection
Hancock Shaker Village, Inc, Pittsfield MA

Shaker Culture
Shaker Village of Pleasant Hill, Harrodsburg KY

Shaker History & Culture Collection
Shaker Museum & Library, Old Chatham NY

Sharp Collection of Glass
Frederic Remington, Ogdensburg NY

Shea
Hirshhorn Museum & Sculpture Garden, Smithsonian Institution, Washington DC

Sheet Music Covers
Liberty Memorial Museum & Archives, The National Museum of World War I, Kansas City MO

Inglis Sheldon-Williams Collection
Regina Public Library, Dunlop Art Gallery, Regina SK

William Ludwell Sheppard Watercolor Collection
Valentine Richmond History Center, Richmond VA

Shipbuilding
Essex Historical Society, Essex Shipbuilding Museum, Essex MA

Henrietta Shore Collection
Santa Clara University, de Saisset Museum, Santa Clara CA

Philip Trammell Shutze Collection
Atlanta Historical Society Inc, Atlanta History Center, Atlanta GA

Silversmithing
John B Aird Gallery, Toronto ON

Simmons Collection
Wake Forest University, Charlotte & Philip Hanes Art Gallery, Winston-Salem NC

B Simon Lithography Collection
The Historic New Orleans Collection, New Orleans LA

Sixteenth-Twentieth Century American & European Works
College of William & Mary, Muscarelle Museum of Art, Williamsburg VA

Sixteenth-Twentieth Century Books
La Casa del Libro Museum, San Juan PR

Dorothy D Skewis Print Collection
Witter Gallery, Storm Lake IA

Sloan Collection
Valparaiso University, Brauer Museum of Art,
Valparaiso IN

Esphyr Slobodkina
Heckscher Museum of Art, Huntington NY

Helen S Slosberg Collection of Oceanic Art
Brandeis University, Rose Art Museum, Waltham MA

David Smith
Hirshhorn Museum & Sculpture Garden, Smithsonian
Institution, Washington DC

Hamilton Sutton Smith Glass Plate Negatives
Museum of Afro-American History, Boston MA

Smith Painting Collection
Woodmere Art Museum, Philadelphia PA

Smith Watch Key Collection
Rollins College, George D & Harriet W Cornell Fine
Arts Museum, Winter Park FL

Smithsonian Collection of American Art
California State University, Fullerton, Art Gallery,
Visual Arts Center, Fullerton CA

Snelgrove Historical Collection
Gadsden Museum of Fine Arts, Inc, Gadsden Museum
of Art and History, Gadsden AL

Steamer W P Snyder Jr
The Ohio Historical Society, Inc, Campus Martius
Museum & Ohio River Museum, Marietta OH

Social History
Monhegan Museum, Monhegan ME

Soldiers' Art & Crafts
Liberty Memorial Museum & Archives, The National
Museum of World War I, Kansas City MO

Sonnenschein Collection
Cornell College, Peter Paul Luce Gallery, Mount
Vernon IA

Spanish Colonial Art
University of New Mexico, University Art Museum,
Albuquerque NM

Scott D F Spiegel Collection
The Museum of Contemporary Art (MOCA), Los
Angeles CA

Leon Spilliaert Collection
The Metropolitan Museum of Art, New York NY

Sporting Art
Genesee Country Village & Museum, John L Wehle
Gallery of Wildlife & Sporting Art, Mumford NY

Benton Spruance Print Collection
Beaver College Art Gallery, Glenside PA

Anisoara Stan Collection
Saint Mary's Romanian Orthodox Cathedral, Romanian
Ethnic Museum, Cleveland OH

Stanford Family Collection
Stanford University, Iris & B Gerald Cantor Center for
Visual Arts, Stanford CA

Staples Collection of Indonesian Art
James Madison University, Sawhill Gallery,
Harrisonburg VA

Ben Steele-Prisoner of War Collection
Montana State University at Billings, Northcutt Steele
Gallery, Billings MT

**John Steele Collection of Furniture, Silver &
Paintings**
Jamestown-Yorktown Foundation, Williamsburg VA

**Stegeman Collection of Japanese Woodcut
Prints (19th & 20th century)**
Northwestern College, Te Paske Gallery, Orange City
IA

**Harry J Stein-Samuel Friedenberg Collection
of Coins from the Holy Land**
The Jewish Museum, New York NY

Stern Collection
Philadelphia Museum of Art, Philadelphia PA

Harold P Stern Collection of Oriental Art
Vanderbilt University, Fine Arts Gallery, Nashville TN

Stern-Davis Collection of Peruvian Painting
New Orleans Museum of Art, New Orleans LA

Carder Steuben Glass Collection
The Rockwell Museum of Western Art, Corning NY

Robert Louis Stevenson Collection
R L S Silverado Museum, Saint Helena CA

Stiegal Glass
Philadelphia Museum of Art, Philadelphia PA

Alfred Stieglitz Collection
Fisk University, Fisk University Galleries, Nashville
TN

Clyfford Still Collection
San Francisco Museum of Modern Art, San Francisco
CA

**Thomas D Stimson Memorial Collection of
Far Eastern Art**
Seattle Art Museum, Seattle WA

**Warda Stevens Stout Collection of 18th
Century German Porcelain**
The Dixon Gallery & Gardens, Memphis TN

Student Art Collection
Gonzaga University, Art Gallery, Spokane WA

**Student Union Collection of Contemporary
Art**
Wake Forest University, Charlotte & Philip Hanes Art
Gallery, Winston-Salem NC

Study Collection of Prints
The Art Galleries of Ramapo College, Mahwah NJ

Sully Portrait Collection
United States Military Academy, West Point Museum,
West Point NY

Swallow Collection
Red Deer & District Museum & Archives, Red Deer
AB

Swedish American Art Collection
Augustana College, Augustana College Art Museum,
Rock Island IL

Swiss Affairs
Swiss Institute, New York NY

Schuette Woodland Indian Collection
Rahr-West Art Museum, Manitowoc WI

Sculpture & Furniture
University of Wisconsin-Madison, Chazen Museum of
Art, Madison WI

Shared Vision Collection
Brevard Museum of Art & Science, Melbourne FL

Sir Mackenzie Bowell Coll
Glanmore National Historic Site of Canada, Belleville
ON

Sloane's Studio
CT Commission on Culture & Tourism, Sloane-Stanley
Museum, Kent CT

Steve Lariccia
New Zone Virtual Gallery, Eugene OR

**Joey and Toby Tanenbaum Collection (19th
century European)**
Art Gallery of Hamilton, Hamilton ON

Taos Society of Artists Collection
Taos, Ernest Blumenschein Home & Studio, Taos NM

Alfredo S G Taylor Architect;
Norfolk Historical Society Inc, Museum, Norfolk CT

Taylor Collection of Southwestern Art
Colorado Springs Fine Arts Center, Colorado Springs
CO

Teacher Training
Georgian Court College, M Christina Geis Gallery,
Lakewood NJ
University of North Dakota, Hughes Fine Arts
Center-Col Eugene Myers Art Gallery, Grand Forks
ND

Technology & Man
John Weaver Sculpture Collection, Hope BC

Technology
Museum of Applied Arts & Sciences, Sydney

Television
American Museum of the Moving Image, Astoria NY

Tell City Pilothouse
The Ohio Historical Society, Inc, Campus Martius
Museum & Ohio River Museum, Marietta OH

Terra Collection
Terra Museum of American Art, Chicago IL

Texan Art
City of El Paso Museum and Cultural Affairs, People's
Gallery, El Paso TX

Texas Contemporary Art
Arlington Museum of Art, Arlington TX

Texas Regional Art
Dallas Museum of Art, Dallas TX

Textile Design
Georgian Court College, M Christina Geis Gallery,
Lakewood NJ

**Justin K Thannhauser Collection of
Impressionist & Post-Impressionist Paintings**
Solomon R Guggenheim, New York NY

**Justin K Thannhauser Collection of
Impressionists & Post-Impressionist Paintings**
Guggenheim Museum Soho, New York NY

Thatcher Family Collection
Rosemount Museum, Inc, Pueblo CO

Theater
Painted Bride Art Center Gallery, Philadelphia PA

Thieme Collection
Fort Wayne Museum of Art, Inc, Fort Wayne IN

Thoroughbred Racing Industry Collection
Kentucky Derby Museum, Louisville KY

Louis Comfort Tiffany Collection
Charles Morse, Charles Hosmer Morse Museum of
American Art, Winter Park FL

Tiffany Glass
The National Trust for Historic Preservation, Lyndhurst,
Tarrytown NY

Tiffany Glass Collection
Mark Twain, Hartford CT

Tobin Theatre Arts Collection
McNay, San Antonio TX

**Tonkin Collection of Chinese Export
Porcelain**
The Pennsylvania State University, Palmer Museum of
Art, University Park PA

Helen Torr
Heckscher Museum of Art, Huntington NY

Dolls Toys
Carteret County Historical Society, Museum of History
& Art, Morehead City NC

**Transportation History (Railroad
Locomotives & Train Cars)**
Pennsylvania Historical & Museum Commission,
Railroad Museum of Pennsylvania, Harrisburg PA

Trees Collection
University of Illinois, Krannert Art Museum and
Kinkead Pavillion, Champaign IL

Trovwer Silver Collection
University of Utah, Utah Museum of Fine Arts, Salt
Lake City UT

Tucker Porcelain Collection
Philadelphia Museum of Art, Philadelphia PA

J M W Turner Watercolor Collection
Columbus Museum of Art and Design, Indianapolis IN

Lyle Tuttle Collection
Tattoo Art Museum, San Francisco CA

**George P Tweed Memorial Collection of
American & European Paintings**
University of Minnesota, Duluth, Tweed Museum of
Art, Duluth MN

Twentieth Century American Art
Albany Museum of Art, Albany GA
Guilford College, Art Gallery, Greensboro NC

**Twentieth Century American Sculpture
Collection**
James A Michener, Doylestown PA

Twentieth Century Art
San Jose Museum of Art, San Jose CA
State University of New York at Stony Brook,
University Art Gallery, Stony Brook NY

Twentieth Century Artists
University of Wisconsin-Eau Claire, Foster Gallery,
Eau Claire WI

Twentieth Century Paintings
Moravian College, Payne Gallery, Bethlehem PA

Two & Three-Dimensional Designs
Coutts Memorial Museum of Art, Inc, El Dorado KS

Tyson Collection
Philadelphia Museum of Art, Philadelphia PA

Thorvaldsen's Collection of Antiquities
Thorvaldsens Museum, Copenhagen

Ukrainian Paintings
The Ukrainian Museum, New York NY

Doris Ulmann Photography Collection
Berea College, Doris Ulmann Galleries, Berea KY

Charles Umlauf Collection
UMLAUF Sculpture Garden & Museum, Austin TX

United States & Foreign Military Equipment
National Infantry Museum, Fort Benning GA

**Nora S Unwin Collection of Wood
Engravings, Drawings, Watercolors**
Sharon Arts Center, Sharon Arts Center Exhibition
Gallery, Sharon NH

USS Constitution Models
USS Constitution Museum, Boston MA

Utah Art
Springville Museum of Art, Springville UT

**Edward Virginius Valentine Sculpture
Collection**
Valentine Richmond History Center, Richmond VA

**Van Ess Collection of Renaissance & Baroque
Art**
Hartwick College, Foreman Gallery, Oneonta NY

Carl Van Vechten Photographs
Fisk University, Fisk University Galleries, Nashville
TN

Vanderpoel Oriental Art Collection
The Slater Memorial Museum, Slater Memorial
Museum, Norwich CT

Carl VanVechten Collection of Photographs
Hammond Museum & Japanese Stroll Garden,
Cross-Cultural Center, North Salem NY

Matthew Vassar Collection
Vassar College, The Frances Lehman Loeb Art Center,
Poughkeepsie NY

Ellis Verink Photograph Collection
Polk Museum of Art, Lakeland FL

Vever Collection
Smithsonian Institution, Arthur M Sackler Gallery,
Washington DC

**Victor Talking Machine Company
Phonographs & Records**
Delaware Division of Historical & Cultural Affairs,
Dover DE

Victoriana
Carteret County Historical Society, Museum of History
& Art, Morehead City NC

Video
Maine College of Art, The Institute of Contemporary
Art, Portland ME

Von Schleinitz Collection
Milwaukee Art Museum, Milwaukee WI

Vernon Hall Collection of European Medals
University of Wisconsin-Madison, Chazen Museum of
Art, Madison WI

Wachovia Permanent Collection
Burke Arts Council, Jailhouse Galleries, Morganton NC

Wagner Collection of African Sculpture
Scripps College, Clark Humanities Museum, Claremont
CA
Scripps College, Ruth Chandler Williamson Gallery,
Claremont CA

Waldo Peirce Collection
Southern Oregon University, Schneider Museum of Art,
Ashland OR

C G Wallace Collection
Heard Museum, Phoenix AZ

Wallcoverings
Cooper-Hewitt, National Design Museum, Smithsonian
Institution, New York NY

Cloud Wampler Collection of Oriental Art
Everson Museum of Art, Syracuse NY

Felix M Warburg Collection of Medieval Sculpture
Vassar College, The Frances Lehman Loeb Art Center, Poughkeepsie NY

Austen D Warburton Native American Art & Artifacts Collection
Triton Museum of Art, Santa Clara CA

Andy Warhol Collection
University of Maryland, College Park, The Art Gallery, College Park MD

Booker T Washington Collection
Tuskegee Institute National Historic Site, George Washington Carver & The Oaks, Tuskegee Institute AL

George Washington Memorabilia
Mount Vernon Ladies' Association of the Union, Mount Vernon VA

George Washington Portraits & Relics
George Washington, Alexandria VA

Homer Watson Collection
Kitchener-Waterloo Art Gallery, Kitchener ON

William Watson Collection of Ceramics
LeMoyne Art Foundation, Inc, Tallahassee FL

Watson Family Artifacts
Homer Watson, Kitchener ON

John Wayne Collection
National Cowboy & Western Heritage Museum, Oklahoma City OK

Weatherhead Collection
Fort Wayne Museum of Art, Inc, Fort Wayne IN

Weaving
Georgian Court College, M Christina Geis Gallery, Lakewood NJ
Taos, La Hacienda de Los Martinez, Taos NM
University of North Dakota, Hughes Fine Arts Center-Col Eugene Myers Art Gallery, Grand Forks ND

Walter Weber Wildlife Paintings
United States Department of the Interior Museum, Washington DC

Esther Webster Art Collection
Port Angeles Fine Arts Center, Port Angeles WA

Wedgewood Collection
Birmingham Museum of Art, Birmingham AL

Wedgwood Collection
R W Norton Art Foundation, Shreveport LA

Teresa Jackson Weill Collection
Brandeis University, Rose Art Museum, Waltham MA

J Alden Weir Archive & Manuscript Collection
National Park Service, Weir Farm National Historic Site, Wilton CT

J Alden Weir Collection
Brigham Young University, B F Larsen Gallery, Provo UT

Wellington Collection of Wood Engravings
Mobile Museum of Art, Mobile AL

William Wendt Collection
California State University Stanislaus, University Art Gallery, Turlock CA

Benjamin West Collection
BJU Museum & Gallery, Bob Jones University Museum & Gallery Inc, Greenville SC

Western & Contemporary Western
Coutts Memorial Museum of Art, Inc, El Dorado KS

Western New York Regional Art
Burchfield-Penney Art Center, Buffalo NY

Candace Wheeler Collection
Mark Twain, Hartford CT

James McNeill Whistler Collection
Isabella Stewart Gardner, Boston MA

White Collection
Philadelphia Museum of Art, Philadelphia PA

Elizabeth White Collection
Sumter Gallery of Art, Sumter SC

Whitney Silver Collection
Montclair Art Museum, Montclair NJ

Bartlett Wicks Collection
University of Utah, Utah Museum of Fine Arts, Salt Lake City UT

Widener Collection
National Gallery of Art, Washington DC

E L Wiegand Art Collection
Nevada Museum of Art, Reno NV

Simon Wiesenthal Collection
Simon Wiesenthal Center Inc, Museum of Tolerance, Los Angeles CA

Albert H Wiggin Collection
Boston Public Library, Albert H Wiggin Gallery & Print Department, Boston MA

Margurite Wildenhain Collection
Luther College, Fine Arts Collection, Decorah IA

Wilder Art Glass & Pottery Collection
Topeka & Shawnee County Public Library, Alice C Sabatini Gallery, Topeka KS

Wildlife Art
Las Vegas Natural History Museum, Las Vegas NV

Wildlife Art (North American & European)
Genesee Country Village & Museum, John L Wehle Gallery of Wildlife & Sporting Art, Mumford NY

Will Collection of Paintings & Drawings
Jersey City Museum, Jersey City NJ

Willard Clockmaking Collection
Willard House & Clock Museum, Inc, North Grafton MA

Archibald M Willard Paintings Collection
Southern Lorain County Historical Society, Spirit of '76 Museum, Elyria OH

Adolph D & Wilkins C Williams Collection
Virginia Museum of Fine Arts, Richmond VA

Hiram Williams Collection of Drawings & Prints
LeMoyne Art Foundation, Inc, Tallahassee FL

Lois Wilson Collection
City of Fayette, Alabama, Fayette Art Museum, Fayette AL

Wilson Collection
Huntington University, Robert E Wilson Art Gallery, Huntington IN

Ralph Wilson Collection
Lehigh University Art Galleries, Museum Operation, Bethlehem PA

Wilstach Collection of Old Masters
Philadelphia Museum of Art, Philadelphia PA

Wingert Collection of African & Oceanic Art
Montclair State University, Art Galleries, Upper Montclair NJ

Wisconsin Art History Collection
Museum of Wisconsin Art, West Bend Art Museum, West Bend WI

Ella Witter Collection
Witter Gallery, Storm Lake IA

Women Artists
La Centrale Powerhouse Gallery, Montreal PQ

Women's Studies
Carteret County Historical Society, Museum of History & Art, Morehead City NC

Grant Wood Collection
Davenport Museum of Art, Davenport IA

Bill Wood Collection
Huronia Museum, Gallery of Historic Huronia, Midland ON

Woodblock (Ukiyo-e) Prints
Lauren Rogers, Laurel MS

Jack Woods Collection
Pioneer Town, Pioneer Museum of Western Art, Wimberley TX

Woodworking
Hui No eau Visual Arts Center, Gallery and Gift Shop, Makawao Maui HI

Theodore Wores Collection
Triton Museum of Art, Santa Clara CA

World War I Covers
Liberty Memorial Museum & Archives, The National Museum of World War I, Kansas City MO

Personnel Index

Aakhus, Michael, *Prof,* University of Southern Indiana, Art Dept, Evansville IN (S)

Aaronson, Lawrence R, *Dean Arts & Sciences,* Utica College of Syracuse University, Division of Art & Science, Utica NY (S)

Abbe, Ronald, *Prog Coordr,* Housatonic Community College, Art Dept, Bridgeport CT (S)

Abbott, Amanda, *Develop Coordr,* Manchester Historic Association, Manchester NH

Abbott, Liz, *Dir Library,* Boulder Public Library & Gallery, Dept of Fine Arts Gallery, Boulder CO

Abdo, George, *VPres Advancement,* The Huntington Library, Art Collections & Botanical Gardens, San Marino CA

Abdo, George, *VPres Advancement,* The Huntington Library, Art Collections & Botanical Gardens, Library, San Marino CA

Abdul-Musawwir, Najjar, *Asst Prof,* Southern Illinois University, School of Art & Design, Carbondale IL (S)

Abdur-Rahman, Uthman, *Head Dept Art,* Tuskegee University, Liberal Arts & Education, Tuskegee AL (S)

Abe, Stanley, *Assoc Prof,* Duke University, Dept of Art, Art History & Visual Studies, Durham NC (S)

Abel, Charles, *Instr,* Springfield College, Dept of Visual & Performing Arts, Springfield MA (S)

Abel, Mickey, *Asst Prof Art History,* University of North Texas, School of Visual Arts, Denton TX (S)

Abele, Susan, *Cur Manuscripts,* Newton History Museum at the Jackson Homestead, Newton MA

Abele, Susan, *Dir,* Newton History Museum at the Jackson Homestead, Research Library, Newton MA

Abell, E J, *Educ,* River Heritage Museum, Paducah KY

Abell, Mary, *Asst Prof Visual Arts,* Dowling College, Dept of Visual Arts, Oakdale NY (S)

Aber, Lynn, *Librn,* Portsmouth Athenaeum, Joseph Copley Research Library, Portsmouth NH

Abercrombie, Bea, *Dir Admin Servs,* Witte Museum, San Antonio TX

Abid, Ann B, *Head Librn,* Cleveland Museum of Art, Cleveland OH

Abide, Joe, *Asst Prof,* Delta State University, Dept of Art, Cleveland MS (S)

Abiko, Bonnie, *Assoc Prof,* Oakland University, Dept of Art & Art History, Rochester MI (S)

Able, Edward H, *Secy AAM/ICOM & Pres AAM,* American Association of Museums, US National Committee of the International Council of Museums (AAM-ICOM), Washington DC

Abler, Timothy, *Asst Prof,* Cardinal Stritch University, Art Dept, Milwaukee WI (S)

Abler, Timothy, *Chmn Art Dept,* Cardinal Stritch University, Art Gallery, Milwaukee WI

Abou-El-Haj, Barbara, *Assoc Prof,* State University of New York at Binghamton, Dept of Art History, Binghamton NY (S)

Aboulhamid, El Mostapha, *Aggregate Prof,* Universite de Montreal, Bibliotheque d'Amenagement, Montreal PQ

Abraham, Bondi, *Dir Memberships,* California Watercolor Association, Gallery Concord, Concord CA

Abraham, Richard, *Instr,* Central Community College - Columbus Campus, Business & Arts Cluster, Columbus NE (S)

Abram, Ronald, *Assoc Prof,* Denison University, Dept of Art, Granville OH (S)

Abram, Trudi, *Instr Art History,* Glendale Community College, Visual & Performing Arts Div, Glendale CA (S)

Abrams, C, *Dir,* The Photon League of Holographers, Toronto ON

Abrams, Ian, *Asst Prof Dramatic Writing,* Drexel University, College of Media Arts & Design, Philadelphia PA (S)

Abrams, Leslie, *Asst Prof,* Springfield College, Dept of Visual & Performing Arts, Springfield MA (S)

Abrams, Leslie, *Head,* University of California, San Diego, Arts Libraries, La Jolla CA

Abrams, Paul, *Instr,* Woodstock School of Art, Inc, Woodstock NY (S)

Abramson, Daniel, *Asst Prof,* Tufts University, Dept of Art & Art History, Medford MA (S)

Abreu, Vidal, *Librn,* Museum of Ossining Historical Society, Library, Ossining NY

Accurso, Li Ching, *Instr,* Columbia College, Fine Arts, Sonora CA (S)

Acero, Raul, *Chair Visual Arts,* Sage Junior College of Albany, Dept Visual Arts, Albany NY (S)

Acevedo, Salvador, *Dir Pub & International Affairs,* Mexican Museum, San Francisco CA

Achtemichuk, Robert, *Bus Mgr,* Canadian Clay & Glass Gallery, Waterloo ON

Acita, Marcia, *Asst Dir,* Bard College, Center for Curatorial Studies, Annandale-on-Hudson NY

Ackerman, Andrew, *Exec Dir,* Children's Museum of Manhattan, New York NY

Ackerman, Philip C, *Chm (V),* Buffalo Museum of Science, Research Library, Buffalo NY

Ackerman, Rudy S, *Prof Emeritus,* Moravian College, Dept of Art, Bethlehem PA (S)

Ackermann, Paul, *Mus Specialist,* United States Military Academy, West Point Museum, West Point NY

Acomb, Merlin, *Exhib Designer & Preparator,* University of Vermont, Robert Hull Fleming Museum, Burlington VT

Acorn, Eleanor, *Dir,* John M Cuelenaere, Grace Campbell Gallery, Prince Albert SK

Acres, Al, *Asst Prof,* Georgetown University, Dept of Art, Music & Theatre, Washington DC (S)

Acs, Alajos, *Midwest Representative,* American Society of Artists, Inc, Palatine IL

Acton, David L, *Cur Prints, Drawings & Photography,* Worcester Art Museum, Worcester MA

Adair, Bill, *Dir Educ,* The Rosenbach Museum & Library, Philadelphia PA

Adair, Cindy, *Office Mgr,* Pennsylvania Historical & Museum Commission, Railroad Museum of Pennsylvania, Harrisburg PA

Adair, Everl, *Communications Dir,* R W Norton Art Foundation, Shreveport LA

Adamcik-Huettel, Patricia, *Multimedia & Web Design,* Art Institute of Pittsburgh, Pittsburgh PA (S)

Adamec, Carol, *Assoc Dir,* George A Spiva, Joplin MO

Adams, Anne, *Registrar,* Menil Foundation, Inc, Houston TX

Adams, Annmarie, *Prof,* McGill University, School of Architecture, Montreal PQ (S)

Adams, Bonnie, *Dir Develop & Mem,* Columbia Museum of Art, Columbia SC

Adams, Brad, *Asst Prof,* Berry College, Art Dept, Mount Berry GA (S)

Adams, Carolyn, *Cur,* National Society of Colonial Dames of America in the State of Maryland, Mount Clare Museum House, Baltimore MD

Adams, Daniel, *Asst Prof,* Harding University, Dept of Art, Searcy AR (S)

Adams, Dennis, *Acting Dean,* Cooper Union, School of Art, New York NY (S)

Adams, Don, *Exec Dir,* The Richmond Art Center, Richmond CA

Adams, Edward, *Instr,* Milwaukee Area Technical College, Graphic Arts Div, Milwaukee WI (S)

Adams, Gladys, *Bookings Mgr,* African American Museum in Philadelphia, Philadelphia PA

Adams, Gloria Rejune, *Dir,* Cornell Museum of Art & History, Delray Beach FL

Adams, Helen, *Admin Asst,* State Capital Museum, Olympia WA

Adams, Henry, *Prof,* Case Western Reserve University, Dept of Art History & Art, Cleveland OH (S)

Adams, Holly, *Adjunct Instr,* Davis & Elkins College, Dept of Art, Elkins WV (S)

Adams, J Marshall, *Cur Educ,* Mississippi Museum of Art, Howorth Library, Jackson MS

Adams, James, *Asst Prof of Art,* Thomas University, Humanities Division, Thomasville GA (S)

Adams, James R C, *Chmn Dept,* Manchester College, Art Dept, North Manchester IN (S)

Adams, Jean, *Adjunct Prof,* Wilkes University, Dept of Art, Wilkes-Barre PA (S)

Adams, Joyce, *Dir Human Resources,* Hillwood Museum & Gardens Foundation, Hillwood Museum & Gardens, Washington DC

Adams, Kathryn, *Exec Dir,* Audrain County Historical Society, Graceland Museum & American Saddlehorse Museum, Mexico MO

Adams, Kathy, *Exec Dir,* Ponca City Cultural Center & Museum, Ponca City OK

Adams, Kathy, *Exec Dir,* Ponca City Cultural Center & Museum, Library, Ponca City OK

Adams, Kelly, *Dir,* East Carolina University, Media Center, Greenville NC

Adams, Kerrington, *Cur Facilities Mgr,* Patterson Homestead, Dayton OH

Adams, Laurie Schneider, *Prof,* City University of New York, PhD Program in Art History, New York NY (S)

Adams, Lucy Perrera, *Cur of Educ,* University of New Mexico, The Harwood Museum of Art, Taos NM

Adams, Mac, *Chmn Art Dept,* State University of New York College at Old Westbury, Amelie A Wallace Gallery, Old Westbury NY

Adams, Madge, *VPres & Controller,* Shaker Village of Pleasant Hill, Harrodsburg KY

Adams, Marlin, *Instr,* Gordon College, Dept of Fine Arts, Barnesville GA (S)

Adams, Nancy, *VPres,* Arts on the Park, Lakeland Center for Creative Arts, Lakeland FL

Adams, Nicholas, *Prof,* Vassar College, Art Dept, Poughkeepsie NY (S)

Adams, Nixon, *CEO & Dir,* Lake Pontchartrain Basin Maritime Museum, Madisonville LA

Adams, Pat, *Dir,* Saskatchewan Craft Council & Gallery, Saskatoon SK

Adams, Patsy Baker, *Gallery Dir & Adminr,* New Orleans Academy of Fine Arts, Academy Gallery, New Orleans LA

Adams, Roberta, *Dir Educ,* Delaware Art Museum, Wilmington DE

Adams, Victoria, *Dir Mem,* Saginaw Art Museum, Saginaw MI

Adams, William R, *Chmn,* City of Saint Augustine, Saint Augustine FL

Adamson, Jeremy, *Chief Prints & Photograph,* Library of Congress, Prints & Photographs Division, Washington DC

Adamson, John, *CEO, VChmn,* Strasburg Museum, Strasburg VA

Adamson, Rob, *Prof,* Salt Lake Community College, Graphic Design Dept, Salt Lake City UT (S)

Adams Ramsey, Susan, *Chmn,* Clinch Valley College of the University of Virginia, Visual & Performing Arts Dept, Wise VA (S)

Adamy, George E, *Dir,* Polyadam Concrete System Workshops, Ossining NY (S)

Adans, Mac, *Chmn,* State University of New York College at Old Westbury, Visual Arts Dept, Old Westbury NY (S)

Adato, Linda, *Treas,* Society of American Graphic Artists, New York NY

Alford, Keith, *VPres,* Mississippi Art Colony, Stoneville MS

Alfred, Ted, *VPres,* Intermuseum Conservation Association, Oberlin OH

Alger, Jeff, *Librn,* Kansas State University, Paul Weigel Library of Architecture Planning & Design, Manhattan KS

Ali, Ronald, *Assoc Prof,* Indiana University of Pennsylvania, College of Fine Arts, Indiana PA (S)

Alkin, Michele E, *Dir Communication,* Simon Wiesenthal Center Inc, Museum of Tolerance, Los Angeles CA

Allan, Michele, *Asst Prof,* California State University, Dominguez Hills, Art Dept, Carson CA (S)

Allard, Lynn, *Instr,* College of Saint Rose, Art Dept, Albany NY (S)

Allardice, Liz, *Art Educ,* Vernon Art Gallery, Vernon BC

Allen, Angelo, *Instr,* Pierce College, Art Dept, Woodland Hills CA (S)

Allen, Anne, *Coordr of Fine Arts,* Indiana University-Southeast, Fine Arts Dept, New Albany IN (S)

Allen, Anne, *Dir,* Arlington Museum of Art, Arlington TX

Allen, Bruce, *Chmn Dept & Prof,* Centenary College of Louisiana, Dept of Art, Shreveport LA (S)

Allen, Carl M, *Prof,* Ashland University, Art Dept, Ashland OH (S)

Allen, Dottie, *Art Prog Coordr,* Hill College, Fine Arts Dept, Hillsboro TX (S)

Allen, Douglas, *Assoc Dean,* Georgia Institute of Technology, College of Architecture, Atlanta GA (S)

Allen, Earlene, *Prof,* Marshall University, Dept of Art, Huntington WV (S)

Allen, Frank R, *Assoc Dir Admin,* University of Central Florida Libraries, Orlando FL

Allen, Heidi, *Asst Prof,* Concordia College, Art Dept, Moorhead MN (S)

Allen, James, *Media Arts & Animation,* Art Institute of Pittsburgh, Pittsburgh PA (S)

Allen, James, *Prof,* Daemen College, Art Dept, Amherst NY (S)

Allen, Jan, *Cur Contemporary Art,* Queen's University, Agnes Etherington Art Centre, Kingston ON

Allen, Jim, *Instr,* Springfield College in Illinois, Dept of Art, Springfield IL (S)

Allen, Judith, *Pres,* Spirit Square Center for Arts & Education, Charlotte NC

Allen, Jules, *Asst Prof,* Queensborough Community College, Dept of Art & Photography, Bayside NY (S)

Allen, Larry, *Senior Dir Finance & Office,* Industrial Designers Society of America, Sterling VA

Allen, Lucy, *Dir Educ & Programs,* Mississippi Department of Archives & History, Old Capitol Museum of Mississippi History, Jackson MS

Allen, Nash, *Chief Financial Officer,* Bank of Mississippi, Art Collection, Tupelo MS

Allen, Nicole, *Dir Develop,* Madison Museum of Contemporary Art, Madison WI

Allen, Pamela, *Asst Prof,* Troy State University, Dept of Art & Classics, Troy AL (S)

Allen, Patience, *Development Dir,* City Art Works, Pratt Fine Arts Center, Seattle WA (S)

Allen, Rachel, *Research & Scholars Center Chief,* Smithsonian American Art Museum, Washington DC

Allen, Regina, *Instr,* Wayne Art Center, Wayne PA (S)

Allen, Richard, *Cur,* The Southland Corporation, Art Collection, Dallas TX

Allen, Robert, *VPres,* South Arkansas Arts Center, El Dorado AR

Allen, Stan, *Chmn Div Urban Design,* Columbia University, Graduate School of Architecture, Planning & Preservation, New York NY (S)

Allen, Walter, *Div Chmn of Art,* James H Faulkner, Art Dept, Bay Minette AL (S)

Allen, William, *Prof,* Arkansas State University, Dept of Art, State University AR (S)

Allen, Zack, *Exec Dir,* Rose Center & Council for the Arts, Morristown TN

Alley, Jon, *Instr,* Bucks County Community College, Fine Arts Dept, Newtown PA (S)

Alley, William, *Archivist & Historian,* Southern Oregon Historical Society, Library, Medford OR

Alley-Bavaes, Royal, *Instr,* Seattle Central Community College, Humanities - Social Sciences Division, Seattle WA (S)

Allison, Andrea, *Librn,* Quetico Park, John B Ridley Research Library, Atikokan ON

Allison, David, *Assoc Prof,* Clemson University, College of Architecture, Clemson SC (S)

Allison , Glenn, *Dir & Cur,* Canadian Clay & Glass Gallery, Waterloo ON

Allison, Jillian, *Registrar,* Nicolaysen Art Museum & Discovery Center, Childrens Discovery Center, Casper WY

Allison, Joseph, *Studio Mgr,* Austin College, Art Dept, Sherman TX (S)

Allison, Tom, *Preparator,* Contemporary Arts Center, Cincinnati OH

Allison, Travis, *Operations Mgr,* Boulder Museum of Contemporary Art, Boulder CO

Allman, Anne, *Prof,* College of the Ozarks, Dept of Art, Point Lookout MO (S)

Allman, Marion, *Pres & CEO,* The Art Institute of Cincinnati, Cincinnati OH (S)

Allman, William G, *Cur,* White House, Washington DC

Allyn, Anita, The College of New Jersey, School of Arts & Sciences, Ewing NJ (S)

Almaraz, Dalia, *Admin Asst,* Museo de las Americas, Denver CO

Almasi, Jesse, *Adjunct Prof,* Community College of Allegheny County, Boyce Campus, Art Dept, Monroeville PA (S)

Alonzo, Daniel, *Archivist/Librn.,* The Old Jail Art Center, Albany TX

Alpert, Gary J, *Dir Publications,* Old Salem Inc, Museum of Early Southern Decorative Arts, Winston-Salem NC

Alpert, L, *Assoc Prof,* University of Oregon, Dept of Fine & Applied Arts, Eugene OR (S)

Alphonso, Christina, *Mgr Admin,* The Metropolitan Museum of Art, The Cloisters, New York NY

Alston, Littleton, *Instr Sculpture,* Creighton University, Fine & Performing Arts Dept, Omaha NE (S)

Alstrin, Beverly, *Bus Manager,* Ellen Noel Art Museum of the Permian Basin, Odessa TX

Altamirano, Noelle, *Coll Cur,* Palm Beach County Parks & Recreation Department, Morikami Museum & Japanese Gardens, Delray Beach FL

Altamura, Mauro, *Asst Prof,* Jersey City State College, Art Dept, Jersey City NJ (S)

Altenau, Kristen Courtney, *Dept Head Interior Design,* Antonelli College, Cincinnati OH (S)

Alter-Muri, Simone, *Asst Prof,* Springfield College, Dept of Visual & Performing Arts, Springfield MA (S)

Altes, Wallace, *Chair,* Albany Institute of History & Art, Albany NY

Althaver, Burt, *Chmn,* Artrain, Inc, Ann Arbor MI

Altman, Diana, *Museum Educator,* B'nai B'rith International, B'nai B'rith Klutznick National Jewish Museum, Washington DC

Altmann, Helen, *Cur,* Chalet of the Golden Fleece, New Glarus WI

Altmann, Thomas, *Coordr Fine Arts,* Milwaukee Public Library, Art, Music & Recreation Dept, Milwaukee WI

Alvarado, Eliud, *Dir Colls & Exhibs,* Robert Gumbiner, Museum of Latin American Art, Long Beach CA

Alvare, Gigi, *Dir Educ,* The Rockwell Museum of Western Art, Corning NY

Alvarez, Jose B, *Instr,* Inter American University of Puerto Rico, Dept of Art, San German PR (S)

Alves, C Douglass, *Dir,* Calvert Marine Museum, Solomons MD

Alward, Sharon, University of Manitoba, School of Art, Winnipeg MB (S)

Amadei, Daniel, *Dir Exhib & Installations,* National Gallery of Canada, Ottawa ON

Aman, Ron, *Asst Prof,* Western Illinois University, Art Dept, Macomb IL (S)

Amason, Alvin, *Assoc Prof,* University of Alaska-Fairbanks, Dept of Art, Fairbanks AK (S)

Amato, Carol, *COO,* Virginia Museum of Fine Arts, Richmond VA

Amato, Diane, *Gallery Asst,* Durham Art Guild Inc, Durham NC

Ambrogio, Lucy Sant, *Cur,* Historical Society of Bloomfield, Bloomfield NJ

Ambrose, Andy, *Dir Research & Progs,* Atlanta Historical Society Inc, Atlanta History Center, Atlanta GA

Ambrose, Richard, *Dir Exhibs/Cur Art,* Avampato Discovery Museum, The Clay Center for Arts & Sciences, Charleston WV

Ambrose, Valerie, *Faculty,* South Florida Art Institute of Hollywood, Dania FL (S)

Ambrosini, Lynne, *Chief Cur,* Cincinnati Institute of Fine Arts, Taft Museum of Art, Cincinnati OH

Ambrosino, Thomas, *Prof,* Sullivan County Community College, Division of Commercial Art & Photography, Loch Sheldrake NY (S)

Ament, Elizabeth, *Asst Prof,* University of Wisconsin-Green Bay, Arts Dept, Green Bay WI (S)

Ameri, Anan, *Dir,* Arab American National Museum, Dearborn MI

Ames, Charlton H, *VChmn,* Portland Museum of Art, Portland ME

Ames, Samuel B, *Prof,* Rhode Island College, Art Dept, Providence RI (S)

Ames-Bell, Linda, *Prof,* University of Toledo, Dept of Art, Toledo OH (S)

Amez, Martha, *Asst Prof,* Wesleyan University, Dept of Art & Art History, Middletown CT (S)

Amick, Alison, *Assoc Cur,* Oklahoma City Museum of Art, Oklahoma City OK

Amico, David, *Vis Instr,* Claremont Graduate University, Dept of Fine Arts, Claremont CA (S)

Amidon, Catherine, *Dir,* Plymouth State University, Karl Drerup Art Gallery, Plymouth NH

Amies, Marian, *Assoc Prof,* University of Missouri, Saint Louis, Dept of Art & Art History, Saint Louis MO (S)

Amling, Diana, *Pres,* Coquille Valley Art Association, Coquille OR

Amling, Diana, *Pres,* Coquille Valley Art Association, Library, Coquille OR

Ammerman, Tiffany, *VPres,* Michelson Museum of Art, Marshall TX

Ammons, Betty, *Asst Librn,* United Methodist Historical Society, Library, Baltimore MD

Amore, Shirley, *City Librn,* Denver Public Library, Reference, Denver CO

Amorous, Martin, *Dept Head,* Sam Houston State University, Art Dept, Huntsville TX (S)

Amos, Maria, *Admin Asst,* Oklahoma City University, Hulsey Gallery-Norick Art Center, Oklahoma City OK

Ams, Charles M, *Pres,* Southern Vermont Art Center, Manchester VT

Amsler, Cory, *Cur Coll,* Bucks County Historical Society, Mercer Museum, Doylestown PA

Amsterdam, Susan, *Young People's Theatre Coordr,* Passaic County Community College, Broadway, LRC, and Hamilton Club Galleries, Paterson NJ

Amundson, Dale, *Dir,* University of Manitoba, School of Art, Winnipeg MB (S)

Amundson, Dale, *School of Art Dir,* University of Manitoba, Gallery One One One, Winnipeg MB

Amyx, Guyla Call, *Instr,* Cuesta College, Art Dept, San Luis Obispo CA (S)

Ananian, Michael, *Prof,* University of North Carolina at Greensboro, Art Dept, Greensboro NC (S)

Anders, Cathryn, *Asst Dir,* The National Trust for Historic Preservation, Lyndhurst, Tarrytown NY

Andersen, Douglas, *Asst Prof,* University of Hartford, Hartford Art School, West Hartford CT (S)

Andersen, Jeffrey, *Dir,* Lyme Historical Society, Library, Old Lyme CT

Andersen, Jeffrey W, *Dir,* Lyme Historical Society, Florence Griswold Museum, Old Lyme CT

Anderson, Arthur, *Assoc Prof,* York College of the City University of New York, Fine & Performing Arts, Jamaica NY (S)

Anderson, Barbara, *Assoc Dean,* Carnegie Mellon University, College of Fine Arts, Pittsburgh PA (S)

Anderson, Barbara, *Instr,* Concordia College, Art Dept, Moorhead MN (S)

Anderson, Betsy, *Pres,* Art League, Alexandria VA

Anderson, Blue, *Mus Shop Mgr,* San Bernardino County Museum, Fine Arts Institute, Redlands CA

Anderson, Bradley, *Children's Theatre,* The Arkansas Arts Center, Museum School, Little Rock AR (S)

Anderson, Brian, *Instr,* Kansas Wesleyan University, Art Dept, Salina KS (S)

Anderson, Carol, *Mus Shop Mgr,* Nevada Northern Railway Museum, Ely NV

Anderson, Christina, *Production Coordr,* Harvestworks, Inc, New York NY

Anderson, Claude, *VPres,* Sturdivant Hall, Selma AL

Anderson, Craig, *Assoc Dir,* NAB Gallery, Chicago IL

Anderson, Cy, *Digital Media Production/Video Production,* Art Institute of Pittsburgh, Pittsburgh PA (S)

Anderson, Daniel J, *Head Ceramic,* Southern Illinois University at Edwardsville, Dept of Art & Design, Edwardsville IL (S)

Anderson, Darrel, *VChmn,* Orange County Museum of Art, Orange County Museum of Art, Newport Beach CA

Anderson, Diana, *Exhibits Coordr,* Red Deer & District Museum & Archives, Red Deer AB

Anderson, Donald, *Prof Emeritus,* University of Louisville, Allen R Hite Art Institute, Louisville KY (S)

Anderson, Donald B, *Dir,* Anderson Museum of Contemporary Art, Roswell NM

Anderson, Donald B, *VPres,* Roswell Museum & Art Center, Roswell NM

Anderson, Donna, *Exec Dir,* The Exhibition Alliance, Hamilton NY

Anderson, Douglas, *Dir,* State University of New York at Geneseo, Bertha V B Lederer Gallery, Geneseo NY

Anderson, Duane, *Dir,* Museum of New Mexico, Museum of Indian Arts & Culture Laboratory of Anthropology, Santa Fe NM

Anderson, Earl, *Pres,* Owatonna Arts Center, Community Arts Center, Owatonna MN

Anderson, Elizabeth, *Prof Art History,* Saint Joseph's University, Dept of Fine & Performing Arts, Philadelphia PA (S)

Anderson, Erin, *Office Mgr,* Salt Lake Art Center, Salt Lake City UT

Anderson, Fran, *Admin Asst,* Charles B Goddard, Ardmore OK

Anderson, Glaire, *Asst Prof,* University of North Carolina at Chapel Hill, Art Dept, Chapel Hill NC (S)

Anderson, Hilary, *Dir Coll & Exhibits,* National Heritage Museum, Lexington MA

Anderson, Hugh B, *Dean of Arts,* Polk Community College, Art, Letters & Social Sciences, Winter Haven FL (S)

Anderson, Jeannine, *Assoc Prof,* Berea College, Art Dept, Berea KY (S)

Anderson, Jeffrey C, *Assoc Prof,* George Washington University, Dept of Art, Washington DC (S)

Anderson, Jim, *Chmn,* Armstrong Atlantic State University, Art & Music Dept, Savannah GA (S)

Anderson, John, *Bus Mgr,* Brandywine River Museum, Chadds Ford PA

Anderson, John, *Chairperson Div Creative Arts,* Monterey Peninsula College, Art Dept, Monterey CA (S)

Anderson, Joseph, *Librn,* Southern Alberta Art Gallery, Library, Lethbridge AB

Anderson, Ken, *Prof,* University of Missouri, Saint Louis, Dept of Art & Art History, Saint Louis MO (S)

Anderson, Kenneth, *Prof,* Peru State College, Art Dept, Peru NE (S)

Anderson, Kristin, *Chmn,* Augsburg College, Art Dept, Minneapolis MN (S)

Anderson, Larry, *Chmn,* Francis Marion University, Fine Arts Dept, Florence SC (S)

Anderson, Linda, *Exec Dir,* Rapid City Arts Council, Dahl Arts Center, Rapid City SD

Anderson, Margaret, *Pres,* Nobles County Art Center Gallery, Worthington MN

Anderson, Margaret F, *VChmn,* Witte Museum, San Antonio TX

Anderson, Mark, *Dir,* Texas A&M University-Corpus Christi, Weil Art Gallery, Corpus Christi TX

Anderson, Mark R, *Chmn,* Presbyterian College, Visual & Theater Arts, Clinton SC (S)

Anderson, Martin, *Dept Head,* Henry Ford Community College, McKenzie Fine Art Ctr, Dearborn MI (S)

Anderson, Maxwell, *Dir & CEO,* Whitney Museum of American Art, New York NY

Anderson, Nancy, *Asst Cur,* Manitoba Historical Society, Dalnavert Museum, Winnipeg MB

Anderson, Nancy, *Asst Prof,* Adams State College, Dept of Visual Arts, Alamosa CO (S)

Anderson, Nancy, *Asst Prof,* University at Buffalo, State University of New York, Dept of Visual Studies, Buffalo NY (S)

Anderson, Neil, *Prof,* Bucknell University, Dept of Art, Lewisburg PA (S)

Anderson, Nina, *VPres,* Wellfleet Historical Society Museum, Wellfleet MA

Anderson, Patricia, *Dir,* New Rochelle Public Library, Art Section, New Rochelle NY

Anderson, Reed, *Adjunct Asst Prof Art Hist,* Johnson County Community College, Visual Arts Program, Overland Park KS (S)

Anderson, Richita, *Librn,* Aesthetic Realism Foundation, Eli Siegel Collection, New York NY

Anderson, Richita, *Librn,* Aesthetic Realism Foundation, Aesthetic Realism Foundation Library, New York NY

Anderson, Robert, *Prof,* West Virginia University, College of Creative Arts, Morgantown WV (S)

Anderson, Shannon, *Installations & Registrar,* Oakville Galleries, Centennial Square and Gairloch Gardens, Oakville ON

Anderson, Sheila, *Prog Coordr,* Newark Museum Association, The Newark Museum, Newark NJ

Anderson, Steven R, *CEO & Dir,* Iowa Great Lakes Maritime Museum, Arnolds Park IA

Anderson, Susan, *Dir,* Bloomington Art Center, Bloomington MN

Anderson, Susan B, *Treas,* Madison & Main Gallery, Greeley CO

Anderson, Susan K, *Archivist,* Philadelphia Museum of Art, Library, Philadelphia PA

Anderson, Sven, *Asst Prof,* State University of New York College at Oneonta, Dept of Art, Oneonta NY (S)

Anderson, Ted, *Designer,* The Exhibition Alliance, Hamilton NY

Anderson, Terry, *Instr,* Northeast Mississippi Junior College, Art Dept, Booneville MS (S)

Anderson, Tim, *Gallery Dir,* Cuesta College, Cuesta College Art Gallery, San Luis Obispo CA

Anderson, W, *Instr,* Humboldt State University, College of Arts & Humanities, Arcata CA (S)

Anderson, Wayne, *Prof,* Wayne State College, Nordstrand Visual Arts Gallery, Wayne NE

Anderson, Wayne, *Prof,* Wayne State College, Dept Art & Design, Wayne NE (S)

Anderson, Whitney, *Computer Instr,* Ames Free-Easton's Public Library, North Easton MA

Anderson, Wyatt, *Dean,* University of Georgia, Franklin College of Arts & Sciences, Lamar Dodd School of Art, Athens GA (S)

Anderson-Coggeshall, Ruth, *Develop Officer,* National Gallery of Art, Washington DC

Andersson, Christiane, *Prof,* Bucknell University, Dept of Art, Lewisburg PA (S)

Andrea, Martha, *Prof,* Colby-Sawyer College, Dept of Fine & Performing Arts, New London NH (S)

Andres, Glenn, *Prof,* Middlebury College, History of Art & Architecture Dept, Middlebury VT (S)

Andress, Thomas, *Pres & VPres, Print Selection Committee Chmn,* Print Club of Albany, Albany NY

Andrew, David, *Prof,* University of New Hampshire, Dept of Arts & Art History, Durham NH (S)

Andrew, Kristy, *Assoc Prof,* Oklahoma State University, Art Dept, Stillwater OK (S)

Andrews, Bill, *Instr,* Mississippi State University, Dept of Art, Mississippi State MS (S)

Andrews, Chad, *Chair,* Interlochen Center for the Arts, Interlochen Arts Academy, Dept of Visual Art, Interlochen MI (S)

Andrews, Debbie, *Educ Coordr,* Farmington Village Green & Library Association, Stanley-Whitman House, Farmington CT

Andrews, Edwin, *Assoc Prof,* Northeastern University, Dept of Art & Architecture, Boston MA (S)

Andrews, Hazel, *Chmn,* Lynnwood Arts Centre, Simcoe ON

Andrews, Jerry, *Pres & Registrar,* Mason County Museum, Mason TX

Andrews, Jim, *Instr,* Seton Hill University, Art Program, Greensburg PA (S)

Andrews, Joseph, *Instr,* Campbellsville University, Department of Art, Campbellsville KY (S)

Andrews, Richard, *Dir,* Henry Gallery Association, Henry Art Gallery, Seattle WA

Andrews, Schuyler Gott, *Pres,* Craft Alliance, Saint Louis MO

Andrews, Tim, *Dir Pub Rels,* Colonial Williamsburg Foundation, Williamsburg VA

Andrich-Worstell, Jackie, *Dir,* Zoo Montana, Billings MT

Andrist, Cheryl, *Dir & Cur,* Estevan National Exhibition Centre Inc, Estevan SK

Andrus, Beryl, *Branch Adminr,* Las Vegas-Clark County Library District, Las Vegas NV

Andrus, Maryanne, *Dir Educ,* Buffalo Bill Memorial Association, Buffalo Bill Historical Center, Cody WY

Andujar, Alphonse, *Installer,* Blauvelt Demarest Foundation, Hiram Blauvelt Art Museum, Oradell NJ

Angel, Catherine, *Prof,* University of Nevada, Las Vegas, Dept of Art, Las Vegas NV (S)

Angeloch, Eric, *Instr,* Woodstock School of Art, Inc, Woodstock NY (S)

Angert, Joe C, *Instr,* Saint Louis Community College at Forest Park, Art Dept, Saint Louis MO (S)

Angie, Joanna, *Founder & Dir,* Buffalo Arts Studio, Buffalo NY

Anglin, B, *Asst Prof,* Christopher Newport University, Dept of Fine Performing Arts, Newport News VA (S)

Anglin, Barbara, *Technical Services Librn,* Lee County Library, Tupelo MS

Anglin, John, *Dir,* East Central College, Art Dept, Union MO (S)

Anguilo, Marco, *Board VPres,* Centro Cultural De La Raza, San Diego CA

Anhorn, Inge, *Treas,* Revelstoke Art Group, Revelstoke BC

Anielewski, Ann, *Acting Dir,* Municipal Art Society of New York, The Information Exchange, New York NY

Aniskovich, Jennifer, *Dir,* CT Commission on Culture & Tourism, Sloane-Stanley Museum, Kent CT

Anke, Douglas, *Gen Educ,* Art Institute of Pittsburgh, Pittsburgh PA (S)

Annable, Edward, *Registrar,* National Infantry Museum, Fort Benning GA

Anreus, Alejandro, *Assoc Prof,* William Paterson University, Dept Arts, Wayne NJ (S)

Ansbro, Sam, *Vol Coordr,* Erie Art Museum, Erie PA

Anschultz, Brandon, *Exhib Mgr,* Contemporary Art Museum St Louis, Saint Louis MO

Ansel, Erynne, *Dir,* Iroquois Indian Museum, Howes Cave NY

Ansell, Joseph P, *Interim Dean,* Auburn University, Dept of Art, Auburn AL (S)

Antaki, Karen, *Dir & Cur,* Concordia University, Leonard & Bina Ellen Art Gallery, Montreal PQ

Antal, Bev, *Secy,* Regina Public Library, Dunlop Art Gallery, Regina SK

Anteaga-Johnson, Giselle, *Rights & Reproductions,* Norton Simon, Pasadena CA

Anthony, Carolyn, *Dir,* Skokie Public Library, Skokie IL

Anthony, David, *Cur Anthropology,* Hartwick College, The Yager Museum, Oneonta NY

Anthony, David, *Dean,* Golden West College, Visual Art Dept, Huntington Beach CA (S)

Antle, Sharon, *Chief Educ,* Ohio Historical Society, National Road-Zane Grey Museum, Columbus OH

Antle, Sharon, *Chief Educ Div,* Ohio Historical Society, Columbus OH

Antliff, Mark, *Prof,* Duke University, Dept of Art, Art History & Visual Studies, Durham NC (S)

Anton, D, *Instr,* Humboldt State University, College of Arts & Humanities, Arcata CA (S)

Anton, Elaine, *Cur Archaeology/Ethnology,* Provincial Museum of Newfoundland & Labrador, Saint John's NF

Anton, Janis K, *Dir Admis,* The Illinois Institute of Art - Chicago, Chicago IL (S)

Anton, Waldo, *Treas,* Guadalupe Historic Foundation, Santuario de Guadalupe, Santa Fe NM

Antonakis, Nick, *Dept Head Visual Arts,* Grand Rapids Community College, Visual Art Dept, Grand Rapids MI (S)

Antonelli, Karen, *Photography,* Art Institute of Pittsburgh, Pittsburgh PA (S)

Antonsen, Lasse, *Coordr Gallery,* University of Massachusetts Dartmouth, College of Visual & Performing Arts, North Dartmouth MA (S)

Antreasian, Tom, *Cur Exhib,* Albuquerque Museum of Art & History, Albuquerque NM

Aok, Katherine, *Asst Prof,* Santa Clara University, Dept of Art & Art History, Santa Clara CA (S)

Aoki, Miho, *Asst Prof,* University of Alaska-Fairbanks, Dept of Art, Fairbanks AK (S)

Apfel, Robert, *Pres Board,* Bakehouse Art Complex, Inc, Miami FL

Appel, Daniel C, *VChmn,* Columbus Museum of Art and Design, Indianapolis IN

Appelhof, Ruth, *Exec Dir,* Guild Hall of East Hampton, Inc, Guild Hall Museum, East Hampton NY

Applebaum, Terry, *Provost,* The University of the Arts, Rosenwald-Wolf Gallery, Philadelphia PA

Applebaum, Terry, *Provost,* University of the Arts, Philadelphia Colleges of Art & Design, Performing Arts & Media & Communication, Philadelphia PA (S)

Applebaun, Ronald, *Pres,* Kean University, James Howe Gallery, Union NJ

Applegate, Barbara, *Asst Dir,* C W Post Campus of Long Island University, Hillwood Art Museum, Brookville NY

Applegate, Reed, *Resource Mgr,* California State University, Chico, Janet Turner Print Museum, Chico CA

Appleman, David, *Chmn Division of Art,* Bob Jones University, Div of Art, Greenville SC (S)

Apraxine, Pierre, *Cur,* The Gilman Paper Company, New York NY

Aquin, Stephane, *Cur Contemporary Art,* Montreal Museum of Fine Arts, Montreal PQ

Aquirre, Carlos, *Assoc Prof,* University of Miami, Dept of Art & Art History, Coral Gables FL (S)

Aravena, Lidia, *Conservator of Paintings,* Museo de Arte de Ponce, Ponce Art Museum, Ponce PR

Arbino, Larry, *Adjunct,* College of the Canyons, Art Dept, Canta Colita CA (S)

Arbolino, Jamie, *Assoc Registrar,* United States Senate Commission on Art, Washington DC

Arbuckle, Linda, *Assoc Prof,* University of Florida, Dept of Art, Gainesville FL (S)

Arbury, Steve, *Chmn,* Radford University, Art Dept, Radford VA (S)

Archabal, Nina M, *CEO & Dir,* Minnesota Historical Society, Saint Paul MN

Archbald, Sara, *Admin Asst & Receptionist,* Maine Historical Society, Portland ME

Archer, Pat, *Site Coordr,* Association for the Preservation of Virginia Antiquities, John Marshall House, Richmond VA

Archer, Richard, *Technical Dir,* Regis College, Carney Gallery, Weston MA

Archibald, Robert, *CEO,* Missouri Historical Society, Saint Louis MO

Archibald, Robert R, *Pres,* Missouri Historical Society, Missouri History Museum, Saint Louis MO

Archible, Robin, *Facility Mgr,* Boca Raton Museum of Art, Boca Raton FL

Area, Ron, *Develop Dir,* National Cowboy & Western Heritage Museum, Oklahoma City OK

Arehart, Anessa, *Sales Gallery Dir,* Kentucky Museum of Art & Craft, Louisville KY

Arellanes, Audrey Spencer, *Dir & Ed,* American Society of Bookplate Collectors & Designers, Cambridge MA

Arena, Annie, *Instr,* Ocean City Arts Center, Ocean City NJ (S)

Arentz, Donald, *Adj Assoc Prof Philosophy,* LeMoyne College, Wilson Art Gallery, Syracuse NY

Arffmann, Kathleen, *Mgr Visitor Svcs,* The Metropolitan Museum of Art, New York NY

Argabrite, Diana, *Dir Arts & Schools Prog,* De Anza College, Euphrat Museum of Art, Cupertino CA

Argent, Lawrence, *Assoc Prof Sculpture,* University of Denver, School of Art & Art History, Denver CO (S)

Arice, Charles, *Instructional Asst,* Sullivan County Community College, Division of Commercial Art & Photography, Loch Sheldrake NY (S)

Arm-band, Gilles, *Prof,* Universite de Montreal, Bibliotheque d'Amenagement, Montreal PQ

Armand, Karen Gabbert, *Children's Librn,* Ames Free-Easton's Public Library, North Easton MA

Armas-Garcia, Daisy, *Treas,* Miami Watercolor Society, Inc, Miami FL

Arminio, Roberta Y, *Dir,* Museum of Ossining Historical Society, Ossining NY

Armistead, Julie, *Registrar,* Saint Mary's College of California, Hearst Art Gallery, Moraga CA

Armontrout, Les, *Prof,* Maryville University of Saint Louis, Art & Design Program, Saint Louis MO (S)

Armstrong, Cara, *Cur Bldgs & Coll,* Western Pennsylvania Conservancy, Fallingwater, Mill Run PA

Armstrong, Chuck, *Instr,* University of Southern Indiana, Art Dept, Evansville IN (S)

Armstrong, Elizabeth, *Dir, CEO,* Orange County Museum of Art, Orange County Museum of Art, Newport Beach CA

Armstrong, Leatrice A, *Asst to Dir,* Wheelwright Museum of the American Indian, Santa Fe NM

Armstrong, Lilian, *Prof,* Wellesley College, Art Dept, Wellesley MA (S)

Armstrong, Matthew, *Cur,* USB Paine Weber, New York NY

Armstrong, Richard, *Dir,* Carnegie Museums of Pittsburgh, Carnegie Museum of Art, Pittsburgh PA

Armstrong-Gillis, Kathy, *Cur/Assoc,* Southwest School of Art & Craft, San Antonio TX

Armstutz, Bruce, *Prof,* Shoreline Community College, Humanities Division, Seattle WA (S)

Arnar, Anna, *Asst Prof,* Minnesota State University-Moorhead, Dept of Art, Moorhead MN (S)

Arndt, Susan, *Art Instr,* Red Rocks Community College, Arts Dept, Lakewood CO (S)

Arneill, Porter, *Dir,* Kansas City Municipal Art Commission, Kansas City MO

Arnette, Laura, *Visual Resources Library Asst,* Colonial Williamsburg Foundation, John D Rockefeller, Jr Library, Williamsburg VA

Arnheim, Dianne, *Asst,* Crane Collection, Gallery of American Painting and Sculpture, Wellesley MA

Arnholm, Ron, *Prof Graphic Design,* University of Georgia, Franklin College of Arts & Sciences, Lamar Dodd School of Art, Athens GA (S)

Arnison, Steve, *Assoc Prof,* Munson-Williams-Proctor Arts Institute, School of Art, Utica NY (S)

Arnoff, Selda, *Resource Mgr,* California State University, Chico, Janet Turner Print Museum, Chico CA

Arnold, Anna, *Receptionist,* Mason County Museum, Mason TX

Arnold, April, *Devel & Marketing Coordr,* Elmhurst Art Museum, Elmhurst IL

Arnold, Cathy, *Pub Information Officer,* Phoenix Art Museum, Phoenix AZ

Arnold, Chester, *Chmn,* College of Marin, Dept of Art, Kentfield CA (S)

Arnold, Dorothea, *Lila Acheson Wallac,* The Metropolitan Museum of Art, New York NY

Arnold, Jessica, *Develop Dir,* Craft Alliance, Saint Louis MO

Arnold, Lee, *Dir Library,* Historical Society of Pennsylvania, Philadelphia PA

Arnold, Pat, *Ofc Mgr,* Lehigh County Historical Society, Allentown PA

Arnold, Patrick, *Instr,* Main Line Art Center, Haverford PA (S)

Arnold, Ralph, *Prof Emeritus,* Loyola University of Chicago, Fine Arts Dept, Chicago IL (S)

Arnold, Wayne, *Site Mgr Huron Lig,* Port Huron Museum, Port Huron MI

Arnold-Miller, Erin, *Adjust Asst Prof Art,* Johnson County Community College, Visual Arts Program, Overland Park KS (S)

Arojo, Elena, *Dir Educ,* Orange County Museum of Art, Orange County Museum of Art, Newport Beach CA

Aron, Kathy, *Exec Dir,* Society for Contemporary Photography, Kansas City MO

Aronowitz, Richard, *Dean Grad & Continuing Educ,* Massachusetts College of Art, Boston MA (S)

Aronson, Julie, *Cur Am Painting & Sculpture,* Cincinnati Museum Association and Art Academy of Cincinnati, Cincinnati Art Museum, Cincinnati OH

Arp, Kimberly, *Prof,* Louisiana State University, School of Art, Baton Rouge LA (S)

Arpad, Tori, *Assoc Prof,* Florida International University, School of Art & Art History, Miami FL (S)

Arpadi, Allen, *Instr,* Saint Louis Community College at Forest Park, Art Dept, Saint Louis MO (S)

Arpin, Pierre, *Dir,* Art Gallery of Greater Victoria, Victoria BC

Arrant, Christopher, *Exhibit Coordr,* Visual Arts Center of Northwest Florida, Visual Arts Center Library, Panama City FL

Arraras, Maria Teresa, *Dir,* La Casa del Libro Museum, San Juan PR

Arrasmith, Anne, *Co-Founder & Co-Dir,* Space One Eleven, Inc, Birmingham AL

Arrasmith, Lynnda, *Cur Exhibits & Registrar,* Canton Museum of Art, Canton OH (S)

Arredondo, Richard, *Chmn,* San Antonio College, Visual Arts & Technology, San Antonio TX (S)

Arrington, Gerald C, *Prof,* Concord College, Fine Art Division, Athens WV (S)

Arrison, John, *Educ Coord,* Penobscot Marine Museum, Searsport ME

Arrison, John, *Librn/Archivist,* Penobscot Marine Museum, Stephen Phillips Memorial Library, Searsport ME

Arroyo-Sucre, Rolando, *Board Dirs,* National Association of Artists' Organizations (NAAO), Birmingham AL

Arsenault, Eileen, *Mus Shop Mgr,* Portland Museum of Art, Portland ME

Arsenault, Todd, *Adjunct Faculty,* Dickinson College, Dept Fine Arts & History, Carlisle PA (S)

Arseneault, Celine, *Botanist & Librn,* Jardin Botanique de Montreal, Bibliotheque, Montreal PQ

Arseneault, Jacques, *Prof Printmaking,* Universite de Moncton, Dept of Visual Arts, Moncton NB (S)

Arsenty, Richard, *Interim Dir,* State University of New York at Purchase, Library, Purchase NY

Arteaga, Agustin, *CEO & Dir,* Museo de Arte de Ponce, Ponce Art Museum, Ponce PR

Arter, Debra L, *Vice Pres,* Pemaquid Group of Artists, Pemaquid Art Gallery, Pemaquid Point ME

Arthur, Kathleen, *Prof,* James Madison University, School of Art & Art History, Harrisonburg VA (S)

Artimovich, Vicki, *Art History Instr,* Bellevue Community College, Art Dept, Bellevue WA (S)

Arture, Nicholas, *Dir,* Association of Hispanic Arts, New York NY

Arvi, Barbara, *Dir Educ,* Southwest Museum, Los Angeles CA

Arya, B N, *Dean,* University of Lucknow, College of Arts and Crafts, Faculty of Fine Arts, Lucknow UP (S)

Asbill, Michael, *Instr,* Woodstock School of Art, Inc, Woodstock NY (S)

Aschkenes, Anna M, *Exec Dir,* Middlesex County Cultural & Heritage Commission, New Brunswick NJ

Ash, Nancy, *Conservator Works,* Philadelphia Museum of Art, Samuel S Fleisher Art Memorial, Philadelphia PA

Ash, Scottie, *Store Mgr,* South Carolina State Museum, Columbia SC

Ashare, Heather, *Mgr, The Store,* Cranbrook Art Museum, Cranbrook Art Museum, Bloomfield Hills MI

Ashbaugh, Sue, *Educ Coordr,* Jefferson County Open Space, Hiwan Homestead Museum, Evergreen CO

Ashby, Andrea, *Librn Technician,* Independence National Historical Park, Library, Philadelphia PA

Ashby, Anna Lou, *Andrew W Mellon Cur,* Pierpont Morgan, New York NY

Ashby, Gil, *Chmn Illustrations,* Center for Creative Studies, College of Art & Design, Detroit MI (S)

Ashby, Lisa Baylis, *Lectr,* Oakland University, Dept of Art & Art History, Rochester MI (S)

Ashby, Marty, *Dir Performing Arts,* Manchester Craftsmen's Guild, Pittsburgh PA

Asher, Alan, *Art & Music Librn,* University of Northern Iowa, Art & Music Collection Rod Library, Cedar Falls IA

Asher, Dorothy, *Dir,* Lizzadro Museum of Lapidary Art, Elmhurst IL

Ashley, Janis, *Adminr,* Los Angeles County Museum of Natural History, William S Hart Museum, Newhall CA

Ashley, Stephen, *Chmn,* George Eastman, Rochester NY

Ashmore, Kathi, *Event Coordr,* Marian College, Allison Mansion, Indianapolis IN

Ashook, Robin, *Dir Develop,* Redwood Library & Athenaeum, Newport RI

Ashton, Deanna, *Secy,* University of Alberta, Dept of Art & Design, Edmonton AB (S)

Ashton, Jean, *Dir Library Div,* New York Historical Society, New York NY

Ashton, Joan, *Gall Asst,* Augustana College, Eide-Dalrymple Gallery, Sioux Falls SD

Ashton, Lynn, *Exec Dir,* Kentucky Derby Museum, Louisville KY

Ashton Fisher, Helen, *Coll Cur,* William A Farnsworth, Library, Rockland ME

Ashworth, Judie, *Cur,* Franklin Mint Museum, Franklin Center PA

Asihene, Emmanuel, *Prof,* Clark-Atlanta University, School of Arts & Sciences, Atlanta GA (S)

Askew, Dan, *Lectr,* University of Texas of Permian Basin, Dept of Art, Odessa TX (S)

Asleson, Rachel, *Exhibit Coordr,* Heritage Hjemkomst Interpretive Center, Moorhead MN

Asmoucha, Tobi, *Instr,* Toronto School of Art, Toronto ON (S)

Asmus, Collin, *Assoc Prof,* Bridgewater State College, Art Dept, Bridgewater MA (S)

Asmus, Collin, *Asst Prof,* Millsaps College, Dept of Art, Jackson MS (S)

Asprodites, Gail, *Controller,* New Orleans Museum of Art, New Orleans LA

Assad, Alan, *Industrial Design Technology,* Art Institute of Pittsburgh, Pittsburgh PA (S)

Assad, Cyril, *Industrial Design Technology,* Art Institute of Pittsburgh, Pittsburgh PA (S)

Asselin, Hedwidge, *Sec (Montreal),* International Association of Art Critics, ALCA Canada, Inc, Tornoto ON

Ast, Karley, *Accounting Specialist,* University of Kansas, Spencer Museum of Art, Lawrence KS

Atchison, Sandra, *Asst Dean,* University of North Texas, Libraries, Denton TX

Atencio, Thomas, *Assoc Dir,* Institute of American Indian Arts Museum, Museum, Santa Fe NM

Atherholt, Wayne David, *Dir,* The Museum of Arts & Sciences Inc, Daytona Beach FL

Atheron, Cynthia, *Prof,* Middlebury College, History of Art & Architecture Dept, Middlebury VT (S)

Atherton, Charles H, *Secy,* United States Commission of Fine Arts, Washington DC

Atherton, Jeff, *Photography Dept Chmn,* Art Center College of Design, Pasadena CA (S)

Atkins, Dean, *Exec Dir,* Springfield Art Association of Edwards Place, Springfield IL

Atkinson, Conrad, *University of California, Davis, Dept of Art & Art History, Davis CA (S)

Atkinson, D Scott, *Cur American Art,* San Diego Museum of Art, San Diego CA

Atkinson, Dianne, *Instr,* Mount Mary College, Art & Design Division, Milwaukee WI (S)

Attenborough, Debra, *Cur Educ,* Rodman Hall Arts Centre, Saint Catharines ON

Attenborough, Debra, *Librn,* Rodman Hall Arts Centre, Library, Saint Catharines ON

Atticks, Barry, *Asst Prof Music,* Drexel University, College of Media Arts & Design, Philadelphia PA (S)

Attie, Diana, *Prof,* University of Toledo, Dept of Art, Toledo OH (S)

Attwood, Maryon, *Exec Dir,* Worcester Center for Crafts, Krikorian Gallery, Worcester MA

Atwater, H Brewster, *Chmn Bd,* Walker Art Center, Minneapolis MN

Atwater, Sue, *Admin Dir,* Round Top Center for the Arts Inc, Arts Gallery, Damariscotta ME

Atwater, Sue, *Admin Dir,* Round Top Center for the Arts Inc, Round Top Library, Damariscotta ME

Atwell, Michael, *Asst Dir,* Purdue University Galleries, West Lafayette IN

Atwood, Stephanie, *Admin Dir,* Diverse Works, Houston TX

Au, Jeri, *Asst Prof,* Webster University, Art Dept, Webster Groves MO (S)

Aubert, Ben, *Cur,* Grossmont Community College, Hyde Art Gallery, El Cajon CA

Aubourg, Vickie, *Asst Dir,* California Polytechnic State University, College of Architecture &

Environmental Design-Architecture Collection, San Luis Obispo CA

Aucella, Frank J, *Ex Dir,* Woodrow Wilson, Washington DC

Audet, Marie-Helene, *Documentalist,* La Chambre Blanche, Quebec PQ

Audette, Marc, *Cur,* York University, Glendon Gallery, Toronto ON

Audiss, Barb, *Develop Officer,* Oregon College of Art & Craft, Hoffman Gallery, Portland OR

Audley, Paul, *Pres,* Discovery Museum, Bridgeport CT

Aufdencamp, Kim, *Dir Fin & Admin,* Columbus Museum of Art, Columbus OH

Augaitis, Daina, *Chief Cur,* Vancouver Art Gallery, Vancouver BC

Augelli, John, *CEO, Exec Dir,* Rosenberg Library, Galveston TX

Augugliaro, Suzanne, *Pub Relations Coord,* Williams College, Museum of Art, Williamstown MA

Augustine, E Kai, *Visitor Serv,* Alaska State Museum, Juneau AK

Augustine, Nathan, *Registrar,* Maricopa County Historical Society, Desert Caballeros Western Museum, Wickenburg AZ

Augustine, Roland, *Pres,* Art Dealers Association of America, Inc, New York NY

Augustine, Susan, *Head Reader Servs,* The Art Institute of Chicago, Ryerson & Burnham Libraries, Chicago IL

Aul, Billie, *Sr Librn,* New York State Library, Manuscripts & Special Collections, Albany NY

Auld, Michael, *Co-Chmn,* Fondo del Sol, Visual Art & Media Center, Washington DC

Aumann, Karen, *Asst Prof,* Philadelphia Community College, Dept of Art, Philadelphia PA (S)

Aune, Alison, *Asst Prof,* University of Minnesota, Duluth, Art Dept, Duluth MN (S)

Aunet, John, *Chmn. Board Dirs,* The American Film Institute, Center for Advanced Film & Television, Los Angeles CA (S)

Aunspaugh, Richard, *Chmn,* Young Harris College, Dept of Art, Young Harris GA (S)

Auping, Michael, *Chief Cur,* Modern Art Museum, Fort Worth TX

Aurandt, David, *Exec Dir,* The Robert McLaughlin, Oshawa ON

Aurbach, Michael, *Prof,* Vanderbilt University, Dept of Art, Nashville TN (S)

Ausfeld, Margaret Lynne, *Cur Coll,* Montgomery Museum of Fine Arts, Montgomery AL

Austin, Beverly, *Instr,* Harding University, Dept of Art, Searcy AR (S)

Austin, Cathy, *Secy,* Alton Museum of History & Art, Inc, Alton IL

Austin, Howard, *Instr,* Milwaukee Area Technical College, Graphic Arts Div, Milwaukee WI (S)

Austin, Jerry, *Chair, Div Studio,* University of North Texas, School of Visual Arts, Denton TX (S)

Austin, Marvin, *Div Chm,* Columbia State Community College, Dept of Art, Columbia TN (S)

Austin, Michael, *Mktg & Develop Officer,* Ellen Noel Art Museum of the Permian Basin, Odessa TX

Austin, Ramona, *Dir,* Hampton University, University Museum, Hampton VA

Ausunbraum, Marjorie, *Liberal Arts Chair,* Montserrat College of Art, Beverly MA (S)

Auth, Susan H, *Cur Classical Coll,* Newark Museum Association, The Newark Museum, Newark NJ

Auther, Elissa, *Asst Prof,* University of Colorado-Colorado Springs, Visual & Performing Arts Dept, Colorado Springs CO (S)

Autry, Carolyn, *Assoc Prof,* University of Toledo, Dept of Art, Toledo OH (S)

Auzelc, Patrick, *Asst Archivist,* Archives of the Archdiocese of St Paul & Minneapolis, Saint Paul MN

Avery, Donna, *Secy,* Eagle Rock Art Museum and Education Center, Inc, Idaho Falls ID

Avery, Laura, *Asst Dir,* Ringling School of Art & Design, Selby Gallery, Sarasota FL

Avery, Robert, *Exec Dir,* Rome Historical Society, Museum & Archives, Rome NY

Avina, Maya, *Asst Prof,* University of Southern Colorado, Dept of Art, Pueblo CO (S)

Avrett, Marty, *Prof,* Oklahoma State University, Art Dept, Stillwater OK (S)

Avril, Ellen, *Chief Cur & Cur Asian Art,* Cornell University, Herbert F Johnson Museum of Art, Ithaca NY

Awotona, Adenrele, *Dean,* Southern University A & M College, School of Architecture, Baton Rouge LA (S)

Axtman, Seb, *Cur,* South Dakota National Guard Museum, Pierre SD

Ayala, Robert, *Museum Store Mgr,* McNay, San Antonio TX

Ayars, Lee, *Adjunct Asst Prof,* Spokane Falls Community College, Fine Arts Dept, Spokane WA (S)

Aydelott, Lindsay, *Dir Asst,* Southern California Institute of Architecture, Los Angeles CA (S)

Ayer, Elizabeth, *Asst Prof,* Hartwick College, Art Dept, Oneonta NY (S)

Ayers, Jesse, *Chmn Fine Arts,* Malone College, Dept of Art, Canton OH (S)

Ayers, Lucie, *Exhibit Coordr,* Tennessee Valley Art Association, Tuscumbia AL

Ayers, Mark, *Exec Asst,* Eubie Blake, Baltimore MD

Aylmer, Annabelle, *Instr,* Glendale Community College, Visual & Performing Arts Div, Glendale CA (S)

Aylward, Marci, *Instr,* Avila College, Art Division, Dept of Humanities, Kansas City MO (S)

Ayott, Diane, *Art Educ,* Montserrat College of Art, Beverly MA (S)

Ayre, Annette, *VPres,* Alberta Society of Artists, Edmonton AB

Ayres, Pamela, *Gallery Dir,* Bradley University, Heuser Art Center, Peoria IL

Ayres, Ted, *Dir,* Wichita State University, Ulrich Museum of Art & Martin H Bush Outdoor Sculpture Collection, Wichita KS

Ayres, William, *Dir Colls & Interpretation,* The Long Island Museum of American Art, History & Carriages, Library, Stony Brook NY

Ayres, William S, *Dir Coll & Interpretation,* The Long Island Museum of American Art, History & Carriages, Stony Brook NY

Ayson, Maud, *Dir,* Fruitlands Museum, Inc, Harvard MA

Azar, John, *Philosophy,* Henry Ford Community College, McKenzie Fine Art Ctr, Dearborn MI (S)

Baba, Ronald, *Assoc Prof,* University of Wisconsin-Green Bay, Arts Dept, Green Bay WI (S)

Babb, Barbara, *Publicist,* Huguenot Historical Society of New Paltz Galleries, New Paltz NY

Babb, Julie, *Pres,* Pemaquid Group of Artists, Pemaquid Art Gallery, Pemaquid Point ME

Babbitt, Steve, *Prof,* Black Hills State University, Art Dept, Spearfish SD (S)

Babcock, Catherine, *Dir,* Lansing Art Gallery, Lansing MI

Babcock, Herb, *Chmn Crafts,* Center for Creative Studies, College of Art & Design, Detroit MI (S)

Babcock, Sidney, *Hon Cur Seals & Tablets,* Pierpont Morgan, New York NY

Babic, Sherry, *Cur Educ,* Hunter Museum of American Art, Chattanooga TN

Baca, Judith F, *Artistic Dir,* Social & Public Art Resource Center, (SPARC), Venice CA

Bach, Beverly, *Museum Registrar,* Miami University, Art Museum, Oxford OH

Bach, Penny Balkin, *Exec Dir,* Fairmount Park Art Association, Philadelphia PA

Bachman, Dona, *Dir,* Aurora University, Schingoethe Center for Native American Cultures, Aurora IL

Bachman, Dona, *Dir,* Southern Illinois University Carbondale, University Museum, Carbondale IL

Bachman, Donna N, *Chmn,* Park University, Dept of Art & Design, Parkville MO (S)

Bacigalupi, Don, *Dir,* Toledo Museum of Art, Toledo OH

Bacin, Mark S, *Exec Dir,* Ventura County Maritime Museum, Inc, Oxnard CA

Backer, Matt, *Asst Prof Art History,* Wabash College, Art Dept, Crawfordsville IN (S)

Bacon, Mardges, *Prof,* Northeastern University, Dept of Art & Architecture, Boston MA (S)

Bacon, Nancy M, *Pres,* San Antonio Art League, San Antonio Art league Museum, San Antonio TX

Bacot, Parrott, *Asst Prof,* Louisiana State University, School of Art, Baton Rouge LA (S)

Baczkowski, Steve, *Music Dir,* Hallwalls Contemporary Arts Center, Buffalo NY

Badalamenti, Kay, *Acting Chief,* Brooklyn Public Library, Art & Music Division, Brooklyn NY

Badder, Susan, *Cur Educ,* Corcoran Gallery of Art, Washington DC

Bader, Emily, *Dir,* Springfield City Library, Springfield MA

Badger, Linda, *Registrar,* Indiana State Museum, Indianapolis IN

Badt, Pat, *Prof,* Cedar Crest College, Art Dept, Allentown PA (S)

Badzio, Bohdana, *Admin Ofcr,* Ukrainian Canadian Archives & Museum of Alberta, Edmonton AB

Baer, Leslie, *VPres Marketing,* Natural History Museum of Los Angeles County, Los Angeles CA

Baert, Renee, *Dir/Cur (gallery),* Saidye Bronfman, Liane & Danny Taran Gallery, Montreal PQ

Baetz, Tracy, *Exec Dir,* Brick Store Museum & Library, Kennebunk ME

Baggett, Lynne, *Asst,* Louisiana State University, School of Art, Baton Rouge LA (S)

Baggett, William, *Prof,* University of Southern Mississippi, Dept of Art & Design, Hattiesburg MS (S)

Baggs, Stephanie Robison, *Instr,* Marylhurst University, Art Dept, Marylhurst OR (S)

Bagnal, Dianne R, *Prof,* Converse College, Dept of Art & Design, Spartanburg SC (S)

Bagnatori, Paola, *VPres,* Museo Italo Americano, San Francisco CA

Bahe, Norman, *Educ Cur,* Navajo Nation, Navajo Nation Museum, Window Rock AZ

Bahler, Barbara, *Dir Asst,* The Haggin Museum, Stockton CA

Bahr, David, *Assoc Prof,* Baltimore City Community College, Dept of Fine Arts, Baltimore MD (S)

Bailey, Carol, *Instr,* Midland College, Art Dept, Midland TX (S)

Bailey, Colin, *Chief Cur,* National Gallery of Canada, Ottawa ON

Bailey, Colin B, *Chief Cur,* Frick Collection, New York NY

Bailey, Daniel, *Assoc Prof,* University of Maryland, Baltimore County, Imaging, Digital & Visual Arts Dept, Baltimore MD (S)

Bailey, Elizabeth, *Dept Head,* Virginia Western Community College, Communication Design, Fine Art & Photography, Roanoke VA (S)

Bailey, Erin, *Dir,* City of Atlanta, Chastain Arts Center, Atlanta GA

Bailey, Erin, *Dir,* City of Atlanta, Gilbert House, Atlanta GA

Bailey, Erin, *Gallery Dir,* City of Atlanta, City Gallery at Chastain, Atlanta GA

Bailey, Hiton, *Archivist,* Caramoor Center for Music & the Arts, Inc, Caramoor House Museum, Katonah NY

Bailey, James, *Chmn, Assoc Prof,* University of Montana, Dept of Art, Missoula MT (S)

Bailey, Jann L M, *Exec Dir,* Kamloops Art Gallery, Kamloops BC

Bailey, Jeff, *Reference Librn,* Arkansas State University-Art Department, Jonesboro, Library, Jonesboro AR

Bailey, Jim, *Res Artist,* Custer County Art & Heritage Center, Miles City MT

Bailey, Kimberly, *Cur Educ,* Museum of Western Colorado, Grand Junction CO

Bailey, Lebe, *Asst Prof,* Wesleyan College, Art Dept, Macon GA (S)

Bailey, Lisbit, *Supervisory Archivist,* San Francisco Maritime National Historical Park, Maritime Museum, San Francisco CA

Bailey, Radcliffe, *Asst Prof Drawing & Painting,* University of Georgia, Franklin College of Arts & Sciences, Lamar Dodd School of Art, Athens GA (S)

Bailey, Rebecca, *Chmn,* Meredith College, Art Dept, Raleigh NC (S)

Bailey, Regina C, *Asst Dir,* Florida International University, The Art Museum at FIU, Miami FL

Bailey, Robert, *Instr,* Ohio Northern University, Dept of Art, Ada OH (S)

Bailey, Robert D., *Under Secy Designate for Finance & Admin,* Smithsonian Institution, Washington DC

Bailey, Ronald, *Treas,* Second Street Gallery, Charlottesville VA

Bailey, Ryan, *Adjunct Asst Prof Art,* Florida Southern College, Melvin Art Gallery, Lakeland FL

Bailey, Ryan, *Asst Prof,* Florida Southern College, Art Dept, Lakeland FL (S)

Bailey, Shannon, *Dir,* Stephen F Austin State University, SFA Galleries, Nacogdoches TX

Bailey, Tina Garbo, *Dir,* Brownsville Art League, Brownsville Museum of Fine Art, Brownsville TX

Bains, Sneh, *Library Dir,* Bayonne Free Public Library, Cultural Center, Bayonne NJ

Bair, Miles, *Dir,* Illinois Wesleyan University, School of Art, Bloomington IL (S)

Baird, Ellen, *Pres,* College Art Association, New York NY

Baird, Jill, *Cur of Educ & Pub Prog,* University of British Columbia, Museum of Anthropology, Vancouver BC

Bajko, Daria, *Admin Dir,* The Ukrainian Museum, New York NY

Baker, Alden, *First VPres,* Art Centre of New Jersey, Livingston NJ (S)

Baker, Alyson, *Exec Dir,* Socrates Sculpture Park, Long Island City NY

Baker, Barry B, *Dir,* University of Central Florida Libraries, Orlando FL

Baker, Benjamin, *Chief Security,* Albany Museum of Art, Albany GA

Baker, Bernard, California State University, Dominguez Hills, Art Dept, Carson CA (S)

Baker, Charlotte, *Pres,* Almond Historical Society, Inc, Hagadorn House, The 1800-37 Museum, Almond NY

Baker, Cindy, *Prog Coordr,* AKA Artist Run Centre, Saskatoon SK

Baker, Cindy, *Program Coordr,* AKA Artist Run Centre, Library, Saskatoon SK

Baker, Darren, *Galleries & Coll Mgr,* Southern Ohio Museum Corporation, Southern Ohio Museum, Portsmouth OH

Baker, David, *Instr,* Kalamazoo Valley Community College, Center for New Media, Kalamazoo MI (S)

Baker, David, *Pres,* Canton Museum of Art, Canton OH

Baker, David R, *Instr,* Southwestern Michigan College, Fine & Performing Arts Dept, Dowagiac MI (S)

Baker, Doug, *Adjunct Prof Art,* Johnson County Community College, Visual Arts Program, Overland Park KS (S)

Baker, Gary, *Cur of Glass,* Chrysler Museum of Art, Norfolk VA

Baker, Gary, *Prof,* Polk Community College, Art, Letters & Social Sciences, Winter Haven FL (S)

Baker, James, *Exec Dir,* Anderson Ranch Arts Center, Snowmass Village CO

Baker, James, *Prof,* Providence College, Art & Art History Dept, Providence RI (S)

Baker, Janet, *Cur Asian Art,* Phoenix Art Museum, Phoenix AZ

Baker, Jim, *Pres,* St Genevieve Museum, Sainte Genevieve MO

Baker, Judith, *Prof,* University of Wisconsin College - Marinette, Art Dept, Marinette WI (S)

Baker, Karen Z, *Registrar,* San Antonio Museum of Art, San Antonio TX

Baker, Kendall, *Dir,* Caldwell College, The Visceglia Art Gallery, Caldwell NJ

Baker, Leslie, *Mktg Dir,* National Cowboy & Western Heritage Museum, Oklahoma City OK

Baker, Lindsey, *Gallery Mgr,* ArtForms Gallery Manayunk, Philadelphia PA

Baker, Loren, *Chmn Dept & Asst Prof,* Biola University, Art Dept, La Mirada CA (S)

Baker, Loren, *Dir Art,* Roberts Wesleyan College, Art Dept, Rochester NY (S)

Baker, Malissa Kay, *Admin Asst,* Art Community Center, Art Center of Corpus Christi, Corpus Christi TX

Baker, Marilyn, University of Manitoba, School of Art, Winnipeg MB (S)

Baker, Michael, *Cur Regional History,* Museum London, London ON

Baker, Michelle, *Registrar,* South Carolina State Museum, Columbia SC

Baker, Monique, *Marketing Dir,* State of North Carolina, Battleship North Carolina, Wilmington NC

Baker, Opal, *Dir,* Fisk University, Aaron Douglas Library, Nashville TN

Baker, Peggy M, *Dir & Librn,* Pilgrim Society, Pilgrim Hall Museum, Plymouth MA

Baker, Peggy M, *Dir & Librn,* Pilgrim Society, Library, Plymouth MA

Baker, Rachel, *Asst Dir,* Loyola University of Chicago, Martin D'Arcy Museum of Art, Chicago IL

Baker, Robert, *Cur Natural Science Research Lab,* Texas Tech University, Museum of Texas Tech University, Lubbock TX

Baker, Sandra, *Asst Prof,* Brazosport College, Art Dept, Lake Jackson TX (S)

Baker, Scott, *Asst Dir,* Howard University, Gallery of Art, Washington DC

Baker, York, *Dir Develop,* Bruce Museum, Inc, Bruce Museum, Greenwich CT

Baker-Robertson, Del, *Dir Mktg & Comm,* Knoxville Museum of Art, Knoxville TN

Baker Horsey, Ann, *Cur Coll,* Delaware Division of Historical & Cultural Affairs, Dover DE

Bakken, Mike, *Dir Comm Sch Arts,* Mayville State University, Northern Lights Art Gallery, Mayville ND

Bakos, Stephanie, *Dir,* Berkeley Heights Free Public Library, Berkeley Heights NJ

Bakst, Marilyn, *Recording Secy,* Miami Watercolor Society, Inc, Miami FL

Balakier, Ann, *Assoc Prof,* University of South Dakota, Department of Art, College of Fine Arts, Vermillion SD (S)

Balasis, Michel, *Assoc Prof,* Loyola University of Chicago, Fine Arts Dept, Chicago IL (S)

Balch, Inge, *Chmn,* Baker University, Dept of Art, Baldwin City KS (S)

Baldi, Wendy, *Head Librn,* Art Institute of Southern California, Ruth Salyer Library, Laguna Beach CA

Baldissera, Lisa, *Cur Contemporary Art,* Art Gallery of Greater Victoria, Victoria BC

Baldonieri, Amy, *Dir Develop & Finance,* Westmoreland Museum of American Art, Art Reference Library, Greensburg PA

Baldridge, Mark, *Prof,* Longwood University, Dept of Art, Farmville VA (S)

Baldus, Jeff, *Lectr,* Briar Cliff University, Art Dept, Sioux City IA (S)

Baldwin, Dana, *Educ Dir,* Portland Museum of Art, Portland ME

Baldwin, Fred, *Pres,* Houston Foto Fest Inc, Houston TX

Baldwin, K Read, *Vis Asst Prof,* Kenyon College, Art Dept, Gambier OH (S)

Baldwin, Leigh, *Communication Mgr,* San Antonio Museum of Art, San Antonio TX

Bale, Andrew, *Adjunct Faculty,* Dickinson College, Dept Fine Arts & History, Carlisle PA (S)

Balicki, Alan, *Conservator,* New York Historical Society, Library, New York NY

Balinsky, Al, *Dean Fine Arts,* Milwaukee Institute of Art & Design, Milwaukee WI (S)

Balint, Valerie, *Asst Cur,* Olana State Historic Site, Hudson NY

Balistreri, Becky, *Dean Design,* Milwaukee Institute of Art & Design, Milwaukee WI (S)

Balk, Moon-he, *Assoc Prof,* University of Louisville, Allen R Hite Art Institute, Louisville KY (S)

Balke, Theresa, *Pres,* DuPage Art League School & Gallery, Wheaton IL

Ball, Allen, *Exec Dir,* Where Edmonton Community Artists Network Society, Harcourt House Arts Centre, Edmonton AB

Ball, Beaca Darshan, *Cur,* Museum of New Mexico, Museum of International Folk Art, Santa Fe NM

Ball, Deena, *Instr,* Wayne Art Center, Wayne PA (S)

Ball, Isabel, *Dean,* Our Lady of the Lake University, Dept of Art, San Antonio TX (S)

Ball, Jeffrey L, *Instr,* Adrian College, Art & Design Dept, Adrian MI (S)

Ball, Larry, *Prof,* University of Wisconsin-Stevens Point, Dept of Art & Design, Stevens Point WI (S)

Ball, Susan L, *Exec Dir,* College Art Association, New York NY

Ball, Truly, *Ceramist Adjunct,* Iowa Wesleyan College, Art Dept, Mount Pleasant IA (S)

Balla, Wesley, *Dir Coll,* New Hampshire Historical Society, Museum of New Hampshire History, Concord NH

Ballantine, Robert, *Graphic Designer,* Museum London, London ON

Ballard, Jan, *Archivist,* Lehigh County Historical Society, Allentown PA

Ballard, Jan, *Librn & Archivist,* Lehigh County Historical Society, Scott Andrew Trexler II Library, Allentown PA

Ballate, Leo, *Dir ISS,* San Francisco Museum of Modern Art, San Francisco CA

Balliet, Nancy, *Vpres,* Atlantic Gallery, New York NY

Ballinger, James K, *Cur American & Western Art,* Phoenix Art Museum, Phoenix AZ

Balogh, Anthony, *Instr,* Madonna University, Art Dept, Livonia MI (S)

Balsamo, Michael, *Treas,* Warwick Museum of Art, Warwick RI

Baltrushunas, John, *Assoc Prof,* Maryville University of Saint Louis, Art & Design Program, Saint Louis MO (S)

Balzekas, Robert, *Dir Genealogy Dept,* Balzekas Museum of Lithuanian Culture, Chicago IL

Balzekas, Robert A, *Librn,* Balzekas Museum of Lithuanian Culture, Research Library, Chicago IL

Balzekas, Stanley, *Pres,* Balzekas Museum of Lithuanian Culture, Chicago IL

Balzekas, Stanley, *Pres,* Balzekas Museum of Lithuanian Culture, Research Library, Chicago IL

Bambo-Kocze, Peter, *Bibliographer,* Corning Museum of Glass, Juliette K and Leonard S Rakow Research Library, Corning NY

Bambrough, Delmar, *Head Security,* Tucson Museum of Artand Historic Block, Tucson AZ

Bamburak, Michele, *Media Arts & Animation,* Art Institute of Pittsburgh, Pittsburgh PA (S)

Bambury, Jill, *Instr,* Southern University A & M College, School of Architecture, Baton Rouge LA (S)

Banasiak, John, *Prof,* University of South Dakota, Department of Art, College of Fine Arts, Vermillion SD (S)

Banchs, William, *Pres,* National Foundation for Advancement in the Arts, Miami FL

Bancou, Marielle, *Exec Dir,* Color Association of the US, New York NY

Bandes, Susan, *Dir,* Michigan State University, Kresge Art Museum, East Lansing MI

Banduric, Pamela, *Instr Interior Design,* Henry Ford Community College, McKenzie Fine Art Ctr, Dearborn MI (S)

Banerjee, Deb, *Asst Educ Cur,* Utah State University, Nora Eccles Harrison Museum of Art, Logan UT

Banerji, Naseem, *Asst Prof,* Weber State University, Dept of Visual Arts, Ogden UT (S)

Bang, Peggy L, *Instr,* North Iowa Area Community College, Dept of Art, Mason City IA (S)

Bangert, Shaun, *Asst Prof,* Saginaw Valley State University, Dept of Art & Design, University Center MI (S)

Baniassad, Essy, *Prof,* Technical University of Nova Scotia, Faculty of Architecture, Halifax NS (S)

Bank, Larissa, *Instr,* Pierce College, Art Dept, Woodland Hills CA (S)

Banker, Amy, *Asst Dir,* Metropolitan State College of Denver, Center for Visual Art, Denver CO

Banker, Amy, *Cur,* U Gallery, New York NY

Banker, Maureen, *Dir,* Meredith College, Frankie G Weems Gallery & Rotunda Gallery, Raleigh NC

Banks, Betty, *VPres,* Coquille Valley Art Association, Coquille OR

Banks, Carol, *Mgr,* Edgecombe County Cultural Arts Council, Inc, Blount-Bridgers House, Hobson Pittman Memorial Gallery, Tarboro NC

Banman, Yvonne, *Finance Adminr,* Society of Decorative Painters, Inc, Decorative Arts Collection Museum, Wichita KS

Bannard, Darby, *Prof,* University of Miami, Dept of Art & Art History, Coral Gables FL (S)

Bannien, Petronella, *Instr,* University of Evansville, Art Dept, Evansville IN (S)

Bannon, Anthony, *Dir,* George Eastman, Rochester NY

Bannon, Anthony, *Dir,* George Eastman, Library, Rochester NY

Banocy-Payne, Marge, *Dean,* Tallahassee Community College, Art Dept, Tallahassee FL (S)

Banta, Charles W, *Pres,* The Buffalo Fine Arts Academy, Albright-Knox Art Gallery, Buffalo NY

Bantens, Robert, *Art Historian,* University of South Alabama, Dept of Art & Art History, Mobile AL (S)

Bantizoglio, Barbara, *Assoc Dir External Affairs,* Whitney Museum of American Art, New York NY

Bantle, Thomas, *Cur Exhib,* City of Grand Rapids Michigan, Public Museum of Grand Rapids, Grand Rapids MI

Banz, Martha, *Dean Arts & Sciences,* Southern Nazarene University, Art Dept, Bethany OK (S)

Banz, Richard, *Cur Coll,* The York County Heritage Trust, Historical Society Museum & Library, York PA

Bao, Li-ying, University of Wisconsin-Eau Claire, Dept of Art, Eau Claire WI (S)

Baptist, Amy, *Catalog Librn,* The Historic New Orleans Collection, New Orleans LA

Barabe, Bryon, *Secy,* Xicanindio, Inc, Mesa AZ

Baral, Jody, *Gallery Dir,* Mount Saint Mary's College, Jose Drudis-Biada Art Gallery, Los Angeles CA

Baral, Judy, *Chmn & Prof,* Mount Saint Mary's College, Art Dept, Los Angeles CA (S)

Barattuci, Maurizio, *Gallery Chmn,* Santa Monica College, Pete & Susan Barrett Art Gallery, Santa Monica CA

Barbee, Rebecca, *Operations & Sales Mgr,* Palo Alto Art Center, Palo Alto CA

Barbehenn, Susan, *Asst Prof,* Ithaca College, Fine Art Dept, Ithaca NY (S)

Barber, Anne, *Asst Prof,* Albion College, Bobbitt Visual Arts Center, Albion MI

Barber, Bruce, *Dir MFA Program,* Nova Scotia College of Art & Design, Halifax NS (S)

Barber, Dan, *Cur Coll,* Genesee Country Village & Museum, John L Wehle Gallery of Wildlife & Sporting Art, Mumford NY

Barber, Diane, *Co-Dir,* Diverse Works, Houston TX

Barber, Diane, National Association of Artists' Organizations (NAAO), Birmingham AL

Barber, Lisa, *Asst Prof,* University of Wisconsin-Parkside, Art Dept, Kenosha WI (S)

Barber, Robbie, *Assoc Prof,* Baylor University, Dept of Art, Waco TX (S)

Barber, X T, *Archivist,* Parsons School of Design, Adam & Sophie Gimbel Design Library, New York NY

Barch, Nancy, *Instr,* Wayne Art Center, Wayne PA (S)

Bardenheuer, Lee, *Treas,* Kent Art Association, Inc, Gallery, Kent CT

Bardhan, Gail, *Reference Librn,* Corning Museum of Glass, Juliette K and Leonard S Rakow Research Library, Corning NY

Bardon, Donna, *Friends of Lovejoy Librn,* Southern Illinois University, Lovejoy Library, Edwardsville IL

Barello, Julia, *Assoc Prof,* New Mexico State University, Art Dept, Las Cruces NM (S)

Barendse, Henry, Weber State University, Dept of Visual Arts, Ogden UT (S)

Barger, Judy, *Deputy Dir,* Polk Museum of Art, Lakeland FL

Basinger, Jeanine, *Prof,* Wesleyan University, Dept of Art & Art History, Middletown CT (S)

Baskins, Cristelle, *Assoc Prof,* Tufts University, Dept of Art & Art History, Medford MA (S)

Basmadjian, Terry, *Instr,* Saginaw Valley State University, Dept of Art & Design, University Center MI (S)

Bass, Carol, *VPres,* Madison County Historical Society, Cottage Lawn, Oneida NY

Bass, George, *Interim Mus Mgr,* The City of Petersburg Museums, Petersburg VA

Bass, Judy, *Prof,* Marymount University, School of Arts & Sciences Div, Arlington VA (S)

Bass, Ruth, *Chmn,* Bronx Community College, Music & Art Dept, Bronx NY (S)

Bassett, Mark S, *CEO & Exec Dir,* Nevada Northern Railway Museum, Ely NV

Bassett, Michele, *Asst Prof,* Hamline University, Dept of Art & Art History, Saint Paul MN (S)

Bassett, Ruth, *Librn,* Brandywine River Museum, Chadds Ford PA

Bassett, Ruth, *Librn,* Brandywine River Museum, Library, Chadds Ford PA

Bassi, George, *Dir,* Lauren Rogers, Laurel MS

Bassinger, Marilyn, *Dir,* Ellen Noel Art Museum of the Permian Basin, Odessa TX

Bassolos, Arturo, *Art Dept Chmn,* Delaware State College, Dept of Art & Art Education, Dover DE (S)

Bassuk, Jane, *Instr,* North Hennepin Community College, Art Dept, Brooklyn Park MN (S)

Baster, Victoria V, *Asst Cur,* University of Lethbridge, Art Gallery, Lethbridge AB

Bastidas, Hugo Xavier, *Dir,* New Jersey City University, Courtney Art Gallery & Lemmerman Gallery, Jersey City NJ

Bastidas, Hugo Xavier, *Dir,* New Jersey City University, Lemmerman Art Gallery, Jersey City NJ

Bastos, Flavia, *Dir Art Educ Prog & Asst Prof Art Educ,* University of Cincinnati, School of Art, Cincinnati OH (S)

Basu, Chandreyi, *Asst Prof,* St Lawrence University, Dept of Fine Arts, Canton NY (S)

Basye, Susan, *Art & Music Library Asst,* University of Northern Iowa, Art & Music Collection Rod Library, Cedar Falls IA

Batchelder, Virginia, *Bd Pres,* Rome Historical Society, Museum & Archives, Rome NY

Batchelor, Anthony, *Prof,* Art Academy of Cincinnati, Cincinnati OH (S)

Batchelor, Betsey, *Assoc Prof,* Beaver College, Dept of Fine Arts, Glenside PA (S)

Batchen, Geoffrey, *Prof,* City University of New York, PhD Program in Art History, New York NY (S)

Batdorff, Jon, *Head,* Goddard College, Dept of Art, Plainfield VT (S)

Bateman, Ellen, *Instr,* Toronto Art Therapy Institute, Toronto ON (S)

Bateman, Nell, *Supv,* Toronto Art Therapy Institute, Toronto ON (S)

Bater, John, *Area Head,* Kentucky State University, Jackson Hall Gallery, Frankfort KY

Bates, Catherine, *Gallery Specialist,* Yeiser Art Center Inc, Paducah KY

Bates, Craig D, *Cur Ethnography,* Yosemite Museum, Yosemite National Park CA

Bates, Judy, *Prog Educ Dir,* Arts Council of the Blue Ridge, Roanoke VA

Bates, Lenny, *Asst Cur,* Sloss Furnaces National Historic Landmark, Birmingham AL

Bates , Michael L, *Cur,* American Numismatic Society, New York NY

Bates, Ron, *Mus Asst,* Sloss Furnaces National Historic Landmark, Birmingham AL

Bates, Tom, *Prof,* La Roche College, Division of Graphics, Design & Communication, Pittsburgh PA (S)

Bates, Ulko, *Head MA Prog,* Hunter College, Art Dept, New York NY (S)

Batey, Dorothy, *Asst Prof,* Clark-Atlanta University, School of Arts & Sciences, Atlanta GA (S)

Batista, Kenneth, *Assoc Prof,* University of Pittsburgh, Dept of Studio Arts, Pittsburgh PA (S)

Batkin, Jonathan, *Dir,* Wheelwright Museum of the American Indian, Santa Fe NM

Batkin, Jonathan, *Dir,* Wheelwright Museum of the American Indian, Mary Cabot Wheelwright Research Library, Santa Fe NM

Batkin, Norton, *Dir,* Bard College, Center for Curatorial Studies Graduate Program, Annandale-on-Hudson NY (S)

Battaile, Chandler, *Dir Develop,* Association for the Preservation of Virginia Antiquities, Richmond VA

Battin, James, *Develop Officer,* Telfair Museum of Art, Telfair Academy of Arts & Sciences Library, Savannah GA

Battis, Nicholas, *Asst Dirr,* Pratt Institute, Rubelle & Norman Schafler Gallery, Brooklyn NY

Battle, Didi, *Pub Rels,* Grevemberg House Museum, Franklin LA

Batzka, Stephen, *Prof,* Manchester College, Art Dept, North Manchester IN (S)

Bauche, Dean, *Cur,* Allen Sapp, North Battleford SK

Bauer, Douglas, *Pres,* Bowne House Historical Society, Flushing NY

Bauer, Marlene, *Instr,* Marylhurst University, Art Dept, Marylhurst OR (S)

Bauer, Pat, *Treas,* Wellfleet Historical Society Museum, Wellfleet MA

Bauer, Penelope, *Business Mgr,* Historical Society of Pennsylvania, Philadelphia PA

Bauer, Sarah, *Assoc Prof,* University of Minnesota, Duluth, Art Dept, Duluth MN (S)

Bauer, Susie, *Exec Asst,* Oklahoma City Museum of Art, Library, Oklahoma City OK

Baugh, Brian, *Asst Prof Art,* Monmouth College, Dept of Art, Monmouth IL (S)

Baughman, Robert J, *Dir,* Museum of Northern Arizona, Flagstaff AZ

Baulos, Doug, *Instr,* University of Alabama at Birmingham, Dept of Art & Art History, Birmingham AL (S)

Bauman, Jan, *Dir Media & Pub,* Memphis Brooks Museum of Art, Memphis TN

Baumann, Richard, *Instr,* Columbia College, Art Dept, Columbia MO (S)

Baumer, Cris, *Dir,* Second Street Gallery, Charlottesville VA

Baumler, Mark, *Preservation Officer,* Montana Historical Society, Helena MT

Baurhenn, Etta, *Asst to Exec Dir,* Fine Arts Work Center, Provincetown MA

Bavar, Ann, *Head Dept,* Manhattanville College, Art Dept, Purchase NY (S)

Bavar, Ann, *Prof Studio Art,* Manhattanville College, Brownson Gallery, Purchase NY

Baxevanis, Susan, *Coll Mgr (Anthropology),* Texas Tech University, Museum of Texas Tech University, Lubbock TX

Baxter, David, *Dept Dir Admin & Develop,* Wadsworth Atheneum Museum of Art, Hartford CT

Baxter, Denise, *Asst Prof Art History,* University of North Texas, School of Visual Arts, Denton TX (S)

Baxter, Ellen, *Chief Conservator,* Carnegie Museums of Pittsburgh, Carnegie Museum of Art, Pittsburgh PA (S)

Baxter, Gary, *Head Art Dept,* Houghton College, Art Dept, Houghton NY (S)

Baxter, Iain, *Prof Emeritus,* University of Windsor, Visual Arts, Windsor ON (S)

Baxter, Karen, *Pres,* Prescott Fine Arts Association, Gallery, Prescott AZ

Baxter, Karen, *Visual Arts Librn,* California Institute of the Arts Library, Santa Clarita CA

Baxter, Lori, *Exec Dir,* The Canadian Craft Museum, Vancouver BC

Baxter, Paula A, *Cur Art & Arch Coll,* The New York Public Library, Art Division, New York NY

Bay, Richard, *Asst Prof,* Radford University, Art Dept, Radford VA (S)

Baylies, Ann, *Museum Educator,* Cape Ann Historical Association, Gloucester MA

Baylor, Trenton, *Asst Prof,* University of Wisconsin-Parkside, Art Dept, Kenosha WI (S)

Baynes, Gloretta, *Asst to Dir,* Museum of the National Center of Afro-American Artists, Boston MA

Bayuzick, Dennis, *Assoc Prof,* University of Wisconsin-Parkside, Art Dept, Kenosha WI (S)

Bazelon, Bruce, *Chief Div Historic Sites,* Pennsylvania Historical & Museum Commission, Harrisburg PA

Bazinet, Kristin, *Gallery Mgr,* Guild of Boston Artists, Boston MA

Beach, Barry, *Admis Dir,* Oregon College of Art & Craft, Portland OR (S)

Beach, Gleny, *Dir Art Activities,* Southeastern Oklahoma State University, Fine Arts Dept, Visual Arts Division, Durant OK (S)

Beach, Mary Agnes, *Cur,* Hickory Museum of Art, Inc, Hickory NC

Beachley, Pati, *Instr,* Middle Tennessee State University, Art Dept, Murfreesboro TN (S)

Beachley, Patricia, *Asst Prof,* Seton Hill University, Art Program, Greensburg PA (S)

Beadle, Kristine, *Instr,* John C Calhoun, Department of Fine Arts, Decatur AL (S)

Beadsley, Laura, *Graphics Head,* Historical Society of Pennsylvania, Philadelphia PA

Beaird, Elisabeth, *Exec Dir,* The Lab, San Francisco CA

Beal, Graham W.J., *Dir,* Detroit Institute of Arts, Detroit MI

Beal, Jane, *Dir Community Arts,* Cambridge Arts Council, CAC Gallery, Cambridge MA

Beal, Stephen, *Provost,* California College of the Arts, San Francisco CA (S)

Beall, Barbara Apelian, *Asst Prof,* Assumption College, Dept of Art & Music, Worcester MA (S)

Beamer, Karl, *Prof,* Bloomsburg University, Dept of Art & Art History, Bloomsburg PA (S)

Beamesdofer, Alice, *Assoc Dir Colls & Project Support,* Philadelphia Museum of Art, Philadelphia PA

Bean, Roger, *Asst Prof,* Illinois Central College, Dept Fine, Performing & Applied Arts, East Peoria IL (S)

Bean, Terrell, *Office Adminr,* Jule Collins Smith Museum of Art, Auburn AL

Bear, Andrea, *Deputy Dir of Develop,* Chrysler Museum of Art, Norfolk VA

Beard, David, *Cur,* Independence Seaport Museum, Philadelphia PA

Beard, Rick, *Exec Dir,* Atlanta Historical Society Inc, Atlanta History Center, Atlanta GA

Bearden, Rob, *Dir Operations,* Portland Art Museum, Northwest Film Center, Portland OR

Beardsley, Kelcey, *Dir,* Marylhurst University, Art Dept, Marylhurst OR (S)

Beardsley, Theodore S, *Pres,* Hispanic Society of America, Museum & Library, New York NY

Bears, Pat, *Treas,* Arizona Watercolor Association, Phoenix AZ

Beasecker, Peter, *Asst Prof,* Southern Methodist University, Division of Art, Dallas TX (S)

Beasley, James M, *Cur Coll,* Springfield Art Museum, Springfield MO

Beatly, Michael, *Assoc Prof,* College of the Holy Cross, Dept of Visual Arts, Worcester MA (S)

Beatty, Brett, *Dir,* Hutchinson Art Association, Hutchinson Art Center, Hutchinson KS

Beaty, Shelly, *Admin Mgr,* Rapid City Arts Council, Dahl Arts Center, Rapid City SD

Beaubier, Don, *Develop Mgr,* Memorial University of Newfoundland, Art Gallery of Newfoundland & Labrador, Saint John's NF

Beauchamp, Darrell, *Dean,* Navarro College, Gaston T Gooch Library & Learning Resource Center, Corsicana TX

Beauchamp, Donnie, *Dept Chair, Photog,* Nossi College of Art, Goodlettsville TN (S)

Beaudoin-Ross, Jacqueline, *Cur Costume,* McCord Museum of Canadian History, Montreal PQ

Beausoleil, Deanne, *Chemeketa Community College, Dept of Humanities & Communications, Salem OR (S)

Beaver, Frank, *Assoc Chair,* University of Hawaii at Manoa, Dept of Art, Honolulu HI (S)

Beaver, Jeanne, *Asst Prof,* Murray State University, Dept of Art, Murray KY (S)

Bebe, Kathryn, *Registrar,* Berkshire Museum, Pittsfield MA

Becher, Melissa, *Reference Team Leader,* American University, Jack & Dorothy G Bender Library & Learning Resources Center, Washington DC

Becherer, Joseph, *Prof,* Aquinas College, Art Dept, Grand Rapids MI (S)

Bechet, Ron, *Chmn,* Xavier University of Louisiana, Dept of Fine Arts, New Orleans LA (S)

Bechham, Terry, *Designer,* Birmingham Museum of Art, Birmingham AL

Becht, Mary A, *Dir,* Broward County Board of Commissioners, Cultural Affairs Div, Fort Lauderdale FL

Bechtel, Tina, *Asst Cur,* University of Wisconsin, Green Bay, Lawton Gallery, Green Bay WI

Bechtol, Nancy, *Pres,* ARC Gallery, Chicago IL

Beck, Jerry, *Artistic Dir,* The Revolving Museum, Lowell MA

Beck, Kimberly, *Deputy Dir Opers,* Columbus Museum, Columbus OH

Beck, Sachiko, *Prof,* Framingham State College, Art Dept, Framingham MA (S)

Beckelman, John, *Chmn Art Dept,* Coe College, Eaton-Buchan Gallery & Marvin Cone Gallery, Cedar Rapids IA

Beckelman, John, *Prof,* Coe College, Dept of Art, Cedar Rapids IA (S)

Becker, Cynthia, *Prof,* University of Saint Thomas, Dept of Art History, Saint Paul MN (S)

Becker, David, *Operations Mgr,* Tippecanoe County Historical Association, Museum, Lafayette IN

Becker, Jack, *Dir,* Cheekwood Botanical Garden & Museum of Art, Nashville TN

Becker, Jack, *Dir,* Cheekwood-Tennessee Botanical Garden & Museum of Art, Museum of Art Library, Nashville TN

Becker, Janis, *Educ Coordr,* Mamie McFaddin Ward, Beaumont TX

Becker, Judy, *Curatorial Asst,* Hebrew Union College, Jewish Institute of Religion Museum, New York NY

Becker, Julia, *Asst Prof Art,* University of Great Falls, Humanities Div, Great Falls MT (S)

Becker, Randy, *Adj Instr,* Northwestern College, Art Dept, Orange City CA (S)

Beckett, Bruce H, *VPres,* State Historical Society of Missouri, Gallery and Library, Columbia MO

Beckham, Peggy, *Adjunct Prof,* Missouri Southern State University, Dept of Art, Joplin MO (S)

Beckham, Terry A, *Exhibs Designer,* Birmingham Museum of Art, Clarence B Hanson Jr Library, Birmingham AL

Beckman, Joy, *Dir,* Beloit College, Wright Museum of Art, Beloit WI

Beckstrom, Robert, *Chmn,* Lorain County Community College, Art Dept, Elyria OH (S)

Beckwith, Alice, *Assoc Prof,* Providence College, Art & Art History Dept, Providence RI (S)

Beckwith, Wendy, *Div Chair,* La Roche College, Division of Graphics, Design & Communication, Pittsburgh PA (S)

Beda, Gaye Elise, *Chmn Scholarship Members,* Salmagundi Club, New York NY

Bedard, Robert J, *Treas,* Art PAC, Washington DC

Beebe, Mary Livingstone, *Dir,* University of California, San Diego, Stuart Collection, La Jolla CA

Beebe, Steven, *Assoc Dean,* Texas State University - San Marcos, Dept of Art and Design, San Marcos TX (S)

Beecher, Raymond, *Librn,* Greene County Historical Society, Bronck Museum, Coxsackie NY

Beegles, Anna, *Site Mgr,* County of Henrico, Library, Glen Allen VA

Beeler, Kristin, Long Beach City College, Art & Photography Dept, Long Beach CA (S)

Beer, Gary, *Sr Business Officer,* Smithsonian Institution, Washington DC

Beers, Debra, *Instr,* Lewis & Clark College, Dept of Art, Portland OR (S)

Beesch, Ruth, *Deputy Dir Prog,* The Jewish Museum, New York NY

Begay, Clarenda, *Cur,* Navajo Nation, Navajo Nation Museum, Window Rock AZ

Begier, Mary Ann, *Pres,* Lyme Historical Society, Florence Griswold Museum, Old Lyme CT

Begley, John, *Gallery Dir & Adjunct Assoc Prof,* University of Louisville, Allen R Hite Art Institute, Louisville KY (S)

Beglin, Patricia, *Instr,* Cazenovia College, Center for Art & Design Studies, Cazenovia NY (S)

Begor, Alison, *Bus & Information Systems Mgr,* Albany Institute of History & Art, Albany NY

Behler, Mark, *Cur,* North Central Washington Museum, Wenatchee Valley Museum & Cultural Center, Wenatchee WA

Behnke, Betsy, *Sec,* Dillman's Creative Arts Foundation, Tom Lynch Resource Center, Lac du Flambeau WI

Behnke, Henryk, *VPres Mktg & Develop,* Staten Island Institute of Arts & Sciences, Staten Island NY

Behnken, William, *Pres,* Society of American Graphic Artists, New York NY

Behrends, Carey, *Exec Dir,* Presidential Museum, Odessa TX

Behrends, Carey, *Exec Dir,* Presidential Museum, Library of the Presidents, Odessa TX

Behrends Frank, Sue, *Asst Cur,* The Phillips Collection, Washington DC

Behrens, Fred, *Prof,* Columbia State Community College, Dept of Art, Columbia TN (S)

Behrens, Roy, *Prof,* University of Northern Iowa, Dept of Art, Cedar Falls IA (S)

Behrens, Sarah, *Dir,* Kimball Art Center, Park City UT

Behrens, Todd, *Cur of Art,* Polk Museum of Art, Lakeland FL

Beibers, Sam, *Instr,* Belhaven College, Art Dept, Jackson MS (S)

Beiderman, Sarah, *Residency Coordr,* SPACES, Cleveland OH

Beidler, Anne, *Chmn,* Agnes Scott College, Dept of Art, Decatur GA (S)

Beidler, Anne, *Printmaker,* Agnes Scott College, Dalton Art Gallery, Decatur GA

Beierlinng, Sharlene, *Appraisals Asst,* Art Dealers Association of Canada, Toronto ON

Beil, Judith, *Cur Educ,* The National Trust for Historic Preservation, Lyndhurst, Tarrytown NY

Beim, David O, *VChmn,* Wave Hill, Bronx NY

Beiner, Susan, *Instr,* California State University, San Bernardino, Dept of Art, San Bernardino CA (S)

Beitel, Elizabeth, *Supv Exhibits,* New Jersey State Museum, Fine Art Bureau, Trenton NJ

Belak, Marilyn, *Pres,* South Peace Art Society, Dawson Creek Art Gallery, Dawson Creek BC

Belan, Kyra, *Gallery Dir,* Broward Community College - South Campus, Art Gallery, Pembroke Pines FL

Beland, Mario, *Cur Early Quebec Art 1850-1900,* Musee du Quebec, Quebec PQ

Belanger, Alain, *Coordr,* Vu Centre D'Animation Et de Diffusion de La Photographie, Quebec PQ

Belanger, Micheline, *Prog Dir,* Pointe Claire Cultural Centre, Stewart Hall Art Gallery, Pointe Claire PQ

Belanger, Pamela, *Cur 19th & 20th Century,* William A Farnsworth, Library, Rockland ME

Belanger, Sandra Lynn, *Communication Asst,* La Centrale Powerhouse Gallery, Montreal PQ

Belanger, Sylvie, *Asst Prof,* University at Buffalo, State University of New York, Dept of Visual Studies, Buffalo NY (S)

Belanger, Tanya, *Fin Adminstr,* Beaverbrook Art Gallery, Fredericton NB

Belanger-Turner, Tammy, *Comptroller,* Caramoor Center for Music & the Arts, Inc, Caramoor House Museum, Katonah NY

Belasco, Ruth, *Prof,* Spring Hill College, Department of Fine & Performing Arts, Mobile AL (S)

Belcher, Patty, *Reference Librn,* Bernice Pauahi Bishop, Library, Honolulu HI

Beldon, Sanford T, *Pres Board Trustees,* Allentown Art Museum, Allentown PA

Belfort-Chalat, Jacqueline, *Chmn & Prof,* Le Moyne College, Fine Arts Dept, Syracuse NY (S)

Belhand, Elizabeth, *Museum Shop Mgr,* Albany Institute of History & Art, Albany NY

Belisle, Tammy, *Gallery Shoppe Coordr,* ArtSpace-Lima, Lima OH

Belkina, Anya, *Asst Prof Practice,* Duke University, Dept of Art, Art History & Visual Studies, Durham NC (S)

Belknap, Beth, *Assoc,* College of Mount Saint Joseph, Art Dept, Cincinnati OH (S)

Bell, Doug, *Preparator & Registrar,* Tufts University, Tufts University Art Gallery, Medford MA

Bell, Eunice, *Exec Dir,* Ocean City Art Center, Ocean City NJ

Bell, Gloria, *Chief Historical Interpreter,* Old Barracks Museum, Trenton NJ

Bell, Greg, *Dir,* University of Puget Sound, Kittredge Art Gallery, Tacoma WA

Bell, Jason, *2-year appt,* Moravian College, Dept of Art, Bethlehem PA (S)

Bell, Jeffrey, *Registrar,* Duke University, Duke University Museum of Art, Durham NC

Bell, Judith, *Instr,* San Jose City College, School of Fine Arts, San Jose CA (S)

Bell, Kathy, *Instr,* Bob Jones University, Div of Art, Greenville SC (S)

Bell, Kurt, *Librn & Archivist,* Pennsylvania Historical & Museum Commission, Railroad Museum of Pennsylvania, Harrisburg PA

Bell, Lynne, *Head,* University of Saskatchewan, Dept of Art & Art History, Saskatoon SK (S)

Bell, Maaji, *Prof,* Concordia University, Division of Performing & Visual Arts, Mequon WI (S)

Bell, Malcolm, *Art History Instr,* University of Virginia, McIntire Dept of Art, Charlottesville VA (S)

Bell, Marybeth, *Dir,* State University of New York at Oswego, Penfield Library, Oswego NY

Bell, Melissa, *Prof,* University of North Carolina at Greensboro, Art Dept, Greensboro NC (S)

Bell, Michael, *Dir,* Carleton University, Dept of Art History, Ottawa ON (S)

Bell, Rex, *Chief Security,* Morris Museum of Art, Augusta GA

Bell, Shauna, *Financial Asst,* Kamloops Art Gallery, Kamloops BC

Bellabia, Kim, *Dir,* Klamath County Museum, Klamath Falls OR

Bellabia, Kim, *Dir,* Klamath County Museum, Research Library, Klamath Falls OR

Bellabia, Kim, *Dir,* Klamath County Museum, Baldwin Hotel Museum Annex, Klamath Falls OR

Bellah, Mary S, *Cur,* Carnegie Art Museum, Oxnard CA

Bellah, Suzzane, *Dir,* Carnegie Art Museum, Oxnard CA

Bellais, Leslie, *Cur Costumes & Textiles,* Wisconsin Historical Society, State Historical Museum, Madison WI

Bellas, Gerald, *Dir,* College of Mount Saint Joseph, Studio San Giuseppe, Cincinnati OH

Bellas, Gerry, *Asst Prof,* College of Mount Saint Joseph, Art Dept, Cincinnati OH (S)

Bellciscio, Tara, *Dir Educ,* Montclair Art Museum, Montclair NJ

Bellerby, Greg, *Cur,* Emily Carr Institute of Art & Design, The Charles H Scott Gallery, Vancouver BC

Belletire, Steve, *Assoc Prof & Design Area Head,* Southern Illinois University, School of Art & Design, Carbondale IL (S)

Belleville, Patricia, *Asst Prof,* Eastern Illinois University, Art Dept, Charleston IL (S)

Bellew, Kevin, *Mem Coord,* The Rosenbach Museum & Library, Philadelphia PA

Bellingham, Susan, *Spec Coll Librn,* University of Waterloo, Dana Porter Library, Waterloo ON

Bellucci, Bettina, *Asst to Dir,* Contemporary Arts Center, Cincinnati OH

Belluscio, Lynne, *Dir,* LeRoy Historical Society, LeRoy NY

Belnap, Jeffrey, *Chmn,* Brigham Young University, Hawaii Campus, Division of Fine Arts, Laie HI (S)

Belovitch, Carol, *Human Resources Specialist,* National Museum of the American Indian, George Gustav Heye Center, New York NY

Belsley, Katherine, *Dir,* Peoria Historical Society, Peoria IL

Beltemacchi, Peter, *Assoc Prof,* Illinois Institute of Technology, College of Architecture, Chicago IL (S)

Beltke, Bridget, *Finance Mgr,* Pelham Art Center, Pelham NY

Belville, Scott, *Assoc Prof Drawing & Painting,* University of Georgia, Franklin College of Arts & Sciences, Lamar Dodd School of Art, Athens GA (S)

Belvo, Hazel, *Faculty,* Grand Marais Art Colony, Grand Marais MN (S)

Beman, Lynn S, *Exec Dir,* Amherst Museum, Neiderlander Research Library, Amherst NY

Ben-Zvi, Paul, *Assoc Prof,* Indiana University of Pennsylvania, College of Fine Arts, Indiana PA (S)

Benaroya, Brooke, *Dir Develop,* Urbanglass, Robert Lehman Gallery, Brooklyn NY

Benassi, Neal, *Dir Facility Operations,* Albany Institute of History & Art, Albany NY

Benbassat, Karen, *Asst,* Community Arts Council of Vancouver, Vancouver BC

Benbow, Julie, *Exec Dir,* Museo Italo Americano, San Francisco CA

Ben David, Allison, *Coordr Exhib,* Museum of Fine Arts, Saint Petersburg, Florida, Inc, Saint Petersburg FL

Bender, Linder, *Dir Natur Ctr,* Genesee Country Village & Museum, John L Wehle Gallery of Wildlife & Sporting Art, Mumford NY

Bender, Mark, *Graphic Design,* Art Institute of Pittsburgh, Pittsburgh PA (S)

Bender, Nathan, *House Cur,* Buffalo Bill Memorial Association, Harold McCracken Research Library, Cody WY

Bender, Phil, *Dir,* Pirate-A Contemporary Art Oasis, Denver CO

Benedetti, Joan M, *Librn,* L A County Museum of Art, Edith R Wyle Research Library of The Craft & Folk Art Museum, Los Angeles CA

Benedetti, Susan, *Librn & Archivist,* The Haggin Museum, Stockton CA

Benedetto, Mark, *Pres,* University of Sioux Falls, Dept of Art, Sioux Falls SD (S)

Benedict, Dow, *Dean,* Shepherd University, Art Dept, Shepherdstown WV (S)

Benedict, Mary Jane, *Librn,* Speed Art Museum, Art Reference Library, Louisville KY

Benedict, Sean, *Media Arts & Animation,* Art Institute of Pittsburgh, Pittsburgh PA (S)

Beneditti, Joan, *Librn,* L A County Museum of Art, Los Angeles CA

Benezra, Neal, *Dir,* San Francisco Museum of Modern Art, San Francisco CA

Benford, Benjamin, *Dean Liberal Arts,* Tuskegee University, Liberal Arts & Education, Tuskegee AL (S)

Bengio, Yoshua, *Aggregate Prof,* Universite de Montreal, Bibliotheque d'Amenagement, Montreal PQ

Benham, Carolyn, *Dir Admin,* Boca Raton Museum of Art, Library, Boca Raton FL

Benham, Carolyn J, *Dir Finance,* Boca Raton Museum of Art, Boca Raton FL

Benington-Kozlowski, Eliza, *Dir Communications & Visitors Svcs,* George Eastman, Rochester NY

Benini, Lorraine, *Pres,* The Benini Foundation & Sculpture Ranch, Johnson City TX

Benio, Pauleve, *Prof,* Adrian College, Art & Design Dept, Adrian MI (S)

Beniston, Susan, *Instr,* Toronto School of Art, Toronto ON (S)

Benitez, Marimar, *Chancellor,* Institute of Puerto Rican Culture, Escuela de Artes Plasticas, San Juan PR (S)

Benjamin, Brent, *Dir,* The Saint Louis Art Museum, Saint Louis MO

Benjamin, Jack, *Chmn,* University of South Carolina at Aiken, Dept of Visual & Performing Arts, Aiken SC (S)

Benjamin, Stephanie, *COO,* New York Historical Society, New York NY

Benjamin, Tim, *Facilities Technician,* The Lab, San Francisco CA

Benn, Carl, *Cur,* Heritage Toronto, Historic Fort York, Toronto ON

Bennett, Dawn, *Exec Dir,* Urbanglass, Robert Lehman Gallery, Brooklyn NY

Bennett, Douglas C, *Pres College,* Earlham College, Leeds Gallery, Richmond IN

Bennett, Fernanda, *Registrar,* Nassau County Museum of Fine Art, Roslyn Harbor NY

Bennett, K Sharon, *Archivist,* Charleston Museum, Charleston SC

Bennett, K Sharon, *Librn,* Charleston Museum, Library, Charleston SC

Bennett, Kelly, *Budget Analyst,* National Museum of the American Indian, George Gustav Heye Center, New York NY

Bennett, Kelly, *Chief Preparator,* Art Museum of the University of Houston, Blaffer Gallery, Houston TX

Bennett, Lois F, *Secy,* Miles B Carpenter, Waverly VA

Bennett, Michael, *Cur Greek & Roman Art,* Cleveland Museum of Art, Cleveland OH

Bennett, Shelley, *Cur British & Continental Art,* The Huntington Library, Art Collections & Botanical Gardens, San Marino CA

Bennett, Swannee, *Cur,* Historic Arkansas Museum, Little Rock AR

Bennett, Swannee, *Cur,* Historic Arkansas Museum, Library, Little Rock AR

Bennett, Valerie, *Cur,* City of Austin Parks & Recreation, O Henry Museum, Austin TX

Bennett, William, *Studio Faculty,* University of Virginia, McIntire Dept of Art, Charlottesville VA (S)

Benninghoff, Herman O, *VPres,* Burlington County Historical Society, Burlington NJ

Benny, Barbara M, *Dir of Human Resources,* The Phillips Collection, Washington DC

Benso, Helen, *VPres Mktg,* Brookgreen Gardens, Murrells Inlet SC

Benson, Aaron Lee, *Chmn,* Union University, Dept of Art, Jackson TN (S)

Benson, Carla, *Treas,* Eagle Rock Art Museum and Education Center, Inc, Idaho Falls ID

Benson, Ilana, *Educator,* Yeshiva University Museum, New York NY

Benson, M D, *Instr,* Humboldt State University, College of Arts & Humanities, Arcata CA (S)

Benson, Martin, *Asst Dir,* Avila College, Thornhill Art Gallery, Kansas City MO

Bent, Anne Searle, *Chmn,* The Art Institute of Chicago, Dept of Prints & Drawings, Chicago IL

Bent, George, *Head,* Washington and Lee University, Div of Art, Lexington VA (S)

Bent, Nila, *Art Reference Librn,* The Society of the Four Arts, Gioconda & Joseph King Library, Palm Beach FL

Bentley, Anne, *Cur,* Massachusetts Historical Society, Boston MA

Bentley, Eden R, *Librn,* Johnson Atelier Technical Institute of Sculpture, Johnson Atelier Library, Mercerville NJ

Benton, Janetta, *Prof,* Pace University, Dyson College of Arts & Sciences, Pleasantville NY (S)

Bentor, Eli, *Asst Prof,* Appalachian State University, Dept of Art, Boone NC (S)

Bentz, Laura, *Asst Prof,* Chadron State College, Dept of Art, Chadron NE (S)

Benzow, Jeff, *Assoc Prof,* University of Wisconsin-Green Bay, Art Dept, Green Bay WI (S)

Berben, Silvan, *Dir,* Owatonna Arts Center, Library, Owatonna MN

Berberich, Hugh, *Prof,* Manhattan College, School of Arts, Riverdale NY (S)

Berckfeldt, Jan, *Dir Develop,* Oakland Museum of California, Art Dept, Oakland CA

Berens, Stephen, *Prof,* Chapman University, Art Dept, Orange CA (S)

Berenz, Elizabeth, *Visual Resources Cur,* Roger Williams University, Architecture Library, Bristol RI

Berezansky, Tracey, *Asst Dir Government Records,* Alabama Department of Archives & History, Museum Galleries, Montgomery AL

Berg, Carl F, *Exhib Coordr,* City of Irvine, Irvine Fine Arts Center, Irvine CA

Berg, Niels, *Sub Dir,* Ages of Man Foundation, Amenia NY

Berg, Stacen, *Exec Dir,* Fellows of Contemporary Art, Los Angeles CA

Berg, Sue, *Educ Coordr,* St. Louis Artists' Guild, Saint Louis MO

Berg, Susan, *Librn,* The Mariners' Museum, Library, Newport News VA

Berg-Johnson, Karen, *Assoc Prof,* Bethel College, Dept of Art, Saint Paul MN (S)

Bergboll, Barry, *Dir Grad Studies,* Columbia University, Dept of Art History & Archaeology, New York NY (S)

Bergdoll, Barry, *Chief Cur,* Museum of Modern Art, New York NY

Bergeman, Rich, *Instr,* Linn Benton Community College, Fine & Applied Art Dept, Albany OR (S)

Bergen, Kim, *Head Registrar,* Wolfsonian-Florida International University, Miami Beach FL

Berger, Carol, *(Acting) Chmn Div,* Saint Louis Community College at Florissant Valley, Liberal Arts Division, Ferguson MO (S)

Berger, Jerry, *Dir,* Southwest Missouri Museum Associates Inc, Springfield Art Museum, Springfield MO

Berger, Jerry A, *Dir,* Springfield Art Museum, Springfield MO

Berger, M, *Librn,* McGill University, Blackader-Lauterman Library of Architecture and Art, Montreal PQ

Berger, Shelly, *Dir,* Mid-America All-Indian Center, Black Bear Bosin Resource Center, Wichita KS

Berger, Theodore, *Exec Dir,* New York Foundation for the Arts, New York NY

Bergeron, Father Andre, *Artistic Cur,* Saint Joseph's Oratory, Museum, Montreal PQ

Bergeron, Suzanne K, *Asst Dir,* Bowdoin College, Museum of Art, Brunswick ME

Bergeron, Tom, *Chmn Creative Arts,* Western Oregon State College, Creative Arts Division, Visual Arts, Monmouth OR (S)

Bergeson, Jacquelyn, *Cur,* Martin and Osa Johnson, Scott Explorers Library, Chanute KS

Bergfeld, Mary Ann, *Assoc Prof,* Saint Xavier University, Dept of Art & Design, Chicago IL (S)

Bergman, Joseph, *Prof,* Siena Heights University, Studio Angelico-Art Dept, Adrian MI (S)

Bergman, Sky, *Assoc Prof,* California Polytechnic State University at San Luis Obispo, Dept of Art & Design, San Luis Obispo CA (S)

Bergmann, Catherine, *Dir Adult Educ,* Dunedin Fine Arts & Cultural Center, Dunedin FL (S)

Bergmann, Malena, *Coordr Undergrad Educ,* University of North Carolina at Charlotte, Dept Art, Charlotte NC (S)

Bergsieker, David, *Instr,* Illinois Valley Community College, Division of Humanities & Fine Arts, Oglesby IL (S)

Beriault, Ginette, *Dir Exhibs,* Canada Science and Technology Museum, Ottawa ON

Berke, Debra, *Museum Cur,* United States Department of the Interior Museum, Washington DC

Berley, Tanya, *Secy,* DuPage Art League School & Gallery, Wheaton IL

Berlingeri, Denise, *Deputy Dir Communications,* Museo de Arte de Ponce, Ponce Art Museum, Ponce PR

Berlyn, Judith, *Librn,* Chateau Ramezay Museum, Library, Montreal PQ

Berman, Kessin, *Cur,* B'nai B'rith International, B'nai B'rith Klutznick National Jewish Museum, Washington DC

Berman, Laura, *Prog Head, Printmaking,* Kansas City Art Institute, Kansas City MO (S)

Berman, Margot, *Curatorial Asst,* Hebrew Union College, Jewish Institute of Religion Museum, New York NY

Berman, Nancy, *Dir Emerita,* Hebrew Union College, Skirball Cultural Center, Los Angeles CA

Berman, Patricia, *Chmn,* Wellesley College, Art Dept, Wellesley MA (S)

Berman, Paul, *Dir School Theater Arts,* University of the Arts, Philadelphia Colleges of Art & Design, Performing Arts & Media & Communication, Philadelphia PA (S)

Bermann, Karen, *Coordr Core Prog,* Iowa State University, Dept of Art & Design, Ames IA (S)

Bernard, Catherine, *Gallery Dir,* State University of New York College at Old Westbury, Amelie A Wallace Gallery, Old Westbury NY

Bernard, Cheryl, *Cur,* Gaston County Museum of Art & History, Dallas NC

Bernard, Mary Ann, *Educ Cur,* Lafayette Natural History Museum & Planetarium, Lafayette LA

Bernard, Sandy, *Pres,* American Association of University Women, Washington DC

Bernardo, Celeste, *Dir Educ,* USS Constitution Museum, Boston MA

Berner, Andrew, *Dir & Cur Collections,* University Club Library, New York NY

Bernhardt, Elise, *Exec Dir,* Kitchen Center for Video, Music, Dance, Performance, Film & Literature, New York NY

Berniek, Ronald, *Instr,* Keystone College, Fine Arts Dept, LaPlume PA (S)

Bernier, Elizabeth, *Asst to Dir,* Old Colony Historical Society, Museum, Taunton MA

Bernier, Ronald R, *Dir,* Wilkes University, Sordoni Art Gallery, Wilkes-Barre PA

Berninger, Ruth Ellen, *Educator,* Columbia County Historical Society, Columbia County Museum, Kinderhook NY

Bernson, Julie, *Educ Dir,* Phillips Academy, Addison Gallery of American Art, Andover MA

Bernstein, Alex, *Glass Dept Head,* Worcester Center for Crafts, Worcester MA (S)

Bernstein, Cindy, *Coordr,* American Textile History Museum, Lowell MA

Bernstein, Ed, *Assoc Prof,* Indiana University, Bloomington, Henry Radford Hope School of Fine Arts, Bloomington IN (S)

Bernstein, Joanne, *Prof,* Mills College, Art Dept, Oakland CA (S)

Bernstein, Jordana, *Librn,* Museum of Fine Arts, Saint Petersburg, Florida, Inc, Saint Petersburg FL

Bernstein, Roberta, *Chair & Art Historian,* University at Albany, State University of New York, Art Dept Visual Resources, Albany NY

Bernstein, Roberta, *Prof,* State University of New York at Albany, Art Dept, Albany NY (S)

Bernstein, Sheri, *Dir Music & Educ,* Hebrew Union College, Skirball Cultural Center, Los Angeles CA

Bernston, Ron, *Librn,* Nutana Collegiate Institute, Memorial Library and Art Gallery, Saskatoon SK

Bero, Meg, *Educ Cur,* Aurora University, Schingoethe Center for Native American Cultures, Aurora IL

Beroza, Barbara, *Coll Mgr,* Yosemite Museum, Yosemite National Park CA

Berrigan, Bruce, *Cur Science Educ,* Omaha Childrens Museum, Inc, Omaha NE

Berrin, Kathleen, *Cur African, Oceania & the Americas,* Fine Arts Museums of San Francisco, Legion of Honor, San Francisco CA

Berrones-Molina, Patricia, *Acting Dir,* Pimeria Alta Historical Society, Library, Nogales AZ

Berry, Ava, *Mrg Mktg,* Charles Allis, Milwaukee WI

Berry, Christopher, *Assoc Prof,* Lakeland Community College, Fine Arts Department, Kirtland OH (S)

Berry, E Raymond, *Chmn,* Randolph-Macon College, Dept of the Arts, Ashland VA (S)

Berry, Eva S, *Mgr Mktg,* Villa Terrace Decorative Art Museum, Milwaukee WI

Berry, Heather L, *Program Assoc, AAM/ICOM,* American Association of Museums, US National Committee of the International Council of Museums (AAM-ICOM), Washington DC

Berry, Jessica, *Event Coordr,* Museum of Mobile, Mobile AL

Berry, Judith, *Lectr,* Wayne State College, Dept Art & Design, Wayne NE (S)

Berry, Paul, *Librn,* Calvert Marine Museum, Library, Solomons MD

Berry, Sarah, *Pres,* Worcester Art Museum, Worcester MA

Berryman, Jill, *Exec Dir,* Sierra Arts Foundation, Reno NV

Bershad, Deborah, *Exec Dir,* Art Commission of the City of New York, New York NY

Bershad, Deborah, *Exec Dir,* Art Commission of the City of New York, Associates of the Art Commission, Inc, New York NY

Berson, Ruth, *Dir Exhibitions,* San Francisco Museum of Modern Art, San Francisco CA

Bert, James, *Dir,* Cuneo Foundation, Museum & Gardens, Vernon Hills IL

Bertin, Maggie, *Asst Dir NMAI National Campaign,* National Museum of the American Indian, George Gustav Heye Center, New York NY

Bertoli, Elena, *Asst Cur,* Florida International University, The Art Museum at FIU, Miami FL

Bessey, Richard B, *Dir,* The Rockwell Museum of Western Art, Library, Corning NY

Bessine, Debbie, *Pres,* Art Guild of Burlington, Arts for Living Center, Burlington IA

Bessire, Mark H C, *Dir,* Maine College of Art, The Institute of Contemporary Art, Portland ME

Bessire, Mark H.C., *Dir,* Bates College, Museum of Art, Lewiston ME

Bessire, Paul, *Dir External Relations,* Institute of Contemporary Art, Boston MA

Best, Jonathan, *Prof,* Wesleyan University, Dept of Art & Art History, Middletown CT (S)

Best, Kathryn, *Cur Educ,* Grace Museum, Inc, Abilene TX

Best, Linda, *Registrar & Coll Mgr,* Mount Holyoke College, Art Museum, South Hadley MA

Best, Mickey D, *Dean,* New Mexico Junior College, Arts & Sciences, Hobbs NM (S)

Best, Sherry L, *Gallery Dir,* Topeka & Shawnee County Public Library, Alice C Sabatini Gallery, Topeka KS

Betancourt, Gladys, *COO,* Museo de Arte de Ponce, Ponce Art Museum, Ponce PR

Betancourt, Michael, *Cur,* Sioux City Art Center, Sioux City IA

Bethany, Adeline, *Chmn Dept,* Cabrini College, Dept of Fine Arts, Radnor PA (S)

Bethel, Ann, *Librart Servs,* Mingei International, Inc, Mingei International Museum, San Diego CA

Bethel, Lenore, *Photo & Painting Teacher,* Locust Street Neighborhood Art Classes, Inc, Buffalo NY (S)

Bethel, Molly, *Dir & Painting Teacher,* Locust Street Neighborhood Art Classes, Inc, Buffalo NY (S)

Betsch, William, *Asst Prof,* University of Miami, Dept of Art & Art History, Coral Gables FL (S)

Betty, Claudia Michelle, *Reference & Pub Servs Librn,* Art Center College of Design, James Lemont Fogg Memorial Library, Pasadena CA

Betz, Scott, *Asst Prof,* Weber State University, Dept of Visual Arts, Ogden UT (S)

Bewley, James, *Prog Dir,* New Langton Arts, San Francisco CA

Bey, Amir, *Gallery Coordr,* Bronx River Art Center, Gallery, Bronx NY

Beyer, Albin, *Prof,* University of South Carolina at Aiken, Dept of Visual & Performing Arts, Aiken SC (S)

Beyer, Irene K, *Dir Admin,* Waterworks Visual Arts Center, Salisbury NC

Beyer, Ken, *Treas,* Fairbanks Arts Association, Fairbanks AK

Bhatt, Vikram, *Prof,* McGill University, School of Architecture, Montreal PQ (S)

Biada, Charles, *Dir Operations,* National Academy Museum & School of Fine Arts, New York NY

Biada, Charles, *Dir Operations,* National Academy Museum & School of Fine Arts, Archives, New York NY

Biagi, Giancarlo, *Ed-in-Chief, Sculpture Review,* National Sculpture Society, New York NY

Bialkin, Kenneth, *Pres (V),* American Jewish Historical Society, The Center for Jewish History, New York NY

Bialy, Mark G, *Prof,* Passaic County Community College, Division of Humanities, Paterson NJ (S)

Bianchini, Dario, *Asst to Exhibit,* Saint Peter's College, Art Gallery, Jersey City NJ

Bianco, Juliette, *Exhib Coordr,* Dartmouth College, Hood Museum of Art, Hanover NH

Biasiny-Rivera, Charles, *Exec Dir,* En Foco, Inc, Bronx NY

Bibas, David, *Technology Cur,* California Science Center, Los Angeles CA

Bibler, Carol, *Instr,* Chemeketa Community College, Dept of Humanities & Communications, Salem OR (S)

Bibler, Helen Ann, *Dir,* Ravalli County Museum, Hamilton MT

Bibler, Robert, *Instr,* Chemeketa Community College, Dept of Humanities & Communications, Salem OR (S)

Bice, Andrew, *Pres,* Octagon Center for the Arts, Ames IA

Bickford, Troy, *Dir Finance,* The Phillips Collection, Washington DC

Bickley, Steve, *Prof,* Virginia Polytechnic Institute & State University, Dept of Art & Art History, Blacksburg VA (S)

Bicknell, Sarah Lou, *Dir Admin,* Cedarhurst Center for the Arts, Mitchell Museum, Mount Vernon IL

Biddle, Mark, *Prof,* Weber State University, Dept of Visual Arts, Ogden UT (S)

Bidell, Lisa, *Cur,* Abigail Adams Smith, New York NY

Biden, Doug, *Assoc Prof (Visual Art),* University of British Columbia Okanagan, Dept of Creative Studies, Kelowna BC (S)

Bidstrup, Wendy, *Dir,* Marion Art Center, Cecil Clark Davis Gallery, Marion MA

Bidwell, John, *Astor Cur & Dept Head Printed Books & Bindings,* Pierpont Morgan, New York NY

Biederman, John, *Ed,* Chicago Artists' Coalition, Chicago IL

Bielejec, Stephanie, *Asst Dir,* Schweinfurth Memorial Art Center, Auburn NY

Bieloh, David, *Instr,* Texas Woman's University, School of the Arts, Dept of Visual Arts, Denton TX (S)

Biemiller, Sarah, *Asst Dir,* Beaver College Art Gallery, Glenside PA

Bienvenu, Yvonne D, *Pres,* Lafayette Museum Association, Lafayette Museum-Alexandre Mouton House, Lafayette LA

Bierinckx, Cis, *Dir Film & Video,* Walker Art Center, Minneapolis MN

Biferie, Dan, *Prof,* Daytona Beach Community College, Dept of Fine Arts & Visual Arts, Daytona Beach FL (S)

Bigazzi, Anna, *Art Reference Librn,* University of Hartford, Mortensen Library, West Hartford CT

Bigazzi, Anna, *Art Reference Librn,* University of Hartford, Anne Bunce Cheney Art Collection, West Hartford CT

Bigelow, Brad, *Mus Store Mgr,* Seattle Art Museum, Library, Seattle WA

Bigelow, Rod, *Dir Finance,* Tacoma Art Museum, Tacoma WA

Biggs, George, *Instr,* New Mexico Junior College, Arts & Sciences, Hobbs NM (S)

Bigler, Steve, *Prof,* University of Northern Iowa, Dept of Art, Cedar Falls IA (S)

Bigley, Heather A, *Dir Gen Educ,* Art Institute of Pittsburgh, Pittsburgh PA (S)

Biglo, Jo, *Bibliographer,* National Gallery of Canada, Library, Ottawa ON

Bilbo, Rebecca, *Chmn,* Thomas More College, Art Dept, Crestview Hills KY (S)

Bilder, Dorothea, *Div Coordr FA Studio,* Northern Illinois University, School of Art, De Kalb IL (S)

Bilello, Michelle, *Operations Asst,* Quapaw Quarter Association, Inc, Villa Marre, Little Rock AR

Bilello, Michelle, *Operations Asst,* Quapaw Quarter Association, Inc, Preservation Resource Center, Little Rock AR

Billings, Cathy, *Librn,* Glendale Public Library, Brand Library & Art Center, Glendale CA

Billings, Doug, *Pres,* Gallery XII, Wichita KS

Billings, Loren, *Dir,* Museum of Holography - Chicago, Chicago IL

Billings, Loren, *Exec Dir,* Museum of Holography - Chicago, David Wender Library, Chicago IL

Billingsley, Robert, *Technology Prog Coordr,* National Museum of the American Indian, George Gustav Heye Center, New York NY

Billington, James H, *Librn,* Library of Congress, Prints & Photographs Division, Washington DC

Billops, Camille, *Pres,* Hatch-Billops Collection, Inc, New York NY

Bills, Danny, *Cur Coll & Exhib,* Wichita Falls Museum & Art Center, Wichita Falls TX

Bilsky, Angela, *Registrar,* Cape Cod Museum of Art Inc, Dennis MA

Bilsky, Thelma, *Registrar,* Sylvia Plotkin Museum of Temple Beth Israel, Scottsdale AZ

Binder, Fred, *Pres,* Yankton County Historical Society, Dakota Territorial Museum, Yankton SD

Binegar, Rachel, *Gallery Shop Mgr,* Dairy Barn Cultural Arts Center, Athens OH

Bing, Judith, *Assoc Prof Architecture,* Drexel University, College of Media Arts & Design, Philadelphia PA (S)

Bingaman, Kate, *Asst Prof,* Mississippi State University, Dept of Art, Mississippi State MS (S)

Bingham, Georganne, *Deputy Dir External Affairs,* North Carolina Museum of Art, Reference Library, Raleigh NC

Bingham, Pam, *Dept Head Bus Office Tech,* Antonelli College, Cincinnati OH (S)

Bingmann, Melissa, *Dir Educ,* Rhode Island Historical Society, Providence RI

Binkley, David, *Chief Cur,* Smithsonian Institution, National Museum of African Art, Washington DC

Binkowski, Kraig, *Head Librn,* Delaware Art Museum, Wilmington DE

Binks, Ronald, *Prof,* University of Texas at San Antonio, Dept of Art & Art History, San Antonio TX (S)

Bintz, Carol, *Assoc Dir Business Operations,* Toledo Museum of Art, Toledo OH

Biondi, Priscilla, *Architectural Librn,* Wentworth Institute of Technology Library, Boston MA

Bippes, Bill, *Div Dir Music Arts,* Spring Arbor College, Art Dept, Spring Arbor MI (S)

Bippes, Will, *Instr,* Hillsdale College, Art Dept, Hillsdale MI (S)

Birchall, Connie, *Bus Mgr,* Owensboro Museum of Fine Art, Owensboro KY

Bird, Donal, *Dean,* Howard Payne University, Dept of Art, Brownwood TX (S)

Bird, Joyce, *Catalogs,* Everson Museum of Art, Syracuse NY

Bird, Mary F, *Asst Cur,* Gadsden Museum, Mesilla NM

Bird, Richard, *Chmn,* Chadron State College, Dept of Art, Chadron NE (S)

Bird, Richard, *Chair Performing & Visual Arts,* Chadron State College, Main Gallery, Chadron NE

Birdsong, Sherri, *Cur Coll,* Mamie McFaddin Ward, Beaumont TX

Birk, Sherry, *Cur Coll,* American Architectural Foundation, The Octogon Museum, Washington DC

Birkner, Tom, *Adjunct Asst Prof,* Drew University, Art Dept, Madison NJ (S)

Birmingham, Robbin, *Exec Asst,* Jule Collins Smith Museum of Art, Auburn AL

Birnbryer, Susan J., *Dir Mktg,* Berkshire Museum, Pittsfield MA

Biron, Normand, *Pres (Montreal),* International Association of Art Critics, ALCA Canada, Inc, Tornoto ON

Bisbee, John, *Lectr,* Bowdoin College, Art Dept, Brunswick ME (S)

Bisbing, Roger, *Technician,* State University of New York at Albany, Art Dept, Albany NY (S)

Bischoff, Pam, *Prog Admin Mgr,* Kentucky Guild of Artists & Craftsmen Inc, Berea KY

Bisenivs, Jim, *Instr,* Morningside College, Art Dept, Sioux City IA (S)

Bishop, Brian, *Prof,* Lansing Community College, Visual Arts & Media Dept, Lansing MI (S)

Bishop, Henry, *Cur,* Society for the Protection & Preservation of Black Culture in Nova Scotia, Black Cultural Center for Nova Scotia, Dartmouth NS

Bishop, Janet, *Librn/Archives Asst,* New Brunswick Museum, Archives & Research Library, Saint John NB

Bishop, Janet C, *Cur Painting & Sculpture,* San Francisco Museum of Modern Art, San Francisco CA

Bishop, Jerold, *Assoc Prof Graphic Illustration,* University of Arizona, Dept of Art, Tucson AZ (S)

Bishop, Michael, *Prof,* California State University, Chico, Department of Art & Art History, Chico CA (S)

Bishop, Ron, *Cur & Dir,* Edison Community College, Gallery of Fine Art, Fort Myers FL

Bishop, Sam, *VPres,* Kappa Pi International Honorary Art Fraternity, Cleveland MS

Bishop, Steve, *Assoc Prof,* Murray State University, Dept of Art, Murray KY (S)

Bisson, Mariella, *Instr,* Woodstock School of Art, Inc, Woodstock NY (S)

Bissonnette, Daniel, *Dir,* Musee Regional de Vaudreuil-Soulanges, Vaudreuil PQ

Bissonnette, Daniel, *Dir,* Musee Regional de Vaudreuil-Soulanges, Centre d'Histoire d'la Presqu'ile, Vaudreuil PQ

Bitter, Ann, *Admin Dir,* Walker Art Center, Minneapolis MN

Bitter, Robert, *Finance Officer,* Laguna Art Museum, Laguna Beach CA

Bittman, Dan, *Instr Computer Graphics,* The Art Institute of Cincinnati, Cincinnati OH (S)

Bittner, Laura, *Intern/Co-op Coordr,* Purdue University, West Lafayette, Patti and Rusty Rueff Department of Visual & Performing Arts, West Lafayette IN (S)

Bitz, Gwen, *Registrar,* Walker Art Center, Minneapolis MN

Bizzarro, Tina Walduier, *Chmn Div,* Rosemont College, Art Program, Rosemont PA (S)

Bjarnesen, Lynne, *Exec Dir,* Danville Museum of Fine Arts & History, Danville VA

Bjelajac, David, *Chmn,* George Washington University, Dept of Art, Washington DC (S)

Bjerke, Kathy, *Bookkeeper,* Northfield Arts Guild, Northfield MN

Bjornseth, Dick, *Cur,* Valdosta State University, Art Gallery, Valdosta GA

Bjurlin, Marvin, *Prof,* State University College of New York at Fredonia, Dept of Art, Fredonia NY (S)

Blache, Gerard J, *Buildings & Ground Supt,* National Trust for Historic Preservation, Chesterwood Estate & Museum, Stockbridge MA

Black, Amy, *Pub Relations & Mktg,* Worcester Center for Crafts, Krikorian Gallery, Worcester MA

Black, Bettye, *Cur,* Langston University, Melvin B Tolson Black Heritage Center, Langston OK

Black, David S, *Dir,* French Institute-Alliance Francaise, Library, New York NY

Black, Diana, *Asst Prof,* University of Wisconsin-Stevens Point, Dept of Art & Design, Stevens Point WI (S)

Black, Elise, *Pres,* New York Society of Women Artists, Inc, Westport CT

Black, Jack, *Bd Chmn & Cur,* City of Fayette, Alabama, Fayette Art Museum, Fayette AL

Black, Jane A, *Exec Dir,* Dayton Visual Arts Center, Dayton OH

Black, Kell, *Assoc Prof,* Austin Peay State University, Dept of Art, Clarksville TN (S)

Black, Larry, *Exec Dir,* Columbus Metropolitan Library, Humanities, Fine Art & Recreation Division, Columbus OH

Black, Mary L, *Head Art Library,* Michigan State University, Fine Arts Library, East Lansing MI

Black, Patricia, *Reference Librn,* Universite du Quebec, Bibliotheque des Arts, Montreal PQ

Black, Sara, *Exten Prog Dir,* Oregon College of Art & Craft, Hoffman Gallery, Portland OR

Black, Steve, *Assoc Prof,* Vincennes University Junior College, Humanities Art Dept, Vincennes IN (S)

Black, Steve O, *Dept Head,* Grayson County College, Art Dept, Denison TX (S)

Black, Sue, *Visitors Serv Mgr,* Southern Alberta Art Gallery, Library, Lethbridge AB

Blackaby, Anita D, *Dir,* Pennsylvania Historical & Museum Commission, Harrisburg PA

Blackburn, Bob, *Exec Dir,* Oklahoma Historical Society, Library Resources Division, Oklahoma City OK

Blackburn, Elizabeth, *Educ, Pub Relations,* Texas Fine Arts Association, Jones Center For Contemporary Art, Austin TX

Blackburn, Gary L, *Assoc Prof,* Mercer University, Art Dept, Macon GA (S)

Blackledge, Lee, *Grant Writer,* University of Kansas, Spencer Museum of Art, Lawrence KS

Blackmon, Mary Collins, *Dir,* Elisabet Ney, Austin TX

Blackmon, Mary Collins, *Dir,* Elisabet Ney, Library, Austin TX

Blackmore, Eric, *Adjunct Instructor Art,* Florida Southern College, Melvin Art Gallery, Lakeland FL

Blackmore, Eric, *Asst Prof,* Florida Southern College, Art Dept, Lakeland FL (S)

Blackmun, Barbara, *Instr,* San Diego Mesa College, Fine Arts Dept, San Diego CA (S)

Blackport, Mary Jo, *Library Dir,* Olivet College, Library, Olivet MI

Blackson, Robert, *Exhibs Coord,* Bronx Council on the Arts, Longwood Arts Gallery, Bronx NY

Blackstone, Julie, *Instr,* Oklahoma Baptist University, Art Dept, Shawnee OK (S)

Blackwelder, Martha, *Cur Asian Art,* San Antonio Museum of Art, San Antonio TX

Blackwell, Mary, *Production Mgr,* City of Hampton, Hampton Arts Commission, Hampton VA

Blackwood, C Roy, *Prof,* Southeastern Louisiana University, Dept of Visual Arts, Hammond LA (S)

Bladen, Martha, *Pres,* Switzerland County Historical Society Inc, Life on the Ohio: River History Museum, Vevay IN

Bladen, Martha, *Pres,* Switzerland County Historical Society Inc, Switzerland County Historical Museum, Vevay IN

Blades, John, *Dir,* Flagler Museum, Palm Beach FL

Blades-Premet, Heather, *Mus Shop Mgr,* Norton Museum of Art, West Palm Beach FL

Blagg, Margaret, *Exec Dir,* The Old Jail Art Center, Green Research Library, Albany TX

Blagg, Margaret, *Exec Dir,* The Old Jail Art Center, Albany TX

Blair, Brent, *Instr,* Gettysburg College, Dept of Visual Arts, Gettysburg PA (S)

Blair, Edward McCormick, *Chmn Emer,* The Art Institute of Chicago, Dept of Prints & Drawings, Chicago IL

Blair, Nikki, *Prof,* University of North Carolina at Greensboro, Art Dept, Greensboro NC (S)

Blair, Steve, *Asst Prof Music-Jazz,* Johnson State College, Dept Fine & Performing Arts, Dibden Center for the Arts, Johnson VT (S)

Blair, Terri, *Instr,* Grayson County College, Art Dept, Denison TX (S)

Blair, Thomas, *Dir Human Resources,* Ferguson Library, Stamford CT

Blair Michele, Terry, *Educ Dir,* Chaffee Center for the Visual Arts, Rutland VT

Blais, Louise, *Cultural Counsellor,* Canadian Embassy, Art Gallery, Washington DC

Blake, Erin, *Cur Art,* Folger Shakespeare, Washington DC

Blake, Holly, *Residency Mgr,* Headlands Center for the Arts, Sausalito CA

Blake, Janet, *Cur Coll,* Laguna Art Museum, Laguna Beach CA

Blake, Jody, *Cur Tobin Theatre Coll & Library,* McNay, San Antonio TX

Blake, Jody, *Prof,* Bucknell University, Dept of Art, Lewisburg PA (S)

Blakely, David, *Dir Theater Dept,* North Carolina Wesleyan College, Dept of Visual & Performing Arts, Rocky Mount NC (S)

Blakely, Glen, *Prof,* Dixie College, Art Dept, Saint George UT (S)

Blakely, Larry, *Asst Prof,* Taylor University, Visual Art Dept, Upland IN (S)

Blakeslee, Michael, *Grad Prog,* University of the Arts, Philadelphia Colleges of Art & Design, Performing Arts & Media & Communication, Philadelphia PA (S)

Blamos, Donald C, *Dir,* McLennan Community College, Visual Arts Dept, Waco TX (S)

Blancett, Janice, *Educ,* Zoo Montana, Billings MT

Blanchard, David, *Dir Develop,* Penobscot Marine Museum, Searsport ME

Blanchard, Jim, *Pres Manitoba Historical Society,* Manitoba Historical Society, Dalnavert Museum, Winnipeg MB

Blanchard-Gross, Diana, *Cur,* Peninsula Fine Arts Center, Newport News VA

Blanche, Sharla, *Registrar,* Anchorage Museum at Rasmuson Center, Anchorage AK

Blanchfield, Michael, *VPres,* Passaic County Historical Society, Paterson NJ

Bland, Brenda, *Develop Officer,* University of Wyoming, University of Wyoming Art Museum, Laramie WY

Bland, Donna, *1st Vice Pres,* Coppini Academy of Fine Arts, Library, San Antonio TX

Bland, Sharon, *Owner,* Tabor Opera House Museum, Leadville CO

Blank, Peter, *Deputy Librn,* Stanford University, Art & Architecture Library, Stanford CA

Blankenbaker, Jeremiah, *Registrar,* Rockford Art Museum, Rockford IL

Blanks, Scott, *Chmn,* Benedict College, Fine Arts Dept, Columbia SC (S)

Blanton, Dennis B, *Dir Archaeology,* Shirley Plantation, Charles City VA

Blanton, Linnis, *Instr,* Lamar University, Art Dept, Beaumont TX (S)

Blasdel, Gregg, *Asst Prof,* St Michael's College, Fine Arts Dept, Colchester VT (S)

Blass, Hillary, *Dir Human Resources,* Whitney Museum of American Art, New York NY

Blatchley, Jeremy, *Reference Librn,* Bryn Mawr College, Rhys Carpenter Library for Art, Archaeology, Classics & Cities, Bryn Mawr PA

Blatherwick, David, *Prof,* University of Windsor, Visual Arts, Windsor ON (S)

Blatherwick, Mary, *Pres,* Sunbury Shores Arts & Nature Centre, Inc, Gallery, Saint Andrews NB

Blatter, Alfred, *Head Dept Performing Arts,* Drexel University, College of Media Arts & Design, Philadelphia PA (S)

Blaugher, Kurt, Mount Saint Mary's University, Visual & Performing Arts Dept, Emmitsburg MD (S)

Blaugrund, Annette, *Dir,* National Academy Museum & School of Fine Arts, New York NY

Blaugrund, Annette, *Dir,* National Academy Museum & School of Fine Arts, Archives, New York NY

Blauvelt, Andrew, *Design Dir,* Walker Art Center, Minneapolis MN

Blazier, Wendy M., *Sr Cur,* Boca Raton Museum of Art, Boca Raton FL

Bleck, Carol, *CFO & Deputy Dir,* Tucson Museum of Artand Historic Block, Tucson AZ

Bleha, Bernie, *Chmn,* Green River Community College, Art Dept, Auburn WA (S)

Bleich, Maxine, *Pres,* Ventures Education Systems Corporation, New York NY

Bleiler, S, *Librn,* Burlington County Historical Society, Burlington NJ

Bleiweis, Maxine, *Dir,* Westport Public Library, Westport CT

Blessin, Sylvia, *Adminr & Prog Coordr,* Contemporary Art Gallery Society of British Columbia, Art Library Service, Vancouver BC

Bletter, Rosemarie Haag, *Prof,* City University of New York, PhD Program in Art History, New York NY (S)

Blevins, Anne, *Dir Admis,* The New England School of Art & Design at Suffolk University, Boston MA (S)

Blevins, Tedd, *Instr,* Virginia Intermont College, Fine Arts Div, Bristol VA (S)

Blevins, Tracy, Jamestown-Yorktown Foundation, Williamsburg VA

Blew, Gregory, *Clin Asst Prof,* University of Illinois at Chicago, Biomedical Visualization, Chicago IL (S)

Blick, Sarah, *Asst Prof,* Kenyon College, Art Dept, Gambier OH (S)

Blinn, Jean, *Sr Librn in Charge,* Oakland Public Library, Art, Music & Recreation Section, Oakland CA

Blinn, Ken, *Educ Progs,* The Barnum Museum, Bridgeport CT

Blisard, Herb, *Faculty,* Yakima Valley Community College, Dept of Visual Arts, Yakima WA (S)

Bliss, Jerry, *Asst Prof,* Colby-Sawyer College, Dept of Fine & Performing Arts, New London NH (S)

Bliss, Kelly, *Cartaloger,* Corning Museum of Glass, Juliette K and Leonard S Rakow Research Library, Corning NY

Bliss MFA, Harry E, *Assoc Prof & Dir,* Palomar Community College, Art Dept, San Marcos CA (S)

Bloch, Alexia, *Cur Northwest Coast,* University of British Columbia, Museum of Anthropology, Vancouver BC

Bloch, Amy, *Asst Prof,* California State University, Chico, Department of Art & Art History, Chico CA (S)

Bloch, Kathleen, *Assoc Dir,* Spertus Institute of Jewish Studies, Asher Library, Chicago IL

Block, Diana, *Gallery Dir,* University of North Texas, Art Gallery, Denton TX

Block, Judy, *Assoc Prof,* Wellesley College, Art Dept, Wellesley MA (S)

Block, Lora, *Pres,* Pastel Society of Oregon, Roseburg OR

Block, Philip, *Dir Educ,* International Center of Photography, New York NY

Block, Sarah, *Admin Support,* Mount Royal College, Dept of Interior Design, Calgary AB (S)

Blocton, Lulu, *Chmn,* Eastern Connecticut State University, Fine Arts Dept, Willimantic CT (S)

Blohm Pultz, Janet, *Dir,* Vesterheim Norwegian-American Museum, Decorah IA

Blomquist, Eric, *Dir Special Events,* National Academy Museum & School of Fine Arts, New York NY

Blomquist, Eric, *Dir Special Events,* National Academy Museum & School of Fine Arts, Archives, New York NY

Blondin, Bruce, *Instr,* Solano Community College, Division of Fine & Applied Art & Behavioral Science, Suisun City CA (S)

Blondin, Jill, *Asst Prof,* University of Texas at Tyler, Deptartment of Art, School of Visual & Performing Arts, Tyler TX (S)

Blood, Peggy, *Dir,* Savannah State University, Dept of Fine Arts, Savannah GA (S)

Bloodgood, Craig, *Spec Projects Cur,* Art Complex Museum, Carl A. Weyerhaeuser Library, Duxbury MA

Bloodgood, Dean, *Assoc Prof,* Oklahoma State University, Art Dept, Stillwater OK (S)

Bloom, Beth, *Art Librn,* Seton Hall University, Walsh Library, South Orange NJ

Bloom, Sharon, *Chmn,* West Shore Community College, Division of Humanities & Fine Arts, Scottville MI (S)

Bloom, Sue, *Dept Head,* Western Maryland College, Dept of Art & Art History, Westminster MD (S)

Bloomenstein, Laura, Yavapai College, Visual & Performing Arts Div, Prescott AZ (S)

Bloomer, Harlan, *Dir,* Minnesota State University, Mankato, Mankato MN

Bloomer, Jerry, *Sec Bd,* R W Norton Art Foundation, Library, Shreveport LA

Bloomer, Jerry M, *Dir Pub Relations,* R W Norton Art Foundation, Shreveport LA

Bloomer, Jerry M, *Secy Bd,* R W Norton Art Foundation, Shreveport LA

Bloomfield, Debra, *Instr,* Solano Community College, Division of Fine & Applied Art & Behavioral Science, Suisun City CA (S)

Bloomquist, Charly, *Instr,* Whitman College, Art Dept, Walla Walla WA (S)

Bloss, Wally, *Exec Dir,* Allied Arts Council of St Joseph, Saint Joseph MO

Blosser, Jacob, *Cur Educ,* Belle Grove Plantation, Middletown VA

Blosser, John, *Chmn,* Goshen College, Art Dept, Goshen IN (S)

Blount, Amy, *Instr,* Pierce College, Art Dept, Woodland Hills CA (S)

Blount, Wayne, *Bldg Supt,* Birmingham Museum of Art, Birmingham AL

Blount, Wayne, *Bldg Supt,* Birmingham Museum of Art, Clarence B Hanson Jr Library, Birmingham AL

Blum, Pat, *Dir Develop,* McAllen International Museum, McAllen TX

Blum, Steve, *Dir Admin,* The Long Island Museum of American Art, History & Carriages, Stony Brook NY

Blum-Cumming, Nancy, *Lectr,* University of Wisconsin-Stout, Dept of Art & Design, Menomonie WI (S)

Blumberg, Linda, *Exec Dir,* Art Dealers Association of America, Inc, New York NY

Blumberg, Naomi, *Exhib Coordr,* Boston College, McMullen Museum of Art, Chestnut Hill MA

Blume, Sharon, *Dir,* Stamford Museum & Nature Center, Stamford CT

Blumenfeld, Erica, *Cur Exhib,* Museum for African Art, Long Island City NY

Blumenthal, Arthur R, *Dir,* Rollins College, George D & Harriet W Cornell Fine Arts Museum, Winter Park FL

Blunck, Kirk V, *Pres Board Trustees,* Edmundson Art Foundation, Inc, Des Moines Art Center, Des Moines IA

Blundell, Harry, *Dir Theatre,* Arts Center of the Ozarks, Springdale AR

Blundell, Kathi, *Dir,* Arts Center of the Ozarks, Springdale AR

Blus, Sharon, *Dir Develop & Mktg,* Oregon Historical Society, Oregon History Center, Portland OR

Bly DeVere, Julia, *Mgr,* Rosicrucian Egyptian Museum & Planetarium, Rosicrucian Order, A.M.O.R.C., San Jose CA

Boada, Maria, *Gen Educ,* Art Institute of Pittsburgh, Pittsburgh PA (S)

Board, Aaron, *Instr,* Mohawk Valley Community College, Utica NY (S)

Boatman, Linda, *Pres,* Palette & Chisel Academy of Fine Arts, Chicago IL

Bober, Andrée Hymel, *Deputy Dir,* Contemporary Arts Center, Cincinnati OH

Boberg, Scott, *Cur Educ,* University of Wyoming, University of Wyoming Art Museum, Laramie WY

Bobick, Bruce, *Chmn,* State University of West Georgia, Art Dept, Carrollton GA (S)

Bobince, Helen, *Asst to Dir,* Phoenix Art Museum, Phoenix AZ

Bobo, Susan, *Architecture Librn,* Oklahoma State University, Architecture Library, Stillwater OK

Bocci, Roberto, *Prof,* Georgetown University, Dept of Art, Music & Theatre, Washington DC (S)

Bochicchio, Nicholas, *Dir Admin Servs,* Ferguson Library, Stamford CT

Bochmann, Gregor, *Assoc Prof,* Universite de Montreal, Bibliotheque d'Amenagement, Montreal PQ

Bochnowski, Jean, *Dir,* National Audubon Society, John James Audubon Center at Mill Grove, Audubon PA

Bockelman, Jim, *Prof,* Concordia College, Art Dept, Seward NE (S)

Bockner, Matt, Olympic College, Social Sciences & Humanities Di, Bremerton WA (S)

Bodden, Charlie, *Mgr Support Svcs,* Tucson Museum of Artand Historic Block, Tucson AZ

Boden, Jim, *Assoc Prof Painting & Drawing,* Coker College, Art Dept, Hartsville SC (S)

Bodenheimer, Louise, *Asst Prof,* Southeast Missouri State University, Dept of Art, Cape Girardeau MO (S)

Bodily, Vince, *Instr,* Ricks College, Dept of Art, Rexburg ID (S)

Bodine, William, *Deputy Dir & Chief Cur,* Columbia Museum of Art, Columbia SC

Bodwitch, Lucy, *Asst Prof,* College of Saint Rose, Art Dept, Albany NY (S)

Boehme, Doro, *Artists' Book Coll Specialist,* School of the Art Institute of Chicago, John M Flaxman Library, Chicago IL

Boehme, Sarah E, *Dir Stark Mus of Art,* Nelda C & H J Lutcher Stark, Stark Museum of Art, Orange TX

Boehr, Kay M, *Asst Prof,* Park University, Dept of Art & Design, Parkville MO (S)

Boelts, Jackson, *Prof Graphic Design-Illustration,* University of Arizona, Dept of Art, Tucson AZ (S)

Boerner, Parker, *Assoc Prof,* Indiana University of Pennsylvania, College of Fine Arts, Indiana PA (S)

Boerner, Steve, *Archivist,* East Hampton Library, Pennypacker Long Island Collection, East Hampton NY

Boese, Kent, *Cataloger,* National Portrait Gallery, Library, Washington DC

Boese, Kent, *Cataloger,* Smithsonian American Art Museum, Library of the Smithsonian American Art Museum, Washington DC

Boetcher, Chris, *Cur Arts,* Randall Junior Museum, San Francisco CA

Bogans, Alphonso, *Bldg & Grounds Mgr,* Albany Museum of Art, Albany GA

Bogart, Michele H, *Prof,* State University of New York at Stony Brook, Dept of College of Arts & Sciences, Art Dept, Stony Brook NY (S)

Bogdanovitch, George, *Prof,* Denison University, Dept of Art, Granville OH (S)

Bogel, Ingrid E, *Exec Dir,* Conservation Center for Art & Historic Artifacts, Philadelphia PA

Boggess, Lynn, *Prof,* Fairmont State College, Div of Fine Arts, Fairmont WV (S)

Boggs, David, *Assoc Prof,* Concordia College, Art Dept, Moorhead MN (S)

Bogle, Bridgett, *Instr,* Sinclair Community College, Division of Fine & Performing Arts, Dayton OH (S)

Bogusky, Alf, *Exec Dir,* Kitchener-Waterloo Art Gallery, Kitchener ON

Bohan, Ruth, *Assoc Prof,* University of Missouri, Saint Louis, Dept of Art & Art History, Saint Louis MO (S)

Bohanon, Gloria, *Prof,* Los Angeles City College, Dept of Art, Los Angeles CA (S)

Bohinelli, Lora, *Cur Folklore,* Salisbury University, Ward Museum of Wildfowl Art, Salisbury MD

Bohlen, H David, *Asst Cur Zoology,* Illinois State Museum, Museum Store, Chicago IL

Bohn, Babette, *Prof,* Texas Christian University, Dept of Art & Art History, Fort Worth TX (S)

Bohnert, Thomas, *Prof,* Mott Community College, Liberal Arts & Sciences, Flint MI (S)

Bohr, G Ted, *Dir,* Creighton University, Lied Art Gallery, Omaha NE

Bohr, Ted, Creighton University, Fine & Performing Arts Dept, Omaha NE (S)

Bohrer, Fred, *Assoc Prof,* Hood College, Dept of Art, Frederick MD (S)

Boice, Linda, *Mus Mgr,* National Audubon Society, John James Audubon Center at Mill Grove, Audubon PA

Boisselle, Melissa, *Event & Volunteer Coordr,* Wistariahurst Museum, Holyoke MA

Boisvert, Tom, *Head Art Dept,* Greenfield Community College, Art, Communication Design & Media Communication Dept, Greenfield MA (S)

Bokelman, Dorothy, *Dir,* Nazareth College of Rochester, Art Dept, Rochester NY (S)

Bokram, Karen, *Pres,* Maryland Art Place, Baltimore MD

Bol, Marsha C, *Deputy Dir,* Museum of New Mexico, Museum of Fine Arts, Unit of NM Dept of Cultural Affairs, Santa Fe NM

Bol, Martha, *Dir,* Museum of New Mexico, Museum of Fine Arts Library and Archive, Santa Fe NM

Bolander, Diana, *Cur & Educ Coordr,* Northwestern Michigan College, Dennos Museum Center, Traverse City MI

Bolden, Joyce, *Chmn,* Alcorn State University, Dept of Fine Arts, Lorman MS (S)

Boldenolo, John, *Theatre Develop,* Wichita Center for the Arts, Mary R Koch Sch of Visual Arts, Wichita KS (S)

Bolding, Gary, *Prof,* Stetson University, Art Dept, Deland FL (S)

Bolen, Jerry, *Dept Head,* Southwestern Illinois College, Art Dept, Belleville IL (S)

Bolen, Virginia, *Instr,* Schenectady County Historical Society, Museum of Schenectady History, Schenectady NY

Bolge, George, *Exec Dir,* Boca Raton Museum of Art, Library, Boca Raton FL

Bolge, George S, *Exec Dir,* Boca Raton Museum of Art, Boca Raton FL

Bolger, Doreen, *Dir,* The Baltimore Museum of Art, Baltimore MD

Bolger, Laurie, *Conservation Librn,* University Club Library, New York NY

Bolis, Valda, *Librn,* The Art Institute of Boston at Lesley University, Library, Boston MA

Bollinger, Ben, *Dean of Faculty,* Citrus College, Art Dept, Glendora CA (S)

Bolon, Don, *Treas,* Print Club of Albany, Albany NY

Bolourchi, Pati, *Librn,* Detroit Public Library, Art & Literature Dept, Detroit MI

Bolser, Barbara, *Asst Prof,* University of Illinois at Springfield, Visual Arts Program, Springfield IL (S)

Bolt, Macyn, *Preparator,* Fried, Frank, Harris, Shriver & Jacobson, Art Collection, New York NY

Bolt, Ron, *Pres,* Royal Canadian Academy of Arts, Toronto ON

Boltan, Randy, *Head Dept Print Medida,* Cranbrook Academy of Art, Bloomfield Hills MI (S)

Boltax, Bernice, *Curatorial Asst,* Hebrew Union College, Jewish Institute of Religion Museum, New York NY

Bolton, Bruce, *Asst Dir Mktg & Visitor Servs,* Department of Community Development, Provincial Museum of Alberta, Edmonton AB

Bolton, Bruce D, *Dir,* The Stewart, Montreal PQ

Bolton, David, *Ceramics,* College of Lake County, Art Dept, Grayslake IL (S)

Bolton, Theresa, *Recording Sec,* Halifax Historical Society, Inc, Halifax Historical Museum, Daytona Beach FL

Bomberg, Nathalie, *Assoc Dir Laurel Operations,* Kelowna Museum, Kelowna BC

Bonadies, Stephen, *Deputy Dir,* Cincinnati Museum Association and Art Academy of Cincinnati, Cincinnati Art Museum, Cincinnati OH

Bonanno, Michael, *Dir Educ,* USS Constitution Museum, Boston MA

Bonansinga, Kate, *Dir,* University of Texas at El Paso, Glass Gallery and Main Gallery, El Paso TX

Bonc, Rod, *Deputy Dir Oper,* Columbus Museum of Art, Columbus OH

Bond, Debra, *Dir,* University of West Florida, Art Gallery, Pensacola FL

Bond, Hallie, *Cur,* The Adirondack Historical Association, The Adirondack Museum, Blue Mountain Lake NY

Bondil, Natalie, *Chief Conservator,* Montreal Museum of Fine Arts, Montreal PQ

Bonin Pissarro, Frederic, *Instr Illustration & Design,* The Art Institute of Cincinnati, Cincinnati OH (S)

Bonjorni, Mary Ann, *Assoc Prof,* University of Montana, Dept of Art, Missoula MT (S)

Bonnell, Bill, *Pres,* Color Association of the US, New York NY

Bonnell, Gayla, *Third VPres,* Arizona Watercolor Association, Phoenix AZ

Bonnelly, Claude, *Dir General Library System,* L'Universite Laval, Library, Quebec PQ

Bonner, Jean, *Dean Art Dept,* Schoolcraft College, Dept of Art & Design, Livonia MI (S)

Bonzelaar, Helen, *Prof,* Calvin College, Art Dept, Grand Rapids MI (S)

Book, Michael, *Assoc Prof,* Louisiana State University, School of Art, Baton Rouge LA (S)

Booker, June, *Gift Shop Chmn,* Alton Museum of History & Art, Inc, Alton IL

Booker, Robert C, *Exec Dir,* Arizona Commission on the Arts, Reference Library, Phoenix AZ

Boone, Charles, *Asst Prof,* College of DuPage, Liberal Arts Division, Glen Ellyn IL (S)

Boone, M Elizabeth (Betsy), *Chair,* University of Alberta, Dept of Art & Design, Edmonton AB (S)

Boone, Susan, *Business Mgr,* Southeastern Center for Contemporary Art, Winston-Salem NC

Booth, David W, *Instr,* Universite de Montreal, Dept of Art History, Montreal PQ (S)

Booth, Helen, *Cur,* Jordan Historical Museum of The Twenty, Jordan ON

Booth, Michael, *Chmn,* Blue Mountain Community College, Fine Arts Dept, Pendleton OR (S)

Booth, Peter, *Educs Progs Mgr,* Maricopa County Historical Society, Desert Caballeros Western Museum, Wickenburg AZ

Booth, Robert, *Prof,* State University College of New York at Fredonia, Dept of Art, Fredonia NY (S)

Boothe, Berrisford, *Assoc Prof,* Lehigh University, Dept of Art & Architecture, Bethlehem PA (S)

Boothe, Constance, *Instr,* Clark-Atlanta University, School of Arts & Sciences, Atlanta GA (S)

Boothe, Power, *Dir,* Ohio University, School of Art, Athens OH (S)

Bopp, Emery, *Instr,* Bob Jones University, Div of Art, Greenville SC (S)

Bopp, Jay, *Instr,* Bob Jones University, Div of Art, Greenville SC (S)

Boppel, Todd, *Prof,* University of Wisconsin-Stout, Dept of Art & Design, Menomonie WI (S)

Borchardt, Susan, *Cur,* Gunston Hall Plantation, Library, Mason Neck VA

Borchardt, Susan A, *Asst Dir,* Gunston Hall Plantation, Mason Neck VA

Borcherbing, Kate, *Asst Prof,* Sam Houston State University, Art Dept, Huntsville TX (S)

Bordeau, Bill, *Prof,* Marymount Manhattan College, Fine & Performing Arts Dept, New York NY (S)

Bordelon, Kathleen, *Exhib Designer,* Norfolk Historical Society Inc, Museum, Norfolk CT

Borden, Tamika, *Dir,* Cambria Historical Society, New Providence NJ

Boree, Katherine, *Marketing Assoc,* Contemporary Crafts Museum & Gallery, Contemporary Crafts Gallery, Portland OR

Borgantti, Teresa, *Registrar,* Museo de Arte de Puerto Rico, San Juan PR

Borge, John, *Instr,* Concordia College, Art Dept, Moorhead MN (S)

Borges, Richard, *Dir,* Bennington Museum, Library, Bennington VT

Borges, Richard, *Exec Dir,* Bennington Museum, Bennington VT

Borgeson, Jacquelyn, *Cur,* Martin and Osa Johnson, Imperato Collection of West African Artifacts, Chanute KS

Borgeson, Jacquelyn, *Cur,* Martin and Osa Johnson, Johnson Collection of Photographs, Movies & Memorabilia, Chanute KS

Borgeson, Jacquelyn, *Cur,* Martin and Osa Johnson, Selsor Art Gallery, Chanute KS

Borgeson, Jacquelyn L, *Cur,* Martin and Osa Johnson, Chanute KS

Boris, Staci, *Sr Cur,* Spertus Institute of Jewish Studies, Spertus Museum, Chicago IL

Borkin, Betty, *Head Technical Servs,* Springfield Free Public Library, Donald B Palmer Museum, Springfield NJ

Borne, Allyn, *Develop Dir,* Lauren Rogers, Laurel MS

Borntrager Quattrocchi, Shelly, *Librn Asst,* Columbus Museum of Art and Design, Stout Reference Library, Indianapolis IN

Borrow, Joseph, *Pres,* Boca Raton Museum of Art, Boca Raton FL

Borrup, Tom, *Exec Dir,* Intermedia Arts Minnesota, Minneapolis MN

Borsanyi, Jackie, *Cur Exhibitions,* Brevard Museum of Art & Science, Melbourne FL

Borst, Kim, *Lectr,* University of Wisconsin-Superior, Programs in the Visual Arts, Superior WI (S)

Bortner, Judy, *Dir Retail Operations,* Kentucky Derby Museum, Louisville KY

Boruchov, Zoya, *Gallery Mgr,* Contemporary Art Gallery, Toronto ON

Borwning, Shirley, *Mem Mgr,* African American Museum in Philadelphia, Philadelphia PA

Borycki, John, *Pres, Security & Cur,* North Tonawanda History Museum, North Tonawanda NY

Bosch, Clark, *Asst Dir,* Zoo Montana, Billings MT

Bosco, Bob, *Instr,* Creighton University, Fine & Performing Arts Dept, Omaha NE (S)

Bose, Arvn, *Assoc Prof,* Herbert H Lehman, Art Dept, Bronx NY (S)

Boshart, Jeff, *Prof,* Eastern Illinois University, Art Dept, Charleston IL (S)

Boshart, Jon D, *Chmn,* Saint Peter's College, Fine Arts Dept, Jersey City NJ (S)

Boskoff, Katie, *Develop Dir,* Maritime Museum of San Diego, San Diego CA

Bosse, David C, *Librn,* Historic Deerfield, Henry N Flynt Library, Deerfield MA

Bosso, O Robert, *Thesis Advisor,* Toronto Art Therapy Institute, Toronto ON (S)

Bosson, Jack, *Chmn Animation,* Woodbury University, Dept of Graphic Design, Burbank CA (S)

Bostock, Bret, *Colls Mgr,* Academy of the New Church, Glencairn Museum, Bryn Athyn PA

Boswell, Cindy, *Mus Shop Mgr,* Portland Art Museum, Northwest Film Center, Portland OR

Boswell, Jane, *VPres,* Tippecanoe County Historical Association, Museum, Lafayette IN

Boswell, Jennifer, *Visitor Svcs Clerk,* Belle Grove Plantation, Middletown VA

Boswell, Peter, *Sr Cur,* Miami Art Museum, Miami FL

Boswell, Tracey, *Adjunct Prof Art Hist,* Johnson County Community College, Visual Arts Program, Overland Park KS (S)

Bosworth, Barbara, *Chmn Media,* Massachusetts College of Art, Boston MA (S)

Botar, Oliver, University of Manitoba, School of Art, Winnipeg MB (S)

Bott, John, *Prof,* Colby-Sawyer College, Dept of Fine & Performing Arts, New London NH (S)

Bottomly-O'Looney, Jennifer, *Registrar,* Montana Historical Society, Helena MT

Botwinick, Michael, *Dir,* The Hudson River Museum, Yonkers NY

Boucher, Bruce, *Cur European Decorative Arts, Sculpture & Classical Art,* The Art Institute of Chicago, Chicago IL

Boughton, Jim, *Gallery Dir,* Chaffee Center for the Visual Arts, Rutland VT

Bouknight, Alice, *Cur Educational Servs,* University of South Carolina, McKissick Museum, Columbia SC

Boulanger, Jennifer, *Dean,* Herkimer County Community College, Humanities Social Services, Herkimer NY (S)

Bounds, G, *Board Dirs,* Gananoque Museum, Gananoque ON

Bounds, Rachel, *Prog Coordr & Assoc Cur,* Arlington Museum of Art, Arlington TX

Bourassa, Linda, *Assoc Prof,* Hiram College, Art Dept, Hiram OH (S)

Bourcier, Paul, *Chief Cur,* Wisconsin Historical Society, State Historical Museum, Madison WI

Bourdon, Donald, *Archives,* Peter & Catharine Whyte Foundation, Whyte Museum of the Canadian Rockies, Banff AB

Bourdon, Richard V, *Fin Dir,* Wiscasset, Waterville & Farmington Railway Museum (WW&F), Alna ME

Bourgault, Therese, *Librn Periodicals,* Montreal Museum of Fine Arts, Library, Montreal PQ

Bourgeois, Amy, *Sales Mgr,* Vermont State Craft Center at Frog Hollow, Middlebury VT

Bourgeois, Angi, *Asst Prof,* Mississippi State University, Dept of Art, Mississippi State MS (S)

Bourgeois, Kelly, *Bus Mgr,* Holter Museum of Art, Helena MT

Bourker, James, *Pres,* Clemson University, College of Architecture, Clemson SC (S)

Bourque, Bev, *Tour Coordr, Sec & Visitor Servs Coordr,* Museum London, London ON

Bourque, Paul, *Technician,* Galerie d'art de l'Universite de Moncton, Moncton NB

Bous, Klaus, *Dir,* SIAS International Art Society, Library, Sherwood Park AB

Bous, Klaus, *Managing Dir,* SIAS International Art Society, Sherwood Park AB

Bousanti, Mike, *Assoc Dir,* The Rosenbach Museum & Library, Philadelphia PA

Bousard-Hui, Eva, *Lectr,* Georgian Court College, Dept of Art, Lakewood NJ (S)

Boutaba, Raouf, *Assoc Prof,* Universite de Montreal, Bibliotheque d'Amenagement, Montreal PQ

Boutin, Steve, *Board Pres,* Pence Gallery, Davis CA

Bovasso, Nina, *Studio Faculty,* University of Virginia, McIntire Dept of Art, Charlottesville VA (S)

Bovey, Patricia E., *Dir,* The Winnipeg Art Gallery, Winnipeg MB

Bowar, Sharon, *Assoc Prof,* Wilkes University, Dept of Art, Wilkes-Barre PA (S)

Bowden, Kimberly D., *Librn, Archivist,* The Haggin Museum, Petzinger Memorial Library & Earl Rowland Art Library, Stockton CA

Bowden, Sue, *Mus Shop Mgr,* Sandwich Historical Society, Center Sandwich NH

Bowe, Crystal, *Admin Asst,* Erie Art Museum, Erie PA

Bowen, Katrina, *Reference,* Mason City Public Library, Mason City IA

Bowen, Ken, *Adjunct Instr,* Virginia Wesleyan College, Art Dept of the Humanities Div, Norfolk VA (S)

Bowen, Linnell R, *Exec Dir,* Maryland Hall for the Creative Arts, Chaney Gallery, Annapolis MD

Bowen, Mary, *Cur Coll,* Evansville Museum of Arts, History & Science, Evansville IN

Bowen, Paul, *Instr, Sculpture,* Truro Center for the Arts at Castle Hill, Inc, Truro MA (S)

Bowen, Tracey, *Coordr Art Placement,* Visual Arts Ontario, Toronto ON

Bower, Bob, *Div Dir,* Southwestern Oregon Community College, Visual Arts Dept, Coos Bay OR (S)

Bower, Gerald, *Prof,* Louisiana State University, School of Art, Baton Rouge LA (S)

Bower, Melanie, *Mgr Coll Access,* Museum of the City of New York, Museum, New York NY

Bower-Peterson, Kathi, *Librn,* Library Association of La Jolla, Athenaeum Music & Arts Library, La Jolla CA

Bowerman, Douglas, *Bldg Operations Mgr,* Allentown Art Museum, Allentown PA

Bowers, John, *Asst Prof,* Oregon State University, Dept of Art, Corvallis OR (S)

Bowers, Michelle, *Assoc Prof,* Grand Valley State University, Art & Design Dept, Allendale MI (S)

Bowers, Paul, *Prof,* State University College of New York at Fredonia, Dept of Art, Fredonia NY (S)

Bowers, Paul, *VPres,* Iroquois County Historical Society Museum, Old Courthouse Museum, Watseka IL

Bowers, Stephanie, *Treas,* Iroquois County Historical Society Museum, Old Courthouse Museum, Watseka IL

Bowie, Barbara, *Dir Retail Svcs,* Witte Museum, San Antonio TX

Bowie, Eleanor, *Div Chmn Humanities,* Penn Valley Community College, Art Dept, Kansas City MO (S)

Bowie, Kim, *Dean,* Art Association of Harrisburg, School & Galleries, Harrisburg PA

Bowie, Lucille, *Librn,* Southern University, Architecture Library, Baton Rouge LA

Bowie, Mary, *VPres Finance & Admin, AAM,* American Association of Museums, US National Committee of the International Council of Museums (AAM-ICOM), Washington DC

Bowitz, John, *Chmn,* Morningside College, Art Dept, Sioux City IA (S)

Bowker, Mary, *Cur,* Evansville Museum of Arts, History & Science, Henry R Walker Jr Memorial Art Library, Evansville IN

Bowles, Johnson, *Asst Prof,* Longwood University, Dept of Art, Farmville VA (S)

Bowles, K Johnson, *Gallery Dir,* Saint Mary's College, Moreau Galleries, Notre Dame IN

Bowles, Kay Johnson, *Dir,* Longwood Center for the Visual Arts, Farmville VA

Bowles, Sandra, *Exec Dir & Ed,* Handweavers Guild of America, Suwanee GA

Bowles, Susannah, *Dir Coll,* Peoria Historical Society, Peoria IL

Bowling, Betty, *Secy,* City of Springdale, Shiloh Museum of Ozark History, Springdale AR

Bowling, Marlene, *Assoc Cur Educ,* Nevada Museum of Art, Reno NV

Bowman, Debbie, *Dir Operations,* Cincinnati Museum Association and Art Academy of Cincinnati, Cincinnati Art Museum, Cincinnati OH

Bowman, Donna, *Vis Arts Librn,* University of Regina, Education/Fine Arts Library, Regina SK

Bowman, James, *Registrar & Exhib Preparator,* Dickinson College, The Trout Gallery, Carlisle PA

Bowman, Karmien, *Assoc Prof,* Tarrant County Junior College, Art Dept, Hurst TX (S)

Bowman, Leah, *Prof,* School of the Art Institute of Chicago, Chicago IL (S)

Bowman, Leslie Greene, *Dir,* Henry Francis DuPont Winterthur Museum, Winterthur DE

Bowman, Pat, *Pres,* Eastern Shore Art Association, Inc, Eastern Shore Art Center, Fairhope AL

Bowman, Roger, *Prof,* University of Central Arkansas, Department of Art, Conway AR (S)

Bowman, Stephanie K, *Asst Prof,* Pittsburg State University, Art Dept, Pittsburg KS (S)

Bownan, JoAnn, *Cur,* Schuyler-Hamilton House, Morristown NJ

Bowser, Diane, *Gen Educ,* Art Institute of Pittsburgh, Pittsburgh PA (S)

Boyce, David, *Mgr,* Oatlands Plantation, Leesburg VA

Boyce, Robert, *Chmn,* Berea College, Doris Ulmann Galleries, Berea KY

Boyce, Robert, *Chmn,* Berea College, Art Dept, Berea KY (S)

Boyce, Roger, *Assoc Prof,* Smith College, Art Dept, Northampton MA (S)

Boyd, Ann, *Co-Dir,* Roy Boyd, Chicago IL

Boyd, Jamie, *Adjunct Prof,* Community College of Allegheny County, Boyce Campus, Art Dept, Monroeville PA (S)

Boyd, Kelly, *Store Mgr,* Morris Museum of Art, Augusta GA

Boyd, Mebane, *Deputy Dir Oper,* Cameron Art Museum, Wilmington NC

Boyd, Patti, *Dir Develop,* National Museum of Wildlife Art, Jackson WY

Boyd, Richard, *Mus Shop Mgr,* Montana Historical Society, Helena MT

Boyd, Roy, *Co-Dir,* Roy Boyd, Chicago IL

Boyd, Roy, *Treas,* Arthur Roy Mitchell, Museum of Western Art, Trinidad CO

Boyd, Willard L, *Pres Emeritus,* Field Museum, Chicago IL

Boyd, William L, *Head Dept,* Alabama A & M University, Art & Art Education Dept, Normal AL (S)

Boyd-Snee, Rancy, *Lectr,* Southeastern Louisiana University, Dept of Visual Arts, Hammond LA (S)

Boydreau, Inga, *Acting Dir,* Greenwich Library, Greenwich CT

Boyer, Cindy, *Dir Mus,* Landmark Society of Western New York, Inc, The Campbell-Whittlesey House Museum, Rochester NY

Boyer, Gretchen, *Assoc Prof,* Northern Arizona University, Museum Faculty of Fine Art, Flagstaff AZ (S)

Boyer, Irene, *Cur Asst Decorative Art,* Illinois State Museum, Illinois Art Gallery & Lockport Gallery, Springfield IL

Boyer, John, *Exec Dir,* Mark Twain, Hartford CT

Boyer, John, *Exec Dir,* Mark Twain, Research Library, Hartford CT

Boyer, Judy, *Gallery & Educ Dir,* Historic Columbian Theatre Foundation, Wamego KS

Boyer, Michel, *Aggregate Prof,* Universite de Montreal, Bibliotheque d'Amenagement, Montreal PQ

Boyer, Sarah, *Oral Historian,* Cambridge Historical Commission, Cambridge MA

Boyes, Janet W, *Financial Adminr,* Newport Historical Society & Museum of Newport History, Newport RI

Boylan, Alexis, *Asst Prof,* Lawrence University, Dept of Art, Appleton WI (S)

Boyle, Johnny, *Treas,* Frontier Times Museum, Bandera TX

Boyle, Melanie, *Dir Develop & Mem,* Amon Carter, Fort Worth TX

Boyle, Patricia, *Educ & Tours,* C M Russell, Frederic G Renner Memorial Library, Great Falls MT

Brabshaw, Larry, *Prof,* University of Nebraska at Omaha, Dept of Art & Art History, Omaha NE (S)

Brack, Mark, *Asst Prof Architecture,* Drexel University, College of Media Arts & Design, Philadelphia PA (S)

Brackbill, Eleanor, *Head Museum Educ,* State University of New York at Purchase, Neuberger Museum of Art, Purchase NY

Bracken, Hazel, *VPres,* Almond Historical Society, Inc, Hagadorn House, The 1800-37 Museum, Almond NY

Brackman, Bob, *Dir Botanical Gardens,* Cheekwood Nashville's Home of Art & Gardens, Education Dept, Nashville TN (S)

Brackney, Kathryn S, *Head Librn,* Georgia Institute of Technology, College of Architecture Library, Atlanta GA

Bracy, Tralice P, *Cur,* Monhegan Museum, Monhegan ME

Bradbury, Leonie, *Gallery Dir,* Montserrat College of Art, Beverly MA (S)

Braden, Jamey, *Asst Coordr,* Western Washington University, Viking Union Gallery, Bellingham WA

Braden, Roger, *CEO & Gen Mgr,* Chelan County Public Utility District, Rocky Reach Dam, Wenatchee WA

Bradfield, Jan, *Asst Prof,* Southwestern Oklahoma State University, Art Dept, Weatherford OK (S)

Bradfield, Jan, *Asst Prof,* University of Wisconsin-Green Bay, Arts Dept, Green Bay WI (S)

Bradfield, Nancy, *Office Mgr,* First Tennessee Bank, Memphis TN

Bradford, Barry, *Head of Dept,* Chattanooga-Hamilton County Bicentennial Library, Fine Arts Dept, Chattanooga TN

Bradham, Sharon, *Exec Dir,* Cedarhurst Center for the Arts, Mitchell Museum, Mount Vernon IL

Bradley, Alisa, *Museum Mgr,* Mississippi River Museum at Mud-Island River Park, Memphis TN

Bradley, Betsy, *Dir,* Mississippi Museum of Art, Howorth Library, Jackson MS

Bradley, Betsy, *Exec Dir,* Mississippi Museum of Art, Jackson MS

Bradley, Christine, *Publications,* Department of Canadian Heritage, Canadian Conservation Institute, Ottawa ON

Bradley, David, *Foundation VPres,* Virginia Museum of Fine Arts, Richmond VA

Bradley, Diane, *VPres,* Saint Augustine Art Association Gallery, Saint Augustine FL

Bradley, Laura, *Archivist,* Yarmouth County Historical Society, Yarmouth County Museum, Yarmouth NS

Bradley, Laurel, *Dir & Cur,* Carleton College, Art Gallery, Northfield MN

Bradley, Norman, *Assoc Prof,* Indiana-Purdue University, Dept of Fine Arts, Fort Wayne IN (S)

Bradley, Richard, *Pres Board Dirs,* Five Civilized Tribes Museum, Muskogee OK

Bradley, Ross, *Arts Prog Coordr,* Alberta Foundation for the Arts, Edmonton AB

Bradley, Steve, *Asst Prof,* University of Maryland, Baltimore County, Imaging, Digital & Visual Arts Dept, Baltimore MD (S)

Bradley, Steven, *Dir,* Western Colorado Center for the Arts, Inc, Grand Junction CO

Bradley, Thomas, *Assoc Dean,* University of Hartford, Hartford Art School, West Hartford CT (S)

Bradley, W Steven, *Assoc Prof,* Mesa State College, Art Dept, Grand Junction CO (S)

Bradshaw, Anne, *VPres,* Art League, Alexandria VA

Bradshaw, Barbara, *Admin Asst,* Piedmont Arts Association, Martinsville VA

Bradshaw, Bruce, *Principal,* Nutana Collegiate Institute, Memorial Library and Art Gallery, Saskatoon SK

Bradshaw, Lynn, *Store Mgr,* Penobscot Marine Museum, Searsport ME

Bradt, Laurie, *Registrar,* Lyme Historical Society, Library, Old Lyme CT

Bradt, Rachelle, *Cur Educ,* Yeshiva University Museum, New York NY

Brady, Dixon W, *Adj Prof,* Brevard College, Division of Fine Arts, Brevard NC (S)

Brady, Edith, *Cur Educ,* High Point Historical Society Inc, Museum, High Point NC

Brady, Kevin, *Asst Prof,* Ripon College, Art Dept, Ripon WI (S)

Brady, Margaret, *Registrar,* Santa Monica Museum of Art, Santa Monica CA

Brady, Meghan, *Vis Asst Prof,* Bowdoin College, Art Dept, Brunswick ME (S)

Braff, Arnold, *Treas,* Greenwich Art Society Inc, Greenwich CT

Bragg, Cheryl, *Dir,* Anniston Museum of Natural History, Anniston AL

Braisted, Todd, *VPres,* Bergen County Historical Society, Steuben House Museum, River Edge NJ

Braley, David, *Chmn Bd Trustees,* McMichael Canadian Art Collection, Kleinburg ON

Braman, Andrew, *Controller,* The Rockwell Museum of Western Art, Corning NY

Brambilla, Bridgette, *Reference Head,* Berkeley Heights Free Public Library, Berkeley Heights NJ

Branaff, Cis, *Prog Mgr,* Coupeville Arts Center, Gallery at the Wharf, Coupeville WA

Branagan, Carmine, *Exec Dir Council,* American Craft Council, New York NY

Brancaccio, Jim, *Cur,* Living Arts & Science Center, Inc, Lexington KY

Brancaccio, Tia, The College of New Jersey, School of Arts & Sciences, Ewing NJ (S)

Branch, Harrison, *Prof,* Oregon State University, Dept of Art, Corvallis OR (S)

Branchick, Thomas J, *Dir,* Williamstown Art Conservation Center, Williamstown MA

Branco, Susan, *Instr,* Wayne Art Center, Wayne PA (S)

Brandach, Joan, *Newsletter Ed,* North Country Museum of Arts, Park Rapids MN

Brandau, Mary, *Mktg & Develop Officer,* Sloss Furnaces National Historic Landmark, Birmingham AL

Branden, Mack, *Chmn,* California Baptist College, Art Dept, Riverside CA (S)

Brander, Susan, *Admin Dir,* Museum of the Hudson Highlands, Cornwall on Hudson NY

Brandley, Jack, *Treas,* Attleboro Museum, Center for the Arts, Attleboro MA

Brandman, Ann, *Cur Film,* Honolulu Academy of Arts, The Art Center at Linekona, Honolulu HI (S)

Brandoli, Susan, *Dir,* Vernon Art Gallery, Vernon BC

Brandon, Betty, *Historic Homes Tour & Garden Walk,* North Tonawanda History Museum, North Tonawanda NY

Brandon, Edwina, *Dir Develop,* Contemporary Arts Center, Cincinnati OH

Brandon, Reiko, *Cur Textiles,* Honolulu Academy of Arts, The Art Center at Linekona, Honolulu HI (S)

Brandson, Lorraine, *Cur,* Eskimo Museum, Churchill MB

Brandson, Lorraine, *Cur,* Eskimo Museum, Library, Churchill MB

Brandt, Thomas, *Dir,* Highland Community College, Art Dept, Freeport IL (S)

Brandt, Tova, *Cur,* Vesterheim Norwegian-American Museum, Decorah IA

Brandt, Tova, *Cur,* Vesterheim Norwegian-American Museum, Reference Library, Decorah IA

Branham, Joan, *Prof,* Providence College, Art & Art History Dept, Providence RI (S)

Branigan, Amy, *Events Coordr,* BJU Museum & Gallery, Bob Jones University Museum & Gallery Inc, Greenville SC

Branlein, Jack, *Dir,* Huguenot Historical Society of New Paltz Galleries, New Paltz NY

Brannan, Beverly W, *Photographs,* Library of Congress, Prints & Photographs Division, Washington DC

Brannan, Ed, *Instr,* Green River Community College, Art Dept, Auburn WA (S)

Branning, Katherine, *Librn,* French Institute-Alliance Francaise, Library, New York NY

Brannon, Patrick, *Dept Head,* University of Saint Francis, Fine Arts Dept, Joliet IL (S)

Branscome, Kimberly, *Exec Dir,* Visual Arts Center of Northwest Florida, Panama City FL

Bransfield, Kevin, *Photog Instr,* Monterey Peninsula College, Art Dept, Monterey CA (S)

Bransford, Pamela, *Registrar,* Montgomery Museum of Fine Arts, Montgomery AL

Branston, Stuart, *Chmn,* Oral Roberts University, Art Dept, Tulsa OK (S)

Brant, Kimberly, *Dir Develop,* Fort Wayne Museum of Art, Inc, Fort Wayne IN

Brant, Pip, *Assoc Prof,* Florida International University, School of Art & Art History, Miami FL (S)

Brantley, Royal, *Head Dept,* West Texas A&M University, Art, Communication & Theatre Dept, Canyon TX (S)

Brase, Don, *Dir,* Chemeketa Community College, Dept of Humanities & Communications, Salem OR (S)

Brashear, Jim, *Assoc Prof,* University of Alaska-Fairbanks, Dept of Art, Fairbanks AK (S)

Brasier, Robert, *Dir Educ,* Palm Springs Art Museum, Palm Springs CA

Bratis, Adrianne, *Registrar,* Mingei International, Inc, Mingei International Museum, San Diego CA

Bratland, Don, *Instr,* Saint Olaf College, Art Dept, Northfield MN (S)

Bratley, Paul, *Reprocessed Prof,* Universite de Montreal, Bibliotheque d'Amenagement, Montreal PQ

Braun, Emily, *Prof,* City University of New York, PhD Program in Art History, New York NY (S)

Braun, Lon R, *Bus Mgr,* Fort Wayne Museum of Art, Inc, Fort Wayne IN

Braun, Marsha, *Dir Develop,* Saginaw Art Museum, Saginaw MI

Braun, Suzan, *Prof,* Eastern Illinois University, Art Dept, Charleston IL (S)

Braunstein, Susan L, *Cur Archaeology,* The Jewish Museum, New York NY

Bravo, M, *Instr,* Humboldt State University, College of Arts & Humanities, Arcata CA (S)

Bray, Ann, *Vis Instr,* Claremont Graduate University, Dept of Fine Arts, Claremont CA (S)

Braysmith, Hilary, *Assoc Prof,* University of Southern Indiana, Art Dept, Evansville IN (S)

Brazil, Sally, *Chief Archivist,* Frick Art Reference Library, New York NY

Brazile, Orella R, *Dir,* Southern University Library, Shreveport LA

Brazun, Matthew, *Exec Dir,* DeWitt Historical Society of Tompkins County, The History Center in Tompkins Co, Ithaca NY

Breault, Christina, *Mus Dir,* Lac du Flambeau Band of Lake Superior Chippewa Indians, George W Brown Jr Ojibwe Museum & Cultural Center, Lac du Flambeau WI

Breaznell, Ann, *Assoc Prof,* College of Saint Rose, Art Dept, Albany NY (S)

Brechter, Bart, *Cur Gardens,* Bayou Bend Collection & Gardens, Houston TX

Brecken, Bradford A, *Pres Emeritus,* Newport Historical Society & Museum of Newport History, Newport RI

Bredendick, Joan, *Adjunct Prof,* North Central College, Dept of Art, Naperville IL (S)

Bregande, Michele, *Asst Dir,* Moore College of Art & Design, The Galleries at Moore, Philadelphia PA

Brehm, Georgia L, *Dir,* Black River Academy Museum & Historical Society, Black River Academy Museum, Ludlow VT

Breiling, Roy, *Instr,* Yavapai College, Visual & Performing Arts Div, Prescott AZ (S)

Breimayer, Mary Phillis, *Assoc Prof,* Georgian Court College, Dept of Art, Lakewood NJ (S)

Breitenbach, Eric, *Prof,* Daytona Beach Community College, Dept of Fine Arts & Visual Arts, Daytona Beach FL (S)

Breitenberg, Mark, *Liberal Arts, Science, Graduate & Academic Studies Chmn,* Art Center College of Design, Pasadena CA (S)

Brekke, Michael, *Assoc Prof,* Atlanta College of Art, Atlanta GA (S)

Brekke, Paul, *Asst Cur,* Gonzaga University, Art Gallery, Spokane WA

Breland, Evelyn, *Treas,* Mississippi Art Colony, Stoneville MS

Breling, Cathleen, *Admin Asst,* Sage Junior College of Albany, Dept Visual Arts, Albany NY (S)

Bremer, D Neil, *Dir,* Elmhurst Art Museum, Elmhurst IL

Bremer, Don, *Financial Officer,* Museum of Fine Arts, Saint Petersburg, Florida, Inc, Saint Petersburg FL

Bremner, Ellen, *Mem Coordr,* Lyman Allyn, New London CT

Brengle, Anne, *Dir,* Old Dartmouth Historical Society, New Bedford Whaling Museum, New Bedford MA

Brennan, Anita, *CEO,* Schuyler-Hamilton House, Morristown NJ

Brennan, Denise, *Sr Management Analyst,* Riverside Municipal Museum, Riverside CA

Brennan, Joan, *Photo,* University of Colorado at Denver, College of Arts & Media Visual Arts Dept, Denver CO (S)

Brennan, Joe, *Dir Facilities,* San Francisco Museum of Modern Art, San Francisco CA

Brennan, Marcia, *Asst Prof,* Rice University, Dept of Art & Art History, Houston TX (S)

Brennan, Robert M, *Pres,* The Queens Museum of Art, Flushing NY

Brennan, Shelia, *Pub Prog,* Naval Historical Center, The Navy Museum, Washington DC

Brenner, M Diane, *Museum Archivist,* Anchorage Museum at Rasmuson Center, Archives, Anchorage AK

Brenner, Paul, *Prog Dir,* Gallery 312, Chicago IL

Brenner, Susan, *Assoc Prof,* University of North Carolina at Charlotte, Dept Art, Charlotte NC (S)

Brenningmeyer, Todd, *Asst Prof,* Maryville University of Saint Louis, Art & Design Program, Saint Louis MO (S)

Bresler, Adrian, *Dir Finance & Admin,* USS Constitution Museum, Boston MA

Bresnahan, Edith, *Chmn,* Dominican College of San Rafael, Art Dept, San Rafael CA (S)

Bress, Betsy, *Publicist,* University of Wyoming, University of Wyoming Art Museum, Laramie WY

Bressani, Martin, *Prof,* McGill University, School of Architecture, Montreal PQ (S)

Breverman, Harvey, *Distinguished Prof,* University at Buffalo, State University of New York, Dept of Visual Studies, Buffalo NY (S)

Brewster, Carrie, *Dir,* Saint Mary's College of California, Hearst Art Gallery, Moraga CA

Brewster, Megan, *Gallery Assoc,* Clay Studio, Philadelphia PA

Brewster, Michael, *Prof,* Claremont Graduate University, Dept of Fine Arts, Claremont CA (S)

Breyer, Alex, *Mgr Mktg Communications,* Cincinnati Institute of Fine Arts, Taft Museum of Art, Cincinnati OH

Breza, Michael, *Asst Dir,* Oshkosh Public Museum, Oshkosh WI

Brian, J Andrew, *Dir,* National Trust for Historic Preservation, Chesterwood Estate & Museum, Stockbridge MA

Brian, Nancy K, *Chmn,* California State University, Fresno, Art & Design, Fresno CA (S)

Bridges, Don, *Bookstore Mgr,* Irvine Museum, Irvine CA

Bridges, Edwin C, *Dir,* Alabama Department of Archives & History, Museum Galleries, Montgomery AL

Bridges, Justin, *Sr Lib Tech,* Miami University, Wertz Art & Architecture Library, Oxford OH

Bridges, Robert, *Prof,* West Virginia University, College of Creative Arts, Morgantown WV (S)

Brief, Martha, *Asst Prof,* Longwood University, Dept of Art, Farmville VA (S)

Brienen, Rebecca P, *Asst Prof,* University of Miami, Dept of Art & Art History, Coral Gables FL (S)

Brienza, Barney, *Prof,* The University Montana - Western, Art Program, Dillon MT (S)

Brier, Dean, *Treas,* North Carolina Museums Council, Raleigh NC

Brier, Ida, *Archivist & Librn,* Olana State Historic Site, Hudson NY

Brietzae, Michelle, *Mktg, Publs Coordr,* Omaha Childrens Museum, Inc, Omaha NE

Briggs, Larry S, *Assoc Prof,* Southern Illinois University, School of Art & Design, Carbondale IL (S)

Brigham, David, *PhD,* Allentown Art Museum, Allentown PA

Bright, Karen, *Assoc Prof,* Monmouth University, Dept of Art & Design, West Long Branch NJ (S)

Briley, Jeff, *Asst Dir Coll,* Oklahoma Historical Society, State Museum of History, Oklahoma City OK

Brill, Margaret, *Prof,* Corning Community College, Division of Humanities, Corning NY (S)

Brill, Peter S, *Head Exhib NY,* National Museum of the American Indian, George Gustav Heye Center, New York NY

Brill, Robert H, *Research Scientist,* Corning Museum of Glass, The Studio, Rakow Library, Corning NY

Brill, Ron, *Mus Shop Mgr,* Wayne County Historical Society, Honesdale PA

Brill, Ron, *Shop Mgr,* Wayne County Historical Society, Museum, Honesdale PA

Brilla, Maureen, *Assoc Prof,* Nazareth College of Rochester, Art Dept, Rochester NY (S)

Brininger, Betsy, *Dir Institute of the Arts,* George Mason University, Dept of Art & Art History, Fairfax VA (S)

Brinkman, Stacy, *Librn,* Miami University, Wertz Art & Architecture Library, Oxford OH

Brisebois, Marcel, *Dir,* Musee d'art Contemporain de Montreal, Montreal PQ

Brittain, Patsy, *Admin Asst,* Art Museum of Southeast Texas, Beaumont TX

Britting, Pam, *Curatorial Asst,* California State University, Chico, Janet Turner Print Museum, Chico CA

Britton, Benjamin, *Assoc Prof Fine Arts,* University of Cincinnati, School of Art, Cincinnati OH (S)

Britton, Greg, *MHS Pres,* Minnesota Historical Society, Saint Paul MN

Britton, Virginia, *Ballet Dir,* Northern Virginia Fine Arts Association, The Athenaeum, Alexandria VA

Britz, Kevin, *VPres Progs & Exhibs Dir,* High Desert Museum, Bend OR

Broad, David, *Dean,* Elgin Community College, Fine Arts Dept, Elgin IL (S)

Brochhauren, Philip, *Program Head,* Western Wisconsin Technical College, Graphics Division, La Crosse WI (S)

Brock, Mary, *Dir,* Arts & Science Center for Southeast Arkansas, Pine Bluff AR

Brock, Paris, *Maintenance,* Carnegie Center for Art & History, New Albany IN

Brock, Stephanie, *Pub Relations,* Wichita Center for the Arts, Mary R Koch Sch of Visual Arts, Wichita KS (S)

Brockington, Lynn, *Librn,* Vancouver Art Gallery, Library, Vancouver BC

Brockmann, J Nicholas, *Media Arts & Animation/Gen Educ,* Art Institute of Pittsburgh, Pittsburgh PA (S)

Broda, Alysan, *Dir Visual & Performing Arts,* Aims Community College, Visual & Performing Arts, Greeley CO (S)

Brodar, Valerie, *Assoc Prof,* University of Colorado-Colorado Springs, Visual & Performing Arts Dept, Colorado Springs CO (S)

Brode, Carol, *Dir Gallery & Asst Prof,* Seton Hill University, Art Program, Greensburg PA (S)

Broder, Deborah, *Dir Develop,* Cummer Museum of Art & Gardens, DeEtte Holden Cummer Museum Foundation, Jacksonville FL

Broderick, Geoff, *Prof,* Abilene Christian University, Dept of Art & Design, Abilene TX (S)

Broderick, Herbert H, *Chmn,* Herbert H Lehman, Art Dept, Bronx NY (S)

Broderick, James, *Prof,* University of Texas at San Antonio, Dept of Art & Art History, San Antonio TX (S)

Brodeur, Danyelle, *Coordr,* Dorval Cultural Centre, Dorval PQ

Brodeur, David, *Asst Prof,* University of North Carolina at Charlotte, Dept Art, Charlotte NC (S)

Brodhead, Heather, *Librn,* Santa Barbara Museum of Art, Library, Santa Barbara CA

Brodie, Lee, *Educ Prog Mgr,* Texas Tech University, Museum of Texas Tech University, Lubbock TX

Brodie, Scott, *Asst Prof,* College of Saint Rose, Art Dept, Albany NY (S)

Brodnax, Vicki, *Exec Asst,* Rollins College, George D & Harriet W Cornell Fine Arts Museum, Winter Park FL

Brodsky, Michael, *Prof,* Loyola Marymount University, Dept of Art & Art History, Los Angeles CA (S)

Brody, Myron, *Prof,* University of Arkansas, Art Dept, Fayetteville AR (S)

Brody, Sally, *Treas,* Atlantic Gallery, New York NY

Brohel, Edward R, *Dir,* State University of New York, SUNY Plattsburgh Art Museum, Plattsburgh NY

Broker, Karin, *Prof,* Rice University, Dept of Art & Art History, Houston TX (S)

Bromley, Kimble, *Asst Prof,* North Dakota State University, Division of Fine Arts, Fargo ND (S)

Bronaugh, Lynda, *Dir Library Svcs,* Redwood Library & Athenaeum, Newport RI

Bronner, Simon J, *Dir Humanities,* Penn State Harrisburg, School of Humanities, Middletown PA (S)

Brons, Jenseen, *Mus Shop Mgr,* Whatcom Museum of History and Art, Library, Bellingham WA

Bronson, AA, *(Acting) Dir,* Printed Matter, Inc, New York NY

Bronson, Susan, *Dir Develop,* Berkshire Museum, Pittsfield MA

Broodwell, Caroyln, *Prof,* Napa Valley College, Art Dept, Napa CA (S)

Brooke, Anna, *Librn,* Hirshhorn Museum & Sculpture Garden, Smithsonian Institution, Washington DC

Brooke, Anna, *Librn,* Hirshhorn Museum & Sculpture Garden, Library, Washington DC

Brooke, Janet M., *Dir,* Queen's University, Agnes Etherington Art Centre, Kingston ON

Brooker, Moe, *Chmn Basic Arts,* Moore College of Art & Design, Philadelphia PA (S)

Brooker, Moe, *Instr,* Main Line Art Center, Haverford PA (S)

Brookhouse, Jon, *Chmn Dept,* Suomi International College of Art & Design, Fine Arts Dept, Hancock MI (S)

Brookman, Philip, *Cur Photo & Media Arts,* Corcoran Gallery of Art, Washington DC

Brooks, Aimee, *Registrar,* Columbus Museum, Columbus GA

Brooks, Bradley, *Dir Lilly House Prog,* Columbus Museum of Art and Design, Indianapolis IN

Brooks, Carol, *Cur,* Arizona Historical Society-Yuma, Sanguinetti House Museum & Garden, Yuma AZ

Brooks, Caroline, *Asst Dir,* Roswell Museum & Art Center, Roswell NM

Brooks, Drex, *Prof,* Weber State University, Dept of Visual Arts, Ogden UT (S)

Brooks, Eric, *Cur,* Liberty Hall Historic Site, Liberty Hall Museum, Frankfort KY

Brooks, George, *Preparator,* Philbrook Museum of Art, Tulsa OK

Brooks, H Gordon, *Dean,* University of Louisiana at Lafayette, College of the Arts, Lafayette LA (S)

Brooks, James, *Instr,* Bob Jones University, Div of Art, Greenville SC (S)

Brooks, Jennifer, *Ofc Mgr,* Peters Valley Craft Center, Layton NJ

Brooks, Kim, *Dir Develop,* Hastings Museum of Natural & Cultural History, Hastings NE

Brooks, Leonard, *Dir,* United Society of Shakers, The Shaker Library, New Glocester ME

Brooks, Leonard L, *Dir,* United Society of Shakers, Shaker Museum, New Glocester ME

Brooks, Sarah, *Technical Svcs,* San Francisco Maritime National Historical Park, Maritime Library, San Francisco CA

Brooks, Tricia, *Visitor Prog Coordr,* Supreme Court of the United States, Washington DC

Brooks, Valerie, *Undergrad Admissions,* Southern Illinois University, School of Art & Design, Carbondale IL (S)

Brooks, Wendell, *Assoc Prof,* The College of New Jersey, School of Arts & Sciences, Ewing NJ (S)

Brooks, William F, *Exec Dir,* Vermont State Craft Center at Frog Hollow, Middlebury VT

Brooks-Myers, Inez, *Assoc Cur History,* Oakland Museum of California, Art Dept, Oakland CA

Brookstein, David S, *Dean,* Philadelphia University, School of Textiles & Materials Technology, Philadelphia PA (S)

Broome, Skooker, *Mgr Design & Production,* University of British Columbia, Museum of Anthropology, Vancouver BC

Brose, Barbara H., *Exec Dir,* Gaston County Museum of Art & History, Dallas NC

Brose, Lawrence, *Exec Dir,* Center for Exploratory & Perceptual Art, CEPA Gallery, Buffalo NY

Brose, Lawrence F, *Exec Dir,* Center for Exploratory & Perceptual Art, CEPA Gallery, Buffalo NY

Brosnaham, Richard, *Exec Dir,* West Florida Historic Preservation, Inc, T T Wentworth, Jr Florida State Museum & Historic Pensacola Village, Pensacola FL

Brosnaham, Richard, *Historian,* Historic Pensacola Preservation Board, T.T. Wentworth Jr. Florida State Museum, Pensacola FL

Brosnan, Susan, *Archivist,* Knights of Columbus Supreme Council, Knights of Columbus Museum, New Haven CT

Brosnihan, Timothy, *Site Mgr/Educ Asst,* Victoria Mansion - Morse Libby House, Portland ME

Bross, John, *Instr,* Greenfield Community College, Art, Communication Design & Media Communication Dept, Greenfield MA (S)

Brothers, Clayton, *Dir,* New Image Art, Los Angeles CA

Brothers, Michael, *Exec Dir,* Museum of Arts & Sciences, Inc, Macon GA

Brotman, Lucy, *Dir Educ,* Newark Museum Association, The Newark Museum, Newark NJ

Brotman, Susan, *Pres Bd,* Seattle Art Museum, Seattle WA

Brotman, Susan, *Pres Bd,* Seattle Art Museum, Library, Seattle WA

Brouard, Scott, *Preservation & Exhib Mgr,* Hillwood Museum & Gardens Foundation, Hillwood Museum & Gardens, Washington DC

Brouch, Virginia, *Coordr Computer Graphics,* Phoenix College, Dept of Art & Photography, Phoenix AZ (S)

Broucke, Peter, *Chmn,* Middlebury College, History of Art & Architecture Dept, Middlebury VT (S)

Broude, Norma, *Prof,* American University, Dept of Art, Washington DC (S)

Broudy, Liza, *Cur of Exhibitions,* Hampton University, University Museum, Hampton VA

Brough, Howard, *Asst Mgr,* Salt Lake City Public Library, Fine Arts & Audiovisual Dept and Atrium Gallery, Salt Lake City UT

Brougher, Kerry, *Chief Cur,* Hirshhorn Museum & Sculpture Garden, Smithsonian Institution, Washington DC

Brouillet, Johanne, *Dir,* University of Sherbrooke, Art Gallery, Sherbrooke PQ

Brouillette, Jackie, *Educ Prog,* Kern County Museum, Library, Bakersfield CA

Brouillette, Susan, *Mus Shop Mgr,* Ohio Historical Society, National Road-Zane Grey Museum, Columbus OH

Broukhim, Milka, *Lectr,* California State Polytechnic University, Pomona, Art Dept, Pomona CA (S)

Broun, Elizabeth, *Dir,* Smithsonian American Art Museum, Washington DC

Brousseau, Francine, *Pres,* Canadian Museums Association, Association des Musees Canadiens, Ottawa ON

Brousseau, Francine, *VPres Development,* Canadian Museum of Civilization, Gatineau PQ

Brouwer, Bert, *Prof,* University of Alabama at Birmingham, Dept of Art & Art History, Birmingham AL (S)

Brouwer, Charles, *Prof,* Radford University, Art Dept, Radford VA (S)

Brouwer, Norman, *Historian & Librn,* South Street Seaport Museum, New York NY

Brouwer, Norman, *Historian & Librn,* South Street Seaport Museum, Melville Library, New York NY

Browdo, Bar, *Cur,* Wenham Museum, Wenham MA

Brown, Ashley, *Instr,* Harding University, Dept of Art, Searcy AR (S)

Brown, Barbara, *Bus Mgr,* Visual Arts Center of Richmond, Richmond VA

Brown, Barbara, *Develop Secy,* Clark County Historical Society, Library, Springfield OH

Brown, Bernadette, *Cur African, Oceanic & New World Art,* University of Utah, Utah Museum of Fine Arts, Salt Lake City UT

Brown, Bill, *Chief Conservator,* North Carolina Museum of Art, Reference Library, Raleigh NC

Brown, Bill, *Chmn Illustration,* Moore College of Art & Design, Philadelphia PA (S)

Brown, Bob, *VPres,* Pioneer Historical Museum of South Dakota, Hot Springs SD

Brown, Brad, *Display Artist,* City of Lethbridge, Sir Alexander Galt Museum, Lethbridge AB

Brown, Brian E, *Prof,* University of Windsor, Visual Arts, Windsor ON (S)

Brown, Bruce, *Prof,* Monroe Community College, Art Dept, Rochester NY (S)

Brown, Cathy, *Asst Dir,* Old Mill Foundation, California Art Club Gallery, San Marino CA

Brown, Chad, *Gen Educ,* Art Institute of Pittsburgh, Pittsburgh PA (S)

Brown, Charlotte V, *Dir,* North Carolina State University, Visual Arts Center, Raleigh NC

Brown, Claire, *Pub Rels,* National Air and Space Museum, Washington DC

Brown, Claudia, *Research Cur Asian Art,* Phoenix Art Museum, Phoenix AZ

Brown, Clinton, *Prof,* Oregon State University, Dept of Art, Corvallis OR (S)

Brown, David, *Cur Renaissance Painting,* National Gallery of Art, Washington DC

Brown, David, *Pres,* Rensselaer County Historical Society, Hart-Cluett Mansion, 1827, Troy NY

Brown, David J, *Chief Cur,* Southeastern Center for Contemporary Art, Winston-Salem NC

Brown, DeSoto, *Archivist,* Bernice Pauahi Bishop, Library, Honolulu HI

Brown , DeSoto, *Archivist,* Bernice Pauahi Bishop, Archives, Honolulu HI

Brown, Deborah, *Byzantine Studies Librn,* Harvard University, Dumbarton Oaks Research Library, Washington DC

Brown, Dorothy D, *Chmn,* Georgia College & State University, Art Dept, Milledgeville GA (S)

Brown, Dottie, *Instr,* Sierra Community College, Art Dept, Rocklin CA (S)

Brown, Drew, *Assoc Cur Educ for Educational Services,* Morris Museum of Art, Augusta GA

Brown, Elizabeth, *Chief Cur,* Henry Gallery Association, Henry Art Gallery, Seattle WA

Brown, Ellsworth, *Dir,* Wisconsin Historical Society, State Historical Museum, Madison WI

Brown, Emilie, *Gallery Admin,* Artspace, Richmond VA

Brown, Francine, *Admin Asst,* Vassar College, The Frances Lehman Loeb Art Center, Poughkeepsie NY

Brown, Geoffrey I, *Dir,* Navajo Nation, Navajo Nation Museum, Window Rock AZ

Brown, Jack Perry, *Dir Libraries,* The Art Institute of Chicago, Ryerson & Burnham Libraries, Chicago IL

Brown, Jack Perry, *Exec Dir Libraries,* The Art Institute of Chicago, Chicago IL

Brown, James, *Assoc Prof,* William Paterson University, Dept Arts, Wayne NJ (S)

Brown, James M, *Asst Dir Exhibits,* South Carolina State Museum, Columbia SC

Brown, Jason, *Assoc Prof,* Eastern Oregon University, School of Arts & Science, La Grande OR (S)

Brown, Jeff, *Chmn Fine Arts,* Jones County Junior College, Art Dept, Ellisville MS (S)

Brown, Joe, *Dean, Theater Arts,* Texas Wesleyan University, Dept of Art, Fort Worth TX (S)

Brown, Johanna M, *Cur & Dir Coll,* Old Salem Inc, Museum of Early Southern Decorative Arts, Winston-Salem NC

Brown, Judith, *Controller,* New Brunswick Museum, Saint John NB

Brown, Judy, *Foundation Dept,* Montserrat College of Art, Beverly MA (S)

Brown, Julia, *Instr, Dir,* The American Federation of Arts, New York NY

Brown, Karen F, *Libr Technician,* Smithsonian Institution, National Museum of African Art, Washington DC

Brown, Kate, *Instr,* Toronto School of Art, Toronto ON (S)

Brown, Lenard, *Asst Prof Painting & Printmaking,* University of Texas Pan American, Art Dept, Edinburg TX (S)

Brown, Leslie, *Cur,* Photographic Resource Center, Boston MA

Brown, Lindie K, *Dir Develop,* Anniston Museum of Natural History, Anniston AL

Brown, Lisa, *Instr Art Educ,* Eastern Oregon University, School of Arts & Science, La Grande OR (S)

Brown, Lisa, Buena Vista Museum of Natural History, Bakersfield CA

Brown, Louise Freshman, *Prof,* University of North Florida, Dept of Communications & Visual Arts, Jacksonville FL (S)

Brown, Michael K, *Cur,* Bayou Bend Collection & Gardens, Houston TX

Brown, Nancy, *VPres Operations,* Manchester Craftsmen's Guild, Pittsburgh PA

Brown, Nell, *Dir Operations,* Arts & Science Center for Southeast Arkansas, Pine Bluff AR

Brown, Pam, *Asst Prof Visual Arts,* Dowling College, Dept of Visual Arts, Oakdale NY (S)

Brown, Pam, *Cur of Ethnology & Media,* University of British Columbia, Museum of Anthropology, Vancouver BC

Brown, Patricia, *Exhib Chmn,* Delta State University, Fielding L Wright Art Center, Cleveland MS

Brown, Patricia L, *Asst Prof,* Delta State University, Dept of Art, Cleveland MS (S)

Brown, Patrick, *Chief Preparator & Exhib Designer,* Worcester Art Museum, Worcester MA

Brown, Ragan, *Asst Prof,* Saint Petersburg College, Fine & Applied Arts at Clearwater Campus, Clearwater FL (S)

Brown, Rebecca, *Asst Prof,* Saint Mary's College of Maryland, Art & Art History Dept, Saint Mary's City MD (S)

Brown, Rebecca, *Libr Asst,* National Museum of Women in the Arts, Library & Research Center, Washington DC

Brown, Regina, *Exec Secy,* National Council on Education for the Ceramic Arts (NCECA), Erie CO

Brown, Robert, *Dir,* Historical Museum at Fort Missoula, Missoula MT

Brown, Robert B, *Secy & Treas,* National Museum of Ceramic Art & Glass, Baltimore MD

Brown, Robert F, *Dir & Journal Ed,* Archives of American Art, New England Regional Center, Washington DC

Brown, Sheena, *Cur,* Morris-Jumel Mansion, Inc, New York NY

Brown, Shirley, *Asst to Dir,* Knoxville Museum of Art, Knoxville TN

Brown, Shirley B, *Adminr,* National Museum of Ceramic Art & Glass, Baltimore MD

Brown, Stephanie, *Assoc Cur Am Mat Cul & Historian,* Hillwood Museum & Gardens Foundation, Hillwood Museum & Gardens, Washington DC

Brown, Stephen, *Assoc Prof,* University of Hartford, Hartford Art School, West Hartford CT (S)

Brown, Stephen, *VPres,* Shoreline Historical Museum, Shoreline WA

Brown, Steven, *Photography & Graphic Design,* Southern Illinois University at Edwardsville, Dept of Art & Design, Edwardsville IL (S)

Brown, Steven, *Prof,* University of Science & Arts of Oklahoma, Arts Dept, Chickasha OK (S)

Brown, Suzy, *Dir Visitor Svcs,* Wave Hill, Bronx NY

Brown, Terrence, *Dir,* Society of Illustrators, New York NY

Brown, Terrence, *Dir,* Society of Illustrators, Museum of American Illustration, New York NY

Brown, William, *Chief Conservator,* North Carolina Museum of Art, Raleigh NC

Brown, William, *Dept Head, Prof,* University of Evansville, Art Dept, Evansville IN (S)

Brown-Urso, Rian, *Asst Prof,* Oberlin College, Dept of Art, Oberlin OH (S)

Brownawell, Christopher, *Dir,* Academy Art Museum, Easton MD

Browne, Charles C, *Dir,* Fairbanks Museum & Planetarium, Saint Johnsbury VT

Browne, Mariane, *Co-2nd Vice Regent,* Schuyler-Hamilton House, Morristown NJ

Browne, Robert, *Pres,* Ontario Crafts Council, Artists in Stained Glass, Toronto ON

Brownell, Louise, *Registrar,* Maryland Historical Society, Library, Baltimore MD

Brownfield, Eleanor, *Dir Mem Svcs,* Alternate ROOTS, Inc, Atlanta GA

Brownfield, John, *Chmn,* University of Redlands, Dept of Art, Redlands CA (S)

Browning, Dawn C, *Dir,* Mason County Museum, Mason TX

Browning, Kathleen, *Cur & Grants Mgr,* Star-Spangled Banner Flag House Association, Flag House & 1812 Museum, Baltimore MD

Browning, Marcia, *Archivist,* Northeastern Nevada Museum, Library & Archives, Elko NV

Browning, Mark, *Exec Dir,* Custer County Art & Heritage Center, Miles City MT

Brownlee, Mary, *Youth Prog Mgr,* Sawtooth Center for Visual Art, Winston-Salem NC (S)

Brownless, Mary, *Members' Gallery,* Lunenburg Art Gallery Society, Lunenburg NS

Brozovich, Tom J, *Instr,* American River College, Dept of Art/Art New Media, Sacramento CA (S)

Brozyna, Steve, *Dep Dir Facilities,* The Museum of Arts & Sciences Inc, Daytona Beach FL

Brozynski, Dennis, *Coordr Fashion Design,* Columbia College, Art Dept, Chicago IL (S)

Bruce, Donald, *Cur,* Cambria Historical Society, New Providence NJ

Bruce, Roger, *Dir Interpretation,* George Eastman, Rochester NY

Brucker, Jane, *Prof,* Loyola Marymount University, Dept of Art & Art History, Los Angeles CA (S)

Bruecks, Jason, *Commission Chairperson,* Cabot's Old Indian Pueblo Museum, Cabot's Old Indian Pueblo Museum, Desert Hot Springs CA

Bruegeman, Nancy, *Asst Coll Mgr,* University of British Columbia, Museum of Anthropology, Vancouver BC

Brueggeman, Mark, *Sr Lectr,* University of Wisconsin-Stevens Point, Dept of Art & Design, Stevens Point WI (S)

Bruggen, Bill, *Asst Dir Admin,* Indiana State Museum, Indianapolis IN

Bruhl, Win, *Chmn,* University of Arkansas at Little Rock, Art Slide Library and Galleries, Little Rock AR

Bruhl, Win, *Chmn,* University of Arkansas at Little Rock, Dept of Art, Little Rock AR (S)

Bruin, Joan, *Dir,* L A County Museum of Art, Los Angeles CA

Brumfield, Ren, *Admin Asst,* The Art Studio Inc, Beaumont TX

Brumgardt, John R, *Dir,* Charleston Museum, Charleston SC

Brummett, Michael, *Instr,* Pepperdine University, Seaver College, Dept of Art, Malibu CA (S)

Bruner, Marianne, *Instr,* Northern Arizona University, Museum Faculty of Fine Art, Flagstaff AZ (S)

Bruner, Rich, *Coordr Photography,* Shepherd University, Art Dept, Shepherdstown WV (S)

Brunett, Keven, *Assoc Lect,* University of Wisconsin-Stevens Point, Dept of Art & Design, Stevens Point WI (S)

Brunette, Peter, *Reynolds Prof Film Studies,* Wake Forest University, Dept of Art, Winston-Salem NC (S)

Bruney, Fred, *Asst Prof,* College of DuPage, Liberal Arts Division, Glen Ellyn IL (S)

Brungrdt, Kevin, *Chmn Human & Fine Arts,* Garden City Community College, Art Dept, Garden City KS (S)

Bruni, Margaret, *Asst Dir Main Library,* Detroit Public Library, Art & Literature Dept, Detroit MI

Bruni, Stephen T, *Dir,* Delaware Art Museum, Wilmington DE

Brunner, Christal, *Head Librn,* Mexico-Audrain County Library, Mexico MO

Brunner, Helen M, *Dir Spec Projects,* Art Resources International, Washington DC

Brunner, Jeffrey, *Asst Registrar,* Bucknell University, Edward & Marthann Samek Art Gallery, Lewisburg PA

Bruns, Craig, *Coll Mgr,* Independence Seaport Museum, Philadelphia PA

Brunscheen, Scott, *Dir,* Salisbury House Foundation, Des Moines IA

Brunson, Ty, *Asst Prof,* Arkansas Tech University, Dept of Art, Russellville AR (S)

Brunswick, Heidi, *Dir Admin,* Jay County Arts Council, Hugh N Ronald Memorial Gallery, Portland IN

Brunvand, Sandy, *Instr,* University of Utah, Dept of Art & Art History, Salt Lake City UT (S)

Brush, Gloria D, *Prof, Head Dept,* University of Minnesota, Duluth, Art Dept, Duluth MN (S)

Bruski, Paul, *Instr,* College of Visual Arts, Saint Paul MN (S)

Bruttomesso, Patty, *Cur,* Louisa May Alcott Memorial Association, Orchard House, Concord MA

Bruya, Chris, *Assoc Dean,* Mount Hood Community College, Visual Arts Center, Gresham OR (S)

Bruya, J Robert, *Prof,* Slippery Rock University of Pennsylvania, Dept of Art, Slippery Rock PA (S)

Bruya, Marilyn, *Prof,* University of Montana, Dept of Art, Missoula MT (S)

Bruzelius, Caroline, *Prof,* Duke University, Dept of Art, Art History & Visual Studies, Durham NC (S)

Bryan, Barbara, *Mus Shop Mgr,* Fairfield Historical Society, Fairfield Museum & History Center, Fairfield CT

Bryan, Charles F, *CEO & Pres,* Virginia Historical Society, Richmond VA

Bryan, Charles F, *Dir, CEO,* Virginia Historical Society, Library, Richmond VA

Bryan, Jerry, *Chmn,* Western Oklahoma State College, Art Dept, Altus OK (S)

Bryan, John, *Chmn Art History,* University of South Carolina, Dept of Art, Columbia SC (S)

Bryan, John H, *Chmn Bd Trustees,* The Art Institute of Chicago, Chicago IL

Bryan, Pat, *Mus Shop Dir,* C M Russell, Frederic G Renner Memorial Library, Great Falls MT

Bryan, Tom, *Pres Bd Dir,* Evansville Museum of Arts, History & Science, Evansville IN

Bryan, Victoria, *Prog Mgr,* Angels Gate Cultural Center, Gallery A & Gallery G, San Pedro CA

Bryan Hood, Mary, *Dir,* Owensboro Museum of Fine Art, Owensboro KY

Bryant, David, *Dir,* New Canaan Library, H. Pelham Curtis Gallery, New Canaan CT

Bryant, James, *Cur Natural History,* Riverside Municipal Museum, Riverside CA

Bryant, Jim, *Chmn,* Eastern New Mexico University, Dept of Art, Portales NM (S)

Bryant, Jim, *Chmn & Dir Exhibits,* Eastern New Mexico University, Dept of Art, Portales NM

Bryant, Jo, *City Librn,* Toronto Public Library Board, Library, Toronto ON

Bryant, Keith, *Lectr,* University of North Carolina at Charlotte, Dept Art, Charlotte NC (S)

Bryant, Landee, *Admin Specialist,* Yeiser Art Center Inc, Paducah KY

Bryck, Ruth, *Pres,* Baldwin Historical Society Museum, Baldwin NY

Brynolf, Anita, *Instr,* San Diego Mesa College, Fine Arts Dept, San Diego CA (S)

Bryson, Doris, *Bookkeeper & HR Dir,* Tyler Museum of Art, Tyler TX

Bryson, Gregg, *Prof,* Virginia Polytechnic Institute & State University, Dept of Art & Art History, Blacksburg VA (S)

Brzezinski, Jamey, *Chmn,* Merced College, Arts Division, Merced CA (S)

Bucci, Rachel, *Dir Mktg & Communications,* The Textile Museum, Washington DC

Buchanan, Alanna, *Pub Relations Coordr,* Independence Seaport Museum, Philadelphia PA

Buchanan, Annette, *Admin Dir,* Anderson County Arts Council, Anderson SC

Buchanan, Jaymie, *Outreach Coordr,* Green Hill Center for North Carolina Art, Greensboro NC

Buchanan, John, *Instr,* Alcorn State University, Dept of Fine Arts, Lorman MS (S)

Buchanan, John E, *Exec Dir,* Portland Art Museum, Portland OR

Buchanan, John E, *Exec Dir,* Portland Art Museum, Northwest Film Center, Portland OR

Buchanan, Lucy, *Dir Develop,* Portland Art Museum, Portland OR

Buchanan, Lucy, *Dir Develop,* Portland Art Museum, Northwest Film Center, Portland OR

Buchanan, Richard, *Head,* Carnegie Mellon University, School of Design, Pittsburgh PA (S)

Bucheit, Chris, *Instr,* Western Wisconsin Technical College, Graphics Division, La Crosse WI (S)

Bucher, Burt, *Prof,* Missouri Southern State University, Dept of Art, Joplin MO (S)

Buchloh, Benjamin, *Chmn,* Columbia University, Barnard College, New York NY (S)

Buchman, Bill, *Instr,* Art Center Sarasota, Sarasota FL (S)

Buchter, Thomas, *Head of Gardens,* Winterthur Gardens & Library, Winterthur DE

Buchunan, Harvey, *Prof Emeritus,* Case Western Reserve University, Dept of Art History & Art, Cleveland OH (S)

Buck, Audra, *Asst Prof,* University of Alabama at Birmingham, Dept of Art & Art History, Birmingham AL (S)

Buck, Lisa, *Cur Educ,* Contemporary Arts Center, Cincinnati OH

Buck, Rebecca, *Registrar,* Newark Museum Association, The Newark Museum, Newark NJ

Buckingham, Bill, *Exec Dir,* Wayne Center for the Arts, Wooster OH

Buckingham, Daniel, *Assoc Prof,* Munson-Williams-Proctor Arts Institute, School of Art, Utica NY (S)

Buckland, Alex, *Instr,* Lincoln Memorial University, Division of Humanities, Harrogate TN (S)

Buckley, Donald G, *Asst Dir,* Westfield Athenaeum, Jasper Rand Art Museum, Westfield MA

Buckley, Kerry, *Instr,* Historic Northampton Museum & Education Center, Northampton MA

Buckley, Laurene, *Dir,* New Britain Museum of American Art, New Britain CT

Buckley, Laurene, *Exec Dir,* The Queens Museum of Art, Flushing NY

Buckley, R F, *Prof,* Florida International University, School of Art & Art History, Miami FL (S)

Buckman, Barbara, *Dept Coordr MFA,* Niagara County Community College, Fine Arts Division, Sanborn NY (S)

Buckner, Virginia, *Corresponding Sec,* Halifax Historical Society, Inc, Halifax Historical Museum, Daytona Beach FL

Buckrell, Anne, *Gallery Admin,* City of Woodstock, Woodstock Art Gallery, Woodstock ON

Buckson, Deborah, *Exhib & Prog Coordr,* Winterthur Gardens & Library, Historic Houses of Odessa, Winterthur DE

Bucuvalas, Tina, *Folk Arts Coordr,* Florida Folklife Programs, Tallahassee FL

Bucy, Carole S, *Secy,* Tennessee Historical Society, Nashville TN

Budahl, Lee P, *Assoc Prof,* Western Carolina University, Dept of Art/College of Arts & Science, Cullowhee NC (S)

Budde, Diana, *Prof,* University of Wisconsin College - Marinette, Art Dept, Marinette WI (S)

Buddenhagen, Jennifer, *Dir Membership, Mktg & Pub Programs Mgr,* Rochester Art Center, Rochester MN

Budney, Jen, *Cur,* Kamloops Art Gallery, Kamloops BC

Budoff, Nathan, *Instr,* University of Puerto Rico, Dept of Fine Arts, Rio Piedras PR (S)

Budrovich, Tony, *Deputy Dir Operations,* California Science Center, Los Angeles CA

Buechler, Brent, *Pub Rels,* Glenbow Museum, Calgary AB

Bueckl, Christine, *Prof,* University of Nebraska, Kearney, Dept of Art & Art History, Kearney NE (S)

Bueschel, Tiffanie, *Mus Dir,* American Numismatic Association, Money Museum, Colorado Springs CO

Buescher, Jean, *Instr,* Siena Heights University, Studio Angelico-Art Dept, Adrian MI (S)

Buesgen, Linda, *Mem Coordr,* Lehigh County Historical Society, Allentown PA

Buettner, Brigitte, *Asst Prof,* Smith College, Art Dept, Northampton MA (S)

Buettner, Steve, *Dir Retail & Wholesale,* Whitney Museum of American Art, New York NY

Buettner, Stewart, *Chmn Dept,* Lewis & Clark College, Dept of Art, Portland OR (S)

Buffalo, Jo, *Prof,* Cazenovia College, Center for Art & Design Studies, Cazenovia NY (S)

Bufferd, Lauren, *Dir Opers,* Board of Parks & Recreation, The Parthenon, Nashville TN

Buffington, Mel, *Instr Photography,* Eastern Oregon University, School of Arts & Science, La Grande OR (S)

Buford, Doug, *Pres (9),* The Arkansas Arts Center, Museum School, Little Rock AR (S)

Bugslag, James, University of Manitoba, School of Art, Winnipeg MB (S)

Buice, William T, *Pres,* Grolier Club Library, New York NY

Buie, Sarah, *Dir,* Clark University, The Schiltkamp Gallery/Traina Center for the Arts, Worcester MA

Buisson, Rene, *Dir,* Le Musee Marc-Aurele Fortin, Montreal PQ

Buj, Otto, *Information Coordr,* Art Gallery of Windsor, Windsor ON

Bukar, Nat, *VPres,* The National Art League, Douglaston NY

Bukowski, Lucy, *Deputy Dir Admin,* Heritage Museums & Gardens, Sandwich MA

Bukowski, William, *Head of Dept,* Bethany Lutheran College, Art Dept, Mankato MN (S)

Bule, Sarah, *Prof,* Clark University, Dept of Visual & Performing Arts, Worcester MA (S)

Bulge, Peggy, *Dir Am Folklife,* Library of Congress, Prints & Photographs Division, Washington DC

Bulger, Stephen, *Dir,* Stephen Bulger Gallery, Toronto ON

Bullard, Diane, *Finance,* Rapid City Arts Council, Dahl Arts Center, Rapid City SD

Bullard, E John, *Dir,* New Orleans Museum of Art, New Orleans LA

Bullock, Jennifer, *Admin Asst,* Canadian Clay & Glass Gallery, Waterloo ON

Bullock, Margaret, *Assoc Cur American Art,* Portland Art Museum, Northwest Film Center, Portland OR

Bullock, Margaret E, *Cur,* University of New Mexico, The Harwood Museum of Art, Taos NM

Bullock, William, *In Charge Industrial Design,* University of Illinois, Urbana-Champaign, School of Art & Design, Champaign IL (S)

Bumpass, Terry, *Cur,* Museum of New Mexico, Office of Cultural Affairs of New Mexico, The Governor's Gallery, Santa Fe NM

Bundock, Bruce, *Preparator,* Vassar College, The Frances Lehman Loeb Art Center, Poughkeepsie NY

Bundy, Annalee, *Exec Dir,* Ames Free-Easton's Public Library, North Easton MA

Bunge, Jean, *Co-Dir,* Nobles County Art Center Gallery, Worthington MN

Bunge, Martin, *Co-Dir,* Nobles County Art Center Gallery, Worthington MN

Bunn, Mike, *Assoc Cur History,* Columbus Museum, Columbus GA

Bunn, Steve, *Exhib Technician,* Bowdoin College, Peary-MacMillan Arctic Museum, Brunswick ME

Bunn, Warren, *Registrar,* Corning Museum of Glass, The Studio, Rakow Library, Corning NY

Bunnenberg-Boehmer, Kay, *Instr,* Chemeketa Community College, Dept of Humanities & Communications, Salem OR (S)

Bunner, Patty, *Instr,* Southwestern Michigan College, Fine & Performing Arts Dept, Dowagiac MI (S)

Buonaccorsi, Jim, *Assoc Prof Sculpture,* University of Georgia, Franklin College of Arts & Sciences, Lamar Dodd School of Art, Athens GA (S)

Buonagurio, Toby, *Prof,* State University of New York at Stony Brook, Dept of College of Arts & Sciences, Art Dept, Stony Brook NY (S)

Burant, Jim, *Documentary Art & Photo Acquisition,* National Archives of Canada, Art & Photography Archives, Ottawa ON

Burbach, Joan, *Secy,* Phelps County Historical Society, Nebraska Prairie Museum, Holdrege NE

Burbach, Sarah, *Chmn Bd,* Morgan County Foundation, Inc, Madison-Morgan Cultural Center, Madison GA

Burbank, Bill, *Mus Asst,* Cornell Museum of Art & History, Delray Beach FL

Burch, Colleen, *School of Art Admin,* Lighthouse Center for the Arts Inc, Tequesta FL

Burchett, Jayme, *Prof,* College of the Ozarks, Dept of Art, Point Lookout MO (S)

Burchett, Kenneth, *Prof,* University of Central Arkansas, Department of Art, Conway AR (S)

Burckes, Sandy, *Cur & Mgr,* New England Maple Museum, Pittsford VT

Burden, Jeff, *Chmn,* Columbus State University, Dept of Art, Fine Arts Hall, Columbus GA (S)

Burden, Jeff, *Dept Head,* Columbus State University, The Gallery, Columbus GA

Burden, Susan, *Dir Admin & Finance Treas,* Simon Wiesenthal Center Inc, Museum of Tolerance, Los Angeles CA

Burdick, Todd, *Interpretation & Educ,* Hancock Shaker Village, Inc, Pittsfield MA

Burdine, Flo, *Prog Dir,* Frankfort Community Public Library, Anna & Harlan Hubbard Gallery, Frankfort IN

Burg, Pat, *Librn,* Illinois State Museum, Museum Store, Chicago IL

Burg, Patricia, *Librn,* Illinois State Museum, Library, Springfield IL

Burgard, Timothy Anglin, *Ednah Root Cur American Art,* Fine Arts Museums of San Francisco, Legion of Honor, San Francisco CA

Burge, Denise, *Foundations Coordr, Undergrad Advisor & Assoc Prof Fine Arts,* University of Cincinnati, School of Art, Cincinnati OH (S)

Burge, Nolina, *Circulations Supv,* Art Center College of Design, James Lemont Fogg Memorial Library, Pasadena CA

Burger, Thomas Julius, *Dir,* University of Bridgeport, School of Arts, Humanities & Social Sciences, Bridgeport CT (S)

Burgess, Virginia, *Office Mgr,* Greenwich Art Society Inc, Greenwich CT

Burgess Smith, Karen, *Dir,* Phillips Exeter Academy, Lamont Gallery, Exeter NH

Burgett, Joe, *Site Mgr Edison De,* Port Huron Museum, Port Huron MI

Burgher, Elijah, *Asst,* The Art Institute of Chicago, Teacher Resource Center, Chicago IL

Burgin, Nancy, *Dir Develop,* Columbus Museum, Columbus GA

Burgner, Kelly, *Chmn,* Ricks College, Dept of Art, Rexburg ID (S)

Burgunder, Heidi, *Admin Asst,* Putnam County Historical Society, Foundry School Museum, Cold Spring NY

Burisch, Nicole, *Prog Asst,* Banff Centre, Walter Phillips Gallery, Banff AB

Burk, Sue, *Develop Asst,* Jay County Arts Council, Hugh N Ronald Memorial Gallery, Portland IN

Burke, Christina, *Cur Native American & Non-Western Art,* Philbrook Museum of Art, Tulsa OK

Burke, Dan, *Prof,* Mercyhurst College, Dept of Art, Erie PA (S)

Burke, Daniel, *Dir,* La Salle University, Art Museum, Philadelphia PA

Burke, G, *Technician,* University of Saskatchewan, Diefenbaker Canada Centre, Saskatoon SK

Burke, J Martin, *Chmn (V),* Missoula Art Museum, Missoula MT

Burke, Jim, *VPres Finance & Admin,* Newberry Library, Chicago IL

Burke, John SJ, *Prof,* Longwood University, Dept of Art, Farmville VA (S)

Burke, Jonathan, *Dean Visual Communication,* Art Institute of Southern California, Laguna Beach CA (S)

Burke, Kathryn, *Gallery Coordr,* Muhlenberg College, Martin Art Gallery, Allentown PA

Burke, Marcus, *Cur Paintings & Metalwork,* Hispanic Society of America, Museum & Library, New York NY

Burke, Rebecca, *Prof,* Mount Allison University, Dept of Fine Arts, Sackville NB (S)

Burke, Shannon, *Dir Educ,* Harriet Beecher Stowe, Hartford CT

Burke, Sheila, *Under Secy for American Museums and Nat'l Programs,* Smithsonian Institution, Washington DC

Burke, William J, *Exec Dir,* Philadelphia Art Commission, Philadelphia PA

Burke, William J, *Prof,* Florida International University, School of Art & Art History, Miami FL (S)

Burkett, Nancy, *Librn,* American Antiquarian Society, Library, Worcester MA

Burkett, Richard, *Studio Graduate Coordr,* San Diego State University, School of Art, Design & Art History, San Diego CA (S)

Burkhalter, Jaime, *Admin Asst,* Custer County Art & Heritage Center, Miles City MT

Burkhart, Vanessa, *Registrar,* Columbus Museum of Art and Design, Indianapolis IN

Burks, Amanda, *Instr,* Biola University, Art Dept, La Mirada CA (S)

Burks, Jean, *Sr Cur,* Shelburne Museum, Library, Shelburne VT

Burks, Sarah, *Preservation-Planner,* Cambridge Historical Commission, Cambridge MA

Burktragermed, Elizabeth, *Instr,* Keystone College, Fine Arts Dept, LaPlume PA (S)

Burleigh, Kimberly, *Dir MFA Prog, Chair & Prof Fine Arts,* University of Cincinnati, School of Art, Cincinnati OH (S)

Burleson, Charles V, *Pres,* Burke Arts Council, Jailhouse Galleries, Morganton NC

Burlingame, William, *Cur of Website,* Ramsay Museum, Honolulu HI

Burmeister, Alice, *Asst Prof,* Winthrop University, Dept of Art & Design, Rock Hill SC (S)

Burner-Harris, Cynthia, *Dir,* Wichita Public Library, Wichita KS

Burnet, Ralph W, *Pres,* Walker Art Center, Minneapolis MN

Burnett, Brian, *Instr & Dir,* Toronto School of Art, Toronto ON (S)

Burnett, Ronald, *Pres,* Emily Carr Institute of Art & Design, Vancouver BC (S)

Burnett, Vernon, *Darkroom Mgr,* Light Work, Robert B Menschel Photography Gallery, Syracuse NY

Burnette, Charles, *Graduate Prog,* University of the Arts, Philadelphia Colleges of Art & Design, Performing Arts & Media & Communication, Philadelphia PA (S)

Burnette, Karin, *Asst Dir Opers,* Southeastern Center for Contemporary Art, Winston-Salem NC

Burnette, Scott, *Instr,* Guilford Technical Community College, Commercial Art Dept, Jamestown NC (S)

Burnham, Laura E, *Exec Dir,* Abington Art Center, Jenkintown PA

Burnham, Richard, *2nd VPres,* Newport Historical Society & Museum of Newport History, Newport RI

Burnley, Gary, *Instr Visual Arts,* Sarah Lawrence College, Dept of Art History, Bronxville NY (S)

Burns, A Lee, *Chmn Art Dept,* Smith College, Art Dept, Northampton MA (S)

Burns, B Jane, *Dir,* Midwest Museum of American Art, Elkhart IN

Burns, Barry, *Asst Prof,* California Lutheran University, Art Dept, Thousand Oaks CA (S)

Burns, Carla, *Exec Dir,* Greensboro Artists' League, Greensboro NC

Burns, Cecil, *Asst,* SLA Arch-Couture Inc, Art Collection, Denver CO

Burns, Courtney, *Chief Cur,* New York State Military Museum and Veterans Research Center, Saratoga Springs NY

Burns, Jeffrey, *Assoc Prof,* Mount Allison University, Dept of Fine Arts, Sackville NB (S)

Burns, John, *VPres,* Oregon Historical Society, Oregon History Center, Portland OR

Burns, Julie A, *Commissioner,* Mayors Office of Arts, Rourism and Special Events, City Hall Galleries, Boston MA

Burns, Kathryn, *Dir & Cur,* Muttart Public Art Gallery, Calgary AB

Burns, Laura, *Exhib Dir & Coll Coordr,* Goucher College, Rosenberg Gallery, Baltimore MD

Burns, Mark, *Prof & Chmn,* University of Nevada, Las Vegas, Dept of Art, Las Vegas NV (S)

Burns, Millie, *Dir,* Marymount Manhattan College Gallery, New York NY

Burns, Sarah, *Assoc Prof,* Indiana University, Bloomington, Henry Radford Hope School of Fine Arts, Bloomington IN (S)

Burns, Steve, *Dir Engineering Svcs,* Disney's Animal Kingdom Theme Park, Bay Lake FL

Burns, Todd, *Asst Prof,* University of Louisville, Allen R Hite Art Institute, Louisville KY (S)

Burr, Josephine, *Studio Mgr,* Greenwich House Inc, Greenwich House Pottery, New York NY (S)

Burr, Linda, *Dir Develop,* University of North Carolina at Greensboro, Weatherspoon Art Museum, Greensboro NC

Burr, Marcy, *Educ Coordr,* Hastings Museum of Natural & Cultural History, Hastings NE

Burrell, Debra, *Arts Coordr,* City of Hampton, Hampton Arts Commission, Hampton VA

Burrell, William, *Prof,* Amarillo College, Visual Art Dept, Amarillo TX (S)

Burrough, Margaret T, *Founder,* DuSable Museum of African American History, Chicago IL

Burroughs, Brody, *Asst Prof,* Ithaca College, Fine Art Dept, Ithaca NY (S)

Burroughs, Charles, *Assoc Prof,* State University of New York at Binghamton, Dept of Art History, Binghamton NY (S)

Burroughs, Charles, *Chmn,* Case Western Reserve University, Dept of Art History & Art, Cleveland OH (S)

Burroughs, Margaret, *Co-Founder,* African American Museums Association, Wilberforce OH

Burroughs, Sarah, *Interim Dir,* Fisk University, Fisk University Galleries, Nashville TN

Burson, Nancy, *Admin Asst,* Scripps College, Clark Humanities Museum, Claremont CA

Burt, Ann, *Dir,* Ormond Memorial Art Museum and Gardens, Ormond Beach FL

Burt, Helen, *Instr,* Toronto Art Therapy Institute, Toronto ON (S)

Burt, Mary Ellen, *Asst Mgr,* New England Maple Museum, Pittsford VT

Burton, Douglas, *Asst Prof,* Lenoir Rhyne College, Dept of Art, Hickory NC (S)

Burton, Joseph, *Assoc Prof,* Clemson University, College of Architecture, Clemson SC (S)

Burton, Judith, *Dir,* Columbia University, Teachers Col Program in Art & Art Educ, New York NY (S)

Burton, Troy, *Prog Dir,* Eubie Blake, Baltimore MD

Burwell, Sandra L, *Assoc Prof,* Indiana University of Pennsylvania, College of Fine Arts, Indiana PA (S)

Burzcyk, Monika, *Instr,* Springfield College, Dept of Visual & Performing Arts, Springfield MA (S)

Busam, Amy, *Chief Develop Officer, Individual Giving,* The American Federation of Arts, New York NY

Busby, James, *Chmn,* Houston Baptist University, Dept of Art, Houston TX (S)

Busceme, Greg, *Dir,* The Art Studio Inc, Beaumont TX

Buscemi, Drusilla, *Dir Develop,* Abington Art Center, Jenkintown PA

Busch, Ellen Cone, *Dir,* Planting Fields Foundation, Coe Hall at Planting Fields Arboretum, Oyster Bay NY

Busch, Jason, *Cur Decorative Arts,* Carnegie Museums of Pittsburgh, Carnegie Museum of Art, Pittsburgh PA

Buschor, Elizabeth, *Paper Conservator,* Midwest Art Conservation Center, Minneapolis MN

Buser, Tom, *Assoc Prof,* University of Louisville, Allen R Hite Art Institute, Louisville KY (S)

Bush, Colleen, *Human Resources Mgr,* The Adirondack Historical Association, The Adirondack Museum, Blue Mountain Lake NY

Bush, Dena, *School Prog & Tour Coordr,* West Florida Historic Preservation, Inc, T T Wentworth, Jr Florida State Museum & Historic Pensacola Village, Pensacola FL

Bush, Teresia, *Sr Educator,* Hirshhorn Museum & Sculpture Garden, Smithsonian Institution, Washington DC

Bushara, Leslie, *Assoc Dir Programs,* Children's Museum of Manhattan, New York NY

Busta, Bill, *Treas & Dir,* Intermuseum Conservation Association, Oberlin OH

Bustamante, Cody, *Chmn Dept Art,* Southern Oregon University, Dept of Art, Ashland OR (S)

Buster, Patricia, *Asst Cur Educ,* Museum of Fine Arts, Saint Petersburg, Florida, Inc, Saint Petersburg FL

Bustos, Betty, *Archivist & Librn,* Panhandle-Plains Historical Society Museum, Research Center, Canyon TX

Butcher, Larry, *Prof,* Delta College, Art Dept, University Center MI (S)

Butckovitz, Dean, *Gallery Mgr,* University of North Carolina at Charlotte, Dept Art, Charlotte NC (S)

Butera, John, *Dir,* Butera School of Art, Boston MA (S)

Butera, Joseph L, *Pres,* Butera School of Art, Boston MA (S)

Butler, Charles T, *Dir,* Columbus Museum, Columbus GA

Butler, Cherie, *Educ Coordr,* Cedar Rapids Museum of Art, Cedar Rapids IA

Butler, Connie, *Chief Cur,* Museum of Modern Art, New York NY

Butler, Diane, *Assoc Cur, Coll Mgr,* Colgate University, Picker Art Gallery, Hamilton NY

Butler, Elizabeth, *Asst VPres Develop,* Brookgreen Gardens, Murrells Inlet SC

Butler, Erin, *Exec Coordr,* Women in the Arts Foundation, Inc, New York NY

Butler, Erin, *Newsletter Ed,* Women in the Arts Foundation, Inc, New York NY

Butler, Janine, *Librn,* Art Gallery of Windsor, Reference Library, Windsor ON

Butler, Janine, *Registrar,* Art Gallery of Windsor, Windsor ON

Butler, Jerry E, *Chmn,* Madison Area Technical College, Art Dept, Madison WI (S)

Butler, Joshua, *Lecturer,* Mesa State College, Art Dept, Grand Junction CO (S)

Butler, Kent, *Asst Prof,* Azusa Pacific University, College of Liberal Arts, Art Dept, Azusa CA (S)

Butler, Maria, *Exec Dir,* Pensacola Museum of Art, Harry Thornton Library, Pensacola FL

Butler, Maria V, *Exec Dir,* Pensacola Museum of Art, Pensacola FL

Butler, Ruth, *Emeritus Prof,* University of Massachusetts - Boston, Art Dept, Boston MA (S)

Butler, Stephen M, *Graphic Design,* Art Institute of Pittsburgh, Pittsburgh PA (S)

Butler, Susan, *Prog Coordr Photography Dept,* Pine Manor College, Visual Arts Dept, Chestnut Hill MA (S)

Butler, Todd, *Dir Mktg & Pub Relations,* Genesee Country Village & Museum, John L Wehle Gallery of Wildlife & Sporting Art, Mumford NY

Butow, Liv, *Exec Dir,* Prince George Art Gallery, Prince George BC

Butts, H Daniel, *Art Dir,* Mansfield Fine Arts Guild, Library, Mansfield OH

Butts, H Daniel, *Dir,* Mansfield Fine Arts Guild, Mansfield Art Center, Mansfield OH

Butts, Patricia, *Asst to Dir,* Columbus Museum, Columbus GA

Buttwinick, Edward, *Dir,* Brentwood Art Center, Los Angeles CA (S)

Butz, Lane, *Instr,* Western Wisconsin Technical College, Graphics Division, La Crosse WI (S)

Buxbaum, Melba, *Chmn,* Blackburn College, Dept of Art, Carlinville IL (S)

Buxkamper, Barry, *Instr,* Middle Tennessee State University, Art Dept, Murfreesboro TN (S)

Buxton, Eliza, *Admin,* Carolina Art Association, Gibbes Museum of Art, Charleston SC

Buxton, Sharon, *Registrar,* Johnson-Humrickhouse Museum, Coshocton OH

Buyers, Jane, *Prof & Chmn,* University of Waterloo, Fine Arts Dept, Waterloo ON (S)

Buzard, Yvette, *Mktg Intern,* Broward County Board of Commissioners, Cultural Affairs Div, Fort Lauderdale FL

Byassee, Jessica, *Dir Pub Rels,* Museum of the American Quilter's Society, Paducah KY

Byce, Joane, *Instr,* Pierce College, Art Dept, Woodland Hills CA (S)

Byer, Stuart, *Pub Rels Mktg & Comm,* Laguna Art Museum, Laguna Beach CA

Byers, Bill, *Assoc Prof,* Brevard College, Division of Fine Arts, Brevard NC (S)

Byers, Bill, *Chmn Art,* Brevard College, James A Jones Library, Brevard NC

Byers, Bill, *Dir,* Brevard College, Spiers Gallery, Brevard NC

Byers, Larry, *Assoc Prof,* Saint Louis Community College at Florissant Valley, Liberal Arts Division, Ferguson MO (S)

Byers, Laura, *Cur Rare Books,* Norfolk Historical Society Inc, Museum, Norfolk CT

Byers, Shannon, *Office Mgr,* University of North Carolina at Greensboro, Weatherspoon Art Museum, Greensboro NC

Bykonen, Lisa, *Mus Security Clerk II,* Alaska Department of Education, Division of Libraries, Archives & Museums, Sheldon Jackson Museum, Sitka AK

Byler, Cynthia, *Asst Prof,* Lincoln University, Dept Fine Arts, Jefferson City MO (S)

Byrd, Cathy, *Dir,* Georgia State University, Art Gallery, Atlanta GA

Byrd, Jeff, *Prof,* University of Northern Iowa, Dept of Art, Cedar Falls IA (S)

Byrd, Jeffery, *Prof,* University of Northern Iowa, Dept of Art, Cedar Falls IA (S)

Byrd, Joan, *Prof,* Western Carolina University, Dept of Art/College of Arts & Science, Cullowhee NC (S)

Byrd, Kathleen, *Staff Performing Artist,* Jay County Arts Council, Hugh N Ronald Memorial Gallery, Portland IN

Byrn, Brian D, *Cur Exhib & Educ,* Midwest Museum of American Art, Elkhart IN

Byrne, Brenda Barry, *Pres Brd Dirs,* Museums Association of Saskatchewan, Regina SK

Byrne, Jeri, *Fine Art Librn,* Beverly Hills Public Library, Fine Arts Library, Beverly Hills CA

Byrne, Joseph, *Chmn, Prof Fine Arts,* Trinity College, Dept of Studio Arts, Hartford CT (S)

Byrne, Richard, *Pres & Dir,* Norfolk Historical Society Inc, Museum, Norfolk CT

Byrum, Donald, *Chmn,* Wichita State University, School of Art & Design, Wichita KS (S)

Bytnerowicz, Dasia, *Exhibitions Designer,* Riverside Municipal Museum, Riverside CA

Bytof, Corey, *Public Rels,* City of San Rafael, Falkirk Cultural Center, San Rafael CA

Bywaters, Diane, *Prof,* University of Wisconsin-Stevens Point, Dept of Art & Design, Stevens Point WI (S)

Bzdak, Michael J, *Art Cur,* Johnson & Johnson, Art Program, New Brunswick NJ

Cabral, Louis, *Exec Dir,* ASTED Inc, Montreal PQ

Cacciatori, Liz, *Mgr,* Equitable Life Assurance Society, The Equitable Gallery, New York NY

Cadaret, Marge, *VPres,* Spectrum Gallery, Toledo OH

Cadby-Sorensen, Robin, *Vol Dir, Cur & Mus Shop Mgr,* Three Forks Area Historical Society, Headwaters Heritage Museum, Three Forks MT

Caddell, Bill, *Dir,* Frankfort Community Public Library, Anna & Harlan Hubbard Gallery, Frankfort IN

Caddell, Foster, *Head Dept,* Foster Caddell's, North Light, Voluntown CT (S)

Cade, Leslie, *Archivist,* Cleveland Museum of Art, Ingalls Library, Cleveland OH

Cadez, Robert, *Mgr Enrichment,* Henry Ford Community College, McKenzie Fine Art Ctr, Dearborn MI (S)

Cadger, Neil, *Assoc Prof (Performance - Theater),* University of British Columbia Okanagan, Dept of Creative Studies, Kelowna BC (S)

Cadigan, Edward, *Supv of Operations,* Memorial University of Newfoundland, Art Gallery of Newfoundland & Labrador, Saint John's NF

Cafferty, Nancy, *Dir Finance,* National Academy Museum & School of Fine Arts, New York NY

Cafferty, Nancy, *Dir Finance & Human Resources,* National Academy Museum & School of Fine Arts, Archives, New York NY

Cagno, Michael, *Exec Dir,* The Noyes Museum of Art, Oceanville NJ

Cahalan, Anthony, *Dean Design,* Ontario College of Art & Design, Toronto ON (S)

Cahalan, Joseph M, *VPres Xerox Foundation,* Xerox Corporation, Art Collection, Stamford CT

Cahan, Susan, *Assoc Prof,* University of Missouri, Saint Louis, Dept of Art & Art History, Saint Louis MO (S)

Cahill, Marilyn, San Jose Museum of Art, Library, San Jose CA

Cahill, Stephen, *Photography,* Pitzer College, Dept of Art, Claremont CA (S)

Cahill, Theresa, *Bus & Vocations Librn,* Long Beach Public Library, Long Beach NY

Cain, Brenda, *Financial Dir,* Urban Institute for Contemporary Arts, Grand Rapids MI

Cain, Daniel, *Pres Board,* Norman Rockwell Museum, Stockbridge MA

Cain, Dawn, *Malcove Cur,* University of Toronto, University of Toronto Art Centre, Toronto ON

Cain, Paula, *Head Technical Svcs,* Ponca City Library, Art Dept, Ponca City OK

Caine, William, General Services Administration, Washington DC

Cairns, R Christopher, *Prof,* Haverford College, Fine Arts Dept, Haverford PA (S)

Cairns, Roger, *Assoc Prof,* Montgomery County Community College, Art Center, Blue Bell PA (S)

Caisly, Sherry, *Cur,* Appaloosa Museum and Heritage Center, Moscow ID

Caivano, Felice, *Cur,* Trinity College, Austin Arts Center, Widener Gallery, Hartford CT

Caivano, Nicholas, *Lectr,* Georgian Court College, Dept of Art, Lakewood NJ (S)

Calabrese, John A, *Prof,* Texas Woman's University, School of the Arts, Dept of Visual Arts, Denton TX (S)

Calabria, Susan, *Educ Cur,* Brattleboro Museum & Art Center, Brattleboro VT

Calafiore, Robert, *Asst Dean,* University of Hartford, Hartford Art School, West Hartford CT (S)

Calamia, Beth, *Dir Educ,* Hickory Museum of Art, Inc, Hickory NC

Caldemeyer, Charles D, *Assoc Prof,* Ashland University, Art Dept, Ashland OH (S)

Calder, Jacqueline, *Cur,* Vermont Historical Society, Museum, Montpelier VT

Calder-Lacroix, Jenny, *Admin Asst,* Concordia University, Leonard & Bina Ellen Art Gallery, Montreal PQ

Calderhead, Jocelyn, *Mktg & Develop Dir,* The Canadian Craft Museum, Vancouver BC

Calderon, Ismael, *Dir Science,* Newark Museum Association, The Newark Museum, Newark NJ

Calderwood, Kathy, *Assoc Prof,* Nazareth College of Rochester, Art Dept, Rochester NY (S)

Caldwell, Blaine, *Prof,* University of the Ozarks, Dept of Art, Clarksville AR (S)

Caldwell, Brenda, *Acting Park Supt,* Tuskegee Institute National Historic Site, George Washington Carver & The Oaks, Tuskegee Institute AL

Caldwell, Carey, *Cur Special Project,* Oakland Museum of California, Art Dept, Oakland CA

Caldwell, Desiree, *Exec Dir,* Concord Museum, Concord MA

Caldwell, Donald R, *Chmn Board,* Pennsylvania Academy of the Fine Arts, Philadelphia PA

Caldwell, Frances, *Pub Information Officer,* Birmingham Museum of Art, Birmingham AL

Caldwell, Michael, *Prof,* Seattle Pacific University, Art Dept, Seattle WA (S)

Caldwell, Peter, *VPres Administration,* Ontario College of Art & Design, Toronto ON (S)

Calhoun, Georgia V, *Chm (V),* Anniston Museum of Natural History, Anniston AL

Calisch, Doug, *Prof,* Wabash College, Art Dept, Crawfordsville IN (S)

Calkins, Ken, *Music Librn,* University of California, San Diego, Arts Libraries, La Jolla CA

Callahan, Betty, *Admin Asst,* Okefenokee Heritage Center, Inc, Waycross GA

Callahan, Christine, *Exec Dir,* Newport Art Museum, Newport RI

Callahan, Colin J, *Dir Art Center,* Saint Paul's School, Art Center in Hargate, Concord NH

Callahan, Debra, *Educ,* Birmingham-Bloomfield Art Center, Art Center, Birmingham MI

Callahan, Diane, *Adjunct Prof,* Southwest Baptist University, Art Dept, Bolivar MO (S)

Callahan, Nancy, *Chmn Art Dept,* State University of New York College at Oneonta, Art Gallery & Sculpture Court, Oneonta NY

Callahan, Nancy, *Instr,* State University of New York College at Oneonta, Dept of Art, Oneonta NY (S)

Callahen, Ruth, *Cur Coll,* Museum of East Texas, Lufkin TX

Callahen, Christine, *Dir Museum,* Newport Art Museum School, Newport RI (S)

Callanan, Susan, *Registrar,* Independent Curators International, New York NY

Callis, Daniel, *Assoc Prof,* Biola University, Art Dept, La Mirada CA (S)

Callisto, Angela, *Pub Rels & Cur,* Hus Var Fine Art, Buffalo NY

Calloway, Edwin, *Chmn,* Truett-McConnell College, Fine Arts Dept & Arts Dept, Cleveland GA (S)

Calloway, William, *Dir,* South Carolina State Museum, Columbia SC

Callus, Tom, *Registrar,* Orange County Museum of Art, Orange County Museum of Art, Newport Beach CA

Calman, Wendy, *Assoc Prof,* Indiana University, Bloomington, Henry Radford Hope School of Fine Arts, Bloomington IN (S)

Calo, Mary Ann, *Asst Prof,* Colgate University, Dept of Art & Art History, Hamilton NY (S)

Calvert, Ann, *Dean, Faculty Fine Arts,* University of Calgary, Dept of Art, Calgary AB (S)

Calza, Susan, *Prof Sculpture,* Johnson State College, Dept Fine & Performing Arts, Dibden Center for the Arts, Johnson VT (S)

Camara, Esperanca, *Asst Prof,* University of Saint Francis, School of Creative Arts, Fort Wayne IN (S)

Camber, Diane W, *Dir,* Bass Museum of Art, Miami Beach FL

Cambre, Javier, *Asst Prof,* Queensborough Community College, Dept of Art & Photography, Bayside NY (S)

Cameron, Ben, *Instr,* Columbia College, Art Dept, Columbia MO (S)

Cameron, Diane, *Dir Finance,* Yellowstone Art Museum, Billings MT

Cameron, Greg, *Assoc Dir & Chief Develop Officer,* Museum of Contemporary Art, Chicago IL

Cameron, John B, *Prof,* Oakland University, Dept of Art & Art History, Rochester MI (S)

Cameron, Joyce M, *Dir Develop,* Eastern Washington State Historical Society, Northwest Museum of Arts & Culture, Spokane WA

Cameron, Sandy, *Acting Dir & Librn,* Regina Public Library, Art Dept, Regina SK

Cammuso, Philomena, *Pres,* Seneca Falls Historical Society Museum, Seneca Falls NY

Camp, Ann, *Asst Cur Educ,* City of El Paso, El Paso TX

Camp, Ann, *Develop,* Laguna Art Museum, Laguna Beach CA

Camp, Carl, *Cur,* Utah Department of Natural Resources, Division of Parks & Recreation, Territorial Statehouse, Salt Lake City UT

Camp, Edward, *Prof & Chmn,* Manatee Community College, Dept of Art & Humanities, Bradenton FL (S)

Camp, Kimberly, *Exec Dir,* Barnes Foundation, Merion PA

Camp, Roger, *Chmn & Instr,* Golden West College, Visual Art Dept, Huntington Beach CA (S)

Campbell, Alex, *VChmn Bd,* Shaker Village of Pleasant Hill, Harrodsburg KY

Campbell, Bruce, *Ctr for Earth,* National Air and Space Museum, Washington DC

Campbell, Charles, *Instr,* Saint Mary's University of Minnesota, Art & Design Dept, Winona MN (S)

Campbell, Clayton, *Co-Dir,* 18th Street Arts Complex, Santa Monica CA

Campbell, Colin, *Pres,* Colonial Williamsburg Foundation, Williamsburg VA

Campbell, Cyndie, *Head Archives,* National Gallery of Canada, Library, Ottawa ON

Campbell, Deborah, *Gallery Dir,* Ann Arbor Art Center, Art Center, Ann Arbor MI

Campbell, Don, *Vol Coordr,* Indiana State Museum, Indianapolis IN

Campbell, Elaine, *Educ Dir,* Gadsden Museum of Fine Arts, Inc, Gadsden Museum of Art and History, Gadsden AL

Campbell , Francis D, *Librn,* American Numismatic Society, New York NY

Campbell, Francis D, *Librn,* American Numismatic Society, Library, New York NY

Campbell, Graham, *Chmn,* Brandeis University, Dept of Fine Arts, Waltham MA (S)

Campbell, Ina, *Pres,* Historical Society of Bloomfield, Bloomfield NJ

Campbell, James, *Librn,* New Haven Colony Historical Society, Whitney Library, New Haven CT

Campbell, James W, *Librn,* New Haven Colony Historical Society, New Haven CT

Campbell, Janet, *Business Mgr,* Woodrow Wilson, Woodrow Wilson Presidential Library, Staunton VA

Campbell, Jean C, *Assoc Prof,* Emory University, Art History Dept, Atlanta GA (S)

Campbell, Kathleen, *Asst Cur,* University of Minnesota, Goldstein Gallery, Saint Paul MN

Campbell, Kay, *Assoc Prof,* Oregon State University, Dept of Art, Corvallis OR (S)

Campbell, Krista, *Exec Dir,* Dairy Barn Cultural Arts Center, Athens OH

Campbell, L.Kathleen, *Asst Prof,* Appalachian State University, Dept of Art, Boone NC (S)

Campbell, Laura, *Assoc Librn,* Library of Congress, Prints & Photographs Division, Washington DC

Campbell, Laura, *Sr VPres,* Please Touch Museum, Philadelphia PA

Campbell, Levin, *VPres,* Massachusetts Historical Society, Library, Boston MA

Campbell, Lynne, *Registrar,* Michigan State University, Kresge Art Museum, East Lansing MI

Campbell, Mary, *Assoc Prof,* Jersey City State College, Art Dept, Jersey City NJ (S)

Campbell, Maryann, *Dir Research Library,* Oregon Historical Society, Oregon History Center, Portland OR

Campbell, Maryann, *Libr Dir,* Oregon Historical Society, Research Library, Portland OR

Campbell, Mei Wan, *Cur Ethnology & Textiles,* Texas Tech University, Museum of Texas Tech University, Lubbock TX

Campbell, Michael, *Asst Prof,* Shippensburg University, Art Dept, Shippensburg PA (S)

Campbell, Nancy, *Dir,* Wayne Art Center, Wayne PA

Campbell, Richard, *Cur Prints & Drawings,* Minneapolis Institute of Arts, Minneapolis MN

Campbell, Robin P, *Assoc Cur,* New York State Office of Parks, Recreation and Historic Preservation, Bureau of Historic Sites, Waterford NY

Campbell, Sally, *Asst Prof,* University of Texas at Tyler, Deptartment of Art, School of Visual & Performing Arts, Tyler TX (S)

Campbell, Sara, *Sr Cur,* Norton Simon, Pasadena CA

Campbell, Shanan, *Commissioner,* United States Department of the Interior, Indian Arts & Crafts Board, Washington DC

Campbell, Stephen, *Chmn,* Spring Hill College, Department of Fine & Performing Arts, Mobile AL (S)

Campbell, Suzy, *Operations Mgr,* Prescott Fine Arts Association, Gallery, Prescott AZ

Campbell, Tom, *Instr,* Toronto School of Art, Toronto ON (S)

Campognone, Andi, *Assoc Dir,* Riverside Art Museum, Riverside CA

Campulli, Eleanor, *Prof,* Jersey City State College, Art Dept, Jersey City NJ (S)

Canaves, Marie, *Prof,* Cape Cod Community College, Art Dept, West Barnstable MA (S)

Candel, Sol, *Gen Mgr,* Museum of Movie Art, Calgary AB

Canfield, Megan, *Educ Coordr,* Liberty Hall Historic Site, Library, Frankfort KY

Cangelosi, Keith, *Chmn Memorial Hall Committee,* Confederate Memorial Hall, Confederate Museum, New Orleans LA

Caniff, Al, *Chmn,* Western State College of Colorado, Quigley Hall Art Gallery, Gunnison CO

Canning, Scott, *Dir Horticulture,* Wave Hill, Bronx NY

Canning, Susan, *Prof,* College of New Rochelle School of Arts & Sciences, Art Dept, New Rochelle NY (S)

Canning-LaCroix, Johane, *Dir,* Musee d'Art de Saint-Laurent, Saint-Laurent PQ

Cannon, Robert, *Dir,* Public Library of Charlotte & Mecklenburg County, Charlotte NC

Cannon, Sara L, *Dir Mus Educ & Tours,* Cultural Affairs Department, Los Angeles Municipal Art Gallery, Los Angeles CA

Cannul, Richard G, *Dir,* Villanova University Art Gallery, Villanova PA

Cannuli, Richard, *Chmn,* Villanova University, Dept of Theater, Villanova PA (S)

Cannup, John, *VPres Facilities Management,* The Mariners' Museum, Newport News VA

Cano, Rose, *Exec Dir,* Plaza de la Raza Cultural Center, Los Angeles CA

Canright, Steve, *Cur Maritime History,* San Francisco Maritime National Historical Park, Maritime Museum, San Francisco CA

Cantella, Michael, *Multimedia & Web Design,* Art Institute of Pittsburgh, Pittsburgh PA (S)

Canter, Nancy, *Dean Creative Arts,* De Anza College, Creative Arts Division, Cupertino CA (S)

Carter Southard, Edna, *Cur Coll,* Miami University, Art Museum, Oxford OH

Carter Stevenson, Ruth, *Chmn Board Trustees,* National Gallery of Art, Washington DC

Cartier, Suzanne J, *1st VChmn,* Guild Hall of East Hampton, Inc, Guild Hall Museum, East Hampton NY

Cartmell, Timothy, *Museum Store Mgr,* Board of Parks & Recreation, The Parthenon, Nashville TN

Cartwright, Derrick R., *Dir,* Dartmouth College, Hood Museum of Art, Hanover NH

Cartwright, Derrick R., *Exec Dir,* San Diego Museum of Art, San Diego CA

Cartwright, Rick, *Dean,* University of Saint Francis, John Weatherhead Gallery, Fort Wayne IN

Cartwright, Rick, *Dean,* University of Saint Francis, School of Creative Arts, Fort Wayne IN (S)

Cartwright, Roy, *Prof Fine Arts,* University of Cincinnati, School of Art, Cincinnati OH (S)

Carty, Connie, *VPres,* Pine Bluff/Jefferson County Historical Museum, Pine Bluff AR

Carusi, Corina, *Exec Dir & Sr Cur,* Glessner House Museum, Chicago IL

Caruthers, Robert, *Prof,* West Texas A&M University, Art, Communication & Theatre Dept, Canyon TX (S)

Carvalho, Cheryl, *Admin Asst,* Newport Historical Society & Museum of Newport History, Newport RI

Carvalho, Joseph, *Exec Dir & Pres,* Springfield Library & Museums Association, Springfield Science Museum, Springfield MA

Carvalho, Joseph, *Pres & Exec Dir,* Springfield Library & Museums Association, Museum of Fine Arts, Springfield MA

Carvalho, Joseph, *Pres & Exec Dir,* Springfield Library & Museums Association, Connecticut Valley Historical Society, Springfield MA

Carvalho, Joseph, *Pres & Exec Dir,* Springfield Museums Association, George Walter Vincent Smith Art Museum, Springfield MA

Carvalho, Mitjl, *Div Dean,* Rio Hondo College Art Gallery, Whittier CA

Carvallo, Ligia, *Asst Prof Art Graphic Design,* Florida Southern College, Melvin Art Gallery, Lakeland FL

Carver, Cynthia, *Ofc Coordr,* Muscatine Art Center, Museum, Muscatine IA

Carver, Cynthia, *Office Coordr,* Muscatine Art Center, Muscatine IA

Carver, Dan, *Mus Educ,* Springfield Art Museum, Springfield MO

Carver, Melvin, *Chmn,* North Carolina Central University, Art Dept, Durham NC (S)

Caryn, Laurel, *Asst Prof Lectr,* University of Utah, Dept of Art & Art History, Salt Lake City UT (S)

Casaletto, Kristin, *Acting Chair,* Augusta State University, Dept of Arts, Augusta GA (S)

Casas, Teresa, *Pub Prog,* Oakville Galleries, Centennial Square and Gairloch Gardens, Oakville ON

Casbarro, Shawn, *Instr,* Taylor University, Visual Art Dept, Upland IN (S)

Case, Karen, *Bus Mgr,* University of Wyoming, University of Wyoming Art Museum, Laramie WY

Case, Niona, *Secy,* Pioneer Historical Museum of South Dakota, Hot Springs SD

Casey, Candace, *Gallery Store,* Worcester Center for Crafts, Worcester MA (S)

Casey, Jonathan, *Archivist,* Liberty Memorial Museum & Archives, The National Museum of World War I, Kansas City MO

Casey, Lynn Rozzi, *Cur,* Nassau Community College, Firehouse Art Gallery, Garden City NY

Cash, G Gerald, *Chmn Fine Arts Div,* Florida Keys Community College, Fine Arts Div, Key West FL (S)

Cash, Sarah, *Bechoefer Cur American Art,* Corcoran Gallery of Art, Washington DC

Cashatt, Everett D, *Cur Zoology,* Illinois State Museum, Museum Store, Chicago IL

Cashman, Carol, *Instr,* Bismarck State College, Fine Arts Dept, Bismarck ND (S)

Casimiro, Charles, *Historic Site Asst,* Philipse Manor Hall State Historic Site, Yonkers NY

Casimiro, Olinda, *Adminr,* The Robert McLaughlin, Oshawa ON

Caslin, Robert, *Design & Installation,* Modern Art Museum, Fort Worth TX

Casper, Joseph, *CEO,* Caspers, Inc, Art Collection, Tampa FL

Cass, Doug, *Archivist,* Glenbow Museum, Library, Calgary AB

Cassara, Tina, *Prof,* Cleveland Institute of Art, Cleveland OH (S)

Cassaro, Amy, *Receptionist,* Boca Raton Museum of Art, Boca Raton FL

Casselman, Carol Ann, *Mgr Resource Centre,* Ontario Crafts Council, The Craft Gallery, Toronto ON

Casselman, Carol Ann, *Portfolio of Makers Mgr,* Ontario Crafts Council, Craft Resource Centre, Toronto ON

Cassetti, Robert K, *Dir Mktg & Guest Srvcs,* Corning Museum of Glass, The Studio, Rakow Library, Corning NY

Cassidy, Anne, *Coll Mgr,* New York State Office of Parks, Recreation and Historic Preservation, Bureau of Historic Sites, Waterford NY

Cassidy, Gary, *Dir,* George Phippen, Phippen Art Museum, Prescott AZ

Cassidy, Stephanie, *Archivist,* Art Students League of New York, New York NY

Cassone, John, *Assoc Prof,* Los Angeles Harbor College, Art Dept, Wilmington CA (S)

Casspm, Richard, *VPres,* Madison County Historical Society, Cottage Lawn, Oneida NY

Cassway, Nick, *Exec Dir,* Nexus Foundation for Today's Art, Philadelphia PA

Cast, David, *Chmn Dept,* Bryn Mawr College, Dept of the History of Art, Bryn Mawr PA (S)

Castagna, Peg, *Bookkeeper,* Ocean City Arts Center, Ocean City NJ (S)

Castald, Mary Louise, *Reference Librn,* The University of the Arts, University Libraries, Philadelphia PA

Castaldi, Alyse, *Community Committee,* Brooklyn Museum, Brooklyn NY

Castaneda, Helen, *Membership Chmn,* Blacksburg Regional Art Association, Blacksburg VA

Castaneda, Ivan, *Asst Prof,* University of Idaho, Dept of Art & Design, Moscow ID (S)

Castellani, Carla, *Museum Shop,* Niagara University, Castellani Art Museum, Niagara NY

Castelluzzo, Julie, *Electronic Serv,* Cooper Union for the Advancement of Science & Art, Library, New York NY

Castelnuovo, Sheri, *Cur Educ & Public Programming,* Madison Museum of Contemporary Art, Madison WI

Castillo, Anna, *Cur Educ,* Museum of Art & History, Santa Cruz, Santa Cruz CA

Castillo, Anna, *Educ Admin,* Tacoma Art Museum, Tacoma WA

Castillo, Marie, *Finance Officer,* Contemporary Art for San Antonio Blue Star Art Space, San Antonio TX

Castle, Charles, *Assoc Dir,* Museum of Contemporary Art, San Diego-Downtown, La Jolla CA

Castle, Delphine, *Registrar & Technician,* Craigdarroch Castle Historical Museum Society, Victoria BC

Castle, Lynn, *Exec Dir,* Art Museum of Southeast Texas, Beaumont TX

Castleberry, May, *Librn,* Whitney Museum of American Art, New York NY

Castner, Patricia, *Pres Bd,* Cheltenham Center for the Arts, Cheltenham PA (S)

Castriota, David, *Instr,* Sarah Lawrence College, Dept of Art History, Bronxville NY (S)

Castro, Ricardo, *Prof,* McGill University, School of Architecture, Montreal PQ (S)

Catchi, Benice, *Exec VPres,* New York Society of Women Artists, Inc, Westport CT

Cate, Barbara, *Prof,* Seton Hall University, College of Arts & Sciences, South Orange NJ (S)

Cateforts, David, *Assoc Prof,* University of Kansas, Kress Foundation Dept of Art History, Lawrence KS (S)

Catellier, Hugo-Lupin, *Technician,* La Chambre Blanche, Quebec PQ

Catherall, Virginia, *Dir Public Prog,* University of Utah, Utah Museum of Fine Arts, Salt Lake City UT

Catizone, Richard, *Media Arts & Animation,* Art Institute of Pittsburgh, Pittsburgh PA (S)

Catling, William, *Chmn Dept,* Azusa Pacific University, College of Liberal Arts, Art Dept, Azusa CA (S)

Caudillo, Robert, *Promotions Coordr,* Creighton University, Lied Art Gallery, Omaha NE

Caulfield, Sean, *Coordr Printmaking & Drawing,* University of Alberta, Dept of Art & Design, Edmonton AB (S)

Caulkins, Beth, *Co-Owner & Creative Dir,* Frank Lloyd Wright Museum, AD German Warehouse, Richland Center WI

Causey, Carley, *Asst Prof,* University of Southern Mississippi, Dept of Art & Design, Hattiesburg MS (S)

Cauthen, Gene, *Chmn Dept Art,* Mount Wachusett Community College, East Wing Gallery, Gardner MA

Cavallaro, Marie, *Assoc Prof,* Salisbury State University, Art Dept, Salisbury MD (S)

Cavallo, Steven, *Children's Librn,* Palisades Park Public Library, Palisades Park NJ

Cavalucci, Renee, The Boston Printmakers, Boston MA

Cavanagh, T, *Assoc Prof,* Technical University of Nova Scotia, Faculty of Architecture, Halifax NS (S)

Cavanaugh, CJ, *Art Instr,* Tyler Junior College, Art Program, Tyler TX (S)

Cavanaugh, Marianne L, *Head Librn,* The Saint Louis Art Museum, Richardson Memorial Library, Saint Louis MO

Cave, Mark, *Manuscripts Librn,* The Historic New Orleans Collection, New Orleans LA

Cavendish, Kim L, *Pres,* Museum of Discovery & Science, Fort Lauderdale FL

Caviness, Madeline H, *Prof,* Tufts University, Dept of Art & Art History, Medford MA (S)

Cavish, Jacquelyn, *Cur Arts,* Ventura County Maritime Museum, Inc, Oxnard CA

Cavnor, Julie, *Interim Exec Dir,* Maryland Art Place, Baltimore MD

Cawthorne, Bonnie, *Library Technical Asst,* University of Maryland, College Park, Art Library, College Park MD

Cayford, Tracie, *Media Dir,* Utah Travel Council, Salt Lake City UT

Cazorla, Patricia, *Asst Cur,* Lehman College Art Gallery, Bronx NY

Cebulash, Glen, *Assoc Prof,* Wright State University, Dept of Art & Art History, Dayton OH (S)

Cecco, Lucia, *Gallery Asst,* Art Gallery of Mississauga, Mississauga ON

Celaya, Enrique Martinez, *Prof,* Pomona College, Dept of Art & Art History, Claremont CA (S)

Celender, Donald, *Prof, Chair,* Macalester College, Art Dept, Saint Paul MN (S)

Celenko, Theodore, *Cur African, S Pacific, Precolumbian,* Columbus Museum of Art and Design, Indianapolis IN

Celentano, Denyce, *Asst Prof,* Louisiana State University, School of Art, Baton Rouge LA (S)

Cembrola, Robert, *Cur Exhibits,* Naval War College Museum, Newport RI

Cendak, Sonja, *Exhib & PR Coordr,* Craft and Folk Art Museum (CAFAM), Los Angeles CA

Cenedelle, Liz, *Pres,* Pen & Brush, Inc, Library, New York NY

Center, Williams, *Asst Dir,* Lafayette College, Williams Center Gallery, Easton PA

Centofanti, Joyce, *Asst Prof Art,* Adams State College, Dept of Visual Arts, Alamosa CO (S)

Centro, Mary, *Admin Asst,* Rome Historical Society, Museum & Archives, Rome NY

Ceperley, Drew, *Dir Mktg & Develop,* Hastings Museum of Natural & Cultural History, Hastings NE

Cepluch, Henry, *Arts in Common Dir,* Fitton Center for Creative Arts, Hamilton OH

Cepluch, Henry, *Arts in Common Dir,* Fitton Center for Creative Arts, Hamilton OH (S)

Cerado, Michael, *Healing Arts,* Kalani Oceanside Retreat, Pahoa HI (S)

Cerny, Eduard, *Prof,* Universite de Montreal, Bibliotheque d'Amenagement, Montreal PQ

Certo, Alberta Patella, *Gen Educ,* Art Institute of Pittsburgh, Pittsburgh PA (S)

Cervantes, James, *Cur Military History,* Heritage Museums & Gardens, Sandwich MA

Cervantez, Margie, *Custodian,* Artesia Historical Museum & Art Center, Artesia NM

Cervino, Anthony, *Asst Dir Exhib,* Maryland Institute, College of Art Exhibitions, Baltimore MD

Cervino, Anthony, *Asst Prof,* Dickinson College, Dept Fine Arts & History, Carlisle PA (S)

Cetlin, Cynthia, *Assoc Prof,* Ohio Wesleyan University, Fine Arts Dept, Delaware OH (S)

Chabot, Aurore, *Assoc Prof Ceramics,* University of Arizona, Dept of Art, Tucson AZ (S)

Chabotar, Kent, *Pres,* Guilford College, Art Gallery, Greensboro NC

Chacon, Rafael, *Assoc Prof,* University of Montana, Dept of Art, Missoula MT (S)

Chadsey, Malinda, *Cur Coll & Exhib,* Arts & Science Center for Southeast Arkansas, Pine Bluff AR

Chadwick-Reid, Ann, *Chmn,* Skagit Valley College, Dept of Art, Mount Vernon WA (S)

Chaffee, Tom, *Prof,* Arkansas State University, Dept of Art, State University AR (S)

Chait, Andrew, *Pres,* National Antique & Art Dealers Association of America, Inc, New York NY

Chak, Fanky, *Asst Prof,* University of Maryland, Baltimore County, Imaging, Digital & Visual Arts Dept, Baltimore MD (S)

Challener, Elizabeth, *Exec Dir,* Montalvo Center for the Arts, Saratoga CA

Chalmers, Kim, *Dept Head,* Western Kentucky University, Art Dept, Bowling Green KY (S)

Chalmers, Lynn, *Head Dept Interior Design,* University of Manitoba, Faculty of Architecture, Winnipeg MB (S)

Chalmers, Pattie, *Asst Prof,* Southern Illinois University, School of Art & Design, Carbondale IL (S)

Chick, Jay, *Gallery Asst,* Central Michigan University, University Art Gallery, Mount Pleasant MI

Chickering, F William, *Dean,* Pratt Institute, Art & Architecture Dept, Brooklyn NY

Chicquor, Isabell, *Prof,* North Carolina Central University, Art Dept, Durham NC (S)

Chieffo, Beverly, *Chmn & Assoc Prof Art,* Albertus Magnus College, Visual and Performing Arts, New Haven CT (S)

Chiego, William J, *Dir,* McNay, San Antonio TX

Chiesa, Wilfredo, *Prof,* University of Massachusetts - Boston, Art Dept, Boston MA (S)

Child, Kent, *Gallery Advisor & Humanities Div Dir,* Gavilan Community College, Art Gallery, Gilroy CA

Childers, Ann, *Southern Illinois Representative,* American Society of Artists, Inc, Palatine IL

Childress, Jennifer, *Asst Prof,* College of Saint Rose, Art Dept, Albany NY (S)

Childs, Peter, *Concert Coordr,* Academy of the New Church, Glencairn Museum, Bryn Athyn PA

Chilla, Benigna, *Instr,* Berkshire Community College, Dept of Fine Arts, Pittsfield MA (S)

Chilton, Meredith, *Cur,* George R Gardiner, Toronto ON

Chimirri-Russell, Geraldine, *Curatorial Asst (Numismatics),* University of Calgary, The Nickle Arts Museum, Calgary AB

Chin, Cecilia, *Chief Librn,* Smithsonian American Art Museum, Library of the Smithsonian American Art Museum, Washington DC

Chin, Cecilia H, *Chief Librn,* National Portrait Gallery, Library, Washington DC

Chin, Cora, *VPres Organization,* DuPage Art League School & Gallery, Wheaton IL

Chinda, Dan-Horia, *Industrial Design Technology,* Art Institute of Pittsburgh, Pittsburgh PA (S)

Chinov, Stefan, *Asst Prof,* East Central University, Art Dept, Ada OK (S)

Chioffi, David, *Div Chair Design Arts,* Memphis College of Art, Memphis TN (S)

Chipley, Sheila M, *Asst Prof,* Concord College, Fine Art Division, Athens WV (S)

Chisholm, Caroline, *Adminr,* Canadian Art Foundation, Toronto ON

Chisneil, Julie, *Exec Secy,* Wayne County Historical Society, Honesdale PA

Chisolm, Sallie, *Museum Store Mgr,* Palm Beach County Parks & Recreation Department, Morikami Museum & Japanese Gardens, Delray Beach FL

Chiu, Melissa, *Museum Dir,* The Asia Society Museum, New York NY

Chmielewski, Wendy, *Cur Peace Coll,* Swarthmore College, Friends Historical Library of Swarthmore College, Swarthmore PA

Choate, Jerry, *Instr,* Northeastern State University, College of Arts & Letters, Tahlequah OK (S)

Choate, Steven B, *Instr,* Harding University, Dept of Art, Searcy AR (S)

Chodkowski, Henry, *Prof Emeritus,* University of Louisville, Allen R Hite Art Institute, Louisville KY (S)

Choen, Lewis, *Asst Prof,* College of William & Mary, Dept of Fine Arts, Williamsburg VA (S)

Choi, Sylvia, *Cataloger,* School of the Art Institute of Chicago, John M Flaxman Library, Chicago IL

Chojecki, Randolph, *Ref Librn,* Daemen College, Marian Library, Amherst NY

Chomnycky, Father Paul, *Dir,* Basilian Fathers, Mundare AB

Choney, Cloyce V, *Commisioner,* United States Department of the Interior, Indian Arts & Crafts Board, Washington DC

Chong, Alan, *Cur.,* Isabella Stewart Gardner, Isabella Stewart Garden Museum Library & Archives, Boston MA

Chong, Elaine, *Adjunct Prof,* College of Saint Elizabeth, Art Dept, Morristown NJ (S)

Chong, Laurie Whitehill, *Special Coll Librn,* Rhode Island School of Design, Fleet Library at RISD, Providence RI

Chong Kim, Hyun, *Assoc Prof,* Jackson State University, Dept of Art, Jackson MS (S)

Choo, Chunghi, *Prof Metalsmithing & Jewelry,* University of Iowa, School of Art & Art History, Iowa City IA (S)

Choo, Philip, *Asst Prof,* University of Minnesota, Duluth, Art Dept, Duluth MN (S)

Choonhafakulchoke, Wutcichai, *Asst Prof,* University of Nebraska, Kearney, Dept of Art & Art History, Kearney NE (S)

Chou, Ju-hsi, *Cur Chinese Art,* Cleveland Museum of Art, Cleveland OH

Chouris, Vicki, *Develop & Mem,* Yesteryear Village, West Palm Beach FL

Chouteau, Suzanne, *Prof,* Xavier University, Dept of Art, Cincinnati OH (S)

Chow, Alan, *Exec Dir,* Chinese-American Arts Council, New York NY

Choy, Cam, *Chmn,* University of Wisconsin-La Crosse, Center for the Arts, La Crosse WI (S)

Chrest, Gwen, *Dir,* Clinton Art Association, River Arts Center, Clinton IA

Chrismas, Douglas, *Dir,* Ace Gallery, Los Angeles CA (S)

Christ, Ronald, *Grad Coordr,* Wichita State University, School of Art & Design, Wichita KS (S)

Christell, Valerie J, *Dir Gallery,* Alverno College Gallery, Milwaukee WI

Christen, Derrick, *Asst Prof,* Northern Michigan University, Dept of Art & Design, Marquette MI (S)

Christensen, Candice, *Tour Registrar,* Minnesota Historical Society, Minnesota State Capitol Historic Site, St Paul MN

Christensen, V A, *Prof,* Missouri Southern State University, Dept of Art, Joplin MO (S)

Christenson, Christiana, *Chmn,* University of California, Irvine, Studio Art Dept, Irvine CA (S)

Christenson, Elroy, *Head Dept,* North Seattle Community College, Art Dept, Seattle WA (S)

Christi, John, *Chmn,* Capitol Community Technical College, Humanities Division & Art Dept, Hartford CT (S)

Christian, Alix, *Instr,* Amarillo College, Visual Art Dept, Amarillo TX (S)

Christian, Ann, *Coordr Cultural Progs,* City of Scarborough, Cedar Ridge Creative Centre, Scarborough ON

Christian, Brantley B, *CEO & Dir,* Yesteryear Village, West Palm Beach FL

Christian, Kathleen, *Asst Prof,* University of Pittsburgh, Henry Clay Frick Dept History of Art & Architecture, Pittsburgh PA (S)

Christian, Michael, *Weave Shed Supv,* American Textile History Museum, Lowell MA

Christiana, David, *Assoc Prof Graphic Design-Illustration,* University of Arizona, Dept of Art, Tucson AZ (S)

Christiano, Melissa, *Instr,* Williams Baptist College, Dept of Art, Walnut Ridge AR (S)

Christie, Leona, *Asst Prof,* State University of New York at Albany, Art Dept, Albany NY (S)

Christiensen, Karen, *Deputy Chmn-Grants & Awards,* National Endowment for the Arts, Washington DC

Christman, D Bruce, *Chief Conservator,* Cleveland Museum of Art, Cleveland OH

Christofferson, Shaila, *Prof,* West Virginia University, College of Creative Arts, Morgantown WV (S)

Christopher, Nicholas J., *Registrar & Prepar,* Pensacola Museum of Art, Pensacola FL

Christopher, Theresa, *Registrar,* DuSable Museum of African American History, Chicago IL

Christopherson, Michael, University of Wisconsin-Eau Claire, Dept of Art, Eau Claire WI (S)

Christovich, Mary Louise, *Chmn,* The Historic New Orleans Collection, New Orleans LA

Chu, Brian, *Asst Prof,* University of New Hampshire, Dept of Arts & Art History, Durham NH (S)

Chu, Doris, *Pres,* Chinese Culture Institute of the International Society, Tremont Theatre & Gallery, Boston MA

Chubrich, Michael, *Pres,* Portsmouth Athenaeum, Joseph Copley Research Library, Portsmouth NH

Chudzik, Theresa, *Instr,* Hibbing Community College, Art Dept, Hibbing MN (S)

Chugg, Juliana L, *Pres,* The Pillsbury Company, Art Collection, Minneapolis MN

Chumbley, Robert, *Pres & CEO,* The Arts Council of Winston-Salem & Forsyth County, Winston-Salem NC

Chumley, Jere, *Head,* Cleveland State Community College, Dept of Art, Cleveland TN (S)

Chung, Derek, *Bd Chmn,* Fusion: The Ontario Clay & Glass Association, Toronto ON

Chung, Ruthie, *Admin Asst,* Art Directors Club, New York NY

Chung, Sam, *Asst Prof,* Northern Michigan University, Dept of Art & Design, Marquette MI (S)

Chupa, Anna, *Assoc Prof,* Lehigh University, Dept of Art & Architecture, Bethlehem PA (S)

Church, Julia, *Cur,* Green Hill Center for North Carolina Art, Greensboro NC

Church, Sara, *Exec Asst,* SLA Arch-Couture Inc, Art Collection, Denver CO

Church, Thos, *Instr,* Madonna University, Art Dept, Livonia MI (S)

Churner, Rachel, *Communications Dir,* New Langton Arts, San Francisco CA

Chytilo, Lynne, *Chmn & Prof,* Albion College, Bobbitt Visual Arts Center, Albion MI

Chytilo, Lynne, *Chmn Dept Visual Arts,* Albion College, Dept of Visual Arts, Albion MI (S)

Cichy, Barbara, *Instr,* Bismarck State College, Fine Arts Dept, Bismarck ND (S)

Cicione, Lauren, *Dir Galleries,* Providence Art Club, Providence RI

Cieslewicz, Kathy C, *Cur & Collections Mgr,* Dixie State College, Robert N & Peggy Sears Gallery, Saint George UT

Ciganko, Richard, *Asst Prof,* Indiana University of Pennsylvania, College of Fine Arts, Indiana PA (S)

Ciganko, Thomas, *Dir Gallery,* City of Brea, Art Gallery, Brea CA

Cigliano, Flavia, *Exec Dir,* Nichols House Museum, Inc, Boston MA

Cignatta, Rose, *Pres,* Arts & Crafts Association of Meriden Inc, Gallery 53, Meriden CT

Cikovsky, Nicholai, *Cur American Art,* National Gallery of Art, Washington DC

Cinelli, Michael J, *Head Dept,* Northern Michigan University, Dept of Art & Design, Marquette MI (S)

Cinq-Mars, Anne-Marie, *Library Technician,* Montreal Museum of Fine Arts, Library, Montreal PQ

Cinquino, David, *Instr,* Daemen College, Art Dept, Amherst NY (S)

Cioccia, Mark, *Instr,* Keystone College, Fine Arts Dept, LaPlume PA (S)

Cioffoletti, Jessica, *Prog Mgr,* Pelham Art Center, Pelham NY

Ciotti, Angelo L, *Gen Educ, Graphic Design,* Art Institute of Pittsburgh, Pittsburgh PA (S)

Cipoletti, Christopher, *Exec Dir,* American Numismatic Association, Money Museum, Colorado Springs CO

Cipriano, M, *Chmn Dept,* Central Connecticut State University, Dept of Art, New Britain CT (S)

Cirone, Christie, *Asst Prof & Dept Chair,* Illinois Central College, Dept Fine, Performing & Applied Arts, East Peoria IL (S)

Cisco, Debra, *Public Information Officer,* National Gallery of Art, Washington DC

Citraro, Caesar, *Conservation Tech,* The Art Institute of Chicago, Dept of Prints & Drawings, Chicago IL

Citron, Harvey, *Chmn,* New York Academy of Art, Graduate School of Figurative Art, New York NY (S)

Ciupka, Larissa, *Dir Mktg & Communications,* Art Gallery of Hamilton, Hamilton ON

Cizek, Judith, *Cur Contemporary Art,* Delaware Art Museum, Wilmington DE

Claassen, Garth, *Dir,* Albertson College of Idaho, Rosenthal Art Gallery, Caldwell ID

Clair, Cynthia, *Exec Dir,* Silvermine Guild Arts Center, School of Art, New Canaan CT

Clair, Cynthia B, *Exec Dir,* Silvermine Guild Arts Center, Silvermine Galleries, New Canaan CT

Clancey, Evin, *Assoc Cur,* Hebrew Union College, Skirball Cultural Center, Los Angeles CA

Clancy, Patrick, *Chmn Photo,* Kansas City Art Institute, Kansas City MO (S)

Clancy, Steven, *Chmn Art History,* Ithaca College, Handwerker Gallery of Art, Ithaca NY

Clapp, Ben, *VPres & CFO,* Plains Art Museum, Fargo ND

Clare, Mary, *Assoc Prof,* Sullivan County Community College, Division of Commercial Art & Photography, Loch Sheldrake NY (S)

Clarien, Gary, *Studio Supv,* Palo Alto Art Center, Palo Alto CA

Clark, Andrea, *Registrar,* Norton Simon, Pasadena CA

Clark, Ann, *VPres Develop & Mktg,* Plains Art Museum, Fargo ND

Clark, Bob, *Instr,* Southwestern Community College, Advertising & Graphic Design, Sylva NC (S)

Clark, Carl, *Instr,* Northern Arizona University, Museum Faculty of Fine Art, Flagstaff AZ (S)

Clark, Christa, *Cur Africa, Americas & Pacific,* Newark Museum Association, The Newark Museum, Newark NJ

Clark, Donald, *Assoc Prof,* Minnesota State University-Moorhead, Dept of Art, Moorhead MN (S)

Clark, Dwayne, *Exhibition Designer & Preparator,* Morris Museum of Art, Augusta GA

Clark, Eleanor, *Museum Cur,* Rosenberg Library, Galveston TX

Clark, Fred, *Prof,* Lansing Community College, Visual Arts & Media Dept, Lansing MI (S)

Clark, Gary F, *Prof,* Bloomsburg University, Dept of Art & Art History, Bloomsburg PA (S)

Clark, Gregory, *Chmn Dept,* University of the South, Dept of Fine Arts, Sewanee TN (S)

Clark, James M, *Prof,* Blackburn College, Dept of Art, Carlinville IL (S)

Clark, Janet, *Instr,* Lakehead University, Dept of Visual Arts, Thunder Bay ON (S)

Clark, Jimmy, *Exec Dir,* Peters Valley Craft Center, Layton NJ

Clark, Joan, *Head Main Library,* Cleveland Public Library, Fine Arts & Special Collections Dept, Cleveland OH

Clark, John, *Head Adult Information Svcs,* Springfield City Library, Springfield MA

Clark, Jon, *Chmn Crafts,* Temple University, Tyler School of Art, Elkins Park PA (S)

Clark, Joyce, *Cur Asst,* Regina Public Library, Dunlop Art Gallery, Regina SK

Clark, Juleigh, *Public Svcs Librn,* Colonial Williamsburg Foundation, John D Rockefeller, Jr Library, Williamsburg VA

Clark, Julie, *Prog Dir,* Dairy Barn Cultural Arts Center, Athens OH

Clark, Karen, *Gift Shop Mgr,* Museum of Western Colorado, Grand Junction CO

Clark, Kimball, *Head Cataloger,* Harvard University, Dumbarton Oaks Research Library, Washington DC

Clark, Marcia, *Dir,* Blue Mountain Gallery, New York NY

Clark, Moira, *Instr,* Toronto School of Art, Toronto ON (S)

Clark, Peter P, *Cur Coll,* National Baseball Hall of Fame & Museum, Inc, Art Collection, Cooperstown NY

Clark, Randy, *Instr,* South Dakota State University, Dept of Visual Arts, Brookings SD (S)

Clark, Raymond R, *Chmn Bd & Pres,* Cincinnati Institute of Fine Arts, Cincinnati OH

Clark, Richard H, *Designer,* United States Military Academy, West Point Museum, West Point NY

Clark, Ron, *Independent Study Prog Dir,* Whitney Museum of American Art, New York NY

Clark, Sara B, *Adjunct Instr,* Saginaw Valley State University, Dept of Art & Design, University Center MI (S)

Clark, Sharon, *Asst to Dir,* University of Rhode Island, Fine Arts Center Galleries, Kingston RI

Clark, Sussanne, *Secy,* Coppini Academy of Fine Arts, Library, San Antonio TX

Clark, Tommy, *Prof of Art,* Campbellsville University, Department of Art, Campbellsville KY (S)

Clark, William, *Asst Prof,* Cedar Crest College, Art Dept, Allentown PA (S)

Clarke, Aaron, *Visual & Media Arts Coordr,* Organization of Saskatchewan Arts Councils (OSAC), Regina SK

Clarke, Ann, *Prof,* Lakehead University, Dept of Visual Arts, Thunder Bay ON (S)

Clarke, Annette J, *Dir,* Kirkland Art Center, Clinton NY

Clarke, Jason, *Gen Mgr,* Arts and Letters Club of Toronto, Library, Toronto ON

Clarke, Jay, *Assoc Cur,* The Art Institute of Chicago, Dept of Prints & Drawings, Chicago IL

Clarke, Neville, *Pres,* Canadian Society of Painters In Watercolour, Toronto ON

Clarke, Robert, *Assoc Prof,* Mohawk Valley Community College, Utica NY (S)

Clary, Owen, *CEO,* Aiken County Historical Museum, Aiken SC

Claussen, Louise Keith, *Dir,* Morris Communications Co. LLC, Corporate Collection, Augusta GA

Claveloux, Eileen, *Art Historian,* Greenfield Community College, Art, Communication Design & Media Communication Dept, Greenfield MA (S)

Clavir, Miriam, *Sr Conservator,* University of British Columbia, Museum of Anthropology, Vancouver BC

Claxton, Ronald, *Assoc Prof,* Central State University, Dept of Art, Wilberforce OH (S)

Clay, Brenda, *Educ Coordr,* Creative Art Center-North Oakland County, Pontiac MI (S)

Clay, Carol Wolfe, *Chmn,* Seattle University, Fine Arts Dept, Division of Art, Seattle WA (S)

Clay, Joe, *Dir Progs,* Koshare Indian Museum, Inc, Library, La Junta CO

Clay, Vaughn H, *Art Dept Chair,* Indiana University of Pennsylvania, College of Fine Arts, Indiana PA (S)

Clay-Robinson, Matthew, *Asst Prof,* Bloomsburg University, Dept of Art & Art History, Bloomsburg PA (S)

Claybourn, Bradford, *Mus Cur,* Mission San Luis Rey de Francia, Mission San Luis Rey Museum, Oceanside CA

Clayden, Stephen, *Cur Botany,* New Brunswick Museum, Saint John NB

Clayton, Beverley, *Office Adminr,* Kamloops Art Gallery, Kamloops BC

Clayton, Christine, *Asst Librn,* Worcester Art Museum, Library, Worcester MA

Clayton, Ron, *Prof & Interim Chmn,* Southeast Missouri State University, Dept of Art, Cape Girardeau MO (S)

Clearwater, Bonnie, *Dir,* Museum of Contemporary Art, North Miami FL

Cleary, Carole, *Dir,* Southampton Art Society, Southampton Art School, Southampton ON (S)

Cleary, John R, *Assoc Prof,* Salisbury State University, Art Dept, Salisbury MD (S)

Cleary, Manon, *Prof,* University of the District of Columbia, Dept of Mass Media, Visual & Performing Arts, Washington DC (S)

Cleary, Theresa, *Mus Shop Mgr,* Deer Valley Rock Art Center, Glendale AZ

Cleary, Tim, *Lectr,* University of Wisconsin-Superior, Programs in the Visual Arts, Superior WI (S)

Cleaver, Connie, *Librn,* Surrey Art Gallery, Library, Surrey BC

Cleckley, Anthony, *Horticulture Supv,* Palm Beach County Parks & Recreation Department, Morikami Museum & Japanese Gardens, Delray Beach FL

Cleland, Camille, *Asst Dir for Technical Svcs,* Skokie Public Library, Skokie IL

Clem, Debra, *Assoc Prof,* Indiana University-Southeast, Fine Arts Dept, New Albany IN (S)

Clem, Patricia, *Secy,* Strasburg Museum, Strasburg VA

Clemens, Lenore, *Arts Programmer,* Richmond Arts Centre, Richmond BC

Clement, Louise, *Instr,* Samuel S Fleisher, Philadelphia PA (S)

Clementi, Bobbie, *Prof,* Daytona Beach Community College, Dept of Fine Arts & Visual Arts, Daytona Beach FL (S)

Clements, Bob, *Digital Design,* Art Institute of Pittsburgh, Pittsburgh PA (S)

Clements, Emmett, *Mus Shop Mgr,* Pasadena Museum of California Art, Pasadena CA

Clements, Martin, *Adjunct Instr,* New York Institute of Technology, Fine Arts Dept, Old Westbury NY (S)

Clemmons, Sarah, *VPres Instr,* Chipola College, Dept of Fine & Performing Arts, Marianna FL (S)

Clendeming, Bonnie, *Exec Dir,* Archaeological Institute of America, Boston MA

Clendenin, Paula, *Asst Prof,* West Virginia State College, Art Dept, Institute WV (S)

Clervi, Paul, *Chmn,* William Woods-Westminster Colleges, Art Dept, Fulton MO (S)

Clervi, Paul, *Chmn Visual, Performing & Communication Div,* William Woods University, Cox Gallery, Fulton MO

Clewell, Fred, *Dir Finance,* Palm Springs Art Museum, Palm Springs CA

Clews, Christopher S, *Pres,* La Napoule Art Foundation, Chateau de la Napoule, Portsmouth NH

Clews, Noele M, *Exec Dir,* La Napoule Art Foundation, Chateau de la Napoule, Portsmouth NH

Cliff, Denis, *Instr,* Toronto School of Art, Toronto ON (S)

Clifford, Melinda, *Cur Asst,* Bishop's University, Art Gallery, Lennoxville PQ

Clift, Vicki, *Instr,* Appalachian State University, Dept of Art, Boone NC (S)

Cliggett, Jack, *Assoc Prof Graphic Design,* Drexel University, College of Media Arts & Design, Philadelphia PA (S)

Cline, Barb, *Admin Asst,* Dayton Visual Arts Center, Dayton OH

Cline, Elaine, *Reference Librn,* National Air and Space Museum, Library, Washington DC

Cline, Lynden, *Pres,* Washington Sculptors Group, Washington DC

Cline, Tricia, *Instr,* Woodstock School of Art, Inc, Woodstock NY (S)

Clinger, Melinda, *Dir Museum,* Fulton County Historical Society Inc, Fulton County Museum, Rochester IN

Clinkingbeard, Brion, *Deputy Dir Prog,* Kentucky Museum of Art & Craft, Louisville KY

Cloar, Virginia, *Publicity & Promotions,* Pine Bluff/Jefferson County Historical Museum, Pine Bluff AR

Close, John, *Instr,* Harriet FeBland, New York NY (S)

Cloud, Mary, *Dir Educ & Outreach,* McAllen International Museum, McAllen TX

Cloudman, Ruth, *Cur,* Speed Art Museum, Louisville KY

Clough, Jan, *Chair Art Dept & Prof,* Western Illinois University, Art Dept, Macomb IL (S)

Clous, Linda, *Registrar,* American Craft Council, Museum of Arts & Design, New York NY

Clouten, Neville H, *Dean,* Lawrence Technological University, College of Architecture, Southfield MI (S)

Cloutier, Nadine, *Pres,* Hartland Art Council, Hartland MI

Clovis, John, *Prof,* Fairmont State College, Div of Fine Arts, Fairmont WV (S)

Clowe, Richard, *Treas,* Schenectady County Historical Society, Museum of Schenectady History, Schenectady NY

Clubb, Barbara, *Dir,* Ottawa Public Library, Fine Arts Dept, Ottawa ON

Cluett, Beverley, *Publicity,* Lunenburg Art Gallery Society, Lunenburg NS

Cluett, Cora, *Asst Prof,* University of Waterloo, Fine Arts Dept, Waterloo ON (S)

Clum, Claire, *Cur Educ,* Boca Raton Museum of Art, Boca Raton FL

Clymer, Frances, *Librn,* Buffalo Bill Memorial Association, Harold McCracken Research Library, Cody WY

Coady, Emma, *Library Technician,* The Winnipeg Art Gallery, Clara Lander Library, Winnipeg MB

Coakley, Stephanie J, *Dir Educ,* Tucson Museum of Artand Historic Block, Tucson AZ

Coan, Michael, *Chmn Jewelry Design,* Fashion Institute of Technology, Art & Design Division, New York NY (S)

Coaston, Shirley, *Head Librn,* Laney College Library, Art Section, Oakland CA

Coates, Darcy, *Registrar,* University of Vermont, Robert Hull Fleming Museum, Burlington VT

Coates, James, *Chmn Dept,* University of Massachusetts Lowell, Dept of Art, Lowell MA (S)

Coates, Joseph, *Asst Prof,* California Polytechnic State University at San Luis Obispo, Dept of Art & Design, San Luis Obispo CA (S)

Coates, Robert, *Asst Prof,* Sinclair Community College, Division of Fine & Performing Arts, Dayton OH (S)

Cobb, June, *Dir Admin & Finance,* National Heritage Museum, Lexington MA

Cobb, Rebekah, *Tours Coordr,* BJU Museum & Gallery, Bob Jones University Museum & Gallery Inc, Greenville SC

Cobbe, Toy L, *Exec Dir,* Piedmont Arts Association, Martinsville VA

Cobble, Kelly, *Cur,* Adams National Historic Park, Quincy MA

Cobbs, David, *Chmn,* Compton Community College, Art Dept, Compton CA (S)

Coburn, Carol, *Chmn Humanities,* Avila College, Thornhill Art Gallery, Kansas City MO

Coburn, Carol, *Chmn Humanities,* Avila College, Art Division, Dept of Humanities, Kansas City MO (S)

Coburn, Oakley H, *Dir,* Wofford College, Sandor Teszler Library Gallery, Spartanburg SC

Cocaougher, Robert L, *Assoc Prof,* University of North Florida, Dept of Communications & Visual Arts, Jacksonville FL (S)

Cochran, Dorothy, *Dir & Cur,* The Interchurch Center, Galleries at the Interchurch Center, New York NY

Cochran, Dorothy, *Dir & Cur Galleries,* The Interchurch Center, The Interchurch Center, New York NY

Cochran, Marci, *Office Mgr,* Regional Arts & Culture Council, Metropolitan Center for Public Arts, Portland OR

Cochran, Marie, *Asst Prof,* Georgia Southern University, Dept of Art, Statesboro GA (S)

Cochran, Michelle, *Instr,* Saint Mary's University of Minnesota, Art & Design Dept, Winona MN (S)

Cochrane, Charles, *Pres Bd Trustees,* Museum of Contemporary Art, San Diego-Downtown, La Jolla CA

Cockerline, Neil, *Field Svcs,* Midwest Art Conservation Center, Minneapolis MN

Cockwell, Jack, *Chmn Bd Trustees,* Royal Ontario Museum, Toronto ON

Codd, Catherine E, *Mus Shop Mgr,* Quincy Art Center, Quincy IL

Codding, Mitchell A, *Dir,* Hispanic Society of America, Museum & Library, New York NY

Coffey, Ann, *Adminr,* Longwood Center for the Visual Arts, Farmville VA

Coffey, John, *Dep Dir Coll,* North Carolina Museum of Art, Reference Library, Raleigh NC

Coffey, John, *Deputy Dir, Coll & Prog,* North Carolina Museum of Art, Raleigh NC

Coffey, Marylyn, *Staff Asst,* University of Alabama at Huntsville, Union Grove Gallery & University Center Gallery, Huntsville AL

Coffin, David, *Pres,* Old State House, Hartford CT

Coffin, Eugene, *Security Off,* Alaska State Museum, Juneau AK

Coffman, Cori, *Dir,* William F Eisner Museum of Advertising & Design, Milwaukee WI

Coffman, Rebecca, *Gallery Dir,* Huntington University, Robert E Wilson Art Gallery, Huntington IN

Coffman, Rebecca L, *Asst Prof,* Huntington College, Art Dept, Huntington IN (S)

Cofi, Dario, *Prof Emeritus,* University of Louisville, Allen R Hite Art Institute, Louisville KY (S)

Cogan, Kathryn, *Asst Dir,* Knights of Columbus Supreme Council, Knights of Columbus Museum, New Haven CT

Cogeval, Guy, *Dir,* Montreal Museum of Fine Arts, Montreal PQ

Coggeshall, Jan, *Pres,* Rosenberg Library, Galveston TX

Coggins, Paul, *Bd Pres,* Wilkes Art Gallery, North Wilkesboro NC

Cogswell, Arnold, *Dir,* Hickory Museum of Art, Inc, Library, Hickory NC

Cogswell, Arnold, *Exec Dir,* Hickory Museum of Art, Inc, Hickory NC

Cogswell, Peggy, *Lectr,* Southeastern Louisiana University, Dept of Visual Arts, Hammond LA (S)

Cohen, Ada, *Assoc Prof,* Dartmouth College, Dept of Art History, Hanover NH (S)

Cohen, Andrew, *Head Dept,* Missouri State University, Dept of Art & Design, Springfield MO (S)

Cohen, Carolyn, *Chief Devel Officer,* American Craft Council, Museum of Arts & Design, New York NY

Cohen, Cora, *Prof,* University of North Carolina at Greensboro, Art Dept, Greensboro NC (S)

Cohen, David, *Dir,* Contemporary Crafts Museum & Gallery, Portland OR

Cohen, David, *Dir,* Contemporary Crafts Museum & Gallery, Contemporary Crafts Gallery, Portland OR

Cohen, David, *Dir Operations,* Portland Children's Museum, Portland OR

Cohen, Elaine, *Dir Develop,* Kala Institute, Kala Art Institute, Berkeley CA

Cohen, Janie, *Cur,* University of Vermont, Robert Hull Fleming Museum, Burlington VT

Cohen , Janie, *Asst Dir & Cur,* University of Vermont, Wilbur Room Library, Burlington VT

Cohen, Marcia, *Public Prog Coordr,* Americas Society Art Gallery, New York NY

Cohen, Marcia R, *Prof,* Atlanta College of Art, Atlanta GA (S)

Cohen, Marianne, *Cir Corp Members,* USS Constitution Museum, Boston MA

Cohen, Mildred Thaler, *Dir,* The Marbella Gallery Inc, New York NY

Cohen, Sarah, *Art Historian,* University at Albany, State University of New York, Art Dept Visual Resources, Albany NY

Cohen, Sarah, *Assoc Prof,* State University of New York at Albany, Art Dept, Albany NY (S)

Cohn, Shelley, *Exec Dir,* Arizona Commission on the Arts, Phoenix AZ

Coish, Elisa, *Malcove Asst Cur,* University of Toronto, University of Toronto Art Centre, Toronto ON

Coish, Theresa, *Dir,* New Bedford Free Public Library, Art Dept, New Bedford MA

Coker, Alyce, University of Minnesota, Duluth, Art Dept, Duluth MN (S)

Colagross, John, *Dept Chair,* John C Calhoun, Art Gallery, Decatur AL

Colagross, John T, *Dept Chmn,* John C Calhoun, Department of Fine Arts, Decatur AL (S)

Colaguori, Louis A, *Pres,* Burlington County Historical Society, Burlington NJ

Colan, John, *Graphic Design,* Montserrat College of Art, Beverly MA (S)

Colangelo, Anna, *VPres,* Fitchburg Art Museum, Fitchburg MA

Colangelo, Carmon, *Dir,* University of Georgia, Franklin College of Arts & Sciences, Lamar Dodd School of Art, Athens GA (S)

Colberg, Sue, *Coordr Visual Communications Design,* University of Alberta, Dept of Art & Design, Edmonton AB (S)

Colbert, Charles, *Asst Prof,* Portland State University, Dept of Art, Portland OR (S)

Colbert, Cynthia, *Chmn Art Educ,* University of South Carolina, Dept of Art, Columbia SC (S)

Colburn, Bolton, *Dir,* Laguna Art Museum, Laguna Beach CA

Colburn, Erin, *Cur Educ,* Leigh Yawkey Woodson, Wausau WI

Colburn, Michele, *Specialist Pub Affairs,* Hirshhorn Museum & Sculpture Garden, Smithsonian Institution, Washington DC

Colburn, Richard, *Prof,* University of Northern Iowa, Dept of Art, Cedar Falls IA (S)

Colby, Gary, *Prof Photography,* University of La Verne, Dept of Art, La Verne CA (S)

Colby, James, *Dir,* Jamestown Community College, The Weeks, Jamestown NY

Colby, Jennifer, *Pres,* Women's Caucus For Art, New York NY

Colchie, Daisy, *Dir Project Look!,* Palo Alto Art Center, Palo Alto CA

Coldiron, Lisa M., *American Specialist,* National Gallery of Art, Department of Image Collections, Washington DC

Cole, Brent, *Vis Asst Prof,* University of Miami, Dept of Art & Art History, Coral Gables FL (S)

Cole, Bruce, *Chmn Art History,* Indiana University, Bloomington, Henry Radford Hope School of Fine Arts, Bloomington IN (S)

Cole, Carol, *Instr,* Main Line Art Center, Haverford PA (S)

Cole, Cynthia, *Dir Educ,* Light Factory, Charlotte NC

Cole, Dean, *Pres Bd Trustees,* Zanesville Art Center, Zanesville OH

Cole, Dorothy Orr, *Pres,* The National Society of The Colonial Dames of America in the State of New Hampshire, Moffatt-Ladd House, Portsmouth NH

Cole, Harold D, *Prof Art History,* Baldwin-Wallace College, Dept of Art, Berea OH (S)

Cole, Julia, *Chmn Interdisciplinary Arts,* Kansas City Art Institute, Kansas City MO (S)

Cole, Lisa, *Dir Devel,* Arts Council Silicon Valley, Santa Clara CA

Cole, Michael, *Instr,* De Anza College, Creative Arts Division, Cupertino CA (S)

Cole, Steve, *Prof,* Birmingham-Southern College, Art Dept, Birmingham AL (S)

Cole, Susan A, *Pres,* Montclair State University, Art Galleries, Upper Montclair NJ

Cole, Vicki, *Gallery Dir,* Palomar Community College, Boehm Gallery, San Marcos CA

Cole-Faber, Alana, *Asst,* College of New Rochelle, Castle Gallery, New Rochelle NY

Cole-Zielanski, Trudy, *Assoc Prof,* James Madison University, School of Art & Art History, Harrisonburg VA (S)

Colegrove, Jim, *Computer Systems Mgr,* Modern Art Museum, Fort Worth TX

Colegrove, Susan, *Admin Asst to Cur,* Modern Art Museum, Fort Worth TX

Coleman, Devin, *Cur,* Macalester College, Macalester College Art Gallery, Saint Paul MN

Coleman, Dorothy, *Exec Dir,* Oil Pastel Association, Stockholm NJ

Coleman, Dorothy J, *Pres,* New Orleans Academy of Fine Arts, Academy Gallery, New Orleans LA

Coleman, Elizabeth, *Pres,* Bennington College, Visual Arts Division, Bennington VT (S)

Coleman, Jess, Wharton County Junior College, Art Dept, Wharton TX (S)

Coleman, Johnny, *Assoc Prof,* Oberlin College, Dept of Art, Oberlin OH (S)

Coleman, Linda, *Pub Progs Coordr,* Manchester Historic Association, Manchester NH

Coleman, Patricia, *Exec Dir,* National Institute of Art & Disabilities (NIAD), Florence Ludins-Katz Gallery, Richmond CA

Coleman, Randy, *Treas,* Midwest Art History Society, Kent OH

Coleman, Romaula, *Mgr IL Artisans Shop,* Illinois State Museum, Illinois Artisans & Visitors Centers, Chicago IL

Coleman, Susan, *Dir Gallery,* Cornell College, Peter Paul Luce Gallery, Mount Vernon IA

Coleman, Thomas, *Prof,* Indiana University, Bloomington, Henry Radford Hope School of Fine Arts, Bloomington IN (S)

Colenda, Marianne, *Dir Spec Events,* Thiel College, Weyers-Sampson Art Gallery, Greenville PA

Colescott, Robert, *Regents Prof,* University of Arizona, Dept of Art, Tucson AZ (S)

Coletta, Natalie, *Instr,* Community College of Rhode Island, Dept of Art, Warwick RI (S)

Colglazier, Gail Nessell, *Dir,* Manchester Historic Association, Manchester NH

Colglazier, Gail Nessell, *Dir,* Manchester Historic Association, Library, Manchester NH

Colgrove, Clare, *Staff Asst,* United States Senate Commission on Art, Washington DC

Colkitt, Brian, *Photography,* Art Institute of Pittsburgh, Pittsburgh PA (S)

Collard, Sara, *Develop Coordr,* Captain Forbes House Mus, Milton MA

Collens, David R, *Dir & Chief Cur,* Storm King Art Center, Mountainville NY

Collens, Kevin, *Special Events,* Salisbury University, Ward Museum of Wildfowl Art, Salisbury MD

Colley, Christine, *Prof,* Shorter College, Art Dept, Rome GA (S)

Colley, Jim, *Asst Prof,* Dallas Baptist University, Dept of Art, Dallas TX (S)

Colley, Scott, *Pres,* Berry College, Moon Gallery, Mount Berry GA

Collicutt, Carol, *Pres,* Organization for the Development of Artists, Gallery Connexion, Fredericton NB

Collier, Denise, *Admin Mgr,* Cranbrook Art Museum, Cranbrook Art Museum, Bloomfield Hills MI

Collier, Malinda, *Prog Dir,* Visual Arts Center of Richmond, Richmond VA

Collier, Ric, *Dir,* Salt Lake Art Center, Salt Lake City UT

Collings, Ed, *Instr Photography & Ceramics,* Columbia College, Art Dept, Columbia MO (S)

Collins, Austin, *Chmn,* University of Notre Dame, Dept of Art, Art History & Design, Notre Dame IN (S)

Collins, D Cheryl, *Dir,* Riley County Historical Society, Riley County Historical Museum, Manhattan KS

Collins, D Cheryl, *Dir,* Riley County Historical Society, Seaton Library, Manhattan KS

Collins, Dana, *Instr,* Illinois Valley Community College, Division of Humanities & Fine Arts, Oglesby IL (S)

Collins, Doris, *Community Coord,* Art Complex Museum, Carl A. Weyerhaeuser Library, Duxbury MA

Collins, Jack, *Assoc Prof,* Baker University, Dept of Art, Baldwin City KS (S)

Collins, Jill, *Admin Asst,* Sioux City Art Center, Library, Sioux City IA

Collins, Jill, *Admin Asst & Contact,* Sioux City Art Center, Sioux City IA

Collins, Jill, *Secy,* Sioux City Art Center, Sioux City IA (S)

Collins, Joel, *Chmn,* Mount Union College, Dept of Art, Alliance OH (S)

Collins, John, *Dean,* Surry Community College, Art Dept, Dobson NC (S)

Collins, Kathleen, *Pres,* Kansas City Art Institute, Kansas City MO (S)

Collins, Kenlyn, *Librn,* The Winnipeg Art Gallery, Winnipeg MB

Collins, Kenlyn, *Librn,* The Winnipeg Art Gallery, Clara Lander Library, Winnipeg MB

Collins, Kristin, *Instr,* Marylhurst University, Art Dept, Marylhurst OR (S)

Collins, Kurt, *Instr,* California State University, San Bernardino, Dept of Art, San Bernardino CA (S)

Collins, Lisa, *Asst Prof,* Vassar College, Art Dept, Poughkeepsie NY (S)

Collins, Lynda, *Mus Educ,* Springfield Museum of Art, Springfield OH

Collins, Michael, *Dean,* Sheridan College, School of Animation, Arts & Design, Oakville ON (S)

Collins, N Taylor, *First VPres,* National League of American Pen Women, Washington DC

Collins, Penny, *Chmn Fashion Design,* Woodbury University, Dept of Graphic Design, Burbank CA (S)

Collins, Ruth, *Asst Deputy Dir Pub Svcs,* Buffalo & Erie County Public Library, Buffalo NY

Collins, Sherry, *Dir Finance,* The Currier Museum of Art, Currier Museum of Art, Manchester NH

Collins, Thom, *Sr Cur,* Contemporary Arts Center, Cincinnati OH

Collins, Thom, *Sr Cur,* Contemporary Arts Center, Library, Cincinnati OH

Collins, Toni, *Adminr,* Pennsylvania Historical & Museum Commission, Brandywine Battlefield Park, Harrisburg PA

Collins Coleman, Clara, *Cur Interpretation,* Laumeier Sculpture Park, Saint Louis MO

Colo, Papo, *Co-Founder-Cultural Production,* Exit Art, New York NY

Colombik, Roger Bruce, *Prof,* Texas State University - San Marcos, Dept of Art and Design, San Marcos TX (S)

Colon, Doreen, *Educ,* Museo de Arte de Puerto Rico, San Juan PR

Colonghi, John, *Dir NMAI National Campaign,* National Museum of the American Indian, George Gustav Heye Center, New York NY

Coloto, Juan, *Asst Cur,* Wells Fargo & Co, History Museum, Los Angeles CA

Colpitt, Frances, *Assoc Prof,* University of Texas at San Antonio, Dept of Art & Art History, San Antonio TX (S)

Colpitt, Frances, *Dept Chair,* University of Texas at San Antonio, Dept of Art & Art History, San Antonio TX (S)

Colpitts, GE, *Chmn Dept Art & Design,* Judson College, Division of Art, Design & Architecture, Elgin IL (S)

Colson, Amy, *Pub Rels,* Museum Science & History, Jacksonville FL

Colter, Jennifer, *Community Affairs,* High Point Historical Society Inc, Museum, High Point NC

Colton, Stan, *Library Develop,* Las Vegas-Clark County Library District, Las Vegas NV

Colvard, Jane, *Asst Librn,* American Numismatic Association, Library, Colorado Springs CO

Colvin, Cynthia, *VPres,* Quincy Art Center, Quincy IL

Colvin, Kaersten, *Asst Prof,* Clarion University of Pennsylvania, Dept of Art, Clarion PA (S)

Colvin, William E, *Acting Dept Chmn,* Alabama State University, Dept of Visual & Theatre Arts, Montgomery AL (S)

Comar, Catherine, *Dir Coll,* Shelburne Museum, Museum, Shelburne VT

Comba, Steve, *Asst Dir & Registrar,* The Pomona College, Montgomery Gallery, Claremont CA

Combs, Jonathan, *Pres,* Graphic Artists Guild, New York NY

Combs, Pamela, *Instr,* University of Evansville, Art Dept, Evansville IN (S)

Comer, Karen, *Dir,* City of Atlanta, City Gallery East, Atlanta GA

Comley, Ruth, *Computer Animation,* Art Institute of Pittsburgh, Pittsburgh PA (S)

Como, Thomas, *Prof, Chmn,* Slippery Rock University of Pennsylvania, Dept of Art, Slippery Rock PA (S)

Compton, Douglas, *Instr,* Joe Kubert, Dover NJ (S)

Compton, Lesa, *Exec Dir,* Seneca Falls Historical Society Museum, Seneca Falls NY

Conarroe, Joel, *Pres,* John Simon Guggenheim, New York NY

Conaty, Gerald, *Cur Ethnology,* Glenbow Museum, Calgary AB

Conaway, Susan, *Curatorial Mgr,* Art Museum of the University of Houston, Blaffer Gallery, Houston TX

Concholar, Dan, *Pres & Dir,* Art Information Center, Inc, New York NY

Condon, Lorna, *Cur Library & Archives,* Historic New England, Library and Archives, Boston MA

Conerty, Kathleen, *Secy,* Marcella Sembrich Memorial Association Inc, Marcella Sembrich Opera Museum, Bolton Landing NY

Confessore, Lisa-Marie, *Exec Dir,* Art Center Sarasota, Sarasota FL (S)

Conforti, Michael, *Dir,* Sterling & Francine Clark, Williamstown MA

Cong, Zhiyuan, *Assoc Prof,* William Paterson University, Dept Arts, Wayne NJ (S)

Conis, Pete, *Chmn,* Des Moines Area Community College, Art Dept, Boone IA (S)

Conklin, David, *Co-Dir,* Casa de Unidad Unity House, Detroit MI

Conklin, Donnelle, *Head Librn,* Lauren Rogers, Laurel MS

Conklin, Donnelle, *Head Librn,* Lauren Rogers, Library, Laurel MS

Conlee, Julie, *System Adminr & Sr Cataloger,* Colonial Williamsburg Foundation, John D Rockefeller, Jr Library, Williamsburg VA

Conley, Alston, *Cur,* Boston College, McMullen Museum of Art, Chestnut Hill MA

Conley, B, *Instr,* Golden West College, Visual Art Dept, Huntington Beach CA (S)

Conley, Cort, *Dir Literature,* Idaho Commission on the Arts, Boise ID

Conlon, Beth, *Exec Dir,* Handweaving Museum & Arts Center, Clayton NY (S)

Conlon, William, *Div Chmn,* Fordham University, Art Dept, New York NY (S)

Conn, David, *Prof,* Texas Christian University, Dept of Art & Art History, Fort Worth TX (S)

Connally, Leslie, *Prog Coordr,* The Dallas Contemporary, Dallas Visual Art Center, Dallas TX

Connell, Anne, *Dir School,* Silvermine Guild Arts Center, Silvermine Galleries, New Canaan CT

Connell, Anne, *Dir School,* Guild Art Center, Silvermine, New Canaan CT (S)

Connell, Anne, *Dir Silvermine School,* Silvermine Guild Arts Center, School of Art, New Canaan CT

Connell, E Jane, *Sr Cur,* Muskegon Museum of Art, Muskegon MI

Connell, Emily, *Asst Librn,* The Baltimore Museum of Art, E Kirkbride Miller Art Library, Baltimore MD

Connell, Jim, *Assoc Prof,* Winthrop University, Dept of Art & Design, Rock Hill SC (S)

Connell, John, *Librn,* Yonkers Public Library, Fine Arts Dept, Yonkers NY

Connell, John, *Librn,* Yonkers Public Library, Will Library, Yonkers NY

Connell, Steven, *Prof,* University of Montana, Dept of Art, Missoula MT

Connelly, David, *Dir Pub Relations,* Museum of Fine Arts, Saint Petersburg, Florida, Inc, Saint Petersburg FL

Connelly, Sarah, *Mus Mgr,* Humboldt Arts Council, Morris Graves Museum of Art, Eureka CA

Conner, Ann, *Prof,* University of North Carolina at Wilmington, Dept of Fine Arts - Division of Art, Wilmington NC (S)

Conner, Margie, *Dir Mktg,* Anniston Museum of Natural History, Anniston AL

Conner, Sandra, *Asst Dir,* Biggs Museum of American Art, Dover DE

Connett, Dee, *Chmn,* Hutchinson Community College, Visual Arts Dept, Hutchinson KS (S)

Conniff-O'Shea, Christine, *Conservation Tech,* The Art Institute of Chicago, Dept of Prints & Drawings, Chicago IL

Connolly, Bruce E, *Access Svcs Librn,* New York State College of Ceramics at Alfred University, Scholes Library of Ceramics, Alfred NY

Connolly , Daniel, *Vis Prof,* College of Wooster, Dept of Art, Wooster OH (S)

Connolly, Edith, *Asst Dir,* Gallery One, Ellensburg WA

Connolly, Felicia, *Office Admin,* Wenham Museum, Wenham MA

Connolly, John, *Gallery Dir,* Mayors Office of Arts, Rourism and Special Events, City Hall Galleries, Boston MA

Connolly, Micahel, *Asst Dir,* National Society of Colonial Dames of America in the State of Maryland, Mount Clare Museum House, Baltimore MD

Connor, Cynthia, *Registrar,* Columbia Museum of Art, Columbia SC

Connor, Kathy, *House Cur,* George Eastman, Rochester NY

Connor, Scot, *Instr,* Mohawk Valley Community College, Utica NY (S)

Connor-Talasek, Catherine, *Chmn Dept,* Fontbonne University, Fine Art Dept, Saint Louis MO (S)

Connors, Jill, *Cur,* Historical Society of Washington DC, The City Museum of Washington DC, Washington DC

Connors, Joseph, *Chmn,* Columbia University, Dept of Art History & Archaeology, New York NY (S)

Connors McQuade, Margaret, *Cur Decorative Arts,* Hispanic Society of America, Museum & Library, New York NY

Connorton, Judy, *Architecture Librn,* City College of the City University of New York, Morris Raphael Cohen Library, New York NY

Connorton, Judy, *Librn,* City College of the City University of New York, Architecture Library, New York NY

Conrad, Eric, *Asst,* Emporia State University, Dept of Art, Emporia KS (S)

Conrad, John, *Instr,* San Diego Mesa College, Fine Arts Dept, San Diego CA (S)

Conradi, Jan, *Asst Prof,* State University College of New York at Fredonia, Dept of Art, Fredonia NY (S)

Conrads, Margi, *Cur American Art,* Nelson-Atkins Museum of Art, Kansas City MO

Conrey, Joseph, *Coordr,* Ocean County College, Humanities Dept, Toms River NJ (S)

Conroy, Michel, *Prof,* Texas State University - San Marcos, Dept of Art and Design, San Marcos TX (S)

Conroy, Robyn, *Ofc Mgr,* St. Louis Artists' Guild, Saint Louis MO

Considine, Raymond, *Asst Dean Arts & Sciences,* Indian River Community College, Fine Arts Dept, Fort Pierce FL (S)

Consolini, Marella, *Exec Dir Develop & Admin,* Skowhegan School of Painting & Sculpture, New York NY (S)

Constant, Carol, *Mus Dir,* Wistariahurst Museum, Holyoke MA

Constantine, Gregory, *Chmn,* Andrews University, Dept of Art, Art History & Design, Berrien Springs MI (S)

Constantino, Tracie, *Exec Dir,* Illinois Alliance for Arts Education (IAAE), Chicago IL

Conte, Lisa, *Dir of Exhibitions,* Contemporary Crafts Museum & Gallery, Contemporary Crafts Gallery, Portland OR

Conte, Phil, *Dir Performing Arts,* Arts & Science Center for Southeast Arkansas, Pine Bluff AR

Contes, Anna, *Instr,* Woodstock School of Art, Inc, Woodstock NY (S)

Contreras-Koterbay, Karluta, *Gallery Dir,* East Tennessee State University, College of Arts and Sciences, Dept of Art & Design, Johnson City TN (S)

Conway, Cindy, *VPres,* Wilmington Trust Company, Wilmington DE

Conway, Jan, *Adjunct Prof,* Wilkes University, Dept of Art, Wilkes-Barre PA (S)

Conway, Matthew, *Registrar,* Cornell University, Herbert F Johnson Museum of Art, Ithaca NY

Conyers, Wayne, *Chmn,* McPherson College, Art Dept, McPherson KS (S)

Conyers, Wayne, *Dir,* McPherson College Gallery, McPherson KS

Cook, Arthur, *Asst Prof,* Seton Hall University, College of Arts & Sciences, South Orange NJ (S)

Cook, Christopher, *Cur,* Sioux City Art Center, Sioux City IA (S)

Cook, David, *Chmn,* Sterling College, Art Dept, Sterling KS (S)

Cook, Ed, *Pres,* Carnegie Center for Art & History, New Albany IN

Cook, Hope, *Shop & Gallery Coordr,* Mankato Area Arts Council, Carnegie Art Center, Mankato MN

Cook, James, *Prof,* Elmira College, Art Dept, Elmira NY (S)

Cook, Jennifer, *Asst Dir,* Sangre de Cristo Arts & Conference Center, Pueblo CO

Cook, Jennifer, *Exec Dir,* Foothills Art Center, Inc, Golden CO

Cook, Lakin, *Dir Performing Arts,* Avampato Discovery Museum, The Clay Center for Arts & Sciences, Charleston WV

Cook, Louann, *Controller,* Independence Seaport Museum, Philadelphia PA

Cook, Marlana L, *Registrar,* United States Military Academy, West Point Museum, West Point NY

Cook, Richard L, *Emeritus,* College of Santa Fe, Art Dept, Santa Fe NM (S)

Cook, Silas B, *Acting Dir,* Reed College, Douglas F Cooley Memorial Art Gallery, Portland OR

Cook, Tom, *Pub Relations,* Montana Historical Society, Helena MT

Cook, Vivian, *Mus Shop Mgr,* The Walker African American Museum & Research Center, Las Vegas NV

Cooke, Adrian G, *Chief Preparator,* University of Lethbridge, Art Gallery, Lethbridge AB

Cooke, Doug, *Webmaster,* Lunenburg Art Gallery Society, Lunenburg NS

Cooke, Judy, *Instr,* Pacific Northwest College of Art, Portland OR (S)

Cooke, Lynne, *Cur,* Dia Center for the Arts, New York NY

Cooke, Lynne, *Grad Comt,* Bard College, Center for Curatorial Studies Graduate Program, Annandale-on-Hudson NY (S)

Cooke, S Tucker, *Chmn,* University of North Carolina at Asheville, Dept of Art, Asheville NC (S)

Cooke, Samuel A, *VChmn,* Honolulu Academy of Arts, The Art Center at Linekona, Honolulu HI (S)

Cooke, Victoria, *Cur Paintings,* New Orleans Museum of Art, New Orleans LA

Cooks, Roberta, *VPres Interpretation,* Independence Seaport Museum, Philadelphia PA

Cooledge, Jennifer, *Exec Dir,* DeLand Museum of Art, Deland FL

Coolidge, Christina, *Asst Librn,* Mount Wachusett Community College, Library, Gardner MA

Coombe, JoAnne, *Dir,* Saint Louis County Historical Society, Duluth MN

Coon, Cyndy, *Dir School-Work & Organization Develop,* Arizona Commission on the Arts, Phoenix AZ

Coones, R C, *Instr,* Northeastern State University, College of Arts & Letters, Tahlequah OK (S)

Cooney, Alice, *Anthony W & Lulu,* The Metropolitan Museum of Art, New York NY

Cooney, Catherine, *Sr Librn Printed Books & Periodical Coll,* Winterthur Gardens & Library, Library, Winterthur DE

Coonin, Victor, *Chmn, Asst Prof,* Rhodes College, Dept of Art, Memphis TN (S)

Cooper, Abraham, *Assoc Dean,* Simon Wiesenthal Center Inc, Los Angeles CA

Cooper, Abraham, *Assoc Dean,* Simon Wiesenthal Center Inc, Museum of Tolerance, Los Angeles CA

Cooper, Angela, *Treas & Exec Dir,* Phelps County Historical Society, Nebraska Prairie Museum, Holdrege NE

Cooper, Charisse, *Facility Coordr,* Philbrook Museum of Art, Tulsa OK

Cooper, Cynthia, *Cur Costume,* McCord Museum of Canadian History, Montreal PQ

Cooper, Deborah, *Coll Coordr,* Oakland Museum of California, Art Dept, Oakland CA

Cooper, Gina, *Mus Store Mgr,* Anniston Museum of Natural History, Anniston AL

Cooper, Kate, *Head Librn,* Maryland College of Art & Design Library, Silver Spring MD

Cooper, Mary Kay, *Dir Grad Adult Studies,* Seton Hill University, Art Program, Greensburg PA (S)

Cooper, Melody, *Instr,* Pierce College, Art Dept, Woodland Hills CA (S)

Cooper, Michael, *Instr,* De Anza College, Creative Arts Division, Cupertino CA (S)

Cooper, Nickki, *Publication Cur,* Fort Morgan Heritage Foundation, Fort Morgan CO

Cooper, Rhonda, *Dir,* State University of New York at Stony Brook, University Art Gallery, Stony Brook NY

Cooper, Rudy, *Dir,* Omaha Childrens Museum, Inc, Omaha NE

Cooper, Virginia, *Registrar,* Muscatine Art Center, Muscatine IA

Cooper, Virginia, *Registrar,* Muscatine Art Center, Museum, Muscatine IA

Copaken, Joel, *Gallery Asst,* BRIC - Brooklyn Information & Culture, Rotunda Gallery, Brooklyn NY

Copas, Susan, *Dept Chair,* Seward County Community College, Art Dept, Liberal KS (S)

Cope, Abner, *Assoc Prof,* Central State University, Dept of Art, Wilberforce OH (S)

Cope, Steve, *Prof Painting,* Saint Joseph's University, Dept of Fine & Performing Arts, Philadelphia PA (S)

Cope, Virginia, *Vol Coordr,* Michelson Museum of Art, Marshall TX

Copeland, Jackie, *Dir Educ,* Walters Art Museum, Baltimore MD

Copeland, Lynn, *Librn,* Simon Fraser University, W A C Bennett Library, Burnaby BC

Copeland, Paul, *Asst Librn,* Simon Fraser University, W A C Bennett Library, Burnaby BC

Copeley, Bill, *Librn,* New Hampshire Historical Society, Museum of New Hampshire History, Concord NH

Copeley, William, *Librn,* New Hampshire Historical Society, Library of History & Genealogy, Concord NH

Coppernoll, Lee, *Asst Dir Administration,* Marquette University, Haggerty Museum of Art, Milwaukee WI

Coppin, Kerry, *Assoc Prof,* University of Miami, Dept of Art & Art History, Coral Gables FL (S)

Copping, Lisette, *Chmn Fine Arts,* Delgado College, Dept of Fine Arts, New Orleans LA (S)

Corbaley, Joanne, *Dir Budget,* California Watercolor Association, Gallery Concord, Concord CA

Corbett, Cornelia, *Chmn,* Tampa Museum of Art, Judith Rozier Blanchard Library, Tampa FL

Corbin, George, *Prof,* City University of New York, PhD Program in Art History, New York NY (S)

Corbin, Tarrence, *Assoc Prof Fine Arts,* University of Cincinnati, School of Art, Cincinnati OH (S)

Corbus, Lili, *Prof Emeritus,* University of North Carolina at Charlotte, Dept Art, Charlotte NC (S)

Corcoran, Kathryn, *Head Librn,* Joslyn Art Museum, Omaha NE

Corcoran, Kathryn, *Librn,* Munson-Williams-Proctor Arts Institute, Museum of Art, Utica NY

Corcoran, Kathryn L, *Dir Library Svcs,* Munson-Williams-Proctor Arts Institute, Art Reference Library, Utica NY

Corcoran, Kathryn L, *Head Librn,* Joslyn Art Museum, Milton R & Pauline S Abrahams Library, Omaha NE

Cordova, Ruben, *Asst Prof,* University of Texas at San Antonio, Dept of Art & Art History, San Antonio TX (S)

Cores, Ellen, *Dir,* South Peace Art Society, Dawson Creek Art Gallery, Dawson Creek BC

Corey, Heather, *Archivist & Vis Resources Mgr,* Hillwood Museum & Gardens Foundation, Hillwood Museum & Gardens, Washington DC

Corey, Maureen, *Vol Coordr,* Kirkland Museum of Fine & Decorative Art, Denver CO

Corey, Sharon, *Prof,* Chapman University, Art Dept, Orange CA (S)

Corey, Shirley Trusty, *Pres & CEO,* Arts Council Of New Orleans, New Orleans LA

Cork, Sheila, *Librn,* New Orleans Museum of Art, New Orleans LA

Cork, Sheila, *Librn,* New Orleans Museum of Art, Felix J Dreyfous Library, New Orleans LA

Corkin, Jane, *Pres,* Art Dealers Association of Canada, Toronto ON

Corle, Ed, *Dir,* University of Findlay, Dudley & Mary Marks Lea Gallery, Findlay OH

Corle, Jack (Ed), *Assoc Prof,* University of Findlay, Art Program, Findlay OH (S)

Cornelius, Camille, *Instr,* Pierce College, Art Dept, Woodland Hills CA (S)

Cornelius, James M, *Treas,* Columbus Museum of Art and Design, Indianapolis IN

Cornelius, Kim, *Treas,* Brown County Art Gallery Foundation, Brown County Art Gallery & Foundation, Nashville IN

Cornelius, Phil, *Acting Area Head Ceramics,* Pasadena City College, Art Dept, Pasadena CA (S)

Cornelius, Sally, *Prof,* Virginia Polytechnic Institute & State University, Dept of Art & Art History, Blacksburg VA (S)

Cornell, Beth, *State Adviser,* Pennsylvania Department of Education, Arts in Education Program, Harrisburg PA

Cornell, Daniell, *Assoc Cur American Painting,* Fine Arts Museums of San Francisco, Legion of Honor, San Francisco CA

Cornell, Thomas B, *Prof,* Bowdoin College, Art Dept, Brunswick ME (S)

Cornett, J, *Prof,* Northern Arizona University, Museum Faculty of Fine Art, Flagstaff AZ (S)

Cornfeld, Michael, *Prof,* Marshall University, Dept of Art, Huntington WV (S)

Cornish, Glenn, *Music Instr,* Edison Community College, Gallery of Fine Arts, Fort Myers FL (S)

Cornish, Jack, *Chmn,* Kean College of New Jersey, Fine Arts Dept, Union NJ (S)

Cornwell, Chad, *Prog Dir,* Sierra Arts Foundation, Reno NV

Correa, Laura, *Dir,* Van Cortlandt House Museum, Bronx NY

Correia, Peter, *Prof,* Ulster County Community College/Suny Ulster, Dept of Visual & Performing Arts, Stone Ridge NY (S)

Corrie, Katie, *Devel Officer,* Albany Institute of History & Art, Albany NY

Corrie, Rebecca W, *Prof, Chmn,* Bates College, Art & Visual Culture, Lewiston ME (S)

Corrigan, David J, *Cur,* Connecticut State Library, Museum of Connecticut History, Hartford CT

Corrigan, Kathleen, *Chm & Assoc Prof,* Dartmouth College, Dept of Art History, Hanover NH (S)

Corrigan, Lese, *Dir,* Tradd Street Press, Elizabeth O'Neill Verner Studio Museum, Charleston SC

Corrigan, Shannon, *Dir,* Emmanuel Gallery, Denver CO

Corrigan, Sym, *Office Mgr,* Dalhousie University, Dalhousie Art Gallery, Halifax NS

Corrin, Lisa, *Deputy Dir Art,* Seattle Art Museum, Library, Seattle WA

Corsaro, James, *Librn,* Rensselaer County Historical Society, Hart-Cluett Mansion, 1827, Troy NY

Corsaro, James, *Librn,* Rensselaer County Historical Society, Museum & Library, Troy NY

Cortes, Yvette, *Reference Librn,* Parsons School of Design, Adam & Sophie Gimbel Design Library, New York NY

Cortez, Jaime, *Dir Prog,* Galeria de la Raza, Studio 24, San Francisco CA

Cortiella, David, *Exec Dir,* Inquilinos Boricuas en Accion, Boston MA

Cortinas, Miguel, *Asst Prof,* University of the Incarnate Word, Art Dept, San Antonio TX (S)

Corwin, Sharon, *Cur,* Colby College, Museum of Art, Waterville ME

Cory, Jackie, *Admin Dir,* Art Center Sarasota, Sarasota FL

Corzo, Miguel-Angel, *Pres,* The University of the Arts, Rosenwald-Wolf Gallery, Philadelphia PA

Cosentino, Cira, *Instr,* Indian River Community College, Fine Arts Dept, Fort Pierce FL (S)

Cosentino, Geraldine, *Dir & Newsletter Editor,* Organization of Independent Artists, Inc, New York NY

Cosentino, Marie, *Registrar,* Pelham Art Center, Pelham NY

Cosme, Lissie, *Prog Asst,* University of South Florida, Contemporary Art Museum, Tampa FL

Cost, Steven, *Asst Prof,* Amarillo College, Visual Art Dept, Amarillo TX (S)

Costa, Denise, *Dir Communications,* High Desert Museum, Bend OR

Costa, Donna, *Serials Technician,* Ames Free-Easton's Public Library, North Easton MA

Costa, Jennifer, *Asst Prof & Cur,* Illinois Central College, Dept Fine, Performing & Applied Arts, East Peoria IL (S)

Costa, Jorge, *Instr,* Springfield College, Dept of Visual & Performing Arts, Springfield MA (S)

Costanzo, Nancy, *Chmn Dept,* Our Lady of Elms College, Dept of Fine Arts, Chicopee MA (S)

Costigan, Constance C, *Prof,* George Washington University, Dept of Art, Washington DC (S)

Cote, Alan, *Instr,* Bard College, Milton Avery Graduate School of the Arts, Annandale-on-Hudson NY (S)

Cote, Marc, *Chmn,* Framingham State College, Art Dept, Framingham MA (S)

Cothran, Brenna, *Registrar & Asst Cur,* Board of Parks & Recreation, The Parthenon, Nashville TN

Cothren, Michael, *Prof,* Swarthmore College, Dept of Art, Swarthmore PA (S)

Cotler Block, Susan, *Chmn Advertising Design,* Fashion Institute of Technology, Art & Design Division, New York NY (S)

Cotner, Teresa, *Asst Prof,* California State University, Chico, Department of Art & Art History, Chico CA (S)

Cott, Sharon H, *Vice Pres & Sec,* The Metropolitan Museum of Art, New York NY

Cottler, Fran, *Registrar,* Winterthur Gardens & Library, Winterthur DE

Cotton, Lisa, *Dir Exhib,* College of Saint Benedict, Art Gallery, Saint Joseph MN

Cottong, Kathy, *Dir,* The Arts Club of Chicago, Reference Library, Chicago IL

Cottong, Kathy S, *Dir,* The Arts Club of Chicago, Chicago IL

Couch, Kirsten, *Instr,* Northeastern Oklahoma A & M College, Art Dept, Miami OK (S)

Couchon, Marie-Paule, *Archivist,* Musee des Augustines de l'Hotel Dieu de Quebec, Archive, Quebec PQ

Coughin, Marge, *Dir Special Events,* American Society of Artists, Inc, Palatine IL

Coughlin, Joan Hopkins, *Cur,* Wellfleet Historical Society Museum, Wellfleet MA

Coulter, Kristienne, *Dir School,* Rockland Center for the Arts, West Nyack NY (S)

Council, Dorothy, *VPres,* Rawls Museum Arts, Courtland VA

Countryman, Paul, *Exhib Prep,* Illinois State Museum, Museum Store, Chicago IL

Coup, Jessica, *Dir Communications,* Mattress Factory, Pittsburgh PA

Coupolos-Selle, Stephanie, *Prof,* University of Wisconsin College - Marinette, Art Dept, Marinette WI (S)

Courant, Diane, *Dir,* Society of Layerists in Multi Media (SLMM), Albuquerque NM

Courson, Bruce, *Dir,* The Sandwich Historical Society, Inc, Sandwich Glass Museum, Sandwich MA

Courson, Bruce, *Dir,* The Sandwich Historical Society, Inc, Library, Sandwich MA

Court, Elizabeth, *Chief Paintings Conservator,* Balboa Art Conservation Center, San Diego CA

Courtney, Julia, *Asst Cur Art,* Springfield Library & Museums Association, Museum of Fine Arts, Springfield MA

Courtney, Vernon, *Actg Dir,* Ohio Historical Society, National Afro American Museum & Cultural Center, Wilberforce OH

Coutellier, Francis, *Chmn Photography Dept,* Universite de Moncton, Dept of Visual Arts, Moncton NB (S)

Coutu, Joan, *Assoc Prof,* University of Waterloo, Fine Arts Dept, Waterloo ON (S)

Couture, Andrea, *Dir Develop,* The Queens Museum of Art, Flushing NY

Covaleskie, Frank, *Pres,* Art Institute of Philadelphia, Philadelphia PA (S)

Covert, Claudia, *Readers' Svrs Librn,* Rhode Island School of Design, Fleet Library at RISD, Providence RI

Covert, Nan, *Dept Head,* Bridgewater College, Art Dept, Bridgewater VA (S)

Covington, Joseph F, *Dir Educ,* North Carolina Museum of Art, Raleigh NC

Covington, Joseph P, *Dir Educ Svcs,* North Carolina Museum of Art, Reference Library, Raleigh NC

Covington-Vogl, Laurel, *Assoc Prof,* Fort Lewis College, Art Dept, Durango CO (S)

Covo, David, *Prof,* McGill University, School of Architecture, Montreal PQ (S)

Cowan, Maribeth, *Dir Pub Relations,* Virginia Historical Society, Library, Richmond VA

Cowardin, Marc, *Instr,* Mississippi State University, Dept of Art, Mississippi State MS (S)

Cowardin, Mark, *Asst Prof Art, Sculp Dept Coordr,* Johnson County Community College, Visual Arts Program, Overland Park KS (S)

Cowart, Jack, *Deputy Dir & Chief Cur,* Corcoran Gallery of Art, Washington DC

Cowden, Chris, *Exec Dir,* Women & Their Work, Austin TX

Cowden, Dorothy, *Dir Gallery,* University of Tampa, Dept of Art, Tampa FL (S)

Cox, Amy, *Assoc Prof,* Harding University, Dept of Art, Searcy AR (S)

Cox, Andy, *Chmn,* Limestone College, Art Dept, Gaffney SC (S)

Cox, Anna, *Asst Prof,* Longwood University, Dept of Art, Farmville VA (S)

Cox, Anne, *Dir,* Savannah College of Art And Design, Georgia Artists Registry, Atlanta GA

Cox, Beverly, *Cur Exhib,* National Portrait Gallery, Washington DC

Cox, Beverly, *Exhibitions & Coll,* National Portrait Gallery, Library, Washington DC

Cox, Carrie, *Cur Educ,* Museum of the American Quilter's Society, Paducah KY

Cox, David N, *Prof,* Weber State University, Dept of Visual Arts, Ogden UT (S)

Cox, Dennis, *Assoc Prof,* Pacific Lutheran University, Dept of Art, Tacoma WA (S)

Cox, Donald M, *VPres,* The American Federation of Arts, New York NY

Cox, Gina, *Preparator,* East Carolina University, Wellington B Gray Gallery, Greenville NC

Cox, Jean, *Assoc Prof,* Oakland City University, Division of Fine Arts, Oakland City IN (S)

Cox, Jonathan, *Asst Prof,* Marshall University, Dept of Art, Huntington WV (S)

Cox, Julie, *Coll Mgr,* Chesapeake Bay Maritime Museum, Howard I Chapelle Memorial Library, Saint Michaels MD

Cox , Maurice, *Dir Business Operations,* Columbus Museum of Art and Design, Indianapolis IN

Cox, Michael, *Co-Dir,* University of Manitoba, Faculty of Architecture Exhibition Centre, Winnipeg MB

Cox, Michael, *Dean,* University of Manitoba, Faculty of Architecture, Winnipeg MB (S)

Cox, Richard, *Prof,* Louisiana State University, School of Art, Baton Rouge LA (S)

Cox, Sarah Beth, *Instr,* West Virginia University at Parkersburg, Art Dept, Parkersburg WV (S)

Cox, Sharon, *Chmn,* Jamestown College, Art Dept, Jamestown ND (S)

Cox-Rearick, Janet, *Distinguished Prof*, City University of New York, PhD Program in Art History, New York NY (S)

Cox-Smith, Susan, *Mem Coordr*, Southern Oregon Historical Society, Jacksonville Museum of Southern Oregon History, Medford OR

Crable, James, *Prof*, James Madison University, School of Art & Art History, Harrisonburg VA (S)

Cracco, Derek, *Asst Prof*, University of Alabama at Birmingham, Dept of Art & Art History, Birmingham AL (S)

Craft, Amy, *Dir Educ*, Massillon Museum, Massillon OH

Craig, Andrew B, *Pres & Chmn*, The Boatmen's National Bank of St Louis, Art Collection, Saint Louis MO

Craig, Briar, *Dept Head & Assoc Prof (Visual Art)*, University of British Columbia Okanagan, Dept of Creative Studies, Kelowna BC (S)

Craig, Gerry, *Cur Educ*, Detroit Zoological Institute, Wildlife Interpretive Gallery, Royal Oak MI

Craig, James, *Art Dept Lead & Instr*, Columbia Basin College, Esvelt Gallery, Pasco WA (S)

Craig, James, *Assoc Cur Coll*, Cape Ann Historical Association, Gloucester MA

Craig, Lynn, *Prof*, Clemson University, College of Architecture, Clemson SC (S)

Craig, Marilyn, *Dir Mktg*, Cherokee Heritage Center, Tahlequah OK

Craig, Rob, *Mgr Family Events*, Newark Museum Association, Junior Museum, Newark NJ

Craig, Robert, *Assoc Prof Art*, Drake University, Dept Art & Design, Des Moines IA (S)

Craig, Susan, *Dir*, Trinity College Library, Washington DC

Craig, Susan V, *Librn*, University of Kansas, Murphy Library of Art & Architecture, Lawrence KS

Craighead, Linda, *Dir*, Palo Alto Art Center, Palo Alto CA

Crainic, Teodor, *Assoc Prof*, Universite de Montreal, Bibliotheque d'Amenagement, Montreal PQ

Crall, Steven, *Asst Prof*, South Carolina State University, Dept of Visual & Performing Arts, Orangeburg SC (S)

Cramer, Patricia T, *Dir*, Westfield Athenaeum, Jasper Rand Art Museum, Westfield MA

Cramer, Sam, *Instr & Coordr*, Luzerne County Community College, Commercial Art Dept, Nanticoke PA (S)

Crane, Barbara, *Prof*, School of the Art Institute of Chicago, Chicago IL (S)

Crane, Bonnie L, *Pres*, Crane Collection, Gallery of American Painting and Sculpture, Wellesley MA

Crane, David, *Prof*, Virginia Polytechnic Institute & State University, Dept of Art & Art History, Blacksburg VA (S)

Crane, Diane, *Instr*, Viterbo College, Art Dept, La Crosse WI (S)

Crane, Ed, *Dir Develop*, Walters Art Museum, Baltimore MD

Crane, Janna, *Spec Events Coordr*, Morris Museum of Art, Augusta GA

Crane, Lois F, *Librn*, Wichita Art Museum, Emprise Bank Research Library, Wichita KS

Crane, Melody, *Exec Asst*, Kansas City Artists Coalition, Kansas City MO

Cranin, Tonya, *Mktg Dir*, Architects Design Group Inc, Winter Park FL

Cranston, Meg, *Vis Instr*, Claremont Graduate University, Dept of Fine Arts, Claremont CA (S)

Crapo, Val, *VPres*, Eagle Rock Art Museum and Education Center, Inc, Idaho Falls ID

Craven, Allen, Fort Hays State University, Dept of Art, Hays KS (S)

Craven, Thorns, *Pres Bd*, Southeastern Center for Contemporary Art, Winston-Salem NC

Craven Fernandez, Happy, *Pres*, Moore College of Art & Design, Philadelphia PA (S)

Cravens, Kate, *Cur Hall of Fame*, National Museum of Racing, National Museum of Racing & Hall of Fame, Saratoga Springs NY

Crawford, Alice, *Registrar*, Carson County Square House Museum, Panhandle TX

Crawford, Barbara, *Head Dept*, Southern Virginia College, Division of Arts and Humanities, Buena Vista VA (S)

Crawford, Cameron, *Prof*, California State University, Chico, Department of Art & Art History, Chico CA (S)

Crawford, Gretchen, *Instr*, Capital University, Fine Arts Dept, Columbus OH (S)

Crawford, Henry B, *Cur History*, Texas Tech University, Museum of Texas Tech University, Lubbock TX

Crawford, J, *Instr*, Humboldt State University, College of Arts & Humanities, Arcata CA (S)

Crawford, James, *Chmn*, Humboldt State University, College of Arts & Humanities, Arcata CA (S)

Crawford, James, *Cur*, Canajoharie Library & Art Gallery, Library, Canajoharie NY

Crawford, Margaret, *Educ*, The Walker African American Museum & Research Center, Las Vegas NV

Crawford, Nina, *Adminr*, Dauphin & District Allied Arts Council, Watson Art Centre, Dauphin MB

Crawford, Pam, *Gallery Mgr*, Brown County Art Gallery Foundation, Brown County Art Gallery & Foundation, Nashville IN

Crawford, Randal, *Chmn Dept*, Delta College, Art Dept, University Center MI (S)

Crawley, George, *Dir Educ*, Tubman African American Museum, Macon GA

Creamer, Mary Lou, *VPres*, Port Huron Museum, Port Huron MI

Creasman, Jody, *Dir Communications*, Oregon College of Art & Craft, Hoffman Gallery, Portland OR

Creasy, June, *Assoc Prof*, Lambuth University, Dept of Human Ecology & Visual Arts, Jackson TN (S)

Crebbs, Jacquelin W, *Dir Advancement*, Norton Museum of Art, West Palm Beach FL

Creech, Allen, *Instr*, Asbury College, Art Dept, Wilmore KY (S)

Creedon, Denise, *Asst Dir*, Perkins Center for the Arts, Moorestown NJ

Creegan-Quinquis, Maureen, *Prof*, Salem State College, Art Dept, Salem MA (S)

Creighton, Sandra, *Visitor Svcs*, National Gallery of Art, Washington DC

Creola, Jamie, *Cur Science Educ*, Louisiana Arts & Science Museum, Baton Rouge LA

Crepeau, Claude, *Assoc Prof*, Universite de Montreal, Bibliotheque d'Amenagement, Montreal PQ

Cresson, Pat, *Prof*, Monmouth University, Dept of Art & Design, West Long Branch NJ (S)

Creston, Bill, *Co-Dir*, eMediaLoft.org, New York NY

Creston, Sena Clara, *Asst*, eMediaLoft.org, New York NY

Creteau, Marie-Lucei, *Dir*, Vu Centre D'Animation Et de Diffusion de La Photographie, Quebec PQ

Crew, John, *Pres*, Wenatchee Valley College, Gallery 76, Wenatchee WA

Crews, Brian, *Union Student Advisor*, Duke University Union, Louise Jones Brown Gallery, Durham NC

Cribelli, Susan, *Acad Dean Communications & Humanities*, Aims Community College, Visual & Performing Arts, Greeley CO (S)

Crider, Gwen, *Dir*, Austin Children's Museum, Austin TX

Cridler, Kim, *Cur*, Kohler Co, John Michael Kohler Arts Center - Arts Industry Program, Sheboygan WI

Crilly, Trevor, *Pres*, Durham Art Gallery, Durham ON

Crim, Michelle, *Museum Store Mgr*, Birmingham Museum of Art, Birmingham AL

Crimson, Linda, *Adjunct Asst Prof*, Indiana University South Bend, Fine Arts Dept, South Bend IN (S)

Cripps, Stephen, *Pres*, Kings County Historical Society & Museum, Hampton NB

Crise, Robert, *Gallery Mgr*, Detroit Focus, Detroit MI

Crismon, David, *Asst Prof*, Oklahoma Christian University of Science & Arts, Dept of Art & Design, Oklahoma City OK (S)

Crisp, Lynn, *Librn*, North Carolina State University, Harrye Lyons Design Library, Raleigh NC

Crittendon, Shelly, *Registrar*, The Old Jail Art Center, Albany TX

Croce, Marianne Della, *Coll Mgr*, Planting Fields Foundation, Coe Hall at Planting Fields Arboretum, Oyster Bay NY

Crocker, Elli, *Dir Studio Art Prog*, Clark University, Dept of Visual & Performing Arts, Worcester MA (S)

Crocker, Heather, *Dir Educ*, Sun Valley Center for the Arts & Humanities, Dept of Fine Art, Sun Valley ID (S)

Crocker, Kyle, *Prof*, Bemidji State University, Visual Arts Dept, Bemidji MN (S)

Crockett, Candace, *Chmn*, San Francisco State University, Art Dept, San Francisco CA (S)

Crockett, Rachel, *Educ Coordr*, City of Lubbock, Buddy Holly Center, Lubbock TX

Croft, Michael, *Prof Jewelry & Metalsmithing*, University of Arizona, Dept of Art, Tucson AZ (S)

Croft, Parker, *Visitng Asst Prof*, Middlebury College, History of Art & Architecture Dept, Middlebury VT (S)

Croft, Terry, *Dir*, Rodman Hall Arts Centre, Saint Catharines ON

Croins, Sonya, *Office Mgr*, Mississippi Museum of Art, Howorth Library, Jackson MS

Crolley, Dennis, *Program Admin*, Wesley Theological Seminary Henry Luce III Center for the Arts & Religion, Dadian Gallery, Washington DC

Cromley, Elizabeth, *Chmn*, Northeastern University, Dept of Art & Architecture, Boston MA (S)

Cronin, Allison, *Mgr Loans & Proj*, University of British Columbia, Museum of Anthropology, Vancouver BC

Cronin, Karen, *VPres Operations*, Independence Seaport Museum, Philadelphia PA

Cronin, Mary W, *Supv Educ*, Brandywine River Museum, Chadds Ford PA

Cronk, Frank, *Prof*, University of Idaho, Dept of Art & Design, Moscow ID (S)

Croog, Elizabeth, *Secy & Gen Counsel*, National Gallery of Art, Washington DC

Crook, Lillian, *Librn Dir*, Dickinson State University, Stoxen Library, Dickinson ND

Crooks, William C, *Chmn*, Historical Society of the Town of Greenwich, Inc, Bush-Holley House Museum, Cos Cob CT

Cropper, Elizabeth, *Dean, Center for Advanced Study in Visual Arts*, National Gallery of Art, Washington DC

Crosby, Suzanne, *Assoc Prof*, Hillsborough Community College, Fine Arts Dept, Tampa FL (S)

Crosby-Hinds, Patricia, *Prof*, Antelope Valley College, Art Dept, Division of Fine Arts, Lancaster CA (S)

Crose, Sherry, *Dir Mktg & Develop*, Kentucky Derby Museum, Louisville KY

Croskrey, Wendy, *Assoc Prof*, University of Alaska-Fairbanks, Dept of Art, Fairbanks AK (S)

Crosman, Christopher B, *Dir*, William A Farnsworth, Museum, Rockland ME

Crosman, Christopher B, *Dir*, William A Farnsworth, Library, Rockland ME

Cross, Louise, *Cur*, Frontier Gateway Museum, Glendive MT

Cross, Scott, *Archivist*, Oshkosh Public Museum, Oshkosh WI

Cross, Scott, *Archivist*, Oshkosh Public Museum, Library, Oshkosh WI

Cross, Tony, *Instr*, Cuyahoga Valley Art Center, Cuyahoga Falls OH (S)

Cross, Whitney, *Event & Tour Coordr*, Oklahoma City Museum of Art, Oklahoma City OK

Crossett, Arlene, *Asst Librn*, Manchester Historic Association, Library, Manchester NH

Crossman, Rodney, *Asst Prof*, Indiana Wesleyan University, Art Dept, Marion IN (S)

Crosson, David, *Dir*, Old Mill Foundation, North Baker Library, San Marino CA

Croston, Robert, *Assoc Prof Design*, Drexel University, College of Media Arts & Design, Philadelphia PA (S)

Croton, Lynn, *Dean Visual & Performing Arts*, C W Post Campus of Long Island University, School of Visual & Performing Arts, Brookville NY (S)

Crouch, Dennis, *Instr*, Oklahoma State University, Graphic Arts Dept, Visual Communications, Okmulgee OK (S)

Crouch, Don, *Prof*, Western Illinois University, Art Dept, Macomb IL (S)

Crouch, Kay, *Registrar*, Cheekwood-Tennessee Botanical Garden & Museum of Art, Museum of Art Library, Nashville TN

Crouch, Kaye, *Registrar*, Cheekwood-Tennessee Botanical Garden & Museum of Art, Nashville TN

Crouse, Michael, *Chmn Art & Art History Dept*, University of Alabama in Huntsville, Dept of Art and Art History, Huntsville AL (S)

Crouther, Betty, *Assoc Prof*, University of Mississippi, Department of Art, University MS (S)

Crow, James, *Instr*, East Central College, Art Dept, Union MO (S)

Crowe, John, *Chair Art Educ*, Massachusetts College of Art, Boston MA (S)

Crowell, Beverly J, *Pub Svcs Librn*, New York State College of Ceramics at Alfred University, Scholes Library of Ceramics, Alfred NY

Crowell, F P, *Pres*, Timken Museum of Art, San Diego CA

Crowley, Gina, *Dir Special Events & Rentals*, Museum of Contemporary Art, Chicago IL

Crowley, Timothy, *Pres*, Chinati Foundation, Marfa TX

Crowley, Tony, *Chmn*, Grinnell College, Dept of Art, Grinnell IL (S)

Crown, Cathleen, *Develop Coordr*, Old Barracks Museum, Trenton NJ

Crozier, Richard, *Studio Faculty*, University of Virginia, McIntire Dept of Art, Charlottesville VA (S)

Crozier, Richard F, *Deputy Dir Finance & Adminr*, Winterthur Gardens & Library, Winterthur DE

Crum, Joan, *Bus Mgr*, Museum of Western Colorado, Grand Junction CO

Crum, Katherine B, *Dir*, Mills College, Art Museum, Oakland CA

Crum, Roger, *Assoc Prof*, University of Dayton, Visual Arts Dept, Dayton OH (S)

Crumlish Joyce, Christine, *Cur & Historian,* Shirley Plantation, Charles City VA

Crusan, Ronald L, *Dir & CEO,* Lyman Allyn, New London CT

Cruz, Alfredo, *Chmn,* Our Lady of the Lake University, Dept of Art, San Antonio TX (S)

Cruz, Michele A, *Instr,* North Carolina Wesleyan College, Dept of Visual & Performing Arts, Rocky Mount NC (S)

Cuba, Kathleen, *Dir Educ,* Missouri Historical Society, Saint Louis MO

Cubbage, John, *Prof Music,* University of Great Falls, Humanities Div, Great Falls MT (S)

Cucchi, Paolo, *Dean,* Drew University, Elizabeth P Korn Gallery, Madison NJ

Cuddy, Pat, *Pres,* Chaffee Center for the Visual Arts, Rutland VT

Cudnik, Carolyn, *Office Mgr,* Old Barracks Museum, Trenton NJ

Cui, Shanshan, *Asst Prof,* Bridgewater State College, Art Dept, Bridgewater MA (S)

Culbertson, Ben, *Coordr,* Hagerstown Junior College, Art Dept, Hagerstown MD (S)

Culbertson, Carol, *Dir Vesterheim Gen,* Vesterheim Norwegian-American Museum, Reference Library, Decorah IA

Culbertson, Margaret, *Dir,* Museum of Fine Arts, Houston, Hirsch Library, Houston TX

Culbertson, Margaret, *Librn,* Art Museum of the University of Houston, William R Jenkins Architecture & Art Library, Houston TX

Culbreath, Gary, *VChmn,* South Carolina State Museum, Columbia SC

Cullen, Charles T, *Pres & Librn,* Newberry Library, Chicago IL

Culligan, Jenine, *Sr Cur,* Huntington Museum of Art, Huntington WV

Culligan, Joe, *Pres,* College of Visual Arts, Gallery, Saint Paul MN

Cullinan, Deborah, *Dir,* Intersection for the Arts, San Francisco CA

Cullip, Joann, *Art Education,* Asbury College, Student Center Gallery, Wilmore KY

Cullip, Joann, *Instr,* Asbury College, Art Dept, Wilmore KY (S)

Cullivan, Lynn, *Publ,* San Francisco Maritime National Historical Park, Maritime Museum, San Francisco CA

Culp, David, *VPres,* Alton Museum of History & Art, Inc, Alton IL

Culp, Ellie, *VPres,* Independence Historical Museum, Independence KS

Culver, Michael, *Dir & Cur,* Ogunquit Museum of American Art, Ogunquit ME

Culver, Michael, *Dir & Cur,* Ogunquit Museum of American Art, Reference Library, Ogunquit ME

Cumby, Rena, *Asst Prof Interior Design,* Drexel University, College of Media Arts & Design, Philadelphia PA (S)

Cumiskey, Marcia, *Assoc Dir Admin & Finance,* Delaware Art Museum, Wilmington DE

Cumming, Avie, *Events Mgr,* Villa Terrace Decorative Art Museum, Milwaukee WI

Cumming, Doug, *Prof,* University of Wisconsin-Stout, Dept of Art & Design, Menomonie WI (S)

Cumming, Jean M, *Adminir,* United States Military Academy, West Point Museum, West Point NY

Cummings, Mary Lou, *Cur & Registrar,* Knights of Columbus Supreme Council, Knights of Columbus Museum, New Haven CT

Cummings, Richard, *Asst Prof,* College of the Ozarks, Dept of Art, Point Lookout MO (S)

Cundall, Robert, *CFO,* Seattle Art Museum, Seattle WA

Cundall, Robert, *CFO,* Seattle Art Museum, Library, Seattle WA

Cundiff, Linda, *Chmn Art,* Campbellsville University, Department of Art, Campbellsville KY (S)

Cuneo, Pia, *Assoc Prof Art History,* University of Arizona, Dept of Art, Tucson AZ (S)

Cunningham, Amy, *Educator,* Vermont Historical Society, Museum, Montpelier VT

Cunningham, Barbara, *Gallery Mgr,* Vermont State Craft Center at Frog Hollow, Middlebury VT

Cunningham, Charles, *Mgr,* Western State College of Colorado, Dept of Art & Industrial Technology, Gunnison CO (S)

Cunningham, David, *Mgr Design & Exhibits,* University of British Columbia, Museum of Anthropology, Vancouver BC

Cunningham, Dennis, *Instr,* Marylhurst University, Art Dept, Marylhurst OR (S)

Cunningham, John, *Pres,* Cape Ann Historical Association, Gloucester MA

Cunningham, Kay, *VPres,* Children's Museum, Indianapolis IN

Cunningham, Linda, *Instr,* Franklin & Marshall College, Art Dept, Lancaster PA (S)

Cunningham, Michael R, *Cur Japanese & Korean Art,* Cleveland Museum of Art, Cleveland OH

Cunningham, Scott, *Asst Dir,* Spartanburg County Museum of Art, Spartanburg SC

Cunningham, William, *Treas,* Pennsylvania Academy of the Fine Arts, Fellowship of the Pennsylvania Academy of the Fine Arts, Philadelphia PA

Curfman, Robert, *Assoc Prof,* Indiana Wesleyan University, Art Dept, Marion IN (S)

Curl, Woralen, *Advertising Publicity,* Illustration House Inc, Gallery Auction House, New York NY

Curlee, Candise, *Gallery Asst,* Ringling School of Art & Design, Selby Gallery, Sarasota FL

Curler, Dawna, *VIP Coordr,* Southern Oregon Historical Society, Jacksonville Museum of Southern Oregon History, Medford OR

Curler, Kim, *Outreach Coordr,* Nevada Museum of Art, Reno NV

Curnow, Kathy, *Assoc Prof,* Cleveland State University, Art Dept, Cleveland OH (S)

Curran, Mary, *Asst to Dir,* Art Complex Museum, Carl A. Weyerhaeuser Library, Duxbury MA

Curran-Gawron, Marguerite, *Pub Relations,* Muskegon Museum of Art, Muskegon MI

Curren, Kerry, *Registrar,* Maine Photographic Workshops, The International T.V. & Film Workshops & Rockport College, Rockport ME (S)

Curreri-Ermatinger, Dyana, *Dir & Chief Cur,* Fresno Arts Center & Museum, Fresno CA

Currier, Janice, *Cur Exhibits,* Loveland Museum Gallery, Loveland CO

Currier, Richard, *Pres,* Willard House & Clock Museum, Inc, North Grafton MA

Curry, David Park, *Sr Cur Dec Arts & American Painting & Sculpture,* The Baltimore Museum of Art, Baltimore MD

Curry, Joseph, *Dir Develop,* Cincinnati Institute of Fine Arts, Taft Museum of Art, Cincinnati OH

Curry, Judy, *Vice Pres,* Leatherstocking Brush & Palette Club Inc, Cooperstown NY

Curry, Larrie Spier, *Dir Museum,* Shaker Village of Pleasant Hill, Harrodsburg KY

Curry, Michael P, *Dir,* City of Hampton, Hampton Arts Commission, Hampton VA

Curtin, Christopher, *Asst Prof,* Appalachian State University, Dept of Art, Boone NC (S)

Curtin, Donna, *Exec Dir,* Plymouth Antiquarian Society, Plymouth MA

Curtin, Nancy, *Dir,* Port Washington Public Library, Port Washington NY

Curtis, Brian, *Assoc Prof,* University of Miami, Dept of Art & Art History, Coral Gables FL (S)

Curtis, David, *Pres,* Rockport Art Association, Rockport MA

Curtis, Julie, *Assoc Prof,* Northeastern University, Dept of Art & Architecture, Boston MA (S)

Curtis, Verna, *Photographs,* Library of Congress, Prints & Photographs Division, Washington DC

Curtis, Winifred, *Dir,* Harcum College, Fashion Design, Bryn Mawr PA (S)

Cusano, John, *Exec Dir,* Farmington Valley Arts Center, Avon CT

Cushman, Brad, *Cur,* University of Arkansas at Little Rock, Art Galleries, Little Rock AR

Cushman, Brad, *Gallery Cur,* University of Arkansas at Little Rock, Art Slide Library and Galleries, Little Rock AR

Cushner, Steven, *Instr,* American University, Dept of Art, Washington DC (S)

Cutler, Jean, *Dir Bur of Historic Sites,* Pennsylvania Historical & Museum Commission, Harrisburg PA

Cutler, Jerry, *Assoc Prof,* University of Florida, Dept of Art, Gainesville FL (S)

Cutler, Walter L, *Pres & CEO,* Meridian International Center, Cafritz Galleries, Washington DC

Cylich, Clarissa, *Dir,* Bartow-Pell Mansion Museum & Gardens, Bronx NY

Cynar, John, *Exhib Coordr,* Birmingham-Bloomfield Art Center, Birmingham MI

Cyphers, Christopher, *Provost,* School of Visual Arts, New York NY (S)

Cyr, Kathy A, *Dir,* Campbell Center for Historic Preservation Studies, Mount Carroll IL (S)

Cyr, Paul, *Dept Head Genealogy & Whaling Coll,* New Bedford Free Public Library, Art Dept, New Bedford MA

Czarnecki, James, *Assoc Prof,* University of Nebraska at Omaha, Dept of Art & Art History, Omaha NE (S)

Czecholwski, Jan, *Chmn,* College of Saint Catherine, Art & Art History Dept, Saint Paul MN (S)

Czechowski, Susan, *Asst Prof,* Western Illinois University, Art Dept, Macomb IL (S)

Czerkowicz, John, *Chmn,* Montclair State University, Fine Arts Dept, Upper Montclair NJ (S)

Czichos, C L, *Dir Video,* Pioneer Town, Pioneer Museum of Western Art, Wimberley TX

Czichos, Raymond L, *Dir,* Pioneer Town, Pioneer Museum of Western Art, Wimberley TX

Czuma, Stanislaw, *Cur Indian & SE Asian Art,* Cleveland Museum of Art, Cleveland OH

D-Arceneaux, Pamela, *Reference Librn,* The Historic New Orleans Collection, New Orleans LA

DaAvis, Katherine M, *VPres,* Liberty Hall Historic Site, Library, Frankfort KY

Dabakis, Melissa, *Assoc Prof,* Kenyon College, Art Dept, Gambier OH (S)

Dabash, Adrian G, *Assoc Prof,* Providence College, Art & Art History Dept, Providence RI (S)

D'Abate, Richard, *Exec Dir,* Maine Historical Society, Portland ME

D'Abate, Richard, *Exec Dir,* Maine Historical Society, MHS Museum, Portland ME

D'Abate, Richard, *Exec Dir,* Maine Historical Society, Wadsworth-Longfellow House, Portland ME

Dabb, Jean Ann, *Chair & Assoc Prof,* Mary Washington College, Dept of Art & Art History, Fredericksburg VA (S)

Dablow, Dean, *Dir,* Louisiana Tech, School of Art, Ruston LA (S)

Dacey, Jill, *Dept Chmn,* University of Idaho, Dept of Art & Design, Moscow ID (S)

Dackman, Linda, *Pub Information Officer,* Exploratorium, San Francisco CA

Da Costa Nunes, Jadviga, *Chmn,* Muhlenberg College, Dept of Art, Allentown PA (S)

Dagdigian, Jamie, *Graphics Instr,* Monterey Peninsula College, Art Dept, Monterey CA (S)

Dagon, Sonja, *Dir,* Contemporary Art Gallery, Toronto ON

Dahm, Kristi, *Asst Paper Conservator,* The Art Institute of Chicago, Dept of Prints & Drawings, Chicago IL

Dai-Yu, Han, *Asst Prof,* Loyola Marymount University, Dept of Art & Art History, Los Angeles CA (S)

Dail, Kelly, *Mktg & Mem,* Duke University, Duke University Museum of Art, Durham NC

Dailey, Buffy, *Registrar,* Institute of American Indian Arts Museum, Museum, Santa Fe NM

Dailey, Charles, *Dir & Mus Studo,* Institute of American Indian Arts Museum, Museum, Santa Fe NM

Dailey, John R, *Dir,* National Air and Space Museum, Washington DC

Daily, Chuck, *Mus Studies Dept Faculty,* Institute of American Indian Arts, Institute of American Indian Arts Museum, Santa Fe NM (S)

Daily, Julia, *Exec Dir,* Craftsmen's Guild of Mississippi, Inc, Agriculture & Forestry Museum, Jackson MS

Dainard, Justine, *Librn,* University of British Columbia, Museum of Anthropology, Vancouver BC

Dainty, Linda, *Dir Art Dept,* Southwestern Community College, Art Dept, Creston IA (S)

Dajani, Virginia, *Exec Dir,* American Academy of Arts & Letters, New York NY

Dale, Alison, *Assoc Prof,* Seton Hall University, College of Arts & Sciences, South Orange NJ (S)

Dale, Kenneth, *Exec Dir,* Salem Art Association, Bush Barn Art Center, Salem OR

D'Alessio, Walter, *VChmn,* Independence Seaport Museum, Philadelphia PA

Daley, Ginny, *Archivist,* Southern Highland Craft Guild, Folk Art Center, Asheville NC

Daley, Ken, *Prof,* Old Dominion University, Art Dept, Norfolk VA (S)

Dalkey, F, *Instr,* Sacramento City College, Art Dept, Sacramento CA (S)

Dallam, Mary Lou, *Dir Arts in Special Educ Project,* Pennsylvania Department of Education, Arts in Education Program, Harrisburg PA

Dalling, Harvey, *Genealogist,* Kings County Historical Society & Museum, Hampton NB

Dallow, Jessica, *Asst Prof,* University of Alabama at Birmingham, Dept of Art & Art History, Birmingham AL (S)

Dalton, Dennis, *Asst Prof,* University of Southern Colorado, Dept of Art, Pueblo CO (S)

Dalton, Sarah, *Asst,* Holland Tunnel Art Projects, Brooklyn NY

Dalva, Leon, *VPres,* National Antique & Art Dealers Association of America, Inc, New York NY

Daly, Maureen, *Dir Theatre,* Rocky Mount Arts Center, Rocky Mount NC

Dalzell, Justin, *Tech Asst,* North Dakota Museum of Art, Grand Forks ND

Damaska, Maureen, *Admin Officer,* Smithsonian American Art Museum, Washington DC

Dambach, Cathy, *Ceramics,* Henry Ford Community College, McKenzie Fine Art Ctr, Dearborn MI (S)

D'Ambra, Eve, *Prof,* Vassar College, Art Dept, Poughkeepsie NY (S)

D'Ambrosio, Anna T, *Cur Decorative Arts,* Munson-Williams-Proctor Arts Institute, Museum of Art, Utica NY

Damian, Carol, *Prof,* Florida International University, School of Art & Art History, Miami FL (S)

Damkoehler, David, *Prof,* University of Wisconsin-Green Bay, Arts Dept, Green Bay WI (S)

Damrosch, Eloise, *Dir,* Regional Arts & Culture Council, Metropolitan Center for Public Arts, Portland OR

Dana, Heather, *Educ Coordr,* Erie Art Museum, Erie PA

Dana, Robin, *Gallery Coordr,* University of Georgia, Franklin College of Arts & Sciences, Lamar Dodd School of Art, Athens GA (S)

Danahy, John, *Assoc Prof,* University of Toronto, Programme in Landscape Architecture, Toronto ON (S)

Dandridge, Peter, *Exec Asst Dir,* Memphis Brooks Museum of Art, Memphis TN

Dane, Kasarian, *Asst Prof,* St Lawrence University, Dept of Fine Arts, Canton NY (S)

Danford, Gerald, *VPres,* Fort Morgan Heritage Foundation, Fort Morgan CO

Danforth, Sally, *Clay Teacher,* Locust Street Neighborhood Art Classes, Inc, Buffalo NY (S)

D'Angelo, John, *Exec Dir,* Mid-America All-Indian Center, Indian Center Museum, Wichita KS

D'Angelo, Starlyn, *Cur,* Shaker Museum & Library, Old Chatham NY

Dangle, Lloyd, *VPres,* Graphic Artists Guild, New York NY

Daniel, Dwayne, *Asst Prof,* Central State University, Dept of Art, Wilberforce OH (S)

Daniel, Mike, *Instr,* Long Beach City College, Art & Photography Dept, Long Beach CA (S)

Daniel, Ray, *Cur Art,* Art Museum of Southeast Texas, Beaumont TX

Daniel, Sallie, *Chmn (V),* Atlanta College of Art, Atlanta GA (S)

Daniels, Christopher, *Preparator,* Greenville Museum of Art, Inc, Greenville NC

Daniels, Eve, *Cur & Registar,* Roberson Museum & Science Center, Binghamton NY

Daniels, John P, *Dir,* Historic Pensacola Preservation Board, T.T. Wentworth Jr. Florida State Museum, Pensacola FL

Daniels, Maygene, *Gallery Archivist,* National Gallery of Art, Washington DC

Danielson, Deborah, *Prof,* Siena Heights University, Studio Angelico-Art Dept, Adrian MI (S)

Danielson, Sarah, *Treas,* Atlanta Contemporary Art Center, Atlanta GA

Danko, Linda, *Office Mgr,* Biggs Museum of American Art, Dover DE

Danna, Tracy, *Asst Dir,* The Art Studio Inc, Beaumont TX

Dannenberg, Penny, *Prog Dir,* New York Foundation for the Arts, New York NY

Dantzic, Cynthia, *Prof,* Long Island University, Brooklyn Campus, Art Dept, Brooklyn NY (S)

Danziger, Maria, *Exec Dir,* The Art School at Old Church, Demarest NJ (S)

Dapena, Ana Maria, *Chief Develop Officer,* Museo de Arte de Ponce, Ponce Art Museum, Ponce PR

Dara, Jenifer, *Communications,* Oakville Galleries, Centennial Square and Gairloch Gardens, Oakville ON

Darding, Kathy, *Cur,* Vermilion County Museum Society, Danville IL

Darish, Patricia, *Asst Prof,* University of Kansas, Kress Foundation Dept of Art History, Lawrence KS (S)

Darke, Eleanor, *Asst Dir,* Museum of Contemporary Canadian Art, Toronto ON

Darley, Claire, *Chmn Foundation Dept,* Art Academy of Cincinnati, Cincinnati OH (S)

Darlin, Denise, *Dir,* Patterson Homestead, Dayton OH

Darling, Barry, *Adjunct Asst Prof,* Le Moyne College, Fine Arts Dept, Syracuse NY (S)

Darling, Wayne, *Security Mgr,* Middlebury College, Museum of Art, Middlebury VT

Darnell, Polly, *Librn,* Shelburne Museum, Library, Shelburne VT

Da Rold, Joseph H, *Dir,* Plainfield Public Library, Plainfield NJ

Darr, Alan, *Cur European Sculpture & Decorative Arts,* Detroit Institute of Arts, Detroit MI

Darr, William, *Vol Coordr,* Bellingrath Gardens & Home, Theodore AL

Darragh, Joan, *Vice Dir Planning,* Brooklyn Museum, Brooklyn NY

Darroch, Richard, *Pub Affairs Officer,* Canadian Museums Association, Association des Musees Canadiens, Ottawa ON

Darrow, Deb, *Exec Dir,* Rosemount Museum, Inc, Pueblo CO

Daschle, Thomas A, *VChmn,* United States Senate Commission on Art, Washington DC

Dasher, Glenn, *Prof,* University of Alabama in Huntsville, Dept of Art and Art History, Huntsville AL (S)

Dashnaw, Cindy, *Dir Communications,* Eiteljorg Museum of American Indians & Western Art, Indianapolis IN

Dass, Dean, *Studio Faculty,* University of Virginia, McIntire Dept of Art, Charlottesville VA (S)

Dassance, Charles, *Pres,* Central Florida Community College Art Collection, Ocala FL

Datlow, Daniel, *Dir Operations Security,* The Phillips Collection, Washington DC

Daubert, Debra, *Cur,* Oshkosh Public Museum, Oshkosh WI

Daugherty, John, *Clinical Asst Prof,* University of Illinois at Chicago, Biomedical Visualization, Chicago IL (S)

Daugherty, Michael, *Dir,* Louisiana State University, School of Art, Baton Rouge LA (S)

Daughhetee, Mark, *Cur Exhib,* Alaska State Museum, Juneau AK

Davenny, Ward, *Assoc Prof,* Dickinson College, Dept Fine Arts & History, Carlisle PA (S)

Davenport, Kimberly, *Dir Art Gallery,* Rice University, Dept of Art & Art History, Houston TX (S)

Davezac, Shehira, *Assoc Prof,* Indiana University, Bloomington, Henry Radford Hope School of Fine Arts, Bloomington IN (S)

David, Lynn, *Librn,* Mason County Museum, Mason TX

David-West, Haig, *Head Div,* Chowan College, Division of Art, Murfreesboro NC (S)

Davidow, Joan, *Dir & Cur,* The Dallas Contemporary, Dallas Visual Art Center, Dallas TX

Davidson, Andrea, *Dir & Librn,* The Temple-Tifereth Israel, Lee & Dolores Hartzmark Library, Beachwood OH

Davidson , Ben, *Dir,* Americans for the Arts, Library, New York NY

Davidson, Conrad, *Chmn Div Humanities,* Minot State University, Dept of Art, Division of Humanities, Minot ND (S)

Davidson, Richard, *Chmn Trustees,* Longfellow's Wayside Inn Museum, South Sudbury MA

Davies, Bruce, *Cur,* Craigdarroch Castle Historical Museum Society, Victoria BC

Davies, Harry, *Chmn,* Adelphi University, Dept of Art & Art History, Garden City NY (S)

Davies, Hugh M, *Dir,* Museum of Contemporary Art, San Diego-Downtown, La Jolla CA

Davies, Kate, *Consulting Dir,* Downey Museum of Art, Downey CA

Davies, Lauren, *Prog Mgr,* Kala Institute, Kala Art Institute, Berkeley CA

Davies, Leigh, *Chmn & Dir Creative Arts,* Russell Sage College, Visual & Performing Arts Dept, Troy NY (S)

Davies, Rick, *Pres,* Middletown Arts Center, Middletown OH

Davies, Sandy, *Publicity,* Redlands Art Association, Redlands Art Association Gallery, Redlands CA

Davies, Stephen, *Pres,* American Society for Aesthetics, Savannah GA

Davila, Arturo, *Prof,* University of Puerto Rico, Dept of Fine Arts, Rio Piedras PR (S)

Davini, Mark, *Visual Com Instr,* Western Wisconsin Technical College, Graphics Division, La Crosse WI (S)

Davis, Allen, *Asst Prof,* Alabama A & M University, Art & Art Education Dept, Normal AL (S)

Davis, Ann, *Dir,* University of Calgary, The Nickle Arts Museum, Calgary AB

Davis, Arcenia, *Prof,* Winston-Salem State University, Art Dept, Winston-Salem NC (S)

Davis, Art, *Head Dept,* Grace College, Dept of Art, Winona Lake IN (S)

Davis, Beth, *Cur,* United States Figure Skating Association, World Figure Skating Museum & Hall of Fame, Colorado Springs CO

Davis, Beth, *Cur,* United States Figure Skating Association, Museum & Hall of Fame Library, Colorado Springs CO

Davis, Bill, *Asst Prof,* Shippensburg University, Art Dept, Shippensburg PA (S)

Davis, Bruce, *Exec Dir,* Arts Council Silicon Valley, Santa Clara CA

Davis, Carol, *Dir,* Edna Hibel, Hibil Museum & Gallery, Jupiter FL

Davis, Carol, *Dir Educ,* Edna Hibel, Hibel Museum of Art, Jupiter FL

Davis, Charles, *Asst Prof Art,* Mississippi Valley State University, Fine Arts Dept, Itta Bena MS (S)

Davis, Cherry, *Visitor Svcs,* Alexandria Museum of Art, Alexandria LA

Davis, Christie, *Art Projects Mgr,* Lannan Foundation, Santa Fe NM

Davis, Christopher, *VPres,* Wayne County Historical Society, Honesdale PA

Davis, Conni, *Business Mgr,* Maricopa County Historical Society, Desert Caballeros Western Museum, Wickenburg AZ

Davis, Debbie, *Business & Events Mgr,* Mount Holyoke College, Art Museum, South Hadley MA

Davis, Deborah, *Mus Mgr,* Aurora Regional Fire Museum, Aurora IL

Davis, Don, *Assoc Prof,* East Tennessee State University, College of Arts and Sciences, Dept of Art & Design, Johnson City TN (S)

Davis, Dustin P, *Chair,* Frostburg State University, The Stephanie Ann Roper Gallery, Frostburg MD

Davis, Dustin P, *Head Dept,* Frostburg State University, Dept of Visual Arts, Frostburg MD (S)

Davis, Gainor B, *Dir,* Vermont Historical Society, Library, Montpelier VT

Davis, Gainor B, *Dir & CEO,* Vermont Historical Society, Museum, Montpelier VT

Davis, Glenn Herbert, *Asst Prof, Photog,* University of Tulsa, School of Art, Tulsa OK (S)

Davis, Gloria, *Cur,* Muchnic Foundation & Atchison Art Association, Muchnic Gallery, Atchison KS

Davis, Gordon, *Dir,* Westminster College, Winston Churchill Memorial & Library in the United States, Fulton MO

Davis, Gordon J, *Pres,* Lincoln Center for the Performing Arts, Cork Gallery, New York NY

Davis, Helaine, *Reference Librn,* National Heritage Museum, Lexington MA

Davis, Irv, *First VPres,* St. Louis Artists' Guild, Saint Louis MO

Davis, Jack R, *Chmn,* Oklahoma City University, Norick Art Center, Oklahoma City OK (S)

Davis, Jacqueline Z, *Dir,* The New York Public Library, The New York Public Library for the Performing Arts, New York NY

Davis, Janet, *Assoc Dir External Affairs,* Delaware Art Museum, Wilmington DE

Davis, Jeff, *Graphic Design,* Art Institute of Pittsburgh, Pittsburgh PA (S)

Davis, John, *Prof,* Smith College, Art Dept, Northampton MA (S)

Davis, John L, *Exec Dir,* The University of Texas at San Antonio, UTSA's Institute of Texan Cultures, San Antonio TX

Davis, Julie, *Asst Prof,* Oberlin College, Dept of Art, Oberlin OH (S)

Davis, Katherine, *Exhibit Designer,* Pratt Institute, Rubelle & Norman Schafler Gallery, Brooklyn NY

Davis, Krista, *Mgr Exhib,* Fine Arts Museums of San Francisco, Legion of Honor, San Francisco CA

Davis, Larry, *Faculty Coordr Fine Arts,* Florida Community College at Jacksonville, South Campus, Art Dept, Jacksonville FL (S)

Davis, Laura, *Dir Educ,* Farmington Valley Arts Center, Avon CT

Davis, Lauren, *Cur,* West Baton Rouge Parish, West Baton Rouge Museum, Port Allen LA

Davis, Lee Baxter, *Instr Printmaking,* Texas A&M University Commerce, Dept of Art, Commerce TX (S)

Davis, Lynn, *Admin Asst,* Patrick Henry, Red Hill National Memorial, Brookneal VA

Davis, Margo, *Assoc,* West Virginia Wesleyan College, Art Dept, Buckhannon WV (S)

Davis, Martin, *Prof,* Clemson University, College of Architecture, Clemson SC (S)

Davis, Mary B, *Librn,* American Craft Council, Library, New York NY

Davis, Megan P, *Educator,* New London County Historical Society, Shaw - Perkins Mansion, New London CT

Davis, Meredith, *Sculpture Chair,* Montserrat College of Art, Beverly MA (S)

Davis, Michael P, *Interim Chmn,* Mount Holyoke College, Art Dept, South Hadley MA (S)

Davis, Myrna, *Exec Dir,* Art Directors Club, New York NY

Davis, Nancy, *Cur Coll,* Maryland Historical Society, Museum of Maryland History, Baltimore MD

Davis, Nancy, *Cur Coll,* Maryland Historical Society, Library, Baltimore MD

Davis, Paul, *Treas,* Northwest Watercolor Society, Renton WA

Davis, Paula, *Events Coordr,* Longview Museum of Fine Art, Longview TX

Davis, Randy, *Photography,* Antonelli Institute, Professional Photography & Commercial Art, Erdenheim PA (S)

Davis, Rebecca, *Registrar,* Butler Institute of American Art, Art Museum, Youngstown OH

Davis, Richard, *Assoc Prof,* Monmouth University, Dept of Art & Design, West Long Branch NJ (S)

Davis, Richard, *Chmn,* Potomac State College, Dept of Art, Keyser WV (S)

Davis, Rusty, *Facilities Mgr,* Springfield Museum of Art, Springfield OH

Davis, Ruth C, *Exec VPres,* Pennsylvania Academy of the Fine Arts, Fellowship of the Pennsylvania Academy of the Fine Arts, Philadelphia PA

Davis, Sarah, *Museum Coll,* American Jewish Historical Society, The Center for Jewish History, New York NY

Davis, Scott M, *Asst to Pres,* Cosanti Foundation, Scottsdale AZ

Davis, Sharon, *Dir & Cur,* Greenville College, Richard W Bock Sculpture Collection, Almira College House, Greenville IL

Davis, Sharon, *Librn,* Greenville College, The Richard W Bock Sculpture Collection & Art Library, Greenville IL

Davis, Sharon, *Memberships,* Walter Anderson, Ocean Springs MS

Davis, Sonya, *Exec Dir,* Lighthouse Center for the Arts Inc, Not Profit Art Center, Tequesta FL

Davis, Susan S, *Dir,* Stanley Museum, Inc, Kingfield ME

Davis, Walter R, *Dir,* Panhandle-Plains Historical Society Museum, Canyon TX

Davis, William, *Chmn,* The New England School of Art & Design at Suffolk University, Boston MA (S)

Davis, William J, *Dir,* MacArthur Memorial, Norfolk VA

Davis, Zina, *Dir,* University of Hartford, Joseloff Gallery, West Hartford CT

Davis-Rosenbaum, Kate, *Instr,* Midway College, Art Dept, Midway KY (S)

Davis-Rosenbaum, Steve, *Chmn,* Midway College, Art Dept, Midway KY (S)

Davish, Peggy, *Adminr,* Middletown Arts Center, Library, Middletown OH

Davish, Peggy, *Dir,* Middletown Arts Center, Middletown OH

Davison, Darlene, *Asst Prof Interior Design,* Maryville University of Saint Louis, Art & Design Program, Saint Louis MO (S)

Davison, Liane, *Cur,* Surrey Art Gallery, Surrey BC

Davison, Liane, *Cur Exhib & Coll,* Surrey Art Gallery, Library, Surrey BC

Davison, Mark, *Instr,* Clinton Community College, Art Dept, Plattsburgh NY (S)

Davison, Susan, *VPres of Marketing & Develop,* Springfield Museums Association, George Walter Vincent Smith Art Museum, Springfield MA

Davison, Susan, *Vice Pres Mktg & Devel,* Springfield Library & Museums Association, Connecticut Valley Historical Society, Springfield MA

Davson, Victor, *Exec Dir,* Aljira Center for Contemporary Art, Newark NJ

Davy, Mark, *Preparator,* Pacific Grove Art Center, Pacific Grove CA

Dawes, John, *Asst Prof,* University of the Incarnate Word, Art Dept, San Antonio TX (S)

Dawes, Roy, *Preparator,* Brandeis University, Rose Art Museum, Waltham MA

Dawkins, Jimmie, *Assoc Prof,* Alabama A & M University, Art & Art Education Dept, Normal AL (S)

Dawn, Leslie, *Asst Prof,* University of Lethbridge, Div of Art, Lethbridge AB (S)

Daws, Russell S, *CEO & Exec Dir,* Tallahassee Museum of History & Natural Science, Library, Tallahassee FL

Daws, Russell S, *Dir,* Tallahassee Museum of History & Natural Science, Tallahassee FL

Dawsari, Elizabeth, *Dir of Library,* Frank Lloyd Wright School, William Wesley Peters Library, Scottsdale AZ

Dawson, Amy, *Dir,* Randall Junior Museum, San Francisco CA

Dawson, Judy, *Dir Develop,* Honolulu Academy of Arts, The Art Center at Linekona, Honolulu HI (S)

Dawson, Will, *Pres,* Klamath Art Association, Klamath Falls OR

Day, Brenda, *Dir,* Baker University, Old Castle Museum, Baldwin City KS

Day, C, *VPres,* Rodman Hall Arts Centre, Saint Catharines ON

Day, Gary, *Assoc Prof,* University of Nebraska at Omaha, Dept of Art & Art History, Omaha NE (S)

Day, Homer, *Instr,* Abraham Baldwin Agricultural College, Art & Humanities Dept, Tifton GA (S)

Day, Jackie, *Pres & CEO,* The Long Island Museum of American Art, History & Carriages, Stony Brook NY

Day, Jacqueline, *Pres & CEO,* The Long Island Museum of American Art, History & Carriages, Library, Stony Brook NY

Day, Janet, *Pres,* Art Institute of Atlanta, Atlanta GA (S)

Day , John, *Chmn & Dean,* University of South Dakota, Department of Art, College of Fine Arts, Vermillion SD (S)

Day, John A, *Dir,* University of South Dakota Art Galleries, Vermillion SD

Day, Ross, *Head Librn,* The Metropolitan Museum of Art, Robert Goldwater Library, New York NY

Day, Tim Ann, *Mus Shop Co-Mgr,* Nicolaysen Art Museum & Discovery Center, Childrens Discovery Center, Casper WY

Deadman, Pat, *Instr,* Art Center Sarasota, Sarasota FL (S)

Deal, Cliff, *Cur Exhibits,* Lafayette Natural History Museum & Planetarium, Lafayette LA

Deal, Georgia, *Chmn Printmaking,* Corcoran School of Art, Washington DC (S)

Deal, Joe, *Provost,* Rhode Island School of Design, Providence RI (S)

Dean, Corinne, *Reference Librn,* Cincinnati Museum Association and Art Academy of Cincinnati, Mary R Schiff Library, Cincinnati OH

Dean, David K, *Assoc Dir Operations,* Texas Tech University, Museum of Texas Tech University, Lubbock TX

Dean, Jim, *Dean Admis,* Ringling School of Art & Design, Sarasota FL (S)

Dean, Kevin, *Dir,* Ringling School of Art & Design, Selby Gallery, Sarasota FL

Dean, Paul, *Asst Prof,* Louisiana State University, School of Art, Baton Rouge LA (S)

Deane, Dennis, *Assoc Prof,* Ohio University-Chillicothe Campus, Fine Arts & Humanities Division, Chillicothe OH (S)

DeAngelis, Anita, *Assoc Prof,* East Tennessee State University, College of Arts and Sciences, Dept of Art & Design, Johnson City TN (S)

DeAngelo, Darlene, *Dir Programming,* Huntington Beach Art Center, Huntington Beach CA

Deans, John, *Pres,* Jefferson Community College, Art Dept, Watertown NY (S)

Dear, Elizabeth, *Cur,* C M Russell, Great Falls MT

de Araujo, Emily, *Public Prog Coordr,* Otis College of Art & Design, Ben Maltz Gallery, Westchester CA

Dearborn, Alan, *Asst Cur Physics,* Northern Maine Museum of Science, Presque Isle ME

DeArechaga, Deborah, *Cur,* Agecroft Association, Agecroft Hall, Richmond VA

DeArechaga, Debrah, *Cur Coll,* Agecroft Association, Museum, Richmond VA

Deason, John, *PT Prof,* Augustana College, Art Dept, Rock Island IL (S)

Deaton, Judy, *Instr,* McMurry University, Art Dept, Abilene TX (S)

Deaton, Linda, *Cur Coll & Exhib,* Tallahassee Museum of History & Natural Science, Tallahassee FL

DeBaecke, Maggie, *Instr,* Wayne Art Center, Wayne PA (S)

DeBardeleben, Patty, *Mus Shop Mgr,* Sturdivant Hall, Selma AL

Debarry, Christina, *Instr,* Woodstock School of Art, Inc, Woodstock NY (S)

Debe', Claude, *Dir,* L'Universite Laval, Ecole des Arts Visuels, Quebec PQ

Debeer, Jan, *Mus Shop Co-Mgr,* Nicolaysen Art Museum & Discovery Center, Childrens Discovery Center, Casper WY

deBeixedon, Dianne, *Assoc Prof,* Old Dominion University, Art Dept, Norfolk VA (S)

Debela, Achameleh, *Prof,* North Carolina Central University, Art Dept, Durham NC (S)

De Biaso, Thomas, *Dean Studio Programs,* Minneapolis College of Art & Design, Minneapolis MN (S)

DeBolt, Dean, *Dir Special Coll,* University of West Florida, Library, Pensacola FL

DeBord, Betty, *Assoc Prof Art,* Lincoln Memorial University, Division of Humanities, Harrogate TN (S)

DeBow, Arthur, *Exhibs Dir,* Oregon College of Art & Craft, Hoffman Gallery, Portland OR

Debrosky, Christine, *Instr,* Woodstock School of Art, Inc, Woodstock NY (S)

DeBruyn, David, *Dir Planetarium,* City of Grand Rapids Michigan, Public Museum of Grand Rapids, Grand Rapids MI

DeBruyne, Paul, *Co-Pres,* Naples Art Gallery, Naples FL

DeBruyne, Suzanne, *Co-Pres,* Naples Art Gallery, Naples FL

DeBus, Charles, *Asst Prof,* Southern Methodist University, Division of Art, Dallas TX (S)

DeCarlo, George, *1st VPres,* National Society of Mural Painters, Inc, New York NY

DeCat, Lisa, *Asst Prof Dance,* Lake Erie College, Fine Arts Dept, Painesville OH (S)

DeCecco, Cynthia, Yavapai College, Visual & Performing Arts Div, Prescott AZ (S)

Decelestino, Blase, *Adjunct Instr,* New York Institute of Technology, Fine Arts Dept, Old Westbury NY (S)

Deci, Edward L, *Pres,* Monhegan Museum, Monhegan ME

DeCicco, Deb, *School Dir,* Sharon Arts Center, Sharon Arts Center Exhibition Gallery, Sharon NH

Decicco, Stephanie, *Chmn,* Waubonsee Community College, Art Dept, Sugar Grove IL (S)

Decker, David, *Assoc Prof,* University of Maine, Dept of Art, Orono ME (S)

Decker, Timothy, *Coll Mgr,* New Jersey Historical Society, Newark NJ

DeCoker, Dean, *Prof,* California State University, Art Dept, Turlock CA (S)

Decoteau, Pamela, *Head Art History,* Southern Illinois University at Edwardsville, Dept of Art & Design, Edwardsville IL (S)

DeCrescenzo, Robert, *Chmn,* Old State House, Hartford CT

DeCurtis, Frank, *Asst Cur,* Mesa Arts Center, Mesa Contemporary Arts , Mesa AZ

DeDonato, Louis, *Chmn Jr Members,* Salmagundi Club, New York NY

Dee, David, *Exec Dir,* University of Utah, Utah Museum of Fine Arts, Salt Lake City UT

Deegan, Ann, *Cur History,* San Bernardino County Museum, Fine Arts Institute, Redlands CA

Deegan, Denis, *Prof,* Daytona Beach Community College, Dept of Fine Arts & Visual Arts, Daytona Beach FL (S)

Deegan, Denise, *Collections Mgr,* Avampato Discovery Museum, The Clay Center for Arts & Sciences, Charleston WV

Deeks, Martin, *Historic Preservation Spec,* Ringwood Manor House Museum, Ringwood NJ

Deering, Bill, *Instr,* University of Delaware, Dept of Art, Newark DE (S)

DeEsch, Vasti, *Colls Mgr,* Reading Public Museum, Reading PA

DeFalla, Josie, *Dir,* Tubac Center of the Arts, Library, Tubac AZ

DeFalla, Josie E., *Exec Dir,* Tubac Center of the Arts, Tubac AZ

de Fato, Elizabeth, *Librn,* Seattle Art Museum, Library, Seattle WA

DeFee, F Brooks, *Asst Prof,* Northwestern State University of Louisiana, School of Creative & Performing Arts - Dept of Fine & Graphic Arts, Natchitoches LA (S)

Defoor, T, *Music Instr,* Edison Community College, Gallery of Fine Arts, Fort Myers FL (S)

Deford, T M, *Dir,* Penobscot Marine Museum, Searsport ME

De Fuchs, Mercedes Chacin, *Instr,* Toronto Art Therapy Institute, Toronto ON (S)

DeFurio, Anthony C, *Prof,* Indiana University of Pennsylvania, College of Fine Arts, Indiana PA (S)

deGennaro, Cristina, *Assoc Prof,* College of New Rochelle School of Arts & Sciences, Art Dept, New Rochelle NY (S)

DeGennaro, Frank J, *Graphic Design,* Art Institute of Pittsburgh, Pittsburgh PA (S)

DeGennaro, Mark, *Preparator,* Miami University, Art Museum, Oxford OH

DeGiacomo, Lynne, *Exec Admin,* Cohasset Historical Society, Captain John Wilson Historical House, Cohasset MA

DeGiacomo, Lynne, *Exec Adminr,* Cohasset Historical Society, Pratt Building (Society Headquarters), Cohasset MA

de Giorgio, Georges, *Archives Asst,* Cascade County Historical Society, High Plains Heritage Center, Great Falls MT

Degler, Suzanne, *Dir,* Minneapolis College of Art & Design, Library, Minneapolis MN

Degnan, June I., *Archivist,* Alaska Department of Education, Division of Libraries, Archives & Museums, Stratton Library, Sitka AK

DeGraaf, Lee, *Treas,* Canton Museum of Art, Canton OH

DeGrazia, Diana, *Deputy Dir,* Columbus Museum of Art and Design, Indianapolis IN

DeGrazia, Diane, *Chief Cur,* Cleveland Museum of Art, Cleveland OH

de Habsburgo, Inmaculada, *Pres,* Spanish Institute, Inc, Center for American-Spanish Affairs, New York NY

Dehavega, Tim, *VPres Board,* Kauai Museum, Lihue HI

DeHaven, Santa Sergio, *Pres,* Artspace, Richmond VA

De Hoet, Robert, *Educ Prog Dir,* Southern Illinois University Carbondale, University Museum, Carbondale IL

De Hoff, William, *Asst Prof,* University of Wisconsin-Stout, Dept of Art & Design, Menomonie WI (S)

Desaulniers, Louise, *Head Exhib,* Maison de la Culture Centre D'Exposition Raymond-Lasnier, Trois Rivieres PQ

Desborough, Jeff D, *Interim Dir,* Wichita Falls Museum & Art Center, Wichita Falls TX

Desborough, Shirley, *Mem Coordr,* Wichita Falls Museum & Art Center, Wichita Falls TX

Deschamps, Yves, *Instr,* Universite de Montreal, Dept of Art History, Montreal PQ (S)

Deschenes, Sylvia, *Dir of Communications,* The Stewart, Montreal PQ

DeSciora, Susan, *Dir,* Hewlett-Woodmere Public Library, Hewlett NY

De Seve, Karen, *Archivist,* Eastern Washington State Historical Society, Library, Spokane WA

Deshauteurs, Aurora, *Librn,* Pennsylvania Academy of the Fine Arts, Library, Philadelphia PA

DeSiano, Michael, *Coordr Art Educ,* Kean College of New Jersey, Fine Arts Dept, Union NJ (S)

Desiderio, Vincent, *Instr,* New York Academy of Art, Graduate School of Figurative Art, New York NY (S)

de Silva, Kauka, *Chmn,* University of Hawaii, Kapiolani Community College, Honolulu HI (S)

De Silvo, Verneal, *Prof,* Compton Community College, Art Dept, Compton CA (S)

Desjardins, Robert Y, *Dir,* Shawinigan Art Center, Shawinigan PQ

DeSloover, Rose, *Dean,* Marygrove College, Department of Art, Detroit MI (S)

Desmarais, Charles, *Dir,* Contemporary Arts Center, Cincinnati OH

Desmarais, Charles, *Dir,* Contemporary Arts Center, Library, Cincinnati OH

de Smet, Louis, *Treas,* Art Centre of New Jersey, Livingston NJ (S)

Desmett, Don, *Exhib Dir,* Western Michigan University, School of Art, Kalamazoo MI

Desmond, Kathleen, *Prof,* Central Missouri State University, Art Dept, Warrensburg MO (S)

Des Rochers, Jacques, *Cur Canadian Art,* Montreal Museum of Fine Arts, Montreal PQ

Dessornes, Maria, *CEO & VPres,* Conejo Valley Art Museum, Thousand Oaks CA

Dessureault, Pierre, *Assoc Cur,* Canadian Museum of Contemporary Photography, Ottawa ON

Desy, Margherita, *Cur,* USS Constitution Museum, Boston MA

DeTemple, Karen, *Individual Support Mgr,* Institute of Contemporary Art, Boston MA

Detrani, Geoffrey, *Asst Dir,* School of Visual Arts, Visual Arts Museum, New York NY

DeTullio, Elizabeth Cross, *Dir Mktg,* Miami Art Museum, Miami FL

Detweiler, Kelly, *Assoc Prof,* Santa Clara University, Dept of Art & Art History, Santa Clara CA (S)

Deutsch, Sanna, *Registrar,* Honolulu Academy of Arts, Honolulu HI

Deutsch, Sanna Saks, *Registrar,* Honolulu Academy of Arts, The Art Center at Linekona, Honolulu HI (S)

de Ville, Roy V, *Cur Alexander Museum,* Louisiana State University at Alexandria, University Gallery, Alexandria LA

deVille, Roy V, *Prof Art,* Louisiana State University at Alexandria, Dept of Fine Arts & Design, Alexandria LA (S)

Devine, Jack, *Bd Pres,* Ocean City Art Center, Ocean City NJ

DeVine, Meta, *Mus Shop Mgr,* Minnesota Historical Society, Saint Paul MN

Devine-Reed, Pat, *Exec Dir,* Boulevard Arts Center, Chicago IL

Devine Nordstrom, Alison, *Cur Photography,* George Eastman, Rochester NY

Devinney, Rosemary A, *Mgr & Coordr,* Shoshone Bannock Tribes, Shoshone Bannock Tribal Museum, Fort Hall ID

DeVinny, Douglas, *Prof,* University of Wisconsin-Parkside, Art Dept, Kenosha WI (S)

DeVito, Natalie, *Admin Dir,* Mercer Union, A Centre for Contemporary Visual Art, Toronto ON

Devlin, Joseph T, *Pres,* Girard College, Stephen Girard Collection, Philadelphia PA

Devlin, Peter, *Tour Interpreter,* Farmington Village Green & Library Association, Stanley-Whitman House, Farmington CT

Devono, Lanny, *Chmn,* Eastern Washington University, Dept of Art, Cheney WA (S)

de Vries, Joyce, *Asst Prof,* Grand Valley State University, Art & Design Dept, Allendale MI (S)

DeVries, Karl, *Asst Dir,* Ships of the Sea Maritime Museum, Savannah GA

Dew, Patsy, *Prog Dir,* Northfield Arts Guild, Northfield MN

Dew, Roderick, *Librn,* Colorado Springs Fine Arts Center, Colorado Springs CO

Dew, Roderick, *Librn,* Colorado Springs Fine Arts Center, Library, Colorado Springs CO

Dewaele, Robert, *VPres,* Artists' Cooperative Gallery, Omaha NE

Dewald, Ann, *Dir,* Archaeological Society of Ohio, Indian Museum of Lake County, Ohio, Willoughby OH

Dewald, Ann, *Dir,* Archaeological Society of Ohio, Indian Museum Library, Willoughby OH

Dewar, Les, *VPres,* Manitoba Society of Artists, Winnipeg MB

DeWaters, Jere, *Faculty Dean,* Creative Photographic Arts Center of Maine, Dorthea C Witham Gallery, Lewiston ME

Dewell, Judith, *Assoc Prof,* Loyola University of Chicago, Fine Arts Dept, Chicago IL (S)

Dewey, Dennis, *Managing Dir,* National Assembly of State Arts Agencies, Washington DC

Dewey, Fred, *Exec & Artistic Dir,* Beyond Baroque Foundation, Beyond Baroque Literary Arts Center, Venice CA

Dewey, Helen, *Develop Dir,* Everson Museum of Art, Syracuse NY

Dewey, Kevin, *Music,* Henry Ford Community College, McKenzie Fine Art Ctr, Dearborn MI (S)

Dewey, Pamela, *Head Photo Archives,* National Museum of the American Indian, George Gustav Heye Center, New York NY

Dewey, Toby, *Dir,* Charles River School, Creative Arts Program, Dover MA (S)

Dewey II, Tom, *Assoc Prof,* University of Mississippi, Department of Art, University MS (S)

Dewhitt, Karen, *Office Mgr,* Huntsville Art League, Huntsville AL

DeWitt, Christine, *Cur Educ,* Irvine Museum, Irvine CA

de Witt, David, *Bader Cur European Art,* Queen's University, Agnes Etherington Art Centre, Kingston ON

DeWitt, Martin, *Dir,* University of Minnesota, Duluth, Tweed Museum of Art, Duluth MN

DeWitte, Elizabeth, *Instr,* University of Utah, Dept of Art & Art History, Salt Lake City UT (S)

DeYoung Kohler, Ruth, *Dir,* Sheboygan Arts Foundation, Inc, John Michael Kohler Arts Center, Sheboygan WI

Deziel, Michelle, *Asst Cur,* Norton Simon, Pasadena CA

Dezio, Joe, *Chmn Board,* Staten Island Institute of Arts & Sciences, Staten Island NY

d'Harnoncourt, Anne, *Dir & CEO,* Philadelphia Museum of Art, Samuel S Fleisher Art Memorial, Philadelphia PA

d'Harnoncourt, Anne, *The George D Widener Dir & CEO,* Philadelphia Museum of Art, Philadelphia PA

Diaconu, Madalina, *Gallery Dir,* Art League, Alexandria VA

Dial, Gail, *Faculty,* Idaho State University, Dept of Art, Pocatello ID (S)

Diamantopoulos, Aella, *Chief Conservator,* Pennsylvania Academy of the Fine Arts, Philadelphia PA

Diamato, Paul, *Instr,* Maine College of Art, Portland ME (S)

Diamond, Sara, *Exec Producer,* Banff Centre, Banff AB (S)

Diamond, Sara, *Pres,* Ontario College of Art & Design, Toronto ON (S)

Diamond-Nigh, John, *Asst,* Elmira College, Art Dept, Elmira NY (S)

Dias-Reid, Cynthia, *Educ Coordr,* Willard House & Clock Museum, Inc, North Grafton MA

Diaz, Alfred, *Student Aid Coordr,* Institute of Puerto Rican Culture, Escuela de Artes Plasticas, San Juan PR (S)

Diaz, Lynette, *Jr Mus Supv,* Newark Museum Association, Junior Museum, Newark NJ

Diaz, Marisol, *Prog Asst,* En Foco, Inc, Bronx NY

DiCapua, Ray, *Assoc Head,* University of Connecticut, Dept of Art & Art History, Storrs CT (S)

Dicciani, Marc, *Dir School Music,* University of the Arts, Philadelphia Colleges of Art & Design, Performing Arts & Media & Communication, Philadelphia PA (S)

DiCicco, John, *Slide Librn,* Providence College, Art & Art History Dept, Providence RI (S)

Dick, James, *Founder & Dir,* James Dick Foundation, Festival - Institute, Round Top TX

Dickens, Denise, *Exec Dir,* Contemporary Art Museum, Raleigh NC

Dickenson, Victoria, *Exec Dir,* McCord Museum of Canadian History, Montreal PQ

Dickerson, Roger, *Music,* Southern University in New Orleans, Fine Arts & Philosophy Dept, New Orleans LA (S)

Dickes, Rodger, *MFA,* Glendale Community College, Visual & Performing Arts Div, Glendale CA (S)

Dickey, Alison, *Librn,* The Currier Museum of Art, Currier Museum of Art, Manchester NH

Dickey, Mike, *Admin,* Arrow Rock State Historic Site, Arrow Rock MO

Dickey, Shawn, *Recorder,* Mississippi University for Women, Fine Arts Gallery, Columbus MS

Dickinson, Carolyn, *Head Fine Arts & Audiovisual Dept,* Salt Lake City Public Library, Fine Arts & Audiovisual Dept and Atrium Gallery, Salt Lake City UT

Dickinson, Geoffrey, *Reference Librn & Adult Svcs,* Ames Free-Easton's Public Library, North Easton MA

Dickinson, James L, *Vol Pres,* Medina Railroad Museum, Medina NY

Dickinson, Pat, *Coordr,* Baycrest Centre for Geriatric Care, Silverman Heritage Museum, Toronto ON

Dickson, Anita, *Asst Prof,* College of DuPage, Liberal Arts Division, Glen Ellyn IL (S)

Dickson, Mary, *Instr,* Oklahoma State University, Graphic Arts Dept, Visual Communications, Okmulgee OK (S)

Dickstein-Thompson, Laura, *Dir Educ,* Schenectady Museum Planetarium & Visitors Center, Schenectady NY

DiCostanza, C, *Instr,* Humboldt State University, College of Arts & Humanities, Arcata CA (S)

DiDiego, Charles, *Adjunct Asst Prof,* New York Institute of Technology, Fine Arts Dept, Old Westbury NY (S)

Diduk, Barbara, *Prof, Chair,* Dickinson College, Dept Fine Arts & History, Carlisle PA (S)

Diebold, William J, *Chmn Art History & Humanities,* Reed College, Dept of Art, Portland OR (S)

Diedrich, Joshua, *Head Sculpture,* Kalamazoo Institute of Arts, KIA School, Kalamazoo MI (S)

Diehl, Kathy, *Mgr,* Indianapolis Marion County Public Library, Interim Central Library, Indianapolis IN

Diehl, Lindsay, *Exec Dir,* Wenham Museum, Timothy Pickering Library, Wenham MA

Diehl, Pamela D, *Treas,* Miles B Carpenter, Waverly VA

Diel, Lori, *Prof,* Texas Christian University, Dept of Art & Art History, Fort Worth TX (S)

Diemente, Deborah, *Registrar,* Worcester Art Museum, Worcester MA

Dienes, Claire, *Assoc Mus Librn,* The Metropolitan Museum of Art, Image Library, New York NY

Diercks, Robert, *Co-Chmn,* Franklin Pierce College, Dept of Fine Arts & Graphic Communications, Rindge NH (S)

Dierdorff, Jo, *Dance Chmn,* Riverside Community College, Dept of Art & Mass Media, Riverside CA (S)

Diethorn, Karie, *Chief Cur,* Independence National Historical Park, Library, Philadelphia PA

Diethorn, Karie, *Chief Mus Branch,* Independence National Historical Park, Philadelphia PA

Dietrich, Julia, *Dir Mktg,* Robert & Mary Montgomery Armory Art Center, West Palm Beach FL

Dietrich, Melinda, *Exec Dir,* Lexington Friends of the Arts, Inc, Monroe Center for the Arts, Lexington MA (S)

Dietz, Judy, *Mgr Coll & Gallery Svcs,* Art Gallery of Nova Scotia, Halifax NS

Dietz, Ulysses G, *Cur Decorative Arts,* Newark Museum Association, The Newark Museum, Newark NJ

Dietze, Christine, *Dep Dir Finance & Admin,* The Baltimore Museum of Art, Baltimore MD

Dietzel, Tracy, *Instr,* Edgewood College, Art Dept, Madison WI (S)

Dietzen, Jenny, *Cur,* Cartoon Art Museum, San Francisco CA

DiFabatino, Peter, *Co-Chmn,* Art Center College of Design, Pasadena CA (S)

DiFate, Vincent, *Pres,* Society of Illustrators, New York NY

DiGennaro, Amy, *Instr,* Macalester College, Art Dept, Saint Paul MN (S)

Diggle, Justin, *Assoc Prof,* University of Utah, Dept of Art & Art History, Salt Lake City UT (S)

Diggs, Edna, *Coordr Traveling Exhibs,* Ohio Historical Society, National Afro American Museum & Cultural Center, Wilberforce OH

DiGiacomo, Michael, *Treas,* Philadelphia Sketch Club, Philadelphia PA

Dill, Raminta, *Chmn Mem,* Balzekas Museum of Lithuanian Culture, Chicago IL

Dillon, John, *Cur Natural Sciences,* Randall Junior Museum, San Francisco CA

Dillon, Robyn, *Slide Library Asst,* Philadelphia Museum of Art, Slide Library, Philadelphia PA

Dillon, Sheila, *Asst Prof,* Duke University, Dept of Art, Art History & Visual Studies, Durham NC (S)

Donnelly, John, *Instr,* Mount Vernon Nazarene University, Art Dept, Mount Vernon OH (S)

Donnelly, Karen, *VPres,* Children's Museum, Indianapolis IN

Donnelly, Nora, *Asst Cur Registrar,* Institute of Contemporary Art, Boston MA

Donnelly, Peter, *Pres,* Corporate Council for the Arts/Arts Fund, Seattle WA

Donner, Heidi, *Community Relations & Educ Programs,* Saint Mary's College of California, Hearst Art Gallery, Moraga CA

Donohue, Bill, *Exec Dir Jekyll Island,* Jekyll Island Museum, Jekyll Island GA

Donovan, Betty, *VPres,* Kentucky Derby Museum, Louisville KY

Donovan, Jeremiah, *Asst Prof,* State University of New York, College at Cortland, Dept Art & Art History, Cortland NY (S)

Donovan, John, *Visiting Prof,* University of West Florida, Dept of Art, Pensacola FL (S)

Donovan, Margaret, *Dir Pub Relations,* Southern Vermont Art Center, Manchester VT

Donovan, Martin, *VPres,* South County Art Association, Kingston RI

Donte, Lisa, *Exhib Coordr,* Contemporary Crafts Museum & Gallery, Portland OR

Doolan, John M, *Assoc Dir,* The National Shrine of the North American Martyrs, Auriesville NY

Dooley, Michelle, *Mgr Pub Relations,* Franklin Mint Museum, Franklin Center PA

Dooley, Tim, *Asst Prof,* University of Northern Iowa, Dept of Art, Cedar Falls IA (S)

Dooley, William, *Chmn,* University of Alabama, Dept of Art & Art History, Tuscaloosa AL (S)

Dooley, William, *Dir,* University of Alabama, Sarah Moody Gallery of Art, Tuscaloosa AL

Dooling, Daniella, *Asst Prof,* Colgate University, Dept of Art & Art History, Hamilton NY (S)

Doolittle, Allora, *Treas,* Society of North American Goldsmiths, Eugene OR

Doran, Faye, *Prof,* Harding University, Dept of Art, Searcy AR (S)

Doran, Marie Andree, *Dir Visual Arts,* Universite Quebec Cite Universitaire, School of Visual Arts, Quebec PQ (S)

Dorantes, Denise, *Librn,* Cranbrook Art Museum, Library, Bloomfield Hills MI

Dore, William, *Prof,* Seattle University, Fine Arts Dept, Division of Art, Seattle WA (S)

Dorethy, Rex, *Prof,* University of Wisconsin-Stevens Point, Dept of Art & Design, Stevens Point WI (S)

Dorey, Audrey, *Admin Secy,* Acadia University, Art Dept, Wolfville NS (S)

Dorfman, Marc, *Dir Develop,* Georgia O'Keeffe Museum, Santa Fe NM

Dorko, Susan, *Educ Coordr,* Noah Webster House, Inc, Noah Webster House, West Hartford CT

Dorman, Nicholas, *Conservator,* Seattle Art Museum, Library, Seattle WA

Dormon, Jessica, *Dir Publications,* The Historic New Orleans Collection, New Orleans LA

Dornish, Jane M, *Secy,* Waterville Historical Society, Redington Museum, Waterville ME

Dorociak, Heather, *Coll Asst,* Cascade County Historical Society, High Plains Heritage Center, Great Falls MT

Dorough, Bonny, *Finance & Operation,* Albany Museum of Art, Albany GA

Dorrien, Carlos, *Prof,* Wellesley College, Art Dept, Wellesley MA (S)

Dorrill, Lisa, *Adjunct Faculty,* Dickinson College, Dept Fine Arts & History, Carlisle PA (S)

Dorrill, Lisa, *Instr,* Gettysburg College, Dept of Visual Arts, Gettysburg PA (S)

D'Orsaneo, Terry, *Adminr,* Polk Museum of Art, Lakeland FL

Dorsett, Wendy, *Mem,* Anthology Film Archives, New York NY

Dorsey, Henry, *Chmn,* Coahoma Community College, Art Education & Fine Arts Dept, Clarksdale MS (S)

Dorsey, Rachael, *Assoc Dir Press & Mktg,* PS1 Contemporary Art Center, Long Island City NY

Dort, Shirley, *Asst Prof,* Virginia State University, Arts & Design, Petersburg VA (S)

D'ortona, Valerie, *Chmn,* Middle Georgia College, Dept of Art, Cochran GA (S)

Doruk, Teoman, *Prof,* Clemson University, College of Architecture, Clemson SC (S)

Dosik, Jeff, *Library Technician,* The National Park Service, United States Department of the Interior, Statue of Liberty National Monument & The Ellis Island Immigration Museum, New York NY

Dost, Martin, *Gallery Coordr,* Henry Street Settlement, Abrons Art Center, New York NY

Doucette, Marian, *Educ Coordr,* Gallery Stratford, Stratford ON

Dougherty, Marijo, *Dir,* University at Albany, State University of New York, University Art Museum, Albany NY

Dougherty, Nancy, *Business Mgr,* Moose Jaw Art Museum, Inc, Art & History Museum, Moose Jaw SK

Dougherty, Peggy, *Deputy Dir Develop,* Newark Museum Association, The Newark Museum, Newark NJ

Dougherty, Richard, *Chmn,* Murray State University, Dept of Art, Murray KY (S)

Douglas, Deanna, *Asst Prof,* University of Southern Mississippi, Dept of Art & Design, Hattiesburg MS (S)

Douglas, Kristopher, *Chief Cur,* Rochester Art Center, Rochester MN

Douglas, Mark, *Asst Prof,* Fontbonne University, Fine Art Dept, Saint Louis MO (S)

Douglas, Robert, *Prof,* University of Louisville, Allen R Hite Art Institute, Louisville KY (S)

Douglass, Larry, *Dir,* Brigham City Corporation, Brigham City Museum & Gallery, Brigham City UT

Douley, Scott, *Asst Prof,* Wittenberg University, Art Dept, Springfield OH (S)

Doumato, Lamia, *Head Reader Svcs,* National Gallery of Art, Library, Washington DC

Douohue, Robyn, *Exhib Prog Coord,* Socrates Sculpture Park, Long Island City NY

Doutrick, Reba, *Vol Chmn,* Riverside, the Farnsley-Moremen Landing, Louisville KY

Dove, Charles, *Lectr,* Rice University, Dept of Art & Art History, Houston TX (S)

Dove, Elizabeth, *Asst Prof,* University of Montana, Dept of Art, Missoula MT (S)

Dove, Ronald, *Pres,* Hussian School of Art, Commercial Art Dept, Philadelphia PA (S)

Dowbiggin, Valerie, *Develop Officer,* Art Gallery of Peel, Peel Heritage Complex, Brampton ON

Dowdy, William, *Chmn Dept,* Blue Mountain College, Art Dept, Blue Mountain MS (S)

Dowell, Cheryl, *Asst Site Mgr,* Illinois Historic Preservation Agency, Bishop Hill State Historic Site, Bishop Hill IL

Dowell, Daphne, *Prog Asst,* Cornell Museum of Art & History, Delray Beach FL

Dowell, Michael B, *Exec Dir,* Fine Arts Center for the New River Valley, Pulaski VA

Dowell-Dennis, Terri, *Cur Educ,* Southeastern Center for Contemporary Art, Winston-Salem NC

Dowhaniuk, Valerie, *Technician,* Alberta College of Art & Design, Illingworth Kerr Gallery, Calgary AB

Dowhie, Leonard, *Prof,* University of Southern Indiana, Art Dept, Evansville IN (S)

Dowling, Dawn, *Spec Events Coordr,* Brandywine River Museum, Chadds Ford PA

Dowling, Russell, *Chmn Bd,* High Plains Museum, McCook NE

Dowling, Sherwood, *Acting Educ Prog Chief,* Smithsonian American Art Museum, Washington DC

Downey, Joanna, *Dean,* Rio Hondo College, Visual Arts Dept, Whittier CA (S)

Downey, Kay, *Serials Librn,* Cleveland Museum of Art, Ingalls Library, Cleveland OH

Downey, Martha J, *Site Mgr,* Illinois Historic Preservation Agency, Bishop Hill State Historic Site, Bishop Hill IL

Downey, Michelle, *Educator,* Fayetteville Museum of Art, Inc, Fayetteville NC

Downie, Keith, *Preparator,* Muskegon Museum of Art, Muskegon MI

Downing, Theresa, *Cur & Educ Mgr,* Minnesota Museum of American Art, Saint Paul MN

Downs, Clyde, *Asst Prof,* Northwestern State University of Louisiana, School of Creative & Performing Arts - Dept of Fine & Graphic Arts, Natchitoches LA (S)

Downs, Linda, *Cur Educ,* National Gallery of Art, Washington DC

Downs, Stuart, *Instr,* James Madison University, School of Art & Art History, Harrisonburg VA (S)

Downs, Stuart C, *Gallery Dir,* James Madison University, Sawhill Gallery, Harrisonburg VA (S)

Dows, Tris, *Develop Dir,* Cedar Rapids Museum of Art, Cedar Rapids IA

Doyle, Erin T, *Asst Chief Librn,* Medicine Hat Public Library, Medicine Hat AB

Doyle, Joan, *Mus Shop Mgr,* Please Touch Museum, Philadelphia PA

Doyle, Leo, *Instr,* California State University, San Bernardino, Dept of Art, San Bernardino CA (S)

Doyle, Linda, *Prog Mgr,* Hui No eau Visual Arts Center, Gallery and Gift Shop, Makawao Maui HI

Doyle, Maura, *Asst Cur & Registrar,* Guild Hall of East Hampton, Inc, Guild Hall Museum, East Hampton NY

Doyle, Richard, *Dir Library Svcs,* Coe College, Stewart Memorial Library & Gallery, Cedar Rapids IA

Doyle, Richard, *VPres & Cur,* San Fernando Valley Historical Society, Mission Hills CA

Doyle , Richard, *Pres & Cur,* San Fernando Valley Historical Society, Mark Harrington Library, Mission Hills CA

Doyon, Lina, *Asst Librn,* Musee du Quebec, Bibliotheque, Quebec PQ

Doyon, Pierre-Simon, *Dir Dept Arts,* University of Quebec, Trois Rivieres, Fine Arts Section, Trois Rivieres PQ (S)

Doyon-Bernard, Suzette J, *Assoc Prof,* University of West Florida, Dept of Art, Pensacola FL (S)

Drachler, Carole, *Instr,* Mesa Community College, Dept of Art, Mesa AZ (S)

Draffen, Jennifer, *Chief Registrar & Exhib Mgr,* Museum of Contemporary Art, Chicago IL

Drake, Cheryl, *Admin Asst,* University of Wyoming, University of Wyoming Art Museum, Laramie WY (S)

Drake, Susan, *Dir Finance & Administration,* Kimbell Art Museum, Fort Worth TX

Drake, Tommi, *Dir,* Rogue Community College, Wiseman Gallery - FireHouse Gallery, Grants Pass OR

Dransfield, Charles, *Second VPres,* Kent Art Association, Inc, Gallery, Kent CT

Draper, James David, *Cur Henry R Kravis,* The Metropolitan Museum of Art, New York NY

Draper, Stacy F Pomeroy, *Cur,* Rensselaer County Historical Society, Hart-Cluett Mansion, 1827, Troy NY

Drayman-Weisser, Terry, *Dir Conservation,* Walters Art Museum, Library, Baltimore MD

Dreghorn, Elisa, *Dir Develop,* Art Museum of the University of Houston, Blaffer Gallery, Houston TX

Dreher, Derick, *Dir,* The Rosenbach Museum & Library, Philadelphia PA

Dreidemie, Carola, *Instr,* University of Miami, Dept of Art & Art History, Coral Gables FL (S)

Dreiling, Janet, *Registrar,* University of Kansas, Spencer Museum of Art, Lawrence KS

Dreishpoon, Douglas, *Sr Cur,* The Buffalo Fine Arts Academy, Albright-Knox Art Gallery, Buffalo NY

Dreiske, Tom, *Bd Dir,* Grand River Museum, Lemmon SD

Dreiss, Joseph, *Prof,* Mary Washington College, Dept of Art & Art History, Fredericksburg VA (S)

Drennen, Barbara, *Asst Prof,* Malone College, Dept of Art, Canton OH (S)

Dresbach, Chad, *Asst Prof,* Winthrop University, Dept of Art & Design, Rock Hill SC (S)

Drescher, Judith, *Dir,* Memphis-Shelby County Public Library & Information Center, Dept of Art, Music & Films, Memphis TN

Dressler, Deborah, *Pres,* Washington Art Association, Washington Depot CT

Dressler, Rachel, *Art Historian,* University at Albany, State University of New York, Art Dept Visual Resources, Albany NY

Dressler, Rachel, *Asst Prof,* State University of New York at Albany, Art Dept, Albany NY (S)

Dreydoppel, Susan, *Exec Dir,* Moravian Historical Society, Whitefield House Museum, Nazareth PA

Dreyer, Carl, *VPres Fin & Admin & CFO,* Museum of the City of New York, New York, New York NY

Dreyer, Chris, *Pres,* Martha's Vineyard Center for the Visual Arts, Firehouse Gallery, Oak Bluffs MA

Dreyer, Tina L, *Exec Dir,* Visual Arts Center of Northwest Florida, Visual Arts Center Library, Panama City FL

Dreyfus, Elizabeth K, *Treas,* John D Barrow, Skaneateles NY

Dreyfus, Renee, *Cur Interpretation,* Fine Arts Museums of San Francisco, Legion of Honor, San Francisco CA

Drieband, Laurence, *Fine Arts Dept Chmn,* Art Center College of Design, Pasadena CA (S)

Drinan, Patricia, *Chmn,* University of San Diego, Art Dept, San Diego CA (S)

Drinkard, Joel F, *Cur,* Southern Baptist Theological Seminary, Joseph A Callaway Archaeological Museum, Louisville KY

Drinkard, Nisha, *Asst Prof,* William Paterson University, Dept Arts, Wayne NJ (S)

Driver, Stephen, Brescia University, Div of Fine Arts, Owensboro KY (S)

Droega, Anthony, *Adjunct Asst Prof,* Indiana University South Bend, Fine Arts Dept, South Bend IN (S)

Droege, John, *Prof,* Bridgewater State College, Art Dept, Bridgewater MA (S)

Drogoul, Laure, *Adjunct,* York College of Pennsylvania, Dept of Music, Art & Speech Communications, York PA (S)

Drost, Lise, *Asst Prof,* University of Miami, Dept of Art & Art History, Coral Gables FL (S)

Dursum, Brian, *Dir,* University of Miami, Lowe Art Museum, Coral Gables FL

Dusanek, Joyce, *VPres,* Paint 'N Palette Club, Grant Wood Memorial Park & Gallery, Anamosa IA

Dusenbury, Carolyn, *Dir,* California State University, Chico, Meriam Library, Chico CA

DuSold, Paul, *Instr,* Wayne Art Center, Wayne PA (S)

Dustin, Robin, *Cur,* Sandwich Historical Society, Center Sandwich NH

Dutlinger, Anne, *Chmn,* Moravian College, Dept of Art, Bethlehem PA (S)

Dutlinger, Anne, *Chmn Art Dept,* Moravian College, Payne Gallery, Bethlehem PA

Dutremaine, James, *Art Educ,* University of Texas Pan American, Art Dept, Edinburg TX (S)

Dutt Justice, Mary Anne, *Dir Develop,* Pennsylvania Academy of the Fine Arts, Philadelphia PA

Dutton, Jeff, *Preparator & Designor,* Montgomery Museum of Fine Arts, Montgomery AL

Dutton, Ron, *Pub Service Mgr,* Vancouver Public Library, Fine Arts & Music Div, Vancouver BC

Duty, Michael W., *Exec Dir,* The Museum of Western Art, cowboy Artists of America Museum, Kerrville TX

D'uva, Joseph, *Asst Prof,* Lawrence University, Dept of Art, Appleton WI (S)

DuVall, Dan, *Gallery Coordr,* Simon's Rock College of Bard, Doreen Young Art Gallery, Great Barrington MA

Dwight, Dorothy, *Assoc Prof,* Loyola University of Chicago, Fine Arts Dept, Chicago IL (S)

Dwyer, Betty H, *VPres,* Monterey Museum of Art Association, Monterey Museum of Art, Monterey CA

Dwyer, Bridget, *Circ Desk Mgr,* Corcoran Gallery of Art, Corcoran Library, Washington DC

Dwyer, Eugene J, *Prof,* Kenyon College, Art Dept, Gambier OH (S)

Dwyer, Rob, *Dir,* Quincy Society of Fine Arts, Quincy IL

Dyas, Sandy, *Instr,* Cornell College, Peter Paul Luce Gallery, Mount Vernon IA

Dybdahl, Tammy, *Financial Aid,* Rocky Mountain College of Art & Design, Lakewood CO (S)

Dye, David, *Assoc Prof,* Hillsborough Community College, Fine Arts Dept, Tampa FL (S)

Dye, Donna, *Dir Mus Div,* Mississippi Department of Archives & History, Old Capitol Museum of Mississippi History, Jackson MS

Dye, Emma, *Exec Dir,* Hendersonville Arts Council, Hendersonville TN

Dye, Joseph, *Lectr,* College of William & Mary, Dept of Fine Arts, Williamsburg VA (S)

Dye, Joseph M, *Cur South Asian Art,* Virginia Museum of Fine Arts, Richmond VA

Dyer, Carrie, *Asst Prof,* University of Central Arkansas, Department of Art, Conway AR (S)

Dyer, M Wayne, *Chmn, Dept of Art & Design & Prof,* East Tennessee State University, College of Arts and Sciences, Dept of Art & Design, Johnson City TN (S)

Dykes, Tim, *Preparator Asst,* Marquette University, Haggerty Museum of Art, Milwaukee WI

Dykhuis, Peter, *Dir,* Nova Scotia College of Art and Design, Anna Leonowens Gallery, Halifax NS

Dyki, Judy, *Dir Library,* Cranbrook Art Museum, Library, Bloomfield Hills MI

Dynak, Sharon, *Exec Dir,* Ucross Foundation, Big Red Barn Gallery, Clearmont WY

Dyrhaug, Kurt, *Assoc Prof,* Lamar University, Art Dept, Beaumont TX (S)

Dysart, William, *Pres,* Maritime Museum of San Diego, San Diego CA

Eacret-Simmons, Carol, *Dir,* Dickinson State University, Art Gallery, Dickinson ND

Eagle, Leatrice, *Vice Chmn,* American Craft Council, New York NY

Ealer, William, *Asst Prof,* Pennsylvania College of Technology, Dept. of Communications, Construction and Design, Williamsport PA (S)

Eamer, Mark, *Exec Dir,* Tri-County Arts Council, Inc, Cobleskill NY

Earenfight, Phillip, *Dir,* Dickinson College, The Trout Gallery, Carlisle PA

Earl, Jari, *Admin Asst,* Institute of American Indian Arts Museum, Museum, Santa Fe NM

Earl, Jary, *Admin & Finance Officer,* Institute of American Indian Arts, Institute of American Indian Arts Museum, Santa Fe NM (S)

Earl, Patricia, *Exec Coordr,* City of Lubbock, Buddy Holly Center, Lubbock TX

Earle, Linda, *Exec Dir Prog,* Skowhegan School of Painting & Sculpture, New York NY (S)

Earle, Susan, *Cur European & American Art,* University of Kansas, Spencer Museum of Art, Lawrence KS

Earley, Nancy J, *Dir Finance & Admin,* Corning Museum of Glass, The Studio, Rakow Library, Corning NY

Earls, Elliott, *Head 2-D Design Dept,* Cranbrook Academy of Art, Bloomfield Hills MI (S)

Early, Sandy, *Admin Asst,* National Council on Education for the Ceramic Arts (NCECA), Erie CO

Early, Susan, *Dir Develop,* Visual Arts Center of Richmond, Richmond VA

Earman, Cynthia, *Librn,* Bucks County Historical Society, Spruance Library, Doylestown PA

Earnest, Greta, *Asst Dir,* Fashion Institute of Technology, Gladys Marcus Library, New York NY

Easby, Rebecca, *Chmn & Assoc Prof,* Trinity College, Fine Arts Program, Washington DC (S)

Eastep, Jim, *Develop Coordnr,* Oklahoma City Museum of Art, Oklahoma City OK

Easter, Earl, *Graphic Design,* Art Institute of Pittsburgh, Pittsburgh PA (S)

Eastes, Zon, *Exec Dir,* Bainbridge Island Arts Council, Bainbridge Isle WA

Eastman, Jeff, *Mus Preparator,* University of Richmond, University Museums, Richmond VA

Easton, Elizabeth, *Cur European Paintings & Sculpture,* Brooklyn Museum, Brooklyn NY

Easton-Moore, Barbara, *Exec Dir,* Rawls Museum Arts, Courtland VA

Eatmon, Cheryl, *Dept Secy, Grad Prog Asst,* North Carolina State University at Raleigh, School of Design, Raleigh NC (S)

Eaton, Lynn, *Reference Archivist,* Duke University Library, Hartman Center for Sales, Advertising & Marketing History, Durham NC

Eberhardt, Herman, *Cur,* National Archives & Records Administration, Franklin D Roosevelt Library, Hyde Park NY

Eberhart, Karen, *Dir Library,* Rhode Island Historical Society, Library, Providence RI

Eberle-Nielander, Lilith, *Instr,* Appalachian State University, Dept of Art, Boone NC (S)

Ebersole, Noriko, *Slide Librn,* Nelson-Atkins Museum of Art, Spencer Art Reference Library, Kansas City MO

Ebert, D, *Instr,* Golden West College, Visual Art Dept, Huntington Beach CA (S)

Ebert, Mary Beth, *Museum Store Mgr,* Modern Art Museum, Fort Worth TX

Ebezmann, Karen, *Prof,* Saint Thomas Aquinas College, Art Dept, Sparkill NY (S)

Eccles, Tom, *Dir,* Public Art Fund, Inc, New York NY

Echeverria, Durand, *Co-Cur,* Wellfleet Historical Society Museum, Wellfleet MA

Echeverria, Felipe, *Prof,* University of Northern Iowa, Dept of Art, Cedar Falls IA (S)

Echevery, Santiago, *Prof,* University of Tampa, Dept of Art, Tampa FL (S)

Echols, Joralyn, *Outreach & Public Relations Coordr,* Academy of the New Church, Glencairn Museum, Bryn Athyn PA

Echtner, Mark, *Prof,* Sinclair Community College, Division of Fine & Performing Arts, Dayton OH (S)

Ecker, Gary, *Restoration Specialist,* Riverside Municipal Museum, Riverside CA

Eckert, Barbara, *Dir Develop,* Tacoma Art Museum, Tacoma WA

Eckert, Mitch, *Assoc Prof,* University of Louisville, Allen R Hite Art Institute, Louisville KY (S)

Economon, Barbara, *Visual Resources Librn,* Walker Art Center, T J Peters Family Library, Minneapolis MN

Economos, Mandy, *Visual Resource Cur,* New York State College of Ceramics at Alfred University, Scholes Library of Ceramics, Alfred NY

Edberg, Jane, *Chmn & Prof,* Gavilan Community College, Art Dept, Gilroy CA (S)

Edberg, Jane, *Prof Art & New Technology,* Gavilan Community College, Art Gallery, Gilroy CA

Edborg, Judy A, *American Artisans Dir,* American Society of Artists, Inc, Palatine IL

Eddey, Roy R, *Dir Mus Admin,* New York Historical Society, New York NY

Eddings, Melissa, *Assoc Prof Art,* Ohio Northern University, Dept of Art, Ada OH (S)

Eddy, Cheri, *Facilities Mgr,* Bank One Wisconsin, Milwaukee WI

Eddy, Dave, *Asst Prof Lectr,* University of Utah, Dept of Art & Art History, Salt Lake City UT (S)

Eddy, Roy, *CFO,* Solomon R Guggenheim, New York NY

Eddy, Warren S, *Dir,* Cortland Free Library, Cortland NY

Edelen, Dawn, *Cur Educ,* Lafayette Natural History Museum & Planetarium, Lafayette LA

Edelman, Deborah, *Pub Info,* Missouri Arts Council, Saint Louis MO

Edelschick, Shelley, *Dir Educ,* Owensboro Museum of Fine Art, Owensboro KY

Edelson, Gilbert S, *Admin VPres & Counsel,* Art Dealers Association of America, Inc, New York NY

Eden, Dave, *Dir,* Union County Public Library Union Room, Monroe NC

Eden, Xandra, *Cur of Exhib,* University of North Carolina at Greensboro, Weatherspoon Art Museum, Greensboro NC

Edgar, Darcy, *Dir,* Contemporary Crafts Museum & Gallery, Portland OR

Edgar, David, *Chmn,* Ashland University, Art Dept, Ashland OH (S)

Edgar, David, *Prof,* University of North Carolina at Charlotte, Dept Art, Charlotte NC (S)

Edgecombe, Wallace I, *Dir,* Hostos Center for the Arts & Culture, Bronx NY

Edin, Phil, *COO,* Oregon Historical Society, Oregon History Center, Portland OR

Edinberg, Lucinda, *Outreach Coordr,* St John's College, Elizabeth Myers Mitchell Art Gallery, Annapolis MD

Edison, Carol, *Folk Arts Coordr,* Utah Arts Council, Chase Home Museum of Utah Folk Arts, Salt Lake City UT

Edison, Diane, *Assoc Prof Drawing & Painting,* University of Georgia, Franklin College of Arts & Sciences, Lamar Dodd School of Art, Athens GA (S)

Edmeades, Mary, *Chmn,* Regional Arts & Culture Council, Metropolitan Center for Public Arts, Portland OR

Edmonds, Nicolas, *Prof,* Boston University, School for the Arts, Boston MA (S)

Edmonson, Randall W, *Prof,* Longwood University, Dept of Art, Farmville VA (S)

Edmunds, Allan L, *Pres & Exec Dir,* Brandywine Workshop, Center for the Visual Arts, Philadelphia PA

Edmunds, Lucy, *Mus Shop Mgr,* Washington County Museum of Fine Arts, Hagerstown MD

Edmundson, John, *Exhibits Mgr,* Witte Museum, San Antonio TX

Edson, Erik, *Assoc Prof,* Mount Allison University, Dept of Fine Arts, Sackville NB (S)

Edson, Gary, *Exec Dir,* Texas Tech University, Museum of Texas Tech University, Lubbock TX

Edward, Whit, *Dir Educ,* Oklahoma Historical Society, Library Resources Division, Oklahoma City OK

Edwards, Adam, *Safety & Security Chief,* Oklahoma City Museum of Art, Oklahoma City OK

Edwards, Amy, *Dir Visitors Svcs,* University of Utah, Utah Museum of Fine Arts, Salt Lake City UT

Edwards, Jim, *Cur,* Salt Lake Art Center, Salt Lake City UT

Edwards, June, *Prof,* Slippery Rock University of Pennsylvania, Dept of Art, Slippery Rock PA (S)

Edwards, Kate, *Vis Asst Prof,* Baylor University, Dept of Art, Waco TX (S)

Edwards, Kimberlee, *Bookkeeper,* Belle Grove Plantation, Middletown VA

Edwards, Lee, *Prof,* Sarah Lawrence College, Dept of Art History, Bronxville NY (S)

Edwards, Matthew J, *Exec Dir,* The Museum, Greenwood SC

Edwards, Nancy, *Cur European Art,* Kimbell Art Museum, Fort Worth TX

Edwards, Pam, *Dir Vis Svcs & Volunteers,* Columbus Museum of Art, Columbus OH

Edwards, Patricia, *Asst Prof,* University of Saint Francis, School of Creative Arts, Fort Wayne IN (S)

Edwards, Patricia, *Lect,* Old Dominion University, Art Dept, Norfolk VA (S)

Edwards, Rebecca, *Adjunct,* College of the Canyons, Art Dept, Canta Colita CA (S)

Edwards, Rebecca, *Educ Mgr,* Pacific - Asia Museum, Pasadena CA

Edwards, Skip, *Master Woodcarver,* Calvert Marine Museum, Solomons MD

Edwards, Susan C S, *Dir Historic Resources,* The Trustees of Reservations, The Mission House, Ipswich MA

Edwins, Steve, *Asst Prof,* Saint Olaf College, Art Dept, Northfield MN (S)

Efimova, Alla, *Chief Cur,* Judah L Magnes, Berkeley CA

Egami, Renay, *Assoc Prof (Visual Art),* University of British Columbia Okanagan, Dept of Creative Studies, Kelowna BC (S)

Egan, Cara, *Pub Rels Mgr,* Seattle Art Museum, Seattle WA

Egan, Gary, *VPres Finance & Admin,* The Mariners' Museum, Newport News VA

Eggebrecht, David, *Academic Dean,* Concordia University Wisconsin, Fine Art Gallery, Mequon WI

Eggers, Jill, *Assoc Prof,* Grand Valley State University, Art & Design Dept, Allendale MI (S)

Eglinski, Edmund, *Assoc Prof,* University of Kansas, Kress Foundation Dept of Art History, Lawrence KS (S)

Egner, David, *Dir Interpretive Programming,* Atwater Kent Museum of Philadelphia, Philadelphia PA

Ehlers, Marla, *Librn,* Grand Rapids Public Library, Grand Rapids MI

Ehlert, Mary, *Mktg & Pub Relations,* Maricopa County Historical Society, Desert Caballeros Western Museum, Wickenburg AZ

Ehlis, Jacqueline, *Instr,* Pacific University in Oregon, Arts Div, Dept of Art, Forest Grove OR (S)

Ehmen, Linda, *Registrar & Collections Mgr,* Rollins College, George D & Harriet W Cornell Fine Arts Museum, Winter Park FL

Ehnbom, Daniel, *Art History Instr,* University of Virginia, McIntire Dept of Art, Charlottesville VA (S)

Ehrenkranz, Joel S, Whitney Museum of American Art, New York NY

Ehrhardt, Ursula M, *Asst Prof,* Salisbury State University, Art Dept, Salisbury MD (S)

Ehrin, Leslie, *Pres,* Wayne Art Center, Wayne PA (S)

Ehringer, Martha, *Dir Public Relations,* Mingei International, Inc, Mingei International Museum, San Diego CA

Eichelberg, Ann, *Registrar,* Portland Art Museum, Portland OR

Eichelberg, Ann, *Registrar,* Portland Art Museum, Northwest Film Center, Portland OR

Eichenberg, Iris, *Head Metalsmithing Dept,* Cranbrook Academy of Art, Bloomfield Hills MI (S)

Eichenberg, Roberta, *Asst,* Emporia State University, Dept of Art, Emporia KS (S)

Eichenberg, Roberta, *Asst Prof of Art,* Emporia State University, Norman R Eppink Art Gallery, Emporia KS

Eichner, Timothy, *Graphic Design Chmn,* Palm Beach Community College, Dept of Art, Lake Worth FL (S)

Eickhorst, William S, *Exec Dir,* Print Consortium, Kansas City MO

Eickmann, Margaret, *Dir Learning Servs,* Portland Children's Museum, Portland OR

Eickmeier, Valerie, *Dean,* Indiana University-Purdue University, Indianapolis, Herron School of Art, Indianapolis IN (S)

Eide, John, *Instr,* Maine College of Art, Portland ME (S)

Eifel, Patricia, *Pres,* Houston Center For Photography, Houston TX

Eike, Claire, *Dir,* School of the Art Institute of Chicago, John M Flaxman Library, Chicago IL

Eikmeier, Linda, *Asst Site Mgr,* County of Henrico, Meadow Farm Museum, Glen Allen VA

Eilerstein, Kate, *Exec Dir,* San Francisco Craft & Folk Art Museum, San Francisco CA

Einecke, Claudia, *Assoc Cur European Art,* Joslyn Art Museum, Omaha NE

Einfalt, Linda, *Assoc Prof Fine Arts,* University of Cincinnati, School of Art, Cincinnati OH (S)

Einreinhofer, Nancy, *Dir,* William Paterson University, Ben Shahn Gallery, Wayne NJ

Eis, Andrea, *Special Instr,* Oakland University, Dept of Art & Art History, Rochester MI (S)

Eisen, Lauren, *Asst Prof,* Denison University, Dept of Art, Granville OH (S)

Eisenbach, Diane, *Ceramics Instr,* Monterey Peninsula College, Art Dept, Monterey CA (S)

Eisenbach-Bush, Laurie, *Instr,* Maryville University of Saint Louis, Art & Design Program, Saint Louis MO (S)

Eisenhauer, Paul, *Dir Progs & Mems,* Wharton Esherick, Paoli PA

Eisman, Hy, *Instr,* Joe Kubert, Dover NJ (S)

Ekblom, Alyson, *Program Asst.,* Arts Extension Service, Amherst MA

Ekelund, Bob, *Co-Dir,* Jule Collins Smith Museum of Art, Auburn AL

Eklund, Lori, *Cur Educ,* City of El Paso, El Paso TX

Eklund, Lori, *Dir Educ,* Amon Carter, Fort Worth TX

El-Omami, Anne, *Chmn Museum Educ,* University of the Arts, Philadelphia Colleges of Art & Design, Performing Arts & Media & Communication, Philadelphia PA (S)

Elam, Chris, *Mem Coordr,* The Dallas Contemporary, Dallas Visual Art Center, Dallas TX

Elder, Sarah, *Cur Educ,* Saint Joseph Museum, Library, Saint Joseph MO

Elder, Sarah M, *Cur Educ & Librn,* Saint Joseph Museum, Saint Joseph MO

Elderfield, John, *Chief Cur, Dept Painting & Sculpture,* Museum of Modern Art, New York NY

Eldredge, Bruce, *CEO,* Eastern Washington State Historical Society, Northwest Museum of Arts & Culture, Spokane WA

Eldredge, Charles, *Prof,* University of Kansas, Kress Foundation Dept of Art History, Lawrence KS (S)

Eldridge, Jan, *Instr,* Solano Community College, Division of Fine & Applied Art & Behavioral Science, Suisun City CA (S)

Eldridge, Lucy, *Registrar,* Pierpont Morgan, New York NY

Eldridge, Todd, *Art Instr,* East Central Community College, Art Dept, Decatur MS (S)

Elena-Torralva, Maria, *Exec Dir,* Guadalupe Cultural Arts Center, San Antonio TX

Elhenny, James, *Painting & Drawing,* University of Colorado at Denver, College of Arts & Media Visual Arts Dept, Denver CO (S)

Elhoff, Paul, *Weekend Gallery Mgr,* Houston Center For Photography, Houston TX

Elish, Herbert, *Dir,* Carnegie Library of Pittsburgh, Pittsburgh PA

Elish, Herbert, *Dir,* Carnegie Museums of Pittsburgh, Carnegie Library of Pittsburgh, Pittsburgh PA

Elkington, Richard, *Asst Prof,* Providence College, Art & Art History Dept, Providence RI (S)

Ellason, Craig, *Prof,* University of Saint Thomas, Dept of Art History, Saint Paul MN (S)

Eller, John W, *COO,* Maryland Historical Society, Library, Baltimore MD

Elligott, Michelle, *Archivist,* Museum of Modern Art, Library and Museum Archives, New York NY

Ellinghausen, Judy, *Archives,* Cascade County Historical Society, High Plains Heritage Center, Great Falls MT

Ellingson, JoAnn, *Dir,* Saint Xavier University, Byrne Memorial Library, Chicago IL

Ellington, Howard W, *Exec Dir,* Wichita Center for the Arts, Wichita KS

Ellington, Howard W, *Exec Dir,* Wichita Center for the Arts, Maude Schollenberger Memorial Library, Wichita KS

Ellington, Howard W, *Exec Dir,* Wichita Center for the Arts, Mary R Koch Sch of Visual Arts, Wichita KS (S)

Ellington, Judy, *VPres,* Glynn Art Association, Saint Simons Island GA

Elliot, Barbara, *Dir Admis,* University of the Arts, Philadelphia Colleges of Art & Design, Performing Arts & Media & Communication, Philadelphia PA (S)

Elliot, Gillian, *Dir,* Place des Arts at Heritage Square, Coquitlam BC

Elliot, Gregory, *Asst Prof,* Louisiana State University, School of Art, Baton Rouge LA (S)

Elliot, John, *Asst Prof,* University of South Carolina at Aiken, Dept of Visual & Performing Arts, Aiken SC (S)

Elliot, Sandy, *Secy,* Western Art Association, Ellensburg WA

Elliot, Steve, *Prof,* Wayne State College, Dept Art & Design, Wayne NE (S)

Elliotsmith, Leslie, *Adjunct Prof,* Louisiana College, Dept of Art, Pineville LA (S)

Elliott, Bob, *Instr,* William Woods-Westminster Colleges, Art Dept, Fulton MO (S)

Elliott, Danial, *Arcadia Dir Libr & Archives,* Philadelphia Museum of Art, Library, Philadelphia PA

Elliott, Diann, *Asst Cur,* Eskimo Museum, Library, Churchill MB

Elliott, John, *Pres,* Oil Pastel Association, Stockholm NJ

Elliott, Joseph, *Asst Prof,* Muhlenberg College, Dept of Art, Allentown PA (S)

Elliott, Vanessa, *Admin Asst,* Ormond Memorial Art Museum and Gardens, Ormond Beach FL

Ellis, Eugenia, *Asst Prof Interior Design,* Drexel University, College of Media Arts & Design, Philadelphia PA (S)

Ellis, George R, *Dir, CEO & Pres,* Honolulu Academy of Arts, The Art Center at Linekona, Honolulu HI (S)

Ellis, Jack, *Co-Chmn Theater,* Western New Mexico University, Dept of Expressive Arts, Silver City NM (S)

Ellis, Joe, *Dir,* Nicolaysen Art Museum & Discovery Center, Museum, Casper WY

Ellis, Lori, *Art Cur,* Peter & Catharine Whyte Foundation, Whyte Museum of the Canadian Rockies, Banff AB

Ellis, Louis, *Prof,* State University of New York, College at Cortland, Dept Art & Art History, Cortland NY (S)

Ellis, Mac, *Custodian,* Glanmore National Historic Site of Canada, Belleville ON

Ellis, Mel, *Dir Admin,* New Britain Museum of American Art, New Britain CT

Ellis, Nancy, *Animal Exhibit Coordr,* Randall Junior Museum, San Francisco CA

Ellis, Nancy L, *Admin,* Hawaii Pacific University, Gallery, Kaneohe HI

Ellis, Seth, *Prof,* University of North Carolina at Greensboro, Art Dept, Greensboro NC (S)

Ellis, Timothy, *Bd Pres,* Ogunquit Museum of American Art, Reference Library, Ogunquit ME

Ellis, Tom, *Pres,* Essex Historical Society, Essex Shipbuilding Museum, Essex MA

Ellison, Rosemary, *Chief Cur,* Southern Plains Indian Museum, Anadarko OK

Ellison, Scott, *VPres Exec Committee,* Bank of Oklahoma NA, Art Collection, Tulsa OK

Ellis Peckham, Courtney, *Cur,* Essex Historical Society, Essex Shipbuilding Museum, Essex MA

Ellis Wilkens, Karen, *Pub Relations,* Christina Cultural Arts Center, Inc, Wilmington DE

Elloian, Peter, *Prof,* University of Toledo, Dept of Art, Toledo OH (S)

El Mabrouk, Nadia, *Asst Prof,* Universite de Montreal, Bibliotheque d'Amenagement, Montreal PQ

Elman, Erin, *Dir Pre-College Prog,* University of the Arts, Philadelphia Colleges of Art & Design, Performing Arts & Media & Communication, Philadelphia PA (S)

Elms, Anthony, *Asst Dir,* University of Illinois at Chicago, Gallery 400, Chicago IL

Elnimeiri, Mahjoub, *Prof,* Illinois Institute of Technology, College of Architecture, Chicago IL (S)

Elorfi, Meredith, *Cur Public Information,* Tampa Museum of Art, Judith Rozier Blanchard Library, Tampa FL

Elsmo, Nancy, *Librn,* Wustum Museum Art Association, Wustum Art Library, Racine WI

Elsner, Linda, *Pres,* Kelly-Griggs House Museum, Red Bluff CA

Emack-Cambra, Jane, *Cur,* Old Colony Historical Society, Museum, Taunton MA

Emack-Cambra, Jane, *Cur,* Old Colony Historical Society, Library, Taunton MA

Emanuel, Martin, *Prof,* Atlanta College of Art, Atlanta GA (S)

Embree, Anna, *Guild Librn,* Guild of Book Workers, Library, New York NY

Emerick, Judson, *Prof,* Pomona College, Dept of Art & Art History, Claremont CA (S)

Emerson, Bert, *Asst Prof,* Salve Regina University, Art Dept, Newport RI (S)

Emerson, Julie, *Ruth J Nutt Cur Drawings,* Seattle Art Museum, Library, Seattle WA

Emert, Carol, *Registrar,* Washburn University, Mulvane Art Museum, Topeka KS

Emery, Lea, *Deputy Dir External Affairs & Admin,* Cincinnati Institute of Fine Arts, Taft Museum of Art, Cincinnati OH

Emison, Patricia, *Assoc Prof,* University of New Hampshire, Dept of Arts & Art History, Durham NH (S)

Emmons, Carol, *Prof,* University of Wisconsin-Green Bay, Arts Dept, Green Bay WI (S)

Emmons-Andarawl, Deborah, *Interpreter,* Schuyler Mansion State Historic Site, Albany NY

Emodi, T, *Dean,* Technical University of Nova Scotia, Faculty of Architecture, Halifax NS (S)

Emont Scott, Deborah, *Chief Cur,* Nelson-Atkins Museum of Art, Kansas City MO

Emslander, Liz, *Dir Visitor Svcs,* Contemporary Arts Center, Cincinnati OH

Enabnit, Kenneth, *Art Librn,* Mason City Public Library, Mason City IA

Ende, Arlyn, *Gallery Dir,* University of the South, University Art Gallery, Sewanee TN

Ender, Betty, *VPres,* Long Beach Art League, Long Beach Library, Long Beach NY

Endersby, Linda, *Asst Dir,* Missouri Department of Natural Resources, Missouri State Museum, Jefferson City MO

Endershy, Linda, *Asst Dir,* Missouri Department of Natural Resources, Elizabeth Rozier Gallery, Jefferson City MO

Endres, Barbara K, *Secy,* Manitoba Society of Artists, Winnipeg MB

Endslow, Ellen, *Dir Coll & Cur,* Chester County Historical Society, West Chester PA

Endy, Mike, *Head Dept Art,* Weatherford College, Dept of Speech Fine Arts, Weatherford TX (S)

Eng, James, *Prof,* Framingham State College, Art Dept, Framingham MA (S)

Engel, Dianne, *Coordr Coll,* Shell Canada Ltd, Calgary AB

Engel, Scott, *Chmn,* Arapahoe Community College, Colorado Gallery of the Arts, Littleton CO

Engelbert, John P, *Pres,* First State Bank, Norton KS

Engelson, Robert, *Head Dept,* Mount Saint Clare College, Art Dept, Clinton IA (S)

Engglezos, Yvonne, *Dir,* Bowne House Historical Society, Flushing NY

Ewick, Cynthia, *Cur Educ,* Indiana State Museum, Indianapolis IN

Ewing, Dan, *Chmn Fine Arts Dept,* Barry University, Dept of Fine Arts, Miami Shores FL (S)

Exline, J, *Adjunct Prof,* Le Moyne College, Fine Arts Dept, Syracuse NY (S)

Exton, Leslie, *Chmn Drawing & Painting,* Corcoran School of Art, Washington DC (S)

Exxon, Randall L, *Chmn,* Swarthmore College, Dept of Art, Swarthmore PA (S)

Eyerdam, Pamela, *Supv Art Svcs,* Cleveland State University, Library & Art Services, Cleveland OH

Eyland, Cliff, *Gallery Dir,* University of Manitoba, Gallery One One One, Winnipeg MB

Eyland, Cliff, University of Manitoba, School of Art, Winnipeg MB (S)

Ezell-Gilson, Carol, *Cur,* City of Charleston, City Hall Council Chamber Gallery, Charleston SC

Fabbri Butera, Virginia, *Chmn Dept,* College of Saint Elizabeth, Art Dept, Morristown NJ (S)

Faber, Carol, *Coordr Core Prog,* Iowa State University, Dept of Art & Design, Ames IA (S)

Faber, Carol, *Instr,* North Iowa Area Community College, Dept of Art, Mason City IA (S)

Faber, David, *Assoc Prof,* Wake Forest University, Dept of Art, Winston-Salem NC (S)

Faberman, Hilarie, *Cur Modern & Contemporary,* Stanford University, Iris & B Gerald Cantor Center for Visual Arts, Stanford CA

Fabing, Suzannah J, *Dir & Chief Cur,* Smith College, Museum of Art, Northampton MA

Fabo, Andy, *Instr,* Toronto School of Art, Toronto ON (S)

Fabozzi, Paul, *Chmn,* Saint John's University, Dept of Fine Arts, Jamaica NY (S)

Fabrick, Lane, *Assoc Prof,* Southeast Missouri State University, Dept of Art, Cape Girardeau MO (S)

Facchini, Gina, *Asst Dir,* Wynick Tuck Gallery, Toronto ON

Faccinto, Victor, *Gallery Dir,* Wake Forest University, Dept of Art, Winston-Salem NC (S)

Facos, Michelle, *Asst Prof,* Indiana University, Bloomington, Henry Radford Hope School of Fine Arts, Bloomington IN (S)

Factor, Yale, *Grad Coordr,* Northern Illinois University, School of Art, De Kalb IL (S)

Fagaly, William A., *Cur African Art,* New Orleans Museum of Art, New Orleans LA

Fagan, Barry, *Financial Coordr,* Queen's University, Agnes Etherington Art Centre, Kingston ON

Fagan, Charlene Chang, *Dir,* Sarah Lawrence College Library, Esther Raushenbush Library, Bronxville NY

Fagan, Meg, *Develop Dir,* Kitchen Center for Video, Music, Dance, Performance, Film & Literature, New York NY

Fagan, Tricia, *Cur,* Mercer County Community College, Arts, Communication & Engineering Technology, Trenton NJ (S)

Fagan, Tricia, *Dir,* Artworks, The Visual Art School of Trenton, Trenton NJ

Fagan, Tricia, *Dir,* Artworks, The Visual Art School of Trenton, Library, Trenton NJ

Fagan, Tricia, *Gallery Dir,* Mercer County Community College, The Gallery, West Windsor NJ

Fagan Affleck, Diane, *Dir Exhib,* American Textile History Museum, Lowell MA

Faggioli, Renzo, *Ceramist-in-Residence,* Moravian College, Dept of Art, Bethlehem PA (S)

Fago, Nancy E, *Asst Dir,* Ursinus College, Philip & Muriel Berman Museum of Art, Collegeville PA

Fahey, Anna, *Communications Mgr,* Henry Gallery Association, Henry Art Gallery, Seattle WA

Fahnestock, Jon, *Asst Prof,* Maryville University of Saint Louis, Art & Design Program, Saint Louis MO (S)

Fahy, Everett, *John Pope Henness Chmn,* The Metropolitan Museum of Art, New York NY

Fair, Barry, *Registrar,* Museum London, London ON

Fair, Donald, *Pres,* Summit County Historical Society, Akron OH

Fairfield, Douglas, *Cur Art,* Albuquerque Museum of Art & History, Albuquerque NM

Fairley-Brown, Ricki, The Names Project Foundation AIDS Memorial Quilt, Atlanta GA

Fairlie, Carol, *Asst Prof,* Sul Ross State University, Dept of Fine Arts & Communications, Alpine TX (S)

Fairman, Hugh, *Treas,* Inter-Society Color Council, Lawrenceville NJ

Faist, Jennifer, *Photo Research Cur,* Art Center College of Design, James Lemont Fogg Memorial Library, Pasadena CA

Fajardo, Rafael, *Asst Prof Electronic Media Arts Design,* University of Denver, School of Art & Art History, Denver CO (S)

Fakundiny, Robert, *Chief Geological Survey,* New York State Museum, Albany NY

Falana, Kenneth, *Prof,* Florida A & M University, Dept of Visual Arts, Humanities & Theatre, Tallahassee FL (S)

Falatovich, Craig, *Sales Mgr,* The Society for Contemporary Crafts, Pittsburgh PA

Falcone, Paul, *Asst Prof,* Northwest Missouri State University, Dept of Art, Maryville MO (S)

Falconer, Jim, *Registrar,* Lyme Academy of Fine Arts, Old Lyme CT (S)

Fales, Christine, *Acad Affairs Asst,* New Hampshire Institute of Art, Manchester NH

Fales, Melanie, *Cur Educ,* Boise Art Museum, Boise ID

Fales, Melanie, *Exec Dir,* Boise Art Museum, Boise ID

Falgner, Susan M, *Head Pub Svcs,* College of Mount Saint Joseph, Archbishop Alter Library, Cincinnati OH

Falk, Karen, *Gallery Dir,* Jewish Community Center of Greater Washington, Jane L & Robert H Weiner Judaic Museum, Rockville MD

Falk, Lorne, *Dean Faculty,* School of the Museum of Fine Arts, Boston MA (S)

Falkenstien-Doyel, Sherry, *Cur,* Wheelwright Museum of the American Indian, Mary Cabot Wheelwright Research Library, Santa Fe NM

Falkenstien-Doyle, Cheri, *Cur,* Wheelwright Museum of the American Indian, Santa Fe NM

Falkner, Avery, *Prof,* Pepperdine University, Seaver College, Dept of Art, Malibu CA (S)

Falkner, Melissa, *Registrar,* Birmingham Museum of Art, Birmingham AL

Falkner, Melissa B, *Registrar,* Birmingham Museum of Art, Clarence B Hanson Jr Library, Birmingham AL

Fallacaro, Bill, *Chief Security,* Flagler Museum, Palm Beach FL

Falls, David, *Installations Officer & Registrar,* University of Western Ontario, McIntosh Gallery, London ON

Falls, Jo, *Dir,* Tohono Chul Park, Tucson AZ

Faloon, Ronda, *Dir,* Cape Ann Historical Association, Gloucester MA

Fancher, Ollie, *Instr,* Middle Tennessee State University, Art Dept, Murfreesboro TN (S)

Fanelli, Doris, *Chief Cultural Resources,* Independence National Historical Park, Library, Philadelphia PA

Fang, Wei, *Educ Cur,* The Contemporary Museum, Honolulu HI

Faquin, Jane, *Vol Coordr,* The Dixon Gallery & Gardens, Memphis TN

Faquin, Jane W, *Educ Coordr,* The Dixon Gallery & Gardens, Library, Memphis TN

Farago, Andrew, *Gallery Mgr,* Cartoon Art Museum, San Francisco CA

Farber, Ellen, *Instr,* State University of New York College at Oneonta, Dept of Art, Oneonta NY (S)

Farber, Janet, *Assoc Cur 20th Century Art,* Joslyn Art Museum, Omaha NE

Farber, Leslie, *Assoc Prof,* William Paterson University, Dept Arts, Wayne NJ (S)

Farcus, Adam, *Preparator,* McLean County Art Association, McLean County Arts Center, Bloomington IL

Farha, Darya, *Adminr,* The Metal Arts Guild, Toronto ON

Faries, Molly, *Prof,* Indiana University, Bloomington, Henry Radford Hope School of Fine Arts, Bloomington IN (S)

Farina, John, *Dir Development,* Beck Center for the Arts, Lakewood OH

Farina, Kate, *Educ Coordr,* Art Directors Club, New York NY

Farish, Tambi, *Fin Dir,* The Ogden Museum of Southern Art, University of New Orleans, New Orleans LA

Farley, Cheryl, *Dir Community Relations,* Old York Historical Society, York ME

Farley, Cheryl, *Dir Community Relations,* Old York Historical Society, Elizabeth Perkins House, York ME

Farley, Cheryl, *Dir Community Relations,* Old York Historical Society, Old Gaol Museum, York ME

Farley, Gale, *Asst Prof,* Herkimer County Community College, Humanities Social Services, Herkimer NY (S)

Farley Harger, Sara, *Exec Dir,* Liberty Hall Historic Site, Library, Frankfort KY

Farmer, Dustin, *Art Instr,* Seward County Community College, Art Dept, Liberal KS (S)

Farnell, Cynthia, *Dir,* Hera Educational Foundation, Hera Gallery, Wakefield RI

Farnet, S Stewart, *Pres Bd,* New Orleans Museum of Art, New Orleans LA

Farnham, Julie, *Registrar,* Roswell Museum & Art Center, Roswell NM

Farnum, Michelle, *VPres,* Octagon Center for the Arts, Ames IA

Farr, Dorothy, *Assoc Dir & Cur,* Queen's University, Agnes Etherington Art Centre, Kingston ON

Farr, Julie, *Exec Dir,* Meadville Council on the Arts, Meadville PA

Farr, Julie, *Exec Dir,* The Society for Contemporary Crafts, Pittsburgh PA

Farr, Libby, *Instr,* Marylhurst University, Art Dept, Marylhurst OR (S)

Farrar, Ellyn Mary, *Cur Landscape,* Fort Ticonderoga Association, Ticonderoga NY

Farrar, Paula, *Reference Librn,* University of British Columbia, Fine Arts, UBC Library, Vancouver BC

Farrar-Wegener, Louise, *Instr,* Marylhurst University, Art Dept, Marylhurst OR (S)

Farrell, Anne, *Dir Develop,* Museum of Contemporary Art, San Diego-Downtown, La Jolla CA

Farrell, Bill, *Prof,* School of the Art Institute of Chicago, Chicago IL (S)

Farrell, Carolyn Bell, *Sr Cur,* Koffler Centre of the Arts, The Koffler Gallery, Toronto ON

Farrell, Cynthia, *Admin Asst,* University of New Hampshire, The Art Gallery, Durham NH

Farrell, Donald M, *Treas,* Belskie Museum, Closter NJ

Farrell, Laurie, *Cur,* Museum for African Art, Long Island City NY

Farrell, Mary, *Prof,* Gonzaga University, Dept of Art, Spokane WA (S)

Farrell, Michael J, *Prof,* University of Windsor, Visual Arts, Windsor ON (S)

Farrell, William, *Industrial Design Technology,* Art Institute of Pittsburgh, Pittsburgh PA (S)

Farrington, Rusty, *Chmn,* Iowa Central Community College, Dept of Art, Fort Dodge IA (S)

Farris, Mary, *Dir,* National Park Community College Library, Hot Springs AR

Farriss, Adra, *Prog Coordr,* Edna Hibel, Hibel Museum of Art, Jupiter FL

Farriss, Adra, *Prog Coordr,* Edna Hibel, Hibil Museum & Gallery, Jupiter FL

Farrokhi, Abdollah, *Instr,* Black Hills State University, Art Dept, Spearfish SD (S)

Farthing, Stephen, *Exec Dir,* New York Academy of Art, Graduate School of Figurative Art, New York NY (S)

Farynyk, Diane, *Registrar,* Frick Collection, New York NY

Fasoldt, Staats, *Instr,* Woodstock School of Art, Inc, Woodstock NY (S)

Fass, Philip, *Assoc Prof,* University of Northern Iowa, Dept of Art, Cedar Falls IA (S)

Fasse, Jane, *Instr,* Edgewood College, Art Dept, Madison WI (S)

Fassett, Brian, *Instr,* University of Louisiana at Monroe, Dept of Art, Monroe LA (S)

Fast, Susan, *Coll Gallery Mgr,* Mingei International, Inc, Mingei International Museum, San Diego CA

Faste, Trygve, *Vis Asst Prof Art,* Whitman College, Art Dept, Walla Walla WA (S)

Faub, Bob, *Controller,* Palm Beach County Cultural Council, West Palm Beach FL

Faubert, Claude, *Dir Gen,* Canada Science and Technology Museum, Ottawa ON

Faude, Wilson H, *Exec Dir,* Old State House, Hartford CT

Faudie, Fred, *Prof,* University of Massachusetts Lowell, Dept of Art, Lowell MA (S)

Faul, Karene, *Chmn,* College of Saint Rose, Art Dept, Albany NY (S)

Faulds, W Rod, *Dir University Galleries,* Florida Atlantic University, University Galleries/Ritter Art Gallery/Schmidt Center Gallery, Boca Raton FL

Faulk, Becky, *Gallery Coordr,* Crowley Art Association, The Gallery, Crowley LA

Faulkes, Eve, *Prof,* West Virginia University, College of Creative Arts, Morgantown WV (S)

Faulkner, Becky, *Art Education,* Asbury College, Student Center Gallery, Wilmore KY

Faulkner, Becky, *Instr,* Asbury College, Art Dept, Wilmore KY (S)

Faunt, Peggy, *Secy,* Monroe County Community College, Humanities Division, Monroe MI (S)

Faust, Cathie, *Finance & Grants Mgr,* Arts Council of Greater Kingsport, Renaissance Center Main Gallery, Kingsport TN

Favata, Alexa A, *Asst Dir,* University of South Florida, Contemporary Art Museum, Tampa FL

Favier, Pieter, *Sculptor,* University of South Alabama, Dept of Art & Art History, Mobile AL (S)

Favis, Robert, *Dept Chmn,* Stetson University, Art Dept, Deland FL (S)

Favre, Lee, *Dir,* Dane G Hansen, Logan KS

Favre, John, *Faculty,* Housatonic Community College, Art Dept, Bridgeport CT (S)

Favrholdt, Linda, *Prog Coordr,* Kamloops Art Gallery, Kamloops BC

Favro, Diane, *First VPres,* Society of Architectural Historians, Chicago IL

Fawkes, Tom, *Instr,* Pacific Northwest College of Art, Portland OR (S)

Fawler, Miriam, *Cur Educ,* Birmingham Museum of Art, Birmingham AL

Faxon, Susan, *Assoc Dir & Cur Art Before 1950,* Phillips Academy, Addison Gallery of American Art, Andover MA

Fay, Ming, *Prof,* William Paterson University, Dept Arts, Wayne NJ (S)

Fayerman, Faye, *Prof,* New York Institute of Technology, Fine Arts Dept, Old Westbury NY (S)

Fazzini, Richard, *Chm Egyptian & Classical Art,* Brooklyn Museum, Brooklyn NY

Fazzino, Joseph, *Dir Pub Relations & Mktg,* Mark Twain, Hartford CT

Fe, Walker, *Artist,* 4D Basement, New York NY

Fe, Walker, *Artist,* U Gallery, New York NY

Fearon, Chris, *Museum Educator,* University of Vermont, Robert Hull Fleming Museum, Burlington VT

Fears, Eileen, *Prof,* California State Polytechnic University, Pomona, Art Dept, Pomona CA (S)

Feast, Terra, *Asst Cur Educ,* Boise Art Museum, Boise ID

Feathers, Denise, *Exec Asst,* Santa Monica Museum of Art, Santa Monica CA

FeBland, Harriet, *Dir,* Harriet FeBland, New York NY (S)

Fecho, Susan C, *Chmn,* Barton College, Art Dept, Wilson NC (S)

Fechter, Earl, *Prof,* Norwich University, Dept of Architecture and Art, Northfield VT (S)

Fecter, Eric, *VPres Finance,* Alberta College of Art & Design, Calgary AB (S)

Fedders, Kristan, *Dir Permanent Coll,* Earlham College, Leeds Gallery, Richmond IN

Fedders, Kristin, *Asst Prof,* University of Saint Francis, School of Creative Arts, Fort Wayne IN (S)

Fedders, Kristin, *Convener,* Earlham College, Art Dept, Richmond IN (S)

Fedeler, Barbara, *Asst Prof,* Wartburg College, Dept of Art, Waverly IA (S)

Federighi, Christine, *Prof,* University of Miami, Dept of Art & Art History, Coral Gables FL (S)

Fedorchenko, Xenia, *Asst Prof,* Lamar University, Art Dept, Beaumont TX (S)

Feeler, William, *Chmn,* Midland College, Art Dept, Midland TX (S)

Feeley, Marc, *Aggregate Prof,* Universite de Montreal, Bibliotheque d'Amenagement, Montreal PQ

Feeney, Lawrence, *Dir,* Mississippi University for Women, Fine Arts Gallery, Columbus MS

Feeny, Lawrence, *Prof,* Mississippi University for Women, Division of Fine & Performing Arts, Columbus MS (S)

Fefee, Claudette, *Secy,* Potsdam College of the State University of New York, Roland Gibson Gallery, Potsdam NY

Feheley, Patricia, *VPres,* Art Dealers Association of Canada, Toronto ON

Feher-Simonelli, Brenda, *Gallery Coordr,* Texas A&M University Commerce, Dept of Art, Commerce TX (S)

Fehlau, Fred, *Computer Graphics Chmn,* Art Center College of Design, Pasadena CA (S)

Fehlner, Jacqueline, *Instr & Supv,* Toronto Art Therapy Institute, Toronto ON

Fehon, Diane, *Educ Coordr,* Academy of the New Church, Glencairn Museum, Bryn Athyn PA

Fehrenbach, Julie, *Assoc Dir,* SPACES, Cleveland OH

Feig, Randy, *Asst Prof,* Edgewood College, Art Dept, Madison WI (S)

Fein, Ruth, *Asst Cur,* National Gallery of Art, Index of American Design, Washington DC

Feinberg, Larry, *Cur European Painting,* The Art Institute of Chicago, Chicago IL

Feinberg, Norman M., *Vice Chm,* Brooklyn Museum, Brooklyn NY

Feinberg, Robert, *VPres,* Walters Art Museum, Library, Baltimore MD

Feinberg, Robert S, *Pres Bd Trustees,* Walters Art Museum, Baltimore MD

Fekete, Ron, *Asst Office Mgr,* Safety Harbor Museum of Regional History, Safety Harbor FL

Fekner, John, *Asst Prof,* C W Post Campus of Long Island University, School of Visual & Performing Arts, Brookville NY (S)

Feldberg, Michael, *Exec Dir,* American Jewish Historical Society, The Center for Jewish History, New York NY

Felder, Dana, *Image Cur,* Cooper Union for the Advancement of Science & Art, Library, New York NY

Feldhausen, Jan, *Dean Foundations,* Milwaukee Institute of Art & Design, Milwaukee WI (S)

Feldman, Bob, *Pres,* Key West Art & Historical Society, East Martello Museum & Gallery, Key West FL

Feldman, Devin, *Coordr Technical Svcs,* Queensborough Community College Library, Kurt R Schmeller Library, Bayside NY

Feldman, Kaywin, *Dir & CEO,* Memphis Brooks Museum of Art, Memphis TN

Feldman, Lisa, *Treas,* New York Artists Equity Association, Inc, New York NY

Feldman, Ronald, *VPres,* Art Dealers Association of America, Inc, New York NY

Feldman, Sally, *Branch Adminr,* Las Vegas-Clark County Library District, Las Vegas NV

Feldmen, Susan, *Exec Dir,* St Ann Center for Restoration & the Arts Inc, Brooklyn NY

Feliciano, Awilda, *Instr,* Guilford Technical Community College, Commercial Art Dept, Jamestown NC (S)

Fell, Katharina, *Cur,* Yeshiva University Museum, New York NY

Felos, Charlene, *Chairperson,* Cypress College, Cypress CA (S)

Felshin, Nina, *Cur Exhib,* Wesleyan University, Ezra & Cecile Zilkha Gallery, Middletown CT

Felter, Susan, *Assoc Prof,* Santa Clara University, Dept of Art & Art History, Santa Clara CA (S)

Felton, Craig, *Prof,* Smith College, Art Dept, Northampton MA (S)

Fencl, Brian, *Asst Prof,* West Liberty State College, Div Art, West Liberty WV (S)

Fender, Kimber L, *Dir,* Public Library of Cincinnati & Hamilton County, Art & Music Dept, Cincinnati OH

Fenety, Lois, *Dir,* Sunbury Shores Arts & Nature Centre, Inc, Library, Saint Andrews NB

Feng, Z.L., *MFA,* Radford University, Art Dept, Radford VA (S)

Fensterstock, Lauren, *Exhibit Develop,* Saco Museum, Saco ME

Fenton, JoAnn, *Librn,* Seattle Public Library, Fine & Performing Arts Dept, Seattle WA

Fenton, Susan, *Photography,* Saint Joseph's University, Dept of Fine & Performing Arts, Philadelphia PA (S)

Fenton, Wendell, *VPres,* Brandywine River Museum, Chadds Ford PA

Ferber, Linda, *Cur American Paintings & Sculpture,* Brooklyn Museum, Brooklyn NY

Ferber, Linda S, *Dir Mus Div,* New York Historical Society, New York NY

Ferdman, Glenn, *Dir,* Spertus Institute of Jewish Studies, Asher Library, Chicago IL

Ference-Kelly, Cynthia, *Dir Communications,* Western Pennsylvania Conservancy, Fallingwater, Mill Run PA

Ferentz, Nicole, *Assoc Prof,* Loyola University of Chicago, Fine Arts Dept, Chicago IL (S)

Ferger, Jane, *Visual Resources Librn,* Columbus Museum of Art and Design, Jane S. Dutton Educational Resource Center, Indianapolis IN

Fergus, Victoria, *Prof,* West Virginia University, College of Creative Arts, Morgantown WV (S)

Ferguson, Andi, *Dir Mktg,* Contemporary Arts Center, Cincinnati OH

Ferguson, Barbara, *Admin Asst,* Dunedin Fine Arts & Cultural Center, Dunedin FL (S)

Ferguson, Jay R, *Dir Cur Svcs,* Kentucky Derby Museum, Louisville KY

Ferguson, John P, *Acting Dir,* Iroquois Indian Museum, Howes Cave NY

Ferguson, Kathleen, *Asst to Dir,* International Foundation for Art Research, Inc, New York NY

Ferguson, Ken, *Business Mgr,* Art Gallery of Windsor, Windsor ON

Ferguson, Mary Catherine, *Mus Dir,* California Center for the Arts, Escondido Museum, Escondido CA

Ferguson, Melissa, *Dir Mkg & Communications,* Columbus Museum of Art, Columbus OH

Ferguson, Russell, *Interim Chmn Found,* Kansas City Art Institute, Kansas City MO (S)

Fergusson, Peter J, *Prof,* Wellesley College, Art Dept, Wellesley MA (S)

Ferland, Jacques A, *Prof,* Universite de Montreal, Bibliotheque d'Amenagement, Montreal PQ

Fern, Alan, *Dir,* National Portrait Gallery, Washington DC

Fernandes, Irene, *Gift Shop Mgr,* Museum of Northern British Columbia, Ruth Harvey Art Gallery, Prince Rupert BC

Fernandes, Maria, *Sr Library Asst,* New York Institute of Technology, Art & Architectural Library, Old Westbury NY

Fernandez, Dolores, *Pres,* Hostos Center for the Arts & Culture, Bronx NY

Fernandez, George, *Asst Prof,* State University of New York at Farmingdale, Visual Communications, Farmingdale NY (S)

Fernandez, Gracie, *Develop Asst,* San Angelo Museum of Fine Arts, San Angelo TX

Fernandez, Sanchie, *Dir Human Resources,* San Francisco Museum of Modern Art, San Francisco CA

Fernandez-Keys, Alba, *Asst Art Reference Librn,* Columbus Museum of Art and Design, Stout Reference Library, Indianapolis IN

Ferra, Max, *Dir,* Intar Latin American Gallery, New York NY

Ferrandi, George, *Asst Prof,* University of Florida, Dept of Art, Gainesville FL (S)

Ferrari, Gerard, *Asst Prof,* North Central College, Dept of Art, Naperville IL (S)

Ferrario, Paola, *Asst Prof,* Rhode Island College, Art Dept, Providence RI (S)

Ferrell, Walt, *Pub Relations,* National Air and Space Museum, Washington DC

Ferri, Rita, *Asst Dir,* Santa Barbara Contemporary Arts Forum, Santa Barbara CA

Ferris, Alison, *Cur,* Bowdoin College, Museum of Art, Brunswick ME

Fertitta, Angelo, *Dean,* Art Institute of Boston at Lesley University, Boston MA (S)

Fertitta, Becky, *Mgr Visitor Center,* Mamie McFaddin Ward, Beaumont TX

Fessler, Katherine, *Exec Dir,* Arts Council of Richmond, Inc, Richmond VA

Fetterman-Mulvey, Mia, *Ceramics,* University of Denver, School of Art & Art History, Denver CO (S)

Fettes, John, *Head Dept,* Magnum Opus, McLean VA (S)

Feught, Johann, *Assoc Prof (Visual Art),* University of British Columbia Okanagan, Dept of Creative Studies, Kelowna BC (S)

Fey, A Michael, *Dir Exhibits,* South Carolina State Museum, Columbia SC

Fich, Dean K, *IMAX(R) Theater Mgr,* Putnam Museum of History and Natural Science, Library, Davenport IA

Fichner-Rathus, Lois, *Chmn & Prof,* College of New Jersey, Art Gallery, Trenton NJ

Fichner-Rathus, Lois, *Chmn Dept,* The College of New Jersey, School of Arts & Sciences, Ewing NJ (S)

Fidler, Spencer, *Dept Head,* New Mexico State University, Art Dept, Las Cruces NM (S)

Field, Addison E, *Dir & Cur Sheldon Mus,* Sheldon Museum & Cultural Center, Inc, Sheldon Museum & Cultural Center, Haines AK

Field, Charles, *Prof Emeritus,* University of Texas at San Antonio, Dept of Art & Art History, San Antonio TX (S)

Field, John, *Dean of Humanities & Fine Arts,* Holyoke Community College, Dept of Art, Holyoke MA (S)

Field, Marshall, *TFA Bd Chmn,* Terra Museum of American Art, Chicago IL

Field, Merilyn, *Dir Art Therapy,* Converse College, Dept of Art & Design, Spartanburg SC (S)

Field, Philip S, *Prof Painting,* University of Texas Pan American, Art Dept, Edinburg TX (S)

Field, Richard, *Dir Gallery,* Indiana University of Pennsylvania, Kipp Gallery, Indiana PA

Fields, Catherine Keene, *Dir,* Litchfield History Museum, Litchfield CT

Fields, Catherine Keene, *Dir,* Litchfield History Museum, Ingraham Memorial Research Library, Litchfield CT

Fields, Laura Kemper, *Dir Art Coll,* Commerce Bancshares, Inc, Fine Art Collection, Kansas City MO

Fields, Leslie, *Gilder Lehrman Collection Asst Cur,* Pierpont Morgan, New York NY

Fields, Robert, *Prof,* Virginia Polytechnic Institute & State University, Dept of Art & Art History, Blacksburg VA (S)

Fieldsted, Tracey, *VPres,* Springville Museum of Art, Springville UT

Fieno, Rosina, *Dean,* Delaware County Community College, Communications & Humanities House, Media PA (S)

Fife, Lin, *Prof,* University of Colorado-Colorado Springs, Visual & Performing Arts Dept, Colorado Springs CO (S)

Fife Harbert, Laurie G, *Cur,* North Canton Public Library, The Little Art Gallery, North Canton OH

Fifer, Sally Jo, *Exec Dir,* Bay Area Video Coalition, Inc, San Francisco CA

Figueroa, Dawn, *Gallery Asst,* Colgate University, Picker Art Gallery, Hamilton NY

Figueroa, Paul, *Exec Dir,* Museum of Art & History, Santa Cruz, Santa Cruz CA

Figueroa, Paul C, *Dir,* Carolina Art Association, Library, Charleston SC

Figueroa, Rose, *Exhibition Specialist,* Southwest Museum, Los Angeles CA

Fleischman, Stephen, *Dir,* Madison Museum of Contemporary Art, Madison WI

Fleischmann, Laura, *Registrar,* The Buffalo Fine Arts Academy, Albright-Knox Art Gallery, Buffalo NY

Fleisher, Pat, *Treas & Membership (Toronto, Ont),* International Association of Art Critics, ALCA Canada, Inc, Tornoto ON

Fleming, Al, *Mem Svcs,* Alberta Craft Council, Edmonton AB

Fleming, Alison, *Asst Prof,* College of the Holy Cross, Dept of Visual Arts, Worcester MA (S)

Fleming, Anne, *Assoc Prof (Creative Writing),* University of British Columbia Okanagan, Dept of Creative Studies, Kelowna BC (S)

Fleming, Elizabeth, *Librn,* Columbia Museum of Art, Lee Alexander Lorick Library, Columbia SC

Fleming, Elma, *Principal High School,* Forest Hills Adult and Youth Center, Forest Hills NY (S)

Fleming, Erika, *Pres College,* International Fine Arts College, Miami FL (S)

Fleming, Jeff, *Sr Cur,* Edmundson Art Foundation, Inc, Des Moines Art Center, Des Moines IA

Fleming, Jennie, *Asst Dir,* University of Maryland, College Park, The Art Gallery, College Park MD

Fleming, Joe, *Instr,* Toronto School of Art, Toronto ON (S)

Fleming, Marnie, *Cur Contemporary Art,* Oakville Galleries, Centennial Square and Gairloch Gardens, Oakville ON

Fleming, Robyn, *Interlibrary Svcs,* The Metropolitan Museum of Art, Thomas J Watson Library, New York NY

Fleming, Tom, *Prof,* University of Wisconsin College - Marinette, Art Dept, Marinette WI (S)

Fleminger, Susan, *Dir,* Henry Street Settlement, Abrons Art Center, New York NY

Flentje, Rachel D, *Exhib Dir,* Bloomington Art Center, Bloomington MN

Flescher, Sharon, *Dir,* International Foundation for Art Research, Inc, Authentication Service, New York NY

Flescher, Sharon, *Exec Dir, Editor in Chief,* International Foundation for Art Research, Inc, New York NY

Flester, Inge, *Office Mgr,* Colonial Williamsburg Foundation, John D Rockefeller, Jr Library, Williamsburg VA

Fletcher, Carrol, *CEO,* Harrison County Historical Museum, Marshall TX

Fletcher, Dorothy, *Lectr,* Emory University, Art History Dept, Atlanta GA (S)

Fletcher, Izzy, *Pres,* Emerald Empire Art Gallery Association, Springfield OR

Fletcher, Marylynn, *Head Dept,* Victoria College, Fine Arts Dept, Victoria TX (S)

Fletcher, Pamela, *Asst Prof,* Bowdoin College, Art Dept, Brunswick ME (S)

Fletcher, Peter, *Prof,* Viterbo College, Art Dept, La Crosse WI (S)

Fletcher, Sara, *Instr,* Cornell College, Peter Paul Luce Gallery, Mount Vernon IA

Fletcher, Sarena, *Head Librn,* Delaware Art Museum, Helen Farr Sloan Library, Wilmington DE

Flexner, Paul, *Chmn,* Salisbury State University, Art Dept, Salisbury MD (S)

Flickinger, Paul, *Head Ceramics,* Kalamazoo Institute of Arts, KIA School, Kalamazoo MI (S)

Flickinger, Paul, *Treas,* Berks Art Alliance, Reading PA

Flinspach, Joan, *Pres & CEO,* The Lincoln Museum, Fort Wayne IN

Flint, Jean, *Instr,* Arkansas State University, Dept of Art, State University AR (S)

Flint, Matt, *Prof 2-D,* Central Wyoming College, Art Center, Riverton WY (S)

Flint, Suzanne, *Cur,* Pocumtuck Valley Memorial Association, Memorial Hall Museum, Deerfield MA

Flitner, Jane V, *Asst Educ,* Brandywine River Museum, Chadds Ford PA

Flocchini, Paola, *Assoc Prof,* Universite de Montreal, Bibliotheque d'Amenagement, Montreal PQ

Flood, James, *Dept Chmn,* Towson State University, Dept of Art, Towson MD (S)

Flood, Richard, *Chief Cur,* Walker Art Center, Minneapolis MN

Flood, Wendy, *Project Coordr,* Frederic Remington, Ogdensburg NY

Flores, Lulu, *Bd Pres,* MEXIC-ARTE Museum, Austin TX

Flores, Richard, *Instr,* College of the Sequoias, Art Dept, Visalia CA (S)

Florian, Michael, *Prof,* Universite de Montreal, Bibliotheque d'Amenagement, Montreal PQ

Flory, Jim, *Instr,* Pacific University in Oregon, Arts Div, Dept of Art, Forest Grove OR (S)

Flower, Ruth, *Pres,* Lunenburg Art Gallery Society, Lunenburg NS

Flowers, Randolph, *Prof,* Del Mar College, Art Dept, Corpus Christi TX (S)

Floyd, Carl, *Prof,* Cleveland Institute of Art, Cleveland OH (S)

Floyd, Rick, *Registrar,* Modern Art Museum, Fort Worth TX

Flug, Janice, *Asst University Librn,* American University, Jack & Dorothy G Bender Library & Learning Resources Center, Washington DC

Flury, Jane, *Vice Pres,* Pacific Grove Art Center, Pacific Grove CA

Flynn, Robert, University of Manitoba, School of Art, Winnipeg MB (S)

Flynn, Sarah, *Dir Pub Relations,* Norton Museum of Art, West Palm Beach FL

Flynn, Sharon, *Group Sales Coordr,* Boca Raton Museum of Art, Boca Raton FL

Focht, Brenda, *Cur Coll & Exhib,* Riverside Municipal Museum, Riverside CA

Fogarty, Lori, *Dir Curatorial Affairs,* San Francisco Museum of Modern Art, San Francisco CA

Fogel, Harris, *Chmn Photography, Media Arts, Film & Animation,* University of the Arts, Philadelphia Colleges of Art & Design, Performing Arts & Media & Communication, Philadelphia PA (S)

Fogerty, Lee, *Asst Dir,* Springfield City Library, Springfield MA

Fogher, Valentina, *Cur,* Museo Italo Americano, San Francisco CA

Fogher, Valentina, *Cur,* Museo Italo Americano, Library, San Francisco CA

Fogle, Douglas, *Cur Contemp Art,* Carnegie Museums of Pittsburgh, Carnegie Museum of Art, Pittsburgh PA

Fogle, Gerda, *Dir Mktg & Communications,* Indiana State Museum, Indianapolis IN

Fogle, Pamela, *Dir Human Resources,* Columbus Museum of Art and Design, Indianapolis IN

Fogt, Rex, *Assoc Prof,* University of Toledo, Dept of Art, Toledo OH (S)

Folda, Jaroslav, *Prof,* University of North Carolina at Chapel Hill, Art Dept, Chapel Hill NC (S)

Foldes, Lance, *Dir,* Berry College, Memorial Library, Mount Berry GA

Foles, Clyde, *Chmn Industrial Design,* Center for Creative Studies, College of Art & Design, Detroit MI (S)

Foley, Cindy M, *Dir Educ,* Maine College of Art, The Institute of Contemporary Art, Portland ME

Foley, Cynthia Meyers, *Dir Educ,* Columbus Museum of Art, Columbus OH

Foley, Edward, *Head Preparator,* Judah L Magnes, Berkeley CA

Foley, Jodie, *Archivist,* Montana Historical Society, Helena MT

Foley, Kathy K, *Dir,* Leigh Yawkey Woodson, Wausau WI

Foley, Mike, *Design Ctr Adjunct,* Iowa Wesleyan College, Art Dept, Mount Pleasant IA (S)

Foley, Mim, *VPres,* Port Angeles Fine Arts Center, Port Angeles WA

Foley, Sean, Maine College of Art, Portland ME (S)

Folkerts, Gerald, *Newsletter Ed,* Manitoba Society of Artists, Winnipeg MB

Folkestad, William, *Chmn,* Central Washington University, Dept of Art, Ellensburg WA (S)

Folsom, James, *Dir Botanical Gardens,* The Huntington Library, Art Collections & Botanical Gardens, San Marino CA

Folsom, James, *Dir Botanical Gardens,* The Huntington Library, Art Collections & Botanical Gardens, Library, San Marino CA

Folts, James, *Chmn,* Oregon State University, Dept of Art, Corvallis OR (S)

Foltz, Amy, *Instr,* Morningside College, Art Dept, Sioux City IA (S)

Folz, Christine, *Weaving,* Worcester Center for Crafts, Worcester MA (S)

Fong, Mimi, *Instr,* Sacramento City College, Art Dept, Sacramento CA (S)

Fontaine-White, Barbar, *Asst Prof,* University of Mary Hardin-Baylor, School of Fine Arts, Belton TX (S)

Fontana, Jeffrey, *Prof,* Austin College, Art Dept, Sherman TX (S)

Fontant, Lilia, *Acting Dir,* Miami-Dade College, Kendal Campus, Art Gallery, Miami FL

Fontenote-Jamerson, Belinda, *Pres,* Museum of African American Art, Los Angeles CA

Foote, Vincent M, *Prof,* North Carolina State University at Raleigh, School of Design, Raleigh NC (S)

Forbes, Susan, *Div Chmn,* Wells College, Dept of Art, Aurora NY (S)

Force, Farrokh, *VPres Finance,* Please Touch Museum, Philadelphia PA

Ford, Beth, *Prof Emerita,* Florida Southern College, Melvin Art Gallery, Lakeland FL

Ford, Betsy, *Secy,* Toledo Artists' Club, Toledo OH

Ford, Janice, *Gallery Dir,* Pikeville College, Humanities Division, Pikeville KY (S)

Ford, John, *Asst Prof,* University of North Carolina at Charlotte, Dept Art, Charlotte NC (S)

Ford, Patricia, *Coll Mgr,* Rochester Historical Society, Rochester NY

Ford, Sharon, *Instr,* Santa Ana College, Art Dept, Santa Ana CA (S)

Ford, Tim, *Instr,* Appalachian State University, Dept of Art, Boone NC (S)

Forde, Ed, *Chmn,* California State University, Los Angeles, Art Dept, Los Angeles CA (S)

Forde, Ed, *Chmn Dept,* University of Nebraska-Lincoln, Dept of Art & Art History, Lincoln NE (S)

Foreman, Henry T, *Instr,* Appalachian State University, Dept of Art, Boone NC (S)

Forgang, David M, *Chief Cur,* Yosemite Museum, Yosemite National Park CA

Fornell, Julie, *Asst Mgr,* Detroit Public Library, Art & Literature Dept, Detroit MI

Forney, Darrell, *Instr,* Sacramento City College, Art Dept, Sacramento CA (S)

Forni, Andrea L, *Curatorial Asst,* The Long Island Museum of American Art, History & Carriages, Library, Stony Brook NY

Forrest, Anne, *Head Children's Prog,* Kalamazoo Institute of Arts, KIA School, Kalamazoo MI (S)

Forsberg, Diane, *Chief Cur,* Canajoharie Library & Art Gallery, Arkell Museum of Canajoharie, Canajoharie NY

Forsberg, Diane, *Cur,* Mark Twain, Research Library, Hartford CT

Forschler, Anne, *Cur Decorative Arts,* Birmingham Museum of Art, Birmingham AL

Forschler, Anne M, *Cur Decorative Arts,* Birmingham Museum of Art, Clarence B Hanson Jr Library, Birmingham AL

Forshay, Patrick, *Instr,* Hillsdale College, Art Dept, Hillsdale MI (S)

Forster, Angela, *Asst Prof Electronic Media Arts Design,* University of Denver, School of Art & Art History, Denver CO (S)

Forsyth, Alex, *Instr,* Guilford Technical Community College, Commercial Art Dept, Jamestown NC (S)

Forsyth, Amy, *Assoc Prof,* Lehigh University, Dept of Art & Architecture, Bethlehem PA (S)

Fort, Karen, *Exhib Prog Mgr,* National Museum of the American Indian, George Gustav Heye Center, New York NY

Fort, Lifran, *Chmn & Instr,* Fisk University, Art Dept, Nashville TN (S)

Fortenberry, Tobin, *Registrar,* Mississippi Museum of Art, Howorth Library, Jackson MS

Fortier, Jerome, *Asst Cur,* Marquette University, Haggerty Museum of Art, Milwaukee WI

Fortin, Jocelyn, *Conservator Contemporary Art,* Le Musee Regional de Rimouski, Centre National d'Exposition, Rimouski PQ

Fortney, Kim, *Cur Educ,* Heritage Center of Lancaster County Museum, Lancaster PA

Fortriede, Steven, *Assoc Dir,* Allen County Public Library, Art, Music & Audiovisual Services, Fort Wayne IN

Fortson, Kay, *Pres,* Kimbell Art Museum, Fort Worth TX

Foshay, Susan MacAlpine, *Dir,* Nova Scotia Centre for Craft & Design, Mary E Black Gallery, Halifax NS

Fosnaught, Patricia S, *Cur Educ,* Gulf Coast Museum of Art, Largo FL

Fosnaught, Patt, *Cur Educ,* Gulf Coast Museum of Art, Inc, Largo FL

Fosque, William, *Prof,* Portland State University, Dept of Art, Portland OR (S)

Foss, MaryBeth, *Exec Dir,* LeMoyne Art Foundation, Inc, Tallahassee FL

Fossum, Andrea, *Educ Dir,* Flagler Museum, Palm Beach FL

Foster, April, *Instr,* Art Academy of Cincinnati, Cincinnati OH (S)

Foster, Bill, *Dir,* Portland Art Museum, Northwest Film Center, Portland OR

Foster, Daniel, *Exec Dir,* Riverside Art Museum, Riverside CA

Foster, David, *Chmn Art Dept,* Lake Tahoe Community College, Art Dept, South Lake Tahoe CA (S)

Foster, Elaine, *Prof,* Jersey City State College, Art Dept, Jersey City NJ (S)

Foster, Elnora, *Dir Finance & Facility,* Piedmont Arts Association, Martinsville VA

Foster, Eryn, *Dir,* Eye Level Gallery, Halifax NS

Foster, Frank, *Chmn,* Victor Valley Community College, Art Dept, Victorville CA (S)

Foster, Heather, *Asst Dir & Cur,* Hammond-Harwood House Association, Inc, Hammond-Harwood House, Annapolis MD

Foster, John R, *Cur Paleontology,* Museum of Western Colorado, Grand Junction CO

Foster, Laura, *Cur,* Frederic Remington, Ogdensburg NY

Foster, Lea, *Coll Mgr,* Hartwick College, The Yager Museum, Oneonta NY

Foster, Lisa, *Develop Dir,* Film Arts Foundation, San Francisco CA

Foster, Mary, *Office Coordr,* University of Notre Dame, Dept of Art, Art History & Design, Notre Dame IN (S)

Foster, Robert, *Gallery Dir,* Artists Association of Nantucket, Nantucket MA

Foster, Stephen, *Assoc Prof (Visual Art),* University of British Columbia Okanagan, Dept of Creative Studies, Kelowna BC (S)

Fostor, Kathy, *McNeil Cur American Art,* Philadelphia Museum of Art, Philadelphia PA

Foti, Silvana, *Chmn,* Methodist College, Art Dept, Fayetteville NC (S)

Fou-hran-Shauil, Lila, *Librn,* The York County Heritage Trust, Library, York PA

Fought, Rick, *Librn,* Art Institute of Fort Lauderdale, Technical Library, Fort Lauderdale FL

Founds, George, *Assoc Prof,* La Roche College, Division of Graphics, Design & Communication, Pittsburgh PA (S)

Fouquet, Monique, *VPres Acad,* Emily Carr Institute of Art & Design, Vancouver BC (S)

Fournet, Cheryl A Hayes, *Assoc Prof,* University of New Orleans-Lake Front, Dept of Fine Arts, New Orleans LA (S)

Fournier, Diane, *Library Technician,* Montreal Museum of Fine Arts, Library, Montreal PQ

Fowler, John, *Pres,* Sierra Arts Foundation, Reno NV

Fowler, Sherry, *Asst Prof,* Lewis & Clark College, Dept of Art, Portland OR (S)

Fowler, Thomas, *Mgr Art, Music, Bus & Technical Science,* San Francisco Public Library, Art & Music Center, San Francisco CA

Fowler, William M, *CEO,* Massachusetts Historical Society, Library, Boston MA

Fowler, William M, *Dir,* Massachusetts Historical Society, Boston MA

Fox, Amy, *Dir of Develop,* Handweaving Museum & Arts Center, Clayton NY (S)

Fox, Anne, *House Adminr,* Charleston Museum, Joseph Manigault House, Charleston SC

Fox, Carol, *Deputy Dir,* Honolulu Academy of Arts, Honolulu HI

Fox, Carson, *Instr,* Main Line Art Center, Haverford PA (S)

Fox, Christopher D, *Cur,* Fort Ticonderoga Association, Ticonderoga NY

Fox, Christopher D, *Cur,* Fort Ticonderoga Association, Thompson-Pell Research Center, Ticonderoga NY

Fox, Edward, *Prof,* Nassau Community College, Art Dept, Garden City NY (S)

Fox, Elizabeth, *Educational Outreach Coordr,* Rawls Museum Arts, Courtland VA

Fox, Ena, *Dir Educ,* Institute of Contemporary Art, Boston MA

Fox, Gail, *Prof,* Delaware County Community College, Communications & Humanities House, Media PA (S)

Fox, Heath, *Dir Admin,* San Diego Museum of Art, San Diego CA

Fox, John, *Asst Prof,* Finger Lakes Community College, Visual & Performing Arts Dept, Canandaigua NY (S)

Fox, Larnie, *Dir Children's Class,* Palo Alto Art Center, Palo Alto CA

Fox, Michael, *Asst Dir Library,* Minnesota Historical Society, Library, Saint Paul MN

Fox, Michael, *Deputy Dir,* Minnesota Historical Society, Saint Paul MN

Fox, Nancy, *COO,* Robert Gumbiner, Museum of Latin American Art, Long Beach CA

Fox, Pamela, *Dean School Fine Arts,* Miami University, Art Dept, Oxford OH (S)

Fox, Paulette, *Dir Pub Relations,* Tennessee State Museum, Nashville TN

Fox, Randall, *Supt,* Nebraska Game and Parks Commission, Arbor Lodge State Historical Park & Morton Mansion, Nebraska City NE

Fox, Ronald, *Exec Dir,* Saint Bernard Foundation & Monastery, North Miami Beach FL

Fox, Sharon, *Publications,* Palo Alto Art Center, Palo Alto CA

Fox, Suzi, *Studio Faculty,* University of Virginia, McIntire Dept of Art, Charlottesville VA (S)

Foxworthy, Deanna, *Assoc Prof,* Glenville State College, Dept of Fine Arts, Glenville WV (S)

Fraas, Kathleen, *Registrar,* Niagara University, Castellani Art Museum, Niagara NY

Fraher, David J, *Exec Dir,* Arts Midwest, Minneapolis MN

Frail, Robert, *Head,* Centenary College, Humanities Dept, Hackettstown NJ (S)

Fraioli, Christine, *Preparator,* Middlebury College, Museum of Art, Middlebury VT

Frakes, Jim, *Asst Prof,* University of North Carolina at Charlotte, Dept Art, Charlotte NC (S)

Frame, Susan, *Faculty,* Grand Marais Art Colony, Grand Marais MN (S)

Franc, Julie, *Admin Asst,* Walter Anderson, Ocean Springs MS

France, Crystal, *Dir Mktg,* Piedmont Arts Association, Martinsville VA

France, Erica, *Cur,* Fort Collins Museum of Contemporary Art, Fort Collins CO

Francey, Mary, *Cur American Art,* University of Utah, Utah Museum of Fine Arts, Salt Lake City UT

Franchino, Mark, *Asst Prof,* Clarion University of Pennsylvania, Dept of Art, Clarion PA (S)

Francik, Jeff, *Vistor Svcs Coordr,* Elmhurst Art Museum, Elmhurst IL

Francis, Judy, *Pres,* Society of Illustrators, Museum of American Illustration, New York NY

Francis, Tom, *Painting Chmn,* Atlanta College of Art, Atlanta GA (S)

Francis, Wayne, *Gallery Dir,* Northern Michigan University Art Museum, Marquette MI

Francke, Hendrik-Jan, *Instr,* University of Delaware, Dept of Art, Newark DE (S)

Franco, Barbara, *Pres & CEO,* Historical Society of Washington DC, The City Museum of Washington DC, Washington DC

Franco, Barbara, *Pres & CEO,* Historical Society of Washington DC, Kiplinger Research Library, Washington DC

Francuz, Liliane, *Visual Arts Prog Mgr,* Department of Commerce, Wyoming Arts Council Gallery, Cheyenne WY

Franczyk, Jean, *Dir Educ,* Museum of Science & Industry, Chicago IL

Frandrup, Dennis, *Chmn,* College of Saint Benedict, Art Dept, Saint Joseph MN (S)

Frandrup, Dennis, *Prof,* Saint John's University, Art Dept, Collegeville MN (S)

Frank, Barbara, *Prof,* State University of New York at Stony Brook, Dept of College of Arts & Sciences, Art Dept, Stony Brook NY (S)

Frank, David, *Prof,* Mississippi University for Women, Division of Fine & Performing Arts, Columbus MS (S)

Frank, Denise, *Dir Fine Arts,* Chattanooga State Technical Community College, Advertising Arts Dept, Chattanooga TN (S)

Frank, Eric, *Prof,* Occidental College, Dept of Art History & Visual Arts, Los Angeles CA (S)

Frank, Ilene, *Art Reference Librn,* University of South Florida, Library, Tampa FL

Frank, Ilene, *Dir Pub Prog,* Rensselaer County Historical Society, Museum & Library, Troy NY

Frank, Ilene, *Pub Program Mgr,* Rensselaer County Historical Society, Hart-Cluett Mansion, 1827, Troy NY

Frank, Jacqueline, *Assoc Prof,* C W Post Campus of Long Island University, School of Visual & Performing Arts, Brookville NY (S)

Frank, Jacqueline, *Recorder,* Neville Public Museum, Green Bay WI

Frank, Jane Susan, *VPres,* Peninsula Fine Arts Center, Newport News VA

Frank, Kim, *Mus Shop Mgr,* Zoo Montana, Billings MT

Frank, Micheline, *Co-Chmn,* Studio Gallery, Washington DC

Frank, Patrick, *Asst Prof,* University of Kansas, Kress Foundation Dept of Art History, Lawrence KS (S)

Frank, Peter, *Sr Cur,* Riverside Art Museum, Riverside CA

Franke, Daniel, *Asst Prof,* University of West Florida, Dept of Art, Pensacola FL (S)

Franke, John C, *Gen Educ,* Art Institute of Pittsburgh, Pittsburgh PA (S)

Franke, Judith A, *Dickson Mounds Mus,* Illinois State Museum, Museum Store, Chicago IL

Frankenbach, Susan, *Registrar,* The Slater Memorial Museum, Slater Memorial Museum, Norwich CT

Frankenhauser, Cyndie, *Develop Dir,* Sierra Arts Foundation, Reno NV

Frankfurt, Judith, *Deputy Dir for Admin,* Brooklyn Museum, Brooklyn NY

Franki, Jamie, *Assoc Prof,* University of North Carolina at Charlotte, Dept Art, Charlotte NC (S)

Franklin, David, *Cur Prints & Drawings,* National Gallery of Canada, Ottawa ON

Franklin, Jonathan, *Head Coll & Database Management,* National Gallery of Canada, Library, Ottawa ON

Franklin, Julia, *Dept Coordr & Assoc Prof,* Graceland University, Fine Arts Div, Lamoni IA (S)

Franklin, Julie, *Exhibs Registrar,* Judah L Magnes, Berkeley CA

Franklin, Richard, *Volunteer Pres,* State Historical Society of Missouri, Columbia MO

Franko, Joseph, *Assoc Dean Arts & Science,* Pace University, Dyson College of Arts & Sciences, Pleasantville NY (S)

Franson, Scott, *Instr,* Ricks College, Dept of Art, Rexburg ID (S)

Frantz, Barry, *Instr,* Cuesta College, Art Dept, San Luis Obispo CA (S)

Frantz, James H, *Conservator In Charge,* The Metropolitan Museum of Art, New York NY

Franzini, Robert, *Chmn,* Morehead State University, Art Dept, Morehead KY (S)

Fraser, Bill, *Chmn Management Comt,* Manitoba Historical Society, Dalnavert Museum, Winnipeg MB

Fraser, David, *Pres & Bd Trustees,* The Textile Museum, Washington DC

Frasier, Stephanie, *Instr,* University of Evansville, Art Dept, Evansville IN (S)

Frasson, Claude, *Prof,* Universite de Montreal, Bibliotheque d'Amenagement, Montreal PQ

Frater, Sally, *Information Officer,* McMaster University, McMaster Museum of Art, Hamilton ON

Frauenglass, M, *Chmn Fine Arts,* Fashion Institute of Technology, Art & Design Division, New York NY (S)

Fravel, Sandi, *Cur Educ,* Sioux City Art Center, Sioux City IA (S)

Frazer, John, *Prof,* Wesleyan University, Dept of Art & Art History, Middletown CT (S)

Frazier, Anne, *Asst Dir & Dir Exhib,* Piedmont Arts Association, Martinsville VA

Frazier, Dianne, *Cur Educ,* Chattahoochee Valley Art Museum, LaGrange GA

Frazier, Eliza, *Co-Dir,* Holter Museum of Art, Helena MT

Freaney, Linda, *Dir & Permanent Coll & Archivist,* Woodstock Artists Association, Woodstock NY

Freaney, Linda, *Head Archivist,* Woodstock Artists Association, WAA Archives, Woodstock NY

Frebrowski, Lorrie, *Operations Mgr,* Basilian Fathers, Library, Mundare AB

Frechette, Suzy Enns, *Mgr Fine Arts Dept,* Saint Louis Public Library, Saint Louis MO

Frederick, Frances A, *Exec Dir,* Associated Artists of Pittsburgh, Pittsburgh PA

Frederick, Jennie, *Head Dept,* Maple Woods Community College, Dept of Art & Art History, Kansas City MO (S)

Fredericks, Cynthia, *Develop Mem,* North Tonawanda History Museum, North Tonawanda NY

Fredrick, Charles, *Prof,* California State Polytechnic University, Pomona, Art Dept, Pomona CA (S)

Fredrick, Paul, *Educ,* Las Vegas Natural History Museum, Las Vegas NV

Fredrick, Steve, *Co-Dir Art Center S,* Salt Lake Art Center, Salt Lake City UT

Freed, Wayne, *Assoc Prof,* Mohawk Valley Community College, Utica NY (S)

Freedman, Jacqueline, *Assoc Prof,* Cuyahoga Community College, Dept of Art, Cleveland OH (S)

Freedman, Matthew, *Sr Critic,* University of Pennsylvania, Graduate School of Fine Arts, Philadelphia PA (S)

Freedman, Susan K, *Pres,* Public Art Fund, Inc, New York NY

Freedman, Susan K, *Pres,* Public Art Fund, Inc, Visual Archive, New York NY

Freehling, Stanley M, *Pres,* The Arts Club of Chicago, Chicago IL

Freeland, Deborah, *Prog Coordr,* University of Mississippi, University Museum, Oxford MS

Freeman, Carla C, *Dir,* New York State College of Ceramics at Alfred University, Scholes Library of Ceramics, Alfred NY

Freeman, Carolyn, *Interior Design,* La Roche College, Division of Graphics, Design & Communication, Pittsburgh PA (S)

Freeman, Dana, *Assoc Prof & Dir Exhibs,* Aquinas College, Art Dept, Grand Rapids MI (S)

Freeman, David, *Prof,* Winthrop University, Dept of Art & Design, Rock Hill SC (S)

Freeman, Gary, *Dept Chmn,* Gaston College, Art Dept, Dallas NC (S)

Freeman, Harris, *Bus,* Antonelli Institute, Professional Photography & Commercial Art, Erdenheim PA (S)

Freeman, Harris, *Placement, Faculty,* Antonelli Institute, Professional Photography & Commercial Art, Erdenheim PA (S)

Freeman, Heather, *Asst Prof,* University of North Carolina at Charlotte, Dept Art, Charlotte NC (S)

Freeman, Jeff, *Prof,* University of South Dakota, Department of Art, College of Fine Arts, Vermillion SD (S)

Freeman, John C, *Assoc Prof,* University of Massachusetts Lowell, Dept of Art, Lowell MA (S)

Freeman, Keith, *Treas,* Halifax Historical Society, Inc, Halifax Historical Museum, Daytona Beach FL

Freeman, Kirk, *Assoc Prof,* Bethel College, Dept of Art, Saint Paul MN (S)

Freeman, Marion, *Dir Educ,* Antonelli Institute, Professional Photography & Commercial Art, Erdenheim PA (S)

Freeman, Marjorie, *Technical Svcs,* Sweet Briar College, Martin C Shallenberger Art Library, Sweet Briar VA

Freeman, Nancy, *Artistic Dir,* Round Top Center for the Arts Inc, Arts Gallery, Damariscotta ME

Freeman, Nancy, *Artistic Dir,* Round Top Center for the Arts Inc, Round Top Library, Damariscotta ME

Freeman, Robert, *Interim Cur,* Art Gallery of Mississauga, Mississauga ON

Freeman, Rusty, *VP Cur & Educ,* Plains Art Museum, Fargo ND

Freeman, Sue, *Pres,* Art Association of Jacksonville, David Strawn Art Gallery, Jacksonville IL

Freeman, Suzanne H, *Head Fine Arts Librn,* Virginia Museum of Fine Arts, Library, Richmond VA

Freer, Elene J, *Cur,* Muskoka Arts & Crafts Inc, Chapel Gallery, Bracebridge ON

Fregin, Nancy J, *Pres,* American Society of Artists, Inc, Palatine IL

Frego, Tina, *Special Events,* Eastern Shore Art Association, Inc, Library, Fairhope AL

Freilach, David, *Chief Adminr,* Alternative Museum, New York NY

Freiman, Lisa, *Assoc Cur Contemporary Art,* Columbus Museum of Art and Design, Indianapolis IN

Freitag, Sally, *Registrar,* National Gallery of Art, Washington DC

French, Annette, *Vistor Info Center,* Mississippi Museum of Art, Howorth Library, Jackson MS

French, Heather, *Mus Shop Mgr,* Riverside, the Farnsley-Moremen Landing, Louisville KY

French, Jeannie, *Assoc Prof,* South Dakota State University, Dept of Visual Arts, Brookings SD (S)

French, Kate Pearson, *Pres,* Wave Hill, Bronx NY

French, Stephanie, *VPres,* The American Federation of Arts, New York NY

French, Susanne, *Gallery Dir,* Merced College, Arts Division, Merced CA (S)

Frenette, Linda, *Exec Dir,* Visual Art Exchange, Raleigh NC

Frenzel, Peter M, *Pres,* Wesleyan University, Friends of the Davison Art Center, Middletown CT

Fretz, Phelan, *VPres Prog,* Museum of Science & Industry, Chicago IL

Freund, David, *Assoc Prof Photo,* Ramapo College of New Jersey, School of Contemporary Arts, Mahwah NJ (S)

Freund, Louise, *Publicity,* Gallery 9, Los Altos CA

Frew, Craig, *Chm (V),* The Barnum Museum, Bridgeport CT

Frey, Barbara, *Dir,* Texas A&M University - Commerce, University Gallery, Commerce TX

Frey, Barbara, *Instr Ceramics,* Texas A&M University Commerce, Dept of Art, Commerce TX (S)

Frey, Erick, *Treas,* Kelly-Griggs House Museum, Red Bluff CA

Frey, Mary, *Assoc Prof,* University of Hartford, Hartford Art School, West Hartford CT (S)

Friars, Ernest, *Co-Genealogist,* Kings County Historical Society & Museum, Hampton NB

Friberg, Ericl, *Pres Bd,* Carolina Art Association, Gibbes Museum of Art, Charleston SC

Fridlington, Bob, Cranford Historical Society, Cranford NJ

Fried, Geoffry, *Chmn Design Dept,* Art Institute of Boston at Lesley University, Boston MA (S)

Fried, John A, *Trustee,* Miami Watercolor Society, Inc, Miami FL

Friedberg, Erin, *Gallery Coordr,* City of Gainesville, Thomas Center Galleries - Cultural Affairs, Gainesville FL

Friedeman, Amanda, *Educator,* Spertus Institute of Jewish Studies, Spertus Museum, Chicago IL

Friedle, Kathy, *Educator,* Sheldon Museum & Cultural Center, Inc, Sheldon Museum & Cultural Center, Haines AK

Friedman, Alice T, *Prof,* Wellesley College, Art Dept, Wellesley MA (S)

Friedman, Ann, *Dir,* Evergreen State College, Evergreen Galleries, Olympia WA

Friedman, Avi, *Prof,* McGill University, School of Architecture, Montreal PQ (S)

Friedman, Barbara, *Prof,* Pace University, Dyson College of Arts & Sciences, Pleasantville NY (S)

Friedman, Betty, *Art Dept Chair,* Notre Dame de Namur University, Wiegand Gallery, Belmont CA (S)

Friedman, Joel, *Asst Prof,* Seton Hall University, College of Arts & Sciences, South Orange NJ (S)

Friedman, Lia, *Instruction & Outreach Librn,* University of California, San Diego, Arts Libraries, La Jolla CA

Friedman, Robert, *Dir,* Stephens College, Lewis James & Nellie Stratton Davis Art Gallery, Columbia MO

Friedman, Robert, *Instr,* Stephens College, Art Dept, Columbia MO (S)

Friedman-Romell, Frederick, *Interim Image Librn,* Cleveland Museum of Art, Ingalls Library, Cleveland OH

Friedman-Romell, Frederick, *Systems Librn,* Cleveland Museum of Art, Ingalls Library, Cleveland OH

Friend, Miles E, *Faculty,* Idaho State University, Dept of Art, Pocatello ID (S)

Frierson, Amy, *Dir,* Houston Museum of Decorative Arts, Chattanooga TN

Friesen, Leslie, *Power Creative Designer-in-Residence,* University of Louisville, Allen R Hite Art Institute, Louisville KY (S)

Friess, Nick, *Educ,* Blanden Memorial Art Museum, Museum Library, Fort Dodge IA

Frigard, Kelly, *Asst Prof,* McPherson College, Art Dept, McPherson KS (S)

Frisbee Johnson, Mary, *Prof & Head,* University of Northern Iowa, Dept of Art, Cedar Falls IA (S)

Frisch, Marianne Brunson, *Cur,* The Reader's Digest Association Inc, Pleasantville NY

Frish, Scott, *Asst Prof,* West Texas A&M University, Art, Communication & Theatre Dept, Canyon TX (S)

Frisse, Bettina, *Site Mgr,* Stone Quarry Hill Art Park, Cazenovia NY

Frisse, Bettina, *Site Mgr,* Stone Quarry Hill Art Park, Winner Gallery, Cazenovia NY

Frisse, Bettina, *Site Mgr,* Stone Quarry Hill Art Park, Jenny Gallery, Cazenovia NY

Fritz, Don, *Lectr,* Santa Clara University, Dept of Art & Art History, Santa Clara CA (S)

Fritz, James, *Prof,* Southwestern Oregon Community College, Visual Arts Dept, Coos Bay OR (S)

Fritz, Jim, *Instr,* Walla Walla Community College, Art Dept, Walla Walla WA (S)

Fritz, Lisa, *Instr,* Indian Hills Community College, Ottumwa Campus, Dept of Art, Ottumwa IA (S)

Fritzinger, John G, *Pres,* The Adirondack Historical Association, The Adirondack Museum, Blue Mountain Lake NY

Froehlich, Conrad G, *Dir,* Martin and Osa Johnson, Chanute KS

Froehlich, Conrad G, *Dir,* Martin and Osa Johnson, Imperato Collection of West African Artifacts, Chanute KS

Froehlich, Conrad G, *Dir,* Martin and Osa Johnson, Johnson Collection of Photographs, Movies & Memorabilia, Chanute KS

Froehlich, Conrad G, *Dir,* Martin and Osa Johnson, Selsor Art Gallery, Chanute KS

Froehlich, Conrad G, *Dir,* Martin and Osa Johnson, Scott Explorers Library, Chanute KS

Froehlich, Kristen, *Cur of Historical Society of PA Coll,* Atwater Kent Museum of Philadelphia, Philadelphia PA

Froen, Rosemary, *Grantsperson & Historian,* Mankato Area Arts Council, Carnegie Art Center, Mankato MN

From, Kristy, *Gallery Adminr,* University of Alabama at Huntsville, Union Grove Gallery & University Center Gallery, Huntsville AL

Froman, David, *Chmn,* Northeastern Oklahoma A & M College, Art Dept, Miami OK (S)

Fromm, Martin, *Assoc Prof,* University of Montana, Dept of Art, Missoula MT (S)

Fronek, Jennifer, *Treas,* DuPage Art League School & Gallery, Wheaton IL

Froom, Aimee, *Cur Islamic Art,* Brooklyn Museum, Brooklyn NY

Frost, Judy, *Accountant,* Whatcom Museum of History and Art, Library, Bellingham WA

Frost, Michelle, *Financial Mgr,* Atlanta Contemporary Art Center, Atlanta GA

Frudakis, Tony, *Asst Prof,* Hillsdale College, Art Dept, Hillsdale MI (S)

Fry, Eileen, *Slide Librn,* Indiana University, Fine Arts Library, Bloomington IN

Fry, Joseph, *Asst Dir,* Kent State University, School of Art, Kent OH (S)

Fryberger, Betsy G, *Cur Prints & Drawings,* Stanford University, Iris & B Gerald Cantor Center for Visual Arts, Stanford CA

Frye, Nancy, *Dir,* Bainbridge Island Arts Council, Bainbridge Isle WA

Frykman, Sharon, *Faculty,* Grand Marais Art Colony, Grand Marais MN (S)

Frykman, Steve, *Faculty,* Grand Marais Art Colony, Grand Marais MN (S)

Fuchs, Angelee, *Prof,* Mount Mary College, Art & Design Division, Milwaukee WI (S)

Fuege, Gary, *Lectr,* Rice University, Dept of Art & Art History, Houston TX (S)

Fuell, Joyce, *Admin Asst,* The College of Wooster, The College of Wooster Art Museum, Wooster OH

Fuentes, Leo, *Prof,* City College of New York, Art Dept, New York NY (S)

Fuentes, Tina, *Assoc Prof,* Texas Tech University, Dept of Art, Lubbock TX (S)

Fugate-Wilcox, Perry, *Treas,* Actual Art Foundation, New York NY

Fuhrman, Robert, *CEO,* Clark County Historical Society, Heritage Center of Clark County, Springfield OH

Fuhrman, Robert, *Dir,* Clark County Historical Society, Library, Springfield OH

Fuhro, Laura, *Asst Dir,* Berkeley Heights Free Public Library, Berkeley Heights NJ

Fukawa, Hirokazu, *Asst Prof,* University of Hartford, Hartford Art School, West Hartford CT (S)

Fulbright, Jana, *Pub Relations,* Art Museum of Southeast Texas, Beaumont TX

Fulghum, Neil, *VPres,* North Carolina Museums Council, Raleigh NC

Fuller, Benjamin A G, *Cur,* Penobscot Marine Museum, Searsport ME

Fuller, Charles, *Dean School Fine Arts,* Ouachita Baptist University, Dept of Visual Art, Arkadelphia AR (S)

Fuller, Cindy, *Board Pres,* North Shore Art League, Winnetka IL (S)

Fuller, Elizabeth E, *Librn,* The Rosenbach Museum & Library, Philadelphia PA

Fuller, Jeffrey, *Dir Develop,* The Currier Museum of Art, Currier Museum of Art, Manchester NH

Fullerton, Deborah, *Assoc Cur Educ,* South Texas Institute for the Arts, Art Museum of South Texas, Corpus Christi TX

Fullerton, Jane, *Mgr Pub Affairs & Acting Dir,* New Brunswick Museum, Saint John NB

Fullerton-Ferrigno, Deborah, *Cur Educ,* South Texas Institute for the Arts, Library, Corpus Christi TX

Fulton, Carol, *Exhibition Designer,* L A County Museum of Art, Los Angeles CA

Fulton, Christopher, *Assoc Prof,* University of Louisville, Allen R Hite Art Institute, Louisville KY (S)

Funderburg, Danielle, *Registrar,* Jule Collins Smith Museum of Art, Auburn AL

Funderburk, Brent, *Prof,* Mississippi State University, Dept of Art, Mississippi State MS (S)

Funk, Chetna, *Asst to Dir,* Greenville Museum of Art, Inc, Greenville NC

Funk, Patricia, *Progs & Mem,* Springfield Museum of Art, Springfield OH

Funke, Claudia, *Rare Books Cur,* Columbia University, Avery Architectural & Fine Arts Library, New York NY

Funkenstein, Susan, *Asst Prof,* University of Wisconsin-Parkside, Art Dept, Kenosha WI (S)

Funkhouser, Kate, *Fine Arts Dept Chmn,* Brazosport College, Art Dept, Lake Jackson TX (S)

Funnell, Jeff, University of Manitoba, School of Art, Winnipeg MB (S)

Furber, Rich, *Dir,* Chief Plenty Coups Museum State Park, Pryor MT

Furches, Stephen, *Instr,* University of Utah, Dept of Art & Art History, Salt Lake City UT (S)

Furdas, Patty, *Mus Shop Mgr,* Old State House, Hartford CT

Furgol, Edward, *Cur,* Naval Historical Center, The Navy Museum, Washington DC

Furlong, James, *Gallery Dir,* Hudson Guild, Hudson Guild Gallery, New York NY

Furlong, Mary Ellen, *Assoc Cur,* Kentucky Museum of Art & Craft, Louisville KY

Furman, David, *Prof Ceramics,* Pitzer College, Dept of Art, Claremont CA (S)

Furry, Stephanie, *Instr,* John C Calhoun, Department of Fine Arts, Decatur AL (S)

Furshong, Peg, *Dir,* North Dakota State University, Memorial Union Gallery, Fargo ND

Furst, Donald, *Prof,* University of North Carolina at Wilmington, Dept of Fine Arts - Division of Art, Wilmington NC (S)

Furtado, Ernestina, *Archivist,* New Bedford Free Public Library, Art Dept, New Bedford MA

Furtak, Rosemary, *Librn,* Walker Art Center, T J Peters Family Library, Minneapolis MN

Furtkamp, Darryl, *Lectr,* New England College, Art & Art History, Henniker NH (S)

Fusco, Peter, *Cur European Sculpture & Works of Art,* Getty Center, The J Paul Getty Museum, Los Angeles CA

Fusco, Peter, *Cur of European Sculpture & Works of Art,* Getty Center, Trust Museum, Los Angeles CA

Fussa, Nilsevady, *Auxiliary Prof,* University of Puerto Rico, Dept of Fine Arts, Rio Piedras PR (S)

Futernick, Robert, *Assoc Dir,* Fine Arts Museums of San Francisco, Legion of Honor, San Francisco CA

Fye, Rebecca, *Dir,* Jackson County Historical Society, John Wornall House Museum, Independence MO

Fyfe, Jo, *Dept Chmn & Asst Prof,* Spokane Falls Community College, Fine Arts Dept, Spokane WA (S)

Fyffe, Ben, *Asst Cur Coll,* City of El Paso, El Paso Museum of Art, El Paso TX

Gaasch, Cynnie, *Exec & Artistic Dir,* Chautauqua Center for the Visual Arts, Chautauqua NY

Gaasch, Cynnie, *Part-time Dir,* State University of New York College at Fredonia, M C Rockefeller Arts Center Gallery, Fredonia NY

Gabany, Donald, *Video Production,* Art Institute of Pittsburgh, Pittsburgh PA (S)

Gabara, Esther, *Asst Prof,* Duke University, Dept of Art, Art History & Visual Studies, Durham NC (S)

Gabarra, Ed, *Admin,* Mission San Luis Rey de Francia, Mission San Luis Rey Museum, Oceanside CA

Gabbard, Sara, *Dir Devel,* The Lincoln Museum, Fort Wayne IN

Gabbard, Susan J, *Pres,* National Art Education Association, Reston VA

Gadd, Richard W, *Exec Dir,* Monterey Museum of Art Association, Monterey Museum of Art, Monterey CA

Gadd, Sarah, *Asst Cur,* University of Wyoming, University of Wyoming Art Museum, Laramie WY

Gaffney, Gary, *Instr,* Art Academy of Cincinnati, Cincinnati OH (S)

Gaffney, T.J., *Cur Coll,* Port Huron Museum, Port Huron MI

Gage, Mary Margaret, *Dir,* Mohawk Valley Heritage Association, Inc, Walter Elwood Museum, Amsterdam NY

Gagnon, Francois Marc, *Instr,* Universite de Montreal, Dept of Art History, Montreal PQ (S)

Gagnon, Paulette, *Cur-in-Chief,* Musee d'art Contemporain de Montreal, Montreal PQ

Gagnon, Rachel, *Communications Mgr,* Craft Alliance, Saint Louis MO

Gaiber, Maxine, *Dir Educ,* San Diego Museum of Art, San Diego CA

Gaiber, Maxine, *Exec Dir,* Delaware Center for the Contemporary Arts, Wilmington DE

Gaines, Anne, *Adjunct Asst Prof,* Drew University, Art Dept, Madison NJ (S)

Gaither, Edmund B, *Dir & Cur,* Museum of the National Center of Afro-American Artists, Boston MA

Gajewski, Cezary, *Coordr Industrial Design,* University of Alberta, Dept of Art & Design, Edmonton AB (S)

Galacsy, Elizabeth, *Technical Serv Librn,* New York State College of Ceramics at Alfred University, Scholes Library of Ceramics, Alfred NY

Galante, Frances, *Instr,* Wayne Art Center, Wayne PA (S)

Galante, Peter, *Asst Prof,* Cardinal Stritch University, Art Dept, Milwaukee WI (S)

Galassi, Peter, *Chief Cur, Dept Photography,* Museum of Modern Art, New York NY

Galassi, Susan Grace, *Cur,* Frick Collection, New York NY

Galazka, Suzanne, *Admin Asst,* Artlink, Inc, Fort Wayne IN

Galbriath, Lynn, *Assoc Prof Art Educ,* University of Arizona, Dept of Art, Tucson AZ (S)

Galczenski, Marian, *Instr,* Cuesta College, Art Dept, San Luis Obispo CA (S)

Galehouse, Ida, *Librn,* Cheekwood-Tennessee Botanical Garden & Museum of Art, Botanic Hall Library, Nashville TN

Galembo, Phyllis, *Prof,* State University of New York at Albany, Art Dept, Albany NY (S)

Galizia, Ed, *Dir Music & Video Bus,* Art Institute of Fort Lauderdale, Fort Lauderdale FL (S)

Gall, Dolores, *Pres,* New Haven Paint & Clay Club, Inc, New Haven CT

Gallagher, Bill, *Sci Registrar,* New Jersey State Museum, Fine Art Bureau, Trenton NJ

Gallagher, Casey, *Dir Education,* Ann Arbor Art Center, Art Center, Ann Arbor MI

Gallagher, Edward, *Dir Educ,* Beck Center for the Arts, Lakewood OH

Gallagher, Edward, *Pres,* American-Scandinavian Foundation, Scandinavia House: The Nordic Center in America, New York NY

Gallagher, James, *Pres,* Philadelphia University, School of Textiles & Materials Technology, Philadelphia PA (S)

Gallagher, Jean, *Graduate Advisor, Instr & Prof,* California State University, Chico, Department of Art & Art History, Chico CA (S)

Gallagher, Marsha V, *Chief Cur, Cur Material Culture,* Joslyn Art Museum, Omaha NE

Gallagher Landis, Gary, *Deputy Dir of Extended Affairs,* San Jose Museum of Art, Library, San Jose CA

Gallant, Aprile, *Assoc Cur Prints, Drawings & Photographs,* Smith College, Museum of Art, Northampton MA

Gallant, Michele, *Registrar & Preparator,* Dalhousie University, Dalhousie Art Gallery, Halifax NS

Gallas, Ron, *Assoc Prof,* Saint Olaf College, Art Dept, Northfield MN (S)

Gallatin, Morgan Dean, *Gallery Dir,* Central Missouri State University, Art Center Gallery, Warrensburg MO

Gallavan, Teresa, *Mus Mgr,* Riverside County Museum, Edward-Dean Museum & Gardens, Cherry Valley CA

Galley, Sandra, *Pres & Dir,* The New England Museum of Telephony, Inc., The Telephone Museum, Ellsworth ME

Galloway, Elizabeth, *VPres & Dir,* Art Center College of Design, James Lemont Fogg Memorial Library, Pasadena CA

Galloway, Kat, *Prof Art,* Eastern Oregon University, School of Arts & Science, La Grande OR (S)

Galloway, Mary Lou, *Dir SIACM,* Illinois State Museum, Illinois Artisans & Visitors Centers, Chicago IL

Galloway, Mary Lou, *So IL Art,* Illinois State Museum, Museum Store, Chicago IL

Galloway, Robert, *Instr,* Mesa Community College, Dept of Art, Mesa AZ (S)

Galloway, Thomas D, *Dean,* Georgia Institute of Technology, College of Architecture, Atlanta GA (S)

Galvin, Mary, *Library Asst,* Detroit Institute of Arts, Research Library, Detroit MI

Gambill, Norman, *Head Dept,* South Dakota State University, Dept of Visual Arts, Brookings SD (S)

Gamble, Steven G, *Pres,* Southern Arkansas University, Art Dept Gallery & Magale Art Gallery, Magnolia AR

Gambliel, Maria Carmen, *Dir Folk & Trad Arts,* Idaho Commission on the Arts, Boise ID

Gammon, Lynda, *Chmn & Assoc Prof,* University of Victoria, Dept of Visual Arts, Victoria BC (S)

Gamon, Patricia, *Instr,* California State University, Dominguez Hills, Art Dept, Carson CA (S)

Gamse, Barbara, *Mus Shop Mgr,* Maryland Historical Society, Library, Baltimore MD

Gamwell, Lynn, *Dir,* State University of New York at Binghamton, University Art Museum, Binghamton NY

Gandara, Nancy, *Asst Dir,* Central Library, Dept of Fine Arts, San Antonio TX

Gander, Chris, *Instr,* Pacific Northwest College of Art, Portland OR (S)

Gandy, Janice, *Art Historian,* University of South Alabama, Dept of Art & Art History, Mobile AL (S)

Gandy, Jim, *Archivist,* New York State Military Museum and Veterans Research Center, Saratoga Springs NY

Gangarosa, Louis P, *Finance Officer,* Morris Museum of Art, Augusta GA

Gangopadhyay, Paula, *Cur Educ,* City of Grand Rapids Michigan, Public Museum of Grand Rapids, Grand Rapids MI

Ganis, John, *Chmn Photography,* Center for Creative Studies, College of Art & Design, Detroit MI (S)

Ganje, Melissa, *Cur,* Elmhurst Art Museum, Elmhurst IL

Ganong, Overton G, *Exec Dir,* South Carolina State Museum, Columbia SC

Gans, Liz, *Co-Dir,* Holter Museum of Art, Helena MT

Gans, Lucy, *Prof,* Lehigh University, Dept of Art & Architecture, Bethlehem PA (S)

Ganstrom, Linda, *Asst Prof,* Fort Hays State University, Dept of Art, Hays KS (S)

Gant, Sally, *Dir Educ & Special Progs,* Old Salem Inc, Museum of Early Southern Decorative Arts, Winston-Salem NC

Ganther, Becky, *Mktg & Pub Relations Mgr,* Golden State Mutual Life Insurance Company, Afro-American Art Collection, Los Angeles CA

Gantner, Bob, *Pres,* Essex Art Association, Inc, Essex CT

Gantner, Ellen, *Dir,* Illinois State Museum, Illinois Artisans & Visitors Centers, Chicago IL

Gantt, Richard, *Lectr,* University of North Carolina at Greensboro, Art Dept, Greensboro NC (S)

Gantz, Richard A, *Exec Dir,* Indiana State Museum, Indianapolis IN

Ganz, James A, *Cur Prints, Drawings & Photographs,* Sterling & Francine Clark, Williamstown MA

Garagan, Brenda, *Asst Dir,* Art Gallery of Nova Scotia, Halifax NS

Garay, Olga, *Dir Cultural Affairs,* Miami-Dade Community College, Wolfson Galleries, Miami FL

Garballey, Jim, *Head Sign Painting,* Butera School of Art, Boston MA (S)

Garber, Elizabeth, *Assoc Prof Chair,* University of Arizona, Dept of Art, Tucson AZ (S)

Garcia, Carole J, *International Representative,* National Native American Co-Operative, North America Indian Information & Trade Center, Tucson AZ

Garcia, Christopher, *Prof,* Antioch College, Visual Arts Dept, Yellow Springs OH (S)

Garcia, Dan, *Dir Gallery,* Asbury College, Art Dept, Wilmore KY (S)

Garcia, Deborah, *Unit Registrar,* Museum of New Mexico, Museum of International Folk Art, Santa Fe NM

Garcia, Donna Marie, *Librn,* Tacoma Art Museum, Reference Library, Tacoma WA

Garcia, E Meren, *Traveling Exhib Officer,* Musee d'art Contemporain de Montreal, Montreal PQ

Garcia, Iziar, *Slide Cur,* The Art Institute of Boston at Lesley University, Library, Boston MA

Garcia, Jose, *Asst Dir,* Miami Art Museum, Miami FL

Garcia, Leo, *Operations Mgr,* 18th Street Arts Complex, Santa Monica CA

Garcia, Martin, *Assoc Prof,* University of Puerto Rico, Dept of Fine Arts, Rio Piedras PR (S)

Garcia-Lomas, Natasha, *Asst Dir,* San Francisco Arts Commission, Gallery & Slide Registry, San Francisco CA

Garcia-Nuthmann, Andre, *Chmn,* New Mexico Highlands University, Dept of Communications & Fine Arts, Las Vegas NM (S)

Gard, Elizabeth, *Collections Mgr,* Harriet Beecher Stowe, Hartford CT

Gardinier, Paul, *Exhibits Technician,* Alaska State Museum, Juneau AK

Gardner, Donald E, *VPres,* Manchester Historic Association, Manchester NH

Gardner, Margaret, *Instr,* Wayne Art Center, Wayne PA (S)

Gardner, William F, *Instr,* North Florida Community College, Dept Humanities & Art, Madison FL (S)

Garen, Selly, *Asst Prof,* Marymount University, School of Arts & Sciences Div, Arlington VA (S)

Garfield, Ellen, *Assoc Prof,* Monmouth University, Dept of Art & Design, West Long Branch NJ (S)

Garfinkel, Tina, *Head Registrar,* San Francisco Museum of Modern Art, San Francisco CA

Gargir, Jacob, *Dir Global Textile Marketing,* Philadelphia University, School of Textiles & Materials Technology, Philadelphia PA (S)

Garhart, Karen M, *Vis Assoc Prof Art,* Kenyon College, Art Dept, Gambier OH (S)

Garhart, Martin, *Prof,* Kenyon College, Art Dept, Gambier OH (S)

Gariff, David, *Asst Prof,* University of Wisconsin-Stout, Dept of Art & Design, Menomonie WI (S)

Garland, James, *Assoc VPres of Univ Rels,* University of Bridgeport Gallery, Bridgeport CT

Garland, Jeff, *Head Dept,* Springfield College in Illinois, Dept of Art, Springfield IL (S)

Garmendia, Tatiana, *Prof,* Seattle Central Community College, Humanities - Social Sciences Division, Seattle WA (S)

Garmon, Carole, *Sr Lectr,* Mary Washington College, Dept of Art & Art History, Fredericksburg VA (S)

Garneau, Neil, *Cur,* Owen Sound Historical Society, Marine & Rail Heritage Museum, Owen Sound ON

Garner, Jennifer, *Dir,* Metropolitan State College of Denver, Center for Visual Art, Denver CO

Garner, Sharon, *Mus Aide,* Historical Museum at Fort Missoula, Missoula MT

Garner, Teresa S, *Chmn,* Mesa State College, Art Dept, Grand Junction CO (S)

Garnett, Joy, *Library Assoc,* The Metropolitan Museum of Art, Robert Goldwater Library, New York NY

Garnett, Leah, *Asst Prof,* Mount Allison University, Dept of Fine Arts, Sackville NB (S)

Garoza, Valdis, *Chmn,* Marietta College, Grover M Hermann Fine Arts Center, Marietta OH

Garoza, Valdis, *Chmn,* Marietta College, Art Dept, Marietta OH (S)

Garr, Robin, *Dir Educ,* Bruce Museum, Inc, Bruce Museum, Greenwich CT

Garrard, Mary, *Prof,* American University, Dept of Art, Washington DC (S)

Garrels, Gary, *Chief Cur,* San Francisco Museum of Modern Art, San Francisco CA

Garrett, Anne, *Dir Educ,* The Art Center of Waco, Creative Art Center, Waco TX

Garrett, Anne, *Dir Educ,* The Art Center of Waco, Creative Art Center, Waco TX

Garrett, Barbara, *Dir Artist Svcs,* Idaho Commission on the Arts, Boise ID

Garrett, Donna, *Secy,* Wayne County Historical Society, Honesdale PA

Garrett, Jural J, *Chief Deputy Dir,* Natural History Museum of Los Angeles County, Los Angeles CA

Garrett, Michael, *Asst Dean Arts & Humanities,* Johnson County Community College, Visual Arts Program, Overland Park KS (S)

Garrett, Michael, *Head Dept,* Mississippi University for Women, Division of Fine & Performing Arts, Columbus MS (S)

Garrison, Denzil, *VChmn,* Oklahoma Historical Society, Library Resources Division, Oklahoma City OK

Garrison, Elizabeth, *Cur Educ,* Portland Art Museum, Northwest Film Center, Portland OR

Garrison, Elizabeth, *Educ Cur,* Willamette University, Hallie Ford Museum of Art, Salem OR

Garrison, Helen, *Dean Liberal Arts,* Art Institute of Southern California, Laguna Beach CA (S)

Garrison, Jim, *Instr,* Mesa Community College, Dept of Art, Mesa AZ (S)

Garrison, Jodie, *Instr Painting,* Columbia College, Art Dept, Columbia MO (S)

Garrity, Noreen Scott, *Cur Educ,* Rutgers University, Stedman Art Gallery, Camden NJ

Garrott, Martha, *Dir,* Craftsmen's Guild of Mississippi, Inc, Mississippi Crafts Center, Ridgeland MS

Gartenmann, Donna, *City of Boulder Arts Commission & Dir Cultural Programs,* Boulder Public Library & Gallery, Dept of Fine Arts Gallery, Boulder CO

Garthwaite, Ernest, *Assoc Prof,* York College of the City University of New York, Fine & Performing Arts, Jamaica NY (S)

Gartner, Jackie, *Asst,* Pope County Historical Society, Pope County Museum, Glenwood MN

Garvey, Susan Gibson, *Dir & Cur,* Dalhousie University, Dalhousie Art Gallery, Halifax NS

Garvey, Timothy, *Instr,* Illinois Wesleyan University, School of Art, Bloomington IL (S)

Garvin, Chris, *Dir Multimedia,* University of the Arts, Philadelphia Colleges of Art & Design, Performing Arts & Media & Communication, Philadelphia PA (S)

Garwood, Joe, *Bus Mgr,* Modern Art Museum, Fort Worth TX

Garwood, Virginia, *Instr,* Wayne Art Center, Wayne PA (S)

Gary, Anne-Bridget, *Prof,* University of Wisconsin-Stevens Point, Dept of Art & Design, Stevens Point WI (S)

Gary, Jenae, *Office Mgr,* Erie Art Museum, Erie PA

Garza, Mario, *Museum Mgr,* Spanish Governor's Palace, San Antonio TX

Gascogne, Laura-Harris, *Assoc Prof Art, Ceramic Dept Coordr,* Johnson County Community College, Visual Arts Program, Overland Park KS (S)

Gascon, France, *Dir,* Musee d'Art de Joliette, Joliette PQ

Gascon, France, *Dir,* Musee d'Art de Joliette, Library, Joliette PQ

Gaske, Fred, *Bureau Chief,* Florida Folklife Programs, Tallahassee FL

Gaskil, Darlene, *Adj Prof,* Oral Roberts University, Art Dept, Tulsa OK (S)

Gasparro, Frank, *Instr,* Samuel S Fleisher, Philadelphia PA (S)

Gasper, Barbara, *Treas,* Birmingham-Bloomfield Art Center, Art Center, Birmingham MI

Gast, Claudia, *Ofc Mgr,* Toledo Artists' Club, Toledo OH

Gastio, Ray, *Exec Dir,* Van Allen Institute, New York NY

Gaston, Elizabeth, *Asst Prof,* Mount Mary College, Art & Design Division, Milwaukee WI (S)

Gaston, Elizabeth, *Cur,* Mount Mary College, Marian Gallery, Milwaukee WI

Gastonguay, N, *Asst Librn,* Musee du Quebec, Bibliotheque, Quebec PQ

Gates, H I, *Prof,* George Washington University, Dept of Art, Washington DC (S)

Gates, James L, *Librn,* National Baseball Hall of Fame & Museum, Inc, Art Collection, Cooperstown NY

Gates, Jay, *Dir,* The Phillips Collection, Washington DC

Gates, Jordene, *Interior Design,* Art Institute of Pittsburgh, Pittsburgh PA (S)

Gates, Leigh, *Head Slide Librn,* The Art Institute of Chicago, Ryerson & Burnham Libraries, Chicago IL

Gates, Mimi, *Dir,* Seattle Art Museum, Seattle WA

Gates, Sue, *Dir,* Dacotah Prairie Museum, Lamont Art Gallery, Aberdeen SD

Gates, Sue, *Dir,* Dacotah Prairie Museum, Ruth Bunker Memorial Library, Aberdeen SD

Gates, William, *Cur,* The American Ceramic Society, Ross C Purdy Museum of Ceramics, Westerville OH

Gates, William, *Cur History,* Ohio Historical Society, National Road-Zane Grey Museum, Columbus OH

Gatten, Jeff, *Dean,* California Institute of the Arts Library, Santa Clarita CA

Gatti, Stanlee, *Pres,* San Francisco City & County Art Commission, San Francisco CA

Gattis, Tom, *Instr,* Suomi International College of Art & Design, Fine Arts Dept, Hancock MI (S)

Gauch, Lois, *Librn,* Rochester Historical Society, Rochester NY

Gauchier, Michelle, *Librn,* Musee d'art Contemporain de Montreal, Mediatheque, Montreal PQ

Gaudieri, Millicent Hall, *Exec Dir,* Association of Art Museum Directors, New York NY

Gaudin, Susanne, *Grants & Fund-raising Advisor to Bd,* Brown County Art Gallery Foundation, Brown County Art Gallery & Foundation, Nashville IN

Gaudreault, Andre, *Instr,* Universite de Montreal, Dept of Art History, Montreal PQ (S)

Gaumond, Lisa, *Gallery Mgr,* University of Hartford, Joseloff Gallery, West Hartford CT

Gautier, Denis, *Dir & Cur,* Burnaby Art Gallery, Burnaby BC

Gautreau, Lara, *Cur Art Educ,* Louisiana Arts & Science Museum, Baton Rouge LA

Gauvin, Claude, *Prof Painting,* Universite de Moncton, Dept of Visual Arts, Moncton NB (S)

Gavin, Leslie, *Pub Relations,* City of San Rafael, Falkirk Cultural Center, San Rafael CA

Gavin, Robin Farwell, *Cur Spanish Colonial Coll,* Museum of New Mexico, Museum of International Folk Art, Santa Fe NM

Gay, Anne, *Educ,* Headley-Whitney Museum, George Headley Library, Lexington KY

Gay, Pody, *Educ Coordr,* City of Springdale, Shiloh Museum of Ozark History, Springdale AR

Gays, Kieran, *Asst Prof,* Azusa Pacific University, College of Liberal Arts, Art Dept, Azusa CA (S)

Gazzo, Bridget, *Pre-Columbian Studies Librn,* Harvard University, Dumbarton Oaks Research Library, Washington DC

Gealt, Barry, *Prof,* Indiana University, Bloomington, Henry Radford Hope School of Fine Arts, Bloomington IN (S)

Gearding, Dave, *Facility Mgr,* Contemporary Arts Center, Cincinnati OH

Gebb, Wayne, *Instr Music & Choir,* Midway College, Art Dept, Midway KY (S)

Gebhardt, Matt, *Cur,* Bergen County Historical Society, Steuben House Museum, River Edge NJ

Gecsei, Jan, *Assoc Prof,* Universite de Montreal, Bibliotheque d'Amenagement, Montreal PQ

Geddes, Mathew, *Instr,* Ricks College, Dept of Art, Rexburg ID (S)

Gedeon, Lucinda H, *Dir,* State University of New York at Purchase, Neuberger Museum of Art, Purchase NY

Gee, Dwight, *VPres Community Affairs,* Corporate Council for the Arts/Arts Fund, Seattle WA

Gee, Margaret, *Asst Dir,* East Bay Asian Local Development Corp, Asian Resource Gallery, Oakland CA

Geelhood, Lisa, *Dir Educ,* Huntington Museum of Art, Huntington WV

Geffen, Amara, *Chair Art Dept,* Allegheny College, Art Dept, Meadville PA (S)

Geft, Liebe, *Dir,* Simon Wiesenthal Center Inc, Museum of Tolerance, Los Angeles CA

Gegen, Dan, *3-D Coordr,* Wichita Center for the Arts, Mary R Koch Sch of Visual Arts, Wichita KS (S)

Geha, Katie, *Cur Modern & Contemporary Art,* Wichita State University, Ulrich Museum of Art & Martin H Bush Outdoor Sculpture Collection, Wichita KS

Gehring, Betty, *Docent Coordr,* Valparaiso University, Brauer Museum of Art, Valparaiso IN

Gehrm, Barbara, *Archives,* Salisbury University, Ward Museum of Wildfowl Art, Salisbury MD

Geibert, Ron, *Prof,* Wright State University, Dept of Art & Art History, Dayton OH (S)

Geiger, Philip, *Studio Faculty,* University of Virginia, McIntire Dept of Art, Charlottesville VA (S)

Geils, Laurelle, *Dir,* McGroarty Cultural Art Center, Tujunga CA (S)

Geimzer, Eugene, *Chmn Fine Arts Dept,* Loyola University of Chicago, Fine Arts Dept, Chicago IL (S)

Geis, M Christina, *Prof,* Georgian Court College, Dept of Art, Lakewood NJ (S)

Geischer, Geraldine, *Instr,* Milwaukee Area Technical College, Graphic Arts Div, Milwaukee WI (S)

Geisinger, William, *Instr,* De Anza College, Creative Arts Division, Cupertino CA (S)

Geist, Aimee, *Educ Coordr,* Wichita State University, Ulrich Museum of Art & Martin H Bush Outdoor Sculpture Collection, Wichita KS

Geist, Joe, *Cur,* Central Methodist University, Ashby-Hodge Gallery of American Art, Fayette MO

Geist, Ronnie, *Dir Programming,* Women's Interart Center, Inc, Interart Gallery, New York NY

Gelabert, Dorcas, *Web Design,* Organization of Independent Artists, Inc, New York NY

Gelber, Irwin, *Exec Dir,* Saint Johnsbury Athenaeum, Saint Johnsbury VT

Geller, Beatrice, *Assoc Prof,* Pacific Lutheran University, Dept of Art, Tacoma WA (S)

Gelzer, Bev, *Asst Dir,* Carrie M McLain, Nome AK

Gemmel, Judy, *Reg,* Lehigh University Art Galleries, Museum Operation, Bethlehem PA

Gendreau, Andree, *Coll & Research,* Musee de l'Amerique Francaise, Quebec PQ

Gendreau, Michel, *Prof,* Universite de Montreal, Bibliotheque d'Amenagement, Montreal PQ

Gendron, Bernard, *Asst Prof,* Universite de Montreal, Bibliotheque d'Amenagement, Montreal PQ

Genevro, Rosalie, *Exec Dir,* Architectural League of New York, New York NY

Geng, Merry, *Dir & Cur,* Lamama La Galleria, New York NY

Gengler, Tom, *Asst Registrar,* Spertus Institute of Jewish Studies, Spertus Museum, Chicago IL

Genshaft, Carole, *Dir Educ,* Columbus Museum of Art, Resource Center, Columbus OH

Genszler, Leslie, *Gallery Shop Mgr,* Madison Museum of Contemporary Art, Madison WI

Gentele, Glen P, *Exec Dir,* Laumeier Sculpture Park, Saint Louis MO

Genteman, Sheila, *Gallery Dir,* Saint Mary-of-the-Woods College, Art Dept, Saint Mary of the Woods IN (S)

Gentile, Thomas, *Dir Finance,* Cleveland Museum of Art, Cleveland OH

Gentilini, David, *Asst Dir,* Capital University, Schumacher Gallery, Columbus OH

Gentine, Muriel, *Secy,* Birger Sandzen Memorial Gallery, Lindsborg KS

Gentry, David, *Instr,* Shasta College, Art Dept, Arts, Communication & Education Division, Redding CA (S)

Gentry, James, *Instr,* Eastern Arizona College, Art Dept, Thatcher AZ (S)

Gentry, Sandra, *Exec Asst,* Pensacola Museum of Art, Pensacola FL

Gentry, Sandra J, *Exec Asst,* Pensacola Museum of Art, Harry Thornton Library, Pensacola FL

Geoffrion, Moira, *Prof Sculpture,* University of Arizona, Dept of Art, Tucson AZ (S)

George, David N, *Prof,* Truett-McConnell College, Fine Arts Dept & Arts Dept, Cleveland GA (S)

George, Haedy, *Chief Cur,* Oklahoma City Museum of Art, Library, Oklahoma City OK

George, Hardy, *Chief Cur,* Oklahoma City Museum of Art, Oklahoma City OK

George, Ivana, *Asst Prof,* Bridgewater State College, Art Dept, Bridgewater MA (S)

Georgiou, Tyrone, *Prof,* University at Buffalo, State University of New York, Dept of Visual Studies, Buffalo NY (S)

Gephart, Geoff, *Pres,* Arts United of Greater Fort Wayne, Fort Wayne IN

Geraci, Phil, *Asst Prof,* Eastern New Mexico University, Dept of Art, Portales NM (S)

Geralds, John, *Trustee,* Brooklyn Historical Society, Brooklyn OH

Gerard, Mira, *Asst Prof,* East Tennessee State University, College of Arts and Sciences, Dept of Art & Design, Johnson City TN (S)

Gerdes, Kirsten, *Assoc Cur,* Boulder Museum of Contemporary Art, Boulder CO

Gerdts, William H, *Prof Cur Emeritus,* City University of New York, PhD Program in Art History, New York NY (S)

Gereracht, Grady, *Asst Prof,* State University of New York at Stony Brook, Dept of College of Arts & Sciences, Art Dept, Stony Brook NY (S)

Gerety, Lorraine, *Slide Cur,* Visual Arts Library, New York NY

Gerhard, Amy, *Visitor Svcs & Vol,* The Lincoln Museum, Fort Wayne IN

Gerhart, Robert, *Prof,* University of North Carolina at Greensboro, Art Dept, Greensboro NC (S)

Gerkin, Pat, *Asst Exec Dir,* Art League, Alexandria VA

Gerlach, Monte, *Assoc Prof,* Saint Xavier University, Dept of Art & Design, Chicago IL (S)

Gerlach, Murney, *Dir,* Rhode Island Historical Society, Providence RI

Gerlough, Kate, *Mgr Sales & Info,* Frick Collection, New York NY

Germano, Thomas, *Assoc Prof,* State University of New York at Farmingdale, Visual Communications, Farmingdale NY (S)

Germany, Robin, *Asst Prof,* Texas Tech University, Dept of Art, Lubbock TX (S)

Germer, Mark, *Music Librn,* The University of the Arts, University Libraries, Philadelphia PA

Gerrietts, Frank, *Pres,* Beaumont Art League, Beaumont TX

Giorgi, Argene, *Secy,* Museo Italo Americano, San Francisco CA

Giorgio, Katie, *Membership & Communications Coordr,* Cedar Rapids Museum of Art, Cedar Rapids IA

Giorgio, Michael, *Pub Relations,* Vermont State Craft Center at Frog Hollow, Middlebury VT

Giovando, Renee, *Mktg Mgr,* Yellowstone Art Museum, Billings MT

Gipe, Thomas D, *Head Sculpture,* Southern Illinois University at Edwardsville, Dept of Art & Design, Edwardsville IL (S)

Giral, Angela, *Dir & Librn,* Columbia University, Avery Architectural & Fine Arts Library, New York NY

Girard, Jack, *Prof,* Transylvania University, Studio Arts Dept, Lexington KY (S)

Girard, Kathryn, *Chief of Staff,* Hebrew Union College, Skirball Cultural Center, Los Angeles CA

Girardo, Juan, West Virginia University, College of Creative Arts, Morgantown WV (S)

Girmschied, Mary Kay, *Mus Shop Mgr,* Trenton City Museum, Trenton NJ

Giroir Luckett, Jeannie, *Educ Cur,* West Baton Rouge Parish, West Baton Rouge Museum, Port Allen LA

Girshman, Beth, *Adult Svc Librn,* Jones Library, Inc, Amherst MA

Gittenstein, R Barbara, *Pres,* College of New Jersey, Art Gallery, Trenton NJ

Gittler, Wendy, *VPres,* New York Artists Equity Association, Inc, New York NY

Giuel, Rosanne, *Dir Visual Communications,* Art Institute of Fort Lauderdale, Fort Lauderdale FL (S)

Giuliani, David S, *Graphic Design,* Art Institute of Pittsburgh, Pittsburgh PA (S)

Giuliano, Marie, *Business Office Supv,* Ferguson Library, Stamford CT

Giuntine, Trey, *Gen Mgr,* Mississippi River Museum at Mud-Island River Park, Memphis TN

Giuntini, Gilles, *Assoc Prof,* University of Hartford, Hartford Art School, West Hartford CT (S)

Givan, Curtis, *Pres,* Gilbert Stuart, Museum, Saunderstown RI

Givens, Rex, *Dir Develop,* Trust Authority, Museum of the Great Plains, Lawton OK

Givnish, Gerry, *Exec Dir,* Painted Bride Art Center Gallery, Philadelphia PA

Gjertson, Sarah, *Asst Prof Foundations,* University of Denver, School of Art & Art History, Denver CO (S)

Gjovick, Peder, *Asst Prof,* Northwest Community College, Dept of Art, Powell WY (S)

Glabicki, Paul, *Prof,* University of Pittsburgh, Dept of Studio Arts, Pittsburgh PA (S)

Gladstone, Caroline T, *Mgr Vol Servs,* Philadelphia Museum of Art, Mount Pleasant, Philadelphia PA

Glanzer, Harvey W, *Co-Owner, Mgr & Dir,* Frank Lloyd Wright Museum, AD German Warehouse, Richland Center WI

Glasby, Vanessa, *Admin Asst, Tour Coordr,* Cranbrook Art Museum, Cranbrook Art Museum, Bloomfield Hills MI

Glascock, Zoe, *Publicist,* Longview Museum of Fine Art, Longview TX

Glaser, Lewis, *Prof,* Texas Christian University, Dept of Art & Art History, Fort Worth TX (S)

Glasgow, Isti Haroh, *Dir,* Cultural Affairs Department City of Los Angeles/Barnsdall Art Centers, Junior Arts Center, Los Angeles CA

Glasgow, Istiharoh, *Dir,* Cultural Affairs Department City of Los Angeles/Barnsdall Art Centers, Library, Los Angeles CA

Glasgow, Linda, *Archivist,* Riley County Historical Society, Riley County Historical Museum, Manhattan KS

Glasgow, Linda, *Library Archivist,* Riley County Historical Society, Seaton Library, Manhattan KS

Glasgow, Paul, *Chmn Dept,* Community College of Baltimore County, Art Dept, Catonsville MD (S)

Glaske, Sheila, *Cur Horticulture,* Paine Art Center & Gardens, Oshkosh WI

Glasper, Mark, *Dir Communications,* The American Ceramic Society, Ross C Purdy Museum of Ceramics, Westerville OH

Glass, Brent D, *Dir,* Smithsonian National Museum of American History, Washington DC

Glass, Brent D, *Exec Dir,* Pennsylvania Historical & Museum Commission, Harrisburg PA

Glass, Dorothy F, *Pres,* International Center of Medieval Art, New York NY

Glass, Ken, *Chmn,* First Horizon National Corp, First Tennessee Heritage Collection, Memphis TN

Glass, Simon, *Instr,* Toronto School of Art, Toronto ON (S)

Glasser, Dale, *Dir, Synagogue Mgr,* Union of American Hebrew Congregations, Synagogue Art & Architectural Library, New York NY

Glassford, C, *Instr,* Golden West College, Visual Art Dept, Huntington Beach CA (S)

Glassman, Elizabeth, *Dir,* Terra Museum of American Art, Chicago IL

Glasson, Lloyd, *Prof,* University of Hartford, Hartford Art School, West Hartford CT (S)

Glavin, Ellen, *Prof,* Emmanuel College, Art Dept, Boston MA (S)

Glavin, Eric, *Instr,* Toronto School of Art, Toronto ON (S)

Glazer, Steve, *Asst Prof,* Concord College, Fine Art Division, Athens WV (S)

Glazer, Susan, *Dir School Dance,* University of the Arts, Philadelphia Colleges of Art & Design, Performing Arts & Media & Communication, Philadelphia PA (S)

Gleba, Jo Anne, *Dir Comm,* Schenectady Museum Planetarium & Visitors Center, Schenectady NY

Gleissner, Stephen, *Chief Cur,* Wichita Art Museum, Wichita KS

Gleissner, Stephen, *Chief Cur,* Wichita Art Museum, Emprise Bank Research Library, Wichita KS

Glenn, Barbara, *Head Art Prog,* J Sargeant Reynolds Community College, Humanities & Social Science Division, Richmond VA (S)

Glenn, Bridgett, *Chmn,* Lock Haven University, Dept of Fine Arts, Lock Haven PA (S)

Glenn, Constance W, *Dir & Chief Cur,* California State University, Long Beach, University Art Museum, Long Beach CA

Glenn, T, *Assoc Prof,* McGill University, Dept of Art History, Montreal PQ (S)

Glenn Norris, Laurie, *Mgr Programming & Communications,* Beaverbrook Art Gallery, Fredericton NB

Glennon, Michael L, *Chairperson,* Northport-East Northport Public Library, Northport NY

Glennon, Rose M, *Cur Educ,* McNay, San Antonio TX

Glick, Michael, *VPres Operations,* Go Antiques, Inc, Dublin OH

Glick, Stephanie, *Dir Admin,* Light Factory, Charlotte NC

Glidden, Craig, *Chmn Fine Arts Prog,* Westminster College of Salt Lake City, Dept of Arts, Salt Lake City UT (S)

Gliniecki, Anita, *VPres Acad Svcs,* Saint Clair County Community College, Jack R Hennesey Art Dept, Port Huron MI (S)

Glispin, Terry, *Dir Fine Arts,* Watkins Institute, College of Art & Design, Nashville TN (S)

Gloeckler, Terry, *Assoc Prof,* Eastern Oregon University, School of Arts & Science, La Grande OR (S)

Glomski, Dan, *Dir Planetarium,* Hastings Museum of Natural & Cultural History, Hastings NE

Glotzer, Mildred, *Exec Asst,* Fairfield Historical Society, Fairfield Museum & History Center, Fairfield CT

Glotzhober, Robert, *Cur Natural History,* Ohio Historical Society, National Road-Zane Grey Museum, Columbus OH

Glover, Cherie, *Co-Owner,* Old West Museum, Sunset TX

Glover, David, *Instr,* Pierce College, Art Dept, Woodland Hills CA (S)

Glover, Jack, *Owner & Cur,* Old West Museum, Sunset TX

Glover, Jamie, *Museum Shop Mgr,* The Studio Museum in Harlem, New York NY

Glover, Rob, *Assoc Prof,* Texas Tech University, Dept of Art, Lubbock TX (S)

Glowaski, Barbara, *Prog Dir,* Saint Petersburg College, Fine & Applied Arts at Clearwater Campus, Clearwater FL (S)

Glueckert, Stephen, *Cur Exhibit,* Missoula Art Museum, Missoula MT

Glusman, Gayle, *Challenger Center Sr Flight Dir,* Louisiana Arts & Science Museum, Baton Rouge LA

Glynn, Kathleen D., *Exec Dir,* Richmond Art Museum, Richmond IN

Gochman, Julie, *International Planning Dir,* International Council for Cultural Exchange (ICCE), Brookhaven NY (S)

Gochman, Stanley I, *Prog Coordr,* International Council for Cultural Exchange (ICCE), Brookhaven NY (S)

Gochnair, Chris, *Instr,* University of Utah, Dept of Art & Art History, Salt Lake City UT (S)

Goddard, Charity, *Asst Graphics Dept,* Tyler Museum of Art, Tyler TX

Goddard, Leslie, *Educ Officer,* Evanston Historical Society, Charles Gates Dawes House, Evanston IL

Goddard, Stephen, *Cur Prints & Drawings,* University of Kansas, Spencer Museum of Art, Lawrence KS

Goddard, Stephen, *Pres,* Print Council of America, Lawrence KS

Goddard, Stephen, *Prof,* University of Kansas, Kress Foundation Dept of Art History, Lawrence KS (S)

Goders, John, California State University, Dominguez Hills, Art Dept, Carson CA (S)

Godfrey, Barbara, *Asst Develop Dir,* Everson Museum of Art, Syracuse NY

Godfrey, Judith, *Pres & CEO,* Grace Museum, Inc, Abilene TX

Godfrey, Robert, *Head Dept,* Western Carolina University, Dept of Art/College of Arts & Science, Cullowhee NC (S)

Godfrey, Stephen, *Cur Paleontology,* Calvert Marine Museum, Solomons MD

Godfrey, Teri, *Adjunct Prof,* Brevard College, Division of Fine Arts, Brevard NC (S)

Godfrey, William R, *Pres,* Environic Foundation International Library, South Bend IN

Godinez, Francisca E, *Exec Dir,* La Raza-Galeria Posada, Sacramento CA

Godleski, Charleen, *Business Mgr,* Chaffee Center for the Visual Arts, Rutland VT

Godlewska, Maja, *Asst Prof,* University of North Carolina at Charlotte, Dept Art, Charlotte NC (S)

Godlewski, Henry, *Assoc Prof,* Mohawk Valley Community College, Utica NY (S)

Godollei, Ruthann, *Prof,* Macalester College, Art Dept, Saint Paul MN (S)

Godsey, William, *Instr,* John C Calhoun, Department of Fine Arts, Decatur AL (S)

Godwin, Stan, *Asst Prof,* Texas A&M University Commerce, Dept of Art, Commerce TX (S)

Goebel, Sharon, *Dir Develop,* Salisbury University, Ward Museum of Wildfowl Art, Salisbury MD

Goebel, Travis, *Cur,* Zoo Montana, Billings MT

Goedde, Lawrence, *Chmn & Art History Instr,* University of Virginia, McIntire Dept of Art, Charlottesville VA (S)

Goering, Douglas, *Prof,* Albion College, Bobbitt Visual Arts Center, Albion MI

Goering, Douglas, *Prof,* Albion College, Dept of Visual Arts, Albion MI (S)

Goering, Karen M, *Exec VPres,* Missouri Historical Society, Saint Louis MO

Goethals, Marion, *Interim Dir,* Williams College, Museum of Art, Williamstown MA

Goetz, Becky, *Pres,* Grand Prairie Arts Council, Inc, Arts Center of the Grand Prairie, Stuttgart AR

Goetz, Mary Anna, *Instr,* Woodstock School of Art, Inc, Woodstock NY (S)

Goffe, Gwen, *Assoc Dir,* Museum of Fine Arts, Houston, Houston TX

Goffe, Gwen, *Assoc Dir Finance & Administration,* Museum of Fine Arts, Houston, Hirsch Library, Houston TX

Goggin, Cheryl, *Asst Prof,* University of Southern Mississippi, Dept of Art & Design, Hattiesburg MS (S)

Gohde, Kurt, *Assoc Prof,* Transylvania University, Studio Arts Dept, Lexington KY (S)

Goheen, Marion, *Pres,* Allied Arts Association, Allied Arts Center & Gallery, Richland WA

Goist, Karen, *Pres,* Society of Scribes, Ltd, New York NY

Golahny, Amy, *Assoc Prof,* Lycoming College, Art Dept, Williamsport PA (S)

Golan, Romy, *Assoc Prof,* City University of New York, PhD Program in Art History, New York NY (S)

Gold, Elaine Kiernan, *Librn,* Newark Public Library, Reference, Newark NJ

Gold, James, *Dir,* New York State Office of Parks, Recreation and Historic Preservation, Bureau of Historic Sites, Waterford NY

Gold, Lawrence, *Assoc Prof,* Pacific Lutheran University, Dept of Art, Tacoma WA (S)

Gold, Lisa, *Develop,* Socrates Sculpture Park, Long Island City NY

Gold, Sue, *Reference Librn,* Webster University, Eden-Webster Library, Saint Louis MO

Gold, Susan, *Prog Dir,* Lockwood-Mathews Mansion Museum, Norwalk CT

Gold, Umber, *Interpreter,* Schuyler Mansion State Historic Site, Albany NY

Gold-Smith, Susan, *Prof,* University of Windsor, Visual Arts, Windsor ON (S)

Goldberg, Beth, *Cur,* City of San Rafael, Falkirk Cultural Center, San Rafael CA

Goldberg, Carol, *Instr,* American University, Dept of Art, Washington DC (S)

Goldberg, Glenn, *Instr,* American University, Dept of Art, Washington DC (S)

Goldberg, Ira, *Exec Dir,* Art Students League of New York, New York NY

Goldberg, Joan, *Instr,* Daemen College, Art Dept, Amherst NY (S)

Goldberg, Kenneth P, *Librn,* Northeast Ohio Areawide Coordinating Agency (NOACA), Information Resource Center, Cleveland OH

Goldberg, Liz, *Instr,* Main Line Art Center, Haverford PA (S)

Goldberg, Marsea, *Dir,* New Image Art, Los Angeles CA

Goldblat, Aaron, *VPres Exhibits,* Please Touch Museum, Philadelphia PA

Golden, Jaqueline, *Assoc Prof,* University of Arkansas, Art Dept, Fayetteville AR (S)

Golden, Jennifer, *Dir Educ,* Tallahassee Museum of History & Natural Science, Tallahassee FL

Golden, Judith, *Prof Emerita,* University of Arizona, Dept of Art, Tucson AZ (S)

Golden, Kenneth, *Assoc Prof,* Queensborough Community College, Dept of Art & Photography, Bayside NY (S)

Golden, Susan, *Dir Pub Relations,* Robert Gumbiner, Museum of Latin American Art, Long Beach CA

Golden, Thelma, *Deputy Dir Progs,* The Studio Museum in Harlem, New York NY

Golden, Thelma, *Grad Comt,* Bard College, Center for Curatorial Studies Graduate Program, Annandale-on-Hudson NY (S)

Goldfarb, Alvin, *Pres,* Western Illinois University, Western Illinos University Art Gallery, Macomb IL

Goldfarb, Barbara, *Second VPres,* Monmouth Museum & Cultural Center, Lincroft NJ

Goldfarb, Hilliard T, *Cur Old Master, Prints & Drawings,* Montreal Museum of Fine Arts, Montreal PQ

Golding, Deeno, *Assoc Prof,* Morehead State University, Art Dept, Morehead KY (S)

Golding, Robert, *Photography,* Antonelli Institute, Professional Photography & Commercial Art, Erdenheim PA (S)

Goldman, Stephen M, *Exec Dir,* Sherwin Miller Museum of Jewish Art, Tulsa OK

Goldman, Steven, *Pres,* Art Institutes International at Portland, Portland OR

Goldner, George R, *Cur in Charge,* The Metropolitan Museum of Art, Dept of Drawings & Prints, New York NY

Goldner, George R, *Drue Heinz Chm Dr,* The Metropolitan Museum of Art, New York NY

Goldring, William, *VChmn,* The Ogden Museum of Southern Art, University of New Orleans, New Orleans LA

Goldschmidt, Lawrence, *Admin Dir,* National Trust for Historic Preservation, Washington DC

Goldsleger, Cheryl, *Dept Head,* Piedmont College, Art Dept, Demorest GA (S)

Goldsleger, Cheryl, *Dir,* Georgia State University, Ernest G Welch School of Art & Design, Atlanta GA (S)

Goldsmith, Alan, *Assoc Prof,* University of Wisconsin-Parkside, Art Dept, Kenosha WI (S)

Goldsmith, Robert B, *Deputy Dir,* Frick Collection, New York NY

Goldstein, Alan, *Instr,* Bucks County Community College, Fine Arts Dept, Newtown PA (S)

Goldstein, Audrey, *Chmn Fine Arts,* The New England School of Art & Design at Suffolk University, Boston MA (S)

Goldstein, Carl, *Prof,* University of North Carolina at Greensboro, Art Dept, Greensboro NC (S)

Goldstein, Gabriel, *Assoc Dir Exhib & Prog,* Yeshiva University Museum, New York NY

Goldstein, Karen, *Cur Exhib,* Pilgrim Society, Pilgrim Hall Museum, Plymouth MA

Goldstein, Leonard, *Chmn,* Arts United of Greater Fort Wayne, Fort Wayne IN

Goldstein, Leslie, *Librn,* New York Institute of Technology, Art & Architectural Library, Old Westbury NY

Goldstein, Marilyn, *Prof,* C W Post Campus of Long Island University, School of Visual & Performing Arts, Brookville NY (S)

Goldstein, Mark, *Library Technician,* San Francisco Maritime National Historical Park, Maritime Library, San Francisco CA

Goley, Mary Anne, *Dir,* Federal Reserve Board, Art Gallery, Washington DC

Golger, Angela, *Cur Arts, Humanities Educ,* Omaha Childrens Museum, Inc, Omaha NE

Golik, Jay, *Prof,* Napa Valley College, Art Dept, Napa CA (S)

Golisek, Lisa, *Visitor Svcs,* Alaska State Museum, Juneau AK

Gollnitz, Sharon, *Arts Specialist,* Patterson Library & Art Gallery, Westfield NY

Golly, Laura, *Chmn Dept Graphic Design,* The New England School of Art & Design at Suffolk University, Boston MA (S)

Golonu, Berin, *Assoc Cur,* Yerba Buena Center for the Arts, San Francisco CA

Gombert, Carl, *Asst Prof,* Maryville College, Dept of Fine Arts, Maryville TN (S)

Gomes, Agnes, *Mktg & Pub Relations,* Pacific - Asia Museum, Pasadena CA

Gomez, Aurelia, *Dir Educ,* Museum of New Mexico, Museum of International Folk Art, Santa Fe NM

Gomez, Drake, *Asst Prof,* Keystone College, Fine Arts Dept, LaPlume PA (S)

Gomez, Drake, *Asst Prof Art,* South Plains College, Fine Arts Dept, Levelland TX (S)

Gomez, Jewelle, *Dir Cultural Equity Grants,* San Francisco City & County Art Commission, San Francisco CA

Gomez, Mirta, *Prof,* Florida International University, School of Art & Art History, Miami FL (S)

Gomula, Jessica, *Prof,* California State University, Art Dept, Turlock CA (S)

Gonchar, Nancy, *Asst Dir,* San Francisco City & County Art Commission, San Francisco CA

Gondek, Tom, *Chmn Foundation Fine Arts,* Kendall College of Art & Design, Grand Rapids MI (S)

Gonzales, Edward, *VPres,* Guadalupe Historic Foundation, Santuario de Guadalupe, Santa Fe NM

Gonzales, Quinton, *Painting & Drawing,* University of Colorado at Denver, College of Arts & Media Visual Arts Dept, Denver CO (S)

Gonzalez, Denise, *Instr,* Wayne Art Center, Wayne PA (S)

Gonzalez, Elyse, *Asst Cur,* University of Pennsylvania, Institute of Contemporary Art, Philadelphia PA

Gonzalez, Manny, *Chmn Photo,* Fashion Institute of Technology, Art & Design Division, New York NY (S)

Gonzalez, Manuel, *Exec Dir & VPres,* The Chase Manhattan Bank, Art Collection, New York NY

Gonzalez, Maria Del Pilar, *Prof,* University of Puerto Rico, Dept of Fine Arts, Rio Piedras PR (S)

Gonzalez, Pedro, *Instr,* Amarillo College, Visual Art Dept, Amarillo TX (S)

Gonzalez-Cid, Malena, *Exec Dir,* Centro Cultural Aztlan, San Antonio TX

Gooch, Peter, *Assoc Prof,* University of Dayton, Visual Arts Dept, Dayton OH (S)

Good, Gretchen, *Asst Dir,* Academy of Art, College Library, San Francisco CA

Good, John, *Bd Pres,* George A Spiva, Joplin MO

Good, Patricia, *Exec Dir,* ArtSpace-Lima, Lima OH

Goodale, Jennifer P, *Dir Corporate Contributions,* Philip Morris Companies Inc, New York NY

Goodale, Margaret, *Science Instr,* Randall Junior Museum, San Francisco CA

Goodarzi, Shoki, *Lectr,* State University of New York at Stony Brook, Dept of College of Arts & Sciences, Art Dept, Stony Brook NY (S)

Goodchild, Christine, *Cur Educ,* Art Gallery of Windsor, Windsor ON

Goode, Jamie, *Instr,* Siena Heights University, Studio Angelico-Art Dept, Adrian MI (S)

Goodheart, John, *Prof,* Indiana University, Bloomington, Henry Radford Hope School of Fine Arts, Bloomington IN (S)

Goodison, Michael, *Archivist & Editor,* Smith College, Museum of Art, Northampton MA

Goodkind, Joan, *Librn,* Simon's Rock College of Bard, Library, Great Barrington MA

Goodlett, Chris, *Cur Coll,* Kentucky Derby Museum, Louisville KY

Goodman, Bill, *Instr,* Hibbing Community College, Art Dept, Hibbing MN (S)

Goodman, Carl, *Cur Digital Media,* American Museum of the Moving Image, Astoria NY

Goodman, Herb, *Asst Prof,* Louisiana State University, School of Art, Baton Rouge LA (S)

Goodman, Marian, *VPres,* Art Dealers Association of America, Inc, New York NY

Goodman, Rhonna, *Dir,* Manhattanville College, Library, Purchase NY

Goodman, Susan, *Cur at Large,* The Jewish Museum, New York NY

Goodman, Ted, *Educ,* Columbia University, Avery Architectural & Fine Arts Library, New York NY

Goodrich, James W, *Exec Dir,* State Historical Society of Missouri, Columbia MO

Goodrich, Jonathan, *Registrar,* Northeast Document Conservation Center, Inc, Andover MA

Goodrich, Kristina, *Exec Dir, COO,* Industrial Designers Society of America, Sterling VA

Goodridge, James, *Instr,* University of Evansville, Art Dept, Evansville IN (S)

Goodson, Lucy, *Asst Prof,* Coe College, Dept of Art, Cedar Rapids IA (S)

Goodwillie, Christian, *Cur Coll,* Hancock Shaker Village, Inc, Pittsfield MA

Goodwin, Daniel, *Asst Prof,* State University of New York at Albany, Art Dept, Albany NY (S)

Goodwin, David, *Assoc Prof,* Coe College, Dept of Art, Cedar Rapids IA (S)

Goodwin, Joan, *Dir,* Art Metropole, Toronto ON

Goodwin, Mary, *Asst Prof,* University of Alaska-Fairbanks, Dept of Art, Fairbanks AK (S)

Goodwin, Stewart, *Dir,* Heritage Museums & Gardens, Sandwich MA

Goody, Dick, *Dir & Cur,* Oakland University, Oakland University Art Gallery, Rochester MI

Goody, Stephen, *Gallery Dir & Special Instr,* Oakland University, Dept of Art & Art History, Rochester MI (S)

Goolsby, Jonathan, *Mktg & Media Specialist,* Lexington Art League, Inc, Lexington KY

Gootee, Marita, *Prof,* Mississippi State University, Dept of Art, Mississippi State MS (S)

Gopaul, Merika Adamas, *Exec Dir,* Irvine Museum, Irvine CA

Gorbelt, Mandi, *Gallery Coordr,* Spectrum Gallery, Toledo OH

Gorczynski, Bohdan, *Asst Cur,* Polish Museum of America, Research Library, Chicago IL

Gordon, Cheryl, *Prog Coordr,* Arts Midland Galleries & School, Midland MI

Gordon, Derek, *VPres Educ,* The John F Kennedy, Education Resources Center, Washington DC

Gordon, Edmund, *Interim Dean,* Columbia University, Teachers Col Program in Art & Art Educ, New York NY (S)

Gordon, Edward, *Dir Educ,* Gibson Society, Inc, Gibson House Museum, Boston MA

Gordon, Heather M, *Archive Mgr,* Vancouver City Archives, Vancouver BC

Gordon, James, *Marketing Coordr,* Kamloops Art Gallery, Kamloops BC

Gordon, Jennifer, *Asst Dean,* University of Lethbridge, Div of Art, Lethbridge AB (S)

Gordon, Kathy, *Dir,* Colby Community College, Visual Arts Dept, Colby KS (S)

Gordon, Lewis, *Assoc Head Music,* Saint Joseph's University, Dept of Fine & Performing Arts, Philadelphia PA (S)

Gordon, Lida, *Prof,* University of Louisville, Allen R Hite Art Institute, Louisville KY (S)

Gordon, Mark, *Assoc Prof,* Barton College, Art Dept, Wilson NC (S)

Gordon, Martha, *Chair,* Tarrant County Junior College, Art Dept, Hurst TX (S)

Gordon, Melanie, *Asst Dir,* Red River Valley Museum, Vernon TX

Gordon, Richard, *Asst Cur,* Alberta College of Art & Design, Illingworth Kerr Gallery, Calgary AB

Gordon, Thomas, *Pres,* Avila College, Thornhill Art Gallery, Kansas City MO

Gordon, Wendy, *Assoc Dir,* Boulder History Museum, Museum of History, Boulder CO

Gordoon, F, *Bd Dir,* Gananoque Museum, Gananoque ON

Gorewitz, Shalom, *Dir,* The Art Galleries of Ramapo College, Mahwah NJ

Gorg, Cathy, *Instr,* Lycoming College, Art Dept, Williamsport PA (S)

Gorham, Linda, *Public Prog Dir,* Saratoga County Historical Society, Brookside Museum, Ballston Spa NY

Gorham-Smth, Karen, *Assoc Cur,* Patrick Henry, Red Hill National Memorial, Brookneal VA

Goring, Rich, *Historic Site Mgr,* Palisades Interstate Park Commission, Senate House State Historic Site, Kingston NY

Goring, Rich, *Historic Site Mgr,* Palisades Interstate Park Commission, Reference Library, Kingston NY

Gorman, Carma, *Assoc Prof,* Southern Illinois University, School of Art & Design, Carbondale IL (S)

Gorman, Joan, *Painting Conservator,* Midwest Art Conservation Center, Minneapolis MN

Gormel, Donna M, *Vol Coordr,* Brandywine River Museum, Chadds Ford PA

Gormley, Jim, *Assoc Prof,* Saint Louis Community College at Florissant Valley, Liberal Arts Division, Ferguson MO (S)

Gormley, Nina Z, *Exec Dir,* Wendell Gilley, Southwest Harbor ME

Gormley, Tom, *Assoc Prof,* University of Miami, Dept of Art & Art History, Coral Gables FL (S)

Goro-Rapoport, Victoria, *Asst Prof,* University of Nebraska, Kearney, Dept of Art & Art History, Kearney NE (S)

Gorse, George, *Chmn, Prof,* Pomona College, Dept of Art & Art History, Claremont CA (S)

Gort, Gene, *Asst Prof,* University of Hartford, Hartford Art School, West Hartford CT (S)

Gorzegno, Janet, *Asst Prof,* University of Southern Mississippi, Dept of Art & Design, Hattiesburg MS (S)

Gosar, Kris, *Instr,* Adams State College, Dept of Visual Arts, Alamosa CO (S)

Gosnell, Julie, *Mus Coordr,* Independence Historical Museum, Independence KS

Goss, Charles, *Prof & Chmn,* Cazenovia College, Center for Art & Design Studies, Cazenovia NY (S)

Goss, John, *Chmn Bd Trustees,* Indiana State Museum, Indianapolis IN

Gosses, Ronald, *Pres,* Toledo Artists' Club, Toledo OH

Gothard, Paul, *Prof,* Lake Erie College, Fine Arts Dept, Painesville OH (S)

Gotlieb, Albert, *Graphic Design,* Art Institute of Pittsburgh, Pittsburgh PA (S)

Gotlieb, Marc, *Chmn,* University of Toronto, Dept of Fine Art, Toronto ON (S)

Gott, Wesley A, *Chmn,* Southwest Baptist University, Art Dept, Bolivar MO (S)

Gottberg, Karen Ann, *Asst Prof Art,* Seattle University, Fine Arts Dept, Division of Art, Seattle WA (S)

Gottesfeld, Linda, *Prof,* Pace University, Dyson College of Arts & Sciences, Pleasantville NY (S)

Gottlieb, Peter, *Dir & Archivist,* Wisconsin Historical Society, Archives, Madison WI

Gottsegen, Mark, *Prof,* University of North Carolina at Greensboro, Art Dept, Greensboro NC (S)

Goudey, Stephen, *Dir Admin,* New Brunswick College of Craft & Design, Library, Fredericton NB

Gouger Miller, Regina, *Secy,* Reading Public Museum, Library, Reading PA

Gough-DiJulio, Betsy, *Dir Educ,* Contemporary Art Center of Virginia, Virginia Beach VA

Gould, Claudia, *Dir,* University of Pennsylvania, Institute of Contemporary Art, Philadelphia PA

Gould, Claudia, *Sr Critic,* University of Pennsylvania, Graduate School of Fine Arts, Philadelphia PA (S)

Gould, Kathy, *Mktg Mgr,* Putnam Museum of History and Natural Science, Library, Davenport IA

Gould, Marie, *Mus Shop Mgr,* New York State Military Museum and Veterans Research Center, Saratoga Springs NY

Gould, Meggan, *Vis Asst Prof,* Bowdoin College, Art Dept, Brunswick ME (S)

Gould, Pat, *Dir Finance,* Kentucky Museum of Art & Craft, Louisville KY

Gould, Peter, *Assoc Dir Fin & Admin,* Cornell University, Herbert F Johnson Museum of Art, Ithaca NY

Gould, Rosemary F, *Graphic Design,* La Roche College, Division of Graphics, Design & Communication, Pittsburgh PA (S)

Goulding, Daniel, *Chmn,* Oberlin College, Dept of Art, Oberlin OH (S)

Gourley, Julia, *Dir Educ,* St Joseph Art Association, Krasl Art Center, Saint Joseph MI

Goutman, Marylyn, *Prof Textiles,* Philadelphia University, School of Textiles & Materials Technology, Philadelphia PA (S)

Gouveia, David F, *VPres,* Old Colony Historical Society, Museum, Taunton MA

Govan, Michael, *Exec Dir,* Dia Center for the Arts, New York NY

Gove, Wayne, *Treas. (V),* The Bartlett Museum, Amesbury MA

Govindaraj, Muthu, *Dir Textile Programs,* Philadelphia University, School of Textiles & Materials Technology, Philadelphia PA (S)

Goward, Rick, *Div Dir,* Henry Ford Community College, McKenzie Fine Art Ctr, Dearborn MI (S)

Gowen, John R, *Prof,* Ocean County College, Humanities Dept, Toms River NJ (S)

Gozani, Tal, *Assoc Cur,* Hebrew Union College, Skirball Cultural Center, Los Angeles CA

Grabbe, Kaye, *Admin Librn,* Lake Forest Library, Fine Arts Dept, Lake Forest IL

Grabill, Vin, *Interim Chmn,* University of Maryland, Baltimore County, Imaging, Digital & Visual Arts Dept, Baltimore MD (S)

Grabow, Nicole, *Objects Conservator,* Midwest Art Conservation Center, Minneapolis MN

Grabowski, Beth, *Asst Chm & Prof,* University of North Carolina at Chapel Hill, Art Dept, Chapel Hill NC (S)

Grabowski, John, *Dir Research,* Western Reserve Historical Society, Library, Cleveland OH

Grabski, Joanna, *Asst Prof,* Denison University, Dept of Art, Granville OH (S)

Grace, Anita, *Communications Mgr,* Canadian Conference of the Arts, Ottawa ON

Grace, Debbie, *Library Technician,* San Francisco Maritime National Historical Park, Maritime Library, San Francisco CA

Grace, James F, *Exec Dir,* Volunteer Lawyers for the Arts of Massachusetts Inc, Boston MA

Grace, Laura, *Slide Cur,* University of Arkansas at Little Rock, Art Slide Library and Galleries, Little Rock AR

Grace, Robert M, *VPres,* The Society of the Four Arts, Palm Beach FL

Grace, Trudie, *Cur,* Putnam County Historical Society, Foundry School Museum, Cold Spring NY

Grace, Whitney, *Prog & Educ Coordr,* San Francisco Camerawork, San Francisco CA

Gracey, Patty, *Operations Mgr,* Rose Center & Council for the Arts, Morristown TN

Grachek, Brenda, *Dir Continuing Studies,* Minneapolis College of Art & Design, Minneapolis MN (S)

Grachos, Louis, *Dir,* The Buffalo Fine Arts Academy, Albright-Knox Art Gallery, Buffalo NY

Gracie, David, *Asst Prof,* Nebraska Wesleyan University, Art Dept, Lincoln NE (S)

Gradle, Sally, *Asst Proff & Head Undergrad Studies,* Southern Illinois University, School of Art & Design, Carbondale IL (S)

Grady, Edward, *Asst Cur,* Langston University, Melvin B Tolson Black Heritage Center, Langston OK

Grady, John, *Instr,* Elgin Community College, Fine Arts Dept, Elgin IL (S)

Graf, Dean, *Prof,* Concordia University, Division of Performing & Visual Arts, Mequon WI (S)

Graff, Allison, *Dir,* State University of New York College at Cortland, Dowd Fine Arts Gallery, Cortland NY

Graff, Allison, *Gallery Dir,* State University of New York, College at Cortland, Dept Art & Art History, Cortland NY (S)

Graff, Laurie, *Library Asst,* Columbia Museum of Art, Lee Alexander Lorick Library, Columbia SC

Graffagnino, Theresa, *Dir Mem,* Business Committee for the Arts, Inc, Long Island City NY

Graffam, Olive, *Cur Coll,* DAR Museum, Library, Washington DC

Gragert, Steven, *Library & Colls,* Will Rogers Memorial Museum & Birthplace Ranch, Claremore OK

Graham, Ann, *Visual Resources Cur,* University of North Texas, Visual Resources Collection, Denton TX

Graham, Cathy, *Secy,* Shippensburg University, Kauffman Gallery, Shippensburg PA

Graham, Conrad, *Cur Decorative Arts,* McCord Museum of Canadian History, Montreal PQ

Graham, Cynthia, *Vis Prof,* Atlanta College of Art, Atlanta GA (S)

Graham, Douglas, *Chmn,* The Turner Museum, Sarasota FL

Graham, Isis, *Chief Cur,* The Turner Museum, Sarasota FL

Graham, Jan, *Reg & Prog Dir,* Coupeville Arts Center, Gallery at the Wharf, Coupeville WA

Graham, Jane, *Mgr,* Frontier Times Museum, Bandera TX

Graham, John R, *Cur Exhib,* Western Illinois University, Western Illinos University Art Gallery, Macomb IL

Graham, Kurt, *Cur McCracken Research Library,* Buffalo Bill Memorial Association, Buffalo Bill Historical Center, Cody WY

Graham, Lanier, *Dir,* California State University, East Bay, University Art Gallery, Hayward CA

Graham, Mark M, *Interim Head,* Auburn University, Dept of Art, Auburn AL (S)

Graham, Michael, *Assoc Prof,* American University, Dept of Art, Washington DC (S)

Graham, Michael, *Cur,* United Society of Shakers, Shaker Museum, New Glocester ME

Graham, Michael, *Cur,* United Society of Shakers, The Shaker Library, New Glocester ME

Graham, Nicholas, *Ref Librn,* Massachusetts Historical Society, Library, Boston MA

Graham, Richard, *Instr,* Salt Lake Community College, Graphic Design Dept, Salt Lake City UT (S)

Graham, Robert, *Prof,* Virginia Polytechnic Institute & State University, Dept of Art & Art History, Blacksburg VA (S)

Graham, Sandra, *Dean Acad Affairs,* The Illinois Institute of Art - Chicago, Chicago IL (S)

Granados, Juan, *Assoc Prof,* Texas Tech University, Dept of Art, Lubbock TX (S)

Granby, Karen, *Dir Human Resources,* The Jewish Museum, New York NY

Grandbois, Michele, *Cur Modern Art,* Musee du Quebec, Quebec PQ

Grande, Eileen, *Finance Mgr,* The Society for Contemporary Crafts, Pittsburgh PA

Granderson, Eddie, *Prog Adminr,* City of Atlanta, Bureau of Cultural Affairs, Atlanta GA

Grandmaitre, Robert, *Chief Coll Consultation,* National Archives of Canada, Art & Photography Archives, Ottawa ON

Grando, Connie, *VPres,* Baldwin Historical Society Museum, Baldwin NY

Grando, Robert, *Treas,* Baldwin Historical Society Museum, Baldwin NY

Granelina, Michelle, *Assoc Prof,* Assumption College, Dept of Art & Music, Worcester MA (S)

Graney, Carol H, *Library Dir,* The University of the Arts, University Libraries, Philadelphia PA

Granger, Robert, *Faculty,* Idaho State University, Dept of Art, Pocatello ID (S)

Granger, Steven T, *Archivist,* Archives of the Archdiocese of St Paul & Minneapolis, Saint Paul MN

Grannis, Sue Ellen, *Cur Books & Art,* Mason County Museum, Mason TX

Granson, Robert, *Dir Finance,* Museum of Art, Fort Lauderdale, Library, Fort Lauderdale FL

Grant, Arthur, *Pres Bd Trustees,* Everson Museum of Art, Syracuse NY

Grant, Barbara, *Mgr,* Salmagundi Club, New York NY

Grant, Gladys, *Bd Mem,* French Art Colony, Gallipolis OH

Grant, Hugh, *Dir,* Kirkland Museum of Fine & Decorative Art, Denver CO

Grant, Jerry, *Librn,* Shaker Museum & Library, Emma B King Library, Old Chatham NY

Grant, Jill, *Dean,* Nova Scotia College of Art & Design, Halifax NS (S)

Grant, Jim, *Pres,* Kelowna Museum, Kelowna BC

Grant, Laurie, *Dir Mktg & Comms,* Pennsylvania Academy of the Fine Arts, Philadelphia PA

Grant, Scott, *Bldg Engineer,* Modern Art Museum, Fort Worth TX

Grant, Susan Kae, *Prof,* Texas Woman's University, School of the Arts, Dept of Visual Arts, Denton TX (S)

Grantham, Tosha, *Assoc Cur Modern & Contemporary Art,* Virginia Museum of Fine Arts, Richmond VA

Grantz, Jody, *Music Coordr,* Urban Institute for Contemporary Arts, Grand Rapids MI

Granzow, Carl, *Assoc Prof,* University of Lethbridge, Div of Art, Lethbridge AB (S)

Graper, Jim, *Facilities Mgr,* Hui No eau Visual Arts Center, Gallery and Gift Shop, Makawao Maui HI

Grash, Valerie, *Dept Head,* University of Pittsburgh at Johnstown, Dept of Fine Arts, Johnstown PA (S)

Grass, Kevin, *Assoc Prof,* Saint Petersburg College, Fine & Applied Arts at Clearwater Campus, Clearwater FL (S)

Grassell, Mary, *Prof,* Marshall University, Dept of Art, Huntington WV (S)

Grate, Steven L, *Sr Cur,* Southwest Museum, Los Angeles CA

Grauer, Michael R, *Cur Art,* Panhandle-Plains Historical Society Museum, Canyon TX

Graveline, Laura, *Librn,* Maine College of Art, Joanne Waxman Library, Portland ME

Graveline, Michelle, *Chmn,* Assumption College, Dept of Art & Music, Worcester MA (S)

Graves, Maurice, Art Institute of Pittsburgh, Pittsburgh PA (S)

Graves, Nancy, *Admin Asst,* Marblehead Arts Association, Inc, Marblehead MA

Graves, Robert, *Interim Dean,* University of Illinois, Urbana-Champaign, College of Fine & Applied Arts, Champaign IL (S)

Graves, Travis, *Asst Prof,* East Tennessee State University, College of Arts and Sciences, Dept of Art & Design, Johnson City TN (S)

Gray, Emily, *Cur Annual Exhibs,* Monhegan Museum, Monhegan ME

Gray, Frances B, *VPres,* Miles B Carpenter, Waverly VA

Gray, Jim, *Adminr,* University of South Florida, Library, Tampa FL

Gray, Johnnie, *Chmn Fine Arts Dept,* Mississippi Gulf Coast Community College-Jackson County Campus, Art Dept, Gautier MS (S)

Gray, Kenneth, *Prof of Theatre Art,* Glendale Community College, Visual & Performing Arts Div, Glendale CA (S)

Gray, Richard, *Grad Dir,* University of Notre Dame, Dept of Art, Art History & Design, Notre Dame IN (S)

Gray, Sharon, *Admin Asst,* Frostburg State University, The Stephanie Ann Roper Gallery, Frostburg MD

Gray, Sharon R, *Asst Dir,* Springville Museum of Art, Springville UT

Gray, Stephanie, *Grant Writer,* Locust Street Neighborhood Art Classes, Inc, Buffalo NY (S)

Graybill, Maribeth, *Assoc Prof,* Swarthmore College, Dept of Art, Swarthmore PA (S)

Grayson, Ilena, *Vice Pres,* Society of Layerists in Multi Media (SLMM), Albuquerque NM

Grazzini, Patricia, *Assoc Dir,* Minneapolis Institute of Arts, Minneapolis MN

Grebl, James, *Library Mgr,* San Diego Museum of Art, Art Reference Library, San Diego CA

Grebl, James, *Mgr Library,* San Diego Museum of Art, San Diego CA

Greco, Anthony, *Prof,* Atlanta College of Art, Atlanta GA (S)

Greeenberg, Jeffrey M., *VPres,* The Haggin Museum, Stockton CA

Green, Al, *Treas,* Sculptor's Society of Canada, Canadian Sculpture Centre, Toronto ON

Green, Amy, *Adjunct,* College of the Canyons, Art Dept, Canta Colita CA (S)

Green, Andrea, *Asst Cur,* Contemporary Art Museum St Louis, Saint Louis MO

Green, Art, *Prof,* University of Waterloo, Fine Arts Dept, Waterloo ON (S)

Green, Carol L H, *Pres Bd,* Yellowstone Art Museum, Billings MT

Green, Eveleth, *Dir,* Gallery One, Ellensburg WA

Green, Felicity, *Communications Mgr,* Asheville Art Museum, Asheville NC

Green, Harriett, *Dir Visual Arts,* South Carolina Arts Commission, Columbia SC

Green, Heather, *Dir Asst,* Rogue Community College, Wiseman Gallery - FireHouse Gallery, Grants Pass OR

Green, Jeffrey, *Chmn,* Georgia Southwestern State University, Art Gallery, Americus GA

Green, John, *Asst Dir,* Plainsman Museum, Aurora NE

Green, Joshua, *Dir Educ Prog,* Manchester Craftsmen's Guild, Pittsburgh PA

Green, Julie, *Asst Prof,* Oregon State University, Dept of Art, Corvallis OR (S)

Green, Leamon, *Assoc Prof,* Texas Southern University, College of Liberal Arts & Behavorial Sciences, Houston TX (S)

Green, Louisa, *Deputy Dir Research & Planning,* Columbus Museum of Art, Columbus OH

Green, Louise, *Reference Librn,* University of Maryland, College Park, Art Library, College Park MD

Green, Mike, *Art Gallery Mgr,* Herrett Center for Arts & Sciences, Jean B King Art Gallery, Twin Falls ID

Green, Mike, *Chmn,* College of Southern Idaho, Art Dept, Twin Falls ID (S)

Green, Mimi, *Instr,* Wayne Art Center, Wayne PA (S)

Green, Nancy E, *Sr Cur Prints, Drawings & Photographs,* Cornell University, Herbert F Johnson Museum of Art, Ithaca NY

Green, Nancy W, *Interim Librn,* American Numismatic Association, Library, Colorado Springs CO

Green, Peter, *Instr Music,* Glendale Community College, Visual & Performing Arts Div, Glendale CA (S)

Green, Richard, *Instr,* Eastern Arizona College, Art Dept, Thatcher AZ (S)

Green, Robert, *Prof,* Abilene Christian University, Dept of Art & Design, Abilene TX (S)

Green, Tom, *Pres,* Polk County Heritage Gallery, Heritage Art Gallery, Des Moines IA

Green, Virginia, *Asst Prof,* Baylor University, Dept of Art, Waco TX (S)

Green, William, *Assoc Prof,* New Mexico State University, Art Dept, Las Cruces NM (S)

Greenaugh, Sara, *Chief Photographic Svcs,* National Gallery of Art, Washington DC

Greenawalt, Rose, *Receptionist,* Frontier Times Museum, Bandera TX

Greenbaum, Michael, *Pres,* Phoenix Art Museum, Phoenix AZ

Greenberg, Gary, *Asst Prof & Chmn,* Clarion University of Pennsylvania, Dept of Art, Clarion PA (S)

Greenberg, Ira, *Asst Prof,* Seton Hall University, College of Arts & Sciences, South Orange NJ (S)

Greenblatt, Arthur, *Dir,* Dundas Valley School of Art, Dofasco Gallery, Dundas ON (S)

Greene, Casey, *Head Special Coll,* Rosenberg Library, Galveston TX

Greene, Fred, *Business Mgr,* University of Lethbridge, Art Gallery, Lethbridge AB

Greene, Ken, *Instr,* William Woods-Westminster Colleges, Art Dept, Fulton MO (S)

Greene, Lois, *Chmn,* University of Kansas, Dept of Design, Lawrence KS (S)

Greene, Lois, *Chmn Dept,* University of Kansas, Dept of Art & Music Education & Music Therapy, Lawrence KS (S)

Greene, Marjorie, *Instr,* Saint Petersburg College, Fine & Applied Arts at Clearwater Campus, Clearwater FL (S)

Greene, Rhonda, *Co-Site Supv,* Fort Totten State Historic Site, Pioneer Daughters Museum, Fort Totten ND

Greene, Tom, *Instr Illustration & Design,* The Art Institute of Cincinnati, Cincinnati OH (S)

Greene, William, *Pub Relations,* Rhode Island Historical Society, Providence RI

Greenfield, Dorothy, *Treas,* Historical Society of Bloomfield, Bloomfield NJ

Greenfield, Mark Steven, *Dir,* Cultural Affairs Department, Los Angeles Municipal Art Gallery, Los Angeles CA

Greenhaigh, Paul, *Pres,* Nova Scotia College of Art & Design, Halifax NS (S)

Greenhalgh, Paul, *Pres,* Nova Scotia College of Art and Design, Anna Leonowens Gallery, Halifax NS

Greening, Cynthia, *Instr,* Mesa Community College, Dept of Art, Mesa AZ (S)

Greening, Suzanne E, *Arts Coordr,* Richmond Arts Centre, Richmond BC

Greenland, Dorothy, *Sr Library Specialist, Fine Arts Dept,* University of Utah, Marriott Library, Salt Lake City UT

Greennagle, Dave, *Dir Coral Act,* Randolph-Macon College, Dept of the Arts, Ashland VA (S)

Greenwald, Lou Anne, *Mak-Cener for Art & Architecture,* MAK - Austrian Museum of Applied Art, West Hollywood CA

Greenwall, Steven R, *Dept Head,* Allen County Community College, Art Dept, Iola KS (S)

Greenwold, Mark, *Assoc Prof,* State University of New York at Albany, Art Dept, Albany NY (S)

Greenwood, Jan, *Pres,* Gallery Stratford, Stratford ON

Greenwood, William, *VPres,* Pennsylvania Academy of the Fine Arts, Fellowship of the Pennsylvania Academy of the Fine Arts, Philadelphia PA

Greer, Ann, *Dir Communications,* The Phillips Collection, Washington DC

Greer, Dwaine, *Prof Art Educ,* University of Arizona, Dept of Art, Tucson AZ (S)

Greer, Joan, *Coordr Grad Programs,* University of Alberta, Dept of Art & Design, Edmonton AB (S)

Greer, Rina, *Dir,* Toronto Sculpture Garden, Toronto ON

Grefe, Morgan, *Dir Goff Institute,* Rhode Island Historical Society, John Brown House, Providence RI

Grefe, Richard, *Exec Dir,* American Institute of Graphic Arts, New York NY

Grefe, Richard, *Exec Dir,* American Institute of Graphic Arts, Library, New York NY

Gregersen, Thomas, *Cur,* Palm Beach County Parks & Recreation Department, Morikami Museum & Japanese Gardens, Delray Beach FL

Gregg, Rebecca, *Instr,* Sierra Community College, Art Dept, Rocklin CA (S)

Gregoire, Mathieu, *Project Mgr,* University of California, San Diego, Stuart Collection, La Jolla CA

Gregorio, Teresa, *Information Officer,* McMaster University, McMaster Museum of Art, Hamilton ON

Gregorski, Peggy, *Develop Coordr,* Kenosha Public Museum, Kenosha WI

Gregory, Dale, *Dir Pub Prog,* New York Historical Society, New York NY

Gregory, John, *Pres,* Arts Council of Greater Kingsport, Renaissance Center Main Gallery, Kingsport TN

Gregory, Maggie, *Registrar,* University of North Carolina at Greensboro, Weatherspoon Art Museum, Greensboro NC

Gregory, Shirley, *Dir,* Barton College, Library, Wilson NC

Gregson, Chris, *Historic Preservation Supv,* County of Henrico, Meadow Farm Museum, Glen Allen VA

Gregson, Sandra, *Instr,* Toronto School of Art, Toronto ON (S)

Greguski, Eva, *Art Cur,* The Long Island Museum of American Art, History & Carriages, Stony Brook NY

Greguski, Eva, *Librn, Archivist & Art Cur,* The Long Island Museum of American Art, History & Carriages, Library, Stony Brook NY

Grehan, John, *Dir Science & Coll,* Buffalo Museum of Science, Research Library, Buffalo NY

Greig, Rick E, *Dir Prog,* Angelo State University, Houston Harte University Center, San Angelo TX

Greiner, William, *Prof & Chair,* Olivet Nazarene University, Dept of Art, Bourbonnais IL (S)

Greminger, Gretchen, *Cur Educ,* Jekyll Island Museum, Jekyll Island GA

Grenville, Bruce, *Sr Cur,* Vancouver Art Gallery, Vancouver BC

Gresham, Jodi Hays, *Asst to Dir,* Cambridge Art Association, Cambridge MA

Gressom, Harriette, *Asst Prof,* Atlanta College of Art, Atlanta GA (S)

Greve, Gail, *Spec Coll Librn & Assoc Cur Rare Books & Manuscripts,* Colonial Williamsburg Foundation, John D Rockefeller, Jr Library, Williamsburg VA

Grey, Spencer Y, *Pres,* Chatham Historical Society, The Atwood House Museum, Chatham MA

Greywall, Hermine, *Publicity Chair,* Gallery XII, Wichita KS

Gribbon, Deborah, *Assoc Dir,* Getty Center, Trust Museum, Los Angeles CA

Gribbon, Deborah, *Dir, VPres,* Getty Center, The J Paul Getty Museum, Los Angeles CA

Griep, Mary, *Assoc Prof,* Saint Olaf College, Art Dept, Northfield MN (S)

Griesinger, Pamela, *Prof,* Daytona Beach Community College, Dept of Fine Arts & Visual Arts, Daytona Beach FL (S)

Griffel, Lois, *Dir,* Cape Cod School of Art, Provincetown MA (S)

Griffen, Sara, *CEO The Olana,* Olana State Historic Site, Hudson NY

Griffen, Sara, *Pres Olana Partnership,* Olana State Historic Site, Library, Hudson NY

Griffin, Cathryn, *Assoc Prof,* Western Carolina University, Dept of Art/College of Arts & Science, Cullowhee NC (S)

Griffin, David, *Instr Computer Graphics,* The Art Institute of Cincinnati, Cincinnati OH (S)

Griffin, Gerald, *Instr,* Ricks College, Dept of Art, Rexburg ID (S)

Griffin, Gerry, *Cur,* Baldwin Historical Society Museum, Baldwin NY

Griffin, Jennifer, *Instr,* Sacramento City College, Art Dept, Sacramento CA (S)

Griffin, Jerri, *Ceramics & Sculpture Instr,* Hutchinson Community College, Visual Arts Dept, Hutchinson KS (S)

Griffin, Kathy, *Gen Educ,* Art Institute of Pittsburgh, Pittsburgh PA (S)

Griffin, Penny, *Asst Prof,* Salem Academy & College, Art Dept, Winston-Salem NC (S)

Griffin, Steve, *Assoc Prof,* Mary Washington College, Dept of Art & Art History, Fredericksburg VA (S)

Griffin MFA, David, *Assoc Prof,* Eastern Illinois University, Art Dept, Charleston IL (S)

Griffis, Larry L, *Dir,* Birger Sandzen Memorial Gallery, Lindsborg KS

Griffis, Mark B, *Dir of Essex,* Ashford Hollow Foundation for Visual & Performing Arts, Griffis Sculpture Park, East Otto NY

Griffis, Simon, *Exec Dir,* Ashford Hollow Foundation for Visual & Performing Arts, Griffis Sculpture Park, East Otto NY

Griffith, Bill, *Asst Dir,* Arrowmont School of Arts & Crafts, Arrowmont School of Arts & Crafts, Gatlinburg TN (S)

Griffith, Deloris, *Western Representative,* Arizona Watercolor Association, Phoenix AZ

Griffith, John, *Asst Prof,* College of Mount Saint Joseph, Art Dept, Cincinnati OH (S)

Griffith, John, *Pres,* Eagle Rock Art Museum and Education Center, Inc, Idaho Falls ID

Griffith, Laura S, *Asst Dir,* Fairmount Park Art Association, Philadelphia PA

Griffith, Mac, *Dir Develop,* McNay, San Antonio TX

Griffith, Roberta, *Prof,* Hartwick College, Art Dept, Oneonta NY (S)

Griffith, William, *Coll Mgr,* University of Mississippi, University Museum, Oxford MS

Griffith, William, *Interim Cur,* Rowan Oak, William Faulker's Home, Oxford MS

Griffiths, Adam, *Develop Mem,* Provisions Library & Gaea Foundation, Washington DC

Griffiths, Jennifer, *Facilities Assoc,* Art Directors Club, New York NY

Griffoul, Richard, *Dir Mktg & Communications,* Oakland Museum of California, Art Dept, Oakland CA

Griggs, Barbara, *Business Mgr,* University of South Carolina, McKissick Museum, Columbia SC

Griggs, Jacob, *Visual Com Instr,* Western Wisconsin Technical College, Graphics Division, La Crosse WI (S)

Griggs, Richard, *Project Mgr,* Public Art Fund, Inc, New York NY

Grignon, Dennis, *Interim Cur of Exhibits,* Neville Public Museum, Green Bay WI

Grillo, Michael, *Assoc Prof,* University of Maine, Dept of Art, Orono ME (S)

Grim, Ruth, *Cur,* Bass Museum of Art, Miami Beach FL

Grimaldi, Ann, *Cur Educ,* University of North Carolina at Greensboro, Weatherspoon Art Museum, Greensboro NC

Grimaldi, Scott, *Prof,* Manhattan College, School of Arts, Riverdale NY (S)

Grimes, Ann, *Bookmobile Librn,* Lee County Library, Tupelo MS

Grimes, Joan, *Admin Asst,* Midwest Museum of American Art, Elkhart IN

Grimes, John Richard, *Dir,* Institute of American Indian Arts, Institute of American Indian Arts Museum, Santa Fe NM (S)

Grimes, Margaret, *MFA Coordr,* Western Connecticut State University, School of Visual & Performing Arts, Danbury CT (S)

Grimes, Tannis, *Develop Officer,* Hui No eau Visual Arts Center, Gallery and Gift Shop, Makawao Maui HI

Grimm, Amy, *Cur Coll,* City of El Paso, El Paso Museum of Art, El Paso TX

Grimm, Eric, *Cur Botany,* Illinois State Museum, Museum Store, Chicago IL

Grimmer, Jean, *Dir Develop,* Nantucket Historical Association, Historic Nantucket, Nantucket MA

Grimsley, Meredith, *Asst Prof,* Bloomsburg University, Dept of Art & Art History, Bloomsburg PA (S)

Grinage, Jeanine, *Head Educ,* New York State Museum, Albany NY

Grinnan, Karen P., *Vice Pres. Mktg,* The Mariners' Museum, Newport News VA

Grinnell, Nancy, *Cur,* Newport Art Museum, Newport RI

Grisaitis, Olga, *Assoc Dir,* Art Directors Club, New York NY

Grisham, Sandee, *Second VPres,* New Mexico Art League, Gallery & School, Albuquerque NM

Grissano, Joan, *Reference Coordr,* New York City Technical College, Ursula C Schwerin Library, Brooklyn NY

Grissim, Mary, *Dir Educ,* Cheekwood Nashville's Home of Art & Gardens, Education Dept, Nashville TN (S)

Grissom, Mary, *Dir Educ,* Cheekwood-Tennessee Botanical Garden & Museum of Art, Nashville TN

Griswold, Joan, *Treas,* New England Watercolor Society, Boston MA

Grittner, James, *Chmn,* University of Wisconsin-Superior, Programs in the Visual Arts, Superior WI (S)

Grivetti, Al, *Assoc Prof,* Clarke College, Dept of Art, Dubuque IA (S)

Grobes, Thelma, *Recording Secy,* American Color Print Society, Princeton NJ

Groce, Susan, *Prof & Interim Chair,* University of Maine, Dept of Art, Orono ME (S)

Groenert, Diane, *Gallery Receptionist,* Artlink, Inc, Fort Wayne IN

Groff, Beth, *Educ Dir,* Stone Quarry Hill Art Park, Winner Gallery, Cazenovia NY

Groff, Beth, *Educ Dir,* Stone Quarry Hill Art Park, Jenny Library, Cazenovia NY

Groff, Marget, *Dir Educ,* Museum of Northwest Art, La Conner WA

Groft, Tammis, *Deputy Dir Coll & Pub Prgms & Chief Cur,* Albany Institute of History & Art, Albany NY

Grogan, Geoffrey, *Asst Prof,* Adelphi University, Dept of Art & Art History, Garden City NY (S)

Grogan, Kevin, *Dir,* Morris Museum of Art, Augusta GA

Grogan, Kevin, *Dir,* Contemporary Art Center of Virginia, Virginia Beach VA

Gron, Jack, *Chmn,* University of Kentucky, Dept of Art, Lexington KY (S)

Gronau, Jane, *Educ Coordr,* Mount Holyoke College, Art Museum, South Hadley MA

Gronsdahl, Troy, *Administrative Coordr,* AKA Artist Run Centre, Library, Saskatoon SK

Gronsdhal, Troy, *Adminstrative Coordr,* AKA Artist Run Centre, Saskatoon SK

Groom, Gloria, *Cur European Painting,* The Art Institute of Chicago, Chicago IL

Groover, Charles, *Head,* Jacksonville State University, Art Dept, Jacksonville AL (S)

Grose, Donald, *Dean,* University of North Texas, Libraries, Denton TX

Grose, J David, *Treas,* Peninsula Fine Arts Center, Newport News VA

Grosowsky, Vera, *Instr,* Solano Community College, Division of Fine & Applied Art & Behavioral Science, Suisun City CA (S)

Gross, Benjamin, *Prof,* Salem State College, Art Dept, Salem MA (S)

Gross, Chaim, *Dir,* The Chaim Gross Studio Museum, New York NY

Gross, Erik, *VPres Finance,* New Hampshire Institute of Art, Manchester NH

Gross, Erika, *Mus Shop Mgr,* Brandywine River Museum, Chadds Ford PA

Gross, Katie, *Exec Admin,* The Stained Glass Association of America, Hartland MI

Gross, Kelly M, *Dir,* Art Association of Jacksonville, David Strawn Art Gallery, Jacksonville IL

Grossbard, Elayne, *Judaica Cur,* Judah L Magnes, Berkeley CA

Grosser, Jean, *Prof Art, Chair,* Coker College, Art Dept, Hartsville SC (S)

Grossman, Barbara, *Instr,* Chautauqua Institution, School of Art, Chautauqua NY (S)

Grossman, Gilda S, *Dir Acad Prog & Internships,* Toronto Art Therapy Institute, Toronto ON (S)

Grossman, Grace Cohen, *Sr Cur,* Hebrew Union College, Skirball Cultural Center, Los Angeles CA

Grossman, Jim, *VPres Research & Educ,* Newberry Library, Chicago IL

Grossman, Rhonda, *Dir Finance & Operations,* Judah L Magnes, Berkeley CA

Grossman, Richard, *Pres Bd Dir,* Photographic Resource Center, Boston MA

Grov, Claude, *Oratory Rector,* Saint Joseph's Oratory, Museum, Montreal PQ

Grove, Nancy, *Prof,* Long Island University, Brooklyn Campus, Art Dept, Brooklyn NY (S)

Grover, Ruth, *Cur Galleries, Exhibs & Colls,* University of Tennessee at Chattanooga, Cress Gallery of Art, Chattanooga TN

Grover, Ryan, *Cur,* Biggs Museum of American Art, Dover DE

Groves, Will E, *Admin Asst,* Broward County Board of Commissioners, Cultural Affairs Div, Fort Lauderdale FL

Grow, Stephanie, *Asst Dir,* Elmhurst Art Museum, Elmhurst IL

Growborg, Erik, *Instr,* Miracosta College, Art Dept, Oceanside CA (S)

Grubb, Tom, *Dir,* Fayetteville Museum of Art, Inc, Fayetteville NC

Grubb, Troy, *Asst Educ,* Pennsylvania Historical & Museum Commission, Railroad Museum of Pennsylvania, Harrisburg PA

Grubbs, Rhonda, *Instr,* Ohio Northern University, Dept of Art, Ada OH (S)

Gruber, Doris, *Periodicals,* Trinity College Library, Washington DC

Gruber, J Richard, *CEO & Dir,* The Ogden Museum of Southern Art, University of New Orleans, New Orleans LA

Gruber, John, *Asst Prof,* Southwest Baptist University, Art Dept, Bolivar MO (S)

Gruber, Roberta, *Assoc Prof Design & Merchandising,* Drexel University, College of Media Arts & Design, Philadelphia PA (S)

Grubler, Mitchell, *Exec Dir,* Queens Historical Society, Kingsland Homestead, Flushing NY

Grubola, James T, *Chmn Dept Fine Arts, Dir Hite Art Institute,* University of Louisville, Allen R Hite Art Institute, Louisville KY (S)

Gruendell, Lana, *Instr,* Salt Lake Community College, Graphic Design Dept, Salt Lake City UT (S)

Gruener, Mark, *Instr,* Wayne Art Center, Wayne PA (S)

Gruenspect, Sara, *Asst to Dir & Docent Coord,* Yeshiva University Museum, New York NY

Gruenwald, Helen, *Prof,* Kirkwood Community College, Dept of Arts & Humanities, Cedar Rapids IA (S)

Gruesbeck, Leslie, *Registrar,* Alexandria Museum of Art, Alexandria LA

Grumbine-Hornock, Penelope, *Adjunct,* York College of Pennsylvania, Dept of Music, Art & Speech Communications, York PA (S)

Grundy, Jane, *Asst Prof,* New York Institute of Technology, Fine Arts Dept, Old Westbury NY (S)

Gruner, Charles J, *Dir Lecture & Demonstration Serv,* American Society of Artists, Inc, Palatine IL

Grunfeld, Joseph, *Prof Visual Studies,* Drexel University, College of Media Arts & Design, Philadelphia PA (S)

Gruninger, Sandi, *Pres,* Wood Tobe-Coburn School, New York NY (S)

Gruol, David, *VPres,* Blackwell Street Center for the Arts, Denville NJ

Grupp, Carl A, *Chmn,* Augustana College, Art Dept, Sioux Falls SD (S)

Grutzeck, Laura, *Visual Resources Librn,* The University of the Arts, University Libraries, Philadelphia PA

Grynsztejn, Madeleine, *Sr Cur Painting,* San Francisco Museum of Modern Art, San Francisco CA

Grzywaca, Linda, *Annual Fund Coordr,* Honolulu Academy of Arts, The Art Center at Linekona, Honolulu HI (S)

Gu, Zhe, *Dir Fund Develop,* Gallery Stratford, Stratford ON

Guan, Zhimin, *Assoc Prof,* Minnesota State University-Moorhead, Dept of Art, Moorhead MN (S)

Guava, Sig, *Prof,* Columbia University, Graduate School of Architecture, Planning & Preservation, New York NY (S)

Gubala, Darius, *Dir,* 4D Basement, New York NY

Gubala, Darius, *Dir,* U Gallery, New York NY

Guckes, Patty, *Instr,* Ocean City Arts Center, Ocean City NJ (S)

Guenther, Bruce, *Chief Cur,* Portland Art Museum, Northwest Film Center, Portland OR

Guenthler, John R, *Assoc Prof,* Indiana University-Southeast, Fine Arts Dept, New Albany IN (S)

Guerin, Francesca Schuler, *Dir,* Schuler School of Fine Arts, Baltimore MD (S)

Guermonporez, Jean Noel, *Vis Asst Prof,* Hamline University, Dept of Art & Art History, Saint Paul MN (S)

Guernsey, Dan, *Assoc Prof,* Florida International University, School of Art & Art History, Miami FL (S)

Guerrero, Irma, *Dir Pub Relations,* Witte Museum, San Antonio TX

Guerrero, Tony, *Dir Operations,* PS1 Contemporary Art Center, Long Island City NY

Guerrero, Yacely, *Admin Asst,* Saint John's University, Chung-Cheng Art Gallery, Jamaica NY

Guerts, Joe, *Dir Canadian War Mus,* Canadian Museum of Civilization, Gatineau PQ

Guffin, R L, *Prof,* Stillman College, Stillman Art Gallery & Art Dept, Tuscaloosa AL (S)

Gugelberger, Rachel, *Asst Dir,* School of Visual Arts, Visual Arts Museum, New York NY

Gugino, Jeanne, *Ceramic Dir,* Kaji Aso Studio, Gallery Nature & Temptation, Boston MA

Guglielmo, Rudy, *Expansion Arts Dir,* Arizona Commission on the Arts, Phoenix AZ

Guheen, Elizabeth, *Cur Coll,* Roswell Museum & Art Center, Roswell NM

Guheen, Elizabeth, *Pres,* Ucross Foundation, Big Red Barn Gallery, Clearmont WY

Guichet, Melody, *Prof,* Louisiana State University, School of Art, Baton Rouge LA (S)

Guida, Marilyn, *Cur Educ,* The Haggin Museum, Stockton CA

Guido, Anthony, *Chmn Industrial Design,* University of the Arts, Philadelphia Colleges of Art & Design, Performing Arts & Media & Communication, Philadelphia PA (S)

Guido, Jeff, *Artistic Dir,* Clay Studio, Philadelphia PA

Guidry, Keith J, *Cur Exhib,* Opelousas Museum of Art, Inc (OMA), Opelousas LA

Guidry, Michael, *Cur Univ Collections,* Art Museum of the University of Houston, Blaffer Gallery, Houston TX

Guild, Henley, *Mus Preparator,* University of Richmond, University Museums, Richmond VA

Guilmette, Joanne, *Dir Communication,* New York State Museum, Albany NY

Guimaraes, Camille, *Develop & Membership Asst,* Judah L Magnes, Berkeley CA

Guinan, Laura, *Instr,* Casper College, Dept of Visual Arts, Casper WY (S)

Guinn, Michael, *Pres,* Plastic Club, Art Club, Philadelphia PA

Guip, David, *Chmn,* University of Toledo, Dept of Art, Toledo OH (S)

Gulacsy, Elizabeth, *Art Reference Librn & Archivist,* New York State College of Ceramics at Alfred University, Scholes Library of Ceramics, Alfred NY

Guleranson, Jim, *VPres,* San Fernando Valley Historical Society, Mark Harrington Library, Mission Hills CA

Gulransen, Scott, *Coordr Book Distribution,* Visual Studies Workshop, Rochester NY

Gumerman, George, *Interim Pres,* School of American Research, Indian Arts Research Center, Santa Fe NM

Gumerman, George J, *VPres,* Amerind Foundation, Inc, Amerind Museum, Fulton-Hayden Memorial Art Gallery, Dragoon AZ

Gummel, Rob, *Instr Guitar,* Ocean City Arts Center, Ocean City NJ (S)

Gunderson, Barry, *Prof, Chmn,* Kenyon College, Art Dept, Gambier OH (S)

Gunderson, Dan, *Dir,* Stetson University, Duncan Gallery of Art, Deland FL

Gunderson, Dan, *Prof,* Stetson University, Art Dept, Deland FL (S)

Gunderson, Dorann, *Dir Develop,* Southern Oregon Historical Society, Jacksonville Museum of Southern Oregon History, Medford OR

Gunderson, Jeff, *Librn,* San Francisco Art Institute, Anne Bremer Memorial Library, San Francisco CA

Gunji, Jennifer, *In Charge Graphic Design,* University of Illinois, Urbana-Champaign, School of Art & Design, Champaign IL (S)

Gunn, Kevin, *Head Humanities Div,* Catholic University of America, Humanities Library, Mullen Library, Washington DC

Gunning, Claire, *Art & Architecture Librn,* Cooper Union for the Advancement of Science & Art, Library, New York NY

Guppy, Susan, *Asst Prof,* Technical University of Nova Scotia, Faculty of Architecture, Halifax NS (S)

Guraedy, J Bruce, *Head Dept,* East Central Community College, Art Dept, Decatur MS (S)

Guralnick, June, *Exec Dir,* City Of Raleigh Arts Commission, Municipal Building Art Exhibitions, Raleigh NC

Gurley, Diana, *Secy,* Algonquin Arts Council, Art Gallery of Bancroft, Bancroft ON

Hall Smith, Beverly, *Asst Prof,* Marygrove College, Department of Art, Detroit MI (S)

Halstead, Jo, *Develop Dir,* The Exhibition Alliance, Hamilton NY

Haltman, Kenneth, *Prog Head,* Michigan State University, Dept of Art & Art History, East Lansing MI (S)

Halushak, Richard, *Pres,* Art Center College of Design, Pasadena CA (S)

Halverson, Aniko, *Reference & Instruction Librn,* California Institute of the Arts Library, Santa Clarita CA

Halvorson, Richard, *Museum Coordr,* Brown County Art Gallery Foundation, Brown County Art Gallery & Foundation, Nashville IN

Hamadeh, Shirine, *Asst Prof,* Rice University, Dept of Art & Art History, Houston TX (S)

Haman, Amanda Martin, *Progs,* University of Kansas, Spencer Museum of Art, Lawrence KS

Hambleton, Judy, *Dir Educ,* Newport Art Museum, Newport RI

Hambleton, Judy, *Dir School,* Newport Art Museum School, Newport RI (S)

Hamblin, Diane, *Doll Cur,* Wenham Museum, Wenham MA

Hambourg, Maria Morris, *Cur In Charge Anci,* The Metropolitan Museum of Art, New York NY

Hambree, Karen, *Cur Educ,* Ellen Noel Art Museum of the Permian Basin, Odessa TX

Hamer, Fritz, *Cur History,* South Carolina State Museum, Columbia SC

Hamer, Linnea, *Cur. Exhibits,* American Architectural Foundation, The Octogon Museum, Washington DC

Hamil, Sherrie, *Cur Educ,* Alabama Department of Archives & History, Library, Montgomery AL

Hamilton, Cindy, *Office Mgr,* Carteret County Historical Society, Museum of History & Art, Morehead City NC

Hamilton, Claire, *Asst Prof,* University of Southern Mississippi, Dept of Art & Design, Hattiesburg MS (S)

Hamilton, David Verner, *Pres,* Tradd Street Press, Elizabeth O'Neill Verner Studio Museum, Charleston SC

Hamilton, Elizabeth, *Gallery Mgr,* Guild of Boston Artists, Boston MA

Hamilton, Gwynn, *Museum Educ Specialist,* Frederic Remington, Ogdensburg NY

Hamilton, J Hank, *Fine Arts Dept Chmn,* Cheyney University of Pennsylvania, Dept of Art, Cheyney PA (S)

Hamilton, Ken, *First VPres,* New Jersey Watercolor Society, Parsippany NJ

Hamilton, Laurie, *Fine Arts Conservator,* Art Gallery of Nova Scotia, Halifax NS

Hamilton, Linda, *Admin Asst,* Where Edmonton Community Artists Network Society, Harcourt House Arts Centre, Edmonton AB

Hamilton, Lynn, *Dir Admin,* Discovery Museum, Bridgeport CT

Hamilton, Mort, *Dir,* Charles B Goddard, Ardmore OK

Hamilton, Paula, *Head Librn,* Mount Angel Abbey Library, Saint Benedict OR

Hamilton, Raymond, *Chmn Mem,* American Color Print Society, Princeton NJ

Hamm, Monte, *Acting Chmn,* Kentucky Wesleyan College, Dept Art, Owensboro KY (S)

Hamm, Rachel, *Office Mgr,* Utah State University, Nora Eccles Harrison Museum of Art, Logan UT

Hamm, Rebecca J, *Lectr,* California State Polytechnic University, Pomona, Art Dept, Pomona CA (S)

Hammell, Peter, *Dir,* National Museum of Racing, National Museum of Racing & Hall of Fame, Saratoga Springs NY

Hammell, Peter H, *Dir,* National Museum of Racing, Reference Library, Saratoga Springs NY

Hammer, Karen, *Dir Art Educ,* Coos Art Museum, Coos Bay OR (S)

Hammer, Leslie, *Mgr Facility,* Arts United of Greater Fort Wayne, Fort Wayne IN

Hammerstrom, Kirsten, *Cur,* Rhode Island Historical Society, John Brown House, Providence RI

Hammett, Beverly, *Asst Librn,* Webster Parish Library, Minden LA

Hammett, Kevin, *Prog Management Specialist,* University of Maryland, College Park, National Trust for Historic Preservation Library Collection, College Park MD

Hammock, April, *Lectr,* Southeastern Louisiana University, Dept of Visual Arts, Hammond LA (S)

Hammock, Virgil, *VPres (Sackville, NB),* International Association of Art Critics, ALCA Canada, Inc, Tornoto ON

Hammond, Harmony, *Prof Painting & Drawing,* University of Arizona, Dept of Art, Tucson AZ (S)

Hammond, Leslie, *Registrar,* Tampa Museum of Art, Tampa FL

Hammond, Pamela, *Pub Relations Coordr,* Ashtabula Arts Center, Ashtabula OH

Hammond, Theresa, *Dir & Cur,* Guilford College, Art Gallery, Greensboro NC

Hammond, Wayne G, *Asst Librn,* Williams College, Chapin Library, Williamstown MA

Hammontree, Eddie, *Librn,* Webster Parish Library, Minden LA

Hamm Walsh, Dawna, *Head Art Dept,* Dallas Baptist University, Dept of Art, Dallas TX (S)

Hampton, Dan, *Graphics Dir,* Gadsden Museum of Fine Arts, Inc, Gadsden Museum of Art and History, Gadsden AL

Hampton, Ellie, *Exec Asst,* Eagle Rock Art Museum and Education Center, Inc, Idaho Falls ID

Hamwi, Richard, *Asst Prof,* Albright College, Dept of Art, Reading PA (S)

Han, Helen, *Mktg Coordr,* Boston Properties LLC, San Francisco CA

Hanbury-Tenison, William, *Asst Dir,* Pacific - Asia Museum, Pasadena CA

Hancock, Blair, *Dir,* Wilkes Community College, Arts & Science Division, Wilkesboro NC (S)

Hancock, John, *Asst Prof,* University of Mary Hardin-Baylor, School of Fine Arts, Belton TX (S)

Hancock, Kathleen, *Asst Prof,* Roger Williams University, Visual Art Dept, Bristol RI (S)

Hancock, Lisa, *Registrar,* Virginia Museum of Fine Arts, Richmond VA

Hancock, Mariko, *Coordr,* Castleton State College, Art Dept, Castleton VT (S)

Hancsak, Julie Ann, *Communications Officer,* Akron Art Museum, Akron OH

Hand, Brandi, *Public Information Officer,* New Orleans Museum of Art, New Orleans LA

Hand, Donald, *Horticulture,* National Gallery of Art, Washington DC

Hand-Evans, Dana, *Cur,* National Society of the Colonial Dames of America in The Commonwealth of Virginia, Wilton House Museum, Richmond VA

Handel, Cynthia, *Asst Prof,* Louisiana State University, School of Art, Baton Rouge LA (S)

Handel, Ken, *Senior Mgr Creative Serv,* The Jewish Museum, New York NY

Handler, Linda, *Dir,* Phoenix Gallery, New York NY

Handsloser, Diane, *Chmn,* Santa Barbara City College, Fine Arts Dept, Santa Barbara CA (S)

Handy, Christopher, *Technical Servs Librn,* The Saint Louis Art Museum, Richardson Memorial Library, Saint Louis MO

Handy, Ellen, *Chmn,* City College of New York, Art Dept, New York NY (S)

Hanen, Jenifer, *Instr,* Biola University, Art Dept, La Mirada CA (S)

Hanes, Jay, *Asst Prof,* University of Maine, Dept of Art, Orono ME (S)

Haney, Art, *Assoc Dir,* East Carolina University, School of Art, Greenville NC (S)

Haney, Beth, *Asst Dir,* Southern Ohio Museum Corporation, Southern Ohio Museum, Portsmouth OH

Haney, Nicholas, *Adjunct Assoc Prof Art,* Johnson County Community College, Visual Arts Program, Overland Park KS (S)

Hanger, Anne, *Visiting Artist,* Mary Baldwin College, Dept of Art & Art History, Staunton VA (S)

Hanger, Barbara, *Assoc Prof,* University of Louisville, Allen R Hite Art Institute, Louisville KY (S)

Hankewych, Jaroslaw J, *Dir & Pres,* Ukrainian National Museum & Library, Chicago IL

Hanks, Cindy, *Vol Coordr,* Salvador Dali, Saint Petersburg FL

Hanley, James T, *Deputy Dir,* Fashion Institute of Technology, Museum at FIT, New York NY

Hanley, M, *Exec Dir,* Atlatl, Phoenix AZ

Hanley, Pat, *Exec Asst,* National Assembly of State Arts Agencies, Washington DC

Hann, Richard, *Chmn Dept Humanities,* Imperial Valley College, Art Dept, Imperial CA (S)

Hanna, Annette Adrian, *Dir,* Blackwell Street Center for the Arts, Denville NJ

Hanna, Carole, *Clerical Hostess,* Red River Valley Museum, Vernon TX

Hanna, Emily, *Cur Americas & Africa,* Birmingham Museum of Art, Clarence B Hanson Jr Library, Birmingham AL

Hanna, Martha, *Dir,* Canadian Museum of Contemporary Photography, Ottawa ON

Hanna, William, *Dean,* Humber College of Applied Arts & Technology, The School of Media Studies, Etobicoke ON (S)

Hannaford, Joey, *Acad Professional Graphic Design,* University of Georgia, Franklin College of Arts & Sciences, Lamar Dodd School of Art, Athens GA (S)

Hannan, Catalina, *Librn,* Historic Hudson Valley, Tarrytown NY

Hannan, Catalina, *Librn,* Historic Hudson Valley, Library, Tarrytown NY

Hanner, Frank, *Dir & Cur,* National Infantry Museum, Fort Benning GA

Hannibal, Joe, *Prof,* California State Polytechnic University, Pomona, Art Dept, Pomona CA (S)

Hanninen, Kim, *Registrar,* Northwestern Michigan College, Dennos Museum Center, Traverse City MI

Hannon, Maureen, *Mgr Resources Develop,* National Trust for Historic Preservation, Chesterwood Estate & Museum, Stockbridge MA

Hannus, L Adrien, *Dir,* Augustana College, Eide-Dalrymple Gallery, Sioux Falls SD

Hanover, Lisa Tremper, *Dir,* Ursinus College, Philip & Muriel Berman Museum of Art, Collegeville PA

Hansel, Debbie, *Asst,* North Canton Public Library, The Little Art Gallery, North Canton OH

Hansen, Al, *Instr Pottery,* Bay De Noc Community College, Art Dept, Escanaba MI (S)

Hansen, Diane, *Dir Educ,* Billie Trimble Chandler, Asian Cultures Museum & Educational Center, Corpus Christi TX

Hansen, Elaine, *Pres,* Bates College, Art & Visual Culture, Lewiston ME (S)

Hansen, Gregory, *Folklife Adminr,* Florida Folklife Programs, Tallahassee FL

Hansen, Harry, *Asst Chmn,* University of South Carolina, Dept of Art, Columbia SC (S)

Hansen, Katherine, *Dir Corporate Relations,* The Phillips Collection, Washington DC

Hansen, Letitia, *Cur & Shop Supv,* Octagon Center for the Arts, Ames IA

Hansen, Linda, *Metals Dept Head,* Worcester Center for Crafts, Worcester MA (S)

Hansen, Lorraine, *Exec Dir,* Ocean City Arts Center, Ocean City NJ (S)

Hansen, Pearl, *Chmn Art,* Wayne State College, Nordstrand Visual Arts Gallery, Wayne NE

Hansen, Pearl, *Dept Chair,* Wayne State College, Dept Art & Design, Wayne NE (S)

Hansen, Pearl, *Prof,* Wayne State College, Dept Art & Design, Wayne NE (S)

Hansen, Peter H, *Dir, External Affairs,* Nelson-Atkins Museum of Art, Kansas City MO

Hansen, Richard, *Assoc Prof,* University of Southern Colorado, Dept of Art, Pueblo CO (S)

Hansen, Steve, *Prof,* Andrews University, Dept of Art, Art History & Design, Berrien Springs MI (S)

Hansen, Victoria, *Assoc Prof,* University of Southern Colorado, Dept of Art, Pueblo CO (S)

Hanslick, Tabitha, *Circulation & ILL,* Fashion Institute of Technology, Gladys Marcus Library, New York NY

Hanson, Annabel, *Admin Coordr,* Queen's University, Agnes Etherington Art Centre, Kingston ON

Hanson, Brent, *Chmn,* Dixie College, Art Dept, Saint George UT (S)

Hanson, Christopher, *Cur Coll,* City of Ketchikan Museum, Tongass Historical Museum, Ketchikan AK

Hanson, David A, *Prof,* Fairleigh Dickinson University, Fine Arts Dept, Teaneck NJ (S)

Hanson, Doug, *Prof,* Cornell College, Peter Paul Luce Gallery, Mount Vernon IA

Hanson, Emma, *Cur Plains Indian Museum,* Buffalo Bill Memorial Association, Buffalo Bill Historical Center, Cody WY

Hanson, Jacquelyn, *Adjunct Asst Prof Art Educ,* Florida Southern College, Melvin Art Gallery, Lakeland FL

Hanson, John, *Asst Prof,* Hope College, Dept of Art & Art History, Holland MI (S)

Hanson, John, *Asst Prof,* Indiana University of Pennsylvania, College of Fine Arts, Indiana PA (S)

Hanson, John, *Dir,* Hope College, De Pree Art Center & Gallery, Holland MI

Hanson, Lowell, *Instr Art,* Everett Community College, Art Dept, Everett WA (S)

Hanson, Robert, *Instr,* Pacific Northwest College of Art, Portland OR (S)

Hantman, Alan M, *Architect of the Capitol,* United States Capitol, Architect of the Capitol, Washington DC

Hanwi, Richard, *Dir Art Educ,* Mercyhurst College, Dept of Art, Erie PA (S)

Hanzal, Carla, *Cur,* Contemporary Art Center of Virginia, Virginia Beach VA

Hanzel, Yvette A, *Dir Mktg,* Beck Center for the Arts, Lakewood OH

Hanzich, Kim, *Awards Prog Assoc,* Art Directors Club, New York NY

Hapgood, Susan, *Exhib Dir,* Independent Curators International, New York NY

Happoldt, Carrie, *Educ,* Biggs Museum of American Art, Dover DE

Harada, Gwen, *Keeper Lending,* Honolulu Academy of Arts, The Art Center at Linekona, Honolulu HI (S)

Harada, Gwen, *Keeper, Lending Center,* Honolulu Academy of Arts, Honolulu HI

Harakal, Eileen E, *Exec Dir Pub Affairs,* The Art Institute of Chicago, Chicago IL

Harbaugh, Claudia, *Mus Shop Mgr,* Westmoreland Museum of American Art, Art Reference Library, Greensburg PA

Harberd, Pat, *VPres & Bd Dir,* Snake River Heritage Center, Weiser ID

Harbison-Samuelson, Carol, *Library Mgr,* Southern Oregon Historical Society, Library, Medford OR

Harcourt, Carolyn, *Asst to Dir,* Willamette University, Hallie Ford Museum of Art, Salem OR

Hard, Michael W, *Pres,* Amerind Foundation, Inc, Amerind Museum, Fulton-Hayden Memorial Art Gallery, Dragoon AZ

Hard, Nicole, *Asst Prof,* Murray State University, Dept of Art, Murray KY (S)

Harders, Faith, *Librn,* University of Kentucky, Hunter M Adams Architecture Library, Lexington KY

Hardesty, Ryan, *Art at Work Mgr,* Eastern Washington State Historical Society, Northwest Museum of Arts & Culture, Spokane WA

Hardesty, Tony, *Registrar,* Owensboro Museum of Fine Art, Owensboro KY

Hardiman, Tom, *Keeper,* Portsmouth Athenaeum, Joseph Copley Research Library, Portsmouth NH

Hardin, Jennifer, *Cur Coll & Exhib,* Museum of Fine Arts, Saint Petersburg, Florida, Inc, Saint Petersburg FL

Harding, Beverly, *Mus Educator,* Seattle Art Museum, Library, Seattle WA

Harding, Catherine, *Asst Prof,* University of Victoria, Dept of History in Art, Victoria BC (S)

Harding, Donald, *Adjunct Instr,* Northwestern College, Art Dept, Orange City CA (S)

Harding, Elaine, *Instr,* University of Utah, Dept of Art & Art History, Salt Lake City UT (S)

Harding, Maureen, *Cur Mus,* Herbert Hoover, West Branch IA

Harding, Robert, *Acting Pres,* National Society of Mural Painters, Inc, New York NY

Hardmon, Frank, *Assoc Prof Art,* Mississippi Valley State University, Fine Arts Dept, Itta Bena MS (S)

Hardwig, Scott, *Prof,* Roanoke College, Fine Arts Dept-Art, Salem VA (S)

Hardwood, Edward S, *Assoc Prof,* Bates College, Art & Visual Culture, Lewiston ME (S)

Hardy, Bea, *Head Librn,* Maryland Historical Society, Library, Baltimore MD

Hardy, Chantal, *Instr,* Universite de Montreal, Dept of Art History, Montreal PQ (S)

Hardy, Charles, *Prof,* Mesa State College, Art Dept, Grand Junction CO (S)

Hardy, David, *Gallery Supt & Preparator,* University of Utah, Utah Museum of Fine Arts, Salt Lake City UT

Hardy, Dominick, *Prog Asst,* Art Gallery of Peterborough, Peterborough ON

Hardy, Gene, *Planetarium Dir,* Museum of the Southwest, Midland TX

Hardy, Ilona, *Faculty,* South Florida Art Institute of Hollywood, Dania FL (S)

Hardy, Mary, *Instr (2-D),* Mississippi Gulf Coast Community College-Jackson County Campus, Art Dept, Gautier MS (S)

Hardy, Myra, *Librn,* Mason County Museum, Mason TX

Hardy, Saralyn Reece, *Dir,* University of Kansas, Spencer Museum of Art, Lawrence KS

Hardy, Tiffany, *Pub Relations Officer,* Mississippi Museum of Art, Jackson MS

Hare, John, *Chief Preparator,* Hunter Museum of American Art, Chattanooga TN

Harger, Sara, *Dir,* Liberty Hall Historic Site, Liberty Hall Museum, Frankfort KY

Harger, Sara, *Dir,* Liberty Hall Historic Site, Orlando Brown House, Frankfort KY

Hargett, Brian, *Reference Librn,* Lee County Library, Tupelo MS

Hargraves, Martine, *Dept Head Reference,* New Bedford Free Public Library, Art Dept, New Bedford MA

Haring, Valerie, *Instr,* Butler County Community College, Art Dept, El Dorado KS (S)

Harington, Donald, *Prof,* University of Arkansas, Art Dept, Fayetteville AR (S)

Hark, Mary, *Instr,* Macalester College, Art Dept, Saint Paul MN (S)

Harker, Barbara, *Admin Asst,* Children's Art Foundation, Museum of International Children's Art, Santa Cruz CA

Harkness, Toni M, *VPres Develop,* Newberry Library, Chicago IL

Harks, Frank, *Chmn,* Mount Royal College, Dept of Interior Design, Calgary AB (S)

Harlan, Susan, *Assoc Prof,* Portland State University, Dept of Art, Portland OR (S)

Harleman, Kathleen, *Exec Dir,* Museum of Art, Fort Lauderdale, Fort Lauderdale FL

Harleman, Kathleen, *Exec Dir,* Bellevue Art Museum, Bellevue WA

Harman, Pam, *Coordr Educ Prog,* Grace Museum, Inc, Abilene TX

Harmon, Betty, *Pres,* Manhattan Graphics Center, New York NY (S)

Harmon, J Scott, *Dir,* United States Naval Academy, USNA Museum, Annapolis MD

Harmon, J Scott, *Dir,* United States Naval Academy, Naval Academy Museum, Annapolis MD

Harmon Miller, Jean, *Assoc Prof,* Missouri Western State University, Art Dept, Saint Joseph MO (S)

Harnisch, Cynthia, *Dir,* Inner-City Arts, Los Angeles CA (S)

Harold, Dorothy, *Clay Teacher,* Locust Street Neighborhood Art Classes, Inc, Buffalo NY (S)

Harpaz, Nathan, *Cur Gallery,* Oakton Community College, Language Humanities & Art Divisions, Des Plaines IL (S)

Harper, John, *Instructor & Gallery Dir,* Shasta College, Art Dept, Arts, Communication & Education Division, Redding CA (S)

Harper, Katherine, *Assoc Prof,* Loyola Marymount University, Dept of Art & Art History, Los Angeles CA (S)

Harper, Kinsey, *Dir Develop,* Atlanta Historical Society Inc, Atlanta History Center, Atlanta GA

Harper, Margaret, *Asst Treas,* Society of Scribes, Ltd, New York NY

Harper, Paula, *Assoc Prof,* University of Miami, Dept of Art & Art History, Coral Gables FL (S)

Harper, Sharon, *Prof,* University of North Carolina at Greensboro, Art Dept, Greensboro NC (S)

Harr, Jemima, *Mus Dir & Cur,* Humboldt Arts Council, Morris Graves Museum of Art, Eureka CA

Harreld Love, Josephine, *Dir,* Heritage Museum Fine Arts Center for Youth, Detroit MI

Harreld Love, Josephine, *Dir,* Heritage Museum Fine Arts Center for Youth, Library, Detroit MI

Harrington, Brooke, *Prog Dir Architecture,* Temple University, Tyler School of Art, Elkins Park PA (S)

Harrington, Christi, *Instr,* Mohawk Valley Community College, Utica NY (S)

Harrington, Ellen, *Exhib Cur,* Academy of Motion Picture Arts & Sciences, The Academy Gallery, Beverly Hills CA

Harrington, Lou Ann, *Deputy Dir,* Cahoon Museum of American Art, Cotuit MA

Harrington, Susan, *Prof,* Texas Christian University, Dept of Art & Art History, Fort Worth TX (S)

Harris, Adam, *Cur,* National Museum of Wildlife Art, Jackson WY

Harris, Beth R, *Dir Library,* Paier College of Art, Inc, Library, Hamden CT

Harris, David J, *Instr,* North Seattle Community College, Art Dept, Seattle WA (S)

Harris, Donna, *Mus Shop Mgr,* African American Historical Museum & Cultural Center of Iowa, Cedar Rapids IA

Harris, Felicia, *Dir Governor's School for the Arts,* Pennsylvania Department of Education, Arts in Education Program, Harrisburg PA

Harris, Gene E, *Cur Coll,* Brandywine River Museum, Chadds Ford PA

Harris, Jada, *Dep Dir Prog,* The Names Project Foundation AIDS Memorial Quilt, Atlanta GA

Harris, Jeff, *Instr,* Whitworth College, Art Dept, Spokane WA (S)

Harris, Julie, *Exec Dir & Mus Shop Mgr,* River Heritage Museum, Paducah KY

Harris, Kara, *Cur Educ,* Saginaw Art Museum, Saginaw MI

Harris, Kevin, *Assoc Prof,* Sinclair Community College, Division of Fine & Performing Arts, Dayton OH (S)

Harris, Kyle, *Coordr Educ,* Los Angeles County Museum of Natural History, William S Hart Museum, Newhall CA

Harris, Lew, *Prof,* University of Tampa, Dept of Art, Tampa FL (S)

Harris, Marie Joan, *Academic Dean,* Avila College, Thornhill Art Gallery, Kansas City MO

Harris, Mark, *Dir, School of Art & Prof Fine Arts,* University of Cincinnati, School of Art, Cincinnati OH (S)

Harris, Nathanial C, *Pres,* Montclair Art Museum, Montclair NJ

Harris, Pamela, *Communications Coordr,* Salina Art Center, Salina KS

Harris, Rae, *Art Educ,* The Winnipeg Art Gallery, Winnipeg MB

Harris, Renata, *Pres,* Hoosier Salon Patrons Association, Inc, Art Gallery, Indianapolis IN

Harris, Robert A, *Dir,* Helen M Plum, Lombard IL

Harris, Steven, *Coordr History of Art, Design & Visual Culture,* University of Alberta, Dept of Art & Design, Edmonton AB (S)

Harris, Sue, *Chmn Humanities,* Quincy College, Art Dept, Quincy MA (S)

Harris, Sue, *Dir of Educ,* Nelda C & H J Lutcher Stark, Stark Museum of Art, Orange TX

Harris, Teresa, *Asst Prof,* Missouri Western State University, Art Dept, Saint Joseph MO (S)

Harris, Tom, *VPres,* Porter-Phelps-Huntington Foundation, Inc, Historic House Museum, Hadley MA

Harris, William, *Sr VPres Develop & Marketing,* California Science Center, Los Angeles CA

Harris-Fernandez, Al, *Dir,* Sioux City Art Center, Sioux City IA

Harris-Fernandez, Al, *Dir,* Sioux City Art Center, Sioux City IA

Harrison, Betsy W, *CEO & Pres,* Genesee Country Village & Museum, John L Wehle Gallery of Wildlife & Sporting Art, Mumford NY

Harrison, Elizabeth, *CEO & Pres,* Genesee Country Village & Museum, John L Wehle Gallery of Wildlife & Sporting Art, Mumford NY

Harrison, Eugene, *Assoc Prof,* Eastern Illinois University, Art Dept, Charleston IL (S)

Harrison, Harry, *Pres & CEO,* African American Museum in Philadelphia, Philadelphia PA

Harrison, Jeff, *Chief Cur,* Chrysler Museum of Art, Norfolk VA

Harrison, Susan, *Program Mgr,* General Services Administration, Washington DC

Harritos, Harry, *Assoc Prof,* Clemson University, College of Architecture, Clemson SC (S)

Harrity, Gail, *COO,* Philadelphia Museum of Art, Philadelphia PA

Harrity, Gail M, *COO,* Philadelphia Museum of Art, Samuel S Fleisher Art Memorial, Philadelphia PA

Harrold, Marty, *Mus Coordr,* Hastings Museum of Natural & Cultural History, Hastings NE

Harrop, Patrick, *Co-Dir & Prof,* University of Manitoba, Faculty of Architecture Exhibition Centre, Winnipeg MB

Harry, Christine, *Marketing & Public Relations,* Ocean City Arts Center, Ocean City NJ (S)

Harsh, Michael, *Actg Chief Coll,* Ohio Historical Society, National Road-Zane Grey Museum, Columbus OH

Harsh, Michael, *Head Collections,* Ohio Historical Society, Archives-Library Division, Columbus OH

Harshbarger, Kern, *Lectr,* University of Nebraska, Kearney, Dept of Art & Art History, Kearney NE (S)

Harshman, Melissa, *Assoc Prof Printmaking,* University of Georgia, Franklin College of Arts & Sciences, Lamar Dodd School of Art, Athens GA (S)

Hart, Barbara A, *Assoc Dir Admin,* National Portrait Gallery, Washington DC

Hart, Diane, *Registrar,* Williams College, Museum of Art, Williamstown MA

Hart, Erdell, *Mus Shop Mgr,* Mississippi Museum of Art, Howorth Library, Jackson MS

Hart, John, *Dir Research & Coll,* New York State Museum, Albany NY

Hart, Jon R, *Pres,* Vesterheim Norwegian-American Museum, Reference Library, Decorah IA

Hart, Katherine, *Cur Acad Progs,* Dartmouth College, Hood Museum of Art, Hanover NH

Hart, Kerry, *Dean,* Laramie County Community College, Division of Arts & Humanities, Cheyenne WY (S)

Hart, Naomi, *Faculty,* Grand Marais Art Colony, Grand Marais MN (S)

Hart, Peggy, *Librn,* Detroit Public Library, Art & Literature Dept, Detroit MI

Hart, Sara, *Chmn,* Shoreline Community College, Humanities Division, Seattle WA (S)

Hart, Sidney, *Ed Charles Willson Peale Papers,* National Portrait Gallery, Washington DC

Hart, Vincent, *Asst Prof,* Georgian Court College, Dept of Art, Lakewood NJ (S)

Harter, David, *Research Secy,* Livingston County Historical Society, Cobblestone Museum, Geneseo NY

Harth, Marjorie L, *Dir,* The Pomona College, Montgomery Gallery, Claremont CA

Harthorn, Sandy, *Cur Art,* Boise Art Museum, Boise ID

Hartigan, Grace, *Dir,* Maryland Institute, Hoffberger School of Painting, Baltimore MD (S)

Hartigan, Lynda, *Chief Cur,* Smithsonian American Art Museum, Washington DC

Hartke, Becki, *Dir Exhib,* Missouri Historical Society, Saint Louis MO

Hartman, Joanne, *Adjunct Asst Prof,* New York Institute of Technology, Fine Arts Dept, Old Westbury NY (S)

Hartman, Mark, *Chmn & Assoc Prof,* University of Nebraska, Kearney, Dept of Art & Art History, Kearney NE (S)

Hartman, Terry L, *Instr,* Modesto Junior College, Arts Humanities & Communications Division, Modesto CA (S)

Hartman, Vladmir, *Photography,* Antonelli Institute, Professional Photography & Commercial Art, Erdenheim PA (S)

Hartmann, Bonnie, *Dir,* Door County, Miller Art Museum, Sturgeon Bay WI

Hartshorn, Willis, *Dir,* International Center of Photography, New York NY

Hartshorn, Willis, *Dir,* International Center of Photography, Midtown, New York NY

Hartsock, Marcia, *Pres,* Association of Medical Illustrators, Lawrence KS

Hartsough, Rachel, *Cur Educ,* Nevada Museum of Art, Art Library, Reno NV

Hartswick, Kim, *Assoc Prof,* George Washington University, Dept of Art, Washington DC (S)

Hartup, Cheryl, *Chief Cur,* Museo de Arte de Ponce, Ponce Art Museum, Ponce PR

Hartwell, Carroll T, *Cur Photo,* Minneapolis Institute of Arts, Minneapolis MN

Hartzold, Susan, *Cur,* McLean County Historical Society, McLean County Museum of History, Bloomington IL

Harvala, Floyd, *VChmn,* North Country Museum of Arts, Park Rapids MN

Harvath, John, *Mgr Fine Arts & Recreation,* Houston Public Library, Houston TX

Harvey, Alan, *Dean,* Foothill College, Fine Arts & Communications Div, Los Altos Hills CA (S)

Harvey, Ben, *Asst Prof,* Mississippi State University, Dept of Art, Mississippi State MS (S)

Harvey, Beth, *Mktg Specialist,* The Rockwell Museum of Western Art, Corning NY

Harvey, Bruce, *Dir,* Housatonic Community College, Library, Bridgeport CT

Harvey, Bunny, *Prof,* Wellesley College, Art Dept, Wellesley MA (S)

Harvey, Clifford, *Prof,* West Virginia University, College of Creative Arts, Morgantown WV (S)

Harvey, Emily, *Discipline Coordr,* Rockland Community College, Graphic Arts & Advertising Tech Dept, Suffern NY (S)

Harvey, Gregory M, *VPres,* Fairmount Park Art Association, Philadelphia PA

Harvey, Kathleen, *Library Dir,* Springfield Art Association of Edwards Place, Michael Victor II Art Library, Springfield IL

Harvey, Liz, *Educ Consultant,* California State University, Long Beach, University Art Museum, Long Beach CA

Harvey, Phillis, *Asst Dir,* Society of Illustrators, Museum of American Illustration, New York NY

Harwood, Ben, *Dir Develop,* Randall Junior Museum, San Francisco CA

Harwood, Ruth Schilling, *Asst Dir,* Maryland-National Capital Park & Planning Commission, Montpelier Arts Center, Laurel MD

Hasamear, Diana, *Business Mgr,* Peoria Art Guild, Peoria IL

Hasegawa, John, *Lectr,* Emporia State University, Dept of Art, Emporia KS (S)

Hasen, Irwin, *Instr,* Joe Kubert, Dover NJ (S)

Hasenberg, Tina, *Educ Dir,* City of Brea, Art Gallery, Brea CA

Haskell, Barbara, *Cur Prewar Art,* Whitney Museum of American Art, New York NY

Haskell, Eric, *Dir,* Scripps College, Clark Humanities Museum, Claremont CA

Haskell, Heather, *Dir,* Springfield Library & Museums Association, Museum of Fine Arts, Springfield MA

Haskell, Heather, *Dir,* Springfield Museums Association, George Walter Vincent Smith Art Museum, Springfield MA

Haskins, Mary Beth, *Pub Rels,* The Ogden Museum of Southern Art, University of New Orleans, New Orleans LA

Haslett, Carrie, *Cur Modern Art,* Portland Museum of Art, Portland ME

Hassen, Carol, *Dir,* Yakima Valley Community College, Larson Gallery, Yakima WA

Hassinger, John L, *Graphic Design,* Art Institute of Pittsburgh, Pittsburgh PA (S)

Hassinger, Maren, *Dir,* Maryland Institute, Rinehart School of Sculpture, Baltimore MD (S)

Hassler, Donna, *Dir,* Rensselaer County Historical Society, Hart-Cluett Mansion, 1827, Troy NY

Hassler, Donna J, *Exec Dir,* Rensselaer County Historical Society, Museum & Library, Troy NY

Hassler, Hilda, *Treas,* Phillips County Museum, Holyoke CO

Hastedt, Catherine A, *Dir,* Texas A&M University, J Wayne Stark University Center Galleries, College Station TX

Hastings, Bill, *Lectr,* Ithaca College, Fine Art Dept, Ithaca NY (S)

Hasvold, Carol, *Registrar & Librn,* Vesterheim Norwegian-American Museum, Reference Library, Decorah IA

Hatch, Bill, *Dept Chmn,* San Juan College, Art Dept, Farmington NM (S)

Hatch, Christine, *Dir,* Eagle Rock Art Museum and Education Center, Inc, Idaho Falls ID

Hatcher, Alison, *Cur,* McLean County Art Association, McLean County Arts Center, Bloomington IL

Hatcher, Gary C, *Assoc Prof & Chmn,* University of Texas at Tyler, Deptartment of Art, School of Visual & Performing Arts, Tyler TX (S)

Hatchett, Dana, *Instr,* Daemen College, Art Dept, Amherst NY (S)

Hatfield, Thomas A, *Exec Dir,* National Art Education Association, Reston VA

Hathaway, Michael, *Dir Collections & Exhibs,* Art Museum of Greater Lafayette, Lafayette IN

Hathaway, Michal, *Registrar,* Art Museum of Greater Lafayette, Library, Lafayette IN

Hatter, Richard, *Develop Office,* John Simon Guggenheim, New York NY

Hau, Amy, *Admin Dir,* Isamu Noguchi, Isamu Noguchi Garden Museum, Long Island City NY

Haubach, Janna L, *Gen Educ,* Art Institute of Pittsburgh, Pittsburgh PA (S)

Haubage-Page, Susan, *Instr,* University of North Carolina at Chapel Hill, Art Dept, Chapel Hill NC (S)

Hauber, Amy, *Asst Prof,* St Lawrence University, Dept of Fine Arts, Canton NY (S)

Haubold, Susan, *Lectr,* Lambuth University, Dept of Human Ecology & Visual Arts, Jackson TN (S)

Haugen, Eunice, *Registrar & Exhib Coordr,* Minnesota Museum of American Art, Saint Paul MN

Haugen, Ilene, *Site Tech,* Jeffers Petroglyphs Historic Site, Comfrey MN

Haught, Ken, *Chmn,* Dickinson State University, Dept of Art, Dickinson ND (S)

Haught, Roy, *Chmn & Prof,* Loras College, Dept of Art, Dubuque IA (S)

Haught, Teri, *Business Mgr,* Cincinnati Institute of Fine Arts, Taft Museum of Art, Cincinnati OH

Haupt, Jeffrey, *Assoc Prof,* Mississippi State University, Dept of Art, Mississippi State MS (S)

Haus, Mary, *Dir Communications,* Whitney Museum of American Art, New York NY

Hause, Melissa, *Asst Prof Art History,* Belhaven College, Art Dept, Jackson MS (S)

Hauser, Erika, The Metropolitan Museum of Art, Robert Goldwater Library, New York NY

Hausey, Robert, *Prof,* Louisiana State University, School of Art, Baton Rouge LA (S)

Hausmann, Doris, *Dir Arts & Educ,* Armory Center for the Arts, Pasadena CA

Haust, Bill, *Head Dept,* Plymouth State College, Art Dept, Plymouth NH (S)

Havas, Sandy, *Dir,* Eccles Community Art Center, Ogden UT

Havekost, Nichole, *Instr,* Adrian College, Art & Design Dept, Adrian MI (S)

Havekost, Niki, *Instr,* Siena Heights University, Studio Angelico-Art Dept, Adrian MI (S)

Havel, Joseph, *Dir,* Glassell School of Art, Houston TX (S)

Havemeyer, Ann, *Archivist,* Norfolk Historical Society Inc, Museum, Norfolk CT

Havlena, Janice M, *Asst Prof,* Edgewood College, Art Dept, Madison WI (S)

Havv, Jane, *Cur Gallery,* Passaic County Community College, Division of Humanities, Paterson NJ (S)

Haw, Jane, *Gallery Cur,* Passaic County Community College, Broadway, LRC, and Hamilton Club Galleries, Paterson NJ

Hawes, Lauren, *Special Asst in Graphic Arts,* American Antiquarian Society, Worcester MA

Hawk, Steven, *Librn & Dir,* Akron-Summit County Public Library, Fine Arts Division, Akron OH

Hawke, Nadine, *Instr,* Arkansas State University, Dept of Art, State University AR (S)

Hawken, George, *Undergrad Coordr Visual Studies,* University of Toronto, Dept of Fine Art, Toronto ON (S)

Hawkes, Carol, *Dean,* Western Connecticut State University, School of Visual & Performing Arts, Danbury CT (S)

Hawkes, Rob, *Prof,* Tidewater Community College, Visual Arts Center, Portsmouth VA (S)

Hawkins, Amy Harris, *Asst Cur,* The Ethel Wright Mohamed Stitchery Museum, Belzoni MS

Hawkins, April, *Dir Residency,* Hambidge Center for the Creative Arts & Sciences, Rabun Gap GA

Hawkins, John, *Sec,* Atlantic Gallery, New York NY

Hawkins, Paulette, *Exhib Coordr,* Where Edmonton Community Artists Network Society, Harcourt House Arts Centre, Edmonton AB

Hawkins, Renee, *Dir,* Longview Museum of Fine Art, Longview TX

Hawks, Lynn, *Chief Develop Dir,* Wichita Art Museum, Wichita KS

Hawks, Lynn, *Chief Develop Dir,* Wichita Art Museum, Emprise Bank Research Library, Wichita KS

Hawley, Anne, *Dir,* Isabella Stewart Gardner, Boston MA

Hawley, Henry, *Cur Baroque & Sculpture,* Cleveland Museum of Art, Cleveland OH

Haworth, John, *Deputy Asst Dir Public Progs,* National Museum of the American Indian, George Gustav Heye Center, New York NY

Haworth, Stephen K, *Assoc Prof,* University of West Florida, Dept of Art, Pensacola FL (S)

Hawthorne, Frances, *Lectr,* University of North Carolina at Charlotte, Dept Art, Charlotte NC (S)

Hawthorne, Lawrence, *Asst Prof,* Virginia State University, Arts & Design, Petersburg VA (S)

Hawthorne, Minnie, *Gift Shop Mgr,* Cascade County Historical Society, High Plains Heritage Center, Great Falls MT

Haxthausen, Charles, *Dir Grad Prog,* Williams College, Dept of Art, Williamstown MA (S)

Hay, Monica, *Registrar,* Art Museum of Southeast Texas, Beaumont TX

Hayashi, Masumi, *Prof,* Cleveland State University, Art Dept, Cleveland OH (S)

Hayashi-Smith, Donna, *Coll Mgr,* White House, Washington DC

Hayden, Carla, *Dir,* Enoch Pratt, Baltimore MD

Hayden, Diane, *Financial Admin,* Sharon Arts Center, Sharon Arts Center Exhibition Gallery, Sharon NH

Hayden, Jason, *Dir Operations,* Owensboro Museum of Fine Art, Owensboro KY

Haydu, John R, *Prof,* Central Missouri State University, Art Dept, Warrensburg MO (S)

Hayes, Bonnie, *Asst Prof,* Beaver College, Dept of Fine Arts, Glenside PA (S)

Hayes, Daniel T, *Pres,* Finger Lakes Community College, Visual & Performing Arts Dept, Canandaigua NY (S)

Hayes, Erin, *Faculty,* Yakima Valley Community College, Dept of Visual Arts, Yakima WA (S)

Hayes, Greg, *Supv Ranger,* Jack London, House of Happy Walls, Glen Ellen CA

Hayes, Meredith, *Dir Public Rel & Mktg,* Tucson Museum of Artand Historic Block, Tucson AZ

Hayes, Rebecca, *Dir Educ,* Williams College, Museum of Art, Williamstown MA

Hayes, Richard, *Instr,* University of Louisiana at Monroe, Dept of Art, Monroe LA (S)

Hayes-Thumann, Karen, *Asst Dir Undergrad,* University of Oklahoma, School of Art, Norman OK (S)

Haymaker, James, *Dir,* Pfeiffer University, Art Program, Misenheimer NC (S)

Hayman, Judy, *Assoc Dir,* James A Michener, Doylestown PA

Hayman, Marc, *Chief Interpretation,* San Francisco Maritime National Historical Park, Maritime Museum, San Francisco CA

Haymond, J Brent, *VPres,* Springville Museum of Art, Springville UT

Hayner, Judith, *Exec Dir,* Muskegon Museum of Art, Muskegon MI

Haynes, Carol, *Pres,* Phillips County Museum, Holyoke CO

Haynes, Chris, *Asst Prof,* Springfield College, Dept of Visual & Performing Arts, Springfield MA (S)

Haynes, Jennifer, *Art Dir,* Hill Country Arts Foundation, Duncan-McAshan Visual Arts Center, Ingram TX

Haynes, Maria, *Dir Communications,* Cummer Museum of Art & Gardens, DeEtte Holden Cummer Museum Foundation, Jacksonville FL

Haynes, Michaele, *Cur History & Textiles,* Witte Museum, San Antonio TX

Haynes, Sandra, *Acting Area Head History,* Pasadena City College, Art Dept, Pasadena CA (S)

Haynes, Thomas, *Educ Dir,* Historical Society of Cheshire County, Keene NH

Haynes, Wendy, *Dir Exhib & Coll Serv,* Amon Carter, Fort Worth TX

Hays, Philip, *Illustration Chmn,* Art Center College of Design, Pasadena CA (S)

Hayton, Greg, *Chief Librn,* Cambridge Public Library and Gallery, Cambridge ON

Haywood, Heather, *Dir Mktg,* The Arkansas Arts Center, Museum School, Little Rock AR (S)

Hayworth, Kathleen, *Head Mktg & Public Rels,* Burchfield-Penney Art Center, Buffalo NY

Hennessey, Maureen Hart, *Assoc Dir Curatorial & Professional Affairs,* Norman Rockwell Museum, Library, Stockbridge MA

Hennessey, William J, *Dir,* Chrysler Museum of Art, Norfolk VA

Hennessy, Jennifer, *Exec Asst,* Houston Center For Photography, Houston TX

Hennessy, Joe, *Exhib Design,* Illinois State Museum, Museum Store, Chicago IL

Hennesy, Cody, *Librn,* California College of the Arts, Libraries, Oakland CA

Henning, Jean, *Coordr Young People's Prog,* Nassau County Museum of Fine Art, Roslyn Harbor NY

Henning, Robert, *Acting Dir,* Santa Barbara Museum of Art, Santa Barbara CA

Henning, William, *Cur,* Contemporary Crafts Museum & Gallery, Portland OR

Henninger, Diane, *Financial Mgr,* Birmingham-Bloomfield Art Center, Art Center, Birmingham MI

Henninger, Michael, *Interim Chmn,* California State University, Hayward, Art Dept, Hayward CA (S)

Hennings, Tyler, *Lectr,* Monmouth College, Dept of Art, Monmouth IL (S)

Henrich, Sarah E, *Exec Dir,* Headley-Whitney Museum, George Headley Library, Lexington KY

Henrikson, Steve, *Cur Coll,* Alaska State Museum, Juneau AK

Henry, Alicia, *Asst Prof,* Fisk University, Art Dept, Nashville TN (S)

Henry, Barbara, *Chief Cur Educ,* Oakland Museum of California, Art Dept, Oakland CA

Henry, Carole, *Assoc Prof Art Educ,* University of Georgia, Franklin College of Arts & Sciences, Lamar Dodd School of Art, Athens GA (S)

Henry, Eileen, *Admisr,* Hunter Museum of American Art, Chattanooga TN

Henry, Elaine, *Chair,* Emporia State University, Dept of Art, Emporia KS (S)

Henry, Eric, *Membership Coordr,* Film Arts Foundation, San Francisco CA

Henry, Greg, *Assoc Prof,* Christopher Newport University, Dept of Fine Performing Arts, Newport News VA (S)

Henry, John, *Advertising Design Faculty,* Saint Clair County Community College, Jack R Hennesey Art Dept, Port Huron MI (S)

Henry, Kevin, *Coordr Pkg Designs,* Columbia College, Art Dept, Chicago IL (S)

Henry, Laura, *Educ Coordr,* Mexican Museum, San Francisco CA

Henry, Lawrence, *CEO & Pres,* Brookgreen Gardens, Murrells Inlet SC

Henry, Lisa, *Pres,* Springfield Museum of Art, Springfield OH

Henry, Mark, *Museum Technician,* Fort George G Meade Museum, Fort Meade MD

Henry, Sarah, *Deputy Dir,* Museum of the City of New York, Museum, New York NY

Henry-Corrington, Sara, *Prof,* Drew University, Art Dept, Madison NJ (S)

Hensel, Jacqueline, *Bulletin Ed,* Marin County Watercolor Society, Corte Madera CA

Henshaw Jones, Susan, *Dir,* Museum of the City of New York, New York NY

Hensley, Fred Owen, *Prof,* University of North Alabama, Dept of Art, Florence AL (S)

Hentchel, Fred, *Prof,* Illinois Central College, Dept Fine, Performing & Applied Arts, East Peoria IL (S)

Henton, Marty, *Dir,* Living Arts & Science Center, Inc, Lexington KY

Hentz, Christopher, *Prof,* Louisiana State University, School of Art, Baton Rouge LA (S)

Henzy, John, *Head,* Gloucester County College, Liberal Arts Dept, Sewell NJ (S)

Hepburn, Tony, *Head Ceramics Dept,* Cranbrook Academy of Art, Bloomfield Hills MI (S)

Hepler, Anna, *Visiting Asst Prof,* Bowdoin College, Art Dept, Brunswick ME (S)

Heppner, Mark, *VPres Mus Svcs & Cur,* Stan Hywet, Akron OH

Hepworth, Russell, *Assoc Prof,* College of Southern Idaho, Art Dept, Twin Falls ID (S)

Herbaugh, Karen, *Cur,* American Textile History Museum, Lowell MA

Herbeck, Edward, *Adjunct Prof,* North Central College, Dept of Art, Naperville IL (S)

Herbein, Kathleen, *Chmn,* Reading Public Museum, Library, Reading PA

Herbein, Kathleen D, *Chair,* Reading Public Museum, Reading PA

Herberg, Mayde, *Dir,* Santa Ana College, Art Gallery, Santa Ana CA

Herberg, Mayde, *Instr,* Santa Ana College, Art Dept, Santa Ana CA (S)

Herbert, Dana, *Prog Coordr,* Farmington Valley Arts Center, Avon CT

Herbert, F John, *Exec Dir,* National Association of Artists' Organizations (NAAO), Birmingham AL

Herbert, Gilles, *Dir,* Mendel Art Gallery & Civic Conservatory, Saskatoon SK

Herbert, James, *Distinguished Research Prof Drawing & Painting,* University of Georgia, Franklin College of Arts & Sciences, Lamar Dodd School of Art, Athens GA (S)

Herbst, Fred, *Assoc Prof,* Corning Community College, Division of Humanities, Corning NY (S)

Herda, Sarah, *Dir,* Storefront for Art & Architecture, New York NY

Herer, David I, *Secy,* The Buffalo Fine Arts Academy, Albright-Knox Art Gallery, Buffalo NY

Hereth, Jennifer, *Asst Prof,* College of DuPage, Liberal Arts Division, Glen Ellyn IL (S)

Hergert, Erin, *Mktg Mgr,* Sangre de Cristo Arts & Conference Center, Pueblo CO

Herhusky, Robert, *Assoc Prof,* California State University, Chico, Department of Art & Art History, Chico CA (S)

Heriard, Robert T, *Chmn Reference Svcs,* University of New Orleans, Earl K Long Library, New Orleans LA

Heric, John, *Assoc Prof Sculpture,* University of Arizona, Dept of Art, Tucson AZ (S)

Herko, Carl, *Communications Specialist,* Tryon Palace Historic Sites & Gardens, New Bern NC

Herlinger, Sara, *Coll Mgr,* Susquehanna University, Lore Degenstein Gallery, Selinsgrove PA

Herman, Adriane, Maine College of Art, Portland ME (S)

Herman, Brenda, *Admin Coordr,* Museums Association of Saskatchewan, Regina SK

Herman, Judy, *Exec Dir,* Main Line Art Center, Haverford PA

Herman, Judy S, *Admin Exec Dir,* Main Line Art Center, Haverford PA (S)

Herman, Monica, *Asst Dir & Store Mgr,* Sid W Richardson, Sid Richardson Museum, Fort Worth TX

Herman, Warren, *Mus Shop Mgr,* San Diego Museum of Art, San Diego CA

Hermann, Kathy, *Asst Prof,* Taylor University, Visual Art Dept, Upland IN (S)

Hermanson, Carole, *Instr,* Marylhurst University, Art Dept, Marylhurst OR (S)

Hermes, Jean, *Office Support Staff,* Neville Public Museum, Green Bay WI

Hern, Mary Ellen, *Assoc Dir External Relations,* Norman Rockwell Museum, Stockbridge MA

Hernandez, Ana Margarita, *Dir Educ,* Museo de Arte de Ponce, Ponce Art Museum, Ponce PR

Hernandez, Jo Farb, *Dir Gallery,* San Jose State University, School of Art & Design, San Jose CA (S)

Hernandez, John, *Dir,* Trust Authority, Museum of the Great Plains, Lawton OK

Hernandez, Josephine, *Art Library Asst,* Smith College, Hillyer Art Library, Northampton MA

Hernandez, Lorna, *Asst Chmn Advertising Design,* Art Institute of Fort Lauderdale, Fort Lauderdale FL (S)

Hernandez, Sam, *Prof,* Santa Clara University, Dept of Art & Art History, Santa Clara CA (S)

Hernandez, Sheila, *Cur,* Wells Fargo & Co, History Museum, Los Angeles CA

Hernandez, T Paul, *Assoc Prof,* Texas Lutheran University, Dept of Visual Arts, Seguin TX (S)

Hernes, Patricia, *Assoc Prof,* Loyola University of Chicago, Fine Arts Dept, Chicago IL (S)

Herr, Sarah, *Dir Develop,* Museum of Photographic Arts, San Diego CA

Herreman, Frank, *Dir Exhib,* Museum for African Art, Long Island City NY

Herren, Angela, *Asst Prof,* University of North Carolina at Charlotte, Dept Art, Charlotte NC (S)

Herrera, Pauline, *Pub Relations & Mktg,* Museo de las Americas, Denver CO

Herrernan, John, *VPres,* Bergen County Historical Society, Steuben House Museum, River Edge NJ

Herrero, Susana, *Prof,* University of Puerto Rico, Dept of Fine Arts, Rio Piedras PR (S)

Herrick, Kristine, *Assoc Prof,* College of Saint Rose, Art Dept, Albany NY (S)

Herring, Rhonda, *VPres,* Biloxi Art Association, Gulfport MS

Herrity, Carol, *Research Librn,* Lehigh County Historical Society, Allentown PA

Herrity, Carol M, *Reference Librn,* Lehigh County Historical Society, Scott Andrew Trexler II Library, Allentown PA

Herrmann, Frank, *Prof Fine Arts,* University of Cincinnati, School of Art, Cincinnati OH (S)

Herrnstadt, Steve, *Coordr Integrated Arts,* Iowa State University, Dept of Art & Design, Ames IA (S)

Herrold, David, *Prof,* DePauw University, Art Dept, Greencastle IN (S)

Herron, Chris, *Registrar,* Kirkland Museum of Fine & Decorative Art, Denver CO

Herron, Cliff, *Chmn,* Okalaosa-Walton Community College, Division of Humanities, Fine & Performing Arts, Niceville FL (S)

Herron, Joseph, *Media Arts & Animation,* Art Institute of Pittsburgh, Pittsburgh PA (S)

Herron, Margaret, *Interior Design,* Art Institute of Pittsburgh, Pittsburgh PA (S)

Hersey, Irwin, *Pres,* The Chaim Gross Studio Museum, New York NY

Hershberger, Abner, *Prof,* Goshen College, Art Dept, Goshen IN (S)

Hershey, Charles, *Pres (V),* The Museum, Greenwood SC

Hershey, David, *Mus Asst,* University of Richmond, University Museums, Richmond VA

Hershman, Lynn, University of California, Davis, Dept of Art & Art History, Davis CA (S)

Hershour, Jenny, *Managing Dir,* Citizens for the Arts in Pennsylvania, Harrisburg PA

Herskowitz, Sylvia A, *Dir,* Yeshiva University Museum, New York NY

Hertel, Christiane, *Prof,* Bryn Mawr College, Dept of the History of Art, Bryn Mawr PA (S)

Hertel-Baker, Kathleen, *Archivist,* Anchorage Museum at Rasmuson Center, Anchorage AK

Hertz, Alain, *Assoc Prof,* Universite de Montreal, Bibliotheque d'Amenagement, Montreal PQ

Hertz, Betti-Sue, *Cur Contemporary Art,* San Diego Museum of Art, San Diego CA

Hertzlieb, Gregg, *Dir,* Valparaiso University, Brauer Museum of Art, Valparaiso IN

Herzog, Melanie, *Assoc Prof,* Edgewood College, Art Dept, Madison WI (S)

Hess, Donnalynn, *Dir Educ,* BJU Museum & Gallery, Bob Jones University Museum & Gallery Inc, Greenville SC

Hess, Honee A, *Dir Educ,* Worcester Art Museum, Worcester MA

Hess, Lali, *Gallery Dir,* Wabash College, Art Dept, Crawfordsville IN (S)

Hess, Richard, *Secy,* Brown County Art Gallery Foundation, Brown County Art Gallery & Foundation, Nashville IN

Hess, Sara, *VPres,* Brown County Art Gallery Foundation, Brown County Art Gallery & Foundation, Nashville IN

Hess, Teresa, *Prof,* Lakeland Community College, Fine Arts Department, Kirtland OH (S)

Hessburg, Aloyse, *Assoc Prof,* Mount Mary College, Art & Design Division, Milwaukee WI (S)

Hesse, Gary, *Assoc Dir,* Light Work, Robert B Menschel Photography Gallery, Syracuse NY

Hesselgrave, Joyce, *Lectr,* California State Polytechnic University, Pomona, Art Dept, Pomona CA (S)

Hessemer, Peter, *Assoc Prof,* Oakton Community College, Language Humanities & Art Divisions, Des Plaines IL (S)

Hester, Paul, *Lectr,* Rice University, Dept of Art & Art History, Houston TX (S)

Heston, Sally, *Instr,* Cuyahoga Valley Art Center, Cuyahoga Falls OH (S)

Heth, Charlotte, *Asst Dir Pub Progs,* National Museum of the American Indian, George Gustav Heye Center, New York NY

Hethcox, Rhonda, *Vol Coordr,* Birmingham Museum of Art, Birmingham AL

Heuer, Curt, *Chmn,* University of Wisconsin-Green Bay, Arts Dept, Green Bay WI (S)

Heuer, Kathryn, *Librn Dir,* College of Visual Arts, Library, Saint Paul MN

Heuker, Jennifer, *Prof,* State University of New York College at Brockport, Dept of Art, Brockport NY (S)

Heumann, Michael, *VPres,* Southwest Museum, Los Angeles CA

Heuser, Douglas, *CEO & Dir,* See Science Center, Manchester NH

Hewett, Daphne, *Mus Shop Mgr,* Memphis Brooks Museum of Art, Memphis TN

Hewitt, Clarissa, *Prof,* California Polytechnic State University at San Luis Obispo, Dept of Art & Design, San Luis Obispo CA (S)

Hewitt, Fenichel, *Dir Commications & Donor Develop,* Women's Studio Workshop, Inc, Rosendale NY

Hewitt, Timothy, *Cur,* Presidential Museum, Odessa TX

Hewlett, Rachel, *Educ Coordr,* Houston Center For Photography, Houston TX

Hext, Charles R, *Prof,* Sul Ross State University, Dept of Fine Arts & Communications, Alpine TX (S)

Hey, Ken, *Instr,* Western Wisconsin Technical College, Graphics Division, La Crosse WI (S)

Heyler, Joanne, *Acting Cur,* SunAmerica, Inc, The SunAmerica Collection, Los Angeles CA

Heyning, John, *Deputy Dir Research,* Natural History Museum of Los Angeles County, Los Angeles CA

Heywood, Stephen, *Prof,* Florida Community College at Jacksonville, South Campus, Art Dept, Jacksonville FL (S)

Hickey, Carol, *Instr,* Franklin & Marshall College, Art Dept, Lancaster PA (S)

Hickey, Christopher, *Assoc Prof,* Clark-Atlanta University, School of Arts & Sciences, Atlanta GA (S)

Hickman, Gerry, *Pres Bd Trustees,* Attleboro Museum, Center for the Arts, Attleboro MA

Hickman, Paul, *Asst Prof,* Arkansas State University, Dept of Art, State University AR (S)

Hickok, Paul, *Pres,* Pioneer Historical Museum of South Dakota, Hot Springs SD

Hicks, Audrey, *Treas,* Moncur Gallery, Boissevain MB

Hicks, Holly, *Educ,* Carson County Square House Museum, Panhandle TX

Hicks, Laurie E, *Assoc Prof,* University of Maine, Dept of Art, Orono ME (S)

Hicks, Steve, *Chmn,* Oklahoma Baptist University, Art Dept, Shawnee OK (S)

Hicks-Connors, Robin, *Pres & CEO,* Historical Society of Martin County, Elliott Museum, Stuart FL

Hieblinger, Faith, *Cur & Adminr,* Homer Watson, Kitchener ON

Hier, Marlene F, *Dir Mem Develop,* Simon Wiesenthal Center Inc, Museum of Tolerance, Los Angeles CA

Hier, Marvin, *Dean,* Simon Wiesenthal Center Inc, Los Angeles CA

Hiesinger, Kathryn B, *Cur European Decorative Art,* Philadelphia Museum of Art, Samuel S Fleisher Art Memorial, Philadelphia PA

Hiester, Jan, *Registrar,* Charleston Museum, Charleston SC

Higby, Wayne, *Chmn Bd,* Haystack Mountain School of Crafts, Deer Isle ME

Higgins, David, *Prof,* Corning Community College, Division of Humanities, Corning NY (S)

Higgins, Janet, *Instr,* Middle Tennessee State University, Art Dept, Murfreesboro TN (S)

Higgins, Larkin, *Prof,* California Lutheran University, Art Dept, Thousand Oaks CA (S)

Higgins, Melissa, *Dir Educ,* Akron Art Museum, Akron OH

Higgins, Sandra, *Coll Mgr,* University of Richmond, University Museums, Richmond VA

Higgins, Steve, University of Manitoba, School of Art, Winnipeg MB (S)

Higgins, Steven, *Acting Chief Cur, Dept Film & Video,* Museum of Modern Art, New York NY

Higgins-Jacob, Coleen, *Treas,* John Simon Guggenheim, New York NY

Higginson, Genevra, *Special Events Officer,* National Gallery of Art, Washington DC

Higgs, Jamie, *Chmn,* Marian College, Art Dept, Indianapolis IN (S)

Higgs, Mathew, *Cur Art & Design,* Capp Street Project, San Francisco CA

Higgs, Matthew, *Cur,* California College of Arts & Crafts, CCAC Wattis Institute for Contemporary Arts, Oakland CA

Higgs, Richard, *Provost,* Milwaukee Institute of Art & Design, Milwaukee WI (S)

High, Steven S, *Exec Dir,* Nevada Museum of Art, Reno NV

High, Steven S, *Exec Dir,* Nevada Museum of Art, Art Library, Reno NV

Highsmith Rowell, Tina, *Coordr Exhibits & Prog,* Okefenokee Heritage Center, Inc, Waycross GA

Hight, Elenor, *Assoc Prof,* University of New Hampshire, Dept of Arts & Art History, Durham NH (S)

Hightower, John B, *Pres,* The Mariners' Museum, Newport News VA

Higonnet, Anne, *Assoc Prof,* Wellesley College, Art Dept, Wellesley MA (S)

Higrite, Heather, *Librn,* Arkansas Arts Center, Elizabeth Prewitt Taylor Memorial Library, Little Rock AR

Hilbert, Mark, *Treas,* Pasadena Museum of California Art, Pasadena CA

Hild, Glenn, *Dept Chmn,* Eastern Illinois University, Art Dept, Charleston IL (S)

Hildebrand, Danna, *Instr,* Sheridan College, Art Dept, Sheridan WY (S)

Hildreth, Susan, *City Librn,* San Francisco Public Library, Art & Music Center, San Francisco CA

Hile, Jeanette, *Prof,* Seton Hall University, College of Arts & Sciences, South Orange NJ (S)

Hileman, Jayne, *Chmn,* Saint Xavier University, Dept of Art & Design, Chicago IL (S)

Hileman, Kristen, *Cur,* Arlington Arts Center, Arlington VA

Hiles, Tim, *Assoc Dir,* University of Tennessee, Knoxville, School of Art, Knoxville TN (S)

Hilgemann, Carol, *VPres,* Fairbanks Arts Association, Fairbanks AK

Hilgers, Ross, *Asst Prof,* Concordia College, Art Dept, Moorhead MN (S)

Hill, Brian O, *Dir & Cur,* Trenton City Museum, Trenton NJ

Hill, C T, *Pres,* Crestar Bank, Art Collection, Richmond VA

Hill, Carolyn, *Dir,* Oklahoma City Museum of Art, Oklahoma City OK

Hill, Carolyn, *Dir & Cur,* Oklahoma City Museum of Art, Library, Oklahoma City OK

Hill, Charles, *Cur Canadian Art,* National Gallery of Canada, Ottawa ON

Hill, Dennis, *Music Instr,* Edison Community College, Gallery of Fine Arts, Fort Myers FL (S)

Hill, Lynn, *Asst Prof,* Elmhurst College, Art Dept, Elmhurst IL (S)

Hill, Michael, *Instr,* University of South Dakota, Department of Art, College of Fine Arts, Vermillion SD (S)

Hill, Michele, *Admin Support Asst,* United States Department of the Interior, Indian Arts & Crafts Board, Washington DC

Hill, Nicholas, *Chmn,* Otterbein College, Art Dept, Westerville OH (S)

Hill, Shannen, *Asst Prof Art History & Gallery Dir,* University of Denver, School of Art & Art History, Denver CO (S)

Hill, Sherri, *Prof,* Manatee Community College, Dept of Art & Humanities, Bradenton FL (S)

Hill, Thom, *Dean of Fine & Performing Arts,* Santa Ana College, Art Dept, Santa Ana CA (S)

Hill, Thomas, *Librn,* Vassar College, Art Library, Poughkeepsie NY

Hill, Tiffany, *Art Dir,* Art & Culture Center of Hollywood, Art Gallery, Hollywood FL

Hill, Tiffany, *Artistic Dir,* Art & Culture Center of Hollywood, Art Gallery, Hollywood FL

Hillbruner, Fred, *Head Technical Svcs,* School of the Art Institute of Chicago, John M Flaxman Library, Chicago IL

Hillhouse, Susan, *Chief Cur,* Triton Museum of Art, Library, Santa Clara CA

Hilliard, David C, *Co-Chmn,* The Art Institute of Chicago, Dept of Prints & Drawings, Chicago IL

Hilliard, Greg, *Dir Operations,* Cedarhurst Center for the Arts, Mitchell Museum, Mount Vernon IL

Hilliard, Mark, *Asst Prof,* Wayland Baptist University, Dept of Art, Plainview TX (S)

Hillier, Harry, *Pres,* Wayne County Historical Society, Museum, Honesdale PA

Hillier, John, *Chmn,* Kilgore College, Visual Arts Dept, Kilgore TX (S)

Hillier, Skip, *VPres,* Wayne County Historical Society, Honesdale PA

Hillman, Arthur, *Prof,* Simon's Rock College of Bard, Visual Arts Dept, Great Barrington MA (S)

Hillman, Eric, *VPres,* Southern Alberta Art Gallery, Lethbridge AB

Hillman, Judy, *Asst Prof,* Hope College, Dept of Art & Art History, Holland MI (S)

Hillstrom, Richard L, *Consultant & Cur,* Lutheran Brotherhood Gallery, Gallery of Religious Art, Minneapolis MN

Hilsdon, Teta, *Operation Mgr,* Brattleboro Museum & Art Center, Brattleboro VT

Hilton, Alison, *Chmn & Prof,* Georgetown University, Dept of Art, Music & Theatre, Washington DC (S)

Hilty, Tomas, *Dir,* Bowling Green State University, School of Art, Bowling Green OH (S)

Hilyard, Stephen, *Asst Prof,* University of Minnesota, Duluth, Art Dept, Duluth MN (S)

Hinchliffe, Robin, *Dir,* Angels Gate Cultural Center, Gallery A & Gallery G, San Pedro CA

Hinckley, Robert L, *Exec VPres,* Wendell Gilley, Southwest Harbor ME

Hinde, Barbara, *Coll Mgr,* The Art Institute of Chicago, Dept of Prints & Drawings, Chicago IL

Hindman, James, *Dir & COO,* The American Film Institute, Center for Advanced Film & Television, Los Angeles CA (S)

Hinds, Jill, *Instr,* Northwestern Michigan College, Art Dept, Traverse City MI (S)

Hine, Charles, *Dir,* Salvador Dali, Museum, Saint Petersburg FL

Hines, Jessica, *Assoc Prof,* Georgia Southern University, Dept of Art, Statesboro GA (S)

Hines, Karen, *Asst Registrar,* Vassar College, The Frances Lehman Loeb Art Center, Poughkeepsie NY

Hines, Rich, *Dir,* University of Portland, Wilson W Clark Memorial Library, Portland OR

Hines, Sally, *VPres Exhibits,* DuPage Art League School & Gallery, Wheaton IL

Hinken, Susan, *Technical Svcs Librn,* University of Portland, Wilson W Clark Memorial Library, Portland OR

Hinojos, Erica, *Mus Shop Mgr,* Kern County Museum, Library, Bakersfield CA

Hinrichsen, Eva, *Archivist,* African American Historical Museum & Cultural Center of Iowa, Cedar Rapids IA

Hinson, Mary Joan, *Prof,* Florida Community College at Jacksonville, South Campus, Art Dept, Jacksonville FL (S)

Hinson, Peggy S, *Prof,* Methodist College, Art Dept, Fayetteville NC (S)

Hinton, David, *Dean Academic Affairs,* Watkins Institute, College of Art & Design, Nashville TN

Hinton, William, *Dir & Cur,* Louisburg College, Art Gallery, Louisburg NC

Hintz, Jayna, *Cur Educ,* Leigh Yawkey Woodson, Wausau WI

Hintz, Jayna, *Cur Educ,* Leigh Yawkey Woodson, Art Library, Wausau WI

Hinz, Sally, *Dir Special Projects,* Putnam Museum of History and Natural Science, Library, Davenport IA

Hinze, Roxanne, *Adjunct Instr,* Northern State University, Art Dept, Aberdeen SD (S)

Hipp, Francis M, *Pres,* Liberty Life Insurance Company, Greenville SC

Hipps, Will, *Gallery Dir,* Maryland Institute, College of Art Exhibitions, Baltimore MD

Hiramoto, Judy, *Instr,* American River College, Dept of Art/Art New Media, Sacramento CA (S)

Hiratsuka, Yuji, *Asst Prof,* Oregon State University, Dept of Art, Corvallis OR (S)

Hirayama, Mikiko, *Asst Prof Art History,* University of Cincinnati, School of Art, Cincinnati OH (S)

Hirsch, Barron, *Prof,* Saginaw Valley State University, Dept of Art & Design, University Center MI (S)

Hirsch, Gilah, California State University, Dominguez Hills, Art Dept, Carson CA (S)

Hirsch, Marjorie, *Dir,* Clark College, Archer Gallery/Gaiser Hall, Vancouver WA

Hirsch, Steven, *Asst Prof,* Pennsylvania College of Technology, Dept. of Communications, Construction and Design, Williamsport PA (S)

Hirschel, Anthony, *Dir & CEO,* Columbus Museum of Art and Design, Indianapolis IN

Hirschfeld, Barbara, *Exec Dir,* Paine Art Center & Gardens, Oshkosh WI

Hirschfield, Jim, *Prof,* University of North Carolina at Chapel Hill, Art Dept, Chapel Hill NC (S)

Hirschorn, Paul, *Head Dept Architecture,* Drexel University, College of Media Arts & Design, Philadelphia PA (S)

Hirsh, Cecilia, *Instr,* Greenfield Community College, Art, Communication Design & Media Communication Dept, Greenfield MA (S)

Hirshon, Stephen, *Asst Prof,* Shippensburg University, Art Dept, Shippensburg PA (S)

Hisa, Asuka, *Dir Educ,* Santa Monica Museum of Art, Santa Monica CA

Hisaw, Ruth, *Human Resources Mgr,* Columbia Museum of Art, Columbia SC

Hiss, Nancy, *Instr,* Marylhurst University, Art Dept, Marylhurst OR (S)

Hissey, Carey, *Assoc Prof,* Oklahoma State University, Art Dept, Stillwater OK (S)

Hitchcock, Alix, *Instr,* Wake Forest University, Dept of Art, Winston-Salem NC (S)

Hitchcock, Julia, *Assoc Prof,* Baylor University, Dept of Art, Waco TX (S)

Hitner, Chuck, *Prof Painting & Drawing,* University of Arizona, Dept of Art, Tucson AZ (S)

Hiuini, Dahn, *Coordr Art Educ,* Shepherd University, Art Dept, Shepherdstown WV (S)

Hixon, Karen, *Chmn Bd Trustees,* San Antonio Museum of Art, San Antonio TX

Hixon, Nancy, *Asst Dir,* Art Museum of the University of Houston, Blaffer Gallery, Houston TX

Hlad, Richard, *Asst Prof,* Tarrant County Junior College, Art Dept, Hurst TX (S)

Hlady, Maria, *Instr,* Toronto School of Art, Toronto ON (S)

Hluska, Karl, *Instr,* Greenfield Community College, Art, Communication Design & Media Communication Dept, Greenfield MA (S)

Hnateyko, Olha, *Pres (V),* The Ukrainian Museum, New York NY

Hoadley, Mary, *Admin,* Cosanti Foundation, Scottsdale AZ

Hoagland, Eleanor T M, *Pres,* Wendell Gilley, Southwest Harbor ME

Hoar, Bill, *Prof,* Northern State University, Art Dept, Aberdeen SD (S)

Hoard, Cindy, *Dir Develop,* Cedarhurst Center for the Arts, Mitchell Museum, Mount Vernon IL

Hobbs, Jon, *Chief Admin Officer,* Royal Architectural Institute of Canada, Ottawa ON

Hobbs, Mary Alice, *Publicity & Heritage Writer,* Brigham City Corporation, Brigham City Museum & Gallery, Brigham City UT

Hobbs, Ronald, *VPres,* Nova Scotia College of Art & Design, Halifax NS (S)

Hobday, John, *Exec Dir (SBC),* Saidye Bronfman, Liane & Danny Taran Gallery, Montreal PQ

Hobin , Timothy J, *Admin Asst,* Center for Exploratory & Perceptual Art, CEPA Library, Buffalo NY

Hobin, Timothy J., *Admin Asst,* Center for Exploratory & Perceptual Art, CEPA Gallery, Buffalo NY

Hock, Louis, *Dept Chmn,* University of California, San Diego, Visual Arts Dept, La Jolla CA (S)

Hock, Rick, *Dir Creative Svcs,* George Eastman, Rochester NY

Hockett, Roland L, *Assoc Prof,* Gulf Coast Community College, Division of Visual & Performing Arts, Panama City FL (S)

Hockfield, Marissa, *Prog Admin Coordr,* Illinois Alliance for Arts Education (IAAE), Chicago IL

Hocking, Christopher, *Assoc Prof Foundations,* University of Georgia, Franklin College of Arts & Sciences, Lamar Dodd School of Art, Athens GA (S)

Hocking, Sheldon, *Dir Gallery,* Ventura College, Art Galleries, Ventura CA

Hockley, Allen, *Assoc Prof,* Dartmouth College, Dept of Art History, Hanover NH (S)

Hodge, Beth, *Exec Dir,* Stauton Augusta Art Center, Staunton VA

Hodgens, Mary Lee, *Prog Coordr,* Light Work, Robert B Menschel Photography Gallery, Syracuse NY

Hodges, Harlow, *Asst Prof,* Southern Arkansas University at Magnolia, Dept of Art, Magnolia AR (S)

Hodges, Jenny, *Educ Dir,* Greenville Museum of Art, Inc, Greenville NC

Hodges, Laura, *Treas,* New Mexico Art League, Gallery & School, Albuquerque NM

Hodges, Pam, *Dir Educ & Public Prog,* Philbrook Museum of Art, Tulsa OK

Hodges, Rhoda, *Co Dir,* Coutts Memorial Museum of Art, Inc, El Dorado KS

Hodges, Rita, *Pres,* Community Council for the Arts, Kinston NC

Hodgin, Linda, *Develop Officer,* Rapid City Arts Council, Dahl Arts Center, Rapid City SD

Hodgins, Anne, *Pres,* Lansing Art Gallery, Lansing MI

Hodgson, Terri, *Admin Asst,* University of Redlands, Peppers Art Gallery, Redlands CA

Hodson, Carol, *Asst Prof,* Webster University, Art Dept, Webster Groves MO (S)

Hodson, David, *Treas,* Kennebec Valley Art Association, Harlow Gallery, Hallowell ME

Hoeck, Gail, *Pres,* Scottsdale Artists' League, Chandler AZ

Hoeffel, Joan, *Asst to Dir,* Franchise Finance Corporation of America, The Fleischer Museum, Scottsdale AZ

Hoeffel, Joan, *Asst to Dir,* Franchise Finance Corporation of America, Fleischer Museum Library, Scottsdale AZ

Hoel, Randall, *Dir,* Sharon Arts Center, Sharon Arts Center Exhibition Gallery, Sharon NH

Hoeltzel, Susan, *Dir,* Lehman College Art Gallery, Bronx NY

Hofacket, Katy, *Coordr,* Deming-Luna Mimbres Museum, Deming NM

Hoff, Liz, *Gallery Mgr,* Crane Collection, Gallery of American Painting and Sculpture, Wellesley MA

Hoffman, Angela, *Registrar,* Palos Verdes Art Center, Rancho Palos Verdes CA

Hoffman, Ann, *Prof,* West Virginia University, College of Creative Arts, Morgantown WV (S)

Hoffman, Barbara, *Business Mgr & Art Cur,* Playboy Enterprises, Inc, Chicago IL

Hoffman, Barbara, *Lectr,* Santa Clara University, Dept of Art & Art History, Santa Clara CA (S)

Hoffman, Diane, *Assoc Prof,* Rhodes College, Dept of Art, Memphis TN (S)

Hoffman, Eva, *Asst Prof,* Tufts University, Dept of Art & Art History, Medford MA (S)

Hoffman, Jill, *Exec Dir,* Millicent Rogers, Taos NM

Hoffman, Joel, *Vice Dir Educ Div,* Brooklyn Museum, Brooklyn NY

Hoffman, Joel M., *Dir,* Vizcaya Museum & Gardens, Miami FL

Hoffman, Katherine, *Chmn,* Saint Anselm College, Dept of Fine Arts, Manchester NH (S)

Hoffman, Kim, *Prof,* Western Oregon State College, Creative Arts Division, Visual Arts, Monmouth OR (S)

Hoffman, Lawrence, *Chief Conservator,* Hirshhorn Museum & Sculpture Garden, Smithsonian Institution, Washington DC

Hoffman, Michael, *Div Head & Assoc Prof,* Norwich University, Dept of Architecture and Art, Northfield VT (S)

Hoffman, Patricia, *Dir Develop,* Woodmere Art Museum, Philadelphia PA

Hoffman, Patricia A, *Dir Develop,* Woodmere Art Museum, Library, Philadelphia PA

Hoffman, Sheila, *Cur,* The Rockwell Museum of Western Art, Corning NY

Hoffman, Steven A, *Exec Dir, CEO,* Washington Pavilion of Arts & Science, Visual Arts Center, Sioux Falls SD

Hoffman, Tom, *Instr,* University of Utah, Dept of Art & Art History, Salt Lake City UT (S)

Hoffman, Tom, *Prof,* University of Maine at Augusta, College of Arts & Humanities, Augusta ME (S)

Hofmaenner, Alexandra, *Gallery Asst,* Pointe Claire Cultural Centre, Stewart Hall Art Gallery, Pointe Claire PQ

Hofmann, Irene, *Dir,* The Contemporary Museum, Museum for Contemporary Arts, Baltimore MD

Hofmann, Sally, *Visual Arts Coordr,* Beaufort County Arts Council, Washington NC

Hofstedt, Matthew, *Assoc Cur,* Supreme Court of the United States, Washington DC

Hofstra, Philip, *Assoc Dean,* University of Kansas, School of Fine Arts, Lawrence KS (S)

Hogan, Jacqueline, *Cur Prints,* State University of New York at Binghamton, University Art Museum, Binghamton NY

Hogan, James, *Dir,* College of the Holy Cross, Dinand Library, Worcester MA

Hogan, Robert, *Assoc Prof,* Clemson University, College of Architecture, Clemson SC (S)

Hogarth, Brian, *Cur Educ,* Asian Art Museum of San Francisco, Chong-Moon Lee Ctr for Asian Art and Culture, San Francisco CA

Hogg, Kathryn, *Cur,* Glenhyrst Art Gallery of Brant, Brantford ON

Hogya, G, *Dean,* University of Victoria, Dept of History in Art, Victoria BC (S)

Hohenberg, Alane, *Dir Develop,* Rensselaer County Historical Society, Hart-Cluett Mansion, 1827, Troy NY

Hohenshelt, Sylvia, *Asst Coll Mgr,* Workman & Temple Family Homestead Museum, City of Industry CA

Hoi, Samuel, *Pres,* Otis College of Art & Design, Fine Arts, Los Angeles CA (S)

Hoisington, Rena, *Assoc Cur Drawings & Photographs,* The Baltimore Museum of Art, Baltimore MD

Hoke, Kay, *Chair Div Fine Arts,* Brevard College, Division of Fine Arts, Brevard NC (S)

Holahan, Mary, *Registrar,* Delaware Art Museum, Wilmington DE

Holbach, Joseph, *Chief Registrar,* The Phillips Collection, Washington DC

Holbert, Kelly, *Asst Cur Medieval Art,* Walters Art Museum, Baltimore MD

Holbrook, Christopher, *Pres,* Historical Society of the Town of Greenwich, Inc, Bush-Holley House Museum, Cos Cob CT

Holbrook, W Paul, *Exec Dir,* American Ceramic Society, Westerville OH

Holce, Tom, *Chmn Bd,* Portland Art Museum, Northwest Film Center, Portland OR

Holden, John, *Asst Prof,* Bemidji State University, Visual Arts Dept, Bemidji MN (S)

Holder, Gary, *Dir Educ,* Sangre de Cristo Arts & Conference Center, Pueblo CO

Holder, Heidi, *Dir Educ,* Museum for African Art, Long Island City NY

Holder, Thomas J, *Prof,* University of Nevada, Las Vegas, Dept of Art, Las Vegas NV (S)

Holdorf, Judi, *Exec Dir,* Quad City Arts Inc, Rock Island IL

Holgrem, Priscilla, *VPres,* Society of Scribes, Ltd, New York NY

Holian, Heather, *Prof,* University of North Carolina at Greensboro, Art Dept, Greensboro NC (S)

Holierhoek, Adrienne, *Mgr Pub Affairs,* Art Gallery of Greater Victoria, Victoria BC

Holihan, Michael, *Prof,* Cleveland Institute of Art, Cleveland OH (S)

Hollaar, Lisa, *Secy,* Augustana College, Center for Western Studies, Sioux Falls SD

Holland, Barbara, *Art Instr,* Tyler Junior College, Art Program, Tyler TX (S)

Holland, Raymond, *VPres,* Lehigh County Historical Society, Allentown PA

Holleran, Owen, *Admin Officer,* Chattahoochee Valley Art Museum, LaGrange GA

Hollingsworth, Priscilla, *Prof,* Augusta State University, Dept of Arts, Augusta GA (S)

Hollingwood, Keith, *Adjunct Faculty,* Mount Wachusett Community College, East Wing Gallery, Gardner MA

Hollingworth, Mar, *Cur Educ,* California African-American Museum, Los Angeles CA

Hollis, Sara, *Chmn,* Southern University in New Orleans, Fine Arts & Philosophy Dept, New Orleans LA (S)

Hollis, Violet Angeles, *Dir Dance,* Jacksonville University, Dept of Art, Jacksonville FL (S)

Hollman, Howard, *Bd Pres,* Centro Cultural De La Raza, San Diego CA

Hollod, Cynthia, *Deputy Dir Mktg,* Newark Museum Association, The Newark Museum, Newark NJ

Holloman, Michael, *Assoc Prof Art,* Seattle University, Fine Arts Dept, Division of Art, Seattle WA (S)

Holloman, Michael, *Dir Plateau Culture Ctr,* Eastern Washington State Historical Society, Northwest Museum of Arts & Culture, Spokane WA

Hollomon, Latoy, *Library Asst,* Morris Museum of Art, Augusta GA

Hollosy, E Gyuri, *Acad Asst,* Johnson Atelier Technical Institute of Sculpture, Mercerville NJ (S)

Hollosy, Gyuri, *Dir Gallery,* Johnson Atelier Technical Institute of Sculpture, Johnson Atelier Library, Mercerville NJ

Holloway, Anna G, *Dir Educ,* The Mariners' Museum, Newport News VA

Holloway, Kay, *Instr,* Millsaps College, Dept of Art, Jackson MS (S)

Hollowell, David, *University of California, Davis, Dept of Art & Art History, Davis CA (S)

Hollrah, Warren, *Archivist,* Westminster College, Winston Churchill Memorial & Library in the United States, Fulton MO

Holly, Michael Ann, *Dir Research & Academic Progs,* Sterling & Francine Clark, Williamstown MA

Holm, Steve, *Dir,* Hillsborough Community College, Fine Arts Dept, Tampa FL (S)

Holman, Brian, *Dir Quilt Operations,* The Names Project Foundation AIDS Memorial Quilt, Atlanta GA

Holman, Larissa, *Communications Coordr,* Visual Arts Nova Scotia, Halifax NS

Holmberg, Jim, *Cur Special Coll,* The Filson Historical Society, Louisville KY

Holmberg, Lori, *Exec Dir,* Middle Border Museum & Oscar Howe Art Center, Mitchell SD

Holmes, Daphne, *Dir Educ & Comm Outreach,* Cameron Art Museum, Wilmington NC

Holmes, David, *Prof,* University of Wisconsin-Parkside, Art Dept, Kenosha WI (S)

Holmes, Elizabeth, *Registrar,* Buffalo Bill Memorial Association, Buffalo Bill Historical Center, Cody WY

Holmes, Jean E, *Third VPres,* National League of American Pen Women, Washington DC

Holmes, Jennifer, *Asst to Dir,* Madison Museum of Contemporary Art, Madison WI

Holmes, Karen, *Registrar,* City of Ukiah, Grace Hudson Museum & The Sun House, Ukiah CA

Holmes, Larry, *Coordr Drawing, Painting & Grad,* University of Delaware, Dept of Art, Newark DE (S)

Holmes, Martha, *Asst Prof,* Fort Hays State University, Dept of Art, Hays KS (S)

Holmes, Nancy, *Assoc Prof (Creative Writing),* University of British Columbia Okanagan, Dept of Creative Studies, Kelowna BC (S)

Holmes, Selean, *Chief Cur,* DuSable Museum of African American History, Chicago IL

Holmes, Willard, *Deputy Dir,* Whitney Museum of American Art, New York NY

Holmes, Willard, *Exec Dir,* Wadsworth Atheneum Museum of Art, Hartford CT

Holness, Lansford, *Asst Prof,* University of Findlay, Art Program, Findlay OH (S)

Holoday, Carol, *Adjunct,* Monterey Peninsula College, Art Dept, Monterey CA (S)

Holowacz, Eric V, *Exec Dir,* USCB Art Gallery, Beaufort SC

Holownia, Thaddeus, *Head Prof,* Mount Allison University, Dept of Fine Arts, Sackville NB (S)

Holsten, Anna, *Instr Art,* Pearl River Community College, Visual Arts, Dept of Fine Arts & Communication, Poplarville MS (S)

Holt, Alison, *Catalog Librn,* Art Center College of Design, James Lemont Fogg Memorial Library, Pasadena CA

Holt, Angela, *Shop Mgr,* Green Hill Center for North Carolina Art, Greensboro NC

Holt, Daniel, *Dir,* Dwight D Eisenhower, Abilene KS

Holt, David, *Prof,* Marymount College of Fordham University, Art Dept, Tarrytown NY (S)

Holt, David J, *Chmn,* Marymount College of Fordham University, Art Dept, Tarrytown NY (S)

Holt, Frank, *Exec Dir,* Mennello Museum of American Art, Orlando FL

Holt, Laura, *Librn,* Museum of New Mexico, Laboratory of Anthropology, Santa Fe NM

Holt, Nici, *Visitor Servs Coordr,* Missoula Art Museum, Missoula MT

Holt, Tom, *Preparator,* Burchfield-Penney Art Center, Buffalo NY

Houston, Brian, *Librn,* Lethbridge Public Library, Art Gallery, Lethbridge AB

Houston, David, *Cur,* The Ogden Museum of Southern Art, University of New Orleans, New Orleans LA

Houston, Joe, *Assoc Cur Contemp Art,* Columbus Museum of Art, Columbus OH

Houston, William, *Artist-in-Residence,* Carson-Newman College, Art Dept, Jefferson City TN (S)

Houy-Tower, Stephane, *Research Assoc,* The Metropolitan Museum of Art, The Costume Institute Library, New York NY

Hovde, Amy, *Business Mgr,* North Dakota Museum of Art, Grand Forks ND

Hovey, David, *Assoc Prof,* Illinois Institute of Technology, College of Architecture, Chicago IL (S)

Hovins, Kristen, *Prof,* Middlebury College, History of Art & Architecture Dept, Middlebury VT (S)

Howard, Andrew, *Chmn Dept,* Wheaton College, Art Dept, Norton MA (S)

Howard, Anne, *Office Coordr,* National Association of Artists' Organizations (NAAO), Birmingham AL

Howard, Carol Hamann, *Dir,* Atlantic Gallery, New York NY

Howard, Carolyn, *Instr,* Wayne Art Center, Wayne PA (S)

Howard, Deborah, *Assoc Prof Drawing & Painting,* University of Denver, School of Art & Art History, Denver CO (S)

Howard, Holli S, *Instr,* University of Science & Arts of Oklahoma, Arts Dept, Chickasha OK (S)

Howard, Jack, *Far Eastern Librarian,* Royal Ontario Museum, Library & Archives, Toronto ON

Howard, Renate, *Security Officer,* Alaska State Museum, Juneau AK

Howard, Sherri, *Dir Prog,* St Thomas-Elgin Public Art Centre, Saint Thomas ON

Howard, Spencer, *Asst Reference Archivist,* Herbert Hoover, West Branch IA

Howard, William, *Asst Prof,* Western Illinois University, Art Dept, Macomb IL (S)

Howard-Rogers, Kathryn, *Asst Prof,* Oakton Community College, Language Humanities & Art Divisions, Des Plaines IL (S)

Howe, Thomas, *Prof,* Southwestern University, Sarofim School of Fine Art, Dept of Art & Art History, Georgetown TX (S)

Howe, Wayne, *Pres,* Jericho Historical Society, Jericho VT

Howell, Bob, *Prof,* Louisiana College, Dept of Art, Pineville LA (S)

Howell, Jason, *Asst Prof,* Southern Illinois University, School of Art & Design, Carbondale IL (S)

Howell, Joyce B, *Assoc Prof,* Virginia Wesleyan College, Art Dept of the Humanities Div, Norfolk VA (S)

Howell, Robert, *Prof,* California Polytechnic State University at San Luis Obispo, Dept of Art & Design, San Luis Obispo CA (S)

Howell, Tom, *Chmn,* Porterville College, Dept of Fine Arts, Porterville CA (S)

Howes, Ann, *Instr,* Wayne Art Center, Wayne PA (S)

Howes, Kim, *Prof,* Xavier University, Dept of Art, Cincinnati OH (S)

Howes, Stephen, *Chmn,* Town of Cummington Historical Commission, Kingman Tavern Historical Museum, Cummington MA

Howey, Peter, *Grants Mgr,* Saginaw Art Museum, Saginaw MI

Howk, Cynthia, *Res Coordr,* Landmark Society of Western New York, Inc, Wenrich Memorial Library, Rochester NY

Howkins, Mary Ball, *Prof,* Rhode Island College, Art Dept, Providence RI (S)

Howlette, Jan, *Exec Dir Visitor Experience,* Royal Ontario Museum, Toronto ON

Hownion, Morris, *Chief Cataloguer,* New York City Technical College, Ursula C Schwerin Library, Brooklyn NY

Howorth, Ted, University of Manitoba, School of Art, Winnipeg MB (S)

Howorth-Bouman, Katherine, *Dir Educ,* Roberson Museum & Science Center, Binghamton NY

Hoydysh, Walter, *Dir Prog,* Ukrainian Institute of America, Inc, New York NY

Hoyt, Edward, *Pres,* Museum of the Hudson Highlands, Cornwall on Hudson NY

Hrehov, John, *Asst Prof,* Indiana-Purdue University, Dept of Fine Arts, Fort Wayne IN (S)

Hricko, Richard, *Chmn Univ Art & Art Educ,* Temple University, Tyler School of Art, Elkins Park PA (S)

Hrivnak, Tom, *Dir Horticulture,* Stan Hywet, Akron OH

Hron, Vincent, *Assoc Prof,* Bloomsburg University, Dept of Art & Art History, Bloomsburg PA (S)

Hron, Vincent, *Dir Gallery,* Bloomsburg University of Pennsylvania, Haas Gallery of Art, Bloomsburg PA

Hrushetska, Maryna, *Exec Dir,* Craft and Folk Art Museum (CAFAM), Los Angeles CA

Hrycelak, George, *Dir,* Ukrainian National Museum & Library, Chicago IL

Hsu, Lillian, *Dir Pub Art,* Cambridge Arts Council, CAC Gallery, Cambridge MA

Hu, Xinran, *Asst Prof,* University of Southern Indiana, Art Dept, Evansville IN (S)

Hu, Zheng, *Exhib Designer,* University at Albany, State University of New York, University Art Museum, Albany NY

Huacuja-Person, Judith, *Asst Prof,* University of Dayton, Visual Arts Dept, Dayton OH (S)

Huang, Binggi, *Asst Prof,* University at Buffalo, State University of New York, Dept of Visual Studies, Buffalo NY (S)

Huard, Micheline, *Dir,* Musee Regional de la Cote-Nord, Sept-Iles PQ

Hubbard, John D, *Prof,* Northern Michigan University, Dept of Art & Design, Marquette MI (S)

Hubbard, Paul, *Fine Arts,* Moore College of Art & Design, Philadelphia PA (S)

Hubbard, Quatro, *Archivist,* Virginia Dept Historic Resources, Research Library, Richmond VA

Hubbard, Rosemary, *Dean,* Marymount University, School of Arts & Sciences Div, Arlington VA (S)

Hubbard, Steve, *Dir Operations,* Palm Springs Art Museum, Palm Springs CA

Hubbard, Walter, *VPres,* Belskie Museum, Closter NJ

Huber, Mary, *Dir,* City of Cedar Falls, Iowa, James & Meryl Hearst Center for the Arts, Cedar Falls IA

Huber, Murray, *Head Commercial Art,* Butera School of Art, Boston MA (S)

Huberman, Brian, *Assoc Prof,* Rice University, Dept of Art & Art History, Houston TX (S)

Hubert, Thomas, *Dept Chmn,* Mercyhurst College, Dept of Art, Erie PA (S)

Hudak, Jane R, *Assoc Prof,* Georgia Southern University, Dept of Art, Statesboro GA (S)

Hudec, Susan, *Mus Educ,* University of Minnesota, Duluth, Tweed Museum of Art, Duluth MN

Hudgins, Cathy, *Pres,* Blacksburg Regional Art Association, Blacksburg VA

Hudson, Christopher, *Dir Publications,* Museum of Modern Art, New York NY

Hudson, Eldred, *Assoc Prof,* University of North Carolina at Charlotte, Dept Art, Charlotte NC (S)

Hudson, Ernest, *Accountant,* Birmingham Museum of Art, Birmingham AL

Hudson, James, *Video Production,* Art Institute of Pittsburgh, Pittsburgh PA (S)

Hudson, Rod, *Gen Mgr,* Chilliwack Community Arts Council, Community Arts Centre, Chilliwack BC

Hudson-Connors, Jenniffer, *Librn,* Nelda C & H J Lutcher Stark, Stark Museum of Art, Orange TX

Huebner, Carla, *Assoc Prof,* Mount Mary College, Art & Design Division, Milwaukee WI (S)

Huebner, Gregory, *Chmn,* Wabash College, Art Dept, Crawfordsville IN (S)

Huebner, Leandro, *Adjunct Prof,* Louisiana College, Dept of Art, Pineville LA (S)

Huebner, Rosemarita, *Chmn,* Mount Mary College, Marian Gallery, Milwaukee WI

Huebner, Rosemarita, *Prof,* Mount Mary College, Art & Design Division, Milwaukee WI (S)

Huebner-Venezia, Carol, *Asst Prof,* C W Post Campus of Long Island University, School of Visual & Performing Arts, Brookville NY (S)

Huenink, Peter, *Assoc Prof,* Vassar College, Art Dept, Poughkeepsie NY (S)

Huerta, Benito, *Dir & Cur,* University of Texas at Arlington, Gallery at UTA, Arlington TX

Hufbauer, Ben, *Assoc Prof,* University of Louisville, Allen R Hite Art Institute, Louisville KY (S)

Huff, David, *Educ,* Tom Thomson, Owen Sound ON

Huff, David, *Educ,* Tom Thomson, Library/Archives, Owen Sound ON

Huff, Mark, *Chmn,* State University of New York College at Potsdam, Dept of Fine Arts, Potsdam NY (S)

Huff, Robert, *Chmn,* Miami-Dade Community College, Arts & Philosophy Dept, Miami FL (S)

Huffaker, Anne, *Asst Dir,* Kentuck Museum & Art Center, Northport AL

Huffman, Bill, *Admin Dir,* A Space, Toronto ON

Huffman, Bill, *Dir & Cur,* Laurentian University, Art Centre Library, Sudbury ON

Huffman, Joan, *Park Supt,* Old Fort Harrod State Park Mansion Museum, Harrodsburg KY

Huffman, John, *Site Adminr,* Mark Twain, State Historic Site Museum, Florida MO

Huffman, Lorilee, *Cur Colls,* Southern Illinois University Carbondale, University Museum, Carbondale IL

Huffmaster, Elizabeth, *Pres,* Biloxi Art Association, Gulfport MS

Huffstutler, Rebecca, *Cur Archives & Registrar,* Witte Museum, San Antonio TX

Huffstutler Norton, Rebecca, *Collections Mgr,* Frontier Times Museum, Bandera TX

Huftalen, Alison, *Library Asst,* The Art Institute of Boston at Lesley University, Library, Boston MA

Huggett, Gretchen, *Head Weaving Dept,* Kalamazoo Institute of Arts, KIA School, Kalamazoo MI (S)

Hughes, Ava, *Dir Arts Educ,* Arts Partnership of Greater Spartanburg, Inc, The Arts Partnership of Greater Spartanburg, Inc, Spartanburg SC

Hughes, Claudine, *Dir Prog,* Meridian International Center, Cafritz Galleries, Washington DC

Hughes, Dewane, *Asst Prof,* University of Texas at Tyler, Deptartment of Art, School of Visual & Performing Arts, Tyler TX (S)

Hughes, Elaine R, *Coll Mgr,* Museum of Northern Arizona, Flagstaff AZ

Hughes, Gary, *Chief Cur,* New Brunswick Museum, Saint John NB

Hughes, George, *Asst Prof,* University at Buffalo, State University of New York, Dept of Visual Studies, Buffalo NY (S)

Hughes, Jeffrey, *Asst Prof,* Webster University, Art Dept, Webster Groves MO (S)

Hughes, Jennifer, *Asst Dir,* Cooperstown Art Association, Cooperstown NY

Hughes, Julie, *Treas,* Kings County Historical Society & Museum, Hampton NB

Hughes, Linda, *Mem,* Maricopa County Historical Society, Desert Caballeros Western Museum, Wickenburg AZ

Hughes, Mark, *Dir Develop,* The Names Project Foundation AIDS Memorial Quilt, Atlanta GA

Hughes, Mary Jo, *Cur Historical Art,* The Winnipeg Art Gallery, Winnipeg MB

Hughes, Michael, *Instr,* East Central University, Art Dept, Ada OK (S)

Hughes, Sharon, *Educ Coordr,* Danville Museum of Fine Arts & History, Danville VA

Hughley, John, *Prof,* North Carolina Central University, Art Dept, Durham NC (S)

Hughson, John, *Prof,* State University College of New York at Fredonia, Dept of Art, Fredonia NY (S)

Hughston, Milan, *Chief Library & Mus Archives,* Museum of Modern Art, Library and Museum Archives, New York NY

Hugo, Corina, *Registrar,* Riley County Historical Society, Riley County Historical Museum, Manhattan KS

Hugo, Corina, *Registrar,* Riley County Historical Society, Seaton Library, Manhattan KS

Huisman, Carl, *Chmn Dept,* Calvin College, Art Dept, Grand Rapids MI (S)

Hulen, Jeannie, *Asst Prof,* University of Arkansas, Art Dept, Fayetteville AR (S)

Hull, David, *Principal Librn,* San Francisco Maritime National Historical Park, Maritime Museum, San Francisco CA

Hull, David, *Principal Librn,* San Francisco Maritime National Historical Park, Maritime Library, San Francisco CA

Hull, John, *Chmn,* University of Colorado at Denver, College of Arts & Media Visual Arts Dept, Denver CO (S)

Hull, Shayne, *Dir Educ,* Kentucky Museum of Art & Craft, Louisville KY

Hull, Vida, *Prof,* East Tennessee State University, College of Arts and Sciences, Dept of Art & Design, Johnson City TN (S)

Hull, William, *Pres Bd,* Hermitage Foundation Museum, Norfolk VA

Hulst, Connie, *Office Mgr,* North Dakota Museum of Art, Grand Forks ND

Hultgren, Mary Lou, *Cur Coll,* Hampton University, University Museum, Hampton VA

Hults, Linda, *Assoc Prof,* College of Wooster, Dept of Art, Wooster OH (S)

Humber, Sarah, *Cur,* Howard University, Architecture & Planning Library, Washington DC

Humbertson, Margaret, *Head Library & Archive Coll,* Springfield Library & Museums Association, Connecticut Valley Historical Society, Springfield MA

Hummel, William A, *Treas,* Contemporary Arts Center, Cincinnati OH

Humphery, Meeghan, *Visual Arts & Exhibit Coordr,* Ashtabula Arts Center, Ashtabula OH

Humphrey, Judy, *Prof,* Appalachian State University, Dept of Art, Boone NC (S)

Humphreys, Maris, *Special Coll Librn,* Redwood Library & Athenaeum, Newport RI

Humphries, Jean, *VPres,* Mason County Museum, Mason TX

Humphries, Kim, *Dir Installation & Coll Mgmt,* Laumeier Sculpture Park, Saint Louis MO

Huncovsky, Camey, *Assoc Dir,* Dickinson State University, Art Gallery, Dickinson ND

Hung, Tien, *Dir,* Bau-Xi Gallery, Toronto ON

Hung, Yen, *Visual Art Coordr,* Chinese Culture Institute of the International Society, Tremont Theatre & Gallery, Boston MA

Hungerford, Constance Cain, *Prof,* Swarthmore College, Dept of Art, Swarthmore PA (S)

Hunisak, John, *Prof,* Middlebury College, History of Art & Architecture Dept, Middlebury VT (S)

Hunn, Lydia, *Assoc Prof Visual Studies,* Drexel University, College of Media Arts & Design, Philadelphia PA (S)

Hunnibell, S, *Instr,* Community College of Rhode Island, Dept of Art, Warwick RI (S)

Hunsinger, Pat, *Lectr,* Ithaca College, Fine Art Dept, Ithaca NY (S)

Hunt, Amy, *Cur,* Washington County Museum of Fine Arts, Hagerstown MD

Hunt, Barbara, *Dir,* Artists Space, New York NY

Hunt , Barbara, *Dir,* Artists Space, Artists Space Gallery, New York NY

Hunt, Barbara, *Dir,* Artists Space, Irving Sandler Artists File, New York NY

Hunt, David, *Assoc Prof,* Fort Lewis College, Art Dept, Durango CO (S)

Hunt, Janice, *Bd Pres (V),* The Trustees of Reservations, The Mission House, Ipswich MA

Hunt, John Dixon, *Chmn,* University of Pennsylvania, Dept of Landscape Architecture & Regional Planning, Philadelphia PA (S)

Hunt, Kat, *Coordr,* Society of Photographers & Artists Representatives, New York NY

Hunt, Mark, *Deputy Dir,* National Archives & Records Administration, Franklin D Roosevelt Library, Hyde Park NY

Hunt, Susan, *Prof,* University of Wisconsin-Stout, Dept of Art & Design, Menomonie WI (S)

Hunt, William, *Chmn Mus Art Board,* Carnegie Museums of Pittsburgh, Carnegie Museum of Art, Pittsburgh PA

Hunter, Allison, *Exec Dir,* Houston Center For Photography, Houston TX

Hunter, Debora, *Asst Prof,* Southern Methodist University, Division of Art, Dallas TX (S)

Hunter, James, *Dir,* Huronia Museum, Gallery of Historic Huronia, Midland ON

Hunter, Jessica, *Dir,* Paris Gibson Square, Museum of Art, Great Falls MT

Hunter, John, *Chief Cur,* Jekyll Island Museum, Jekyll Island GA

Hunter, John, *Chmn,* Cleveland State University, Art Dept, Cleveland OH (S)

Hunter, Kathleen, *Educ Coordr,* Old State House, Hartford CT

Hunter, Lance, *Dir Gallery,* Brescia University, Anna Eaton Stout Memorial Art Gallery, Owensboro KY

Hunter, Richard, *Coll Mgr,* Nelda C & H J Lutcher Stark, Stark Museum of Art, Orange TX

Hunter, Sharon, *Acad Dean,* Lyme Academy of Fine Arts, Old Lyme CT

Hunter, Sharon, *Acad Dean,* Lyme Academy of Fine Arts, Old Lyme CT (S)

Hunter-Stiebel, Penelope, *Consulting Cur European Art,* Portland Art Museum, Northwest Film Center, Portland OR

Huntley, Patty, *Mus Store Mgr,* The Haggin Museum, Stockton CA

Huntley, Sondra, *Archivist,* Town of Cummington Historical Commission, Kingman Tavern Historical Museum, Cummington MA

Huntoon, Katherine, *Dir Gallery,* Old Dominion University, Art Dept, Norfolk VA

Huntoon, Katherine, *Dir Gallery,* Old Dominion University, Art Dept, Norfolk VA (S)

Huntsman, Glenda, *Dir Advancement,* Quad City Arts Inc, Rock Island IL

Hupfel, Gretchen, *Asst Prof Foundations,* University of Georgia, Franklin College of Arts & Sciences, Lamar Dodd School of Art, Athens GA (S)

Hurley, Brennan, *Gen Mgr,* Arts Club of Washington, James Monroe House, Washington DC

Hurley, Nell, *External Affairs,* Minnesota Museum of American Art, Saint Paul MN

Hurly, Janet, *Advocacy,* Fusion: The Ontario Clay & Glass Association, Toronto ON

Hurry, Robert J, *Registrar,* Calvert Marine Museum, Solomons MD

Hurry, Robert J, *Registrar,* Calvert Marine Museum, Library, Solomons MD

Hursey, Susie, *Finance Officer,* Chattahoochee Valley Art Museum, LaGrange GA

Hurst, Larry, *Adjunct,* College of the Canyons, Art Dept, Canta Colita CA (S)

Hurst, Ronald, *VPres Coll & Museums,* Colonial Williamsburg Foundation, Williamsburg VA

Hurst, William, *Dir Dept Arts & Science,* Dominican College of Blauvelt, Art Dept, Orangeburg NY (S)

Hurt, Jane, *Assoc Prof,* Clemson University, College of Architecture, Clemson SC (S)

Hurt, Susanne, *Recording Secy,* American Artists Professional League, Inc, New York NY

Hurwitz, Jeffrey, *Photographer-in-Residence,* Moravian College, Dept of Art, Bethlehem PA (S)

Hurwitz, Sidney, *VPres,* The Boston Printmakers, Boston MA

Husayny, Ryan, *Chmn Bd,* Detroit Artists Market, Detroit MI

Husband, Timothy, *Cur,* The Metropolitan Museum of Art, The Cloisters, New York NY

Huseboe, Arthur R, *Exec Dir,* Augustana College, Center for Western Studies, Sioux Falls SD

Hussey, Kathryn, *Registrar,* Brick Store Museum & Library, Kennebunk ME

Hussman, Dale, *Chmn Dept of Art,* Carlow College, Art Dept, Pittsburgh PA (S)

Huston, Alan, *Assoc Prof,* Winthrop University, Dept of Art & Design, Rock Hill SC (S)

Huston, John, *Assoc Prof Theater,* Lake Erie College, Fine Arts Dept, Painesville OH (S)

Huston, Kathleen, *City Librn,* Milwaukee Public Library, Art, Music & Recreation Dept, Milwaukee WI

Hus Var, Sean, *Pres, Dir & Treas,* Hus Var Fine Art, Buffalo NY

Hutcheson, Scott, *COO,* Arts Council Of New Orleans, New Orleans LA

Hutchins, Monalea, *Instr,* Cuyahoga Valley Art Center, Cuyahoga Falls OH (S)

Hutchinson, Barbara, *Sales,* Lahaina Arts Society, Art Organization, Lahaina HI

Hutchinson, Linda, *Instr,* Cuyahoga Valley Art Center, Cuyahoga Falls OH (S)

Hutchison, Jane Campbell, *Secy,* Midwest Art History Society, Kent OH

Hutchison, Johannah, *Pres,* International Sculpture Center, Hamilton NJ

Hutlova-Foy, Zora, *Mgr Exhibitions,* Seattle Art Museum, Library, Seattle WA

Hutson, Bill, *Instr,* Creighton University, Fine & Performing Arts Dept, Omaha NE (S)

Hutt, Sarah, *Dir Visual Arts Prog,* Mayors Office of Arts, Rourism and Special Events, City Hall Galleries, Boston MA

Hutter, Cherie, *Chair,* Grace A Dow, Fine Arts Dept, Midland MI

Hutton, Dale, *Assoc Prof,* Clemson University, College of Architecture, Clemson SC (S)

Hutton, John, *Prof,* Salem Academy & College, Art Dept, Winston-Salem NC (S)

Hutton, Kathleen F B, *Coordr Educ,* Reynolda House Museum of American Art, Winston Salem NC

Hutton, Peter, *Instr,* Bard College, Milton Avery Graduate School of the Arts, Annandale-on-Hudson NY (S)

Hutton De Angelus, Susan, *Secy,* Philadelphia Sketch Club, Philadelphia PA

Hutula, Betsy, *Prog & Vol Coordr,* Glessner House Museum, Chicago IL

Huun, Kathleen, *Instr,* Marylhurst University, Art Dept, Marylhurst OR (S)

Huxhold, Stacey, *Art, Music & Audiovisual Mgr,* Allen County Public Library, Art, Music & Audiovisual Services, Fort Wayne IN

Hwangho, Imi, *Assoc Prof Sculpture,* University of Georgia, Franklin College of Arts & Sciences, Lamar Dodd School of Art, Athens GA (S)

Hyams, L Collier, *Asst Prof,* Georgetown University, Dept of Art, Music & Theatre, Washington DC (S)

Hyde, Budge, *Instr,* Greenfield Community College, Art, Communication Design & Media Communication Dept, Greenfield MA (S)

Hyde, Melissa, *Prof,* University of Florida, Dept of Art, Gainesville FL (S)

Hyde, Thomas R, *VPres,* The Buffalo Fine Arts Academy, Albright-Knox Art Gallery, Buffalo NY

Hyland, Alice R M, *Consulting Cur,* Art Complex Museum, Carl A. Weyerhaeuser Library, Duxbury MA

Hyland, Tom, *Dir Develop,* San Francisco Craft & Folk Art Museum, San Francisco CA

Hyleck, Walter, *Dir Cert Apprentice,* Berea College, Art Dept Library, Berea KY

Hylen, Beth, *Reference Asst,* Corning Museum of Glass, Juliette K and Leonard S Rakow Research Library, Corning NY

Hylton, David, *Assoc Prof,* California State Polytechnic University, Pomona, Art Dept, Pomona CA (S)

Hymas, Alison, *VPres,* Royal Canadian Academy of Arts, Toronto ON

Hynes, William, *Chmn Art Dept,* Shippensburg University, Art Dept, Shippensburg PA (S)

Hynes-Bouska, Kathleen, *Cur Coll,* Rome Historical Society, William E Scripture Memorial Library, Rome NY

Hyslin, Richard P, *Prof Sculpture,* University of Texas Pan American, Art Dept, Edinburg TX (S)

Iannucci, Heather, *Historic Site Mgr,* Philipse Manor Hall State Historic Site, Yonkers NY

Ibach, Dick, *Asst Prof,* Spokane Falls Community College, Fine Arts Dept, Spokane WA (S)

Ibbitson, R, *Fine Arts Technician,* Mount Allison University, Owens Art Gallery, Sackville NB

Iberti, Elissa, *Dept Chair, Coordr Visual Communications Prog & Asst Prof Visual Arts,* Dowling College, Dept of Visual Arts, Oakdale NY (S)

Ice, Joyce, *Dir,* Museum of New Mexico, Museum of International Folk Art, Santa Fe NM

Ickes, Jennifer, *Asst Registrar,* New Orleans Museum of Art, New Orleans LA

Ida, Richard, *Div Dean,* Solano Community College, Division of Fine & Applied Art & Behavioral Science, Suisun City CA (S)

Ide, Linda, *Tour Coordr,* Dartmouth College, Hood Museum of Art, Hanover NH

Idelson, Jeffrey, *VPres,* National Baseball Hall of Fame & Museum, Inc, Art Collection, Cooperstown NY

Idrogo, Curt, *Principal Librn,* Newark Public Library, Reference, Newark NJ

Ifft, Evelyn, *Pres,* Redlands Art Association, Redlands Art Association Gallery, Redlands CA

Igoe, Kim, *VPres Policy & Progs, AAM,* American Association of Museums, US National Committee of the International Council of Museums (AAM-ICOM), Washington DC

Igwe, Kod, *Assoc Prof,* Claflin College, Dept of Art, Orangeburg SC (S)

Ihrke, Josephine, *Field Serv Project Mgr,* Balboa Art Conservation Center, San Diego CA

Iler, Henry, *Assoc Prof,* Georgia Southern University, Dept of Art, Statesboro GA (S)

Iles, Crissie, *Cur Film & Video,* Whitney Museum of American Art, New York NY

Iliescu, Sandra, *Studio Faculty,* University of Virginia, McIntire Dept of Art, Charlottesville VA (S)

Illig, Laura, *Office Asst,* Arts of the Southern Finger Lakes, Corning NY

Illuzzi, Michael C, *Dir,* Everhart Museum, Scranton PA

Imami-Paydar, Niloofar, *Cur Textiles & Costumes,* Columbus Museum of Art and Design, Indianapolis IN

Imbriale, Karen, *Recording Secy,* South County Art Association, Kingston RI

Imm-Stroukoff, Eumie, *Librn,* Georgia O'Keeffe Museum, Santa Fe NM

Impert, Sylvia, *Div Dean,* Orange Coast College, Division of Fine Arts, Costa Mesa CA (S)

Imus, Valerie, *Curatorial Assoc,* California College of Arts & Crafts, CCAC Wattis Institute for Contemporary Arts, Oakland CA

Indeck, Karen, *Cur Asst,* The First National Bank of Chicago, Art Collection, Chicago IL

Indick, Janet, *2d VPres Sculpture,* Catharine Lorillard Wolfe, New York NY

Ingber, Rabbi Abie, *Exec Dir,* Hillel Foundation, Hillel Jewish Student Center Gallery, Cincinnati OH

Ingberman, Jeannette, *Dir,* Exit Art, New York NY

Ingbretson, Paul, *Pres,* Guild of Boston Artists, Boston MA

Ingerson, Lorrin, *Dir Craft Stores,* Shaker Village of Pleasant Hill, Harrodsburg KY

Inglis, Erik, *Asst Prof,* Oberlin College, Dept of Art, Oberlin OH (S)

Inglis, Stephen, *Dir Gen Research & Coll,* Canadian Museum of Civilization, Gatineau PQ

Ingram, Anna, *Admin Asst,* McDowell House & Apothecary Shop, Danville KY

Ingram, Millard, *Chmn,* Charles B Goddard, Ardmore OK

Ingram, Wendy, *Sales Mgr,* Canadian Art Foundation, Toronto ON

Inlow, Terry, *Prof,* Wilmington College, Art Dept, Wilmington OH (S)

Inman, Jan, *Instr,* La Sierra University, Art Dept, Riverside CA (S)

Innes, Rob, *Archivist,* University of Saskatchewan, Diefenbaker Canada Centre, Saskatoon SK

Innis, Mike, *VPres,* Mason County Museum, Mason TX

Inselmann, Andrea, *Cur Modern & Contemporary Art,* Cornell University, Herbert F Johnson Museum of Art, Ithaca NY

Inserra, Margaret, *Exec Dir,* Lighthouse Center for the Arts Inc, Tequesta FL

Inwood, Judy, *Art & Music Dept,* Public Library of Cincinnati & Hamilton County, Art & Music Dept, Cincinnati OH

Ioloscon, Filomena, *Prog Asst,* Pelham Art Center, Pelham NY

Ionno, Sabra, *Asst Librn,* Harriet Beecher Stowe, Harriet Beecher Stowe House & Library, Hartford CT

Iott, Anne, *Dir,* Tidewater Community College, Visual Arts Center, Portsmouth VA (S)

Ipson, Daniel A, *Dean Fine Arts,* Hartnell College, Art & Photography Dept, Salinas CA (S)

Irby, Frank, *Instr,* Pacific Northwest College of Art, Portland OR (S)

Ireland, Lynda, *Cur,* Autozone, Autozone Corporation Collection, Memphis TN

Ireland, Terese, *Exec Dir,* Pewabic Society Inc, Pewabic Pottery, Detroit MI

Irick, Chris, *Assoc Prof,* Munson-Williams-Proctor Arts Institute, School of Art, Utica NY (S)

Iringan, Rita, *Native American Heritage Prog Coordr,* School of American Research, Indian Arts Research Center, Santa Fe NM

Irmas, Audrey, *Chmn,* The Museum of Contemporary Art (MOCA), Los Angeles CA

Irrgang, William, *Dir Finance,* Minnesota Historical Society, Saint Paul MN

Irvin, Stan, *Dir,* Saint Edward's University, Fine Arts Exhibit Program, Austin TX

Irvine, Betty Jo, *Head Librn,* Indiana University, Fine Arts Library, Bloomington IN

Irvine, Mary, *Asst to Visitor Svcs,* Alaska State Museum, Juneau AK

Irwin, Lori, *Educ Asst,* Reading Public Museum, Reading PA

Isaac, Oneal A, *Dir Publications,* East Baton Rouge Parks & Recreation Commission, Baton Rouge Gallery Inc, Baton Rouge LA

Isaacson, Gene, *Art Instr,* Santa Ana College, Art Dept, Santa Ana CA (S)

Isaacson, M, *Instr,* Humboldt State University, College of Arts & Humanities, Arcata CA (S)

Isaacson, Marcia, *Prof,* University of Florida, Dept of Art, Gainesville FL (S)

Isenberg, E Duane, *Assoc Prof,* Mohawk Valley Community College, Utica NY (S)

Isenstein, Laura, *Dir,* Central Library, Dept of Fine Arts, San Antonio TX

Isham, Nina, *Colls Technician,* Lac du Flambeau Band of Lake Superior Chippewa Indians, George W Brown Jr Ojibwe Museum & Cultural Center, Lac du Flambeau WI

Ishikawa, Chiyo, *Cur European Painting,* Seattle Art Museum, Library, Seattle WA

Ishikawa, Joseph, *Dir Emeritus,* Michigan State University, Kresge Art Museum, East Lansing MI

Ishino, Catherine, *Asst Prof,* University of Minnesota, Duluth, Art Dept, Duluth MN (S)

Isman, Bonnie, *Dir,* Jones Library, Inc, Amherst MA

Ison, Judy, *Deputy Dir,* Fine Arts Center for the New River Valley, Pulaski VA

Ison, Mary M, *Head Reference Section,* Library of Congress, Prints & Photographs Division, Washington DC

Ison, Susan, *Dir Cultural Svcs,* Loveland Museum Gallery, Loveland CO

Istre, Brenda, *Treas,* Crowley Art Association, The Gallery, Crowley LA

Itami, Michi, *Dir Grad Studies,* City College of New York, Art Dept, New York NY (S)

Itter, William, *Prof,* Indiana University, Bloomington, Henry Radford Hope School of Fine Arts, Bloomington IN (S)

Ittmann, John, *Cur Prints,* Philadelphia Museum of Art, Samuel S Fleisher Art Memorial, Philadelphia PA

Ivan, Sorina, *Instr Visual Arts,* Dowling College, Dept of Visual Arts, Oakdale NY (S)

Ivanova, Elena, *Cur Educ,* Cranbrook Art Museum, Cranbrook Art Museum, Bloomfield Hills MI

Ivanova, Silvia, *Cur Educ,* State University of New York at Binghamton, University Art Museum, Binghamton NY

Ivers, Louise, *Chmn,* California State University, Dominguez Hills, Art Dept, Carson CA (S)

Ives, Colin, *Asst Prof,* University of Maryland, Baltimore County, Imaging, Digital & Visual Arts Dept, Baltimore MD (S)

Ives, Jack, *Asst Dir Archaeology & Ethnology,* Department of Community Development, Provincial Museum of Alberta, Edmonton AB

Ives, Laura, *Chmn,* Appalachian State University, Dept of Art, Boone NC (S)

Ives Hunter, Elizabeth, *Exec Dir,* Cape Cod Museum of Art Inc, Dennis MA

Ivey, Paul, *Assoc Prof Art History,* University of Arizona, Dept of Art, Tucson AZ (S)

Ivey, William J, *Chmn,* National Endowment for the Arts, Washington DC

Ivins, Jerry, *Acting Div Chmn & Dean Fine Arts,* San Jacinto Junior College, Division of Fine Arts, Pasadena TX (S)

Ivy, Carol Mohamed, *Cur,* The Ethel Wright Mohamed Stitchery Museum, Belzoni MS

Iwata, Chris, *Dir Humanities & Fine Arts,* Sacramento City College, Art Dept, Sacramento CA (S)

Iwerson, Kathleen, *Dir Develop,* Whatcom Museum of History and Art, Library, Bellingham WA

Jaber, George, *Chmn,* Community College of Allegheny County, Fine Arts Dept, West Mifflin PA (S)

Jablonski, Mary Kathryn, *Asst to Dir,* Skidmore College, Schick Art Gallery, Saratoga Springs NY

Jablow, Lisa, *Assoc Prof,* Johnson State College, Dept Fine & Performing Arts, Dibden Center for the Arts, Johnson VT (S)

Jack, Marlene, *Assoc Prof,* College of William & Mary, Dept of Fine Arts, Williamsburg VA (S)

Jack , Meredith M, *Prof,* Lamar University, Art Dept, Beaumont TX (S)

Jacklitch, Paul, *Dir,* Baldwin-Wallace College, Fawick Art Gallery, Berea OH

Jacks, Marilyn, *Ofc Mgr,* Rapid City Arts Council, Dahl Arts Center, Rapid City SD

Jacks, Philip, *Assoc Prof,* George Washington University, Dept of Art, Washington DC (S)

Jackson, Amy, *Admin,* Illinois State Museum, Illinois Art Gallery & Lockport Gallery, Springfield IL

Jackson, Anke, *Deputy Dir,* The Parrish Art Museum, Southampton NY

Jackson, Arnold, *Dir Promotional Svcs,* American Society of Artists, Inc, Palatine IL

Jackson, Bill, *Chmn Art Dept,* Simon's Rock College of Bard, Doreen Young Art Gallery, Great Barrington MA

Jackson, Christopher, *Dean,* Concordia University, Faculty of Fine Arts, Montreal PQ (S)

Jackson, Craig, *Reference Librn,* Mechanics' Institute Library, San Francisco CA

Jackson, David, *Dir Archives,* Jackson County Historical Society, Research Library & Archives, Independence MO

Jackson, Duke, *Chmn,* Georgia Southwestern State University, Dept of Fine Arts, Americus GA (S)

Jackson, Greg, *Staff Librn,* Children's Museum, Indianapolis IN

Jackson, James, *Dir Security & Plant Operations,* BJU Museum & Gallery, Bob Jones University Museum & Gallery Inc, Greenville SC

Jackson, Jerry, *Admin Cultural Arts,* Rocky Mount Arts Center, Rocky Mount NC

Jackson, Joe, *Dir,* New Image Art, Los Angeles CA

Jackson, Leslie, *Instr Drawing,* Truro Center for the Arts at Castle Hill, Inc, Truro MA (S)

Jackson, Lora, *Educ Cur,* City of El Paso, El Paso Museum of Archaeology, El Paso TX

Jackson, Margaret A, *Asst Prof,* University of Miami, Dept of Art & Art History, Coral Gables FL (S)

Jackson, Marian, *Chmn,* Wayne State University, Dept of Art & Art History, Detroit MI (S)

Jackson, Marsha, *Deputy Dir,* Museum of New Mexico, Museum of Indian Arts & Culture Laboratory of Anthropology, Santa Fe NM

Jackson, Mavis, *Mgr,* Altanta-Fulton Public Library, Art-Humanities Dept, Atlanta GA

Jackson, Phyllis, *Asst Prof,* Pomona College, Dept of Art & Art History, Claremont CA (S)

Jackson, Robert, *Asst Prof Jewelry & Metalwork,* University of Georgia, Franklin College of Arts & Sciences, Lamar Dodd School of Art, Athens GA (S)

Jackson, Robin, *Chmn,* Treasure Valley Community College, Art Dept, Ontario OR (S)

Jackson, Sandra, *Dir Educ & Pub Prog,* The Studio Museum in Harlem, New York NY

Jackson, Stefanie, *Assoc Prof Drawing & Painting,* University of Georgia, Franklin College of Arts & Sciences, Lamar Dodd School of Art, Athens GA (S)

Jackson, Susan, *Communications & Pub Relations,* Contemporary Arts Center, Cincinnati OH

Jackson, Susan, *Prof,* Marshall University, Dept of Art, Huntington WV (S)

Jackson, Suzanne, *Recep & Gift Shop Mgr,* Bradford Brinton, Big Horn WY

Jackson, Tom, *Develop Dir,* Nevada Museum of Art, Art Library, Reno NV

Jackson, Tom, *Dir Develop,* Nevada Museum of Art, Reno NV

Jackson, W Herbert, *Prof,* Davidson College, Art Dept, Davidson NC (S)

Jackson, William D, *Prof,* Simon's Rock College of Bard, Visual Arts Dept, Great Barrington MA (S)

Jackson-Forsberg, Eric, *Educ Coordr,* Niagara University, Castellani Art Museum, Niagara NY

Jackson-Reese, Carla, *Instr,* Tuskegee University, Liberal Arts & Education, Tuskegee AL (S)

Jacob, Preminda, *Asst Prof,* University of Maryland, Baltimore County, Imaging, Digital & Visual Arts Dept, Baltimore MD (S)

Jacobi, Richard, *Instr,* Casper College, Dept of Visual Arts, Casper WY (S)

Jacobs, Anita, *Dir Pub Progs,* Brooklyn Botanic Garden, Steinhardt Conservatory Gallery, Brooklyn NY

Jacobs, Bud, *Prof,* Niagara County Community College, Fine Arts Division, Sanborn NY (S)

Jacobs, Carin, *Educ Cur,* Judah L Magnes, Berkeley CA

Jacobs, Del, *Prof, Film,* Manatee Community College, Dept of Art & Humanities, Bradenton FL (S)

Jacobs, Jack, *Production Mgr,* Hostos Center for the Arts & Culture, Bronx NY

Jacobs, John, *Cur Science,* Neville Public Museum, Green Bay WI

Jacobs, Joseph, *Cur Painting & Sculpture,* Newark Museum Association, The Newark Museum, Newark NJ

Jacobs, Joyce, *Asst Prof,* Georgian Court College, Dept of Art, Lakewood NJ (S)

Jacobs, Lynn, *Assoc Prof,* University of Arkansas, Art Dept, Fayetteville AR (S)

Jacobs, Mina, *Asst Archivist,* Anchorage Museum at Rasmuson Center, Archives, Anchorage AK

Jacobs, Rich, *Dir,* New Image Art, Los Angeles CA

Jacobs, Sarah, *Develop Dir,* Birmingham-Bloomfield Art Center, Art Center, Birmingham MI

Jacobsen, Don, *Dir Library,* Englewood Library, Fine Arts Dept, Englewood NJ

Jacobsen, Robert, *Cur Oriental Arts,* Minneapolis Institute of Arts, Minneapolis MN

Jacobsohn, Dori, *Educ,* Terra Museum of American Art, Chicago IL

Jacobson, Jake, *Assoc Prof,* University of Nebraska, Kearney, Dept of Art & Art History, Kearney NE (S)

Jacobson, Lee, *Instr,* Chemeketa Community College, Dept of Humanities & Communications, Salem OR (S)

Jacobson, Paul, *Chmn Div Language,* Western Nebraska Community College, Division of Language & Arts, Scottsbluff NE (S)

Jacobson, Susana, *Adjunct Assoc Prof,* University of Pennsylvania, Graduate School of Fine Arts, Philadelphia PA (S)

Jacobson, Thora E, *Dir,* Philadelphia Museum of Art, Samuel S Fleisher Art Memorial, Philadelphia PA

Jacobson, Thora E, *Dir,* Samuel S Fleisher, Philadelphia PA (S)

Jacobson-Sire, Emma, *Pub Rels,* Pasadena Museum of California Art, Pasadena CA

Jacobus, Ann, *Mgr Corporate & Foundation Gifts,* Bellevue Art Museum, Bellevue WA

Jacques, John, *Prof,* Clemson University, College of Architecture, Clemson SC (S)

Jaeckel, Robin, *Managing Dir,* Rochester Contemporary, Rochester NY

Jaehn, Tomas, *Head Librn,* Museum of New Mexico, Fray Angelico Chavez History Library, Santa Fe NM

Jaffe, Amanda, *Dir Ceramics,* New Mexico State University, Art Dept, Las Cruces NM (S)

Jaffe, John G, *Dir,* Sweet Briar College, Martin C Shallenberger Art Library, Sweet Briar VA

Jaffe, Linda, *Exec Dir,* Monterey History & Art Association, Maritime Museum of Monterey, Monterey CA

Jagoda, Peter, *Adjunct Asst Prof,* Spokane Falls Community College, Fine Arts Dept, Spokane WA (S)

Jahnke-Banla, Karen, *Cur Coll,* The Haggin Museum, Stockton CA

Jahns, Tim, *Educ Coordr,* City of Irvine, Irvine Fine Arts Center, Irvine CA (S)

Jahos, Catherine, *Asst to Dir,* Monmouth Museum & Cultural Center, Lincroft NJ

Jalenak, Mala, *Museum Cur,* Louisiana Arts & Science Museum, Baton Rouge LA

Jamar, Janet, *Dir Communications,* Ventures Education Systems Corporation, New York NY

James, Anne, *Museum Specialist,* United States Department of the Interior Museum, Washington DC

James, Beth, *Exec Dir,* South Arkansas Arts Center, El Dorado AR

James, Catti, *Supv Art Educ,* City College of New York, Art Dept, New York NY (S)

James, Christopher, *Art History Instr,* University of Virginia, McIntire Dept of Art, Charlottesville VA (S)

James, Christopher, *Chmn Photography Dept,* Art Institute of Boston at Lesley University, Boston MA (S)

James, David, *Prof,* University of Montana, Dept of Art, Missoula MT (S)

James, Hugh F, *VPres & Dir,* Medina Railroad Museum, Medina NY

James, Louise, *Dir & Cur,* Plains Indians & Pioneers Historical Foundation, Museum & Art Center, Woodward OK

James, Pat, *Pres,* Ontario Crafts Council, The Craft Gallery, Toronto ON

James, Portia P, *Historian,* Anacostia Museum, Washington DC

James, Sara N, *Assoc Prof,* Mary Baldwin College, Dept of Art & Art History, Staunton VA (S)

James, Scott, *Archivist,* Arts and Letters Club of Toronto, Toronto ON

James, Theodore, *Coll & Exhib Mgr,* Joslyn Art Museum, Omaha NE

James, Thomas A, *Pres,* Salvador Dali, Saint Petersburg FL

Jamra, Mark, *Instr,* Maine College of Art, Portland ME (S)

Jancosek, Pat, *Asst Prof,* Saint Mary-of-the-Woods College, Art Dept, Saint Mary of the Woods IN (S)

Jandl, Stefanie Spray, *Andrew M Mellon Foundation Assoc Cur Acad Prog,* Williams College, Museum of Art, Williamstown MA

Janecek, James, *Asst Prof,* Providence College, Art & Art History Dept, Providence RI (S)

Janelle, Louise, *Admin Secy,* Rocky Mount Arts Center, Rocky Mount NC

Janes, Todd, *Exec Dir,* Latitude 53 Contemporary Visual Culture, Edmonton AB

Janick, Richard, *Art Hist Instr,* Monterey Peninsula College, Art Dept, Monterey CA (S)

Janke, James, *Assoc Prof,* Dakota State University, College of Liberal Arts, Madison SD (S)

Janke, Lucinda, *Coll Mgr,* Historical Society of Washington DC, Kiplinger Research Library, Washington DC

Janken, Amy, *Educ Coordr,* Elmhurst Art Museum, Elmhurst IL

Janklow, Linda, *Dir Educ,* San Francisco Craft & Folk Art Museum, San Francisco CA

Jankowski, Edward, *Asst Prof,* Monmouth University, Dept of Art & Design, West Long Branch NJ (S)

Janosy, Mimi, *Photography,* Antonelli Institute, Professional Photography & Commercial Art, Erdenheim PA (S)

Janotte, Nicole, *Asst Dir,* Queens College, City University of New York, Godwin-Ternbach Museum, Flushing NY

Janowich, Ron, *Asst Prof,* University of Florida, Dept of Art, Gainesville FL (S)

Jansen, Catherine, *Instr,* Bucks County Community College, Fine Arts Dept, Newtown PA (S)

Jansen, Charles, *Instr,* Middle Tennessee State University, Art Dept, Murfreesboro TN (S)

Jansma, Linda, *Cur,* The Robert McLaughlin, Oshawa ON

Janssen, David, *VPres Internal Operations,* Edsel & Eleanor Ford, Grosse Pointe Shores MI

Janssen, Suzanne, *Business Svcs,* Loveland Museum Gallery, Loveland CO

Jantzen, Franz, *Photograph Coll Mgr,* Supreme Court of the United States, Washington DC

Janz, Rita, *Mus Cur,* Balzekas Museum of Lithuanian Culture, Chicago IL

Janzen, Mark, *Coll Mgr,* Wichita State University, Ulrich Museum of Art & Martin H Bush Outdoor Sculpture Collection, Wichita KS

Janzen, Reinhild, *Assoc Prof,* Washburn University of Topeka, Dept of Art, Topeka KS (S)

Jarboe, Kate, *Reference Librn,* School of the Art Institute of Chicago, John M Flaxman Library, Chicago IL

Jarosi, Susan, *Asst Prof,* University of Louisville, Allen R Hite Art Institute, Louisville KY (S)

Jarvis, John, *Dir,* Bay Path College, Dept of Art, Longmeadow MA (S)

Jaska, Robin, *Gift Shop Mgr,* University of Calgary, The Nickle Arts Museum, Calgary AB

Jaskot, Paul, *Asst Prof,* DePaul University, Dept of Art, Chicago IL (S)

Jaskowiak, Jennifer, *Cur,* Rockford Art Museum, Rockford IL

Jaudes, Sherri, *Adjunct,* Maryville University of Saint Louis, Art & Design Program, Saint Louis MO (S)

Javan, Marjorie, *Treas.,* The Boston Printmakers, Boston MA

Javorski, Susanne, *Art Librn,* Wesleyan University, Art Library, Middletown CT

Jay, Stephen, *Dean, College of Performing Arts,* University of the Arts, Philadelphia Colleges of Art & Design, Performing Arts & Media & Communication, Philadelphia PA (S)

Jaynell, Chambers, *Dir,* Mohave Museum of History & Arts, Kingman AZ

Jebsen, Mary, *Asst Dir,* Museum of New Mexico, Museum of Fine Arts, Unit of NM Dept of Cultural Affairs, Santa Fe NM

Jebsen, Mary, *Asst Dir,* Museum of New Mexico, Museum of Fine Arts Library and Archive, Santa Fe NM

Jedda McNab, Barbara, *Cur & Mgr,* American Kennel Club, Museum of the Dog, Saint Louis MO

Jedlicka, Judith A, *Pres,* Business Committee for the Arts, Inc, Long Island City NY

Jefferies, Eric, *Head Dept,* Atlanta Technical Institute, Visual Communications Class, Atlanta GA (S)

Jeffers, Jim, *Adjunct Asst Prof,* Drew University, Art Dept, Madison NJ (S)

Jeffers, Susan, *Gallery Coordr,* Ulster County Community College, Muroff-Kotler Visual Arts Gallery, Stone Ridge NY

Jefferson, Calandra, *Dir Marketing & Develop,* Albany Museum of Art, Albany GA

Jefferson, Lori, *Dir Publicity,* East Baton Rouge Parks & Recreation Commission, Baton Rouge Gallery Inc, Baton Rouge LA

Jeffett, William, *Cur Exhibs,* Salvador Dali, Museum, Saint Petersburg FL

Jeffrey, Jinn, *Sculpture Garden Mgr,* New Orleans Museum of Art, New Orleans LA

Jeffries, Jennifer, *Grants,* Newport Art Museum, Newport RI

Jehle, Michael, *CEO,* Fairfield Historical Society, Fairfield Museum & History Center, Fairfield CT

Jehle, Michael, *Cur,* Old Dartmouth Historical Society, New Bedford Whaling Museum, New Bedford MA

Jemmson-Pollard, Dianne, *Chmn,* Texas Southern University, College of Liberal Arts & Behavorial Sciences, Houston TX (S)

Jendrzejewski, Andrew, *Chmn,* Vincennes University Junior College, Humanities Art Dept, Vincennes IN (S)

Jendyk, Khrystyna, *Pres,* Ukrainian Canadian Archives & Museum of Alberta, Edmonton AB

Jenkins, Andre, *Prog Asst,* Rocky Mount Arts Center, Rocky Mount NC

Jenkins, Chuck, *Registrar,* Sioux City Art Center, Sioux City IA (S)

Jenkins, Dee, *Adjunct Faculty,* Dickinson College, Dept Fine Arts & History, Carlisle PA (S)

Jenkins, Delanie, *Assoc Prof,* University of Pittsburgh, Dept of Studio Arts, Pittsburgh PA (S)

Jenkins, Donald, *Chief Cur & Cur Asian Art,* Portland Art Museum, Portland OR

Jenkins, Donald, *Cur Asian Art,* Portland Art Museum, Northwest Film Center, Portland OR

Jenkins, John, *Pres,* The Illinois Institute of Art - Chicago, Chicago IL (S)

Jenkins, Lawrence, *Asst,* University of New Orleans-Lake Front, Dept of Fine Arts, New Orleans LA (S)

Jenkins, Paul, *Dir,* College of Mount Saint Joseph, Archbishop Alter Library, Cincinnati OH

Jenkins, Rupert, *Art Commission Gallery,* San Francisco City & County Art Commission, San Francisco CA

Jenkins, Rupert, *Dir,* San Francisco Arts Commission, Gallery & Slide Registry, San Francisco CA

Jenkins, Suzanne, *Registrar,* National Portrait Gallery, Washington DC

Jenkins, Valerie, *Chmn Fine Arts,* College of Visual Arts, Saint Paul MN (S)

Jenkins, Virginia, *Instr,* University of Northern Colorado, Dept of Visual Arts, Greeley CO (S)

Jenkner, Ingrid, *Dir Art Gallery,* Mount Saint Vincent University, Art Gallery, Halifax NS

Jenneman, Eugene A, *Dir Mus,* Northwestern Michigan College, Dennos Museum Center, Traverse City MI

Jennings, C W, *Prof,* California Polytechnic State University at San Luis Obispo, Dept of Art & Design, San Luis Obispo CA (S)

Jennings, Charles, *Chmn,* San Joaquin Delta College, Art Dept, Stockton CA (S)

Jennings, Corrine, *Dir,* Kenkeleba House, Inc, Kenkeleba Gallery, New York NY

Jennings, DeAnn, *Instr,* Los Angeles Harbor College, Art Dept, Wilmington CA (S)

Jennings, Joyce, *Treas,* Rhode Island Watercolor Society, Pawtucket RI

Jennings, Mary Lou, *Admin Asst,* Swope Art Museum, Research Library, Terre Haute IN

Jennings, Susan, *Exec Dir,* Arts Council of the Blue Ridge, Roanoke VA

Jensen, Carl, *Asst Prof,* University of Southern Colorado, Dept of Art, Pueblo CO (S)

Jensen, Elisa, *Dir Prog,* New York Studio School of Drawing, Painting & Sculpture, New York NY (S)

Jensen, Elisa, *Prog Dir,* New York Studio School of Drawing, Painting & Sculpture, Gallery, New York NY

Jensen, Eric, *Pres,* North Central Washington Museum, Wenatchee Valley Museum & Cultural Center, Wenatchee WA

Jensen, Heidi, *Prof,* University of Wisconsin College - Marinette, Art Dept, Marinette WI (S)

Jensen, Hilbert J, The Agricultural Memories Museum, Penn Yan NY

Jensen, Holly, *Office Mgr,* Lewistown Art Center, Lewistown MT

Jensen, James, *Assoc Dir & Chief Cur,* The Contemporary Museum, Honolulu HI

Jensen, James, *Assoc Prof,* Loyola University of Chicago, Fine Arts Dept, Chicago IL (S)

Jensen, Jennifer R, *Owner & Operator,* The Agricultural Memories Museum, Penn Yan NY

Jensen, Joy, *Store Mgr,* Millicent Rogers, Taos NM

Jensen, Leslie D, *Cur Weapons,* United States Military Academy, West Point Museum, West Point NY

Jensen, William M, *Prof,* Baylor University, Dept of Art, Waco TX (S)

Jent, Deanna, *Assoc Prof,* Fontbonne University, Fine Art Dept, Saint Louis MO (S)

Jeon, Kijeong, *Assoc Prof,* California State University, Chico, Department of Art & Art History, Chico CA (S)

Jercich, George, *Prof,* California Polytechnic State University at San Luis Obispo, Dept of Art & Design, San Luis Obispo CA (S)

Jerger, Holly, *Educ Dir,* Craft and Folk Art Museum (CAFAM), Los Angeles CA

Jero, Rebecca, Hebrew Union College - Jewish Institute of Religion, Skirball Museum Cincinnati, Cincinnati OH

Jerry, Jane, *Pres,* Cheekwood-Tennessee Botanical Garden & Museum of Art, Nashville TN

Jerry, Jane, *Pres,* Cheekwood Nashville's Home of Art & Gardens, Education Dept, Nashville TN (S)

Jervas, Scott, *Aquarium Asst,* Berkshire Museum, Pittsfield MA

Jessen, Mark, *Security & Maintenance,* Blanden Memorial Art Museum, Fort Dodge IA

Jessop, F Bradley, *Chair,* East Central University, Art Dept, Ada OK (S)

Jessup, Wesley, *Dir & Cur,* Pasadena Museum of California Art, Pasadena CA

Jette, Carol, *Dir,* Copper Village Museum & Arts Center, Anaconda MT

Jette, Carol, *Dir,* Copper Village Museum & Arts Center, Library, Anaconda MT

Jewell, Elizabeth A, *Exec Dir,* Worthington Arts Council, Worthington OH

JianXin, Xue, *Cur Chinese Art,* New England Center for Contemporary Art, Brooklyn CT

Jicha, Jon, *Prof,* Western Carolina University, Dept of Art/College of Arts & Science, Cullowhee NC (S)

Jilg, Michael, *Prof,* Fort Hays State University, Dept of Art, Hays KS (S)

Jim, Neel, *Prof,* Birmingham Southern College, Doris Wainwright Kennedy Art Center, Birmingham AL

Jim, Peters, *Instr Painting,* Truro Center for the Arts at Castle Hill, Inc, Truro MA (S)

Jimenez, Ingrid, *Assoc Prof,* University of Puerto Rico, Dept of Fine Arts, Rio Piedras PR (S)

Jimenez, Pancho, *Lectr,* Santa Clara University, Dept of Art & Art History, Santa Clara CA (S)

Jimenez-Torres, Maria, *School Coordr,* Plaza de la Raza Cultural Center, Los Angeles CA

Jimerson, Nadine, *Shop Mgr,* Seneca-Iroquois National Museum, Salamanca NY

Jimison, Tom, *Cur,* Middle Tennessee State University, Baldwin Photographic Gallery, Murfreesboro TN

Jipson, Jim, *Chmn,* University of West Florida, Dept of Art, Pensacola FL (S)

Jircik MA, Nancy L, *Chmn Art History,* University of Saint Thomas, Art Dept, Houston TX (S)

Jirsa, Barbara, *Dir Pub & Community Affairs,* Bellevue Art Museum, Bellevue WA

Joanis, Marc, *Chef de Bibliotheque,* Universite de Montreal, Bibliotheque d'Amenagement, Montreal PQ

Jobe, Barbara, *Educator Group Tours,* Chester County Historical Society, West Chester PA

Jobe, Brock, *Deputy Dir Coll,* Winterthur Gardens & Library, Winterthur DE

Jobe, Gary, *Instr,* Oklahoma State University, Graphic Arts Dept, Visual Communications, Okmulgee OK (S)

Jochims, Jennifer, *Dir,* Witter Gallery, Storm Lake IA

Joe, Diana, *Membership Coordr,* Santa Monica Museum of Art, Santa Monica CA

Jofchak, Vincent, *Film Coordr,* Urban Institute for Contemporary Arts, Grand Rapids MI

Johaneman, Elaine, *Bookkeeper,* Lehigh County Historical Society, Allentown PA

Johansen, Chris, *Dir,* New Image Art, Los Angeles CA

Johanson, David, *Asst Prof,* North Park University, Art Dept, Chicago IL (S)

Johanssen, Betty, *Art Instr,* Big Bend Community College, Art Dept, Moses Lake WA (S)

John, Jessy, *Chmn,* Troy State University, Dept of Art & Classics, Troy AL (S)

Johnson, Amy Jo, *Dir Gallery,* Idaho State University, John B Davis Gallery of Fine Art, Pocatello ID

Johnson, Anne, *Instr,* Pacific Northwest College of Art, Portland OR (S)

Johnson, Anne J., *Chmn & Pres (V),* Bicentennial Art Center & Museum, Paris IL

Johnson, Arthur, *Arts Instr,* Kalani Oceanside Retreat, Pahoa HI (S)

Johnson, Brad, *Instr,* West Liberty State College, Div Art, West Liberty WV (S)

Johnson, Brooks, *Cur Photo,* Chrysler Museum of Art, Norfolk VA

Johnson, Bruce, *Sr Librn,* San Diego Public Library, Art & Music Section, San Diego CA

Johnson, Byron, *Dir & Supt,* Texas Ranger Hall of Fame & Museum, Waco TX

Johnson, Carl, *Dir Museum,* Le Musee Regional de Rimouski, Centre National d'Exposition, Rimouski PQ

Johnson, Carl, *Dir Museum,* Le Musee Regional de Rimouski, Library, Rimouski PQ

Johnson, Carla C, *Dir,* New York State College of Ceramics at Alfred University, Scholes Library of Ceramics, Alfred NY

Johnson, Carlyle, *Instr,* Middle Tennessee State University, Art Dept, Murfreesboro TN (S)

Johnson, Charles, *Res Librn,* Ventura County Historical Society, Museum of History & Art, Ventura CA

Johnson, Charlie, *Instr,* Southern University in New Orleans, Fine Arts & Philosophy Dept, New Orleans LA (S)

Johnson, Colleen, *Admin Asst,* Keene State College, Thorne-Sagendorph Art Gallery, Keene NH

Johnson, Craig, *Chmn,* Hillsborough Community College, Fine Arts Dept, Tampa FL (S)

Johnson, Cynthia A, *Dir Reader Svcs,* Pratt Institute, Art & Architecture Dept, Brooklyn NY

Johnson, Dale R, *Prof,* Bethel College, Dept of Art, Saint Paul MN (S)

Johnson, Daryl, *Library & Archives Asst,* New Brunswick Museum, Archives & Research Library, Saint John NB

Johnson, David, *Assoc Prof,* Old Dominion University, Art Dept, Norfolk VA (S)

Johnson, David, *Instr,* Indian Hills Community College, Dept of Art, Centerville IA (S)

Johnson, David D, *Instr,* Indian Hills Community College, Ottumwa Campus, Dept of Art, Ottumwa IA (S)

Johnson, David J, *Archivist,* Headquarters Fort Monroe, Dept of Army, Casemate Museum, Fort Monroe VA

Johnson, David T, *Deputy Dir Colls & Chief Cur,* Hillwood Museum & Gardens Foundation, Hillwood Museum & Gardens, Washington DC

Johnson, Dawn, *Cur Educ,* Tampa Museum of Art, Judith Rozier Blanchard Library, Tampa FL

Johnson, Deborah, *Asst Prof,* Providence College, Art & Art History Dept, Providence RI (S)

Johnson, Denise, *Registrar,* Phillips Academy, Addison Gallery of American Art, Andover MA

Johnson, Diane, *Librn,* Waterville Historical Society, Redington Museum, Waterville ME

Johnson, Donna, *Archivist,* Kelowna Museum, Kelowna BC

Johnson, Donna, *Archivist,* Kelowna Museum, Archives, Kelowna BC

Johnson, Doro, *Recording Secy,* San Bernardino Art Association, Inc, Sturges Fine Arts Center, San Bernardino CA

Johnson, Dorothy, *Dir,* University of Iowa, School of Art & Art History, Iowa City IA (S)

Johnson, Douglas C, *Exec Dir,* McLean County Art Association, McLean County Arts Center, Bloomington IL

Johnson, Drew, *Assoc Cur Art Photography,* Oakland Museum of California, Art Dept, Oakland CA

Johnson, Edward, *Cur Science,* Staten Island Institute of Arts & Sciences, Staten Island NY

Johnson, Eileen, *Cur Anthropology,* Texas Tech University, Museum of Texas Tech University, Lubbock TX

Johnson, Elizabeth, *Cur Ethnology & Document,* University of British Columbia, Museum of Anthropology, Vancouver BC

Johnson, Eric, *Dean,* Dakota State University, College of Liberal Arts, Madison SD (S)

Johnson, Eric B, *Prof,* California Polytechnic State University at San Luis Obispo, Dept of Art & Design, San Luis Obispo CA (S)

Johnson, Frederic P, *Pres Historical Society,* Waterville Historical Society, Redington Museum, Waterville ME

Johnson, Gloria J, *Security Chief,* United States Military Academy, West Point Museum, West Point NY

Johnson, Harvey, *Art Coordr & Assoc Prof,* Texas Southern University, College of Liberal Arts & Behavorial Sciences, Houston TX (S)

Johnson, Isabelle, *Librn,* Women's Art Association of Canada, Library, Toronto ON

Johnson, James, *Chmn,* University of Colorado, Boulder, Dept of Art & Art History, Boulder CO (S)

Johnson, James, *Chmn Photography & Digital Arts,* Moore College of Art & Design, Philadelphia PA (S)

Johnson, James A, *Chmn,* The John F Kennedy, Washington DC

Johnson, Jane, *Community Svcs,* Westerly Public Library, Hoxie Gallery, Westerly RI

Johnson, Jane, *Dir,* Eastern Washington State Historical Society, Library, Spokane WA

Johnson, Jeanne, *Exec Dir,* Thornton W Burgess, Museum, Sandwich MA

Johnson, Jennifer, *Arts Adminr,* Columbus Cultural Arts Center, Columbus OH

Johnson, Jim, *Dean Div,* Modesto Junior College, Arts Humanities & Communications Division, Modesto CA (S)

Johnson, Jon, *Chmn,* South Plains College, Fine Arts Dept, Levelland TX (S)

Johnson, Joyce, *Archaeology Asst Cur,* University of British Columbia, Museum of Anthropology, Vancouver BC

Johnson, Joyce, *Instr Sculpture,* Truro Center for the Arts at Castle Hill, Inc, Truro MA (S)

Johnson, Kate, *Dir,* Fullerton College, Division of Fine Arts, Fullerton CA (S)

Johnson, Kathleen E, *Cur,* Historic Hudson Valley, Tarrytown NY

Johnson, Kathryn C, *Chmn Educ,* Minneapolis Institute of Arts, Minneapolis MN

Johnson, Kendra, *Project Coordr,* McLean County Art Association, McLean County Arts Center, Bloomington IL

Johnson, Kevin, *Vis Asst Prof Art,* Whitman College, Art Dept, Walla Walla WA (S)

Johnson, Kristen, *Retail Gallery Mgr,* The Society of Arts & Crafts, Boston MA

Johnson, Larry, *Chmn Dept,* California State University, Fullerton, Art Dept, Fullerton CA (S)

Johnson, Lee, *Art Area Coordr,* Western State College of Colorado, Quigley Hall Art Gallery, Gunnison CO

Johnson, Linda, *Dir Publs,* Association of Medical Illustrators, Lawrence KS

Johnson, Lisa, *Dir,* Farmington Village Green & Library Association, Stanley-Whitman House, Farmington CT

Johnson, Lois, *Chmn Fine Arts Dept,* University of the Arts, Philadelphia Colleges of Art & Design, Performing Arts & Media & Communication, Philadelphia PA (S)

Johnson, Lori, *Asst Prof,* University at Buffalo, State University of New York, Dept of Visual Studies, Buffalo NY (S)

Johnson, Lori, *Librn,* Oregon College of Art & Craft, Library, Portland OR

Johnson, Lydia, *Dir,* Southern Utah University, Braithwaite Fine Arts Gallery, Cedar City UT

Johnson, Lynne, *Asst Prof,* Wake Forest University, Dept of Art, Winston-Salem NC (S)

Johnson, Margaret, *Assoc Prof,* Winthrop University, Dept of Art & Design, Rock Hill SC (S)

Johnson, Mark, *Instr,* Maine College of Art, Portland ME (S)

Johnson, Mark M, *Dir,* Montgomery Museum of Fine Arts, Montgomery AL

Johnson, Mark M, *Mus Dir,* Montgomery Museum of Fine Arts, Library, Montgomery AL

Johnson, Martha, *Cur Educ,* Randolph-Macon Woman's College, Maier Museum of Art, Lynchburg VA

Johnson, Mary Joy, Bay De Noc Community College, Art Dept, Escanaba MI (S)

Johnson, Maurianna, *Educator,* Trust Authority, Museum of the Great Plains, Lawton OK

Johnson, Melvin, *Asst Preparator,* Mississippi Museum of Art, Howorth Library, Jackson MS

Johnson, Michael, *Assoc Prof,* Murray State University, Dept of Art, Murray KY (S)

Johnson, Michael, *Coordr Sculpture,* University of Delaware, Dept of Art, Newark DE (S)

Johnson, Mimi, *Acad Dept Assoc,* University of Wisconsin-Stevens Point, Dept of Art & Design, Stevens Point WI (S)

Johnson, Nancy, *Mus Shop Mgr,* Aiken County Historical Museum, Aiken SC

Johnson, Neil, *Lectr,* Centenary College of Louisiana, Dept of Art, Shreveport LA (S)

Johnson, Pam, *Instr,* Sierra Community College, Art Dept, Rocklin CA (S)

Johnson, Pamela, *Assoc Prof,* Bates College, Art & Visual Culture, Lewiston ME (S)

Johnson, Patricia, *Assoc Div Chmn,* J Sargeant Reynolds Community College, Humanities & Social Science Division, Richmond VA (S)

Johnson, Patty, *Office,* McPherson Museum, McPherson KS

Johnson, Paul, *Assoc Dir,* Museum of Fine Arts, Houston, Houston TX

Johnson, Paul, *Dir Develop,* The Museum of Contemporary Art (MOCA), Los Angeles CA

Johnson, Paul, *Dir Exhibit Design & & Fabrication,* Bowers Museum of Cultural Art, Bowers Museum, Santa Ana CA

Johnson, R, *Instr,* Humboldt State University, College of Arts & Humanities, Arcata CA (S)

Johnson, Richard, *Assoc Dir,* University of Georgia, Franklin College of Arts & Sciences, Lamar Dodd School of Art, Athens GA (S)

Johnson, Richard A, *Chmn,* University of New Orleans-Lake Front, Dept of Fine Arts, New Orleans LA (S)

Johnson, Rick, *Chmn,* Iowa Great Lakes Maritime Museum, Arnolds Park IA

Johnson, Robert S, *Cur,* Fort George G Meade Museum, Fort Meade MD

Johnson, Ron, *Dean Div Arts, Communication & Educ,* Shasta College, Art Dept, Arts, Communication & Education Division, Redding CA (S)

Johnson, Sallie, *Deputy Dir,* Memphis-Shelby County Public Library & Information Center, Dept of Art, Music & Films, Memphis TN

Johnson, Samantha, *Curatorial Asst,* California State University, Chico, Janet Turner Print Museum, Chico CA

Johnson, Sara, *Dir,* Southern Ohio Museum Corporation, Southern Ohio Museum, Portsmouth OH

Johnson, Sarah, *Cur,* Jacques Marchais, Staten Island NY

Johnson, Scott, *Photography Dept Head,* Johnson State College, Dept Fine & Performing Arts, Dibden Center for the Arts, Johnson VT (S)

Johnson, Steven, *Deputy Dir,* Vesterheim Norwegian-American Museum, Decorah IA

Johnson, Steven, *Dir Facilities & Historic Sites,* Vesterheim Norwegian-American Museum, Reference Library, Decorah IA

Johnson, Sue, *Dept Chmn,* Saint Mary's College of Maryland, Art & Art History Dept, Saint Mary's City MD (S)

Johnson, Suellen, *Dir Gallery,* Western Oregon University, Campbell Hall Gallery, Monmouth OR

Johnson, Suni, *Librn,* United Methodist Historical Society, Library, Baltimore MD

Johnson, Susan, *Dir,* Stone Quarry Hill Art Park, Jenny Library, Cazenovia NY

Johnson, Thomas B, *Cur,* Old York Historical Society, York ME

Johnson, Thomas B, *Cur Coll,* Old York Historical Society, Elizabeth Perkins House, York ME

Johnson, Tom, *Cur,* Old York Historical Society, Old Gaol Museum, York ME

Johnson, Valerie, *Asst Exec Dir,* Boca Raton Museum of Art, Boca Raton FL

Johnson, Vel, *VPres,* Rocky Mount Arts Center, Rocky Mount NC

Johnson, Wanda, *Dir,* Beaufort County Arts Council, Washington NC

Johnson, William, *Coordr,* Visual Studies Workshop, Research Library, Rochester NY

Johnson Jr, Charles W, *Chmn,* University of Richmond, Dept of Art and Art History, Richmond VA (S)

Johnston, Amanda, *Gallery Asst,* Pointe Claire Cultural Centre, Stewart Hall Art Gallery, Pointe Claire PQ

Johnston, Bonny, *Dir Prog,* The University of Texas at San Antonio, UTSA's Institute of Texan Cultures, San Antonio TX

Johnston, Byron, *Assoc Prof (Visual Art),* University of British Columbia Okanagan, Dept of Creative Studies, Kelowna BC (S)

Johnston, Catherine, *Cur European Art,* National Gallery of Canada, Ottawa ON

Johnston, Eileen, *Registrar,* Howard University, Gallery of Art, Washington DC

Johnston, Jeff, *Prof,* College of the Ozarks, Dept of Art, Point Lookout MO (S)

Johnston, Jennifer, *Dir Educ,* Vesterheim Norwegian-American Museum, Reference Library, Decorah IA

Johnston, Jim, *Dir,* Copper Village Museum & Arts Center, Anaconda MT

Jurgensmeier, Charles, *Instr Music,* Creighton University, Fine & Performing Arts Dept, Omaha NE (S)

Jurist, Susan, *Visual Arts Librn,* University of California, San Diego, Arts Libraries, La Jolla CA

Jurus, Richard, *Prof,* Sinclair Community College, Division of Fine & Performing Arts, Dayton OH (S)

Jurvais, Roger, *Chief,* Universite de Moncton, Campus d'Edmundston, Dept of Visual Arts Arts & Lettres, Edmundston NB (S)

Jussila, Neil, *Dir,* Montana State University at Billings, Northcutt Steele Gallery, Billings MT

Just, Joanne D, *Pres,* Berks Art Alliance, Reading PA

Justice, Gloria, *Cur Educ,* Port Huron Museum, Port Huron MI

Juszczyk, James, *Treas,* American Abstract Artists, New York NY

Jutras, Michel, *Dir,* Maison de la Culture Centre D'Exposition Raymond-Lasnier, Trois Rivieres PQ

Kachur, Louis, *Coordr Art History,* Kean College of New Jersey, Fine Arts Dept, Union NJ (S)

Kaczmarczyk, Madeline, *Adjunct Instr Ceramics,* Aquinas College, Art Dept, Grand Rapids MI (S)

Kadish, Skip, *Adjunct,* Monterey Peninsula College, Art Dept, Monterey CA (S)

Kadoche, Salomon, *Second VPres,* Art Centre of New Jersey, Livingston NJ (S)

Kadow, Joan, *Instr,* Mount Mary College, Art & Design Division, Milwaukee WI (S)

Kaericher, John, *Chmn, Prof,* Northwestern College, Art Dept, Orange City CA (S)

Kaericher, John, *Exhib Coordr,* Northwestern College, Te Paske Gallery, Orange City IA

Kagan, Judy, *Asst Dir,* Wooster Community Art Center, Danbury CT

Kahan, Mitchell, *Dir,* Akron Art Museum, Akron OH

Kahle, David, *Dept Head,* Mount Marty College, Art Dept, Yankton SD (S)

Kahle, Patricia, *Dir,* National Trust for Historic Preservation, Shadows-on-the-Teche, New Iberia LA

Kahler, Bruce, *Dr,* Bethany College, Art Dept, Lindsborg KS (S)

Kahler, Caroline, *Head Art Dept,* Bethany College, Art Dept, Lindsborg KS (S)

Kahler , Chris, *Asst Prof,* Eastern Illinois University, Art Dept, Charleston IL (S)

Kahler, Colleen Passalacqua, *Prog & Comm Coordr,* Sculpture Space, Inc, Utica NY

Kahn, David M, *Museum Dir,* Louisiana Department of Culture, Recreation & Tourism, Louisiana State Museum, New Orleans LA

Kahn, Deborah, *Assoc Prof,* American University, Dept of Art, Washington DC (S)

Kahn, Eunice, *Archivist,* Navajo Nation, Navajo Nation Museum, Window Rock AZ

Kahn, Harold, *VPres,* New York Society of Architects, New York NY

Kahn, Leo, *Pres,* Guadalupe Historic Foundation, Santuario de Guadalupe, Santa Fe NM

Kahn, Leslie, *Supv,* Newark Public Library, Reference, Newark NJ

Kahng, Eik, *Assoc Cur 18th Century Art,* Walters Art Museum, Library, Baltimore MD

Kaigler, Doug, *Prof Art,* Eastern Oregon University, School of Arts & Science, La Grande OR (S)

Kaimal, Padma, *Asst Prof,* Colgate University, Dept of Art & Art History, Hamilton NY (S)

Kain, Eugene, *Assoc Prof & Dir Gallery,* Ripon College, Art Dept, Ripon WI (S)

Kain, Eugene, *Chmn,* Ripon College Art Gallery, Ripon WI

Kain, Evelyn, *Chmn,* Ripon College, Art Dept, Ripon WI (S)

Kain, Karen, *Chmn,* Canada Council for the Arts, Conseil des Arts du Canada, Ottawa ON

Kaino, Glen, *Co-Pres,* Los Angeles Center for Photographic Studies, Hollywood CA

Kaiser, Allison, *Dir,* Kentucky Guild of Artists & Craftsmen Inc, Berea KY

Kaiser, Allison, *Exec Dir,* Lexington Art League, Inc, Lexington KY

Kaiser, Charles, *Prof,* Mount Mary College, Art & Design Division, Milwaukee WI (S)

Kaiser, Karen, *Adjunct Asst Prof,* Spokane Falls Community College, Fine Arts Dept, Spokane WA (S)

Kaiser, Kurt, *Assoc Prof,* Aquinas College, Art Dept, Grand Rapids MI (S)

Kaiser, Michael M., *Pres,* The John F Kennedy, Washington DC

Kaiser, Michel, *Instr Commercial Art,* Honolulu Community College, Commercial Art Dept, Honolulu HI (S)

Kajer, Andrea, *Deputy Dir External Relations,* Minnesota Historical Society, Saint Paul MN

Kajitani, Nobuko, *Conservator In charge,* The Metropolitan Museum of Art, New York NY

Kakas, Karen, *Chmn Art Educ,* Bowling Green State University, School of Art, Bowling Green OH (S)

Kalavrezou, Ioli, *Chmn Dept,* Harvard University, Dept of History of Art & Architecture, Cambridge MA (S)

Kalb, Marty J, *Prof,* Ohio Wesleyan University, Fine Arts Dept, Delaware OH (S)

Kaldor, Cynthia, *Dir,* Mayville State University, Northern Lights Art Gallery, Mayville ND

Kalin, Amelia, *Dir Exhib,* Valley Cottage Library, Gallery, Valley Cottage NY

Kalish, Alex, *Asst Registrar,* The Currier Museum of Art, Currier Museum of Art, Manchester NH

Kalke, Ed, *Chmn,* Carthage College, Art Dept, Kenosha WI (S)

Kallenberger, Christine, *Dir Exhib & Coll,* Philbrook Museum of Art, Tulsa OK

Kallenberger, Klaus, *Instr,* Middle Tennessee State University, Art Dept, Murfreesboro TN (S)

Kallos, Kay Klein, *Academic Dean,* Atlanta College of Art, Atlanta GA (S)

Kallsen, Mark, *Asst Prof,* University of Wisconsin-Stout, Dept of Art & Design, Menomonie WI (S)

Kalmbach, Ann, *Exec Dir,* Women's Studio Workshop, Inc, Rosendale NY

Kalnin, Jim, *Assoc Prof (Visual Art),* University of British Columbia Okanagan, Dept of Creative Studies, Kelowna BC (S)

Kalogeropoulos, Astero, *Prog Coordr,* Homer Watson, Kitchener ON

Kaloyanides, Michael G, *Chmn,* University of New Haven, Dept of Visual & Performing Arts & Philosophy, West Haven CT (S)

Kaltenbach, Marc, *Assoc Prof,* Universite de Montreal, Bibliotheque d'Amenagement, Montreal PQ

Kam, D Vanessa, *Admin Librn,* University of British Columbia, Fine Arts, UBC Library, Vancouver BC

Kamal, Kathleen, *Asst Prof,* College of DuPage, Liberal Arts Division, Glen Ellyn IL (S)

Kamalipour, Yahya R, *Head,* Purdue University Calumet, Dept of Communication & Creative Arts, Hammond IN (S)

Kamanski, David, *Exec Dir,* Pacific - Asia Museum, Pasadena CA

Kamas, Louise, *Prof Art,* Clarke College, Dept of Art, Dubuque IA (S)

Kamin, Benjamin Alon, *Sr Rabbi,* The Temple-Tifereth Israel, The Temple Museum of Religious Art, Beachwood OH

Kaminishi, Ikumi, *Asst Prof,* Tufts University, Dept of Art & Art History, Medford MA (S)

Kaminitz, Marian, *Head Conservation,* National Museum of the American Indian, George Gustav Heye Center, New York NY

Kaminski, Vera, *Assoc Prof Foundations,* University of Delaware, Dept of Art, Newark DE (S)

Kamm, David, *Gallery Coordr,* Luther College, Fine Arts Collection, Decorah IA

Kamm, James J, *Dir,* The Dixon Gallery & Gardens, Memphis TN

Kamm, James J, *Dir,* The Dixon Gallery & Gardens, Library, Memphis TN

Kammerer, Steve, *Bd Trustees,* Sioux City Art Center, Sioux City IA

Kamniker, Jim, *Pres,* Go Antiques, Inc, Dublin OH

Kamniker, Kathy, *Sr VPres Business Develop,* Go Antiques, Inc, Dublin OH

Kamnitzer, Jon, *Interim Chmn Design,* Kansas City Art Institute, Kansas City MO (S)

Kamoche, Niambi, *Dir Library,* Langston University, Melvin B Tolson Black Heritage Center, Langston OK

Kamps, Toby, *Cur,* Museum of Contemporary Art, San Diego-Downtown, La Jolla CA

Kanafani, Sarah, *Asst Archivist,* Whitney Museum of American Art, Frances Mulhall Achilles Library, New York NY

Kanatsiz, Susan, Weber State University, Dept of Visual Arts, Ogden UT (S)

Kandianis, Patricia, *Ed,* Lehigh University Art Galleries, Museum Operation, Bethlehem PA

Kane, Erin, *Asst Cur,* Scottsdale Cultural Council, Scottsdale AZ

Kane, Katherine, *Exec Dir,* Harriet Beecher Stowe, Harriet Beecher Stowe House & Library, Hartford CT

Kane, Katherine, *Dir,* Harriet Beecher Stowe, Hartford CT

Kane, Melissa, *Dir Develop,* DeCordova Museum & Sculpture Park, Lincoln MA

Kane, Susan, *Assoc Prof,* Oberlin College, Dept of Art, Oberlin OH (S)

Kang, Sung Yung, *Coordr Graphic Design,* Iowa State University, Dept of Art & Design, Ames IA (S)

Kangas, Steven, *Lectr,* Dartmouth College, Dept of Art History, Hanover NH (S)

Kaniean-Fairen, Joan, *Exec Dir,* Museums Association of Saskatchewan, Regina SK

Kanter, Charlene, *Librn,* Art Museum of the University of Houston, William R Jenkins Architecture & Art Library, Houston TX

Kanter, Joshua S, *Chmn Bd,* International Sculpture Center, Hamilton NJ

Kanter, Laurence B, *Cur In Charge Rob,* The Metropolitan Museum of Art, New York NY

Kanter, Sharon, *Dir Develop,* Contemporary Art Museum, Raleigh NC

Kantgias, Amy, *VPres,* Birmingham-Bloomfield Art Center, Art Center, Birmingham MI

Kantor, Hal, *Pres,* Orlando Museum of Art, Orlando FL

Kantor, Hal, *Pres,* Orlando Museum of Art, Orlando Sentinel Library, Orlando FL

Kanwischer, Charlie, *Dir Grad Studies,* Bowling Green State University, School of Art, Bowling Green OH (S)

Kapinan, Catherine, *Dir,* Wesley Theological Seminary Henry Luce III Center for the Arts & Religion, Dadian Gallery, Washington DC

Kapitan, Lynn, *Chmn,* Mount Mary College, Art & Design Division, Milwaukee WI (S)

Kaplan, Dan, *Dir Maine Memory Network,* Maine Historical Society, Portland ME

Kaplan, Ilee, *Assoc Dir,* California State University, Long Beach, University Art Museum, Long Beach CA

Kaplan, Janice, *Dir Pub Affairs,* Smithsonian Institution, National Museum of African Art, Washington DC

Kaplan, Julius, *Instr,* California State University, San Bernardino, Dept of Art, San Bernardino CA (S)

Kaplan, Leah, *Prog Coordr,* Hebrew Union College, Jewish Institute of Religion Museum, New York NY

Kaplan, Richard, *Head,* Carnegie Library of Pittsburgh, Pittsburgh PA

Kaplan, Ruth, *Dep Dir of Mktg & Communications,* Museum of Modern Art, New York NY

Kaplan, Susan A, *Dir,* Bowdoin College, Peary-MacMillan Arctic Museum, Brunswick ME

Kaplen, Barbara, *Dean,* Sarah Lawrence College, Dept of Art History, Bronxville NY (S)

Kapler, Joseph, *Cur Art Coll,* Wisconsin Historical Society, State Historical Museum, Madison WI

Kaplowitz, Kenneth, *Assoc Prof,* The College of New Jersey, School of Arts & Sciences, Ewing NJ (S)

Kapplinger, Kent, *Lectr,* North Dakota State University, Division of Fine Arts, Fargo ND (S)

Karagheusian-Murphy, Marsha, *Prof & Chair,* Xavier University, Dept of Art, Cincinnati OH (S)

Karalias, Ioannis, *VPres,* Chicago Athenaeum, Museum of Architecture & Design, Galena IL

Karberg, Richard, *Assoc Prof,* Cuyahoga Community College, Dept of Art, Cleveland OH (S)

Kardon, Carol, *Instr,* Main Line Art Center, Haverford PA (S)

Kardon, Peter, *Dir Planning & Latin America Prog,* John Simon Guggenheim, New York NY

Karem-Read, Daisy, *Develop Officer,* Walter Anderson, Ocean Springs MS

Karibo, Lou, *Cur,* Kentucky New State Capitol, Division of Historic Properties, Frankfort KY

Karl, Alexandra, *Instr,* University of Utah, Dept of Art & Art History, Salt Lake City UT (S)

Karlisch, Marita, *Librn & Archivist,* American Swedish Institute, Minneapolis MN

Karlotski, William, *Instr,* Luzerne County Community College, Commercial Art Dept, Nanticoke PA (S)

Karlstad, Donna, *Experience Works,* Moody County Historical Society, Flandreau SD

Karlstrom, Ann Heath, *Publications Mgr,* Fine Arts Museums of San Francisco, Legion of Honor, San Francisco CA

Karlstrom, Paul J, *Regional Dir,* Archives of American Art, Archives of American Art, Washington DC

Karnes, Andrea, *Asst Cur,* Modern Art Museum, Fort Worth TX

Karns, Lynn, *Art Instr,* Grand Canyon University, Art Dept, Phoenix AZ (S)

Karp, Diane R, *Dir,* Santa Fe Arts Institute, Santa Fe NM (S)

Karp, Susan C Katz, *Adminr,* International Center of Medieval Art, New York NY

Karpinich, Tania, *Pub Relations Coordr,* Independence Seaport Museum, Philadelphia PA

Karpman, Estie, *Dir Develop,* Illinois State Museum, Museum Store, Chicago IL

Karraker, Jack, *Prof,* University of Nebraska, Kearney, Dept of Art & Art History, Kearney NE (S)

Karras, Deana, *Dir Retail Operations,* The Baltimore Museum of Art, Baltimore MD

Karslake, Dick, *Pres,* Chautauqua Center for the Visual Arts, Chautauqua NY

Karson, Jennifer, *Community Relations,* University of Vermont, Robert Hull Fleming Museum, Burlington VT

Karson, Richard, *Chief Design & Installations,* San Jose Museum of Art, Library, San Jose CA

Karstadt, Bruce, *Dir,* American Swedish Institute, Minneapolis MN

Karstadt, Robert, *Prog Dir,* Hoyt Institute of Fine Arts, New Castle PA

Kartje, Jean V, *Dean,* College of Lake County, Art Dept, Grayslake IL (S)

Kasel, Karen, *Gallery Mgr,* College of Visual Arts, Gallery, Saint Paul MN

Kaselle, Marion, *Dir,* Max Hutchinson's Sculpture Fields, Kenoza Lake NY

Kasfir, Sidney L, *Assoc Prof,* Emory University, Art History Dept, Atlanta GA (S)

Kashatus, William C, *Dir Pub Prog,* Chester County Historical Society, West Chester PA

Kasl, Ronda, *Cur Painting & Sculpture to 1800,* Columbus Museum of Art and Design, Indianapolis IN

Kaspar, Thomas L, *Preservation,* Nebraska State Capitol, Lincoln NE

Kasper, David C, *Pres,* Crary Art Gallery Inc, Warren PA

Kasper, Michael, *Reference & Fine Arts Librn,* Amherst College, Robert Frost Library, Amherst MA

Kass, Emily S, *Dir,* Tampa Museum of Art, Tampa FL

Kass, Ray, *Prof,* Virginia Polytechnic Institute & State University, Dept of Art & Art History, Blacksburg VA (S)

Kassoy, Bernard, *Instr,* Harriet FeBland, New York NY (S)

Kast, Sawn M, *Cur & CEO,* North Country Museum of Arts, Park Rapids MN

Kaszarski, Richard, *Sr Historian,* American Museum of the Moving Image, Astoria NY

Katauskas, Joseph, *VPres,* Balzekas Museum of Lithuanian Culture, Chicago IL

Katchen, Michael, *Archivist,* Franklin Furnace Archive, Inc, New York NY

Kather, Jan, *Asst,* Elmira College, Art Dept, Elmira NY (S)

Kato, Bruce, *Chief Cur,* Alaska State Museum, Juneau AK

Katrosits, Stephen, *Chmn,* University of Wisconsin-Eau Claire, Dept of Art, Eau Claire WI (S)

Katsiff, Bruce, *Dir,* James A Michener, Doylestown PA

Katsimpalis, Tom, *Cur Interpretation,* Loveland Museum Gallery, Loveland CO

Katsourides, Andrew, *Assoc Prof,* Central Missouri State University, Art Dept, Warrensburg MO (S)

Katz, Barbara P, *VPres,* Maryland Historical Society, Library, Baltimore MD

Katz, Jan, *Mus Shop Mgr,* The Ogden Museum of Southern Art, University of New Orleans, New Orleans LA

Katz, Janice, *Asst Cur Japanese Art,* The Art Institute of Chicago, Department of Asian Art, Chicago IL

Katz, Jill, *Mgr Mktg & Comm,* University of Pennsylvania, Institute of Contemporary Art, Philadelphia PA

Katz, Jonathan, *Exec Dir,* National Assembly of State Arts Agencies, Washington DC

Katz, Lynda, *Instr,* Southeastern Louisiana University, Dept of Visual Arts, Hammond LA (S)

Katz, Morton, *Pres,* Sculptor's Society of Canada, Canadian Sculpture Centre, Toronto ON

Katz, Paula, *Asst Cur Art,* Columbus Museum, Columbus GA

Katz, Robert, *Prof,* University of Maine at Augusta, College of Arts & Humanities, Augusta ME (S)

Katz, Sarah, *Prog & Exhib Coordr,* Fairmount Park Art Association, Philadelphia PA

Katz, Susan, *Instr,* Greenfield Community College, Art, Communication Design & Media Communication Dept, Greenfield MA (S)

Kaufman, Glen, *Prof Fabric Design,* University of Georgia, Franklin College of Arts & Sciences, Lamar Dodd School of Art, Athens GA (S)

Kaufman, Jan Wilson, *Bookeeper & Photographer,* Kala Institute, Kala Art Institute, Berkeley CA

Kaufman, Jolene, *Business Mgr,* Oregon Trail Museum Association, Scotts Bluff National Monument, Gering NE

Kaufman, Robert, *Chmn Illustration Dept,* Art Institute of Boston at Lesley University, Boston MA (S)

Kaufmann, Faith, *Arts & Music Librn,* Forbes Library, Northampton MA

Kaumeyer, Kenneth, *Cur Estuarine Biology,* Calvert Marine Museum, Solomons MD

Kaur, Amrita, *Library Asst,* University of Maryland, College Park, Art Library, College Park MD

Kavanagh, Brian, *Registrar,* Hirshhorn Museum & Sculpture Garden, Smithsonian Institution, Washington DC

Kavanagh, Robert, *Prin,* New Brunswick College of Craft & Design, Library, Fredericton NB

Kaven, Dennis, *Dept Head,* Grand View College, Art Dept, Des Moines IA (S)

Kawamoto, Wayne, *Design Asst,* University of Hawaii at Manoa, Art Gallery, Honolulu HI

Kay, Gloria, *Co-Pres,* Long Beach Art League, Long Beach Library, Long Beach NY

Kay, Jaeson, *Assoc Dir,* American Museum of Cartoon Art, Inc, Santa Monica CA

Kay, Jeremy, *Dir & Cur,* American Museum of Cartoon Art, Inc, Santa Monica CA

Kay, Liz, *Treas,* American Museum of Cartoon Art, Inc, Santa Monica CA

Kay, Mary, *Prof,* Bethany College, Art Dept, Lindsborg KS (S)

Kay, Pamela, *Business Office,* Blanden Memorial Art Museum, Fort Dodge IA

Kaye, Jennifer, *Dir,* Textile Museum of Canada, Toronto ON

Kaye, Sheldon, *Dir,* Portland Public Library, Art - Audiovisual Dept, Portland ME

Kaylor, Scot, *Asst Prof,* University of Pennsylvania, Graduate School of Fine Arts, Philadelphia PA (S)

Kays, Elena, *Asst Prof Interior Design,* Centenary College, Humanities Dept, Hackettstown NJ (S)

Kazan, Katie, *Dir Public Info,* Madison Museum of Contemporary Art, Madison WI

Keairns, Jim, *Mem Coordr,* Embroiderers Guild of America, Margaret Parshall Gallery, Louisville KY

Keane, Richard, *Prof,* School of the Art Institute of Chicago, Chicago IL (S)

Kearnan, Kathleen, *Assoc Dir,* Center for Exploratory & Perceptual Art, CEPA Gallery, Buffalo NY

Kearnan, Kathleen, *Assoc Dir,* Center for Exploratory & Perceptual Art, CEPA Library, Buffalo NY

Kearney, John, *Instr Apprentice Prog,* Contemporary Art Workshop, Chicago IL (S)

Kearney, John, *Pres,* Contemporary Art Workshop, Chicago IL

Kearney, Judy, *Reference Archivist,* Bernice Pauahi Bishop, Library, Honolulu HI

Kearney, Lynn, *Dir,* Contemporary Art Workshop, Chicago IL

Kearse, Mary Boyd, *VPres Bd Dir,* Associates for Community Development, Boarman Arts Center, Martinsburg WV

Keator, Carol, *Dir,* Santa Barbara Public Central Library, Faulkner Memorial Art Wing, Santa Barbara CA

Keckeisen, Robert, *Dir Mus,* Kansas State Historical Society, Kansas Museum of History, Topeka KS

Keddington-Lang, Marianne, *Oregon Historical,* Oregon Historical Society, Oregon History Center, Portland OR

Kee, Cynthia, *Instr,* University of Louisiana at Monroe, Dept of Art, Monroe LA (S)

Keech, John, *Prof,* Arkansas State University, Dept of Art, State University AR (S)

Keefe, John W, *Cur Decorative Arts,* New Orleans Museum of Art, New Orleans LA

Keeffe, Patrick, *Assoc VPres Pub Relations,* American Craft Council, Museum of Arts & Design, New York NY

Keegan, Daniel, *Exec Dir,* San Jose Museum of Art, San Jose CA

Keegan, Daniel T, *Exec Dir,* San Jose Museum of Art, Library, San Jose CA

Keegan, Rachel, *Archive Asst,* American Jewish Historical Society, The Center for Jewish History, New York NY

Keegan, Trish, *Registrar & Coll Coordr,* Kamloops Art Gallery, Kamloops BC

Keeler, Emily, *Artistic Dir,* San Francisco Arts Education Project, San Francisco CA

Keeler, William, *Cur,* Landmark Society of Western New York, Inc, Wenrich Memorial Library, Rochester NY

Keeling, Bob, *Instr,* Southwestern Community College, Advertising & Graphic Design, Sylva NC (S)

Keenan, Edward, *Dir,* Harvard University, Dumbarton Oaks Research Library & Collections, Washington DC

Keenan, Jon, *Chair,* Colby-Sawyer College, Dept of Fine & Performing Arts, New London NH (S)

Keenan, Joseph, *Dir,* Free Public Library of Elizabeth, Fine Arts Dept, Elizabeth NJ

Keeney, Bill, *Chmn Graphic Design,* Woodbury University, Dept of Graphic Design, Burbank CA (S)

Keesee, Dolores, *Gallery Receptionist,* Artlink, Inc, Fort Wayne IN

Keesee, Tom, *Instr,* University of Saint Francis, School of Creative Arts, Fort Wayne IN (S)

Keeton, Darra, *Assoc Prof,* Rice University, Dept of Art & Art History, Houston TX (S)

Kegl, Balazs, *Asst Prof,* Universite de Montreal, Bibliotheque d'Amenagement, Montreal PQ

Kegler, Kevin, *Asst Prof,* Daemen College, Art Dept, Amherst NY (S)

Kegler, Kevin, *Dir,* Daemen College, Fanette Goldman & Carolyn Greenfield Gallery, Amherst NY

Kehoe, Nita, *Chair Dept,* Central Wyoming College, Art Center, Riverton WY (S)

Keifer, Stephanie, *Admin Asst,* Dickinson College, The Trout Gallery, Carlisle PA

Keifer-Boyd, Karen, *Asst Prof,* Texas Tech University, Dept of Art, Lubbock TX (S)

Keil, Kate, *Cur Colls,* Missouri Department of Natural Resources, Missouri State Museum, Jefferson City MO

Keim, Barbara, *Chmn,* Westfield State College, Art Dept, Westfield MA (S)

Keim-Campbell, Delphine, *Assoc Prof,* University of Idaho, Dept of Art & Design, Moscow ID (S)

Keiser, Sandra, *Assoc Prof,* Mount Mary College, Art & Design Division, Milwaukee WI (S)

Keister, Ann, *Assoc Prof,* Grand Valley State University, Art & Design Dept, Allendale MI (S)

Keiter, Ellen J, *Cur Exhibs,* The Hudson River Museum, Yonkers NY

Keith, Herman, *Chmn,* Claflin College, Dept of Art, Orangeburg SC (S)

Keith, Morrison, *Dean,* San Francisco State University, Art Dept, San Francisco CA (S)

Kekke, Rhonda, *Head Dept,* Kirkwood Community College, Dept of Arts & Humanities, Cedar Rapids IA (S)

Keland, H William, *Pres,* Monterey Museum of Art Association, Monterey Museum of Art, Monterey CA

Kelder, Diane, *Prof Emerita,* City University of New York, PhD Program in Art History, New York NY (S)

Kelker, Nancy, *Instr,* Middle Tennessee State University, Art Dept, Murfreesboro TN (S)

Kellam, M Katherine, *VPres Low County,* Brookgreen Gardens, Murrells Inlet SC

Kellar, Jane, *Dir,* Friends of Historic Kingston, Fred J Johnston House Museum, Kingston NY

Keller, Amy, *Admin Asst,* Belle Grove Plantation, Middletown VA

Keller, Benita, *Dir Exhib,* Shepherd University, Art Dept, Shepherdstown WV (S)

Keller, Candace, *Prof,* Wayland Baptist University, Dept of Art, Plainview TX (S)

Keller, Dorothy Bosch, *Chmn Dept,* Saint Joseph College, Dept of Fine Arts, West Hartford CT (S)

Keller, John, *Chmn Dept,* Harding University, Dept of Art, Searcy AR (S)

Keller, Katie, *Ref Librn,* Stanford University, Art & Architecture Library, Stanford CA

Keller, Peter, *Pres,* Bowers Museum of Cultural Art, Bowers Museum, Santa Ana CA

Keller, Rudolf K, *Aggregate Prof,* Universite de Montreal, Bibliotheque d'Amenagement, Montreal PQ

Kelley, Carla, *Registrar,* Zanesville Art Center, Zanesville OH

Kelley, Don, *Prof Fine Arts,* University of Cincinnati, School of Art, Cincinnati OH (S)

Kelley, Frances, *Dir Finance & Admin,* American Textile History Museum, Lowell MA

Kelley, Judy, *Mem Secy,* Newport Historical Society & Museum of Newport History, Newport RI

Kelley, Karen, *Mgr Reference,* Denver Public Library, Reference, Denver CO

Kelley, Mattie, *Registrar,* Sterling & Francine Clark, Williamstown MA

Kellison, Robert P, *Dir Major Gifts & Planned Giving,* Contemporary Arts Center, Cincinnati OH

Kellman, Julia, *In Charge Art Educ,* University of Illinois, Urbana-Champaign, School of Art & Design, Champaign IL (S)

Kellner, Tana, *Artistic Dir,* Women's Studio Workshop, Inc, Rosendale NY

Kellogg, Wayne, *Treas,* Almond Historical Society, Inc, Hagadorn House, The 1800-37 Museum, Almond NY

Kellum, Barbara, *Asst Prof,* Smith College, Art Dept, Northampton MA (S)

Kelly, Amy, *Registrar,* The Old Jail Art Center, Green Research Library, Albany TX

Kelly, Ann, *Operations Mgr,* Fremont Center for the Arts, Canon City CO

Kelly, Carla, *Registrar,* Zanesville Art Center, Library, Zanesville OH

Kelly, Cathie, *Assoc Prof,* University of Nevada, Las Vegas, Dept of Art, Las Vegas NV (S)

Kelly, Donna, *Asst Prof, Coordr Art Educ,* Rhode Island College, Art Dept, Providence RI (S)

Kelly, Gemey, *Adjunct Prof,* Mount Allison University, Dept of Fine Arts, Sackville NB (S)

Kelly, Gemey, *Dir,* Mount Allison University, Owens Art Gallery, Sackville NB

Kelly, James, *Dir Mus,* Virginia Historical Society, Richmond VA

Kelly, James C, *Asst Dir Mus,* Virginia Historical Society, Library, Richmond VA

Kelly, Jim, *Exec Dir,* King County Arts Commission, Seattle WA

Kelly, Larry, *VPres,* Allegany County Historical Society, Gordon-Roberts House, Cumberland MD

Kelly, Madeline, *Supv Reference,* Berkshire Athenaeum, Reference Dept, Pittsfield MA

Kelly, Margaret, *Assoc Prod,* Saint Louis Community College at Meramec, Art Dept, Saint Louis MO (S)

Kelly, Margaret, *VPres,* Forbes Magazine, Inc, Forbes Collection, New York NY

Kelly, Mathew, *Vis Asst Prof Art,* Whitman College, Art Dept, Walla Walla WA (S)

Kelly, Nancy, *Cur,* University of Nebraska at Omaha, Art Gallery, Omaha NE

Kelly, Nannette, *Asst Prof Art,* Imperial Valley College, Art Dept, Imperial CA (S)

Kelly, Rose, *Cur,* National Institute of Art & Disabilities (NIAD), Florence Ludins-Katz Gallery, Richmond CA

Kelly, Samantha, *Asst Cur Educ,* Montgomery Museum of Fine Arts, Montgomery AL

Kelly, Wendy, *Acting Cur,* Discovery Museum, Bridgeport CT

Kelly, Winston, *Dir Operations,* The Studio Museum in Harlem, New York NY

Kelman, M, *Instr,* Community College of Rhode Island, Dept of Art, Warwick RI (S)

Kelsey, Josephine, *Exec Dir,* Michigan Guild of Artists & Artisans, Michigan Guild Gallery, Ann Arbor MI

Kemmerer, Allison, *Assoc Cur Art After 1950 & Photography,* Phillips Academy, Addison Gallery of American Art, Andover MA

Kemp, Jane, *Supv,* Luther College, Fine Arts Collection, Decorah IA

Kempe, Alexandra, *CFO & VPres,* Brookgreen Gardens, Murrells Inlet SC

Kempe, Deborah, *Chief, Coll Management & Access,* Frick Art Reference Library, New York NY

Kemper, David W, *CEO & Pres,* Commerce Bancshares, Inc, Fine Art Collection, Kansas City MO

Kemper, Julie, *Cur,* Missouri Department of Natural Resources, Elizabeth Rozier Gallery, Jefferson City MO

Kemper, Julie, *Cur Exhibs,* Missouri Department of Natural Resources, Missouri State Museum, Jefferson City MO

Kemper, Mark, *Asst Supt,* Nebraska Game and Parks Commission, Arbor Lodge State Historical Park & Morton Mansion, Nebraska City NE

Kemper, R Crosby, *Chmn,* UMB Financial Corporation, Kansas City MO

Kempf, Joan, *Assoc Prof,* University of Southern Indiana, Art Dept, Evansville IN (S)

Kenada, Shirley, *Prof,* Claremont Graduate University, Dept of Fine Arts, Claremont CA (S)

Kendall, Alison, *Instr,* Lakehead University, Dept of Visual Arts, Thunder Bay ON (S)

Kendall, Andrew, *Exec Dir,* The Trustees of Reservations, The Mission House, Ipswich MA

Kendall, Donald M, *Former Chmn & CEO,* PepsiCo Inc, Donald M Kendall Sculpture Garden, Purchase NY

Kendall, Gail, *Chmn Grad Comt,* University of Nebraska-Lincoln, Dept of Art & Art History, Lincoln NE (S)

Kendall, Ginny, *Instr,* Main Line Art Center, Haverford PA (S)

Kendrick, Diane, *Coordr,* Averett College, Art Dept, Danville VA (S)

Kennedy, Amy, *Instr,* Muskingum College, Art Department, New Concord OH (S)

Kennedy, Arlene, *Dir,* University of Western Ontario, McIntosh Gallery, London ON

Kennedy, Becky, *Accountant,* Arts Council of the Blue Ridge, Roanoke VA

Kennedy, Carol, *Dir Visual Arts,* Jay County Arts Council, Hugh N Ronald Memorial Gallery, Portland IN

Kennedy, David, *Cur Art,* Everhart Museum, Scranton PA

Kennedy, Douglas R, *Video Production,* Art Institute of Pittsburgh, Pittsburgh PA (S)

Kennedy, Elise Ledy, *Branch Adminr,* Miami-Dade Public Library, Miami FL

Kennedy, Ellizabeth, *Cur,* Terra Museum of American Art, Chicago IL

Kennedy, Greg, *Visual Arts Chmn,* Idyllwild Arts Academy, Idyllwild CA (S)

Kennedy, Janet, *Assoc Prof,* Indiana University, Bloomington, Henry Radford Hope School of Fine Arts, Bloomington IN (S)

Kennedy, Jo, *Pres,* Visual Arts Center of Richmond, Richmond VA

Kennedy, Joan, *Graphic Designer,* Birmingham Museum of Art, Birmingham AL

Kennedy, Joanne, *Admin Dir,* Visual Arts Center of Northwest Florida, Visual Arts Center Library, Panama City FL

Kennedy, Joyce, *Div Chmn,* Governors State University, College of Arts & Science, Art Dept, University Park IL (S)

Kennedy, Kari, *Mus Educator,* Seneca-Iroquois National Museum, Salamanca NY

Kennedy, Mary, *Cur,* Iowa Great Lakes Maritime Museum, Arnolds Park IA

Kennedy, Mary, *Cur Coll,* Aurora University, Schingoethe Center for Native American Cultures, Aurora IL

Kennedy, Mihail, *Pub Rels,* Zoo Montana, Billings MT

Kennedy, Patricia, *Prof,* Ocean County College, Humanities Dept, Toms River NJ (S)

Kennedy, Philip, *Exhibits Designer Art,* Illinois State Museum, Illinois Art Gallery & Lockport Gallery, Springfield IL

Kennedy, Ronald, *Prof,* Southeastern Louisiana University, Dept of Visual Arts, Hammond LA (S)

Kennedy, Susan, *Dir Develop,* Creative Time, New York NY

Kennedy, Terrence, *Cur,* Maharishi University of Management, Department of Fine Arts, Fairfield IA

Kennell, Elizabeth, *Dir Develop,* McCord Museum of Canadian History, Montreal PQ

Kenney, Eliza, *Assoc Prof,* Loyola University of Chicago, Fine Arts Dept, Chicago IL (S)

Kennon, Robert, *Prof Art,* Mount Saint Clare College, Art Dept, Clinton IA (S)

Kenseth, Joy, *Prof,* Dartmouth College, Dept of Art History, Hanover NH (S)

Kent, Jo Anne, *Coll Mgr,* Koshare Indian Museum, Inc, La Junta CO

Kent, Marcia, *Pres,* Marin Society of Artists Inc, Ross CA

Kent, Richard, *Assoc Prof,* Franklin & Marshall College, Art Dept, Lancaster PA (S)

Kenworthy, Steve, *Dir,* Rhinelander District Library, Rhinelander WI

Kenyon, Betsy, *Art,* Glendale Community College, Visual & Performing Arts Div, Glendale CA (S)

Kenyon, Colleen, *Exec Dir,* Center for Photography at Woodstock Inc, Woodstock NY

Keogh, Michael, *Instr,* Casper College, Dept of Visual Arts, Casper WY (S)

Keough, Jane, *Dir Corporate Mem Svcs,* Fitchburg Art Museum, Fitchburg MA

Keough, Tracey, *Dir,* City of Providence Parks Department, Roger Williams Park Museum of Natural History, Providence RI

Keown, Gary, *Asst Prof,* Southeastern Louisiana University, Dept of Visual Arts, Hammond LA (S)

Kephart, Betsy, *Exec Dir,* Historic Paris - Bourbon County, Inc, Hopewell Museum, Paris KY

Kephart, Bob, *Preparator,* The Currier Museum of Art, Currier Museum of Art, Manchester NH

Kerber, Gwen, *Instr,* Bucks County Community College, Fine Arts Dept, Newtown PA (S)

Kerkhoven, Marijke, *Cur & Colls Mgr,* Textile Museum of Canada, Toronto ON

Kerl, John, *Educator,* Prairie Art Gallery, Grande Prairie AB

Kerlavage, Marianne S, *Chmn,* Millersville University, Art Dept, Millersville PA (S)

Kern, Amy, *Graphic Design,* Art Institute of Pittsburgh, Pittsburgh PA (S)

Kern, Ellyn, *Secy,* Switzerland County Historical Society Inc, Life on the Ohio: River History Museum, Vevay IN

Kern, Ellyn, *Treas,* Switzerland County Historical Society Inc, Switzerland County Historical Museum, Vevay IN

Kern, Lucy, *Librn,* Pennsylvania German Cultural Heritage Center at Kutztown University, Pennsylvania German Heritage Library, Kutztown PA

Kern, Steven, *Cur European Art,* San Diego Museum of Art, San Diego CA

Kern Paster, Gail, *Dir,* Folger Shakespeare, Washington DC

Kerns, Ed, *Prof Art,* Lafayette College, Dept of Art, Easton PA (S)

Kerr, Don, *Adjunct Prof,* Aquinas College, Art Dept, Grand Rapids MI (S)

Kerr, Gloria, *Exec Asst,* Museum London, London ON

Kerr, James, *Pres,* Morris-Jumel Mansion, Inc, New York NY

Kerr, Joellen, *Dir,* University of Charleston, Carleton Varney Dept of Art & Design, Charleston WV (S)

Kerr, Larry, *Pres,* Cuyahoga Valley Art Center, Cuyahoga Falls OH (S)

Kerr, Nancy, *Div Chmn,* Dean College, Visual Art Dept, Franklin MA (S)

Kerr, Norwood, *Archival Librn,* Alabama Department of Archives & History, Library, Montgomery AL

Kerr, Pat, *Instr,* Wayne Art Center, Wayne PA (S)

Kerr, Peggy, *Festival & Art Gallery Shop Dir,* Birmingham-Bloomfield Art Center, Birmingham MI (S)

Kerr, Peggy, *Festival & Gallery Shop Dir,* Birmingham-Bloomfield Art Center, Art Center, Birmingham MI

Kersev, Barbara, *VPres,* Crary Art Gallery Inc, Warren PA

Kersey, Lynda, *Park Ranger II,* Bluemont Historical Railroad Junction, Arlington VA

Kerton, R, *Dean,* University of Waterloo, Fine Arts Dept, Waterloo ON (S)

Kerven, Don, *Facilities Mgr,* Museum of Western Colorado, Grand Junction CO

Kerzie, Ted, *Chmn,* California State University, Bakersfield, Dept of Performing Arts Dept of Art, Bakersfield CA (S)

Kessel, Suzan, *Pres,* Fairfield Art Association, Fairfield IA

Kessler, Jean, *Comptroller,* Children's Museum of Manhattan, New York NY

Kessler, Karey E, *Gallery Mgr,* District of Columbia Arts Center (DCAC), Washington DC

Kestenbaum, Joy, *Art & Architecture Librn,* Pratt Institute, Art & Architecture Dept, Brooklyn NY

Kestenbaum, Stuart J, *Dir,* Haystack Mountain School of Crafts, Deer Isle ME

Kestenbaum, Stuart J, *Dir,* Haystack Mountain School of Crafts, Library, Deer Isle ME

Kestenbaum, Stuart J, *Dir,* Haystack Mountain School of Crafts, Deer Isle ME (S)

Kester, Marilyn, *Pres,* Cambridge Museum, Cambridge NE

Kester, Susanne, *Media Resources Coordr,* Hebrew Union College, Skirball Cultural Center, Los Angeles CA

Kesterson-Bullen, Sharon, *Prof,* College of Mount Saint Joseph, Art Dept, Cincinnati OH (S)

Ketcham, Christopher, *Assoc Registrar,* The Phillips Collection, Washington DC

Ketner, Joseph D, *Dir,* Brandeis University, Rose Art Museum, Waltham MA

Ketter, Cathy, *Operations Mgr,* Allied Arts Council of St Joseph, Saint Joseph MO

Kettering, Alison, *Chmn,* Carleton College, Dept of Art & Art History, Northfield MN (S)

Kettering, Karen L, *Cur Russian & Eastern Euro Art,* Hillwood Museum & Gardens Foundation, Hillwood Museum & Gardens, Washington DC

Keville, Jim, *Asst Prof,* California State University, Dominguez Hills, Art Dept, Carson CA (S)

Key, Bonnie, *Office Mgr,* Embroiderers Guild of America, Dorothy Balicock Memorial Library, Louisville KY

Key, Lisa, *Dir Foundation & Corporate Relations,* The Art Institute of Chicago, Chicago IL

Keyes, David, *Prof,* Pacific Lutheran University, Dept of Art, Tacoma WA (S)

Keyes, George, *Cur European Painting,* Detroit Institute of Arts, Detroit MI

Keyes, William, *Dir Historic Sites,* Minnesota Historical Society, Saint Paul MN

Keys, Kathleen, *Dir Community Develop,* Idaho Commission on the Arts, Boise ID

Khachatoorian, Haig, *Head Design & Technology Dept,* North Carolina State University at Raleigh, School of Design, Raleigh NC (S)

Khalsa, Sant, *Instr,* California State University, San Bernardino, Dept of Art, San Bernardino CA (S)

Khan, Beverly, *Acting Dean,* Fairfield University, Visual & Performing Arts, Fairfield CT (S)

Khan, Sabir, *Assoc Dean,* Georgia Institute of Technology, College of Architecture, Atlanta GA (S)

Khanam, Ferdousi, *Secy,* United States Department of the Interior, Indian Arts & Crafts Board, Washington DC

Kharchi, Antje, *Chmn Computer Graphics,* Corcoran School of Art, Washington DC (S)

Khewhok, Carol, *Cur Art Center,* Honolulu Academy of Arts, Honolulu HI

Khewhok, Carol, *Cur Art Ctr,* Honolulu Academy of Arts, The Art Center at Linekona, Honolulu HI (S)

Khewhok, Sanit, *Cur,* Hawaii Pacific University, Gallery, Kaneohe HI

Kibler, Brian, *Dir Operations,* Urbanglass, Robert Lehman Gallery, Brooklyn NY

Klebe, Elizabeth, *Devel Coordr,* Victoria Mansion - Morse Libby House, Portland ME

Kleber, Beth, *Assoc Dir Library,* Visual Arts Library, New York NY

Klecan, Lesley, *Dir Educ,* Rogue Valley Art Association, Rogue Gallery & Art Center, Medford OR

Kleckner, Christine, *Admin Dir,* Eye Level Gallery, Halifax NS

Kleeblatt, Norman, *Chief Cur,* The Jewish Museum, New York NY

Kleeman, Theresia, *Dir Art Gallery,* Bakersfield College, Fine Arts Dept, Bakersfield CA (S)

Klees, Rachel, *Cur I Exhib,* Kenosha Public Museum, Kenosha WI

Klein, Adaire J, *Dir,* Simon Wiesenthal Center Inc, Library & Archives, Los Angeles CA

Klein, Aimee, *Admin Asst,* Longview Museum of Fine Art, Longview TX

Klein, Emanuel, *Pres,* Brown County Art Gallery Foundation, Brown County Art Gallery & Foundation, Nashville IN

Klein, Janet, *VChmn,* Pennsylvania Historical & Museum Commission, Harrisburg PA

Klein, Jeanette, *Asst Prof,* Berea College, Art Dept, Berea KY (S)

Klein, Linda, *Pub Rels & Mus Shop Mgr,* Medina Railroad Museum, Medina NY

Klein, Mary Anne, *Corresp Secy,* The National Art League, Douglaston NY

Klein, Richard, *Asst Dir,* Aldrich Museum of Contemporary Art, Ridgefield CT

Klein, Ron, *Prof Ceramics,* Saint Joseph's University, Dept of Fine & Performing Arts, Philadelphia PA (S)

Kleinbauer, Eugene, *Prof,* Indiana University, Bloomington, Henry Radford Hope School of Fine Arts, Bloomington IN (S)

Kleinfelder, Arthur, *Dept Head,* Suffolk County Community College, Art Dept, Selden NY (S)

Kleiser, David, *Vice Dir Finance,* Brooklyn Museum, Brooklyn NY

Klem, Alan, *Assoc Chair Performing Arts,* Creighton University, Fine & Performing Arts Dept, Omaha NE (S)

Klema, Stephen A, *Graphic Design Coordr,* Tunxis Community Technical College, Graphic Design Dept, Farmington CT (S)

Klich, Carol, *Exec Secy & Operations Mgr,* Mingei International, Inc, Mingei International Museum, San Diego CA

Kligensmith, Ann, *Chmn Fine Arts Div,* Iowa Wesleyan College, Art Dept, Mount Pleasant IA (S)

Klima, Stefan, *Supv Fine Arts Svcs,* Beverly Hills Public Library, Fine Arts Library, Beverly Hills CA

Klimaszowski, Cathy, *Assoc Dir & Cur Educ,* Cornell University, Herbert F Johnson Museum of Art, Ithaca NY

Klindt, Steve, *Dir Develop,* Tampa Museum of Art, Judith Rozier Blanchard Library, Tampa FL

Kline, Katy, *Dir,* Bowdoin College, Museum of Art, Brunswick ME

Klingman, Berry J, *Prof,* Baylor University, Dept of Art, Waco TX (S)

Klink, Peter J, *Pres,* Heritage Center, Inc, Pine Ridge SD

Klinker, Scott, *Head 3-D Design Dept,* Cranbrook Academy of Art, Bloomfield Hills MI (S)

Klobe, Thomas, *Dir Gallery,* University of Hawaii at Manoa, Dept of Art, Honolulu HI (S)

Klobe, Tom, *Dir,* University of Hawaii at Manoa, Art Gallery, Honolulu HI

Klocke, Dave, *Pres,* Cincinnati Art Club, Cincinnati OH

Klocke, Richard, *Exhib Designer,* University of Kansas, Spencer Museum of Art, Lawrence KS

Kloner, Jay, *Assoc Prof,* University of Louisville, Allen R Hite Art Institute, Louisville KY (S)

Klooz, Donan, *Cur Exhib,* Mobile Museum of Art, Mobile AL

Klopfer, Dennis, *Asst Prof,* Mount Mary College, Art & Design Division, Milwaukee WI (S)

Klopfer, Mary, *Assoc Prof,* University of Saint Francis, School of Creative Arts, Fort Wayne IN (S)

Klos, Sheila, *Head Librn,* Harvard University, Dumbarton Oaks Research Library, Washington DC

Klosky, Peter, *Dir Exhibits,* Roberson Museum & Science Center, Binghamton NY

Klossner, Alyssa, *Mus Shop Mgr,* MEXIC-ARTE Museum, Austin TX

Klotz, Steve, *Dir Philanthropy,* Art & Culture Center of Hollywood, Art Gallery, Hollywood FL

Kluba, William, *Assoc Prof,* Tunxis Community Technical College, Graphic Design Dept, Farmington CT (S)

Klueg, James, *Prof,* University of Minnesota, Duluth, Art Dept, Duluth MN (S)

Kluk, Stephanie, *Mem Coordr,* Chicago Artists' Coalition, Chicago IL

Kluttz, Ann, *Lectr,* University of North Carolina at Charlotte, Dept Art, Charlotte NC (S)

Kmelitsky, Dimitri, *Asst Prof,* Loyola Marymount University, Dept of Art & Art History, Los Angeles CA (S)

Kmetz, Janice, *Assoc Prof,* University of Minnesota, Duluth, Art Dept, Duluth MN (S)

Knaack, Beth, *Coordr Visitor Svcs,* Putnam Museum of History and Natural Science, Library, Davenport IA

Knapp, Jacquelyn, *Instr,* University of Science & Arts of Oklahoma, Arts Dept, Chickasha OK (S)

Knapp, M Jason, *Chmn,* Anderson University, Art Dept, Anderson IN (S)

Knapp, Marilyn, *Cur History,* Anchorage Museum at Rasmuson Center, Anchorage AK

Knapp, Melinda, *Chief Registrar & Exhib Mgr,* Columbus Museum of Art, Columbus OH

Knapp, Sandra, *Asst to Dir,* Niagara University, Castellani Art Museum, Niagara NY

Knapp, Tim, *Asst Dir,* Cleveland State University, Art Gallery, Cleveland OH

Knash, Bob, *Treas,* Wayne County Historical Society, Museum, Honesdale PA

Knash, Robert, *Treas,* Wayne County Historical Society, Honesdale PA

Knavel, Jenny, *Assoc Prof,* Western Illinois University, Art Dept, Macomb IL (S)

Knebelsberger, Caroline, *Asst Dir,* Roswell Museum & Art Center, Library, Roswell NM

Knecht, John, *Chmn,* Colgate University, Dept of Art & Art History, Hamilton NY (S)

Knecht, Samuel, *Dir,* Hillsdale College, Art Dept, Hillsdale MI (S)

Knechtel, Nancy, *Prof,* Niagara County Community College, Fine Arts Division, Sanborn NY (S)

Knedler, Cory, *Cur,* University of South Dakota Art Galleries, Vermillion SD

Kneeland, Donna, *Dir Develop,* Monterey Museum of Art Association, Monterey Museum of Art, Monterey CA

Knepper, Alice, *Adjunct Prof,* Missouri Southern State University, Dept of Art, Joplin MO (S)

Knibb, Nicole, *Information Officer,* McMaster University, McMaster Museum of Art, Hamilton ON

Knickmeyer, Hank, *Prof,* Fontbonne University, Fine Art Dept, Saint Louis MO (S)

Knight, Brooke, *Asst Prof,* University of Maine, Dept of Art, Orono ME (S)

Knight, Charles R, *Cur,* MacArthur Memorial, Norfolk VA

Knight, Clarence, *Chmn,* Bowie State University, Fine & Performing Arts Dept, Bowie MD (S)

Knight, Cynthia, *Dir,* Woodbridge Township Cultural Arts Commission, Barron Arts Center, Woodbridge NJ

Knight, David, *Dir,* Northern Kentucky University, Highland Heights KY

Knight, Dean, *Librn,* Tryon Palace Historic Sites & Gardens, Library, New Bern NC

Knight, Dean, *Registrar,* Tryon Palace Historic Sites & Gardens, New Bern NC

Knight, James, *Cur Natural History,* South Carolina State Museum, Columbia SC

Knight, Katie, *Cur Educ,* Holter Museum of Art, Helena MT

Knight, Mary Ann, *Music & Arts Librn,* Berkshire Athenaeum, Reference Dept, Pittsfield MA

Knight, Michael, *Cur Chinese Art,* Asian Art Museum of San Francisco, Chong-Moon Lee Ctr for Asian Art and Culture, San Francisco CA

Knight, Robert E, *Exec Dir,* Tucson Museum of Artand Historic Block, Tucson AZ

Knight, Stacy, *Educ Coordr,* Heritage Museum Association, Inc, The Heritage Museum of Northwest Florida, Valparaiso FL

Knight, Stephen, *Asst Prof,* Illinois Central College, Dept Fine, Performing & Applied Arts, East Peoria IL (S)

Knight Lawrence, Gwendolyn, *Hon Pres,* New York Artists Equity Association, Inc, New York NY

Knittel, K D, *Asst Prof,* Seton Hall University, College of Arts & Sciences, South Orange NJ (S)

Knoblauch, Ann-Marie, *Prof,* Virginia Polytechnic Institute & State University, Dept of Art & Art History, Blacksburg VA (S)

Knode, Marilu, *Sr Cur,* Scottsdale Cultural Council, Scottsdale AZ

Knodel, Gerhardt, *Dir,* Cranbrook Academy of Art, Bloomfield Hills MI (S)

Knoke, Christine, *Assoc Cur,* Norton Simon, Pasadena CA

Knoles, Thomas, *Librn,* American Antiquarian Society, Worcester MA

Knoles, Thomas M, *Chair Bd Trustees,* Museum of Northern Arizona, Flagstaff AZ

Knopf, David, *Business Mgr,* Speed Art Museum, Louisville KY

Knopp, Michael, *Cur Chemistry,* Northern Maine Museum of Science, Presque Isle ME

Knott, Robert, *Prof,* Wake Forest University, Dept of Art, Winston-Salem NC (S)

Knowles, Brigitte, *Assoc Dean Main Campus Prog,* Temple University, Tyler School of Art, Elkins Park PA (S)

Knowlton, Alexis, *Library Asst,* San Francisco Art Institute, Anne Bremer Memorial Library, San Francisco CA

Knowlton, Kenn, *Instr,* Art Academy of Cincinnati, Cincinnati OH (S)

Knowlton, Paul, *Tech,* Keene State College, Thorne-Sagendorph Art Gallery, Keene NH

Knox, Tyra, *Exec Secy,* Springfield Art Museum, Springfield MO

Knudsen, Dean, *Historian,* Oregon Trail Museum Association, Scotts Bluff National Monument, Gering NE

Knudsen, Sandra E, *Assoc Cur Ancient Art, Coordr Scholarly Publs,* Toledo Museum of Art, Toledo OH

Knutsen, Jim, *Dir,* Black Hills State University, Ruddell Gallery, Spearfish SD

Knutson, Audrey, *Pres,* LeSueur County Historical Society, Chapter One, Elysian MN

Knutson, James, *Prof,* Black Hills State University, Art Dept, Spearfish SD (S)

Knutson, Jennifer, *Coordr Annual Fund & Mem,* Bellevue Art Museum, Bellevue WA

Knutson, Karen, *Faculty,* Grand Marais Art Colony, Grand Marais MN (S)

Knutson, Michael, *Prof Art,* Reed College, Dept of Art, Portland OR (S)

Koberg, William, *Installations Mgr,* The Phillips Collection, Washington DC

Kobik, Steven, *Pres,* The Huntington Library, Art Collections & Botanical Gardens, Library, San Marino CA

Koblik, Steven S, *Pres,* The Huntington Library, Art Collections & Botanical Gardens, San Marino CA

Kobrynich, Bill, *Dir Interior Design,* Art Institute of Fort Lauderdale, Fort Lauderdale FL (S)

Koby, Saundra, *Cur,* French Art Colony, Gallipolis OH

Koch, Aimee, *Gallery Admin,* 1708 Gallery, Richmond VA

Koch, Arthur, *Assoc Prof,* Southern Methodist University, Division of Art, Dallas TX (S)

Koch, Cynthia, *Dir,* National Archives & Records Administration, Franklin D Roosevelt Museum, Hyde Park NY

Koch, Cynthia M, *Dir,* National Archives & Records Administration, Franklin D Roosevelt Library, Hyde Park NY

Koch, Katie, *CFO,* San Francisco Museum of Modern Art, San Francisco CA

Kocs, Constance, *Instr,* Pierce College, Art Dept, Woodland Hills CA (S)

Koda, Harold, *Cur,* The Metropolitan Museum of Art, The Costume Institute Library, New York NY

Koda, Harold, *Cur In Charge Cost,* The Metropolitan Museum of Art, New York NY

Kodoin, Chantal, *Mus Guide,* Musee d'Art de Saint-Laurent, Saint-Laurent PQ

Koebbe, Margaret, *Treas,* Big Horn County Historical Museum, Hardin MT

Koefoed, Lori, *Instr,* Pierce College, Art Dept, Woodland Hills CA (S)

Koehler, Catherin, *Secy,* Kappa Pi International Honorary Art Fraternity, Cleveland MS

Koehler, Ron, *Pres,* Kappa Pi International Honorary Art Fraternity, Cleveland MS

Koehler, Ron, *Prof,* Delta State University, Dept of Art, Cleveland MS (S)

Koehn, Linda, *Staff Asst,* Stauth Foundation & Museum, Stauth Memorial Museum, Montezuma KS

Koenig, Richard, *Prof,* Kalamazoo College, Art Dept, Kalamazoo MI (S)

Koeninger, Kay, *Asst Prof,* Sinclair Community College, Division of Fine & Performing Arts, Dayton OH (S)

Koerber, Susannah, *Cur,* Art Museum of Western Virginia, Roanoke VA

Koerner, Michelle, *Mgr Mktg,* Art Gallery of Ontario, Toronto ON

Koester, Chris, *Dir Human Resources,* Royal Ontario Museum, Toronto ON

Koetting, Delores, *Treas,* St Genevieve Museum, Sainte Genevieve MO

Kohl, Allan, *Slide Librn,* Minneapolis College of Art & Design, Library, Minneapolis MN

Kohler, Ruth, *Dir,* Kohler Co, John Michael Kohler Arts Center - Arts Industry Program, Sheboygan WI

Kohloff, Lisbeth Neergaard, *Gallery Coordr,* Colorado Photographic Arts Center, Denver CO

Kohloff, R Skip, *Pres,* Colorado Photographic Arts Center, Denver CO

Koivisto, Chris, *Instr,* Vermilion Community College, Art Dept, Ely MN (S)

Kolasinski, Jacek, *Asst Prof,* Florida International University, School of Art & Art History, Miami FL (S)

Kolb, Jennifer, *Cur Antropology,* Wisconsin Historical Society, State Historical Museum, Madison WI

Kolb, Nancy D, *Pres & CEO,* Please Touch Museum, Philadelphia PA

Kolbo, John, *Instr,* Morningside College, Art Dept, Sioux City IA (S)

Kolbo, Scott, *Assoc Prof,* Whitworth College, Art Dept, Spokane WA (S)

Koles, Jeanne V, *Outreach Coordr,* Tufts University, Tufts University Art Gallery, Medford MA

Koletsky, Susan, *Dir Mus,* The Temple-Tifereth Israel, The Temple Museum of Religious Art, Beachwood OH

Kolinski, Laura, *Cur Educ,* Canton Museum of Art, Canton OH (S)

Kollmeyer, Mary, *1st VPres,* San Angelo Art Club, Helen King Kendall Memorial Art Gallery, San Angelo TX

Kolmstetter, Ursula, *Head Librn,* Columbus Museum of Art and Design, Indianapolis IN

Kolmstetter, Ursula, *Head Librn,* Columbus Museum of Art and Design, Stout Reference Library, Indianapolis IN

Kolster, Michael, *Asst Prof,* Bowdoin College, Art Dept, Brunswick ME (S)

Kolsters, Stephanie, *Cur,* Mississippi Valley Conservation Authority, R Tait McKenzie Memorial Museum, Almonte ON

Kolt, Ingrid, *Cur Prog,* Surrey Art Gallery, Library, Surrey BC

Kolt, Ingrid, *Cur Progs,* Surrey Art Gallery, Surrey BC

Kominos, Nicolette, *Sunday Coordr,* Cultural Affairs Department City of Los Angeles/Barnsdall Art Centers, Junior Arts Center, Los Angeles CA

Komodore, Bill, *Prof,* Southern Methodist University, Division of Art, Dallas TX (S)

Komor, Valerie, *Head Prints, Photos, & Architecture,* New York Historical Society, Library, New York NY

Komor, Valerie, *Supv & Archivist,* Archives of American Art, New York Regional Center, Washington DC

Kompelien, Carolyn, *Historic Site Mgr,* Minnesota Historical Society, Minnesota State Capitol Historic Site, St Paul MN

Konau, Britta, *Cur,* Center for Maine Contemporary Art, Art Gallery, Rockport ME

Konetzni, Bobbie, *Vol Coordr,* Newport Art Museum, Newport RI

Kong, Anne, *Chmn Display Design,* Fashion Institute of Technology, Art & Design Division, New York NY (S)

Kong, Ron, *Cur,* The Canadian Craft Museum, Vancouver BC

Konrad, Jim, *Adjunct,* Augustana College, Art Dept, Rock Island IL (S)

Kontar, Diane, *Asst Prof,* University of Findlay, Art Program, Findlay OH (S)

Koob, Pam, *Cur,* Art Students League of New York, New York NY

Koob, Richard, *Exec Dir,* Kalani Oceanside Retreat, Pahoa HI (S)

Koolman, Bill, *Library Technician,* San Francisco Maritime National Historical Park, Maritime Library, San Francisco CA

Koomler, Sharon Duane, *Cur Coll,* Hancock Shaker Village, Inc, Library, Pittsfield MA

Koonce , Norman L, *Exec VPres,* American Institute of Architects, Washington DC

Koons McCullough, Hollis, *Cur Fine Arts & Exhibits,* Telfair Museum of Art, Telfair Academy of Arts & Sciences Library, Savannah GA

Koop, Kathy, *Dir,* Westminster College, Art Gallery, New Wilmington PA

Koop, Rebecca, *Instr,* William Jewell College, Art Dept, Liberty MO (S)

Koopmans, Dorothy, *Secy,* New Mexico Art League, Gallery & School, Albuquerque NM

Koos, Greg, *Exec Dir,* McLean County Historical Society, McLean County Museum of History, Bloomington IL

Kopczak, Chuck, *Cur World Ecology,* California Science Center, Los Angeles CA

Kopelman, Arie, *VPres,* Nantucket Historical Association, Historic Nantucket, Nantucket MA

Kopf, Vicki, *Exec Dir,* Southeastern Center for Contemporary Art, Winston-Salem NC

Kopielski, Camille, *Treas,* Polish Museum of America, Research Library, Chicago IL

Kopp, Judy, *Accountant,* Embroiderers Guild of America, Margaret Parshall Gallery, Louisville KY

Kopren, Eileen, *Dir Pub Svcs,* Dickinson State University, Stoxen Library, Dickinson ND

Korchinski, Kevin, *Performing Arts Coordr,* Organization of Saskatchewan Arts Councils (OSAC), Regina SK

Kordich, Diane D, *Prof,* Northern Michigan University, Dept of Art & Design, Marquette MI (S)

Koreiva, M J, *Exec Dir,* Coos Art Museum, Coos Bay OR (S)

Korenblat, Ellen, *Dir Communications,* Historic Arkansas Museum, Little Rock AR

Korff, David, *Coordr Galleries & Exhibits,* Saint Clair County Community College, Jack R Hennesey Art Galleries, Port Huron MI

Korff, David, *Dept Chmn,* Saint Clair County Community College, Jack R Hennesey Art Dept, Port Huron MI (S)

Korman, Jaymie, *Site Tech,* Minnesota Historical Society, Minnesota State Capitol Historic Site, St Paul MN

Kornblum, Aaron T, *Acting Librn,* Judah L Magnes, Blumenthal Rare Book & Manuscript Library, Berkeley CA

Kornblum, Aaron T, *Archivist, Western Jewish History Center,* Judah L Magnes, Berkeley CA

Kornek, Jay, *Radio,* Henry Ford Community College, McKenzie Fine Art Ctr, Dearborn MI (S)

Kornfeld, Fran, *Pub Relations,* Holland Tunnel Art Projects, Brooklyn NY

Kornhauser, Stephen, *Conservator,* Wadsworth Atheneum Museum of Art, Hartford CT

Korow, Elinore, *Instr,* Cuyahoga Valley Art Center, Cuyahoga Falls OH (S)

Korte, Jenny, *Guest Services Supv,* Hastings Museum of Natural & Cultural History, Hastings NE

Korte, Ken, *Exhib & Design Coordr,* Chadron State College, Main Gallery, Chadron NE

Korzon, John, *Chmn & Instr,* Southwestern Michigan College, Fine & Performing Arts Dept, Dowagiac MI (S)

Kosak, Jackie, *Coll Mgr,* Safeco Insurance Company, Art Collection, Seattle WA

Koschmann, Edward, *VPres,* Brooklyn Historical Society, Brooklyn OH

Koshar, Summerlea, *Admin & Asst Dir,* Cartoon Art Museum, San Francisco CA

Kosinski, Joan, *VPres,* Polish Museum of America, Research Library, Chicago IL

Kosinski, Joanna, *Pres,* Polish Museum of America, Chicago IL

Koski, Ann, *Mus Adminr,* Wisconsin Historical Society, State Historical Museum, Madison WI

Koski, Beth, *Exec Dir,* Ashtabula Arts Center, Ashtabula OH

Kosmere, Ellen, *Prof,* Worcester State College, Visual & Performing Arts Dept, Worcester MA (S)

Kostelny, Elizabeth, *Exec Dir,* Association for the Preservation of Virginia Antiquities, John Marshall House, Richmond VA

Kostelny, Elizabeth, *Interim Exec Dir,* Association for the Preservation of Virginia Antiquities, Richmond VA

Koster, Julia, *Mus Shop Mgr,* Naval War College Museum, Newport RI

Kostuch, Dorothy, *Chmn Liberal Arts,* Center for Creative Studies, College of Art & Design, Detroit MI (S)

Kostyniuk, Jeff, *Media Relations,* Royal Ontario Museum, Toronto ON

Kosuge, Michihiro, *Dept Chmn, Prof,* Portland State University, Dept of Art, Portland OR (S)

Kot, Malgorzata, *Librn,* Polish Museum of America, Research Library, Chicago IL

Koterbay, Scott, *Assoc Prof,* East Tennessee State University, College of Arts and Sciences, Dept of Art & Design, Johnson City TN (S)

Kotik, Charlotta, *Cur Contemporary Art,* Brooklyn Museum, Brooklyn NY

Kouba, Don, *Dept Chmn,* Prairie State College, Art Dept, Chicago Heights IL (S)

Kourasis, Betty, *Dean Student Affairs,* The Illinois Institute of Art - Chicago, Chicago IL (S)

Koutecky, Judy, *Admin Asst,* Mendel Art Gallery & Civic Conservatory, Saskatoon SK

Kovacs, Rudy, *Chair,* Idaho State University, John B Davis Gallery of Fine Art, Pocatello ID

Kovacs, Rudy, *Chmn,* Idaho State University, Dept of Art, Pocatello ID (S)

Koval, Anne, Mount Allison University, Dept of Fine Arts, Sackville NB (S)

Kovatch, Ron, *In Charge Ceramics,* University of Illinois, Urbana-Champaign, School of Art & Design, Champaign IL (S)

Kowal, Calvin, *Instr,* Art Academy of Cincinnati, Cincinnati OH (S)

Kowal, Jill, *Educ Coordr,* Art Center Sarasota, Sarasota FL (S)

Kowalchek, Elizabeth, *Asst Prof,* University of Kansas, Dept of Art & Music Education & Music Therapy, Lawrence KS (S)

Kowalske, Fred, *Pres,* Peoria Historical Society, Peoria IL

Kowalski, Jeff, *Div Coordr Art History,* Northern Illinois University, School of Art, De Kalb IL (S)

Kowalski, Libby, *Prof,* State University of New York, College at Cortland, Dept Art & Art History, Cortland NY (S)

Kowski, Robert, *Prof,* Greensboro College, Dept of Art, Division of Fine Arts, Greensboro NC (S)

Kozbial, Ardys, *Librn,* Payette Associates Architects Planners, Library, Boston MA

Kozionnyi, Alexander, *Dir Exhib Installation & Architect,* Chicago Athenaeum, Museum of Architecture & Design, Galena IL

Kozlowski, Barbara, *Assoc Dir Pub Svcs,* Skokie Public Library, Skokie IL

Kozman, Kathryn Hubner, *Instr & Supervisor,* Toronto Art Therapy Institute, Toronto ON (S)

Kozokoff, Neil, *Chmn,* Chicago Athenaeum, Museum of Architecture & Design, Galena IL

Kraball, Merrill, *Chmn,* Bethel College, Dept of Art, North Newton KS (S)

Kraemer, Pat, *Instr,* Rochester Community & Technical College, Art Dept, Rochester MN (S)

Kraft, Michelle, *Chmn & Instr,* Lubbock Christian University, Dept of Communication & Fine Art, Lubbock TX (S)

Krainak, Paul, *Prof,* West Virginia University, College of Creative Arts, Morgantown WV (S)

Krajewski, Laura, *Mgr Tour Svcs,* Agecroft Association, Museum, Richmond VA

Kralisz, Victor, *Mgr Fine Art Div,* J Eric Johnson, Fine Arts Division, Dallas TX

Kramer, Don, *Art Educ Adjunct,* Iowa Wesleyan College, Art Dept, Mount Pleasant IA (S)

Kramer, Gerald, *Coordr Fine Art Prog,* Cuyahoga Community College, Dept of Art, Cleveland OH (S)

Kramer, Jim, *Gallery Operations Mgr,* Madison Museum of Contemporary Art, Madison WI

Kramer, Kathryn, *Asst Prof,* State University of New York, College at Cortland, Dept Art & Art History, Cortland NY (S)

Kramer, Leslie, *Asst Prof,* Elmira College, Art Dept, Elmira NY (S)

Kramer, Leslie, *Dir,* Elmira College, George Waters Gallery, Elmira NY

Kramer, Maria, *Office Mgr,* Indian Arts & Crafts Association, Albuquerque NM

Kramer, Steve, *Head Dept South Campus,* Austin Community College, Dept of Commercial Art, North Ridge Campus, Austin TX (S)

Kramer, Trudy, *Dir,* The Parrish Art Museum, Southampton NY

Krammes, Barry, *Prof,* Biola University, Art Dept, La Mirada CA (S)

Krane, Susan, *Dir,* Scottsdale Cultural Council, Scottsdale AZ

Krane, Susan, *Dir,* University of Colorado, CU Art Galleries, Boulder CO

Krannig, Dora, *Instr Dance,* Glendale Community College, Visual & Performing Arts Div, Glendale CA (S)

Krantzler, Robert, *Prof,* Miami-Dade Community College, Arts & Philosophy Dept, Miami FL (S)

Kraskin, Sandra, *Dir,* Baruch College of the City University of New York, Sidney Mishkin Gallery, New York NY

Krasowska, Dorothy, *Asst Cur,* Columbia University, Dept of Art History & Archaeology, New York NY

Kraus, Corrine, *Instr,* Milwaukee Area Technical College, Graphic Arts Div, Milwaukee WI (S)

Kraus-Perez, Linda, *Adjunct Asst Prof,* Spokane Falls Community College, Fine Arts Dept, Spokane WA (S)

Krause, Bonnie J, *Dir,* University of Mississippi, University Museums Library, Oxford MS

Krause, Joann, *Instr,* Grand Marais Art Colony, Grand Marais MN (S)

Krause, Kim, *Instr,* Art Academy of Cincinnati, Cincinnati OH (S)

Krause, Lawrence, *Prof,* Cleveland Institute of Art, Cleveland OH (S)

Krause, Martin, *Cur Prints & Drawings,* Columbus Museum of Art and Design, Indianapolis IN

Kraushaar, Andy, *Cur Visual Materials,* Wisconsin Historical Society, State Historical Museum, Madison WI

Krauss, James A, *Chmn & Prof,* Oakton Community College, Language Humanities & Art Divisions, Des Plaines IL (S)

Krauss, John L, *VPres,* Columbus Museum of Art and Design, Indianapolis IN

Krauss, Sharon, *Asst Dir,* Becker College, William F Ruska Library, Worcester MA

Krausz, Peter, *Instr,* Universite de Montreal, Dept of Art History, Montreal PQ (S)

Kravis, Marie-Josee, *Pres,* Museum of Modern Art, New York NY

Kravitz, M, *Prof,* George Mason University, Dept of Art & Art History, Fairfax VA (S)

Kray, Hazele, *Cur,* The Bartlett Museum, Amesbury MA

Krazer, Kim A, *Registrar,* Newport Historical Society & Museum of Newport History, Newport RI

Kreager, Tom, *Prof,* Hastings College, Art Dept, Hastings NE (S)

Kreamer, Todd, *Cur History,* Museum of Mobile, Mobile AL

Kreeger, Keith, *Instr Ceramics,* Truro Center for the Arts at Castle Hill, Inc, Truro MA (S)

Kreft, Barbara, *Asst Prof,* Hamline University, Dept of Art & Art History, Saint Paul MN (S)

Kreger, Philip, *Dir Exhib,* Tennessee State Museum, Nashville TN

Krehbiel, Bryce, *Pres,* Maude Kerns Art Center, Eugene OR

Krehbiel, James, *Chmn,* Ohio Wesleyan University, Fine Arts Dept, Delaware OH (S)

Krehmeier, Bill, *Instr,* Hannibal La Grange College, Art Dept, Hannibal MO (S)

Kreider, Paul, *Dean College Fine Arts & Communication,* Western Illinois University, Art Dept, Macomb IL (S)

Kreiner, Mary Beth, *Librn,* Cranbrook Art Museum, Library, Bloomfield Hills MI

Kreipe de Montano, Marty, *Resource Center Mgr,* National Museum of the American Indian, George Gustav Heye Center, New York NY

Kreischer, Patricia, *Graphic Artist,* Lake Forest Library, Fine Arts Dept, Lake Forest IL

Krejcarek, Philip, *Assoc Prof,* Carroll College, Art Dept, Waukesha WI (S)

Krejci, Mark, *Instr Set Design,* Creighton University, Fine & Performing Arts Dept, Omaha NE (S)

Kremer, Gary R, *Exec Dir,* State Historical Society of Missouri, Gallery and Library, Columbia MO

Kremers, Michele, *Instr,* Marylhurst University, Art Dept, Marylhurst OR (S)

Kremgold, David, *Assoc Prof,* University of Florida, Dept of Art, Gainesville FL (S)

Krempel, Sara, *Prof,* Central Oregon Community College, Dept of Art, Bend OR (S)

Kren, Thom, *Cur Manuscripts,* Getty Center, Trust Museum, Los Angeles CA

Kren, Thomas, *Cur Manuscripts,* Getty Center, The J Paul Getty Museum, Los Angeles CA

Kreneck, Lynwood, *Prof,* Texas Tech University, Dept of Art, Lubbock TX (S)

Krens, Thomas, *Dir,* Solomon R Guggenheim, New York NY

Krensky, Beth, *Asst Prof,* University of Utah, Dept of Art & Art History, Salt Lake City UT (S)

Kress, Stephanie, *Media Coordr,* Pensacola Museum of Art, Pensacola FL

Kress, Toby, *Mgr,* Exit Art, New York NY

Kret, Robert A, *Dir,* Hunter Museum of American Art, Chattanooga TN

Kret, Robert A, *Dir,* Hunter Museum of American Art, Reference Library, Chattanooga TN

Kreutzer, Teresa, *Cur,* Hastings Museum of Natural & Cultural History, Hastings NE

Kreye, Zoe, *Technician & Preparator,* Open Space, Victoria BC

Kreymer, Oleg, *Systems Librn,* The Metropolitan Museum of Art, Thomas J Watson Library, New York NY

Krezel, Cindy, *Dir Develop,* Planting Fields Foundation, Coe Hall at Planting Fields Arboretum, Oyster Bay NY

Kribs, Michele, *Film Archivist,* Oregon Historical Society, Oregon History Center, Portland OR

Krichman, Michael, *Exec Dir,* Installation Gallery, San Diego CA

Kriebel, Marjorie, *Head Dept Interiors & Graphic Studies,* Drexel University, College of Media Arts & Design, Philadelphia PA (S)

Kriegsman, Bethany, *Assoc Prof Drawing & Printmaking,* University of Denver, School of Art & Art History, Denver CO (S)

Krist, Dennis, *Asst Prof,* Indiana-Purdue University, Dept of Fine Arts, Fort Wayne IN (S)

Kristen, Regina, *Librarian,* Hillwood Museum & Gardens Foundation, Hillwood Museum & Gardens, Washington DC

Kristof, Jane, *Assoc Prof,* Portland State University, Dept of Art, Portland OR (S)

Kritselis, Alex, *Dean Div,* Pasadena City College, Art Gallery, Pasadena CA

Kritzman, George, *Asst Cur,* Southwest Museum, Los Angeles CA

Krody, Sumru Belger, *Assoc Cur Eastern Hemisphere,* The Textile Museum, Washington DC

Kroeker, Richard, *Assoc Prof,* Technical University of Nova Scotia, Faculty of Architecture, Halifax NS (S)

Kroft, David, *Chmn,* Concordia University, Dept of Fine Arts, Austin TX (S)

Krohn-Andros, Laurie, *Cafe Mgr,* Worcester Art Museum, Worcester MA

Krol, Penne, *Instr,* Greenfield Community College, Art, Communication Design & Media Communication Dept, Greenfield MA (S)

Kroll, Jim, *Mgr - Western History & Genealogy,* Denver Public Library, Reference, Denver CO

Krone, Ted, *Chmn,* Friends University, Art Dept, Wichita KS (S)

Kronfield, Eliazabeth, *Asst Prof,* University of Nebraska, Kearney, Dept of Art & Art History, Kearney NE (S)

Kroning, Melissa, *Registrar,* Smithsonian American Art Museum, Washington DC

Kropf, Joan R, *Cur,* Salvador Dali, Museum, Saint Petersburg FL

Kropf, Peter, *Aggregate Prof,* Universite de Montreal, Bibliotheque d'Amenagement, Montreal PQ

Kruckeberg, Vicky, *Dir Textile Conservation Center,* American Textile History Museum, Lowell MA

Krueger-Corrado, Kristen, *Marketing & Communications Mgr,* Grand Rapids Public Library, Grand Rapids MI

Krug, Kersti, *Mgr Directed Studies & the Critical Curatorial Studies Prog,* University of British Columbia, Museum of Anthropology, Vancouver BC

Kruger, Laura, *Cur,* Hebrew Union College, Jewish Institute of Religion Museum, New York NY

Krule, Bernard K, *Assoc Prof,* Oakton Community College, Language Humanities & Art Divisions, Des Plaines IL (S)

Krulick, Jan, *Dir Educ,* Phoenix Art Museum, Phoenix AZ

Krull, Jeffrey R, *Dir,* Allen County Public Library, Art, Music & Audiovisual Services, Fort Wayne IN

Krumenauer, Kristine S., *Dir Art Prog,* Marian College, Art Dept, Fond Du Lac WI (S)

Kruschen, Franziska, *Dir,* Acadia University Art Gallery, Wolfville NS

Kruse, Gerald, *Assoc Prof,* South Dakota State University, Dept of Visual Arts, Brookings SD (S)

Krush, Wayne, *Dept Chmn,* State University of New York at Farmingdale, Visual Communications, Farmingdale NY (S)

Kuan, Baulu, *Assoc Prof,* Saint John's University, Art Dept, Collegeville MN (S)

Kuan, Baulu, *Assoc Prof,* College of Saint Benedict, Art Dept, Saint Joseph MN (S)

Kubert, Joe, *Pres,* Joe Kubert, Dover NJ (S)

Kubota, Glenn, *Awards Prog Assoc,* Art Directors Club, New York NY

Kuchar, Kathleen, *Prof,* Fort Hays State University, Dept of Art, Hays KS (S)

Kucharski, Malcolm E, *Assoc Prof,* Pittsburg State University, Art Dept, Pittsburg KS (S)

Kuchinski, Marina, *Assoc Prof,* College of DuPage, Liberal Arts Division, Glen Ellyn IL (S)

Kuchler, Lee, *Instr,* Ocean City Arts Center, Ocean City NJ (S)

Kueber, Rita, *Dir Marketing & Communications,* Western Reserve Historical Society, Library, Cleveland OH

Kuecker, Susan, *Cur,* African American Historical Museum & Cultural Center of Iowa, Cedar Rapids IA

Kuenstler, Karin, *Head Dept Design,* Drexel University, College of Media Arts & Design, Philadelphia PA (S)

Kuentzel, Peter, *Prof,* Miami-Dade Community College, Arts & Philosophy Dept, Miami FL (S)

Kuhlmann, Karen, *Dir,* Lewistown Art Center, Lewistown MT

Kuhn, Carrie, *Admin Asst,* Fremont Center for the Arts, Canon City CO

Kuhre, Margo, *Publ Mgr,* Santa Cruz Art League, Inc, Center for the Arts, Santa Cruz CA

Kuhta, Richard J, *Librn,* Folger Shakespeare, Washington DC

Kuhu, Heather, *Dir Mktg & Pub Relations,* Grace Museum, Inc, Abilene TX

Kuiper, James, *Prof,* California State University, Chico, Department of Art & Art History, Chico CA (S)

Kuipers, Margorie, *Acting Dir,* Urban Institute for Contemporary Arts, Grand Rapids MI

Kukella, Joseph, *Asst Prof & Chmn,* Daemen College, Art Dept, Amherst NY (S)

Kukla, Jon, *Exec Dir,* Patrick Henry, Red Hill National Memorial, Brookneal VA

Kulhavy, Val, *Admin Asst,* Nicolaysen Art Museum & Discovery Center, Childrens Discovery Center, Casper WY

Kulik, Gary, *Dir,* Winterthur Gardens & Library, Library, Winterthur DE

Kulp, Gladi, *Cur Coll,* Alaska State Library, Alaska Historical Collections, Juneau AK

Kumnick, Charles, *Assoc Prof,* The College of New Jersey, School of Arts & Sciences, Ewing NJ (S)

Kunce, Craig, *Instr,* Western Wisconsin Technical College, Graphics Division, La Crosse WI (S)

Kundar, Cynthia A, *Dir & Educ Dir,* Merrick Art Gallery, New Brighton PA

Kung-Haga, Vivian, *Cur,* The Dixon Gallery & Gardens, Memphis TN

Kuntz, Margaret, *Asst Prof,* Drew University, Art Dept, Madison NJ (S)

Kuntz, Melissa, *Asst Prof,* Clarion University of Pennsylvania, Dept of Art, Clarion PA (S)

Kuo, Alice, *Adjunct Asst Prof Art Hist,* Johnson County Community College, Visual Arts Program, Overland Park KS (S)

Kuper, Christine, *Exhib Coordr,* SPACES, Cleveland OH

Kupper, Adrienne, *Dir Educ,* New York Historical Society, New York NY

Kupper, Ketti, *Asst Prof,* University of Bridgeport, School of Arts, Humanities & Social Sciences, Bridgeport CT (S)

Kupspis, Dick, *Pres,* Arts & Crafts Association of Meriden Inc, Gallery 53 of Meridan, Meriden CT

Kuranda, Alicia, *Dir Develop,* Lyman Allyn, New London CT

Kurayanagi, Heather, *Exec Asst,* Gadsden Museum of Fine Arts, Inc, Gadsden Museum of Art and History, Gadsden AL

Kuretsky, Susan D, *Prof,* Vassar College, Art Dept, Poughkeepsie NY (S)

Kuriakose, Madathikudy K, *Dir,* Free Public Library, Reference Dept, Trenton NJ

Kurnit, Daniel, *Admin Asst,* School of American Research, Indian Arts Research Center, Santa Fe NM

Kuronen, Melissa, *Communications Mgr,* Institute of Contemporary Art, Boston MA

Kurtz, Howard, *Asst Cur Costumes & Textiles,* Hillwood Museum & Gardens Foundation, Hillwood Museum & Gardens, Washington DC

Kurtz, Steven, *Assoc Prof,* University at Buffalo, State University of New York, Dept of Visual Studies, Buffalo NY (S)

Kusaba, Yoshio, *Prof Emeritus,* California State University, Chico, Department of Art & Art History, Chico CA (S)

Kushner, Marilyn, *Cur Prints & Drawing,* Brooklyn Museum, Brooklyn NY

Kuspit, Donald B, *Prof,* State University of New York at Stony Brook, Dept of College of Arts & Sciences, Art Dept, Stony Brook NY (S)

Kussack, John, *Admin Mgr,* Oregon Trail Museum Association, Scotts Bluff National Monument, Gering NE

Kusser, Robert L, *Dir,* South Dakota National Guard Museum, Pierre SD

Kuster, Deborah, *Asst Prof,* University of Central Arkansas, Department of Art, Conway AR (S)

Kuster, Diane, *Archivist,* Art Gallery of Peel, Archives, Brampton ON

Kusz, Thomas, *Instr,* Milwaukee Area Technical College, Graphic Arts Div, Milwaukee WI (S)

Kutbay, Bonnie, *Asst Prof & Chmn Dept,* Mansfield University, Art Dept, Mansfield PA (S)

Kvinsland, Anna, *Exec Dir,* Arts Council of Mendocino County, Fort Bragg CA

Kwan, Billy, *Assoc Mus Librn,* The Metropolitan Museum of Art, Image Library, New York NY

Kwapil, Brian, *Dir Visitor Svcs,* Columbus Museum of Art and Design, Indianapolis IN

Kwasigroh, David, *Dir,* State University of New York at Oswego, Tyler Art Gallery, Oswego NY

Kwiatkowski, Helen, *Asst Prof,* University of Mary Hardin-Baylor, School of Fine Arts, Belton TX (S)

Kwiatkowski, Phillip C, *Exec Dir,* Tippecanoe County Historical Association, Museum, Lafayette IN

Kwok, Alan, *Assoc Prof,* Indiana Wesleyan University, Art Dept, Marion IN (S)

Kwon, Hannah, *Librn,* Newark Public Library, Reference, Newark NJ

Kyle, Nick, *Dept Head,* Missouri Southern State University, Dept of Art, Joplin MO (S)

Labadie, John, *Asst Prof,* University of North Carolina at Pembroke, Art Dept, Pembroke NC (S)

LaBarbera, Anne, *Museum Shop,* Niagara University, Castellani Art Museum, Niagara NY

Labbe, Armand, *Treas,* Mingei International, Inc,
Mingei International Museum, San Diego CA

Labe, Paul, *Chmn,* Harford Community College, Fine
& Applied Arts Division, Bel Air MD (S)

Labelle, Diane, *Mng Dir,* Guilde Canadienne des
Metiers d'Art Quebec, Canadian Guild of Crafts
Quebec, Montreal PQ

LaBelle, Marguarite, *Assoc Prof,* Jersey City State
College, Art Dept, Jersey City NJ (S)

Laber, Philip, *Olive DeLuce Art Gallery Coll Cur,*
Northwest Missouri State University, DeLuce Art
Gallery, Maryville MO

Laber, Philip, *Prof,* Northwest Missouri State
University, Dept of Art, Maryville MO (S)

LaBlanc, Necol, *Secy,* Galerie d'art de l'Universite de
Moncton, Moncton NB

LaBossiere, Holly, *Dir,* Ponca City Library, Art Dept,
Ponca City OK

Labranche, Robert, *Lectr,* Southeastern Louisiana
University, Dept of Visual Arts, Hammond LA (S)

LaBrie, Danielle, *Treas,* Alberta Society of Artists,
Edmonton AB

Labuz, Ronald, *Prof,* Mohawk Valley Community
College, Utica NY (S)

LaCasse, Yves, *Dir Reseach & Coll,* Musee du Quebec,
Quebec PQ

Lacasse, Yves, *Dir Research & Coll,* Musee du
Quebec, Bibliotheque, Quebec PQ

Lachowicz, Keith, *Asst Dir,* Mills College, Art
Museum, Oakland CA

Lachowicz, Keith, *Preparator,* Willamette University,
Hallie Ford Museum of Art, Salem OR

Lackey, Jane, *Head Fiber Dept,* Cranbrook Academy
of Art, Bloomfield Hills MI (S)

LaCourse, Patricia, *Engineering & Science Librn,* New
York State College of Ceramics at Alfred
University, Scholes Library of Ceramics, Alfred NY

LaCroix, Catherine, *Exec Dir,* Billie Trimble Chandler,
Asian Cultures Museum & Educational Center,
Corpus Christi TX

LaCrosse, Patricia J, *Secy,* Columbus Museum of Art
and Design, Indianapolis IN

Lacy, Suzanne, *Chmn Fine Arts,* Otis College of Art &
Design, Fine Arts, Los Angeles CA (S)

Ladd, Spencer, *Chmn Design,* University of
Massachusetts Dartmouth, College of Visual &
Performing Arts, North Dartmouth MA (S)

Ladd-Simmons, Marilyn, *Gallery Mgr,* SPACES,
Cleveland OH

Ladis, Andrew, *Franklin Prof Art History,* University of
Georgia, Franklin College of Arts & Sciences,
Lamar Dodd School of Art, Athens GA (S)

Ladkin, Nicola, *Registrar,* Texas Tech University,
Museum of Texas Tech University, Lubbock TX

Ladnier, Paul, *Assoc Prof,* University of North Florida,
Dept of Communications & Visual Arts,
Jacksonville FL (S)

LaDouceur, Philip Alan, *Dir,* Zanesville Art Center,
Library, Zanesville OH

Ladson, Jack, *Pres,* Inter-Society Color Council,
Lawrenceville NJ

La Due Henry, Paige, *Exec Dir,* Visual Arts Minnesota,
Saint Cloud MN

Lae, Vivian, *Dir,* Noah Webster House, Inc, Noah
Webster House, West Hartford CT

Lafargue, Philippe, *Deputy Dir,* Tryon Palace Historic
Sites & Gardens, New Bern NC

Lafferty, Daniel, *VPres & Dean Educ,* The Art
Institutes, The Art Institute of Seattle, Seattle WA
(S)

Lafferty, Susan, *Dir Educ,* The Huntington Library, Art
Collections & Botanical Gardens, San Marino CA

Lafferty, Susan, *Dir Educ,* The Huntington Library, Art
Collections & Botanical Gardens, Library, San
Marino CA

Laffitte, Polly, *Chief Cur Art,* South Carolina State
Museum, Columbia SC

Lafitte, Bryan, *Assoc Prof,* North Carolina State
University at Raleigh, School of Design, Raleigh
NC (S)

LaFlamme, Judy, *Mus Shop Mgr,* Manchester Historic
Association, Manchester NH

LaFleur, Bill, *Maintenance Supr,* Patterson Homestead,
Dayton OH

Laflin, John, *Prof,* Dakota State University, College of
Liberal Arts, Madison SD (S)

Lafo, Rachel, *Cur,* DeCordova Museum & Sculpture
Park, Lincoln MA

Lafond, Judy, *Treas,* South Peace Art Society, Dawson
Creek Art Gallery, Dawson Creek BC

Laframboise, Alain, *Instr,* Universite de Montreal, Dept
of Art History, Montreal PQ (S)

La France, Michael, *Treas,* LeSueur County Historical
Society, Chapter One, Elysian MN

Lagerkvist, Irmfriede, *Chmn Art Dept,* Barat College,
Dept of Art, Lake Forest IL (S)

Lagoria, Georgianna, *Dir,* The Contemporary Museum
at First Hawaiian Center, Honolulu HI

Lagoria, Georgianna M, *Dir,* The Contemporary
Museum, Honolulu HI

Lagos, Marta, *Co-Dir,* Casa de Unidad Unity House,
Detroit MI

LaGrassa, Stephan J, *Assoc Dean,* University of Detroit
Mercy, School of Architecture, Detroit MI (S)

Lagried, Ted, *VChmn,* Oakland Museum of California,
Art Dept, Oakland CA

Lagsteid, Carol, *Asst Prof,* Saint Thomas Aquinas
College, Art Dept, Sparkill NY (S)

LaGue, Mary, *Registrar,* Art Museum of Western
Virginia, Roanoke VA

Lahaie, Leeann, *Curatorial Asst,* Laurentian University,
Art Centre Library, Sudbury ON

Lahikainen, Dean, *Cur,* Peabody Essex Museum,
Andrew-Safford House, Salem MA

Lai, Charlie, *Co-Founder,* Museum of Chinese in the
Americas, New York NY

Lai, Waihang, *Faculty,* Kauai Community College,
Dept of Art, Lihue HI (S)

Laing, Aileen H, *Prof,* Sweet Briar College, Art History
Dept, Sweet Briar VA (S)

Laing, Beverly, *Site Adminstr,* Delaware Division of
Historical & Cultural Affairs, Dover DE

Laing, Greg, *Cur Special Coll,* Haverhill Public
Library, Special Collections, Haverhill MA

Laing, Sue, *Instr,* Jefferson Davis Community College,
Art Dept, Brewton AL (S)

Laing-Malcolmson, Bonnie, *Pres,* Oregon College of
Art & Craft, Hoffman Gallery, Portland OR

Laing-Malcolmson, Bonnie, *Pres,* Oregon College of
Art & Craft, Portland OR (S)

Lainhoff, Thomas, *Dir,* Gunston Hall Plantation,
Library, Mason Neck VA

Lainhoff, Thomas A, *Dir,* Gunston Hall Plantation,
Mason Neck VA

Laird, Scott, *Coordr Exhib,* Visual Studies Workshop,
Rochester NY

Lake, Ellen, *Head Dept,* Central Community College -
Columbus Campus, Business & Arts Cluster,
Columbus NE (S)

Lake, Jerry L, *Prof,* George Washington University,
Dept of Art, Washington DC (S)

Laken, Lorraine, *Dir,* Hammond Museum & Japanese
Stroll Garden, Cross-Cultural Center, North Salem
NY

Lally, Michael H, *Exec Dir,* Lowell Art Association,
Inc, Whistler House Museum of Art, Lowell MA

Lalonde, Jerome, *Assoc Prof,* Mohawk Valley
Community College, Utica NY (S)

Lalumiere, Marilyn A, *Dir Develop,* Portland Museum
of Art, Portland ME

LaMalfa, James, *Prof,* University of Wisconsin College
- Marinette, Art Dept, Marinette WI (S)

La Malfa, Larry, *AV Technician,* Neville Public
Museum, Green Bay WI

Laman, Jean, *Prof,* Texas State University - San
Marcos, Dept of Art and Design, San Marcos TX
(S)

Lamar, Kent, *Chmn, Prof Art,* University of Science &
Arts of Oklahoma, Arts Dept, Chickasha OK (S)

Lamarche, Lise, *Instr,* Universite de Montreal, Dept of
Art History, Montreal PQ (S)

LaMarcz, Howard, *Prof,* C W Post Campus of Long
Island University, School of Visual & Performing
Arts, Brookville NY (S)

LaMark, Michael W, *Graphic Design,* Art Institute of
Pittsburgh, Pittsburgh PA (S)

Lamb, Donna, *Dir,* Schweinfurth Memorial Art Center,
Auburn NY

Lamb, Rebekah, *Asst Dir,* Boston University, Boston
University Art Gallery, Boston MA

Lambert, Alice, *Chmn Art Dept,* Anna Maria College,
Saint Luke's Gallery, Paxton MA

Lambert, Alice, *Chmn Dept,* Anna Maria College, Dept
of Art, Paxton MA

Lambert, Ed, *Prof Fabric Design,* University of
Georgia, Franklin College of Arts & Sciences,
Lamar Dodd School of Art, Athens GA (S)

Lambert, Kirby, *Cur,* Montana Historical Society,
Helena MT

Lambert, Kirby, *Cur Coll,* Montana Historical Society,
Library, Helena MT

Lambert, Lisa Shippee, *Asst Dir,* Panhandle-Plains
Historical Society Museum, Canyon TX

Lambert, Philip, *Chair,* Bernard M Baruch College of
the City University of New York, Art Dept, New
York NY (S)

Lambert, Phyllis, *Founding Dir,* Canadian Centre for
Architecture, Library, Montreal PQ

Lambert, Susanne, *Coll Mgr,* Utah State University,
Nora Eccles Harrison Museum of Art, Logan UT

Lambertson, John, *Chmn Art Dept & Assoc Prof,*
Washington & Jefferson College, Art Dept,
Washington PA (S)

Lambertson, Kristen, *Cur Asst,* Kamloops Art Gallery,
Kamloops BC

Lambrechts, Lillian, *Dir & Cur,* Fleet Boston Financial,
Gallery, Boston MA

Lamers, Nancy, *Chmn,* Alverno College, Art Dept,
Milwaukee WI (S)

Lamet, Rebecca, *Asst to the Dir,* Portland Harbor
Museum, South Portland ME

Lamia, Stephen, *Assoc Prof Visual Arts,* Dowling
College, Dept of Visual Arts, Oakdale NY (S)

Lammers, Heather, *Coll Mgr,* McNay, San Antonio TX

Lamont, Peter, *Dir,* New Haven Colony Historical
Society, New Haven CT

Lamothe, Donat, *Prof,* Assumption College, Dept of
Art & Music, Worcester MA (S)

Lamoureux, Johanne, *Instr,* Universite de Montreal,
Dept of Art History, Montreal PQ (S)

Lampela, Laurel, *Assoc Prof,* Cleveland State
University, Art Dept, Cleveland OH (S)

Lampert, Andrew, *Archivist,* Anthology Film Archives,
New York NY

Lance, Janie, *Chmn,* Crowder College, Art & Design,
Neosho MO (S)

Lance, Kipper, *Dir Mktg & Pub Relations,* Norton
Museum of Art, West Palm Beach FL

Lancet, Marc, *Instr,* Solano Community College,
Division of Fine & Applied Art & Behavioral
Science, Suisun City CA (S)

Land, Chris, *Art Handler,* Columbus Museum,
Columbus GA

Land, Peter, *Prof,* Illinois Institute of Technology,
College of Architecture, Chicago IL (S)

Land-Weber, E, *Instr,* Humboldt State University,
College of Arts & Humanities, Arcata CA (S)

Landau, Ellen, *Prof,* Case Western Reserve University,
Dept of Art History & Art, Cleveland OH (S)

Landau, Laureen, *Instr,* Sacramento City College, Art
Dept, Sacramento CA (S)

Landauee, Susan, *Chief Cur,* San Jose Museum of Art,
San Jose CA

Landauer, Susan, *Chief Cur,* San Jose Museum of Art,
Library, San Jose CA

Landay, Janet, *Cur Exhibitions, Asst to Dir,* Museum of
Fine Arts, Houston, Hirsch Library, Houston TX

Lander, Beth, *Asst Librn,* Bucks County Historical
Society, Spruance Library, Doylestown PA

Landers, Matt, *Sr Maintenance Repair Worker,* Sloss
Furnaces National Historic Landmark, Birmingham
AL

Landis, Ann, *Div Chmn,* Thomas University,
Humanities Division, Thomasville GA (S)

Landis, Connie M, *Head,* Montana State
University-Billings, Art Dept, Billings MT (S)

Landis, Dick, *Pres,* Southern Lorain County Historical
Society, Spirit of '76 Museum, Elyria OH

Landis, Gary, *Dir Develop,* San Jose Museum of Art,
San Jose CA

Landis, Sandy, *Exec Dir,* Community Council for the
Arts, Kinston NC

Landman, Brenda, *Chmn Asst,* University of Memphis,
Art Dept, Memphis TN (S)

Landrum-Bittle, Jenita, *Dir,* Ohio University, Seigfred
Gallery, Athens OH

Landry, Craig, *Lead Interpreter,* Grevemberg House
Museum, Franklin LA

Landry, Linda, *Head Colls,* Missouri Historical Society,
Saint Louis MO

Landsmark, Ted, *Pres,* Boston Architectural Center,
Boston MA

Lane, Anne, *Cur Coll,* Museum of York County, Staff
Research Library, Rock Hill SC

Lane, Barbara, *Prof,* City University of New York, PhD
Program in Art History, New York NY (S)

Lane, Diane, *Admin Asst,* Art Gallery of Windsor,
Windsor ON

Lane, Elizabeth, *Dir,* New York State Library,
Manuscripts & Special Collections, Albany NY

Lane, Hugh C, *Pres,* Charleston Museum, Charleston
SC

Lane, Kerstin B, *Exec Dir,* Swedish-American Museum
Association of Chicago, Chicago IL

Lane, Linn, *Contact,* WomanKraft, Tucson AZ

Lane, Maria, *Exec Dir,* Arthur Griffin, Winchester MA

Lane, Mikki, *Book Store & Receptionist Coordr,*
Middlebury College, Museum of Art, Middlebury
VT

Lane, Richard, *Treas-Secy,* The American Federation of
Arts, New York NY

Lane, Rosemary, *Coordr Printmaking,* University of
Delaware, Dept of Art, Newark DE (S)

Lane, William, *Gallery Dir,* Rio Hondo College Art
Gallery, Whittier CA

Lang, Brian J, *Art Dir,* Mellon Financial Corporation,
Pittsburgh PA

Lang, Georgia, *Cur Educ,* Leigh Yawkey Woodson, Art
Library, Wausau WI

Lang, Kathy, *Dir Mktg & Communications,* Columbus Museum of Art and Design, Indianapolis IN

Lang, Meng, *Humanities Coordr,* Chinese Culture Institute of the International Society, Tremont Theatre & Gallery, Boston MA

Lang, Michelle, *Assistant Prof,* University of Nebraska, Kearney, Dept of Art & Art History, Kearney NE (S)

Lang, Tom, *Chmn,* Webster University, Art Dept, Webster Groves MO (S)

Lang, Tom, *Dept Chair,* Webster University, Cecille R Hunt Gallery, Saint Louis MO

Langa, Helen, *Asst Prof,* American University, Dept of Art, Washington DC (S)

Lange, Gerard, *Asst Prof,* Barton College, Art Dept, Wilson NC (S)

Lange, Jane, *Dir,* City of San Rafael, Falkirk Cultural Center, San Rafael CA

Lange, Mary, *Cur,* Federal Reserve Bank of Minneapolis, Minneapolis MN

Langenecker, Martha W, Mingei International, Inc, Reference Library, San Diego CA

Langer, James V, *Instr,* Greensboro College, Dept of Art, Division of Fine Arts, Greensboro NC (S)

Langer-Holt, Una Charlene, Art Institute of Pittsburgh, Pittsburgh PA (S)

Langevin, Ann, *Exten Svcs,* Las Vegas-Clark County Library District, Las Vegas NV

Langley, James L, *Exhib Designer,* Calvert Marine Museum, Solomons MD

Langnas, Bob, *Assoc Prof,* Saint Louis Community College at Florissant Valley, Liberal Arts Division, Ferguson MO (S)

Langoy, Virginia, *Archivist Librn,* Schenectady County Historical Society, Library, Schenectady NY

Langston, Judy, *Asst Prof,* Oakton Community College, Language Humanities & Art Divisions, Des Plaines IL (S)

Langton, Charlie, *Dir Media,* Vesterheim Norwegian-American Museum, Reference Library, Decorah IA

Lani, Charlene, *Dir,* Galerie Restigouche Gallery, Campbellton NB

Lanier, Fran, *Dir Gallery,* Hambidge Center for the Creative Arts & Sciences, Rabun Gap GA

Lankford, E Louis, *Des Lee Foundation Prof Art Educ,* University of Missouri, Saint Louis, Dept of Art & Art History, Saint Louis MO (S)

Lankin-Hayes, Mollie, *Prog Adminr,* Arizona Commission on the Arts, Phoenix AZ

Lanmon, Dwight P, *Dir,* Winterthur Gardens & Library, Winterthur DE

Lansbury, Edgar, *Pres,* Nicholas Roerich, New York NY

Lansdown, Robert R, *Dir,* The Frank Phillips, Woolaroc Museum, Bartlesville OK

Lansdown, Robert R, *Dir,* The Frank Phillips, Library, Bartlesville OK

Lantz, Bunny, *Shop Mgr,* Northfield Arts Guild, Northfield MN

Lantz, Dona, *Dean,* Moore College of Art & Design, Philadelphia PA (S)

Lanza, Bianca, *Mus Store Mgr,* Bass Museum of Art, Miami Beach FL

Lanzl, Christine, *Project Mgr,* UrbanArts Institute at Massachusetts College of Art, Boston MA

Lapaite, Livija, *Dir BAC Educ,* Cultural Affairs Department City of Los Angeles/Barnsdall Art Centers, Library, Los Angeles CA

Lapalme, Guy, *Prof,* Universite de Montreal, Bibliotheque d'Amenagement, Montreal PQ

Lapalombara, David, *Prof,* Antioch College, Visual Arts Dept, Yellow Springs OH (S)

Lapelle, Rodger, *Pres,* Pennsylvania Academy of the Fine Arts, Fellowship of the Pennsylvania Academy of the Fine Arts, Philadelphia PA

Lapham, Jennifer, *Dir,* Illinois Wesleyan University, Merwin & Wakeley Galleries, Bloomington IL

Lapham, Melissa, *Admin Asst,* MonDak Heritage Center, History Library, Sidney MT

Lapilio, Lani, *Dir,* Judiciary History Center, Honolulu HI

LaPlante, Dave, *Supr Exhibit Production,* New York State Museum, Albany NY

Laplante, Louise, *Registrar, Coll Manager,* Smith College, Museum of Art, Northampton MA

LaPlantz, D M, *Instr,* Humboldt State University, College of Arts & Humanities, Arcata CA (S)

Lapointe, André, *Prof Sculpture,* Universite de Moncton, Dept of Visual Arts, Moncton NB (S)

LaPorte, Angela M, *Asst Prof,* University of Arkansas, Art Dept, Fayetteville AR (S)

LaPorte, Chris, *Adjunct Assoc Prof,* Aquinas College, Art Dept, Grand Rapids MI (S)

La Porte, Mary, *Prof,* California Polytechnic State University at San Luis Obispo, Dept of Art & Design, San Luis Obispo CA (S)

Lara, Margaret Anne, *Pub Relations,* McNay, San Antonio TX

Lara, Rosa, *Dir Educ,* Blauvelt Demarest Foundation, Hiram Blauvelt Art Museum, Oradell NJ

Larabee, Shawnee, *Mus Gift Store Mgr,* Muskegon Museum of Art, Muskegon MI

Large, Anne Marie, *Cataloger,* Ames Free-Easton's Public Library, North Easton MA

Large, David, *Pres,* International Society of Marine Painters, Eagle ID

Large, Michael, *Assoc Dean Design,* Sheridan College, School of Animation, Arts & Design, Oakville ON (S)

Large, Peter, *Shows,* Society of Canadian Artists, Burlington ON

Laris, Jeorgia, *Instr,* San Diego Mesa College, Fine Arts Dept, San Diego CA (S)

Lark, Tom, *Cur Coll,* Albuquerque Museum of Art & History, Albuquerque NM

Lark, Tracy, *VChmn,* Detroit Artists Market, Detroit MI

Larkin, Alan, *Prof,* Indiana University South Bend, Fine Arts Dept, South Bend IN (S)

Larkin, Patti, *Cur Campbell House,* Eastern Washington State Historical Society, Northwest Museum of Arts & Culture, Spokane WA

Larmann, Ralph, *Asst Prof,* University of Evansville, Art Dept, Evansville IN (S)

Larned, Ron, *Chmn,* Rollins College, Dept of Art, Main Campus, Winter Park FL (S)

LaRoche, Lynda, *Asst Prof,* Indiana University of Pennsylvania, College of Fine Arts, Indiana PA (S)

Larochelle, Steven, *Librn,* Thomas College Art Gallery, Mariner Library, Waterville ME

Larocque, Peter, *Cur New Brunswick Cultural History & Art,* New Brunswick Museum, Saint John NB

LaRose, Matthew, *Head, Assoc Prof,* Davis & Elkins College, Dept of Art, Elkins WV (S)

Larose, Thomas, *Chmn & Dir,* Virginia State University, Arts & Design, Petersburg VA (S)

LaRou, George, *Instr,* Maine College of Art, Portland ME (S)

Larouche, Michel, *Dir,* Universite de Montreal, Dept of Art History, Montreal PQ (S)

Larry, Charles, *Arts Librn,* Northern Illinois University, The University Libraries, De Kalb IL

Larsen, Devon, *Registrar,* Tampa Museum of Art, Judith Rozier Blanchard Library, Tampa FL

Larsen, Patrick, *Prof,* University of Central Arkansas, Department of Art, Conway AR (S)

Larson, Bradley, *Dir,* Oshkosh Public Museum, Oshkosh WI

Larson, Derek, *Adjunct Asst Prof Art,* Johnson County Community College, Visual Arts Program, Overland Park KS (S)

Larson, Erik, *Dir Educ,* Fairfield Historical Society, Fairfield Museum & History Center, Fairfield CT

Larson, Evan H., *Instr,* Rhode Island College, Art Dept, Providence RI (S)

Larson, Janeen, *Prof,* Black Hills State University, Art Dept, Spearfish SD (S)

Larson, Jeanne, *Instr,* Grand Marais Art Colony, Grand Marais MN (S)

Larson, Judy L, *Admin Dir,* National Museum of Women in the Arts, Washington DC

Larson, Judy L, *Exec Dir,* Art Museum of Western Virginia, Roanoke VA

Larson, Julie, *Dir Exhib,* Salem Art Association, Bush Barn Art Center, Salem OR

Larson, Mike, *Prof,* Shoreline Community College, Humanities Division, Seattle WA (S)

Larson, Nathan, *Cur Asst,* University of Arkansas at Little Rock, Art Galleries, Little Rock AR

Larson, Rebecca, *Cur Educ,* Polk Museum of Art, Lakeland FL

Larson, Sarah Beth, *Mus Shop Mgr,* The Dixon Gallery & Gardens, Memphis TN

Larson, Sidney, *Instr,* Columbia College, Art Dept, Columbia MO (S)

Larson, Stephan, *Asst Prof,* Northern Michigan University, Dept of Art & Design, Marquette MI (S)

Larson, Will, *Dir,* Maryland Institute, Graduate Photography, Baltimore MD (S)

Lary, Diane, *First VPres & Co-Chmn,* Miami Watercolor Society, Inc, Miami FL

Lasansky, Leonardo, *Dir Exhibits,* Hamline University Studio Arts & Art History Depts, Gallery, Saint Paul MN

Lasansky, Leonardo, *Head Dept,* Hamline University, Dept of Art & Art History, Saint Paul MN (S)

Lasch, Pedro, *Asst Prof Practice,* Duke University, Dept of Art, Art History & Visual Studies, Durham NC (S)

LaSeurer, Stephan, *Dept Chair, Graphic Design,* Nossi College of Art, Goodlettsville TN (S)

Lash, Jean, *Instr,* Siena Heights University, Studio Angelico-Art Dept, Adrian MI (S)

Lasher, Marie, *Librn,* Chester College of New England, Wadleigh Library, Chester NH

Laskey, Tilly, *Cur Exhib,* South Dakota State University, South Dakota Art Museum, Brookings SD

Lassen, Barbara, *VChmn,* Kenosha Public Museum, Kenosha WI

Lasser, Robin, *Photography Coordr,* San Jose State University, School of Art & Design, San Jose CA (S)

Laszlo, Krisztina, *Archivist,* University of British Columbia, Morris & Helen Belkin Art Gallery, Vancouver BC

Laszlo, Krisztina, *Archivist,* University of British Columbia, Museum of Anthropology, Vancouver BC

Latham, Ron, *Dir,* Berkshire Athenaeum, Reference Dept, Pittsfield MA

Lathan, Marty, *Admin Officer NY,* National Museum of the American Indian, George Gustav Heye Center, New York NY

Lathan, Stephanie, *Registrar,* Telfair Museum of Art, Savannah GA

Lathan, Stephanie, *Registrar,* Telfair Museum of Art, Telfair Academy of Arts & Sciences Library, Savannah GA

Lathrop, Sara, *VPres,* Mystic Art Association, Inc, Mystic Arts Center, Mystic CT

Latman, Laura, *Registrar,* Bowdoin College, Museum of Art, Brunswick ME

Latour, John, *Information Specialist,* Artexte Information Centre, Documentation Centre, Montreal PQ

Latour, Terry S, *Dir Library Svcs,* Delta State University, Roberts LaForge Library, Cleveland MS

LaTrespo, Brigitte, *Chmn,* Pikeville College, Humanities Division, Pikeville KY (S)

Latta, Douglas, *Assoc Prof,* Oral Roberts University, Art Dept, Tulsa OK (S)

Lattanzi, Greg, *AE Registrar,* New Jersey State Museum, Fine Art Bureau, Trenton NJ

Lau, Loren, *CFO,* Detroit Institute of Arts, Detroit MI

Laub, Richard S, *Cur Geology,* Buffalo Museum of Science, Research Library, Buffalo NY

Laubach, Gale C, *Admin Asst,* Museum of Fine Arts, Saint Petersburg, Florida, Inc, Saint Petersburg FL

Lauck, Joan, *Dir Develop,* Akron Art Museum, Akron OH

Lauder, Leonard A, *VChmn,* Whitney Museum of American Art, New York NY

Lauder, Ronald S, *Chmn Emeritus,* Museum of Modern Art, New York NY

Lauderbaugh, Ann, *Adjunct Asst Prof,* Spokane Falls Community College, Fine Arts Dept, Spokane WA (S)

Lauder Burke, Adele, *Learning for Life,* Hebrew Union College, Skirball Cultural Center, Los Angeles CA

Laudolff, Joanne, *VPres Educ,* DuPage Art League School & Gallery, Wheaton IL

Laufer, Marilyn, *Co-Dir,* Jule Collins Smith Museum of Art, Auburn AL

Laughlin, Page, *Prof,* Wake Forest University, Dept of Art, Winston-Salem NC (S)

Laughton, John, *Dean Col,* University of Massachusetts Dartmouth, College of Visual & Performing Arts, North Dartmouth MA (S)

Laurent, Dominique, *Dir,* Galerie Montcalm, Gatineau PQ

Laurent, Elizabeth, *Assoc Dir Historical Resources,* Girard College, Stephen Girard Collection, Philadelphia PA

Laurette, Sandra, *Cur Educ,* Art Museum of Southeast Texas, Beaumont TX

Laurich, Robert, *Head Reference Div,* City College of the City University of New York, Morris Raphael Cohen Library, New York NY

Laurin, Gordon, *Dir & Cur,* St Mary's University, Art Gallery, Halifax NS

Laurin, Katherine, *Dean Faculty Fine Arts,* University of Regina, Art Education Program, Regina SK (S)

Laury, Chenta, *Head Educ,* Isamu Noguchi, Isamu Noguchi Garden Museum, Long Island City NY

Lauter, Nancy A, *Pres,* The Art Institute of Chicago, Society for Contemporary Art, Chicago IL

Lauterbach, Ann, *Instr,* Bard College, Milton Avery Graduate School of the Arts, Annandale-on-Hudson NY (S)

La Valle, Elaine, *1st VPres,* Catharine Lorillard Wolfe, New York NY

Lavallee, Paul, *Dir Admin,* Montreal Museum of Fine Arts, Montreal PQ

LaValley, Dennis, *Chmn,* Alvin Community College, Art Dept, Alvin TX (S)

Lavenstein, Hollie, *Asst Prof,* University of Maryland, Baltimore County, Imaging, Digital & Visual Arts Dept, Baltimore MD (S)

Lavernia, Laura, *Asst Cur Educ,* Florida International University, The Art Museum at FIU, Miami FL

Lee, Rodney, *Dir,* Mount Vernon Public Library, Fine Art Dept, Mount Vernon NY

Lee, Rodney, *Fin Dir,* Oklahoma City Museum of Art, Oklahoma City OK

Lee, Steph D, *CAS Gen,* Columbus Historic Foundation, Blewett-Harrison-Lee Museum, Columbus MS

Lee, Susan, *Technical Svcs Adminr,* Miami-Dade Public Library, Miami FL

Lee, Thom, *Instr Art,* Everett Community College, Art Dept, Everett WA (S)

Lee, Yachin Crystal, *Asst Prof,* California State Polytechnic University, Pomona, Art Dept, Pomona CA (S)

Lee-Warren, S, *Instr,* Golden West College, Visual Art Dept, Huntington Beach CA (S)

Leebrick, Gilbert, *Dir,* East Carolina University, Wellington B Gray Gallery, Greenville NC

Leedy, James, *Exec Dir,* Leedy Voulko's, Kansas City MO

Leedy Jr, Walter, *Prof,* Cleveland State University, Art Dept, Cleveland OH (S)

Leete, William C, *Prof,* Northern Michigan University, Dept of Art & Design, Marquette MI (S)

Leete Smith, Avery, *Pred Board,* Friends of Historic Kingston, Fred J Johnston House Museum, Kingston NY

Lefebvre, Allen, *Mgr Finance & Operations,* University of Regina, MacKenzie Art Gallery, Regina SK

Lefebvrre-Carter, Michelle, *Dir,* Will Rogers Memorial Museum & Birthplace Ranch, Claremore OK

LeFevre, Rick, *Facilities Mgr,* Saginaw Art Museum, Saginaw MI

Leff, Cathy, *Dir,* Wolfsonian-Florida International University, Miami Beach FL

Leff, Deborah, *Dir,* National Archives & Records Administration, John F Kennedy Presidential Library & Museum, Boston MA

Leffel, Joann, *Instr Art History,* Bay De Noc Community College, Art Dept, Escanaba MI (S)

Legette, Lee David, *Interim Chmn,* Winston-Salem State University, Art Dept, Winston-Salem NC (S)

Legge, Katie Frinkle, *Pres (V),* Artists Association of Nantucket, Nantucket MA

Legge, Susan, *VPres,* Artspace, Richmond VA

Leggio, James, *Head Publs & Editorial Svcs,* Brooklyn Museum, Brooklyn NY

Legleiter, Kim, *Dir & Financial Dir,* Stauth Foundation & Museum, Stauth Memorial Museum, Montezuma KS

Lehane, Debra, *Mgr Civic Art Coll,* San Francisco City & County Art Commission, San Francisco CA

Lehman, Arnold L, *Dir,* Brooklyn Museum, Brooklyn NY

Lehman, Linda, *Instr,* Ohio Northern University, Dept of Art, Ada OH (S)

Lehman, Marie, *Instr,* Toronto School of Art, Toronto ON (S)

Lehnhardt, John, *Dir Animal Operations,* Disney's Animal Kingdom Theme Park, Bay Lake FL

Lehr, Lydia, *Instr,* Main Line Art Center, Haverford PA (S)

Lehr, William, *Pres,* Susquehanna Art Museum, Home of Doshi Center for Contemporary Art, Harrisburg PA

Lehrer MFA, Leonard, *Prof,* New York University, Dept of Art & Art Professions, New York NY (S)

Lehrman, Samuel, *Pres,* Jewish Community Center of Greater Washington, Jane L & Robert H Weiner Judaic Museum, Rockville MD

Leibold, Cheryl, *Archivist,* Pennsylvania Academy of the Fine Arts, Archives, Philadelphia PA

Leibsohn, Dana, *Asst Prof,* Smith College, Art Dept, Northampton MA (S)

Leidich, David, *Asst to Dir,* Moravian College, Payne Gallery, Bethlehem PA

Leidy, John, *Deputy Dir,* The Currier Museum of Art, Currier Museum of Art, Manchester NH

Leifer, Elizabeth, *Instr,* Suomi International College of Art & Design, Fine Arts Dept, Hancock MI (S)

Leigh, Sheri, *Dir Summer Arts,* Sierra Nevada College, Fine Arts Dept, Incline Village NV (S)

Leighten, Patricia, *Prof,* Duke University, Dept of Art, Art History & Visual Studies, Durham NC (S)

Leightner, Sabel, *Pub Sales Mgr,* National Gallery of Art, Washington DC

Leighton, Jay, *Oral Historian,* Southern Oregon Historical Society, Jacksonville Museum of Southern Oregon History, Medford OR

Lein, Sharon, *Dir,* Deming-Luna Mimbres Museum, Deming NM

Leinaweaver, Chad, *Dir Library,* New Jersey Historical Society, Library, Newark NJ

Leinaweaver, Chad, *Library Dir,* New Jersey Historical Society, Newark NJ

Leininger, Matthew, *Registrar,* Oklahoma City Museum of Art, Oklahoma City OK

Leininger-Miller, Theresa, *Dir Art Hist Prog & Asst Prof Art Educ,* University of Cincinnati, School of Art, Cincinnati OH (S)

Leipzig, Mel, *Prof,* Mercer County Community College, Arts, Communication & Engineering Technology, Trenton NJ (S)

Leiser, Amy, *Exec Dir,* Monroe County Historical Association, Elizabeth D Walters Library, Stroudsburg PA

Leister, Claudia, *Coll Mgr,* Delaware Division of Historical & Cultural Affairs, Dover DE

Leithauser, Mark, *Chief Design & Installation,* National Gallery of Art, Washington DC

Leja, Ilga, *Dir,* Nova Scotia College of Art and Design, Library, Halifax NS

Lemay, Bonnie White, *Adminr,* Palm Beach County Parks & Recreation Department, Morikami Museum & Japanese Gardens, Delray Beach FL

Lemay, Brian, *Exec Dir,* The Bostonian Society, Old State House Museum, Boston MA

Lemke, Chad, *Visitor Svcs Coordr,* Minnesota Museum of American Art, Saint Paul MN

Lemke, Melissa Beck, *Italian Specialist,* National Gallery of Art, Department of Image Collections, Washington DC

Lemley, Cynthia, *Develop Mem,* The Walker African American Museum & Research Center, Las Vegas NV

Lemmerman, Harold, *Prof,* Jersey City State College, Art Dept, Jersey City NJ (S)

Lemmon, Alfred, *Dir Williams Research Ctr,* The Historic New Orleans Collection, New Orleans LA

LeMoine, Genevieve, *Cur,* Bowdoin College, Peary-MacMillan Arctic Museum, Brunswick ME

Lemon, Robert, *Chmn,* Marshall University, Dept of Art, Huntington WV (S)

Lemons, Charles R, *Cur,* Cavalry-Armor Foundation, Patton Museum of Cavalry & Armor, Fort Knox KY

Lemos, Anne, *Instr,* University of Miami, Dept of Art & Art History, Coral Gables FL (S)

Lemp, Frank J, *Chmn,* Ottawa University, Dept of Art, Ottawa KS (S)

Lempel, Leonard, *First VPres,* Halifax Historical Society, Inc, Halifax Historical Museum, Daytona Beach FL

Lempka, Wayne, *Coll Mgr,* State University of New York at New Paltz, Samuel Dorsky Museum of Art, New Paltz NY

Lenaghan, Patrick, *Cur Iconography,* Hispanic Society of America, Museum & Library, New York NY

Lenard, Liz, *Admin Dir,* Society of North American Goldsmiths, Eugene OR

L'Enfant, Julie, *Asst Prof,* College of Visual Arts, Saint Paul MN (S)

Lenfest, H F Gerry, *Chmn Bd,* Philadelphia Museum of Art, Samuel S Fleisher Art Memorial, Philadelphia PA

Lenfest, H L (Gerry), *Chmn Bd,* Philadelphia Museum of Art, Philadelphia PA

LenFestey, Harold, *Asst Prof,* West Texas A&M University, Art, Communication & Theatre Dept, Canyon TX (S)

L'Engle, Madeleine, *Vol Librn,* Cathedral of Saint John the Divine, Library, New York NY

Lenhardt, Barbara, *Mus Shop Mgr,* Virginia Museum of Fine Arts, Richmond VA

Lenihan, Teresa, *Asst Prof,* Loyola Marymount University, Dept of Art & Art History, Los Angeles CA (S)

Lennon, Madeline, *Chmn,* University of Western Ontario, John Labatt Visual Arts Centre, London ON (S)

Lenoir, Tim, *Prof Visual Studies,* Duke University, Dept of Art, Art History & Visual Studies, Durham NC (S)

Lentz, Craig, *VPres,* Hammond Castle Museum, Gloucester MA

Lentz, Lamar, *Dir Library & Mus,* James Dick Foundation, Festival - Institute, Round Top TX

Lentz, Thomas, *Dir Int'l Art Museums,* Smithsonian Institution, Washington DC

Lenz, Mary Jane, *Acting Head Curatorial,* National Museum of the American Indian, George Gustav Heye Center, New York NY

Lenz, William, *Dir Fine & Performing Arts,* Chatham College, Art Gallery, Pittsburgh PA

Lenzi, Kristina, *Instr,* University of Utah, Dept of Art & Art History, Salt Lake City UT (S)

Leo, Vince, *Chair, Media Arts,* Minneapolis College of Art & Design, Minneapolis MN (S)

Leon, Lamgen, *Admin Dir,* Museum of Chinese in the Americas, New York NY

Leonard, Donald, *Registrar,* United States Naval Academy, USNA Museum, Annapolis MD

Leonard, Douglas, *Exec Dir,* Peter & Catharine Whyte Foundation, Whyte Museum of the Canadian Rockies, Banff AB

Leonard, Glen, *Dir,* Church of Jesus Christ of Latter-Day Saints, Museum of Church History & Art, Salt Lake City UT

Leonard, John, *Instr,* Toronto School of Art, Toronto ON (S)

Leonard, Robert, *Exec Dir,* Wharton Esherick, Paoli PA

Leonard, Susan, *Dir,* South Carolina Arts Commission, Media Center, Columbia SC

Leonard, Susan, *Head Media,* South Carolina Arts Commission, Columbia SC

Leonard, Susan, *Librn,* Bard College, Center for Curatorial Studies, Annandale-on-Hudson NY

Leonard, Susan, *Librn,* Bard College, Center For Curatorial Studies Library, Annandale-on-Hudson NY

Leonard-Cravens, Mary, *Prof,* Eastern Illinois University, Art Dept, Charleston IL (S)

Le Page, Carmen D, *Supt,* Forges du Saint-Maurice National Historic Site, Trois Rivieres PQ

Lepine, Micheline, *Business Operations Mgr,* Burchfield-Penney Art Center, Buffalo NY

LePore, William, *Asst Prof,* Portland State University, Dept of Art, Portland OR (S)

Lepper, Sandra, *Instr Art,* Everett Community College, Art Dept, Everett WA (S)

LeRiche, Sharon, *Gallery Coordr,* Craft Council of Newfoundland & Labrador, Saint John's NF

Lerma, Liz, *Dir Community Arts & Educ,* San Francisco City & County Art Commission, San Francisco CA

Lerner, Lynne, *Asst Dir,* Greenwich House Inc, Greenwich House Pottery, New York NY (S)

Le Roux, Matt, *Coordr Educ Prog,* Berkshire Museum, Pittsfield MA

LeRoy, Louis, *Exec Dir,* Yuma Fine Arts Association, Art Center, Yuma AZ

Lesher, Pete, *Cur,* Chesapeake Bay Maritime Museum, Saint Michaels MD

Lesher, Pete, *Cur,* Chesapeake Bay Maritime Museum, Howard I Chapelle Memorial Library, Saint Michaels MD

Leshnoff, Susan, *Asst Prof,* Seton Hall University, College of Arts & Sciences, South Orange NJ (S)

LeShock, Ed, *Asst Prof,* Radford University, Art Dept, Radford VA (S)

Leskard, Marta, *Conservator,* Kelowna Museum, Kelowna BC

Lesko, Diane, *Dir & CEO,* Telfair Museum of Art, Telfair Academy of Arts & Sciences Library, Savannah GA

Lesko, Jim, *Assoc Prof,* University of Bridgeport, School of Arts, Humanities & Social Sciences, Bridgeport CT (S)

Leslie, Alfred, *Sr Critic,* University of Pennsylvania, Graduate School of Fine Arts, Philadelphia PA (S)

Leslie, Alfred, *Visiting Prof,* Boston University, School for the Arts, Boston MA (S)

Leslie, Carolyn, *Receptionist,* Embroiderers Guild of America, Margaret Parshall Gallery, Louisville KY

Leslie, Ken, *Head Dept Painting,* Johnson State College, Dept Fine & Performing Arts, Dibden Center for the Arts, Johnson VT (S)

Leslie, Matt, *Exhib & Educ Adminr,* Muckenthaler Cultural Center, Fullerton CA

Leslie, Mike, *Asst Dir,* National Cowboy & Western Heritage Museum, Oklahoma City OK

Leslie, Richard, *Visiting Assoc Prof,* State University of New York at Stony Brook, Dept of College of Arts & Sciences, Art Dept, Stony Brook NY (S)

Lesser, Harriet, *Co-Chmn,* Studio Gallery, Washington DC

Lessig, Kay, *VPres Mem,* Berks Art Alliance, Reading PA

Lester, DeeGee, *Dir Educ,* Board of Parks & Recreation, The Parthenon, Nashville TN

LeSuer, Sharon, *Acad Dean,* Tunxis Community Technical College, Graphic Design Dept, Farmington CT (S)

Lesztak, Sarah, *Cur,* John Weaver Sculpture Collection, Hope BC

Letarte, Mary Ellen, *Dir Mem,* Fitchburg Art Museum, Fitchburg MA

Lethen, Paulien, *Dir,* Holland Tunnel Art Projects, Brooklyn NY

Lethen, Roy, *Graphic Designer,* Holland Tunnel Art Projects, Brooklyn NY

Letocha, Louise Dusseault, *Dept Head,* Universite du Quebec a Montreal, Famille des Arts, Montreal PQ (S)

Letson, Carol, *Pres,* Pocumtuck Valley Memorial Association, Memorial Hall Museum, Deerfield MA

Lettenstrom, Dean R, *Prof,* University of Minnesota, Duluth, Art Dept, Duluth MN (S)

Lettieri, Robin, *Dir,* Port Chester Public Library, Port Chester NY

Leuchak, Rebecca, *Asst Prof,* Roger Williams University, Visual Art Dept, Bristol RI (S)

Leuenberger, Joan, *Controller,* Vesterheim Norwegian-American Museum, Reference Library, Decorah IA

Leusch, Kelly, *Develop Dir,* Cedar Rapids Museum of Art, Cedar Rapids IA

Leuthold, Marc, *Asst Prof,* State University of New York College at Potsdam, Dept of Fine Arts, Potsdam NY (S)

Leuthold, Steve, *Asst Prof,* Northern Michigan University, Dept of Art & Design, Marquette MI (S)

Lev, Vicki, *Pres,* Arizona Artists Guild, Phoenix AZ

Leven, Ann, *Treas,* National Gallery of Art, Washington DC

Levensky-Vogel, Elayne, *Instr,* Green River Community College, Art Dept, Auburn WA (S)

Leventhal, James, *Dir Develop,* Judah L Magnes, Berkeley CA

Lever, Briles, *Instr Graphics,* Lander University, College of Arts & Humanities, Greenwood SC (S)

Leverette, Carlton, *Coordr Arts,* Baltimore City Community College, Art Gallery, Baltimore MD

Leveson, Meg, *Treas,* Blue Mountain Gallery, New York NY

Levesque, Kristen, *Dir Mktg & Pub Relations,* Portland Museum of Art, Portland ME

Levesque, Marcel, *Archivist,* Wiscasset, Waterville & Farmington Railway Museum (WW&F), Alna ME

Levesque, Maude, *Programming Coordr,* La Chambre Blanche, Quebec PQ

Levesque, Richard, *VPres,* International Society of Marine Painters, Eagle ID

Levesque, Sophie, *Technician,* Musee Regional de la Cote-Nord, Sept-Iles PQ

Levett, Judd, *Admin Asst,* McMaster University, McMaster Museum of Art, Hamilton ON

Levi, Thomas, *Treas,* African American Historical Museum & Cultural Center of Iowa, Cedar Rapids IA

Levin, Brett M, *Cur & Dir,* University of Alabama at Birmingham, Visual Arts Gallery, Birmingham AL

Levin, Gail, *Prof,* City University of New York, PhD Program in Art History, New York NY (S)

Levin, Janet, *Oral Historian,* The National Park Service, United States Department of the Interior, Statue of Liberty National Monument & The Ellis Island Immigration Museum, New York NY

Levin, Pamela, *Dir,* Sylvia Plotkin Museum of Temple Beth Israel, Scottsdale AZ

Levin, Victor, *Publications,* Fusion: The Ontario Clay & Glass Association, Toronto ON

Levine, Kathy, *Assoc Prof Visual Arts,* Dowling College, Dept of Visual Arts, Oakdale NY (S)

Levine, Martin, *Asst Prof,* State University of New York at Stony Brook, Dept of College of Arts & Sciences, Art Dept, Stony Brook NY (S)

Levine, May, *Dir,* The American Foundation for the Arts, Miami FL

LeVine, Newton, *Assoc Prof Architecture,* Ramapo College of New Jersey, School of Contemporary Arts, Mahwah NJ (S)

Levine, Phyllis, *Dir Communications,* International Center of Photography, New York NY

Levine, Phyllis, *Dir Pub Information,* International Center of Photography, Library, New York NY

Levine, Richard, *Pres,* The American Foundation for the Arts, Miami FL

Levine, Steven, *Prof,* Bryn Mawr College, Dept of the History of Art, Bryn Mawr PA (S)

Levinson, Jay, *Dir,* Museum of Modern Art, New York NY

Levinthal, Beth E, *Dir,* Hofstra University, Hofstra Museum, Hempstead NY

Levis, Zoila, *Vol Pres,* Museo de Arte de Puerto Rico, San Juan PR

Levy, David C, *Pres & Dir,* Corcoran Gallery of Art, Washington DC

Levy, Gady, *Dir,* University of Judaism, Dept of Continuing Education, Los Angeles CA (S)

Levy, Sue, *Cur,* CIGNA Corporation, CIGNA Museum & Art Collection, Philadelphia PA

Lewandowski, Mary Francis, *Prof,* Madonna University, Art Dept, Livonia MI (S)

Lewang, Debbi, *Controller,* Seattle Art Museum, Library, Seattle WA

Lewin, Jackie, *Cur History,* Saint Joseph Museum, Saint Joseph MO

Lewin, Louise, *VPrin,* York University, Glendon Gallery, Toronto ON

LeWinter, Stephen S, *Assoc Prof,* University of Tennessee at Chattanooga, Dept of Art, Chattanooga TN (S)

Lewis, Anissa, *Dir Educ,* Perkins Center for the Arts, Moorestown NJ

Lewis, Barbara, *Prof,* James Madison University, School of Art & Art History, Harrisonburg VA (S)

Lewis, C Douglas, *Cur Sculpture,* National Gallery of Art, Washington DC

Lewis, C Stanley, *Prof,* American University, Dept of Art, Washington DC (S)

Lewis, Carolyn, *Instr,* Cuyahoga Valley Art Center, Cuyahoga Falls OH (S)

Lewis, Carolyn Chinn, *Asst Dir,* University of Kansas, Spencer Museum of Art, Lawrence KS

Lewis, Chris, *Acting Asst University Librn,* American University, Jack & Dorothy G Bender Library & Learning Resources Center, Washington DC

Lewis, David, *Cur,* Aurora Regional Fire Museum, Aurora IL

Lewis, Eileen, *Gift Shop Mgr,* Ships of the Sea Maritime Museum, Savannah GA

Lewis, Elma, *Artistic Dir,* Museum of the National Center of Afro-American Artists, Boston MA

Lewis, Frank, *Cur & Dir,* Lawrence University, Wriston Art Center Galleries, Appleton WI

Lewis, Gary E, *Pres,* American Numismatic Association, Money Museum, Colorado Springs CO

Lewis, Glen, *Prof,* North Carolina State University at Raleigh, School of Design, Raleigh NC (S)

Lewis, Jack R, *Art Coordr,* Georgia Southwestern State University, Art Gallery, Americus GA

Lewis, Janice, *Chmn Fashion Design,* Moore College of Art & Design, Philadelphia PA (S)

Lewis, Jerry, *Chmn Dept,* Joliet Junior College, Fine Arts Dept, Joliet IL (S)

Lewis, Joe, *Dean,* Fashion Institute of Technology, Art & Design Division, New York NY (S)

Lewis, Joe, *Dept Chmn,* California State University, Northridge, Dept of Art, Northridge CA (S)

Lewis, Katheryn, *Assoc Prof,* Delta State University, Dept of Art, Cleveland MS (S)

Lewis, Kevin, *Community Svcs Coordr,* National Museum of the American Indian, George Gustav Heye Center, New York NY

Lewis, Louise, *Dir,* California State University, Northridge, Art Galleries, Northridge CA

Lewis, Lynn, *Gallery Coordr,* Florida Community College at Jacksonville, South Gallery, Jacksonville FL

Lewis, Michael, *Chmn Art History,* Williams College, Dept of Art, Williamstown MA (S)

Lewis, Michael H, *Prof,* University of Maine, Dept of Art, Orono ME (S)

Lewis, Mike, *Pres,* Belskie Museum, Closter NJ

Lewis, Richard, *Chmn Dept,* Salem State College, Art Dept, Salem MA (S)

Lewis, Samella, *Founder,* Museum of African American Art, Los Angeles CA

Lewis, Sherry M., *Mktg Mgr,* Orlando Museum of Art, Orlando FL

Lewis, Stanley, *Instr,* Chautauqua Institution, School of Art, Chautauqua NY (S)

Lewis, Steve, *Head,* Allan Hancock College, Fine Arts Dept, Santa Maria CA (S)

Lewis, Susan, *Chief Librn,* Boston Architectural Center, Library, Boston MA

Lewis Quint, Marjie, *Dir,* ArtForms Gallery Manayunk, Philadelphia PA

Lewitin, Margot, *Artistic Dir,* Women's Interart Center, Inc, Interart Gallery, New York NY

Leys, Dale, *Prof,* Murray State University, Dept of Art, Murray KY (S)

Leyva, Maria, *Cur,* Art Museum of the Americas, Archive of Contemporary Latin American Art, Washington DC

Leyva, Maria, *Cur Reference Center,* Art Museum of the Americas, Washington DC

L'Heureux, Stephanie, *Coordr,* Conseil des Arts du Quebec (CATQ), Diagonale, Centre des arts et des fibres du Quebec, Montreal PQ

Li, Chu-tsing, *Prof Emeritus,* University of Kansas, Kress Foundation Dept of Art History, Lawrence KS (S)

Li, Yu, *Librn,* The University of Texas at San Antonio, UTSA's Institute of Texan Cultures, San Antonio TX

Libbey, Lizabeth, *Prof,* University of Maine at Augusta, College of Arts & Humanities, Augusta ME (S)

Libby, Gary R, *Art Cur,* The Museum of Arts & Sciences Inc, Daytona Beach FL

Liberman, Jack, *Instr,* Cuyahoga Valley Art Center, Cuyahoga Falls OH (S)

Libke, Audrey, *Receptionist,* Michigan Guild of Artists & Artisans, Michigan Guild Gallery, Ann Arbor MI

Licata, Chris, *Assoc Prof,* Saint Louis Community College at Florissant Valley, Liberal Arts Division, Ferguson MO (S)

Licka, Sean, *Chmn,* University of Alaska Anchorage, Dept of Art, Anchorage AK (S)

Liddle, Matt, *Asst Prof,* Western Carolina University, Dept of Art/College of Arts & Science, Cullowhee NC (S)

Liddy, Tim, *Assoc Prof,* Fontbonne University, Fine Art Dept, Saint Louis MO (S)

Lidtke, Thomas D, *Exec Dir,* Museum of Wisconsin Art, West Bend Art Museum, West Bend WI

Lieberman, Andi, *Instr,* Wayne Art Center, Wayne PA (S)

Lieberman, Arlene, *Pres Bd Trustees,* Newark Museum Association, The Newark Museum, Newark NJ

Lieberman, William S, *Jacques & Natasha,* The Metropolitan Museum of Art, New York NY

Liebling, Alex, *Pres,* Harrison County Historical Museum, Marshall TX

Liebman, Stuart, *Prof,* City University of New York, PhD Program in Art History, New York NY (S)

Liebowitz, Michele, *Coll Photographer,* Spertus Institute of Jewish Studies, Spertus Museum, Chicago IL

Liell, Lilli, *Mus Shop Mgr,* National Museum of the American Indian, George Gustav Heye Center, New York NY

Liem, L Gie, *Chmn Bd,* Please Touch Museum, Philadelphia PA

Lien, Andrea, *Mng Dir,* Angels Gate Cultural Center, Gallery A & Gallery G, San Pedro CA

Lien, Kim, *VPres,* Dacotah Prairie Museum, Lamont Art Gallery, Aberdeen SD

Light, Dotty, *Ofc Mgr,* Emerald Empire Art Gallery Association, Springfield OR

Light, Rolland, *Chmn Management Comt,* Iroquois County Historical Society Museum, Old Courthouse Museum, Watseka IL

Lightfoot, Robert, *Pres Bd Dirs,* Red River Valley Museum, Vernon TX

Lightfoot, Roselyn, *Exec Dir,* Maui Historical Society, Bailey House, Wailuku HI

Ligo, Larry L, *Prof,* Davidson College, Art Dept, Davidson NC (S)

Ligon, Claude M, *Dir Develop,* African Art Museum of Maryland, Columbia MD

Ligon, Doris Hillian, *Dir,* African Art Museum of Maryland, Columbia MD

Li Grand, Ritch, *VPres,* Sioux City Art Center, Sioux City IA (S)

Lillehoj, Elizabeth, *Assoc Prof,* DePaul University, Dept of Art, Chicago IL (S)

Lilly, Bruce, *Dir,* Minnesota Museum of American Art, Saint Paul MN

Lilly, Tina, *Interim Dir,* Morgan County Foundation, Inc, Madison-Morgan Cultural Center, Madison GA

Lily, Jane, *Asst Prof Interior Design,* University of Georgia, Franklin College of Arts & Sciences, Lamar Dodd School of Art, Athens GA (S)

Limouze, Dorothy, *Assoc Prof,* St Lawrence University, Dept of Fine Arts, Canton NY (S)

Lin, Cynthia, *Asst Prof,* Southern Methodist University, Division of Art, Dallas TX (S)

Lincoln, Louise, *Cur Ethnographic Arts,* Minneapolis Institute of Arts, Minneapolis MN

Lind, Ted, *Cur Ed,* Cincinnati Museum Association and Art Academy of Cincinnati, Cincinnati Art Museum, Cincinnati OH

Lindall, Terrance, *Pres & Exec Dir,* Williamsburg Art & Historical Center, Brooklyn NY

Lindblom, Michelle, *Instr,* Bismarck State College, Fine Arts Dept, Bismarck ND (S)

Lindblom, Ronald Allan, *Chmn,* Point Park College, Performing Arts Dept, Pittsburgh PA (S)

Lindeman, Leslie, *Dir Mktg,* Newport Historical Society & Museum of Newport History, Newport RI

Lindenberger, Beth, *Instr,* Cuyahoga Valley Art Center, Cuyahoga Falls OH (S)

Lindenheim, Diane, *Instr,* Bucks County Community College, Fine Arts Dept, Newtown PA (S)

Linder, Brad, *Exec Dir,* Southern Oregon Historical Society, Jacksonville Museum of Southern Oregon History, Medford OR

Linder, Joan, *Asst Prof,* University at Buffalo, State University of New York, Dept of Visual Studies, Buffalo NY (S)

Lindland, Pauline, *Art Cur,* Petro-Canada, Corporate Art Programme, Calgary AB

Lindner, Harry, *Instr,* Northeast Community College, Dept of Liberal Arts, Norfolk NE (S)

Lindquist, Evan, *Prof,* Arkansas State University, Dept of Art, State University AR (S)

Lindsay, Betsy, *Instr,* Pacific Northwest College of Art, Portland OR (S)

Lindsay, Trina, *Art Dir,* Western Colorado Center for the Arts, Inc, Grand Junction CO

Lindsey, Anne, *Prof,* University of Tennessee at Chattanooga, Dept of Art, Chattanooga TN (S)

Lindsey, Jack, *Cur American Decorative Art,* Philadelphia Museum of Art, Samuel S Fleisher Art Memorial, Philadelphia PA

Lindsey, Jack, *Cur American Decorative Arts,* Philadelphia Museum of Art, Mount Pleasant, Philadelphia PA

Lindsey, Rob, *Pres (V),* Art Museum of Greater Lafayette, Lafayette IN

Lindstrom, Eric, *Dean Educ,* Art Institutes International at Portland, Portland OR

Lindstrom, Janet, *Exec Dir,* New Canaan Historical Society, New Canaan CT

Linehan, James, *Prof Art, Chairperson,* University of Maine, Dept of Art, Orono ME (S)

Linehan, Monika, *Asst Prof,* Cameron University, Art Dept, Lawton OK (S)

Linehan, Thomas E, *Pres,* Ringling School of Art & Design, Sarasota FL (S)

Lines, Barbara, West Texas A&M University, Art, Communication & Theatre Dept, Canyon TX (S)

Linforth, Jennifer, *Educator,* Wendell Gilley, Southwest Harbor ME

Lingen, Joan, *Chmn & Prof Art,* Clarke College, Dept of Art, Dubuque IA (S)

Lingen, Ruth, *Vis Asst Prof Art,* Whitman College, Art Dept, Walla Walla WA (S)

Lingner, Richard, *Librn & Asst. Cur.,* Isabella Stewart Gardner, Isabella Stewart Garden Museum Library & Archives, Boston MA

Linhares, Philip, *Chief Cur Art,* Oakland Museum of California, Art Dept, Oakland CA

Linhart, Lucie E, *Registrar,* University of Lethbridge, Art Gallery, Lethbridge AB

Link, Sarah, *Instr,* Lakehead University, Dept of Visual Arts, Thunder Bay ON (S)

Link, Wayne, *Cur,* Algonquin Arts Council, Art Gallery of Bancroft, Bancroft ON

Linker, Wayne, *Exec VPres,* American Academy in Rome, New York NY (S)

Linn, Jane, *Exec Dir,* Birmingham-Bloomfield Art Center, Art Center, Birmingham MI

Linn, Jane, *Exec Dir,* Birmingham-Bloomfield Art Center, Birmingham MI (S)

Linn, Patti, *CEO & Dir,* Riverside, the Farnsley-Moremen Landing, Louisville KY

Linnehan, Sharon, *Asst Prof,* Dickinson State University, Dept of Art, Dickinson ND (S)

Linnell, Eric, *Pres,* Parson Fisher House, Jonathan Fisher Memorial, Inc, Blue Hill ME

Linnell, Sandra, *Admintr,* Parson Fisher House, Jonathan Fisher Memorial, Inc, Blue Hill ME

Linnemann, Julie, *Div Coordr Youth Svcs,* Wichita Public Library, Wichita KS

Linskey, Mara, *Registrar & Cur Asst,* Charles H MacNider, Mason City IA

Linsky, Carol, *Exec Dir,* Rockport Art Association, Rockport MA

Linsley, Robert, *Asst Prof,* University of Waterloo, Fine Arts Dept, Waterloo ON (S)

Linton, Harold, *Chair,* Bradley University, Dept of Art, Peoria IL (S)

Linton, Harold, *Dir Art Div,* Bradley University, Heuser Art Center, Peoria IL

Linton, Henri, *Dept Chmn,* University of Arkansas at Pine Bluff, Art Dept, Pine Bluff AR (S)

Linton, Liz, *Serials Librn,* Sweet Briar College, Martin C Shallenberger Art Library, Sweet Briar VA

Linton, Margot, *VPres,* The American Federation of Arts, New York NY

Linton, Meg, *Dir,* Otis College of Art & Design, Ben Maltz Gallery, Westchester CA

Linton, Meg, *Exec Dir,* Santa Barbara Contemporary Arts Forum, Santa Barbara CA

Linz Ross, Judy, *Dir Mktg & Pub Relations,* Westmoreland Museum of American Art, Art Reference Library, Greensburg PA

Liontas-Warren, Kathy, *Assoc Prof,* Cameron University, Art Dept, Lawton OK (S)

Lipfert, Nathan, *Dir Library,* Maine Maritime Museum, Bath ME

Lipfert, Nathan, *Dir Library,* Maine Maritime Museum, Archives Library, Bath ME

Lipinski, Marlene, *Coordr Graphics,* Columbia College, Art Dept, Chicago IL (S)

Lipman, Rena, *Mus Operations Mgr,* Spertus Institute of Jewish Studies, Spertus Museum, Chicago IL

Lippe, Micki, *Pres,* Society of North American Goldsmiths, Eugene OR

Lippincott, Bertram, *Librn,* Newport Historical Society & Museum of Newport History, Library, Newport RI

Lippincott, Louise W, *Cur Fine Art,* Carnegie Museums of Pittsburgh, Carnegie Museum of Art, Pittsburgh PA

Lippincott III, Bert, *Reference Librarian & Genealogist,* Newport Historical Society & Museum of Newport History, Newport RI

Lippman, Barbara, *Dir Continuing Studies,* University of the Arts, Philadelphia Colleges of Art & Design, Performing Arts & Media & Communication, Philadelphia PA (S)

Lippman, Judith, *Dir,* Meredith Gallery, Baltimore MD

Lippman, Paula, *Representative,* Art Without Walls Inc, Art Without Walls Inc, Sayville NY

Lippman, Sharon, *Exec Dir,* Art Without Walls Inc, Art Without Walls Inc, Sayville NY

Lipps, Matt, *Develop & Communications Coordr,* Los Angeles Contemporary Exhibitions, Los Angeles CA

Lipschutz, Jeff, *Chmn,* University of Wisconsin-Oshkosh, Dept of Art, Oshkosh WI (S)

Lipschutz, Jeff, *Dir,* University of Wisconsin Oshkosh, Allen R Priebe Gallery, Oshkosh WI

Lipscomb, Bill, *Pres,* Intermuseum Conservation Association, Oberlin OH

Lipscomb, Diane, *Chmn,* Feather River Community College, Art Dept, Quincy CA (S)

Lipski, Jeffrey, *Dir Educ,* Lexington Friends of the Arts, Inc, Monroe Center for the Arts, Lexington MA (S)

Lipsky, Patricia, *Assoc Prof,* University of Hartford, Hartford Art School, West Hartford CT (S)

Lipsmeyer, Elizabeth, *Assoc Prof,* Old Dominion University, Art Dept, Norfolk VA (S)

Lisak, Pamela A, *Interior Design,* Art Institute of Pittsburgh, Pittsburgh PA (S)

Liscomb, Kathlyn, *Assoc Prof,* University of Victoria, Dept of History in Art, Victoria BC (S)

Liscomb, Trish, *Admin Asst,* Oklahoma Historical Society, State Museum of History, Oklahoma City OK

Lisiecki, Denise, *Dir KIA School,* Kalamazoo Institute of Arts, KIA School, Kalamazoo MI (S)

Lisk, Susan J, *Exec Dir,* Porter-Phelps-Huntington Foundation, Inc, Historic House Museum, Hadley MA

Liss, David, *Dir,* Museum of Contemporary Canadian Art, Toronto ON

Liss, Kay, *Gallery Mgr,* Lincoln County Historical Association, Inc, Maine Art Gallery, Wiscasset ME

Liss, Laurence A, *Pres,* Wharton Esherick, Paoli PA

List, Kathleen, *Dir Library,* Ringling School of Art & Design, Verman Kimbrough Memorial Library, Sarasota FL

Litch, Debbie, *Dir Develop,* Memphis Brooks Museum of Art, Memphis TN

Litcofsky, Rachel, *Museum Coordr,* Hebrew Union College, Jewish Institute of Religion Museum, New York NY

Litner, Jerry, *Pres,* Lyme Art Association, Inc, Old Lyme CT

Litow, Joseph, Orange County Community College, Arts & Communication, Middletown NY (S)

Littell, David, *Instr,* Saginaw Valley State University, Dept of Art & Design, University Center MI (S)

Little, Bruce, *Assoc Prof,* Georgia Southern University, Dept of Art, Statesboro GA (S)

Little, Christine, *Library & Archives Asst,* New Brunswick Museum, Archives & Research Library, Saint John NB

Little, Ken, *Prof,* University of Texas at San Antonio, Dept of Art & Art History, San Antonio TX (S)

Little, Nancy, *Dir Schol,* National Academy Museum & School of Fine Arts, New York NY

Little, Nancy, *Dir School,* National Academy School of Fine Arts, New York NY (S)

Little, Nancy, *School Dir,* National Academy Museum & School of Fine Arts, Archives, New York NY

Little, Polly, *Dir Develop,* Hallwalls Contemporary Arts Center, Buffalo NY

Little, Stephen, *Dir,* Honolulu Academy of Arts, Honolulu HI

Little, Tess, *Prof Reach Coordr,* Sinclair Community College, Division of Fine & Performing Arts, Dayton OH (S)

Littles, Marilyn, *Accountant,* Buffalo Arts Studio, Buffalo NY

Littman, Mara, *Dir Mktg & Pub Rel,* Cambridge Arts Council, CAC Gallery, Cambridge MA

Littrell, Ennes, *Pres,* The Print Center, Philadelphia PA

Litts, Douglas, *Dir Library,* Corcoran Gallery of Art, Corcoran Library, Washington DC

Litzer, Doris, *Chmn,* Linn Benton Community College, Fine & Applied Art Dept, Albany OR (S)

Liu, Heping, *Asst Prof,* Wellesley College, Art Dept, Wellesley MA (S)

Liu, Hung, *Assoc Prof,* Mills College, Art Dept, Oakland CA (S)

Liu, Jun-Cheng, *Assoc Prof,* Franklin & Marshall College, Art Dept, Lancaster PA (S)

Liu, Lily, *Lectr,* Emporia State University, Dept of Art, Emporia KS (S)

Liu, Sofia Galarza, *Coll Mgr,* University of Kansas, Spencer Museum of Art, Lawrence KS

Livaudais, Larry, *Asst,* Louisiana State University, School of Art, Baton Rouge LA (S)

Lively, Carter, *Exec Dir,* Hammond-Harwood House Association, Inc, Hammond-Harwood House, Annapolis MD

Livesay, Mary Grace, *VPres,* Beaumont Art League, Beaumont TX

Livesay, Thomas, *CEO & Dir,* Whatcom Museum of History and Art, Library, Bellingham WA

Livingston, Valerie, *Dir,* Susquehanna University, Lore Degenstein Gallery, Selinsgrove PA

Lizak, Andrew Mann, *VPres,* Fall River Historical Society, Fall River MA

Lizotte, Sylvie, *Dir,* Cornwall Gallery Society, Cornwall Regional Art Gallery, Cornwall ON

Lizzadro, John S, *Exec Dir,* Lizzadro Museum of Lapidary Art, Elmhurst IL

Lloyd, Craig, *Asst Prof,* College of Mount Saint Joseph, Art Dept, Cincinnati OH (S)

Lloyd, James, *Instr,* Wayne Art Center, Wayne PA (S)

Lloyd, Jane, *Asst Prof,* William Paterson University, Dept Arts, Wayne NJ (S)

Lloyd, Joan, *Registrar,* Oshkosh Public Museum, Oshkosh WI

Lloyd, Judith, *Educ & Pub Relations,* Illinois State Museum, Chicago Gallery, Chicago IL

Lloyd, June, *Head Librn,* The York County Heritage Trust, Historical Society Museum & Library, York PA

Lloyd, Kenita, *Operations Mgr,* Museum for African Art, Long Island City NY

Lloyd, Phoebe, *Asst Prof,* Texas Tech University, Dept of Art, Lubbock TX (S)

Lloyd, Wendy, *Mgr Communications,* Bergstrom-Mahler Museum, Neenah WI

Lo, Beth, *Prof,* University of Montana, Dept of Art, Missoula MT (S)

Lobb, Diana, *Community Develop Coordr,* Canadian Clay & Glass Gallery, Waterloo ON

Lobbig, Lois, *Pres,* Alton Museum of History & Art, Inc, Alton IL

Lobe, Robert, *Dir Library,* Visual Arts Library, New York NY

Locatelli, Rev Paul, *Academic Pres,* Santa Clara University, de Saisset Museum, Santa Clara CA

Loccisano, Joe, *Prof,* Manatee Community College, Dept of Art & Humanities, Bradenton FL (S)

Lochhead, Mary, *Head,* University of Manitoba, Architecture & Fine Arts Library, Winnipeg MB

LoCicero, Doreen, *Dir Develop,* Bass Museum of Art, Miami Beach FL

Locke, Angus, *Admin,* New Hampshire Art Association, Inc, Boscawen NH

Locke, Linda, *Dir Pub Relations,* The Hudson River Museum, Yonkers NY

Locke, Michelle, *Assoc Cur,* South Texas Institute for the Arts, Art Museum of South Texas, Corpus Christi TX

Lockerman, Leslie B, *Graphic Design,* Art Institute of Pittsburgh, Pittsburgh PA (S)

Lockhear, Laurie, *Coordr Mktg & Pub Relations,* Morris Museum of Art, Augusta GA

Lockheardt, Maria, *Mem Pub Relations,* Phillips Academy, Addison Gallery of American Art, Andover MA

Lockman, Br James, *Exec Dir,* Mission San Luis Rey de Francia, Mission San Luis Rey Museum, Oceanside CA

Lockman, Lisa, *Assoc Prof,* Nebraska Wesleyan University, Art Dept, Lincoln NE (S)

Locks, Norman, *Chmn,* University of California, Santa Cruz, Art Dept, Santa Cruz CA (S)

Loder, Chad, *Cur Outdoor Areas,* Northern Maine Museum of Science, Presque Isle ME

Loeb, Barbara, *Assoc Prof,* Oregon State University, Dept of Art, Corvallis OR (S)

Loeblein, Christopher, *Cur History,* Charleston Museum, Charleston SC

Loehr, Scott W, *Exec Dir,* Newport Historical Society & Museum of Newport History, Newport RI

Loehr, Thomas, *Prof, Chmn Communications Div,* Spring Hill College, Department of Fine & Performing Arts, Mobile AL (S)

Loescher, Robert, *Prof,* School of the Art Institute of Chicago, Chicago IL (S)

Loesl, Sue, *Instr,* Mount Mary College, Art & Design Division, Milwaukee WI (S)

Lofchy, Jodi, *Psychiatric Consultant to Training Prog,* Toronto Art Therapy Institute, Toronto ON (S)

Loflin, Morris, *House Admintr,* Charleston Museum, Heyward-Washington House, Charleston SC

Loft, Elaine, *Exec Dir,* New Hampshire Antiquarian Society, Hopkinton NH

Lofthus, Brian, *Asst to Dir,* North Dakota Museum of Art, Grand Forks ND

Loftness, Vivian, *Head,* Carnegie Mellon University, School Architecture, Pittsburgh PA (S)

Loftus, Maria, *Pub Relations, Mktg Mgr & Dir Commun,* Carolina Art Association, Gibbes Museum of Art, Charleston SC

Logan, Burt, *Exec Dir,* USS Constitution Museum, Boston MA

Logan, Heather, *Adjunct Lectr,* Rice University, Dept of Art & Art History, Houston TX (S)

Logan, Juan, *Assoc Prof,* University of North Carolina at Chapel Hill, Art Dept, Chapel Hill NC (S)

Logan, Julia, *Asst Archivist,* Charleston Museum, Charleston SC

Logan, Julia, *Asst Archivist,* Charleston Museum, Library, Charleston SC

Logan, Sarah, *Cur,* The Art Center of Waco, Creative Art Center, Waco TX

Logan-Dechene, Hillarie, *Dir Develop,* The Adirondack Historical Association, The Adirondack Museum, Blue Mountain Lake NY

Logback, Nadine, *Display Arrangement,* McPherson Museum, McPherson KS

Logisz, Sabina, *Secy,* Polish Museum of America, Research Library, Chicago IL

LoGrippo, Bob, *Dir Art School,* Spartanburg County Museum of Art, Spartanburg SC

Lohmiller, Nancy, *Asst Prof,* Mount Mary College, Art & Design Division, Milwaukee WI (S)

Lohr, Kathleen, *Instr,* Central Community College - Columbus Campus, Business & Arts Cluster, Columbus NE (S)

Lohr, Nancy, *Dir Operations & Ed,* ArtSpace-Lima, Lima OH

Loiacono, Carole, *VPres,* North Shore Arts Association, Inc, Gloucester MA

Loilhite, Haley, *Develop Coordr,* Jule Collins Smith Museum of Art, Auburn AL

Lokensgard, Lynne, *Prof,* Lamar University, Art Dept, Beaumont TX (S)

Lolla, Donna, *Pub Relations Mgr,* Children's Museum, Indianapolis IN

Lomahaftewa-Slock, Tatiana, *Assoc Cur,* Institute of American Indian Arts, Institute of American Indian Arts Museum, Santa Fe NM (S)

Lomaheftewa-Stoc, Tatiana, *Asst Cur Coll,* Institute of American Indian Arts Museum, Museum, Santa Fe NM

Lomas, Kim, *Cur Educ,* Gulf Coast Museum of Art, Inc, Art Reference Library, Largo FL

Lombard, Lynette, *Asst Prof,* Knox College, Dept of Art, Galesburg IL (S)

Lombino, Mary Kay, *Cur Exhibs,* California State University, Long Beach, University Art Museum, Long Beach CA

Lonchyna, Natalia, *Librn,* North Carolina Museum of Art, Raleigh NC

Lonchyna, Natalia, *Librn,* North Carolina Museum of Art, Reference Library, Raleigh NC

London, Joe, *Chmn,* Southwestern Oklahoma State University, Art Dept, Weatherford OK (S)

Londono, Clarice, *Pres,* Miami Watercolor Society, Inc, Miami FL

Long, Andrea, *Registrar,* Orlando Museum of Art, Orlando FL

Long, Andrea, *Registrar,* Orlando Museum of Art, Orlando Sentinel Library, Orlando FL

Long, Barry, *Prof,* Mount Saint Mary's University, Visual & Performing Arts Dept, Emmitsburg MD (S)

Long, Blake, *Co-Dept Chair, Illustration,* Nossi College of Art, Goodlettsville TN (S)

Long, Brenda K, *Dir,* The Arkansas Arts Center, Museum School, Little Rock AR (S)

Long, Erin, *Pub Relations Specialist,* Florida Department of State, Division of Cultural Affairs, Florida Arts Council, Tallahassee FL

Long, Greg, *Pres,* Wayne County Historical Society, Honesdale PA

Long, Jane, *Assoc Prof,* Roanoke College, Fine Arts Dept-Art, Salem VA (S)

Long, Matt, *Asst Prof,* University of Mississippi, Department of Art, University MS (S)

Long, Nancy, *Prof,* Munson-Williams-Proctor Arts Institute, School of Art, Utica NY (S)

Long, Phillip C, *Dir Mus,* Cincinnati Institute of Fine Arts, Taft Museum of Art, Cincinnati OH

Long, Randy, *Assoc Prof,* Indiana University, Bloomington, Henry Radford Hope School of Fine Arts, Bloomington IN (S)

Long, Robert, *Prof,* Mississippi State University, Dept of Art, Mississippi State MS (S)

Longenecker, Doug, *Treas,* Toledo Artists' Club, Toledo OH

Longenecker, Martha W, *Pres & Dir,* Mingei International, Inc, Mingei International Museum, San Diego CA

Longford, Nicola, *VPres Communications,* Missouri Historical Society, Saint Louis MO

Longhauser, Elsa, *Exec Dir,* Santa Monica Museum of Art, Santa Monica CA

Longman-Marien, Deborah, *Coordr School Prog,* Manchester Historic Association, Manchester NH

Longon, Jennifer, *Library & Archives Asst,* New Brunswick Museum, Archives & Research Library, Saint John NB

Longtin, Barbara C, *Dir,* Muscatine Art Center, Muscatine IA

Longtin, Barbara C, *Dir,* Muscatine Art Center, Museum, Muscatine IA

Longwell, Alicia, *Lewis B. & Dorothy Cullman Chief Cur, Art & Educ,* The Parrish Art Museum, Southampton NY

Longwell, David, *Preparator,* Tucson Museum of Artand Historic Block, Tucson AZ

Lonnberg, Tom, *Cur History,* Evansville Museum of Arts, History & Science, Evansville IN

Loomer, Dennis, *Dir Operations,* Kentucky Derby Museum, Louisville KY

Loomis, Judith, *Pres,* Allied Arts Association, Allied Arts Center & Gallery, Richland WA

Loomis, Tom, *Assoc Prof,* Mansfield University, Art Dept, Mansfield PA (S)

Looney, Mary Beth, *Studio Arts Prog Dir,* Brenau University, Art & Design Dept, Gainesville GA (S)

Loonsk, Susan, *Assoc Prof,* University of Wisconsin-Superior, Programs in the Visual Arts, Superior WI (S)

Looper, Matt, *Assoc Prof,* California State University, Chico, Department of Art & Art History, Chico CA (S)

Loorem, Nancy, *Head of School,* Bellevue Art Museum, Bellevue WA

Lopes, Cyriaco, *Assoc Prof,* Stetson University, Art Dept, Deland FL (S)

Lopez, Alex, *Asst Prof,* Southern Illinois University, School of Art & Design, Carbondale IL (S)

Lopez, Dina, *Exec Dir,* Xicanindio, Inc, Mesa AZ

Lopez, Donald, *Deputy Dir,* National Air and Space Museum, Washington DC

Lopez, J Tomas, *Prof,* University of Miami, Dept of Art & Art History, Coral Gables FL (S)

Lopez, Janice, *Accounts Supvr,* Museum London, London ON

Lopez, John, *Bd Dir,* Grand River Museum, Lemmon SD

Lopez, Myrna, *Exhibs Mgr,* Museo de Arte de Puerto Rico, San Juan PR

Lopez-Isnardi, C Sandy, *Asst Prof,* Alma College, Clack Art Center, Dept of Art & Design, Alma MI (S)

Lopez-Morton, Yvonne, *Media Relations Mgr,* Eastern Washington State Historical Society, Northwest Museum of Arts & Culture, Spokane WA

Lorance, Jane, *Branch Adminr,* Las Vegas-Clark County Library District, Las Vegas NV

Lord, Allyn, *Dir,* City of Springdale, Shiloh Museum of Ozark History, Springdale AR

Lord, Evelyn, *Catalog & Systems Librn,* Laney College Library, Art Section, Oakland CA

Lord, Keith, *Asst Prof Art,* University of La Verne, Dept of Art, La Verne CA (S)

Lord, Richard, *Vol Treas,* Macartney House Museum, Oakland ME

Lord, Sue, *Office Mgr,* Prescott Fine Arts Association, Gallery, Prescott AZ

Lord, Victoria, *Cur Prog,* City of Ketchikan Museum, Tongass Historical Museum, Ketchikan AK

Lord, Victoria A, *Sr Cur Prog,* City of Ketchikan Museum Dept, Ketchikan AK

Lordi, Michael, *Librn,* California College of the Arts, Libraries, Oakland CA

Lorence, Marian, *Adjunct,* York College of Pennsylvania, Dept of Music, Art & Speech Communications, York PA (S)

Lorenson, Rob, *Assoc Prof,* Bridgewater State College, Art Dept, Bridgewater MA (S)

Lorenz, Elaine, *Asst Prof,* William Paterson University, Dept Arts, Wayne NJ (S)

Lorenz, Hilary, *Prof,* Long Island University, Brooklyn Campus, Art Dept, Brooklyn NY (S)

Lorigan, Jim, *Chair,* College of the Canyons, Art Dept, Canta Colita CA (S)

Loring, Karla, *Dir Pub Relations,* Museum of Contemporary Art, Chicago IL

Lorini, Frederick, *Gen Educ,* Art Institute of Pittsburgh, Pittsburgh PA (S)

Lorren, Margaret N, *VPres,* Pensacola Museum of Art, Harry Thornton Library, Pensacola FL

Lorys, Jan M, *Dir,* Polish Museum of America, Chicago IL

Lorys, Jan M, *Dir,* Polish Museum of America, Research Library, Chicago IL

Losavio, Sam, *Asst Dir,* Louisiana Arts & Science Museum, Baton Rouge LA

Losavio, Sam, *Asst Dir,* Louisiana Arts & Science Museum, Library, Baton Rouge LA

Losch, Michael, *Assoc Prof,* Western Maryland College, Dept of Art & Art History, Westminster MD (S)

Losch, Michael, *Dir,* Western Maryland College, Esther Prangley Rice Gallery, Westminster MD

LoSchiavo, Joseph A, *Exec Dir,* Saint Bonaventure University, Regina A Quick Center for the Arts, Saint Bonaventure NY

Lossmann, Robert, *Painting & Watercolor,* College of Lake County, Art Dept, Grayslake IL (S)

Lostis, Lynnea, *Pres,* Ella Sharp, Jackson MI

Lostus, Sydney, *Exec Dir,* Madison County Historical Society, Cottage Lawn, Oneida NY

Loto, Judith, *Cur,* Litchfield History Museum, Litchfield CT

Lott, Linda, *Rare Book Librn,* Harvard University, Dumbarton Oaks Research Library, Washington DC

Lott, Trent, *Chmn,* United States Senate Commission on Art, Washington DC

Lotz, Stacy, *Dept Chair & Assoc Prof Art,* Monmouth College, Dept of Art, Monmouth IL (S)

Lotz, Theo, *Cur & Exhib Designer,* Rollins College, George D & Harriet W Cornell Fine Arts Museum, Winter Park FL

Lou, Julie, *Controller,* The Queens Museum of Art, Flushing NY

Lou, Richard, *Chmn,* San Diego Mesa College, Fine Arts Dept, San Diego CA (S)

Loudenback, Brad, *Asst Prof,* Webster University, Art Dept, Webster Groves MO (S)

Louder, Richard, *VPres,* Arthur Roy Mitchell, Museum of Western Art, Trinidad CO

Loudermilk, Wanda, *Ex Dir,* Grand Prairie Arts Council, Inc, Arts Center of the Grand Prairie, Stuttgart AR

Loudon, George, *Dir Organization Svcs & Outreach,* Arts Partnership of Greater Spartanburg, Inc, The Arts Partnership of Greater Spartanburg, Inc, Spartanburg SC

Loudon, Sarah, *Sr Mus Educator,* Seattle Art Museum, Library, Seattle WA

Loughheed, Claire, *Dir Educ,* DeCordova Museum & Sculpture Park, Lincoln MA

Loughlin, Nancy, *Treas,* Northwest Pastel Society (NPS), Kirkland WA

Loughlin, Winifred, *Chmn Bd,* Porter Thermometer Museum, Onset MA

Loughridge, Sally, *Recording Secy,* Pemaquid Group of Artists, Pemaquid Art Gallery, Pemaquid Point ME

Loughridge Bush, Sally, *Bd Pres,* Lincoln County Historical Association, Inc, Maine Art Gallery, Wiscasset ME

Louis, Elizabeth, *Gallery Coordr,* Florida Community College at Jacksonville, South Campus, Art Dept, Jacksonville FL (S)

Louisdhon-Lovinis, Lucrece, *Youth Svcs Adminr,* Miami-Dade Public Library, Miami FL

Lousplain, Mary, *Coordr,* Middlebury College, History of Art & Architecture Dept, Middlebury VT (S)

Love, Angela, *Media Arts & Animation,* Art Institute of Pittsburgh, Pittsburgh PA (S)

Love, Ann Rowson, *Educ,* The Ogden Museum of Southern Art, University of New Orleans, New Orleans LA

Loveday, Amos, *Head Historic Preservation,* Ohio Historical Society, Columbus OH

Lovejoy, Claudine, *Admin Asst,* Museum of East Texas, Lufkin TX

Lovelace, Alice, *Dir,* Alternate ROOTS, Inc, Atlanta GA

Lovelace, Joan, *Admin Operations Dir,* Rochester Art Center, Rochester MN

Loveland, Barry, *Chief Div Architecture,* Pennsylvania Historical & Museum Commission, Harrisburg PA

Loveless, Jim, *Prof,* Colgate University, Dept of Art & Art History, Hamilton NY (S)

Lovell, Carol, *Cur,* Stratford Historical Society, Catharine B Mitchell Museum, Stratford CT

Lovell, Carol, *Dir,* Kauai Museum, Lihue HI

Lovell, Carol W, *Cur,* Stratford Historical Society, Geneological Library, Stratford CT

Lovell, Charles, *Dir Gallery,* New Mexico State University, Art Gallery, Las Cruces NM

Lovell, Charles M., *Dir,* University of New Mexico, The Harwood Museum of Art, Taos NM

Lovell, John, *Asst Dir,* New York State Office of Parks, Recreation and Historic Preservation, Bureau of Historic Sites, Waterford NY

Lovell, Lorry, *Dir Mktg & Pub Relations,* Louisiana Department of Culture, Recreation & Tourism, Louisiana Historical Center Library, New Orleans LA

Lovely, Kim, *Asst Prof,* University of Maryland, Baltimore County, Imaging, Digital & Visual Arts Dept, Baltimore MD (S)

Loven, Del Ray, *Dept Head,* University of Akron, Myers School of Art, Akron OH (S)

Lovergne, Oday, *Pres (V),* Alexandria Museum of Art, Alexandria LA

Lovering-Brown, Theresa, *Jewelry & Metals Instr,* Monterey Peninsula College, Art Dept, Monterey CA (S)

Lovett, Margaret, *Cur,* Kauai Museum, Lihue HI

Lovett, O Rufus, *Instr,* Kilgore College, Visual Arts Dept, Kilgore TX (S)

Loveys, Geraldine, *Registrar,* McMaster University, McMaster Museum of Art, Hamilton ON

Loveys, Gerrie, *Operations Mgr,* McMaster University, Library, Hamilton ON

Loving, Cary, *Instr,* South Plains College, Fine Arts Dept, Levelland TX (S)

Loving, Glenna, *Mus Shop Mgr,* Strasburg Museum, Strasburg VA

Loving, Richard, *Prof,* School of the Art Institute of Chicago, Chicago IL (S)

Low, Bill, *Cur Coll,* Bates College, Museum of Art, Lewiston ME

Lowe, Arline, *Asst Prof,* Seton Hall University, College of Arts & Sciences, South Orange NJ (S)

Lowe, Constance, *Assoc Prof,* University of Texas at San Antonio, Dept of Art & Art History, San Antonio TX (S)

Lowe, Darrell, *Theater Coordr,* Ashtabula Arts Center, Ashtabula OH

Lowe, Debbie, *Admin Asst,* Zanesville Art Center, Library, Zanesville OH

Lowe, Debbie, *Asst Dir,* Zanesville Art Center, Zanesville OH

Lowe, Erica, *Admin Asst,* Nova Scotia Centre for Craft & Design, Mary E Black Gallery, Halifax NS

Lowe, Gail, *Contact,* Anacostia Museum, Branch Library, Washington DC

Lowe, Jeralyn, *Treas,* Saint Augustine Art Association Gallery, Saint Augustine FL

Lowe, Maurice, *Prof Emeritus,* University of Pennsylvania, Graduate School of Fine Arts, Philadelphia PA (S)

Lowe, Patricia, *Librn,* Will Rogers Memorial Museum & Birthplace Ranch, Media Center Library, Claremore OK

Lowe, Phillip, *Coordr Music Prog,* Hill College, Fine Arts Dept, Hillsboro TX (S)

Lowe-Stockwell, Susie, *Dir,* League of New Hampshire Craftsmen, League Gallery, Concord NH

Lowe-Stockwell, Susie, *Dir,* League of New Hampshire Craftsmen, Library, Concord NH

Lowenberg, Susan, *Info Resources Librn,* California Institute of the Arts Library, Santa Clarita CA

Lowery, Liz, *Dept Chair,* Howard College, Art Dept, Big Spring TX (S)

Lowery, Stephen, *Prof,* Aurora University, Art Dept, Aurora IL (S)

Lowley, Scott, *Chmn,* Mars Hill College, Art Dept, Mars Hill NC (S)

Lowly, Tim, *Dir Gallery,* North Park University, Carlson Tower Gallery, Chicago IL

Lowrance, Sandy, *Acting Chmn,* University of Memphis, Art Dept, Memphis TN (S)

Lowrey, Cynthia, *Asst Dir,* Port Huron Museum, Port Huron MI

Lowrey, David, *VPres,* Guild of Boston Artists, Boston MA

Lowry, Glenn D, *Dir Mus,* Museum of Modern Art, New York NY

Lowry, Sara Jane, *Dir External Rels & CFO,* Westmoreland Museum of American Art, Greensburg PA

Loy, Jessica, *Asst Prof,* College of Saint Rose, Art Dept, Albany NY (S)

Loy, Laura, *Dir Pub Relations & Mktg,* Tippecanoe County Historical Association, Museum, Lafayette IN

Loye, David, *Cheif Financial Officer,* Canadian Museum of Civilization, Gatineau PQ

Loyless, David, *Dir Develop,* Arlington Museum of Art, Arlington TX

Loyola, Walter, *Assoc Prof,* College of Mount Saint Joseph, Art Dept, Cincinnati OH (S)

Luark, Carolyn, *Dept Chmn,* Bellevue Community College, Art Dept, Bellevue WA (S)

Lubben, Kristen, *Interim Traveling Exhibits Coordr,* International Center of Photography, New York NY

Luber, Katherine Crawford, *Asst Cur,* Philadelphia Museum of Art, John G Johnson Collection, Philadelphia PA

Luber, Patrick, *Chmn,* University of North Dakota, Art Department, Grand Forks ND (S)

Lubin, David M, *Charlotte C Weber Prof Art,* Wake Forest University, Dept of Art, Winston-Salem NC (S)

Lubowsky-Talbott, Susan, *Dir,* Edmundson Art Foundation, Inc, Des Moines Art Center, Des Moines IA

Lubrano, Joseph V, *Pres,* American Society of Contemporary Artists (ASCA), Bronx NY

Luca, Frank, *Head Librn,* Wolfsonian-Florida International University, Miami Beach FL

Lucas, Paula, *Instr,* West Liberty State College, Div Art, West Liberty WV (S)

Lucchesi, Joe, *Asst Prof,* Saint Mary's College of Maryland, Art & Art History Dept, Saint Mary's City MD (S)

Lucchesi, Roxanne, *Cataloging Librn,* Moore College of Art & Design, Library, Philadelphia PA

Luce, Ken, *Instr,* San Jacinto College-North, Art Dept, Houston TX (S)

Lucere, Lisa, *Park Supt,* Red Rock State Park, Red Rock Museum, Church Rock NM

Lucere, Lisa, *Park Supt,* Red Rock State Park, Library, Church Rock NM

Lucero, Dennis, *Exhib Designer,* Museo de las Americas, Denver CO

Lucero, Keith, *Retail Mktg Mgr,* Indian Pueblo Cultural Center, Albuquerque NM

Lucero Sand, Barbara, *Mus Studies Dept Faculty,* Institute of American Indian Arts, Institute of American Indian Arts Museum, Santa Fe NM (S)

Lucic, Karen, *Prof,* Vassar College, Art Dept, Poughkeepsie NY (S)

Luckhower, Arlene, *Faculty,* South Florida Art Institute of Hollywood, Dania FL (S)

Luckman, Stewart, *Prof,* Bethel College, Dept of Art, Saint Paul MN (S)

Luderowski, Barbara, *Exec Dir,* Mattress Factory, Pittsburgh PA

Ludwig, Colleen, *Asst Prof,* Southern Illinois University, School of Art & Design, Carbondale IL (S)

Ludwig, Daniel, *Assoc Prof,* Salve Regina University, Art Dept, Newport RI (S)

Ludwig, Jeffrey, *Preparator,* Lehigh University Art Galleries, Museum Operation, Bethlehem PA

Lue, Joanne, *Admin Asst,* University at Albany, State University of New York, University Art Museum, Albany NY

Luecking, Stephen, *Chmn Dept,* DePaul University, Dept of Art, Chicago IL (S)

Luft, Alan, *Asst Prof,* Edgewood College, Art Dept, Madison WI (S)

Luhikhuizen, Henry, *Prof,* Calvin College, Art Dept, Grand Rapids MI (S)

Luka, Nik, *Prof,* McGill University, School of Architecture, Montreal PQ (S)

Lukacher, Brian, *Assoc Prof,* Vassar College, Art Dept, Poughkeepsie NY (S)

Lukas, Vicki A, *Dept Head Technical Svcs,* New Bedford Free Public Library, Art Dept, New Bedford MA

Luke, Gregorio, *Exec Dir,* Robert Gumbiner, Museum of Latin American Art, Long Beach CA

Luke, Margie L, *Treas & Archivist,* Grevemberg House Museum, Franklin LA

Luke, Suzanne, *Cur & Mgr,* Wilfrid Laurier University, Robert Langen Art Gallery, Waterloo ON

Lukow, Gregory, *Asst Chief Motion Pictures,* Library of Congress, Prints & Photographs Division, Washington DC

Luman, Mitch, *Dir Science Planetarium,* Evansville Museum of Arts, History & Science, Evansville IN

Lumbria-McDonald, Julie, *Librn,* New Brunswick College of Craft & Design, Library, Fredericton NB

Lumpkin, Farnese, *Asst Prof,* Savannah State University, Dept of Fine Arts, Savannah GA (S)

Luna, Samuel, *Acting Gen Mgr,* El Pueblo de Los Angeles Historical Monument, Los Angeles CA

Lund, David, *Instr,* Chautauqua Institution, School of Art, Chautauqua NY (S)

Lund, Richard, *Prof,* College of DuPage, Liberal Arts Division, Glen Ellyn IL (S)

Lunde, Mary Lee, *Chairwoman,* State University of New York College at Fredonia, M C Rockefeller Arts Center Gallery, Fredonia NY

Lunde, Mary Lee, *Chmn,* State University College of New York at Fredonia, Dept of Art, Fredonia NY (S)

Lundgren, Jessica, *Adminr,* Victoria Mansion - Morse Libby House, Portland ME

Lundskow, Peter, *Conservator,* Indiana State Museum, Indianapolis IN

Lundy, Cara, *Cur,* Headley-Whitney Museum, George Headley Library, Lexington KY

Luner, Karin, *Admin,* Women's Caucus For Art, New York NY

Lunn, Gerry, *Cur,* Nova Scotia Museum, Maritime Museum of the Atlantic, Halifax NS

Lunning, Elizabeth, *Chief Conservator,* Menil Foundation, Inc, Houston TX

Luong, Renata, *Contact,* Rhode Island Historical Society, Aldrich House, Providence RI

Lupher, Vance, *Registrar,* Erie Art Museum, Erie PA

Lupo, Joseph, *Prof,* West Virginia University, College of Creative Arts, Morgantown WV (S)

Lupton, Ellen, *Cur Contemporary Design,* Cooper-Hewitt, National Design Museum, Smithsonian Institution, New York NY

Lurie, Janice Lea, *Head Librn,* Minneapolis Institute of Arts, Art Research & Reference Library, Minneapolis MN

Lurie, Janice Lea, *Head Librn,* The Buffalo Fine Arts Academy, G Robert Strauss Jr Memorial Library, Buffalo NY

Lurowist, Peter, *Librn,* Ryerss Victorian Museum & Library, Library & Museum, Philadelphia PA

Lusas, Sarah, *Secy,* Mystic Art Association, Inc, Mystic Arts Center, Mystic CT

Lusceo Sand, Barbara, *Mus Studies,* Institute of American Indian Arts Museum, Museum, Santa Fe NM

Lussky, Richard, *Cur Exhib,* The Museum of Arts & Sciences Inc, Daytona Beach FL

Lustman, Francois, *Prof,* Universite de Montreal, Bibliotheque d'Amenagement, Montreal PQ

Lutar, Terry, *Exec Asst,* Iredell Museum of Arts & Heritage, Statesville NC

Luther, Olivia, *Exhib Coordr,* California Center for the Arts, Escondido Museum, Escondido CA

Lutomski, James, *Asst Prof,* Marygrove College, Department of Art, Detroit MI (S)

Lutsch, Gail, *Assoc Prof,* Bethel College, Dept of Art, North Newton KS (S)

Lutz, Jim, *Prof,* Rhodes College, Dept of Art, Memphis TN (S)

Lutze, Margaret, *Treas,* Women's Caucus For Art, New York NY

Lutzker-Milford, Mary-Ann, *Prof History,* Mills College, Art Dept, Oakland CA (S)

Luukkonen, John, *School of Design,* Art Institute of Houston, Houston TX (S)

Luxenberg, Alisa, *Asst Prof Art History,* University of Georgia, Franklin College of Arts & Sciences, Lamar Dodd School of Art, Athens GA (S)

Ly, Boreth, *Asst Prof,* University of Utah, Dept of Art & Art History, Salt Lake City UT (S)

Lybarger, Mary, *Instr,* Edgewood College, Art Dept, Madison WI (S)

Lydecker, Kent, *Assoc Dir Educ,* The Metropolitan Museum of Art, New York NY

Lyders, Laurie S, *Treas,* Liberty Village Arts Center & Gallery, Chester MT

Lydon, Catherine, *Instr,* Springfield College, Dept of Visual & Performing Arts, Springfield MA (S)

Lydon, Kate, *Dir Exhibs,* The Society for Contemporary Crafts, Pittsburgh PA

Lyford, Amy, *Prof,* Occidental College, Dept of Art History & Visual Arts, Los Angeles CA (S)

Lyke, Linda, *Pres,* Occidental College, Weingart Galleries, Los Angeles CA

Lykins, Jere, *Asst Prof,* Berry College, Art Dept, Mount Berry GA (S)

Lyle, Janice, *Dir,* Palm Springs Art Museum, Library, Palm Springs CA

Lyle, Janice, *Exec Dir,* Palm Springs Art Museum, Palm Springs CA

Lyman, Daniel, *Interim Pres,* New Hampshire Institute of Art, Manchester NH

Lyman, Daniel, *Interim Pres,* New Hampshire Institute of Art, Manchester NH (S)

Lyman, David H, *Founder & Dir,* Maine Photographic Workshops/Rockport College, Rockport ME

Lyman, David H, *Founder & Dir,* Maine Photographic Workshops, The International T.V. & Film Workshops & Rockport College, Rockport ME (S)

Lyman, Linda, *Educ Cur,* Nicolaysen Art Museum & Discovery Center, Childrens Discovery Center, Casper WY

Lyman, Merlene, *Prof,* Fort Hays State University, Dept of Art, Hays KS (S)

Lynagh, Pat, *Asst Librn,* National Portrait Gallery, Library, Washington DC

Lynagh, Patricia, *Asst Librn,* Smithsonian American Art Museum, Library of the Smithsonian American Art Museum, Washington DC

Lynch, Fred, *Illustration,* Montserrat College of Art, Beverly MA (S)

Lynch, Harry P, *Pres & CEO,* Stan Hywet, Akron OH

Lynch, James, *Asst Archivist,* Bethel College, Mennonite Library & Archives, North Newton KS

Lynch, John W, *Assoc Prof,* Central Missouri State University, Art Dept, Warrensburg MO (S)

Lynch, Mary, *Libr Assoc,* New York School of Interior Design, New York School of Interior Design Library, New York NY

Lynch, Matthew, *Asst Prof Fine Arts,* University of Cincinnati, School of Art, Cincinnati OH (S)

Marcincowski, David, *Dir,* Pratt Institute, Pratt Manhattan, New York NY (S)

Marcinowski, Gary, *Assoc Prof,* University of Dayton, Visual Arts Dept, Dayton OH (S)

Marco, Ed, *Photography,* Antonelli Institute, Professional Photography & Commercial Art, Erdenheim PA (S)

Marconi, Nello, *Chief Design & Production,* National Portrait Gallery, Washington DC

Marcotte, Patrice, *Prof,* Universite de Montreal, Bibliotheque d'Amenagement, Montreal PQ

Marcum-Estes, Leah, *Dir,* Oak Ridge Art Center, Oak Ridge TN

Marcum-Estes, Leah, *Dir,* Oak Ridge Art Center, Library, Oak Ridge TN

Marcus, Elisheva, *Prog Assoc,* Kala Institute, Kala Art Institute, Berkeley CA

Marcus, Evelyn, *Cur Exhib,* Dartmouth College, Hood Museum of Art, Hanover NH

Marcus, Rory, *Pub Relations Mgr,* Cape Cod Museum of Art Inc, Dennis MA

Marcus, Susan Bass, *Sr Educator,* Spertus Institute of Jewish Studies, Spertus Museum, Chicago IL

Marden, Margaret Ann, *VPres,* Waterville Historical Society, Redington Museum, Waterville ME

Maresca, Mary, *Asst Dir,* Nichols House Museum, Inc, Boston MA

Margalit, Nathan, *Visiting Assoc Prof,* Trinity College, Dept of Studio Arts, Hartford CT (S)

Margauti, Mary, *Library Dir,* Old Mill Foundation, North Baker Library, San Marino CA

Margeson, Hank, *Asst Prof,* North Georgia College & State University, Fine Arts Dept, Dahlonega GA (S)

Margitich, Michael, *Dep Dir for External Affairs,* Museum of Modern Art, New York NY

Margol, Deborah, *Deputy Dir,* South Florida Cultural Consortium, Miami Dade County Cultural Affairs Council, Miami FL

Marian, Marko, *Instructor,* Shasta College, Art Dept, Arts, Communication & Education Division, Redding CA (S)

Marichal, Flavia, *Cur Art,* University of Puerto Rico, Museum of Anthropology, History & Art, Rio Piedras PR

Maricle, Zebulin, *Cur Cross Orchard,* Museum of Western Colorado, Grand Junction CO

Marinas, Silvia, *Conservator,* New Mexico State University, Art Gallery, Las Cruces NM

Marino, Jane, *Dir Library,* Bronxville Public Library, Bronxville NY

Marino, Julie, *Educ Dir,* Museo de las Americas, Denver CO

Marino, Ruta, *Deputy Dir,* Saint Bonaventure University, Regina A Quick Center for the Arts, Saint Bonaventure NY

Marinsky, Jane, *Instr,* Daemen College, Art Dept, Amherst NY (S)

Marion, Suzanne, *Head Mem Servs,* Canadian Museums Association, Association des Musees Canadiens, Ottawa ON

Marioni, Tom, *Dir,* Archives of MOCA (Museum of Conceptual Art), San Francisco CA

Marioni, Tom, *Dir,* Archives of MOCA (Museum of Conceptual Art), Library, San Francisco CA

Mariscol, Joe, *Instr,* San Joaquin Delta College, Art Dept, Stockton CA (S)

Mark, Lisbeth, *Dir Pub Relations,* The American Federation of Arts, New York NY

Mark, Peter, *Prof,* Wesleyan University, Dept of Art & Art History, Middletown CT (S)

Markert, Diane, *Dir Devel,* Art Museum of Western Virginia, Roanoke VA

Markey, Mike, *Instr Arts Mgmt,* Creighton University, Fine & Performing Arts Dept, Omaha NE (S)

Markin, Linda, *Sr VPres,* Discovery Museum, Bridgeport CT

Markishtum, Merlee, *Dir,* Sacred Circle Gallery of American Indian Art, Daybreak Star Arts Center, Discovery Park, Seattle WA

Markley, Melissa, *Develop Asst,* Maryland Art Place, Baltimore MD

Markoe, Glenn E, *Cur Classical, Near Eastern Art,* Cincinnati Museum Association and Art Academy of Cincinnati, Cincinnati Art Museum, Cincinnati OH

Markopoulos, Leigh, *Deputy Dir,* California College of Arts & Crafts, CCAC Wattis Institute for Contemporary Arts, Oakland CA

Markopoulos, Leigh, *Deputy Dir,* Capp Street Project, San Francisco CA

Markowitz, Joan, *Sr Cur,* Boulder Museum of Contemporary Art, Boulder CO

Markowitz, John, *Asst Dir,* University of West Florida, Art Gallery, Pensacola FL

Markowski, Eugene D, *Lectr,* Trinity College, Fine Arts Program, Washington DC (S)

Marks, Andrea, *Asst Prof,* Oregon State University, Dept of Art, Corvallis OR (S)

Marks, Laura, *Dir Visitor Servs,* Hancock Shaker Village, Inc, Pittsfield MA

Marlais, Michael, *Prof,* Colby College, Art Dept, Waterville ME (S)

Marlatt, Megan, *Studio Faculty,* University of Virginia, McIntire Dept of Art, Charlottesville VA (S)

Marling, Michael, *Instr,* Brenau University, Art & Design Dept, Gainesville GA (S)

Marling de Cuellar, Michael, *Asst Prof,* North Georgia College & State University, Fine Arts Dept, Dahlonega GA (S)

Marlowe, Claudia, *Catalog Asst,* San Francisco Art Institute, Anne Bremer Memorial Library, San Francisco CA

Marmet, Terry, *Exec Dir,* Kansas State Historical Society, Kansas Museum of History, Topeka KS

Marmon, Betty, *Dir Develop,* Philadelphia Museum of Art, Philadelphia PA

Marotta, Joseph, *Prof,* University of Utah, Dept of Art & Art History, Salt Lake City UT (S)

Marquardt, Jeane F, *Exec Dir,* Taos Center for the Arts, Stables Gallery, Taos NM

Marquardt, Steve, *Dean Libraries,* South Dakota State University, Hilton M. Briggs Library, Brookings SD

Marquardt-Cherry, Janet, *Prof,* Eastern Illinois University, Art Dept, Charleston IL (S)

Marquet, Cynthia, *Librn,* Historical Society of the Cocalico Valley, Ephrata PA

Marquez, Lorrie, *Rentals Coordr, Facilities & Beverage Mgr,* Sangre de Cristo Arts & Conference Center, Pueblo CO

Marquez, Rene, *Coordr Foundations,* University of Delaware, Dept of Art, Newark DE (S)

Marquis, David, *Painting Conservator,* Midwest Art Conservation Center, Minneapolis MN

Marren, James, *Dir,* Los Angeles Valley College, Art Gallery, Valley Glen CA

Marrin, Elizabeth, *Asst Prof,* University of Massachusetts - Boston, Art Dept, Boston MA (S)

Marriott, Bill, *Assoc Prof Drawing & Painting,* University of Georgia, Franklin College of Arts & Sciences, Lamar Dodd School of Art, Athens GA (S)

Marron, Donald B, *CEO,* USB Paine Weber, New York NY

Marrow, Kara, *Asst Prof Art History,* Albion College, Bobbitt Visual Arts Center, Albion MI

Marsalis, Nelson, *Asst Prof,* Xavier University of Louisiana, Dept of Fine Arts, New Orleans LA (S)

Marsden, Susan, *Cur,* Museum of Northern British Columbia, Ruth Harvey Art Gallery, Prince Rupert BC

Marsden, Susan, *Cur,* Museum of Northern British Columbia, Library, Prince Rupert BC

Marsden-Atlass, Lynn, *Cur American & Contemporary Art,* Chrysler Museum of Art, Norfolk VA

Marsee, Todd, *Instr,* Siena Heights University, Studio Angelico-Art Dept, Adrian MI (S)

Marsh, Cindy, *Chair,* Austin Peay State University, Dept of Art, Clarksville TN (S)

Marsh, Robert, *Prof,* Averett College, Art Dept, Danville VA (S)

Marshall, Alison, *Dir Educ,* Arizona Commission on the Arts, Phoenix AZ

Marshall, Amy, *Archivist Special Coll,* Art Gallery of Ontario, Edward P Taylor Research Library & Archives, Toronto ON

Marshall, Herman, *Pres Bd Trustees,* Art Museum of Western Virginia, Roanoke VA

Marshall, Lydon, *Div Chmn,* University of Great Falls, Humanities Div, Great Falls MT (S)

Marshall, Michael, *Asst Prof Photography,* University of Georgia, Franklin College of Arts & Sciences, Lamar Dodd School of Art, Athens GA (S)

Marshall, Stephen, *Pres,* Art Gallery of Windsor, Windsor ON

Marshman, Robert, *Assoc Prof,* University of West Florida, Dept of Art, Pensacola FL (S)

Marsolais, Gilles, *Instr,* Universite de Montreal, Dept of Art History, Montreal PQ (S)

Marsten, Heidi M, *Media & Exhibitions Coordr,* Bromfield Art Gallery, Boston MA

Martel, Jean, *Admin Dir,* Ottawa Public Library, Fine Arts Dept, Ottawa ON

Martel, Richard, *Coordr,* Les Editions Intervention, Inter-Le Lieu, Documentation Center, Quebec PQ

Martello, Anita, Gonzaga University, Art Gallery, Spokane WA

Marten, Robert, *Interim Chmn,* Wayne State University, Dept of Art & Art History, Detroit MI (S)

Martin, Alissa, *Group Sales & Events Coordr,* The Society for Contemporary Crafts, Pittsburgh PA

Martin, Allan, *Restoration Mgr,* Pennsylvania Historical & Museum Commission, Railroad Museum of Pennsylvania, Harrisburg PA

Martin, Andrew, *Asst Prof,* Texas Tech University, Dept of Art, Lubbock TX (S)

Martin, Anna, *Registrar,* National Academy Museum & School of Fine Arts, New York NY

Martin, Anna, *Registrar,* National Academy Museum & School of Fine Arts, Archives, New York NY

Martin, Art, *Registrar,* Muskegon Museum of Art, Muskegon MI

Martin, Bobby, *Instr,* Northeastern State University, College of Arts & Letters, Tahlequah OK (S)

Martin, Cameron, *Group Tour,* Concord Museum, Concord MA

Martin, Charlotte, *Instr,* Wayne Art Center, Wayne PA (S)

Martin, Chas E, *Dept Head Photography,* Antonelli College, Cincinnati OH (S)

Martin, Craig, *Dir Gallery,* Purdue University Galleries, West Lafayette IN

Martin, Don, *Chmn,* Flagler College, Visual Arts Dept, Saint Augustine FL (S)

Martin, Florence C, *Secy,* Federation of Modern Painters & Sculptors, New York NY

Martin, Frank, *Instr,* South Carolina State University, Dept of Visual & Performing Arts, Orangeburg SC (S)

Martin, Gordon, *Pres,* Montgomery Museum of Fine Arts, Montgomery AL

Martin, Hal, *Pres,* Coppini Academy of Fine Arts, San Antonio TX

Martin, Hal, *Pres,* Coppini Academy of Fine Arts, Library, San Antonio TX

Martin, Jane, *Assoc Prof,* University of Saint Francis, School of Creative Arts, Fort Wayne IN (S)

Martin, Jane, *Chmn Bd,* Turtle Mountain Chippewa Historical Society, Turtle Mountain Heritage Center, Belcourt ND

Martin, Jane, *Chmn Board,* Turtle Mountain Chippewa Historical Society, Heritage Center Archives, Belcourt ND

Martin, Jenny, *Coll Mgr,* Morris Museum, Morristown NJ

Martin, Kate, *Dept Head,* University of Northern Iowa, Art & Music Collection Rod Library, Cedar Falls IA

Martin, Kathi, *Asst Prof Fashion Design,* Drexel University, College of Media Arts & Design, Philadelphia PA (S)

Martin, Lindsey, *Pub Progs Coordr,* Museum of Northern British Columbia, Ruth Harvey Art Gallery, Prince Rupert BC

Martin, Lisa, *Exec Asst,* Blue Lake Fine Arts Camp, Art Dept, Twin Lake MI (S)

Martin, Lyn, *Special Coll,* Willard Library, Dept of Fine Arts, Evansville IN

Martin, Marianne, *Visual Resources Editorial Librn,* Colonial Williamsburg Foundation, John D Rockefeller, Jr Library, Williamsburg VA

Martin, Marlene, *Dir,* Children's Art Carnival, New York NY

Martin, Martha Kent, *Instr,* Main Line Art Center, Haverford PA (S)

Martin, Michael, *Coll Mgr,* Madison County Historical Society, Cottage Lawn, Oneida NY

Martin, Michel, *Cur Contemporary Art,* Musee du Quebec, Quebec PQ

Martin, Nancy, *Exec Dir,* Organization of Saskatchewan Arts Councils (OSAC), Regina SK

Martin, Nicholas A., *French Specialist,* National Gallery of Art, Department of Image Collections, Washington DC

Martin, Patrick, *Asst Prof,* Emporia State University, Dept of Art, Emporia KS (S)

Martin, Ray, *Assoc Prof,* Greensboro College, Dept of Art, Division of Fine Arts, Greensboro NC (S)

Martin, Ray, *Prof,* School of the Art Institute of Chicago, Chicago IL (S)

Martin, Rebecca, *Educ Coordr,* Litchfield History Museum, Litchfield CT

Martin, Rebecca J, *Dir Educ,* Sid W Richardson, Sid Richardson Museum, Fort Worth TX

Martin, Roly, *Instr,* Lakehead University, Dept of Visual Arts, Thunder Bay ON (S)

Martin, Sarah, *VPres Operations,* Avampato Discovery Museum, The Clay Center for Arts & Sciences, Charleston WV

Martin, Sue, *Dir Visitors Svcs,* The Frick Art & Historical Center, Frick Art Museum, Pittsburgh PA

Martin, Terry, *Cur Anthropology,* Illinois State Museum, Museum Store, Chicago IL

Martin, Terry, *Dir,* William Woods University, Cox Gallery, Fulton MO

Martin, Terry, *Instr,* William Woods-Westminster Colleges, Art Dept, Fulton MO (S)

Martin, Terry, *Instr,* Salt Lake Community College, Graphic Design Dept, Salt Lake City UT (S)

Martin, Tony, *Faculty,* Idaho State University, Dept of Art, Pocatello ID (S)

Martin, Wilbert R, *Prof Printmaking & Drawing,* University of Texas Pan American, Art Dept, Edinburg TX (S)

Martin, William, *Dir,* Valentine Richmond History Center, Richmond VA

Martin, William, *Prof,* Rhode Island College, Art Dept, Providence RI (S)

Martin-Hamon, Amanda, *Asst Dir,* Washburn University, Mulvane Art Museum, Topeka KS

Martin-Mathewson, Nancy, *Business Mgr,* Hartwick College, The Yager Museum, Oneonta NY

Martin-Schaff, Linda, *Cataloger,* Philadelphia Museum of Art, Library, Philadelphia PA

Martindale, Robin, *Prof,* Appalachian State University, Dept of Art, Boone NC (S)

Martindale, Wendy, *Dir,* Red Deer & District Museum & Archives, Red Deer AB

Martinez, Andres, *Graphic & Exhib Designer,* MEXIC-ARTE Museum, Austin TX

Martinez, Andy, *Archivist,* Rhode Island School of Design, Fleet Library at RISD, Providence RI

Martinez, Carmen, *Dir Library Svcs,* Oakland Public Library, Art, Music & Recreation Section, Oakland CA

Martinez, Dan, *Chmn,* Cabrillo College, Visual & Performing Arts Division, Aptos CA (S)

Martinez, Dennis, *Asst Prof,* Dixie College, Art Dept, Saint George UT (S)

Martinez, Ed W, *Chmn Dept,* University of Nevada, Reno, Art Dept, Reno NV (S)

Martinez, Jodi, *Tourism Mgr,* Pueblo of San Ildefonso, Maria Martinez Museum, Santa Fe NM

Martinez, Juan, *Prof,* Florida International University, School of Art & Art History, Miami FL (S)

Martinez, Kim, *Asst Prof,* University of Utah, Dept of Art & Art History, Salt Lake City UT (S)

Martinez, Manual, *Instr,* Cochise College, Art Dept, Douglas AZ (S)

Martinez, Pablo Miguel, *Artistic Dir,* Guadalupe Cultural Arts Center, San Antonio TX

Martinez, Val, *Discovery Center Coordr,* Nicolaysen Art Museum & Discovery Center, Museum, Casper WY

Martini, Kathryn, *Acting Cur,* Everson Museum of Art, Syracuse NY

Martiniz-Lemke, Tania, *Dir,* Los Angeles Center for Photographic Studies, Hollywood CA

Martins, Michael, *Cur,* Fall River Historical Society, Fall River MA

Martinson, Kate, *Head Dept,* Luther College, Art Dept, Decorah IA (S)

Martone, Sally Ann, *Pres,* Rhode Island Watercolor Society, Pawtucket RI

Martyka, Paul, *Assoc Prof,* Winthrop University, Dept of Art & Design, Rock Hill SC (S)

Martz, Jean-Marie, *Chmn Dance,* Idyllwild Arts Academy, Idyllwild CA (S)

Martz, Mary J, *Coordr Handicapped Svcs,* Cultural Affairs Department City of Los Angeles/Barnsdall Art Centers, Junior Arts Center, Los Angeles CA

Maruck, Andrew, Southwestern Oklahoma State University, Art Dept, Weatherford OK (S)

Marvin, Hier, *Dean & Founder,* Simon Wiesenthal Center Inc, Museum of Tolerance, Los Angeles CA

Marvin, Judy, *Registrar,* Susquehanna University, Lore Degenstein Gallery, Selinsgrove PA

Marvin, Miranda, *Prof,* Wellesley College, Art Dept, Wellesley MA (S)

Marx, Charlene, *Mus Shop Mgr,* Columbus Museum, Columbus GA

Marxer, Donna, *Exec Dir,* Artists Talk on Art, New York NY

Mary Ann, Anderson, *Admin Asst,* Purdue University Galleries, West Lafayette IN

Marzio, Peter C, *Dir,* Museum of Fine Arts, Houston, Houston TX

Marzio, Peter C, *Dir,* Museum of Fine Arts, Houston, Hirsch Library, Houston TX

Marzolf, Helen, *Dir,* Open Space, Victoria BC

Marzolf, John G, *Dir,* The National Shrine of the North American Martyrs, Auriesville NY

Marzullo, Angelo, *Chmn,* Hus Var Fine Art, Buffalo NY

Mas, Deborah, *Dean Academic Affairs,* International Fine Arts College, Miami FL (S)

Maschino, David, *Exhib Coordr,* Bowdoin College, Peary-MacMillan Arctic Museum, Brunswick ME

Mashburn, Cheron, *Visitor Services Coordr,* Houston Museum of Decorative Arts, Chattanooga TN

Mashibini, Deborah, *Asst Dir Arts Center,* Very Special Arts New Mexico, Very Special Arts Gallery, Albuquerque NM

Masler, Marilyn, *Assoc Registrar,* Memphis Brooks Museum of Art, Memphis TN

Masley, Mary, *Circulation Supv,* Roger Williams University, Architecture Library, Bristol RI

Maslin, Jennifer, *Library Technician,* Hirshhorn Museum & Sculpture Garden, Library, Washington DC

Mason, Bonnie C, *Cur Educ,* Miami University, Art Museum, Oxford OH

Mason, Dan, *Instr,* North Hennepin Community College, Art Dept, Brooklyn Park MN (S)

Mason, Darielle, *Cur Indian & Himalayan Art,* Philadelphia Museum of Art, Samuel S Fleisher Art Memorial, Philadelphia PA

Mason, Glenn, *COO,* Oregon Historical Society, Oregon History Center, Portland OR

Mason, Hannah, *Mgr Exhib,* Brooklyn Museum, Brooklyn NY

Mason, Henri, *Dir,* Drew County Historical Society, Museum, Monticello AR

Mason, Joel, *Chmn,* New York City Technical College of the City University of New York, Dept of Advertising Design & Graphic Arts, Brooklyn NY (S)

Mason, Karen, *Dir of Outreach,* California Watercolor Association, Gallery Concord, Concord CA

Mason, Kelvin, *Chmn & Assoc Prof,* West Virginia Wesleyan College, Art Dept, Buckhannon WV (S)

Mason, Robert, *Instr,* Andrews University, Dept of Art, Art History & Design, Berrien Springs MI (S)

Mason, Steve, Yavapai College, Visual & Performing Arts Div, Prescott AZ (S)

Mason, Terry J, *Dir,* Douglas Art Association, The Gallery and Gift Shop, Douglas AZ

Mason, Wally, *Dir,* University of Maine, Museum of Art, Bangor ME

Massaro, Marilyn R, *Cur,* City of Providence Parks Department, Roger Williams Park Museum of Natural History, Providence RI

Massaro, Mona, *Asst Prof,* Silver Lake College, Art Dept, Manitowoc WI (S)

Massaroni, Dino, *Instr,* Cuyahoga Valley Art Center, Cuyahoga Falls OH (S)

Masse, Helene, *Pres,* Musee d'Art de Joliette, Joliette PQ

Massey, Bryan, *Prof,* University of Central Arkansas, Department of Art, Conway AR (S)

Massey, Debra, *Staff Asst,* National Gallery of Art, Department of Image Collections, Washington DC

Massey, Lew, *Property Mgr,* Bank One Fort Worth, Fort Worth TX

Massey, Scott, *Asst Prof,* University of Louisville, Allen R Hite Art Institute, Louisville KY (S)

Massey, Scott, *Sculpture,* University of Colorado at Denver, College of Arts & Media Visual Arts Dept, Denver CO (S)

Massey, Tim, *Asst Prof,* State University of New York College at Brockport, Dept of Art, Brockport NY (S)

Massie, William, *Head Archit Dept,* Cranbrook Academy of Art, Bloomfield Hills MI (S)

Massie-Lane, Rebecca, *Dir,* Sweet Briar College, Art Gallery, Sweet Briar VA

Massier, John, *Visual Arts Cur,* Hallwalls Contemporary Arts Center, Buffalo NY

Massing, Peter, *Prof,* Marshall University, Dept of Art, Huntington WV (S)

Massman, Mackenzie, *Registrar,* Wichita Art Museum, Wichita KS

Massman, Mackenzie, *Registrar,* Wichita Art Museum, Emprise Bank Research Library, Wichita KS

Mastandrea, Eva, *Prof,* The University Montana - Western, Art Program, Dillon MT (S)

Master, Diane, *Mus Shop Mgr,* Palo Alto Art Center, Palo Alto CA

Master-Karnik, Paul, *Dir,* DeCordova Museum & Sculpture Park, Lincoln MA

Master-Karnik, Paul, *Dir,* DeCordova Museum & Sculpture Park, DeCordova Museum, Lincoln MA

Masters, Jonelle, *Chmn,* Bismarck State College, Fine Arts Dept, Bismarck ND (S)

Masterson, Judith P, *Gallery Coordr,* College of New Jersey, Art Gallery, Trenton NJ

Masterson, Mike, *Chmn,* Northwest Community College, Dept of Art, Powell WY (S)

Masterson, Nancy, *Color & Graphic Instr,* Hutchinson Community College, Visual Arts Dept, Hutchinson KS (S)

Mastin, Cathy, *Cur Art,* Glenbow Museum, Calgary AB

Mastrianni, Joseph, *Treas,* Marcella Sembrich Memorial Association Inc, Marcella Sembrich Opera Museum, Bolton Landing NY

Masuoka, Mark, *Exec Dir,* Bemis Center for Contemporary Arts, Omaha NE

Materne, Delancey, *Admin,* Washington Art Association, Washington Depot CT

Materne, Delancey, *Admin,* Washington Art Association, Library, Washington Depot CT

Matero, Cathy, *Librn,* Maine Maritime Museum, Archives Library, Bath ME

Mates, Judy, *Instr,* Joe Kubert, Dover NJ (S)

Matheny, Paul, *Cur Art,* South Carolina State Museum, Columbia SC

Mather, Charles E, *Pres,* Fairmount Park Art Association, Philadelphia PA

Mather, Tim, *Asst Prof,* Indiana University, Bloomington, Henry Radford Hope School of Fine Arts, Bloomington IN (S)

Matheson, Pat, *Cur,* University of Regina, Visual Resource Center, Regina SK

Matheson, Steven, *Asst Prof,* Mills College, Art Dept, Oakland CA (S)

Mathewes, Perry, *Horticulturist,* Tryon Palace Historic Sites & Gardens, New Bern NC

Mathews, John, *Instr,* Bucks County Community College, Fine Arts Dept, Newtown PA (S)

Mathews, Karen, *Asst Prof,* University of Colorado at Denver, College of Arts & Media Visual Arts Dept, Denver CO (S)

Mathews, Nancy, *Cur Educ,* Kenosha Public Museum, Kenosha WI

Mathews, Nancy Mowll, *Prendergast Cur,* Williams College, Museum of Art, Williamstown MA

Mathews, Patricia, *Assoc Prof,* Oberlin College, Dept of Art, Oberlin OH (S)

Mathews, Susie, *Dir Educ,* Peoria Art Guild, Peoria IL

Mathey, Carole, *Asst Dir,* St Lawrence University, Richard F Brush Art Gallery, Canton NY

Mathias, Eve Page, *Coordr Fine Arts,* San Jose City College, School of Fine Arts, San Jose CA (S)

Mathiason, Jerry, *Instr,* North Hennepin Community College, Art Dept, Brooklyn Park MN (S)

Mathie, William, *Dir Gallery,* Edinboro University of Pennsylvania, Art Dept, Edinboro PA (S)

Mathies, Linda, *Tour Coordr,* Old Barracks Museum, Trenton NJ

Mathis, Jaci, *Instr,* Northeastern Junior College, Art Department, Sterling CO (S)

Matias, Bienvenida, *Exec Dir,* Center for Arts Criticism, Minneapolis MN

Matijcio, Steven, *Cur,* Plug In, Institute of Contemporary Art, Winnipeg MB

Matis, Walter, *Prog & Vol Coordr,* Fairfield Historical Society, Fairfield Museum & History Center, Fairfield CT

Matlock, Ann, *Assoc Prof,* Lamar University, Art Dept, Beaumont TX (S)

Mato, Nancy, *Deputy Dir,* The Society of the Four Arts, Palm Beach FL

Matson, Karen, *Coordr Technical Communications,* Kalamazoo Valley Community College, Center for New Media, Kalamazoo MI (S)

Matsuda, Fay Chew, *Exec Dir,* Museum of Chinese in the Americas, New York NY

Mattern, Yvette, *Asst Prof,* State University of New York at Albany, Art Dept, Albany NY (S)

Matthews, Balencia, *Dir,* Florida A & M University, Dept of Visual Arts, Humanities & Theatre, Tallahassee FL (S)

Matthews, Cathy, *Chief Librn,* Ryerson University, Ryerson University Library, Toronto ON

Matthews, Claire, *Exec Dir,* Mystic Art Association, Inc, Mystic Arts Center, Mystic CT

Matthews, Harriett, *Prof,* Colby College, Art Dept, Waterville ME (S)

Matthews, Marsha, *Dir Artifact Coll & Exhibits,* Oregon Historical Society, Oregon History Center, Portland OR

Matthews, Nancy, *Dir,* Meridian International Center, Cafritz Galleries, Washington DC

Matthews, Paula, *Asst to Dir,* Palm Beach Institute of Contemporary Art, Museum of Art, Lake Worth FL

Matthews, Sharon C, *Exec Dir,* National Architectural Accrediting Board, Inc, Washington DC

Matthews, Trish, *Exec Asst to Dir,* Amon Carter, Fort Worth TX

Matthis, Rose, *Instr,* Lamar University, Art Dept, Beaumont TX (S)

Mattice, Matt, *Educ Specialist,* Judiciary History Center, Honolulu HI

Mattice, Shelby, *Mus Mgr,* Greene County Historical Society, Bronck Museum, Coxsackie NY

Matticks, Rebecca, *Dir,* Hastings Museum of Natural & Cultural History, Hastings NE

Mattson, John, *Co-Site Supv,* Fort Totten State Historic Site, Pioneer Daughters Museum, Fort Totten ND

Mattson, John, *Preparator,* San Angelo Museum of Fine Arts, San Angelo TX

Mattson, Robert, *Chmn Art Dept & Coordr Art Gallery,* Ridgewater College, Art Dept, Willmar MN (S)

Mattys, Joe, *Assoc Prof,* Randolph-Macon College, Dept of the Arts, Ashland VA (S)

Matus, Edward M, *Gen Educ,* Art Institute of Pittsburgh, Pittsburgh PA (S)

Matvey, Richard, *Gen Educ,* Art Institute of Pittsburgh, Pittsburgh PA (S)

Matyas, Diane, *Dir Exhib & Programs,* Staten Island Institute of Arts & Sciences, Staten Island NY

Matzner, Paul, *Cur Library Natural Science,* Oakland Museum of California, Art Dept, Oakland CA

Mauersberger, George, *Chmn & Assoc Prof,* Cleveland State University, Art Dept, Cleveland OH (S)

Maul, John, *Asst Prof,* Oregon State University, Dept of Art, Corvallis OR (S)

Mauldin, Barbara, *Cur Latin American Folk Art,* Museum of New Mexico, Museum of International Folk Art, Santa Fe NM

Mauldin, Stephen L, *Instr,* Saint Gregory's University, Dept of Art, Shawnee OK (S)

Maullsby, Sarah, *Supv,* Page-Walker Arts & History Center, Cary NC

Maunder, John, *Cur Natural History,* Provincial Museum of Newfoundland & Labrador, Saint John's NF

Maupin, Sandra, *Adjunct Prof,* Southwest Baptist University, Art Dept, Bolivar MO (S)

Mauren, Paul, *Assoc Prof,* College of Saint Rose, Art Dept, Albany NY (S)

Maurer, Evan, *Dir,* Minneapolis Institute of Arts, Minneapolis MN

Maurer, Neil, *Assoc Prof,* University of Texas at San Antonio, Dept of Art & Art History, San Antonio TX (S)

Maurer, Sherry C, *Dir Gallery,* Augustana College, Augustana College Art Museum, Rock Island IL

Maurer, Tracy, *Instr,* University of Evansville, Art Dept, Evansville IN (S)

Maurier, Adele, *Opers & Design,* See Science Center, Manchester NH

Mauro, Robert, *Chmn,* Beaver College, Dept of Fine Arts, Glenside PA (S)

Maury, Kate, *Asst Prof,* University of Wisconsin-Stout, Dept of Art & Design, Menomonie WI (S)

Mausel, Olivia, *Chmn Holyoke Historical Commission, Chmn,* Wistariahurst Museum, Holyoke MA

Mavor, Carol, *Prof,* University of North Carolina at Chapel Hill, Art Dept, Chapel Hill NC (S)

Mawani, Salma, *Shop Mgr Wholesale & Supv Admin,* University of British Columbia, Museum of Anthropology, Vancouver BC

Maxey, Jeannette, *Head Jewelry Dept,* Kalamazoo Institute of Arts, KIA School, Kalamazoo MI (S)

Maxion, Cornelia, *Instr,* Wayne Art Center, Wayne PA (S)

Maxon, Mary, *Cur,* Rapid City Arts Council, Dahl Arts Center, Rapid City SD

Maxwell, Deborah, *Lectr,* Emporia State University, Dept of Art, Emporia KS (S)

Maxwell, Diane, *Dir Communications,* San Jose Museum of Art, San Jose CA

Maxwell, Jack, *Head Dept & Chmn,* Abilene Christian University, Dept of Art & Design, Abilene TX (S)

Maxwell, K C, *Prof,* Shoreline Community College, Humanities Division, Seattle WA (S)

Maxwell, Kathleen, *Chmn,* Santa Clara University, Dept of Art & Art History, Santa Clara CA (S)

Maxwell, Kent, *Dir Media Center,* Salt Lake Art Center, Salt Lake City UT

Maxwell, Linda, *Secy,* Wichita State University, Ulrich Museum of Art & Martin H Bush Outdoor Sculpture Collection, Wichita KS

Maxwell, William C, *Prof,* College of New Rochelle School of Arts & Sciences, Art Dept, New Rochelle NY (S)

May, James, *Dir Coll,* Indiana State Museum, Indianapolis IN

May, James M, *Asst Prof,* University of Nebraska, Kearney, Dept of Art & Art History, Kearney NE (S)

May, Joyce, *Instr,* Northeastern Junior College, Art Department, Sterling CO (S)

May, Larry, *Instr,* Art Academy of Cincinnati, Cincinnati OH (S)

May, Leni, *Chm (V),* The Jewish Museum, New York NY

May, Meyer H, *Exec Dir,* Simon Wiesenthal Center Inc, Museum of Tolerance, Los Angeles CA

May, Pat, *Admin Asst,* Gulf Coast Museum of Art, Inc, Largo FL

Maya, Gloria, *Prof,* Western New Mexico University, Dept of Expressive Arts, Silver City NM (S)

Maycock, Bryan, *Dir Foundation Studies,* Nova Scotia College of Art & Design, Halifax NS (S)

Maycock, Susan, *Dir Survey,* Cambridge Historical Commission, Cambridge MA

Mayeda, Cynthia, *Deputy Dir Institutional Advancement,* Brooklyn Museum, Brooklyn NY

Mayer, Bob, *Instr,* University of Saint Francis, School of Creative Arts, Fort Wayne IN (S)

Mayer, Carol, *Cur Ethnology & Ceramics,* University of British Columbia, Museum of Anthropology, Vancouver BC

Mayer, Edward, *Prof,* State University of New York at Albany, Art Dept, Albany NY (S)

Mayer, Jan, *Chmn,* The American Federation of Arts, New York NY

Mayer, John, *Cur,* Maine Historical Society, Portland ME

Mayer, Marc, *Deputy Dir Art,* Brooklyn Museum, Brooklyn NY

Mayer, William, Hope College, Dept of Art & Art History, Holland MI (S)

Mayes, Catherine, *Sr Cur,* Art Complex Museum, Carl A. Weyerhaeuser Library, Duxbury MA

Mayes, Dewey, *Instr,* Wilkes Community College, Arts & Science Division, Wilkesboro NC (S)

Mayes, Steven, *Dir,* Arkansas State University-Art Department, Jonesboro, Fine Arts Center Gallery, Jonesboro AR

Mayes, Steven L, *Prof,* Arkansas State University, Dept of Art, State University AR (S)

Mayfield, Signe, *Cur,* Palo Alto Art Center, Palo Alto CA

Mayhew, Rebecca, *Educ & Mem,* See Science Center, Manchester NH

Mayhugh, Cathy, *Exhib,* Fitton Center for Creative Arts, Hamilton OH

Mayhugh, Cathy, *Exhib,* Fitton Center for Creative Arts, Hamilton OH (S)

Maynard, Margaret, *Dir Visitor Experience & Interpreter,* San Jose Museum of Art, Library, San Jose CA

Maynard, Michael, *Assoc Dean Visual Arts,* Sheridan College, School of Animation, Arts & Design, Oakville ON (S)

Maynard, Michael, *Chmn,* George Brown College of Applied Arts & Technology, Dept of Graphics, Toronto ON (S)

Mayo, Doug, *Catalog Librn,* Colonial Williamsburg Foundation, John D Rockefeller, Jr Library, Williamsburg VA

Mayo, Milton A, *Chmn Bd Trustees,* African Art Museum of Maryland, Columbia MD

Mayor, Babette, *Chair, Prof,* California State Polytechnic University, Pomona, Art Dept, Pomona CA (S)

Mayrhofer, Ingrid, *Asst Cur,* McMaster University, McMaster Museum of Art, Hamilton ON

Mayrhofer, Ingrid, *Dir Prog,* A Space, Toronto ON

Mays, Gayle, *Libr Asst,* Fort Worth Public Library Arts & Humanities, Fine Arts Section, Fort Worth TX

Mays, Peter, *Exec Dir,* Gallery 825/Los Angeles Art Association, Gallery 825, Los Angeles CA

Mayse, Kevin, *Chmn Performing Arts & Media,* Riverside Community College, Dept of Art & Mass Media, Riverside CA (S)

Maytum, Donna, *Pub Relations & Mem,* Newport Art Museum, Newport RI

Mayweather, Deidra, *Dir Pub Relations,* City of Grand Rapids Michigan, Public Museum of Grand Rapids, Grand Rapids MI

Mazellen, Ron, *Assoc Prof,* Indiana Wesleyan University, Art Dept, Marion IN (S)

Mazonowicz, Douglas, *Dir,* Gallery of Prehistoric Paintings, New York NY

Mazonowicz, Douglas, *Dir,* Gallery of Prehistoric Paintings, Library, New York NY

Mazur, Catherine, *Educ & Publicity Coordr,* University of New Hampshire, The Art Gallery, Durham NH

Mazur, Michael J, *Treas,* Monterey Museum of Art Association, Monterey Museum of Art, Monterey CA

Mazzei, Rebecca, *Dir Communications,* Intuit: The Center for Intuitive & Outsider Art, Chicago IL

Mazziotti Gillan, Maria, *Exec Dir Cultural Arts,* Passaic County Community College, Division of Humanities, Paterson NJ (S)

McAdams, Margaret, *Assoc Prof,* Ohio University-Chillicothe Campus, Fine Arts & Humanities Division, Chillicothe OH (S)

McAdams, Scott, *Security & Visitor Svcs,* Alaska Department of Education, Division of Libraries, Archives & Museums, Sheldon Jackson Museum, Sitka AK

Mcafee, Michael, *Cur History,* United States Military Academy, West Point Museum, West Point NY

McAffee, Dionne, *Co-Dir,* YYZ Artists' Outlet, Toronto ON

McAlear, Donna, *Assoc Dir & Cur Svcs,* The Winnipeg Art Gallery, Winnipeg MB

McAlister, Amber, *Instr,* University of Miami, Dept of Art & Art History, Coral Gables FL (S)

McAlister, Richard A, *Assoc Prof,* Providence College, Art & Art History Dept, Providence RI (S)

McAllister, Lowell, *Exec Dir,* Frederic Remington, Ogdensburg NY

McAlpine, Donald, *Cur Zoology,* New Brunswick Museum, Saint John NB

McArdle, Karen, *Assoc Prof,* University of Saint Francis, School of Creative Arts, Fort Wayne IN (S)

McArthur, Andrew, *Pres Bd Dir,* Boulder Museum of Contemporary Art, Boulder CO

McArthur, Damon, *Asst Prof,* Western Illinois University, Art Dept, Macomb IL (S)

McArthur, Meher, *Cur East Asian Art,* Pacific - Asia Museum, Pasadena CA

McAuliffe, Alice, *Mus Shop Mgr,* Walters Art Museum, Library, Baltimore MD

McAvey, Suzette, *Chief Cur,* William A Farnsworth, Museum, Rockland ME

McAvity, John G, *Exec Dir,* Canadian Museums Association, Association des Musees Canadiens, Ottawa ON

McAvoy, Suzette L, *Chief Cur,* William A Farnsworth, Library, Rockland ME

McBoggs, Mayo, *Prof,* Converse College, Dept of Art & Design, Spartanburg SC (S)

McBratney-Stapleton, Deborah, *Exec Dir,* Anderson Fine Arts Center, Anderson IN

McBride, Carolyn N, *Secy,* National Hall of Fame for Famous American Indians, Anadarko OK

McBride, Debbie, *Admin Asst,* Alaska State Museum, Juneau AK

McBride, Joe, *Dir & Exec VPres,* National Hall of Fame for Famous American Indians, Anadarko OK

McBride, Peggy, *Dir Mktg,* Hambidge Center for the Creative Arts & Sciences, Rabun Gap GA

McCabe, Caroline, *Gallery Coordr,* Santa Ana College, Art Gallery, Santa Ana CA

McCabe, Diana, *VPres to Dean,* Watkins Institute, College of Art & Design, Nashville TN

McCabe, Elsie Crum, *Pres,* Museum for African Art, Long Island City NY

McCabe, Mary Kennedy, *Dir,* Mid America Arts Alliance & Exhibits USA, Kansas City MO

McCabe, Michael M, *Library Dir,* Brevard College, Spiers Gallery, Brevard NC

McCabe, Michael M, *Library Dir,* Brevard College, James A Jones Library, Brevard NC

McCafferty, Jay, *Instr,* Los Angeles Harbor College, Art Dept, Wilmington CA (S)

McCafferty, Michael, *Exhibitions Designer,* Seattle Art Museum, Library, Seattle WA

McCaffrey, Morra, *Dir Coll & Res,* McCord Museum of Canadian History, Montreal PQ

McCall, Robert, *Prof,* Saint Mary's University of Minnesota, Art & Design Dept, Winona MN (S)

McCalla, Mary Bea, *Dir,* French Art Colony, Library, Gallipolis OH

McCalla, Mary Bea, *Prog Dir,* French Art Colony, Gallipolis OH

McCallister Clark, Ellen, *Dir Library,* Society of the Cincinnati, Museum & Library at Anderson House, Washington DC

McCampbell, Jerry, *Chmn Math & Science,* Idyllwild Arts Academy, Idyllwild CA (S)

McCandaless, Michael, Creighton University, Fine & Performing Arts Dept, Omaha NE (S)

McCandless, Barbara, *Cur Photographic Coll,* Amon Carter, Fort Worth TX

McCandless, Harry, *Treas,* Lancaster County Art Association, Inc, Strasburg PA

McCandless, Janet, *Exec Dir,* Association of Medical Illustrators, Lawrence KS

McCarroll, Stacey, *Acting Dir & Cur,* Boston University, Boston University Art Gallery, Boston MA

McCartan, Edward, *Div Chmn,* Emma Willard School, Arts Division, Troy NY (S)

McCarte, John W, *Pres,* Field Museum, Chicago IL

McCarthy, Alexis, *Office Mgr,* Beaumont Art League, Beaumont TX

McCarthy, Christine, *Exec Dir,* Provincetown Art Association & Museum, Provincetown MA

McCarthy, Christine, *Exec Dir,* Provincetown Art Association & Museum, Library, Provincetown MA

McCarthy, David, *Assoc Prof,* Rhodes College, Dept of Art, Memphis TN (S)

McCarthy, Indi, *Asst Dir,* University of California, Irvine, Beall Center for Art and Technology, and University Art Gallery, Irvine CA

McCartney, Henry, *Exec Dir,* Landmark Society of Western New York, Inc, The Campbell-Whittlesey House Museum, Rochester NY

McCartney, Kevin, *Dir,* Northern Maine Museum of Science, Presque Isle ME

McCartney, Paula, *Curatorial & Educ Assoc,* Minnesota Museum of American Art, Saint Paul MN

McCarty, Gayle, *Chmn,* Hinds Community College, Dept of Art, Raymond MS (S)

McCarty, Gayle, *Chmn & Dir,* Hinds Community College District, Marie Hull Gallery, Raymond MS

McCarty, Ruth, *Cur,* Shores Memorial Museum and Victoriana, Lyndon Center VT

McCaslin, Jack, *Prof,* James Madison University, School of Art & Art History, Harrisonburg VA (S)

McCauley, Anne, *Assoc Prof,* Albion College, Bobbitt Visual Arts Center, Albion MI

McCauley, Anne, *Chmn,* University of Massachusetts - Boston, Art Dept, Boston MA (S)

McCauley, Barbara, *Chmn,* North Florida Community College, Dept Humanities & Art, Madison FL (S)

McCauley, Jan, *Pub Rel & Marketing,* Tyler Museum of Art, Tyler TX

McCauley, Robert N, *Chmn Dept Fine Arts,* Rockford College, Dept of Fine Arts, Rockford IL (S)

McCaw, Sandy, *Pres,* South County Art Association, Kingston RI

McCaye, Patrick, *Chmn Fine Arts,* Center for Creative Studies, College of Art & Design, Detroit MI (S)

McClanahan, John D, *Chmn,* Baylor University, Dept of Art, Waco TX (S)

McClanan, Anne, *Asst Prof,* Portland State University, Dept of Art, Portland OR (S)

McClay, Malcolm, *Lectr,* Southeastern Louisiana University, Dept of Visual Arts, Hammond LA (S)

McClean, Jan V, *Dir,* Jesse Besser, Philip M Park Library, Alpena MI

McCleary, Joan Jeffers, *Office Mgr,* Pacific Grove Art Center, Pacific Grove CA

McCleary, Stephen, *Pres,* Ocean County College, Humanities Dept, Toms River NJ (S)

McClellan, Andrew, *Chmn Art & Art History,* Tufts University, Dept of Art & Art History, Medford MA (S)

McClellan, Nancy, *Exec Dir,* Firehouse Art Center, Norman OK

McClenney-Brooke, Cheryl, *Dir External Affairs,* Philadelphia Museum of Art, Samuel S Fleisher Art Memorial, Philadelphia PA

McClenney-Brooker, Cheryl, *Dir,* Philadelphia Museum of Art, Philadelphia PA

McCloat, Elizabeth, *Dir,* Bryant Library, Roslyn NY

McCloskey, William, *Dean,* Monroe County Community College, Fine Arts Council, Monroe MI

McClung, Elizabeth, *Exec Dir,* Belle Grove Plantation, Middletown VA

McClure, Jeff, *Pres,* Whatcom Museum of History and Art, Library, Bellingham WA

McClure, Joy, *Registry Coordr,* Maryland Art Place, Baltimore MD

McClusky, Pamela, *Cur African Art,* Seattle Art Museum, Library, Seattle WA

McClyment, David, *Project Officer,* Visual Arts Ontario, Toronto ON

McCoart, Janice, *Prof,* Marymount University, School of Arts & Sciences Div, Arlington VA (S)

McColl, Bruce, *Dir Art Center,* The Currier Museum of Art, Currier Museum of Art, Manchester NH

McColl, Terrie L, *Dir,* Palisades Park Public Library, Palisades Park NJ

McCollum, Ken, *Asst Prof,* Muskingum College, Art Department, New Concord OH (S)

McCombs, Bruce, *Prof,* Hope College, Dept of Art & Art History, Holland MI (S)

McCone, John, *Pres,* The Bartlett Museum, Amesbury MA

McConnell, Michael, *Prof,* University of New Hampshire, Dept of Arts & Art History, Durham NH (S)

McConnell, Pamela Violante, *Registrar,* United States Capitol, Architect of the Capitol, Washington DC

McConnor, Sean, *Dir Permanent Coll,* Thiel College, Weyers-Sampson Art Gallery, Greenville PA

McCormick, Daniel Y, *Operations & Finance,* George Eastman, Rochester NY

McCormick, David, *Instr, Chair,* Southeastern Community College, Dept of Art, Whiteville NC (S)

McCormick, Donald, *Cur Recordings,* The New York Public Library, The New York Public Library for the Performing Arts, New York NY

McCormick, Jan, *Cur History & Science,* The Museum of Arts & Sciences Inc, Daytona Beach FL

McCormick, John, *Assoc Prof,* Delta College, Art Dept, University Center MI (S)

McCormick, Karen, *Asst Prof,* Mount Mary College, Art & Design Division, Milwaukee WI (S)

McCosker, Jane, *First VPres,* Monmouth Museum & Cultural Center, Lincroft NJ

McCourt, Tim, *Assoc Prof,* Mississippi State University, Dept of Art, Mississippi State MS (S)

McCoy, Claire B, *Asst Prof,* Longwood University, Dept of Art, Farmville VA (S)

McCoy, Dennis, *1st VPres,* Newport Historical Society & Museum of Newport History, Newport RI

McCoy, John, *Collechous & Admin Specialist,* Boston College, McMullen Museum of Art, Chestnut Hill MA

McCoy, Kevin, *Asst Prof,* City College of New York, Art Dept, New York NY (S)

McCoy, Paul A, *Prof & Ceramic in Res,* Baylor University, Dept of Art, Waco TX (S)

McCracken, Ursula E, *Dir,* The Textile Museum, Washington DC

McCrane, John, *Dir Finance & Admin,* The Trustees of Reservations, The Mission House, Ipswich MA

McCrea, Judith, *Chmn,* University of Kansas, Dept of Art, Lawrence KS (S)

McCreanor, Trudy, *Pres,* Arts Council of Mendocino County, Fort Bragg CA

McCreary, Robert, *Instr,* University of South Carolina at Aiken, Dept of Visual & Performing Arts, Aiken SC (S)

McCredie, James R, *Dir,* New York University, Institute of Fine Arts, New York NY (S)

McCrohan, Kathleen, *Chair,* Montgomery College, Dept of Art, Rockville MD (S)

McCroskey, Nancy, *Asst Prof,* Indiana-Purdue University, Dept of Fine Arts, Fort Wayne IN (S)

McCue, Harry, *Chmn,* Ithaca College, Fine Art Dept, Ithaca NY (S)

McCuistion, Mary Ann, *Exec Dir,* Red River Valley Museum, Vernon TX

McCullagh, Suzanne Folds, *Cur Earlier Prints & Drawings,* The Art Institute of Chicago, Dept of Prints & Drawings, Chicago IL

McCulloch, Judith, *Dir,* Cape Ann Historical Association, Cape Ann Historical Museum, Gloucester MA

McCullough, Gloria, *Librn,* Wayne County Historical Society, Honesdale PA

McCullough, Gloria, *Librn,* Wayne County Historical Society, Museum, Honesdale PA

McCullough, Holly K, *Cur Fine Arts & Exhibs,* Telfair Museum of Art, Savannah GA

McCullough, James, *Instr,* Oklahoma State University, Graphic Arts Dept, Visual Communications, Okmulgee OK (S)

McCullough, Robert, *Assoc Prof,* Old Dominion University, Art Dept, Norfolk VA (S)

McCullough-Hudson, Mary, *Exec Dir,* Cincinnati Institute of Fine Arts, Cincinnati OH

McCully, Robert, *Cur,* Jamestown-Yorktown Foundation, Williamsburg VA

McDade, Elizabeth, *Dir,* State University of New York, College at Brockport, Tower Fine Arts Gallery, Brockport NY

McDaniel, Cindy, *Educ Asst,* Tyler Museum of Art, Tyler TX

McDaniel, Craig, *Fine Arts Dept Chair,* Indiana University-Purdue University, Indianapolis, Herron School of Art, Indianapolis IN (S)

McDaniel, David, *Dir Prog,* Indiana State Museum, Indianapolis IN

McDaniel, Sheila, *CFO & COO,* The Studio Museum in Harlem, New York NY

McDaniel, Taylor, *Events Coordr,* The Dallas Contemporary, Dallas Visual Art Center, Dallas TX

McDaniel, Todd, *Preparator,* Cheekwood-Tennessee Botanical Garden & Museum of Art, Nashville TN

McDarby, Teri, *Second VPres,* Arizona Watercolor Association, Phoenix AZ

McDavid, Stephanie, *Chmn Art Dept & Instr,* Saint Andrews Presbyterian College, Art Program, Laurinburg NC (S)

McDermott, Brian, *Instr,* Seton Hill University, Art Program, Greensburg PA (S)

McDermott, Inez, *Asst Prof,* New England College, Art & Art History, Henniker NH (S)

McDermott, LeRoy, *Assoc Prof,* Central Missouri State University, Art Dept, Warrensburg MO (S)

McDevitt, John, *Sr VPres,* Please Touch Museum, Philadelphia PA

McDole, Amber, *Instr,* Graceland University, Fine Arts Div, Lamoni IA (S)

McDonald, Ann, *Asst Prof,* Northeastern University, Dept of Art & Architecture, Boston MA (S)

McDonald, Beth, *Mus Shop Mgr,* Cedarhurst Center for the Arts, Mitchell Museum, Mount Vernon IL

McDonald, Claire, *Dept Chmn,* University of Saint Thomas, Art Dept, Houston TX (S)

McDonald, Ed, *Chmn Animation & Digital Media,* Center for Creative Studies, College of Art & Design, Detroit MI (S)

McDonald, Gordon, *Dir,* The Art Gallery of Southwestern Manitoba, Brandon MB

McDonald, Heather, *Educ Asst,* Fruitlands Museum, Inc, Harvard MA

McDonald, J P, *Exec Dir,* Museum of East Texas, Lufkin TX

McDonald, John, *Admin Mus Ed,* Buffalo Museum of Science, Research Library, Buffalo NY

McDonald, Louann, *Dir,* Lee County Library, Tupelo MS

McDonald, Louisa, *Asst Prof,* University of Nevada, Las Vegas, Dept of Art, Las Vegas NV (S)

McDonald, Margie, *Accountant & Conference Coordr,* Organization of Saskatchewan Arts Councils (OSAC), Regina SK

McDonald, Mercedes, *Adjunct,* College of the Canyons, Art Dept, Canta Colita CA (S)

McDonald, Neal, *Asst Prof,* University of Saint Francis, School of Creative Arts, Fort Wayne IN (S)

McDonald, Norman D, *Pres,* Museum of Ossining Historical Society, Ossining NY

McDonald, Robert, *Coordr Art,* Cape Cod Community College, Art Dept, West Barnstable MA (S)

McDonald, Susan, *Dir,* North Hennepin Community College, Art Gallery, Brooklyn Park MN

McDonald, Terry, *Exec Dir,* Roberson Museum & Science Center, Binghamton NY

McDonald, Timothy, *Asst Prof,* Framingham State College, Art Dept, Framingham MA (S)

McDonnell, Kathleen, *Dir Gallery,* New York Studio School of Drawing, Painting & Sculpture, Gallery, New York NY

McDonnell, Mary Catharine, *Secy,* Lunenburg Art Gallery Society, Lunenburg NS

McDonnell, Patricia, *Dir & Chief Cur,* Tacoma Art Museum, Tacoma WA

McDonough, Julianne, *Cur Asst,* Phillips Academy, Addison Gallery of American Art, Andover MA

McDonough, Sue, *Dir Develop,* Old York Historical Society, Elizabeth Perkins House, York ME

McDonough, Thomas, *Asst Prof,* State University of New York at Binghamton, Dept of Art History, Binghamton NY (S)

McDowell, Bill, *Prof Photography,* Texas A&M University Commerce, Dept of Art, Commerce TX (S)

McDowell, Peggy, *Prof,* University of New Orleans-Lake Front, Dept of Fine Arts, New Orleans LA (S)

McDunn, Mary, *Dean of Liberal Studies,* Minneapolis College of Art & Design, Minneapolis MN (S)

McDunn, Mary, *Liberal Arts,* Minneapolis College of Art & Design, Minneapolis MN (S)

McElroy, Keith, *Assoc Prof Art History,* University of Arizona, Dept of Art, Tucson AZ (S)

McElroy, Penny, *Chair Art Dept,* University of Redlands, Peppers Art Gallery, Redlands CA

McElroy, Sherri, *Instr,* Illinois Wesleyan University, School of Art, Bloomington IL (S)

McElwain, Mary, *Exec Dir,* Missouri Arts Council, Saint Louis MO

McElwain, Peter, *Asst Dir,* Bass Museum of Art, Miami Beach FL

McEvilley, Thomas, *Distinguished Lectr,* Rice University, Dept of Art & Art History, Houston TX (S)

McEvoy, Maureen, *Prog Mgr,* Canadian Museum of Contemporary Photography, Ottawa ON

McEwin, Florence, *Head Dept,* Western Wyoming Community College, Art Dept, Rock Springs WY (S)

McFadden, David Revere, *Chief Cur & VPres Progs & Coll,* American Craft Council, Museum of Arts & Design, New York NY

McFadden, Robert, *Educ,* Pennsylvania Historical & Museum Commission, Library, Harrisburg PA

McFall, Tom, *Exec Dir,* Alberta Craft Council, Edmonton AB

McFalls, Amy, *Dir Mktg,* Creative Arts Guild, Dalton GA

McFarland, Brian, *Assoc VPres Educ,* American Craft Council, Museum of Arts & Design, New York NY

McFarland, Felix, *Buildings & Grounds Supv,* Mamie McFaddin Ward, Beaumont TX

McFarland, Thomas, *Chmn,* Union College, Music and Fine Arts Dept, Barbourville KY (S)

McFarlane, James, *Instr,* Wayne Art Center, Wayne PA (S)

McFarlane, Leesa, *Dir Sales,* State of North Carolina, Battleship North Carolina, Wilmington NC

McFee, Doris, *Asst Librn,* Chappell Memorial Library and Art Gallery, Chappell NE

McFredrick, Quinn, *Animal Exhibit Asst,* Randall Junior Museum, San Francisco CA

McGaffin, Terri, *Asst Prof,* Morningside College, Art Dept, Sioux City IA (S)

McGahey, Laurie, *Dir Pub Relations,* The Fabric Workshop & Museum, Philadelphia PA

McGarry, Jane, *Chief Designer,* North Carolina Museum of Art, Raleigh NC

McGarry, Steve, *Pres,* National Cartoonists Society, Winter Park FL

McGee, Gigi, *Chmn Graphic Design,* Moore College of Art & Design, Philadelphia PA (S)

McGee, J David, *Chmn,* Grand Valley State University, Art & Design Dept, Allendale MI (S)

McGee, Judi, *Asst Prof,* Oklahoma Baptist University, Art Dept, Shawnee OK (S)

McGee, Mike, *Dir,* California State University, Fullerton, Art Gallery, Visual Arts Center, Fullerton CA

McLeese, Sue, *Exec VPres,* South Carolina State Museum, Columbia SC

McLellan, Iain, *Asst Dir,* Saint Anselm College, Chapel Art Center, Manchester NH

McLemore, Mary, *Dean,* Motlow State Community College, Art Dept, Tullahoma TN (S)

McLendon, Kirk, *Graphic Design,* Henry Ford Community College, McKenzie Fine Art Ctr, Dearborn MI (S)

McLendon, Marty, *Chair Visual Arts,* Northeast Mississippi Junior College, Art Dept, Booneville MS (S)

McLennan, Bill, *Mgr Design & Photog,* University of British Columbia, Museum of Anthropology, Vancouver BC

McLeod, Christian, *Asst Cur,* Maslak-McLeod Gallery, Toronto ON

McLeod, Kersti, *Asst Cur,* Maslak-McLeod Gallery, Toronto ON

McLerran, Jennifer, *Cur,* Ohio University, Kennedy Museum of Art, Athens OH

McLinn, Val, *Pres,* Minneapolis Institute of Arts, Friends of the Institute, Minneapolis MN

McLoud, Melissa, *Dir Center Chesapeake Studies,* Chesapeake Bay Maritime Museum, Saint Michaels MD

Mcloud, Melissa, *Dir Center for Chesapeake Studies,* Chesapeake Bay Maritime Museum, Howard I Chapelle Memorial Library, Saint Michaels MD

McMahan, Evadine, *Deputy Exec Dir,* Tennessee State Museum, Nashville TN

McMahan, Robert, *Prof,* Antelope Valley College, Art Dept, Division of Fine Arts, Lancaster CA (S)

McMahon, Diane, *Mus Shop Mgr,* Wenham Museum, Timothy Pickering Library, Wenham MA

McMahon, Ellen, *Asst Prof Graphic Design-Illustration,* University of Arizona, Dept of Art, Tucson AZ (S)

McMahon, Lori M, *Exec Dir,* Waterworks Visual Arts Center, Salisbury NC

McMahon, Maggie, *Prof,* University of Tennessee at Chattanooga, Dept of Art, Chattanooga TN (S)

McMahon, Sharon, *Chmn,* Saint Mary's University, Dept of Fine Arts, San Antonio TX (S)

McManus, James, *Prof Emeritus,* California State University, Chico, Department of Art & Art History, Chico CA (S)

McManus Zurko, Kitty, *Dir,* The College of Wooster, The College of Wooster Art Museum, Wooster OH

McMaster, Mary Beth, *Pres,* Erie Art Museum, Erie PA

McMath, Hope, *Dir Educ,* Cummer Museum of Art & Gardens, DeEtte Holden Cummer Museum Foundation, Jacksonville FL

McMath, Lavita, *Government & Com,* Brooklyn Museum, Brooklyn NY

McMath, Sheila, *Educator,* Canadian Clay & Glass Gallery, Waterloo ON

McMathon, Janet, *Admin Spec,* Iowa State University, Brunnier Art Museum, Ames IA

McMichael, Luci, *Instr,* University of Missouri, Saint Louis, Dept of Art & Art History, Saint Louis MO (S)

McMillan, Alan C, *Dir Student Svcs,* Emily Carr Institute of Art & Design, Vancouver BC

McMillan, Barbara, *Librn,* Mount Vernon Ladies' Association of the Union, Mount Vernon VA

McMillan, Barbara, *Librn,* Mount Vernon Ladies' Association of the Union, Library, Mount Vernon VA

McMillan, Bobbie, *Mus School Dir,* Brevard Museum of Art & Science, Melbourne FL

McMillan, David, University of Manitoba, School of Art, Winnipeg MB (S)

McMillan, Edna, *Chmn,* Cameron University, Art Dept, Lawton OK (S)

McMillan, Kim, *Pub Relations Dir,* Arts & Science Council, Charlotte VA

McMillan, Mima, *Office Mgr,* Fayetteville Museum of Art, Inc, Fayetteville NC

McMillan, Morgan, *Coll Mgr,* Lehigh County Historical Society, Allentown PA

McMillan, Murray, *Asst Prof,* Biola University, Art Dept, La Mirada CA (S)

McMillan, Pat, *Dir,* Favell Museum of Western Art & Indian Artifacts, Klamath Falls OR

McMillan, R Bruce J, *Dir,* Illinois State Museum, Illinois Art Gallery & Lockport Gallery, Springfield IL

McMillian, R Bruce, *Dir,* Illinois State Museum, Museum Store, Chicago IL

McMillian-Fox, Melinda, *Mgr Gardens,* Philbrook Museum of Art, Tulsa OK

McMullen, Paul, *Asst Prof,* Siena Heights University, Studio Angelico-Art Dept, Adrian MI (S)

McMurrey, Enfys, *Instr,* Indian Hills Community College, Dept of Art, Centerville IA (S)

McNair, Amy, *Assoc Prof,* University of Kansas, Kress Foundation Dept of Art History, Lawrence KS (S)

McNally, Dennis, *Chmn,* Saint Joseph's University, Dept of Fine & Performing Arts, Philadelphia PA (S)

McNamara, Chris, *Registrar,* The Parrish Art Museum, Southampton NY

McNamara, Mary, *Pres & Exec Dir,* The Interchurch Center, The Interchurch Center, New York NY

McNamara, Mary Jo, *Asst Prof,* State University of New York College at Potsdam, Dept of Fine Arts, Potsdam NY (S)

McNamara, Sarah, *Pub Rels & Spec Events,* Rockford Art Museum, Rockford IL

McNamee, Donald W, *Chief Librn,* Natural History Museum of Los Angeles County, Research Library, Los Angeles CA

McNaught, William, *Dir,* Oysterponds Historical Society, Museum, Orient NY

McNaughton, John, *Prof,* University of Southern Indiana, Art Dept, Evansville IN (S)

McNaughton, Mary Davis, *Dir,* Scripps College, Ruth Chandler Williamson Gallery, Claremont CA

McNaughton, Patrick, *Assoc Prof,* Indiana University, Bloomington, Henry Radford Hope School of Fine Arts, Bloomington IN (S)

McNeal, Meridith, *Dir Educ,* BRIC - Brooklyn Information & Culture, Rotunda Gallery, Brooklyn NY

McNeer, James B, *Pres,* Richard Bland College, Art Dept, Petersburg VA (S)

McNeil, Lanette, *Cur Educ,* College of William & Mary, Muscarelle Museum of Art, Williamsburg VA

McNeil Kemp, Linda, *Dir Educ,* Cape Cod Museum of Art Inc, Dennis MA

McNeill, Janice, *Librn,* Terra Museum of American Art, Chicago IL

McNeill, Janice, *Librn,* Terra Museum of American Art, Library, Chicago IL

McNeill, Winifred, *Asst Prof,* Jersey City State College, Art Dept, Jersey City NJ (S)

McNichol, Charlene, *Cur Asst,* Banff Centre, Walter Phillips Gallery, Banff AB

McNickle, Mollie, *Barnes Foundation Lectr,* Saint Joseph's University, Dept of Fine & Performing Arts, Philadelphia PA (S)

McNiell, Winifred, *Dept Chair,* New Jersey City University, Courtney Art Gallery & Lemmerman Gallery, Jersey City NJ

McNorris, Lillian, *Pub Rels,* The Walker African American Museum & Research Center, Las Vegas NV

McNulty, John, *Mus Shop Mgr,* Tucson Museum of Artand Historic Block, Tucson AZ

McNutt, James, *Adjunct Prof,* Washington & Jefferson College, Art Dept, Washington PA (S)

McNutt, James C, *Pres & Exec Dir,* Witte Museum, San Antonio TX

McOmber, Christina, *Chmn Dept Art,* Cornell College, Peter Paul Luce Gallery, Mount Vernon IA

McPhee, Sarah, *Asst Prof,* Emory University, Art History Dept, Atlanta GA (S)

McPherson, Heather, *Prof,* University of Alabama at Birmingham, Dept of Art & Art History, Birmingham AL (S)

McQuade, Jayne, *Branch Librn,* Arlington County Department of Public Libraries, Fine Arts Section, Arlington VA

McQueen, Jack, *Exec Dir,* Old Mill Foundation, California Art Club Gallery, San Marino CA

McQueen, Katherine, *Prog Dir,* Women & Their Work, Austin TX

McQuillen, Troy, *Adjunct Instr,* Northern State University, Art Dept, Aberdeen SD (S)

McQuiston, William, *Dir,* Rensselaer Newman Foundation Chapel & Cultural Center, The Gallery, Troy NY

McRay, Sara, *Registrar,* Nevada Museum of Art, Art Library, Reno NV

McSweeney, Emmett, *Dir,* Silas Bronson, Art, Theatre & Music Services, Waterbury CT

McTighe, Lake, *Dir Gallery,* College of Santa Fe, Art Dept, Santa Fe NM (S)

McTique, Mary, *Exec Dir,* Boston Center for Adult Education, Boston MA (S)

McTyer, Sheila, *Develop Officer,* California African-American Museum, Los Angeles CA

McVaugh, Robert, *Assoc Prof,* Colgate University, Dept of Art & Art History, Hamilton NY (S)

McVay, Darice, *Secy,* Culberson County Historical Museum, Van Horn TX

McVicker, Charles, *Asst Prof,* The College of New Jersey, School of Arts & Sciences, Ewing NJ (S)

McWeeney, Jim, *Instr,* Joe Kubert, Dover NJ (S)

McWhorter, Jeanine, *Mus Shop Mgr,* Orange County Museum of Art, Orange County Museum of Art, Newport Beach CA

McWhorter, Linda, *Cur Educ,* South Carolina State Museum, Columbia SC

McWhorter, Mark, *Dept Head,* Indian Hills Community College, Ottumwa Campus, Dept of Art, Ottumwa IA (S)

McWhorter, Mark, *Head Dept,* Indian Hills Community College, Dept of Art, Centerville IA (S)

McWilliam, Deb, *Dir Main Library,* Columbus Metropolitan Library, Humanities, Fine Art & Recreation Division, Columbus OH

McWilliam, Neil, *Prof,* Duke University, Dept of Art, Art History & Visual Studies, Durham NC (S)

McWilliams, Martha, *Chmn Academic Studies,* Corcoran School of Art, Washington DC (S)

McWillie, Judy, *Prof Drawing & Painting,* University of Georgia, Franklin College of Arts & Sciences, Lamar Dodd School of Art, Athens GA (S)

Meacham, Sue, *Secy,* San Angelo Art Club, Helen King Kendall Memorial Art Gallery, San Angelo TX

Mead, Christopher, *Pres,* Society of Architectural Historians, Chicago IL

Mead, Elizabeth, *Assoc Prof,* Portland State University, Dept of Art, Portland OR (S)

Mead-Donaldson, Barbara Young, *Art Svcs Librn,* Miami-Dade Public Library, Miami FL

Meade, James, *Prof,* University of Southern Mississippi, Dept of Art & Design, Hattiesburg MS (S)

Meade, JoAnn, *Cur,* Alcan Aluminium Ltd, Montreal PQ

Meade, Rose, *Educator,* Pope County Historical Society, Pope County Museum, Glenwood MN

Meadows, Christine, *Cur,* Mount Vernon Ladies' Association of the Union, Mount Vernon VA

Meadows, Ted, *Adjunct Assoc Prof Art Hist,* Johnson County Community College, Visual Arts Program, Overland Park KS (S)

Meadows, Teresa, *Assoc Prof,* University of Colorado-Colorado Springs, Visual & Performing Arts Dept, Colorado Springs CO (S)

Meadows-Rogers, Robert, *Asst Prof,* Concordia College, Art Dept, Moorhead MN (S)

Means, Jim, *Theatre Prog Coordr,* Rocky Mount Arts Center, Rocky Mount NC

Mear, Margaret, *Prof,* Saint Mary's University of Minnesota, Art & Design Dept, Winona MN (S)

Mears, Bill, *Pres (V),* Art League of Manatee County, Bradenton FL

Mecklenburg, Frank, *Archivist,* Leo Baeck, Library, New York NY

Mecklenburg, Frank, *Chief Archivist,* Leo Baeck, New York NY

Mecky, Debra L, *Exec Dir,* Historical Society of the Town of Greenwich, Inc, Bush-Holley House Museum, Cos Cob CT

Medeiros, Mark, *Deputy Dir,* Oakland Museum of California, Art Dept, Oakland CA

Medina, Anastasia, *Mem Coordr,* Museum of Fine Arts, Saint Petersburg, Florida, Inc, Saint Petersburg FL

Medina, Dennis, *Cur Mus,* Dwight D Eisenhower, Abilene KS

Medina, Ron, *Instr,* Laramie County Community College, Division of Arts & Humanities, Cheyenne WY (S)

Medina, Rubens, *Law Librn,* Library of Congress, Prints & Photographs Division, Washington DC

Medley, Chris, *Asst Prof,* Maryland College of Art & Design, Silver Spring MD (S)

Medlin, Annette, *VPres Merchandise,* Brookgreen Gardens, Murrells Inlet SC

Medlock, Rudy, *Art Dept Chmn,* Asbury College, Art Dept, Wilmore KY (S)

Medlock, Rudy, *Head Art Dept,* Asbury College, Student Center Gallery, Wilmore KY

Medrano, Jerry, *Asst Cur,* City of El Paso, El Paso TX

Medvedow, Jill, *Dir,* Institute of Contemporary Art, Boston MA

Meehan, Brian, *Exec Dir,* Museum London, London ON

Meehan, Carole Anne, *ICA/Vita Brevis Project Dir,* Institute of Contemporary Art, Boston MA

Meehan, Tracy, *Registrar & Colls Mgr,* The Adirondack Historical Association, The Adirondack Museum, Blue Mountain Lake NY

Meek, A J, *Prof,* Louisiana State University, School of Art, Baton Rouge LA (S)

Meek, Ken, *Cur Coll,* The Frank Phillips, Woolaroc Museum, Bartlesville OK

Meek, Kristina, *Pub Relations,* Library Association of La Jolla, Athenaeum Music & Arts Library, La Jolla CA

Meek, William, *Prof,* Texas State University - San Marcos, Dept of Art and Design, San Marcos TX (S)

Meeker, Cheryl, *Prof Art,* Monmouth College, Dept of Art, Monmouth IL (S)

Meeker, Jerry, *Gallery Mgr,* Redlands Art Association, Redlands Art Association Gallery, Redlands CA

Meeks, Donna M, *Chmn & Prof,* Lamar University, Art Dept, Beaumont TX (S)

Meeks, Milly, *Curatorial Asst,* University of Vermont, Wilbur Room Library, Burlington VT

Mehlferber, Jon, *Chmn,* Virginia Intermont College, Fine Arts Div, Bristol VA (S)

Mehran, Laleh, *Asst Prof Digital Media,* University of Georgia, Franklin College of Arts & Sciences, Lamar Dodd School of Art, Athens GA (S)

Mehring, Gretchen, *Exec Dir,* Art Museum of Greater Lafayette, Library, Lafayette IN

Meier, Eleanor, *Pres,* Catharine Lorillard Wolfe, New York NY

Meier, Jan, *Mgr,* Maritz, Inc, Library, Fenton MO

Meiers, Susanna, *Dir,* El Camino College Art Gallery, Torrance CA

Meijer, Lena, *Prof Art History,* Aquinas College, Art Dept, Grand Rapids MI (S)

Meijier, Yolanda, *Dir Develop,* Art Gallery of Greater Victoria, Victoria BC

Meillan, Eileen, *Librn,* The Stewart, Montreal PQ

Meir, Katia, *Asst Dir,* Saidye Bronfman, Liane & Danny Taran Gallery, Montreal PQ

Meissner, Walt, *Dean,* Boston University, School for the Arts, Boston MA (S)

Meister, Pam, *Dir Colls Resources,* Atlanta Historical Society Inc, Atlanta History Center, Atlanta GA

Meizner, Karen, *Admnr,* Sitka Historical Society, Isabel Miller Museum, Sitka AK

Mejchar, James D, *Exec Dir,* International Clown Hall of Fame & Research Center, Inc, West Allis WI

Mejer, Robert Lee, *Dir Gallery,* Quincy University, The Gray Gallery, Quincy IL

Mejer, Robert Lee, *Prof Art,* Quincy University, Dept of Art, Quincy IL (S)

Mejia-Krumbein, Beatriz, *Prof,* La Sierra University, Art Dept, Riverside CA (S)

Mekas, Jonas, *Dir & Vol Pres,* Anthology Film Archives, New York NY

Melancon, Joseph, *Instr,* Art Center Sarasota, Sarasota FL (S)

Meland, Janet, *Treas,* Frontier Gateway Museum, Glendive MT

Melandri, Lisa, *Deputy Dir Exhibitions,* Santa Monica Museum of Art, Santa Monica CA

Melanson, De Rae, *Technician,* Crook County Museum & Art Gallery, Sundance WY

Melcher-Brethorst, Barbara, *Cur Educ,* Lakeview Museum of Arts & Sciences, Peoria IL

Melchionne, Kevin, *Dir,* Temple University, Tyler School of Art, Temple Gallery, Elkins Park PA

Melick, Randolph, *Instr,* New York Academy of Art, Graduate School of Figurative Art, New York NY (S)

Melio, Cathy, *Educ Dir,* Center for Maine Contemporary Art, Art Gallery, Rockport ME

Mella, Joseph S, *Dir,* Vanderbilt University, Fine Arts Gallery, Nashville TN

Mellen, Jill, *Dir Educ & Sci,* Disney's Animal Kingdom Theme Park, Bay Lake FL

Mellili, Mary, *Prof,* Salem State College, Art Dept, Salem MA (S)

Mellin, Robert, *Prof,* McGill University, School of Architecture, Montreal PQ (S)

Mellings, Kelly, *Art Enrichment Coordr,* Where Edmonton Community Artists Network Society, Harcourt House Arts Centre, Edmonton AB

Mello, Sally Dean, *Coordr Educ,* Art Complex Museum, Carl A. Weyerhaeuser Library, Duxbury MA

Mello-Nee, Mary, *Pres,* Witter Gallery, Storm Lake IA

Mellon , Doug, *Printing & Drawing,* Asbury College, Student Center Gallery, Wilmore KY

Mellon, Marc Richard, *Pres,* Artists' Fellowship, Inc, New York NY

Melmer, Janeen, *Head Librn,* Crazy Horse Memorial, Indian Museum of North America, Native American Educational & Cultural Center & Crazy Horse Memorial Library (Reference), Crazy Horse SD

Melton, Allison, *Instr,* Delta State University, Dept of Art, Cleveland MS (S)

Melton, Celiz, *Asst Collection Mgr,* California State University, Chico, Janet Turner Print Museum, Chico CA

Melton, Laura, *Chmn Music,* Idyllwild Arts Academy, Idyllwild CA (S)

Melton, Matthew, *Chmn,* Lee University, Dept of Communication & the Arts, Cleveland TN (S)

Meltzer, Doris I, *Exec Dir,* Bakehouse Art Complex, Inc, Miami FL

Melvin, Douglas, *Chmn,* North Central Michigan College, Art Dept, Petoskey MI (S)

Melvin, Meg, *Mod & Contemp Specialist,* National Gallery of Art, Department of Image Collections, Washington DC

Memoli, Frank, *Chmn Interior Design,* Fashion Institute of Technology, Art & Design Division, New York NY (S)

Menard, Lloyd, *Prof,* University of South Dakota, Department of Art, College of Fine Arts, Vermillion SD (S)

Menard, Michael J, *Cur Archives & Librn,* Museum of Western Colorado, Grand Junction CO

Menchaca, Belinda, *Dir Dance Prog,* Guadalupe Cultural Arts Center, San Antonio TX

Mencini, Susan, *Instr,* Cuyahoga Valley Art Center, Cuyahoga Falls OH (S)

Menconeri, Kate, *Dir Prog,* Center for Photography at Woodstock Inc, Woodstock NY

Mendell, Cyndi, *Instr Foundation Art,* The Art Institute of Cincinnati, Cincinnati OH (S)

Mendelson, Haim, *Pres,* Federation of Modern Painters & Sculptors, New York NY

Mendelson, Shari, *Instr,* Chautauqua Institution, School of Art, Chautauqua NY (S)

Mendez, Ivan, *Cur Archaeology,* University of Puerto Rico, Museum of Anthropology, History & Art, Rio Piedras PR

Mendiola, Brenda, *Finance Admin,* Houston Center For Photography, Houston TX

Mendoza, Mary, *Pres,* Long Beach Art League, Long Beach Library, Long Beach NY

Mendoza, Valerie, *Asst Prof,* University of Florida, Dept of Art, Gainesville FL (S)

Menger, Linda, *Prof,* Delta College, Art Dept, University Center MI (S)

Menn, Richard J, *Cur,* Carmel Mission & Gift Shop, Carmel CA

Menna, Sari, *Financial Coordr,* Women in the Arts Foundation, Inc, New York NY

Menning, Daleene, *Prof,* Grand Valley State University, Art & Design Dept, Allendale MI (S)

Mercede, Nevin, *Dir,* Antioch College, Noyes & Read Gallery/Herndon Gallery, Yellow Springs OH

Mercede, Nevin, *Prof,* Antioch College, Visual Arts Dept, Yellow Springs OH (S)

Mercedes, Dawn J, *Asst Prof,* Oakton Community College, Language Humanities & Art Divisions, Des Plaines IL (S)

Mercer, Bill, *Cur Native American Art,* Portland Art Museum, Portland OR

Mercer, Bill, *Cur Native American Art,* Portland Art Museum, Northwest Film Center, Portland OR

Mercer, Cydna, *Head Programs,* Museum London, London ON

Mercer, John, *Coordr, Photograph Dept,* Phoenix College, Dept of Art & Photography, Phoenix AZ (S)

Mercer, Valerie, *Cur African American Art,* Detroit Institute of Arts, Detroit MI

Merchant, Liane, *Pres,* New Rochelle Public Library, New Rochelle Art Association, New Rochelle NY

Merdzinski, Marilyn, *Colls Mgr,* City of Grand Rapids Michigan, Public Museum of Grand Rapids, Grand Rapids MI

Meredith, Jill, *Dir,* Amherst College, Mead Art Museum, Amherst MA

Meredith, Mary Ellen, *Exec Adminr,* Cherokee Heritage Center, Tahlequah OK

Meredith, Susi, *Admin Asst,* Yakima Valley Community College, Larson Gallery, Yakima WA

Merhib, David J, *Dir Visual Arts Ctr,* Washington Pavilion of Arts & Science, Visual Arts Center, Sioux Falls SD

Merkel, Leonora, *Dir Nat Progs,* Business Committee for the Arts, Inc, Long Island City NY

Merker, Mary Ann, *Civic Arts Coordr,* Berkeley Civic Arts Program, Berkeley CA

Merkle, Sarah, *Dir Marketing & Bus Operations,* BJU Museum & Gallery, Bob Jones University Museum & Gallery Inc, Greenville SC

Merkur, Barbara, *Instr & Supv,* Toronto Art Therapy Institute, Toronto ON (S)

Merle, Michel D, *Prof,* Worcester State College, Visual & Performing Arts Dept, Worcester MA (S)

Merling, Mitchell, *Cur Paul Mellon,* Virginia Museum of Fine Arts, Richmond VA

Merrick, Theodore C, *Trustee,* Merrick Art Gallery, New Brighton PA

Merrill, Alice, *Dir School,* Art League, Alexandria VA

Merrill, Joyce, *VPres,* Indian Pueblo Cultural Center, Albuquerque NM

Merrill, Ross, *Chief Conservation,* National Gallery of Art, Washington DC

Merriman, Bill, *Pres,* The Peggy Lewis Gallery at the Allied Arts Center, Yakima WA

Merriman, Larry, *Asst Prof & Gallery Dir,* Coker College, Art Dept, Hartsville SC (S)

Merriman, Larry, *Dir,* Coker College, Cecelia Coker Bell Gallery, Hartsville SC

Merritt, Joni, *Asst Librn,* Manchester Historic Association, Library, Manchester NH

Merritt, Scott, *Head Coll,* National Museum of the American Indian, George Gustav Heye Center, New York NY

Merryday, Michaela, *Asst Prof, Art Hist & Visual Cult,* University of Tulsa, School of Art, Tulsa OK (S)

Mersmann, Armin, *Studio School Coordr & Registrar,* Arts Midland Galleries & School, Midland MI

Mertens, Robert, *Chmn,* University of Wisconsin-Whitewater, Dept of Art, Whitewater WI (S)

Mertz, Joan, *Asst Cur & Coll Mgr,* Sangre de Cristo Arts & Conference Center, Pueblo CO

Mesa, Osvaldo, *Co-Chmn,* Fondo del Sol, Visual Art & Media Center, Washington DC

Mesa-Gaido, Elisabeth, *Assoc Prof,* Morehead State University, Art Dept, Morehead KY (S)

Mesch, Claudia, *Asst Prof,* Cleveland State University, Art Dept, Cleveland OH (S)

Mesina, Micah, *Business Mgr,* Hui No eau Visual Arts Center, Gallery and Gift Shop, Makawao Maui HI

Mesquita, Ivo, *Grad Comt,* Bard College, Center for Curatorial Studies Graduate Program, Annandale-on-Hudson NY (S)

Mess, Tamara, *Office Mgr,* New Visions Gallery, Inc, Marshfield WI

Messec, Don, *Asst Prof,* College of Santa Fe, Art Dept, Santa Fe NM (S)

Messenger, Janet, *Exec Dir,* Bicentennial Art Center & Museum, Paris IL

Messer, James, *Instr,* Mitchell Community College, Visual Art Dept, Statesville NC (S)

Messer, Jennifer, *Asst to Dir,* Sweetwater County Library System and School District #1, Community Fine Arts Center, Rock Springs WY

Messerschmidt, Gale, *Educ Dir,* West Florida Historic Preservation, Inc, T T Wentworth, Jr Florida State Museum & Historic Pensacola Village, Pensacola FL

Messina, Mitchell, *Assoc Prof,* Nazareth College of Rochester, Art Dept, Rochester NY (S)

Messinger, Faye, *Librn,* Monterey History & Art Association, Library, Monterey CA

Meszaros, Cheryl, *Head Pub Progs,* Vancouver Art Gallery, Vancouver BC

Metcalf, 'D', *Libr Asst,* Fort Worth Public Library Arts & Humanities, Fine Arts Section, Fort Worth TX

Metcalf, Lisa, *Acting Exec Dir,* The Drawing Center, New York NY

Metcalf, Michael, *Co-Chmn Art,* Western New Mexico University, Dept of Expressive Arts, Silver City NM (S)

Metcalf, Ned, *Sate Svcs,* The Arkansas Arts Center, Museum School, Little Rock AR (S)

Metcalf, Preston, *Mgr External Affairs & Assoc Cur,* Triton Museum of Art, Santa Clara CA

Metcalf, Susan E, *Cur,* Miracle at Pentecost Foundation, Biblical Arts Center, Dallas TX

Metcalfe, Robin, *Cur Contemporary Art,* Museum London, London ON

Metcoff, Donald, *Chicago Representative,* American Society of Artists, Inc, Palatine IL

Metcoff, Donald, *Librn,* American Society of Artists, Inc, Library Organization, Palatine IL

Metraux, M, *Cur,* York University, Fine Arts Phase II Slide Library, Toronto ON

Metrou, Wendy, *Publicist,* Ford Motor Company, Henry Ford Museum & Greenfield Village, Dearborn MI

Mettala, Teri, *Dir,* Ojai Art Center, Ojai CA

Mettler, Bonnie, *Instr,* Main Line Art Center, Haverford PA (S)

Metz, Don, *Assoc Dir,* Burchfield-Penney Art Center, Buffalo NY

Metz, Donna, *Exec Dir,* St Joseph Art Association, Krasl Art Center, Saint Joseph MI

Metzen, Greg, *Chmn,* Ellsworth Community College, Dept of Fine Arts, Iowa Falls IA (S)

Metzger, Lynn, *VPres,* Summit County Historical Society, Akron OH

Metzger, Robert, *Dir,* Reading Public Museum, Library, Reading PA

Metzker, Dale, *Assoc Prof,* Pennsylvania College of Technology, Dept. of Communications, Construction and Design, Williamsport PA (S)

Metzler, Sally, *Dir,* Loyola University of Chicago, Martin D'Arcy Museum of Art, Chicago IL

Meuleer, James, *Chief Historian,* Independence National Historical Park, Library, Philadelphia PA

Meunier, Brian A, *Assoc Prof,* Swarthmore College, Dept of Art, Swarthmore PA (S)

Mew, T J, *Prof & Chmn,* Berry College, Art Dept, Mount Berry GA

Mew, T J, *Prof Art,* Berry College, Memorial Library, Mount Berry GA

Mey, Andree, *Cur Coll,* Lehigh County Historical Society, Allentown PA

Meyer, Charles, *Exec Dir,* Bakersfield Art Foundation, Bakersfield Museum of Art, Bakersfield CA

Miller, Marie Celeste, *Prof,* Aquinas College, Art Dept, Grand Rapids MI (S)

Miller, Marlene, *Instr,* Bucks County Community College, Fine Arts Dept, Newtown PA (S)

Miller, Mary, *Exec Dir,* Kentucky Museum of Art & Craft, Louisville KY

Miller, Mary Jane, *Acting Registrar,* Pennsylvania Historical & Museum Commission, The State Museum of Pennsylvania, Harrisburg PA

Miller, Michael, *Co-Dir,* University of Portland, Buckley Center Gallery, Portland OR

Miller, Michael, *Coordr Grad Progs & Instr Painting,* Texas A&M University Commerce, Dept of Art, Commerce TX (S)

Miller, Michael, *Dir Develop,* Octagon Center for the Arts, Ames IA

Miller, Michael, *Prof,* School of the Art Institute of Chicago, Chicago IL (S)

Miller, Michael B, *Asst Prof,* California Polytechnic State University at San Luis Obispo, Dept of Art & Design, San Luis Obispo CA (S)

Miller, Pamela, *Dir Programs,* California Watercolor Association, Gallery Concord, Concord CA

Miller, Patricia, *VPres,* Sierra Arts Foundation, Reno NV

Miller, Patrick, *Graphic Design,* University of South Alabama, Dept of Art & Art History, Mobile AL (S)

Miller, Patrick, *Assoc Prof,* Mississippi State University, Dept of Art, Mississippi State MS (S)

Miller, Randall, *Webmaster,* Art Association of Harrisburg, School & Galleries, Harrisburg PA

Miller, Randy, *Cur Geology,* New Brunswick Museum, Saint John NB

Miller, Remy, *Div Chair Foundations,* Memphis College of Art, Memphis TN (S)

Miller, Rob, *Lectr,* University of Wisconsin-Parkside, Art Dept, Kenosha WI (S)

Miller, Robert B, *Vis Lect,* Lewis & Clark College, Dept of Art, Portland OR (S)

Miller, Rod S, *Dir,* Art Community Center, Art Center of Corpus Christi, Corpus Christi TX

Miller, Roger, *Asst Dir,* State of North Carolina, Battleship North Carolina, Wilmington NC

Miller, Roland, *Photography,* College of Lake County, Art Dept, Grayslake IL (S)

Miller, Ron, *Dir,* World Archaeological Society, Information Center & Library, Hollister MO

Miller, Ronald, *Dir Develop,* Detroit Institute of Arts, Detroit MI

Miller, Ronald A, *Graphic Design,* Art Institute of Pittsburgh, Pittsburgh PA (S)

Miller, Stan, *Treas,* Whatcom Museum of History and Art, Library, Bellingham WA

Miller, Steve, *Assoc Prof,* Palomar Community College, Art Dept, San Marcos CA (S)

Miller, Steven H., *CEO & Exec Dir,* Morris Museum, Morristown NJ

Miller, Susan, *Exec Dir,* New Langton Arts, San Francisco CA

Miller, Tammy, *Ed,* Historical Society of Pennsylvania, Philadelphia PA

Miller, Thomas, *Chmn,* Indiana University South Bend, Fine Arts Dept, South Bend IN (S)

Miller, Valerie, *Coordr Coll,* Red Deer & District Museum & Archives, Red Deer AB

Miller-LeDoux, Karen, *Secy,* Lafayette Natural History Museum & Planetarium, Lafayette LA

Miller Zohn, Kristen, *Cur Educ,* Columbus Museum, Columbus GA

Millett, Cristin, *Asst Prof,* University of Maine, Dept of Art, Orono ME (S)

Millie, Elena G, *Posters,* Library of Congress, Prints & Photographs Division, Washington DC

Milligan, Frank D, *CEO,* Nantucket Historical Association, Historic Nantucket, Nantucket MA

Millin, Laura J, *CEO & Dir,* Missoula Art Museum, Missoula MT

Millington, Jennifer, *Publicist & Dir Educ,* Rome Art & Community Center, Rome NY

Millios, Bill, *Coordr Pub Rels,* Manchester Historic Association, Manchester NH

Mills, Beth, *Head Reference,* New Rochelle Public Library, Art Section, New Rochelle NY

Mills, Cynthia, *Asst Exec Dir,* Birmingham-Bloomfield Art Center, Birmingham MI (S)

Mills, Cynthia K, *Assoc Dir,* Birmingham-Bloomfield Art Center, Art Center, Birmingham MI

Mills, Dan, *Dir,* Bucknell University, Edward & Marthann Samek Art Gallery, Lewisburg PA

Mills, Don, *Dir Library Svcs,* Mississauga Library System, Mississauga ON

Mills, Don, *Dir Library Svcs,* Mississauga Library System, Central Library, Arts Dept, Mississauga ON

Mills, Emmy, *Admin Asst,* Arts Midland Galleries & School, Midland MI

Mills, Josephine, *Dir,* University of Lethbridge, Art Gallery, Lethbridge AB

Mills, Kelly, *Instr,* Avila College, Art Division, Dept of Humanities, Kansas City MO (S)

Mills, L Charmayne, *Chmn Bd,* California African-American Museum, Los Angeles CA

Mills, Lea, *Dean,* College of the Redwoods, Arts & Languages Dept Division, Eureka CA (S)

Mills, Richard, *Asst Prof,* C W Post Campus of Long Island University, School of Visual & Performing Arts, Brookville NY (S)

Mills, Ron, *Chmn Dept,* Linfield College, Art Dept, McMinnville OR (S)

Millstein, Barbara, *Cur Photography,* Brooklyn Museum, Brooklyn NY

Milne, Joseph W, *Graphic Design & Digital Design,* Art Institute of Pittsburgh, Pittsburgh PA (S)

Milnes, Robert, *Dir,* San Jose State University, School of Art & Design, San Jose CA (S)

Milosevich, Joe, *Instr,* Joliet Junior College, Fine Arts Dept, Joliet IL (S)

Milosevich, Joe B, *Dir Gallery,* Joliet Junior College, Laura A Sprague Art Gallery, Joliet IL

Milot, Barbara, *Prof,* Framingham State College, Art Dept, Framingham MA (S)

Milroy, Elizabeth, *Assoc Prof,* Wesleyan University, Dept of Art & Art History, Middletown CT (S)

Milton-Elmore, Kara, *Exec Dir,* Wilkes Art Gallery, North Wilkesboro NC

Mimeault, Sonia, *Registrar,* Musee de l'Amerique Francaise, Quebec PQ

Mims, Michael, *Acting Area Head Photography,* Pasadena City College, Art Dept, Pasadena CA (S)

Minahan, Nancy, *Pres,* Superior Public Museums Inc, Archives, Superior WI

Minchin, Edward, *Instr,* Art Center Sarasota, Sarasota FL (S)

Min Chung, Young, *Asst Registrar,* Art Museum of the University of Houston, Blaffer Gallery, Houston TX

Mindlin, Beth, *Third VPres,* Halifax Historical Society, Inc, Halifax Historical Museum, Daytona Beach FL

Miner, Melvin, *Mus Aid,* Indian Arts & Crafts Board, US Dept of the Interior, Sioux Indian Museum, Rapid City ND

Minet, Cynthia, *Asst Prof,* Antelope Valley College, Art Dept, Division of Fine Arts, Lancaster CA (S)

Mink, Pat, *Asst Prof,* East Tennessee State University, College of Arts and Sciences, Dept of Art & Design, Johnson City TN (S)

Minkkinen, Arno, *Prof,* University of Massachusetts Lowell, Dept of Art, Lowell MA (S)

Minkler, Christine, *Dir Educ,* Columbia Museum of Art, Columbia SC

Minkler, Jim, *Dean,* Spokane Falls Community College, Fine Arts Dept, Spokane WA (S)

Minks, Ronald, *Co-Dir Gallery,* Mississippi Valley State University, Fine Arts Dept, Itta Bena MS (S)

Minning, Carl, *VPres,* Zanesville Art Center, Zanesville OH

Minogue, Eileen, *Asst Dir,* Northport-East Northport Public Library, Northport NY

Minor, Charlotte, *Pres,* Virginia Museum of Fine Arts, Richmond VA

Minor, Lauren, *Mus Shop Mgr,* Silvermine Guild Arts Center, School of Art, New Canaan CT

Minor, Madge, *Deputy Dir Finance & Admin,* Hillwood Museum & Gardens Foundation, Hillwood Museum & Gardens, Washington DC

Mintich, Mary, *Prof,* Winthrop University, Dept of Art & Design, Rock Hill SC (S)

Minton, Randy, *Instr,* Hinds Community College, Dept of Art, Raymond MS (S)

Mintz, Anne, *Dir,* Berkshire Museum, Pittsfield MA

Mintz, Deborah, *Exec Dir,* Arts Council of Fayetteville-Cumberland County, The Arts Center, Fayetteville NC

Mintz, Loren A, *Pres & CEO,* Historical Society of Palm Beach County, West Palm Beach FL

Mintz, Ward, *Deputy Dir Prog & Coll,* Newark Museum Association, The Newark Museum, Newark NJ

Mirabella, Giacomo, *Registrar,* Museum for African Art, Long Island City NY

Miraglia, Anthony J, *Chmn Fine Art,* University of Massachusetts Dartmouth, College of Visual & Performing Arts, North Dartmouth MA (S)

Miranda, Candida, *VPres Admin,* Museum of Science & Industry, Chicago IL

Miranda, Sam, *Asst Prof Interior Design,* University of North Texas, School of Visual Arts, Denton TX (S)

Mirensky, Gabriela, *Dir Exhib,* American Institute of Graphic Arts, New York NY

Mirrer, Louise, *Pres,* New York Historical Society, New York NY

Misegadis, Lois, *Head Dept,* Hesston College, Art Dept, Hesston KS (S)

Mishler, John, *Asst Prof,* Goshen College, Art Dept, Goshen IN (S)

Misner, Mary, *Coordr Cultural Svcs,* Cambridge Public Library and Gallery, Cambridge ON

Missal, Paul, *Instr,* Pacific Northwest College of Art, Portland OR (S)

Misterka, Halina, *Archivist,* Polish Museum of America, Research Library, Chicago IL

Mitas, William R, *Industrial Design Technology,* Art Institute of Pittsburgh, Pittsburgh PA (S)

Mitchell, Ann, *Dept Chmn,* Long Beach City College, Art & Photography Dept, Long Beach CA (S)

Mitchell, Barbara, *Gift Shop Coordr,* Morris-Jumel Mansion, Inc, New York NY

Mitchell, Becca, *Educator,* Albany Institute of History & Art, Albany NY

Mitchell, Brenda, *Assoc Prof,* Indiana University of Pennsylvania, College of Fine Arts, Indiana PA (S)

Mitchell, Charles D, *Pres & Acting Exec Dir,* Headley-Whitney Museum, Lexington KY

Mitchell, Cynthia, *Asst Librn,* Thomas College Art Gallery, Mariner Library, Waterville ME

Mitchell, Denise, *MFO,* College Art Association, New York NY

Mitchell, Gary, *Provincial Archivist,* British Columbia Information Management Services, BC Archives, Victoria BC

Mitchell, Gina, *Registrar,* Hickory Museum of Art, Inc, Hickory NC

Mitchell, Jackie, *Museum Educator,* New Mexico State University, Art Gallery, Las Cruces NM

Mitchell, James, *Librn,* American Folk Art Museum, Shirley K. Schlafer Library, New York NY

Mitchell, Joe, *Asst Prof,* Florida Southern College, Art Dept, Lakeland FL (S)

Mitchell, Joseph, *Adjunct Prof Art,* Florida Southern College, Melvin Art Gallery, Lakeland FL

Mitchell, Kathryn, *Dir Educ,* The Old Jail Art Center, Albany TX

Mitchell, Kristina, *Educ & Progs,* University of Kansas, Spencer Museum of Art, Lawrence KS

Mitchell, Lauren, *Develop Officer,* Buffalo Arts Studio, Buffalo NY

Mitchell, Leanne, *Theatre Librn,* University of Regina, Education/Fine Arts Library, Regina SK

Mitchell, Mark D, *Assoc Cur Nineteenth Century Art,* National Academy Museum & School of Fine Arts, New York NY

Mitchell, Mark D, *Assoc Cur Nineteenth Century Art,* National Academy Museum & School of Fine Arts, Archives, New York NY

Mitchell, Nancy, *Instr,* Sinclair Community College, Division of Fine & Performing Arts, Dayton OH (S)

Mitchell, Shannon, *Instr,* University of Arkansas, Art Dept, Fayetteville AR (S)

Mitchell, Starr, *Educ Coordr,* Historic Arkansas Museum, Little Rock AR

Mitchell, Starr, *Educ Coordr,* Historic Arkansas Museum, Library, Little Rock AR

Mitchell, Suzanne, *Prof Emeritus,* University of Louisville, Allen R Hite Art Institute, Louisville KY (S)

Mitchell, Teresa, *Mus Mgr,* Lac du Flambeau Band of Lake Superior Chippewa Indians, George W Brown Jr Ojibwe Museum & Cultural Center, Lac du Flambeau WI

Mitenberg, Valerie, *Information Access,* State University of New York at New Paltz, Sojourner Truth Library, New Paltz NY

Mitsanas, D, *Instr,* Humboldt State University, College of Arts & Humanities, Arcata CA (S)

Mittanthal, Cherie, *Dir,* Truro Center for the Arts at Castle Hill, Inc, Truro MA (S)

Mittelstaedt, Lilah J, *Reference Librn,* Philadelphia Museum of Art, Library, Philadelphia PA

Mitten, Patrick, *Instr,* Milwaukee Area Technical College, Graphic Arts Div, Milwaukee WI (S)

Mitton, Maureen, *Asst Prof,* University of Wisconsin-Stout, Dept of Art & Design, Menomonie WI (S)

Mixon, Jamie, *Prof,* Mississippi State University, Dept of Art, Mississippi State MS (S)

Miyagawa, Haruyo, *Head Librn,* Birmingham Public Library, Arts, Literature & Sports Department, Birmingham AL

Miyahara, Tami, *Gallery Asst,* Gallery 312, Chicago IL

Miyata, Masako, *Prof,* James Madison University, School of Art & Art History, Harrisonburg VA (S)

Miyata, Wayne A, *Faculty,* Kauai Community College, Dept of Art, Lihue HI (S)

Moak, Mark, *Chmn,* Rocky Mountain College, Art Dept, Billings MT (S)

Moats, Tamara, *Dir Educ,* Henry Gallery Association, Henry Art Gallery, Seattle WA

Moberg, David, *Chmn Fine Arts,* Indian River Community College, Fine Arts Dept, Fort Pierce FL (S)

Moberly, Juanita, *Gallery Mgr,* Brown County Art Gallery Foundation, Brown County Art Gallery & Foundation, Nashville IN

Mobley, Ree, *Librn,* Museum of New Mexico, Museum of International Folk Art, Santa Fe NM

Mobley, Ree, *Librn,* Museum of New Mexico, Library, Santa Fe NM

Modica, Lee, *Arts Adminr,* Florida Department of State, Division of Cultural Affairs, Florida Arts Council, Tallahassee FL

Moe, Richard, *Pres,* National Trust for Historic Preservation, Washington DC

Moeller, Gary E, *Dir,* Rogers State College, Art Dept, Claremore OK (S)

Moffat, Constance, *Prof,* Pierce College, Art Dept, Woodland Hills CA (S)

Moffatt, Laurie Norton, *Dir,* Norman Rockwell Museum, Stockbridge MA

Moffit, Judy, *Art Hist Instr,* Grand Canyon University, Art Dept, Phoenix AZ (S)

Mofford, Juliet, *Dir Educ & Re,* Andover Historical Society, Andover MA

Mohan, Rahjee, *Adjunct Assoc Prof Art Hist,* Johnson County Community College, Visual Arts Program, Overland Park KS (S)

Mohar, Karen, *Asst Librn,* Lourdes College, Duns Scotus Library, Sylvania OH

Mohr, Cynthia, *Assoc Prof Interior Design,* University of North Texas, School of Visual Arts, Denton TX (S)

Mohsin, Mohammad, *Gallery Dir,* Saint John's University, Dept of Fine Arts, Jamaica NY (S)

Mohsin, Parvez, *Dir Gallery,* Saint John's University, Chung-Cheng Art Gallery, Jamaica NY

Moir, Lindsay, *Librn,* Glenbow Museum, Library, Calgary AB

Mokren, Jennifer, *Asst Prof,* University of Wisconsin-Green Bay, Arts Dept, Green Bay WI (S)

Moldenhauer, Richard, *Business Mgr,* Mendel Art Gallery & Civic Conservatory, Saskatoon SK

Moldenhauer, Susan, *Dir & Chief Cur,* University of Wyoming, University of Wyoming Art Museum, Laramie WY

Moldwin, Jennifer L S, *Library Consultant,* Detroit Institute of Arts, Research Library, Detroit MI

Molen, Jan, *Chmn & Dir,* Napa Valley College, Art Dept, Napa CA (S)

Moles, Kathleen, *Cur Art,* Whatcom Museum of History and Art, Library, Bellingham WA

Moleski, Charles, *Prog Mgr,* Fairmount Park Art Association, Philadelphia PA

Molesworth, Kris, *Exec Dir,* Museum of Northwest Art, La Conner WA

Molife, Brenda, *Asst Prof,* Bridgewater State College, Art Dept, Bridgewater MA (S)

Molina, Samuel B, *Prof,* George Washington University, Dept of Art, Washington DC (S)

Molinard, Stephanie, *Educator,* Brandeis University, Rose Art Museum, Waltham MA

Mollenkamp, Stewart, *VPres,* Atlanta College of Art, Atlanta GA (S)

Mollett, David, *Asst Prof,* University of Alaska-Fairbanks, Dept of Art, Fairbanks AK (S)

Mollner, Allison, *Dir Mktg,* Bellevue Art Museum, Bellevue WA

Mollo, Arlene, *Chmn Art Educ,* University of Massachusetts Dartmouth, College of Visual & Performing Arts, North Dartmouth MA (S)

Molloy, Bryan, *Gallery Asst,* Art Association of Harrisburg, School & Galleries, Harrisburg PA

Molloy, Erin, *Dir Mktg,* Palm Beach County Parks & Recreation Department, Morikami Museum & Japanese Gardens, Delray Beach FL

Molnar, Margaret, *Cur Registrar,* Montclair Art Museum, Montclair NJ

Molnar, Mike, *Instr,* Luzerne County Community College, Commercial Art Dept, Nanticoke PA (S)

Molner, Frank, *Instr,* Santa Ana College, Art Dept, Santa Ana CA (S)

Moloney, Katherine, *Visual Arts Coordr,* Amon Carter Library, Fort Worth TX

Moltke-Hansen, David, *Pres,* Historical Society of Pennsylvania, Philadelphia PA

Momim, Shamim, *Branch Dir,* Philip Morris & Assoc Cur, Whitney Museum of American Art, New York NY

Momin, Shamin, *Branch Dir,* Whitney Museum of American Art, Whitney Museum at Altria, New York NY

Monaco, Amy, *Pres,* Allegany County Historical Society, Gordon-Roberts House, Cumberland MD

Monaco, Theresa, *Chmn Art Dept,* Emmanuel College, Art Dept, Boston MA (S)

Moncur, Shannon, *Chmn,* Moncur Gallery, Boissevain MB

Monge-Rafuls, Pedro, *Exec Dir,* Ollantay Center for the Arts, Jackson Heights NY

Monk, Deidre, University of Wisconsin-Eau Claire, Dept of Art, Eau Claire WI (S)

Monk, Richard, *Coll Mgr (Sciences) & Cur of Coll (Sciences),* Texas Tech University, Museum of Texas Tech University, Lubbock TX

Monk, Suny, *Dir,* Virginia Center for the Creative Arts, Camp Gallery, Sweet Briar VA

Monkhouse, Christopher, *Cur Decorative Arts,* Minneapolis Institute of Arts, Minneapolis MN

Monroe, Arthur, *Registrar Art,* Oakland Museum of California, Art Dept, Oakland CA

Monroe, Dan L, *Exec Dir,* Peabody Essex Museum, Salem MA

Monroe, Dan L, *Exec Dir,* Peabody Essex Museum, Cotting-Smith-Assembly House, Salem MA

Monroe, Dimitri, *Mus Shop Mgr,* California African-American Museum, Los Angeles CA

Monroe, Gary, *Prof,* Daytona Beach Community College, Dept of Fine Arts & Visual Arts, Daytona Beach FL (S)

Monroe, Mark, *Chair,* Austin College, Ida Green Gallery, Sherman TX

Monroe, Mark, *Prof,* Austin College, Art Dept, Sherman TX (S)

Monroe, Rose, *Chmn,* Baltimore City Community College, Dept of Fine Arts, Baltimore MD (S)

Monson, Richard D, *Prof,* Central Missouri State University, Art Dept, Warrensburg MO (S)

Montag, Ann, *Finance Mgr,* Shaker Museum & Library, Old Chatham NY

Montaluo, Emmanuel, *Advertising Publicity,* Illustration House Inc, Gallery Auction House, New York NY

Monteith, Jerry, *Assoc Prof & Studio Area Head,* Southern Illinois University, School of Art & Design, Carbondale IL (S)

Montera, Melissa, *Dir Special Events,* Caramoor Center for Music & the Arts, Inc, Caramoor House Museum, Katonah NY

Montes, Chemi, American University, Dept of Art, Washington DC (S)

Monteyne, Joseph, *Asst Prof,* State University of New York at Stony Brook, Dept of College of Arts & Sciences, Art Dept, Stony Brook NY (S)

Montgomery, Alexandra, *Exec Dir,* George R Gardiner, Toronto ON

Montgomery, Charlotte A, *CFO,* Illinois State Museum, Museum Store, Chicago IL

Montgomery, D Bruce, *VPres,* Sandwich Historical Society, Center Sandwich NH

Montgomery, Edward, *Prof,* Miami University, Dept Fine Arts, Hamilton OH (S)

Montgomery, Florence, *Pres,* Bromfield Art Gallery, Boston MA

Montgomery, Janet, *Instr,* Appalachian State University, Dept of Art, Boone NC (S)

Montgomery, Matthew, *Pub Relations,* Rhode Island School of Design, Museum of Art, Providence RI

Montgomery, Scott, *Asst Prof Art History,* University of Denver, School of Art & Art History, Denver CO (S)

Montgomery, Susan, *Adjunct Faculty,* Mount Wachusett Community College, East Wing Gallery, Gardner MA

Montijo, Mark, *Cur,* Maritime Museum of San Diego, San Diego CA

Montileaux, Paulette, *Cur,* Indian Arts & Crafts Board, US Dept of the Interior, Sioux Indian Museum, Rapid City ND

Montley, Pat, *Chmn,* Chatham College, Fine & Performing Arts, Pittsburgh PA (S)

Montour, Michelle, *Admin Asst,* Museo De Las Americas, Denver CO

Montoya, Malaquias, University of California, Davis, Dept of Art & Art History, Davis CA (S)

Moodie, Kathleen, *Dir Exhib,* Museum of Art & History, Santa Cruz, Santa Cruz CA

Moodie, Laurie, *Dir,* Simon Fraser University, Simon Fraser Gallery, Burnaby BC

Moody, Dianna, *Educ,* Huronia Museum, Gallery of Historic Huronia, Midland ON

Moody, Larrie J, *Chairperson,* Pittsburg State University, Art Dept, Pittsburg KS (S)

Moody, Marge, *Asst Prof,* Winthrop University, Dept of Art & Design, Rock Hill SC (S)

Moody, Phil, *Assoc Prof,* Winthrop University, Dept of Art & Design, Rock Hill SC (S)

Moon, Bruce, *Prof,* Mount Mary College, Art & Design Division, Milwaukee WI (S)

Mooney, Allen, *Asst Prof,* State University of New York, College at Cortland, Dept Art & Art History, Cortland NY (S)

Mooney, Tom, *Archivist & Cur,* Cherokee Heritage Center, Library & Archives, Tahlequah OK

Mooney, Wanda, *Admin Staff Specialist,* Memorial University of Newfoundland, Art Gallery of Newfoundland & Labrador, Saint John's NF

Moonie, Liana, *Co-Pres,* Greenwich Art Society Inc, Greenwich CT

Moore, Carol, *Coordr Grad Prog,* University of the Arts, Philadelphia Colleges of Art & Design, Performing Arts & Media & Communication, Philadelphia PA (S)

Moore, Connie, *Graphic Design,* Art Institute of Pittsburgh, Pittsburgh PA (S)

Moore, Craig, *Assoc Prof,* Taylor University, Visual Art Dept, Upland IN (S)

Moore, Daryl, *Chmn Art Dept,* Montclair State University, Art Galleries, Upper Montclair NJ

Moore, David G, *Adjunct Asst Prof,* Le Moyne College, Fine Arts Dept, Syracuse NY (S)

Moore, Debbie, *Admin Asst,* Touchstone Center for Crafts, Farmington PA

Moore, Del, *Reference Librn,* Colonial Williamsburg Foundation, John D Rockefeller, Jr Library, Williamsburg VA

Moore, Donald Everett, *Chmn,* Mitchell Community College, Visual Art Dept, Statesville NC (S)

Moore, EC, *Financial Dir,* Menil Foundation, Inc, Houston TX

Moore, Elizabeth, *Asst Cur,* Telfair Museum of Art, Telfair Academy of Arts & Sciences Library, Savannah GA

Moore, Elizabeth, *Asst Prof,* Cazenovia College, Center for Art & Design Studies, Cazenovia NY (S)

Moore, Ellen, *Cur Educ,* Roswell Museum & Art Center, Roswell NM

Moore, Fay, *VPres,* The Allied Artists of America, Inc, New York NY

Moore, Gary, *Interim Dir,* Thomas Gilcrease, Gilcrease Museum, Tulsa OK

Moore, Heather, *Asst Registrar,* University of North Carolina at Greensboro, Weatherspoon Art Museum, Greensboro NC

Moore, James, *Dir,* Albuquerque Museum of Art & History, Albuquerque NM

Moore, Jennifer W, *Exec Dir,* Green Hill Center for North Carolina Art, Greensboro NC

Moore, John, *Asst Prof,* Smith College, Art Dept, Northampton MA (S)

Moore, John, *Chair,* University of Pennsylvania, Graduate School of Fine Arts, Philadelphia PA (S)

Moore, John, *Mgr Soc Independent Artists,* Archives of MOCA (Museum of Conceptual Art), San Francisco CA

Moore, Kemille, *Prof, Chmn,* University of North Carolina at Wilmington, Dept of Fine Arts - Division of Art, Wilmington NC (S)

Moore, Mae Frances, *Acquisition Librn,* Laney College Library, Art Section, Oakland CA

Moore, Marilyn, *Asst to Dir,* California State University, Fullerton, Art Gallery, Visual Arts Center, Fullerton CA

Moore, Mark, *Instr,* Oklahoma State University, Graphic Arts Dept, Visual Communications, Okmulgee OK (S)

Moore, Mary, *Dean,* Arkansas State University-Art Department, Jonesboro, Library, Jonesboro AR

Moore, Mary Lou, *Dir Gallery,* Rhode Island Watercolor Society, Pawtucket RI

Moore, Mary Ruth, *Lectr Photography,* University of Georgia, Franklin College of Arts & Sciences, Lamar Dodd School of Art, Athens GA (S)

Moore, Melodye, *Historic Site Mgr,* New York State Office of Parks, Recreation & Historical Preservation, Mills Mansion State Historical Site, Staatsburg NY

Moore, Phyliss, *Chmn Liberal Arts,* Kansas City Art Institute, Kansas City MO (S)

Moore, Rebecca, *Dir Communication,* North Carolina Museum of Art, Reference Library, Raleigh NC

Moore, Ross, *Mus Educator,* Kentucky Derby Museum, Louisville KY

Moore, Sandy, *Exec Asst,* Pyramid Hill Sculpture Park & Museum, Hamilton OH

Moore, Sarah, *Asst Prof Art History,* University of Arizona, Dept of Art, Tucson AZ (S)

Moore, Stanley, *Speech,* Henry Ford Community College, McKenzie Fine Art Ctr, Dearborn MI (S)

Moore, Susan, *Gallery & Exhib Dir & Instr,* Paris Junior College, Art Dept, Paris TX (S)

Moore, Sylvia, *Educ,* Midmarch Associates, Women Artists Archive and Library, New York NY

Moore, Thomas, *CEO & Dir,* African American Historical Museum & Cultural Center of Iowa, Cedar Rapids IA

Moore, Vicki, *Secy,* Zanesville Art Center, Zanesville OH

Moore, Viola, *Exec Dir,* Carson County Square House Museum, Panhandle TX

Moore, William, *Instr,* Pacific Northwest College of Art, Portland OR (S)

Moorehouse, Megan, *Studio Collaborator,* Dieu Donne Papermill, Inc, New York NY

Moorman, Evette, *Inst,* Grayson County College, Art Dept, Denison TX (S)

Moos, David, *Cur Painting & Sculpture,* Birmingham Museum of Art, Birmingham AL

Moos, Walter A, *Pres,* Gallery Moos Ltd, Toronto ON

Moose, Nancy, *Assoc Prof,* Dakota State University, College of Liberal Arts, Madison SD (S)

Moover, Lindsay, *Dir Visual Arts,* Arts Center of the Ozarks, Springdale AR

Moppett, George, *Asst Cur,* Mendel Art Gallery & Civic Conservatory, Saskatoon SK

Moppett, Ron, *Dir & Cur,* Alberta College of Art & Design, Illingworth Kerr Gallery, Calgary AB

Moralde, Jocelyn, *Coordr,* The Art Institute of Chicago, Teacher Resource Center, Chicago IL

Morales, Raymond, *Prof,* University of Utah, Dept of Art & Art History, Salt Lake City UT (S)

Morales, Reinaldo, *Asst Prof,* University of Central Arkansas, Department of Art, Conway AR (S)

Morales-Coll, Eduardo, *Pres,* Ateneo Puertorriqueno, Ateneo Gallery, San Juan PR

Morales-Coll, Eduardo, *Pres,* Ateneo Puertorriqueno, Library, San Juan PR

Moran, Barbara Fulton, *Interim Admin,* New Jersey State Museum, Fine Art Bureau, Trenton NJ

Moran, Diane D, *Prof,* Sweet Briar College, Art History Dept, Sweet Briar VA (S)

Moran, George F, *Treas,* National Hall of Fame for Famous American Indians, Anadarko OK

Moran, Jill, *Prog Specialist,* United States Department of the Interior, Indian Arts & Crafts Board, Washington DC

Moran, Joe, *Chmn Art Dept,* California State University, San Bernardino, San Bernardino CA

Moran, Joe, *Chmn Dept & Instr,* California State University, San Bernardino, Dept of Art, San Bernardino CA (S)

Moran, Kati, *Mus Shop Mgr,* Brooklyn Museum, Brooklyn NY

Moran, Lois, *Ed-in-Chief American Craft Magazine,* American Craft Council, New York NY

Moran, Nancy, *Pres,* Buckham Fine Arts Project, Gallery, Flint MI

Moran, Paula G, *Dir,* Summit County Historical Society, Akron OH

Moran, Susan, *Assoc Dean Students,* Corcoran School of Art, Washington DC (S)

Moran, Susan, *Dir Resource Center,* Art Institute of Pittsburgh, John P. Barclay Memorial Gallery, Pittsburgh PA

Morand, Anne, *Exec Dir & Cur,* C M Russell, Frederic G Renner Memorial Library, Great Falls MT

Morandi, Thomas, *Prof,* Oregon State University, Dept of Art, Corvallis OR (S)

Morash, Terrence, *Exec Dir,* Photographic Resource Center, Boston MA

Moreau, Robert, *Asst Prof,* Northwestern State University of Louisiana, School of Creative & Performing Arts - Dept of Fine & Graphic Arts, Natchitoches LA (S)

Morec, Marti, *Librn,* Berkeley Public Library, Berkeley CA

Morehouse, Dorothy V, *Pres, Dir & CEO,* Monmouth Museum & Cultural Center, Lincroft NJ

Morehouse, Nancy, *Dir Visitor Svcs,* Putnam Museum of History and Natural Science, Library, Davenport IA

Moreira, Dana D, *First VPres,* Mattatuck Historical Society, Mattatuck Museum, Waterbury CT

Morel, Sylvie, *Dir Exhib & Programs,* Canadian Museum of Civilization, Gatineau PQ

Morello, S.E., *Treas,* Buckham Fine Arts Project, Gallery, Flint MI

Morello, Sam, *Faculty Emeritus,* Mott Community College, Liberal Arts & Sciences, Flint MI (S)

Moren, Lisa, *Asst Prof,* University of Maryland, Baltimore County, Imaging, Digital & Visual Arts Dept, Baltimore MD (S)

Moreno, Barry, *Library Technician,* The National Park Service, United States Department of the Interior, Statue of Liberty National Monument & The Ellis Island Immigration Museum, New York NY

Moreno, Julie, *Dir Educ,* Museo De Las Americas, Denver CO

Moreno, Laura, *Deputy Dir,* Caribbean Cultural Center, Cultural Arts Organization & Resource Center, New York NY

Moreno, Mario, *Instr,* San Joaquin Delta College, Art Dept, Stockton CA (S)

Morey, Gina, *Dir Prog & Educ,* Anniston Museum of Natural History, Anniston AL

Morfeld, Courtney, *Coll Mgr,* Amon Carter, Fort Worth TX

Morgan, Barbara, *Coordr Public Information,* State University of New York at Purchase, Neuberger Museum of Art, Purchase NY

Morgan, Dahlia, *Dir,* Florida International University, The Art Museum at FIU, Miami FL

Morgan, Dave, *Cur Coll,* Museum of Mobile, Mobile AL

Morgan, David, *Asst Prof,* University of Wisconsin-Stout, Dept of Art & Design, Menomonie WI (S)

Morgan, Donna, *Adjunct Instr,* Davis & Elkins College, Dept of Art, Elkins WV (S)

Morgan, Elizabeth L, *Assoc Dir Planning & Develop,* Reynolda House Museum of American Art, Winston Salem NC

Morgan, Ellen, *Exec Dir,* Association of Community Arts Agencies of Kansas, Salina KS

Morgan, Jeremy, *Exec Dir,* Saskatchewan Arts Board, Regina SK

Morgan, Kenn, *Photog Teacher,* Locust Street Neighborhood Art Classes, Inc, Buffalo NY (S)

Morgan, Kenneth, *Assoc Prof Studio Art,* Bethany College, Dept of Fine Arts, Bethany WV (S)

Morgan, Laura, *Serials/Architecture,* Chicago Public Library, Harold Washington Library Center, Chicago IL

Morgan, Linda D, *Librn,* University of South Carolina, Slide Library, Columbia SC

Morgan, M, *Instr,* Humboldt State University, College of Arts & Humanities, Arcata CA (S)

Morgan, Mathew, *Information System,* Brooklyn Museum, Brooklyn NY

Morgan, Melissa, *Cur Educ,* Mobile Museum of Art, Mobile AL

Morgan, Patty, *VPres,* Susquehanna Art Museum, Home of Doshi Center for Contemporary Art, Harrisburg PA

Morgan, William, *Prof,* University of Wisconsin-Superior, Programs in the Visual Arts, Superior WI (S)

Morgan, William, *Prof Emeritus,* University of Louisville, Allen R Hite Art Institute, Louisville KY (S)

Morgano, Stephanie, *Pres,* Trenton City Museum, Trenton NJ

Moriarty, John, *Instr,* Springfield College, Dept of Visual & Performing Arts, Springfield MA (S)

Morice, Kit, *Cur Educ,* Eastern Illinois University, Tarble Arts Center, Charleston IL

Morin, Faye, *Palm Beach County Parks & Recreation Department, Morikami Museum & Japanese Gardens, Delray Beach FL

Morin, Mark, *Treas,* Westfield Athenaeum, Jasper Rand Art Museum, Westfield MA

Morin, Suzanne, *Archivist,* McCord Museum of Canadian History, Montreal PQ

Morin, Virginia E, *Dir,* Portsmouth Historical Society, John Paul Jones House, Portsmouth NH

Morita, Linda, *Librn & Archivist,* McMichael Canadian Art Collection, Library & Archives, Kleinburg ON

Morlan, Jenny, *Asst Prof,* DePaul University, Dept of Art, Chicago IL (S)

Morley, Janet, *Fashion Merchandising Prog Dir,* Brenau University, Art & Design Dept, Gainesville GA (S)

Morley, Stephen H, *Dir,* Academy of the New Church, Glencairn Museum, Bryn Athyn PA

Morningstar, William, *Assoc Prof,* Berea College, Art Dept, Berea KY (S)

Morphy, Richard, *Dir,* Minnesota Historical Society, Library, Saint Paul MN

Morr, Lynell, *Dir,* Center for Creative Studies, College of Art & Design Library, Detroit MI

Morrell, John, *Asst Prof,* Georgetown University, Dept of Art, Music & Theatre, Washington DC (S)

Morrelli, William P, *VPres,* Tennessee Historical Society, Nashville TN

Morrill, Michael, *Assoc Prof,* University of Pittsburgh, Dept of Studio Arts, Pittsburgh PA (S)

Morrin, Peter, *Adjunct Assoc Prof,* University of Louisville, Allen R Hite Art Institute, Louisville KY (S)

Morrin, Peter, *Dir,* Speed Art Museum, Louisville KY

Morris, Amy, *Instr,* Wittenberg University, Art Dept, Springfield OH (S)

Morris, Anne O, *Head Librn,* Toledo Museum of Art, Library, Toledo OH

Morris, Curtis, *Exhib Designer,* City of Springdale, Shiloh Museum of Ozark History, Springdale AR

Morris, Fae, *Circ,* J T & E J Crumbaugh, Le Roy IL

Morris, James, *Assoc Prof,* State University of New York College at Brockport, Dept of Art, Brockport NY (S)

Morris, Jerry W, *Chmn,* Miami University, Art Dept, Oxford OH (S)

Morris, Joella, *Pres Emeritus,* Museum of Southern History, Sugarland TX

Morris, Katherine, *Asst Prof,* Santa Clara University, Dept of Art & Art History, Santa Clara CA (S)

Morris, Paul, *Dir Pub Information & Literature,* Arizona Commission on the Arts, Phoenix AZ

Morris, Stuart, *Asst Prof,* University of Wisconsin-Stevens Point, Dept of Art & Design, Stevens Point WI (S)

Morris, Terry, *Chmn of Bd,* North Country Museum of Arts, Park Rapids MN

Morris, W S, *Chmn & CEO,* Morris Communications Co. LLC, Corporate Collection, Augusta GA

Morrisey, Bob, *Prof,* Polk Community College, Art, Letters & Social Sciences, Winter Haven FL (S)

Morrisey, Marena Grant, *Exec Dir,* Orlando Museum of Art, Orlando FL

Morrisey, Marena Grant, *Exec Dir,* Orlando Museum of Art, Orlando Sentinel Library, Orlando FL

Morrison, Cindi, *Dir,* Lancaster Museum of Art, Lancaster PA

Morrison, Darrin, *Project Mgr Conservation,* University of British Columbia, Museum of Anthropology, Vancouver BC

Morrison, Ian, *Asst Prof Art, Chair,* Grand Canyon University, Art Dept, Phoenix AZ (S)

Morrison, Ken, *Thesis Advisor,* Toronto Art Therapy Institute, Toronto ON (S)

Morrison, Patrick, *Educ,* Pennsylvania Historical & Museum Commission, Railroad Museum of Pennsylvania, Harrisburg PA

Morrison, Rosalyn, *Exec Dir,* Ontario Crafts Council, The Craft Gallery, Toronto ON

Morrison, Shelby, *Sales & Mktg,* City of Lubbock, Buddy Holly Center, Lubbock TX

Morrison, Stephen, *VPres,* Columbia Museum of Art, Columbia SC

Morrison, Susan, *Prof,* University of Wisconsin-Stevens Point, Dept of Art & Design, Stevens Point WI (S)

Morrisroe, Julia, *Dir,* Central Michigan University, University Art Gallery, Mount Pleasant MI

Morrissey, Fae, *Museum Aid,* Newton History Museum at the Jackson Homestead, Newton MA

Morrissey, Jennifer, *Publ Relations Officer,* Museum of Contemporary Art, San Diego-Downtown, La Jolla CA

Morrissey, T, *Instr,* Community College of Rhode Island, Dept of Art, Warwick RI (S)

Morrissey, Tom, *Dir & Librn,* Community College of Rhode Island, Flanagan Valley Campus Art Gallery, Warwick RI

Morrone, Robert, *Dir Operations,* Philadelphia Museum of Art, Samuel S Fleisher Art Memorial, Philadelphia PA

Morrow, Delores, *Photograph Cur,* Montana Historical Society, Library, Helena MT

Morrow, Frances, *Assoc Dir,* Alexandria Museum of Art, Alexandria LA

Morrow, Hal, *Pres Bd,* Brownsville Art League, Brownsville Museum of Fine Art, Brownsville TX

Morrow, Lisa, *Visual Cur,* Center for Creative Studies, College of Art & Design Library, Detroit MI

Morrow, Terry, *Prof,* Texas Tech University, Dept of Art, Lubbock TX (S)

Morscheck, Charles, *Dir,* The Museum at Drexel University, Philadelphia PA

Morscheck, Charles, *Prof Art History,* Drexel University, College of Media Arts & Design, Philadelphia PA (S)

Morse, Bart, *Assoc Prof,* University of Arizona, Dept of Art, Tucson AZ (S)

Morse, William, *Asst Prof Art,* Belhaven College, Art Dept, Jackson MS (S)

Morse Majewski, Sally, *Contact Person,* Sterling & Francine Clark, Williamstown MA

Mortensen, Loring, *Pub & Community Relations,* University of North Carolina at Greensboro, Weatherspoon Art Museum, Greensboro NC

Mortimore, Carol, *Gallery Dir,* North Shore Arts Association, Inc, Gloucester MA

Morton, Christopher, *Registrar,* New York State Military Museum and Veterans Research Center, Saratoga Springs NY

Morton, Janet, *Instr,* Toronto School of Art, Toronto ON (S)

Morton, Jean Pell, *Staff,* Gallery 9, Los Altos CA

Morton, Lisa, *Gallery Dir,* Durham Art Guild Inc, Durham NC

Mosby, Dewey F, *Dir,* Colgate University, Picker Art Gallery, Hamilton NY

Moscardini, Gina, *Mus Shop Mgr.,* The Bartlett Museum, Amesbury MA

Moscarillo, Mark, *Assoc Prof,* State University of New York at Farmingdale, Visual Communications, Farmingdale NY (S)

Moseley, Bill, *Prof,* University of Maine at Augusta, College of Arts & Humanities, Augusta ME (S)

Mosena, David, *Pres & CEO,* Museum of Science & Industry, Chicago IL

Moser, Ken, *Vice Dir Coll & Chief Conservator,* Brooklyn Museum, Brooklyn NY

Moser, Kenneth, *Chief Conservator,* Brooklyn Museum, Brooklyn NY

Moser, Nikki, *Instr,* Keystone College, Fine Arts Dept, LaPlume PA (S)

Moser, Suzy, *Asst VPres Advancement,* The Huntington Library, Art Collections & Botanical Gardens, Library, San Marino CA

Moses, H. Vincent, *Dir Mus,* Riverside Municipal Museum, Riverside CA

Moses, Jennifer, *Asst Prof,* University of New Hampshire, Dept of Arts & Art History, Durham NH (S)

Mosher, Laverne, *Prof,* Mesa State College, Art Dept, Grand Junction CO (S)

Mosher, Mike, *Asst Prof,* Saginaw Valley State University, Dept of Art & Design, University Center MI (S)

Mosher, Ted, *Pres,* High Wire Gallery, Philadelphia PA

Moshier, Wendy, *Dir Community Develop,* Salina Art Center, Salina KS

Mosier, Joe, *Archivist,* Chrysler Museum of Art, Jean Outland Chrysler Library, Norfolk VA

Moskowitz, Anita, *Prof,* State University of New York at Stony Brook, Dept of College of Arts & Sciences, Art Dept, Stony Brook NY (S)

Moskowitz, Herb, *Chief Registrar,* The Metropolitan Museum of Art, New York NY

Moskowitz, Mollie, *Admin Asst,* Queens College, City University of New York, Queens College Art Center, Flushing NY

Moskowitz, Mollie, *Admin Asst,* Queens College, City University of New York, Art Library, Flushing NY

Mosley, Joshua, *Asst Prof,* University of Pennsylvania, Graduate School of Fine Arts, Philadelphia PA (S)

Mosley, Kim, *Prof,* Saint Louis Community College at Florissant Valley, Liberal Arts Division, Ferguson MO (S)

Mosley, Leigh, *Accounting Clerk,* Contemporary Arts Center, Cincinnati OH

Moss, Barbara Lee, *Dir,* Heritage Museum Association, Inc, The Heritage Museum of Northwest Florida, Valparaiso FL

Moss, David, *Exec Dir,* Saidye Bronfman, Liane & Danny Taran Gallery, Montreal PQ

Moss, Gilian, *Cur Textiles,* Cooper-Hewitt, National Design Museum, Smithsonian Institution, New York NY

Moss, Karen, *Dir Gallery,* San Francisco Art Institute, Galleries, San Francisco CA

Moss, Kenneth, *Dir,* Morris-Jumel Mansion, Inc, New York NY

Moss, Kent, *Instr,* Midland College, Art Dept, Midland TX (S)

Moss, Marcia H., *Deputy Dir External Rels,* Albany Institute of History & Art, Albany NY

Moss, Nina, *Asst to Dir,* Mississippi Museum of Art, Howorth Library, Jackson MS

Moss, Rick, *History Program Mgr,* California African-American Museum, Los Angeles CA

Moss, Roger W, *Dir,* Athenaeum of Philadelphia, Philadelphia PA

Moss, Sedgwick, *Ranger,* Bluemont Historical Railroad Junction, Arlington VA

Mossaides Strassfield, Christina, *Cur,* Guild Hall of East Hampton, Inc, Guild Hall Museum, East Hampton NY

Mossgraber, Jim, *Dir Develop,* Genesee Country Village & Museum, John L Wehle Gallery of Wildlife & Sporting Art, Mumford NY

Moster, Hilary, *Exec Dir,* Maude Kerns Art Center, Eugene OR

Motes, J Barry, *Coordr Fine Arts,* Jefferson Community College, Fine Arts, Louisville KY (S)

Motley, Anne, *Librn,* Colonial Williamsburg Foundation, Abby Aldrich Rockefeller Folk Art Center Library, Williamsburg VA

Mott, Rebecca, *Assoc Prof,* West Shore Community College, Division of Humanities & Fine Arts, Scottville MI (S)

Mott, Sarah, *Instr,* Dean College, Visual Art Dept, Franklin MA (S)

Mottern III, Robert E, *Asst VPres,* Brookgreen Gardens, Murrells Inlet SC

Motto, Brian, *Pres,* Maui Historical Society, Bailey House, Wailuku HI

Mottram, Ron, *Chmn,* Illinois State University, Art Dept, Normal IL (S)

Motts, Wayne E, *Exec Dir,* Adams County Historical Society, Gettysburg PA

Moudry, Mary Lou, *Exec Dir,* Crow Wing County Historical Society, Brainerd MN

Moulton, Dana, *Supv Bldgs,* Old York Historical Society, Elizabeth Perkins House, York ME

Moulton, Robert, *Assoc Prof,* Illinois Central College, Dept Fine, Performing & Applied Arts, East Peoria IL (S)

Moultrie, Cynthia, *COO,* African American Museum in Philadelphia, Philadelphia PA

Mounger, Becky, *Instr,* Oklahoma State University, Graphic Arts Dept, Visual Communications, Okmulgee OK (S)

Mountain, Michele, *Mktg Mgr,* Museum of Northern Arizona, Flagstaff AZ

Moura-Ona, Sylvia, *Asst Dir,* Miami-Dade Public Library, Miami FL

Mouton, Alexander, *Asst Prof,* Denison University, Dept of Art, Granville OH (S)

Mouw, Doug, *Merchandising Mgr,* Portland Art Museum, Northwest Film Center, Portland OR

Mowder, William, *Dean,* Kutztown University, College of Visual & Performing Arts, Kutztown PA (S)

Mowers, Charlene Donchez, *Exec Dir,* Historic Bethlehem Partnership, Kemerer Museum of Decorative Arts, Bethlehem PA

Moxley, Elizabeth, *Dir & Custodian Holdings,* National Archives of Canada, Art & Photography Archives, Ottawa ON

Moxley, Richard W, *Exec Dir,* Agecroft Association, Agecroft Hall, Richmond VA

Moxley, Richard W, *Exec Dir,* Agecroft Association, Museum, Richmond VA

Moyer, Darlene E, *Asst Dir,* Pennsylvania German Cultural Heritage Center at Kutztown University, Pennsylvania German Heritage Library, Kutztown PA

Moyer, Nancy, *Chmn Dept,* University of Texas Pan American, Art Dept, Edinburg TX (S)

Moyers, Michael, *Assoc Dean,* Yuba College, Fine Arts Division, Marysville CA (S)

Moyhahan, Karen P, *Assoc Dir,* National Association of Schools of Art & Design, Reston VA

Moynahan, Alberta, *Asst Dir,* McDowell House & Apothecary Shop, Danville KY

Mroczkowski, Dennis, *Dir,* Headquarters Fort Monroe, Dept of Army, Casemate Museum, Fort Monroe VA

Mudd, Douglas, *Museum Cur,* American Numismatic Association, Money Museum, Colorado Springs CO

Mudd, Jane, *Instr,* William Woods-Westminster Colleges, Art Dept, Fulton MO (S)

Mudd, Michael, *Dir,* Huntington Beach Art Center, Huntington Beach CA

Mudd, Peter, *Exec Dir,* C G Jung, Evanston IL

Mudrinich, David, *Asst Prof,* Arkansas Tech University, Dept of Art, Russellville AR (S)

Muehlemann, Kathy, *Acting Chmn,* Randolph-Macon Woman's College, Dept of Art, Lynchburg VA (S)

Muehlig, Linda, *Cur Paintings & Sculpture,* Smith College, Museum of Art, Northampton MA

Mueller, Barbara, *Pres,* Glynn Art Association, Saint Simons Island GA

Mueller, Carlyn, *Dir Mktg,* Museum for African Art, Long Island City NY

Mueller, Jo, *Exec Dir,* George A Spiva, Joplin MO

Mueller, John, *Exec Dir,* McAllen International Museum, McAllen TX

Mueller, John C, *Prof,* University of Detroit Mercy, School of Architecture, Detroit MI (S)

Mueller, Judith, *Registrar,* African American Museum in Philadelphia, Philadelphia PA

Mueller, Lyn, *Instr,* Wayne Art Center, Wayne PA (S)

Mueller, Margaret, *Librn,* Riverside County Museum, Library, Cherry Valley CA

Mueller, Marion, *VP Office Mgmt,* DuPage Art League School & Gallery, Wheaton IL

Mueller, Marlene, *Prof,* Wayne State College, Nordstrand Visual Arts Gallery, Wayne NE

Mueller, Marlene, *Prof,* Wayne State College, Dept Art & Design, Wayne NE (S)

Mueller, Mitzi, *Mus Serv Coordr,* Paine Art Center & Gardens, Oshkosh WI

Mueller, Robert, *Asst Prof,* University of Florida, Dept of Art, Gainesville FL (S)

Mugavero, C J, *Owner,* The Artful Deposit, Inc., Bordentown City NJ

Muggeridge, Rosalind, *Pub Relations,* Abigail Adams Smith, New York NY

Muhlbauer, Mic, *Asst Prof,* Eastern New Mexico University, Dept of Art, Portales NM (S)

Muhn, B G, *Assoc Prof,* Georgetown University, Dept of Art, Music & Theatre, Washington DC (S)

Muhsam, Armin, *Asst Prof,* Northwest Missouri State University, Dept of Art, Maryville MO (S)

Muir, Tom, *Museum Adminr,* Historic Pensacola Preservation Board, T.T. Wentworth Jr. Florida State Museum, Pensacola FL

Muka, Cheryl L H, *Chief Adminr & Human Resources Assoc,* Cornell University, Herbert F Johnson Museum of Art, Ithaca NY

Mukerji, Alka, *Asst Prof,* Manhattanville College, Brownson Gallery, Purchase NY

Mulcahey, Fran, *Cur Educ,* Museum of Art, Fort Lauderdale, Fort Lauderdale FL

Mulcahy, Fran, *Cur Educ,* Museum of Art, Fort Lauderdale, Library, Fort Lauderdale FL

Muldavin, Phyllis, *Instr,* Los Angeles City College, Dept of Art, Los Angeles CA (S)

Mulder, Bruce, *Chmn Design Studies,* Kendall College of Art & Design, Grand Rapids MI (S)

Mulford, Hansen, *Cur,* Orlando Museum of Art, Orlando FL

Mulford, Hansen, *Cur,* Orlando Museum of Art, Orlando Sentinel Library, Orlando FL

Mulgrew, John, *Chmn,* Pace University, Dyson College of Arts & Sciences, Pleasantville NY (S)

Mulgrew, John, *Dept Chair,* Pace University Gallery, Art Gallery in Choate House, Pleasantville NY

Mulhollan, Daniel P, *Dir Congressional,* Library of Congress, Prints & Photographs Division, Washington DC

Mulhollen, Jack, *Instr,* Cuyahoga Valley Art Center, Cuyahoga Falls OH (S)

Mulkey, Elly, *Treas/Sec,* Roswell Museum & Art Center, Roswell NM

Mullan, Patricia, *Head Reference,* Berkeley Public Library, Berkeley CA

Mullen, Denise, *Chmn,* Jersey City State College, Art Dept, Jersey City NJ (S)

Mullen, Jim, *Prof,* Bowdoin College, Art Dept, Brunswick ME (S)

Mullen, John, *Dir Finance,* Henry Gallery Association, Henry Art Gallery, Seattle WA

Mullen, Karen, *Cur Educ,* Laumeier Sculpture Park, Saint Louis MO

Mullen, Ruth, *Librn,* Reynolda House Museum of American Art, Library, Winston Salem NC

Muller, Arlene, *Gift Shop Mgr,* Eccles Community Art Center, Ogden UT

Muller, Debra, *Asst to Dir,* Eccles Community Art Center, Ogden UT

Muller, Dena, *Dir,* A I R Gallery, New York NY

Muller, Sheila, *Prof,* University of Utah, Dept of Art & Art History, Salt Lake City UT (S)

Muller, William, *VPres,* Society of American Historical Artists, Oyster Bay NY

Mulligan, Therese, *Cur Photography,* George Eastman, Library, Rochester NY

Mullineaux, Connie, *Chairperson,* Edinboro University of Pennsylvania, Art Dept, Edinboro PA (S)

Mullings, Ted, *VPres,* Lake County Civic Center Association, Inc, Heritage Museum & Gallery, Leadville CO

Mullins, Barbara, *CFO,* Memphis Brooks Museum of Art, Memphis TN

Mullins, Kevin, *Cur Exhibs,* Wichita State University, Ulrich Museum of Art & Martin H Bush Outdoor Sculpture Collection, Wichita KS

Mullins, Kira, *Develop Asst,* Ellen Noel Art Museum of the Permian Basin, Odessa TX

Mullis, Connie, *Pres Commission Bd,* Drew County Historical Society, Museum, Monticello AR

Mulvaney, James F., *Chmn,* Mingei International, Inc, Mingei International Museum, San Diego CA

Mulvaney, Rebecca, *Dir Galleries,* Northern State University, Northern Galleries, Aberdeen SD

Muncaster, Ian, *Treas,* Art Dealers Association of Canada, Toronto ON

Mundy, James, *Dir,* Vassar College, The Frances Lehman Loeb Art Center, Poughkeepsie NY

Munger, Kari, *Head Librn,* Canajoharie Library & Art Gallery, Arkell Museum of Canajoharie, Canajoharie NY

Muniz, Carleen, *Treas,* North Shore Arts Association, Inc, Gloucester MA

Munns, Judith, *Cur,* Skagway City Museum & Archives, Skagway AK

Munns, Lynn R, *Div Head,* Casper College, Dept of Visual Arts, Casper WY (S)

Muno, Ed, *Coll Cur,* National Cowboy & Western Heritage Museum, Oklahoma City OK

Munoz, Martha, *Admin Asst,* Billie Trimble Chandler, Asian Cultures Museum & Educational Center, Corpus Christi TX

Munoz, Teresa, *Prof,* Loyola Marymount University, Dept of Art & Art History, Los Angeles CA (S)

Munro, Eleanor, *Instr, Memoir,* Truro Center for the Arts at Castle Hill, Inc, Truro MA (S)

Munro, Gale, *Art Coll Cur,* Naval Historical Center, The Navy Museum, Washington DC

Munro, Gale, *Cur,* United States Navy, Art Gallery, Washington DC

Munro, Hilary, *Head Adult Servs,* Medicine Hat Public Library, Medicine Hat AB

Munsch, Anne, *CFO,* Columbus Museum of Art and Design, Indianapolis IN

Murad, Andrew, *Coordr,* McLennan Community College, Visual Arts Dept, Waco TX (S)

Murano, David, *Dir Gallery,* Wichita Center for the Arts, Mary R Koch Sch of Visual Arts, Wichita KS (S)

Murawski, Alex, *Asst Prof Graphic Design,* University of Georgia, Franklin College of Arts & Sciences, Lamar Dodd School of Art, Athens GA (S)

Murback, Mitch, *Prof Chmn,* DePauw University, Art Dept, Greencastle IN (S)

Murch, Anna Valentina, *Assoc Prof,* Mills College, Art Dept, Oakland CA (S)

Murchinson, Alex, *Prog Unit Coordr,* Holland College, Media & Communications Dept, Charlottetown PE (S)

Murden, Steven H, *Part-time Archivist,* Virginia Museum of Fine Arts, Library, Richmond VA

Murdoch, Carol, *Reference Librn,* North Central College, Oesterle Library, Naperville IL

Murdoch, Elena, *Financial Officer,* Portland Museum of Art, Portland ME

Murdock, John, *Dir Art Div,* The Huntington Library, Art Collections & Botanical Gardens, San Marino CA

Murdock, John, *Dir Colls,* The Huntington Library, Art Collections & Botanical Gardens, Library, San Marino CA

Murdock, Ronda, *Library Technical Asst,* French Institute-Alliance Francaise, Library, New York NY

Murdock, Tina, *Music Librn,* J Eric Johnson, Fine Arts Division, Dallas TX

Murphey, F Warren, *Dir Mus & Historic Preservation,* Jekyll Island Museum, Jekyll Island GA

Murphy, Brian, *Registrar,* Memorial University of Newfoundland, Art Gallery of Newfoundland & Labrador, Saint John's NF

Murphy, Camay, *Exec Dir,* Eubie Blake, Baltimore MD

Murphy, Debra E, *Asst Prof,* University of North Florida, Dept of Communications & Visual Arts, Jacksonville FL (S)

Murphy, Greg, *Dean,* Maine College of Art, Portland ME (S)

Murphy, Greta, University of Wisconsin-Eau Claire, Dept of Art, Eau Claire WI (S)

Murphy, Harold, *Chmn,* Yesteryear Village, West Palm Beach FL

Murphy, Jeff, *Assoc Prof,* University of North Carolina at Charlotte, Dept Art, Charlotte NC (S)

Murphy, Joan, *Exec Dir,* Malaspina College, Nanaimo Art Gallery, Nanaimo BC

Murphy, John, *VPres,* Belskie Museum, Closter NJ

Murphy, Julie, *Dir Develop,* Yellowstone Art Museum, Billings MT

Murphy, Kevin, *Assoc Prof,* City University of New York, PhD Program in Art History, New York NY (S)

Murphy, Laura, *Instr,* Adams State College, Dept of Visual Arts, Alamosa CO (S)

Murphy, Margaret H, *Chmn,* Alabama Southern Community College, Art Dept, Monroeville AL (S)

Murphy, Marilyn, *Chair,* Vanderbilt University, Dept of Art, Nashville TN (S)

Murphy, Marilyn, *Librn,* Mount Mercy College, Library, Cedar Rapids IA

Murphy, Michael, *Exhibits Mgr,* Putnam Museum of History and Natural Science, Davenport IA

Murphy, Michael, *Exhibits Mgr,* Putnam Museum of History and Natural Science, Library, Davenport IA

Murphy, Michaela A, *Cur Photog,* Norfolk Historical Society Inc, Museum, Norfolk CT

Murphy, Nita, *Librn,* Taos, Southwest Research Center of Northern New Mexico Archives, Taos NM

Murphy, Nita, *Librn,* Taos, Ernest Blumenschein Home & Studio, Taos NM

Murphy, Nita, *Librn,* Taos, La Hacienda de Los Martinez, Taos NM

Murphy, Patricia, *Pub Rels,* Friends of Historic Kingston, Fred J Johnston House Museum, Kingston NY

Murphy, Patrick, *Assoc Prof,* Pennsylvania College of Technology, Dept. of Communications, Construction and Design, Williamsport PA (S)

Murphy, Randolph, *Cur,* Napa Valley Museum, Yountville CA

Murphy, Vince, *Thesis Advisor,* Toronto Art Therapy Institute, Toronto ON (S)

Murray, Agnes, *Art Services Dir,* Brooklyn Arts Council, Brooklyn NY

Murray, Barbara, *Exec Dir,* Philadelphia Sketch Club, Philadelphia PA

Murray, Catherine, *Assoc Prof,* East Tennessee State University, College of Arts and Sciences, Dept of Art & Design, Johnson City TN (S)

Murray, Clair, *Assoc Prof,* Malone College, Dept of Art, Canton OH (S)

Murray, David, *Assoc Prof,* Black Hawk College, Art Dept, Moline IL (S)

Murray, Debi, *Dir Research & Archives,* Historical Society of Palm Beach County, West Palm Beach FL

Murray, Donna, *Dir Educ,* Putnam Museum of History and Natural Science, Davenport IA

Murray, Donna, *Dir Educ,* Putnam Museum of History and Natural Science, Library, Davenport IA

Murray, Gale, *Assoc Prof,* Colorado College, Dept of Art, Colorado Springs CO (S)

Murray, Holly, *Dir Gallery,* Springfield College, William Blizard Gallery, Springfield MA

Murray, Holly, *Instr,* Springfield College, Dept of Visual & Performing Arts, Springfield MA (S)

Murray, Jan, *Prof,* University of Mississippi, Department of Art, University MS (S)

Murray, Jeanne, *Librn,* Newark Public Library, Reference, Newark NJ

Murray, Jeffery, *Cur Interpretation,* Wade House & Wesley W Jung Carriage Museum, Historic House & Carriage Museum, Greenbush WI

Murray, Karin, *Dir Gallery,* Valdosta State University, Art Gallery, Valdosta GA

Murray, Linda, *Secy,* Kennebec Valley Art Association, Harlow Gallery, Hallowell ME

Murray, Mary, *Cur,* Monterey Museum of Art Association, Monterey Museum of Art, Monterey CA

Murray, Mary E, *Cur Modern & Contemporary Art,* Munson-Williams-Proctor Arts Institute, Museum of Art, Utica NY

Murray, Michelle, *Slide Librn,* Sarah Lawrence College Library, Esther Raushenbush Library, Bronxville NY

Murray, Neale, *Chmn Dept,* North Park University, Art Dept, Chicago IL (S)

Murray, Ruth Anne, *Publicity & Promotion Coordr,* Museum London, London ON

Murray, Timothy G, *Coordr Fine Arts & Prof,* Brevard College, Division of Fine Arts, Brevard NC (S)

Murray, Todd, *Photography,* Antonelli Institute, Professional Photography & Commercial Art, Erdenheim PA (S)

Musacchio, Jacqueline, *Asst Prof,* Vassar College, Art Dept, Poughkeepsie NY (S)

Muscar, Carolyn, *Secy,* The Boston Printmakers, Boston MA

Muscat, Ann, *Exec VPres,* Natural History Museum of Los Angeles County, Los Angeles CA

Muschio, Glen, *Asst Prof Digital Media,* Drexel University, College of Media Arts & Design, Philadelphia PA (S)

Muse, Vance, *Pub Relations,* Menil Foundation, Inc, Houston TX

Muse-Mclea, Robin, *Dir Educ,* Barnes Foundation, Merion PA

Musgnug, Kristin, *Dept Chairperson, Assoc Prof,* University of Arkansas, Art Dept, Fayetteville AR (S)

Musgrave, Jason, *Facilities & Collections Mgr,* Kirkland Museum of Fine & Decorative Art, Denver CO

Musgrave, Jason, *Preparator & Registrar,* Museum of Contemporary Art Denver, Denver CO

Musgrove, Carrie, *Crafts,* Kalani Oceanside Retreat, Pahoa HI (S)

Musselman, Jeffery, *VPres,* Wayne County Historical Society, Honesdale PA

Musto, Linda, *Gen Educ,* Art Institute of Pittsburgh, Pittsburgh PA (S)

Muto, Iya, *Intern,* New Image Art, Los Angeles CA

Mutter, William, *Adjunct Asst Prof,* Drew University, Art Dept, Madison NJ (S)

Myer, Kate, *Exec Dir,* Historical Society of Kent County, Chestertown MD

Myers, Chris, *Chmn Graphic Design,* University of the Arts, Philadelphia Colleges of Art & Design, Performing Arts & Media & Communication, Philadelphia PA (S)

Myers, Derek, *Prof,* Virginia Polytechnic Institute & State University, Dept of Art & Art History, Blacksburg VA (S)

Myers, Jane, *Sr Cur Prints & Drawings,* Amon Carter, Fort Worth TX

Myers, Jeff, *VPres & COO,* Indiana State Museum, Indianapolis IN

Myers, Joanne, *Dir Educ,* Fruitlands Museum, Inc, Harvard MA

Myers, Joanne, *Dir Educ & Pub Progs,* National Heritage Museum, Lexington MA

Myers, Kat, *Assoc Prof,* Western Illinois University, Art Dept, Macomb IL (S)

Myers, Pamela L, *Exec Dir,* Asheville Art Museum, Asheville NC

Myers, Rita, *Mus Shop Mgr,* Kenosha Public Museum, Kenosha WI

Myers, Susan, *Instr,* Ocean City Arts Center, Ocean City NJ (S)

Myers, Tracy, *Cur Architecture,* Carnegie Museums of Pittsburgh, Carnegie Museum of Art, Pittsburgh PA

Myers, Virginia, *Prof Foil Stamping,* University of Iowa, School of Art & Art History, Iowa City IA (S)

Myers-Bromwell, Erika, *Asst Dir,* University of Southern Indiana, New Harmony Gallery of Contemporary Art, New Harmony IN

Mygatt, Nancy, *VPres,* Washington Art Association, Washington Depot CT

Myrick, Bryon, *Pres,* Mississippi Art Colony, Stoneville MS

Myrick, Tommy, *Instr,* Southern University in New Orleans, Fine Arts & Philosophy Dept, New Orleans LA (S)

Naab, Michael, *Dir,* City of Ketchikan Museum, Tongass Historical Museum, Ketchikan AK

Naab, Michael, *Dir,* City of Ketchikan Museum Dept, Ketchikan AK

Naab, Michael, *Dir,* City of Ketchikan Museum Dept, Library, Ketchikan AK

Naar, Harry I, *Prof Art & Dir,* Rider University, Art Gallery, Lawrenceville NJ

Nabutovsky, Yana, *Dir Mem,* Philadelphia Art Alliance, Philadelphia PA

Nacy, Richard, *Devel Officer,* Albany Institute of History & Art, Albany NY

Nadaskay, Chris, *Prof,* Union University, Dept of Art, Jackson TN (S)

Nadel, Joshua, *Chmn,* University of Maine at Augusta, College of Arts & Humanities, Augusta ME (S)

Nadel, Ramona, *Asst to Dir,* Santa Clara University, de Saisset Museum, Santa Clara CA

Nadler, Andrei, *Controller,* Museum for African Art, Long Island City NY

Nadler, Linda, *Dir Develop,* Museum of Art, Fort Lauderdale, Fort Lauderdale FL

Naef, Weston, *Cur Photographs,* Getty Center, Trust Museum, Los Angeles CA

Naef, Weston, *Cur Photographs,* Getty Center, The J Paul Getty Museum, Los Angeles CA

Naficy, Mark, *Chair,* Rice University, Dept of Art & Art History, Houston TX (S)

Nagar, Devvrat, *Instr,* La Roche College, Division of Graphics, Design & Communication, Pittsburgh PA (S)

Nagasawa, Nobuho, *Assoc Prof,* State University of New York at Stony Brook, Dept of College of Arts & Sciences, Art Dept, Stony Brook NY (S)

Nagel, Alexander, *Undergrad Coordr Art History,* University of Toronto, Dept of Fine Art, Toronto ON (S)

Nagel, John Wm, *Prof,* Saint Louis Community College at Meramec, Art Dept, Saint Louis MO (S)

Nagel, Toni, *Photo Archivist,* Whatcom Museum of History and Art, Library, Bellingham WA

Nagle, Ron, *Prof,* Mills College, Art Dept, Oakland CA (S)

Nagy, Helen, *Chmn,* University of Puget Sound, Art Dept, Tacoma WA (S)

Nagy, Jean, *Instr,* Middle Tennessee State University, Art Dept, Murfreesboro TN (S)

Nagy, Rebecca M, *Assoc Dir Educ,* North Carolina Museum of Art, Reference Library, Raleigh NC

Nakajima, Takashi, *Faculty Dean Arts, Architecture & Amenagent,* Universite Quebec Cite Universitaire, School of Visual Arts, Quebec PQ (S)

Nakamura, Kayo, *Asst Prof,* Biola University, Art Dept, La Mirada CA (S)

Nakamura, Patricia, *Instr,* San Joaquin Delta College, Art Dept, Stockton CA (S)

Nakano, Yuzo, *Artistic Dir,* Kala Institute, Kala Art Institute, Berkeley CA

Nakao, Susan, *Lectr,* Emporia State University, Dept of Art, Emporia KS (S)

Nakashima, Tom, *Morris Eminent Scholar in Art,* Augusta State University, Dept of Arts, Augusta GA (S)

Nakatani, Hajame, *Asst Prof,* Rice University, Dept of Art & Art History, Houston TX (S)

Nakazato, Hitoshi, *Adjunct Prof,* University of Pennsylvania, Graduate School of Fine Arts, Philadelphia PA (S)

Nakoneczny, Michael, *Asst Prof,* University of Alaska-Fairbanks, Dept of Art, Fairbanks AK (S)

Nalon, J, *Bd Dirs,* Gananoque Museum, Gananoque ON

Nam, Yun-Dong, *Prof,* University of North Carolina at Chapel Hill, Art Dept, Chapel Hill NC (S)

Nance, Lynn, *Art School Reception,* Boca Raton Museum of Art, Boca Raton FL

Nance, William W, *Prof,* Alabama A & M University, Art & Art Education Dept, Normal AL (S)

Nanney, Nancy, *Chmn,* West Virginia University at Parkersburg, Art Dept, Parkersburg WV (S)

Nanni, Lisa, *Sr Libr Asst,* The Metropolitan Museum of Art, Library and Teacher Resource Center in the Uris Center for Education, New York NY

Napier, Louise, *Chmn Div,* Wingate University, Art Department, Wingate NC (S)

Napran, Laura, *Cur,* Enook Galleries, Waterloo ON

Naragon, Dwain, *Assoc Prof,* Eastern Illinois University, Art Dept, Charleston IL (S)

Narcum-Perez, Patricia, *Bush House Coordr,* Salem Art Association, Bush House Museum, Salem OR

Narcum-Perez, Patricia, *Bush House Coordr,* Salem Art Association, Archives, Salem OR

Narkiewicz-Laine, Christian K, *Dir & Pres,* Chicago Athenaeum, Museum of Architecture & Design, Galena IL

Narrow, Kathryn, *Managing Dir,* Clay Studio, Philadelphia PA

Nartonis, Cynthia, The Boston Printmakers, Boston MA

Nash, Shelia, *Sr Librn,* Los Angeles Public Library, Art, Music, Recreation & Rare Books, Los Angeles CA

Nasisse, Andy, *Grad Coordr,* University of Georgia, Franklin College of Arts & Sciences, Lamar Dodd School of Art, Athens GA (S)

Naskarin, Daniel, *Asst Prof,* University of Victoria, Dept of Visual Arts, Victoria BC (S)

Nassar, Joanne, *VPres,* Arts & Crafts Association of Meriden Inc, Gallery 53, Meriden CT

Nasse, Harry, *Dir & Chmn Bd,* Ward-Nasse Gallery, New York NY

Natale, Marie, *Instr,* Ocean City Arts Center, Ocean City NJ (S)

Nathan, Gail, *Exec Dir,* Bronx River Art Center, Gallery, Bronx NY

Nathan, Jacqueline, *Dir Gallery,* Bowling Green State University, School of Art, Bowling Green OH (S)

Nathan, Jacqueline S, *Dir Galleries,* Bowling Green State University, Fine Arts Center Galleries, Bowling Green OH

Nathanson, Carol, *Assoc Prof,* Wright State University, Dept of Art & Art History, Dayton OH (S)

Naubert-Riser, Constance, *Instr,* Universite de Montreal, Dept of Art History, Montreal PQ (S)

Naujoks, Robert, *Chmn Dept,* Mount Mercy College, Art Dept, Cedar Rapids IA (S)

Nauts, Alan, *Instr,* University of Saint Francis, School of Creative Arts, Fort Wayne IN (S)

Nauyok, Michael, *VPres Exhibs,* Natural History Museum of Los Angeles County, Los Angeles CA

Navaretta, Cynthia, *Exec Dir,* Midmarch Associates, Women Artists Archive and Library, New York NY

Navarro, Leonard, *Deputy Dir Admin,* Natural History Museum of Los Angeles County, Los Angeles CA

Navas, Eduardo, *Instr,* Pierce College, Art Dept, Woodland Hills CA (S)

Navas-Nieves, Tariana, *Cur Coll,* Museo de las Americas, Denver CO

Navin, Patrick, *Instr,* Green River Community College, Art Dept, Auburn WA (S)

Navlty, Rosemary, *Develop Dir,* Springfield Museum of Art, Library, Springfield OH

Navone, Edward, *Prof,* Washburn University of Topeka, Dept of Art, Topeka KS (S)

Navy, Carmen Y, Lighthouse Center for the Arts Inc, Tequesta FL

Nawrocki, Thomas, *Prof,* Mississippi University for Women, Division of Fine & Performing Arts, Columbus MS (S)

Nawrocki, Tom, *Treas,* Kappa Pi International Honorary Art Fraternity, Cleveland MS

Nay, Barbara, *Admin Asst,* Sharon Arts Center, Sharon Arts Center Exhibition Gallery, Sharon NH

Naylor, Valerie J., *Supt,* Oregon Trail Museum Association, Scotts Bluff National Monument, Gering NE

Nazionale, Nina, *Head Library Pub Svcs,* New York Historical Society, Library, New York NY

Neaderland, Louise, *Dir,* International Society of Copier Artists (ISCA), Brooklyn NY

Neagley, Linda, *Assoc,* Rice University, Dept of Art & Art History, Houston TX (S)

Neal, Jack, *Pres,* Danville Museum of Fine Arts & History, Danville VA

Neal, Kenneth, *Art Librn,* Mayfield Regional Library, Mayfield Village OH

Nealis, Sharon, *Dir,* Allegany County Historical Society, Gordon-Roberts House, Cumberland MD

Near, Susan R, *Dir Mus Svcs,* Montana Historical Society, Helena MT

Neary, John, *Dir,* Saint Norbert College, Div of Humanities & Fine Arts, De Pere WI (S)

Neault, Carolyn, *Cur,* Columbus Historic Foundation, Blewett-Harrison-Lee Museum, Columbus MS

Nechis, Barbara, *Instr,* Art Center Sarasota, Sarasota FL (S)

Needell, Allan, *Space History Dept,* National Air and Space Museum, Washington DC

Neel, Jim, *Asst Prof,* Birmingham-Southern College, Art Dept, Birmingham AL (S)

Neely, Gaylord, *Pres,* Provisions Library & Gaea Foundation, Washington DC

Neely, Linda, *Asst Prof Art Educ,* Lander University, College of Arts & Humanities, Greenwood SC (S)

Neff, Jean W, *Cur Educ,* Amherst Museum, Amherst NY

Neff, John, *Exec Dir,* Reynolda House Museum of American Art, Winston Salem NC

Neff Heppner, Leianne, *Cur,* Summit County Historical Society, Akron OH

Negrea, Marylin, *Second VPres,* Halifax Historical Society, Inc, Halifax Historical Museum, Daytona Beach FL

Negroponte, George, *Pres,* The Drawing Center, New York NY

Neil, Daniel S, *Exhib & Bldg Mgr,* Jule Collins Smith Museum of Art, Auburn AL

Neill, Peter, *Pres,* South Street Seaport Museum, New York NY

Neises, John, *VPres,* Telfair Museum of Art, Telfair Academy of Arts & Sciences Library, Savannah GA

Nell-Smith, Bruce, *Head Dept,* Newberry College, Dept of Art, Newberry SC (S)

Nellermoe, J, *Chmn,* Texas Lutheran University, Dept of Visual Arts, Seguin TX (S)

Nelly, Benjamin F, *Coll Mgr,* Adams County Historical Society, Gettysburg PA

Nelsen, Kenneth, *Assoc Prof,* Northwest Missouri State University, Dept of Art, Maryville MO (S)

Nelson, Andrea, *Registrar,* Sheldon Museum & Cultural Center, Inc, Sheldon Museum & Cultural Center, Haines AK

Nelson, Carol, *Treas,* North Country Museum of Arts, Park Rapids MN

Nelson, Christine, *Asst Dir,* Stetson University, Duncan Gallery of Art, Deland FL

Nelson, Dean, *Mus Adminr,* Connecticut State Library, Museum of Connecticut History, Hartford CT

Nelson, Eric, *Exec Dir,* Napa Valley Museum, Yountville CA

Nelson, Fred, *Coordr Illustration,* Columbia College, Art Dept, Chicago IL (S)

Nelson, Gene, *Asst Dir,* Las Vegas-Clark County Library District, Las Vegas NV

Nelson, Genene, *Chm (V),* Alabama Department of Archives & History, Museum Galleries, Montgomery AL

Nelson, Irving, *Librn,* Navajo Nation Library System, Window Rock AZ

Nelson, Jessica, *Asst Dir,* DeCordova Museum & Sculpture Park, Lincoln MA

Nelson, Julianne, *Cur Asst,* Frederick R Weisman, Los Angeles CA

Nelson, Julie D, *Exec Dir,* Quincy Art Center, Quincy IL

Nelson, Kelly, *Asst Prof,* Longwood University, Dept of Art, Farmville VA (S)

Nelson, Kristi, *Prof Art History,* University of Cincinnati, School of Art, Cincinnati OH (S)

Nelson, Leona, *Asst Prof,* Mount Mary College, Art & Design Division, Milwaukee WI (S)

Nelson, Marilyn, *Assoc Prof,* University of Arkansas, Art Dept, Fayetteville AR (S)

Nelson, Mary Carroll, *Founder,* Society of Layerists in Multi Media (SLMM), Albuquerque NM

Nelson, Maryann, *Pres,* Douglas Art Association, The Gallery and Gift Shop, Douglas AZ

Nelson, Nels, *First VPres,* Swedish-American Museum Association of Chicago, Chicago IL

Nelson, Nick, *Cur Educ,* Albany Museum of Art, Albany GA

Nelson, Norman L, *chmn,* First State Bank, Norton KS

Nelson, Paula, *Pres,* Woodstock School of Art, Inc, Woodstock NY (S)

Nelson, Sarah, *Cur Educ,* Lehigh County Historical Society, Allentown PA

Nelson, Sarah, *Silversmith,* Worcester Center for Crafts, Worcester MA (S)

Nelson, Steve, *Asst Prof,* Hope College, Dept of Art & Art History, Holland MI (S)

Nelson, Steve, *Mgr,* Hope College, De Pree Art Center & Gallery, Holland MI

Nelson, Susan, *Assoc Prof,* Indiana University, Bloomington, Henry Radford Hope School of Fine Arts, Bloomington IN (S)

Nelson, Susan, *Assoc Prof & Dir Prog,* Saint Mary College, Fine Arts Dept, Leavenworth KS (S)

Nelson-Mayson, Un, *Dir,* University of Minnesota, Goldstein Gallery, Saint Paul MN

Nemcosky, Gary, *Assoc Prof,* Appalachian State University, Dept of Art, Boone NC (S)

Nemec, Vernita, *Dir,* Viridian Artists Inc, New York NY

Nemec, Vernita, *Dir & Cur,* Earthfire, Art from Detritus: Recycling with Imagination, New York NY

Nemet, Susan, *Cur Educ,* Westmoreland Museum of American Art, Art Reference Library, Greensburg PA

Nemiroff, Diane, *Cur Contemporary Art,* National Gallery of Canada, Ottawa ON

Nenno, Mardis, *Asst Prof,* Spokane Falls Community College, Fine Arts Dept, Spokane WA (S)

Nero, Irene, *Asst Prof,* Southeastern Louisiana University, Dept of Visual Arts, Hammond LA (S)

Nesbit, Molly, *Prof,* Vassar College, Art Dept, Poughkeepsie NY (S)

Nesbitt, Bill, *Cur,* Dundurn Castle, Hamilton ON

Nesbitt, Carl, *Pres,* Art Gallery of Greater Victoria, Victoria BC

Nesin, Jeffrey, *Pres,* Memphis College of Art, Memphis TN (S)

Ness, Gary, *Dir,* Ohio Historical Society, Columbus OH

Ness, Gary C, *CEO,* Ohio Historical Society, National Road-Zane Grey Museum, Columbus OH

Ness, Karla, *Prof,* Concordia College, Art Dept, Saint Paul MN (S)

Ness, Kim G., *Dir & Cur,* McMaster University, Library, Hamilton ON

Nesser-Chu, Janice, *Instructor II,* Saint Louis Community College at Florissant Valley, Liberal Arts Division, Ferguson MO (S)

Nesteruk, Janet, *Prof,* Northwestern Connecticut Community College, Fine Arts Dept, Winsted CT (S)

Nestor, James P, *Prof,* Indiana University of Pennsylvania, College of Fine Arts, Indiana PA (S)

Netsky, Ron, *Head Dept,* Nazareth College of Rochester, Art Dept, Rochester NY (S)

Netsky, Ron, *Instr,* Woodstock School of Art, Inc, Woodstock NY (S)

Netter, D Perence, *Dean,* Jacksonville University, Dept of Art, Jacksonville FL (S)

Nettleton, John, *Asst Prof,* Oregon State University, Dept of Art, Corvallis OR (S)

Netzer, Nancy, *Dir,* Boston College, McMullen Museum of Art, Chestnut Hill MA

Netzer, Sylvia, *Assoc Prof,* City College of New York, Art Dept, New York NY (S)

Neu, Noreen, *Dir,* Regina Public Library, Dunlop Art Gallery, Regina SK

Neuenswander, Terri, Riverside County Museum, Edward-Dean Museum & Gardens, Cherry Valley CA

Neuhaus, Margie, *Chmn,* College of New Rochelle School of Arts & Sciences, Art Dept, New Rochelle NY (S)

Neuman, Teresa, *Coordr Promotions,* Red Deer & District Museum & Archives, Red Deer AB

Neuman de Vegvar, Carol, *Prof,* Ohio Wesleyan University, Fine Arts Dept, Delaware OH (S)

Neumann, Timothy C, *Dir,* Pocumtuck Valley Memorial Association, Memorial Hall Museum, Deerfield MA

Neumer, Marrie, *Dir for Develop,* Cornell University, Herbert F Johnson Museum of Art, Ithaca NY

Neuroth, Karl, *Prof,* Keystone College, Fine Arts Dept, LaPlume PA (S)

Nevadomi, Kenneth, *Prof,* Cleveland State University, Art Dept, Cleveland OH (S)

Neves, Todd, *Pres Bd,* Visual Arts Center of Northwest Florida, Visual Arts Center Library, Panama City FL

Nevin, Mike, Honolulu Academy of Arts, The Art Center at Linekona, Honolulu HI (S)

Nevins, Jerome, *Prof Art,* Albertus Magnus College, Visual and Performing Arts, New Haven CT (S)

Nevitt, Stephen, *Chmn,* Columbia College, Dept of Art, Columbia SC (S)

Newbill, Maureen, *Dir Mktg,* Waterloo Center of the Arts, Waterloo IA

Newbold, Abbey, *Preparator,* Cranbrook Art Museum, Cranbrook Art Museum, Bloomfield Hills MI

Newbold, Rodger, *Co-Dir Art Center S,* Salt Lake Art Center, Salt Lake City UT

Newbold, Theodore T, *Treas,* Fairmount Park Art Association, Philadelphia PA

Newcomb, Janet T, *Exec Dir,* Arts of the Southern Finger Lakes, Corning NY

Newell, Aimee, *Cur Masonic Coll,* National Heritage Museum, Lexington MA

Newhoff, Tony, *Pub Relations & Mktg Mgr,* Bass Museum of Art, Miami Beach FL

Newhouse, Keith, *Prof Visual Studies,* Drexel University, College of Media Arts & Design, Philadelphia PA (S)

Newhouse, Larry, *Dir Gallery,* Eastern Michigan University, Ford Gallery, Ypsilanti MI

Newirth, Richard, *Dir Cultural Affairs,* San Francisco City & County Art Commission, San Francisco CA

Newkirk, Dale, *Asst Prof,* Indiana University, Bloomington, Henry Radford Hope School of Fine Arts, Bloomington IN (S)

Newland, Judy, *Cur,* Beloit College, Wright Museum of Art, Beloit WI

Newman, Alan B, *Exec Dir Imaging & Technical Serv,* The Art Institute of Chicago, Chicago IL

Newman, Geoffrey, *Dean,* Montclair State University, Art Galleries, Upper Montclair NJ

Newman, Geoffrey, *Dean,* Montclair State University, Fine Arts Dept, Upper Montclair NJ (S)

Newman, Jane, *Admin Asst,* Folk Art Society of America, Richmond VA

Newman, John, *Assoc Prof,* University of Arkansas, Art Dept, Fayetteville AR (S)

Newman, Marsha, *Mus Shop Mgr,* Sioux City Art Center, Sioux City IA (S)

Newman, William, *Chm (V),* Ann Arbor Art Center, Art Center, Ann Arbor MI

Newquist, Ruth, *2d VPres Painting,* Catharine Lorillard Wolfe, New York NY

Newsome, Denise, *Exhibit Design Mgr,* Texas Tech University, Museum of Texas Tech University, Lubbock TX

Newsome, Levi, *Dir,* Danbury Scott-Fanton Museum & Historical Society, Inc, Danbury CT

Newsome, Levi, *Dir,* Danbury Scott-Fanton Museum & Historical Society, Inc, Library, Danbury CT

Newsome, Steven, *Dir,* Anacostia Museum, Washington DC

Newstrawn, Sylvia, University of Virginia, McIntire Dept of Art, Charlottesville VA (S)

Newton, David, *Prof of Art,* Guilford College, Art Dept, Greensboro NC (S)

Newton, Janet, *Asst Prof,* Illinois Central College, Dept Fine, Performing & Applied Arts, East Peoria IL (S)

Newton, Janet, *Pres,* Women's Art Association of Canada, Toronto ON

Ney, Susan, *Assoc Prof,* Azusa Pacific University, College of Liberal Arts, Art Dept, Azusa CA (S)

Neyer, Tom, *Pres,* Contemporary Arts Center, Cincinnati OH

Ngoc Bich, Nguyen, *Pres,* VICANA (Vietnamese Cultural Association in North America) Library, Springfield VA

Ngoh, Soon Ee, *Assoc Prof,* Mississippi State University, Dept of Art, Mississippi State MS (S)

Ngote, Lisa, *Lectr,* Oakland University, Dept of Art & Art History, Rochester MI (S)

Nguien-Ouy, Pipo, *Asst Prof,* Oberlin College, Dept of Art, Oberlin OH (S)

Nguyen, Blood, *Prof, Dir,* Universite de Montreal, Bibliotheque d'Amenagement, Montreal PQ

Nguyen, Grace, *Mktg & Develop Assoc,* Craft and Folk Art Museum (CAFAM), Los Angeles CA

Nguyen, Thuy, *CFO,* Bowers Museum of Cultural Art, Bowers Museum, Santa Ana CA

Nguyen, Trian, *Asst Prod,* Bates College, Art & Visual Culture, Lewiston ME (S)

Niblett, Michael, *Prof,* Texas Christian University, Dept of Art & Art History, Fort Worth TX (S)

Nicandri, David, *Dir,* Washington State History Museum, Tacoma WA

Niceley, H T, *Chmn Dept,* Carson-Newman College, Art Dept, Jefferson City TN (S)

Nicholas, Grace, *Admin Asst,* 1890 House-Museum & Center for the Arts, Cortland NY

Nicholas, Grace, *Admin Asst,* 1890 House-Museum & Center for the Arts, Kellogg Library & Reading Room, Cortland NY

Nicholls, Dave, *Cur Exhibits,* Anchorage Museum at Rasmuson Center, Anchorage AK

Nicholls, Susan, *Admin Asst,* East Carolina University, Wellington B Gray Gallery, Greenville NC

Nichols, Alan, *Mus Shop Mgr,* Alabama Department of Archives & History, Museum Galleries, Montgomery AL

Nichols, Angela, *Dir Visual Arts,* Morgan County Foundation, Inc, Madison-Morgan Cultural Center, Madison GA

Nichols, Charlotte, *Chmn,* Seton Hall University, College of Arts & Sciences, South Orange NJ (S)

Nichols, Charlotte, *Dir,* University of Northern Colorado, School of Art and Design, John Mariani Gallery, Greeley CO

Nichols, Charlotte, *Dir,* Seton Hall University, South Orange NJ

Nichols, Jeff, *Dir Educ,* Mark Twain, Hartford CT

Nichols, Jeffrey L, *Educ Dir,* The Barnum Museum, Bridgeport CT

Nichols, John W, *Dir Mus Svcs,* The American Federation of Arts, New York NY

Nichols, Kimberly, *Dir Communications,* Palm Springs Art Museum, Palm Springs CA

Nichols, Lawrence, *Cur European Painting & Sculpture Before 1900,* Toledo Museum of Art, Toledo OH

Nichols, Madeleine, *Cur Dance,* The New York Public Library, The New York Public Library for the Performing Arts, New York NY

Nichols, Mark, *Pres,* National Oil & Acrylic Painters Society, Osage Beach MO

Nichols, Ray, *Coordr Visual Communication,* University of Delaware, Dept of Art, Newark DE (S)

Nichols, Sue, *Dir Operations,* Atlanta Historical Society Inc, Atlanta History Center, Atlanta GA

Nicholson, Joseph, *VPres,* Woodmere Art Museum, Library, Philadelphia PA

Nicholson, Marilyn, *Gallery Clerk,* City of Toronto Culture Division, The Market Gallery, Toronto ON

Nicholson, Paul, *VPres,* Legacy Ltd, Seattle WA

Nickard, Gary, *Asst Prof,* University at Buffalo, State University of New York, Dept of Visual Studies, Buffalo NY (S)

Nickel, Douglas R, *Cur Photography,* San Francisco Museum of Modern Art, San Francisco CA

Nickel, Lorene, *Prof,* Mary Washington College, Dept of Art & Art History, Fredericksburg VA (S)

Nickel, Richard, *Assoc Prof,* Old Dominion University, Art Dept, Norfolk VA (S)

Nickel, Richard, *Instr,* Valley City State College, Art Dept, Valley City ND (S)

Nickell, Jeff, *Asst Dir,* Kern County Museum, Bakersfield CA

Nickell, Jeff, *Cur,* Kern County Museum, Library, Bakersfield CA

Nickels, Sara, *Grants Adminr,* Broward County Board of Commissioners, Cultural Affairs Div, Fort Lauderdale FL

Nickerson, Cindy, *Dir & Cur,* Cahoon Museum of American Art, Cotuit MA

Nicklaus, Mike, *District Naturalist,* Grand Teton National Park Service, Colter Bay Indian Arts Museum, Moose WY

Nickles, Rocky, *Business Mgr,* The Arkansas Arts Center, Museum School, Little Rock AR (S)

Nickolaisen, Donna, *Registrar,* Brigham City Corporation, Brigham City Museum & Gallery, Brigham City UT

Nickson, Graham, *Dean,* New York Studio School of Drawing, Painting & Sculpture, Gallery, New York NY

Nickson, Graham, *Dean,* New York Studio School of Drawing, Painting & Sculpture, Library, New York NY

Nickson, Graham, *Dean,* New York Studio School of Drawing, Painting & Sculpture, New York NY (S)

Nicolescu, Alec, *Dir Gallery,* Kean University, James Howe Gallery, Union NJ

Nicolescu, Alec, *Dir Gallery,* Kean College of New Jersey, Fine Arts Dept, Union NJ (S)

Nicoletti, Lisa, *Vis Asst Prof,* Centenary College of Louisiana, Dept of Art, Shreveport LA (S)

Nicoll, Jessica, *Chief Cur,* Portland Museum of Art, Portland ME

Nicolosi, Anthony S, *Dir,* Naval War College Museum, Newport RI

Niel, M, *Librn,* Art Gallery of Greater Victoria, Library, Victoria BC

Nielsen, Debbie, *Dir,* Sunbury Shores Arts & Nature Centre, Inc, Gallery, Saint Andrews NB

Nielsen, Erik, *Chmn,* Texas State University - San Marcos, Dept of Art and Design, San Marcos TX (S)

Nielsen, Kim, *Dir,* Naval Historical Center, The Navy Museum, Washington DC

Nielson, Nancy, *Coll Access,* State University of New York at New Paltz, Sojourner Truth Library, New Paltz NY

Niemeyer, Kirk, *Dir,* Oklahoma City University, Hulsey Gallery-Norick Art Center, Oklahoma City OK

Nietcr, Gary, *Assoc Prof,* Grace College, Dept of Art, Winona Lake IN (S)

Nieves, Marysol, *Cur,* Museo de Arte de Puerto Rico, San Juan PR

Nieves, Marysol, *Dir Galleries & Chief Cur,* Moore College of Art & Design, The Galleries at Moore, Philadelphia PA

Niewald, Janet, *Prof,* Virginia Polytechnic Institute & State University, Dept of Art & Art History, Blacksburg VA (S)

Nigh, Robin, *Admin,* City of Tampa, Public Art Program, Tampa FL

Nigro, Christie, *Chmn,* Worcester State College, Visual & Performing Arts Dept, Worcester MA (S)

Nii, Yuko, *Founder & Artistic Dir,* Williamsburg Art & Historical Center, Brooklyn NY

Niki, Kenji, *Librn,* Saint John's University, Asian Collection, Jamaica NY

Nikitas, Kali, *Chair, Design,* Minneapolis College of Art & Design, Minneapolis MN (S)

Niles, Alicia, *Pub Relations Coordr,* Columbus Museum, Columbus GA

Niles, Fred, *Chmn Dept,* University of Dayton, Visual Arts Dept, Dayton OH (S)

Niles, Kristi, *Membership Mgr,* Yellowstone Art Museum, Billings MT

Niles, Naomi, *Assoc Mus Librn,* The Metropolitan Museum of Art, Library and Teacher Resource Center in the Uris Center for Education, New York NY

Nilson, Craig, *Prof,* Tidewater Community College, Visual Arts Center, Portsmouth VA (S)

Nishioka, Reiko, *Dir Educ,* Palm Beach County Parks & Recreation Department, Morikami Museum & Japanese Gardens, Delray Beach FL

Niskarer, Valerie, *Exec Dir,* North Shore Art League, Winnetka IL

Nissenhold, Mark, *Chmn Visual Arts Dept,* Lakehead University, Dept of Visual Arts, Thunder Bay ON (S)

Niswonger, Gary, *Asst Prof,* Smith College, Art Dept, Northampton MA (S)

Niven, Don, *Chmn,* St Lawrence College, Dept of Graphic Design, Kingston ON (S)

Nivens, Charles, *Prof,* Eastern Illinois University, Art Dept, Charleston IL (S)

Nix, William, *VPres & CPO,* Palm Beach County Cultural Council, West Palm Beach FL

Nixon, Rob, *Production Dir,* Golden Isles Arts & Humanities Association, Brunswick GA

Nixon, Sean, *Assoc Prof,* University of Bridgeport, School of Arts, Humanities & Social Sciences, Bridgeport CT (S)

Nixon, Sean, *Prof,* Ulster County Community College/Suny Ulster, Dept of Visual & Performing Arts, Stone Ridge NY (S)

Nixx, Tanja, *Mgr,* Tattoo Art Museum, San Francisco CA

Njah, Doug, *VPrin,* Nutana Collegiate Institute, Memorial Library and Art Gallery, Saskatoon SK

Nkambou, Roger, *Assoc Prof,* Universite de Montreal, Bibliotheque d'Amenagement, Montreal PQ

Nobel, Doug, *Exec Dir,* Indiana State Museum, Indianapolis IN

Nobili, Nicolas, *Chief Preparator,* Dartmouth College, Hood Museum of Art, Hanover NH

Noble, Bonnie, *Asst Prof,* University of North Carolina at Charlotte, Dept Art, Charlotte NC (S)

Noble, Cynthia, *Asst Prof,* Springfield College, Dept of Visual & Performing Arts, Springfield MA (S)

Noble, Douglas R, *CEO,* Indiana State Museum, Indianapolis IN

Noble, Joni, *Instr,* University of Louisiana at Monroe, Dept of Art, Monroe LA (S)

Noble, Nancy, *CEO,* Vancouver Museum, Vancouver BC

Noble, Nancy, *Cataloger,* Maine Historical Society, Library and Museum, Portland ME

Noblett, David, *Prof,* Missouri Southern State University, Dept of Art, Joplin MO (S)

Nocero, Antonia, *Education Mgr,* National Audubon Society, John James Audubon Center at Mill Grove, Audubon PA

Nodine, Jane, *Dir Gallery,* University of South Carolina at Spartanburg, Art Gallery, Spartanburg SC

Noe, Lendon H, *Asst Prof,* Lambuth University, Dept of Human Ecology & Visual Arts, Jackson TN (S)

Noeding, Thomas, *Owner,* Bent Museum & Gallery, Taos NM

Noel, William, *Cur Mss,* Walters Art Museum, Library, Baltimore MD

Noel, William, *Cur Mss & Rare Books,* Walters Art Museum, Baltimore MD

Noever, Peter, *Dir,* Mak-Cener for Art & Architecture, MAK - Austrian Museum of Applied Art, West Hollywood CA

Nofziger, Lori, *Patron Srvcs Librn,* Cleveland Institute of Art, Jessica Gund Memorial Library, Cleveland OH

Nohe, Tim, *Asst Prof,* University of Maryland, Baltimore County, Imaging, Digital & Visual Arts Dept, Baltimore MD (S)

Nolan, John, *Cur,* BJU Museum & Gallery, Bob Jones University Museum & Gallery Inc, Greenville SC

Nolan, Mary, *Asst Dir & Ed,* C G Jung, Evanston IL

Nolan, Patricia E, *Special Arts Servs Dir,* American Society of Artists, Inc, Palatine IL

Nolan, Sarah, *Reference Librn,* Minneapolis College of Art & Design, Library, Minneapolis MN

Noland, Lloyd U, *Chm,* The Mariners' Museum, Newport News VA

Noland, William, *Assoc Prof Practice,* Duke University, Dept of Art, Art History & Visual Studies, Durham NC (S)

Nolan Warren, Gwen, *Mus Shop Mgr,* Harrison County Historical Museum, Marshall TX

Nold, Carl R, *Pres,* Historic New England, Boston MA

Nolen, Lori, *Instr,* Union University, Dept of Art, Jackson TN (S)

Nolf, Richard A, *Dir,* Saint Joseph Museum, Saint Joseph MO

Nolf, Richard A, *Dir,* Saint Joseph Museum, Library, Saint Joseph MO

Nolin, Anne-Marie, *Dir Communications,* Montclair Art Museum, Montclair NJ

Norberg, Deborah, *Deputy Dir,* San Jose Museum of Art, San Jose CA

Norbert, Deborah, *Deputy Dir,* San Jose Museum of Art, Library, San Jose CA

Nordine, Andrew, *Head Preparator,* Marquette University, Haggerty Museum of Art, Milwaukee WI

Nordtorp-Madson, Shelly, *Prof,* University of Saint Thomas, Dept of Art History, Saint Paul MN (S)

Nordyke, John, *Asst Prof,* University of Hartford, Hartford Art School, West Hartford CT (S)

Nore, Nano, *Chmn,* William Jewell College, Art Dept, Liberty MO (S)

Noreen, Kirsten, *Asst,* Louisiana State University, School of Art, Baton Rouge LA (S)

Noreen, Kirstin, *Assoc Prof,* Loyola Marymount University, Dept of Art & Art History, Los Angeles CA (S)

Noriega, Ed, *Prof,* Troy State University, Dept of Art & Classics, Troy AL (S)

Norlander, Angela, *Exec Dir,* Young Audiences Inc, Colo Chapter, Denver CO

Norley, Mark, *Chmn & Pres,* Hockaday Museum of Arts, Kalispell MT

Norman, Denver, *Gen Asst,* Black American West Museum & Heritage Center, Denver CO

Norman, Janis, *Chmn Educ Art,* University of the Arts, Philadelphia Colleges of Art & Design, Performing Arts & Media & Communication, Philadelphia PA (S)

Norman, Joe, *Assoc Prof Drawing & Painting,* University of Georgia, Franklin College of Arts & Sciences, Lamar Dodd School of Art, Athens GA (S)

Norman, Richard, *Prof,* Clemson University, College of Architecture, Clemson SC (S)

Normand, Fred, *First VPres,* Rome Historical Society, Museum & Archives, Rome NY

Norms, Judy, *Asst Prof,* Assumption College, Dept of Art & Music, Worcester MA (S)

Norris, Andrea, *Dir Mus,* University of Kansas, Kress Foundation Dept of Art History, Lawrence KS (S)

Norris, Jade, *Educator,* San Angelo Museum of Fine Arts, San Angelo TX

Norris, Tim, *Prog Coordr,* Muskegon Community College, Dept of Creative & Performing Arts, Muskegon MI (S)

North, Bruce, *Assoc Prof,* Ithaca College, Fine Art Dept, Ithaca NY (S)

North, Holly, *Cur Coll,* Grace Museum, Inc, Abilene TX

North, Kenda, *Chmn,* University of Texas at Arlington, Dept of Art & Art History, Arlington TX (S)

Northam, Donna, *Reference Librn,* Fort Hays State University, Forsyth Library, Hays KS

Northrop, Eileen, *Dir Admis,* Art Institute of Fort Lauderdale, Fort Lauderdale FL (S)

Northrup, JoAnne, *Sr Cur,* San Jose Museum of Art, San Jose CA

Northrup, JoAnne, *Sr Cur,* San Jose Museum of Art, Library, San Jose CA

Northup, Marjorie J, *Asst Dir Prog,* Reynolda House Museum of American Art, Winston Salem NC

Northway, Heather, *Registrar,* Phoenix Art Museum, Phoenix AZ

Norton, Ann Wood, *Chmn,* Providence College, Art & Art History Dept, Providence RI (S)

Norton, Brenda, *Visitor Servs Mgr,* Omaha Childrens Museum, Inc, Omaha NE

Norton, Heidi, *Shop Mgr,* The Currier Museum of Art, Currier Museum of Art, Manchester NH

Norton, James, *Instr,* University of Louisiana at Monroe, Dept of Art, Monroe LA (S)

Norton, Jessica A, *Cur,* Amherst Museum, Amherst NY

Norton, M Lewis, *Pres Bd,* R W Norton Art Foundation, Shreveport LA

Norton, Maria, *Educ Coordr,* Muscatine Art Center, Muscatine IA

Norton, Maria, *Educ Coordr,* Muscatine Art Center, Museum, Muscatine IA

Nostrala, Justin, *Asst Prof,* Simpson College, Farnham Gallery, Indianola IA

Notz, Janis W, *Pres,* The Art Institute of Chicago, Antiquarian Society of the Art Institute of Chicago, Chicago IL

Novacek, Vera, *Secy,* Art Gallery of Peterborough, Peterborough ON

Novak, Allen, *AV Librn,* Ringling School of Art & Design, Verman Kimbrough Memorial Library, Sarasota FL

Novak, Barbara, *VChmn,* National Portrait Gallery, Library, Washington DC

Novak, Constance, *Supervising Librn,* The New York Public Library, Mid-Manhattan Library, Picture Collection, New York NY

Novak, Emily R, *Librn/Archivist,* Historic New England, Library and Archives, Boston MA

Novak, Philip, *Asst Dir,* Stamford Museum & Nature Center, Stamford CT

Novikova, Svetlorna, *Adminr,* Gallery Moos Ltd, Toronto ON

Nowack, Margaret, *Cur,* Woodrow Wilson, Washington DC

Nowicki, Angie, *Ranger,* Jack London, House of Happy Walls, Glen Ellen CA

Nowosielski, Rodney, *Assoc Prof,* Saginaw Valley State University, Dept of Art & Design, University Center MI (S)

Noyes, Julia, *Dir,* Noyes Art Gallery, Lincoln NE

Noyes, Julie, *Instr,* Northeast Community College, Dept of Liberal Arts, Norfolk NE (S)

Noyes, Nicholas, *Dir Library Svcs,* Maine Historical Society, Library and Museum, Portland ME

Noyes, Nick, *Head Library Svcs,* Maine Historical Society, Portland ME

Noyes, Royal, *Pres,* Big Horn County Historical Museum, Hardin MT

Nozynski, John H, *Dir,* 1890 House-Museum & Center for the Arts, Cortland NY

Nuell, Christie, *Instr,* Middle Tennessee State University, Art Dept, Murfreesboro TN (S)

Nuell, Lon, *Instr,* Middle Tennessee State University, Art Dept, Murfreesboro TN (S)

Nugent, Marjorie, *Media Relations Mgr,* Minnesota Historical Society, Saint Paul MN

Nugent, Patricia, *Assoc Prof & Dir Gallery,* Rosemont College, Art Program, Rosemont PA (S)

Null, Charleen A, *Instr,* Pearl River Community College, Visual Arts, Dept of Fine Arts & Communication, Poplarville MS (S)

Nunez, Mercedes, *Prof,* Bridgewater State College, Art Dept, Bridgewater MA (S)

Nunley, Helen, *Information Technology Coordr,* Arts Council of the Blue Ridge, Roanoke VA

Nunley, Jimmy, *Security,* The Walker African American Museum & Research Center, Las Vegas NV

Nunn, Tey Marianna, *Cur Contemporary Hispano & Latino Colls,* Museum of New Mexico, Museum of International Folk Art, Santa Fe NM

Nunoo-Quarcoo, Franc, *Asst Prof,* University of Maryland, Baltimore County, Imaging, Digital & Visual Arts Dept, Baltimore MD (S)

Nurse, Margaret, *Treas,* Society of Canadian Artists, Burlington ON

Nusbaum, Patricia, *VPres,* LeSueur County Historical Society, Chapter One, Elysian MN

Nusz, Nancy, *Dir Oregon Folklife,* Oregon Historical Society, Oregon History Center, Portland OR

Nutting, Ryan, *Coll Mgr,* Saco Museum, Saco ME

Nuvayestewa, Grace, *Co-Chairperson,* Institute of American Indian Arts Museum, Library, Santa Fe NM

Nuzum, Thomas, *Prof,* Mott Community College, Liberal Arts & Sciences, Flint MI (S)

Nuzum, Thomas, *VPres,* Buckham Fine Arts Project, Gallery, Flint MI

Nybak, Arne, *Cur,* San Luis Obispo Art Center, San Luis Obispo CA

Nydorf, Roy, *Prof of Art,* Guilford College, Art Dept, Greensboro NC (S)

Nye, Linda, *Dir,* Cuyahoga Valley Art Center, Cuyahoga Falls OH (S)

Nyerges, Alex, *Dir, CEO,* Virginia Museum of Fine Arts, Richmond VA

Nyman, Jennifer, *Technical Dir,* State University of New York at Binghamton, University Art Museum, Binghamton NY

Nyman, William, *Asst Prof,* The College of New Jersey, School of Arts & Sciences, Ewing NJ (S)

Nyquist, Lars, *Industrial Design,* Art Institute of Pittsburgh, Pittsburgh PA (S)

Nzegwu, NKiru, *Assoc Prof,* State University of New York at Binghamton, Dept of Art History, Binghamton NY (S)

Oakes, W Steven, *Historic Site Asst,* New York State Office of Parks Recreation & Historic Preservation, John Jay Homestead State Historic Site, Katonah NY

Oaklander, Christine I, *Cur Colls & Exhibs,* Allentown Art Museum, Allentown PA

Oakley, Sara, *Head Painting,* Western Colorado Center for the Arts, Inc, Grand Junction CO

Oaks, Gary, *Asst Prof,* Southern University in New Orleans, Fine Arts & Philosophy Dept, New Orleans LA (S)

Oats, Joclyn, *Architectural-Grad Studies & Coordr Interior Design,* Columbia College, Art Dept, Chicago IL (S)

Obed, Martin, *Dept Chair Humanities,* Kalamazoo Valley Community College, Center for New Media, Kalamazoo MI (S)

Obee, Natalee, *Human Resources & Events Mgr,* Minnesota Museum of American Art, Saint Paul MN

Ober, Kathy, *Librn,* Art Institute of Pittsburgh, Resource Center, Pittsburgh PA

Oberkirsch, Marie, *Adjunct,* Maryville University of Saint Louis, Art & Design Program, Saint Louis MO (S)

Obershan, Micheal, *Temp Asst Prof,* Georgia Southern University, Dept of Art, Statesboro GA (S)

Obert, Susan, *Develop Officer,* The Haggin Museum, Stockton CA

Oberweiser, Don, *Staff Artist,* Oshkosh Public Museum, Oshkosh WI

Obetz, Tim, *Exhib Mgr,* Institute of Contemporary Art, Boston MA

O'Bourke, Rosemarie, *Dir,* Gulf Coast Community College, Division of Visual & Performing Arts, Panama City FL (S)

O'Brien, Cara, *Dir Educ,* Central Michigan University, University Art Gallery, Mount Pleasant MI

O'Brien, Carole, *Dir Educ,* Butler Institute of American Art, Art Museum, Youngstown OH

O'Brien, David, *In Charge History,* University of Illinois, Urbana-Champaign, School of Art & Design, Champaign IL (S)

O'Brien, Derek, *Instr,* Lakeland Community College, Fine Arts Department, Kirtland OH (S)

O'Brien, Eileen, *Cur Library Coll,* Manchester Historic Association, Manchester NH

O'Brien, Kate, *Mem & Spec,* Art Museum of Greater Lafayette, Lafayette IN

O'Brien, Kathleen, *Dir,* Society of Layerists in Multi Media (SLMM), Albuquerque NM

O'Brien, Kevin, *CEO, Exec Dir,* Tippecanoe County Historical Association, Museum, Lafayette IN

O'Brien, Liz Hunt, *Dir Arts Prog,* Artists Association of Nantucket, Nantucket MA

O'Brien, Neil, *Registrar,* The Dixon Gallery & Gardens, Memphis TN

O'Brien, Neil, *Registrar,* The Dixon Gallery & Gardens, Library, Memphis TN

O'Brien, Susan, *Asst Prof,* Murray State University, Dept of Art, Murray KY (S)

O'Brien-Lyons, Susan, *Pres,* The Art Institute of Chicago, Auxiliary Board of the Art Institute of Chicago, Chicago IL

Obrochta, Bill, *Asst Dir Educ,* Virginia Historical Society, Library, Richmond VA

O'Callaghan, Thomas A., *Spanish Specialist,* National Gallery of Art, Department of Image Collections, Washington DC

Occhiogrosso, Gina, *Asst Prof,* College of Saint Rose, Art Dept, Albany NY (S)

Occhiuto, Joseph, *Rector,* San Carlos Cathedral, Monterey CA

Ocello, Claudia, *Cur Educ,* New Jersey Historical Society, Library, Newark NJ

Och, Marjorie, *Asst Prof,* Mary Washington College, Dept of Art & Art History, Fredericksburg VA (S)

Ochoa, Cristina, *Cur,* Self Help Graphics, Los Angeles CA

Ochoa, Jody, *Registrar,* Idaho Historical Museum, Boise ID

Ochoa, Maria, *Dir,* Sun Gallery, Hayward CA

Ochs, Steven, *Asst Prof,* Southern Arkansas University at Magnolia, Dept of Art, Magnolia AR (S)

Ochs, Steven, *Prof,* Southern Arkansas University, Art Dept Gallery & Magale Art Gallery, Magnolia AR

Ockershausen, Cindylou, *Conservator,* National Portrait Gallery, Washington DC

O'Coin, Thomas, *VPres Develop,* Meridian International Center, Cafritz Galleries, Washington DC

O'Connell, Bonnie, *Asst Prof,* University of Nebraska at Omaha, Dept of Art & Art History, Omaha NE (S)

O'Connell, Dan, *Circulation Mgr,* Wentworth Institute of Technology Library, Boston MA

O'Connell, Daniel M, *Commissioner of Cultural Affairs & Artistic Dir,* City of Pittsfield, Berkshire Artisans, Pittsfield MA

O'Connell, John, *Asst Prof,* University of Utah, Dept of Art & Art History, Salt Lake City UT (S)

O'Connell, John, *Instr,* Middle Tennessee State University, Art Dept, Murfreesboro TN (S)

O'Connell, Meg, *Pres,* Skaneateles Library Association, Skaneateles NY

O'Connor, Harold, *Head,* Dunc_onor Workshops, Salida CO (S)

O'Connor, J. Dennis, *Under Secy for Science,* Smithsonian Institution, Washington DC

O'Connor, John, *Asst Prof,* Radford University, Art Dept, Radford VA (S)

O'Connor, John A, *Prof,* University of Florida, Dept of Art, Gainesville FL (S)

O'Connor, Kathleen B, *Dir Educ,* Bayou Bend Collection & Gardens, Houston TX

O'Connor, Lawrence A, *VPres,* Columbus Museum of Art and Design, Indianapolis IN

O'Connor, Linda, *Asst,* Arts Council of Southwestern Indiana, Evansville IN

O'Connor, Renee, *Operations Mgr for Art Quest,* Green Hill Center for North Carolina Art, Greensboro NC

O'Day, Steve, *Instr,* Pacific University in Oregon, Arts Div, Dept of Art, Forest Grove OR (S)

O'Day, Terry, *Prof,* Pacific University in Oregon, Arts Div, Dept of Art, Forest Grove OR (S)

O'Day, Tom, *Asst Prof,* Spokane Falls Community College, Fine Arts Dept, Spokane WA (S)

Oddo, Shawn, *Culinary Arts & Management,* Art Institute of Pittsburgh, Pittsburgh PA (S)

Odegaard, Jill, *Asst Prof,* Cedar Crest College, Art Dept, Allentown PA (S)

O'Dell, Kathy, *Asst Prof,* University of Maryland, Baltimore County, Imaging, Digital & Visual Arts Dept, Baltimore MD (S)

Odence, Janet, *Secy,* Bergen County Historical Society, Steuben House Museum, River Edge NJ

Odom, Anne, *Cur Emerita,* Hillwood Museum & Gardens Foundation, Hillwood Museum & Gardens, Washington DC

Odoms, Rae Anne, *Treas, Project Dir & Bd Dirs,* Snake River Heritage Center, Weiser ID

O'Donahue, Patrick, *Interim Exec Dir,* Mexican Museum, San Francisco CA

O'Donnell, Hugh, *Prof,* Boston University, School for the Arts, Boston MA (S)

O'Donnell, Mark Stansbury, *Prof,* University of Saint Thomas, Dept of Art History, Saint Paul MN (S)

O'Donnell, Maryann, *Dean of Art,* Manhattan College, School of Arts, Riverdale NY (S)

O'Dowd, Ann, *VPres,* Lunenburg Art Gallery Society, Lunenburg NS

Oduyoye, Carole L, *Events Coordr,* African Art Museum of Maryland, Columbia MD

Oehlke, Vailey, *Dir Central Library,* Multnomah County Library, Henry Failing Art & Music Dept, Portland OR

Oerichbauer, Edgar, *Exec Dir,* Koochiching Museums, International Falls MN

Oertling, Sewall, *Chmn,* State University of New York College at Oswego, Art Dept, Oswego NY (S)

Oettinger, Marion, *Dir,* San Antonio Museum of Art, San Antonio TX

Offner, Elliot, *Pres,* National Sculpture Society, New York NY

Offner, Elliot, *Prof,* Smith College, Art Dept, Northampton MA (S)

Offredi, Cynthia, *Treas,* Essex Art Association, Inc, Essex CT

Offutt, Treva, *Dir Educ & Outreach,* Kitchen Center for Video, Music, Dance, Performance, Film & Literature, New York NY

Ofner, Ronald, *Dir Mktg & Communications,* The Adirondack Historical Association, The Adirondack Museum, Blue Mountain Lake NY

Ogden, Dale, *Cur Americana,* Indiana State Museum, Indianapolis IN

Ogden, Jackie, *Dir Animal Progs,* Disney's Animal Kingdom Theme Park, Bay Lake FL

Ogden, Vivian, *Cur,* Kelly-Griggs House Museum, Red Bluff CA

Ogle, Philip, *Prof,* College of Visual Arts, Saint Paul MN (S)

Ogren, Dawn, *Registrar,* Anderson Ranch Arts Center, Snowmass Village CO

O'Grody, Jeannine A, *Cur European Art,* Birmingham Museum of Art, Clarence B Hanson Jr Library, Birmingham AL

O'Halloran, Therese, *Instr,* Illinois Wesleyan University, School of Art, Bloomington IL (S)

O'Hanian, Hunter, *Exec Dir,* Fine Arts Work Center, Provincetown MA

O'Hara, Ann, *1st VPres,* Wayne County Historical Society, Honesdale PA

O'Hara, Ann, *VPres,* Wayne County Historical Society, Museum, Honesdale PA

O'Hara, J, *Prof,* Northern Arizona University, Museum Faculty of Fine Art, Flagstaff AZ (S)

O'Hara, Shana, *Gallery Mgr,* Aljira Center for Contemporary Art, Newark NJ

O'Hara, Sherman, *Chief Exhib Designer,* Columbus Museum of Art and Design, Indianapolis IN

O'Hara, Virginia, *Assoc Cur,* Brandywine River Museum, Chadds Ford PA

Ohira, Akemi, *Studio Faculty,* University of Virginia, McIntire Dept of Art, Charlottesville VA (S)

Ohlinger, Chris, *Gen Mgr,* Cosanti Foundation, Arcosanti, Scottsdale AZ

Ohnesorgen, Maggie, *Mus Shop Mgr,* Institute of American Indian Arts Museum, Museum, Santa Fe NM

Ohnesorgen, Maggie, *Mus Shop Mgr,* Institute of American Indian Arts, Institute of American Indian Arts Museum, Santa Fe NM (S)

Ohrmann, Bill, *Artist & Owner,* Ohrmann Museum and Gallery, Drummond MT

Oishei, Judith, *Prog Dir,* Library Association of La Jolla, Athenaeum Music & Arts Library, La Jolla CA

Ojala, Meg, *Assoc Prof,* Saint Olaf College, Art Dept, Northfield MN (S)

Oka, Sara, *Mgr Textile Coll,* Honolulu Academy of Arts, Honolulu HI

Okaya, Michiko, *Dir Gallery,* Lafayette College, Williams Center Gallery, Easton PA

O'Keefe, Elizabeth, *Dir Coll Info Systems,* Pierpont Morgan, New York NY

O'Keefe, Michael J, *Chmn,* Oklahoma Christian University of Science & Arts, Dept of Art & Design, Oklahoma City OK (S)

O'Keefe, Ruth, *Chmn Art History & Liberal Arts,* Kendall College of Art & Design, Grand Rapids MI (S)

O'Keefed, Michael, *Pres,* Minneapolis College of Art & Design, Minneapolis MN (S)

O'Keeffe, Timothy, *Asst Prof,* University of Wisconsin-Stout, Dept of Art & Design, Menomonie WI (S)

O'Kelley, Elvee, *Coll Asst & Receptionist,* The Art Institute of Chicago, Dept of Prints & Drawings, Chicago IL

Okuyama, Ken, *Transportation Design Chmn,* Art Center College of Design, Pasadena CA (S)

Olah, Laura, *Gallery Cur & Educ Dir,* Embroiderers Guild of America, Margaret Parshall Gallery, Louisville KY

O'Laughaire, Niamh, *Dir,* University of Toronto, University of Toronto Art Centre, Toronto ON

O'Laughlin, Thomas C, *Asst Dir,* Albuquerque Museum of Art & History, Albuquerque NM

Olbrantz, John, *Dir,* Willamette University, Hallie Ford Museum of Art, Salem OR

Oldach, Linda R, *Dir,* Mount Wachusett Community College, Library, Gardner MA

Oldfield, Barney, *Chmn Bd,* Anthology Film Archives, New York NY

Oldham, Terry, *Dir,* The Albrecht-Kemper Museum of Art, Saint Joseph MO

Oldham, Terry, *Dir,* The Albrecht-Kemper Museum of Art, Bradley Art Library, Saint Joseph MO

Oldknow, Tina, *Cur Modern Glass,* Corning Museum of Glass, The Studio, Rakow Library, Corning NY

Oldknow, Tina, *Vice Chmn,* American Craft Council, New York NY

Olds, Clifton, *Prof,* Bowdoin College, Art Dept, Brunswick ME (S)

O'Leary, Daniel, *Dir,* Portland Museum of Art, Portland ME

O'Leary, Daniel E, *Dir,* Portland Museum of Art, Portland ME

O'Leary, Elizabeth, *Assoc Cur American Arts,* Virginia Museum of Fine Arts, Richmond VA

O'Leary, Heather, *Asst Dir,* Art League of Manatee County, Library, Bradenton FL

Olgesby, Janet, *Electronic Imaging & Print Instr,* Western Wisconsin Technical College, Graphics Division, La Crosse WI (S)

Olijnyk, Michael, *Cur,* Mattress Factory, Pittsburgh PA

Olivant, David, *Prof,* California State University, Art Dept, Turlock CA (S)

Olive, Nancy, *Chmn,* University of Sioux Falls, Dept of Art, Sioux Falls SD (S)

Oliver, Debbie, *Registrar,* Nicolaysen Art Museum & Discovery Center, Museum, Casper WY

Oliver, Elizabeth, *N European Specialist,* National Gallery of Art, Department of Image Collections, Washington DC

Oliver, James M, *Asst Prof,* Pittsburg State University, Art Dept, Pittsburg KS (S)

Oliver, Janet, *Lectr,* University of North Carolina at Greensboro, Art Dept, Greensboro NC (S)

Oliver, Judith, *Assoc Prof,* Colgate University, Dept of Art & Art History, Hamilton NY (S)

Oliver, Kurt, *Access Mgr,* Wentworth Institute of Technology Library, Boston MA

Oliver, Marsha, *Dir Community Relations,* Columbus Museum of Art and Design, Indianapolis IN

Oliver, Patricia, *Chmn Environmental Design,* Art Center College of Design, Pasadena CA (S)

Oliveri, Meg, *Cur,* Nassau Community College, Firehouse Art Gallery, Garden City NY

Oliveri, Michael, *Asst Prof Digital Media,* University of Georgia, Franklin College of Arts & Sciences, Lamar Dodd School of Art, Athens GA (S)

Olivier-Salmon, Camille, *Dir Prog,* San Francisco Arts Education Project, San Francisco CA

Olivo, Sandra, *Cur Educ,* Middlebury College, Museum of Art, Middlebury VT

Ollman, Arthur, *Dir,* Museum of Photographic Arts, San Diego CA

Olsen, Bill, *Gallery Mgr,* Pemaquid Group of Artists, Pemaquid Art Gallery, Pemaquid Point ME

Olsen, Carol, *VPres,* Contemporary Arts Center, Cincinnati OH

Olsen, Charles, *Chmn,* St Francis College, Fine Arts Dept, Loretto PA (S)

Olsen, Denise, *Asst Dir,* Yakima Valley Community College, Larson Gallery, Yakima WA

Olsen, Dennis, *Prof,* University of Texas at San Antonio, Dept of Art & Art History, San Antonio TX (S)

Olsen, Geoffrey, *Grad Prof,* Florida International University, School of Art & Art History, Miami FL (S)

Olsen, Karen, *Dir Gallery,* Mount Mary College, Marian Gallery, Milwaukee WI

Olsen, Maude, *Treas,* Pemaquid Group of Artists, Pemaquid Art Gallery, Pemaquid Point ME

Olsen, Mel, *Prof,* University of Wisconsin-Superior, Programs in the Visual Arts, Superior WI (S)

Olsen, Sandra H, *Dir,* Niagara University, Castellani Art Museum, Niagara NY

Olsen, Valerie L, *Assoc Dir,* Glassell School of Art, Houston TX (S)

Olsen, Yvonne, *Dir Develop,* Arts Council of the Blue Ridge, Roanoke VA

Olson, A. J., *Prof,* Troy State University, Dept of Art & Classics, Troy AL (S)

Olson, Alan, *Dir Colls,* Dallas Historical Society, Hall of State, Dallas TX

Olson, Alan, *Dir Colls,* Dallas Historical Society, Research Center Library, Dallas TX

Olson, David, *Dir,* Newton History Museum at the Jackson Homestead, Newton MA

Olson, Dennis, *Asst Prof,* Amarillo College, Visual Art Dept, Amarillo TX (S)

Olson, Dona, *Purchasing,* New England Maple Museum, Pittsford VT

Olson, Janet, *Assoc Prof,* Boston University, School for the Arts, Boston MA (S)

Olson, Janis, *Cur Coll,* Whatcom Museum of History and Art, Bellingham WA

Olson, Janis, *Cur Coll,* Whatcom Museum of History and Art, Library, Bellingham WA

Olson, Jim, *Gallery Admin,* Open Space, Victoria BC

Olson, Kristina, *Prof,* West Virginia University, College of Creative Arts, Morgantown WV (S)

Olson, Marilyn, *Treas,* Muttart Public Art Gallery, Calgary AB

Olson, Marisa, *Assoc Dir,* San Francisco Camerawork, San Francisco CA

Olson, Sarah, *Supt,* Roosevelt-Vanderbilt National Historic Sites, Hyde Park NY

Olson, Susan, *Develop Secy,* Iowa State University, Brunnier Art Museum, Ames IA

Olson, Thomas H, *Pres,* New England Maple Museum, Pittsford VT

Olson-Clark, Kim, *Develop Officer,* Evanston Historical Society, Charles Gates Dawes House, Evanston IL

Olson-Janjic, Kathleen, *Assoc Prof,* Washington and Lee University, Div of Art, Lexington VA (S)

Olszewski, Edward J, *Prof,* Case Western Reserve University, Dept of Art History & Art, Cleveland OH (S)

Olt, Frank, *Assoc Prof,* C W Post Campus of Long Island University, School of Visual & Performing Arts, Brookville NY (S)

Oltjenbruns, Leona, *Secy,* Phillips County Museum, Holyoke CO

Oltman, Bob, *Chmn,* Pasadena Museum of California Art, Pasadena CA

Oltvedt, Carl, *Prof,* Minnesota State University-Moorhead, Dept of Art, Moorhead MN (S)

Olvera, John, *Prof,* Winthrop University, Dept of Art & Design, Rock Hill SC (S)

O'Malley, Bill, *Faculty Emeritus,* Mott Community College, Liberal Arts & Sciences, Flint MI (S)

O'Malley, Dennis M, *Dir,* Rhode Island College, Edward M Bannister Gallery, Providence RI

O'Malley, Jeannette, *Exec Dir,* Pasadena Historical Museum, Pasadena CA

O'Malley, Kathleen, *Assoc Registrar,* Dartmouth College, Hood Museum of Art, Hanover NH

O'Malley, Kathleen L., *Pres,* Cohasset Historical Society, Captain John Wilson Historical House, Cohasset MA

O'Malley, Kelly, *Admin Asst/Exhib Fair Coordr,* Society for Photographic Education, Oxford OH

O'Malley, Therese, *Second VPres,* Society of Architectural Historians, Chicago IL

O'Malley, Tom, *Dept Head,* Worcester Center for Crafts, Worcester MA (S)

Oman, Earl, *Cur Colls (Emeritus),* Northern Maine Museum of Science, Presque Isle ME

Oman, Nicole, *Coordr Family Prog,* Art Museum of Western Virginia, Roanoke VA

Oman, Richard, *Dept Chmn,* Muskegon Community College, Dept of Creative & Performing Arts, Muskegon MI (S)

O'Mara, Joan, *Assoc Prof,* Washington and Lee University, Div of Art, Lexington VA (S)

O'Mara, Sharyn, *Chmn Foundation Prog,* Temple University, Tyler School of Art, Elkins Park PA (S)

O'Mara, Shawn, *Digital Design,* Art Institute of Pittsburgh, Pittsburgh PA (S)

Omari, Mikelle, *Assoc Prof Art History,* University of Arizona, Dept of Art, Tucson AZ (S)

O'Meara, Nancy G, *Exec Dir,* Philadelphia Museum of Art, Women's Committee, Philadelphia PA

Omogbai, Meme, *Deputy Dir Finance,* Newark Museum Association, The Newark Museum, Newark NJ

Ondrizek, Geraldine, *Asst Prof Art,* Reed College, Dept of Art, Portland OR (S)

O'Neil, Karen, *Instr,* Woodstock School of Art, Inc, Woodstock NY (S)

O'Neil, Kevin, *Instr,* Keystone College, Fine Arts Dept, LaPlume PA (S)

O'Neil, Maureen, *Instr,* Flagler College, Visual Arts Dept, Saint Augustine FL (S)

O'Neil, Robert, *Asst Prof,* College of Saint Rose, Art Dept, Albany NY (S)

O'Neill, Cheryl, *Librn,* Art Complex Museum, Carl A. Weyerhaeuser Library, Duxbury MA

O'Neill, Cheryl, *Librn,* Art Complex Museum, Library, Duxbury MA

O'Neill, Deborah, *Asst Educ,* Abigail Adams Smith, New York NY

o'Neill, Ed, *Chmn,* Brookdale Community College, Center for the Visual Arts, Lincroft NJ (S)

O'Neill, John, *Cur Mss & Rare Books,* Hispanic Society of America, Library, New York NY

O'Neill, John, Hispanic Society of America, Museum & Library, New York NY

O'Neill, John P, *Ed In Chief,* The Metropolitan Museum of Art, New York NY

O'Neill, Kevin, *Dir,* Chatillon-DeMenil House Foundation, DeMenil Mansion, Saint Louis MO

O'Neill, Mark, *Corp Sec & Dir Gen Strategic Planning,* Canadian Museum of Civilization, Gatineau PQ

O'Neill, Mark, *VPres Pub Affairs& Publishing,* Canadian Museum of Civilization, Gatineau PQ

O'Neill, Walt, *Dir,* Education Alliance, Art School & Gallery, New York NY (S)

O'Neill, Yvette, *Instr,* Lower Columbia College, Art Dept, Longview WA (S)

Onofrio, Jennifer, *Assoc Prof,* Augusta State University, Dept of Arts, Augusta GA (S)

Onuf, Rachel, *Dir Archives,* Historical Society of Pennsylvania, Philadelphia PA

Onyile, Onyile B, *Assoc Prof,* Georgia Southern University, Dept of Art, Statesboro GA (S)

Opalko, Michael N, *Graphic Design,* Art Institute of Pittsburgh, Pittsburgh PA (S)

Opp, Nathan, *Instr,* Oral Roberts University, Art Dept, Tulsa OK (S)

Oppenheim, Phyllis, *Colls Mgr,* Herrett Center for Arts & Sciences, Jean B King Art Gallery, Twin Falls ID

Oppenheimer, Sarah, The College of New Jersey, School of Arts & Sciences, Ewing NJ

Oppenhimer, Ann, *VPres,* Folk Art Society of America, Richmond VA

Oppenhimer, William, *Financial Dir,* Folk Art Society of America, Richmond VA

Oppio, Amy, *Deputy Dir,* Nevada Museum of Art, Art Library, Reno NV

Oppio, Amy, *Dir Communications,* Nevada Museum of Art, Reno NV

Ore, Joyce, *Dir Pub Relations,* Hastings College, Art Dept, Hastings NE (S)

O'Reilly, Jack, *Treas,* New Jersey Watercolor Society, Parsippany NJ

O'Reilly, Margaret M, *Cur Fine Art,* New Jersey State Museum, Fine Art Bureau, Trenton NJ

Orelind, Bob, *Pres,* Swedish-American Museum Association of Chicago, Chicago IL

Orescan, Sharon, *Admin Clerk,* University of Alberta, Dept of Art & Design, Edmonton AB (S)

Oresky, Melissa, *Conservator,* Spertus Institute of Jewish Studies, Asher Library, Chicago IL

Orgill, Von D, *Pres & Gen Mgr,* Polynesian Cultural Center, Laie HI

O'Riordan, Vickie, *Cur Visual Resources,* University of California, San Diego, Arts Libraries, La Jolla CA

Oritsky, Mimi, *Instr,* Main Line Art Center, Haverford PA (S)

Orlando, Fran, *Dir Exhib,* Bucks County Community College, Hicks Art Center, Newtown PA

Orlando, Joe, *Dir Educ,* Art Institute of Houston, Houston TX (S)

Orlofski, Patsy, *Dir,* Textile Conservation Workshop Inc, South Salem NY

Orlovski, Stas, *Instr,* Long Beach City College, Art & Photography Dept, Long Beach CA (S)

Orndorff, Vivian, *Prog Mgr,* National Foundation for Advancement in the Arts, Miami FL

O'Rourke, Kristin, *Adjunct Asst Prof,* Dartmouth College, Dept of Art History, Hanover NH (S)

Orozco, Sylvia, *CEO,* MEXIC-ARTE Museum, Austin TX

Orr, Amy, *Asst Prof,* Rosemont College, Art Program, Rosemont PA (S)

Orr, Clint, *Graphic Design,* University of South Alabama, Dept of Art & Art History, Mobile AL (S)

Orr, Michael, *Prof,* Lawrence University, Dept of Art, Appleton WI (S)

Orr, Rebecca, *Mem Adminr,* Southern Highland Craft Guild, Folk Art Center, Asheville NC

Orr-Cahall, Christina, *Dir,* Norton Museum of Art, Museum, West Palm Beach FL

Orr-Cahall, Christina, *Dir & CEO,* Norton Museum of Art, West Palm Beach FL

Orring, Kjell, *Pres,* Society of Canadian Artists, Burlington ON

Ortbals, John, *Assoc Prof,* Saint Louis Community College at Florissant Valley, Liberal Arts Division, Ferguson MO (S)

Ortega, Lisete, *Educator,* Fayetteville Museum of Art, Inc, Fayetteville NC

Orth, Fredrick, *Dir,* San Diego State University, School of Art, Design & Art History, San Diego CA (S)

Ortiz, Jose, *Mgr Admin,* The Metropolitan Museum of Art, The Cloisters, New York NY

Ortner, Frederick, *Chmn,* Knox College, Dept of Art, Galesburg IL (S)

O'Sahaugnessy, Maureane, *Dir,* Arts Club of Washington, James Monroe House, Washington DC

Osajima, Rachel, *Cur,* San Francisco Craft & Folk Art Museum, San Francisco CA

Osborn, Nancy, *Theater,* Saint Clair County Community College, Jack R Hennesey Art Dept, Port Huron MI (S)

Osborne, Darlene, *Gift Shop Clerk,* Cascade County Historical Society, High Plains Heritage Center, Great Falls MT

Osborne, John L, *Prof,* University of Victoria, Dept of History in Art, Victoria BC (S)

Osborne, Ruth, *Treas,* Switzerland County Historical Society Inc, Life on the Ohio: River History Museum, Vevay IN

Osborne, Ruth, *Treas,* Switzerland County Historical Society Inc, Switzerland County Historical Museum, Vevay IN

Osbourne, Ginger, *Office Mgr,* Fairmount Park Art Association, Philadelphia PA

Osepchook, Felicity, *Coordr, Head Archives & Research Library,* New Brunswick Museum, Archives & Research Library, Saint John NB

O'Shaughnessy, David, *Chmn,* Los Angeles Harbor College, Art Dept, Wilmington CA (S)

O'Shea, Deborah H., *Dir,* Rome Art & Community Center, Rome NY

O'Shello, Wanda, *Ed Arts Quarterly,* New Orleans Museum of Art, New Orleans LA

Oshima, David, *Art Dept Chmn,* Pierce College, Art Dept, Woodland Hills CA (S)

Osler, John C, *Chmn,* Alberta Foundation for the Arts, Edmonton AB

Osmond, Jerry, *Registrar,* Medicine Hat Museum & Art Gallery, Medicine Hat AB

Oste-Alexander, Pia, *Instr,* Woodstock School of Art, Inc, Woodstock NY (S)

Ostedorf, Eleanor, *Cur Historic House,* Iowa State University, Brunnier Art Museum, Ames IA

Osterhus, Cynthia B, *Dir,* Horizons Unlimited Supplementary Educational Center, Science Museum, Salisbury NC

Osterlund, Angelo, *Digital Design,* University of Wisconsin College - Marinette, Art Dept, Marinette WI (S)

Ostrander, Kathy, *Asst Archivist,* Brick Store Museum & Library, Kennebunk ME

Ostromoukhov, Victor, *Aggregate Prof,* Universite de Montreal, Bibliotheque d'Amenagement, Montreal PQ

Ostrosky, Amelia, *Exec Dir,* Robert & Mary Montgomery Armory Art Center, West Palm Beach FL

Ostrow, Mindy, *Asst Dir,* State University of New York at Oswego, Tyler Art Gallery, Oswego NY

Oszuscik, Philippe, *Art Historian,* University of South Alabama, Dept of Art & Art History, Mobile AL (S)

Otis, Michaelin, *Faculty,* Grand Marais Art Colony, Grand Marais MN (S)

O'Toole, Judith H, *CEO & Dir,* Westmoreland Museum of American Art, Greensburg PA

O'Toole, Judith H, *Dir & CEO,* Westmoreland Museum of American Art, Art Reference Library, Greensburg PA

O'Toole, Kate, *VPres,* New York Artists Equity Association, Inc, New York NY

Otremsky, Bill, *Asst Prof,* Florida Southern College, Art Dept, Lakeland FL (S)

Otremsky, William, *Assoc Prof Art & Dir Studio Prog,* Florida Southern College, Melvin Art Gallery, Lakeland FL

Ott, Lili, *Dir,* Shaker Museum & Library, Old Chatham NY

Ott-Hansen, Henry, *Treas,* Cleveland Museum of Art, Print Club of Cleveland, Cleveland OH

Ottaviano, Lillian, *Prof,* Cazenovia College, Center for Art & Design Studies, Cazenovia NY (S)

Otto, Elizabeth, *Ast Prof,* University at Buffalo, State University of New York, Dept of Visual Studies, Buffalo NY (S)

Otto, Martha, *Head Archaeology,* Ohio Historical Society, Columbus OH

Otto, Richard H, *Pres,* American Academy of Art, Chicago IL (S)

Otton, William, *Dir,* South Texas Institute for the Arts, Art Museum of South Texas, Corpus Christi TX

Ouchi, Eugene, *Acad Head Design,* Alberta College of Art & Design, Calgary AB (S)

Ouellet, Line, *Dir Exhibs & Educ,* Musee du Quebec, Quebec PQ

Ouellette, David, *Dir Galleries,* Florida School of the Arts, Visual Arts, Palatka FL (S)

Oughton, Linda, *Admin Asst,* American Homing Pigeon Institute, Oklahoma City OK

Ouimet, Gayla, *Treas,* Kateri Tekakwitha Shrine, Kahnawake PQ

Ourecky, Irma, *Exec Dir & Chmn,* Wilber Czech Museum, Wilber NE

Ousey, Jack, *Instr,* Southeastern Oklahoma State University, Fine Arts Dept, Visual Arts Division, Durant OK (S)

Outlaw, Billy, *Bookkeeper,* Alexandria Museum of Art, Alexandria LA

Overall, Scott, *Asst Cur,* University Club Library, New York NY

Overbeck, John, *Prof,* State University of New York at Albany, Art Dept, Albany NY (S)

Overfield, Helen, *Dir Pub Relations,* Kentucky Museum of Art & Craft, Louisville KY

Overstreet, Joe, *Art Dir,* Kenkeleba House, Inc, Kenkeleba Gallery, New York NY

Overstreet, Kim W, *Dir,* Gertrude Herbert, Augusta GA

Overton, Robert, *Assoc Dir,* West Florida Historic Preservation, Inc, T T Wentworth, Jr Florida State Museum & Historic Pensacola Village, Pensacola FL

Overy, Jane Bunker, *Founder,* Searchlight Historic Museum & Mining Park, Searchlight NV

Ovrebo, Reidun, *Chair,* West Virginia State College, Art Dept, Institute WV (S)

Owcvark, Bob, *Div Chmn,* Pine Manor College, Visual Arts Dept, Chestnut Hill MA (S)

Owczarski, Marian, *Dir,* St Mary's Galeria, Orchard Lake MI

Owen, Paula, *Pres,* Southwest School of Art & Craft, San Antonio TX

Owen, Robert, *Facilities & Special Events,* Tyler Museum of Art, Tyler TX

Owen, Robert, *Special Events & Facilities Manager,* Tyler Museum of Art, Reference Library, Tyler TX

Owen Moss, Eric, *Dir,* Southern California Institute of Architecture, Los Angeles CA

Owens, Carlotta, *Asst Cur,* National Gallery of Art, Index of American Design, Washington DC

Owens, Chris, *Coll Mgr,* Saint Gregory's Abbey & University, Mabee-Gerrer Museum of Art, Shawnee OK

Owens, Chris, *Part-Time Instr,* Oklahoma Baptist University, Art Dept, Shawnee OK (S)

Owens, Jennifer, *Admin Asst,* Sangre de Cristo Arts & Conference Center, Pueblo CO

Owens, John, *Asst Prof,* Central Missouri State University, Art Dept, Warrensburg MO (S)

Owens, Keith, *Asst Prof Communication Design,* University of North Texas, School of Visual Arts, Denton TX (S)

Owens, Lou B, *Rental Coordr,* Art Community Center, Art Center of Corpus Christi, Corpus Christi TX

Owens, Robert G, *Head Division of Fine Arts & Humanities,* Fayetteville State University, Performing & Fine Arts, Fayetteville NC (S)

Owens, Suzanne, *Dir,* Individual Artists of Oklahoma, Oklahoma City OK

Parker, Michael, *Visual Resource Coordr,* Corcoran Gallery of Art, Corcoran Library, Washington DC

Parker, Niles, *Chief Cur,* Nantucket Historical Association, Historic Nantucket, Nantucket MA

Parker, Pat, *Educ Asst,* Farmington Valley Arts Center, Avon CT

Parker, Phil, *Coordr Graphic Design,* Florida School of the Arts, Visual Arts, Palatka FL (S)

Parker, Shalon, *Asst Prof,* Gonzaga University, Dept of Art, Spokane WA (S)

Parker, Stephen, *Prof,* Black Hills State University, Art Dept, Spearfish SD (S)

Parker, Stuart, *Acad Head Fine Arts,* Alberta College of Art & Design, Calgary AB (S)

Parker Adams, Lisa, *Tour Coordr,* Academy of the New Church, Glencairn Museum, Bryn Athyn PA

Parker Phfiefer, Gene, *Pres,* Art Commission of the City of New York, New York NY

Parkinson, Carol, *Dir,* Harvestworks, Inc, New York NY

Parkinson, George, *Div Chief & State Archivist,* Ohio Historical Society, Archives-Library Division, Columbus OH

Parkinson, Trude, *Instr,* Marylhurst University, Art Dept, Marylhurst OR (S)

Parks, Aaron, *Dir Marketing,* The University of Texas at San Antonio, UTSA's Institute of Texan Cultures, San Antonio TX

Parks, Bob, *Prof,* Oklahoma State University, Art Dept, Stillwater OK (S)

Parks, Chris, *Business Mgr,* Salisbury University, Ward Museum of Wildfowl Art, Salisbury MD

Parks, Janet, *Cur Drawings & Archives,* Columbia University, Avery Architectural & Fine Arts Library, New York NY

Parks, Mary, *Coll Cur,* Willamette University, Hallie Ford Museum of Art, Salem OR

Parks, Michael, *Admin Asst,* Five Civilized Tribes Museum, Muskogee OK

Parks, Nancy, *Asst Prof Art Educ,* University of Cincinnati, School of Art, Cincinnati OH (S)

Parks, Robert, *Dir Library & Mus Svcs,* Pierpont Morgan, New York NY

Parks, Tom, *Chief Security Officer,* Nelda C & H J Lutcher Stark, Stark Museum of Art, Orange TX

Parks-Kirby, Carrie Anne, *Prof, Chmn,* Alma College, Clack Art Center, Dept of Art & Design, Alma MI (S)

Parmenter, Marian, *Dir,* San Francisco Museum of Modern Art, Artist Gallery, San Francisco CA

Parnes, Laura, *Bd Dir,* Momenta Art, Brooklyn NY

Parra, Adrian, *Programming Coordr,* The Center for Contemporary Arts of Santa Fe, Santa Fe NM

Parris, David, *Cur Science,* New Jersey State Museum, Fine Art Bureau, Trenton NJ

Parris, Mike, *Instr CAD,* Converse College, Dept of Art & Design, Spartanburg SC (S)

Parrott, Frances, *Chmn,* Iowa Western Community College, Art Dept, Council Bluffs IA (S)

Parrott, Karen, *Dir,* Dorland Mountain Arts Colony, Temecula CA (S)

Parry, John, *Exec Dir,* Saskatchewan Association of Architects, Saskatoon SK

Parry, Lee, *Prof Art History,* University of Arizona, Dept of Art, Tucson AZ (S)

Parry, Pamela, *Registrar,* Norton Museum of Art, West Palm Beach FL

Parsley, Myrtie, *Instr,* Campbellsville University, Department of Art, Campbellsville KY (S)

Parsley-Welch, Krista, *Electronic Catalog Project Mgr,* Scripps College, Ruth Chandler Williamson Gallery, Claremont CA

Parson, Del, *Asst Prof,* Dixie College, Art Dept, Saint George UT (S)

Parson, Leon, *Instr,* Ricks College, Dept of Art, Rexburg ID (S)

Parsons, Austin, *Asst Prof,* Technical University of Nova Scotia, Faculty of Architecture, Halifax NS (S)

Parsons, David, *Dir Finance,* Historic Hudson Valley, Tarrytown NY

Parsons, David, *Instr,* California State University, Dominguez Hills, Art Dept, Carson CA (S)

Parsons, Merribell, *Adjunct Cur Decorative Arts,* San Antonio Museum of Art, San Antonio TX

Parsons-O'Keefe, Colby, *Asst Prof,* Texas Woman's University, School of the Arts, Dept of Visual Arts, Denton TX (S)

Partin, Bruce, *Chmn,* Roanoke College, Fine Arts Dept-Art, Salem VA (S)

Partington, Judith, *Librn,* The Filson Historical Society, Reference & Research Library, Louisville KY

Partlow, Gayle, *Prof,* Los Angeles City College, Dept of Art, Los Angeles CA (S)

Partovi, Pat, *Dir,* Spokane Public Library, Spokane WA

Partridge, Kathleen, *Instr,* Mohawk Valley Community College, Utica NY (S)

Partridge, Rae Ann, *Exhibits Mgr,* Lowell Art Association, Inc, Whistler House Museum of Art, Lowell MA

Parx, Roger, *Ed, Nathanael Green Papers,* Rhode Island Historical Society, Providence RI

Pascale, Mark, *Assoc Cur,* The Art Institute of Chicago, Dept of Prints & Drawings, Chicago IL

Pasch, Laura, *New Media & Image Coordr,* Morris Museum of Art, Augusta GA

Paschal, Huston, *Assoc Dir Modern Art,* North Carolina Museum of Art, Reference Library, Raleigh NC

Paschal, Mary Lou, *Chmn,* Central Piedmont Community College, Visual & Performing Arts, Charlotte NC (S)

Paschall, W Douglass, *Cur Coll,* Woodmere Art Museum, Library, Philadelphia PA

Paschall, W Douglass, *Cur of Coll,* Woodmere Art Museum, Philadelphia PA

Paska, Judith, *Vice Dir Develop,* Brooklyn Museum, Brooklyn NY

Pass, Dwayne, *Instr,* Tulsa Community College, Art Dept, Tulsa OK (S)

Passanise, Gary, *Asst Prof,* Webster University, Art Dept, Webster Groves MO (S)

Passic, Frank, *Chm Numismatic D,* Balzekas Museum of Lithuanian Culture, Chicago IL

Passlof, Pat, *Dir,* College of Staten Island, Performing & Creative Arts Dept, Staten Island NY (S)

Paster, Carol, *Exec Dir,* Creative Arts Center, Pontiac MI

Paster, Carol, *Exec Dir,* Creative Art Center-North Oakland County, Pontiac MI (S)

Pasternak, Anne, *Exec Dir,* Creative Time, New York NY

Pasternak, Stephanie, *Secy,* Town of Cummington Historical Commission, Kingman Tavern Historical Museum, Cummington MA

Pastore, Andrew, *Exhibit Mgr,* Hartwick College, The Yager Museum, Oneonta NY

Pastore, Heather, *Controller,* Elmhurst Art Museum, Elmhurst IL

Pastore, Shiela, *Vol Coordr,* Palo Alto Art Center, Palo Alto CA

Pasture, Randy Good, *Facilities Mgr & Gen Mgr,* American Homing Pigeon Institute, Oklahoma City OK

Patchell, Chris, *Graphic Design,* Antonelli Institute, Professional Photography & Commercial Art, Erdenheim PA (S)

Patchen, Jeffrey, *Pres & CEO,* Children's Museum, Indianapolis IN

Pate, Annette, *Med Adjunct Prof,* Oklahoma Christian University of Science & Arts, Dept of Art & Design, Oklahoma City OK (S)

Patel, Joy, *Chief Library Svcs,* Department of Canadian Heritage, Canadian Conservation Institute, Ottawa ON

Paterniti, John, *CFO,* San Diego Museum of Art, San Diego CA

Paterson, Nancy, *Asst Librn,* Walters Art Museum, Library, Baltimore MD

Patnode, J Scott, *Prof,* Gonzaga University, Dept of Art, Spokane WA (S)

Patout, Gerald F, *Head Librn,* The Historic New Orleans Collection, New Orleans LA

Patrick, Jill, *Dir,* Ontario College of Art & Design, Dorothy H Hoover Library, Toronto ON

Patrick, Jill, *Dir Library Servs,* Ontario College of Art & Design, Toronto ON (S)

Patrick, Lucinda, *Head Dept,* Middlesex Community College, Fine Arts Div, Middletown CT (S)

Patrick, Pat, *Exec Dir,* Arthur Roy Mitchell, Museum of Western Art, Trinidad CO

Patrick, Stephen, *Cur,* George Washington, Alexandria VA

Patrick, Stephen, *Vol Pub Rels,* Bluemont Historical Railroad Junction, Arlington VA

Patrick, Vernon, *Prof Emeritus,* California State University, Chico, Department of Art & Art History, Chico CA (S)

Patridge, Margaret, *Pub Information,* Walker Art Center, Minneapolis MN

Patry, J Michael, *Exec Dir,* Creative Photographic Arts Center of Maine, Dorthea C Witham Gallery, Lewiston ME

Patt, Stephne, *Instr,* La Sierra University, Art Dept, Riverside CA (S)

Patt, Susan, *Chmn,* La Sierra University, Art Dept, Riverside CA (S)

Patten, James, *Cur Contemporary Art & Photography,* The Winnipeg Art Gallery, Winnipeg MB

Patten, James, *Publicity,* Wiscasset, Waterville & Farmington Railway Museum (WW&F), Alna ME

Patterson, Aubrey B, *Pres,* Bank of Mississippi, Art Collection, Tupelo MS

Patterson, Belinda A, *Lectr,* Lambuth University, Dept of Human Ecology & Visual Arts, Jackson TN (S)

Patterson, Brent, *Asst Prof,* West Virginia Wesleyan College, Art Dept, Buckhannon WV (S)

Patterson, Carolyn, *Dir ILL Artisans Prog,* Illinois State Museum, Illinois Artisans Shop, Chicago IL

Patterson, Carolyn, *Dir ILL Artisans Prog,* Illinois State Museum, Illinois Artisans & Visitors Centers, Chicago IL

Patterson, Carolyn, *IL Artisans Prog,* Illinois State Museum, Museum Store, Chicago IL

Patterson, Curtis, *Assoc Prof,* Atlanta College of Art, Atlanta GA (S)

Patterson, Jeremiah, *Asst Prof,* University of Hartford, Hartford Art School, West Hartford CT (S)

Patterson, L Dale, *Archivist,* Archives & History Center of the United Methodist Church, Madison NJ

Patterson, Michelle, *Prof,* North Carolina Central University, Art Dept, Durham NC (S)

Patterson, Myron, *Fine Arts Librn,* University of Utah, Marriott Library, Salt Lake City UT

Patterson, Oscar, *Chmn,* University of North Florida, Dept of Communications & Visual Arts, Jacksonville FL (S)

Patterson, Richard, *Dir,* Old Barracks Museum, Trenton NJ

Patterson, Vivian, *Cur Colls,* Williams College, Museum of Art, Williamstown MA

Patterson, William C, *Pres,* Philadelphia Sketch Club, Philadelphia PA

Patton, Andy, *Toronto School of Art,* Toronto ON (S)

Patton, Larry, *Dean,* Butler County Community College, Art Dept, El Dorado KS (S)

Patton, Tom, *Chmn,* California State University, Chico, Department of Art & Art History, Chico CA (S)

Patula, Timothy A, *Dir of Design,* Chicago Athenaeum, Museum of Architecture & Design, Galena IL

Paukert, Karel, *Cur Musical Arts,* Cleveland Museum of Art, Cleveland OH

Paul, April, *Cur Coll,* The Chaim Gross Studio Museum, New York NY

Paul, Eli, *Dir,* Liberty Memorial Museum & Archives, The National Museum of World War I, Kansas City MO

Paul, Rosemary, *Admin Officer,* Herbert Hoover, West Branch IA

Pauley, Ed, *CEO & Exec Dir,* The Cultural Center of Fine Arts, Art Gallery, Parkersburg WV

Pauley, Edward E, *Pres & CEO,* Plains Art Museum, Fargo ND

Pauley, Steve, *Instr,* North Hennepin Community College, Art Dept, Brooklyn Park MN (S)

Paulick, Ron, *Bookkeeper,* Cascade County Historical Society, High Plains Heritage Center, Great Falls MT

Paulin, Luc, *Dir Craft School,* New Brunswick College of Craft & Design, Fredericton NB (S)

Paulin, Luc, *Prin,* New Brunswick College of Craft & Design, Fredericton NB

Paulsen, John Q, *Bd Dir Chmn,* Plains Art Museum, Fargo ND

Paulsen, Richard, *Chmn,* Elmhurst College, Art Dept, Elmhurst IL (S)

Paulson, Alan, *Prof,* Gettysburg College, Dept of Visual Arts, Gettysburg PA (S)

Paulson, Wesley E, *Pres,* Maryland College of Art & Design, Silver Spring MD (S)

Paulus, Norma, *Dir,* Oregon Historical Society, Oregon History Center, Portland OR

Pauly, Lauren, *Mktg & Events Coordr,* Captain Forbes House Mus, Milton MA

Pautler, Charles D, *Historic Site Mgr,* Charles A Lindbergh Historic Site, Little Falls MN

Pavelec, Karen Marie, *Exec Dir,* Maude Kerns, Eugene OR (S)

Pavlock, Paul, *Instr,* Marylhurst University, Art Dept, Marylhurst OR (S)

Pavlovic, Milutin, *Designer & Preparator,* Telfair Museum of Art, Telfair Academy of Arts & Sciences Library, Savannah GA

Pavovic, Milutin, *Designer,* Telfair Museum of Art, Savannah GA

Pawlicki, Patti, *Instr,* Suomi International College of Art & Design, Fine Arts Dept, Hancock MI (S)

Pawloski, Carole, *Visual Resource Librn,* Eastern Michigan University, Art Dept Slide Collection, Ypsilanti MI

Pawlowicz, Peter, *Assoc Prof,* East Tennessee State University, College of Arts and Sciences, Dept of Art & Design, Johnson City TN (S)

Paxson, Sue Ellen, *Dir Exhib & Special Projects,* Columbus Museum of Art and Design, Indianapolis IN

Payne, Christopher, *Chmn,* Huntingdon College, Dept of Art, Montgomery AL (S)

Payne, Chuck, *Exhibit Specialist,* Headquarters Fort Monroe, Dept of Army, Casemate Museum, Fort Monroe VA

Payne, Darien, *Graphics Instr,* Monterey Peninsula College, Art Dept, Monterey CA (S)

Payne, J Couric, *Gen Mgr Mus Stores,* Fine Arts Museums of San Francisco, Legion of Honor, San Francisco CA

Payne, Jennifer Cover, *Exec Dir,* Cultural Alliance of Greater Washington, Washington DC

Payne, Laura, *Pub Relations Mgr,* Kentucky Derby Museum, Louisville KY

Payne, Thomas, *Dept Head,* Wartburg College, Dept of Art, Waverly IA (S)

Payton, Mary, *Photo Archivist,* Phelps County Historical Society, Donald O. Lindgren Library, Holdrege NE

Payton, Sidney, *Dir,* Museum of Contemporary Art Denver, Denver CO

Pazcoguin, Melissa, *Exec Asst,* The Art School at Old Church, Demarest NJ (S)

Peak, Elizabeth, *Assoc Prof,* Georgia Southern University, Dept of Art, Statesboro GA (S)

Peak, Marianne, *Supt,* Adams National Historic Park, Quincy MA

Peak, Pamela, *Chmn,* Charleston Southern University, Dept of Language & Visual Art, Charleston SC (S)

Pear, William H, *Historian,* Nichols House Museum, Inc, Boston MA

Pearce, A Blake, *Acting Head Art Dept,* Valdosta State University, Art Gallery, Valdosta GA

Pearce, A Blake, *Dept Head,* Valdosta State University, Dept of Art, Valdosta GA (S)

Pearce, Donald, *VChmn,* Town of Cummington Historical Commission, Kingman Tavern Historical Museum, Cummington MA

Pearce, John N, *Dir,* James Monroe, James Monroe Memorial Library, Fredericksburg VA

Pearce, Michael, *Asst Prof,* California Lutheran University, Art Dept, Thousand Oaks CA (S)

Pearce-Adashkevich, Vladimir, *Art Gallery Coordr,* Villanova University Art Gallery, Villanova PA

Pearlman, Alison, *Asst Prof,* California State Polytechnic University, Pomona, Art Dept, Pomona CA (S)

Pearlman, Eden Juron, *Cur,* Evanston Historical Society, Charles Gates Dawes House, Evanston IL

Pearlstein, Elinor, *Assoc Cur Chinese Art,* The Art Institute of Chicago, Department of Asian Art, Chicago IL

Pearse, Harold, *Assoc Dean,* Nova Scotia College of Art & Design, Halifax NS (S)

Pearson, A Faye, *Dir,* Kings County Historical Society & Museum, Hampton NB

Pearson, Andrea, *Assoc Prof,* Bloomsburg University, Dept of Art & Art History, Bloomsburg PA (S)

Pearson, Clifton, *Chmn,* University of Montevallo, College of Fine Arts, Montevallo AL (S)

Pearson, Dana, *Dir Library Svcs,* North Central Texas College, Library, Gainesville TX

Pearson, Gary, *Assoc Prof (Visual Art),* University of British Columbia Okanagan, Dept of Creative Studies, Kelowna BC (S)

Pearson, Gary, *Instr,* Ricks College, Dept of Art, Rexburg ID (S)

Pearson, Jim, *Prof,* Vincennes University Junior College, Humanities Art Dept, Vincennes IN (S)

Pearson, John, *Prof,* Oberlin College, Dept of Art, Oberlin OH (S)

Pearson, John H., American Textile History Museum, Lowell MA

Pearson, Mary, *Pub Relations,* Green Hill Center for North Carolina Art, Greensboro NC

Pearson, Sally, *Vice Pres Merchandise,* The Metropolitan Museum of Art, New York NY

Pearson Yamashiro, Jennifer, *Exec Dir,* Society for Photographic Education, Oxford OH

Pease, Brian, *Asst Site Mgr,* Minnesota Historical Society, Minnesota State Capitol Historic Site, St Paul MN

Pease, Silvia, *Instr,* University of Miami, Dept of Art & Art History, Coral Gables FL (S)

Peatross, C Ford, *Cur Architecture,* Library of Congress, Prints & Photographs Division, Washington DC

Pecimon, Sandy, *Business Mgr,* Summit County Historical Society, Akron OH

Peck, Amy, *Dir Educ,* Arts & Science Center for Southeast Arkansas, Pine Bluff AR

Peck, Inna, *Coordr,* Western Washington University, Viking Union Gallery, Bellingham WA

Peck, James, *Cur European & American Art,* Philbrook Museum of Art, Tulsa OK

Peck, Judith, *Prof,* Ramapo College of New Jersey, School of Contemporary Arts, Mahwah NJ (S)

Peck, Mary, *Dir,* New Visions Gallery, Inc, Marshfield WI

Peck, Nathan, *Instr,* Saint Xavier University, Dept of Art & Design, Chicago IL (S)

Peckham, Cynthia, *Cur,* Sandy Bay Historical Society & Museums, Sewall Scripture House-Old Castle, Rockport MA

Peckham Allen, Kathleen, *Mus Educator,* Seattle Art Museum, Library, Seattle WA

Pecorara, Patricia, *Chief Cur Exhib,* New Orleans Museum of Art, New Orleans LA

Peden, Susan, *Educ Coordr,* Henry Sheldon Museum of Vermont History and Research Center, Middlebury VT

Pedersen, Deanna, *Business Mgr,* Cedar Rapids Museum of Art, Cedar Rapids IA

Pedersen, Morrie, *Chmn,* Fort Steilacoom Community College, Fine Arts Dept, Lakewood WA (S)

Pederson, Curt, *Cur,* American Swedish Institute, Minneapolis MN

Pederson, Ron, *Chmn Dept & Prof,* Aquinas College, Art Dept, Grand Rapids MI (S)

Pedone, Francis, *Dir Operations,* Worcester Art Museum, Worcester MA

Peer, Charles, *Head Dept,* John Brown University, Art Dept, Siloam Springs AR (S)

Peery, Michael, *Instr,* Woodstock School of Art, Inc, Woodstock NY (S)

Peglau, Michael, *Dept Chmn,* Drew University, Art Dept, Madison NJ (S)

Peick, Jean, *Librn,* Oregon College of Art & Craft, Library, Portland OR

Peimer, Jordan, *Prog Dir,* Hebrew Union College, Skirball Cultural Center, Los Angeles CA

Peiser, Judy, *Exec Dir,* Center for Southern Folklore, Memphis TN

Peitz, Doris, *Financial Business Mgr,* Paine Art Center & Gardens, Oshkosh WI

Pejovich, Carol, *Webmaster, Publicity,* The Haggin Museum, Stockton CA

Pekarshy, Melvin H, *Chmn & Prof,* State University of New York at Stony Brook, Dept of College of Arts & Sciences, Art Dept, Stony Brook NY (S)

Pekor, Renee, *Develop Dir,* Carnegie Museums of Pittsburgh, Carnegie Museum of Art, Pittsburgh PA

Pelasky Hout, Jacqueline, *Art Image Cur & Developer,* Denison University, Slide Library, Granville OH

Pelfrey, Bob, *Chmn Fine Arts Div & Instr,* Cuesta College, Art Dept, San Luis Obispo CA (S)

Pelkey, Brenda Francis, *Dir & Prof,* University of Windsor, Visual Arts, Windsor ON (S)

Pell, Edward W, *Pres,* Fort Ticonderoga Association, Ticonderoga NY

Pellcrito, Marlene, *Instr,* Saginaw Valley State University, Dept of Art & Design, University Center MI (S)

Pellegrino, Karen, *Admin Asst,* York University, Art Gallery of York University, Toronto ON

Pelletier, Carol, *Assoc Prof,* West Virginia Wesleyan College, Art Dept, Buckhannon WV (S)

Peltier, Cynthia, *Operations Mgr,* Bucknell University, Edward & Marthann Samek Art Gallery, Lewisburg PA

Peluso, Robert, *Gen Educ,* Art Institute of Pittsburgh, Pittsburgh PA (S)

Pena, Annie, *Coll Asst,* Hostos Center for the Arts & Culture, Bronx NY

Penafiel, Guillermo, *Prof,* University of Wisconsin-Stevens Point, Dept of Art & Design, Stevens Point WI (S)

Pence, David, *Industrial Design Technology,* Art Institute of Pittsburgh, Pittsburgh PA (S)

Pence-Brown, Amy, *Asst Cur Art,* Boise Art Museum, Boise ID

Pendell, David, *Prof,* University of Utah, Dept of Art & Art History, Salt Lake City UT (S)

Pendergrass, Ethel K, *CFO,* Telfair Museum of Art, Telfair Academy of Arts & Sciences Library, Savannah GA

Pendergrass, Gayle, *Instr,* Arkansas State University, Dept of Art, State University AR (S)

Pendery, Nancy, *Secy,* Cincinnati Art Club, Cincinnati OH

Pendleton, Belle, *Prof,* Christopher Newport University, Dept of Fine Performing Arts, Newport News VA (S)

Pendleton, Debbie, *Asst Dir Pub Svcs,* Alabama Department of Archives & History, Museum Galleries, Montgomery AL

Pendleton, Edith, *Head Dept Fine & Performing Arts,* Edison Community College, Gallery of Fine Arts, Fort Myers FL (S)

Penenori, Greta, *Grants Asst,* Broward County Board of Commissioners, Cultural Affairs Div, Fort Lauderdale FL

Pener, Sydney, *Adjunct Assoc Prof Art,* Johnson County Community College, Visual Arts Program, Overland Park KS (S)

Penick, Carol, *Dir Develop,* Mississippi Museum of Art, Jackson MS

Penick, Denise, *Cur Educ,* Longwood Center for the Visual Arts, Farmville VA

Penick, Pamela, *Exec Dir,* Arts & Humanities Council of Tuscaloosa, Junior League Gallery, Tuscaloosa AL

Peniston, William, *Librn,* Newark Museum Association, The Newark Museum, Newark NJ

Penn, Barbara, *Assoc Prof Painting & Drawing,* University of Arizona, Dept of Art, Tucson AZ (S)

Penn, Beverley, *Prof,* Texas State University - San Marcos, Dept of Art and Design, San Marcos TX (S)

Penn, Doris Brown, *Pub Art & Design Asst,* Broward County Board of Commissioners, Cultural Affairs Div, Fort Lauderdale FL

Pennell, Allison, *Librn,* Fine Arts Museums of San Francisco, Library, San Francisco CA

Penney, David, *Cur Native American Art,* Detroit Institute of Arts, Detroit MI

Pennington, Claudia, *Exec Dir,* Key West Art & Historical Society, East Martello Museum & Gallery, Key West FL

Pennington, Julia, *Coll Mgr,* Turtle Bay Exploration Park, Redding CA

Penti, Celine, *Mission Coordr,* Buehler Challenger & Science Center, Paramus NJ

Penuel, Jaime, *Lectr,* North Dakota State University, Division of Fine Arts, Fargo ND (S)

Pepall, Rosalynd, *Cur Non-Canadian Decorative Arts,* Montreal Museum of Fine Arts, Montreal PQ

Pepich, Bruce W, *Dir,* Wustum Museum Art Association, Racine WI

Pepich, Bruce W, *Dir,* Wustum Museum Art Association, Charles A Wustum Museum of Fine Arts, Racine WI

Pepich, Bruce W, *Dir,* Wustum Museum Art Association, Wustum Art Library, Racine WI

Pepion, Loretta F, *Cur,* Museum of the Plains Indian & Crafts Center, Browning MT

Peppe, Dee, *Vis Asst Prof,* Colby College, Art Dept, Waterville ME (S)

Pepper, Jerold L, *Librn,* The Adirondack Historical Association, The Adirondack Museum, Blue Mountain Lake NY

Pepper, Jerold L, *Librn,* The Adirondack Historical Association, Library, Blue Mountain Lake NY

Pequignot, Andrew, *Dir of Vol Services,* Georgia Lawyers for the Arts, Atlanta GA

Percy, Ann, *Cur Drawings,* Philadelphia Museum of Art, Philadelphia PA

Percy, Ann B, *Cur Drawings,* Philadelphia Museum of Art, Samuel S Fleisher Art Memorial, Philadelphia PA

Perez, Edgardo (Tico), *Facility & Gallery Mgr,* Contemporary Art for San Antonio Blue Star Art Space, San Antonio TX

Perez, Jennifer, *Asst to Dir,* Hofstra University, Hofstra Museum, Hempstead NY

Perez, Linda, *Catalog Librn,* San Francisco Art Institute, Anne Bremer Memorial Library, San Francisco CA

Perez, Myrna Z, *Develop Mem,* Museo de Arte de Puerto Rico, San Juan PR

Perez, Sandra M, *Exec Dir,* Association of Hispanic Arts, New York NY

Perez-Gomez, Alberto, *Prof,* McGill University, School of Architecture, Montreal PQ (S)

Perinet, Francine, *Dir,* Oakville Galleries, Centennial Square and Gairloch Gardens, Oakville ON

Perkins, Abigail, *Office Mgr,* Noah Webster House, Inc, Noah Webster House, West Hartford CT

Perkins, Beverly N, *Field Serv Officer,* Balboa Art Conservation Center, San Diego CA

Perkins, Douglas, *Admin Operations Mgr,* Middlebury College, Museum of Art, Middlebury VT

Perkins, Keely, *Dir Educ,* Custer County Art & Heritage Center, Miles City MT

Perkins, Kristen, *Staff Asst,* Tufts University, Tufts University Art Gallery, Medford MA

Perkins, Phyllis, *VPres,* Southern Lorain County Historical Society, Spirit of '76 Museum, Elyria OH

Perkins, Stephen, *Acad Cur Art,* University of Wisconsin, Green Bay, Lawton Gallery, Green Bay WI

Perkins, Stephen, *Cur,* Bennington Museum, Bennington VT

Perkins, Stephen, *Cur,* Bennington Museum, Library, Bennington VT

Perkinson, Stephen, *Asst Prof,* Bowdoin College, Art Dept, Brunswick ME (S)

Perlin, Ruth, *Head Educ Resources Progs,* National Gallery of Art, Washington DC

Perlman, Bill, *VPres,* Women's Interart Center, Inc, Interart Gallery, New York NY

Perlman, Liz, *Prog Coordr,* Columbia University, School of the Arts, Division of Visual Arts, New York NY (S)

Perloneo, Marie, *Instr,* Mount Mary College, Art & Design Division, Milwaukee WI (S)

Perlov, Diane, *Deputy Dir Exhib,* California Science Center, Los Angeles CA

Perlroth, Bruce, *Pres,* New Haven Colony Historical Society, New Haven CT

Permohos, Susan, *Contact Person,* Springfield Free Public Library, Donald B Palmer Museum, Springfield NJ

Pero, Linda, *Cur,* Norman Rockwell Museum, Library, Stockbridge MA

Pero, Linda, *Cur Norman Rockwell Art,* Norman Rockwell Museum, Stockbridge MA

Perrault, Nathalie, *Inter Mag Mgr,* Les Editions Intervention, Inter-Le Lieu, Documentation Center, Quebec PQ

Perrell, Franklin Hill, *Cur,* Nassau County Museum of Fine Art, Roslyn Harbor NY

Perret, Marguerite, *Catron Prof of Art,* Washburn University of Topeka, Dept of Art, Topeka KS (S)

Perron, Margot, *Dir Educ,* Wave Hill, Bronx NY

Perron, Michel, *Dir,* Societe des Musees Quebecois, Montreal PQ

Perron, Mireille, *Acad Head Liberal Studies,* Alberta College of Art & Design, Calgary AB (S)

Perron, Nicole, *Dir Mus,* Musee des Augustines de l'Hotel Dieu de Quebec, Quebec PQ

Perron, Nicole, *Dir Mus,* Musee des Augustines de l'Hotel Dieu de Quebec, Archive, Quebec PQ

Perry, Birthe, *Pres,* Allied Arts Council of Lethbridge, Bowman Arts Center, Lethbridge AB

Perry, Bob, *CEO,* Frontier Times Museum, Bandera TX

Perry, Claire, *Cur American Art,* Stanford University, Iris & B Gerald Cantor Center for Visual Arts, Stanford CA

Perry, Donna, *Registrar,* Kalani Oceanside Retreat, Pahoa HI (S)

Perry, Elizabeth, *Assoc Prof,* Framingham State College, Art Dept, Framingham MA (S)

Perry, Karen, *Asst to Dir Admin & Develop,* Hermitage Foundation Museum, Norfolk VA

Perry, Karen, *Asst to Dir Admin & Develop,* Hermitage Foundation Museum, Library, Norfolk VA

Perry, Mary, *Instr,* Appalachian State University, Dept of Art, Boone NC (S)

Perry, Mike, *Dir,* Museum of Western Colorado, Grand Junction CO

Perry, Nancy S, *Dir,* Portsmouth Museums, Courthouse Galleries, Portsmouth VA

Perry, Rachel, *Asst Dir Historic Site,* Indiana State Museum, Indianapolis IN

Perry, Spence W, *Pres,* Washington County Museum of Fine Arts, Hagerstown MD

Perry, Stephanie, *Gen Educ,* Art Institute of Pittsburgh, Pittsburgh PA (S)

Perry, Steven, *Dir,* Ramapo College of New Jersey, School of Contemporary Arts, Mahwah NJ (S)

Perry, Susan, *Interim Exec Dir,* Phelps County Historical Society, Donald O. Lindgren Library, Holdrege NE

Perry, Susan L, *Dir,* Mount Holyoke College, Art Library, South Hadley MA

Perry, Wendy, *Dir Devel,* Heritage Museums & Gardens, Sandwich MA

Perryman, Tom, *Instr,* Lenoir Rhyne College, Dept of Art, Hickory NC (S)

Pershey, Ed, *Dir Mus Servs,* Western Reserve Historical Society, Library, Cleveland OH

Pertl, Susan, *Cur,* McDonald's Corporation, Art Collection, Oakbrook IL

Peshek, Brian, *Instr,* Pierce College, Art Dept, Woodland Hills CA (S)

Pessa, Joanna, *Res Prog Coordr,* Philipse Manor Hall State Historic Site, Yonkers NY

Pesselato, Michael, *Adjunct Assoc Prof Art,* Johnson County Community College, Visual Arts Program, Overland Park KS (S)

Pestel, Michael, *Asst Prof,* Chatham College, Fine & Performing Arts, Pittsburgh PA (S)

Pestel, Michael, *Dir,* Chatham College, Art Gallery, Pittsburgh PA

Petell, Dorothy, *Secy,* Greenwich Art Society Inc, Greenwich CT

Peter, Carolyn, *Dir,* Loyola Marymount University, Laband Art Gallery, Los Angeles CA

Peters, Belinda A, *Chmn Dept,* Clark-Atlanta University, School of Arts & Sciences, Atlanta GA (S)

Peters, Bill, *Dir,* Department of Canadian Heritage, Canadian Conservation Institute, Ottawa ON

Peters, Joel, *Exec Dir Mkg & Comm Develop,* Royal Ontario Museum, Toronto ON

Peters, John, *Instr,* Augustana College, Art Dept, Sioux Falls SD (S)

Peters, Judy, *Instr,* West Shore Community College, Division of Humanities & Fine Arts, Scottville MI (S)

Peters, Julie, *Dir Retail Svcs,* Vesterheim Norwegian-American Museum, Reference Library, Decorah IA

Peters, L Gabby, *Admissions,* Bass Museum of Art, Miami Beach FL

Peters, Laura, *Registrar,* Touchstone Center for Crafts, Farmington PA (S)

Peters, Martha, *Art in Pub Places Mgr,* City of Austin Parks & Recreation Department, Julia C Butridge Gallery, Austin TX

Peters, Marybeth, *Register Copyright,* Library of Congress, Prints & Photographs Division, Washington DC

Peters, Nikole, *Visual & Media Arts Coordr,* Organization of Saskatchewan Arts Councils (OSAC), Regina SK

Peters, Tom F, *Prof,* Lehigh University, Dept of Art & Architecture, Bethlehem PA (S)

Petersen, Chris, *Treas,* Swedish-American Museum Association of Chicago, Chicago IL

Petersen, Mark, *Dir,* Dixie State College, Robert N & Peggy Sears Gallery, Saint George UT

Peterson, Allan, *Dir,* Pensacola Junior College, Visual Arts Gallery, Anna Lamar Switzer Center for Visual Arts, Pensacola FL

Peterson, Allan, *Head Dept,* Pensacola Junior College, Dept of Visual Arts, Pensacola FL (S)

Peterson, Brian, *Cur Exhib & Sr Cur,* James A Michener, Doylestown PA

Peterson, Carole, *Registrar Art,* Illinois State Museum, Illinois Art Gallery & Lockport Gallery, Springfield IL

Peterson, Chuck, *Pres,* Caspers, Inc, Art Collection, Tampa FL

Peterson, Constance, *Prof,* Lansing Community College, Visual Arts & Media Dept, Lansing MI (S)

Peterson, D R, *Instr,* Normandale Community College, Art Dept, Bloomington MN (S)

Peterson, Dean A, *Asst Prof,* Salisbury State University, Art Dept, Salisbury MD (S)

Peterson, Elizabeth, *Chair & Assoc Prof,* University of Utah, Dept of Art & Art History, Salt Lake City UT (S)

Peterson, Eric, *Acting Area Head Design,* Pasadena City College, Art Dept, Pasadena CA (S)

Peterson, Eric, *Coordr Visual Resources/Facilitator Web Enhanced Curriculum,* Southern Illinois University, School of Art & Design, Carbondale IL (S)

Peterson, Frederick, *Chmn,* University of Minnesota, Morris, Humanities Division, Morris MN (S)

Peterson, Gaylen, *Head Dept,* Lutheran Brethren Schools, Art Dept, Fergus Falls MN (S)

Peterson, Glen L, *Instr,* Yavapai College, Visual & Performing Arts Div, Prescott AZ (S)

Peterson, James, *Chmn Dept,* Franklin & Marshall College, Art Dept, Lancaster PA (S)

Peterson, Jane, *Prog Asst,* University of California, San Diego, Stuart Collection, La Jolla CA

Peterson, Jeff, *CFO,* Oregon Historical Society, Oregon History Center, Portland OR

Peterson, John, *Dir,* Timken Museum of Art, San Diego CA

Peterson, John C, *Pres,* Turtle Bay Exploration Park, Redding CA

Peterson, John E, *Cur Archives,* Lutheran Theological Seminary, Krauth Memorial Library, Philadelphia PA

Peterson, Karin, *Dir Mus,* CT Commission on Culture & Tourism, Sloane-Stanley Museum, Kent CT

Peterson, Kip, *Registrar,* Memphis Brooks Museum of Art, Memphis TN

Peterson, Kirk, *Chmn Art,* Mount San Antonio College, Art Dept, Walnut CA (S)

Peterson, Lisa Lee, *Chmn Div,* Purdue University, West Lafayette, Patti and Rusty Rueff Department of Visual & Performing Arts, West Lafayette IN (S)

Peterson, Margaret, *Prof,* Central Missouri State University, Art Dept, Warrensburg MO (S)

Peterson, Marge, *Treas,* High Wire Gallery, Philadelphia PA

Peterson, Merlin, *Cur,* Pope County Historical Society, Pope County Museum, Glenwood MN

Peterson, Nedra, *Art Subject Librn,* State University of New York at Oswego, Penfield Library, Oswego NY

Peterson, Nick, *Display Technician,* Herrett Center for Arts & Sciences, Jean B King Art Gallery, Twin Falls ID

Peterson, Pauline M, *Reference Librn,* Jones Library, Inc, Amherst MA

Peterson, Robert, *Film Dept Chmn,* Art Center College of Design, Pasadena CA (S)

Peterson, Robyn, *Art Cur,* Turtle Bay Exploration Park, Redding CA

Peterson, Robyn G, *Dir,* Yellowstone Art Museum, Billings MT

Peterson Mason, Dayna, *Chmn Art Dept,* Riverside Community College, Dept of Art & Mass Media, Riverside CA (S)

Pethjohn, JuDee, *Dir,* Florida Department of State, Division of Cultural Affairs, Florida Arts Council, Tallahassee FL

Petik, Jim, *Bd Dir,* Grand River Museum, Lemmon SD

Petik, Kim, *Bd Dir,* Grand River Museum, Lemmon SD

Petke, Debra, *Deputy Dir,* Mark Twain, Hartford CT

Petre, Tracy, *Instr,* Columbia Basin College, Esvelt Gallery, Pasco WA (S)

Petrenko, Alexander, *Assoc Prof,* Universite de Montreal, Bibliotheque d'Amenagement, Montreal PQ

Petridis, Constantine, *Asst Prof,* Case Western Reserve University, Dept of Art History & Art, Cleveland OH (S)

Petrillo, Jane, *Asst Prof,* Colby-Sawyer College, Dept of Fine & Performing Arts, New London NH (S)

Petroff, Samuel, *VPres,* Springfield Museum of Art, Springfield OH

Petros, Michael, *Assoc Prof of Media Art,* Glendale Community College, Visual & Performing Arts Div, Glendale CA (S)

Petroskey, Dale A, *Pres,* National Baseball Hall of Fame & Museum, Inc, Art Collection, Cooperstown NY

Petrosky, Ron, *Adjunct,* College of the Canyons, Art Dept, Canta Colita CA (S)

Petrova, Nadejda, *Cur & Mus Shop Mgr,* Hus Var Fine Art, Buffalo NY

Petrovich-Mwaniki, Louis, *Assoc Prof,* Western Carolina University, Dept of Art/College of Arts & Science, Cullowhee NC (S)

Petrulis, Alan, *Asst Mgr,* First Street Gallery, New York NY

Petrulis, Elizabeth, *Registrar,* Swope Art Museum, Terre Haute IN

Petrulis, Lisa, *Registrar & Preparator,* Swope Art Museum, Research Library, Terre Haute IN

Petry, Karen, *Curatorial Asst,* Nassau County Museum of Fine Art, Roslyn Harbor NY

Petry, Sue, *Pub Relations Mgr,* Plains Art Museum, Fargo ND

Petsch, Jean, *Asst Prof,* University of Northern Iowa, Dept of Art, Cedar Falls IA (S)

Petteplace, Jennifer, *Preparator,* McMaster University, McMaster Museum of Art, Hamilton ON

Petterson, Leslie, *Chicago Artists' Archive,* Chicago Public Library, Harold Washington Library Center, Chicago IL

Petteway, Steve, *Photographer,* Supreme Court of the United States, Washington DC

Pettibone, John W, *Acting Dir & Cur,* Hammond Castle Museum, Gloucester MA

Pettibone, Judy L, *Asst Dir Operations,* Archives of American Art, Smithsonian Institution, Washington DC

Pettus, Mary, *Dir,* Whatcom Museum of History and Art, Bellingham WA

Petty, Renee, *Adjunct,* Maryville University of Saint Louis, Art & Design Program, Saint Louis MO (S)

Pevec, Stephanie, *Educ Coordr,* Wayne Center for the Arts, Wooster OH

Peven, Michael, *Prof,* University of Arkansas, Art Dept, Fayetteville AR (S)

Pevitts, Bob, *Dir Art Dept,* Texas Wesleyan University, Dept of Art, Fort Worth TX (S)

Pevny, Chrystyna, *Mus Shop Mgr,* The Ukrainian Museum, New York NY

Peyrat, Jean, *Librn,* Center for Creative Studies, College of Art & Design Library, Detroit MI

Pezza, Elizabeth, *Visitor Svcs,* Santa Monica Museum of Art, Santa Monica CA

Pfaff, Judy, *Co-Chair,* Bard College, Fisher Art Center, Annandale-on-Hudson NY

Pfaff, Larry, *Deputy Librn,* Art Gallery of Ontario, Edward P Taylor Research Library & Archives, Toronto ON

Pfanschmidt, Martha, *Instr,* Marylhurst University, Art Dept, Marylhurst OR (S)

Pfeifer, Jean, *Treas,* Ravalli County Museum, Hamilton MT

Pfeifer, Nezka, *Cur,* The Sandwich Historical Society, Inc, Sandwich Glass Museum, Sandwich MA

Pfeifer, William, *Dir,* Colonial Williamsburg Foundation, Visitor Center, Williamsburg VA

Pfeiffer, Cheryl, *Dir,* University of the South, Jessie Ball duPont Library, Sewanee TN

Pfliger, Terry, *Dept Coordr,* St Lawrence College, Art Gallery, Kingston ON

Pflueger, Beth, *Assoc Prof Music,* Glendale Community College, Visual & Performing Arts Div, Glendale CA (S)

Pfotenhauer, Louise, *Cur Colls,* Neville Public Museum, Green Bay WI

Phagan, Patricia, *Cur,* Vassar College, The Frances Lehman Loeb Art Center, Poughkeepsie NY

Pham, Jenny, *Account Subscriptions,* Illustration House Inc, Gallery Auction House, New York NY

Phelan, Andrew, *Dir,* University of Oklahoma, School of Art, Norman OK (S)

Phelan, Carly, *Mem Assoc,* Berkshire Museum, Pittsfield MA

Phelan, Mary, *Grad Prog,* University of the Arts, Philadelphia Colleges of Art & Design, Performing Arts & Media & Communication, Philadelphia PA (S)

Phelan, Thomas, *Treas,* Rensselaer Newman Foundation Chapel & Cultural Center, The Gallery, Troy NY

Phelps, Carol, *Pres,* San Fernando Valley Historical Society, Mission Hills CA

Phelps, Cathleen, *Exec Dir,* Northern Virginia Fine Arts Association, The Athenaeum, Alexandria VA

Phelps, Claudette, *Admin Spec,* Loveland Museum Gallery, Loveland CO

Phelps, David, *Exhib Preparator,* Loveland Museum Gallery, Loveland CO

Phelps, Elisa, *Dir Prog & Coll,* Witte Museum, San Antonio TX

Phelps, Kelly, *Prof,* Xavier University, Dept of Art, Cincinnati OH (S)

Phelps, Martin C, *CEO & Dir,* Medina Railroad Museum, Medina NY

Pheney, Kathleen, *Dir,* East Baton Rouge Parks & Recreation Commission, Baton Rouge Gallery Inc, Baton Rouge LA

Phifer, Glenn, *Prof,* Appalachian State University, Dept of Art, Boone NC (S)

Phifer, William G., *Prof,* Appalachian State University, Dept of Art, Boone NC (S)

Philbin, Gail, *Exec Dir,* Urban Institute for Contemporary Arts, Grand Rapids MI

Philbrick, Harry, *Dir,* Aldrich Museum of Contemporary Art, Ridgefield CT

Philbrick, Ruth, *Cur Photo Archives,* National Gallery of Art, Washington DC

Philipps, Roxanne, *Dir,* Maryville University Saint Louis, Morton J May Foundation Gallery, Saint Louis MO

Phillbrick, Stephanie, *Reference Asst,* Maine Historical Society, Library and Museum, Portland ME

Phillip, Bill, *Pres,* Western Art Association, Ellensburg WA

Phillips, Anthony, *Prof,* School of the Art Institute of Chicago, Chicago IL (S)

Phillips, Anthony, *Users Svcs Mgr,* Arkansas State University-Art Department, Jonesboro, Library, Jonesboro AR

Phillips, Carolyn, *Head Dept,* Eastern Wyoming College, Art Dept, Torrington WY (S)

Phillips, Carolyn, *Instr,* Eastern Iowa Community College, Clinton Community College, Clinton IA (S)

Phillips, Edward, *Acting Dir,* University of Guelph, Fine Art Dept, Guelph ON (S)

Phillips, Joan, *Registrar-Archivist,* Taos, Southwest Research Center of Northern New Mexico Archives, Taos NM

Phillips, Joan A, *Registrar,* Taos, Ernest Blumenschein Home & Studio, Taos NM

Phillips, Joan A, *Registrar,* Taos, La Hacienda de Los Martinez, Taos NM

Phillips, Kenneth E, *Aerospace Cur,* California Science Center, Los Angeles CA

Phillips, Kris, *Instr Visual Arts,* Sarah Lawrence College, Dept of Art History, Bronxville NY (S)

Phillips, Larry, *Photographer,* Institute of American Indian Arts Museum, Museum, Santa Fe NM

Phillips, Larry, *Special Projects & Community Relations Officer,* Institute of American Indian Arts, Institute of American Indian Arts Museum, Santa Fe NM (S)

Phillips, Melissa, *Assoc Dir Pub Programs,* Whitney Museum of American Art, New York NY

Phillips, Nancy, *Exec Assoc,* The Society for Contemporary Crafts, Pittsburgh PA

Phillips, Phil, *Assoc Dir,* East Carolina University, School of Art, Greenville NC (S)

Phillips, Richard, *Asst Prof Art History,* University of Texas Pan American, Art Dept, Edinburg TX (S)

Phillips, Robert, *Pres Board Trustees,* Roswell Museum & Art Center, Roswell NM

Phillips, Ruth, *Dir & Prof,* University of British Columbia, Museum of Anthropology, Vancouver BC

Phillips, Sandra S, *Sr Cur Photography,* San Francisco Museum of Modern Art, San Francisco CA

Phillips, Stephen, *Cur,* The Phillips Collection, Washington DC

Phillips, Susan, *Prof,* Waynesburg College, Dept of Fine Arts, Waynesburg PA (S)

Phillips-Pendleton, Robyn, *Coordr Illustration,* University of Delaware, Dept of Art, Newark DE (S)

Philpot, Eloise, *Asst Prof,* Radford University, Art Dept, Radford VA (S)

Phinney, Gail, *Dir Educ Progs,* Palos Verdes Art Center, Rancho Palos Verdes CA

Phong, Ann, *Lectr,* California State Polytechnic University, Pomona, Art Dept, Pomona CA (S)

Piasecki, Jane, *VPres Finance,* Natural History Museum of Los Angeles County, Los Angeles CA

Piasentin, Joe, *Prof,* Pepperdine University, Seaver College, Dept of Art, Malibu CA (S)

Piatt, Margaret, *Pres & CEO,* Piatt Castles, West Liberty OH

Piazza, Paul J, *Controller,* George Eastman, Rochester NY

Picano, John, *Pub Rels,* Yesteryear Village, West Palm Beach FL

Picco, Ronald, *Prof,* College of Santa Fe, Art Dept, Santa Fe NM (S)

Piccuirro, Jeneen, *Instr,* American University, Dept of Art, Washington DC (S)

Pick, Elly, *Dir Develop,* Museum of Wisconsin Art, West Bend Art Museum, West Bend WI

Pickard, Carey, *Exec Dir,* Tubman African American Museum, Macon GA

Pickel, John, *Assoc Prof,* Wake Forest University, Dept of Art, Winston-Salem NC (S)

Pickens, Donna, *Asst Cur Educ,* Montgomery Museum of Fine Arts, Montgomery AL

Pickering, Amy, *Visitor Svcs,* State University of New York at New Paltz, Samuel Dorsky Museum of Art, New Paltz NY

Pickering-Carter, Yvonne, *Chairperson & Prof,* University of the District of Columbia, Dept of Mass Media, Visual & Performing Arts, Washington DC (S)

Pickett, Denny, *Lectr,* Baylor University, Dept of Art, Waco TX (S)

Picon, Carlos, *Cur In Charge,* The Metropolitan Museum of Art, New York NY

Piehl, Walter, *Art Dept Coordr,* Minot State University, Dept of Art, Division of Humanities, Minot ND (S)

Piejko, Alex, *Asst Prof,* Mohawk Valley Community College, Utica NY (S)

Piepenburg, Robert, *Chmn,* Oakland Community College, Art Dept, Farmington Hills MI (S)

Pier, Gwen M, *Exec Dir,* National Sculpture Society, New York NY

Pier, Gwen P, *Exec Dir,* National Sculpture Society, Archival Library, New York NY

Pierce, Beverly, *Asst Dir Finance & Administration,* Hirshhorn Museum & Sculpture Garden, Smithsonian Institution, Washington DC

Pierce, Charles E, *Dir,* Pierpont Morgan, New York NY

Pierce, Christopher, *Asst Prof,* Berea College, Art Dept, Berea KY (S)

Pierce, Frederick S., *Chmn (V),* The American Film Institute, Center for Advanced Film & Television, Los Angeles CA (S)

Pierce, Greg, *Instr,* Columbia Basin College, Esvelt Gallery, Pasco WA (S)

Pierce, Jina, *Visual Art Cur,* Sangre de Cristo Arts & Conference Center, Pueblo CO

Pierce, Karin, *Dir Gallery & Instr,* Columbia Basin College, Esvelt Gallery, Pasco WA (S)

Piercy, Marge, *Instr, Poetry,* Truro Center for the Arts at Castle Hill, Inc, Truro MA (S)

Pierson Ellingson, Susan, *Asst Prof,* Concordia College, Art Dept, Moorhead MN (S)

Pietrzak, Ted, *Dir,* Burchfield-Penney Art Center, Buffalo NY

Pigat, Heather, *Coll Mgr,* University of Toronto, University of Toronto Art Centre, Toronto ON

Pihl, Erik, *Dir Devel & External Affairs,* Santa Barbara Museum of Art, Santa Barbara CA

Piispanen, Ruth, *Dir Arts Educ,* Idaho Commission on the Arts, Boise ID

Pike, Denise, *Admin Asst,* South Dakota State University, Hilton M. Briggs Library, Brookings SD

Pike, Kermit, *COO,* Western Reserve Historical Society, Cleveland OH

Pike, Kermit J, *COO,* Western Reserve Historical Society, Library, Cleveland OH

Pilachowski, David, *Librn,* Williams College, Sawyer Library, Williamstown MA

Pilarczyk, Ann, *Pub Rels & Tours,* Wayne County Historical Society, Honesdale PA

Pilcher, Jerry, *Educ & Fundraising Coordr,* Visual Arts Center of Northwest Florida, Panama City FL

Pilgram, Suzanne, *Asst Prof,* Georgian Court College, Dept of Art, Lakewood NJ (S)

Pilic, Patty, *Secy,* Mississippi Art Colony, Stoneville MS

Pillod, Elizabeth, *Prof,* Oregon State University, Dept of Art, Corvallis OR (S)

Pilmaier, Jason, *Communications Asst,* Marquette University, Haggerty Museum of Art, Milwaukee WI

Pimentel, Ursula, *Cur European Art,* University of Utah, Utah Museum of Fine Arts, Salt Lake City UT

Pinales, Deena, *Mus Educ,* Springfield Museum of Art, Library, Springfield OH

Pinardi, Brenda, *Prof,* University of Massachusetts Lowell, Dept of Art, Lowell MA (S)

Pinckley, Donna, *Asst Prof,* University of Central Arkansas, Department of Art, Conway AR (S)

Pincus-Witten, Robert, *Prof Emeritus,* City University of New York, PhD Program in Art History, New York NY (S)

Pindell, Howardena, *Prof,* State University of New York at Stony Brook, Dept of College of Arts & Sciences, Art Dept, Stony Brook NY (S)

Pindle, Arthur, *Instr,* Southern University in New Orleans, Fine Arts & Philosophy Dept, New Orleans LA (S)

Pine, Steven, *Conservator,* Bayou Bend Collection & Gardens, Houston TX

Pinette, Robert J, *Cur Herbarium,* Northern Maine Museum of Science, Presque Isle ME

Pink, Jim, *Prof,* University of Nevada, Las Vegas, Dept of Art, Las Vegas NV (S)

Pinkel, Sheila, *Assoc Prof,* Pomona College, Dept of Art & Art History, Claremont CA (S)

Pinkham, Ashley Peel, *Asst Dir,* The Print Center, Philadelphia PA

Pinkham, Ashley Peel, *Nat Conf Coord,* Society for Photographic Education, Oxford OH

Pinkston, Heidi, *Educ Coordr,* Piedmont Arts Association, Martinsville VA

Pinkston, Howell, *Instr,* Pierce College, Art Dept, Woodland Hills CA (S)

Pinson, Patricia, *Cur Coll,* Walter Anderson, Ocean Springs MS

Pinto, Marcus, *Asst Cur & Sr Web Master,* Alternative Museum, New York NY

Piombino, Dante, *Multimedia & Web Design,* Art Institute of Pittsburgh, Pittsburgh PA (S)

Pionati, Francis A, *Media Arts & Animation,* Art Institute of Pittsburgh, Pittsburgh PA (S)

Pionk, Richard, *Pres,* Salmagundi Club, New York NY

Piper, Andre, *Asst Prof,* Emporia State University, Dept of Art, Emporia KS (S)

Piper, Bill, *Instr,* Walla Walla Community College, Art Dept, Walla Walla WA (S)

Piper, Clinton, *Mus Prog Asst,* Western Pennsylvania Conservancy, Fallingwater, Mill Run PA

Pires, Wendy, *Cur Educ,* Dickinson College, The Trout Gallery, Carlisle PA

Pirosky, Daniel, *Assoc Prof,* Portland State University, Dept of Art, Portland OR (S)

Pirtle, Kenneth, *Dept Head,* Amarillo College, Visual Art Dept, Amarillo TX (S)

Pisano, Dominick, *Aeronautics Dept,* National Air and Space Museum, Washington DC

Pisano, Jane, *Pres & Dir,* Natural History Museum of Los Angeles County, Los Angeles CA

Pishkur, Frank, *Prof,* Missouri Southern State University, Dept of Art, Joplin MO (S)

Pitluga, Kurt, *Prof,* Slippery Rock University of Pennsylvania, Dept of Art, Slippery Rock PA (S)

Pitt, Paul, *Prof,* Harding University, Dept of Art, Searcy AR (S)

Pitt, Sheila, *Asst Prof Gallery Management,* University of Arizona, Dept of Art, Tucson AZ (S)

Pittenger, Charles, *Registrar,* Speed Art Museum, Louisville KY

Pittman, Daniel, *4D Basement,* New York NY

Pittman, John, *Chmn,* John Jay College of Criminal Justice, Dept of Art, Music & Philosophy, New York NY (S)

Pittman, Shante, *Office Mgr,* Mississippi Museum of Art, Jackson MS

Pitts, Bobby, University of Wisconsin-Eau Claire, Dept of Art, Eau Claire WI (S)

Pitts, Terence, *Dir,* Cedar Rapids Museum of Art, Cedar Rapids IA

Pitts, Terence, *Dir,* Cedar Rapids Museum of Art, Herbert S Stamats Library, Cedar Rapids IA

Pitts, Tom R, *Assoc Prof Art History,* Lander University, College of Arts & Humanities, Greenwood SC (S)

Pivovar, Ronald A, *Chmn Dept,* Thiel College, Dept of Art, Greenville PA (S)

Pizzo, Tony, *Exec Dir,* Ships of the Sea Maritime Museum, Savannah GA

Pizzollo, Sissy, *Dir,* Muse Art Gallery, Philadelphia PA

Plakias, Elaine, *Staff Asst,* Art Complex Museum, Carl A. Weyerhaeuser Library, Duxbury MA

Plant, Anthony, *Prof,* Cornell College, Peter Paul Luce Gallery, Mount Vernon IA

Plapler, Dina, *Chief Dev Officer,* Mark Twain, Hartford CT

Plate, Kenneth, *Librn,* Palm Springs Art Museum, Library, Palm Springs CA

Plater, Daryl, *Chmn Dept,* Langara College, Dept of Display & Design, Vancouver BC (S)

Platnick, Danny, *Seminars Dir,* Film Arts Foundation, San Francisco CA

Platow, Raphaela, *Cur,* Brandeis University, Rose Art Museum, Waltham MA

Platow, Raphaela, *International Cur,* Contemporary Art Museum, Raleigh NC

Platt, Carol, *Asst Prof,* Brenau University, Art & Design Dept, Gainesville GA (S)

Platt, Gina, *Educ Coordr,* University of Maine, Museum of Art, Bangor ME

Platt, Susan, *Reference Technician,* Sheridan College of Applied Arts and Technology, Trafalgar Campus Library, Oakville ON

Plaut, Tony, *Head Dept,* Cornell College, Art Dept, Mount Vernon IA (S)

Plax, Julie, *Assoc Prof Art History,* University of Arizona, Dept of Art, Tucson AZ (S)

Plays, Dana, *Prof,* Occidental College, Dept of Art History & Visual Arts, Los Angeles CA (S)

Plear, Scott, *Div Chmn,* Langara College, Dept of Display & Design, Vancouver BC (S)

Pleasants, Craig, *Prog Dir,* Virginia Center for the Creative Arts, Camp Gallery, Sweet Briar VA

Pleasants, Sheila Gully, *Admissions Coordr,* Virginia Center for the Creative Arts, Camp Gallery, Sweet Briar VA

Plesch, Veronique, *Assoc Prof,* Colby College, Art Dept, Waterville ME (S)

Plosky, Charles, *Assoc Prof,* Jersey City State College, Art Dept, Jersey City NJ (S)

Plotkin, Edna, *Exec Trustee,* Edna Hibel, Hibel Museum of Art, Jupiter FL

Plotkin, Theodore, *Chmn,* Edna Hibel, Hibel Museum of Art, Jupiter FL

Ploughman, Jane, *Librn,* Henry Sheldon Museum of Vermont History and Research Center, Middlebury VT

Plourde, Nelie, *Exec Dir,* UMLAUF Sculpture Garden & Museum, Austin TX

Pluckinbaum, Roger, *VPres,* Indiana State Museum, Indianapolis IN

Plumb, Susan, *Assoc Cur Educ,* James A Michener, Doylestown PA

Plummer, Bruce, *Dean Library,* Becker College, William F Ruska Library, Worcester MA

Plummer, Carol, *Develop Dir,* Nicolaysen Art Museum & Discovery Center, Childrens Discovery Center, Casper WY

Plummer, Johanna, *Cur Educ,* University of Pennsylvania, Institute of Contemporary Art, Philadelphia PA

Plummer, Martel, *Assoc Dean,* Indiana University-Purdue University, Indianapolis, Herron School of Art, Indianapolis IN (S)

Plumtree, Darlene, *Dir Develop,* Old Mill Foundation, North Baker Library, San Marino CA

Plunkett, Stephanie H, *Assoc Dir Exhib & Prog,* Norman Rockwell Museum, Stockbridge MA

Plyler, Anne, *Gallery Coordr,* James Prendergast, Jamestown NY

Pochapin, Pam, *Dir Develop,* The Society for Contemporary Crafts, Pittsburgh PA

Pocius, Edward, *Cur Cartography D,* Balzekas Museum of Lithuanian Culture, Chicago IL

Pockriss, Peter, *Dir Develop,* Historic Hudson Valley, Tarrytown NY

Pocock, Dan, *Asst Prof,* Indiana Wesleyan University, Art Dept, Marion IN (S)

Podedworny, Carol, *Dir & Cur,* McMaster University, McMaster Museum of Art, Hamilton ON

Podedworny, Carol, *Dir/Cur,* University of Waterloo, Art Gallery, Waterloo ON

Podmaniczky, Christine B., *Assoc Cur N C W,* Brandywine River Museum, Chadds Ford PA

Poe, Jan, *Dir Finance,* Portland Art Museum, Northwest Film Center, Portland OR

Poe, Robert H, *Assoc Prof Art,* Lander University, College of Arts & Humanities, Greenwood SC (S)

Poeschl, Paul, *Activities Coordr,* Oshkosh Public Museum, Oshkosh WI

Poff, Amy, *Deputy,* Howard County Arts Council, Ellicott City MD

Pogue, Craig, *Prof,* Smith College, Art Dept, Northampton MA (S)

Pogue, Ed, *Asst Prof,* Bethany College, Art Dept, Lindsborg KS (S)

Pohl, Frances, *Assoc Prof,* Pomona College, Dept of Art & Art History, Claremont CA (S)

Pohlad, Mark, *Asst Prof,* DePaul University, Dept of Art, Chicago IL (S)

Pohle, Peter, *Asst Prof,* John Brown University, Art Dept, Siloam Springs AR (S)

Pohlkamp, Mark, *Lect,* University of Wisconsin-Stevens Point, Dept of Art & Design, Stevens Point WI (S)

Pohlman, Ken, *Designer,* Middlebury College, Museum of Art, Middlebury VT

Pohlman, Lynette, *Dir,* Iowa State University, Brunnier Art Museum, Ames IA

Poindexter, David, *Asst Prof,* University of Texas of Permian Basin, Dept of Art, Odessa TX (S)

Poindexter, Edith, *Cur,* Patrick Henry, Red Hill National Memorial, Brookneal VA

Poire, Danielle, *Conservation & Management Dir,* Musee de l'Amerique Francaise, Quebec PQ

Poirier, Francine, *Dir,* Museum for Textiles, Canada Aviation Museum, Ottawa ON

Poirier, Noel, *Dir Educ,* Historic Bethlehem Partnership, Kemerer Museum of Decorative Arts, Bethlehem PA

Poisaant, Margaret, *Pres (V),* Art League of Houston, Houston TX

Poland, Barbara, *Research Librn,* Warner Bros Studio Research Library, Burbank CA

Polenberg, Marcia, *Instr,* Barton County Community College, Fine Arts Dept, Great Bend KS (S)

Polera, Josephine, *Dir Student Servs,* Ontario College of Art & Design, Toronto ON (S)

Poley, Darren, *Head Pub Serv,* Lutheran Theological Seminary, Krauth Memorial Library, Philadelphia PA

Poliakov, Lev, *Asst Prof,* New York Institute of Technology, Fine Arts Dept, Old Westbury NY (S)

Polich, Debra, *Exec Dir,* Artrain, Inc, Ann Arbor MI

Poling, Clark V, *Prof,* Emory University, Art History Dept, Atlanta GA (S)

Polishook, Mark, *Prof,* University of Maine at Augusta, College of Arts & Humanities, Augusta ME (S)

Polito, Ronald, *Assoc Prof,* University of Massachusetts - Boston, Art Dept, Boston MA (S)

Polk, Andrew, *Assoc Prof Printmaking,* University of Arizona, Dept of Art, Tucson AZ (S)

Polk, Andrew W, *Foundations, Dept Head,* University of Arizona, Dept of Art, Tucson AZ (S)

Polk, Tom, *Assoc Prof Art History,* University of Georgia, Franklin College of Arts & Sciences, Lamar Dodd School of Art, Athens GA (S)

Pollack, Yvonne, *Pres,* Katonah Museum of Art, Katonah NY

Pollan, Renee, *Adminr,* Warwick Museum of Art, Warwick RI

Pollard, DeRionne P, *VPres Educ Affairs,* College of Lake County, Art Dept, Grayslake IL (S)

Pollard, Frances S, *Asst Dir Library Servs,* Virginia Historical Society, Library, Richmond VA

Pollen, Jason, *Chmn Fiber,* Kansas City Art Institute, Kansas City MO (S)

Pollen, Jason, *Pres,* Surface Design Association, Inc, Sebastopol CA

Pollick, Marilyn, *Dir Devel,* University of Pennsylvania, Institute of Contemporary Art, Philadelphia PA

Pollitt, Anne, *Educ Coordr,* Mason County Museum, Mason TX

Pollyea, Alexandra, *Pub Rels & Mktg,* Santa Monica Museum of Art, Santa Monica CA

Poloukhine, Olga, *Recording Sec,* New York Society of Women Artists, Inc, Westport CT

Polowy, Barbara, *Librn,* Smith College, Hillyer Art Library, Northampton MA

Polskin, Philippa, *Pres,* Ruder Finn Arts & Communications, Inc, New York NY

Polster, Kathy, *Dir Human Resources,* Columbus Museum of Art, Columbus OH

Pomeroy, Dan, *Dir Coll,* Tennessee State Museum, Nashville TN

Pomeroy, Dan, *Dir Coll,* Tennessee State Museum, Library, Nashville TN

Pomeroy Draper, Stacy, *Cur,* Rensselaer County Historical Society, Museum & Library, Troy NY

Pommer, Joyce, *Treas,* New York Society of Women Artists, Inc, Westport CT

Ponce, Magaly, *Asst Prof,* Bridgewater State College, Art Dept, Bridgewater MA (S)

Ponce de Leon, Carolina, *Dir,* Galeria de la Raza, Studio 24, San Francisco CA

Ponder, Anita, *Asst Dir,* Tubman African American Museum, Macon GA

Pondone, Marc, *Instr,* Solano Community College, Division of Fine & Applied Art & Behavioral Science, Suisun City CA (S)

Pongracic, Ana, *Asst Prof,* Indiana Wesleyan University, Art Dept, Marion IN (S)

Ponikvar, Laura, *Image & Instruc Srvcs Librn,* Cleveland Institute of Art, Jessica Gund Memorial Library, Cleveland OH

Pool, Peter, *Pres,* Nevada Museum of Art, Reno NV

Poole, Barbara, *Treas,* Bromfield Art Gallery, Boston MA

Poole, Kristine, *Visual Arts Dir,* Sun Valley Center for the Arts & Humanities, Dept of Fine Art, Sun Valley ID (S)

Poole, Marc, *Lectr,* Mississippi State University, Dept of Art, Mississippi State MS (S)

Poole, Mary, *Exec Dir,* Artspace Inc, Raleigh NC

Poole, Maynard W, *VPres Develop,* Independence Seaport Museum, Philadelphia PA

Poor, Anna, *Instr, Sculpture,* Truro Center for the Arts at Castle Hill, Inc, Truro MA (S)

Poorbaugh, Susan, *Librn,* Museum of New Mexico, Museum of Fine Arts Library and Archive, Santa Fe NM

Poore, Henry, *Exec Dir,* Iredell Museum of Arts & Heritage, Statesville NC

Popadils, Joel, *Pres,* New Jersey Watercolor Society, Parsippany NJ

Pope, Barbara, *Registrar,* Museum of Photographic Arts, San Diego CA

Pope, Jennifer, *Coordr Mem,* Montgomery Museum of Fine Arts, Montgomery AL

Pope, Karen, *Lectr,* Baylor University, Dept of Art, Waco TX (S)

Pope, Louise, *Assoc Prof,* Dakota State University, College of Liberal Arts, Madison SD (S)

Poplack, Robert, *Gallery Dir,* Notre Dame de Namur University, Wiegand Gallery, Belmont CA (S)

Poplawski, Tina, *Instr,* Toronto School of Art, Toronto ON (S)

Popovich, George, *Dir Theater,* Henry Ford Community College, McKenzie Fine Art Ctr, Dearborn MI (S)

Popp, Heather, *Gallery Assoc,* Topeka & Shawnee County Public Library, Alice C Sabatini Gallery, Topeka KS

Popp, Joe, *Frame Shop Mgr,* Erie Art Museum, Erie PA

Popp, Zan, *Gallery Assoc,* Topeka & Shawnee County Public Library, Alice C Sabatini Gallery, Topeka KS

Poppenhouse, Jerry, *Instr,* Oklahoma State University, Graphic Arts Dept, Visual Communications, Okmulgee OK (S)

Poras, E Linda, *Exec Dir,* The Brush Art Gallery & Studios, Lowell MA

Porcari, George, *Acquisitions Librn,* Art Center College of Design, James Lemont Fogg Memorial Library, Pasadena CA

Porcelli, Gina, *Asst Prof,* Marymount College of Fordham University, Art Dept, Tarrytown NY (S)

Poresky, Barbara, *Exhibits,* Riley County Historical Society, Riley County Historical Museum, Manhattan KS

Poresky, Barbara, *Exhibits,* Riley County Historical Society, Seaton Library, Manhattan KS

Poritius, Clark, *Exec Asst,* Society for Photographic Education, Oxford OH

Porps, Ernest O, *Prof,* University of Colorado at Denver, College of Arts & Media Visual Arts Dept, Denver CO (S)

Porsild, Charlene, *Head Librn & Archivist,* Montana Historical Society, Library, Helena MT

Porter, Alberta, *Vol Pres,* Macartney House Museum, Oakland ME

Porter, Amy, *Dir Corporate,* Portland Museum of Art, Portland ME

Porter, Ann, *Dir,* University of Vermont, Robert Hull Fleming Museum, Burlington VT

Porter, Ann, *Dir,* University of Vermont, Wilbur Room Library, Burlington VT

Porter, Barbara A, *Asst Cur,* Porter Thermometer Museum, Onset MA

Porter, David S, *Assoc Prof,* University of North Florida, Dept of Communications & Visual Arts, Jacksonville FL (S)

Porter, Elwin, *Dir,* South Florida Art Institute of Hollywood, Dania FL (S)

Porter, Jenelle, *Assoc Cur,* University of Pennsylvania, Institute of Contemporary Art, Philadelphia PA

Porter, Jenelle, *Cur,* Artists Space, Irving Sandler Artists File, New York NY

Porter, John R, *Exec Dir,* Musee du Quebec, Quebec PQ

Porter, Larry, *Assoc Prof,* Central State University, Dept of Art, Wilberforce OH (S)

Porter, Michele, *Cur Coll,* Dacotah Prairie Museum, Ruth Bunker Memorial Library, Aberdeen SD

Porter, Nancy Duncan, *Deputy Dir Institutional Advanc,* Columbus Museum of Art, Columbus OH

Porter, Richard T, *Cur,* Porter Thermometer Museum, Onset MA

Porter, Robert F, *Fine Arts Chmn,* Queens College, Fine Arts Dept, Charlotte NC (S)

Porter, Ron, *Sr Lectr,* Vanderbilt University, Dept of Art, Nashville TN (S)

Porter, Stephanie, *Educ Officer,* City of Woodstock, Woodstock Art Gallery, Woodstock ON

Porter, Tom, *Instr,* Bismarck State College, Fine Arts Dept, Bismarck ND (S)

Porter Finestone, Pattie, *Sec,* Washington Sculptors Group, Washington DC

Poruchnyk, Alexander, University of Manitoba, School of Art, Winnipeg MB (S)

Porwitt, Barbara, *Admin,* University of Minnesota, Goldstein Gallery, Saint Paul MN

Post, Barbara T, *VPres Prog,* Berks Art Alliance, Reading PA

Post, Diane, *Dir Educ,* Wichita Center for the Arts, Mary R Koch Sch of Visual Arts, Wichita KS (S)

Post, Stephanie, *Librn,* The Metropolitan Museum of Art, Image Library, New York NY

Post, William, *Cur Ornithology,* Charleston Museum, Charleston SC

Poster, Amy, *Cur Asian Art,* Brooklyn Museum, Brooklyn NY

Postlewait, Deb, *Assoc Prof,* College of DuPage, Liberal Arts Division, Glen Ellyn IL (S)

Postlewaitt, Tim, *Admin Asst,* The Art Studio Inc, Beaumont TX

Poston, Virginia, *Instr,* University of Southern Indiana, Art Dept, Evansville IN (S)

Pote, Judy, *Pres,* Philadelphia Museum of Art, Women's Committee, Philadelphia PA

Poteel, Daniel, *Provost,* School of the Museum of Fine Arts, Boston MA (S)

Poteet, Billie, *Admin Asst,* Carson County Square House Museum, Panhandle TX

Potochniak, Andrea, *Publicity & Publications Coordr,* Cornell University, Herbert F Johnson Museum of Art, Ithaca NY

Potochnik, Sherry, *Educational Specialist,* The Ohio Historical Society, Inc, Campus Martius Museum & Ohio River Museum, Marietta OH

Potter, Bryn, *Asst Cur,* Southwest Museum, Los Angeles CA

Potter, Dave, *Asst Prof,* Keystone College, Fine Arts Dept, LaPlume PA (S)

Potter, Edmund, *Dir Coll,* Woodrow Wilson, Staunton VA

Potter, Edmund, *Dir Coll,* Woodrow Wilson, Woodrow Wilson Presidential Library, Staunton VA

Potter, Joann, *Registrar,* Vassar College, The Frances Lehman Loeb Art Center, Poughkeepsie NY

Potter, Joe, *Instr,* William Woods-Westminster Colleges, Art Dept, Fulton MO (S)

Potter, Leslie, *Exhib Coordr,* Saskatchewan Craft Council & Gallery, Saskatoon SK

Potter, Margret, *Asst Dir,* Stone Quarry Hill Art Park, Jenny Library, Cazenovia NY

Potter, Robert, *Exec Dir,* Lyme Art Association, Inc, Old Lyme CT

Potter, Susan, *Librn,* Springfield Art Museum, Springfield MO

Potter, William, *Coordr Foundation,* Indiana University-Purdue University, Indianapolis, Herron School of Art, Indianapolis IN (S)

Pottier, Amy, *Asst Art Cur,* Vanderbilt University, Fine Arts Gallery, Nashville TN

Potts, Timothy, *Dir,* Kimbell Art Museum, Fort Worth TX

Pottunger, Mark, *Prof,* Manhattan College, School of Arts, Riverdale NY (S)

Potvin, Jean-Yves, *Prof,* Universite de Montreal, Bibliotheque d'Amenagement, Montreal PQ

Poubeak, Anne, *Educator,* Old York Historical Society, Old Gaol Museum, York ME

Poubeau, Anne, *Dir Educ,* Old York Historical Society, York ME

Poubeau, Anne, *Dir Educ,* Old York Historical Society, Elizabeth Perkins House, York ME

Poulin, Pierre, *Aggregate Prof,* Universite de Montreal, Bibliotheque d'Amenagement, Montreal PQ

Poulos, Basilios N, *Prof,* Rice University, Dept of Art & Art History, Houston TX (S)

Poulton, Michael, *Prof,* Technical University of Nova Scotia, Faculty of Architecture, Halifax NS (S)

Pounsett, Donald F, *Pres,* Arts and Letters Club of Toronto, Toronto ON

Povse, Matt, *Chmn,* Marywood University, Art Dept, Scranton PA (S)

Powell, Ann, *Dir Devel,* The Trustees of Reservations, The Mission House, Ipswich MA

Powell, Bobbie, *Dir,* Riverside Art Museum, Library, Riverside CA

Powell, Earl A, *Dir,* National Gallery of Art, Washington DC

Powell, Edward, *Assoc Prof,* University of Pittsburgh, Dept of Studio Arts, Pittsburgh PA (S)

Powell, Faith, *Curatorial Asst,* Judah L Magnes, Berkeley CA

Powell, James, *Dir,* Natural History Museum of Los Angeles County, Los Angeles CA

Powell, John, *Cur,* City of Saint Augustine, Saint Augustine FL

Powell, Lalana, *Library Technician,* University of Kentucky, Hunter M Adams Architecture Library, Lexington KY

Powell, Lauren, *Coordr Mem Svcs,* Morris Museum of Art, Augusta GA

Powell, Leslie, *Museum Educator,* San Diego Museum of Art, San Diego CA

Powell, Linda, *Educ Prog Dir,* Hirshhorn Museum & Sculpture Garden, Smithsonian Institution, Washington DC

Powell, Loreen, *Library Technician,* San Francisco Maritime National Historical Park, Maritime Library, San Francisco CA

Powell, Mary Ellen, *Registrar,* Frederick R Weisman, Los Angeles CA

Powell, Nancy, *Mus Collections Specialist,* National Audubon Society, John James Audubon Center at Mill Grove, Audubon PA

Powell, Nancy, *VPres,* San Angelo Museum of Fine Arts, San Angelo TX

Powell, Richard J, *Prof,* Duke University, Dept of Art, Art History & Visual Studies, Durham NC (S)

Powell, Steven, *Assoc Prof Music,* Drexel University, College of Media Arts & Design, Philadelphia PA (S)

Powelson, Rosemary, *Chmn,* Lower Columbia College, Art Dept, Longview WA (S)

Power, Dennis M, *Chief Exec Dir,* Oakland Museum of California, Art Dept, Oakland CA

Power, Susan, *Prof,* Marshall University, Dept of Art, Huntington WV (S)

Powers, Catherine, *Cur,* Ashland Historical Society, Ashland MA

Powers, Dennis, *Dir Devel,* The Hudson River Museum, Yonkers NY

Powers, Everett G, *Pres & COO,* Arts Partnership of Greater Spartanburg, Inc, The Arts Partnership of Greater Spartanburg, Inc, Spartanburg SC

Powers, Jessica Davis, *Consulting Cur Ancient Art,* San Antonio Museum of Art, San Antonio TX

Powers, Joan, *Assoc Prof,* C W Post Campus of Long Island University, School of Visual & Performing Arts, Brookville NY (S)

Powers, Leland, *Chmn,* Fort Hays State University, Moss-Thorns Gallery of Arts, Hays KS

Powers, Leland, *Chmn,* Fort Hays State University, Dept of Art, Hays KS (S)

Powers, Linda, *Develop Dir,* Koshare Indian Museum, Inc, La Junta CO

Powers, Tom, *Release Print Ed,* Film Arts Foundation, San Francisco CA

Powlowski, Eugene, *Prof,* Cleveland Institute of Art, Cleveland OH (S)

Poynor, Robin, *Assoc Prof,* University of Florida, Dept of Art, Gainesville FL (S)

Poyourow, Jill, *Instr,* Pierce College, Art Dept, Woodland Hills CA (S)

Ppili, Leleala E, *Exec Dir & Cur,* Jean P Haydon, Pago Pago, American Samoa PI

Pracht, Carl, *Dir,* Southeast Missouri State University, Kent Library, Cape Girardeau MO

Pradel, Chari, *Asst Prof,* California State Polytechnic University, Pomona, Art Dept, Pomona CA (S)

Prager, Janice, *Dir Develop Western Region,* Simon Wiesenthal Center Inc, Museum of Tolerance, Los Angeles CA

Prater, Teresa, *Chm of Dept & Assoc Prof,* Converse College, Dept of Art & Design, Spartanburg SC (S)

Prather, Marla, *Cur Postwar Art,* Whitney Museum of American Art, New York NY

Prather, Mary, *Instr,* Appalachian State University, Dept of Art, Boone NC (S)

Pratt, Benjamin, *Asst Prof,* University of Wisconsin-Stout, Dept of Art & Design, Menomonie WI (S)

Pratt, Elizabeth, *Instr Painting,* Truro Center for the Arts at Castle Hill, Inc, Truro MA (S)

Praytor, Blake, *Dept Head,* Greenville Technical College, Visual Arts Dept, Greenville SC (S)

Preble, Michael, *Mus Educ,* The Arkansas Arts Center, Museum School, Little Rock AR (S)

Prebor, Victor, *Pres,* Arts on the Park, Lakeland Center for Creative Arts, Lakeland FL

Precella, Jane, *Museum Shop Mgr,* Joslyn Art Museum, Omaha NE

Predel, Ron, *Dir,* University of Tulsa, Alexandre Hogue Gallery, Tulsa OK

Prelinger, Elizabeth, *Prof,* Georgetown University, Dept of Art, Music & Theatre, Washington DC (S)

Prendergast, Sylvie, *Interim Park Dir,* Stone Quarry Hill Art Park, Winner Gallery, Cazenovia NY

Prendergast, Tracey, *VPres Develop,* Please Touch Museum, Philadelphia PA

Prendergnot, Sylvia, *Asst Dir,* Stone Quarry Hill Art Park, Cazenovia NY

Prenevost, William, *Mgr Communications & Marketing,* Cleveland Museum of Art, Cleveland OH

Prentice, Jeffrey, *Asst Prog,* University of New Orleans-Lake Front, Dept of Fine Arts, New Orleans LA (S)

Pressley, Sheila, *Dir Educ,* Fine Arts Museums of San Francisco, Legion of Honor, San Francisco CA

Preston, Carol, *Cur Natural Sciences,* Randall Junior Museum, San Francisco CA

Preston, Charles, *Cur Draper Mus of Natural History,* Buffalo Bill Memorial Association, Buffalo Bill Historical Center, Cody WY

Preston, George, *Prof,* City College of New York, Art Dept, New York NY (S)

Preston, Jeff, *Co-Dept Chair, Illustration,* Nossi College of Art, Goodlettsville TN (S)

Preston, Lesley, *Asst Prof,* Presbyterian College, Visual & Theater Arts, Clinton SC (S)

Preston, Mary, *Museum Tech,* Fort Morgan Heritage Foundation, Fort Morgan CO

Preston, Tatum, *Library Adminr,* Birmingham Museum of Art, Clarence B Hanson Jr Library, Birmingham AL

Preston, Teresa, *Art History Instr,* Hutchinson Community College, Visual Arts Dept, Hutchinson KS (S)

Prestwich, Larry B, *Prof,* Northeastern Junior College, Art Department, Sterling CO (S)

Preus, Sharon Diana, *Prog Coordr,* Contemporary Art Gallery Society of British Columbia, Vancouver BC

Prevec, Rose Anne, *Communications Officer,* McMaster University, McMaster Museum of Art, Hamilton ON

Prevec, Rose Anne, *Communications Officer,* McMaster University, Library, Hamilton ON

Prevost, Joel, *Mktg Dir,* Malaspina College, Nanaimo Art Gallery, Nanaimo BC

Price, Amita, *Cur,* Dartmouth Heritage Museum, Dartmouth NS

Price, Beth, *Conservation Scientist,* Philadelphia Museum of Art, Samuel S Fleisher Art Memorial, Philadelphia PA

Price, Cheryl, *Community Outreach,* Brick Store Museum & Library, Kennebunk ME

Price, Heather, *Dir Pub Relations,* Ella Sharp, Jackson MI

Price, Jeff, *Assoc Prof,* Oklahoma State University, Art Dept, Stillwater OK (S)

Price, Jennifer Casler, *Cur of Asian Art,* Kimbell Art Museum, Fort Worth TX

Price, L, *Instr,* Humboldt State University, College of Arts & Humanities, Arcata CA (S)

Price, Linda, *Lectr,* Ithaca College, Fine Art Dept, Ithaca NY (S)

Price, Lois, *Assoc Conservator Librn Coll,* Winterthur Gardens & Library, Library, Winterthur DE

Price, Maggie, *Cur, Acting Dir,* Potsdam College of the State University of New York, Roland Gibson Gallery, Potsdam NY

Price, Mark, *Chmn Art Dept,* Middle Tennessee State University, Art Dept, Murfreesboro TN (S)

Price, Marla, *Dir,* Modern Art Museum, Fort Worth TX

Price, Marshall, *Asst Cur Contemporary Art,* National Academy Museum & School of Fine Arts, New York NY

Price, Marshall, *Asst Cur Contemporary Art,* National Academy Museum & School of Fine Arts, Archives, New York NY

Price, Marti, *Artistic Dir,* Boulevard Arts Center, Chicago IL

Price, Mary Jo, *Exhib Librn,* Frostburg State University, Lewis J Ort Library, Frostburg MD

Price, Mary Sue Sweeney, *Dir,* Newark Museum Association, The Newark Museum, Newark NJ

Price, Michael, *Prof,* Hamline University, Dept of Art & Art History, Saint Paul MN (S)

Price, Pam, *Chmn,* University of Texas of Permian Basin, Dept of Art, Odessa TX (S)

Price, Pam, *Library Dir,* Mercer County Community College, Library, West Windsor NJ

Price, Richard W, *Managing Editor,* Corning Museum of Glass, The Studio, Rakow Library, Corning NY

Price, Rob, *Prof,* University of Wisconsin-Stout, Dept of Art & Design, Menomonie WI (S)

Price, Sally Irwin, *Dir,* Baycrafters, Inc, Bay Village OH

Price, Terri, *Cur Exhibits,* Museum of Mobile, Mobile AL

Price Shimp, Robert, *Exec Dir,* Buffalo Bill Memorial Association, Buffalo Bill Historical Center, Cody WY

Priest, Mark, *Assoc Prof,* University of Louisville, Allen R Hite Art Institute, Louisville KY (S)

Priest, Sheyna, *Living History Coordr,* West Florida Historic Preservation, Inc, T T Wentworth, Jr

Florida State Museum & Historic Pensacola Village, Pensacola FL

Prime, Carolyn, *Cur,* West Florida Historic Preservation, Inc, T T Wentworth, Jr Florida State Museum & Historic Pensacola Village, Pensacola FL

Prime, Craig, *Instr,* Saginaw Valley State University, Dept of Art & Design, University Center MI (S)

Prince, Lily, *Asst Prof,* William Paterson University, Dept Arts, Wayne NJ (S)

Prinz, Peter, *Co-Founder & Co-Dir,* Space One Eleven, Inc, Birmingham AL

Prior, Barbara Q, *Art Librn,* Oberlin College, Clarence Ward Art Library, Oberlin OH

Prior, Gail, *Sales Shop Mgr,* Jericho Historical Society, Jericho VT

Priscoll, Jeanne Baker, *Asst Dir Mem & Devel,* Archives of American Art, Smithsonian Institution, Washington DC

Pritchard, O, *Cur,* Gananoque Museum, Gananoque ON

Pritchett, Mark, *Fine Arts Program Dir,* San Antonio College, Visual Arts & Technology, San Antonio TX (S)

Pritzker, Elisa, *VPres,* New York Society of Women Artists, Inc, Westport CT

Privitt, Bob, *Prof,* Pepperdine University, Seaver College, Dept of Art, Malibu CA (S)

Probes, Anna Greidanus, *Assoc Prof,* Calvin College, Art Dept, Grand Rapids MI (S)

Prochaska, David, *Instr,* Cuesta College, Art Dept, San Luis Obispo CA (S)

Procknow, Patti, *Gallery Store Coordr,* Kamloops Art Gallery, Kamloops BC

Procos, D, *Prof,* Technical University of Nova Scotia, Faculty of Architecture, Halifax NS (S)

Procter, Kenneth J, *Dean,* University of Montevallo, College of Fine Arts, Montevallo AL (S)

Proctor, Grover B, *Exec Dir,* Northwood University, Alden B Dow Creativity Center, Midland MI (S)

Prohaska, Albert, *Adjunct Prof,* New York Institute of Technology, Fine Arts Dept, Old Westbury NY (S)

Prokop, Clifton, *Chmn Fine Arts,* Keystone College, Fine Arts Dept, LaPlume PA (S)

Prokopowicz, Gerald, *Lincoln Scholar Dir,* The Lincoln Museum, Fort Wayne IN

Prol, Elbertus, *Cur,* Ringwood Manor House Museum, Ringwood NJ

Propeack, Scott, *Registrar,* Burchfield-Penney Art Center, Archives, Buffalo NY

Propeack, Scott, *Registrar & Coll & Traveling Exhibs Mgr,* Burchfield-Penney Art Center, Buffalo NY

Proper, Donna, *Asst Prof,* State University of New York at Farmingdale, Visual Communications, Farmingdale NY (S)

Proper, Hope, *Cur of Exhibs,* Perkins Center for the Arts, Moorestown NJ

Proper, Joann, *Circulation Library Asst,* Colonial Williamsburg Foundation, John D Rockefeller, Jr Library, Williamsburg VA

Propersi, August, *Chmn,* Connecticut Institute of Art, Greenwich CT (S)

Propersi, Michael, *Dir & Pres,* Connecticut Institute of Art, Greenwich CT (S)

Prose, Catherine, *Asst Dir,* City of Lubbock, Buddy Holly Center, Lubbock TX

Pross, Ann, *Assoc Dir,* Salisbury House Foundation, Des Moines IA

Prosser, Andrea, *Site Mgr,* Hermitage Foundation Museum, Norfolk VA

Prosser, Andrea, *Site Mgr,* Hermitage Foundation Museum, Library, Norfolk VA

Proulx, Shirley, *Asst Cur Contemporary Art,* National Gallery of Canada, Ottawa ON

Provan, Jill, *Research Librn,* Tucson Museum of Artand Historic Block, Tucson AZ

Provan, Jill E, *Librn,* Tucson Museum of Artand Historic Block, Library, Tucson AZ

Provence, Dana, *Asst Prof Art,* Adams State College, Dept of Visual Arts, Alamosa CO (S)

Provine, William, *Instr,* John C Calhoun, Department of Fine Arts, Decatur AL (S)

Provo, Dan, *Dir,* Oklahoma Historical Society, State Museum of History, Oklahoma City OK

Provo, Dan, *Okla Mus,* Oklahoma Historical Society, Library Resources Division, Oklahoma City OK

Provost, Elaine, *Treas,* Blackwell Street Center for the Arts, Denville NJ

Pruden, Matt, *Prog Coordr,* Philadelphia Art Alliance, Philadelphia PA

Prudhomme, Sue, *Dir,* Twin City Art Foundation, Masur Museum of Art, Monroe LA

Prudic, Nancy, *Asst Prof Visual Art,* Lake Erie College, Fine Arts Dept, Painesville OH (S)

Prufer, Mona, *VPres Corporate,* Brookgreen Gardens, Murrells Inlet SC

Pruner, Gary, *Instr,* American River College, Dept of Art/Art New Media, Sacramento CA (S)

Prusinowski, Nancy, *Asst Dir,* Prince Street Gallery, New York NY

Pry, George, *Pres,* Art Institute of Pittsburgh, Pittsburgh PA (S)

Pryor, Eric, *Pres,* Visual Arts Center of New Jersey, Summit NJ

Pryor, Gerald, *Artist-in-Residence,* New York University, Dept of Art & Art Professions, New York NY (S)

Przaskos, Lawrence, *Supt Greater Amsterdam School District,* Mohawk Valley Heritage Association, Inc, Walter Elwood Museum, Amsterdam NY

Przyblek, Stephanie, *Dir Coll,* Schenectady Museum Planetarium & Visitors Center, Schenectady NY

Przybylek, Stephanie, *Librn,* Cayuga Museum of History & Art, Library, Auburn NY

Pshyk, Christal, *Prog Coordr,* Where Edmonton Community Artists Network Society, Harcourt House Arts Centre, Edmonton AB

Puaskett, Nicole, *Prog Mgr,* Art Dealers Association of Canada, Toronto ON

Puccinelli, Keith, *VPres,* Santa Barbara Contemporary Arts Forum, Santa Barbara CA

Puckett, Paula, *Chmn,* Kellogg Community College, Arts & Communication Dept, Battle Creek MI (S)

Puej, Pedro, *Adminr,* Centro de Estudios Avanzados, Old San Juan PR

Puff, Allison, *Assoc Prof,* State University of New York at Farmingdale, Visual Communications, Farmingdale NY (S)

Puffer, John, *Assoc Prof,* Vincennes University Junior College, Humanities Art Dept, Vincennes IN (S)

Pugh, Lawrence R, *VPres,* Portland Museum of Art, Portland ME

Pugh, Mary Jo, *Coll Mgr,* San Francisco Maritime National Historical Park, Maritime Museum, San Francisco CA

Puleo, Joe, *Pres,* Marblehead Arts Association, Inc, Marblehead MA

Pulin, Carol, *Dir,* American Print Alliance, Peachtree City GA

Pulinka, Steven M, *Site Adminr,* Winterthur Gardens & Library, Historic Houses of Odessa, Winterthur DE

Pulitzer, Ramelle, *Exec Dir,* Associated Artists of Winston-Salem, Winston-Salem NC

Pulliam, Jonell, *Dir Educ,* Carolina Art Association, Gibbes Museum of Art, Charleston SC

Pulliam, Myrta J, *Pres,* Columbus Museum of Art and Design, Indianapolis IN

Pullias, Frances, *Mus Shop Mgr,* Putnam Museum of History and Natural Science, Library, Davenport IA

Pullini Brown, Ada, *Paintg & Drawing Instr,* Rio Hondo College, Visual Arts Dept, Whittier CA (S)

Puls, Lucy, University of California, Davis, Dept of Art & Art History, Davis CA (S)

Pulsifer, Dorothy, *Assoc Prof,* Bridgewater State College, Art Dept, Bridgewater MA (S)

Pultz, Janet, *Exec Dir,* Vesterheim Norwegian-American Museum, Reference Library, Decorah IA

Pultz, John, *Assoc Prof,* University of Kansas, Kress Foundation Dept of Art History, Lawrence KS (S)

Pumphrey, M Jo, *Assoc Prof,* Brevard College, Division of Fine Arts, Brevard NC (S)

Pumphrey, Richard, *Prof,* Lynchburg College, Art Dept, Lynchburg VA (S)

Punch, Walter, *Dir,* Wentworth Institute of Technology Library, Boston MA

Punt, Gerry, *Instr,* Augustana College, Art Dept, Sioux Falls SD (S)

Pura, Bill, University of Manitoba, School of Art, Winnipeg MB (S)

Purcell, Amy Lixi, *Prof,* University of North Carolina at Greensboro, Art Dept, Greensboro NC (S)

Purcell, Carl, *Chmn,* Snow College, Art Dept, Ephraim UT (S)

Purdue, James R, *Zoology Chair,* Illinois State Museum, Museum Store, Chicago IL

Purdy, Ana, *Mktg Mgr,* Museum of Contemporary Art, San Diego-Downtown, La Jolla CA

Purinton, Nick, *Business Mgr,* Concord Museum, Concord MA

Purkiss, Christine, *Library Asst,* Bryn Mawr College, Rhys Carpenter Library for Art, Archaeology, Classics & Cities, Bryn Mawr PA

Purrington, Robert H, *Innkeeper,* Longfellow's Wayside Inn Museum, South Sudbury MA

Pursell, Clay, *Adjunct Instr,* Maryville University of Saint Louis, Art & Design Program, Saint Louis MO (S)

Purves, Eric, *Assoc Prof,* Appalachian State University, Dept of Art, Boone NC (S)

Purvis, Alston, *Dir,* Boston University, School for the Arts, Boston MA (S)

Putka, Robert, *Instr,* Cuyahoga Valley Art Center, Cuyahoga Falls OH (S)

Putman, Sumi, *Printmaker,* University of South Alabama, Dept of Art & Art History, Mobile AL (S)

Putnam, Catherine, *Interim Dir,* Santa Fe, Santa Fe NM

Putnam, Christy, *Assoc Dir Operations,* Whitney Museum of American Art, New York NY

Putnam, Thomas, *Deputy Dir,* National Archives & Records Administration, John F Kennedy Presidential Library & Museum, Boston MA

Putney, Carolyn M, *Cur of Asian Art & Art Mgmt Work Group Mgr,* Toledo Museum of Art, Toledo OH

Putsch, Henry E, *Pres,* Lyme Academy of Fine Arts, Old Lyme CT

Putsch, Henry E, *Pres,* Lyme Academy of Fine Arts, Old Lyme CT (S)

Puttason-Weber, Brittany, *Dir Educ,* Historical Museum at Fort Missoula, Missoula MT

Pye, Jennifer, *Cur Coll,* Monhegan Museum, Monhegan ME

Pygin, Cynthia, *CFO,* California Science Center, Los Angeles CA

Pyle, Dorothy, *Div Chmn,* Maui Community College, Art Program, Kahului HI (S)

Pynn, Jo Ann, *Mus Adminr,* Heritage Toronto, Historic Fort York, Toronto ON

Quackenbush, Laura, *Cur,* Leelanau Historical Museum, Leland MI

Quadhamer, Roger, *Dean Div,* El Camino College, Division of Fine Arts, Torrance CA (S)

Quarcoopome, Nii, *Cur African, Oceanic & New World Cultures Art,* Detroit Institute of Arts, Detroit MI

Quay, Cindy, *Educ,* Walter Anderson, Ocean Springs MS

Quay, Jackie, *Dir Riverside Acad & SPECTRA,* Fitton Center for Creative Arts, Hamilton OH

Quednau, Howard, *Acting Chair Fine Arts,* Minneapolis College of Art & Design, Minneapolis MN (S)

Questell, Victoria, *Communications,* Chatillon-DeMenil House Foundation, DeMenil Mansion, Saint Louis MO

Quick, Jonathan, *Asst Prof,* Ohio Wesleyan University, Fine Arts Dept, Delaware OH (S)

Quigley, Austin, *Dean,* Columbia University, Columbia College, New York NY (S)

Quigley, Suzanne, *Head Registrary,* Whitney Museum of American Art, New York NY

Quimby, Sarah, *Assoc Librn,* Minneapolis Institute of Arts, Art Research & Reference Library, Minneapolis MN

Quin, Langdon, *Asst Prof,* University of New Hampshire, Dept of Arts & Art History, Durham NH (S)

Quinan, John, *Distinguished Prof,* University at Buffalo, State University of New York, Dept of Visual Studies, Buffalo NY (S)

Quincy, Susan, *Environmental Educ,* Osborne Homestead Museum, Derby CT

Quinn, Dorene, *Assoc Prof,* Munson-Williams-Proctor Arts Institute, School of Art, Utica NY (S)

Quinn, Ellen, *Asst Prof,* Jersey City State College, Art Dept, Jersey City NJ (S)

Quinn, Kristin, *Instr,* Saint Ambrose University, Art Dept, Davenport IA (S)

Quinn, Lisa, *Educ Dir,* Dairy Barn Cultural Arts Center, Athens OH

Quinn, Mairin, *Secy,* Rensselaer Newman Foundation Chapel & Cultural Center, The Gallery, Troy NY

Quinn, Megan, *Prof,* Augustana College, Art Dept, Rock Island IL (S)

Quinn, William, *Dir,* Kent State University, School of Art, Kent OH (S)

Quinn-Hensley, Carolyn I, *Assoc Prof,* Mesa State College, Art Dept, Grand Junction CO (S)

Quinney, G B, *Chief Security,* Birmingham Museum of Art, Birmingham AL

Quinney, G B, *Security Dir,* Birmingham Museum of Art, Clarence B Hanson Jr Library, Birmingham AL

Quinones-Keber, Eloise, *Prof,* City University of New York, PhD Program in Art History, New York NY (S)

Quinonez, Gary, *Sculpture Instr,* Monterey Peninsula College, Art Dept, Monterey CA (S)

Quintanilla, Faustino, *Dir,* Queensborough Community College, Art Gallery, Bayside NY

Quintanilla, Mimi, *Exec VPres,* Witte Museum, San Antonio TX

Quintanilla, Sonya, *Cur Asian Art,* San Diego Museum of Art, San Diego CA

Quinteros, Alejandro, *Assoc Prof,* University of Puerto Rico, Dept of Fine Arts, Rio Piedras PR (S)

Quinton, Sarah, *Contemporary Gallery Cur,* Textile Museum of Canada, Toronto ON

Quirarte, Jacinto, *Prof Emeritus,* University of Texas at San Antonio, Dept of Art & Art History, San Antonio TX (S)

Quirino, Barbara, *Mus Shop Mgr,* Hancock Shaker Village, Inc, Pittsfield MA

Quiroga, Mercedes, *Chmn,* Miami-Dade Community College, Wolfson Galleries, Miami FL

Quiroz, Alfred, *Assoc Prof Painting & Drawing,* University of Arizona, Dept of Art, Tucson AZ (S)

Quitberg, Gwendolyn, *Receptionist,* Sweetwater County Library System and School District #1, Community Fine Arts Center, Rock Springs WY

Raab, Judith M, *Dir Membership & Events,* Williams College, Museum of Art, Williamstown MA

Raatz, Heidi, *Visual Resource Librn,* Minneapolis Institute of Arts, Art Research & Reference Library, Minneapolis MN

Rabb, George, *Board Chmn,* Illinois State Museum, Museum Store, Chicago IL

Rabe, Michael, *Assoc Prof,* Saint Xavier University, Dept of Art & Design, Chicago IL (S)

Raben, Katrina, *Program Coordr,* Queens Historical Society, Kingsland Homestead, Flushing NY

Rabinovitch, Victor, *Chief Exec Officer,* Canadian Museum of Civilization, Gatineau PQ

Rabun, Julie, *Asst Prof,* Carson-Newman College, Art Dept, Jefferson City TN (S)

Raby, Mary Beth, *Librn,* College of Visual Arts, Library, Saint Paul MN

Racey, Nicholas, *VPres,* Strasburg Museum, Strasburg VA

Rackow, Marcia, *Coordr,* Aesthetic Realism Foundation, Terrain Gallery, New York NY

Raczka, Laurel, *Exec Dir,* Painted Bride Art Center Gallery, Philadelphia PA

Raczka, Robert, *Gallery Dir,* Allegheny College, Bowman, Megahan & Penelec Galleries, Meadville PA

Raczynska, Joanna, *Media Cur,* Hallwalls Contemporary Arts Center, Buffalo NY

Radan, George, *Prof,* Villanova University, Dept of Theater, Villanova PA (S)

Radant, Carrie, *Membership Coordr,* University of Utah, Utah Museum of Fine Arts, Salt Lake City UT

Radecki, Betsy, *Dir Educ,* The Long Island Museum of American Art, History & Carriages, Stony Brook NY

Radecki, Martin, *Dir Cur Coll Support & Chief Conservator,* Columbus Museum of Art and Design, Indianapolis IN

Radice, Mike, *Educ & Visitor Servs,* Harriet Beecher Stowe, Harriet Beecher Stowe House & Library, Hartford CT

Radke, Don, *Adjunct Assoc Prof,* Texas Woman's University, School of the Arts, Dept of Visual Arts, Denton TX (S)

Radke, Doug, *Chmn,* Blue Mountain Community College, Fine Arts Dept, Pendleton OR (S)

Radosh, Sondra M, *Asst Dir, Children's Librn,* Jones Library, Inc, Amherst MA

Radycki, Diane, *Dir,* Moravian College, Payne Gallery, Bethlehem PA

Radycki, Diane, *Dir of Paine Gallery,* Moravian College, Dept of Art, Bethlehem PA (S)

Rafat, Pasha, *Assoc Prof,* University of Nevada, Las Vegas, Dept of Art, Las Vegas NV (S)

Rafferty, Emily K, *Sr Vice Pres Exter,* The Metropolitan Museum of Art, New York NY

Raffield, Stacey, *Library Asst,* Chrysler Museum of Art, Jean Outland Chrysler Library, Norfolk VA

Raftery, Summer, *Prog Asst,* Kentucky Guild of Artists & Craftsmen Inc, Berea KY

Ragbir, Lise, *Asst Dir,* Perkins Center for the Arts, Moorestown NJ

Rager, Rick, *Visitor Services Dir,* Flagler Museum, Palm Beach FL

Rago, Juliet, *Prof Emeritus,* Loyola University of Chicago, Fine Arts Dept, Chicago IL (S)

Raguin, Virginia C, *Prof,* College of the Holy Cross, Dept of Visual Arts, Worcester MA (S)

Rahaim, Margaret, *Prof,* Mount Saint Mary's University, Visual & Performing Arts Dept, Emmitsburg MD (S)

Rahe, Diane, *VPres,* Phillips County Museum, Holyoke CO

Raia, Nancy, *ASC Project Dir,* Eastern Shore Art Association, Inc, Library, Fairhope AL

Raid, Tiit, University of Wisconsin-Eau Claire, Dept of Art, Eau Claire WI (S)

Raimondo, Cristina, *Admin Asst,* York University, Glendon Gallery, Toronto ON

Raines, Kevin, *Prof,* College of Notre Dame of Maryland, Art Dept, Baltimore MD (S)

Rains, Jerry, *Chmn,* Northeast Mississippi Junior College, Art Dept, Booneville MS (S)

Rainwater, Robert, *Asst Dir for Art, Prints & Photographs & Cur Spencer Coll,* The New York Public Library, Spencer Collection, New York NY

Rais, Dagmar, *Assoc Dir & Cur,* Basilian Fathers, Library, Mundare AB

Raiselis, Richard, *Assoc Prof,* Boston University, School for the Arts, Boston MA (S)

Rait, Elearnor, *Cur Coll,* Hofstra University, Hofstra Museum, Hempstead NY

Raithel, Jan, *Dept Chmn,* Chaffey Community College, Art Dept, Rancho Cucamonga CA (S)

Raizman, David, *Head Dept Fashion & Visual Studies,* Drexel University, College of Media Arts & Design, Philadelphia PA (S)

Rakes, Susan, *Cur Arts Educ,* Art & Culture Center of Hollywood, Art Gallery, Hollywood FL

Ralph, Katherine, *Mus Shop Mgr,* Oakland Museum of California, Art Dept, Oakland CA

Ralston, Roger, *Adjunct Asst Prof,* Spokane Falls Community College, Fine Arts Dept, Spokane WA (S)

Rama, Ronnie, *Prof,* Abilene Christian University, Dept of Art & Design, Abilene TX (S)

Ramage, William, *Prof,* Castleton State College, Art Dept, Castleton VT (S)

Ramirez, Cynthia, *Instr,* Southern University in New Orleans, Fine Arts & Philosophy Dept, New Orleans LA (S)

Ramirez, Rebecca, *Dir Progs & Servs,* Association of Hispanic Arts, New York NY

Ramming, Nita, *Mus Shop Mgr,* Carson County Square House Museum, Panhandle TX

Ramon, Art, *Archives,* Deming-Luna Mimbres Museum, Deming NM

Ramos, Jim, *Instr,* Gettysburg College, Dept of Visual Arts, Gettysburg PA (S)

Ramos, Julianne, *Exec Dir,* Rockland Center for the Arts, West Nyack NY

Ramos, Julianne, *Exec Dir,* Rockland Center for the Arts, West Nyack NY (S)

Ramsaran, Helen, *Assoc Prof,* John Jay College of Criminal Justice, Dept of Art, Music & Philosophy, New York NY (S)

Ramsay, Cheryl, *Controller,* Southwest Museum, Los Angeles CA

Ramsay, Chris, *Prof,* Oklahoma State University, Art Dept, Stillwater OK (S)

Ramsey, Chuck, *Coordr,* Clark College, Art Dept, Vancouver WA (S)

Ramsey, Nicole, *Bus Mgr,* Historical Society of Martin County, Elliott Museum, Stuart FL

Ranalli, Daniel, *Dir,* Boston University, Graduate Program - Arts Administration, Boston MA (S)

Rancourt, Allan, *Treas,* Waterville Historical Society, Redington Museum, Waterville ME

Rand, Anne Gimes, *Deputy Dir,* USS Constitution Museum, Boston MA

Rand, Charles E, *Research Ctr Dir,* National Cowboy & Western Heritage Museum, Oklahoma City OK

Rand, Erica, *Prof,* Bates College, Art & Visual Culture, Lewiston ME (S)

Rand, Richard, *Cur Mathematics,* Northern Maine Museum of Science, Presque Isle ME

Rand, Richard, *Sr Cur of Paintings & Sculpture,* Sterling & Francine Clark, Williamstown MA

Rand, Valerie, *Dir Housing,* The Illinois Institute of Art - Chicago, Chicago IL (S)

Randall, Ross, *Dir,* Frank Lloyd Wright, Mount Vernon VA

Randall, Ross, *Dir,* Woodlawn/The Pope-Leighey, Mount Vernon VA

Randall, Susan, *Instr,* Midland College, Art Dept, Midland TX (S)

Randolph, Adrian, *Prof,* Dartmouth College, Dept of Art History, Hanover NH (S)

Randolph, Karen, *Prof,* Lubbock Christian University, Dept of Communication & Fine Art, Lubbock TX (S)

Rangel, Gabriela, *Dir,* Americas Society Art Gallery, New York NY

Rank-Beauchamp, Beth, *CEO, Pres,* Sharon Arts Center, Sharon Arts Center Exhibition Gallery, Sharon NH

Rankin, Thomas, *Assoc Prof Practice,* Duke University, Dept of Art, Art History & Visual Studies, Durham NC (S)

Ransom, Bernard, *Cur Military History,* Provincial Museum of Newfoundland & Labrador, Saint John's NF

Ransom, Brian, *Asst Prof,* Eckerd College, Art Dept, Saint Petersburg FL (S)

Ranspach, Ernest, *Prof,* Lynn University, Art & Design Dept, Boca Raton FL (S)

Rantoul, T Neal, *Assoc Prof,* Northeastern University, Dept of Art & Architecture, Boston MA (S)

Raphael, Molly, *Multnomah County Libr Interim Dir,* Multnomah County Library, Henry Failing Art & Music Dept, Portland OR

Rapkievian, Carolyn, *Public Prog Coordr,* National Museum of the American Indian, George Gustav Heye Center, New York NY

Rapkin, Grace, *Dir Mktg,* The Jewish Museum, New York NY

Rapp, Maggie, *Dir New Harmony Gallery,* Hoosier Salon Patrons Association, Inc, Art Gallery, Indianapolis IN

Rappaport, Deborah, *Pres,* San Jose Museum of Art, Library, San Jose CA

Rapporport, Matt, *Asst Prof,* University of Dayton, Visual Arts Dept, Dayton OH (S)

Rasbury, Patricia, *Dir Opers,* Tennessee State Museum, Nashville TN

Rash, Brennan, *Public Affairs Officer,* National Portrait Gallery, Washington DC

Rasic, Alexandra, *Pub Prog Mgr,* Workman & Temple Family Homestead Museum, City of Industry CA

Rasile, Kelly, *Admin Asst,* Massillon Museum, Massillon OH

Rasmussen, Jack, *Dir & Cur,* American University, Katzen Art Center Gallery, Washington DC

Rasmussen, Keith, *Exec Dir,* Chattahoochee Valley Art Museum, LaGrange GA

Rasmussen, Mary, *Res Asst Prof,* University of Illinois at Chicago, Biomedical Visualization, Chicago IL (S)

Rasmussen, William, *Cur Art,* Virginia Historical Society, Library, Richmond VA

Rasmussen, William, *Cur of Virginia Art,* Virginia Historical Society, Richmond VA

Rass, Patty, *Instr,* Mount Mary College, Art & Design Division, Milwaukee WI (S)

Rassweiler, Janet, *Prog & Colls Dir,* New Jersey Historical Society, Newark NJ

Ratcliff, Gary, *Instr,* University of Louisiana at Monroe, Dept of Art, Monroe LA (S)

Rathbone, Eliza, *Chief Cur,* The Phillips Collection, Washington DC

Rathbone, Eliza, *Chief Cur,* The Phillips Collection, Library, Washington DC

Rathbone, Bob, *Dir,* Sloss Furnaces National Historic Landmark, Birmingham AL

Rathburn, Linda, *Gen Educ,* Art Institute of Pittsburgh, Pittsburgh PA (S)

Rathje, Terry, *Asst Prof,* Western Illinois University, Art Dept, Macomb IL (S)

Rathwell, Robert, *Vol Coordr,* Craigdarroch Castle Historical Museum Society, Victoria BC

Ratliff, Diana, *Pub Relations Dir & Marketing,* Shaker Village of Pleasant Hill, Harrodsburg KY

Ratliff, Divonna, *Dir Prog,* Portland Children's Museum, Portland OR

Ratner, Don, *VPres Finance,* Terra Museum of American Art, Chicago IL

Ratner, Peter, *Asst Prof,* James Madison University, School of Art & Art History, Harrisonburg VA (S)

Ratner, Rhoda, *Librn,* Smithsonian National Museum of American History, Branch Library, Washington DC

Rattner, Carl, *Prof,* Saint Thomas Aquinas College, Art Dept, Sparkill NY (S)

Ratzkin, Rebecca, *Gallery Manager,* Soho 20 Gallery, Soho20 Chelsea, New York NY

Rau, Sue, *Instr Paintign,* Ocean City Arts Center, Ocean City NJ (S)

Rauf, Barb, *Dir,* Thomas More College, TM Gallery, Crestview KY

Rauf, Barbara, *Assoc Prof,* Thomas More College, Art Dept, Crestview Hills KY (S)

Rauhauser, Andrew, *VPres,* Ages of Man Foundation, Amenia NY

Rauhoff, Christopher, *Dir of Exhib,* Carnegie Museums of Pittsburgh, Carnegie Museum of Art, Pittsburgh PA

Ravenal, John, *Cur Modern & Contemporary Art,* Virginia Museum of Fine Arts, Richmond VA

Ravenwood, Gregory, *Exhib Coordr,* Boulder Public Library & Gallery, Dept of Fine Arts Gallery, Boulder CO

Rawlins, Dori, *Cur,* City of Irvine, Irvine Fine Arts Center, Irvine CA (S)

Rawlins, Gary, Chemeketa Community College, Dept of Humanities & Communications, Salem OR (S)

Rawlins, Kathleen, *Asst Dir,* Cambridge Historical Commission, Cambridge MA

Rawlins, W Scott, *Asst Prof,* Beaver College, Dept of Fine Arts, Glenside PA (S)

Rawls, James A, *Chmn,* Pearl River Community College, Visual Arts, Dept of Fine Arts & Communication, Poplarville MS (S)

Rawson, Gale, *Mus Registrar,* Pennsylvania Academy of the Fine Arts, Philadelphia PA

Rawson, Kimberly, *Assoc Dir Marketing Commission,* Norman Rockwell Museum, Stockbridge MA

Rawstern, Sherri, *Cur Educ,* Dacotah Prairie Museum, Lamont Art Gallery, Aberdeen SD

Ray, Cindy, *Coordr,* Mississippi Delta Community College, Dept of Fine Arts, Moorhead MS (S)

Ray, Jeffrey, *Cur Coll,* Atwater Kent Museum of Philadelphia, Philadelphia PA

Ray, Lawrence A, *Chmn,* Lambuth University, Dept of Human Ecology & Visual Arts, Jackson TN (S)

Ray, Will, *Pres & CEO,* Palm Beach County Cultural Council, West Palm Beach FL

Rayca, Brian, *Collection Analyst,* United States Military Academy, West Point Museum, West Point NY

Rayen, James W, *Prof,* Wellesley College, Art Dept, Wellesley MA (S)

Rayme, Mary, *Adjunct Instr,* Davis & Elkins College, Dept of Art, Elkins WV (S)

Raymond, Kelley, *Educ Coordr,* Western Colorado Center for the Arts, Inc, Grand Junction CO

Rayne, Angela, *Cur,* Jefferson County Open Space, Hiwan Homestead Museum, Evergreen CO

Raynor, Anne E, *Arts Coordr,* Worthington Arts Council, Worthington OH

Re, Peggy, *Asst Prof,* University of Maryland, Baltimore County, Imaging, Digital & Visual Arts Dept, Baltimore MD (S)

Read, Bob, *Art Dir,* New Mexico Highlands University, The Fine Arts Gallery, Las Vegas NM

Read, Cindy, *Asst Prof,* Marygrove College, Department of Art, Detroit MI (S)

Read, Ron, *Librn,* Church of Jesus Christ of Latter-Day Saints, Art Library, Salt Lake City UT

Reading, Christine, *Instr,* Sacramento City College, Art Dept, Sacramento CA (S)

Reagan, Pat, *Assoc Prof,* Southeast Missouri State University, Dept of Art, Cape Girardeau MO (S)

Real, William, *Dir Tech Initiatives,* Carnegie Museums of Pittsburgh, Carnegie Museum of Art, Pittsburgh PA

Reardon, Steven, *Marketing,* Terra Museum of American Art, Chicago IL

Reasoner, Kathryn, *Exec Dir,* Headlands Center for the Arts, Sausalito CA

Reaves, James, *Dir of Librn,* United Methodist Historical Society, Lovely Lane Museum, Baltimore MD

Reaves, Wendy W, *Cur Prints & Drawings,* National Portrait Gallery, Washington DC

Reaves, Wendy Wick, *Cur Prints,* National Portrait Gallery, Library, Washington DC

Reazer, John, *Librn,* Harriet Beecher Stowe, Harriet Beecher Stowe House & Library, Hartford CT

Reba, Kathy, *Asst Prof Visual Arts,* Dowling College, Dept of Visual Arts, Oakdale NY (S)

Rebac, Laurie, *Asst Gallery Mgr,* Sharon Arts Center, Sharon Arts Center Exhibition Gallery, Sharon NH

Reber, Mick, *Prof,* Fort Lewis College, Art Dept, Durango CO (S)

Reber, Paul, *Exec Dir,* National Trust for Historic Preservation, Decatur House, Washington DC

Reber, Wally, *Assoc Dir,* Buffalo Bill Memorial Association, Buffalo Bill Historical Center, Cody WY

Reboli, Father John, *Assoc Prof,* College of the Holy Cross, Dept of Visual Arts, Worcester MA (S)

Recchia, Marissa, *Instr,* Middle Tennessee State University, Art Dept, Murfreesboro TN (S)

Rech, Leslie, *Asst Prof,* South Carolina State University, Dept of Visual & Performing Arts, Orangeburg SC (S)

Recht, Robert, *Asst Prof,* Florida Southern College, Art Dept, Lakeland FL (S)

Reck, Pat, *Museum Coordr,* Indian Pueblo Cultural Center, Albuquerque NM

Reckitt, Helena, *Dir Exhib & Educ,* Atlanta Contemporary Art Center, Atlanta GA

Redden, Deborah, *Pres,* Guild of Creative Art, Shrewsbury NJ (S)

Reddicliffe, Harold, *Assoc Prof,* Boston University, School for the Arts, Boston MA (S)

Reddig, Deborah, *Dir Mus Advancement,* Pennsylvania Historical & Museum Commission, Railroad Museum of Pennsylvania, Harrisburg PA

Redding, Jim, *Prof,* Lansing Community College, Visual Arts & Media Dept, Lansing MI (S)

Redding, Mary Anne, *Exec Dir,* Light Factory, Charlotte NC

Redding, Shawn, *Dir,* City of Atlanta, Arts Clearinghouse, Atlanta GA

Reddy, N Krishna, *Artist-in-Residence,* New York University, Dept of Art & Art Professions, New York NY (S)

Redman, Scott, *Instr,* Springfield College, Dept of Visual & Performing Arts, Springfield MA (S)

Redmann, Gail, *Libr VPres,* Historical Society of Washington DC, Kiplinger Research Library, Washington DC

Redmann, Gail, *VPres Library,* Historical Society of Washington DC, The City Museum of Washington DC, Washington DC

Redmond, Michael, *Dean Art & Humanities,* Bergen Community College, Visual Art Dept, Paramus NJ (S)

Redvale, Jolene, *Cur Educ,* San Bernardino County Museum, Fine Arts Institute, Redlands CA

Reece Hardy, Saralyn, *Dir,* Salina Art Center, Salina KS

Reed, Alan, *Assoc Prof,* Saint John's University, Art Dept, Collegeville MN (S)

Reed, Amy, *Cur Educ,* City of El Paso, El Paso Museum of Art, El Paso TX

Reed, Arthur, *After School Employee,* Okefenokee Heritage Center, Inc, Waycross GA

Reed, Barbara, *Acquisitions Coordr,* The Metropolitan Museum of Art, Thomas J Watson Library, New York NY

Reed, Barbara, *Gift Shop Mgr,* Salisbury University, Ward Museum of Wildfowl Art, Salisbury MD

Reed, Barbara E, *Librn,* Dartmouth College, Sherman Art Library, Hanover NH

Reed, Barry, *Security,* Yesteryear Village, West Palm Beach FL

Reed, Carl, *Chmn,* Colorado College, Dept of Art, Colorado Springs CO (S)

Reed, Dennis, *Chmn,* Los Angeles Valley College, Art Dept, Van Nuys CA (S)

Reed, Dottie, *Outreach Publicity Coordr,* Dickinson College, The Trout Gallery, Carlisle PA

Reed, Evan, *Dir Gallery,* Georgetown University, Dept of Art, Music & Theatre, Washington DC (S)

Reed, Jane, *Assoc Dir,* University Club Library, New York NY

Reed, Judy, *Creative Dir,* Creative Arts Guild, Dalton GA

Reed, Katharine, *Sr Catalogue Librn,* Nelson-Atkins Museum of Art, Spencer Art Reference Library, Kansas City MO

Reed , Katherine Lee, *Dir,* Cleveland Museum of Art, Cleveland OH

Reed, Nancy, *Assoc Prof,* Texas Tech University, Dept of Art, Lubbock TX (S)

Reed, Pamela, *Art History,* Phoenix College, Dept of Art & Photography, Phoenix AZ (S)

Reed, Roger, *Pres,* Illustration House Inc, Gallery Auction House, New York NY

Reed, Roger, *Prof,* Dakota State University, College of Liberal Arts, Madison SD (S)

Reed, Ruby, *Pres,* Fulton County Historical Society Inc, Fulton County Museum, Rochester IN

Reed, Scott, *Assoc Prof,* Colby College, Art Dept, Waterville ME (S)

Reed, Sharon, *Pub Rels Coordr,* Dartmouth College, Hood Museum of Art, Hanover NH

Reeder, Dean, *Dir,* Utah Travel Council, Salt Lake City UT

Reeder, Leah, *Registrar,* Fort Wayne Museum of Art, Inc, Fort Wayne IN

Reeder, Sharen, *Pres Bd,* Fort Smith Art Center, Fort Smith AR

Reed Sanchez, Pamela, *Dir Develop,* George Eastman, Rochester NY

Reedy, Denise, *Ofc Mgr,* Arts Council of the Blue Ridge, Roanoke VA

Reekie, Clara, *Dir,* Five Civilized Tribes Museum, Muskogee OK

Reekie, Clara, *Dir,* Five Civilized Tribes Museum, Library, Muskogee OK

Reel, David M, *Dir,* United States Military Academy, West Point Museum, West Point NY

Rees, James C, *Resident Dir,* Mount Vernon Ladies' Association of the Union, Mount Vernon VA

Rees, Norma, *Pres,* California State University, East Bay, University Art Gallery, Hayward CA

Reese, Becky Duval, *Dir,* City of El Paso, El Paso TX

Reese, Brandon, *Asst Prof,* Oklahoma State University, Art Dept, Stillwater OK (S)

Reese, Heinz, *VPres Prog Exhib,* Glenbow Museum, Calgary AB

Reeve, Gordon, University of Manitoba, School of Art, Winnipeg MB (S)

Reeves, Alvin, *Asst Cur Agriculture (Emeritus),* Northern Maine Museum of Science, Presque Isle ME

Reeves, Archie T, *Pres,* Sturdivant Hall, Selma AL

Reeves, Louise, *Registrar,* Museum of Fine Arts, Saint Petersburg, Florida, Inc, Saint Petersburg FL

Reeves, Roger, *Exhibit Designer & Production Coordr,* Columbus Museum, Columbus GA

Reeves V, I S K, *Pres,* Architects Design Group Inc, Winter Park FL

Regalado, Lydia, *Educ Coordr,* The Dallas Contemporary, Dallas Visual Art Center, Dallas TX

Regan, Thomas, *Dean of Arts,* Acadia University, Art Dept, Wolfville NS (S)

Regan, Tom, *Dean,* Texas A&M University, College of Architecture, College Station TX (S)

Regan-Dalzell, Kathie, *Instr,* Main Line Art Center, Haverford PA (S)

Register, Christopher M, *Assoc Prof,* Longwood University, Dept of Art, Farmville VA (S)

Regutti, Carl, *Dir,* North Carolina Nature Artists Association (NCNAA), Cary NC

Rehm-Mott, Denise, *Prof,* Eastern Illinois University, Art Dept, Charleston IL (S)

Rehnstrand, Bill, *Coll Mgr,* Superior Public Museums Inc, Archives, Superior WI

Reibach, Lois, *Head Technical Servs,* Lutheran Theological Seminary, Krauth Memorial Library, Philadelphia PA

Reich, Christopher J, *Dir,* Putnam Museum of History and Natural Science, Davenport IA

Reich, Christopher J, *Dir, CEO,* Putnam Museum of History and Natural Science, Library, Davenport IA

Reich, Dindy, *Gallery Dir,* University of Texas Pan American, Art Dept, Edinburg TX (S)

Reich, Marsha, *Educ Coordr,* Southern Alberta Art Gallery, Library, Lethbridge AB

Reichert, Herb, *Instr Visual Arts,* Dowling College, Dept of Visual Arts, Oakdale NY (S)

Reichert, John, *Preparator,* Regina Public Library, Dunlop Art Gallery, Regina SK

Reichertz, Mathew, *Prog Coordr,* St Mary's University, Art Gallery, Halifax NS

Reichmann, Monica, *Dir of Special Events,* Nassau County Museum of Fine Art, Roslyn Harbor NY

Reid, Chris, *Cur,* The Art Gallery of Southwestern Manitoba, Brandon MB

Reid, Dennis, *Chief Cur,* Art Gallery of Ontario, Toronto ON

Reid, Grace, *Librarian,* Birmingham Museum of Art, Birmingham AL

Reid, Graeme, *Asst Dir,* Museum of Wisconsin Art, West Bend Art Museum, West Bend WI

Reid, Graeme, *Cur,* Art Museum of Greater Lafayette, Library, Lafayette IN

Reid, Jacqueline, *Dir,* Duke University Library, Hartman Center for Sales, Advertising & Marketing History, Durham NC

Reid, Joan Elizabeth, *Registrar,* Walters Art Museum, Baltimore MD

Reid, Joan-Elisabeth, *Registrar,* Walters Art Museum, Library, Baltimore MD

Reid, Margaret, *Head,* Guilford Technical Community College, Commercial Art Dept, Jamestown NC (S)

Reid, Megan, *Div Dir,* Arizona Historical Society-Yuma, Sanguinetti House Museum & Garden, Yuma AZ

Reid, Michelle, *Cur Colls,* Cascade County Historical Society, High Plains Heritage Center, Great Falls MT

Reid, Pat, *Technical Servs Assoc,* Corcoran Gallery of Art, Corcoran Library, Washington DC

Reid, Randal, *Prof,* Texas State University - San Marcos, Dept of Art and Design, San Marcos TX (S)

Reid, Shannon, *Shop Mgr,* Craft Council of Newfoundland & Labrador, Saint John's NF

Reid, Stuart, *Dir,* Tom Thomson, Owen Sound ON

Reid, Stuart, *Dir,* Tom Thomson, Library/Archives, Owen Sound ON

Reidel, Caroline, *Registrar,* University of Victoria, Maltwood Art Museum and Gallery, Victoria BC

Reidhaar, James, *Assoc Prof,* Indiana University, Bloomington, Henry Radford Hope School of Fine Arts, Bloomington IN (S)

Reiff, Daniel, *Prof,* State University College of New York at Fredonia, Dept of Art, Fredonia NY (S)

Reifsneider, Jennifer, *Registrar,* Missoula Art Museum, Missoula MT

Reiland, Neal, *Prof,* Salt Lake Community College, Graphic Design Dept, Salt Lake City UT (S)

Reilly, Edwin D, *Pres,* Schenectady County Historical Society, Museum of Schenectady History, Schenectady NY

Reilly, Jerry M, *Instr,* Modesto Junior College, Arts Humanities & Communications Division, Modesto CA (S)

Reilly, Karen, *Assoc Dir,* College of the Holy Cross, Dinand Library, Worcester MA

Reily, Shelia, *Deputy Dir Prog,* South Carolina State Museum, Columbia SC

Reimen, Greg, *Instr,* Southeastern Oklahoma State University, Fine Arts Dept, Visual Arts Division, Durant OK (S)

Rein, Ann M, *Admin,* National Art Museum of Sport, Indianapolis IN

Reinauer, Lisa, *Chmn,* McNeese State University, Dept of Visual Arts, Lake Charles LA (S)

Reinckens, Sharon, *Deputy Dir,* Anacostia Museum, Washington DC

Reinhardt, Paulette, *Dir Finance & Human Resources,* Fayetteville Museum of Art, Inc, Fayetteville NC

Reintjes, Brandon, *Cur Exhib & Coll,* Holter Museum of Art, Helena MT

Reis, Bill, *Dir,* Warwick Museum of Art, Warwick RI

Reisch, Peggy, *Rec Secy,* Berks Art Alliance, Reading PA

Reising, Christine, *Prof & Chmn,* Siena Heights University, Studio Angelico-Art Dept, Adrian MI (S)

Reisman, Celia, *Asst Prof,* Swarthmore College, Dept of Art, Swarthmore PA (S)

Reisner, Vicki, *Specail Events,* Honolulu Academy of Arts, The Art Center at Linekona, Honolulu HI (S)

Reiss, Ellen, *Class Chmn Aesthetic Realism,* Aesthetic Realism Foundation, New York NY

Reiss, Ellen, *Class Chmn Aesthetic Realism,* Aesthetic Realism Foundation, New York NY (S)

Reiss, Tom, *Asst Prof,* Jersey City State College, Art Dept, Jersey City NJ (S)

Reissman, Elyse, *Deputy Dir for Information,* Montclair Art Museum, Montclair NJ

Reist, Inge, *Chief, Coll Develop & Research,* Frick Art Reference Library, New York NY

Reitinger Oakley, Rochelle L, *Coll Mgr, Registrar,* Saint Joseph College, Saint Joseph College Art Gallery, West Hartford CT

Reitz, Chris, *Ann Awards Mgr,* Art Directors Club, New York NY

Reitzenstein, Reinhard, *Asst Prof,* University at Buffalo, State University of New York, Dept of Visual Studies, Buffalo NY (S)

Reizen, Sandie, *Mus Shop Mgr,* Rensselaer County Historical Society, Hart-Cluett Mansion, 1827, Troy NY

Rejcevich, Linda, *Dir Marketing & Public Relations,* Joslyn Art Museum, Omaha NE

Rejholec, Joe, *Chmn,* South Suburban College, Art Dept, South Holland IL (S)

Rekedael, Jane, *Adjunct Prof,* Gavilan Community College, Art Dept, Gilroy CA (S)

Reker, Les, *Exec Dir,* Saginaw Art Museum, Saginaw MI

Renaldi, Beverly, *Properties Mgr,* Lehigh County Historical Society, Allentown PA

Render, Jill, *Educ Coordr,* Anderson Fine Arts Center, Anderson IN

Rendon, Joanne, *Librn,* The Society of the Four Arts, Gioconda & Joseph King Library, Palm Beach FL

Reneav, Davie, *Instr,* Campbellsville University, Department of Art, Campbellsville KY (S)

Renfro, William, *Prof,* Texas A&M University-Kingsville, Art Dept, Kingsville TX (S)

Rennert, Jim, *Dir Develop,* The Long Island Museum of American Art, History & Carriages, Stony Brook NY

Rennick, Greg, *Information Officer,* McMaster University, McMaster Museum of Art, Hamilton ON

Rennie, Mark, *Exec Dir,* Eyes & Ears Foundation, San Francisco CA

Rennie, Neil, *Asst Prof,* New England College, Art & Art History, Henniker NH (S)

Reno, Carolyn, *Coll Mgr,* City of Springdale, Shiloh Museum of Ozark History, Springdale AR

Rentof, Beryl, *Reference Head,* Fashion Institute of Technology, Gladys Marcus Library, New York NY

Reo, Danielle, *Assoc Dir,* Installation Gallery, San Diego CA

Repinski, Robert, *Asst Prof,* University of Minnesota, Duluth, Art Dept, Duluth MN (S)

Replogee, Ray, *Prof,* Wayne State College, Nordstrand Visual Arts Gallery, Wayne NE

Reres, Sara, *Dir, Treas & Cur,* Sea Cliff Village Museum, Sea Cliff NY

Resch, Tyler, *Librn,* Bennington Museum, Library, Bennington VT

Resnick, Alyssa, *Sr Library Supvr,* Glendale Public Library, Brand Library & Art Center, Glendale CA

Resnick, Elizabeth, *Chair Communication Design,* Massachusetts College of Art, Boston MA (S)

Reso-Hickman, Dorothy, *Vol Coord,* Red Deer & District Museum & Archives, Red Deer AB

Rettew, Robert H, *Librn,* Saint Paul's School, Ohrstrom Library, Concord NH

Reuter, Laurel J, *Dir & Chief Cur,* North Dakota Museum of Art, Grand Forks ND

Revelle, Barbara Jo, *Chmn,* University of Florida, Dept of Art, Gainesville FL (S)

ReVille, Grayson, *Pres,* Portraits South, Raleigh NC

Rey, Alberto, *Prof,* State University College of New York at Fredonia, Dept of Art, Fredonia NY (S)

Reyes, Roman, *Chmn,* Phoenix College, Dept of Art & Photography, Phoenix AZ (S)

Reymann, Patrick, *Exec Dir,* Western Reserve Historical Society, Cleveland OH

Reymann, Patrick H, *VPres,* Western Reserve Historical Society, Library, Cleveland OH

Reynolds, Ben, *Acad Professional Photography,* University of Georgia, Franklin College of Arts & Sciences, Lamar Dodd School of Art, Athens GA (S)

Reynolds, Edmond, *Dir,* R L S Silverado Museum, Saint Helena CA

Reynolds, Edmond, *Dir,* R L S Silverado Museum, Reference Library, Saint Helena CA

Reynolds, Gaylon, *Maintenance,* Museum of Western Colorado, Grand Junction CO

Reynolds, Harold M, *Assoc Prof,* Central Missouri State University, Art Dept, Warrensburg MO (S)

Reynolds, Joclyn L, *Grants Dir,* Arts Council Of New Orleans, New Orleans LA

Reynolds, Karen, *Pub Relations Coordr,* Eastern Shore Art Association, Inc, Library, Fairhope AL

Reynolds, Liz, *Registrar,* Brooklyn Museum, Brooklyn NY

Reynolds, Ryan, *Lectr,* Santa Clara University, Dept of Art & Art History, Santa Clara CA (S)

Reynolds, Stephen, *Prof,* University of Texas at San Antonio, Dept of Art & Art History, San Antonio TX (S)

Reynolds, Valrae, *Cur Asian Coll,* Newark Museum Association, The Newark Museum, Newark NJ

Reynolds, Vic, *Prof,* Wayne State College, Dept Art & Design, Wayne NE (S)

Reynolds, Wiley R, *Pres,* The Society of the Four Arts, Palm Beach FL

Reynolds-Botwin, Virginia, *Corresp Secy,* Miami Watercolor Society, Inc, Miami FL

Rheault, Martine, *Dir,* York University, Glendon Gallery, Toronto ON

Rhei, Marylin, *Prof,* Smith College, Art Dept, Northampton MA (S)

Rhoad, Julie, *Exec Dir,* The Names Project Foundation AIDS Memorial Quilt, Atlanta GA

Rhoads, Beverly, *Prof,* Lynchburg College, Art Dept, Lynchburg VA (S)

Rhoback, Kristie, *Textile Cur,* Amherst Museum, Amherst NY

Rhoda, Lynn, *Comm Arts Devel Dir,* Arts of the Southern Finger Lakes, Corning NY

Rhoden, Brian, *Adult Librn,* Willard Library, Dept of Fine Arts, Evansville IN

Rhodes, Che, *Asst Prof,* University of Louisville, Allen R Hite Art Institute, Louisville KY (S)

Rhodes, Corinne, *Develop Mgr,* Asian-American Arts Centre, New York NY

Rhodes, David, *Pres,* School of Visual Arts, New York NY (S)

Rhodes, Leah, *Office Mgr,* Stauton Augusta Art Center, Staunton VA

Rhodes, Mark, *Assoc Prof,* University of Richmond, Dept of Art and Art History, Richmond VA (S)

Rhodes, Richard, *Ed,* Canadian Art Foundation, Toronto ON

Rhodes, Silas H, *Chmn,* School of Visual Arts, New York NY (S)

Rhodes, Tisha, *Spec Events Coordr,* Montgomery Museum of Fine Arts, Montgomery AL

Rhodier, Vicki, *Corresp Secy,* Berks Art Alliance, Reading PA

Rhude, Adam, *Asst to Dir,* Cahoon Museum of American Art, Cotuit MA

Rial, Vicki, *Asst to Dir,* University of Alabama, Sarah Moody Gallery of Art, Tuscaloosa AL

Rian, Kirsten, *Dir,* Blue Sky Gallery, Oregon Center for the Photographic Arts, Portland OR

Ribas, Jose, *Preparator,* Bowdoin College, Museum of Art, Brunswick ME

Ribkoff, Natalie, *Cur Art,* Toronto Dominion Bank, Toronto ON

Ribner, Naomi, *Instr,* College of the Holy Cross, Dept of Visual Arts, Worcester MA (S)

Riccardi, Lee-Ann, The College of New Jersey, School of Arts & Sciences, Ewing NJ (S)

Ricci, Francis R, *Educ Cur,* Reading Public Museum, Reading PA

Ricci, Pat, *Cur,* Confederate Memorial Hall, Confederate Museum, New Orleans LA

Ricciardelli, Catherine, *Registrar,* Minneapolis Institute of Arts, Minneapolis MN

Ricciardelli, Cathy, *Registrar,* Terra Museum of American Art, Chicago IL

Ricco, John Paul, *Asst Prof,* University of Nevada, Las Vegas, Dept of Art, Las Vegas NV (S)

Ricco, Wendy, *Dept Secy,* University of Nevada, Reno, Sheppard Fine Arts Gallery, Reno NV

Rice, Danielle, *Cur Educ,* Philadelphia Museum of Art, Samuel S Fleisher Art Memorial, Philadelphia PA

Rice, Kevin, *Acting,* Truro Center for the Arts at Castle Hill, Inc, Truro MA (S)

Rice, Kevin, *Registrar,* Confederation Centre Art Gallery and Museum, Charlottetown PE

Rice, Laura, *Cur,* The Adirondack Historical Association, The Adirondack Museum, Blue Mountain Lake NY

Rice, Lindsley, *Cur,* Chesapeake Bay Maritime Museum, Saint Michaels MD

Rice, Matthew, *Assoc Prof,* Clemson University, College of Architecture, Clemson SC (S)

Rice, Nancy, *Prof & Dir Art & Design Prog & Studio Art,* Maryville University of Saint Louis, Art & Design Program, Saint Louis MO (S)

Rice, Nancy, *Treas,* Artspace, Richmond VA

Rice, Nancy N, *Gallery Dir,* Maryville University Saint Louis, Morton J May Foundation Gallery, Saint Louis MO

Rice, Noelle, *Asst Cur,* University of South Carolina, McKissick Museum, Columbia SC

Rice, Tom, *Chmn,* Kalamazoo College, Art Dept, Kalamazoo MI (S)

Rice-Allen, Daphne, *Coordr,* Black American West Museum & Heritage Center, Denver CO

Rich, Adelle, *Instr,* Fort Hays State University, Dept of Art, Hays KS (S)

Rich, Fred, *Exhib Mgr,* College of William & Mary, Muscarelle Museum of Art, Williamsburg VA

Rich, Gretchen, *Dean,* Huron University, Arts & Sciences Division, Huron SD (S)

Rich, Nancy, *Cur Educ,* Smith College, Museum of Art, Northampton MA

Rich-Wulfmeyer, Rebecca, *Chief Librn & Archivist,* Albany Institute of History & Art, Albany NY

Richard, Charles, *Media Chmn,* Riverside Community College, Dept of Art & Mass Media, Riverside CA (S)

Richard, Christopher, *Assoc Cur Natural Science,* Oakland Museum of California, Art Dept, Oakland CA

Richard, Harold James, *Prof,* University of New Orleans-Lake Front, Dept of Fine Arts, New Orleans LA (S)

Richard, Jack, *Dir,* Richard Gallery & Almond Tea Gallery, Divisions of Studios of Jack Richard, Cuyahoga Falls OH

Richard, Jack, *Dir,* Richard Gallery & Almond Tea Gallery, Library, Cuyahoga Falls OH

Richard, Jack, *Dir,* Studios of Jack Richard, Professional School of Painting & Design, Cuyahoga Falls OH (S)

Richard, Lucille, *Vol Secy,* Rangeley Lakes Region Logging Museum, Rangeley ME

Richard, Michelle, Place des Arts at Heritage Square, Coquitlam BC

Richard, Rodney C, *Vol Pres & Dir,* Rangeley Lakes Region Logging Museum, Rangeley ME

Richard, Stephen A, *Festival Coordr,* Rangeley Lakes Region Logging Museum, Rangeley ME

Richard, Tom, *Chmn,* University of Arkansas at Monticello, Fine Arts Dept, Monticello AR (S)

Richards, Allison, *Dir External Relations,* University of Utah, Utah Museum of Fine Arts, Salt Lake City UT

Richards, Anita, *Admin Dir,* Marcella Sembrich Memorial Association Inc, Marcella Sembrich Opera Museum, Bolton Landing NY

Richards, Charles O, *VPres,* Marcella Sembrich Memorial Association Inc, Marcella Sembrich Opera Museum, Bolton Landing NY

Richards, David, *Librn,* University of Southern Mississippi, McCain Library & Archives, Hattiesburg MS

Richards, Evann, *Asst Prof,* Saint Louis Community College at Forest Park, Art Dept, Saint Louis MO (S)

Richards, Judith, *Exec Dir,* Independent Curators International, New York NY

Richards, Karen, *Accountant,* The Haggin Museum, Stockton CA

Richards, L Jane, *Sr Cur,* Historical Museum at Fort Missoula, Missoula MT

Richards, Nancy, *Cur Coll,* Tryon Palace Historic Sites & Gardens, New Bern NC

Richards, Ronald, *Chief Cur Natural History,* Indiana State Museum, Indianapolis IN

Richards, Rosalyn, *Head Dept,* Bucknell University, Dept of Art, Lewisburg PA (S)

Richardson, Carl, *Asst Prof,* Spokane Falls Community College, Fine Arts Dept, Spokane WA (S)

Richardson, Elvis, *Asst Prof Visual Arts,* Dowling College, Dept of Visual Arts, Oakdale NY (S)

Richardson, Nelson, *Graphic Dept Dir,* Bakersfield College, Fine Arts Dept, Bakersfield CA (S)

Richardson, Terry, *Instr,* Rochester Community & Technical College, Art Dept, Rochester MN (S)

Richardson, Wallace, *Chmn,* Mid America Arts Alliance & Exhibits USA, Kansas City MO

Richars, Larry W, *Dean,* University of Toronto, Faculty of Architecture, Landscape & Design, Toronto ON (S)

Richbourg, Lance, *Assoc Prof,* St Michael's College, Fine Arts Dept, Colchester VT (S)

Richelson, Paul W, *Asst Dir, Chief Cur,* Mobile Museum of Art, Mobile AL

Richelson, Paul W, *Asst Dir, Chief Cur,* Mobile Museum of Art, Library, Mobile AL

Richerson, Jim, *Exec Dir,* Lakeview Museum of Arts & Sciences, Peoria IL

Richey-Ward, Diane, *Instr,* American River College, Dept of Art/Art New Media, Sacramento CA (S)

Richie, Nathan, *Cur of Coll & Programs,* Swope Art Museum, Research Library, Terre Haute IN

Richie, Robert C, *Dir Research & Educ,* The Huntington Library, Art Collections & Botanical Gardens, Library, San Marino CA

Richman, Irwin, *Prof,* Penn State Harrisburg, School of Humanities, Middletown PA (S)

Richman, Martin, *Dir Develop,* Worcester Art Museum, Worcester MA

Richman, Roger, *Prof,* University of Maine at Augusta, College of Arts & Humanities, Augusta ME (S)

Richmond, D, *Board Dirs,* Gananoque Museum, Gananoque ON

Richmond, David, *Asst Prof Photography,* Simpson College, Art Dept, Indianola IA (S)

Richmond, David, *Head Art Dept,* Simpson College, Farnham Gallery, Indianola IA

Richmond, Pat, *Dir,* Art League of Manatee County, Library, Bradenton FL

Richmond, Patricia, *Dir,* Art League of Manatee County, Bradenton FL

Richter, Donald, *VPres,* Vermilion County Museum Society, Library, Danville IL

Richter, Susan, *Dir,* Vermilion County Museum Society, Danville IL

Richter, Susan E, *Mus Shop Mgr,* Vermilion County Museum Society, Library, Danville IL

Rickard, Jolene, *Assoc Prof,* University at Buffalo, State University of New York, Dept of Visual Studies, Buffalo NY (S)

Ricker, Maria, *Cur,* City of Woodstock, Woodstock Art Gallery, Woodstock ON

Ricks-Bates, Anita, *Instr,* Marygrove College, Department of Art, Detroit MI (S)

Riddle, John, *Visual Arts Program,* California African-American Museum, Los Angeles CA

Riddle, Lola, *Treas,* Fulton County Historical Society Inc, Fulton County Museum, Rochester IN

Rider, Diane, *Library-LRC Dir,* Art Institute of Fort Lauderdale, Technical Library, Fort Lauderdale FL

Rider, Geoff, *Dir Curatorial,* Canada Science and Technology Museum, Ottawa ON

Ridpath, Marjorie, *Cur,* Cambridge Museum, Cambridge NE

Riedel, Walter, *Pres & CEO,* Nelda C & H J Lutcher Stark, Stark Museum of Art, Orange TX

Riedinger, Robert J, *Correspondence Secy,* Artists' Fellowship, Inc, New York NY

Riedmann, LeSan, *Pres,* Northwest Watercolor Society, Renton WA

Riegel, James, *Head Photography Dept,* Kalamazoo Institute of Arts, KIA School, Kalamazoo MI (S)

Rieger, Sonja, *Prof,* University of Alabama at Birmingham, Dept of Art & Art History, Birmingham AL (S)

Rieman, Diane, *Asst Prof,* Marygrove College, Department of Art, Detroit MI (S)

Riese, Beatrice, *Pres,* American Abstract Artists, New York NY

Riese, Tara, *Asst Librn,* The Buffalo Fine Arts Academy, G Robert Strauss Jr Memorial Library, Buffalo NY

Riesenberg, Mindy, *Marketing and Pub Relations,* Kimbell Art Museum, Fort Worth TX

Riess, Jonathan, *Prof Art History,* University of Cincinnati, School of Art, Cincinnati OH (S)

Rieth, Sheri, *Assoc Prof,* University of Mississippi, Department of Art, University MS (S)

Rietveld, Rickard, *Chmn,* Valencia Community College - East Campus, Art Dept, Orlando FL (S)

Rifedorph, Martin, *Dir Operations,* Ann Arbor Art Center, Art Center, Ann Arbor MI

Riffee, Steve, *Asst Dir,* Lynchburg College, Daura Gallery, Lynchburg VA

Riffel, Rich, *Secy,* Inter-Society Color Council, Lawrenceville NJ

Riffle, Brenda, *Librn,* Hampshire County Public Library, Romney WV

Rigby, Bruce, *Prof,* The College of New Jersey, School of Arts & Sciences, Ewing NJ (S)

Rigby, Ida K, *Art History Graduate Coordr,* San Diego State University, School of Art, Design & Art History, San Diego CA (S)

Rigby, Ida K, *Dir,* San Diego State University, University Art Gallery, San Diego CA

Rigdon, Lois, *Dir,* Art Guild of Burlington, Arts for Living Center, Burlington IA

Rigg, Frank, *Cur,* National Archives & Records Administration, John F Kennedy Presidential Library & Museum, Boston MA

Rigg, Jim, *Pres,* Kansas Watercolor Society, Hutchinson KS

Riggins-Ezzell, Lois, *Exec Dir,* Tennessee State Museum, Nashville TN

Riker, Janet, *Dir,* BRIC - Brooklyn Information & Culture, Rotunda Gallery, Brooklyn NY

Riley, Dixie, *Head Librn,* Chappell Memorial Library and Art Gallery, Chappell NE

Riley, Lynn, *Mgr,* Delaware Division of Historical & Cultural Affairs, Dover DE

Riley, Thomas J, *Bd Dir VChmn,* Plains Art Museum, Fargo ND

Rime, Robyn, *Mgr Publications,* George Eastman, Rochester NY

Rimel, Luanne, *Educ Dir,* Craft Alliance, Saint Louis MO

Rimpela, Cindy, *Business Mgr,* Ashtabula Arts Center, Ashtabula OH

Rinaldi, Tina, *Gallery Dir,* Lane Arts Council, Jacobs Gallery, Eugene OR

Rinaldo, Lisa, *Instr,* Biola University, Art Dept, La Mirada CA (S)

Rinder, Lawrence R, *Cur Contemporary Art,* Whitney Museum of American Art, New York NY

Rindfleisch, Jan, *Dir,* De Anza College, Euphrat Museum of Art, Cupertino CA

Rindlisbacher, David, *Assoc Prof,* West Texas A&M University, Art, Communication & Theatre Dept, Canyon TX (S)

Rineberg, Stephen, *Pres Bd Trustees,* Phoenix Art Museum, Phoenix AZ

Rinehart, Patrick, *Prog Dir,* Walt Whitman Cultural Arts Center, Inc, Camden NJ

Ring, Dan, *Extension Coordr & Asst Cur,* Mendel Art Gallery & Civic Conservatory, Saskatoon SK

Ring, Diane, *Fine Arts Librn,* Beverly Hills Public Library, Fine Arts Library, Beverly Hills CA

Ringering, Dennis L, *Head Drawing,* Southern Illinois University at Edwardsville, Dept of Art & Design, Edwardsville IL (S)

Ringle, Steve, *Registrar/Preparator,* University of Maine, Museum of Art, Bangor ME

Ringler, Sara, *Prof,* Cape Cod Community College, Art Dept, West Barnstable MA (S)

Ringwald, Marie, *Chmn Foundation,* Corcoran School of Art, Washington DC (S)

Rinker, Andrew, *Chmn,* Louisiana Department of Culture, Recreation & Tourism, Louisiana State Museum, New Orleans LA

Rinklin, Cristi, *Asst Prof,* College of the Holy Cross, Dept of Visual Arts, Worcester MA (S)

Riopelle, Christopher, *Assoc Cur,* Philadelphia Museum of Art, Rodin Museum of Philadelphia, Philadelphia PA

Riordon, Bernard, *Chief Exec Officer & Dir,* Art Gallery of Nova Scotia, Halifax NS

Riordon, Bernard, *Dir & CEO,* Beaverbrook Art Gallery, Fredericton NB

Ripley, Richard, *Instructional Aide,* Victor Valley Community College, Art Dept, Victorville CA (S)

Ripley, Robert C, *Mgr Capitol Restoration & Promotion,* Nebraska State Capitol, Lincoln NE

Rippe, Diane, *Dir Operations,* Key West Art & Historical Society, East Martello Museum & Gallery, Key West FL

Risbeck, Phil, *Chmn,* Colorado State University, Dept of Art, Fort Collins CO (S)

Riseman, Henry, *Dir,* New England Center for Contemporary Art, Brooklyn CT

Rishel, Joseph, *Cur,* Philadelphia Museum of Art, John G Johnson Collection, Philadelphia PA

Rishel, Joseph, *Cur of Pre-1900 European Painting & Sculpture,* Philadelphia Museum of Art, Rodin Museum of Philadelphia, Philadelphia PA

Rishel, Joseph J, *Cur European Painting,* Philadelphia Museum of Art, Samuel S Fleisher Art Memorial, Philadelphia PA

Riske, Patricia, *Instr,* Biola University, Art Dept, La Mirada CA (S)

Risley, Mary, *Adjunct Assoc Prof Emerita,* Wesleyan University, Dept of Art & Art History, Middletown CT (S)

Ritchie, Cathy, *Theater/Film Librn,* J Eric Johnson, Fine Arts Division, Dallas TX

Ritchie, Christina, *Dir & Cur,* Contemporary Art Gallery Society of British Columbia, Vancouver BC

Ritchie, David, *Instr,* Pacific Northwest College of Art, Portland OR (S)

Ritchie, Marilou C, *Librn & Archivist,* Ruthmere Museum, Robert B. Beardsley Arts Reference Library, Elkhart IN

Ritchie, Robert C, *Dir Research,* The Huntington Library, Art Collections & Botanical Gardens, San Marino CA

Ritger, Suzanne, *Gallery Dir,* Johnson State College, Dept Fine & Performing Arts, Dibden Center for the Arts, Johnson VT (S)

Ritiger, Scott, *Industrial Design Technology,* Art Institute of Pittsburgh, Pittsburgh PA (S)

Ritson, Kate, *Chmn & Prof,* Trinity University, Dept of Art, San Antonio TX (S)

Rittelmann, Leesa, *Assoc Prof,* Hartwick College, Art Dept, Oneonta NY (S)

Rittenhouse, Cherri, *Prof,* Rock Valley College, Humanities and Fine Arts Division, Rockford IL (S)

Ritter, Connie, *Interpretive Resource Technician,* Mark Twain, State Historic Site Museum, Florida MO

Ritter, Josef, *Prof,* Cazenovia College, Center for Art & Design Studies, Cazenovia NY (S)

Rittler, Steve, *Asst Prof,* William Paterson University, Dept Arts, Wayne NJ (S)

Rivard, T.J., *Chmn,* Indiana University-East, Humanities Dept, Richmond IN (S)

Rivera, Beverly, *Dir,* State University of New York at Stony Brook, Dept of College of Arts & Sciences, Art Dept, Stony Brook NY (S)

Rivera, Diane, *Mus Asst,* Blauvelt Demarest Foundation, Hiram Blauvelt Art Museum, Oradell NJ

Rivera, Frank, *Prof,* Mercer County Community College, Arts, Communication & Engineering Technology, Trenton NJ (S)

Rivera, George, *Exec Dir,* Triton Museum of Art, Library, Santa Clara CA

Rivera, George, *Exec Dir & Sr Cur,* Triton Museum of Art, Santa Clara CA

Rivera, Jason, *Publ Dir,* MEXIC-ARTE Museum, Austin TX

Rivera, Paula, *Registrar,* Institute of American Indian Arts, Institute of American Indian Arts Museum, Santa Fe NM (S)

Rivero, Arturo, *Industrial Design Technology,* Art Institute of Pittsburgh, Pittsburgh PA (S)

Rivers-Landes, Kathleen, *Asst Prof,* East Central University, Art Dept, Ada OK (S)

Riviera, George, *Exec Dir,* Pueblo of Pojoaque, Poeh Museum, Santa Fe NM

Riznyk, Myroslaw, *Facilities Mgr NY,* National Museum of the American Indian, George Gustav Heye Center, New York NY

Rizzardi, Nancy, *Instr,* Pierce College, Art Dept, Woodland Hills CA (S)

Rizzo, Mike, *Designer,* National Heritage Museum, Lexington MA

Rizzo, Tania, *Archivist,* Pasadena Historical Museum, Pasadena CA

Roach, Bill, *Instr,* East Central University, Art Dept, Ada OK (S)

Roach, Colleen, *Pub Relations & Marketing,* Institute of American Indian Arts Museum, Museum, Santa Fe NM

Roach, Dawn, *Head of Progs & Projects,* Canadian Museums Association, Association des Musees Canadiens, Ottawa ON

Roan, Joan, *Circ & Interlibrary Loan,* Ames Free-Easton's Public Library, North Easton MA

Rob, Elizabeth, *Controller,* State of North Carolina, Battleship North Carolina, Wilmington NC

Robb, Lisa, *Exec Dir,* Pelham Art Center, Pelham NY

Robbin, C Roxanne, *Prof,* California State University, Art Dept, Turlock CA (S)

Roberge, Michele, *Asst Mgr,* Lincoln County Historical Association, Inc, Maine Art Gallery, Wiscasset ME

Roberson, Robert, *Dir Asst,* Plains Indians & Pioneers Historical Foundation, Museum & Art Center, Woodward OK

Robert, Annick, *Librn,* Saint Joseph's Oratory, Library, Montreal PQ

Robert, Brenda, *Dean,* Anoka Ramsey Community College, Art Dept, Coon Rapids MN (S)

Robert, Randy, *Asst Dir/Exh Devel,* Schenectady Museum Planetarium & Visitors Center, Schenectady NY

Roberts, Anne, *Chmn,* Lake Forest College, Dept of Art, Lake Forest IL (S)

Roberts, Brady, *Cur Modern & Contemporary Art,* Phoenix Art Museum, Phoenix AZ

Roberts, Dana, *Gallery Asst,* Bunnell Street Gallery, Homer AK

Roberts, Dave, *Assoc Prof,* Oklahoma State University, Art Dept, Stillwater OK (S)

Roberts, Gail, *Bus Mgr,* Museum London, London ON

Roberts, Jill, *Cur Gallery Sport,* Genesee Country Village & Museum, John L Wehle Gallery of Wildlife & Sporting Art, Mumford NY

Roberts, John, *Instr,* Bob Jones University, Div of Art, Greenville SC (S)

Roberts, Kelley, *Instr,* Southern University A & M College, School of Architecture, Baton Rouge LA (S)

Roberts, Lydia, *Mem,* Laguna Art Museum, Laguna Beach CA

Roberts, Marie, *Prof,* Fairleigh Dickinson University, Fine Arts Dept, Teaneck NJ (S)

Roberts, Marion, *Dir of Grad Studies & Art History Instr,* University of Virginia, McIntire Dept of Art, Charlottesville VA (S)

Roberts, Matt, *Assoc Prof,* Stetson University, Art Dept, Deland FL (S)

Roberts, Myron, *CFO,* Oregon Historical Society, Oregon History Center, Portland OR

Roberts, Nancy, *Dir Exhib & Collections,* Emory University, Michael C Carlos Museum, Atlanta GA

Roberts, Page, *Dir & Cur,* Beverly Historical Society, Cabot, Hale & Balch House Museums, Beverly MA

Roberts, Page, *Dir,* Beverly Historical Society, Library, Beverly MA

Roberts, Perri Lee, *Prof,* University of Miami, Dept of Art & Art History, Coral Gables FL (S)

Roberts, Rachel, *Archives Dir,* Dallas Historical Society, Research Center Library, Dallas TX

Roberts, Rachel, *Archivist,* Dallas Historical Society, Hall of State, Dallas TX

Roberts, Susan, *Prof Graphic Design,* University of Georgia, Franklin College of Arts & Sciences, Lamar Dodd School of Art, Athens GA (S)

Roberts, Suzanne O, *Visual Resource Cur,* New York State College of Ceramics at Alfred University, Scholes Library of Ceramics, Alfred NY

Roberts-Manganelli, Susan, *Head Registration-Conservation,* Stanford University, Iris & B Gerald Cantor Center for Visual Arts, Stanford CA

Robertson, Charles, *Deputy Dir,* Smithsonian American Art Museum, Washington DC

Robertson, Dennis, *Pres,* Dillman's Creative Arts Foundation, Lac du Flambeau WI

Robertson, Dennis, *Pres,* Dillman's Creative Arts Foundation, Tom Lynch Resource Center, Lac du Flambeau WI

Robertson, Donna, *Dean,* Illinois Institute of Technology, College of Architecture, Chicago IL (S)

Robertson, F, *Instr,* Community College of Rhode Island, Dept of Art, Warwick RI (S)

Robertson, James, *Instr Pottery,* Red Rocks Community College, Arts Dept, Lakewood CO (S)

Robertson, Lynn, *Dir,* University of South Carolina, McKissick Museum, Columbia SC

Robertson, Lynn, *Gallery Dir,* Capitol Arts Alliance, Ervin G Houchens Gallery, Mezzanine Gallery, Bowling Green KY

Robertson, Lynne, *Museum Cur,* Historic Pensacola Preservation Board, T.T. Wentworth Jr. Florida State Museum, Pensacola FL

Robertson, Lynne, *Chief Cur,* West Florida Historic Preservation, Inc, T T Wentworth, Jr Florida State Museum & Historic Pensacola Village, Pensacola FL

Robertson, Nadine, *Educ Cir,* Lewistown Art Center, Lewistown MT

Robertson, Roderick, *Prof,* Saint Mary's University of Minnesota, Art & Design Dept, Winona MN (S)

Robertson, Ruthanne, *Adjunct Asst Prof Art,* Johnson County Community College, Visual Arts Program, Overland Park KS (S)

Robertson, Scott, University of Wisconsin-Eau Claire, Dept of Art, Eau Claire WI (S)

Robertson, Sherry, *Mgr Develop & Mktg,* Muttart Public Art Gallery, Calgary AB

Robertson, Sue, *VPres,* Dillman's Creative Arts Foundation, Lac du Flambeau WI

Robertson, Sue, *VPres,* Dillman's Creative Arts Foundation, Tom Lynch Resource Center, Lac du Flambeau WI

Robertson, Susan, *Exec Dir,* Wiregrass Museum of Art, Dothan AL

Robicheaux, Carol, *Mus Shop Mgr,* Jule Collins Smith Museum of Art, Auburn AL

Robin, James, *Prof,* State University of New York at Stony Brook, Dept of College of Arts & Sciences, Art Dept, Stony Brook NY (S)

Robin, Madeleine, *Dir Art,* L'Universite Laval, Library, Quebec PQ

Robins, Gay, *Chmn,* Emory University, Art History Dept, Atlanta GA (S)

Robins, Henriann, *Ref Dept,* Springfield Free Public Library, Donald B Palmer Museum, Springfield NJ

Robinson, Alexandra, *Asst Prof,* Saint Mary College, Fine Arts Dept, Leavenworth KS (S)

Robinson, Bonnell, *Dir Gallery & Exhib,* The Art Institute of Boston at Lesley University, Main Gallery, Boston MA

Robinson, Brian, *Art Teacher,* Motlow State Community College, Art Dept, Tullahoma TN (S)

Robinson, Chalita, *Chmn,* Bakersfield College, Fine Arts Dept, Bakersfield CA (S)

Robinson, Cheryl, *Secy of Gallery,* University of Victoria, Maltwood Art Museum and Gallery, Victoria BC

Robinson, Dana, *Marketing & Public Relations Coordr,* University of Utah, Utah Museum of Fine Arts, Salt Lake City UT

Robinson, Diane, *Head Mktg Develop,* Vancouver Art Gallery, Vancouver BC

Robinson, Donald J, *Mgr Financial Operations,* The Winnipeg Art Gallery, Winnipeg MB

Robinson, Franklin W, *Dir,* Cornell University, Herbert F Johnson Museum of Art, Ithaca NY

Robinson, George, *Prof,* Bethel College, Dept of Art, Saint Paul MN (S)

Robinson, Gregory, *Exec Dir,* City Art Works, Pratt Fine Arts Center, Seattle WA (S)

Robinson, Heidi J, *Curatorial Specialist,* Northern Arizona University, Art Museum & Galleries, Flagstaff AZ

Robinson, Hilary, *Dean,* Carnegie Mellon University, College of Fine Arts, Pittsburgh PA (S)

Robinson, James, *Cur Asian Art,* Columbus Museum of Art and Design, Indianapolis IN

Robinson, Kathryn D, Northeastern State University, College of Arts & Letters, Tahlequah OK (S)

Robinson, Kim, *Museum Specialist,* United States Department of the Interior Museum, Washington DC

Robinson, Kim, *Office Mgr,* Mennello Museum of American Art, Orlando FL

Robinson, Marian, *Libr Asst,* Mason County Museum, Mason TX

Robinson, Mary, *Librn,* Buffalo Bill Memorial Association, Buffalo Bill Historical Center, Cody WY

Robinson, Mary, *Pres,* Belle Grove Plantation, Middletown VA

Robinson, Michael P, *Pres, CEO & Dir,* Glenbow Museum, Calgary AB

Robinson, Peter, *Co-Pres,* Greenwich Art Society Inc, Greenwich CT

Robinson, Phillip, *Asst Prof,* University of Missouri, Saint Louis, Dept of Art & Art History, Saint Louis MO (S)

Robinson, Roger W, *Chmn,* Willard House & Clock Museum, Inc, North Grafton MA

Robinson, Sandra, *Dept Chair,* Mount San Jacinto College, Art Dept, San Jacinto CA (S)

Robinson, Scott, *Prof,* North Central Texas College, Division of Communications & Fine Arts, Gainesville TX (S)

Robinson, Travis, *Cur,* Headley-Whitney Museum, Lexington KY

Robles, Mary Jane, *Mus Shop Mgr,* Polish Museum of America, Research Library, Chicago IL

Robson, Ronald P, *Bd Dir Treas,* Plains Art Museum, Fargo ND

Roby, Linda, *Pub Relations,* Cosanti Foundation, Arcosanti, Scottsdale AZ

Rocchetta, Alisha, *Develop Assoc,* The Long Island Museum of American Art, History & Carriages, Stony Brook NY

Roche, Bernie, *Area Mgr,* Canadian Heritage - Parks Canada, Laurier House, National Historic Site, Ottawa ON

Roche, Joanne, *Librn,* Yonkers Public Library, Fine Arts Dept, Yonkers NY

Roche, Joanne, *Librn,* Yonkers Public Library, Will Library, Yonkers NY

Roche, Valerie, *Dance Coordr,* Creighton University, Fine & Performing Arts Dept, Omaha NE (S)

Rochester, Susan, *Dir Fine Arts,* Umpqua Community College, Fine & Performing Arts Dept, Roseburg OR (S)

Rochford, Dympna, *Asst Prof,* Mount Mary College, Art & Design Division, Milwaukee WI (S)

Rochfort, Desmond, *Pres,* Alberta College of Art & Design, Calgary AB (S)

Rockhill, King, *Pres,* Appaloosa Museum and Heritage Center, Moscow ID

Roddenberry, Heather, *Asst Cur & Registrar,* Pensacola Museum of Art, Harry Thornton Library, Pensacola FL

Roddenberry, Heather K, *Assoc Cur,* Pensacola Museum of Art, Pensacola FL

Rode, Meredith, *Prof,* University of the District of Columbia, Dept of Mass Media, Visual & Performing Arts, Washington DC (S)

Rode, Sabrina, *Cur Educ,* Southern Oregon Historical Society, Jacksonville Museum of Southern Oregon History, Medford OR

Rodeiro, Jose, *Assoc Prof,* Jersey City State College, Art Dept, Jersey City NJ (S)

Rodenbeck, Judith, *Prof,* Sarah Lawrence College, Dept of Art History, Bronxville NY (S)

Rodgers, Darlene, *Secy,* Glanmore National Historic Site of Canada, Belleville ON

Rodgers, Forrest, *VPres Operations,* High Desert Museum, Bend OR

Rodgers, Kenneth, *Prof, Dir Art Museum,* North Carolina Central University, Art Dept, Durham NC (S)

Rodgers, Kenneth G, *Dir,* North Carolina Central University, NCCU Art Museum, Durham NC

Rodgers, Richard, *VPres Educ & Visitors,* Meridian International Center, Cafritz Galleries, Washington DC

Rodgers, Tim, *Chief Cur,* Museum of New Mexico, Museum of Fine Arts, Unit of NM Dept of Cultural Affairs, Santa Fe NM

Rodgers, Tim, *Chief Cur,* Museum of New Mexico, Museum of Fine Arts Library and Archive, Santa Fe NM

Rodgers, Tommie, *Registrar,* Lauren Rogers, Laurel MS

Rodney, Lee, University of Windsor, Visual Arts, Windsor ON (S)

Rodriguez, Annabella, *Cur,* Taller Puertorriqueno Inc, Lorenzo Homar Gallery, Philadelphia PA

Rodriguez, Geno, *Exec Dir,* Alternative Museum, New York NY

Rodriguez, Linda, *Assoc Cur Educ,* South Texas Institute for the Arts, Art Museum of South Texas, Corpus Christi TX

Rodriguez, Maria del Carmen, *Staff Supv,* Museo de las Americas, Denver CO

Rodriguez, Yolanda, *Mgr,* Art Museum of the University of Houston, William R Jenkins Architecture & Art Library, Houston TX

Rodriguez A, Rommy, *Outreach Coordr,* Ontario Crafts Council, Craft Resource Centre, Toronto ON

Rodriguez A, Rommy, *Outreach Coordr,* Ontario Crafts Council, The Craft Gallery, Toronto ON

Roe, Rebecca J, *Lectr,* California State Polytechnic University, Pomona, Art Dept, Pomona CA (S)

Roe, Ruth, *Librn,* Orange County Museum of Art, Library, Newport Beach CA

Roe, Ward V, *Assoc Prof,* Keystone College, Fine Arts Dept, LaPlume PA (S)

Roedel, Paul R, *Treas,* Reading Public Museum, Reading PA

Roedel, Paul R, *Treas,* Reading Public Museum, Library, Reading PA

Roeloffs, Abigail, *Librn,* International Museum of Cartoon Art, Library, Boca Raton FL

Roeper, Susan, *Librn,* Sterling & Francine Clark, Clark Art Institute Library, Williamstown MA

Roese, Ronnie L, *Dir,* Miracle at Pentecost Foundation, Biblical Arts Center, Dallas TX

Roever, James, *VPres,* Missouri Western State College, Gallery 206 Foyer Gallery, Saint Joseph MO

Roff, Kira, *Asst VPres,* Brookgreen Gardens, Murrells Inlet SC

Roffe, Wilfred, *Treas,* Livingston County Historical Society, Cobblestone Museum, Geneseo NY

Rogan, Clare, *Cur,* Wesleyan University, Davison Art Center, Middletown CT

Rogan, Ed, *VPres Legal,* Belskie Museum, Closter NJ

Rogerge, Celeste, *Asst Prof,* University of Florida, Dept of Art, Gainesville FL (S)

Rogers, Barbara, *Prof Painting & Drawing,* University of Arizona, Dept of Art, Tucson AZ (S)

Rogers, Byran, *Head,* Carnegie Mellon University, School of Art, Pittsburgh PA (S)

Rogers, Cathy, *Bus Mgr,* University of North Carolina at Greensboro, Weatherspoon Art Museum, Greensboro NC

Rogers, Charles, *Dir,* Millikin University, Perkinson Gallery, Decatur IL

Rogers, Dan, *Instr,* Bismarck State College, Fine Arts Dept, Bismarck ND (S)

Rogers, Darlene, *Interpretive Program Dir,* Schuyler Mansion State Historic Site, Albany NY

Rogers, Deborah, *Librn,* Carnegie Library of Pittsburgh, Pittsburgh PA

Rogers, Dolores, *Receptionist,* Frontier Times Museum, Bandera TX

Rogers, Eric, *Exec Dir,* Jay County Arts Council, Hugh N Ronald Memorial Gallery, Portland IN

Rogers, Floretta, *Cur,* Clark County Historical Society, Pioneer - Krier Museum, Ashland KS

Rogers, James, *Chmn Dept,* Florida Southern College, Art Dept, Lakeland FL (S)

Rogers, James, *Pres,* Westfield Athenaeum, Jasper Rand Art Museum, Westfield MA

Rogers, James, *Prof Art History & Chair,* Florida Southern College, Melvin Art Gallery, Lakeland FL

Rogers, Kristin, *Dir Human Resources,* Cleveland Museum of Art, Cleveland OH

Rogers, Nancy M, *Exec Dir,* Wooster Community Art Center, Danbury CT

Rogers, Nancy M, *Exec Dir,* Wooster Community Art Center, Library, Danbury CT

Rogers, Patricia J, *Head Libm,* Corning Museum of Glass, Juliette K and Leonard S Rakow Research Library, Corning NY

Rogers, Prescott, *Pres,* Academy of the New Church, Glencairn Museum, Bryn Athyn PA

Rogers, Richard L, *Pres,* Center for Creative Studies, College of Art & Design, Detroit MI (S)

Rogers, Robert, *Assoc Prof,* Queensborough Community College, Dept of Art & Photography, Bayside NY (S)

Rogers, Robert, *Cur Antique Auto Mus,* Heritage Museums & Gardens, Sandwich MA

Rogers, Robert Meadows, *Chair,* Concordia College, Art Dept, Moorhead MN (S)

Rogers-Naff, Shirley, *Store Mgr,* Martin and Osa Johnson, Chanute KS

Rogerson, Lynn K, *Dir,* Art Services International, Alexandria VA

Rogstad, Mary Labate, *Registrar,* Vermont Historical Society, Museum, Montpelier VT

Roh, Michael, *Dir Facility Operations,* Columbia Museum of Art, Columbia SC

Rohdenburg, Ernest, *Cur,* Chatham Historical Society, The Atwood House Museum, Chatham MA

Rohn, Mathew, *Assoc Prof,* Saint Olaf College, Art Dept, Northfield MN (S)

Rohouit, Ron, *Deputy Dir Educ,* California Science Center, Los Angeles CA

Rohrbach, John, *Cur Photographs,* Amon Carter, Fort Worth TX

Rohrer, Judith C, *Assoc Prof,* Emory University, Art History Dept, Atlanta GA (S)

Rohrer, Susan, *Cur Educ,* State Capital Museum, Olympia WA

Roizen, Morrie, *Adjunct,* Gavilan Community College, Art Dept, Gilroy CA (S)

Roizen, Morry, *Chmn,* West Valley College, Art Dept, Saratoga CA (S)

Rojers, June, *Exec,* Fairbanks Arts Association, Fairbanks AK

Rokfalusi, J Mark, *Asst Prof of Communication Design,* Atlanta College of Art, Atlanta GA (S)

Roland, Craig, *Asst Prof,* University of Florida, Dept of Art, Gainesville FL (S)

Roland, Marya, *Asst Prof,* Western Carolina University, Dept of Art/College of Arts & Science, Cullowhee NC (S)

Roley, Scott, *Acting Dir,* National Archives & Records Administration, Harry S Truman Museum and Library, Independence MO

Rolfe, Nigel, *Senior Critic,* University of Pennsylvania, Graduate School of Fine Arts, Philadelphia PA (S)

Rolla, Maureen, *Deputy Dir,* Carnegie Museums of Pittsburgh, Carnegie Museum of Art, Pittsburgh PA

Rolland, Natalie, *Pres,* Conseil des Arts du Quebec (CATQ), Diagonale, Centre des arts et des fibres du Quebec, Montreal PQ

Rolle, James, *Lectr,* Saint John's University, Art Dept, Collegeville MN (S)

Roller, Terry M, *Prof,* Baylor University, Dept of Art, Waco TX (S)

Rollins, Avon William, *Mrg,* Beck Cultural Exchange Center, Inc, Knoxville TN

Rollins, Eleanor, *Admin Asst,* Beaufort County Arts Council, Washington NC

Rollins, Ken, *Exec Dir,* Gulf Coast Museum of Art, Largo FL (S)

Rollins, Ken, *Interium Dir,* Tampa Museum of Art, Judith Rozier Blanchard Library, Tampa FL

Rollins, Rich, *Instr,* Marylhurst University, Art Dept, Marylhurst OR (S)

Rolon, Edwin, *Asst Cur Modern Books,* Hispanic Society of America, Library, New York NY

Rom, Cristine, *Library Dir,* Cleveland Institute of Art, Jessica Gund Memorial Library, Cleveland OH

Roma, Hedy, *Dir Devel,* Independent Curators International, New York NY

Romais, Miriam, *Managing Dir,* En Foco, Inc, Bronx NY

Romano, Jaime, *Prof,* University of Puerto Rico, Dept of Fine Arts, Rio Piedras PR (S)

Romano, Pia, *Reference,* Wentworth Institute of Technology Library, Boston MA

Rome, Stuart, *Assoc Prof Photography,* Drexel University, College of Media Arts & Design, Philadelphia PA (S)

Romeo, Louise, *Asst Dean,* New World School of the Arts, Gallery, Miami FL

Romeo, Louise, *Dean,* New World School of the Arts, Miami FL (S)

Romer, Teresa, *Admin Asst,* Pace University Gallery, Art Gallery in Choate House, Pleasantville NY

Romero, Chelsea, *Exhib,* Birmingham-Bloomfield Art Center, Art Center, Birmingham MI

Romiti, Debra, *Devel Coordr,* Everhart Museum, Scranton PA

Ron, Will, *Art Dept Chmn,* Montana State University-Northern, Humanities & Social Sciences, Havre MT (S)

Rondestvedt, Nancy, *Library Asst,* Asian Art Museum of San Francisco, Library, San Francisco CA

Ronolich, Jean F, *Adminr,* CIGNA Corporation, CIGNA Museum & Art Collection, Philadelphia PA

Roodman, Karen, *Mus Shop Mgr,* St. Louis Artists' Guild, Saint Louis MO

Rooks, Michael, *Assoc Cur,* The Contemporary Museum, Honolulu HI

Rooney, Jan, *Asst Dir,* Alternative Museum, New York NY

Rooney, Marsha, *Cur History,* Eastern Washington State Historical Society, Northwest Museum of Arts & Culture, Spokane WA

Rooney, Steve, *Deputy Dir for Adminr,* International Center of Photography, New York NY

Roos, Jane, *Prof,* City University of New York, PhD Program in Art History, New York NY (S)

Roosa, Mark, *Dir Preservation,* Library of Congress, Prints & Photographs Division, Washington DC

Roosa, Wayne L, *Prof,* Bethel College, Dept of Art, Saint Paul MN (S)

Roosevelt, Janice, *Dir Public Relations,* Winterthur Gardens & Library, Winterthur DE

Root, Linda, *Office Mgr,* Koshare Indian Museum, Inc, La Junta CO

Root, Patricia, *Head of Reference,* Bronxville Public Library, Bronxville NY

Roper, Timothy, *Lectr,* Southeastern Louisiana University, Dept of Visual Arts, Hammond LA (S)

Rorschach, Kimberly, *Adjunct Prof,* Duke University, Dept of Art, Art History & Visual Studies, Durham NC (S)

Ros, Karen, *Asst Prof,* Indiana University, Bloomington, Henry Radford Hope School of Fine Arts, Bloomington IN (S)

Rosa, Joseph, San Francisco Museum of Modern Art, San Francisco CA

Rosata, Nancy, *Assoc Dir,* Regis College, Carney Gallery, Weston MA

Rose, Barbara, *Prof,* American University, Dept of Art, Washington DC (S)

Rose, Ellen, *Circulation Librn,* Athenaeum of Philadelphia, Philadelphia PA

Rose, Ellen, *Circulation Librn,* Athenaeum of Philadelphia, Library, Philadelphia PA

Rose, James, *Asst Prof,* Clarion University of Pennsylvania, Dept of Art, Clarion PA (S)

Rose, Joshua, *Prof,* New Mexico State University, Art Dept, Las Cruces NM (S)

Rose, Julia, *Dir,* West Baton Rouge Parish, West Baton Rouge Museum, Port Allen LA

Rose, June, *Gallery Mgr,* Boothbay Region Art Foundation, Boothbay Harbor ME

Rose, Patrice, *Dir Admin,* St Joseph Art Association, Krasl Art Center, Saint Joseph MI

Rose, Richard, *Chmn Studio,* University of South Carolina, Dept of Art, Columbia SC (S)

Rose, Robert, *Pres,* Artworks, The Visual Art School of Trenton, Trenton NJ

Rose, Robert, *Pres,* Artworks, The Visual Art School of Trenton, Library, Trenton NJ

Rose, Steve, *Pres,* Passaic County Community College, Division of Humanities, Paterson NJ (S)

Rosedale, Jeff, *Asst Library Dir,* Manhattanville College, Library, Purchase NY

Rosehart, Robert, *Pres,* Wilfrid Laurier University, Robert Langen Art Gallery, Waterloo ON

Rosek, Mary, *Assoc Lect,* University of Wisconsin-Stevens Point, Dept of Art & Design, Stevens Point WI (S)

Rosell, Karen, *Chmn Dept,* Juniata College, Dept of Art, Huntingdon PA (S)

Roselli, Bart A, *Dir,* Schenectady Museum Planetarium & Visitors Center, Hall of Electrical History, Schenectady NY

Roselli, David, *Asst Dir,* Duke University, Duke University Museum of Art, Durham NC

Roseman, Harry, *Prof,* Vassar College, Art Dept, Poughkeepsie NY (S)

Rosen, Annabeth, University of California, Davis, Dept of Art & Art History, Davis CA (S)

Rosen, Emily, *Deputy Dir Marketing,* North Carolina Museum of Art, Reference Library, Raleigh NC

Rosen, Leila, *Librn,* Aesthetic Realism Foundation, Eli Siegel Collection, New York NY

Rosen, Seymour, *Dir,* Saving & Preserving Arts & Cultural Environments, Los Angeles CA

Rosen, Seymour, *Dir,* Saving & Preserving Arts & Cultural Environments, Spaces Library & Archive, Los Angeles CA

Rosenbaum, Arthur, *Wheatley Prof Drawing & Painting,* University of Georgia, Franklin College of Arts & Sciences, Lamar Dodd School of Art, Athens GA (S)

Rosenbaum, Joan, *Dir,* The Jewish Museum, New York NY

Rosenbaum, Joan H, *Dir,* The Jewish Museum, Library, New York NY

Rosenbberg, Jocelyn Lucas, Art Directors Club, New York NY

Rosenberg, Barry A, *Dir Visual Arts,* Real Art Ways (RAW), Hartford CT

Rosenberg, Eric, *Assoc Prof,* Tufts University, Dept of Art & Art History, Medford MA (S)

Rosenberg, Herbert, *Assoc Prof,* Jersey City State College, Art Dept, Jersey City NJ (S)

Rosenberg, Howard, *Art Dept Chmn,* University of Nevada, Reno, Sheppard Fine Arts Gallery, Reno NV

Rosenberg, Lisa, *Advisor,* Western Washington University, Viking Union Gallery, Bellingham WA

Rosenberg, Rebecca, *Cur of Educ,* Nevada Museum of Art, Reno NV

Rosenberger, Pat, *Exec Dir,* Valley Art Center Inc, Clarkston WA

Rosenberger, Stephen, *Reference,* Fashion Institute of Technology, Gladys Marcus Library, New York NY

Rosenberger, Theresa, *Pres,* New Hampshire Historical Society, Museum of New Hampshire History, Concord NH

Rosenblatt, Arthur, *Chmn Board,* Salmagundi Club, New York NY

Rosenblatt, Charles, *Pres,* Cleveland Museum of Art, Print Club of Cleveland, Cleveland OH

Rosenblum, Paul, *Mng Dir,* Caramoor Center for Music & the Arts, Inc, Caramoor House Museum, Katonah NY

Rosenfeld, Andrew, *Prof,* Mount Saint Mary's University, Visual & Performing Arts Dept, Emmitsburg MD (S)

Rosenfeld, Daniel, *Dir,* Colby College, Museum of Art, Waterville ME

Rosenfield Lafo, Rachel, *Cur,* DeCordova Museum & Sculpture Park, DeCordova Museum, Lincoln MA

Rosenholtz, Ellen M, *Dir of Progs,* Painted Bride Art Center Gallery, Philadelphia PA

Rosensaft, Jean Bloch, *Dir,* Hebrew Union College, Jewish Institute of Religion Museum, New York NY

Rosensweig, Larry, *Dir,* Palm Beach County Parks & Recreation Department, Morikami Museum & Japanese Gardens, Delray Beach FL

Rosenthal, Angela, *Assoc Prof,* Dartmouth College, Dept of Art History, Hanover NH (S)

Rosenthal, Barbara, *Co-Dir, Cur & Grants Officer,* eMediaLoft.org, New York NY

Rosenthal, Deborah, *Cur,* Door County, Miller Art Museum, Sturgeon Bay WI

Rosenthal, Donald, *Dir,* Saint Anselm College, Chapel Art Center, Manchester NH

Rosenthal, Frieda, *Vice Chm,* Brooklyn Museum, Brooklyn NY

Rosenthal, Mark, *Sr Adjunct Cur,* Menil Foundation, Inc, Houston TX

Rosenthal, Staci, *Office Mgr,* San Francisco Craft & Folk Art Museum, San Francisco CA

Rosera, Kathy, *Admin Coordr,* Neville Public Museum, Green Bay WI

Rosette, Auturo, *Prof,* Gavilan Community College, Art Dept, Gilroy CA (S)

Rosetti, Elizabeth, *Treas,* Biloxi Art Association, Gulfport MS

Rosetti, Janet, *Mgr Facility Usage,* Worcester Art Museum, Worcester MA

Roseu, Rhoda, *Dir,* Spertus Institute of Jewish Studies, Spertus Museum, Chicago IL

Rosier, Ken, *Assoc Prof,* Del Mar College, Art Dept, Corpus Christi TX (S)

Rosier, Ken, *Chair Art & Drama Dept,* Del Mar College, Joseph A Cain Memorial Art Gallery, Corpus Christi TX

Rosine, Gary, *Chmn,* Boise State University, Art Dept, Boise ID (S)

Roslak, Robyn, *Assoc Prof,* University of Minnesota, Duluth, Art Dept, Duluth MN (S)

Rosoff, Nancy, *Cur Arts of the Amer,* Brooklyn Museum, Brooklyn NY

Rosoff, Susan, *Cur of Educ,* Orlando Museum of Art, Orlando FL

Rosoff, Susan, *Cur of Educ,* Orlando Museum of Art, Orlando Sentinel Library, Orlando FL

Rospert, Jennifer, *Asst Prof,* University of Central Arkansas, Department of Art, Conway AR (S)

Ross, Alex, *Head Librn,* Stanford University, Art & Architecture Library, Stanford CA

Ross, Alice, *Museum Shop Mgr,* Victoria Mansion - Morse Libby House, Portland ME

Ross, Carole, *Assoc Dean Grad Studies,* University of Kansas, School of Fine Arts, Lawrence KS (S)

Ross, Christine, *Chmn,* McGill University, Dept of Art History, Montreal PQ (S)

Ross, Cynthia, *Instr,* Goddard College, Dept of Art, Plainfield VT (S)

Ross, Dave, *Div Chmn,* Rock Valley College, Humanities and Fine Arts Division, Rockford IL (S)

Ross, Gary, *Chmn,* Capital University, Fine Arts Dept, Columbus OH (S)

Ross, Ian D, *Exec Dir,* Burlington Art Centre, Burlington ON

Ross, Jerry, *Dir,* New Zone Virtual Gallery, Eugene OR

Ross, Joan Stuart, *Instr,* North Seattle Community College, Art Dept, Seattle WA (S)

Ross, John, *Dir,* Fort Hays State University, Forsyth Library, Hays KS

Ross, Judith, *Dir Mktg & Pub Rels,* Westmoreland Museum of American Art, Greensburg PA

Ross, Kathryn, *Develop Dir,* Rochester Art Center, Rochester MN

Ross, Lauren, *Asst Dir,* White Columns, New York NY

Ross, Laurie, *Exec Dir,* Chaffee Center for the Visual Arts, Rutland VT

Ross, Laurie Ann, *Mgr (V),* The Arkansas Arts Center, Museum School, Little Rock AR (S)

Ross, Linda, *Dir Humanities,* Penn State Harrisburg, School of Humanities, Middletown PA (S)

Ross, Margaret, *Dir,* Chatham College, Fine & Performing Arts, Pittsburgh PA (S)

Ross, Melanie, *Youth & Family Programs Coordr,* Columbus Museum, Columbus GA

Ross, Murray, *Instr,* University of Colorado-Colorado Springs, Visual & Performing Arts Dept, Colorado Springs CO (S)

Ross, Nancy, *Instr,* Mary Baldwin College, Dept of Art & Art History, Staunton VA (S)

Ross, Robert, *Prof Emeritus,* University of Arkansas, Art Dept, Fayetteville AR (S)

Ross, S, *Instr,* Humboldt State University, College of Arts & Humanities, Arcata CA (S)

Ross, Tim, *Asst Prof,* Manhattanville College, Brownson Gallery, Purchase NY

Ross-Davis, Chis, *Art Educ Coord,* Space One Eleven, Inc, Birmingham AL

Rosselli, Bart A, *Dir,* Schenectady Museum Planetarium & Visitors Center, Schenectady NY

Rossen, Susan F, *Exec Dir Publications,* The Art Institute of Chicago, Chicago IL

Rosser, Warren, *Chmn Painting,* Kansas City Art Institute, Kansas City MO (S)

Rossi, Linda, *Asst Prof,* College of Visual Arts, Saint Paul MN (S)

Rossi, Robert, *VPres,* Fitchburg Art Museum, Fitchburg MA

Rossman, Michael, *Co-Chmn Foundation Prog,* University of the Arts, Philadelphia Colleges of Art & Design, Performing Arts & Media & Communication, Philadelphia PA (S)

Rossman, Val, *Instr,* Main Line Art Center, Haverford PA (S)

Rossol, Monona, *Pres,* Arts, Craft & Theater Safety, New York NY

Rostek, Philip, *Asst Prof,* Seton Hill University, Art Program, Greensburg PA (S)

Roth, Cathryn, *Instr,* University of Southern Indiana, Art Dept, Evansville IN (S)

Roth, Dan, *Cur & Dir,* US Navy Supply Corps School, US Navy Supply Corps Museum, Athens GA

Roth, John, *Asst Prof,* Old Dominion University, Art Dept, Norfolk VA (S)

Roth, Linda, *Cur European Decorate Arts,* Wadsworth Atheneum Museum of Art, Hartford CT

Roth, Michael, *Pres,* California College of Arts and Crafts, San Francisco CA (S)

Roth, Michael S, *Pres,* California College of the Arts, San Francisco CA (S)

Roth, Moira, *Prof Art Hist,* Mills College, Art Dept, Oakland CA (S)

Roth, Ronald C, *Dir & Cur Fine Arts,* Reading Public Museum, Reading PA

Roth, Ronald C, *Dir, CEO,* Reading Public Museum, Library, Reading PA

Rothchild, Jennifer, *Pres,* Association of Hawaii Artists, Honolulu HI

Rothermel, Barbara, *Dir,* Lynchburg College, Daura Gallery, Lynchburg VA

Rothermel, Barbara, *Lectr,* Lynchburg College, Art Dept, Lynchburg VA (S)

Rothkopf, Katherine, *Cur Painting & Sculpture,* The Baltimore Museum of Art, Baltimore MD

Rothman, Margaret, *Assoc Prof,* William Paterson University, Dept Arts, Wayne NJ (S)

Rothman, Roger, *Art Historian,* Agnes Scott College, Dalton Art Gallery, Decatur GA

Rothrock, Kathy, *History Specialist,* Headquarters Fort Monroe, Dept of Army, Casemate Museum, Fort Monroe VA

Rothrock, Kristin, *Lectr,* University of North Carolina at Charlotte, Dept Art, Charlotte NC (S)

Rothschild, Deborah M, *Sr Cur of Modern & Contemporary Art,* Williams College, Museum of Art, Williamstown MA

Rothstein, Bret L, *Asst Prof,* Rhode Island College, Art Dept, Providence RI (S)

Rotondo-McCord, Lisa, *Cur Asian Art,* New Orleans Museum of Art, New Orleans LA

Rouleau, Bishop Reynald, *Dir,* Eskimo Museum, Churchill MB

Rousseas, Ermioni, *Librn,* Ryerss Victorian Museum & Library, Philadelphia PA

Rousseau, Jaques, *Dir,* Technical University of Nova Scotia, Faculty of Architecture, Halifax NS (S)

Rousseau, Jean-Marc, *Assoc Prof,* Universite de Montreal, Bibliotheque d'Amenagement, Montreal PQ

Rousseau, T Marshall, *Exec Dir,* Salvador Dali, Saint Petersburg FL

Rousseau, William, *Deputy Dir,* Telfair Museum of Art, Savannah GA

Rout, James, *Art Librn,* Banff Centre, Paul D Fleck Library & Archives, Banff AB

Routledge, Marie, *Asst Cur Inuit Art,* National Gallery of Canada, Ottawa ON

Routley, Keith, *Cur,* Shoreline Historical Museum, Shoreline WA

Row, Brian, *Prof,* Texas State University - San Marcos, Dept of Art and Design, San Marcos TX (S)

Rowan, Gerald, *Prog Coordr,* Northampton Community College, Art Dept, Bethlehem PA (S)

Rowars, Lorelei, *Merchandise Mgr,* Newark Museum Association, The Newark Museum, Newark NJ

Rowe, Ann P, *Cur Western Hemisphere,* The Textile Museum, Washington DC

Rowe, Donald, *Dir,* Olivet College, Armstrong Collection, Olivet MI

Rowe, Donald, *Prof,* Olivet College, Art Dept, Olivet MI (S)

Rowe, Libby, *Sr Lectr,* Vanderbilt University, Dept of Art, Nashville TN (S)

Rowe, M Jessica, *Deputy Dir,* Edmundson Art Foundation, Inc, Des Moines Art Center, Des Moines IA

Rowe, Martha, *Dir Research Center,* Old Salem Inc, Museum of Early Southern Decorative Arts, Winston-Salem NC

Rowe, Martha, *Dir Research Ctr,* Old Salem Inc, Library and Research Center, Winston-Salem NC

Rowe, Robert, *Prof,* Marshall University, Dept of Art, Huntington WV (S)

Rowe, Susan, *Instr,* Olivet College, Art Dept, Olivet MI (S)

Rowe, Victoria, *Dir & Chief Cur,* Utah State University, Nora Eccles Harrison Museum of Art, Logan UT

Rowe, William Brit, *Chmn,* Ohio Northern University, Dept of Art, Ada OH (S)

Rowe, William H, *Instr,* Arkansas State University, Dept of Art, State University AR (S)

Rowlands, J, *Dean & Prof,* Camden County College, Visual & Performing Arts Dept, Blackwood NJ (S)

Rowley, Matthew, *Cur,* Please Touch Museum, Philadelphia PA

Rowley, Roger, *Cur Exhib, Coll Mgr,* Washington State University, Museum of Art, Pullman WA

Rowley, Roger, *Gallery Dir & Lectr,* University of Idaho, Dept of Art & Design, Moscow ID (S)

Rowsey, Willis, *Business Mgr,* Art Museum of Western Virginia, Roanoke VA

Roy, Denise, *Instr,* Marylhurst University, Art Dept, Marylhurst OR (S)

Roy, John, *VPres,* Rensselaer County Historical Society, Hart-Cluett Mansion, 1827, Troy NY

Roy, Rob, *Painting,* Montserrat College of Art, Beverly MA (S)

Roy, Sebastien, *Asst Prof,* Universite de Montreal, Bibliotheque d'Amenagement, Montreal PQ

Royall, Richard R, *Managing Dir,* James Dick Foundation, Festival - Institute, Round Top TX

Royek, Walter, *Instr,* Milwaukee Area Technical College, Graphic Arts Div, Milwaukee WI (S)

Royer, Catherine M, *Chmn, Assoc Prof,* Adrian College, Art & Design Dept, Adrian MI (S)

Royer, Debra, *Library Dir,* Portland Art Museum, Crumpacker Family Library, Portland OR

Royer, Debra, *Librn,* Portland Art Museum, Northwest Film Center, Portland OR

Royer, Jean, *Pres,* Musee d'Art de Saint-Laurent, Saint-Laurent PQ

Royer, Randall, *Prof,* Black Hills State University, Art Dept, Spearfish SD (S)

Royster, Kenneth, *Coordr Art Dept,* Morgan State University, Dept of Art, Baltimore MD (S)

Rozak, Tony, *Assoc Prof,* University at Buffalo, State University of New York, Dept of Visual Studies, Buffalo NY (S)

Rozene, Janette, *Catalog Head,* Fashion Institute of Technology, Gladys Marcus Library, New York NY

Rozier, Robert, *Assoc Prof,* Alma College, Clack Art Center, Dept of Art & Design, Alma MI (S)

Rozko, Laurie, *Deputy Dir,* San Bernardino County Museum, Fine Arts Institute, Redlands CA

Rozman, Joseph, *Prof,* Mount Mary College, Art & Design Division, Milwaukee WI (S)

Rub, Timothy, *Dir,* Cincinnati Museum Association and Art Academy of Cincinnati, Cincinnati Art Museum, Cincinnati OH

Rubel, William, *Pres,* Children's Art Foundation, Museum of International Children's Art, Santa Cruz CA

Rubin, Jane, *Dir Coll & Exhib,* The Jewish Museum, New York NY

Rubin, Robert S, *Chm,* Brooklyn Museum, Brooklyn NY

Rubin Downes, Anna, Fairbanks Museum & Planetarium, Saint Johnsbury VT

Rubio, Pablo, *Prof,* University of Puerto Rico, Dept of Fine Arts, Rio Piedras PR (S)

Ruby, Janet, *Assoc Prof,* Shippensburg University, Art Dept, Shippensburg PA (S)

Ruby, Scott, *Asst Cur Russian & Eastern Euro Art,* Hillwood Museum & Gardens Foundation, Hillwood Museum & Gardens, Washington DC

Ruda, Jeffrey, *Dir Art History,* University of California, Davis, Dept of Art & Art History, Davis CA (S)

Rudder, Jennifer, *Exec Dir,* Gallery Stratford, Stratford ON

Rudder, John, *Special Projects Mgr,* Mount Vernon Ladies' Association of the Union, Library, Mount Vernon VA

Rudey, Liz, *Prof,* Long Island University, Brooklyn Campus, Art Dept, Brooklyn NY (S)

Rudick, Nancy, *Supv,* Skidmore College, Lucy Scribner Library, Saratoga Springs NY

Rudolf, Scooter, *Dir,* New Image Art, Los Angeles CA

Rudolph, Beth, *Exec Dir,* Very Special Arts New Mexico, Very Special Arts Gallery, Albuquerque NM

Rudolph, Beth, *Exec Dir,* VSA Arts of New Mexico, Enabled Arts Center, Albuquerque NM (S)

Rudolph, Jeffrey N, *Pres & CEO,* California Science Center, Los Angeles CA

Rueb, Teri, *Asst Prof,* University of Maryland, Baltimore County, Imaging, Digital & Visual Arts Dept, Baltimore MD (S)

Ruedi, Katerina, *Dir School Archit,* University of Illinois at Chicago, College of Architecture, Chicago IL (S)

Ruedy, Don, *Prof,* University of Wisconsin College - Marinette, Art Dept, Marinette WI (S)

Ruedy, Don, *Prof,* University of Wisconsin, Center-Barron County, Dept of Art, Rice Lake WI (S)

Rufe, Laurie, *Dir,* Roswell Museum & Art Center, Roswell NM

Ruff, Elizabeth, *Asst Prof,* Newberry College, Dept of Art, Newberry SC (S)

Ruff, Eric, *Cur,* Yarmouth County Historical Society, Yarmouth County Museum, Yarmouth NS

Ruff, Gloria, *Asst Cur & Registrar,* Valparaiso University, Brauer Museum of Art, Valparaiso IN

Ruffolo, Robert E, *Pres,* Princeton Antiques Bookservice, Art Marketing Reference Library, Atlantic City NJ

Ruggerio, Marie, *Mus Shop Mgr,* Bergen County Historical Society, Steuben House Museum, River Edge NJ

Ruggiero, Laurence, *Dir,* Charles Morse, Charles Hosmer Morse Museum of American Art, Winter Park FL

Ruggie Saunders, Cathie, *Assoc Prof,* Saint Xavier University, Dept of Art & Design, Chicago IL (S)

Ruggles, Janet, *Dir & Chief Paper Conservator,* Balboa Art Conservation Center, San Diego CA

Ruggles, Janet, *General Mgr,* Balboa Art Conservation Center, Richard D Buck Memorial Library, San Diego CA

Ruggles, Jeanne, *Prof,* California Polytechnic State University at San Luis Obispo, Dept of Art & Design, San Luis Obispo CA (S)

Rugoff, Ralph, *Dir,* California College of Arts & Crafts, CCAC Wattis Institute for Contemporary Arts, Oakland CA

Rugoff, Ralph, *Dir,* Capp Street Project, San Francisco CA

Rugoff, Ralph, *Dir,* Center for Critical Architecture, AAES (Art & Architecture Exhibition Space), San Francisco CA

Ruhstaller, Tod, *Dir,* The Haggin Museum, Petzinger Memorial Library & Earl Rowland Art Library, Stockton CA

Ruhstaller, Tod, *Dir & Cur of History,* The Haggin Museum, Stockton CA

Ruiz, Amber, *Acting Head, VRC,* Stanford University, Art & Architecture Library, Stanford CA

Ruiz de Fischler, Carmen T, *Dir,* Museo de Arte de Puerto Rico, San Juan PR

Ruleaux, Don, *Instr,* Chadron State College, Dept of Art, Chadron NE (S)

Rumbold, Kathryn, *Dir Programming,* Art Gallery of Hamilton, Hamilton ON

Rumley, Bill, *Exhib Mgr,* University of Colorado, CU Art Galleries, Boulder CO

Rumm, David, *Dir,* Old Island Restoration Foundation Inc, Wrecker's Museum - Oldest House, Key West FL

Rumrill, Alan, *Dir,* Historical Society of Cheshire County, Keene NH

Rundell, Laura, *Edu Coordr,* The Society for Contemporary Crafts, Pittsburgh PA

Rundels, Donna, *Slide Librn,* Center for Creative Studies, College of Art & Design Library, Detroit MI

Rundgren, Jordan, *Pub Relations Mgr,* Toledo Museum of Art, Toledo OH

Runge, Kay K, *Dir,* Public Library of Des Moines, Central Library Information Services, Des Moines IA

Runge, Peggy, *Asst Librn,* Cincinnati Museum Association and Art Academy of Cincinnati, Mary R Schiff Library, Cincinnati OH

Runnells, Jamie, *Asst Prof,* Mississippi State University, Dept of Art, Mississippi State MS (S)

Runyon, Paul, *Asst Prof Photography,* Drexel University, College of Media Arts & Design, Philadelphia PA (S)

Ruoeco, Nick, *Dir Curatorial & Prog,* Wadsworth Atheneum Museum of Art, Hartford CT

Rusak, Sandy, *Assoc Dir Educ,* Virginia Museum of Fine Arts, Richmond VA

Rusfvold, Georgia, *Prog Coordr,* SVACA - Sheyenne Valley Arts & Crafts Association, Bjarne Ness Gallery at Bear Creek Hall, Fort Ransom ND

Rush, Kent, *Prof,* University of Texas at San Antonio, Dept of Art & Art History, San Antonio TX (S)

Rush, Michael, *Dir,* Palm Beach Institute of Contemporary Art, Museum of Art, Lake Worth FL

Rush, Sallee, *Instr,* Main Line Art Center, Haverford PA (S)

Rushing, Jack, *Chmn,* University of Missouri, Saint Louis, Gallery 210, Saint Louis MO

Rushing, Kim, *Asst Prof,* Delta State University, Dept of Art, Cleveland MS (S)

Rushing, Molly, *Instr,* Delta State University, Dept of Art, Cleveland MS (S)

Rushing, W Jackson, *Chmn,* University of Houston, Dept of Art, Houston TX (S)

Rushton, Ed, *Asst Prof,* Viterbo College, Art Dept, La Crosse WI

Rushton, Ed, *Dir,* Viterbo University, Art Gallery, La Crosse WI

Rushton, Edward, *Asst Prof,* Viterbo College, Art Dept, La Crosse WI (S)

Rusk, Carol, *Librn,* Whitney Museum of American Art, Frances Mulhall Achilles Library, New York NY

Rusk, Carol, *Librn & Assoc Cur Spec Coll,* Whitney Museum of American Art, New York NY

Rusnock, Andrea, *Instr Art History,* Glendale Community College, Visual & Performing Arts Div, Glendale CA (S)

Russ, Barbara, *Museum Asst,* CT Commission on Culture & Tourism, Sloane-Stanley Museum, Kent CT

Russell, Ann, *Exec Dir,* Northeast Document Conservation Center, Inc, Andover MA

Russell, Barry, *Instr Dean Fine Arts,* Cerritos Community College, Fine Arts & Communication Div, Norwalk CA (S)

Russell, Christie, *Chm,* Bicentennial Art Center & Museum, Paris IL

Russell, Donald, *Dir & Cur,* Provisions Library & Gaea Foundation, Washington DC

Russell, Donald H, *Exec Dir,* Art Resources International, Washington DC

Russell, Douglas, *Sr Research Assoc,* Oregon State University, Dept of Art, Corvallis OR (S)

Russell, Graham, *Dir Membership,* Norton Museum of Art, West Palm Beach FL

Russell, John, *Chmn Critical Studies,* Massachusetts College of Art, Boston MA (S)

Russell, John I, *Exec Dir,* Brookfield Craft Center, Inc, Gallery, Brookfield CT

Russell, Lisa, *Asst Prof,* Rhode Island College, Art Dept, Providence RI (S)

Russell, Marilyn M, *Cur Educ,* Carnegie Museums of Pittsburgh, Carnegie Museum of Art, Pittsburgh PA

Russell, Rebecca, *Cur Educ,* Museum of Fine Arts, Saint Petersburg, Florida, Inc, Saint Petersburg FL

Russell, Robert, *Chmn & Assoc Prof Art Educ,* University of Cincinnati, School of Art, Cincinnati OH (S)

Russi Kirshner, Judith, *Dean,* University of Illinois at Chicago, College of Architecture, Chicago IL (S)

Russo, Barbara, *Fine Arts Mgr,* Cypress College, Cypress CA (S)

Russo, Howard, *Instr,* Elgin Community College, Fine Arts Dept, Elgin IL (S)

Russo, Kathleen, *Chmn,* Florida Atlantic University, Art Dept, Boca Raton FL (S)

Russo, Susan, *Chmn,* Youngstown State University, Dept of Art, Youngstown OH (S)

Rust, Brian, *Prof,* Augusta State University, Dept of Arts, Augusta GA (S)

Rustige, Rona, *Cur,* Glanmore National Historic Site of Canada, Belleville ON

Ruston, Shelley S, *Dir Special Progs,* Santa Barbara Museum of Art, Library, Santa Barbara CA

Rutberg, Alan, *Asst Prof,* University of Maryland, Baltimore County, Imaging, Digital & Visual Arts Dept, Baltimore MD (S)

Rutkowski, Sandra, *Dir Libr Servs,* Lourdes College, Duns Scotus Library, Sylvania OH

Rutledge, Bethany S, *Cur,* Thornton W Burgess, Museum, Sandwich MA

Rutledge, Margaret, *Asst Prof,* Delta State University, Dept of Art, Cleveland MS (S)

Ruttner, Nancy, *Dir,* Art Institute of Pittsburgh, John P. Barclay Memorial Gallery, Pittsburgh PA

Ruzicka, Joseph, *Dir,* Washington County Museum of Fine Arts, Hagerstown MD

Ruzicka, Joseph, *Dir,* Washington County Museum of Fine Arts, Library, Hagerstown MD

Ryan, Allyson, *Cur Educ,* Institute of American Indian Arts Museum, Museum, Santa Fe NM

Ryan, Darlene, *VChmn,* Port Angeles Fine Arts Center, Port Angeles WA

Ryan, David, *Cur Coll,* Wells Fargo, Minneapolis, Arts Program, Minneapolis MN

Ryan, Deborah, *Dir Devel,* Atlanta Contemporary Art Center, Atlanta GA

Ryan, Joan, *Chmn Fine Arts Dept & Found Dept,* Art Institute of Boston at Lesley University, Boston MA (S)

Ryan, Kathy, *Prog Coordr,* McMaster University, School of Art, Drama & Music, Hamilton ON (S)

Ryan, Linda Lee, *Instr,* Casper College, Dept of Visual Arts, Casper WY (S)

Ryan, Mark, *Registrar,* Plains Art Museum, Fargo ND

Ryan, Mary Ann, *Librn,* Fishkill Historical Society, Van Wyck Homestead Museum, Fishkill NY

Ryan, Paul, *Assoc Prof,* Mary Baldwin College, Dept of Art & Art History, Staunton VA (S)

Ryan, Raymund, *Cur Architecture,* Carnegie Museums of Pittsburgh, Carnegie Museum of Art, Pittsburgh PA

Ryan, Susan, *Asst,* Louisiana State University, School of Art, Baton Rouge LA (S)

Ryan-Cook, Joelle, *Dir Educ,* Columbia Museum of Art, Columbia SC

Ryberg, Diane, *VPres Institution,* Missouri Historical Society, Saint Louis MO

Rychlak, Bonnie, *Dir Coll,* Isamu Noguchi, Isamu Noguchi Garden Museum, Long Island City NY

Ryckbosch, Bart, *Archivist,* The Art Institute of Chicago, Ryerson & Burnham Libraries, Chicago IL

Rydell, Christine, *Instr,* Solano Community College, Division of Fine & Applied Art & Behavioral Science, Suisun City CA (S)

Ryden, Michelle, *Registrar,* City of El Paso, El Paso Museum of Art, El Paso TX

Ryder, Jeffrey, *Dir Writing Media,* University of the Arts, Philadelphia Colleges of Art & Design, Performing Arts & Media & Communication, Philadelphia PA (S)

Ryerson, John, *COO,* McMichael Canadian Art Collection, Kleinburg ON

Rykels, Sam, *Dir Cur Serv,* Louisiana Department of Culture, Recreation & Tourism, Louisiana State Museum, New Orleans LA

Ryker-Crawford, Jessie, *Mus Studies Dept Faculty,* Institute of American Indian Arts, Institute of American Indian Arts Museum, Santa Fe NM (S)

Ryley, Bryan, *Assoc Prof (Visual Art),* University of British Columbia Okanagan, Dept of Creative Studies, Kelowna BC (S)

Rzoska, Linda, *Coordr Ctr for New Media,* Kalamazoo Valley Community College, Center for New Media, Kalamazoo MI (S)

Saarnio, Robert, *Cur,* Peabody Essex Museum, Peirce-Nichols House, Salem MA

Sablow, Mark, *Prof,* Florida Community College at Jacksonville, South Campus, Art Dept, Jacksonville FL (S)

Sabolosi, Susanna, *Librn,* Montclair Art Museum, LeBrun Library, Montclair NJ

Sacavsky, Stacey, *Public Art Prog,* City of Atlanta, Bureau of Cultural Affairs, Atlanta GA

Sachs, Samuel, *Dir,* Frick Collection, New York NY

Sachs, Sid, *Dir Exhibs,* The University of the Arts, Rosenwald-Wolf Gallery, Philadelphia PA

Sackel, Matthew, *Art Hist Librn,* University of Wisconsin-Stevens Point, Dept of Art & Design, Stevens Point WI (S)

Sackman, Elmer, *Librn,* Fort Worth Public Library Arts & Humanities, Fine Arts Section, Fort Worth TX

Sackrey, Ponteir, *Mktg Dir,* National Museum of Wildlife Art, Jackson WY

Sadao, Shoji, *Exec Dir,* Isamu Noguchi, Isamu Noguchi Garden Museum, Long Island City NY

Sadler, Cody, *Co-Dir,* Canadian Wildlife & Wilderness Art Museum, Ottawa ON

Sadler, Cody, *Co-Dir,* Canadian Wildlife & Wilderness Art Museum, Library, Ottawa ON

Sadler, Donna, *Chmn Art Dept,* Agnes Scott College, Dalton Art Gallery, Decatur GA

Sadler, Ginna, *Prof,* Abilene Christian University, Dept of Art & Design, Abilene TX (S)

Sadongei, Alyce, *Training Coordr,* National Museum of the American Indian, George Gustav Heye Center, New York NY

Saeedpour, Vera Beaudin, *Dir,* Kurdish Museum, Brooklyn NY

Safford, Lisa, *Chmn,* Hiram College, Art Dept, Hiram OH (S)

Safford, Monique, *Visual Resource Coord,* Parsons School of Design, Adam & Sophie Gimbel Design Library, New York NY

Safrin, Robert W, *Dir,* The Society of the Four Arts, Palm Beach FL

Saganic, Livio, *Chmn Art Dept,* Drew University, Elizabeth P Korn Gallery, Madison NJ

Saganic, Livio, *Prof,* Drew University, Art Dept, Madison NJ (S)

Sager, Judy, *Art Show Coordr,* University of North Texas Health Science Center Forth Worth, Atrium Gallery, Fort Worth TX

Sager, Judy, *Owner,* Sager Studios, Fort Worth TX (S)

Saggus, Frank, *Instr,* Brenau University, Art & Design Dept, Gainesville GA (S)

Sahdana-Melber, Soledad, *Educ Dir,* Coupeville Arts Center, Gallery at the Wharf, Coupeville WA

Sahlstrand, James, *Dir Art Gallery,* Central Washington University, Sarah Spurgeon Gallery, Ellensburg WA

Sahraoui, Houari, *Asst Prof,* Universite de Montreal, Bibliotheque d'Amenagement, Montreal PQ

Saikai, Paul, *Coordr, Graphic Design,* York College of Pennsylvania, Dept of Music, Art & Speech Communications, York PA (S)

Saint-Pierre, Adrienne, *Cur,* Fairfield Historical Society, Fairfield Museum & History Center, Fairfield CT

Sajet, Kim, *Deputy Dir,* Pennsylvania Academy of the Fine Arts, Philadelphia PA

Saka, Tuna, *Instr,* Pennsylvania College of Technology, Dept. of Communications, Construction and Design, Williamsport PA (S)

Sakamoto, Michael, *Prog Coodr,* 18th Street Arts Complex, Santa Monica CA

Sakauye, Beverly, *Develop Mem,* The Ogden Museum of Southern Art, University of New Orleans, New Orleans LA

Sakoulas, Thomas, *Instr,* State University of New York College at Oneonta, Dept of Art, Oneonta NY (S)

Sakowski, Robert, University of Manitoba, School of Art, Winnipeg MB (S)

Salam, Halide, *Prof,* Radford University, Art Dept, Radford VA (S)

Salazar, Alvaro, *Dir,* Kateri Tekakwitha Shrine, Kahnawake PQ

Salazar, Carolina, *Dir,* Miami-Dade Community College, Wolfson Galleries, Miami FL

Salazar, Jim Bob, *Asst Prof,* Sul Ross State University, Dept of Fine Arts & Communications, Alpine TX (S)

Salberg, Lester, *Prof,* Rock Valley College, Humanities and Fine Arts Division, Rockford IL (S)

Sale, Gregory, *Visual Arts Dir,* Arizona Commission on the Arts, Phoenix AZ

Sale, Tom, *Dir,* Navarro College, Art Dept, Corsicana TX (S)

Salerno, Robert, *VPres Finance & Adminstr,* American Craft Council, Museum of Arts & Design, New York NY

Salesses, John J, *Pres,* Newport Historical Society & Museum of Newport History, Newport RI

Saliga, Pauline, *Exec Dir,* Society of Architectural Historians, Chicago IL

Saliklis, Ruta, *Cur Textiles,* Allentown Art Museum, Allentown PA

Salisbury, Anne, *Instr,* Saint John's University, Art Dept, Collegeville MN (S)

Sall, Doug, *Dir & Cur,* Yankton County Historical Society, Dakota Territorial Museum, Yankton SD

Salmon, Patricia, *Cur History,* Staten Island Institute of Arts & Sciences, Staten Island NY

Salmon, Ray, *Instr,* Solano Community College, Division of Fine & Applied Art & Behavioral Science, Suisun City CA (S)

Salmon, Robin R, *VPres & Cur,* Brookgreen Gardens, Murrells Inlet SC

Salmond, Wendy, *Prof,* Chapman University, Art Dept, Orange CA (S)

Salomon, Carol, *Engineering & Science,* Cooper Union for the Advancement of Science & Art, Library, New York NY

Salomon, Suzanne, *Chair Art Committee,* New Canaan Library, H. Pelham Curtis Gallery, New Canaan CT

Salsbury, Kathleen, *Library Asst,* Munson-Williams-Proctor Arts Institute, Art Reference Library, Utica NY

Salson, Sharon, *Dir Marketing & Communications,* Art Gallery of Ontario, Toronto ON

Salter, Ann C, *Exec Dir,* Rochester Historical Society, Rochester NY

Salter, Tamara G, *Coordr Educ Programs,* Houston Museum of Decorative Arts, Chattanooga TN

Saltonstall, G West, *Chmn, VPres,* USS Constitution Museum, Boston MA

Saltz, Ina, *Assoc Prof,* City College of New York, Art Dept, New York NY (S)

Saltz, Laura, *Asst Prof,* Colby College, Art Dept, Waterville ME (S)

Saltzman, Lisa, *Assoc Prof,* Bryn Mawr College, Dept of the History of Art, Bryn Mawr PA (S)

Saluato, Michael, *Asst Prof,* Philadelphia Community College, Dept of Art, Philadelphia PA (S)

Salvayon, Leon L, *Multimedia & Web Design,* Art Institute of Pittsburgh, Pittsburgh PA (S)

Salveson, Douglas, *Prof,* University of Findlay, Art Program, Findlay OH (S)

Salvest, John J, *Assoc Prof,* Arkansas State University, Dept of Art, State University AR (S)

Salzberg, Rick, *Pub Relations Mgr,* Chrysler Museum of Art, Norfolk VA

Salzman, Kevin, *Asst Prof,* Wittenberg University, Art Dept, Springfield OH (S)

Sam, Jared, *Genl Mgr,* Kalani Oceanside Retreat, Pahoa HI (S)

Samel, Hiram M., *Vice-Chmn,* American Textile History Museum, Lowell MA

Sammon, Christine E, *Library Dir,* Alberta College of Art & Design, Luke Lindoe Library, Calgary AB

Sammons, Mark J, *Exec Dir,* Newburyport Maritime Society, Custom House Maritime Museum, Newburyport MA

Sammons, Richard, *Assoc Prof,* Bismarck State College, Fine Arts Dept, Bismarck ND (S)

Sammons, Tania J, *Cur,* Telfair Museum of Art, Savannah GA

Sample, George, *Asst Prof,* Central Missouri State University, Art Dept, Warrensburg MO (S)

Samples-Davis, Olga, *Dir Educ,* San Antonio Museum of Art, San Antonio TX

Samuels, Clifford, *Dir,* Trova Foundation, Philip Samuels Fine Art, Saint Louis MO

Samuels, Linda, *Prog Dir,* Headlands Center for the Arts, Sausalito CA

Samuels, Philip, *Pres,* Trova Foundation, Philip Samuels Fine Art, Saint Louis MO

Samuelson, Jerry, *Dean School of Arts,* California State University, Fullerton, Art Dept, Fullerton CA (S)

Samuelson, Laura, *Dir,* Carrie M McLain, Nome AK

Sanchez, Anna Marie, *Registrar & Cur Colls,* California State University, Long Beach, University Art Museum, Long Beach CA

Sanchez, Jacquelyn Roesch, *Dir,* Montclair Art Museum, Yard School of Art, Montclair NJ (S)

Sanchez, Joseph, *Cur,* Institute of American Indian Arts, Institute of American Indian Arts Museum, Santa Fe NM (S)

Sanchez, Joseph, *Exhib Designer,* Institute of American Indian Arts Museum, Museum, Santa Fe NM

Sanchez, Nereida, *Admin Off Mgr,* New York Society of Architects, New York NY

Sanchez, Ramon Vasquez Y, *Arts Prog Dir,* Centro Cultural Aztlan, San Antonio TX

Sanchis, Frank E, *Dir,* Municipal Art Society of New York, New York NY

Sand, Viki, *Exec Dir,* Atwater Kent Museum of Philadelphia, Philadelphia PA

Sandberg, Curtis, *Dir Exhib,* Meridian International Center, Cafritz Galleries, Washington DC

Sandberg, Sharon, *Adjunct Assoc Prof Painting,* Aquinas College, Art Dept, Grand Rapids MI (S)

Sander, Betty, *Mus Shop Mgr,* Plymouth Antiquarian Society, Plymouth MA

Sanders, Albert E, *Cur Natural History,* Charleston Museum, Charleston SC

Sanders, Jan, *Dir,* Pasadena Public Library, Fine Arts Dept, Pasadena CA

Sanders, Joanne, *Pres,* South Florida Art Institute of Hollywood, Dania FL (S)

Sanders, Joe, *Assoc Prof Printmaking,* University of Georgia, Franklin College of Arts & Sciences, Lamar Dodd School of Art, Athens GA (S)

Sanders, Mary, *Instr,* Cuyahoga Valley Art Center, Cuyahoga Falls OH (S)

Sanders, Philip, *Asst Prof,* The College of New Jersey, School of Arts & Sciences, Ewing NJ (S)

Sanders, Rebecca, *Dir. Art School,* Boca Raton Museum of Art, Boca Raton FL

Sanders, Tom, *Site Mgr,* Jeffers Petroglyphs Historic Site, Comfrey MN

Sanders, William, *Instr,* Surry Community College, Art Dept, Dobson NC (S)

Sanderson, Arlene, *Head Publ,* Carnegie Museums of Pittsburgh, Carnegie Museum of Art, Pittsburgh PA

Sanderson, Doug, *Asst Prof,* Oberlin College, Dept of Art, Oberlin OH (S)

Sanderson, John R, *Treas,* The Buffalo Fine Arts Academy, Albright-Knox Art Gallery, Buffalo NY

Sandford, Harriet, *Pres,* Arts & Science Council, Charlotte VA

Sandiford, Vickie, *Mgr Retail Operations,* The Adirondack Historical Association, The Adirondack Museum, Blue Mountain Lake NY

Sandin, Karl, *Dept Chmn,* Denison University, Dept of Art, Granville OH (S)

Sandkulher, Iris, *Temp Asst Prof,* Georgia Southern University, Dept of Art, Statesboro GA (S)

Sandman, Kieth, *Prof,* Munson-Williams-Proctor Arts Institute, School of Art, Utica NY (S)

Sandoval, Angelica, *Adjunct Asst Prof Art,* Johnson County Community College, Visual Arts Program, Overland Park KS (S)

Sands, Diane, *Grants Admin,* Historical Museum at Fort Missoula, Missoula MT

Sands, Janice, *Exec Dir,* Pen & Brush, Inc, New York NY

Sands, John, *Exec VPres,* Brookgreen Gardens, Murrells Inlet SC

Sandusky, Bill, *Chmn,* Saint Mary's College, Dept of Art, Notre Dame IN (S)

Sandvik, Loren, *Asst Dir,* Santa Ana College, Art Gallery, Santa Ana CA

Sanftner, Patricia, *Co-1st Vice Regent,* Schuyler-Hamilton House, Morristown NJ

Sanftner, Phyllis, *Cur,* Schuyler-Hamilton House, Morristown NJ

Sangelo, Trish, *Gallery Coordr,* Arapahoe Community College, Colorado Gallery of the Arts, Littleton CO

Sanger, Erika, *Dir Educ,* Albany Institute of History & Art, Albany NY

Sanguinetti, Arthur, *VPres,* The Haggin Museum, Stockton CA

Sankey, Gretchen, *Instr,* Toronto School of Art, Toronto ON (S)

Sano, Emily, *Dir,* Asian Art Museum of San Francisco, Chong-Moon Lee Ctr for Asian Art and Culture, San Francisco CA

Sanpei, Sandra, *Dept Head,* Honolulu Community College, Commercial Art Dept, Honolulu HI (S)

Sansone, Bettielee, *Dir,* Pine Castle Center of the Arts, Orlando FL

Sansone, Tara, *Dir of Educ,* Socrates Sculpture Park, Long Island City NY

Santana, Nil, *Prof,* Abilene Christian University, Dept of Art & Design, Abilene TX (S)

Santelli, Thomas, *Asst Prof,* College of Saint Rose, Art Dept, Albany NY (S)

Santiago, Alfonso, *Head Dept,* Catholic University of Puerto Rico, Dept of Fine Arts, Ponce PR (S)

Santiago, Fernando, *Auxiliary Prof,* Inter American University of Puerto Rico, Dept of Art, San German PR (S)

Santiago, Frances, *Dir,* University of Puerto Rico, Mayaguez, Dept of Humanities, College of Arts & Sciences, Mayaguez PR (S)

Santiago, Maria, *Prof,* College of Visual Arts, Saint Paul MN (S)

Santiago, Raymond, *Dir,* Miami-Dade Public Library, Miami FL

Santis, Jorge, *Cur Coll,* Museum of Art, Fort Lauderdale, Fort Lauderdale FL

Santmyers, Stephanie, *Chmn,* North Carolina Agricultural & Technical State University, Visual Arts Dept, Greensboro NC (S)

Santora, Olga, *Pres,* Greene County Historical Society, Bronck Museum, Coxsackie NY

Santoro, Geradine, *Cur Coll,* The National Park Service, United States Department of the Interior, Statue of Liberty National Monument & The Ellis Island Immigration Museum, New York NY

Santos, Allison, *A A to Pres,* The Illinois Institute of Art - Chicago, Chicago IL (S)

Santos, Rui, *Pres,* Plymouth Antiquarian Society, Plymouth MA

Santry, Karen, *Asst Prof,* Jersey City State College, Art Dept, Jersey City NJ (S)

Sapotiuk, Owen, *Preparator & Colls Mgr,* University of British Columbia, Morris & Helen Belkin Art Gallery, Vancouver BC

Sapp, Aimee, *Instr,* William Woods-Westminster Colleges, Art Dept, Fulton MO (S)

Sapp, David, *Assoc Prof Art,* Bowling Green State University, Firelands College, Humanities Dept, Huron OH (S)

Sapp, Rocky, *Assoc Prof Sculpture,* University of Georgia, Franklin College of Arts & Sciences, Lamar Dodd School of Art, Athens GA (S)

Sarallano, David, *VPres,* California Watercolor Association, Gallery Concord, Concord CA

Sargent, Jennifer, *Cur Galleries,* Memphis College of Art, Memphis TN (S)

Sargent, Shannon, *Instr,* Morningside College, Art Dept, Sioux City IA (S)

Sarjeant-Jenkins, Rachel, *Chief Librn,* Medicine Hat Public Library, Medicine Hat AB

Sarn, Nicola, *School & Educ Svcs Coordr,* Columbus Museum, Columbus GA

Sarni, Elena, *Prog Dir,* Cape Ann Historical Association, Gloucester MA

Sarns, Mary, *Dept Chair,* Willoughby School of Fine Arts, Visual Arts Dept, Willoughby OH (S)

Sarre, Camille, *Assoc Prof,* Murray State University, Dept of Art, Murray KY (S)

Sarris, Rita, *Gallery Dir,* Arts & Crafts Association of Meriden Inc, Gallery 53, Meriden CT

Sartor, Curtis, *Chmn Dept Architecture,* Judson College, Division of Art, Design & Architecture, Elgin IL (S)

Sartori, Dean, *Conservator,* Kirkland Museum of Fine & Decorative Art, Denver CO

Sartorius, Tara, *Cur Educ,* Montgomery Museum of Fine Arts, Montgomery AL

Sarver, Jennifer, *Dir Educ,* Cedarhurst Center for the Arts, Mitchell Museum, Mount Vernon IL

Sasaki, Les, *Chair Visual Arts,* Memorial University of Newfoundland, Division of Fine Arts, Visual Arts Program, Corner Brook NF (S)

Saslow, James, *Chmn,* Queens College, Art Dept, Flushing NY (S)

Saslow, James M, *Prof,* City University of New York, PhD Program in Art History, New York NY (S)

Sasse, Julie, *Chief Cur & Cur Mod & Contemp Art,* Tucson Museum of Artand Historic Block, Tucson AZ

Sasser, Teiko, *Instr,* Sacramento City College, Art Dept, Sacramento CA (S)

Sasso, Paul, *Prof,* Murray State University, Dept of Art, Murray KY (S)

Sasson-Mason, Judith, *Adjunct Asst Prof,* University of Maine, Dept of Art, Orono ME (S)

Satalino, Jennifer, *Dir Enrol,* Pacific Northwest College of Art, Portland OR (S)

Satchell, Ernest R, *Coordr Art Educ,* University of Maryland Eastern Shore, Art & Technology Dept, Princess Anne MD (S)

Satoda, Ikuko, *Controller,* San Francisco Museum of Modern Art, San Francisco CA

Satre, Malena, *Communications Dir,* Nevada Museum of Art, Art Library, Reno NV

Satterfield, Barbara, *Lect,* University of Central Arkansas, Department of Art, Conway AR (S)

Satterfield, Debra, *Assoc Prof,* Arkansas State University, Dept of Art, State University AR (S)

Satterfield, Debra, *Coordr Graphic Design,* Iowa State University, Dept of Art & Design, Ames IA (S)

Satterlee, Craig, *Assoc Prof,* Northwest Community College, Dept of Art, Powell WY (S)

Satterlee, Joy, *Exec Dir,* Art & Culture Center of Hollywood, Art Gallery, Hollywood FL

Saucedo, Christopher, *Asst Prof,* University of New Orleans-Lake Front, Dept of Fine Arts, New Orleans LA (S)

Sauer, Stacey, *Mus Asst,* Rockford Art Museum, Rockford IL

Sauers, Richard A, *Exec Dir,* Fetherston Foundation, Packwood House Museum, Lewisburg PA

Sauls, Allison, *Chmn Dept,* Missouri Western State University, Art Dept, Saint Joseph MO (S)

Sauls, Allison, *Chmn Dept Art,* Missouri Western State College, Gallery 206 Foyer Gallery, Saint Joseph MO

Saunders, Evelyn, *Secy,* Blacksburg Regional Art Association, Blacksburg VA

Saunders, Jeffrey J, *Geology Chair,* Illinois State Museum, Museum Store, Chicago IL

Saunders, Joseph, *Chief Exec Officer,* Art Services International, Alexandria VA

Saunders, Joyan, *Assoc Prof New Genre,* University of Arizona, Dept of Art, Tucson AZ (S)

Saunders, Kathy, *Comp,* Huntington Museum of Art, Huntington WV

Saunders, Preston, *Asst Prof,* Bridgewater State College, Art Dept, Bridgewater MA (S)

Saunders, Richard, *Dir College Museum,* Middlebury College, History of Art & Architecture Dept, Middlebury VT (S)

Saunders, Richard H, *Dir,* Middlebury College, Museum of Art, Middlebury VT

Saunders, Stephanie, *Store Mgr,* Tampa Museum of Art, Judith Rozier Blanchard Library, Tampa FL

Saunders, Susanna T, *Instr,* Main Line Art Center, Haverford PA (S)

Saupe, Ted, *Assoc Prof Ceramics,* University of Georgia, Franklin College of Arts & Sciences, Lamar Dodd School of Art, Athens GA (S)

Saurer, John, *Asst Prof,* Saint Olaf College, Art Dept, Northfield MN (S)

Savage, Cort, *Assoc Prof,* Davidson College, Art Dept, Davidson NC (S)

Savage, Kirk, *Chmn,* University of Pittsburgh, Henry Clay Frick Dept History of Art & Architecture, Pittsburgh PA (S)

Saviello, Debbie, *Mus Shop Mgr,* The Barnum Museum, Bridgeport CT

Savill, Becky, *Educ Coordr,* Rollins College, George D & Harriet W Cornell Fine Arts Museum, Winter Park FL

Saville, Jennifer, *Cur Western Art,* Honolulu Academy of Arts, Honolulu HI

Saville, Jennifer, *Cur Western Art,* Honolulu Academy of Arts, The Art Center at Linekona, Honolulu HI (S)

Savini, Richard, *Prof,* California State University, Art Dept, Turlock CA (S)

Saw, James T, *Assoc Prof,* Palomar Community College, Art Dept, San Marcos CA (S)

Sawada, Naomi, *Prog Coordr,* University of British Columbia, Morris & Helen Belkin Art Gallery, Vancouver BC

Sawchuk, Michele, *Reference & Coll Develop Librn - Fine Arts & Archit,* University of Waterloo, Dana Porter Library, Waterloo ON

Sawkins, AnneMarie, *Assoc Cur,* Marquette University, Haggerty Museum of Art, Milwaukee WI

Sawyer, Carol, *Conservator Paintings,* Virginia Museum of Fine Arts, Richmond VA

Sawyer, J Brooks, *Dir,* Joslyn Art Museum, Omaha NE

Saxon, Mark, *Instr,* Milwaukee Area Technical College, Graphic Arts Div, Milwaukee WI (S)

Sayers, Troy, *Photography/Graphic Design,* Antonelli Institute, Professional Photography & Commercial Art, Erdenheim PA (S)

Saylor, Julie, *Educ,* Montana Historical Society, Helena MT

Sayre, Henry, *Prof,* Oregon State University, Dept of Art, Corvallis OR (S)

Sayre, Mary Chris, *Registrar,* The Art Institute of Dallas, Dallas TX (S)

Sayre, Roger, *Prof,* Pace University, Dyson College of Arts & Sciences, Pleasantville NY (S)

Scalera, Michelle, *Conservator,* Florida State University, John & Mable Ringling Museum of Art, Sarasota FL

Scallen, Catherine, *Assoc Prof,* Case Western Reserve University, Dept of Art History & Art, Cleveland OH (S)

Scanlan, Traci, *Office Mgr,* Mount Saint Vincent University, Art Gallery, Halifax NS

Scanlon, James, *Pres,* Missouri Western State College, Gallery 206 Foyer Gallery, Saint Joseph MO

Scaramella, Julie, *Dir,* Boston Sculptors at Chapel Gallery, West Newton MA

Scarborough, Don, *Pres,* Anson County Historical Society, Inc, Wadesboro NC

Scarpitta, Salvatore, *Faculty,* Maryland Institute, Mount Royal School of Art, Baltimore MD (S)

Scarpitti, Kay, *Bus Mgr,* Canton Museum of Art, Canton OH (S)

Scarpitti, Kay, *Business Mgr,* Canton Museum of Art, Canton OH

Scarvelis, Elaine, *First VPres,* Toledo Artists' Club, Toledo OH

Scearce, Geraldine, *Ofc Mgr,* Danville Museum of Fine Arts & History, Danville VA

Schaad, Dee, *Chair,* University of Indianapolis, Art Dept, Indianapolis IN (S)

Schaad, Dee, *Chmn,* University of Indianapolis, Christel DeHaan Fine Arts Gallery, Indianapolis IN

Schaber, Ken, *Instr,* Lake Michigan College, Dept of Art & Science, Benton Harbor MI (S)

Schachter, Ruth, *Library Dir,* Art Institute of Philadelphia Library, Philadelphia PA

Schad, Lauren, *Prog & Events Coordr,* Minnesota Museum of American Art, Saint Paul MN

Schaefer, Evva, *Fin Dir,* Nevada Northern Railway Museum, Ely NV

Schaefer, Matt, *Reference Archivist,* Herbert Hoover, West Branch IA

Schaefer, Patricia M, *Pres,* New London County Historical Society, Shaw - Perkins Mansion, New London CT

Schaefer, Scott, *Cur Paintings & Drawings,* Getty Center, Trust Museum, Los Angeles CA

Schaefer, Scott, *Cur Paintings & Drawings,* Getty Center, The J Paul Getty Museum, Los Angeles CA

Schaefer, Susan, *Asst Gallery Mgr,* Sharon Arts Center, Sharon Arts Center Exhibition Gallery, Sharon NH

Schaeffer, Astrida, *Asst Dir,* University of New Hampshire, The Art Gallery, Durham NH

Schaeffer, Ron, *Archivist,* Bernice Pauahi Bishop, Library, Honolulu HI

Schaeffer, Ron, *Archivist,* Bernice Pauahi Bishop, Archives, Honolulu HI

Schafer, Carl, *Registrar,* Allentown Art Museum, Allentown PA

Schafer, Michael I, *Pres,* Mohawk Valley Community College, Utica NY (S)

Schafer, Sheldon, *Science Planetarium Dir,* Lakeview Museum of Arts & Sciences, Peoria IL

Schaffer, Chrissy, *Prog Dir & Assoc Prof,* Seton Hill University, Art Program, Greensburg PA (S)

Schaffer, Dale E, *Co-owner,* Gloridale Partnership, National Museum of Woodcarving, Custer SD

Schaffer, Gloria, *Co-owner,* Gloridale Partnership, National Museum of Woodcarving, Custer SD

Schaffer, Marcy, *Historic Site Mgr,* Schuyler Mansion State Historic Site, Albany NY

Schaffer, Mark, *Treas,* National Antique & Art Dealers Association of America, Inc, New York NY

Schaffner, Ingrid, *Sr Cur,* University of Pennsylvania, Institute of Contemporary Art, Philadelphia PA

Schafle, Larry, *Graphic Design,* Antonelli Institute, Professional Photography & Commercial Art, Erdenheim PA (S)

Schaller, Arthur, *Asst Prof,* Norwich University, Dept of Architecture and Art, Northfield VT (S)

Schaller, Hydee, *Dir,* St John's College, Elizabeth Myers Mitchell Art Gallery, Annapolis MD

Schamberger, Sue, *Dir Programs,* Farmington Valley Arts Center, Avon CT

Schaming, Mark, *Dir Exhibits,* New York State Museum, Albany NY

Schantz, Michael W, *CEO, Dir & Cur,* Woodmere Art Museum, Library, Philadelphia PA

Schantz, Michael W, *Dir,* Woodmere Art Museum, Philadelphia PA

Schapp, Rebecca M, *Dir,* Santa Clara University, de Saisset Museum, Santa Clara CA

Schar, Stuart, *Dean,* University of Hartford, Hartford Art School, West Hartford CT (S)

Scharf, Carrie, *Circ Asst,* National Gallery of Art, Department of Image Collections, Washington DC

Scharf, Patricia, *Dir Finance & Admin,* Santa Monica Museum of Art, Santa Monica CA

Schartow, Christianna, *Asst Dir,* Northwood University, Alden B Dow Creativity Center, Midland MI (S)

Schatz, Charlotte, *Instr,* Bucks County Community College, Fine Arts Dept, Newtown PA (S)

Schatz, Doug, *Instr,* Middle Tennessee State University, Art Dept, Murfreesboro TN (S)

Schaunam, Lora, *Cur Exhib,* Dacotah Prairie Museum, Lamont Art Gallery, Aberdeen SD

Schawang, Janet, *Mus Shop Mgr,* Hastings Museum of Natural & Cultural History, Hastings NE

Schawlbe, Kurt Shag, *Project Coordr,* Chicago Artists' Coalition, Chicago IL

Scheele, Christie, *Instr,* Woodstock School of Art, Inc, Woodstock NY (S)

Scheer, Stephen, *Assoc Prof Photography,* University of Georgia, Franklin College of Arts & Sciences, Lamar Dodd School of Art, Athens GA (S)

Schefcik, Jerry, *Dir,* University of Nevada, Las Vegas, Donna Beam Fine Art Gallery, Las Vegas NV

Scheibraur, Kim, *Office Mgr,* Santa Cruz Art League, Inc, Center for the Arts, Santa Cruz CA

Scheid, Ann, *Archivist,* University of Southern California/The Gamble House, Greene & Greene Archives, San Marino CA

Scheidt, Diana, *Dir,* Big Horn County Historical Museum, Hardin MT

Schell, Edwin, *Exec Sec,* United Methodist Historical Society, Lovely Lane Museum, Baltimore MD

Schell, Edwin, *Secy,* United Methodist Historical Society, Library, Baltimore MD

Schell, Nancy, *Exec Dir,* New Brunswick Arts Council Inc, Saint John NB

Schell, William H, *Dir,* Martin Memorial Library, York PA

Schelsser, Edward, *Chief Exhib,* Hirshhorn Museum & Sculpture Garden, Smithsonian Institution, Washington DC

Schenck, Marvin, *Cur,* City of Ukiah, Grace Hudson Museum & The Sun House, Ukiah CA

Schenk, Joe, *Exec Dir,* Thomas Gilcrease, Gilcrease Museum, Tulsa OK

Schenk, Joseph B, *Dir,* Mobile Museum of Art, Library, Mobile AL

Scher, Anne J, *Dir Communications,* The Jewish Museum, New York NY

Scherpereel, Richard, *Prof,* Texas A&M University-Kingsville, Art Dept, Kingsville TX (S)

Schertz, Peter, *Cur Ancient Art,* Virginia Museum of Fine Arts, Richmond VA

Scheu, David R, *Exec Dir,* State of North Carolina, Battleship North Carolina, Wilmington NC

Schiaro, Laura, *Cur,* Historical Society of Washington DC, The City Museum of Washington DC, Washington DC

Schick, Marjorie K, *Prof,* Pittsburg State University, Art Dept, Pittsburg KS (S)

Schieferdecker, Marilyn, *Dir,* Arts Council of Greater Kingsport, Renaissance Center Main Gallery, Kingsport TN

Schiemann, Larry, *Dir,* Ashland College Arts & Humanities Gallery, The Coburn Gallery, Ashland OH

Schienbaum, David, *Asst Prof,* College of Santa Fe, Art Dept, Santa Fe NM (S)

Schierman, Mary Ann, *Dir Vol,* McLean County Historical Society, McLean County Museum of History, Bloomington IL

Schiever, Lawrence, *Treas,* Amerind Foundation, Inc, Amerind Museum, Fulton-Hayden Memorial Art Gallery, Dragoon AZ

Schiff, Jeffrey, *Assoc Prof,* Wesleyan University, Dept of Art & Art History, Middletown CT (S)

Schiffer, Tim, *Exec Dir,* Ventura County Historical Society, Museum of History & Art, Ventura CA

Schifferdecker, Patrick, *Site Mgr,* Minnesota Historical Society, North West Company Fur Post, Saint Paul MN

Schiller, Joyce, *Assoc Cur 19th & 20th Century,* Delaware Art Museum, Wilmington DE

Schiller, Joyce K, *Cur American Art,* Reynolda House Museum of American Art, Winston Salem NC

Schilling, Eugene, *Prof Art,* Adams State College, Dept of Visual Arts, Alamosa CO (S)

Schillings, Chuck, *Exec Dir,* Omniplex, Oklahoma City OK

Schillizzi, Chris, *Chief Interpretation,* Independence National Historical Park, Library, Philadelphia PA

Schillo, Deb, *Librn,* Southern Highland Craft Guild, Folk Art Center, Asheville NC

Schimenti, Margie, *Board Dir,* Artists' Cooperative Gallery, Omaha NE

Schimmel, Paul, *Chief Cur,* The Museum of Contemporary Art (MOCA), Los Angeles CA

Schimmelman, Janice G, *Chmn Dept,* Oakland University, Dept of Art & Art History, Rochester MI (S)

Schimmelpfennig, Rob, *Pres,* Ashtabula Arts Center, Ashtabula OH

Schindel, Terri, *Cur Costumes,* Boulder History Museum, Museum of History, Boulder CO

Schindler, Annette, *Dir,* Swiss Institute, New York NY

Schindler, Richard, *Adjunct Asst Prof,* Spokane Falls Community College, Fine Arts Dept, Spokane WA (S)

Schipporeit, George, *Assoc Prof,* Illinois Institute of Technology, College of Architecture, Chicago IL (S)

Schirm, David, *Chmn, Prof,* University at Buffalo, State University of New York, Dept of Visual Studies, Buffalo NY (S)

Schisla, Gretchen, *Assoc Prof,* University of Missouri, Saint Louis, Dept of Art & Art History, Saint Louis MO (S)

Schitinger, Jim, *Dir Gall,* Millikin University, Perkinson Gallery, Decatur IL

Schlanger, Gregg, *Assoc Prof,* Austin Peay State University, Dept of Art, Clarksville TN (S)

Schlatter, N Elizabeth, *Asst Dir,* University of Richmond, University Museums, Richmond VA

Schlawin, Judy, *Prof,* Winona State University, Dept of Art, Winona MN (S)

Schlee, Kathryn, *Librn & Cur Research Coll,* Old Salem Inc, Library and Research Center, Winston-Salem NC

Schlee, Katie, *Librn & Cur Research Coll,* Old Salem Inc, Museum of Early Southern Decorative Arts, Winston-Salem NC

Schlegel, Amy Ingrid, *Cur,* Philadelphia Art Alliance, Philadelphia PA

Schlegel, Amy Ingrid, *Dir,* Tufts University, Tufts University Art Gallery, Medford MA

Schleicher, Sarah J, *Art Mobile Cur,* University of Wyoming, University of Wyoming Art Museum, Laramie WY

Schlesier, Dona, *Assoc Prof Art,* Divine Word College, Father Weyland SVD Gallery, Epworth IA

Schlesier, Douglas, *Prof Art,* Clarke College, Dept of Art, Dubuque IA (S)

Schlesinger, Heather, *Office Mgr,* Marietta-Cobb Museum of Art, Marietta GA

Schlesinger, Kyle, *Vis Asst Prof,* University at Buffalo, State University of New York, Dept of Visual Studies, Buffalo NY (S)

Schleuter, Marilyn, *Operation Mgr,* Rome Art & Community Center, Rome NY

Schlichting, Eunice, *Chief Cur,* Putnam Museum of History and Natural Science, Davenport IA

Schlichting, Eunice, *Chief Cur,* Putnam Museum of History and Natural Science, Library, Davenport IA

Schlimmer, Alexa, *Asst Prof,* High Point University, Fine Arts Dept, High Point NC (S)

Schlinke, John, *Architecture Art Librn,* Roger Williams University, Architecture Library, Bristol RI

Schlitt, Melinda, *Prof,* Dickinson College, Dept Fine Arts & History, Carlisle PA (S)

Schlorff, Cara, *Mgr ILL Artisans Shop,* Illinois State Museum, Illinois Artisans Shop, Chicago IL

Schlorff, Cara, *Mus Shop Mgr,* Illinois State Museum, Museum Store, Chicago IL

Schlosser, Tom, *Chmn Dept,* College of Saint Mary, Art Dept, Omaha NE (S)

Schlottman, Kerri, *Develop Dir,* Detroit Artists Market, Detroit MI

Schmaljohn, Russell, *Asst Prof,* Northwest Missouri State University, Dept of Art, Maryville MO (S)

Schmandt, Marianne, *FAU Marketing Intern,* Broward County Board of Commissioners, Cultural Affairs Div, Fort Lauderdale FL

Schmeichel, Carol, *Dean Students,* Jamestown College, Art Dept, Jamestown ND (S)

Schmidd, Robert, *Prof,* Norwich University, Dept of Architecture and Art, Northfield VT (S)

Schmidel, Deirdre, *Librn,* Newark Public Library, Reference, Newark NJ

Schmidlapp, Don, *Assoc Prof,* Winona State University, Dept of Art, Winona MN (S)

Schmidt, Alicia, *Ops Mgr,* Film Arts Foundation, San Francisco CA

Schmidt, Carolyn, *CFO,* Missouri Historical Society, Saint Louis MO

Schmidt, Edward, *Bd Dir,* Grand River Museum, Lemmon SD

Schmidt, Edward, *Instr,* New York Academy of Art, Graduate School of Figurative Art, New York NY (S)

Schmidt, Eirka, *Asst Prof,* Florida Southern College, Art Dept, Lakeland FL (S)

Schmidt, Eleanore, *Dir Libr Servs,* Long Beach Public Library, Long Beach CA

Schmidt, Erika, *Adjunct Asst Prof Art,* Florida Southern College, Melvin Art Gallery, Lakeland FL

Schmidt, Ferne, *Second VPres,* San Bernardino Art Association, Inc, Sturges Fine Arts Center, San Bernardino CA

Schmidt, Kenneth, *Prof,* Concordia College, Art Dept, Seward NE (S)

Schmidt, Kristen, *Asst Registrar,* Tucson Museum of Artand Historic Block, Tucson AZ

Schmidt, Lawrence, *Exec Dir,* The Noyes Museum of Art, Library, Oceanville NJ

Schmidt, Lisa, *Bd Dir,* Grand River Museum, Lemmon SD

Schmidt, Mary, *Assoc Head,* Carnegie Mellon University, School of Art, Pittsburgh PA (S)

Schmidt, Maurice, *Prof,* Texas A&M University-Kingsville, Art Dept, Kingsville TX (S)

Schmidt, Patrick T, *Asst Prof,* Washington & Jefferson College, Art Dept, Washington PA (S)

Schmidt, Peter, *Facilities Mgr,* The Art School at Old Church, Demarest NJ (S)

Schmidt, Phyllis, *Bd Dir,* Grand River Museum, Lemmon SD

Schmidt, Stuart, *Pres, Bd Dir,* Grand River Museum, Lemmon SD

Schmidt, Susan S, *Assoc Prof,* College of the Holy Cross, Dept of Visual Arts, Worcester MA (S)

Schmiegel, Karol A, *Dir,* Biggs Museum of American Art, Dover DE

Schmierbach, Amy, *Asst Prof,* Fort Hays State University, Dept of Art, Hays KS (S)

Schmits, John, *Chmn,* Saint Ambrose University, Art Dept, Davenport IA (S)

Schmitt, Helmut, *Dir,* Merritt College, Art Dept, Oakland CA (S)

Schmoyer, Hadley A, *Cur,* Portland Harbor Museum, South Portland ME

Schmuckli, Claudia, *Dir Pub Relations,* Art Museum of the University of Houston, Blaffer Gallery, Houston TX

Schnabel, JoAnn, *Prof,* University of Northern Iowa, Dept of Art, Cedar Falls IA (S)

Schnackenberg, Elliot, *Instr,* Milwaukee Area Technical College, Graphic Arts Div, Milwaukee WI (S)

Schneider, Claire, *Assoc Cur,* The Buffalo Fine Arts Academy, Albright-Knox Art Gallery, Buffalo NY

Schneider, Elsa, *Public Relations Dir,* The Historic New Orleans Collection, New Orleans LA

Schneider, Gary, *Artist in Res,* State University of New York at Stony Brook, Dept of College of Arts & Sciences, Art Dept, Stony Brook NY (S)

Schneider, Julie, *Adjunct Assoc Prof,* University of Pennsylvania, Graduate School of Fine Arts, Philadelphia PA (S)

Schneider, Karen, *Librn,* The Phillips Collection, Washington DC

Schneider, Karen, *Librn,* The Phillips Collection, Library, Washington DC

Schneider, Laurie, *Prof,* John Jay College of Criminal Justice, Dept of Art, Music & Philosophy, New York NY (S)

Schneider, Minna, *Dir,* Abigail Adams Smith, New York NY

Schneider, Richard, *Assoc Prof,* Cleveland State University, Art Dept, Cleveland OH (S)

Schneider, U, *Instr Visual Arts,* Sarah Lawrence College, Dept of Art History, Bronxville NY (S)

Schneidermann, Cheryl, *Instr,* Marylhurst University, Art Dept, Marylhurst OR (S)

Schnell, Eric, *Instr,* Brazosport College, Art Dept, Lake Jackson TX (S)

Schneph, Scott, *Chmn,* University of New Hampshire, Dept of Arts & Art History, Durham NH (S)

Schnikter, Karen, *Dir Library,* Union of American Hebrew Congregations, Synagogue Art & Architectural Library, New York NY

Schoch, Gloria, *Pub Rels Dir,* Museo De Las Americas, Denver CO

Schoenbaum, Mark, *Instr,* University of Evansville, Art Dept, Evansville IN (S)

Schoenfeld, Judy, *Chmn,* Mason County Museum, Mason TX

Schoenfelder, Lisa, *Chmn,* Viterbo College, Art Dept, La Crosse WI (S)

Schoenwaldt, Karen, *Registrar,* The Rosenbach Museum & Library, Philadelphia PA

Schoenwetter, Hilda, *Corresp Secy,* Plastic Club, Art Club, Philadelphia PA

Schofield, Amy, *Ref Librn,* Parsons School of Design, Adam & Sophie Gimbel Design Library, New York NY

Schol, Don R, *Assoc Dean,* University of North Texas, School of Visual Arts, Denton TX (S)

Scholder, Laurence, *Prof,* Southern Methodist University, Division of Art, Dallas TX (S)

Scholten , Lisa, *Cur Marghab Coll,* South Dakota State University, South Dakota Art Museum, Brookings SD

Schoonover, Larry, *Deputy Dir,* Eastern Washington State Historical Society, Library, Spokane WA

Schoonover, Larry, *Dir Exhibits/Progs,* Eastern Washington State Historical Society, Northwest Museum of Arts & Culture, Spokane WA

Schorr, David, *Prof,* Wesleyan University, Dept of Art & Art History, Middletown CT (S)

Schorr, Elizabeth A., *Registrar,* City of El Paso, El Paso TX

Schorsch, Ismar, *Pres,* Leo Baeck, New York NY

Schorske, Bonnie, *Recording Secy,* Plastic Club, Art Club, Philadelphia PA

Schott, Daniel, *Program Assoc,* National Alliance for Media Arts & Culture, San Francisco CA

Schott, Gene A, *Dir,* Heritage Museums & Gardens, Sandwich MA

Schousen, Steve, *Prof,* Aquinas College, Art Dept, Grand Rapids MI (S)

Schoyer, Elizabeth, *Studio Faculty,* University of Virginia, McIntire Dept of Art, Charlottesville VA (S)

Schram, Chris, *VPres, Prog,* National Foundation for Advancement in the Arts, Miami FL

Schrand, Richard, *Dept Chair, Computer Graphics,* Nossi College of Art, Goodlettsville TN (S)

Schranom, Harry, *Pres (V),* The Cultural Center of Fine Arts, Art Gallery, Parkersburg WV

Schreiber, Monica, *Departmental Secy,* Florida Southern College, Melvin Art Gallery, Lakeland FL

Schreiber, Susan, *VPres Programs,* Historical Society of Washington DC, The City Museum of Washington DC, Washington DC

Schriber, Stephanie, *Pres,* Santa Cruz Art League, Inc, Center for the Arts, Santa Cruz CA

Schrock, Eileen, *VPres,* Phelps County Historical Society, Nebraska Prairie Museum, Holdrege NE

Schrock, Peggy, *Asst Prof,* Murray State University, Dept of Art, Murray KY (S)

Schroder, Anne, *Adjunct Asst Prof,* Duke University, Dept of Art, Art History & Visual Studies, Durham NC (S)

Schroder, R. Scott, *Dir Develop,* Brandywine River Museum, Chadds Ford PA

Schroeder, Chuck, *Exec Dir,* National Cowboy & Western Heritage Museum, Oklahoma City OK

Schroeder, Elaine, *Admin Asst,* Rahr-West Art Museum, Manitowoc WI

Schroeder, George, *Prof,* Hiram College, Art Dept, Hiram OH (S)

Schroeder, Ivy, *Chmn Dept,* Southern Illinois University at Edwardsville, Dept of Art & Design, Edwardsville IL (S)

Schroeder, Mary, *Registrar,* Wadsworth Atheneum Museum of Art, Hartford CT

Schroepfer, Dave, *Financial Officer,* Rockford Art Museum, Rockford IL

Schroer, Sher, *Dir Operations,* Newport Art Museum, Newport RI

Schroth, Adella, *Cur Anthropology,* San Bernardino County Museum, Fine Arts Institute, Redlands CA

Schroth, Sarah, *Adjunct Assoc Prof,* Duke University, Dept of Art, Art History & Visual Studies, Durham NC (S)

Schroth, Sarah, *Cur,* Duke University, Duke University Museum of Art, Durham NC

Schubert, Jason, *Dir,* Philmont Scout Ranch, Philmont Museum, Cimarron NM

Schubert, Jason, *Dir,* Philmont Scout Ranch, Seaton Memorial Library, Cimarron NM

Schubert, Michael, *Pres,* Muskegon Museum of Art, Muskegon MI

Schubert, Steven, *Exec Dir,* Graphic Artists Guild, New York NY

Schueler, Dean A, *Develop Dir,* Augustana College, Center for Western Studies, Sioux Falls SD

Schueler, Paul, *Cir Coll,* Tippecanoe County Historical Association, Museum, Lafayette IN

Schueler, Paul J, *Dir Colls & Library,* Tippecanoe County Historical Association, Alameda McCollough Library, Lafayette IN

Schuessler, Richard, *Asst Prof,* University of Nebraska, Kearney, Dept of Art & Art History, Kearney NE (S)

Schulenberg, Melissa, *Asst Prof,* St Lawrence University, Dept of Fine Arts, Canton NY (S)

Schuler, Jane, *Prof,* York College of the City University of New York, Fine & Performing Arts, Jamaica NY (S)

Schulhof, Hannelore, *VPres,* The American Federation of Arts, New York NY

Schultz, Judy, *Cur Educ,* Portland Art Museum, Portland OR

Schultz, Kathryn, *Dir,* Cambridge Art Association, Cambridge MA

Schultz, Robert, *Supv,* Mesa Arts Center, Mesa Contemporary Arts , Mesa AZ

Schulz, Andrew P, *Assoc Prof Art,* Seattle University, Fine Arts Dept, Division of Art, Seattle WA (S)

Schulz, Cornelia, *University of California, Davis,* Dept of Art & Art History, Davis CA (S)

Schulz, Emily L, *Deputy Dir & Cur,* Society of the Cincinnati, Museum & Library at Anderson House, Washington DC

Schulz, Regine, *Cur Ancient Art,* Walters Art Museum, Library, Baltimore MD

Schulz, Roswitha, *Bd Dir, VChmn,* Plumas County Museum, Museum Archives, Quincy CA

Schulze, Michele, *Dir Develop,* Tucson Museum of Artand Historic Block, Tucson AZ

Schumacher, Sheila, *Asst Prof Art,* Grand Canyon University, Art Dept, Phoenix AZ (S)

Schumaker, Julie, *Prog Mgr,* Boulder History Museum, Museum of History, Boulder CO

Schumann, Elka, *Mgr,* Bread & Puppet Theater Museum, Glover VT

Schumann, Max, *Mgr,* Printed Matter, Inc, New York NY

Schumann, Peter, *Artist,* Bread & Puppet Theater Museum, Glover VT

Schurmacher, Judy, *Bookkeeper,* Hammond Museum & Japanese Stroll Garden, Cross-Cultural Center, North Salem NY

Schussheim-Anderson, Rowen, *Chmn Dept,* Augustana College, Art Dept, Rock Island IL (S)

Schuster, Barbara R, *Registrar,* Bradford Brinton, Big Horn WY

Schuster, Kenneth L, *Dir & Chief Cur,* Bradford Brinton, Big Horn WY

Schuster, Sarah, *Assoc Prof,* Oberlin College, Dept of Art, Oberlin OH (S)

Schutt, Maria, *Instr,* Cornell College, Peter Paul Luce Gallery, Mount Vernon IA

Schutte, Richard, *Treas,* Valley Art Center Inc, Clarkston WA

Schutz, Tim, *Pres,* The Art Institutes, The Art Institute of Seattle, Seattle WA (S)

Schuyler, Leslie, *Communications Coordr,* Henry Gallery Association, Henry Art Gallery, Seattle WA

Schuyler, Michael, *Asst Librn,* Munson-Williams-Proctor Arts Institute, Art Reference Library, Utica NY

Schuyler-King, Lynn, *Financial Officer,* San Jose Museum of Art, Library, San Jose CA

Schwab, Michael C, *Media Arts & Animation,* Art Institute of Pittsburgh, Pittsburgh PA (S)

Schwab, Norman, *Chmn,* Los Angeles City College, Dept of Art, Los Angeles CA (S)

Schwab, Steve, *Dir Educ,* Art Institute of Fort Lauderdale, Fort Lauderdale FL (S)

Schwab-Dorfman, Debbie, *Dir Bus Develop,* The Jewish Museum, New York NY

Schwabach, James Bruce, *Assoc Prof,* Herkimer County Community College, Humanities Social Services, Herkimer NY (S)

Schwager, Michael, *Art Chmn,* Sonoma State University, Art & Art History Dept, Rohnert Park CA (S)

Schwager, Michael, *Dir,* Sonoma State University, University Art Gallery, Rohnert Park CA

Schwager, Sue, *Assoc Secy,* John Simon Guggenheim, New York NY

Schwam, Gena, *Interim Cur Art,* Eastern Washington State Historical Society, Library, Spokane WA

Schwappach-Shirriff, Lisa, *Cur,* Rosicrucian Egyptian Museum & Planetarium, Rosicrucian Order, A.M.O.R.C., San Jose CA

Schwarm, Larry, *Prof,* Emporia State University, Dept of Art, Emporia KS (S)

Schwartz, Abby S, *Cur Educ,* Cincinnati Institute of Fine Arts, Taft Museum of Art, Cincinnati OH

Schwartz, Amy, *Deputy Dir Educ & Studio,* Corning Museum of Glass, The Studio, Rakow Library, Corning NY

Schwartz, Carole, *Dept Head,* Jacksonville Public Library, Fine Arts & Recreation Dept, Jacksonville FL

Schwartz, Constance, *Dir & Chief Cur,* Nassau County Museum of Fine Art, Roslyn Harbor NY

Schwartz, David, *Chief Cur Film & Video,* American Museum of the Moving Image, Astoria NY

Schwartz, Deborah, *Managing Dir,* New Langton Arts, San Francisco CA

Schwartz, Judith, *Dir,* University of Toronto, Justina M Barnicke Gallery, Toronto ON

Schwartz, Judith S, *Dir Undergraduate Studies,* New York University, Dept of Art & Art Professions, New York NY (S)

Schwartz, Lorraine, *Assoc Prof,* Western Illinois University, Art Dept, Macomb IL (S)

Schwartz, Melanie, *Prof,* Southwestern Oregon Community College, Visual Arts Dept, Coos Bay OR (S)

Schwartz, Michael, *Prof,* Augusta State University, Dept of Arts, Augusta GA (S)

Schwartz, Robin, *Asst Prof,* William Paterson University, Dept Arts, Wayne NJ (S)

Schwartz, Samuel, *Chmn,* Winterthur Gardens & Library, Winterthur DE

Schwartzbaum, Paul, *Conservator,* Solomon R Guggenheim, New York NY

Schwarzer, Lynn, *Assoc Prof,* Colgate University, Dept of Art & Art History, Hamilton NY (S)

Schwegler, Amanda, *Graphic Designer,* University of Kansas, Spencer Museum of Art, Lawrence KS

Schweitzer, Julie, *Art Dir,* Carnegie Center for Art & History, New Albany IN

Schweitzer, Rob, *Dir Pub Relations,* Historic Hudson Valley, Tarrytown NY

Schweitzer, Tricia, *Gallery Mgr,* University of Minnesota, Paul Whitney Larson Gallery, Saint Paul MN

Schweizer, Paul D, *Dir,* Munson-Williams-Proctor Arts Institute, Museum of Art, Utica NY

Schwender, Judy, *Cur & Registrar,* Museum of the American Quilter's Society, Paducah KY

Schwetman, Sondra, Fort Hays State University, Dept of Art, Hays KS (S)

Schwitzner, Ted, *Pub Servs Librn,* North Central College, Oesterle Library, Naperville IL

Sciacca, Lucille, *Museum Educator,* Philipse Manor Hall State Historic Site, Yonkers NY

Scime, Toniann, *Librn,* Amherst Museum, Neiderlander Research Library, Amherst NY

Sconyers, Jim, *Asst Prof,* Mary Baldwin College, Dept of Art & Art History, Staunton VA (S)

Scott, A M, *Instr,* Humboldt State University, College of Arts & Humanities, Arcata CA (S)

Scott, Ann, *Ref Librn,* Kansas State University, Paul Weigel Library of Architecture Planning & Design, Manhattan KS

Scott, Anthony, *Communications Coordr,* Eiteljorg Museum of American Indians & Western Art, Indianapolis IN

Scott, Bobbie, *Vol/Educ,* Paine Art Center & Gardens, Oshkosh WI

Scott, Carson, *Dept Chmn,* East Los Angeles College, Art Dept, Monterey Park CA (S)

Scott, Charlie, University of Manitoba, School of Art, Winnipeg MB (S)

Scott, Christina, *Administrator,* Albany Institute of History & Art, Albany NY

Scott, Curtis, *Publications Mgr,* Sterling & Francine Clark, Williamstown MA

Scott, Darwin, *Librn,* Brandeis University, Leonard L Farber Library, Waltham MA

Scott, David, *Interim Head,* Angelo State University, Art & Music Dept, San Angelo TX (S)

Scott, Donals, *Deputy Librn,* Library of Congress, Prints & Photographs Division, Washington DC

Scott, Donna A, *Asst Dir Administration,* National Museum of the American Indian, George Gustav Heye Center, New York NY

Scott, Elizabeth, *Program Asst,* Rocky Mount Arts Center, Rocky Mount NC

Scott, Ernesto, *In Charge Photography,* University of Illinois, Urbana-Champaign, School of Art & Design, Champaign IL (S)

Scott, Henrietta, *Instr,* Campbellsville University, Department of Art, Campbellsville KY (S)

Scott, Jan, *Dir,* Sid W Richardson, Sid Richardson Museum, Fort Worth TX

Scott, Jesse, *Prog Asst,* Open Space, Victoria BC

Scott, John, *Assoc Prof,* University of Florida, Dept of Art, Gainesville FL (S)

Scott, John T, *Prof,* Xavier University of Louisiana, Dept of Fine Arts, New Orleans LA (S)

Scott, Jonathon, *Head Dept,* Castleton State College, Art Dept, Castleton VT (S)

Scott, Judy, *Exec Asst,* Royal Architectural Institute of Canada, Ottawa ON

Scott, Judy, *Exec Asst,* Royal Architectural Institute of Canada, Library, Ottawa ON

Scott, Julie, *Dir,* Rosicrucian Egyptian Museum & Planetarium, Rosicrucian Order, A.M.O.R.C., San Jose CA

Scott, Laurel, *Assoc Prof,* University of Wisconsin-Superior, Programs in the Visual Arts, Superior WI (S)

Scott, Stanley, *Dir,* Colorado State University, Curfman Gallery, Fort Collins CO

Scott, Steve, *Marketing Mgr,* Caspers, Inc, Art Collection, Tampa FL

Scott, Sue, *Press Liasion,* Independent Curators International, New York NY

Scott, Teresa S, *Co Dir,* Coutts Memorial Museum of Art, Inc, El Dorado KS

Scott, William, *Chmn Theater,* Idyllwild Arts Academy, Idyllwild CA (S)

Scott-Stewart, Diane, *Exec Dir,* Nova Scotia Association of Architects, Halifax NS

Scully, Cammie V, *Dir,* Waterloo Center of the Arts, Waterloo IA

Seabnoks, Nettie, *COO,* Detroit Institute of Arts, Detroit MI

Seabold, Thomas, *Dir,* Keokuk Art Center, Keokuk IA

Seabrook, Debra, *Art Dir,* St Thomas-Elgin Public Art Centre, Saint Thomas ON

Seabury, Linda, *Dir Communications,* New Hampshire Institute of Art, Manchester NH

Seacord, Cynthia, *Secy Bd Trustees,* Schenectady County Historical Society, Museum of Schenectady History, Schenectady NY

Seals, Hershall, *Chmn,* University of Mary Hardin-Baylor, School of Fine Arts, Belton TX (S)

Searles, Rose, *Head Circulation Dept,* Springfield Free Public Library, Donald B Palmer Museum, Springfield NJ

Searls-McConnel, Maryse, *Assoc Prof,* University of New Hampshire, Dept of Arts & Art History, Durham NH (S)

Sears, Nancy, *Dir of Community and Donor Relations,* Henry Gallery Association, Henry Art Gallery, Seattle WA

Sears, Stanton, *Assoc Prof,* Macalester College, Art Dept, Saint Paul MN (S)

Seay, Pamela R, *Dir Develop & Pub Relations,* Virginia Historical Society, Library, Richmond VA

Sebald, Romi, *Registrar,* Potsdam College of the State University of New York, Roland Gibson Gallery, Potsdam NY

Sebberson, David, *Chair,* Saint Cloud State University, Dept of Art, Saint Cloud MN (S)

Seckelson, Linda, *Head Reader Servs,* The Metropolitan Museum of Art, Thomas J Watson Library, New York NY

Seckinger, Craig, *Instr Drawing & Design,* Bay De Noc Community College, Art Dept, Escanaba MI (S)

Seckinger, Linda, *Prof,* Mississippi State University, Dept of Art, Mississippi State MS (S)

Secrest, Donna, *Office Mgr,* Ponca City Art Association, Ponca City OK

See, Prudence, *Asst Gallery Mgr,* Woodstock Artists Association, Woodstock NY

Seeds, Jennifer, *Assoc Registrar Exhibs,* Columbus Museum of Art, Columbus OH

Seeley, J, *Prof,* Wesleyan University, Dept of Art & Art History, Middletown CT (S)

Seeman, Bonnie, *Instr,* University of Miami, Dept of Art & Art History, Coral Gables FL (S)

Seeman, Rebecca, *Instr,* Art Academy of Cincinnati, Cincinnati OH (S)

Seemans, Jessrey, *Pres Board,* Rehoboth Art League, Inc, Rehoboth Beach DE

Sefcik, James F, *Dir,* Louisiana Department of Culture, Recreation & Tourism, Louisiana Historical Center Library, New Orleans LA

Segall, Andrea, *Librn,* Berkeley Public Library, Berkeley CA

Segalman, Richard, *Instr,* Woodstock School of Art, Inc, Woodstock NY (S)

Segger, Martin, *Dir & Cur,* University of Victoria, Maltwood Art Museum and Gallery, Victoria BC

Seghers, George D, *Exec Secy & Treas,* George Washington, Alexandria VA

Seibert, Liz, *Admin Asst,* Owensboro Museum of Fine Art, Owensboro KY

Seibert, Peter S, *Exec Dir,* Heritage Center of Lancaster County Museum, Lancaster PA

Seiden, Jane, *Principal Librn,* Newark Public Library, Reference, Newark NJ

Seidl, Joan, *Cur History,* Vancouver Museum, Vancouver BC

Seif, Denise, *Gallery Dir,* Parkland College, Art Gallery, Champaign IL

Seigel, Judy, *Educ,* Midmarch Associates, Women Artists Archive and Library, New York NY

Seitz, Becca, *Dep Dir for Marketing & Communications,* The Baltimore Museum of Art, Baltimore MD

Seitz, Carole, *Instr,* Creighton University, Fine & Performing Arts Dept, Omaha NE (S)

Seiz, Janet, *Faculty,* Saint Ambrose University, Art Dept, Davenport IA (S)

Seiz, John, *Instr,* Springfield College in Illinois, Dept of Art, Springfield IL (S)

Selbe, Nancy, *Dir,* Deines Cultural Center, Russell KS

Selby, Robert, *Instr,* Pacific Northwest College of Art, Portland OR (S)

Selden, Scott, *Instr,* Mohawk Valley Community College, Utica NY (S)

Seley, Beverly, *Prof,* Grand Valley State University, Art & Design Dept, Allendale MI (S)

Self, Dana, *Cur of Colls & Exhibs,* Knoxville Museum of Art, Knoxville TN

Seligman, Thomas K, *Dir,* Stanford University, Iris & B Gerald Cantor Center for Visual Arts, Stanford CA

Seline, Janice, *Assoc Cur Film & Video,* National Gallery of Canada, Ottawa ON

Sellars, Steven, *Asst Prof,* Cardinal Stritch University, Art Dept, Milwaukee WI (S)

Selle, Thomas, *Co-Chmn,* Carroll College, Art Dept, Waukesha WI (S)

Selleck, Laurie, *Asst Prof,* Cazenovia College, Center for Art & Design Studies, Cazenovia NY (S)

Sellin, Christine, *Asst Prof,* California Lutheran University, Art Dept, Thousand Oaks CA (S)

Sells, Lorelei, *Educ,* Deer Valley Rock Art Center, Glendale AZ

Seltzer, Dan S, *Prof of Art,* Transylvania University, Studio Arts Dept, Lexington KY (S)

Seltzer, Karen, *Asst Dir,* Hoosier Salon Patrons Association, Inc, Art Gallery, Indianapolis IN

Selz, Bernard, *Vics Chm,* Brooklyn Museum, Brooklyn NY

Semerena, Wade, *Prof,* Miami-Dade Community College, Arts & Philosophy Dept, Miami FL (S)

Semivan, Doug, *Chmn Art Dept,* Madonna University, Art Dept, Livonia MI (S)

Semler, Jerry, *VPres,* Hoosier Salon Patrons Association, Inc, Art Gallery, Indianapolis IN

Semowich, Charles, *Cur,* Print Club of Albany, Albany NY

Sendecki, Heidi, *VPres & Cur,* Chase Manhattan, New York NY

Senie, Harriet, *Prof,* City University of New York, PhD Program in Art History, New York NY (S)

Senie, Harriet F, *Dir Museum Studies,* City College of New York, Art Dept, New York NY (S)

Senior, Gordon, *Chmn Dept,* California State University, Art Dept, Turlock CA (S)

Senior, Heidi, *Reference Librn,* University of Portland, Wilson W Clark Memorial Library, Portland OR

Seniuk, Jake, *CEO,* Port Angeles Fine Arts Center, Port Angeles WA

Senn, Barbara, *Admin Asst,* The Pomona College, Montgomery Gallery, Claremont CA

Senn, Carol Johnson, *Dir,* McDowell House & Apothecary Shop, Danville KY

Senn, Kurt, *Dir,* Missouri Department of Natural Resources, Elizabeth Rozier Gallery, Jefferson City MO

Senn, Kurt, *Mus Dir,* Missouri Department of Natural Resources, Missouri State Museum, Jefferson City MO

Sennefeld, Jacques, *Webmaster,* The Turner Museum, Sarasota FL

Sensenig, Pauline, *VChmn,* Sioux City Art Center, Sioux City IA (S)

Serebrennikov, Nina, *Asst Prof,* Davidson College, Art Dept, Davidson NC (S)

Serenco, Henry, *Assoc Prof,* University of Nebraska at Omaha, Dept of Art & Art History, Omaha NE (S)

Serfass, Jan, *Asst,* Plymouth State University, Karl Drerup Art Gallery, Plymouth NH

Serfaty, Gail F, *Dir,* US Department of State, Diplomatic Reception Rooms, Washington DC

Serio, Alexis, *Asst Prof,* Florida Southern College, Art Dept, Lakeland FL (S)

Serio, Alexis, *Asst Prof,* University of Texas at Tyler, Deptartment of Art, School of Visual & Performing Arts, Tyler TX (S)

Serio, Faye, *Assoc Prof,* St Lawrence University, Dept of Fine Arts, Canton NY (S)

Serroes, Richard, *Instr,* Modesto Junior College, Arts Humanities & Communications Division, Modesto CA (S)

Sertic, Allison, *Communications Mgr,* Sierra Arts Foundation, Reno NV

Servan, Jody, *Asst Cur,* Palm Beach Institute of Contemporary Art, Museum of Art, Lake Worth FL

Servetas, John, *Treas,* Federation of Modern Painters & Sculptors, New York NY

Sessions, Billie, *Instr,* California State University, San Bernardino, Dept of Art, San Bernardino CA (S)

Sessums, Danny M, *Cur,* Museum of Southern History, Sugarland TX

Sethem, Brian, *Asst Prof,* California Lutheran University, Art Dept, Thousand Oaks CA (S)

Sethi, Rebecca, *VPres Educ,* Please Touch Museum, Philadelphia PA

Sethi, Sanjit, *Dir Grad Studies,* Memphis College of Art, Memphis TN (S)

Settle, Gina, *Asst Dir,* Tippecanoe County Historical Association, Museum, Lafayette IN

Settle-Cooney, Mary, *Exec Dir,* Tennessee Valley Art Association, Tuscumbia AL

Settler, Faye, *Dir & Owner,* Upstairs Gallery, Winnipeg MB

Sevak, Amanda, *Office Mgr,* Judah L Magnes, Berkeley CA

Sever, Ziya, *Chmn Art,* Western Nebraska Community College, Division of Language & Arts, Scottsbluff NE (S)

Severe, Milton, *Exhib Design,* Grinnell College, Art Gallery, Grinnell IA

Severstad, Jami, *Cur,* Bergstrom-Mahler Museum, Neenah WI

Severtson, Johan, *Chmn Graphic Design,* Corcoran School of Art, Washington DC (S)

Sevigne, Nick, *Chmn,* Community College of Rhode Island, Dept of Art, Warwick RI (S)

Sevigney, Nichola, *Chmn,* Community College of Rhode Island, Art Department Gallery, Warwick RI

Sewell, Darrel L, *Cur American Art,* Philadelphia Museum of Art, Samuel S Fleisher Art Memorial, Philadelphia PA

Sewell, Dennita, *Cur Fashion Design,* Phoenix Art Museum, Phoenix AZ

Sexton, Randall, *Assoc Dir, Design,* San Jose State University, School of Art & Design, San Jose CA (S)

Sexton, Rives, *Interim Dir,* Albany Museum of Art, Albany GA

Seydler-Hepworth, Betty Lee, *Asst Dean,* Lawrence Technological University, College of Architecture, Southfield MI (S)

Seyl, Susan, *Dir Image Coll,* Oregon Historical Society, Oregon History Center, Portland OR

Seymour, Gayle, *Prof,* University of Central Arkansas, Department of Art, Conway AR (S)

Sfirri, Mark, *Instr,* Bucks County Community College, Fine Arts Dept, Newtown PA (S)

Sgrazzutti, William, *Music Librn,* University of Regina, Education/Fine Arts Library, Regina SK

Shaarhan, Jeff, *Prof,* Concordia University, Division of Performing & Visual Arts, Mequon WI (S)

Shady, Ronald L, *Chair, Prof,* University of North Alabama, Dept of Art, Florence AL (S)

Shafer, Anders, University of Wisconsin-Eau Claire, Dept of Art, Eau Claire WI (S)

Shafer, Phyllis, *Painting Instr,* Lake Tahoe Community College, Art Dept, South Lake Tahoe CA (S)

Shaffer, Bob, *Treas,* Octagon Center for the Arts, Ames IA

Shailer, Kathryn, *Dean Liberal Studies,* Ontario College of Art & Design, Toronto ON (S)

Shaken, Andy, *Asst Prof,* Oberlin College, Dept of Art, Oberlin OH (S)

Shaker, Andrea, *Asst Prof,* Saint John's University, Art Dept, Collegeville MN (S)

Shaker, Andrea, *Asst Prof,* College of Saint Benedict, Art Dept, Saint Joseph MN (S)

Shakespeare, Valerie, *Pres,* Actual Art Foundation, New York NY

Shalom, Karen, *Admin Dir,* The Art School at Old Church, Demarest NJ (S)

Shamblin, Barbara, *Chmn,* Salve Regina University, Art Dept, Newport RI (S)

Shames, Susan, *Decorative Arts Librn,* Colonial Williamsburg Foundation, John D Rockefeller, Jr Library, Williamsburg VA

Shamro, Joyhce, *Prof,* Bluefield State College, Division of Arts & Sciences, Bluefield WV (S)

Shanahan, Carl, *Chmn,* State University of New York College at Geneseo, Dept of Art, Geneseo NY (S)

Shand, Rhona E, *Asst Prof,* Pittsburg State University, Art Dept, Pittsburg KS (S)

Shaner, Carol, *Exhibits Librn,* Sarah Lawrence College Library, Esther Raushenbush Library, Bronxville NY

Shaner, Susan, *Cur,* Judiciary History Center, Honolulu HI

Shang, Xuhong, *Assoc Prof,* Southern Illinois University, School of Art & Design, Carbondale IL (S)

Shanis, Carole Price, *Pres,* Philadelphia Art Alliance, Philadelphia PA

Shank, Nick, *Dir,* University of Minnesota, Katherine E Nash Gallery, Minneapolis MN

Shankle, Kent, *Cur,* Waterloo Center of the Arts, Waterloo IA

Shanklin-Peterson, Scott, *Sr Deputy Chmn,* National Endowment for the Arts, Washington DC

Shankmiller, David, *Cur,* Dunedin Fine Arts & Cultural Center, Dunedin FL (S)

Shankweiler, David, *Exec Dir,* Greenville Museum of Art, Inc, Greenville NC

Shanley, Kevin, *Chmn Board of Trustees,* Newark Museum Association, The Newark Museum, Newark NJ

Shannon, Anna-Maria, *Asst Dir,* Washington State University, Museum of Art, Pullman WA

Shannon, Jenkins, *Develop Mem,* Pasadena Museum of California Art, Pasadena CA

Shannon, Linda, *Office Mgr,* The Lincoln Museum, Fort Wayne IN

Shannon, Lucia M, *Head Adult Serv,* Brockton Public Library System, Joseph A Driscoll Art Gallery, Brockton MA

Shapiro, Avra, *Dir Public Relations,* Simon Wiesenthal Center Inc, Museum of Tolerance, Los Angeles CA

Shapiro, Babe, *Faculty,* Maryland Institute, Mount Royal School of Art, Baltimore MD (S)

Shapiro, Cara, *Dir Educ,* Louisa May Alcott Memorial Association, Orchard House, Concord MA

Shapiro, David, *Prof,* William Paterson University, Dept Arts, Wayne NJ (S)

Shapiro, Denise, *District Gallery Dir,* Las Vegas-Clark County Library District, Las Vegas NV

Shapiro, Denise, *District Gallery Mgr,* Las Vegas-Clark County Library District, Flamingo Gallery, Las Vegas NV

Shapiro, Laura, *Volunteer Coordr,* Wing Luke Asian Museum, Seattle WA

Shapiro, Martin, *Coll Develop Librn,* American University, Jack & Dorothy G Bender Library & Learning Resources Center, Washington DC

Sharafy, Azyz, *Assoc Prof,* Washburn University of Topeka, Dept of Art, Topeka KS (S)

Sharer, Soudra J, *Financial Officer,* Telfair Museum of Art, Savannah GA

Sharkey, Cindy, *Asst to Dir,* College of William & Mary, Muscarelle Museum of Art, Williamsburg VA

Sharman, Karen, *Dir Human Resources,* Historic Hudson Valley, Tarrytown NY

Sharon, Dan, *Reference Librn,* Spertus Institute of Jewish Studies, Asher Library, Chicago IL

Sharp, Bert, *Chief Preparator,* Memphis Brooks Museum of Art, Memphis TN

Sharp, Kevin, *Cur American Art,* Norton Museum of Art, West Palm Beach FL

Sharp, Kevin, *Dir Visual Arts,* Cedarhurst Center for the Arts, Mitchell Museum, Mount Vernon IL

Sharp, Megan, *Dir,* Plainsman Museum, Aurora NE

Sharp, Paige, *Dir Educ,* Art Museum of Greater Lafayette, Lafayette IN

Sharp, Paige, *Dir of Educ,* Art Museum of Greater Lafayette, Library, Lafayette IN

Sharp, Pamela, *Art Educ Coordr,* San Jose State University, School of Art & Design, San Jose CA (S)

Sharpe, David, *Assoc Prof,* Illinois Institute of Technology, College of Architecture, Chicago IL (S)

Sharpe, Linda, *Librn,* Turtle Bay Exploration Park, Shasta Historical Society Research Library, Redding CA

Sharpe, Yolanda, *Instr,* State University of New York College at Oneonta, Dept of Art, Oneonta NY (S)

Sharps, David, *Pres & CEO,* Waterfront Museum, Brooklyn NY

Sharps, Nancy, *Instr,* Chadron State College, Dept of Art, Chadron NE (S)

Shaskan, Isabel, *Instr,* Sacramento City College, Art Dept, Sacramento CA (S)

Shastal, Belinda, *Secy,* Chicago Athenaeum, Museum of Architecture & Design, Galena IL

Shatzman, Merrill, *Assoc Prof Practice,* Duke University, Dept of Art, Art History & Visual Studies, Durham NC (S)

Shaul, David, *Instr,* Middle Tennessee State University, Art Dept, Murfreesboro TN (S)

Shaul, Mark, *Bd Dir Secy,* Plains Art Museum, Fargo ND

Shaw, Ali, *Develop Assoc,* Kentucky Museum of Art & Craft, Louisville KY

Shaw, Catherine Elliot, *Cur,* University of Western Ontario, McIntosh Gallery, London ON

Shaw, Diane, *Instr,* University of Utah, Dept of Art & Art History, Salt Lake City UT (S)

Shaw, Doris, *Exec Dir,* Putnam County Historical Society, Foundry School Museum, Cold Spring NY

Shaw, Frank, *Asst Prof,* Bethany College, Art Dept, Lindsborg KS (S)

Shaw, Haley, *Curatorial Asst,* Palm Beach Institute of Contemporary Art, Museum of Art, Lake Worth FL

Shawhan, Jeffrey, *Gallery Dir,* Concordia University Wisconsin, Fine Art Gallery, Mequon WI

Shay, Edward, *Prof,* Southern Illinois University, School of Art & Design, Carbondale IL (S)

Shay, Robert, *Dean,* University of Kentucky, Dept of Art, Lexington KY (S)

Shayne, Diana, *VPres,* Northwest Watercolor Society, Renton WA

Shea, Ann, *Librn,* California African-American Museum, Los Angeles CA

Shea, Beth, *Educ Chair,* Illinois State Museum, Museum Store, Chicago IL

Shea, Norman, *Pres,* Hagerstown Junior College, Art Dept, Hagerstown MD (S)

Sheaks, Barclay, *Assoc Prof,* Virginia Wesleyan College, Art Dept of the Humanities Div, Norfolk VA (S)

Shealy, Tony, *Deputy Dir Admin,* South Carolina State Museum, Columbia SC

Shearer, Christine, *Arts Admin,* Massillon Museum, Massillon OH

Shearer, Lee Ann, *Contact,* First State Bank, Norton KS

Shearer, Suzanne, *Mem Coordr,* Kentucky Derby Museum, Louisville KY

Sheary, Patrick, *Cur Historic Furnishings,* DAR Museum, Library, Washington DC

Shebairo, Richard, *Treas,* Artists Space, New York NY

Sheehan, Kathryn, *Registrar,* Rensselaer County Historical Society, Hart-Cluett Mansion, 1827, Troy NY

Sheehan, Kathryn, *Registrar,* Rensselaer County Historical Society, Museum & Library, Troy NY

Sheehan, Liz Kelton, *Asst Cur,* Bates College, Museum of Art, Lewiston ME

Sheehy, Carolyn A, *Dir,* North Central College, Oesterle Library, Naperville IL

Sheer, Doug, *Chmn Board of Dir,* Artists Talk on Art, New York NY

Sheets, Allen, *Prof,* Minnesota State University-Moorhead, Dept of Art, Moorhead MN (S)

Sheets, Luke, *Instr,* Ohio Northern University, Dept of Art, Ada OH (S)

Sheffer, Beth, *Coll Mgr,* National Museum of Racing, Reference Library, Saratoga Springs NY

Sheffield, Ellen, *Coordr,* Kenyon College, Olin Art Gallery, Gambier OH

Shein, Rich, *CFO,* New York Historical Society, New York NY

Shekore, Mark, *Prof,* Northern State University, Art Dept, Aberdeen SD (S)

Shelby, Shanna, *Registrar,* Museo de las Americas, Denver CO

Sheldon, Sara, *Assoc Museum Dir,* Leanin' Tree Museum of Western Art, Boulder CO

Sheley, David, *Dir & Cur,* Turner House Museum, Hattiesburg MS

Shell, Martin, *Asst Prof,* Springfield College, Dept of Visual & Performing Arts, Springfield MA (S)

Shelton, Betty, *Dean Fine Arts,* Art Institute of Southern California, Laguna Beach CA (S)

Shelton, Carol, *Gallery Asst,* Saint Paul's School, Art Center in Hargate, Concord NH

Shelton, Kay, *Chief Librn,* Alaska State Library, Alaska Historical Collections, Juneau AK

Shelton, Ronald G, *Cur Science & Technology,* South Carolina State Museum, Columbia SC

Shelton, Tom, *Photo Archivist,* The University of Texas at San Antonio, UTSA's Institute of Texan Cultures, San Antonio TX

Shen, Lester, *Chair, BS: Visualization,* Minneapolis College of Art & Design, Minneapolis MN (S)

Shen, Richard, *Adjunct Asst Prof,* New York Institute of Technology, Fine Arts Dept, Old Westbury NY (S)

Sheon, Aaron, *Prof Emeritus,* University of Pittsburgh, Henry Clay Frick Dept History of Art & Architecture, Pittsburgh PA (S)

Shepard, Bruce, *Dir,* University of Saskatchewan, Diefenbaker Canada Centre, Saskatoon SK

Shepard, E Lee, *Asst Dir Sr Archives,* Virginia Historical Society, Library, Richmond VA

Shephard, Charles A, *Dir,* Fort Wayne Museum of Art, Inc, Fort Wayne IN

Shepherd, Murray, *Univ Librn,* University of Waterloo, Dana Porter Library, Waterloo ON

Shepherd, Roxanne, *Campaign Dir,* Corporate Council for the Arts/Arts Fund, Seattle WA

Shepherd, Ryan, *Collections Librn,* Historical Society of Washington DC, Kiplinger Research Library, Washington DC

Sheppard, Adrian, *Prof,* McGill University, School of Architecture, Montreal PQ (S)

Sherer, Aaron, *Exec Dir,* Paine Art Center & Gardens, George P Nevitt Library, Oshkosh WI

Sheret, Mary Ames, *Cur Coll & Exhibs,* Southern Oregon Historical Society, Jacksonville Museum of Southern Oregon History, Medford OR

Sheret, Mary Ames, *Cur Colls,* State of North Carolina, Battleship North Carolina, Wilmington NC

Sherhofer, Ron, *Managing Dir Olin Fine Arts Ctr,* Washington & Jefferson College, Olin Fine Arts Center Gallery, Washington PA

Sheridan, Clare, *Librn,* American Textile History Museum, Lowell MA

Sheridan, Clare, *Librn,* American Textile History Museum, Library, Lowell MA

Sheridan, Phil, *Pub Affairs Officer,* Independence National Historical Park, Library, Philadelphia PA

Sheriff, Mary, *Chm & Prof,* University of North Carolina at Chapel Hill, Art Dept, Chapel Hill NC (S)

Sherk, Scott, *Assoc Prof,* Muhlenberg College, Dept of Art, Allentown PA (S)

Sherman, Gordon, Fort Hays State University, Dept of Art, Hays KS (S)

Sherman, James, *Public Serv Intern,* Broward County Board of Commissioners, Cultural Affairs Div, Fort Lauderdale FL

Sherman, Joy L, *Dir Choral Activities,* Seattle University, Fine Arts Dept, Division of Art, Seattle WA (S)

Sherman, Paul T, *Admin Services Librn,* New York City Technical College, Ursula C Schwerin Library, Brooklyn NY

Sherman, Sondra, *Asst Prof,* Rhode Island College, Art Dept, Providence RI (S)

Sherman, Todd, *Dept Chmn,* University of Alaska-Fairbanks, Dept of Art, Fairbanks AK (S)

Shernoff, Marcia, *Librn,* Fayetteville Museum of Art, Inc, Fayetteville NC

Sherrell, Steve, *Instr,* Joliet Junior College, Fine Arts Dept, Joliet IL (S)

Sherrock, Roger, *Dir Opers,* Clark County Historical Society, Heritage Center of Clark County, Springfield OH

Sherrock, Roger, *Dir Opers & Personnel,* Clark County Historical Society, Library, Springfield OH

Sherry, Christopher R, *Interior Design Prog Dir,* Brenau University, Art & Design Dept, Gainesville GA (S)

Sherry, James, *Pres,* Segue Foundation, Reading Room-Archive, New York NY

Sherwood, Heather, *Dir Grants & Government Relations,* Contemporary Arts Center, Cincinnati OH

Shestack, Alan, *Deputy Dir,* National Gallery of Art, Washington DC

Shevelew, Cynthia, *Develop Asst,* The Art School at Old Church, Demarest NJ (S)

Shewchuk, Diane, *Registrar,* Albany Institute of History & Art, Albany NY

Shiba, Hiromi, *Exec Dir,* Museo de Arte de Ponce, Library, Ponce PR

Shibata, Naomi, *Educ Dir,* National Park Service, Hubbell Trading Post National Historic Site, Ganado AZ

Shick, Andrew, *Dir,* Passaic County Historical Society, Library, Paterson NJ

Shick, Andrew, *Exec Dir,* Passaic County Historical Society, Paterson NJ

Shieh, Annie, *Asst Prof,* Saint Thomas Aquinas College, Art Dept, Sparkill NY (S)

Shield, Jan, *Chmn,* Pacific University in Oregon, Arts Div, Dept of Art, Forest Grove OR (S)

Shield, Margaret M, *Exec Dir,* Lincoln County Historical Association, Inc, Pownalborough Courthouse, Wiscasset ME

Shield, Nancy, *Assoc Dir Operations,* Museum of Wisconsin Art, West Bend Art Museum, West Bend WI

Shields, Alissa, *Asst Dir,* Chautauqua Center for the Visual Arts, Chautauqua NY

Shields, David, *Prof,* Texas State University - San Marcos, Dept of Art and Design, San Marcos TX (S)

Shields, Paul M, *Asst Prof,* York College, Art Dept, York NE (S)

Shields, Sharon, *Admin Mgr,* Toronto School of Art, Toronto ON (S)

Shields, Tom, *Asst Prof,* Augustana College, Art Dept, Sioux Falls SD (S)

Shields, Van W, *Exec Dir,* Museum of York County, Rock Hill SC

Shields, Wendy, *Adult Educ Coordr,* City of Irvine, Irvine Fine Arts Center, Irvine CA

Shiels, Margaret M, *Exec Dir,* Lincoln County Historical Association, Inc, 1811 Old Lincoln County Jail & Lincoln County Museum, Wiscasset ME

Shier, Reid, *Cur,* Contemporary Art Gallery Society of British Columbia, Vancouver BC

Shifflet, Ann, *Visual Resources Cur,* Columbus College of Art & Design, Packard Library, Columbus OH

Shiffman, Carol, *Exec Dir,* Centrum Arts & Creative Education, Port Townsend WA

Shifman, Barry, *Cur Decorative Arts,* Columbus Museum of Art and Design, Indianapolis IN

Shiga-Gattullo, Catherine, *Dir Education,* The Hudson River Museum, Yonkers NY

Shiga-Gattullo, Cathrine, *Exec Dir,* Edward Hopper, Nyack NY

Shih, Chia-Chun, *Librn,* Kimbell Art Museum, Fort Worth TX

Shih, Chia-Chun, *Librn,* Kimbell Art Museum, Library, Fort Worth TX

Shillabeer, S L, *Asst Prof,* Troy State University, Dept of Art & Classics, Troy AL (S)

Shin, Roberta, *Bus Asst,* Dartmouth College, Hood Museum of Art, Hanover NH

Shin-tsu Tai, Susan, *Cur Asian Art,* Santa Barbara Museum of Art, Library, Santa Barbara CA

Shine, Susan, *Devel Dir,* Caramoor Center for Music & the Arts, Inc, Caramoor House Museum, Katonah NY

Shinkle, Kathy, *Pub Relations Dir,* Palos Verdes Art Center, Rancho Palos Verdes CA

Shinn, Deborah, *Cur Applied Arts,* Cooper-Hewitt, National Design Museum, Smithsonian Institution, New York NY

Shinners, Jackie, *Art Historian,* Northwestern Michigan College, Art Dept, Traverse City MI (S)

Shipley, Anne, *Chmn,* Sierra Nevada College, Fine Arts Dept, Incline Village NV (S)

Shipley, Roger, *Prof,* Lycoming College, Art Dept, Williamsport PA (S)

Shipley, Roger D, *Dir,* Lycoming College Gallery, Williamsport PA

Shipman, John, *Exhib Designer,* University of Maryland, College Park, The Art Gallery, College Park MD

Shipp, Tony, *Prof,* Sam Houston State University, Art Dept, Huntsville TX (S)

Shippey, Lee, *Art Dept Asst,* Ripon College, Art Dept, Ripon WI (S)

Shiras, Susan, *Librn,* Brooks Institute of Photography, Santa Barbara CA

Shirley, Donna, *Dir,* Science Fiction Museum and Hall of Fame, Seattle WA

Shirley, Jon, *Chmn Bd,* Seattle Art Museum, Library, Seattle WA

Shirley, Margaret, *Instr,* Marylhurst University, Art Dept, Marylhurst OR (S)

Shirripa, Ann, *Mem Coordr,* Art Directors Club, New York NY

Shively, Mike, *Maintenance Supv,* Patterson Homestead, Dayton OH

Shives, Christine, *Admin Asst,* Washington County Museum of Fine Arts, Hagerstown MD

Shives, Christine, *Admin Asst,* Washington County Museum of Fine Arts, Library, Hagerstown MD

Shoaff, Jeanne, *Exec Dir,* Fort Collins Museum of Contemporary Art, Fort Collins CO

Shockley, Darlas, *Dean Arts & Sciences,* Indian Hills Community College, Ottumwa Campus, Dept of Art, Ottumwa IA (S)

Shockley, Evelyn, *Prog Mgr,* Xerox Corporation, Art Collection, Stamford CT

Shockley, Susan, *Cur,* Board of Parks & Recreation, The Parthenon, Nashville TN

Shoemaker, Edward C, *Dir Library Resources Div,* Oklahoma Historical Society, Library Resources Division, Oklahoma City OK

Shoemaker, Innis, *Sr Cur Prints, Drawings & Photographs,* Philadelphia Museum of Art, Philadelphia PA

Shoemaker, Innis H, *Sr Cur Prints & Drawing,* Philadelphia Museum of Art, Samuel S Fleisher Art Memorial, Philadelphia PA

Shoemaker, Marla, *Cur Educ,* Philadelphia Museum of Art, Philadelphia PA

Shoger, Jan, *Assoc Prof,* Saint Olaf College, Art Dept, Northfield MN (S)

Shomer, Dan, *Dir Facilities,* Kentucky Derby Museum, Louisville KY

Shook, Kevin, *Asst Prof,* Birmingham-Southern College, Art Dept, Birmingham AL (S)

Shook, Melissa, *Assoc Prof,* University of Massachusetts - Boston, Art Dept, Boston MA (S)

Shook, Raymond, *Cur,* Patterson Homestead, Dayton OH

Shopsis, Mari, *Docent Coordr,* Everson Museum of Art, Syracuse NY

Shore, Bob, *VChmn,* Kern County Museum, Library, Bakersfield CA

Shore, Don, *Chmn Animation,* Mount San Antonio College, Art Dept, Walnut CA (S)

Shore, Francine, *Instr,* Main Line Art Center, Haverford PA (S)

Shoreman, Mike, *Bus & Capital Development,* Royal Ontario Museum, Toronto ON

Shores, Venila, *Historian,* Shores Memorial Museum and Victoriana, Lyndon Center VT

Shorlemer, Beth, *Art Coll Develop Specialist,* Central Library, Dept of Fine Arts, San Antonio TX

Shorr, Ken, *Assoc Prof Photography,* University of Arizona, Dept of Art, Tucson AZ (S)

Short, Frank, *Coordr,* Montgomery County Community College, Art Center, Blue Bell PA (S)

Short, Gloria A, *Librn,* Springfield Art Museum, Library, Springfield MO

Short, Janet, *Librn,* Bernice Pauahi Bishop, Library, Honolulu HI

Short, Sherry, *Asst Prof,* Minnesota State University-Moorhead, Dept of Art, Moorhead MN (S)

Short, Susan, *Asst Prof,* College of Visual Arts, Saint Paul MN (S)

Short, William, *Dir,* Mission San Miguel Museum, San Miguel CA

Shortridge, Katherine, *Asst Prof,* Roanoke College, Fine Arts Dept-Art, Salem VA (S)

Shortslef, Lisa M, *Admin Aide,* State University of New York at Oswego, Tyler Art Gallery, Oswego NY

Shortt, A J (Fred), *Cur,* Museum for Textiles, Canada Aviation Museum, Ottawa ON

Shostak, Anthony, *Educ Coordr,* Bates College, Museum of Art, Lewiston ME

Shott, Cynthia, *Pres (V),* Missoula Art Museum, Missoula MT

Shrack, Marsha, *Art Instr,* Pratt Community College, Art Dept, Pratt KS (S)

Shrenk, Lisa, *Architectural History,* Norwich University, Dept of Architecture and Art, Northfield VT (S)

Shrewder, Susan, *Mus Shop Mgr,* Philbrook Museum of Art, Tulsa OK

Shropshire, Anne, *Exhit & Outreach Technician,* City of Toronto Culture Division, The Market Gallery, Toronto ON

Shrum, Vance, *Dir Operations,* Cummer Museum of Art & Gardens, DeEtte Holden Cummer Museum Foundation, Jacksonville FL

Shuck, Ann, *Archives Asst,* The Saint Louis Art Museum, Richardson Memorial Library, Saint Louis MO

Shuck, Patrick, *Prof,* Saint Louis Community College at Meramec, Art Dept, Saint Louis MO (S)

Shuckerow, Tim, *Asst Prof,* Case Western Reserve University, Dept of Art History & Art, Cleveland OH (S)

Shuey, Nicole, *Public Affairs Dir,* Flagler Museum, Palm Beach FL

Shuey Altamirano, Noelle, *Coll Cur,* Palm Beach County Parks & Recreation Department, Donald B Gordon Memorial Library, Delray Beach FL

Shugart, Sanford, *Pres,* Valencia Community College, Art Gallery-East Campus, Orlando FL

Shuiely, Donna, *Cur of Educ,* Eccles Community Art Center, Ogden UT

Shultes, Steph, *Cur,* Iroquois Indian Museum, Howes Cave NY

Simpson, Kathleen, *Dir Museum Educ,* Springfield Library & Museums Association, Springfield Science Museum, Springfield MA

Simpson, Kathleen, *Dir Museum Educ,* Springfield Museums Association, George Walter Vincent Smith Art Museum, Springfield MA

Simpson, Larry, *Chmn & Graphic Design,* University of South Alabama, Dept of Art & Art History, Mobile AL

Simpson, Larry L, *Chmn,* University of South Alabama, Ethnic American Slide Library, Mobile AL

Simpson, Leslie T, *Dir,* Winfred L & Elizabeth C Post, Post Memorial Art Reference Library, Joplin MO

Simpson, Lisa A, *Dir,* Louisa May Alcott Memorial Association, Orchard House, Concord MA

Simpson, Mary Caroline, *Prof,* University of Nebraska at Omaha, Dept of Art & Art History, Omaha NE (S)

Simpson, Michael, *Lectr,* University of North Carolina at Charlotte, Dept Art, Charlotte NC (S)

Simpson, Pamela H, *Prof,* Washington and Lee University, Div of Art, Lexington VA (S)

Simpson, Paula, *Dir,* Monterey Public Library, Art & Architecture Dept, Monterey CA

Simpson, Renee, *Develop Dir,* Painted Bride Art Center Gallery, Philadelphia PA

Simpson, Shannon, *Cur,* Ellis County Museum Inc, Waxahachie TX

Simpson Voth, Karrie, Fort Hays State University, Dept of Art, Hays KS (S)

Sims, JoAnn, *Acting Develop Officer,* Smithsonian American Art Museum, Washington DC

Sims, Lowery, *Exec Dir,* The Studio Museum in Harlem, New York NY

Sims, Nathan, *Instr,* Waynesburg College, Dept of Fine Arts, Waynesburg PA (S)

Sims, Richard, *Dir,* Montana Historical Society, Helena MT

Sinclair, Duane, *Asst Dir,* Broward County Board of Commissioners, Cultural Affairs Div, Fort Lauderdale FL

Sinclair, Jane, *Prof,* Chapman University, Art Dept, Orange CA (S)

Sinclair, Jay, *VPres,* Monterey Museum of Art Association, Monterey Museum of Art, Monterey CA

Sincox, Kim Robinson, *Mus Services Dir,* State of North Carolina, Battleship North Carolina, Wilmington NC

Sindelar, Norma, *Archivist,* The Saint Louis Art Museum, Richardson Memorial Library, Saint Louis MO

Sing, Susan, *Instr,* Glendale Community College, Visual & Performing Arts Div, Glendale CA (S)

Singer, Dana, *Exec Dir,* Society of North American Goldsmiths, Eugene OR

Singer, Debra, *Branch Cur,* Whitney Museum of American Art, New York NY

Singer, Marijane, *Dir,* Blauvelt Demarest Foundation, Hiram Blauvelt Art Museum, Oradell NJ

Singerman, Howard, *Art History Instr,* University of Virginia, McIntire Dept of Art, Charlottesville VA (S)

Singleton, David, *Interim Dir & Deputy Dir,* Philbrook Museum of Art, Tulsa OK

Singleton, Pamela, *Treas,* Artists' Fellowship, Inc, New York NY

Sinha, Ajay, *Art History,* Mount Holyoke College, Art Dept, South Hadley MA (S)

Sinsheimer, Karen, *Cur Photo,* Santa Barbara Museum of Art, Santa Barbara CA

Sinsheimer, Karen, *Cur Photography,* Santa Barbara Museum of Art, Library, Santa Barbara CA

Siokalo, Zorianne, *Cur Pub Progs,* James A Michener, Doylestown PA

Sipiorski, Dennis, *Art Dept Head,* Nicholls State University, Dept of Art, Thibodaux LA (S)

Sipp, Geo, *Asst Prof,* Missouri Western State University, Art Dept, Saint Joseph MO (S)

Sipp, Jerry, *Theatre Dir,* Rocky Mount Arts Center, Rocky Mount NC

Sippel, Jeffrey, *Assoc Prof,* University of Missouri, Saint Louis, Dept of Art & Art History, Saint Louis MO (S)

Siriclo, Melissa, *Interim Dir,* Wethersfield Historical Society Inc, Old Academy Library, Wethersfield CT

Sirman, Robert, *Dir,* Canada Council for the Arts, Conseil des Arts du Canada, Ottawa ON

Sirna, Jessie, *Assoc Prof,* Mott Community College, Liberal Arts & Sciences, Flint MI (S)

Sirnandi, Marcella, *Prof,* Oklahoma State University, Art Dept, Stillwater OK (S)

Siry, Joseph, *Prof,* Wesleyan University, Dept of Art & Art History, Middletown CT (S)

Sissen, Melissa M, *Public Servs Librn,* Siena Heights College, Art Library, Adrian MI

Sisson, Mark, *Prof,* Oklahoma State University, Art Dept, Stillwater OK (S)

Sisson, Williams, *Chief Cur,* Pennsylvania Historical & Museum Commission, The State Museum of Pennsylvania, Harrisburg PA

Sitterling, Nicolette, *Office Mgr,* Schenectady County Historical Society, Museum of Schenectady History, Schenectady NY

Sivulich, Ken, *Dir,* Jacksonville Public Library, Fine Arts & Recreation Dept, Jacksonville FL

Sixt, Diera, *Head Prog Dept,* Goethe Institute New York, German Cultural Center, New York NY

Sizemore, Tina, *Children's Librn,* Willard Library, Dept of Fine Arts, Evansville IN

Sjosten, David, *Deputy Dir Administration,* Worcester Art Museum, Worcester MA

Sjovold, Erling, *Asst Prof,* University of Richmond, Dept of Art and Art History, Richmond VA (S)

Skabo, Kirk, *Dir Finance,* Colorado Springs Fine Arts Center, Colorado Springs CO

Skaggs, Steve, *Prof,* University of Louisville, Allen R Hite Art Institute, Louisville KY (S)

Skaggs, Tracie, *Develop Dir,* George A Spiva, Joplin MO

Skeeles, Celia, *Librn,* Amerind Foundation, Inc, Fulton-Hayden Memorial Library, Dragoon AZ

Skeffington, Thomas, *Chmn,* Rowan University, Dept of Art, Glassboro NJ (S)

Skelley, Robert C, *Prof,* University of Florida, Dept of Art, Gainesville FL (S)

Skinner, Arthur, *Asst Prof,* Eckerd College, Art Dept, Saint Petersburg FL (S)

Skinner, Bill, *Chmn Div of Communications & Arts,* North Arkansas Community-Technical College, Art Dept, Harrison AR (S)

Skinner, Jaineth, *Asst Prof,* Bemidji State University, Visual Arts Dept, Bemidji MN (S)

Sklar, Rita, *Dir Workshops,* California Watercolor Association, Gallery Concord, Concord CA

Sklarski, Bonnie, *Prof,* Indiana University, Bloomington, Henry Radford Hope School of Fine Arts, Bloomington IN (S)

Sklaver, Ellen, *Librn Mgr,* Suffolk University, New England School of Art & Design Library, Boston MA

Skoglund, Margaret, *Assoc Prof,* University of Southern Indiana, Art Dept, Evansville IN (S)

Skove, Margaret, *Dir,* Blanden Memorial Art Museum, Fort Dodge IA

Skove, Margaret A, *Dir,* Huntington Museum of Art, Huntington WV

Skowronski, Nancy, *Library Dir,* Detroit Public Library, Art & Literature Dept, Detroit MI

Skroch, Diana P, *Division Chair,* Valley City State College, Art Dept, Valley City ND (S)

Skuratofsky, Carol, *Mgr,* Prudential Art Program, Newark NJ

Skurkis, Barry, *Assoc Prof,* North Central College, Dept of Art, Naperville IL (S)

Skvarla, Diane, *Cur,* United States Senate Commission on Art, Washington DC

Skwerski, Thomas, *Mus Cur,* Springfield Museum of Art, Library, Springfield OH

Skwerski, Thomas, *Preparator,* Terra Museum of American Art, Chicago IL

Slaby, Allison, *Mem Coordr,* Brandeis University, Rose Art Museum, Waltham MA

Slade, Terry, *Asst Prof,* Hartwick College, Art Dept, Oneonta NY (S)

Slagell, Jeff H, *Asst Dir,* Delta State University, Roberts LaForge Library, Cleveland MS

Slagle, Nancy, *Asst Prof,* Texas Tech University, Dept of Art, Lubbock TX (S)

Slamka, Neil F, *Pres,* Leigh Yawkey Woodson, Wausau WI

Slaney, Deborah, *Cur History,* Albuquerque Museum of Art & History, Albuquerque NM

Slater, Kaiti, *Assoc Prof,* University of Utah, Dept of Art & Art History, Salt Lake City UT (S)

Slater, Sandra, *Genealogy Librn,* Phelps County Historical Society, Donald O. Lindgren Library, Holdrege NE

Slater-Tanner, Susan, Orange County Community College, Arts & Communication, Middletown NY (S)

Slatery, W Patrick, *Art Dept Chmn,* Palm Beach Community College, Dept of Art, Lake Worth FL (S)

Slatkin, Wendy E, *Lectr,* California State Polytechnic University, Pomona, Art Dept, Pomona CA (S)

Slato, Alex, *Deputy Dir,* Robert Gumbiner, Museum of Latin American Art, Long Beach CA

Slattery, Michael, *Instr,* Bob Jones University, Div of Art, Greenville SC (S)

Slatton, Ralph, *Prof,* East Tennessee State University, College of Arts and Sciences, Dept of Art & Design, Johnson City TN (S)

Slaughter, Alan, *2nd VPres,* Historical Society of Bloomfield, Bloomfield NJ

Slavick, Elin O, *Prof,* University of North Carolina at Chapel Hill, Art Dept, Chapel Hill NC (S)

Slavik, Barbara, *Educ Dir,* Port Angeles Fine Arts Center, Port Angeles WA

Slavik, John, *Adjunct Prof,* North Central College, Dept of Art, Naperville IL (S)

Slawson, Brian, *Asst Prof,* University of Florida, Dept of Art, Gainesville FL (S)

Slaymaker, Samuel C, *Exec Dir,* Rock Ford Foundation, Inc, Historic Rock Ford & Kauffman Museum, Lancaster PA

Slayton, Joel, *Digital Media Art Prog Coordr,* San Jose State University, School of Art & Design, San Jose CA (S)

Sledd, Michael, *Instr,* Columbia College, Art Dept, Columbia MO (S)

Slein, Alison, *Prof,* Virginia Polytechnic Institute & State University, Dept of Art & Art History, Blacksburg VA (S)

Slicer, David, *Maintenance & Security,* Wiregrass Museum of Art, Dothan AL

Slicer, Rita, *Office Mgr,* Wiregrass Museum of Art, Dothan AL

Slichter, Jennifer, *Cur Coll,* Loveland Museum Gallery, Loveland CO

Slider, HJ, *Adjunct Asst Prof Art Educ,* Aquinas College, Art Dept, Grand Rapids MI (S)

Slimmer, Elizabeth, *Registrar,* San Bernardino County Museum, Fine Arts Institute, Redlands CA

Slimon, Gary, *Dir,* Canadian Wildlife & Wilderness Art Museum, Ottawa ON

Slimon, Gary, *Dir,* Canadian Wildlife & Wilderness Art Museum, Library, Ottawa ON

Sloan, Alan P, *Pres,* Art Center Sarasota, Sarasota FL

Sloan, David, *Chmn,* Whittier College, Dept of Art, Whittier CA (S)

Sloan, Katherine, *Pres,* Massachusetts College of Art, Boston MA (S)

Sloan, Mark, *Gallery Dir,* College of Charleston, Halsey Institute of Contemporary Art, Charleston SC

Sloane, Kim, *Asst Prof,* Cedar Crest College, Art Dept, Allentown PA (S)

Sloane, Robert, *Head Art Information Center; Dance Librn/Photography,* Chicago Public Library, Harold Washington Library Center, Chicago IL

Sloane, Ruragna, *Mus Shop Mgr,* Van Cortlandt House Museum, Bronx NY

Sloat, Richard, *VPres,* Society of American Graphic Artists, New York NY

Sloboda, Stacey, *Asst Prof,* Southern Illinois University, School of Art & Design, Carbondale IL (S)

Slobodin, Brent, *Dir,* Yukon Historical & Museums Association, Whitehorse YT

Slome, Lynn, *Archivist,* American Jewish Historical Society, Lee M Friedman Memorial Library, New York NY

Slome, Lynn, *Dir Library & Archives,* American Jewish Historical Society, The Center for Jewish History, New York NY

Slorck, Lonnie, *Prof Photography,* Central Wyoming College, Art Center, Riverton WY (S)

Sloss, Katie, *Music Dir,* Kaji Aso Studio, Gallery Nature & Temptation, Boston MA

Sloss, Tencha, *Operations Chmn,* Brownsville Art League, Brownsville Museum of Fine Art, Brownsville TX

Slouffman, James, *Dept Head Commercial Arts,* Antonelli College, Cincinnati OH (S)

Slovin, Rochelle, *Dir,* American Museum of the Moving Image, Astoria NY

Sluterbeck, Kay R, *Admin Asst,* Wassenberg Art Center, Van Wert OH

Slutzky, Robert, *Prof,* University of Pennsylvania, Graduate School of Fine Arts, Philadelphia PA (S)

Slyfield, Donna, *Adult Servs,* Helen M Plum, Lombard IL

Small, Carol, *Asst Prof,* Gettysburg College, Dept of Visual Arts, Gettysburg PA (S)

Small, Lawrence, *Secy,* Smithsonian Institution, Washington DC

Small, Marcella, *Asst Prof,* Delta State University, Dept of Art, Cleveland MS (S)

Smalley, Gail, *Office Mgr,* Lynnwood Arts Centre, Simcoe ON

Smalley, Stephen, *Prof,* Bridgewater State College, Art Dept, Bridgewater MA (S)

Smallwood, Donnely, *Instr,* Toronto School of Art, Toronto ON (S)

Smelko, James J, *Interior Design,* Art Institute of Pittsburgh, Pittsburgh PA (S)

Smetak, Robert, *Dir Financial Services,* The Illinois Institute of Art - Chicago, Chicago IL (S)

Smetana, David, *Chmn Art Committee,* North Canton Public Library, The Little Art Gallery, North Canton OH

Smetana, Zbynek, *Lectr,* Murray State University, Dept of Art, Murray KY (S)

Smiglin, Carol, *Group Tour Admin,* The Currier Museum of Art, Currier Museum of Art, Manchester NH

Smigocki, Stephen, *Prof,* Fairmont State College, Div of Fine Arts, Fairmont WV (S)

Smigrod, Claudia, *Chmn Photography,* Corcoran School of Art, Washington DC (S)

Smith, Alison, *Registrar,* Society for Photographic Education, Oxford OH

Smith, Allison, *Asst Prof Art Hist, Art Hist Coordr,* Johnson County Community College, Visual Arts Program, Overland Park KS (S)

Smith, Ann, *Chmn Dept Art,* Howard Payne University, Dept of Art, Brownwood TX (S)

Smith, Ann, *Cur,* Mattatuck Historical Society, Mattatuck Museum, Waterbury CT

Smith, Ann, *Cur,* Mattatuck Historical Society, Library, Waterbury CT

Smith, Anne, *VPres,* Norton Museum of Art, West Palm Beach FL

Smith, Arthur, *Library Mgr,* Royal Ontario Museum, Library & Archives, Toronto ON

Smith, B J, *Dir,* Oklahoma State University, Gardiner Art Gallery, Stillwater OK

Smith, Barbara, *Dir Devel,* Burlington Art Centre, Burlington ON

Smith, Barbara, *Pres,* Yarmouth County Historical Society, Yarmouth County Museum, Yarmouth NS

Smith, Billie, *Special Events Mgr,* Wiregrass Museum of Art, Dothan AL

Smith, Bob, *Library Coordr,* Nevada Museum of Art, Art Library, Reno NV

Smith, Bob, Buena Vista Museum of Natural History, Bakersfield CA

Smith, Bradley, *Cur,* Pennsylvania Historical & Museum Commission, Railroad Museum of Pennsylvania, Harrisburg PA

Smith, Brian, *Photo Lab Technician,* Trust Authority, Museum of the Great Plains, Lawton OK

Smith, Brydon, *Cur 20th Century Art,* National Gallery of Canada, Ottawa ON

Smith, C, *Instr,* Community College of Rhode Island, Dept of Art, Warwick RI (S)

Smith, C Martin, *Product Design Chmn,* Art Center College of Design, Pasadena CA (S)

Smith, C Shaw, *Chmn,* Davidson College, Art Dept, Davidson NC (S)

Smith, Carol, *Sr Librn,* Jacksonville Public Library, Fine Arts & Recreation Dept, Jacksonville FL

Smith, Catherine, *Instr,* Mott Community College, Liberal Arts & Sciences, Flint MI (S)

Smith, Catherine, *Pres,* Mattatuck Historical Society, Mattatuck Museum, Waterbury CT

Smith, Catherine Howett, *Assoc Dir,* Emory University, Michael C Carlos Museum, Atlanta GA

Smith, Charles, *Instr,* Southern University A & M College, School of Architecture, Baton Rouge LA (S)

Smith, Cheryl, *Exec Dir,* Ontario Association of Art Galleries, Toronto ON

Smith, Christy, *Student Servs,* Maine Photographic Workshops, The International T.V. & Film Workshops & Rockport College, Rockport ME (S)

Smith, Claude, *Prof,* Western New Mexico University, Dept of Expressive Arts, Silver City NM (S)

Smith, Claudia, *Prof,* University of Wisconsin-Stout, Dept of Art & Design, Menomonie WI (S)

Smith, Colleen, *Educ Mgr,* Indiana State Museum, Indianapolis IN

Smith, Connie, *Mgr Mus Shop,* Glenbow Museum, Calgary AB

Smith, Constance, *Dir,* ArtNetwork, Nevada City CA

Smith, Craig, *Instr,* American River College, Dept of Art/Art New Media, Sacramento CA (S)

Smith, Curtis, *Instr,* University of Colorado-Colorado Springs, Visual & Performing Arts Dept, Colorado Springs CO (S)

Smith, Darold, *Prof,* West Texas A&M University, Art, Communication & Theatre Dept, Canyon TX (S)

Smith, David, *Assoc Prof,* University of New Hampshire, Dept of Arts & Art History, Durham NH (S)

Smith, David, *Assoc Prof,* Edgewood College, Art Dept, Madison WI (S)

Smith, David, *Pres,* Brewton-Parker College, Visual Arts, Mount Vernon GA (S)

Smith, Diane, *Chmn Acad Studies Dept,* Art Academy of Cincinnati, Cincinnati OH (S)

Smith, Diane, *Dir,* Sonoma Valley Historical Society's Depot Park Museum, Sonoma CA

Smith, Dickson K, *Dean Arts & Scis,* Cardinal Stritch University, Art Dept, Milwaukee WI (S)

Smith, Don, *Dean,* Maryland College of Art & Design, Silver Spring MD (S)

Smith, Dorothy V, *Publicity,* Leatherstocking Brush & Palette Club Inc, Cooperstown NY

Smith, Doug, *Instr,* Modesto Junior College, Arts Humanities & Communications Division, Modesto CA (S)

Smith, Doug, *Pres,* Taos Center for the Arts, Stables Gallery, Taos NM

Smith, Douglas, *Dir Retail Operations,* Columbus Museum of Art and Design, Indianapolis IN

Smith, Edward, *Asst,* Louisiana State University, School of Art, Baton Rouge LA (S)

Smith, Elise, *Chmn,* Millsaps College, Dept of Art, Jackson MS (S)

Smith, Elizabeth, *Chief Cur,* Museum of Contemporary Art, Chicago IL

Smith, Fred T, *Pres,* Midwest Art History Society, Kent OH

Smith, Gail, *Develop Officer,* Oakville Galleries, Centennial Square and Gairloch Gardens, Oakville ON

Smith, Gary T, *Dir,* Hartnell College Gallery, Salinas CA

Smith, George, *Asst Prof,* University of the District of Columbia, Dept of Mass Media, Visual & Performing Arts, Washington DC (S)

Smith, George, *Prof,* Rice University, Dept of Art & Art History, Houston TX (S)

Smith, Gidget, *Planetarium/Laser Show Oper,* Wichita Falls Museum & Art Center, Wichita Falls TX

Smith, Gil R, *Chmn,* Eastern Kentucky University, Art Dept, Richmond KY (S)

Smith, Gregory A, *Pres,* Art Academy of Cincinnati, Cincinnati OH (S)

Smith, Greta, *Library Asst,* Old Colony Historical Society, Library, Taunton MA

Smith, Heather, *Cur,* Moose Jaw Art Museum, Inc, Art & History Museum, Moose Jaw SK

Smith, Jack, *VPres,* Westmoreland Museum of American Art, Art Reference Library, Greensburg PA

Smith, James F, *Registrar,* Carleton College, Art Gallery, Northfield MN

Smith, Jan, *Dir,* Rahr-West Art Museum, Manitowoc WI

Smith, Janet, *Board Chair,* The Lindsay Gallery Inc, Lindsay ON

Smith, Jeanette, *Mus Shop Mgr,* Cape Ann Historical Association, Gloucester MA

Smith, Jennifer, *Tour Coord,* Anniston Museum of Natural History, Anniston AL

Smith, Jessica, *Cur American Art,* The Huntington Library, Art Collections & Botanical Gardens, San Marino CA

Smith, Jo, *Office Mgr, Dir,* Marin Society of Artists Inc, Ross CA

Smith, Joanne, *Asst to Dir,* Southwest Museum, Los Angeles CA

Smith, Joel, *Cur,* Vassar College, The Frances Lehman Loeb Art Center, Poughkeepsie NY

Smith, John O., *Prof,* University of Wisconsin-Stevens Point, Dept of Art & Design, Stevens Point WI (S)

Smith, Jonathan, *Cur Coll,* Burlington Art Centre, Burlington ON

Smith, Joseph, *Studio Chmn,* Mount Holyoke College, Art Dept, South Hadley MA (S)

Smith, Joseph E, *Prof,* Oakland City University, Division of Fine Arts, Oakland City IN (S)

Smith, Judith, *Coordr Marketing & Pub Relations,* Reynolda House Museum of American Art, Winston Salem NC

Smith, K C, *Facility Mgr,* Film Arts Foundation, San Francisco CA

Smith, Karen, *Grants Financial Analyst,* Broward County Board of Commissioners, Cultural Affairs Div, Fort Lauderdale FL

Smith, Karen Burgess, *VPres Acad Affairs,* New Hampshire Institute of Art, Manchester NH

Smith, Kathy, *Admnn Dir,* Riverside Art Museum, Library, Riverside CA

Smith, Kent, *Adjunct Asst Prof Art,* Johnson County Community College, Visual Arts Program, Overland Park KS (S)

Smith, Kent, *Dir Art,* Illinois State Museum, Chicago Gallery, Chicago IL

Smith, Kent, *Dir Art,* Illinois State Museum, Museum Store, Chicago IL

Smith, Kent J, *Dir Art,* Illinois State Museum, Illinois Art Gallery & Lockport Gallery, Springfield IL

Smith, Kim, *Registrar,* C M Russell, Great Falls MT

Smith, Kim, *Registrar,* C M Russell, Frederic G Renner Memorial Library, Great Falls MT

Smith, Kimberly, *Assoc Prof,* Southwestern University, Sarofim School of Fine Art, Dept of Art & Art History, Georgetown TX (S)

Smith, Kory, *Park Dir,* El Pueblo de Los Angeles Historical Monument, Los Angeles CA

Smith, Laura Lake, *Museum Asst,* Cheekwood-Tennessee Botanical Garden & Museum of Art, Museum of Art Library, Nashville TN

Smith, Lisa Deanne, *Co-Dir,* YYZ Artists' Outlet, Toronto ON

Smith, Liz, *Asst Prof,* University of Central Arkansas, Department of Art, Conway AR (S)

Smith, Luther, *Prof,* Texas Christian University, Dept of Art & Art History, Fort Worth TX (S)

Smith, Margaret Supplee, *Assoc Prof,* Wake Forest University, Dept of Art, Winston-Salem NC (S)

Smith, Mariann, *Cur Educ,* The Buffalo Fine Arts Academy, Albright-Knox Art Gallery, Buffalo NY

Smith, Marilyn, *Assoc Dir,* South Texas Institute for the Arts, Art Museum of South Texas, Corpus Christi TX

Smith, Marilyn, *Dir,* Southern Alberta Art Gallery, Lethbridge AB

Smith, Marilyn, *Dir,* Southern Alberta Art Gallery, Library, Lethbridge AB

Smith, Marilyn, *Prof,* Appalachian State University, Dept of Art, Boone NC (S)

Smith, Marion, *Chmn,* Eckerd College, Art Dept, Saint Petersburg FL (S)

Smith, Mark, *Interim Dir,* State University of New York at Purchase, Library, Purchase NY

Smith, Mark, *Prof,* Austin College, Art Dept, Sherman TX (S)

Smith, Mark A, *Information Systems Librn,* New York State College of Ceramics at Alfred University, Scholes Library of Ceramics, Alfred NY

Smith, Martha C, *Reference-Visual Arts Specialist,* State University of New York at Purchase, Library, Purchase NY

Smith, Mary Ruth, *Prof,* Baylor University, Dept of Art, Waco TX (S)

Smith, Maureen, *Finance Dir,* Southern Oregon Historical Society, Jacksonville Museum of Southern Oregon History, Medford OR

Smith, Maureen, *Mgr Programs & Facilities,* University of Toronto, University of Toronto Art Centre, Toronto ON

Smith, Melanie, *Dir Membership,* The Phillips Collection, Washington DC

Smith, Melinda K, *Assoc Dir,* United States Senate Commission on Art, Washington DC

Smith, Michael, *Prof,* East Tennessee State University, College of Arts and Sciences, Dept of Art & Design, Johnson City TN (S)

Smith, Michael J., *Pres & CEO,* American Textile History Museum, Lowell MA

Smith, Michele L, *Exec Dir,* Wassenberg Art Center, Van Wert OH

Smith, Mitchel, *Dir Fin,* The Adirondack Historical Association, The Adirondack Museum, Blue Mountain Lake NY

Smith, Monica, *Conservator,* Vancouver Art Gallery, Vancouver BC

Smith, Nan, *Assoc Prof,* University of Florida, Dept of Art, Gainesville FL (S)

Smith, Nelson, *Chmn & Asst Prof,* Marygrove College, Department of Art, Detroit MI (S)

Smith, Patricia F, *Vol Chmn,* Sea Cliff Village Museum, Sea Cliff NY

Smith, Patrick, *Cur,* Connecticut State Library, Museum of Connecticut History, Hartford CT

Smith, Paul, *Preparator,* Southern Alberta Art Gallery, Lethbridge AB

Smith, Pauline, *Dir,* City of Atlanta, Atlanta Cyclorama, Atlanta GA

Smith, Peter, *Coordr Pub Progs,* Museum London, London ON

Smith, Priscilla, *Coordr Photography,* University of Delaware, Dept of Art, Newark DE (S)

Smith, Rachel, *Chmn,* Taylor University, Chronicle-Tribune Art Gallery, Upland IN

Smith, Rachel, *Chmn, Assoc Prof, Gilkison Family Chair in Art History,* Taylor University, Visual Art Dept, Upland IN (S)

Smith, Rand, *Instr,* Cottey College, Art Dept, Nevada MO (S)

Smith, Rhonda, *Admin Dir,* Morgan County Foundation, Inc, Madison-Morgan Cultural Center, Madison GA

Smith, Rhonda, *Coordr Printmaking & Mixed Media,* Shepherd University, Art Dept, Shepherdstown WV (S)

Smith, Richard E, *Assoc Prof & Studio Area Head,* Southern Illinois University, School of Art & Design, Carbondale IL (S)

Smith, Rob, *Dir,* Lachenmeyer Arts Center, Art Resource Library, Cushing OK

Smith, Robynn, *Painting Instr,* Monterey Peninsula College, Art Dept, Monterey CA (S)

Smith, Sandra, *Dir Mus Coll,* National Trust for Historic Preservation, Washington DC

Smith, Sharon, *Prof Emeritus,* California State University, Chico, Department of Art & Art History, Chico CA (S)

Smith, Stafford, *Asst Prof,* Lycoming College, Art Dept, Williamsport PA (S)

Smith, Stephanie, *Instr,* Ouachita Baptist University, Dept of Visual Art, Arkadelphia AR (S)

Smith, Sterling, *Chief Preparator,* University of Wyoming, University of Wyoming Art Museum, Laramie WY

Smith, Suzanne, *Registrar,* Sherwin Miller Museum of Jewish Art, Tulsa OK

Smith, Terence, *Mellon Prof,* University of Pittsburgh, Henry Clay Frick Dept History of Art & Architecture, Pittsburgh PA (S)

Smith, Thom, *Cur Natural Science,* Berkshire Museum, Pittsfield MA

Smith, Thomas H, *Asst Prof,* Park University, Dept of Art & Design, Parkville MO (S)

Smith, Thomas O, *Chmn,* Grambling State University, Art Dept, Grambling LA (S)

Smith, Timothy B, *Asst Prof,* Birmingham-Southern College, Art Dept, Birmingham AL (S)

Smith, Timothy H, *Research Asst,* Adams County Historical Society, Gettysburg PA

Smith, Todd D, *Dir,* Carolina Art Association, Gibbes Museum of Art, Charleston SC

Smith, Todd D, *Exec Dir,* Knoxville Museum of Art, Knoxville TN

Smith, Tracy, *Vol Coordr,* Workman & Temple Family Homestead Museum, City of Industry CA

Smith, Trudy, *Treas,* Leatherstocking Brush & Palette Club Inc, Cooperstown NY

Smith, Valerie, *Dir Exhib,* The Queens Museum of Art, Flushing NY

Smith, Virginia, *Chmn,* Bernard M Baruch College of the City University of New York, Art Dept, New York NY (S)

Smith-Abbott, Katherine, *Visiting Asst Prof,* Middlebury College, History of Art & Architecture Dept, Middlebury VT (S)

Smith-Bove, Holly, *Dir Finance,* Springfield Library & Museums Association, Museum of Fine Arts, Springfield MA

Smith-Bove, Holly, *Dir Finance,* Springfield Library & Museums Association, Springfield Science Museum, Springfield MA

Smith-Ferri, Sherrie, *Dir,* City of Ukiah, Grace Hudson Museum & The Sun House, Ukiah CA

Smith-Hunter, Susan, *Chmn,* Green Mountain College, Dept of Art, Poultney VT (S)

Smith de Tarnowsky, Andrea, *Cur,* T C Steele, Nashville IN

Smith Lake, Kendal, *Public Information Officer,* Modern Art Museum, Fort Worth TX

Smithson, Sandra, *Instr,* Millsaps College, Dept of Art, Jackson MS (S)

Smoak, Janet, *Coll Mgr,* Jesse Besser, Philip M Park Library, Alpena MI

Smolen, David, *Spec Coll Librn,* New Hampshire Historical Society, Library of History & Genealogy, Concord NH

Smolkin, Robert, *Gallery Mgr,* Academy of Motion Picture Arts & Sciences, The Academy Gallery, Beverly Hills CA

Smoot, Michael, *Rental Supv,* Patterson Homestead, Dayton OH

Smotherman, Ann, *Art Teacher,* Motlow State Community College, Art Dept, Tullahoma TN (S)

Smulian, Sam, *Exec Dir,* Atlanta Contemporary Art Center, Atlanta GA

Smutko, Paul, *Coll Mgr,* Museum of New Mexico, Museum of International Folk Art, Santa Fe NM

Smyrnios, Arleigh, *Dir Fine Art,* Kalamazoo Valley Community College, Center for New Media, Kalamazoo MI (S)

Smyser, Michael, *Assoc Prof,* Montgomery County Community College, Art Center, Blue Bell PA (S)

Smyth, Colleen, *Mgr Educ,* Indiana State Museum, Indianapolis IN

Smythe, James E, *Prof,* Western Carolina University, Dept of Art/College of Arts & Science, Cullowhee NC (S)

Snapp, Brian, *Assoc Prof,* University of Utah, Dept of Art & Art History, Salt Lake City UT (S)

Snapp, Ronald, *Assoc Prof,* Old Dominion University, Art Dept, Norfolk VA (S)

Sneddeker, Duane, *Cur Photographs,* Missouri Historical Society, Saint Louis MO

Snellenberger, Earl, *Prof,* University of Indianapolis, Art Dept, Indianapolis IN (S)

Snibbe, Robert M, *Pres,* Napoleonic Society of America, Museum & Library, Clearwater FL

Snider, Karen, *Assoc Dir Exhibits,* Children's Museum of Manhattan, New York NY

Snider, Meredith, *Dir,* Organization for the Development of Artists, Gallery Connexion, Fredericton NB

Snoddy, Suzie, *Admin,* Museum of Southern History, Sugarland TX

Snodgrass, Susan, *Pres,* Gilpin County Arts Association, Central City CO

Snook, Randy, *Instr,* Sierra Community College, Art Dept, Rocklin CA (S)

Snouffer, Karen F, *Asst Prof,* Kenyon College, Art Dept, Gambier OH (S)

Snow, Beverly, *Dir,* Danforth Museum of Art School, Framingham MA (S)

Snowden, Gilda, *Gallery Dir,* Detroit Repertory Theatre Gallery, Detroit MI

Snowman, Tracy, *Instr,* Spoon River College, Art Dept, Canton IL (S)

Snyder, Barry, *Prof,* Fairmont State College, Div of Fine Arts, Fairmont WV (S)

Snyder, Gerry, *Chmn,* College of Santa Fe, Art Dept, Santa Fe NM (S)

Snyder, Janet, *Prof,* West Virginia University, College of Creative Arts, Morgantown WV (S)

Snyder, Jennifer, *Asst to Dir,* Fetherston Foundation, Packwood House Museum, Lewisburg PA

Snyder, Joel, *Prof,* University of Chicago, Dept of Art History & Committee on Visual Art, Chicago IL (S)

Snyder, Kelly M., *Educ Coordr,* Pensacola Museum of Art, Pensacola FL

Snyder, Kimberly, *Develop Dir,* Grace Museum, Inc, Abilene TX

Snyder, Mark, *Asst Prof,* University of Hartford, Hartford Art School, West Hartford CT (S)

Snyder, Patricia, *Exec Dir,* East End Arts & Humanities Council, Riverhead NY

Snyder, Randy, *Chmn Fine Arts Dept,* San Jacinto College-North, Art Dept, Houston TX (S)

Snyder, Robert, *Dir Develop,* Washington State University, Museum of Art, Pullman WA

Snyder, Robin D, *Chmn,* Samford University, Art Dept, Birmingham AL (S)

Snyder, Sheryl, *Admin Asst,* Adams County Historical Society, Gettysburg PA

Snyder-Grenier, Ellen, *Dir Spec Projects,* New Jersey Historical Society, Newark NJ

Soave, Sergio, *Chmn Div of Art,* West Virginia University, College of Creative Arts, Morgantown WV (S)

Sobieralski, Casondra, *Exec Asst,* Judah L Magnes, Berkeley CA

Sobolik, Bonnie, *Dir Develop,* North Dakota Museum of Art, Grand Forks ND

Sobral, Luis de Moura, *Instr,* Universite de Montreal, Dept of Art History, Montreal PQ (S)

Sobre, Judith, *Prof,* University of Texas at San Antonio, Dept of Art & Art History, San Antonio TX (S)

Socha, H Norman, *Dir,* Enook Galleries, Waterloo ON

Soehner, Kenneth, *Arthur K Watson C,* The Metropolitan Museum of Art, New York NY

Soehner, Kenneth, *Chief Librn,* The Metropolitan Museum of Art, Thomas J Watson Library, New York NY

Soetje, Peter, *Dir,* Goethe Institute New York, German Cultural Center, New York NY

Softie, Tanja, *Assoc Prof,* University of Richmond, Dept of Art and Art History, Richmond VA (S)

Soga, Takashi, *Studio Mgr,* Sculpture Space, Inc, Utica NY

Sogard, Carol, *Assoc Prof,* University of Utah, Dept of Art & Art History, Salt Lake City UT (S)

Sohi, Marilyn, *Registrar,* Madison Museum of Contemporary Art, Madison WI

Sojka, Nancy, *Cur Graphic Arts,* Detroit Institute of Arts, Detroit MI

Sok, Lisa, *Admin Coordr,* Brandywine Workshop, Center for the Visual Arts, Philadelphia PA

Soklove, Deborah, *Cur,* Wesley Theological Seminary Henry Luce III Center for the Arts & Religion, Dadian Gallery, Washington DC

Sokol, David, *Chmn Dept Art & Art History,* University of Illinois at Chicago, College of Architecture, Chicago IL (S)

Sokoloff, Emily, *Trustee,* Miami Watercolor Society, Inc, Miami FL

Sokolove, Nancy, *Instr,* Appalachian State University, Dept of Art, Boone NC (S)

Solcyk, Phyllis, *Treas,* National Watercolor Society, San Pedro CA

Solecki, Kathy, *Dir,* Arts Council of Southwestern Indiana, Evansville IN

Soleri, Paolo, *Pres,* Cosanti Foundation, Scottsdale AZ

Soles, Kathleen A, *Assoc Prof,* Emmanuel College, Art Dept, Boston MA (S)

Soles, Mary Ellen, *Cur Ancient,* North Carolina Museum of Art, Reference Library, Raleigh NC

Soles, Teresa, *Instr,* West Shore Community College, Division of Humanities & Fine Arts, Scottville MI (S)

Solimon, Ron, *Dir,* Indian Pueblo Cultural Center, Albuquerque NM

Solis, Claudia, *Exec Dir,* Art League of Houston, Houston TX

Solmssen, Peter, *Pres,* University of the Arts, Philadelphia Colleges of Art & Design, Performing Arts & Media & Communication, Philadelphia PA (S)

Solomon, Andrea, *Events & Programs Coordr,* Middlebury College, Museum of Art, Middlebury VT

Solomon-Kiefer, C, *Asst Prof,* McGill University, Dept of Art History, Montreal PQ (S)

Solon, Lisa, *Adjunct Asst Prof,* Drew University, Art Dept, Madison NJ (S)

Soloway, Lynn, *Dir,* Concordia University, Marx Hausen Art Gallery, Seward NE

Soloway, Lynn, *Prof,* Concordia College, Art Dept, Seward NE (S)

Solt, Mary, *Exec Dir of Museum Registration,* The Art Institute of Chicago, Chicago IL

Solvay, Marilyn, *Exec Dir,* Saco Museum, Saco ME

Somaio, Theresa, *Visual Resource Assoc,* Skidmore College, Lucy Scribner Library, Saratoga Springs NY

Somers, David, *Cur,* Art Gallery of Peel, Peel Heritage Complex, Brampton ON

Somers, David, *Cur,* Art Gallery of Peel, Archives, Brampton ON

Somers, Eric, *Dir,* Dutchess Community College, Dept of Visual Arts, Poughkeepsie NY (S)

Somerson, RoseAnne, *Pres,* Haystack Mountain School of Crafts, Deer Isle ME

Sonderman, Karen, *Library Dir,* North Canton Public Library, The Little Art Gallery, North Canton OH

Song, Felicia, *Adult Svcs Coordr,* Lake Forest Library, Fine Arts Dept, Lake Forest IL

Song, Xiaoyu, *Assoc Prof,* Universite de Montreal, Bibliotheque d'Amenagement, Montreal PQ

Sonnema, Roy, *Art Dept Chmn,* University of Southern Colorado, College of Liberal & Fine Arts, Pueblo CO

Sonnema, Roy, *Chmn,* University of Southern Colorado, Dept of Art, Pueblo CO (S)

Sonnema, Roy B, *Assoc Prof,* Georgia Southern University, Dept of Art, Statesboro GA (S)

Sonner, Grace, *VPres,* College of San Mateo, Creative Arts Dept, San Mateo CA (S)

Sons, Ruth, *Chief Accountant,* Tucson Museum of Artand Historic Block, Tucson AZ

Sontag, Marilyn, *Secy,* New York Artists Equity Association, Inc, New York NY

Sorel, Paul, *Assoc Dir,* New England Center for Contemporary Art, Brooklyn CT

Sorensen, Lee, *Librn & Art Bibliographer,* Duke University, Lilly Art Library, Durham NC

Sorom, Denise, *Exec Dir,* Rochester Art Center, Rochester MN

Sorrell, Robert, *Asst Prof,* College of Santa Fe, Art Dept, Santa Fe NM (S)

Sossa, Oscar, *Gallery Conservator,* Queensborough Community College, Art Gallery, Bayside NY

Sotak, Erin, *Vis Prof,* College of Wooster, Dept of Art, Wooster OH (S)

Soule, Debora Thaxton, *Dir,* Sweetwater County Library System and School District #1, Community Fine Arts Center, Rock Springs WY

Sourakli, Judy, *Cur Coll,* Henry Gallery Association, Henry Art Gallery, Seattle WA

Sousa, Bonnie, *Registrar,* American Textile History Museum, Lowell MA

Sousa, James, *Assoc Registrar,* Phillips Academy, Addison Gallery of American Art, Andover MA

South, Allison, *Asst Dir,* Salt Lake Art Center, Salt Lake City UT

South, Will, *Cur Coll,* University of North Carolina at Greensboro, Weatherspoon Art Museum, Greensboro NC

Southworth, Michael, *Instr,* University of South Carolina at Aiken, Dept of Visual & Performing Arts, Aiken SC (S)

Sovern, Michael I, *Chmn,* American Academy in Rome, New York NY (S)

Sowd, Laurie, *Assoc VPres Operations,* The Huntington Library, Art Collections & Botanical Gardens, Library, San Marino CA

Sowd, Laurie, *Dir Oper,* The Huntington Library, Art Collections & Botanical Gardens, San Marino CA

Sowden, Alison, *VPres Financial Affairs,* The Huntington Library, Art Collections & Botanical Gardens, San Marino CA

Sowder, Cheryl, *Art Chmn,* Jacksonville University, Dept of Art, Jacksonville FL (S)

Sowers, Russ, *Dir,* Ramsay Museum, Honolulu HI

Sowinski, Larry, *Dir,* Knights of Columbus Supreme Council, Knights of Columbus Museum, New Haven CT

Sowiski, Peter, *Chmn,* State University College at Buffalo, Fine Arts Dept, Buffalo NY (S)

Soyka, Ed, *Chmn Illustrations,* Fashion Institute of Technology, Art & Design Division, New York NY (S)

Spack, Carol, *Dir,* Boston Visual Artists Union, Boston MA

Spaeth, Timothy, *Dir Business Affairs,* Atlanta College of Art, Atlanta GA (S)

Spahr, P Andrew, *Cur,* The Currier Museum of Art, Currier Museum of Art, Manchester NH

Spaid, Gregory P, *Prof, Assoc Provost,* Kenyon College, Art Dept, Gambier OH (S)

Spain, Sharon, *Slide Registry Mgr,* San Francisco Arts Commission, Gallery & Slide Registry, San Francisco CA

Spalatin, Ivana, *Instr Art History,* Texas A&M University Commerce, Dept of Art, Commerce TX (S)

Spallina, Emily, *Registrar,* Canajoharie Library & Art Gallery, Arkell Museum of Canajoharie, Canajoharie NY

Spangenberg, Kristin L, *Cur Prints & Drawings,* Cincinnati Museum Association and Art Academy of Cincinnati, Cincinnati Art Museum, Cincinnati OH

Spangler, Bonnie, *Educ dir,* Michelson Museum of Art, Marshall TX

Spangler, David R, *Pres,* St Martins College, Humanities Dept, Lacey WA (S)

Spann, Edward, *Dean Fine Arts,* Dallas Baptist University, Dept of Art, Dallas TX (S)

Sparagana, John, *Assoc Prof,* Rice University, Dept of Art & Art History, Houston TX (S)

Sparkman, Barry, *Registrar,* Florida International University, The Art Museum at FIU, Miami FL

Sparks, Kevin, *Instr,* Asbury College, Art Dept, Wilmore KY (S)

Sparks, Rhonda, *Librn,* Cedarhurst Center for the Arts, Cedar Hurst Library, Mount Vernon IL

Sparks, Wendy, *Educ Cur,* Riverside Municipal Museum, Riverside CA

Sparrow, Diane, *Office Coordr,* Boston Architectural Center, Boston MA

Sparrow, James, *Dir Develop,* Arts United of Greater Fort Wayne, Fort Wayne IN

Spataro, Peter, *Instr,* Art Center Sarasota, Sarasota FL (S)

Spatz-Rabinowitz, Elaine, *Assoc Prof,* Wellesley College, Art Dept, Wellesley MA (S)

Spaulding, Daniel, *Cur Collections,* Anniston Museum of Natural History, Anniston AL

Spaulding, Fred, *Prof,* Victoria College, Fine Arts Dept, Victoria TX (S)

Spaziani, Carol, *Pres,* Arts Iowa City, Art Center & Gallery, Iowa City IA

Spear, Ellen, *Dir Advancement,* American Textile History Museum, Lowell MA

Spear, Ellen, *Pres,* Hancock Shaker Village, Inc, Pittsfield MA

Spears, Dolores, *Cur,* Zigler Museum, Jennings LA

Spears, Kimberly, *Exec Dir,* Anderson County Arts Council, Anderson SC

Spears, Leslie, *Commun Mgr,* Oklahoma City Museum of Art, Oklahoma City OK

Spears, Susan, *Dir,* Michelson Museum of Art, Marshall TX

Specht, Debbie, *Pres FSM Vol,* Indiana State Museum, Indianapolis IN

Speck, Erin, *Dept Chmn,* George Washington University, School of Interior Design, Washington DC (S)

Spector, Nancy, *Assoc Cur,* Solomon R Guggenheim, New York NY

Speed, Bonnie, *Dir,* Emory University, Michael C Carlos Museum, Atlanta GA

Speicher, Leslie, *Instr,* University of Miami, Dept of Art & Art History, Coral Gables FL (S)

Speight, Jerry, *Prof,* Murray State University, Dept of Art, Murray KY (S)

Speight, Pamela, *Cur,* Malaspina College, Nanaimo Art Gallery, Nanaimo BC

Speigle, Elizabeth K, *Cur,* Yesteryear Village, West Palm Beach FL

Speiring, Ken, *Adjunct Asst Prof,* Spokane Falls Community College, Fine Arts Dept, Spokane WA (S)

Speller, Virginia, *Librn,* Old York Historical Society, Administration Building & Library, York ME

Spellman-Grimes, Diane, *Art Lectr & Prog Coordr,* Burlington County College, Humanities & Fine Art Div, Pemberton NJ (S)

Spellman-Grimes, Diane, *Coordr, Asst Prof,* Cumberland County College, Humanities Div, Vineland NJ (S)

Spence, Betty, *Div Chair Liberal Studies,* Memphis College of Art, Memphis TN (S)

Spence, Catherine, *Library Asst,* University of Toronto, Fine Art Library, Toronto ON

Spence, Margaret, *Librn,* Arts and Letters Club of Toronto, Toronto ON

Spence, Margaret, *Librn,* Arts and Letters Club of Toronto, Library, Toronto ON

Spence, Muneera U., *Asst Prof,* Oregon State University, Dept of Art, Corvallis OR (S)

Spence, Rachel, *Educ & Outreach,* Beck Center for the Arts, Lakewood OH

Spence, Scott, *Artistic Dir,* Beck Center for the Arts, Lakewood OH

Spencer, Howard Dalee, *Cur of Art,* Washington Pavilion of Arts & Science, Visual Arts Center, Sioux Falls SD

Spencer, Sarah, *Pub Relations Rep,* Wiregrass Museum of Art, Dothan AL

Spencer, Stephanie, *Dir,* Printmaking Council of New Jersey, North Branch NJ

Spencer, Sue, *Dir,* Spoon River College, Art Dept, Canton IL (S)

Spencer, Sue, *Pres Heritage Foundation,* Fort Morgan Heritage Foundation, Fort Morgan CO

Spencer, Sunnee, *Deputy Dir Mus Prog & Srvcs,* Heritage Museums & Gardens, Sandwich MA

Spencer, Vivian L, *Cur Educ,* Pensacola Museum of Art, Harry Thornton Library, Pensacola FL

Spencer, William T, *VPres,* National Baseball Hall of Fame & Museum, Inc, Art Collection, Cooperstown NY

Spencer Forsythe, Laurel, *Cur Coll & Educ,* Paine Art Center & Gardens, Oshkosh WI

Spengler, Cheryl, *Mktg & Develop,* Buffalo Museum of Science, Research Library, Buffalo NY

Spera, Lisa, *Secy,* High Wire Gallery, Philadelphia PA

Speranza, Linda, *Instr,* Mesa Community College, Dept of Art, Mesa AZ (S)

Sperath, Albert, *Dir,* Rowan Oak, William Faulker's Home, Oxford MS

Sperath, Albert, *Dir,* University of Mississippi, University Museum, Oxford MS

Sperath, Albert, *Gallery Dir,* Murray State University, Dept of Art, Murray KY (S)

Sperling, Christine, *Chmn,* Bloomsburg University, Dept of Art & Art History, Bloomsburg PA (S)

Sperling, Christine, *Chmn Dept of Art,* Bloomsburg University of Pennsylvania, Haas Gallery of Art, Bloomsburg PA

Sperling, L Joy, *Assoc Prof,* Denison University, Dept of Art, Granville OH (S)

Spevers, Franklin, *Prof,* Calvin College, Art Dept, Grand Rapids MI (S)

Spewock, Kelly JK, *Interior Design,* Art Institute of Pittsburgh, Pittsburgh PA (S)

Speyerer, Jay W, *Multimedia & Web Design,* Art Institute of Pittsburgh, Pittsburgh PA (S)

Spicehandler, Dawn, *Catalog Librn,* Visual Arts Library, New York NY

Spicer, Ann, *Chmn,* Wayne Community College, Liberal Arts Dept, Goldsboro NC (S)

Spicer, Joaneath, *Cur Renaissance,* Walters Art Museum, Library, Baltimore MD

Spicer, Joaneath, *Cur Renaissance & Baroque Art,* Walters Art Museum, Baltimore MD

Spierkel, Karen, *Dir Public Affairs,* National Gallery of Canada, Ottawa ON

Spies, Kathleen, *Assoc Prof,* Birmingham-Southern College, Art Dept, Birmingham AL (S)

Spiller, Harley, *Adminr,* Franklin Furnace Archive, Inc, New York NY

Spiller, Virginia, *Librn,* Old York Historical Society, York ME

Spiller, Virginia, *Librn,* Old York Historical Society, Elizabeth Perkins House, York ME

Spiller, Virginia, *Librn,* Old York Historical Society, Old Gaol Museum, York ME

Spillman, Jane, *Cur American Glass,* Corning Museum of Glass, The Studio, Rakow Library, Corning NY

Spinar, Melvin, *Prof,* South Dakota State University, Dept of Visual Arts, Brookings SD (S)

Spinelli, Christopher, *Libr Assoc,* New York School of Interior Design, New York School of Interior Design Library, New York NY

Spinski, Victor, *Coordr Ceramics,* University of Delaware, Dept of Art, Newark DE (S)

Spires, Sherry, *Cur Educ,* Knoxville Museum of Art, Knoxville TN

Spiro, Edmund, *Treas,* Middlesex County Cultural & Heritage Commission, New Brunswick NJ

Spisak, Robin, *Gallery Asst,* Contemporary Art Gallery Society of British Columbia, Vancouver BC

Spitler, Carol, *Assoc Prof,* Oakland City University, Division of Fine Arts, Oakland City IN (S)

Spitzer, Jennifer, *Mgr Exhib,* Indiana State Museum, Indianapolis IN

Spitzzeri, Paul, *Coll Mgr,* Workman & Temple Family Homestead Museum, City of Industry CA

Spitzzeri, Paul, *Coll Mgr & Library Head,* Workman & Temple Family Homestead Museum, Research Library, City of Industry CA

Spivey, Cooper, *Art Instr,* Birmingham-Southern College, Art Dept, Birmingham AL (S)

Spivey, Sherwood, *Deputy Dir Admin,* Phoenix Art Museum, Phoenix AZ

Spnung, Loa, *Dir Communications,* National Watercolor Society, San Pedro CA

Spock, Dan, *Head Exhib,* Minnesota Historical Society, Saint Paul MN

Spoerner, Thomas, *Chmn,* Ball State University, Dept of Art, Muncie IN (S)

Sponenberg, Susan, *Coordr,* Luzerne County Community College, Commercial Art Dept, Nanticoke PA (S)

Sponsler, Julie, *Dir of Finance & Operations,* Corporate Council for the Arts/Arts Fund, Seattle WA

Spoon, Jennifer, *Assoc Prof,* Radford University, Art Dept, Radford VA (S)

Spooner, Larry, *Pres,* Tubac Center of the Arts, Tubac AZ

Spooner, Peter, *Cur/Registrar,* University of Minnesota, Duluth, Tweed Museum of Art, Duluth MN

Sporny, Stan, *Prof,* Marshall University, Dept of Art, Huntington WV (S)

Spote, Richard T, *Pres,* Fine Arts Association, School of Fine Arts, Willoughby OH

Spradling, Kim, *Asst Prof & Chmn,* Northwest Missouri State University, Dept of Art, Maryville MO (S)

Spradun, Becky, *Instr,* Ouachita Baptist University, Dept of Visual Art, Arkadelphia AR (S)

Sprague, Donovin, *Dir Educ,* Crazy Horse Memorial, Indian Museum of North America, Native American Educational & Cultural Center & Crazy Horse Memorial Library (Reference), Crazy Horse SD

Sprengnether, Kate, *Visual Art Specialist,* Lexington Art League, Inc, Lexington KY

Spriggs, Lynne, *Bison Cur,* C M Russell, Frederic G Renner Memorial Library, Great Falls MT

Spring, Michael, *Exec Dir,* South Florida Cultural Consortium, Miami Dade County Cultural Affairs Council, Miami FL

Springer, John, *Asst Cur,* Sloss Furnaces National Historic Landmark, Birmingham AL

Springer, Kathleen, *Sr Cur Paleontology,* San Bernardino County Museum, Fine Arts Institute, Redlands CA

Sprokkereef, Michelle, *Develop Dir,* California State University, Long Beach, University Art Museum, Long Beach CA

Sprouls, Ellen V, *Cur Educ,* Muskegon Museum of Art, Muskegon MI

Sprout, Francis, *Instr,* Indian River Community College, Fine Arts Dept, Fort Pierce FL (S)

Spruance, Halsey, *Dir Pub Rels,* Brandywine River Museum, Chadds Ford PA

Spruce, Duane Blue, *Facilities Planning Mgr,* National Museum of the American Indian, George Gustav Heye Center, New York NY

Sprung, Lowri, *Webmistress,* National Watercolor Society, San Pedro CA

Spungen, Elizabeth F, *Interim Dir,* The Print Center, Philadelphia PA

Spurgeon, Elizabeth, *Instr,* Marylhurst University, Art Dept, Marylhurst OR (S)

Spurgeon, Lisa, *Coll Cur,* Deere & Company, Moline IL

Squires, Ann, *VPres,* Jericho Historical Society, Jericho VT

Sriram, Patty, *Membership Coordr,* Gulf Coast Museum of Art, Inc, Largo FL

Srsen, Judy, *Dir Educ,* Owatonna Arts Center, Community Arts Center, Owatonna MN

St-Arnaud, Jacques, *Guide,* Musee des Augustines de l'Hotel Dieu de Quebec, Quebec PQ

St. Cyr, Chris, *Asst Prof Electronic Media Arts Design,* University of Denver, School of Art & Art History, Denver CO (S)

St. Denis, Suzanne, *Admin Coordr,* La Centrale Powerhouse Gallery, Montreal PQ

St. Louis, Pat, *Gift Shop/Reception,* University of Saskatchewan, Diefenbaker Canada Centre, Saskatoon SK

Staats, Jenn, *Educ,* Rowland Evans Robinson, Rokeby Museum, Ferrisburgh VT

Stabila, Luciana, *Registrar,* The Illinois Institute of Art - Chicago, Chicago IL (S)

Stabile, Mary Jean, *Graphic Design,* Art Institute of Pittsburgh, Pittsburgh PA (S)

Stacey, Kathleen, *Head Librn,* Walters Art Museum, Library, Baltimore MD

Stacey, Kathleen, *Librn,* Walters Art Museum, Baltimore MD

Stachura, Irene, *Reference,* San Francisco Maritime National Historical Park, Maritime Library, San Francisco CA

Stack, Lotus, *Cur Textiles,* Minneapolis Institute of Arts, Minneapolis MN

Stack, Patricia, *Library Asst,* North Carolina Museum of Art, Reference Library, Raleigh NC

Stacy, Bonnie, *Coll Mgr,* Historic Bethlehem Partnership, Kemerer Museum of Decorative Arts, Bethlehem PA

Stadsklev, Joan, *Dir Fine & Performing Arts,* Chipola College, Dept of Fine & Performing Arts, Marianna FL (S)

Staebler, Tom, *VPres & Art Dir,* Playboy Enterprises, Inc, Chicago IL

Staffne, Dennis, *Prof,* Northern Michigan University, Dept of Art & Design, Marquette MI (S)

Stafford, Jerry, *Dir Develop,* Colorado Springs Fine Arts Center, Colorado Springs CO

Stafford, John, *Mus Shop Mgr,* Museum of New Mexico, Museum of Fine Arts, Unit of NM Dept of Cultural Affairs, Santa Fe NM

Stahlman, Joshua, *Asst Librn,* The York County Heritage Trust, Library, York PA

Staib, Mildred, *Registrar,* Woodmere Art Museum, Library, Philadelphia PA

Staib, Mildred O, *Registrar,* Woodmere Art Museum, Philadelphia PA

Staider, Sarah, *Exec Dir,* Charles Allis, Milwaukee WI

Stake, Peter, *Chmn,* Skidmore College, Dept of Art & Art History, Saratoga Springs NY (S)

Stakoe, Diane, *Dir,* Marblehead Arts Association, Inc, Marblehead MA

Stallard, Hugh R, *Pres,* Virginia Historical Society, Library, Richmond VA

Staller, Natasha, *Chmn,* Amherst College, Dept of Fine Arts, Amherst MA (S)

Stallings, Tyler, *Cur of Exhib,* Laguna Art Museum, Laguna Beach CA

Stallworth, Portia, *Admin Secy,* Birmingham Museum of Art, Birmingham AL

Stalnaker, Budd, *Prof,* Indiana University, Bloomington, Henry Radford Hope School of Fine Arts, Bloomington IN (S)

Stalsworth, Lee, *Chief Photography,* Hirshhorn Museum & Sculpture Garden, Smithsonian Institution, Washington DC

St Ama, Caryl, *Instr,* Glendale Community College, Visual & Performing Arts Div, Glendale CA (S)

Stamas, Christine, *Gallery Mgr,* Detroit Artists Market, Detroit MI

Stammler, Ursula, *Dir,* University of Kansas, Architectural Resource Center, Lawrence KS

Stamps, Ray, *Pres Board Dirs,* Lake County Civic Center Association, Inc, Heritage Museum & Gallery, Leadville CO

Stancliffe, Thomas, *Prof,* University of Northern Iowa, Dept of Art, Cedar Falls IA (S)

Standen, Jeff, *Visitor Serv Manager,* Asheville Art Museum, Asheville NC

Standish, Leann, *Dir Institutional Advancement,* Columbus Museum of Art and Design, Indianapolis IN

Stanford, Verne, *Exec Dir,* Portland Children's Museum, Portland OR

Stang, Andrea, *Develop Assoc,* 18th Street Arts Complex, Santa Monica CA

Stangl, Denise, *Asst to Dir,* Lehigh University Art Galleries, Museum Operation, Bethlehem PA

Stanicky, Paul, *Board Dirs,* Ukrainian Cultural & Educational Centre, Gallery, Winnipeg MB

Stanicky, Paul, *Pres Board Dirs,* Ukrainian Cultural & Educational Centre, Winnipeg MB

Stanicky, Paul, *Pres Board Dirs,* Ukrainian Cultural & Educational Centre, Library & Archives, Winnipeg MB

Stanier, Linda, *Cur Generations Gallery,* Multicultural Heritage Centre, Stony Plain AB

Stanislow, Gail, *Coll Librn,* Brandywine River Museum, Library, Chadds Ford PA

Stanko, John, *Asst Prof,* Graceland University, Fine Arts Div, Lamoni IA (S)

Stanley, Annie, *Educ Coordr,* Ellen Noel Art Museum of the Permian Basin, Odessa TX

Stanley, B, *Exec Dir,* District of Columbia Arts Center (DCAC), Washington DC

Stanley, Chris, *Assoc Prof,* University of Texas of Permian Basin, Dept of Art, Odessa TX (S)

Stanley, David, *Assoc Prof,* University of Florida, Dept of Art, Gainesville FL (S)

Stanley, Diane, *Cur,* Southern Lorain County Historical Society, Spirit of '76 Museum, Elyria OH

Stanley, Janet L, *Librn,* Smithsonian Institution, National Museum of African Art, Washington DC

Stanley, Kathi, *Assoc Librn,* New York State Library, Manuscripts & Special Collections, Albany NY

Stanley, Lynn, *Educ Coordr,* Provincetown Art Association & Museum, Provincetown MA

Stanley, Robert A, *Asst Prof,* Ashland University, Art Dept, Ashland OH (S)

Stanley, Susie, *Prof,* Lansing Community College, Visual Arts & Media Dept, Lansing MI (S)

Stanley, T, *Instr,* Humboldt State University, College of Arts & Humanities, Arcata CA (S)

Stanley, Tom, *Dir,* Winthrop University Galleries, Rock Hill SC

Stansbury, George, *Dean,* University of Mary Hardin-Baylor, School of Fine Arts, Belton TX (S)

Stansbury, Lynda, San Diego Museum of Art, San Diego CA

Stanton, Meridith Z, *Dir,* United States Department of the Interior, Indian Arts & Crafts Board, Washington DC

Stapelman, Heather, *Library Asst,* Cranbrook Art Museum, Library, Bloomfield Hills MI

Stapes, Anne, *Asst Dir,* Contemporary Art Workshop, Chicago IL

Staples, Lila, *VPres,* Monterey Museum of Art Association, Monterey Museum of Art, Monterey CA

Staples, Wayne, *Chmn & Prof,* Acadia University, Art Dept, Wolfville NS (S)

Staples, William, *Asst Librn,* Wadsworth Atheneum Museum of Art, Auerbach Art Library, Hartford CT

Stapleton, Doug, *Preparations,* Illinois State Museum, Chicago Gallery, Chicago IL

Stapleton, Nancy, *Asst Dir,* East Baton Rouge Parks & Recreation Commission, Baton Rouge Gallery Inc, Baton Rouge LA

Stark, Jennifer, *Mus Mgr,* Arlington Museum of Art, Arlington TX

Stark, Robert, *Dir,* Art Exchange, Union Dale PA

Stark, Sandra, University of Wisconsin-Eau Claire, Dept of Art, Eau Claire WI (S)

Stark, Sharon, *Admin Asst,* Owatonna Arts Center, Community Arts Center, Owatonna MN

Stark, William, *Admin/Deputy Dir,* Mamie McFaddin Ward, Beaumont TX

Starks, Beverly, *Librn,* Watkins Institute, Library, Nashville TN

Starks, George, *Prof Music,* Drexel University, College of Media Arts & Design, Philadelphia PA (S)

Starnes, Ed, *Pres,* Watercolor Society of Alabama, Birmingham AL

Starr, Daniel, *Mgr Bibliography,* The Metropolitan Museum of Art, Thomas J Watson Library, New York NY

Starr, Lori, *Dir,* Koffler Centre of the Arts, The Koffler Gallery, Toronto ON

Starr, Tom, *Assoc Prof,* Northeastern University, Dept of Art & Architecture, Boston MA (S)

Starrow, Melissa, *Adminr,* T W Wood, Montpelier VT

Stasiak, Marilyn, *Cur Art,* Neville Public Museum, Green Bay WI

Stasiewski, Dan, *Publicist,* Erie Art Museum, Erie PA

Stassi, Sally, *Prints/Photo Cur,* The Historic New Orleans Collection, New Orleans LA

Statlander, Raymond, *Assoc Prof,* Jersey City State College, Art Dept, Jersey City NJ (S)

St Aubyn, Jacklyn, *College Asst Prof,* New Mexico State University, Art Dept, Las Cruces NM (S)

Stauffer, Randall, *Chmn Interior Design,* Woodbury University, Dept of Graphic Design, Burbank CA (S)

Stausland, Lillian, *Instr,* Wagner College, Arts Administration Dept, Staten Island NY (S)

Stave, Pari, *VPres & Dir,* Equitable Life Assurance Society, The Equitable Gallery, New York NY

Stavenhagen, Marianne, *Archivist & Data Mgr,* Light Work, Robert B Menschel Photography Gallery, Syracuse NY

Stavitsky, Gail, *Chief Cur,* Montclair Art Museum, Montclair NJ

Stayman, Wendy, *Collections Management Admin,* Springfield Museums Association, George Walter Vincent Smith Art Museum, Springfield MA

Stayman, Wendy, *Dir Coll Management,* Springfield Library & Museums Association, Museum of Fine Arts, Springfield MA

Stayman, Wendy, *Dir Coll Mgmt,* Springfield Library & Museums Association, Springfield Science Museum, Springfield MA

Stayton, Kevin, *Acting Chief Cur,* Brooklyn Museum, Brooklyn NY

Stayton, Kevin, *Cur Decorative Arts,* Brooklyn Museum, Brooklyn NY

St Denis, Paul, *Prof,* Cleveland Institute of Art, Cleveland OH (S)

Steadman, Clinton, *VPres,* Rochester Historical Society, Rochester NY

Steadman, Thomas, *Prof,* Georgia Southern University, Dept of Art, Statesboro GA (S)

Steans, Joan, *Asst Prof,* Jersey City State College, Art Dept, Jersey City NJ (S)

Stearns, Daniel, *Assoc Prof of Art,* Glendale Community College, Visual & Performing Arts Div, Glendale CA (S)

Stearns, Emily, *Dir,* Wenham Museum, Wenham MA

Stebbins, Joan, *Cur,* Southern Alberta Art Gallery, Lethbridge AB

Stebbins, Joan, *Cur,* Southern Alberta Art Gallery, Library, Lethbridge AB

Steck, Aroyce Elaine, *Treas,* Brooklyn Historical Society, Brooklyn OH

Steedle, Bill, *Assoc Prof,* State University of New York at Farmingdale, Visual Communications, Farmingdale NY (S)

Steeds, Ralph, *Asst Prof,* University of North Carolina at Pembroke, Art Dept, Pembroke NC (S)

Steel, David H, *Cur European,* North Carolina Museum of Art, Reference Library, Raleigh NC

Steel, Virginia Oberlin, *Dir & Cur,* Rutgers University, Stedman Art Gallery, Camden NJ

Steele, Brian, *Assoc Prof,* Texas Tech University, Dept of Art, Lubbock TX (S)

Steele, Brian R, *Assoc Prof,* Adrian College, Art & Design Dept, Adrian MI (S)

Steele, Curtis, *Assoc Prof,* Arkansas State University, Dept of Art, State University AR (S)

Steele, Curtis, *Chair Art Dept,* Arkansas State University-Art Department, Jonesboro, Fine Arts Center Gallery, Jonesboro AR

Steele, Kelly, *Historic Preservation Off,* United States Senate Commission on Art, Washington DC

Steele, Linda, *Dir Community Relations,* The Art Institute of Chicago, Chicago IL

Steele, Lisa, *Assoc Chair Visual Studies,* University of Toronto, Dept of Fine Art, Toronto ON (S)

Steele, Priscilla, *Adjunct,* Coe College, Dept of Art, Cedar Rapids IA (S)

Steele, Steve, *Dir,* Rocky Mountain College of Art & Design, Lakewood CO (S)

Steele, Tammy, *Cur Educ,* Terra Museum of American Art, Chicago IL

Steele, Tim, *Prof,* South Dakota State University, Dept of Visual Arts, Brookings SD (S)

Steele, Valerie, *Dir,* Fashion Institute of Technology, Museum at FIT, New York NY

Steele-Hamme, Nancy, *Chair,* Midwestern State University, Lamar D. Fain College of Fine Arts, Wichita Falls TX (S)

Steen, Karen, *Assoc Prof,* Cazenovia College, Center for Art & Design Studies, Cazenovia NY (S)

Steen, Laura, *Admin Asst,* Ursinus College, Philip & Muriel Berman Museum of Art, Collegeville PA

Steeves, Dan, *Lectr,* Mount Allison University, Dept of Fine Arts, Sackville NB (S)

Stefani, Robert, *Pres,* The National Art League, Douglaston NY

Steffen, Lisa, *Dir Finance,* Cummer Museum of Art & Gardens, DeEtte Holden Cummer Museum Foundation, Jacksonville FL

Steffen, Margaret, *Secy,* Wayne County Historical Society, Honesdale PA

Steffen, Pamela, *Assoc Prof,* Mount Mary College, Art & Design Division, Milwaukee WI (S)

Stefl, Bob, *Assoc Prof,* Lincoln College, Art Dept, Lincoln IL (S)

Steggles, Mary Ann, University of Manitoba, School of Art, Winnipeg MB (S)

Stegmann, William, *Cur Arts of Africa & Pacific Islands,* Brooklyn Museum, Brooklyn NY

Stein, Amy, Yavapai College, Visual & Performing Arts Div, Prescott AZ (S)

Stein, Betty R, *Mus Shop Mgr,* Woodmere Art Museum, Library, Philadelphia PA

Stein, Emily, *Assoc Prof,* College of New Rochelle School of Arts & Sciences, Art Dept, New Rochelle NY (S)

Stein, Michael, *Faculty,* Housatonic Community College, Art Dept, Bridgeport CT (S)

Stein, Raymond, *Adjunct Asst Prof,* Drew University, Art Dept, Madison NJ (S)

Stein, Renata, *Art Cur,* Leo Baeck, New York NY

Stein, Renata, *Cur,* Leo Baeck, Library, New York NY

Steinbacher-Kern, William, *Librn & Archivist,* McLean County Historical Society, McLean County Museum of History, Bloomington IL

Steinberg, Anne, *Instr,* Milwaukee Area Technical College, Graphic Arts Div, Milwaukee WI (S)

Steinberg, Barbara, *Slide Librn,* University of New Hampshire, Dept of the Arts Slide Library, Durham NH

Stinespring, John, *Assoc Prof,* Texas Tech University, Dept of Art, Lubbock TX (S)

Stinnett, Hester, *Chmn Graphic Arts & Design,* Temple University, Tyler School of Art, Elkins Park PA (S)

Stinson, Lisa, *Asst Prof,* Appalachian State University, Dept of Art, Boone NC (S)

Stiny, Bruce, *Museum Technician,* California Department of Parks & Recreation, California State Indian Museum, Sacramento CA

Stip, Patricia, *Exec Asst,* Burlington County Historical Society, Burlington NJ

Stippell, Patricia A, *Art Consultant,* National League of American Pen Women, Washington DC

Stirton-Broad, Carol, *Instr,* Main Line Art Center, Haverford PA (S)

Stiteler, Tey, *Communications Mgr,* Carnegie Museums of Pittsburgh, Carnegie Museum of Art, Pittsburgh PA

Stites, Zoey, *Asst Prof,* Florida Southern College, Art Dept, Lakeland FL (S)

St John, Maryann, *Membership & Public Relations Coordr,* Bennington Museum, Bennington VT

St Laurent, Beatrice, *Asst Prof,* Bridgewater State College, Art Dept, Bridgewater MA (S)

St Michael, Sean, *Head Develop,* Art Gallery of Ontario, Toronto ON

Stockebrand, Marianne, *Dir,* Chinati Foundation, Marfa TX

Stocki, Robert, *Instr,* Milwaukee Area Technical College, Graphic Arts Div, Milwaukee WI (S)

Stocksdale, Joy, *Exec Dir,* Surface Design Association, Inc, Sebastopol CA

Stockwell, Ross, *Instr,* San Diego Mesa College, Fine Arts Dept, San Diego CA (S)

Stoddard, Barbara R, *Secy Art Committee,* Purdue University Calumet, Library Gallery, Hammond IN

Stoddard, Brooks, *Assoc Prof,* University of Maine at Augusta, College of Arts & Humanities, Augusta ME (S)

Stoddard, Leah, *Dir,* Second Street Gallery, Charlottesville VA

Stoddard, Pamela, *Gallery Coordr,* Michigan Guild of Artists & Artisans, Michigan Guild Gallery, Ann Arbor MI

Stoessell, Pamela, *Prof,* Marymount University, School of Arts & Sciences Div, Arlington VA (S)

Stohn, Franz, *Asst Chmn of Art,* Edinboro University of Pennsylvania, Art Dept, Edinboro PA (S)

Stojanovic, Jelena, *Dir,* Ithaca College, Handwerker Gallery of Art, Ithaca NY

Stokall, Krista, *Assoc Dir Admin,* Kelowna Museum, Kelowna BC

Stoker, E, *Prof,* University of the Incarnate Word, Art Dept, San Antonio TX (S)

Stokes, David, *Assoc Prof,* Winthrop University, Dept of Art & Design, Rock Hill SC (S)

Stokes, Sally Sims, *Librn,* University of Maryland, College Park, National Trust for Historic Preservation Library Collection, College Park MD

Stokstad, Marilyn, *Prof,* University of Kansas, Kress Foundation Dept of Art History, Lawrence KS (S)

Stollhans, Cindy, *Chmn,* Saint Louis University, Fine & Performing Arts Dept, Saint Louis MO (S)

Stolyarik, Elena, *Cur,* American Numismatic Society, New York NY

Stolzer, Rob, *Prof,* University of Wisconsin-Stevens Point, Dept of Art & Design, Stevens Point WI (S)

Stomberg, John, *Assoc Dir,* Williams College, Museum of Art, Williamstown MA

Stone, Carla, *Exhib Coordr,* Sonoma State University, University Art Gallery, Rohnert Park CA

Stone, Caroline, *Educ & Exhib Cur,* Memorial University of Newfoundland, Art Gallery of Newfoundland & Labrador, Saint John's NF

Stone, Denise, *Asst Prof,* University of Kansas, Dept of Art & Music Education & Music Therapy, Lawrence KS (S)

Stone, Elizabeth, *Pres,* Wenham Museum, Wenham MA

Stone, Ellen, *Dep Dir, Devel & Mem,* North Carolina Museum of Art, Raleigh NC

Stone, Evalyn, *Serials Librn,* The Metropolitan Museum of Art, Thomas J Watson Library, New York NY

Stone, Frank, *VPres Mktg,* Please Touch Museum, Philadelphia PA

Stone, Joy, *Asst Prof,* University of New Hampshire, Dept of Arts & Art History, Durham NH (S)

Stone, Kenneth H, *Deputy Dir Finance,* Buffalo & Erie County Public Library, Buffalo NY

Stone, Linda, *Cur Art,* The Frank Phillips, Woolaroc Museum, Bartlesville OK

Stone, Millard, *Treas,* Spectrum Gallery, Toledo OH

Stone, Patrick, *Chair Bd Trustees,* Santa Barbara Museum of Art, Library, Santa Barbara CA

Stone, Robin, *Chmn,* Hannibal La Grange College, Art Dept, Hannibal MO (S)

Stone, Shelby, *Co-Pres,* Los Angeles Center for Photographic Studies, Hollywood CA

Stone, Thelma, *Unit Mgr,* Fort Worth Public Library Arts & Humanities, Fine Arts Section, Fort Worth TX

Stone-Ferrier, Linda, *Dept Chair,* University of Kansas, Kress Foundation Dept of Art History, Lawrence KS (S)

Stone-Miller, Rebecca, *Assoc Prof,* Emory University, Art History Dept, Atlanta GA (S)

Stone-Street, Nancy, *Instr,* Mississippi Delta Community College, Dept of Fine Arts, Moorhead MS (S)

Stoner, Kathy, *Asst Cur,* City of Fayette, Alabama, Fayette Art Museum, Fayette AL

Stoner, Pamela, *Pres Bd,* Rock Ford Foundation, Inc, Historic Rock Ford & Kauffman Museum, Lancaster PA

Stoner, Richard, *Instr,* Seton Hill University, Art Program, Greensburg PA (S)

Stoops, Susan, *Cur Contemporary Art,* Worcester Art Museum, Worcester MA

Stopka, Christina, *Head,* Texas Ranger Hall of Fame & Museum, Texas Ranger Research Center, Waco TX

Storer, Gail, *Librn,* Columbus College of Art & Design, Packard Library, Columbus OH

Storey, Charles, *Treas,* Essex Historical Society, Essex Shipbuilding Museum, Essex MA

Storey, Joyce B, *Prof Print Design,* Philadelphia University, School of Textiles & Materials Technology, Philadelphia PA (S)

Storke, Ed, *Assoc Dean Liberal Arts,* College of DuPage, Liberal Arts Division, Glen Ellyn IL (S)

Storkerson, Peter, *Asst Prof,* Southern Illinois University, School of Art & Design, Carbondale IL (S)

Storr, Robert, *Grad Comt,* Bard College, Center for Curatorial Studies Graduate Program, Annandale-on-Hudson NY (S)

Story, Elizabeth, *Sr Libr Assoc,* Ohio University, Fine Arts Library, Athens OH

Stott, Annette, *Dir & Assoc Prof Art History,* University of Denver, School of Art & Art History, Denver CO (S)

Stoughton, Kathleen, *Dir,* University of California-San Diego, University Art Gallery, La Jolla CA

Stout, Andrew, *Asst Dir Grad,* University of Oklahoma, School of Art, Norman OK (S)

Stout, Cathy, *Head Reference Dept,* Free Public Library, Reference Dept, Trenton NJ

Stout, Ken, *Prof,* University of Arkansas, Art Dept, Fayetteville AR (S)

Stout, Paul, *Asst Prof,* University of Utah, Dept of Art & Art History, Salt Lake City UT (S)

Stout, Scotland, *Chmn,* Southern Arkansas University at Magnolia, Dept of Art, Magnolia AR (S)

Stout, Scotland, *Chmn Art Dept,* Southern Arkansas University, Art Dept Gallery & Magale Art Gallery, Magnolia AR

Stover, Nan, *Librn,* The Museum of Western Art, Library, Kerrville TX

Stowe, Tim, *Museum Shop Mgr,* Danville Museum of Fine Arts & History, Danville VA

Stowers, Robert, *Prof,* University of Wisconsin-Stevens Point, Dept of Art & Design, Stevens Point WI (S)

St Phillip, Henry, *Security,* The Ogden Museum of Southern Art, University of New Orleans, New Orleans LA

Strahan, Donna, *Conservator,* Asian Art Museum of San Francisco, Chong-Moon Lee Ctr for Asian Art and Culture, San Francisco CA

Straight, Robert, *Coordr Drawing & Painting,* University of Delaware, Dept of Art, Newark DE (S)

Strain, David, *Chmn,* University of the Ozarks, Dept of Art, Clarksville AR (S)

Straka, Keri, *Asst Prof,* Framingham State College, Art Dept, Framingham MA (S)

Strand, Laura, *Head Fiber & Fabric,* Southern Illinois University at Edwardsville, Dept of Art & Design, Edwardsville IL (S)

Strandberg, Kevin, *Instr,* Illinois Wesleyan University, School of Art, Bloomington IL (S)

Strange, Georgia, *Assoc Prof,* Indiana University, Bloomington, Henry Radford Hope School of Fine Arts, Bloomington IN (S)

Stranges, Robert, *Instr,* Siena Heights University, Studio Angelico-Art Dept, Adrian MI (S)

Strassberg, Roy, *Chmn,* Mankato State University, Art Dept, Mankato MN (S)

Strassberg, Roy, *Prof & Chair,* University of North Carolina at Charlotte, Dept Art, Charlotte NC (S)

Stratford, Linda, *Instr,* Asbury College, Art Dept, Wilmore KY (S)

Stratford, Linda, *Prof Art History,* Asbury College, Student Center Gallery, Wilmore KY

Stratis, Harriet, *Paper Conservator,* The Art Institute of Chicago, Dept of Prints & Drawings, Chicago IL

Stratton, David, Brescia University, Div of Fine Arts, Owensboro KY (S)

Stratton, Donald, *Prof,* University of Maine at Augusta, College of Arts & Humanities, Augusta ME (S)

Stratton, Jack, *Preparator,* University of North Carolina at Greensboro, Weatherspoon Art Museum, Greensboro NC

Stratyner, Barbara, *Cur Exhib,* The New York Public Library, The New York Public Library for the Performing Arts, New York NY

Strauss, Carol Kahn, *Dir,* Leo Baeck, Library, New York NY

Strauss, Carol Kahn, *Exec Dir,* Leo Baeck, New York NY

Strauss, David Levi, *Grad Comt,* Bard College, Center for Curatorial Studies Graduate Program, Annandale-on-Hudson NY (S)

Strauss, Melville, *Chmn,* Guild Hall of East Hampton, Inc, Guild Hall Museum, East Hampton NY

Strauss, Samara, *Arts Coordr,* Northwood University, Jeannette Hare Art Gallery, West Palm Beach FL

Strawbridge, Simone, *Chmn,* Mississippi Delta Community College, Dept of Fine Arts, Moorhead MS (S)

Strawfer, Gary, *Maintenance,* Zanesville Art Center, Zanesville OH

Strean, Jeffrey, *Dir Design & Facilities,* Cleveland Museum of Art, Cleveland OH

Streed, Crit, *Prof,* University of Northern Iowa, Dept of Art, Cedar Falls IA (S)

Streepey, Helen, *Registrar,* Carnegie Center for Art & History, New Albany IN

Street, Mark, *Asst Prof,* University of Maryland, Baltimore County, Imaging, Digital & Visual Arts Dept, Baltimore MD (S)

Streeter, Anita, *Exec Dir,* Embroiderers Guild of America, Margaret Parshall Gallery, Louisville KY

Streetman, Evon, *Prof,* University of Florida, Dept of Art, Gainesville FL (S)

Streetman, John W, *Dir,* Evansville Museum of Arts, History & Science, Evansville IN

Streifler, Leesa, *Head,* University of Regina, Visual Arts Dept, Regina SK (S)

Streit, Ruth, *VPres,* Red River Valley Museum, Vernon TX

Strelitz, Karen, *Pres,* Alpert Jewish Community Center, Gatov Gallery, Long Beach CA

Stremsterfer, Joanne, *Pres,* St. Louis Artists' Guild, Saint Louis MO

Stremsterfer, Marianne, *Instr,* Springfield College in Illinois, Dept of Art, Springfield IL (S)

Streu, Karin, *Gallery Asst,* Plug In, Institute of Contemporary Art, Winnipeg MB

Strick, Jeremy, *Dir,* The Museum of Contemporary Art (MOCA), Los Angeles CA

Strickland, Alice, *Exec Dir,* The Arts Council of Wayne County, Goldsboro NC (S)

Strickland, Barbour, *Exec Dir,* Greenville Museum of Art, Inc, Greenville NC

Strickland, Barbour, *Exec Dir,* Greenville Museum of Art, Inc, Reference Library, Greenville NC

Strickland, Ken, *VPres for Acad Affairs/Dean,* Memphis College of Art, Memphis TN (S)

Strickland, Rod, *Instr,* University of Windsor, Visual Arts, Windsor ON (S)

Strickland, William, *Pres & CEO,* Manchester Craftsmen's Guild, Pittsburgh PA

Strickler, Susan, *Dir,* The Currier Museum of Art, Currier Museum of Art, Manchester NH

Stricklin, Linda, *Asst Prof,* McMurry University, Art Dept, Abilene TX (S)

Stringam, Susannah, *Dir of Mktg,* San Diego Museum of Art, San Diego CA

Stringel, Rita, *Office Mgr,* Balzekas Museum of Lithuanian Culture, Chicago IL

Stringer, Candace, *Instr,* Wayne Art Center, Wayne PA (S)

Stringer, Howard, *Chmn Board Trustees,* The American Film Institute, Center for Advanced Film & Television, Los Angeles CA (S)

Strobel, Heidi, *Assoc Prof,* Baker University, Dept of Art, Baldwin City KS (S)

Strohm, Robert, *COO, Assoc Dir,* Virginia Historical Society, Richmond VA

Strohm, Robert F, *Assoc Dir,* Virginia Historical Society, Library, Richmond VA

Strohmeyer, Beverly, *Asst Dir Progs,* Missouri Arts Council, Saint Louis MO

Stromberg, Linda, *Opers Mgr,* Northern Arizona University, Art Museum & Galleries, Flagstaff AZ

Strong, Barbara, *Instr,* College of the Sequoias, Art Dept, Visalia CA (S)

Strong, John, *Dir,* Lake George Arts Project, Courthouse Gallery, Lake George NY

Swain, Anna, *Gallery Mgr,* Lyme Art Association, Inc, Old Lyme CT

Swain, Darlene, *Instr,* Mesa Community College, Dept of Art, Mesa AZ (S)

Swain, Kristin A, *Dir,* The Rockwell Museum of Western Art, Corning NY

Swain, Tim, *Gallery Asst,* Anderson Fine Arts Center, Anderson IN

Swaminadhan, Anand, *VPres,* Musee d'Art de Joliette, Joliette PQ

Swanborn, Sara Heil, *Bush House Coordr,* Salem Art Association, Bush House Museum, Salem OR

Swangstu, Holly, *Managing Dir,* Leedy Voulko's, Kansas City MO

Swanson, Ann, *Coll Mgr,* Rome Historical Society, Museum & Archives, Rome NY

Swanson, Catherine, *Archivist,* National Heritage Museum, Lexington MA

Swanson, Don, *Chief, Coll Preservation,* Frick Art Reference Library, New York NY

Swanson, Erik, *Dir,* Cripple Creek District Museum, Cripple Creek CO

Swanson, James, *Assoc Prof,* Dakota State University, College of Liberal Arts, Madison SD (S)

Swanson, Jessica, *Vis Asst Prof Art,* Whitman College, Art Dept, Walla Walla WA (S)

Swanson, Kenneth J, *Museum Adminr,* Idaho Historical Museum, Boise ID

Swanson, Kris, *Bus Mgr for the Arts,* University of Wisconsin - Platteville, Harry Nohr Art Gallery, Platteville WI

Swanson, Lealan, *Assoc Prof,* Jackson State University, Dept of Art, Jackson MS (S)

Swanson, Linda, *Adjunct Assoc,* College of Santa Fe, Art Dept, Santa Fe NM (S)

Swanson, Mark, *Librn & AV Production Mgr,* C G Jung, Evanston IL

Swanson, Michael, *Chmn Dept,* Franklin College, Art Dept, Franklin IN (S)

Swanson, Roy, *Prof,* Hutchinson Community College, Visual Arts Dept, Hutchinson KS (S)

Swanson, Vern G, *Dir,* Springville Museum of Art, Springville UT

Swarez, Bibiana, *Assoc Prof,* DePaul University, Dept of Art, Chicago IL (S)

Swart, Donna, *Cur,* Pioneer Florida Museum Association, Inc, Pioneer Florida Museum & Village, Dade City FL

Swart, Paula, *Cur Asian Studies,* Vancouver Museum, Vancouver BC

Swartwood, Larry, *Asst Prof,* University of Arkansas, Art Dept, Fayetteville AR (S)

Swartz, Dick, *Bus Mgr,* Wayne Center for the Arts, Wooster OH

Swayer, David, *Art Cur,* The Museum of Arts & Sciences Inc, Daytona Beach FL

Swearer, H Randolph, *Dean,* Parsons School of Design, New York NY (S)

Sweatt, Lilla, *Slide Cur,* San Diego State University, Art Department Slide Library, San Diego CA

Sweeney, Dennis F, *Mgr Bldgs & Secy,* Frick Collection, New York NY

Sweeney, Robert T, *Head of Studio,* Amherst College, Dept of Fine Arts, Amherst MA (S)

Sweeters, Jim, *Preparator,* California State University, Northridge, Art Galleries, Northridge CA

Sweeting, Floyd, *Head Information Systems,* Frick Art Reference Library, New York NY

Sweeting, Robert, *Store Mgr,* Walter Anderson, Ocean Springs MS

Swenson, David, *Lectr,* North Dakota State University, Division of Fine Arts, Fargo ND (S)

Swenson, Lisa, *Exec Dir,* Peninsula Fine Arts Center, Newport News VA

Swenson-Wolsey, Sonja, *Chmn,* Taft College, Art Department, Taft CA (S)

Swick, Deane, *Lectr,* California State Polytechnic University, Pomona, Art Dept, Pomona CA (S)

Swider, Bougdon, *Prof,* Colorado College, Dept of Art, Colorado Springs CO (S)

Swiderski, Christine, *Cur,* Ontario College of Art & Design, OCAD Gallery, Toronto ON

Swierenga, Heidi, *Conservator,* University of British Columbia, Museum of Anthropology, Vancouver BC

Swindull, Laurie, *Instr,* American University, Dept of Art, Washington DC (S)

Swing, Michael, *Instr,* Guilford Technical Community College, Commercial Art Dept, Jamestown NC (S)

Switzer, Elizabeth, *Prog Dir,* Rochester Contemporary, Rochester NY

Swoiak, Christine, *Asst Cur (Art),* University of Calgary, The Nickle Arts Museum, Calgary AB

Swonger, Denny, *Dean Arts & Scis,* Eastern Oregon University, School of Arts & Science, La Grande OR (S)

Swopes, Thomas, *Assoc Prof,* Saint Mary-of-the-Woods College, Art Dept, Saint Mary of the Woods IN (S)

Sydenstricker, Janet, *Dir Pub Relations,* Tidewater Community College, Visual Arts Center, Portsmouth VA (S)

Sylvester, Alison, *Admin Asst,* Tucson Museum of Artand Historic Block, Tucson AZ

Sylvester, Cindy, *Dir,* San Jose Museum of Art, Library, San Jose CA

Sylvester, Cindy, *Museum Store Mgr,* San Jose Museum of Art, San Jose CA

Sylvester, Louise, *Dir Develop,* Historic Bethlehem Partnership, Kemerer Museum of Decorative Arts, Bethlehem PA

Sylvester, Laurie, *Instr,* Columbia College, Fine Arts, Sonora CA (S)

Symmes, Edwin C, *Pres,* Symmes Systems, Photographic Investments Gallery, Atlanta GA

Symmes, Marilyn, *Cur Drawings & Prints,* Cooper-Hewitt, National Design Museum, Smithsonian Institution, New York NY

Synan, Jenny, *Interactive Mgr,* Art Directors Club, New York NY

Synder, Fred, *Dir & Consultant,* National Native American Co-Operative, North America Indian Information & Trade Center, Tucson AZ

Syvertson, Alma, *Asst Dir,* Fillmore County Historical Society, Fountain MN

Szavuly, Erin Palmer, *Chmn Fine Arts,* Lourdes College, Art Dept, Sylvania OH (S)

Szmagaj, Kenneth, *Prof,* James Madison University, School of Art & Art History, Harrisonburg VA (S)

Szoke, Andrew, *Asst Prof,* Northampton Community College, Art Dept, Bethlehem PA (S)

Szycher, Lawrence, *Chmn,* Caldwell College, Art Dept, Caldwell NJ (S)

Szynkowski, Stan, *APO,* University of Alberta, Dept of Art & Design, Edmonton AB (S)

Taaffe, Ranee, *Cur Educ,* Missoula Art Museum, Missoula MT

Taaffe, Susan, *Preparator,* University of North Carolina at Greensboro, Weatherspoon Art Museum, Greensboro NC

Tabaha, Kathy, *Mus Tech,* National Park Service, Hubbell Trading Post National Historic Site, Ganado AZ

Tabb, Winston, *Assoc Librn,* Library of Congress, Prints & Photographs Division, Washington DC

Taber, Norman, Southwestern Oklahoma State University, Art Dept, Weatherford OK (S)

Tacang, Lee, *Instr,* De Anza College, Creative Arts Division, Cupertino CA (S)

Taddie, Dan, *Chmn,* Maryville College, Dept of Fine Arts, Maryville TN (S)

Taft, Dudley S, *VChmn,* Cincinnati Institute of Fine Arts, Cincinnati OH

Tagg, John, *Chmn Dept,* State University of New York at Binghamton, Dept of Art History, Binghamton NY (S)

Tai, Evangeline, *Educ,* Napa Valley Museum, Yountville CA

Tai, Gloria, *Interim Exec Dir,* Chinese Culture Foundation, Center Gallery, San Francisco CA

Tai, Susan Shin-Tsu, *Cur Asian Art,* Santa Barbara Museum of Art, Santa Barbara CA

Tailford, Matt, *Asst Prof,* Taylor University, Visual Art Dept, Upland IN (S)

Tait, Jennifer Woodruff, *Head Librn,* Archives & History Center of the United Methodist Church, Library, Madison NJ

Takahashi, Mina, *Exec Dir,* Dieu Donne Papermill, Inc, New York NY

Takekawa, Beth, *Assoc Dir,* Wing Luke Asian Museum, Library, Seattle WA

Takemori, Lianne, *Asst Cur Edu,* Mississippi Museum of Art, Howorth Library, Jackson MS

Takeuchi, Arthur, *Assoc Prof,* Illinois Institute of Technology, College of Architecture, Chicago IL (S)

Taki, Elga, *Sec,* Saint Peter's College, Art Gallery, Jersey City NJ

Talachy, Melissa, *Cur,* Pueblo of Pojoaque, Poeh Museum, Santa Fe NM

Talaga, Sally, *Dir,* Wayne County Historical Society, Museum, Honesdale PA

Talaga, Sally, *Exec Dir,* Wayne County Historical Society, Honesdale PA

Talasek, J D, *Exhibition Coordr,* National Academy of Sciences, Arts in the Academy, Washington DC

Talbat-Stanaway, Susan, *Librn,* Muskegon Museum of Art, Library, Muskegon MI

Talbert, Hope C, *Dir,* Santarella Museum & Gardens, Tyringham MA

Talbot, Joan, *2d VPres,* Washington Art Association, Washington Depot CT

Talbott, Ronald, *Instr,* Harrisburg Area Community College, Division of Communication & the Arts & Social Science, Harrisburg PA (S)

Talent, Rachel, *Registrar,* Bass Museum of Art, Miami Beach FL

Taliana, James, *Pres,* Boothbay Region Art Foundation, Boothbay Harbor ME

Talkington, John, *Mgr Fin & Oper,* The Contemporary Museum, Honolulu HI

Tall Chief, Russ, *Dir Public Affairs,* National Museum of the American Indian, George Gustav Heye Center, New York NY

Talley, Andrew, *Registrar,* California African-American Museum, Los Angeles CA

Talmon, Renee, *Dir of Admissions,* San Francisco Art Institute, San Francisco CA (S)

Tamplin, Illi-Maria, *Dir,* Art Gallery of Peterborough, Peterborough ON

Tamsburg, Margaret W, *Office Mgr,* Historical Society of Palm Beach County, West Palm Beach FL

Tamura, Tomiaki, *Dir of Design,* Cosanti Foundation, Scottsdale AZ

Tan, Gina, *Dir Membership,* Fine Arts Museums of San Francisco, M H de Young Museum, San Francisco CA

Tan, Gina, *Dir Membership,* Fine Arts Museums of San Francisco, Legion of Honor, San Francisco CA

Tan, Suzanne, *Dir External Affairs,* Santa Monica Museum of Art, Santa Monica CA

Tanenhaus, Belle, *Coord (V),* Brooklyn Museum, Brooklyn NY

Tang, Janet, *Finance Officer,* Stanford University, Iris & B Gerald Cantor Center for Visual Arts, Stanford CA

Taniguchi, Dennis, *Exec Dir,* Japantown Art & Media Workshop, San Francisco CA

Tankersley, Suzy, *Prog Coordr,* Schweinfurth Memorial Art Center, Auburn NY

Tannebaum, Marilyn, *Instr,* Solano Community College, Division of Fine & Applied Art & Behavioral Science, Suisun City CA (S)

Tannen, Jason, *Chmn,* California State University, Chico, University Art Gallery, Chico CA

Tannen, Jason, *Instr,* California State University, Chico, Department of Art & Art History, Chico CA (S)

Tannenbaum, Barbara, *Chief Cur,* Akron Art Museum, Martha Stecher Reed Art Library, Akron OH

Tannenbaum, Barbara, *Chief Cur & Dir Head P,* Akron Art Museum, Akron OH

Tanner, Jim, *Assoc Prof (Visual Art),* University of British Columbia Okanagan, Dept of Creative Studies, Kelowna BC (S)

Tanner, Martha, *Asst to Dir,* Vesterheim Norwegian-American Museum, Reference Library, Decorah IA

Tanselle, G Thomas, *VPres & Secy,* John Simon Guggenheim, New York NY

Tanze, Don, *Asst Prof,* Seattle Central Community College, Humanities - Social Sciences Division, Seattle WA (S)

Taraba, Fred, *Dir,* Illustration House Inc, Gallery Auction House, New York NY

Tarantal, Stephen, *Dean, College of Art & Design,* University of the Arts, Philadelphia Colleges of Art & Design, Performing Arts & Media & Communication, Philadelphia PA (S)

Tarapor, Mahrukh, *Assoc Dir Exhibition,* The Metropolitan Museum of Art, New York NY

Tarbell, Mike, *Educator,* Iroquois Indian Museum, Howes Cave NY

Tarchi, Claudio, *VPres,* Museo Italo Americano, San Francisco CA

Tardif, Mark, *Pub Rels Dir,* Thomas College Art Gallery, Waterville ME

Tarnow, Terry, *Museum Shop Mgr,* Northwestern Michigan College, Dennos Museum Center, Traverse City MI

Tarr, Blair, *Cur of Decorative Art,* Kansas State Historical Society, Kansas Museum of History, Topeka KS

Tarrell, Robert, *Prof,* Edgewood College, Art Dept, Madison WI (S)

Tarsitano, Robert, *Treas,* Arts on the Park, Lakeland Center for Creative Arts, Lakeland FL

Tarver, Paul, *Registrar,* New Orleans Museum of Art, New Orleans LA

Tasaka, Sharon, *Assoc Dir,* University of Hawaii at Manoa, Art Gallery, Honolulu HI

Tassone, Rachel, *Mgr of Coll Info,* Williams College, Museum of Art, Williamstown MA

Tate, Belinda, *Dir, Cur, Develop& Registrar,* Winston-Salem State University, Diggs Gallery, Winston-Salem NC

Tate, Alan, *Head Landscape Archit,* University of Manitoba, Faculty of Architecture, Winnipeg MB (S)

Tate, Alicia, *Chair,* Illinois Benedictine University, Fine Arts Dept, Lisle IL (S)

Tate, Barbara, *Dir,* Henry Street Settlement Arts for Living Center, New York NY (S)

Tate, Carolyn, *Asst Prof,* Texas Tech University, Dept of Art, Lubbock TX (S)

Tate, Jamie, *Dir,* Mississippi Art Colony, Stoneville MS

Tate, Linda, *Accounting Mgr,* Hunter Museum of American Art, Chattanooga TN

Tate, Pat, *Cur,* Sturdivant Hall, Selma AL

Tate, William, *Asst Prof,* James Madison University, School of Art & Art History, Harrisonburg VA (S)

Tateischi, Cheryl, *Deputy Dir Admin,* California Science Center, Los Angeles CA

Tatro, Amy, *Asst to Dir,* Williams College, Museum of Art, Williamstown MA

Tatsuno, Marlene, *Ceramics Dept Dir,* Bakersfield College, Fine Arts Dept, Bakersfield CA (S)

Tatum, James, *Prof,* Lincoln University, Dept Fine Arts, Jefferson City MO (S)

Taub, Peter, *Dir of Performance Prog,* Museum of Contemporary Art, Chicago IL

Taubenberger, Michael, *Dir Finance,* Institute of Contemporary Art, Boston MA

Taucci, Christopher, *Build & Grounds,* Belle Grove Plantation, Middletown VA

Taugner, Stephanie, *Instr,* Art Institute of Southern California, Laguna Beach CA (S)

Taugner, Stephanie, Marian College, Art Dept, Indianapolis IN (S)

Taurins, Irene, *Registrar,* Philadelphia Museum of Art, Philadelphia PA

Taurins, Irene, *Registrar,* Philadelphia Museum of Art, Samuel S Fleisher Art Memorial, Philadelphia PA

Tavani, Robert, *Gallery Dir,* DePaul University, Dept of Art, Chicago IL (S)

Tayes, Debra, *So IL Art,* Illinois State Museum, Museum Store, Chicago IL

Tayler, Felicity, *Information Specialist,* Artexte Information Centre, Documentation Centre, Montreal PQ

Taylor, Adams, *Historic Sites & Colls Mgr,* Newport Historical Society & Museum of Newport History, Newport RI

Taylor, Aletha, *Children's Librn,* Mexico-Audrain County Library, Mexico MO

Taylor, Barbara, *Exhibits Specialist,* Fort George G Meade Museum, Fort Meade MD

Taylor, Barbara E, *Exec Dir,* High Point Historical Society Inc, Museum, High Point NC

Taylor, Ben, *Dir Sales Shop,* Colorado Springs Fine Arts Center, Colorado Springs CO

Taylor, Beth, *Asst Cur Entomology,* Northern Maine Museum of Science, Presque Isle ME

Taylor, Brian, *Co-Chair,* Shorter College, Art Dept, Rome GA (S)

Taylor, Brigitte, *Asst Chair,* University of Wisconsin-Milwaukee, Dept of Art, Milwaukee WI (S)

Taylor, Bruce, *Assoc Prof,* University of Waterloo, Fine Arts Dept, Waterloo ON (S)

Taylor, Bruce T, *VPres,* National Museum of Ceramic Art & Glass, Baltimore MD

Taylor, Carole, *Library Dir,* Fort Valley State College, H A Hunt Memorial Library, Fort Valley GA

Taylor, Colleen, *Secy,* Fort Hays State University, Moss-Thorns Gallery of Arts, Hays KS

Taylor, Darrelll, *Dir,* University of Northern Iowa, UNI Gallery of Art, Cedar Falls IA

Taylor, David, *County of Lambton,* Gallery Lambton, Sarnia ON

Taylor, David, *Photo Dir,* New Mexico State University, Art Dept, Las Cruces NM (S)

Taylor, David E, *Conservator,* Tryon Palace Historic Sites & Gardens, New Bern NC

Taylor, Diane, *Mem & Communications Mgr,* Birmingham-Bloomfield Art Center, Art Center, Birmingham MI

Taylor, Diane, *Mem & Develop Mgr,* Birmingham-Bloomfield Art Center, Birmingham MI (S)

Taylor, Ed, *Secy Board Dirs.,* National Association of Artists' Organizations (NAAO), Birmingham AL

Taylor, Evelyn, *Mem Coordr,* Brevard Museum of Art & Science, Melbourne FL

Taylor, Glenda, *Art & Theatre Arts Chmn,* Washburn University of Topeka, Dept of Art, Topeka KS (S)

Taylor, Howard J, *Dir,* San Angelo Museum of Fine Arts, San Angelo TX

Taylor, Jayson, *Asst Prof,* Fort Hays State University, Dept of Art, Hays KS (S)

Taylor, Jeffrey, *Collections Mgr,* Norton Simon, Pasadena CA

Taylor, Joan, *Assoc Prof,* Fairleigh Dickinson University, Fine Arts Dept, Teaneck NJ (S)

Taylor, Judith, *Asst Prof,* Beaver College, Dept of Fine Arts, Glenside PA (S)

Taylor, Kathryn T, *Dir,* Westerly Public Library, Hoxie Gallery, Westerly RI

Taylor, Marcia, *Assoc Prof,* The College of New Jersey, School of Arts & Sciences, Ewing NJ (S)

Taylor, Marilyn S, *Cur Ethnology,* Saint Joseph Museum, Saint Joseph MO

Taylor, Mark A, *Graphic Design Prog Dir,* Brenau University, Art & Design Dept, Gainesville GA (S)

Taylor, Mary, *Pres,* San Angelo Art Club, Helen King Kendall Memorial Art Gallery, San Angelo TX

Taylor, Mary Diane, *Chmn,* Brescia University, Div of Fine Arts, Owensboro KY (S)

Taylor, Mary Diane, *Chmn Dept Art,* Brescia University, Anna Eaton Stout Memorial Art Gallery, Owensboro KY

Taylor, Mary Rand, *Vice Chmn,* Mingei International, Inc, Mingei International Museum, San Diego CA

Taylor, Michael, *Assoc Prof,* Lewis & Clark College, Dept of Art, Portland OR (S)

Taylor, Michael, *Chmn Art History,* University of Massachusetts Dartmouth, College of Visual & Performing Arts, North Dartmouth MA (S)

Taylor, Mike, *Pub Affairs,* Okefenokee Heritage Center, Inc, Waycross GA

Taylor, Nancy, *Art Dept Convener,* Earlham College, Leeds Gallery, Richmond IN

Taylor, Pam, *Asst Prof Art Educ,* University of Georgia, Franklin College of Arts & Sciences, Lamar Dodd School of Art, Athens GA (S)

Taylor, Richard, *Pres,* National Museum of Ceramic Art & Glass, Baltimore MD

Taylor, Robert, *Theatre Cur,* The New York Public Library, The New York Public Library for the Performing Arts, New York NY

Taylor, Rod A, *Head Dept,* Norfolk State University, Fine Arts Dept, Norfolk VA (S)

Taylor, Rose, *Mem,* Salisbury University, Ward Museum of Wildfowl Art, Salisbury MD

Taylor, Ruth, *Acquisitions Librn,* Mexico-Audrain County Library, Mexico MO

Taylor, Saddler, *Cur Folk Art & Research,* University of South Carolina, McKissick Museum, Columbia SC

Taylor, Stephanie, *Asst Prof,* New Mexico State University, Art Dept, Las Cruces NM (S)

Taylor, Sue, *Assoc Prof,* Portland State University, Dept of Art, Portland OR (S)

Taylor, Tom, *Coordr Fine Arts,* Columbia College, Art Dept, Chicago IL (S)

Taylor, Warren, *Instr,* Midland College, Art Dept, Midland TX (S)

Taylor, William, *Dir Develop,* Menil Foundation, Inc, Houston TX

Taylor-Gore, Victoria, *Instr,* Amarillo College, Visual Art Dept, Amarillo TX (S)

Tchen, John K W, *Co-Founder,* Museum of Chinese in the Americas, New York NY

Teague, Beth, *Communication Dir,* Hickory Museum of Art, Inc, Hickory NC

Teahan, John W, *Librn,* Wadsworth Atheneum Museum of Art, Auerbach Art Library, Hartford CT

Teal, Randall, *Instr,* Southern University A & M College, School of Architecture, Baton Rouge LA (S)

Teats, Gloria, *Co-Chmn,* Valley Art Center Inc, Clarkston WA

Teaza, Annette, *Gallery Dir,* Huntsville Art League, Huntsville AL

Tebbenhoff, Karen, *Mktg & Pub Relations,* The Currier Museum of Art, Currier Museum of Art, Manchester NH

Tebow, Duncan, *Chmn,* Northern Virginia Community College, Art Dept, Annandale VA (S)

Teczar, Steven, *Prof,* Maryville University of Saint Louis, Art & Design Program, Saint Louis MO (S)

Tederick, Lydia, *Asst Cur,* White House, Washington DC

Tedeschi, Martha, *Cur,* The Art Institute of Chicago, Dept of Prints & Drawings, Chicago IL

Tedeschi, Martha, *Cur Prints & Drawings,* The Art Institute of Chicago, Chicago IL

Tedford, Catherine, *Dir,* St Lawrence University, Richard F Brush Art Gallery, Canton NY

Teipel, Juliet S, *Librn,* The Illinois Institute of Art - Chicago, Chicago IL (S)

Teitelbaum, Matthew, *Dir,* Art Gallery of Ontario, Toronto ON

Teitelbaum, Richard, *Instr,* Bard College, Milton Avery Graduate School of the Arts, Annandale-on-Hudson NY (S)

Teixido, Mercedes, *Asst Prof,* Pomona College, Dept of Art & Art History, Claremont CA (S)

Teja, Carole, *Dir Meetings & Prog,* Association of Medical Illustrators, Lawrence KS

Telfair, Tula, *Assoc Prof,* Wesleyan University, Dept of Art & Art History, Middletown CT (S)

Telford, John, *Chmn,* Brigham Young University, Dept of Visual Arts, Provo UT (S)

Tellier, Cassandra Lee, *Prof,* Capital University, Schumacher Gallery, Columbus OH

Telljohann, Jean, *Dir Develop,* National Academy Museum & School of Fine Arts, New York NY

Telljohann, Jean, *Dir Develop,* National Academy Museum & School of Fine Arts, Archives, New York NY

Temkin, Ann, *Cur Modern & Contemporary Art,* Philadelphia Museum of Art, Samuel S Fleisher Art Memorial, Philadelphia PA

Temkin, Susanna, *Visual Arts Committee Chair,* Duke University Union, Louise Jones Brown Gallery, Durham NC

Temmer, James D, *Exec Dir,* Villa Terrace Decorative Art Museum, Milwaukee WI

Temple, Daniel, *VPres Library,* Kenyon College, Olin Art Gallery, Gambier OH

Temple, Harold, *Prof,* Wayland Baptist University, Dept of Art, Plainview TX (S)

Temple, Leslie Alcott, *Pres,* SLA Arch-Couture Inc, Art Collection, Denver CO

Temple, Paula, *Prof,* University of Mississippi, Department of Art, University MS (S)

Temple, Steve, *Dir,* Gadsden Museum of Fine Arts, Inc, Gadsden Museum of Art and History, Gadsden AL

Templer, Peggy, *Exec Dir,* Mendocino Art Center, Gallery & School, Mendocino CA

Templer, Peggy, *Exec Dir,* Mendocino Art Center, Mendocino CA (S)

Templer, Peggy, *Exec Dir,* Mendocino Art Center, Library, Mendocino CA

Templeton, Amy, *Dir Devel,* Birmingham Museum of Art, Birmingham AL

Templeton, Amy W, *Dir of Develop,* Birmingham Museum of Art, Clarence B Hanson Jr Library, Birmingham AL

Templeton, Ed, *Dir,* New Image Art, Los Angeles CA

Templeton, Kimberly, *Dir Extern Affairs,* Art Museum of Western Virginia, Roanoke VA

Tenckhoff, Diana, *Asst Prof,* Southwestern University, Sarofim School of Fine Art, Dept of Art & Art History, Georgetown TX (S)

Tennant, Andy, *Mus Services & Special Events Adminr,* Jule Collins Smith Museum of Art, Auburn AL

Tennent, Elaine, *Dir,* Tennent Art Foundation Gallery, Honolulu HI

Tennent, Elaine, *Dir,* Tennent Art Foundation Gallery, Library, Honolulu HI

Tenny, Elissa, *Dean,* New School University, Adult Education Division, New York NY (S)

Tent, Lauren, *Educ Coordr,* Center for Exploratory & Perceptual Art, CEPA Gallery, Buffalo NY

Tent , Lauren, *Educ Coordr,* Center for Exploratory & Perceptual Art, CEPA Library, Buffalo NY

Teramoto, John, *Assoc Cur Asian Art,* Columbus Museum of Art and Design, Indianapolis IN

Teramoto, John, *Asst Prof,* University of Kansas, Kress Foundation Dept of Art History, Lawrence KS (S)

Terra, Daniel J, *Founder,* Terra Museum of American Art, Chicago IL

Terrano, Robert A, *Dean,* Mercer County Community College, Arts, Communication & Engineering Technology, Trenton NJ (S)

Terrell, James, *Chmn,* Northeastern State University, College of Arts & Letters, Tahlequah OK (S)

Terrell, Richard, *Head Dept,* Doane College, Dept of Art, Crete NE (S)

Terrono, Evie, *Lectr,* Randolph-Macon College, Dept of the Arts, Ashland VA (S)

Terry, Carol, *Dir,* Rhode Island School of Design, Fleet Library at RISD, Providence RI

Terry, James H, *Chair,* Stephens College, Art Dept, Columbia MO (S)

Terry, Robin, *Dir Communications,* Center for Creative Studies, College of Art & Design, Detroit MI (S)

Terry, Shepherd, *Head of Ceramics,* Western Colorado Center for the Arts, Inc, Grand Junction CO

Terry, Susan, *Bus Mgr,* New York Studio School of Drawing, Painting & Sculpture, Gallery, New York NY

Tersteeg, William, *Prof,* Keystone College, Fine Arts Dept, LaPlume PA (S)

Terwilliger, Steven, University of Wisconsin-Eau Claire, Dept of Art, Eau Claire WI (S)

Terzia, Louise, *Develop Dir,* Historic Arkansas Museum, Little Rock AR

Tesi, Donna J, *Vol Pres,* Grevemberg House Museum, Franklin LA

Tesman, Laura, *Asst Prof,* University of Colorado-Colorado Springs, Visual & Performing Arts Dept, Colorado Springs CO (S)

Tessman, Nancy, *Dir,* Salt Lake City Public Library, Fine Arts & Audiovisual Dept and Atrium Gallery, Salt Lake City UT

Tesso, Jane B, *Art Consultant,* Federal Reserve Bank of Cleveland, Chesterland OH

Testa, Adena, *Chair Board Trustees,* Walters Art Museum, Baltimore MD

Testa, Adena W, *VChmn,* Walters Art Museum, Library, Baltimore MD

Teteriatnikov, Natalia, *Photo Archives Cur,* Harvard University, Dumbarton Oaks Research Library, Washington DC

Teunis, Janet, *Visual Arts Coordr,* Urban Institute for Contemporary Arts, Grand Rapids MI

Tewell, Tanya, *Instr,* Middle Tennessee State University, Art Dept, Murfreesboro TN (S)

Texley, Carolyn, *Dir Colls, Archivist,* The Lincoln Museum, Fort Wayne IN

Texon, Wanda, *Cur Educ,* Bass Museum of Art, Miami Beach FL

Thaler, Janice M, *Bd Mem,* French Art Colony, Gallipolis OH

Thames, Charles, *Cur, Art Coll,* 3M, Art Collection, Saint Paul MN

Thatcher, C Gregory, *Dir,* Maharishi University of Management, Department of Fine Arts, Fairfield IA

Thaxton-Ward, Vanessa D, *Cur of History,* Hampton University, University Museum, Hampton VA

Theberge, Pierre, *Deputy Dir Bus,* National Gallery of Canada, Ottawa ON

Theberge, Pierre, *Dir,* National Gallery of Canada, Ottawa ON

Theeck, Jennifer, *Educ Coordr,* Museum of Mobile, Mobile AL

Theel, Marcia M, *Assoc Dir,* Leigh Yawkey Woodson, Wausau WI

Theide, Billie, *In Charge Metals,* University of Illinois, Urbana-Champaign, School of Art & Design, Champaign IL (S)

Theilking, Kristin, *Asst Prof,* University of Wisconsin-Stevens Point, Dept of Art & Design, Stevens Point WI (S)

Thein, John, *Instr,* Creighton University, Fine & Performing Arts Dept, Omaha NE (S)

Theisen, Nate, *Asst Prof of Art,* Belhaven College, Art Dept, Jackson MS (S)

Theiss, Kristin, *Museum Shop Mgr,* Museum of Northwest Art, La Conner WA

Theodore, Wiebke, *Vis Asst Prof,* Bowdoin College, Art Dept, Brunswick ME (S)

Theriault, Raymond, *Pres,* Alberta Society of Artists, Edmonton AB

The Rider, Pierre, *Prof, Head Computational Finance,* Universite de Montreal, Bibliotheque d'Amenagement, Montreal PQ

Thesen, Sharon, *Assoc Prof (Creative Writing),* University of British Columbia Okanagan, Dept of Creative Studies, Kelowna BC (S)

Thesing, Claudia I, *Dir Develop Coordr,* New Britain Museum of American Art, New Britain CT

Thew, Christos, University of Wisconsin-Eau Claire, Dept of Art, Eau Claire WI (S)

Thibault, Barbara, *Dir,* Gibson Society, Inc, Gibson House Museum, Boston MA

Thibodeau, Kate Navarra, *Cur,* Wistariahurst Museum, Holyoke MA

Thibodeau, Rich, *Dir,* Lovewell Studios, Superior NB (S)

Thiele, John, *VPres,* Timken Museum of Art, San Diego CA

Thiesen, Barbara A, *Librn,* Bethel College, Mennonite Library & Archives, North Newton KS

Thiesen, John D, *Archivist,* Bethel College, Mennonite Library & Archives, North Newton KS

Thi Hoi, Dao, *Librn,* VICANA (Vietnamese Cultural Association in North America) Library, Springfield VA

Thistle, Paul, *Dir,* Dawson City Museum & Historical Society, Dawson City YT

Thistle, Paul C, *Dir & Cur,* Dawson City Museum & Historical Society, Klondike History Library, Dawson City YT

Thistlethwaite, Mark, *Prof,* Texas Christian University, Dept of Art & Art History, Fort Worth TX (S)

Thode, David, *Instr,* California State University, Chico, Department of Art & Art History, Chico CA (S)

Thomas, Ann, *Acting Cur Photo Coll,* National Gallery of Canada, Ottawa ON

Thomas, Brad, *Dir,* Davidson College, William H Van Every Jr & Edward M Smith Galleries, Davidson NC

Thomas, Bruce, *Assoc,* Lehigh University, Dept of Art & Architecture, Bethlehem PA (S)

Thomas, C David, *Prof,* Emmanuel College, Art Dept, Boston MA (S)

Thomas, Christopher, *Asst Prof,* University of Victoria, Dept of History in Art, Victoria BC (S)

Thomas, Colleen, *Chmn Board Trustees,* Indiana State Museum, Indianapolis IN

Thomas, Eliane, *Develop Coordr,* The Sandwich Historical Society, Inc, Sandwich Glass Museum, Sandwich MA

Thomas, Floyd, *Cur,* Ohio Historical Society, National Afro American Museum & Cultural Center, Wilberforce OH

Thomas, Gary, *Prof,* Culver-Stockton College, Art Dept, Canton MO (S)

Thomas, Jacob, *Dir of Arboretum,* Barnes Foundation, Merion PA

Thomas, James C, *Pres & CEO,* Shaker Village of Pleasant Hill, Harrodsburg KY

Thomas, Jamieson, *Mus Shop Mgr,* Orlando Museum of Art, Orlando FL

Thomas, Jamieson, *Mus Shop Mgr,* Orlando Museum of Art, Orlando Sentinel Library, Orlando FL

Thomas, Janet, *Technical Servs Librn,* Ringling School of Art & Design, Verman Kimbrough Memorial Library, Sarasota FL

Thomas, Joe, *Assoc Prof,* Clarion University of Pennsylvania, Dept of Art, Clarion PA (S)

Thomas, Joe, *Chmn,* Clarion University, Hazel Sandford Gallery, Clarion PA

Thomas, Johathan, *Instr,* University of Miami, Dept of Art & Art History, Coral Gables FL (S)

Thomas, Kurtis, *Registrar,* Mobile Museum of Art, Mobile AL

Thomas, Larry, *Prof Art, Painting/Drawing/Digital Dept Coordr,* Johnson County Community College, Visual Arts Program, Overland Park KS (S)

Thomas, Lorelle, *Assoc Prof,* Grand Valley State University, Art & Design Dept, Allendale MI (S)

Thomas, Lowell, *Pres,* Hancock County Trustees of Public Reservations, Woodlawn Museum, Ellsworth ME

Thomas, M. Jean, *VPres for Mgt,* Meridian International Center, Cafritz Galleries, Washington DC

Thomas, Mark, *Prof,* Art Academy of Cincinnati, Cincinnati OH (S)

Thomas, Michele M, *Gen Educ,* Art Institute of Pittsburgh, Pittsburgh PA (S)

Thomas, Paul, *Assoc Prof,* Illinois Institute of Technology, College of Architecture, Chicago IL (S)

Thomas, Prince, *Assoc Prof,* Lamar University, Art Dept, Beaumont TX (S)

Thomas, Prince, *Lectr,* Rice University, Dept of Art & Art History, Houston TX (S)

Thomas, Robert, *Deputy Dir,* Oklahoma Historical Society, Library Resources Division, Oklahoma City OK

Thomas, Ronald, *Prof,* Saint Louis Community College at Meramec, Art Dept, Saint Louis MO (S)

Thomas, Steve, *Educ Cur,* Riverside Art Museum, Riverside CA

Thomas, Tara, *Bemis Art School Dir,* Colorado Springs Fine Arts Center, Colorado Springs CO

Thomas, Troy, *Assoc Prof,* Penn State Harrisburg, School of Humanities, Middletown PA (S)

Thomas, Valerie, *Develop Mgr -Individ,* Allentown Art Museum, Allentown PA

Thomas, William, *Grounds & Maintena,* Art Complex Museum, Carl A. Weyerhaeuser Library, Duxbury MA

Thomas, William, *Prof,* West Virginia University, College of Creative Arts, Morgantown WV (S)

Thomas, William G, *Supt,* San Francisco Maritime National Historical Park, Maritime Museum, San Francisco CA

Thomas-Vickory, Stacy, *Printmaking,* Montserrat College of Art, Beverly MA (S)

Thomasgard, Robert, *Assoc Dir,* Wisconsin Historical Society, State Historical Museum, Madison WI

Thommen, Lynn, *Deputy Dir External,* The Jewish Museum, New York NY

Thompson, Ann, *Instr,* Appalachian State University, Dept of Art, Boone NC (S)

Thompson, Anna, *Exec Dir of Fine Arts Programming,* College of Saint Benedict, Art Gallery, Saint Joseph MN

Thompson, Ben, *Registrar,* Brandeis University, Rose Art Museum, Waltham MA

Thompson, Bob, *Head Educ,* Tyler Museum of Art, Tyler TX

Thompson, Cheryl, *Dir Admin,* Dawson City Museum & Historical Society, Dawson City YT

Thompson, Chris, Maine College of Art, Portland ME (S)

Thompson, Christy, *Dir,* Redhead Gallery, Toronto ON

Thompson, Conor, *Preparator & Facilities,* Craft and Folk Art Museum (CAFAM), Los Angeles CA

Thompson, Daren, *Cur Educ,* Honolulu Academy of Arts, The Art Center at Linekona, Honolulu HI (S)

Thompson, Dave, *Fin Dir,* The New England Museum of Telephony, Inc., The Telephone Museum, Ellsworth ME

Thompson, Deborah, *Co-Dir,* Gilbert Stuart, Museum, Saunderstown RI

Thompson, Dolly, *Instr,* Morningside College, Art Dept, Sioux City IA (S)

Thompson, Durant, *Asst Prof,* University of Mississippi, Department of Art, University MS (S)

Thompson, Frank, *VChmn,* Contemporary Art Museum, Raleigh NC

Thompson, Gigi, *Dir Marketing & Communications,* Industrial Designers Society of America, Sterling VA

Thompson, Greig, *Instr,* William Woods-Westminster Colleges, Art Dept, Fulton MO (S)

Thompson, Harry F, *Cur & Managing Ed,* Augustana College, Center for Western Studies, Sioux Falls SD

Thompson , Health, *Cur,* L D Brinkman, Kerrville TX

Thompson, Ida, *Dir,* Midtown Art Center, Houston TX

Thompson, James, *Assoc Prof,* Azusa Pacific University, College of Liberal Arts, Art Dept, Azusa CA (S)

Thompson, James, *Prof,* Western Carolina University, Dept of Art/College of Arts & Science, Cullowhee NC (S)

Thompson, John, *Co-Dir,* Gilbert Stuart, Museum, Saunderstown RI

Thompson, John T, *Chmn,* Columbus Museum of Art and Design, Indianapolis IN

Thompson, Judy, *Receptionist,* Irvine Museum, Irvine CA

Thompson, Karen, *Cur Educ,* Honolulu Academy of Arts, Honolulu HI

Thompson, Kelly, *Coordr Educ Pub Prog,* Vassar College, The Frances Lehman Loeb Art Center, Poughkeepsie NY

Thompson, Larry, *Chmn,* Ouachita Baptist University, Dept of Visual Art, Arkadelphia AR (S)

Thompson, Laurie, *Registrar,* New Mexico State University, Art Gallery, Las Cruces NM

Thompson, Marc, *Dir,* City of El Paso, El Paso Museum of Archaeology, El Paso TX

Thompson, Mark R, *Exec Dir,* Portland Harbor Museum, South Portland ME

Thompson, Melissa, *Registrar,* Amon Carter, Fort Worth TX

Thompson, Patricia, *Prof,* Daytona Beach Community College, Dept of Fine Arts & Visual Arts, Daytona Beach FL (S)

Thompson, Paul, *Dir,* Cooper-Hewitt, National Design Museum, Smithsonian Institution, New York NY

Thompson, Pauline, *CEO,* Vancouver Museum, Vancouver Museum Library, Vancouver BC

Thompson, Peter, *Chmn,* Coe College, Dept of Art, Cedar Rapids IA (S)

Thompson, Peter G, *Dean,* University of Kansas, School of Fine Arts, Lawrence KS (S)

Thompson, Richard, *Dean,* New York State College of Ceramics at Alfred University, School of Art & Design, Alfred NY (S)

Thompson, Rosie, *Prof,* North Carolina Central University, Art Dept, Durham NC (S)

Thompson, Scott B, *Dir,* Laurens County Historical Society, Dublin-Laurens Museum, Dublin GA

Thompson, Sharon, *Dir Div Liberal Arts,* Philadelphia Community College, Dept of Art, Philadelphia PA (S)

Thompson, Stuart, *Prof,* Seton Hill University, Art Program, Greensburg PA (S)

Thompson, William R., *Cur of Coll,* City of El Paso, El Paso TX

Thomsen, Charles, *Assoc Dean, Head Environmental Design,* University of Manitoba, Faculty of Architecture, Winnipeg MB (S)

Thomson, Bill, *Asst Prof,* University of Hartford, Hartford Art School, West Hartford CT (S)

Thomson, Carl, *Historian,* Artists' Fellowship, Inc, New York NY

Thomson, Frank, *Cur,* Asheville Art Museum, Asheville NC

Thomson, John, *Dir Distribution,* Electronic Arts Intermix, Inc, New York NY

Thomson, Sandra, *Provincial Archivist,* Department of Community Development, Provincial Archives of Alberta, Edmonton AB

Thomson, Stewart, *Treas,* Haystack Mountain School of Crafts, Deer Isle ME

Thornborough, Kathy, *Chief Librn,* The Art Gallery of Southwestern Manitoba, Brandon Public Library, Brandon MB

Thornburg, Doris, *Receptionist,* Wichita Falls Museum & Art Center, Wichita Falls TX

Thornton, Terri, *Cur Educ,* Modern Art Museum, Fort Worth TX

Thorp-Shepherd, Jillian, *Production Mgr,* Canadian Art Foundation, Toronto ON

Thorpe, Judith, *Head Dept,* University of Connecticut, Dept of Art & Art History, Storrs CT (S)

Thorpe, Judith, *Sr Assoc Dean,* Temple University, Tyler School of Art, Elkins Park PA (S)

Thorpe, Lynn, *Instr & Asst Prof,* Northwest Community College, Dept of Art, Powell WY (S)

Thorrat, Lori, *Assoc Librn Bibliography Access,* Cleveland Museum of Art, Ingalls Library, Cleveland OH

Thorsell, William, *Dir,* Royal Ontario Museum, Toronto ON

Thorson, Zaiga, *Asst Prof & Co Chair Communication & Fine Arts,* Black Hawk College, Art Dept, Moline IL (S)

Thrift, Linda, *Keeper Catalog of American Portraits,* National Portrait Gallery, Washington DC

Throop, Mary Jane, *Weekend Receptionist,* Glanmore National Historic Site of Canada, Belleville ON

Thrush, George, *Assoc Prof,* Northeastern University, Dept of Art & Architecture, Boston MA (S)

Thueber, T Barton, *Cur European Art,* Dartmouth College, Hood Museum of Art, Hanover NH

Thumsujarit, Chaiwat, *Assoc Prof,* Fort Hays State University, Dept of Art, Hays KS (S)

Thun-Hohenstein, Christoph, *Dir,* Austrian Cultural Forum Gallery, New York NY

Thurber, Frances, *Chmn,* University of Nebraska at Omaha, Dept of Art & Art History, Omaha NE (S)

Thurman, Christa, *Cur,* The Art Institute of Chicago, Department of Textiles, Textile Society, Chicago IL

Thurman, Christa C Mayer, *Cur Textiles,* The Art Institute of Chicago, Chicago IL

Thurman, Hal, *Emeritus Prof,* University of Massachusetts - Boston, Art Dept, Boston MA (S)

Thurman, Henry, *Instr,* Southern University A & M College, School of Architecture, Baton Rouge LA (S)

Thurmer, Robert, *Dir,* Cleveland State University, Art Gallery, Cleveland OH

Thurston, Nancy, *Librn,* Art Institutes International at Portland, Portland OR

Tibbel, Deborah, *Shop Mgr Retail,* University of British Columbia, Museum of Anthropology, Vancouver BC

Tibbets, Roger, *Chmn Fine Arts 2D,* Massachusetts College of Art, Boston MA (S)

Tibbitts, Alvin, *VPres,* Heritage Center, Inc, Pine Ridge SD

Tibbitts, Cory, *Cur Exhib,* Lakeview Museum of Arts & Sciences, Peoria IL

Tibbs Copeland, Jacquiline, *Dir Educ,* Walters Art Museum, Library, Baltimore MD

Tice, Carol, *Chmn,* Blue Lake Fine Arts Camp, Art Dept, Twin Lake MI (S)

Tichich, Richard, *Dir,* East Carolina University, School of Art, Greenville NC (S)

Tichich, Richard, *Head Dept,* Georgia Southern University, Dept of Art, Statesboro GA (S)

Tiedamann, Sarah, *Dir Pub Information,* Everson Museum of Art, Syracuse NY

Tierney, Nathan, *Chmn,* California Lutheran University, Art Dept, Thousand Oaks CA (S)

Tierno, Mark, *Pres,* Cazenovia College, Center for Art & Design Studies, Cazenovia NY (S)

Tighe, Ann, *Coll Mgr,* Art Gallery of Greater Victoria, Victoria BC

Tiknis, Michael, *Pres,* Arts Midland Galleries & School, Midland MI

Tilak, Elizabeth, *Asst Prof,* Cameron University, Art Dept, Lawton OK (S)

Tileston, Jackie, *Asst Prof,* University of Pennsylvania, Graduate School of Fine Arts, Philadelphia PA (S)

Tilghman, Carla, *Adjunct Asst Prof Art Hist,* Johnson County Community College, Visual Arts Program, Overland Park KS (S)

Till, Barry, *Cur Asian Art,* Art Gallery of Greater Victoria, Victoria BC

Tilley, Betty, *Dir Student Affairs,* Atlanta College of Art, Atlanta GA (S)

Tillinger, Elaine, *Chmn,* Lindenwood University, Harry D Hendren Gallery, Saint Charles MO

Tillinger, Elaine, *Chmn Dept, Contact,* Lindenwood College, Art Dept, Saint Charles MO (S)

Tillinghast, Anne, *Mus Shop Mgr,* Rhode Island School of Design, Museum of Art, Providence RI

Tillman, Patricia, *Asst Prof,* Trinity College, Dept of Studio Arts, Hartford CT (S)

Tillotson, Jimmy, *Instr,* Hinds Community College, Dept of Art, Raymond MS (S)

Tillotson, Lisa, *Registrar,* University of Calgary, The Nickle Arts Museum, Calgary AB

Tilton, Barbara, *Co-Chair,* University of Montana, Dept of Art, Missoula MT (S)

Tilton, Sumner, *VPres,* Willard House & Clock Museum, Inc, North Grafton MA

Timberlake, Samuel, *Instr,* John C Calhoun, Department of Fine Arts, Decatur AL (S)

Timlin, Aaron, *Exec Dir,* Detroit Artists Market, Detroit MI

Timlin, Rachel, *Dir Events & Educ,* Detroit Artists Market, Detroit MI

Timm-Ballard, Charles, *Co-Chmn,* Whitman College, Art Dept, Walla Walla WA (S)

Timmers, Gwilyn, *Booking Coordr,* University of British Columbia, Museum of Anthropology, Vancouver BC

Timms, Peter, *Dir,* Fitchburg Art Museum, Fitchburg MA

Timoshuk, Walter W, *Pres,* Norton Simon, Pasadena CA

Timothy, John, *Dir,* Ataloa Lodge Museum, Muskogee OK

Tinch, Crystal, *Community Educ,* Center for Exploratory & Perceptual Art, CEPA Gallery, Buffalo NY

Tinch, Crystal, *Commun Educ,* Center for Exploratory & Perceptual Art, CEPA Library, Buffalo NY

Tiner, Archie, *Instr,* Southern University A & M College, School of Architecture, Baton Rouge LA (S)

Tingley, Sue, *Mgr Finance & Operations,* Art Gallery of Nova Scotia, Halifax NS

Tingley, Tyler, *Principal,* Phillips Exeter Academy, Lamont Gallery, Exeter NH

Tinney, Harle, *Exec Dir,* Royal Arts Foundation, Belcourt Castle, Newport RI

Tinsley, Marjorie, *Treas,* Mason County Museum, Mason TX

Tio, Adrian R, *Chmn, School of Art,* Northern Illinois University, School of Art, De Kalb IL (S)

Tio, Teresa, *Prof,* University of Puerto Rico, Dept of Fine Arts, Rio Piedras PR (S)

Tippit, Mike, *Mus Shop Mgr,* Oklahoma Historical Society, Library Resources Division, Oklahoma City OK

Tirone, Steve, *Assoc Prof,* Morehead State University, Art Dept, Morehead KY (S)

Tischler, Maynard, *Prof Ceramics,* University of Denver, School of Art & Art History, Denver CO (S)

Tisdale, J, *Fine Arts Conservator,* Mount Allison University, Owens Art Gallery, Sackville NB

Tisdale, Shelby J, *Exec Dir,* Millicent Rogers, Library, Taos NM

Tite, Winston, *Assoc Prof,* University of North Carolina at Charlotte, Dept Art, Charlotte NC (S)

Titmus, Wilma, *Office Mgr,* Herrett Center for Arts & Sciences, Jean B King Art Gallery, Twin Falls ID

Titus, Harry B, *Prof,* Wake Forest University, Dept of Art, Winston-Salem NC (S)

Titus, Jack, *Assoc Prof,* Oklahoma State University, Art Dept, Stillwater OK (S)

Titus, Van, *Dir,* Stone Quarry Hill Art Park, Cazenovia NY

Titus Searle, Marion, *Cur Earlier Prints & Drawings,* The Art Institute of Chicago, Dept of Prints & Drawings, Chicago IL

Tjardes, Tamara, *Cur Middle Eastern-Asian Coll,* Museum of New Mexico, Museum of International Folk Art, Santa Fe NM

Tobia, Blaise, *Assoc Prof Photography,* Drexel University, College of Media Arts & Design, Philadelphia PA (S)

Tobias, Harvey, *Treas,* San Bernardino Art Association, Inc, Sturges Fine Arts Center, San Bernardino CA

Tobias, Jennifer, *Librn, Collection Develop,* Museum of Modern Art, Library and Museum Archives, New York NY

Tocchet, Mark, *Chmn Illustration,* University of the Arts, Philadelphia Colleges of Art & Design, Performing Arts & Media & Communication, Philadelphia PA (S)

Tocci, Alison, *Vol,* Waterfront Museum, Brooklyn NY

Todd, David, *Pres,* Iroquois County Historical Society Museum, Old Courthouse Museum, Watseka IL

Todd, Gui, *Instr,* Modesto Junior College, Arts Humanities & Communications Division, Modesto CA (S)

Todd, Mark, *Prof,* Texas State University - San Marcos, Dept of Art and Design, San Marcos TX (S)

Todd, Melody, *Asst Prof,* Mount Mary College, Art & Design Division, Milwaukee WI (S)

Todd, Susan, *Dir Development,* Bellevue Art Museum, Bellevue WA

Todenhoff, Mary, *Adjunct,* York College of Pennsylvania, Dept of Music, Art & Speech Communications, York PA (S)

Todisco, Ann, *Asst,* Arthur Griffin, Winchester MA

Todisco, Jocelyn, Evansville Museum of Arts, History & Science, Henry R Walker Jr Memorial Art Library, Evansville IN

Todosco, Joycelyn, *Registrar,* Evansville Museum of Arts, History & Science, Evansville IN

Toedtmeier, Terry, *Cur Photog,* Portland Art Museum, Portland OR

Toedtmeier, Terry, *Cur Photog,* Portland Art Museum, Northwest Film Center, Portland OR

Toennies, Jamie, *Develop Mem,* African American Historical Museum & Cultural Center of Iowa, Cedar Rapids IA

Toensing, Robert E, *Instr,* Anoka Ramsey Community College, Art Dept, Coon Rapids MN (S)

Togneri, Carol, *Chief Cur,* Norton Simon, Pasadena CA

Toku, Masami, *Assoc Prof,* California State University, Chico, Department of Art & Art History, Chico CA (S)

Tokumaru, Kyoko, *Vis Artist-in-Residence,* Contemporary Crafts Museum & Gallery, Portland OR

Tolbert, Javier, *Instr,* Clark-Atlanta University, School of Arts & Sciences, Atlanta GA (S)

Toler, Joey, *Prog Dir,* Beaufort County Arts Council, Washington NC

Toll, Kay, *VPres The Olana,* Olana State Historic Site, Hudson NY

Tollette, Wallace Yvonne, *Exec Dir,* Black American West Museum & Heritage Center, Denver CO

Tolmie, Kris, *Instr,* College of Saint Rose, Art Dept, Albany NY (S)

Tolnick, Judith, *Galleries Dir,* University of Rhode Island, Fine Arts Center Galleries, Kingston RI

Tolstedt, Lowell, *Dean,* Columbus College of Art & Design, Fine Arts Dept, Columbus OH (S)

Toluse, Joe, *Cur,* Idaho Historical Museum, Boise ID

Tom, Patricia, *Pub Relations,* Montana State University at Billings, Northcutt Steele Gallery, Billings MT

Tomasch, Otto, *Asst Prof,* York College of Pennsylvania, Dept of Music, Art & Speech Communications, York PA (S)

Tomasello, Terry, *Exec Dir,* Creative Arts Guild, Dalton GA

Tomberlin, Pat, *Mus Shop Mgr,* Montgomery Museum of Fine Arts, Montgomery AL

Tomczak, Pat, *Dean of Library,* Quincy University, Brenner Library, Quincy IL

Tomga, Linda, *Hawaiian Arts,* Kalani Oceanside Retreat, Pahoa HI (S)

Tomio, Ken, *Cur,* Tyler Museum of Art, Tyler TX

Tomio, Ken, *Cur,* Tyler Museum of Art, Reference Library, Tyler TX

Tomio, Kimberley Bush, *Dir,* Tyler Museum of Art, Tyler TX

Tomio, Kimberley Bush, *Dir,* Tyler Museum of Art, Reference Library, Tyler TX

Tomko, Monika, *Registrar,* Carnegie Museums of Pittsburgh, Carnegie Museum of Art, Pittsburgh PA

Tomlin, Terry, *Chmn Fine Arts,* University of Texas at Brownsville & Texas Southmost College, Fine Arts Dept, Brownsville TX (S)

Tomlinson, Janis A, *Dir,* National Academy of Sciences, Arts in the Academy, Washington DC

Tomlinson, Mary Ann, *Pres,* Mohawk Valley Heritage Association, Inc, Walter Elwood Museum, Amsterdam NY

Tompkins-Baldwin, Linda, *Library Dir,* The Baltimore Museum of Art, E Kirkbride Miller Art Library, Baltimore MD

Tompkins-Baldwin, Linda, *Librn,* The Baltimore Museum of Art, Baltimore MD

Tomsen, Mary, *Dir Pub Rels,* North Central Washington Museum, Wenatchee Valley Museum & Cultural Center, Wenatchee WA

Tomsic, Walt, *Assoc Prof,* Pacific Lutheran University, Dept of Art, Tacoma WA (S)

Tonelli, Laura, *Dean,* Montserrat College of Art, Beverly MA (S)

Toner, Rochelle, *Dean,* Temple University, Tyler School of Art, Temple Gallery, Elkins Park PA

Toner, Rochelle, *Dean,* Temple University, Tyler School of Art, Elkins Park PA (S)

Tonetti, Charles, *Chief Architect,* Independence National Historical Park, Library, Philadelphia PA

Tong, Darlene, *Art Librn,* San Francisco State University, J Paul Leonard Library, San Francisco CA

Tonkonow, Leslie, *VPres,* Artists Space, New York NY

Tonz, Sandra, *Instr,* Mount Mary College, Art & Design Division, Milwaukee WI (S)

Toohey, Jeanette, *Chief Cur,* Cummer Museum of Art & Gardens, DeEtte Holden Cummer Museum Foundation, Jacksonville FL

Toohey, Jeanette, *Chief Cur,* Cummer Museum of Art & Gardens, Library, Jacksonville FL

Tootle, Ann, *Registrar,* The Albrecht-Kemper Museum of Art, Saint Joseph MO

Toplovich, Ann, *CEO,* Tennessee Historical Society, Nashville TN

Topolski, Allen C, *Chmn,* University of Rochester, Dept of Art & Art History, Rochester NY (S)

Torchia, Richard, *Gallery Dir,* Beaver College Art Gallery, Glenside PA

Torcoletti, Enzo, *Prof,* Flagler College, Visual Arts Dept, Saint Augustine FL (S)

Torinus, Sigi, *Prof,* University of Windsor, Visual Arts, Windsor ON (S)

Torke, Ann, *Assoc Prof,* University of Massachusetts - Boston, Art Dept, Boston MA (S)

Tornheim, N, *Instr,* Golden West College, Visual Art Dept, Huntington Beach CA (S)

Interior, Statue of Liberty National Monument & The Ellis Island Immigration Museum, New York NY

Tsolakis, Alkis, *Chmn,* Drury College, Art & Art History Dept, Springfield MO (S)

Tsosie, Michael, *Creative Serv Dir,* Atlatl, Phoenix AZ

Tsuji, Bill, *Dean Humanities,* Sierra Community College, Art Dept, Rocklin CA (S)

Tsujimoto, Karen, *Sr Cur Art,* Oakland Museum of California, Art Dept, Oakland CA

Tsukashima, Rodney, *Instr,* Long Beach City College, Art & Photography Dept, Long Beach CA (S)

Tucci, Judy, *Instr,* Northeast Mississippi Junior College, Art Dept, Booneville MS (S)

Tuccillo, John, *Asst Prof & Dept Chair,* Illinois Central College, Dept Fine, Performing & Applied Arts, East Peoria IL (S)

Tuck, David, *Co-Dir,* Wynick Tuck Gallery, Toronto ON

Tucker, Ben, *Co-chmn Music,* Western New Mexico University, Dept of Expressive Arts, Silver City NM (S)

Tucker, Carrie, *Prof,* Hardin-Simmons University, Art Dept, Abilene TX (S)

Tucker, David, *Cur Educ,* Morris Museum of Art, Augusta GA

Tucker, Gary, *Gallery Dir,* Kaji Aso Studio, Gallery Nature & Temptation, Boston MA

Tucker, Kevin W, *Interim Chief Cur,* Columbia Museum of Art, Columbia SC

Tucker, LC, *Chief Preparator,* Mississippi Museum of Art, Howorth Library, Jackson MS

Tucker, Mark S, *Sr Conservator Paintings,* Philadelphia Museum of Art, Samuel S Fleisher Art Memorial, Philadelphia PA

Tucker, Michael, *Museum Cur,* California Department of Parks & Recreation, California State Indian Museum, Sacramento CA

Tucker, Paul, *Prof,* University of Massachusetts - Boston, Art Dept, Boston MA (S)

Tucker, Susan, *Bookstore Mgr,* Laguna Art Museum, Laguna Beach CA

Tucker, Yvonne, *Prof,* Florida A & M University, Dept of Visual Arts, Humanities & Theatre, Tallahassee FL (S)

Tugwell, Maurice, *Asst Dean of Arts,* Acadia University, Art Dept, Wolfville NS (S)

Tully, Inger, *Artistic Progs Dir,* Hui No eau Visual Arts Center, Gallery and Gift Shop, Makawao Maui HI

Tuma, Mary, *Assoc Prof,* University of North Carolina at Charlotte, Dept Art, Charlotte NC (S)

Tuman, Donna, *Asst Prof,* C W Post Campus of Long Island University, School of Visual & Performing Arts, Brookville NY (S)

Tunstall, Arnold, *Registrar,* Akron Art Museum, Akron OH

Tupper, Jon, *Dir,* Confederation Centre Art Gallery and Museum, Charlottetown PE

Turek, Todd, *Vis Asst Prof,* Baylor University, Dept of Art, Waco TX (S)

Turk, Gloria, *Librn,* San Jose Museum of Art, Library, San Jose CA

Turk, James, *Cur Cultural History,* New Jersey State Museum, Fine Art Bureau, Trenton NJ

Turley, G. Pasha, *Gallery Dir,* Southwestern College, Art Gallery, Chula Vista CA

Turlington, Matthew, *Photog Instr,* Southwestern Community College, Advertising & Graphic Design, Sylva NC (S)

Turlington, Patricia, *Instr,* Wayne Community College, Liberal Arts Dept, Goldsboro NC (S)

Turman, Michelle, *Exec Dir,* Gulf Coast Museum of Art, Inc, Largo FL

Turmel, Jean, *Admin Asst,* Hermitage Foundation Museum, Norfolk VA

Turner, Becky, *Treas,* Wichita Center for the Arts, Wichita KS

Turner, Colin, *Exec Dir,* Midwest Art Conservation Center, Minneapolis MN

Turner, Elizabeth Hutton, *Sr Cur,* The Phillips Collection, Washington DC

Turner, Georgette, *Supervising Docent,* Olana State Historic Site, Hudson NY

Turner, Holly, *Exec Dir,* Nicolaysen Art Museum & Discovery Center, Childrens Discovery Center, Casper WY

Turner, J Rigbie, *Cur Music Manuscripts,* Pierpont Morgan, New York NY

Turner, James, *Instr,* Bethany College, Art Dept, Lindsborg KS (S)

Turner, Jeff, *Asst prof,* Maryville College, Dept of Fine Arts, Maryville TN (S)

Turner, John, *Assoc Prof,* Indiana University, Bloomington, Henry Radford Hope School of Fine Arts, Bloomington IN (S)

Turner, John D, *Assoc Prof,* University of North Alabama, Dept of Art, Florence AL (S)

Turner, Joyce, *Educ Coordr,* Fayetteville Museum of Art, Inc, Fayetteville NC

Turner, Judith, *Dir,* Art Instruction Schools, Education Dept, Minneapolis MN (S)

Turner, Kevin, *Instr (3-D),* Mississippi Gulf Coast Community College-Jackson County Campus, Art Dept, Gautier MS (S)

Turner, Laurel, *Cur Exhibitions,* Charles Allis, Milwaukee WI

Turner, Marietta, *Instr,* Bismarck State College, Fine Arts Dept, Bismarck ND (S)

Turner, Michele, *Librn,* The Currier Museum of Art, Library, Manchester NH

Turner, Randy, *Supt,* National Park Service, Weir Farm National Historic Site, Wilton CT

Turner, Richard, *Prof,* Chapman University, Art Dept, Orange CA (S)

Turner, Sam, *Pres,* Creative Arts Guild, Dalton GA

Turner, Sarah, *Dir,* American Institute of Architects, AIA Library & Archives, Washington DC

Turner, Tom, *Chmn,* Pacific Union College, Art Dept, Angwin CA (S)

Turner-Lowe, Susan, *Assoc VPres Communications,* The Huntington Library, Art Collections & Botanical Gardens, San Marino CA

Turner-Lowe, Susan, *VPres Communications,* The Huntington Library, Art Collections & Botanical Gardens, Library, San Marino CA

Turner-Rahman, Gregory, *Asst Prof,* University of Idaho, Dept of Art & Design, Moscow ID (S)

Turnipseed, Charlotte, *Facilities Mktg Coord,* Birmingham Museum of Art, Birmingham AL

Turnock, Jack, *Dir,* Jacksonville University, Alexander Brest Museum & Gallery, Jacksonville FL

Turnure, James, *Prof,* Bucknell University, Dept of Art, Lewisburg PA (S)

Turo, Sharon, *Librn,* New Canaan Historical Society, New Canaan CT

Turpin, David, *Pres,* University of Victoria, Maltwood Art Museum and Gallery, Victoria BC

Turri, Scott, *Instr,* Clarion University of Pennsylvania, Dept of Art, Clarion PA (S)

Turrill, Catherine, *Chmn,* California State University, Sacramento, Dept of Art, Sacramento CA (S)

Turtell, Neal, *Chief Librn,* National Gallery of Art, Washington DC

Turtell, Neal, *Exec Librn,* National Gallery of Art, Library, Washington DC

Tusa, Bobs M, *Archivist,* University of Southern Mississippi, McCain Library & Archives, Hattiesburg MS

Tuscano,, *Prof,* Lynn University, Art & Design Dept, Boca Raton FL (S)

Tussing, George, *Prof,* Tidewater Community College, Visual Arts Center, Portsmouth VA (S)

Tustin, Kerry, *Asst Prof,* Flagler College, Visual Arts Dept, Saint Augustine FL (S)

Tuttle, Gail, *Dir & Cur,* Memorial University of Newfoundland, Sir Wilfred Grenfell College Art Gallery, Corner Brook NF

Tuttle, Judith, *Consultant,* Tattoo Art Museum, San Francisco CA

Tuttle, Kevin, *Instr,* Muhlenberg College, Dept of Art, Allentown PA (S)

Tuttle, Lyle, *Dir,* Tattoo Art Museum, San Francisco CA

Tweedy, Joan, *Asst Prof,* University of North Carolina at Charlotte, Dept Art, Charlotte NC (S)

Tweney, Kathleen, *Assoc Librn (Technical),* Toledo Museum of Art, Library, Toledo OH

Tyler, Cathie, *Chm Div Fine Art & Instr,* Paris Junior College, Art Dept, Paris TX (S)

Tyler, Gregory, *Registrar,* North Carolina State University, Visual Arts Center, Raleigh NC

Tymas-Jones, Raymond, *Dean,* University of Utah, Dept of Art & Art History, Salt Lake City UT (S)

Tynemouth, Brian, *Librn,* Suffolk University, New England School of Art & Design Library, Boston MA

Tyree, Morgan, *Asst Prof,* Northwest Community College, Dept of Art, Powell WY (S)

Tyrer, Nancy, *Asst Dir,* Heritage Museums & Gardens, Sandwich MA

Tysick, Cindi, *Registrar, Archivist & Webmaster,* North Tonawanda History Museum, North Tonawanda NY

Uchin, Andrew, *Mus Store Mgr,* Norton Simon, Pasadena CA

Udechukwu, Obiora, *Prof,* St Lawrence University, Dept of Fine Arts, Canton NY (S)

Uduehi, Joseph, *Assoc Prof,* University of Southern Indiana, Art Dept, Evansville IN (S)

Ueillerte, William, *Exec Dir,* New Hampshire Historical Society, Museum of New Hampshire History, Concord NH

Uhde, Jan, *Prof,* University of Waterloo, Fine Arts Dept, Waterloo ON (S)

Uhlein, Thomas, *Asst Prof,* William Paterson University, Dept Arts, Wayne NJ (S)

Uhlenbrock, Jaimee, *Assoc Cur of Coll,* State University of New York at New Paltz, Samuel Dorsky Museum of Art, New Paltz NY

Uhlig, Sue, *Grad Coordr,* Purdue University, West Lafayette, Patti and Rusty Rueff Department of Visual & Performing Arts, West Lafayette IN (S)

Uithol, Ruthann, *Asst Dir Colls & Colls Mgr,* Hillwood Museum & Gardens Foundation, Hillwood Museum & Gardens, Washington DC

Ulloa, Derby, *Prof,* Florida Community College at Jacksonville, South Campus, Art Dept, Jacksonville FL (S)

Ulman, Martin, *Spec Projects,* Boston Visual Artists Union, Boston MA

Ulmer, Marie-Rene, *Prof Ceramics,* Universite de Moncton, Dept of Visual Arts, Moncton NB (S)

Ulmer, Sean, *Cur,* Cedar Rapids Museum of Art, Cedar Rapids IA

Ulrich, Jim, *Painting Dept,* Alberta College of Art & Design, Calgary AB (S)

Ulry, James E, *Acad Dir,* Johnson Atelier Technical Institute of Sculpture, Mercerville NJ (S)

Umberger, Eugene, *Dir,* Neville Public Museum, Green Bay WI

Umberger, Leslie, *Cur,* Sheboygan Arts Foundation, Inc, John Michael Kohler Arts Center, Sheboygan WI

Umlauf, Karl, *Prof & Artist in Res,* Baylor University, Dept of Art, Waco TX (S)

Unchester, Robert, *Exhib & Coll Mgr,* Cameron Art Museum, Wilmington NC

Underwood, David, *Assoc Prof & Second Dept Chmn,* Carson-Newman College, Art Dept, Jefferson City TN (S)

Underwood, Katie, *Dir,* Roberts County Museum, Miami TX

Underwood, Susan, *Pres,* North Shore Art League, Winnetka IL

Underwood, Tut, *Dir Public Information & Marketing,* South Carolina State Museum, Columbia SC

Unger, Fred, *Pres Board Trustees,* Beck Center for the Arts, Lakewood OH

Unger, Howard, *Prof,* Ocean County College, Humanities Dept, Toms River NJ (S)

Ungerman, Temmi, *Instr,* Toronto Art Therapy Institute, Toronto ON (S)

Uno, Allan, *Bldgs & Grounds Supv,* Tucson Museum of Artand Historic Block, Tucson AZ

Unre, Sarah, *Chief Cur,* Orange County Museum of Art, Orange County Museum of Art, Newport Beach CA

Unterschultz, Judy, *Exec Dir,* Multicultural Heritage Centre, Stony Plain AB

Unterschulz, Cheryl, *Asst Prof,* Lincoln University, Dept Fine Arts, Jefferson City MO (S)

Updike Walker, Janis, *Dir Develop,* Philbrook Museum of Art, Tulsa OK

Uphoff, Joseph A, *Dir & Edit in Chief, Journal of Regional Criticism,* Arjuna Library, Digital Visual Dream Laboratory & Acoustic Studio, Colorado Springs CO

Upp, Janeanne, *CEO,* Tacoma Art Museum, Tacoma WA

Upshur, Marquis, *Mem Coordr,* Historical Society of Pennsylvania, Philadelphia PA

Uraneck, Joan, *Instr,* Maine College of Art, Portland ME (S)

Uranz, Rebecca, *Asst Librn,* New York School of Interior Design, New York School of Interior Design Library, New York NY

Urban, Erin, *Dir,* The John A Noble, Staten Island NY

Urban, Jason, *Asst Prof,* Southern Illinois University, School of Art & Design, Carbondale IL (S)

Urbanik, Markus, *Ceramics,* Central Wyoming College, Art Center, Riverton WY (S)

Urbizu, William, *Asst Dir,* Miami-Dade Public Library, Miami FL

Ure, Maureen O'Hara, *Asst Prof Lectr,* University of Utah, Dept of Art & Art History, Salt Lake City UT (S)

Urian, Edward A, *Media Arts & Animation,* Art Institute of Pittsburgh, Pittsburgh PA (S)

Urtom, Michele, *Coll Mgr,* New Britain Museum of American Art, New Britain CT

Ushakoff, Doreen, *Pres,* Beverly Historical Society, Cabot, Hale & Balch House Museums, Beverly MA

Ushenko, Audrey, *Assoc Prof,* Indiana-Purdue University, Dept of Fine Arts, Fort Wayne IN (S)

Uslaner, Diane, *Dir Cultural Programming ,Marketing & Develop,* Koffler Center of the Arts, School of Visual Art, Toronto ON (S)

Ussler, Christine, *Prof Practice,* Lehigh University, Dept of Art & Architecture, Bethlehem PA (S)

Utz, Karen, *Coll Cur,* Sloss Furnaces National Historic Landmark, Birmingham AL

Vadala, Teresa, *Asst Prof,* Bloomsburg University, Dept of Art & Art History, Bloomsburg PA (S)

Vadeboncoeur, Guy, *Cur,* The Stewart, Montreal PQ

Vaigardson, Val, *Asst Prof,* Rhodes College, Dept of Art, Memphis TN (S)

Vail, Marci, *Librn,* East Hampton Library, Pennypacker Long Island Collection, East Hampton NY

Vail, Marguerite K, *VPres Develop,* The Mariners' Museum, Newport News VA

Vail, Mita, *VPres Devel,* The Mariners' Museum, Newport News VA

Vaitkute, Karile, *Dir Educ & Edit,* Balzekas Museum of Lithuanian Culture, Chicago IL

Valand, Roger, *Asst Prof,* Spring Arbor College, Art Dept, Spring Arbor MI (S)

Valderrama, Tonito, *Mus Educator,* C W Post Campus of Long Island University, Hillwood Art Museum, Brookville NY

Valencia, Romolo, *Instr Graphic Arts,* Honolulu Community College, Commercial Art Dept, Honolulu HI (S)

Valentine, Christina, *Instr,* Biola University, Art Dept, La Mirada CA (S)

Valentine, John, *Asst Prof,* Southeastern Louisiana University, Dept of Visual Arts, Hammond LA (S)

Valentine, Terry, *Prof,* Concordia University, Division of Performing & Visual Arts, Mequon WI (S)

Valero, Meghan, *Admin,* Artists Association of Nantucket, Nantucket MA

Valino, Karyn, *Dir Membership,* Color Association of the US, New York NY

Valiquette, Carol, *Exec Asst Finance & Admin,* United Westurne Inc, Art Collection, Montreal PQ

Valiulis, Jo, *Mus Shop Mgr,* Southwest Museum, Los Angeles CA

Valleau, Steven, *Carver-in-Residence,* Wendell Gilley, Southwest Harbor ME

Vallee, Francois, *Production Coordr,* La Chambre Blanche, Quebec PQ

Valley, Derek R, *Dir,* State Capital Museum, Olympia WA

Valliant, John R, *Dir,* Chesapeake Bay Maritime Museum, Saint Michaels MD

Vallieres, Nicole, *Dir Coll Management,* McCord Museum of Canadian History, Montreal PQ

Vallila, Marja, *Assoc Prof,* State University of New York at Albany, Art Dept, Albany NY (S)

van Aalst, Kirsten, *Asst Prof,* Norwich University, Dept of Architecture and Art, Northfield VT (S)

VanAllen, David, *Asst Prof,* Mount Mercy College, Art Dept, Cedar Rapids IA (S)

Van Allen, David, *Dir,* Mount Mercy College, White Gallery, Cedar Rapids IA

Van Auken, Michelle, *Data Entry Specialist,* Colgate University, Picker Art Gallery, Hamilton NY

Van Ausdal, Kaarin, *Librn,* Carnegie Library of Pittsburgh, Pittsburgh PA

Vanausdall, John, *Pres & Chief Exec Officer,* Eiteljorg Museum of American Indians & Western Art, Indianapolis IN

Van Ausdall, Kristen, *Vis Asst Prof,* Kenyon College, Art Dept, Gambier OH (S)

Van Balgooy, Mary, *Colls Mgr,* Supreme Court of the United States, Washington DC

VanBalgooy, Max, *Dir Interpretation,* National Trust for Historic Preservation, Washington DC

van Balgooy, Max A, *Asst Dir,* Workman & Temple Family Homestead Museum, City of Industry CA

Van Beke, Timothy, *Asst Prof,* Southeastern Louisiana University, Dept of Visual Arts, Hammond LA (S)

Van Buren, David, *Chmn,* University of Wisconsin-Platteville, Dept of Fine Art, Platteville WI (S)

Vance, Alex, *Exec Dir,* Bergstrom-Mahler Museum, Neenah WI

Vance, Alex, *Exec Dir & Cur,* Bergstrom-Mahler Museum, Library, Neenah WI

Vance, Steve, *Instr,* University of Wisconsin-Platteville, Dept of Fine Art, Platteville WI (S)

Vanche, Sheri, *Registrar,* Eastern Shore Art Association, Inc, Library, Fairhope AL

Vanco, John, *Dir,* Erie Art Museum, Erie PA

Vandam, Cynthia, *VPres,* Passaic County Historical Society, Paterson NJ

van de Guchte, Maarten, *Dir,* Cummer Museum of Art & Gardens, DeEtte Holden Cummer Museum Foundation, Jacksonville FL

Vanden Berg, Eli, *Gallery Store Mgr,* The Print Center, Philadelphia PA

Vanderbrug, Kelly, *Asst Prof,* North Park University, Art Dept, Chicago IL (S)

Vanderhaden, Sandra, *Exec Dir,* California State University, Long Beach Foundation, Long Beach CA

van der Heijden, Merijn, *Acting Dir,* Denison University, Art Gallery, Granville OH

Vanderhill, Rein, *Prof,* Northwestern College, Art Dept, Orange City CA (S)

Vanderhill, Rein, *Rotation Exhib Coordr,* Northwestern College, Te Paske Gallery, Orange City IA

VanDerpool, Karen, *Prof,* California State University, Chico, Department of Art & Art History, Chico CA (S)

Vanderway, Richard, *Educ Coordr,* Whatcom Museum of History and Art, Bellingham WA

Vanderway, Richard, *Educ Coordr,* Whatcom Museum of History and Art, Library, Bellingham WA

Vandest, Bill, *Theater Coordr,* Creighton University, Fine & Performing Arts Dept, Omaha NE (S)

Van Divender, Grace, *Dir,* Jamestown-Yorktown Foundation, Williamsburg VA

Van Dorp, Dale, *Mgr Performing Arts,* Henry Ford Community College, McKenzie Fine Art Ctr, Dearborn MI (S)

Van Dorston, Teri, *Registrar,* Cedar Rapids Museum of Art, Cedar Rapids IA

Van Duesen, Patrick, *Prof,* Daytona Beach Community College, Dept of Fine Arts & Visual Arts, Daytona Beach FL (S)

Van Duyne, Sue, *Instr,* Ocean City Arts Center, Ocean City NJ (S)

Van Dyk, Stephen, *Librn,* Cooper-Hewitt, National Design Museum, Smithsonian Institution, New York NY

Van Dyk, Stephen, *Librn,* Cooper-Hewitt, National Design Museum, Smithsonian Institution, Doris & Henry Drefuss Memorial Study Center, New York NY

VanDyke, Dore, *Dir,* Attleboro Museum, Center for the Arts, Attleboro MA

VanDyke, Fred, *Prof,* Salt Lake Community College, Graphic Design Dept, Salt Lake City UT (S)

VanDyke, Jonathon, *Cur,* Susquehanna Art Museum, Home of Doshi Center for Contemporary Art, Harrisburg PA

Van Dyke, Lissa, *Librn,* Lyman Allyn, Hendel Library, New London CT

Vangas, Pedro, *Security,* Museo de Arte de Puerto Rico, San Juan PR

Van Gent, Elona, *Assoc Prof,* Grand Valley State University, Art & Design Dept, Allendale MI (S)

van Gestel, Andrea, *Pres,* North Shore Arts Association, Inc, Gloucester MA

Van Haitsma, Kristin, *Admin,* Hope College, De Pree Art Center & Gallery, Holland MI

Van Hook, L Bailey, *Head Dept,* Virginia Polytechnic Institute & State University, Dept of Art & Art History, Blacksburg VA (S)

Van Hooten, Joan, *Exec Dir,* Public Corporation for the Arts, Long Beach CA

VanHorn, Cindy, *Registrar & Library,* The Lincoln Museum, Fort Wayne IN

Van Horn, Donald, *Dean,* Marshall University, Dept of Art, Huntington WV (S)

Van Horn, Walter, *Cur Coll,* Anchorage Museum at Rasmuson Center, Anchorage AK

Van Keuren, Francis, *Prof Art History,* University of Georgia, Franklin College of Arts & Sciences, Lamar Dodd School of Art, Athens GA (S)

VanKeuren, Philip, *Dir,* Southern Methodist University, Division of Art, Dallas TX (S)

Van Laar, Tim, *In Charge Painting and Sculpture,* University of Illinois, Urbana-Champaign, School of Art & Design, Champaign IL (S)

Van Leer, Jerrye, *Docents,* University of Kansas, Spencer Museum of Art, Lawrence KS

Van Lusk, Kyle, *Instr,* Appalachian State University, Dept of Art, Boone NC (S)

VanMeter, Mitzi, *VChmn,* Mason County Museum, Mason TX

Van Meter, Peggy, *Cataloger,* Fulton County Historical Society Inc, Fulton County Museum, Rochester IN

Van Miegroet, Hans J, *Chair & Prof,* Duke University, Dept of Art, Art History & Visual Studies, Durham NC (S)

Vannorsdel, Laura, *Cur Fine Art,* Kansas State Historical Society, Kansas Museum of History, Topeka KS

Van Nort, Sydney, *Archivist,* City College of the City University of New York, Morris Raphael Cohen Library, New York NY

van Osnabrugge, William, *Pres,* Art Center Sarasota, Sarasota FL (S)

Vanouse, Paul, *Assoc Prof,* University at Buffalo, State University of New York, Dept of Visual Studies, Buffalo NY (S)

Van Over, Nancy, *Assoc Prof,* Adrian College, Art & Design Dept, Adrian MI (S)

VanPutten, Joseph, *Asst Prof,* William Paterson University, Dept Arts, Wayne NJ (S)

van Rhyn, Jacqueline, *Cur Prints & Photographs,* The Print Center, Philadelphia PA

VanRooyen, Robin, *Art Gallery Dir,* Grand Rapids Community College, Visual Art Dept, Grand Rapids MI (S)

Van Roy, Eugene, *Electronic Imag & Print Instr,* Western Wisconsin Technical College, Graphics Division, La Crosse WI (S)

Van Schaack, Eric, *Prof,* Colgate University, Dept of Art & Art History, Hamilton NY (S)

van Straaten, Natalie, *Exec Dir,* Art Dealers Association of Chicago, Chicago IL

Van Strander, Kitren, *Dir,* Rochester Institute of Technology, Corporate Education & Training, Rochester NY

Van Tassel, Rhoda, *Instr,* Muskingum College, Art Department, New Concord OH (S)

Van Velson, Ciara, *Dir Progs,* Coos Art Museum, Coos Bay OR (S)

Vanviane, Trish, *Gift Shop Coordr,* Vernon Art Gallery, Vernon BC

Van Waehonen, Kathryn, *Pres,* Tacoma Art Museum, Tacoma WA

Van Wey, Ken, *Program Asst,* United States Department of the Interior, Indian Arts & Crafts Board, Washington DC

VanWinkle, Benita, *Adult Prog Mgr,* Sawtooth Center for Visual Art, Winston-Salem NC (S)

Van Winkle, Sarah, *Prog Coordr,* USCB Art Gallery, Beaufort SC

Van Zandt, Paul, *Chmn Dept,* University of North Carolina at Pembroke, Art Dept, Pembroke NC (S)

Varga, Vincent V, *Exec Dir & CEO,* McMichael Canadian Art Collection, Kleinburg ON

Vargas, Kathy, *Chmn,* University of the Incarnate Word, Art Dept, San Antonio TX (S)

Varnadoe, Kimberly, *Assoc Prof,* Salem Academy & College, Art Dept, Winston-Salem NC (S)

Varner, Eric, *Asst Prof,* Emory University, Art History Dept, Atlanta GA (S)

Varner, Victoria Star, *Chmn Prof,* Southwestern University, Sarofim School of Fine Art, Dept of Art & Art History, Georgetown TX (S)

Varnum, Maevernon, *Instr,* Wayne Art Center, Wayne PA (S)

Vasbinder, Sam, *Asst Prof,* Malone College, Dept of Art, Canton OH (S)

Vasey, Daniel, *Dir Pub Relations and Marketing,* Colorado Springs Fine Arts Center, Colorado Springs CO

Vasher-Dean, April, *Dir,* University of Southern Indiana, New Harmony Gallery of Contemporary Art, New Harmony IN

Vasquez, Clare, *Pub Serv Librn,* The Saint Louis Art Museum, Richardson Memorial Library, Saint Louis MO

Vassar, Andrew, *Instr Art History,* Northeastern State University, College of Arts & Letters, Tahlequah OK (S)

Vassar, Theodore, *Asst Prof Art,* Monroe County Community College, Humanities Division, Monroe MI (S)

Vassell, Michelle, *Corporate Consultant,* San Francisco Museum of Modern Art, Artist Gallery, San Francisco CA

Vasseur, Dominique, *Assoc Cur European Art,* Columbus Museum of Art, Columbus OH

Vasseur, Dominique, *Deputy Dir,* Springfield Museum of Art, Springfield OH

Vatandoust, Cyrus, *Exec Dir,* Nossi College of Art, Goodlettsville TN (S)

Vatandoust, Nossi, *Founder, CEO & Pres,* Nossi College of Art, Goodlettsville TN (S)

Vaucher, Jean, *Prof,* Universite de Montreal, Bibliotheque d'Amenagement, Montreal PQ

Vaughan, Clayton, *Libr Specialist II,* Old Dominion University, Elise N Hofheimer Art Library, Norfolk VA

Vaughn, Dorothy, *Co-Gallery Dir,* Mississippi Valley State University, Fine Arts Dept, Itta Bena MS (S)

Vaughn, Elaine, *VPres Communication,* Please Touch Museum, Philadelphia PA

Vaughn, James, *VPres,* National Trust for Historic Preservation, Washington DC

Vaux, Richard, *Prof,* Adelphi University, Dept of Art & Art History, Garden City NY (S)

Vavora, Penelope, *Public Relations Mgr,* Albany Institute of History & Art, Albany NY

Vavra, Jan, *Art Coll Coordr,* Society of Decorative Painters, Inc, Decorative Arts Collection Museum, Wichita KS

Vazques-abad, Felisa J, *Aggregate Prof,* Universite de Montreal, Bibliotheque d'Amenagement, Montreal PQ

Vazquez, Oscar, *Assoc Prof,* State University of New York at Binghamton, Dept of Art History, Binghamton NY (S)

Veatch, James, *Assoc Prof,* University of Massachusetts Lowell, Dept of Art, Lowell MA (S)

Veazey, Shari, *Dir Develop,* Mississippi Museum of Art, Howorth Library, Jackson MS

Vecchil, Chris, *Chm of Bd,* Nexus Foundation for Today's Art, Philadelphia PA

Vecchio, Marjorie, *Dir, Cur,* University of Nevada, Reno, Sheppard Fine Arts Gallery, Reno NV

Veda, Chris, *Instr,* Luzerne County Community College, Commercial Art Dept, Nanticoke PA (S)

Veenstra, Faith, *Asst Prof,* Judson College, Division of Art, Design & Architecture, Elgin IL (S)

Veerkamp, Patrick, *Prof,* Southwestern University, Sarofim School of Fine Art, Dept of Art & Art History, Georgetown TX (S)

Veikley, Avis, *Dir,* Minot State University, Northwest Art Center, Minot ND

Veith, Gene Edward, *Dir,* Concordia University, Division of Performing & Visual Arts, Mequon WI (S)

Velasquez, Geraldine, *Dir,* Georgian Court College, M Christina Geis Gallery, Lakewood NJ

Velasquez, Geraldine, *Head Dept,* Georgian Court College, Dept of Art, Lakewood NJ (S)

Velders, Deborah, *Dir,* Cameron Art Museum, Wilmington NC

Velders, Deborah, *Exhib Coordr,* Menil Foundation, Inc, Houston TX

Venable, Andrew, *Dir,* Cleveland Public Library, Fine Arts & Special Collections Dept, Cleveland OH

Veneman, Katherine, *Cur Educ,* Art Museum of the University of Houston, Blaffer Gallery, Houston TX

Venker, Josef V, *Asst Prof Art,* Seattle University, Fine Arts Dept, Division of Art, Seattle WA (S)

Venner, Tom, *Dept Head,* Eastern Michigan University, Ford Gallery, Ypsilanti MI

Venner, Tom, *Head Dept,* Eastern Michigan University, Dept of Art, Ypsilanti MI (S)

Vensel, William, *Dept Chmn,* Ohio Dominican College, Art Dept, Columbus OH (S)

Ventimiglia, John T, *Instr,* Maine College of Art, Portland ME (S)

Ventrello, Barbara, *Admin & Program Asst,* Lannan Foundation, Santa Fe NM

Ventrudo, Meg, *Exec Dir,* Jacques Marchais, Staten Island NY

Venturino, Philip T, *Vice Pres Facilities,* The Metropolitan Museum of Art, New York NY

Venus, Lee, *Vol Coord,* Visual Arts Center of Northwest Florida, Visual Arts Center Library, Panama City FL

Venz, Pamela, *Art Chair,* Birmingham-Southern College, Art Dept, Birmingham AL (S)

Vera, Maria Garcia, *Auxiliary Prof,* Inter American University of Puerto Rico, Dept of Art, San German PR (S)

Verdi, Kirsten, *Registrar,* Corcoran Gallery of Art, Washington DC

Verdon, Ron, *Head Dept,* University of Wisconsin-Stout, Dept of Art & Design, Menomonie WI (S)

Vergara, Lisa, *Prof,* City University of New York, PhD Program in Art History, New York NY (S)

Verhoff, Andrew J, *Mgr,* The Ohio Historical Society, Inc, Campus Martius Museum & Ohio River Museum, Marietta OH

Verkerk, Dorothy, *Assoc Prof,* University of North Carolina at Chapel Hill, Art Dept, Chapel Hill NC (S)

Vermillion, Emily, *School Dir,* Library Association of La Jolla, Athenaeum Music & Arts Library, La Jolla CA

Verna, Gaetane, *Gen Dir,* Musee d'Art de Joliette, Joliette PQ

Verna, Gaëtane, *Dir, Cur,* Bishop's University, Art Gallery, Lennoxville PQ

Vernon, Mary, *Asst Prof,* Southern Methodist University, Division of Art, Dallas TX (S)

Verpoorten, Frank, *Dir Visual Arts,* Snug Harbor Cultural Center, Newhouse Center for Contemporary Art, Staten Island NY

Verschoor, Lynn, *Dir,* South Dakota State University, South Dakota Art Museum, Brookings SD

Verstegen, Mark, *Technical Servs Supvr,* Madison Museum of Contemporary Art, Madison WI

Vervoort, Patricia, *Prof,* Lakehead University, Dept of Visual Arts, Thunder Bay ON (S)

Vesely, Carolyn, *Dir,* Kitchener-Waterloo Art Gallery, Eleanor Calvert Memorial Library, Kitchener ON

Vesty, Mary, *Mus Svcs,* Nelda C & H J Lutcher Stark, Stark Museum of Art, Orange TX

Vettel, Greg, *Exhib Coordr,* North Dakota Museum of Art, Grand Forks ND

Vetter, Jill, *Archivist,* Walker Art Center, T J Peters Family Library, Minneapolis MN

Vetz, M Katherine, *Dir,* Xavier University, Art Gallery, Cincinnati OH

Vey, Penny, *Admin Asst,* Prairie Art Gallery, Grande Prairie AB

Viau, Christophe, *Technician,* La Chambre Blanche, Quebec PQ

Vicario, Gilbert, *Asst Cur,* Institute of Contemporary Art, Boston MA

Vice, Christopher, *Visual Comun Dept Chair,* Indiana University-Purdue University, Indianapolis, Herron School of Art, Indianapolis IN (S)

Vicens, Nury, *Instr,* Main Line Art Center, Haverford PA (S)

Vicich, Gerald, *Instr,* Pierce College, Art Dept, Woodland Hills CA (S)

Victor, Holly, *Marketing Dir,* Kirkland Museum of Fine & Decorative Art, Denver CO

Victoria, Karin, *Dir Government Relations,* The Art Institute of Chicago, Chicago IL

Vidal, Helena, *Assoc Dir Pub Prog,* Whitney Museum of American Art, New York NY

Vidaurri, Polly, *Director Finance & Admin,* San Antonio Museum of Art, San Antonio TX

Vidergar, Stephanie, *Assoc Marketing & Communication,* San Jose Museum of Art, Library, San Jose CA

Viditz-Ward, Vera, *Prof,* Bloomsburg University, Dept of Art & Art History, Bloomsburg PA (S)

Viens, Katheryn P, *Dir,* Old Colony Historical Society, Library, Taunton MA

Viens, Katheryn P, *Dir, CEO,* Old Colony Historical Society, Museum, Taunton MA

Viera, Ricardo, *Dir Exhib & Coll,* Lehigh University Art Galleries, Museum Operation, Bethlehem PA

Viera, Ricardo, *Prof,* Lehigh University, Dept of Art & Architecture, Bethlehem PA (S)

Vierra, Stephanie, *Interim Exec Dir,* Association of Collegiate Schools of Architecture, Washington DC

Vikan, Gary, *CEO, Dir,* Walters Art Museum, Library, Baltimore MD

Vikan, Gary, *Dir,* Walters Art Museum, Baltimore MD

Vilella, Maria Angela Lopez, *Asst Dir,* Museo de las Americas, Denver CO

Viljoen, Madeleine, *Cur,* La Salle University, Art Museum, Philadelphia PA

Villalobos Echeufefa, Patricia, *Assoc Prof,* Indiana University of Pennsylvania, College of Fine Arts, Indiana PA (S)

Villanvena, Isabela, *Asst Cur,* Americas Society Art Gallery, New York NY

Villarreal, Raul, *Adjunct Prof,* College of Saint Elizabeth, Art Dept, Morristown NJ (S)

Villasenor, Lilla, *Mus Shop Mgr,* Oregon Historical Society, Oregon History Center, Portland OR

Villela, Khristaan, *Assoc Prof,* College of Santa Fe, Art Dept, Santa Fe NM (S)

Villeneuve, Rene, *Asst Cur Early Canadian Art,* National Gallery of Canada, Ottawa ON

Villicana-Lara, Pablo, *Dir of Communications,* California Watercolor Association, Gallery Concord, Concord CA

Villmagna, Robert, *Assoc Prof,* West Liberty State College, Div Art, West Liberty WV (S)

Vincelli, Deborah, *Electronic Resource Librn,* The Metropolitan Museum of Art, Thomas J Watson Library, New York NY

Vincent, Christine J, *Pres,* Maine College of Art, Portland ME (S)

Vincent, Haideh, *Accountant,* Creative Growth Art Center, Oakland CA

Vincent, Marc, *Chmn Div,* Baldwin-Wallace College, Dept of Art, Berea OH (S)

Vinczencz, Terezia, *Admin Asst,* Prince George Art Gallery, Prince George BC

Vine, Naomi, *Dir,* Orange County Museum of Art, Orange County Museum of Art, Newport Beach CA

Vinograd, Richard, *Chmn Dept Art,* Stanford University, Dept of Art, Stanford CA (S)

Vinokurov, Bryce, *Asst Prof,* Worcester State College, Visual & Performing Arts Dept, Worcester MA (S)

Virgin, Louise, *Cur Asian Art,* Worcester Art Museum, Worcester MA

Viscardi, Anthony, *Chmn & Assoc Prof,* Lehigh University, Dept of Art & Architecture, Bethlehem PA (S)

Viskochil, James, *Librarian,* Brooklyn Museum, Brooklyn NY

Vissat, Maureen, *Asst Prof,* Seton Hill University, Art Program, Greensburg PA (S)

Visser, Mary, *Prof,* Southwestern University, Sarofim School of Fine Art, Dept of Art & Art History, Georgetown TX (S)

Visser, Susan R, *Exec Dir,* South Bend Regional Museum of Art, South Bend IN

Visser, Susan R, *Exec Dir,* South Bend Regional Museum of Art, Library, South Bend IN

Vitale, James, *Instr,* Mohawk Valley Community College, Utica NY (S)

Vitale, Thomas Jewell, *Assoc Prof,* Loras College, Dept of Art, Dubuque IA (S)

Vito, Kimberly, *Assoc Prof,* Wright State University, Dept of Art & Art History, Dayton OH (S)

Viverette, Lee B, *Reference Librn,* Virginia Museum of Fine Arts, Library, Richmond VA

Viviano, Shirley, *Dept Head,* Enoch Pratt, Baltimore MD

Vlack, Donald, *Chief Designer,* The New York Public Library, The New York Public Library for the Performing Arts, New York NY

Voce, Yolanda, *VPres, Acting Pres,* San Bernardino Art Association, Inc, Sturges Fine Arts Center, San Bernardino CA

Voci, Donna, *Adjunct Asst Prof,* New York Institute of Technology, Fine Arts Dept, Old Westbury NY (S)

Voci, Peter, *Chmn,* New York Institute of Technology, Gallery, Old Westbury NY

Voci, Peter, *Chmn & Assoc Prof,* New York Institute of Technology, Fine Arts Dept, Old Westbury NY (S)

Vodish, Glenn, *Dir,* Butte Silver Bow Arts Chateau, Butte MT

Voduarka, Frank, *Assoc Prof,* Loyola University of Chicago, Fine Arts Dept, Chicago IL (S)

Voelkel, David, *Cur,* James Monroe, James Monroe Memorial Library, Fredericksburg VA

Voelkel, David B, *Cur,* James Monroe, Fredericksburg VA

Voelker, Jim, *Head Dept,* Bluefield State College, Division of Arts & Sciences, Bluefield WV (S)

Voelkle, William M, *Cur Medieval & Renaissance Manuscripts,* Pierpont Morgan, New York NY

Voellinger, David, *Dir Develop,* Lehigh County Historical Society, Allentown PA

Vogel, Alita, *Chief Cur & Cur Decorative Arts,* Cincinnati Museum Association and Art Academy of Cincinnati, Cincinnati Art Museum, Cincinnati OH

Vogel, Craig, *Assoc Dean,* Carnegie Mellon University, College of Fine Arts, Pittsburgh PA (S)

Vogel, John, *Board Chmn,* Arts in Progress Inc, Boston MA

Vogel, Stephan P, *Dean,* University of Detroit Mercy, School of Architecture, Detroit MI (S)

Vogel, Theodore, *Asst Prof,* Lewis & Clark College, Dept of Art, Portland OR (S)

Vogelsong, Diana, *Acting University Librn,* American University, Jack & Dorothy G Bender Library & Learning Resources Center, Washington DC

Vogler, Cheryl, *Slide Cur,* The Saint Louis Art Museum, Richardson Memorial Library, Saint Louis MO

Vogt, Allie, *Dept Chmn,* North Idaho College, Art Dept, Coeur D'Alene ID (S)

Vogt Fuller, Anne, *Cur Earlier Prints & Drawings,* The Art Institute of Chicago, Dept of Prints & Drawings, Chicago IL

Voight, Robert, *Asst Prof,* College of Mount Saint Joseph, Art Dept, Cincinnati OH (S)

Voinot, Andrea, *Gallery Coordr,* San Francisco Museum of Modern Art, Artist Gallery, San Francisco CA

Voit, Irene, *Bus Serv,* Las Vegas-Clark County Library District, Las Vegas NV

Vokt, Emily, *Research Asst,* The Art Institute of Chicago, Dept of Prints & Drawings, Chicago IL

Volk, Joyce, *Cur,* Warner House Association, MacPheadris-Warner House, Portsmouth NH

Volk, Ulla, *Dir,* Cooper Union for the Advancement of Science & Art, Library, New York NY

Volkert, James, *Deputy Asst Dir Exhib,* National Museum of the American Indian, George Gustav Heye Center, New York NY

Vollmer, David L, *Dir,* Swope Art Museum, Research Library, Terre Haute IN

Volmar, Michael, *Cur,* Fruitlands Museum, Inc, Harvard MA

Volmar, Michael A, *Cur,* Fruitlands Museum, Inc, Library, Harvard MA

Volpacchio, John, *Prof,* Salem State College, Art Dept, Salem MA (S)

Volz, Robert L, *Custodian,* Williams College, Chapin Library, Williamstown MA

Vom Baur, Daphne, *Secy,* Tradd Street Press, Elizabeth O'Neill Verner Studio Museum, Charleston SC

Vonada, Wayne, *Sr Preparator,* Florida State University, Museum of Fine Arts, Tallahassee FL

Von Barghahn, Barbara, *Prof,* George Washington University, Dept of Art, Washington DC (S)

VonBehren, Connie, *Develop,* Las Vegas Natural History Museum, Las Vegas NV

Von Bloomberg, Randell, *Gallery Dir,* New World School of the Arts, Gallery, Miami FL

Von Bothmer, Dietrich, *Distinguished Research,* The Metropolitan Museum of Art, New York NY

von Dassanowsky, Robert, *Prof,* University of Colorado-Colorado Springs, Visual & Performing Arts Dept, Colorado Springs CO (S)

Vondraf, Barbara, *Dir,* Dawson County Historical Society, Museum, Lexington NE

Von Kann, Lisa, *Librn,* Saint Johnsbury Athenaeum, Saint Johnsbury VT

Vonkeman, Anine, *Head Pub Rels,* Southern Alberta Art Gallery, Library, Lethbridge AB

Vonkeman, Anine, *Pub Prog Cur,* Southern Alberta Art Gallery, Lethbridge AB

Von Kerssenbrock-Krosigk, Dedo, *Cur European Glass,* Corning Museum of Glass, The Studio, Rakow Library, Corning NY

von Krusenstiern, Konstantin, *Dir,* Brattleboro Museum & Art Center, Brattleboro VT

von Lates, Adrienne, *Educ Cur,* Museum of Contemporary Art, North Miami FL

Von Martin, Christaan, *Sr Preparator,* Riverside Art Museum, Riverside CA

Von Netzer, Mary Ellen, *Treas,* Beaumont Art League, Beaumont TX

Von Rosk, Laura, *Gallery Dir,* Lake George Arts Project, Courthouse Gallery, Lake George NY

Von Schlegell, Mark, *Circulation Supv,* Art Center College of Design, James Lemont Fogg Memorial Library, Pasadena CA

Von Sonnenburg, Hubert, *Sherman Fairchild Chm,* The Metropolitan Museum of Art, New York NY

VonVoetcsch, Kurt, *Gallery Mgr,* Niagara University, Castellani Art Museum, Niagara NY

Von Wolffersdorff, Joy, *Adjunct,* College of the Canyons, Art Dept, Canta Colita CA (S)

Vookles, Laura, *Cur,* The Hudson River Museum, Yonkers NY

Vookles, Laura, *Cur Collections,* The Hudson River Museum, Yonkers NY

Voorheis, Lynn, *Cur Coll and Historic Structures,* Riverside Municipal Museum, Riverside CA

Voorheis, Peter, *Folk Arts,* Arts of the Southern Finger Lakes, Corning NY

Vos, Larry, *Adult Serv Div Coordr,* Wichita Public Library, Wichita KS

Voss, Barbara, *Mgr Retail Opers,* Terra Museum of American Art, Chicago IL

Voss, Barbara, *Mus Shop Mgr,* Terra Museum of American Art, Chicago IL

Voss, Jennifer, *Dir Finance,* Putnam Museum of History and Natural Science, Library, Davenport IA

Voutselas, Eleanore, *Archivist,* Museum of New Mexico, Library, Santa Fe NM

Vradenburg, George, *Chmn of Brd,* The Phillips Collection, Washington DC

Vrooman, Wendy, *Admin Asst,* George A Spiva, Joplin MO

Vrotsus, Susan, *Dir Sales & Rental,* Cambridge Art Association, Cambridge MA

Vruwink, J, *Chmn,* Central College, Art Dept, Pella IA (S)

Vuilleumier, Ellie, *Registrar,* Portland Museum of Art, Portland ME

Waale, Kim, *Assoc Prof,* Cazenovia College, Center for Art & Design Studies, Cazenovia NY (S)

Wachna, Pamela, *Cur,* City of Toronto Culture Division, The Market Gallery, Toronto ON

Wacker, Kelly, *Gallery Dir,* University of Montevallo, The Gallery, Montevallo AL

Wada, W, *Prof Painting,* Ramapo College of New Jersey, School of Contemporary Arts, Mahwah NJ (S)

Waddell, Roberta, *Cur Prints,* The New York Public Library, Print Room, New York NY

Waddingham, Tim, *Treas,* Madison County Historical Society, Cottage Lawn, Oneida NY

Waddington, Murray, *Chief Librn,* National Gallery of Canada, Library, Ottawa ON

Wade, Cara, *Asst Prof,* University of Saint Francis, School of Creative Arts, Fort Wayne IN (S)

Wade, Diane, *Office Adminr,* Fusion: The Ontario Clay & Glass Association, Toronto ON

Wade, Edwin L, *Deputy Dir,* Museum of Northern Arizona, Flagstaff AZ

Wade, Karen Graham, *Dir,* Workman & Temple Family Homestead Museum, City of Industry CA

Wademan, Marilyn, *Asst Secy,* Reading Public Museum, Library, Reading PA

Wadley, William, *Head,* Texas A&M University Commerce, Dept of Art, Commerce TX (S)

Wadsworth, David, *Historian,* Cohasset Historical Society, Pratt Building (Society Headquarters), Cohasset MA

Wadsworth, David H, *Sr Cur,* Cohasset Historical Society, Cohasset Maritime Museum, Cohasset MA

Wagan, Sixto, *Co-Dir,* Diverse Works, Houston TX

Wagener, Thomas, *Dir,* University of Wisconsin-Eau Claire, Foster Gallery, Eau Claire WI

Wagener, Tom, University of Wisconsin-Eau Claire, Dept of Art, Eau Claire WI (S)

Waggoner, Lynda, *Dir,* Western Pennsylvania Conservancy, Fallingwater, Mill Run PA

Wagner, Ann, *Cur,* Washington County Museum of Fine Arts, Library, Hagerstown MD

Wagner, Beverly, *Admin Secy,* Texas A&M University, J Wayne Stark University Center Galleries, College Station TX

Wagner, Bob, *Preparator,* State University of New York at New Paltz, Samuel Dorsky Museum of Art, New Paltz NY

Wagner, Brian, *Assoc Prof Visual Studies,* Drexel University, College of Media Arts & Design, Philadelphia PA (S)

Wagner, Catherine, *Assoc Prof,* Mills College, Art Dept, Oakland CA (S)

Wagner, Denise, *Secy,* Hartwick College, The Yager Museum, Oneonta NY

Wagner, Laurie, *Educ Coordr,* Art Gallery of Swift Current NEC, Swift Current SK

Wagner, Lois, *Pres,* Lois Wagner Fine Arts Inc, New York NY

Wagner, Margaret, *Asst Prof,* University of Massachusetts - Boston, Art Dept, Boston MA (S)

Wagner, Mary, *Admin Asst,* Marquette University, Haggerty Museum of Art, Milwaukee WI

Wagner, Michael, *Library Asst,* Southwest Museum, Los Angeles CA

Wagner, Michael, *Library Asst,* Southwest Museum, Braun Research Library, Los Angeles CA

Wagner, Nancy, *Mus Outreach Coordr,* Bowdoin College, Peary-MacMillan Arctic Museum, Brunswick ME

Wagner, Teri, *Asst Prof,* Cardinal Stritch University, Art Dept, Milwaukee WI (S)

Wagoner, Phillip, *Assoc Prof,* Wesleyan University, Dept of Art & Art History, Middletown CT (S)

Wagoner, Scott Bishop, *Communications Adminr,* Jule Collins Smith Museum of Art, Auburn AL

Wahl, Gary, *Visiting Asst Prof,* Albion College, Bobbitt Visual Arts Center, Albion MI

Wahl, Sonja, *Cur,* Handweaving Museum & Arts Center, Clayton NY (S)

Wahlgren, Bob, *VPres Finance,* DuPage Art League School & Gallery, Wheaton IL

Wahlgren, Kay, *VPres Buildings & Grounds,* DuPage Art League School & Gallery, Wheaton IL

Wahnee, B J, *Instr,* Haskell Indian Nations University, Art Dept, Lawrence KS (S)

Waidelich, Elaine, *National Pres,* National League of American Pen Women, Washington DC

Wainwright, Lisa, *Undergrad Div Chmn,* School of the Art Institute of Chicago, Chicago IL (S)

Wainwright, Paige, *Metal Arts Cur,* Sloss Furnaces National Historic Landmark, Birmingham AL

Wait, Tamara, *Pub Historian,* Clark County Historical Society, Library, Springfield OH

Waits, Roy, *Design Dir,* The Art Institute of Cincinnati, Cincinnati OH (S)

Wakeford, Elizabeth, *Cur Asst,* Dundurn Castle, Hamilton ON

Wakeling, Melissa, *Educ,* Glanmore National Historic Site of Canada, Belleville ON

Walch, Margaret, *Dir,* Color Association of the US, New York NY

Walch, Timoth, *Library Dir,* Herbert Hoover, West Branch IA

Walden, Jerry, *Chmn,* Winthrop University, Dept of Art & Design, Rock Hill SC (S)

Walder, Penelope, *Gallery Adminr,* Allied Arts Association, Allied Arts Center & Gallery, Richland WA

Waldman, Arthur, *Prof,* Ocean County College, Humanities Dept, Toms River NJ (S)

Waldo, Elizabeth, *Asst Dir,* San Jose Institute of Contemporary Art, San Jose CA

Waldrep, Lee W, *Asst Dean for Student Affairs,* Illinois Institute of Technology, College of Architecture, Chicago IL (S)

Waldron, Craig, *Dir,* Liberty Village Arts Center & Gallery, Chester MT

Waldrop, Tim, *Asst Prof,* Western Illinois University, Art Dept, Macomb IL (S)

Wale, George, *Dir Programs,* Burlington Art Centre, Burlington ON

Walenda, Diane, *VPres Activities,* DuPage Art League School & Gallery, Wheaton IL

Walford, E John, *Chmn,* Wheaton College, Dept of Art, Wheaton IL (S)

Walker, Beth, *Prin Librn & Information Access Servs,* Pasadena Public Library, Fine Arts Dept, Pasadena CA

Walker, Beth, *Reference Librn,* Center for Creative Studies, College of Art & Design Library, Detroit MI

Walker, Bev, *Asst Dir,* Cumberland Theatre, Lobby for the Arts Gallery, Cumberland MD

Walker, Celeste, *Theatre,* Saint Joseph's University, Dept of Fine & Performing Arts, Philadelphia PA (S)

Walker, Celia, *Chief Cur,* Cheekwood-Tennessee Botanical Garden & Museum of Art, Nashville TN

Walker, Celia, *Cur Coll,* Cheekwood Nashville's Home of Art & Gardens, Education Dept, Nashville TN (S)

Walker, Dean, *Sr Cur European Decorative Art,* Philadelphia Museum of Art, Samuel S Fleisher Art Memorial, Philadelphia PA

Walker, Denise, *Admin Dir,* Visual Arts Center of Northwest Florida, Panama City FL

Walker, Dennis, *Registrar,* Walter Anderson, Ocean Springs MS

Walker, Doug, *Chmn,* College of the Desert, Art Dept, Palm Desert CA (S)

Walker, Edwin G, *Chmn Art Dept,* Millikin University, Art Dept, Decatur IL (S)

Walker, Grant, *Research Assoc,* United States Naval Academy, USNA Museum, Annapolis MD

Walker, Gwendolyn, *Founder & Cur,* The Walker African American Museum & Research Center, Las Vegas NV

Walker, Hamza, *Educ Dir,* The Renaissance Society, Chicago IL

Walker, Jeffry, *Dir,* Trinity College, Austin Arts Center, Widener Gallery, Hartford CT

Walker, John, *Prof,* Boston University, School for the Arts, Boston MA (S)

Walker, Joy, *Registrar Art,* Oakland Museum of California, Art Dept, Oakland CA

Walker, Juanita, *Fin Dir,* The Walker African American Museum & Research Center, Las Vegas NV

Walker, Kathy Y, *Instr,* Pennsylvania College of Technology, Dept. of Communications, Construction and Design, Williamsport PA (S)

Walker, Lisa, *Project Coordr,* City of Atlanta, Bureau of Cultural Affairs, Atlanta GA

Walker, Lulen, *Art Coll Coordr,* Georgetown University, Lauinger Library-Special Collections Division, Washington DC

Walker, Lulen, *Cur,* Georgetown University, Art Collection, Washington DC

Walker, Martha, *Fine Arts Librn,* Cornell University, Fine Arts Library, Ithaca NY

Walker, Melissa, *Dir Educ,* Perkins Center for the Arts, Moorestown NJ

Walker, Melveta, *Library Dir,* Eastern New Mexico University, Golden Library, Portales NM

Walker, Natalie, *Art Educ,* Alexandria Museum of Art, Alexandria LA

Walker, Patricia, *Asst Prof,* Georgia Southern University, Dept of Art, Statesboro GA (S)

Walker, Robert, *Instr,* College of the Canyons, Art Dept, Canta Colita CA (S)

Walker, Roslyn A, *Dir,* Smithsonian Institution, National Museum of African Art, Washington DC

Walker, Sarah, *Assoc Prof,* Clark University, Dept of Visual & Performing Arts, Worcester MA (S)

Walker, Victoria, *Library Asst III,* Michigan State University, Fine Arts Library, East Lansing MI

Walker-Millar, Kathy, *Head Dept,* McMurry University, Art Dept, Abilene TX (S)

Walkerbone, Kara, *Dir of Educ,* Palm Beach Institute of Contemporary Art, Museum of Art, Lake Worth FL

Wall, Brent, *Assoc Prof,* Saint Xavier University, Dept of Art & Design, Chicago IL (S)

Wall, Deborah, *Lectr,* University of North Carolina at Charlotte, Dept Art, Charlotte NC (S)

Wall, F L, *Chmn Sculpture & Ceramics,* Corcoran School of Art, Washington DC (S)

Wall, Kathleen, *Exhib Coordr,* Prairie Art Gallery, Grande Prairie AB

Walla, Chris, *Asst Prof,* Minnesota State University-Moorhead, Dept of Art, Moorhead MN (S)

Wallace, Alan, *Asst Prof,* Chattanooga State Technical Community College, Advertising Arts Dept, Chattanooga TN (S)

Wallace, Brian, *Cur,* State University of New York at New Paltz, Samuel Dorsky Museum of Art, New Paltz NY

Wallace, Brian, *Dir Exhib & Chief Cur,* International Center of Photography, New York NY

Wallace, Bruce, *Assoc Prof,* University of Tennessee at Chattanooga, Dept of Art, Chattanooga TN (S)

Wallace, Charles, *Dir,* Pump House Center for the Arts, Chillicothe OH

Wallace, Fred, *Chief Conservator,* Cincinnati Museum Association and Art Academy of Cincinnati, Cincinnati Art Museum, Cincinnati OH

Wallace, Glenna, *Div Chmn,* Crowder College, Art & Design, Neosho MO (S)

Wallace, Isabelle, *Art History,* University of New Orleans-Lake Front, Dept of Fine Arts, New Orleans LA (S)

Warwick, Mark, *Chmn,* Gettysburg College, Dept of Visual Arts, Gettysburg PA (S)

Wasemiller, Kitty, *Prof,* Abilene Christian University, Dept of Art & Design, Abilene TX (S)

Washburn, William, *Instr,* Marylhurst University, Art Dept, Marylhurst OR (S)

Washer, Joyce, *Instr,* Woodstock School of Art, Inc, Woodstock NY (S)

Washington, Joe, *Assoc Prof,* Alabama A & M University, Art & Art Education Dept, Normal AL (S)

Washington, Laura, *Dir Pub Affairs,* New York Historical Society, New York NY

Washler, Deb, *Exec Dir,* Artlink, Inc, Fort Wayne IN

Wasinger, Tracy, *Instr,* University of Charleston, Carleton Varney Dept of Art & Design, Charleston WV (S)

Wass, Janice, *Cur Decorative Arts,* Illinois State Museum, Museum Store, Chicago IL

Wass, Janice, *Cur Decorative Arts,* Illinois State Museum, Illinois Art Gallery & Lockport Gallery, Springfield IL

Wasserboehr, Patricia, *Head,* University of North Carolina at Greensboro, Art Dept, Greensboro NC (S)

Wasserman, Fred, *Dir Cur Admin,* The Jewish Museum, New York NY

Wasserman, Sharon, *Dir of Library & Research Center,* National Museum of Women in the Arts, Washington DC

Wasserman, sharon M, *Dir of Libr & Res Ctr,* National Museum of Women in the Arts, Library & Research Center, Washington DC

Wassermann, Mary, *Slide Librn,* Philadelphia Museum of Art, Slide Library, Philadelphia PA

Wassermann, Mary S, *Librn Collection Develop,* Philadelphia Museum of Art, Library, Philadelphia PA

Wastler, Brad, *Second VPres,* St. Louis Artists' Guild, Saint Louis MO

Wat, Katherine, *Cur Exhibs,* Akron Art Museum, Akron OH

Watanabe, Eric, *CFO,* Honolulu Academy of Arts, The Art Center at Linekona, Honolulu HI (S)

Watanabe, Joan, *Prof of Photography,* Glendale Community College, Visual & Performing Arts Div, Glendale CA (S)

Watchman, Theadora, *Mus Clerk,* Red Rock State Park, Red Rock Museum, Church Rock NM

Watcke, Tom, *Prof,* Albright College, Dept of Art, Reading PA (S)

Waterfield, Doug, *Asst Prof,* Southern Arkansas University, Art Dept Gallery & Magale Art Gallery, Magnolia AR

Waterfield, Doug, *Asst Prof,* Southern Arkansas University at Magnolia, Dept of Art, Magnolia AR (S)

Waterfield, Linda, *Colls Mgr & Registrar,* Judah L Magnes, Berkeley CA

Waterman, Cindy, *Security,* University of Kansas, Spencer Museum of Art, Lawrence KS

Waters, Deborah, *Cur Decorative Arts & Manuscripts,* Museum of the City of New York, Museum, New York NY

Waters, Julia, *Public Relations Dir,* Wave Hill, Bronx NY

Waters, Kathryn, *Prof,* University of Southern Indiana, Art Dept, Evansville IN (S)

Waters, Moya, *Mgr Admin,* University of British Columbia, Museum of Anthropology, Vancouver BC

Waters, Sara, *Prof,* Texas Tech University, Dept of Art, Lubbock TX (S)

Waterston, George, *Treas,* South County Art Association, Kingston RI

Wathen, Briget, *Deputy Dir Opers,* Kentucky Museum of Art & Craft, Louisville KY

Watkins, Helga, *Asst Prof,* University of Nevada, Las Vegas, Dept of Art, Las Vegas NV (S)

Watkins, Lynette, *Asst Prof,* South Plains College, Fine Arts Dept, Levelland TX (S)

Watkins, Ron, *Treas,* Coppini Academy of Fine Arts, Library, San Antonio TX

Watkins, Sonya, *Pres,* Halifax Historical Society, Inc, Halifax Historical Museum, Daytona Beach FL

Watkins, W Anthony, *Asst Prof,* Northwestern State University of Louisiana, School of Creative & Performing Arts - Dept of Fine & Graphic Arts, Natchitoches LA (S)

Watkinson, Sharon, *Chmn,* Niagara University, Fine Arts Dept, Niagara Falls NY (S)

Watley, Lauren, *Admis Asst,* Craft and Folk Art Museum (CAFAM), Los Angeles CA

Watriss, Wendy, *Dir Art,* Houston Foto Fest Inc, Houston TX

Watrous, Livingston, *Prof,* University at Buffalo, State University of New York, Dept of Visual Studies, Buffalo NY (S)

Watsky, Andrew, *Asst Prof,* Vassar College, Art Dept, Poughkeepsie NY (S)

Watson, Abigail, *Asst Cur,* Erie Art Museum, Erie PA

Watson, Amy, *Library Technician,* Hirshhorn Museum & Sculpture Garden, Library, Washington DC

Watson, Bernard, *Pres Board Trustees,* Barnes Foundation, Merion PA

Watson, Donna, *Adjunct Prof,* Oklahoma Christian University of Science & Arts, Dept of Art & Design, Oklahoma City OK (S)

Watson, Donna, *Pres,* National Watercolor Society, San Pedro CA

Watson, George, *Pres,* Society of Photographers & Artists Representatives, New York NY

Watson, Ian, *Deputy Chair,* Rutgers University, Newark, Dept of Visual & Performing Arts, Newark NJ (S)

Watson, Kim, *Dir,* Manitoba Association of Architects, Winnipeg MB

Watson, Kimbellee, *Educ Coordr,* Sloss Furnaces National Historic Landmark, Birmingham AL

Watson, Maya, *Instr,* Texas Southern University, College of Liberal Arts & Behavorial Sciences, Houston TX (S)

Watson, Neil, *Exec Dir,* Katonah Museum of Art, Katonah NY

Watson, Richard, *Exhib Dir,* African American Museum in Philadelphia, Philadelphia PA

Watson, Ronald, *Chmn of Art & Art History,* Texas Christian University, Dept of Art & Art History, Fort Worth TX (S)

Watson, Ronald, *Dir,* Texas Christian University, University Art Gallery, Fort Worth TX

Watson, Scott, *Dir & Cur,* University of British Columbia, Morris & Helen Belkin Art Gallery, Vancouver BC

Watson, Thomas R, *Pres,* Portsmouth Historical Society, John Paul Jones House, Portsmouth NH

Watson, Tom, *Chmn,* Columbia College, Art Dept, Columbia MO (S)

Watson, Wendy, *Cur,* Mount Holyoke College, Art Museum, South Hadley MA

Wattenmaker, Richard J, *Dir,* Archives of American Art, Smithsonian Institution, Washington DC

Watters, Clare, *Sales Gallery Mgr,* Southwest School of Art & Craft, San Antonio TX

Watterson, Martha, *Assoc Dir,* Intuit: The Center for Intuitive & Outsider Art, Chicago IL

Watts, Barbara, *Assoc Prof,* Florida International University, School of Art & Art History, Miami FL (S)

Watts, Greg, *Chmn,* Metropolitan State College of Denver, Art Dept, Denver CO (S)

Watts, Michael, *Dir,* Eastern Illinois University, Tarble Arts Center, Charleston IL

Watts, Mitra, *Dean Academic Affairs,* Art Institute of Colorado, Denver CO (S)

Watts, Steve, *Coordr,* University of Charleston, Carleton Varney Dept of Art & Design, Charleston WV (S)

Watts, Tracy, *Asst Prof,* State University of New York College at Potsdam, Dept of Fine Arts, Potsdam NY (S)

Waugaman, Linda, *Vis Arts Dir,* Indian River Community College, Fine Arts Dept, Fort Pierce FL (S)

Waugh, Michael, *Resource Dir,* Momenta Art, Brooklyn NY

Wauhkonen, Robert, *Chmn Liberal Arts,* Art Institute of Boston at Lesley University, Boston MA (S)

Wavrat, Dennis, *Prof,* University of South Dakota, Department of Art, College of Fine Arts, Vermillion SD (S)

Wawzonek, Donna, *Dir,* Struts Gallery, Sackville NB

Way, Catherine A, *Dir,* James Prendergast, Jamestown NY

Wayman, Adele, *Prof of Art, Dept Chair,* Guilford College, Art Dept, Greensboro NC (S)

Wayne, Cynthia, *Dir,* Albin O Kuhn Library & Gallery, Baltimore MD

Wayne, Nan, *Exec Dir,* The Fine Arts Center of Hot Springs, Hot Springs AR

Weake, Gay, *Exec Dir,* Sun Valley Center for the Arts & Humanities, Dept of Fine Art, Sun Valley ID (S)

Weakland, Cindy, *Supv Pub Progs,* The Rockwell Museum of Western Art, Corning NY

Wear, Lori, *Cur,* Kern County Museum, Bakersfield CA

Wearing, Shannon, *Librn,* Solomon R Guggenheim, Library, New York NY

Wease, Ken, *Bus Mgr,* Calvert Marine Museum, Solomons MD

Weatherford, Elizabeth, *Head Film & Video Center,* National Museum of the American Indian, George Gustav Heye Center, New York NY

Weatherley, Glynn, *Lectr,* Lambuth University, Dept of Human Ecology & Visual Arts, Jackson TN (S)

Weathers, Dennis, *Area Dir,* College of the Siskiyous, Theatre Dept, Weed CA (S)

Weaver, Henry C, *Pres & Cur,* John Weaver Sculpture Collection, Hope BC

Weaver, Herb, *Head Dept,* Bethany College, Dept of Fine Arts, Bethany WV (S)

Weaver, Kimberly, *Mus Shop Mgr,* Missouri Historical Society, Saint Louis MO

Weaver, Pat, *Dir,* Glynn Art Association, Saint Simons Island GA

Weaver, Patsy, *Treas,* Coquille Valley Art Association, Coquille OR

Weaver, Timothy, *Asst Prof Electronic Media Arts Design,* University of Denver, School of Art & Art History, Denver CO (S)

Webb, Dixie, *Slide Librn,* Austin Peay State University, Art Dept Library, Clarksville TN

Webb, Duncan J, *Dir Educ,* American Academy of Art, Chicago IL (S)

Webb, Frank, *Instr,* Art Center Sarasota, Sarasota FL (S)

Webb, Greg, *Instr,* Joe Kubert, Dover NJ (S)

Webb, Hugh, *Dir,* Portland Community College, North View Gallery, Portland OR

Webb, Jennifer, *Communications Mgr,* University of British Columbia, Museum of Anthropology, Vancouver BC

Webb, Lanny, *Prof Graphic Design,* University of Georgia, Franklin College of Arts & Sciences, Lamar Dodd School of Art, Athens GA (S)

Webb, Michael, *Prof Visual Studies,* Drexel University, College of Media Arts & Design, Philadelphia PA (S)

Webb, Ron, *Dean,* Huntington College, Art Dept, Huntington IN (S)

Webber, Jeffrey V, *VPres,* The New England Museum of Telephony, Inc., The Telephone Museum, Ellsworth ME

Webber, Mark, *Dir,* Prince Street Gallery, New York NY

Webber, Nancy E, *Asst Prof,* Los Angeles Harbor College, Art Dept, Wilmington CA (S)

Weber, Heather, *Dir,* Northeastern Illinois University, Gallery, Chicago IL

Weber, Heather, *Dir,* Northern Illinois University, Art Gallery in Chicago, Chicago IL

Weber, Jean M, *Exec Dir,* Nantucket Historical Association, Historic Nantucket, Nantucket MA

Weber, Joan, *VPres,* Washington Sculptors Group, Washington DC

Weber, John, *Prof,* Elmhurst College, Art Dept, Elmhurst IL (S)

Weber, Joseph A, *Art Educ,* Southern Illinois University at Edwardsville, Dept of Art & Design, Edwardsville IL (S)

Weber, Lester, *Archivist,* The Mariners' Museum, Library, Newport News VA

Weber, Marcia, *Bd Pres,* Atlanta Contemporary Art Center, Atlanta GA

Weber, Megan, *Residency Coordr,* Young Audiences Inc, Long Chapter, Denver CO

Weber, Mike, University of Wisconsin-Eau Claire, Dept of Art, Eau Claire WI (S)

Weberg, Lorraine, *Reference & Systems,* Fashion Institute of Technology, Gladys Marcus Library, New York NY

Webster, Angela, *Library Assoc,* Miami University, Wertz Art & Architecture Library, Oxford OH

Webster, Drew, *Prof, Photography,* Manatee Community College, Dept of Art & Humanities, Bradenton FL (S)

Webster, Helen, *Graphic Design, Media Arts & Animation,* Art Institute of Pittsburgh, Pittsburgh PA (S)

Webster, Jenneth, *Gallery Dir Programming Dept,* Lincoln Center for the Performing Arts, Cork Gallery, New York NY

Webster, Lynn, *Assoc Prof Art,* Albertson College of Idaho, Rosenthal Art Gallery, Caldwell ID

Webster, Maryann, *Instr,* University of Utah, Dept of Art & Art History, Salt Lake City UT (S)

Webster, Melissa, *Instr,* Walla Walla Community College, Art Dept, Walla Walla WA (S)

Webster, Paul, *Lectr,* Oakland University, Dept of Art & Art History, Rochester MI (S)

Webster, Sally, *Prof,* City University of New York, PhD Program in Art History, New York NY (S)

Webster, Susan V, *Prof,* University of Saint Thomas, Dept of Art History, Saint Paul MN (S)

Wechsler, Helen, *Dir, AAM/ICOM,* American Association of Museums, US National Committee of the International Council of Museums (AAM-ICOM), Washington DC

Wechsler, Judith, *Prof,* Tufts University, Dept of Art & Art History, Medford MA (S)

Weckbacher, Vernon, *Cur,* McAllen International Museum, McAllen TX

Weckbacher, Vernon, *Cur Colls,* McAllen International Museum, Library, McAllen TX

Weddle, Wavneath, *Instr,* East Central University, Art Dept, Ada OK (S)

Wedel, Pam, *Instr,* Oklahoma State University, Graphic Arts Dept, Visual Communications, Okmulgee OK (S)

Wedig, Dale, *Prof,* Northern Michigan University, Dept of Art & Design, Marquette MI (S)

Weedman, Kenneth R, *Chmn,* Cumberland College, Dept of Art, Williamsburg KY (S)

Weekley, Carolyn, *Dir,* Colonial Williamsburg Foundation, Abby Aldrich Rockefeller Folk Art Center, Williamsburg VA

Weekley, Carolyn J, *Dir,* Colonial Williamsburg Foundation, DeWitt Wallace Gallery, Williamsburg VA

Weekly, Nancy, *Head Colls & Programming,* Burchfield-Penney Art Center, Archives, Buffalo NY

Weekly, Nancy, *Head Colls & Programming & Charles Cary Rumsey Cur,* Burchfield-Penney Art Center, Buffalo NY

Weeks, Jason, *Exec Dir,* Cambridge Arts Council, CAC Gallery, Cambridge MA

Weg, Carol L, *VPres,* Wendell Gilley, Southwest Harbor ME

Weg, Phil Vander, *Chmn Dept,* Western Michigan University, Dept of Art, Kalamazoo MI (S)

Wegener, Brenda, *Fine Art,* San Diego Public Library, Art & Music Section, San Diego CA

Wegman, Jay D, *Reverend Canon,* Cathedral of Saint John the Divine, New York NY

Wegman, Tom, *Pres-Elect,* Arts Iowa City, Art Center & Gallery, Iowa City IA

Wegner, Susan, *Dir Art History,* Bowdoin College, Art Dept, Brunswick ME (S)

Wehrung, Marybeth, *Clay Prog Coordr,* Women's Studio Workshop, Inc, Rosendale NY

Weickart, Joseph G, *Exec Dir,* Amherst Museum, Amherst NY

Weidel, Geraldine, *Hist Site Asst,* Olana State Historic Site, Library, Hudson NY

Weidel, Geraldine, *Historic Site Asst,* Olana State Historic Site, Hudson NY

Weider, Greg, *Media Arts & Animation,* Art Institute of Pittsburgh, Pittsburgh PA (S)

Weidman, James F, *Pres,* Arts & Education Council of Greater Saint Louis, Saint Louis MO

Weidman, Jeffrey, *Sr Librn Pub Servs & Coll Develop,* Nelson-Atkins Museum of Art, Spencer Art Reference Library, Kansas City MO

Weidman, Jill, *Pres,* Lancaster County Art Association, Inc, Strasburg PA

Weidner, Marsha, *Prof & Asian Grad Advisor,* University of Kansas, Kress Foundation Dept of Art History, Lawrence KS (S)

Weiffenbach, Jeanie, *Dir,* University of California, Irvine, Beall Center for Art and Technology, and University Art Gallery, Irvine CA

Weiffenbach, Jeanie, *Exec Dir,* Roswell Museum & Art Center, Library, Roswell NM

Weigand, Herbert, *Chmn,* East Stroudsburg University, Fine Arts Center, East Stroudsburg PA (S)

Weightman, David, *Dir School,* University of Illinois, Urbana-Champaign, School of Art & Design, Champaign IL (S)

Weiglin, Peter, *Pres,* Arts Council of San Mateo County, Belmont CA

Weigo, Norman, *Chmn,* Triton College, School of Arts & Sciences, River Grove IL (S)

Weil, Benjamin, *Cur Media Arts,* San Francisco Museum of Modern Art, San Francisco CA

Weiland, Christopher, *Prof,* Indiana University of Pennsylvania, College of Fine Arts, Indiana PA (S)

Weiland, Kim, *Instr,* Ocean City Arts Center, Ocean City NJ (S)

Weiler, Megan, *Art in Pub Places Coordr,* City of Austin Parks & Recreation Department, Julia C Butridge Gallery, Austin TX

Weiler, Robert, *Auditorium Coordr,* Northwestern Michigan College, Dennos Museum Center, Traverse City MI

Weimer, Susan S, *Exec Dir,* Georgia Council for the Arts, Georgia's State Art Collection, Atlanta GA

Wein, JoAnn, *Chmn,* Queensborough Community College, Dept of Art & Photography, Bayside NY (S)

Weinberg, H Barbara, *Alice Pratt Brown Chm,* The Metropolitan Museum of Art, New York NY

Weinberg, H Barbara, *Prof Emerita,* City University of New York, PhD Program in Art History, New York NY (S)

Weiner, Sarah Elliston, *Dir,* Columbia University, Miriam & Ira D Wallach Art Gallery, New York NY

Weingait, Megan, *Pres,* Cleveland Institute of Art, Cleveland Art Association, Cleveland OH

Weininger, Arielle, *Coll Mgr,* Spertus Institute of Jewish Studies, Spertus Museum, Chicago IL

Weinke, Jane, *Cur Coll,* Leigh Yawkey Woodson, Wausau WI

Weinkein, John, *Dir School of the Arts,* Texas Woman's University, School of the Arts, Dept of Visual Arts, Denton TX (S)

Weinkein, John L, *Chair,* Texas Woman's University Art Gallery, Denton TX

Weinman, Sember, *Educ Cur,* Lehman College Art Gallery, Bronx NY

Weinreb, Allan, *Head Educ,* Olana State Historic Site, Hudson NY

Weinreb, Allan M, *Interpretive Progs Asst,* New York State Office of Parks Recreation & Historic Preservation, John Jay Homestead State Historic Site, Katonah NY

Weinstein, Celia, *Dir Educ & Progs,* Industrial Designers Society of America, Sterling VA

Weinstein, Richard, *Prof,* Green Mountain College, Dept of Art, Poultney VT (S)

Weintraub, Annette, *Prof,* City College of New York, Art Dept, New York NY (S)

Weipert, Eve, *Cur Coll,* High Point Historical Society Inc, Museum, High Point NC

Weir, Laura, *Asst Dir,* Long Beach Public Library, Long Beach NY

Weir, Sonja, *Pres,* American Artists Professional League, Inc, New York NY

Weirman, Traci, *Dir Educ,* Turtle Bay Exploration Park, Redding CA

Weis, Dick, *Prof,* Green Mountain College, Dept of Art, Poultney VT (S)

Weis, Helene H, *Librn,* Willet Stained Glass Studios, Philadelphia PA

Weis, Richard, *Assoc Prof,* Grand Valley State University, Art & Design Dept, Allendale MI (S)

Weisbeck, Diane, *Mus Shop Mgr,* Genesee Country Village & Museum, John L Wehle Gallery of Wildlife & Sporting Art, Mumford NY

Weise, Katrin, *Instr,* La Sierra University, Art Dept, Riverside CA (S)

Weisend, Susan, *Prof,* Ithaca College, Fine Art Dept, Ithaca NY (S)

Weisenfeld, Gennifer, *Assoc Prof,* Duke University, Dept of Art, Art History & Visual Studies, Durham NC (S)

Weislogel, Andrew, *Asst Cur & Master Teacher,* Cornell University, Herbert F Johnson Museum of Art, Ithaca NY

Weisman, Billie Milam, *Dir,* Frederick R Weisman, Los Angeles CA

Weisman, Eleanor, *Asst Prof,* University of Maine, Dept of Art, Orono ME (S)

Weiss, Clare, *Cur,* City of New York Parks & Recreation, Arsenal Gallery, New York NY

Weiss, John, *Coordr Photography,* University of Delaware, Dept of Art, Newark DE (S)

Weiss, Lois, *Mem,* Cleveland Museum of Art, Print Club of Cleveland, Cleveland OH

Weiss, Olga, *Exhib Cur,* Spertus Institute of Jewish Studies, Spertus Museum, Chicago IL

Weisser, Terry Drayman, *Dir Conservation & Technical Research,* Walters Art Museum, Baltimore MD

Weissinger, Sue, *Site Mgr,* No Man's Land Historical Society Museum, Goodwell OK

Weiss Le, Jo, *Instr,* American University, Dept of Art, Washington DC (S)

Weissler, Edye, *Librn,* M Knoedler, Library, New York NY

Weisz, Helen, *Instr,* Bucks County Community College, Fine Arts Dept, Newtown PA (S)

Weitz, Ankeney, *Asst Prof,* Colby College, Art Dept, Waterville ME (S)

Weitz, Gayle, *Assoc Prof,* Appalachian State University, Dept of Art, Boone NC (S)

Weizman, Sandra Morton, *Cur Cultural History,* Glenbow Museum, Calgary AB

Weiznegger, Peter, *Technician,* University of Minnesota, Duluth, Tweed Museum of Art, Duluth MN

Welch, Beverly Morgan, *Exec Dir,* Museum of Afro-American History, Boston MA

Welch, Janet, *Admin Asst,* Old York Historical Society, Elizabeth Perkins House, York ME

Welch, Janet, *Admin Asst,* Old York Historical Society, Old Gaol Museum, York ME

Welch, John, *Dir Educ,* Chrysler Museum of Art, Norfolk VA

Welch, Margo, *Dir Exhib Prog,* Royal Ontario Museum, Toronto ON

Welch, Nancy, *Campus Dir,* Greenville Technical College, Visual Arts Dept, Greenville SC (S)

Welch, S Anthony, *Prof,* University of Victoria, Dept of History in Art, Victoria BC (S)

Welch, Steven J, *Dir,* Corbit-Calloway Memorial Library, Odessa DE

Welcker, Joan, *Membership Coordr,* James A Michener, Doylestown PA

Welge, William, *Manuscripts & Archives,* Oklahoma Historical Society, Library Resources Division, Oklahoma City OK

Weliver, Evelyn R, *Head Librn,* Interlochen Center for the Arts, Interlochen MI

Weller, Dennis P, *Assoc Cur Europe,* North Carolina Museum of Art, Reference Library, Raleigh NC

Weller, Eric, *Prof,* Texas State University - San Marcos, Dept of Art and Design, San Marcos TX (S)

Weller, Joe, *VChmn,* Memphis Brooks Museum of Art, Memphis TN

Weller, Kate, *Cur,* Schenectady County Historical Society, Museum of Schenectady History, Schenectady NY

Weller, Laurie, *Adjunct Assoc Prof,* Texas Woman's University, School of the Arts, Dept of Visual Arts, Denton TX (S)

Wellington, Judith, *CEO/Pres,* Avampato Discovery Museum, The Clay Center for Arts & Sciences, Charleston WV

Welliver, Michael, *Instr,* Mercer County Community College, Arts, Communication & Engineering Technology, Trenton NJ (S)

Welliver, Neil, *Prof Emeritus,* University of Pennsylvania, Graduate School of Fine Arts, Philadelphia PA (S)

Wellman, Lesley, *Cur Educ,* Dartmouth College, Hood Museum of Art, Hanover NH

Wells, Annette, *Asso Prof Sr,* Miami-Dade Community College, Arts & Philosophy Dept, Miami FL (S)

Wells, Connie, *Instr,* Illinois Wesleyan University, School of Art, Bloomington IL (S)

Wells, Donna, *Pres,* Leatherstocking Brush & Palette Club Inc, Cooperstown NY

Wells, Edna, *Museum Mgr,* Cabot's Old Indian Pueblo Museum, Cabot's Old Indian Pueblo Museum, Desert Hot Springs CA

Wells, Gerald, *Chmn & Prof,* Fort Lewis College, Art Dept, Durango CO (S)

Wells, Heather Marie, *Collections Asst,* City of Springdale, Shiloh Museum of Ozark History, Springdale AR

Wells, Keith, *Assoc Cur,* Washington State University, Museum of Art, Pullman WA

Wells, Laura, *Business Mgr,* UMLAUF Sculpture Garden & Museum, Austin TX

Wells, Raymond, *Proj Dir,* National Conference of Artists, Michigan Chapter Gallery, Detroit MI

Wells, Shannon, *Admin Aid,* Frederic Remington, Ogdensburg NY

Wells, Suzanne, *Special Exhibs Coordr,* Philadelphia Museum of Art, Philadelphia PA

Wells, Terry, *Chmn Art Dept,* Western Connecticut State University, School of Visual & Performing Arts, Danbury CT (S)

Welsh, Caroline, *Cur,* The Adirondack Historical Association, The Adirondack Museum, Blue Mountain Lake NY

Welsh, Nicole, *Prog Coordr,* Contemporary Art Museum, Raleigh NC

Welsh, Peter, *CEO,* Deer Valley Rock Art Center, Glendale AZ

Welsh, Rosemary, *Asst Prof,* Wells College, Dept of Art, Aurora NY (S)

Welter, Cole H, *Dir,* James Madison University, School of Art & Art History, Harrisonburg VA (S)

Welter, Matt, *Cur of Educ,* Neville Public Museum, Green Bay WI

Weltge, Sigrid, *Prof Art History,* Philadelphia University, School of Textiles & Materials Technology, Philadelphia PA (S)

Welu, James A, *Dir,* Worcester Art Museum, Worcester MA

Welu, Judith A, *Assoc Prof,* Briar Cliff University, Art Dept, Sioux City IA (S)

Welu, William J, *Chairperson,* Briar Cliff University, Art Dept, Sioux City IA (S)

Welych, Anita, *Assoc Prof,* Cazenovia College, Center for Art & Design Studies, Cazenovia NY (S)

Wemmlinger, Raymond, *Cur & Librn,* Hampden-Booth Theatre Library, New York NY

Weng, Siegfried, *Dir Emeritus,* Evansville Museum of Arts, History & Science, Evansville IN

Wengler, Maureen, *Registrar,* Art Complex Museum, Carl A. Weyerhaeuser Library, Duxbury MA

Wengrovitz, Sy, *VPres,* Art League, Alexandria VA

Wenner, Majorie, *Educ Coordr,* UMLAUF Sculpture Garden & Museum, Austin TX

Wenowr, Stanley, *Treas,* Studio Gallery, Washington DC

Wentenhall, John, *Dir Museum,* Cheekwood Nashville's Home of Art & Gardens, Education Dept, Nashville TN (S)

Wentworth, Eryl J, *Dir,* American Architectural Foundation, The Octogon Museum, Washington DC

Wenzel, Duane, *Head Librn,* Bernice Pauahi Bishop, Library, Honolulu HI

Wepler, William, *Cur Anthropology,* Indiana State Museum, Indianapolis IN

Werbel, Amy, *Asst Prof,* St Michael's College, Fine Arts Dept, Colchester VT (S)

Werfel, Gina, *Chmn Art Studio,* University of California, Davis, Dept of Art & Art History, Davis CA (S)

Werhan, Lee, *Mus Shop Mgr,* Phoenix Art Museum, Phoenix AZ

Werle, Thomas, *Prof,* Capitol Community Technical College, Humanities Division & Art Dept, Hartford CT (S)

Werlink, Joy, *Asst Cur Manuscripts,* Washington State History Museum, Research Center, Tacoma WA

Werner, Charlotte, University of Manitoba, School of Art, Winnipeg MB (S)

Werner, Michael, *Assoc Prof,* State University of New York at Albany, Art Dept, Albany NY (S)

Werness, Hope, *Prof,* California State University, Art Dept, Turlock CA (S)

Wertheimer, Gary, *Chmn,* Olivet College, Art Dept, Olivet MI (S)

Wertkin, Gerard C, *Dir,* American Folk Art Museum, New York NY

Wertz , Dinyelle, *Assoc Cur,* CIGNA Corporation, CIGNA Museum & Art Collection, Philadelphia PA

Wertz, Sandra, *Chmn Media Arts,* University of South Carolina, Dept of Art, Columbia SC (S)

Wescoat, Bonna D, *Assoc Prof,* Emory University, Art History Dept, Atlanta GA (S)

Wescott, Dusty, *Pres,* North Carolina Museums Council, Raleigh NC

Wesley, John, *Photo Instr,* Bellevue Community College, Art Dept, Bellevue WA (S)

Wesley, John C, *Dir Bur of Man,* Pennsylvania Historical & Museum Commission, Harrisburg PA

Wesley, Richard, *Interim Chmn,* University of Pennsylvania, Dept of Architecture, Philadelphia PA (S)

Wesolowski, Katherine, *Mem & Vis Svcs Mgr,* Tucson Museum of Artand Historic Block, Tucson AZ

Wessel, Frederick, *Prof,* University of Hartford, Hartford Art School, West Hartford CT (S)

Wesselman Jackson, Linda, *Mgr Collections & Interpretation,* National Trust for Historic Preservation, Chesterwood Estate & Museum, Stockbridge MA

West, Arleen, *Gift Shop Mgr,* San Antonio Museum of Art, San Antonio TX

West, Bonnie J, *Pres,* New Mexico Art League, Gallery & School, Albuquerque NM

West, Bruce, *Visiting Lect,* Lewis & Clark College, Dept of Art, Portland OR (S)

West, Carolyn, *Prog Facilitator,* Central Florida Community College, Humanities Dept, Ocala FL (S)

West, Claire, *Performing Art Dir,* Arizona Commission on the Arts, Phoenix AZ

West, Coleen, *Exec Dir,* Howard County Arts Council, Ellicott City MD

West, John, *Dir Educ,* Urbanglass, Robert Lehman Gallery, Brooklyn NY

West, Matt, *Instr,* Laramie County Community College, Division of Arts & Humanities, Cheyenne WY (S)

West, Ruth, *Instr,* Springfield College, Dept of Visual & Performing Arts, Springfield MA (S)

West, W Richard, *Dir,* Smithsonian Institution, National Museum of the American Indian, Washington DC

West, W Richard, *Dir,* National Museum of the American Indian, George Gustav Heye Center, New York NY

West, W Richard, *Vice Chair, AAM/ICOM,* American Association of Museums, US National Committee of the International Council of Museums (AAM-ICOM), Washington DC

West, William, *Adjunct Asst Prof,* Le Moyne College, Fine Arts Dept, Syracuse NY (S)

Westbrook, Nicholas, *Exec Dir,* Fort Ticonderoga Association, Ticonderoga NY

Westbrook, Nicholas, *Exec Dir,* Fort Ticonderoga Association, Thompson-Pell Research Center, Ticonderoga NY

Westbrook, Paul, *Asst Dean,* Northeastern State University, College of Arts & Letters, Tahlequah OK (S)

Westbrook, Tricia, *Office Mgr,* Napa Valley Museum, Yountville CA

Westerbeck, Colin, *Cur Photography,* The Art Institute of Chicago, Chicago IL

Westerson, Kris, *Asst Dir,* The Museum of Western Art, cowboy Artists of America Museum, Kerrville TX

Westfall, Fred, *Pres,* Peninsula Fine Arts Center, Newport News VA

Westgard, Jill, *Develop Dir,* State University of New York at Purchase, Neuberger Museum of Art, Purchase NY

Westheimer, Michael, *Devel Consultant,* Contemporary Art for San Antonio Blue Star Art Space, San Antonio TX

Westin, Robert, *Prof,* University of Florida, Dept of Art, Gainesville FL (S)

Westlake, Richard, *Theatre Arts Instr,* Edison Community College, Gallery of Fine Arts, Fort Myers FL (S)

Westley, Judith, *Exec Dir,* Saint Augustine Art Association Gallery, Saint Augustine FL

Westmacott, Jean, *Cur, Arts Management Prog Dir,* Brenau University, Art & Design Dept, Gainesville GA (S)

Westman, Hans, *Media Arts & Animation,* Art Institute of Pittsburgh, Pittsburgh PA (S)

Westmoreland, Avril M, *Pub Rels Dir,* The Barnum Museum, Bridgeport CT

Westmoreland, LaMont, *Prof,* Los Angeles City College, Dept of Art, Los Angeles CA (S)

Westmorland, Lamont, *Dir,* California State University, Los Angeles, Fine Arts Gallery, Los Angeles CA

Weston, Victoria, *Asst Prof,* University of Massachusetts - Boston, Art Dept, Boston MA (S)

Westpfahl, Richard, *Chmn,* Western Wisconsin Technical College, Graphics Division, La Crosse WI (S)

Westwood, Dan, *Pres,* Southern Alberta Art Gallery, Lethbridge AB

Westwood, Lyn, *Instr,* Toronto Art Therapy Institute, Toronto ON (S)

Wetenhall, John, *Exec Dir,* Florida State University, John & Mable Ringling Museum of Art, Sarasota FL

Wetherbee, Maggie, *Assoc Cur Educ,* Riverside Municipal Museum, Riverside CA

Wetherell, Ann, *Instr,* Pacific University in Oregon, Arts Div, Dept of Art, Forest Grove OR (S)

Wetherington, Mark V, *Dir,* The Filson Historical Society, Louisville KY

Wethli, Mark, *Chair,* Bowdoin College, Art Dept, Brunswick ME (S)

Wetmiller, Cathy, *Museum Shop Mgr,* The Phillips Collection, Washington DC

Wetta, Frank, *Dean,* Daytona Beach Community College, Dept of Fine Arts & Visual Arts, Daytona Beach FL (S)

Wetzel, Anita, *Develop Dir,* Women's Studio Workshop, Inc, Rosendale NY

Wetzel, Jean, *Asst Prof,* California Polytechnic State University at San Luis Obispo, Dept of Art & Design, San Luis Obispo CA (S)

Wetzen, Lisa, *VChmn,* Detroit Artists Market, Detroit MI

Weyerhaeuser, Charles, *Dir,* Art Complex Museum, Library, Duxbury MA

Weyerhaeuser, Charles A, *Dir & CEO,* Art Complex Museum, Carl A. Weyerhaeuser Library, Duxbury MA

Weygandt, Virginia, *Cur,* Clark County Historical Society, Library, Springfield OH

Weygandt, Virginia, *Sr Cur,* Clark County Historical Society, Heritage Center of Clark County, Springfield OH

Weyhrich, Denise, *Prof,* Chapman University, Art Dept, Orange CA (S)

Weymouth, George A., *Chmn (V),* Brandywine River Museum, Chadds Ford PA

Whalen, Connie, *Cur,* Wells Fargo, Wells Fargo History Museum Phx, Phoenix AZ

Whalen, Wickie, *Prof,* Miami-Dade Community College, Arts & Philosophy Dept, Miami FL (S)

Wharton, Annabel, *Prof,* Duke University, Dept of Art, Art History & Visual Studies, Durham NC (S)

Wharton, Kay, *Publicity Coordr,* Wayne Center for the Arts, Wooster OH

Wheaton, Laura, *Dir Educ,* McLean County Historical Society, McLean County Museum of History, Bloomington IL

Wheeler, Adrienne, *Asst Coordr,* Society of Photographers & Artists Representatives, New York NY

Wheeler, Barbara, *Dir,* Roswell P Flower, Watertown NY

Wheeler, Bonnie, *Registrar,* Dundas Valley School of Art, Dofasco Gallery, Dundas ON (S)

Wheeler, Elizabeth, *Pres,* Porter-Phelps-Huntington Foundation, Inc, Historic House Museum, Hadley MA

Wheeler, Ken, *Vol Chmn,* River Heritage Museum, Paducah KY

Wheeler, Lawrence, *Dir,* North Carolina Museum of Art, Raleigh NC

Wheeler, Lawrence J, *Dir,* North Carolina Museum of Art, Reference Library, Raleigh NC

Wheeler, Nancy, *Registrar,* Yellowstone Art Museum, Billings MT

Wheelock, Arthur, *Cur Northern Baroque Painting,* National Gallery of Art, Washington DC

Wheelock, Scott, *Instr,* Main Line Art Center, Haverford PA (S)

Whelan, Agnieszka, *Instr,* Old Dominion University, Art Dept, Norfolk VA (S)

Whelan, John, *Instr,* Saint Mary's University of Minnesota, Art & Design Dept, Winona MN (S)

Wheless, Andrea, *Chmn,* High Point University, Fine Arts Dept, High Point NC (S)

Whetstone, Jeff, *Asst Prof,* University of North Carolina at Chapel Hill, Art Dept, Chapel Hill NC (S)

Whight, Ian, *Acting Head Dept City Planning,* University of Manitoba, Faculty of Architecture, Winnipeg MB (S)

Whinney, Paul, *Instr,* University of Pittsburgh at Johnstown, Dept of Fine Arts, Johnstown PA (S)

Whisenhunt, Ted, *Head of Art Dept,* Judson College, Division of Fine and Performing Arts, Marion AL (S)

Whisman, Evelyn, *Asst Cur,* Plumas County Museum, Quincy CA

Whisman, Evelyn, *Asst Cur,* Plumas County Museum, Museum Archives, Quincy CA

Whistler, Debbie, *Interim Chmn Dept,* Hanover College, Dept of Art, Hanover IN (S)

Whitaker, Jayne, *Asst Prof,* University of Dayton, Visual Arts Dept, Dayton OH (S)

Whitaker, Joel, *Asst Prof,* University of Dayton, Visual Arts Dept, Dayton OH (S)

Whitaker, Julia, *Dir & Cur,* Prince George Art Gallery, Prince George BC

Whitaker, Kathy, *Dir,* School of American Research, Indian Arts Research Center, Santa Fe NM

Whitaker, Martha, *Instr,* Maryville University of Saint Louis, Art & Design Program, Saint Louis MO (S)

White, Betty, *Repatriation Prog Mgr,* National Museum of the American Indian, George Gustav Heye Center, New York NY

White, Beverly M, *Fine Arts Librn,* Manchester City Library, Manchester NH

White, Blunt, *Treas,* Mystic Art Association, Inc, Mystic Arts Center, Mystic CT

White, Brooke, *Asst Prof,* University of Mississippi, Department of Art, University MS (S)

White, Charles, *Chmn Dept Fine Arts,* La Salle University, Dept of Art, Philadelphia PA (S)

White, Chris, *Dir Retail Opers,* USS Constitution Museum, Boston MA

White, Cliff, *Pres,* Peter & Catharine Whyte Foundation, Whyte Museum of the Canadian Rockies, Banff AB

White, David, *Prog Rep,* Southern Illinois University, Applied Arts, Carbondale IL (S)

White, Dennis, *Dean Fine & Performing Arts Div,* Antelope Valley College, Art Dept, Division of Fine Arts, Lancaster CA (S)

White, Derrick, *Art Instr,* Tyler Junior College, Art Program, Tyler TX (S)

White, Donna, *Dir & Cur,* Prairie Art Gallery, Grande Prairie AB

White, Donny, *Dir,* Medicine Hat Museum & Art Gallery, Medicine Hat AB

White, E Alan, *Head,* University of Tennessee at Chattanooga, Dept of Art, Chattanooga TN (S)

White, Elizabeth, *Community Arts Admin,* Cambridge Arts Council, CAC Gallery, Cambridge MA

White, Hugh, *VPres,* Virginia Historical Society, Library, Richmond VA

White, J Phil, *Pres,* Salt Lake Art Center, Salt Lake City UT

White, James, *VPres,* Piatt Castles, West Liberty OH

White, Jennifer C, *Dir Educ,* New Haven Colony Historical Society, New Haven CT

White, John D, *Secy & Treas,* Pioneer Town, Pioneer Museum of Western Art, Wimberley TX

White, Julia, *Cur Asian Art,* Honolulu Academy of Arts, Honolulu HI

White, Julia, *Cur Asian Art,* Honolulu Academy of Arts, The Art Center at Linekona, Honolulu HI (S)

White, Kathy, *Dir of Mktg,* Salvador Dali, Saint Petersburg FL

White, Kathy, *Mem Asst,* Library Association of La Jolla, Athenaeum Music & Arts Library, La Jolla CA

White, Kim, *Shop Mgr,* The Arkansas Arts Center, Museum School, Little Rock AR (S)

White, Larry, *Instr,* Long Beach City College, Art & Photography Dept, Long Beach CA (S)

White, Lois St Aubin, *Admin Asst,* Central United Methodist Church, Swords Into Plowshares Peace Center & Gallery, Detroit MI

White, Mark, *Asst Prof,* Oklahoma State University, Art Dept, Stillwater OK (S)

Williams, Anne, *Pres,* San Angelo Museum of Fine Arts, San Angelo TX

Williams, Annette, *Instr,* Southern University A & M College, School of Architecture, Baton Rouge LA (S)

Williams, Barbara, *Dir & Owner,* The Mather Homestead Museum, Library & Memorial Park, Wellsville NY

Williams, Benjamin, *Librn & Spec Coll Librn,* Field Museum, Library, Chicago IL

Williams, Bernice, *Devlop Dir,* Contemporary Art for San Antonio Blue Star Art Space, San Antonio TX

Williams, Carla, *Exposure Ed,* Society for Photographic Education, Oxford OH

Williams, Carol, *Dir Library,* Saint Paul Public Library, Central Adult Public Services, Saint Paul MN

Williams, Cecil, *Instr,* Claflin College, Dept of Art, Orangeburg SC (S)

Williams, Chandora, *Educator,* University of Mississippi, University Museum, Oxford MS

Williams, Charles, *Treas,* Charles B Goddard, Ardmore OK

Williams, Chester, *Prof,* Florida A & M University, Dept of Visual Arts, Humanities & Theatre, Tallahassee FL (S)

Williams, Christine, *Dir Communications,* National Academy Museum & School of Fine Arts, New York NY

Williams, Christine, *Dir Communications,* National Academy Museum & School of Fine Arts, Archives, New York NY

Williams, Clay, *Dir Exhibits,* Mississippi Department of Archives & History, Old Capitol Museum of Mississippi History, Jackson MS

Williams, Cynthia, *Librn,* Archives of American Art, Midwest Regional Center, Washington DC

Williams, Debby, *Dir,* Saint Gregory's Abbey & University, Mabee-Gerrer Museum of Art, Shawnee OK

Williams, Deborah, *Dir,* Patterson Library & Art Gallery, Westfield NY

Williams, Donna, *Dir Bur of Historic Sites,* Pennsylvania Historical & Museum Commission, Harrisburg PA

Williams, Ed, *Dir Photo,* Art Institute of Fort Lauderdale, Fort Lauderdale FL (S)

Williams, Eileen, *Admin Asst,* Yakima Valley Community College, Larson Gallery, Yakima WA

Williams, Gloria, *Cur,* Norton Simon, Pasadena CA

Williams, Greg, *Asst Dir,* Colby College, Museum of Art, Waterville ME

Williams, Harry R, *Dir,* Brockton Public Library System, Joseph A Driscoll Art Gallery, Brockton MA

Williams, Idaherma, *Pres,* American Color Print Society, Princeton NJ

Williams, James, *Pres, Chmn,* Old State House, Hartford CT

Williams, Jane, *Agent,* Richard Gallery & Almond Tea Gallery, Divisions of Studios of Jack Richard, Cuyahoga Falls OH

Williams, Jane, *Assoc Prof Art History,* University of Arizona, Dept of Art, Tucson AZ (S)

Williams, Janice, *Exec Dir,* Sumter Gallery of Art, Sumter SC

Williams, Janice, *Prof,* Augusta State University, Dept of Arts, Augusta GA (S)

Williams, Jay, *Chief Cur,* University of South Carolina, McKissick Museum, Columbia SC

Williams, Jere, *Instr,* Brenau University, Art & Design Dept, Gainesville GA (S)

Williams, Jim, *Prof Fine Arts,* University of Cincinnati, School of Art, Cincinnati OH (S)

Williams, John, *Lectr,* Longwood University, Dept of Art, Farmville VA (S)

Williams, Kathy, *Dir,* Fort Smith Art Center, Fort Smith AR

Williams, Kay P, *Dir,* Tryon Palace Historic Sites & Gardens, New Bern NC

Williams, Keith, *Chmn,* Concordia College, Art Dept, Saint Paul MN (S)

Williams, Keith, *Dir,* North Central Washington Museum, Wenatchee Valley Museum & Cultural Center, Wenatchee WA

Williams, Ken, *Prof Graphic Design,* University of Georgia, Franklin College of Arts & Sciences, Lamar Dodd School of Art, Athens GA (S)

Williams, Linda, *Mgr Museum Store,* American Textile History Museum, Lowell MA

Williams, Lisa, *Gallery Mgr,* Woodstock Artists Association, Woodstock NY

Williams, Lorraine, *Cur Archaeology-Ethnology,* New Jersey State Museum, Fine Art Bureau, Trenton NJ

Williams, Lydia, *Assoc Cur Educ for Educational Services,* Morris Museum of Art, Augusta GA

Williams, Lyle, *Assoc Cur Prints & Drawings,* McNay, San Antonio TX

Williams, Lyneise, *Asst Prof,* University of North Carolina at Chapel Hill, Art Dept, Chapel Hill NC (S)

Williams, Margene, *Dir Educ,* Cleveland Museum of Art, Cleveland OH

Williams, Marilyn, *Communications & Mktg Mgr,* The Winnipeg Art Gallery, Winnipeg MB

Williams, Mark, *Chmn,* West Liberty State College, Div Art, West Liberty WV (S)

Williams, Marquita, *Office Mgr,* East Bay Asian Local Development Corp, Asian Resource Gallery, Oakland CA

Williams, Megan, *Instr,* Toronto School of Art, Toronto ON (S)

Williams, Megan, *National Dir,* Canadian Conference of the Arts, Ottawa ON

Williams, Mildred, *Box Office Mgr,* City of Hampton, Hampton Arts Commission, Hampton VA

Williams, Nancy, *Mus Shop Mgr,* Olana State Historic Site, Hudson NY

Williams, Nancy, *Registrar,* Queens College, City University of New York, Godwin-Ternbach Museum, Flushing NY

Williams, Paige, *Instr,* Art Academy of Cincinnati, Cincinnati OH (S)

Williams, Peter, *Art Instr,* Kellogg Community College, Arts & Communication Dept, Battle Creek MI (S)

Williams, Phill, *Library Admin,* Warner Bros Studio Research Library, Burbank CA

Williams, Randolph, *Prof,* Manhattanville College, Brownson Gallery, Purchase NY

Williams, Rebecca, *Exec Dir,* Peace Museum, Chicago IL

Williams, Richard, *Prof,* Miami-Dade Community College, Arts & Philosophy Dept, Miami FL (S)

Williams, Robert, *Instr,* South Central Technical College, Commercial & Technical Art Dept, North Mankato MN (S)

Williams, Robert, *Instr,* Wagner College, Arts Administration Dept, Staten Island NY (S)

Williams, Roberta, *Instr,* Marian College, Art Dept, Indianapolis IN (S)

Williams, Roger, *Acad Dean,* Center for Creative Studies, College of Art & Design, Detroit MI (S)

Williams, Roger D, *Exec Dir,* Quapaw Quarter Association, Inc, Villa Marre, Little Rock AR

Williams, Roger D, *Exec Dir,* Quapaw Quarter Association, Inc, Preservation Resource Center, Little Rock AR

Williams, Sally, *Public Information Officer,* Brooklyn Museum, Brooklyn NY

Williams, Stephen R, *Dir, CEO,* Port Huron Museum, Port Huron MI

Williams, Suzanne, *Treas,* Surface Design Association, Inc, Sebastopol CA

Williams, T, *Admin Asst,* Fisk University, Fisk University Galleries, Nashville TN

Williams, Tom, *Asst Prof Visual Arts,* Dowling College, Dept of Visual Arts, Oakdale NY (S)

Williams, Vonnie, *Volunteer Coordr,* Wilkes Art Gallery, North Wilkesboro NC

Williams, Wayne, *Prof,* Finger Lakes Community College, Visual & Performing Arts Dept, Canandaigua NY (S)

Williams-Cosner, Cheryl, *Dir,* Carnegie Art Center, Walla Walla WA

Williamson, Ginger, *Instr,* Greensboro College, Dept of Art, Division of Fine Arts, Greensboro NC (S)

Williamson, Jacquelyn, *Mus Shop Mgr,* Belle Grove Plantation, Middletown VA

Williamson, Jan, *Co-Dir,* 18th Street Arts Complex, Santa Monica CA

Williamson, Jane, *Dir,* Rowland Evans Robinson, Rokeby Museum, Ferrisburgh VT

Williamson, Jay S, *Cur,* Historical Society of Old Newbury, Cushing House Museum, Newburyport MA

Williamson, Keith, *Pres,* Stamford Museum & Nature Center, Stamford CT

Williamson, Roberta, *Dir,* Moody County Historical Society, Flandreau SD

Williamson, Sandra, *Admin Asst,* Intermuseum Conservation Association, Oberlin OH

Willick, Damon, *Asst Prof,* Loyola Marymount University, Dept of Art & Art History, Los Angeles CA (S)

Willis, Janis, *Dir Fine Arts,* College of San Mateo, Creative Arts Dept, San Mateo CA (S)

Willis, Jim, *Art Head,* Northwest Nazarene College, Art Dept, Nampa ID (S)

Willis, Tim, *Asst Dir Exhibits & Communications,* Department of Community Development, Provincial Museum of Alberta, Edmonton AB

Willits, Zinnia, *Registrar,* Carolina Art Association, Gibbes Museum of Art, Charleston SC

Willkom, Jan, *Grant Proj Dir,* Tucson Museum of Artand Historic Block, Library, Tucson AZ

Willner, Judith, *Chmn,* Coppin State College, Dept Fine & Communication Arts, Baltimore MD (S)

Willoughby, Alan, *Dir,* Perkins Center for the Arts, Moorestown NJ

Willoughby, Laura, *Coll Cur,* The City of Petersburg Museums, Petersburg VA

Wills, Carol, *Registrar & Cur Coll,* Saint Joseph Museum, Saint Joseph MO

Willse, Michael, *Assoc Prof,* Rosemont College, Art Program, Rosemont PA (S)

Willsey, Dorothy, *Pres,* Madison County Historical Society, Cottage Lawn, Oneida NY

Willson, MichaelW., *Dir Finance & Administration,* Berkshire Museum, Pittsfield MA

Willumsen, Laura, *Exec Dir,* Pittsburgh Center for the Arts, Pittsburgh PA

Willwerth, Ardis, *Dir Exhib,* Pasadena Historical Museum, Pasadena CA

Wilmarth-Rabineau, Susan, *Asst Prof,* University of Hartford, Hartford Art School, West Hartford CT (S)

Wilmers, Gertrude, *Spec Research Assoc,* International Foundation for Art Research, Inc, New York NY

Wilsbach, Tom, *Art & AV Librn,* Portland Public Library, Art - Audiovisual Dept, Portland ME

Wilson, A, *Secy General,* Canadian Society for Education Through Art, Oakville ON

Wilson, Aaron, *Asst Prof,* University of Northern Iowa, Dept of Art, Cedar Falls IA (S)

Wilson, Ann H, *Dir Marketing & Communications,* Walters Art Museum, Baltimore MD

Wilson, Ann Hume, *Dir Marketing & Communication,* Walters Art Museum, Library, Baltimore MD

Wilson, Ben, *Theater Dept Chmn,* Jacksonville University, Dept of Art, Jacksonville FL (S)

Wilson, Carol, *Chmn Board,* Wichita Center for the Arts, Wichita KS

Wilson, Carol, *Chmn Board,* Wichita Center for the Arts, Maude Schollenberger Memorial Library, Wichita KS

Wilson, Cathryn, *Circ Coordr,* Milwaukee Institute of Art & Design, Library, Milwaukee WI

Wilson, Cathy, *Dir Grad Studies,* Memphis College of Art, Memphis TN (S)

Wilson, Chris, *Prof,* Barton College, Art Dept, Wilson NC (S)

Wilson, Cindy, *Adjunct Asst Prof,* Spokane Falls Community College, Fine Arts Dept, Spokane WA (S)

Wilson, Clifford, *Pres (V),* Ashland Historical Society, Ashland MA

Wilson, Dermot, *Artistic Dir,* Niagara Artists' Company, Saint Catharines ON

Wilson, Gary, *Asst Prof Art,* Monroe County Community College, Humanities Division, Monroe MI (S)

Wilson, Gillian, *Cur Decorative Arts,* Getty Center, Trust Museum, Los Angeles CA

Wilson, Gillian, *Cur Decorative Arts,* Getty Center, The J Paul Getty Museum, Los Angeles CA

Wilson, Gordon, *Assoc Prof,* Whitworth College, Art Dept, Spokane WA (S)

Wilson, Harry, *Photography,* Bakersfield College, Fine Arts Dept, Bakersfield CA (S)

Wilson, Hazel Mohamed, *Asst Cur & Webmaster,* The Ethel Wright Mohamed Stitchery Museum, Belzoni MS

Wilson, Heather, *Develop Officer,* Cameron Art Museum, Wilmington NC

Wilson, Hugh Allen, *Assoc Pres,* Marcella Sembrich Memorial Association Inc, Marcella Sembrich Opera Museum, Bolton Landing NY

Wilson, Ian, *National Archivist,* National Archives of Canada, Art & Photography Archives, Ottawa ON

Wilson, Jackie, *Educ Asst,* Iowa State University, Brunnier Art Museum, Ames IA

Wilson, Jane, *Asst Dir,* Owensboro Museum of Fine Art, Owensboro KY

Wilson, Jean, *Assoc Prof,* State University of New York at Binghamton, Dept of Art History, Binghamton NY (S)

Wilson, Jenny, *Registrar,* Vancouver Art Gallery, Vancouver BC

Wilson, John, *Exec Dir,* Lakeside Studio, Lakeside MI

Wilson, Joyce, *Chmn,* Bellevue College, Art Dept, Bellevue NE (S)

Wilson, Kay, *Cur,* Grinnell College, Art Gallery, Grinnell IA

Wilson, Keyser, *Asst Prof,* Stillman College, Stillman Art Gallery & Art Dept, Tuscaloosa AL (S)

Wilson, Lee Anne, *Mus Studies Dept Chair,* Institute of American Indian Arts, Institute of American Indian Arts Museum, Santa Fe NM (S)

Wilson , Letha, *Artists File Coordr,* Artists Space, Irving Sandler Artists File, New York NY

Wolpert, Denise, *Mem Assoc,* Bass Museum of Art, Miami Beach FL

Wolsk, Nancy, *Dir,* Transylvania University, Morlan Gallery, Lexington KY

Wolsk, Nancy, *Prog Dir,* Transylvania University, Studio Arts Dept, Lexington KY (S)

Woltereck, Jane, *Dir,* National Society of Colonial Dames of America in the State of Maryland, Mount Clare Museum House, Baltimore MD

Wolterstorff, Robert, *Dir,* Victoria Mansion - Morse Libby House, Portland ME

Womochil Bray, Sandra, *Dir Performing Arts,* Colorado Springs Fine Arts Center, Colorado Springs CO

Wondolowski, Diane, *CFO,* Santa Barbara Museum of Art, Library, Santa Barbara CA

Wong, Albert, *Head Dept,* University of Texas at El Paso, Dept of Art, El Paso TX (S)

Wong, Allison, *Assoc Cur,* The Contemporary Museum, Honolulu HI

Wong, Allison, *Cur,* The Contemporary Museum at First Hawaiian Center, Honolulu HI

Wong, Dorothy, *Art History Instr,* University of Virginia, McIntire Dept of Art, Charlottesville VA (S)

Wong, Eddie, *Prof,* University of Wisconsin-Stout, Dept of Art & Design, Menomonie WI (S)

Wong, Virgil, *Cur Asst,* Alternative Museum, New York NY

Wong-Ligda, Ed, *Prof,* Grand Valley State University, Art & Design Dept, Allendale MI (S)

Wonsidler, Mark, *Coll Mgr,* Lehigh University Art Galleries, Museum Operation, Bethlehem PA

Woo, Janice, *Dir Libraries,* California College of the Arts, Libraries, Oakland CA

Woo, Suzanne, *Membership & Spec Events,* Modern Art Museum, Fort Worth TX

Wood, Darrow, *Chief Librn,* New York City Technical College, Ursula C Schwerin Library, Brooklyn NY

Wood, David, *Cur,* Concord Museum, Concord MA

Wood, Deborah, *Registrar,* United States Senate Commission on Art, Washington DC

Wood, Deena, *Store Mgr,* Five Civilized Tribes Museum, Muskogee OK

Wood, Denise, *COO,* American Institute of Graphic Arts, New York NY

Wood, Donald A, *Chief Cur & Cur of Asian Art,* Birmingham Museum of Art, Birmingham AL

Wood, Donald A, *Chief Cur & Cur of Asian Art,* Birmingham Museum of Art, Clarence B Hanson Jr Library, Birmingham AL

Wood, James N, *Pres & Dir,* The Art Institute of Chicago, Chicago IL

Wood, Joe, *Chmn Fine Arts 3D,* Massachusetts College of Art, Boston MA (S)

Wood, Katherine, *Acting Dir Communications,* National Endowment for the Arts, Washington DC

Wood, Kathy, *Asst,* University of Nevada, Reno, Sheppard Fine Arts Gallery, Reno NV

Wood, Katie, *Business Mgr,* Swope Art Museum, Research Library, Terre Haute IN

Wood, Lawrence, *Chmn,* Christopher Newport University, Dept of Fine Performing Arts, Newport News VA (S)

Wood, Margaret K, *Pres,* Goshen Historical Society, Goshen CT

Wood, Marilyn, *Instr,* Normandale Community College, Art Dept, Bloomington MN (S)

Wood, Neva, *Asst Prof,* Central Missouri State University, Art Dept, Warrensburg MO (S)

Wood, Richard, *Assoc Prof,* Centenary College, Humanities Dept, Hackettstown NJ (S)

Wood, Robert, *Photography,* Antonelli Institute, Professional Photography & Commercial Art, Erdenheim PA (S)

Wood, Rose, *Comptroller,* Storm King Art Center, Mountainville NY

Wood, Ruth W, *Cur,* Macartney House Museum, Oakland ME

Wood, Sharon, *Prof,* Lansing Community College, Visual Arts & Media Dept, Lansing MI (S)

Wood, Susan, *Prof,* Oakland University, Dept of Art & Art History, Rochester MI (S)

Wood, Wilma, *Dir & Cur,* City of Lethbridge, Sir Alexander Galt Museum, Lethbridge AB

Woodard, Bill, *Mng Ed & Pub Relations,* University of Kansas, Spencer Museum of Art, Lawrence KS

Woodard, Katherine, *Pres,* Artists Space, New York NY

Woodard, Stan, *Communications Dir,* Atlanta Contemporary Art Center, Atlanta GA

Woodard, Teresa, *Assoc Cur Coll,* Riverside Municipal Museum, Riverside CA

Woodburn, Steven, *Adjunct Asst Prof,* New York Institute of Technology, Fine Arts Dept, Old Westbury NY (S)

Woodcock, Jo, *Instr,* Silver Lake College, Art Dept, Manitowoc WI (S)

Woodford, Don, *Instr,* California State University, San Bernardino, Dept of Art, San Bernardino CA (S)

Woodhull, Margaret, *Asst Prof,* Rhodes College, Dept of Art, Memphis TN (S)

Woodhull, Victoria, *Assoc Dir,* William A Farnsworth, Museum, Rockland ME

Woodhull, Victoria, *Assoc Dir,* William A Farnsworth, Library, Rockland ME

Woodman, Charles, *Assoc Prof Fine Arts,* University of Cincinnati, School of Art, Cincinnati OH (S)

Woodman, Sarah, *Educ,* Fort Morgan Heritage Foundation, Fort Morgan CO

Woodniff, Ann, *Registrar,* Louisiana Department of Culture, Recreation & Tourism, Louisiana State Museum, New Orleans LA

Woodoff, Ellen, *Dir Mktg & Communications,* Columbia Museum of Art, Columbia SC

Woodruff, Lynne, *Head Art Library,* University of Maryland, College Park, Art Library, College Park MD

Woodruff Tait, Jennifer, *Librn,* Archives & History Center of the United Methodist Church, Madison NJ

Woods, Brinda, *Visitor Assoc,* SPACES, Cleveland OH

Woods, Denise, *Bus Mgr,* Arkansas Arts Center, Little Rock AR

Woods, Elen, *Librn,* Salvador Dali, Museum, Saint Petersburg FL

Woods, James, *Dir,* Herrett Center for Arts & Sciences, Jean B King Art Gallery, Twin Falls ID

Woods, Jean, *Dir,* Washington County Museum of Fine Arts, Library, Hagerstown MD

Woods, Leon, *Gallery Asst,* Winston-Salem State University, Diggs Gallery, Winston-Salem NC

Woods, Marianne, *Performing Arts Coordr,* Organization of Saskatchewan Arts Councils (OSAC), Regina SK

Woods, Marianne Berger, *Asst Prof,* University of Texas of Permian Basin, Dept of Art, Odessa TX (S)

Woods, Shirley A, *Asst Dir Operations,* Montgomery Museum of Fine Arts, Montgomery AL

Woods, Vicki, *Dir,* St. Louis Artists' Guild, Saint Louis MO

Woodson, Jim, *Prof,* Texas Christian University, Dept of Art & Art History, Fort Worth TX (S)

Woodson, Shirley, *Gallery Dir,* National Conference of Artists, Michigan Chapter Gallery, Detroit MI

Woodson, Yoko, *Cur Japanese Art,* Asian Art Museum of San Francisco, Chong-Moon Lee Ctr for Asian Art and Culture, San Francisco CA

Woodward, Bev, *Exec Dir,* Heritage Hjemkomst Interpretive Center, Moorhead MN

Woodward, Hiram, *Cur Asian Art,* Walters Art Museum, Baltimore MD

Woodward, Hiram, *Cur Asian Art,* Walters Art Museum, Library, Baltimore MD

Woodward, John, *1st VChmn,* Reading Public Museum, Library, Reading PA

Woodward, John, *VChair,* Reading Public Museum, Reading PA

Woodward, Kristen, *Chmn,* Albright College, Dept of Art, Reading PA (S)

Woodward, Richard, *Cur African Art,* Virginia Museum of Fine Arts, Richmond VA

Woodward, Roland H, *Exec Dir,* Chester County Historical Society, West Chester PA

Woodward, Thomas, *COO,* Historical Society of Pennsylvania, Philadelphia PA

Woodward, W T, *Prof,* George Washington University, Dept of Art, Washington DC (S)

Woodworth, Patricia, *Exec VPres Admin Affairs,* The Art Institute of Chicago, Chicago IL

Wooff, Annette, *Admin,* The Canadian Craft Museum, Vancouver BC

Wooff, Annette, *Adminr,* University of British Columbia, Morris & Helen Belkin Art Gallery, Vancouver BC

Woolbright, Kelly, *Registrar,* Morris Museum of Art, Augusta GA

Woolever, Mary, *Architecture Librn,* The Art Institute of Chicago, Ryerson & Burnham Libraries, Chicago IL

Wooley, Arlene, *Exec Dir,* The Community Education Center, Philadelphia PA

Woolf, David, *Assoc Prof,* Norwich University, Dept of Architecture and Art, Northfield VT (S)

Woolger, Bonnie Jean, *Circ Manager,* Atlanta College of Art, Atlanta GA

Woolley, Lois, *Instr,* Woodstock School of Art, Inc, Woodstock NY (S)

Woolston, William, *Prof & Dean CAA,* University of Idaho, Dept of Art & Design, Moscow ID (S)

Woon, Wendy, *Deputy Dir Educ,* Museum of Modern Art, New York NY

Woon, Wendy, *Educ Dir,* Museum of Contemporary Art, Chicago IL

Wooters, David A, *Archivist,* George Eastman, Library, Rochester NY

Wooton, Chris, *Assoc Dir,* Vancouver Art Gallery, Vancouver BC

Worden, MIchelle, *Dir Special Program,* Genesee Country Village & Museum, John L Wehle Gallery of Wildlife & Sporting Art, Mumford NY

Workman, Mary Jo, *Art Div,* Lane Community College, Art & Applied Design Dept, Eugene OR (S)

Worley, Ken, *Adjunct Instr,* Maryville University of Saint Louis, Art & Design Program, Saint Louis MO (S)

Worona, Jon, *Librn,* California College of the Arts, Libraries, Oakland CA

Worrell, Philip, *Visual Resource Cur,* Texas Tech University, School of Art Visual Resource Center, Lubbock TX

Worrington, Susan, *Art Instr,* Phillips Community College at The University of Arkansas, Dept of English & Fine Arts, Helena AR (S)

Worteck, Edward, *Chmn,* Goucher College, Art Dept, Baltimore MD (S)

Worth, Timothy, *Cur,* Manitoba Historical Society, Dalnavert Museum, Winnipeg MB

Wortham, Greg, *Adjunct Asst Prof Art,* Florida Southern College, Melvin Art Gallery, Lakeland FL

Wortheimer, Gary, *Chmn Arts & Comm Depts,* Olivet College, Armstrong Collection, Olivet MI

Worthen, Natalie, *Devel Coordr,* Columbus Museum, Columbus GA

Worthen, W B, *Dir,* Historic Arkansas Museum, Library, Little Rock AR

Worthen, William B, *Dir,* Historic Arkansas Museum, Little Rock AR

Worthington, Anne, *Supt,* National Park Service, Hubbell Trading Post National Historic Site, Ganado AZ

Wren, John P, *Admin Mgr,* Tampa Museum of Art, Judith Rozier Blanchard Library, Tampa FL

Wren, Linnea, *Chmn,* Gustavus Adolphus College, Art & Art History Dept, Saint Peter MN (S)

Wren, Lisa, *Youth Prog Coordr,* City of Irvine, Irvine Fine Arts Center, Irvine CA

Wright, Astri, *Assoc Prof,* University of Victoria, Dept of History in Art, Victoria BC (S)

Wright, Audrey, *Chmn,* Seattle Central Community College, Humanities - Social Sciences Division, Seattle WA (S)

Wright, Carolyn, *Dir,* The Dalles Art Association, The Dalles OR

Wright, Cathy, *Dir Exhib,* Colorado Springs Fine Arts Center, Colorado Springs CO

Wright, Erin, *Assoc Prof,* University of Alabama at Birmingham, Dept of Art & Art History, Birmingham AL (S)

Wright, Gene, *Asst Prof Scientific Illustration,* University of Georgia, Franklin College of Arts & Sciences, Lamar Dodd School of Art, Athens GA (S)

Wright, J Franklin, *Prof,* George Washington University, Dept of Art, Washington DC (S)

Wright, Joy, *Librn,* Laumeier Sculpture Park, Saint Louis MO

Wright, Lorri, *Asst Museum Store Mgr,* Modern Art Museum, Fort Worth TX

Wright, Marsha, *Pres,* Arizona Watercolor Association, Phoenix AZ

Wright, Mary A, *Dept Head,* Central Library, Dept of Fine Arts, San Antonio TX

Wright, Maya, *Marketing & Mem Asst,* Kirkland Museum of Fine & Decorative Art, Denver CO

Wright, Megan, Marian College, Art Dept, Indianapolis IN (S)

Wright, Michael, *Cur Colls,* Mississippi Department of Archives & History, Old Capitol Museum of Mississippi History, Jackson MS

Wright, Pope, *Lectr,* University of Wisconsin-Superior, Programs in the Visual Arts, Superior WI (S)

Wright, Robert, *Assoc Dean, Dir Prog in Landscape Architecture,* University of Toronto, Programme in Landscape Architecture, Toronto ON (S)

Wright, Ron, *Prof,* Marietta College, Art Dept, Marietta OH (S)

Wright, Schawannah, *Community Invole,* Brooklyn Museum, Brooklyn NY

Wright, Sharyl, *Instr,* Avila College, Art Division, Dept of Humanities, Kansas City MO (S)

Wright, Suzane, *Dir of Educ,* The Phillips Collection, Washington DC

Wright, Tony, *Head Design & Installation,* Modern Art Museum, Fort Worth TX

Wright, Ursula, *Research Librn,* Portsmouth Athenaeum, Joseph Copley Research Library, Portsmouth NH

Wright, Vicki C, *Dir,* University of New Hampshire, The Art Gallery, Durham NH

Wright, Vincent, *Asst Prof,* C W Post Campus of Long Island University, School of Visual & Performing Arts, Brookville NY (S)

Wright, Welynda, *Asst Prof Iterior Design,* University of Georgia, Franklin College of Arts & Sciences, Lamar Dodd School of Art, Athens GA (S)

Wrights, John, *Instr,* Benedict College, Fine Arts Dept, Columbia SC (S)

Wrinn, Mariann, *Assoc Prof,* Herkimer County Community College, Humanities Social Services, Herkimer NY (S)

Wroble, Stephen, *Prof,* Schoolcraft College, Dept of Art & Design, Livonia MI (S)

Wroblewski, Grzegorz, *Asst,* U Gallery, New York NY

Wroblewski, Grzegorz, *Mgr,* 4D Basement, New York NY

Wrona, Theodore, *Mus Facility & Security Supv,* Williams College, Museum of Art, Williamstown MA

Wu, Ina, *Instr,* Olympic College, Social Sciences & Humanities Di, Bremerton WA (S)

Wu, Jialu, *Gen Educ,* Art Institute of Pittsburgh, Pittsburgh PA (S)

Wubbena, Christopher, *Asst Prof,* University of Southern Mississippi, Dept of Art & Design, Hattiesburg MS (S)

Wukich, Richard, *Prof,* Slippery Rock University of Pennsylvania, Dept of Art, Slippery Rock PA (S)

Wulkan, Reba, *Contemporary Exhib Coordr,* Yeshiva University Museum, New York NY

Wunder, Elizabeth V, *Office Asst,* Washburn University, Mulvane Art Museum, Topeka KS

Wurmfeld, Sanford, *Chmn Art Dept,* Hunter College, Art Dept, New York NY (S)

Wyatt, Jeffrey, *VPres,* Santa Barbara Contemporary Arts Forum, Santa Barbara CA

Wyatt, Judy, *Library Asst,* Kansas State University, Paul Weigel Library of Architecture Planning & Design, Manhattan KS

Wyatt, Victoria, *Assoc Prof,* University of Victoria, Dept of History in Art, Victoria BC (S)

Wyckoff, Dennis, *VPres,* Rhode Island Watercolor Society, Pawtucket RI

Wye, Deborah, *Chief Cur, Prints & Illustrated Books,* Museum of Modern Art, New York NY

Wykes, Andrew, Hamline University, Dept of Art & Art History, Saint Paul MN (S)

Wylde, Nanette, *Assoc Prof,* California State University, Chico, Department of Art & Art History, Chico CA (S)

Wylder, Viki D, *Cur Educ,* Florida State University, Museum of Fine Arts, Tallahassee FL

Wylie, Alfred E, *Pres,* Wiscasset, Waterville & Farmington Railway Museum (WW&F), Alna ME

Wylie, Liz, *Cur,* University of Toronto, University of Toronto Art Centre, Toronto ON

Wylie, Lyndsey, *Cur Asst,* San Jose Museum of Art, Library, San Jose CA

Wylie, William, *Studio Faculty,* University of Virginia, McIntire Dept of Art, Charlottesville VA (S)

Wyly, Mary, *Librn,* Newberry Library, Chicago IL

Wyman, Dorris, *VPres,* New York Artists Equity Association, Inc, New York NY

Wyman, Marlena, *Sr A-V Archivist,* Department of Community Development, Provincial Archives of Alberta, Edmonton AB

Wyngaard, Shirley, *Exec Dir,* Allied Arts Council of Lethbridge, Bowman Arts Center, Lethbridge AB

Wynick, Lynne, *Co-Dir,* Wynick Tuck Gallery, Toronto ON

Wynn, LaMetta, *Vol Pres, Bd of Dirs,* African American Historical Museum & Cultural Center of Iowa, Cedar Rapids IA

Wynn, Nancy, *Asst Prof,* University of Hartford, Hartford Art School, West Hartford CT (S)

Wysocki, Bob, *Asst Prof,* University of Nevada, Las Vegas, Dept of Art, Las Vegas NV (S)

Xander, Diana, *Dir Financial Servs,* Association of Medical Illustrators, Lawrence KS

Xiao, Peter, *Assoc Prof,* Augustana College, Art Dept, Rock Island IL (S)

Xu, Gan, *Instr,* Maine College of Art, Portland ME (S)

Xu, Jay, *Cur Asian Art,* The Art Institute of Chicago, Chicago IL

Xu, Jay, *Pritzker Cur Asian Art,* The Art Institute of Chicago, Department of Asian Art, Chicago IL

Yaffe, Richard, *Treas,* New York Society of Architects, New York NY

Yager, David, *Prof & Dir of Gallery,* University of Maryland, Baltimore County, Imaging, Digital & Visual Arts Dept, Baltimore MD (S)

Yagoda, Linda, *Library Asst,* Rome Historical Society, Museum & Archives, Rome NY

Yahnke, David, *Instr,* Mohawk Valley Community College, Utica NY (S)

Yakel, Norm, *Chair Arts Educ Prog,* University of Regina, Art Education Program, Regina SK (S)

Yale, Madeline, *Prog Dir,* Houston Center For Photography, Houston TX

Yale-Read, Barbara, *Assoc Prof,* Appalachian State University, Dept of Art, Boone NC (S)

Yanari-Rizzo, Sachi, *Assoc Cur of Colls,* Fort Wayne Museum of Art, Inc, Fort Wayne IN

Yancey, Shirley S, *Pres,* Miles B Carpenter, Waverly VA

Yanero, Susan, *Instr,* American University, Dept of Art, Washington DC (S)

Yank, Paul, *Art Dir,* Wisconsin Fine Arts Association, Inc, Ozaukee Art Center, Cedarburg WI

Yankowski, Michael, *Prof,* Northwestern State University of Louisiana, School of Creative & Performing Arts - Dept of Fine & Graphic Arts, Natchitoches LA (S)

Yanow, Elaine, *Admin Asst,* Williams College, Chapin Library, Williamstown MA

Yanto, Paul, *Asst Prof,* Oberlin College, Dept of Art, Oberlin OH (S)

Yapelli, Tina, *Gallery Dir,* San Diego State University, University Art Gallery, San Diego CA

Yarbedra, Ronald F, *Prof,* Florida A & M University, Dept of Visual Arts, Humanities & Theatre, Tallahassee FL (S)

Yard, Sally, *Dir,* University of San Diego, Founders' Gallery, San Diego CA

Yarlow, Loretta, *Dir Exhib,* Pratt Institute, Rubelle & Norman Schafler Gallery, Brooklyn NY

Yarnall, James, *Newsletter Editor,* Newport Historical Society & Museum of Newport History, Newport RI

Yarrington, Kathryn Jo, *Prof, Chmn,* Fairfield University, Visual & Performing Arts, Fairfield CT (S)

Yassin, Robert A, *Exec Dir,* Palos Verdes Art Center, Rancho Palos Verdes CA

Yasuda, Kim, *Chmn Dept,* University of California, Santa Barbara, Dept of Art Studio, Santa Barbara CA (S)

Yasuda, Robert, *Prof,* C W Post Campus of Long Island University, School of Visual & Performing Arts, Brookville NY (S)

Yates, Steve, *Cur Photography,* Museum of New Mexico, Museum of Fine Arts, Unit of NM Dept of Cultural Affairs, Santa Fe NM

Yau, Ester, *Prof,* Occidental College, Dept of Art History & Visual Arts, Los Angeles CA (S)

Yaukey, Margaret, *Asst Prof,* Appalachian State University, Dept of Art, Boone NC (S)

Yeager, Lynn, *Comptroller,* Museum of Northern Arizona, Flagstaff AZ

Yeager, Raymond, *Chmn Art Dept,* MacMurray College, Art Dept, Jacksonville IL (S)

Yeager, William, *Cur,* Eva Brook Donly, Simcoe ON

Yeager, William, *Cur,* Eva Brook Donly, Library, Simcoe ON

Yeaworth, David, *Pres,* Allied Arts of Seattle, Seattle WA

Yedinak, James, *Industrial Design,* Art Institute of Pittsburgh, Pittsburgh PA (S)

Yee, Kay, *Acting Area Head Jewelry,* Pasadena City College, Art Dept, Pasadena CA (S)

Yee, Shirley, *Graphic Design,* Art Institute of Pittsburgh, Pittsburgh PA (S)

Yeffeth, Laura, *Res,* School of Visual Arts, Visual Arts Museum, New York NY

Yeh, John, *Technical Dir,* Maryland-National Capital Park & Planning Commission, Montpelier Arts Center, Laurel MD

Yelavich, Susan, *Asst Dir Public Projects,* Cooper-Hewitt, National Design Museum, Smithsonian Institution, New York NY

Yeldham, Virginia, *Cultural Assoc,* Girard College, Stephen Girard Collection, Philadelphia PA

Yelverton, Robin, *Admin Asst,* Wiregrass Museum of Art, Dothan AL

Yerdon, Lawrence J, *Pres,* Hancock Shaker Village, Inc, Pittsfield MA

Yerkovich, Sally, *Pres & CEO,* New Jersey Historical Society, Newark NJ

Yerkovich, Sally, *Pres & CEO,* New Jersey Historical Society, Library, Newark NJ

Yerxa, Beth, *Chwmn,* City Of Raleigh Arts Commission, Municipal Building Art Exhibitions, Raleigh NC

Yes, Phyllis, *Prof,* Lewis & Clark College, Dept of Art, Portland OR (S)

Yetter, George, *Assoc Cur Architecture Coll,* Colonial Williamsburg Foundation, John D Rockefeller, Jr Library, Williamsburg VA

Yevich, Courtney C, *Asst Librn,* Virginia Museum of Fine Arts, Library, Richmond VA

Yi, Phillia, *Chmn,* Hobart & William Smith Colleges, Art Dept, Geneva NY (S)

Yobbi, Charmain, *Publ Relations & Community Partnership Mgr,* Art & Culture Center of Hollywood, Art Gallery, Hollywood FL

Yocom, Margaret, *Vol Mus Folklorist, Cur & Archivist,* Rangeley Lakes Region Logging Museum, Rangeley ME

Yoder, Barbara, *Educ Coordr,* Washburn University, Mulvane Art Museum, Topeka KS

Yokley, Shirley, *Instr,* Middle Tennessee State University, Art Dept, Murfreesboro TN (S)

Yokum, Toni, *Store Mgr,* Art Museum of Western Virginia, Roanoke VA

Yolleck, Frima, *Bookkeeper,* Visual Arts Ontario, Toronto ON

Yont, Barbara, *Asst Prof,* Saint Thomas Aquinas College, Art Dept, Sparkill NY (S)

Yontz, Terri, *Publicist,* Xavier University, Art Gallery, Cincinnati OH

Yoo, Teri, *Communications Coordr,* Florida State University, Museum of Fine Arts, Tallahassee FL

Yoon, Sang, *Assoc Prof,* James Madison University, School of Art & Art History, Harrisonburg VA (S)

York, Robert, *Instr of Art,* Edison Community College, Gallery of Fine Arts, Fort Myers FL (S)

Yoshida, Ray, *Prof,* School of the Art Institute of Chicago, Chicago IL (S)

Yoshimine-Webster, Carol, *Assoc Prof,* Centenary College, Humanities Dept, Hackettstown NJ (S)

Youds, Robert, *Prof,* University of Victoria, Dept of Visual Arts, Victoria BC (S)

Young, Alice D, *Cur Educ,* Agecroft Association, Agecroft Hall, Richmond VA

Young, Amber, *Prog Coordr,* Rocky Mount Arts Center, Rocky Mount NC

Young, Becky, *Adjunct Assoc Prof,* University of Pennsylvania, Graduate School of Fine Arts, Philadelphia PA (S)

Young, Beth, *Adjunct Instr,* Mary Baldwin College, Dept of Art & Art History, Staunton VA (S)

Young, Brent, *Assoc Prof,* Cleveland Institute of Art, Cleveland OH (S)

Young, Brian, *Cur Arts,* The Arkansas Arts Center, Museum School, Little Rock AR (S)

Young, Brian, *Cur of Exhib,* Cranbrook Art Museum, Cranbrook Art Museum, Bloomfield Hills MI

Young, Brian, *Cur,* Arkansas Arts Center, Little Rock AR

Young, Gary, *Gallery Cur,* University of Saskatchewan, Gordon Snelgrove Art Gallery, Saskatoon SK

Young, Jean, *Fiscal Officer & Registrar,* Florida State University, Museum of Fine Arts, Tallahassee FL

Young, Jeff, *Chair, Assoc Prof,* University of Central Arkansas, Department of Art, Conway AR (S)

Young, Jocelyn, *Cur Pub Art,* Anchorage Museum at Rasmuson Center, Anchorage AK

Young, Karen S, *Dir,* Taos, Taos NM

Young, Karen S, *Dir,* Taos, Southwest Research Center of Northern New Mexico Archives, Taos NM

Young, Karen S, *Dir,* Taos, Ernest Blumenschein Home & Studio, Taos NM

Young, Karen S, *Dir,* Taos, La Hacienda de Los Martinez, Taos NM

Young, Lisa, *Educ & Exhib Coord,* Museum of Northwest Art, La Conner WA

Young, Lisa Jaye, *Dir,* Nassau Community College, Firehouse Art Gallery, Garden City NY

Young, Marjorie, *Team Leader Bibliographic Access,* State University of New York at New Paltz, Sojourner Truth Library, New Paltz NY

Young, Mary, *Educ Dir,* Green Hill Center for North Carolina Art, Greensboro NC

Young, Patience, *Cur Educ,* Stanford University, Iris & B Gerald Cantor Center for Visual Arts, Stanford CA

Young, Phil, *Prof,* Hartwick College, Art Dept, Oneonta NY (S)

Young, Susan, *Outreach Coordr,* City of Springdale, Shiloh Museum of Ozark History, Springdale AR

Young, Tara, *Asst Cur Modern Art,* Seattle Art Museum, Library, Seattle WA

Young, Thomas E, *Librn,* Philbrook Museum of Art, HA & Mary K Chapman Library, Tulsa OK

Young, Timothy, *Assoc Prof,* Grace College, Dept of Art, Winona Lake IN (S)

Young, Victoria, *Prof,* University of Saint Thomas, Dept of Art History, Saint Paul MN (S)

Young, Zenida, *Architecture & Interior Design Chmn,* Palm Beach Community College, Dept of Art, Lake Worth FL (S)

Young-Gomes, Cynthia, *Registrar,* Old York Historical Society, York ME

Young-Gomes, Cynthia, *Registrar,* Old York Historical Society, Elizabeth Perkins House, York ME

Young-Gomes, Cynthia, *Registrar,* Old York Historical Society, Old Gaol Museum, York ME

Younger, Dan, *Chmn,* University of Missouri, Saint Louis, Dept of Art & Art History, Saint Louis MO (S)

Younger, Daniel P, *Gallery Dir, Vis Asst Prof,* Kenyon College, Art Dept, Gambier OH (S)

Youngers, Peter L, *Instr,* Northeastern Junior College, Art Department, Sterling CO (S)

Younginger, Jennifer, *Dir Exhib & Coll,* Heritage Museums & Gardens, Sandwich MA

Youngmann, Gene, *Pres,* Colorado Watercolor Society, Denver CO

Youngs, Christopher, *Dir,* Albright College, Freedman Gallery, Reading PA

Youngs, Christopher, *Lectr,* Albright College, Dept of Art, Reading PA (S)

Yount, Sylvia, *Cur,* Pennsylvania Academy of the Fine Arts, Philadelphia PA

Yourman, Judy, *Asst Prof,* Saint Olaf College, Art Dept, Northfield MN (S)

Yox, David, *Prof,* Delaware County Community College, Communications & Humanities House, Media PA (S)

Yslas, Alfredo, *Maintenance,* Museum of Western Colorado, Grand Junction CO

Yu, Chilin, *Head Librn,* Columbus College of Art & Design, Packard Library, Columbus OH

Yu, Yunhui Maggie, *Lectr,* California State Polytechnic University, Pomona, Art Dept, Pomona CA (S)

Yuan, Juliana, *Sr Lectr,* University of Missouri, Saint Louis, Dept of Art & Art History, Saint Louis MO (S)

Yuan, Ting, *Gallery Coordr,* China Institute in America, China Institute Gallery, New York NY

Yu Cheng, Pao, *Mgr Art Education,* China Institute in America, China Institute Gallery, New York NY

Yulo, Winifred, *Mus Shop Mgr,* Kauai Museum, Lihue HI

Yunas, Louise, *Chmn,* Occidental College, Dept of Art History & Visual Arts, Los Angeles CA (S)

Yurkanin, Sharon, *Mus Shop Mgr,* Allentown Art Museum, Allentown PA

Yust, Becky L, *Head Dept,* University of Minnesota, Dept of Design, Housing & Apparel, Saint Paul MN (S)

Zabaga, Peter, *Chmn,* Bucks County Historical Society, Mercer Museum, Doylestown PA

Zabela, E. Kate, *Dir,* Peoria Art Guild, Peoria IL

Zaborowski, Dennis, *Prof,* University of North Carolina at Chapel Hill, Art Dept, Chapel Hill NC (S)

Zacharias, David, *Assoc Prof,* Converse College, Dept of Art & Design, Spartanburg SC (S)

Zafran, Eric, *Cur European Art,* Wadsworth Atheneum Museum of Art, Hartford CT

Zahner, Mary, *Assoc Prof,* University of Dayton, Visual Arts Dept, Dayton OH (S)

Zaknic, Ivan, *Prof,* Lehigh University, Dept of Art & Architecture, Bethlehem PA (S)

Zaloom, Lorraine, *Public Progs Dir,* The Art School at Old Church, Demarest NJ (S)

Zamagias, James D, *Chmn,* Allegany Community College, Art Dept, Cumberland MD (S)

Zamora, Frank, *Instr,* Sacramento City College, Art Dept, Sacramento CA (S)

Zamora, Herlinda, *Mus Educator,* MEXIC-ARTE Museum, Austin TX

Zandler, Richard, *Dir,* Maryland-National Capital Park & Planning Commission, Montpelier Arts Center, Laurel MD

Zanetti, Maria, *Office Mgr,* Oakville Galleries, Centennial Square and Gairloch Gardens, Oakville ON

Zapella, Christine, *Asst to Exhib,* Saint Peter's College, Art Gallery, Jersey City NJ

Zapolis, Frank, *Cur Folk Art,* Balzekas Museum of Lithuanian Culture, Chicago IL

Zappulla, Barbara, Maryville University of Saint Louis, Art & Design Program, Saint Louis MO (S)

Zapton, Steve, *Prof,* James Madison University, School of Art & Art History, Harrisonburg VA (S)

Zardini, Mirko, *Dir,* Canadian Centre for Architecture, Library, Montreal PQ

Zaretsky, Barbara, *Exhibit Coordr,* C G Jung, Evanston IL

Zaros, Christa, *Coll Mgr,* The Long Island Museum of American Art, History & Carriages, Stony Brook NY

Zaros, Christa, *Colls Mgr,* The Long Island Museum of American Art, History & Carriages, Library, Stony Brook NY

Zarr, Carolyn, *Registrar,* Mesa Arts Center, Mesa Contemporary Arts , Mesa AZ

Zaruba, Gary E, *Prof,* University of Nebraska, Kearney, Dept of Art & Art History, Kearney NE (S)

Zarucchi, Jeanne Morgan, *Prof,* University of Missouri, Saint Louis, Dept of Art & Art History, Saint Louis MO (S)

Zarur, Elizabeth, *Assoc Prof,* New Mexico State University, Art Dept, Las Cruces NM (S)

Zaugg, Elwood, *Dean,* Salt Lake Community College, Graphic Design Dept, Salt Lake City UT (S)

Zavada, Jeanne, *Dir, CEO,* Old Slater Mill Association, Slater Mill Historic Site, Pawtucket RI

Zawada, Elizabeth, *Dir,* Greenwich House Inc, Greenwich House Pottery, New York NY (S)

Zawora, Ed, *Graphic Design,* Antonelli Institute, Professional Photography & Commercial Art, Erdenheim PA (S)

Zazo, Carol, *Marketing,* Ford Motor Company, Henry Ford Museum & Greenfield Village, Dearborn MI

Zazo, Jennifer, *Dir,* College of New Rochelle, Castle Gallery, New Rochelle NY

Zea, Philip, *Pres,* Historic Deerfield, Deerfield MA

Zebot, George, *Instr,* Art Institute of Southern California, Laguna Beach CA (S)

Zee, Rosa, *Vol Coordr,* Pacific - Asia Museum, Pasadena CA

Zeftel, Julie, *Mus Librn,* The Metropolitan Museum of Art, Image Library, New York NY

Zegers, Peter, *Res Cur,* The Art Institute of Chicago, Dept of Prints & Drawings, Chicago IL

Zehner, Jeffrey, *Media Arts & Animation,* Art Institute of Pittsburgh, Pittsburgh PA (S)

Zehr, Connie, *Chair,* Claremont Graduate University, Dept of Fine Arts, Claremont CA (S)

Zeidberg, David, *Dir Library,* The Huntington Library, Art Collections & Botanical Gardens, San Marino CA

Zeidberg, David, *Dir Library,* The Huntington Library, Art Collections & Botanical Gardens, Library, San Marino CA

Zelenik, John, *Design & Production Chief,* Smithsonian American Art Museum, Washington DC

Zell, Carla, *Secy,* Glynn Art Association, Saint Simons Island GA

Zella, Robbin, *Dir,* Housatonic Community College, Housatonic Museum of Art, Bridgeport CT

Zelleke, Ghenete, *Cur European Decorative Arts & Sculpture,* The Art Institute of Chicago, Chicago IL

Zellnerneal, Donna, *Actg Dir & Pub Rels,* North Tonawanda History Museum, North Tonawanda NY

Zelonis, Mark, *Dir Oldfields & IMA Grounds,* Columbus Museum of Art and Design, Indianapolis IN

Zenith, Darshan, *Pres,* Lahaina Arts Society, Art Organization, Lahaina HI

Zephier, Elicia, *Dir,* Heritage Center, Inc, Pine Ridge SD

Zercher, Wendel, *Cur,* Heritage Center of Lancaster County Museum, Lancaster PA

Zerendow, Chris, *Cur,* University of Wisconsin-Stout, J Furlong Gallery, Menomonie WI

Zerreigon, Andres, *Asst Prof Art History,* University of La Verne, Dept of Art, La Verne CA (S)

Zetzman, Frank, *Prof,* University of Wisconsin College - Marinette, Art Dept, Marinette WI (S)

Zhang, He, *Asst Prof,* William Paterson University, Dept Arts, Wayne NJ (S)

Zhang, Hong Nian, *Instr,* Woodstock School of Art, Inc, Woodstock NY (S)

Zhang, Nagun, *Prof,* West Virginia University, College of Creative Arts, Morgantown WV (S)

Zhang, Sharon, *Acquisitions Librn,* Nelson-Atkins Museum of Art, Spencer Art Reference Library, Kansas City MO

Zhou, Yan, *Slide Cur,* College of Wooster, Dept of Art, Wooster OH (S)

Zic, Virginia F, *Prof,* Sacred Heart University, Dept of Art, Fairfield CT (S)

Zicterman, Karen, *Adminr,* Art Museum of the University of Houston, Blaffer Gallery, Houston TX

Zidek, Al, *Instr,* Solano Community College, Division of Fine & Applied Art & Behavioral Science, Suisun City CA (S)

Ziegler, Anne, *Sr Library Asst,* Whitney Museum of American Art, Frances Mulhall Achilles Library, New York NY

Ziegler, Arthur P, *Pres,* Pittsburgh History & Landmarks Foundation, James D Van Trump Library, Pittsburgh PA

Ziegler, Dimmie, *Exec Dir,* Hambidge Center for the Creative Arts & Sciences, Rabun Gap GA

Ziegler, Georgianna, *Head of Ref,* Folger Shakespeare, Washington DC

Ziegler, Janice, *Dir Educ,* Western Reserve Historical Society, Library, Cleveland OH

Ziegler, Joanna, *Prof,* College of the Holy Cross, Dept of Visual Arts, Worcester MA (S)

Zielinski, Henrietta, *Bibliographer,* School of the Art Institute of Chicago, John M Flaxman Library, Chicago IL

Zierden, Martha, *Cur Historic Archaeology,* Charleston Museum, Charleston SC

Zieselman, Ellen, *Educator,* Museum of New Mexico, Museum of Fine Arts, Unit of NM Dept of Cultural Affairs, Santa Fe NM

Zietz, Stephen, *Head Special Colls,* Cleveland Public Library, Fine Arts & Special Collections Dept, Cleveland OH

Zigas, Irma, *Dir Retail & Wholesale,* San Francisco Museum of Modern Art, San Francisco CA

Zigler Becker, Janis, *Educ Cur,* Art Museum of Southeast Texas, Library, Beaumont TX

Zimmer, Jeffrey, *Outreach Coordr,* National Academy of Sciences, Arts in the Academy, Washington DC

Zimmer, Jim, *Lockport Gallery,* Illinois State Museum, Museum Store, Chicago IL

Zimmer, Stephen, *Dir,* Philmont Scout Ranch, Philmont Museum, Cimarron NM

Zimmerer, Kathy, *Gallery Dir,* University Art Gallery at California State University, Dominguez Hills, Carson CA

Zimmerlink, P J, *Preparator,* Westmoreland Museum of American Art, Art Reference Library, Greensburg PA

Zimmerlink, PJ, *Preparator,* Westmoreland Museum of American Art, Greensburg PA

Zimmerly, Karen, *Coll Mgr,* San Angelo Museum of Fine Arts, San Angelo TX

Zimmerman, Denny, *CFO,* National Cowboy & Western Heritage Museum, Oklahoma City OK

Zimmerman, Harvey, *VPres,* Warwick Museum of Art, Warwick RI

Zimmerman, Jerome, *Chmn & Prof,* C W Post Campus of Long Island University, School of Visual & Performing Arts, Brookville NY (S)

Zimmerman, Jim, *Archivist & Preparator,* Provincetown Art Association & Museum, Provincetown MA

Zimmerman, Mary R, *Dir,* Louisiana State Exhibit Museum, Shreveport LA

Zimmerman, Melissa, *Cur Educ,* Agecroft Association, Museum, Richmond VA

Zimmerman, Randy, *Instr Computer Graphics,* The Art Institute of Cincinnati, Cincinnati OH (S)

Zimprich, Shirley, *Dir,* LeSueur County Historical Society, Collections Library, Elysian MN

Zimprich, Shirley, *Genealogist,* LeSueur County Historical Society, Chapter One, Elysian MN

Zingone, Robert, *Asst Dir & Cur,* St Mary's University, Art Gallery, Halifax NS

Zinkham, Helena, *Head Technical Serv Section,* Library of Congress, Prints & Photographs Division, Washington DC

Zins, Daniel, *Assoc Prof,* Atlanta College of Art, Atlanta GA (S)

Zinser, Kenneth, *Pres Board Trustees,* Anderson Fine Arts Center, Anderson IN

Zinz, Kasia, *Secy,* Pioneer Town, Pioneer Museum of Western Art, Wimberley TX

Ziolkowski, Anne, *Mus & Center Dir,* Crazy Horse Memorial, Indian Museum of North America, Native American Educational & Cultural Center & Crazy Horse Memorial Library (Reference), Crazy Horse SD

Ziolkowski, Ruth, *CEO & Pres,* Crazy Horse Memorial, Indian Museum of North America, Native American Educational & Cultural Center & Crazy Horse Memorial Library (Reference), Crazy Horse SD

Zipay, Terry, *Chmn,* Wilkes University, Dept of Art, Wilkes-Barre PA (S)

Zippay, Lori, *Exec Dir,* Electronic Arts Intermix, Inc, New York NY

Zipperer, Joyce, *Treas,* Washington Sculptors Group, Washington DC

Zirkel, Ross, *Instr,* Asbury College, Art Dept, Wilmore KY (S)

Zirkle, Merle W, *Prof,* Grinnell College, Dept of Art, Grinnell IA (S)

Zirnhelt, James, *Chmn,* North Iowa Area Community College, Dept of Art, Mason City IA (S)

Zito, Ross, *Dir,* Museum of the Hudson Highlands, Cornwall on Hudson NY

Zivich, Matthew, *Prof,* Saginaw Valley State University, Dept of Art & Design, University Center MI (S)

Zivkovich, Kay M, *Asst Dir & Assoc Prof,* Southern Illinois University, School of Art & Design, Carbondale IL (S)

Zlock, Colleen, *Mus Shop Mgr,* Storm King Art Center, Mountainville NY

Zlock, Georgene, *Admin,* Storm King Art Center, Mountainville NY

Zlotsky, Deborah, *Asst Prof,* College of Saint Rose, Art Dept, Albany NY (S)

Zobel, James W, *Archivist,* MacArthur Memorial, Norfolk VA

Zobel, James W, *Archivist,* MacArthur Memorial, Library & Archives, Norfolk VA

Organization Index

1811 Old Lincoln County Jail & Lincoln County Museum, see Lincoln County Historical Association, Inc, Wiscasset ME

The 1859 Jail, Marshal's Home & Museum, see Jackson County Historical Society, Independence MO

4D Basement, New York NY (M)

AAES (Art & Architecture Exhibition Space), see Center for Critical Architecture, San Francisco CA

Aaron Douglas Library, see Fisk University, Nashville TN

Abilene Christian University, Dept of Art & Design, Abilene TX (S)

Abington Art Center, Jenkintown PA (M)

Abraham Baldwin Agricultural College, Art & Humanities Dept, Tifton GA (S)

Milton R & Pauline S Abrahams Library, see Joslyn Art Museum, Omaha NE

Abrons Art Center, see Henry Street Settlement, New York NY

Academy Art Museum, Easton MD (M)

The Academy Gallery, see Academy of Motion Picture Arts & Sciences, Beverly Hills CA

Academy of Art College, Fine Arts Dept, San Francisco CA (S)

Academy of Art, College Library, San Francisco CA (L)

Academy of Motion Picture Arts & Sciences, The Academy Gallery, Beverly Hills CA (M)

Academy of the New Church, Glencairn Museum, Bryn Athyn PA (M)

Acadia University, Art Dept, Wolfville NS (S)

Acadia University Art Gallery, Wolfville NS (M)

Ace Gallery, Los Angeles CA (S)

A Centre for Contemporary Visual Art, see Mercer Union, Toronto ON

Actual Art Foundation, New York NY (A)

Adams County Historical Society, Gettysburg PA (M)

Hunter M Adams Architecture Library, see University of Kentucky, Lexington KY

Adams National Historic Park, Quincy MA (M)

Adams State College, Dept of Visual Arts, Alamosa CO (S)

Addison Gallery of American Art, see Phillips Academy, Andover MA

Adelphi University, Dept of Art & Art History, Garden City NY (S)

Adelphi University, Fine & Performing Arts Library, Garden City NY (L)

AD German Warehouse, see Frank Lloyd Wright Museum, Richland Center WI

The Adirondack Historical Association, The Adirondack Museum, Blue Mountain Lake NY (M,L)

Adirondack Lakes Center for the Arts, Blue Mountain Lake NY (A)

Adrian College, Art & Design Dept, Adrian MI (S)

Aesthetic Realism Foundation, New York NY (A,M,L)

Aesthetic Realism Foundation, New York NY (S)

African American Historical Museum & Cultural Center of Iowa, Cedar Rapids IA (M)

African American Museum in Philadelphia, Philadelphia PA (M)

African American Museums Association, Wilberforce OH (O)

African Art Museum of Maryland, Columbia MD (M)

Agecroft Association, Agecroft Hall, Richmond VA (A,M)

Ages of Man Foundation, Amenia NY (A)

Agnes Scott College, Dalton Art Gallery, Decatur GA (M)

Agnes Scott College, Dept of Art, Decatur GA (S)

The Agricultural Memories Museum, Penn Yan NY (M)

Agriculture & Forestry Museum, see Craftsmen's Guild of Mississippi, Inc, Jackson MS

AIA Library & Archives, see American Institute of Architects, Washington DC

Aiken County Historical Museum, Aiken SC (M)

Aims Community College, Visual & Performing Arts, Greeley CO (S)

A I R Gallery, New York NY (M)

Airpower Museum Library, Ottumwa IA (L)

AKA Artist Run Centre, Saskatoon SK (M,L)

Akron Art Museum, Akron OH (M,L)

Akron-Summit County Public Library, Fine Arts Division, Akron OH (L)

Alabama A & M University, Art & Art Education Dept, Normal AL (S)

Alabama Department of Archives & History, Museum Galleries, Montgomery AL (M,L)

Alabama Southern Community College, Art Dept, Monroeville AL (S)

Alabama State University, Dept of Visual & Theatre Arts, Montgomery AL (S)

Alaska Department of Education, Division of Libraries, Archives & Museums, Sheldon Jackson Museum, Sitka AK (M,L)

Alaska Museum of Natural History, Anchorage AK (M)

Alaska State Library, Alaska Historical Collections, Juneau AK (L)

Alaska State Museum, Juneau AK (M)

Alaska Watercolor Society, Anchorage AK (A)

Albany Institute of History & Art, Albany NY (M,L)

Albany Museum of Art, Albany GA (M)

Alberta College of Art & Design, Calgary AB (S)

Alberta College of Art & Design, Illingworth Kerr Gallery, Calgary AB (M,L)

Alberta Craft Council, Edmonton AB (A)

Alberta Foundation for the Arts, Edmonton AB (A)

Alberta Society of Artists, Edmonton AB (A)

Albertson College of Idaho, Rosenthal Art Gallery, Caldwell ID (M)

Albertus Magnus College, Visual and Performing Arts, New Haven CT (S)

Albin O Kuhn Library & Gallery, Baltimore MD (M)

Albion College, Bobbitt Visual Arts Center, Albion MI (M)

Albion College, Dept of Visual Arts, Albion MI (S)

The Albrecht-Kemper Museum of Art, Saint Joseph MO (M,L)

Albright College, Dept of Art, Reading PA (S)

Albright College, Freedman Gallery, Reading PA (M)

Albright-Knox Art Gallery, see The Buffalo Fine Arts Academy, Buffalo NY

Albuquerque Museum of Art & History, Albuquerque NM (M)

ALCA Canada, Inc, see International Association of Art Critics, Tornoto ON

Alcan Aluminium Ltd, Montreal PQ (C)

Alcorn State University, Dept of Fine Arts, Lorman MS (S)

Aldrich Museum of Contemporary Art, Ridgefield CT (M)

Alexandria Museum of Art, Alexandria LA (M)

Algonquin Arts Council, Art Gallery of Bancroft, Bancroft ON (M)

Alice Lloyd College, Art Dept, Pippa Passes KY (S)

Aljira Center for Contemporary Art, Newark NJ (A)

Allan Hancock College, Fine Arts Dept, Santa Maria CA (S)

Allegany Community College, Art Dept, Cumberland MD (S)

Allegany County Historical Society, Gordon-Roberts House, Cumberland MD (M)

Allegheny College, Art Dept, Meadville PA (S)

Allegheny College, Bowman, Megahan & Penelec Galleries, Meadville PA (M)

Allen County Community College, Art Dept, Iola KS (S)

Allen County Public Library, Art, Music & Audiovisual Services, Fort Wayne IN (L)

Allen Memorial Art Museum, see Oberlin College, Oberlin OH

Allen R Hite Art Institute, see University of Louisville, Louisville KY

Allentown Art Museum, Allentown PA (M)

Robert Allerton Library, see Honolulu Academy of Arts, Honolulu HI

The Allied Artists of America, Inc, New York NY (O)

Allied Arts Association, Allied Arts Center & Gallery, Richland WA (A)

Allied Arts Council of Lethbridge, Bowman Arts Center, Lethbridge AB (A)

Allied Arts Council of St Joseph, Saint Joseph MO (A)

Allied Arts of Seattle, Seattle WA (A)

Charles Allis, Milwaukee WI (M)

Allison Mansion, see Marian College, Indianapolis IN

Lyman Allyn, New London CT (M)

Alma College, Clack Art Center, Dept of Art & Design, Alma MI (S)

Almond Historical Society, Inc, Hagadorn House, The 1800-37 Museum, Almond NY (M)

Alpert Jewish Community Center, Gatov Gallery, Long Beach CA (M)

Altanta-Fulton Public Library, Art-Humanities Dept, Atlanta GA (L)

Alternate ROOTS, Inc, Atlanta GA (M)

Alternative Museum, New York NY (M)

Alton Museum of History & Art, Inc, Alton IL (M)

Alverno College, Art Dept, Milwaukee WI (S)

Alverno College Gallery, Milwaukee WI (M)

Alvin Community College, Art Dept, Alvin TX (S)

Amarillo College, Visual Art Dept, Amarillo TX (S)

American Abstract Artists, New York NY (O)

American Academy in Rome, New York NY (S)

American Academy of Art, Chicago IL (S)

American Academy of Arts & Letters, New York NY (O)

American Antiquarian Society, Worcester MA (O,L)

American Architectural Foundation, The Octogon Museum, Washington DC (M)

American Artists Professional League, Inc, New York NY (O)

American Association of Museums, US National Committee of the International Council of Museums (AAM-ICOM), Washington DC (O)

American Association of University Women, Washington DC (O)

American Ceramic Society, Westerville OH (O)

The American Ceramic Society, Ross C Purdy Museum of Ceramics, Westerville OH (M,L)

American Color Print Society, Princeton NJ (O)

American Craft Council, New York NY (O,L)

American Craft Council, Museum of Arts & Design, New York NY (M)

The American Federation of Arts, New York NY (O)

The American Film Institute, Center for Advanced Film & Television, Los Angeles CA (S)

American Folk Art Museum, New York NY (M,L)

The American Foundation for the Arts, Miami FL (O)

Muriel Isabel Bostwick Library, see Art Gallery of Hamilton, Hamilton ON

Botanic Hall Library, see Cheekwood-Tennessee Botanical Garden & Museum of Art, Nashville TN

Boulder History Museum, Museum of History, Boulder CO (A)

Boulder Museum of Contemporary Art, Boulder CO (A)

Boulder Public Library & Gallery, Dept of Fine Arts Gallery, Boulder CO (L)

Boulevard Arts Center, Chicago IL (M)

Bowdoin College, Art Dept, Brunswick ME (S)

Bowdoin College, Peary-MacMillan Arctic Museum, Brunswick ME (M)

Bowers Museum of Cultural Art, Bowers Museum, Santa Ana CA (M)

Bowie State University, Fine & Performing Arts Dept, Bowie MD (S)

Bowling Green State University, Firelands College, Humanities Dept, Huron OH (S)

Bowling Green State University, Fine Arts Center Galleries, Bowling Green OH (M)

Bowling Green State University, School of Art, Bowling Green OH (S)

Bowman, Megahan & Penelec Galleries, see Allegheny College, Meadville PA

Bowman Arts Center, see Allied Arts Council of Lethbridge, Lethbridge AB

Bowne House Historical Society, Flushing NY (A)

The Dwight Frederick Boyden Gallery, see St Mary's College of Maryland, Saint Mary City MD

Roy Boyd, Chicago IL (M)

The Bradford Group, Niles IL (M)

Bradley University, Dept of Art, Peoria IL (S)

Bradley University, Heuser Art Center, Peoria IL (M)

Braithwaite Fine Arts Gallery, see Southern Utah University, Cedar City UT

Brandeis University, Dept of Fine Arts, Waltham MA (S)

Brandeis University, Rose Art Museum, Waltham MA (M,L)

Brandon Public Library, see The Art Gallery of Southwestern Manitoba, Brandon MB

Brandywine Battlefield Park, see Pennsylvania Historical & Museum Commission, Harrisburg PA

Brandywine River Museum, Chadds Ford PA (M,L)

Brandywine Workshop, Center for the Visual Arts, Philadelphia PA (A)

Brant Historical Society, Brant County Museum & Archives, Brantford ON (M,L)

Brattleboro Museum & Art Center, Brattleboro VT (M)

Brauer Museum of Art, see Valparaiso University, Valparaiso IN

Braun Research Library, see Southwest Museum, Los Angeles CA

Brazosport College, Art Dept, Lake Jackson TX (S)

Bread & Puppet Theater Museum, Glover VT (M)

Anne Bremer Memorial Library, see San Francisco Art Institute, San Francisco CA

Brenau University, Art & Design Dept, Gainesville GA (S)

Brenner Library, see Quincy University, Quincy IL

Brentwood Art Center, Los Angeles CA (S)

Brescia University, Anna Eaton Stout Memorial Art Gallery, Owensboro KY (M)

Brescia University, Div of Fine Arts, Owensboro KY (S)

Alexander Brest Museum & Gallery, see Jacksonville University, Jacksonville FL

Brevard College, Division of Fine Arts, Brevard NC (S)

Brevard College, Spiers Gallery, Brevard NC (M,L)

Brevard Museum of Art & Science, Melbourne FL (M)

Brewton-Parker College, Visual Arts, Mount Vernon GA (S)

Briar Cliff University, Art Dept, Sioux City IA (S)

BRIC - Brooklyn Information & Culture, Rotunda Gallery, Brooklyn NY (M)

Brick Store Museum & Library, Kennebunk ME (M)

Bridgewater College, Art Dept, Bridgewater VA (S)

Bridgewater State College, Art Dept, Bridgewater MA (S)

Hilton M. Briggs Library, see South Dakota State University, Brookings SD

Brigham City Corporation, Brigham City Museum & Gallery, Brigham City UT (M)

Brigham Young University, Hawaii Campus, Division of Fine Arts, Laie HI (S)

Brigham Young University, Dept of Visual Arts, Provo UT (S)

L D Brinkman, Kerrville TX (M)

Bradford Brinton, Big Horn WY (M)

British Columbia Information Management Services, BC Archives, Victoria BC (L)

Broadway, LRC, and Hamilton Club Galleries, see Passaic County Community College, Paterson NJ

Brockton Public Library System, Joseph A Driscoll Art Gallery, Brockton MA (L)

Bromfield Art Gallery, Boston MA (M)

Bronck Museum, see Greene County Historical Society, Coxsackie NY

Saidye Bronfman, Liane & Danny Taran Gallery, Montreal PQ (A)

Silas Bronson, Art, Theatre & Music Services, Waterbury CT (L)

Bronx Community College (CUNY), Hall of Fame for Great Americans, Bronx NY (M)

Bronx Community College, Music & Art Dept, Bronx NY (S)

Bronx Council on the Arts, Longwood Arts Gallery, Bronx NY (M)

Bronx Museum of the Arts, Bronx NY (M)

Bronx River Art Center, Gallery, Bronx NY (M)

Bronxville Public Library, Bronxville NY (L)

Brookdale Community College, Center for the Visual Arts, Lincroft NJ (S)

Brookfield Craft Center, Inc, Gallery, Brookfield CT (M)

Brookgreen Gardens, Murrells Inlet SC (M,L)

Brooklyn Arts Council, Brooklyn NY (A)

Brooklyn Botanic Garden, Steinhardt Conservatory Gallery, Brooklyn NY (M)

Brooklyn College, Art Dept, Brooklyn NY (S)

Brooklyn Historical Society, Brooklyn OH (M)

Brooklyn Museum, Brooklyn NY (M,L)

Brooklyn Public Library, Art & Music Division, Brooklyn NY (L)

Brookside Museum, see Saratoga County Historical Society, Ballston Spa NY

Brooks Institute of Photography, Santa Barbara CA (L)

Broward Community College - South Campus, Art Gallery, Pembroke Pines FL (M)

Broward County Board of Commissioners, Cultural Affairs Div, Fort Lauderdale FL (A)

Brown County Art Gallery Foundation, Brown County Art Gallery & Foundation, Nashville IN (A)

George W Brown Jr Ojibwe Museum & Cultural Center, see Lac du Flambeau Band of Lake Superior Chippewa Indians, Lac du Flambeau WI

John Brown House, see Rhode Island Historical Society, Providence RI

Orlando Brown House, see Liberty Hall Historic Site, Frankfort KY

Brownson Gallery, see Manhattanville College, Purchase NY

Brownsville Art League, Brownsville Museum of Fine Art, Brownsville TX (M)

Bruce Museum, see Bruce Museum, Inc, Greenwich CT

Bruce Museum, Inc, Bruce Museum, Greenwich CT (M)

Brunnier Art Museum, see Iowa State University, Ames IA

The Brush Art Gallery & Studios, Lowell MA (M)

Richard F Brush Art Gallery, see St Lawrence University, Canton NY

Bryant Library, Roslyn NY (L)

Bry Gallery, see University of Louisiana at Monroe, Monroe LA

Bryn Mawr College, Dept of the History of Art, Bryn Mawr PA (S)

Bryn Mawr College, Rhys Carpenter Library for Art, Archaeology, Classics & Cities, Bryn Mawr PA (L)

Buckham Fine Arts Project, Gallery, Flint MI (M)

Buckley Center Gallery, see University of Portland, Portland OR

Bucknell University, Dept of Art, Lewisburg PA (S)

Bucknell University, Edward & Marthann Samek Art Gallery, Lewisburg PA (M)

Richard D Buck Memorial Library, see Balboa Art Conservation Center, San Diego CA

Bucks County Community College, Fine Arts Dept, Newtown PA (S)

Bucks County Community College, Hicks Art Center, Newtown PA (M)

Bucks County Historical Society, Mercer Museum, Doylestown PA (M,L)

Buehler Challenger & Science Center, Paramus NJ (M)

Buena Vista Museum of Natural History, Bakersfield CA (M)

Buffalo & Erie County Public Library, Buffalo NY (L)

Buffalo Arts Studio, Buffalo NY (M)

Buffalo Bill Memorial Association, Buffalo Bill Historical Center, Cody WY (A,L)

The Buffalo Fine Arts Academy, Albright-Knox Art Gallery, Buffalo NY (M,L)

Buffalo Museum of Science, Research Library, Buffalo NY (L)

Ruth Bunker Memorial Library, see Dacotah Prairie Museum, Aberdeen SD

Bunnell Street Gallery, Homer AK (M)

Burchfield-Penney Art Center, Buffalo NY (M,L)

Bureau of Cultural Affairs, see City of Atlanta, Atlanta GA

Bureau of Historic Sites, see New York State Office of Parks, Recreation and Historic Preservation, Waterford NY

Thornton W Burgess, Museum, Sandwich MA (M)

Burke Arts Council, Jailhouse Galleries, Morganton NC (M)

Burlington Art Centre, Burlington ON (M)

Burlington County College, Humanities & Fine Art Div, Pemberton NJ (S)

Burlington County Historical Society, Burlington NJ (A)

Burnaby Art Gallery, Burnaby BC (M)

Bush Barn Art Center, see Salem Art Association, Salem OR

Bush-Holley House Museum, see Historical Society of the Town of Greenwich, Inc, Cos Cob CT

Bush House Museum, see Salem Art Association, Salem OR

Business Committee for the Arts, Inc, Long Island City NY (A)

Butera School of Art, Boston MA (S)

Butler County Community College, Art Dept, El Dorado KS (S)

Butler Institute of American Art, Art Museum, Youngstown OH (M,L)

Julia C Butridge Gallery, see City of Austin Parks & Recreation Department, Austin TX

Butte College, Coyote Gallery, Oroville CA (M)

Butte Silver Bow Arts Chateau, Butte MT (M)

Byrne Memorial Library, see Saint Xavier University, Chicago IL

Cabot's Old Indian Pueblo Museum, see Cabot's Old Indian Pueblo Museum, Desert Hot Springs CA

Cabot's Old Indian Pueblo Museum, Cabot's Old Indian Pueblo Museum, Desert Hot Springs CA (M)

Cabot, Hale & Balch House Museums, see Beverly Historical Society, Beverly MA

Cabrillo College, Visual & Performing Arts Division, Aptos CA (S)

Cabrini College, Dept of Fine Arts, Radnor PA (S)

CAC Gallery, see Cambridge Arts Council, Cambridge MA

Foster Caddell's, North Light, Voluntown CT (S)

Cafritz Galleries, see Meridian International Center, Washington DC

Cahoon Museum of American Art, Cotuit MA (M)

Joseph A Cain Memorial Art Gallery, see Del Mar College, Corpus Christi TX

Caldwell College, Art Dept, Caldwell NJ (S)

Caldwell College, The Visceglia Art Gallery, Caldwell NJ (M)

Calgary Contemporary Arts Society, Triangle Gallery of Visual Arts, Calgary AB (M)

Calgary Public Library, Arts & Recreation Dept, Calgary AB (L)

John C Calhoun, Art Gallery, Decatur AL (M)

John C Calhoun, Department of Fine Arts, Decatur AL (S)

California African-American Museum, Los Angeles CA (M)

California Art Club Gallery, see Old Mill Foundation, San Marino CA

California Baptist College, Art Dept, Riverside CA (S)

California Center for the Arts, Escondido Museum, Escondido CA (M)

California College of Arts & Crafts, CCAC Wattis Institute for Contemporary Arts, Oakland CA (M)

California College of Arts and Crafts, San Francisco CA (S)

California College of the Arts, San Francisco CA (S)

California College of the Arts, Libraries, Oakland CA

California Department of Parks & Recreation, California State Indian Museum, Sacramento CA (M)

California Institute of the Arts Library, Santa Clarita CA (L)

California Institute of the Arts, School of Art, Valencia CA (S)

Center for Creative Studies, College of Art & Design Library, Detroit MI (L)

Center for Critical Architecture, AAES (Art & Architecture Exhibition Space), San Francisco CA (A)

Center for Exploratory & Perceptual Art, CEPA Gallery, Buffalo NY (M,L)

Center for Maine Contemporary Art, Art Gallery, Rockport ME (A)

Center for Photography at Woodstock Inc, Woodstock NY (A)

Center for Southern Folklore, Memphis TN (A)

Central College, Art Dept, Pella IA (S)

Central Community College - Columbus Campus, Business & Arts Cluster, Columbus NE (S)

Central Connecticut State University, Art Dept Museum, New Britain CT (M)

Central Connecticut State University, Dept of Art, New Britain CT (S)

Central Florida Community College Art Collection, Ocala FL (M)

Central Florida Community College, Humanities Dept, Ocala FL (S)

Central Iowa Art Association, Inc, Marshalltown IA (A,L)

Central Library, Dept of Fine Arts, San Antonio TX (L)

Central Methodist University, Ashby-Hodge Gallery of American Art, Fayette MO (M)

Central Michigan University, Dept of Art, Mount Pleasant MI (S)

Central Michigan University, University Art Gallery, Mount Pleasant MI (M)

Central Missouri State University, Art Center Gallery, Warrensburg MO (M)

Central Missouri State University, Art Dept, Warrensburg MO (S)

Central Oregon Community College, Dept of Art, Bend OR (S)

Central Piedmont Community College, Visual & Performing Arts, Charlotte NC (S)

Central State University, Dept of Art, Wilberforce OH (S)

Central United Methodist Church, Swords Into Plowshares Peace Center & Gallery, Detroit MI (M)

Central Washington University, Dept of Art, Ellensburg WA (S)

Central Washington University, Sarah Spurgeon Gallery, Ellensburg WA (M)

Central Wyoming College, Art Center, Riverton WY (S)

Centre National d'Exposition, see Le Musee Regional de Rimouski, Rimouski PQ

Centre National D'Exposition a Jonquiere, see Institut des Arts au Saguenay, Jonquiere PQ

Centro Cultural Aztlan, San Antonio TX (A)

Centro Cultural De La Raza, San Diego CA (M)

Centro de Estudios Avanzados, Old San Juan PR (A)

Centrum Arts & Creative Education, Port Townsend WA (A)

Century Gallery, see County of Los Angeles, Sylmar CA

CEPA Gallery, see Center for Exploratory & Perceptual Art, Buffalo NY

Cerritos Community College, Fine Arts & Communication Div, Norwalk CA (S)

Chabot College, Humanities Division, Hayward CA (S)

Chadron State College, Dept of Art, Chadron NE (S)

Chadron State College, Main Gallery, Chadron NE (M)

Chaffee Center for the Visual Arts, Rutland VT (A)

Chaffey Community College, Art Dept, Rancho Cucamonga CA (S)

The Chaim Gross Studio Museum, New York NY (M)

Chalet of the Golden Fleece, New Glarus WI (M)

Billie Trimble Chandler, Asian Cultures Museum & Educational Center, Corpus Christi TX (M)

Chaney Gallery, see Maryland Hall for the Creative Arts, Annapolis MD

Chapel Art Center, see Saint Anselm College, Manchester NH

Chapel Gallery, see Muskoka Arts & Crafts Inc, Bracebridge ON

Howard I Chapelle Memorial Library, see Chesapeake Bay Maritime Museum, Saint Michaels MD

Chapin Library, see Williams College, Williamstown MA

Chapman Art Center Gallery, see Cazenovia College, Cazenovia NY

Chapman University, Art Dept, Orange CA (S)

Chappell Memorial Library and Art Gallery, Chappell NE (L)

Charles A Lindbergh Historic Site, Little Falls MN (M)

Charles River School, Creative Arts Program, Dover MA (S)

Charleston Museum, Charleston SC (M,L)

Charleston Southern University, Dept of Language & Visual Art, Charleston SC (S)

Chase Home Museum of Utah Folk Arts, see Utah Arts Council, Salt Lake City UT

Chase Manhattan, New York NY (C)

The Chase Manhattan Bank, Art Collection, New York NY (C)

Chastain Arts Center, see City of Atlanta, Atlanta GA

Chateau Ramezay Museum, Montreal PQ (M,L)

Chatham College, Art Gallery, Pittsburgh PA (M)

Chatham College, Fine & Performing Arts, Pittsburgh PA (S)

Chatham Cultural Centre, Thames Art Gallery, Chatham ON (M)

Chatham Historical Society, The Atwood House Museum, Chatham MA (M)

Chatillon-DeMenil House Foundation, DeMenil Mansion, Saint Louis MO (M)

Chattahoochee Valley Art Museum, LaGrange GA (M)

Chattanooga-Hamilton County Bicentennial Library, Fine Arts Dept, Chattanooga TN (L)

Chattanooga State Technical Community College, Advertising Arts Dept, Chattanooga TN (S)

Chautauqua Center for the Visual Arts, Chautauqua NY (M)

Chautauqua Institution, School of Art, Chautauqua NY (S)

Fray Angelico Chavez History Library, see Museum of New Mexico, Santa Fe NM

Cheekwood Nashville's Home of Art & Gardens, Education Dept, Nashville TN (S)

Cheekwood-Tennessee Botanical Garden & Museum of Art, Nashville TN (M,L)

Chelan County Public Utility District, Rocky Reach Dam, Wenatchee WA (M)

Cheltenham Center for the Arts, Cheltenham PA (S)

Chemeketa Community College, Dept of Humanities & Communications, Salem OR (S)

Cherokee Heritage Center, Tahlequah OK (A,L)

Chesapeake Bay Maritime Museum, Saint Michaels MD (M)

Chester College of New England, Wadleigh Library, Chester NH (L)

Chester County Historical Society, West Chester PA (A)

Chesterwood Estate & Museum, see National Trust for Historic Preservation, Stockbridge MA

Cheyney University of Pennsylvania, Dept of Art, Cheyney PA (S)

Chicago Artists' Coalition, Chicago IL (A)

Chicago Athenaeum, Museum of Architecture & Design, Galena IL (M)

Chicago Gallery, see Illinois State Museum, Chicago IL

Chicago Public Library, Harold Washington Library Center, Chicago IL (L)

Chief Plenty Coups Museum State Park, Pryor MT (M)

The Children's Aid Society, Visual Arts Program of the Greenwich Village Center, New York NY (S)

Children's Art Carnival, New York NY (S)

Children's Art Foundation, Museum of International Children's Art, Santa Cruz CA (M)

Children's Museum, Indianapolis IN (M)

Children's Museum Inc, Boston MA (M)

Children's Museum of Manhattan, New York NY (M)

Chilliwack Community Arts Council, Community Arts Centre, Chilliwack BC (A)

China Institute Gallery, see China Institute in America, New York NY

China Institute in America, China Institute Gallery, New York NY (M)

Chinati Foundation, Marfa TX (M)

Chinese-American Arts Council, New York NY (A)

Chinese Culture Foundation, Center Gallery, San Francisco CA (M)

Chinese Culture Institute of the International Society, Tremont Theatre & Gallery, Boston MA (M)

Chinese Information & Culture Center Library, see Taipei Economic & Cultural Office, New York NY

Chipola College, Dept of Fine & Performing Arts, Marianna FL (S)

Chong-Moon Lee Ctr for Asian Art and Culture, see Asian Art Museum of San Francisco, San Francisco CA

Chowan College, Division of Art, Murfreesboro NC (S)

Christina Cultural Arts Center, Inc, Wilmington DE (A)

Christopher Newport University, Dept of Fine Performing Arts, Newport News VA (S)

Chronicle-Tribune Art Gallery, see Taylor University, Upland IN

Jean Outland Chrysler Library, see Chrysler Museum of Art, Norfolk VA

Chrysler Museum of Art, Norfolk VA (M,L)

Chung-Cheng Art Gallery, see Saint John's University, Jamaica NY

Winston Churchill Memorial & Library in the United States, see Westminster College, Fulton MO

Church of Jesus Christ of Latter-Day Saints, Mormon Visitors' Center, Independence MO (M)

Church of Jesus Christ of Latter-Day Saints, Museum of Church History & Art, Salt Lake City UT (M,L)

CIGNA Corporation, CIGNA Museum & Art Collection, Philadelphia PA (C)

Cincinnati Art Club, Cincinnati OH (A)

Cincinnati Art Museum, see Cincinnati Museum Association and Art Academy of Cincinnati, Cincinnati OH

Cincinnati Institute of Fine Arts, Cincinnati OH (A)

Cincinnati Institute of Fine Arts, Taft Museum of Art, Cincinnati OH (M)

Cincinnati Museum Association and Art Academy of Cincinnati, Cincinnati Art Museum, Cincinnati OH (M,L)

Citizens for the Arts in Pennsylvania, Harrisburg PA (A)

Citrus College, Art Dept, Glendora CA (S)

City Art Works, Pratt Fine Arts Center, Seattle WA (S)

City College of New York, Art Dept, New York NY (S)

City College of the City University of New York, Morris Raphael Cohen Library, New York NY (L)

City Gallery at Chastain, see City of Atlanta, Atlanta GA

City Gallery East, see City of Atlanta, Atlanta GA

The City Museum of Washington DC, see Historical Society of Washington DC, Washington DC

City of Atlanta, Bureau of Cultural Affairs, Atlanta GA (A,M,L)

City of Austin Parks & Recreation Department, Julia C Butridge Gallery, Austin TX (A)

City of Austin Parks & Recreation, O Henry Museum, Austin TX (M)

City of Brea, Art Gallery, Brea CA (M)

City of Cedar Falls, Iowa, James & Meryl Hearst Center for the Arts, Cedar Falls IA (M)

City of Charleston, City Hall Council Chamber Gallery, Charleston SC (M)

City of El Paso, El Paso TX (M,L)

City of El Paso Museum and Cultural Affairs, People's Gallery, El Paso TX (M)

City of Fayette, Alabama, Fayette Art Museum, Fayette AL (M)

City of Fremont, Olive Hyde Art Gallery, Fremont CA (M)

City of Gainesville, Thomas Center Galleries - Cultural Affairs, Gainesville FL (M)

City of Grand Rapids Michigan, Public Museum of Grand Rapids, Grand Rapids MI (M)

City of Hampton, Hampton Arts Commission, Hampton VA (A)

City of Irvine, Irvine Fine Arts Center, Irvine CA (S)

City of Irvine, Irvine Fine Arts Center, Irvine CA (M)

City of Ketchikan Museum Dept, Ketchikan AK (M,L)

City of Ketchikan Museum, Tongass Historical Museum, Ketchikan AK (M)

City of Lethbridge, Sir Alexander Galt Museum, Lethbridge AB (M)

City of Lubbock, Buddy Holly Center, Lubbock TX (M)

City of New York Parks & Recreation, Arsenal Gallery, New York NY (M)

The City of Petersburg Museums, Petersburg VA (M)

City of Pittsfield, Berkshire Artisans, Pittsfield MA (M)

City of Providence Parks Department, Roger Williams Park Museum of Natural History, Providence RI (M,L)

City Of Raleigh Arts Commission, Municipal Building Art Exhibitions, Raleigh NC (A)

City of Saint Augustine, Saint Augustine FL (A)

City of San Rafael, Falkirk Cultural Center, San Rafael CA (M)

City of Scarborough, Cedar Ridge Creative Centre, Scarborough ON (M)

City of Springdale, Shiloh Museum of Ozark History, Springdale AR (M)

City of Tampa, Public Art Program, Tampa FL (A)

City of Toronto Culture Division, The Market Gallery, Toronto ON (M)

City of Ukiah, Grace Hudson Museum & The Sun House, Ukiah CA (M)

Eastern Washington University, Dept of Art, Cheney WA (S)

Eastern Wyoming College, Art Dept, Torrington WY (S)

Eastfield College, Humanities Division, Art Dept, Mesquite TX (S)

East Hampton Library, Pennypacker Long Island Collection, East Hampton NY (L)

East Los Angeles College, Art Dept, Monterey Park CA (S)

East Los Angeles College, Vincent Price Gallery, Monterey Park CA (M)

George Eastman, Rochester NY (M,L)

East Martello Museum & Gallery, see Key West Art & Historical Society, Key West FL

East Stroudsburg University, Fine Arts Center, East Stroudsburg PA (S)

East Tennessee State University, College of Arts and Sciences, Dept of Art & Design, Johnson City TN (S)

Eaton-Buchan Gallery & Marvin Cone Gallery, see Coe College, Cedar Rapids IA

Eccles Community Art Center, Ogden UT (A)

Eckerd College, Art Dept, Saint Petersburg FL (S)

Ecole des Arts Visuels, see L'Universite Laval, Quebec PQ

Edgecombe County Cultural Arts Council, Inc, Blount-Bridgers House, Hobson Pittman Memorial Gallery, Tarboro NC (M)

Edgewood College, Art Dept, Madison WI (S)

Edinboro University of Pennsylvania, Art Dept, Edinboro PA (S)

Edison Community College, Gallery of Fine Art, Fort Myers FL (M)

Edison Community College, Gallery of Fine Arts, Fort Myers FL (S)

Edith R Wyle Research Library of The Craft & Folk Art Museum, see L A County Museum of Art, Los Angeles CA

Edmundson Art Foundation, Inc, Des Moines Art Center, Des Moines IA (M,L)

Education Alliance, Art School & Gallery, New York NY (S)

Edward-Dean Museum & Gardens, see Riverside County Museum, Cherry Valley CA

Eide-Dalrymple Gallery, see Augustana College, Sioux Falls SD

1890 House-Museum & Center for the Arts, Cortland NY (M,L)

18th Street Arts Complex, Santa Monica CA (A)

Dwight D Eisenhower, Abilene KS (L)

Eiteljorg Museum of American Indians & Western Art, Indianapolis IN (M)

El Camino College Art Gallery, Torrance CA (M)

El Camino College, Division of Fine Arts, Torrance CA (S)

Elder Gallery, see Nebraska Wesleyan University, Lincoln NE

Electronic Arts Intermix, Inc, New York NY (A)

Elgin Community College, Fine Arts Dept, Elgin IL (S)

Elizabeth City State University, Dept of Art, Elizabeth City NC (S)

Leonard & Bina Ellen Art Gallery, see Concordia University, Montreal PQ

Ellen Noel Art Museum of the Permian Basin, Odessa TX (M)

Elliott Museum, see Historical Society of Martin County, Stuart FL

Ellis County Museum Inc, Waxahachie TX (M)

Ellsworth Community College, Dept of Fine Arts, Iowa Falls IA (S)

Elmhurst Art Museum, Elmhurst IL (M)

Elmhurst College, Art Dept, Elmhurst IL (S)

Elmira College, Art Dept, Elmira NY (S)

Elmira College, George Waters Gallery, Elmira NY (M)

El Paso Museum of Archaeology, see City of El Paso, El Paso TX

El Pueblo de Los Angeles Historical Monument, Los Angeles CA (A)

Elverhoj Museum of History and Art, Solvang CA (M)

Walter Elwood Museum, see Mohawk Valley Heritage Association, Inc, Amsterdam NY

Embroiderers Guild of America, Margaret Parshall Gallery, Louisville KY (A,L)

eMediaLoft.org, New York NY (M)

Emerald Empire Art Gallery Association, Springfield OR (A)

Emerson Gallery, see Hamilton College, Clinton NY

Emily Carr Institute of Art & Design, Vancouver BC (S)

Emily Carr Institute of Art & Design, The Charles H Scott Gallery, Vancouver BC (M,L)

Emmanuel College, Art Dept, Boston MA (S)

Emmanuel Gallery, Denver CO (M)

Emma Willard School, Arts Division, Troy NY (S)

Emory University, Art History Dept, Atlanta GA (S)

Emory University, Michael C Carlos Museum, Atlanta GA (M)

Emporia State University, Dept of Art, Emporia KS (S)

Emporia State University, Norman R Eppink Art Gallery, Emporia KS (M)

Emprise Bank Research Library, see Wichita Art Museum, Wichita KS

Enabled Arts Center, see VSA Arts of New Mexico, Albuquerque NM

Endicott College, School of Art & Design, Beverly MA (S)

En Foco, Inc, Bronx NY (M)

Englewood Library, Fine Arts Dept, Englewood NJ (L)

Enook Galleries, Waterloo ON (M)

Environic Foundation International Library, South Bend IN (L)

Norman R Eppink Art Gallery, see Emporia State University, Emporia KS

The Equitable Gallery, see Equitable Life Assurance Society, New York NY

Equitable Life Assurance Society, The Equitable Gallery, New York NY (C)

Erie Art Museum, Erie PA (M)

Erie County Historical Society, Erie PA (M)

Ervin G Houchens Gallery, Mezzanine Gallery, see Capitol Arts Alliance, Bowling Green KY

Escuela de Artes Plasticas, see Institute of Puerto Rican Culture, San Juan PR

Wharton Esherick, Paoli PA (M)

Eskimo Museum, Churchill MB (M,L)

Essex Art Association, Inc, Essex CT (A)

Essex Historical Society, Essex Shipbuilding Museum, Essex MA (M)

Essex Shipbuilding Museum, see Essex Historical Society, Essex MA

Estevan National Exhibition Centre Inc, Estevan SK (M)

Esvelt Gallery, see Columbia Basin College, Pasco WA

The Ethel Wright Mohamed Stitchery Museum, Belzoni MS (M)

Agnes Etherington Art Centre, see Queen's University, Kingston ON

Ethnic American Slide Library, see University of South Alabama, Mobile AL

Euphrat Museum of Art, see De Anza College, Cupertino CA

Evanston Historical Society, Charles Gates Dawes House, Evanston IL (M)

Evansville Museum of Arts, History & Science, Evansville IN (M,L)

Everett Community College, Art Dept, Everett WA (S)

Evergreen State College, Evergreen Galleries, Olympia WA (M)

Everhart Museum, Scranton PA (M)

Everson Museum of Art, Syracuse NY (M)

The Exhibition Alliance, Hamilton NY (A)

Exit Art, New York NY (M)

Exploratorium, San Francisco CA (A)

Eye Level Gallery, Halifax NS (M)

Eyes & Ears Foundation, San Francisco CA (A)

The Fabric Workshop & Museum, Philadelphia PA (M)

Henry Failing Art & Music Dept, see Multnomah County Library, Portland OR

Fairbanks Arts Association, Fairbanks AK (A)

Fairbanks Museum & Planetarium, Saint Johnsbury VT (M)

Fairfield Art Association, Fairfield IA (L)

Fairfield Historical Society, Fairfield Museum & History Center, Fairfield CT (A,L)

Fairfield University, Visual & Performing Arts, Fairfield CT (S)

Fairfield University, Thomas J Walsh Art Gallery, Fairfield CT (M)

Fairleigh Dickinson University, Fine Arts Dept, Teaneck NJ (S)

Fairmont State College, Div of Fine Arts, Fairmont WV (S)

Fairmount Park Art Association, Philadelphia PA (A)

Falkirk Cultural Center, see City of San Rafael, San Rafael CA

Fallingwater, see Western Pennsylvania Conservancy, Mill Run PA

Fall River Historical Society, Fall River MA (M)

Famille des Arts, see Universite du Quebec a Montreal, Montreal PQ

Leonard L Farber Library, see Brandeis University, Waltham MA

Farmington Valley Arts Center, Avon CT (A)

Farmington Village Green & Library Association, Stanley-Whitman House, Farmington CT (M)

Farnham Gallery, see Simpson College, Indianola IA

William A Farnsworth, Museum, Rockland ME (M,L)

Fashion Institute of Technology, Art & Design Division, New York NY (S)

Fashion Institute of Technology, Museum at FIT, New York NY (M,L)

Father Weyland SVD Gallery, see Divine Word College, Epworth IA

James H Faulkner, Art Dept, Bay Minette AL (S)

Faulkner Memorial Art Wing, see Santa Barbara Public Central Library, Santa Barbara CA

Favell Museum of Western Art & Indian Artifacts, Klamath Falls OR (M)

Fawick Art Gallery, see Baldwin-Wallace College, Berea OH

Fayette Art Museum, see City of Fayette, Alabama, Fayette AL

Fayetteville Museum of Art, Inc, Fayetteville NC (M)

Fayetteville State University, Performing & Fine Arts, Fayetteville NC (S)

Feather River Community College, Art Dept, Quincy CA (S)

Harriet FeBland, New York NY (S)

Federal Reserve Bank of Cleveland, Chesterland OH (C)

Federal Reserve Bank of Minneapolis, Minneapolis MN (C)

Federal Reserve Board, Art Gallery, Washington DC (M)

Federation of Modern Painters & Sculptors, New York NY (O)

Fellowship of the Pennsylvania Academy of the Fine Arts, see Pennsylvania Academy of the Fine Arts, Philadelphia PA

Fellows of Contemporary Art, Los Angeles CA (A)

Ferguson Library, Stamford CT (L)

Ferris State University, Visual Communication Dept, Big Rapids MI (S)

Festival - Institute, see James Dick Foundation, Round Top TX

Fetherston Foundation, Packwood House Museum, Lewisburg PA (M)

Field Museum, Chicago IL (M,L)

55 Mercer Gallery, New York NY (M)

Fillmore County Historical Society, Fountain MN (A)

Film Arts Foundation, San Francisco CA (A)

The Filson Historical Society, Louisville KY (A,L)

Fine & Performing Arts Dept, see Seattle Public Library, Seattle WA

Fine Arts Association, School of Fine Arts, Willoughby OH (A)

Fine Arts Center for the New River Valley, Pulaski VA (M)

The Fine Arts Center of Hot Springs, Hot Springs AR (M)

The Fine Arts Gallery, see New Mexico Highlands University, Las Vegas NM

Fine Arts Museums of San Francisco, M H de Young Museum, San Francisco CA (M,L)

Fine Arts Work Center, Provincetown MA (A)

Finger Lakes Community College, Visual & Performing Arts Dept, Canandaigua NY (S)

Firehouse Art Center, Norman OK (M)

Firehouse Art Gallery, see Nassau Community College, Garden City NY

Firehouse Gallery, see Martha's Vineyard Center for the Visual Arts, Oak Bluffs MA

Firelands Association for the Visual Arts, Oberlin OH (A)

First Horizon National Corp, First Tennessee Heritage Collection, Memphis TN (C)

The First National Bank of Chicago, Art Collection, Chicago IL (C)

First State Bank, Norton KS (C)

First Street Gallery, New York NY (M)

First Tennessee Bank, Memphis TN (C)

First Tennessee Heritage Collection, see First Horizon National Corp, Memphis TN

Fisher Art Center, see Bard College, Annandale-on-Hudson NY

Jonathan Fisher Memorial, Inc, see Parson Fisher House, Blue Hill ME

Fishkill Historical Society, Van Wyck Homestead Museum, Fishkill NY (M)

Fisk University, Art Dept, Nashville TN (S)

Fisk University, Fisk University Galleries, Nashville TN (M,L)

Fitchburg Art Museum, Fitchburg MA (M)

Fitton Center for Creative Arts, Hamilton OH (M)

Fitton Center for Creative Arts, Hamilton OH (S)

Five Civilized Tribes Museum, Muskogee OK (M,L)

Flag House & 1812 Museum, see Star-Spangled Banner Flag House Association, Baltimore MD

Flagler College, Visual Arts Dept, Saint Augustine FL (S)

Flagler Museum, Palm Beach FL (M)

Flamingo Gallery, see Las Vegas-Clark County Library District, Las Vegas NV

Flanagan Valley Campus Art Gallery, see Community College of Rhode Island, Warwick RI

Flaten Art Museum, see Saint Olaf College, Northfield MN

John M Flaxman Library, see School of the Art Institute of Chicago, Chicago IL

Paul D Fleck Library & Archives, see Banff Centre, Banff AB

Fleet Boston Financial, Gallery, Boston MA (C)

The Fleischer Museum, see Franchise Finance Corporation of America, Scottsdale AZ

Fleischer Museum Library, see Franchise Finance Corporation of America, Scottsdale AZ

Samuel S Fleisher Art Memorial, see Philadelphia Museum of Art, Philadelphia PA

Samuel S Fleisher, Philadelphia PA (S)

Robert Hull Fleming Museum, see University of Vermont, Burlington VT

Florida A & M University, Dept of Visual Arts, Humanities & Theatre, Tallahassee FL (S)

Florida Arts Council, see Florida Department of State, Division of Cultural Affairs, Tallahassee FL

Florida Atlantic University, Art Dept, Boca Raton FL (S)

Florida Atlantic University, University Galleries/Ritter Art Gallery/Schmidt Center Gallery, Boca Raton FL (M)

Florida College, Division of Art, Temple Terrace FL (S)

Florida Community College at Jacksonville, South Campus, Art Dept, Jacksonville FL (S)

Florida Community College at Jacksonville, South Gallery, Jacksonville FL (M)

Florida Department of Environmental Protection, Stephen Foster State Folk Culture Center, White Springs FL (M)

Florida Department of State, Division of Cultural Affairs, Florida Arts Council, Tallahassee FL (A)

Florida Folklife Programs, Tallahassee FL (A,L)

Florida International University, School of Art & Art History, Miami FL (S)

Florida International University, The Art Museum at FIU, Miami FL (M)

Florida Keys Community College, Fine Arts Div, Key West FL (S)

Florida School of the Arts, Visual Arts, Palatka FL (S)

Florida Southern College, Art Dept, Lakeland FL (S)

Florida Southern College, Melvin Art Gallery, Lakeland FL (M)

Florida State University, Museum of Fine Arts, Tallahassee FL (M)

Florida State University, John & Mable Ringling Museum of Art, Sarasota FL (M,L)

Roswell P Flower, Watertown NY (M)

James Lemont Fogg Memorial Library, see Art Center College of Design, Pasadena CA

Folger Shakespeare, Washington DC (L)

Folk Art Society of America, Richmond VA (M)

Fondo del Sol, Visual Art & Media Center, Washington DC (M)

Fontbonne University, Fine Art Dept, Saint Louis MO (S)

Foothill College, Fine Arts & Communications Div, Los Altos Hills CA (S)

Foothills Art Center, Inc, Golden CO (A)

Forbes Library, Northampton MA (L)

Forbes Magazine, Inc, Forbes Collection, New York NY (C)

Edsel & Eleanor Ford, Grosse Pointe Shores MI (M)

Ford Gallery, see Eastern Michigan University, Ypsilanti MI

Hallie Ford Museum of Art, see Willamette University, Salem OR

Fordham University, Art Dept, New York NY (S)

Henry Ford Museum & Greenfield Village, see Ford Motor Company, Dearborn MI

Ford Motor Company, Henry Ford Museum & Greenfield Village, Dearborn MI (C)

Foreman Gallery, see Hartwick College, Oneonta NY

Forest Hills Adult and Youth Center, Forest Hills NY (S)

Forges du Saint-Maurice National Historic Site, Trois Rivieres PQ (M)

Forsyth Library, see Fort Hays State University, Hays KS

Fort Collins Museum of Contemporary Art, Fort Collins CO (M)

Fort George G Meade Museum, Fort Meade MD (M)

Fort Hays State University, Dept of Art, Hays KS (S)

Fort Hays State University, Moss-Thorns Gallery of Arts, Hays KS (M,L)

Fort Lewis College, Art Dept, Durango CO (S)

Fort Morgan Heritage Foundation, Fort Morgan CO (M)

Fort Smith Art Center, Fort Smith AR (M)

Fort Steilacoom Community College, Fine Arts Dept, Lakewood WA (S)

Fort Ticonderoga Association, Ticonderoga NY (M,L)

Fort Totten State Historic Site, Pioneer Daughters Museum, Fort Totten ND (A)

Fort Valley State College, H A Hunt Memorial Library, Fort Valley GA (L)

Fort Wayne Museum of Art, Inc, Fort Wayne IN (M)

Fort Worth Public Library Arts & Humanities, Fine Arts Section, Fort Worth TX (L)

Foster Gallery, see University of Wisconsin-Eau Claire, Eau Claire WI

Stephen Foster State Folk Culture Center, see Florida Department of Environmental Protection, White Springs FL

Foundry School Museum, see Putnam County Historical Society, Cold Spring NY

Framingham State College, Art Dept, Framingham MA (S)

Franchise Finance Corporation of America, The Fleischer Museum, Scottsdale AZ (A,L)

Francis Marion University, Fine Arts Dept, Florence SC (S)

Frankfort Community Public Library, Anna & Harlan Hubbard Gallery, Frankfort IN (L)

Frankie G Weems Gallery & Rotunda Gallery, see Meredith College, Raleigh NC

Franklin & Marshall College, Art Dept, Lancaster PA (S)

Franklin College, Art Dept, Franklin IN (S)

Franklin Furnace Archive, Inc, New York NY (L)

Franklin Mint Museum, Franklin Center PA (M)

Franklin Pierce College, Dept of Fine Arts & Graphic Communications, Rindge NH (S)

Frank Lloyd Wright Museum, AD German Warehouse, Richland Center WI (M)

Frank Lloyd Wright School, William Wesley Peters Library, Scottsdale AZ (L)

Simon Fraser Gallery, see Simon Fraser University, Burnaby BC

Freedman Gallery, see Albright College, Reading PA

Free Public Library of Elizabeth, Fine Arts Dept, Elizabeth NJ (L)

Free Public Library, Reference Dept, Trenton NJ (L)

Fremont Center for the Arts, Canon City CO (A)

French Art Colony, Gallipolis OH (A,L)

French Institute-Alliance Francaise, Library, New York NY (L)

Fresno Arts Center & Museum, Fresno CA (M)

Fresno City College, Art Dept, Fresno CA (S)

The Frick Art & Historical Center, Frick Art Museum, Pittsburgh PA (M)

Frick Art Museum, see The Frick Art & Historical Center, Pittsburgh PA

Frick Art Reference Library, New York NY (L)

Frick Collection, New York NY (M)

Henry Clay Frick Dept History of Art & Architecture, see University of Pittsburgh, Pittsburgh PA

Fried, Frank, Harris, Shriver & Jacobson, Art Collection, New York NY (C)

Lee M Friedman Memorial Library, see American Jewish Historical Society, New York NY

Friends Historical Library of Swarthmore College, see Swarthmore College, Swarthmore PA

Friends of Historic Kingston, Fred J Johnston House Museum, Kingston NY (M)

Friends University, Art Dept, Wichita KS (S)

Frontier Gateway Museum, Glendive MT (M)

Frontier Times Museum, Bandera TX (M)

Frostburg State University, Dept of Visual Arts, Frostburg MD (S)

Frostburg State University, The Stephanie Ann Roper Gallery, Frostburg MD (M,L)

Robert Frost Library, see Amherst College, Amherst MA

Fruitlands Museum, Inc, Harvard MA (M,L)

Fullerton College, Division of Fine Arts, Fullerton CA (S)

Fulton County Historical Society Inc, Fulton County Museum, Rochester IN (M)

Fulton County Museum, see Fulton County Historical Society Inc, Rochester IN

Fulton-Hayden Memorial Library, see Amerind Foundation, Inc, Dragoon AZ

J Furlong Gallery, see University of Wisconsin-Stout, Menomonie WI

Furman University, Dept of Art, Greenville SC (S)

Fusion: The Ontario Clay & Glass Association, Toronto ON (A)

Gadsden Museum, Mesilla NM (M)

Gadsden Museum of Fine Arts, Inc, Gadsden Museum of Art and History, Gadsden AL (M)

Galeria de la Raza, Studio 24, San Francisco CA (M)

Galerie d'art de l'Universite de Moncton, Moncton NB (M)

Galerie d'Art du Parc-Manoir de Tonnancour, Manoir de Tonnancour, Trois Rivieres PQ (M)

Galerie Montcalm, Gatineau PQ (M)

Galerie Restigouche Gallery, Campbellton NB (M)

The Galleries at Moore, see Moore College of Art & Design, Philadelphia PA

Galleries at the Interchurch Center, see The Interchurch Center, New York NY

Gallery 76, see Wenatchee Valley College, Wenatchee WA

Gallery 825, see Gallery 825/Los Angeles Art Association, Los Angeles CA

Gallery 825/Los Angeles Art Association, Gallery 825, Los Angeles CA (A)

Gallery A & Gallery G, see Angels Gate Cultural Center, San Pedro CA

Gallery and Gift Shop, see Hui No eau Visual Arts Center, Makawao Maui HI

Gallery Connexion, see Organization for the Development of Artists, Fredericton NB

Gallery Moos Ltd, Toronto ON (M)

Gallery Nature & Temptation, see Kaji Aso Studio, Boston MA

Gallery 9, Los Altos CA (M)

Gallery of Contemporary Art, see Sacred Heart University, Fairfield CT

Gallery of Prehistoric Paintings, New York NY (M,L)

Gallery of Religious Art, see Lutheran Brotherhood Gallery, Minneapolis MN

Gallery One, Ellensburg WA (M)

Gallery Stratford, Stratford ON (M)

Gallery 312, Chicago IL (M)

Gallery XII, Wichita KS (M)

Sir Alexander Galt Museum, see City of Lethbridge, Lethbridge AB

Gananoque Museum, Gananoque ON (M)

Garden City Community College, Art Dept, Garden City KS (S)

Gardiner Art Gallery, see Oklahoma State University, Stillwater OK

George R Gardiner, Toronto ON (M)

Isabella Stewart Gardner, Boston MA (M,L)

Garibaldi & Meucci Museum, see Order Sons of Italy in America, Staten Island NY

Gaston College, Art Dept, Dallas NC (S)

Gaston County Museum of Art & History, Dallas NC (M)

Gatov Gallery, see Alpert Jewish Community Center, Long Beach CA

Gavilan Community College, Art Dept, Gilroy CA (S)

Gavilan Community College, Art Gallery, Gilroy CA (M)

M Christina Geis Gallery, see Georgian Court College, Lakewood NJ

Gem County Historical Society and Museum, Emmett ID (M)

General Board of Discipleship, The United Methodist Church, The Upper Room Chapel & Museum, Nashville TN (M)

General Services Administration, Washington DC (O)

Genesee Country Village & Museum, John L Wehle Gallery of Wildlife & Sporting Art, Mumford NY (M)

George A Spiva, Joplin MO (A)

George Brown College of Applied Arts & Technology, Dept of Graphics, Toronto ON (S)

George Mason University, Dept of Art & Art History, Fairfax VA (S)

Georges Goguen CBC Art Gallery, see Radio-Canada SRC CBC, Moncton NB

Georgetown University, Art Collection, Washington DC (M,L)

Georgetown University, Dept of Art, Music & Theatre, Washington DC (S)

George Washington University, Dept of Art, Washington DC (S)

George Washington University, School of Interior Design, Washington DC (S)

George Washington University, The Dimock Gallery, Washington DC (M)

Georgia Artists Registry, see Savannah College of Art And Design, Atlanta GA

Georgia College & State University, Art Dept, Milledgeville GA (S)

Georgia Council for the Arts, Georgia's State Art Collection, Atlanta GA (A)

Georgia Institute of Technology, College of Architecture, Atlanta GA (S)

Georgia Institute of Technology, College of Architecture Library, Atlanta GA (L)

Georgia Lawyers for the Arts, Atlanta GA (A)

Georgian Court College, Dept of Art, Lakewood NJ (S)

Georgian Court College, M Christina Geis Gallery, Lakewood NJ (M)

Georgia O'Keeffe Museum, Santa Fe NM (M)

Georgia Southern University, Dept of Art, Statesboro GA (S)

Georgia Southwestern State University, Art Gallery, Americus GA (M)

Georgia Southwestern State University, Dept of Fine Arts, Americus GA (S)

Georgia State University, School of Art & Design, Visual Resource Center, Atlanta GA (L,M)

Georgia State University, Ernest G Welch School of Art & Design, Atlanta GA (S)

German Cultural Center, see Goethe Institute New York, New York NY

Getty Center, Trust Museum, Los Angeles CA (L,M)

Gettysburg College, Dept of Visual Arts, Gettysburg PA (S)

The J Paul Getty Museum, see Getty Center, Los Angeles CA

Gibbes Museum of Art, see Carolina Art Association, Charleston SC

Gibson-Barham Gallery, see Imperial Calcasieu Museum, Lake Charles LA

Gibson House Museum, see Gibson Society, Inc, Boston MA

Roland Gibson Gallery, see Potsdam College of the State University of New York, Potsdam NY

Gibson Society, Inc, Gibson House Museum, Boston MA (M)

Gilbert House, see City of Atlanta, Atlanta GA

Thomas Gilcrease, Gilcrease Museum, Tulsa OK (M,L)

Wendell Gilley, Southwest Harbor ME (M)

The Gilman Paper Company, New York NY (C)

Gilpin County Arts Association, Central City CO (A)

Adam & Sophie Gimbel Design Library, see Parsons School of Design, New York NY

Girard College, Stephen Girard Collection, Philadelphia PA (M)

Stephen Girard Collection, see Girard College, Philadelphia PA

Glanmore National Historic Site of Canada, Belleville ON (M)

Glassboro Heritage Glass Museum, Glassboro NJ (M)

Glassell School of Art, Houston TX (S)

Glenbow Museum, Calgary AB (M,L)

Glencairn Museum, see Academy of the New Church, Bryn Athyn PA

Glendale Community College, Visual & Performing Arts Div, Glendale CA (S)

Glendale Public Library, Brand Library & Art Center, Glendale CA (M)

Glendon Gallery, see York University, Toronto ON

Glenhyrst Art Gallery of Brant, Brantford ON (M)

Glenville State College, Dept of Fine Arts, Glenville WV (S)

Glessner House Museum, Chicago IL (M)

Gloridale Partnership, National Museum of Woodcarving, Custer SD (M)

Gloucester County College, Liberal Arts Dept, Sewell NJ (S)

Glynn Art Association, Saint Simons Island GA (A)

Go Antiques, Inc, Dublin OH (A)

Charles B Goddard, Ardmore OK (A)

Goddard College, Dept of Art, Plainfield VT (S)

Godwin-Ternbach Museum, see Queens College, City University of New York, Flushing NY

Goethe Institute New York, German Cultural Center, New York NY (M)

Gogebic Community College, Fine Arts Dept, Ironwood MI (S)

Golden Isles Arts & Humanities Association, Brunswick GA (A)

Golden State Mutual Life Insurance Company, Afro-American Art Collection, Los Angeles CA (C)

Golden West College, Visual Art Dept, Huntington Beach CA (S)

Fanette Goldman & Carolyn Greenfield Gallery, see Daemen College, Amherst NY

Goldstein Gallery, see University of Minnesota, Saint Paul MN

Robert Goldwater Library, see The Metropolitan Museum of Art, New York NY

Gonzaga University, Art Gallery, Spokane WA (M)

Gonzaga University, Dept of Art, Spokane WA (S)

Gaston T Gooch Library & Learning Resource Center, see Navarro College, Corsicana TX

Gordon College, Dept of Fine Arts, Barnesville GA (S)

Donald B Gordon Memorial Library, see Palm Beach County Parks & Recreation Department, Delray Beach FL

Goshen College, Art Dept, Goshen IN (S)

Goshen Historical Society, Goshen CT (M)

Goucher College, Art Dept, Baltimore MD (S)

Goucher College, Rosenberg Gallery, Baltimore MD (M)

Governors State University, College of Arts & Science, Art Dept, University Park IL (S)

Grace College, Dept of Art, Winona Lake IN (S)

Graceland Museum & American Saddlehorse Museum, see Audrain County Historical Society, Mexico MO

Graceland University, Fine Arts Div, Lamoni IA (S)

Grace Museum, Inc, Abilene TX (M)

Grambling State University, Art Dept, Grambling LA (S)

Grand Canyon University, Art Dept, Phoenix AZ (S)

Grand Marais Art Colony, Grand Marais MN (S)

Grand Prairie Arts Council, Inc, Arts Center of the Grand Prairie, Stuttgart AR (A)

Grand Rapids Community College, Visual Art Dept, Grand Rapids MI (S)

Grand Rapids Public Library, Grand Rapids MI (L)

Grand River Museum, Lemmon SD (M)

Grand Teton National Park Service, Colter Bay Indian Arts Museum, Moose WY (M)

Grand Valley State University, Art & Design Dept, Allendale MI (S)

Grand View College, Art Dept, Des Moines IA (S)

Grant Wood Memorial Park & Gallery, see Paint 'N Palette Club, Anamosa IA

Graphic Artists Guild, New York NY (A)

The Gray Gallery, see Quincy University, Quincy IL

Grayson County College, Art Dept, Denison TX (S)

Wellington B Gray Gallery, see East Carolina University, Greenville NC

Great Lakes Historical Society, Inland Seas Maritime Museum, Vermilion OH (M)

Great Plains Art Collection, see University of Nebraska-Lincoln, Lincoln NE

Greene & Greene Archives, see University of Southern California/The Gamble House, San Marino CA

Greene County Historical Society, Bronck Museum, Coxsackie NY (M)

Greenfield Community College, Art, Communication Design & Media Communication Dept, Greenfield MA (S)

Green Hill Center for North Carolina Art, Greensboro NC (M)

Ida Green Gallery, see Austin College, Sherman TX

Green Mountain College, Dept of Art, Poultney VT (S)

Green Research Library, see The Old Jail Art Center, Albany TX

Green River Community College, Art Dept, Auburn WA (S)

Greensboro Artists' League, Greensboro NC (A)

Greensboro College, Irene Cullis Gallery, Greensboro NC (M)

Greensboro College, Dept of Art, Division of Fine Arts, Greensboro NC (S)

Greenville College, Art Dept, Greenville IL (S)

Greenville College, Richard W Bock Sculpture Collection, Almira College House, Greenville IL (M,L)

Greenville County Museum School of Art, Museum School of Art, Greenville SC (S)

Greenville Museum of Art, Inc, Greenville NC (A,L)

Greenville Technical College, Visual Arts Dept, Greenville SC (S)

Greenwich Art Society Inc, Greenwich CT (A)

Greenwich House Inc, Greenwich House Pottery, New York NY (S)

Greenwich Library, Greenwich CT (L)

Sir Wilfred Grenfell College Art Gallery, see Memorial University of Newfoundland, Corner Brook NF

Grevemberg House Museum, Franklin LA (M)

Allie Griffin Art Gallery, see Weyburn Arts Council, Weyburn SK

Arthur Griffin, Winchester MA (M)

Griffis Sculpture Park, see Ashford Hollow Foundation for Visual & Performing Arts, East Otto NY

Grinnell College, Art Gallery, Grinnell IA (M)

Grinnell College, Dept of Art, Grinnell IA (S)

Florence Griswold Museum, see Lyme Historical Society, Old Lyme CT

Grolier Club Library, New York NY (L)

Grossmont Community College, Hyde Art Gallery, El Cajon CA (M)

Guadalupe Cultural Arts Center, San Antonio TX (A)

Guadalupe Historic Foundation, Santuario de Guadalupe, Santa Fe NM (M)

John Simon Guggenheim, New York NY (A)

Solomon R Guggenheim, New York NY (M,L)

Guild Art Center, Silvermine, New Canaan CT (S)

Guilde Canadienne des Metiers d'Art Quebec, Canadian Guild of Crafts Quebec, Montreal PQ (A)

Guild Hall of East Hampton, Inc, Guild Hall Museum, East Hampton NY (M)

Guild of Book Workers, New York NY (O,L)

Guild of Boston Artists, Boston MA (A)

Guild of Creative Art, Shrewsbury NJ (S)

Guilford College, Art Dept, Greensboro NC (S)

Guilford College, Art Gallery, Greensboro NC (M)

Guilford Technical Community College, Commercial Art Dept, Jamestown NC (S)

Gulf Coast Community College, Division of Visual & Performing Arts, Panama City FL (S)

Gulf Coast Museum of Art, Largo FL (S)

Gulf Coast Museum of Art, Inc, Largo FL (A,L)

Robert Gumbiner, Museum of Latin American Art, Long Beach CA (M)

Jessica Gund Memorial Library, see Cleveland Institute of Art, Cleveland OH

Gunston Hall Plantation, Mason Neck VA (M,L)

George Gustav Heye Center, see National Museum of the American Indian, New York NY

Gustavus Adolphus College, Art & Art History Dept, Saint Peter MN (S)

HA & Mary K Chapman Library, see Philbrook Museum of Art, Tulsa OK

Haas Gallery of Art, see Bloomsburg University of Pennsylvania, Bloomsburg PA

Hagadorn House, The 1800-37 Museum, see Almond Historical Society, Inc, Almond NY

Hagerstown Junior College, Art Dept, Hagerstown MD (S)

Haggerty Museum of Art, see Marquette University, Milwaukee WI

The Haggin Museum, Stockton CA (M,L)

Halifax Historical Society, Inc, Halifax Historical Museum, Daytona Beach FL (M)

Hall of Electrical History, see Schenectady Museum Planetarium & Visitors Center, Schenectady NY

Hall of Fame for Great Americans, see Bronx Community College (CUNY), Bronx NY

Hall of State, see Dallas Historical Society, Dallas TX

Hallwalls Contemporary Arts Center, Buffalo NY (M)

Halsey Institute of Contemporary Art, see College of Charleston, Charleston SC

Hambidge Center for the Creative Arts & Sciences, Rabun Gap GA (M)

Hamilton College, Emerson Gallery, Clinton NY (M)

Hamline University, Dept of Art & Art History, Saint Paul MN (S)

Hammond Castle Museum, Gloucester MA (M)

Hammond-Harwood House Association, Inc, Hammond-Harwood House, Annapolis MD (M)

Hammond Museum & Japanese Stroll Garden, Cross-Cultural Center, North Salem NY (M)

Hampden-Booth Theatre Library, New York NY (L)

Hampshire County Public Library, Romney WV (L)

Hampton Arts Commission, see City of Hampton, Hampton VA

Hampton University, Dept of Fine & Performing Arts, Hampton VA (S)

Hampton University, University Museum, Hampton VA (M)

Hancock County Trustees of Public Reservations, Woodlawn Museum, Ellsworth ME (M)

John Hancock Warehouse, see Old York Historical Society, York ME

Henry Radford Hope School of Fine Arts, see Indiana University, Bloomington, Bloomington IN

Hopewell Museum, see Historic Paris - Bourbon County, Inc, Paris KY

Hopi Cultural Center Museum, Second Mesa AZ (M)

Edward Hopper, Nyack NY (M)

Hopper Resource Library, see Butler Institute of American Art, Youngstown OH

Horizons Unlimited Supplementary Educational Center, Science Museum, Salisbury NC (M)

Hostos Center for the Arts & Culture, Bronx NY (A)

Houghton College, Art Dept, Houghton NY (S)

Housatonic Community College, Art Dept, Bridgeport CT (S)

Housatonic Community College, Housatonic Museum of Art, Bridgeport CT (M,L)

House of Happy Walls, see Jack London, Glen Ellen CA

Houston Baptist University, Dept of Art, Houston TX (S)

Houston Baptist University, Museum of American Architecture and Decorative Arts, Houston TX (M)

Houston Center For Photography, Houston TX (A)

Houston Foto Fest Inc, Houston TX (A)

Houston Museum of Decorative Arts, Chattanooga TN (M)

Houston Public Library, Houston TX (L)

Howard College, Art Dept, Big Spring TX (S)

Howard County Arts Council, Ellicott City MD (A)

Howard Payne University, Dept of Art, Brownwood TX (S)

Howard University, Gallery of Art, Washington DC (M,L)

James Howe Gallery, see Kean University, Union NJ

Hoxie Gallery, see Westerly Public Library, Westerly RI

Hoyt Institute of Fine Arts, New Castle PA (M)

Anna & Harlan Hubbard Gallery, see Frankfort Community Public Library, Frankfort IN

Hubbell Trading Post National Historic Site, see National Park Service, Ganado AZ

Grace Hudson Museum & The Sun House, see City of Ukiah, Ukiah CA

Hudson Guild Gallery, see Hudson Guild, New York NY

Hudson Guild, Hudson Guild Gallery, New York NY (M)

The Hudson River Museum, Yonkers NY (M)

Hudson River Reference Collection, see Alice Curtis Desmond, Garrison NY

Hughes Fine Arts Center-Col Eugene Myers Art Gallery, see University of North Dakota, Grand Forks ND

Huguenot Historical Society of New Paltz Galleries, New Paltz NY (M)

Hui No eau Visual Arts Center, Gallery and Gift Shop, Makawao Maui HI (M)

Marie Hull Gallery, see Hinds Community College District, Raymond MS

Hulsey Gallery-Norick Art Center, see Oklahoma City University, Oklahoma City OK

Humanities, Fine Art & Recreation Division, see Columbus Metropolitan Library, Columbus OH

Humber College of Applied Arts & Technology, The School of Media Studies, Etobicoke ON (S)

Humboldt Arts Council, Morris Graves Museum of Art, Eureka CA (A)

Humboldt State University, College of Arts & Humanities, Arcata CA (S)

Cecille R Hunt Gallery, see Webster University, Saint Louis MO

Hunter College, Art Dept, New York NY (S)

Hunter Museum of American Art, Chattanooga TN (M,L)

H A Hunt Memorial Library, see Fort Valley State College, Fort Valley GA

Huntingdon College, Dept of Art, Montgomery AL (S)

Huntington Beach Art Center, Huntington Beach CA (M)

Huntington College, Art Dept, Huntington IN (S)

The Huntington Library, Art Collections & Botanical Gardens, San Marino CA (M,L)

Huntington Museum of Art, Huntington WV (M)

Huntington University, Robert E Wilson Art Gallery, Huntington IN (M)

Huntsville Art League, Huntsville AL (A)

Huronia Museum, Gallery of Historic Huronia, Midland ON (M)

Huron University, Arts & Sciences Division, Huron SD (S)

Hussian School of Art, Commercial Art Dept, Philadelphia PA (S)

Hus Var Fine Art, Buffalo NY (M)

Hutchinson Art Association, Hutchinson Art Center, Hutchinson KS (A)

Hutchinson Community College, Visual Arts Dept, Hutchinson KS (S)

Hyde Art Gallery, see Grossmont Community College, El Cajon CA

Hyde Collection Trust, Glens Falls NY (M,L)

Olive Hyde Art Gallery, see City of Fremont, Fremont CA

Stan Hywet, Akron OH (M)

Idaho Commission on the Arts, Boise ID (A)

Idaho Historical Museum, Boise ID (M)

Idaho State University, John B Davis Gallery of Fine Art, Pocatello ID (M)

Idaho State University, Dept of Art, Pocatello ID (S)

Idyllwild Arts Academy, Idyllwild CA (S)

Illinois Alliance for Arts Education (IAAE), Chicago IL (A)

Illinois Art Gallery & Lockport Gallery, see Illinois State Museum, Springfield IL

Illinois Artisans & Visitors Centers, see Illinois State Museum, Chicago IL

Illinois Artisans Shop, see Illinois State Museum, Chicago IL

Illinois Benedictine University, Fine Arts Dept, Lisle IL (S)

Illinois Central College, Dept Fine, Performing & Applied Arts, East Peoria IL (S)

Illinois Historic Preservation Agency, Bishop Hill State Historic Site, Bishop Hill IL (M)

The Illinois Institute of Art - Chicago, Chicago IL (S)

Illinois Institute of Technology, Chicago IL (S)

Illinois State Museum, Chicago Gallery, Chicago IL (M)

Illinois State Museum, Illinois Art Gallery & Lockport Gallery, Springfield IL (M,L)

Illinois State University, Art Dept, Normal IL (S)

Illinois Valley Community College, Division of Humanities & Fine Arts, Oglesby IL (S)

Illinois Wesleyan University, Merwin & Wakeley Galleries, Bloomington IL (M,L)

Illinois Wesleyan University, School of Art, Bloomington IL (S)

Illustration House Inc, Gallery Auction House, New York NY (M)

Imhoff Art Gallery, Alberta SK (M)

Imperato Collection of West African Artifacts, see Martin and Osa Johnson, Chanute KS

Imperial Calcasieu Museum, Lake Charles LA (M,L)

Imperial Valley College, Art Dept, Imperial CA (S)

Independence Historical Museum, Independence KS (M)

Independence National Historical Park, Philadelphia PA (M,L)

Independence Seaport Museum, Philadelphia PA (M,L)

Independent Curators International, New York NY (A)

Index of American Design, see National Gallery of Art, Washington DC

Indianapolis Marion County Public Library, Interim Central Library, Indianapolis IN (L)

Indiana-Purdue University, Dept of Fine Arts, Fort Wayne IN (S)

Indian Arts & Crafts Association, Albuquerque NM (A)

Indian Arts & Crafts Board, see United States Department of the Interior, Washington DC

Indian Arts & Crafts Board, US Dept of the Interior, Sioux Indian Museum, Rapid City ND (M)

Indiana State Museum, Indianapolis IN (M)

Indiana State University, University Art Gallery, Terre Haute IN (M)

Indiana University, Bloomington, Henry Radford Hope School of Fine Arts, Bloomington IN (S)

Indiana University-East, Humanities Dept, Richmond IN (S)

Indiana University, Fine Arts Library, Bloomington IN (L)

Indiana University of Pennsylvania, College of Fine Arts, Indiana PA (S)

Indiana University of Pennsylvania, Kipp Gallery, Indiana PA (M)

Indiana University-Purdue University, Indianapolis, Herron School of Art, Indianapolis IN (S)

Indiana University South Bend, Fine Arts Dept, South Bend IN (S)

Indiana University-Southeast, Fine Arts Dept, New Albany IN (S)

Indiana Wesleyan University, Art Dept, Marion IN (S)

Indian Center Museum, see Mid-America All-Indian Center, Wichita KS

Indian Hills Community College, Ottumwa Campus, Dept of Art, Ottumwa IA (S)

Indian Hills Community College, Dept of Art, Centerville IA (S)

Indian Museum of Lake County, Ohio, see Archaeological Society of Ohio, Willoughby OH

Indian Museum of North America, Native American Educational & Cultural Center & Crazy Horse Memorial Library (Reference), see Crazy Horse Memorial, Crazy Horse SD

Indian Pueblo Cultural Center, Albuquerque NM (M)

Indian River Community College, Fine Arts Dept, Fort Pierce FL (S)

Individual Artists of Oklahoma, Oklahoma City OK (M)

Industrial Designers Society of America, Sterling VA (O)

Ingalls Library, see Cleveland Museum of Art, Cleveland OH

Ingraham Memorial Research Library, see Litchfield History Museum, Litchfield CT

Inland Seas Maritime Museum, see Great Lakes Historical Society, Vermilion OH

Inner-City Arts, Los Angeles CA (S)

Inquilinos Boricuas en Accion, Boston MA (A)

Installation Gallery, San Diego CA (A)

Institut des Arts au Saguenay, Centre National D'Exposition a Jonquiere, Jonquiere PQ (M)

Institute for Arts & Humanities Education, New Jersey Summer Arts Institute, New Brunswick NJ (S)

Institute of American Indian Arts, Institute of American Indian Arts Museum, Santa Fe NM (S)

Institute of American Indian Arts Museum, Museum, Santa Fe NM (M,L)

Institute of Contemporary Art, Boston MA (M)

The Institute of Contemporary Art, see Maine College of Art, Portland ME

Institute of Puerto Rican Culture, Escuela de Artes Plasticas, San Juan PR (S)

Intar Latin American Gallery, New York NY (M)

Inter American University of Puerto Rico, Dept of Art, San German PR (S)

The Interchurch Center, see The Interchurch Center, New York NY

The Interchurch Center, Galleries at the Interchurch Center, New York NY (M,L)

Interior Designers Society of Quebec, see La Societe des designers d'interior de Quebec, Montreal PQ

Interlochen Center for the Arts, Interlochen MI (L)

Interlochen Center for the Arts, Interlochen Arts Academy, Dept of Visual Art, Interlochen MI (S)

Intermedia Arts Minnesota, Minneapolis MN (M)

Intermuseum Conservation Association, Oberlin OH (O)

International Association of Art Critics, Toronto ON (O)

International Association of Art Critics, ALCA Canada, Inc, Tornoto ON (O)

International Center of Medieval Art, New York NY (A)

International Center of Photography, New York NY (M,L)

International Clown Hall of Fame & Research Center, Inc, West Allis WI (M)

International Council for Cultural Exchange (ICCE), Brookhaven NY (S)

International Fine Arts College, Miami FL (S)

International Foundation for Art Research, Inc, New York NY (O)

International Sculpture Center, Hamilton NJ (M)

International Society of Copier Artists (ISCA), Brooklyn NY (O)

International Society of Marine Painters, Eagle ID (A)

Intersection for the Arts, San Francisco CA (A)

Inter-Society Color Council, Lawrenceville NJ (O)

Intuit: The Center for Intuitive & Outsider Art, Chicago IL (M)

Iowa Central Community College, Dept of Art, Fort Dodge IA (S)

Iowa Great Lakes Maritime Museum, Arnolds Park IA (M)

Iowa Lakes Community College, Dept of Art, Estherville IA (S)

Iowa State University, Brunnier Art Museum, Ames IA (M)

Iowa State University, Dept of Art & Design, Ames IA (S)

Iowa Wesleyan College, Art Dept, Mount Pleasant IA (S)

Emma B King Library, see Shaker Museum & Library, Old Chatham NY

Gioconda & Joseph King Library, see The Society of the Four Arts, Palm Beach FL

Kingman Tavern Historical Museum, see Town of Cummington Historical Commission, Cummington MA

Kingsborough Community College, CUNY, Art Gallery, Brooklyn NY (M)

Kingsborough Community College, Dept of Art, Brooklyn NY (S)

Kings County Historical Society & Museum, Hampton NB (M)

Kipp Gallery, see Indiana University of Pennsylvania, Indiana PA

Kirkland Art Center, Clinton NY (A)

Kirkland Museum of Fine & Decorative Art, Denver CO (M)

Kirkwood Community College, Dept of Arts & Humanities, Cedar Rapids IA (S)

Kitchen Center for Video, Music, Dance, Performance, Film & Literature, New York NY (M)

Kitchener-Waterloo Art Gallery, Kitchener ON (M,L)

Kittredge Art Gallery, see University of Puget Sound, Tacoma WA

Klamath Art Association, Klamath Falls OR (A)

Klamath County Museum, Klamath Falls OR (M,L)

Klemm Gallery, Studio Angelico, see Siena Heights College, Adrian MI

Knights of Columbus Supreme Council, Knights of Columbus Museum, New Haven CT (M)

M Knoedler, Library, New York NY (L)

Knox College, Dept of Art, Galesburg IL (S)

Knoxville Museum of Art, Knoxville TN (M)

Koffler Center of the Arts, School of Visual Art, Toronto ON (S)

Koffler Centre of the Arts, The Koffler Gallery, Toronto ON (M)

The Koffler Gallery, see Koffler Centre of the Arts, Toronto ON

Kohler Co, John Michael Kohler Arts Center - Arts Industry Program, Sheboygan WI (C)

John Michael Kohler Arts Center, see Sheboygan Arts Foundation, Inc, Sheboygan WI

Koochiching Museums, International Falls MN (M)

Elizabeth P Korn Gallery, see Drew University, Madison NJ

Koshare Indian Museum, Inc, La Junta CO (M,L)

Kraft Education Center/Museum Education, see The Art Institute of Chicago, Chicago IL

Krasl Art Center, see St Joseph Art Association, Saint Joseph MI

Krauth Memorial Library, see Lutheran Theological Seminary, Philadelphia PA

Kresge Art Museum, see Michigan State University, East Lansing MI

Kress Foundation Dept of Art History, see University of Kansas, Lawrence KS

Joe Kubert, Dover NJ (S)

Kurdish Museum, Brooklyn NY (M)

Kutztown University, College of Visual & Performing Arts, Kutztown PA (S)

L'Universite Laval, Ecole des Arts Visuels, Quebec PQ (M,L)

The Lab, San Francisco CA (M)

Laband Art Gallery, see Loyola Marymount University, Los Angeles CA

John Labatt Visual Arts Centre, see University of Western Ontario, London ON

La Casa del Libro Museum, San Juan PR (M)

Lac du Flambeau Band of Lake Superior Chippewa Indians, George W Brown Jr Ojibwe Museum & Cultural Center, Lac du Flambeau WI (M)

La Centrale Powerhouse Gallery, Montreal PQ (M)

La Chambre Blanche, Quebec PQ (M)

Lachemeyer Arts Center, Art Resource Library, Cushing OK (L)

Lackawanna Junior College, Fine Arts Dept, Scranton PA (S)

L A County Museum of Art, Los Angeles CA (M,L)

Lafayette College, Dept of Art, Easton PA (S)

Lafayette College, Williams Center Gallery, Easton PA (M)

Lafayette Museum Association, Lafayette Museum-Alexandre Mouton House, Lafayette LA (M)

Lafayette Natural History Museum & Planetarium, Lafayette LA (M)

La Grange College, Lamar Dodd Art Center Museum, LaGrange GA (S)

La Grange College, Lamar Dodd Art Center Museum, LaGrange GA (M)

Laguna Art Museum, Laguna Beach CA (M)

La Hacienda de Los Martinez, see Taos, Taos NM

Lahaina Arts Society, Art Organization, Lahaina HI (A)

Lake County Civic Center Association, Inc, Heritage Museum & Gallery, Leadville CO (A)

Lake Erie College, Fine Arts Dept, Painesville OH (S)

Lake Forest College, Dept of Art, Lake Forest IL (S)

Lake Forest Library, Fine Arts Dept, Lake Forest IL (L)

Lake George Arts Project, Courthouse Gallery, Lake George NY (M)

Lakehead University, Dept of Visual Arts, Thunder Bay ON (S)

Lakeland Community College, Fine Arts Department, Kirtland OH (S)

Lake Michigan College, Dept of Art & Science, Benton Harbor MI (S)

Lake Pontchartrain Basin Maritime Museum, Madisonville LA

Lakeside Studio, Lakeside MI (M)

Lake Tahoe Community College, Art Dept, South Lake Tahoe CA (S)

Lakeview Museum of Arts & Sciences, Peoria IL (M)

Lamama La Galleria, New York NY (M)

Lamar University, Art Dept, Beaumont TX (S)

Lambuth University, Dept of Human Ecology & Visual Arts, Jackson TN (S)

Lamont Art Gallery, see Dacotah Prairie Museum, Aberdeen SD

Lamont Gallery, see Phillips Exeter Academy, Exeter NH

La Napoule Art Foundation, Chateau de la Napoule, Portsmouth NH (A)

Lancaster County Art Association, Inc, Strasburg PA (A)

Lancaster Museum of Art, Lancaster PA (M)

Clara Lander Library, see The Winnipeg Art Gallery, Winnipeg MB

Lander University, College of Arts & Humanities, Greenwood SC (S)

Landmark Society of Western New York, Inc, The Campbell-Whittlesey House Museum, Rochester NY (M,L)

Lane Arts Council, Jacobs Gallery, Eugene OR (M)

Lane Community College, Art & Applied Design Dept, Eugene OR (S)

Lane Community College, Art Dept Gallery, Eugene OR (M)

Laney College, Art Dept, Oakland CA (S)

Laney College Library, Art Section, Oakland CA (L)

Langara College, Dept of Display & Design, Vancouver BC (S)

Robert Langen Art Gallery, see Wilfrid Laurier University, Waterloo ON

Langston University, Melvin B Tolson Black Heritage Center, Langston OK (M)

Lannan Foundation, Santa Fe NM (O)

Lansing Art Gallery, Lansing MI (M)

Lansing Community College, Visual Arts & Media Dept, Lansing MI (S)

Laramie County Community College, Division of Arts & Humanities, Cheyenne WY (S)

La Raza-Galeria Posada, Sacramento CA (M)

La Roche College, Division of Graphics, Design & Communication, Pittsburgh PA (S)

Mabel Larsen Fine Arts Gallery, see Austin Peay State University, Clarksville TN

Larson Gallery, see Yakima Valley Community College, Yakima WA

Paul Whitney Larson Gallery, see University of Minnesota, Saint Paul MN

La Salle University, Art Museum, Philadelphia PA (M)

La Salle University, Dept of Art, Philadelphia PA (S)

La Sierra University, Art Dept, Riverside CA (S)

La Societe des designers d'interior du Quebec, Interior Designers Society of Quebec, Montreal PQ (A)

Las Vegas-Clark County Library District, Las Vegas NV (L,M)

Las Vegas Natural History Museum, Las Vegas NV (M)

Latitude 53 Contemporary Visual Culture, Edmonton AB (A)

Lauinger Library-Special Collections Division, see Georgetown University, Washington DC

Laumeier Sculpture Park, Saint Louis MO (M)

Laurens County Historical Society, Dublin-Laurens Museum, Dublin GA (M)

Laurentian University, Sudbury ON (L)

Laurier House, National Historic Site, see Canadian Heritage - Parks Canada, Ottawa ON

Lawrence Technological University, College of Architecture, Southfield MI (S)

Lawrence University, Dept of Art, Appleton WI (S)

Lawrence University, Wriston Art Center Galleries, Appleton WI (M)

League Gallery, see League of New Hampshire Craftsmen, Concord NH

League of New Hampshire Craftsmen, League Gallery, Concord NH (A,L)

Leanin' Tree Museum of Western Art, Boulder CO (M)

Leatherstocking Brush & Palette Club Inc, Cooperstown NY (A)

LeBrun Library, see Montclair Art Museum, Montclair NJ

Bertha V B Lederer Gallery, see State University of New York at Geneseo, Geneseo NY

Lee County Library, Tupelo MS (L)

Leeds Gallery, see Earlham College, Richmond IN

Leelanau Historical Museum, Leland MI (M)

Lee University, Dept of Communication & the Arts, Cleveland TN (S)

Leeward Community College, Arts & Humanities Division, Pearl City HI (S)

Legacy Ltd, Seattle WA (M)

Legion of Honor, see Fine Arts Museums of San Francisco, San Francisco CA

Lehigh County Historical Society, Allentown PA (M,L)

Lehigh University Art Galleries, Museum Operation, Bethlehem PA (M)

Lehigh University, Dept of Art & Architecture, Bethlehem PA (S)

Lehman College Art Gallery, Bronx NY (M)

Herbert H Lehman, Art Dept, Bronx NY (S)

Robert Lehman Collection Library, see The Metropolitan Museum of Art, New York NY

Lemmerman Art Gallery, see New Jersey City University, Jersey City NJ

LeMoyne Art Foundation, Inc, Tallahassee FL (M)

Le Moyne College, Fine Arts Dept, Syracuse NY (S)

LeMoyne College, Wilson Art Gallery, Syracuse NY (M)

Le Musee Marc-Aurele Fortin, Montreal PQ (M)

Le Musee Regional de Rimouski, Centre National d'Exposition, Rimouski PQ (M,L)

Lenoir Community College, Dept of Visual Art, Kinston NC (S)

Lenoir Rhyne College, Dept of Art, Hickory NC (S)

J Paul Leonard Library, see San Francisco State University, San Francisco CA

Anna Leonowens Gallery, see Nova Scotia College of Art and Design, Halifax NS

LeRoy Historical Society, LeRoy NY (A)

Les Editions Intervention, Inter-Le Lieu, Documentation Center, Quebec PQ (L)

Dean Lesher, Bedford Gallery, Walnut Creek CA (M)

LeSueur County Historical Society, Chapter One, Elysian MN (M,L)

Lethbridge Public Library, Art Gallery, Lethbridge AB (L)

Lewis & Clark College, Dept of Art, Portland OR (S)

Lewis & Clark Community College, Art Dept, Godfrey IL (S)

Lewis-Clark State College, Art Dept, Lewiston ID (S)

Lewistown Art Center, Lewistown MT (A)

Lexington Art League, Inc, Lexington KY (A)

Lexington Friends of the Arts, Inc, Monroe Center for the Arts, Lexington MA (S)

Liberty Hall Historic Site, Liberty Hall Museum, Frankfort KY (M,L)

Liberty Hall Museum, see Liberty Hall Historic Site, Frankfort KY

Liberty Life Insurance Company, Greenville SC (C)

Liberty Memorial Museum & Archives, The National Museum of World War I, Kansas City MO (M)

Liberty Village Arts Center & Gallery, Chester MT (M)

Library, see Albany Institute of History & Art, Albany NY

Library, see Olana State Historic Site, Hudson NY

Library, see The Long Island Museum of American Art, History & Carriages, Stony Brook NY

Library and Teacher Resource Center in the Uris Center for Education, see The Metropolitan Museum of Art, New York NY

Library Association of La Jolla, Athenaeum Music & Arts Library, La Jolla CA (L)

Library of Congress, Prints & Photographs Division, Washington DC (L)

Light Factory, Charlotte NC (M)

Lighthouse Center for the Arts Inc, Tequesta FL (M,L)

Light Work, Robert B Menschel Photography Gallery, Syracuse NY (A)
Lilly Art Library, see Duke University, Durham NC
Limestone College, Art Dept, Gaffney SC (S)
Lincoln Arts Council, Lincoln NE (A)
Lincoln Center for the Performing Arts, Cork Gallery, New York NY (M)
Lincoln College, Art Dept, Lincoln IL (S)
Lincoln County Historical Association, Inc, Pownalborough Courthouse, Wiscasset ME (A,L,M)
Lincoln Memorial University, Division of Humanities, Harrogate TN (S)
The Lincoln Museum, Fort Wayne IN (M)
Lincoln University, Dept Fine Arts, Jefferson City MO (S)
Lindenwood College, Art Dept, Saint Charles MO (S)
Lindenwood University, Harry D Hendren Gallery, Saint Charles MO (M)
Luke Lindoe Library, see Alberta College of Art & Design, Calgary AB
The Lindsay Gallery Inc, Lindsay ON (M)
Linfield College, Art Dept, McMinnville OR (S)
Linn Benton Community College, Fine & Applied Art Dept, Albany OR (S)
Litchfield History Museum, Litchfield CT (A,L)
The Little Art Gallery, see North Canton Public Library, North Canton OH
Living Arts & Science Center, Inc, Lexington KY (M)
Livingston County Historical Society, Cobblestone Museum, Geneseo NY (M)
Lizzadro Museum of Lapidary Art, Elmhurst IL (M)
Lobby for the Arts Gallery, see Cumberland Theatre, Cumberland MD
Lock Haven University, Dept of Fine Arts, Lock Haven PA (S)
Lockwood-Mathews Mansion Museum, Norwalk CT (M)
Locust Street Neighborhood Art Classes, Inc, Buffalo NY (S)
The Frances Lehman Loeb Art Center, see Vassar College, Poughkeepsie NY
Lois Wagner Fine Arts Inc, New York NY (C)
Jack London, House of Happy Walls, Glen Ellen CA (M)
Long Beach Art League, Long Beach Library, Long Beach NY (L)
Long Beach City College, Art & Photography Dept, Long Beach CA (S)
Long Beach Public Library, Long Beach CA (L)
Long Beach Public Library, Long Beach NY (L)
Earl K Long Library, see University of New Orleans, New Orleans LA
Longfellow's Wayside Inn Museum, South Sudbury MA (M)
Longfellow-Evangeline State Commemorative Area, Saint Martinville LA (M)
Long Island Graphic Eye Gallery, Bellmore NY (M)
The Long Island Museum of American Art, History & Carriages, Stony Brook NY (M,L)
Long Island University, Brooklyn Campus, Art Dept, Brooklyn NY (S)
Longview Museum of Fine Art, Longview TX (M)
Longwood Arts Gallery, see Bronx Council on the Arts, Bronx NY
Longwood Center for the Visual Arts, Farmville VA (A)
Longwood University, Dept of Art, Farmville VA (S)
Lorain County Community College, Art Dept, Elyria OH (S)
Loras College, Dept of Art, Dubuque IA (S)
Lore Degenstein Gallery, see Susquehanna University, Selinsgrove PA
Lorenzo Homar Gallery, see Taller Puertorriqueno Inc, Philadelphia PA
Lee Alexander Lorick Library, see Columbia Museum of Art, Columbia SC
Los Angeles Center for Photographic Studies, Hollywood CA (A)
Los Angeles City College, Dept of Art, Los Angeles CA (S)
Los Angeles Contemporary Exhibitions, Los Angeles CA (M)
Los Angeles County Museum of Natural History, William S Hart Museum, Newhall CA (M)
Los Angeles Harbor College, Art Dept, Wilmington CA (S)
Los Angeles Public Library, Art, Music, Recreation & Rare Books, Los Angeles CA (L)
Los Angeles Valley College, Art Dept, Van Nuys CA (S)

Los Angeles Valley College, Art Gallery, Valley Glen CA (M)
Louisa May Alcott Memorial Association, Orchard House, Concord MA (A)
Louisburg College, Art Gallery, Louisburg NC (M)
Louisiana Arts & Science Museum, Baton Rouge LA (M,L)
Louisiana College, Dept of Art, Pineville LA (S)
Louisiana Department of Culture, Recreation & Tourism, Louisiana State Museum, New Orleans LA (M,L)
Louisiana Historical Center Library, see Louisiana Department of Culture, Recreation & Tourism, New Orleans LA
Louisiana State Exhibit Museum, Shreveport LA (M)
Louisiana State Museum, see Louisiana Department of Culture, Recreation & Tourism, New Orleans LA
Louisiana State University at Alexandria, Dept of Fine Arts & Design, Alexandria LA (S)
Louisiana State University at Alexandria, University Gallery, Alexandria LA (M)
Louisiana State University, School of Art, Baton Rouge LA (S)
Louisiana Tech, School of Art, Ruston LA (S)
Lourdes College, Art Dept, Sylvania OH (S)
Lourdes College, Duns Scotus Library, Sylvania OH (L)
Lovejoy Library, see Southern Illinois University, Edwardsville IL
Loveland Museum Gallery, Loveland CO (M)
Lovely Lane Museum, see United Methodist Historical Society, Baltimore MD
Lovewell Studios, Superior NB (S)
Lowe Art Museum, see University of Miami, Coral Gables FL
Lowell Art Association, Inc, Whistler House Museum of Art, Lowell MA (A)
Lower Columbia College, Art Dept, Longview WA (S)
Loyola Marymount University, Dept of Art & Art History, Los Angeles CA (S)
Loyola Marymount University, Laband Art Gallery, Los Angeles CA (M)
Loyola University of Chicago, Martin D'Arcy Museum of Art, Chicago IL (M)
Loyola University of Chicago, Fine Arts Dept, Chicago IL (S)
Loyola University of New Orleans, Dept of Visual Arts, New Orleans LA (S)
Lubbock Christian University, Dept of Communication & Fine Art, Lubbock TX (S)
Lunenburg Art Gallery Society, Lunenburg NS (M)
Lutheran Brethren Schools, Art Dept, Fergus Falls MN (S)
Lutheran Brotherhood Gallery, Gallery of Religious Art, Minneapolis MN (M)
Lutheran Theological Seminary, Krauth Memorial Library, Philadelphia PA (L)
Luther College, Art Dept, Decorah IA (S)
Luther College, Fine Arts Collection, Decorah IA (M)
Luzerne County Community College, Commercial Art Dept, Nanticoke PA (S)
Lycoming College, Art Dept, Williamsport PA (S)
Lycoming College Gallery, Williamsport PA (M)
Lyme Academy of Fine Arts, Old Lyme CT (S)
Lyme Academy of Fine Arts, Old Lyme CT (L)
Lyme Art Association, Inc, Old Lyme CT (A)
Lyme Historical Society, Florence Griswold Museum, Old Lyme CT (M,L)
Lynchburg College, Art Dept, Lynchburg VA (S)
Lynchburg College, Daura Gallery, Lynchburg VA (M)
Tom Lynch Resource Center, see Dillman's Creative Arts Foundation, Lac du Flambeau WI
Lyndhurst, see The National Trust for Historic Preservation, Tarrytown NY
Lynn University, Art & Design Dept, Boca Raton FL (S)
Lynnwood Arts Centre, Simcoe ON (A)
Harrye Lyons Design Library, see North Carolina State University, Raleigh NC
Mabee-Gerrer Museum of Art, see Saint Gregory's Abbey & University, Shawnee OK
Macalester College, Art Dept, Saint Paul MN (S)
Macalester College, Macalester College Art Gallery, Saint Paul MN (M,L)
MacArthur Memorial, Norfolk VA (M,L)
Macartney House Museum, Oakland ME (M)
Macdonald Stewart Art Centre, Guelph ON (M)
MacKenzie Art Gallery, see University of Regina, Regina SK
MacKenzie Art Gallery Resource Centre, see University of Regina, Regina SK

MacMurray College, Art Dept, Jacksonville IL (S)
Charles H MacNider, Mason City IA (M,L)
Macomb Community College, Art Dept, Warren MI (S)
MacPheadris-Warner House, see Warner House Association, Portsmouth NH
Madison & Main Gallery, Greeley CO (M)
Madison Area Technical College, Art Dept, Madison WI (S)
Madison County Historical Society, Cottage Lawn, Oneida NY (M,L)
Madison-Morgan Cultural Center, see Morgan County Foundation, Inc, Madison GA
Madison Museum of Contemporary Art, Madison WI (M)
Madonna University, Art Dept, Livonia MI (S)
Judah L Magnes, Berkeley CA (M,L)
Magnum Opus, McLean VA (S)
Maharishi University of Management, Department of Fine Arts, Fairfield IA (A)
Mahoney Library, see College of Saint Elizabeth, Morristown NJ
Maier Museum of Art, see Randolph-Macon Woman's College, Lynchburg VA
Maine Art Gallery, see Lincoln County Historical Association, Inc, Wiscasset ME
Maine College of Art, Portland ME (S)
Maine College of Art, Joanne Waxman Library, Portland ME (L,M)
Maine Historical Society, Portland ME (A,M,L)
Maine Maritime Museum, Bath ME (M,L)
Maine Photographic Workshops, The International T.V. & Film Workshops & Rockport College, Rockport ME (S)
Maine Photographic Workshops/Rockport College, Rockport ME (A,L)
Main Line Art Center, Haverford PA (A)
Main Line Art Center, Haverford PA (S)
Maison de la Culture Centre D'Exposition Raymond-Lasnier, Trois Rivieres PQ (A)
Maison Saint-Gabriel Museum, Montreal PQ (M)
MAK - Austrian Museum of Applied Art, see Mak-Cener for Art & Architecture, West Hollywood CA
Mak-Cener for Art & Architecture, MAK - Austrian Museum of Applied Art, West Hollywood CA (M)
Malaspina College, Nanaimo Art Gallery, Nanaimo BC (M)
Malone College, Dept of Art, Canton OH (S)
Maltwood Art Museum and Gallery, see University of Victoria, Victoria BC
Manatee Community College, Dept of Art & Humanities, Bradenton FL (S)
Manchester City Library, Manchester NH (L)
Manchester College, Art Dept, North Manchester IN (S)
Manchester Community College, Fine Arts Dept, Manchester CT (S)
Manchester Craftsmen's Guild, Pittsburgh PA (M)
Manchester Historic Association, Manchester NH (A,L)
Manhattan College, School of Arts, Riverdale NY (S)
Manhattan Graphics Center, New York NY (S)
Manhattanville College, Art Dept, Purchase NY (S)
Manhattanville College, Brownson Gallery, Purchase NY (M,L)
Joseph Manigault House, see Charleston Museum, Charleston SC
Manitoba Association of Architects, Winnipeg MB (A)
Manitoba Historical Society, Dalnavert Museum, Winnipeg MB (M)
Manitoba Society of Artists, Winnipeg MB (A)
Mankato Area Arts Council, Carnegie Art Center, Mankato MN (M)
Mankato State University, Art Dept, Mankato MN (S)
Mansfield Fine Arts Guild, Mansfield Art Center, Mansfield OH (A,L)
Mansfield University, Art Dept, Mansfield PA (S)
Maple Woods Community College, Dept of Art & Art History, Kansas City MO (S)
The Marbella Gallery Inc, New York NY (M)
Marblehead Arts Association, Inc, Marblehead MA (A)
Marcella Sembrich Memorial Association Inc, Marcella Sembrich Opera Museum, Bolton Landing NY (A)
Jacques Marchais, Staten Island NY (M)
Gladys Marcus Library, see Fashion Institute of Technology, New York NY
Marian College, Allison Mansion, Indianapolis IN (M)
Marian College, Art Dept, Fond Du Lac WI (S)
Marian College, Art Dept, Indianapolis IN (S)
Marian Gallery, see Mount Mary College, Milwaukee WI
Marian Library, see Daemen College, Amherst NY

Michigan State University, Kresge Art Museum, East Lansing MI (M,L)

Mid-America All-Indian Center, Indian Center Museum, Wichita KS (M,L)

Mid America Arts Alliance & Exhibits USA, Kansas City MO (O)

Middle Border Museum & Oscar Howe Art Center, Mitchell SD (M)

Middlebury College, History of Art & Architecture Dept, Middlebury VT (S)

Middlebury College, Museum of Art, Middlebury VT (M)

Middle Georgia College, Dept of Art, Cochran GA (S)

Middlesex Community College, Fine Arts Div, Middletown CT (S)

Middlesex County College, Visual Arts Dept, Edison NJ (S)

Middlesex County Cultural & Heritage Commission, New Brunswick NJ (A)

Middle Tennessee State University, Art Dept, Murfreesboro TN (S)

Middle Tennessee State University, Baldwin Photographic Gallery, Murfreesboro TN (M)

Middletown Arts Center, Middletown OH (A,L)

Midland College, Art Dept, Midland TX (S)

Midmarch Associates, Women Artists Archive and Library, New York NY (L)

Midtown, see International Center of Photography, New York NY

Midtown Art Center, Houston TX (M)

Midway College, Art Dept, Midway KY (S)

Midwest Art Conservation Center, Minneapolis MN (A)

Midwest Art History Society, Kent OH (O)

Midwestern State University, Lamar D. Fain College of Fine Arts, Wichita Falls TX (S)

Midwest Museum of American Art, Elkhart IN (M)

Miles Community College, Dept of Fine Arts & Humanities, Miles City MT (S)

Millard Sheets Art Center-Williamson Gallery, see Scripps College, Claremont CA

Miller Art Museum, see Door County, Sturgeon Bay WI

E Kirkbride Miller Art Library, see The Baltimore Museum of Art, Baltimore MD

Millersville University, Art Dept, Millersville PA (S)

Milliken Art Gallery, see Converse College, Spartanburg SC

Millikin University, Art Dept, Decatur IL (S)

Millikin University, Perkinson Gallery, Decatur IL (M)

Millsaps College, Dept of Art, Jackson MS (S)

Mills College, Art Dept, Oakland CA (S)

Mills College, Art Museum, Oakland CA (M)

Mills Mansion State Historical Site, see New York State Office of Parks, Recreation & Historical Preservation, Staatsburg NY

Milwaukee Area Technical College, Graphic Arts Div, Milwaukee WI (S)

Milwaukee Institute of Art & Design, Milwaukee WI (S)

Milwaukee Institute of Art & Design, Library, Milwaukee WI (L)

Milwaukee Public Library, Art, Music & Recreation Dept, Milwaukee WI (L)

Mingei International, Inc, Mingei International Museum, San Diego CA (M,L)

Minneapolis College of Art & Design, Minneapolis MN (S)

Minneapolis College of Art & Design, Library, Minneapolis MN (L)

Minneapolis Institute of Arts, Minneapolis MN (M,L,A)

Minnesota Historical Society, Saint Paul MN (A,L,M)

Minnesota Historical Society, Minnesota State Capitol Historic Site, St Paul MN (A)

Minnesota Museum of American Art, Saint Paul MN (M)

Minnesota State University, Mankato, Mankato MN (M)

Minnesota State University-Moorhead, Dept of Art, Moorhead MN (S)

Minot Art Association, Lillian & Coleman Taube Museum of Art, Minot ND (M)

Minot State University, Dept of Art, Division of Humanities, Minot ND (S)

Minot State University, Northwest Art Center, Minot ND (M)

Miracle at Pentecost Foundation, Biblical Arts Center, Dallas TX (M)

Miracosta College, Art Dept, Oceanside CA (S)

Sidney Mishkin Gallery, see Baruch College of the City University of New York, New York NY

The Mission House, see The Trustees of Reservations, Ipswich MA

Mission San Luis Rey de Francia, Mission San Luis Rey Museum, Oceanside CA (M)

Mission San Luis Rey Museum, see Mission San Luis Rey de Francia, Oceanside CA

Mission San Miguel Museum, San Miguel CA (M)

Mississauga Library System, Mississauga ON (L)

Mississippi Art Colony, Stoneville MS (A)

Mississippi College, Art Dept, Clinton MS (S)

Mississippi Delta Community College, Dept of Fine Arts, Moorhead MS (S)

Mississippi Department of Archives & History, Old Capitol Museum of Mississippi History, Jackson MS (M)

Mississippi Gulf Coast Community College-Jackson County Campus, Art Dept, Gautier MS (S)

Mississippi Museum of Art, Jackson MS (M,L)

Mississippi River Museum at Mud-Island River Park, Memphis TN (M)

Mississippi State University, Dept of Art, Mississippi State MS (S)

Mississippi University for Women, Division of Fine & Performing Arts, Columbus MS (S)

Mississippi University for Women, Fine Arts Gallery, Columbus MS (M)

Mississippi Valley Conservation Authority, R Tait McKenzie Memorial Museum, Almonte ON (M)

Mississippi Valley State University, Fine Arts Dept, Itta Bena MS (S)

Missoula Art Museum, Missoula MT (M)

Missouri Arts Council, Saint Louis MO (A)

Missouri Department of Natural Resources, Missouri State Museum, Jefferson City MO (M)

Missouri Historical Society, Saint Louis MO (M)

Missouri Southern State University, Dept of Art, Joplin MO (S)

Missouri State Museum, see Missouri Department of Natural Resources, Jefferson City MO

Missouri State University, Dept of Art & Design, Springfield MO (S)

Missouri Western State College, Gallery 206 Foyer Gallery, Saint Joseph MO (M)

Missouri Western State University, Art Dept, Saint Joseph MO (S)

Arthur Roy Mitchell, Museum of Western Art, Trinidad CO (M)

Mitchell Community College, Visual Art Dept, Statesville NC (S)

Elizabeth Myers Mitchell Art Gallery, see St John's College, Annapolis MD

Mobile Museum of Art, Mobile AL (M,L)

Modern Art Museum, Fort Worth TX (M)

Modesto Junior College, Arts Humanities & Communications Division, Modesto CA (S)

Moffatt-Ladd House, see The National Society of The Colonial Dames of America in the State of New Hampshire, Portsmouth NH

Mohave Museum of History & Arts, Kingman AZ (M)

Mohawk Valley Community College, Utica NY (S)

Mohawk Valley Heritage Association, Inc, Walter Elwood Museum, Amsterdam NY (M)

Momenta Art, Brooklyn NY (M)

Moncur Gallery, Boissevain MB (M)

MonDak Heritage Center, History Library, Sidney MT (M)

Monhegan Museum, Monhegan ME (M)

Monmouth College, Dept of Art, Monmouth IL (S)

Monmouth Museum & Cultural Center, Lincroft NJ (M)

Monmouth University, Dept of Art & Design, West Long Branch NJ (S)

Monroe Center for the Arts, see Lexington Friends of the Arts, Inc, Lexington MA

Monroe Community College, Art Dept, Rochester NY (S)

Monroe County Community College, Fine Arts Council, Monroe MI (A)

Monroe County Community College, Humanities Division, Monroe MI (S)

Monroe County Historical Association, Elizabeth D Walters Library, Stroudsburg PA (M)

James Monroe Memorial Library, see James Monroe, Fredericksburg VA

James Monroe House, see Arts Club of Washington, Washington DC

James Monroe, Fredericksburg VA (M,L)

Montalvo Center for the Arts, Saratoga CA (A)

Montana Historical Society, Helena MT (A,L)

Montana State University at Billings, Northcutt Steele Gallery, Billings MT (M)

Montana State University-Billings, Art Dept, Billings MT (S)

Montana State University-Northern, Humanities & Social Sciences, Havre MT (S)

Montclair Art Museum, Montclair NJ (M,L)

Montclair Art Museum, Yard School of Art, Montclair NJ (S)

Montclair State University, Art Galleries, Upper Montclair NJ (M,L)

Montclair State University, Fine Arts Dept, Upper Montclair NJ (S)

Monterey History & Art Association, Monterey CA (A,M,L)

Monterey Museum of Art Association, Monterey Museum of Art, Monterey CA (A)

Monterey Peninsula College, Art Dept, Monterey CA (S)

Monterey Public Library, Art & Architecture Dept, Monterey CA (L)

Montgomery College, Dept of Art, Rockville MD (S)

Montgomery County Community College, Art Center, Blue Bell PA (S)

Montgomery Gallery, see The Pomona College, Claremont CA

Montgomery Museum of Fine Arts, Montgomery AL (M,L)

Robert & Mary Montgomery Armory Art Center, West Palm Beach FL (M)

Monticello, see Thomas Jefferson, Charlottesville VA

Montpelier Arts Center, see Maryland-National Capital Park & Planning Commission, Laurel MD

Montreal Museum of Fine Arts, Montreal PQ (M,L)

Montserrat College of Art, Beverly MA (S)

Moody County Historical Society, Flandreau SD (A)

Sarah Moody Gallery of Art, see University of Alabama, Tuscaloosa AL

Moon Gallery, see Berry College, Mount Berry GA

Moore College of Art & Design, Philadelphia PA (S)

Moore College of Art & Design, The Galleries at Moore, Philadelphia PA (M,L)

Moose Jaw Art Museum, Inc, Art & History Museum, Moose Jaw SK (M)

Moravian College, Dept of Art, Bethlehem PA (S)

Moravian College, Payne Gallery, Bethlehem PA (M)

Moravian Historical Society, Whitefield House Museum, Nazareth PA (M)

Moreau Galleries, see Saint Mary's College, Notre Dame IN

Morehead State University, Art Dept, Morehead KY (S)

Morehead State University, Kentucky Folk Art Center, Morehead KY (M)

Morgan County Foundation, Inc, Madison-Morgan Cultural Center, Madison GA (M)

Pierpont Morgan, New York NY (L)

Morgan State University, Dept of Art, Baltimore MD (S)

Morikami Museum & Japanese Gardens, see Palm Beach County Parks & Recreation Department, Delray Beach FL

Morlan Gallery, see Transylvania University, Lexington KY

Morningside College, Art Dept, Sioux City IA (S)

Morris Communications Co. LLC, Corporate Collection, Augusta GA (C)

Morris-Jumel Mansion, Inc, New York NY (M)

Morris Library, see Southern Illinois University Carbondale, Carbondale IL

Morris Museum, Morristown NJ (M)

Morris Museum of Art, Augusta GA (M)

Charles Morse, Charles Hosmer Morse Museum of American Art, Winter Park FL (M)

Mortensen Library, see University of Hartford, West Hartford CT

Moss-Thorns Gallery of Arts, see Fort Hays State University, Hays KS

Motlow State Community College, Art Dept, Tullahoma TN (S)

Mott Community College, Liberal Arts & Sciences, Flint MI (S)

Mount Allison University, Dept of Fine Arts, Sackville NB (S)

Mount Allison University, Owens Art Gallery, Sackville NB (M)

Mount Angel Abbey Library, Saint Benedict OR (L)

Mount Clare Museum House, see National Society of Colonial Dames of America in the State of Maryland, Baltimore MD

National Hall of Fame for Famous American Indians, Anadarko OK (M)
National Heritage Museum, Lexington MA (M)
National Infantry Museum, Fort Benning GA (M)
National Institute of Art & Disabilities (NIAD), Florence Ludins-Katz Gallery, Richmond CA (A)
National League of American Pen Women, Washington DC (O)
National Museum of African Art, see Smithsonian Institution, Washington DC
National Museum of Ceramic Art & Glass, Baltimore MD (M)
National Museum of Racing & Hall of Fame, see National Museum of Racing, Saratoga Springs NY
National Museum of Racing, National Museum of Racing & Hall of Fame, Saratoga Springs NY (M,L)
National Museum of the American Indian, George Gustav Heye Center, New York NY (M)
National Museum of Wildlife Art, Jackson WY (M,L)
National Museum of Women in the Arts, Washington DC (M,L)
National Museum of Woodcarving, see Gloridale Partnership, Custer SD
National Native American Co-Operative, North America Indian Information & Trade Center, Tucson AZ (A)
National Oil & Acrylic Painters Society, Osage Beach MO (O)
National Park Community College Library, Hot Springs AR (L)
The National Park Service, United States Department of the Interior, Statue of Liberty National Monument & The Ellis Island Immigration Museum, New York NY (M)
National Park Service, Hubbell Trading Post National Historic Site, Ganado AZ (M)
National Park Service, Weir Farm National Historic Site, Wilton CT (M)
National Portrait Gallery, Washington DC (M,L)
National Road-Zane Grey Museum, see Ohio Historical Society, Columbus OH
National Sculpture Society, New York NY (O,L)
The National Shrine of the North American Martyrs, Auriesville NY (M)
National Society Daughters of the American Revolution, see DAR Museum, Washington DC
National Society of Colonial Dames of America in the State of Maryland, Mount Clare Museum House, Baltimore MD (M,L)
National Society of Mural Painters, Inc, New York NY (O)
National Society of Painters in Casein & Acrylic, Inc, Whitehall PA (O)
National Society of the Colonial Dames of America in The Commonwealth of Virginia, Wilton House Museum, Richmond VA (M)
The National Society of The Colonial Dames of America in the State of New Hampshire, Moffatt-Ladd House, Portsmouth NH (A)
National Trust for Historic Preservation, Washington DC (M)
National Trust for Historic Preservation, Chesterwood Estate & Museum, Stockbridge MA (M,L)
The National Trust for Historic Preservation, Lyndhurst, Tarrytown NY (M)
National Trust for Historic Preservation, Shadows-on-the-Teche, New Iberia LA (M)
National Watercolor Society, San Pedro CA (O)
Natural Heritage Trust, see New York Office of Parks, Recreation & Historic Preservation, Albany NY
Natural History Museum of Los Angeles County, Los Angeles CA (M,L)
Navajo Nation Library System, Window Rock AZ (L)
Navajo Nation, Navajo Nation Museum, Window Rock AZ (M)
Naval Historical Center, The Navy Museum, Washington DC (M)
Naval War College Museum, Newport RI (M)
Navarro College, Art Dept, Corsicana TX (S)
Navarro College, Gaston T Gooch Library & Learning Resource Center, Corsicana TX (L)
The Navy Museum, see Naval Historical Center, Washington DC
Nazareth College of Rochester, Art Dept, Rochester NY (S)
NCCU Art Museum, see North Carolina Central University, Durham NC
Nebraska Game and Parks Commission, Arbor Lodge State Historical Park & Morton Mansion, Nebraska City NE (M)

Nebraska State Capitol, Lincoln NE (M)
Nebraska Wesleyan University, Art Dept, Lincoln NE (S)
Nebraska Wesleyan University, Elder Gallery, Lincoln NE (M)
Neiderlander Research Library, see Amherst Museum, Amherst NY
Nelson-Atkins Museum of Art, Kansas City MO (M,L)
Bjarne Ness Gallery at Bear Creek Hall, see SVACA - Sheyenne Valley Arts & Crafts Association, Fort Ransom ND
Neuberger Museum of Art, see State University of New York at Purchase, Purchase NY
Nevada Museum of Art, Reno NV (M,L)
Nevada Northern Railway Museum, Ely NV (M)
Neville Public Museum, Green Bay WI (M,L)
George P Nevitt Library, see Paine Art Center & Gardens, Oshkosh WI
Newark Museum Association, The Newark Museum, Newark NJ (M)
Newark Public Library, Reference, Newark NJ (L)
New Arts Program, Inc, NAP Museum, Gallery, Resource Library, Kutztown PA (M)
New Bedford Free Public Library, Art Dept, New Bedford MA (L)
New Bedford Whaling Museum, see Old Dartmouth Historical Society, New Bedford MA
Newberry College, Dept of Art, Newberry SC (S)
Newberry Library, Chicago IL (L)
New Britain Museum of American Art, New Britain CT (M)
New Brunswick Arts Council Inc, Saint John NB (A)
New Brunswick College of Craft & Design, Fredericton NB (A,L)
New Brunswick College of Craft & Design, Fredericton NB (S)
New Brunswick Museum, Saint John NB (M,L)
Newburyport Maritime Society, Custom House Maritime Museum, Newburyport MA (M)
New Canaan Historical Society, New Canaan CT (M)
New Canaan Library, H. Pelham Curtis Gallery, New Canaan CT (L)
New College of the University of South Florida, Fine Arts Dept, Humanities Division, Sarasota FL (S)
New England Center for Contemporary Art, Brooklyn CT (M)
New England College, Art & Art History, Henniker NH (S)
New England Maple Museum, Pittsford VT (M)
The New England Museum of Telephony, Inc., The Telephone Museum, Ellsworth ME (M)
The New England School of Art & Design at Suffolk University, Boston MA (S)
New England School of Art & Design Library, see Suffolk University, Boston MA
New England Watercolor Society, Boston MA (O)
New Hampshire Antiquarian Society, Hopkinton NH (M)
New Hampshire Art Association, Inc, Boscawen NH (A)
New Hampshire Historical Society, Museum of New Hampshire History, Concord NH (A,L)
New Hampshire Institute of Art, Manchester NH (M)
New Hampshire Institute of Art, Manchester NH (S)
New Haven Colony Historical Society, New Haven CT (A,L)
New Haven Paint & Clay Club, Inc, New Haven CT (A)
Newhouse Center for Contemporary Art, see Snug Harbor Cultural Center, Staten Island NY
New Image Art, Los Angeles CA (M)
New Jersey City University, Courtney Art Gallery & Lemmerman Gallery, Jersey City NJ (M)
New Jersey Historical Society, Newark NJ (M,L)
New Jersey Institute of Technology, Architecture Library, Newark NJ (L)
New Jersey State Museum, Fine Art Bureau, Trenton NJ (M)
New Jersey Summer Arts Institute, see Institute for Arts & Humanities Education, New Brunswick NJ
New Jersey Watercolor Society, Parsippany NJ (A)
New Langton Arts, San Francisco CA (M)
New London County Historical Society, Shaw - Perkins Mansion, New London CT (A)
New Mexico Art League, Gallery & School, Albuquerque NM (A)
New Mexico Highlands University, Dept of Communications & Fine Arts, Las Vegas NM (S)
New Mexico Highlands University, The Fine Arts Gallery, Las Vegas NM (M)

New Mexico Junior College, Arts & Sciences, Hobbs NM (S)
New Mexico State University, Art Dept, Las Cruces NM (S)
New Mexico State University, Art Gallery, Las Cruces NM (M)
New Orleans Academy of Fine Arts, Academy Gallery, New Orleans LA (M)
New Orleans GlassWorks Gallery & Printmaking Studio, New Orleans ArtWorks Gallery, New Orleans LA (M)
New Orleans Museum of Art, New Orleans LA (M,L)
Newport Art Museum, Newport RI (M)
Newport Art Museum School, Newport RI (S)
Newport Historical Society & Museum of Newport History, Newport RI (A,L)
New Rochelle Art Association, see New Rochelle Public Library, New Rochelle NY
New Rochelle Public Library, Art Section, New Rochelle NY (L,A)
New School University, Adult Education Division, New York NY (S)
Newton History Museum at the Jackson Homestead, Newton MA (M,L)
New Visions Gallery, Inc, Marshfield WI (M)
New World Art Center, T F Chen Cultural Center, New York NY (M)
New World School of the Arts, Miami FL (S)
New World School of the Arts, Gallery, Miami FL (M)
New York Academy of Art, Graduate School of Figurative Art, New York NY (S)
New York Artists Equity Association, Inc, New York NY (A)
New York City Technical College of the City University of New York, Dept of Advertising Design & Graphic Arts, Brooklyn NY (S)
New York City Technical College, Ursula C Schwerin Library, Brooklyn NY (L)
New York Foundation for the Arts, New York NY (L)
New York Historical Society, New York NY (A,L)
New York Institute of Photography, New York NY (S)
New York Institute of Technology, Fine Arts Dept, Old Westbury NY (S)
New York Institute of Technology, Gallery, Old Westbury NY (M,L)
The New York Kunsthalle Library, New York NY (L)
New York Office of Parks, Recreation & Historic Preservation, Natural Heritage Trust, Albany NY (A)
The New York Public Library for the Performing Arts, see The New York Public Library, New York NY
The New York Public Library, Humanities Department, New York NY (L,M)
New York School of Interior Design, New York NY (S)
New York School of Interior Design, New York School of Interior Design Library, New York NY (L)
New York Society of Architects, New York NY (A)
New York Society of Women Artists, Inc, Westport CT (A)
New York State College of Ceramics at Alfred University, Scholes Library of Ceramics, Alfred NY (L)
New York State College of Ceramics at Alfred University, School of Art & Design, Alfred NY (S)
New York State Library, Manuscripts & Special Collections, Albany NY (L)
New York State Military Museum and Veterans Research Center, Saratoga Springs NY (M)
New York State Museum, Albany NY (M)
New York State Office of Parks, Recreation & Historical Preservation, Mills Mansion State Historical Site, Staatsburg NY (M)
New York State Office of Parks, Recreation and Historic Preservation, Bureau of Historic Sites, Waterford NY (A)
New York State Office of Parks Recreation & Historic Preservation, John Jay Homestead State Historic Site, Katonah NY (M)
New York Studio School of Drawing, Painting & Sculpture, New York NY (S)
New York Studio School of Drawing, Painting & Sculpture, Gallery, New York NY (M,L)
New York University, Institute of Fine Arts, New York NY (S)
New Zone Virtual Gallery, Eugene OR (M)
Nexus Foundation for Today's Art, Philadelphia PA (M)
Elisabet Ney, Austin TX (M,L)
Niagara Artists' Company, Saint Catharines ON (M)
Niagara County Community College, Art Gallery, Sanborn NY (M)

Niagara County Community College, Fine Arts Division, Sanborn NY (S)

Niagara University, Castellani Art Museum, Niagara NY (M)

Niagara University, Fine Arts Dept, Niagara Falls NY (S)

Nicholls State University, Dept of Art, Thibodaux LA (S)

Nichols House Museum, Inc, Boston MA (M)

The Nickle Arts Museum, see University of Calgary, Calgary AB

Nicolaysen Art Museum & Discovery Center, Childrens Discovery Center, Casper WY (M,L)

The Nippon Club, the Nippon Gallery, New York NY (M)

Noah Webster House, Inc, Noah Webster House, West Hartford CT (M)

Nobles County Art Center Gallery, Worthington MN (A)

The John A Noble, Staten Island NY (M)

Isamu Noguchi Garden Museum, see Isamu Noguchi, Long Island City NY

Isamu Noguchi, Isamu Noguchi Garden Museum, Long Island City NY (M)

Harry Nohr Art Gallery, see University of Wisconsin - Platteville, Platteville WI

No Man's Land Historical Society Museum, Goodwell OK (M)

Nordstrand Visual Arts Gallery, see Wayne State College, Wayne NE

Norfolk Historical Society Inc, Museum, Norfolk CT (M)

Norfolk State University, Fine Arts Dept, Norfolk VA (S)

Norick Art Center, see Oklahoma City University, Oklahoma City OK

Normandale Community College, Art Dept, Bloomington MN (S)

Norman Rockwell Museum, Rutland VT (M)

Norman Rockwell Museum, Stockbridge MA (M,L)

North America Indian Information & Trade Center, see National Native American Co-Operative, Tucson AZ

Northampton Community College, Art Dept, Bethlehem PA (S)

North Arkansas Community-Technical College, Art Dept, Harrison AR (S)

North Canton Public Library, The Little Art Gallery, North Canton OH (L)

North Carolina Agricultural & Technical State University, Visual Arts Dept, Greensboro NC (S)

North Carolina Central University, Art Dept, Durham NC (S)

North Carolina Central University, NCCU Art Museum, Durham NC (M)

North Carolina Museum of Art, Raleigh NC (M,L)

North Carolina Museums Council, Raleigh NC (A)

North Carolina Nature Artists Association (NCNAA), Cary NC (M)

North Carolina State University at Raleigh, School of Design, Raleigh NC (S)

North Carolina State University, Harrye Lyons Design Library, Raleigh NC (L,M)

North Carolina Wesleyan College, Dept of Visual & Performing Arts, Rocky Mount NC (S)

North Central College, Dept of Art, Naperville IL (S)

North Central College, Oesterle Library, Naperville IL (L)

North Central Michigan College, Art Dept, Petoskey MI (S)

North Central Texas College, Division of Communications & Fine Arts, Gainesville TX (S)

North Central Texas College, Library, Gainesville TX (L)

North Central Washington Museum, Wenatchee Valley Museum & Cultural Center, Wenatchee WA (M)

North Country Museum of Arts, Park Rapids MN (M)

Northcutt Steele Gallery, see Montana State University at Billings, Billings MT

North Dakota Museum of Art, Grand Forks ND (M)

North Dakota State College of Science, Dept of Graphic Arts, Wahpeton ND (S)

North Dakota State University, Division of Fine Arts, Fargo ND (S)

North Dakota State University, Memorial Union Gallery, Fargo ND (M)

Northeast Community College, Dept of Liberal Arts, Norfolk NE (S)

Northeast Document Conservation Center, Inc, Andover MA (A)

Northeastern Illinois University, Art Dept, Chicago IL (S)

Northeastern Illinois University, Gallery, Chicago IL (M)

Northeastern Junior College, Art Department, Sterling CO (S)

Northeastern Nevada Museum, Elko NV (M,L)

Northeastern Oklahoma A & M College, Art Dept, Miami OK (S)

Northeastern State University, College of Arts & Letters, Tahlequah OK (S)

Northeastern University, Dept of Art & Architecture, Boston MA (S)

Northeast Louisiana Children's Museum, Monroe LA (M)

Northeast Mississippi Junior College, Art Dept, Booneville MS (S)

Northeast Ohio Areawide Coordinating Agency (NOACA), Information Resource Center, Cleveland OH (L)

Northern Arizona University, Art Museum & Galleries, Flagstaff AZ (M)

Northern Arizona University, Museum Faculty of Fine Art, Flagstaff AZ (S)

Northern Galleries, see Northern State University, Aberdeen SD

Northern Illinois University, Art Gallery in Chicago, Chicago IL (M)

Northern Illinois University, NIU Art Museum, De Kalb IL (M,L)

Northern Illinois University, School of Art, De Kalb IL (S)

Northern Kentucky University, Highland Heights KY (M)

Northern Kentucky University, Art Dept, Highland Heights KY (S)

Northern Lights Art Gallery, see Mayville State University, Mayville ND

Northern Maine Museum of Science, Presque Isle ME (M)

Northern Michigan University Art Museum, Marquette MI (M)

Northern Michigan University, Dept of Art & Design, Marquette MI (S)

Northern State University, Art Dept, Aberdeen SD (S)

Northern State University, Northern Galleries, Aberdeen SD (M)

Northern Virginia Community College, Art Dept, Annandale VA (S)

Northern Virginia Fine Arts Association, The Athenaeum, Alexandria VA (A)

Northfield Arts Guild, Northfield MN (A)

North Florida Community College, Dept Humanities & Art, Madison FL (S)

North Georgia College & State University, Fine Arts Dept, Dahlonega GA (S)

North Hennepin Community College, Art Dept, Brooklyn Park MN (S)

North Hennepin Community College, Art Gallery, Brooklyn Park MN (M)

North Idaho College, Art Dept, Coeur D'Alene ID (S)

North Iowa Area Community College, Dept of Art, Mason City IA (S)

Northland Pioneer College, Art Dept, Holbrook AZ (S)

North Park University, Art Dept, Chicago IL (S)

North Park University, Carlson Tower Gallery, Chicago IL (M)

Northport-East Northport Public Library, Northport NY (L)

North Seattle Community College, Art Dept, Seattle WA (S)

North Shore Art League, Winnetka IL (S)

North Shore Art League, Winnetka IL (A)

North Shore Arts Association, Inc, Gloucester MA (A)

North Tonawanda History Museum, North Tonawanda NY (M)

North View Gallery, see Portland Community College, Portland OR

Northwest Art Center, see Minot State University, Minot ND

Northwest Community College, Dept of Art, Powell WY (S)

Northwestern College, Art Dept, Orange City CA (S)

Northwestern College, Te Paske Gallery, Orange City IA (M)

Northwestern Connecticut Community College, Fine Arts Dept, Winsted CT (S)

Northwestern Michigan College, Art Dept, Traverse City MI (S)

Northwestern Michigan College, Dennos Museum Center, Traverse City MI (M)

Northwestern State University of Louisiana, School of Creative & Performing Arts - Dept of Fine & Graphic Arts, Natchitoches LA (S)

Northwest Missouri State University, DeLuce Art Gallery, Maryville MO (M)

Northwest Missouri State University, Dept of Art, Maryville MO (S)

Northwest Museum of Arts & Culture, see Eastern Washington State Historical Society, Spokane WA

Northwest Nazarene College, Art Dept, Nampa ID (S)

Northwest Pastel Society (NPS), Kirkland WA (A)

Northwest Watercolor Society, Renton WA (A)

Northwood University, Alden B Dow Creativity Center, Midland MI (S)

Northwood University, Jeannette Hare Art Gallery, West Palm Beach FL (M)

Norton Museum of Art, West Palm Beach FL (M)

Norwich University, Dept of Architecture and Art, Northfield VT (S)

Nossi College of Art, Goodlettsville TN (S)

Notre Dame de Namur University, Wiegand Gallery, Belmont CA (S)

Nova Scotia Association of Architects, Halifax NS (A)

Nova Scotia Centre for Craft & Design, Mary E Black Gallery, Halifax NS (M)

Nova Scotia College of Art & Design, Halifax NS (S)

Nova Scotia College of Art and Design, Anna Leonowens Gallery, Halifax NS (M,L)

Nova Scotia Museum, Maritime Museum of the Atlantic, Halifax NS (M)

Noyes & Read Gallery/Herndon Gallery, see Antioch College, Yellow Springs OH

Noyes Art Gallery, Lincoln NE (M)

The Noyes Museum of Art, Oceanville NJ (M,L)

Nutana Collegiate Institute, Memorial Library and Art Gallery, Saskatoon SK (L)

Oakland City University, Division of Fine Arts, Oakland City IN (S)

Oakland Community College, Art Dept, Farmington Hills MI (S)

Oakland Museum of California, Art Dept, Oakland CA (M,L)

Oakland Public Library, Art, Music & Recreation Section, Oakland CA (L)

Oakland University Art Gallery, see Oakland University, Rochester MI

Oakland University, Dept of Art & Art History, Rochester MI (S)

Oakland University, Oakland University Art Gallery, Rochester MI (M)

Oak Ridge Art Center, Oak Ridge TN (A,L)

Oakton Community College, Language Humanities & Art Divisions, Des Plaines IL (S)

Oakville Galleries, Oakville ON (M)

Oatlands Plantation, Leesburg VA (M)

Oberlin College, Allen Memorial Art Museum, Oberlin OH (M,L)

Oberlin College, Dept of Art, Oberlin OH (S)

Occidental College, Dept of Art History & Visual Arts, Los Angeles CA (S)

Occidental College, Weingart Galleries, Los Angeles CA (M)

Ocean City Art Center, Ocean City NJ (A)

Ocean City Arts Center, Ocean City NJ (S)

Ocean County College, Humanities Dept, Toms River NJ (S)

Octagon Center for the Arts, Ames IA (A)

Oesterle Library, see North Central College, Naperville IL

Office of Cultural Affairs of New Mexico, The Governor's Gallery, see Museum of New Mexico, Santa Fe NM

The Ogden Museum of Southern Art, University of New Orleans, New Orleans LA (M)

Ogunquit Museum of American Art, Ogunquit ME (M,L)

O Henry Museum, see City of Austin Parks & Recreation, Austin TX

Ohio Dominican College, Art Dept, Columbus OH (S)

Ohio Historical Society, Columbus OH (A,L)

The Ohio Historical Society, Inc, Campus Martius Museum & Ohio River Museum, Marietta OH (M)

Ohio Historical Society, National Afro American Museum & Cultural Center, Wilberforce OH (M)

Ohio Historical Society, National Road-Zane Grey Museum, Columbus OH (M)

Ohio Northern University, Dept of Art, Ada OH (S)

Ohio University-Chillicothe Campus, Fine Arts & Humanities Division, Chillicothe OH (S)

Ohio University-Eastern Campus, Dept Comparative Arts, Saint Clairsville OH (S)

Ohio University, Kennedy Museum of Art, Athens OH (M,L)

Ohio University, School of Art, Athens OH (S)

Ohio Wesleyan University, Fine Arts Dept, Delaware OH (S)

Ohrmstrom Museum and Gallery, Drummond MT (M)

Ohrstrom Library, see Saint Paul's School, Concord NH

Oil Pastel Association, Stockholm NJ (A)

Ojai Art Center, Ojai CA (A)

Okaloosa-Walton Community College, Division of Humanities, Fine & Performing Arts, Niceville FL (S)

Okefenokee Heritage Center, Inc, Waycross GA (M)

Oklahoma Baptist University, Art Dept, Shawnee OK (S)

Oklahoma Christian University of Science & Arts, Dept of Art & Design, Oklahoma City OK (S)

Oklahoma City Museum of Art, Oklahoma City OK (M,L)

Oklahoma City University, Hulsey Gallery-Norick Art Center, Oklahoma City OK (M,L)

Oklahoma City University, Norick Art Center, Oklahoma City OK (S)

Oklahoma Historical Society, State Museum of History, Oklahoma City OK (M,L)

Oklahoma State University, Art Dept, Stillwater OK (S)

Oklahoma State University, Gardiner Art Gallery, Stillwater OK (M,L)

Oklahoma State University, Graphic Arts Dept, Visual Communications, Okmulgee OK (S)

Olana State Historic Site, Hudson NY (M,L)

Old Academy Library, see Wethersfield Historical Society Inc, Wethersfield CT

Old Barracks Museum, Trenton NJ (M)

Old Capitol Museum of Mississippi History, see Mississippi Department of Archives & History, Jackson MS

Old Castle Museum, see Baker University, Baldwin City KS

Old Colony Historical Society, Museum, Taunton MA (M,L)

Old Dartmouth Historical Society, New Bedford Whaling Museum, New Bedford MA (M,L)

Old Dominion University, Art Dept, Norfolk VA (M,L)

Old Dominion University, Art Dept, Norfolk VA (S)

Old Fort Harrod State Park Mansion Museum, Harrodsburg KY (M)

Old Gaol Museum, see Old York Historical Society, York ME

Old Island Restoration Foundation Inc, Wrecker's Museum - Oldest House, Key West FL (M)

The Old Jail Art Center, Albany TX (M,L)

Old Mill Foundation, California Art Club Gallery, San Marino CA (M,L)

Old Salem Inc, Museum of Early Southern Decorative Arts, Winston-Salem NC (M,L)

Old Slater Mill Association, Slater Mill Historic Site, Pawtucket RI (M)

Old State House, Hartford CT (M)

Old State House Museum, see The Bostonian Society, Boston MA

Old West Museum, Sunset TX (M)

Old York Historical Society, York ME (A,M,L)

Olin Art Gallery, see Kenyon College, Gambier OH

Olin Fine Arts Center Gallery, see Washington & Jefferson College, Washington PA

Olivet College, Armstrong Collection, Olivet MI (M,L)

Olivet College, Art Dept, Olivet MI (S)

Olivet Nazarene University, Dept of Art, Bourbonnais IL (S)

Ollantay Center for the Arts, Jackson Heights NY (A)

Olympic College, Social Sciences & Humanities Di, Bremerton WA (S)

Omaha Childrens Museum, Inc, Omaha NE (M)

Omniplex, Oklahoma City OK (M)

Ontario Association of Art Galleries, Toronto ON (A)

Ontario College of Art & Design, Toronto ON (S)

Ontario College of Art & Design, OCAD Gallery, Toronto ON (M,L)

Ontario Crafts Council, The Craft Gallery, Toronto ON (M,L,A)

Opelousas Museum of Art, Inc (OMA), Opelousas LA (M)

Open Space, Victoria BC (A)

Oral Roberts University, Art Dept, Tulsa OK (S)

Orange Coast College, Division of Fine Arts, Costa Mesa CA (S)

Orange County Community College, Arts & Communication, Middletown NY (S)

Orange County Museum of Art, see Orange County Museum of Art, Newport Beach CA

Orange County Museum of Art, Newport Beach CA (M,L)

Orchard House, see Louisa May Alcott Memorial Association, Concord MA

Order Sons of Italy in America, Garibaldi & Meucci Museum, Staten Island NY (M)

Oregon Center for the Photographic Arts, see Blue Sky Gallery, Portland OR

Oregon College of Art & Craft, Portland OR (S)

Oregon College of Art & Craft, Hoffman Gallery, Portland OR (L)

Oregon Historical Society, Oregon History Center, Portland OR (A,L)

Oregon State University, Dept of Art, Corvallis OR (S)

Oregon Trail Museum Association, Scotts Bluff National Monument, Gering NE (M)

Organization for the Development of Artists, Gallery Connexion, Fredericton NB (M)

Organization of Independent Artists, Inc, New York NY (A)

Organization of Saskatchewan Arts Councils (OSAC), Regina SK (O)

Organization of Saskatchewan Arts Councils (OSAC), Regina SK

Orlando Museum of Art, Orlando FL (M,L)

Orlando Sentinel Library, see Orlando Museum of Art, Orlando FL

Ormond Memorial Art Museum and Gardens, Ormond Beach FL (M)

Lewis J Ort Library, see Frostburg State University, Frostburg MD

Osborne Homestead Museum, Derby CT (M)

Oshkosh Public Museum, Oshkosh WI (M,L)

Otero Junior College, Dept of Arts, La Junta CO (S)

Otis College of Art & Design, Ben Maltz Gallery, Westchester CA (M,L)

Otis College of Art & Design, Fine Arts, Los Angeles CA (S)

Ottawa Public Library, Fine Arts Dept, Ottawa ON (L)

Ottawa University, Dept of Art, Ottawa KS (S)

Otterbein College, Art Dept, Westerville OH (S)

Ouachita Baptist University, Dept of Visual Art, Arkadelphia AR (S)

Our Lady of Elms College, Dept of Fine Arts, Chicopee MA (S)

Our Lady of the Lake University, Dept of Art, San Antonio TX (S)

Owatonna Arts Center, Community Arts Center, Owatonna MN (A,L)

Owens Art Gallery, see Mount Allison University, Sackville NB

Owensboro Museum of Fine Art, Owensboro KY (M,L)

Owen Sound Historical Society, Marine & Rail Heritage Museum, Owen Sound ON (M)

Oysterponds Historical Society, Museum, Orient NY (M)

Ozark Folk Center, Arkansas State Park, Ozark Cultural Resource Center, Mountain View AR (L)

Ozaukee Art Center, see Wisconsin Fine Arts Association, Inc, Cedarburg WI

Pace University, Dyson College of Arts & Sciences, Pleasantville NY (S)

Pace University Gallery, Art Gallery in Choate House, Pleasantville NY (M)

Pace University, Theatre & Fine Arts Dept, New York NY (S)

Pacific - Asia Museum, Pasadena CA (M)

Pacific Grove Art Center, Pacific Grove CA (A)

Pacific Lutheran University, Dept of Art, Tacoma WA (S)

Pacific Northwest College of Art, Portland OR (S)

Pacific Union College, Art Dept, Angwin CA (S)

Pacific University in Oregon, Arts Div, Dept of Art, Forest Grove OR (S)

Packard Library, see Columbus College of Art & Design, Columbus OH

Packwood House Museum, see Fetherston Foundation, Lewisburg PA

Page-Walker Arts & History Center, Cary NC (M)

Paier College of Art, Inc, Hamden CT (S)

Paier College of Art, Inc, Library, Hamden CT (L)

Paine Art Center & Gardens, Oshkosh WI (A,L)

Paint 'N Palette Club, Grant Wood Memorial Park & Gallery, Anamosa IA (A)

Painted Bride Art Center Gallery, Philadelphia PA (M)

Palace of Governors, see Museum of New Mexico, Santa Fe NM

Palette & Chisel Academy of Fine Arts, Chicago IL (M)

Paley Design Center, see Philadelphia University, Philadelphia PA

Palisades Interstate Park Commission, Senate House State Historic Site, Kingston NY (M,L)

Palisades Park Public Library, Palisades Park NJ (L)

Palm Beach Community College, Dept of Art, Lake Worth FL (S)

Palm Beach County Cultural Council, West Palm Beach FL (A)

Palm Beach County Parks & Recreation Department, Morikami Museum & Japanese Gardens, Delray Beach FL (M,L)

Palm Beach Institute of Contemporary Art, Museum of Art, Lake Worth FL (M)

Donald B Palmer Museum, see Springfield Free Public Library, Springfield NJ

Palm Springs Art Museum, Palm Springs CA (M,L)

Palo Alto Art Center, Palo Alto CA (A)

Palo Alto Junior Museum & Zoo, Palo Alto CA (M)

Palomar Community College, Art Dept, San Marcos CA (S)

Palomar Community College, Boehm Gallery, San Marcos CA (M)

Palos Verdes Art Center, Rancho Palos Verdes CA (A)

Panhandle-Plains Historical Society Museum, Canyon TX (M,L)

Paris Gibson Square, Museum of Art, Great Falls MT (M)

Paris Junior College, Art Dept, Paris TX (S)

Parkland College, Art Gallery, Champaign IL (M)

Philip M Park Library, see Jesse Besser, Alpena MI

Park University, Dept of Art & Design, Parkville MO (S)

The Parrish Art Museum, Southampton NY (M)

Parson Fisher House, Jonathan Fisher Memorial, Inc, Blue Hill ME (M)

Parsons School of Design, New York NY (S)

Parsons School of Design, Adam & Sophie Gimbel Design Library, New York NY (L)

The Parthenon, see Board of Parks & Recreation, Nashville TN

Pasadena City College, Art Dept, Pasadena CA (S)

Pasadena City College, Art Gallery, Pasadena CA (M)

Pasadena Historical Museum, Pasadena CA (M)

Pasadena Museum of California Art, Pasadena CA (M)

Pasadena Public Library, Fine Arts Dept, Pasadena CA (L)

Passaic County Community College, Broadway, LRC, and Hamilton Club Galleries, Paterson NJ (M)

Passaic County Community College, Division of Humanities, Paterson NJ (S)

Passaic County Historical Society, Paterson NJ (M,L)

Pastel Society of America, National Arts Club Gallery, New York NY (O)

Pastel Society of Oregon, Roseburg OR (O)

William Paterson University, Ben Shahn Gallery, Wayne NJ (M)

Patterson Homestead, Dayton OH (M)

Patterson Library & Art Gallery, Westfield NY (L)

Patton Museum of Cavalry & Armor, see Cavalry-Armor Foundation, Fort Knox KY

Payette Associates Architects Planners, Library, Boston MA (L)

Payne Gallery, see Moravian College, Bethlehem PA

Peabody Essex Museum, Salem MA (M,L)

Peace College, Art Dept, Raleigh NC (S)

Peace Museum, Chicago IL (M)

Pearl River Community College, Visual Arts, Dept of Fine Arts & Communication, Poplarville MS (S)

Peary-MacMillan Arctic Museum, see Bowdoin College, Brunswick ME

Peel Heritage Complex, see Art Gallery of Peel, Brampton ON

The Peggy Lewis Gallery at the Allied Arts Center, Yakima WA (A,L)

Peirce-Nichols House, see Peabody Essex Museum, Salem MA

Pelham Art Center, Pelham NY (M)

Pemaquid Group of Artists, Pemaquid Art Gallery, Pemaquid Point ME (A)

Pen & Brush, Inc, New York NY (A,L)

Pence Gallery, Davis CA (M)

Penfield Library, see Polk Museum of Art, Lakeland FL

Penfield Library, see State University of New York at Oswego, Oswego NY

Peninsula Fine Arts Center, Newport News VA (A)

Penland School of Crafts, Penland NC (S)

Penn State Harrisburg, School of Humanities, Middletown PA (S)

Pennsylvania Academy of the Fine Arts, Philadelphia PA (M,L,A)

Pennsylvania Academy of the Fine Arts, Philadelphia PA (S)

Pennsylvania College of Technology, Dept. of Communications, Construction and Design, Williamsport PA (S)

Pennsylvania Department of Education, Arts in Education Program, Harrisburg PA (A)

Pennsylvania German Cultural Heritage Center at Kutztown University, Pennsylvania German Heritage Library, Kutztown PA (L)

Pennsylvania German Heritage Library, see Pennsylvania German Cultural Heritage Center at Kutztown University, Kutztown PA

Pennsylvania Historical & Museum Commission, Harrisburg PA (A,M,L)

Pennsylvania School of Art & Design, Lancaster PA (S)

Pennsylvania State University at New Kensington, Depts of Art & Architecture, Upper Burrell PA (S)

Penn Valley Community College, Art Dept, Kansas City MO (S)

Pennypacker Long Island Collection, see East Hampton Library, East Hampton NY

Penobscot Marine Museum, Searsport ME (M,L)

Pensacola Junior College, Dept of Visual Arts, Pensacola FL (S)

Pensacola Junior College, Visual Arts Gallery, Anna Lamar Switzer Center for Visual Arts, Pensacola FL (M)

Pensacola Museum of Art, Pensacola FL (M,L)

People's Gallery, see City of El Paso Museum and Cultural Affairs, El Paso TX

Peoria Art Guild, Peoria IL (A)

Peoria Historical Society, Peoria IL (M)

Pepperdine University, Seaver College, Dept of Art, Malibu CA (S)

Peppers Art Gallery, see University of Redlands, Redlands CA

PepsiCo Inc, Donald M Kendall Sculpture Garden, Purchase NY (C)

Perkins Center for the Arts, Moorestown NJ (M)

Perkinson Gallery, see Millikin University, Decatur IL

Peru State College, Art Dept, Peru NE (S)

Peter Paul Luce Gallery, see Cornell College, Mount Vernon IA

Peters Valley Craft Center, Layton NJ (L)

William Wesley Peters Library, see Frank Lloyd Wright School, Scottsdale AZ

Petro-Canada, Corporate Art Programme, Calgary AB (C)

Petzinger Memorial Library & Earl Rowland Art Library, see The Haggin Museum, Stockton CA

Pewabic Pottery, see Pewabic Society Inc, Detroit MI

Pewabic Society Inc, Pewabic Pottery, Detroit MI (M)

Pfeiffer University, Art Program, Misenheimer NC (S)

Phelps County Historical Society, Nebraska Prairie Museum, Holdrege NE (M,L)

Philadelphia Art Alliance, Philadelphia PA (A)

Philadelphia Art Commission, Philadelphia PA (A)

Philadelphia Colleges of Art & Design, Performing Arts & Media & Communication, see University of the Arts, Philadelphia PA

Philadelphia Community College, Dept of Art, Philadelphia PA (S)

Philadelphia Museum of Art, Philadelphia PA (M,L,A)

Philadelphia Sketch Club, Philadelphia PA (A)

Philadelphia University, Paley Design Center, Philadelphia PA (M)

Philadelphia University, School of Textiles & Materials Technology, Philadelphia PA (S)

Philbrook Museum of Art, Tulsa OK (M,L)

Philip Morris Companies Inc, New York NY (C)

Philipse Manor Hall State Historic Site, Yonkers NY (M)

Phillips Academy, Addison Gallery of American Art, Andover MA (M)

The Phillips Collection, Washington DC (M,L)

Phillips Community College at The University of Arkansas, Dept of English & Fine Arts, Helena AR (S)

Phillips County Museum, Holyoke CO (M)

Phillips Exeter Academy, Lamont Gallery, Exeter NH (M)

The Frank Phillips, Woolaroc Museum, Bartlesville OK (M,L)

Phillips Library, see Peabody Essex Museum, Salem MA

Walter Phillips Gallery, see Banff Centre, Banff AB

Philmont Scout Ranch, Philmont Museum, Cimarron NM (M,L)

Phippen Art Museum, see George Phippen, Prescott AZ

George Phippen, Phippen Art Museum, Prescott AZ (M)

Phoenix Art Museum, Phoenix AZ (M,L)

Phoenix College, Dept of Art & Photography, Phoenix AZ (S)

Phoenix Gallery, New York NY (M)

Photographic Investments Gallery, see Symmes Systems, Atlanta GA

Photographic Resource Center, Boston MA (M)

The Photon League of Holographers, Toronto ON (A)

Piatt Castles, West Liberty OH (M)

Picker Art Gallery, see Colgate University, Hamilton NY

Timothy Pickering Library, see Wenham Museum, Wenham MA

Piedmont Arts Association, Martinsville VA (M)

Piedmont College, Art Dept, Demorest GA (S)

Pierce College, Art Dept, Woodland Hills CA (S)

Pikeville College, Humanities Division, Pikeville KY (S)

Pilchuck Glass School, Seattle WA (S)

Pilgrim Society, Pilgrim Hall Museum, Plymouth MA (M,L)

The Pillsbury Company, Art Collection, Minneapolis MN (C)

Pimeria Alta Historical Society, Nogales AZ (A,L)

Pine Bluff/Jefferson County Historical Museum, Pine Bluff AR (M)

Pine Castle Center of the Arts, Orlando FL (A)

Pine Manor College, Visual Arts Dept, Chestnut Hill MA (S)

Pioneer Daughters Museum, see Fort Totten State Historic Site, Fort Totten ND

Pioneer Florida Museum & Village, see Pioneer Florida Museum Association, Inc, Dade City FL

Pioneer Florida Museum Association, Inc, Pioneer Florida Museum & Village, Dade City FL (L)

Pioneer Historical Museum of South Dakota, Hot Springs SD (M)

Pioneer - Krier Museum, see Clark County Historical Society, Ashland KS

Pioneer Museum of Western Art, see Pioneer Town, Wimberley TX

Pioneer Town, Pioneer Museum of Western Art, Wimberley TX (M)

Pirate-A Contemporary Art Oasis, Denver CO (M)

Pittsburgh Center for the Arts, Pittsburgh PA (A)

Pittsburgh History & Landmarks Foundation, James D Van Trump Library, Pittsburgh PA (L)

Pittsburg State University, Art Dept, Pittsburg KS (S)

Pitzer College, Dept of Art, Claremont CA (S)

Place des Arts at Heritage Square, Coquitlam BC (A)

Plainfield Public Library, Plainfield NJ (L)

Plains Art Museum, Fargo ND (M)

Plains Indians & Pioneers Historical Foundation, Museum & Art Center, Woodward OK (M)

Plainsman Museum, Aurora NE (M)

Planting Fields Foundation, Coe Hall at Planting Fields Arboretum, Oyster Bay NY (L)

Plastic Club, Art Club, Philadelphia PA (A)

Playboy Enterprises, Inc, Chicago IL (C,L)

Plaza de la Raza Cultural Center, Los Angeles CA (A)

Please Touch Museum, Philadelphia PA (M)

Plug In, Institute of Contemporary Art, Winnipeg MB (M)

Plumas County Museum, Quincy CA (M,L)

Helen M Plum, Lombard IL (M)

Plymouth Antiquarian Society, Plymouth MA (A)

Plymouth State College, Art Dept, Plymouth NH (S)

Plymouth State University, Karl Drerup Art Gallery, Plymouth NH (S)

Pocumtuck Valley Memorial Association, Memorial Hall Museum, Deerfield MA (A)

Pointe Claire Cultural Centre, Stewart Hall Art Gallery, Pointe Claire PQ (A)

Point Park College, Performing Arts Dept, Pittsburgh PA (S)

Polish Museum of America, Chicago IL (M,L)

Polk Community College, Art, Letters & Social Sciences, Winter Haven FL (S)

Polk County Heritage Gallery, Heritage Art Gallery, Des Moines IA (M)

Polk Museum of Art, Lakeland FL (M,L)

Polyadam Concrete System Workshops, Ossining NY (S)

Polynesian Cultural Center, Laie HI (A)

Pomona College, Dept of Art & Art History, Claremont CA (S)

The Pomona College, Montgomery Gallery, Claremont CA (M)

Ponca City Art Association, Ponca City OK (A)

Ponca City Cultural Center & Museum, Ponca City OK (M,L)

Ponca City Library, Art Dept, Ponca City OK (L)

Ponce Art Museum, see Museo de Arte de Ponce, Ponce PR

Pope County Historical Society, Pope County Museum, Glenwood MN (M)

Port Angeles Fine Arts Center, Port Angeles WA (M)

Port Chester Public Library, Port Chester NY (L)

Dana Porter Library, see University of Waterloo, Waterloo ON

Porter-Phelps-Huntington Foundation, Inc, Historic House Museum, Hadley MA (M)

Porter Thermometer Museum, Onset MA (M)

Porterville College, Dept of Fine Arts, Porterville CA (S)

Port Huron Museum, Port Huron MI (M)

Portland Art Museum, Portland OR (M,L,A)

Portland Children's Museum, Portland OR (M)

Portland Community College, North View Gallery, Portland OR (M)

Portland Community College, Visual & Performing Arts Division, Portland OR (S)

Portland Harbor Museum, South Portland ME (M)

Portland Museum of Art, Portland ME (M)

Portland Public Library, Art - Audiovisual Dept, Portland ME (L)

Portland State University, Dept of Art, Portland OR (S)

Portraits South, Raleigh NC (A)

Portsmouth Athenaeum, Joseph Copley Research Library, Portsmouth NH (M)

Portsmouth Historical Society, John Paul Jones House, Portsmouth NH (M)

Portsmouth Museums, Courthouse Galleries, Portsmouth VA (M)

Port Washington Public Library, Port Washington NY (L)

Post Memorial Art Reference Library, see Winfred L & Elizabeth C Post, Joplin MO

Winfred L & Elizabeth C Post, Post Memorial Art Reference Library, Joplin MO (L)

Potomac State College, Dept of Art, Keyser WV (S)

Potsdam College of the State University of New York, Roland Gibson Gallery, Potsdam NY (M)

Potsdam Public Museum, Potsdam NY (M)

Alice Powers Art Gallery, see William Bonifas, Escanaba MI

Pownalborough Courthouse, see Lincoln County Historical Association, Inc, Wiscasset ME

Prairie Art Gallery, Grande Prairie AB (M)

Prairie Panorama Museum, see Shorncliffe Park Improvement Assoc, Czar AB

Prairie State College, Art Dept, Chicago Heights IL (S)

Pratt Building (Society Headquarters), see Cohasset Historical Society, Cohasset MA

Pratt Community College, Art Dept, Pratt KS (S)

Enoch Pratt, Baltimore MD (L)

Pratt Fine Arts Center, see City Art Works, Seattle WA

Pratt Fine Arts Center, Gallery, Seattle WA (A)

Pratt Institute, Art & Architecture Dept, Brooklyn NY (L,M)

Pratt Institute, Pratt Manhattan, New York NY (S)

James Prendergast, Jamestown NY (L)

Presbyterian College, Visual & Theater Arts, Clinton SC (S)

Prescott Fine Arts Association, Gallery, Prescott AZ (A)

Presidential Museum, Odessa TX (M,L)

Vincent Price Gallery, see East Los Angeles College, Monterey Park CA

Allen R Priebe Gallery, see University of Wisconsin Oshkosh, Oshkosh WI

Prince Edward Island Museum & Heritage Foundation, Charlottetown PE (A)

Prince George's Community College, Art Dept, Largo MD (S)

Prince George Art Gallery, Prince George BC (M)

Prince Street Gallery, New York NY (M)

Princeton Antiques Bookservice, Art Marketing Reference Library, Atlantic City NJ (L)

Principia College, School of Nations Museum, Elsah IL (M)

The Print Center, Philadelphia PA (O)

Print Club of Albany, Albany NY (A)

Print Club of Cleveland, see Cleveland Museum of Art, Cleveland OH

Print Consortium, Kansas City MO (M)

Print Council of America, Lawrence KS (O)

Printed Matter, Inc, New York NY (C)

Printmaking Council of New Jersey, North Branch NJ (A)
Pro Arts, Oakland CA (M)
Professional Art Dealers Association of Canada, Toronto ON
Promote Art Works Inc (PAWI), Job Readiness in the Arts-Media-Communication, Brooklyn NY (S)
Providence Art Club, Providence RI (A)
Providence Athenaeum, Providence RI (M,L)
Providence College, Art & Art History Dept, Providence RI (S)
Providence Public Library, Art & Music Services, Providence RI (L)
Provincetown Art Association & Museum, Provincetown MA (A,L)
Provincial Archives of Alberta, see Department of Community Development, Edmonton AB
Provincial Museum of Alberta, see Department of Community Development, Edmonton AB
Provincial Museum of Newfoundland & Labrador, Saint John's NF (M,L)
Provisions Library & Gaea Foundation, Washington DC (L)
Prudential Art Program, Newark NJ (C)
PS1 Contemporary Art Center, Long Island City NY (M)
Painting Space 122 Association Inc, New York NY (M)
Public Art Fund, Inc, New York NY (A,L)
Public Art Program, see City of Tampa, Tampa FL
Public Corporation for the Arts, Long Beach CA (A)
Public Library of Charlotte & Mecklenburg County, Charlotte NC (L)
Public Library of Cincinnati & Hamilton County, Art & Music Dept, Cincinnati OH (L)
Public Library of Des Moines, Central Library Information Services, Des Moines IA (L)
Public Museum of Grand Rapids, see City of Grand Rapids Michigan, Grand Rapids MI
Pueblo of Pojoaque, Poeh Museum, Santa Fe NM (A)
Pueblo of San Ildefonso, Maria Martinez Museum, Santa Fe NM (M)
Pump House Center for the Arts, Chillicothe OH (M)
Purdue University, West Lafayette, Patti and Rusty Rueff Department of Visual & Performing Arts, West Lafayette IN (S)
Purdue University Calumet, Dept of Communication & Creative Arts, Hammond IN (S)
Purdue University Calumet, Library Gallery, Hammond IN (M)
Purdue University Galleries, West Lafayette IN (M)
Ross C Purdy Museum of Ceramics, see The American Ceramic Society, Westerville OH
Putnam County Historical Society, Foundry School Museum, Cold Spring NY (M)
Putnam Museum of History and Natural Science, Davenport IA (M,L)
Pyramid Hill Sculpture Park & Museum, Hamilton OH (M)
Quad City Arts Inc, Rock Island IL (A)
Quapaw Quarter Association, Inc, Villa Marre, Little Rock AR (M,L)
Queen's University, Dept of Art, Kingston ON (S)
Queen's University, Agnes Etherington Art Centre, Kingston ON (M,L)
Queensborough Community College, Art Gallery, Bayside NY (M)
Queensborough Community College, Dept of Art & Photography, Bayside NY (S)
Queensborough Community College Library, Kurt R Schmeller Library, Bayside NY (L)
Queens Borough Public Library, Fine Arts & Recreation Division, Jamaica NY (L)
Queens College, City University of New York, Godwin-Ternbach Museum, Flushing NY (M,L)
Queens College, Art Dept, Flushing NY (S)
Queens College, Fine Arts Dept, Charlotte NC (S)
Queens Historical Society, Kingsland Homestead, Flushing NY (A)
The Queens Museum of Art, Flushing NY (M)
Quetico Park, John B Ridley Research Library, Atikokan ON (L)
Quickdraw Animation Society, Calgary AB (O)
Quickdraw Animation Society, Calgary AB
Quincy Art Center, Quincy IL (A)
Quincy College, Art Dept, Quincy MA (S)
Quincy Society of Fine Arts, Quincy IL (A)
Quincy University, Dept of Art, Quincy IL (S)
Quincy University, The Gray Gallery, Quincy IL (M,L)
Radford University, Art Dept, Radford VA (S)
Rahr-West Art Museum, Manitowoc WI (M)

Railroad Museum of Pennsylvania, see Pennsylvania Historical & Museum Commission, Harrisburg PA
Ramapo College of New Jersey, School of Contemporary Arts, Mahwah NJ (S)
Ramsay Museum, Honolulu HI (M)
Randall Junior Museum, San Francisco CA (M)
Jasper Rand Art Museum, see Westfield Athenaeum, Westfield MA
Randolph-Macon College, Dept of the Arts, Ashland VA (S)
Randolph-Macon Woman's College, Dept of Art, Lynchburg VA (S)
Randolph-Macon Woman's College, Maier Museum of Art, Lynchburg VA (M)
Rangeley Lakes Region Logging Museum, Rangeley ME (M)
Rapid City Arts Council, Dahl Arts Center, Rapid City SD (M)
Esther Raushenbush Library, see Sarah Lawrence College Library, Bronxville NY
Ravalli County Museum, Hamilton MT (M)
Rawls Museum Arts, Courtland VA (M)
The Reader's Digest Association Inc, Pleasantville NY (C)
Reading Public Museum, Reading PA (M,L)
Real Art Ways (RAW), Hartford CT (M)
Red Deer & District Museum & Archives, Red Deer AB (M)
Red Deer College, Dept of Visual Arts, Red Deer AB (S)
Redhead Gallery, Toronto ON (M)
Red Hill National Memorial, see Patrick Henry, Brookneal VA
Redington Museum, see Waterville Historical Society, Waterville ME
Redlands Art Association, Redlands Art Association Gallery, Redlands CA (A)
Red River Valley Museum, Vernon TX (M)
Red Rock Museum, see Red Rock State Park, Church Rock NM
Red Rocks Community College, Arts Dept, Lakewood CO (S)
Red Rock State Park, Red Rock Museum, Church Rock NM (M,L)
Redwood Library & Athenaeum, Newport RI (L)
Reed College, Douglas F Cooley Memorial Art Gallery, Portland OR (M)
Reed College, Dept of Art, Portland OR (S)
Martha Stecher Reed Art Library, see Akron Art Museum, Akron OH
Reeves Memorial Library, see Seton Hill College, Greensburg PA
Regina A Quick Center for the Arts, see Saint Bonaventure University, Saint Bonaventure NY
Regina Public Library, Art Dept, Regina SK (L,M)
Regional Arts & Culture Council, Metropolitan Center for Public Arts, Portland OR (A)
Regis College, Dept of Art, Weston MA (S)
Regis College, Carney Gallery, Weston MA (M)
Regis University, Fine Arts Dept, Denver CO (S)
Rehoboth Art League, Inc, Rehoboth Beach DE (S)
Rehoboth Art League, Inc, Rehoboth Beach DE (A)
Reinberger Galleries, see Cleveland Institute of Art, Cleveland OH
Frederic Remington, Ogdensburg NY (M)
Renaissance Center Main Gallery, see Arts Council of Greater Kingsport, Kingsport TN
The Renaissance Society, Chicago IL (A)
Frederic G Renner Memorial Library, see C M Russell, Great Falls MT
Rensselaer County Council for the Arts, The Arts Center of the Capital Region, Troy NY (A)
Rensselaer County Historical Society, Hart-Cluett Mansion, 1827, Troy NY (M,L)
Rensselaer Newman Foundation Chapel & Cultural Center, The Gallery, Troy NY (M)
Renwick Gallery, see Smithsonian American Art Museum, Washington DC
Revelstoke Art Group, Revelstoke BC (A)
The Revolving Museum, Lowell MA (M)
Reynolda House Museum of American Art, Winston Salem NC (M,L)
Rhinelander District Library, Rhinelander WI (L)
Rhode Island College, Art Dept, Providence RI (S)
Rhode Island College, Edward M Bannister Gallery, Providence RI (M)
Rhode Island Historical Society, Providence RI (A,M,L)
Rhode Island School of Design, Providence RI (S)
Rhode Island School of Design, Museum of Art, Providence RI (M,L)

Rhode Island Watercolor Society, Pawtucket RI (A)
Rhodes College, Clough-Hanson Gallery, Memphis TN (M)
Rhodes College, Dept of Art, Memphis TN (S)
Rhys Carpenter Library for Art, Archaeology, Classics & Cities, see Bryn Mawr College, Bryn Mawr PA
Rice University, Dept of Art & Art History, Houston TX (S)
Richard Bland College, Art Dept, Petersburg VA (S)
Richard Gallery & Almond Tea Gallery, Divisions of Studios of Jack Richard, Cuyahoga Falls OH (M,L)
Richardson Memorial Library, see The Saint Louis Art Museum, Saint Louis MO
Sid W Richardson, Sid Richardson Museum, Fort Worth TX (M)
Studios of Jack Richard, Professional School of Painting & Design, Cuyahoga Falls OH (S)
Richard W Bock Sculpture Collection, Almira College House, see Greenville College, Greenville IL
The Richmond Art Center, Richmond CA (A)
Richmond Art Museum, Richmond IN (A,L)
Richmond Arts Centre, Richmond BC (A)
Ricks College, Dept of Art, Rexburg ID (S)
Rider University, Art Gallery, Lawrenceville NJ (M)
Rider University, Dept of Fine Arts, Lawrenceville NJ (S)
Ridgewater College, Art Dept, Willmar MN (S)
John B Ridley Research Library, see Quetico Park, Atikokan ON
Riley County Historical Society, Riley County Historical Museum, Manhattan KS (M,L)
Rinehart School of Sculpture, see Maryland Institute, Baltimore MD
John & Mable Ringling Museum of Art, see Florida State University, Sarasota FL
Ringling School of Art & Design, Sarasota FL (S)
Ringling School of Art & Design, Verman Kimbrough Memorial Library, Sarasota FL (L)
Ringling School of Art & Design, Selby Gallery, Sarasota FL (M)
Ringwood Manor House Museum, Ringwood NJ (M)
Rio Hondo College Art Gallery, Whittier CA (M)
Rio Hondo College, Visual Arts Dept, Whittier CA (S)
Ripon College, Art Dept, Ripon WI (S)
Ripon College Art Gallery, Ripon WI (M)
River Arts Center, see Clinton Art Association, Clinton IA
River Heritage Museum, Paducah KY (M)
Riverside, the Farnsley-Moremen Landing, Louisville KY (M)
Riverside Art Museum, Riverside CA (M,L)
Riverside Community College, Dept of Art & Mass Media, Riverside CA (S)
Riverside County Museum, Edward-Dean Museum & Gardens, Cherry Valley CA (M,L)
Riverside Municipal Museum, Riverside CA (M)
Rivier College, Art Dept, Nashua NH (S)
Roanoke College, Fine Arts Dept-Art, Salem VA (S)
Roberson Museum & Science Center, Binghamton NY (M)
Robert N & Peggy Sears Gallery, see Dixie State College, Saint George UT
Roberts County Museum, Miami TX (M)
Roberts Wesleyan College, Art Dept, Rochester NY (S)
Rowland Evans Robinson, Rokeby Museum, Ferrisburgh VT (A)
Rochester Art Center, Rochester MN (A)
Rochester Community & Technical College, Art Dept, Rochester MN (S)
Rochester Contemporary, Rochester NY (M)
Rochester Historical Society, Rochester NY (A)
Rochester Institute of Technology, Corporate Education & Training, Rochester NY (L)
John D Rockefeller, Jr Library, see Colonial Williamsburg Foundation, Williamsburg VA
Abby Aldrich Rockefeller Folk Art Center, see Colonial Williamsburg Foundation, Williamsburg VA
Abby Aldrich Rockefeller Folk Art Center Library, see Colonial Williamsburg Foundation, Williamsburg VA
M C Rockefeller Arts Center Gallery, see State University of New York College at Fredonia, Fredonia NY
Rockford Art Museum, Rockford IL (A)
Rockford College Art Gallery, Rockford IL (M)
Rockford College, Dept of Fine Arts, Rockford IL (S)
Rock Ford Foundation, Inc, Historic Rock Ford & Kauffman Museum, Lancaster PA (M)
Rockland Center for the Arts, West Nyack NY (M)
Rockland Center for the Arts, West Nyack NY (S)

Rockland Community College, Graphic Arts & Advertising Tech Dept, Suffern NY (S)

Rockport Art Association, Rockport MA (A)

Rock Valley College, Humanities and Fine Arts Division, Rockford IL (S)

The Rockwell Museum of Western Art, Corning NY (M,L)

Rocky Mountain College, Art Dept, Billings MT (S)

Rocky Mountain College of Art & Design, Lakewood CO (S)

Rocky Mountain Museum of Military History, Missoula MT (M)

Rocky Mount Arts Center, Rocky Mount NC (A)

Rocky Reach Dam, see Chelan County Public Utility District, Wenatchee WA

Rodin Museum of Philadelphia, see Philadelphia Museum of Art, Philadelphia PA

Rodman Hall Arts Centre, Saint Catharines ON (A,L)

Nicholas Roerich, New York NY (M)

Lauren Rogers, Laurel MS (M,L)

Millicent Rogers, Taos NM (M,L)

Rogers State College, Art Dept, Claremore OK (S)

Will Rogers Memorial Museum & Birthplace Ranch, Claremore OK (M,L)

Roger Williams University, Architecture Library, Bristol RI (L)

Roger Williams University, Visual Art Dept, Bristol RI (S)

Rogue Community College, Wiseman Gallery - FireHouse Gallery, Grants Pass OR (M)

Rogue Valley Art Association, Rogue Gallery & Art Center, Medford OR (A)

Rokeby Museum, see Rowland Evans Robinson, Ferrisburgh VT

Rollins College, George D & Harriet W Cornell Fine Arts Museum, Winter Park FL (M)

Rollins College, Dept of Art, Main Campus, Winter Park FL (S)

Rome Art & Community Center, Rome NY (A)

Rome Historical Society, Museum & Archives, Rome NY (M,L)

Hugh N Ronald Memorial Gallery, see Jay County Arts Council, Portland IN

Franklin D Roosevelt Museum, see National Archives & Records Administration, Hyde Park NY

Franklin D Roosevelt Library, see National Archives & Records Administration, Hyde Park NY

Roosevelt-Vanderbilt National Historic Sites, Hyde Park NY (M)

The Stephanie Ann Roper Gallery, see Frostburg State University, Frostburg MD

Rose Art Museum, see Brandeis University, Waltham MA

Rose Center & Council for the Arts, Morristown TN (A)

Rosemont College, Art Program, Rosemont PA (S)

Rosemount Museum, Inc, Pueblo CO

The Rosenbach Museum & Library, Philadelphia PA (M)

Rosenberg Gallery, see Goucher College, Baltimore MD

Rosenberg Library, Galveston TX (L)

Rosenthal Art Gallery, see Albertson College of Idaho, Caldwell ID

Rosicrucian Egyptian Museum & Planetarium, Rosicrucian Order, A.M.O.R.C., San Jose CA (M)

Roswell Museum & Art Center, Roswell NM (M,L)

Rothmans, Benson & Hedges, Art Collection, Don Mills ON (C)

Rotunda Gallery, see BRIC - Brooklyn Information & Culture, Brooklyn NY

Round Top Center for the Arts Inc, Arts Gallery, Damariscotta ME (M,L)

Round Top Library, see Round Top Center for the Arts Inc, Damariscotta ME

Rowan Oak, William Faulker's Home, Oxford MS (M)

Rowan University, Dept of Art, Glassboro NJ (S)

Royal Architectural Institute of Canada, Ottawa ON (O,L)

Royal Architectural Institute of Canada, Ottawa ON

Royal Arts Foundation, Belcourt Castle, Newport RI (M)

Royal Canadian Academy of Arts, Toronto ON (O)

Royal Canadian Academy of Arts, Toronto ON

Royal Ontario Museum, Toronto ON (M,L)

Elizabeth Rozier Gallery, see Missouri Department of Natural Resources, Jefferson City MO

R Tait McKenzie Memorial Museum, see Mississippi Valley Conservation Authority, Almonte ON

Rubelle & Norman Schafler Gallery, see Pratt Institute, Brooklyn NY

Ruddell Gallery, see Black Hills State University, Spearfish SD

Ruder Finn Arts & Communications, Inc, New York NY (C)

William F Ruska Library, see Becker College, Worcester MA

C M Russell, Great Falls MT (M,L)

Russell Sage College, Visual & Performing Arts Dept, Troy NY (S)

Rutgers University, Camden, Art Dept, Camden NJ (S)

Rutgers University, Newark, Dept of Visual & Performing Arts, Newark NJ (S)

Rutgers University, Stedman Art Gallery, Camden NJ (M)

Ruthmere Museum, Robert B. Beardsley Arts Reference Library, Elkhart IN (L)

R W Norton Art Foundation, Shreveport LA (M,L)

Ryan Fine Arts Center, see McMurry University, Abilene TX

Ryerson & Burnham Libraries, see The Art Institute of Chicago, Chicago IL

Ryerson University, Ryerson University Library, Toronto ON (L)

Ryerss Victorian Museum & Library, Philadelphia PA (M,L)

Alice C Sabatini Gallery, see Topeka & Shawnee County Public Library, Topeka KS

Arthur M Sackler Gallery, see Smithsonian Institution, Washington DC

Saco Museum, Saco ME (M)

Sacramento City College, Art Dept, Sacramento CA (S)

Sacred Circle Gallery of American Indian Art, Daybreak Star Arts Center, Discovery Park, Seattle WA (M)

Sacred Heart University, Dept of Art, Fairfield CT (S)

Sacred Heart University, Gallery of Contemporary Art, Fairfield CT (M)

Safeco Insurance Company, Art Collection, Seattle WA (C)

Safety Harbor Museum of Regional History, Safety Harbor FL (M)

Sage Junior College of Albany, Dept Visual Arts, Albany NY (S)

Sager Studios, Fort Worth TX (S)

Saginaw Art Museum, Saginaw MI (M)

Saginaw Valley State University, Dept of Art & Design, University Center MI (S)

Saint Ambrose University, Art Dept, Davenport IA (S)

Saint Andrews Presbyterian College, Art Program, Laurinburg NC (S)

Saint Anselm College, Chapel Art Center, Manchester NH (M)

Saint Anselm College, Dept of Fine Arts, Manchester NH (S)

Saint Augustine Art Association Gallery, Saint Augustine FL (A)

Saint Bernard Foundation & Monastery, North Miami Beach FL (M)

Saint Bonaventure University, Regina A Quick Center for the Arts, Saint Bonaventure NY (M)

Saint Clair County Community College, Jack R Hennesey Art Galleries, Port Huron MI (M)

Saint Clair County Community College, Jack R Hennesey Art Dept, Port Huron MI (S)

Saint Cloud State University, Dept of Art, Saint Cloud MN (S)

Saint Edward's University, Fine Arts Exhibit Program, Austin TX (M)

St Francis College, Fine Arts Dept, Loretto PA (S)

St Francis Xavier University, Fine Arts Dept, Antigonish NS (S)

St Genevieve Museum, Sainte Genevieve MO (M)

Saint Gregory's Abbey & University, Mabee-Gerrer Museum of Art, Shawnee OK (M)

Saint Gregory's University, Dept of Art, Shawnee OK (S)

St John's College, Elizabeth Myers Mitchell Art Gallery, Annapolis MD (M)

Saint John's University, Art Dept, Collegeville MN (S)

Saint John's University, Chung-Cheng Art Gallery, Jamaica NY (M)

Saint John's University, Dept of Fine Arts, Jamaica NY (S)

Saint Johnsbury Athenaeum, Saint Johnsbury VT (M)

Saint Joseph's Oratory, Museum, Montreal PQ (M,L)

Saint Joseph's University, Dept of Fine & Performing Arts, Philadelphia PA (S)

St Joseph Art Association, Krasl Art Center, Saint Joseph MI (M)

Saint Joseph College Art Gallery, see Saint Joseph College, West Hartford CT

Saint Joseph College, Dept of Fine Arts, West Hartford CT (S)

Saint Joseph College, Saint Joseph College Art Gallery, West Hartford CT (M)

Saint Joseph Museum, Saint Joseph MO (M,L)

St Lawrence College, Art Gallery, Kingston ON (M)

St Lawrence College, Dept of Graphic Design, Kingston ON (S)

St Lawrence University, Richard F Brush Art Gallery, Canton NY (M)

St Lawrence University, Dept of Fine Arts, Canton NY (S)

The Saint Louis Art Museum, Saint Louis MO (M,L)

Saint Louis Community College at Florissant Valley, Liberal Arts Division, Ferguson MO

Saint Louis Community College at Forest Park, Art Dept, Saint Louis MO (S)

Saint Louis Community College at Meramec, Art Dept, Saint Louis MO (S)

Saint Louis County Historical Society, Duluth MN (M)

Saint Louis Public Library, Saint Louis MO (L)

Saint Louis University, Fine & Performing Arts Dept, Saint Louis MO (S)

Saint Luke's Gallery, see Anna Maria College, Paxton MA

St Martins College, Humanities Dept, Lacey WA (S)

Saint Mary's College, Dept of Art, Notre Dame IN (S)

Saint Mary's College, Moreau Galleries, Notre Dame IN (M)

Saint Mary's College of California, Hearst Art Gallery, Moraga CA (M)

Saint Mary's College of Maryland, Art & Art History Dept, Saint Mary's City MD (S)

St Mary's College of Maryland, The Dwight Frederick Boyden Gallery, Saint Mary City MD (M)

St Mary's Galeria, Orchard Lake MI (M)

Saint Mary's Romanian Orthodox Cathedral, Romanian Ethnic Museum, Cleveland OH (M)

St Mary's University, Art Gallery, Halifax NS (M)

Saint Mary's University, Dept of Fine Arts, San Antonio TX (S)

Saint Mary's University of Minnesota, Art & Design Dept, Winona MN (S)

Saint Mary College, Fine Arts Dept, Leavenworth KS (S)

Saint Mary-of-the-Woods College, Art Dept, Saint Mary of the Woods IN (S)

St Michael's College, Fine Arts Dept, Colchester VT (S)

Saint Norbert College, Div of Humanities & Fine Arts, De Pere WI (S)

Saint Olaf College, Art Dept, Northfield MN (S)

Saint Olaf College, Flaten Art Museum, Northfield MN (M)

Saint Paul's School, Art Center in Hargate, Concord NH (M)

Saint Paul Public Library, Central Adult Public Services, Saint Paul MN (L)

Saint Peter's College, Art Gallery, Jersey City NJ (M)

Saint Peter's College, Fine Arts Dept, Jersey City NJ (S)

Saint Petersburg College, Fine & Applied Arts at Clearwater Campus, Clearwater FL (S)

Saint Thomas Aquinas College, Art Dept, Sparkill NY (S)

St Thomas-Elgin Public Art Centre, Saint Thomas ON (M)

Saint Xavier University, Byrne Memorial Library, Chicago IL (L)

Saint Xavier University, Dept of Art & Design, Chicago IL (S)

Salem Academy & College, Art Dept, Winston-Salem NC (S)

Salem Art Association, Salem OR (A,M,L)

Salem State College, Art Dept, Salem MA (S)

Salina Art Center, Salina KS (M)

Salisbury House Foundation, Des Moines IA (M)

Salisbury State University, Art Dept, Salisbury MD (S)

Salisbury University, Ward Museum of Wildfowl Art, Salisbury MD (M)

Salmagundi Club, New York NY (O,L)

Salt Lake Art Center, Salt Lake City UT (A)

Salt Lake City Public Library, Fine Arts & Audiovisual Dept and Atrium Gallery, Salt Lake City UT (L)

Salt Lake Community College, Graphic Design Dept, Salt Lake City UT (S)

Salve Regina University, Art Dept, Newport RI (S)

Ruth Salyer Library, see Art Institute of Southern California, Laguna Beach CA

Edward & Marthann Samek Art Gallery, see Bucknell University, Lewisburg PA

Samford University, Art Dept, Birmingham AL (S)

Sam Houston State University, Art Dept, Huntsville TX (S)

Philip Samuels Fine Art, see Trova Foundation, Saint Louis MO

San Angelo Art Club, Helen King Kendall Memorial Art Gallery, San Angelo TX (M)

San Angelo Museum of Fine Arts, San Angelo TX (M)

San Antonio Art League, San Antonio Art league Museum, San Antonio TX (A,L)

San Antonio College, Visual Arts & Technology, San Antonio TX (S)

San Antonio Museum of Art, San Antonio TX (M)

San Bernardino Art Association, Inc, Sturges Fine Arts Center, San Bernardino CA (A)

San Bernardino County Museum, Fine Arts Institute, Redlands CA (M)

San Bernardino Valley College, Art Dept, San Bernardino CA (S)

San Carlos Cathedral, Monterey CA (M)

Hazel Sandford Gallery, see Clarion University, Clarion PA

San Diego Mesa College, Fine Arts Dept, San Diego CA (S)

San Diego Museum of Art, San Diego CA (M,L)

San Diego Public Library, Art & Music Section, San Diego CA (L)

San Diego State University, School of Art, Design & Art History, San Diego CA (S)

San Diego State University, University Art Gallery, San Diego CA (M,L)

Sandwich Historical Society, Center Sandwich NH (M)

The Sandwich Historical Society, Inc, Sandwich Glass Museum, Sandwich MA (M,L)

Sandy Bay Historical Society & Museums, Sewall Scripture House-Old Castle, Rockport MA (A)

San Fernando Valley Historical Society, Mission Hills CA (A,L)

San Francisco Art Institute, San Francisco CA (S)

San Francisco Art Institute, Galleries, San Francisco CA (M,L)

San Francisco Arts Commission, Gallery & Slide Registry, San Francisco CA (M)

San Francisco Arts Education Project, San Francisco CA (A)

San Francisco Camerawork, San Francisco CA (A)

San Francisco City & County Art Commission, San Francisco CA (A)

San Francisco Craft & Folk Art Museum, San Francisco CA (M)

San Francisco Maritime National Historical Park, Maritime Museum, San Francisco CA (M,L)

San Francisco Museum of Modern Art, San Francisco CA (M,L)

San Francisco Public Library, Art & Music Center, San Francisco CA (L)

San Francisco State University, Art Dept, San Francisco CA (S)

San Francisco State University, J Paul Leonard Library, San Francisco CA (L)

Sangre de Cristo Arts & Conference Center, Pueblo CO (A)

Sanguinetti House Museum & Garden, see Arizona Historical Society-Yuma, Yuma AZ

San Jacinto College-North, Art Dept, Houston TX (S)

San Jacinto Junior College, Division of Fine Arts, Pasadena TX (S)

San Joaquin Delta College, Art Dept, Stockton CA (S)

San Jose City College, School of Fine Arts, San Jose CA (S)

San Jose Institute of Contemporary Art, San Jose CA (M)

San Jose Museum of Art, San Jose CA (M,L)

San Jose State University, School of Art & Design, San Jose CA (S)

San Juan College, Art Dept, Farmington NM (S)

San Luis Obispo Art Center, San Luis Obispo CA (A)

Santa Ana College, Art Dept, Santa Ana CA (S)

Santa Ana College, Art Gallery, Santa Ana CA (M)

Santa Barbara City College, Fine Arts Dept, Santa Barbara CA (S)

Santa Barbara Contemporary Arts Forum, Santa Barbara CA (A)

Santa Barbara Museum of Art, Santa Barbara CA (M,L)

Santa Barbara Public Central Library, Faulkner Memorial Art Wing, Santa Barbara CA (L)

Santa Clara University, Dept of Art & Art History, Santa Clara CA (S)

Santa Clara University, de Saisset Museum, Santa Clara CA (M)

Santa Cruz Art League, Inc, Center for the Arts, Santa Cruz CA (A)

Santa Fe, Santa Fe NM (M)

Santa Fe Arts Institute, Santa Fe NM (S)

Santa Monica College, Pete & Susan Barrett Art Gallery, Santa Monica CA (M)

Santa Monica Museum of Art, Santa Monica CA (M)

Santarella Museum & Gardens, Tyringham MA (M)

Santa Rosa Junior College, Art Dept, Santa Rosa CA (S)

Santuario de Guadalupe, see Guadalupe Historic Foundation, Santa Fe NM

Allen Sapp, North Battleford SK (M)

Sarah Lawrence College, Dept of Art History, Bronxville NY (S)

Sarah Lawrence College Library, Esther Raushenbush Library, Bronxville NY (L)

Saratoga County Historical Society, Brookside Museum, Ballston Spa NY (A)

Saskatchewan Arts Board, Regina SK (O)

Saskatchewan Arts Board, Regina SK

Saskatchewan Association of Architects, Saskatoon SK (A)

Saskatchewan Craft Council & Gallery, Saskatoon SK (M)

Savannah College of Art And Design, Georgia Artists Registry, Atlanta GA (L)

Savannah State University, Dept of Fine Arts, Savannah GA (S)

Saving & Preserving Arts & Cultural Environments, Los Angeles CA (A,L)

Sawhill Gallery, see James Madison University, Harrisonburg VA

Sawtooth Center for Visual Art, Winston-Salem NC (S)

Sawyer Library, see Williams College, Williamstown MA

Schenectady County Historical Society, Museum of Schenectady History, Schenectady NY (A)

Schenectady Museum Planetarium & Visitors Center, Schenectady NY (M,L)

Mary R Schiff Library, see Cincinnati Museum Association and Art Academy of Cincinnati, Cincinnati OH

Schingoethe Center for Native American Cultures, see Aurora University, Aurora IL

Scholes Library of Ceramics, see New York State College of Ceramics at Alfred University, Alfred NY

Maude Schollenberger Memorial Library, see Wichita Center for the Arts, Wichita KS

Schomburg Center for Research in Black Culture, see The New York Public Library, New York NY

Schoolcraft College, Dept of Art & Design, Livonia MI (S)

School of American Research, Indian Arts Research Center, Santa Fe NM (M)

School of Art Institute of Chicago, Video Data Bank, Chicago IL (A)

School of Fashion Design, Boston MA (S)

School of Nations Museum, see Principia College, Elsah IL

School of the Art Institute of Chicago, Chicago IL (S)

School of the Art Institute of Chicago, John M Flaxman Library, Chicago IL (L)

School of the Museum of Fine Arts, Boston MA (S)

School of Visual Arts, New York NY (S)

School of Visual Arts, Visual Arts Museum, New York NY (M)

Schuler School of Fine Arts, Baltimore MD (S)

Schumacher Gallery, see Capital University, Columbus OH

Schuyler-Hamilton House, Morristown NJ (M)

Schuyler Mansion State Historic Site, Albany NY (M)

Schweinfurth Memorial Art Center, Auburn NY (M)

Ursula C Schwerin Library, see New York City Technical College, Brooklyn NY

Science Fiction Museum and Hall of Fame, Seattle WA (M)

Scott Explorers Library, see Martin and Osa Johnson, Chanute KS

Scotts Bluff National Monument, see Oregon Trail Museum Association, Gering NE

Scottsdale Artists' League, Chandler AZ (A)

Scottsdale Artists' School, Scottsdale AZ (S)

Scottsdale Artists' School Library, Scottsdale AZ (L)

Scottsdale Cultural Council, Scottsdale AZ (M)

The Charles H Scott Gallery, see Emily Carr Institute of Art & Design, Vancouver BC

Lucy Scribner Library, see Skidmore College, Saratoga Springs NY

Scripps College, Clark Humanities Museum, Claremont CA (M)

Scripps College, Millard Sheets Art Center-Williamson Gallery, Claremont CA (S)

Scripps College, Ruth Chandler Williamson Gallery, Claremont CA (S)

William E Scripture Memorial Library, see Rome Historical Society, Rome NY

Sculptor's Society of Canada, Toronto ON (O)

Sculptor's Society of Canada, Canadian Sculpture Centre, Toronto ON (O)

Sculptors Guild, Inc, New York NY (O)

Sculpture Space, Inc, Utica NY (O)

Sea Cliff Village Museum, Sea Cliff NY (M)

Searchlight Historic Museum & Mining Park, Searchlight NV (M)

Seaton Library, see Riley County Historical Society, Manhattan KS

Seaton Memorial Library, see Philmont Scout Ranch, Cimarron NM

Seattle Art Museum, Seattle WA (M,L)

Seattle Central Community College, Humanities - Social Sciences Division, Seattle WA (S)

Seattle Pacific University, Art Dept, Seattle WA (S)

Seattle Public Library, Fine & Performing Arts Dept, Seattle WA (L)

Seattle University, Fine Arts Dept, Division of Art, Seattle WA (S)

Second Street Gallery, Charlottesville VA (M)

See Science Center, Manchester NH (M)

Segue Foundation, Reading Room-Archive, New York NY (A)

Seigfred Gallery, see Ohio University, Athens OH

Selby Gallery, see Ringling School of Art & Design, Sarasota FL

Self Help Graphics, Los Angeles CA (A)

Selsor Art Gallery, see Martin and Osa Johnson, Chanute KS

Marcella Sembrich Opera Museum, see Marcella Sembrich Memorial Association Inc, Bolton Landing NY

Senate House State Historic Site, see Palisades Interstate Park Commission, Kingston NY

Seneca Falls Historical Society Museum, Seneca Falls NY (M)

Seneca-Iroquois National Museum, Salamanca NY (M)

Seton Hall University, South Orange NJ (M,L)

Seton Hall University, College of Arts & Sciences, South Orange NJ (S)

Seton Hill College, Reeves Memorial Library, Greensburg PA (L)

Seton Hill University, Art Program, Greensburg PA (S)

1708 Gallery, Richmond VA (M)

Sewall Scripture House-Old Castle, see Sandy Bay Historical Society & Museums, Rockport MA

Seward County Community College, Art Dept, Liberal KS (S)

SFA Galleries, see Stephen F Austin State University, Nacogdoches TX

Shadows-on-the-Teche, see National Trust for Historic Preservation, New Iberia LA

Ben Shahn Gallery, see William Paterson University, Wayne NJ

The Shaker Library, see United Society of Shakers, New Glocester ME

Shaker Museum, see United Society of Shakers, New Glocester ME

Shaker Museum & Library, Old Chatham NY (M,L)

Shaker Village of Pleasant Hill, Harrodsburg KY (M)

Martin C Shallenberger Art Library, see Sweet Briar College, Sweet Briar VA

Sharon Arts Center, School Arts & Crafts, Peterborough NH (S)

Sharon Arts Center, Sharon Arts Center Exhibition Gallery, Sharon NH (M)

Ella Sharp, Jackson MI (M)

Shasta College, Art Dept, Arts, Communication & Education Division, Redding CA (S)

Shasta Historical Society Research Library, see Turtle Bay Exploration Park, Redding CA

Lemuel Shattuck Memorial Library, see Bisbee Arts & Humanities Council, Bisbee AZ

Shawinigan Art Center, Shawinigan PQ (A)

Sheboygan Arts Foundation, Inc, John Michael Kohler Arts Center, Sheboygan WI (A)

Sheean Library, see Illinois Wesleyan University, Bloomington IL

Millard Sheets Library, see Otis College of Art & Design, Westchester CA

Shelburne Museum, Museum, Shelburne VT (M,L)

Sun Gallery, Hayward CA (M)

Sun Valley Center for the Arts & Humanities, Dept of Fine Art, Sun Valley ID (S)

SUNY Plattsburgh Art Museum, see State University of New York, Plattsburgh NY

Suomi International College of Art & Design, Fine Arts Dept, Hancock MI (S)

Supreme Court of the United States, Washington DC (M)

Surface Design Association, Inc, Sebastopol CA (A)

Surrey Art Gallery, Surrey BC (M,L)

Surry Community College, Art Dept, Dobson NC (S)

Susquehanna Art Museum, Home of Doshi Center for Contemporary Art, Harrisburg PA (A)

Susquehanna University, Lore Degenstein Gallery, Selinsgrove PA (M)

SVACA - Sheyenne Valley Arts & Crafts Association, Bjarne Ness Gallery at Bear Creek Hall, Fort Ransom ND (M,L)

Swarthmore College, Dept of Art, Swarthmore PA (S)

Swarthmore College, Friends Historical Library of Swarthmore College, Swarthmore PA (L)

Swedish-American Museum Association of Chicago, Chicago IL (M)

Sweet Briar College, Art History Dept, Sweet Briar VA (S)

Sweet Briar College, Martin C Shallenberger Art Library, Sweet Briar VA (L,M)

Sweetwater County Library System and School District #1, Community Fine Arts Center, Rock Springs WY (A)

Swiss Institute, New York NY (M)

Switzerland County Historical Society Inc, Life on the Ohio: River History Museum, Vevay IN (M)

Swope Art Museum, Terre Haute IN (M,L)

Swords Into Plowshares Peace Center & Gallery, see Central United Methodist Church, Detroit MI

Sylvia Plotkin Museum of Temple Beth Israel, Scottsdale AZ (M)

Symmes Systems, Photographic Investments Gallery, Atlanta GA (M)

Synagogue Art & Architectural Library, see Union of American Hebrew Congregations, New York NY

Tabor Opera House Museum, Leadville CO (M)

Tacoma Art Museum, Tacoma WA (M,L)

Tacoma Community College, Art Dept, Tacoma WA (S)

Tacoma Public Library, Handforth Gallery, Tacoma WA (L)

Taft College, Art Department, Taft CA (S)

Taft Museum of Art, see Cincinnati Institute of Fine Arts, Cincinnati OH

Taipei Economic & Cultural Office, Chinese Information & Culture Center Library, New York NY (L)

Tallahassee Community College, Art Dept, Tallahassee FL (S)

Tallahassee Museum of History & Natural Science, Tallahassee FL (M,L)

Taller Puertorriqueno Inc, Lorenzo Homar Gallery, Philadelphia PA (A)

Tampa Museum of Art, Tampa FL (M,L)

Taos Center for the Arts, Stables Gallery, Taos NM (A)

Taos, Taos NM (M,L)

Taos Public Library, Fine Art Collection, Taos NM (L)

Tarble Arts Center, see Eastern Illinois University, Charleston IL

Tarrant County Junior College, Art Dept, Hurst TX (S)

Tattoo Art Museum, San Francisco CA (M)

Edward P Taylor Research Library & Archives, see Art Gallery of Ontario, Toronto ON

Elizabeth Prewitt Taylor Memorial Library, see Arkansas Arts Center, Little Rock AR

Taylor University, Chronicle-Tribune Art Gallery, Upland IN (M)

Taylor University, Visual Art Dept, Upland IN (S)

Technical University of Nova Scotia, Faculty of Architecture, Halifax NS (S)

Telfair Museum of Art, Savannah GA (M,L)

Temiskaming Art Gallery, Haileybury ON (M)

Temple College, Art Dept, Temple TX (S)

Temple Gallery, see Temple University, Tyler School of Art, Elkins Park PA

The Temple-Tifereth Israel, The Temple Museum of Religious Art, Beachwood OH (M,L)

Temple University, Tyler School of Art, Temple Gallery, Elkins Park PA (M)

Temple University, Tyler School of Art, Elkins Park PA (S)

Tennent Art Foundation Gallery, Honolulu HI (M,L)

Tennessee Historical Society, Nashville TN (A)

Tennessee State Museum, Nashville TN (M,L)

Tennessee Valley Art Association, Tuscumbia AL (A)

1078 Gallery, Chico CA (M)

Te Paske Gallery, see Northwestern College, Orange City IA

Terrain Gallery, see Aesthetic Realism Foundation, New York NY

Terra Museum of American Art, Chicago IL (M,L)

Sandor Teszler Library Gallery, see Wofford College, Spartanburg SC

Texarkana College, Art Dept, Texarkana TX (S)

Texas A&M University, Art Gallery, Kingsville TX (M)

Texas A&M University, College of Architecture, College Station TX (S)

Texas A&M University Commerce, Dept of Art, Commerce TX (S)

Texas A&M University - Commerce, University Gallery, Commerce TX (M)

Texas A&M University-Corpus Christi, Weil Art Gallery, Corpus Christi TX (M)

Texas A&M University-Kingsville, Art Dept, Kingsville TX (S)

Texas A&M University, J Wayne Stark University Center Galleries, College Station TX (M,A)

Texas Christian University, Dept of Art & Art History, Fort Worth TX (S)

Texas Christian University, University Art Gallery, Fort Worth TX (M)

Texas Fine Arts Association, Jones Center For Contemporary Art, Austin TX (A)

Texas Lutheran University, Dept of Visual Arts, Seguin TX (S)

Texas Ranger Hall of Fame & Museum, Waco TX (M,L)

Texas Ranger Research Center, see Texas Ranger Hall of Fame & Museum, Waco TX

Texas Southern University, College of Liberal Arts & Behavorial Sciences, Houston TX (S)

Texas State University - San Marcos, Dept of Art and Design, San Marcos TX (S)

Texas Tech University, Dept of Art, Lubbock TX (S)

Texas Tech University, Museum of Texas Tech University, Lubbock TX (M,L)

Texas Wesleyan University, Dept of Art, Fort Worth TX (S)

Texas Woman's University Art Gallery, Denton TX (M)

Texas Woman's University, School of the Arts, Dept of Visual Arts, Denton TX (S)

Textile Conservation Workshop Inc, South Salem NY (A)

The Textile Museum, Washington DC (M,L)

Textile Museum of Canada, Toronto ON (M)

Thames Art Gallery, see Chatham Cultural Centre, Chatham ON

Thiel College, Dept of Art, Greenville PA (S)

Thiel College, Weyers-Sampson Art Gallery, Greenville PA (M)

Thomas Center Galleries - Cultural Affairs, see City of Gainesville, Gainesville FL

Thomas College Art Gallery, Waterville ME (M,L)

Thomas More College, Art Dept, Crestview Hills KY (S)

Thomas More College, TM Gallery, Crestview KY (M)

Thomas University, Humanities Division, Thomasville GA (S)

Nancy Thompson Library, see Kean University, Union NJ

Thompson-Pell Research Center, see Fort Ticonderoga Association, Ticonderoga NY

Tom Thomson, Owen Sound ON (M,L)

Thorne-Sagendorph Art Gallery, see Keene State College, Keene NH

Thornhill Art Gallery, see Avila College, Kansas City MO

Harry Thornton Library, see Pensacola Museum of Art, Pensacola FL

Three Forks Area Historical Society, Headwaters Heritage Museum, Three Forks MT (M)

3M, Art Collection, Saint Paul MN (C)

Tidewater Community College, Visual Arts Center, Portsmouth VA (S)

Timken Museum of Art, San Diego CA (M)

Tinkertown Museum, Sandia Park NM (M)

Tippecanoe County Historical Association, Museum, Lafayette IN (M,L)

TM Gallery, see Thomas More College, Crestview KY

Tohono Chul Park, Tucson AZ (M)

Toledo Artists' Club, Toledo OH (A)

Toledo Museum of Art, Toledo OH (M,L)

Melvin B Tolson Black Heritage Center, see Langston University, Langston OK

Topeka & Shawnee County Public Library, Alice C Sabatini Gallery, Topeka KS (M)

Toronto Art Therapy Institute, Toronto ON (S)

Toronto Dominion Bank, Toronto ON (C)

Toronto Public Library Board, Toronto ON (L)

Toronto School of Art, Toronto ON (S)

Toronto Sculpture Garden, Toronto ON (M)

Touchstone Center for Crafts, Farmington PA (A)

Touchstone Center for Crafts, Farmington PA (S)

Tower Fine Arts Gallery, see State University of New York, College at Brockport, Brockport NY

Town of Cummington Historical Commission, Kingman Tavern Historical Museum, Cummington MA (M)

Towson State University, Dept of Art, Towson MD (S)

Tradd Street Press, Elizabeth O'Neill Verner Studio Museum, Charleston SC (M)

Margaret Fort Trahern Gallery, see Austin Peay State University, Clarksville TN

Transylvania University, Morlan Gallery, Lexington KY (M)

Transylvania University, Studio Arts Dept, Lexington KY (S)

Treasure Valley Community College, Art Dept, Ontario OR (S)

Tremont Theatre & Gallery, see Chinese Culture Institute of the International Society, Boston MA

Trenton City Museum, Trenton NJ (M)

Scott Andrew Trexler II Library, see Lehigh County Historical Society, Allentown PA

Triangle Gallery of Visual Arts, see Calgary Contemporary Arts Society, Calgary AB

Tri-County Arts Council, Inc, Cobleskill NY (A)

Trinity College, Austin Arts Center, Widener Gallery, Hartford CT (M)

Trinity College, Dept of Studio Arts, Hartford CT (S)

Trinity College, Fine Arts Program, Washington DC (S)

Trinity College Library, Washington DC (L)

Trinity University, Dept of Art, San Antonio TX (S)

Triton College, School of Arts & Sciences, River Grove IL (S)

Triton Museum of Art, Santa Clara CA (M,L)

The Trout Gallery, see Dickinson College, Carlisle PA

Trova Foundation, Philip Samuels Fine Art, Saint Louis MO (M)

Troy State University, Dept of Art & Classics, Troy AL (S)

Truett-McConnell College, Fine Arts Dept & Arts Dept, Cleveland GA (S)

Harry S Truman Museum and Library, see National Archives & Records Administration, Independence MO

Truman State University, Art Dept, Kirksville MO (S)

Truro Center for the Arts at Castle Hill, Inc, Truro MA (S)

Trust Authority, Museum of the Great Plains, Lawton OK (M,L)

The Trustees of Reservations, The Mission House, Ipswich MA (M)

Sojourner Truth Library, see State University of New York at New Paltz, New Paltz NY

Tryon Palace Historic Sites & Gardens, New Bern NC (M,L)

T T Wentworth, Jr Florida State Museum & Historic Pensacola Village, see West Florida Historic Preservation, Inc, Pensacola FL

Tubac Center of the Arts, Tubac AZ (M,L)

Tubman African American Museum, Macon GA (M,L)

Tucson Museum of Artand Historic Block, Tucson AZ (M,L)

Tucson Museum of Art School, Tucson AZ (S)

Tufts University, Dept of Art & Art History, Medford MA (S)

Tufts University, Tufts University Art Gallery, Medford MA (M)

Tulsa Community College, Art Dept, Tulsa OK (S)

Tunxis Community Technical College, Graphic Design Dept, Farmington CT (S)

Turner House Museum, Hattiesburg MS (M)

The Turner Museum, Sarasota FL (M)

Turtle Bay Exploration Park, Redding CA (M,L)

Turtle Mountain Chippewa Historical Society, Turtle Mountain Heritage Center, Belcourt ND (M,L)

Turtle Mountain Heritage Center, see Turtle Mountain Chippewa Historical Society, Belcourt ND

Tusculum College, Fine Arts Dept, Greeneville TN (S)

Tuskegee Institute National Historic Site, George Washington Carver & The Oaks, Tuskegee Institute AL (M)

Tuskegee University, Liberal Arts & Education, Tuskegee AL (S)

University of Maine, Museum of Art, Bangor ME (M)

University of Manitoba, Winnipeg MB (S)

University of Manitoba, Gallery One One One, Winnipeg MB (M,L)

University of Mary Hardin-Baylor, School of Fine Arts, Belton TX (S)

University of Maryland, Baltimore County, Imaging, Digital & Visual Arts Dept, Baltimore MD (S)

University of Maryland, College Park, The Art Gallery, College Park MD (M,L)

University of Maryland Eastern Shore, Art & Technology Dept, Princess Anne MD (S)

University of Massachusetts - Boston, Art Dept, Boston MA (S)

University of Massachusetts Dartmouth, College of Visual & Performing Arts, North Dartmouth MA (S)

University of Massachusetts Lowell, Dept of Art, Lowell MA (S)

University of Memphis, Art Dept, Memphis TN (S)

University of Miami, Dept of Art & Art History, Coral Gables FL (S)

University of Miami, Lowe Art Museum, Coral Gables FL (M)

University of Minnesota, Duluth, Art Dept, Duluth MN (S)

University of Minnesota, Duluth, Tweed Museum of Art, Duluth MN (M)

University of Minnesota, Morris, Humanities Division, Morris MN (S)

University of Minnesota, Dept of Design, Housing & Apparel, Saint Paul MN (S)

University of Minnesota, Paul Whitney Larson Gallery, Saint Paul MN (M)

University of Minnesota, Katherine E Nash Gallery, Minneapolis MN (M)

University of Mississippi, Department of Art, University MS (S)

University of Mississippi, University Museum, Oxford MS (M,L)

University of Missouri, Saint Louis, Dept of Art & Art History, Saint Louis MO (S)

University of Missouri, Saint Louis, Gallery 210, Saint Louis MO (M)

University of Missouri-Kansas City, Dept of Art & Art History, Kansas City MO (S)

University of Missouri-Kansas City, Gallery of Art, Kansas City MO (M)

University of Montana, Dept of Art, Missoula MT (S)

The University of Montana - Western, Art Gallery Museum, Dillon MT (M,L)

University of Montevallo, College of Fine Arts, Montevallo AL (S)

University of Montevallo, The Gallery, Montevallo AL (M)

University of Nebraska, Kearney, Dept of Art & Art History, Kearney NE (S)

University of Nebraska at Omaha, Art Gallery, Omaha NE (M)

University of Nebraska at Omaha, Dept of Art & Art History, Omaha NE (S)

University of Nebraska-Lincoln, Dept of Art & Art History, Lincoln NE (S)

University of Nebraska-Lincoln, Great Plains Art Collection, Lincoln NE (M)

University of Nevada, Las Vegas, Donna Beam Fine Art Gallery, Las Vegas NV (M)

University of Nevada, Las Vegas, Dept of Art, Las Vegas NV (S)

University of Nevada, Reno, Art Dept, Reno NV (S)

University of Nevada, Reno, Sheppard Fine Arts Gallery, Reno NV (M)

University of New Brunswick, Art Centre, Fredericton NB (M)

University of New Brunswick, Art Education Section, Fredericton NB (S)

University of New Hampshire, Dept of Arts & Art History, Durham NH (S)

University of New Hampshire, The Art Gallery, Durham NH (M,L)

University of New Haven, Dept of Visual & Performing Arts & Philosophy, West Haven CT (S)

University of New Mexico, The Harwood Museum of Art, Taos NM (M)

University of New Orleans, Fine Arts Gallery, New Orleans LA (M,L)

University of New Orleans-Lake Front, Dept of Fine Arts, New Orleans LA (S)

University of North Alabama, Dept of Art, Florence AL (S)

University of North Carolina at Asheville, Dept of Art, Asheville NC (S)

University of North Carolina at Chapel Hill, Art Dept, Chapel Hill NC (S)

University of North Carolina at Charlotte, Dept Art, Charlotte NC (S)

University of North Carolina at Greensboro, Art Dept, Greensboro NC (S)

University of North Carolina at Greensboro, Weatherspoon Art Museum, Greensboro NC (M)

University of North Carolina at Pembroke, Art Dept, Pembroke NC (S)

University of North Carolina at Wilmington, Dept of Fine Arts - Division of Art, Wilmington NC (S)

University of North Dakota, Art Department, Grand Forks ND (S)

University of North Dakota, Hughes Fine Arts Center-Col Eugene Myers Art Gallery, Grand Forks ND (M)

University of Northern Colorado, School of Art and Design, John Mariani Gallery, Greeley CO (M)

University of Northern Colorado, Dept of Visual Arts, Greeley CO (S)

University of Northern Iowa, Dept of Art, Cedar Falls IA (S)

University of Northern Iowa, UNI Gallery of Art, Cedar Falls IA (M,L)

University of North Florida, Dept of Communications & Visual Arts, Jacksonville FL (S)

University of North Texas, Art Gallery, Denton TX (M,L)

University of North Texas Health Science Center Forth Worth, Atrium Gallery, Fort Worth TX (M)

University of North Texas, School of Visual Arts, Denton TX (S)

University of Notre Dame, Dept of Art, Art History & Design, Notre Dame IN (S)

University of Oklahoma, School of Art, Norman OK (S)

University of Oregon, Dept of Fine & Applied Arts, Eugene OR (S)

University of Pennsylvania, Arthur Ross Gallery, Philadelphia PA (M)

University of Pennsylvania, Graduate School of Fine Arts, Philadelphia PA (S)

University of Pennsylvania, Institute of Contemporary Art, Philadelphia PA (A)

University of Pittsburgh, Pittsburgh PA (S)

University of Pittsburgh at Johnstown, Dept of Fine Arts, Johnstown PA (S)

University of Portland, Buckley Center Gallery, Portland OR (M)

University of Portland, Wilson W Clark Memorial Library, Portland OR (L)

University of Puerto Rico, Mayaguez, Dept of Humanities, College of Arts & Sciences, Mayaguez PR (S)

University of Puerto Rico, Dept of Fine Arts, Rio Piedras PR (S)

University of Puerto Rico, Museum of Anthropology, History & Art, Rio Piedras PR (M)

University of Puget Sound, Art Dept, Tacoma WA (S)

University of Puget Sound, Kittredge Art Gallery, Tacoma WA (M)

University of Quebec, Trois Rivieres, Fine Arts Section, Trois Rivieres PQ (S)

University of Redlands, Dept of Art, Redlands CA (S)

University of Redlands, Peppers Art Gallery, Redlands CA (M)

University of Regina, Regina SK (M,L)

University of Regina, Regina SK (S)

University of Rhode Island, Fine Arts Center Galleries, Kingston RI (S)

University of Richmond, Dept of Art and Art History, Richmond VA (S)

University of Richmond, University Museums, Richmond VA (M)

University of Rochester, Dept of Art & Art History, Rochester NY (S)

University of Saint Francis, Fine Arts Dept, Joliet IL (S)

University of Saint Francis, School of Creative Arts, Fort Wayne IN (S)

University of Saint Francis, John Weatherhead Gallery, Fort Wayne IN (M)

University of Saint Thomas, Art Dept, Houston TX (S)

University of Saint Thomas, Dept of Art History, Saint Paul MN (S)

University of San Diego, Art Dept, San Diego CA (S)

University of San Diego, Founders' Gallery, San Diego CA (M)

University of Saskatchewan, Dept of Art & Art History, Saskatoon SK (S)

University of Saskatchewan, Gordon Snelgrove Art Gallery, Saskatoon SK (M)

University of Science & Arts of Oklahoma, Arts Dept, Chickasha OK (S)

University of Sherbrooke, Art Gallery, Sherbrooke PQ (M)

University of Sioux Falls, Dept of Art, Sioux Falls SD (S)

University of South Alabama, Dept of Art & Art History, Mobile AL (S)

University of South Alabama, Ethnic American Slide Library, Mobile AL (L)

University of South Carolina at Aiken, Dept of Visual & Performing Arts, Aiken SC (S)

University of South Carolina at Spartanburg, Art Gallery, Spartanburg SC (M)

University of South Carolina, Dept of Art, Columbia SC (S)

University of South Carolina, McKissick Museum, Columbia SC (M,L)

University of South Dakota Art Galleries, Vermillion SD (M)

University of South Dakota, Department of Art, College of Fine Arts, Vermillion SD (S)

University of Southern California/The Gamble House, Greene & Greene Archives, San Marino CA (L)

University of Southern Colorado, College of Liberal & Fine Arts, Pueblo CO (S)

University of Southern Colorado, Dept of Art, Pueblo CO (S)

University of Southern Indiana, Art Dept, Evansville IN (S)

University of Southern Indiana, New Harmony Gallery of Contemporary Art, New Harmony IN (M)

University of Southern Maine, Art Dept, Gorham ME (S)

University of Southern Mississippi, Dept of Art & Design, Hattiesburg MS (S)

University of Southern Mississippi, McCain Library & Archives, Hattiesburg MS (L)

University of South Florida, Contemporary Art Museum, Tampa FL (M,L)

University of South Florida, School of Art & Art History, Tampa FL (S)

University of Tampa, Dept of Art, Tampa FL (S)

University of Tennessee, Knoxville, School of Art, Knoxville TN (S)

University of Tennessee at Chattanooga, Cress Gallery of Art, Chattanooga TN (M)

University of Tennessee at Chattanooga, Dept of Art, Chattanooga TN (S)

University of Texas at Arlington, Dept of Art & Art History, Arlington TX (S)

University of Texas at Arlington, Gallery at UTA, Arlington TX (M)

University of Texas at Brownsville & Texas Southmost College, Fine Arts Dept, Brownsville TX (S)

University of Texas at El Paso, Dept of Art, El Paso TX (S)

University of Texas at El Paso, Glass Gallery and Main Gallery, El Paso TX (M)

University of Texas at San Antonio, Dept of Art & Art History, San Antonio TX (S)

The University of Texas at San Antonio, UTSA's Institute of Texan Cultures, San Antonio TX (M)

University of Texas at Tyler, Deptartment of Art, School of Visual & Performing Arts, Tyler TX (S)

University of Texas of Permian Basin, Dept of Art, Odessa TX (S)

University of Texas Pan American, Art Dept, Edinburg TX (S)

University of the Arts, Philadelphia Colleges of Art & Design, Performing Arts & Media & Communication, Philadelphia PA (S)

The University of the Arts, Rosenwald-Wolf Gallery, Philadelphia PA (M,L)

University of the District of Columbia, Dept of Mass Media, Visual & Performing Arts, Washington DC (S)

University of the Incarnate Word, Art Dept, San Antonio TX (S)

University of the Ozarks, Dept of Art, Clarksville AR (S)

University of the Pacific, College of the Pacific, Dept of Art & Art History, Stockton CA (S)

University of the Pacific, Jeannette Powell Art Center, Stockton CA (M)

University of the South, Dept of Fine Arts, Sewanee TN (S)

University of the South, Jessie Ball duPont Library, Sewanee TN (L)

Thomas J Walsh Art Gallery, see Fairfield University, Fairfield CT

Walters Art Museum, Baltimore MD (M,L)

Elizabeth D Walters Library, see Monroe County Historical Association, Stroudsburg PA

Walt Whitman Cultural Arts Center, Inc, Camden NJ (A)

Clarence Ward Art Library, see Oberlin College, Oberlin OH

Mamie McFaddin Ward, Beaumont TX (M,L)

Ward Museum of Wildfowl Art, see Salisbury University, Salisbury MD

Ward-Nasse Gallery, New York NY (M)

Warner Bros Studio Research Library, Burbank CA (L)

Warner House Association, MacPheadris-Warner House, Portsmouth NH (M)

Wartburg College, Dept of Art, Waverly IA (S)

Warther Museum Inc, Dover OH (M)

Warwick Museum of Art, Warwick RI (M)

Washburn University, Mulvane Art Museum, Topeka KS (M)

Washburn University of Topeka, Dept of Art, Topeka KS (S)

Washington & Jefferson College, Art Dept, Washington PA (S)

Washington & Jefferson College, Olin Fine Arts Center Gallery, Washington PA (M)

Washington and Lee University, Div of Art, Lexington VA (S)

Washington Art Association, Washington Depot CT (A,L)

Washington County Museum of Fine Arts, Hagerstown MD (M,L)

George Washington, Alexandria VA (M)

Harold Washington Library Center, see Chicago Public Library, Chicago IL

Washington Pavilion of Arts & Science, Visual Arts Center, Sioux Falls SD (M,L)

Washington Sculptors Group, Washington DC (O)

Washington State History Museum, Tacoma WA (M,L)

Washington State University, Fine Arts Dept, Pullman WA (S)

Washington State University, Museum of Art, Pullman WA (M)

Wassenberg Art Center, Van Wert OH (M)

Watercolor Society of Alabama, Birmingham AL (M)

Waterfront Museum, Brooklyn NY (M)

Waterloo Center of the Arts, Waterloo IA (M)

George Waters Gallery, see Elmira College, Elmira NY

Waterville Historical Society, Redington Museum, Waterville ME (M)

Waterworks Visual Arts Center, Salisbury NC (M)

Watkins Institute, College of Art & Design, Nashville TN (A,L)

Watkins Institute, College of Art & Design, Nashville TN (S)

Homer Watson, Kitchener ON (M)

Thomas J Watson Library, see The Metropolitan Museum of Art, New York NY

Waubonsee Community College, Art Dept, Sugar Grove IL (S)

Wave Hill, Bronx NY (M)

Wayland Baptist University, Dept of Art, Plainview TX (S)

Wayne Art Center, Wayne PA (A)

Wayne Art Center, Wayne PA (S)

Wayne Center for the Arts, Wooster OH (M)

Wayne Community College, Liberal Arts Dept, Goldsboro NC (S)

Wayne County Historical Society, Honesdale PA (M)

Wayne County Historical Society, Museum, Honesdale PA (M)

Waynesburg College, Dept of Fine Arts, Waynesburg PA (S)

Wayne State College, Dept Art & Design, Wayne NE (S)

Wayne State College, Nordstrand Visual Arts Gallery, Wayne NE (M)

Wayne State University, Dept of Art & Art History, Detroit MI (S)

Weatherford College, Dept of Speech Fine Arts, Weatherford TX (S)

John Weatherhead Gallery, see University of Saint Francis, Fort Wayne IN

Weatherspoon Art Museum, see University of North Carolina at Greensboro, Greensboro NC

Weber State University, Dept of Visual Arts, Ogden UT (S)

Noah Webster House, see Noah Webster House, Inc, West Hartford CT

Webster Parish Library, Minden LA (L)

Webster University, Art Dept, Webster Groves MO (S)

Webster University, Cecille R Hunt Gallery, Saint Louis MO (M,L)

Wedell-Williams Memorial Aviation Museum, Patterson LA (M)

The Weeks, see Jamestown Community College, Jamestown NY

Paul Weigel Library of Architecture Planning & Design, see Kansas State University, Manhattan KS

Weil Art Gallery, see Texas A&M University-Corpus Christi, Corpus Christi TX

Jane L & Robert H Weiner Judaic Museum, see Jewish Community Center of Greater Washington, Rockville MD

Weingart Galleries, see Occidental College, Los Angeles CA

Weir Farm National Historic Site, see National Park Service, Wilton CT

Frederick R Weisman, Los Angeles CA (A)

Wellesley College, Art Dept, Wellesley MA (S)

Wellfleet Historical Society Museum, Wellfleet MA (M)

Wells College, Dept of Art, Aurora NY (S)

Wells Fargo & Co, History Museum, Los Angeles CA (C)

Wells Fargo, Minneapolis, Arts Program, Minneapolis MN (C)

Wells Fargo Bank, Wells Fargo History Museum, San Francisco CA (C)

Wells Fargo, Wells Fargo History Museum Phx, Phoenix AZ (C)

Wenatchee Valley College, Art Dept, Wenatchee WA (S)

Wenatchee Valley College, Gallery 76, Wenatchee WA (M)

David Wender Library, see Museum of Holography - Chicago, Chicago IL

Wenham Museum, Wenham MA (A,L)

Wenrich Memorial Library, see Landmark Society of Western New York, Inc, Rochester NY

Wentworth Institute of Technology Library, Boston MA (L)

Wertz Art & Architecture Library, see Miami University, Oxford OH

Wesleyan College, Art Dept, Macon GA (S)

Wesleyan University, Davison Art Center, Middletown CT (M,A)

Wesleyan University, Dept of Art & Art History, Middletown CT (S)

Wesley Theological Seminary Henry Luce III Center for the Arts & Religion, Dadian Gallery, Washington DC (M)

West Baton Rouge Parish, West Baton Rouge Museum, Port Allen LA (M)

Westchester Art Workshop, see Westchester Community College, White Plains NY

Westchester Community College, Westchester Art Workshop, White Plains NY (S)

Westerly Public Library, Hoxie Gallery, Westerly RI (M)

Western Art Association, Ellensburg WA (A)

Western Carolina University, Dept of Art/College of Arts & Science, Cullowhee NC (S)

Western Colorado Center for the Arts, Inc, Grand Junction CO (A,L)

Western Connecticut State University, School of Visual & Performing Arts, Danbury CT (S)

Western Illinois University, Art Dept, Macomb IL (S)

Western Illinois University, Western Illinos University Art Gallery, Macomb IL (M)

Western Kentucky University, Art Dept, Bowling Green KY (S)

Western Maryland College, Dept of Art & Art History, Westminster MD (S)

Western Maryland College, Esther Prangley Rice Gallery, Westminster MD (M)

Western Michigan University, Dept of Art, Kalamazoo MI (S)

Western Michigan University, School of Art, Kalamazoo MI (M)

Western Nebraska Community College, Division of Language & Arts, Scottsbluff NE (S)

Western New Mexico University, Dept of Expressive Arts, Silver City NM (S)

Western Oklahoma State College, Art Dept, Altus OK (S)

Western Oregon State College, Creative Arts Division, Visual Arts, Monmouth OR (S)

Western Oregon University, Campbell Hall Gallery, Monmouth OR (M)

Western Pennsylvania Conservancy, Fallingwater, Mill Run PA (M)

Western Reserve Historical Society, Cleveland OH (M,L)

Western State College of Colorado, Dept of Art & Industrial Technology, Gunnison CO (S)

Western State College of Colorado, Quigley Hall Art Gallery, Gunnison CO (M)

Western Washington University, Art Dept, Bellingham WA (S)

Western Washington University, Viking Union Gallery, Bellingham WA (M)

Western Wisconsin Technical College, Graphics Division, La Crosse WI (S)

Western Wyoming Community College, Art Dept, Rock Springs WY (S)

Westfield Athenaeum, Jasper Rand Art Museum, Westfield MA (M)

Westfield State College, Art Dept, Westfield MA (S)

West Florida Historic Preservation, Inc, T T Wentworth, Jr Florida State Museum & Historic Pensacola Village, Pensacola FL (M)

West Hills Community College, Fine Arts Dept, Coalinga CA (S)

West Hills Unitarian Fellowship, Doll Gardner Art Gallery, Portland OR (A)

West Liberty State College, Div Art, West Liberty WV (S)

Westminster College, Art Dept, New Wilmington PA (S)

Westminster College, Art Gallery, New Wilmington PA (M)

Westminster College, Winston Churchill Memorial & Library in the United States, Fulton MO (M)

Westminster College of Salt Lake City, Dept of Arts, Salt Lake City UT (S)

Westmoreland Museum of American Art, Greensburg PA (M,L)

Westover, Charles City VA (M)

West Point Museum, see United States Military Academy, West Point NY

Westport Public Library, Westport CT (L)

West Shore Community College, Division of Humanities & Fine Arts, Scottville MI (S)

West Texas A&M University, Art, Communication & Theatre Dept, Canyon TX (S)

West Valley College, Art Dept, Saratoga CA (S)

West Virginia Institute of Technology, Creative Arts Dept, Montgomery WV (S)

West Virginia State College, Art Dept, Institute WV (S)

West Virginia University at Parkersburg, Art Dept, Parkersburg WV (S)

West Virginia University, College of Creative Arts, Morgantown WV (S)

West Virginia Wesleyan College, Art Dept, Buckhannon WV (S)

Wethersfield Historical Society Inc, Museum, Wethersfield CT (M,L)

Weyburn Arts Council, Allie Griffin Art Gallery, Weyburn SK (M)

Weyers-Sampson Art Gallery, see Thiel College, Greenville PA

Whalers Village Museum, Lahaina HI (M)

Wharton County Junior College, Art Dept, Wharton TX (S)

Whatcom Museum of History and Art, Bellingham WA (M,L)

Wheaton College, Art Dept, Norton MA (S)

Wheaton College, Dept of Art, Wheaton IL (S)

Wheaton Village Inc, Museum of American Glass, Millville NJ (M)

Wheeler Gallery, Providence RI (M)

Mary Cabot Wheelwright Research Library, see Wheelwright Museum of the American Indian, Santa Fe NM

Wheelwright Museum of the American Indian, Santa Fe NM (M,L)

Where Edmonton Community Artists Network Society, Harcourt House Arts Centre, Edmonton AB (M)

Whistler House Museum of Art, see Lowell Art Association, Inc, Lowell MA

White Columns, New York NY (M)

Whitefield House Museum, see Moravian Historical Society, Nazareth PA

White Gallery, see Mount Mercy College, Cedar Rapids IA

White House, Washington DC (M)

Whitman College, Art Dept, Walla Walla WA (S)

Whitney Library, see New Haven Colony Historical Society, New Haven CT

Whitney Museum of American Art, New York NY (M,L)

Whittier College, Dept of Art, Whittier CA (S)